THE PRINCETON
ENCYCLOPEDIA OF
CLASSICAL SITES

THE EDITORIAL PREPARATION OF THIS BOOK
WAS MADE POSSIBLE BY GRANTS FROM

Samuel H. Kress Foundation
The Andrew W. Mellon Foundation
National Endowment for the Humanities
Old Dominion Foundation

THE PRINCETON
ENCYCLOPEDIA OF
CLASSICAL SITES

RICHARD STILLWELL

EDITOR

William L. MacDonald

ASSOCIATE EDITOR

Marian Holland McAllister

ASSISTANT EDITOR

PRINCETON, NEW JERSEY

PRINCETON UNIVERSITY PRESS

1976

Published by Princeton University Press, Princeton, New Jersey
In the United Kingdom: Princeton University Press,
Guildford, Surrey

Library of Congress Cataloging in Publication Data
will be found on the last printed page of this book.

This book has been composed in Linotype Times Roman.

Printed in the United States of America
by Princeton University Press, Princeton, New Jersey

Map production and printing by
Rand McNally & Company

The description of the monuments in the entry on
Miletos by Gerhard Kleiner is a translation of
excerpts from his book *Die Ruinen von Milet* (1968)
and is included here with his permission and
the permission of the publisher,
Walter de Gruyter & Company, Berlin.

PREFACE

OUR AIM IN preparing this book has been to provide a one-volume source of information on sites that show remains from the Classical period. In delimiting the period, the mid eighth century B.C. was chosen as the upper terminus. This includes the period marking the expansion of Classical culture to the west, with the Hellenic colonization of Sicily and South Italy, and to the eastern shore of the Aegean. The lower terminus was more difficult to determine. In general the beginning of the sixth century of the Christian era seemed a suitable limit. Early Christian sites of the fourth and fifth centuries, while in many ways dependent on Classical antecedents, have not been included. The Note to the Reader preceding the text covers matters of editorial procedure.

Our Advisory Board joins us in extending thanks to the many scholars who helped in shaping and preparing this book. To the following we are indebted for help in selecting the sites, in assessing their importance, in suggesting authors, or in serving in other ways as editorial consultants: Jorge de Alarcao, Jacques Allain, Guy Barruol, Giovanni Becatti, A. Garcia y Bellido, Luigi Bernabò Brea, Maria-Louise Bernhard, Roger Billoret, Michel de Bouard, H. Brunsting, William A. Childs, Christophe Clairmont, Victorine von Gonzenbach Clairmont, Howard Comfort, Jacques Coupry, Siegfried J. De Laët, Paul Marie Duval, Robert W. Ehrich, Cevat Erder, Stephen Foltiny, Edmond Frezouls, Christian Goudineau, Michael Gough, Michel Labrousse, Jean Lassus, Marcel Le Glay, Lucien Lerat, Roland Martin, Gérard Nicolini, Rudolf Noll, T. S. Noonan, Michel Petit, Peter Petru, Kyle Phillips, Charles Pietri, Vladislav Popović, Friedrich Rakob, François Salviat, Hans Schönberger, Henri Seyrig, William Kelly Simpson, Ronald S. Stroud, Edit B. Thomas, Eugene Vanderpool, John B. Ward-Perkins, David R. Wilson, F. E. Winter. We owe to R. V. Schoder, S.J., among other helpful suggestions, the idea of limiting the book to the Classical period.

To the authors themselves we are grateful for helpful and understanding cooperation in bringing this work to fruition. They have signed their entries and their names are listed on pp. xi ff.

The editors wish to join Princeton University Press in thanking the foundations that have supported our editorial work. The Samuel H. Kress Foundation, the Andrew W. Mellon Foundation, the National Endowment for the Humanities, and the Old Dominion Foundation have all been generous both with original grants and with supplementary grants when it became apparent that our task was larger than expected. We at first thought that there would be about 2000 sites; in fact this volume contains entries on about 3000 sites by 375 authors written originally in nine languages but published here in English.

The editorial office was established at the Press, which administered the grants and which has been the sponsor of the project from the beginning. Harriet Anderson

of the staff of the Press first suggested the desirability of such a work as this. Her unflagging enthusiasm and ability in organizing the innumerable details involved in the publication have made our task as editors possible.

R. S.
W. L. MacD.
M. H. McA.

CONTENTS

Preface vii

List of Authors xi

Abbreviations

 ancient sources xvii

 books and periodicals xix

Note to the Reader 2

SITES 3

Glossary 1003

Note on the Maps 1010

Maps *24 pages following* 1010

Map Indexes 1011

LIST OF AUTHORS

DINU ADAMESTEANU, Soprintendenza alle Antichità della Basilicata, Potenza

EKREM AKURGAL, Ankara University

LESLIE ALCOCK, University of Glasgow

JOHN A. ALEXANDER, Georgia State University, Atlanta

N. ALFIERI, Istituto di Archeologia, Università degli Studi di Bologna

HUBERT L. ALLEN, University of Illinois, Urbana

ROBERT AMY, Centre National de la Recherche Scientifique, Aix-en-Provence

F. K. ANNABLE, Wiltshire Archaeological and Natural History Society, Devizes

ROBERT ARAMBOUROU, Centre National de la Recherche Scientifique, Dax

D. JAVIER ARCE, Instituto Español de Arqueologia, Madrid

PAUL ÅSTRÖM, Göteborg Universitet

DIETWULF BAATZ, Saalburgmuseum, Bad Homburg

ALBERTO BALIL, Universidad de Valladolid

L. BARKOCZI, Magyar Tudományos Akadémia, Budapest

ION BARNEA, L'Institut d'Archéologie, Bucharest

GUY BARRUOL, Direction des Antiquités Historiques du Languedoc-Roussillon, Montpellier

GEORGE BASS, American Institute of Nautical Archaeology, Philadelphia

CEVDET BAYBURTLUOĞLU, Klassik Arkeoloji Bölümü, Ankara

GEORGE E. BEAN, Lavenham, Suffolk

MALCOLM BELL, University of Virginia, Charlottesville

ANTONIO BELTRÁN MARTÍNEZ, Ciudad Universitaria, Zaragoza

J. L. BENSON, University of Massachusetts, Amherst

YVES BÉQUIGNON, Université de Strasbourg

GIOVANNA BERMOND MONTANARI, Soprintendenza alle Antichità, Bologna

MARIE-LOUISE BERNHARD, Instytut Archeologii, Uniwersytet Jagielloński, Krakow

LUISA BERTACCHI, Aquileia

JEAN-JACQUES BERTAUX, Musée de Normandie, Caen

LUIGI BESCHI, Istituto Universitario Orientale, Naples

J. D. BESTWICK, University of Manchester

MARTIN BIDDLE, Winchester Research Unit

WILLIAM R. BIERS, University of Missouri, Columbia

R. BILLORET, Université de Nancy

DAVID J. BLACKMAN, University of Bristol

J. M. BLAZQUEZ, Instituto Español de Arqueologia, Madrid

J.H.F. BLOEMERS, Rijksdienst voor het Oudheidkundig Bodemonderzoek, Amersfoort

ALAIN BLONDY, Office national d'information sur les enseignements et les professions, Ministère de l'Education Nationale, Paris

JOHN BOARDMAN, University of Oxford

PIERA BOCCI POCINI, Museo Archeologico di Firenze

J. FR. BOMMELAER, Université de Strasbourg

NICOLA BONACASA, Istituto di Archeologia, Università di Palermo

E. B. BONIS, Hungarian National Museum, Budapest

L. BONNAMOUR, Musée Denon, Chalon-sur-Saône

NANCY BOOKIDIS, American School of Classical Studies, Athens

GEORGE C. BOON, National Museum of Wales, Cardiff

JÜRGEN BORCHHARDT, Johann Wolfgang Goethe Universität, Frankfurt a. M.

CEDRIC BOULTER, University of Cincinnati

KEITH BRANIGAN, University of Bristol

OLWEN BROGAN, Cambridge, England

OSCAR T. BRONEER, University of Chicago

FRANK E. BROWN, American Academy in Rome

PHILIPPE BRUNEAU, Paris

VINCENT J. BRUNO, State University of New York at Binghamton

H. BRUNSTING, Vrije Universiteit, Archeologisch Instituut, Amsterdam

GIOVANNI BRUSIN, Museo Aquileia

HERMANN BULLINGER, Karl-Geib-Museum, Bad Kreuznach

CARMELA BUSCEMI INDELICATO, Istituto di Archeologia, Catania Università

CARLO CARDUCCI, Soprintendenza alle Antichità del Piemonte, Turin

PAUL CARTLEDGE, University of Dublin

JOHN L. CASKEY, University of Cincinnati

FERDINANDO CASTAGNOLI, Scuola Nazionale de Archeologia, Università di Roma

ALEKSANDRINA CERMANOVIĆ-KUZMANOVIĆ, Arheoloski Seminar, Belgrade

D. CHARLESWORTH, Department of the Environment, London

JEAN CHARMASSON, Direction Regionale des Antiquités Historique du Languedoc-Roussillon, Montpellier

JÜRGEN CHRISTERN, Deutsches Archaeologisches Institut, Athens

VALERIO CIANFARANI, Soprintendenza alle Antichità degli Abruzzi, Chieti

UMBERTO CIOTTI, Soprintendenza alle Antichità del Lazio, Rome

VICTORINE VON GONZENBACH CLAIRMONT, Princeton, New Jersey

A. J. CLARIDGE, Institute of Archaeology, London

MONIQUE CLAVEL-LÉVÊQUE, Université de Besançon

OLIVER COLBURN, Narberth, Pennsylvania

GIOVANNI COLONNA, Università di Bologna

Howard Comfort, Haverford College

Baldassare Conticello, Soprintendenza alle Antichità del Lazio, Rome; Museo Nazionale Archeologico di Sperlonga

Frederick A. Cooper, University of Minnesota, Minneapolis

J. Coquet, Abbaye Saint-Martin, Ligugé

William D. E. Coulson, University of Minnesota, Minneapolis

J. J. Coulton, University of Edinburgh

Paul Courbin, École des Hautes Études, Paris

Mauro Cristofani, Università di Pisa

Barry Cunliffe, Institute of Archaeology, University of Oxford

H. Cüppers, Rheinisches Landesmuseum, Trier

Amalia Curcio, Soprintendenza alle Antichità, Syracuse

S. Dakaris, University of Ioannina

Charles M. Daniels, University of Newcastle upon Tyne

François Daumas, Université Paul Valéry, Montpellier

Alfredo De Agostino, Soprintendenza alle Antichità dell'Etruria, Rome

Jorge de Alarcão, Instituto de Arqueologia, Universidad de Coimbra

Jacques Debal, Société Archéologique et Historique de l'Orléanais, Orléans

Alfonso De Franciscis, Soprintendenza alle Antichità, Naples

Siegfried J. de Laët, Rijksuniversiteit, Gent

Maria Del Campo, Soprintendenza alle Antichità, Syracuse

Mario A. Del Chiaro, University of California, Santa Barbara

Jean Deneauve, Centre National de la Recherche Scientifique, Institut d'Archéologie, Aix-en-Provence

Pedro de Palol, Universidad de Barcelona

Jean-Michel Desbordes, Direction Regional des Antiquités Historiques de Picardie, Amiens

A. P. Detsicas, Kent Archaeological Society

Paul Deussen, Michigan State University, East Lansing

B. Devauges, Direction des Antiquités de Bourgogne, Ministère des Affaires Culturelles, Dijon

Ferdinand Jozef De Waele, Katholieke Universiteit, Nijmegen; State University, Gent

D. de Weerd, Instituut voor Prae- en Protohistorie, Universiteit van Amsterdam

Antonino Di Vita, Istituto di Archeologia, Università di Macerata

M. A. Dollfus, La Société Nationale des Antiquaires de France, Paris

O. Doppelfeld, Romisch-Germanisches Museum, Cologne

Emilia Dorutiu-Boila, Institutul de Arheologie, Bucharest

Pierre Ducrey, University of Lausanne

André Dumoulin, Musée de Cavaillon, Vaucluse

Pierre Dupuy, Touring Club de France, Limoges

C. William J. Eliot, American School of Classical Studies, Athens

Gabrielle Emard, Bordeaux; Groupe Archéologique du T.C.F., Paris

Abdelmajid Ennabli, Institut National d'Archéologie et d'Arts, Tunis

Kenan Erim, New York University

Robert Etienne, Université de Bordeaux, Talence

Maurice Euzennat, Institut Français d'Archéologie Méditerranéenne, Aix-en-Provence

Fr. Eygun, Monterre-sur-Blourde

Concepción Fernández-Chicarro, Museo Arqueológico Hispalense, Seville

P.-A. Février, Université de Provence, Aix-en-Provence

Philipp Filtzinger, Württembergisches Landesmuseum, Stuttgart

Silvana Finocchi, Soprintendenza alle Antichità per il Piemonte, Torino

Nezih Firatli, Archaeological Museum of Istanbul

U. Fischer, Museum für Vor- und Frühgeschichte, Frankfurt a. M.

Jenö Fitz, István Király Múzeum, Székesfehérvár

Robert Fleischer, Österreichisches Archäologisches Institut, Universität, Vienna

Domingo Fletcher, Servicio de Investigacion Prehistorica, Valencia

Michel Fleury, École pratique des Hautes Études, Paris

Bruna Forlati Tamaro, Soprintendenza alle Antichità delle Venezie

Pierre-Fr. Fournier, Clermont-Ferrand

Aileen Fox, University of Exeter

Alison Frantz, American School of Classical Studies, Athens

S. S. Frere, All Souls College, University of Oxford

Edmond Frézouls, Direction régionale des Antiquités Historiques de Campagne-Ardenne, Chalons sur Marne

M. Fritsch, Chatellerault

Antonio Frova, Soprintendenza alle Antichità, Genoa

Werner Fuchs, Archäologisches Seminar der Universität, Domplatz

F. Fülep, Magyar Nemzeti Múzeum, Musée Nationale de Hongrie, Budapest

C. Gabet, Société de Géographie, Rochefort-sur-Mer

Hubert Gallet de Santerre, Université Paul Valéry, Montpellier

Jochen G. Garbsch, Praehistorische Staatssammlung, Munich

Marc Gauthier, Direction des Antiquités Historiques d'Aquitaine, Bordeaux

Maria Gavrili, Archaeological Society, Athens

Michel Gayraud, Université Paul Valéry, Montpellier

Gino Vinicio Gentili, Soprintendenza alle Antichità dell'Emilia e della Romagna, Bologna

CAIROLI F. GIULIANI, Istituto di Topografia Antica, Università degli Studi, Rome

BARBARA GOSS, Rome

CHRISTIAN GOUDINEAU, Université de Provence, Aix-en-Provence

MICHAEL GOUGH, Pontifical Institute of Mediaeval Studies, Toronto (deceased)

H. S. GRACIE, Gloucester

J. WALTER GRAHAM, University of Toronto (emeritus)

PIERRE GROS, École Française de Rome

PIER GIOVANNI GUZZO, Soprintendenza alle Antichità della Calabria, Reggio Calabria

J. K. HAALEBOS, Instituut voor Oude Geschiedenis en Archeologie, Katholieke Universiteit, Nijmegen

N.G.L. HAMMOND, University of Bristol

GEORGE M. A. HANFMANN, Harvard University

RICHARD P. HARPER, Dumbarton Oaks Center for Byzantine Studies, Washington, D.C.

A. C. HARRISON, Kent Archaeological Society, The Museum, Maidstone

R. M. HARRISON, University of Newcastle upon Tyne

K. F. HARTLEY, The University, Leeds

MAX G. HEBDITCH, Guildhall Museum, Museum of London

B. HOBLEY, Herbert Art Gallery and Museum, Coventry

R. ROSS HOLLOWAY, Brown University, Providence

ERIK J. HOLMBERG, Göteborg University

CLARK HOPKINS, University of Michigan, Ann Arbor

M. HUGONIOT, Musée, St.-Amand-Montrond

MARK REGINALD HULL, Colchester Museum (emeritus)

GEORGE LEONARD HUXLEY, The Queen's University of Belfast

LUIS G. IGLESIAS, Instituto Español de Arqueologia, Madrid

JALE İNAN, Istanbul

CLASINA ISINGS, Archaeologisch Instituut der Rijksuniversiteit, Utrecht

T. W. JACOBSEN, Indiana University, Bloomington

MICHAEL H. JAMESON, University of Pennsylvania, Philadelphia

MICHAEL G. JARRETT, University College, Cardiff

GEORGE JOBEY, University of Newcastle upon Tyne

RENÉ JOFFROY, Musée des Antiquités Nationales, Saint-Germain-en-Laye

WERNER JOHANNOWSKY, Soprintendenza alle Antichità, Naples

G.D.B. JONES, University of Manchester

RAYMOND KAPPS, Auxerre

HANS-JÖRG KELLNER, Prähistorische Staatssammlung, Munich

KATHLEEN M. KENYON, British School of Archaeology in Jerusalem

M. KLEFSTAD-SILLONVILLE, Bordeaux

GERHARD KLEINER, Johann Wolfgang Goethe Universität, Frankfurt a. M.

A. KOLLING, Staatliches Konservatoramt, Saarbrücken

NIKOLAOS KONTOLEON, University of Athens

GEORGE STYL. KORRÈS, University of Athens

MICHEL LABROUSSE, Université de Toulouse-Le Mirail

JEAN LACHASTRE, Musée d'Harfleur, Le Havre

B. LACROIX, Domecy-sur-Cure

ADRIANO LA REGINA, Istituto di Archeologia, Università di Perugia

JEAN LASSUS, Centre National de la Recherche Scientifique, Institut d'Archéologie, Aix-en-Provence

J. LAUFFRAY, Centre Franco-Égyptien d'Études d'Archéologie et d'Architecture des Temples de Karnak, Luxor

CLELIA LAVIOSA, Soprintendenza Antichità, Florence

DIMITRIOS LAZARIDES, Athens

J. LE GALL, L'Hay-les-Roses

MARCEL LE GLAY, Université de Paris

PHYLLIS WILLIAMS LEHMANN, Smith College, Northampton; Institute of Fine Arts, New York University

CHARLES LELONG, Tours

PIERRE LEMAN, Direction des Antiquités Historiques de la Region Nord Pas-de-Calais, Lille

MICHEL LE PESANT, Archives Nationales, Paris

LUCIEN LERAT, Université de Besançon

CHRISTIAN LE ROY, Université de Caen

BARBARA LEVICK, University of Oxford

GUY LINTZ, Gare de Gimel, Corrèze

FELICE GINO LO PORTO, Soprintendenza alle Antichità della Puglia, Taranto

IRIS CORNELIA LOVE, Long Island University, Brookville

MARCEL LUTZ, Centre National de la Recherche Scientifique, Paris

MARIAN HOLLAND MCALLISTER, American School of Classical Studies, Athens

JAMES R. MCCREDIE, American School of Classical Studies, Athens; New York University

WILLIAM L. MACDONALD, Smith College, Northampton

PIERRE A. MACKAY, University of Washington, Seattle

THEODORA S. MACKAY, University of Washington, Seattle

PAUL MACKENDRICK, University of Wisconsin, Madison

JUAN MALUGUEUR DE MOTES, Universidad de Barcelona

DORICA MANCONI, Rome

M. MANGARD, Direction des Antiquités Historiques de Haute-Normandie, Rouen

J. C. MANN, University of Durham

W. H. MANNING, University College, Cardiff

GUIDO A. MANSUELLI, Istituto di Archeologia, Università di Bologna

JEAN MARCILLET-JAUBERT, Institut F. Courby, Université de Lyon

LUCIA MARINESCU-ȚEPOSU, Muzeul de Istorie al R.S. România, Bucharest

R. MARTIN, Université Panthéon Sorbonne, Paris

RICHARD S. MASON, University of North Carolina, Chapel Hill

RAYMOND A. MAUNY, Sorbonne, Paris

LOUIS MAURIN, Institut d'Histoire, Université de Bordeaux

RUSSELL MEIGGS, Balliol College, University of Oxford

MACHTELD J. MELLINK, Bryn Mawr College

JOZEF R. MERTENS, University of Louvain

ALDO MESSINA, Università di Catania

STELLA GROBEL MILLER, Stanford University

PAOLINO MINGAZZINI, Rome

STEPHEN MITCHELL, Christ College, University of Oxford

TERENCE B. MITFORD, Fife

VERONIKA MITSOPOULOU-LEON, Österreichisches Archäologisches Institut, Athens

GIORGIO MONACO, Bologna

J.-H. MOREAU, Rochechouart

JEAN-PAUL MOREL, Université de Besançon

HENRI GEORGES MORESTIN, Université d'Avignon

GEORGES MYLONAS, American School of Classical Studies, Athens

ERNEST NASH, American Academy in Rome (deceased)

RUDOLF NAUMANN, Deutsches Archäologisches Institut, Istanbul

ABRAHAM NEGEV, Hebrew University of Jerusalem

KYRIAKOS NICOLAOU, Cyprus Museum, Nicosia

GÉRARD NICOLINI, Université de Poitiers

ROLF NIERHAUS, Seminar für Alte Geschichte der Universität, Freiburg

RUDOLF NOLL, University of Vienna

T. S. NOONAN, University of Minnesota, Minneapolis

PIERO ORLANDINI, Università Statale, Milan

CARL ERIC ÖSTENBERG, Swedish Institute for Classical Studies, Rome

MICHAEL OWEN, Roman Baths and Museum, Bath

VENTURINO PANEBIANCO, Direzione dei Musei Provinciali, Salerno

J. C. PAPINOT, Direction des Antiquités Historiques de la région Poitou-Charentes, Poitiers

MILTIS PARASKEVAÏDIS, Athens

FRANCA PARISE BADONI, Ufficio Centrale del Catalogo, Rome

VELJKO PAŠKVALIN, Zemaljski muzej Sarajevo, Bosnia and Hercegovina

PAOLA PELAGATTI, Soprintendenza alle Antichità della Sicilia Orientale, Syracuse

MANUEL PELLICER CATALÁN, Universidad de la Laguna, Tenerife

E. G. PEMBERTON, University of Maryland, College Park

JEAN PERRIER, Limoges

D. F. PETCH, Grosvenor Museum, Chester

MICHEL PETIT, Direction des Antiquités Historiques, Ministère des Affaires Culturelles, Paris

PETAR PETROVIĆ, Archeological Institute, Belgrade

PHOTIOS PETSAS, University of Ioannina

P. PEYRE, Centre National de la Recherche Scientifique, Chirac

KYLE MEREDITH PHILLIPS, JR., Bryn Mawr College

GILBERT CHARLES PICARD, Circonscription Archéologique du Centre, Ministère des Affaires Culturelles, Versailles

OLIVIER PICARD, University of Paris

MARIA GRAZIA PICOZZI, Istituto di Archeologia, Università di Roma

CHARLES PIETRI, Direction des Antiquités Historiques, Pas-de-Calais

CHRISTIAN PILET, Université de Caen

DANICA PINTEROVIĆ, Centar za znanstveni rad Jugoslavenske akademije, Osijek

DIONIS M. PIPPIDI, Institut d'Archéologie, Bucharest

JOSEPH M. PIVETEAU, Angoulême (deceased)

DIETER PLANCK, Landesdenkmalamt Baden-Württemberg-Zentralstelle Abt. Bodendenkmalpflege, Stuttgart

ERNEST PLANSON, Chantier National des Fouilles Archéologiques des Bolards, Dijon

SZ. K. POCZI, Budapest

CHARLES E. POTUT, Charmant; Groupe d'Archéologie Antique du T.C.F., Paris

JEAN-CLAUDE POURSAT, Université de Clermont-Ferrand

JAMES B. PRITCHARD, University Museum, University of Pennsylvania, Philadelphia

MICHEL PY, Centre Archéologique de Vaunage, Depot Archéologique, Caveirac

S. QUILICI GIGLI, Centro di Studio per l'Archeologia Etrusco-Italica, Rome

ALADAR RADNOTI, Universität Frankfurt a. M.

FROELICH RAINEY, University Museum, University of Pennsylvania, Philadelphia

WILHELM W. REUSCH, Rheinisches Landesmuseum, Trier

JEAN-PAUL REY-COQUAIS, Université de Dijon

L. RHODES, Gloucester Museum

JEAN-CLAUDE M. RICHARD, Centre National de la Recherche Scientifique, Montpellier

EMELINE RICHARDSON, University of North Carolina, Chapel Hill

LAWRENCE RICHARDSON, JR., Duke University, Durham

GISELA M. A. RICHTER, Rome (deceased)

BRUNILDE S. RIDGWAY, Bryn Mawr College

P. J. RIIS, Institute of Classical and Near Eastern Archaeology, University of Copenhagen

A.L.F. RIVET, University of Keele

GIOVANNI RIZZA, Istituto di Archeologia, Università di Catania

LOUIS ROBERT, Collège de France et École des Hautes Études, Paris

MARIO MIRABELLA ROBERTI, Istituto di Archeologia, Università degli Studi di Trieste, Milan

ANNE S. ROBERTSON, Hunterian Museum,
 University of Glasgow
HENRY S. ROBINSON, American School of
 Classical Studies, Athens
PAUL ROESCH, Institut Fernand-Courby,
 Université de Lyon
JOSÉ MANUEL ROLDÁN HERVÁS, Universidad
 de Granada
CLAUDE ROLLEY, Université de Dijon
GEORGES ROUX, L'École Française d'Athènes;
 l'Université de Lyon
JAMES RUSSELL, University of British
 Columbia, Vancouver
EDWARD TOGO SALMON, McMaster University,
 Hamilton
FRANÇOIS SALVIAT, Aix-en-Provence
VALNEA SANTAMARIA, Soprintendenza alle
 Antichità di Roma
JAROSLAV ŠAŠEL, Slovenska Akademija
 Znanosti in Umetnosti, Ljubljana
BIANCA MARIA SCARFI, Soprintendenza alle
 Antichità, Padua
DANIEL C. SCAVONE, Indiana State University,
 Evansville
JÖRG SCHÄFER, Universität Heidelberg
DEMETRIUS U. SCHILARDI, Princeton University
R. SCHINDLER, Rheinisches Landesmuseum, Trier
RAYMOND V. SCHODER (S.J.), Loyola
 University, Chicago
HANS SCHÖNBERGER, Römisch-Germanische
 Kommission des Deutschen Archäologischen
 Instituts, Frankfurt a. M.
HELMUT SCHOPPA, Der Landesarchäologe von
 Hessen, Wiesbaden
GIACOMO SCIBONA, Istituto d'Archeologia,
 Università di Messina
JANE AYER SCOTT, Harvard University,
 Cambridge
ROBERT L. SCRANTON, University of Chicago
GIOVANNA SCROFANI, Soprintendenza alle
 Antichità, Syracuse
J. B. SEGAL, University of London
ÜMIT SERDAROĞLU, Ankara University
P. C. SESTIERI, Museo Preistorico Etnografico
 Luigi Pigorini, Rome
IONE MYLONAS SHEAR, American School of
 Classical Studies, Athens (Agora Excavations)
SAMY SHENOUDA, Alexandria University
JEAN-MAURICE SIMON, Avallon
ANDRÉ SIRAT, Centre de Recherches Historiques
 et Archéologiques de Bort Margerides,
 Bort-les-Orgues
HEDI SLIM, Institut d'Archéologie et d'Art
 Tunisien, Tunis
JOCELYN PENNY SMALL, Dartmouth College,
 Hanover
DAVID J. SMITH, University of Newcastle
 upon Tyne
YVES SOLIER, Centre National de la Recherche
 Scientifique, Institut d'Archéologie, Montpellier
PAOLO SOMMELLA, Istituto Topografia Antica,
 Università di Roma
S. SOPRONI, Magyar Nemzeti Múzeum, Budapest

R. SOULIGNAC, Groupe Archéologique du
 T.C.F., Paris
GEORGES SOUVILLE, Institut Français
 d'Archéologie Méditerranéenne,
 Aix-en-Provence
S. C. STANFORD, Birmingham University
I. M. STEAD, British Museum, London
K. A. STEER, The Royal Commission on the
 Ancient & Historical Monuments of Scotland,
 Edinburgh
RICHARD STILLWELL, Princeton University
 (emeritus)
B. H. STOLTE, Katholieke Universiteit, Nijmegen
RONALD S. STROUD, University of California,
 Berkeley
TIHAMÉR SZENTLÉLEKY, Museum of Fine Arts,
 Budapest
O. TAFFANEL, Centre National de la Recherche
 Scientifique, Mailhac
ANNA TALOCCHINI, Soprintendenza alle
 Antichità, Florence
RAMÓN TEJA, Universidad de Salamanca
C. M. TERNES, Centre Alexandre-Wiltheim,
 Universitaire de Luxembourg
EDIT B. THOMAS, Magyar Nemzeti Múzeum
 Budapest
F. H. THOMPSON, Society of Antiquaries of
 London
R. THOUVENOT, Poitiers
J. L. TOBIE, Bordeaux
MALCOLM TODD, University of Nottingham
MARIO TORELLI, Università di Cagliari
JOHN TRAVLOS, American School of Classical
 Studies, Athens
JAN A. TRIMPE BURGER, State Service for
 Archaeological Investigations in the
 Netherlands, Amersfoort
KLAUS TUCHELT, Deutsches Archäologisches
 Institut, Istanbul
DUMITRU TUDOR, Université de Bucharest
VINCENZO TUSA, Soprintendenza alle Antichità,
 Palermo
G. ULBERT, Institut für Vor- und Frühgeschichte
 Abt. f. Provinzialrömische Archäologie,
 Munich
GEORGES VALLET, École Française de Rome
EUGENE VANDERPOOL, American School of
 Classical Studies, Athens
VELIZAR VELKOV, Archaeological Institut, Sofia
HUGHES VERTET, Centre National de la
 Recherche Scientifique, Yzeure
MICHAEL VICKERS, Ashmolean Museum,
 University of Oxford
FRANÇOIS VILLARD, École Française de Rome
LICIA VLAD BORRELLI, Direzione Generale
 Antichità e Belle Arti, Rome
HARALD VON PETRIKOVITS, Rheinisches
 Landesmuseum, Bonn (emeritus)
OTTO-WILHELM VON VACANO,
 Eberhard-Karls-Universität, Tübingen
GUISEPPE VOZA, Soprintendenza alle Antichità
 della Siracusa Orientale
HELEN WACE, Athens
JOHN S. WACHER, University of Leicester

M. B. WALLACE, University College, Toronto

J. B. WARD-PERKINS, British School at Rome

HANS WEBER, Universität Freiburg/Breisgau, Freiburg

GRAHAM WEBSTER, University of Birmingham

WILLIAM J. WEDLAKE, Bath

SAUL S. WEINBERG, University of Missouri, Columbia

ANNE WEIS, Ph.D. Candidate, Bryn Mawr College

MICHAEL R. WERNER, Pennsylvania State University, University Park

DONALD WHITE, University Museum, University of Pennsylvania, Philadelphia

J. B. WHITWELL, York Archaeological Trust

DONALD N. WILBER, Princeton, New Jersey

JOHN PETER WILD, University of Manchester

J. J. WILKES, Institute of Archaeology, London

CHARLES KAUFMAN WILLIAMS II, American School of Classical Studies, Athens

G. F. WILLMOT, Yorkshire Museum

D. R. WILSON, University of Cambridge

F. E. WINTER, University of Toronto

JAMES R. WISEMAN, Boston University

DANIEL E. WOODS, Manhattanville College, Purchase

HENNING WREDE, University of Munich

WILLIAM FRANK WYATT, JR., Brown University, Providence

RICHARD ERNEST WYCHERLEY, University College of North Wales, Bangor

N. YALOURIS, National Museum, Athens

JOHN H. YOUNG, The Johns Hopkins University, Baltimore

RODNEY S. YOUNG, University Museum, University of Pennsylvania, Philadelphia (deceased)

MAURICE YVART, Lillebonne, France

EBERHARD KUNO ZAHN, Rheinisches Landesmuseum, Trier

MARIN ZANINOVIĆ, Zagreb University

FAUSTO ZEVI, Soprintendenza Antichità di Ostia, Rome

LJUBICA ZOTOVIĆ, Arheološki Institut, Belgrade

ABBREVIATIONS

ANCIENT SOURCES

Ael.: Aelianus
 NA: *De natura animalium*
 VH: *Varia Historia*
Aesch. *In Ctes.*: Aeschines, *Against Ctesiphon*
Amm. Marc.: Ammianus Marcellinus
Amp. *Lib. Mem.*: Ampelius, *Liber Memoralis*
Anon. Ravenna, see *Rav. Cosm.*
Ant. It., see *It. Ant.*
Apollod. *Bibl.*: Apollodorus, *Bibliotheca*
App.: Appian
 BCiv.: *The Civil Wars*
 Hann.: *The Hannibalic Wars*
 Hisp. or *Iber.*: *The Wars in Spain*
 Ill.: *The Illyrian Wars*
 Mith.: *The Mithridatic Wars*
Apul. *Met.*: Apuleius, *Metamorphoses*
Arist.: Aristotle
 Ath. Pol.: *The Athenian Constitution*
 Meteor.: *Meteorologica*
 Oec.: *Oeconomica*
 Pol.: *Politica*
Arn. *Adv. Nat.*: Arnobius, *Adversus Nationes*
Arr. *Anab.*: Arrian, *Anabasis*
Ath. *Deip.*: Athenaeus, *Deipnosophists*
Aur. Vict. *Epit. de Caes.*: Aurelius Victor,
 Epitome de Caesaribus
Auson.: Ausonius
 Mos.: *Mosella*
 Ordo Nob.: *Ordo Nobilium Urbium*
Avien. *Or. Mar.*: Avienus, *Ora Maritima*

BAlex.: *Bellum Alexandrinum*

Caes. *BCiv.*: Caesar, *Bellum Civile*
Cass. Dio: Cassius Dio
Cassiod. *Var.*: Cassiodorus, *Variae*
Cic.: Cicero (Marcus Tullius)
 ad Brut.: *Epistulae ad Brutum*
 Arch.: *Pro Archia*
 Att.: *Epistulae ad Atticum*
 Balb.: *Pro Balbo*
 Cael.: *Pro Caelio*
 Cat.: *In Catilinam*
 Clu.: *Pro Cluentio*
 Div.: *De Divinatione*
 Fam.: *Epistulae ad Familiares*
 Flac.: *Pro Flacco*
 Font. or *Pro. Font.*: *Pro Fonteio*
 Har. Resp.: *De Haruspicum Responso*
 Nat. D. or *ND*: *De Natura Deorum*
 Phil.: *Orationes Philippicae*
 Planc.: *Pro Plancio*
 Quinct.: *Pro Quinctio*
 Sest.: *Pro Sestio*
 Sull.: *Pro Sulla*
 Verr.: *In Verrem*

Claud.: Claudianus
 Cons. Hon.: *De consulatu Honorii*
 De bello Gild.: *De bello Gildonico*
 Bell. Goth.: *De bello Gothico*

Dem. *De Cor.*: Demosthenes, *De Corona*
 Lacrit.: *Against Lacritus*
 Lept.: *Against Leptines*
Dio Chrys. *Or.*: Dio Chrysostomus, *Orationes*
Diod. or Diod. Sic.: Diodorus Siculus
Diog. Laert.: Diogenes Laertius
Dion. Hal.: Dionysius Halicarnassensis
Dionys. Per.: Dionysius Periegeta
 Ant. Rom.: *Antiquitates Romanae*
D.S., see Diod. Sic.

Etym. Magn.: *Etymologicum Magnum*
Eur.: Euripides
 Alc.: *Alcestis*
 IT: *Iphigenia Taurica*
Euseb.: Eusebius
 Chron.: *Chronica*
Eust. ad Dion.: Eustathius, *Commentarii in
 Dionysii*
 Il.: *ad Iliadem*
Eutrop.: Flavius Eutropius

FGrH: F. Jacoby, *Fragmente der
 griechischen Historiker*
FHG: C. Müller, *Fragmenta Historicorum
 Graecorum* (1841-70)
Festus, *Gloss. Lat.*: W. M. Lindsay, *Glossaria
 Latina*, IV (2d ed. of Festus)
Frontin.: Frontinus
 Aq.: *De aquae ductu urbis Romae*
 Str.: *Strategemata*

GGM: C. Müller, *Geographici Graeci
 Minores* (1855-61)
Gell. *NA*: Aulus Gellius, *Noctes Atticae*
Gram. Lat.: H. Keil, *Grammatici Latini*

Hdt.: Herodotos
Hell. Oxy.: *Hellenica Oxyrhynchia*
Herodianus, *Pros.*: Herodianus, *Prosodia
 catholica*
Hes. *Theog.*: Hesiod, *Theogonia*
Hippol. *Haer*: Hippolytus, *Refutatio omnium
 Haeresium*
Hom. *Il.*: Homer, *Iliad*
Hor.: Horace
 Carm.: *Carmina*
 Carm. Saec.: *Carmen Saeculare*
 Sat.: *Satirae*

It. Ant.: Itineraria Antonini Augusti
It. Burd.: Itinerarium Burdigalense

Joseph.: Josephus
 AJ: Antiquitates Judaicae
 BJ: Bellum Judaicum
 Vit.: Vita
Julian.: Julianus Imperator
 Epist.: Epistulae
Just. Epit.: Justinus, Epitome

Lactant. De Mort. pers.: Lactantius,
 De mortibus persecutorum
Lib. Colon.: Libri coloniarum
Livy, Epit.: Livy, Epitomae
 Per.: Periochae
Lucan, Phars.: Lucan, De Bello Civili
 (or "The Pharsalia")
Lucian, Alex.: Lucian, Alexander
 Hist. conscr.: Quomodo Historia
 conscribenda sit
Lycoph. Alex.: Lycophron, Alexandra

Macrob. Sat.: Macrobius, Saturnalia

Nic. Ther.: Nicander, Theriaca
Nicol. Damsc.: Nicolaus Damascenus
Nonnus, Dion.: Nonnus, Dionysiaca
Not. Dig. occ. or or.: Notitia dignitatum in
 partibus Occidentis or Orientis
Not. Gall.: Notitia Galliarium

Oros.: Orosius
Ov.: Ovid
 Am.: Amores
 Ars Am.: Ars Amatoria
 Met.: Metamorphoses
 Pont.: Epistulae ex Ponto

Paus.: Pausanias
Philostr.: Philostratus
 Imag.: Imagines
 VA: Vita Apollonii
 VS: Vitae Sophistarum
Pind.: Pindar
 Ol.: Olympian Odes
 Pyth.: Pythian Odes
Pl. Min.: Plato, Minos
Plin.: Pliny (the Elder)
 HN: Naturalis Historia
Plin.: Pliny (the Younger)
 Ep.: Epistulae
 Pan.: Panegyricus
Plut.: Plutarch
 Mor.: Moralia
 Conv. Sept. Sap.: Convivium Septem
 Sapientium
 De def. or.: De defectu oraculorum
 De mul. vir.: De mulierum virtutibus
 Quaest. conv.: Quaestiones convivales
 Vit.: Vitae Parallelae
 Ages.: Agesilaus

Alex.: Alexander
Ant.: Antonius
Arat.: Aratus
Cam.: Camillus
Cic.: Cicero
Dem.: Demosthenes
Flam.: Flamininus
Pel.: Pelopidas
Per.: Pericles
Pomp.: Pompeius
Pyrrh.: Pyrrhus
Sert.: Sertorius
Sull.: Sulla
Them.: Themistokles
Thes.: Theseus
Tim.: Timoleon
Pol. Hist.: Pollio, Historia
Poll.: Pollux
Polyaenus, Strat.: Polyaenus, Strategemata
Polyb.: Polybios
Prisc. Inst.: Priscian, Instituto de arte
 grammatica
Procop.: Procopius Caesariensis
 De Aed.: De Aedificiis
 Goth.: De Bello Gothico
 Vand.: De Bello Vandalico
Prop.: Propertius
Prudent. c. Symm.: Prudentius, contra
 Symmachum
Ptol. Geog.: Ptolemaeus, Geographia

Rav. Cosm.: Cosmographia Anonymi
 Ravennatis
Rut. Namat.: Rutilius Namatianus, De Reditu

S.H.A.: Scriptores Historiae Augustae
Hadr.: Hadrianus
 Tyr. Trig.: Tyranni Triginta
Sall.: Sallust
 Cat.: Bellum Catilinae or De Catilinae
 coniuratione
 H.: Historiae
Schol. Dan.: Scholia Danielis
Scymn.: Scymnus
Sen.: Seneca (the Younger)
 Ep.: Epistulae
 QNat.: Quaestiones Naturales
Serv. Aen.: Servius, In Aeneidem
Sid. Apoll. Carm.: Sidonius Apollinaris,
 Carmina
Sil. (or Sil. It.) Pun.: Silius Italicus, Punica
Solin.: Solinus
Soph.: Sophocles
 Ant.: Antigone
 Oed. Tyr.: Oedipus Tyrannus
Stad.: Stadiasmus
Stat.: Statius
 Silv.: Silvae
 Theb.: Thebais
Steph. Byz.: Stephanos Byzantios or Byzantinos
Strab.: Strabo
Suet.: Suetonius
 Aug.: Divus Augustus

Calig.: *Gaius Caligula*
 Gram.: *De Grammaticis*
 Ner.: *Nero*
 Tib.: *Tiberius*
 Vesp.: *Vespasianus*
 Vit.: *Vitellius*

Tac.: Tacitus
 Agr.: *Agricola*
 Ann.: *Annales*
 Germ.: *Germania*
 Hist.: *Historiae*
Theophr. Hist. Pl.: Theophrastus, *Historia*
 Plantarum
Thuc.: Thucydides

Tzetz. Chil.: Tzetzes, *Historiarum variarum*
 Chiliades

Val. Max.: Valerius Maximus
Varro, Ling.: Varro, *De Lingua Latina*
 Rust.: *De Re Rustica*
Vell. Pat.: Velleius Paterculus
Verg.: Virgil
 Aen.: *Aeneid*
 G.: *Georgics*

Xen.: Xenophon
 Hell.: *Hellenica*
 Vect.: *De Vectigalibus*

Zonar.: Zonaras

Books and Periodicals

AA: Archäologischer Anzeiger (in Jahrbuch des
 deutschen archäologischen Instituts, Berlin)
AAA: Athens Annals of Archaeology
AAES: Publications of an American
 Archaeological Expedition to Syria
AASOR: Annual of the American School of
 Oriental Research
AB: Art Bulletin
Abh: Abhandlungen (followed by name of
 academy, abbreviated, e.g. AbhBerl)
ABV: J. D. Beazley, Attic Black-figure
 Vase Painters
ACRMI: Analele Academiei Române.
 Memoriile Secţiunii Istorice
ActaA: Acta Archaeologica, Copenhagen
AdI: Annali dell'Istituto di corrispondenza
 archeologica
A.E., see AEpigr
AEArq: Archivo Español de Arqueología
AEM: Archäologisch-epigraphische
 Mitteilungen aus Oesterreich (-Ungarn)
AEpigr: L'Année épigraphique
Africa: Revue de l'Institut National
 d'Archéologie et d'Art de Tunis
AJA: American Journal of Archaeology
AM, see AthMitt
AMSEAEP: Actas y Memorias de la Sociedad
 Española de Antropoligia, Etnografia y
 Prehistoria, Madrid
AnatSt: Anatolian Studies presented to
 Sir W. M. Ramsay
AnEpigr, see AEpigr
AnnArchBrux: Annales de la Société r.
 d'Archéologie de Bruxelles
Ann. Athen., see AAA
AnnLiv: Annals of Archaeology and
 Anthropology, Liverpool
Annuario: Annuario d. Scuola archeologica
 di Atene
ANSMN: American Numismatic Society,
 Museum Notes
AntAth: J. Stuart & N. Revett, The Antiquities
 of Athens (1762, suppl. 1830)
AntCl: L'Antiquité classique

AntDenk: Antike Denkmäler
AntJ: Antiquaries' Journal
AntK: Antike Kunst
AnzSchweiz: Anzeiger für schweizerische
 Altertumskunde
AnzWien: Anzeiger der Österreichischen
 Akademie der Wissenschaften, Wien,
 Phil.-hist. Klasse
Arch. Ael.: Archaeologia Aeliana,
 Newcastle-upon-Tyne
ArchAnalekta, see ArchAnAth
ArchAnAth: Archaiiologika analekta Athenon
ArchAnthrop.: Archivio per l'anthropologia e la
 etnologia
Arch. Anz., see AA
ArchByzMnem: Archeion ton Byzantinon
 Mnemeion tes Hellados
ArchCl: Archeologia Classica
ArchDelt, see Deltion
ArchEph: Archaiologike Ephemeris
ArchEsp: Archivo Español de Arte y Arqueologia,
 Madrid, vols. 1-39 (1925-1937).
 (From vol. 40 appears as two journals)
ArchEspArq: Archivo Español de Arqueologia
ArchJ: Archaeological Journal
ArchMiss: Archives des missions scientifiques
 et littéraires, Paris
ArchRW: Archiv für Religionswissenschaft
ArchStSir: Archivio Storico Siracusano
AS, see AnatSt
ASAE: Annales du Service des antiquités
 de l'Egypte
ASAtene: Annuario della Scuola Archeologica
 di Atene
ASPABA: Atti della Società Piemontese di
 Archeologia e Belle Arte
AthMitt: Mitteilungen des deutschen
 archäologischen Instituts. Athenische
 Abteilung
ATL: B. D. Meritt et al., Athenian Tribute Lists
AttiMGrecia: Atti e Memorie della Società
 Magna Grecia
AttiPontAcc: Atti della Pontificia Accademia
 Romana di Archeologia

AttiVen: Atti dell'Istituto Veneto di Scienze, Lettere ed Arti

AUBIst: Analele Universității din București, seria Istorie

AZ: Archäologische Zeitung

BABesch: Bulletin van de Vereeniging tot Bevordering der Kennis van de Antike Beschaving

BAC: Bulletin archéologique du Comité des travaux historiques et archéologiques

BAntFr: Bulletin de la Société nationale des antiquaires de France

BCH: Bulletin de correspondance hellénique. École française d'Athènes, Paris

BCMI: Buletinul Comisiunii Monumentelor Istorice

BCTH: Bulletin archéologique du Comité des Travaux historiques et archéologiques

BdA: Bolletino d'Arte

Belleten: Belleten Türk Tarih Kurumu

BEO: Bulletin d'études orientales (Damascus)

BerlBer: Preussischen Akademie den Wissenschaften, Berlin. Monatsberichte

BIA: Bullettino del R. Istituto di Archeologia e Storia dell'Arte

BIABulg: Bulletin de l'Institut archéologique bulgare

BIM: Boletin de Informacion Municipal, Valencia

BLund: Bulletin de la Société r. de lettres de Lund

BMBeyrouth: Bulletin du Musée de Beyrouth

BMCCat: British Museum Coins Catalogue

BMI: Buletinul Monumentelor Istorice

BMMN: Buletinul Muzeului Militar Național

BMon: Bulletin monumental

BMQ: British Museum Quarterly

BMusArt: Bulletin des Musées r. d'art et d'histoire

BMusImp: Bullettino del Museo dell'Impero Romano

BonnJbb: Bonner Jahrbücher

BPC: Bollettino della Società per gli studi storici archeologici nella Provincia di Cuneo

BPI: Bollettino de Paletnologia Italiana

BPW: Berliner philologische Wochenschrift

BSA: British School at Athens. Annual

BSAA: Boletin del Seminario de Estudios de Arte y Arqueologia

BSAF, see BAntFr

BSPABA: Bollettino della Società Piemontese di Archeologia e Belle Arte

BSPF: Bulletin de la Société préhistorique française

BSR, see *PBSR*

BSRAA: Bulletin de la Société r. d'archéologie d'Alexandrie

BStM: Bollettino dell'Associazione Internazionale degli Studi Mediterranei

BullArch, see *BullComm*

BullComm: Bullettino della Commissione archeologica comunale di Roma

ByzZeit, see *BZ*

BZ: Byzantinische Zeitschrift

CAH: Cambridge Ancient History

CahArch: Cahiers archéologiques

CahHistArch: Cahiers d'histoire et d'archéologie

CahTun: Cahiers de Tunisie, Tunis

CASJ: Chester Archaeological Society Journal

CIE: Corpus Inscriptionum Etruscarum

CIL: Corpus Inscriptionum Latinarum

ClMed: Classica et Mediaevalia

CP: Classical Philology

CQ: Classical Quarterly

CR: Classical Review

CRAI: Comptes rendus de l'Académie des inscriptions et belles-lettres

CronArch: Cronache di Archeologia

CW: Classical Weekly

DACL: Cabrol and Leclercq, Dictionnarie d'archéologie chrétienne et de liturgie

Déchelette: Manuel d'archéologie préhistorique, celtique et gallo-romaine (1908-14; for vol. v see Grenier)

Deltion: Archaiologikon deltion

DenkschrWien: Akademie der Wissenschaften, Wien, Denkschriften

Diels, *Dox. Graec.*: H. Diels, Doxigraphi Graeci (1879)

Diz. Epigr.: Dizionario epigrafico di antichità romana

DOP or *DOPapers*: Dumbarton Oaks Papers

EAA: Enciclopedia dell'arte antica, classica e orientale, I-VII

EphDac: Ephemeris Dacoromana

Ergon: To Ergon tes en Athenais Archaiologikes Hetairias

Expedition: Expedition, The Magazine of Archaeology and Anthropology, University Museum of the University of Pennsylvania

FA: Fasti Archaeologici

FD: Fouilles de Delphes

FelRav: Felix Ravenna

Forma orbis romani = Carte archéologique de la Gaule Romaine (Institut de France, Academie des Inscriptions et Belles Lettres. Forma orbis romani. 1931-)

GazArch: Gazette archéologique

GBA: Gazette des beaux-arts

Germania: Germania. Anzeiger der Römisch-Germanischen Kommission des Deutschen Archäologischen Instituts, Frankfurt

GGA: Göttingische Gelehrte Anzeigen

GGM: C. Muller, Geographici Graeci Minores

GL: A. Philippson & E. Kirsten, Die Griechischen Landschaften, Frankfurt

Gnomon: Gnomon, Kritische Zeitschrift für die gesamte klassische Altertumswissenschaft

Grenier: A. Grenier, Manuel d'archéologie gallo-romaine (1931-34; = vol. v of Déchelette)

GZM Sarajevo: Glasnik Zemaljskog muzeja Sarajevo

HdArch: G. Lippold, Handbuch des Archäologie

Head, *Hist. Num*: B. V. Head, Historia Numorum (2d ed. 1911)

Hesperia: Hesperia: Journal of the American School of Classical Studies at Athens

HSCP: Harvard Studies in Classical Philology

HThR: Harvard Theological Review

ICr: Inscriptiones Creticae

IEJ: Israel Exploration Journal

IG or *IGA*: Inscriptiones Graecae antiquissimae

IG Bulg: G. Mihailov, Inscriptiones Graecae in Bulgaria repertae, Sofia

IGRR: Inscriptiones Graecae ad Res Romanas Pertinentes

IJNA: International Journal of Nautical Archaeology and Underwater Exploration

ILN: Illustrated London News

ILS: Dessau, Inscriptiones Latinae Selectae

Inscr. It.: Inscriptiones Italiae

IstForsch: Istanbuler Forschungen. Deutsches Archäologisches Institut, Abteilung Istanbul

IstMitt: Mitteilungen des deutschen archäologischen Instituts, Abteilung Istanbul

Jahrbuch, see *JdI*

JdI: Jahrbuch des deutschen archäologischen Instituts

JEA: Journal of Egyptian Archaeology

JFA: Journal of Field Archaeology

JGS: Journal of Glass Studies

JHS: Journal of Hellenic Studies

JKF: Jahrbuch für kleinasiatische Forschung

JOAI: Jahreshefte des Oesterreichischen Archäologischen Instituts in Wien

JOAIBeibl: Jahreshefte des Oesterreichischen Archäologischen Instituts, Beiblatt

JOB: Jahrbuch der Oesterreichischen Byzantinistik

JRS: Journal of Roman Studies

JWarb: Journal of the Warburg and Courtauld Institutes

Karthago: Karthago. Revue d'Archéologie Africaine

Klio: Klio, Beiträge zur alten Geschichte

Kl. Pauly: Der Kleine Pauly

Kl. Schr.: Kleine Schriften (of various authors)

KretChron: Kretika Chronika

KSIA: Kratkie soobshcheniia Instituta arkheologii

KSIIMK: Kratkie soobshcheniia Instituta istorii material'noi kul'tury

Leake, *Nor. Gr.*: Travels in Northern Greece

Liverpool AAA: Liverpool Annals of Archaeology and Anthropology

MAAR: Memoirs of the American Academy in Rome

MadrMitt: Mitteilung des deutschen archäologischen Instituts, Madrider Abteilung

MAL, see *MemLinc*

MAMA: Monumenta Asiae Minoris Antiqua, Manchester

MAntFr: Mémoires de la Société nationale des antiquaires de France

MarbWPr: Marburger Winckelmann-Programm. Marburg/Lahn

MCA: Materiale și Cercetări Arheologice

MEFR, see *MélRome*

MélEcFranc: Mélanges d'Archéologie et d'Histoire, École Française de Rome

MélPiganiol: Mélanges Pignaniol

MélRome: Mélanges d'archéologie et d'histoire de l'École française de Rome

MélStJ, see *MélUSJ*

MélUSJ: Mélanges de l'Université Saint Joseph, Beyrouth

MémAcInscr: Mémoires présentés par divers Savants à l'Académie des inscriptions et belles-lettres

MemAmAcRome, see *MAAR*

MemLinc: Memorie della R. Accademia Nazionale dei Lincei

MemNap: Memorie della R. Accademia di Archeologia, Lettere e Belle Arti, Società R. di Napoli

MemPontAcc: Atti della Pontificia Accademia Romana di Archeologia, Memorie

MetrMusStud: Metropolitan Museum of Art, Studies, New York

MMAI, *see* MonPiot

MonAnt: Monumenti Antichi pubblicati per cura della Reale Accademia dei Lincei, Rome

MonatsbBerl, see *BerlBer*

MonPiot: Monuments et mémoires publ. par l'Académie des inscriptions et belles-lettres. Fondation Piot

MusHelv: Museum Helveticum

NAkG: Nachrichten von der Akademie der Wissenschaften in Göttingen

NJbb: Neue Jahrbücher für das klassische Altertum

NNM: Numismatic Notes and Monographs. American Numismatic Society, New York City

NouvArch: Nouvelles archives des missions scientifiques

NSc: Notizie degli Scavi di Antichità

OGIS: W. Dittenberger, Orientis Graeci Inscriptiones Selectae

OJh, see *JOAI*

Op. Ath.: Opuscula Atheniensia

OpusArch: Opuscula Archaeologica

PAAR: American Academy in Rome, Papers and Monographs

PAE, see *Praktika*

PAES: Publications of the Princeton University Archaeological Expeditions to Syria

ParPass: La parola del passato, Naples

Pauly-Wissowa, see *RE*

PBSR: Papers of the British School at Rome

PdP, see *ParPass*

PEQ: Palestine Exploration Quarterly

Philol: Philologus, Zeitschrift für das klassische Altertum, Berlin-Wiesbaden

PM: Petermanns Mitteilungen

PraktAkAth: Praktika tes Akademias Athenon

Praktika: Praktika tes en Athenais Archaiologikes Hetairias

ProcBritAc: Proceedings of the British Academy

ProcPhilSoc: Proceedings of the American Philosophical Society
PWRE, see *RE*
QDAP: Quarterly of the Department of Antiquities in Palestine
RA: Revue archéologique
RAC: Reallexikon für Antike und Christentum
RACrist: Rivista di Archeologia Cristiana
RAN: Revue archéologique de Narbonnaise
RB, see *RBibl*
RBArch: Revue belge d'archéologie et d'histoire d'art
RBibl: Revue biblique
RBPhil: Revue belge de philologie et d'histoire
RDAC: Report of the Department of Antiquities of Cyprus, Nicosia
RE: A. Pauly and G. Wissowa, Real-encyclopädie der classischen Altertumswissenschaft, Stuttgart
REA: Revue des études anciennes
REG: Revue des études grecques
REL: Revue des études latines
RendAccIt: Rendiconti della Classe di Scienze Morali, Atti della R. accademia d'Italia
RendIstLomb: R. Istituto Lombardo di Scienze e Lettere, Rendiconti
RendLinc: Rendiconti della Classe di Scienze Morali, Storiche e filologiche dell'Accademia dei Lincei
RendNap: Rendiconti della R. Accademia di Archeologia, Lettere ed Arti, Naples
RendPontAcc: Rendiconti della Pontificia Accademia Romana di *RevAC*: Revue de l'art chrétien Archeologia
Rev. Ét. Anc.: Revue des études anciennes
RevPhil: Revue de Philologie, Nouv. Sér.
RFC, see *RivFC*
RGKomm: Römisch-germanische Kommission d. arch. Inst. d. deutschen Reichs, Berichte
RHM, see *RhM*
RhM: Rheinisches Museum für Philologie
RIB: R. G. Collingwood & R. P. Wright, Roman Inscriptions of Britain
RIV, see *RN*
RivFC: Rivista di Filologia e d'Istruzione Classica,
RLS, see *RStLig*
RM, see *RömMitt*
RN: Revue numismatique
RömMitt: Mitteilungen des Deutschen Archäologischen Instituts. Römische Abteilung
RStLig: Rivista di Studi Liguri
RStO: Rivista degli Studi Orientali
SB: Sitzungsberichte (followed by name of academy, abbreviated, e.g. SBBerl)
SCIV: Studii şi Cercetări de Istorie Veche
SCN: Studii şi Cercetări Numismatice
SEG: Supplementum Epigraphicum Graecum
SGDI: Sammlung der Griechischen Dialekt-Inschriften
Sic. Gym.: Siculorum Gymnasium
SLS Ann. Rpt.: Society for Libyan Studies, Annual Reports
SMIM: Studii şi Materiale de Muzeografie şi Istorie Militară
SovArkh: Sovetskaia Arkheologiia
Spomenik SAN: Spomenik Srpske kraljevske akademije nauka, Beograd
Stad: *Stadiasmus maris magni*, see C. Muller, ed., Geographi Graeci Minores, I (1882)
StBiz: Studi Bizantini e Neoellenici
StEtr: Studi Etruschi
Tab. Peut.: Tabula Peutingeriana
TAM: E. Kalinka & R. Herberdey, Tituli Asiae Minoris, Vienna
TAPA: Transactions of the American Philological Association
ThLL: Thesaurus Linguae Latinae
TIR: Tabula Imperii Romani
TRPhilSoc: Transactions of the Philosophical Society
TrZ: Trierer Zeitschrift
Tudor, Oraşe: D. Tudor, Oraşe, tîrguri şi sate în Dacia romană, Bucharest
TürkArkDerg: Türk Arkeoloji Dergisi
TürkTarDerg: Türk Tarih, Arkeologya ve Etnografya Dergisi
VCH: Victoria County History
VDI: Vestnik Drevnej Istorii
VHAD: Vjesnik Hrvatskog arheološkog društva
VMMK: Veszprém Megyei Múzeumok Közleménye
WJh: Wiener Jahrshefte
WMBH: Wissenschaftliche Mitteilungen aus Bosnien und Herzegovina, Wien
ZDPV: Zeitschrift des deutschen Palästina-Vereins
ZSchwAKg: Zeitschrift für schweizerische Archaeologie und Kunstgeschichte

THE PRINCETON
ENCYCLOPEDIA OF
CLASSICAL SITES

NOTE TO THE READER

NORMALLY each entry represents a site with actual remains and is listed under its name in Classical times with the modern name, if it differs, following. If the ancient name is unknown, the entry bears the name of the place by which the ruins or excavations are identified. In this case a name may follow in quotation marks to indicate that an identification with a site known from ancient literature is probable but not yet fully confirmed.

A few entries include a number of sites (small islands, Alexandrian foundations, limites, shipwrecks, towns or cities with outlying sanctuaries or tombs). All sites thus subsumed appear also as cross references.

Excavation history is limited to the dates of expeditions and a general summary of the extent of the work. More detailed information, including the sponsorship and direction of the excavations, can nearly always be found in the publications listed at the end of the entry.

Site plans, maps, and illustrations were regretfully excluded to keep the encyclopedia to one volume. The superior letters MPI accompanying bibliographical items indicate where site maps, plans, and illustrations may be found.

Titles in the bibliographies are listed chronologically except that all titles by one author are listed together beginning with the item of earliest date.

Greek spelling has been favored, following in general the practice of the American School of Classical Studies at Athens. Exceptions reflect the familiar dilemmas which no system yet devised has been able to avoid.

Finally, it should be noted that after this book had been set in type some of the county names and boundaries in England and Wales were changed.

THE PRINCETON
ENCYCLOPEDIA OF
CLASSICAL SITES

AACHEN, *see* AQUAE GRANNI

AARDENBURG Zeeland, Netherlands. Map 21. Vicus whose ancient name is unknown; in the early Middle Ages it was Rodanborch. Excavations have revealed some large stone buildings (forum?) and the foundations of a Celtic-Roman temple (5.5 x 5.5 m). The vicus (area ca. 10 ha) seems to have flourished particularly in the 2d and 3d c. A.D. No coins found there date later than ca. 273. Aardenburg probably belonged to the civitas Menapiorum, and may have had a military function ca. 170-270. Many bronzes, especially statuettes, and much pottery have been found, mostly of Flemish-Roman workmanship.

BIBLIOGRAPHY. J. A. Trimpe Burger, *Zeeland in Roman Times, Proceedings of the State Service for Archaeological Investigations in the Netherlands* (n.d.).

J. A. TRIMPE BURGER

ABAI Phokis, Greece. Map 11. Important city near Exarcho village in the upper reaches of a tributary of the Kephisos. Abai and nearby Hyampolis were on the main Orchomenos-Opous road, and astride the main route from E Lokris into NE Phokis (Paus. 10.1.1, 35.1). The valley was the scene of two famous Phokian victories over the Thessalians, shortly before 480 (Hdt. 8.27-28; Paus. 10.1.3-11). Half of the spoils and several colossal figures were dedicated to Apollo at Abai; this oracular shrine was famous enough to be consulted by Croesus (Hdt. 1.46).

The hill of Abai is encircled by two well-preserved lines of wall; a considerable portion of these has been regarded as archaic. Some parts, and probably also the walls descending the E and NE slopes to the plain, can hardly be earlier than the mid 4th c. There are scattered remains inside these latter walls, and Pausanias saw an ancient theater and agora.

Some 600 m NW of the city a temenos was explored, probably that of Apollo. In addition to a classical stoa, it contained two buildings, identified as the old temple, burned by Xerxes and again in the Third Social War, and a small Hadrianic replacement (Paus. 10.35.2-4). *IG* IX 1.78 is a letter from Philip V reconfirming the ancient tax-exemption of the sanctuary.

Cemeteries have been found W of the sanctuary, and also near Exarcho.

BIBLIOGRAPHY. V. W. Yorke in *JHS* 16 (1896) 291ff; J. G. Frazer, *Paus. Des. Gr.* (1898) v 436ff; G. Soteriadis, *Praktika* (1909) 125-26; F. Schober, *Phokis* (1924) 20ff; R. L. Scranton, *Greek Walls* (1941) 37-38, 47.

F. E. WINTER

ABALAVA, *see* HADRIAN'S WALL

ABALLO (Avallon) Yonne, France. Map 23. Called Aballo in the *Peutinger Table*, its location at the edge of limestone and granite deposits and its proximity to the Agrippan road made it a much-frequented place in antiquity. Statues, pottery, and coins have been found by chance in the town itself, and two pink marble columns from an unknown temple were reused in the church of St-Martin du Bourg.

The Roman city has been located on a rocky spur overlooking the Cousin valley. A temple of the 1st c. A.D. was discovered in the 19th c. It consists of a room (17 m square) surrounded by a gallery that contained the remains of some fine white marble statues (among them a head of Minerva) and fragments of an incomplete dedication. The god that was worshiped here has not been identified: the inscription was long thought to be a dedication to Mercury, but a recent study has suggested that the god's name begins with NURC or NERC. . . .

Avallon has a local museum.

BIBLIOGRAPHY. A. Parat, *Le temple romain du Montmartre* (1928); B. Lacroix, *Dieux gaulois et romains de la vallée de la Cure* (1970).

B. LACROIX
J. M. SIMON

ABDERA Thrace, Greece. Map 9. Coastal city situated on Cape Bulustra, about 17 km NE of the estuary of the river Nestos, birthplace of the philosopher Demokritos and other illustrious men. The founding of the city, according to ancient tradition, can be traced back to mythical times since it is related to the eighth labor of Herakles, the capture of the man-eating horses of King Diomedes of the Bistonians. Another tradition refers to Timesios of Klazomenai as an inhabitant of the city (656-652 B.C.), but his colonists were driven back by the Thracians. In 545 B.C., the Ionians of Teos, unable to suffer Persian domination any longer, settled on the site of Abdera, which they rebuilt (Hdt. 50.68). The city dominated a large and rich area, "covered with vineyards and fertile," which it fought hard to wrest from the Thracians (Pind., Second Hymn).

Abdera was subjugated by the Persians during their period of action in Thrace and in 492 B.C. It was used as a base of operations (Hdt. 6.46,47; 7.120). As a member of the First Athenian Alliance, it contributed to the Athenian treasury the sum of 10 to 15 talents, starting in 454 B.C. This heavy taxation and the rich silver currency are an indication of the economic prosperity of the city.

In 376 B.C. Abdera was destroyed by the invasion of the Thracian tribe of the Triballi, who killed all the citizens who took part in the battle (Diod. Sic. 15.36). A little later, ca. 350 B.C., Philip II of Macedon con-

quered the city. About the 3d century B.C. it fell successively to King Lysimachos of Thrace, to the Seleucids, the Ptolemies, and again to the Macedonians, who dominated it until 196 B.C., when the Romans declared it a free state. Abdera suffered a second catastrophe in 170 B.C., when the Roman armies and those of Eumenes II, king of Pergamon besieged and sacked it (Diod. Sic. 30.6). During Roman Imperial times, it lost political importance and went into decline. In the 6th c. A.D. a small Byzantine town, the seat of a bishopric, was established on the NW hill of the great ancient city.

Large sections of the immense wall, which dated from the archaic period, were uncovered in the W, N, and E parts of the city. In the W wall a gate with two towers was uncovered, and to this led a central street of the city, as well as the road that came from the W harbor. (Under the surface of the sea, stone plinths and rocks that form a large breakwater have been preserved.) A second small open harbor appears to have been situated on the sandy shore of the E end of the city, where a round tower is preserved in the sea. In the N section near the wall the theater was uncovered. In the W part large clusters of habitations of the Hellenistic and Roman periods, with a strict N-S orientation, show that the area was built according to the Hippodamian system of city planning. A mosaic floor found in the courtyard of a house depicts dolphins, rosettes, and lilies. The foundations of a large building in the SW section appear to belong to Roman baths. N of the city stretched a large suburb, and at a distance of 2 to 4 km N and NW, a group of graves and tombs yielded findings that date from the late archaic and Classical periods.

The findings of the excavation—which consist mainly of pots, architectural fragments, corner tiles decorated with reliefs and lettering, sculptures, lamps, and especially a rich collection of terracotta figurines, the product of a local workshop of image-makers—are on exhibit in the Museum of Kavala. The agora and the sacred temples of the city, whose existence is known from ancient sources, have not yet been uncovered.

BIBLIOGRAPHY. W. Regel, "Abdera," AthMitt 12 (1887) 161ff; Fr. Munzer-M. L. Strack, Die Antiken Münzen Nordgriechenlands II (1912); Δημ.Λαζαρίδη, Πρακτικά Ἀρχαιολογικῆς Ἑταιρείας (1950, 1952, 1954, 1955, 1956, 1966); Πήλινα εἰδώλια Ἀβδήρων, Ἀθῆναι (1960); Ἀρχαιολογικόν Δελτίον, Χρονικά (1961, 1963, 1964, 1967); Νεάπολις-Χριστούπολις-Καβάλα, Ὁδηγός Μουσείου Καβάλας (1969) σελ.161 κ.ἑ.; J.M.F. May, The Coinage of Abdera (1966). D. LAZARIDES

ABERGAVENNY, see GOBANNIUM

ABILA later SELEUCIA ABILA (Tell Abil) Jordan. Map 6. A Ptolemaic town in N Palestine, ca. 19 km N of Irbid, which attained importance in the Hellenistic-Roman period. It was conquered by Antiochus III (Polyb. 5.71; 16.39). At the beginning of the 1st c. B.C. it was taken by Alexander Jannaeus (Joseph., AJ 11.136), but freed by Pompey in 64 B.C., who made it autonomous. At this time, when it became part of the Decapolis, it minted its own coins. Seleucid influence is evident in the title Seleucia Abila, found on coins from the time of Caracalla. Eusebius (Onom. 32.14) knew the place as 19 km E of Gadara. In the Byzantine period it was part of Palestina Secunda. It has not been excavated, but surveys have noted the bridge connecting the two mounds of the site, the fortifications, a Roman temple, a theater, and a basilica.

BIBLIOGRAPHY. F. M. Abel, Géographie de la Palestine II (1938) 234-35; M. Avi-Yonah, The Holy Land (1966) 40, 96, 175. A. NEGEV

ABODIACUM (Epfach) Upper Bavaria, Germany. Map 20. At the intersection of the Via Claudia (Verona-Augsburg) and the road from Bregenz to Salzburg, and by a ford of the river Lech, a civilian settlement was founded under Tiberius or Claudius, belonging to a military camp (see below). In the early Flavian period this settlement became a rather important way-station (municipium?), which was destroyed by the Alamanni in 233. The military post grew up on the nearby mountain (Lorenzberg) soon after 15 B.C., to control the road. The remains are of palisaded or plank structures.

In late antiquity the mountain was again occupied; under Diocletian an enceinte was erected with wooden buildings inside. In 353-57 it suffered a catastrophic fire and destruction by the Alamanni; the magazine (mansio?) was rebuilt ca. 360. About 370 a rectangular chamber (15.5 x 9.5 m) with tripartite E termination, possibly an Early Christian church, was erected on the highest point of the Lorenzberg. From 383 the site was a garrison, the latest traces of settlement stemming from Danubian foederati in the period after 400. Continuity of the Christian cult does not exist, the Lorenzkirche having been erected after 955.

BIBLIOGRAPHY. J. Werner, ed., "Der Lorenzberg bei Epfach. Die spätrömischen und frühmittelalterlichen Anlagen," Münchner Beiträge zur vor- und frühgeschichte 8 (1969)MPI. J. GARBSCH

ABONAE (Sea Mills) Bristol, England. Map 24. Situated 19.2 km NW of Bath (Aquae Sulis), near the mouth of the tidal river Avon (for which the settlement is named), a small harbor made by the confluence of the river Trym. Military artifacts indicate a fort on this site soon after the Roman invasion of A.D. 43. Stamped tiles of Legio II Augusta indicate a continuing military presence in the 2d c., perhaps supervising the shipping of supplies to garrisons in Wales. A civilian settlement also grew up, covering ca. 5.2 ha. The site was abandoned at the end of the Roman period.

The two known streets suggest an irregular grid originating at the end of the 1st c. A number of civilian buildings have been excavated, including a row of three shops with stone foundations succeeding earlier timber structures. The defenses have yet to be discovered. A cemetery S of the town, indicated by an inscribed tombstone (RIB 137), has been confirmed by excavation. Finds are in the City Museum, Bristol.

BIBLIOGRAPHY. Various authors in Trans. Bristol and Gloucestershire Arch. Soc. 45 (1923) 193-201; 61 (1939) 202-23; 64 (1945) 258-95; R. Reece, "Roman Coins from Sea Mills," ibid. 85 (1966) 218-20; A.L.F. Rivet, "The British Section of the Antonine Itinerary," Britannia 1 (1970) 34-82 (for name). M. G. HEBDITCH

ABONUTEICHOS later IONOPOLIS (Inebolu) Pontus, Turkey. Map 5. A minor city, presumably an Ionian foundation, halfway along the inhospitable Paphlagonian shore of the Black Sea (Pontus Euxinus). It achieved full civic status in the 1st c. A.D. and adopted the name Ionopolis under Marcus Aurelius. Its only claim to fame (considerable at the time) was as the seat of the bogus oracle set up by the charlatan Alexander (Luc. Pseudomantis). Traces of ancient walls have been recorded on the acropolis, and architectural fragments are common in the town.

BIBLIOGRAPHY. G. Jacopi, Dalla Paflagonia alla Commagene (1936) 8. D. R. WILSON

ABRITTUS (Razgrad) Bulgaria. Map 12. A Roman center covering ca. 10 ha, defended by a fortification wall varying between 2.40 and 2.85 m in thickness, and reinforced by several round towers at the corners,

as well as by U-shaped and rectangular towers. In several places near the gate the height of the fortification wall reaches 10 m. As in other Roman sites in Scythia Minor, stones bearing inscriptions, and architectural fragments from earlier ruins, were reused in the repair of the wall. Two gates have been discovered, as well as several posterns. The N and S gates, and also the posterns, were closed up at the time of the city's crisis. The date of the fortifications, like those at Histria, may be fixed after the invasion of the Goths in 250-251.

The S necropolis has been identified and partially excavated. It contains tombs datable between the 2d and the 4th c. The funerary material is very meager.

With the identification of Abrittus at Razgrad one of the most difficult problems of Roman topography in the S part of Scythia Minor has been resolved.

BIBLIOGRAPHY. T. Ivanov, "Urkrepitelvrata sistema na Abrittus," *Archeologia* 4; *Bul. d'Archéologie sud-est européenne* (Assoc. Internationale d'Etudes du Sud-Est Européen, Commission d'Archéologie) 1 (1969) 44; 2 (1971) 43.
D. ADAMESTEANU

ABUSINA (Eining) Bavaria, Germany. Map 20. A Roman auxiliary fort on the Danube ca. 30 km SW of Regensburg (Castra Regina). The name was derived from the Abens, a tributary of the Danube. Originally a timbered earth fort erected by the Cohors IV Gallorum in A.D. 79-81, it was located at the place where the Danube crossing branches off from the Roman road S and runs parallel to the Raetian limes. The stone fort, oriented approximately N-S, is asymmetrical. The area (1.8 ha) is rather small for the requirements of a fort and probably accommodated only one vexillation. The fort was rebuilt under Antoninus Pius (139-161) and was occupied by the Cohors III Britannorum equitata, or part of it. It was ravaged by an Alemannic assault in 233. The Romans disbanded the fort, including its headquarters, about 254 and it was temporarily occupied by Germanic forces. About 280 a quadrangular praesidium was built in the SW corner, and in the 4th c. additional buildings were placed S of it. A towerlike annex reinforced the entrance gate. The fort was abandoned by the Romans about 410.

Excavations have revealed the fort, the "commander's villa" with two extensions, and a bath building with annexes, all on the N side. Two sanctuaries were discovered N of the vicus. The E part of the vicus has not yet been excavated. The location of the Roman cemetery is unknown. At Unterfeld, ca. 1 km E of the Danube, a four-cornered entrenchment was examined in 1968. Open towards the river, it was probably a supply base with a quay, used briefly in the second half of the 2d c. To the NE of it, in the so-called Weinberg, a watchtower and a Temple of Mars and Victoria were traced.

BIBLIOGRAPHY. W. M. Schmid, *Das römische Kastell Abusina* (2d ed. 1910); P. Reinecke, *Festschrift z. 75j. Bestehen des RGZ-Ms. in Mainz* (1927) 157ff; H. Schönberger, *Germania* 48 (1970) 66ff; H. J. Kellner, *Die Römer in Bayern* (1971) 62-65.
A. RADNOTI

ABŪ ṢIR Egypt. May 5. The Arabic name of several sites connected in the past with the cult of Osiris:

1) Abû Ṣir Bana, identified with Busiris (Hdt. 2.59, 61) and Cynopolis (Strab. 17.1.19), lies in the Delta S of modern Samannud.

2) Abû Ṣir El-Malaq, in the vicinity of the Faiyum district and N of modern Ihnasia el-Medina. This, the Heracleopolis Magna of Strabo (17.1.39) is the site of a Graeco-Roman necropolis.

3) Abû Ṣir, near the Giza Pyramids, is the Busiris of Pliny (36.12.76), famous as a cult center. The latest tombs date from the Ptolemaic period.

4) Abû Ṣ(uwe)ir, a short distance W of Ismailia on the Suez Canal, was probably the site of the Egyptian city of Pithom, capital of the seventh nome of Lower Egypt, or Patumus (Hdt. 11.158), where a stele of Ptolemy II Philadelphos was found together with fragments of other Ptolemaic inscriptions.

BIBLIOGRAPHY. B. Porter & R. Moss, *Topographical Bibliography of Ancient Egyptian Hieroglyphic Texts, Reliefs and Paintings, IV. Lower and Middle Egypt* (1934); J. Ball, *Egypt in the Classical Geographers* (1942)M; K. Michalowski, *L'Art de l'Ancienne Égypte* (1968) 491-94.
S. SHENOUDA

ABYDOS (Nağara Point) Turkey. Map 7. City in Mysia 6 km N of Çanakkale, first mentioned in the Trojan Catalogue (*Il.* 2.836). According to Strabo (590-91) it was occupied after the Trojan War by Thracians, until it was settled by Milesians with the consent of Gyges king of Lydia ca. 700 B.C. Burnt by Darios in 512, it formed one end of Xerxes' bridge across the Hellespont. In the Delian Confederacy it paid a tribute of four talents, but was always hostile to Athens (Dem., *Aristocr.* 158), and in 411 revolted from the confederacy and became a Spartan base. By the peace of Antalkidas it passed to Persia until the arrival of Alexander in 334. In 200 Abydos was attacked by Philip V and taken after a desperate resistance (Polyb. 16.29-34). After the defeat of Philip the city was given freedom by Rome (Livy 33.30), and under the Empire became an important toll station. The abundant coinage extends from the early 5th c. B.C. to the mid 3d c. A.D. Abydos possessed gold mines at a spot called variously Astyra or Kremaste (Xen. 4.8.37), but these were near exhaustion in Strabo's time.

The site, first recognized in 1675, is on the bay S of Nağara Point; the acropolis hill is called Mal Tepe. This bay is out of the main current and by far the best natural harbor in the straits. The accounts of travelers down to 1830 speak of considerable remains of walls and buildings; later, however, little or nothing could be seen. In this century the area has been a prohibited zone, and for the present state of the site no information is available.

BIBLIOGRAPHY. Choiseul-Gouffier, *Voyage Pittoresque* (1822) 449M; W. Leaf, *Strabo on the Troad* (1923) 116-19; J. M. Cook, *The Troad* (1973) 56-57.
G. E. BEAN

ACBUNAR Tulcea, Romania. Map 12. The present-day village is 13 km from the great military camp of Troesmis, which for a long period was occupied by Legio V Macedonica. The village very probably lies on the site of a vicus of veterans that formed part of the territorium Troesmense. No systematic excavations have been carried out, but a chance find made in 1908 suggests that the vicus must have contained a mithraeum. Besides some wall sections, tiles and lamps, a dozen marble relief fragments have been found, connected with the Mithraic cult. These are small ex-votos, non-epigraphic for the most part. Only one of them still shows traces of a Latin inscription, but they are barely comprehensible.

BIBLIOGRAPHY. V. Pârvan, *An. Acad. Rom., Mem. Sect. Ist.* 35 (1913) 509-18, 544-46.
D. M. PIPPIDI

ACCHO, *see* PTOLEMAIS

ACCI (Guadix) Granada, Spain. Map 19. Town 59 km NE of Granada, whose modern name comes from the Arabic Wadi-Aci. Pliny refers to it as Colonia Accitana Gemellensis (3.25), adding that it possessed Italic law from the time of its founding. Ptolemy (2.6) calls it Ἄκκι and locates it among the Bastetani. The *Antonine Itinerary* (402.1; 404.6) calls it Acci. On the inscriptions (*CIL* II, 3391, 3393-94) it appears as Colonia Iulia Gem-

ella Accis, and on coins as Col(onia) Iul(ia) Gem(ella) Acci; the abbreviations L I II refer to Legions I and II, whose veterans were settled there. The name Gemella comes from these two legions. It was founded to guard the mountainous area in which it was located. Until the reform of Augustus (7-2 B.C.) it was part of Baetica, but was then transferred to Tarraconensis.

Its establishment as a colony has been attributed to Caesar or Octavius because of the name Iulia and the fact that it lacked an epithet referring to Augustus. However, not all the places founded by Augustus bear a name referring to him and, moreover, the name Iulia was employed by Augustus before 27. Most likely it was founded by Lepidus in 42 B.C. in the name of Octavius. It has not been excavated.

BIBLIOGRAPHY. F. Vittinghoff, *Römische Kolonisation und Bürgerrechtspolitik unter Caesar und Augustus* (1952) 107, 149M; A. García y Bellido, "Las Colonias romanas en España," *Anuario de Historia del Derecho Español* 29 (1959)M. R. TEJA

ACELUM (Asolo) Italy. Map 14. A city in the Veneto region (Plin. 3.130; Ptol. 3.1.30), between Treviso and Feltre, to the W of the Via Claudia Augusta. In the surrounding territory have been found manifestations of the Paleolithic Age, remains of elephas primigenius and an Iron Age necropolis. It was probably a Roman municipium ascribed to the Claudia tribus. The ruins of a theater are visible, with parts of the scaena and of the cavea, as well as a bath building. In the Civic Museum are fragments of architectural decoration from the theater, funerary monuments, and small bronzes.

BIBLIOGRAPHY. P. Fraccaro, "Intorno ai confini e alla centurazione degli agri di Patavium e di Acelum," *Studi di Antichità Classica* (1940); R. Battaglia et al., *Storia di Venezia* I (1957). See also *NSc* (1876-85).
 B. M. SCARFÌ

ACHARACA (Salavatlı) Turkey. Map 7. To the W of Sultanhisar, 5 km from Nysa. The city was founded, probably together with Nysa, by Antiochos Soter I in the first half of the 3d c. B.C. Strabo, who was a student at Nysa, mentions Acharaca, especially the sacred cave and the temple. According to the remains, the temple is peripteral, in the Doric order with 6 by 12 columns. It is probably Hellenistic although Roman capitals found in the foundations indicate reconstruction. Byzantine additions suggest that the building became a Christian church. In addition to the temple, ancient walls and fortifications are visible, and the remains of a bridge in the direction of Nysa.

BIBLIOGRAPHY. W. von Diest & H. Pringsheim, "Nysa ad Maeandrum," *JdI* suppl. vol. 10 (1913).
 C. BAYBURTLUOĞLU

ACHARNAI (Menidi) Attica, Greece. Map 11. In the first year of the Peloponnesian War, Archidamos encamped the Spartans at Acharnai, the largest of the Attic demes, 60 stades distant from Athens (Thuc. 2.19.2, 21.2). In 404-403 B.C. the army of the Thirty Tyrants also camped here in an action designed to guard against Thrasyboulos at Phyle (Diod. 14.32.6). From these two notices it is therefore clear that the deme was located S of Mt. Parnes in the general neighborhood of the modern villages of Menidi and Epano Liosia. That Acharnai was in fact either at, or near, the former can be plausibly argued from the number of inscriptions concerned with Acharnaians found in the churches and houses of Menidi.

Proof of this identification, in the form of foundations of buildings, is entirely lacking today, though in the early 19th c. the remains "of a considerable town" could be observed 1 km to the W of Menidi beneath the hill on which is the church dedicated to the Forty Saints. Thus some scholars have felt free to look elsewhere for the inhabited center of Acharnai. Despite the claims made for a broad, fortified hill called Yerovouno, 2 km SW of Menidi, no compelling alternative has been advanced, and the weight of evidence still makes Menidi the best choice for the location of Acharnai. There is perhaps still hope that some remains from the Sanctuaries of Apollo Argyieus and Herakles, mentioned by Pausanias (1.31.6), may yet be discovered. As for Ares and Athena Areia, their temple may have been the one moved to the marketplace of Athens and there reinstalled in Augustan times.

BIBLIOGRAPHY. E. Dodwell, *A Classical and Topographical Tour through Greece* . . . (1819) I 521-22; A. Milchhöfer, "Antikenbericht aus Attika," *AthMitt* 13 (1888) 337-43; M. N. Tod, *Greek Historical Inscriptions* (1933-48) II 204; E. Kirsten, "Acharnai," *Kl.Pauly* (1964) I 43; E. Vanderpool, "The Acharnian Aqueduct," Χαριστήριον εἰς Ἀναστάσιον Κ. Ὀρλάνδον I (1965) 166-75M. C.W.J. ELIOT

ACHOLLA (Henchir Botria) Tunisia. Map 18. Forty-five km N of Sfax, some 10 km S of Cape Kaboudia. The abandoned site, spread along the seashore, is identified by an inscription found there in 1947. This town is mentioned several times in ancient sources. Presumably founded by the Maltese, it later came under Carthaginian rule. It took sides with Rome in the third Punic war. This won it the status of a free city, and at the time of the civil war it joined Caesar. It became a municipium under Hadrian. The town soon experienced a period of great prosperity, essentially because of the cultivation of olive trees and its commerce by both land and sea routes. The quality and richness of its mosaics bear witness to this prosperity.

Of the pre-Roman era only a sanctuary is known, presumably the tophet, partially excavated in 1937. Large-scale excavations, undertaken between 1947 and 1955, revealed only Roman remains.

About 800 m from the sea the Baths of Trajan, of which there remains a frigidarium with a double apse, was paved with a remarkable mosaic representing the Triumph of Bacchus and the Dionysiac cycle, now in the Bardo Museum at Tunis.

South of the town, the incomplete excavation as well as the deterioration of the Baths of the Marine Revel, constructed of very fragile material, permitted the decipherment only of the general plan. The mosaics alone have survived.

Apart from these two public buildings, several villas have been excavated. The Villa of the Head of Oceanus, situated 50 km E of the baths, included some rooms paved in mosaic of which one represented the seasons. Another with painted walls was decorated with a satyr and nymphs with an Eros and panther. A head of Oceanus decorated a semicircular fountain.

In the Villa of the Triumph of Neptune, excavated in 1954, a portico of a peristyle had three semicircular fountains paved with marine scenes in mosaic. Opposite was a room also paved with a fine mosaic representing a Bacchic troop of revelers and a Triumph of Neptune.

The House of Asinius Rufinus was also arranged around a peristyle. The rooms opened on galleries, one of which was paved with a mosaic showing Herakles and his Labors. In one of these rooms an inscription was found, mentioning the cursus honorum of Asinius Rufinus, native senator of Acholla, who built (or probably bought) the villa in A.D. 184, the year Commodus

named him consul. The cycle of Herakles in mosaic commemorates the kinship of the emperor with the divine hero. In the Villa with the Red Columns, one room of which is decorated with still-life paintings, excavation has not been completed. In all these edifices, ingenuity and finesse in plan and decoration are coupled with mediocrity of construction: walls of unbaked brick raised on a masonry foundation coated with stucco and paint.

A public square paved with flagstones is situated nearly at the center of the site. Bordered on the E by the Baths of Trajan, on the N by the house of Asinius Rufinus; it is identified as the forum, but it has not been completely excavated.

From the Christian period, a baptistery with double apse survives and several tombs, the epitaphs of which were in mosaic.

BIBLIOGRAPHY. *BAC* (1928) 86-88; (1938) 151; (1946-47) 300-6, 381; (1954) 113-15; G. Picard in *CRAI* (1947) 557-62; (1953) 322; *Etudes d'archéologie classiques, Nancy* 2 (1959) 75-95[MPI]; *Antiquités Africaines* 2 (1968) 95-151[MPI]. A. ENNABLI

ACHZIB, *see* ECDIPPA

ACINCO, *see* AQUINCUM

ACINCUM, *see* AQUINCUM

ACQUAROSSA Italy. Map 16. Etruscan acropolis 4.6 km N of Viterbo, destroyed ca. 500 B.C. and not rebuilt. It was the archaic predecessor of the Etrusco-Roman town of Ferentium (Ferento), which was built later ca. 1.6 km NE and flourished in the Augustan epoch and the early Empire. At the excavations on the acropolis (1000 x 600 m), relatively well-preserved remains of dwellings and monumental buildings have been unearthed.

The walls of the houses were of various construction, built either entirely of tufa ashlars or of sun-dried mud bricks framed by wooden poles and beams in a half-timber construction on a footing of ashlar blocks or of hurdles of brushwood or reed (cannae) covered with clay and likewise with a stone footing. The house plans range from a building with a single room to two or three rooms in a row. The entrance was normally on the long side and the hearth placed either near the center of the room or set into the back wall. A more elaborate type has three rooms preceded by a narrow hall or porch. The coeval rock-cut chamber tombs display close analogies to all these house types, and it seems evident that Etruscans in their tomb architecture reproduced the houses of the living. The dwellings were very often embellished with architectural terracottas, acroteria, antepagmenta, painted roof tiles, antefixes, decorative elements previously considered to be only for temples. A complex of monumental buildings, within an area of ca. 25 by 40 m and comprising columned porticos, was probably the administrative, political, and possibly also the religious center of the city. A series of terracotta frieze-plaques found in this context are among the finest of their kind.

The city plan was irregular, but the monumental center was of a regular, orthogonal plan—an early example of urban planning in Italy. The results and the observations at Acquarossa concerning both construction technique and domestic and public architecture are probably relevant not only for Etruscan but also for Roman architecture of the archaic period. The archaic houses excavated at the Forum Romanum were very fragmentary but seem to have been very similar to those found at Acquarossa with respect to construction technique, size, and plan.

BIBLIOGRAPHY. C. E. Östenberg, "Technology and the Arts," *Tryckluft* 3 (1968) 3ff; id., "Le terrecotte architettoniche etrusche di Acquarossa," *Colloqui del Sodalizio* 2 (1968-70) 98ff; id., "Gli scavi dell'Istituto Svedese all'-Acquarossa," *Tuscia Archeologica* (1970) 4ff; S. Moscati, *Italia Sconosciuta* (1971) 143ff; P. Giannini, *Ferento* (1971); A. Andrén, "Osservazioni sulle terrecotte architettoniche etrusco-italiche," *Lectiones Boethianae I, Acta Instituti Romani Regni Sueciae*, 4.31 (1972) 1ff; E. Wetter et al., *Med kungen på Acquarossa* (1972); F. Boitani et al., *Le città etrusche* (1973). C. E. ÖSTENBERG

ACRE (Israel), *see* PTOLEMAIS

ACRE (Sicily), *see* AKRAI

ACRUVIUM (Kotor) Yugoslavia. Map 12. According to the ancient sources (Plin. *HN* 3.144; Ptol. *Geog.* 2.16) on the S Dalmatian coast between Risan and Budva.

Archaeological soundings around the Bay of Kotor have not yet definitely located the site, but evidence available (mediaeval literary tradition, inscriptions now at Kotor, and ceramic finds from the soundings) indicates that Kotor is the most likely site for the Roman city.

Before the Roman conquest, Acruvium was probably a stronghold for the Illyrian pirates who raided the coast. The inhabitants, the Agravonitae, may have been made tax-exempt under the settlement of the praetor L. Anicius Gallus in 167 B.C. for not siding with Illyrian Gentius, and they certainly made up one of the three divisions into which Anicius divided the Illyrian kingdom (Livy 45.26). Pliny mentions the city later as an oppidum civium Romanorum (*HN* 3.144); it probably derived its livelihood from agriculture and trade. It was enrolled in the tribus Sergia and its magistrates were IIviri.

BIBLIOGRAPHY. I. Sindik, "Gde se nalazio Acruvium?" *Glasnik geografskog društva* 27 (1947) 117-21; M. Parović-Pešikan, "Novi arheološki nalazi u okolini Tivta," *Starinar*, NS 13-14 (1962-63) 211-17; P. Mijović, "Acruvium-Dekatera. Kotor u svetlu novih arheoloških otravića," *Starinar*, NS 13-14 (1962-63) 27-48; J. J. Wilkes, *Dalmatia* (1969)[M]. M. R. WERNER

ÁCS-BUM-BUMKUT, *see* LIMES PANNONIAE

ÁCS-VASPUSZTA, *see* LIMES PANNONIAE

ACUMINCUM, *see* LIMES PANNONIAE (Yugoslav Sector)

ADADA (Karabavlı) Pisidia, Turkey. Map 7. Near Sütçüler, about 35 km S of Eğridir. The city is first mentioned in an inscription of the 2d c. B.C. recording a treaty of friendship and alliance with Termessos Maior; reference is made to "the democracy established in each of the cities." Coinage began in the 1st c. B.C., with the title "Autonomous," and continued to the time of Gallienus. Later the city was a bishopric under the metropolitan of Antiocheia.

The location at Karabavlı is accepted, though not strictly proved. The ruins are quite impressive, including a Temple of the Emperors and Aphrodite, and a Temple of the Emperors and Zeus Sarapis. From the agora a finely preserved stairway leads up to a tower and other buildings, apparently the acropolis of the city. Many of the buildings are standing to several stories.

BIBLIOGRAPHY. C. Ritter, *Erdkunde* IX.2 pp. 572-74; G. Hirschfeld in *GGA* (1888) 567f; J.R.S. Sterrett, *Wolfe Expedition to Asia Minor* (1888) 281ff; A. Wilhelm in *SBWien* 3 (1910) 3ff; D. Magie, *Roman Rule* (1950) 264. G. E. BEAN

ADAMCLISI, *see* Tropaeum Traiani

ADANA later ANTIOCHEA AD SARUM Cilicia Campestris, Turkey. Map 6. In the center of the alluvial plain at the main crossing of the river Seyhan (Sarus), it is ca. 32 km E of Tarsus. Although the place was almost certainly an important city in Pre-Hellenic times, and would have been the logical place for Xenophon and the Ten Thousand to cross over the Sarus, Adana appears first in literature only in the time of Alexander the Great and as Antiochea ad Sarum when Cilicia was under the suzerainty of Antiochus Epiphanes in the 2d c. B.C. After Pompey's victory at Korakesion, Adana was settled by "reformed" ex-pirates who proved themselves such successful farmers that under the Roman Empire the city was celebrating "holy ecumenical Dionysia" (Dionysos Kallikarpos was much venerated in the cities of the fertile Cilician plain). With its occupation by the Parthians in A.D. 260, Adana lost semiautonomous status, but became a bishopric of Cilicia Prima with the emancipation of the church. Taken by the Arabs in the 7th c., it was recaptured for Christendom by Nikephoros Phokas in 964.

Of classical monuments in Adana only the great bridge over the Sarus, restored by Justinian and recently widened by the Turkish authorities, remains intact. On the citadel, and wherever foundations are prepared for new buildings, architectural fragments and mosaic floors of the ancient city tend to be exposed. Local brickwork is still Roman in type.

BIBLIOGRAPHY. Scylax 101-2; App. *Mith.* 96.

Maggiore, *Adana, città dell'Asia Minore* (1842); N. Hammond, *CAH* (2d ed. 1961-) XXXVI, 23-24; R. Barnett, "Mopsus," *JHS* 83 (1953) 140-43. M. GOUGH

ADANDA, *see* Lamos

AD AQUAS GRADATAS (Grado) Italy. Map 14. The first port for ships on the Natissa (Natisone) en route to Aquileia, the most renowned commercial center in N Italy during the Roman period. Although the city was not autonomous its commercial importance is attested by frequent finds of tablets, sarcophagi, sculpture, as well as the bronzes that adorned its villas. The remains of one of these villas has come to light on the islet of Gorgo.

At the beginning of the 4th c. A.D. a castrum was erected at Grado with four or five gates protected by polygonal towers, one of which is still visible above ground.

In 452 Niceta, Bishop of Aquileia, took refuge briefly at Grado and also in the 5th c. began the construction of Grado's first Cathedral, the first church of S. Maria delle Grazie, and the Baptistery.

BIBLIOGRAPHY. C. Costantini, *Aquileia e Grado* (1916); G. B. Brusin, *Aquileia e Grado* (1947); V. Degrassi, "Esplorazioni arch. nel territorio della laguna di Grado," *Aquileia nostra* 21 (1950) coll. 5-24; 23 (1952) coll. 27-36; M. M. Roberti, *Grado* (1971); *CIL* V, 84.

L. BERTACCHI

AD CONFLUENTES (Koblenz) Germany. Map 20. At the confluence of Rhine and Moselle. The name is first mentioned by Suetonius (*Calig.* 8; later literature: *It. Ant.* 371; *Tab. Peut.*; *Geogr. Rav.* 4.26, p. 234 = 4.24, p. 227 P.; *CIL* XIII, 9158, I, Z.4). The earliest Roman finds from the area of Koblenz date from Tiberian times. Necropoleis are located at Löhrstrasse, Kaiserin Augusta-Ring (today Moselring), Neuendorf on the left bank of the Moselle. During construction work on the Münz-platz in 1952 the W surrounding trench of an auxiliary castellum from the first half of the 1st c. A.D. was found. The castellum extended from the corner of Marktstrasse and Münzplatz ca. 150 m E, ran N to the Moselle and S to the Late Roman wall. Finds from the bottom of the trench show that this camp already existed in late Tiberian or early Claudian times. The main function of the auxiliary castellum must have been to guard the Moselle crossing. The existence of a bridge across the Nahe has been established for the year A.D. 70. It is therefore likely that the Roman Rhine road crossed the Rhine tributaries via bridges. During work on the river in 1865 and 1894 thousands of wooden piles with iron tips were removed from the river bed, remains of a Moselle bridge of Middle or Late Imperial times. Numerous spolia from Roman monuments were found in and next to pile gratings 10.6 m wide, also several thousand coins on the E side of the first pillar in the river. The Roman bridge was 15 m wide and 16.3 m high, had 9 pillars and 10 arches. On the Roman road coming from Mogontiacum (Mainz) through the Rhine valley 6 milestones were found side by side in Koblenz, with the dates 44-45, 97 and 98-99 (*CIL* XIII, 9145-9149). They give the distance "A Mogontiaco" as 59 Roman miles (87.32 km). The Roman road followed as the Löhrstrasse to the Münzplatz, bypassed the castellum, probably on the W side, crossed the Moselle bridge and led through the Neuwied basin down the Rhine to Andernach (Antunnacum). The auxiliary vicus extended E of the Löhrstrasse to the bank of the Rhine and N of the Schlossstrasse to the bank of the Moselle.

During the rebellion of the Batavi, the auxiliary castellum was destroyed (name of the garrison still unknown). After the spring of A.D. 70 no regular Roman military units were stationed in any castellum N of the Nahe. Possibly the Castellum Koblenz was rebuilt after the Batavi rebellion (stone castellum?) and continued as a road castellum in the rear of the limes. The civilian settlement continued to exist in the 2d and 3d c. There was possibly a customs station in Koblenz (*CIL* XIII, 7623). After the first invasion by the Franks in 258, the limes area on the right side of the Rhine was lost. As in Augustan times, the Rhine was once more the NE border of the Roman imperium. During the Frankonian raids Koblenz was destroyed, as documented by the layer of rubble from the 3d century A.D. The reconstruction of the town, including strong fortifications, took place during the rule of the first tetrarchy when Maximianus restored the safety of the Gallic provinces. The late Roman castellum—a rectangular structure with 2 arched sides, 19 round towers, 16 to 25 m high interturria and a gate in the S (area 5.8 ha)—extended from the Münzplatz in the W to the Florin church in the E, and from the Liebfrauenkirche in the S to the bank of the Moselle in the N. The fortification was still extant in 354. A section of milites defensores was stationed in Koblenz in the 4th c. under the command of a praefectus who was under the dux Mogontiacensis, commander of the frontier garrisons of Germania Prima from Selz (Saletio) to Andernach (Antunnacum) (*Not. dig. occ.* 41). This late Roman Koblenz probably fell without trouble to the Franks after the withdrawal of the Roman troops in 402.

BIBLIOGRAPHY. J. Hagen, *Römerstrassen der Rheinprovinz* (1931) 17ff; A. Günther, "Das römische Koblenz," *BonnJbb* 142 (1937) 35ff; id., "Die Kunstdenkmäler des Landkreises Koblenz," *Die Kunstdenkmäler der Rheinprovinz* 16 (1944) 7ff; id., *Die Kunstdenkmäler von Rheinland-Pfalz. 1: Die Kunstdenkmäler der Stadt Koblenz* (1954) 2ff; id., "Verf., Kastell Koblenz," *BonnJbb* 160 (1960) 168ff. PH. FILTZINGER

AD FINES, *see* Limes, Rhine

AD FLEXUM, *see* Limes Pannoniae

AD MAIORES (Henchir Besseriani) Algeria. Map 18. Ca. 5 km S of Négrine, an oasis 140 km S of Tébessa, was a large military camp. Its site is indicated on the *Peutinger Table*, and the minutes of the Conference of Carthage in A.D. 411 indicate a bishop "plebis Nigrensium Maiorum."

The camp was founded by Trajan in A.D. 105 on the route that runs along, and defines, the S of the mountains of Nememchas and Aurès, in a region which today is desert. It was a rectangular fortress 170 x 110 m, with four gates and a square tower at each corner. A fairly extensive enceinte surrounded the camp, flanked by numerous towers; it is still partly visible to the S. Vestiges of arches were left after its destruction by an earthquake in 267. The town, of which there are only minimal traces to be seen on aerial photographs, extended to the N where the mountain is still called Djebel Majour, a corruption of its antique name. Here springs were harnessed and channeled toward the town. Necropoleis to N and W have not been excavated. The unpublished epitaph of a soldier's wife shows that the camp was occupied by the cavalry of a corps still unidentified, a wing or numerus.

A section of the Roman limes has been recognized N of the route from Négrine to Nefta. The camp was an important station at the crossing of the routes coming on the one hand from Thelepte, Thevestis and Capsa, and on the other from Gemellae; it is probable that many of the remains designated as bazinas, Berber tombs, are really buried towers of the limes.

One km N of the oasis, near the palm orchard of Négrine el Kdima, in the middle of prehistoric stonefields, lie the ruins of a villa with apsidal chamber, hexagonal pool, and mosaic-floored rooms, their decorations destroyed after the last phase of the Algerian war; on the one hand, amid vegetal motifs in geometric arrangement, is a checkerboard of 90 squares formed by the letters of the name Flaviorum, probably a game; on the other, framed by a decorative border of shells and canthari, a gnomic text with some pretensions to meter. In the Algiers Museum is an ostrakon of the Byzantine period, with writing in ink on a pottery fragment.

BIBLIOGRAPHY. Gueneau, *BAC* (1907) 322-26^M; S. Gsell, *Atlas archéologique de l'Algérie* (1911) 50, nos. 152 & 128; Baradez, *Fossatum Africae* (1949) 109-10, 118^P; Baghli & Février, *Bulletin des Antiquités algériennes* 2 (1966-67) 6-8^P. J. MARCILLET-JAUBERT

"AD MEDIAM," *see* Mehadia

AD MILITARE, *see* Limes Pannoniae (Yugoslav Sector)

AD MURES, *see* Limes Pannoniae

AD NOVAS (Suiar des Beni Aros) Morocco. Map 19. A station of the *Antonine Itinerary* (24.3), S of Tingi on the Roman road going to Volubilis. It is very likely in the valley of the Kharroub, which is strewn with ancient settlements. The most probable location is Suiar des Beni Aros where ruins of a small settlement have been found, dating from pre-Roman times and destroyed in the middle of the 3d c. A.D., and ruins of a later castellum.

BIBLIOGRAPHY. T. Garcia Figueras, "La incognita del Valle del Jarub: las ruinas romanas de Suiar," *I° Congreso arqueologico del Marruecos español* (1953) 331-35; M. Euzennat, "Les voies romaines du Maroc dans l'Itinéraire Antonin," *Hommages à Albert Grenier*, coll. *Latomus* 58 (1962) 605-6. M. EUZENNAT

AD NOVAS, *see* Limes Pannoniae (Yugoslav Sector)

ADONY, *see* Vetus Salina *and* Limes Pannoniae

AD PANNONIOS Caraş-Severin, Romania. Map 12. Roman camp and civil settlement 2 km N of Teregova, on the right bank of the Timiş. The ancient name, probably referring to Pannonian colonists, is mentioned in early sources (*Tab.Peut.*; *Rav.Cosm.* 4.14). The camp was 120 m long. Cohors VIII Raetorum was stationed here. The flourishing civil settlement, on the Dierna-Tibiscum road, was probably a vicus.

BIBLIOGRAPHY. M. Macrea "Garnizoanele cohortei a VIII-a Raetorum în Dacia," *Omagiu lui Constantin Daicoviciu* (1960) 339-51; D. Tudor, *Oraşe, tîrguri şi sate în Dacia romană* (1968) 34-35. L. MARINESCU

AD PONTEM (Thorpe) Nottinghamshire, England. Map 24. On the Fosse Way 30.5 km SW of Lindum and mentioned in the *Antonine Itinerary* (477.7). A fortlet, probably less than 1 ha in area was established soon after A.D. 43 on a native site near to where the Fosse Way ran close to the river Trent. The road then probably lay farther W than the line it followed later. A polygonal annex on the NE side of the fort was several times larger. The fort and annex seem to have been abandoned early in the Flavian period, but in the following years a civilian settlement grew up along the road, the line of which was moved E. Later in the 2d c. part of this settlement was enclosed by a single ditch, without preventing growth outside it. The ditch remained functional until well into the 3d c., but probably early in the 4th c. new fortifications were erected, enclosing a different area. A freestanding stone wall, ca. 2 m thick, was built, with two ditches in front of it. Probably about the middle of the 4th c. the double-ditch system was replaced by a single wide ditch and it is possible that external bastions were added to the wall, although none have yet been found.

Little is known of the internal buildings. A large rectangular structure just inside the NE gate shows clearly in aerial photographs. Partial excavations showed that it dated to the 4th c. Its solid construction distinguishes it from other buildings in the area, and it may have had an administrative function (mutatio?). Other buildings, probably shops, line the Fosse Way. A road branching off the Fosse Way to the SE also shows in aerial photographs and may have been matched by one going in the opposite direction to cross the river Trent. A small, isolated, squarish building, not far from the postulated SE gate, might be interpreted as a temple. Some continuity of settlement is suggested by sherds of Anglo-Saxon pottery found here.

Early excavations were mostly on a small scale, but aerial photography led to excavations in 1963 and 1965, which demonstrated the sequence described above. Nothing is now visible above the surface. Some earlier finds, including a rough stone relief of a Celtic god and goddess, possibly Sucellus and Nantosvelta, are in Nottingham University Museum; the remainder are in Newark Museum.

BIBLIOGRAPHY. J. S. Wacher, *JRS* 54 (1964) 159-60^{PI}; 56 (1966) 203-4^P; J. K. St. Joseph, ibid. 43 (1953) 91; 48 (1958) 98^I; id., in J. S. Wacher, ed., *Civitas Capitals*

of Roman Britain (1966) 28[PI]; J.M.C. Toynbee, *Art in Roman Britain* (1962) 156, no. 79[I]; R. R. Inskeep, *Trans. Thoroton Soc.* 69 (1966) 19-39[PI].

J. S. WACHER

ADRANO, *see* ADRANON

ADRANON (Adrano) Sicily. Map 17B. A city on the SW slopes of Mt. Aetna near the Simeto river, ca. 28 km NW of Catania. It was founded by Dionysios of Syracuse ca. 400 B.C., near the sanctuary of the ancient Sikel deity Adranos, who was connected with volcanic phenomena and was therefore traditionally assimilated to the Greek Hephaistos (Plut. *Vit. Tim.* 12; Ael. *NA* 2.3). The city was conquered by Timoleon in 343-342 B.C. and fell under Rome in 263 B.C. Pliny includes it in his list of stipendiary cities.

The site was explored at the beginning of this century, but the first excavation was carried out in 1959. The perimeter of the wall circuit is known for long stretches. It delimits the urban area on the E and W sides. On the S side, along the Simeto, defense was provided by a steep ravine; the N side has almost entirely disappeared under modern buildings. The walls were built of isodomic blocks of lava stone and are particularly well preserved on the E side (Cartalemi district); at the NE end a rectangular tower has been incorporated into the Church of San Francesco.

Excavation has brought to light some houses of the 4th c. containing Italiote pottery and an interesting hoard of contemporary coins. No other monument of the city is as yet known, not even the site of the Sanctuary of Adranos. The city minted coins during the time of Timoleon (among the types appears Adranos as river deity).

Two excavation campaigns have investigated the wall circuit as well as part of the archaic necropolis which stretches SE of the city (Sciare Manganelli). The graves are of a type unusual in Sicily: small and crude circular structures in lava stone which vaguely recall the Mycenean tholoi.

The finds, among which are archaic small bronzes of considerable interest, are exhibited in the Archaeological Museum located within the Norman Castle of Adrano.

BIBLIOGRAPHY. G. Sangiorgio-Mazza, *Storia di Adernò* (1820); S. P. Russo, *Illustrazione storico-archeologica di Adernò* (1897); P. Orsi, ed. P. Pelagatti, "Adrano e la città sicula del Mendolito 1898-1909," *ArcStorSir* (1967-68)[P]; id., "A. insigne ripostiglio di bronzi siculi," *NSc* (1919) 387; id., "Ghianda fittile iscritta. Epigrafi laterizie sicule," *NSc* (1912) 414; id., "Deposito di terrecotte ieratiche," *NSc* (1915) 227; G. Parlangeli in *Kokalos* 10-11 (1964-65) 211ff; P. Pelagatti, op.cit., 245ff.

P. PELAGATTI

ADRIA (Atria) Veneto, Italy. Map 14. An ancient city in the territory of the Veneti, between the Adige and Po and today about 22 km from the Adriatic Sea, from which it derives its name (Strab. 5.1.8). Some ancient sources attribute its founding to the Greeks (Just. *Epit.* 20.1.9) and others to the Etruscans (Plut. *Vit. Cam.* 16; Livy 5.33.7; Plin. *HN* 3.16.120-21), but there is also some evidence pointing toward a Venetic origin. It flourished especially from the middle of the 6th c. until the end of the 5th c. B.C. when it was the principal port of the Adriatic as a result of the importation of Greek products into the valley of the Po. It is uncertain whether it became a true Greek colony or was an emporium of the Etruscans, whose influence during that period was spreading N. At the beginning of the 4th c. B.C., Dionysios I of Syracuse sought to supplant the commercial hegemony of Athens with that of Sicily, and the founding of Atria is also attributed to him (*Etym. Magn.*, s.v. Ἀδρίας τὸ πέλαγος). However, archaeological finds show no Sicilian influence. Toward the end of the 4th c. B.C., Atria was probably occupied by the Gauls, as seems to be indicated by the discovery of funerary furniture similar to that found in Gallic tombs. In the Roman period, Atria became a municipium inscribed on the rolls of the tribus Camilia. Pliny (loc.cit.) mentions the "Atrianorum paludes quae Septem Maria appellantur" and says that the city was blessed with a renowned harbor. It is certain that Atria was at that time less than an hour from the sea, as shown by two lines of marine dunes to the E of the city. The first dates to the Graeco-Etruscan era and the second, farther E, to the Roman era. It is entirely possible that even in antiquity Atria was not on the sea but, like Spina, was connected to the Adriatic by a series of canals.

As early as the Renaissance, there is evidence of archaeological investigations at Atria. From 1700 on, the Bocchi family of Atria collected Attic red-figure and black-figure vases, jewelry of local and Etruscan production, inscriptions, pottery, and Roman glass—nearly all discovered accidentally in the city. The Bocchi collection, given to the Italian government at the beginning of the 20th c., still constitutes the most important collection of the Adria museum. All the Greek pottery from the 6th c. and the 5th c. B.C., for the most part fragmentary, comes not from tombs but from the ancient settlement in the S part of the modern city. In that area were discovered remains of buildings on pilings and also of a theater (known from a drawing of 1662) probably dating to the 2d c. A.D. No ancient building in Adria is now visible. Because of the flooding of the rivers and because of the coastal bradyseism, the archaeological levels are very deep (from 1 to 2 m for the Roman period, and from 3 to 7 m for the pre-Roman period). Excavations have been made even more difficult by the existence of water-bearing strata near the surface. The cemeteries that surround the ancient site to the E, S, and W, only partially explored, date at the earliest to the 4th c. B.C. and span the years until the Roman Imperial period. The archaic cemeteries have not yet been discovered.

BIBLIOGRAPHY. R. Schöne, *Le antichità del Museo Bocchi di A.* (1878); G. Ghirardini, "Il Museo Civico di A.," *Nuovo Archivio Veneto* NS 4 (1905); G. Fogolari, "Scavo di una necropoli preromana e romana presso A.," *StEtr* 14 (1940); B. Forlati Tamaro, "Iscrizioni inedite di A.," *Epigraphica*, 18 (1956); G. Riccioni, *C.V.A., Adria I* (1957); id., "Problemi storici e archeologici di A. preromana," *Cisalpina* I (1959); G. Bermond Montanari, "Ceramica attica a figure nere del Museo Archeologico di A.," *BdA* 49 (1964); G. Fogolari & B. M. Scarfì, *Adria antica* (1970).

B. M. SCARFÌ

AD SAVA MUNICIPIUM (Hammam Guergour) Algeria. Map 18. The ruins occupy a large area on the slopes of the right bank of the Bou Sellam River, where it emerges from the gorges cutting through the Bibans range, beyond the meanderings of the wadi in the eastern high plains of the Constantinois.

The modern importance of the village derives from a hot spring, which is used for public baths. Near the modern baths, excavations have just brought to light those of antiquity. On the hilltops dominating the town one can still see mausolea and caves.

By general agreement the site is identified as Ad Sava Municipium, a stop on the road from Saldae to Sitifis, according to the *Antonine Itinerary*. Perhaps Ad Sava is the bishopric of Assava of the conference of 411.

P.-A. FÉVRIER

AD SAXA RUBRA (Prima Porta) Italy. Map 16. A station on the Via Flaminia on the right bank of the Tiber 14.4 km from Rome. Here the Via Tiberina detaches itself from the Flaminia, and another road led off along the Cremera to Veii. The cliffs of red tufa, coming close to the river at this point, give the road passage strategic importance and this was the scene of Constantine's victory over the army of Maxentius in A.D. 312 (Aur. Vict. *Caes.* 40.23), shown in the frieze of the Arch of Constantine in Rome. Nearby, the villa of Livia called Ad Gallinas, famous for its breed of white chickens and for its laurel grove (Plin. *HN* 15.136), was discovered and explored as early as 1596. In 1867 was found the heroic cuirass statue of Augustus now in the Vatican (Braccio Nuovo). The villa occupied the height dominating the view down the Tiber valley to Rome, and its lands seem eventually to have extended even across the Tiber to Fidenae (*NSc* [1909] 434). Except for works of terracing, all that can be seen today are three vaulted subterranean rooms with reticulate and quasi-reticulate facing, from the largest of which (11.7 x 5.9 m) a fine decoration showing an illusionary garden was removed and is now in the Museo delle Terme. The vault above was covered with stucco reliefs of which only poor remains survive.

The name Prima Porta comes from an arch, thought to be of the time of Honorius, one of the brick-faced piers of which is built into the corner of the modern church.

BIBLIOGRAPHY. G. Tomassetti, *La campagna romana* 3 (1913) 253-59; G. Lugli, *BullComm* 51 (1923) 26-46; T. Ashby, *The Roman Campagna in Classical Times* (1927) 248; M. M. Gabriel, *Livia's Garden Room at Prima Porta* (1955)[I]; H. Ingholt, "The Prima Porta Statue of Augustus," *Archaeology* 22 (1969) 176-87, 304-18.

L. RICHARDSON, JR.

AD SILANUM Lozère, France. Map 23. A statio in the commune of Nasbinals, mentioned in the *Peutinger Table*. Situated in the great forest on the river Aubrac, it is 18 Gallic leagues from Anderitum and 24 from Segodunum. Most scholars identify Ad Silanum with the statio near the village of Puech Cremat, where the Agrippan road from Lyon to Toulouse crosses the Fontanilles. The site forms a regular rectangle with the ancient road running through it; substructures can be noted on both sides inside the rectangle. Occupation seems to have lasted from the 1st c. B.C. to the 5th c. A.D., with an apparent hiatus in the 3d c. Coins are most plentiful in the 1st and 2d c.

Among the objects found are a white-slip bowl with painted decoration, and terra sigillata from La Graufesenque and Banassac. The bronze and iron articles are badly damaged.

BIBLIOGRAPHY. *Bull. soc. Lozère* (1866) 227ff; (1867) 105-45; (1968) 85ff, 141ff; Prunières, "Notes sur quelques découvertes archéologiques faites dans les montagnes d'Aubrac," *Revue d'Archéologie du Midi* (1869-70); *Journal de l'Aveyron*, 23 Sept. 1928; M. Balmelle, *Répertoire archéologique du Département de la Lozère* (1937); Albengue, *Les Ruthénes* (1948).

P. PEYRE

AD STATUAS, *see* LIMES PANNONIAE

"AD STOMA," *see* SARINASUF

AD TURREM (Tourves) Var, France. Map 23. About 50 km E of Aix-en-Provence (Aquae Sextiae) on the road from Italy to Spain, a statio (*Tab. Peut.*, etc.) at the foot of Saint-Probace hill, which had a fortified enclosure in the Celto-Ligurian period. The site has produced many remains of Gallo-Roman occupation, which include part of a large villa. Several rooms with mosaics are grouped around a peristyle, as well as flagged chambers over hypocausts with swimming pools, latrines, and a household shrine. A second courtyard must have been at the center of premises used for agricultural purposes. This villa underwent several remodelings from the 1st to the 3d c. It included a potter's kiln intended for the production of tiles. The Early Christian and mediaeval site of La Gayole (necropoleis and trilobate chapel) attests to the continuity of occupation from antiquity to the Middle Ages.

BIBLIOGRAPHY. *Forma Orbis Romani*: Var (1932); "Chronique des circonscriptions arch.," *Gallia* (1950ff).

C. GOUDINEAU

"AD TURRES," *see* MOGORJELO

AECAE (Troja) Apulia, Italy. Map 14. A city of the Daunii 22 km SW of Foggia on the Via Traiana, which runs between Benevento and Brindisi. It was taken by Hannibal after the battle of Cannae and was reconquered two years later in 214 B.C. by Fabius Maximus (Polyb. 3.88; Livy 24.20). In the Imperial age the city was called Colonia Augusta Apula (*CIL* IX, 950) and was perhaps ascribed to the tribus Papiria (*CIL* VI, 2381). In Pliny (*HN* 3.105) the name appears as Aecani (cf. ager Aecanus in *Lib. Colon.*, p. 210), and as Aecas on the itineraries.

The ruins of the ancient city lie under the present town. Stelai, Daunian tombs, and Roman inscriptions have been found in the surrounding necropoleis. Finds from the site are preserved in the municipal building at Troja and in the Museo Civico at Foggia.

BIBLIOGRAPHY. W. Smith, *Dictionary of Greek and Roman Geography*, I (1856) 29 (E. H. Bunbury); *RE* I.1 (1894) 443 (Hülsen); E. De Ruggiero, *Dizionario epigrafico di antichità romane*, I (1895) 135; K. Miller, *Itineraria Romana* (1916) 373.

F. G. LO PORTO

AECLANUM (Eclano) Italy. Map 14. A road center and market town of the Hirpini, situated on the Via Appia, 24 km E of Benevento, near Mirabella Eclano, at the point where the Via Aeclanensis left the Via Appia to join the Via Traiana Nova at Herdoniae. Besieged and sacked by Sulla in 89 B.C., it rapidly recovered, becoming successively a municipium and, in the 2d c., a colonia. Later the seat of a bishopric, it was captured and destroyed by Constans II in 660, after which it disappears from history.

The town occupied an irregular promontory, with modest natural defenses on the S side, overlooking the river Calore, and open to the N towards the crest of the ridge that carried the Via Appia. The principal remains above ground are those of the circuit of walls and towers, in opus quasi-reticulatum. They date from the second quarter of the 1st c. B.C. with substantial repairs at a slightly later date, and are important because unusually well documented epigraphically. Excavation within the town has revealed a long history of pre-Roman settlement. It has also exposed two quarters of the Roman town, of which the most noteworthy monument is a bath building, probably Augustan with later modifications.

BIBLIOGRAPHY. I. Sgobbo, *Atti del II Congresso di Studi Romani* (1931) 394ff; *EAA* 3 (1960) 207 (G. Colonna); G. O. Onorato, *La ricerca archeologica in Irpinia*, Naples, 1960.

J. B. WARD-PERKINS

AEGILIUM INSULA (Giglio) Etruria, Italy. Map 14. Cited by various Latin writers (Caesar, Pliny, Pomponius Mela, Rutilius Namatianus), the island was inhabited from the Stone Age into the Roman era. Many dis-

coveries have been made on land and in the sea. Roman remains are visible at Giglio Porto (Villa Marittima).

BIBLIOGRAPHY. *CIL* XI, 2643; G. Pellegrini, *NSc* (1901) 95-97; P. Raveggi, *NSc* (1919) 275-79; *EAA* 3 (1960) 895 (G. Maetzke); Bizzarri, *StEtr* 33 (1965) 81ff, 515-20; Uggeri & Bronson, *StEtr* 38 (1970) 202-5; G. Monaco in *FA*, vols. 14 to 20; *StEtr* (Rassegna Scavi e scoperte) 28 (1960) to 41 (1973). G. MONACO

AEGYSSUS (Tulcea) Dobrudja, Romania. Map 12. About 64 km E-SE of Galaţi, a Getaean settlement, conquered by the Romans. The name may be Celtic. Ovid mentions it as an old fortress, founded by a certain Caspios Aegisos, on the right side of the Danube, on a high, almost inaccessible hill. No archaeological excavations have been undertaken. The identification with modern Tulcea has been confirmed by an inscription mentioning a "vexillatio (a)egisse(n)sis." Ruined Roman walls, two relief carvings (a Thracian knight and a funeral feast), and other chance finds are of interest.

BIBLIOGRAPHY. Ov. *Pont.* 1.8.13, 4.7.21, 23-24, 53; *Ant. It.* 226.2; *Not. Dig. or.* 39.9.17.34; Hierocl. *Synecd.* 637.14; Procop. *De aed.* 4.7.

I. Barnea, "O inscripţie de la Aegyssus," *Studi şi cercetări de istorie veche*, I, 2 (1950) 175-84; *TIR*, L.35 (1969) s.v.; N. Gostar, "Caspio Aegisos," *Danubius* 4 (1970) 113-21. I. BARNEA

AELANA or AILA (Tell el-Khuleifa) Israel. Map 6. An ancient port at the N end of the NE arm of the Red Sea, known today as the Gulf of Aqaba. In Biblical literature this place is frequently mentioned, together with Ezion-geber, as an important naval station on the trade route to "Ophir."

Early in the Hellenistic period the Ptolemies of Egypt had established a port named Berenike "not far from the city of Aelana" (Joseph. *AJ* 8.163). Strabo (16.759) knew the port of Aila (Elath) at the head of the Arabian Gulf, at a distance of 1260 stadia from Gaza. From Early Hellenistic times the port of Aila had apparently been in the hands of the Nabateans and was prominent in their Indo-Arabian spice trade. Probably Strabo's reference to the caravans of camels crossing the desert from Aila to Gaza should be understood in this context. This is also confirmed by Pliny (*HN* 5.65). Ptolemy (*Geog.* 16.1) in the early 2d c. A.D. knew the village of Aelana in Arabia Petraea, the name by which he refers to the Nabatean kingdom. The region of Aila retained its importance in Late Roman and Byzantine times. During the early 2d c. A.D. a unit of the Legio III Cyrenaica was stationed near Aila, probably in order to guard the road to the copper mines at Sinai, the exploitation of which was renewed at this period. About A.D. 300, during the reign of Diocletian, this legion was replaced by the Legio X Fretensis (Euseb. *Onom.* 6.17-20; 8.1.). In the 4th c. Aila became the seat of the prefect of that legion (*Not. Dig.* 73.16.30). In the Byzantine period Aila must have been an important station on the pilgrim's way to Mt. Sinai.

The remains of ancient Aelana should be probably sought at Tell el-Khuleifa, where remains of an Israelite fortified emporium have been unearthed. Persian, Attic, Roman-Nabatean, and Byzantine pottery attest to the later occupation of the site.

BIBLIOGRAPHY. N. Glueck, "Explorations in Eastern Palestine II," *AASOR* 15 (1935) 26-7, 42-5, 47-8, 138-9; 3 (1939) 3-7; M. Avi-Yonah, *The Holy Land from the Persian to the Arab Conquests (536 B.C. to A.D. 640). A Historical Geography* (1966). A. NEGEV

AELIA CAPITOLINA (Jerusalem) Israel. Map 6. Jerusalem cannot really be said to have entered the Classical world until the time of Herod the Great in the last third of the 1st c. B.C. The influence of the Classical Greek period barely penetrated into Palestine and not at all into Jerusalem. Palestine was peacefully incorporated into Alexander's empire after the battle of Issus in 333 B.C. At first it was governed by the Ptolemies of Egypt, but for the whole century of Ptolemaic rule there is little evidence of Hellenistic influence. Jerusalem remained the cult center for the worship of Yahweh, and the old Semitic material culture prevailed. In 198 B.C. it passed into the hands of the Seleucids of Syria.

The misguided attempt of Antiochus IV Epiphanes in 167 B.C. to substitute the worship of Zeus Olympios for that of Yahweh caused the revolt under the Maccabees, which resulted in a virtually independent Jewish kingdom in the 2d and 1st c. B.C., fiercely xenophobic and opposed to all forms of Hellenistic culture. The archaeological evidence of this is not only the complete absence of Classical architecture, but also of imported Hellenistic pottery and its imitations, so common in the N part of Palestine, for instance at Samaria. Jerusalem thus had no true Hellenistic period. It entered the Roman world with the reign of Herod the Great (40-4 B.C.), who achieved power at the expense of the heirs of the Maccabees, and was a great admirer of Rome and Augustus.

In Jerusalem, Herod's enthusiasm for Classical culture was severely circumscribed by the orthodox adherents of Yahweh; it was in other areas that he could build Classical structures, for instance at Samaria and Caesarea. On the evidence of Josephus, he built a theater and amphitheater at Jerusalem, but no trace of them has survived; probably such alien structures were outside the walls. In connection with the Temple and with the area of his palace, however, there is visible evidence.

The great monument of the Old City of Jerusalem today is the Moslem Dome of the Rock. It stands on a massive platform which is in effect the enlarged platform built by Herod for his new Temple. The join between Herod's masonry, characterized by massive blocks with slight margins and beautifully flat centers, and that of the earlier platform can be seen ca. 32 m N of the SE corner of the platform. The Herodian masonry can be traced right along the S side and for at least 185 m on the W face. The whole W face was therefore probably a Herodian rebuilding, to provide the doubling of the area predicated by Josephus. Of Herod's Temple itself, nothing survives. The description of Josephus suggests that it was purely Semitic in form and decoration, but with some Classical elements in the architectural features.

Of Herod's other buildings, the only certain element to survive is a part of the three towers on the W of the two ridges covered by later Jerusalem. The main tower of the modern citadel adjoining the Jaffa Gate is today called the Tower of David, but its lower courses are unambiguously Herodian, and it is probably the tower Phasael of Herod.

Josephus states that the Temple platform and the W ridge were connected by a bridge. Two arches spring from the platform wall. That known as Robinson's Arch, a little N of the SW angle, has been shown by excavations possibly to be part of a staircase from the S. Perhaps, therefore, the bridge was on the line of Wilson's Arch, 185 m N of the corner. Excavations in progress since 1967 have added details of adjacent streets and the approach to the Temple from the S.

The N wall of Herod's Jerusalem is probably the second north wall described by Josephus. Excavations have provided a clue to its line. Its terminal to the E is the

fortress Antonia, built by Herod at the NW corner of the Temple platform to replace the Maccabean tower Baris. The general position of Antonia is certain, but the association with it of a pavement in the area of the Convent of the Sisters of Sion, which it is claimed is the lithostratos of the Gospels, has been disputed with some cogency. Evidence suggests that the wall turns S to join the earlier wall about halfway between the Temple and the citadel, which would mean that the traditional sites of the Crucifixion and of the Holy Sepulcher were outside the contemporary wall.

The relatively independent rule of Herod the Great broke down owing to the inadequacies of his successors, and direct rule from Rome followed. A brief acknowledgment of the influence of native leaders comes with the recognition of Herod Agrippa I as the ruler of a relatively minor area centered on Jerusalem. The official period of his reign is A.D. 40-44, and he seems to have accomplished quite a lot.

To the S of the city and beyond the present Old City extend the spurs of the two main ridges upon which Jerusalem is built. The original town was on the E ridge, but later, probably only in the Maccabean period ca. 100 B.C., the greater part of the W ridge was included within the city. Excavations indicate that only at the time of Herod Agrippa was a complete circuit joining the two ridges established. The surviving evidence of Herod Agrippa's extension to the S is not architecturally impressive, for very little survives. On the evidence of Josephus, Herod Agrippa also extended the city to the N, for he built the third north wall of Josephus. Excavations have proved that there is, under the present Damascus Gate, a part of a gate in Roman style that can be stratigraphically dated to the mid 1st c. A.D. It is quite certain that there was here an extension of the town, with a gate built in masonry of Herodian type, at this period.

The final stage of the First Revolt of the Jews was the siege of Jerusalem by Titus in A.D. 70. It is probable that the wall of circumvallation built by Titus is to be identified in a wall ca. 200 m N of the Old City, constructed of enormous ashlar blocks, originally of high quality, but battered and obviously reused. When Jerusalem eventually fell to Titus, the city was destroyed. Only the great walls supporting the Temple platform and the towers of Herod's palace survived. Titus left the Legio X Fretensis to guard the ruins. On the evidence of Josephus, the legionary headquarters were in the area of Herod's palace on the W ridge, and the towers of the palace formed part of the defenses. No remains of the headquarters have been found, and the only evidence of the presence of the legion in Jerusalem until ca. A.D. 200 is the large number of bricks with its stamp.

The second revolt of the Jews led Hadrian, in A.D. 135, to complete the abolition of Jewish Jerusalem by substituting for it Aelia Capitolina. The S part of the site, including all of Davidic Jerusalem and the greater part of the city of subsequent periods, was left outside the walls, and much of the whole area was quarried to provide stone for the new town.

The best evidence for Aelia Capitolina is the street plan of the present Old City, the antiquity of which is shown by the Madaba mosaic of the 6th c. A.D. The N-S axis was a colonnaded street running S from the Damascus Gate; portions of the columns survive in shops adjoining the present street. There was no E-W street crossing the whole city, for the great mass of the Temple platform made this impossible. The main E gate is that now known as St. Stephen's Gate; the main W gate, shown by the line of the present David's Street, was approximately on the site of the present Jaffa Gate. The streets from both gates connected with that from the Damascus Gate. On the line of the street from the E gate was a triumphal arch, part of which survives in the Convent of the Sisters of Sion, and part is still visible in the street today. Good reason has been given to suggest that the pavement, shown to visitors as part of the lithostratos of the time of the Crucifixion, is contemporary with the arch, and forms part of a small forum. The main forum may be adjacent to the present Church of the Holy Sepulcher, but nothing is visible today.

The street plan shows that there must have been a gate on the site of the present Damascus Gate. In a rebuilding of the arch over the E pedestrian entrance of the Herod Agrippa gate is a stone with an incomplete inscription certainly referring to Aelia Capitolina. It is not exactly in situ, but may have been only slightly displaced in Ommayad times. The evidence of the street plan suggests that it can be accepted as belonging to the original gate of Aelia Capitolina.

Probably the S wall of Aelia corresponded closely with that of the present Old City. The area immediately E of the present Dung Gate forms a salient from the Herodian Temple platform. The wall here is certainly post-Herodian and grandiose in its masonry. There is no exact evidence, but it seems probable that it belonged to the S wall of Aelia Capitolina. Certainly there is nothing Roman (pre-Byzantine) to the S.

There is little evidence concerning the history of Aelia. The city regained its importance with the conversion to Christianity of the Emperor Constantine, and by the 5th c. A.D. had expanded once more to the S. Remains of the Constantinian church can be identified beneath the Church of the Holy Sepulcher. The city fell to the Arabs in A.D. 638.

Museums: Palestine Archaeological Museum (Rockefeller Museum) N of the Old City; Eretz Israel Museum in W Jerusalem.

BIBLIOGRAPHY. Josephus, *Antiquities of the Jews* and *War of the Jews*, trans. W. Whiston, ed. D. S. Margoliouth (1906); L. H. Vincent & F. M. Abel, *Jérusalem, Recherches de Topographie, d'Archéologie et d'Histoire.* II. *Jérusalem Nouvelle* (1914-26); K. M. Kenyon, *Jerusalem: Excavating 3000 Years of History* (1969); id., *Digging up Jerusalem* (1974); J. B. Hennessy, "Preliminary Report of Excavations at the Damascus Gate," *Levant* 2 (1970); P. Bénoit, "L'Antonia d'Hérode le Grand et le Forum Oriental d'Aelia Capitolina," *HThR* 64 (1971); B. Mazar, *The Excavations in the Old City of Jerusalem, near the Temple Mount* (1969). Preliminary report. K. M. KENYON

"AELIA HADRIANA AUGUSTA," *see* ZAMA

AEMINIUM (Coimbra) Beira Litoral, Portugal. Map 19. Mentioned by Pliny (*HN* 4.24) and Ptolemy (2.5) and in the *Antonine Itinerary*, the name also occurs in an inscription dedicated to Constantius Chlorus. Conimbriga, 16 km to the S, was in the 6th c. the seat of a bishopric in which Aeminium was a parish, but ca. 589 the Bishop Posidonius was transferred from Conimbriga to Aeminium, and part of Conimbriga's population also took refuge there. In the 9th c. Aeminium took the name of Colimbria, a corruption of Conimbriga.

Nothing remains of the Roman monuments of Aeminium except the cryptoporticus under the Museu Machado de Castro. Two arches still standing in the 18th c. in Estrela (next to the present-day government building) were once thought to be remains of a Roman triumphal arch, but they may have been ruins of one of the fortification gates of the 9th c. There were, however, some

Roman baths, called in the 12th c. the Baths of the King, in the area where the monastery of Santa Cruz was built. The aqueduct now called Arcos do Jardim seems to have been built in the 16th c. over the ruins of the Roman aqueduct. The Roman road coming from Conimbriga crossed the river E of the present bridge and probably ran alongside the aqueduct. Near the aqueduct was the cemetery. On the Largo da Sé Velha, remains of a Roman building were uncovered, and coins and ceramics were found. Traces of the Roman period in Coimbra are scarce, but the crytoporticus under the Museu Machado de Castro is one of the chief remaining Roman structures of Portugal.

The hillside between the present-day terraces of the cathedrals (Sé Velha and Sé Nova) was the site of the cryptoporticus on which the Romans constructed their forum, a huge artificial platform on two levels. On the upper level, a pi-shaped gallery surrounds another of the same plan. In each arm of the pi three corridors give access from one gallery to the other, and they are also connected at the top. Between the arms of the pi are chambers connected by narrow vaulted passageways. On the lower level were other rooms, higher and more spacious, arranged along a gallery with narrow passageways connecting them. This level was partially destroyed by houses built against it, and later, perhaps when the bishop's palace was reconstructed in the 16th c., the galleries were filled in with rubble. In the debris were uncovered four marble heads, representing a priestess, Agrippina, Vespasian, and Trajan. In the excavations on the site of the present-day church of S. João de Almedina pieces of entablature have been found which can perhaps be attributed to the temple in the forum. The chronology of the complex has not been established, but the suggested dates in the 3d-5th c. are certainly too late.

Among the native sons of Aeminium was the architect Gaius Servius Lupus, builder of the lighthouse of La Coruña in NE Spain.

BIBLIOGRAPHY. V. Correia, *Obras* I (1946); J. M. Bairrão Oleiro, "O criptopórtico de Aeminium," *Humanitas* NS 4-5 (1955-56) 151-60[P]; id. & J. Alarcão, "Le cryptoportique d'Aeminium," *Les cryptoportiques dans l'architecture romaine* (Colloques du C.N.R.S.) (1973) 349-69. J. ALARCÃO

AENARIA (Ischia) Italy. Map 17A. An island off the W coast of Campania opposite Cumae, its central mountain, Epomaeus, actively volcanic in Classical times. Called Pithekoussai by the Greeks (the plural sometimes also implies nearby Prochyta/Procida), it is also referred to as Inarime (e.g., by Vergil and Martianus Capella), apparently on the basis of the mention (*Il.* 2.783) of Typhoeus being chained down "ein Arimois."

Euboian Greeks from Eretria and Chalkis established here in the early 8th c. B.C. a commercial post to facilitate trade with mainland Etruscans. From here they set up at Cumae, around 750 B.C., the earliest Greek colony in Europe. Pliny rightly derives the Greek name from the local ceramic clay deposits, not from pithekos (ape); he explains the Latin name as connected with Aeneas' beachhead. The island was mostly under the political control of Naples, and was famous for its pottery, fruit, and rich wine.

The Monte Vico area was inhabited from the Bronze Age. The acropolis settlement has been located and some Mycenean and Iron Age pottery as well as evidence of continuous occupation into the 1st c. B.C.

The Greek necropolis nearby has been extensively explored, the 8th and 7th c. graves being especially instructive. Numerous bronze and silver fibulae, Egyptian scarabs, oriental seals, and imported Greek pottery show vigorous trade with Athens, Corinth, Ionia, Euboia, Syria, Phoenicia, and Egypt. Local ware is also well attested, including a Geometric krater with a vivid shipwreck scene and fish devouring sailors. A Rhodian skyphos of ca. 740 B.C. carries one of the earliest of all examples of the Greek alphabet, in Chalkidian script from right to left: a trochaic trimeter followed by two dactylic hexameters which include a reference to Nestor's cup—perhaps implying knowledge already of the *Iliad*.

BIBLIOGRAPHY. Strab. 1.3.10; 2.5.19; 5.4.9; 6.1.6; Plin. *NH* 3.6.12; Pomp. Mela 2.121; Verg. *Aen.* 9.716; Sil. *Pun.* 8.541; 12.147; Stat. *Silv.* 2.2.76; Martianus Capella 6.644; Ov. *Met.* 14.90-100.

G. Buchner, "Scavi nella Necropoli di Pithecusa" in *Atti e Memorie Soc. Magna Grecia* (1954) 3-11; id. & C. Russo, "La Coppa di Nestore e una Iscrizione Metrica da Pitecusa" in *RendLinc* (1955) 215-34; *EAA* 4 (1961) 224-29; id., "Pithecusae, Oldest Greek Colony in the West," *Expedition* (U.Pa.Museum) (1966) 4-12; A. Maiuri, "Pithecusana" in his *Sagga di Varia Antichità* (1954) 167-200; J. Bérard, *L'Expansion et la Colonisation Grecques* (1960) 70-72, 84-87. Map in *Napoli e Dintorni* (CTI) 336. R. V. SCHODER

AENONA (Nin) Croatia, Yugoslavia. Map 12. About 14 km N of Zadar, an important center of the Liburni from the Early Iron Age, as confirmed by the rich finds in several necropoleis of the 9th to the 1st c. B.C. After the suppression of the Illyrian rebellion (A.D. 6-9), Aenona became a municipium under Tiberius. It was a center in a large and important civitas mentioned by Pliny among the coastal centers of the Liburni (*HN* 3.140).

The peninsula on which it stood (450 m long) was encircled with walls and connected by two bridges to the mainland and a road to Iader. Some parts of the walls are still visible under mediaeval walls. At the intersection of the cardo and decumanus is the forum with a monumental temple on the W side, built in the 1st c. A.D. most probably by the Flavian emperors. It had an elevated podium with the six columns in front; the interior was divided into three naves by columns. The temple was probably a center of the imperial cult if the monumental statues of Augustus and Tiberius can be assigned to it. Its dimensions (45 x 21.5 m) make it the largest temple to be excavated so far in Yugoslavia. A rich necropolis of the 1st-3d c. lay along the road to Iader. In the ager of Aenona the remains of an aqueduct were found. The many inscriptions from the area indicate a romanized Liburnian population that respected their native traditions. By 500 Aenona was under the Ostrogoths. At the beginning of the 7th c. it was conquered by Croats. The finds are preserved in a local archaeological collection and in the Archaeological Museum at Zadar.

BIBLIOGRAPHY. M. Suić et al., *Nin, Problems of Archaeological Excavations* (1968); id., "Antički Nin (Aenona) i njegovi spomenici," *RADOVI* (Institute of Yugoslav Academy at Zadar) 16-17 (1969), 61-104.

M. ZANINOVIĆ

AEOLIAE INSULAE (Lipari Islands) Messina, Sicily. Map 14. The peaks of the volcanic range of which Vesuvius and Aetna are a part form this archipelago off Cape of Milazzo in NE Sicily. Greek and Roman tombs have been located at various points on Filicudi; Salina has produced Roman house walls and Greek and Latin inscriptions; a Roman habitation with a hypogeum, traces of wall painting and mosaics is located on Basiluzzo, while Stromboli, famous in antiquity, has yielded millstones and Roman tombs. Of the entire group, Lipari

(ancient Lipara) is of the greatest importance archaeologically.

Pentathlos' Knidians arrived at Lipara in 580 B.C. and settled on the site of the modern village in the area now known as Castello or la Cittade. The colony waged a successful struggle against the Etruscans for control of the Tyrrhenian Sea. During the intervention of Athens in the affairs of the West in 427 B.C., Lipara was allied with Syracuse and withstood the assault of a combined force of Athenians and Rhegines. Carthaginian forces succeeded in holding the site briefly during their struggles with Dionysios I in 394, but once they were gone the polis entered a three-way alliance which included Dionysios' new colony at Tyndaris. Lipara prospered, but in 304 Agathokles took the town by treachery and is said to have lost 50 talents worth of pillage from it in a storm at sea. Lipara became a Carthaginian naval base during the first Punic war, but fell to C. Aurelius in 252-251, and again to Agrippa in Octavian's campaign against S. Pompeius. Under the Empire, it was a place of retreat, baths, and exile.

The excavation of Graeco-Roman Lipara is complicated by the existence of the modern town over the ancient site. The discovery of the necropolis at the outskirts of the town indicates that the ancient and modern settlements are coterminous. During excavation a sanctuary to Demeter and Persephone was discovered on the ancient road leading to the necropolis. The sanctuary, which consisted of an altar open to the sky within a temenos, has produced a well-dated series of ex voto dating from the 4th c. to the Roman capture. Near the Comune, portions of the Greek defense wall of the 4th-3d c. are still visible. At the site of the museum, the Castello, the construction of the square in front of the cathedral at the beginning of this century destroyed all archaeological evidence over a large part of the acropolis, but what remains shows a "tell deposit" 9 m deep from the Neolithic to the present. Excavation has traced the Graeco-Roman street grid and has uncovered house remains. The Hellenistic and Roman remains rest on the prehistoric strata.

There are important collections from Lipari at Palermo, Cefalu, Syracuse, Glasgow, and Oxford, in addition to the Aeolian Museum at Lipari.

BIBLIOGRAPHY. A. Mezquirez de Irujo, "Ceramica ibérica en Lípari," *Archivo Espanol de Arqueologia* 28 (1955) 112; L. Bernabò Brea, "Lipari nel IV sec. a. C.," *Kokalos* 4 (1958) 119ff; id. & M. Cavalier, *Il Castello di Lipari e il Museo Archeologico Aeoliano* (1958) with bibliography; idd., *Meligunìs-Lipára II: La Necropoli Greca e Romana nella Contrada Diana* (1965); idd., "Lipari—la zona archeologica del Castello," *BA* 5, 50 (1965) 202-5; L. Zagami, *Le Monete di Lipara* (1959); *TCI Guida d'Italia: Sicilia* (1968) 444-80; A. D. Trendall & T.B.L. Webster, "The Stevenson Collection from Lipari," *Scottish Art Review* 12, 1 (1969) 1-7 (serialized). H. L. ALLEN

AEQUINOCTIUM, see LIMES PANNONIAE

AEQUUM (Čitluk) Croatia, Yugoslavia. Map 12. The Roman Colonia Claudia Aequum was situated 6 km N of Sinj. It was founded by the emperor Claudius sometime after A.D. 45 and settled with the veterans of Legio VII when they left the neighboring camp at Tilurium for Moesia. Even before its foundation, a community of Roman citizens, traders, and settlers, probably from Salona, was already established there as conventus. Aequum was the only Roman colony in the interior of the province of Dalmatia, the others (Salona, Iader,

Narona, Epidaurum) being on the Adriatic coast. It was enrolled in the tribus Tromentina.

Situated in a rich, fertile plain, formerly territory of the Delmatae, it was a planned city of 32 ha enclosed by walls (400 x 330 m). The site has been only partly explored. The walls followed as regular a plan as the site permitted: the W part of the town was on the plain and the E on a low hill. The forum, in the center of the city plan, was built a little off the main city street. It measured 90 by 60 m and had a paved courtyard with colonnades and shops on three sides. The remains of the curia were found also, with other rooms on either side of it. In one room were found fragments of imperial statues. Outside the city walls to the NW was a necropolis with sarcophagi and other tombs. In the W wall the traces of a gate were found with a relief in the keystone arch representing Victoria with a captured Delmata kneeling before her. Citizens of Aequum appear at Salona, both in the legions and as traders and functionaries in Dacia. One of the greatest families in the province of Dalmatia were the Iulii from Aequum. Scxtus Iulius Severus was Hadrian's best general and consul with a splendid military career. He suppressed the Jewish rebellion in Judaea A.D. 135 and served as a governor of Dacia, Britannia, and Syria. His son (or nephew) Cn. Iulius Verus was also consul 151 and controller of the state treasury in Rome, the governor of Germania Inferior and Britain.

Abbé Fortis, the 17th c. traveler, noted the remains of the amphitheater W of the town, but nothing of it can be seen today. The town was destroyed by Goths or Slavs and Avars. Its ruins served as a quarry for neighboring villages and for the town of Sinj, which replaced it as the center of the area.

A head of Hercules, a statue of Hecate, and many other finds and inscriptions are preserved in the archaeological collection of the Franciscan Monastery at Sinj.

BIBLIOGRAPHY. E. Reisch, "Colonia Claudia Aequum," *JOAI* 16 (1911) 137-40; A. P. Mišura, *Colonia Romana Aequum Claudium (Čitluk)* (1921); M. Abramič, *Zbornik Kazarov* (1951) 238-40. M. ZANINOVIĆ

AESERNIA (Isernia) Abruzzi e Molise, Italy. Map 14. A pivotal communications center ca. 176 km by road E-SE of Rome. It was a Samnite town before 295 B.C., a Latin colony after 263 B.C., and, from 80 B.C., a Roman municipium. Polygonal walls of the Latin colony, in Via Roma and elsewhere, postulate a town of ca. 12 ha, whose cardo maximus was the modern Corso Marcelli. The massive 3d c. B.C. podium now forming part of the Cathedral probably supported the Capitolium. The campanile, Fontana Fraterna, and Sordo bridge also embody Roman masonry. The sculpture collection in the Museo Comunale includes important Italic pieces.

BIBLIOGRAPHY. A. La Regina, "Contributo dell'Archeologia alla Storia Sociale: I Territori Sabellici e Sannitici," *Dialoghi di Archeologia* 4-5 (1970-71) 443-59. E. T. SALMON

AESICA, see HADRIAN'S WALL

AESIS (Iesi) Umbria, Italy. Map 16. A site on the left bank of the river Aesis, the boundary between Umbria and Picenum, ca. 18 km inland from the Adriatic. Under the Romans it was inscribed in the tribus Pollia and at some time given the rank of colonia. It seems not to have been of great consequence in Roman times. Antiquities from the area are kept in the Palazzo della Signoria. L. RICHARDSON, JR.

AETOS, see KESTRIA

AEZANI (Çavdarhisar) Phrygia, Turkey. Map 5. The district of Aezani, today called Örencik Ovasi, is located on the upper course of the Rhyndakos (Çavdarhisar Suyu), 54 km SW of Kütahya, in Azanitis (Strab. 12.576). It was captured by Eumenes II from Prusias I of Bithynia in 184 B.C. and attached to the kingdom of Pergamon; from 133 B.C. it belonged to Rome.

The oldest pottery finds of Late Hellenistic and Early Roman times come from the Holy of Holies of the Meter Steunene (Kybele) 3.5 km W of the town, on the Penkalas (Paus. 8.4.3; 10.32.3), the upper course of the Rhyndakos. Coins from the 1st c. B.C. bear the inscription EZEANITΩN. The important ruins of the Roman city, visible today, belong for the most part to the 2d c. A.D. It was a bishop's seat in the Christian period, with a church built into a Temple of Zeus. Later it was expanded as a fort by the Tartar race of the Çavdar, and from that derives its present name.

The Roman city had no fortifications. It extended on both sides of the river, whose deep channel was contained between high embankments of large ashlar blocks. From bank to bank there originally stretched four bridges of ashlar, of which two are still in use. The five barrel vaults of one of these increase in width and height toward the center.

On the left bank of the river lie the agora, with a small market temple, a second, Doric agora, the precinct of the Temple of Zeus, baths with a gymnasium, a stadium, and a theater. On the right bank are the tholos of a macellum and the ruins of two temples. Sprawling necropoleis with sarcophagi and portal-shaped tombstones lie on the slopes surrounding the town.

With its 16 columns still standing, the Temple of Zeus is the best-preserved Ionic temple in Asia Minor. It towers high above the surrounding area, being set on a high, vaulted platform, with double-aisled porticos around the edge. These porticos enclosed a courtyard of 112 x 130 m. In the center, the temple stood on a podium 2.86 m high, approached by stairways of 11 and 7 steps. One climbed directly up to the temple precinct from the agora through an imposing propylon with 27 steps, by which a characteristic impressiveness, usual in imperial architecture, was achieved. Between the propylon and the temple and on an axis with them lay an altar for burnt sacrifices.

The temple itself was pseudodipteral, with 8 Ionic columns on the ends and 15 on the flanks. The columns were farther apart at the center than at the ends, in the ratio of 4:4:5:6. The cella had 4 columns in front of the pronaos, in the manner of a prostyle, and 2, with composite capitals, in antis in the opisthodomos. Between the cella and the opisthodomos a staircase was inserted. The general plan is similar to the Hellenistic type created by Hermogenes in Magnesia, which was also used for the Temple of Augustus in Ancyra. The cella walls have the unusual attribute of an inscription zone, framed with meander band and molding over an orthostat socle. The inscriptions concern a lawsuit over the possession of the temple, from which the date of the building may be set in the time of Hadrian, between A.D. 125 and 145, and honorary decrees from the year A.D. 157 for M. Ulpius Apuleius Eurykles, a famous citizen of Aezani. An interesting enrichment of the architecture is provided by small vases in relief in the upper zones of the column-flutes, below the Ionic capitals.

The excavated remains of the large central akroterion of the gable show a bust of Zeus on the E and on the W a female bust, perhaps to be identified as Kybele. It may be conjectured that an impressive vault located under the temple, of the same dimensions as its inner structure and accessible from the opisthodomos in the W via the stairs mentioned above, was dedicated to the goddess. This is also suggested by the dedicatory inscription of a priest "of Zeus and Kybele." From here, the Spring processions may have led to the Holy of Holies of the Meter Steunene.

On the right bank of the river, near the upper of the surviving Roman bridges, there were revealed in 1971 the remains of a round structure 14 m in diameter. The socle of this building, consisting of a base, lower molding, orthostates, and cornice, formed a platform reached by two 10-stepped stairways, on which apparently rested a tholos with 16 columns and conical roof. This evidently formed the central building of a macellum, and probably housed a fountain. Subsequently there was added to the orthostates a copy of the Price Edict promulgated by Diocletian in 302. Of the original 12 whole and 4 half-orthostates there survive 8 whole and one half, densely inscribed with Edict lists. They have been set up in their original places.

BIBLIOGRAPHY. C. Texier, *Description de l'Asie Mineure* (1839) I 95-127, III pls. 23-49; P. Le Bas, *Voyage Archéol.* (1850) pls. 1-35; id. & S. Reinach, *Voyage Archéol.* (1888) 142ff; A. Körte, "Das Alter des Zeustempels in Aizanoi," *Festschrift für O. Benndorf* (1898) 209-14; M. Schede, *Untersuchungen am Tempel in Aezani* (1930) 227-31; R. Naumann, "Das Heiligtum der Meter Steunene bei Aezani," *IstMitt* 17 (1967) 218-47; id. & F. Naumann, "Der Rundbau in Aezani," *IstMitt* 10 (1973); H. Weber, "Der Zeus-Tempel von Aezani—ein panhellenisches Heiligtum der Kaiserzeit," *AM* 84 (1969) 182; E. Akurgal, *Ancient Civilizations and Ruins of Turkey* (2d ed. 1970) 267-70PI; U. Laffi, "I Terreni del tempio di Zeus ad Aizanoi," *Athenaeum* NS 49 (1971) 3-53.

R. NAUMANN

AGATHA (Agde) Hérault, France. Map 23. Massalian trading post (Scymn. v. 208; Strab. 4.1.5-6; Plin. 3.33; Pompon. 2.5; Ptol. 2.10.2; Steph. Byz. s.v.) at the head of the delta of the Hérault on a low butte which has been inhabited continually since antiquity. It is a few km S of the important native oppidum of Bessan. While the Massaliots possessed several trading posts on the shores of Provence and the E coast of Spain, Agatha, which was founded in the 6th c. B.C. shortly after the installation of the Phokaians at Marseille, was the only town on the Gulf of Lion which was occupied by the Greeks in the pre-Roman period. There were several complementary motives for its foundation: a military one, raised by Strabo, for the protection of Greek commerce from barbarian incursions, and above all an economic reason. Agde, at the mouth of the coastal river which, with the Aude, is the most important of all Languedoc, was particularly well placed to serve as a way-station and intermediary between the Mediterranean lands and the interior of Gaul, including the Cévennes Massif, famous in antiquity for its mineral wealth. Agde was both a river- and seaport, and played a commercial role of the first importance in the W Mediterranean, a role apparently maintained under the Romans, despite the fact that the town was some distance from the great highway of Cn. Domitius Ahenobarbus, which ran close to the neighboring city of Baeterrae (Béziers) and not far from the great port of Narbonne. In the 5th c. Agde became the center of a small diocese, and a council was held there in 506.

Sporadic explorations during the last few decades have shown that the Greek town was situated on the highest (16 m) part of the site of the mediaeval and modern town. Aerial reconnaissance and study of the topography indicate that it was a true citadel, probably laid out in a checkerboard pattern measuring 200 m a side. This is very similar to the plan of Olbia in Provence and Empo-

rion in Catalonia. It was surrounded by a rampart of which some vestiges probably remain. The few soundings which have been made confirm these observations. They have also led to the discovery of some interesting ceramics and three Greek inscriptions, the only ones so far discovered in Languedoc. The extent of the Roman town is uncertain, but appears to have been no greater than that of the Greek town. Under the Late Empire, two Early Christian funerary basilicas, St. André and St Sever, were established outside the walls, SW of the agglomeration.

The principal discoveries testifying to the commercial activity of Agde in antiquity have been made not in the town itself, but in the bed of the Hérault and at sea off Cape Agde (brass and lead ingots, imported amphorae and ceramics, metal dishes, basalt millstones made near Agde). It was in the river bed at Agde that a magnificent bronze statue was discovered in 1964. It is 1.4 m high, and believed to be the portrait of a Hellenistic prince.

All the archaeological finds made at Agde, in the surrounding area, and at sea, are preserved in the local Archaeological Museum.

BIBLIOGRAPHY. "Informations," *Gallia* 6 (1948) 203; 7 (1950) 111; 20 (1962) 622; 22 (1964) 486-88[I]; 24 (1966) 462-64[I]; J. Jannoray, *Ensérune. Contribution à l'étude des civilisations préromaines de la Gaule méridionale* (1955); M. Clavel, *Béziers et son territoire dans l'Antiquité* (1970). G. BARRUOL

"AGATHYRNON," *see* CAPO D'ORLANDO

AGDE, *see* AGATHA, *and* ROCHELONGUES *under* SHIP-WRECKS

AGEDINCUM (Sens) Yonne, France. Map 23. A city at the Yonne-Vanne confluence, 110 km SE of Paris.

Caesar mentions the name Agedincum, on the territory of the Senones, several times in his Commentaries. The site, although certainly marshy before the Roman Conquest, had already acquired importance as the crossroads of two highways, one a road running roughly N-S, which the Via Agrippa was to follow later, and the other running E-W and linking Genabum (Orléans) and Augustabona (Troyes) in the Roman period. However, it was not until after the Conquest that the river junction was altered (traces of the engineering work have been found) so that the first buildings could be put up on the actual site of the city.

The earliest traces of monuments are stones reused to build the Late Empire rampart. There are blocks from two great facades each with four large windows separated by engaged columns 7 m high. One of the facades has been partly restored. From the style of the sculptures it has been suggested that the monument dates to the first half of the 2d c. A.D. Dating to the Early Empire, perhaps to the 1st c. A.D., is a huge complex outside the city walls. Situated in the area known as La Motte du Ciar (a corruption of the name Caesar), it has a double circuit wall, a portico and apse, and a pool 84 m long. In the town itself some mosaics have been uncovered in situ, along with some baths (3d c. A.D. ?) with the rampart running through them. Two large necropoleis have been located (also some stelae found in the rampart, including a fine series showing craftsmen with the instruments of their trade) together with the aqueduct system, which is remarkably well preserved.

The city does not seem to have played an administrative role until after the reform of the provinces in 375. It is not certain that, as some have believed, the rampart, of which part can still be seen today, is earlier than this date. It is one of the largest ramparts in Gaul.

BIBLIOGRAPHY. Julliot, *Inscriptions et Monuments du Musée gallo-romain de Sens* (1898); id., *Essai sur l'enceinte de la ville de Sens* (1913); Parruzot, "Cultes indigènes et culte de Mercure dans la Civitas Senonum," *Rev. Arch. de l'Est* 6 (1955) 334-45; Hatt, "Esquisse d'une histoire de la sculpture régionale de Gaule romaine," *REA* (1957) 75-107 passim; Harmand, "Le sanctuaire gallo-romain de la Motte du Ciar à Sens," *Rev. Arch. de l'Est* 9 (1958) 43-73. C. ROLLEY

AGEN, *see* AGINNUM

AGENNUM, *see* AGINNUM

AGGAR (Henchir Sidi Amara) Tunisia. Map 18. Until the Dorsale could be crossed by road between Mactar and Kairouan, the way between the N regions of Siliana, Sers, and Le Kef, and the basins of El Ala, Ousseltia, and Kairouan to the S lay over one of the very few passes in the continuous chain formed by the Jebels Barbrou, Kesra, Bellota, and Serj. At this pass—Foum el Afrit—several roads converged before crossing the Dorsale; the pass was used continually in every period and, up to recent times, by nomads moving their flocks. In antiquity it was dominated by an important city, Aggar; today all that is left of it is ruins, with the Sidi Amara marabout overlooking them. Aggar appears in the *Peutinger Table* between Althiburos and Thysdrus, halfway between Uzappa and Aqua Regia; it is also mentioned by Arab writers who refer to it as a station on the road from Jelloula to Lorbeus. Proof of the importance of this highway is the fine bridge on the wadi Jilf, on the other side of the pass. The city's identification is confirmed by certain inscriptions.

At the beginning of the 3d c., Aggar was still a municipium (*CIL* VIII, 714), to become a colonia later. Situated at the outlet of the rocky pass and backed against the S flank of the mountain, it enjoys a favorable position from which it overlooks the immense basin of the wadi Marouf and Bahir ech Chiha (formerly Behir Aggar), which is bounded to the SE by the Ousselet and to the S by the Trozza.

The ruins are fairly extensive and have not been excavated. A Byzantine citadel can be made out; it is 30 m square with square, slightly projecting towers at the corners. This fortress was put up on the site of a large monument that has been identified as a Temple of Juno; a great arcade is still standing. To the right is a triumphal gate, only the piers of which remain. It led to a large porticoed square (whose fallen columns are still lodged in the ground) with a temple behind it. These are, presumably, the capitol and forum. Adjoining the citadel is a temple (undetermined) that stands SE of the city. On its SE facade the monumental gate gives onto a courtyard surrounded by a portico. In the plain at the foot of the mountain stands the two-tiered mausoleum of C. Marius Romanius (Ksar Khima); the roofing is almost intact.

Some 1500 m farther W, on the other side of the pass, is the aforementioned bridge over the wadi Jilf, six of whose ten original arches are still preserved.

BIBLIOGRAPHY. *NouvArch* 4 (1893) 387-89[I].
 A. ENNABLI

AGIA GALINI, *see* SOULIA

AĞIN, *see* DASCUSA

AGINNUM (Agen) Lot-et-Garonne, France. Map 23. Agen was first the capital of the Nitiobrigi, a Celtic people established on the borders of Aquitaine on both sides of the Garonne. Originally settled on the oppidum of the Plateau de l'Ermitage and doubtless possessing an

important market place at the foot of the slope, the Nitio-brigi established themselves definitively in the plain, in the Roman period, in the triangle formed by the Garonne and the Masse. Augustus' establishment in A.D. 27 of the Civitas Aginnensis in Aquitaine put an end to their kingdom. According to the Notitia provinciarum, by the 4th c. the prosperous Aginnum, served by several major routes, had become the second city of Aquitainia II.

For a long time the site of the imperial town was thought to be in the S area of the present town and its suburbs, for in the 18th c. there were still visible in this large open space the vestiges of large monuments (a Temple to Diana, an amphitheater), luxurious habitations, and artisans' quarters. But more recent discoveries of equally important monuments (a temple to Jupiter, another to the Iunones Augustales, perhaps a forum) and evidence of occupation (altars, inscriptions, statues, mosaics, and furniture now in the museum of Agen), have proved that the city of that period extended as far N as the modern one. Contrary to earlier conjecture that, from 276 on, it was merely a tongue of land on the promontory lying farther N, it now appears that the whole site was permanently occupied from the 1st c. until the invasions at the beginning of the 5th.

BIBLIOGRAPHY. J. F. Boudon de St. Amans, *Essai sur les Antiquités du Département du Lot-et-Garonne* (1859)[P]; Labrunie, *Abrégé chronologique des antiquités d'Agen* (1892 [from a MS of the 18th c.])); P. Lauzun, *Les enceintes successives d'Agen* (1894); G. Tholin, "Causeries sur les origines de l'Agenais," *Rev. de l'Agensis* (1895-96); J. Mommeja, "L'oppidum des Nitiobriges," *Congres Arch. de France Agen-Auch* (1901); J. Coupry, "Informations arch.," *Gallia* 17 (1959) 2[I]; 19 (1961) 2[I]; 21 (1963) 2; 25 (1967) 2; 27 (1969); J. Eche, "Le développement topographique d'Agen aux XII et XIII siècles," *Federation Historique de Sud-Ouest, XIV-XVII Congrès d'études Régionales, Villeneuve/Lot* (1961)[P].
M. KLEFSTAD-SILLONVILLE

AGIRA, *see* AGYRION

AĞLASUN, *see* SAGALASSOS

AGRIGENTO, *see* AKRAGAS

AGRIGENTUM, *see* AKRAGAS

AGRILOVOUNI, *see* LIMES, GREEK EPEIROS

AGRINION Greece. Map 9. A town in central Aitolia ca. 3 km NE of the modern town of the same name (formerly called Vrachori). Its general location, E of the Acheloos river below Stratos, is given by Polybios (5.7.7) in his account of the march of Philip V on Thermon in 218 B.C. The town, which had been occupied by the Akarnanians in 314 B.C., was sacked by the Aitolians (Diod. 19.67-68). Excavations have uncovered a stretch of city wall ca. 2 km in circumference, and foundations of several buildings.

BIBLIOGRAPHY. *Praktika* (1928) 96-110[PI]; Philippson-Kirsten, *Gr. Landschaften* II, 2 (1958) 337-39.
E. VANDERPOOL

AGRIPPIAS, *see* ANTHEDON

AGUNTUM East Tyrol, Austria. Map 20. Located ca. 4 km E of Lienz in the Drau valley. It was on the road from Virunum-Teurnia-Puster valley to the Brenner Road, the most important E-W connection in S Noricum. According to the name it must have been an Illyrian settlement (nt-suffix). Aguntum belonged to the settlement area of the Celtic tribe of the Laianci, but the Celtic oppidum has as yet not been found. The town was founded—as is known from Pliny (*HN* 3.146)—under Claudius (41-54) as Municipium Claudium Aguntum. The expanding town was destroyed ca. 275 by a raid of the Alemanni, as is indicated by the discovery of a coin hoard; soon rebuilt, it was again destroyed by a raid of the Visigoths ca. 400. Venantius Fortunatus saw the town on his journey: "sedens in colle superbit Aguntus." The last Roman municipium in the region of the E Alps, Aguntum succumbed in 610 to the Slavs, who were moving upward into the Drau valley.

Although the extensive ruins had been known for centuries, excavations were begun only in 1912. Since the end of WW II they have continued without interruption. However, knowledge of the town's plan is relatively limited. In particular the center with its public buildings is still unknown. It is probably situated W of the present excavation area.

The town wall, built on the E side of the settlement, is almost 2.5 m wide. Erected in the 2d c. (under Hadrian?), it seems to have been built not for defense but for prestige. The two-lane main gate (for the passage of the Drau valley road) has an inner width of 8.6 m and is flanked by two towers. The most impressive building is the house with the atrium, a structure unique in the E Alpine region for its plan. It is a luxurious dwelling, 65 x 60 m. In its latest form it dates to the 3d c. but is located on a building of the 1st c. The complex includes the residence with atrium, baths, storage rooms, and work rooms. An extensive quarter for craftsmen is located N of the decumanus maximus, and adjoining are (as the first public building) large baths which, with several enlargements and modifications, were used until the beginning of the 5th c.

When Aguntum became the seat of a bishop in the 4th c., a simple hall church (29.5 x 9.5 m) with a horseshoe-shaped bench for the clergy was constructed on the foundations of an older Roman building. A cruciform funeral chapel with two apses dates from the 5th c. Both buildings are E of the town wall.

An extensive part of the excavation area has been transformed into a remarkable open air museum. Some of the finds are shown in the Grabungshaus Aguntum, others are exhibited in the Heimatmuseum Schloss Bruck (Lienz).

BIBLIOGRAPHY. W. Alzinger in *EAA* 1 (1958) 161ff; id., "Aguntum," *Das Altertum* 7 (1961) 85ff[MPI]; id., *Aguntum und Lavant. Führer durch die römerzeitlichen Ruinen Osttirols* (1974)[MPI]. The two preceding entries include early bibliography. St. Karwiese, "Aguntum," *RE* Suppl. XII (1970) 4ff[P].
R. NOLL

AGYRION (Agira) Sicily. Map 17B. A city of ancient but uncertain origins, 25 km NE of Enna at the head of the valley of Katane. The city occupied the slopes of a prominent hill (824 m), commanding the valley of the Kyamosoros (Salso) to the N, and the valley of the Chrysas (Dittaino) to the S. The main road connecting inland Sicily with Katane passed through Agyrion; another road ran S to Morgantina. The modern town overlies the ancient site; although little is known of the physical remains, certain monuments are mentioned by Diodoros (4.24.80; 16.83.3), who was a native. These monuments are attributed to the benevolence of either Herakles or Timoleon. To the former, who passed through in the course of his tenth labor, are credited the foundation of precincts of Iolaos and of Geryon, and the creation of a nearby lake. To Timoleon, who settled 10,000 Greeks at Agyrion after 339 B.C., Diodoros attributes a major building program. The theater he described as being the finest in Sicily after the one at Syracuse; it is thought to have stood near the churches of S. Pietro and SS. Trinità.

Diodoros also mentions a city wall with towers, and tombs adorned with pyramids. The quarries that were the source of stone for the Temple of the Meteres at Engyon are thought to be located in the Frontè district. Of the pre-Timoleonic settlement hardly anything is known; a painted roof-tile of the second half of the 6th c. was found on the summit of the hill and may belong to a small temple. Our knowledge of Roman Agyrium is equally limited.

BIBLIOGRAPHY. G. Favaloro, *Agyrium* (1922) 33f; L. Bernabò Brea, *NSc* (1947) 250; G. Uggeri, "La Sicilia nella 'Tabula Peutingeriana,'" *Vichiana* 6 (1969) 163.

M. BELL

"AIANE," *see* KALIANE

AIDAP, *see* IOTAPE

AIDEPSOS (Loutra) Euboia, Greece. Map 11. Remains of the ancient site are to be found in the neighborhood of the modern resort community of Loutra Aidepsou, about 5 km to the S of the town of Aidepsos in the NW part of the region.

Aidepsos was best known in antiquity for its health-giving thermal springs, which still flow today. Although legend connected these springs with Herakles (Strab. 9.4.2), the earliest reference to them in literature belongs to the 4th c. B.C. (Arist. *Meteor.* 2.8). Yet it was not until the late Hellenistic period or early Roman Imperial times that the site came to be widely known as a health resort. Sulla, seeking relief from gout, is said to have spent a holiday there (Plut. *Sulla* 26; cf. also Strab. 10.1.9, where the springs visited by Sulla are erroneously placed in the Lelantine Plain near Chalkis). By the 2d c. A.D. it had become an elegant spa frequented by artists, statesmen, and the idle rich—some in search of a quick cure, but many apparently interested only in a good time (Plut. *Quaest. conv.* 4.1 and *De frat. amor.* 487).

Owing partly to the proximity of the modern resort and partly to the lack of excavation, little is known of the grand public and private buildings referred to in our sources. Yet small-scale investigations in the early years of this century produced remains of a bathing establishment possibly belonging to the 2d and 3d c. A.D. The finds from this complex, which seems to have drawn its water from the nearby thermal springs, indicate that it continued to be used into the Christian period.

There is some slight evidence to indicate that the town was also the source of both copper and iron and the home of a metal-working industry (Steph. Byz. s.v. Αἴδηψος). At the site of Khironisi—a headland not far from modern Aidepsos—crucible fragments, slag, and pieces of malachite and azurite in quartz (of which one sample contained ca. 15 percent copper and over 5 percent iron) have been found on the surface. Other surface finds indicate that this site was occupied in Classical and earlier times, thus suggesting an explanation for the tradition related by Stephanos.

BIBLIOGRAPHY. F. Geyer, *Topographie und Geschichte der Insel Euböa* (1903); G. A. Papavasileiou, Ἀνασκαφαί ἐν Εὐβοίᾳ, *Praktika* (1904) 31-32; A. Philippson, *GL* I.2 (1951); L. Sackett et al., "Prehistoric Euboea: Contributions Toward a Survey," *BSA* 61 (1966)M.

T. W. JACOBSEN

AIGAI Aiolis, Turkey. Map 7. At Nemrud Kalesi, 35 km S of Pergamon. One of the twelve mainland cities of the Aiolians, but never a member of the Delian Confederacy. The city was taken by Attalos I in 218 B.C. (Polyb. 5.77) and thenceforth belonged to Pergamon. It was ravaged by Prusias II in his war with Attalos II

(156-154 B.C.), and in the peace treaty received an indemnity of 100 talents (Polyb. 33.13). The coinage began about 300 B.C. and continued to the middle of the 3d c. A.D.

The ruins, not yet excavated, are impressive. The city wall, of mixed polygonal and ashlar masonry, encloses an area a little over 900 m in length. Paved roads, partly preserved, led up from the SW and NE. The most conspicuous building is a fine market hall, over 75 m long and still standing 10 m high. It was in three stories, of which the lowest comprised 16 pairs of rooms one behind the other, evidently shops, each provided with a door and window. These opened on the E to a terrace on which was a circular foundation. The middle story had similar chambers communicating by arched doorways. The top story formed an open gallery with a row of columns down the middle and windows in the back wall, and opened on the W by a colonnade to a broad terrace, evidently the agora. Just to the N is a building identified as the bouleuterion.

In the NW corner of the enclosure are the foundations of three temples, one identified by an inscription as that of Demeter and Kore. Below on the W is the theater; the seats are not preserved, but the vaulted passages supporting them are still in good condition. Farther to the S is the stadium, of which one long wall is standing.

Some 45 minutes on foot to the E is the Temple of Apollo Chresterios, dedicated by the people (of Pergamon) under P. Servilius Isauricus, proconsul of Asia in 46 B.C. The building has collapsed; all that is now standing is the framework of the cella door, with monolithic jambs 8.7 m high.

The general character of the buildings at Aigai is strikingly similar to those of Pergamon; they date certainly to the time of the Attalid kingdom and were erected by the munificence of the kings.

BIBLIOGRAPHY. R. Bohn & C. Schuchhardt, *Altertümer von Aegae* (1889); L. Robert, *ÉtudAnat* (1937) 74-87.

G. E. BEAN

AIGINA Greece. Map 11. A mountainous and volcanic island in the Saronic gulf, halfway between Attica and the Peloponnesos. Its geographic position explains its importance in the commerce between the Greek states and around the Mediterranean basin from the most remote periods of history. The island had commercial relations with the Cyclades, with the cities along the coast of Anatolia, and with Egypt.

Archaeological remains indicate that the most ancient inhabitants of the island came from the Near East. The first settlement, however, must have been the result of a migration by Peloponnesian peoples around the end of the 4th millennium B.C. Remains testify to uninterrupted occupation and to a definite cultural unity with the centers of population in the Peloponnesos, as well as close ties with the Cyclades and S Greece.

Two great periods about which little is known can be identified: one ca. 2000 B.C. with the appearance of peoples who used Minoan ware, the other ca. 1400 B.C. when another people, of Achaian stock, brought Mycenaean ware.

The historic period begins around 950 B.C., probably after a brief abandonment by the population in the 12th-10th c. Classical sources indicate that the colonizers probably came from the Peloponnese, perhaps from Epidauros (Herod. 8.46; Paus. 2.29.9). During the 7th and 6th c. B.C., Aigina became a maritime power of the first order. There is no evidence of strong land ownership, unlike the mainland where feudal concentration could provoke serious social disturbances. Aigina had a stable and developed mercantile aristocracy which spread

the fame of its products, particularly pottery and bronze ware, throughout the Mediterranean basin. In this connection, it is significant that the oldest system of weights in the Classical world was developed on Aigina between 656 and 650 B.C., and the spread of Aiginetan money shows clearly her absolute supremacy.

At the beginning of the 6th c. B.C., Athens began to oppose the supremacy of Aigina, and Solon passed special laws to limit the spread of Aiginetan commerce, thereby causing the island to ally itself first with Sparta, then with Thebes, and finally with Persia to oppose the rising Athenian power. In 488 B.C. the Aiginetan navy routed the Athenian ships, but 30 years later Athens defeated the combined naval forces of Aigina and of Corinth, and in the following years forced the island to surrender. In 431 B.C. Athens expelled the last of the native population and apportioned the land among Athenians. After the Pergamene conquest the island enjoyed a new period of prosperity (210 B.C.).

The most important archaeological sites on the island are near Cape Colonna (named for the remains of a single column of a temple), on Mt. St. Elia, and in the area of Mesagro. In the zone of Cape Colonna, the most important and the oldest area, the remains of the stereobate of the temple mentioned above are still visible, as well as some pedimental decorations of Parian marble.

The building was constructed of a yellowish, shell-bearing limestone (a local poros), with a portico of Doric columns (6 x 12). In front of the cella was a pronaos and behind the cella an opisthodomos from which the surviving column comes. The date of the temple must be 520-500 B.C. At a lower level traces of an older temple were discovered, dating from between the end of the 8th and the beginning of the 6th c. A semicircular antefix from this temple has been preserved. The archaic temple was dedicated to Apollo (to whom some inscriptions refer) or to Poseidon. In the Late Roman period the temple was destroyed and replaced by a building of huge proportions, similar to a fortress. Its cistern has been found between the temple and the sea.

There are remains, SE of the temple, of an archaic propylon with reliefs on the walls and an altar in the center, dating from the 6th c. It was probably the Aiakeion. North of the archaic temple are traces of two small naiskoi and of a round structure which was probably the tomb of Phokos (Paus. 2.29.9). Farther W is a Pergamene building, perhaps the Attaleion. At the foot of the hill, to the E, are a theater and a stadium. The outer wall of this sacred area is partially preserved.

Excavations on the slopes of Mt. St. Elia have brought to light a Thessalian settlement of ca. the 13th c. B.C. The site was abandoned at the same time as the destruction of the Late Mycenaean centers of the area and was reoccupied in the Geometric period; it took on a monumental character only in the Pergamene era. In the Byzantine period a sanctuary, resembling a monastery in structure, was built on the mountain; its remains can still be seen. With regard to Mesagro, there are some Mycenaean ex-voto offerings, the oldest indications of a religious practice. Around the middle of the 7th c., when the thalassocracy of Aigina developed, a primitive sanctuary was built. Its sacred precinct included a small altar, of which there are a few remains, and perhaps a small structure for the image of Aphaia (Paus. 3.14.2), a divinity worshiped on the island in this period who had a priestly service.

In the 6th c., when the thalassocracy of Aigina had reached its greatest development, the sanctuary underwent modifications of a more monumental character. The first temple (distyle in antis with a cella of three naves and an adyton in two sections) was built; a second altar was set behind the first; to the S, the monumental entrance to the sanctuary was constructed with an appropriate propylon. To this building phase (the second) we may attribute a large inscription which refers to the construction of an oikos of Aphaia during the hiereia of a Kleoita or of a Dreoita.

The great building phase (the third) came at the beginning of the 5th c. The temple was enlarged and reoriented and the sacred area was tripled. A large ramp was built from the temple to the altar, which was also enlarged and made more imposing by a double staircase. The new temple was built on a krepidoma of three steps. It was hexastyle, distyle in antis, with twelve columns on the side; the cella had three naves with a double colonnade of five columns; the limestone of the walls was covered by fine stucco. The pediment was painted and the roof had marble tiles on the more visible portions and terracotta tiles elsewhere. The acroterion consisted of an architectural motif with palmettes flanked by two female figures. The first propylon gave access to the sacred area and a second led to an inner division, on the S, for the priests.

The identity of the divinity to whom the sanctuary was dedicated has been much discussed. The sculptures on the front clearly refer to Athena, but an important dedicatory inscription mentions the building of an oikos of Aphaia, a divinity named on numerous other inscriptions cut into the rock. Probably the temple was dedicated to Athena but the local populace, assimilating this divinity to their own autochthonous Aphaia, continued to use the name of the old goddess to whom the archaic temple must have belonged.

The most important sculptures from Aigina are those of the front of the temple of Aphaia, discovered in 1811. Seventeen statues from the pedimental decoration are now in the Munich Glyptothek; they represent the first European contact with archaic Greek art. Ten fairly well-preserved statues come from the W pediment and five in less good condition from the E pediment; numerous fragments come from at least two other statues, but it is impossible to establish their positions.

The subject on both pediments is nearly the same: the struggle between the heroes of Aigina and Troy in the presence of Athena. Comparison of the two pediments reveals stylistic differences which raise the problem of contemporaneous or successive production. The figures on the E side appear freer and less exact in superficial detail, and present a more mature study of masses and of volumes. The so-called archaic smile, obvious on the W side, is no longer present on the E. A different date for the two pediments has therefore been proposed by many scholars, but cannot be established with certainty, given the poor preservation of the figures from the E side. If one accepts different dates, the W pediment was probably completed just before the Persian wars and the E pediment after the battle of Marathon.

Recent restorations of the groups in the Munich Glyptothek, carried out by Italian experts under supervision of the museum staff, have fundamentally changed their external appearance. Both the groupings and the positions of individual statues against the background of the pediments have been altered.

Fragments of a third pediment group, now in the National Museum at Athens, seem to complicate the problem of style. These fragments show obvious stylistic affinities with the sculptures of the W pediment, so that we may reasonably suppose this third group to be the original decoration of the E side of the temple of Aphaia which was replaced by the new decoration mentioned

above. This would explain the obvious superiority shown by the W pediment grouping compared to the E side. The first pediment probably remained on view inside the sacred precinct, where it suffered badly from the weather.

It is impossible, however, to substantiate this conjecture as to the problem of the differences in style between the two pediments; the problem remains open to discussion.

BIBLIOGRAPHY. A. Furtwängler, *Aegina, das Heiligtum der Aphaia* (1906); R. Carpenter, *Greek Sculpture* (1960) 115ff; B. Conticello, *EAA* (1960) 246ff; G. Grüben, "Die Sfinx-Saule von Aigina," *AthMitt* 80 (1965) 170ff; A. Invernizzi, *I frontoni del tempio di Aphaia ad Egina* (1965); B. Ridgway, *The Severe Style in Greek Sculpture* (1970) Ch. 2, pp. 12-28. B. CONTICELLO

AIGINION Thessaly, Greece. Map 9. A town on the border between Thessaly and Epeiros; according to Strabo, it belonged to the Tymphaei. It appears several times in Livy's account of the Macedonian War, where it is described as secure and almost impregnable; it was destroyed by the Romans in 167 B.C. Subsequently, in the Civil Wars, Caesar joined Domitius Calvinus there before marching on Pompey at Pharsalus. The ancient town has been identified with Kalabaka, where there are no ancient remains; the literary sources are more easily reconciled with the Rock of the Goat N of the modern village of Nea Koutsoufliani. This small site is surrounded by cliffs, and retains traces of a tower and rubble walls faced with squared stone blocks. A modern road to the E of the acropolis has cut through a group of pithos and cist burials.

BIBLIOGRAPHY. Strab. 7.7.9; Livy 32.15; Caes. *BCiv.* 3.79; N.G.L. Hammond, *Epirus* (1967)M. Also: Livy 36.13; 44.46; 45.27; Plin. 4.10.17§33; Ptol. 3.13,44.
 M. H. MCALLISTER

AIGION (mediaeval Vostitsa) Achaia, Greece. Map 9. Lies some 45 km E of Patras and 96.5 km NE of Corinth. Inhabited from very earliest antiquity, it was formed of the synoecism of seven or eight earlier cities (Strab. 8.3.2), and was, according to Homer (*Il.* 2.574), a part of the domain of Agamemnon in heroic times. During the Classical period it was reckoned one of the twelve cities of Achaia (Hdt. 1.145), and, at least after the destruction of Helike (Strab. 8.7.2) in 373, it became the meeting place of the Achaian League, a position it held at least until the time of Pausanias (7.24.4). Its importance declined after the Augustan period when Patrai became the chief city of the area.

The modern city is built over the ancient and has largely obliterated any traces of ancient remains. Pausanias (7.22.5-24.4) mentions a number of sanctuaries, of which no traces remain in situ. It is possible that some architectural members of some of these buildings have been found built into a later building of Roman times located near the old reservoir and N along Solomos St. The Classical cemetery was located NW of the reservoir, while the Mycenaean necropolis with a number of chamber tombs lies N of the gymnasium in the embankment of the main highway. Finds, mainly pottery and minor objects from Mycenaean and Hellenistic tombs and buildings, have, since 1954, been housed in a local apotheke and in the Patras Museum.

BIBLIOGRAPHY. C. Yalouris, *Praktika* (1954) 287-90; A. Stauropoulos, *Historia tis poleos Aigiou* (1954); P. Åström, "Mycenaean Pottery from the Region of Aigion with a List of Prehistoric Sites in Achaea," *Op. Ath.* 5 (1964) 89-110; *Deltion* 26 (1971) 175-85; Photios Petsas, *AAA* 5 (1972) 496-502; A. J. Pappadopoulos, *The Archaeology of the Mycenaean Achaea*, forthcoming. W. F. WYATT, JR.

AIGOSTHENA (Porto Germano) Greece. Map 11. In the Megarian sphere, Aigosthena was situated on the slopes of the Kithairon in a deep inlet of the Gulf of Corinth, on the road between Boiotia and the Peloponnesos.

Xenophon recorded the battles that took place here in 378 B.C. and the presence of the army of Archidamos, and mentioned the inaccessibility of the site (*Hell.* 5.4.18; 6.4.26). The fort is also mentioned by Pausanias (1.44.5). Along with Megara, Aigosthena formed part of the Achaian League in 244, was then ceded to Boiotia for a brief time, and re-entered the League after the second Macedonian war. The interior circuit protecting the acropolis and the entire encircling wall of the city are among the best examples of Greek military architecture. The acropolis is to the E, defended by a mighty polygon of wall which is well preserved, particularly on the E and NE sides. Eight large square towers in the wall served as bulwarks. There was an entrance to the W and a rear entrance to the E. Each tower consisted of two rooms and could be entered from the circuit wall by means of a stairway. The N and S sides of the fortification walls extend, toward the sea, into the two arms. Large square towers defend the curtain wall here also. On the N side there are eight additional towers, while the wall and the towers on the S side have mostly disappeared.

The whole fortification system is built of hard local limestone (a quarry is identifiable inside the city walls) and in conglomerate rock, and shows two different techniques. One is an irregular trapezoidal technique with a squared face, datable to the 5th c.; the other is regular isodomic with the face perfectly squared, datable to the 4th c. (several scholars, however, attribute the latter to the beginning of the Hellenistic age). The few Roman constructions on the inside of the city walls did not alter the fortifications.

Very few monumental remains have been discovered in the area of the city. A small Byzantine church was built on an apsidal Early Christian basilica (25.15 x 20.38 m) with three large aisles. Against the S side of the basilica was a quadrangular baptistery.

BIBLIOGRAPHY. E. F. Benson, *JHS* 15 (1895); Head, *Hist.Num.*; R. L. Scranton, *Greek Walls* (1941); N.G.L. Hammond, *BSA* 49 (1954); A. K. Orlandos, *Ergon 1954* (1955); A. W. Lawrence, *Greek Architecture* (1957); M. Bollini, *ASAtene* 41-42 (1963-64); K. Ghiannoulidou, Πλάτων 16 (1964). N. BONACASA

AIGUES-VIVES Locality of Pataran, canton of Sommières, Gard, France. Map 23. Gallo-Roman establishment ca. 1 km S of the Via Domitiana between Nemausus and Ambrussum. Recent excavations on the site have uncovered a relatively vast and luxurious architectural ensemble from the Late Empire consisting principally of private baths.

BIBLIOGRAPHY. "Informations," *Gallia* 24 (1966) 473; 27 (1969) 401-2I. G. BARRUOL

AILA, *see* AELANA

AIME, *see* AXIMA

AÎN GASSA Tunisia. Map 18. A small rural site with ruins of an agricultural settlement from which has been recovered a group of seven stelae dedicated to Saturn by the peasants of the area. These stelae date from the 2d

c. to the beginning of the 3d c. Some bear inscriptions with tria nomina and also sculptured decorations of various symbols pertaining to the deity: the crescent, star, crown, and pine cone.

BIBLIOGRAPHY. M. Leglay in *CahTun* (1963) 63-68P.

A. ENNABLI

AÏN JAMAA, *see* SIDI MOUSA BOU FRI

AINOS (Enoz) Thrace, Turkey. Map 7. A harbor town at the mouth of the Hebros (Maritza, Meriç) river. Its Thracian name was Poltyobria, after the legendary Thracian king Poltys (Strab. 7. frag. 52; Steph. Byz.), but the name Ainos appears very early, associated with the Trojan war (*Il.* 4.520). The name Apsinthos is also recorded (Steph. Byz.).

The town was resettled by Greek colonists from the Aeolic region (Alopekonessos, Mytilene, Kyme) in the 7th c. B.C. It occupied a high ridge dominating a good harbor at the river mouth, which has silted up so as to become almost unusable. The abundant coinage of the city shows that it was a significant economic center, but almost nothing is known of its history. The town is mentioned sporadically in accounts of Athenian, Thracian, Macedonian, and Roman activity in the region, but never in an important role.

The ancient site is presumed to be approximately co-extensive with the modern town. The acropolis is occupied by the mediaeval castle of the Gattilusi, which probably incorporates any surviving fragments of Classical architecture. No systematic survey or excavation has been done.

BIBLIOGRAPHY. F. W. Hasluck, "Monuments of the Gattelusi," *BSA* 15 (1908-9) 249-57MI; S. Casson, *Macedonia, Thrace and Illyria* (1926) 255-59P; J.M.F. May, *Ainos, Its History and Coinage* (1950)M.

T. S. MAC KAY

AÏN SCHKOR Morocco. Map 19. Roman ruins 3 km N of Volubilis. These consist of remains of a castellum occupied in the 1st and 2d c. A.D. by the cohors I Asturum et Callaecorum and rebuilt in the 3d c. by the cohors IV Tungrorum, and indistinct traces of a settlement S of this camp. The area to the W and S is extremely rich in ruins of Roman farms and agricultural villages; to the E, on the foothills of the Jebel Zerhoun, are quarries that were worked in antiquity.

BIBLIOGRAPHY. L. Chatelain, *Le Maroc des Romains* (1944) 119-20; M. Euzennat, "Une inscription inédite d'Aïn Schkor (Maroc)," *BAC* (1963-64) 137-42; G. Feray and P. Paskof, "Recherches sur les carrières romaines des environs de Volubilis," *Bulletin d'Archéologie Marocaine* 6 (1966) 279-300. M. EUZENNAT

AIPION (Eliniko) Triphylia, Greece. Map 9. One of the six Minyan foundations (Hdt. 4.148), between Heraia and Makistos (Xen. *Hell.* 3.2.30), was a natural stronghold in Makistia (Strab. 8.3.24), continually threatened with Elean domination (Xen. 3.2.30, Polyb. 4.77, 80). There is considerable uncertainty about the name, Herodotos giving Ἔπιον, Xenophon Ἤπειον, Polybios Αἴπιον, whereas Strabo identifies it with Homeric Αἰπύ (*Il.* 2.592), thus including it in Nestor's realm. This identification is unlikely to be correct and it is perhaps best to follow Xenophon, a near neighbor, and adopt Ἤπειον as the correct spelling. The location is also uncertain. The usual assumption has been that Ἤπειον is to be identified with the remains in a place called Eliniko (now Epio) above Platiana just off the modern road from Andritsena to Pyrgos. However, good rea-

sons have been advanced for identifying this site with Trypaneae, and also for placing Ἤπειον at modern Mazi, which is usually identified with ancient Skillous. Though the former is likely to be correct, it has seemed best here to retain the traditional identification, and to describe the remains at Eliniko.

The town lies on an exposed hill in a position commanding the entire area at an altitude of ca. 600 m above sea level, and is unusually long and narrow (680 x 60-80 m). It is divided into three parts: an upper acropolis area separated by terrace walls from a lower area still included within the fortification walls, and a NW extension of the walls which guards a relatively easy approach to the walls. The acropolis is itself divided into a number of terraces, of which the highest (to the W) has its own wall, and must have served as the citadel. The terrace next to the one farthest E contains a theater, while the next seems to have served as an agora. The main entrance to the town was a gate in the imposing E wall at its SE corner. The walls all seem of Hellenistic, possibly 3d c., date, and are very well preserved in parts, particularly in the area of the citadel.

BIBLIOGRAPHY. *BSA* (1948) 190; E. Meyer, *Neue Peloponnesische Wanderungen* (1957) 22-36, 60-69PI; *BCH* (1961) 719-22; *CP* 59 (1964) 184-85.

W. F. WYATT, JR.

AIRE-SUR-L'ADOUR, *see* VICUS IULII

AITNA, *see* INESSA

AITNE, *see* KATANE

AIX-EN-DIOIS Drôme, France. Map 23. Possibly a watering-place in Gallia Narbonensis, on a Roman road that follows the valley of the Drôme between Dea Augusta (Die) and Lucus Augusti (Luc-en-Diois), probably at the point where the road branches off toward the Menée pass and the plateau of Trièves. There was at least a cult at this spot, attested by a dedication to the Celtic divinities of hot springs, Bormanus and Bormana (*CIL* XII, 1961).

In 1958-60 some baths were discovered in the area known as l'Oche, 700 m downstream from a well-known saline spring. Excavation of the site, in 1965, revealed some bath buildings consisting of pools with run-off pipes; two rooms with hypocausts connected by archways with voussoirs of brick; the caldarium, and an adjacent room. The remains of the furnace include a fire-hole, and a conduit with piers getting progressively narrower from W to E to facilitate the draft; the bottom of the fire-hole is tiled. To the N is a dolium that may have been used to store water collected from the roofs. The furnace opens on a small oval courtyard, where many objects have been found: terra sigillata, everyday pottery, and fragments of painted stucco from the walls of one of the rooms. The buildings seem to be private baths belonging to a villa that was first built in the 1st c., underwent various changes, and lasted, at least in part, until the late 3d or even 4th c. However, there is a possibility that they were part of a sanctuary.

BIBLIOGRAPHY. J. Sautel, *Carte archéologique de la Gaule romaine* XI, *Drôme* (1957) 71, no. 78; H. Desaye, "Aperçus sur la campagne dioise à l'époque romaine," *Actes du 89e congrès national des Sociétés savantes, Lyon, 1964* (1965) 173-84; M. Leglay, "Informations," *Gallia* 24 (1966) 517; 26 (1968) 593; 29 (1971) 429.

M. LEGLAY

AIX-EN-PROVENCE, *see* AQUAE SEXTIAE SALUVORIUM

AIX-LES-BAINS (Savoie), *see* Aquae

AJKA County of Veszprém, Hungary. Map 12. A Roman grove shrine erected by Sextus Acurius and his wife Iulia Prisca. Their names suggest Dalmatian origins. The couple erected a statue and altar to Hercules and placed their tombstone—prepared in advance—here also. The tombstone's inscription is . . . DEXTER AN . . . SIBI ET COI IVLIAE PR ISCE AN. . . . The blank spaces left for the date show that the tombstone was never used. The statue, three-quarters life size and made of limestone, depicts Hercules Commodus; it is the only known example of the Caesar cult of inner Pannonia and is a work typical of a provincial Pannonian sculptor. The sandstone altar that was unearthed has the inscription HERCVLI P. SEX. ACVRIVS DEXTER. The artifacts of the shrine were made between the last decade of the 2d c. and the first decade of the 3d. The shrine was destroyed following 15 May 319, when Constantine forbade the practice of pagan cults. The artifacts of the Hercules shrine are in the Lapidarium of the museum at Tihany.

BIBLIOGRAPHY. E. Thomas, "Ein Heiligtum des Hercules aus Pannonien," *Arch. Ért.* (1952) 108-12; id. & T. Szentléleky, *Führer durch die Archäologischen Sammlungen des Bakonyer Museums in Veszprém* (1959).

E. B. THOMAS

AKALISSOS Lycia, Turkey. Map 7. In the mountains 27 km N of Kumluca, somewhat inaccessible. Mentioned only by Stephanos and Hierokles and in the Byzantine bishop-lists. The coins are of Gordian III. The inscriptions show that Akalissos was at the head of a sympolity including Idebessos and Kormi and belonging to the Lycian League. The city possessed the title of neocorus, though apparently not before the 3d c.

The ruins are very scanty. There is a low acropolis hill, an assortment of walls and two churches; otherwise the only remnants of antiquity are the numerous sarcophagi and a few plain rock tombs in a cliff to the N.

BIBLIOGRAPHY. T.A.B. Spratt & E. Forbes, *Travels in Lycia* I (1847) 167-68; *TAM* II.3 (1940) 318.

G. E. BEAN

AKANTHOS Chalkidike, Greece. Map 9. A city on the Chalkidean Isthmus of Akte between the Singitic and Strymonic Gulfs at the modern village of Ierissos. According to Thucydides (4.84) it was founded as a colony of Andros. Akanthos is well known for its coins, which had a wide circulation. Its primary source of income was probably agriculture.

Historically, Akanthos appears first in connection with the Persian Wars when it supported first Mardonios (Hdt. 6.44) and then Xerxes (Hdt. 7.22; 115ff; 121). It was particularly important in aiding the latter dig his canal across the Isthmus of Akte (Hdt. 7.22, 115; Thuc. 4.109). The line of this canal can be traced today starting at the village of Nea Rhoda, which is approximately 2 km SE of Ierissos. In the Athenian Tribute Lists Akanthos regularly paid 3 talents after 446-445; 5 talents were paid in the only preserved list of the first two tribute periods in 450-449 (*ATL* III 239ff, 267ff). Originally siding with Athens in the Peloponnesian War, Akanthos went over to Brasidas in 424 on the urging of the oligarchic faction (Thuc. 4.84ff). The fact that its troops are named in addition to the Chalkideans in Brasidas' army indicates that Akanthos did not join the Chalkidean League. With the Peace of Nikias the city was granted autonomy but was forced to resume paying tribute to Athens (Thuc. 5.18.5). Although Akanthos was taken over by the Macedonians in the 4th c. it was apparently not destroyed by

them. It was then joined on the Isthmus by the new city of Uranopolis, founded by Alexarchos. The Romans pillaged Akanthos in 200 A.D. (Livy 31.45.15ff), but its harbor was still important in 167 (Livy 45.30.4). Evidence of continued existence in Imperial times is provided by the Roman inscriptions found on the acropolis.

Silver coins were first minted in Akanthos around 530 in large quantities on the Euboic standard. Around 424 there was a change over to the Phoenician standard. The Akanthos mint had ceased operation by, at the latest, the middle of the 4th c.

No systematic excavations have been undertaken as yet at Akanthos. The most significant remains preserved today are the impressive walls on the acropolis standing for some distance nearly 8 m in height. Ancient architectural blocks such as capitals, columns, and geison blocks are reused in a ruinous Byzantine church and others are lying in the vicinity of the acropolis. Remains of an ancient mole in the harbor are reported by Leake and Struck. A Roman sarcophagus, a Roman inscription, and a Roman inscribed column drum have been found at the site.

BIBLIOGRAPHY. W. M. Leake, *Nor. Gr.* (1835) III 147ff; B. V. Head, *Catalogue of Greek Coins, Macedonia . . .*, 5 (1879); R. Pietschmann, "Akanthos," *RE* I (1894) 1147-48; A. Struck, *Makedonische Fahrten* I (1907) 66; J. Desneux, "Les Tetradrachmes d'Akanthos," *Revue belge de numismatique* 95 (1949) 5-122; A. Guillou & J. Bompaire, "Recherches au Mont Athos: Vestiges Antiques au Mont-Athos," *BCH* 82 (1958) 192; id., *Deltion* 24 (1969) 309I; M. Zahrnt, *Olynth und die Chalkidier* (1971) 146-50.

S. G. MILLER

AKARNANIAN, *see* AKTION

AKÇAKOCA formerly Akşehir, Turkey. Map 5. On the Black Sea 56 km NW of Bolu is a town near which may have been the site of ancient Dia. According to ancient sources Dia was a town on the Pontos (Steph. Byz.) 60 stadia E of the mouth of the Hypios (Marcian Herakl. *Epit. Peripl. Menipp.* 1.8) now the Melen Deresi, and a harbor for small ships (Anon. *Peripl. Pont. Eux.*, which also places it 60 stadia E of the Hypios). Ptolemy (5.1.2) mentions a Diospolis in Bithynia. These references have been believed to identify the same site, generally placed at or near Akçakoca. An Imperial inscription found at nearby Kepenç mentions harbor improvements to an unnamed city, and sherds from the Roman to the Turkish period have been found on a hill near the coast 3 km W of Akçakoca. Dia may have been the port for Prusias ad Hypium, ca. 30 km inland and reached from the coast by a modern road which may survive from antiquity.

BIBLIOGRAPHY. G. Perrot, *Exploration Archéologique de la Galatie et de la Bithynie* (1862) 20; G. Mendel, "Inscriptions de la Bithynie," *BCH* 25 (1901) 49-55; F. Dörner & W. Hoepfner, "Vörlaufiger Bericht über eine Reise in Bithynien 1961," *ArchAnz* (1962) 572-79MI; id., *AnzWien* (1962) 30-35.

T. S. MACKAY

AKRAGAS later AGRIGENTUM (Agrigento) Sicily. Map 17B. Graeco-Roman city founded ca. 582 B.C. by Rhodio-Cretan colonists from Gela led by Aristonoos and Pystilos. The new city, which took its name from the river along its E boundary, stood on a steep hill defended on three sides by the abrupt drop of the natural (tufa) rock. On the S side the hill slopes gently down to the lofty ridge, on which the temples stand, and opens toward the sea. This natural position is described and praised by Polybios (9.27).

In its early years the city was ruled by an oligarchic government. About 570 B.C. it came under the tyrant Phalaris, who carried out an energetic military and political program to extend Akragan territory, conquering Sikanian towns of the interior and even threatening Himera. At his death (ca. 554 B.C.) Phalaris was succeeded by other tyrants such as Alkamenes and Alkandros. During the second half of the 6th c. B.C. the city gained prosperity by the production and export of grain, wine, and olives, as well as by the breeding of livestock. In this period Akragas minted its first silver coins, with an eagle on the obverse and a crab on the reverse. The city reached the peak of its military and political power under Theron, of the family of the Emmenids (488-473 B.C.), who ruled with justice and moderation, though he continued Phalaris' expansionist policy. He conquered Himera, provoking Carthaginian intervention. In 480 B.C. the Carthaginians were thoroughly defeated by a Greek army led by Theron and his brother-in-law Gelon. After this victory Akragas undertook a grandiose building program, including the Temple to Olympian Zeus and the system of aqueducts planned by the architect Phaiax. Pindar lived at the court of Theron.

A semi-aristocratic government followed the tyrants, and was in turn superseded by a democratic constitution; a notable role in this change was played by Empedokles. Until the end of the 5th c. B.C. Akragas enjoyed a long period of prosperity and splendor, disturbed only by a Sikel revolt led by Ducetius, who was defeated at the Akragan border around 450 B.C. The Akragans' wealth, enjoyment of life, and urge to erect splendid public and private buildings were so great that Empedokles remarked that his fellow citizens "ate as if they would die the next day, and built as if they would never die."

At the end of the 5th c. the Carthaginians, resuming their attempt to conquer Sicily, captured Himera and Selinus and marched quickly toward Akragas. After a long siege the city was taken in 406 B.C.; temples and shrines were burnt and sacked, the whole city was razed to the ground. For many decades Akragas lay abandoned; it was rebuilt and repopulated only after 338 B.C. by the new lord of Syracuse, the Corinthian Timoleon, who defeated the Carthaginians and restored peace and democratic governments in the Sicilian towns. Akragas' new colonists, who were joined by the former inhabitants of the city, came from Elea and were led by Megellus and Pheristos. In this period the city expanded considerably and enjoyed a certain prosperity. Between 286 and 280 B.C. it came under the tyrant Phintias, who tried in vain to restore the city to its former power. At his death, all hopes of freedom rested on Pyrrhos, who tried to expel the Carthaginians from Sicily and managed to conquer Akragas in 276 B.C. When Pyrrhos' expedition failed, Akragas came again under Carthaginian domination and suffered the conflict between Rome and Carthage in the first and second Punic wars. In 262, 255, and finally in 210 B.C., Akragas was besieged and occupied by the Roman army. From this moment onward the city disappeared as a political entity although under Roman domination it enjoyed a lasting peace and a notable economic recovery. It was repopulated by Roman colonists in 207 B.C. and again in the Augustan period. Under Roman administration Agrigentum was civitas decumana, though it retained civic offices of Greek type. In the Imperial period, besides its usual agricultural production, the city developed a textile industry and the extraction of sulphur; it also had an important commercial harbor, the Emporium, cited by Strabo and Ptolemy. With the spread of Christianity, the end of the Roman empire, and the subsequent Byzantine domination, Agrigentum rapidly declined. The tem-

ples were abandoned or transformed into Christian basilicas; the city area became progressively smaller and the hill of the temples was used for cemeteries and catacombs. When the Arabs invaded it in 825, the city was reduced to a village.

During Greek and Roman times the city occupied a large square area delimited by ravines and by a powerful circuit of fortification walls which, in their original form, probably went back to the 6th c. B.C. On the S side the wall follows a winding course to its SE corner, formed by the so-called Temple of Juno. In this stretch the scant remains of Gate I are followed by a powerful pincer bastion to block a canyon that provided easy access to the city. This bastion was formed by two ashlar walls meeting at an angle and defended by a strong square tower. Gate II, called the Geloan Gate, opened farther S; it was cut into the rock and spanned a road which, from the valley of the river Akragas, climbed up to the city between steep cliffs protected by walls; one can still see today the deep furrows made by wheeled traffic. On the ridge immediately to the W of the Temple of Juno stood Gate III, of which only a few remains survive together with the road level and the vehicle tracks. From this point the fortifications ran along the S edge of the temple hill and were partly cut into the natural rock. To the W of the Temple of Herakles was Gate IV, today called the Golden Gate. It was the most important city gate, and led toward the sea, to the Emporium; there are now no traces of its defenses. The walls continue S of the Temple of Zeus and the Shrine of the Chthonian Divinities; Gate V was in a set-back of the walls and was protected on the right by a bastion projecting ca. 25 m. Today the gate is blocked by tumbled masonry. Beyond Gate V other stretches of the walls have been brought to light, with postern gates and square towers up to the SW corner. Along the W side, the walls resume a winding course to Gate VI, probably a dipylon defended by two towers. Farther N Gate VII was also defended by towers and a projecting bastion; at this point the fortifications curved in an ample arc toward the E and then back to the foot of the acropolis. Gates VIII and IX were built in this stretch. The whole N side of the town was protected only by the rock scarp; to the NW it included the hill called di Girgenti on which the modern town is built, and to the NE the other peak called the Athenian Rock, which most scholars identify with the lophos athenaios mentioned by Polybios.

Along the circuit of the walls, as if in defense of the city, rose the series of temples and sanctuaries which still form the greatest archaeological attraction of Agrigentum. Starting from the NE corner, on the slopes of the Athenian Rock, one sees first the Sanctuary of Demeter. In the center are the foundations of its temple in antis (30.2 x 13.3 m), on which, in the Middle Ages, the Normans built the small church of St. Biagio, partly incorporating into its structure the cella of the Greek temple. This latter dates from 480-460 B.C. and carried a stone sima with lion head water spouts. Along the N side of the temple are two round altars with bothroi, typical of the cult of Chthonian divinities. On its S side the sanctuary was closed by a long retaining wall; access to the temple was by means of two roads cut into the rock and still preserved with their deep furrows cut by the chariots' wheels. Nearby, but outside the walls at the foot of the rock scarp, lies another Sanctuary of Demeter, of pre-Hellenic origin. It consists of two natural grottos from which water flowed, and which were found filled with terracotta busts of Demeter and Kore. In the archaic period a rectangular building with inward leaning walls was erected in front of the grottos; it was probably a cistern that gathered the water of the caves and

channeled it into various troughs on the outside. At a later phase the sanctuary was enclosed by a trapezoidal wall and the entrance was flanked by pilasters.

Another small rock sanctuary, with little niches for votive pinakes cut into the cliff, lies farther S to the side of Gate II. The temple hill proper formed the S side of the city; on its highest point is the so-called Temple of Juno (38.15 x 16.9 m), Doric peripteral (6 x 13). The conditions of the ground required the construction of a massive platform which increases the upward thrust of the building. On the N side the columns, the epistyle and part of the frieze are standing, but on the other three sides only the columns are partially preserved. The door leading from the pronaos into the cella is flanked by piers with traces of stairways to the roof; the opisthodomos was inaccessible from the cella. The temple is dated ca. 460-440 B.C., and was restored in Roman times. To the E of the temple lie the large foundations of its altar. Descending along the ridge, where the rock is honeycombed with Early Christian and Byzantine arched tombs, one reaches the so-called Temple of Concord. Its exceptional state of preservation is due to the fact that in the 6th c. A.D. the temple (to the Dioskouroi?) was transformed into a Christian church to SS. Peter and Paul. The temple (39.4 x 16.9 m) is Doric peripteral (6 x 13) and dates from ca. 450-440 B.C. Columns, pediments, and entablature up to the level of the cornice are still standing. The cella, with pronaos, opisthodomos, and piers, with inner stairways, now appears transformed by its adaptation to a Christian church: the rear wall is missing and the side walls are pierced by 12 arches; the pronaos shows evidence of its change into a sacristy and bishop's lodgings. The whole area between the so-called Temple of Concord and the next temple (of Herakles) is filled with Roman graves and Christian catacombs and cemeteries. The Roman necropolis contains heroa in the Hellenistic tradition, cist graves, and sarcophagi; the most notable structure is the so-called Tomb of Theron near the Golden Gate. It is a typical Hellenistic heroon of Asia Minor form, dating from the 1st c. B.C.; it consists of a square podium surmounted by a chamber with engaged Attic-Ionic columns at the corners, and a Doric entablature.

The Christian cemeteries lie around and under the modern Villa Aurea, with rock-cut tombs and catacombs formed by corridors with arched entrances and round halls adapted from ancient cisterns. On the crest above the Golden Gate stands the Temple of Herakles, perhaps mentioned by Cicero (*Verr.* 2.4.43). It is the earliest of Akragas' temples, datable to the end of the 6th c. B.C. because of the shape of columns and capitals, the elongated plan of the foundations (67 x 25.34 m) and the ratio of the facade columns to those of the flanks (6 x 15). It is a Doric peripteral temple, of which 9 columns still stand or have been re-erected, 8 of them on the S side. From this building come parts of the stone entablature with lion head water spouts (at present on display in the National Museum) which can be assigned to a restoration of the temple during the first half of the 5th c. B.C. Remains of the altar were found E of the temple. Beyond the Golden Gate one sees the ruins of the colossal Temple of Olympian Zeus, begun after the victory of Himera and left unfinished at the time of the Carthaginian destruction in 406 B.C. Its size (112.6 x 56.3 m) makes it comparable to Temple G in Selinus and the great Ionic temples of Asia Minor, e.g., the Artemision at Ephesos and the Didymaion at Miletos. Although Doric in style, this temple is unique architecturally. Over the foundations and the five-stepped crepidoma, in place of the traditional colonnade there extended a solid wall, strengthened at regular intervals

by Doric half columns on the exterior and pilasters on the interior. Between the half columns, at mid height up against the solid wall, stood colossal statues of Telamons, 7.65 m high, with arms bent at head level as if supporting an architrave. One of these Telamons was reassembled during the past century and is now exhibited in the National Museum; it was originally lying among the ruins of the temple where it has now been replaced by a cast. The building was almost certainly hypaethral, but we cannot restore its entablature. We only know that the facades were decorated with sculptural representations of the Gigantomachy and the Fall of Troy.

At some distance from the E front of the temple lie the remains of the great altar (54.5 x 17.5 m), which was originally a platform supported by piers. Near the SE corner of the Temple of Zeus are the foundations of a small temple with a double-naved cella; its chronology is controversial (between the 6th and 4th c. B.C.). Safely dated to the second half of the 4th c. B.C. is a long portico set along the crest of the walls S of the Temple of Zeus; a trough filled with votive terracottas was found at one end of it. Another portico, of which only the foundations are preserved, separated the Temple of Zeus from the adjacent Sanctuary of the Chthonian Divinities. Excavation in this area revealed traces of prehistoric settlements going back to the Neolithic period. The sanctuary and its various architectural structures are surrounded by a wall that is still extant on the W side. The earliest monuments are on the S side of the sanctuary and consist of 8 round and square altars; two enclosures, each containing several rooms and two interior altars; three shrines with pronaos, cella, and adyton; and various bothroi scattered among the structures. During the 6th c. B.C. work started on two temples that were left unfinished and are now preserved only as foundations; a third temple was completed during the first half of the 5th c. B.C., and is now erroneously called the Temple of the Dioskouroi. Its foundations are preserved and, at the NW corner, a group of four columns with entablature, in a picturesque but incorrect reconstruction of the 19th c. which incorporated architectural elements of various periods. A few yards to the S are the foundations, column drums, and entablature blocks of a Hellenistic temple (now called "Temple L") and its altar. Very recent excavations E of this temple have uncovered a paved court and another shrine of rather complex plan, built in the 5th c. B.C. over an earlier archaic shrine. Another sanctuary, perhaps also of the Chthonian Divinities, has recently been identified at the W end of the hill, but the scarce monumental remains that have come to light (shrine platforms, a round altar) do not allow positive identification. A narrow valley lies under the N ridge of the Sanctuary of the Chthonian Divinities; it is perhaps to be identified as the "Colimbetra," the reservoir into which flowed the waters of the Akragan aqueducts planned by Phaiax. Beyond this valley, on a small hill, stands the so-called Temple of Vulcan. It was of the Doric order (43 x 20.8 m). At present only the foundations of peristyle and cella, a few sections of the crepidoma, and the shafts of two columns remain. The temple dates from the second half of the 5th c. B.C., but it contains in its interior the foundations of an earlier temple in antis of the 6th c. B.C.; pieces of its polychrome terracotta revetments are now on display in the National Museum.

The Temple of Asklepios is outside the city in the center of the plain of St. Gregorius, almost at the confluence of the rivers Akragas and Hypsas. It is almost certainly the temple mentioned by Polybios (1.18) in his description of the Roman siege in 262 B.C. According to Cicero (*Verr.* 2.4.43) it contained a statue of Apollo

by Myron, stolen by Verres. This small temple of the second half of the 5th c. B.C. is built on a high podium; it is Doric, in antis (21.7 x 10.7 m) with pronaos, cella, and a false opisthodomos formed by a solid wall decorated with two Doric half-columns in between corner pilasters. The remains of another temple, of the first half of the 5th c. B.C., lie in the center of the modern city, on the colle di Girgenti, under the mediaeval church of S. Maria dei Greci. The drums of six columns and 22.5 m of the krepidoma are preserved. It has been suggested that this is the Temple of Athena built by Theron, but excavations have provided no evidence to confirm this theory.

Two important archaeological complexes have been uncovered in the last twenty years in the center of the valley of the temples. One is the archaeological area between the church of S. Nicola and the new National Museum; the other is the Hellenistic and Roman quarter nearby. The first archaeological area is called S. Nicola after the beautiful mediaeval church next to it; here the famous Phaedra sarcophagus is at present exhibited. This masterpiece is attributable to an Attic workshop of the 2d-3d c. A.D. In the 6th and 5th c. B.C. the area next to the church must have housed a Sanctuary of the Chthonian Divinities; its scanty remains have been sacrificed to the construction of the new museum. Around the middle of the 3d c. B.C. the rocky plateau was cut into a semicircular cavea with low steps, which has been identified as the meeting place of the citizens' assembly, either the ekklesiasterion or the comitium of the early Roman city. It is an important monument because it represents the first public structure of a civic character to be discovered in Agrigento. In the 1st c. B.C. the cavea was filled in and replaced by a court, and at one end of it was built the famous prostyle temple on a high podium known by the conventional name of Oratory of Phalaris. It was once thought to be a monumental tomb, but the discovery of an altar with semicircular exedra has confirmed that it was a shrine. In the Imperial period this area was occupied by private houses of which a few rooms with mosaics are visible at the foot of the cavea.

Not far from the S. Nicola area, on the opposite side of the national road, recent excavations have uncovered a large section of the Roman living quarters, built on an earlier Hellenistic site with a regular grid plan which, on stratigraphic evidence, seems to go back to the 5th c. B.C. Aerial photography has revealed that the entire slope of the valley was occupied by these habitation quarters with regular plan. The road system of the area thus far excavated includes four long parallel cardines, ca. 4 m wide and separated one from another by ca. 30 m. The cardines end at the present state road, which in this section must overlie the ancient decumanus, as shown by sections of terracotta paving in opus spicatum one of which is preserved in place. The houses, aligned in rows between the cardines, are separated from each other by narrow ambitus and lie at different levels according to their different chronology. Some houses belong to the Late Republican period and have floors in opus signinum; most of them however belong to the Imperial period, with polychrome mosaic floors. Some houses have an atrium of Italic type, others the Hellenistic peristyle. They are all built with blocks of local limestone, and no bricks were used. Large fragments of wall paintings with geometric motifs are preserved. Among the most important are the Peristyle House, the House of Aphrodite, and the House of the Gazelle, now displayed in the National Museum. Among the houses there are also some tabernae and, on the surface, a few Early Christian or Byzantine graves which infiltrated into the quarter after it was abandoned in the 5th c. A.D.

Other notable monuments, though not easily accessible, are the so-called hypogea, subterranean installations of the Greek aqueducts of the 5th c. B.C. The best known are the Hypogeum Giacatello, to the N of the Museum, and the Hypogeum del Paradiso in the center of the modern city. They are large rooms supported by pilasters into which converge the galleries of the aqueducts.

Outside Agrigento, besides the so-called Tomb of Theron and the already-mentioned Temple of Asklepios, are the remains of a small Early Christian apsidal basilica in the valley of the river Akragas, along the road that climbs to the Temple of Juno. A large monumental complex has also been discovered recently in the area of the modern quarter of Villa Seta, between Agrigento and Porto Empedocle. It consists of the massive ashlar foundations of a large quadrangular portico, probably with an Ionic colonnade as suggested by an extant base. It may have been a large public building or an extramural sanctuary of the Hellenistic-Roman period.

All the archaeological material once in the old Museo Comunale and the finds from recent excavations in Agrigento and its territory are today gathered in the new National Museum near the church of S. Nicola, which also houses the Superintendency to the Antiquities.

BIBLIOGRAPHY. E. A. Freeman, *History of Sicily* (1891); A. Holm, *Storia della Sicilia nell'antichità* (1896-1900); Koldewey & Puchstein, *Die Griechischen Tempel in Unteritalien und Sizilien* (1899); B. Pace, *Arte e civiltà della Sicilia antica* (1935-1949); J. Berard, *La colonisation grecque de l'Italie Méridionale et de la Sicile dans l'antiquité* (1941; 2d ed., 1957); G. E. Rizzo, *Monete greche della Sicilia* (1946); T. J. Dunbabin, *The Western Greeks* (1948); L. Pareti, *Sicilia antica* (1959); M. I. Finley, *Ancient Sicily* (1968).

Specialized Bibliography. G. Schubring, *Topografia storica di Agrigento* (1888); A. Salinas, *NSc* (1901); id., *Atti e Mem. Ist. It. di Numismatica* (1914); Th. Lenschau, *BPW* (1903) 187ff; E. Gabrici, *NSc* (1925) 420ff; P. Marconi, *NSc* (1926) 93ff; id., *Agrigento, topografia ed arte* (1929); id., *RivIstArch* 1 (1929) 293ff; 2 (1930) 7ff; *NSc* (1932) 405ff; id., *Agrigento Arcaica* (1933); G. Ricci, *Le Arti* 3 (1940-41) 135ff; P. Griffo, *Ultimi scavi e scoperte in Agrigento* (1946); id., "Agrigento Romana," *Atti Acc. Agrigento* (1947); id., *Atti Primo Congresso Arch. Cristiana* (1952) 191ff; id., *Sulla collocazione dei Telamoni nel Tempio di Giove Olimpico in Agrigento* (1952); id., *Atti VII Congresso. Naz. Storia Architettura* (1955); id., & G. Schmiedt, *Agrigento antica dalle fotografie aeree e dai recenti scavi* (1958); Griffo, *Agrigento-Guida ai monumenti e agli scavi* (1962); id., *Kokalos* 9 (1963) 163ff; E. De Miro, *RendLinc* (1957) 135ff; id., *CronArchStoria d'Arte* (1963) 59ff; id., *Palladio* (1967) 164ff. P. ORLANDINI

AKRAI (Acre) Sicily. Map 17B. An ancient city in the Province of Siracusa to the W of the modern center of Palazzuolo Acreide. It is on the summit of a hill, almost level but with steep and precipitous flanks except on the E side. It is between the Anapo and the Tellaro, near the mouths of which are respectively Syracuse and Eloro. The hill has been frequented since the Paleolithic period, as is shown by finds during repair under the cliff of S. Corrado.

Akrai, founded by Syracuse in 664 B.C. (Thuc. 5.5.3), represents the first of the city's three colonies. The other two were Kasmenai and Kamarina, which were founded, according to the chronology of Thucydides, respectively in 644 and 599 B.C. Akrai was founded to protect one of the key points of access to Syracuse in the triangle of

SE Sicily. Conspicuous strategic use of the site, however, preceded the foundation of the colony. The sources give little information about the initial period of the sub-colony's life, but it may be supposed that it was subordinate to the mother city. Plutarch records Akrai as a stopping place of Dion during the expedition he led against Dionysios II. It is known (Diod. Sic. 23.4.1) that in the peace treaty between Rome and Syracuse in 263 Akrai was one of the cities, along with Leontinoi, Megara, Heloros/Neton/Tauromenion, to be assigned to Hieron II. Other notice of interest is that given by Pliny that counts Akrai among the civitates stipendiariae, the cities, that is, that owed a fixed tribute to Rome because their territory was considered property of the Roman people. Written mention of the city is scarce during the Roman period, even though recently acquired archaeological evidence shows continuity of life there until the Late Imperial era. In the 4th and 5th c. Akrai was the seat of an important Christian community. It is probable that the city was destroyed in 827 during the first large invasion of Arabs into Sicily.

Temples in honor of Artemis, Aphrodite, and Kore (IGS 217) were built here, and there is evidence also of the cults of Zeus Akrios and of the nymphs.

The fortification system of the city developed along the margins of the terrace that is occupied by the urban center. Traces of the structures relating to the city walls are evident along the NW, S, and E margins of the city. The position of the two principal gates has also been identified. The Siracusana gate is to the E, and the Selinuntina to the W. The latter, cited also in the inscriptions, linked Akrai with nearby Kasmenai.

Inside the city, traces are clearly visible of the artery that crossed the urban area in an E-W direction, almost in the middle of the plateau. This area, which constituted the urban center, was itself situated at the midpoint of the level summit. Its N sector, slightly sloping toward the N, contained no archaeological remains. Apparently, although included in the circuit of the fortifications for defensive reasons, it did not make up part of the true urban center. The actual inhabited area in the central part of the level area shows well-regulated development. This is in part because the city was founded at a precise historical moment as a result of the expansionist politics of Syracuse, rather than growing gradually from a primitive nuclear settlement. The principal artery of the city has recently been brought to light for ca. 200 m, and it leads precisely between the two gates of the city mentioned above. The well-preserved tract of road is paved in volcanic rock. Excavation has also brought to light the intersections between this central road and several others, five on its N side and two on the S. The intersections are not at right angles, but rather slightly inclined, thus creating a singular urban plan not previously documented in Sicily.

The archaeological documentation recovered in several stratified cuts made in the central area of the city dates from archaic times to the Roman Imperial period.

Among the monumental urban remains is the base of a Doric peripteral temple at the highest point of the city, on the sacred acropolis, probably dedicated to Aphrodite.

Included in a complex discovered in the 19th c. is a small theater with a maximum diameter of 37.5 m. It dates from the 3d c. B.C. and is made up of a cavea supported by a slope and composed of nine cunei and 12 steps, largely rebuilt. Of the original logeion only the stylobate is preserved. The pavement of the orchestra and the remnants of the stage are rebuildings from the Roman era. To the W of the theater are the remains of a small bouleuterion with three cunei that must have opened on the agora. At the rear of the theater are the two Latomie

called the Intagliata and the Intagliatella, which bear traces of defunct cults for hero worship. In the Christian-Byzantine period they were transformed into habitations and sepulchers.

The so-called Templi Ferali are found to the E of the city. They consist of niches dug into the vertical wall of a Latomia, and were evidently related to a cult of the dead. Also to be mentioned are the so-called Santoni, which are rude sculptures relating to the cult of the Great Mother, dating to the 3d c. B.C.

To the SE of the city are the necropoleis of Torre Iudica from the archaic era, and of Colle Orbo from the Hellenistic-Roman period. The Sikel necropolis, composed of burials in artificial grottos, probably dates to the Late Bronze age. It is in the section called "Pinita" in the scenic rocky cliffs that outline the S flank of the hill of Akrai.

The material coming from the excavations at Akrai and from its necropoleis is in the small antiquarium near the monumental complex, in the Museo Archeologico at Syracuse, and in the Iudica collection, which Italy is in the process of acquiring.

BIBLIOGRAPHY. G. Iudica, *Le Antichità di Acre scoperte descritte e illustrate* (1819); L. Bernabò Brea, *Akrai* (1956); P. Pelagatti, *BdA* (1966) 92; G. Voza, *Un quinquennio di attività nella Provincia di Siracusa* (1971) 72.

G. VOZA

AKRAIPHIA (Akraifnion, formerly Kardhitsa) Boiotia, Greece. Map 11. A city on the site of the modern village, E of the ancient Lake Kopais. It lies at the foot of a tall hill linked to Mt. Ptoos to the E by a long rocky ridge.

The site does not seem to have been occupied until the Geometric age. The earliest finds, on the W slope of the acropolis, are Geometric terracottas, particularly some small horses (now in the Thebes Museum)—a reminder that the Kopais region was noted for horse-breeding. The city enjoyed a certain autonomy in the 6th and 5th c. B.C., minted its coins, and made a number of dedications to the Ptoios Hero (cf. Ptoion). From 447 to 387 and from 378 to 338 it joined Kopai and Chaironeia to form one of the 11 Boiotian districts. Independent in the Boiotian Koinon, the city was untouched by the invasions and was responsible for administering the Sanctuary of Ptoan Apollo. Even in the 1st c. A.D. it still had some prestige, thanks to the influential Epaminondas, son of Epaminondas (*IG* VII 2711-13).

The city of Akraiphia has not yet been excavated. The lower city was on the N foothills of the Kriaria ridge; foundations dating from the Classical and Hellenistic eras could still be seen at the end of the 19th c. An altar dedicated to Zeus Soter, the city's chief divinity, stood on the agora; in his honor the city organized the Soteria festivals, with their gymnastic and musical contests. The Haghios Georgios Church, on the foothills of the mountain, seems to have been erected on the site of the Temple of Dionysos; it is built largely with ancient materials: monumental stone blocks, Ionic capitals and inscriptions, notably two large stelai honoring Epaminondas of Akraiphia, and one stele bearing the text of a speech delivered by Nero on November 28, A.D. 67 (in the Thebes Museum).

The acropolis, on the top of the hill, is built into the city ramparts. A wall climbs straight from the lower city to the summit; it has no towers or gates and is built of large rectangular blocks placed in regular courses. At the top of the hill, the wall turns at an angle and starts to run SW along the wide flat crest of the ridge; then it joins the narrow pass leading to Akraiphia from the S (there is a gate in the rampart here), spans it, and

climbs N again. After that it disappears. In the most uneven parts of the wall a curious polygonal masonry of nearly regular courses, slightly convex in surface, is combined, at the wall base, with regular masonry of horizontal courses with vertical or oblique facing joints (SW and W section of the wall). The rampart, of gray limestone, is ca. 2 m thick. Despite the differences in masonry it dates from no earlier than the 4th c. B.C.

A number of necropoleis have been discovered: W of the acropolis (late and proto-Corinthian Geometric ware), E of it (Roman period), and in the plain now crossed by the new national highway, between the Kopaic basin and Lake Iliki (7th-4th c. B.C.).

BIBLIOGRAPHY. J. G. Frazer, *Paus. Des. Gr.* v (1898) 97-99ᴹ; M. Holleaux, *Études d'Épigraphie et d'Histoire grecques* I (1938) 165-85; P. Guillon, *Les trépieds du Ptoion*, 2 vols. (1943)ᴹᴵ; *La Béotie antique* (1948) 105 & pls. 11, 32ᴹᴵ; S. Lauffer in *RE* (1959), s.v. Ptoion, 1524-26ᴹ; P. Roesch, *Thespies et la Confédération béotienne* (1965)ᴹ; N. Papahadjis, *Pausaniou Hellados Periegesis* v (1969) 132-33; Y. Garlan, *BCH* 98 (1974) 95-118; id., *Recherches de poliorcétique grecque* (1974) 13, 333. P. ROESCH

AKRI, *see* AKTION

AKSARAY, *see* COLONIA ARCHELAIS

AKŞEHIR, *see* AKÇAKOCA

AKSU, *see* PERGE

AKTAŞ, *see* GAGAI

AKTION later **AKARNANIAN (Akri)** Greece. Map 9. A peninsula of Akarnania, which with the Epirote peninsula of Preveza, forms the mouth of the Ambrakian gulf. Aktion was under the control of Anaktorion (Thuc. 1.29.3), 40 stades away from the temple (Strab. 10.2.7), a Corinthian colony perhaps of the time of Kypselos. It was famous for the Temple of Apollo and the games (Aktia) celebrated there biennially. During the Peloponnesian War, Aktion became Akarnanian, after the latter's sack of Anaktorion (Thuc. 4.49). According to an inscription of ca. 200 B.C., found at Olympia, the Anaktorians were unable to finance the games after the Social War, and so the temple became a federal shrine of the Akarnanians.

After the battle of Aktion, the games were moved to Augustus' new city of Nikopolis, musical and naval contests were added to the original gymnastic and cavalry games, the contests became quadrennial, and the Spartans were placed in charge (Strab. 7.7.6; Dio Cass. 51.1.1-3). Augustus also enlarged the Aktion sanctuary and one of his great victory votives, a dedication of ten ships, was near the temple. Strabo says, however, that by his time the dedication and the docks were burned (7.7.6).

Strabo's description of the site as on a hill with a grove down below is difficult to reconcile with the present flat, sandy appearance of the peninsula. But the sanctuary must be near the mouth of the Ambrakian gulf (Thuc. 1.29.3; Polyb. 4.63.4; Dio Cass. 50.12.7). The earliest probable evidence for a sanctuary are the two fragmentary kouroi now in the Louvre, found in 1867. Leake saw Roman ruins, possibly from Augustan rebuilding (opus reticulatum), Hammond noted blocks under water, suggesting a rise in sea level, and there is Byzantine and especially Turkish building on the peninsula. But no full-scale excavation has as yet been undertaken to determine the exact location of the sanctuary. See also Nikopolis.

BIBLIOGRAPHY. W. M. Leake, *Nor. Gr.* (1835; repr. 1967) I, ch. 4 & IV, ch. 34; M. Collignon, "Torsoes Archaïques en Marbre Provenant d'Actium," *Gazette Archéologique* (1886) 235-43; E. Oberhummer, *Akarnanien* (1887); Hirschfeld, *RE* I (1894) 1214-15; J. Gagé, "Actiaca," *Mélanges d'Archéologie* 53 (1936) 37-100; C. Habicht, "Eine Urkunde des Akarnanischen Bundes," *Hermes* 85 (1957) 86-122; A. Philippson & E. Kirsten, *Die Griechischen Landschaften* II.2 (1958) 380-81; N. Hammond, *Epirus* (1967) 62-63; C. Edmonson, "Augustus, Actium and Nikopolis," *AJA* 73 (1969) 235. For the battle see W. Tarn, "Actium," *JRS* 28 (1938) 165-68 with previous bibliography.

E. G. PEMBERTON

ALABANDA (Araphisar) Caria, Turkey. Map 7. About 11 km W of the present town of Çine. It was one of the three inland cities of Caria which Strabo considered noteworthy. According to Stephanos of Byzantium it was named by King Kar after his son Alabandos in consequence of a cavalry victory, for in Carian *ala* = horse and *banda* = victory. A god Alabandos is mentioned by Cicero (*ND* 3.50). Herodotos describes Alabanda in one case as in Caria, in the other as in Phrygia, but there is no doubt that the same city is meant. Stephanos' second city of Alabanda in Caria can never have existed.

Late in the 3d c. Alabanda was colonized by the Seleucids and took the name of "Antiocheia of the Chrysaorians" in honor of Antiochos III. Under this name it was recognized by the Amphictyonic Council as inviolable and sacred to Zeus Chrysaoreus and Apollo Isotimos. Despite this privilege the city and its territory was sacked soon afterwards by Philip V of Macedon in the course of his Carian expedition (201-197). Rhodian domination after Magnesia in 190 was hardly more than nominal, and about 170 the Alabandians obtained an alliance with Rome. They had already at that time built a Temple of Urbs Roma. After 129 B.C. Alabanda suffered like the rest in the province of Asia from the provincial maladministration, and by 51 B.C. was in debt to the Roman banker Cluvius. In 40 B.C. the city with its sanctuaries was harshly treated by Labienus for its resistance to him. Under the Empire Alabanda had the status of a conventus.

The site at Araphisar is said by Strabo (660) to lie under two adjoining hills in such a way as to resemble a pack-ass loaded with its panniers. The city wall runs over these hills and included also a large area of the plain. On the hills the wall is well preserved in places, but on the level ground it has virtually disappeared. The masonry is a slightly bossed ashlar with rubble filling. There are numerous towers, and half a dozen gates may be recognized by gaps in the wall.

Excavations in 1905 brought to light the foundations of two temples. The first of these is the Temple of Apollo Isotimos. It was Ionic, with a peristyle (8 x 13 columns), orientated NE-SW; the frieze showed a battle of Greeks and Amazons. At present hardly anything remains visible. The epithet Isotimos, peculiar to Apollo at Alabanda, is thought to mean "equal in honor (to Zeus Chrysaoreus)." In Imperial times the temple was rededicated to Apollo Isotimos and the Divine Emperors.

The second temple stood on the slope of the hill a little above the plain. It was Doric, with a peristyle (6 x 11 columns), and comprised a pronaos and a cella; the entrance was on the W. It is commonly called Temple of Artemis from a figurine of Artemis-Hekate found on the spot, but this evidence is obviously slender. The date is probably about 200 B.C. This building too has suffered much since the excavation.

Of the theater only the ends of the retaining wall of

the cavea are standing, in elegant bossed ashlar, with an arched entrance on either side; the seats and stage building are gone. The cavea is large and comprises rather more than a semicircle. This building has not been excavated.

Outside the city wall on the N stands a single arch of an aqueduct, of the usual Roman type, but the upper part, including the water channel, is not preserved.

The most conspicuous building on the plain is a rectangular structure in brown stone standing over 9 m in height; it is probably a council house. The S front contained four doors and a row of windows; in the interior a staircase on either side led up to the curved rows of seats. In the exterior of all four sides, especially on the S front, a horizontal row of square holes has been cut at some later date; their purpose is not clear. Close by are the ruins of another large building which has not been excavated; it is thought to have been a bath building. Between this and the council house is a broad open space, probably the agora. The excavators unearthed a colonnaded stoa surrounding it, with an entrance at the NW corner, but of this nothing is now visible. The street leading to the city on the E was lined by an extensive necropolis. The tombs are of sarcophagus type, with inscriptions frequently recording the trade or profession of the deceased.

BIBLIOGRAPHY. Ethem Bey, "Fouilles d'Alabanda en Carie," *CRAI* (1905) 443f; (1906) 407f; L. Robert, *Études Anatoliennes* (1937) 434-36; G. E. Bean, *Anadolu Araştırmaları* (1955) I 52-53; id., *Turkey beyond the Maeander* (1971) ch. 15[MI]. G. E. BEAN

ALAGONIA Lakonia, Greece. Map 9. A site occupied in mediaeval times by the fortress of Zarnata, S of the modern town of Kambos on the Mani peninsula. Pausanias (3.26.11) lists it among the Free Lakonian cities and mentions Sanctuaries of Dionysos and Artemis. There are traces of polygonal masonry in the facade of the fortress.

BIBLIOGRAPHY. J. G. Frazer, *Paus. Des. Gr.* (1898) III 408. M. H. MC ALLISTER

ALALIA later ALERIA Corsica, France. Map 23. Half way down the E coast of Corsica, opposite the W shores of Etruria, it was first a Greek, then a Roman colony. According to Herodotos (1.162-67), a group of settlers from Phokaia established themselves on the site about twenty years before the campaigns conducted by the Persian king Cyrus against the Greek cities of Ionia, in other words about 565-560. They were joined around 545-540 by part of the population of the besieged Phokaia. By practicing piracy in Etruscan territory and among the Carthaginian possessions in Sardinia, the Greeks of Alalia provoked a punitive expedition by the Punic and Etruscan fleets. The battle of Alalia (about 535) was a costly Pyrrhic victory for the Phokaians. Contrary to Herodotos' assertions, it does not appear that the whole population then left Alalia, first for Rhegion, then Velia (Elea). Certainly Etruscans, and possibly Carthaginians, came to join the Greek and native elements. They made Alalia a very active, cosmopolitan port. After a short period of Carthaginian control, Rome took the town ca. 259 B.C. (the epitaph of L. Cornelius Scipio: HEC CEPIT CORSICA(M) ALERIA(M)QUE URBEM: *CIL* 1.32). In 81 Aleria, which had resisted Sulla, became a military colony. First Caesar, then Augustus made new settlements and the town took the name of Colonia Veneria Julia Pacensis Restituta Tertianorum Aleria. Augustus established a detachment of the Misenum fleet there. The development of the port of Ostia led little by little to the economic decline

of Aleria, but it remained the political and administrative capital of Corsica under the Empire.

The town and its vicinity have been systematically explored since 1955. The first phase of occupation of the site by the Phokaians has left no remains except for a stratigraphic level found in deep test pits made under the Roman town. It corresponds to the 6th c. B.C. and is characterized by sherds of Ionian, Phokaian, Rhodian, and Attic black-figure ware. Neither the dwellings nor the tombs of this period have been brought to light as yet. However, the excavation of the necropolis of Casabianda, whose access road has been cleared, has permitted the discovery of tombs cut into the rock. They include a dromos, an antechamber (sometimes double), and a chamber furnished with benches. Low brick walls blocked the entrances. Some of these tombs retain traces of pictorial decoration. The oldest goes back to the end of the archaic or the beginning of the Classical period. The grave goods include works of the very first rank: jewels, weapons, metal artifacts, bronze and ceramic plates and dishes—in particular, Attic cups, rhytons, kraters with little columns, etc. They are decorated by artists such as the painters of Pan, Alkimakos, Kalliope, Myson, and many others. They are all exceptional works which are not found in such abundance except on the largest Etruscan sites, and can be seen in the Aleria Museum.

In addition to the Casabianda necropolis, others prove the continuity of occupation. No break appears in the material from the 5th c. B.C. until the 3d or 4th c. A.D. Even more, the enormous quantity and high value of the grave goods show that before the Roman conquest Alalia was a center of importance. Further excavations should permit the extrication of the sites and architecture of the Greek and Hellenistic town. At the same time, they should provide an answer to a difficult problem: what importance should be assigned to an Etruscan presence, attested until now only by a very small proportion of the finds and by graffiti still under study.

The Roman town (no doubt like the earlier settlements) grew up on a plateau ca. 3 km long. At its foot the river Tavignano describes a large curve, and the commercial port was established inside this elbow. In relation to the port a mansio was created, the baths of which have been discovered (the so-called Baths of Santa Laurina). The war fleet anchored in the pool of Diana.

The Roman colony is still only incompletely excavated. A part of the ramparts is visible to the W, on both sides of the Praetorian Gate which passed over the decumanus. This last has been followed until it crosses the cardo just outside the forum on its S side. The forum has the shape of a slightly irregular trapezoid 92 m long, orientated E-W. After its founding by Sulla, it underwent numerous rearrangements.

The E side is occupied by a temple, whose podium in opus incertum has survived. Probably it was a Temple to Augustus and Rome (an inscription to a flamen of Caracalla), and raised in the time of Hadrian. The N and S sides of the square are adorned with porticos with brick columns. The W ends of the porticos stand against two monuments of uncertain nature (a small temple to the N and an office of the aediles to the S ?). Near them are two arches: a S arch marking the beginning of the cardo and a second one, to the N and orientated to the W, which gives access to the praetorium. This edifice occupies all of the W part of the forum, to a depth of about 50 m. There are three porticos surrounding a vast central court with a complex system of basins, cisterns, and nymphaea. The NW corner contained chambers possibly used as strong rooms.

The W portico was altered at a late date in order to permit the construction of a new tribunal.

Several buildings have been excavated outside the forum. The most important of these is located N of the praetorium and stands 5 m higher than it. It includes two large cisterns, chambers adorned with mosaics, tabernae, and bath pools with hypocausts. Tradition places the apartments of the governor there; it is certain that this bath could not have been public. Perhaps it was the theater of the events reported by Tacitus (*Hist.* 2.16), the assassination in the baths of the procurator Decimus Pacarius. To the W was an establishment which included many basins and contained an enormous quantity of shells; it must have been a preserving and salting factory. North of the Temple of Augustus and Rome, the so-called House of the Dolium has been excavated. Its oldest level has pavings of opus signinum decorated with white lapilli and goes back to the period of Sulla. A second level dates to the 1st c. A.D. and contains the outline of a house with a peristyle. South of the temple another house (the House of the Impluvium) has been only partly excavated. Also noteworthy are the foundations of a small Early Christian chapel with an apse, on top of the remains of the N portico and virtually touching the temple. Other monuments have been identified but not cleared. Notable examples are the amphitheater, near the S gate of the ramparts, and a mausoleum situated outside the W sector of the fortifications.

In the modern village the fort of Matra contains the museum, where the rich collections from the necropoleis and the products of the excavations in the town are on exhibit.

BIBLIOGRAPHY. J. Jehasse, *Aleria grecque et romaine, Hist. et visite des fouilles*; id., "Les fouilles d'Aleria: le plateau et ses problèmes," *Gallia* 21 (1963); "Chroniques arch.," *Gallia*, since 1958; J. & J. Jehasse, "La nécropole préromaine d'Aleria," *Gallia*, Suppl. 25 (1973).
C. GOUDINEAU

ALANGE ("Castrum Colubri") Badajoz, Spain. Map 19. Roman town 15 km SE of Mérida, built over a pre-Roman settlement and now covered by the mediaeval castle. Traditionally it was Castrum Colubri, but this name appears in none of the sources of the Roman period. The baths, the basic structure of which is still recognizable despite later restorations, are still in use. They consist of a rectangular enclosure (28 x 13 m) inside which are two round rooms with separate entrances. Each room, 11.3 m in diameter, is flanked by four exedras and has a round pool in the center.

BIBLIOGRAPHY. J. R. Mélida, *Catálogo Monumental de España. Provincia de Badajoz* (1926) I, 361-66[PI].
L. G. IGLESIAS

ALA NOVA, see LIMES PANNONIAE

ALÂNYA, see KORAKESION

ALAŞEHIR, see PHILADELPHIA (Lydia)

ALATRI, see ALETRIUM

ALAUNA Commune Valognes, Dept. Manche, France. Map 23. The city is situated to the N of the peninsula of Cotentin, on a route used by tin traders and in the heart of the territory belonging to the Gallic people called the Unelli, for whom it perhaps served as a capital. Alauna is mentioned in the *Antonine Itinerary* and in the *Peutinger Table*. The coins found there run from Domitian to Maximus Magnus. Destruction is attributed to Victor, son of Maximus, at the time of his retreat toward Britanny (A.D. 388). There is an echo of the word Alauna in the present parish of Notre Dame d'Alleaume, a rural quarter of Valognes.

The site was excavated at the very end of the 17th c., but the most extensive excavations came in the first half of the 19th. Further digging was done in 1954.

No indisputable trace of fortifications has been found although the present place-name, Le Câtelet, has given rise to the hypothesis of a castellum. The settlement was composed of insulae built of wood and clay on stone foundations often without mortar. Some villas, more or less distant from the center of the city, have been located.

Monumental remains are few and in bad repair, as the ruins served as a source for stone by later builders. A wall 50 m long, near which the ruins of a column have been found, belongs to a structure not yet identified.

The ruins of the baths called at present Vieux Château, partially destroyed in 1773, are well known through a survey made in 1765, the accuracy of which was borne out by work done in 1954. Another survey published in the 18th c. is actually a plan of the baths at Vieux (Aragenua). This may have led to the incorrect assumption that there were no baths at Alauna. From these, oriented E-NE–W-SW, five rooms have been fully excavated. One of them housed a circular bath heated by hypocaust. The walls are made of rubble between two facings of small stones, the frames of the bays being alternately of brick and stone. Water was supplied by an underground aqueduct fed by a spring at the Câtelet, where a man-made cistern regulated the flow.

The theater was situated at the easternmost point of the city, 800 m from the baths. It is located in a natural hollow but additional earth was necessary to make the W part. Part of the outside wall still exists. The masonry stands on foundations of dry stone. The interior of the theater consisted of a pulpitum smaller than the proscenium, the orchestra, two maeniana separated by walls and aisles, and an upper gallery. Spectators entered by stairways. The theater held about 3700 people. In the center of the orchestra was a drain covered by a flagstone slab. The only decorative object found was a limestone candelabra (Cherbourg museum). No statuary has been found.

BIBLIOGRAPHY. C. de Gerville, "Recherches sur les villes et les voies romaines du Cotentin," *Mém. Soc. Antiq. Ndie* v (1829-30) 1-52[PI]; id., *Les Monuments romains d'Alleaune* (1838); A. Delalande, "Rapport sur les fouilles de Valognes," *Mém. Soc. Antiq. Ndie* XIV (1844) 317-31[PI]; A. de Caumont, "Notes additionnelles sur les ruines de quelques théâtres gallo-romains," *Bull. Monumental* 38 (1862) 410-18; Lemarquand, "Exploration des sources du Câtelet," *Bull. Soc. Arch. de Valognes* 6 (1900-1903) 45-51; C. Birette, "Contribution à l'histoire de Valognes. Iᵉ partie: De la préhistoire au moyen âge," *Annuaire des 5 dépts de Normandie* XCIII (1926) 229-85; A. Grenier, "Les thermes de Valognes n'existent pas," *Pays Bas-Normand* 46 (1953) 2-4; J. Macé, "Les ruines antiques d'Alauna près de Valognes," *Bull. Soc. Antiq. Ndie* 54 (1957-58) 384-95[P].
J. J. BERTAUX

ALAUNA (Maryport) Cumberland, England. Map 24. The name Alauna derives from the *Ravenna Cosmography*. The Roman fort lies on a cliff with a wide outlook across the Solway Firth, and commands the mouth of the river Ellen. We may presume that the fort was built as part of the coastal defenses which continued the system of Hadrian's Wall SW along the shore of the Solway.

The fort (ca. 160 x 150 m, an area of 2.4 ha) faces seaward. Stone-robbing in the 17th and 18th c. has re-

moved most of the Roman walls, and the site was also subject to several ill-recorded excavations during the same period. Excavation in 1966 produced evidence of occupation from ca. 125 to the end of the 4th c.

A large number of inscriptions from earlier excavations provide important evidence for the units in garrison. These were the following cohorts: I Hispanorum equitata (under Hadrian); I Delmatarum (under Antoninus Pius); I Baetasiorum c.R. Two other units, of uncertain title, are also attested. Three of the four known units were cohortes quingenariae, though the fort was certainly large enough for a cohors milliaria equitata. There is nothing to indicate the use made of the extra space.

The original parade ground lay NE of the fort, and a series of altars was found buried near it. A new parade ground was created in the 3d c. SW of the fort. The area to the NE, along the cliff, was occupied by an extensive civil settlement, defended by a bank and ditch which also enclosed the fort. Outside this enclosure there was apparently some ribbon development beside the road which led SE to Papcastle. There is slight evidence for Roman harbor installations on the S bank of the Ellen, but these, like much else, have been covered by the modern town.

The site of the fort, however, remains open, and the defenses may readily be identified; nothing else can be seen except the spoil heaps of stone robbers. Most of the important inscriptions and sculptured stones are preserved at Netherhall, Maryport.

BIBLIOGRAPHY. E. Birley, *Research on Hadrian's Wall* (1961) 216-23. M. G. JARRETT

ALBA FUCENS (Albe) Italy. Map 16. The remains of this ancient Roman colonia stand on a hill that rises almost 300 m above the basin formerly occupied by the Fucine Lake. A memory of the ancient glory lingers on in the name of the modern village (commune of Massa d'Albe), 8 km to the W of Avezzano. Alba Fucens was situated on a crossroads, of which the most important route, the Via Valeria Tiburtina, linked Rome to the Adriatic. Another road gave passage from S Etruria to the Campania by way of the valley of the Liri. This geographical position determined the history of Alba, whose development is due entirely to the military events which took place in central Italy.

Rome founded this colony in 303 B.C., a year after the submission of the Aequi, by transferring there 6000 colonists. During the 3d c. wars, at first against the Samnites, then against the Carthaginians, Alba remained a faithful ally. In the 2d c. the town served as a fortress to which dethroned kings such as Syphax, Perseus V, and Bituitus were relegated. During the social wars, Alba, which remained faithful, was besieged, but in 89 it was relieved by Rome. From this point begins a period of great prosperity for the town. Whole districts of the town were rebuilt, and the center of the city was entirely remodeled according to Hellenistic ideas of urban planning. From the 3d c. A.D. decline is marked, accelerating in the following century. The last reference to the city is made by Procopius, who mentions that in 537 Justinian's troops took up their winter quarters there.

The first systematic exploration of the city was begun in 1949 and has continued without interruption. The center of the city has been excavated and a detailed study of most of the public and private edifices has been made.

The town was on an oblong hill, its greatest length running N-S. On the acropolis, a rocky spur, the mediaeval village formerly stood and perhaps also the pre-Roman settlement. To the S is the hill of San Pietro, with a Romanesque church and Italic temple. To the E is the Pettorino, on which are the remains of another temple. Between these two heights stretches a valley some 100 m wide, where the principal buildings of the town were situated. The town's perimeter included the summits of all three hills and took the form of an elongated lozenge (1150 x 675 m), the whole surrounded by a wall 2925 m long. The original wall, which was between 2.8 m and 3.4 m thick, was constructed of massive rubble work. It dates, for the most part, to the mid 3d c.; some modifications were made in the 2d c. and at the beginning of the 1st c. B.C. The wall is pierced by four gates identical in plan: rubble work construction with a tower or bastion advanced to the right.

The streets are laid out on a grid pattern, the outside of the grid measuring 336 m by 246 m. It is subdivided into regular sectors by the two axes of the city: the decumanus or Via Valeria, which runs along the bottom of the valley, and the transverse cardo. A second street, the Via dei Pilastri, is parallel to the decumanus. Between the two stood all the official buildings and monuments of the city, which stretch from the N to the S as follows: the comitium (2d c. B.C.); the forum (142 x 43.5 m), which is terminated at the S by a portico and a rectangular basilica (53.1 x 23.3 m), which has three doors opening onto the forum; then the market, the baths, and the Sanctuary of Hercules, the last being a vast complex consisting of a small cella and a very large esplanade surrounded by a double portico. Along the principal streets are shops of standardized ground plan. In the outlying districts are some opulent houses with mosaic floors and frescoed walls, the theater and the amphitheater, and the remarkable remains of the Temple of Apollo, which are incorporated in a beautiful Romanesque church. The temple probably dates from the 2d c. B.C.

On the N flank of the town stretches a large terrace surrounded by a portico terminating in an exedra. In the center stands a square monumental pillar. The whole dates from the 1st c. A.D.

The immense rubble work wall attests the essentially military character of Alba. The monumental center of the city is an example of city planning dating in its principal elements from the end of the Republican period (1st c. B.C.); the amphitheater and some private dwellings date from the 1st c. A.D.

The principal objects discovered in the course of the excavations—the Venus of Alba, a statue of Herakles Epitrapezios, marble portrait busts, bronze statuettes, inscriptions, etc.—are preserved at the National Museum of the Abruzzi at Chieti.

BIBLIOGRAPHY. F. De Visscher et al., *Les fouilles d'Alba Fucens de 1951 a 1953* (1955) = *AntCl* 23 (1954) & 24 (1955); De Visscher, "Epitrapezios," *AntCl* 30 (1961) 67-120; id. et al., "Le sanctuaire d'Hercule et ses portiques à Alba Fucens," *Monum. Ant. Lincei* 46 (1963) 333-96; J. Mertens, "Il foro di Alba Fucens," *NSc* 22 (1968) 205-17; id., Etude topographique d'Alba Fucens dans *Alba Fucens* I (Etudes de philologie, d'archeologie et d'histoire anciennes publiées par l'Institut historique belge de Rome XII, 1969) 37-118[MPI]; dans le même volume, bibl. complète, pp. 33-36, et historique des fouilles; *Alba Fucens* II (Etudes XIII, 1969) contient des études sur les temples italiques d'Albe (J. Mertens), l'église romane de San Pietro (R. Delogu) et le sanctuaire d'Hercule (J. C. Balty). J. MERTENS

ALBA HELVIORUM (Alba) Ardèche, France. Map 23. The capital of the Helvii, in Gallia Narbonensis. Their territory on the right bank of the Rhône corresponds almost exactly to the department of Ardèche. A Roman colony under Augustus, the Alba prospered from the 1st c. until it was sacked by the Alemanni in

the 3d c. The city owed its prosperity to its location in the fertile plain below the basalt massif of the Coiron, which shields it on the N and makes it a rich wine-growing region; Pliny (*HN* 14.43) mentions a local wine of good repute. It was also important as a road junction: three major roads go from Alba to Lugdunum, Nemausus, and Gergovia. A Christian community grew up there in the 4th c.; it was the seat of the first five bishops, but in the 5th c. the bishopric was transferred to Viviers. At that time the city belonged to the Viennoise province.

The earliest of the principal monuments, excavated 1935-39 and from 1964 on, is a theater (65 m in diam.) built under Augustus. It could hold 5000-6000 spectators. The cavea, which is built against a hill, is edged by two parallel semicircular walls; five entrances give access from the top. Between the radiating walls piles of basalt blocks supported the seats, which have nearly all disappeared. The orchestra level was recently determined by the discovery of a number of stone slabs. The scena has mostly disappeared, but the back wall of the stage was uncovered in 1968. On the W side of the two lower entrances are some unusual semicircular abutments. Behind the scena is a large monument, not yet identified; in the Late Empire some little shops were put up against its S wall.

At the spot known as La Planchette are some small baths consisting of five adjacent rooms (apodyterium, frigidarium, two tepidaria, caldarium) with apsidal and kidney-shaped pools. A curious water system 150 m W of the theater includes a principal main, one wall of which has small openings in its upper section while the other discharges at floor level into small, steeply sloping arched channels. This arrangement made it possible to recover the infiltrating water and use it for irrigation elsewhere.

The forum has been only partly uncovered. On a slight rise 150 m NW of the theater, it is a huge esplanade 42.8 m wide, with porticos the back walls of which are decorated with alternately rectangular and semicircular exedras. The W side of the piazza is lined with shops and to the N is a large monument (temple or curia?).

In the center of the city are two houses, separated by a road running E-W. One of them has 13 rooms, seven of them with mosaics; it is set in the middle of a peristyle with an oblong pool. The cardo maximus has been located for 150 m, and one section paved with massive polygonal stone slabs has been uncovered. The sidewalks are made of the same hard limestone blocks as the curbstones. The road crosses the city N-S and runs along the W side of the forum. The forum and all other monuments excavated or located have the same orientation— Alba was laid out on a grid.

At the spot called Saint-Pierre, NW of the town, is a monument built over two others. At the bottom level is a Severan building with a portico 3.5 m wide, which has been traced for over 23 m. It has a gutter on either side, and runs around an esplanade with a large pool (10.75 x 7 m). The portico opens onto some large rooms, many of them with mosaic floors; according to two inscriptions citing the presence at Alba of four corporations associated with viticulture—the dendrophori, fabri, centonarii, and utriclarii—this may have been a building reserved for collegia, possibly a meeting-place for corporations. This monument was destroyed at the end of the 3d c. In the 4th-5th c. an Early Christian group of buildings was erected: a baptistery (?) approached by a corridor and a small courtyard, both paved; adjacent to it and reached by a long paved corridor, a central building (18 x 17 m) which has a raised presbyterium with a flat chevet (martyrium?); and N of this monument and reached by the same corridor, the cathedral with three aisles, the floor crammed with tombs. These tombs are on two levels: some are tile-covered tombs in the Roman tradition, others are Merovingian sarcophagi, nearly all made of reused material. Finally, a Romanesque chapel was added in the 12th c. over the N part of the church.

A small museum is being set up to house the mosaics, inscriptions, and other objects. Various finds are in the British Museum, the Musée Calvet at Avignon, and in private collections.

BIBLIOGRAPHY. C. Filhol, "Alba Helviorum," *Rhodania* 1243 & 1245 (1927); F. Delarbre, *Alba Augusta Helviorum* (1958); H. P. Eydoux, *Lumières sur la Gaule* (1960) 295-306; M. Leglay, "Les fouilles d'Alba Augusta Helviorum (Ardèche)," *CRAI* (1964) 401-15; id., "Autour des corporations d'Alba," *BAntFr* (1964) 140-52; id., "Informations," *Gallia* 24 (1966) 522-25; 26 (1968) 596-99; id. & S. Tourrenc, "Le forum d'Alba Augusta Helviorum," *Hommages à M. Renard* III, *Coll. Latomus* 103 (1969) 346-59[PI]; id., "Alba Augusta Helviorum: un curieux ouvrage hydraulique," *Hommage à F. Benoît* IV (1972) 131.	M. LEGLAY

ALBA IULIA, see APULUM

ALBANO LAZIALE Italy. Map 16. A town on the Via Appia that grew up in and around the camp built by Septimius Severus to house the Legio II Parthica (formed in A.D. 193) on the steep outer slope of the crater that encloses Lago d'Albano. The site seems to have been chosen to put the camp near the imperial villa built by Domitian at Castel Gandolfo; the ager albanus, sweeping in an arc from Castrimoenium to Aricia, was probably largely imperial domain by this time.

There are good remains of the fortifications, all in massive blocks of the local tufa, some stretches heavily rusticated, some very lightly if at all. The triple porta praetoria in the SW front has been excavated, and the SE front with an arched gate and a rectangular tower can be followed for nearly its whole length. Near the highest point is a cistern carved in the tufa with a capacity of 10,000 cubic m. It is divided into five aisles by four rows of nine pillars supporting vaulted roofs and is still in use without, it is said, ever having been repaired. Other adjuncts of the camp outside its walls include an aqueduct, an amphitheater, two baths, and a necropolis. A circular nymphaeum in opus mixtum listatum with figured mosaic floors inside the camp may originally have stood in the park of Domitian's villa; it has been converted into the church of S. Maria Rotonda.

In the Villa Comunale of Albano, on a ridge dominating the campagna, are extensive remains of masonry of several periods, going back as far as the Late Republic, commonly identified as ruins of the villa of Pompey, an attractive notion, since it was certainly an exceptionally fine building.

Between Albano and Castel Gandolfo lies the emissary of Lago d'Albano, a tunnel said to have been driven originally in 398-397 B.C. to keep the level of the lake constant (Livy 5.15-19). It is ca. 2 m high, 1 m broad, and 1800 m long.

Just outside Albano on the way to Aricia is the Sepolcro degli Orazi e Curiazi, a monumental tomb, much restored, with a square base surmounted by a round drum and four elongated cones at the corners. The whole is built of concrete with a tufa facing, and there is no evidence of how it continued above this point or of a burial chamber. It can hardly be pre-Augustan.

BIBLIOGRAPHY. G. B. Piranesi, *Antichità d'Albano e di Castel Gandolfo* (1762)[I]; G. Lugli, *BullComm* 45 (1917) 29-78; 46 (1918) 3-68; 47 (1919) 153-205; 48 (1920) 3-69; id., *Ausonia* 9 (1919) 211-65; 10 (1921) 210-59, pls. 4-7[MPI]; id., *NSc* (1946) 60-83; T. Ashby, *The Roman*

Campagna in Classical Times (1927) 191-94; H. W. Benario, "Albano and the Second Parthian Legion," *Archaeology* 25 (1972) 256-63. L. RICHARDSON, JR.

ALBA LONGA (Castel Gandolfo) Latium, Italy. Map 16. The most eminent city of the Latin league is now believed to have been situated here, 24 km SE of Rome. Remains have been found of villas datable to the Late Republican and the Imperial periods, including the villa of Domitian, whose peregrinations along the lake are referred to by Pliny the Younger (*Pan.* 81.82). Domitian's villa contained its own theater, and also a grotto along the coast of Lake Albano where a number of fragmentary sculptures in high relief were found in 1841. There were identifiable as a gigantic recumbent Polyphemos, a ram, a Scylla, etc., reminiscent of the sculptures found at Sperlonga. The grotto itself resembles the one at Sperlonga in that it consists of several sections: a large circular one in the middle, and several smaller ones along the sides. The Polyphemos is in the same late Hellenistic style as the similar statue from Sperlonga; and though its surface is considerably worn, the variegated modeling also seems to point to Greek workmanship, contemporary with the Pergamine Altar.

The grotto here and at Sperlonga suggest that there were in Greece—perhaps on Rhodes or at Pergamon—grottos adorned with sculptures representing the adventures of Odysseus and other Homeric heroes, which were later taken by the Romans to Italy and placed in similar settings. Such grottos with several divisions may be found along the indented coast of many Greek lands, and one of them has been immortalized in Homer's description of Odysseus' encounter with Polyphemos (*Od.* 9.190ff).

BIBLIOGRAPHY. G. Lugli, "Lo scavo fatto nel 1841 nel Ninfeo detto Bergantino sulla riva del lago Albano," *BullCom* 41 (1913) 89ff; id., "La villa di Domiziano sui colli Albani," *BullCom* 47 (1919) 153ff and 48 (1920) 3ff; id., "Una Pianta e due Ninfei di età imperiale romana," *Scritti di Storia dell'Arte in onore di Edoardo Arslan* (1966) 47ff; A. Halland, "Une transposition de la grotte de Tibère à Sperlonga: Le Ninfeo Bergantino di Castelgandolfo," *Mel. Ec. Franc. de Rome* 79 (1967) 421ff; F. Magi, "Il Polfemo di Castel Gandolfo," *RendPontAcc* 41 (1969) 69ff; K. D. Licht, *Analecta Romana Instituti Danici* 7 (1974) 37-66.

Alba Longa. T. Ashby, "Alba Longa," *JP* 27 (1901) 37ff; G. Lugli, "Albano Laziale," *NSc* (1946) 60ff; E. L. Wadsworth, "Stucco reliefs of the first and second centuries," *Memoirs Am. Ac.* 4 (1924) 49ff; *EAA* 2 (1959) 68 (F. Castagnoli). G.M.A. RICHTER

ALBA POMPEIA (Alba) Liguria, Italy. Map 14. A city on the right bank of the Tanaro river, NE of Pollentia in the Augustan Regio IX. In inscriptions, in the *Peutinger Table*, and in the Latin authors, the name Pompeia is occasionally added, perhaps because Cn. Pompeius Strabo conferred Latin citizenship on the entire area across the Po river. As a municipium, the city was enrolled in the tribus Camilla and was the birthplace of the emperor Pertinax. The city may have been built on a pre-Roman settlement on either side of the road from Augusta Taurinorum to Aquae Statiellae. It had a circuit wall whose entire polygonal perimeter is known and of which some sections, replaced in the Middle Ages, are still visible on the N side. The walls, probably of the Augustan period, were constructed with a solid core faced with long bricks ca. 2.45 m thick at the base. In one section toward the Tanaro river, a system of fortified passages may have formed one of the city gates. The modern streets, which follow the ancient line and the remains of the Roman sewers (whose underground network is still extant), reveal a regular plan with crossing axis streets. The cardo corresponds to the present-day Via Vittorio Emanuele and Via Vernazza, connecting with the road to Pollentia to the W and to Aquae Statiellae and Hasta to the E. The decumanus, recognizable in the straight course of Via Cavour-Via Vida, was linked to the road to Vada Sabatia (Savona). At the junction of the major axis streets, the modern Piazza del Risorgimento occupies the area of the forum. Here, in 1839 in the Cathedral (the ancient Capitolium?), a colossal marble head of Juno was brought to light. Outside the walls, no visible monumental remains exist today. However, remains of buildings have been isolated in the basements of homes, and precious mosaic pavements have been recovered in the area of the Church of SS. Cosmas and Damian (a temple, baths?) and near the Church of San Giuseppe. On each occasion, discoveries have been made of inscriptions, sculptures, and objects coming mainly from the necropolis (the major cemetery on Via di Pollenzo) and today are maintained in the Museo Federico Eusebio of the city.

BIBLIOGRAPHY. Plin. 3.5, 17.4; Ptol. 3.1.45; *Tab. Peut; Rav. Cosm.* 4.32.

CIL v, 1, 863f, 7595; E. Ferrero, "Testa muliebre di marmo scoperta ad Alba," *ASPABA* (1875) 315ff; F. Eusebio, *Alba antica prima dell'era volgare* (1884); id., *Le mura romane di Alba Pompeia* (1906); "Sul Museo Civico di Alba e sopra alcune scoperte archeologiche del territorio albese," *ASPABA* (1897) 200ff; A. Piva, "Albensi Vagienni e Statielli," *BSPABA* (1932) 7ff; P. Barocelli, *Il Piemonte dalla capanna neolitica ai monumenti di Augusto* (1933) III, p. 37; N. Lamboglia, *Alba Pompeia e il Museo Storico Archeologico F. Eusebio* (1949); C. Carducci, *Trovamenti ad Alba,* N.S. (1950) 211ff; id., "Problemi archeologici di Alba romana," *Boll. Soc. St. Stor. Arch. Cuneo* (1969) 1ff. S. FINOCCHI

ALBE, *see* ALBA FUCENS

ALBENGA, *see* SHIPWRECKS

ALBI (Albiga?) Tarn, France. Map 23. Albi was, at least in the Late Empire, the capital of a Gallo-Roman civitas which belonged to the province of Aquitaine. No monuments survive: the only known remains are isolated, accidental finds. In the past 20 years such discoveries have led to the identification of a potter's workshop (1st c. A.D.) in the Rue de la Piaule, 2d c. cremation tombs around Saint-Salvy, and a very late inhumation cemetery 2 km S of the town. Some funeral pits from the beginning of our era were found in 1973.

BIBLIOGRAPHY. M. Labrousse, *Gallia* 13 (1955) 217 & fig. 19; 17 (1959) 441 & figs. 39-41; 20 (1962) 599; 22 (1964) 467-68; 28 (1970) 433; J. Lautier, *Bull. de la Soc. des Sciences, Arts et Belles-Lettres du Tarn* 20 (1959) 69-80. M. LABROUSSE

ALBIAS Tarn-et-Garonne, France. Map 23. Near the low hill of Sainte-Rafine, a ford allowed the Roman road from Toulouse to Cahors to cross the Aveyron. Cosa, whose name appears on the *Peutinger Table*, was a center of some importance from the time of Augustus on. A Gallic coin imitating an Ampurias drachma was found in the bed of the Aveyron. The site itself, which extended along the left bank of the river, has produced a large number of Roman coins and terra sigillata, among other finds. Some of the coins came from Italy, the pottery from Montans and La Graufesenque.

BIBLIOGRAPHY. Capitaine Nougarède, "Cosa-Hispalia," *Bull. de la Soc. arch. de Tarn-et-Garonne* 62 (1934) 77-

123 (avec les remarques critiques d'E. Espérandieu, *BCTH* [1936-37] 94-95); M. Labrousse & B. Frédefon, "Trouvailles romaines à Sainte-Rafine, commune d'Albias (Tarn-et-Garonne)," *Actes du Xº Congrès d'études de la Fédération des Soc. académiques et savantes Languedoc-Pyrénées-Gascogne (29-31 mai 1954)* 77-91; Labrousse et al., "Les découvertes de *Cosa*," *Bull. de la Soc. arch. de Tarn-et-Garonne* (1959) 31-73, figs. 1-18; Labrousse, "Imitation gauloise de drachme ampuritaine trouvée dans l'Aveyron, sur le site de *Cosa* (Tarn-et-Garonne)," *Ogam* 14 (1962) 185-93; id., réédition de Guillaume Lacoste, *Hist. générale de la province de Quercy* (1968) I xxiii.

For a review of the findings, cf. Labrousse, *Gallia* 13 (1955) 216; 15 (1957) 274; 20 (1962) 605-6 & figs. 67-68; 22 (1964) 470-71 & fig. 52; 24 (1966) 446 & fig. 39; 26 (1968) 555. M. LABROUSSE

ALBINTIMILIUM (Ventimiglia) Liguria, Italy. Map 14. A contracted form of the name of the Ligurian center Albium Intemelium, of which nothing is known, was used by the Roman city founded (2d-1st c. B.C.) on the same site between the Roia and Nervia rivers in the narrow coastal plain. The city prospered until the 5th c. A.D. Surrounded by walls with round towers wherever the wall changed direction, the city had straight, paved streets, and dry-block buildings.

Stratigraphic excavations have revealed the different phases of the development of the city through evidence gained from pottery. In the 1st c. A.D., the old Republican walls of the city were destroyed and the city was enlarged with new insulae and a new monumental paved road. To the S, the necropolis was extended and included numerous monumental tombs, enclosed and rich in funerary furnishings. Of the houses only a few of the mosaic pavements surrounding them have been uncovered. The major remaining monument is the theater, constructed during the first half of the 2d c. A.D. It was built over an angle of the Republican walls and some other buildings that had been destroyed earlier.

BIBLIOGRAPHY. P. Barocelli, "Albintimilium," *Monumenti Antichi di Liguria* 29 (1923); N. Lamboglia, *Liguria romana* 1 (1938) 90; id., *Gli scavi di A. e la cronologia della ceramica romana* I (1950); id., "Primi risultati cronologici e storico-topografici degli scavi di A.," *Riv. St. Lig.* 22 (1956) 91ff; id., *Ventimiglia romana* (1964). A. FROVA

ALBURNUS MAIOR (Roşia Montană) Alba, Romania. Map 12. An important settlement, center of gold mining in Roman Dacia Superior, in the Apuseni mountains. In the hills of Cetatea Mare and Cetatea Mică traces are preserved of ancient Roman mines.

Under Trajan Dalmatian colonists (Pirustae, Baridustae, Sardeates) settled here, each tribe dwelling in a separate village or quarter.

Fragments of inscriptions and sculpture have been found as well as mining and washing equipment. Also 25 tabulae ceratae (A.D. 131-67) with information about work in the mines, sale and purchase contracts, receipts of loans with interest, sale of slaves, etc. Finds are in the History Museum of the Socialist Republic of Romania, of Transilvania in the History Museum in Cluj, and in the Alba Iulia Regional Museum.

BIBLIOGRAPHY. C. Daicoviciu, "Les Castella Dalmatarum de Dacie. Un aspect de la colonisation et de la romanisation de la province de Dacie," *Dacia*, N.S. (1958) 2. 259-66; D. Tudor, *Oraşe, tîrguri şi sate în Dacia romană* (1968) 194-204. L. MARINESCU

ALCALÁ DE HENARES, *see* COMPLUTUM

ALCÁNTARA Cáceres, Spain. Map 19. Town on the Tajo 62 km NW of Cáceres where an immense bridge carried the Roman road from Norba to Conimbriga. The road may be traced from the Alcántara bridge to the Segura bridge over the Erjas at the Portuguese border, also built by the Romans. The Alcántara bridge, 194 m long, spans the river with six arches; it is almost perfectly symmetrical. The maximum height is 71 m, of which 14 m are the triumphal arch in the center of the bridge. This arch, disfigured by restorations of the 16th c. and earlier, bears an inscription dedicated to Trajan (*CIL* II, 759), in whose reign the bridge was built. The imperial titles are those of the year A.D. 104. The columns of the arch also bore inscriptions, now lost, listing the municipalities which paid for the bridge (*CIL* II, 760). At the S side is a small shrine on the pediment of which is another inscription of Trajan (*CIL* II, 761) giving the name of the architect of the viaduct, C. Iulius Lacer.

BIBLIOGRAPHY. P. Gazzola, *Ponti romani* (1963) 133-34; C. Fernández Casado, *Historia del puente en España* (1962) fasc. 560-69; J. R. Mélida, *Catálogo Monumental de España. Provincia de Cáceres* I (1924) 118-38.
 L. G. IGLESIAS

ALCHESTER Oxfordshire, England. Map 24. A Roman walled town 17 km NE of Oxford at the point where the Roman Akeman Street was joined by a branch road from Watling Street. The area bounded by defenses, ca. 10 ha, is almost square. The earliest defenses consisted of a gravel rampart and one or more ditches; later, a stone wall was added to the rampart. The dating of these two phases is obscure. Circular mounds are still visible at the NE and SE angles and partial excavation of that at the NE corner has demonstrated that these were external towers. Their plan remains uncertain. Part of what appeared to be an internal turret was also partially excavated.

The buildings of Alchester have not been thoroughly excavated. The planning of streets approaches a rectangular grid, uncommon in the smaller Romano-British towns. Along the main street, air photography has revealed the presence of numbers of narrow, rectangular strip buildings. Near the center of the town lay a building with a central court, surrounded by a portico on three sides. Outside the W defenses, excavation in 1766 of what was then a prominent mound known as the Castle uncovered a sizable bath.

Iron Age settlement is attested close to the later Roman town, and Roman occupation of the site began in the Claudian period, possibly in the form of a fort. After the 5th c. A.D. the place was deserted.

BIBLIOGRAPHY. *Archaeologia Oxoniensis* 1 (1892) 34; *AntJ* 7 (1927) 154; 9 (1929) 105; 12 (1932) 35; *VCH Oxfordshire* 1 (1939) 281. M. TODD

ALCONÉTAR Cáceres, Spain. Map 19. Deserted site at the confluence of the Tajo and Almonte rivers, where the Roman road from Augusta Emerita to Asturica Augusta crossed the Tajo over a bridge 290 m long. Several piers and arches survive, two sets of which have been reconstructed. In the vicinity is the Turmulos mansio of the *Antonine Itinerary* 433.5. Ruins of a Roman castrum and parts of a wall of granite blocks have been found, and an Early Christian basilica of the 5th or 6th c., built on the ruins of an earlier villa. The site is now flooded.

BIBLIOGRAPHY. J. R. Mélida, *Catálogo Monumental de España. Provincia de Cáceres* (1924) I, 139-44I; C. Callejo, *La arqueología de Alconétar* (1963); P. Gazzola, *Ponti romani* (1963) 135-36; L. Caballero, "Al-

conétar," *Excavaciones Arqueológicas en España* 70 (1970)[MPI]. L. G. IGLESIAS

ALCUDIA DE POLLENSA, *see* POLLENTIA

ALDBOROUGH, *see* ISORBRIGANTIUM

ALEBAECE REIORUM APOLLINARIUM (Riez) Alpes de Haute-Provence, France. Map 23. Capital of the tribe of the Reii, whose territory extended from the middle Durance to the Verdon gorges, the Celto-Ligurian oppidum of Alebaece was probably on the hill of Saint-Maxime, which rises above the modern town. The Roman town (Plin. *HN* 3.36) founded under Augustus, whose official name is revealed by inscriptions to have been Colonia Julia Augusta Apollinaris Reiorum, lay for the most part in the small plain at the juncture of three valleys.

Situated at the E extremity of the Provincia Narbonensis and next to the Alpes Maritimae, it was a crossroads of secondary highways. Located as it was, however, away from the great transalpine highways and in the center of the S Alps, the town was above all an administrative and religious center whose role has been made increasingly clear by explorations since 1963. The wide-ranging activity of its first bishops, Maximus (434-460) and Faustus (461-493), both former abbots of Lérins, made it an important center of Christianity under the Late Empire; it was the meeting-place for a famous council (439).

The extent of the site (at least 15 ha) has been established with relative precision. The remains of a temple, bath house, residential quarter, and an Early Christian cathedral complex have been uncovered, and the ground plan of the city appears to have been regular and oriented towards the four cardinal points. In the Late Empire, a wall (no longer visible) surrounded the town. Of the tetrastyle temple of large-block construction, only the E facade remains, along with part of the podium. It is uncertain to whom it was dedicated; it may have been a municipal monument to Rome and Augustus, or, more likely, the main unit of a sanctuary of Apollo, for the surname Apollinaris borne by the site suggests that the cult of the healing god was important in the town. Support for this hypothesis comes from the fact that there is a large spring near the temple, and an inscription to Aesculapius was discovered there in the 17th c.

In another sector of the town, at Pré de Foire, recent explorations have revealed the remains of large and complex public baths, as well as a group of expensive private houses arranged one above the other on the S side of the valley of the Colostre and served by a network of alleys.

The cathedral complex, one of the few of Narbonese Gaul, dates from the 5th c. or earlier. It was built in the S half of the city on top of public buildings from the Early Empire which were probably destroyed at the end of the 3d c. along with the other buildings in this sector. The baptistery, which still rises to its full height though restored and remodeled, was constructed with reused Roman materials on the site of a former bath house. To the E of the baptistery, and on its axis, was the original cathedral, Notre-Dame du Siège, which was completely destroyed at the end of the 16th c. This basilica, which stood in a large monumental complex, consisted of a nave and two side aisles separated by rows of reused Roman columns, and a deep semicircular apse.

The objects discovered are preserved on the site in the Archaeological Museum.

BIBLIOGRAPHY. J. J. M. Féraud, *Histoire de la ville de Riez* (1885); M. Provence, *Catalogue du Musée Lapi-daire de Riez* (1932)[I]; H. Leclerc, "Riez," *Dictionnaire d'Archéologie Chrétienne et de Liturgie* 14,2 (1948) cols. 2423-26; P. A. Février, "Riez," *Villes épiscopales de Provence* (1954) 39-43; id., *Le développement urbain en Provence de l'époque romaine à la fin du XIVe siècle* (1964)[I]; G. Barruol, "Un centre administratif et religieux des Alpes du Sud: Riez," *Archéologia* 21 (1968) 20-27[MI]; id., *Les peuples préromains du sud-est de la Gaule. Etude de géographie historique* (1969) 218-20; "Informations," *Gallia* 14 (1956) 55-63; 20 (1962) 661-63; 22 (1964) 554-55[I]; 25 (1967) 392-95[PI]; 28 (1970) 448-51[I]; 30 (1972) 533-34[I]. G. BARRUOL

ALEPPO, *see* BEROEA

ALERIA, *see* ALALIA

ALESIA (Alise-Ste-Reine) Côte d'Or, France. Map 23. An oppidum of a Gallic tribe, the Mandubii, situated 260 km SE of Paris and 65 km NW of Dijon. Here Caesar besieged Vercingetorix in 52 B.C.; a large Gallic army tried in vain to raise the siege and Vercingetorix was forced to surrender. This is the most famous episode of the Gallic Wars, thanks to Caesar's account of it (*BGall.* 7.68-90).

Thereafter as a small Gallo-Roman town Alesia prospered in the 1st and 2d c. A.D., owing largely to its craftsmen working in bronze, silver, and iron (Plin. *HN* 34.162). Completely destroyed towards the end of the 2d c., the city was rebuilt, perhaps after being abandoned for a few years. It was Christian from the 3d c. on, and disappeared gradually in the Late Empire.

The oppidum occupied the plateau (2 km x 800 m maximum), on top of Mont Auxois (Mons Alisiensis). Its natural defenses were formidable: rising between the valleys of the Oze and the Ozerain, the slopes were topped by a steep limestone cliff; only the W and E ends (La Pointe and La Croix-St-Charles) required artificial defenses (at La Pointe there are traces of a dry stone wall). There is a water-bearing stratum on the plateau (Croix-St-Charles springs) and some tributary springs at the foot of the cliff, outside the oppidum but beyond the range of the Roman projectiles. Moreover, Mont Auxois is ringed with hills of the same height (Montagne de Flavigny, Mont Pennevelle, Montagne de Bussy, Mont Réa), except to the W where the plain of Les Laumes begins (3000 Roman feet long).

Caesar's siege-works are known from his account, from excavations (1861-65 by order of Emperor Napoleon III), and from some recent digs. The arms and coins found in 1861-65 are in the Musée des Antiquités Nationales at St-Germain-en-Laye; on the site itself can be seen casts of weapons, the outline of some of the Roman trenches.

The Gallo-Roman city was also on the summit of Mont Auxois. The forum and the area around it are the chief elements that have been excavated. A large architectural complex has been uncovered (mid 2d c. A.D.) including a basilica with three apses and a portico surrounding an earlier temple, some houses with shops opening under colonnades in front of them, a theater (end of 1st c. A.D.) with a cavea of more than a semicircle, and a house that probably was the corporate headquarters of the bronze- and silver-workers, who also worked extensively in iron. The principal streets, oriented E-W by the lay of the land, were frequently lined with galleries of shops. At Croix-St-Charles there was a large sanctuary built around a healing spring, with baths dedicated to Apollo Moritasgus. The houses, built around a central courtyard on no regular plan, often had one room heated by hypocaust and always had a basement with one or

more niches, which served as a sanctuary for domestic cults rather than as a cellar. Objects found on the site are in the two museums in the village of Alise: like the monuments, they reflect a mixed civilization, at once Gallic and Roman, in which the Gallic tradition was for a long time the dominant influence, especially as to religion.

The Gallic oppidum seems to have been simply a fortress-refuge; not until the early stages of the Roman occupation did a sizable population live there permanently, and the huts of dry stone and mud were replaced by masonry buildings during the 1st c.

In Frankish times only a church and a cemetery stood on the site. In a Gallo-Roman well at Alesia a eucharistic service was found, made of lead and identified by a chrism bearing several graffiti with the name Regina. The service dates from the 4th c. A.D. and is one of the earliest pieces of archaeological evidence for the cult of a saint in Gaul.

BIBLIOGRAPHY. The siege: Napoleon III, *Histoire de Jules César* (1866-67)[MPI]; Joly, *Plan du siège d'Alesia* (1966)[M]; id., *Guide du siège d'Alesia* (1966)[MPI]; J. Harmand, *Une campagne césarienne: Alesia* (1967).

The siege and the city: *Revue Pro Alesia* (1906-32); J. Le Gall, *Alesia, archéologie et histoire* (1963)[MPI]; Conference, Dijon, "Connaissance d'Alesia" (1966).

J. LE GALL

ALETIUM (Alezio) Apulia, Italy. Map 14. This ancient Messapian center was mentioned by Pliny (*HN* 3.105) and Ptolemy (3.1). Its position is clearly indicated in the name of the ancient church of S. Maria della Lizza, around which the mediaeval settlement called Picciotti grew up, and from which the modern town retook the ancient name. The flourishing economic life of Aletium was associated, especially around the 4th c. B.C., with its proximity to Kallipolis (Gallipoli) ca. 7 km away. There is evidence of the ancient city in the modern town, on the outskirts of which tombs with Messapian inscriptions frequently appear. Several tombs have been reconstructed in an archaeological park. Messapian inscriptions are to be found in the Municipal Library at Alezio and in the Castromediano Museum at Lecce.

BIBLIOGRAPHY. W. Smith, *Dictionary of Greek and Roman Geography*, I (1856) 95 (E. H. Bunbury); *RE* I.2 (1894) 1371 (Hülsen); O. Parlangeli, *Studi Messapici* (1960) 202. F. G. LO PORTO

ALETO (St. Servan sur Mer) Ille et Vilaine, France. Map 23. The ancient city was set on a granite promontory overlooking the English Channel and linked to the mainland by a narrow isthmus. It was probably occupied from the Gallic period on, and is mentioned in the 5th c. A.D. as the seat of a garrison responsible for defending a section of the Armorican shoreline. Towards the end of the 3d c. A.D. the city acquired a strong circuit wall; only a small section of it remains today, on the cliff edge opposite the modern port of St. Malo. Recent excavations have uncovered the base of this wall for some 20 m, as well as three curious semicircular structures that were an integral part of the defense system.

The rock underlying the rampart had been hewn (deep perpendicular notches and small square basins) to accommodate the walls of a small religious building. The same method of working the rock was used in a cove W of Aleto, where a series of rectangular ditches cut in the rock was recently found. One of these ditches contained a large wooden machine construction of undetermined purpose.

BIBLIOGRAPHY. A. Dos, "Cinq campagnes de fouilles archéologiques à la Cité d'Aleth à St Servan sur Mer," *Annales de Bretagne* 76, 1 (1969). M. PETIT

ALETRIUM (Alatri) Italy. Map 16. On a lofty hill in olive-growing country, about 72 km E-SE of Rome. It controls the valley of the river Cosa. A town of the Hernici, Aletrium dates perhaps from the 6th c. B.C. From the 4th c. B.C. on, it was a loyal ally of Rome. In 90 B.C. it acquired Roman citizenship and became a municipium but is rarely mentioned in ancient literature. It has always been a considerable town.

Its massive walls, the finest and most remarkable example of polygonal construction in Italy, are its principal monument. They are built of large blocks of limestone, which are sometimes over 3 m long and over 2 m high: the irregularly shaped blocks are fitted tightly together without cement and their faces have been smoothed. The walls are in two circuits, usually thought to be contemporaneous: they may belong to the 4th c. B.C., but some scholars date them as late as the 2d or even the 1st c. B.C. Both circuits can be traced in their entirety.

The first circuit, which is mingled with mediaeval fortifications, surrounds the town as a whole. Elliptical in shape, it extends for ca. 4 km. Impressive sections of it, over 3 m high in places, can be seen in the N quarter of the town between the Porta S. Francesco and the Porta S. Pietro. Both these gates are ancient and were originally double, their two faces separated by small courts. Some of the polygonal blocks have apotropaic figures carved on them in bas relief, but these are badly weathered.

The second circuit, much shorter but far more impressive, is trapezoidal and extends for more than 600 m around the citadel at the town summit. These walls, except for a short stretch on the N, are almost perfectly preserved and free of later accretions; and they are now easily accessible, since a peripheral road (Via Gregoriana) was built at the foot of them in 1843. Their height varies according to the slope of the ground. At the SE angle they rise to ca. 17 m in 14 interlocked courses. Near the same angle, in the S wall, is the main entrance (Porta di Civita) by which one ascends through the thickness of the wall along an inclined ramp and up some steps to the citadel above: the actual gate (2.75 x 4.50 m) has for its lintel an enormous horizontal monolith. A smaller gate (Grotta del Seminario) pierces the NW wall of the citadel in the same way; its lintel also is horizontal and huge and, although smaller than its mate, weighs several tons: it is adorned with three much damaged apotropaic phalli in bas relief.

Antiquities are housed in the Museo Civico (Palazzo Casegrandi). The notable collection of Latin inscriptions includes one which reveals that ca. 100 B.C. the local grandee L. Betilienus Varus brought an aqueduct into Aletrium from the S. Agnello springs, some 16 km to the N above Guarcino: conspicuous remains of it are visible near the confluence of the river Cosa and the Fosso del Purpuro.

A small temple of the so-called Etrusco-Italic type was excavated on the N outskirts of Alatri in the late 19th c., and a full-scale, if somewhat fanciful, reconstruction of it was erected in the garden of the Museo Nazionale di Villa Giulia in Rome, where it can still be seen.

BIBLIOGRAPHY. H. Winnefeld, "Antichità di Alatri" in *Mitteil. deut. arch. Inst., Röm. Abt.* 4 (1889), 126-52, pls. V, VI[MPI]; M. E. Blake, *Ancient Roman Construction in Italy* (1947) 97f; G. Lugli, *La Tecnica Edilizia Romana* (1957) 131-34, pls. VII, XXI; L. Gasperini, *Aletrium I* (1965). E. T. SALMON

ALEXANDRIA Egypt. Map 5. A harbor city at the NW corner of the Nile Delta. Founded by Alexander the Great in 332-331 B.C., it became the first known city in history to bear the name of the founder rather than of a god or mythological hero. The plan of the city is credited to Deinokrates, the Macedonian architect of the

new Temple of Artemis at Ephesos. By the construction of the Heptastadion, a mole to bridge the distance of 1500 m, between the Island of Pharos (long known to the Greeks, Hom. *Od.* 4.351ff), and the frontier settlement Ra-kedet (Strab. 17.1.6; Plin. *HN* 5.10.62), on the extreme W end of the narrow rocky isthmus between Lake Mareotis and the Mediterranean Sea, two harbors were formed and consequently the boundaries of the new city were determined.

On leaving Egypt, Alexander appointed Kleomenes, a Greek from Naukratis, as financial administrator of Egypt, responsible for building the new city and settling it. Settlement was accomplished largely by transferring the citizens of Canôpus, NE of Alexandria (Hdt. 2.15. 97). The first recorded public building, the Hephaisteion, dates from this period. This mortuary monument was built by Kleomenes at the command of Alexander in memory of a Macedonian captain who had died in 324 B.C. On the death of Alexander in 323, Egypt was entrusted to Ptolemy, son of Lagos. He had the body of Alexander buried in Memphis until a suitable tomb could be built for him in Alexandria. Meanwhile, fearing a rival in Kleomenes, Ptolemy had him assassinated and confiscated his wealth, amounting to 8000 talents in gold. Such a large sum undoubtedly launched Ptolemy into the realization of his ambition to become absolute ruler of Egypt. In 304 B.C., he was crowned king of Egypt, founding a dynasty that lasted until 30 B.C. Early in that period, the founding of the Library and the Mouseion marked the advance of scholarship and arts in Alexandria. Three new cults were instituted, the cult of Alexander the Great, the cult of the Ptolemies, and the cult of Serapis, enriching the capital with numerous sacred buildings. The last recorded temple from the Ptolemaic period was the Caesarion, which Cleopatra began to erect for Antony in 34 B.C. It was later completed by Augustus and renamed the Sebasteion. The two obelisks that Augustus had transferred from Heliopolis to be set in the enclosure of his temple (Plin. 5.6.10), remained until the end of the 19th c. on the site now occupied by the Metropole Hotel in Ramleh Station. One obelisk is now in New York and the other in London. The Caesarion marks the end of the Ptolemaic period and the beginning of a regime that imposed the cult of the Roman emperors.

Fortunately, we have a gratifying list of the edifices of the city at this point of its history: Strabo, who visited Egypt ca. 25 B.C., saw the Pharos (the lighthouse of Alexandria), the two harbors, the palaces, the Mouseion, the two libraries, the theater, the Caesarion, and the Timonium (Plut. *Ant.* 69). He also visited the gymnasion, the dikasterion, the stadion, the Paneion, a magnificent park, the Serapeon, and admired the necropolis with its gardens. Augustus enlarged the city by planning a new suburb to the E of the ancient city, which he called Nikopolis to commemorate his victory over Antony. Although Rome was the capital of the Empire, Alexandria was still able to exert some influence on the formation of its major policies. It was at Alexandria, for example, that Vespasian had himself proclaimed emperor in A.D. 69, and after him a long train of emperors visited Alexandria. Hadrian (117-38) restored peace to the city when it was threatened by rioting Jews. The decline of the city started with Caracalla (211-17), who when mocked by the citizens massacred a great number of its youth. Aurelian (272) destroyed the royal quarter to avenge an attempt at independence made by the city after his defeat of Zenobia, Queen of Palmyra. In 294-95 when Diocletian took possession of the rebellious city after nine months, he ordered an even more terrible massacre and destruction.

According to tradition, Christianity was introduced into Alexandria in A.D. 60. The Alexandrian Christian school produced such eminent thinkers as Clement, Origen, and Athenaius. Under the Byzantine emperor Theodosius (379-95), the Patriarch Theophilus was instrumental in abolishing paganism, and to this time dates the destruction of all pagan monuments, temples, statues, and even books. After the Persian invasion, the city was restored to the Empire by Heraclius. In 641 the Arab conquest brought to an end a millennium of Graeco-Roman Alexandria.

Cisterns. The drinking water used by the city was stored in underground cisterns, connected to the main canal by tunnels. Isolated cisterns were fed by rain or through wells that were connected with the nearest underground canal. Mahmoud El-Falaki (1860) knew of 700 such cisterns. The Nabih cistern in the E part of Elshahid Salah Moustapha Street is in very good condition and seems to have been used through the Byzantine period.

City Walls. According to Mahmoud El-Falaki (1860), the city was 5090 m in length and ranged from 1150 to 2250 m in width. The wall that surrounded it was 15,800 m long. The remains of wall to be seen in the neighborhood of the "Flower Clock" on Nasser Road dates from the Arab period.

Library. Founded by Ptolemy I to serve the Museion, it was greatly enlarged by Ptolemy II. By the 1st c. B.C. it contained 700,000 items. The scholars in charge of the Library are listed in the Oxyrhynchus Papyrus (10.1241). It is not known exactly where in the royal quarter the Library stood.

Mouseion. According to Strabo (17.1.8), it occupied part of the palace of the Ptolemies. Here gathered scholars, artists, men of letters, among them Euclid the mathematician, Aristarchos the astronomer, Eratosthenes the mathematician and geographer, the poets Theokritos and Kallimachos, and the painter Apelles. Ptolemy I is credited with founding it at the suggestion, according to some authorities, of Demetrios of Phaleron, who came to Alexandria in exile in 307 B.C.

Necropoleis. Apart from the tombs of Alexander and the Ptolemies, Strabo (17.1.10) mentions only one necropolis. It lay to the W of the city. Excavations, however, have yielded a number of necropoleis in all parts of the city. The best known is the Catacomb of Kom-el-Shugafa, a short distance SW of the Serapeon. Its three stories are carved out of living rock. A spiral staircase leads to the triclinium on the first story. On the second story, the main burial chamber was decorated with a mixture of Egyptian, Greek, and Roman themes and styles. At Wardian is the Catacomb of Mex, distinguished by the first appearance of niche halls for burial and a complete peristyle court surrounded by rooms. Between the two catacombs many rock-cut tombs were discovered when the new dykes on the W harbor were being built. One of these was decorated with a landscape depicting a waterwheel. At Anfushy, between the E and W harbors, are a group of earlier tombs: a staircase leads down to a rectangular open court with two burials. One of the tombs was twice decorated in the Greek First Style; later, in Egyptian style. Some idea of the palaces and houses of ancient Alexandria may be derived from the plans of the tombs of Shatby and Moustapha Pasha. Each tomb consists of a peristyle court with side chambers decorated in the incrustation style. The one at Moustapha Pasha, comfortably arranged as a family meeting place on the required occasions, even had water piped into the tomb from its own well.

The tombs in Hadara, SE of the ancient city, now abolished as a result of modern construction, have

yielded statues, mosaics, vases, sculptured terracotta, sarcophagi, and most notably the Tanagra figurines. The Alexandrian Hellenistic style is clearly illustrated by these finds. In the same quarter, within the enclosure walls of the Roman necropolis, is a very fine tomb chamber of alabaster. Because of its location, right in the SE part of the old city, it has been called the Tomb of Alexander, the site of which has never actually been identified.

Pharos. The lighthouse of Alexandria (Strab. 17.1.6), bears the name of the island on which it was erected. It was planned by Ptolemy I Soter and inaugurated by Ptolemy II Philadelphos. According to Strabo, who read the dedication at the base of the tower, its architect was Sostratos, son of Dexiphanes of Knidos, who dedicated it to the Savior Gods on behalf of navigators. Its place is occupied at present by the Fort of Kait Bey, which was built in the 15th c. by the Sultan of that name.

Pompey's pillar. The Column of Diocletian, on a rocky hill SW of Ramleh Station. It was the only relic known from Graeco-Roman Alexandria until the discovery of the Theater of Kom-El-Dikka in 1960. According to the Greek inscription on the W side of its base, the column was erected in A.D. 297 to honor Diocletian. The total height of the column, including the base and the capital, is 26.85 m; the shaft, monolithic granite, measures 20.75 m and has a diameter of 2.7 m at the base and 2.3 m at the top. Reused blocks form the substructure: the one to the W bears the name of Seti I, the one to the E bears an inscription in honor of queen Arsinoë Philadelphos carved on the green porphyry base of a statue that an Alexandrian—Thestor, son of Satyros—had erected to the sister and wife of Ptolemy II.

Theater of Kom-el-Dikka. A marble structure discovered in 1960 to the NW of the Alexandria railway station under a hill of accumulated rubbish. The auditorium contains twelve rows numbered according to the Greek alphabet. Coins found under the seats date from the time of Constantine II (337-61). The reused marble blocks, to judge from their architectural decorations, belong to the 2d c. B.C. Like many other edifices in Alexandria, the theater was converted into a church.

Serapeion. Excavations at the site of the Column of Diocletian in 1944 yielded the foundation deposits of the Temple of Serapis. These are two sets of ten plaques, one set found in a hollow 77 m, the length of the W side of the temple, from the other set. Each set contains one plaque of gold, one of silver, one of bronze, one of faïence, one of the Nile mud, and five of opaque glass. They are all inscribed both in Greek and in Egyptian hieroglyphs, with the statement that Ptolemy III Euergetes (246-221 B.C.) built the Serapeion. The foundation deposits of a temple dedicated to Harpokrates from the reign of Ptolemy IV were also found within the enclosure walls at the NE side of the Serapeion. We have detailed descriptions of the Serapeion, but nothing has been left above the ground to attest them. Parmaniskos was assigned as architect. The sub galleries under the temple were most probably designed for the mysteries of Serapis. The black granite (diorite) statue representing Serapis incarnated in the Apis bull, holding the sundisk between his two horns decorated with the Uraeus, was found here in 1895. The inscription on the small column supporting the bull indicates that it was made in the reign of Hadrian (117-38). Lying at the E side of the Serapeion at the foot of the hill is a colossal red granite statue of the goddess Isis, which was rescued from the sea near the island of Pharos.

The Graeco-Roman Museum preserves many of the finds from the sites discussed above.

BIBLIOGRAPHY. E. Breccia, *Alexandria ad Aegyptum* (1922)MPI; E. M. Forster, *A History and a Guide* (1930 paperback, 1961)P; P. M. Fraser, "Two Studies on the Cult of Sarapis in the Hellenistic World," *Opuscula Atheniensia* 3 (1960) 1-54; A. Adriani, *Repertorio d'Arte dell'Egitto Greco-Romano*MPI; K. Michalowski, *Aegypten* (1968) 489-93MPI; J. Marlowe, *The Golden Age of Alexandria* (1971)MP; W. Helck & E. Otto, *Lexikon der Äegyptologie* I, 1 (1972) 134-35; S. Shenouda, "Alexandria University Excavations on the Cricket Playgrounds in Alexandria," *Opusc. Rom.* IX.23 (1973) 173-205. S. SHENOUDA

ALEXANDRIA-AD-CAUCASUM, *see* ALEXANDRIAN FOUNDATIONS, 5

ALEXANDRIA AD ISSUM (Iskenderun) Turkey. Map 6. City of Cilicia Campestris on a narrow coastal plain at the SE corner of the gulf of Issus, controlling the N end of the road from Antioch as it emerged from the Syrian Gates. It was founded either by Alexander or, more probably, by Seleucus Nicator, and lasted through the Hellenistic and Roman periods. Insignificant remains have been noted, particularly a little inland of the modern city at the foot of a hill (fragments of mosaic, cisterns) beside a cemetery called Nosairis.

BIBLIOGRAPHY. F. Beaufort, *Karamania* (1818) 286; R. Heberdey & A. Wilhelm, *Reisen in Kilikien, Denkschr-Wien* 44 (1896) 19M; R. Dussaud, *Topographie Historique de la Syrie Antique et Médiévale* (1927) 446f; H. Seyrig, "Cachets Publics des Villes de la Syrie," *MélStJ* 23 (1940) 96; L. Jalabert & R. Moutarde, *Inscriptions Grècques et Latines de la Syrie* (1950) 394f.
 T. S. MAC KAY

ALEXANDRIA-AD-TANAIS, *see* ALEXANDRIAN FOUNDATIONS, 6

ALEXANDRIA APUD ORITAS, *see* ALEXANDRIAN FOUNDATIONS, 11

ALEXANDRIA ESCHATE, *see* ALEXANDRIAN FOUNDATIONS, 6

ALEXANDRIA (Herat), *see* ALEXANDRIAN FOUNDATIONS, 2

ALEXANDRIA-IN-ARACHOSIA, *see* ALEXANDRIAN FOUNDATIONS, 3

ALEXANDRIA MARGIANA, *see* ALEXANDRIAN FOUNDATIONS, 8

ALEXANDRIA NEAR GHAZNI, *see* ALEXANDRIAN FOUNDATIONS, 4

ALEXANDRIA NEAR GULASHKIRD, *see* ALEXANDRIAN FOUNDATIONS, 13

ALEXANDRIA NEAR MASHKID, *see* ALEXANDRIAN FOUNDATIONS, 12

ALEXANDRIA, NEAR MULTAN, *see* ALEXANDRIAN FOUNDATIONS, 9

ALEXANDRIA OF MYGDONIA, *see* ALEXANDRIAN FOUNDATIONS, 1

ALEXANDRIA *or* PATALA, *see* ALEXANDRIAN FOUNDATIONS, 10

ALEXANDRIA OXIANA, *see* ALEXANDRIAN FOUNDATIONS, 7

ALEXANDRIA TROAS Anatolia. Map 7. City on a lagoon of the Aegean coast opposite Bozcaada (Tenedos). Built by Antigonos in 310 B.C., it was called Antigonia until Lysimachos changed its name to Alexandria. Although Strabo barely mentions the city, it must have developed rapidly in the days of Lysimachos and was under Roman domination under the reign of Antiochos. It was reconstructed through the efforts of Augustus, Hadrian, and Herodes Atticus. Later it came under Byzantine rule. In the 17th c. its ruins supplied columns for buildings in Istanbul.

A rectangular fortification wall (2500 x 1700 m) enclosed the harbor, which was suitable for shipbuilding as well as for shelter. No trace remains of the aqueduct built by Herodes Atticus at great expense. It has been suggested that the bath be dated to the time of Herodes Atticus because of the resemblance of its architectural decoration to that of his odeion in Athens. Of the theater only the cavea is visible. The small Doric temple, the stadium, agora, and gymnasium, all known to have existed can no longer be seen.

BIBLIOGRAPHY. R. Koldewey, "Das Bad von Alexandria Troas," *AthMitt* 9 (1884); W. Leaf, *Strabo and the Troad* (1923). C. BAYBURTLUOĞLU

ALEXANDRIAN FOUNDATIONS Iraq, Iran, Afghanistan, Soviet Central Asia, India. In his course across Asia Alexander the Great founded numerous towns: the present concern is with those established E of the Tigris between 331 and 325 B.C. In the listing below the order follows the course of Alexander to the E, then S along the rivers of India, and W on his return route. The primary sources either refer to these towns as Alexandrias, or provide other, specific names. Later Classical writers applied descriptive terminologies to those named for Alexander. These towns were at sites of strategic and commercial importance, and the practice was to draw upon local Greek populations, which were already relatively numerous under Achaemenid rule, as well as Greek mercenaries who had served the Achaemenid empire and Macedonian troops. Some of these towns probably had very brief lives, others prospered and served as conveyors of Hellenistic art and culture in remote regions.

BIBLIOGRAPHY. Route of Alexander and the founding of his towns: C. A. Robinson, Jr., *The Ephemerides of Alexander's Expedition* (1932); P. Jouguet, *L'Impérialisme Macédonien et l'Hellénisation de l'Orient* (1937) 37-62; P. Sykes, *A History of Persia* I (1958) 255-78; G. Woodcock, *The Greeks in India* (1966) 27-41. These sources are not repeated in bibliographies below, where references have been largely restricted to Classical writers.

1) *Alexandria* or Alexandria of Mygdonia (Erbil) Map 5. Iraq. Founded in 331, probably in the area of Arbela, the site of a battle between the forces of Alexander and Darius III. Arbela lies SW of the Greater Zab river, a tributary of the Tigris.

BIBLIOGRAPHY. Plin. 6.26; L. Dillemann, *Haute Mesopotamie orientale et pays adjacents . . .* (1962) 160; *The Middle East. Lebanon-Syria-Jordan-Iraq-Iran,* Hachette World Guides (1966) 702.

2) *Alexandria* (Herat) Afghanistan. Map 5. Founded in 330, at Artacoana, capital of the province of that name at, or near, Herat on the Hari river.

BIBLIOGRAPHY. Plin. 6.21; Isodore Charax 15; Strab. 11.8.9; 10.1; Amm. Marc. 23.6.69.

Prophthasia Afghanistan. Earlier capital of Sistan; in 330 made into a Greek colony by Alexander.

BIBLIOGRAPHY. Strab. 11.8.8; Sykes, *History of Persia* 303.

3) *Alexandria* or Alexandria-in-Arachosia, or Alexandropolis (Qandahar) Afghanistan. Map 5. Founded in the spring of 329 at or near Qandahar; the name is a corruption of Alexander.

BIBLIOGRAPHY. Isodore Charax 19; Woodcock, *Greeks in India* 27, 111.

4) *Alexandria* Afghanistan. Map 5. Founded in 329 near the modern town of Ghazni.

BIBLIOGRAPHY. Woodcock, *Greeks in India* 27, 111.

5) *Alexandria* or Alexandria-ad-Caucasum, Afghanistan. Map 5. Founded in 329 on the Kabul river; it may be present-day Jebal Seraj. It was S of the Parapamisus range (Hindu Kush), which the Macedonians mistakenly called the Caucasus.

BIBLIOGRAPHY. Arr. 3.28.4; Curtius 7.3.23; Woodcock, *Greeks in India* 27, 28, 31, 86, 87, 96, 105.

6) *Alexandria* or Alexandria Eschate, or Alexandria-ad-Tanais, Soviet Central Asia. Map 5. Founded in 329 on the Jaxartes river, near present-day Khojand. Alexander spent 20 days supervising the building of the walls of the town, which measured 60 stadia. There he settled people of the region, Greek mercenaries and some Macedonian troops who were past fighting. Later, the town was rebuilt by Antiochos I.

BIBLIOGRAPHY. Arr. 4.1.3; 4.1; 22.5; Curtius 7.6.13, 25-26; Plin. 6.49; Frye, *The Heritage of Persia* (1963) 131; Sykes, *History of Persia* 268.

7) *Alexandria* or Alexandria Oxiana, Afghanistan. Map 5. Founded in 328 on the Oxus, possibly near the present village of Nakhshab.

BIBLIOGRAPHY. Ptol. 6.12.6.

8) *Alexandria* or Alexandria Margiana, Soviet Central Asia. Map 5. Six towns were said to have been founded in 328 in this region, later known as the oasis of Merv, or Marv, but only this one is precisely recorded.

BIBLIOGRAPHY. Curtius 7.10.15; Isodore Charax 14; Strab. 11.516.

Nikaia (Jalalabad) Afghanistan. Map 5. Founded in 327 at or near Jalalabad.

BIBLIOGRAPHY. Arr. 5.19.4; Justin 12.8.8; Woodcock, *Greeks in India* 31, 111; Sykes, *History of Persia* 270.

Nikaia India. Map 5. Founded in 326 and named after the victory over the Indians under Porus which took place nearby. On the W bank of the Jhelum, possibly at, or near, present-day Mong.

BIBLIOGRAPHY. Arr. 5.19.4; Curtius 9.1.6; 3.23; Woodcock, *Greeks in India* 111.

Buchephala India. Map 5. Founded in 326 and named after his steed Buchephalos, which succumbed to old age at this spot. It was on the E bank of the Jhelum, just across from Nikaia, and possibly at, or near, modern Jelalpur. It maintained an active existence at least through the 1st c. A.D.

BIBLIOGRAPHY. Arr. 5.19.4; Curtius 9.1.6; 3.23; Woodcock, *Greeks in India* 35, 39, 110, 111; Sykes, *History of Persia* 273.

9) *Alexandria* India. Map 5. Founded in 325 at the junction of the Akesines (modern Chenab) and Indus rivers. Alexander hoped that it would become great and famous in the world. Possibly the site is near modern Multan.

BIBLIOGRAPHY. Arr. 6.15.2; Curtius 9.8.8; Woodcock, *Greeks in India* 39, 111.

10) *Alexandria* or Patala, India. Map 5. In 325 a Greek city was founded beside the old Indian town of Patala, which lay at the mouth of the Indus, much farther inland than it is today.

BIBLIOGRAPHY. Woodcock, *Greeks in India* 40.

11) *Alexandria* or Alexandria apud Oritas, India. Map 5. In 325 Alexander arrived at the village of Rambacia, and left Hephaestion behind to found a city there. The capital of a people called Oritus, it lay in a desolate region W of the Indus river.

BIBLIOGRAPHY. Arr. 6.21.5.

12) *Alexandria* Iran. Map 5. Founded in 325 in the land of the Fish Eaters, the region later called Makran, with its site possibly near present-day Mashkid.

BIBLIOGRAPHY. E. R. Bevan, *The House of Seleucus* I (1902) 273.

13) *Alexandria* Iran. Map 5. Founded in 325 at the place where his admiral Nearchus came up from the Persian Gulf to join him. The site is N of modern Bandar 'Abbas, at or near present-day Gulashkird, the Walasgird of the Arab geographers.

BIBLIOGRAPHY. Plin. 6.107; Sykes, *History of Persia* I, 303; id., *Ten Thousand Miles in Persia or Eight Years in Iran* (1902) 270, 445. D. N. WILBER

ALEXANDROPOLIS, see ALEXANDRIA-IN-ARACHOSIA *under* ALEXANDRIAN FOUNDATIONS, 3

ALEZIO, *see* ALETIUM

ALFARO ("Gracchurris") Logroño, Spain. Map 19. Town in the upper Ebro valley 22 km SE of Calahorra, founded in 179 or 178 B.C. by Tiberius Sempronius Gracchus on the site of the Iberian Illurci (Livy, *Per.* 41; Pomp. *Festo* 86.4). Its name is frequently mentioned in the war against Sertorius in 76 B.C. (Livy) and Pliny (3.24) describes it as oppidum Latii veteres within the Conventus juridicus Caesaraugustanus. During the agrarian reform of 133 B.C. an agricultural colony is also thought to have been established there. No inscriptions or remains have been found.

Coins were minted here, although they do not appear until the time of Tiberius, denoting that the town was a Latin municipium. The asses bear the bull and the semisses a bull's head with the laurel-crowned head of the emperor and the name Gracchurris.

BIBLIOGRAPHY. *Fontes Hispaniae Antiquae* III, 223ff; IV, 189; VIII, 134; *RE* VII, 1687; A. García y Bellido, "Las colonias romanas de Hispania," *Anuario de Historia del Derecho Español* 29 (1959) 448ff. A. BELTRÁN

ALGIDUS Italy. Map 16. The N and E parts of the outer crater of the Alban Hills from the borders of Tusculum to those of Velitrae. It was traditionally cold and heavily forested with oak and ilex. A number of peaks can be distinguished, but perhaps none was singled out as Algidus Mons; if one was, it is likely to have been the modern Monte Artemisio, since Diana is known to have had a sanctuary on Algidus (Hor. *Carm.* 1.21.6; *Carm. Saec.* 69). A Temple of Fortuna is also mentioned (Livy 21.62.8). The pass of Algidus (still called Cava dell'Aglio), through which the Via Latina went, was strategically important in Rome's wars with the Aequi in the 5th c. There seems never to have been a town here; under the Empire it was known for its pleasant summer houses (Stat. *Silv.* 4.4.16; Mart. 10.30.6).

L. RICHARDSON, JR.

ALGIERS, *see* ICOSIUM

ALIANELLO, *see* ALIANO-ALIANELLO

ALIANO-ALIANELLO Basilicata, Italy. Map 14. Adjacent centers surrounded by a large necropolis that extends from the district of Cazzaiola to that of Santa Croce. Both sites lie beneath the present towns, which are within the broad area of Greek penetration formed by the valley of the river Agri and its tributary the Sauro. Settlements of this area began in the second half of the 8th c. B.C. Even before that, some settlements were scattered in the triangle framed by the two rivers and by hills. The last traces of these two settlements date to the end of the 4th c. and the beginning of the 3d c. B.C.

The earliest documentation concerning the settlements and their necropoleis derives from lamps and small sacrificial bowls of mixed form dating to the second half of the 8th c. B.C. At the end of the 7th c. and the beginning of the 6th c., local pottery is represented by large cinerary urns, thymiateria, and kantharoi typical of the Val d'Agri and of the Vallo di Diano and also, in part, typical of Palinuro. Greek imports included Corinthian aryballoi, and products of Siris are represented by a rich series of wide-bodied cups and painted cups (usually red, rust, or brown). During the 6th c. a local shop, difficult to locate precisely, imitated the Greek products of the Ionian coast and normally produced umbilicate bowls.

At the end of the 6th c. black-figure vases (a lekythos by the Painter of Edinburgh) appeared and the so-called Ionic cups. Greek imports were more numerous and the products became more valuable in the 5th c. B.C.; in the 4th c. a local product spread throughout Magna Graecia.

BIBLIOGRAPHY. D. Adamesteanu, "Siris-Heraclea," *Policoro, Dieci anni di autonimia comunale* (1969) 203-6; id., *Popoli anellenici in Basilicata* (1971) 52-55; id., "Tomba arcaica di Armento," *Atti e Mem. Soc. Magna Grecia* (1970-71) 83-92. D. ADAMESTEANU

ALICANTE, *see* LUCENTUM

ALIFE, *see* ALLIFAE

ALINDA (Karpuzlu, formerly DemirciOeresi) Caria, Turkey. Map 7. Apparently a member of the Delian Confederacy, but for only a few years. The elder Ada, expelled from Halikarnassos by her brother Pixodaros about 340 B.C., retired to Alinda; when Alexander arrived in 334, she offered to surrender the city to him and to adopt him as her son, asking in return to be restored to her throne. Alexander responded favorably, and after the capture of Halikarnassos appointed her queen of Caria (Strab. 657; Arr. 1.23.8). Arrian describes Alinda as "a place among the strongest in Caria." It is probable that the city soon afterwards took the name of Alexandria by Latmos; a place of this name, otherwise unrecorded, is mentioned by Stephanos of Byzantium, who says it possessed a sanctuary of Adonis with an Aphrodite by Praxiteles. By 81 B.C. at the latest, the old name had been revived (*OGIS* 441). The coinage extended from the 3d c. B.C. to the 3d c. A.D. A bishopric of Alinda is recorded in the Byzantine lists.

The site at Karpuzlu is identified by coins found there. It answers well to Arrian's description. The city wall, in good ashlar, is well preserved on the hill. Arrian's words suggest that it was standing in 334 B.C., and it is likely that it was built by Mausolos. Near the top of the hill a fine tower in two stories is still almost complete.

The outstanding feature of the ruins is a superb market building, over 90 m long and 15 m high. It is in three stories, of which the lower two are preserved entire. The first story consists of pairs of chambers, one behind the other, evidently used as shops; they open to the S on a narrow terrace partly rock-cut, partly supported by masonry. The second story is divided down its whole length by a row of double half-columns; it seems to have formed a single long gallery, lighted by a large window at the W end, with no division into rooms. Narrow slits in the front wall afforded additional lighting. The top story was on a level with the agora, which adjoins it on

the N and was accessible from it. Here too a row of columns ran lengthwise down the middle; a few stumps only are preserved, and of the walls only a part at the W end. The agora is an empty level space some 90 by 30 m; of its surrounding stoa practically nothing now remains.

The theater is also in excellent preservation. Contrary to Vitruvius' rule, it faces SW. The retaining wall of the cavea, and the analemmata, are in handsome ashlar masonry of Hellenistic date; an arched entrance leads to the diazoma on either side. The stage building was reconstructed in Roman times by merely extending the stage towards the orchestra; the building has collapsed, but its front wall is discernible. Of the stage itself the lower part is buried; the upper part is unusually well preserved. It is supported on plain pilasters carrying stone paving-blocks of which a number are still in place; it projects 5.1 m from the stage building.

At the summit of the hill are two foundations, one circular, over 15 m in diameter and of unknown purpose, the other apparently a small temple.

On the hill immediately to the SW is the second acropolis similarly fortified by ashlar masonry with towers, enclosing an area some 227 m in length. It seems to have been residential only, and is covered with remains of houses; just inside the wall is a row of six cisterns thickly coated with plaster still showing traces of red color. Adjoining on the S at a much lower level is a similar enclosure entered by a gate.

In the dip beyond this second acropolis, a stretch of an aqueduct is standing almost complete. Four arches are preserved, and a solid wall pierced by a gate 1.8 m wide. Over the arches is the water channel, with some of its covering stones still in position.

Tombs are numerous and of various kinds, some sarcophagi, many of "Carian" type, and some built tombs now converted to modern houses. None of them is inscribed.

BIBLIOGRAPHY. C. Fellows, *Lycia* (1841) 58-64; E. Fabricius in *Altertümer von Aegae* (1889) 27-30; E. Hula & E. Szanto in *SBWien* 132 (1895) Abh. 2,2-3; W. R. Paton & J. Myres in *JHS* 16 (1896) 238-42; *ATL* I (1939) 467-68; G. E. Bean, *Turkey beyond the Maeander* (1971) ch. 16[MI].

G. E. BEAN

ALIPHEIRA Arkadia, Greece. Map 9. The city farthest W in the district of Kynouraioi at the border between Arkadia and Triphylia, lying on a hill (683 m) about two hours NW of Andritsaina, near the village of Rongkozio. It was named for Aliphon or Alipheiron, one of the sons of Lykaon, the son of Pelasgos, the mythical king of Arkadia. The first evidence of it relates to the worship of Athena in the middle of the 6th c. Later, in the 4th and 3d c., the city appears to have been joined to the Arkadian League with the other Arkadian cities, and was brought into the Megalopolitan Synoecism under whose jurisdiction it remained until 244 B.C. when Lydiadas ceded it to the Eleians. After that the city began to decline from the height of prosperity it had reached ca. the beginning of the 3d c. B.C. Alipheira briefly resisted the advance of Philip V (219 B.C.). After the Macedonian king had conquered it he installed a garrison: an inscription referring to it has been found. During the 2d c. it was one of the cities of the Achaian League, but it continued to dwindle, and by Pausanias' time had become "a city of no size." Remains of the Christian period show the area was inhabited even later.

Excavations in 1932-35 uncovered the whole acropolis. The impressive fortification wall, well constructed of polygonal or rectangular blocks with towers at intervals, surrounds the steep slope of the hillside except for a part of the precipitous region which remained unwalled.

Besides the circuit wall, the highest point of the hill ("the heights") is also fortified by a wall in the shape of an irregular quadrangle. One tower is on the S side, where the entrance is; others on the W face provide greater strength and fortify the terrace where the Precinct of Athena is located. Here, on a lower level, a terrace wall which is terminated by towers supports the platform where the temple was built. The temple, which is preserved to the stylobate, probably replaced an earlier one. It was Doric, peripteral (6 x 15 columns), without pronaos or opisthodomos (dimensions at the euthynteria are 10.65 x 29.60 m). It has the characteristics of an Arkadian temple, such as N-S orientation, similar plan and height of columns, and similar tiles. Its date—ca. the end of the 6th to the beginning of the 5th c.—is indicated by its definitely archaic features. Among these are the single step krepidoma with the second step serving as the stylobate, the columns with 16 flutes and with drums of irregular heights, the annulets below the neck, the elliptical guttai on the mutules of the geison, the alternating wide and narrow mutules (0.432, 0.335 m), the difference in intercolumniation between the long and short sides, the existence of angle contraction in the temple, the number of the columns, and the gorgon antefixes on the lowest cover tiles. The shape of the capitals and the triglyphs are especially indicative of a date of ca. 500-490 B.C.

Along the front of the temple were uncovered rectangular and triagonal bases belonging to dedicatory statues as well as a long altar and the end of a large inscribed statue base, apparently belonging to a colossal bronze statue of Athena, the work of the Theban sculptor Hypatodoros.

According to Pausanias, the Sanctuary of Asklepios was located on the low area to the W of the acropolis. The temple, which is a simple rectangular structure (5.75 x 9.30 m) with a pronaos in antis, has preserved on the axis of the sanctuary the cubical base of an akrelephantine statue. Directly in front of the base two lion-footed slabs were used to support an offering table. The altar of the temple was rectangular (2.18 x 5.36 m), parallel to the front of the temple and to the E of it. The orthostates on the euthynteria are preserved, as are one of the supporting blocks on each end, which bear a painted rosette on one side and take the shape of a pediment. The altar is dated to the end of the 4th c. B.C., while the Temple of Asklepios dates ca. 300 B.C. A rectangular building to the SE of the altar with a peristyle of unfluted columns was perhaps the healing area of the Asklepieion. The trapezoidal peribolos of the sanctuary was used in places as a part of the fortification wall of Alipheira.

Remains of the city have been noted inside the fortification wall at a place forming the "suburb outside the heights," although it has been suggested that this was a fortified strip extending to the SE of the acropolis. Building foundations have also been found on the NE side of the hill, where were the lower city and the Fountain of Tritonis (Nerositsa). Finally, the necropolis extends around the E and W skirts of the hill. Among the funerary monuments one is outstanding for its size and interest. This is a heroon with a chamber dug in the earth and rock of the hillside, intended for Sentheas (or Santheas) according to the inscription on its front. Four other heroa were found, all of them, like the first, from the Hellenistic period. Tomb 5 differs from the rest in architectural form.

BIBLIOGRAPHY. A. K. Orlandos, Ἡ ἀρκαδικὴ Ἀλίφειρα, Πελοποννησιακαὶ ἀρχαιολογικαὶ ἔρευναι, Βιβλιοθήκη τῆς ἐν Ἀθήναις Ἀρχαιολογικῆς Ἑταιρείας, 58 (1967-68).

M. GAVRILI

ALISCA, *see* LIMES PANNONIAE

ALISE-STE-REINE, *see* ALESIA

ALJUSTREL, *see* VIPASCA

ALKOMENAI, *see under* PRILEP

"ALLARIA," *see* KHAMALEVRI

ALLAS-LES-MINES Dordogne, France. Map 23. A Gallo-Roman villa was found here in 1949 (mosaics), and important work buildings belonging to it were uncovered in 1956. These form a rectangular complex (31 x 11 m), terraced from W to E on a hillside. The buildings are of masonry with a fairly coarse facing of small squared blocks. All the walls are coated with mortar containing broken tiles, dark red in color. The floors are well built and made of a concrete of small stones covered with a thick concrete of broken tiles. There are three main parts:

1. A room opening on the W front (10.8 m S-N x 5.32 m W-E). The floor slopes slightly toward the E. The joint between the floor and the walls is decorated with a quarter-round molding made of a concrete of broken tiles.

2. A room (10.8 x 6.65 m) of which only the foundations and part of the floor to the S remain.

3. A complex, modified several times. It has not been possible as yet to reach the E end. The most important elements are: to the W a large pool (a), raised in relation to the floor around it and with its long sides running N-S (6.34 x 1.22 m); the sides and bottom are covered with an extremely fine coating of broken tiles. In the middle of the E side a drain leads down to a smaller pool (b), similar in construction but without a drain. Two treads can be seen on the edges; clearly they were for holding beams on which vessels could be rested, to be taken away as they were filled (probably wooden troughs). Farther E is a wall 90 cm thick built in a right angle; it supported the base of a very well-built structure (2.5 m sq.) the floor of which had a very thin coating of plaster and perhaps was covered with marble slabs in the middle. Area (c) was drained by a pipe of lead-tin alloy into another basin slightly lower, which has a deep cup-shaped depression, no doubt to hold a vessel which was removed when filled. In area (c) was found a Tuscan capital of limestone.

The purpose of the first two buildings is still uncertain; some believe they were watertight, but it is hard to imagine that they were large tanks in the absence of any traces of outflow. The third complex consists of a large wine press (a) that emptied into vats placed under the basin (b); (c) and (d) very probably belong to a winch press, identical to that represented on the square medallions of the Saint-Roman-en-Gal mosaic in the Musée des Antiquités Nationales.

As for dates, excavations have revealed only a few scattered potsherds (suggesting the use of casks, possibly stored in the first two rooms?) and seven coins from the end of the 1st c. and the end of the 3d c. A.D. The complex appears to have been built and used in the 1st c.; only the later section (the wine press and winch press) were used thereafter. Traces of a fire were found to the SE, a probable indication that the complex was destroyed at the end of the 3d c.

BIBLIOGRAPHY. P. Grimal, "Informations archéologiques," *Gallia* 7,1 (1949) 130-31 and fig. 2. J. Coupry, ibid. 15,2 (1957) 240-41; 17,2 (1959) 390-95. L. Maurin, "Etablissement vinicole à Allas-les-Mines (Dordogne)," *Gallia* 22,1 (1964) 209-21. L. MAURIN

ALLEGRE (Les Fumades) Canton of Saint-Ambroix, Gard, France. Map 23. Ancient watering place (cold sulphur springs), partially explored at the end of the 19th c. In addition to the buildings that were uncovered (circular swimming pool, neighboring rooms, of varying construction, with mosaics) there was a well with 24 altars, of which 11 bore dedications to the nymphs and bas-reliefs representing nymphs or mother goddesses. Utilitarian artifacts (wooden bucket, pipes) were found in the ruins, and a large number of votive objects including more than 1000 Roman coins, some gold, which indicate that the establishment was most frequented under the Flavians and the Antonines.

BIBLIOGRAPHY. *Carte archéologique de la Gaule romaine*, fasc. VIII, Gard (1941) 198, no. 326; Grenier, *Manuel* IV, 2 (1960) 521. G. BARRUOL

ALLIFAE (Alife) Caserta, Italy. Map 17A. A city of the central valley of Volturno and, in the 4th c. B.C., a part of Samnium; after the Augustan redistricting it became part of Campania. In the first half of the 4th c., the city coined its own money and later was involved on many occasions in the problems of the second and third Samnite wars. It was reduced to a colony during the second triumvirate and must have suffered damage from an earthquake in the 4th c. B.C. Its territory comprised a huge, low-lying belt, on the left of the Volturno, almost bounded by the Titerno and Lete rivers, and the eminence of the Matese (Tifernus).

In addition to occasional finds from the prehistoric era, there is evidence of a settlement of the Iron Age in the area of Cila, above Piedimonte d'Alife. Many cemeteries have been noted, over the entire area at the foot of the mountains, the most important of which are in the vicinity of Alife and Piedimonte, dating from the 7th c. B.C. to the Roman era. On the basis of various bits of evidence, the fortification wall at the foot of Mt. Cila appears to date to the period of the Samnite wars, while much evidence supports the notion that the population was widely scattered or lived in vici, as was also somewhat true in the Roman period.

The city, rectangular in plan, still preserves a large part of its straight, urban grid and of its fortifications. The latter in limestone opus incertum, with towers for the most part square and circular with four gates on piers of limestone blocks, apparently date to the Late Republican era. Of the same period were the theater, to which were added the stage in the Augustan period, the three-aisled basement with a cistern, and the oldest sections of the two houses with atrium. There are also some large funerary monuments from the period between the end of the Republic and the 1st c. of the Empire. They are mainly tower-like, in the area in which there are also important remains of country and would-be urban villas.

BIBLIOGRAPHY. F. V. Duhn, *Italische Gräberkunde* I (1924) 610; D. Marrocco, *L'Antica Alife* (1952)[MPI]; M. Merolla in *ArchCl* 16 (1964) 36f; see also *NSc* 1876-78, 1880-81, 1915, 1916, 1927-29, 1965. W. JOHANNOWSKY

ALLONNES Sarthe, France. Map 23. A sanctuary of the 2d c. on the slopes of a wooded hillock overlooking the Sarthe, near the small town. All that can be seen today are the remains of a large round cella and of the square peristyle that surrounded it, but excavations have traced the general plan of the complex. The peristyle opens to the E on to a colonnaded pronaos. This group of structures forms the sanctuary and stands at the W end of a huge square courtyard with a gallery around it. Backed against the outer N and S walls of this gallery

is a series of adjoining rooms, presumed to be shops, while in the NE and SE corners of the gallery are two small buildings connected by three parallel walls which were probably pierced by a monumental gate. This large religious complex seems to have replaced an earlier one of the Augustan period, dated by three dedications to the emperor Augustus and the god Mars Mullo.

About 1200 m to the SW, at Les Perrières, the remains of a square building were discovered in 1968. The W wall contains a circular opening edged with radiating bricks. There are openings lined with stones laid edgewise in each of the four sides and near the corners of this small building. Its function has not yet been determined.

BIBLIOGRAPHY. P. Terouanne, "Dédicaces à Mars Mullo," *Gallia* 18, 1 (1960); id., "Les Sanctuaires d'Allonnes," ibid. 25, 1 (1967). M. PETIT

ALLONVILLE Somme, France. Map 23. In the Amiens arrondissement, canton of Amiens-Nord. Allonville is in the center of the city of the Ambiani, NE of Amiens, between the Roman roads running from Amiens to Arras and from Amiens to Cambrai and Bavay. Aerial photography has recently revealed far more than the archaeological studies of the 19th c.: a Roman villa in the area of Les Faurieux, another building of the same period at La Vallée du Cange, and two tumuli of an undetermined period (Bronze Age? Iron Age?) at Le Beuvrin. However, two important digs in 1966 confirmed the richness of the Allonville site. The first allows us to settle the much-debated problem of the dividing sandhills that are an essential feature of the Picardy landscape. These are not the result of natural modifications of the soil, as had long been thought, but of man's efforts to prevent erosion of the land. Excavation revealed a series of fossil-bearing furrows, showing that swing-plows once passed over the chalky soil, at the edge of a prehistoric ditch. A pile of earth was spread over everything, to break the slope. The other dig revealed a large cremation tomb inside a square enclosure. The large number of objects found there—vases, goblets, urns, etc.—seems to argue in favor of dating the tomb from Iron Age I. Now in the Musée de Picardie at Amiens, this material is being studied.

BIBLIOGRAPHY. R. Agache, "Archéologie aérienne de la Somme," *Bulletin spécial de la Préhistoire du Nord* 6 (1964) pl. 32, no. 105; id., "Détection aérienne de vestiges protohistoriques gallo-romains et médiévaux dans la bassin de la Somme et ses abords," *Bulletin de la Préhistoire du Nord* 7 (1970) pl. 82, no. 275, p. 194, no. 315, pl. 205, no. 651; E. Will, "Information archéologique de la circonscription Nord-Picardie," *Gallia* 25, 2 (1967) 200-2. P. LEMAN

ALMA KERMEN Crimea. Map 5. Scythian site on the left bank of the Alma river in the SW Crimea, dating to the 3d c. B.C.

The settlement had links with Chersonesus, and much pottery from that city has been found on the site. Detachments of Roman legionaries occupied the site in the 2d-3d c., and building during this period includes a house with frescos and a glassmaking workshop.

Excavation has concentrated on the necropolis (over 200 tombs on the 2-ha surface). The chief archaeological finds consist of articles imported from the Greek cities on the N coast of the Black Sea. The most interesting of these are funerary stelai (1st-2d c. A.D.) with a stylized figure of a man, perhaps a warrior, with a rhyton and spear. The Moscow Historical Museum contains material from this site.

BIBLIOGRAPHY. T. N. Vysotskaia, "Nekotorye dannye o sel'skom khoziaistve pozdneskifskogo gorodishcha Alma-Kermen," *Kratkie soobshcheniia Instituta arkheologii*

Ukrainskoi SSR 11 (1961) 75-79; id., *Pozdnie Skify v iugo-zapadnom Krymu* (1972) 32-63, 76-78; N. O. Bogdanova, "Mogyl'nyk I st. do n.e.-III st. n.e. bilia s. Zavitne Bakhchisarais'kogo raionu," *Arkheologiia* 15 (1963) 95-109; id. & I. I. Gushchina, "Raskopki mogil'nikov pervykh vekov nashei ery v Iugo-Zapadnom Krymu v 1960-1961 gg.," *SovArkh* (1964) 1.324-31; I. I. Gushchina, "O sarmatakh v iugo-zapadnom Krymu (Po materialam nekotorykh mogil'nikov I-IV vv.)," *SovArkh* (1967) 1.40-51; T. M. Vysots'ka, "Gorodishche Alma-Kermen u Krymu," *Arkeologiia* 24 (1970) 179-93. M. L. BERNHARD & Z. SZTETYŁŁO

ALMÁSFÜZITŐ, *see* LIMES PANNONIAE

ALMENARA DE ADAJA Valladolid, Spain. Map 19. In the vicinity are the remains of a large Roman villa, now in course of excavation, with cubicula built about a rectangular enclosure. Of the 1500 m thus far uncovered, 400 were adorned with mosaics, implying a luxurious dwelling based on important agricultural activity. The mosaics are geometric and floral, and no furnishings have survived. The villa was abandoned before the 5th c. invasions.

BIBLIOGRAPHY. G. Nieto, "La Villa Romana de Almenara de Adaja (Valladolid)," *Boletin Seminario de Arte y Arqueologia* (Universidad de Valladolid) 9 (1942-43) 197ffPI. J. ARCE

ALMENDRALEJO Badajoz, Spain. Map 19. Site 55 km S of Mérida (Emerita Augusta), whose ancient name is not known. The Disk of Theodosius was discovered near here in 1847, a flat silver disk about 15 kg in weight and 0.74 m in diameter, now in the museum of the Royal Academy of History in Madrid. The obverse is decorated and its border reads D N THEODOSIUS PERPT. AUG. OB DIEM FELICCISSIMUM X; it commemorates the tenth anniversary of Theodosius' accession (January 19, 389). The design shows a portico of Corinthian columns surmounted by a tympanum framing a scene in which a seated Theodosius is handing a diptych to some high functionary; to each side are Arcadius and Valentinian II (or Honorius?). Actually the piece is a serving platter (missorium) and comes from a Salonica workshop.

BIBLIOGRAPHY. R. Delbrueck, *Die Consulardiptychen und Verwandte Denkmäler* (1929) 235-42I; A. García y Bellido, *Esculturas Romanas de España y Portugal* (1949) I, 470ff; II, 494I. J. ARCE

AL MINA Turkey (Hatay province). Map 6. A site at the mouth of the Orontes, thought by some scholars to be the ancient Posideion. There are slight signs of Bronze Age occupation, with Mycenaean pottery, at a nearby hill site, Sabouni. The main period of occupation begins in the later 9th c. B.C., continuing with a break at about 700. In this period the finds indicate the existence of a trading post manned by Greeks (Euboians), Cypriots, and natives. In the 7th c. Greek interest is dominant, with plentiful East Greek and Corinthian pottery finds. The period of Babylonian supremacy in the 6th c. saw a recession, followed by reoccupation by Greeks until the later 4th c. and the eclipse of the site's prosperity by the foundation of Seleucia. The architecture of the last period best illustrates the town's commercial role in the prevalence of courtyard buildings, like warehouses, some with rows of shops along the street fronts. There was no evidence for public buildings or religious structures, but it has been suggested that the center of the site had been washed away. Some intramural burials in stone sarcophagi were found. The finds were distributed between Antakya Museum, the British Museum, and other museums in Britain.

BIBLIOGRAPHY. L. Woolley, "Excavations at Al Mina, Sueidia, I, II," *JHS* 58 (1938)[MPI]; id., *A Forgotten Kingdom* (1963) ch. x; J. Boardman, *The Greeks Overseas* (1973) 37-56. J. BOARDMAN

ALONE (Watercrook) Westmorland, England. Map 24. An earth and timber fort for an infantry unit 500 strong, founded in the late 1st c. and subsequently replaced in stone. The occupation continued into the late 4th c. The only known garrison is Cohors III Nerviorum. A civil settlement grew up around the fort and pottery may have been made there.

BIBLIOGRAPHY. E. B. Birley, "The Roman fort at Watercrook," *Trans. Cumberland and Westmorland Arch. Soc.* ser. 2, 57 (1958) 13-17. D. CHARLESWORTH

ALTAMURA Apulia, Italy. Map 14. The site of an ancient center of the Peucetii on the Murge river ca. 50 km SW of Bari. The ancient name is unknown. The territory was inhabited from the Neolithic age (Putecchia). During the Bronze Age the area was thickly covered with settlements, documented by the discovery of numerous burials in the form of artificial grottos or caves. They occur in Pisciulo and Casal Sabini, from which comes a bossed bone plaque. This is valuable testimony of the first commercial contacts between Apulia and the Aegean world in the pre-Mycenaean age. During the Iron Age, between the 9th and 8th c. B.C., there was widespread use of inhumation burial in ditches dug in the rock and covered by tumuli. These occur at La Mena, Castiglione, and Scalcione.

In the section of the city called La Croce recent excavation has brought to light the existence of villages, built one on top of another and regularly stratified, which seem to span the period up to the 3d c. B.C. Houses with a rectangular plan, often with contiguous pit tombs or sarcophagi, as in the analogous Peucetian village of Monte Sannace near Gioia del Colle, are clearly urban in character toward the end of the 5th c. B.C. A megalithic circuit wall, still visible for long stretches, was provided with gates, among them the gate called Aurea or Alba. The tombs discovered both inside and outside the walls contained rich deposits of vases and terracottas, presently in preparation for installation in the new Archaeological Museum of Altamura, in the La Croce section of the city.

BIBLIOGRAPHY. M. Mayer, *Apulien* (1914) 345; F. G. Lo Porto, "Prospettive archeologiche altamurane," *Altamura* 12 (1970) 3ff. F. G. LO PORTO

ALTA RIPA, *see* LIMES PANNONIAE

ALTAVA (Ouled Mimoun) Algeria. Map 19. On Route Nationale 7, 33 km E of Tlemcen, rises the little plateau of Hadjar Roum, "the Roman stones." Here, on the military road that defined the S end of the mountain chains of central Algeria, from Rapidum to Numerus Syrorum (Marnia), a military camp was built under Septimius Severus; the position commanded one of the crossroads of migrating Nomads. It was thus linked to the E with the garrisons of Lucu, Ala Miliaria, and Cohors Breucorum, and to the W with those of Pomaria and Numerus Syrorum; to the N, one road led to Albulae (Aïn Temouchent) and to Portus Magnus (Bettioua, ex-St. Leu); to the NE, a road led via Aquae Sirenses (Bou Hanifia) and Mina (Relizane) to the great road over the plain of Chelif. The ruins have suffered much in the building of the modern village and the construction of the railroad crossing the camp, which measured ca. 400 x 300 m. The infrequent excavations on the site have exposed only confused ruins,

late and rebuilt. In fact, the interest of Altava depends on the important series of inscriptions, almost all funerary, discovered by farmers working among the necropoleis which surround the ancient town on all sides. Except for two fragments embedded in the walls of the modern village, and three inscriptions preserved in the Tlemcen Museum, all of these monuments are today in the Oran Museum. The oldest inscriptions, from the period of Septimius Severus, show that the camp served as a garrison for the second cavalry wing of the Thracians and the cohort IV of Sardinians. The epigraphical collection consists primarily of a series of dated epitaphs dating from 302 to 599; the importance of such a series for the study of linguistics and epigraphy, is readily conceivable.

Of particular note is a Christian basilica, still to be excavated, erected after 309 on the tomb of the martyr Januarius. The great majority of the epitaphs are Christian; their decoration runs from simple palm branches flanking a rosette to a complex system of arches enclosing Christian symbols. The formulae show in the 6th c. a fashion for expressions like "crudelis uixi" or, to designate the tomb, "domus aeternalis." One may note in the same period a unique style of lettering. Methodical excavations would greatly enrich our knowledge of this site.

BIBLIOGRAPHY. S. Gsell, *Atlas archéologique de l'Algérie* (1911) 31, no. 68; Pouthier, "Evolution municipale d'Altava," *MélRome* (1956) 205-45; J. Marcillet-Jaubert, *Les inscriptions d'Altaua* (1968)[PM].

J. MARCILLET-JAUBERT

ALTENBURG Aargau, Switzerland. Map 20. Roman fort on the right bank of the Aare, just W of Brugg. The ancient name is unknown. A rocky ford here necessitated protection for nearby military roads and for a bridge leading to the legionary camp of Vindonissa 2 km to the E. There are few traces of the 1st c. A.D. military installations, but under Diocletian or Valentinian I a fort was built, a link in a chain of defenses on the Rhine-Aare waterway similar to Salodurum and Ollodunum. About A.D. 401 the site was abandoned by the garrison, but the fortress survived in part because in the Early Middle Ages it was transformed into a castle of the Habsburg family.

The fortress was small (60 x 40 m; area 2929 sq. m) and exclusively military; it did not include an earlier civil settlement or the river-fort mentioned above. The walls were ca. 3 m thick and the plan was bell-shaped, with the base (ca. 65 m) towards the river. There were probably eight towers, semicircular or larger segments of circles (max. diam. 6 m), and two gates, the main one flanked by two towers. Some of the towers still stand 3-8 m high (four have been excavated). A berm (18 m wide) and a double ditch (each 8 m wide) surrounded the fortress.

See also Limes, Rhine.

BIBLIOGRAPHY. R. Laur-Belart, "Altenburg," *AnzSchweiz* 37 (1935) 172, 174-75[PI]; H. Herzig, "Das Kastell Altenburg," *Jber. Gesell. Pro Vindonissa* (1946-47) 69-71[PI]; F. Staehelin, *Die Schweiz in römischer Zeit* (3d ed. 1948) 309-11, 632; E. Ettlinger, *RE* IX A (1961) 95; T. Pékary, *Jber. Gesell. Pro Vindonissa* (1966) 12-13.

V. VON GONZENBACH

ALTHIBUROS (Ebba Ksour) Tunisia. Map 18. Situated in W Tunisia, on the Sra Ouartene, a high plateau between the two grain-growing plains of the Zouarines and the Thala. The ancient city was at the confluence of the Oum-el-Abid and Médeina, at the outlet of the Fej el Tamar, the only natural way onto the road from Le Kef

to Theveste. The fact that its history goes far back in antiquity was proved by the discovery of several pre-Roman documents, one of which, a Neo-Carthaginian inscription now in the Louvre, mentions a Sanctuary of Baal Hammon.

A city of Berger tradition, it came under the influence of Carthage; under the Roman Empire it remained an indigenous civitas until it was raised to the status of a municipium by Hadrian: municipium aelium hadrianum augustum althiburitanum. Only later was it granted the ius Italicum. The town, long since abandoned in favor of Ebba-Ksour, an agricultural center in the plain, lay outside the main route of circulation from Le Kef to the S; thus its most important ruins have been largely preserved. Thanks to 18th c. travelers and to a few sporadic excavations we have some knowledge of the city's history.

The forum (44.6 x 37.15 m over-all) is a paved esplanade (23.35 x 30.8 m) surrounded by a portico with 10 x 12 columns raised on a step 6.9 m wide. On the NW side of the portico there is a row of aediculae, some religious in function: a statue of Minerva was found in one. To the SW is the capitol, separated from the forum by a small square closed to the W by a Hadrianic triumphal arch (now destroyed). Part of the facade is still intact, to a considerable height. Built of large blocks, it was Corinthian, prostyle, and tetrastyle. It had a central cella (8 x 7.5 m), two smaller cellae flanking it, and a pronaos on a stylobate 3 m high that was reached by a broad staircase. A low enclosing wall surrounded the temple. During the excavation of 1912, some fragments were found of the dedication that complemented those documents noted above, making it possible to identify the capitol with certainty and to date it to 185-191. The white marble head of a statue, probably of Juno, was also recovered.

A second temple stood on the other side of the forum to the NE, opposite the capitol. All that remains of it is the podium and some architectural fragments. Also Corinthian, it was tetrastyle. The cella was ringed with a wall giving onto two lateral corridors on the sides. According to an inscription found nearby, it apparently dates from 145. At the E corner of the forum, near this temple, is a complex of buildings, the most noteworthy of which is a house with a peristyle of 16 columns set up on dados carved with various motifs. The floors of the four porticos are paved with geometric mosaics that vary in design from one bay to the next. Opening onto these galleries were rooms of a NE wing and a large room, possibly a triclinium, where apparently a geometric mosaic, now at the Bardo Museum in Tunis, was discovered.

On the SE side of the public square, SW of the house just mentioned, is another, quite different quarter. Among somewhat confused remains, the most interesting structure is a building (10 x 7 m) which probably was a factory. It consists of a rotunda, two courtyards whose walls hold several series of niches, and some ground-level basins that were installed at a later date. A monumental fountain 4 m square stands S of this area, at the end of a paved street that continues the esplanade between the capitol and the forum. It is constructed of large blocks. On each of two of its sides a niche is framed by large pilasters above a molded stylobate with a basin. In the course of excavating this sector many inscriptions were found that originally came from the forum and elsewhere and were reused.

Outside this excavated city center are some other monuments which, although not excavated, are notable for their size. First among these is a theater. Its cavea (57.5 m in diameter) is ringed with a wall, several of whose arcades are still standing among many fallen blocks.

According to an inscription, it apparently was built before A.D. 172. On the other side at the entrance to the site is a fairly well-preserved triumphal arch, standing in the fields. An inscription on its entablature dates it from the 4th-5th c. Its arcade is 11.25 m long and has an arch 7 x 5.25 m. Finally, on the outskirts of the city and on the hilltops can be seen a few mausolea; that called Ksar Ben Hannoun, to the W, has a cella 3.2 x 2.5 m with an inscription on the entablature.

Three other private buildings that have been uncovered add to the interest of the site: A large villa, the House of the Muses, stands on the right bank to the W. Its rooms and apartments, arranged around a peristyle, are noteworthy for their many and varied mosaic floors. Two rooms are important: the triclinium, which has a mosaic floor of sea scenes (badly damaged) and the apsed exedra at right angles to it, whose floor has a design of the muses (also damaged). The peristyle is paved with geometric mosaics.

Another house, the House of the Fishing Scene, stands on the other side of the wadi Oum el Abid, on the left bank fairly close to the capitol. The rooms, badly damaged, are arranged around a peristyle paved with mosaics. One of the rooms has two symmetrical apses at each end and is paved with a mosaic representing a fishing scene with the head of Oceanus depicted at either end. The floor of an adjacent room has two panels of imbricated mosaics.

The Asklepeia monument, so-called after the mosaic inscription in the axial room, whose function is still undetermined, is remarkable for the originality of its plan, the harmony of its architectural arrangement, and the quality of its mosaic floors. Strictly symmetrical in plan, the monument has a long gallery terminating at either end in two corner turrets. The facade has several windows on either side of an impressive entrance on axis. This corridor opens onto a large square room flanked on either side by a basin with a horseshoe-shaped passageway running around it, making a sort of atrium tuscanicum. This great vestibule gives onto a peristyle equipped with a complete hydraulic system. Framing both sides of this peristyle are two large symmetrical oeci along with their adjoining rooms. The main wing, to the NE at the rear, consists of a series of rooms arranged symmetrically on either side of the Asclepeia room located in the axis, opposite the principal entrance. All these rooms were paved with beautiful mosaics.

BIBLIOGRAPHY. A. Merlin, "Forum et maisons d'Althiburos," *Notes et Documents*, VI (1913). A. ENNABLI

ALTIAIENSIUM (Alzey) Rhineland Palatinate, Germany. Map 20. The Roman name of the vicus appears in inscriptions. Remains of a large castellum built between 357 and 370 have been preserved. Many altars and reliefs of Herakles, Mercury, Vulcan, and Venus from the foundations of a building within the castellum are to be found in the Alzey museum. The square castellum had walls 3 m thick, each 170 m long, two gateways, probably 14 towers, and was further reinforced by an angular ditch 11 m from the wall.

BIBLIOGRAPHY. E. Anthes & W. Unverzagt, "Das Kastell Alzei," *BonnerJbb* 122 (1912) 137-69; W. Unverzagt, "Ein neuer Gesamtplan vom Römerkastell Alzey (Rheinhessen)," *Germania* 38 (1960) 393-403; B. Stümpel, *Alzeyer Geschichtsblätter* I (1964) 48ff; H. Klumbach, "Alzey zur Römerzeit," *Führer zu vor- und frühgeschichtlichen Denkmälern* 12 (1969) 214-18P. H. BULLINGER

ALTILIA, see SAEPINUM

ALTINO, see ALTINUM

ALTINSIVRISI ("Euthena") Turkey. Map 7. A conspicuous peak in Caria, 9 km N of Marmaris, where the remains are probably those of a Peraean deme of Rhodes attached to the city of Kamiros which seems to be mentioned (the MS readings vary greatly) by Mela (1.84) and Pliny (*HN* 5.107), who establish the approximate location. On the summit of the peak is a walled citadel with a small fort at either end, and on the steep slope of the hill are the closely packed ruins of a considerable town, built on terraces. In the village of Ovacık at the foot of the hill was found an epitaph of a Euthenite.

BIBLIOGRAPHY. W. R. Paton, *JHS* 11 (1882) 110; P. M. Fraser & G. E. Bean, *The Rhodian Peraea* (1954) 69; Bean & J. M. Cook, *BSA* 52 (1957) 62-64. G. E. BEAN

ALTINTAŞ, *see* ZIMARA

ALTINUM (Altino) Veneto, Italy. Map 14. A city in the territory of the Veneti (Ptol. 3.1.30) near the Sile river, along the coast NE of the Laguna di Venezia. At first, a center of the Veneti, the city became a Roman municipium enrolled in the tribus Scaptia and reached its period of greatest prosperity during the first centuries of the Empire. In A.D. 452, it was destroyed by Attila and finally, in the late Roman period, was abandoned by its inhabitants, who sought refuge at Torcello and on other islands in the group where later Venice was to rise.

Altino is mentioned by Velleius Paterculus (2.76.2) in his description of the civil war in 42 B.C. and then by Vitruvius (1.4.11), Strabo (5.214), Pliny (3.126), Tacitus (Hist. 3.6), and Martial (4.25.1), who extols the beauty of its coastline and the richness of its villas. The ancient sources do not furnish specific dates for a clear understanding of this city, one of the most famous in N Italy and strategic as a highway junction and as a center of commerce.

Sporadic investigations were carried out right up until the end of the 19th c., but only in the last few years have regular excavations been undertaken. Recent discoveries of Attic and ancient Venetic vases, dating to the 5th c. B.C., and of Venetic funerary inscriptions indicate that Altino was an inhabited center and perhaps an important port of call in the pre-Roman era. The importance of the city increased with the Romanization of Veneto and with the building of the Via Annia (131 B.C.), which, coming from Adria, connected Altino with Aquileia. The construction of the Via Claudia Augusta (begun by Drusus and completed by his son, the emperor Claudius), which began at Altino, put the city in contact with the Roman territories across the Alps. The Via Annia as well as the Via Claudia Augusta had high embankments which kept them safe from possible flooding from the Sile and from the Laguna. The exact boundary of the city is not known. It had no walls, but must have been surrounded by canals and by low-lying, swampy ground. In the area of the city to the E, there is evidence of a road, more than 5 m wide and flanked by sidewalks and the foundations of houses containing mosaic pavements. A huge cornice, dating to the 1st c. A.D. and surely belonging to a public building, comes from the higher area where the center of the city was situated with its temples, porticos, gardens, and baths, as mentioned in an inscription discovered in the cathedral of Grado and in another inscription honoring Tiberius (*CIL* V, 2149). A large structure in stone blocks, perhaps the pier of a harbor canal, and the remains of a portico are at the S boundary of the city; to the N is a large brick shed and homes nearby with mosaics of the 1st c. B.C. With the systematic exploration of ca. 2 km of the NE necropolis along the Via Annia, many funerary enclosures have been found, with portraits, statues, and inscriptions. Nearly 1,000 cremation tombs and numerous stone tomb markers of various types have been found: niched stele with busts, clipeus portraits; large octagonal and round altars richly decorated, urns—some covered by half-round stones, others decorated with acanthus leaves or with flames of funeral pyres; and to avert evil, animal likenesses, such as dogs, sphinxes, and lions. Nearly all the finds are preserved in the museum at Altino.

BIBLIOGRAPHY. E. Ghislanzoni, *NSc* (1930); G. Brusin, "Il problema archeologico di A.," *Atti dell'Istituto Veneto* 105 (1946-47); id., "Che cosa sappiamo dell'antica A.," ibid. 109 (1950-51); id. et al., *Atti del Convegno per il retroterra veneziano* (1956); G. Sena Chiesa, "Le stele funerarie a ritratti di A.," *Memorie Istituto Veneto* 33 (1960); B. M. Scarfì. "Altino (Venezia). Le iscrizioni funerarie romane provenienti dagli scavi 1965-1969," *Atti Istituto Veneto* 128 (1969-70); id., "Documentazione archeologica preromana e romana," *Mostra storica della Laguna Veneta* (1970). B. M. SCARFÌ

ALTINUM, *see* LIMES PANNONIAE

ALTRIER Luxembourg. Map 21. Altrier comprises a group of sites important in prehistoric times (Magdalenian collections Graf and Bisenius), then an Iron Age oppidum (op Casselt, the Castle), and later a Roman vicus. Remains of Roman houses were visible until the middle of the 19th c. (Comes' house). The roads from Trèves to Mersch and from Dalheim N to the Eifel crossed here. A number of inscriptions have been found: one dedicated to Jupiter Optimus Maximus, and many others to private citizens including the family of the Secundini. Apparently there were one or more sanctuaries dedicated to Oriental gods: besides the usual statues of Apollo, Mercurius, Priapus, Diana, Epona, Mars, and Jupiter, there are hundreds of statuettes of Isis, Ceres, Fortuna, and Dea Mater, produced locally. The coins date from the beginning of the Roman occupation to the 4th c. A.D. Other finds include Roman pottery of local provenience as well as Italian and French terra sigillata (Niederbieber 19), stamps by Iustinus and Adiutix, oil lamps (one stamped CITOGLV), mosaics (Schneider house), remains of wall paintings, aryballoi, fibulas (one marked VENIO SI DAS), jewelry (bracelets, necklaces, gold rings with carved semi-precious stones), foundations of a tower (fanum?), remains of houses, and perhaps some ruins of a 4th c. fortification wall. Nothing is now visible on the site; the finds are in the Landesmuseum in Trèves or the Musée d'Histoire et d'Art in Luxembourg.

BIBLIOGRAPHY. J. Engling, Das Römerlager zu Altrier," *Publications de la section historique de l'Institut Grand-Ducal* 8 (1852) 99ff; J. Dheedene, "Altrier, un atelier de figurines en terre cuite?" *Helinium* 1 (1961) 211ff; C. M. Ternes, *Les Inscriptions Antiques du Luxembourg* (1965) 271-83; id., *Répertoire archéologique du Grand-Duché de Luxembourg* (1971) I, 19ff; II, 23ff; id., *Das römische Luxemburg* (1974) 171ff. C. M. TERNES

ALZEY, *see* ALTIAIENSIUM

"AMANTIA" *see* KLOS

AMAROUSION (Marusi) Attica, Greece. Map 11. Named for a sanctuary dedicated to the Euboian cult of Artemis Amarysia, in the deme of Athmonon. Pausanias (1.1417) refers to a local legend that a Sanctuary of Aphrodite Urania was founded there by a King Porphyrion, a name taken by Frazer to indicate a Phoenician

settlement. SW of Marusi, Lolling found two boundary inscriptions for the Artemis Sanctuary, one archaic, the other perhaps from a period of renovation under Herodes Atticus. A reference to Amarysian games occurs in another inscription concerning a local township decree.

BIBLIOGRAPHY. Paus. 1.31.5; H. G. Lolling, *AM* 5 (1880) 290; J. G. Frazer, *Paus. Des. Gr.* (1898) II 413f.

M. H. MC ALLISTER

AMASEIA (Amasya) Pontus, Turkey. Map 5. A natural fortress at the W margin of the Pontic mountains, 82 km inland as the crow flies but 136 km by road on the ancient trade route to Samsun (Amisos) formerly known as the Baghdad Road. Amaseia was capital of the Hellenistic kingdom of Pontus from its foundation ca. 300 B.C. by Mithridates I Ktistes until shortly after the fall of Sinope to Pharnakes I in 183 B.C. After that date it continued to be important to the royal house, being close to the Sanctuary of Zeus Stratios (invoked by Mithridates VI Eupator in 82 and 73 B.C.) and itself the site of memorials to the early Mithridatic kings. Amaseia was captured by Lucullus in 70 B.C., assigned a large and fertile territory in Pompey's new province of Bithynia and Pontus (64 B.C.), put in the hands of an unknown dynast by Antony, and annexed to Galatia in 3-2 B.C., becoming metropolis of the minor district Pontus Galaticus. When this was transferred to Cappadocia by Trajan and incorporated in Pontus Mediterraneus (with metropolis Neocaesarea), Amaseia retained the honorary title of metropolis. In the reorganization of Diocletian and Constantine, Amaseia became metropolis of Diospontus/Helenopontus.

Amaseia was the birthplace of the geographer Strabo, whose proud description of it (12.561) is still one of the best. The original city grew up on a restricted site of great strength on the W bank of the Yeşil Irmak (Iris fl.). At its back rises a lofty crag (Harşene Kalesi), now carrying mediaeval fortifications as well as a tower and several lengths of wall of Hellenistic date. Beneath the twin summits cliffs plunge 250 m to the river, closing off the city on both sides. At the foot of the crag a terrace retained by Hellenistic masonry marks the site of the royal palace. Rock-cut steps gave access to the fortress above and to the five "memorials" of the earlier Pontic kings, which take the form of freestanding heroa carved out of the living rock, one (that of Pharnakes I?) left unfinished. Within the fortress two rock-cut monumental stairways descend through tunnels into the heart of the crag; a third stairway, apparently unknown to Strabo, is found farther down the slope. They belong to a class of monument, probably designed for ritual use, found from Phrygia to Commagene; whatever the original purpose, those at Amaseia were used in Late Hellenistic times to obtain water in time of siege. A bridge (Alçakköprü) connected the city to its suburbs on the E bank, where the modern town lies; Roman arches support a post-Roman superstructure. About 1 km S of Amasya are remains of an aqueduct-channel beside the main road, cut into the rock of Ferhatkaya. Some 2 km downstream is the rock-cut tomb of the high priest Tes, similar in type to the royal memorials but better finished. Other rock-cut tombs are common in and around Amasya.

BIBLIOGRAPHY. F. & E. Cumont, *Studia Pontica* II (1906) 146-71; J.G.C. Anderson et al., *Studia Pontica* III.1 (1910) 109-48; G. de Jerphanion, *MélUSJ* 13 (1928) 5-14, 41¹; G. E. Bean, "Inscriptions from Pontus," *Belleten* 17 (1953) 167-72. D. R. WILSON

AMASRA, *see* AMASTRIS

AMASTRIS (Amasra) Pontus, Turkey. Map 5. Founded in the early 4th c. B.C. by Amastris, queen of Herakleia Pontica, by the synoecism of four small Ionian colonies on the coast E of Herakleia: (1) Tios, which soon seceded; (2) Sesamos, center of the new city, later named Amastris; (3) Kromna, 40 km to the E, on Zeytin Burnu, W of Kurucaşile; and (4) Kytoros, now Gideriz, 25 km E of Kromna. Its tyrant Eumenes presented the city of Amastris to Ariobarzanes of Pontus in ca. 265-260 B.C. rather than submit it to domination by Herakleia, and it remained in the Pontic kingdom until its capture by Lucullus in 70 B.C.

The original nucleus of the city itself was a peninsula and adjacent island (now linked by bridge) on the W side of a sheltered bay which formed the main harbor. This part of the city is covered by Genoese fortifications and the modern Turkish town. In the Roman period Amastris also extended inland over the little valley behind this bay, and the suburbs covered some of the lower hills. Roman buildings can still be traced for 1.5 km inland from the sea. The most impressive are a temple, and a warehouse 115 m long and three stories high. Other buildings, no longer visible, were recorded in the mid 19th c. The stream, "nomine quidem flumen, re vera cloaca foedissima," covered over by Pliny (*Ep.* 10.98), still runs beneath a Roman vault. Four ancient moles protect the main harbor. A lesser harbor W of the city provided refuge from E gales. Inscriptions and architectural fragments are housed in the municipal museum. Four km S-SW of Amasra, at Kuşkaya, the Roman road from Bartin (Parthenia) runs on a rock-cut terrace, with associated inscriptions and relief sculpture.

The site of Kromna is marked by occupation material but no surviving buildings. Construction of the harbor offices at Kurucaşile revealed columns which now adorn the administrative buildings at Bartin. At Kytoros the remains of impressive harbor buildings used to be indicated by columns along the seashore.

BIBLIOGRAPHY. W. F. Ainsworth, *Travels and Researches in Asia Minor, Mesopotamia, Chaldea, and Armenia* (1842) I 54-58; X. Hommaire de Hell, *Voyage en Turquie et en Perse* (1860) IV 389-92; W. von Diest, "Von Pergamon über den Dindymos zum Pontus," *PM* 20 (1889) 69-71ᴾ; E. Mendel, "Inscription de Kytoros," *BCH* 26 (1902) 287-88; K. Lehmann-Hartleben, "Die antiken Hafenanlagen des Mittelmeeres," *Klio* Suppl. 14 (= NF 1) (1923) 131-32, plan XX; A. Gökoğlu, *Paphlagonia* (1952) 23. D. R. WILSON

AMASYA, *see* AMASEIA

AMATHOUS Cyprus. Map 6. On the S coast, about 11 km E of Limassol. The ruins cover a large area on top of a hill and on the slopes reaching the sea to the S. The lower city lies between the acropolis and the sea and to the E. Remains of the ancient city wall and of the harbor still survive. The relatively well-preserved wall across the acropolis is of Early Byzantine times. The necropolis extends E, N, and W of the town.

One of the ancient kingdoms of Cyprus, its legendary founder was Kinyras, who called the city after his mother Amathous. It was said in antiquity that the people were autochthonous. They used a non-Greek language, as shown by inscriptions in the Cypriot syllabary used down to the 4th c. B.C. According to one version of the Ariadne legend, Theseus abandoned Ariadne at Amathousa, where she died. The Amathousians are said to have called the grove where she was buried the "Wood of Aphrodite Ariadne."

Nothing is known of the earliest history of the city.

At the time of the Ionian Revolt (499-498 B.C.) it sided with the Persians. Onesilos, king of Salamis, who led the revolt, persuaded all the Cypriots except those of Amathous to join him against Persia. Onesilos proceeded to lay siege to Amathous, but forced by other events to abandon the siege, he fell in the battle that ensued on the plain of Salamis.

King Euagoras I of Salamis (411-374/373 B.C.) reduced Amathous at the time of his attempt to liberate Cyprus from the Persians. Its king Rhoikos had been made a prisoner, but then returned home, his release having been effected by the Athenians, who were Euagoras' allies. King Androkles of Amathous assisted Alexander the Great at the siege of Tyre. The history of the city was written in nine books by Eratosthenes of Kyrene (275-195 B.C.). The kings of Amathous who are known to have issued coins are Zotimos, Lysandros, Epipalos, and possibly Rhoikos. The city continued to flourish throughout the Hellenistic and Graeco-Roman periods down to Early Byzantine times, when it became the seat of a bishop, but it was gradually abandoned after the first Arab raids of A.D. 647.

Some stretches of the walls still stand but practically nothing of the city has been uncovered so far. A number of built tombs had been excavated in the 19th c., while more tombs were excavated in 1930. In recent years the ruins of two Early Christian basilican churches were excavated. A built tomb can be seen on the seaward side of the main Nicosia-Limassol road a little W of the ruins of the city. A large dromos, measuring 13 x 7 m, slopes down to the doorway. The interior of the tomb consists of two rectangular chambers; both have corbeled, slightly curved saddle roofs with flat top stones. It is dated to the beginning of the Cypro-archaic I period, shortly after 700 B.C.

The city wall may be traced in practically all its course; the circuit starts at the E end by the sea near the Church of Haghia Varvara, extends N along the edge of the acropolis, and returns along its W edge. Remains of this Classical wall survive at both ends. Of the ancient harbor only a little is now visible, on the SE of the acropolis. Part of it has silted up and only scanty remains of the artificial breakwaters can still be seen above water. The sites of a gymnasium and of a theater are suspected but they have never been investigated. The Temple of Aphrodite (also known as Amathousia) is to be sought on the summit of the acropolis. We also know of the worship in Amathous of Zeus, Hera, Hermes and Adonis, but nothing about the position of their sanctuaries. Cut into the face of a rock on the E side of the acropolis there is a Greek inscription recording the construction by Lucius Vitellius Callinicus at his own expense of the steps leading up to it and of an arch.

Casual finds in the city site are frequent. A colossal statue in gray limestone, measuring 4.20 m in height and 2 m in width at the shoulders, now in the Istanbul Museum, was found in 1873 by the harbor. This curious colossus has been much discussed and many identifications have been put forward, but most probably it represents Bes. Its date too is disputed but it may well be an archaistic statue of the Roman period. In 1862 a colossal stone vase, now in the Louvre, was found on the summit of the acropolis. It may have stood at the entrance to the Temple of Aphrodite. It has four horizontal arched handles ending with palmettes, within each of which is placed a bull. Many small finds are in the Nicosia and Limassol Museums.

BIBLIOGRAPHY. Luigi Palma di Cesnola, *Cyprus, its Ancient Cities, Tombs and Temples* (1877); A. Sakellarios, Τὰ Κυπριακά I (1890); A. S. Murray et al., *Excavations in Cyprus* (1900); I. K. Peristianes, Γενικὴ Ἱστορία τῆς νήσου Κύπρου (1910); Einar Gjerstad et al., *Swedish Cyprus Expedition* II (1935); George Hill, "Amathus," *Mélanges Emile Boisacq* V (1937) 485-91; V. R. d'A. Desborough, "A Group of Vases from Amathous," *JHS* 77 (1957) 212-19[I]; V. Karageorghis, "Découvertes à Amathonte," *BCH* 85 (1961), 312-13[I]; Olivier Masson, *Les Inscriptions Chypriotes Syllabiques* (1961) 201-12; C. Adelman, "A Sculpture in Relief from Amathous," *Report of the Department of Antiquities, Cyprus* (1971) 59-64[PI]; *BCH* 97 (1973) 685-86; *AJA* 77 (1973) 432.

K. NICOLAOU

AMAY Belgium. Map 21. A Gallo-Roman vicus of the civitas Tungrorum, situated where the road from Tongres to Arlon crosses the Meuse by a ford that was still used in the Middle Ages. In 1842 some thick planks were found which were interpreted as the remains of a wooden bridge, but the matter is still uncertain. The built-up area covered 3 ha, mostly on the left bank of the Meuse. However, foundations have been noted on the other side of the river. The road probably dates to the time of Claudius.

The vicus grew from then on, perhaps around a mutatio along the road. An industrial district was located on the outskirts of the settlement. Several potters' kilns were in use from ca. A.D. 50 to 150. There were also iron smithies. Inside the vicus itself, rectangular houses were built on both sides of the road, with the narrow side facing the street. Several cellars have been excavated, as well as some round wells built of sandstone ashlar without mortar. Several tombs dating from the 1st to the 4th c. have been found. Study of the coins and the terra sigillata indicates that the occupation was unbroken from the middle of the 1st c. A.D. until well into the 4th c. Although the vicus was laid waste ca. 270 during the barbarian invasion, it was soon rebuilt.

BIBLIOGRAPHY. M. Vanderhoeven, "La terra sigillata trouvée dans le vicus romain d'Amay," *Chronique arch. du Pays de Liège* 51-52 (1960-61) 41-64; A. M. Defize-Lejeune, *Répertoire bibliographique des trouvailles archéologiques de la province de Liège* (1964) 2-3; J. Willems, "Le Vicus belgo-romain d'Amay," *Bull. du Cercle arch. Hesbaye-Condroz* 8 (1968) 5-18.

S. J. DE LAET

AMBLESIDE, see GALAVA

AMBRAKOS (Phidhokastro) S Epeiros, Greece. Map 9. The port of Ambrakia on the bank of a lagoon by the Gulf of Arta, where the foundations of a circuit wall ca. 1200 m long are awash. A gap in the foundation marks the exit of the harbor, which led into the course of the river Arachthos. It was a locked harbor with fortifications (Scylax 33 and Polyb. 4.61.7), and there was a small town there (*StBiz.* s.v.).

BIBLIOGRAPHY. N.G.L. Hammond, *Epirus* (1967) 137f.

N.G.L. HAMMOND

AMBRUSSUM Locality of Le Devès, commune of Villetelle, canton of Lunel, Hérault, France. Map 23. Pre-Roman and Gallo-Roman oppidum and way station on the Via Domitiana between Nemausus (Nîmes) and Sextantio (Castelnau-le-Lez), near Montpellier; it is mentioned in the antique itineraries. The great Roman road which served the Provincia from the Alps to the Pyrenees crossed the coastal river of the Vidourle here, on a stone bridge today called the Pont-Ambroix. Remains of it are still visible at the foot of the oppidum.

The settlement, on a low hill on the right bank of the river at the crossing, is surrounded by a dry stone wall. Towers with rounded corners are found ca. every 10 m.

Systematic exploration, recently resumed, has uncovered a large dwelling occupied during the 1st c. B.C. and built above a native dwelling of the first half of the 3d c. B.C. On the river, near the bridge and at the foot of the oppidum, was the lower town, which was occupied throughout the Roman period.

BIBLIOGRAPHY. *Carte archéologique de la Gaule romaine*, fasc. VIII, Gard (1941) 17, no. 49; fasc. x, Hérault (1946) 3, no. 4; "Informations," *Gallia* 27 (1969) 401; 29 (1971) 388-89; 31 (1973) 498-99ᴵ. G. BARRUOL

AMELIA, *see* AMERIA

AMELIE-LES-BAINS Canton of Arles-sur-Tech, Pyrénées-Orientales, France. Map 23. Gallo-Roman bath complex in the locality formerly known as Arles in the middle valley of the Tech or Vallespir. Among the architectural remains visible in the modern establishment is a vast barrel-vaulted room containing a swimming pool. Its side walls contain semicircular and square niches. Other remains include a small swimming pool surrounded by small chambers (some with the original vaulting), various antique sub-structures, wells, and drains. In 1845 a votive deposit was found at the mouth of the thermal spring. It contained coins and lead plaques bearing the names of local water divinities.

BIBLIOGRAPHY. E. Espérandieu, *Répertoire archéologique des Pyrénées-Orientales* (1936) 13-19; P. Ponsich, *Etudes Roussillonnaises* 2 (1952) 215-25, 227-32; 4 (1954-55) 83-99. G. BARRUOL

AMERIA (Amelia) Umbria, Italy. Map 16. A municipium on a tributary of the Tiber founded, according to Cato (Plin. *HN* 3.114), in 1134 B.C. It was inscribed in the tribus Clustumina and supplied fruit and osiers to the Roman market. The site is naturally strong, improved by impressive fortifications of polygonal masonry. There is considerable variation in the work, with much coursing, and in places most blocks are quadrilateral.

South of the city was found in 1963 a complete bronze cuirass statue thought to be Germanicus. Antiquities from the site are kept in the Palazzo Comunale.

BIBLIOGRAPHY. *EAA* 1 (1958) 317 (C. Pietrangeli & U. Ciotti); *AA* 85 (1970) 318 (H. Blanck).

L. RICHARDSON, JR.

AMESTRATOS, *see* MISTRETTA

AMIDA (Diyarbakır) Turkey. Map 5. A city situated at the limit of navigation of the Tigris, on a bluff at a bend of the river. Though there was an earlier settlement, the site was not important until Constantius, as Caesar in the East, founded and fortified a large city there to protect the Armenian satrapies between the Antitauros and Masios mountains still retained from Diocletian's conquests. It was garrisoned by Legio V Parthica. When the Persian King Sapor II invaded, the garrison was increased to seven legions; nevertheless the city fell to siege in A.D. 359. Ammianus Marcellinus, a Roman officer there, has left an eyewitness account (19.1-8). The city was retaken by Julian and the population restored by refugees from Nisibis, ceded to the Persians by Jovian, in A.D. 363 and the completion of rebuilding may be recorded by an inscription of A.D. 367-75 (*CIL* III, 6730). After capture by Kobad in A.D. 503 and recapture by Anastasius, the walls were restored again by Justinian (Procop., *Buildings* 2.3.27). Amida changed hands several times in the Byzantine period and the walls reached their final form by A.D. 1068. The black basalt walls seen today at Diyarbakır are essentially built to the 4th c. plan. The courtyard of the Ulu Cami is built of Byzantine

architectural elements. Some stray finds are in the Diyarbakır Museum.

BIBLIOGRAPHY. M. Van Berchen & J. Strzygowski, *Amida* (1910); A. Gabriel, *Voyages archéologiques dans la Turquie orientale* (1940); D. Oates, *Studies in the Ancient History of N. Iraq* (1968). R. P. HARPER

AMIENS, *see* SAMAROBRIVA

AMISOS (Samsun) Pontus, Turkey. Map 5. An Ionian colony founded in the mid 6th c. on the S coast of the Black Sea (Pontos Euxeinos), at the terminus of the only easy route to this coast from Cappadocia. In the mid 5th c. it received cleruchs from Athens and adopted the name Peiraeus. Its democratic constitution, suppressed under Persian rule, was restored by Alexander the Great, and the name Amisos was resumed. After being incorporated in the Pontic kingdom, perhaps by Mithridates II, it was adorned and enlarged, especially by Mithridates VI Eupator, who built a walled satellite-town called Eupatoria at a certain distance from the main city (to be distinguished from the inland Eupatoria refounded by Pompey as Magnopolis). Eupatoria was destroyed by Lucullus in 71 B.C. and Amisos was largely burnt and pillaged though subsequently restored by Lucullus, who freed the city and extended its territory. In the winter of 48-47 B.C. Amisos fell to Pharnakes II but only after long resistance, in recognition of which Caesar confirmed the city's freedom. A tyrant imposed by Antony ca. 36 B.C. was removed by Octavian in 31 B.C., and the grant of freedom was renewed.

The site of the Greek, Roman, and Byzantine city (Eski Samsun) was on a massive headland NW of the modern city, bounded on two sides by the sea and cut off on the W by the ravine of the Kürtün Irmaği. It was thus virtually a peninsula, with a fine view over the great bay between the deltas of the Kizil Irmak (Halys fl.) and Yeşil Irmak (Iris fl.), and with an easily defended approach from the S. In the 19th c. the remains of walls and semicircular towers on the acropolis were reported and 2 km inland a temple with columns and relief sculpture, from which fragments were taken to adorn the residence of the governor of Samsun. Abundant surface traces of the city (architectural debris, pottery, etc.) were said to extend more than 1 km inland. Although no standing buildings survive, there are several underground cisterns, and the steep sides of the headland contain rock-cut tomb chambers. Today the ancient site is occupied by military installations, and access to the site is restricted. A large signed mosaic of Achilles and Thetis, recently discovered, is now on display in Samsun. There was no natural harbor; the city's commercial prosperity rested solely on good communications with the hinterland. The ancient anchorage lay N of the modern one, close under the headland, and was protected by two moles.

BIBLIOGRAPHY. W. J. Hamilton, *Researches in Asia Minor, Pontus, and Armenia* (1842) I 290-91; V. Cuinet, *La Turquie d'Asie* (1890) I 102; F. & E. Cumont, *Studia Pontica* II (1906) 111-17ᴾ; J.G.C. Anderson et al., *Studia Pontica* III.1 (1910) 1-25. D. R. WILSON

AMITERNUM (San Vittorino) Latium, Italy. Map 16. A town in fertile country at the foot of the Gran Sasso, ca. 135 km by road NE of Rome. Livy (10.39.2 = 293 B.C.) also records an otherwise unknown Amiternum in NW Samnium. Traditional cradle of the Sabine nation, Amiternum was fully Roman by the 2d c. B.C. The historian Sallust was born here in 86 B.C. Under the Empire it flourished, became an episcopal see, and remained such in mediaeval times. It ceased to exist ca. A.D. 1250 when

its population migrated to newly founded Aquila, some 8 km to the SE.

The modern village, whose romanesque church embodies ancient Roman materials, occupies the ancient citadel. Ruins show that the town stood mostly at the foot of the hill. The theater is E of the road running N: its walls of (Augustan ?) quasi-opus reticulatum survive; its cavea (54 m in diameter) had two tiers of stone seats, the lower with 18 rows divided into sections by three radial stairways; its scaena has mostly disappeared. The amphitheater lay outside the town across the river Aternus to the W: remains of two circumambient corridors, each with 48 arches, reveal its elliptical perimeter (external axes: 78 x 63 m): the much repaired, brick-veneered walls date from ca. 100 A.D. Remains also exist of baths and an aqueduct (Tiberian ?).

Antiquities include a celebrated calendar, the Fasti Amiternini (now at Aquila), and sepulchral slabs of ca. A.D. 50 with gladiatorial scenes in local style (now at Chieti).

BIBLIOGRAPHY. L. Franchi et al., *Monumenti di Amertino* (= *Studi Miscellanei del Seminario di Archeologia e Storia dell'Arte*, X, 1963-64) (1966)MPI.

E. T. SALMON

AMLAIDINA, *see* LAZU

AMMAEDARA (Haidra) Tunisia. Map 18. One of the largest and most imposing sites of Tunisia is situated on the Algerian frontier at the crossing of the great route of penetration toward the interior from Carthage to Theveste, with the route connecting the basin of the High Medjerba to that of the Foussana. The station commanded access to the mountainous confines: the first camp of the third Augustan legion, it became a colony under the Flavians from the time of the transfer of this legion to Tebessa (then later on to Lambasa) and again took up its military role under the Byzantines, who constructed important fortresses there.

The remains reveal several centuries of occupation—Roman, Vandal, and Byzantine. Visited by travelers in the 18th and 19th c., the site was explored by Saladin, who described and sketched the principal monuments; and by Cagnat, who called attention to their visible inscriptions. Sadoux made a survey of certain edifices described by Gsell. Sporadic borings were carried out before the excavations in 1909 and between 1930 and 1940 when clearance was limited to several buildings only. What little excavation there has been has not been completely published. The monuments standing or unearthed are few in number for the extent of the site.

On the right bank of the wadi there is a small triumphal arch with engaged piers hollowed out of two square niches; and on the right bank, E of the town, stands a fine triumphal arch with engaged piers at the side of two projecting parts, each made up of two Corinthian columns supporting a complete entablature upon which is carried a long inscription dedicated to Septimius Severus. In the Byzantine period this arch was transformed into a small fort.

There were numerous cemeteries on the outskirts, especially at the gates and the starting points of the great roads of the city. The most important extends to the foot of the great triumphal arch. Excavated in 1909, it has revealed epitaphs of the legionnaires of the Flavian era.

Several important mausolea were found, one hexagonal with two floors, another garlanded, and the largest, tetrastyle, rose above a rectangular foundation.

Several meters from the road and from the building of the ancient customs station, stood a large tetrastyle temple, thought to be the capitol. The foundations and

one lone column have survived. In front of it was the forum, a large paved enclosure known since the 19th c., excavated in 1934, and still unpublished.

Farther E, a square court bordered by small rooms, excavated at the same period, appeared to be a market. To the N, only partly uncovered, is a large bath. All these monuments are still unpublished. The building with troughs to the NE was once considered a church but the identification of it is still puzzling, as is that of the monument with the "windows." The theater, partially excavated in 1926, resulted in the discovery of numerous statues and inscriptions indicating restorations.

Monuments of the Christian period include basilicas: The most remarkable is that of Melleus so-called, alongside the modern road, 100 m W of the ancient customs station. The church of "Candidus" outside the Roman town in the middle of the necropolis is 150 m SW of the arch of triumph. The Vandal Chapel, situated on the outskirts of the site, is one of the oldest monuments known at Haidra.

The monument par excellence of the Byzantine period is the citadel, constructed under Justinian. An important irregular quadrilateral with multiple towers, it extends all over the S slope of a small hill as far as the wadi.

A little farther to the S but on the other side of the encircling wall, there is another small church, also excavated but remaining unpublished.

BIBLIOGRAPHY. Piganiol in *MélRome* (1912) 69-229PI; S. Gsell in *RevTun* (1932) 277-300P; Y. and N. Duval in *MélPiganiol* 2 (1966) 1153-89; *VII congrès d'archeol. chret. Treves* (1965) 473-78; *CRAI* (1968) 321; P.-M. Duval in *CRAI* (1969) 410PI; for the fortress, see C. Diehl, *Afrique byzantine* (1896). A. ENNABLI

AMMAN, *see* PHILADELPHIA

AMMOTOPOS, *see* LIMES, GREEK EPEIROS

AMNATOS Mylopotamou, Crete. Map 11. A small Graeco-Roman town 14 km E of Rethymno. The settlement stands on a flat-topped hill and covers approximately 2 hectares. Walls of domestic dwellings can be traced on the settlement site, while several rock-cut tombs can be seen in the face of the cliff bounding the settlement on the E. At least one of these appears to be of Roman date, but sherds from the settlement site indicate occupation from the Classical period onward.

BIBLIOGRAPHY. M.S.F. Hood, P. M. Warren, & G. Cadogan, "Travels in Crete, 1962," *BSA* 59 (1964) 67-69M. K. BRANIGAN

"AMNISOS," *see* KARTEROS

"AMNISTOS," *see* SÖĞÜT

AMORGOS Greece. Map 7. Island SE of Naxos with three areas of habitation, centering on Aigiale (modern Vigla), Minoa (Katapola), and Arkesine (Kastri). Many Early Bronze Age burials and rich grave goods have been known since the 19th c., and recently neighboring islets, Ano Kouphonesi, Donousa, Herakleia, Keros, and Schoinoussa have yielded extensive finds. Donousa also had a fortified Geometric settlement.

The Greek inhabitants may have come from Samos and perhaps Naxos. The Amorgians participated collectively in the Athenian Empire from 437 B.C. on, and in the Second Athenian Confederacy (Athens garrisoned Arkesine ca. 357); they issued coins (cf. Lambros) and certified amphoras, and their cloth was especially fine. The Battle of Amorgos ended the Lamian War in 322.

Amorgos belonged at various times to the Island League, and was later attached to the Roman province of Asia, though the island enjoyed autonomy which was reaffirmed by Antoninus Pius. It was a place of exile under the Julio-Claudian emperors. Each of the three cities had an independent constitution and magistrates at least from the 4th c. on, and in the late 3d c. B.C. a Samian settlement existed at Minoa and a Milesian settlement at Aigiale. The Naxian settlement at Arkesine is not certainly attested until Imperial times.

Extensive remains have been recorded: architectural, sculptural, ceramic, and epigraphic, from prehistoric to late Roman times, and finds continue. So-called Hellenic towers and Roman tombs appear especially in the center and E of the island, while at Arkesine, in the W, Greek walls surround an acropolis. Remains of temples are cited from Minoa and Aigiale, but no systematic descriptions have been published. Some finds are in the Katapola museum, others in Syros or Athens.

BIBLIOGRAPHY. *SIG* 193; Tac. *Ann.* 4.13,30; Plut., *Dem.* 11.3; Poll. 7.74; St. B & *Souda* s.v.; schol. Dionys. Per. 525; P. Lambros, "Sur un Symbole . . . ," *BCH* 1 (1877) 216-19, cf. *ArchEph* (1870) 352-58; T. Bent, *Aegean Greece* (1885) 469-501; G. Deschamps, "Fouilles dans l'île d'Amorgos," *BCH* 12 (1888) 324-27; cf. 13 (1889) 40-47; C. Tsountas, "Kykladika," *ArchEph* (1898) 137-212[I]; *BSA* 12 (1905-6) 157[I] (Hellenic towers); J. Delamarre, *IG* 12, 7 (with bibl.); W. Ruppel, "Zur Verfassung und Verwaltung der amorginischen Städte," *Klio* 21 (1927) 313-39; L. Robert, "Les Asklepieis de l'Archipel," *REG* 46 (1933) 423-42, esp. 437; J. Vanseveren, "Inscriptions d'Amorgos et de Chios," *RevPhil* 11 (1937) 313-47[I]; P. Zapheiropoulou, *AAA* 4 (1971) 210-16[PI]; id., *Deltion* 24 (1969) Chronika 390-93[P]; C. Renfrew, *The Emergence of Civilization* (1972) 520-23, 534-35, cf. 509. For reports of finds: *JHS* 71 (1951) 251; ibid. 82 (1962) Arch. Rep. 22; *AthMitt* 76 (1961) 115-20, cf. n. 1; *Praktika* 1960 (= 1966) 268-72.

M. B. WALLACE

AMOS (Hisarburnu) Turkey. Map 7. A Rhodian deme in Caria 11 km S of Marmaris, probably attached to the city of Lindos. Aischines owned land there (*Ep.* 9; cf. 12.11) and refers to its fertility; this is confirmed by a series of land leases found at Hisarburnu and dating from about 200 B.C. These fertile estates probably lay on the plain near Gölenye, a few km to the N. The inscriptions show that Amos had a board of hieromnamones and that the principal deity was Apollo, with the otherwise unknown epithet Samnaios.

The acropolis has a fortification wall in coursed polygonal masonry, apparently dating to the early Hellenistic period and still standing 3 or 4 m high, with towers and a gate on the N. Inside it are the foundations of a small temple in antis about 13 m long, which may be that of Apollo Samnaios. Amos was one of the three Peraean demes which had a theater; it is small but fairly well preserved. The analemmata stand 5 m high, and the foundations of the stage building survive, divided into three compartments. The site has never been excavated.

BIBLIOGRAPHY. A. Maiuri, *Annuario* 4.5 (1921-22) 415-19; P. M. Fraser & G. E. Bean, *The Rhodian Peraea* (1954) 6-24, 125-26; Bean, *Turkey beyond the Maeander* (1971) 158-59.

G. E. BEAN

AMPELUM (Zlatna) Alba, Romania. Map 12. Seat of the imperial gold mining administration, important commercial center, and probably customs office, the ancient town spread SE of the present town as far as Pătrînjeni. The remains of ancient gold mining operations can be seen even today: there are traces of buildings, and

of a rectangular water reservoir and its supply channels ca. 4 km from Zlatna, on the NW slope of Mt. Breaza.

The settlement, epigraphically attested from the time of Trajan, was the seat of the procurator of the gold mines, M. Ulpius Hermias (*CIL* III, 1312), whose epitaph was found here. During the reign of Septimius Severus the town became a municipium (*CIL* III, 1308, 1293). It has not yet been systematically investigated.

The town had economic and administrative connections with Apulum (Alba Iulia) and a great many mining settlements developed around it. The area was defended by detachments of Legio XIII Gemina and by a Numerus Maurorum Hisp.

In the Botes and Corabia hills, incineration necropoleis, both of colonists and of Dacian natives, have been investigated.

Rich epigraphical and archaeological material have been found; many inscriptions refer to the organization of gold mining operations, and to the religious beliefs of the miners, who were ethnically heterogeneous. The archaeological material is in the History Museum of Transylvania in Cluj and in the Alba Iulia Regional Museum.

BIBLIOGRAPHY. D. Tudor, *Oraşe, tîrguri şi sate în Dacia romană* (1968) 183-90; D. Protase, *Riturile funerare la daci şi daco-romani* (1971) 104-7.

L. MARINESCU

AMPHILOCHIA, *see* LIMNAIA

AMPHIPOLIS Thrace, Greece. Map 9. City in the Edonian region, on the E bank of the river Strymon, about 4 km N of its estuary. The city was built on a level plateau dominating the surrounding country, on the SW slope of the Pangaium range and at the point where the Strymon makes a 180° curve before flowing into the Aegean. In 497 B.C. Histiaeus, the tyrant of Miletos, and his son-in-law Aristagoras attempted to colonize the site, but they were driven back by the Edonians (Hdt. 5.23.124ff; 7.114ff). A new attempt by the Athenians to colonize the area in 465 B.C. ended in failure (Hdt. 9.75, Thuc. 1.100, 4.102). In 437 B.C. Agnon, son of Nicias, succeeded in founding Amphipolis on the site of the Nine Roads, as the area was formerly called, using as a base the old Persian fortress at the mouth of the river Eïon, which became a trading port of the Athenians in 476 B.C., after its conquest by Kimon (Thuc. 4.102).

The Spartan general Brasidas, marching from Chalkidike in 424 B.C., easily conquered the city because of its mixed population and treason on the part of its Argilian colonists. The intervention of Thucydides, "general over Thrace," with seven triremes, resulted in the rescue of only the Eïon. The expedition of the Athenian demagogue Kleon with strong forces in 422 B.C. did not succeed in breaking off Amphipolis from the Lakedemonians. In the battle that ensued in front of the walls, the generals Brasidas and Kleon were killed. Brasidas was buried within the city walls and honored as a hero and founder with annual games and sacrifices (Thuc. 5.6-11).

In spite of repeated efforts by the Athenians, Amphipolis remained autonomous until 357 B.C., when it was conquered by King Philip II of Macedon. During Alexander the Great's campaign to Asia in 334 B.C., the city was used as a naval base, and his fleet gathered in the waters of the Strymon from its estuary to Lake Cercinitis (Arr. *Anab.* 1, 2.3). Alexander the Great's three most celebrated admirals, Nearchos, Androsthenes, and Laomedon, were natives of Amphipolis. During the Hellenistic period it was a Macedonian city, a fortress, and one of the royal mints where Philip II's famous gold staters were coined.

After the battle of Pydna (168 B.C.) Emilius Paulus conquered the city. A council constituted of Romans and 10 select representatives of Hellenic cities met there to decide on the fate of areas of the Macedonian kingdom. Macedonia was divided into four districts, the merides, and Amphipolis was declared capital of the first district (Plin. HN 4.38). Coins minted here in the period 168-146 B.C. carry the inscription ΜΑΚΕΔΟΝΩΝ ΠΡΩΤΗΣ. The city's prosperity lasted through Roman times, and the great Roman Via Egnatia passes through Amphipolis. It is not known when the city was deserted, but it is probable that it was destroyed during the Slavic incursions of the early 9th c. During Byzantine times the area was known as Popolia.

During the Balkan wars of 1912-13 fragments of a large statue were uncovered on the W bank of the Strymon near the present-day bridge. Excavation of the site revealed foundations of a structure which carried a pyramid-shaped base for a lion. The statue was reconstructed and reerected in 1936 on a contemporary base built with ancient architectural material. The lion of Amphipolis belongs to a large funeral monument, influenced by the architecture of the Ionian tumuli, very probably that of Alexander the Great's admiral, Laomedon. It is dated from the last quarter of the 4th c. B.C.

A large necropolis of Hellenistic times was excavated systematically in the N of the city, as well as graves outside it, located singly and in groups. A total of about 440 graves of various types (pit-shaped, tile-roofed, box-shaped, sculptured underground) have been studied. Three "Macedonian" graves built with stone-plinths of limestone and with arched roofs, found N and E of the city, consist of an entrance, a death chamber, and often an antechamber. There are built-in beds for the deceased. The beds of Macedonian grave I, which dates from the second half of the 3d c. B.C., are decoratively painted with dionysiac forms, animals, utensils, etc. Another box-shaped grave of Hellenistic times is decorated with water birds flying among flower garlands.

The graves yielded terracotta figurines, pots, tombstones, and gold jewelry fashioned into wreaths of oak or olive leaves, diadems, earrings, rings, necklaces, and charms. The gravestones cover the period from the end of the 5th c. B.C. to Roman Imperial times. They picture isolated forms: older men, suppers for the dead, scenes of the reception of the dead, or scenes of everyday life.

Trial excavations have uncovered parts of habitations of the 4th c. of the Hellenistic and Roman periods. In a house of the Roman period a mosaic floor depicts the Rape of Europa. On the edge of a deep ravine in the hill of the present-day village, walls of a structure, in strict isodomic style, remain. A dedicatory inscription identifies the building as the Temple of Clio. Of the fortifications known from Thucydides' account (4.102, 103; 5.10), a large section of the wall was found in the part of the city farthest W. On the crest of a line of hills in the SE of the city, stone plinths of a long wall directed toward the river are preserved, as are small sections of wall in the E and N section.

On the site of "Bezesteni" in the center of the city, the stylobate of a large stoa of the Roman or Early Christian period was excavated for a length of 53.50 m. Its marble columns (five Ionic and one Doric) come from more ancient buildings. In the same region four Early Christian basilicas were uncovered. Two of these, which were excavated in large part, have very beautiful multicolored mosaic decorations. Mosaic floors depict rich geometric motifs, fountains, pots, and plants as well as a large number of fish and various birds and animals, both wild and tame. Neither the agora nor any of the large temples of the city known from ancient sources have been uncovered.

BIBLIOGRAPHY. P. Perdrizet, "Un Tombeau du Type Macédonien au N. O. Du Pangée," BCH (1898) 335ff; "Études Amphipolitaines," BCH (1922) 36ff; J. Papstravru, "Amphipolis Geschichte und Prosopographie," Klio Supplement 37, Vol. 24 (1936); O. Broneer, The Lion Monument at Amphipolis (1941); D. Lazarides, "Fouilles dans La Région du Pangée," Huitiéme Congrés International d'Archeologie Classique (1963) 293ff; K. Pritchett, Studies in Ancient Topography (1965) 30-48.

D. LAZARIDES

AMPHISSA (Salona), see WEST LOKRIS

AMPSANCTUS (Rocca San Felice) Campania, Italy. Map 14. At this place in the Hirpine country a sanctuary of Mephitis (Pliny HN 2.208) stood near a volcanic spring that constantly boils with the release of noisome gases. There are no remains of the sanctuary except votive material, including interesting wooden figures, now in the Museo Irpino at Avellino. The coins come from mints all over S Italy and show the shrine was venerated from the 5th c. B.C. to the 2d c. A.D. Vergil (Aen. 7.563-71) sets the descent of Allecto to the Underworld here.

L. RICHARDSON, JR.

AMPURIAS, see EMPORION

AMRÎT, see MARATHOS

AMWAS, see EMMAUS

AMYKLAI Achaia, Greece. Map 9. According to Pausanias, an "Achaian" or pre-Dorian stronghold, incorporated by conquest as the fifth village of Sparta probably early in the 8th c. B.C. Excavation has been almost entirely confined to the hill of Haghia Kyriaki about 5 km S of Sparta. The prehistoric settlement, which spanned the entire Bronze Age, was concentrated on the SE slopes; the historical site may have extended in an arc from N of the hill to modern Amyklae.

A little way down the hill, immediately outside and below a terrace wall, a small stratified deposit, composed of debris accumulated discontinuously between the Byzantine and Early Mycenaean periods, has been identified.

The Sanctuary of Apollo was laid out in the 8th c. Its centerpiece was the "tomb" (presumably an earthen tumulus) of Hyakinthus, a pre-Greek divinity whose cult was conflated with that of Apollo in the annual festival of the Hyakinthia. In the 7th or early 6th c. a 15 m-high statue of Apollo was fashioned in the form of a cylinder with arms (holding spear and bow) and helmeted head. About 550 B.C. the face of Apollo was plated with Lydian gold, a gift from King Croesus, and shortly thereafter Bathykles of Magnesia designed the Doric-Ionic complex later known as the "throne" of Apollo. The cult statue was set on an altar faced with stone reliefs depicting mythological scenes; similar reliefs decorated the interior and exterior friezes of the surrounding superstructure, whose main entrance was formed by four half-columns crowned by console capitals. The rich archaic dedications include bronze vessels and figurines, terracotta figurines (mainly female), and a few lead and ivory pieces; pottery was comparatively scarce. A contemporary deposit of over 10,000 dedications to Alexandra-Kassandra has been excavated at Haghia Paraskevi nearby; these and sporadic finds from the neighborhood confirm the evidence of Haghia Kyriaki that Amyklaean material culture, like that of Sparta, reached its zenith in

the 7th and 6th c. There is nothing noteworthy among the later finds.

BIBLIOGRAPHY. Paus. 3.10.8, 3.16.2, 18.6-19.6; Strab. 8.5.1; Polyb. 5.19.1.

G. Hirschfeld in *PW* I (1893) 1196-97; E. Fiechter, "Amyklae. Der Thron des Apollon," *Jahrbuch* 33 (1918) 107-245; *Gnomon* 2 (1926) 120; *ArchAnz* 41 (1926) col. 424; E. Buschor & W. von Massow, "Vom Amyklaion," *AthMitt* 52 (1927) 1ff; E. Vanderpool, "News Letter from Greece," *AJA* 61 (1957) 283; *Deltion* 16 (1960) 102-3[1]: *Ergon* (1961) 172-74. P. CARTLEDGE

AMYZON (Mazı n Kalesi) Turkey. Map 7. In the hills of Caria 15 km NW of Alinda (Karpuzlu). Called by Strabo (658) a peripolion of Alabanda and of less account; mentioned also by Pliny, Ptolemy, Hierokles, and in the Byzantine bishopric lists. In the 3d c. the city was allied first with the Ptolemies, then with the Seleucids; in the 2d c. it concluded an alliance with Herakleia under Latmos. On one occasion it sent a delegation to the oracle at Klaros. The rare coins are Hellenistic and Imperial.

A stretch of the city wall stands 6 m high in excellent isodomic ashlar, and inside it are one or two ruined and unidentifiable buildings, also a row of a dozen large vaulted underground chambers, apparently storerooms. Outside the city is the poorly preserved temple of Artemis, dating from the time of the Hekatomnids, and built on a series of terraces. The temple was in the Doric order, 16 by 5 m, and an architrave block has been found bearing a dedication by Idrieus. The cult, with which Apollo was associated, dates back to the 6th c. The numerous inscriptions found are not yet published.

BIBLIOGRAPHY. L. Robert, *CRAI* (1953) 403-15.
 G. E. BEAN

ANAGNI, *see* ANAGNIA

ANAGNIA (Anagni) Italy. Map 16. The capital of the Ernici in the valley of the Sacco (Trerus) at an elevation of 460 m. In 305 B.C. the Ernici were finally defeated by Rome (Livy 9.43.24). The city later became a civitas without suffrage, and by the time of Cicero (*De Dom.* 81) it was a municipium.

In the pre-Roman period the city must have extended slightly beyond the area covered in the Roman era. Inside the enclosing wall in the S part of the city several tombs from the second half of the 4th c. B.C. are of great importance for the dating of the great city wall in opera quadrata, which is largely preserved. Within it may be distinguished several brief stretches of very fine polygonal work, which must be dated to the period of the city's independence. The three sanctuaries in the city probably date from the same period. One of these was dedicated to Venus Libitina.

The walls from the Roman period are datable to the end of the 4th c. with various rebuildings, among which are the extensive terraces called the Arcazzi. A large foundation datable to the age of Sulla must have provided an artificial level for the forum above. In the suburbs has been found a large votive deposit of the late Republican era in connection with a sanctuary perhaps dedicated to Ceres. There are also remains probably of the Compitum Anagninum (mentioned in the Itineraries) on the Via Latina and the Via Labicana (cf. also Livy 26.4.12) and of various villas, among them the Villa Magna built by Septimius Severus (*CIL* x, 5909).

BIBLIOGRAPHY. R. A. De Magistris, *Storia di Anagni* (1889); P. Zappasodi, *Anagni attraverso i secoli* (1908); M. Mazzolani, *Anagnia* (Forma Italiae) (1969).
 F. CASTAGNOLI

ANAMUR, *see* ANEMURIUM

ANAPE, *see* GORGIPPIA

ANAVARZA, *see* ANAZARBOS

ANAZARBOS Cilicia Campestris, Turkey. Map 6. On the right bank of the Sumbas Çay, a tributary of the Ceyhan (Pyramos), ca. 40 km NE of Adana. Probably subject earlier in the 1st c. B.C. to the dynasty of Tarcondimotos, who ruled from Hieropolis Castabala, the city was refounded in 19 B.C., following a visit by Augustus, as Caesarea by Anazarbos. Such was its importance and subsequent prosperity that during the 3d c. it was the keen rival of Tarsus, the provincial metropolis, and it claimed the same grandiloquent honorific titles, even to the extent of naming Elagabalos in 221 as demiurgus of the city. By way of revenge, Tarsus later chose Alexander Severus to hold the same office there. During the reorganization of the provinces under Diocletian, Anazarbos was confirmed as metropolis of Cilicia Secunda; but after a devastating earthquake in the 6th c. it was again refounded, this time as Justinianopolis. After its capture and occupation by the Arabs, Anazarbos (now renamed 'Ayn Zarba) was fortified in 796 by Harun-ar-Rashid; but the city was conquered for Byzantium by Nikephoros Phokas in his campaign of 962. Later, in the 12th c., the place was the temporary capital of the Kingdom of Little Armenia, and its life ended only with its fall to the Mamelukes in 1375.

The acropolis of Anazarbos, an imposing limestone outcrop ca. 200 m high, rises like an island out of the surrounding plain, and it was immediately at the foot of its precipitous W face that the walled city was founded. The lower Roman courses of these walls and their later mediaeval accretions are visible to this day. Outside the city, and less than a km S of it, is the elliptical amphitheater (part freestanding and part backing onto the crag), in which, according to the circumstantial and topographically accurate account in *Acta Sanctorum*, Tarachus, Probus, and Andronicus were martyred in the persecutions. NE of this amphitheater is the stadium with a central concrete spina and rock-cut terraces for spectators, a theater with a wide vista W over the plain, and an extensive necropolis. From behind the theater a rock stairway gives access to the summit of the crag on which stands the massively imposing fortress, nearly 1 km long from N to S, where the Byzantine and Armenian ramparts and military quarters stand in part on Roman foundations. Zeus, as the Storm-god, was certainly worshiped at Anazarbos; and as city coins exist with the god's bust against a fortress-crowned rock, a castle must have existed on the crag from Roman times at least. At the S end of the main street, which was flanked by continuous colonnades, is a magnificent triumphal arch of probable Severan date. On its S facade, each of three openings was emphasized by a pair of black granite columns, above which was a frieze of "peopled" acanthus scroll-work. To either side of the high central arch on the N facade was a niche for statuary.

N of the triumphal arch, the cardo is traceable for just under 1 km where it crosses the line of the probable decumanus, another street flanked by columns of reddish conglomerate. As in other Cilician and Syrian cities, some of the columns carry brackets, probably to support statuary. Some 220 m NW of the street crossing is a bath building of concrete faced with brick. From 450 m N of the probable limit of the mediaeval city wall, a fine aqueduct dedicated in A.D. 90 to Domitian by the people of Caesarea (Anazarbos) runs NW over the plain to the headwaters of the Sumbas Çay. E of arches farthest S

is evidence of a huge decastyle Corinthian temple, very possibly the one featured on an Anazarbene coin of Marcus Aurelius and Lucius Verus.

BIBLIOGRAPHY. A. Wilhelm & R. Heberdey, *JOAI* (1915) 55-58; A.H.M. Jones, *Cities of the Eastern Roman Provinces* (2d ed. 1971); E. H. King, *Journal Royal Central Asian Soc.* 24 (1937) 234-36; M. Gough, "Anazarbus," *AnatSt.* 2 (1952) 85-160; P. Verzone, "Anazarbus," *Palladio* 1 (1957) 9-25. M. GOUGH

ANCASTER ("Causennae") Lincolnshire, England. Map 24. The Roman settlement at Ancaster lies 29 km S of Lincoln on Ermine Street. The place has long been identified as the Causennae of the *Antonine Itinerary*, but if the Itinerary distances are accepted Causennae should lie S of Ancaster. The settlement lies at the junction of two important routes: the N-S ridge followed by Ermine Street, and an E-W route through the Ancaster Gap. An Iron Age settlement occupied the site at the time of the Roman conquest.

The first Roman occupation of Ancaster took the form of a fort, built not long after A.D. 43 and held until ca. A.D. 70-80. Only a section of the defenses has so far been recovered. After the withdrawal of the army unit a civilian vicus developed, which received its own defenses, probably in the later 3d c. These consisted of a stone wall 2.1 m wide, an earth rampart behind it, and, in the final form, two broad ditches outside (3.6 ha). Projecting towers were built at the angles, probably in the 4th c. Knowledge of the interior is limited. A few pieces of religious sculpture, including a relief of the Matres, suggest a temple or temples. Agricultural buildings are known outside the walls, and an early Anglo-Saxon cemetery immediately outside the S defenses suggests that occupation continued at least into the 5th c.

BIBLIOGRAPHY. E. Trollope, "Ancaster, the Roman Causennae," *ArchJ* 17 (1870) 1ff; C.F.C. Hawkes, "Roman Ancaster, Horncastle and Caistor," *ArchJ* 103 (1946) 17ff. M. TODD

ANCONA Marche, Italy. Map 16. The most important port in Picenum, founded by Syracusans in 387 B.C. on the site of important Picene and Villanovan settlements, and the only Greek colony in this part of Italy. The city stands on a promontory, the easternmost spur of Monte Conero (m. Cunerus), in an arc around an excellent natural harbor artificially improved. The city was taken over by the Romans ca. 268 B.C.; after Philippi and Actium there were deductions of colonists, and the city was inscribed in the tribus Lemonia. It had a flourishing Mediterranean commerce under the Republic and became under the Empire the principal port of Roman traffic with Dalmatia. Trajan undertook improvement of the harbor, notably a new mole, to which an arch bears witness. The city was ultimately destroyed by the Goths after a long struggle.

The most important remains are those of the elegant arch of Trajan of Hymettos marble (A.D. 115), light and graceful in design. Its inscription (*CIL* IX, 5894) is preserved and the original stair descending to the seashore. There are also well-preserved remains of an amphitheater, and substructions of a Greek temple lie under the cathedral in a situation that commanded a panoramic view. This was presumably dedicated to Aphrodite (Catull. 36.13; Juvenal 4.40). The fortifications of the acropolis and the walls of the town on the sea side can be traced with gaps and uncertainties; various ancient buildings, especially horrea in the vicinity of the port and houses higher in the city, have come to light from time to time; and Picene, Hellenistic, and Roman necropoleis have been located and explored.

Antiquities from the province have been assembled in the Museo Nazionale delle Marche. The most important materials are the numerous tomb groups, ranging from Picene graves of the 9th c. down to the Roman period, and including the tombs of Fabriano.

BIBLIOGRAPHY. M. Moretti, *Ancona*, Reale Istituto di Studi Romani (1945)[MPI]; *BPI* 10 (1956) 237-62 (D. Lollini)[PI]; *AA* 74 (1959) 173-78 (B. Andreae); ibid. 85 (1970) 312 (H. Blanck); *Atti del Convengo sui Centri Storici delle Marche* (1968) 221-51[MI].

L. RICHARDSON, JR.

ANCYRA (Ankara) Galatia, Turkey. Map 5. The chief city of the Roman province of Galatia, in central Asia Minor. Its legendary founder was King Midas, but it does not appear in the historical record until the time of Alexander the Great. Until Galatia became a Roman province in 25 B.C., Ancyra remained comparatively insignificant although its commercial importance increased as that of the old Phrygian capital, Gordion, diminished. Throughout the period of the Roman Empire the city flourished, and its importance continued during the Byzantine era when the city was strongly fortified against invasions from the East.

Most of the Roman city has been destroyed by modern Ankara, but some monuments have survived, notably the Temple of Rome and Augustus, the Roman baths and palaestra, and the "Column of Julian."

The temple was octostyle pseudodipteral, with 15 columns down the flanks, four detached columns in front of the pronaos, and two between the antae of the opisthodomos. Only the core of the building still stands, preserved through its later use as a church when the opisthodomos was converted into an apse. The walls of the pronaos carry the Latin text of the Res Gestae Divi Augusti and the S cella wall the Greek, complete except for some areas of damage. Another important inscription, the list of high priests of the koinon of Galatia under Tiberius, stands on the left-hand anta of the pronaos. It has been maintained that the temple was originally dedicated to the god Mên and dates to the middle of the 2d c. B.C., but for both architectural and historical reasons an Augustan date is preferable.

The Roman baths lie to the W of the temple near the site of the old Turkish city gate leading to Çankırı (now destroyed). The baths stood behind a palaestra that was surrounded by a colonnaded portico. Although little of the superstructure survives, the hypocausts and much of the substructure have been excavated and restored. The baths were dated by the excavators to the time of Caracalla, and are notable for their size and for the number of hot rooms, which the city's winter climate made desirable. The palaestra serves as a depot for the inscriptions and architectural fragments from Roman and Byzantine Ancyra. Beside it is a Byzantine burial chamber, decorated with painted frescos. This was excavated near the railway station and re-erected on its present site. The "Column of Julian" stands alone between the baths and the temple. Its attribution to the reign of Julian is uncertain although it is clearly of late Roman date.

The most striking remnant of ancient Ancyra is the Byzantine citadel. The inner fortifications were possibly built ca. A.D. 630 after the city had been recaptured by the emperor Heraclius from Chosroes II. It was restored on several occasions, most notably by the emperor Michael III in A.D. 859. At some undetermined date the outer fortifications were added. The walls are largely built from the debris of the Roman city and are full of architectural pieces and inscriptions. The most impressive section is the W wall of the inner fortifica-

tion where the regular, closely spaced, pentagonal towers give the profile of the blade of a giant saw.

Ancyra's archaeological museums, the Museum of Anatolian Civilizations and the Museum of the Middle East Technical University, contain little from the Roman or Byzantine period but are chiefly of interest to Classical archaeologists for their very rich collections of Phrygian material.

BIBLIOGRAPHY. G. de Jerphanion, "Mélanges d'Archéologie Anatolienne," *Mélanges de l'Université St.-Joseph* 13 (1928) ch. XII-XV[PI]; E. Mamboury, *Ankara, Guide Touristique* (1934)[MP]; D. Krencker & M. Schede, *Der Tempel in Ankara* (1936)[PI], reviewed by E. Wiegand, *Gnomon* 13 (1937) 414-22; N. Dolunay, "Türk Tarih Kurumu yapılan Çankırıkapı hafriyatı," *Belleten* 5 (1941) 261-66; E. Bosch, *Quellen zur Geschichte der Stadt Ankara im Altertum* (1967); M. Akok, "Ankara Şehrindeki Roma hamamı," *Türk Arkeoloji Dergisi* 17 (1968) 5-37[PI]. S. MITCHELL

ANDANCE Drôme, France. Map 23. Situated in Gallia Narbonensis. Some 1500 m S of the modern town is a large country villa with annexes (the only parts to have been excavated), and a garden with a three-lobed pool and an exedra. The garden is supported by a series of eight low arches and flanked to the S by five rooms. The main buildings were probably on this side.

BIBLIOGRAPHY. M. Leglay, "Informations," *Gallia* 24 (1966) 519-20. M. LEGLAY

ANDANOS, *see* BARGYLIA

ANDAUTONIA (Ščitarjevo) Croatia, Yugoslavia. Map 12. A village 7 km SE of Zagreb, where there was a Roman military camp on the road from Poetovio to Siscia on the right bank of the Sava river. The camp later was a municipium in Pannonia Superior, enrolled in the tribus Quirina. The territory belonged to the Illyrian community of Andautonians (*CIL* III, 4008: respublica Andautonensium). The remains include wall paintings, sarcophagi, inscriptions, and an interesting relief of Nemesis. Material is preserved in the Archaeological Museum at Zagreb.

BIBLIOGRAPHY. V. Hoffiller & B. Saria, *Antike Inschriften aus Jugoslawien*, I (1938) 212-18; J. Klemenc, *Archäologische Karte von Jugoslawien, Blatt Zagreb* (1938).
M. ZANINOVIĆ

ANDEDA Pisidia, Turkey. Map 7. At or near Yavuz, formerly Andya, some 24 km N of Korkuteli. The city is known only from coins and inscriptions, except that the Notitiae record a bishop of "Sandida." The location is fixed by the evident survival of the name, and by a decree of the Council and People of the Andedans (*AM* 10 [1885], 337). About a km to the N of Yavuz is a stone marking the boundary between An(deda) and Po(gla). Apart from the fairly numerous inscriptions no remains of the city have been found, and the exact site remains uncertain.

BIBLIOGRAPHY. W. M. Ramsay in *AM* 10 (1885) 335-39; A. M. Woodward in *BSA* 16 (1909-10) 123; G. E. Bean in *AS* 10 (1960) 65-67. G. E. BEAN

ANDEMATUNUM (Langres) Haute-Marne, France. Map 23. Gallo-Roman city a few km from the sources of the Marne on a sturdy scarped spur overlooking the Langres plateau, which acts as a mole dividing the waters of the Saône, the Rhône, the Meuse, and the Seine. Andematunum was also the meeting-point of several pre-Roman roads running E-W and N-S, and the center of the powerful civitas of the Lingones.

It has a long history of human habitation: Neolithic flints and axes and Bronze Age weapons (hatchet, dagger, knives) mark a continuity that fades somewhat in the Iron Age. Nevertheless it is generally admitted that the Lingones, appearing at the time of the conquest to be loyal allies of Caesar, had established themselves on the plateau long before, and had their center in the oppidum of Langres. Their advantageous position after the Roman road network was built, and their privileged status as a federal city (granted them by Caesar) favored the building of a large city. At first part of Belgica, then of Germania Superior, and finally of Lugdunensis Prima, Andematunum was one of the leading cities of E Gaul.

An open city in the Early Empire, Andematunum probably extended a little way beyond the present-day ramparts to the S, but not as far as Saint-Geosme. Some elements of the city plan have been located, but the density of the modern town prevents its complete recovery. The Rue Diderot, however, may lie along the original cardo. The 3d c. invasions brought about some retrenchment on the N and middle sections of the spur, and the hasty erection of a surrounding wall, with many reused blocks. This wall was probably duplicated in the 5th c. by another wall enclosing a wider area. Four gates, more or less modified in the Middle Ages, gave access to the city: to the S, two gates known as the Porte de Moab and Porte au Pain; to the N the so-called Longe-Porte, a few traces of which remain; and to the W the Porte du Marché. This last is the only one preserved, although it is built into the present-day rampart (20 m long; preserved ht. 10.7 m; ht. to the arch soffit 7.95 m). The gate has Corinthian pilasters set between two arches whose archivolts consist of three unequal bands; above is a frieze of arms. The upper section is missing. The date, which is debated, seems to be before the 3d c. The monument probably is a so-called triumphal arch, subsequently included in the Late Empire circuit wall as, it is generally agreed, the Longe-Porte was also.

Inscriptions, blocks from monumental architecture, colossal statues, and various other finds indicate that the site contained many public monuments such as temples, a theater, and baths, but none of these has yet been located with certainty. On the other hand four necropoleis have been found: to the N, on the hillside, to the NE, to the S below the present-day Citadel, and the fourth to the E. Chance finds of mosaics, bas-reliefs, statuettes, inscriptions, thousands of coins, and a considerable quantity of pottery attest the density and prosperity of the settlement. Moreover the wealthy residential quarter, discovered several km from the city on the Baume plateau along with a necropolis filled with grave gifts, should probably be considered in connection with Andematunum.

Excavations at the foot of the present-day rampart at the modern Porte des Auges have recently uncovered a huge complex: three main buildings arranged around a large rectangular courtyard, and also some structures aligned parallel to a road; the walls of these latter structures still stand in places over 4 m high. So far the purpose of the different parts of this complex has not been determined, but the abundant pottery finds and coins indicate an early date, the first half of the 1st c. A.D. This date agrees with the evidence of hundreds of potters' stamps uncovered in chance finds: here the 1st c. is, on the average, four times more frequently represented than the 2d c. Terra sigillata comes from Arezzo (a few samples), but mainly from La Graufesenque and sometimes Lezoux, far more often than from E workshops. Similarly, the most numerous coins are those from the Early Empire, particularly the reign of Augustus.

Most of the finds uncovered at Langres are in local

collections: the Musée des Antiquités Nationales at St. Germain-en-Laye, the Musée du Breuil, and especially the Musée Saint-Didier at Langres have important collections, notably of sculptures and inscriptions.

BIBLIOGRAPHY. S. Migneret, *Précis de l'histoire de Langres* (1835); Luquet, *Antiquités de Langres* (1838); R. Mowat, *RA* 16, 2 (1890) 33, 61; A. Blanchet, *Mél. d'archéologie gallo-romaine* I (1893); A. Roserot, *Dictionnaire topographique du Département de la Haute-Marne* (1903); G. Drioux, *Bacth* (1932-33) 671ff; (1936-37) 481; (1941-42) 429; id., *Bull. Soc. d'Étude des Sciences Naturelles de la Haute-Marne* (1924) 266; (1933) 712, and later issues; P. Ballet, *La Haute-Marne antique* (1971) 167-74; E. Frézouls, *Gallia* 27 (1969) 310-13; 29 (1971) 303-5PI; 32 (1973) 418-21.

E. FRÉZOULS

ANDERIDA (Pevensey) Sussex, England. Map 24. Now several km inland on a hillock overlooking the Pevensey levels, which in the Roman period provided a navigable approach. Apart from a few fragments of tiles stamped CL BR (Classis Britannica) of the 2d or 3d c. A.D., the principal occupation began soon after 340 with the construction of a stone-walled fort belonging to the series of Saxon Shore Forts built to protect the S and E coasts of Britain from pirate raids. The fort is mentioned in the *Notitia Dignitatum* as Anderido or Anderida and was garrisoned by a Numerus Abulcorum. According to the Anglo-Saxon Chronicle the inhabitants of the fort were massacred by Saxon troops in 491. The site was used as a castle during the Norman Conquest and remained sporadically in use until WW II.

The Roman wall, enclosing an irregular oval-shaped area of ca. 4 ha, is 3.6 m wide and built of flint and sandstone rubble faced with coursed greensand and ironstone blocks. Forward-projecting D-shaped bastions, integral with the wall, were spaced so as to provide covering fire to protect all approaches. The main gate lay on the E side between two close-spaced bastions: it was a simple opening 3 m wide, flanked by rectangular guard chambers of which only the foundations now survive. There were two other gates, an S-shaped postern in the N wall and a simple opening through the W wall. Traces of timber buildings have been discovered in the interior.

BIBLIOGRAPHY. L. F. Salzman, *Excavations on the site of the Roman Fortress at Pevensey* (1907); id., *Excavations at Pevensey: second report* (1908); J. P. Bushe-Fox, "Some Notes on Roman Coastal Defences," *JRS* 22 (1932) 60ff; C. Peers, *Pevensey Castle* (1960).

B. W. CUNLIFFE

ANDERITUM or Gabalum (Javols) Lozère, France. Map 23. The chief city of the Gabales, 29 km from Mende, 7 km S of Aumont and Route Nationale 9. It was on the Lyon-Toulouse road and is mentioned in the *Peutinger Table*. The site is at an altitude of 950 m, in a granite basin drained by the Triboulin. The ancient city lies outside the modern settlement.

Finds of gold coins and globular bowls with the inscription SITIO—CARISSIME NATE, AVIANA were noted at the end of the 18th c. During the 19th c. there were a variety of discoveries: a cippus bearing the inscription: D. M. ALBINISE—NATORIS—DOMITIA LVRVNDIA; a circular wall in a field on the right bank of the Triboulin with a milestone 2 m high in the middle of it bearing the inscription: IMP. CM CASS/ANIO LATINO POSTUMO VICTO/P F AUG—PON. MA/XI MOT P. P. COS IIII/CIVIT. CAB; a monolithic limestone tablet with PEREGRI US FECIT on one side, and coins of Augustus, Tiberius, Claudius, Domitianus, Trajan, Hadrian, Antoninus, Marcus Aurelius, and Claudius Gothicus. The remains of a large monument (73 x

23 m) were uncovered on the left bank of the Triboulin. It consisted of a wall surrounding small compartments, and had a floor paved with granite. Among the objects found here were fragments of a colossal statue ca. 6 m high, 73 coins, terra sigillata from Banassac, and painted ware. A badly damaged mosaic was discovered on the right bank of the river, and on the left, 14 cellas decorated with frescos. In the same sector were 43 adjacent compartments in an area covering a little less than a hectare, and a semicircular pool 3 m in diameter and 2.55 m deep. Steps led down to the water.

Excavations since 1937 have followed a wall on the left bank for 30 m, and several fragments of Corinthian capitals have been found. Some long sections of wall were located on the right bank. A rudimentary stratigraphy was noted at the NE corner of the present-day cemetery, down to the 1.8 m level, revealing broken glass, undecorated situlae, amphora sherds, bronze spatulas, needles of bone. Below that level were found Gallic coins, spindle whorls, silex strigils, and a bronze fibula. Another semicircular pool was discovered near the one found previously, and the river quays were located. They are built of large blocks of granite and extend for 90 m. The excavations have yielded over 35,000 objects, including more than 100 intact bowls. The most interesting piece was a lifesize statue of Bacchus. On his left are two casks, a small amphora, and a cornucopia; and on his right a panther with one paw on an overturned vase, and a climbing vine.

Three burned-out strata date the occupation of the site. The earliest contained the great mass of archaeological evidence and is fixed between 140 and 180 A.D. The second dates from the 3d c. The latest is Early Christian. The finds are in a storehouse on the site.

BIBLIOGRAPHY. J.J.M. Ignon, *Mémoire de la Société d'Agriculture de Mende* (1830) 28-31; (1831) 33; (1832) 32; (1839) 171; id., *Annuaire de la Lozère* (1830) 87-90; id., "Notes sur les monuments antiques du Département," *Mémoire de la Société d'Agriculture de la Lozère* (1840-41) 152-75; De More, "Monnaies trouvées à Javols," ibid. (1856) 247-48; id., "Fouilles de 1857," ibid. (1859) 48-53; (1863) 113; id., *Congrés archéologique de France, Mende* 99-110, 210-14, 230; A. de Caumont, *BMon* (1857) 581-83; (1862) 288; Delapierre, "Fouilles 1863," *Bull. soc. d'agriculture de la Lozère* (1864) 337-39; (1866) 23; Laurens, ibid. (1869) 429; (1870) 23 (bridge); Gemer-Durand, ibid. (1882) 142-46; A. Boose, "Monnaies de Javols," ibid. (1890) 106-7; Portal, *Notes historiques et statistiques de Javols* (1890); A. Remize, *Saint-Privat: les fouilles de Javols*; F. Lot, "Recherches sur la population et la superficie des cités remontant à la période Gallo-romaine," *Bibliothèque des Hautes Études* (1950); M. Balmelle, *Répertoire archéologique du département de la Lozère, période Gallo-romaine*; id., *Précis d'histoire du Gévaudan*; id., "Anderitum capitale des Gabales," *Bulletin de la Société des Lettres, Sciences et Arts de la Lozère* (1957) 31-35; id., "Vestiges nouvellement découvertes à Javols," ibid. (1959) 15; C. Morel, "Compte rendu des fouilles faites a Javols en 1937 et 1950," *86e Congrés des Sociétés savantes à Montpellier 1961*; A. Dalle, "Javols, capitale des Gabales," *Lou Païs* (Feb.-June 1968); Walckenaer, "Mémoire sur l'étendue et les limites des Gabali," *Nouveaux*; M. Bouchard, *Histoire des Fouilles de Javols*; F. André, "Notes sur les communes de la Lozère," Archives departementales J. 900 Fonds.

P. PEYRE

ANDESINA, *see* GRAND

ANDIFLI, *see* ANTIPHELLOS

ANDILLY-EN-BASSIGNY Haute-Marne, France. Map 23. Large Gallo-Roman settlement about 20 km NE of Langres, in S Champagne. The site lies near Mont Mercure, which divides the waters flowing to the Mediterranean (the Saône), the North Sea (Meuse) and the English Channel (Marne), and close to the point where the road from Langres to the Rhine crosses that from Chaumont to Bourbonne-les-Bains.

A huge complex has been uncovered, over 140 m long, arranged around a long rectangular courtyard. To the N are some living quarters, to the W several large halls and some rooms used as workshops, and to the S some very complete baths with well-preserved hypocausts; the rooms include frigidarium, tepidarium, caldarium, laconicum, apodyterium, latrine, and others. Digging has begun on some living areas 50 m to the W, at the foot of a hill immediately over the site. Finds have been abundant: tools and various metal objects (an anvil, brick-making instruments, a prisoner's shackle with a double lock), as well as mirrors, lamps, terra sigillata and common ware, coins, and some sculptures. The finds point to continuous occupation until at least the 3d c. A.D. and to further activity, perhaps after some interruption, under Constantine. Abandoned thereafter, the site was taken over by a Merovingian necropolis (6th-7th c.) in which were found weapons, shields and shield-disks, fibulas, and necklace elements.

A certain luxury in construction and decoration is shown by architectural blocks (particularly a large sandstone capital), some multicolored marble facings, many cubes of mosaic, and fragments of wall paintings. No agricultural buildings have yet been found, and the proximity of connecting roads may suggest a road mutatio. Some historians have proposed (without presenting decisive arguments) that the site should be identified with Andesina in the *Peutinger Table*. Perhaps, however, it is simply the residential section of a large villa; although no farm buildings have been uncovered so far, there could be traces in some unexplored parts of the site.

The finds are housed in the Chaumont Museum and especially in a small antiquarium on the site.

BIBLIOGRAPHY. V. Multier, *Bull. Soc. Hist. et Arch. de Langres* 4 (1896) 86ff; P. Ballet, *Cahiers Haut-Marnais* 74 (1963) 108ff; 76 (1964) 1ff; 78 (1964) 97; 82-83 (1965) 110ff; 87 (1966) 133ff; 92 (1968) 1ff; 100 (1970) 27ff; id., *Le site gallo-romain d'Andilly-en-Bassigny* (1970)[PI]; R. Martin, *Gallia* 22 (1964) 320f; E. Frézouls, ibid. 25 (1967) 287[PI]; 27 (1969) 304f; 29 (1971) 299ff[PI]; 31 (1973) 414. E. FRÉZOULS

ANDREEVKA IUZHNAIA Bosporus. Map 5. The site, on a small hill 1.5 km SW of the modern village of Andreevka and 11 km W of Kerch, was first inhabited in the Bronze Age. Excavations have uncovered the remains of modest dwellings and grain pits from a Greek or Hellenized agricultural settlement of the 6th-4th c. B.C. The earliest homes had walls of poorly baked brick or adobe resting on a stone foundation or socle, and the floor of one house was slightly sunk into the ground. In the 4th c. B.C. these separated and isolated homes gave way to the large stone farmstead of a Bosporan Greek consisting of a complex of storage rooms, cattle stalls, and living quarters built around a large interior court. The farmstead complex itself covered an area of ca. 1000 sq. m, and small detached structures and grain pits belonging to the farmstead were found elsewhere on the hill. The farmstead was abandoned in the 3d c. B.C.

BIBLIOGRAPHY. I. T. Kruglikova, "Antichnaia sel'skokhoziaistvennaia usad'ba bliz Kerchi," *Antichnaia istoriia i kul'tura Sredizemnomor'ia i Prichernomor'ia: Sbornik statei* (1968) 206-12; id., "Raskopki sel'skikh poselenii Bosporskogo tsarstva," *Arkheologicheskie Otkrytiia 1968 goda* 307-9; id. & M. A. Romanovskaia, "Antichnye poseleniia u dereven' Andreevka i Novo-Otradnoe," *Arkheologicheskie Otkrytiia 1970 goda* 252-54.
 T. S. NOONAN

ANDROS One of the Cyclades, Greece. Map 11. The farthest N of these islands, lying between Euboia and Tenos. Andros, son of Eurymachos or Anios, gave his name to it; according to another tradition, the name is associated with Andros, to whom Radamanthys gave the island (Diod. Sic. 5.79; Paus. 10.13.3). The Andrians were Ionian descendants. Though dependent on Eretria in the 8th c. B.C., Andros prospered by the next century, and founded numerous colonies. It submitted to Persia in 490, received an Athenian cleruchy in 450-440, and later entered the second Athenian League (378-377). In 200 B.C. it was captured by Pergamene and Roman forces, and the cities mercilessly looted.

Major sites lie in the W part of the island. The ancient center of Andros is located at Palaiopolis, in the middle of the W coast, where there is an acropolis with vestiges of walls on the N side. Sections of walls and one gate are preserved at several points around the city. Ruins of a stoa dated in the 3d or 2d c. B.C. are preserved in the agora. In the city there were a famous Temple of Dionysos, a Fountain of Zeus (Plin. *HN* 2.231; Paus. 6.26.2; Philostr. *Imag.* 1.25) and Temples of Apollo, Hestia, and Athena Ταυροπόλος (Suidas, s.v. Ταυροπόλον). Further to the N is the harbor Γαύρειον (Xen. *Hell.* 1.4.22; Diod. Sic. 13.69). To the NE is Haghios Petros, a village where a Hellenistic tower survives. Ancient iron mines have been reported in the area. Quarries of marble existed in the N part of the island. The important site of Geometric Zagora lies to the SE of Palaiopolis. The settlement, which flourished during the late 8th c. B.C. was fortified with a strong wall. One gate has been found on the S side; the N side is still unexcavated. The town is represented by a complex of rooms and courts. At a central position is a temple (10 x 8 m) consisting of a closed prodomos and an almost square cella which contained a stone altar (?). The temple is almost entirely built of schist, and probably had a flat roof. The plan is reminiscent of the temples at Xombourgo on Tenos and Emporio on Chios. There is an archaeological collection in Andros with sculptures of archaic, Classical, and Hellenistic periods and Geometric ceramic.

BIBLIOGRAPHY. L. Ross, *Reisen auf den griechischen Inseln des Aegaeischen meeres* II (1843) 12ff; Hirschfeld, *RE* I[2] (1894) 2169-71 s.v. Andros; T. Saucius, *Andros* (1914); B. D. Meritt, *ATL* I (1939) 469; A. Cambitoglou, *Praktika* (1967) 103-11; M. Ervin, *AJA* 72 (1968) 381-82; A. Cambitoglou, *Praktika* (1969) 134-38; id., *Zagora* I (1971)[MP]. D. SCHILARDI

"ANDUSIA," *see* ANDUZE

ANDUZE ("Andusia") Gard, France. Map 23. Pre-Roman and Roman settlement in a cross-valley of the Gardon, at a point which commands one of the principal access routes to the Cévennes. It was one of the 24 towns of the Volcae Arecomici, a federation of which Nîmes was the capital (Strab. 4.1.12; Plin. 3.37). Its name is known with certainty from a votive inscription (*CIL* XII, 3362) found in the 18th c. at Nîmes near the sanctuary of the god Nemausus.

The exact site of the settlement is uncertain. The pre-Roman oppidum is perhaps best located on the hill of Castelvieil St-Julien, near Anduze, where numerous artifacts have been found. The Roman town was perhaps at Château-Bourbon, where several inscriptions have recently been discovered.

BIBLIOGRAPHY. *Carte archéologique de la Gaule romaine*, fasc. VIII, Gard (1941) 207, nos. 376-77; "Informations," *Gallia* 20 (1962) 628; 22 (1964) 497-98.
G. BARRUOL

ANEMURIUM (Eski Anamur) later ISAURIA Rough Cilicia, Turkey. Map 6. On the E flank of Cape Anamur, southernmost point of Asia Minor, a mere 64 km from Cyprus. Historical references are few but its existence in Hellenistic times is certain (Livy 33.20). Tacitus mentions an abortive siege in A.D. 52 by the native Cietae (*Ann.* 12.55.2), and a similar threat from inland Isaurians probably accounts for the restoration of the seawall by Matronianus, Comes Isauriae in A.D. 382, mentioned in an inscription. A significant road station and port of call, Anemurium appears constantly in topographic works from Skylax to mediaeval portolans, which refer to it as Stallimur. The coin series extends from Antiochos IV of Commagene to Valerian, but the city's prosperity continued till the mid 7th c. when it was largely, if not wholly, abandoned, probably as a result of the Arab occupation of Cyprus. Sometime in the 12th c. the site was in part reoccupied and the citadel rebuilt as a stronghold of little Armenia, but evidence of a subsequent Seljuk or Ottoman presence is lacking.

The city is divided into an upper citadel and a lower town. The former occupies the actual cape, protected on three sides by steep cliffs and on the landward side by a wall with towers and zigzag reentrants. Both the fortifications and the structures within are of mediaeval date, but masonry of Hellenistic character is visible in places. Covering an area at least 1500 m long from N to S and 400 m wide, the lower town is bounded on the S by the fortification wall of the citadel, on the E by a seawall, still standing in places, and on the W by the higher of two aqueducts constructed on the slopes of the promontory. Only to the N, where the ruins lie buried in sand dunes, are the limits uncertain.

The most striking feature is the necropolis rising up the hillside in the NW quarter of the site. It consists of some 350 individual numbered tombs, dating from the 1st c. A.D. to the early 4th c. They were built in fairly coarse manner of local gray limestone; the interiors were decorated with painted plaster and mosaic. The simplest examples consist of barrel-vaulted chambers on stone platforms with arcosolia along three walls, but other types have developed well beyond this nucleus to incorporate anterooms, side-halls for funerary banquets, second stories, and small courtyards.

In the city proper the principal monuments still recognizable above ground are mainly at the S end of the city and include a large theater, an odeon-bouleuterion, an apsed exedra, perhaps belonging to a basilica, three large baths, and traces of a colonnaded street traversing the city from N to S. Since 1965 two of the baths and the odeon have been cleared and restored. Fine mosaic floors have appeared in both buildings and, most recently, in a palaestra attached to the largest baths. This consists of an open piazza almost 1000 sq m in extent, floored entirely with mosaic of geometric design. None of the structures so far studied in the city appears earlier than the late 2d c. A.D. Buildings of later date include several churches and a small, but well-preserved, bath with mosaic floor of complex design. Finds, for the most part Late Roman or Early Byzantine, are deposited in the Alanya Museum.

BIBLIOGRAPHY. Annual reports in *TürkArkDerg* from 1965; E. Rosenbaum et al., *A Survey of Coastal Cities in Western Cilicia* (1967)ᴹᴾᴵ; E. Alföldi-Rosenbaum, *The Necropolis of Anemurium* (1971). J. RUSSELL

"ANGEIA," see RENTINA

ANGERS (Juliomagus) Maine et Loire, France. Map 23. Near an important ford on the Maine, Juliomagus is believed to have been the original capital of the tribus Andes, and epitomized the provincial Gallo-Roman city. It was occupied from the 1st c. A.D. to the 4th c. and thereafter in the Merovingian period.

In the Late Empire it acquired many public monuments, erected near the great approach roads and on the boundary of the ancient settlement. They consist of an amphitheater to the NE, as well as a circus, a forum, and huge bath buildings to the SW. Towards the end of the 3d c. a fortified rampart ca. 1000 m in circumference was built on top of the rock overlooking the city and the ford. Flanked by round towers, traces of which can still be seen, the wall had two main gates to the E and a postern gate to the W. In the 4th c. the lower city was occupied again, as evidenced by the great polychrome geometric mosaic discovered in the Place du Ralliement. Many objects from ancient Juliomagus are now in the Musée Archéologique St. Jean at Angers.

BIBLIOGRAPHY. A. Guéry, *Angers à travers les âges*, (1913); Pinier, "Deuxième note sur le rempart romain d'Angers," *Revue del l'Anjou* (1914) 5-43; G. H. Forsyth, *The Church of St Martin at Angers* (1953).
M. PETIT

ANGUSTIA (Brețcu) Covasna, Romania. Map 12. Roman camp and civil settlement, at the Oituz Pass, N of Brețcu. The ancient name of the settlement is mentioned by Ptolemy (3.8.4). The camp (188 x 141 m) had a wall, well preserved, with round corner towers. The baths are 100 m from the camp. Cohors I Hispanorum and Cohors I Bracaraugustanorum were stationed here.

In the civil settlement, the finds include Dacian ceramics and the military diploma of a veteran from classis Flavia Moesica, dated June 14, 92 (*CIL* XVI, 37).

BIBLIOGRAPHY. R. Vulpe, "Angustia," *In amintirea lui C. Giurescu* (1944) 551-59; M. Macrea, "Despre rezultatele cercetărilor întreprinse de șantierul arheologic Sf. Gheorghe—Brețcu—1950," *Studii și cercetări de istorie veche* 2.1 (1951) 287-96; D. Tudor, *Orașe tîrguri și sate în Dacia romană* (1968) 279-80.
L. MARINESCU

ANKARA, see ANCYRA

ANNABA, see HIPPO REGIUS

ANNAMATIA, see LIMES PANNONIAE

ANNECY-LES-FINS, see BOUTAE

ANNOUNA, see THIBILIS

ANSE, see ASA PAULINI

ANSEDONIA, see COSA

ANTAKYÉ, see ANTIOCH ON THE ORONTES

ANTALYA, see ATTALEIA

ANTAS ("Metalla") Sardinia, Italy. Map 14. In SW Sardinia in the territory of Fluminimaggiore, to the N of Iglesias, on the Rio Antas. Surrounded by limestone quarries and lead and iron mines worked since antiquity, the site seems identifiable with Metalla on the Tibula-Sulcis road (*It. Ant.* 85; Ptol. 3.3.2.).

The most important monument has been completely

uncovered. It is a Roman temple, datable in its final form to the beginning of the 3d c. A.D., oriented SE-NW and rectangular in plan. It is on a low podium and is entered by means of a flight of steps on the SE. On the exterior, large square blocks of limestone masonry are accurately worked and laid in perfectly regular courses. On the interior, enough remains of the upper level to permit reconstruction of its plan. The pronaos has four columns on the front and two on each side; the cella, in antis, has a limestone pavement covered by mosaic in white tesserae with a band of turquoise-colored tesserae delimiting a narrow quadrangular area in the center. The cella has two symmetrical lateral entrances reached by steps; large squared blocks constitute the foundation of pilasters built against the interior walls to support the roof beams. From the back wall of the cella open two smaller cellae. The architectural decoration includes Doric and Ionic capitals and carved antefixes and gutters with leonine heads. The temple was dedicated to Sardus Pater, who according to the literary sources was considered the son of Hercules and colonizer of the island to which his name was given. In an earlier phase the temple honored a Phoenician god sd, to whom, toward the end of the 6th c. or the beginning of the 5th c. B.C., was dedicated a sanctuary. The principal nucleus consists of an altar open to the sky, surrounded by a series of courtyards and a large external enclosure entered from the SE.

A few hundred meters to the SW of the temple are the ruins of a nuraghic village whose modest dwellings, circular in plan, were later reused by the Romans. Tombs from the Imperial age have been found in the locality called S. Marinedda. The limestone quarries that provided the stone for the temple are at the N extremity of the Antas valley on the slopes of Mount Conca S' Omu. A short distance from the quarries is a rectangular room where fragments of votive sculpture have been found. The material from the excavations is in the National Museum at Cagliari.

BIBLIOGRAPHY. A. Lamarmora, *Viaggio in Sardegna*, II (ed. ital., 1927) 371f; E. Aquaro et al., *Richerche puniche ad Antas*, Ist. di Studi del Vicino Oriente (1969)[PI].

D. MANCONI

ANTEQUERA, see ANTICARIA

ANTHEDON Boiotia, Greece. Map 11. A Boiotian harbor on the Gulf of Euboia, 13 km W of Chalkis and 2 km N of the village of Loukisia, at the foot of Mt. Messapios.

Included in the catalogue of ships of the *Iliad* (2.508), it belonged to the Theban districts until 387 B.C. when it became independent in the Boiotian Confederacy. Destroyed by Sulla at the same time as Larymna and Halai in 86 B.C., it was restored and its harbor rebuilt in the 4th c. A.D.

The site of Anthedon was occupied from Mycenaean times and was still inhabited in the 6th c. A.D. According to ancient testimony, the city was fortified; its agora was planted with trees and flanked with a double portico. Inside the city was a Kabeirian temple and, close by, another dedicated to Demeter and Kore, while outside the city walls, to the SE, was a Temple of Dionysos. The gymnasium was consecrated to Zeus Karaios and to Anthas, the eponym of the city. Partial excavations have been conducted.

The rampart, which no doubt is Hellenistic, started from the N mole, then ran along the coast for 225 m going W, circled the city to the W and S, reached the coastline NE of the acropolis and followed the slope of the acropolis N down to the mole E of the port. The city covered an area ca. 550-650 m from N to S and

600 m from E to W. To the NE the acropolis overlooks the sea and the harbor from a height of some 20 m. Excavations there have yielded only two small crude walls and some bronze objects of the 12th-11th c. The port, which doubtless is very old, was rebuilt under the Late Empire. Its nearly circular basin (130 x 120 m) is protected to the N and E by two moles built of large blocks, and surrounded to the N, W, and S by quays along a 370 m length. The S quay is porticoed. To the S of the portico the remains of an Early Christian basilica have been excavated; it is apsed and paved with polychrome marble. The little temple (ca. 10 x 6 m) discovered SE of the city in 1889 may be that of Dionysos.

BIBLIOGRAPHY. J. C. Rolfe in *AJA* 5 (1889) 443-60; 6 (1890) 96-107[PI]; J. G. Frazer, *Paus. Des. Gr.* v (1898) 92-95[P]; K. Lehmann-Hartleben, *Die antiken Hafenanlagen, Klio* 14 (1923) 77-78, 105; H. Schläger, D. J. Blackman, & J. Schäfer, "Der Hafen von Anthedon," *Arch. Anz.* (1968) 21-102[MPI]; N. Papahadjis, *Pausaniou Hellados Periegesis* v (1969) 125-28[MP]; S. C. Bakhuizen, *Salganeus and the Fortifications on its Mountains* (1970).

P. ROESCH

ANTHEDON later AGRIPPIAS (Khirbet Teda) Israel. Map 6. A Greek city 3.2 km N of Gaza on the Mediterranean coast. Pliny (*HN* 5.14), who writes that Anthedon was an inland town, was probably mistaken. The city was conquered by Alexander Jannaeus (Joseph., *AJ* 13.395), but freed by Pompey in 64 B.C. Augustus gave the city to Herod (*AJ* 10.217), who renamed it Agrippias or Agrippion in honor of Augustus' son-in-law Marcus Vispanius Agrippa. On coins struck from the times of Elagabalus to Septimius Severus, however, the old name reappears.

BIBLIOGRAPHY. F. M. Abel, *Géographie de la Palestine* II (1938) 244-45; M. Avi-Yonah, *The Holy Land* (1966) 70, 89, 100, 150.

A. NEGEV

ANTHEDOS Corinthia, Greece. Map 11. Anthedos, a port on the Saronic Gulf, is named only by Pliny (*HN* 4.5) in a list of significant coastal toponyms: the Spiraion promontory and the ports Anthedos, Boukephalos, and Kenchreai. The progression in the list is from S to N. The narrow cove at the mouth of the Sellondas river (ancient Sellanys) on the S side of the Bay of Sophikon is the probable location of the harbor.

BIBLIOGRAPHY. H. N. Fowler & R. Stillwell, *Corinth I, i: Introduction. Topography. Architecture* (1932) 20-23; J. R. Wiseman, *The Land of the Ancient Corinthians* (forthcoming).

J. R. WISEMAN

ANTHÉE Belgium. Map 21. A Gallo-Roman villa, one of the largest in Belgium, excavated between 1863 and 1872 according to the rather summary methods of the time. We know the buildings in their final state, but it is impossible to establish time divisions in their construction. The group of buildings consisted of three courts, each surrounded by walls. In the middle of the SW court stood a luxurious H-shaped dwelling more than 106 m long. The villa had 90 rooms and chambers on the ground floor and probably had a second story. Several rooms had hypocausts. To the NE was a bath building. The NW enclosure contained no buildings and probably was used for livestock. Finally, the SE court contained several appended buildings in two parallel rows. Certain of these also had been used as dwellings (there were mosaics and hypocausts). Others had served as workshop, forge (to judge by the presence of large quantities of slag), barn, shed, stable, etc. The suggestion that Anthée was the main center for the production of enameled bronzes, especially fibulas and seal boxes has been ac-

cepted uncritically in most of the works devoted to the ancient art of enameling. However, a recent study based on a new examination of the archaeological finds and on the archives of the archaeological museum at Namur has proved that this theory must be abandoned.

The villa of Anthée goes back to the first half of the 1st c. It was devastated in A.D. 275 during one of the barbarian invasions, was rebuilt, and continued to be occupied until the end of the 4th c.

BIBLIOGRAPHY. E. Del Marmol, "La villa d'Anthée," *Annales de la Soc. Arch. de Namur* 14 (1877) 165-94; 15 (1881) 1-40[P]; A. Bequet, "Les grands domaines et les villas de l'Entre-Sambre-et-Meuse," ibid. 20 (1893) 9-26; id., "La bijouterie chez les Belges ous l'Empire romain," ibid. 24 (1902) 237-76; R. de Maeyer, *De Romeinsche Villa's in België* (1937) esp. 77-83[P]; id., *De Overblijfselen van de Romeinsche Villa's in België* (1940) 229-37; P. Spitaels, "La villa gallo-romaine d'Anthée, centre d'émailerie légendaire," *Helinum* 10 (1970) 209-241.　　　　　　　　　　　S. J. DE LAET

ANTIBES, *see* ANTIPOLIS *and under* SHIPWRECKS

ANTICARIA (Antequera) Málaga, Spain. Map 19. Town 62 km N of Málaga, built over a megalithic cultural center. The Roman town is documented in the *Antonine Itinerary*, 412.2, and by the Ravenna Cosmographer, 316.1 and 18. The nucleus of Roman Anticaria was probably under the mediaeval castle.

A building E of the present city, beyond the megalithic caves, has a wall of blind arches 54 m long, 2.8 m high, and ca. 1.5 m thick, closely connected to a rectangular enclosure of the same length and 8 m wide by 2.8 m deep. This was probably a villa rather than a bath because of its distance from the urban center; mosaic fragments have been found. Sculptural and epigraphic material and metal work found in the area is in the municipal museum, notably a portrait of Drusus Maior and two busts, of a man and a woman, of the Antonine period.

BIBLIOGRAPHY. S. Giménez Reyna & A. García y Bellido, "Antigüedades romanas de Antequera," *ArchEspArq* 21 (1948) 48-66[MPI]; A. de Luque, "Arqueología antequerana," *XI Congreso Nacional de Arqueología, Mérida, 1968* (1970) 557-67[MI].　　　L. G. IGLESIAS

ANTIGONEA S Albania. Map 9. A city identified by inscriptions on voting discs, lies above Saraginishtë E of Argyrokastro on a ridge 762 m above sea level. Founded by Pyrrhos and named after his first wife Antigone, the city had a circuit wall ca. 4000 m long. Chief inland city of Chaonia, it controlled the fertile Drin valley and traded with Apollonia down the Aous valley, Korkyra via Onchesmos or Buthrotum, and Dodona to the S. Its forces could block the pass of the Drin through which the Illyrians and later the Romans entered Epeiros from the N (Polyb. 2.5.6; 2.6.6; and Livy 32.5.9; 43.23.2). Excavations have revealed towers and gateways of fine ashlar masonry, public buildings, some 450 coins of the Hellenistic period and evidence of metalworking in bronze and iron.

BIBLIOGRAPHY. N.G.L. Hammond, *Epirus* (1967) 209ff; id., "Antigonea in Epirus," *JRS* 61 (1971) 112ff; D. Budina, "Rezultatet e gërmimeve arkeologjike në qytetin ilir të Jermës," *Materiale të Sesionit arkeologjik* (1968) 40ff; F. Prendi, "La civilisation illyrienne de la vallée du Drino," *Studia Albanica* 2 (1970.2) 68ff.

N.G.L. HAMMOND

ANTIKYRA (Palatia) Phokis, Greece. Map 11. A port E of Kirrha noted in antiquity for the production of the medicinal herb hellebore. It was destroyed by Philip of Macedon in 346 B.C. but was rebuilt; it was captured by the Romans under Otilius. Pausanias identifies it with Homeric Kyparissos and mentions gymnasia and a Sanctuary of Poseidon. At Palatia, on a promontory near Aspra Spitia, foundations have been identified with Antikyra by local inscriptions.

BIBLIOGRAPHY. Paus. 10.36.5-10; J. G. Frazer, *Paus. Des. Gr.* v 3. Also Paus. 7.7.9; 10.1.2; 10.3.1.

M. H. MC ALLISTER

ANTIKYTHERA, *see* SHIPWRECKS

ANTINOÖPOLIS (Sheikh-'Ibada) Egypt. Map 5. A city 286 km S of Cairo on the E bank of the Nile, opposite Hermopolis Magna. Also called Antinoë, Antenon, Adrianopolis, Besantinopolis and, in Arabic documents, Antina, it was founded by Hadrian in memory of his beloved Antinoös, whose suicide by drowning in the Nile took place not far from here in A.D. 130. The city was built either on the ruins of the ancient Besa, sacred to the god Bes, or at Nefrusi, where the goddess Hathor was worshiped. The new settlement was colonized by Greeks brought from other cities, especially from the Faiyûm, to whom were given the right of Conubium (the right to marry an Egyptian woman without forfeiting Greek privileges). The city flourished under Diocletian (A.D. 286) when it became the capital of the whole Thebaid nome. In the reign of Valens (A.D. 364-78), it became a bishopric with one Orthodox bishop and one Monophysite bishop. The earliest finds date to the New Kingdom (1567-1085 B.C.). Among Greek and Roman monuments still standing at the beginning of the 19th c., a theater, many temples, a triumphal arch, two streets with double colonnades, a circus, and a hippodrome. At present little is left above ground: the blocks of stone were rebuilt into the new sugar factories at El-Rodah.

BIBLIOGRAPHY. A. Gayet, "L'Exploration des nécropoles gréco-byzantine d'Antinoè," *Ann. Mus. Guimet*, 30.2 (1902) pl. xx; id., *Antinoè et Les Sculptures des Thais et Serapion* (1902); *Descr. de l'Égypte Ant.* IV (1818) 209ff[I]; E. Breccia & A. Adriani, "The Funeral Chapel of Theodosia," *Orientalia* 36,2 (1967) 193f; S. Donadoni in W. Helck & E. Otto, *Lexikon der Ägyptologie* I, 3 (1973) 323-25.　　　　　　　　　　S. SHENOUDA

ANTIOCH later CHARAX Iraq-Iran. Map 5. A site on an artificial elevation at the point where the Tigris and Karun rivers unite. Allegedly founded by Alexander as an Alexandria, but the evidence is unreliable. When known as Charax, and Charax Spasinou, the site was restored by Antiochos IV, the Seleucid ruler, who gave it his name. However, the name Charax continued in use; it is used later as a destination for caravans traveling from Palmyra.

BIBLIOGRAPHY. Plin. 6.138; J. B. Chabot, *Choix d'inscriptions de Palmyre* (1922) 24; Arr. 7.7; J. Hansman, "Charax and the Kharkheh," *Iranica Antiqua* 7 (1967) 21-24[M]; E. Herzfeld, *The Persian Empire. Studies in Geography and Ethnography of the Ancient Near East* (1968) 9.　　　　　　　　　　　　　　D. N. WILBER

ANTIOCH Phrygia, Turkey. Map 5. A city, near modern Yalvaç, described as being "towards Pisidia" (Strab. 12.) and "of Pisidia" (*Acts* 13:14; Ptol. 5.4.9), in Phrygia Paroreios. Founded before 261 and refounded 25 B.C. as Colonia Caesarea in Provincia Galatia, it became metropolis of Byzantine Pisidia, fell to the Arabs in 712-713, and perished in the 13th c.

The site (46.5 ha) lies on seven hills. The forum (Augusta Platea) has a semicircular rock-cut rear wall

(traces of a stoa) and contains foundations of a temple, perhaps of Jupiter. To the W of a stairway is the Tiberia Platea, which yielded the Monumentum Antiochenum. A small theater, a Christian church and basilica (4th c. mosaics), and Decumanus Maximus leading from the triple city gate of Severan times may also be seen. Part of the city wall is preserved at the NW corner of the site. More striking are the remains of an aqueduct to the N and the ruins of the shrine of Mên on the hill of Kara Kuyu to the SE.

Yalvaç museum contains monuments and coins; the Kara Kuyu dedications are in the Classical Museum, Konya, the Monumentum in Ankara, and other inscriptions and sculpture in Afyon and Istanbul (Archaeological Museum).

BIBLIOGRAPHY. F.V.J. Arundell, *Discoveries in Asia Minor*, 2 vols. (1834)[MPI]; M. M. Hardie, "The shrine of Mên Askaenos," *JHS* 32 (1912)[PI]; W. M. Ramsay, "Religious Antiquities of Asia Minor," *BSA* 18 (1911-12)[P]; "Dedications from the Sanctuary," *JRS* 8 (1918)[P]; D. M. Robinson, "Excavations," *AJA* 2d ser. 18 (1924)[I]; "Roman Sculptures," *AB* 9, 1 (1926)[MPI]; J. Inan & E. Rosenbaum, *Roman . . . Portrait Sculpture* (1966)[I]; B. Levick, *Roman Colonies* (1967)[MI]; *RE* Suppl. XI (1968). The last two with bibliography. B. LEVICK

ANTIOCH BY THE CALLIRHOE, later JUSTINOPO-LIS (Edessa; Urfa)

Turkey. Map 5. Founded by Seleucus Nicator ca. 303-302 B.C., it was seat of a semi-independent Arab kingdom from ca. 131-132 B.C. until it came under the direct rule of Rome ca. 242 as capital of Osrhoene. It was taken by the Muslims in 639, but returned to Byzantium in 1031-32. In 1098 it was occupied by Crusaders, but finally regained by the Turks in 1144.

The city walls on the W and S follow the contours of the hills and retain some Roman and Byzantine courses. A citadel on a crag in the SW was included within the walls by Justinian, and was frequently rebuilt. Among its ruins stand two columns of Late Roman date with Corinthian capitals, ca. 15 m high. On one a Syriac text shows that it once bore the statue of a queen.

The Scirtos (Daişan) flowed below the W wall to enter the city in the SW by sluices and water gates (of which there are remains). Uniting with two springs and forming two pools for sacred fish, it passed through the city and ran into the Gullab. After the floods of A.D. 525, a dam was built NW of the walls and the main stream led along its present bed outside the city (Procop. *Buildings*). The spring waters still flow through the streets. Outside Urfa another spring (Bir Eyüp) has healing properties.

Four gates marked the entry of ancient trade routes into the city, linking Iran and the Far East with the Mediterranean. Those in the W and S are old in part; the E gate, subject to frequent enemy attack, has a fort (the lower citadel, built before 1122). Gates and citadels carry inscriptions in Greek, Armenian, and Arabic.

Cut in the hills outside the walls are over a hundred cave tombs of modest size, with conventional arcosolia. Some have inscriptions, mostly brief, in Syriac (three in Hebrew, one in Greek), as well as reliefs and sculpture. At least 10 had floor mosaics, one showing Orpheus, another the Phoenix, and four dated between A.D. 225 and 278. In 1971 only two floor mosaics survived at Urfa (in private houses), a third and fragments of a fourth are at Istanbul. Some statues are at the Urfa Museum, one at Diyarbakir.

These remains are of Semitic planet worshipers with Hellenistic and Iranian influence. There is little trace of the Jewish community, and little to testify that from the 4th c. the city was a center of Christian pilgrimage and home of the Syriac church and of classical Syriac literature. Only one copy (in Greek) was found there of the legendary letter from Jesus to Abgar of Edessa. Mosques and public buildings, however, probably stand on the site of churches—notably the ancient cathedral (rebuilt by Justinian and considered one of the wonders of the world) and shrines with relics of the Apostle Thomas, and of St. John and St. Addai (scene of the Roman law courts). A Roman hot bath was found in 1954 N of the pools but is no longer visible. Recent building at Urfa has obscured some early sites, but a third pool has been constructed and a water gate restored in the SW.

A ruined monastery, Deyr Yakup, 8 km S of Urfa and once a pagan burial place, has short Palmyrene-Greek inscriptions. At Sarimağara to the NW is a Greek inscription in a cave, but there are no Classical remains at Suruç (Batnae, Serug) or Viranşehir (Constantia, Tella). In the Tektek mountains are Sumatar Harabesi (a center of planet worship, with Syriac inscriptions, reliefs and ruins of the 2d-3d c. A.D.), Şuayp Şahr (ruins) and Sanimağara (pagan altar and a ruined monastery).

BIBLIOGRAPHY. H. Pognon, *Inscriptions sémitiques de la Syrie . . .* (1907); E. Honigmann, *Ostgrenze des byzantinischen Reiches . . .* (1935); J. B. Segal, *Edessa: 'The Blessed City'* (1970)[MPI]; H.J.W. Drijvers, *Old-Syriac (Edessean) Inscriptions* (1972). J. B. SEGAL

ANTIOCH ON THE MAEANDER

Turkey. Map 7. City in Caria near Azizabat, 20 km E of Nazilli, on the S bank of the Maeander. Founded according to Stephanos Byzantios by Antiochos II; but the rest of his notice is unreliable. Pliny (*HN* 5.108) says it replaced two cities called Symmaithos and Kranaos. Strabo (630) calls it a modest city, but possessed of extensive territory on both sides of the river; he notes that the region is liable to earthquakes. The city gained some importance from a bridge over the Maeander, now vanished, but has little or no individual history.

Remains are scanty. On the hill is a mediaeval fortress and castle incorporating some ancient blocks, and on the NW side is the hollow of the theater, but no masonry survives. Marble blocks and column drums are scattered over the ground, especially on a level space near the top on the N side. In the 19th c. there were many remains of buildings, arches, massive acropolis walls, and a stadium 0.8 km to the E, but little is to be seen today. There is even some disagreement about the exact site.

BIBLIOGRAPHY. W. J. Hamilton, *Researches in Asia Minor* (1842) 529; A. Laumonier, *Les Cultes Indigènes en Carie* (1958) 471. G. E. BEAN

ANTIOCH ON THE ORONTES (Antakyé)

Turkey. Map 6. Alexander reached Syria from Asia Minor by way of the coast at Issus, and founded Alexandretta, a port girded by mountains. On the other side of the Amanus ridge, Antigonus, Alexander's successor, founded Antigoneia on the banks of the Orontes. Seleucus I founded two towns, Seleucia at the mouth of the river, Antioch, 17 km from the sea, in a plain near Antigonia. Apparently Seleucia was his capital at first but Antioch soon received the title. Greek civilization made Antioch its principal Asian outpost, replacing Aleppo, 100 km to the E, as the leading city of N Syria. Aleppo, however, regained its former importance with the Islamic conquest; Seleucia has disappeared and Iskandarun and Antakyé today are small towns. The chief road connecting Asia Minor and Syria crosses the Taurus passes and dips down again along the edge of the steppe—no longer along the valley of the Orontes.

Even before Antioch was founded the low valley of the Orontes was a trade route: excavations have uncovered an Athenian trading post dating from the 5th c. B.C. at El Mina, at the mouth of the river, and some Cretan objects in the Hittite palace of Tell Atchana. Also, excavations at Antioch, well below the monumental Roman street, have revealed preclassical sherds beneath the stone paving of the Hellenistic road.

The site, between Mt. Silpius and the river, facing a vast plain dominated by the peaks of the Amanus ridge, favored the establishment of a military, political, and commercial capital, and Seleucia offered an outlet on the Mediterranean to the silk route that came from the heart of Asia through Iran and the Fertile Crescent, or by way of the Persian Gulf and the Euphrates.

The city at first occupied only a few hectares along the river but, according to ancient chroniclers as well as archaeological evidence, it was laid out from the beginning on the strict gridiron plan common to all Hellenistic cities in this period. The plan apparently covered the whole area of the plain, and was followed rigorously as the city developed.

Successive enlargements, each marked by spurts of construction, are milestones in the life of the city. Seleucus II Callinicus (246-226 B.C.) set up a new quarter on the Island of the Orontes, surrounding it with a wall, and Antiochus IV Epiphanes (175-164 B.C.) extended the city to the foothills of the mountains. This new city, called Epiphaneia, did not receive its rampart until Tiberius' reign, according to Malalas. Only then was its area finally settled, except for the alterations carried out for strategic reasons by Justinian when the city was rebuilt after A.D. 540.

Antioch's history is also marked by a series of catastrophes, particularly earthquakes that damaged or destroyed it; efforts to repair or rebuild the city were often made several times in a century, and each occasion called for the intervention of the emperor of Rome or Byzantium. Alexander Balas intervened in 140 B.C., Caligula in A.D. 37, Trajan in 115, Leon I in 458, and Justinian in 526 and 528. After this the destruction of the city was completed by Chrosroes, who seized it in a surprise raid in 540. The chroniclers also report several lesser earthquakes, to which should be added the terrible storms that caused the streams, especially Parmenios, to overflow. Each time torrents caused serious damage, particularly by raising the ground level. Since the 3d c. B.C. the ground has risen 11 m in the axis of the city; the stratum representing the second Byzantine conquest of the 10th c. A.D. is on the average 4 m below the present ground level, that of the reconstruction under Justinian 7 m, and that of the monumental Roman street 8.5 m.

Yet few ancient cities are as well known from the texts as Antioch. Strabo, Malalas, Evagrius, Procopius, Libanius, the Emperor Julian, John Chrysostom—have described the city, its urban plan and its monuments, and have recounted its history and its misfortunes, its reconstruction, and the daily life of its citizens.

In the period of its greatest expansion Antioch occupied the whole plain between the Orontes and the mountains, an area of 3.2 by 1.2-1.5 km. At each end the hills and the river came closer together, almost sealing off the plain. The great porticoed street constituted the axis, from the Daphne Gate to the S to the Aleppo Gate to the N. The rampart wall scaled the mountain side, enclosing vast stretches of uninhabitable ground, and the citadel was on top of Mt. Silpius. To the W the wall ran along the river and encircled the Island, which was linked to the ancient city by five bridges.

Inside this wall the city had from the beginning been laid out on a grid of blocks ca. 120 by 35 m, spreading from the long axis to the river and the last inhabited

slopes. Water conduits, from the aqueducts hollowed out high in the mountain, followed the E-W streets, and from them terracotta pipes ran beneath the sidewalks of the N-S streets to supply the houses.

From the 2d c. A.D. on, the colonnaded street was over 27 m wide, ca 9 m for the roadway and for each portico. In his praise of Antioch, Libanius dwells particularly on the breadth, beauty, and convenience of these porticos. A similar road, not located, led to the Island from an open place—the omphalos—where the Temple of the Nymphs stood. The latter was also a fountain, frequently described. At one of the other intersections of the main street stood the column of Tiberius, at another the Μέση Πύλη, the central gate built by Trajan. The Island also had a gridiron plan, laid out like that of the city but probably on different axes: two porticoed streets at right angles to each other with a tetrapylon at the intersection. One street led to the palace, rebuilt by Diocletian, and the hippodrome, erected in 56 B.C.

Two main streams flowed into the Orontes: Phyrminus to the S, which skirted part of the outer rampart, and Parmenios in the center of the city, which invaded the town itself during floods. In every period protective measures were necessary: Hellenistic arches, discovered during excavation, the vaults of the Forum of Valens, and a dam built by Justinian at Bab el Hadid.

Aerial photographs have revealed the Hellenistic gridiron plan: it can still be traced in the Turkish town, barely hidden under the jumble of winding streets; it reappears in the olive grove that now occupies four-fifths of the ancient site, in the cart-tracks, and the property limits. The main street of the modern town, which is continued to the NE on the same axis by the Aleppo road, follows the axis of the ancient city: excavations have shown that it was built over the W portico of the colonnaded street.

The depth of the ancient strata made excavation difficult: in the beginning only a few walls could be seen, mainly sections of the surrounding wall built by Seleucus I, enlarged, probably by Antiochus Epiphanus, and rebuilt by Tiberius and Justinian. In the 18th c. Cassas drew some impressive overall views of the wall, but after that it served, at least its S section, as a quarry for a new barracks. The wall, 18 km around, climbed Mt. Silpius and topped the crest, which was crowned with a citadel. Farther N it ran down a steep slope to Parmenios, then scaled the other side, on Mt. Stauris. Here are the Iron Gates, Bab el Hadid, where architects of the 6th c. A.D. built a dam to curb the floods. Beyond Mt. Stauris the wall turned W where the mountain is closest to the river, then crossed the monumental axis and headed back S, following the river bank. Only one Roman bridge survives out of the five that led to the Island (now gone). No trace could be seen of the wall on the whole W face, although it has been located here and there during later excavation.

A few houses built on the terracing of the mountain slopes have been uncovered, along with their mosaics; a monumental rock-hewn bust, evidence of a chthonic cult, in the Charonion area remains visible. But other excavations in the city had to contend with the problems of deep excavation. Part of an amphitheater at the foot of Mt. Silpius was uncovered, however, and, farther N, some immense baths, probably built by Tiberius but containing a mosaic dated by an inscription after the 528 earthquake. Excavations on the edge of the main street have clarified the history of the street and its porticos, which had been buried in the earthquakes and quarried in every period.

In the 3d c. B.C. the street was paved with stone—a road rather than a street, with no monuments. Later, in a higher stratum, modest structures appear on both sides,

and then narrow sidewalks. To the N of Parmenios in a slightly higher stratum are traces of a monumental reconstruction dating from about the beginning of our era: sidewalks 4.4 m wide were added, probably lined with the first colonnade, which included a series of shops and is attributed by the texts to Herod and Tiberius. Then the street was destroyed (probably in the earthquake of A.D. 115, under Trajan); after some provisional restoration it was completely rebuilt, and the total width increased to more than 40 m. The roadway was paved with opus polygonale, and the colonnade had disappeared, except for the foundations (in one excavation the intercolumniation measured 4.8 m, elsewhere 3.65 m). This sumptuous complex was begun under Trajan and completed under Antoninus, and when Justinian later rebuilt the street, he laid a pavement of lava 1 m higher and set the columns upright again.

These layers partly explain the confusion of the chroniclers and historians. Only Procopius, in a somewhat fanciful account, shows us Justinian's city built on the ruins of the Roman one. But the colonnade that Malalas describes, where Libanius and the Antiochians strolled to the satirical amusement of the emperor Julian, is not that of Herod and Tiberius but of Trajan and Antoninus, which was 2 m higher and retained only the orientation of the older street.

Excavation has revealed twin Hellenistic arches that carried the road across the Parmenios when it was in spate. They served until A.D. 526, by which time they were clogged with alluvial deposits and Justinian's architects built the dam at the Iron Gates. No trace has been found of the omphalos, where the second colonnaded street leading to the Island began, nor of the Forum of Valens, the imperial palace, or the church of Constantine

In 636 Antioch was taken by the Arabs without a battle, but the monumental street was again destroyed at an undetermined date. The paving stones served as foundations for other structures and the street, now on a different axis, was set up over the W portico, where it remained. After Nicephorus II Phocas' conquest in 969 the Byzantines built another city, part of which was apparently on an uninhabited site. It followed the same orientation but was far smaller, though large and well built. A church and cemetery have been uncovered on the other side of Parmenios, and another church at Daphne. After the Mameluke conquest this city was laid waste in its turn, and again 4 m of earth piled up in the olive grove.

On the Island the ancient strata were not as deep. Several baths were found there, some of them immense, a second hippodrome, that of Q. Marcus Rex, dating from 50 B.C., some distance from the first, and a villa with mosaics (the triclinium of the Judgment of Paris). Later, however, the water level was too high for excavation.

A suburb named Daphne developed 9 km S of Antioch on the first plateau overlooking the Orontes and the plain, built around the springs of Castalia and Pallas, next to which stood the Temple of Apollo. The water reached Antioch in underground aqueducts set at a calculated slope, which then crossed several valleys on arcades and ran in high galleries along the mountainsides above the city. Thus, as Libanius says, every house could have its fountain.

At Daphne itself the original villas were later included in an orthogonal city plan. The archaeological strata here were only 2-3 m below the surface, but olive groves, orchards, and fields prevented extensive exploration; thus only a few houses could be excavated, and many mosaics were removed.

The mosaics of both Antioch and Daphne have almost all been raised and dispersed; some are in the local museum in Antioch, some in Paris, some in museums in the United States. Only two mosaics of the 1st c. A.D. have been found. They consist of geometric patterns. Figured mosaics begin in the 2d c. and continue through to the end of the Classical period of Antioch in the 6th c. They form a most valuable series, illustrating the development of the art of the mosaicist through the Roman period.

Little sculpture and few inscriptions have survived, and the only monuments that have been thoroughly explored are the Theater of Daphne and the Martyrion of Qaoussié. The latter, with mosaics executed in A.D. 387, is cruciform in plan: four naves 25 by 11 m, set on the sides of a square 16 by 16 m. Instead of an apse there was a horseshoe-shaped Syrian bema at the center of the square. In one corner was the sarcophagus that had held the body of Babylas, bishop and martyr, which the emperor Julian returned from Daphne to Antioch (identified by inscriptions now at Princeton University). Another church at Machouka, N of the city, was a conventional basilica paved throughout with flowered mosaics (6th c.).

The monuments listed in the ancient texts—temples and baths, honorific monuments, fountains, two Hellenistic agoras, a forum of the 4th c. A.D., an amphitheater, civic basilicas, palaces, churches, the octagonal Church of Constantine, and the round Church of the Virgin built by Justinian—can probably never be brought to light.

BIBLIOGRAPHY. C. O. Müller, *Antiquitates Antiochenae* (1839) with map based on sources; R. Förster, "Antiochia am Orontes," *JdI* 12 (1897) 103-49; L. Jalabert & R. Mouterde, *Inscriptions grecques et latines de la Syrie* (1929-); *Antioch on the Orontes* 1. *The Excavations of 1932* (1934); 2. *The Excavations, 1933-1936* (1938); 3. *The Excavations, 1937-1939* (1941); 4 pt. 1. *Ceramics and Islamic Coins* (1948); 4 pt. 2. *Greek, Roman, Byzantine and Crusaders' Coins* (1952); 5. *Les portiques d'Antioche* (1970); C. R. Morey, *The Mosaics of Antioch* (1938); D. Levi, *Antioch Mosaic Pavements* (1947); A. J. Festugière, *Antioche païenne et chrétienne* (1959) with an archaeological study by R. Martin; R. Stillwell, "The Houses of Antioch," *DOPapers* 15 (1961) 47-57; G. Downey, *A History of Antioch in Syria from Seleucus to the Arab Conquest* (1961) with abbr. & bibl.; id., *Ancient Antioch* (1963). J. LASSUS

ANTIOCH-IN-PERSIS, *see* LAODICEA (Iran)

ANTIOCHEA AD SARUM, *see* ADANA

ANTIOCHEIA AD CRAGUM (Endişegüney) Turkey. Map 6. Site in Cilicia Aspera, 18 km SE of Gazipaşa, identified by the ancient authorities as E of Selinos. The city has no history. The ruins stand on the crest of a steep slope, some 300 m above the sea, and the principal feature is a long main street running E-W, lined with numerous statue bases. At its E end is a gateway still in fair condition; at the W end the street bends S to a knoll which may have formed the acropolis. In the NE part of the site are the collapsed ruins of a marble temple, on the walls of which was inscribed a dice oracle of unfamiliar content. On the shore below are the remains of a landing-place, a gate, and a small fort, and there are numerous tombs on the hillside.

BIBLIOGRAPHY. R. Heberdey & A. Wilhelm, *Reisen in Kilikien* (1896) 152f; G. E. Bean & T. B. Mitford, *Journeys in Rough Cilicia in 1962 and 1963* (1965) 34-42. G. E. BEAN

ANTIPATREA (Berat) Albania. Map 12. At the W end of the gorge of the Osum river. The foundations of ancient fortifications are visible at the foot of a Turkish fort; the city was destroyed by Rome in 200 B.C. (Livy 31.27).

BIBLIOGRAPHY. *Studia Albanica* (1964) 1, 184ff; N.G.L. Hammond, "The Opening Campaigns and the Battle of the Aoi Stena in the Second Macedonian War," *JRS* 56 (1966) 42. N.G.L. HAMMOND

ANTIPATRIS Israel. Map 6. One of the most important stations on the Via Maris. Its ancient name, Aphek, appears on Egyptian name lists and in Biblical literature. It is situated in the borderland between the plain of Sharon and the hills of Samaria, in the midst of a fertile plain, rich in springs, about 18 km to the NE of Tel-Aviv.

In Early Hellenistic times a fort was built on the site as a blockhouse on the border between the districts of Samaria and the Sharon. At this period it was named Pegai, on account of its abundant springs. About 132 B.C. the fort was conquered by John Hyrcanus (Joseph. *AJ* 16.142). At this time it was known also as Arethuse. After the conquest of Judea by the Romans, it was among the towns rebuilt in 63 B.C. by Pompey (Joseph. *BJ* 1.155-57). After his ascent to the throne, Herod the Great built on the site a new town, naming it Antipatris in honor of his father Antipater (Joseph. *BJ* 1.417). Antipatris became the center of a populous district and was still in existence in the Late Roman period. The Pilgrim of Bordeaux (25:21) refers to it as a road station 16 km from Lydda. It declined in the Byzantine period.

Antipatris is identified with the large mound named Râs el-'Ain (Tel Aphek), on top of which are now extensive remains of a Turkish citadel built on the remains of a Crusader castle. To the Roman period belongs a mausoleum. It consists of an open court, a vestibulum, and a single burial chamber in which one ornamented sarcophagus was discovered.

BIBLIOGRAPHY. A. Eitan, "Tel Aphek," *Israel Exploration Journal* 12 (1962) 149-50; M. Avi-Yonah, *The Holy Land from the Persian to the Arab Conquests (536 B.C. to A.D. 640). A Historical Geography* (1966); A. Eitan, "A Sarcophagus and an Ornamental Arch from the Mausoleum at Rosh Ha'ayin," *Eretz-Israel* 8 (1967) 114-18. A. NEGEV

ANTIPHELLOS (KAŞ, formerly Andifli) Lycia, Turkey. Map 7. The earliest occurrence of the name is in a bilingual epitaph of the 4th c. B.C. found at Kaş; and half a dozen other Lycian inscriptions, all on tombs, prove the antiquity of the site. The rise of Antiphellos to importance began in the Hellenistic age, and by the Roman period it was by far the most important city of the region. The coinage includes Hellenistic issues of federal and nonfederal types, and of Gordian III. The city was the seat of a bishopric in Byzantine times.

Antiphellos lies at the base of a narrow promontory running E-W, which forms on the N side a long sheltered bay known as Bucak Limanı (formerly Vathy); above this the main coast rises almost vertically to a height of some 450 m. Bucak Limanı is, however, only usable with difficulty by sailing vessels, and the harbor of Antiphellos, like that of Kaş, lay on the other, seaward side of the isthmus. It is protected by a reef which may also be partly artificial, but is suitable only for small boats. A stretch of ancient sea wall runs along the S side of the promontory.

The principal ruins are on the rising ground of the promontory to the W of the modern town. On the S side, not far above the shore, are the foundations and lower parts of a small temple in elegant masonry. Farther to the W is the theater, small but well preserved, of Hellenistic date. The retaining wall is of regular bossed ashlar and encloses 26 rows of seats divided by four stair-

ways into three cunei. There seems never to have been a permanent stage building. On the E slope of the hill is an unusual square tomb, cut out of the rock, damaged in its upper part; the grave inside is decorated with a frieze of 25 dancing figures.

Tombs are numerous, especially on the slopes of the hills to the W and N of the town, and at the head of Bucak Limanı. In the town itself, on the E side, is a particularly fine Lycian sarcophagus on a high base, with a long inscription (possibly poetic) in the peculiar dialect of Lycian which occurs also on the well-known pillar tomb at Xanthos. On the hillside to the N is a rock tomb with a Lycian inscription to which has been added later another in Latin. Many sarcophagi of later type are scattered over the site, and many more have been destroyed in modern times.

Across the water from Kaş, in the SE corner of the bay, is the little harbor of Bayındır Limanı, and on the hill directly above is a small city site of which the ancient name was apparently Sebeda. It has a wall of neat polygonal masonry and a number of sarcophagi, one of which carries a Greek epitaph with a fine of 10,000 drachmai, payable to Phellos, for violation of the tomb. In the cliff face above the harbor are two or three rock-cut tombs, one having an inscription in Lycian. There is no water on the site and virtually no arable land.

BIBLIOGRAPHY. C. Fellows, *Asia Minor* (1838) 219-20; T.A.B. Spratt & E. Forbes, *Travels in Lycia* (1847) I 69-73[M], 79-81; E. Petersen & F. von Luschan, *Reisen in Lykien* (1889) II 60-61. G. E. BEAN

ANTIPOLIS (Antibes) Alpes-Maritimes, France. Map 23. Town on the French Riviera between Nice and Cannes, with a protected harbor and a small promontory. It was in the Ligurian territory of the Deciates, and was inhabited from the 10th c. B.C. on. A Greek outpost, established here by Massilia or Phokaia, left pottery dating from the 6th c. The area has yielded more and longer Greek inscriptions than anywhere else in S France: the Terpon stone, a lead curse tablet, the victory monument at Biot, and many sherds with names of divinities and worshipers. Local coinage, with ANTIP and LEPI in Greek and a victory trophy (rev.), and head of Apollo (obv.), dates from the 2d c. B.C.

The consul Q. Opimius drove off besieging Ligurians in 154 B.C., and thereafter Antipolis was protected and developed by Rome; although in Gallia Narbonensis, it was treated as an Italiote city and given ius Latii. Coin finds indicate its importance in the Empire, especially in the time of Constantine and the so-called Gallic usurpers.

Exploratory excavations have located the acropolis under the cathedral and the adjacent Grimaldi Castle. Here were two Roman cisterns with octagonal stone columns, and probably the city's main temple; there are Roman houses nearby. The lower town and port area were expanded in Roman times. Ruins of the theater, demolished in 1691, lie under the bus station; an amphitheater was apparently near Rue Fersen. Parts of the ancient ramparts and port jetties survive. Baths and aqueducts are known, and shipwrecks have been explored. At nearby Vaugrenier are extensive Roman ruins, and evidence suggesting a Greek shrine of an earth cult. Finds from the whole area are in the two local museums.

BIBLIOGRAPHY. Strab. 4.1.5, 9; Polyb. 33.8; Livy, *Epit.* 47; Plin. *HN* 3.4; 31.43; *IG* XIV, 2424-30; *CIL* XII, 165-246; E. Muterse, *Antibes: des Origines au IVe Siècle* (1939); J.-P. Clébert, *Provence Antique* (1966) I, 173-75; II, 95-102; J. Clergues, *La Recherche Archéologique à Antibes* (1966)[PI]; id., *Antibes: La Ville Grecque du VIe Siècle avant J.C. et l'Habitat Protohistorique* (1969)[PI]; P. Méjean, *D'Antipolis à Juan-les-Pins*

(1969)ᴹᴾᴵ; J.-E. Dugand, *De l'Aegitna de Polybe au Trophée de la Brague* (1970) 173-203, 213-31, with bibl.ᴹᴾᴵ; latest reports: *Nice-Matin* 2 Sept. 1972; 13-15 Aug. 1973; R. Schoder, "Graeco-Roman Antipolis on the French Riviera," *Antipolis* 1 (1974) 1-7, bibl.

R. V. SCHODER

ANTISSA, see LESBOS

ANTIUM (Anzio) Latium, Italy. Map 16. A site, ca. 52 km S of Rome, inhabited long before it became a Volscian city in the 5th c. B.C. The archaic cremation and inhumation burials from the 8th and 7th c. B.C. are closely related to those in the Alban Hills and at Rome. One of the most important Volscian cities, it participated in the struggle against Rome until 467 B.C. when it became the site of one of the priscae coloniae Latinae. An uprising against Rome in 338 B.C., after the battle at the river Astura, was suppressed. The port, the Caenon, was occupied, the fleet destroyed, and the rostra were set up as a triumph in the Roman forum. In the same year a Roman colony was founded at Antium governed by magistrates sent from Rome. Not until 317 did the city obtain its own magistrates. A new colony formed of veterans of the praetorian guard was created under Nero, who also gave new importance to the harbor.

The barbarian invasions of the 5th and 6th c. A.D., as well as the later Saracen invasions, led to the abandonment of the city, which was not repopulated until the 18th c.

The ancient city had a perimeter of ca. 3900 m, enclosed by fortifications consisting of earthworks with a supporting wall of tufa blocks dated on stratigraphic evidence to the 5th or 4th c. B.C. There must have been at least three gates, one toward Rome where the Via Anziatina together with the Via Severiana entered the city. The course of the latter outside the city remains unchanged today. A second gate must have been situated to the S toward the sea on an axis with the first. A third gate must have given egress to the Via Anziatina, which led to Astura. For defensive reasons the port remained outside the fortified area.

The location of the older harbor, the Caenon (Liv. 2.63.6; Dion. Hal. 9.56) is not known. Nero built the Roman harbor (Suet. *Ner.* 9) with two piers built out on two small promontories. The W pier, of which there are scarce remains, was ca. 850 m long. The S pier was ca. 700 m long with the beacon at the end of it. Part of this shorter pier was reused in building the harbor of Innocent XII. The entrance to the harbor, 68 m long, opened toward SE. There are remains of storehouses near the W pier.

Remains of a building with a semicircular front and straight sides, perhaps a circus, lie between the Villa Corsini and the route of the Via Anziatina towards Rome. The Villa Spingarelli, in the area called Le Vignacce, is built on the remains of a Roman villa constructed on terraces descending toward the sea. Of the ancient theater, found in the city proper, the cavea has a diameter of 30 m and there is a long colonnade behind the scena. It is constructed in opus mixtum and is dated to the second half of the 1st c. A.D. An aqueduct of the 2d c. A.D. built of brick brought water into the city from a spring ca. 4 km to the W. On the coast, beyond the W pier are the remains of an imperial villa mainly dating between the reigns of Nero and Hadrian. It faced the sea with terraces, cryptoportici, and an exedra surrounded by a colonnade. Of the villa's theater, built on an artificial terrace, there are no remains. Almost all the emperors of the 1st c. A.D. and Septimius Severus lived here.

Ruins no longer visible are known to us from the works of G. R. Volpi. Thus we know how the Temple of Fortuna looked although we do not know its location. The shore in front of the harbor was occupied by a series of buildings, probably horrea with windows and arched doors. The Temple of Aesculapius mentioned by Livy (43.4.7) and by Ovid (*Met.* 15.718) must have been located in the same area, near the harbor.

BIBLIOGRAPHY. L. Bayard, "Elpénor à Antium?," *MélRome* 40 (1923) 115-22; G. Lugli, "Saggio sulla topografia della antica Antium," *RivIstArch* 7 (1940) 153-88; id., "Le fortificazioni delle antiche città italiche," *RendLinc* 2 (1947) 294-307; P. Barocelli, "Sepolcreto preromano di Anzio," *BPI* 5-6 (1941-52) 231; L. Morpurgo, "Sepolcreto sotterraneo pagano," *NSc* (1944-45) 105-26; cf. also *AttiPontAcc* 22 (1946-47) 155-66; R. De Coster, "La Fortuna d'Antium," *AntCl* 19 (1950) 65-80; M. L. Scevola, *RendIstLomb* 93 (1959) 417-36; 94 (1960) 221-60: 100 (1966) 205-43; L. R. Taylor, "The voting districts of the Roman republic," *PAAR* 20 (1960) 319-23; A. La Regina, *EAA* 6 (1965) s.v. Porto d'Anzio, with bibl. on ancient art objects found at Antium; P. G. Gierow, *The Iron Age Culture of Latium*, I (1966) passim; G. Schmiedt, *Atlante Aerofotografico*, II (1970) pls. 22, 133.

A. LA REGINA

ANTONINE WALL Scotland. Map 24. Early in the reign of Antoninus Pius Roman troops under the governor of Britain, Lollius Urbicus, reoccupied the Scottish Lowlands. Hadrian's Wall was abandoned, and in its place another barrier, the Antonine Wall, was built ca. 160 km farther N, across the narrow isthmus between the firths of Forth and Clyde. The new Wall, completed by A.D. 143, ran from Bridgeness on the Forth to Old Kilpatrick on the Clyde, a distance of 59 km. It consisted of a ditch up to 12 m wide and 3.6 m deep, behind which was a rampart built for the most part of turf blocks set on a stone foundation 4.2 m broad; the height of the rampart, including the breastwork, is estimated to have been ca. 4.5 m. The garrison was housed in a series of forts, normally attached to the rear face of the rampart and spaced at intervals of ca. 3.2 km. Originally there were probably 18 or 19 such forts, but to date only 13 have been located: from E to W they are at Mumrills, Rough Castle, Castlecary, Westerwood, Croy Hill, Bar Hill, Auchendavy, Kirkintilloch, Cadder, Balmuildy, Bearsden, Castlehill, Duntocher, and Old Kilpatrick. The E end of the Wall was guarded by a fort at Carriden, 1.6 km SE of Bridgeness. Other forts prolonged the defensive system along the S shores of the Forth and Clyde estuaries, while the forward area was supervised by a chain of outposts extending as far N as the river Tay. The Wall forts are of widely different sizes, the internal areas ranging from 2.6 ha (Mumrills) to only 0.2 ha (Duntocher), and while Castlecary and Balmuildy were defended by stone walls, the rest had ramparts of turf, rammed earth, or clay. The principal buildings were, however, generally of stone and the barracks of timber. A well-built road, the Military Way, linked the forts, but bypass loops were provided for through traffic.

Today the best surviving stretch of the Wall runs from the E end of Tentfield Plantation, 1.6 km W of Falkirk, to Bonnyside House. Throughout this sector the rampart and ditch are visible with only minor interruptions, the former standing 1.5 m high in places, and at the crossing of the Rowan Tree Burn is the fort of Rough Castle, with well-preserved defenses. Within, the foundations of the headquarters building, the commandant's house, and a granary are exposed, while a fortified annex on the E contains some remains of a bath house. From the N gate an unexcavated causeway across the ditch leads to a staggered series of defensive pits (lilia); it is possible that

pointed stakes were planted in them. The fort has produced inscriptions of Cohors VI Nerviorum, but cannot have accommodated the whole of that regiment. Other auxiliary regiments known to have been in garrison on the Wall at one time or another are the Ala I Tungrorum and the Cohors II Thracum (Mumrills), the Cohors I Tungrorum and the Cohors I Vardullorum (Castlecary), the Cohors I Baetasiorum (Bar Hill and Old Kilpatrick), the Cohors I Hamiorum (Bar Hill), and the Cohors IV Gallorum (Castlehill). The only fort whose Roman name is known is that at Carriden, the Velunia of the *Ravenna Cosmography*, but Old Kilpatrick may have been Credigone, listed in the same source. From Old Kilpatrick a road led W along the N bank of the Clyde to a harbor at Dumbarton.

Traces of small posts attached to the back of the rampart have been found at Watling Lodge, where the road serving the outpost forts crossed the limes, at Wilderness Plantation, and at Glasgow Bridge. Each of these posts occurs about midway between a pair of forts, and it is possible that there was a regular series of them, comparable to the milecastles on Hadrian's Wall. On the other hand no evidence of a continuous system of turrets has been discovered on the Antonine Wall. A few turf platforms projecting from the back of the rampart have been identified as emplacements for beacons, but their disposition indicates that they were designed for long-distance communication with the forward and rear areas, and not for lateral signaling between the Wall forts. As at Rough Castle, most if not all of the forts were equipped with defended annexes. None of them has been adequately explored, but their main purpose was no doubt to protect the civilian communities of the kind attested epigraphically at Carriden; they could also accommodate stores and convoys.

The Wall was built by legionaries from each of the three legions in Britain at the time, II Augusta, VI Victrix, and XX Valeria. A number of temporary camps, which probably housed the working-parties, have been revealed by crop markings on air photographs, although no remains can be seen above ground. Each legion seems to have contributed two building squads, and as each sector was completed stone tablets were placed at either end recording the length of the sector and the name of the unit responsible. Initially the sectors were ca. 6.4 km long and were measured in Roman paces, but from Castlehill to the Clyde they were shorter and were measured in feet. To date 18 such tablets have been discovered, many of them elaborately decorated; like most of the other finds from the Wall, they are preserved either in the National Museum of Antiquities in Edinburgh, or in the Hunterian Museum, Glasgow.

It used to be thought that every Wall fort was built on the site of one of the chain of posts (praesidia) which Agricola had constructed between the Forth and Clyde some 60 years earlier, but this now seems doubtful. The supposed praesidium at Mumrills has been shown to be simply the annex of the Antonine fort; the Flavian date previously assigned to the curious earthworks underlying the forts at Croy Hill and Bar Hill has been challenged; and no trace of Agricolan occupation has been found during excavations at Duntocher and Rough Castle. On the other hand, fresh studies of the pottery from the Wall have confirmed that a few forts, such as Castlecary and Cadder, have produced small quantities of 1st c. sherds which may have been derived from praesidia on or near the sites in question.

The reoccupation of the Scottish Lowlands under Antoninus Pius was evidently intended to relieve the pressure on the cooperative tribes in the region, increasingly harassed by hostile neighbors. But the policy failed to establish lasting peace on the N frontier. The forts on the Antonine Wall were destroyed at least twice, first probably by the Romans themselves in A.D. 155-158, when the entire Scottish garrison appears to have been withdrawn to deal with a revolt of the Brigantes, a powerful tribe in the N of England. The date of the second destruction is uncertain, but there is no convincing evidence that the Wall was held after A.D. 196-197, when the usurper Albinus took the army of Britain to Gaul in an unsuccessful attempt to win the imperial throne. From A.D. 208-211 the emperor Severus conducted a series of punitive campaigns in Scotland, but his successor Caracalla abandoned any designs of bringing the country once more within the province, and Hadrian's Wall again became the fixed frontier line.

BIBLIOGRAPHY. G. Macdonald, *The Roman Wall in Scotland* (1934); K. A. Steer, "John Horsley and the Antonine Wall," *Arch. Ael.* 42 (1964) 1-39; Ordnance Survey Map, *The Antonine Wall* (1969); A. S. Robertson, *The Antonine Wall* (1970). K. A. STEER

ANTWERP Belgium. Map 21. The town of Antwerp had its origin in a Gallo-Roman vicus, whose existence has been known for certain for only about ten years. Since the 16th c., however, numerous finds of the Roman period (mostly individual artifacts) have been reported at several localities in the town, the most important being a necropolis near the Abbey of St. Michael. In 1610, 1774, and at the beginning of the 19th c., cremation tombs were found there; they date to the 1st and 2d c. A.D. Among the finds of 1610 was an ornate white marble sarcophagus with a funerary inscription (*CIL* VI, 29507). However, most archaeologists consider that it was not found in situ but had been brought from Rome during the Renaissance. Still, the finds of 1774 and later at the same spot indicate that the authenticity of the find must not be discounted a priori. The existence of the vicus was proved beyond doubt by the excavations conducted in the old town near the Scheldt from 1952 to 1961. Wooden houses and streets of the Carolingian period were found; under this mediaeval layer, beds of fill, stuffed with sherds of pottery and glassware of Roman date, were used to raise the level of the ground. The Roman remains date to the period between A.D. 140 and the second half of the 3d c. The end of Roman occupation can be attributed either to the invasions of the Franks during the second half of the 3d c. or to the Dunkirk II marine transgression (around 300), which flooded the low ground all along the Scheldt.

The Roman vicus was succeeded by a Merovingian settlement, evangelized by St. Amand in the 7th c. The course of the road from Bavai N goes through Asse, Rumpst, and Kontich, and then can be traced no farther. It probably passed through the vicus of Antwerp and then continued N by Rijsbergen and Utrecht to the Netherlands. Other roads linked Antwerp to Bruges (to the W) and Tongres (to the E).

BIBLIOGRAPHY. The abundant bibliography may be found in M. Bauwens-Lesenne, *Bibliografisch repertorium der oudheidkundige vondsten in de provincie Antwerpen* (1965) 1-14. For the recent excavations: O. Vandenborn, "Gallo-romeinse vondsten te Antwerpen," *Helinium* 5 (1965) 252-83. S. J. DE LAET

ANZIO, *see* ANTIUM

AOSTA, *see* AUGUSTA PRAETORIA

APAMEA (Qalaat al-Mudik) Syria. Map 6. One of the four great cities founded by Seleucus I Nicator (301-281 B.C.) in N Syria, Apamea on the Orontes was a citadel

of the Seleucid kings, their treasury, and their horse-breeding center. In the 1st c. B.C. Pompey destroyed the fortress and Augustus punished the city for having sided with Anthony. Reestablished in the 1st c. A.D. under the name Claudia Apamea, in the Late Empire it was the seat of famous schools of philosophy. It became an important Christian metropolis, was fortified by Justinian, sacked by the Persians, and destroyed in the Moslem conquest in the 7th c. A.D. Only the acropolis, which was made into a fortress, remained inhabited.

The site is a plateau on the SW tip of Jebel Zawiye overlooking the valley of the Orontes. The ancient ramparts enclosed an area of more than 200 ha. The principal remains are a theater, a great colonnaded avenue, a basilican building and a forum, several large churches, the N rampart gate, and some necropoleis.

The citadel was on a hill to the W separated from the plateau by a slight hollow; the only traces are the many stones reused in the Saracen ramparts and in modern houses. In the hollow SE of the acropolis are the ruins of a large theater of the Roman period, with a diameter of 145 m. The hemicycle, which is badly damaged, is supported by the slope of the hill to the W and by thick, radiating walls and arcades to the E. The scaenae frons follows the Roman pattern of a semicircular exedra flanked by two rectangular ones, while the Corinthian pilasters on the rear facade of the stage building and the precision of the stone-cutting and joints exemplify the Hellenistic tradition.

Linking the ruins is a N-S avenue ca. 1600 m long built in the 2d c. A.D.; it is 24 m wide, and has a covered portico 10.5 m high and 7.5 m wide on each side. In different sections the columns have plain shafts, straight fluting, or curious spiral fluting. Several sections have been restored. At the extreme S the rear wall of the W portico, which has doorways at ground level and windows above, bears traces of painted inscriptions from the Late Empire, actually a wine tariff. At the center of the avenue, to the E, is a section made up of columns with spiral fluting and brackets, engaged in the shafts, that carried statues of Antoninus Pius, Marcus Aurelius, and Lucius Verus. The portico at the N end still bears a series of inscriptions honoring the founder, Lucius Julius Agrippa, who dedicated the portico, a basilica, and some adjacent baths in A.D. 116. A large part of the porticos was paved with mosaics.

Near the middle of the avenue, to the E, is a quadrangular pillar carved with vine scrolls and Bacchic scenes, among them the legend of Lycurgus and Ambrosia. This pillar supported a great arch at the entrance to a cross street. The E-W streets off the great avenue are regularly spaced at intervals of ca. 110 m; the N-S streets are 55 m apart. The gridiron plan probably dates from the beginning of the Hellenistic period.

At the center of the great avenue, on its W side, are the massive remains of a monument, basilican in plan, which an inscription apparently identifies as the Tycheion. Three large bays, with arches over them supported by engaged Corinthian columns, led to a huge three-naved hall lighted on the other three sides by windows with grilles. The hall stands on a podium ca. 3 m high. To the W is the forum, a large rectangular courtyard lined with columned porticos. It is reached from the great avenue by a street 9 m wide, with a double colonnade. At the entrance to this street were two enormous columns with spiral fluting, at the other end four similar columns carrying honorific statues. The outer wall of the forum had windows with grilles let into it, and the outside of the wall bore brackets for statues. On the N side stood a large portico, only a few columns of which are still standing. They have swelling bases carved with five rows

of ivy leaves with broad acanthus leaves above them, and are supported by two molded plinths placed one on top of the other.

Near the intersection of the great avenue and the street leading from the theater was a circular building ca. 25 m in diameter that consisted of a portico surrounding a courtyard. To the SE was a market, a section of which was paved with mosaic in the middle of the 5th c. A.D. At 150 m S of the intersection was an enormous church with an atrium, opening onto the E side of the colonnade. Its earliest mosaics date from the end of the 4th c. A.D., but it was rebuilt several times in the 5th and 6th c. The church was found to have been built over the great synagogue of the late 4th c. A.D., which had an enormous floor mosaic containing numerous Greek donor inscriptions. The principal mosaic was a composition in the Pompeian style in shimmering colors, representing the Muses dancing.

Ruins of several other Christian basilicas of conventional plan (three naves and a narthex) have been found, one NW of the city, another outside the city walls, 500 m to the N. A large Christian church had been built with materials from a monument of the Roman period, mosaics from which have been found beneath the marble floors. A number of buildings, notably a large house with a triclinium now being excavated, contain storied floor mosaics in many colors. The majority of the Apamea mosaics as well as many pieces of marble sculpture have been moved to the Damascus and Brussels museums (part of the Brussels collection was lost in a fire).

At the N end of the great avenue is a gate in the wall, rebuilt in the Byzantine period. It consists of a semicircular archway flanked by two half-ruined towers. The necropoleis, principally to the N and E of the city, contain various types of tombs, sarcophagi, urns, and hypogaea with arcosolia; many stelai were reused in the ramparts during the Byzantine period.

BIBLIOGRAPHY. H. C. Butler, *AAES* Pt. II, *Architecture and other Arts* (1903)[1]; F. Mayence, *AntCl* 1 (1932); 4 (1935); 5 (1936); 8 (1939)[1]; id., *BMusArt* 3 ser. 3 (1931); 4 (1932); 6 (1935); 8 (1936); 10 (1938)[1]; E. Frézouls, "Les théâtres romains de Syrie," *Annales archéologiques de Syrie* 2 (1952)[1]; id., *Syria* 36 (1959); 38 (1961)[1]; V. Verhoogen, *Apamée de Syrie aux Musées royaux d'art et d'histoire* (1964)[1]; J.-C. Balty, "Rapport sommaire concernant les campagnes de 1965 et 1966 à Apámee," *Annales archéologiques arabes syriennes* 17 (1967)[1]; id., "La grande mosaïque de chasse du Triclinos," *Fouilles d'Apamée de Syrie*, Misc. 2 (1969)[1]; id., ed., *Apamée de Syrie, Bilan des recherches archéologiques* (Colloques de Bruxelles, 1969 et 1972)[PI]; id. "Mosaïque de Gè et des Saisons à Apamée," *Syria* 50 (1973)[1]. J.-P. REY-COQUAIS

APAMEIA, *see* KELAINAI

APERLAI (Sıçak Iskelesi, formerly Avasarı) Turkey. Map 7. Town in Lycia 14.4 km E-SE of Kaş, mentioned first by Pliny, then by Ptolemy, Hierokles, in the *Stadiasmus* and in inscriptions. Some 5th c. silver coins inscribed APR or PRL in Lycian are probably to be ascribed to Aperlai, as are coins of League type inscribed AΠ. In Imperial times (but probably not earlier, see Apollonia) Aperlai was at the head of a sympolity including Simena, Isinda, and Apollonia, and citizens of those cities are described, for example, as Aperlite from Simena. There is also a scanty coinage of Gordian III. In the bishopric lists the city's name appears as Aprillae.

The ruins are on a low hill by the shore at the head of a deep bay. The hill is surrounded by a wall of fairly regular ashlar still standing to a considerable height, with

a small gate surmounted by a blind arch. One or two buildings of late appearance are still to be seen, and a great number of Lycian sarcophagi with so-called Gothic lids, mostly of Roman date.

BIBLIOGRAPHY. F. Beaufort, *Karamania* (1818) 22; G. Hirschfeld, *AEM* 9 (1885) 192ff; R. Heberdey & E. Kalinka, *Bericht über zwei Reisen* (1896) 17.

G. E. BEAN

APHEK, *see* ANTIPATRIS

APHIDNA, *see* LIMES, ATTICA

APHRODISIAS Caria, Turkey. Map 7. Generally reckoned among the cities of NE Caria though close to the confines of Lydia and Phrygia, the site is located in a well-watered tributary valley of the Maeander (Büyük Menderes) river system. It lies on a plateau ca. 600 m high by the W slopes of the Salbakos (Baba Dağ) range, in the vilāyet of Aydin, near Karacasu, ca. 230 km SE of Izmir. The hamlet of Geyre situated in the SE part of the ancient city was resettled by governmental decree on a new site 2 km to the W a few years ago.

Recent discoveries have revealed a long prehistory for Aphrodisias, dating back at least to the Chalcolithic period (early 3d millennium B.C.) and ranging through all phases of the Bronze Age, with especially rich evidence for Early Bronze II and III. Textual sources provide little information about the city. Stephanos of Byzantium refers to it as Ninoe and by several other names. It is possible that Ninoe is to be connected with the Akkadian (Nin or Nina) names for the goddess Ishtar. In view of the fertility of the soil, a nature goddess cult probably developed here early and combined several native Anatolian with eastern traditions, culminating in the equation of the divinity with Aphrodite in the later Hellenistic period (hence the name Aphrodisias, a Greek version of Ninoe). Numismatic and epigraphic evidence suggests a sympoity with the neighboring town of Plarasa in the late 2d—early 1st c. B.C. Occasional references are encountered in Strabo, Pausanias, Tacitus, and Pliny the Elder. Extremely cordial relations with Rome started with Sulla (App. 1.97), continued with Julius Caesar and Octavian, who was involved in the grant of privileges (including the inviolability of its sanctuary) to the city. Most emperors maintained their benevolent support. It is, therefore, during the early centuries A.D. that Aphrodisias (eventually metropolis of Caria) reached great fame and prosperity both as a religious site and as a center of art and culture. Because of the popularity of Aphrodite, paganism remained strong in Early Christian times, even though the city became the seat of the bishops of Caria. Consequently, the name Stavropolis, and more simply Caria, began to be used to eradicate the memory of the goddess. Except for sporadic mentions of bishops, the history of Byzantine Aphrodisias is relatively obscure, though its role continued to be significant. Located in an area strategic in the 11th to 13th c., Caria (Aphrodisias) suffered at least four captures by the Seljuks, recorded by Nicetas Choniates and George Pachymeres between 1080 and 1260. The site was then virtually abandoned, though eventually the small Turkish village Geyre (etymologically derived from Caria) grew up among its ruins.

The evidence of some 30 signatures on many items found in Rome and elsewhere, bolstered by the discovery of much statuary and decorative sculpture of high quality, induced scholars to identify Aphrodisias as one of the major sculpture centers, as well as marble suppliers (quarries are located ca. 2 km E of the site in the mountains), of the Graeco-Roman world. New discoveries have more than confirmed the validity of this theory. Aphro-

disias' contributions to other fields also merit attention: Xenocrates was a medical writer of the late 1st c.; Chariton, an early novelist; and Alexander was an exponent of Aristotelian philosophy.

The core of the city is surrounded by a fortification system over 3.5 km long, begun in the A.D. 260s against the threat of Gothic invasion, repaired in the mid 4th c. (according to a dedication to Constantius over one of the gates) and in the Byzantine period. A great quantity of architectural blocks, inscriptions, and sculptural fragments was incorporated in the wall construction. The circuit is irregular in shape with several towers at intervals and at least six gates. The enclosed area is ca. 520 ha, though it does not represent the full extent of the Roman city. The ground is essentially flat with a gentle inclination towards the S, and a tributary of the Maeander (today, the Geyre, possibly ancient Morsynos). A conical hill ca. 15-20 m high rises in the S sector of the site. Though labeled an acropolis, this formation is actually a prehistoric mound. The remains of a series of mudbrick settlements of all phases of the Anatolian Bronze Age were brought to light on the W slope. Similar and even earlier (Chalcolithic) discoveries were made SE of the acropolis at Pekmez. The great number of artifacts recorded in both areas indicates that Aphrodisias was a significant prehistoric site connected with the Aegean, NW (Troy, Yortan, Kusura) and NE (Beycesultan) Anatolia, as well as the center (Kültepe) and the SE (Karataş) of the peninsula in the 3d and 2d millennia B.C.

The Temple of Aphrodite, chief sanctuary of the city, is located at about the center of the settlement; 14 columns of its peristyle are still standing. The building was transformed into a Christian basilica from the 6th c. onwards by removal of its cella, the shifting of its columns (to create a nave and two aisles) and the addition of an apse, including a presbyterion, prothesis, and diakonikon incorporated within an early temenos (?) wall to the E. A double narthex and an atrium were contrived to the W within the Roman temenos colonnade. The temple was Ionic, octostyle with 13 columns on the sides. Though generally dated to Hadrianic times, recent discoveries have suggested the 1st c. B.C. for the beginning of construction. The elaborate Corinthian temenos with naiskoi was, however, erected under Hadrian according to its epistyle inscription. The cella, destroyed by later transformations, consisted of a large chamber with a pronaos, but no opisthodomos. Testimonia of earlier structures, presumably sanctuaries, were also recorded, including a rough mosaic pavement of the 3d c. B.C. and some late archaic (6th c. B.C.) fragments, terracotta as well as architectural. Unfortunately, subsequent rebuilding activities have obliterated much of the earlier evidence, but the antiquity and sanctity of the area is secure since even prehistoric data were found here.

Though the Hadrianic temenos featured a central gate opening to the E towards an open area, the chief doorway lay farther E. A monumental tetrapylon was discovered and studied there. Built in the mid 2d c., it consisted of two pairs of four columns standing on high bases. The pairs farthest E, spirally fluted and double Corinthian, presented an elaborate facade with a central door and a broken arcuated pediment and marble screens. The temple side was decorated with handsome pedimental reliefs showing Eros and Nike figures among acanthus scrolls and elaborate acroteria. The space between the two column pairs was probably timber-roofed.

South of the temenos there is a well-preserved odeon; its lower cavea consisted of nine tiers of seats, but its summa cavea, once supported by 11 vaulted chambers, collapsed in late Roman-early Byzantine times and was

never repaired. The orchestra was modified, as shown by its opus sectile mosaic, in order to create a conistra. Handsome statuary decorated the elaborate stage, which consisted of four naiskoi between five doors opening on a backstage corridor. At opposite ends of the corridor, staircases led to the upper cavea, whose seats reached over the vaults of the parodoi. Five other doors opened from the corridor onto a porticus post scaenam, part of the large agora complex and decorated with the portraits of prominent citizens. Large buttresses built at intervals along the exterior semicircle of the cavea were connected with the timber-roofing scheme of the building.

West of the Odeon, an elaborate complex of rooms and halls, including a triconch to the E and a peristyle court communicating with it, was probably begun in Late Roman times as a private residence and subsequently turned into a bishop's palace, to judge from a number of seals uncovered during the excavations.

The plan of the agora S of the odeon and bishop's palace was initiated in the 1st c. Its large dimensions, however, extended the period of its construction into the 2d c. Most of this marketplace remains to be investigated, but it consisted of two adjacent Ionic porticos (ca. 205 x 120 m each) with colonnades on at least three sides. A long row of the columns of the N portico is still standing. The N side of the S portico is shown by its epistyle inscription to have been dedicated under Tiberius. The most elegant feature of this portico was its frieze featuring a vast repertory of beribboned masks and heads (including identifiable dramatic types) joined by garlands of fruit and flowers. Recent excavations in the SW part produced an unusual number of fragments of Diocletian's Edict on Maximum Prices. This decree was probably exhibited here in a large basilica which lay S of the colonnade.

The S side of the Portico of Tiberius partly skirted the acropolis, but its W end communicated with imposing Baths of Hadrian. Many huge consoles, in the shape of Medusa, Minotaur, bull, or lion protomes were found here. Large pillars decorated with elaborate scroll motifs with figures formed large exedras and an unusual facade for the baths. Most of these decorative elements are today in the Istanbul Archaeological Museum. Their resemblance to finds made at Leptis Magna (especially in the Severan basilica) have led several scholars to suggest the involvement of Aphrodisian sculptors in the decoration of the forum of that North African city.

Newly excavated portions of the baths (dedicated to Aphrodite and Hadrian) have revealed that the core of the building was constructed of large, uneven tufa blocks, revetted with marble and colored stone. Five large galleries, parallel and intercommunicating, have so far been revealed. The central one, beyond a praefurnium, was a caldarium with shallow stepped pools at either end, and flanked by two tepidaria (?). On either side of the praefurnium, sudatoria with a central circular pool were located. To the N, an area with a rectangular stepped pool adorned, like the whole establishment, with much statuary (including Achilles-Penthesileia and Menelaus-Patroklos groups) may be the frigidarium. Intricate networks of underground corridors crisscrossed the whole area. The baths were used in Byzantine times but their size was modified, possibly after earthquake damage.

The large theater of Aphrodisias was located in the heart of the city, built against the E acropolis. When the hillock was turned into a Byzantine fortress, some of its features, as in Miletos, were incorporated into the defensive system. Recent operations have revealed a well-preserved monument with several unique characteristics. The summa cavea was heavily damaged, but below the N diazoma, 27 rows of seats were revealed in excellent condition. The theater was built in the 1st c. B.C. Its plan shows the horseshoe-shaped cavea typical of many theaters in Asia Minor. In the 2d c., modifications were undertaken to accommodate gladiatorial games, wrestling bouts, and animal baiting. Only half of the stage has so far been excavated, but a conistra and via venatorum arrangement are recognizable. Six vaulted rooms of the stage were used as storage areas for "props" at one time. The wall of the stage building facing the N parodos proved to be entirely covered with a long series of inscriptions cut in the 2d and 3d c. The documents include a senatus consultum and official letters, some dating back to Republican times and all relevant to the history of Asia Minor and the city. Many of the abundant sculptures found on or near the stage betray signs of ancient repair, probably due to earthquake damage in late Roman times. The ultimate destruction of the stage and the lower theater, however, occurred in Byzantine times (post 6th c. ?). Evidence indicates Early Christian occupation at several points.

No attempt seems to have been made to restore the theater after this date. Activities were transferred to the E half of the imposing stadium located in the N part of the city. This very well-preserved structure was incorporated in the fortifications in late antiquity. Both its extremities were semicircular, but its long sides bow out gently, giving it a roughly elliptical shape (ca. 262 x 59 m, with 30 tiers of seats). Byzantine transformations created an arena in the E end with a conistra and protective gates or booths.

Several other monuments require brief mention. North of the temple and E of the tetrapylon, two large early Byzantine houses with peristyle courts decorated with figurative mosaic pavements have been partly revealed. A triconch church (martyrion?) was investigated at the SW foot of the acropolis. Several columns of an area partly explored and labeled gymnasium were re-erected to the SE of the acropolis.

Though only a few streets and roads have so far been located, the plan of the city betrays essentially a grid system with chief arteries cutting one another at right angles. The scheme was probably initiated in late Hellenistic or early Imperial times since most of the known thoroughfares appear to be axially aligned with the agora porticos. Areas long occupied, however, like the Precinct of Aphrodite and the acropolis, fell outside the grid which grew organically around them.

BIBLIOGRAPHY. *Antiquities of Ionia*, Society of Dilettanti (1840) II; C. Texier, *Description de l'Asie Mineure* (1849) III, 149ff.

Early excavations: *CRAI* (1904) 703-11, (1906) 178-84, (1914) 46ff; Th. Reinach, "Inscriptions d'Aphrodisias," *REG* 19 (1906) 79-150 & 205-98; G. Jacopi, "Gli scavi della Missione Archeologica Italiana ad Afrodisiade" and L. Crema, "I monumenti architettonici afrodisiensi," *MonAnt* 38 (1939-40); M. Squarciapino, *La Scuola di Afrodisia* (1943); J.M.C. Toynbee & J. B. Ward-Perkins, "Peopled Scrolls," *BSR* 18 (1950) 1ff; J.M.R. Cormack, *Notes on the History of the Inscribed Monuments of Aphrodisias* (1955); J.M.R. Cormack in *Monumenta Asiae Minoris Antiqua*, VIII: *Monuments from Lycaonia, the Pisido-Phrygian Borderland, Aphrodisias* (1962); L. Robert, "D'Aphrodisias á la Lycaonie," *Hellenica* 13 (1965) 190ff; id., "Inscriptions d'Aphrodisias," *AntCl* 35 (1966) 377ff; K. T. Erim, "The School of Aphrodisias," *Archaeology* 20.1 (1967) 18-27.

Recent excavations: K. T. Erim in *TürkArkDerg* (in vols. for 1961, 1962, 1964, 1967); id. in *ILN*, 13 Jan. 1962, 5 Jan. and 21 & 28 Dec. 1963, 20 & 27 Feb. 1965; id., "De Aphrodisiade," *AJA* 71.3 (July 1967) 233-43; id., "Roman and Early Byzantine Portrait Sculpture in

Asia Minor: Supplement I," *Belleten* 32, 125 (1968) 4-18; id. in E. Akurgal, *Ancient Civilizations and Ruins of Turkey* (1969) 171-75; id. with Joyce Reynolds, "A Letter of Gordian III from Aphrodisias in Caria," *JRS* 59 (1969) 56-86; id., "The Copy of Diocletian's Edict on Maximum Prices from Aphrodisias in Caria," *JRS* 60 (1970) 120-41; Erim, "Aphrodisias, Awakened City of Ancient Art," *National Geographic* 141, 6 (June 1972) 766-91; id. et al. "Diocletian's Currency Reform: a New Inscription," *JRS* 61 (1971) 171-77; Erim, "The 'Acropolis' of Aphrodisias: Investigations of the Theater and the Prehistoric Mounds, 1966-1967," *National Geographic Society Research Reports* (1973) 89-112; id. & Joyce Reynolds, "The Aphrodisias Copy of Diocletian's Edict on Maximum Prices," *JRS* 63 (1973) 99-110; Erim, "A Portrait Statue of Domitian from Aphrodisias," *Opuscula Romana* 9, 15 (1973) 135-42; id., "The Satyr and Young Dionysus Group from Aphrodisias," *Melanges Mansel* (1974) 767-75; id., "Il teatro di Afrodisia" in D. De Bernardi Ferrero, *I Teatri Classici in Asia Minore*, IV (1974). K. ERIM

APHRODISION Cyprus. Map 6. On the N coast 38 km E of Kerynia. The ruins of a small town identified with Aphrodision lie by the shore at the locality Liastrika, due N of Akanthou village. The ruins cover the fields inland as well as a headland which separates two bays. On the W side of the headland is a perfectly shaped horseshoe bay, which may have served as a harbor.

Nothing is known of the founding of the town or of its history but it is mentioned by Strabo (14.682) and by Ptolemy (5.14.4). The reading Uppridissa equated with Aphrodision on the prism of Esarhaddon (673-672 B.C.) is not to be trusted. The worship of Hera in the 2d c. B.C. is attested by a recently discovered inscription. Aphrodision seems to have flourished from Hellenistic to Early Byzantine times, when it was gradually abandoned after the first Arab raids of A.D. 647. The town site is now a field of ruins under cultivation and it is so far unexcavated.

BIBLIOGRAPHY. E. Oberhummer, *Zeitschrift der Gesellschaft für Erdkunde zu Berlin* 27 (1892), 448-51; D. G. Hogarth, *Devia Cypria* (1889) 94, 98-99; I. K. Peristianes, Γενικὴ Ἱστορία τῆς νήσου Κύπρου (1910) 510-14; I. Nicolaou, "Inscriptiones Cypriae Alphabeticae III (1963)," *Report of the Department of Antiquities, Cyprus* (1964) 199-201. K. NICOLAOU

APHRODITOPOLIS or Pathyris (El-Gabalein) Egypt. Map 5. Ca. 16 km S of Arment. One of several sites where Hathor, whom the Greeks identified with Aphrodite, was worshiped. This site was noted by Strabo (17.1.47). The remains of a temple dedicated to Hathor were rebuilt by Ptolemy Euergetes II. A necropolis from the Ptolemaic period has yielded Greek papyri and ostraca.

BIBLIOGRAPHY. A. Weigall, *A Guide to the Antiquities of Upper Egypt* (1913) 297-99; Porter & Moss, *Top. Bibl., V. Upper Egypt: Sites* (1937) 161-64; E. Brunner-Traut & V. Hell, *Aegypten* (1966) 627. S. SHENOUDA

APHYTIS Chalkidike, Greece. Map 9. Identified by Leake with Athytos near the modern village of Nea Phlogita on the E side of the Kassandra peninsula. Herodotos names it as one of the cities of Pallene (Phlegra) from which Xerxes' fleet took ships and men. A Sanctuary of Dionysos there is mentioned by Xenophon. Local coins bearing the head of Zeus Ammon were first issued in 424 B.C.

BIBLIOGRAPHY. Hdt. 7.123; Strab. 7, frag. 27; Thuc. 1.64; Xen. *Hell.* 5.3.19; W. M. Leake, *Nor. Gr.* (1835) III 155f. M. H. MC ALLISTER

APOLLINOPOLIS MAGNA (Idfu) Egypt. Map 5. A city on the W bank of the Nile, 105 km S of Thebes, noted by Strabo (17.1.47). It was the throne of Horus, whom the Greeks identified with Apollo, and it continued to be an important religious center all through the Classical period. The capital of the second nome of Upper Egypt, it owed its prosperity to its situation on the caravan road to Nubia. Its temple (137 x 79 m), begun by Ptolemy III in 237 B.C., was completed in 57 B.C. Its pylon is 36 m high.

BIBLIOGRAPHY. Porter & Moss, *Top. Bibl., V. Upper Egypt: Sites* (1937) 200-5; id., *VI. Upper Egypt: Chief Temples* (1939) 119-77[P]; A. H. Gardiner, *Ancient Egyptian Onomastica* II (1947) 6*-7*; K. Michalowski, *L'Art de l'Ancienne Égypte* (1968) 544-46[PI].

S. SHENOUDA

APOLLONIA (Pojani) Epeiros, Albania. Map 12. An ancient city near the mouth of the Aous river (the Vojussa). The remains are scattered over the hill of Pojani near a monastery which is said to have been built on the site of a temple of Apollo on the hill of Sthyllas. In the monastery a single Doric column is preserved, belonging to a hexastyle temple of the 5th c. B.C. The necropolis is in the valley of Kryegyata. The founding of Apollonia, in 588 B.C., is attributed to colonists from Corinth and Kerkyra. Its location favored its development. Quite early, the city must have defended itself against incursions by Macedonians and Illyrians as a result of which it sought an alliance with Rome in 260 B.C., and in 229 it came under Roman protection. Cicero called it an "urbs gravis et nobilis" and the city had a renowned school of rhetoric which even Octavian attended.

The walls, ca. 4 km long and well preserved, are constructed of limestone blocks and fortified with towers. The S side of the acropolis is buttressed by a beautifully terraced wall of ornamentally bossed stones. A gate with a pointed arch is set in the walls.

The theater, set apart on the W slopes of the hill of the acropolis, is identified by limestone blocks with a molding characteristic of theater seats.

A Hellenistic portico at the foot of the acropolis had a wall with 17 arched niches in front of which were Ionic half-columns with limestone capitals. In another niche, larger than the others, a small rectangular Hellenistic temple, with angular pilasters, is set. In front of the temple is an elegant altar.

The small odeon or covered theater next to the temple is Roman in design, rectangular in plan, with a semicircular cavea.

The monument of the public games superintendents is rectangular (19 x 15 m) on the outside, with a portico along the front and with a pedimental roof. There is a small vestibule inside and a small cavea with an orchestra. There were Corinthian columns on the facade and a richly carved cornice. On the architrave, there is an inscription in Greek which says that the building was constructed in the Antonine period by Q. Villius Crespinus Furius Proculus, a prytaneus, or superintendent of the public games, and high priest for life, in honor and memory of his brother Villius Valerius Furius Proculus, prefect of a cohort in Syria, tribune of Legio X (or XIV) in Pannonia, and a superintendent designate of the public games. The plan and structure of the building are quite similar to those of the bouleuterion of Miletos.

The acropolis had two summits, the major one being to the S. The lower level of a Greek temple was uncovered there and perhaps a limestone Ionic frieze found in the vicinity is part of that temple. The frieze has relief figures of warriors in combat.

A bath complex has been partially excavated near the W section of the city walls. Two rooms are visible, one of which has a mosaic pavement, as well as the heating room.

The remains of a gymnasium have been partially excavated about 300 m S of the monastery. It is perhaps the gymnasium mentioned by Strabo which was destined for other uses in the Roman period. Two archaic antefixes belonged to an older structure as did a stater struck at Metapontion. It was decorated with statues and the base was discovered there for a statue of Aphrodite, as is clear from a Greek inscription on one of its sides which mentions the prytaneus Psillus and the hieromnemones. During the Hellenistic period, the building was provided with a terracotta bathing tub set into the pavement, but in the Roman period it was turned into a home. Coins dating to the 4th c. A.D., have been discovered there.

Minor monuments include the remains of Roman houses, a triple-opening triumphal arch, a row of shops along a street, and a large hall in which it is tempting to recognize a library.

The necropolis, in the valley of Kryegyata, includes Greek tombs dating to the 6th c. B.C. as well as Roman tombs. The Roman tombs of the Imperial period are often shaped like small temples.

Various works of art have been found in the area of the ancient city. The most important is certainly the previously mentioned archaic frieze, coming perhaps from a temple on the acropolis. In the Louvre is a copy of the Anapauomenos of Praxiteles; in the Kunsthistorisches Museum in Vienna is a copy of the head of the Ludovisi Ares; and in Tirana is the Meleager of Skopas. The limestone stelai, which are somewhat reminiscent of Tarentine art works, are the most characteristic, in form and decoration, and can be considered Apollonian originals. Among Apollonian works of art is the votive offering dedicated to Olympia for a victory over Thronion. It is the work of Lykios, the son of Myron.

BIBLIOGRAPHY. Strab. 7.322, 9.424; Ptol. 3.12.2; Plin. *NH* 3.145; Cic. *Ad Fam.* 13.29.2.

C. Praschniker, "Muzakhia und Malakastra," *JOAI-Beibl* 21-22 (1921) 16ff; P. C. Sestieri, "Sculture romane rinvenute in Albania," *Bull. del Museo dell'Impero* 13 (1942) 7ff; id., "Le stele d'Apollonia," *Le Arti* 5 (1943) 115ff. P. C. SESTIERI

APOLLONIA (Marsa Susa) Libya. Map 18. On the coast about 184 km NE of Benghazi (Euesperides and later Berenice). The town served from its foundation as the port for Cyrene, whose history it shared until achieving autonomy during Roman times, if not before, when it was recognized as one of the five cities of the Libyan Pentapolis. As the fortunes of both Cyrene and Ptolemais waned in later times, Apollonia grew in prestige and power, until it was created the provincial capital in the 6th c. A.D. During Christian times it was more commonly called Sozusa, from which it developed its modern Arab name of Marsa Susa. Urban life ceased with the Arab invasion of A.D. 643.

Excavations fall into two phases: those of the 1920s and 1930s and those following the Second World War. The first phase saw the clearance and restoration of the large E basilica (6th c.), excavation of tombs, recovery of statuary, and the documenting of some topographical features, such as the aqueduct and an extra-mural triconch church. The latter monument, notable for traces of a triple apse at its E end, has not been excavated.

The second phase led to the investigations of remaining important features, underwater and land. The S edge of the walled town ran ca. 1,000 m parallel to the coast before turning N to meet the line of the sea. While its width today nowhere exceeds 200 m, the original town must have included a third more territory than it does at present since its outer and inner harbor facilities, with their moles, warehouses, docks, shipsheds, and slipways, have almost completely disappeared beneath the sea.

The principal buildings found inside the town walls are Roman or later. However, earlier inhabitation is documented by tombs in its SW corner and on the acropolis, in which pottery and coins of the 5th through the 3d c. have been found. Furthermore, pottery from a settlement of the first half of the 6th c. B.C. has been brought to light in the lowest occupation stratum W of the acropolis in the vicinity of the eastern basilica. In all probability Apollonia was used as the main port for Cyrene as early as the second generation of settlers following the foundation of the metropolis ca. 631 B.C.

The side of the town facing seaward was never walled. The defensive system was constructed in the Hellenistic period (ca. 250 B.C.) and then extensively overhauled and repaired in early Byzantine times. It consisted of three elements: towers, gates, and curtain wall. Nineteen towers survive on land, two round and the remainder rectangular. Only one major gateway survives at the W end of the city, while traces of smaller posterns have been found by each tower along the W and S perimeter. The original curtain consisted throughout of stone headers and stretchers. Each tower was connected by a short line of straight curtain to form an indented trace.

Within its walls Apollonia was divided lengthwise by a broad avenue, which ran from the W end of town to the acropolis hill occupying the E quarter. Here the rise in ground level halted the further progress of the decumanus, which was crossed at right angles by narrow cardines at intervals of every 35 m, at least in the urban center where traces of two such streets have been located.

The first monument to be encountered in the W sector is a Byzantine mortuary chapel, built against an exterior angle of the city wall. This structure, which has four central pillars supporting a dome, housed the remains of a saint or bishop in a Roman sarcophagus, re-cut in Byzantine times. Just inside the line of the city wall is the restored western basilica, whose apse occupies a former rectangular wall tower. Its nave and side aisles are divided by columns of varying types, sizes, and materials. A complex of rooms E of its narthex contained a small baptistery with sunken baptismal tank. Both the church and baptistery date to the 6th c. Nearby, along the inner face of the city wall, are three excavated rooms of Byzantine date. Their design, as well as their proximity to the main W gate and its associated small oval piazza, suggest that their function was largely governmental and bureaucratic.

The 6th c. central basilica lies ca. 200 m E of the west gate. Its restored interior was originally entered from the W through a small atrium, which in turn led into a long narrow narthex with apses at either end. Local limestone provided the material for some of its columns as well as sections of its paving. Since the rest of its fittings were of marble, evidently pre-cut materials were shipped to Apollonia where a structure had to be improvised for their accommodation. A substantial Roman bath, which, prior to its conversion around A.D. 100, served as a Late Hellenistic *palazzo signorile*, is located E of the church. Immediately N are remains of the late baths, built to replace the Roman baths after the earthquake of A.D. 365. Their construction indicates that they were never completed.

The Palace of the Byzantine Dux (ca. A.D. 500) was

erected on the hillside SE of the Roman baths. This major complex was divided into two sections, with its W half containing the ceremonial chambers of the governor when Apollonia was the provincial capital. These include an audience hall, guardroom, armory, atrium, and chapel. The E wing is less monumental and appears largely residential in nature. An early Roman villa and small houses belonging to the Byzantine period are located ca. 100 m to the NE of the palace. Separated from the Byzantine housing quarter is the restored E basilica (5th or 6th c.), built on top of an unidentified Hellenistic building. The nave of this imposing monument is divided by large monolithic columns of cipollino marble. A baptistery of triconch plan is attached to its NE corner.

As ground rises toward the acropolis hill a rocky outcropping marks the site of a heroon dedicated to the nymph (?) Callicrateia. Further NE are a series of chambers, probably functioning as warehouses, hewn out of the rock ledge facing the sea. Remains of vaulted cisterns and Byzantine houses are located close by. The top of the acropolis hill was left open, with a series of rooms of late date grouped around. No sure identification of this area's use has been made.

The Hellenistic theater, whose scene building was reconstructed during the reign of Domitian, is located just outside the city walls E of the acropolis. A small section of slipways is visible about half a kilometer off shore from the center of the city. These once belonged to the inner harbor and today rise above the sea in the form of an island. A second island slightly to the E preserves traces of the base of an ancient pharos. About a kilometer W of the city are foundations of a Hellenistic temple, as yet unidentified.

BIBLIOGRAPHY. R. G. Goodchild, "A Byzantine Palace at Apollonia (Cyrenaica)," *Antiquity* 34 (1960) 246-58; *Cyrene and Apollonia. An Historical Guide* (1963)[MI]; *Kyrene und Apollonia* (1970)[MPI]; J. du P. Taylor, *Marine Archaeology* (1965) 168-78[M]; D. White, "Excavations at Apollonia, Cyrenaica," *AJA* 70 (1966) 259-65[MP]; J. G. Pedley, "Excavations at Apollonia, Cyrenaica," *AJA* 71 (1967) 141-47[MP]. See also J. Ph. Lauer, "L'enceinte d'Apollonia à Mersa Souza (Cyrénaïque)," *RA* 7.1 (1963) 130-53. D. WHITE

APOLLONIA later SOZUSA Israel. Map 6. A town on the Mediterranean coast, between Jaffa and Caesarea (Plin. *HN* 5.14), ca. 24 km from Jaffa. The Semitic-Phoenician name of the place was Rishpon, "the city of the god Resheph," identified by the Greeks with Apollo. It is possible that Apollonia had already been conquered by John Hyrcanus I, but certainly by the time of Alexander Jannaeus it was incorporated into the Hasmonaean kingdom (Joseph. *AJ* 13.395). The city was freed by Pompey in 64 B.C. and was subsequently rebuilt by Gabinius (Joseph. *BJ* 1.166). Although there is no written evidence, it is certain that Apollonia was given to Herod at the beginning of his reign and received the status of a polis. After the destruction of the Temple it was once again made autonomous by Vespasian.

Apollonia was one of the few coastal cities that did not mint coins. It is possible therefore that during most of the Late Roman period, for which we have no written records, Apollonia was an insignificant town, and revived only in the Byzantine period when its name was changed from Apollonia to Sozusa, "City of the Savior" (Hierocles *Synecd.* 719.5). It has not been excavated.

BIBLIOGRAPHY. M. Avi-Yonah, *The Holy Land from the Persian to the Arab Conquests (536 B.C. to A.D. 640). A Historical Geography* (1966). A. NEGEV

APOLLONIA (Kılınçlı, formerly Siçak) Turkey. Map 7. City in Lycia 12 km E of Kaş, not mentioned by the ancient writers (except that Stephanos Byzantios records an island off the coast of Lycia under Apollonia) and known chiefly from its inscriptions. There is said to be a coin of Lycian League type inscribed ΑΠΟ; if this is correct it must be ascribed to Apollonia, which cannot then have been merely a subordinate member at that time, as it was later, of a sympolity under Aperlae.

The ruins are on a hill some 90 m above the village, with a small walled area at the highest point. Otherwise, apart from a poorly preserved theater, a large vaulted reservoir, and a number of cisterns of the familiar bell shape, there remain only tombs. Among them are four or five Lycian pillar tombs, none inscribed, proving the antiquity of the site, and one Lycian rock tomb with a Greek inscription.

BIBLIOGRAPHY. R. Heberdey & E. Kalinka, *Bericht über zwei Reisen* (1896) 17-18. G. E. BEAN

APOLLONIA Sicily. Map 17B. An unexplored city on the N coast (Commune of S. Fratello, Province of Messina) between Halontion and Kalakta (Steph. Byz.). Historical references to the site are few: around the middle of the 4th c. B.C. it was dominated by Leptines, tyrant of Engyon; in 342 B.C. Timoleon made the two cities autonomous, after having defeated the tyrant and exiled him to the Peloponnese (Diod. 16:72). The site was sacked by Agathokles in 307 B.C. (Diod. 20:56). In the 1st c. B.C. it was civitas decumana (Cic. *Verr.* 3.43,103), and it was represented by one ship in the fleet gathered against the pirates (Cic. *Verr.* 5.33, 86; 34,90).

The city occupies a vast rocky plateau on the summit of Monte Vecchio, a foothill of the central Nebrods; from this position it dominates a large stretch of the coastline from Kephaloidion to Agathyrnon. The ruins of the ancient city are visible on the mountain peak. On the entire S and W sides one can follow the line of the fortification walls built with isodomic masonry of local marble; the remains of at least two buildings, in the same isodomic technique, lie on the E side of the plateau, to the W and to the NE of the Norman Church (12th c.) of the Three Saints; on the summit of the mount a large cistern (?) has been cut into the rock, as well as a kind of altar and a few units at the end of a stairway climbing from the E.

BIBLIOGRAPHY. A. Salinas & S. Fratello, *NSc* (1880) 198. G. SCIBONA

APOLLONIA DEL PONTO (Sozopol) Burgas, E Bulgaria. Map 12. On the W coast of the Black Sea, a Milesian colony (Ps. Scym., 730-731; Strab. C.319), founded ca. 600 B.C. Two large gates and an island are known where the celebrated Sanctuary of Apollo and the major part of the ancient city were situated. A Greek inscription records the reconstruction of the ruined city and of the famous sanctuary by a Thracian tribe. The Imperial coins continue to use the name Apollonia until the 3d c. A.D., when the name Sozopol appears. During the Byzantine Empire Sozopol was the seat of a bishop, a rich and prosperous city that was frequented by the Genoese until it fell under Turkish domination in 1383. Today it is a modest town. Nothing of the ancient city remains visible above ground. Early excavations furnished little clarification. It is certainly on the island of St. Ciriaco where the stele of Anaxandros was found that the Temple of Apollo must be sought since all the material found in 1904, including a series of terracotta figurines datable to the 6th c. B.C., is connected with that cult; on the island of St. George there are traces of Byzantine con-

struction. Both older and more recent excavations at Kalfata and the port of Giardino brought to light rich Greek necropoleis containing painted funerary vases dating between the 5th and the 2d c. B.C. The promontory is called Cape Kolokuntas (pumpkins) because of the great number of tumuli in the area. They are scattered over the upland and contain dromoi and funerary chambers, as was the Thracian custom. There are also cultural blendings as in the tumulus of Mapès, with dromoi and painted sarcophagi, where the Greek influence dominates.

For the Temple of Apollo, Kalamis made the bronze statue of the god (ca. 13.2 m tall), which was stolen by Licinius Lucullus in A.D. 73 after the seizure of Apollonia, and transported to the Campidoglio in Rome. The symbolic lion of Apollo is found on the coins of Apollonia. There are many inscriptions and also an important decree. The only notable monument surviving is the stele of Anaxandros, now in the National Museum of Sofia. It is a masterpiece of Ionic art from the end of the 6th c. B.C., representing the deceased cloaked, with his dog. At the Louvre is a fragment of a slab from Apollonia in the archaic Ionic style.

BIBLIOGRAPHY. G. Seure, *RevArch* (1924); F. Bilabel, *Die Jonische Kolonisation* (1920) 13-15; G. Mihailov, *Inscriptiones graecae in Bulgaria repertae*, I (1957); I. Venedikov et al., *Les fouilles dans la nécropole d'Apolonia en 1947-1949* (1963); D. Dimitrov, *Ann. Univ. Sofia fac. stor. filol.* 34 (1942-43). A. FROVA

APOLLONIS Turkey. Map 7. City in Lydia midway on the road between Sardis and Pergamon (Strab. 13.4.4), founded by Eumenes II of Pergamon (197-160 B.C.). Cicero refers to it as well deserving and prosperous (*Flac.* 29.71). It is on a hill half an hour's walk N of modern Mecidiye (formerly Palamut). Partly preserved is a large wall circuit with some 24 towers, of Hellenistic coursed trapezoidal (and some polygonal) masonry. Inside are remains of a rectangular building (gymnasium?). On a lower hill to the NW, connected by a saddle, is a smaller fortress. The main wall is thought to date earlier than the 190s. Nearby there was apparently a Macedonian colony, Doidye, not certainly located.

BIBLIOGRAPHY. A. Fontrier, Μουσεῖον καὶ βιβλ. Ἐυαγγ. σχολ (1886) 61f; *BCH* 11 (1887) 85; C. Schuchhardt, *AthMitt* 13 (1888) 2-17; 24 (1899) 153-56[P]; J. Keil & A. von Premerstein, "Bericht über eine Reise in Lydien . . . 1906," *DenkschrWien* 53, 2 (1908) 45[M]; id., "Bericht über eine zweite Reise, 1908," ibid., 54, 2 (1911) 53-58; P. Herrmann, "Neue Inschriften zur Hist. Landeskunde von Lydien," ibid. 77, 1 (1959) 6-10; L. Robert, *Villes de l'Asie Mineure* (2d ed. 1962) 24ff, 246-49[MI]. T. S. MACKAY

APTARA, see APTERA

APTERA or Aptara (Palaiokastro, near Megala Choraphia) Apokoronas district, Crete. Map 11. On a steepsided plateau (231 m) just inland from Kalami on the S side of entrance to Suda Bay. Various attempts were made in antiquity to explain the name: e.g., that this was the site of the song contest of the Muses and Sirens; the latter lost their wings when defeated (Steph. Byz. s.v. Aptera; 'aptera' = 'wingless'); another legend has an eponymous hero Apteros. The city's name may in fact derive from the epithet of Artemis there (see below). The foundation of the city is variously ascribed to Glaukos of Cyrene or Pteras of Delphi.

There are few literary references to the city's history: archers from A. fought for Sparta in the second Messenian war (late 7th c.; Paus. 4.20.8); in 220 B.C. the city was forced by Polyrrhenia to desert its alliance with Knossos (Polyb. 4.55.4). A little can be gleaned from inscriptions: A. probably supported Sparta against Pyrrhos (272) and in the Chremonidean war (267/6-1); at this time it had links with Ptolemaic Egypt but was strangely absent from the alliances with Miletos (mid 3d c.); Scipios and their staff were honored there (189) as well as pro-Roman Achaeans (early 2d c.), Attalus I or II, and Prusias II. The city joined the treaty with Eumenes (183).

Impressive city walls indicate prosperity in the Early Hellenistic period, and wide commercial and political contacts are attested by a series of proxeny decrees (mainly 2d c.); the city's position at the mouth of the safest anchorage in Crete was of benefit. However, Aptera seems to have declined before the Roman Conquest, perhaps becoming dependent on its powerful neighbor Kydonia. Archaeological evidence of continued settlement through the Early Byzantine period is confirmed by a mention in Hierokles (650.11) and references to bishops of Aptera (*Notitiae* 8.227; 9.136). Geographical sources refer to it, usually as an inland city, without much detail: [Scylax] 47; Strab. 10.4.13, p. 479; Dion. Call. 122f.; Plin. *HN* 4.12.59 (*Minoium Apteron* are two separate sites); Ptol. *Geogr.* 3.5.7; *Stad.* 344 (confusion with Minoa?); *Rav. Cosm.* V.21; Steph. Byz. s.v. The form Aptara was apparently the usual one in Crete, and Aptera outside: coins have Aptara, inscriptions both, literary texts mostly Aptera. Coins portray a number of deities, especially Artemis Aptera, who seems to have been the chief deity (related to Diktynna and associated with initiation rites: see Willetts). Coins also commonly depict an armed man, Ptolioikos (the hero Apteros?), a bee, a torch, and a bow. Coinage started ca. 330 and ceased well before the Roman Conquest; there was none under Roman rule.

Pashley first correctly identified the site, previously thought to be Minoa or Amphimalla. Considerable remains survive, though nowhere to full height, of the city walls which are 4 km long, probably of 3d c. date, and all of one period despite differences in style. They surround the entire plateau, some of which was probably not built on even at times of maximum population. The work is particularly solid (2.4-2.8 m thick) on the W side, the normal approach at least from the Hellenistic period and the easiest route of access. The main gate is set at an oblique angle and flanked by towers; farther S is another tower shielding a sally port. Only traces survive of the wall line along the S and central N side, and on the NW side the work is rougher (with a steep drop outside). On the E side the terrain is rougher and the plateau edge irregular; the wall course is correspondingly irregular. The E gate (now Sideroporta) lay where the wall crossed a deep gully running into the site from the NE. Earlier the city may have been more clearly oriented towards the plain to the E, and there are possible traces of early defenses farther up the gully and around a low hill near the E side of the city, S of the gully, which seems to have been the acropolis; only rock cuttings survive on its top.

Apart from the city walls, the most striking ancient remains are the two great cisterns in the center of the site on the S side of the main gully (since these, like the walls, remained in use for centuries, they escaped demolition in the Early Byzantine period when all other ancient buildings were stripped of reusable building material; the walls suffered more during Venetian and Turkish fortification of Suda Bay). Both cisterns were built of concrete faced with brick and then mortar. One (W of the monastery of St. John of Patmos) has one aisle and turns at a right angle (6.3 m clear width). The other

(NE of the monastery) has three barrel-vaulted aisles divided by two rows of four longitudinal arched piers (overall size 24.7 x 18.5 x 8.2 m high); it is of Roman date, at least in its final form (with barrel vaults). To the SW of the monastery is a small double-cella temple (cf. Sta. Lenika) of careful, heavily clamped ashlar (5th-4th c.); later, graves were put inside and a mediaeval building over it. Behind is a terrace wall (associated with Protogeometric-Geometric sherds?). Nearby to the SE, a wall containing a number of (mainly proxeny) inscriptions was seen by Pococke and Pashley and excavated by Wescher (1862-64) but largely demolished in the 1890s; three more inscriptions were found in 1928. They may be in situ, not reused, and perhaps associated with the prytaneion. The wall has now entirely disappeared, but nearby is a 7th-8th c. church. To the E of this is a Roman apsidal building (bouleuterion?), with W wall, of poor concrete work with three niches, partly surviving. To the S of this, Early Byzantine houses have been excavated, and others of this period N of the cisterns.

The small theater lay inside the S city wall; the cavea (diam. 55 m) and orchestra (diam. 18 m) are now a simple hollow covered with stone. Diazoma, some seats and the paraskenia are still visible, but little of the stage building (25 x 6 m). Remains of brick walls attest alterations in the Roman period. To the E of the theater are traces of a small Doric temple (of Dionysos?). Between the acropolis(?) and E city wall is a small, poorly preserved temple of the Early Roman period: distyle in antis, with two statue bases in front; it was perhaps a Temple of Demeter and Kore (excavated 1958). The earlier attribution to it of bull statues is probably wrong. The existence of a temple under the Turkish Fort Izzedin at the NE corner of the site is uncertain.

Sherds of all periods from Classical (a few) to Early Byzantine and later cover the site. The main area of occupation in earlier periods was in the larger part S of the gully; remains in the N part seem to be mostly Byzantine or later. Buildings were probably never closely crowded. In the Roman period the city probably became rather agricultural in character. The site was destroyed in the Arab conquest and probably not reoccupied until Venetian times.

The necropolis lay on the saddle to the W near Megala Choraphia and contained rock-cut graves as well as chamber tombs of Late Classical-Roman times and an earlier pithos burial. Some rock-cut graves found within the city walls (S side) indicate lack of habitation there. The port was at Kisamos; Aptera is thought by some to have controlled Minoa across the bay entrance. To the W is Mt. Malaxa (ancient Berekynthos), where the Idaean Daktyloi lived, legendary inventors of metallurgy (Diod. 5.64.5).

BIBLIOGRAPHY. R. Pashley, *Travels in Crete* (1837, repr. 1970) 36-60, II.1; C. Wescher, "Fouilles d'Aptère. Découvertes d'inscriptions crétoises," *RA* NS 10 (1864) 75-78; id., *Archives des missions scientifiques et littéraires* 2d ser. 1 (1865) 433, 439-43; T.A.B. Spratt, *Travels and Researches in Crete* II (1865) 127-30; L. Mariani, *MonAnt* 6 (1895) 208-10[I]; Hirschfeld, "Aptera (1)," *RE* II (1896) 286-87; L. Savignoni, *MonAnt* 11 (1901) 289-95[I]; G. de Sanctis, ibid., 525-28; M. Guarducci, *RivFC* NS 14 (1936) 158-62; id. *ICr* II (1939) 9-38; H. van Effenterre, *La Crète et le monde grec de Platon à Polybe* (1948); H. Drerup, "Paläokastro-Aptara," in F. Matz, ed., *Forschungen auf Kreta, 1942* (1951) 89-98[MI]; id., "Zweizelliges Heiligtum in Aptara," ibid., 99-105[PI]; *BCH* 83 (1959) 749-53; R. F. Willetts, *Aristocratic Society in Ancient Crete* (1955); id., *Cretan Cults and Festivals* (1962); S. G. Spanakis, *Kriti*, II (n.d.) 64-70 (in Greek)[M]. D. J. BLACKMAN

APULUM (Alba Iulia) Romania. Map 12. The most important center of Roman Dacia. The name, linked with the name of the Dacian tribe Apuli is mentioned in ancient sources (Ptol. 3.8, *Tab.Peut.*, *Rav.Cosm.* 4.7) and inscriptions.

Older archaeological excavations, the material discovered in the course of construction in the modern town, and especially the hundreds of inscriptions have documented the history of the two ancient towns that developed here. Their situation on the fertile land around the Mureş river, at the crossroads of several highways, and not far from the gold-bearing mountains, contributed to their development.

Legio XIII Gemina was stationed here, from the Roman conquest until the Aurelian withdrawal in the 270s. The camp of the legion on the river Mureş, at the place called Cetate (Fortress) today, was built of stone. The camp (600-750 x 500-400 m; ca. 24-30 ha) was destroyed to build various mediaeval structures, especially the 18th c. fortress on the same site.

South of the camp, farther up to the Mureş river, in the present Partoş district, the legion dug canabae, mentioned epigraphically from the time of Trajan until the time of Marcus Aurelius (*CIL* III, tab. cer. xxv) when the settlement there became the Municipium Aurelium Apulense (*CIL* III, 986). Under Commodus it became colonia Aurelia Apulensis. An inscription of 253 in honor of Volusianus, the son of emperor Trebonianus Gallus, calls the town col(onia) Aur(elia) Ap(ulensis) Chrisop (olis).

The ruins of this town were preserved until the middle of the 19th c. Among the many buildings, some paved with mosaics, a long edifice (49.90 x 14.65 m), used for handicraft workshops was discovered.

Parallel with this town a second town developed to the N, E, and SE of the camp. It became a municipium under Septimius Severus (*CIL* III, 976, 985, 1051) and coexisted with the colony Aurelia Apulensis. Its name was col(onia) nova Apule(n)s(is) and it was mentioned in the year 250 in an inscription in honor of Trajan, called "Restitutor Daciarum" (*CIL* III, 1176).

There were baths, temples, a Mithraeum, the residence of the governor(?), streets, aqueducts, buildings. Inscriptions mention: temples, porticos, basilicas, public wells, none of which remain.

After the administrative reforms made by Hadrian (in 118-120), the governor of Dacia Superior had his residence in Apulum. He was also the commander of Legio XIII Gemina; after the administrative reform of Marcus Aurelius in 168, this was the seat of the governor of the three Dacias, Legatus Augusti pro praetore Daciarum trium.

The importance of handicrafts is attested by the great quantity of ceramics, oil lamps, metal objects, and tiles and bricks bearing the seal of the Legio XIII Gemina and often accompanied by the name of the head of the workshop. Inscriptions testify to the existence of collegia: collegium fabrum, centonariorum, nautarum and dendrophorum. Treasuries, coins that attest an uninterrupted monetary circulation until the 4th c., money bags, and inscriptions all prove the commercial activity of this place. The inhabitants of the towns were granted ius Italicum.

Recent archaeological discoveries have identified two Roman necropoleis. A variety of religious cults existed according to inscriptions and remains of sculpture, and Aesculapius and Hygieia seem to have been the patron deities of the town.

The epigraphic and sculptural material is on display in the lapidarium of the regional museum in Alba Iulia.

BIBLIOGRAPHY. C. Daicoviciu, "Aşezarea autohtonă de

la Apulum," *Studii si Cercetări de Istorie Veche* 1-2 (1950) 225-28; I. Berciu et al., *Cetatea Alba Iulia* (1968) 8-13; M. Macrea, *Viaţa în Dacia romană* (1969) 125-28; A. Popa & I. A. Aldea, "Colonia Aurelia Apulensis Chrysopolis," *Apulum* 10 (1972) 209-20.

L. MARINESCU

AQUAE (Aix-les-Bains) Savoie, France. Map 23. A district (vicus) of the city of Vienna, governed by 10 delegates (decemlecti) designated as landlords (possessores Aquenses): *CIL* XII, 2459, 2460, 5874; *AEpigr* (1934) 165.

Three monuments are well known. First is a funerary arch known as the Campanus arch because of an inscription mentioning that L. Pompeius Campanus had the monument erected in honor of all his relatives. This type of tomb is very unusual. It is 9.15 m high, 6.7 m wide, and has a 3 m span. Built of finely cut stone, it has an entablature terminating in a projecting cornice and topped by an attic. On the E side of the arch are eight niches, alternately rectangular and curved, for the busts of the dignitaries listed below, while those of the other six mentioned on the attic were probably on the top of the arch.

The next monument is called a temple, a rectangular building (17 x 13 x 14.5 m); its walls, built of large stones, still stand 9.75 m high. According to local tradition this was a temple to Diana, but the tradition is unfounded.

Finally, the baths, remodeled since antiquity and incompletely excavated, consist of three frigidaria, two adjacent tepidaria, and two pools and one room, all heated. The pools were faced with marble and the walls with painted stucco. The healing god Bormo (or Borvo) was worshiped at Aix.

The town museum has inscriptions, sculptures (Constantine? a Muse?) and other finds from the surrounding area.

BIBLIOGRAPHY. P. Wuilleumier, *Le passé d'Aix-les-Bains* (1950)[1].

M. LEGLAY

AQUAE (Călan) Hunedoara, Romania. Map 12. An important civil settlement and health resort on a terrace of the Strei river NW of the present town. The name appears as Hydata in Ptolemy (3.8.4). The site, called pagus Aquensis, belonged to the territory of Ulpia Traiana Sarmizegetusa and was ruled by a praefectus, who was at the same time the decurion of Sarmizegetusa.

All that remains is a basin at a water source, and traces of the imperial road to Ulpia Traiana Sarmizegetusa. The camp traces are uncertain. The neighboring quarry was used in antiquity.

Among important inscriptions discovered was one from A.D. 161, in honor of the governor P. Furius Saturninus (*CIL* III, 1412), and tiles and bricks bearing the seals of Legio XIII Gemina.

BIBLIOGRAPHY. V. Christescu, *Viaţa economică a Daciei romane* (1929) 102; D. Tudor, *Oraşe, tîrguri şi sate în Dacia romană* (1968) 115-19.

L. MARINESCU

AQUAE (Cioroiul Nou) Dolj, Romania. Map 12. A statio in Dacia inferior, near the sources of the Apa Cioroiului river. It comprised a civil agglomeration covering ca. 20 ha, a quadrilateral citadel (130 x 235 m) in the center, and a necropolis at its S end. The earth citadel was built by the local population after the invasion of the Carpes in 245-247. The name of this place appears in the votive inscription of a certain Germanus speculator leg. VII Claudiae, dedicated to genio stationis Aquensium; and a dedication to Hercules: pro sal. Aquensium made by M. Opellius Maximus, dec. Montanensium.

It was probably a fiscal customs statio, and was located in the center of a vast, fertile plain. The archaeological excavations uncovered a villa rustica, public baths, a temple, pottery ovens, and foundations of houses. The coins discovered go from Trajan to Heraclius. The temple, having a naos, a pronaos, and a vestibulum, covered an area of 6.6 by 17.8 m and was very likely consecrated to Hercules. In a ditch, buried as membra disiecta, were 37 fragments of statues (Minerva, Mercurius, Bacchus, Hekate, Apollo, Venus, Matres, Iupiter, Aion, etc.). They are from a ritual burial performed after the destruction of the Carpes. (At present, these remains are preserved with other pieces of the same type in the Museum of Craiova.) The statio Aquensis was also an administrative center of an important agricultural area divided among several large landowners, such as C. Ant. Iulianus, M. Cassius Herculanus.

BIBLIOGRAPHY. *AnÉpigr* (1959) 330-31; (1963) 136; (1967) 392.

D. Tudor, "Săpăturile arheologice de la Cioroiul Nou," *MCA* 8 (1962) 547-54; id., Templul şi statuetele romane de la Cioroiul Nou," *Omagiu P. Constantinescu-Iaşi* (1965) 109-15; id., "Aquae en Dacie inférieure," *Latomus* 25, 4 (1966) 847-54; id., "Şantierul arheologic Cioroiul Nou," *Apulum* 6 (1967) 593-605; id., *Oltenia romană* (3d ed., 1968) 214-20; id., *Oraşe* (1968) 315-23; *TIR*, L.34 (1969) 47.

D. TUDOR

AQUAE ARNEMETIAE (Buxton) N. Derbyshire, England. Map 24. The name of this watering place is preserved in the *Ravenna Cosmography* and clearly relates to the present spa at Buxton. The site is the principal center of the Peak District; in the Roman period it lay at the junction of the Manchester-Littleborough road with another running E from Brough-on-Noe. The name relates to the goddess Arnemetia who was associated with St. Anne's Well opposite the pump room. A Flavian fort probably lay nearby at Silverlands. Finds are in the local museum.

BIBLIOGRAPHY. F. Haverfield, *VCH Derbyshire* I (1905) 222ff.

G.D.B. JONES

AQUAE DACICAE (Sidi Moulay Yakoub) Morocco. Map 19. Situated in Mauretania Tingitana (*Ant. It.* 23.3), it should be identified with the ruins of some large Roman baths found in the valley of the el Hamma river 20 km S of Sidi-Slimane, near the sulphurous spring Sidi Moulay Yakoub. Piped since Roman times, the spring fed, by aqueduct, several pools that have been partially preserved. They are in the center of houses that extended over roughly 50 m.

BIBLIOGRAPHY. M. Euzennat, "Les voies romaines du Maroc dans l'Itinéraire Antonin," *Hommages à Albert Grenier* coll. *Latomus* 58 (1962) 599-600; A. Luquet, "Moulay-Yakoub: bains romains," *Bulletin d'Archéologie Marocaine* 5 (1964) 357.

M. EUZENNAT

AQUAE FLAVIAE (Chaves) Trás-os-Montes, Portugal. Map 19. The modern city is the site of a Roman municipium. The only remains are many inscriptions and the bridge across the Tâmega, completed under Trajan (A.D. 104). It is 140 m long and has 18 arches, six of which are now almost completely underground. An inscription from the time of Vespasian preserved in the bridge (it is not certain how it came to be there) records the fact that ten people of the region contributed to a great work which cannot be certainly identified. Could it be the bridge itself? Or the road from Bracara to Asturica for which the bridge must have been a crossing?

Aquae Flaviae derived its importance from the road and from its medicinal springs. There seem to have been

two baths outside the fortifications, one to the S at the site of Tabolado, another to the N, in the vicinity of the fort of S. Vicente. The street of Santo Antonio is perhaps aligned along an aqueduct, no longer visible, which once fed the N baths. The mediaeval fortifications may follow the plan of the Roman ones, or they may be only a reconstruction of them. The Largo da Principal may correspond to the forum, and some of the streets preserve the alignment of the Roman ones.

BIBLIOGRAPHY. A. C. Ribeiro Carvalho, *Chaves Antiga* (1929); M. Cardozo, *Algumas inscrições lusitano-romanas da região de Chaves* (1943); A. Montalvão Machado, "Permanece a urbanística de Aquae Flaviae?" *Conimbriga* 11 (1972) 35-39P. J. ALARCÃO

AQUAE GRANNI (Aachen) Germany. Map 20. West of the province Germania Inferior, probably in the region of the Sunuci settled in the time of Augustus and Tiberius. About A.D. 80 the legions in this province built above the hot sulfur springs two baths, the Bücheltphermae and the Münsterthermae, which were still in use in the second half of the 4th c. A.D. Together with a large temple complex the baths formed an important health center, probably for the troops that built them. The Roman living quarters were included in the area of the baths. To the NW of the settlement was a necropolis of the 3d and 4th c. Various finds in Burtscheid suggest that there too baths had existed. Most of the finds are now in the Rheinisches Landesmuseum in Bonn.

BIBLIOGRAPHY. J. Hagen, *Römerstrassen der Rheinprovinz* (2d ed. 1931) 246-50; H. v. Petrikovits, "Aachen (Grabungen)," *BonnJbb* 145 (1940) 307-11; id., "Aquae Iasae," *Arheološki Vestnik* 19 (1968) 89-93; H. Christ, "Das Karolingische Thermalbad der Aachener Pfalz," *Germania* 36 (1958) 119-32; L. Hugot, "Die römischen Bücheltbhermen in Aachen," *BonnJbb* 163 (1963) 188-97; H. Cüppers, "Aquae," *Der kleine Pauly* 1 (1964) 475f; H. Nesselhauf & H. v. Petrikovits, "Ein Weihaltar . . . aus Aachen-Burtscheid," *BonnJbb* 167 (1967) 268-79. H. VON PETRIKOVITS

AQUAE HELVETICAE (Baden) Aargau, Switzerland. Map 20. Roman vicus on the W bank of the Limmat, 32 km downstream from Zurich. The name occurs in an inscription, *CIL* XIII 10027, 204 = Howald-Meyer no. 448: Aquis He(lveticis) Gemellianus f(ecit). The site is on a hairpin curve, where the river flows for 2.2 km in a ravine with a bottleneck at each end. The vicus developed from the river crossing of the military road from Aventicum and Augusta Raurica to Raetia, and also because of hot springs on both sides of the bend. It was settled in the early years of Tiberius' reign, and during the 1st c. A.D. a military post manned from the legionary camp of Vindonissa, 7 km away, guarded road and bridge. Sacked in A.D. 69 by the legions of Vitellius under Caecina, because the Helvetii sided with Galba (Tac. 1.67-69), it recovered and flourished until the incursions of the Alamanni ca. A.D. 260. Habitation continued, however, through the 4th c.

The Roman site lies N of the mediaeval town and bridge, near the upper bottleneck. It extends on both sides of the Roman road between the bridge and the foot of the Martinsberg, where cemeteries have been found. A fortification wall, once visible on the left bank of the river from the bridge to the Martinsberg, which was not precisely dated, has now disappeared. There was a military lookout on the hilltop. Bathing establishments are still built over the hot springs, making excavation impossible.

The W part of the vicus appears to have been a business district, with the short sides of oblong buildings lining the road. The E part, under the modern casino park, was residential; villa-like buildings with wall paintings and mosaics have been discovered. The destruction level of A.D. 69 is noticeable throughout. A building (40 x 35 m), with 14 rooms containing many medical instruments, has been identified as a hospital for the legionary camp at Vindonissa. Legionary titles indicate that the hospital was built by the army.

The baths covered an area of at least 35 by 30 m. Built against the slope where the springs gush out, the rooms were cut at different levels in the gravel. The foundations were laid on wooden piles and the basin walls were isolated by clay packing. Two of the latter have been explored, and are partly preserved under the Stadhof. There is no heating system. Wide seats or steps surround one basin beneath the water level, and votive deposits have been found in a shaft. A temple to Isis is attested near Wettingen, ca. 1.7 km upstream (*CIL* XIII, 5233), and a possibly related silver treasure was found and melted down in 1663. The historical museum is in the Landvogteischloss.

BIBLIOGRAPHY. F. Staehelin, *Die Schweiz in römischer Zeit* (3d ed. 1948) 189-90, 472; V. v. Gonzenbach, *BonnJbb* 163 (1963) 100-1; O. Mittler, *Geschichte der Stadt Baden* (2d ed. 1966) 17-36PI, 356 (bibl. 1948-66); C. M. Wells, *The German Policy of Augustus* (1972); excavations: *AnzSchweiz* (1872) 309-12; (1893) 262-69; (1895) 434-41, 458-62; (1896) 2-5PI (hospital and villas); H. R. Wiedemer, "Die Entdeckung der römischen Heilthermen von Baden-Aquae Helveticae 1967," *Jber. Gesell. Pro Vindonissa* (1967) 83-93PI; *Jb. Schweiz. Gesell. f. Urgeschichte* 55 (1970) 204-5.

 V. VON GONZENBACH

AQUAE IASAE (Varaždinske Toplice) Croatia, Yugoslavia. Map. 12. A spa ca. 12 km S-SE of Varaždin is in the territory of the Illyrian tribe of Iasi where there developed an important settlement in the 1st and 2d c. A.D. Being at a crossroads the hot springs attracted many visitors, who left votive monuments especially to the Nymphs and to Silvanus. In the 2d c. A.D. the respublica Poetoviensis, to whose territory Aquae Iasae belonged, built a sanctuary to the Nymphs there. Constantine the Great reconstructed the bath buildings after a fire and built porticos.

Systematic excavation has uncovered the bath complex, forum, and capitolium, where a fine statue of Minerva was discovered. The earlier architecture was mainly wooden and large oak beams were found preserved by layers of mineral. The pottery was imported from Italy, Germania, and Gallia, but local production kept the native traditions. M. Fabius Fabullus, legatus Augusti provinciae Africae, came here as a patient in the middle of the 1st c. A.D. The settlement was destroyed in the end of the 4th c.

The finds are preserved in a local collection and in the Archaeological Museum at Zagreb.

BIBLIOGRAPHY. V. Hoffiller & B. Saria, *Antike Inschriften aus Jugoslawien*, I (1938) 205-11; B. Vikić-Belančić & M. Gorenc, "Arheološka istraživanja antiknog kupališta u Varaždinskim Toplicama," *Vjesnik Arheološkog muzeja u Zagrebu* 1-3 (1958-68). M. ZANINOVIĆ

AQUAE MATTIACAE (Wiesbaden) Germany. Map 20. Capital of the Civitas Mattiacorum, the town took its name from the hot springs described by Pliny (*HN* 31.20) and mentioned by Martial (*Ep.* 14.27). The name was first mentioned in an inscription on a milestone from Mainz-Kastel (Castellum Mattiacorum) A.D. 121-22. Before that, a series of military installations is known: 1) A lookout post from the time of Germanicus'

campaigns, A.D. 14-16, known through pottery finds. 2) A camp of the Claudian period, established probably in A.D. 40 and destroyed in 68-69, known from finds and the remains of buildings. 3) From the time of Vespasian, various citadels, the latest a stone-built one under Domitian, abandoned in 121-22: it was garrisoned by Cohors II Raetorum and Cohors IV Delmatarum.

The economic center of the vicus Aquae Mattiacorum was the baths, built ca. 89-90, a combination of baths and spa, with four shallow pools and private cells. Diana Mattiaca was revered as the goddess of healing. Temples to Jupiter Dolichenus, Mithras, and Sirona, and a schola for negotiatores civitatis Mattiacorum are known through inscriptions and foundations.

After the fall of the limes in 259-60, the population fell off sharply. In the 4th c., under Valentinian I, Wiesbaden is believed to have formed the center of a fortified bridgehead for Mainz. The only remnant from the Roman period is the so-called Heidenmauer, ca. 500 m long and set with engaged-towers. It cut through the vicus, excluding the baths. Since it could be circumvented at both ends, it may in fact be a part of the unfinished citadel. The necropoleis of the vicus lie on the roads leading out from the citadel built under Domitian, particularly on the road to Castellum Mattiacorum, the second vicus of the civitas. At least two districts of the town are known, vicus Vetus and vicus Melonionorum. Among its public buildings, a large bath complex has been excavated. Castellum Mattiacorum remained in Roman hands at least until the beginning of the 5th c., according to a coin hoard with coins from the end of the reign of Constantine III (A.D. 408). The hoard probably represents the paymaster's treasury from a military detachment.

BIBLIOGRAPHY. *ORL* B, 30-31; H. Schoppa, "Aquae Mattiacorum und Civitas Mattiacorum," *BonnJbb* (1972). In preparation. H. SCHOPPA

AQUAE NERI (Neris les Bains) Allier, France. Map 23. Some Gallo-Roman baths mentioned in the *Peutinger Table* have been partly excavated. They were quite luxurious, with marble veneers; some pools can still be seen. Tiles bearing the mark of Legio VIII and the presence of a camp suggest that there was a valetudinarium here. Remains of an amphitheater, some rich villas, and two aqueducts are still standing. A number of inscriptions have been found, several of them with the dedication: DEO NERIO.

Sculptures representing the traditional Gallic gods have also been found: a crouching god, a god with a snake, one snake with a ram's head. Others show Epona and Abundance, while Oriental religions are represented by a lamp with a dedication to the Mother of the Gods.

A remarkable number of bowls of metal as well as of glass and terracotta have been found on the site. Two potter's kilns of the Tiberian period have been discovered; they were used to bake terra sigillata and ordinary domestic bowls. Bowls with a lead glaze were also found in the furnace dump.

BIBLIOGRAPHY. H. Vertet, "Lampe en bronze dedié à Cybèle, trouvée à Neris," *Revue archéologique du Centre* 1 (1962) 348-50[I]; "Informations," *Gallia* 25 (1967) 297-98[I]; 29 (1971) 323-24[I]. H. VERTET

AQUAE S. (Ilidža) Bosnia-Hercegovina, Yugoslavia. Map 12. A resort on the main road to the coast 3 km SE of Sarajevo. Under Roman control by the 1st c. A.D., it achieved its greatest prosperity early in the 3d c. and continued in use through the 4th c. The settlement became a municipium towards the end of the 2d c. A.D.

Excavations have produced the remains of the main spa built over the source of the springs. This was a large building richly decorated with imported Corinthian capitals, painted walls, and numerous mosaic floors. The remains of a courtyard house and hospital have been uncovered. The house, possibly the administrative center for the spa, contained more than 30 rooms oriented around a courtyard portico. The hospital included a small bath block flanked by two groups of small rooms with mosaic pavements of geometric design. The finds from the site are kept in the Zemaljski Muzej in Sarajevo.

BIBLIOGRAPHY. J. Kellner, "Römische Baureste in Ilidže bei Sarajevo," *Wissenschaftliche Mitteilungen aus Bosnien und der Hercegovina* 5 (1897) 131-62; E. Pašalić, "Rimsko naselje u Ilidže kod sarajevo," *Glasnik Zemaljskog Muzeja u Sarajevo* 14 (1959) 113-36; id., *Antička naselja i komunikacije u Bosni i Hercegovini* (1960); J. J. Wilkes, *Dalmatia* (1969)[MP]. M. R. WERNER

AQUAE SEGETAE (Sceaux du Gâtinais) Loire, France. Map 23. Mentioned in the *Peutinger Table* as Aquae Segestae. A thermal center on the road from Agedincum (Sens) to Orléans, 82 leagues from Agedincum and 22 leagues from Fines (Ingrannes). The well-preserved section of the road in this area is known as Le Chemin de César. The name Sceaux comes from Segeta, a goddess of the springs worshiped both at Saint Galmier in the Vosges and at Moind in Le Forez.

Much digging has been done on the site since 1836, and important ruins have been located at Le Préau, E of the modern village. These consist, first, of a long rectangular building (400 x 75 m) oriented NW-SE, with a pool at either end. The N pool terminates in an apse. The S corner, which includes several rooms around a basin to the N, is now being cleared. The architecture is carefully executed, and fragments of marble from different regions have been found. The building apparently goes back to the Flavian era, and underwent changes and embellishments in the 2d c. This is undoubtedly the Sanctuary of Segeta, with its healing pools fed by a ferruginous spring (now dried up) and probably also by an aqueduct, traces of which have been located for a distance of 30 km.

A theater 104 m in diameter lies NW of the spa buildings; its cavea is built on embankments supported by walls, and the orchestra is semi-elliptical. Traces of several other monuments have been located, and a great number of finds have come from the ruins, in particular, hoards of coins and silver plate. The city also had necropoleis. A very large, rich Merovingian cemetery in the area known as Le Mérie is being excavated, and a second has been located.

BIBLIOGRAPHY. A. Grenier, *Manuel d'archéologie gallo-romaine* III, 2 (1958) Ludi, 874-76; Abbé Nouel, *Origines gallo-romaines du Sud du Bassin Parisien*, 22-23; *Gallia* 26, 2 (1968) 325-27; Mémoires inédits de M. Roncin et de Mlle. Matthieu. G. C. PICARD

AQUAE SEXTIAE SALLUVIORUM (Aix-en-Provence) Bouches-du-Rhône, France. Map 23. The town derives its names from its hot springs and its founder. Caius Sextius Calvinus created it in 122 B.C. on the territory of the indigenous confederation of the Salluvii, whose capital of Entremont nearby he had just destroyed (Livy *Epit.* 61; Vell. Pat. 1.15; Strab. 4.15). Originally Aix was a castellum occupied by a garrison which was supposed to watch over the routes leading from Marseille to the Durance and from the Rhône to the Italian frontier. It is the oldest Roman foundation in Gaul. The presence of a Roman garrison must quickly have attracted merchants and businessmen, and it was prob-

ably Caesar who made it the capital of a civitas after 49 and divided the territory of Marseille between it and Arles. A Latin colony under Caesar, it later became a Roman one, perhaps under Augustus. Around 375 it became the capital of provincia Narbonensis secunda.

Rather few archaeological remains have been found in situ. The area occupied by the castellum and the colonia respectively is a subject for discussion. The most generally accepted opinion identifies the Roman castellum with the Bourg Saint-Sauveur, which was the capitulary residence in the Middle Ages. Its location somewhat higher than the rest of the site and its dimensions (ca. 400 m N-S and 300 E-W) would correspond fairly well with characteristics of a fortified post. Unfortunately, archaeological proof is lacking and reconstruction of the fortifications remains hypothetical. Only some stretches of road have been noted. Similarly, the course and extent of the wall of the colony are the subject of various hypotheses. Ancient documents allow one to place the S gate. Its arrangement as a half-moon shape protected by two round towers, analogous to gates at Fréjus and Arles, may indicate that it dates to the Augustan period. The Via Julia Augusta entered the town by this gate, and in the past tombs and a mausoleum have been noted in the vicinity. Two pieces of wall found long ago, burials, and funerary inscriptions permit the approximate reconstruction of an enclosure with a perimeter of some 3 km. It was elongated along an E-W axis and very much off center with respect to the original castellum. However, the details of the topography still remain to be specified. Sections of the cardo have been known for a long time and recent excavations have reconstructed the axis of the decumanus. There are remains, some of them sizable, of five aqueducts.

According to different indications there probably were an amphitheater and an arch of triumph or trophy. Three villae urbanae have been partly excavated in the Grassi gardens. One of them, probably Augustan, included two peristyles.

Of Early Christian Aix there remains the baptistery of Saint-Sauveur cathedral. It can be dated to the end of the 4th or beginning of the 5th c. Eight unmatching columns in it were borrowed from pagan buildings. The seat of the archbishopric has not yet been found.

There is a Gallo-Roman collection at the Musée Granet.

BIBLIOGRAPHY. M. Clerc, *Aquae Sextiae* (1916)[MPI]; F. Benoît, F.O.R. (1936); *Gallia* 5 (1947) 98-122; *Gallia* 12 (1954) 294-300; *Chronique des circonscriptions arch.*, passim; A. Grenier, *Manuel d'arch. gallo-romaine* III, IV; P. A. Février, *Le développement urbain en Provence* (1964); R. Ambard et al., "Fouilles d'urgence et découverte du decumanus à Aix-en-Provence," *Revue Arch. Narbonnaise* 5 (1972). C. GOUDINEAU

AQUAE STATIELLAE Liguria, Italy. Map 14. A city inhabited before the Roman conquest by the Ligurian Statielli. Discoveries of rough-hewn flint and small knives found in the valley of the railroad bridge toward Ovada and in the higher part of the site give evidence that this area was inhabited in Neolithic times.

Pliny mentions the city among the civitates of the Augustan Regio IX and remarks that its inhabitants, at the time of the war between the Ligurians and the Romans, were taken prisoner by the Romans and reduced to slavery. However, they were later freed and allotted lands beyond the Po.

The interest of the Romans in this capital of the Statielli was mainly strategic for the city was at the junction of two great communication arteries: the Aemilia Scauri (later the Julia Augusta)—which, from Vada Sabatia and from the sea, went as far as Dertona to join the Via Postumia, which united the large centers of the E Po valley—and another road which, passing Alba, permitted direct communication with Augusta Taurinorum and the Alpine passes beyond.

Numerous finds from the interior of the modern city illuminate the Roman passion for bathing establishments. The city was rich in spas and monumental buildings around Fonte Bollente. A large aqueduct, bringing water from the Erro river, a few km upstream from the city, approached the city by following the slope of the valley. Running underground, the aqueduct then joined the territory of the Acqui, across the Bormida, on arches of a truly grand Roman scale.

Today eight large piers of this marvelous work remain on the flat right bank sloping toward the river. Particularly majestic are seven others with low, ogival arches. These follow the river bed, their walls covered by small squares of local stone.

A series of tombs discovered at the perimeter of the city define its boundaries and have supplied notable archaeological finds from the first centuries of the Empire. A mosaic pavement has inscriptions which mention L. Ullatius and L. Valerius, high officials of the town, who constructed or reconstructed the chambers, pavimenta, and tecta of the building.

BIBLIOGRAPHY. G. Biorci, *Antichità e prerogative della città di Acqui Tortona* (1818-20); V. Scati, "Antichità Acquensi," *Atti della Società Piemontese di Archeologia e Belle Arti* (1887) 30ff; id., "Scoperta di un nuovo acquedotto romano in Acqui," *Rivista di Storia Arte e Archeologia della Provincia di Alessandria* 2 (1892); id., "La fonte bollente in Acqui e gli edifici eretti intorno alla medesima," op.cit. (1898) 23ff; U. Mazzini, "Piscina romana," *NSc* (1922) 200ff. C. CARDUCCI

AQUAE SULIS (Bath) Avon, England. Map 24. Situated in a meander of the river Avon on low, marshy ground, ca. 20 km from Bristol and 30 from the sea. The sole reason for a settlement in such a position is the existence of the hot mineral water spring with its healing properties.

The settlement was founded ca. A.D. 75; it flourished throughout the period of official imperial protection of Britain and probably for an indeterminate period afterwards. The principal monument to be seen today is the vast bathing establishment. Some parts were recognized during the 18th c., but it was mostly uncovered in 1878-95 and 1922-25.

The hot spring, with a wall around it, served as a reservoir which fed the various baths. The principal ones were the Great Bath (24 x 12 m and 1.65 m deep) with steps all around it and a lead-lined bottom; the Lucas Bath and a rectangular bath later filled in; and at least one other bath which was later replaced. A circular bath, 10 m in diameter and 1.4 m deep, was later inserted into the large hall of the initial construction. To these were added an elaborate series of Turkish and sauna baths, one series at each end, which reached their maximum extent in the 4th c. A.D.

The whole establishment was large and architecturally splendid, as was the other monument with which it was integrally arranged. This was the Temple of Sulis Minerva, parts of which were found when the present Pump Room was built in 1790-95; more has been discovered in excavations since 1964. This was a temple of the Corinthian order, standing on a podium within a large colonnaded precinct. It had a four-columned portico, and the cella behind covered the rear two-thirds of the podium with Corinthian pilasters bordering it. The front pediment depicted a bearded male Medusa head within a

central shield bounded by oak leaves and acorns, and supported by flying winged victories on either side; Tritons filled the corner spaces. The podium proportions (2:1) were Vitruvius' ideal.

The temple precinct contained the usual clutter of altars, remains of monuments, such as a frieze of the four seasons and other friezes and pediments. Discovered in 1965 was a statue base inscribed with the name of one Lucius Marcius Memor an Haruspex, apparently an important soothsayer. Another large public building about which little is known may be a theater. This complex is unlike anything else in Roman Britain and can best be paralleled in Mediterranean Gaul.

The remainder of the settlement is comparatively unexplored, largely because of later building, but traces have been found of houses, or possibly hotels.

A bank and ditch defense was added in the middle of the 2d c. A.D., later replaced by a stone wall which stood almost intact, although repaired, until 1720. Little now survives. The enclosed area covered about 110,000 sq. m. The stone used in all construction work was the local oölite limestone known as Bath stone.

Finds from Aquae Sulis and vicinity are in the museum adjoining the Roman baths. Notable are a gilt bronze head of Minerva, presumably from a cult statue, and fine stone work from the baths and temple (including the temple pediment). There is also a fine hoard of imported intaglios.

BIBLIOGRAPHY. A. M. Scarth, *Aquae Sulis* (1865); F. Haverfield, *VCH Somerset* (1905); I. A. Richmond & J.M.C. Toynbee, "The Temple of Sulis Minerva at Bath," *JRS* 45 (1955) 97; B. W. Cunliffe, "Temple of Sulis Minerva at Bath," *Antiquity* 40 (1966) 199-204; id., *Roman Bath* (1970). M. B. OWEN

AQUAE TARBELLICAE (Dax) Dept. Landes, France. Map 23. The settlement, on the left bank of the Adour River, lying in a low region bordered by low sand ridges, has been inhabited since the beginning of the Bronze Age. The presence of a hot spring (57° centigrade) determined its future, giving it its name, exactly that of the original inhabitants, the Tarbelli. In the 5th c. it became a civitas Aquensium.

The ramparts, built after the invasion of 276, were for the most part destroyed in the 19th c. Making an irregular quadrilateral of 1465 m, these walls (4 m thick), strengthened by 43 round turrets, enclosed an area of 12.6 ha.

About 20 m S of the hot spring, a wall E-W ca. 2 m wide separates the rest of the city from the boggy ground of the thermal quarter (many of the ancient structures there are on short piles). Three to five levels of successive occupation have been noted. Almost half of the known coins belong to the 4th c.; more than a quarter, to the 3d. The terra sigillata pottery is chiefly Spanish. Dax, one of the stops on the route from Bordeaux to Spain, was also the point of departure for Toulouse. Two cemeteries are known, one SE (the Peyrelongue quarter), the other SW, where the remains of St. Vincent, the first bishop and local martyr, were buried.

BIBLIOGRAPHY. Reports in *Bulletin de la Société de Borda* (1876———); A. Blanchet, "Dax" in *Les enceintes romaines de la Gaule* (1907); F. Lot, *Recherches sur la population et la superficie des cités remontant à la période gallo-romaine*, part 3 (1953). R. ARAMBOUROU

AQUA VIVA (Petrijanec) Yugoslavia. Map 12. About 32 km to the E of Poetovio. In Julio-Claudian times this post station lay in Pannonia Superior on the Rochade road, which joined the main fortresses of Illyricum: Carnuntum, Scarbantia, Poetovio, Siscia, Burnum. After the creation of the Danube limes the road served merely for communication between provinces. At Aqua Viva the road was crossed by the highway running from Poetovio to Mursa and on to Sirmium. There have been sporadic finds: necropoleis, inscriptions, remains of buildings, a rich cache of jewelry.

BIBLIOGRAPHY. J. Klemenc & B. Saria, *Archaeologische Karte von Jugoslavien, Blatt Ptuj* (1936)M; S. Pahič, "K poteku rimskih cest med Ptujem in Središčem," *Arheološki vestnik* 15-16 (1964-65)M; M. Fulir, "Topografska istraživanja rimskih cesta na Varaždinskom i Medjimurskom području," *Razprave* (Slovenska akademija znanosti, 1. razred) 6 (1969)MI; B. Vikić & M. Gorenc, *Prilog istraživanju antiknih naselja i putova u sjeverozapadnoj Hrvatskoj* (1969)I. J. SASEL

AQUILEIA Udine, Veneto, Italy. Map 14. At the extreme E end of the plain of Veneto, a few km from the sea. It was founded by the Romans in 181 B.C. under the triumvirs P. Scipio Nasica, C. Flaminius, and L. Manlius Acidinus (Livy 39.55.5-6; 40.34.2). The city was established essentially for military reasons at the moment when, after the conquest of the entire peninsula, Roman power extended all the way to the Po valley. Aquileia was the base of operations against the Carnici, whose advances were brought under control in 115 B.C. (*CIL* I², p. 177). The city was also the staging point for the wars against the Istri in 178-177 B.C. (Livy 41.1-5, 9-11; Flor. 1.26) and for the victorious campaigns of the consul C. Sempronius Tuditanus, which permitted the Romans to triumph over the Taurisci, Iapides, and the Liburni in 129 B.C. (Per. Liv. 59; Plin. *HN* 3.129; App. *Ill.* 10.30, 1.1, 13.1 pp. 82-83 n. 32; *CIL* I², 652). The Taurisci and the Iapides attacked Aquileia again in 52 B.C. (Strab. 4.6.10; App. *Ill.* 18.1). From the Augustan age onward, a long and prosperous period of peace was interrupted by two sieges, one by the Quadi and Marcomanni in A.D. 169 (Amm. Marc. 29.6.1; Lucian *Alex.* 48) and the other by Maximinus of Thrace in A.D. 238 (Herodian 7.2-3; Jul. *Capitol. Maxim. duo* 21-23; id. *Epitome* 25; Eutrop. 9.1; Oros. 7.19.2; Zonar. 12.16). From the middle of the 3d c. until the end of the Roman Empire, Aquileia was a participant in the struggles among the emperors. At the end of the 3d c. the barbarian invasions commenced, and Aquileia was the first to suffer from them because of its geographic position. Afterwards, the city slowly recovered and only in the 9th c., under the Patriarchs, did it regain any real importance.

Although the founding of Aquileia was dictated by military considerations, it was also intended to create peaceful agricultural and commercial conditions. Beginning in 181 B.C., the territory was divided into centuries. At the start, 3000 colonists were settled there, each with an allotment of 50 ha. of land. Another 1500 colonists were settled there in 169 B.C. and still another probably in the Augustan period. Commerce was the reason for the great prosperity of Aquileia. In the Republican period, it was a customs station where the portorium was collected (Cic. *Pro Font.* 1.2) and where two stationes of the 3d c. A.D. are attested (Ann. épigr. 1934, n. 234). In times of prosperity, the city had 70,000-100,000 inhabitants to judge from the extent of its urban structures. It must also have been quite populous in late antiquity, as is evidenced by the size and number of its Early Christian basilicas. Commerce profited from a good highway network and from a large harbor at the mouth of the river, which allowed the transport of merchandise manufactured on site.

The roads comprising the network were: the Via Postumia (*CIL* v, 8313); the Via Annia (*CIL* v, 7992) con-

structed in 131 B.C.; the so-called Via Julia Augusta, which ran N and passed through Tricesimum and Julium Carnicum (*It. Ant.*, ed. Cuntz, 279-80); the road which passed over the valley of Natisone and through Forum Iuli and thence to Virunum; the road which crossed the valleys of Isonzo and Vipacco in the direction of Emona; and the road toward Tergeste, which is probably to be identified with the Via Gemina (*CIL* v, 7989). The harbor developed along a river which at the time was quite wide, 48 m from one bank to the other.

Originally a colonia under Roman law, Aquileia in 90 B.C. became a municipium (*CIL* v, 968). It became a part of Italy in 48 B.C. when Julius Caesar extended the borders of Italy as far as Formio (the Risano river). The citizens of Aquileia were enrolled in the tribus Velina, so called from the homonymous lake in Sabine territory, near Rieti. Inscriptions attest the existence of a senatus (*CIL* v, 961, 875, 8288, 8313), of duoviri (*CIL* v, 971), of quattuorviri, decuriones, and aediles (*CIL* v, 1015), of praetores and praefecti iure dicundo (*CIL* v, 949, 953, 961, 8291), of praefecti aedilicia potestate (*CIL* v, 749), and of quaestores (*CIL* v, 8293, 8298) and patroni. Other offices were priestly, among which were: pontifices (*CIL* v, 1015), augures (*CIL* v, 1016), haruspices (S.I., 197), sacerdotes (*CIL* v, 786, 8218; S.I., 210), flamines (*CIL* v, 8293), and seviri augustales, who were grouped into collegia, occasionally with their patronus (*CIL* v, 1012).

The vast archaeological zone of Aquileia has undergone much suffering in the course of its history. From the outset of its intense life, which spanned more than seven centuries, there was a series of reconstructions and modifications. Later, as a result of the numerous sieges, the citizens were obliged more than once to demolish monuments in order to erect fortifications. Finally, as a result of earthquakes and the long centuries of being abandoned, the city became a quarry for construction materials. The archaeological excavations undertaken since the last century have permitted the identification of the essential elements of the ancient city. Yet, little more than the foundations have been preserved.

The direction of the Republican walls has been determined. At the beginning, they were nearly square, but as time went on they were enlarged toward the N to connect with the harbor. They were of fine Roman brick and in some sections had a bossed foundation. Two gates have been brought to light, one with an inner court and the other of the Augustan type with round towers. The late walls are composed of two larger, exterior circuits. Walls of the patriarchal period indicate a settlement in that period roughly half the size of the preceding one.

The excavations have isolated elements of the most ancient phase of the harbor as described by Strabo (5.1.8). The section which is today visible is probably datable to the Claudian period and is composed of a pier more than 300 m long, with a double loading platform and accompanying moorings. Large storehouses are connected to the harbor by ramps. This complex is on the right bank of the river; the left bank, although dammed, was not equally equipped. The bridges and the entire inner highway network have been discovered. The highway system is composed of paved roads, many stretches of which were provided with porticos. The roads separated insulae of various sizes where dwellings, decorated with splendid mosaics, have been brought to light. Some of the mosaics are in the local museum and some have been preserved in situ.

The partially excavated forum, at the center of the city, is decorated with large columns and fine capitals and sculptures. However, there is a plan from the end of the 2d c. A.D. on the basis of which it is supposed that the forum of the Republican period should be sought elsewhere. The structures, such as temples, which can be definitely identified are mysteriously few; inscriptions, however, attest to the worship of more than 30 divinities, including those common to the entire Roman world and those which were characteristically of local origin, such as Belenus, Timavus, Liber, etc. In the course of the excavations, large horrea have been discovered in the SE section of the city, three bath complexes, some kilns, the amphitheater, and the circus. The theater has not yet been found. Even the imperial palace, which certainly existed, given the frequent visits of emperors to Aquileia, is no more than a subject for conjecture.

The rich necropolis set off along the sides of the roads outside the city was many kilometers in length. There are areas of tombs, marked off by stones which indicate the owner and the measurements, along with ostentatious relief monuments and inscriptions. One burial area may be seen in situ; the monuments of the other areas have been transferred to the local museum. Cinerary urns and sarcophagi have supplied fine objects of glass, amber, ivory, gold, and bronze, as well as jewels and lamps of countless types.

The Early Christian and patriarchal periods have left important traces of monuments as well as of funerary objects. In the patriarchal basilica, part of which dates from the period after Attila, there is preserved the largest figured mosaic pavement from antiquity. In the Cripta degli Scavi, next to the basilica, mosaics on three levels and from different periods are visible. The lowest levels belong to a Roman house of the Augustan period. In the district of Monastero di Aquileia there is another large Early Christian church. Its mosaic pavement is now in the Museo Paleocristiano.

Archaeological materials from Aquileia may also be found in the museums at Trieste, Udine, and Vienna; however, the Museo Archeologico at Aquileia contains the majority. In 1961, the materials of late antiquity were transferred to the Museo Paleocristiano.

BIBLIOGRAPHY. G. B. Brusin, *Aquileia, Guida storico artistica* (1929); id., *Gli scavi di Aquileia* (1934); id., *Nuovi Monumenti sepocrali di Aquileia* (1941)[PI] id., "Le epigrafi di Aquileia," *RendLinc* 21, 3-4 (1966) 27-35[I]; A. Caldarini, *Aquileia romana* (1930); V. Scrinari, *Capitelli romani di Aquileia* (1952)[I]; S. Panciera, *La vita economica di Aquileia in età romana* (1957); L. Ruaro Loseri, *Il foro imperiale di Aquileia* (1961)[PI]; A. Degrassi, "Quando Aquileia divenne Municipio romano," *RendLinc* (1963) 139-43; L. Bertacchi, "Un cippo gromatico aquileiese di recente rinvenimento," *Atti I Congr. Intern. di Arch. dell' It. Sett.* (1963) 111-16[I]; id., "Ritrovamenti archeologici in fondo ex Moro e in fondo ex Cassis," *BdA* (1964) 253-66[I]; id., "Le più antiche fasi urbanistiche di Aquileia," *NSc* (1965 suppl.) 1-11[PI]; M. Mirabella Roberti, "Il porto romano di Aquileia," *Atti del Convegno Intern. di Studi sulle Antichità di Classe* (1968).

G. Sena Chiesa, *Gemme del Museo Naz. di Aquileia* (1966)[I]; M. C. Calvi, *Vetri del Museo di Aquileia* (1968)[I]; V. Santamaria Scrinari, *Museo Arch. di Aquileia—Catalogo delle sculture romane* (1972)[I].

In preparation: G. B. Brusin, "Aquileia," *Inscriptiones Italiae* (2 vols.)[PMI]; E. Buchi, *Le lucerne di Aquileia, I, Le "Firmalampen"*[I]; L. Bertacchi, *La pianta archeologica di Aquileia*[P]. L. BERTACCHI

AQUINCUM or Acincum, Acinco (Budapest) Hungary. Map 12. At the important Danube crossing (*It. Ant.* 245.7; 263.9) there was an ala camp from the time of

Tiberius, a castrum for legions from the time of Domitian. Aquincum was the capital of Pannonia inferior from A.D. 106. The civilian settlement rose to the rank of municipium in 124, to that of colonia in 194. At the end of the 2d c. two facing fortresses were built on the left bank of the Danube across from the camp of Legio II adiutrix, Transaquincum and Contra-Aquincum; the latter was reconstructed during the time of Diocletian (Hydatius Fasti a 294). In the middle of the 4th c. the territory of Aquincum was under constant Sarmatian attacks. In 374-75, when Valentinian I put up fortifications with guard towers all along the banks of the Danube, he could not find adequate winter quarters in the suffering city (Amm.Marc. 19.11.8). Between 395 and 398 the formation was transferred to Gallia (Not.Dig. occ. 33.54). In the first decade of the 5th c. the Germans, arriving with the Huns, overran the town, but the remnants of the romanized population still remained (Sid. Apoll. 5.107). In the early Middle Ages Buda developed from the legionary camp of Aquincum, Pest from the fort of Contra-Aquincum.

The ruins of the legionary camp extend under a thickly populated section of Óbuda (ancient Buda). Of the buildings of the castrum, today only the ruins of the legion's bath are visible under a modern building. Among the cannabae relics the ruined complex of the amphitheater can be seen, and in a small museum in its vicinity are preserved the ruins of a house with wall paintings, and the rooms of a balneum with bathtubs. The mosaic floors of a Roman villa, decorated with mythological scenes, can be seen in situ. The foundations of a tripartite cella decorate the small square of a new housing development. The remains of Aquincum's wall and its two bastions were preserved in the park under the approach to the Elizabeth bridge on the Pest side.

The center of the civilian city was opened up during the last decades of the 19th c.; in the W section of town excavations were started during the 1960s. The Roman buildings were destroyed to such an extent that today the order of the industrial and commercial settlement emerges only in outline. A fairly long section of the cardo and decumanus is visible with a portico and rows of shops, a sanctuary on the forum, a basilica, a bath and the buildings of the macellum. Along the smaller streets are the headquarters of the collegium, two more public baths, two Mithraea, a sanctuary of Fortuna, ruins of dwellings and workshops. In a Roman hall are placed on exhibit mosaics, wall paintings, and statues. Among the ruins on exhibit at the Museum of Aquincum are the bronze parts of a portable organ, a wooden barrel with customs stamp, a tomb with mummy and a man's portrait painted on wood. In the lapidarium, connected to the museum, there are statues, altar stones, tombstones.

Outside the city walls are visible the ruins of Aquincum's smaller amphitheater, that of the civilian town. From here the pillar stumps of the aqueduct lead N to a modern beach, where the Roman works of the springs that fed the waterworks are now preserved, with a few relics of the sanctuary circle discovered there.

BIBLIOGRAPHY. B. Kuzsinszky, Aquincum, Ausgrabungen und Funde (1934); L. Nagy, Az Aquincumi orgona (1936); id., Az Eskü-téri erőd Pest város őse (1946); id., Budapest Műemlékei 2 (1962); A. Alföldi et al., Budapest Története I-II. Budapest az ókorban (1942); J. Szilágyi, Aquincum (1956); A. Mócsy, Die Bevölkerung von Pannonien bis zu den Markomannenkriegen (1959); id., RE Suppl. IX (1962); L. Barkóczi, Acta Arch. H. 16 (1964) 256ff; É. Bónis, Die spätkeltisehe Siedlung Gellérthegy-Tabán in Budapest (1969); J. Szilágyi, RE Suppl. XI (1969); Budapest Régiségei I-XXI passim.

SZ. K. PÓCZY

AQUINO, see AQUINUM

AQUINUM (Aquino) Frosinone, Latium, Italy. Map 17A. In the Liri valley 4.8 km N-NE of Pontecorvo, this town in antiquity was a Volscian city on the ancient Via Latina. It entered into the Roman sphere of influence in 313 B.C., and the population probably had Roman citizenship after the social war. The first reference to the city dates to 63 B.C. (Cic. Fam. 13.76). It was a colony under Caesar or under the Triumvirate (Plin. HN 3.63; Lib. Colon. 229). Its position topographically is characterized by the presence of three lakes, now dry, which were fed by the Melfa river and irregularly divided the whole E flank of the valley (Vallone d'Aquino). The city was on one lake and a ditch into which water from the lakes was diverted enclosed the city on its other three sides. The inhabited area developed on the plain; and the network of streets, taking the urban stretch of the Via Latina as its axis, is regular but not orthogonal, for the intersections of the streets are oblique and the city blocks rhomboidal. Several stretches of the city walls, in polygonal work, remain visible. Besides these, the monuments which have been noted include the so-called Capitolium in opera quadrata with a Doric frieze, the remains of a theater, a bath building, and an amphitheater. Aerial photographs have revealed, besides the outlines of numerous roads, an accumulation of structural remains belonging to large buildings. In the suburban area is a triumphal arch with a single span. In the territory around Aquinum are abundant remains of centuriation.

BIBLIOGRAPHY. M. Cagiano De Azevedo, "Aquinum," Italia Romana: Municipi e Colonie, ser. I, vol. IX (1947); F. Castagnoli, RendLinc (1956) 376ff; G. Cressedi, EAA 1 (1958) 552 (G. Cressedi); C. F. Giuliani, Quaderni Ist. Topografia Antica Univ. Roma, I (1964) 41ff; F. Coarelli, ibid. 51ff; G. Schmiedt, Atlante aerofotografico delle sedi umane in Italia, II (1970), tav. CV, 3.

C. F. GIULIANI

AQUIQ, see PTOLEMAIS THERON

AQUIS CALIDIS (Vichy) Allier, France. Map 23. Roman baths mentioned in the Peutinger Table. No visible traces remain except for a well faced with marble, which is badly damaged. Marble architectural fragments have been found, and the necropolis, with the stele of a soldier of Cohors XVII Lugdunensis. A milestone of A.D. 248-49 has also been found.

Excavation has revealed a number of ancient sculptures and bronzes, including 10 statuettes in bronze, 25 cm high, of Jupiter, Mars, and Mercury; a seated Dionysos (31 cm high), Minerva, a dancing girl, a Hellenistic bronze of a woman drinking water and another representing the Labors of Hercules, two bronze circlets (2.5 kg), one with the dedication MARTI VOROCCIO, the other to Diana. Native gods are represented by a crouching god and a god with a mallet, Oriental divinities by 80 thin slabs of silver dedicated to Jupiter Sabazius, made by a Gaul called Carassounos.

Evidence of industrial activity is provided by bronze founders' molds, forging material, and coin molds, but the most important industry was that of the potters, several of whose workshops have been located. They turned out terra sigillata, both molded and plain, and clay figurines (Venus, mother goddesses, animals; noteworthy is a torso of Apollo), as well as lead-glaze bowls, others slip-decorated or mica-coated, and coarse and fine wares. Most of the evidence dates the work from the period of the Flavians to the end of the 2d c.

BIBLIOGRAPHY. Grenier, Manuel IV:2, 435-42[PI].

H. VERTET

ARAD Israel. Map 6. A fortress on the S border of Judea, 30 km E of Beersheba, occupied from Biblical times to the Early Arab and Mameluke period. The site has been extensively excavated. Ten occupation levels have been unearthed, of which the earlier five represent a series of Israelite Iron Age royal fortresses. The earliest remains of the Classical period are sherds of the 5th-4th c. B.C. (Stratum V, the Persian period), which included Attic imported wares. In the Hellenistic period (Stratum IV, 3d-2d c. B.C.) a tower 18 m square was built in the center of the mound. This was replaced in the Early Roman period (Stratum III, 1st c. A.D.) by a fortress (25 x 20 m) which consisted of a central courtyard surrounded by rooms on two of three sides. This fortress probably formed part of the Flavian limes Palaestinae.

BIBLIOGRAPHY. Y. Aharoni & R. Amiran, "Excavations at Tel Arad," *Israel Exploration Journal* 14 (1964) 131-47; M. Avi-Yonah, *The Holy Land from the Persian Period to the Arab Conquests (536 B.C. to A.D. 640). A Historical Geography* (1966). A. NEGEV

ARADUS Syria. Map 6. An island 3 km SW of Tartus, which was the Antaradus of antiquity. A powerful Phoenician city that led a federation of mainland cities extending as far as the Orontes valley, Aradus submitted to Alexander, was granted autonomy by the Seleucids, and declined in the Roman era, while Antaradus flourished. After a long period of resistance, it was conquered in A.D. 641 by Moawiya, who laid waste the city.

The island has a perimeter of 1.5 km. According to Strabo, the houses had several stories; Chariton mentions a temple of Aphrodite and a vast agora lined with porticos, but no trace of these has been found. The main ruins are those of a sturdy rampart that encircled the island. A few sections of it, consisting of four or five courses of huge blocks of stone, are still standing on the side of the island facing the open sea. The methods of stonecutting and joining range from the Persian to the Roman periods. The base of the rampart consists of a berm cut in the living rock. Excavation has uncovered an esplanade, wider to N and S and today partly buried: it had a regular floor and the foundations of huge buildings. The port, which faces the mainland, consists of two coves separated by a natural dike which was raised in antiquity by adding a layer of enormous blocks to make a jetty. There is no trace of quays.

BIBLIOGRAPHY. E. Renan, *Mission de Phénicie* (1864-74)[MPI]; J. Weulersse, *Les pays des Alaouites* (1940)[MI]; H. Seyrig, "Questions aradiennes," *RN* 6 ser., 6 (1964)[MI]; H. Frost, "Rouad, ses récifs et ses mouillages," *Annales archéologiques de Syrie* 14 (1964); id., "The Arwad Plans 1964 . . . ," ibid. 16 (1966)[MPI]; id. in *L'archéologie subaquatique, une discipline naissante* (UNESCO, 1973)[MPI]; J.-P. Rey-Coquais, *Arados et sa pérée* (1974). J.-P. REY-COQUAIS

ARAE FLAVIAE (Rottweil) Baden-Württemburg, Germany. Map 20. On either side of the Neckar, 2 km E of the town of Rottweil. Its ancient name is found in early sources (Ptol. *Geog.* 2.11.15; *Tab. Peut.* 2.5; 4.1). In addition, the text on a wooden tablet found in 1950 documents the incorporation of the town "actum municipio Aris." The tablet dates from the 5th consulship of the emperor Commodus, A.D. 186, and describes the place as municipium, but we have as yet no exact conception of its legal status. The Roman city lay at the crossroads of two military routes that were important in the Roman conquest of SW Germany. The one road led from the legionary camp Argentorate to Raetia, the other from the legionary camp Vindonissa into the central Neckar area.

The settlement began in the early years of Vespasian, probably in A.D. 73, in which year the legatus augusti pro praetore Cn. Pinarius Cornelius Clemens carried out a border realignment. To secure this new cross connection from the upper Rhine to the Danube, Roman citadels were built. The four thus far identified had the immediate function of protecting this road and later served as supply bases for posts farther E. With the establishment of the oldest permanent camp on the R side of the Neckar, there developed a small civilian settlement, out of which grew, probably in the Flavian period, the municipium Arae Flaviae. The settlement lasted until A.D. 260 at the latest. As excavations carried out since 1967 have shown, the city consisted of sprawling buildings of stone and wood. Among public buildings, thus far three large baths are known, the largest of which has been preserved since 1971 as an outdoor museum; a Gallo-Roman temple precinct, a large civilian warehouse, and various quarters for artisans. The finds from the city area are in the city museum of Rottweil.

BIBLIOGRAPHY. P. Goessler, *Arae Flaviae. Führer durch die Altertumshalle der Stadt Rottweil* (1928); W. Schleiermacher, *ORL* Abt. B no. 62 (1936); W. Schleiermacher, "Municipium Arae Flaviae," *Gymnasium* Beihefte 1 I (1962) 59ff; D. Planck, *Arae Flaviae. Neue Untersuchungen zur Geschichte des römischen Rottweil* (erscheint Ende 1974 in der Reihe Forschungen und Berichte zur Vor- und Frühgeschichte in Baden-Württemberg, herausgeg. vom Landesdenkmalamt Baden-Württemberg); id., Bd. 6 *Das römische Bad von Rottweil. Ein Führer* (1972). D. PLANCK

ARAPHEN (Raphina) Attica, Greece. Map 11. Because the small ancient community was topographically associated with Halai Araphenides, now securely placed in the environs of Loutsa, it is thus certain that Araphen was on, or near, the E coast of Attika, and therefore reasonable to assume that the modern port of Raphina has inherited not only the name of the site, but also its general location. A prehistoric settlement has been excavated 2 km to the S at Asketario, a promontory particularly rich in material from the Early Bronze Age, which emphasizes the close connection at that time between E Attica and the Cyclades. The place of the Classical deme, however, can no longer be studied, since modern development has resulted in the loss of all traces of the historic remains reported by explorers in the 19th c. These vestiges were centered for the most part a little more than 1 km from the shore within the valley of the Megalo Revma on its N side, but a few were also noticed at the mouth of the river itself. Among these traces of the Classical settlement were the foundations of a structure sufficiently large that it was reported to be either a temple or a public building.

BIBLIOGRAPHY. A. Milchhöfer, *Karten von Attika. Erläuternder Text* 3-6 (1889) 39; id., "Araphen," *RE* (1896) II 379; D. Theochares, Ἀνασκαφαὶ ἐν Ἀραφῆνι, *Praktika* (1951) 77. C.W.J. ELIOT

ARAPHISAR, *see* ALABANDA

ARAQ EL-EMIR Jordan. Map 6. An ancient site 17.6 km W of Amman, consisting of a mound, now partly inhabited, with ancient buildings and other remains to the NW, W, and SW. To the NW of the mound is a steep cliff in which natural and artificial caves were excavated. To the SW of the mound are remains of a large building known as Qasr el-Abd, "the fortress of the slave." Be-

tween this building and the caves are remains of the so-called "square building," and of a water conduit.

These ruins have long been identified by many scholars with the fortress of Tyrus, the capital of the land of the Tobiads, built at the beginning of the 2d c. B.C. by Hyrcanus who resided there between 187 and 175 (Joseph. *AJ* 12.233).

On the mound six occupation levels have been observed beginning with the Chalcolithic period (5th millennium B.C.). The Early Bronze Age is represented by scanty building remains. In the Iron Age I (11th c. B.C.) the settlement was surrounded by a wall. This probably is the Biblical Ramath-mizpeh, conquered by the Ammonites at the end of the century. The site was then abandoned until, as already noted, Tyrus of the Tobiads was built by Hyrcanus ca. 182 B.C. The dating of the different buildings of this phase is done mainly by pottery. During most of the 2d c. B.C. the site was abandoned but ca. 100 B.C. the settlement was surrounded by a casemate wall. This settlement was abandoned by the middle of the 1st c. A.D. At the end of this century the old buildings were reconstructed with minor changes. After the destruction of the settlement at the end of the 2d c. A.D. new traces of habitation were discovered. No building remains later than 200 A.D. were observed on the mound.

Of the buildings on the mound itself one is dated to ca. 175 B.C. The building (12.5 x 9 m) stood within an enclosure (18.5 x 18 m). The walls of the building were plastered white outside, white and pink inside.

To the SW of the mound, the so-called "square building," was probably built at the beginning of the 2d c. B.C., when the Qasr el-Abd was built. Identified over the years as a fortress, palace, funerary monument, and temple, it is now generally agreed that it was a temple. Erected on a platform (30 x 15 m) it faces N-NW, and is approached by five monumental steps. Entrance to the building is gained through a porch distyle in antis. On all four corners of the basilica-like building staircase towers led onto a balcony which rested on attached half columns on the lateral walls and on two rows of columns. Two pairs of lions were set high up on the wall of the facade. The building contained a pronaos, naos and opisthodomos, thus complying with the ancient Canaanite-Syrian plan of temple.

BIBLIOGRAPHY. H. C. Butler, *Syria*, II (1919) 1-22; P. W. Lapp, *BASOR* 165 (1962) 16-34; 171 (1963) 8-39; M.J.B. Brett, ibid., 39-45; D. K. Hill, ibid., 45-55.

A. NEGEV

ARAUSIO (Orange) Dépt. Vaucluse, France. Map 23. Situated 7 km E of the Rhône and slightly S of the Aigues river, Arausio in pre-Roman times was one of the centers of the confederation of the Cavares, occupying the corridor of the Rhône between the Durance and the Isère (Strab. 4.1.11). This confederation was made up of the Cavares properly speaking—the Menini, Segovellauni, and Tricastini—and was the richest and most powerful tribe of SE Gaul. Probably allied with Marseille, then with Rome at the time of the conquest, these people were one of the most rapidly and thoroughly Romanized (Strab. 4.1.12). Rome divided the territory of the confederation into six civitates, the chief cities being Valence, Saint-Paul-Trois-Chateaux, Carpentras, Avignon and, most important, Orange.

Like Nîmes-Nemausus, Orange very likely got its name from that of a water divinity (dedication Arausioni on a bronze tablet: Inscr. lat. Narbon., No. 184). That it was occupied for so many centuries may be explained by the strategic importance of the site: the

Saint-Eutrope hill rises more than 100 m above the plain, dominating the whole region and in particular providing a means of controlling the great traffic route along the banks of the Rhône. It is quite certain that the Roman legions occupied the hill in their campaign against the Cimbri and the Teutones, and one of the functions given the colony that Augustus created ca. 35 B.C. was that of a citadel: cf. the epithet *firma* in its official name, Colonia Julia Firma Secundanorum Arausio, a colony with Roman rights for veterans of the 2d Gallic Legion.

From various remains that have been found of the city rampart it is possible to trace its plan. Hexagonal in shape, it ran around the Saint-Eutrope hill to the S, then at the foot of the hill to the N enclosed some 50 ha of low ground, which would give it a perimeter of 3,500 m and a total area of some 70 ha. The ancient sewers and foundations, those monuments that are still standing in situ, and the orientation of the modern streets all point to a strict overall plan. The path of the cardo maximus has been traced from the arch N of the city up to a postern gate in the S curtain of the surrounding wall, also that of the decumanus which is strictly perpendicular to it. The forum probably lay SE of the spot where the two axes crossed, that is, N of the theater: there is nothing left of the forum, but on the other hand Orange is fortunate in having preserved not only a great many objects (sculptures, pottery, inscriptions, etc., many of them in the museums at Avignon and Saint-Germain-en-Laye) but also two extremely important monuments and remains of a number of others.

The most famous monuments at Orange are the arch and the theater. The former stands 50 m N of the rampart and marks the spot where the Agrippan road reached the city; it was erected on the foundations of an earlier monument (either an arch or a gate). It has been described as the oldest of the homogeneous triple arches, with the clumsiness of a provincial attempt at innovation, at the same time showing a "rare virtuosity" so far as sculpture is concerned. Its massive, square form with a double attic and central pediment, its trophies, panels of arms and naval spoils, and its battle scenes are well known. Its date, long disputed, may be set between A.D. 10 and 26-27 (perhaps following the events of 21).

The theater is oriented to the N and has a diameter of 103 m. Its cavea is built against the Saint-Eutrope hill and is divided into three sections by two praecinctiones and surmounted by a portico; it could seat 7000 spectators. Essentially it is interesting because of the preservation of the stage section, particularly the stage wall which stands 103 m wide and 37 m high. It is generally believed to date from the Augustan period, but this theory is based more on town-planning criteria than on architectural study of the monument, which might possibly assign it a somewhat later date.

Also backed against the hill, to the W of the theater and connected to it is another, smaller, semicircular building (74 m in diameter) with the remains of a large temple 35 x 24 m in the middle of it. In the subfoundation underneath the cella were several vaulted chambers. The podium, which was 3.75 m high, was reached by a stairway on the N side. The temple was peripteral octostyle, the colonnade breaking off on the S side where an apse was hollowed out of the cella. The impressive dimensions of this building have generally led it to be dated relatively late, in the 2d c., though some writers date it to the Augustan period. The semicircle, on the other hand, is commonly dated from the Augustan period, and its original purpose has given rise to dif-

ferent hypotheses. If its side walls are extended theoretically 200 m to the N, they are found to meet other rectilinear walls, in the foundations as well as in elevation. A rectangular area like this, very elongated and ending in a semicircle, has suggested a circus or a gymnasium. On the other hand, excavations N of the temple have revealed some fragments of substructures that may possibly represent the base of a stage wall. Thus a third hypothesis has been proposed, that a smaller theater may have preceded the "great" theater, then, when the latter was built, have been used as the peribolus of the temple. According to this theory, the N walls of the semicircle formed a monumental portico that was part of the Forum; if this is correct, a new date should be found for the great theater. The debate is highly complex and probably cannot be settled without decisive evidence that the semicircle predates the temple.

Traces of two more monuments, possibly religious buildings, have been found S of the semicircle and exactly on its axis; they stood on two terraces cut in the Saint-Eutrope hill and thus overlooked the city. The first, probably a temple, has a porticoed peribolus around it and was 7.70 m wide (its length is not known). All that remains of the second building are some huge subfoundations, which some believe may have belonged to a large Capitolium; this identification is still hypothetical.

One particularly important find has made it possible to reconstruct, in part, the cadastres of the rural territory of the Orange colony. From several hundred fragments found in a pile along with various architectural elements in a limekiln near the theater it was possible to piece together part of three such surveys, A, B, and C. The first, A, has an inscription at the top showing that it was posted up in the city tabularium in 77 by order of the emperor Vespasian. B, the most complete of the surveys, apparently dates from Trajan's reign. C is later than the other two, although it cannot be dated precisely. The only certain localization of terrain is in B. Research is still going on into the information provided by these documents on land confiscation when the colony was formed and the restitution of the least fertile of them to the natives, the extension of the civitas, its encroachment on the territory of other cities, and so on.

BIBLIOGRAPHY. J. Sautel, *Forma Orbis Romani, Carte arch. de la Gaule romaine, VII* (1939) (avec bibliographie précédente)MPI; A. Grenier, *Manuel d'arch. gallo-romaine* III (1958)MPI; L. Crema, *L'architettura romana* (1959); R. Amy et al., "L'Arc d'Orange," *Gallia*, Suppl. XV (1962)PI; A. Piganiol, "Les documents cadastraux de la colonie romaine d'Orange," *Gallia*, Suppl. XVI (1962)MPI; G. Barruol, *Les peuples pré-romains du Sud-Est de la Gaule* (1969)M. C. GOUDINEAU

ARAXA (Ören) Lycia, Turkey. Map 7. At the N end of the Xanthus valley. Nothing is recorded of its foundation, no Lycian inscriptions have been found on the site, and its Lycian name is not known. An inscription at Sidyma (*TAM* II.1.174) mentions a local legend that Leto bore Apollo and Artemis at Araxa. All that is known of the city's history is contained in an inscription found at Ören in 1946 (*JHS* [1949] 46, no. 11 = *SEG* XVIII 570): At an uncertain date in the 2d c. B.C., hostilities broke out between Araxa and Bubon and again later between Araxa and Cibyra; in both cases Araxa appealed to the Lycian League, of which she was a member, whereas Bubon and Cibyra at that time were not. Some time afterwards Araxa was instrumental in securing the admission of her neighbor Orloanda (otherwise unknown) to the Lycian League. In general the inscription shows Araxa functioning as a full and active member of the League. No coinage is known; the former attribution of a single specimen of the time of Hadrian is now discredited. In Byzantine times the bishop of Araxa ranked fourth under the metropolitan of Myra.

The ruins are not extensive. The acropolis hill is immediately above the village; it is precipitous on the SE, but is quite low. A little below the summit are remains of a "cyclopean" wall of very large blocks with a superficial area up to 3 sq. m, in some cases drafted at the edges; most conspicuous is a massive tower over 9 m wide. In the village is a stretch of polygonal wall 9 m long and still 3 m high.

A kilometer or so to the W of the village is a group of a dozen rock-cut tombs at the base of a rocky hillock; most of these are of Lycian house type, but they are not inscribed. One, evidently later, has two antae decorated with rosettes and nondescript capitals, an architrave, a row of dentils, and a curiously naked pediment lacking the usual raking cornices. By the river, close to the village, are a number of gable-shaped sarcophagus lids with inscribed panels.

A little to the N of Ören is an exceedingly abundant spring which, though not the actual source of the Xanthos river, supplies the greater part of its stream.

BIBLIOGRAPHY. C. Fellows, *Lycia* (1840) 123-27; T.A.B. Spratt & E. Forbes, *Travels in Lycia* (1847) I 38-40; *TAM* II.2 (1930) 259. G. E. BEAN

ARBEIA, *see* HADRIAN'S WALL

ARBON, *see* ARBOR FELIX

ARBOR FELIX (Arbon) Thurgau, Switzerland. Map 20. Roman fort on the SW shore of Lake Constance, about 30 km W of Brigantium (Bregenz). Mentioned in the *Antonine Itinerary* (237.5, 251.3), the *Not.Dig.Occ.* (35.34), *Amm. Marc.* (31.10.20). Arbor is the first station on the Rhine-Danube highway E of the Raetian border at Ad Fines. A large fort was built here, probably under Diocletian, on a peninsula in the lake. In the 4th c. a military flotilla, a numerus barcariorum, was stationed at Constance or Brigantium, and Arbor is strategically located midway between them. The fortress was occupied probably until the late 5th c., towards the end by the Cohors Herculea Pannoniorum. Some remains were visible until the 16th c., and since the late 19th c. the vicus, its cemeteries, and parts of the fortress have been excavated.

Little is known of the plan and buildings of the settlement. In antiquity the fort at the tip of the peninsula lay on the shore, but today it is a short distance inland. It was surrounded on three sides by the lake; the fourth must have been protected by a rampart and ditch, now under the modern town. The fortress, adapted to the terrain, had an irregular plan (ca. 150 x 65-80 m, area 1 ha). In the N part a mediaeval castle was built on the Roman foundations and walls, and to the S a church of St. Martin and a chapel of St. Gallus. The walls, which have been partially explored, had towers of various shapes both at the corners and on the sides: rectangular, semicircular, or segments of circles. Above the foundations the walls were 2.6 m thick, but 2 m towards the lake. The remains of one SW tower are preserved to some height. The interior of the fort has not been completely explored, but the church of St. Martin may be built over a 4th c. sanctuary as in Tenedo and Castrum Rauracense. A church and a Christian community inside the walls are attested in the Vita Sancti Galli. The museum is in the castle.

BIBLIOGRAPHY. F. Staehelin, *Die Schweiz in römischer Zeit* (3d ed. 1948) 313, 323, 597; E. Vonbank, "Arbor

Felix, zu den Ausgrabungen 1958-1962 in Arbon," *Ur-Schweiz* 28 (1964) 1-24PI; id., *Jb. Schweiz. Gesell. f. Urgeschichte* 51 (1964) 107; H. Lieb & R. Wüthrich, *Lexikon Topographicum der römischen und frühmittelalterlichen Schweiz* 1 (1967) 20-22.

V. VON GONZENBACH

ARCIDAVA (Vărădia) Caraş-Severin, Romania. Map 12. Roman camp and civil settlement on the left bank of Caraş river, on the main strategic and commercial road Lederata-Tibiscum, linking the Danube with the capital of Roman Dacia. The camp (174 x 154 m) was built of stone. Cohors I Vindelicorum was stationed here. In the civil settlement traces were discovered of a building with several rooms and a bath.

BIBLIOGRAPHY. G. Florescu, "Le camp romain de Arcidava, fouilles de 1932," *Istros* 1 (1934) 60-72; D. Tudor, *Oraşe, tîrguri şi sate în Dacia romană* (1968) 48.

L. MARINESCU

ARDEA Latium, Italy. Map 16. A city of the Rutuli ca. 4.5 km from the coast on the last slopes of the mountain chain that culminates in the Alban Hills. Connected with the legend of Aeneas in Latium (Verg. *Aen.* 7.409-411), Ardea is recorded in the first Roman-Carthaginian treaty (Polyb. 3.22.24) and was one of the thirty cities of the Latin League (Dion. Hal. 5.61.3). A Latin colony from 442 B.C. (Livy 4.9-11; Diod. 12.34.3), Ardea is mentioned by ancient sources (Ptol. 3.1.61), which refer particularly to the principal temples (Plin. *HN* 35.115, Iuno Regina; Serv. *Aen.* 1.44, Castor et Pollux). Like other centers in S Latium, Ardea was important in archaic times, but in steady decline after the middle Republican period. It was already reduced to a small hamlet in the first Imperial age, and Virgil could say of it: nunc magnum Ardea nomen, sed fortuna fuit (*Aen.* 7.412).

The terrain, level but crossed by frequent and deep fissures, probably accounts for the articulation of the Latin city that, like nearby Lavinium, had its acropolis almost completely isolated from the remaining urban zone. Recent excavations in the part of the acropolis occupied by the modern town have brought to light remains of protohistoric huts with material that dates to the Early Iron Age. Earlier occupation is attested by the discovery of ceramics from the Late Bronze Age. A considerable number of axes, hatchets, and fibulae in bronze have been found in a cache from the 9th-8th c. B.C. The archaic city expanded on the hill of Civitavecchia to the E of the acropolis, which has natural defenses on three sides and on the NE flank an interesting fortification with an agger and fore-ditch. The agger, constructed with the earth extracted from the ditch, was consolidated by a rampart of large blocks of tufa in squared work, placed on its exterior to contain it. The acropolis had its own autonomous fortification at the point of contact with Civitavecchia, but the handsome wall in blocks of yellow tufa visible today seems to date between the second half of the 3d c. and the beginning of the 1st c. B.C. The remains of a three-celled temple, identified by some as that of Juno Regina, are visible in the W zone. It is famous for the paintings executed there by M. Plautius, and its architectural terracottas are preserved in the Museum of the Villa Giulia in Rome. Nearby, next to a storage place for water and for foodstuffs and a drainage tunnel, the remains of a private house with two construction phases have been found. The second is in opus incertum and the mosaic pavement has the name P. Cervisius inserted in it.

In the Casalinaccio section of the city is a temple from which there remain parts of the podium with the characteristic profiles of projecting moldings and fictile decorations analogous to those found on the acropolis. Beside it is one of the oldest basilicas known, probably built at the beginning of the 1st c. B.C. There remain structural parts in opus incertum and the bases of the colonnade. Also inside the city there have been sporadic finds of villas and a monetary treasure from the Imperial period. Outside the city, several tombs have been found at Casalazzaro. A necropolis with painted chambered tombs and a small dromos from the 4th-3d c. B.C. has been discovered to the SW of the city at the place called Valle Guarniera. Recently a Roman hypogeum has been found, which was probably used for cult purposes and reused in mediaeval times. A large villa with massive foundations in squared work, which occupies a level area along the road to the sea, has been discovered.

BIBLIOGRAPHY. For bibliography to 1954 see C. Caprino in *EAA* 1 (1958) 600; A. Andrén, "Scavi e scoperte sull'acropoli di Ardea," *Acta Inst. Rom. R. Sueciae* 21 (1961) 1-68; P. C. Sestieri, "Il Museo della Preistoria e Protostoria del Lazio," *Itiner. Mus. Gall.* 58 (1964) 23; P. G. Gierow, "The Iron Age Culture of Latium," *Acta Inst. Rom. R. Sueciae* 26.1 (1966) 440ff; R. Peroni, "Considerazioni ed ipotesi sul ripostglio di Ardea," *BPI* 75 (1966) 176-96; id., "Inventaria Archaeologica," *Italia* 4.19 (1967).

City plan and fortifications: G. Lugli, *La tecnica edilizia romana*, I (1957) 269f; A. Boëthius, "Le fortificazioni di Ardea," *Acta Inst. Rom. R. Sueciae* 22 (1962) 29-43; L. Quilici, "A proposito del secondo aggere di Ardea," *ArchCl* 20.1 (1968) 137-40; G. Schmiedt, *Atlante aereofotografico della sedi umane in Italia*, II (1970) plan 20.

The Temple on Casalinaccio: L. T. Shoe, "Etruscan and Republican Mouldings," *MemAmAcRome* 28 (1965) 84ff.

Roads and Monuments outside the City: A. Ferrua, "Oratorio cristiano ipogeo in quel di Ardea," *AttiPontAcc* 3.37 (1964-65) 283-306; P. Sommella, "La via Ardeatina," *Quad. Ist. Topog. Ant. Univ. Roma*, I (1964) 17ff; G. M. De Rossi, *Tellenae, Forma Italiae*, IV (1967) 128ff.

P. SOMMELLA

ARDOCH Perthshire, Scotland. Map 24. The most impressive Roman auxiliary fort in Scotland is at Ardoch, 16 km N of Stirling. On the Roman trunk road from Camelon (q.v.) to the Tay and Strathmore, it also commands two lateral routes, one E along the foot of the Ochils and the other NW by the Knaik Water to Dalginross. Today the most striking feature is the complicated ditch system on the N and E sides of the fort. The S side has been largely obliterated by cultivation, and the W defenses by the modern road from Greenloaning to Crieff.

It is clear from the plan, and from 1896 excavations, that the existing remains comprise two forts. The earlier, an oblong enclosure of ca. 2.5 ha, was defended by a rampart and three ditches. Subsequently this was reduced to 2 ha by cutting off the N end, but at the same time the number of ditches was increased to five. The new fort was therefore exceptionally strong, and the ditches were rendered more formidable by erecting mounds of dumped upcast on the flat spaces between them, thereby increasing their effective width and depth. Later still an external bank was added, starting at the NW angle and terminating opposite an external clavicula at the E gate. The disposition of the four gates shows that the later of the two forts faced S.

All the visible defenses probably date to the Antonine period, but the excavations revealed the presence of an earlier buried ditch, and the finds included Flavian as well as Antonine pottery. Moreover, although only about

a quarter of the interior of the later fort was examined, the buildings marked on the plan show at least three, and possibly four, structural periods: the latest is represented by a barrack-block with stone walls, while the earlier buildings were constructed of timber. It seems likely, therefore, that a fort was first established here by Agricola ca. A.D. 83; that another fort was erected on the same site ca. A.D. 140 as an outpost of the Antonine Wall; and that the latter was drastically remodeled and strengthened in late Antonine times. But further excavation is needed. The fort has been tentatively identified with the Alauna of Ptolemy's *Geographia*, and a tombstone found in the 17th c. commemorates a centurion of the Cohors I Hispanorum. But both the buildings and the acreage of the two Antonine forts suggest a larger garrison, probably cavalry.

To the N are slight remains of a large annex bounded by a single rampart and ditch, and also of two marching camps, one of 25.2 ha and the other of 48 ha, which are believed to have been built during successive campaigns of the emperor Septimius Severus against the tribes in the N in A.D. 208-211. On the E the defenses of the larger camp cut through a small signal station beside the Roman road, consisting of a timber tower enclosed by double ditches. Several more camps have been detected in the same area, and also E of the fort, by crop marks on air photographs. The Roman road is visible almost without interruption for ca. 1.6 km on either side of the fort: it bypasses the defenses on the E, but branch roads are provided to the N and S gates. Apart from the tombstone, which is in the Hunterian Museum, Glasgow, the finds from the site are in the National Museum of Antiquities of Scotland.

BIBLIOGRAPHY. *Proc. Soc. Ant. Scotland* 32 (1898) 399-476; *Britannia* 1 (1970)[1]. K. A. STEER

"ARDOTALIA," *see* MELANDRA CASTLE

AREGENUA (Vieux) Calvados, France. Map 23. Site of the chief city of the civitas of the Viducasses, in the commune of the Evrecy canton on the left bank of the Guine, a tributary of the Orne, 10 km SE of Caen. The valley of the Guine was occupied at a very early date and three prehistoric stations have been located: Mousterian at the confluence of the Orne and the Guine, Robenhausian in the fields beside the Saint-Germain road, and Chellean at La Croix des Filandriers.

Aregenua is mentioned on Ptolemy's map and in the *Peutinger Table*. The ancient remains have been known for centuries but there has been no systematic excavation. The city, though not large, had a temple, several baths, a theater, private houses, underground water pipes, an aqueduct, and burial grounds on its outskirts. It was never walled. Traces of the old city have been found N and S of the Chemin Haussé, the ancient Roman road, and in subfoundations in the Saint-Martin and Bas de Vieux quarters.

On the Chemin Haussé SE of Vieux a dump was found containing more than 40,000 kg of animal bones, piled up with coins, potsherds, and fragments of glass and iron. On the other side of the Chemin Haussé was the spot where the aqueduct ended; it passed underneath the old Château de la Palue and then down, to the SE, to the Fontaine des Mareaux. A mosaic was found to the left of the Chemin Haussé, but all that was left was the mortar section that supported it. Two small border fragments, however, are in the museum of the Société des Antiquaires in Caen; it is a mediocre work of irregular cubes of red standstone and white dice.

Some baths were uncovered to the W, in the Champ des Crêtes, in the mid-19th c. A first group of buildings (62 x 30 m) had two parts: the baths, with remains of marble facings and a semicircular, carefully paved pool with three steps leading into it, then a rectangular courtyard terminating in a semicircular wall that served as a palestra. A huge bowling ball of micaceous quartz was found in it. The second group (29.45 x 6.50 m) contained two circular pools surrounded by several small narrow rooms, along with a drainage pipe going down to the Guine, and a large paved room. Later another series of rooms was found, with some hypocausts and heating pipes in the walls.

To the NE of the Champ des Crêtes, near the Chemin Haussé, were found traces of cement floors and subfoundations of ancient houses; one room had a hypocaust. To the right of the Chemin Haussé beneath the choir of the Eglise Notre-Dame were found what may be the remains of a temple along with some sculptures. A corner capital was discovered amid the debris, as well as a stone decorated with two badly damaged bas-reliefs.

The site of a large monument oriented S has been recognized in the garden of the Château La Palue; the ruins have not yet been identified. To the E, in the Jardin Poulain, are the foundations of the theater. The site is inclined slightly NE-SW and dominates the surrounding area. The tiers faced SW. Masonry has been found below ground at depths ranging from 0.2 to 1.5 m. Excavation was carried out down to the 2 m level, the usual depth of the wall bases, which were set on a mortar floor 0.4 m thick. The stage, orchestra, and hemicycle of tiers were uncovered. Three corridors, to the right and left of the stage and in the middle of the hemicycle, led to the orchestra. The vertical sections were probably built largely of wood. The monument measured 236 m around, 80 m at its widest point and 67 m at the narrowest. The stage was 60 by 18 m, the orchestra was oval, 30-35 m in diameter, and the podium gallery was 55 m in circumference and 5 m wide. The tiers were raised 20 m high and measured 80 m around; the theater could seat 3500. The walls of the orchestra formed a complete circle, so that the theater could serve as an amphitheater and the orchestra as an arena. A study of the masonry, however, has shown that the Vieux theater was not originally built for a double purpose: the S semicircular wall of the orchestra-arena is not nearly as well built as the right rear wall, which it joins; it may be a later addition. Two more peculiarities have been noted: the inner wall of the circular gallery at the top of the hemicycle is 2.2 m thick for 22 m to the E, but not more than 0.9 m thick everywhere else. There may have been a box at this point. Also, six semicircles of stone, 0.75 m thick and well built on both sides, are supported by the S end of the E wall. These structures have not been identified.

In the Saint-Martin quarter N of the village, on Le Grand Champ, some column stumps have been excavated, along with several fragments of Corinthian friezes, and a rectangular building 13 by 9 m. Its function has not been determined.

The city was destroyed at the end of the 3d c., probably by Saxon pirates; the proximity of the Orne probably facilitated these raids. A few families may have gone on living in the ruins, judging from the 4th and 5th c. coins found on the site. Some Merovingian tombs found in eight places seem to represent burials of a later period (end of the 7th and 8th c.), but at present it is not known whether or not the city was abandoned from the 5th to the 7th c.

BIBLIOGRAPHY. "Fouilles de l'intendant Foucault," *MémAcInscr* 1 (1717) 290-94; *Mercure de France*, June 1730; A. Charma, *Rapport sur les fouilles de Vieux*,

1852-1854, Mémoires de la Société des Antiquaires de Normandie 20 (1853) 458-85; M. Besnier, "Histoire des fouilles de Vieux," ibid. (1909) 225-335, or *MAntFr* 69 (1910) 225; Doranlo, "Sur la destruction d'Aregenua," *Bulletin de la Société des Antiquaires de Normandie* 38 (1928-29) 472-75. C. PILET

ARELATE (Arles sur Rhône) Bouches-du-Rhône, France. Map 23. Situated 90 km W of Marseille on a rocky spur overhanging ancient marshland. The first Phokaian settlement was destroyed by the Ligurians in 535 B.C. Revived in the 4th c. B.C., the settlement developed considerably after Marius had built the Fossae Marianae, the canals linking Arles with the Golfe de Fos (104 B.C.). In 49 B.C. the city provided Caesar with seagoing ships for the siege of Marseille, and in 46 the Colonia Julia Paterna Arelate Sexterum was founded opposite the Gallo-Greek city. An important seaport and naval shipyard grew up on the Via Aurelia. The city was developed under Augustus and Christianized under Constantine. The Council of 314 took place here. About A.D. 400 Arles became the residence of the Prefect of the Gauls, replacing Lyon, and ca. 480 the city was laid waste by the Visigoths.

The most important extant monuments date from the Augustan and Constantinian periods. From the first we have the earliest surrounding wall, with its decumanus gate of half-moon plan marking the beginning of the Aurelian Way to the E; to the SE is a well-preserved section ca. 200 m long. The rest of the wall must have formed four more sides, one of them running parallel to the Rhône. Two municipal arches, now gone but known from descriptions and drawings, marked the limits of the pomaerium to the NE and SW—the Arcus Admirabilis and the so-called Arch of Constantine, both dating from the late Republican era. At that time the city probably was slightly less than 20 ha in area. The modern streets reflect the grid pattern of the rectangular insulae, as well as the cardo and decumanus, at the crossing of which was the forum. Its site is marked by huge cryptoporticos, very well preserved, built below ground on three of its sides. The complex is U-shaped and opens to the E, 90 x 60 m. It was lit by vents, the outer ends of which terminated at the base of a podium built inside the U. Traces were found of the fourth side of the forum and some remains indicate a date from the Augustan period. The N gallery is lined with a row of stalls set up below the forum.

Outside the forum, to the W, are remains of a large paved courtyard bounded to the S by a wall that forms a huge exedra with a monumental gate cut in it. At either end are remains of colonnades leading N. These may indicate the peribolos of a temple of ca. the 2d c. A.D.

The theater (diam. 102 m) is ca. 300 m E of the forum and fits into the plan of the ancient city: its scaenae frons is aligned with a cardo. Although the theater is on the W slope of the city escarpment, every part of it is built; the cavea was supported by a continuous system of radiating arches, demonstrated by a modern restoration in situ. The outer walls are almost completely destroyed except at two points, one of which, known as Roland's Tower, shows three superimposed architectural orders framing the arcades. The scaenae frons is in ruins except for two columns which, with their architrave, remain in situ to the right of the site of the valvia regia. The complex of the postscaenium and the parascaenia could be restored, and the stone floor of the orchestra is well preserved. Three altars have been excavated and some statues, among them the famous Venus of Arles and a torso, with head, of a colossal statue of Augustus.

The outer architectural decoration together with the continuing use of Doric elements suggest that the theater may have been begun under the second triumvirate, while the statue of Augustus suggests that it was completed during that emperor's reign.

The amphitheater is less than 100 m from the theater in an oblique SE-NW position relative to the grid of the insulae. The great axis of the ellipse is 136.2 m, the small axis 106.75, and the arena 69.10 by 39.65 m. The outer wall is well preserved up to the first-story entablature; the attic has gone. Two stories of 60 arcades with two superimposed architectural orders are still standing, among them four lower ones for entrance on the axes. The lower arcades open on to a wide gallery with a stone ceiling that serves as the floor of a second gallery one story above. Corridors and stairways lead to more galleries, then to more stairways, so as to serve the entire cavea. Many of the seats in the lower section are still preserved, as is the podium, originally covered with slabs of marble. Part of the wall surrounding the colony had to be pulled down to build the amphitheater. Its position in the city and certain details of its structure date it to the Flavian period.

The circus was outside the city along the Rhône, downstream and ca. 500 m from the surrounding wall (outside width 100 m; inner width 83.3 m; width of spina 6.00 m; total length probably 400 m). An obelisk found there is now in the Place de la République. Built in the 1st c. A.D., this circus was still in use in the 6th and 7th c.

Remains of minor monuments were noted in the 17th and 18th c. E of the theater, at the city's highest point. There were probably two temples here, one of them consecrated to the Good Goddess. There were doubtless other sanctuaries, large or small, for indigenous cults and for those from the Orient and Rome, first pagan, then Christian.

In the Constantine period the N gallery of the crytoporticos was duplicated by an arcaded gallery that curved back E and W to encircle a second courtyard, or another forum. This new gallery and that of the cryptoporticos were interrupted along the axis by the foundations of a monument with a vestibule of four columns, two of which are still standing in the modern Place du Forum. The frieze and architrave had an inscription in bronze letters alluding to Constantine II (A.D. 337-340). Farther N are the remains of a monument (94 x 47 m) that terminates, quite near the Rhône, in a huge, well-preserved, vaulted apse. These are the remains of baths with several heated rooms; but modern building makes it impossible to tell whether there were porticos surrounding a vast courtyard, or a basilica. The use of brick, more systematic than in the arcaded gallery, suggests that the complex dates from the beginning of the 4th c. A.D.

The city received its water from two aqueducts that came from the Alpilles and met at Barbegal, where remains of a flour mill can still be seen.

Opposite Arles, on the right bank of the Rhône, was a sizable settlement now known as Faubourg de Trinquetaille. It was approached by a pontoon bridge; the remains of one of the first stone arches are still to be seen on the left bank. This suburb included a seaport and docks; farther off were houses of ship fitters, merchants, and landowners, and, farther still, farms and villas. The remains of a cella can be seen 1 km from the river bank. The area of this second Arles is still to be determined.

Since the left-bank city was partly surrounded by marshlands, the necropoleis could not be extended along the roads, but spread out parallel to the SE and S surrounding walls. The largest one, to the SE, famous in legend in the Middle Ages and known since then as Les Aliscamps, contained several layers of tombs. Stone and

marble sarcophagi have been found there, also funerary monuments, stelae, cippi, and mausoleums.

There is a museum rich in Roman antiquities and a museum of Christian art containing a number of marble sarcophagi.

BIBLIOGRAPHY. J. Formigé, "Remarques sur les théâtres romains," *Mémoires présentés par divers savants à l'Académie* (1914)[I]; id., "L'Amphithéâtre d'Arles," *RA* (1964: 2) 25-41, 113-63[I]; (1965:1) 1-46[I]; L. A. Constans, *Arles antique* (1921)[I]; F. Benoit, *Forma orbis romani: Bouches du Rhône* (1936); id., "Sarcophages paléochrétiens d'Arles et de Marseille," *Gallia 5* (1954) Suppl.; Grenier, *Manuel* II:1, 289-95; II:2, 493-510; III:1, 158-71; III:2, 613-39; IV:1, 75-88[I]; A. Boethius & J. Ward-Perkins, *Etruscan and Roman Architecture* (1970) see index for Arles; M. Euzennat, "Le monument à rotonde de la nécropole du cirque à Arles," *CRAI* (1972)[I]; R. Amy, "Les cryptoportiques d'Arles," *Actes du colloque de Rome* (1973)[I]. R. AMY

ARENTSBURG, *see* FORUM HADRIANI

AREOPOLIS, *see* RABBATHMOBA

ARETHUSE, *see* ANTIPATRIS

AREZZO, *see* ARRETIUM

ARGAMUM (Dolojman) Dobrudja, Romania. Map 12. First Greek colony in Dobrudja mentioned by an ancient source (Hekataios of Miletos, 6th-5th c.). Also mentioned in the centuriation of the rural territory of Istria (A.D. 100) under Manius Laberius Maximus, governor of Moesia Inferior, and by Procopius of Caesarea. The late Roman circuit wall (4th-6th c.) and two Christian basilicas (6th c.) were uncovered during the archaeological excavations.

BIBLIOGRAPHY. Procop. *De aed.* 4.11.20.

P. Nicorescu, "Les basiliques byzantines de Dolojman," *Bulletin de la Section Historique de l'Académie Roumaine* 25.1 (1944) 95-101; D. M. Pippidi, *Contribuţii la istoria veche a României* (2d ed. 1967) 353, 363, 369; *TIR*, L. 35 (1969) s.v.; M. Coja, "Cercetări pe malul lacului Razelm, epoca romană şi romano-bizantină," *Peuce* 2 (1971) 179-90; id., *BMI* 41.3 (1972) 33-42.

I. BARNEA

ARGENTOMAGUS Indre, France. Map 23. An oppidum of the Bituriges Cubi and center of the W section of the territory of the civitas that formerly made up Bas-Berry and is now the department of Indre, Argentomagus gave its name to Argenton sur Creuse. However, as the city was transferred from one bank of the Creuse to the other at the end of the Classical period, the ancient site today has hardly been built on at all; the village of Saint Marcel occupies only the NW quarter of it, outside the Gallic rampart. It is the only ancient city in central France of which this is true, hence its exceptional archaeological importance.

Argentomagus lay at the junction of two important routes: N-S, from Cenabum (Orléans) to Augustoritum (Limoges); W-E, from Limonum (Poitiers) to Avaricum (Bourges). The Gallic oppidum was set up on the right bank of the Creuse, on the Plateau des Mersans, which is bounded to the S by the river valley and to the E and W by the valleys of two lesser tributaries. An earth vallum, still partly recognizable, barred access from the N.

Occupation of the Mersans plateau dates from the Neolithic age, as evidenced by flints found in deep strata. But as far as we now know, the settlement does not appear to have been established definitively before the 2d c. B.C., the date of the earliest stratified archaeological layers excavated in the center of the Mersans plateau, immediately W of the monumental fountain.

At that time the settlement consisted of huts made of light materials; their foundations, which sometimes were paved, can be recognized quite clearly. Scraps of smelting iron and crucibles attest the working of iron and gold, and there is evidence of vigorous commercial activity in the many coins that have been found, belonging not only to the Bituriges but to the Pictones, Lemovici, Carnutes, and Arverni, as well as some semi-oboles from Marseille and some denarii of the Roman Republic.

After the Roman Conquest, which apparently inflicted no serious damage on the city, life seems to have gone on for a long time without much change. Indeed, in the area W of the fountain, there is evidence that huts made of light materials continued to be used throughout the pre-Claudian period, and the coinage is still almost exclusively Gallic. On the other hand, dumps excavated at various spots in the Mersans plateau, some dating from Augustus' reign, others from the Claudian era, contain not only local pottery—typified especially by long-necked white jugs, several of them bearing the name INDUTOLLA —but also terra sigillata from Arezzo or Lyon, and oil lamps. The most curious of these imported articles is a bronze amulet shaped like a purse and decorated with a miniature but very finely executed bust of a pharaoh, which was found in an Augustan stratum. A cavalryman's spearhead and the soles of a caliga studded with nails lead one to suppose that a military detachment passed this way, possibly at the time of the revolt of the Turones, in A.D. 21. Furthermore, osteological analyses provide information on the stock-farming and dietary habits of the citizens of Argentomagus, whose meat came mainly from the domestic pig.

A small Augustan cemetery lies directly N of the vallum, proving that at that time the settlement had not yet spread beyond the Gallic rampart. However, at the beginning of Augustus' reign a theater was erected outside the city limits, on the S slope of a hill overlooking the Creuse, W of the Mersans plateau. The fact that the monument was located so far from the city center is hard to explain, unless there was a sanctuary in the area that has not yet been found. This first theater, shaped like a horseshoe, was extremely rustic; the seats were set directly on the hillside slope. If there was a stage building, it has completely disappeared.

A number of public buildings were erected in the center of the city from the 1st c. on; these are now being excavated. There was a monumental fountain, consisting of a rectangular basin hollowed out to ca. 3 m below the ancient ground level. On all four sides of the pool are stone steps, which to the E and W form monumental staircases starting from the city ground level, but to the N and S stop at the foot of walls bounding the fountain area. The steps may have been used as seats, perhaps for people taking part in a ceremony of some sort, as well as for stairs. The chronology of the fountain, which was redesigned many times, is still uncertain. A very large overflow channel was built, probably in the late 1st or early 2d c., as a vaulted passageway 2 m high leading E. It is still intact and may be followed for more than 100 m.

The pool, however, was clearly already there before the underground channel was built because a drain-well has been found on its path, near the entrance, which drained off the water in the Augustan period, as the objects discovered there show. Among the most interesting of these are a miniature hexagonal bronze shield with a hanging ring, and a sword, also miniature. In the

layers above the fountain more than 500 coins were found, the majority minted in the 3d c., mainly in the reign of Tetricus; also some coins with the heads of 2d c. emperors, and a few minted under the Constantinian dynasty. At this stage it is impossible to state that the coins represent offerings since most of them appear to have been thrown there when the basin had already been filled in. It would also be rash to say that the animal horns found in profusion in the basin itself and in the channel are ex-votos. Only one inscription has so far been found in the basin, a dedication Numini Augustorum et Minervae, which, however, may have come from another monument. Nor can we as yet identify the provenance of the columns and the Tuscan capital that were lying in the basin and on the steps. In spite of these uncertainties, we can now be sure that this was a sacred fountain of great religious importance and architectural originality.

During the 1970 excavations a sacred area consisting of two sanctuaries was identified ca. 100 m W of the fountain. The larger of these, E of the temenos, is a square fanum with a gallery around it. In its latest form (which, however, was destroyed) it apparently went back to a period no earlier than the 3d c. A.D., but this late sanctuary was built on the ruins of an earlier monument. An important series of religious sculptures was found here. The most unusual is a stone statuette whose geometric form recalls the wooden ex-votos found at the sources of the Seine and at Chamallières; it may possibly date from the 1st c. A.D. A statue of a god, crouching (the head is missing), it had an inscription on the base; only the word AUG can be made out today. Two damaged stone statues represented Apollo, draped and playing his lyre, and Venus (?), naked. There was also a head— somewhat unusual in a Gallic sanctuary—belonging to a statue of Serapis, and finally a life-size bull's head was found in the foundations of the 3d c. temple. Probably it was in this temple that two inscriptions, reused in a monument nearby, originated; this latter monument apparently was not religious in purpose. The texts of the inscriptions are practically identical: Numinibus Aug(ustorum duorum) et deo Mercurio Felici Q. Sergius Macrinus aedem d(ei?) nov(am) donavit v(otum) s(olvit) l(ibens) m(erito). Hitherto, the only known instances of the use of the epithet Felix for Mercury were on some coins of Postumus and on *médaillons d'applique* from the Rhône valley, contemporary with the Gallic emperors. G. Sergius Macrinus must have rebuilt the temple after it had been torn down, probably in the Germanic invasions of 259-260.

The 1970 excavations in the same area revealed a great E-W street and its open sewer with wooden culverts, as well as a number of complex buildings whose function is as yet undetermined.

The importance of the cult of Mercury at Argentomagus is confirmed 1) by an inscription reused in the facade of the church: (Deo Mercu)rio et de(ae)/ . . . Aug(ustae) Ates/ . . . (Ae)liani (filius), 2) by a small statue, the lower part of which survives, representing the seated god accompanied by a goat; it was discovered in 1969 between the temples and the fountain. Also possibly associated with the cult are two images of the god crouching, found in 1969 and 1970 in a street and a garden in Saint Marcel. They may represent Mercury himself or his companion, Cernunnos.

The theater of Le Virou was completely rebuilt at the end of the 1st c. The enlarged building had a cavea with maeniana, the lowest resting directly on the ground, the second on a framework, the third supported by an embankment across which ran four vaulted vomitoria, and the fourth again resting on a frame. The horseshoe-shaped orchestra was reached by two open gates at either end of a straight rear wall decorated only by Tuscan pilasters. We know the date the theater was rebuilt from coins found in the earth bank supporting the third maenianum: two of them were minted in the last year of Nero's reign. The reconstruction should therefore be dated in the Flavian period, and this is confirmed by a study of the stonework—a core of mortared rubble faced with small stones, but as yet without courses of brick. Other changes were made later, the most important being the erection of a little rectangular stage building alongside the orchestra.

Some of the architectural features of this monument are reminiscent of theater-amphitheaters, particularly that at Sanxay. But the Virou theater, without a podium, could be used neither for venationes nor for gladiatorial combat, and Argentomagus already had an amphitheater (still relatively well preserved) at the NE edge of the settlement. Judging from its masonry, that monument must be contemporary with the second Virou theater.

In the 2d c. the settlement spread over all the Saint Marcel territory to the N and reached as far as the Creuse to the S. This expansion is marked to the NE by the amphitheater mentioned above and by a large unexplored monument known as Les Palais; in it was found a colossal head whose style shows certain Celtic characteristics. The great cemetery of the Champ de l'Image, which marks the N boundary of Argentomagus, has recently been excavated; it is a cremation necropolis, most of the tombs dating from the 2d c. and first half of the 3d. The ashes, in many cases those of children, are placed in glass or pottery urns, or often enclosed in wooden or stone caskets together with various kinds of offerings, including many statuettes of white Allier clay. The most noteworthy of these burials consist of an urn of imitation Lezoux ware made in Marcus Aurelius' reign; above it were six statuettes, arranged in a circle: three of Venus, two of horses, one of a mother goddess. Some of the tombs had carved stelai, only fragments of which have been found.

On the S side of the city, in what is now the Argenton suburb of Saint Étienne, were baths. They were destroyed in the 19th c. when the Argenton railroad station was built. Their plan was drawn, but is difficult to interpret; there is a pillar decorated with dense foliage in the Chateauroux museum, which dates from the first half of the 2d c. The N necropolis was beside the Limoges road, which crossed the Creuse over a bridge whose piles are still standing. From this necropolis come some funerary stelai and epitaphs preserved in the Chateauroux museum. And it was here that the cult of St. Étienne originated: a church (now secularized) was dedicated to him.

According to the *Notitia dignitatum*, Argentomagus had state-owned workshops for making armaments; the site has not yet been located. Nor do we know in what period the Mersans site was abandoned. Nevertheless, it is certain that the site was not fortified at the end of the 3d c. Possibly at that time a fortress was built on the left bank of the Creuse, on the spur where the statue of La Bonne-Dame stands today; it must have been the forerunner of the Chateau d'Argenton, which was finally destroyed under Louis XIII. One of the towers of this castle still bears the name Tour d'Héracle, a link with the story of St. Marcellus. According to legend, Marcellus was a preacher who was beheaded during the Valerian persecution for destroying idols, on the order of the governor Heraclius. Quite possibly this tradition originated in the destruction of the Temple of Mercury (under Valerian, in fact) which G. Sergius Macrinus had sought to remedy.

BIBLIOGRAPHY. E. Hubert, *Le Bas-Berry, Histoire et Archéologie,* 15ff; J. Allain et al., "Deux dépotoirs gallo-romains à Argentomagus," *Rev. Arch. du Centre* 3 (1964) 341-56; "Un dépotoir augustéen à Argentomagus," ibid. 5, 1 (1966) 3, 16; 5, 3 (1966) 195-219; J. Allain, "Argenton, Histoire d'un site urbain," *Archeologia* 23 (1968) 341ff; G. C. Picard, *Gallia* 24, 2 (1966) 248-53; *Gallia* 26, 2 (1968) 327-37; *CRAI* (1967) 30-42; *CRAI* (1969) 153-61. G. C. PICARD

ARGENTON SUR CREUSE, *see* ARGENTOMAGUS

ARGIVE HERAION Argolid, Greece. Map 11. Accessible by road from Mycenae (5 km) and Argos (10 km). Located on a hill to the SW of Mt. Euboia, the Heraion commands a view of the Argive plain and of the citadel of Argos. The Sanctuary of Hera was founded on the site of a prehistoric settlement. Except for a tholos tomb on a ridge to the W, little can be seen of the settlement or of the extensive Middle and Late Helladic cemeteries. In the archaic and Classical periods the Argive cult of Hera assumed major religious and political importance. Two early 6th c. B.C. statues (now in the Delphi Museum) commemorated Kleobis and Biton, Argive worshipers of Hera. In the early 5th c. B.C., the Spartan king Kleomenes seized the sanctuary in a war against Argos. By ca. 468 B.C., administrative control of the sanctuary had become a source of dispute between Mycenae and Argos. The cult continued to flourish in the Roman period, as is evident from Imperial dedications. Discovered in 1831 by Colonel Gordon, the site has been excavated intermittently. The reconstructions and the dates proposed for many of the structures are controversial; research on these problems is now being done at the site.

The earliest and still the most impressive feature at the Heraion is the "Cyclopean" wall. Tentatively dated to the Late Geometric period, the massive wall of conglomerate boulders supports a paved terrace, which was once approached by a ramp at the SE. No building is clearly contemporary with this terrace, although a late 8th c. B.C. terracotta model, rectangular in plan and having a gabled roof and a prostyle porch (displayed along with other finds from the site in the Athens National Museum) may represent a temple that existed during this period. On the terrace the stone stylobate of what should be considered a later temple is partially preserved. The wide spacing of the circular cuttings for columns suggests that it had a wooden entablature, characteristic of an early stage in the development of peripteral temples.

This temple was destroyed by fire in 423 B.C. A new temple may already have been planned in the middle of the 5th c. B.C., at the same time as the construction of a lower terrace. The extant architectural members, however, seem to date from the very end of the century. Designed by the Argive architect Eupolemos, the Doric temple had six columns on the facades and twelve on the flanks; its interior arrangement is less sure. Some architectural details were Attic in style. The sculptural decoration included marble metopes, pediments, cornice, and akroteria; Polykleitos made the chryselephantine cult statue. Only a platform of poros foundations remains in situ. Fragments of a Hellenistic triglyph altar with a meander pattern in low relief lie among the blocks to the NE of the temple foundations.

The lower terrace had a monumental stairway or stepped retaining wall at the S; at the W a road led to Mycenae. At its E edge are the conglomerate foundations of a large hypostyle hall, the function of which is unknown. Other variously dated structures line the N side of the terrace. At the NE is a small rectangular building with both interior column bases and partition walls. To

the W of this structure is a platform reached by a short flight of steps and surmounted by bases for statues and stelai. Farther to the W is a long stoa dated as early as the 7th c. B.C. by the column capitals found within it. The W end of the stoa appears to have undergone an alteration when a tile flooring was installed.

Directly below the temple terrace are two relatively well-preserved buildings. The structure to the W of the temple is almost square in plan, having an open court surrounded on three sides by covered porticos and flanked on the N by an entrance corridor and a row of three dining rooms. Archaic architectural members have been cited as proof of a late 6th c. B.C. date, but this structure may more probably have been built after the 5th c. B.C. terrace wall. South of the temple is a stoa securely dated to the middle of the 5th c. B.C. Its interior columns, one of which lies fallen at the E, are Doric and extremely slender. Among its refinements are a stepped back wall which has projecting buttresses and a W wall which is elaborated with decorative panels.

At the site there are several other structures of which little is preserved and less is known. To the N of the building with the peristyle court is a large structure, which has been incorrectly identified as a propylon. To the W of these foundations are the remains of a Roman bath and of a large L-shaped gymnasium. Finally, to the S of the temple are traces of a Roman building, which has been identified as a foundry.

BIBLIOGRAPHY. Hdt. 1.31, 6.81-82; Hellanikos in *FGrH* I 4 F 74-83; Thuc. 4.133; Diod. Sic. 11.65; Strab. 8.368, 372; Paus. 2.17; P. Stamatakis, Περὶ τοῦ παρὰ τὸ Ἡραῖον καθαρισθέντος τάφου, *AthMitt* 3 (1879) 271-86; C. Waldstein et al., *The Argive Heraeum,* 2 vols. (1902-5)ᴹ; A. Frickenhaus, "Griechische Banketthäuser," *JdI* XXXII (1917) 121-30; C. W. Blegen, *Prosymna,* 2 vols. (1937); id., "Post-Mycenaean Deposits in Chamber Tombs," *ArchEph* 100 (1937) 1, 377-90; id., "Prosymna: Remains of Post-Mycenaean Date," *AJA* 42 (1939) 410-44; S. D. Markman, "Building Models and the Architecture of the Geometric Period," *Studies Presented to D. M. Robinson,* ed. G. E. Mylonas (1951) I 259-71; J. L. Caskey & P. Amandry, "Investigations at the Heraion of Argos, 1949," *Hesperia* 21 (1952) 165-221; Amandry, "Observations sur les monuments de l'Héraion d'Argos," ibid., 222-74ᴾᴵ; G. Roux, *L'architecture de l'Argolide aux IVᵉ et IIIᵉ siècles avant J.-C.* (1961) 57-65; J. J. Coulton, "The Columns and Roof of the South Stoa at the Argive Heraion," *BSA* 68 (1973) 65-85; S. G. Miller, "The Date of the West Building at the Argive Heraion," *AJA* 77 (1973) 9-18; H. Lauter, "Zur frühklassischen Neuplanung des Heraions von Argos," *AthMitt* 88 (1973) 175-87. R. S. MASON

ARGOS Central Greece. Map 11. The city lies at the foot of two hills a few km from the sea, dominating the Argive plain. Described by Pausanias, it has been cited many times by historians and orators, as well as by epic and tragic poets.

The earliest of the Pelasgian settlements, it was also the most important. Legend very soon associated it with a goddess (Hera), the cow (Io), and the wolf (Danaos). The Danaans were portrayed as invaders, succeeded in their turn by the Achaians possibly at the beginning of the second millennium. In any event, the region was already divided at the time of Perseus the Danaid. Argos still played a major role in the two campaigns of the Achaians against Thebes; however, the Trojan expedition was led by Agamemnon, king of Mycenae. The rivalry with Sparta, which was to dominate the next centuries, may go back to Orestes.

After the Dorian invasions Argos once again flour-

ished under the tyrant Pheidon; it may have been he who introduced into Greece a sort of money in the form of spits, or oboloi (second half of the 8th c.). Then when Sparta eclipsed Argos and grew at its expense, it joined almost every one of the anti-Lakonian leagues until Flaminus rescued it from Nabis (195 B.C.). Argos does not seem to have suffered under the Romans, and in spite of the pillaging of the Goths the life of the city never stopped.

We know nothing of how the city was laid out in any period of antiquity. There is evidence of a Neolithic settlement in the S region, and of one from the Early Helladic period on the Aspis (to the N). This hill most probably was the Middle Helladic acropolis. The Larissa, which dominates the site to the NW, apparently was fortified only in the Mycenaean period. The only other finds from the 2d millennium are a few remains of dwellings at the foot of the hills and some tombs, many of them cut in the rock and particularly rich in Late Helladic III B.

Grave-offerings, the chief evidence of the next centuries, once again become extremely plentiful about Pheidon's time; the museum has a unique collection of the original Geometric ware of Argos as well as a cuirass found beside a helmet with a crest shaped like a crescent, both exceptionally well preserved. On the other hand, the sculpture schools of archaic and classical Argos, so renowned in antiquity, have left practically no trace on the site.

Some topographical locations can be determined: that of the Temple of Pythian Apollo, with its manteion, and the Temple of Athena Oxyderkes, on the W flank of the Aspis; that of the temples and citadel of the Larissa; hewn in the E side of that hill, one of the finest theaters in Greece (end of the 4th c.); farther S, under a Roman odeum, the remains of a theater with straight banks of seats, built before the 4th c., perhaps as a meeting place for the assembly. The discovery of an Aphrodision next to the odeum enables us to interpret Pausanias' description and to presume that the foundations of a square hypostyle hall (the boule?) and a long 5th c. portico almost opposite the theater belong to the agora. Changes made to the theater, the odeum, the building of great baths as well as villas (mosaics are in the museum) point to sustained activity in the 1st-2d and 4th-5th c. A.D.

BIBLIOGRAPHY. Reports of annual excavations in *BCH* 77-83 (1953-59); 91-93 (1967-69)[PI]; 94-96 (1970-73)[P]; A. Boëthius, *Zur Topographie des dorischen Argos, Strena P. Persson*, 248-89 (1922); W. Vollgraff, *Le sanctuaire d'Apollon Pythéen à Argos* (1956); G. Roux, *L'architecture de l'Argolide aux IVᵉ et IIIᵉs.* (1961); P. Courbin, *La céramique géométrique de l'Argolide* (1966)[M]; J. Deshayes, *Argos: les fouilles de la Deiras* (1966); R. A. Tomlinson, *Argos and the Argolid* (1972); R. Ginouvès, *Le theatron à gradins droits et l'Odéon d'Argos* (1973).

Pausanias, *Description of Greece* 2.18-24; Strabo, *Geography* 8.6.7-10.　　　　　　J. F. BOMMELAER

ARGOS AMPHILOCHIKON Epeiros, Greece. Map 9. The ancient site is on the Botoko river near the modern town of Loutron on the Gulf of Arta. According to varying traditions cited by Strabo, it was founded after the Trojan War by Alkmeion or his brother Amphilochos. No Mycenaean remains have been found, but Hekataios mentions the site at the end of the 6th c. B.C. The rival of Ambrakia (Arta) in the 5th c., it was allied with Athens at the beginning of the Peloponnesian War. The circuit wall and tower on the acropolis probably originated in the 6th c.; the two long walls, each ending in a tower, which run down toward the plain were probably added about the middle of the 5th. There are traces of a theater with carved stone seats.

BIBLIOGRAPHY. Strab. 7.7.7; N.G.L. Hammond, *Epirus* (1967)[M].　　　　　　M. H. MC ALLISTER

ARGOS HIPPION or ARGYRIPPA (Arpi) Apulia, Italy. Map 14. A city whose name (Strab. 5.1.9; 6.3.9; Ptol. 3.1.72; Plin. *HN* 3.104), gave rise to the legend of its foundation by the Argive King Diomede. One of the most important cities of the Daunii, who were Illyrian in origin, it is in the heart of the Tavoliere, ca. 20 km E of Luceria and 30 km from Sipontum, its outlet to the sea. During the period of the city's greatest expansion, Sipontum was included in its territory (Livy 34.45; Dio. 20.3). The city played an important role in the struggle between Greeks and Italici and between Oscans and Latins for supremacy in Italy. In order to save its territory from the Sabelli during the second Samnite war, it concluded a treaty of alliance with Rome in 326 B.C. (Livy 9.13). This contributed to a flourishing period in the city's history, largely datable to the 3d c. B.C. and documented by an immense coinage in silver and bronze. The coins bore a legend in Greek and images of Greek deities, including Zeus, Athena, Persephone, and Ares. During the Pyrrhic war the city was still allied to Rome, but in the second Punic war it surrendered to Hannibal, who wintered there at the end of 215 B.C. Two years later Fabius Maximus occupied its territory, reducing its importance as a result of the loss of its outlet to the sea, where in 194 B.C. the Romans built the colony of Sipontum (Polyb. 3.118; Livy 22.61; App., Hann. 31). It had lost all importance by the Imperial age.

Two inscriptions from nearby Vaccarella belong perhaps to Luceria (*CIL* IX, 934, 935). The site of the ancient city is easily recognizable a few km N of Foggia. Extensive excavation during the last few years has brought to light the remains of numerous buildings of the Hellenistic-Roman age, pit tombs from the 6th-5th c. B.C. and grotto tombs from the 4th-3d c. B.C. The material found is preserved in the museums at Foggia and Taranto.

BIBLIOGRAPHY. W. Smith, *Dictionary of Greek and Roman Geography*, I (1856) 220 (E. H. Bunbury); *RE* II.1 (1895) 1217-18 (Hülsen); E. De Ruggiero, *Dizionario epigrafico di antichità romane*, I (1895) 678.

F. G. LO PORTO

"ARGOS IPPATUM," *see* KASTRION

ARGURA Thessaly, Greece. Map 9. A city of Pelasgiotis, in antiquity identified with Homeric Argissa (*Il.* 2.738; Strab. 9.440; Steph. Byz. s.v.). It was on the left bank of the Peneios river, supposed to be 40 stades (ca. 7 km) from Atrax (Strab. 9.438). This has long been considered an ancient site at a prehistoric mound (Gremnos or Gremnos Magoula) about 7 km W of Larissa, just on the left bank of the Peneios. This identification was denied by Stählin, who placed Argura at an ancient site at Gunitza, ca. 8 km W of Gremnos Magoula, but the Gremnos-Argura identification has recently been reasserted by Franke and Milojčić. The history of the city is virtually unknown.

The prehistoric mound has been half carried away by the river. It served as the acropolis of the ancient city, which is otherwise in a flat plain. Excavations on the mound in 1955-58 turned up sherds from the Geometric through Roman periods as well as prehistoric. One well found in 1956 contained Classical, another early Hellenistic, pottery. A fragment of an early Classical terracotta revetment found on the mound may indicate the

presence of a temple, perhaps to Artemis, to whom an inscription was found in the excavations. A test trench on the N side of the mound produced parts of two archaic-Classical buildings. Right at the river's edge below and a little to the E of the mound are a few courses remaining of a tower constructed of large rectangular blocks, which was built over the remains of an earlier one of polygonal masonry, and seems itself to have been rebuilt. It is conjectured that this was a late archaic tower rebuilt in the 4th c. B.C. From the mound the course of two concentric city walls can be seen to the NE and W, about 350-450 m away from the mound. The inner one is possibly archaic or Classical; the outer, Hellenistic. Investigations within the lower city area in 1958 turned up sherds of the 6th c. B.C. through the Hellenistic period, and some scanty remains of a public building and houses. The agora of the ancient city may have been in the flat area immediately to the E of the mound. Objects from the excavations and some found by chance are in the Larissa Museum.

A tumulus (Skismeni Magoula) ca. 2 km NW of Gremnos Magoula and 1 km N of the river was partially excavated in 1958-59. Under the edge of the mound were three stone sarcophagi, close to each other and radiating from the center of the mound. These were plain, and had each been lined with a wooden coffin, one of which was well preserved and contained fragments of clothing and a pillow along with the skeleton. One of the others contained a lekythos of the 4th c. B.C. No trace of a built tomb or other grave was found in the center of the mound. Between Gremnos Magoula and Skismeni Magoula was a Hellenistic necropolis on the road leading towards Gunitza. This was investigated in 1955 and 1958 and yielded a few objects. Some 70 m W-SW of the Hellenistic necropolis one of the Classical period was discovered in 1958. To the N of the road to Larissa from Gremnos Magoula, 2 km E of the mound, is a group of eight tumuli (Pente Magoules), perhaps Hellenistic grave mounds, but so far uninvestigated. By the road at this point Leake noted some ancient foundations and blocks, and a piece of a Doric column (chord of flute 6 inches).

BIBLIOGRAPHY. W. M. Leake, *Nor. Gr.* (1835) III 367; IV 534; A.J.B. Wace & M. S. Thompson, *Prehistoric Thessaly* (1912) 54f; F. Stählin, *Das Hellenische Thessalien* (1924) 99-100; V. Milojčić, *AA* (1955) 191-219MI; (1956) 166-79I; P. Franke, "Eine Bisher Unbekante Thessalische Münze aus Argura," *AA* (1955) 230-36; H. Biesantz, *AA* (1957) 37-51PI; (1959) 74-76.

T. S. MAC KAY

ARGYRIPPA, *see* ARGOS HIPPION

ARIASSOS Turkey. Map 7. In Pisidia near Yürükbademlisi, 3 km SW of Dağ Nahiyesi. The city is listed by Ptolemy, Hierokles, and the *Notitiae*, but is unknown to history. The site is proved by an inscription found on the spot (*IGR* III, 422). It is on two hills of no great height, approached from the N by a road spanned by a triple-arched gateway of the familiar form, handsome and well preserved. The W hill carries a ring wall preserved in part, and on both hills are numerous built tombs, some still in good condition. One or two other buildings in good masonry stand to a fair height but are not identifiable.

BIBLIOGRAPHY. V. Bérard, *BCH* 16 (1892) 427.

G. E. BEAN

ARICCIA, *see* ARICIA

ARICIA (Ariccia) Italy. Map 16. An ancient Latin town on the Via Appia at the 16th milestone. It lies on a spur at the juncture of the outer slopes of the craters of Lago d'Albano and Lago di Nemi facing SW over Valle Ariccia, the remains of a lesser crater. From a very early period it was one of the most important and most powerful of the Latin towns, and from an early period it led these in war against Rome (Livy 1.50-51). It was finally subdued in the Latin war of 338 B.C. from which time it enjoyed civitas sine suffragio (Livy 8.13). It later was given full citizenship and was inscribed in the tribus Horatia. Its highest magistrate was called dictator even in the time of the Empire; it also had two quaestors, two aediles, and an ordo decurionum called senatus. It had the distinction of being the birthplace of P. Clodius and Atia, the mother of Augustus, as well as many Roman magistrates (Cic. *Phil.* 3.15-16).

The remains of the town itself spread on either side of the old Via Appia, climbing to a triangular height at the NE, the arx of the town, and spreading out on a broad front on the edge of Valle Ariccia. Three periods of construction in the remains of fortifications have been distinguished: the earliest embracing only the arx; the middle one, an extension of this into lower ground to the S; the last, a further extension to enclose what one may think of as the lower city. There the Appia seems to have been the main street, and an arched gate spanned it at the SE, so these fortifications are not likely to be earlier than Hellenistic, but they seem to be towerless, so the arch may have been inserted later. Little remains of the earlier fortifications.

Among the remains of buildings, only a temple has been more than cursorily examined. This reminds one of the Temple of Gabii but is on a smaller scale, the interior of the cella measuring only 7.70 by 13.15 m. It was a temple with Vitruvian alae; there were four columns across the front and four down each flank; and it stood on a platform 1.75 m high that has largely disappeared. There is no indication of the god of this temple; it is commonly called the Tempio dell'Orto di Mezzo or Tempio di Diana. In 1927 a votive deposit containing an abundance of material, including large statues and busts of terracotta of superior workmanship, was discovered. The divinities here were clearly Ceres and Proserpina.

The most impressive remains lie outside the walls, a viaduct of large rusticated ashlar facing a concrete core that carried the Via Appia across a valley just SE of the town. Canina, who saw it in better state at the beginning of the 19th c., measured it as 231.25 m long, 13.2 m in its greatest height, 8.22 m wide at the level of the pavement. There is a slight batter to each face, and it is pierced at three points by arched tunnels. A building inscription found nearby proves it Augustan in date.

Within the town's territory lay two important sanctuaries, the lucus Ferentinae and the nemus aricinum of Diana in associaton with Egeria and Virbius. The former was a grove surrounding a spring at the foot of the Alban Mount where the Latins assembled in council to award imperium. This was the custom from the time of the destruction of Alba to the consulate of P. Decius Mus, 340 B.C. (Livy 1.50-51; Festus 276L s.v. praetor). It has never been located.

The nemus aricinum lay NE of the Lago di Nemi looking out over the water the poets called "speculum Dianae." Here a natural shelf was improved by terracing to make a rectangular platform with a surface area of 45,000 square m. Around the E corner runs a retaining wall, the only conspicuous remains today, a series of half-domed semicircular niches faced with opus incertum. The temple itself was not centered on the platform but set back toward the N corner, raised on a podium (overall dimensions: 30 m x 15.9 m). It is reported that Doric capitals were found, but in most other features the temple is not clear. In the vicinity were found a way flanked

with bases, colonnades, and a great many structures of unknown purpose. Just outside the precinct to the NW was found a theater of the Imperial period and other remains suggestive of baths.

The whole area has been the object of antiquarian researches since the early 17th c. at least, and in the 18th and 19th c. considerable quantities of antiquities were removed. Most of the material was votive, of the Hellenistic and Imperial periods. Some small portions of the temple's decorations in terracotta and gilt bronze were recovered; from the paucity of the terracottas (antefixes only) it would appear that most of the decoration was carried out in bronze.

The nemus, like the lucus Ferentinae and the Sanctuary of Jupiter Latiaris, seems to have been the shrine of a Latin amphictyony. The extraordinary character and initiation of the rex nemorensis with its overtones of human sacrifice, the mystery cult of Virbius with its theme of resurrection, and the theatrical festival in which women carried torches in procession to the nemus are well known and explain the enormous popularity of the cult in antiquity, but the unsolved problems connected with it are numerous, and the site today is so intensely cultivated that a visitor can see little and form no idea of the whole.

It was known as early as the 15th c. that under the waters of the lake near its edge lay the remains of two large ships (see Shipwrecks).

Considerable collections of material from Aricia and the nemus are in the Museo delle Terme, the British Museum, the museum of Nottingham, and the Ny Carlsberg Glyptothek in Copenhagen.

BIBLIOGRAPHY. L. Morpurgo, *MonAnt* 13 (1903) 297-392; id., *NSc* (1931) 237-305; G. Florescu, *EphDac* 3 (1925) 1-57; R. Paribeni, *NSc* (1930) 370-80, pls. 16-17; F. Poulsen, *ActaA* 12 (1941) 1-52, pls. 1-3[I]; G. Ucelli, *Le navi di Nemi* (1950)[MPI]; A. Alföldi, *AJA* 64 (1960) 137-44, pls. 31-34; S. Haynes, *RömMitt* 67 (1960) 34-45, pls. 12-19; P. J. Riis, *ActaA* 37 (1966) 67-75. L. RICHARDSON, JR.

ARICONIUM (near Weston under Penyard) Gloucestershire, England. Map 24. A town ca. 20 km NW of Gloucester on the road towards the Wye valley. Excavations have produced 13 British coins which may suggest a native or Roman military site as the precursor of the town. Substantial stone buildings have been found, but no defenses. In an area of ca. 100 ha the fields abound with iron slag and the debris of smelting, some of which was reused in the 17th and 18th c. Some furnaces have been excavated, and it seems probable that the town was the center of an iron smelting industry. The pottery and coins indicate a peak of activity in the 3d and early 4th c. The name appears in the *Antonine Itinerary*, but its meaning is not known.

BIBLIOGRAPHY. *AntJ* 3 (1923) 66-67; *Trans. Woolhope Nat. Field Club* (1921-23); furnaces: ibid. 38 (1965) 124-35. G. WEBSTER

ARIENZO Italy. Map 17A. Remains of a villa in the province of Caserta in the area of Suessula. Well preserved in part, the villa was built during the first half of the 2d c. A.D., but was destroyed by a flood in the 4th c. Thus far the complex, which is a short distance from the Via Appia, has been excavated on only a modest scale. There are remains of a nymphaeum with niches between half-columns, two rooms with mosaic floors, and some remains of painted decoration, all dating from the time of Hadrian. W. JOHANNOWSKY

ARIMINUM (Rimini) Forlì, Emilia-Romagna, Italy. Map 14. On the Adriatic coast half way between Ancona and Ravenna and between the Ariminus (Marecchia) and the Aprusa (Ausa) rivers. According to Strabo it was first an Umbrian colony, then in 268 B.C. a Latin colony, recolonized under Augustus. In the 3d c. B.C. Ariminum, with Arretium, was a stronghold in the line of defense against the Gauls in the Padana plain. It was the terminal point of the Via Flaminia, and later also of the Via Aemilia and the Via Popilia, making the city a port of notable size at the mouth of the Ariminus. Ariminum followed the party of Marians, and as a consequence was damaged and depressed by the Sullans. The site was of great strategic importance in the 2d c. B.C., and later was Caesar's point of departure for the civil war. It was the temporary headquarters of Augustus during the Illyrian wars, and was later variously involved in the events of the 3d-4th c. A.D., and in the Gothic war at the time of Justinian. Ariminum was a component of the Adriatic pentarchy. It was the seat of a bishopric at least from the 4th c., and in A.D. 359 was also the seat of a council.

The principal monuments are an arch of Augustus, a bridge of Tiberius, and an amphitheater. At either side of the arch stretches of the walls remain and bases of towers contemporary with the first colonization, both in polygonal work of local stone. Of the new circuit wall constructed in the time of Sulla in opera quadrata, there remains the S gate with two arches, which has since been reconstructed in another position. Several funerary monuments found along the Via Flaminia complete the Republican remains at Ariminum, made more understandable today by the discovery of ceramic workshops contemporary with the first colonial city plan. The arch, which dates from 27 B.C., was substituted for the E gate, and is the monument commemorating the roadbuilding policies of Augustus. It is a single span framed by the Corinthian order in Classical style, and is the oldest preserved monument of this type. It bears four shields with images of divinities inspired by the ideology of the period after the battle of Actium. The bridge of Tiberius, from A.D. 14, is an imposing work with decoration and inscription which indicate its sacred nature. The amphitheater, probably Hadrianic, in the NE part of the city near the large ancient port, has a single row of arches. It was in rubble concrete revetted with brick, and with pilasters in the Tuscan order.

The city was orthogonal in plan except in the SE sector, but the outline of the walls was semicircular, conforming to the concavity of the land. The grid of streets is almost entirely preserved in the modern streets, with the forum at the intersection of the principal axes. In the Imperial age a block adjacent to the forum held the theater. The cardo led to the port and was originally the principal road of the city. Later, following the junction of the Via Flaminia with the Via Aemilia, the most heavily used artery became and remained the decumanus. The port was gradually moved as the course of the river changed with time, and as a consequence a second forum was built to the W in late antiquity in the area that became the center of life in the mediaeval period.

Excavations in the last ten years have documented the life and activity of the urban center during the first colonial age and have also brought to light an important phase of late antiquity. The latter is linked with a period of impressive rebuilding, especially in the private sector. Large homes contained polychrome mosaic pavements featuring geometric and figured designs of great variety and size, and showing a notable level of artistic achievement. The plans of private buildings from the late and middle Imperial age are also shown by recent excavation to be outstanding and complex. Evidence is scarce concerning the city's economic life, with the exception of the ceramic workshops located in the S and W suburbs and

a private horreum mentioned in an inscription and perhaps located near the ancient port. The entrance to this is now buried and unrecognizable. A suburb beyond the Marecchia, and included within the mediaeval walls, is perhaps of ancient origin. Necropoleis have been recognized to the S and E, but little is known of them. In the E burial area the first Christian ecclesiastical building was constructed. The territory to the NW shows traces of a centuriation oriented secundum caelum, and considered to be very ancient. There were numerous inhabited centers in the territory around Ariminum, and from mediaeval documents it appears that the land was farmed throughout the entire ancient period.

BIBLIOGRAPHY. Tonini, *Storia civile e sacra riminese*, I-VI (1848); Aurigemma, *Guida ai più notevoli monumenti romani e al Museo archeologico di Rimini* (1934)MPI; G. A. Mansuelli, *Ariminum* (1941)MPI; id., "L'arco di Augusto a Rimini" *Emilia Romana* II (1944) 109-91; id., "Additamenta ariminensia," *Studi in onore di C. Lucchesi* (1952) 113-28; id., "Il monumento augusteo del 27 a.C.," *Arte antica e moderna* 8 (1959) 363-91; 11 (1960) 16-35; Arias, "Mosaico romano policromo di Rimini," *Studi in onore di C. Lucchesi* (1952) 1-10; Zuffa, "Nuove scoperte di archeologia e storia riminese," *Studi archeologici riminesi* (Studi Romagnoli 13) (1964) 47-94MPI. G. A. MANSUELLI

ARISBA, *see* LESBOS

ARISTONAUTAI, *see under* PELLENE

ARLES SUR RHONE, *see* ARELATE

ARLON, *see* OROLAUNUM

ARMANT, *see* HERMONTHIS

ARMENTO Basilicata, Italy. Map 14. In the valley of the Agri river, remains of a series of small habitation centers surround and include the modern town. In addition to Armento itself the most important of these centers are Serra Lustrante, Caprarella, and S. Giovanni. With the exception of the last, which dates from the Hellenistic-Roman period, they date from the second half of the 8th c. B.C.; to the N of Armento a chamber tomb has been found, dated by its deposits to the end of the 7th or the beginning of the 6th c. B.C. Besides items of local manufacture, among which are a bronze cuirass and iron spits, the tomb contained Greek bronzes (helmet, phiale) and vases (Corinthian aryballos), as well as vases from Siris and Etruscan bucchero ware.

At Serra Lustrante, remains of habitation from the second Iron Age have been found as well as a small Lucanian sanctuary constructed and decorated in the Greek style. The sanctuary is dated by coins to ca. 330 B.C., and the antefixes and the ex-voto found in the sacellum must date to the same period. The wealth of bronzes from this sanctuary justifies the attribution of the Satyr now in the Glyptothek of Munich to this same provenance, and probably the gold crown of Kritonios in the same museum came from here. The errors noted in the inscription on the crown point to the work of a Lucanian artist who studied at Herakle or at Taranto. Among those objects found in the sacellum, which dominates the whole sanctuary, are the so-called Sandals of Herakles, and fragments of a sculptured head. Next to the sacellum, but still within the sanctuary, was found a large cistern carved out of the extremely hard earth and completely covered with resistant plaster. The sanctuary fell into disuse at the beginning of the 3d c. B.C. At Armento, as at all the other centers dominating the Agri

valley, there is evidence of contact with Siris and Heraklea.

BIBLIOGRAPHY. D. Adamesteanu, *BdA* I (1967) 44; "Siris-Heraclea," *Policoro, Dieci anni di autonomia* (1969) 204-7; id., *Popoli anellenici* (1971) 66-68; id., "Tomba arcaica da Armento," *Atti e Mem. Soc. Magna Grecia* 11-12 (1970-71) 83, 92; id., "Attività archeologica in Basilicata," *Atti IX Convegno Studi Magna Grecia* (1970) 229-31; id., "Scavi, scoperte e ricerche storiche-archeologiche (in Basilicata)," *Realtà del Mezzogiorno* 8-9 (1971) 843, 857. D. ADAMESTEANU

ARNEAI (Ernes) Lycia, Turkey. Map 7. About 25 km NW of Finike. Rarely mentioned in antiquity, the city is abundantly identified by its inscriptions and by the evident survival of the name. Its antiquity is proved by an inscription in the Lycian language, but it was never important though in Byzantine times its bishop ranked ninth under the metropolitan of Myra. Arneai was the head of a sympolity of towns, one of which was named Coroae; the small site, with a Lycian inscription, near Çağman was no doubt a member of this sympolity. The very rare coins of Arneai are, as usual in Lycia, of Gordian III. The inscriptions reveal a close association with Myra, whose territory was adjacent on the S.

The extant ruins are mostly Byzantine. The ring wall still stands for most of its length, with towers and at least two gates, but the greater part was repaired in mediaeval times. In the interior are two churches and some unrecognizable remains of buildings; the public buildings mentioned in the inscriptions, notably a gymnasium and a public guest house, are not now discernible. From earlier times there survive a few tombs of Lycian type, some parts of the city wall, and numerous inscriptions of the Roman period, mostly built into the late wall; one of them is an ex-voto to a local deity, Tobaloas.

BIBLIOGRAPHY. C. Ritter, *Kleinasien* (1859) II 1134-36; H. Rott, *Kleinasiatische Denkmäler* (1908) 74f; *TAM* II.3 (1940) 279fM; L. Robert, *Hellenica* 10 (1955) 215ff.
 G. E. BEAN

ARNISSA Greece. Map 9. The first town of the Macedonian kingdom reached after going S through the Kirli Derven pass into Lynkos. In 524 B.C. the Spartan leader Brasidas, abandoned by his Macedonian ally, reached Arnissa after a long day that ended with the storming of the pass (Thuc. 4.128.3). An important Classical site can probably be identified with Arnissa just E of the S end of the pass, N of the village of Petres and near its lake. Rectangular foundations, possibly of a defense wall, are visible; several inscriptions and numerous small objects have been found. There have been no excavations.

Arnissa was still of some importance in Late Roman times, and appears, misnamed as Larissa, in the *Synekdemos* of Hierokles (638.11). The village of Ostrovo, at the head of Lake Ostrovo, has been officially renamed Arnissa, but this cannot be correct, since it is based on misidentification of the pass into Lynkos. No ancient name can convincingly be associated with the remains at Ostrovo.

BIBLIOGRAPHY. W. M. Leake, *Travels in Northern Greece* III (1835) 315; C. Edson, "The location of Cellae and the route of the via Egnatia in western Macedonia," *CP* 46 (1951) 1-16; N.G.L. Hammond, *A History of Macedonia* 1 (1972) 104-8. P. A. MACKAY

AROSFA GAREG Wales. Map 24. This large marching camp lies on the Carmarthenshire-Brecknock border at SN802263. Its position testifies to the activity of a sizable Roman army unit operating at the W end of the Usk corridor in S Wales. The camp was first located by

aerial photography in 1955. Despite the moorland conditions the ramparts were accurately laid out; they measure 503 by 308 m, enclosing an area of 18 ha. Two inturned claviculae survive. Excavation revealed a rampart 3.5 m wide, built of mixed earth and stone with a turf cheek. Local conditions explain the absence of any ditch.

BIBLIOGRAPHY. G.D.B. Jones, *Bulletin of the Board of Celtic Studies* 21 (1966) 174ff[MI].　　　　G.D.B. JONES

ARPI, *see* ARGOS HIPPION

ARPINO, *see* ARPINUM

ARPINUM (Arpino) Campania, Italy. Map 17A. A Volscian and later (4th c. B.C.) Samnite hill town in the Liris river basin. Captured by Rome and granted civitas sine suffragio in 305-303 B.C., it gained full citizenship in 188 B.C. and became a municipium after the social war, ca. 90 B.C., after which it seldom appears in the sources. The modern town is roughly congruous with the ancient site.

Most noteworthy of the ancient remains are the megalithic polygonal circuit walls, still well-preserved, standing as much as 3.35 m high in places and 2 m wide at the top. The pre-Roman Porta dell'Arco leads through the wall to the acropolis. Its great stones, inclining gradually toward one another with a corbeled effect to an acutely angled point 4.5 m high, is really a false arch, requiring a vertical pier of squared-stone blocks as a support. The pier also bisects the gateway forming twin passages. There is a Roman gate as well.

The acropolis, now called Civitavecchia, contained the Temple of Mercury Lanarius, which is perhaps represented by the ancient remains under the Church of S. Maria. Traces exist of some sewers of the Republican period, the restoration of which is recorded in an inscription (*CIL* x, 5679).

The town was the birthplace of Cicero and Marius. The site of Cicero's villa, later owned by Silius Italicus, is marked by the 12th c. Church of S. Domenico 1.2 km N of the town of Isola del Liri below Arpino (*Ep. ad Quint. fr.* 3.1).

BIBLIOGRAPHY. O. E. Schmidt, *A., eine topographisch-historische Skizze* (1900); L. Venturini, *Notizie in A. e dintorni* (1907); G. Pierleoni, *Il patrimonio archeologico di A.* (1907); id., *Scoperte di antichità nel territorio di A.* (1911); L. Ippoliti, *Il luogo di nascita di M. T. Cicerone* (1936), with bibliography; I Negrisoli, *Atti di Scienze, Lettere ed Arti in Bergamo* 28 (1953-54).

D. C. SCAVONE

ARPITSA, *see* LIMES, GREEK EPEIROS

ARRABONA (Győr) Hungary. Map 12. A castrum on the limes Pannoniae, strategically linked to Carnuntum and Brigetio, and to Sipianae and Sabaria. It is 105 km N-NW of Budapest. It was of major importance for the surveillance of the barbaricum beyond the Danube. Situated at the mouth of the Arabon river, it was thus part of Pannonia Superior (Ptol. 6.11.3). During the invasions the locality was known under the name of Aqua Nigra. The castrum was built on the Kaptalan hill and its slopes, while the canabae grew up in the area of the modern town near Calvario street. The circuit wall of the castrum was constructed of large blocks of sandstone.

The center is mentioned in the ancient literature (*Ant. It.* 246, 263, 269, *Tab. Peut.*, and *Not. Dig.* 33, pp. 28ff). Facing the barbaricum dominated by the Quadi and the Suebi, the fortress was the seat of the numerous formations of cavalry that made up Legio I adiutrix: ala I Ulpia contrariorum, ala I Augusta Itureorum, ala I

Arevacorum, and ala Pannoniorum. Other troops included equites promoti, cuneus equitum stablesianorum, and milites liburnarii Legio X et XV geminae (*Not. Dig. occ.*).

In the vicinity of the castrum and of the canabae (near modern Koronko) a pagus developed. A villa was built nearby in the vicinity of Féhervar. From an inscription it is known that in 137 the military forces honored the emperor Hadrian with a statue (*CIL* 3,4366). During the medieval period the center took the name of Jaurinum.

See also Limes Pannoniae.

BIBLIOGRAPHY. *CIL* III, p. 546, 1045; E. Lovas, "I risultati degli studi archeologici su Arrabona e dintorni," *Boll. Assoc. Intern. Studi Mediterranei* 2, 3 (1931) 1-12; D. Adamesteanu, *EAA* 1 (1958) 672.　　　D. ADAMESTEANU

ARRAS, *see* NEMETACUM

ARRETIUM (Arezzo) Tuscany, Italy. Map 14. An Etruscan town, perhaps called Peithesa, on the height of Castelsecco (Poggio di San Cornelio), a height well fortified by ashlar stone walls, 3 km SE of Arezzo. The Arretines, according to Dion. Hal. (*Ant.Rom.* 3.51), joined other Etruscans in offering aid to the Latins against Tarquinius Priscus (fl. 616-579 B.C.) and must have been included in the Etruscan decapolis, living there in probable political dependence upon Clusium. The date and circumstances of the migration to Arretium are unknown, but the new citadel was a low eminence now occupied by the Cathedral, public gardens, and Fortezza Medicea above the Castro, a small tributary of the Chiana and Arno. The city wall composed partly of stone, partly of lightly fired brick, and partly of rock escarpment, has been found at points in the E section of the upper modern town, the cemetery, and N outskirts. The cardo of this Arretium was the modern Via Pelliceria and Via San Lorenzo. Whether the brick represents repairs or the stone represents constructional reinforcement at selected points is debated; Vitruvius (2.8, 9), and Pliny (*HN* 13.13 and 35.19), considered Arretium's "vetustus murus" as essentially constructed "e latere." The date of the wall is assigned to ca. 300 B.C., the approximate period of a 30-year treaty (321 B.C.) and a treaty of peace and alliance with Rome in 294, the year in which a Roman relieving army was beaten at Arretium by the besieging Senones. Tombs near Poggio del Sole, outside the Etruscan town but just inside the Medicean wall, and the famous 5th c. bronze Chimera, the red-figure krater by Euphronios, the 4th c. bronze Minerva, and fictile revetments of various temples show that Arezzo had acquired and perhaps actually produced considerable evidence of prosperity and culture long before the imminence of Roman expansion.

Arretium's advanced industrialization in the 3d c. B.C. permitted the furnishing of large quantities of bronze (and iron?) weapons and agricultural implements, as well as 120,000 modii of wheat, to Scipio's African expedition in 205 B.C., at which time there must also have been a lively production of Etrusco-Campanian black-surfaced ceramics.

Arretium supported Marius and was punished in territory, civil status, the imposition of a veterans' colony (Arretini fidentiores, contrasted with the native Arretini veteres; Julius Caesar later settled the Arretini Iulienses as well) and, on the evidence of plentiful black pottery but no red Arretine, the dismantling of the city wall and various finely decorated public buildings within it, and perhaps the blocking of the cisterns of the citadel. Later, Arretium (sc. Sulla's veterans) espoused Catiline's conspiracy.

Arretium's inhabited and industrial area must always have exceeded the fortified perimeter, but with the colonizations and under the Empire the expansion and reorientation must have been considerable; the new cardo was apparently the Corso Vittorio Emanuele and the forum has been conjectured as near Fonte Pozzolo N of the citadel. Nine roads radiated from the hilltop, and there are traces of a 1st-2d c. aqueduct entering the city at Fonte Veneziana on the E.

Etruscan and Roman graves, mosaics, inscriptions, and minor objects are common in Arretium, but its importance in mediaeval and Renaissance Italy has militated against the preservation and excavation of conspicuous architectural monuments except for those already noted and a large late cistern 23.5 m square in the Giardino Pubblico, a theater and several baths of which remains are scanty, and the 1st-2d c. amphitheater of ca. 7500 sq. m, well-preserved because of its conversion into the Orti and Convento di S. Bernardo, part of which is now the Museo Archeologico.

Already in Augustan times Arretium was famous for its plain and molded red-surfaced pottery of the late Republic and early Empire, superposing manufacturing techniques and artistic themes, imported from the Hellenistic East by a great influx of Greek-named workmen, upon vase shapes of Etrusco-Campanian ancestry. Within the present town numerous factories have been found and their operators identified, most notably the factory of M. Perennius and his successors at the church of S. Maria in Gradi, but also at Carciarelle and Orciolaia, 1 km from town, and as far away as Cincelli and Ponte a Buriano 7 km distant on the Arno. To what extent Maecenas, a native Arretine, was responsible for this artistic and industrial upsurge is not known. Excavations of the 1880s and 1890s produced vast amounts of Arretine ware, now partly in the Museo Archeologico, partly in private hands, partly dispersed to foreign museums; the vases of Ateius found in 1954-57 are at Florence, as is much else from the site. Further, Arretine ware was exported to military and civilian consumers throughout the Roman world and beyond (Britain, India), enriching many local museums of Western and Central Europe and North Africa. Arretium's primacy was Augustan and Tiberian, but even under Augustus an emigration of potters was under way, and by Flavian times Arretium had lost its significance to imitators elsewhere in Italy and in the provinces.

BIBLIOGRAPHY. G. Maetzke, *Rei Cretariae Romanae Fautorum Acta*, II, 25-27 (1959) (Ateius ware in Via Nardi).

Articles by various authors on individual finds, *Studi Etruschi*, 21, 22, 23, 32; F. Carpanelli, *Notizie degli Scavi di Antichità* (1950) 227-40[PI] (amphitheater); F. Rittatore & F. Carpanelli, *Edizione Archeologica della Carta d'Italia al 100,000 (Foglio 114 [Arezzo])* (1951)[MP] (exhaustive text and topographical bibliography to 1950); C. Hülsen, *PW* II, cols. 1227-28 (chiefly historical); *CIL* XI, 1820-1902; *ThLL* II, s.v. Arretium.

Arretine ware: H. Comfort et al., *Terra Sigillata, La Ceramica a Rilievo Ellenistica e Romana* (1968) 49-71[PI] (with principal bibliography of Arretine ware to 1958); A. Oxé & H. Comfort, *Corpus Vasorum Arretinorum* (1968) (names stamped on Arretine ware); A. Stenico, *La Ceramica Arretina* II, *Punzoni, modelli, calchi, ecc.* (1966)[I], and *La Ceramica Arretina* I, *Rasinius* I (1960). H. COMFORT

ARRUBIUM (Măcin) Galati, SE Romania. Map 12. The origin of this center seems to go back to the 3d c. B.C. when the Celtic kingdom of Tylis had to reinforce its S confines with several strongholds. The name is certainly Celtic. Arrubium, as much as Noviodunum, dominated the S arc of the Danube before it flowed into the Black Sea. At the time the Romans organized the limes (Danubianus), building the fortifications for their legions, their alae, and their vexillationes on the right bank of the river, Arrubium must have already existed. It was linked with the other centers on the right side of the Danube, Troesmis and Noviodunum, by the great road from Transmarisca that followed the course of the river. Between the 2d and the 4th c. it became the seat of the ala I Vespasiana Dardanorum (*CIL* 3,7512), and at the end of the 3d c. under Diocletian the great Roman road that passed through Arrubium was rebuilt (*CIL* 3,7610). Another piece of information (*Not. Dig.* 39, ed. Seeck) mentions the presence of a cuneus equitum catafractariorum, and thus in the 4th c. the settlement at Arrubium still existed. The last to mention this center is the Geographer of Ravenna.

BIBLIOGRAPHY. R. Vulpe, *Histoire Ancienne de la Dobroudja* (1938) passim; id. & I. Barnea, *Din istoria Dobrogei* (1968) passim. D. ADAMESTEANU

ARSA, *see* ARSADA

ARSADA (Arsa) Lycia, Turkey. Map 7. A village high up on the E side of the Xanthos valley. It is not mentioned by any ancient author, nor are any coins known. It is identified by an inscription found on the spot (*TAM* II.2.539) and by the evident survival of the name. One or two rock-cut Lycian tombs of house type confirm the city's antiquity though the Lycian inscriptions on them, reported by Spratt, have not been seen again. It is not known whether Arsada was a member of the Lycian League, and the inscriptions give no information about the city apart from the mention of a temple and priest of Apollo.

The acropolis hill, which is quite low, was defended by a wall of rather rough polygonal masonry, of which a stretch over 270 m long survives on the E slope; the wall seems to be lacking on the W side, which is precipitous. At the summit on the N is a tower, some 9 m square, of a more regular style of polygonal. The interior contains only a mass of uncut building stones, with the occasional outline of a house.

In and around the village are a number of "Gothic" sarcophagi, the lids decorated with lions' heads, round shields, phallic emblems, and in one case human heads. None of these is inscribed. Just above the village, on an outcrop of rock, is a relief showing horse and rider, apparently a dedication to one of the Anatolian equestrian deities.

BIBLIOGRAPHY. T.A.B. Spratt & E. Forbes, *Travels in Lycia* (1847) I 292-93; *TAM* II.2 (1930) 201; G. E. Bean in *JHS* 69 (1949) 40-45. G. E. BEAN

ARSAMEIA (Eski Kâhta) Turkey. Map 5. About 59 km SE of Malatya in ancient Commagene (the area between the Taurus range and the Euphrates) on the river Nymphaios (the Kâhta Çay). Founded by a certain Arsames, an ancestor of a Seleucid king, Arsameia was by the 1st c. B.C. a fortified city containing a royal palace. It was here that Antiochos I of Commagene built a tomb and a cult center (hierotheseion) for his father, king Mithridates Kallinikos, about the middle of the 1st c. B.C.; this is attested by a remarkable rock-cut inscription. Above the inscription is a large and well-preserved relief, recently re-erected, showing king Mithridates shaking hands with Herakles (the Persian Artagnes); the style is provincial Greek. About 2 km SW of the town is a Roman bridge erected in honor of the Septimian house by four Commagene cities (ca. A.D. 200). The bridge was marked by four columns, two at each end,

symbolizing the emperor, Julia Domna, Caracalla, and Geta; one is missing and may have been dismantled after Geta's murder. Farther on, beside the Nymphaios, is a tumulus that served as the burial place of Commagene queens and princesses. There three Ionic columns carry statues of animals (a lion, an eagle, and a bull), and these works may be contemporary with Antiochos' own hierotheseion, the celebrated remains of which are nearby upon Nemrud Dağ.

BIBLIOGRAPHY. F. K. Dörner, "Die Entdeckung von Arsameia am Nymphenflus . . . ," *Neue Deutsche Ausgrabungen im Mittelmeergebiet und im vorderen Orient* (1959) 71-88[MPI]; id. et al., *Arsameia am Nymphaios* (1963)[PI]; E. Akurgal, *Ancient Civilizations and Ruins of Turkey* (3d ed. 1973) 347f. W. L. MAC DONALD

ARSINOE Cyprus. Map 6. There were at least three towns so named, all three on the coast. A fourth one in the interior is rather doubtful. One was formerly Marion on the NW coast near Cape Arnauti, another at modern Famagusta on the E coast, and the third somewhere between Old and New Paphos on the SW coast. As to the fourth, it is said to be at Arsos in the Limassol district. Of the four, only the first has been explored.

The best known Arsinoe is the former Marion (q.v.). After Alexander the Great, Stasioikos II, the last king of Marion, sided with Antigonos against Ptolemy. In 312 B.C. the city was razed by Ptolemy and its inhabitants were transferred to Paphos. On the ruins a new city was founded about 270 B.C. by Ptolemy Philadelphus who renamed it after his wife and sister. We probably know more of this Arsinoe than of its predecessor Marion.

The ruins of this town are to be found to the N of the modern village of Polis. Part of the site is now a field of ruins under cultivation and part is inhabited, but the town may have extended S under the modern village. The necropolis, also the Classical necropolis of Marion, lies mainly to the S. This Arsinoe is well known to geographers and historians (Strab. 14.683; Ptol. 5.14.4; Plin. *HN* 5.130; Steph. Byz.). The *Stadiasmus* (309) and inscriptions record it. The town flourished during the Hellenistic and Graeco-Roman era, and in Early Christian times it became the seat of a bishop. The site has never been excavated. Some soundings made in 1929 were intended to locate the earlier city.

From an inscription of the 3d c. B.C. we know that there was a Hellenistic gymnasium but its position remains unknown. There was probably a theater but we have no evidence although its position can be conjectured. We learn from Strabo that there was a Sacred Grove to Zeus and from an inscription of the time of Tiberius we are told of the existence of a Temple of Zeus and Aphrodite. The site of a sanctuary is known at the far end of a small ridge at Maratheri, E of the ancient town. This sanctuary may well be that of Zeus and Aphrodite mentioned in the above inscription, which almost certainly came from this site. This cult may be earlier for on some coins of Stasioikos II is shown on the obverse the head of Zeus and on the reverse that of Aphrodite. In fact, casual finds also date this sanctuary from the archaic to the Graeco-Roman period. The site is the most important town in Cyprus of this name and as we know of many Arsinoeia in the island we may presume that there was one here too.

A number of tombs of the Hellenistic and Graeco-Roman era were excavated in the necropolis S of Polis. These tombs contain the familiar Hellenistic and Roman pottery and other furniture and very often are rich in jewelry. However, there is nothing to be seen at present above ground.

BIBLIOGRAPHY. D. G. Hogarth, *Devia Cypria* (1889); Einar Gjerstad et al., *Swedish Cyprus Expedition* II (1935) s.v. Marion; Sir George Hill, *A History of Cyprus* I (1949); *RE*, s.v. Arsinoe. K. NICOLAOU

ARSINOE (Cyprus), *see* MARION

ARSINOE (Libya), *see* TAUCHEIRA

ARTACOANA, *see* ALEXANDRIA (Herat) *under* ALEXANDRIAN FOUNDATIONS, 2

ARTASHAT, *see* ARTAXATA

ARTAXATA (Artashat) Armenia, U.S.S.R. Map 5. Armenian royal city founded by king Artaxias I (190-156 B.C.) on the advice of the exiled Hannibal of Carthage. "It is situated on a peninsula-like elbow of land and its walls have the river [Araxes] as protection all round them" (Strab. 11.14.6).

The bed of the Araxes has shifted southwards, leaving the ruins of Artaxata in a "low-lying and rather swampy site" which is ca. 30 km S of the present Armenian capital of Erevan. Chosen primarily for defensive reasons, the site may have become unhealthy quite early in its history since numerous alternative royal cities were established in the near vicinity, notably Garni, 35 km to the NE.

Artaxata was several times invaded by Roman forces. In 68 B.C., Lucullus fought inconclusively in the vicinity. Pompey subsequently defeated Tigranes, and set him up as a client king in Artaxata in 66 B.C. Corbulo captured the city in A.D. 58, and Trajan entered it once again in 114. An inscription of the Fourth Scythian Legion, dating from 116, has been found. Artaxata was still of importance in the 4th and 5th c. Systematic excavations are planned.

BIBLIOGRAPHY. C. F. Lehmann-Haupt, *Armenien einst und jetzt* (1910) 173-76[M]; D. M. Lang, *Armenia, Cradle of Civilization* (1970); C. Burney & D. M. Lang, *The Peoples of the Hills* (1971). T. S. MAC KAY

ARTEMISION Euboia, Greece. Map 11. A promontory on the NW coast, named for the Sanctuary of Artemis Proseoia. The first encounter between the Greek and Persian fleets took place offshore in July 480 B.C. Although Pliny lists it among the cities of Euboia, Herodotos and Plutarch mention only the temple; it seems probable that the region took on the name because of the importance of the sanctuary. The site was identified by Lolling at Haghios Georgios near Potaki on the Bay of Pevki. It lies to the W of Gouves on an isolated spur of the hills which limit the small coastal plain of Kurbatsi, and is now marked by the ruins of a 6th c. Byzantine complex. These were cleared by excavators, digging several trenches. They reported numerous ancient blocks, column drums, stele bases, and terracottas ranging from an early painted sima to a Roman acanthus leaf fragment, but failed to find the location of the temple itself. Lolling concluded that the Byzantine building, of which he excavated only one room, must have followed the foundations of the Classical period. Other building blocks indicated the site of a settlement on the higher slope to the S.

The well-known bronze statue of Poseidon, now in the National Museum at Athens, was found off Cape Artemision itself, an arm in 1926, the rest in 1928.

BIBLIOGRAPHY. Hdt. 7.175f; Plut. *Them.* 8; Plin. 4.12.64; H. G. Lolling, *AM* 8-9 (1883) 7f[M], 200f[P]. Sculpture: *AJA* 33 (1928) 141. M. H. MC ALLISTER

ARTEMISION, *see* Dianium Insula *and* Shipwrecks

ARTSISTA, *see* Limes, Greek Epeiros

ARTZA, *see* Limes, Greek Epeiros

ARUTELA or Alutela(?) (Călimănești) Romania. Map 12. An important military station on the limes Alutanus, in the S zone of the Carpathian gorge of the Olt, halfway between Castra Traiana and Praetorium (*Tab. Peut.*). The name is probably derived from the name of the Alutus-Aluta river (Tomaschek).

Excavations have explored all the remains of the camp not covered by the railroad. The only side of the camp that is preserved (toward the E), 60 m long, was penetrated by a gate guarded by two square towers. The gates opening on the N and S sides of the camp had no towers. The W side was entirely destroyed by the waters of the Olt. Inside, the wall was supported by buttresses, which also served as supports for the wooden floor of the patrol path, under which were the stables. Within the camp were a praetorium, a basilica (?), dwellings, the via praetoria, the via principalis, and the via sagularis. Baths excavated near the camp are now covered by the railroad. The Roman road of Olt, paved with stone, passed 10 m from the porta praetoria to the E. Two inscriptions with identical texts inform us that the camp was constructed in 137-38 by the Suri sagittari on the order of T. Fl. Constans, proc. Aug. of Dacia inferior. The soldiers of the Coh. I Hisp. veterana were also stationed in this camp. Coins of Heliogabalus have been found, and among the most recent discoveries are a fragment of an inscription by Trajan and a glass vase with the name of a certain Menophantos. The finds have been deposited in the Central Military Museum of Bucarest.

BIBLIOGRAPHY. *CIL* III, 12601, a-b = 13793-94; 12602-3.
D. Tudor, "Castra Daciae inferioris: Bivolari," *BCMI* 35 (1942) 143-49; id., *Oltenia romană* (3d ed., 1968) 266-70, 324-26; id., *Orașe* (1968) 371; id., "Le camp romain d'Arutela," *Hommages à M. Renard* (1969) 579-85; id. et al., "Rezultatul primelor două companii de săpături arheologice (1967-1968) de la Bivolari-Arutela," *SMIM* 2-3 (1969-70) 8-45. D. TUDOR

ARYKANDA Turkey. Map 7. Ruins of an ancient city near the village of Arif, midway on the Elmalı-Finike road. Its name seems to indicate Anatolian origin of the second millennium, and documents from nearby Karataş-Semahüyük support this conjecture. The name appears in the inscriptions of the monument erected in Rhodiapolis to Opramoas, a wealthy man from Lycia who provided many cities with financial help.

The city was built on terraces which still survive on sloping land at the S foot of Akdağ. The walls that surround the city to the E and W are well preserved and characteristic of Hellenistic masonry. On the W side of the torrent bed that divides the city N-S are the private and public buildings. The stadium, probably Hellenistic with Roman additions, is on the highest level of the terraces. The theater, which is well preserved, has a horseshoe-shaped orchestra, and the cavea is built against the slope of the hill. The scaena, built separately, is trapezoidal; it opens through three doors into the lowest part of the proscaena, now completely ruined. The remains of a triglyph-metope decoration confirm its origin in the 2d c. B.C. The necropolis is on the E side of the torrent bed.

In the necropolis there are more than a dozen tomb buildings, one completely excavated. Usually each tomb rests on a podium, and the grave chamber is generally vaulted. One tomb is in the shape of a temple in antis.

The sarcophagi appear to date to the end of the 2d c. A.D. or the beginning of the 3d to judge from their inscriptions and architectural elements. The many rock-cut tombs, probably built in the 4th c. B.C. and still in use in the Christian era, have nearly all been robbed. To the S of the necropolis a great building stands intact to the level of the second floor. It consists of three large rooms, and the water pipes indicate a bath or gymnasium.

BIBLIOGRAPHY. *RE* II, 2 (1896) 1497.
C. BAYBURTLUOĞLU

"ASAI," *see* Assos

ASA PAULINI (Anse, La Grange-du-Bief) Rhône, France. May 23. A station mentioned in the *Antonine Itinerary*, in Gallia Lugdunensis near the confluence of the Saône and the Azergues. Traces of a pre-Roman settlement have been excavated on this site, a focus of roads and waterways.

Some mosaics were first discovered, then a large Gallo-Roman villa (owned by Paulinus?) which has been under excavation since 1964. The villa is of a type frequently found in Gaul, with a galleried facade (175 m long at least) to the E. The colonnades are of brick faced with stucco and covered with tiles. Eleven of its rooms have been excavated, several of them with frescos and mosaics. In the middle of the facade is room IX, the oecus of the villa, where the main mosaic was found in 1843 (now in the Hôtel de Ville at Anse). There are several apsed rooms that probably served to receive guests. Each end of the gallery is extended by a perpendicular wing containing rooms with mosaics and painted walls. Room VII of the S wing, which contained an Early Christian tomb, is decorated with stuccos painted in different colors, with flower and bird motifs. The finds, the construction of the buildings, and the style of decoration indicate two periods: a 1st c. rustic villa was replaced by a villa urbana in the early 2d c.; the latter was torn down at the end of the 2d c., then partly rebuilt and lived in until the 4th c.

An oval-shaped castellum was built to the E in the Late Empire.

BIBLIOGRAPHY. L. B. Morel, *La station romaine d'Ansa Paulini* (1925); Grenier, *Manuel* I (1931) 445-46; J. Guey & P. M. Duval, "Les mosaïques de la Grange-du-Bief," *Gallia* 18 (1960) 83-102; R. Perraud, "La villa gallo-romaine de la Grange-du-Bief," *Activités beaujolaises* 22 (Dec. 1965); M. Leglay, "Informations," *Gallia* 24 (1966) 498; 26 (1968) 576-78. M. LEGLAY

ASAR, *see* Takina

ASARDIBI, *see* Kasara

ASAR KÖYÜ, *see* Sillyon

ASARLIK, *see* Termera

ASAR TEPE, *see* Kasai

ASCALON Israel. Map 6. An ancient city on the coast of Palestine about midway between Azotus and Gaza. Its territory once extended over a large area. Early in the Hellenistic period the city freed itself from Phoenician rule and enjoyed autonomy again. Under the Ptolemies Ascalon began minting coins. At first minting was restricted to copper and bronze coins, but from 111 B.C. it also minted in silver. In 104 B.C. the city became independent, and its new dating era began. The city withstood the assaults of the Hasmonaean kings and, except for Ptolemais, remained the only independent city on the Palestinian coast. Strabo (16.2.29) refers to it as

a small town, and Pliny (*HN* 5.14) calls it an oppidum libera. Although surrounded by Jewish territories, the city retained its independence even under Herod the Great. As a city greatly influenced by Hellenistic culture, Ascalon enjoyed the king's generosity. Herod built a royal palace, a stoa, and baths (Joseph. *BJ* 1.422). After Herod's death Augustus gave Salome, Herod's daughter, the royal palace as a present (Joseph. *AJ* 17.321). At the beginning of the revolt against the Romans the insurgents massacred part of the inhabitants of Ascalon (Joseph. *BJ* 2.460), but these retaliated by killing 2500 of the local Jews (Joseph. *BJ* 2.477).

According to the ancient sources there were temples dedicated to Apollo, Atargatis, and Isis and from the coins we learn that Derketo and Herakles were also worshiped there. A prominent city also in the Late Roman and Byzantine periods, it is referred to by Eusebius (*Onom.* 22.15) as to the most famous city of Palestine. It was a seat of a bishop early in the Byzantine period. Eusebius (*Onom.* 168.3) and other Early Christian writers mention a "Well of Peace" there. A Jewish community and remains of a synagogue were found there. Two miles to the S was its port, named Maiumas Ascalon.

No archaeological investigations have been undertaken save for a limited trial dig on the ancient mound in 1920-1921. The 64 ha of the Roman city remains unexplored although statues and other stray finds have come to light from time to time.

BIBLIOGRAPHY. F. M. Abel, *Géographie de la Palestine* II (1938) 252-53; M. Avi-Yonah, *The Holy Land from the Persian to the Arab Conquests (536 B.C. to A.D. 640). A Historical Geography* (1966). A. NEGEV

ASCIBURGIUM (Krefeld-Asberg and Rheinhausen) Germany. Map 20. An auxiliary castellum of the limes Germaniae Inferioris. The existence of a pre-Roman settlement has been deduced from place names and Tacitus (*Germ.* 3). A camp with wooden buildings was constructed perhaps in the reign of Drusus but certainly in the first decade A.D., as the first of a succession of camps. Until ca. A.D. 70 it was the garrison for the ala (I Tungrorum) Frontoniana, afterwards for the ala Moesica. To the W was a vicus and a necropolis. The camp was destroyed during the uprising of the Batavi (A.D. 70; Tac. *Hist.* 4.33). Most finds are in the Niederrheinisches Museum in Duisburg.

BIBLIOGRAPHY. H. v. Petrikovits, "Asciburgium," *Reallexikon der Germanischen Altertumskunde* (2d ed. 1971); T. Bechert, *Rheinische Ausgrabungen* 12 (1972) 147ff; id., *Archäologisches Korrespondenzblatt* 3 (1973) 39ff; G. Krause, *Quellenschriften zur Westdeutschen Vor-u. Fruhgeschichte* 9 (1974) 115ff. H. VON PETRIKOVITS

ASCOLI PICENO, *see* ASCULUM PICENUM

ASCOLI SATRIANO, *see* ASCULUM

ASCULUM (Ascoli Satriano) Apulia, Italy. Map 14. An ancient indigenous center ca. 28 km S of Foggia near the spot where the Romans suffered defeat at the hands of Pyrrhos in 279 B.C. (Flor. 1.18.9; Plut., *Vit. Pyrrh.* 21; Zonar. 8.5; Dionys. 20.1). The city seems to have enjoyed a certain amount of autonomy and prosperity, to judge from its coinage, which was minted between the 4th and the 3d c. B.C. From the coins it may be deduced that the city's true name was Ausculum or Ausclum (in Oscan, Auhusclum). Its territories, sacked during the social war (App. *BCiv.* 1.52), were distributed first by C. Gracchus and again later by Julius Caesar (*Lib. Colon.*, pp. 210, 260). It is doubtful that Asculum

obtained the rights of a colony or attained the status of a municipium during the Empire. In the scarce inscriptions (*CIL* IX, 665, 666, 669) it is called civitas Ausculanorum or res publica with aediles iure dicundo as magistrates, and was ascribed to the tribus Papiria. Some would like to see in Asculum the oppidulum at which Horace stopped on his way to Brindisi (*Sat.* 1.5.87).

The modern city occupies approximately the same position as the ancient one. This is attested by the frequent discoveries of remains of ancient buildings (often with mosaics, as in the building found in Piazza Plebiscito in 1936), epigraphical fragments, statues, columns, and other material. Two milestones of the Via Traiana, LXII and LXVI, were found in Largo Aulisio. A brick arch is preserved in the locality called Valle dell'Arco and ruins of an aqueduct in the section called Tesoro. Numerous finds from the surrounding necropoleis are in the local Museo Civico and in the museums at Foggia and Taranto.

BIBLIOGRAPHY. W. Smith, *Dictionary of Greek and Roman Geography*, I (1856) 231 (E. H. Bunbury); *RE* II.2 (1896) 1527-28 (Hülsen); E. De Ruggiero, *Dizionario epigrafico di antichità romane*, I (1895) 950; B. V. Head, *Historia Numorum* (1911) 45; K. Miller, *Itineraria Romana* (1916) 374. F. G. LO PORTO

ASCULUM PICENUM (Ascoli Piceno) Marche, Italy. Map 16. The principal city of the Piceni (Flor. 1.14), it was founded by the Sabines (Festus *Gloss. Lat.* 320) in the center of the valley of the Tronto river at its confluence with the Castellano. An ally of the Romans in 299 B.C., it was subjugated by them in 268 (Fast. Triumph. 486 a.u.c.; Flor. cit. Eutr. 2.16). In 91 B.C., the social war began at Ascoli (Livy *Per.* 72; Vell. Pat. 2.15.1; App. *BCiv.* 1.38; Flor. 2.6.9; Oros. 5.18.8) and was concluded in 89 with the capture of the city under the command of Pompeius Strabo (Fast. Triumph. 665 a.u.c.; Livy *Per.* 74, 76; Vell. Pat. 2.21.1; App. *BCiv.* 1.47-48; Plin. *HN* 7.135; Frontin. *Str.* 3.17.8; Gell. *NA* 15.4). Specific documentation of the long siege is found in the thousands of missiles discovered around Ascoli (*CIL* IX, pp. 631-47; *Eph. Epigr.* 6 [1885] 5-47; A. DeGrassi, *Inscript. Lat. lib. reipubl.*, II, 298ff). The city subsequently became a municipium (Cic. *Sull.* 25) and was enrolled in the tribus Fabia. It sided with Caesar in 49 (Caes. *BCiv.* 1.15; Luc. 2.468) and became a triumviral or Augustan colony (Plin. *HN* 3.111), gaining a territorial increase in the S sector (Grom. Vet. pp. 18-19, Lachmann). It was an Early Christian diocesan seat.

The Via Salaria (*It. Ant.* 307-8; *Tab. Peut.*; *CIL* IX, p. 582) passed through the settlement, entering (W) from the Porta Gemina and leaving (SE) by the Ponte di Cecco. A diverticulum (*It. Ant.* 316-17; *CIL* IX, p. 479), passing over the Ponte Solestà (or dei Cappuccini), was a direct route to Firmum and to N Piceno.

Even the ancients (Strab. 5.241) emphasized the characteristics of security and defensibility of the site. There is, in fact, a rocky terrace isolated on three sides by streams and closed off (SW) by the Colle dell'Annunziata. This eminence, where the Capitolium probably rose, represented the arx, whose fortifications seem to be linked to the lower defensive system of Porta Gemina. From that point, the circuit wall must have followed (as in the Middle Ages) the irregular course dictated by the eroded banks of the Tronto and Castellano. The reticulate Roman road is substantially maintained in the modern roadway: Corso Mazzini corresponds to the decumanus maximus and Via Pretoriana and Via Malta correspond to the cardo maximus. The forum was at the intersection of these two axis streets, between Piazza del

Popolo and Via del Foro (rather than at Piazza Arringo where the center of the city moved in the Middle Ages). The urban plan, perhaps prior to the social war, was refurbished in the Augustan Age. To that period date the major remaining architectural works: the so-called Temple of Vesta (21 x 11 m, prostyle, tetrastyle, with Corinthian columns) now transformed into the Chiesa di San Gregorio Magno; the Porta Gemina; the Ponte di Cecco (with two vaults, 14.5 m and 7.15 m); and the Ponte Solestà (with a single vault 22.2 m). The theater (at the foot of Colle dell'Annunziata) and the amphitheater (in the NW sector of the city) have not yet been sufficiently explored.

Pre-Roman and Roman artifacts from Ascoli and its vicinity are preserved in the Civic Museum.

BIBLIOGRAPHY. C. L. Agostini, *Asculum* (1947); M. E. Blake, *Ancient Roman Construction in Italy* (1947) 76, 201, 212, 216, 233; F. Castagnoli, *Ippodamo di Mileto* (1956) 93; G. Lugli, *La tecnica edilizia romana* (1957) 350, 357, 634; *EAA* I (1958) 705-6 (N. Alfieri); L. Crema, *L'architettura romana* (1959) 220; P. Gazzola, *I ponti romani* (1963) 65-66; G. Annibaldi, "L'architettura dell'antichità nelle Marche," *Atti XI Congresso di Storia dell'Architettura* (1965) 3-44. N. ALFIERI

ASEA Arkadia, Greece. Map 9. The site is on a steep hill overlooking a valley between Tripolis and Megalopolis. Remains of a circuit wall around the top of the hill and of two spur walls which surround a lower town at E are dated to mid 3d c. B.C. Some houses belong to the Hellenistic period. One of them is of the Priene type, previously known only outside of Greece. The Hellenistic site seems to have existed into the 1st c. B.C. Ancient sources mention an Asea also during the Classical period, but this town must have lain somewhere else in the valley. Immediately below the Hellenistic stratum on the hill are the remains of a Middle Helladic settlement, which ceased at a time corresponding to the transition between MH II and MH III.

BIBLIOGRAPHY. Xen., *Hell.* 6.5, 11, 15; 7.5.5; Paus. 8.27.3; E. J. Holmberg, *The Swedish Excavations at Asea in Arcadia* (1944). E. J. HOLMBERG

ASHDOD, see AZOTUS

ASHMŪNEIN, see HERMOPOLIS MAGNA

ASIDO (Medina Sidonia) Cádiz, Spain. Map 19. A Roman colony near the S coast of Baetica and belonging to the juridical area of Hispalis (Seville) (Plin. 3.11). It is SE of Cádiz. The name appears to be of Punic origin, as shown by its bilingual coins. The mint employed the Libyo-Phoenician alphabet, and the leading motifs were the bull, the dolphin, and the full-front head of Hercules. Later it coined asses and semisses bearing ears of grain and fish. Variants of the name appear in Ptolemy (2.4.10) and in the Ravenna Cosmographer (317.9).

Remains include portraits, busts, togate figures, statues of divinities, sarcophagi, inscriptions, columns, cameos, rings, and coins. Among these finds are the epigram, now in the archaeological museum of Seville, dedicated to the quattuorvir Quintus Fabius Senica by the Municipes Caesarini (perhaps a relative of the Fabia Prisca of Asido, who occurs in a Cordova inscription), and the portraits of Livia and Tiberius now in the archaeological museum of Cádiz. The Roman town must lie under the modern one, as remains of buildings have been recorded in the area of the present convents of S. Francisco and S. Cristobal, and the Calle Althaona Vieja. No Phoenician or Punic remains have been found, but there has been no deep excavation.

BIBLIOGRAPHY. E. Romero de Torres, *Catálogo Monumental de España: Provincia de Cádiz* (1934) 174, 210; A. García y Bellido, "Las colonias romanas de Hispania," *Anuario de Historia del Derecho español* 29 (1959) 476ff; *Mélanges André Piganiol* (1966) III, 481ff.

C. FERNANDEZ-CHICARRO

ASINE Argolid, Greece. Map 11. On the coast ca. 8 km SE of Nauplia and a little over one km NE of Tolon. Prehistoric settlement with remains dating from the Early, Middle, Late Helladic, Protogeometric, and Geometric periods. Deserted about 700 B.C., it was again inhabited from shortly after 300 B.C. in Hellenistic and Roman times. The site is mentioned by Homer, Strabo, Ptolemy, and Pausanias.

Remains were uncovered on the acropolis, in the lower city, in a field NE of the acropolis, and on Mt. Barbouna. The acropolis and the lower town were surrounded by a Hellenistic fortification wall provided with towers. A city gate leads to the lower town remodeled in Roman and Venetian times. There is a Hellenistic oil or wine press on the top of the acropolis.

Architectural remains from Early and Middle Helladic, Late Helladic III, Geometric, Hellenistic, and Roman times were found. Notable are two Early Helladic houses with absidal ends, a Roman bath, a great reservoir belonging to the Hellenistic or Roman period, and burials from various periods consisting of cists, pithoi, shafts or earth-cut graves. House G is an important Late Mycenaean building consisting of at least nine rooms, one of which had two column bases and a cult ledge in one corner.

There are Mycenaean tombs on the NE and N side of Mt. Barbouna. Seven Mycenaean chamber tombs, a Geometric pit tomb, and three Hellenistic shaft tombs were investigated, but many more tombs were traced. Geometric stone-settings were excavated on the S side of the hill and an archaic building, perhaps a Temple to Apollo Pythaios, mentioned by Pausanias, was found on the uppermost terrace of Mt. Barbouna.

Early and Late Mycenaean, Protogeometric, and Geometric habitation remains and tombs of Middle Helladic, Protogeometric and archaic date were found in recent excavations in a field NE of the acropolis. Early Mycenaean and Geometric house walls were also uncovered on the lowest slope of Mt. Barbouna, just opposite the acropolis. Traces of an extramural cemetery of the Middle Helladic period were found on the same slope.

The principal finds are in the Nauplia Museum, in Uppsala, and in the Museum of Mediterranean Antiquities in Stockholm.

BIBLIOGRAPHY. E. Curtius, *Peloponnesos* (1852) II 167ff; H. Schliemann, *Tiryns* (1886) 48ff; J. G. Frazer, *Paus. Des. Gr.* (1898) V 601ff; L. Renaudin, "Note sur le site d'Asiné en Argolide," *BCH* 45 (1921) 295ff; A. W. Persson, "Recherches préliminaires en vue de fouilles suédoises," *BLund* (1920-21) 17ff; id., "Aperçu provisoire des résultats obtenus au cours des fouilles d'Asiné faites en 1922," *BLund* (1922-23) 25ff; O. Frödin & Persson, "Rapport préliminaire sur les fouilles d'Asiné 1922-1924," *BLund* (1924-1925) 23ff; Persson, *Asine* (1931); Frödin & Persson, *Asine: Results of the Swedish Excavations 1922-1930* (1938)MPI; R. L. Scranton, *Greek Walls* (1941); N. Valmin, *Vid vinrött hav*, 2d rev. ed. (1953) 11-25; R. Hägg, "Geometrische Gräber von Asine," *Opus. Athen.* 6 (1965) 116ff; C. G. Styrenius & A. Vidén, "New Excavations at Asine," *AAA* 4 (1971) 147-148; S. Dietz, "Kistegrave fra en første græsk storhedstid —en foreløbig meddelelse fra udgravningerne i Asine," *Fra Nationalmuseets arbejdsmark* (1971) 57-70; I. & R. Hägg, "Excavations in the Barbouna Area at Asine, 1,"

Boreas 4.1 (1973) with bibliography on pp. 14-15; R. Hägg, "Die Gräber der Argolis, 1. Lage und Form der Gräber," *Boreas* 7.1 (1974) 47-56.

Hom. *Il.* 2.560; Strab. 8.4.4, 8.6.3, 8.6.11, 8.6.13, 8.16.17; Ptol. 3.16.20; Paus. 2.28.2, 2.36.4-5, 3.7.4, 4.8.3, 4.24.4, 4.27.8, 4.34.9-12; Diod. Sic. 4.37.2; Herodian 1. 333L; Nic. Dam. 38 (FHG 3.376).　　　P. ÅSTRÖM

ASISIUM (Assisi) Umbria, Italy. Map 16. On a W foothill of the Appenines, it is best known for its mediaeval son St. Francis but was probably also the birthplace of the Roman poet Propertius. It belonged in Roman times to the Tribus Sergia and was a municipium. From epigraphic evidence it is known that its chief magistrates retained the old Umbrian title of Marones. The town enjoyed modest prosperity under the Empire, when its public buildings multiplied. Totila destroyed most of it in A.D. 545.

The Roman town, built over a previous Umbrian settlement, was surrounded by a substantial wall of rectangular blocks of local limestone. Ruins of one of the gates survive. Houses and civic buildings on the acropolis hill were supported by a series of terraces with strong substructures of travertine.

The forum had porticos except to the N where a temple faced it from a somewhat higher level. Remnants of the forum's limestone-block pavement have been found, and the foundations of its tribunal and of a small temple-like shrine to the Dioscuri.

The temple, traditionally ascribed to Minerva, had six Corinthian monolithic columns across the front, with its approach stairs built between their bases, and a molding around the pediment above. These extant elements of the facade, and some of the interior, are now incorporated into the Church of Santa Maria, which stands on the site of the temple. Greek influence on the style is manifest. The temple probably dates to the late 1st c. A.D.

Considerably to the E are the remains of a theater, its cavea facing E. Nearby is a large Roman cistern, under the campanile of the present Church of San Rufino, built of large travertine blocks and with a barrel vault. An inscription in place ascribes its construction and that of some other buildings to the Marones, seemingly in the 2d c. A.D.

To the NE, outside the city wall, was the small amphitheater, built of brick with a veneer of local stone. Not much of it survives.

Some houses have been traced within the limits of the modern town, especially near the Bishop's palace. One of these has yielded some good frescos, including a charming scene of birds among leafy branches. Some of the paintings carry epigrams in Greek.

Excavations since 1956 promise further data on this rather neglected site.

BIBLIOGRAPHY. Strab. 5.2.10 (calling the town "Aision"); Plin. *NH* 3.113; Ptol. *Geogr.* 3.1.53.

E. Zocca, *Assisi and its Environs* (1950); G. Antolini, *Il Tempio di Minerva in Assisi* (1828); guidebook: *Assisi e Dintorni* (1954); *EAA* 1 (1958) 741 (C. Pietrangeli).P.
　　　　　　　　　　　　　　　　R. V. SCHODER

ASKRA Boiotia, Greece. Map 11. N of Mt. Helikon and 7 km NW of Thespiai, the site is on the N bank of the Permessos, the stream that runs through the Valley of the Muses. Legend has it that Askra was founded by Oikles and the sons of Poseidon, Otos and Ephialtes; it is the birthplace of the poet Hesiod. At some unknown date the Thespians were said to have destroyed the city, which thereafter became merely a kome of Thespiai, uninhabited in Plutarch's time. Pausanias saw there nothing but the tower that still stands on top of the rocky peak called Pyrgaki (cf. Keressos).

Some travelers have placed Askra near the village of Neochori, 4 km W of Thespiai, on the slopes of Mt. Marandali (Pouqueville, Dodwell), others at Xironomi, a village 10 km SW of Thespiai (Kirsten). The limestone peak of Pyrgaki (633 m) dominates the Sanctuary of the Muses to the S from a height of 250 m; to the E the Haghios Christos valley separates it from the chain of hills running to Thespiai and Thebes; to the N it descends abruptly to the Kopaic basin, and to the W a narrow pass links it to Mt. Koursara (900 m). Exposed to the N wind and barred from the sea breezes by Mt. Helikon, Askra was, in Hesiod's words, "a wretched village, bad in winter, disagreeable in summer, good at no time" (*Works and Days*, 639-40). Where was the village? The slopes of this mountain are steep on all sides, its summit narrow and windswept and completely taken up by a small fort. Perhaps we should look for it toward the base of the slope, near cultivable land, on the S or SE flank. At the spot known as Episkopi, near the confluence of the Permessos and the Haghios Christos stream, are some ruins of mediaeval houses containing many ancient stones; nearby are a great quantity of archaic, Classical, and Hellenistic potsherds. However, up to now this area has never been dug.

The little fort on the mountain top consists of an elliptical surrounding wall (approximately 150 x 30 m) that links the "Tower of Askra," mentioned by Pausanias. To the E a postern gate 1.45 m wide opened onto the old pathway. The wall is of rough polygonal rubblework; 4.5 m thick, it very probably was topped with a palisade of stakes. At the highest point is a 7.7 m square tower, still with its 13 courses, very carefully built in isodomic masonry. The blocks, which were quarried on the spot, have a convex surface. The four corners of the tower are carefully grooved. To the E is a gate, 2 x 0.88 m, that leads to a narrow guard house (2 x 6 m), from which a stairway runs to the upper floor. The rest of the surface is filled with large blocks of stone divided into two lots by a cross-wall. A floor covered the whole surface (6 sq. m). In spite of the differences in masonry, the surrounding wall and tower may have been built together in the 4th c. B.C., either shortly before the battle of Leuktra (371) with the aid of the Spartans, or in the second half of the century.

BIBLIOGRAPHY. E. Dodwell, *A Classical and Topographical Tour through Greece* I (1819) 255-56; Pouqueville, *Voyage de la Grèce* IV (1826) 198; W. M. Leake, *Nor. Gr.* (1835) II 491; A. Conze, *Philol.*, 19 (1863) 181-82; J. G. Frazer, *Paus. Des. Gr.* V (1898) 149-50; A. Philippson-Kirsten, *GL* I (1951) 452; 672; 718, n. 82; G. Roux, "La tour d'Ascra," *BCH* 78 (1954) 45-48PI; N. Papahadjis, *Pausaniou Hellados Periegesis* V (1969) 95, 172-77MI.
　　　　　　　　　　　　　　　　P. ROESCH

ASOLO, *see* ACELUM

ASPENDOS (Belkis) Pamphylia, Turkey. Map 7. About 30 km E of Antalya, 13 km inland and on the Eurymedon river. Strabo (667) says it was founded by Argives; these may have been either an Argive contingent of the "mixed peoples" who settled Pamphylia under Mopsos, Calchas, and Amphilochos after the Trojan war, or later settlers in the 7th or 6th c. The connection with Mopsos is confirmed by the early name of the city, which appears on coins as Estwediiys; this derives almost certainly from Asitawandas, founder of the recently discovered city at Karatepe in E Cilicia, who describes himself in a bilingual inscription as a descendant of Mopsos (Muksos or MPS).

In 469 B.C. a Persian fleet and army collected at Aspendos was attacked and defeated on land and sea by the Athenian Kimon at the battle of the Eurymedon. This may have resulted in the enrollment of Aspendos in the Delian Confederacy; her name appears in the assessment of 425 B.C. though there is no evidence that she ever paid tribute, and in 411 the city was used by the Persians as a base. In 389 Aspendos was the scene of the murder of Thrasybulos by the local inhabitants (Xen. *Hell.* 4.8.30; Diod. 14.99).

On the arrival of Alexander in 333 the Aspendians at first offered to surrender their city, but later declined to accept his terms; upon being invested, however, they submitted meekly enough (Arr. 1.26-7). Under Alexander's successors, Pamphylia was claimed both by the Seleucids and by the Ptolemies; a 3d c. inscription of Aspendos confers citizenship on certain soldiers for their services to King Ptolemy (apparently Soter). On the other hand, about 220 B.C. the Aspendians contributed 4,000 men to Achaeus' lieutenant Garsyeris (Polyb. 5.73). After the battle of Magnesia in 190 B.C. Manlius Vulso, in the course of his march through Asia Minor, levied 50 talents from Aspendos (and a similar amount from the other Pamphylian cities), apparently as the price of Roman friendship (Polyb. 21.35; Livy 38.15). Described as populous by Strabo (667), Aspendos was unmercifully looted by Verres.

The coinage, which began in the early 5th c. B.C., continued abundant through the Imperial period. In the 5th c. A.D. Aspendos took for a time the name of Primupolis; the reason for this is not known, and in the *Notitiae* the old name is again in use.

The city occupies a flat-topped hill some 39 m high, divided into two unequal parts by a deep hollow. The sides are for the most part precipitous, but two gullies on the E side led to gates of which little now survives; a third gate near the N extremity is better preserved.

In the outer face of the E part of the hill is the theater, generally admitted to be the finest extant specimen of a Roman theater. Apart from the stage itself and the greater part of the decoration of the stage building, it is virtually complete. It faces a little S of E and is built of pudding-stone, with seats, floors, and facings of marble. It was constructed in the 2d c. A.D. by a local architect, Zeno, and was dedicated to the gods of the country and the Imperial House by two brothers, Curtius Crispinus and Curtius Auspicatus. Although the cavea rests on the hillside, the form of the building is essentially Roman; whether a theater stood on the spot in Hellenistic times is uncertain. The outer, E face of the stage building consists of a high wall pierced by a central door (later enlarged and now used for the admission of visitors) and two smaller doors on either side. Above these are four rows of windows varying in shape and size; above and below the top row are stone blocks pierced with holes for holding the masts which supported the awning (velum) over the cavea. At either end is an entrance for spectators; there are two other smaller entrances from the hillside at the back of the cavea, but the vaulted vomitoria familiar in Graeco-Roman theaters are lacking. The inner face of the stage building has the usual five doors opening onto the stage, and a row of smaller doors below to the space under the stage. The facade had originally two rows of columns in two stories, with niches holding statues; over each niche was a pediment supported by small columns. Of all this only those parts survive which were actually let into the wall. At the top is a large pediment containing a relief of Bacchus surrounded by flowers. Sloping grooves high up in the side walls indicate a wooden roof to the stage, possibly intended as a sounding board. The stage itself was some

6 m in depth from front to back and a little over 1.5 m in height. At either end an enclosed staircase led to the separate floors of the stage building. The cavea has 40 rows of seats, equally divided by a single diazoma; on some of them, names have been carved to reserve the places. At the top is an open passage backed by an arcade; this has been repaired more than once, most recently in the last few years. There are 10 stairways below the diazoma and 21 above it.

On the level ground to the N of the theater is the stadium, running roughly N and S. The N end is rounded, the S open, as at Perge. Under the seats was a vaulted gallery used apparently for the circulation of the spectators. On the outer E side, also as at Perge, is a row of chambers serving as shops; small windows in their back wall open to the vaulted gallery, which was thus not entirely dark. No starting-sill is preserved. A hippodrome is mentioned in an inscription (*CIG* 3.4342d), but has not been found; probably it was merely an open space without permanent seating.

The main part of the city stood on the hill to the W of the theater, separated from the theater hill by a deep depression. The ruins, all of Roman date, are impressive. The central feature is the agora, surrounded on three sides by public buildings. Of these the most conspicuous is a basilica on the E side; this is in two parts, a main hall of which only the foundations remain, and an annex at the N end still standing over 15 m high. The combined length is as much as 125 m. The annex has three doors communicating with the main hall, and another arched door on its N side; in its S wall are two windows, and four exterior buttresses support the W wall.

On the N side of the agora is an unusual building of uncertain use. It is nearly 15 m high and about 50 m long, but only 1.8 m thick. The back, facing N, is plain; on the front, towards the agora, are two horizontal rows of five niches; in the lower row the larger middle niche is pierced by a door, while the others have openings later blocked up. Embedded in the wall above these niches are the remains of an entablature which was carried on columns arranged in pairs; of these only the bases survive. The building has been supposed to be a nymphaeum, despite the total absence of the necessary pipes, basins, and other apparatus; the only tangible evidence for the identification is a dolphin's-head spout found on the spot, combined with a general resemblance to the facade of other nymphaea, and the fact that the aqueduct, so far as preserved, leads towards it. Others have thought it a purely ornamental facade, designed, in the absence of the usual stoa, to bound the agora on the N.

Facing the basilica across the agora is a long market hall, comparatively poorly preserved. It was in two stories, with a row of shops backed by a gallery. The stoa in front of it is now destroyed, but its position is marked by a line of steps.

Near the NW corner of the agora is another building of uncertain purpose. It is some 48 x 27 m and is rounded at the E end. A covered theater or odeum has been suggested, or perhaps a council house, but there is no provision for seating. The suggestion that it was a gymnasium is equally doubtful.

The fine aqueduct, certainly among the most interesting that survive from the Roman period, brought water to the city across the marshy land from the hills to the N. The water channel, formed of pierced cubical blocks, was carried on arches which served at the same time as a viaduct. By the foot of the hills on the N, and again close to the city, it was carried up to towers about 30 m in height, descending again on the other side. Both towers and most of the arcade, less than 0.8 km long, are well preserved. At the top of each tower the water ran

into an open basin, thus releasing the air from the pipe to afford a freer flow; the additional height prevented loss of pressure on the far side of the basin. After rising to the rim of the acropolis, the aqueduct ran across the flat summit towards the city center, but in this part it is now destroyed and the meager traces of its course do not allow a reconstruction of its form. The building of this aqueduct is alluded to in an inscription (*BCH* 10.160.8) recording a munificent gift by a certain Tiberius Claudius Italicus "for the introduction of water." It dates to the 1st or 2d c. A.D. and refers evidently to the original construction. What provision was previously made for a supply of water does not appear; perhaps the river sufficed.

In the lower part of the city, S of the theater, are two large buildings close together. Like the rest of the city they are unexcavated but are identified as baths, though here again there is no trace of water supply, or of any of the usual apparatus of baths.

The necropolis, or at least the main burial ground, lay beside a road that ran below the acropolis on the E. Here are several built tombs and one rock-cut, and in this region great numbers of funeral stelai have come to light. These have a characteristic form, with pediment and acroteria, and in most cases are inscribed merely with the name and patronymic of one or more persons; on some are carved a knotted ribbon. The names are written in the characteristic Aspendian script and dialect, and are largely Anatolian; they date in general to the Hellenistic period.

BIBLIOGRAPHY. K. Lanckoroński, *Städte Pamphyliens und Pisidiens* (1890) I 85-124, 179MI; J. B. Ward Perkins, "The Aqueduct at Aspendos," *BSR* 23 (1955) 115-23I; G. E. Bean, *Turkey's Southern Shore* (1968) ch. 5MI.

G. E. BEAN

ASPIS (Evraionisos) Corinthia, Greece. Map 11. An island in the Saronic Gulf. A well-preserved mediaeval castle crowns the sloping ridge that runs the length of the island, and remains are also known of the Mycenaean (Late Helladic III C) to late Roman times. The island is named by Pliny (*HN* 4.57) who locates it 7 (Roman) miles from Kenchreai. The Athenian fleet must have anchored there briefly after the battle of Solygia in 425 B.C. while heralds were sent back to recover the only two Athenian casualties of the engagement before sailing to Krommyon (Thuc. 4.44-45).

BIBLIOGRAPHY. J. R. Wiseman, *The Land of the Ancient Corinthians* (forthcoming). J. B. WISEMAN

ASPIS, *see* CLUPEA (Tunisia)

ASPROPYRGOS Attica, Greece. Map 11. West of the plain of Athens, and separated from it by the range of Aigaleos, is the Thriasian plain with its most important ancient centers at Eleusis at the W end of the Bay of Eleusis and at Thria. The position of the latter is not precisely located. What indications there are, however, point to the neighborhood of the modern town of Aspropyrgos, once the rural community of Chalyvia, set towards the E end of the plain about 3 km from the shore. Here, sculpture and inscriptions—one, *IG* II² 6266, a grave monument for a demesman of Thria—have been discovered in the walls of the houses and chapels in the vicinity. Moreover, in antiquity the road leading into the plain of Athens through the gap between Parnes and Aigaleos passed nearby. Today the only obvious ancient remain is a rectangular grave plot of Early Roman Imperial date. It is enclosed with large white marble blocks, one of which is decorated with a sculptured wreath and supports a marble table inscribed with the names of the deceased, Straton of the deme of Kyda-

thenaion, his wife, and son. The grave lies some distance S of Aspropyrgos, alongside the Athens-Eleusis highway, a few m W of the junction between it and the road to Aspropyrgos.

BIBLIOGRAPHY. W. Wrede, "Thria" & Θριάσιον πεδίον, *RE* (1936) VI 598, 599-601. C.W.J. ELIOT

ASSE Belgium. Map 21. Gallo-Roman vicus in the N part of the civitas Nerviorum, on the ancient road linking Bavai to Utrecht by Asse, Rumpst, Antwerp, and Rijsbergen. In the locality of Borgstad one can still see earthworks that may be the remains of the ramparts of an Iron Age oppidum in the plain. It is now being excavated. The Gallo-Roman vicus extended immediately to the N of this oppidum, in the locality of Kalkoven. The remains uncovered by old excavations, restudied systematically in 1942-43, have made possible a precise account of the history of the site. Coins and pottery indicate that the origins of the center go back to the beginning of the Roman period, perhaps to the end of the Republic, certainly to the time of Augustus. The remains of the Early Empire include the foundations of dwellings arranged on both sides of the ancient causeway, paved streets, wells (one of which was lined with wood) and numerous artifacts (coins, pottery, fibulas, two bronze statuettes of Mars and Mercury, terracotta statuettes, glassware, etc.). The series of coins is interrupted with Tetricus (268-73); traces of fire indicate that the vicus was devastated during one of the barbarian invasions of the period. However, coins of the time of Constantine seem to suggest that the vicus was reoccupied in the 4th c., but apart from the coins no archaeological remains of that period have been found. Nothing is known of economic activities at the vicus. Among the most interesting finds are some 50 statuettes of horses in white terracotta from the workshops of the Allier. They indicate the existence of a sanctuary dedicated to a horse deity (Epona ?) or to a deity having the protection of horses among its attributes. Asse was linked by less important roads to Tienen and Tongres to the E and to Hofstade and Ganda (Ghent) to the W.

BIBLIOGRAPHY. For the older bibliography, see M. Desittere, *Bibliografisch repertorium der oudheidkundige vondsten in Brabant* (1963) 5-8; S. J. De Laet, "Figurines en terre-cuite de l'époque romaine trouvées à Asse-Kalkoven," *AntCl* 11 (1942) 41-54; id., "De terra-sigillata van Asse-Kalkoven," *RBArch* 13 (1943) 97-115; id., *Asse-Kalkoven, een Gallo-Romeinse nederzetting in onze gewesten, Bijdragen tot de Geschiedenis en Oudheidkunde* (1943) 29-46; J. Mertens, "Archeologisch onderzoek van een Romeinse straat te Asse," *Eigen Schoon en de Branbander* 34 (1951) 129-40; G. Faider-Feytmans, "Ornement de char d'Asse," *Latomus* 14 (1955) 297-302.

S. J. DE LAET

ASSERIA Croatia, Yugoslavia. Map 12. On the Podgradje hill near Benkovac ca. 30 km E of Zadar. In pre-Roman times a center in S Liburnia for the Asseriates, it was later exempted by Rome from the payment of tribute (Plin. *HN* 3.143). In the 1st c. A.D. a Roman military post, it developed into a flourishing agricultural center; it was probably granted municipium status under Claudius and enrolled in the tribus Claudia. Its leading citizens were local Liburnian families and Italian immigrants, the latter probably from the nearby colony of Iader. Some of the inhabitants received Roman citizenship under Augustus or Tiberius.

The walled city is irregularly shaped; the walls are rusticated ashlar work, predating Roman occupation. Excavations have uncovered the Roman forum, built during the 1st c. A.D. and consisting of a rectangular open area

bordered by porticos. A long, narrow building without aisles (probably the city basilica) was built along one of the short sides of the forum. A monumental city gate, in form similar to that of a triumphal arch, was dedicated by one of the local citizens to the emperor Trajan in A.D. 113. The finds from the site are at the Archaeological Museum in Zadar.

BIBLIOGRAPHY. H. Liebl & W. Wilberg, "Ausgrabung in Asseria," *JOAI* 11 (1908) 18-87[PI]; J. J. Wilkes, *Dalmatia* (1969)[MP]; A. Boëthius & J. B. Ward-Perkins, *Etruscan and Roman Architecture* (1970)[I].

M. R. WERNER

ASSISI, *see* ASISIUM

ASSORO, *see* ASSOROS

ASSOROS (Assoro) Enna, Sicily. Map 17B. The site's ancient name is probably of Sikel origin. A prominent center in antiquity, it is mentioned by Diodoros (14.58.-78) and Cicero (*Verr.* 4.44); it reached its greatest splendor at the time of Dionysios, but by the 1st c. B.C. it had declined considerably. Cicero speaks of the Temple of Crysas at Assoros, on the road from Assoros to Henna. Considerable remains of the walls are still visible, and one of the fortification gates was extant as late as the 17th c., together with about eight rows of the walls of a temple (?) on the mountain, which had been incorporated into modern constructions. The city spread across the plateau between the rivers Salso and Dittaino in a remarkably strong position, naturally defended by the steepness of the hillsides which contain numerous chamber tombs, especially in the S area. Grave goods date from the 10th to the 5th c. B.C. Finds from cist graves come down to the 2d c. B.C. and include imported vases as well as many of Italic manufacture.

BIBLIOGRAPHY. G. C. Gentili, "Resti di tombe sicule del tipo di 'Licodia Eubea,'" *NSc* (1961) 217-21. Morel, "Recherches archéologiques et topographiques dans la région d'Assoro," *MélRome* (1963) 263-301.

A. CURCIO

ASSOS ("Asai") Corinthia, Greece. Map 11. Theopompos (apud Steph. Byz., s.v. ’Ασαί) recorded that Asai and Mausos were large and populous towns. The ancient name of the former may be reflected in the name of the modern town of Assos on the Corinthian Gulf not far W of Corinth. A large ancient site, occupied at least from the 6th c. B.C. to the 5th-6th c. A.D., which is located ca. one km S of Assos near a Church of Haghios Charalambos. A Roman bath was excavated there in the 1950s and extensive remains of walls of houses and larger buildings as well as poros sarcophagi can be seen in the vicinity.

BIBLIOGRAPHY. S. Charitonides & R. Ginouvès, "Bain romain de Zevgolatio près de Corinthe," *BCH* 79 (1955) 102-20; J. R. Wiseman, *The Land of the Ancient Corinthians* (forthcoming).

J. R. WISEMAN

ASSOS Asia Minor. Map 7. On the S shore of the Troad, Assos looks toward Lesbos, 11 km distant; its territorial limits are not known. The city proper occupied a steep hill, rising almost directly from the sea to an elevation of 234 m and consisting of volcanic rock (andesite) which provided the material for almost all the buildings and walls of the city. On the N side, away from the sea, the hill slopes down more gradually to the plain of the river Touzla (anc. Satnioeis), 0.8 km away; the river has its springs in the W foothills of Mt. Ida and its mouth on the W coast of the Troad, between Cape Lecton and Alexandria Troas.

The oldest architectural monument thus far exposed is a temple of the late 6th c. on the acropolis. It is reasonable to suppose, however, that this easily defensible site was occupied in the Bronze Age. Hellanikos of Lesbos records that the city of Assos was founded by Aiolians from Lesbos, presumably in the 7th c. Under Lydian and subsequently under Persian domination, the city acquired its freedom ca. 479 B.C. and was a tribute-paying member of the Delian League during the 5th c. In the second quarter of the 4th c. Eubulus and his successor Hermias ruled over Assos and Atarneus (some 70 km to the SW). Hermias had been a fellow student of Aristotle and Xenokrates at the Academy and he entertained them at Assos and Atarneus between 347 and 345 B.C. After the conquests and death of Alexander, Assos was at first subject to the Seleucid kings; later it formed a part of the independent Pergamene kingdom and, with that kingdom, passed to Rome in 133 B.C.

The fortification walls of Assos are well preserved: some towers still stand to a height of 18-20 m. Two major gateways flanked by towers, seven smaller gates, one round and numerous square towers testify to the sophistication of defense design in the Hellenistic age. The walls enclose a considerable area to the N of the acropolis (where the modern village of Behram Kale has developed) and on the S extend down to the sea to enclose the two ancient harbors. The space within the circuit amounts to a little more than 55 ha. The acropolis was fortified as a separate unit. Late Roman or mediaeval repairs to the fortifications appear on the acropolis, but the walls of the city proper were never repaired in late antiquity. The walls served their purpose well in 365 B.C. against the combined land and sea investment by Autophradates and Mausolos and against the ravages of the Gauls in the middle of the 3d c.; but the city fortifications were probably never used after 133 B.C. At a number of points in the circuit, just behind the face of the Hellenistic walls, are visible important sections of earlier fortifications in at least three different styles of masonry, some of which surely belong to the archaic period. Within the city area terrace walls of polygonal style must belong to domestic buildings of the 6th and 5th c.

The archaic temple on the acropolis is of the Doric order (mainland Greek, probably Attic, influence). The peristyle (6 x 13; the columns have 16 flutes) encloses a long, narrow cella with a pronaos, distyle in antis, but no opisthodomos. The rock of the hilltop at some points forms the euthynteria, upon which rested two steps only. The Doric entablature had sculptured metopes on the E facade and probably on the W, but not along the flanks; the subjects are varied and unrelated, some repeated: facing sphinxes, centaur, Europa on the Bull, etc. Eight metopes survive, whole or in part. In addition 15 sculptured architrave blocks survive; the subjects include: Herakles and Triton, Herakles and Centaurs, banquet (Herakles?), facing sphinxes, and facing bulls. The 15 preserved blocks must have filled all five intercolumnar spaces on each facade and at least some of the flank spaces. The presence of reliefs on the architrave (cf. the archaic Temple of Apollo at Didyma) reveals Ionic influence on Doric design. The date of the temple is ca. 540-530 B.C. The cult is presumed to be that of Athena Polias. Assos was a member of a synedrion of cities in the Troad which jointly celebrated a Panathenaia at Troy; the synedrion was in existence at least by the end of the 4th c. There is epigraphical evidence for the cult of Zeus Soter at Assos and also for the Roman worship of the Divi Augusti.

From the main W gate of the city a paved road led E toward the agora. Just inside the gate on the left is a gymnasium consisting of a large peristyle court on the N side of which are located the ephebeion and a circular bath. The W stoa of the Hellenistic building was

repaired or rebuilt in the 1st c. of our era by Q. Lollius Philetairos, hereditary king of Assos and priest of the cult of the Divus Augustus.

The agora measures ca. 150 x 60 m, its longitudinal axis approximately E-W; it lies below the acropolis, facing S toward the sea. The main structures are of the Pergamene period. A large stoa in two stories was built on the N flank, backed up against a steep scarp of the hill; this was divided internally, on each floor, by a longitudinal row of columns, but there were no separate shop rooms. On the opposite side another stoa rose to the height of a single story above the agora pavement; but beneath that main level the foundations extended down the steep hill slope in two additional stories for storage and shop space. The narrow E end of the agora was marked by the bouleuterion; the wider W extremity was graced by a small prostyle temple. Below the agora were the Greek theater and a large Roman bath. The principal cemeteries, with burials of late archaic to Roman times, lay along the two roads leading W from the main city gate; one of these roads extended to the Satnioeis, which it traversed on a stone bridge of Greek date. Remains of domestic structures are visible at many points throughout the city, but none of these has been excavated.

The site was excavated in 1881-83. There is no museum at the site. The temple sculptures are divided among the Louvre and the museums of Istanbul and Boston. The small finds of the excavations are in part in Istanbul, in part in Boston; the larger inscriptions remain at the site.

BIBLIOGRAPHY. J. T. Clarke, *Report on the Investigations at Assos, 1881* and *Report on the Investigations at Assos, 1882, 1883, Part I* (no more publ.)[PI] (=*Papers of the Archaeological Institute of America, Classical Series*, I, II (1882, 1898); Clarke et al., *Investigations at Assos, Drawings and Photographs of the Buildings and Objects Discovered during the Excavations of 1881-1883* (1902-21)[MPI]; Félix Sartiaux, *Les Sculptures et la Restauration du Temple d'Assos en Troade* (1915), repr. from *RA* 4e ser., 22 (1913) and 23 (1914)[I]. J.R.S. Sterrett, "Inscriptions of Assos" (*Papers of the American School of Classical Studies at Athens, I, 1882-1883* [1885] 1-90). H. S. ROBINSON

ASTA, *see* HASTA REGIA

ASTAPA or Ostippo (Estepa) Sevilla, Spain. Map 19. Situated between Osuna and Puente Genil and mentioned by Pliny (*NH* 3.12). The modern town surrounds the hill on which Astapa must have stood; but excavation has produced no traces. Livy (28.22; 28.23.5) and Appian (*Iber.* 33) recount the capture of Astapa by Marcius while Scipio retired to Carthago Nova after taking Castulo and Iliturgi in 206 B.C. Famous for its defense by its inhabitants who, after firing the town and consigning its valuables to the flames, slew their wives and children and one another. Rome gained nothing by its capture. Livy writes of it "ingenia incolarum latrocinio laeta." Its final fate reminds us of Numantia.

BIBLIOGRAPHY. *CIL* II, 1435-66; *Fontes Hispaniae Antiquae* III, 148ff. J. ARCE

"ASTERION," *see* PEIRASIA

ASTI, *see* HASTA

ASTORGA, *see* ASTURICA-AUGUSTA

ASTURA (Torre Astura) Italy. Map 16. A small inhabited center on the Tyrrhenian Sea between Anzio and Terracina. The river Astura is recorded by Livy (8.13.5; 12) for the battle fought near it in 338 B.C. by the Consul Menius against the Latini and the Volsci. The island of Astura is recorded particularly in the writings of the geographers (Strab. 5.3.232; Plin. *HN* 3.57.81).

The center itself, called an oppidum only by Servius (*Ad Aen.* 7.801), is indicated as a way station on the Via Severiana in the Itineraries. The major mention of Astura appears in the letters written by Cicero to Atticus (12.9; 19.1; 40.2-3; 45.2; 13.21.3; 26.2; 34; 38.2; 14.2.4 etc.) in 45 and 44 B.C. when he retired to his villa there after the death of his daughter Tullia, and from which he embarked in 43 B.C. on a dramatic attempt at flight (Cic., *Att.* 12.40.3). Astura is also mentioned in the lives of Augustus and of Tiberius, both of whom contracted grave illnesses there (Suet., *Aug.* 97; *Tib.* 72).

While there remains no trace of the center, there are remains of a villa. It must have been built on a tiny island, today joined to the coast, while in ancient times it was reached by a long bridge. Around the villa was constructed a large protected fishpond on the sea. Its articulated structure is well preserved. To it was annexed a portico, of which there remain notable parts of two wharves and the sea wall. The major part of these structures may be dated to the 1st and 2d c. A.D.

BIBLIOGRAPHY. A. Nibby, *Analisi . . . della carta de' dintorni di Roma* (2d ed., 1848) I, 266ff; L. Jacono, "Note di archeologia Marittima," *Neapolis* 1 (1913) 363ff; M. Hofmann, *RE* VIII (1956) 1228ff; F. Castagnoli, "Astura," *Studi Romani* 11 (1963) 637-44. F. CASTAGNOLI

ASTURICA-AUGUSTA (Astorga) León, Spain. Map 19. Roman city and mining and communications center 47 km SW of León (*Antonine Itinerary* 422-23, 425, 427, 429, 431, 439, 448, 453). It belonged to the tribe of the Astures and was capital of the *conventus*; it was also inhabited in pre-Roman times. Pliny (3.28) calls it a great city. It was a bishopric as early as the middle of the 3d c., and its bishops are quoted in the Spanish councils from the 4th c. on.

Its mediaeval walls are built over Roman ones of the Late Empire, with towers and gates. The city was rebuilt by Augustus, using the soldiers of the Legio X Gemina, stationed there in the 1st c. The ergastula and an extensive network of sewers are preserved. Several Roman sculptures of the 1st c. have been found, sarcophagi without reliefs, and one urban house of several rooms with Pompeian paintings and many inscriptions, some in Greek, besides those mentioning mine administration personnel. The inscriptions are dedicated to Roman deities such as Jupiter, Juno, Regina, Minerva, Fortuna, Salus, Ceteri dei inmortales y Ceteri dei deasque; oriental deities: Serapis, Isis, Tyche, Nemesis, and Kore; and occidental deities: Apollo, Grannus, and Mars Sagatus, dating from the Antonine and Severan periods. The inscriptions also refer to a grammarian (*CIL* II, 5079) and to flamines of the conventus in the temple of Augustus in Tarraco in the provincial concilium (*CIL* II, 2637, 4223, 5124).

BIBLIOGRAPHY. J. M. Luengo, "Astorga (Léon). Exploraciones de las cloacas romanas," *Noticiario Arqueológico Hispánico* 2 (1953) 143-52[I]; id., "Astorga romana," ibid. 5 (1962) 152-77[I]; A. García y Bellido, "Lápidas votivas a deidades exóticas halladas recientemente en Astorga y León," *Boletin de la Real Academia de la Historia* 163 (1968) 191-209[I]. J. M. BLÁZQUEZ

ASTYPALAIA (Chora) Dodecanese, Greece. Map 7. Island lying between Anaphe and Kos, which was named after the ancient town and capital. The modern capital now occupies the site of the ancient city, as is testified by many ruins, inscriptions, and coins found there. The

mole, which protects the port from the N, was built evidently during the Roman Imperial period.

The island was inhabited first by the Carians, later by Minoans (Ov. *Met.* 7.456-62), and then, during the historical period, by Megarians and Dorians from the Argolis. It became a member (454-424 B.C.) of the Delian-Athenian Confederacy. As has been attested, especially from Hellenistic inscriptions, the city must have played an important role in the Aegean, owing to the seafaring ability of its inhabitants and the fertility of the soil. The town was governed by the boule, the demos, and gerousia.

There were a prytaneion, an agora, a theater, and the Sanctuaries of Athena and Asklepios, Apollo, and Artemis. Small Hellenistic coins represent Perseus, Gorgo, and later Dionysos, Athena, and Asklepios.

During the Roman period, Astypalaia became civitas foederata, while in the Imperial period it was autonomous.

BIBLIOGRAPHY. E. Oberhummer, *RE* II 1873ff; *IG* XII.3, nos. 167-246, & p. 229-30; B. V. Head, *HN* (2d ed. 1911) 630ff; *IG* I (2d ed.) nos. 192ff; B. D. Meritt, *The Athenian Tribute Lists* (1939) I 240ff; (1950) III 21, 53, 210, 270; A. Philippson & E. Kirsten, *GL* (1959) IV 159ff; Kl. Pauly, I, 669; W. Peek, *Inschriften von den dorischen Inseln, AbhLeipzig* 62 Heft. 1 (1969) 34-51[I].

G. S. KORRÈS

ASTYPALAIA, see KOS

ASWAN, *see* SYÊNÊ

ATELLA Italy. Map 17A. A city of the Campanian plain, S of Clanis, in the vicinity of modern Sant'Arpino and Frattaminore. The city plan was trapezoidal with a grid that contained three major streets and some cross-streets. The settlement appears to date to the first half of the 4th c. B.C., but the area was already inhabited during the Iron Age.

During the war with Hannibal, Atella formed part of the state of the Campani although it was formally independent and struck its own coins. It made common cause with Capua in the defection from Rome and for that act was punished after the surrender of 211 by the confiscation of a large portion of its territory, put under the praefecti Capuam Cumas along with neighboring Campanian territory. In the Imperial period, Atella was a flourishing municipium with tributaries in Spain. In the Late Empire it was destroyed, and abandoned in the 11th c. The Oscan farce known as the fabulae Atellanae derives its name from Atella.

A few remains of the walls, protected by a wide trench and constructed of tufa blocks, are visible and in the urban area are remains of a large bath building dating to the first half of the 2d c. A.D. Recently, remains of private dwellings and a bath of the late Republican period have been discovered. All were restored in the Late Empire. The existence of an amphitheater in the reign of Tiberius is attested by Tacitus. Square tombs from the 4th c. have been excavated in the necropolis as well as partially chambered tombs of the Hellenistic and Roman periods, some of which had sumptuous furnishings. Numerous other tombs of the 4th and 3d c. B.C. have been discovered in the area, particularly near Afragola and at Caivano, which is also the place of origin of the paintings of a funerary hypogeum of the 2d c. A.D.

BIBLIOGRAPHY. Th. Mommsen in *CIL* X, 359; J. Beloch, *Campanien* (2d ed., 1890) 379f; Hülsen in *RE* II 2 (1896) 1913f; G. Castaldi in *Memorie Accademia Napoli*

(1908) 62f. For the necropoleis here and there in the area, see *NSc*, 1879, 1889, 1931, 1944-45, and in *MonAnt* 34 (1931).

W. JOHANNOWSKY

ATHENS Attica, Greece. Map 11. The city lies approximately in the middle of the largest plain of the region, at a distance of 6-7 km from the shore of the Saronic gulf. Except for the S edge, which is open to the sea, the plain is enclosed on all sides by a wall of mountains, Hymettos, Pentele, Parnes, and Aigaleos. At first the city was established on the rock of the Acropolis, but in time it spread out all around to a distance of not greater than 1 km, over terrain that was level except for the SW quarter, which was hilly and included the hills of the Muses, of the Pnyx, of the Nymphs, and of the Areopagus. The Eridanos River cut through the city at the N, the Ilissos at the E, and to the W at a distance of 3 km flowed the Kephisos.

The earliest inhabitants settled on the Acropolis and in the surrounding area in Neolithic times. From then on and up to the time of Theseus the most ancient city included, besides the Acropolis, a large area to the S of it. In that first period the city seems to have had no particular distinction, but to have developed equally with the other kingdoms of Attica. The great expansion of Athens is due to Theseus, who brought about the unification of all the small kingdoms and founded the city state of Athens. In memory of this unification, called the Synoecism, a special festival, the Synoikia, was inaugurated and at the same time, the Panathenaia, in honor of the patron of the city, the goddess Athena.

Tradition has it that during the Dorian invasion the city was saved by the self-sacrifice of King Kodros, who brought about his own death at the hands of the enemy so as to carry out an oracle according to which the city would be saved by the death of the king. The Athenians, in honor of his great sacrifice, ended the custom of kingship since they believed there could be no worthy successor to Kodros. During all the long Geometric period (1050-700 B.C.) the city of Athens continued to increase, new settlements were founded, and the city kept growing towards its peak and highest prosperity. In Athens as in other cities of Greece, aristocratic government succeeded to monarchy. At first the principal magistrate (archon) kept control for a period of ten years. Even after the archonship was made a yearly office, beginning in 683-682 B.C., the aristocracy continued to have great strength since it owned the greater part of the land and held all political power in its hands. The eupatrid, Kylon, exploiting the dissatisfaction of the farmers and other citizens, attempted a revolution in 636 or 632 with the aim of becoming tyrant, but the attempt failed.

The Athenians continued their struggles, demanding basically the franchise and the recording of the laws. In 624 B.C. Draco drew up a new system of law and codified the ancient, predominantly criminal, body of laws. But the citizens were still not content and unrest continued until the beginning of the 6th c. B.C. In 594 B.C. the warring parties agreed on the choice of Solon, a man trusted by all, to reform the state and the laws. The emergence of Solon ended a stage in the history of Athens. He was particularly honored by the Athenians for his advice concerning the acquisition of Salamis, and the consequent reduction of the power of Megara. Another success of his was the final union of Eleusis with Athens, and the astonishing increase in the might and authority and influence of Athens. After his election as archon in 594-593 B.C. Solon established a new body of law with radical changes. He brought about the abo-

lition of agrarian debts, the liberation of those enslaved because of debt, and the foundation of the Heliaia and other popular courts. At the same time he established a new council of 400, the boule, composed of 100 members from each of Athens' four tribes, and achieved the inclusion of the Thetes, the lowest, neglected rank of citizens, into the ekklesia of the people.

In spite of all this development of the state, inner peace was not secured, and in 561 B.C. Peisistratos set up a tyranny. Although he retained the basic elements of Solon's law code he instituted his own ideas as well. The tyranny of Peisistratos and his successors lasted until 510 B.C. Through the whole period, in spite of the Athenians' dissatisfaction, a series of measures improved the city's progress through notable advances in spiritual, artistic, architectural, and commercial matters. In 508 B.C., Kleisthenes made a series of radical changes which resulted in the establishment of the Athenian democracy. The most important of these was the division of the population into 10 tribes. With the new division, the membership of the boule was increased to 500, 50 from each tribe. The boule prepared drafts of the laws which were debated and ratified by the ekklesia, which had become the sovereign body. With all these innovations the Athenians reached such a peak of spirit and idealism that their few repulsed the great Persian assault, and so brought about the victories of Marathon (490 B.C.) and later of Salamis (480 B.C.). Immediately after the victory the provident Themistokles had a new wall built around the ruined city, and he completed the fortification of the Peiraeus which he had chiefly been responsible for initiating when he was archon in 493-492 B.C. because he understood its particular importance for the development of Athenian naval power. The completion of his plan was brought about shortly afterwards with the building of the Long Walls.

Fortification was not the only concern of the Athenians. In 478 B.C. Kimon instituted the first Athenian Confederacy and the Athenian state was revealed as a great power. At the same time, about mid 5th c. B.C., under Perikles and a staff of inspired artists, the masterworks of the classical age were created on the Acropolis, in the lower city, and in the principal demes of Attica. These, along with philosophy, letters, and other kinds of intellectual manifestations, created the Golden Age. The catastrophic disasters of the Peloponnesian War and the cruelties exhibited during both phases of it, exhausted the city and its people.

The appearance of the Macedonians and the defeat of the Athenians in the battle of Chaironeia in 338 B.C. brought about a great reaction in the Athenians, since they realized they had lost the leadership of the Greek world. Athens experienced a temporary revival of influence during the administration of the orator Lykourgos (338-326 B.C.). The Lamian War in 322 B.C. brought new disaster to Athens since its unexpected result was a change of regime, installation of a Macedonian garrison, and the destruction of the commercial fleet. The appearance of Roman conquerors also brought disastrous consequences to Athens. In 86 B.C. the Athenians revolted to obtain their freedom, but the conquest of the city by Sulla was the result. The walls of the city and of Peiraeus were demolished by the victorious Roman general who sought in this way the diminution of Athens' power.

In the Imperial period the city enjoyed a certain amount of freedom and was enriched with grandiose new buildings and temples. But in A.D. 267, in spite of Valerian's fortification of the city, Athens suffered a fearful devastation by the Herulians. In the 5th c. A.D. much energy was put into the reconstruction of the city, which for all its vicissitudes remained an important intellectual center. The philosophical schools, which were known throughout the Greek world, practiced until A.D. 529 when a strict order issued by Justinian closed their doors. The closing of the schools put an end to the city's community spirit and to its ancient glory, but it continued as the capital of an eparchy in the great Byzantine Empire until 1204. There followed the occupation of the city by the Franks until 1456 and then the Turkish occupation until 1821, when, after a harsh struggle, the Greeks gained their freedom. The city of Athens in 1833 was proclaimed capital of the new Greek state.

Excavations. The work of uncovering the monuments of the ancient city began in 1834 with the dismantling of all their mediaeval additions. At the same time excavations began, which in 1860 took on a systematic character. The excavations, together with the preserved literary evidence, particularly the description of the city's monuments by Pausanias in the 2d c. A.D., allow identification of the monuments and a virtually complete description of Athenian topography.

The Fortifications. In the second half of the 13th c. B.C. the so-called Pelargikon, or Pelasgian wall, was erected on the peak of the Acropolis hill. The city seems not to have been surrounded by a wall until the beginning of the 6th c. B.C. The first circuit wall, which is mentioned by Thucydides (1.89.3) must have been built by Solon, or more probably by Peisistratos. Unfortunately, no traces of this wall have yet been discovered.

After the destruction of the city by the Persians in 480-479 B.C., the so-called Themistoklean wall was built, which enclosed an area said to be much greater than that contained by the older wall. Within this new wall were included the Eridanos and the Olympieion, as well as the whole extent of the Pnyx, from the Hill of the Muses to that of the Nymphs. The gates, in order from the W side of the wall were: the Demian ("executioner's") Gate; the Peiraeus Gate; the Sacred Gate; the Thriasian Gate (Dipylon); the Eria ("funeral") Gate; the Acharnian Gate; the North Gate; the Gate of Diochares; the Hippades ("cavalry") Gate; the Diomeian Gate; the Itonian Gate; the Halade ("seaward") Gate; the South Gate. The Themistoklean wall was destroyed by the Lakedaimonians in 404 B.C. and was rebuilt by Konon in 394 B.C. In about mid 4th c. B.C., around the whole lower section of the city, from the base of the Hill of the Nymphs to that of the Hill of the Muses, a second wall, the proteichisma, was built outside the main one, and a deep ditch dug in front of that. At the same time a cross wall was built along the spine of the Pnyx hill, between the two peaks, by which the city was diminished in size.

After Sulla broke down the wall in 86 B.C. the city remained unwalled until the time of Valerian (A.D. 253-260). He rebuilt the wall and included in it as well the new city which had been built by Hadrian. For greater security he changed the Acropolis into a fort, as it had been before. After the great Herulian destruction of A.D. 267 a small circuit was built to the N of the Acropolis, known as the Late Roman wall. The outer ancient circuit, which appears to have been preserved and which was repaired in Justinian's time, was in use through the whole Byzantine period until A.D. 1204.

The Acropolis. A few remains of the Mycenaean period and considerable remnants of the Pelargikon remain on the top of the hill from prehistoric times. No

remains of the Geometric period have been discovered. The first shrines must be dated at the earliest to the 8th c. B.C. In 566 B.C., the year when Peisistratos instituted the festival and games of the Great Panathenaia, the highest section of the Mycenaean tower in front of the entrance to the Acropolis was taken down and the first altar was consecrated there to Athena Nike. At the same time a straight ramp was built up the hill to help the procession in its ascent and the first temples were built inside the Acropolis: the Hekatompedon in 570-566 on the site where the Parthenon was later erected, the Old Temple of Athena in 529-520 whose foundations have been preserved, and a number of smaller buildings.

In the period from 490 to 480 B.C. the Acropolis was still surrounded by the Pelargikon wall, but this had lost its defensive role. In 485 B.C. a new propylon had replaced the old entrance, and near the Altar of Athena Nike a small poros temple was built. The Hekatompedon was torn down and in its place the first marble Parthenon was begun. This was in a half-finished state when the Acropolis was razed by the Persians in 480 B.C. A new program for rebuilding the temples and other buildings which had been destroyed was started in 448 B.C. after the signing of Kallias' Peace Treaty with the Persians at Susa. Among the first works on the Acropolis was the construction of strong retaining walls, partly to level the area, but chiefly to enlarge the area of the Acropolis. Then followed monuments which still remain today in a remarkable state of preservation: the Parthenon in 447-438 B.C., the Propylaia in 437-432, the Erechtheion in 421-406, the Temple of Brauronian Artemis, the Chalkotheke, and other small temples and altars.

In Hellenistic and Roman times only minor buildings were constructed on the Acropolis. Immediately after 27 B.C. the Erechtheion was repaired and a circular temple of Rome and Augustus was built to the E of the Parthenon. The temples of the Acropolis remained virtually untouched through the whole mediaeval period, save for their conversion to Christian churches. Their destruction and demolition began in the middle of the 17th c. A.D. and continued until the Greek War of Independence.

Around the Acropolis. In the whole area around the Acropolis remains and sherds from the Neolithic through the Late Geometric periods are found. From the 7th, but chiefly from the 6th c. B.C. through the Roman period, all along the Peripatos road which surrounds the Acropolis numerous shrines and other buildings were constructed. In 465 B.C. the Klepsydra fountain was built and at some time after the Persian wars the cult of Pan was instituted in a small cave above it, next door to a cave in which Apollo Hypoakraios had been worshiped since an early period. East of it, in the cave of Aglauros, a fountain had been built in Mycenaean times, which communicated directly to the Acropolis by means of a stair. Even after the destruction of the fountain, the stair was still used by the Arrephoroi to get down to the neighboring Shrine of Aphrodite and Eros. On the S slope of the Acropolis were the Odeion of Perikles and W of it on the ruins of the old Theater of Dionysos Eleuthereus, the new theater, which was finally completed under Lykourgos (338-326 B.C.). At the highest point behind the theater the monument of Thrasyllos was built in 321-320 B.C., while to the S of the scene building was the Sanctuary of Dionysos Eleutheros, including a stoa and two temples. The cult of Asklepios was founded in 419-418 B.C. to the W of the theater, with a sanctuary incorporating numerous buildings. Later a stoa was built in front of it by Eumenes II (197-159 B.C.). Above the E end of this was the monument of Nikias (320-319) and at the other end, the

Odeion of Herodes Atticus which was built soon after A.D. 160. The Shrine of the Nymphs was uncovered in front of the odeion. Sherds found in it dated from about the middle of the 7th c. B.C.

Besides the Peripatos, the street of the Tripods surrounded the Acropolis. This started at the Prytaneion and ended in front of the propylon of the Shrine of Dionysos Eleuthereus. Along this were numerous choregic monuments, of which many bases have been found, and one of which, the monument of Lysikrates (335-334 B.C.), is nearly intact. The Prytaneion was in the Agora of Theseus, where the street of the Tripods branches off from the Panathenaic Way. Near this spot the Eleusinion was built around the middle of the 6th c. B.C.

Areopagus. The open-air jury court of the same name was probably held on the top of the rocky Areopagus Hill. Around the hill were found many Mycenaean and Geometric graves, and the remains of buildings dating from the Classical to the Late Roman period. Near the SW corner of the Agora an "Oval House" of the 8th c. B.C. and the Triangular Shrine of the Classical period were excavated. To the W of the Areopagus Hill at a distance of 300 m was found the Temple of Artemis Aristoboule, and among the houses on the S slope of the hill the Amyneion was uncovered as well as the Shrine probably of Herakles Alexikakos, over which the Baccheion was built in Roman times. There are also the remains of a fountain and another small temple.

Agora. The first Agora of the city, known as the Ancient Agora, was founded by Theseus, and is located on the NW slope of the Acropolis. The Agora of Solon, which was known from the outset simply as the Agora or Kerameikos was placed to the N of the Areopagus in an open, level spot where the prehistoric and Geometric cemetery of the city had been. The new Agora consisted of a large rectangular area, 200 x 250 m, whose four sides were bordered by buildings. The chief buildings, from the mid 6th c. B.C. to approximately 480 B.C. were as follows: on the W side, in order, the Royal Stoa, the Sanctuary of Zeus Eleutherios, the Temple of Apollo Patroos, the Temple of the Mother of the Gods, the Old Bouleuterion, and the Prytaneion. On the S side were the Court of the Heliaia and the Southeast Fountain-house. Another very ancient sanctuary was the Leokorion at the NW corner of the Agora and the Altar of the Twelve Gods (521-520 B.C.) which was used as the starting point for milestones. Inside the Agora square a section of the Panathenaic Way was used, from 566 B.C. on, as a race track, called the Dromos, for the gymnastic and horse racing contests, while the area called the orchestra in the middle of the square was for the musical and dramatic contests of the Panathenaic festival.

From the destruction of the city in 480-479 B.C. by the Persians to the end of the 4th c. B.C., the old buildings were repaired and new ones built as well. On the W side were built the Stoa of Zeus Eleutherios in 430 B.C., the Temple of Zeus Phratrios and Athena Phratria, a new Temple of Apollo Patroos, the new Bouleuterion around the end of the 5th c., the Tholos in 465 B.C. and the Strategeion. Around the middle of the 4th c. B.C. the monument to the Eponymous Heroes was built, and on top of the Agora hill (Kolonos Agoraios) the Temple of Hephaistos (449-444 B.C.) which has remained virtually intact until now. On the S side of the Agora ca. the end of the 5th c. B.C. the Southwest Fountain-house, the South Stoa I, and the mint (Argyrokopeion) were built. On the E side was the square peristyle, built over the ruins of a law court in the beginning of the 4th c. B.C. Finally, on the N side were a number of buildings of the 5th c. whose purpose is unknown, and in the unex-

cavated section of this side must be the Stoa of the Herms and the Stoa Poikile. In Hellenistic times a large building of unknown purpose was built on the Agora hill, to the N of the Temple of Hephaistos. North of this, at the base of the hill was a Temple of Aphrodite Ourania and from 177-176 B.C. the Altar of Aphrodite Ourania, the Demos, and the Graces.

Around the middle of the 2d c. B.C. considerable changes were made in the Agora square, which now took on a regular form on account of the building of large stoas and other buildings around it. On the W side the Metroon was built on the site of the old Bouleuterion, on the S side the South Stoa II; the whole of the E side was taken up by the Stoa of Attalos (159-138 B.C.) which was rebuilt in 1956. In front and in the middle of this was the monument of the donor and in front of that the bema (speaker's platform) of the Agora. In the square, the so-called Middle Stoa, which divided the Agora in two sections, was built parallel to the South Stoa II, 32 m away. In a few years the S section so formed was bounded at the E by the E building.

In Roman times the Agora was enriched with new buildings and monuments. To the N of the Middle Stoa the Odeion of Agrippa was built around 15 B.C., while in the other section of the square several temples were built from parts of older Attic temples that had been destroyed by Sulla in 86 B.C. Thus, the Temple of Ares which had been built in the deme of Acharne in 440-436 B.C. was dismantled and moved to the NW corner of the Agora in 12 B.C. and there re-erected. Other temples were built with the architectural members of the Temple of Demeter from Thorikos and of the Temple of Athena from Sounion. Later on, around A.D. 100, the Library of Pantainos was built to the S of the Stoa of Attalos and around the middle of the 2d c. A.D., the NE Stoa. A colossal Nymphaion took the place of the mint building, and in Hadrian's period a large basilica was built next to the Stoa of Attalos in the N side of the Agora, with a circular fountain in front of it.

Besides the Agora area where the political and religious life of the city went on, there was also a large stretch of public land to the E of the Stoa of Attalos where there were markets and public buildings such as the Andronikos of Kyrrhos (Tower of the Winds) from the middle of the 1st c. B.C., the so-called Agoranomeion, the Roman Agora (29-9 B.C.), the library of Hadrian and the common Shrine of All the Gods which was also built in the time of Hadrian. Somewhere in this vicinity, to the E of the Roman Agora, must be the Diogeneion and the Gymnasium of Ptolemy. According to the literary evidence the Theseion ought to be close by, probably just S of the Roman Agora, in a place corresponding to the very center of the city.

Almost all of the Agora buildings were destroyed in A.D. 267 by the Herulians. In A.D. 400 the Gymnasium of the Giants and other smaller buildings filled the Agora Square.

The Pnyx. The densest district of the city was the Koile quarter on the heights of the Pnyx hill. On the N slope of the hill was the first theater-shaped area, built around the end of the 6th c. B.C. for the meetings of the popular assembly. The second phase of the Pnyx is dated to 404-403 B.C. and the third to 330-326 B.C. To this last period belongs the great square above the Bema of the Pnyx, which was bounded to the S by two large stoas. The Heliotropion of the astronomer Meton (433-432 B.C.) is believed to have been situated in the center of this square, and next to the Bema the Shrine of Zeus Hypsistos and the Altar of Zeus Agoraios which was moved to the Agora in the time of Augustus. After the building of the Diateichisma the Koile quarter was de-

serted and the whole area was used as a cemetery throughout Hellenistic and Roman times. In A.D. 114-16 a funerary monument to C. Julius Antiochus Philopappos was built by the Athenians on the top of the Hill of the Muses.

The Ilissos District. To the S of the Acropolis, in the area between the Hill of the Muses and the Ilissos river, numerous prehistoric remains have been found. These finds confirm not only the location, but also the extent of the most ancient city, just as Thucydides (2.15.3-6) delineated it, on the S side of the Acropolis. It is precisely in this area that the very ancient shrines are to be found: the Olympieion, the Pythion, and the Shrine of Dionysos in the Marshes, along with the Kallirrhoe spring and the Enneakrounos fountain.

According to Pausanias (1.18.8) the first temple to Olympian Zeus was erected by Deukalion. Over this Peisistratos the Younger laid the foundations of a large poros Doric temple but never finished it. This temple was to have had not only the same dimensions but also the same general appearance as the Hellenistic-Roman temple. In 174 B.C. Antiochos Epiphanes started the construction of a marble Corinthian temple which was finished in A.D. 131-132 under Hadrian. At the same time a great peribolos wall was built around the temple and in its NW corner is still preserved the gate in honor of Hadrian which set the boundary between the old city and the new one founded by Hadrian.

Within the Themistoklean wall and to the S of the Olympieion the following buildings have been discovered: the poros Temple of Apollo Delphinios (450 B.C.) which, according to tradition, was built on the site of a very ancient temple, the court of the Delphinion which is dated to 500 B.C., the Temple of Kronos and Rhea from the period of the Antonines, and the Panhellenion (A.D. 131/2). Next to the wall of the city, but outside it, should be the site of the Pythion, according to a number of relevant inscriptions which have been discovered. A small stoa SW of the Olympieion dating to the mid 6th c. B.C. must be identified as the court of the Palladion. To the S of it the discovery of an ancient boundary stone in situ confirms the site of the Shrine of Kodros, Neleus, and Basile, and associated with this and in front of it (according to the inscription *IG* I² 94), the Sanctuary of Dionysos in the Marshes.

On the other bank of the Ilissos, near the Church of St. Photini, is the site of Kynosarges, where the ruins of the Gymnasium, built in A.D. 134 by Hadrian, were found. The little mid 5th c. B.C. Ionic temple of the Ilissos now vanished should be attributed to Artemis Agrotera, and the ruins which have been discovered next to the Ilissos, to the Metroon in the Fields. Somewhat to the N, in the hollow between the hills by the Ilissos river, the first stadium was built by Lykourgos. On the same site Herodes Atticus built the new Stadium in A.D. 143-44. This was restored in 1896 for the holding of the first Olympic Games. North of this was the site of the Shrine of Herakles Pankrates, and between the Ilissos and the E side of the city was the Gymnasium of the Lykeion and the Gardens of Theophrastos.

The Kerameikos. In the area of the Kerameikos a part of the Themistoklean wall has been uncovered, and two gates, the Dipylon and the Sacred Gates. Within the wall was the Inner Kerameikos. From the Dipylon Gate the Panathenaic Way began, which then cut through the Agora and ended at the Propylaia of the Acropolis. Along this road on both sides were stoas and numerous monuments which are mentioned by Pausanias (1.2.4-5). Parts of the stoas near the Agora have been found, and about at the middle of the road the site of the Monument of Euboulides was discovered. The ruins of

three successive buildings uncovered between the Sacred Gate and the Dipylon are the remains of the Pompeion. The oldest dates to about 400 B.C., the second to mid 2d c. A.D., and the third to the 4th c. A.D.

Outside the walls, in the Outer Kerameikos was the main city cemetery. The earliest graves dated to the Submycenaean and Protogeometric periods, but burials in this area, which lies along the banks of the Eridanos River, continued until Late Roman Imperial times. Besides the graves of private persons, this cemetery also held public graves in the so-called state burial ground, where notable Athenians and those killed in war were buried. The private graves were ranged along the Sacred Way, which started at the Sacred Gate and went to Eleusis. They also lined the road to Peiraeus. The peribolos of the Temple of Tritopatres was located at the junction of these roads. The public graves were on both sides of the 39 m wide road that led from the Dipylon Gate to the Academy of Plato. On the left side of the road, at a distance of 250 m from the Dipylon was the site of the Temple of Artemis Ariste and Kalliste. Pausanias (1.29.4) lists the graves of notable men and men fallen in war from this point to the entrance of the Academy.

The entrance to the Academy was about 1500 m from the Dipylon Gate, and had various shrines and altars around it, but none of their sites has been determined. The Gymnasium of the Academy was founded by Peisistratos and was surrounded by a wall under Hipparchos. A large gymnasium dating to the end of the Hellenistic period and a square peristyle of the 4th c. B.C. have been uncovered in the Academy grounds.

Archaeological Areas and Museums. The larger section of the ancient city with private dwellings lies under the modern city of Athens, but most of the monuments which have been preserved or uncovered through excavation are set aside as Archaeological Zones. These are: the Acropolis and the area around it, the Areopagus, the Pnyx, the Agora, the Library of Hadrian, the Roman Agora, the Kerameikos, the Academy, and the area of the Olympieion. Finds from the excavations are kept mainly in the National Archaeological Museum, but there are three other local museums: on the Acropolis, in the Agora, and in the Kerameikos. To these must be added two storehouses where chance finds from the whole city are stored temporarily, and the Byzantine Museum where all the finds from the mediaeval city are collected.

BIBLIOGRAPHY. C. Wachsmuth, *Die Stadt Athen im Alterthum*, I-II (1874-90); J. E. Harrison & M. de G. Verrall, *Mythology and Monuments of Ancient Athens* (1890); E. Curtius, *Die Stadtgeschichte von Athen* (1891); J. G. Frazer, *Paus. Des. Gr.* (1898) I-VI; P. Cavvadias-G. Kawerau, *Die Ausgrabung der Akropolis vom Jahre 1885 bis zum Jahre 1890* (1906)P (καὶ ἑλληνιστί); O. Walter, *Athen Akropolis* (1929); W. Judeich, *Topographie von Athen* (1931²)M; W. Wrede, *Attische Mauern* (1933)I; G. P. Stevens, "The Periclean Entrance Court of the Acropolis of Athens," *Hesperia* 5 (1936) 443-520P; id., "The Northeast Corner of the Parthenon," *Hesperia* 15 (1946) 1-26; id., "Architectural Studies Concerning the Acropolis of Athens," *Hesperia* 15 (1946) 73-106P; W. Kraiker-K. Kübler, "Die Nekropolen des 12. bis 10. Jahrhunderts," *Kerameikos* 1 (1939); Kübler, "Die Nekropolen des 10. bis 8. Jahrhunderts," *Kerameikos* 5 (1954); id., "Die Nekropolen des späten 8. bis frühen 6. Jahrhunderts," *Kerameikos* 6 (1959); H. A. Thompson & R. L. Scranton, "Stoas and City Walls on the Pnyx," *Hesperia* 7 (1943) 269-301PI; Thompson, *The Athenian Agora: A Guide to the Excavation and Museum* (1962); Thompson & R. E.

Wycherley, *The Agora of Athens: The Athenian Agora* XIV (1972)PI; O. Broneer, "Plato's Description of Early Athens . . . ," *Hesperia* Suppl. VIII (1949) 49-59; W. B. Dinsmoor, *The Architecture of Ancient Greece* (1950)PI; I. T. Hill, *The Ancient City of Athens* (1953); R. E. Wycherley, *Literary and Epigraphical Testimonia: The Athenian Agora* III (1957); 'I. Τραυλός, Πολεοδομικὴ ἐξέλιξις τῶν Ἀθηνῶν ἀπὸ τῶν προϊστορικῶν χρόνων μέχρι τῶν ἀρχῶν τοῦ 19ου αἰῶνος (1960)MPI; id., *Pictorial Dictionary of Ancient Athens* (1971)MPI (καὶ γερμανιστί); Σ. Ἰακωβίδης, Ἡ Μυκηναϊκὴ Ἀκρόπολις τῶν Ἀθηνῶν (1962)PI; Ἀ. Κόκκου, Ἀδριάνεια ἔργα εἰς τὰς Ἀθήνας, Δελτ. 25 (1970) 150-73MPI; S. A. Immerwahr, *The Neolithic and Bronze Ages: The Athenian Agora* XIII (1971); J. A. Bundgaard, *The Excavations of the Athenian Acropolis* (1974)PI. J. TRAVLOS

ATHIES Arrondissement of Péronne, canton of Chaulnes, Somme, France. Map 23. A Gallo-Roman site (100 x 400 m).

The site which includes to the NE a group of buildings of uncertain use. Rectangular rooms connected by a narrow passage may represent the remains of a remodeled hypocaust. In the other sector (also to the N) a cellar (3.22 x 4.3 m) has been uncovered. Three apses of varying width (1.2-1.6 m) were found along the W wall, and a larger one in the N wall. The apses terminate in half-domes and are decorated in a peculiar fashion: the masonry has regularly spaced chaincourses with tiles laid in V-patterns between them. The cellar, which had a large vestibule, was remodeled several times, but it is not yet possible to establish a chronology. Nor is it possible to connect this ensemble with a network of Roman roads, although it was located between two highways, one to the N running from Amiens to Saint Quentin, the other to the SE, from Bavay to Beauvais.

The artifacts, rather few at present, are in the Athies town hall. The cellar, which is worth preserving, can be visited.

BIBLIOGRAPHY. M. Guillemain, "La villa gallo-romaine d'Athies (Somme)," *Revue du Nord* 155 (1967) 715-20; J. Desbordes, *Gallia* 32 (1973) 346-47. P. LEMAN

ATHRIBIS (Tell-Atrîb) Egypt. Map 5. A city to the NE of Benha, 174 km SE of Alexandria on the Damietta branch of the Nile Delta. It was the capital of the tenth nome of Lower Egypt and an important city throughout the Roman period. Excavations have yielded the remains of a temple dedicated by Ptolemy XI Neos Dionysos to Horus. The inscription on the architrave indicates that it was reconstructed during the reign of Tiberius and Germanicus. A trilingual decree of asylum (year 18 of Ptolemy XI) and a bust of a Roman Emperor found here are in the Cairo Museum.

BIBLIOGRAPHY. "Le topographie d'Athribis a l'époque romaine," *ASAE* 57 (1962) 19-31P; I. Kamel, "A bronze hoard at Athribis," *ASAE* 60 (1968) 65-71; K. Michalowski, *L'Art de l'Ancienne Égypte* (1968); P. Vernus in W. Helk & E. Otto, *Lexikon der Ägyptologie* I, 4 (1973) 519-24. S. SHENOUDA

ATHYMBRA, *see under* NYSA

ATRAX Thessaly, Greece. Map 9. A city of Pelasgiotis (Strab. 9.441), 10 Roman miles from Larissa (Livy 32.15.8) by the Peneios (Strab. 9.438), evidently prosperous from at least the 5th c. It issued coinage ca. 400 B.C. It had a Macedonian garrison and was besieged by T. Quinctius Flamininus in 198 B.C. but he failed to take it, as did Antiochus III in 191 B.C. when it was a Roman stronghold (Livy 32.15.8, 17.4-18; 33.10.2, 13.4).

Atrax is commonly now identified with a site (Palaio-
kastro) on the right bank of the Peneios near modern
Alifaka, ca. 23 km W of Larissa. The walls of the site
have a circuit of about 3 km, surrounding an acropolis
peak (265 m) which is a N spur of modern Mt. Dhov-
routsi, and coming down the hill to the river plain, where
the wall is poorly preserved. A cross wall divided the
circuit into an upper and lower city. The original wall
was built of rough stones and was about 3 to 4 m thick;
it may have been Mycenaean. In Hellenistic times (?)
this wall was repaired with rectangular blocks and the
wall between the acropolis and city, immediately below
the acropolis, was provided with five towers. The wall was
again improved in Byzantine times. In the lower city
architectural fragments are frequent. By the river are a
number of sarcophagi. Some ancient objects have come
from this site, including a 6th c. B.C. marble head.

Six km W of the site by Koutsochiro, a Chapel of
Haghias Nikolaus stands on a mound. Inscriptions of
Atrax were found here. This site may have been a Tem-
ple of Poseidon, and the area seems to belong naturally
to the Alifaka site, so supporting the Atrax-Alifaka site
identification.

Leake and later Edmonds favored placing Atrax at
Gunitza, where a large wall circuit of rough stones climbs
the steep hill on the left bank of the Peneios just as it
enters the E Thessalian plain. Stählin placed Argura here.
Lack of Classical and Hellenistic sherds, however, have
led to the belief this was not a city in Greek times. For
the Alifaka site Edmonds suggested Phakion.

BIBLIOGRAPHY. W. M. Leake, *Nor. Gr.* (1835) I 433;
III 368 (Gunitza); IV 292. H. G. Lolling, *AM* 8 (1883)
111, 129f; C. D. Edmonds, *BSA* 5 (1898-99) 21f, 24;
A. S. Arvanitopoullos, *Praktika* (1910) 187f; (1914)
217f; id., *ArchEph* (1913) 236; F. Stählin, *Das Hellen-
ische Thessalien* (1924) 101fᴾ; V. Milojčić, *AA* (1955)
219ᴵ; (1960) 171ᴵ (Gunitza); H. Biesantz, *Die Thes-
salischen Grabreliefs* (1965) 122ᴵ; D. Theocharis, *Del-
tion* 21 (1966) chron. 246fᴵ.				T. S. MAC KAY

ATREBATUM, *see* NEMETACUM

ATRI, *see* HADRIA

ATRIA, *see* ADRIA

ATTALEIA (Antalya) Turkey. Map 7. City in Pam-
phylia founded by Attalos II Philadelphos, probably be-
fore 150 B.C. After the end of the Pergamene kingdom
in 133 Attaleia seems to have been left free; it remained
so even after the formation of the province of Cilicia, but
was finally annexed to Rome by Servilius Isauricus in
77. Proof is lacking that the city had been involved with
the pirates to any considerable extent. Attaleia served as
a base for Pompey in assembling his fleet in 67 B.C., and
a visit by Hadrian in A.D. 130 was the occasion for much
restoration and embellishment. At a comparatively late
date Attaleia appears with the title Colonia. In Byzantine
times, when much more mention is made of the city, the
bishop of Attaleia came under the metropolitan of Perge-
Sillyon, until in 1042 he was raised to the rank of met-
ropolitan.

Whether Attaleia was founded on the site of an earlier
town or city is disputed. Strabo's words (667) are none
too clear, but certainly do not imply that Attaleia re-
placed a town of Korykos; and the old idea that Antalya
is the site of Olbia is quite untenable. The harbor,
though small, is nevertheless the best natural harbor on
this coast, and it is likely enough that there was some
earlier habitation. If so, however, the name is unknown.

Nothing is standing today apart from the fortifications.

No theater, stadium, temple, or any public building has
ever been located. The wall circuit remains virtually
whole, but only a few sections in the N part have been
dubiously attributed to Attalos' original foundation. The
rest, as it now stands, dates from the time of Hadrian
or later, with much subsequent repair and reconstruction,
including many reused stones, some sculptured or in-
scribed. Many of the towers are well preserved and con-
tain more ancient work. Seven gates are identifiable; the
Gate of Hadrian, on the E side of the circuit, is the most
impressive.

At the extreme end of the wall on the S side stands
a tower quite unlike the rest; it is known today as
Hıdırlık Kulesi. It is thought to have always been isolated
and not to have formed part of the wall circuit. It is in
two stories, the lower square, the upper round, both ex-
cellently preserved. The total height is 14 m. The lower
story consists of a nearly solid mass of masonry, in
which a passage leads from the door on the E to a small
room in the center; short passages lead off from this
towards the other three sides. At ground level on the
outside a door in the N wall leads to a narrow staircase
ascending in the thickness of the wall to the foot of the
round upper story; a second similar stairway leads to the
top of the building. Here a circular wall with crenela-
tions surrounds a platform open to the sky; in the center
is a solid rectangular base 4.56 m thick, resting on a
vaulted substructure. Its purpose has been disputed; it
may have served as a base for a lighthouse or for artil-
lery. A suggestion that the whole building is a mausoleum
is clearly improbable.

The Gate of Hadrian has recently been cleared and
reconstructed. It is a triple-arched gateway of familiar
form and carried two dedications to Hadrian. One was
on the architrave in letters of bronze and was evidently
the dedication of the gate itself; the other, seen only by
early travelers, seems to have been placed on the upper
story of the gate, related perhaps to a statue of the em-
peror. There can hardly be a doubt that the building was
erected on the occasion of Hadrian's visit in A.D. 130.

The three arches are all the same size, their undersides
decorated with cassettes containing shallow-cut rosettes
and flowers. In front of each of the four piers of the
gate, on the inner and outer sides, stood an unfluted
granite column on a high plinth; the rest of the building
was of white marble. The capitals are in the Composite
order, the bases Attic, and the epistyle was richly deco-
rated with ovolo and leaf moldings. The upper story has
disappeared.

The new museum in Antalya houses sarcophagi from
Perge, epichoric epitaphs from Aspendos, and reliefs of
the twelve gods from Lycia.

BIBLIOGRAPHY. K. Lanckoronski, *Die Städte Pamphyl-
iens* (1890) 7-32.					G. E. BEAN

ATUATUCA TUNGRORUM (Tongeren or Tongres)
Belgium. Map 21. Capital of the civitas Tungrorum. The
name is written Aduaca in the *Antonine Itinerary* (378),
Atuaca on the *Peutinger Table*, Ἀτουατουκον by Ptolemy
(2.9.4-6). Ammianus Marcellinus (15.11.7; 17.8.3) and
the *Notitia Galliarum* (8) refer to the civitas Tungro-
rum, Julius Honorius (*Cosmographia Occidentis* 18-19)
to Tungri oppidum, and the *Notitia dignitatum* (occ. 42)
to Tungri. The town is on the right bank of the Jeker,
on the hilltop dominating the entire neighboring region.

At the time of the Roman conquest, Atuatuca was a
fortress of the Atuatuci (the descendants of the Cimbri
and the Teutones) in the heart of the territory of their
tributaries, the Eburones. Caesar established a winter
camp there (*BGall.* 6.32,35); it was occupied by a legion
and a half, commanded by Sabinus and Cotta. In 54 B.C.

the Eburones, led by Ambiorix, attacked the camp and massacred the Roman troops. The identification of this Atuatuca Eburonum with the Atuatuca Tungrorum of the Imperial period is still not entirely certain. The pre-Roman remains found at Tongres are very few. The Eburones were exterminated by Caesar and replaced under Augustus by the Tungri, a tribe probably from beyond the Rhine. The newcomers established their main settlement on the site of the fortress of the Atuatuci and retained its name.

Only in the excavations of recent years have there begun to appear some remains dating to before the revolt of the Batavi in A.D. 69-70. It seems more and more likely that under Augustus there was at Tongres a military camp, since remains of the W side of such an establishment have been found. A V-section ditch with a palisade has been excavated a little to the W of the 2d c. walls. A little farther E, wooden hutting of elongated plan belonged either to this camp or to the canabae. A considerable quantity of sherds of Italic terra sigillata and a large number of Gallic coins with the legend AVAUCIA attest that the civilian vicus already had a certain economic importance. Even at this time Tongres became an important nexus from which roads went out to Bavai, Cassel, Antwerp, Nijmegen, Cologne, Trier, and Arlon. Tongres is situated in the fertile alluvial region of central Belgium with many rich villas whose produce was destined for the Roman armies stationed along the Rhine frontier; it became a very important commercial center. The abandonment of the military camp at the end of the reign of Augustus in no way jeopardized this vitality.

The checkerboard network of streets dates to the reign of Claudius. The streets were bordered by elongated wooden houses, some of which have been excavated. The large aqueduct dates to the same period. Massive foundations have been found and can be followed for 2.5 km. The revolt of the Batavi under Julius Civilis in A.D. 69-70 had fatal consequences for Tongres; thick burning layers testify to its complete destruction. During the period of the Pax Romana the town was quickly rebuilt and it flourished. It certainly had the rank of municipium and may have been destined to become a colony. Trajan or Hadrian had an impressive enceinte built around the town with a perimeter of 4544 m, ca. 500 m longer than the walls of Cologne. This enclosed the built-up area and an undeveloped district as well, but the project of establishing colonists at Tongres was abandoned. The enclosing wall (2.1 to 2.15 m thick) rested on a foundation of dry masonry and was composed of a core of flint nodules bound by mortar. The wall was furnished with large round towers, 9 m in diameter. The approach to the fortifications was defended by a system of V-section ditches. Several gates passed through the fortifications. At least one had a double arcade and was flanked by two rectangular towers. Four other gates have been located, but there certainly were more.

The network of streets was composed of seven parallel streets running E-W, with an average width of 5.5 m, cut at right angles by at least seven other streets. The location of the forum is not known for certain. On the forum must have been placed the eight-sided itinerary milestone which mentioned the road network for all N Gaul and lower Germany (*CIL* XIII, 9158). Unfortunately, only three sides of this black limestone monument have been preserved, and those only partially. One side enumerates the localities between Cologne and Worms along the Rhine, the second those along the Metz-Reims-Amiens road, and the third those along the road from Cassel to the frontier of the Atrebates.

The distances are given in Celtic leugae (2.22 km) instead of in Roman miles.

The most monumental remains excavated to date are those of an impressive sanctuary, located in the N part of the town, near the ramparts. In order to compensate for the slope of the ground an artificial terrace was constructed. This esplanade was surrounded by a portico (112 x 71.5 m wide). A temple with a podium stood in the middle; it had a rectangular cella (13 x 10 m), a pronaos, and a peristyle (about 24 x 29 m). The temple seems to date, in its first stage, to the end of the 1st c. It is exceptional in Gaul, for it differs greatly from sanctuaries in the indigenous tradition, with their square cellae; strong Roman influence is indicated. The temple was remodeled and enlarged during the 2d c. (possibly when the ramparts were built). Of the other remains of a religious character found at Tongres, the following are of note: the torso of a snake-footed giant; the capital of a column, depicting a rider trampling a double snake-footed giant under the hoofs of his horse; a stone with four deities; and a putative statue of Jupiter and Juno which, by certain details, shows that it really depicts the Celtic god Taranis and his cult associate.

Three large necropoleis extended to the W, N, and E of the town, along the roads going out from it. Thousands of tombs of the Early Empire have been found. Most are cremation burials, but there are also inhumations, beginning as early as the end of the 1st c. The artifacts found as grave goods form the basis of the rich collections in the archaeological museum at Tongres: pottery, glassware, fibulas, jewelry.

From the middle of the 3d c., the period of the Pax Romana was disturbed by the first barbarian invasions. The town of Tongres was taken and pillaged by the Franks around 275-76. Once the barbarians were pushed back, the defenses of the town were restored by the construction of a new but smaller enceinte. This wall was thicker than the earlier one. It was furnished with a larger number of towers, possibly more than 100, placed only 20 m apart. They served as magazines for ammunition and communicated with the inside of the town by a narrow door. The new wall no longer had ditches in front of it. The facing presents on the outer side a projection surmounted by two rows of tiles and consists of regular ashlar of various kinds of stone. The funerary monuments in the necropoleis were reutilized in the foundations. This new enceinte may date to the last years of the 3d c. or the beginning of the 4th c.

The civitas Tungrorum, which in the Early Empire had formed part of the province of Belgica, was henceforth attached to Germania secunda and the region took on more and more of a military character. Germanic peoples were authorized to establish themselves in the region and were enrolled in the military. These are the Laeti Lagenses prope Tungros mentioned in the *Notitia dignitatum*. The town itself never again knew its former prosperity in spite of a long period of relative tranquillity. A certain number of 4th c. tombs are known, all inhumations. Some must be graves of Germanic Laeti and often contain bronze accessories (belt trimmings, etc.) with "excised" geometric (*Kerbschnitt*) or animal-style decoration. Some tombs show that a part of the population had been converted to Christianity: for example, a funerary cellar with walls decorated with frescos of garlands and doves. Tongres was even the seat of a bishop. However, the center of economic and political gravity of the region shifted to the region of the Meuse. The seat of the bishop was moved to Maastricht. It is even possible that Maastricht also replaced Tongres as the capital of the civitas. We know very little about the end of the Roman period, only that the fall of Co-

logne in 457-58 also meant the end of the Roman period at Tongres.

BIBLIOGRAPHY. H. Van de Weerd, *De Civitas Tungrorum* (1914); id., "Sculptures inédites de Tongres," *Musée belge* 32 (1928) 5-18; id., "Romeinse terra-cottabeeldjes van Tongeren," *AntCl* 1 (1932) 277-301; 2 (1933) 377-78; id., *Inleiding tot de Gallo-Romeinsche Archeologie der Nederlanden* (1944) 66-73, 88-91[PI]; J. Paquay, "Tongeren voorheen," *Jaarboek van het Limburgs Geschied- en Oudheidkundig Genootschap* (1934) 27ff; P. de Schaetzen & M. Vanderhoeven, "La terra sigillata de Tongres," *Bull. de l'Inst. archéol. liégeois* 70 (1953-54) 7-284; id., *Terra Sigillata te Tongeren* 2 (1964); F. Ulrix, "Comparaison des plans des villes romaines de Cologne, Trèves et Tongres," *Kölner Jahrbuch* 6 (1962-63) 58-70[P]; H. van Crombruggen, "Les nécropoles gallo-romaines de Tongres," *Helinium* 2 (1962) 36-50; M. Vanderhoeven, *Romeins glas uit Tongeren* (1962); id., "De terra sigillata te Tongeren, 3. De italische terra sigillata," *Helinium* 7 (1967) 32-64, 193-228; J. Mertens, "Enkele beschouwingen over Limburg in de Romeinse tijd," *Arch.Belgica* 75 (1964)[P]; id., "Een Romeins tempelcomplex te Tongeren," *Kölner Jahrbuch* 9 (1967-68) 101-6[P]. S. J. DE LAET

AUBENAS Ardèche, France. Map 23. Situated in Gallia Narbonensis. Although not a Gallo-Roman city, it is surrounded by a number of Gallic and Roman sites. At Saint-Pierre-le-Vieux, in the area called the Champ des Colonnes, is a somewhat carelessly built Gallo-Roman villa which has yielded some pottery (terra sigillata, everyday ware, and white Allier ware) and a bronze statuette of the goddess Victoria. The oppidum of Jastres was first Gallic, then Roman. At Saint-Martin-les-Ollières and at Mas Geole are two villas that show traces of iron-working and pottery manufacture.

BIBLIOGRAPHY. M. Leglay, "Informations," *Gallia* 22 (1964) 537-39. M. LEGLAY

AUCH Gers, France. Map 23. Auch was the capital of the civitas of the Ausci. During the Roman Empire it was a double town: the old oppidum of Elimberris dominated the left bank of the Gers; new districts were built on the flood-plain on the right bank. In these districts of La Hourre, Le Garros, and Matalin, modern housing construction has allowed one to trace the sewer network of the ancient town, as well as to discover potters' kilns, rich assemblages of terra sigillata, an inscription concerning a sevir of Augustalis, and dwellings with mosaics.

BIBLIOGRAPHY. M. Labrousse, "Inscription romaine découverte à l'Hôpital d'Auch," *Bull. de la Soc. arch. du Gers* 55 (1954) 347-65 (= P. Wuilleumier, *Inscr. latines des Trois Gaules* [1963] 44-45, no. 135); id., *Gallia* 12 (1954) 221[I]; 13 (1955) 210-11[I]; 15 (1957) 268; 17 (1959) 415[I]; 20 (1962) 578-80[I]; 22 (1964) 451-52[I]; 24 (1966) 430-31; 26 (1968) 538-39; 28 (1970) 415; id., "Céramique sigillée trouvée à Auch en 1963," ibid. 65 (1964); A. Péré, "Les vestiges gallo-romains du parc de La Hourre," *Bull. de la Soc. arch. du Gers* 57 (1956) 268-74; id., "Les sites d'Elimberris et d'Augusta Auscorum," 65 (1964) 372-82; Péré & M. Cantet, "Regards sur Augusta Auscorum," ibid. 65 (1964) 139-58; 66 (1965) 66-74; id., "Fouilles gallo-romaines à Mathalin-Auch," ibid. 67 (1966) 449-58; id., "Regards sur Augusta Auscorum: les égouts dans la ville gallo-romaine," ibid. 70 (1969) 184-203. Espérandieu-Lantier, *Recueil* . . . , xv (1966) 62[I]. M. LABROUSSE

AUCHENDAVY, see ANTONINE WALL

AUERBERG, see LIMES RAETIAE

AUFKIRCHEN, see LIMES RAETIAE

AUGERS-EN-BRIE Dept. Seine-et-Marne, France. Map 23. Situated in the arrondissement of Provins, in the canton of Villiers-Saint Georges, it marks the site of a Gallo-Roman village that was inhabited to the 3d c. It was located on the outskirts of the civitas Meldorum and the civitas Senonorum. Many objects from the 2d and 3d c. have been found there. Since 1960 underground Gallo-Roman huts, cut out of the loess or built of stone, have been unearthed. This type of dwelling therefore seems to cover the whole of the period of the Early Empire, and it also turns up later in the same area: in 1964 two sunken houses that were inhabited in the mid 4th c. were discovered near the village of Neufmontiers-les-Meaux (Seine-et-Marne).

BIBLIOGRAPHY. M. Fleury, "Informations arch.," *Gallia* (1965, 1967). J.-M. DESBORDES

AUGSBURG, see AUGUSTA VINDELICUM and LIMES RAETIAE

AUGSBURG-OBERHAUSEN, see LIMES RAETIAE

AUGST, see AUGUSTA RAURICORUM

AUGUSTA Cilicia Campestris, Turkey. Map 6. Just over 16 km N of Adana in a loop of the river Seyhan (Sarus), and at the W end of a narrow plain bounded N and S by low hills. With the Roman urbanization of the E Cilician plain after the fall of the Tarcondimotid house in A.D. 17, the city (named for Livia, the widow of Augustus) was founded in A.D. 20. Represented at the Council of Chalcedon in 451, the city probably did not long survive, as an important center, the Moslem invasion of Cilicia in the 7th c.

The site, discovered by chance in 1955, was identified by ancient literary references and from the presence there, and in the neighboring village of Gübe, of local semiautonomous coins of Augusta. In the same year (1955) Gübe, and with it the ruins of Augusta, disappeared below the waters of the Seyhan dam, but not before the site had been partially surveyed and individual buildings planned. Among these were the foundations of a triumphal arch, two colonnaded streets crossing each other at right angles in the manner typical of town planning in Roman Cilicia, a theater, a civic basilica, some shops, a bath building, and a dam on the river. These structures were all of brick and mortar, and probably of 3d c. date.

BIBLIOGRAPHY. F. Blumer, *Kleinasiatische Münzen* (1902) III 436-37; M. Gough, "Augusta Ciliciae," *AnatSt* 6 (1956) 165-77; M. Akok, "Augusta şehri harabesi," *TürkArkDerg* 7.2 (1957) 15-20; A.H.M. Jones, *Cities of the Eastern Roman Provinces* (2d ed. 1971) 206. M. GOUGH

AUGUSTA AMBIANORUM Seine-Maritime, France. Map 23. Located in the L'Abbé woods, ca. 4 km SE of the town of Eu. The name Augusta, transmitted by 7th c. texts, is probably that of an ancient estate; it appears again in the name of the modern village of Oust. The ruins correspond to the conciliabulum of a pagus (Ambianus), the name of which appears in the dedicatory inscription of a theater as CATUSLOV. The ensemble, partially excavated in the 19th c., covers more than 30 ha on a plateau dominating the valley of the Bresle.

The great temple, built under Septimius Severus at the farthest extension of the plateau, was perhaps dedicated

to Rome and Augustus. Forming a quadrilateral (32 x 27 m), it consists of a vestibule in antis opening on a cella 13 m on a side; the whole was surrounded on three sides by a gallery 4 m wide. Built of local materials (flint and limestone) with brick bonding courses, it has lost its painted and carved decoration over the centuries. The cella was constructed on the ruins of a small pseudoperipteral temple, 8 m on a side, built under Antoninus. Part of its decorations (composite order) have survived.

These buildings occupied the site of a depository of sacred objects, used from the time of Augustus to that of Claudius. The area, which underwent architectural development about the middle of the 1st c. A.D., has yielded discoveries of importance, particularly for the study of Belgic numismatics. To the N, W, and S, soundings have revealed the presence of other buildings, perhaps linked by a portico. They appear to have been contemporaneous with the large temple, and to have replaced older (Flavian?) structures.

At an undetermined date, two parallel walls 84 m long and 13 m apart connected the vestibule of the large temple on the E with a square fanum measuring 12 m on a side. The fanum, excavated in the 19th c., was built on substructures of uncertain origin. The theater is 200 m to the E, on the E slope of the plateau, towards the forest. Its facade, still only partially excavated, is ca. 100 m long, and from the middle of the stage wall to the surrounding wall is ca. 60 m. This wall, which has been partially uncovered, was constructed of small blocks without brick bonding courses. It was modified and repaired, and during one of these modifications, in which flint, chalk, and tufa are mixed with brick, the stage wall was built in the 3d c. The stage shows traces of a colonnade with a decoration of overlapping leaves, supporting a wooden architrave to which a long inscription was applied at the time of construction. It gives the municipal cursus of a quattuor vir and the name of the pagus.

To the SE the fields are scattered with remains which may be those of a bath house, and on the edge of the forest are large substructures.

BIBLIOGRAPHY. L. Estancelin, "Mémoire sur les Antiquités de la Ville d'Eu et de son territoire," *Mémoires de la Société des Antiquaires de Normandie* (1825); Cochet, "Fouilles du Bois l'Abbé," *Bulletin de la Commission des Antiquités de la Seine-Inferieure* 3 (1872); E. Varambaux, "Notes sur des découvertes faites dans le canton d'Eu," *Annuaire des cinq départements de la Normandie* (1873)[PI]; M. de Boûard, "Informations," *Gallia* (1966, 1968, 1970)[I]; M. Mangard, "Présentation des fouilles . . . d'Augusta Ambianorum," *Annuaire des cinq départements de la Normandie* (1970). 　　　　M. MANGARD

AUGUSTA BAGIENNORUM Liguria, Italy. Map 14. Near Benevagienna, one of the nobilissima oppida mentioned by Pliny in the territory of the Bagienni, a Ligurian tribe. Toward the end of the 5th c B.C., following the Gallic invasions, it was assimilated with those peoples and vitalized the Celto-Ligurian stock. Its first contact with Rome came in the 3d c. B.C., but only toward the middle of the 2d c. were the Bagienni subjugated by the Romans. War continued in their territory as a result of the struggle between Marius and Sulla. It did not become a Roman municipium before 5 B.C., as shown by an inscription discovered at Sant'Alba Stura with a dedication to Augustus by its citizens. Its founding must be dated to the period that saw the unveiling of the trophy of the Turbia (17-14 B.C.) and the signing of the peace treaty with Cottius, memorialized on the frieze of the Arch of Susa (9-8 B.C.).

The city was built on a level site on the brow of a deep canyon produced by a small stream. It was almost perfectly rectangular in form. The gates and towers date to the time of Augustus; but since no section of the walls has been preserved, it is believed that the city, like Albintimilium and Libarna, had no defensive walls.

Through brief soundings, monuments were once identified which today are covered by a thin layer of earth. Recent explorations have brought to light the site of the theater and of the portico post scaenam in the middle of which there was once a sacred building (probably a basilica). There has also been discovered what remains of the ancient forum set in the center of the city, exactly in the spot conjectured from the regularity of the original plan. Shops opened onto a portico, which was richly decorated.

The theater, set off-center, has been buttressed and restored and can be seen today in its full development. The front of the stage, which still preserves the marble jambs of the entrance gates, the cavea built entirely of brick, the remains of some very fine facing, column bases faced with colored marble, are the major remains of this monument. Outside the circuit wall was a sizable amphitheater. The remains of an aqueduct and some baths have been discovered by surface digging. The pottery, glass, marbles, and coins have been collected in a small museum in the Palazzo Comunale.

An examination of the few public inscriptions that have come to light reveals a Pontifex Augusta Bagiennorum and so demonstrates the importance of this city from the point of view also of church history.

BIBLIOGRAPHY. G. Assandria & G. Vacchetta, "Augusta Bagiennorum," *Atti della Società Piemontese di Archeologia* 10 (1921-25) 183ff; C. Carducci, "Benevagienna. Saggi e scavi," *NSc* (1950) 202ff; A. Bovolo, "Augusta Bagiennorum," *Bollettino della Società Storica Archeologica e Artistica della Provincia di Cuneo* 30 (1952) 26ff; A. T. Sartori, *Pollentia ed Augusta Bagiennorum* (1965). 　　　　C. CARDUCCI

AUGUSTA EMERITA (Mérida) Badajoz, Spain. Map 19. Town at the confluence of the Guadiana (the Anas of the Romans) and the Albarregas. It was founded by P. Carisius, the legate of Augustus, in 25 B.C. for the veterans discharged after the Cantabrian wars. It came to outrank all other towns of Lusitania and was one of the most important Roman settlements of the Iberian peninsula: chief town of the Conventus Iuridicus, according to Pliny (4.117) and a colony attested by Pliny, by the coins minted there, and by numerous inscriptions. Augustan boundary stones show the extensive territory of the colony—they have been found 100 km from the town—and Frontinus (*De controversiis agrorum* 2.52, Lachmann) says that even after several land distributions there was still land left over. The original colonists were apparently veterans of the Legiones V Alauda and X Gemina but the sources, in addition to Frontinus, allude to later settlers of more obscure origin: the families sent there by Otto in A.D. 69 for example (Tac., *Hist.* 1.78). Inscriptions refer to colonists from the legiones VI Victrix and VII Gemina. Emerita was also important during the age of the Visigoths and has been inhabited without a break ever since.

The rectangular plan typical of Roman camps is still reflected in the modern town. The decumanus maximus survives almost unchanged from the head of the Roman bridge over the Guadiana to the site of the so-called town gate; the cardo maximus ran from Trajan's arch to the problematic Arch of Cimbron (no longer extant). Probably there was originally a walled enclosure framing this central quadrilateral. There are no visible remains of this enclosure, only references to the sites of the gates; but Trajan's arch, which some think is a monumental

gateway in the wall, and the stretch of wall recently unearthed during excavation of the Moorish citadel may be remains of it. This wall runs SW-NE, parallel to the river. There are also stretches of a larger circuit wall, obviously of a much later date and including the theater and amphitheater. Although it has not been dated accurately, it is interesting to note that the wall stopped up one of the gates of the amphitheater and affected part of the walls of the so-called House of the Amphitheater. These facts indicate a later date: not only is the house essentially a 2d c. construction, but the wall is typical of defensive works hastily thrown up when danger is imminent. It appears to date from the second half of the 3d c. A.D., the time of the invasions of the Franks and the Alamanni.

The Roman road N to Asturica and S to Italica ran over the bridges, still extant, across the Albarregas and the Guadiana respectively. The first is the smaller (130 m long), but retains much of its original Roman design. The larger bridge (792 x 4.5) over the Guadiana has been rebuilt at various times; the reconstructions are well documented. At present it has 57 arches of various periods. The best-preserved Roman part, the structure of which is still intact, is between the town and the first of the two ramps off the bridge, the one to the island that splits the river. In this stretch the cut-waters, built of rusticated ashlar masonry like all the original work, are rounded, and above them between the larger arches are spillways to reduce the resistance to floodwater. Along the wall of the citadel and near the ramp to the island there are extensive remains of what must have been wharves; at that time the Guadiana was navigable up to Mérida.

Nothing is known of the forum, which must have been near the modern Plaza Mayor, at the intersection of the cardo and decumanus, but extensive remains of two of its temples survive. Near the decumanus some parts of a temple usually called the temple of Diana, have been incorporated into a 16th c. house: a few granite columns, several of them still supporting fragments of the architrave. It was a hexastyle peripteral temple set on a high podium, with the entrance probably on the N. On its E side are six columns without capitals, half-covered, in the main facade of the house. On the S side are six more columns, but parts of the shafts have disappeared. These columns, from one of the smaller sides of the temple, are so arranged that the central intercolumniation is slightly wider than the others. The W part, visible from the patio of the house, consists of five columns with Corinthian capitals, four of which still support the architrave over three intercolumniations. The columns are 8 m high and their diameter at the bottom is 0.85 m; the intercolumniations are 2.1 m; the podium, still partly buried and over 2 m high, is 21.5 m long and 15.6 m wide. It is made of granite and must have been adorned with stucco or marble.

Fragments of a temple dedicated to Mars have been incorporated into the so-called Hornita de Santa Eulalia chapel. They consist of two engaged columns with Corinthian capitals supporting stretches of the entablature profusely decorated on the frieze with heads of Medusa and palms, and with plants, animals, and military regalia on the soffits, all from about the middle of the 2d c. Set into the frieze is a cartouche with the inscription MARTI SACRUM/VETTILLA PACULI. The material is marble of various hues.

In the SE part of the town was a religious complex where the mystery cults of Mithras, Serapis, and other exotic gods were celebrated. The finds include a seated Mercury whose lyre bears an inscription, dated the 180th year after the foundation of the colony (A.D. 155) and showing C. Accius Hedychrus, the pater of the Mithras cult known from other inscribed stones from Emerita. Recent excavations have revealed the remains of Roman houses undoubtedly connected with the Mithraeum, with patios, cisterns, bathing facilities, and mosaic pavements. The mosaic of the creation of the universe, one of the most important ever found in the Empire, can be dated from the end of the 2d c. B.C. Another villa, mentioned above, has been unearthed near the amphitheater. It consists of several rooms, some with large mosaics, arranged around a small central peristyle and along a broad corridor. Painted stucco is preserved at the bottom of the walls. A few private back-to-back baths seem to be those of a neighboring house not yet excavated. The material found in the House of the Amphitheater suggests a date between the latter part of the 1st and the second half of the 3d c., when it was destroyed. Mosaic pavements in houses have also been found in other parts of the town.

Ruins of the theater and the amphitheater formed a complex E of the town; the circus is farther off. The theater is outstanding. A large cavea of concrete and granite ashlar blocks has 13 entrances, 13 vomitoria, and two large side entrances between the seats of the cavea and the scaena, the lintels of which bear inscriptions of M. Agrippa dated 16 B.C. Some marble from the scaena has fallen but most of it is still in place, including statues in the intercolumniations of the two tiers of colonnades, on a high podium, which constituted the scaena. Three valvae gave access to a spacious porticoed patio behind. The maximum diameter of the building is 86.82 m. The structure, perhaps begun by Agrippa, was later reconstructed.

Across a paved highway 6.5 m wide, the amphitheater consists of a large ellipse; the N-S diameter is 126.3 m and the E-W one 102.65 m. It has 16 entrances, each of which gave access to a stairway connecting the 32 vomitoria that open into the cavea. There are two aditus on the longer axis, and four tribunes placed at the poles of each diameter. Inscriptions, preserved in part, mention the probable date of construction, 8 B.C., under Augustus. Construction is of concrete and granite ashlar, and there is a large cruciform pit in the arena similar to that in the amphitheater at Italica.

About 500 m to the E are the remains of the circus. Its plan is the usual one, long and narrow, with two almost parallel tiers of seats closed at one end by a semicircle and at the other by the main facade. The central spina is slightly out of line with the main axis. The whole building (433 x 114 m) is in worse condition than the other two public buildings.

The town was supplied with water by an hydraulic system consisting basically of two capacious reservoirs, the dams of which, restored at various periods, are still in working order; two main aqueducts, and several secondary conduits. One of the reservoirs is now called the Proserpina reservoir because an inscription to Ataecina-Proserpina was found nearby. The dam has a sloping wall more than 400 m long and 6 m thick. It has been calculated that it can impound more than 5 million cu. m of water. Large parts of the aqueduct still survive, particularly a series of arches, ca. 825 m long, that cross the Albarregas valley on slender pillars with alternating granite and brick courses. They appear to date from the second half of the 3d c., although earlier dates have been suggested.

The dam of the so-called Cornalvo reservoir is 220 m long; the wall has a very steep batter and rows of steps along the part of the dike facing the water. The Roman structure has been badly disfigured by subsequent restorations except for the water tower, which is in the

reservoir and has well-preserved rusticated ashlars. Water from this reservoir was carried by several aqueducts, remains of which can be recognized in the E part of the town. The San Lazaro aqueduct, however, ca. 1600 m long and not far from the circus, took its water from springs and water courses in the environs of the town and not from the Cornalvo reservoir. A few pillars of the arches with alternating granite and brick courses still survive.

Many other Roman remains have been found, some of which have disappeared. Scattered remains of baths have been recognized, and the cemetery areas identified. On the San Albin hill, between the Mithraeum and the public buildings, various types of tombs have been discovered, including columbaria with two burial chambers, one rectangular and the other trapezoidal, with fresco paintings and funerary inscriptions. Apparently the town was not extended to the E, and all this area was for cemeteries. Funerary remains have also been discovered at the two exits of the Roman road near the two bridges. Recent excavations in the Arab citadel have uncovered streets and houses of the Roman era. The sewer system is well preserved and part of it is still in use; its network is complete and provides an accurate idea of the topography of the ancient town.

Most of the finds are in the Mérida Archaeological Museum. The sculpture collection includes objects found in the theater and the Mithraeum; there are epigraphic and coin collections, ceramic and glass household ware, and a large number of domestic utensils and tradesmen's tools. Other material is in the Badajoz and Sevilla Provincial Museums and the National Archaeological Museum in Madrid.

BIBLIOGRAPHY. J. R. Mélida, *El teatro romano de Mérida* (1915)[PI]; id., *Memorias de la Junta Superior de Excavaciones y Antigüedades* 2-118 (1915-31)[I]; id., *Catálogo Monumental de España. Provincia de Badajoz* (1926)[I]; A. Floriano, "Excavaciones en Mérida," *ArchEspArq* 17 (1944) 151-86; J. A. Sáenz de Buruaga & J. García de Soto, "Nuevas aportaciones al estudio de la Necrópolis oriental de Mérida," ibid. 19 (1946) 70-85; id., "Museo Arqueológico de Mérida," *Memorias de los Museos Arqueológicos Provinciales* 4-22 (1943-61)[I]; A. García y Bellido, *Esculturas romanas de España y Portugal* (1949)[I]; id., "Mérida. La gran necrópolis romana de la salida del puente," *Excavaciones Arqueológicas en España* 11 & 45 (1962-66)[I]; id., *Les réligions orientales dans l'Espagne romaine* (1967); E. García Sandoval, "Informe sobre las casas de Mérida y excavaciones en la 'Casa del Anfiteatro,'" *Excavaciones Arqueológicas en España* 49 (1966)[PI]. L. G. IGLESIAS

AUGUSTA PRAETORIA (Aosta) Val d'Aosta, Italy. Map 14. About 80 km N-NW of Turin in a beautiful valley 3 km wide, surrounded by mountains ca. 3050 m high. At the confluence of the Dora Baltea and Buthier, it is a highly strategic site where the Great and Little St. Bernard passes converge, after crossing the Pennine and Graian Alps.

The Roman general Terentius Varro conquered the earliest identifiable inhabitants of the area, the troublesome Salassi, in 25 B.C.; and to control the Alpine approaches, Augustus (emperor 27 B.C.-A.D. 14) at once replaced Varro's camp with a military colony. Its 3000 settlers were praetorians: hence the name Augusta Praetoria (Cass. Dio 53.25.3-5). Although never very populous, the town has always been of great military importance; it has often been controlled from beyond the Alps. Today it is the capital of Val d'Aosta, an autonomous French-speaking region.

The Roman monuments, some partly buried by today's higher ground level, are mainly Augustan. The town walls stand, although much damaged, for almost their entire circuit. They enclosed a rectangular castrum (572 x 724 m). Originally over 10 m high, they are of concrete, with a squared-stone facing of local travertine most of which has disappeared (except on the S wall). Of the twenty square towers that reinforced the walls two survive: Torre del Pailleron in the S wall, a restored but good specimen of Roman military architecture, and Torre del Lebbroso in the W wall, a structure with much Renaissance modification. The town gates were portcullised and built of squared-stone blocks: the S one, Porta Principalis Dextra with a single opening, is still visible; the E one, Porta Praetoria, a magnificent two-curtained affair, has three passageways and a large interior court (11.87 x 19.80 m).

Outside the walls stands the handsome Arch of Augustus. It is ca. 320 m E of the Porta Praetoria, close to a Roman bridge over the Buthier, and is axially aligned with both monuments. It is of stone and has engaged Corinthian columns supporting a Doric entablature on each face; its single opening is 11.5 m high; attic and dedicatory inscriptions vanished centuries ago.

Inside the walls the modern street plan reflects the ancient grid of seven decumani and seven cardines. The theater, or more accurately odeum (since, for climatic reasons, it was roofed), stood near the Porta Praetoria: the S section of its perimetral wall still towers 22 m above the cavea, orchestra, and scaena. North of it but also, somewhat surprisingly, inside the walls, was the amphitheater, eight of the stone arcades of which still survive. The forum lay farther W, at the present Piazza della Cattedrale: surrounding it was a quadrilateral cryptoporticus (79.2 x 89 m), of which three sides still exist, together with part of the podium of a temple (the Capitolium ?). The baths, between forum and amphitheater, are poorly preserved. Some remains of houses have also been found.

The museum of antiquities, in the Priorato di S. Orso, contains the famous inscription honoring Augustus, which was set up by the Salassi in 23 B.C. The Cathedral houses an ivory diptych of A.D. 406 bearing likenesses of the contemporary emperor Honorius, and its crypt has ten Roman columns and an Early Christian altar.

The mountains around Aosta contain numerous specimens of Roman engineering: bridges, viaducts, rock-cuts, etc.

BIBLIOGRAPHY. P. Barocelli, *Augusta Praetoria* (= *Forma Italiae*: Regio XI, Transpadana. Vol. I) (1948) with good earlier bibliography[MPI]; F. Castagnoli, *Orthogonal Town Planning in Antiquity* (1971) 112, 113; S. Finocchi, *Augusta Praetoria* (in the *Municipi e Colonie* series), Rome, Istit. di Studi Romani, forthcoming. E. T. SALMON

AUGUSTA RAURICORUM (Augst) Baselland, Switzerland. Map 20. Roman colony on the S bank of the Rhine, 12 km above Basel (Plin., *HN* 4.106; *It. Ant.* 251.7; Ptol. 2.9.9; *Tab. Peut.*).

The colony was obviously planned by Caesar and by L. Munatius Plancus in 44 B.C. (*CIL* X, 6087). Its primary function was to prevent further incursions into Caesar's new province from the East. The territory of the colony was taken from that of the Raurici and comprised the land between the Rhine and the Jura mountains. As no remains of the period 44-15 B.C. have been discovered, it is possible that the town was actually founded at this place only under Augustus.

The site assumed new importance during the campaigns E of the Rhine and the conquest of the central Alps under Tiberius and Drusus in 15 B.C.: it was the

terminus of the roads to the Rhine from Gaul and Italy via Genava and Aventicum. In 15 B.C. the site was occupied by a military post, and during the 1st c. A.D. by a detachment from the legion garrisoned in Vindonissa. In A.D. 73-74, in connection with the conquest of the Agri Decumates by C. Pinarius Clemens, troops of Legio I adiutrix and Legio VII gemina felix were temporarily garrisoned here. The town flourished until the incursions of the Alamanni in A.D. 260, but was only sparsely settled thereafter. In the 4th c. the lower town was abandoned, the highest part, Kastelen, was fortified, and the road outside the E gate protected by a small earth and timber fort. The population removed to the neighbourhood of a new fort on the Rhine, built in the early 4th c. 400 m N of Kastelen, called Castrum Rauracense.

The exploration of Augusta Rauricorum, instigated by the Humanists of Basel in the 16th c., has recently been intensive: first the public center, then the residential and commercial sections, and finally the E edge of the town (temple enclosures, mansio, amphitheater 2, gates). The site is on an elevated spit not far from the Rhine; it is protected on three sides by steep slopes to the plain, and by tributary streams to E and W. The road from Italy and Gaul met here the military highway to Raetia and the Danube, which ran along the N foot of Kastelen. Here two roads connected the town with its harbor and two bridges were built. The 1st c. bridge, at a rocky ford 200 m wide, was fortified in the 4th c., and remains of its stone piles were visible until the 16th c. The second bridge, a short distance downstream, took advantage of the island called Gwerd. Probably built somewhat later, it was perhaps a temporary timber construction, protected by a small fort on the island.

The town covered a roughly rectangular area (ca. 700 x 400 m) with 52 insulae. The decumanus maximus extended for 800 m on the long axis of the spit, which was 4-7 insulae wide. The insulae averaged 66 by 55 m, but some were up to 85 m long. To the W the town was bordered by a series of temple enclosures and a second amphitheater, while to the E the insulae extend to the edge of the spit. On the S side a road connected the town with the highway network already mentioned. Two stretches of wall (300 and 120 m) have been explored on the S side, where the connecting road passed through it. The walls, built in the late 2d c., were never completed; the gateways, flanked by semicircular towers (6 m wide), are missing. Outside the E gate stood a cylinder-shaped grave monument of the 2d c. (diam. 15 m), which contained a modest incineration burial and votive objects and might be interpreted as a heroon.

Throughout the town the first period is represented by earth and timber structures, later transformed into the stone buildings and architectural complexes described below. The civic center was S of Kastelen hill, and covered the entire width of the spit. It comprised the forum, a temple of Jupiter, a basilica, a curia, a theater and a temple related to it, and a secondary forum with annex and baths. The buildings of the main forum were aligned perpendicular to the decumanus maximus: from W to E the temple of Jupiter, an open square (58 x 33m), paved with red sandstone slabs and surrounded by a portico (6 m wide) and a double row of 10-12 rooms on the long sides. The square was closed off to the E by the basilica and curia.

The Basilica: in period 1 (49 x 22 m) it had three aisles and apsidal ends with two rows of 10 columns between the aisles; in period 2 it was enlarged to a rectangle with an opening onto the forum 10 columns wide. The outer wall on the edge of the spit was supported by a sustaining wall. Attached to this was the curia, three-quarters of a circle in plan (diam. 16 m). In period 1 this building contained a room with two windows and a door opening between eight abutment piers; it carried the wooden floor and benches of the curia. In period 2 this room was filled in with a concrete floor and steps for seats (5 rows, 2 m wide). The curia was connected with the basilica by two doors, on each side of the podium opposite the seats. (Period 1 of both buildings is ca. A.D. 150.) The Temple of Jupiter, standing on a podium (26 x 15 m), was prostyle and peripteral (8 x 6 columns); a wide stairway led up to the podium. The building inscription dates period 2 here to A.D. 145). The temple is surrounded on three sides by porticos and rows of rooms like those in the E part of the forum, added in the 3d c. A.D.

The theater immediately W of the forum lay on a slightly different axis; it was aligned with the temple on Schönbühl hill, with which it formed an architectural and functional unit observed elsewhere in Gaul. The theater had three structural phases: theater, amphitheater, larger theater. Phases I and II had been thought to exclude other, since the presence of the army in A.D. 74-75 would have made transformation into an amphitheater desirable. Recently, however, the possibility of interpreting phase II as a combination of both ("théâtre à arène") has been discussed. Theater I (capacity 7000) took advantage of the sloping terrain for its cavea, with supplementary wooden structures on each side. For the period of the amphitheater no seats have been found on the E side; the arena was 49 by 36 m. Theater III (capacity 8000) had an unusual gap in the stage building, 15 m wide, which could be closed when necessary by wooden screens. This is explained by the visual inclusion of the facade of the temple on Schönbühl and the stairway (18 m wide) leading up to it. This latest phase of the theater is dated to A.D. 150.

The plateau of Schönbühl hill had been a sacred area since the foundation of the town; it had two phases, representing entirely different architectural concepts. In Phase I (to A.D. 150) it was a sanctuary in the Celtic tradition, with at least five rectangular chapels (2-11 m on a side) of Gallo-Roman plan within a triangular enclosure. The chapels were wooden structures with half-timbered walls until A.D. 50, and were then rebuilt in stone. Phase II (ca. A.D. 150) is contemporary with the larger theater: a temple of Roman axial and symmetrical plan (prostyle and peripteral, 9 x 6 columns), on a high podium (ca. 30 x 16 m) approached by a wide flight of steps. The altar stood on a platform. The temple court (96 x 48 m) had porticos on both interior and exterior, and was connected with the theater by a stairway.

Immediately S of Schönbühl a secondary forum occupied one insula. The building (84 x 61 m; peristyle 49 x 31 m) had rooms on three sides and staircases at the corners leading to a second story. The fourth (W) side, with larger, but symmetrically arranged rooms, probably opened on a covered terrace with a belvedere at the edge of the plateau, flanked by stairs descending to the Ergolz valley. In the NE corner a smaller court (45 x 11.5 m), with 11 shops on each long side, connected the main building with the theater area.

Two public baths have been identified. One, near the main forum, was built ca. A.D. 50 and remodeled in the 2d c.; the other built ca. A.D. 70 and rebuilt in the 2d c., was in the center of the residential section. The earlier Frauenbad occupied one insula (ca. 60 x 50 m), and was of the symmetrical Reihenbad type; the plan resembled that of the Stabian bath at Pompeii, with a large

adjacent peristyle court and an open natatio (14.8 x 8.2), suppressed in period 2. The so-called Central bath spread over more than one insula. It was axial and symmetrical (96 x 48 m), without round or apsidal rooms. The caldarium and frigidarium had black and white geometric mosaics.

About 52 insulae have been identified, and ca. 20 with residenital remains have been excavated, three of them completely. The streets were bordered by porticos 3 m wide, and the columns had Tuscan capitals. The streets themselves were 6 m wide (15 m including gutters and porticos). The water mains were embedded in the street paving, and there were several roadside fountains. The original division of an insula (200 x 160 Roman ft.) may have been into two rows of six lots, 80 x 30 feet each, including the portico. Workshops and industrial installations, sometimes as large as 21 by 9 m and usually combined with a residence, have been excavated. Besides the usual trades, scalding tubs and smoke chambers for the processing of meat and sausage have been identified; they were a specialty of Gaul according to Varro (*Rust.* 2.4.10). In the 1st c. A.D. there was an artisans' quarter immediately S of the regular street grid. Later this area was occupied by commercial buildings, warehouses, and a hotel or mansio (ca. 60 x 50 m), with an inner court (30 x 30 m) and storage rooms.

Bordering the town on the SW were three temple precincts and a second amphitheater. The amphitheater, only partly excavated, was built ca. A.D. 150 against the slope above the Ergolz river; it apparently replaced the arena destroyed by the enlargement of the theater in the city. Earth banks between stone retaining walls carried wooden seats (100 x 87 m; arena 48 x 33 m). The sanctuary farthest N, on the Grienmatt, was dedicated to the healing gods according to inscriptions found there. In its latest stage (A.D. 150) it was a peristyled court (132 x 125 m) with several small chapels (not excavated), a main building in the center, and a small bath (27 x 27 m) outside the main gate. The central building, in a separate low enclosure, was rectangular (ca. 18 x 12 m), with a two-storied double facade and a wing on each side. It has been interpreted as a temple, a nymphaeum, or, recently, as a septizonium. The second sanctuary, on Sichelen hill, was a Gallo-Roman temple with portico (6 m on a side), a smaller chapel, and a priests' house in an enclosure 45 x 45 m. The third sanctuary, called Sichelen 2, lies near the W town wall, on the tangent road mentioned above: a temple, annex buildings, and shops in a large irregular enclosure (100 x 100 m). The main temple is of a peculiar type, combining Roman and Gaulish plans. The rectangular and very high cella (10 x 9.3 m) stands on a podium reached by staircases on each of the narrow sides. The cella is surrounded by a two-storied portico (20.5 x 22 m), the lower story of which is a cryptoporticus.

The cemeteries of Augusta Rauricorum have not been completely explored. One on the highway towards Basilia was used from the 1st c. to A.D. 300, and others lie outside the W and E gates. In the latter is the round monument of the 2d c. already mentioned.

Remains of buildings which are still visible include the curia and the sustaining wall of the basilica; theater complex; temple on Schönbühl hill (stairway and sustaining wall); Septizonium on Grienmatt; amphitheater 2; potteries near the E gate; some workshops and basements in the town area. The silver treasure from Castrum Rauracense is in the Augst museum. Adjacent to it stands a full-scale model of a Roman peristyle house with all its equipment.

BIBLIOGRAPHY. R. Laur-Belart, *Führer durch Augusta Raurica* (4th ed. 1966)[MPI] & bibl. to 1966, 178-79; E. Meyer, *Jb. Schweiz. Gesell. f. Urgeschichte* 54 (1968-69) 86-91[PI]; id., *Handbuch der Schweizer Geschichte* 1 (1972) 57-59; H. Lieb, "Zur Zweiten Colonia Raurica," *Chiron* 4 (1974) 415-23. V. VON GONZENBACH

AUGUSTA SUESSIONUM (Soissons) Aisne, France. Map 23. Situated at the juncture of the Crise and the Aisne, the Roman city is recorded in the *Peutinger Table* and the *Antonine Itinerary*.

Despite the discovery of Gallic artifacts in the town, the actual Gallic capital was to the NE at Pommiers, where a large oppidum, still well preserved, stood at the edge of the plateau between the Aisne and the Juvigny. This Iron Age III fortress, one of the largest of the territory of the Suessiones, corresponds to the Noviodunum of the Gallic wars where Caesar received the submission of the Suessiones. Thousands of Gallic fragments have been found on the site, and Gallic necropoleis and settlements from the same period have been identified at Pernant, Marcin et Vaux, Crouy, Ciry, and Chassemy.

The foundation of the Roman city cannot be precisely dated, and the network of roads indicates that the Gallic site of Pommiers was still occupied in the Roman period. Thus Pommiers-Soissons is an example of a new town created by Rome to replace an old Gallic town, just as Vermand was replaced by Saint-Quentin, Bibracte by Autun, Gergovia by Clermont.

The Roman city must have developed around the road from Rheims to Amiens, but we know nothing of the dimensions of the insulae or the nature of the dwellings. Excavations in the 19th c. uncovered remains of a theater 300 m W of the Late Empire wall, and extensive ruins to the N, but no ancient edifice has been preserved. Frequent discoveries of carved blocks prove, however, that the capital of the civitas of the Suessiones must have been as well supplied with monuments as the other cities of Belgic Gaul. Recently some 20 carved blocks were discovered, reused in the wall of the Late Empire; some of them obviously came from a monumental ensemble (cornices, pilasters, modillions). Among remains of carvings Apollo with his lyre is represented. The style and proportions of the figures bear some resemblance to the decorations on large funerary monuments of the Trèves area. The plan of the rampart is not completely known. It was probably built at the end of the 3d c., and protected a 12 ha sector slightly set back from the Aisne. Only the S side is partially visible, at the rue des Minimes near the episcopal palace, and only one tower has been found, at the SW right angle of the wall.

In the 4th c., according to the *Notitia Dignitatum*, Soissons became a center of arms manufacture. And the discovery of a necropolis on the Aisne with Tombs containing weapons seems to indicate the presence of allies, perhaps Laeti. The last representative of Roman authority resided here before his defeat by Clovis. The finds from Soissons are in the Musée Saint Léger.

BIBLIOGRAPHY. F. Vercauteren, *Les civitates de la Belgique Seconde* (1934) 106-51; G. Lobjois, "La nécropole de Pernant," *Celticum* 18 (1967); E. Will, "Informations," *Gallia* 25, 2 (1967) 189-91; J. Desbordes, *Gallia* 31 (1973) 326. P. LEMAN

AUGUSTA TAURINORUM (Torino) Italy. Map 14. A colony near the Po and Dora rivers, founded probably ca. 25 B.C., about the time that the capital of the Salassi (Augusta Praetoria Salussorum) was founded. Both reflect Roman strategic needs and tactical initiatives in the area W of the Po valley. The Romans also needed new centers for veterans and for those incolae whom the Lex Pompeia de Gallia Citeriore had Romanized.

All these sites (often cited as outstanding examples of urban grid planning or of the Augustan fortified city) were presumably brought into being according to a perfectly regulated and predetermined plan of the Roman land surveyors. The plan of the center of the city at Torino is unequivocally Roman in origin, connected with the geometric format of the castra metatio. Enclosed within a powerful defensive square, its area (ca. 800 x 700 m) is quite close to the canonical measurements fixed by Hyginus for the foundation of a fortified city.

The inner city was divided into four sections by the intersection of the cardo and the decumanus; the blocks were further divided by cardines and decumani minores. The perfect unity of the plan is evidenced by the position of the towers at the ends of the principal streets, where four gates, according to tradition, opened to meet the cardo and the principal decumanus.

Remains of the ancient boundaries are still visible within the city, and the walls reveal an open rubble core faced on the inner side with a refined opus incertum of pebbles from the river bed, interrupted by a double course of flat brick. The outer side of the wall had a curtain formed by a false brick facade. The best known section of these walls was for some time the section next to the Chiesa della Consolata. However, other notable remains had come to light in all periods, even beneath the present-day Public Health building and beneath the Academy of Sciences in the vicinity of Via Roma. The bombings of WW II brought to light a long section of the circuit wall in the area closest to the Porta Principalis sinistra (Porta Palatina); it is still the best preserved even though mediaeval defensive structures were built over it.

The Porta Palatina, considered one of the most beautiful examples of an urban gate, has two vaulted openings to permit the passage of vehicles and a smaller one at either side for pedestrians. The architects of this gate knew well how to harmonize the solidity of a defensive structure with the refined elegance of a palace facade. The chronology of this gate is still under discussion, though its unity with the Augustan circuit wall would seem to obviate attribution to the Flavian and Trajanic periods.

The characteristics of the Porta Palatina are repeated in two other gates in the city: the marble Principalis Dextra, destroyed in 1635, recorded in a sketch by Giuliano da Sangallo; and the Porta Decumana, whose remains are still visible in the facade of the Palazzo Madama.

The Roman theater is still partly visible in the area adjacent to the Porta Palatina, partly hidden by a wing of the Palazzo Reale. Built close to the city walls in order to avoid a natural gradient in the land, the theater occupied nearly an entire block. On two sides it was bounded by two streets while the porticus post scaenam was its N boundary, right next to the city walls.

The remains still preserved in the former royal garden show that in a period following the original construction the building was enlarged and the rectangular enclosure replaced by a more traditional front. The new and larger semicircle, with strong pilasters buttressing the walls, exceeded the boundary set by the earlier facade and encroached on the roadbed of the neighboring street. White marble slabs covered the podium which was decorated with false pilasters.

In the Middle Ages, an initial phase of dissolution and disorientation of Roman organization may usually be observed, but in Turin the perfect symmetry of the Roman plan has been continuously preserved.

BIBLIOGRAPHY. C. Promis, *Torino Antica* (1865); G. Bandinelli, *Torino Romana* (1929); P. Barocelli, "Appunti sopra le Mura Romane di cinta di Torino," *Atti della Società Piemontese di Archeologia e Belle Arti* (1933); C. Carducci, "L'Architettura in Piemonte nella antichità," *Atti del X Congresso di Storia dell'Architettura* (1957); S. Finocchi, "I nuovi scavi del Teatro Romano di Torino," *Bollettino della Società Piemontese di Archeologia e Belle Arti* (1962-63) 142ff; id., *BdA* 49.4 (1964).
C. CARDUCCI

AUGUSTA TREVERORUM (Trier) Germany. Map 20. Situated at a widening of the Moselle valley, this site was settled in the pre-Roman period by mixed Celtic-Germanic tribes of the Treveri. The town was the point from which three ancient highways spread out to meet the Rhine at Cologne, Coblenz, and Mainz. Owing to the natural mountain barriers of Hunrück and Eifel, it lay sheltered from surprise attack. During his sojourn in Gaul in 15-13 B.C., Augustus showed particular favor to the town, which subsequently took the name Augusta Treverorum. Under Claudius, it maintained the aspect of an Italian city with the title colonia, an honorific without legal significance; thus one encounters at that period the designation Colonia Augusta Treverorum. At first it remained a purely civilian settlement, divided into rectangular blocks of dwellings (insulae) and covering an area of ca. 81 ha. It was the seat of the imperial fiscal authority for three provinces, Procurator Provinciarum Belgicae et Utriusque Germaniae (*CIL* III, 5215), and because of its advantageous position, it became a supply center for the armies of the Rhine and outposts on the limes.

Trade and industry were able to develop undisturbed; among its manufactures, pottery took the lead. Remains of richly decorated houses and palaces, the amphitheater, the St. Barbara baths, temples, and the large number of mosaic floors, wall paintings, and architectural fragments, as well as innumerable minor archaeological finds, all bear eloquent witness to the town's economic prosperity. Also, native sculptors produced works of outstanding quality.

Only toward the end of the 2d c. A.D. was the city surrounded by a solid fortification wall. The best-preserved and best-known city gate from that period is the Porta Nigra in the N section of the enceinte. The city suffered from the attack of the Franks and Alemanni in 275-76 and its prosperity declined sharply.

With the imperial reforms of Diocletian, the city assumed a new role. In 293, Constantius I made it his imperial seat, a distinction well suited to its situation— protected, yet favorable to trade, and nearly equidistant from the Rhenish border centers of Cologne and Mainz. Constantius immediately expanded his residence, which soon was simply called Treveri or Treveris. Under his son and successor Constantine the Great the imperial palace quarter came into being, to which belong the Late Roman core of the cathedral, the Aula Palatina (the so-called basilica), and the imperial baths, all still visible. To make room for this, some of the existing streets and buildings (for instance, the peristyle villa under the imperial baths and the older palace under the so-called basilica) were obliterated. Near the Roman harbor on the Moselle were extensive warehouses. After a period of political setbacks, the city enjoyed renewed prosperity under Valentinian I (364-75) and his son Gratian (375-83).

The city was the seat not only of an imperial court but also of the Prefecture of Gaul, stretching over W Europe from the Scottish border to the Rhine, S to the S coast of Spain, and including Mauretania Tingitana on

the NW coast of Africa. At its head was the Praefectus Praetorio Galliarum. In addition to many other institutions, the city possessed a university, a mint, workshops for gold- and silversmiths, and state textile mills. The imperial residence exercised a strong attraction: Lactantius, and later Ausonius, came there as imperial tutors at the court.

The Christian community was important also. On the N end of the imperial palace precinct Constantine the Great had built two large churches, parallel to one another. Bishop Leontius of Trier was primate of the Gallic church. Among important churchmen in residence during the 4th and 5th c. were Athanasius, the Church Fathers Jerome and Ambrose, and Bishop Martin of Tours. Toward the end of Roman rule the city had at least eight churches. From the necropoleis over 800 Early Christian inscriptions have been collected so far. A glassworks manufactured souvenirs for Christian pilgrims, and a sculpture workshop turned out sarcophagi carved with stories from Scripture. Christian symbols and inscriptions appear also on coins and on small utensils of all sorts. For about a century, the imperial residence experienced a period of glory as the spiritual and political center of W Europe, and enjoyed the fame of a major capital, reaching its largest extent in the 4th c. A.D. with a population of over 80,000 on ca. 285 ha. About 395 the court moved to Milan, and the prefecture to Arles.

Roman bridges led over the Moselle to the part of the city that lay on its E bank. In 1921 traces were discovered of a bridge on pilings, which may well be identical with the one mentioned by Tacitus (*Hist.* 4.77). It was succeeded by a stone bridge, built a little way upstream from it in the second half of the 2d c. A.D. and still in use, though restored. This bridge opened upon the E-W axis of the street grid, the decumanus maximus, which originally led to the amphitheater but was later blocked by the forum and the imperial baths. This brought into prominence the next E-W street to the S, which led W past the forum and imperial baths and terminated at the St. Barbara baths near the Roman bridge. The latter bath complex, once 240 m long from N to S and approximately 170 m broad, was built ca. mid 2d c. A.D. and remained in use until the end of Roman rule. Of the whole luxuriously equipped series of rooms, today only the SE part is visible in ground plan: frigidarium (incomplete), tepidarium, and caldarium, with adjoining anterooms to the E. From the richly decorated N facade of the frigidarium survives, among other items, a Roman copy of Phidias' Amazon. Subterranean service corridors allowed the business of bathing to proceed smoothly above. On the N side of that same E-W street lay the imperial baths (ca. 260 x 145 m), begun at the start of the 4th c. In sequence E to W was the triple-apsed caldarium—still standing to a height of 19 m—the tepidarium, frigidarium, and palaestra, which was bounded on three sides by colonnades. On both sides of the main axis were anterooms, symmetrically arranged. The W facade was emphasized midway by a weighty portal with three entrances. Subterranean service corridors and drainage channels, partly two-storied, connected the whole complex which was, however, never completed or used. Under Valentinian it was rebuilt and used for other purposes. The W part of the baths has now been excavated and is preserved in such a way that nearly the whole extent of the construction is visible. In the course of these excavations, the remains of overbuilding from the 1st to the 3d c. were found, including a palatial private house with wall paintings and mosaics.

The imperial baths form the S termination of the palace quarter, which stretches N over a natural terrace ca. 700 m long. In the center of this complex is the Constantinian Aula Palatina (so-called basilica), the imperial audience hall. It is a simple but impressive rectangular chamber with a large apse embracing practically all of one end. Its interior length is 67 m, width 27.5 m, height 30 m. In front of its S face there was originally an elongated, narthex-like transverse forehall, also 67 m long and with an apse at the W; thus the Aula originally had a T-shaped ground plan. The immense wall surfaces were articulated on the exterior by high arcades, in which two rows of nine windows each were set; the apse had two rows of four windows each. Beneath each row ran exterior galleries, reached by spiral staircases in the walls. The heated marble-paved floor and the marble-revetted walls, as well as gold-glass mosaics in the seven wall niches, exemplified the richness of the building's interior decoration, while clever exploitation of perspective effects made its imposing dimensions appear even greater. Beneath Constantine's Aula Palatina and built on the same axis are the remains of an older, single-naved apsidal hall, apparently part of the old palace complex of the Procurator Provinciarum Belgicae et Utriusque Germaniae.

The N end of the imperial palace precinct was marked by two Early Christian basilicas, placed parallel to each other with a large baptistery between, the whole complex begun in A.D. 326. The S church (today the Liebfrauenkirche) was soon completed and already in use in 330. Construction of the significantly larger N church, the Early Christian Bishop's church (today the Cathedral), took longer. Both churches have flat E ends with side chambers; that of the N church was extended in the 4th c. and several times remodeled. Over the E part of the foundation of the rectangular Constantinian building, which was destroyed by fire, Gratian had a new rectangular building erected; its walls are preserved today up to 30 m high in some places. In the S church fragments of ceiling painting have come to light. The chancel of the E choir was altered several times and in the plaster of two of the three chancel walls, Christian graffiti were discovered. From the baptistery also remains of a ceiling painting were recovered, geometric in design as in the S church.

Under the Constantinian N building has been found the coffered ceiling of a residential palace, finely painted. The portraits, over life-size and of high artistic quality, depict the mother of Constantine the Great, Flavia Helena, and the empress Fausta. This palace was demolished during Constantine's lifetime, and the double church complex built on its site.

Somewhat W of the parallel churches, the tree-lined cardo maximus led N to the Porta Nigra. This gate consists of the gatehouse and two flanking towers, which project in semicircles to the outside but on the city side are reflected merely in lightly emphasized corner projections. The great blocks of gray sandstone, laid without mortar, were originally bound by iron clamps fastened into the stones with lead. The front sides of the blocks show over 200 quarry marks. The gatehouse encloses a courtyard, which could be shut off on the outer side by two portcullises and on the city side by two gates. The towers had four stories in all, one story projecting above the gatehouse. Their ground floors were lighted only by narrow slots but, as in the gatehouse, the open galleries above have round-arched windows all around. The total length of the Porta Nigra (excluding choir apse) is 35 m, the width of the towers ca. 21.5 m and their height, now complete only in the W tower, ca. 29.5 m. In the Middle Ages the Porta Nigra was used as a church,

the top story of the E tower having been removed and an apse added.

On the W fringes of the city, near the ancient harbor, lay horrea, built in the 4th c. A.D. Two parallel halls, originally two-storied, were separated by a loading alley 12 m wide, forming in toto a rectangle ca. 53 by 70 m.

On the continuation of the decumanus maximus at the E edge of the city lies the amphitheater, built ca. A.D. 100. The E part of its cavea was hollowed from the slope of the hill. The arena (75 x 50 m) has in its center a cross-shaped cellar, cut out of the living rock. In this was the machinery for a platform that could be lowered. Later the city wall was joined to the cavea, so that the N amphitheater entrance is now inside the wall, the S outside it. Consequently, the amphitheater also served as a city gate.

The sacred precinct in the Altbach valley near the imperial baths, like the Temple of Lenus Mars and the tribal Sanctuary of the Treveri on the opposite (E) bank of the Moselle, indicate that the town was a religious and political center for the Treveri. An outstanding archaeological collection is to be found at the Rheinisches Landesmuseum.

BIBLIOGRAPHY. D. Krencker & E. Krüger, *Die Trierer Kaiserthermen* (1929)[PI]; W. Reusch, "Die Aula Palatina in Trier," *Germania* 33 (1955) 180-210[PI]; id., "Die kaiserliche Palastaula," *Basilika-Festschrift* (1956) 11-39[PI]; id., "Die Ausgrabungen im Westteil der Trierer Kaiserthermen (Grabungen 1960-61)," *Germania* 42 (1964) 92-126[PI]; id. "(Grabungen 1962-66)" 51.-52. *RGKomm* (1970-71) 233-82[PI]; K. Kempf, "Trierer Domgrabungen 1943-54," *Neue Ausgrabungen in Deutschland* (1958) 368-79[PI]; id., "Untersuchungen und Beobachtungen am Trierer Dom 1961-63," *Germania* 42 (1964)[PI]; id., Grundrissentwicklung und Baugeschichte des Trierer Domes," *Das Münster* 21 (1968) 1-32[PI]; id. & W. Reusch, *Frühchristliche Zeugnisse* (1965)[PI]; J. Steinhausen, "Das Trierer Land unter der römischen Herrschaft," *Geschichte des Trierer Landes* I (1964) 98-221[MPI]; H. Cüppers, *Die Trierer Römerbrücken* (1969)[MPI]; E. Gose, *Die Porta Nigra in Trier* (1969)[PI]; id., *Der gallo-romische Tempelbezirk im Altbachtal zu Trier* (1972)[MPI]; E. Wightman, *Roman Trier and the Treveri* (1970)[PI]; R. Schindler, *Landesmuseum Trier* (2d ed. 1971)[PI]. W. REUSCH

"AUGUSTA VERMANDUORUM," *see* SAINT-QUENTIN

AUGUSTA VINDELICUM (Augsburg) Bavaria, Germany. Map 20. On the broad spit between Wertach (Virdo) and Lech (Licca). No pre-Roman Celtic settlement seems to have existed there. The oldest Roman finds come from Oberhausen, a W suburb of Augsburg. Thousands of early Roman objects, in part military, were found 2 km NW on the other side of the Wertach and outside the area of the later city. This is supposedly the location of a legion area camp of Augustan times, built after the Alpine campaign of Drusus and Tiberius in 15 B.C. It existed from ca. 10-5 B.C. until A.D. 17 at the latest. The garrison consisted probably of one or two legions. When the camp was given up in early Tiberian times, the area between the two rivers was extensively settled. During this time there was probably at first a garrison in the area of the later provincial capital. Under Claudius at the latest, Augusta became the provincial capital of Raetia. The legal status of Augusta in the 1st c. A.D. is still obscure; it probably corresponded to a civitas (of the Vindelici). The concept colonia (Tac. *Germ.* 41: splendidissima Raetiae provinciae colonia) is therefore probably not used in the strict sense of municipal

law. Only under Hadrian did Augsburg acquire the status of a Roman municipium. At this time the municipal fortifications were probably completed. After the transfer of a legion under Marcus Aurelius to Raetia (Legio III Italica to Castra Regina), Augusta remained the seat of the legatus Augusti pro praetore. The town was damaged extensively during the Allemanic invasions in the 3d c. A.D. After the Diocletian reform, Augusta remained capital of the province Raetia Secunda, and became perhaps, in the 4th c., the seat of the bishop for this province. The fate of the town and of the Roman population in the 5th and 6th c. is largely unknown. Continuity of the Christian cult is confirmed through literary sources. The martyr Afra (died 304) was buried in the Roman necropolis on the Via Claudia near the present Church of SS. Ulrich and Afra. Venantius Fortunatus (A.D. 565) still found active veneration of the saint there.

The supposed legion camp of Augustan times was located W of the Wertach, 2 km N of the town area proper. No traces of the camp have been discovered so far but there have been several thousand finds of bronze, iron, and ceramic, which in part belonged to the equipment of the Roman legionnaires. The 380 coins and Italic terra sigillata suggest dating between 10-5 B.C. and A.D. 17. Recently the existence of a legionary camp has been questioned and different interpretations—though not fully convincing—of the finds have been offered. The extent of the settlement in the area of the Roman town between Wertach and Lech is difficult to judge since the Roman strata lie as deep as 7 m under today's level. Post Roman, mediaeval, and modern buildings were superimposed and caused partial destruction. No buildings above ground exist today. The division of the town does not correspond to the customary schematic insula system. It was evidently oriented along the major roads coming from the S (Via Claudia) and W. Probably those two roads formed the major axes of the decumanus and cardo. The total area of the settlement (ca. 800 m square) was fairly evenly built up by the middle of the 1st c. At this time wooden buildings were predominant and a strong palisade as part of the town's fortifications is said to have existed. These were gradually built up in stone in the late 1st and above all in the 2d c. A.D. (especially under Hadrian), the time of the town's greatest prosperity. To this period perhaps belongs also the town's stone wall, large parts of which can be followed to the W. Here is the only gate that has been discovered, with two rectangular towers. There is no trace of such public buildings as forum, temple, theater, amphitheater. A sizable bath building was found in the N (Georgenstrasse). Parts of presumably public buildings (temple?) were found in the NE (Pettenkoferstrasse). In various places all over town, buildings ascribed to several periods were found, usually living quarters, but also small temples, warehouses, etc. A large house with a peristyle, probably from Hadrian's time, S of the cathedral, had been rebuilt several times. In this vicinity, under the remains of the Church of St. John (pulled down in the 10th c.) is a baptistery which is Early Christian; the exact dating is, however, not known.

In Late Roman times the town was evidently completely resettled, at least Late Roman finds occur in the whole town area. It may be assumed that the fortified district was reduced to the area of the later bishopric, as in other Roman towns in the Gallic-Germanic area.

The existence of Early Christian cult buildings can be assumed although archaeologically not proven. They are supposed to have been in the vicinity of the cathedral near St. Stephan and outside of the town to the S near the Roman necropolis.

The Römische Museum (Dominikanerkirche) contains all Roman and post-Roman finds from Augusta. A number of Roman inscriptions and sculptures are to be seen on the so-called Roman Wall of the Cathedral.

BIBLIOGRAPHY. Oberhausen: G. Ulbert, "Die römische Keramik aus dem Legionslager Augsburg-Oberhausen," *Materialhefte z. Bayer. Vorgeschichte* 14 (1960); K. Kraft, "Zum Legionslager Augsburg-Oberhausen," *Aus Bayerns Frühzeit. Fr. Wagner z. 75. Geburtstag* (1962) 139ff; W. Hubener, "Die röm. Metallfunde von Augsburg-Oberhausen," *Materialhefte & Bayer. Vorgeschichte* 28 (1973).

Augusta Vindelicum: F. Vollmer, *Inscriptiones Baiuariae* (1915) No. 95ff; F. Wagner, "Neue Inschriften aus Raetien," *Ber. RGKomm.* 37-38 (1956-57) No. 21ff; L. Ohlenroth, "Zum Stadtplan der Augusta Vindelicum," *Germania* 32 (1954) 76ff; id., *Bayer. Vorgeschichtsbl.* 21 (1956) 256ff; 22 (1957) 179ff; W. Hübener, "Zum römischen und frühmittelalterlichen Augsburg," *Jahrb. RGZM.* 5 (1958) 154ff; W. Schleiermacher, *Augusta Vindelicum. Germania Romana I. Römerstädte in Deutschland* (1960) 78ff. G. ULBERT

AUGUSTOBONA (Troyes) Aube, France. Map 23. Situated in the marshy Seine valley in Champagne, at a crossroads of ancient highways (to Poitiers, Reims, Langres, Autun, Orléans), Augustobona was the center of the civitas of the Tricasses, who had been separated from the Senones tribe by Augustus. The Early Empire settlement, 80 ha in area, replaced a Gallic one of unknown size. Some traces of the ancient roads have been found, including the SW-NE urban section of the Lyon-Boulogne road that served as the cardo, as well as some cellars and other residential elements (especially in the Chaillouet quarter), some remains of an aqueduct, and several necropoleis. However, no public monument has been found.

Reduced to an area of 16 ha in the Late Empire, from which time on it was known as urbs Tricassium or Tricassae, the city was ringed by a wall with four gates; construction of the wall caused the surrounding areas to be at least partly abandoned. Christianization probably took place under Aurelianus, and the city, situated in Lugdunensis Secunda, was the seat of a bishopric after the reign of Constantine.

BIBLIOGRAPHY. Ptol. 2.8.10; Plin., *HN* 4.107; Amm. Marc. 15.10.11-12; 16.2.6.

Corrard de Bréban, *Mém. Soc. Arch. de l'Aube* (1831-62) passim; H. d'Arbois de Jubainville, *Répertoire archéologique de l'Aube* (1861); A. Blanchet, *Les enceintes romaines de la Gaule* (1907); M. Toussaint, *Répertoire archéologique de l'Aube* (1954) 82-110; J. Scapula, *La Vie en Champagne* (1962, 1964, 1968); E. Frézouls, *Gallia* 25 (1967) 280f; 31 (1973) 406. E. FRÉZOULS

AUGUSTOBRIGA (Talavera la Vieja) Cáceres, Spain. Map 19. A city on the left bank of the Tagus on the road connecting Emerita Augusta and Toletum (*Antonine Itinerary* 438.6). It was the tributary city of Lusitania (Plin. 4.118). It had two temples, one of the Republican period which closely resembled Etruscan temples, with access by a flight of steps; the other was a temple of the Antonine period with eight columns. Both stood in a porticoed plaza; the bases of the columns have been found. The impluvium of an urban villa yielded a large painted krater; a sewer and several portraits from the necropolis are also known. The walls are from the Tetrarchic period and have rectangular towers. Several inscriptions have been found.

BIBLIOGRAPHY. A. García y Bellido, "Excavaciones en Augustobriga (Talavera la Vieja, Cáceres)," *Noticiario Arqueológico Hispánico* 5 (1956-61) 235-37[1].

J. M. BLÁZQUEZ

AUGUSTODUNUM (Autun) Saône-et-Loire, France. Map 23. Chief city of the Aedui, in central Gaul, which derives its name from Augustus' decision to replace Bibracte, the former capital of the Aedui, with a new city. At the time of Sacrovir's revolt in A.D. 21 it was a wealthy town (Tac. *Ann.* 3.43); yet a few dozen years before, Strabo was familiar only with Bibracte. Situated on the great roads linking Lugdunum (Lyon) with the cities of the Senones and the Parisii and the Saône and Loire valleys, between the territories of the Sequani and the Bituriges, Augustodunum was a faithful ally of the Romans and enjoyed great prosperity, as its monuments attest. During the 2d c. A.D. the first Christian communities were set up, outside the walls around St. Pierre-de-Lestrier. The city declined after it was besieged and captured by Tetricus in 269. Constantius Chlorus, a benefactor of the town, took steps to restore its former splendor, as we know from the speeches made by Eumenius between 297 and 311, but these efforts were in vain: it shrank to the area around the high city, which later acquired a surrounding wall, mostly mediaeval.

The city that Augustus founded had a regular plan defined by the two highway axes. One of these, running S-N, linked the Porte de Rome with the present-day Porte d'Arroux (ca. 1200 m long); the E-W road connected the Porte St. André with the Porte St. Andoche. Two of these gateways are well preserved, but only a tower remains of the last one, while the first has been completely destroyed. The E-W decumanus had an angle toward the middle; this was due to the placement of the gates, determined by the roads coming from outside the city but not by the geometric path of the axes. The circuit of the rampart was dictated by the lie of the land, a gentle slope from S to N which gave the city a lozenge-shaped plan.

The fortifications are ca. 6 km long and enclose an area of close to 200 ha. The curtains, 2.5 m thick, were flanked by round towers (4.5-4.6 m). The walls had a filling of rough rubble set in a bed of mortar; the facings consisted of small blocks of sandstone placed in regular, horizontal courses. This meticulous and regular masonry, with no reused material suggests an early date, probably fairly close to the time the city was founded. The wall is all of one date, even at the spot level with the theater, which has sometimes been thought to be a later enlargement. Two of the gateways are among the best-preserved Roman monuments at Autun: the Porte d'Arroux to the N and the Porte St. André to the E. They are very similar in design and dimensions. Each has a central structure flanked by two towers, one of which, at the Porte St. André, is well preserved. The towers on the outside of the rampart are rounded, those on the inside rectangular. The facade of the Porte St. André was 19.18 m long, the Porte d'Arroux 18.55 m. Each gate had four passageways with semicircular vaults, two in the middle for vehicles and one on either side for pedestrians (4.43 and 1.67 m wide at the Porte d'Arroux; 4.1 and 2 m at the Porte St. André). An upper story allowed free passage between the wall walks; it was protected on the outside by an attic of Corinthian columns with blind arcades (total ht.: Porte d'Arroux 16.7 m; Porte St. André 14.6 m). An error was made in restoring the upper gallery of the Porte St. André where an arched passageway was put up; the Porte d'Arroux shows that the gallery was unroofed.

For the most part the gateways are built of regular courses of large blocks: sandstone in the subfoundations and limestone in the upper sections. The use of sandstone

in the upper story of the Porte St. André raises the problem of chronology; however, this was a repair. The date of the gateways has been a matter of dispute: early 4th c. A.D. according to Eumenius; others vary from the Augustan period to that of Vespasian. The evidence, however, places the gateways as a whole in the Augustan period: the plan, type of masonry, the style of the Corinthian capitals, the molding of the bases and pilasters, all confirm the date. Later the upper story of the Porte St. André was rebuilt, at some time before the 3d c. A.D.

The other extant monuments are the theater and the Temple of Janus. The city had both an amphitheater and a theater, attested by the texts and by 16th and 17th c. accounts, but only the theater has survived. It was one of the largest theaters in Gaul, indeed in the Roman world (max. diam. 147.8 m, orchestra 44.8 m). The tiers of seats were arranged in three praecinctiones consisting, from bottom to top, of 16 seats in probably 12 rows; vertically, the cavea was divided into 16 cunei. The eight vomitoria opened on the first praecinctio. Along the top there was probably a portico. For the most part the theater is built of well-cut small blocks faced with a solid mass of mortar, a technique similar to that of the ramparts. In some sections the facing consisted of courses of large blocks. It is certain that theater and amphitheater were included in the Augustan plan of the city. But were they built as early as this period? The building technique undoubtedly belongs to the 1st c. A.D., but the discovery of a coin of Vespasian stuck in the mortar shows that construction was still under way at the end of the century.

There were many religious monuments in the Aeduan city, judging from texts mentioning the temples of Berecyntia, Apollo, and Diana. Eumenius speaks of the Temple of Apollo, and the Capitolium, which was dedicated to Jupiter, Minerva, and Juno, but nothing remains of them. Standing alone in the countryside are the high walls of a building known as the Temple of Janus, one of a series of indigenous temples or fana. The plan is roughly square (16.75 x 16.25 m), but only the S and W cella walls, 23.75 m high, are standing. At a height of 13.3 m on each wall were three windows; the horizontal wooden lintels have left their imprint on the mortar. Over each window was a brick relieving arch. Inside there is a semicircular niche (3.4 m high, 1.8 wide) in the middle of the W wall, flanked by arcades. The S wall is decorated with a central arcade 3 m wide, the rear wall of which has been breached by quarrying, and on each side of the arcade is a niche. On the outside of both walls are niches with a blind arcade, flat in back. The 17th c. writers mention a mosaic floor in the cella, as well as traces of a pedestal or altar. The latter may possibly be confirmed by the recent discovery of the base of a religious statue inside a cella of the same type.

The cella had the usual courtyard around it: the foundations of the colonnade 5.3 m from the cella walls and parallel to them have been found, and two rows of post-holes for beams in the outer facings of the walls. The masonry is mortared rubble, with mortar and uncut blocks inside and a facing of small cut stones laid in regular courses. The great thickness of the walls (2.2 m) and the slight batter resulting from the offset of the walls at a height of 17.25 m suggest that the cella was vaulted over, as was recently found to be the case in the Vesunna Tower at Périgueux. There is no evidence for a building date.

The famous schools of Augustodunum described by Eumenius, then their principal, at the end of the 3d c. A.D. were in the center of the city, near the forum. They probably consisted of huge covered areas with porticos; the rear walls were covered with maps of the Empire.

An effective instrument of the policy of Romanization, education was conspicuous in Autun, and was noted by Tacitus only a few dozen years after the city was founded.

Augustodunum was surrounded by vast necropoleis which have not been completely explored. All that remains of a large funerary monument on the road to Lyon, known as the Pierre de Couard, is the core, consisting of sandstone rubble set in a solid mortar. Excavations in the 19th c., however, determined that the monument consisted of a square subfoundation, 10.5 m high and 22.65 m on a side, topped by a pyramid 22.65 m high, the sides of which had an angle of 63 degrees. The subfoundation facings were covered with masonry of large Prodhun sandstone blocks, but the pyramid was faced with blocks of white limestone. No funerary chamber has been found inside the base.

The Musée Rollin has a collection of stelai from the necropoleis which are an important source of information on ancient trades, worship, and costume. There is also a mosaic bearing a portrait of Anakreon, with some lines from one of the poet's odes.

BIBLIOGRAPHY. H. de Fontenay & A. de Charmasse, *Autun et ses monuments* (1889) still essential; Grenier, *Manuel* v, 1 (1931) 337-44 (ramparts); III, 1 (1958) 234-44 (city); III, 2 (1958) 689-91, 799-803 (amphitheater & theater); P. Wuilleumier, *REA* (1940) 699-706 (theater); gates: H. Kähler, *JdI* 57 (1942) 29[I]; P. M. Duval, *BAntFr* (1950-51) 26f. 81f; *Mem. Soc. Eduenne* passim. R. MARTIN

AUGUSTODURUM (Bayeux) Dept. Calvados, France. Map 23. The modern town takes its name from the Baiocasses, the Gallic people for whom the old town served as a capital. The settlement in fact dates from before the Roman conquest. According to a tradition to which Ausonius refers in his eulogy of Attius Patera (*Comm. Prof. Burdigalensium* 4.7-8), this was once the site of a Druidic cult. More important is the fact that the name Augustodurum kept the Gallic root durum (fortified place), the emperor's name being added at the beginning of the 1st c. The Baiocasses minted coins. Their territory was centered in the valleys of the Seulles and the Aure, and on this latter river the town was built. It may originally have been included in the city of the Viducasses (cf. Araguena) before forming an autonomous city in the second Lugdunensis province: the civitas Baiocassium. Augustodurum is mentioned in the *Peutinger Table*. At the end of the 3d c., the city withdrew inside an enceinte as a defense against the invasions. A garrison of barbarian conscripts occupied it in the next century. Most probably, it was only in the 4th c. that the town was Christianized and became an episcopal see; there is no serious evidence to support the tradition that an early Christian martyr was tortured there under Maximinus. No doubt it was largely thanks to its role as a diocesan and military center that the city survived.

The ancient site is covered by the modern town. Thus our knowledge of it comes essentially from chance discoveries, few of which have been exploited systematically. In the past, as today, the settlement was centered on a slope exposed to the SE and descending to the left bank of the Aure. It spread out freely on the opposite bank, on the lowest slopes of Mt. Phaunus, and along the roads leading toward Noviomagus to the E and Aragenua to the SE. A W road linked Augustodurum with Cotentin. We can safely say that the main street of Bayeux (rues St.-Jean, St.-Martin, St.-Malo, and St.-Patrice) follows the lie of the great thoroughfare that crossed the ancient city from E to W.

The many small objects casually unearthed over the past 150 years have unfortunately not all been recorded;

many are now scattered. Some potsherds and a collection of Gallic and Roman coins have been preserved at the Bibliothèque Municipale de Bayeux; other objects are now in the collections of the Musée Baron-Gerard, Bayeux. The recent chance discovery of amphora sherds has made it possible to locate the site of a shop.

The most important piece of domestic architecture to be traced in the last century is a hypocaust used for heating the baths of a large house; the tile foundations can still be seen underneath the former post office in the rue Laitière. In 1901, fragments of a mosaic are said to have been found in the rue aux-Coqs, no doubt originally belonging to a large house in the E suburb of the town. However, most dwellings were usually built of clay and timber, as they were everywhere at that time in what is now Basse Normandie (cf. Alauna).

Several architectural remains suggest, by their size and ornament, that they belonged to religious edifices. The only such building located with any certainty is the temple that stood almost exactly on the site of the present cathedral, S of which an important series of carved architectural elements was discovered in 1850 (Dépôt Lapidaire de la Cathédrale, Bayeux). Among these, besides pieces of columns and cornices, is a series of large blocks that look as if they had formed part of the piers and arches of doorways or arcades decorated with carved pilasters and friezes. Sometimes, as in the case of human figures, the carving has a very marked relief. Its style has a strong provincial flavor similar to that of the sculptures found at Sées in 1966 (cf. Sagii), which some have suggested date from the first half of the 2d c. We have no information as to the plan of the building to which they belonged.

Similar carved remains were discovered as early as 1796 in the foundations of the castle of Bayeux, then being demolished. Since then, other finds have been made at different times on the castle site, the most notable including stumps of columns; a capital with the bust of a human figure over the corner volute; a statuette of a person sitting on a throne with right-angled armrests; and the head of a woman or young man finely carved of local limestone (Creully stone), found in 1943 (Musée de la Ville, Bayeux; other fragments at the Musée de la Société des Antiquaires de Normandie, Caen). These fragments suggest that there were one or several religious buildings dating from the same time as the one located near the cathedral. However, the site is still undetermined, the carved fragments having been reused as foundations.

Similar to the head referred to above, both in material and style, is a headless statue of a figure reclining in the characteristic pose of the river gods. It is impossible at this time to tell precisely where and how it was discovered (Dépôt Lapidaire de la Cathédrale, Bayeux).

Found at the same time as the carved blocks were a number of milestones in the foundations of the old castle and Porte St.-André. They range in date from Marcus Aurelius to Maximinus and are now in the Section Lapidaire of the Musée de la Ville alongside other milestones from the Bayeux region, the oldest of which dates from the reign of Claudius, the latest from that of Constantine. Together, these stones confirm that Augustodurum was an important road junction under both the High and Low Empires.

All these architectural remains were reused in foundations of fortifications from the time of the invasions. Nevertheless, the presence of the Celtic root durum in the Gallo-Roman name indicates that Augustodurum never quite lost its military importance in the period before the Roman conquest. Be that as it may, the mediaeval castle of Bayeux seems to have taken the place of a castrum at the highest, SW corner of the city wall (now Place Ch. de Gaulle, 150 m W of the cathedral). The town ramparts formed a narrow quadrilateral whose outer perimeter is now largely followed by rue Larcher (to the E), rue des Bouchers (to the N), rue Royale (to the W), rue de la Poterie and rue Tardif (to the S). Sections of the wall can still be seen inside some private gardens; it has been broken up and half leveled off into terraces supporting houses in the rue Bourbesneur and in the rue General-de-Dais. In typical Roman fashion, the facing is of rubble with a horizontal brick course. The framework of these late 3d c. fortifications was preserved in the mediaeval defenses.

Under the Late Empire, the enceinte no doubt did not include the baths in its NE boundaries, near the left bank of the Aure. First recognized in 1760, these baths were excavated in the last century underneath the present Eglise St.-Laurent and its old cemetery. Apparently of 2d c. origin, they seem to have been damaged in the first invasions then restored, possibly under Gallienus. Coins found in the ruins range from Trajan to Gratian. The remains were largely destroyed in the course of their discovery, but certain deep foundations are still standing, a section of which was discovered in 1956. A hypocaust, bath-houses, a cold pool, and drains piping off the water toward the Aure have been identified. The two most remarkable elements of the building were an octagonal hall paved in white marble and a large room with a pool and at one end a colonnaded apse of red marble from Vieux (Aragenua). The veneers were likewise of blue marble. The framework of the building was of rubble faced with small blocks of local limestones and bonded with a double row of bricks; the vaults were of local tufa. Some fragments of sculpture decorating the baths have been uncovered: a helmeted head of Minerva, the torso of a young girl, a bas-relief of a man standing beside a bull (Musée de la Société des Antiquaires de Normandie, Caen). Water for the baths was carried by an aqueduct, a fragment of which was found 150 m to the W (rue Genas-Duhomme), from a spring 1700 m from that spot (route de Port-en-Bessin).

Traces of another aqueduct have been discovered in the E section of the settlement underneath the old Halle aux Grains (corner of rue St.-Jean and rue aux-Coqs). The channel, trapezoidal in section, was coated on the base and side walls with a cement of crushed brick and covered over with large, juxtaposed stone slabs. This aqueduct is thought to have been fed by a spring at Mondaye, 7 km S of Bayeux; however, it may simply have piped the waters of Bellefontaine (in the street of the same name) just a few hundred meters from the discovery site.

No identifiable remains of a theatre or amphitheater have been located at Bayeux.

The ancient necropoleis stretched out beyond the suburbs on the right bank of the Aure, on the slopes of Mt. Phaunus (rue St.-Floscel, Bayeux, and the adjacent area in the commune of St. Vigor-le-Grand); the tombs of the first bishops were venerated at the E exit of the settlement (Eglise St.-Exupère). Funeral urns of stone and glass are preserved at the Musée Baron-Gerard, Bayeux.

BIBLIOGRAPHY. M. Béziers, *Histoire sommaire de la ville de Bayeux* (1773) passim; M. Surville, *Mémoire sur les vestiges des thermes de Bayeux découverts en 1760 et recherchés en 1821* (1822) 46; E. Lambert, "1er Mémoire sur les constructions antiques et les objets découverts en 1821, lors des fouilles exécutées dans l'ancien cimetière de la paroisse St.-Laurent de la ville de Bayeux," *Mem. Soc. Antiq. Ndie* 1 (1824) 17-28[I]; id., "2ème Mémoire sur les thermes antiques de la ville de Bayeux,"

ibid. 29-49[I]; id., "3ème Mémoire sur les thermes antiques de la ville de Bayeux," ibid. 2 (1825) 146-56[I]; id., "Lettre . . . à M. de Caumont sur des débris romains exhumés à Bayeux," ibid. 5 (1829-30) 331-35; id., "Notice sur les thermes antiques de la ville de Bayeux," ibid. 14 (1844) 266-97[PI]; id., "Notice sur l'ancienne nécropole de la cité de Bayeux," ibid. (1847-49) 437-54; F. Pluquet, *Essai historique sur la ville de Bayeux et son arrondissement* (1829) passim; A. de Caumont, "Extrait des rapports faits sur les travaux de la Société . . . ," *Mem. Soc. Ant. Normandie* VI (1831-33) xxxvii-xxxviii; id., *Statistique Monumentale du Calvados* III (1857) 451-59[I]; Abbé Baudard, "Le nom primitif de Bayeux," *Bull. Académie ébroïcienne* (1835) 229-33; C. Bourdon, "Vestiges gallo-romains trouvés sous le planître de la cathédrale de Bayeux," *Bull. Monumental* 17 (1851) 211-14[I]; C. Gervais, *Catalogue et description des objets d'art de l'Antiquité, du Moyen-Age, . . . , exposés au Musée de la Soc. des Antiq. de Ndie* (1864) passim; Doucet, "Lettre à la Soc. des Antiq. de Normandie" (sur les bains privés découverts rue Laitière), *Bull. Soc. Antiq. Ndie* 11 (1881-82) 609-12; Le Lièvre, "Note sur les édifices romains découverts dans la rue Saint-Laurent à Bayeux," ibid. 5 (1900) 81-99; G. Villers, "Le sous-sol bayeusain," *Bull. Soc. Sciences, Arts et Belles-Lettres de Bayeux* 6 (1901) 61-66; R. N. Sauvage, "Les druides de Bayeux," *Rev. de Cherbourg et de la Basse-Normandie* 1 (1906-7) 81-86; id., "La Basse-Normandie gallo-romaine," *Congrès archéologique de France. Caen.* (1908) II 502-15; A. Létienne, *Catalogue de la section lapidaire du Musée Reine Mathilde* (1932) 5-15 (nos. 1-22)[I]; L. Le Mâle & P. Desprairie, "Les thermes de Saint-Laurent de Bayeux," *Bull. Soc. Antiq. de Ndie* 46 (1938) 339-42; A. Grenier, *Manuel d'archéologie gallo-romaine. 4e partie: Les monuments des eaux. I. Aqueducs-Thermes* (1960) 355-61.

<div align="right">J. J. BERTAUX</div>

AUGUSTOMAGUS (Senlis) Oise, France. Map 23. The capital of the civitas of the Silvanectes, it extended along the N bank of the Nonette. Only the amphitheater remains, but the modern city preserves the ring formed by the wall which protected the fortified sector of Augustomagus under the Late Empire.

There appears to have been no Gallic settlement on the site but several neighboring oppida (Gonvieux, Canneville, Le Tremblaye) bear witness to the importance throughout the Iron Age of the path along the left bank of the Oise. And the sanctuary in the forest of Halette N of Senlis, where more than 200 votive sculptures have been found, must have replaced a very ancient cult-site. Despite the absence of large-scale exploration, it has been possible to reconstitute the plan of the Roman city: an area (846 x 564 m) was divided into 36 rectangular insulae intersected by the cardo maximus (a segment of the road from Senlis to Lutetia), and the decumanus maximus (part of the road from Beauvais to Rheims).

It has been suggested that the site of a capitolium can be made out under the cathedral, and a temple of Venus under the church of St. Vincent, but this is hypothetical. Only two parts of the city of the Early Empire have been explored, the amphitheater and the sector of the praetorium.

The amphitheater, to the SW, was excavated 1865-89. Its dimensions are small: the axes of the arena are 42 and 34 m. The E and W entrances, on the long axis, were vaulted; the vaulting has disappeared, but the pilasters which supported it were built of large blocks and can still be seen. A few stone seats are visible behind the parapet preserved in the N part of the cavea. On either side of the main entrances were narrow rooms with barred openings probably used for wild animals. On the N-S axis two recesses (ca. 3 x 2 m) opened into the arena. There were niches with semicircular arches in the walls of these recesses: seven in the S and larger one, three in the N one. The discovery of sculpture remains (torsos of Hercules and Mercury, and of a head of Venus) suggests that these recesses were sanctuaries dedicated to the gods of the theater. As for a platform in the amphitheater too big to be a tribune, it may have been a stage added for theatrical performances. This modification probably dates from the end of the 3d c., while construction of the building itself must have begun in the early 1st c.

In the royal castle at Senlis, S of a large tower built of large blocks and set against the inside face of the wall of the Late Empire Roman fortress, an architectural complex was uncovered at a depth of over 3 m. The main feature is a sill (4 x 60 m), with an alignment of column bases. A bronze socle 1.5 m high, on which a statue of the emperor Claudius must have stood, was also found in this area. The perfectly preserved inscription from the year A.D. 48 rendered homage to Claudius for his creation of the civitas of the Silvanectes at the expense of the civitas of the Suessiones. A bronze fragment representing a semirecumbent river god is more puzzling: perhaps it was part of the ornamentation of Claudius' cuirass. Recently a large funerary stele has been found, representing a man in a toga seated in a niche.

We know nothing of the other monuments of the city of the Early Empire. They were doubtless destroyed and the building materials reused in the fortress, which forms an oval of 840 m protecting 6 ha of the ancient city. The wall was flanked by 28 semicircular towers, 3 m high with two stories. Another wall with one tower, perpendicular to the ring wall, has been found buried in a layer of burned debris inside the royal castle. Some see these remains as the vestiges of an earlier surrounding wall destroyed ca. 355 and then leveled to make way for a more extensive one built under Valentinian.

Artifacts from the excavations, including the socle for the statue of Claudius, are exhibited in the Musée du Haubergier at Senlis.

BIBLIOGRAPHY. Grenier, *Manuel* III (1958) 246-49, 886-90; F. Amanieux, "Présentation des fouilles de Senlis," *Mémoires et Compte-rendus de la Société d'Histoire et d'archéologie de Senlis* (1964-66) LI-LIII; M. Roblin, "Cités ou citadelles? Les enceintes romaidu Bas Empire d'après l'exemple de Senlis," *REA* 67 (1965) 368-91.

<div align="right">P. LEMAN</div>

AUGUSTONEMETUM (Arvernis, Clermont-Ferrand) Puy-de-Dôme, France. Map 23. While Gaul was still independent, an agricultural population lived in the basin where the Tiretaine valley slopes down out of the mountains and opens onto the plain of Limagne. After the Roman conquest the population was urban and settled around a small hill located in the middle of the basin. The town grew until it covered an area of nearly 150 ha and at that time was unwalled.

The crisis of the 3d c. began a period of decline for the town. Depopulated, it was enclosed within narrow, fortified walls, and occupied only the N third of the hilltop (ca. 2.5-3 ha). It opened to the outside by five gates. No remains are left.

Architectural fragments found at the summit of the hill (Place de la Victoire) suggest that there were buildings at that spot, but they have been completely destroyed. Ruins of a monument of large size to the W of the town are described by Gregory of Tours (*Hist. Franc.*, I, 32) as a temple, to which he gave the name of "Vasso," of Jaude (Vasso Galate). He was probably correct in calling it a temple. The only visible

remains of the monument is a wall of ashlar masonry with brick bonding courses and semicircular buttresses (the "Mur des Sarrasins" on the Rue Rameau). This was the N side of a rectangular building erected on a thick beton platform. A mineral water spring 600 m to the SW at Les Roches was frequented by a popular cult. Several thousand wooden votive offerings, carved and uncarved, have been found there. Some 1700 m SW of the central hill on the E slope of Montaudou hill, a wall of ashlar masonry, now 60 m long, may have been the facade wall of a theater. It too is called Mur des Sarrasins.

The town obtained its water ca. 4 km away in the valley of Villars, where sections of an underground aqueduct have been noticed on several occasions. On its exit from this narrow valley, the aqueduct rises to the surface (it is mentioned in the Life of Saint Stremonius, in the 9th or 10th c.). It carried water to the summit of the hillock, from which it was distributed by underground channels. Sections of these channels are preserved under the Place de la Victoire.

BIBLIOGRAPHY. A. Tardieu, *Hist. de la ville de Clermont-Ferrand*, 2 vols. in-fol. (1870-72); A. Audollent, "Clermont gallo-romain," *Faculté des lettres de Clermont-Ferrand, Mélanges littéraires publiés à l'occasion du centenaire de sa création* (1910) 103-55; E. Desforges et al., *Nouvelles recherches sur les origines de Clermont-Ferrand* (1970). P. FOURNIER

AUGUSTORITUM LEMOVICUM (Limoges) Haute-Vienne, France. Map 23.

Capital of one of the largest cities of Roman Gaul, the Civitas Lemovicum, in the province of Aquitania. In the Gallic period an oppidum, hypothetically situated on the Puy Saint-Étienne, dominated a ford or ritos on the Vienne; hence the name given to the Augustan city. The first Gallo-Roman city was built on the right bank of the Vienne, on a hillside facing S. Its buildings were erected on terraced levels and aligned on a grid plan.

The cardo ran NW with a 35° decline; it is represented by the axis of the modern Rue Saint-Martial and Rue de l'Hôpital. A bridge spanned the river at the beginning of the cardo. It was destroyed in 1182 and soon rebuilt on the ancient piles; this is the present Pont Saint-Martial. The route to Périgueux and Cahors ran S from the bridge, and the Agrippan Road from Lyon to Saintes cut across the city from E to W. Whether the forum was near what is now the Hôtel de Ville is still conjectural.

In Augustan times a theater stood on the lower part of the hillside not far from the river, E of the cardo. Its seats took advantage of the natural slope and faced S. No visible traces of this monument remain.

In the 2d c., its period of greatest expansion, the settlement spread out over a roughly equilateral triangle 1500 m on each side; its base was formed by the Vienne, from Le Naveix to La Roche au Go, and its apex, to the NW, was the amphitheater, on a point overlooking the town where the Jardin d'Orsay is today. The amphitheater (138 x 116 m) was built about the beginning of the 2d c. of a core of mortared rubble faced with small blocks; its long axis was aligned with the decumani. Its ruins were partially uncovered in 1967. A 1st-2d c. cremation cemetery, which marks the outer limit of the city in this direction, is 200 m away.

A number of underground aqueducts brought the city its water. The Aigoulène aqueduct, from Corgnac, is still in use. Remains of the aqueduct network are still standing, hollowed out of tufa or built of masonry.

Traces of fire and subsequent scattered rebuilding testify to the partial destruction of the city at the time of the invasion of Aquitania, 275-276. No coins in a hoard of over 7000 denarii discovered in 1926 are later than the time of Postumus. After this invasion the core of the settlement was moved to the E, on the Puy Saint-Etienne, inside a smaller, fortified city. The civitas of the late 3d c. was to keep its name throughout the Middle Ages. Its walls were extended in a circle of ca. 1300 m, protecting an area of ca. 12 ha.

Christianity came to Augustoritum in the time of St. Martial, one of the seven bishops sent from Rome to evangelize Gaul in the 3d c. His original tomb was discovered when the old Abbey of Saint-Martial was excavated in 1960. A simple sarcophagus of smooth granite, it was found on the site of an Early Christian cemetery on the NE edge of the city. After the religious peace of Constantine's reign, the cathedral church was built at the main crossroads of the civitas. In the 5th c. it was consecrated to St. Étienne. A find of 200 quinarii of Honorius' reign at the site of the amphitheater confirms that the Vandals passed through the area (presumably causing a fresh wave of destruction) at the very beginning of the 5th c.

The municipal museum of Limoges has some local antiquities, including the wall paintings from a villa of the second half of the 1st c., discovered in 1962 in the Boulevard Gambetta.

BIBLIOGRAPHY. A. Grenier, *Manuel d'archéologie gallo-romaine* III (1958) 250-52, 675-76MPI; M.-M. Gauthier, "Première campagne de fouilles dans le 'Sepulcre' de Saint-Martial de Limoges," *CahArch* 12 (1962) 205-48MPI; J. Perrier, "Carte archéologique de la Gaule romaine," fasc. 14, "département de la Haute-Vienne" (1964)MPI. J. PERRIER

AUJA EL-HAFIR, *see* NESSANA

AULIS Boiotia, Greece. Map 11.

Situated on the Boiotian shore of the Euripos, between the bay of Mikro Vathy to the N and the bay and village of Vathy to the S. According to legend it was here that the Greek fleet gathered before setting sail for Troy and awaited the favorable winds that Agamemnon obtained by sacrificing his daughter Iphigenia to Artemis (Eur., *Iphigeneia at Aulis*). Remains of a Mycenaean settlement have been located on the rocky Yeladhovouni promontory separating the two bays. Never a city, Aulis was part of the Theban districts up to 387 B.C., then of the territory of Tanagra. Agelisaus, king of Sparta, the "new Agamemnon," sacrificed here before setting off for Asia in 397 B.C. Aulis depended for its livelihood on the sanctuary, its potters' workshops, and fishing.

The Sanctuary of Artemis Aulideia was excavated from 1955 to 1961 by I. Threpsiadis. Open to the SE, the temple is built on the oblong archaic plan (31 x 9.70 m). In front of the two columns in antis of the 5th c. temple a prostoon of four Doric columns was added in the Hellenistic period. Inside the sekos were two rows of four columns; in the rear a double door, whose marble threshold has been preserved, led to the adyton; two statues of Artemis and Apollo flanked the doorway, and in front of the N statue was a round altar for libations, with a drain. A large base found in the sekos may have been used to support the 1000-year-old plane tree mentioned by Pausanias (9.19.7). Inside the adyton, which measured 3.70 x 7.55 m, was the offering table, part of which has been recovered, along with a triangular tripod base and two round altars. Underneath the pronaos were found the remains of a circular building assumed to date from the 8th c. B.C. In Roman times all the columns were replaced; later the prostoon was incorporated into some small thermae covering part of the sekos.

In front of the temple a square fountain was excavated

which measured 1.8 m square inside; six steps led down inside it. Close by are the remains of an altar. SW of the temple were found two or three potters' establishments, with a store of clay and a kiln. A large hostelry for pilgrims was immediately to the S.

BIBLIOGRAPHY. I. Threpsiadis in *Praktika* (1956) 94-104; in *Ergon* (1956-61); "Chronique des Fouilles," *BCH* (1956-62); E. Kirsten & W. Kraiker, *Griechenlandkunde*[5] (1967) 183-84[P]; N. Papahadjis, *Pausaniou Hellados Periegesis* v (1969) 109-16[MPI]; R. Hope Simpson & J. F. Lazenby, *The Catalogue of the Ships in Homer's Iliad* (1970) 19; S. C. Bakhuizen, *Salganeus and the Fortifications on its Mountains* (1970) 96-100, 152-56[MI].
P. ROESCH

AUMES Canton of Montagnac, Hérault, France. Map 23. Pre-Roman oppidum of the Pioch Balat or the Télégraphe on a hill on the left bank of the Hérault, across from Pézenas and in the communes of Aumes and Montagnac. The few soundings which have been made of this large and important acropolis, which stands out in the valley of the Hérault—a valley which also gives access to the Cévennes and the Causses—show it to have been occupied from the end of Iron Age I to the Roman period.

On the upper plateau a structure built of large blocks is generally interpreted as a sanctuary but could have been a funerary monument. The forepart of a pre-Roman limestone lion has been found in a pit in the oppidum. A votive capital bearing a Gallo-Greek pre-Roman inscription apparently dedicated to a water divinity has also been found. The site, abandoned during the Roman period, was again occupied in the Early Christian period. A large spring runs from the foot of the hill, near the chapel of St-Martin-de-Graves. Examination of the site, which owing to its privileged position near the ancient trade routes became one of the principal population centers of the region very early, would be well worthwhile, for recent research has shown that this oppidum was located on an ethnic, cultural, linguistic, and administrative boundary.

BIBLIOGRAPHY. "Informations," *Gallia* 8 (1950) 112; M. Clavel, *Béziers et son territoire dans l'Antiquité* (1970).
G. BARRUOL

AURINIA (Saturnia) Tuscany, Italy. Map 16. A center in the province of Grosseto on a limestone plateau on the left bank of the Albegna, near its confluence with the Stellata. After the fall of Caletra it apparently became the principal city of the Ager Caletranus, a territory that extended along the Albegna valley among the territories of Sovana, Heba, and Roselle. Sources that cite it are: Pliny (*HN* 3.8), Dionysios of Halikarnassos (*Arch.* 1,20), Livy (*Hist.* 39.55); Ptolemy (*Geogr.* 3.1.43), Festus (s.v. "praefectura"). It is also recorded as a station on the Via Clodia (*Peutinger Table* and Anon. Ravenna).

Excavations made at the end of the last century attest to the continuity of life in this inland Etruscan center from the Villanovan to the Roman periods, with an interruption from the 5th to the 3d-2d c. B.C., as is the case in most Etruscan centers.

In 280 B.C. Saturnia passed under Roman domination as a praefectura with a military praefectus sent from Rome, and in 183 B.C. it was declared a Roman colony by the triumvirate of Q. Fabius Labeo, C. Afranius Stellius, and T. Sempronius Graccus. As a Roman colony it was ascribed to the tribus Sabatina and is recorded as saturniana colonia by Ptolemy and by inscriptions from the 2d c. of the Empire (*CIL* vi, 2404a; x, 4832).

Little remains of the Etruscan city save a few sections of the encircling wall, the longest and best-preserved being on the S near the Porta Romana. From the Roman city remain sections of the city walls, which must have had four gates aligned with the cardo and the decumanus, corresponding to the ancient roads that led from the valleys of the Albegna and the Stellata. Also preserved are numerous remains of public and private buildings constructed in opus reticulatum. Among these are the remains of a castellum aquarium in the locality called Le Murella, and of a public building with engaged columns in travertine. Vestiges of the Roman age include a large bath building in the locality called Bagno di Saturnia, a building at Pratogrande whose ruins are under those of a mediaeval building called the Castellaccio, and stretches of road paved with limestone blocks.

Various necropoleis surround the city. In the necropolis at Sede di Carlo, NE of the city, are cinerary urns mixed with contemporary inhumation burials in pit tombs. The latter, from the late Villanovan age, are more numerous, though they include rather meager fittings. At Pancotta and Pratogrande there are tumulus graves with inhumation burials. A unique type of tomb occurs at both Campo delle Caldane and Pian di Palma. These are small chambered tombs constructed of rough slabs of travertine positioned upright and covered by horizontal blocks. On the exterior are piled more slabs, and the whole is covered by a tumulus of earth. The material they contain dates to the late 7th-early 6th c. B.C. There are hypogeum tombs with a single cell and inclined dromos cut into the rock in the necropoleis at Costone degli Sterpeti and of Pian di Palma. Among these is the tomb called the Pellegrina, dating between the 6th and 5th c. B.C. Remains of jars and tiles, presumably from covered tombs, have been found in Porcareccia and Podere S. Bernardino. Much of the material found in excavations at the turn of the century has been lost, and the small part remaining is preserved in the Museo Archeologico in Florence. In Saturnia there is a notable private collection, the Collezione Ciacci.

BIBLIOGRAPHY. R. Bianci Bandinelli, Carta Archeologica id., *Mon. Ant. Lincei* 30 (1932) 209ff; A. Minto, *Mon. Ant. Lincei* 30 (1932) 585ff; *EAA* 7 (1966) 78-79 (A. Talocchini).
A. TALOCCHINI

AUSA (Vich) Barcelona, Spain. Map 19. Town in Tarraconensis W of Gerona and 50 km N of Barcelona, mentioned by Pliny (*HN* 22-23) and Ptolemy (2.6.69). The town takes its name from a tribe of the Ausetani, who held sway as far as Gerunda. Under Amusicus, Ausa revolted against the Romans but was subdued after a 30-day winter siege by Cneus Cornelius Scipio. In the 2d c. B.C. the town minted many coins based on the Roman system with the Iberian legend AUSESCEN and, according to Pliny, had Latin rights. A small prostyle hexastyle Corinthian temple survives from the Imperial age; the cella (10.1 x 12.1 m) is built in opus emplecton lined with small ashlar.

BIBLIOGRAPHY. J. Gudiol, *L'Ausa romana* (1907); J. Puig i Cadafalch, *L'Arquitectura romana a Catalunya* (1934) 107ff.
J. MALUQUER DE MOTES

AUSCULUM, *see* ASCULUM

AUTERIVE Haute-Garonne, France. Map 23. A Gallo-Roman establishment has been found and excavated 1 km S of Auterive, on the left bank of the Ariège, at the locality named Saint-Orens or Le Purgatoire. It dates from the 1st c. B.C. to the 1st c. A.D. No doubt part of the dependencies of a villa, it seems to have owed its existence to navigation along the Ariège and to the trade in wine and other luxury products from Italy. Thus, dec-

orated Arretine vases were imported during the Augustan period. The site provides good evidence of the gradual penetration of Roman customs and fashions into a primitive Gallic context.

BIBLIOGRAPHY. Abbé Carrière, *Mém. de la Soc. arch. du Midi de la France* VIII (1861-65) 305-16, 344-58; M. Labrousse in *Gallia* 9 (1951) 127-28; 20 (1962) 556; 22 (1964) 435-37; 24 (1966) 418; 26 (1968) 523; 28 (1970) 403-4; id., *Mélanges André Piganiol* (1966) 533-46; L. Latour, "Les fouilles gallo-romaines d'Auterive (Haute-Garonne): étude des couches anciennes," *Mém. de la Soc. arch. du Midi de la France* 35 (1970) 9-69.
 M. LABROUSSE

AUTESSIODURUM (Auxerre) Yonne, France. Map 23. Located next to the Yonne on its left bank, the ancient town seems to have had little importance. Julius Caesar makes no mention of it in his *Commentaries*. Autessiodurum grew only after the Conquest. Owing to its location it became a sort of crossroads where important roads met: from Sens and Lutetia, from Augustodunum (Autun; the road of Agrippa), from Interannum (Entrains), from Augustobona (Troyes). The town seems first to have been located along the sides of the channel of the Vallan and the Yonne. The substructure of a temple dedicated to Apollo has been found in the vicinity of the Fontaine Ronde. A statue of a horseman has been found nearer the Yonne, as well as a column and a capital on which Mercury, Mars, and Apollo can be recognized. Finally, two flat silver dishes (found in 1830) attest that Autessiodurum was a municipality. Since the town continued to grow on the same site, the upper part of the Gallo-Roman remains have disappeared. The real Gallo-Roman city was located on a hill dominating the Yonne.

The substructures of a rampart furnished with towers have been found at that spot. It is still poorly dated (end of the 3d or beginning of the 4th c.). It is a thick and extremely resistant construction. In general it stands on architectural or carved blocks, some of which date to the 3d c.: pieces of stelae with pictures of individuals or decorative fragments of large size. All of the Gallo-Roman remains are on view at the museum in Saint-Germain abbey.

BIBLIOGRAPHY. M. Quantin, *Répertoire arch. du département de l'Yonne* (1868); Quantin & Ricque, *Catalogue raisonné du musée d'Auxerre: Monuments lapidaires* (1884) i; R. Louis, *Les Eglises d'Auxerre* (1952) i; id. "Rapport sur les fouilles de R. Kapps," *Gallia* 12.2 (1954) i. R. KAPPS

AUTRICUM (Chartres) Dept. Eure-et-Loir, France. Map 23. Located 96 km SW of Paris on the Eure (Autura) river, Autricum was the capital of the Carnutes (Ptol. 2.8.10), who at first resisted the Romans (as shown in the death of Tasgetios) in the massacre of some Roman merchants and a Roman officer at Cenabum (Orléans) and in their sending 12,000 men to relieve Alesia, but they were submissive after the defeat of Vercingetorix. (Caes. *BGall.* 5.25; 6.3; 7.3, 75; 8.4, 31, 38, etc.) Autricum became one of the six allied Lyonese cities. Governed by a legatus Augusti pro praetore assisted by a procurator Augusti, and with a full complement of judges, Autricum suffered the counterblows of the great barbarian invasions (A.D. 275); it was taken in 742 by the Norman Thierry.

Very little is known of the Carnutian settlement (a hammer of polished stone and Late Iron Age pottery) and not very much was known except by chance finds, at least until 1962, of the Gallo-Roman city. This city occupied the end of the plain of Beauce and the slopes

which go down to the Eure; suburbs and cemeteries surround it at the NE, at the SE and at the S, bordering the Roman routes which connect it to Dreux, Sens, and Orléans, Blois, Le Mans, and Verneuil. The plan of the city seems to be preserved in the orientation and spacing of several present-day streets. Their direction N-NE–S-SW would seem confirmed by the discovery in 1968, at the foot of the Chapel Saint-Piat, of a white marble base of what perhaps was a temple, and ca. 150 m to the N of a building of small stones with a series of square rooms and a doorway opening on a court (perhaps a forum with small shops). This orientation is the same as that of walls observed here and there in the same quarter, of three walls discovered in 1962 under the ancient Chapel Saint-Serge, or the well-known walls of the crypt of the cathedral thought mistakenly to be part of the Roman enclosing wall. This latter has been the subject of different hypotheses; for example, with a trapezoidal plan, the wall would have surrounded the whole of the old quarter of the present city, but the discovery of large exterior walls to the SE and SW does not substantiate this layout.

Among recent discoveries, the most interesting is that in 1965 to the E in the quarter of Saint-André of an amphitheater (unfortunately reduced to the foundations: three concentric walls joined by radiating ones). If the sustaining walls attached to the slope mark the outline of the cavea, the ellipse would have been about 117.5 x 102.5 m; the street, Cloître Saint-André, reproduces more or less the outline of the amphitheater. It seems that there was no scaena; one can then assume a separate theater elsewhere.

Numerous remains have been found accidentally (aqueducts, drains, hypocausts to the S and SW, kilns, columns and capitals, cornices, mosaics with figures, some funerary sculpture, coins, a very few inscriptions), but the non-systematic nature of the excavations makes any interpretation of them hazardous. Autricum needs further excavation.

The Musée Municipal preserves many of the finds. In addition there are archaeological storehouses at the Société Archéologique and at the cellar of Loëns.

BIBLIOGRAPHY. "Procès-Verbaux," *Bull. Soc. Arch. d'Eure-&-Loir* (1856-1935) passim; G. Boisvillette, *Statistique arch. d'E-&-L.* (1864); P. Buisson & P. Bellier de la Chavignerie, *Tableau de la Ville de Ch. en 1750* (1896); L. Bonnard, in *REA* 15 (1913) 60-72; C. Challine, *Recherches sur Ch.* (1918); "Mémoires," *Bull. Soc. Arch. d'E.-&-L.* 23 (1968) 260-67; 21 (1957-61) 279-88; "Chroniques," ibid. 2 (1966) 18-39; Report in *Gallia* 26 (1968) 321-24. P. COURBIN

AUTUN, see AUGUSTODUNUM

AUVE Marne, France. Map 23. A Gallo-Roman villa with broken-down walls W of Sainte-Menehould in Champagne. It has been partly explored, and consists of a series of central rooms between porticos to the E and W. Pits and well-cut post-holes found inside the rooms and in some cases underneath the foundations are evidence of a settlement dating from Iron Age III. Outside the villa there was a defensive trench which also had a stockade and no doubt protected a settlement, probably of the Late Bronze Age.

BIBLIOGRAPHY. E. Frézouls, *Gallia* 25 (1967) 284[I]; 27 (1969) 301-3[PI]. E. FRÉZOULS

AUXERRE, see AUTESSIODURUM

AUXIMUM (Osimo) Italy. Map 16. Near the Adriatic coast 19 km S of Ancona and ca. 242 km N-NE of Rome, on a strong and isolated hill (457 m above sea level) that

dominates the valley of the Musone, the approaches to S Picenum, and the roads to Rome. The area has been continuously inhabited since the Stone Age. Senonese Gauls penetrated it in the 4th c. B.C. despite tough Picene resistance.

Gallic necropoleis have been found W of Osimo on the road to Iesi (Aesis). They were excavated just before WW I, and the wealth of objects unearthed now constitutes one of the glories of the Museo Nazionale delle Marche in Ancona: they include vitreous vases, objects in amber, ivory, and bronze, numerous imports from Magna Graecia and Etruria, and splendid specimens of Gallic jewelry, some of it in gold.

Early in the 3d c. B.C. the Romans helped the Picenes to expel the Senones, only to make themselves the masters of the whole region shortly afterwards (268 B.C.). Later they established a Roman colony at Auximum, exactly when is uncertain: Velleius Paterculus (1.15.3) assigns the colony to 157 B.C., but he is almost certainly wrong. The foundation may belong to 128 B.C. The town has always been of importance. In the civil war of 49 B.C. it quickly sided with Julius Caesar against Pompey the Great, despite the latter's large estates and considerable influence in the neighborhood: the earliest inscription found at Auximum, now in the Palazzo Comunale, names Pompey as the town's patron is 52 B.C. (cf. also Plut. Vit. Pomp. 6.3). It became a bishopric in the 4th c. and changed hands more than once in the Gothic wars (535-553).

The town walls, which apparently go back to the 2d c. B.C., are the principal Roman monument at Auximum. They survive only in part but, as they evidently followed the contours of the hill on which the town is perched, the entire enceinte can be conjectured with some probability. Not a particularly large town-site (200-300 x 600-700 m), the total circuit of the walls may have been ca. 1700 m and the enclosed area something less than 16 ha. The best surviving stretch of the walls is under the convent of S. Francesco on the N side of the town, a splendid example, 200 m in length, of isodomic Roman opus quadratum. The rectangular blocks (1-1.6 m x 40-45 cm) are of a hard local tufa. Twenty courses are still in situ, very methodically laid, the blocks progressively smaller as they rise. The walls, over 2 m thick at the bottom, attained a height of 10 m or more.

Conforming to the Italic pattern, the town had three gates: to the NW, Porta Vetus Auximum, for the road to Ancona; to the S, Porta Musone, for the roads to Aesis and Cingulum; to the E, the gate for the road to Potentia probably stood at the Largo S. Agostino.

A postern near the NE corner of the town leads to the imposing ruins of the Fonte Magna, a structure of apsidal appearance implausibly assigned to Pompey the Great (whence its name): together with a nearby cistern and some connecting underground tunnels (of Augustan date ?) it formed part of a complex that, according to Procopius (Goth. 2.23-28), provided the town's water supply.

The streets at the modern town center partly preserve the Roman plan, Corso Mazzini corresponding to the decumanus maximus and Via del Sacramento to the cardo maximus. The Arx, in the Gomero or NW quarter of Osimo, had its own wall of opus quadratum, remains of which can still be seen in the bishop's palace; it also had a concrete building, of rectangular shape (4 x 9 m) but unknown purpose. The forum was farther W at the Piazza del Comune, where numerous finds have been made, starting in 1487; no Roman buildings, however, remain, at least above ground. The Capitolium may have stood where the Cathedral now is: local tradition places a Temple of Jupiter there. Vaulted and circular remains, in Piazza Don Minzoni and Via S. Francesco respectively, perhaps belonged to baths. Private houses have not been found although mosaic pavements have occasionally come to light.

Ever since 1741 antiquities have been housed for the most part in the atrium, portico, and cortile of the Palazzo Comunale. They include numerous inscriptions and architectural fragments, but above all an important and representative collection of Roman sculpture, mostly of the Early Empire. Its chief pieces are: ten headless marble statues, slightly larger than life size, said to have once adorned the forum; a limestone bas relief depicting the town magistrates and a lictor; and a well-preserved and remarkably realistic head of an old man of the 1st c. B.C. There are antiquities also in the Palazzo Balleani-Baldeschi, in the Villa Barbalarga outside the Porta Musone, and in the Cathedral crypt (the usual Roman columns and Early Christian sarcophagi).

Traces of Roman centuriation have been found in the neighboring valley of the Musone.

BIBLIOGRAPHY. H. Nissen, Italische Landeskunde (1902) II, 418f; G. V. Gentili, Auximum (= Ser. I, Vol. XV in the Italia Romana: Municipi e Colonie series), (1955) with good bibliographyMPI; C. Grillantini, La Storia di Osimo (1957); E. T. Salmon, Roman Colonization under the Republic (1970) 112-16. E. T. SALMON

AVALLON, see ABALLO

AVARICUM (Bourges) Cher, France. Map 23. The chief city of the Bituriges Urbi at the time of the Gallic wars, Avaricum gets its name from the Avara river (modern Yèvre). The city stood on a hill 25 m high and covering 26 ha at the heart of a complicated network of waterways: five rivers, the Yèvre, Yévrette, Voiselle, Moulon, and Auron meet here. It was surrounded by wide stretches of marshlands, except to the SE, where a sort of isthmus, 2 to 500 m wide today and no doubt far narrower in antiquity, connected the hill with terra firma. Avaricum was reputed to be the finest city in Gaul, and its inhabitants refused to destroy it when Caesar invaded the region in March 52 B.C. They put their faith in their fortifications, a murus gallicus of mixed stones and beams similar to that found in the same tribe's territory at Chateaumeillant (Mediolanum Biturigum); this type of fortification seems to have become widespread at the beginning of the 1st c. B.C. Caesar set up camp on the isthmus, on the site of the modern Place Séraucourt, 300 m S of the rampart. Vercingetorix took up his first position 25.6 km NE of Avaricum, on the Sancerre road; later he moved closer to the besieged Gauls, easily communicating with them across the marshes. After 27 days of siege the city was taken and destroyed. No trace has been found of it and we know nothing about its monuments, only that there was a public square in the city center, which Caesar calls a forum.

The history of Avaricum in the Roman period may be traced stratigraphically thanks to excavations carried out in 1964-65 near the surrounding wall built in the Late Empire (see below) and around the site of the old church of Notre Dame de Sales. Inside the wall five superimposed building strata were uncovered, ranging from the Augustan period to the late 3d c. The buildings were probably private houses, some of which retain their painted walls.

During the Middle Empire the city was on the hill where the Gallic town stood. Even today this section of the city has extremely steep streets oriented more or less according to the points of the compass. The Rue Moyenne, probably the old cardo maximus, has remained the principal artery; the Rue Porte Jaune runs parallel

to it on the E, and these two cardines are intersected by three decumani, the farthest N of which corresponds to the present Rue Coursalon.

In the basements of buildings between the Rue Moyenne and the cathedral can be seen the remains of a large temple of the Antonine period, including fluted Tuscan columns, elements of the stylobates and podium, and fragments of the entablature (architraves, friezes, and cornices).

In the 1st c. the W side of the hill underwent some large-scale town planning at the point where the Argentomagus road, linking the Caesarodunum-Cabillonum route to that from Limonum to Lugdunum, entered the city. A N-S wall with a monumental gateway encircled the foot of the hill. The gate opened onto a paved vestibule from which steps and ramps led to the upper city.

In the 2d c. the same area was redesigned on an even more monumental scale. A series of alternately square and semicircular vaulted chambers was built to support the hillside; this complex, separated from the hill by a drainage ditch 0.6 m wide and 5 m deep, was erected in front of the 1st c. buildings, concealing them and making them unusable. The rooms are built of a core of mortared rubble faced with small stones and banded with brick. The facade consisted of arcades built of large blocks of stone, supported by piers with engaged Tuscan columns as well as fluted and cabled columns. This facade probably extended on either side of a monumental fountain cut in the rock, a rectangular basin set in the middle of a paved area with cippi standing on it. The arrangement follows the formulas for building on hills that had been perfected in the 2d c. B.C., notably at Praeneste, and used in Imperial times, for instance at Carthage.

These buildings were in turn ringed by the Late Empire rampart, and the whole complex served as a basis for the palace of Duke Jean de Berry. When the cellars of this palace, underneath some modern houses, were explored in 1860 the remains described above, which are still accessible today, were uncovered.

Avaricum's amphitheater stood NW of the city on the site of the present-day Place de la Nation, which has very nearly retained the elliptical plan. It was still sufficiently well preserved at the beginning of the 16th c. to be used for theatrical productions.

The course of an aqueduct has also been located: it came into the city from the E, N of the cathedral, and continued up to the city center.

Avaricum's prosperity in the 2d and 3d c. is attested by funerary monuments. An entablature fragment from a large circular mausoleum discovered near the Porte de Lyon is now in the museum; it had been reused in the lowest layers of the rampart, and has a frieze with carvings of tritons above a richly decorated cornice. A number of funerary cippi have been unearthed at various points in the city. The earliest ones are without sculptural decoration. From the second half of the 2d c. on, rectangular cippi appear, made in imitation of a mausoleum with a gabled roof with acroteria. On the front a niche framed by piers with carved foliage holds the image of the deceased; his epitaph is engraved on the archivolt. Some of these carved figures, either full- or half-length, are good portraits in the so-called realist style of the middle of the 3d c. Others give a very lively picture of the activities of the deceased; one of the most remarkable and most recently discovered shows a rich man sitting jealously on his coffers.

Ravaged by the invasions of 256 and 257, Avaricum, like most of the cities of Gaul, was forced to build a rampart; its course has been located with certainty and important fragments are still standing. The area it protected was more or less the same as in the Gallic city (26 ha), which makes it one of the largest castra in Gaul, surpassed only by Rheims, Sens, Poitiers, and Bordeaux. The total length of the rampart is 1830 m, and it had 46 towers. The foundations are made of courses of large blocks, often taken from earlier buildings; the rampart itself has a core of mortared rubble faced with small stones and banded with brick. Two coins of Tetricus found beneath the foundation date the construction in the last quarter of the 3d c. The section best preserved today is to the SE, in the area of the old church NW of Sales. Another important portion constitutes the foundation for the palace of Jacques Coeur, to the NW.

BIBLIOGRAPHY. C. Jullian, *Histoire de la Gaule* (1908-55) III, 441ff; A. Grenier, *Manuel d'archéologie gallo-romaine* I, 1 (1931) Travaux militaires, 415; H. P. Eydoux, *Réalites et enigmes de l'archéologie*, 271-304; C. Picard, *Gallia* 17, 2 (1959) 293; 19, 2 (1961) 311-14; J. Favière, *La vie gallo-romaine au Musée de Bourges* (1961); G. C. Picard, *Gallia* 24, 2 (1966) 242-47.

G. C. PICARD

AVASARI, see APERLAI

AVEIA Abruzzi, Italy. Map 16. A city of the Vestini and a Roman prefecture in the upper Aterno valley, today in the province of Aquila. In an inscription from the 3d c. A.D. it is mentioned as the municipium Habae (*ILS* 9087). The official name of the community, Aveiates Vestini, included indication of its ethnic makeup (*CIL* IX, 4206; *Ann. Épigr.* 1937, 119, l. 12; 121, l. 10ff).

Part of the city was in the area occupied by the modern town on the slope of the mountain, and part was farther down in the valley. The exact limits and the urban plan of the settlement have not been studied even though there remain stretches of the city walls in opus incertum and remnants of buildings including a theater so-called the Palazzo del Re.

BIBLIOGRAPHY. V. M. Giovenazzi, *Della città di Aveia ne' Vestini* (1773); *CIL* IX, p. 341; H. Nissen, *Italische Landeskunde* 2 (1902) 442; R. Gardner, in *JRS* 3 (1913) 216ff; A. La Regina in *MemLinc* 13 (1968) 383ff, 429ff.

A. LA REGINA

AVENCHES, see AVENTICUM

AVENTICUM (Avenches) Vaud, Switzerland. Map 20. Near the W end of Lake Morat, probably the successor of a fortified oppidum of the Helvetii on Mt. Vully, at the NE end of the lake. The Celtic name Aventicum is known from ancient sources (Tac. *Hist.* 1.68; *It. Ant.* 352.4; *Tab. Peut.*; Amm. Marc. 15.11.12). The town, founded ca. 16-13 B.C., was the administrative center of the Helvetii on the Swiss plateau. Probably in A.D. 73-74 Vespasian founded the colonia Pia Flavia Constans Emerita Helvetiorum Foederata (or colonia Helvetiorum) on the same site. The colonists were veterans, who were to guard the military highway from Italy via the St. Bernhard pass to the Rhine after the troubles of A.D. 69 (Tac. *Hist.* 1.67-70). Until then Aventicum had a military post guarding arterial roads and the harbor. The city was destroyed by the Alamanni (Fredegar 2.40), but the site was not abandoned. In the 6th c. Aventicum was the seat of a bishop, who was later transferred to Lousonna. The mediaeval town on the hilltop W of the amphitheater has existed since the 12th c.

The Pre-Roman oppidum on Mt. Vully controlled the waterways in the area of Lakes Neuchâtel, Bienne, and Morat, but the Roman military road from the Rhone to the Rhine, completed under Claudius, ran farther S,

through Aventicum. The harbor, identified but not fully explored, was used for the shipment and the preparation of building stones from the quarries in the Jura mountains.

The town plan reflects several building periods: 1) to ca. A.D. 45 earth and timber constructions, including many warehouses and workshops, indicate a population mainly of merchants and artisans; 2) from A.D. 45 to 73-74 the buildings were gradually transformed into stone, and the artisans' quarters moved to the periphery of the settlement. The more urban aspect in this period may reflect a greater Roman influence, since the army was then working on the highway from the St. Bernhard pass to Vindonissa; 3) the foundation of the colonia brought a complete rebuilding of the town and the first city walls; 4) during the 2d c. A.D. the main sanctuaries and the theaters were rebuilt or enlarged. The first orientation corresponds to the Claudian period (2), but the definitive system dates from the foundation of the colonia, and accounts for some irregularities in the size and shape of adjacent insulae.

The settlement is in a shell-shaped depression sloping NW to the lake and the marshy plain of the river Broye. The town was built in the flat area on the edge of the plain, but its walls (5.7 km long) followed the crest of the hills and enclosed an area more than twice the size of the town (2.33 sq. km). In the flat, marshy areas both walls and buildings were bedded on wooden piles. The following description applies mainly to period 3 and later. The walls (at least 4 gates; 73 towers set at intervals of 70-90 m) are of two periods. The second, affecting perhaps only the towers and the main E and W gates, probably dates from the late 3d c. The wall was ca. 5 m high to the sentry walk (av. width 2.3 m, foundations 2.95 m), and the crenellations rose ca. 2 m higher. The average depth of the foundations was 1.5 m (in the marshy sections 2.4-3 m). The horseshoe-shaped towers (original ht. unknown) were set against the inside of the wall; in the first period they may have been semicircular. They had two stories, with access from ground level. There was a berm (2 m wide) and ditch (3.8 m wide, 1.6 m deep) except in the marshy plain, where the number of posterns was increased instead. The E and W gates were flanked on the outside by two towers (round in plan, but polygonal on the exterior), they had a double central thoroughfare through a court for vehicles, and a smaller passageway on each side for pedestrians.

Over 40 insulae have been identified. Their average size is 110 by 70 m, measured from the middle of the streets, which are 3.6 or 4.5 m wide and frequently bordered by porticos 2.4 m wide. The still unexcavated forum comprises two insulae (140 x 110 m). A temple of Jupiter, scholae, shops, and a curia are as yet attested only by inscriptions. The baths of insula 19, built ca. A.D. 60, were, according to an inscription, connected with a sphairisterium, or covered building for ballgames. The Flavian baths, found near the Forum at En Perruet, occupied one insula and included a palaestra and an open pool, later given up. The baths of insula 18, built in the late 2d c., are remarkable for the size of the tepidarium as compared with the caldarium and for sumptuous marble revetments. A number of geometric and figured mosaics from private houses, mainly from the late 2d and 3d c. A.D., are in the museum.

Some sanctuaries and the theaters are on the W edge of the town. The temple called La Grange du Dîme dedicated perhaps to Mercury and/or the Matronae, is of Gallo-Roman type (peristyle 21 x 20 m; cella 9.8 m on a side), and stands on a high podium approached by a wide stairway. Before the foundation of the colony it was perhaps part of a larger sanctuary which included the forerunner of the nearby temple called Le Cigognier. Completely rebuilt in the 2d c., together with the theater with which it shares the main axis, Le Cigognier is part of a monumental architectural complex. The cella is square and probably Gallo-Roman; it stood on a high podium. The pronaos and facade were incorporated into the center of a double portico, built on a podium of the same height and bordering three sides of a square court (105 m on a side). The fourth side, towards the theater, was closed off by a fence with a gate in the center, to allow a view of the facade of the theater. The altar stood on the paved processional way leading from the temple to the gate, and perhaps farther, towards the theater. The theater in its latest period had a capacity of ca. 9000 (105 x 74 m). The center rear wall of the stage building could perhaps have been fitted with removable screens, to open up the view of the temple and its altar. Apparently here, as at Augusta Raurica, temple and theater formed an architectural and functional unit. The amphitheater, built in the late 2d c., had a capacity of 8000 (115 x 87 m).

The cemeteries lie along the arterial roads, and those in the plain were sporadically explored in the 19th c. Best known is the one outside the W gate, from which almost all extant tombstones come. One of its tombs, dated to the middle of the 4th c., contained an inscribed glass beaker, early evidence of Christianity in Switzerland.

The monuments visible are stretches of the walls, the tower called La Tornallaz, the E and W gates, the theater and amphitheater, and the baths En Perruet. The museum is in a mediaeval tower built above the main entrance to the amphitheater.

BIBLIOGRAPHY. F. Staehelin, *Die Schweiz in römischer Zeit* (3d ed. 1948) 604-11 & index s.v. Aventicum, bibl. to 1948; G. T. Schwarz, "Les scholae et le forum d'Aventicum," *Bull. Ass. Pro Aventico* 7 (1957) 13-80[PI]; id., "Aventicum, Neue Beobachtungen zu Stadtmauer und Toranlagen," *Jb. Schweiz. Gesell. f. Urgeschichte* 51 (1964) 63-70[I]; id., *Die Kaiserstadt Aventicum* (1964)[PI]; id., "Die flavischen Thermen 'en Perruet' in Aventicum," *Bull. Ass. Pro Aventico* 20 (1969) 59-68[PI]; V. v. Gonzenbach, *BonnJbb* 163 (1963) 84-91[P]; E. Meyer, *Jb. Schweiz. Gesell. f. Urgeschichte* 54 (1968-69) 91; id., *Handbuch der Schweizergeschichte* (1972) 73-75; Pro Aventico, ed., *Plan archéologique* (1972); excavation reports: *Bull. Ass. Pro Aventico* 1- (1888-) esp. 15- (1951-); bibl. & summaries, *Jb. Schweiz. Gesell. f. Urgeschichte* beginning 50 (1963). V. VON GONZENBACH

AVRIGNEY Haute-Saône, France. Map 23. In the Vergenne woods near the road from Vesontio (Besançon) to Andematunnum (Langres) are quarries which were used in Roman times. They are connected to the highway by a road 3-6 km long. The stone used in the construction of the monuments of Vesontio came from these quarries. It was on Mt. Colombin that the three-horned bronze bull was found in 1756. It is the only one (with that of Martigny) of large size, but it is better preserved than the latter and more naturalistic. It has been in the museum at Besançon since 1873.

BIBLIOGRAPHY. Site and quarries: L. Suchaux, *Dictionnaire historique, topographique et statistique de la Haute-Saône* I (1866) 40, 130-31. The bull: P. Lebel, *Catalogue des collections archéologiques de Besançon,* V. *Les bronzes figurés* (1961) 47-48, no. 132, with earlier bibl. L. LERAT

AXELODUNUM, see HADRIAN'S WALL

AXIA (Castel d'Asso) Etruria, Italy. Map 16. An Etruscan center 9 km W of Viterbo, on a branch of the ancient Via Cassia that led from Veii-Caere and Tarquinia to Orvieto and the N. After a phase of cultural predominance by Caere in the 6th c. B.C., it was absorbed by the state of Tarquinia, enjoying a particularly flourishing period in the 4th and 3d c. B.C. In 68 B.C., Cicero defined it as a castellum in the territory of Tarquinia. In the Middle Ages it contained a feudal fortress conquered by the citizens of Viterbo at the end of the 12th c. Later the site was abandoned.

The Etruscan settlement occupied the level top of a hill wedged between the valleys caused by the erosion of the Riosecco and Freddano rivers, which flow together at its base and carve out an area roughly triangular in shape. At the base of the triangle ran a large, irregularly shaped ditch, quite visible in an aerial photograph. A second ditch, equally irregular in shape, separated the actual settlement from the acropolis, which corresponds to the upper half of the triangle. Finally, a third ditch, dating from the Middle Ages, isolated the feudal fortress set at the vertex of the triangle in a dominating position. The second ditch was bordered by an isodomic tufa wall of which there are a few remains. There are drainage channels visible, traces of streets cut into the tufa, and chamber tombs set on the slopes of the settlement, together with caves carved out in the Middle Ages as dwellings or as shelters for animals. Architectural components in terracotta embellished by figures have been found in the area of the settlement, which has never been an excavation site.

The necropolis surrounds the settlement on every side. The section in the Freddano valley facing the acropolis was begun in the middle of the 4th c. B.C., and has taken on a certain monumentality because of the carvings on ca. 50 rock-cut tombs in the tufa slopes of the main valley and of a smaller side valley. There are simple, square tombs and two-story tombs with a closed or porticoed lower story, decorated with moldings, false doors in relief, plinths, etc. On the upper terraces are the remains in situ of tombstones that are mainly undecorated but that often bear large inscriptions with the family name or the name of the person who built the tomb. The inhumation chambers (the greatest 17 m long and containing 62 graves) are quite deep and unadorned, for the most part containing earthen graves covered by stone or tile lids. The tombs are distributed, in the main valley, in two or three rows one above another, almost paralleling the system of streets coming from the city. After 150 B.C., the use of the monumental necropolis continued until A.D. 50, but burials were made only in existing tombs.

BIBLIOGRAPHY. F. Orioli, *Dei sepolcrali edifizi dell'Etruria media e in generale dell'architettura tuscanica* (1826); G. Dennis, *The Cities and Cemeteries of Etruria* (1907) 272-85; G. Rosi, *JRS* 15 (1925) 14ff; E. Colonna Di Paolo & G. Colonna, *Castel d'Asso* I-II (1970).

G. COLONNA

AXIMA (Aime) Savoie, France. Map 23. Ancient capital of the Ceutrones, who inhabited the Tarentaise region (valley of the Isère). Conquered by Caesar and subdued by Augustus, the region became a procuratorial province of the Alpis Graia. Darantasis (Moutiers) was the first capital, then Axima, which was on the Roman road leading from the Val d'Aoste to Vienne and Lyon by the Little Saint-Bernard Pass. Under Claudius it was known as Forum Claudii. At Aime the present national highway closely follows the Roman road, which used to be lined with funerary monuments. Many ancient remains and inscriptions have been unearthed in different areas.

In the Saint-Martin district, 3.3 m below the Romanesque basilica, is a rectangular Roman building which may have been a temple of Silvanus or, more likely, a secular basilica from the late 1st or early 2d c., judging from the base of a statue of Trajan found there. It was destroyed, and replaced in the 5th c. by an apsed Early Christian basilica (22.9 x 9.1 m). In the Saint-Sigismond district, on the hill above Saint-Martin, the traces of a temple with an altar dedicated to Mars can still be seen. Under the chapel is a necropolis. In the Poëncet district, between the Grande Rue and the Tessens road, many inscriptions and architectural fragments have been found; they are now in the Saint-Martin church. In the Replat district, between Saint-Martin and the national highway, are some tombs in which have been found epitaphs, pottery, and many other objects now at the Musée de l'Académie du Val d'Isère at Moutiers.

BIBLIOGRAPHY. R. L. Borrel, *Les monuments anciens de Tarentaise* (1884)[PI]; M. Hudry, *La basilique de Saint-Martin d'Aime* (n.d.).

M. LEGLAY

AXIOPOLIS, see HERAKLEIA (Romania)

AYAKLI, see EUROMOS

AYAŞ (Rough Cilicia), see ELAEUSSA

AYASOFYA, see KOLYBRASSOS

AYDIN, see TRALLES

AYDINCIK, see KELENDERIS

AYIA TRIAS, see LIMES, GREEK EPEIROS

AYIOS KHARALAMBOS, see MESOPOTAMON

AZAILA ("Beligio") Teruel, Spain. Map 19. Hispano-Roman town, possibly Beligio, 12 km W of Escatron. A fortified oppidum on the Cabezo de Alcala which covered the slopes of the hill and the surrounding plain as far as the river Aguas. Nothing is known of its history, but there were at least three towns: the first, founded in the Iron Age (ca. 500 B.C.), occupied by the Iberians from the middle of the 5th c. B.C., and destroyed by Cato between 197 and 195 B.C.; the second, reconstructed in the Iberian fashion on the ruins of the first, ca. 195 B.C., and destroyed in the Sertorian wars between 81 and 72 B.C.; a large amount of material from the second town was used during the Roman period for the construction of a third town. After the battle of Ilerda, 49 B.C., it was not rebuilt.

The ruins are well preserved. Excavation has uncovered a complex defensive system including a ditch and drawbridge, and walls of small rubble which follow the contour of the hill. They apparently date from the Republican period, and are arranged in terraces with communicating stairways. Two streets climb directly to the acropolis and a third serves as a ring road. The decumanus runs N-S, divides into two in the last third of its course, and has short cardines, one of which ends in a watch tower; all the streets were paved with large irregular stones and had sidewalks, reflecting advanced city planning. The approach to the acropolis was protected by two towers. Except for a few houses (one with grindstones) and the guard house, the N part is occupied by a large house or palace. In the center of the oppidum there is a small temple in antis and another of the native

type near a deep and well-built cistern. In the first temple was found a group of bronze statues; two of them, from before 49 B.C., were once thought to be Augustus and Livia but almost certainly represent the ranking Roman of the district and his wife. The remains of a horse, fragments of a bed, and some ladles were also found here, also a little bull from the native temple.

The pottery includes painted Iberian ware, Campanian, and common ware (wheel-turned jars and amphorae), but no terra sigillata. None of the 802 coins studied are later than 45 B.C. Unlike that of the Bronze Age tumulus, the site of the Ibero-Roman cemetery is unknown.

Finds are in the National Archaeological Museum in Madrid and the Zaragoza Museum.

BIBLIOGRAPHY. J. Cabré, Los bronces de Azaila," *ArchEspArq* 3 (1925); id., *Azaila* (1929); id., *Corpus Vasorum Hispanorum. Cerámica de Azaila: Museos de Madrid, Barcelona, Zaragoza* (1944); P. Beltrán, "La cronología del poblado ibérico del Cabezo de Alcalá (Azaila) según las monedas allí aparecidas," *Boletin Arqueológico del Sudeste Español* 1 (1945) 135; A. Beltrán, "Notas sobre la cronología del Cabezo de Alcalá en Azaila (Teruel)," *Caesaraugusta* 23-24 (1964) 79; id., "Arqueologia e Historia de las ciudades antiguas del Cabezo de Alcalá de Azaila (Teruel)," *Etudios . . . Zaragoza* 2 (1973) 95.　　　　A. BELTRÁN

AZAUM, *see* LIMES PANNONIAE

AZEFFOUN, *see* RUZASUS

AZETIUM (Rutigliano) Apulia, Italy. Map 14. From the listing of its position in the *Peutinger Table*, ca. 12 km SE of Caelia (modern Ceglie del Campo) on the Via Traiana leading to Egnatia, the site of the city has been recognized in the environs of modern Rutigliano. Its name is found on bronze coins from the 3d c. B.C., minted in imitation of Tarentine coins. In the itineraries the corrupt form of the name is Ezetium, while reference to the center's ethnic makeup, Aegetini, is found only in Pliny (*HN* 3.105) in the Roman form of the name. In a section of the modern town called Castiello the remains of megalithic walls are visible. The ruins of a Roman aqueduct may be seen near the Chapel of S. Lorenzo. Numerous remains from the ancient city are in the Archaeological Museum at Bari.

BIBLIOGRAPHY. W. Smith, *Dictionary of Greek and Roman Geography*, I (1856) 354 (E. H. Bunbury); *RE* II.2 (1896) 2642 (Hülsen); B. V. Head, *Historia Numorum* (1911) 45; M. Mayer, *Apulien* (1914) 72, 357; K. Miller, *Itineraria Romana* (1916) 375.　　F. G. LO PORTO

AZIB EL HARRAK, *see* FRIGIDAE

AZOTUS Palestine, Israel. Map 6. A town in Philistia, whose Biblical name was Ashdod, one of the five lordships of the Philistines. To the NW of the ancient town a new, maritime town was built in the Hellenistic period, known as Azotus Paralios (coastal Azotus) while the other was then named Azotus Mesogeios (inland Azotus). Jonathan, brother of Judas Maccabeus, destroyed inland Azotus (I Macc. 10:77-8), and Jews settled there (I Macc. 11:4-5). During the reign of Alexander Jannaeus it was incorporated into the Judean kingdom (Joseph. *AJ* 13.395). Pompey restored its autonomy (Joseph. *BJ* 1.156). Herod seized it early in his reign, and maritime Azotus at that time became a Jewish town (Joseph. *BJ* 4.13), while inland Azotus was settled by Herod's veterans. It remained part of the domain of Herod's sister, and for some time it was in possession of Livia, wife of Augustus, and her son Tiberius (Joseph. *AJ* 17.189; 18.31, 159). During the Jewish War the city was conquered by Vespasian (Joseph. *BJ* 4.130). Azotus flourished in the Late Roman period (Eus. *Onom.* 20.18; 22.11). In the Byzantine period it was a bishopric and declined during the Arab period.

Extensive excavations have been in progress at inland Azotus since 1962. The remains of the two uppermost occupation levels (Byzantine and Roman) are poor, seeming to confirm that maritime Azotus was the more important town in this period. The towns of the Early Roman and Hellenistic periods are more important. On the acropolis, remains of large public buildings, probably in the agora, were unearthed. The finds, including official weights, marked with the names of agoranomoi, support this conclusion. Remains of private dwellings were unearthed on other parts of the mound.

BIBLIOGRAPHY. M. Dothan & D. N. Freedman, "Ashdod I, the First Season of Excavations, 1962," *Atiqot* VII (1967).　　A. NEGEV

B

BAALBEK, *see* HELIOPOLIS

BABBA IULIA CAMPESTRIS Morocco. Map 19. Augustan colony of W Mauretania, mentioned by Pliny, Ptolemy, Stephanos of Byzantium, the Ravenna Geographer, and perhaps the Notitia Dignitatum. Its existence is confirmed by an inscription found at Thamusida. It has usually been placed between Tingis and the wadi Loukkos, but it should rather be sought between that wadi and the Sebou, perhaps on the lower reaches of the Ouerrha, although none of the Roman settlements hitherto found in that area is large enough to be called a colony.

BIBLIOGRAPHY. R. Rebuffat, "Les erreurs de Pline et la position de Babba Iulia Campestris," *Antiquités Africaines* 1 (1967) 31-57.　　M. EUZENNAT

BABES ("Ossa") Peloponnesos, Greece. Map 9. The boundaries of the territory of Skillous are not known. To the N, however, they extended to the mountainous area S of Olympia, today known by the name Babes. Apparently the Temple of Skillountian Athena was located there (Strab. 8.343). On the heights of Babes, which even today are fertile, are located 17 settlements: in the areas of Mazi and Phanari, Arnokatarrhako, Gerakovouni, Rhasa, Haghios Elias, Haghios Triphonas, Vageni, Louzi, and Rhethi, notable finds dating from the prehistoric to the Roman period have been made. On the hill of Arnokatarrhako a Doric shrine of Zeus has been uncovered dating to the beginning of the 5th c. B.C. Around the hill a settlement extends for some distance. A section of this, where there are clusters of large houses with roads between, has been excavated. Another Doric

temple has been found NE of Arnokatarrhako on the peak of the hill Haghios Elias, just opposite Olympia. In the same area, architectural fragments of other Doric temples (?) have been collected. The remains preserved at the village of Haghios Triphonas at the highest point of Babes belong to monumental building. The remains of the settlement in the area near the town of Mazi are extensive and also monumental. On the hill, Kastro, which dominates this ancient settlement, is preserved a temple of the 4th c. B.C. with pedimental sculptures (on display in the Patras museum). Finally, the remains of a settlement and acropolis near the town of Phanari probably belong to ancient Phrixa. These settlements in Babes perhaps belong to the territory of Skillous at the period of its greatest extent. Ancient sources mention the cities of Phrixa, Aipion, Pyrgos, and Bolax in this area. Three of these may be identified with some probability: Phrixa with the settlement at Phanari, Aipion with the settlement at Mazi, and Pyrgos with the settlement at Arnokatarrhako.

BIBLIOGRAPHY. G. Papandreou, J. Sperling, *AJA* 46 (1942) 81, 83, 84[M]; N. Yalouris in *Praktika* (1954) 290ff[I]; (1955) 243ff[I]; (1956) 187ff[PI]; (1958) 194ff[PI]; (1960) 174ff[I]; id. in *Ergon* (1954) 40f[I]; (1955) 86f[I]; (1956) 83f[I]; (1960) 135ff[I]; id. in *BCH* 78 (1954) 128ff[I]; 79 (1955) 252ff[I]; 80 (1956) 287ff; 81 (1957) 570ff[I]; 83 (1959) 656ff[I]; 84 (1960) 722; 85 (1961) 719ff[I]; id. in *Deltion* 16 (1960) 135ff[I]; 20 (1965) 210[I]; 21 (1966) 171[I]; E. Meyer, *Peloponnesische Wanderungen* (1957) passim[I]; G. Papathanassopoulos, *Deltion* 22 (1967) 209ff; 24 (1969) 149. N. YALOURIS

BAB KHALED, *see* JEBEL OUST

BADALONA, *see* BAETULO

BADBURY RINGS, *see* VINDOCLADIA

BADEN, *see* AQUAE HELVETICAE

BAD KREUZNACH, *see* CRUCINIACUM

BAELO (Bolonia) Cádiz, Spain. Map 19. Town near Tarifa which in Roman times belonged to the juridical district of Gades. Pliny (3.7; 5.2) refers to it as the oppidum of S Baetica nearest Tingi (Tangier). Its name appears variously in the sources (Mela 2.96; Strab. 3.140. 153; Ptol. 2.4.5; Plin. *loc.cit.*; Solinus 24.1; *Ant. It.* 407.3; Livy 33.21.8) and as Bailo on its own bilingual coinage. For this the Libyo-Phoenician alphabet was employed, with types of a standing bull on the obverse and an ear of grain on the reverse, and occasionally the head of Hercules. During the main period of romanization it also coined other types on asses, semisses, and quadrantes with the names of magistrates. Under Claudius it was declared a municipium, as shown by the designation Belone Claudia in the Ravenna Cosmographer 305.12 and 344.9, and confirmed by a coin and a recently discovered inscription.

As a community of the Turdetani devoted to the fishing industry, it was noted for its production of garum and other fish sauces. Some salting vats may still be seen. Excavations have revealed the fortified enceinte with its gates, the forum, theater, a nymphaeum, remains of the aqueduct, houses, and Roman, Christian, Visigothic, and Mohammendan cemeteries. Many Latin inscriptions have also been found, sculptures of divinities and humans, a sun-dial, fragments of Arretine ware, terra sigillata (S Gallic and Hispanic) and plain ware. In view of the Libyo-Phoenician characters on its coins, the town was probably founded before the Roman period, but this has not been established. The oldest ceramic finds, however, are of Campanian B and C, with a single example of decorated Iberian.

BIBLIOGRAPHY. P. Paris, *Fouilles de Belo* (1923); E. Romero de Torres, Catálogo Monumental de España. Provincia de Cádiz (1934) 230-42; C. Domergue et al., "Reouverture d'un chantier de fouilles à Bolonia-Baelo (Cádiz)," *Mélanges de la Casa de Velázquez* III (1967) 507ff. C. FERNANDEZ-CHICARRO

BAETERRAE (Baitera) Dept. Hérault, Béziers, France. Map 23. Situated in the place where the Herculean Way crosses the Orb river, Béziers has been inhabited at least since 750-650 B.C. Its pre-Roman name of Besara is attested in an account of a journey to Marseilles made by Festus Avienus in the 6th c. Black- and red-figure Attic pottery has been found there, besides some Campanian pottery, which shows old and lasting commercial ties with Marseilles, through Agde, 22 km SW of Béziers. Its people, at first Iberian, came little by little under Celtic influence. Starting from about 250-230, the city comprised part of the territory of the Volcae Tectosages.

Conquered by the Romans at the time of the annexation of Transalpine Gaul, it was at first a city of those indigenous to the region, and issued bronze coins in the names of the Longostaletes, a Volcian tribe, of Gallic chiefs or chiefs of Bétarratis. In 36-35 a Roman colony was founded there for veterans of the Legio VII, Colonia Urbs Julia Baeterrae Septimanorum, whose citizens were numbered in the tribe Pupinia. The city, which commanded a rather large and prosperous region, experienced remarkable growth under Augustus because of special ties established with the family of the local ruler. These bonds are shown in the patronage C. Caesar bestowed on him and by the early appearance of the imperial cult. Its prosperity, which lasted throughout the Early Empire, was founded on profitable farming of the rich land (the wine amphorae of Béziers were known at Monte Testaccio in Rome in the 2d c.), on the working of copper and lead mines of the outlying regions, on trade encouraged by an important network of roads of which it was the center, and by the nearness of the ports Agde and Narbonne. Ravaged by the invasions of 276, it erected fortifications for the first time at the end of the 3d c. It was from the time of Diocletian onward one of the five cities of the first Narbonensis. Christianity appeared toward the middle of the 3d c., and expanded so much that a synod was held there in 356. It was overtaken by waves of Vandals and Alans (406-9), and then conquered in 412-13 by the Visigoths, who held it for three centuries, until the Arab conquest of Anbasa ibn Suhayn.

Béziers was an acropolis, well defended by nature. It was a secure city according to Strabo (4.1.6). The Romans had some trouble establishing a uniform grid, whose orientation, NW-SE, is clear, however, in ancient maps and also today in aerial photographs. The NE quarter, however, is arranged around an oblique axis, which is the same as that of the road from Pézenas and of the start of the aqueduct, 30 km long, which brought water from higher reaches, from the Libron and the Lenne. The route of Domitian ran along the edge of the city below and crossed the river by a bridge some of whose structure the present Pont Vieux preserves.

The forum (77 x 129 m) is off-center in relation to the cardo maximus which borders it at the E whereas the decumanus maximus ends in the middle of its largest side. From the rather inconclusive diggings which have been done there, and from some of the finds (a colossal head of Jupiter; a colossal statue of Apollo mentioned in the 17th c. description of A. de Rulman; a head of Hercules preserved in the same area; a series of portraits

from the beginning of the 1st c.), one can presumably locate a Doric portico, the Temples of Jupiter, Apollo, and Bacchus, a sanctuary of the imperial cult; and a market where an inscription from Severian times mentions improvements.

From a municipal arch there remains a certain number of sculptured pieces (friezes of arms, quoins, and *paneled arches* decorated with military motifs). It seems to have been an arch with a flat top (like that of the Gavii at Verona), and was constructed in the Augustan era at the W edge of the city where the decumanus maximus ends in a terrace overhanging the Orb (the site of the Cathedral of Saint-Nazaire). In the same area the Temple of Bacchus is assumed to be located, from the discovery there of a head of the god and a statue of a satyr.

A sanctuary of indigenous gods has been identified at the edge of the city, on the far side of the route of Domitian, the present Plateau des poètes. It includes votives to some Celtic deities (the Mothers, the Menmandutiae and Ricoria, and Dioskouroi, the Digines) and a Mars in a clearly autochthonic style.

The amphitheater rises beyond the route of Domitian, next to the hill Saint-Jacques. The remains are very few; however, they do allow one to recognize rather modest dimensions (74 x 103, 60 m) and the plan of its construction (an oval formed by successive arcs of circles). It seems to go back to the first part of the 1st c. A.D. The aerial photograph shows a theater 35 to 40 m in diameter next to the amphitheater.

The fortification of the end of the 3d c. has a perimeter of ca. 1570 m. Four sectors are still visible. The wall is made of two ashlar facings without mortar joined together by rubble, and rises from a large foundation showing scattered fragments of reused stone. Some round towers, constructed also of medium-sized ashlar fortified it: two were still visible in the 17th c., as were the gates, which have also disappeared.

Béziers has left a large number of Latin inscriptions. Among the most noteworthy pieces of sculpture are a statue of Augustus now called Augustus Pépézuc, and the series of busts of the imperial family already mentioned (now in the Museum Saint-Raymond in Toulouse) representing Augustus and Livia, Octavia, Agrippa and L. Caesar, Tiberius and Drusus the Younger, Germanicus and Antonia the Younger. This group, which dates from the last years of the reign of Augustus seems to have been erected by a citizen, L. Aponius, produumvir of C. Caesar in his country and linked closely to the family of Augustus. Also worthy of attention are a fine marble torso of Venus, some funerary statues, corresponding to the customs and tastes of different social classes, in general remarkable for their restraint, a beautiful intaglio showing the three-horned bull of the Celts, some geometric mosaics, much Roman pottery. There is little evidence of early Christianity except some tombs grouped ad sanctos around the church dedicated to St. Aphrodise, the first bishop of Béziers, and a fine sarcophagus of the school of Aquitaine in the same church.

Two museums in Béziers itself preserve the antiquities: le Musée du Vieux Biterrois and le Musée épigraphique, in the cathedral cloister.

BIBLIOGRAPHY. *Bull. Soc. arch. de Béziers* (1836 et seq)[I]; L. Noguier, *Béziers colonie romaine* (1883); J. Dardé et J. Sournies, *L'histoire de Béziers racontée par ses pierres* (1912)[I]; M. Clavel, *Béziers et son territoire dans l'Antiquité* (1970)[MPI]. M. CLAVEL-LÉVÊQUE

BAETOCECE (Hosn Soleiman) Syria. Map 6. About 30 km E of Tartus in the heart of the Alaouite mountains at an altitude of close to 1000 m, Baetocece was the federal sanctuary of the Phoenicians of Arados. A long inscription tells of its importance, both religious and commercial, from the beginning of the Hellenistic period to the Late Empire.

The site, which has never been excavated, contains two groups of monuments: to the N, some improperly identified remains and to the S, the principal sanctuary dedicated to a local god identified with Zeus.

The sanctuary has a rectangular surrounding wall with a door in the middle of each side. The wall, remarkably well preserved, is built of large stones laid edgewise. The main entrance, to the N, is a triple gateway with a triangular pediment over it; the propylaea portico has disappeared. The molding and carved ornamentation are austere. From inscriptions and from similarities in religious iconography to Arados coins it is possible to date the complex to the 3d c. A.D. The cella stood on a podium in the center of the enclosure; its facade, to the N, consisted of a four-columned portico, and its walls were decorated on the outside with engaged columns with Ionic capitals. To the E of the cella stood a bronze altar, dedicated in A.D. 185-86.

BIBLIOGRAPHY. H. C. Butler, *AAES* (1903); D. Krencker & W. Zschietzschmann, *Römische Tempel in Syrien* (1938)[PI]; H. Seyrig, "Arados et Baetocécé," *Syria* 28 (1951); J.-P. Rey-Coquais, *Inscriptions grecques et latines de la Syrie.* VII. *Arados et régions voisines* (1970)[MI]. J.-P. REY-COQUAIS

BAETULO (Badalona) Barcelona, Spain. Map 19. Town on the coast of Laietania, 10 km NE of Barcelona, near the mouth of the Baetulo (Besos) in Tarraconensis. The suffix -ilo, typically Iberian, suggests that originally it was a native oppidum, which has not been identified. It grew in the 1st c. B.C. when several nearby Iberian settlements were abandoned. According to Pliny (*HN* 3.22) it was an oppidum enjoying Roman rights; it is also mentioned by P. Mela (2.90) and Ptolemy (2.6.18). Its prosperity in the 1st-3d c. was due to trade in local wine. The town was reduced to ruins during the invasion of the Franks, but was rebuilt and fortified by great walls, some sectors of which still survive.

Excavation has uncovered Roman houses with mosaics (now in the Barcelona Archaeological Museum) and many inscriptions; the earliest (*CIL* II, 4606-4608), include an important bronze tabula patronatus. The local archaeological museum, in addition to Roman material, has finds from nearby prehistoric deposits and Iberian oppida, in particular the Mas Boscá.

BIBLIOGRAPHY. J. de C. Serra Ráfols, "Excavaciones a Badalona," *Anuari de l'Institut d'Estudis Catalans* 8 (1927-31) 100; *Forma Conventus Tarraconensis,* I. *Baetulo-Blandae* (1928); "Una *tabula Hospitalis* trobada a Badalona," *Butlletí Museus d'Art de Barcelona* 4 (1934) 334; "Excavaciones en Badalona y descubrimiento de la puerta NE de la ciudad," *Ampurias* 1 (1939) 268. J. MALUQUER DE MOTES

BAGACUM (Bavai or Bavay) Nord, France. Map 23. City in the Belgica province of Gaul. Although its typically Celtic name was taken from a Gallic settlement the location of which is unknown, the city of Bagacum was a Roman creation. Searching the territory of the civitas of the Nervii for a suitable site for a capital city, the Romans chose a position overlooking strategic routes (from Tongres and Trèves on the one hand, from Cambrai and Tournai on the other); they also selected a convenient, healthy spot—the summit of a hill sloping down to the Bavai stream.

The first piece of chronological evidence is a dedication to Tiberius (A.D. 4). The city flourished from the

1st c. on, as evidenced by finds made to the S (Arretine ware) and traces of a monumental development in the city center. The construction of this huge complex, which may have been accompanied by a general reorganization of the city plan, can be dated from the 2d c., the period of the city's greatest vitality. That Bagacum was a victim of the invasions of the mid-3d c. is indicated by the very recent discovery of a large quantity of bronzes buried in haste (statuettes, handles of chests, etc.). Only a narrow urban area (4 ha) was rebuilt and walled: from that time on, Bavai was merely a fortress of minor importance; not mentioned in the later texts, it disappeared at the beginning of the 5th c.

The Roman remains make it clear that under the Empire the city covered the same area as the mediaeval city and at some points spread beyond it. Some remains of Roman structures appear outside the mediaeval embankment, to the W along the modern road to Valenciennes and E on the road to Maubeuge. To the SW, still outside the mediaeval limits, a whole series of sand-pits were worked, and this apparently gave rise to a kind of industrial suburb with a number of potter's furnaces and some fairly rich houses. These various remains, the evidence of the roads (curving as they near the settlement), and the position of certain tombs (tomb of Julia Feticula to the S, next to a vault with niches decorated with painted stuccos) indicate the approximate boundaries of the inhabited area. Bagacum extended ca. 700 m E-W and 600-650 m N-S, a total area of ca. 40-45 ha; it remained a small city and did not experience the economic expansion of Amiens. Judging from the arrangement of some of the streets that have been traced (especially the Rue des Gommeries), from that of the sewers which run parallel below ground, and from the alignment of many remains of houses, the city appears to have been designed on an orthogonal plan. Several groups of houses have been found (Rue de Valenciennes, Rue des Gommeries), some of which are fairly rich (rooms with hypocausts, mosaic floors, wall paintings, and stuccos), and an industrial quarter with poor homes S of the great complex. There is evidence of public monuments at several points: a temple was discovered in 1722 at Le Bisoir, an area unknown today but probably situated to the S; several dedications show that the wealthiest citizens of Bavai contributed their denarii to the building of useful works (for example, public scales); remains of hypocausts and mosaics have located the public baths close to the church. The water supply came from the Floursies springs by a system of aqueducts.

But most important was the large complex in the city center, which has been systematically excavated since 1942. It consists of a double forum, designed for political and commercial purposes, 95 m N-S and ca. 230 m E-W. East of it stands a building with a central nave (16 x 66 m) and two side naves (6 x 78 m), against which on three sides (N, E, and S) were built wide, deep shops. This huge monument was a basilica, originally dating from the 1st c. A.D. West of the basilica is a square, paved with blue stone and lined to N and S with a double row of shops opening on the square and street. Probably separated from this square by a N-S road is another square, extending farther W; it is edged on the other three sides (N, S, and W, each 60 m long) with a great portico the pillars of which supported a wooden frame. The N and S galleries that form the two ends of this horseshoe-shaped structure terminate to the W in an apse; the W gallery leads, through a vestibule flanked by two rectangular rooms, to a large hall (23 x 25 m); in the middle of the W wall is a flattened apse. The purpose of this last complex is hard to determine: is it a curia or perhaps some development connected with the cult of emperors.

Below the portico is a cryptoporticus, identical in plan: it has three galleries similar in arrangement and dimensions to those on the ground level, but differing in that the N and S galleries are interrupted at regular intervals by four barrel-vaulted enlargements. Covering the whole of the cryptoporticus is a groined vault supported by strong piers. To the W is a large rectangular room laid out like the one at ground level; originally it had a ceiling supported by beams, but after a fire it was split up into three vaulted naves. The function of this substructure remains uncertain; the paintings with which all the stonework was decorated seem to rule out mere cellars, which has sometimes been suggested. More likely the complex is a better protected continuation of the forum, a cryptoforum, perhaps with quarters for the collegia of artisans. Finally, in the middle of the square, with the portico galleries around it, is a foundation block 2 m high, 20 m wide, and 32 m long. A foundation of this kind and in this spot could only be that of a temple, and a large one at that; the frieze fragments and capitals discovered in the excavations probably come from it.

The city was ravaged by the 3d c. invasions, and both public and private buildings provided the materials for a double surrounding wall: the first, built hurriedly at the end of the 3d c., was followed by one more solid in the period of Diocletian and Constantine. This rampart, which enclosed the monumental complex of the Empire, took the somewhat unusual form of a very long rectangle (100 m N-S, 400 m E-W); it was divided by a N-S wall into twin castella, that to the W being the larger and stronger. The area of the city inside the wall was very small, ca. 4 ha. Thus Bagacum in the Late Empire was not only a walled city but a veritable fortress.

The large quantity of pottery and bronzes proves beyond doubt that this was a local production center (especially so-called Bavai vases). A museum is being established which will house all local finds.

BIBLIOGRAPHY. H. Biévelet, "L'Exploration archéologique de Bavai," *Gallia* (1944); E. Will, *Bavai, cité gallo-romaine* (1957); id., "Les enceintes du Bas-Empire a Bavai," *Revue du Nord* 44 (1962) 391-401; id., "Recherches sur le développement urbain sous l'empire romain dans le nord de la France," *Gallia* 20 (1962) 79-101; *Gallia*, periodic reports of the excavations.　C. PIETRI

BAGINTON Warwickshire, England. Map 24. Roman fort called The Lunt (SP344752), an almost vertical wooded escarpment above the river Sowe, S of which is a flat plateau. To E and W the ground slopes appreciably, making the site an ideal location for a Roman fort. The Roman road now called the Fosse Way is ca. 7 km to the S.

The Lunt was discovered in 1960; subsequent excavations have defined its occupation as ca. A.D. 60-80. The foundation date would therefore be the year of the rebellion of Queen Boudicca, not of the initial Roman conquest. There were at least four main periods of occupation. The first military occupation was very extensive and came during or immediately after the Boudiccan revolt. After the suppression of the revolt the garrison was reduced to a cohors quingenaria peditata of auxiliary troops, and a 1.2 ha fort built. Subsequently, as the political situation was resolved, the fort was further reduced in size to less than 1 ha, some time before the final abandonment ca. A.D. 80. However, there is some structural evidence to suggest temporary military reoccupation early in the 2d c.

The 1966-73 excavations have, in the main, been an

examination of the Period 2 fort. Its defenses, as with most 1st c. Roman forts in Britain, comprised a ditch system backed by a turf and timber rampart with three gates. The E gate, porta principalis sinistra, has been extensively excavated, and 45.72 m of the turf and timber rampart has been reconstructed. The most interesting aspect of the defenses is the sinuosity on the E side. Excavation within the fort has shown that this unique S-shape arose from the construction of a circular structure 32 m in diameter. Arena features of this size are not usually found within the defenses of Roman forts, and direct parallels for this structure have not as yet been found. It could possibly have been connected with the breaking of horses or with individual weapon training. Its boundary was marked by a timber palisade or fence.

Elsewhere within the fort the buildings were also constructed of timber with a wattle and daub lining. The principia is in the normal position, at the T junction of the via principalis and via praetoria. Within the sacellum an unusual pit-cellar was discovered, which had been built to store the garrison's pay chest. Four granaries and six barrack blocks have been excavated, and over 100 rubbish pits and water storage tanks containing stratified artifacts, principally coins, pottery, glass, military equipment. One exceptional object was a bowl of black burnished ware of eggshell thinness polished to a fine luster, with a central pedestal or finial in the interior, a feature which could be a copy of a finial on late Hellenistic silver vessels from Italy.

There are no non-military Roman buildings but there is ample evidence of continued occupation within the village of Baginton, presumably purely civil, well into the 4th c.

BIBLIOGRAPHY. "Baginton," *Current Archaeology* 1, 4 (1967-68) 86-89; B. Hobley, "An Experimental Reconstruction of a Roman Military Turf Rampart," *Proc. Seventh International Congress of Roman Frontier Studies* (1967)[MPI]; id., "A Neronian-Vespasianic Military Site at 'The Lunt,' Baginton, Warwickshire," *Trans. Birmingham Arch. Soc.* 83 (1969) 65-129[MPI]; id., "The Lunt Roman Fort, Baginton, Warwickshire. Excavations 1966-70," *Britannia* 2 (1971) 262[I]; id., "Excavations at 'The Lunt' Roman Military Site, Baginton, Warwickshire, 1968-70—II Interim Report," *Trans. Birmingham Arch. Soc.* 85 (1971)[MPI]; "The Lunt," *Current Archaeology* 3, 24 (1971) 16-21; *Britannia* 3 (1972) 318-19[P].

B. HOBLEY

BAGNACAVALLO Emilia, Italy. Map 14. The site is in the plain 19 km from Ravenna. It was a Roman pagus at the border of the centurial area to the E of Faventia, and the center of the extensive territory between Senio and Ronco, to which it appears to have belonged. There is not sufficient data to indicate that it had autonomous civil government but the site is rich in Roman age archaeological material.

The probable existence nearby of a sanctuary for diverse cults of salutary divinities is attested by four cippi. Three bear inscriptions that mention Quies, Salus, and Feronia, whose cult is thus documented for the first time in the Cisalpine region. Feronia, given the significance of "lady of the forests," thus coincides with the existence nearby of the parish church of S. Pietro in Silvis, in ancient times in the middle of a wooded area. It was located near the wooded strip that separated the centurial plain from the lagoons before Ravenna. Other evidence is present in the Classical architectural elements employed in the construction of the church, and in an altar lacking title or dedication which was found at Boncellino and is

now in the Museo Civico at Bologna. Dedications to other divinities, Jupiter Libertas and Jupiter Obsequiens, provide evidence of a cult of freedmen. It is possible that the cult of Jupiter was supplanted by the cult of St. Peter. The sanctuary continued in use for about five centuries.

The necropolis, which contains numerous tombs and inscriptions, has been found in the area of the modern brick furnace. Bagnacavallo was probably the seat of a collegium iuvenum Ioviensium recorded by an inscription in which the patron, C. Mansuanius, is mentioned.

BIBLIOGRAPHY. *CIL* XI, 657-659; P. Ducati, *RömMitt* 23 (1908) 131; P. E. Arias, *FA* VII (1956) 264 n. 3608; M. A. Veggi Donati, *Ricerche e documentazioni su Bagnacavallo romana* (1960); G. Susini, "Il santuario di Feronia e delle divinità salutari a Bagnacavallo," *Studi Romagnoli* (1962); id., "La stele del curiale Mansuanio," *Atti e Mem. Deputaz. di Storia Patria per le Romagne,* n.s. 9 (1957-58) 1962 35ff; L. Balduzzi, *Atti Mem. Deputazione Storia Patria per le Romagne* 2, 1 (1974) 1-11.

G. BERMOND MONTANARI

BAĞYAKA, see PANAMARA

BAIAE Campania, Italy. Map 17A. A city belonging in antiquity to Cumae and situated 4 km from it on the Tyrrhenian Sea. Despite its proximity Baiae contrasts with Cumae significantly. It has no specific and defensible citadel but was built on a long hillside sloping down to the shore, "a subsidiary crater in the wall of Avernus." Only in 178 B.C. were its thermal springs (aquae Cumanae) first mentioned; and not until a century later, perhaps as a by-product of the social war or the Sullan period, did it become the Roman fashionable resort par excellence. From this time until at least Alexander Severus its landholders were Roman aristocracy, especially after a large part of the town became imperial property under Augustus and his successors. Like Puteoli, it was and is far more subject to bradyseism; it is estimated that Roman Baiae extended more than 100 m beyond the present shore. Except for the controversial interpretation of the Great Antrum, it had no special cult significance, and no genuine temples have been identified. It had no amphitheater; presumably those at Cumae and especially Puteoli sufficed. It was uniquely famous among poets and vacationers for its natural loveliness and charm and for its hot and curative mineral springs which supplied the baths and, above all, for its licentious living at all periods. Cicero makes it synonymous with libidines, amores, adulteria, actae, convivia, commissationes, cantus, symphoniae, navigia (*Cael.* 15.35), and Seneca gives a critical but lively account of its life and of Vatia's nearby villa (*Ep.* 51.55); (for a more rural estate, cf. Martial 3.58). Cumae inspired no souvenir glass vases, but the principal monuments of Baiae are illustrated and identified on a 4th c. glass bottle like those of Puteoli now in the Museo Borgio of the Propaganda Fide, and on the famous Piombino/Populonia glass now at the Corning Museum, which includes scenes of both Baiae and Puteoli. The former bottle shows a pharos, the stagnu(m) Neronis (Nero's fishing lake), a silva and the place-name Baiae; the latter includes the palatiu(m); and both show the famous ostriaria (*sic*) and a second stagnu(m). According to A. De Franciscis the ruins probably represent an Imperial Palatium (cited in the literary and epigraphical sources) occupying the slope of the hillside, extending upward as far as the ridge, and in the arrangement of its various parts, so adapted to the lay of the land as to have the advantage of the panoramic view. Established on an area where there were already constructions, the build-

ing of the complex would have developed over the course of several centuries, its principal monuments originating in the age of Augustus, in the middle of the 2d c., and at the beginning of the 3d c. In the various elements on the several levels Professor de Franciscis identifies a vast porticoed courtyard, terraces, grandiose rooms, salons and minor rooms of various dimensions with several sections for receiving delegations, others for lodging, and a vast sector of baths. The coastline of the principal archaeological area runs almost directly N-S with the following principal monuments:

1) The so-called Temple of Diana is a domed structure externally octagonal and internally circular (29.5 m diam.), half preserved, together with its appendages, on the side supported by the hill. It is probably Hadrianic, and has a slightly elliptical profile; possibly it was a casino.

2) South of the railroad, and likewise supported by the hill, the so-called Temple of Mercury is a great round vaulted building (21.5 m diam.), with a circular opening at the top. This vaulted dome, built up over concentric contracting levels of temporary wooden falsework, is a kind of opus incertum of tufa set in cement with a predominance of wedge-shaped tufa blocks of which the wider outward ends conform to the greater outside radius of the dome; toward the center opening the thickness of the shell is 60 cm, increasing down to the junction with the vertical walls. The whole is obviously reminiscent of the Pantheon at Rome, and about half its size, but is assignable to the late Republic or earliest years of Augustus by its fine and careful reticulate work to the exclusion of brick. Cramp-holes on the interior indicate an ornamental marble veneer. Like all the other bath constructions it had high windows for light and ventilation and niches for statues and, in addition, ground-level extensions on a NW-SE axis of which the NW, a kind of nymphaeum, connected with the aqueduct supplying water and the other was perhaps for outflow. A small corridor at the rear exterior base of the dome served both as a retaining wall and drainage channel for earth and water descending from the hill, for maintenance, and as a platform for a small staircase whereby the center opening and high windows could be covered in inclement weather. From the main rotunda a passage leads to a later large rectangular tepidarium(?) embellished with niches and an apse. Bradyseism, neglect, and the installation of a vineyard over the vault had reduced the monument to near ruin when emergency restoration was undertaken, though not thorough excavation, and the whole rotunda was identified as a natatorium. Further excavations (1964-65) in this area have shown dwelling and service quarters, including some late Flavian and Severan painted decoration.

3) To the S and E of this complex a considerable lower area is still unexcavated, but higher on the hill there are over 100 m of parallel N-S loggias, a portico, and an ambulatio on different levels. From here the evening view down the slope of fine buildings and across the bay to Vesuvius, with Sorrento on the right, must have been magnificent.

4) The next considerable unit, excavated in 1951, is the charming Acque della Rogna, so-called from its curative powers, or more elegantly the Terme di Sosandra from a statue found in its upper part. It consists of three levels set in the hill: first, a high residential quarter recently interpreted as a monastery; then lower, a small exedra-and-nymphaeum with a round pool in an orchestra adaptable for dramatic, oratorical, or musical events; and finally, 8 m still lower, a promenade and lounging area surrounding a rectangular swimming pool (34.8 x 28.6 m). This whole unit from top to bottom is bounded on N and S by grand staircases and ramps ca. 60 m long.

5) The most southerly of the baths centered round the so-called Temple of Venus now also confusingly but more accurately described as the Baths of Venus. The area shows remains of Augustan construction, but the present spectacular structure is Hadrianic. Its lower story, the natatorium, is externally roughly square with at least one highly complicated annex, and internally circular (26.3 m diam.) with four large bays; its upper story is octagonal outside but the interior circle continues with high windows.

A part of the same bathing establishment and several meters higher than the so-called Temple lie the Baths of Venus across the modern strada provinciale, excavated early in WW II. These baths rise 5 or 6 stories against the hill; their principal feature is a large apsed rectangular hall enclosing a bathing basin.

6) Still higher, at the 23 m level, is a Sacred Area, a complex of buildings of several periods and the entrance to the spectacularly impressive Great Antrum, which consists of a descending passage (0.5 x 2.5 m) cut straight back into the rock for 124.5 m and continued by a complicated series of further passages downward to a tunnel flooded by hot springs at about sea level, and upward to an inner sanctuary. The whole unit extends ca. 350 m from the entrance.

The remainder of Baiae, both the seashore and the heights behind, including Julius Caesar's magnificently located villa, has been archaeologically wrecked and aesthetically ruined by the construction of Don Pedro de Toledo's castle, installation of the modern port, pozzolana quarries, road building, etc.

Some serious underwater archaeology has been undertaken at Punta dell'Epitaffio to the N and elsewhere, as well as less systematic raising of columns, statues, etc. Some of these are now in the Naples Museum.

BIBLIOGRAPHY. General: A. Maiuri, *The Phlegraean Fields* (Guide books to Museums and Monuments in Italy, 32) (3d ed. 1958, tr. Priestley)[MPI]; M. Napoli in *EAA* (1958)[PI]; J. H. D'Arms, *Romans on the Bay of Naples* (1970)[MI]; *ThLL* II, s.v Baiae.

A. Maiuri, "Il restauro di una sala termale a Baia," *BdA* 2, 10 (1930-31) 241-55 (Tempio di Mercurio)[PI]; id., "Terme di Baia: scavi, restauri e lavori di sistemazione," *BdA* 4, 36 (1951) 359-64 (Terme di Sosandra)[PI]; G. d'Ossat, "Il 'Tempio di Venere' a Baia," *BMusImp* 12 (1941) 121-32 (Appendice al vol. 69 del *BullComm*)[PI]; M. Napoli, "Di una villa marittima in Baia," *Boll. Storia dell'Arte del Mag. Salerno* 3 (1953) 77-109 (Severan villa with statues); id., "Una nuova replica della Sosandra di Calamide," *BdA* 4, 39 (1954) 1-10[I]; P. Mingazzini, "Due statue ercolanesi rivendicate a Baia," *Scritti in onore di Guido Libertini* (1958) 111-16[I]; N. Lamboglia, "Forma Maris Antiqui," *RStLig* 25 (1959) 302-9[PI]; 26 (1960) 361-64[P]; F. Rakob, "*Litus beatae Veneris aureum*: Untersuchungen am 'Venustempel' in Baiae," *RömMitt* 68 (1961) 114-49[MPI]; A. De Franciscis, *FA* 18-19 (1963-64) no. 7303; id., "Underwater Discoveries around the Bay of Naples," *Archaeology* 20 (1967) 209-16[PI]; P. E. Auberson, "Etudes sur les 'Thermes de Vénus' à Baies," *RendNap* NS 39 (1964) 167-78; W. Johannowski, *FA* 20 (1965) no. 4601; R. F. Paget, "The Great Antrum at Baiae," *BSR* 35 (1967) 102-12[PI]; id., *In the Footsteps of Orpheus* (1967) (Great Antrum)[MPI]; id., "From Baiae to Misenum," *Vergilius* 17 (1971) 22-38[PI]; id., *Atti Taranto* (1970) 126ff; C. G. Hardie, "The Great Antrum at Baiae," *BSR* 27 (1969) 14-33. H. COMFORT

BAITERA, *see* BAETERRAE

BAKRAINA ("Mopsion") Thessaly, Greece. Map 9. A city described by Livy as on a hill between Larissa and Gonnos. It was previously identified by Stählin with Drachmani (Rachmani), a nameless site whose ruins are visible E of the road and railroad leading N to the Vale of Tempe. It is situated on a height at the S end of the Kalamitsa plain. Failing to find significant remains of a city, Stählin subsequently placed Mopsion at Bakraina, a double-peaked site connected by a saddle to Mt. Erimon's farthest S spur. The hill is concave and much eroded toward the S; the other sides are steep. There are two walls of primitive construction around the W peak, the inner quite small in circumference and linked to the outer by two cross walls. A third wall encloses both peaks in an oval. There are no towers; the only remaining gate is in the SE corner. The masonry, possibly 4th c. B.C., is two-faced polygonal with a fill of rubble.

BIBLIOGRAPHY. Strab. 9.5.20,22; Livy 42.61.11; F. Stählin in *RE* 16[1] (1935) 236[P].　　M. H. MC ALLISTER

BALÁCAPUSZTA County of Veszprém, Hungary. Map 12. A peristyle villa begun in the second half of the 1st c. A.D. It was a large stone building, the floors covered with mosaic, and the walls with frescos crowned by stucco moldings. The heating system of the building ensured a pleasant warmth in the N colony and there was a bath complex attached to the main building. A wall enclosed the main buildings, stables, and agricultural buildings. The architecture of the villa—the main building and the bath—resembles villas of Italy and North Africa. The farm buildings do not differ from those used elsewhere in the province.

The main axis of the villa is enclosed by a semicircular room. Later reconstruction surrounded the building with corridors. Alterations resulting in the rebuilding of the inner rooms may be dated to the last third of the 1st c., to judge from the basic plan and some of the frescos, the dining room, the red-and-black room, the yellow-and-purple room, and the black room. Of the stuccos the serrated, pearl-like classical molding which belonged to the yellow-purple room, and the finely chiseled beam belonging to the black-red room, are also part of the early villa. From a later era come certain frescos, ceiling fragments, and certain mosaic floors. In the third period, the villa's exterior architecture was renewed with galleries built around the core of the building. This period can be placed between the end of the 2d c. and the first decades of the 3d. At this time the frescos were broken up and the debris was used to fill up the floor space under the galleries. The mosaic floors were still in use. In the first half of the 3d c., the villa took final shape and, with some small interior alterations, served until the end of the Roman era. The discovery of hearths and their remnants on some of the mosaic floors prove that the building was inhabited during the migrations. Faint traces point to the occupation of the Roman villa even during the early Middle Ages.

BIBLIOGRAPHY. D. Laczkó & G. Rhé, *Baláca* (1912) 104 pp.; E. Thomas, *Baláca. Mozaik, Freskó, Stukkó* (1964) 80 pp.; id., *Arch. Funde* (1956) 214-19; id., *Römische Villen . . .* (1964) 73-107[I]; A. Kiss, "The mosaic pavements of the Roman villa at Baláca," *Acta Arch. Hung.* 11 (1959) 159-236; T. Gedeon & A. Nemesics, "Technische Untersuchung der Fresken der Römischen Villa von Baláca," *VMMK* (1961-65) 459-72.

E. B. THOMAS

BALARUC-LES-BAINS Canton of Frontignan, Hérault, France. Map 23. Ancient spa situated at the E edge of the Étang de Thau. Important remains were discovered in the 19th c. Among the artifacts found were altars to Neptune and the nymphs.

BIBLIOGRAPHY. L. Bonnard, *La Gaule thermale* (1908) 362-64; *Carte archéologique de la Gaule romaine*, fasc. x, Hérault (1946) 15, no. 37.　　G. BARRUOL

BALAT, see MILETOS

BALBURA (Çölkayığı) Turkey. Map 7. City in Lycia 6 km SE of Dirmil. When first mentioned (Strab. 631) Balbura appears as a member of a tetrapolis headed by Kibyra, with one vote to Kibyra's two. This tetrapolis was formed at an uncertain date in the 2d c. B.C., and was dissolved by Murena ca. 82 B.C.; Balbura was then attached to the Lycian League, and continued to be a member as long as it lasted. Balbura, Bubon, and Oinoanda are listed by Pliny and Ptolemy as the cities of Kabalia (called Kabalis by Strabo). The coins are Hellenistic of non-League types and Imperial of Caligula. Balbura is recorded by Hierokles and in the Byzantine bishopric lists.

The ruins are on two hills and on the plain below. The N hill rises some 125 m above the plain and almost 1500 m above sea level. The summit was defended by a ring wall still standing up to 2.4 m high, built mainly of dry rubble but with a stretch of polygonal masonry near the top, 1.8 m thick; in general the wall is of late date and made of reused material. On the S slope of this hill, facing S, is a small theater of remarkable construction. The cavea contains 16 rows of seats, interrupted in the middle by a large mass of the native rock left unworked, except that the ends of the rows are fitted to it. There is no stage building, but the platform which it would occupy is supported by a high wall of heavily bossed polygonal masonry with buttresses of smooth rectangular blocks. This polygonal work is of Roman date.

At the foot of the S hill is a second theater or theater-like building. The cavea, facing E, consists merely of the hollow in the hillside, with a few seats cut here and there in the rock. In place of the stage building is a narrow platform of solid masonry supported on arches, some 45 m long, with a small platform in the middle projecting towards the cavea. No permanent stone building seems to have been erected on this substructure.

Little remains of the public buildings in the plain: they included a temple of Nemesis, and an agora with a triple-arched gate on its W side dedicated to Septimius Severus and Geta. Inscriptions refer also to an aqueduct and a reservoir.

The tombs are of various kinds, but none of Lycian type. Some are built bombs, others of Carian type; still others are in the form of a coffin set in a recess cut in the rock, or a sarcophagus with a recumbent lion on the lid.

BIBLIOGRAPHY. T.A.B. Spratt & E. Forbes, *Travels in Lycia* I (1847) 267-71; E. Petersen & F. von Luschan, *Reisen in Lykien* II (1889) 183-86; R. Heberdey & E. Kalinka, *Bericht über zwei Reisen* (1896) 37-39.

G. E. BEAN

BALDOCK Hertfordshire, England. Map 24. On the line of the Icknield Way, a pre-Roman route, an important settlement for at least 50 years before the Roman conquest. It flourished throughout the Roman period, when the Icknield Way was crossed by roads to Braughing, Sandy, and St. Albans.

Excavations in 1925-30 uncovered an extensive cemetery and traces of settlement. The 16 ha Walls Field was scheduled as an ancient monument, and in 1968 the dis-

covery of a rich pre-Roman burial initiated large-scale excavations. The burial was a cremation with two firedogs, two wooden buckets with bronze fittings, two bronze dishes, a bronze and iron cauldron, and an amphora. Pottery of the same period, and British coins, have been found over a wide area, but defenses or limits to the settlement have yet to be identified.

The Roman settlement is also large, and apparently undefended. It extends SW of Walls Field, where it is covered by the houses of the modern town, and also to the NE where recent excavations have stripped an area of occupation. This is represented principally by ditches, rubbish pits, and wells, with only slight traces of timber buildings; one of these had stone foundations to prevent subsidence into earlier pits. Only one substantial building has been found in Baldock—a structure with flint walls and brick quoins—and only one corner of that could be uncovered because of modern development.

BIBLIOGRAPHY. *ArchJ* 88 (1931) 247-301[PI]; *AntJ* 48 (1968) 306. I. M. STEAD

BALETIUM (Valesio) Apulia, Italy. Map 14. Located by Pliny (*HN* 3.101) between Lupiae (Lecce) and Caelia (Ceglie Messapica), in the same place in which Balentium appears in the *Peutinger Table*. The name is found as Valetium in Mela (2.4). Silver coins of the Tarentine type dating from about 350 B.C. with the Messapian legend Balethas or Valethas are attributed to the city.

The ruins of the city are found in the section of Agro di Torchiarolo called Valesio 2 km N of S. Pietro Vernotico. The Provincial Museum at Brindisi preserves numerous Messapian inscriptions and funerary material from Baletium.

BIBLIOGRAPHY. W. Smith, *Dictionary of Greek and Roman Geography*, I (1856) 375 (E. H. Bunbury); *RE* VIII.1 (1955) 259-60; B. V. Head, *Historia Numorum* (1911) 51; M. Mayer, *Apulien* (1914) 78; K. Miller, *Itineraria Romana* (1916) 362; O. Parlangeli, *Studi Messapici* (1960) 124. F. G. LO PORTO

BALKIS (Syria), *see* ZEUGMA

BALKIZ, *see* KYZIKOS

"BALLA," *see* VERGHINA

BALMUILDY, *see* ANTONINE WALL

BALSA (Tavira) Algarve, Portugal. Map 19. Mentioned by Mela (3.1), Pliny (*HN* 4.22), Ptolemy (2.5), and in the *Antonine Itinerary*, Balsa has been identified with a site between Santa Luzia and Senhora de Luz, near Tavira, by many inscriptions and other objects found in the region. The cemetery has been explored but there has been no extensive excavation. The finds are in the National Museum of Archaeology in Lisbon.

BIBLIOGRAPHY. A. Viana, "Balsa y la necropolis romana d'As Pedras d'El Rei," *Archivo Español de Arqueologia* (1952) 261-85. J. ALARCÃO

BANASA (Sidi Ali bou Djenoun) Morocco. Map 19. An ancient city of the province of Mauretania Tingitana situated on the road from Tingi to Sala and mentioned by Pliny, Ptolemy, the *Antonine Itinerary* and the Geographer of Ravenna. Numerous inscriptions confirm the site, which is located where the mausoleum of Sidi Ali bou Djenoun was later built, 17 km W of Mechra bel Ksiri. The ruins are on the left bank of the wadi Sebou, which Pliny (5.5) described as: amnis Sububus praeter Banasam coloniam defluens magnificus et nauigabilis.

It probably could be crossed by bridge in the Roman period.

The site appears to have been occupied as early as the 4th c. B.C., perhaps earlier. A Mauretanian village of some size stood there in the 3d-2d c., and it was on this site that Augustus formed a veterans' colony, colonia Iulia Valentia Banasa, during the period between the death of King Bocchus and the accession of Juba II (33-25 B.C.). It may be that this first Roman settlement suffered in the disorders following the assassination of Ptolemy of Mauretania in A.D. 40 and the annexing of his kingdom. The buildings that have been uncovered do not, as a whole, predate the end of the 1st c. A.D.: this is the period of the last stage of the forum, which was rebuilt on earlier remains. On becoming colonia Aurelia Banasa under Marcus Aurelius (the circumstances are unknown but may be connected with disorders that befell the province at this time), the city was laid waste and abandoned in the late 3d c., probably even before Diocletian had evacuated S Tingitania.

The strata dating from before the Roman conquest are buried beneath thick layers of alluvial deposits from successive floods of the wadi Sebou. So far they have been located in limited digs only in the S quarter and, to the N, along the main cardo between the forum and the marabout of Sidi Ahmed el Garge. The first potsherds encountered in the excavations, 10.25 m from the surface, cannot be dated and are not matched by any building. The first structures are 4.5 down, below the Roman stratum: a great number of potter's kilns and what may be remains of dwellings of mud and unbaked brick, which can be dated from the 3d-2d c. B.C. From this time on, even up to the 1st c. A.D., the Banasa potters produced characteristic painted ware, inspired by the Punic and Iberian models that were exported rather widely in the region. Also corresponding to these early strata are a number of tombs found SE of the forum. They contained Punic jewels, possibly 6th-5th c. B.C., but the grave gifts are probably later.

The Roman city was built on an overall NE-SW grid plan forming regular but unequal insulae. However, a second, more obviously N, orientation can be made out, especially to the W. It crops up again in the S section beyond the forum and is echoed in the plan of a section of the city rampart found to the SW. Possibly, this second orientation reflects the plan of the Augustan colony, in which case the rampart, which is usually dated from the Late Empire (against all probability), would be that of the colony.

The forum lies in the center of the settlement. A trapezoidal paved piazza (37 x 34 m), it is lined to W and E by porticos and flanked to the N by a rectangular basilica, to the E by a small apsidal hall, and to the S by five cellae fronted by a common portico. These cellae stand on a podium in front of which is a row of stone plinths and statue bases. It is difficult to see a Capitolium in this structure, as some have claimed, yet it is in fact a temple, built on a plan (frequently found in Mauretania, as at Sala in the Augustan era, Volubilis under the Severi, and Cherchel), which, together with the nearby forum, suggests that the architects carried out the idea of a principia of a military camp. Up to now no other religious monument has been found, with the possible exception of a little temple, not identified with certainty, in the SW quarter. Yet from dedications and the presence of a flaminica and seuiri augustales we have proof that the imperial religion flourished; other inscriptions as well as representations of figures attest the presence of the customary gods of the Graeco-Roman pantheon and of Isis; also there was a temple of the Mater deum. However, the only public monuments uncovered apart from

the forum are baths—these are numerous, five having been found in the only section of the city to be excavated. There is also a macellum, which should be placed W of the forum, where it takes up an entire insula, and not in the NW quarter where the name has been given erroneously to a large domus.

The wealthiest houses in Banasa lack originality; very similar to those found at Volubilis, though not as rich, they are set around a central peristyle according to the traditional plans of W provinces. On the other hand, simpler houses are laid out according to a less regular plan; they are reminiscent of the Mauretanian houses found, for example, at Tamuda and at Lixus. Shops abound in the whole of the excavated section, and several bakeries have been uncovered (recognizable by their equipment) but, not surprisingly in this region traditionally given over to cereal production, only a very small number of oil-making installations.

The poor appearance of these buildings can bc explained by the fact that the nearest quarries, which provided only coarse stone, are a considerable distance away. In most cases walls were built of mud or unbaked brick on a base of irregularly shaped stones. Ashlar was reserved for public buildings or for decoration, the poor quality of the latter being amended somewhat, in the 2d-3d c. at least, by mosaic floors, imported marble veneers, or painted frescos, some of which show traces of a design of figures.

Some important objects have been uncovered. Stone statuary is rare and usually crude; that in bronze is represented by minute fragments of large statues and a few statuettes. Epigraphical material is exceptionally rich, the bronze inscriptions being especially noteworthy: these include a dozen military diplomas, four decrees of patronage, and two important legal texts (an edict of Caracalla exempting the inhabitants of Banasa from taxes in 216, and the Tabula banasitana from the period of Marcus Aurelius and Commodus, which set forth the conditions under which aliens could be granted the right of the city and the manner in which the consilium principis and the imperial chancellery were organized).

To the SW of the settlement, aerial photography has revealed what probably are traces of a military camp and a small fort of lesser importance; however, no remains of the site can be detected on the ground itself.

BIBLIOGRAPHY. R. Thouvenot, *Une colonie romaine de Maurétanie tingitane: Valentia Banasa* (1941); id., "Une remise d'impôt sous l'empereur Caracalla," *CRAI* (1946) 548-58; id., *Publications du Service des Antiquités du Maroc* 11 (1954) and 9 (1951); M. Euzennat "Chroniques," *Bulletin d'Archéologie Marocaine* 2 (1957) 202-5[MPI]; id. & W. Seston, "Un dossier de la chancellerie romaine: la *Tabula Banasitana*," *CRAI* (1971) 468-90.

M. EUZENNAT

BANASSAC Lozère, France. Map 23. In the ancient territory of the Gabales, Banassac lies on what is now the boundary of the departments of Aveyron and Lozère, at the confluence of the Lot and the Urugne beside Route Nationale 9.

Local craftsmen were attracted to the site at the beginning of the 1st c. A.D. by the quality of the clay, the proximity of the Causses forests, and the plentiful supply of water. Besides ordinary ware, they turned out painted bowls with a white slip and geometric patterns. The arrival of the Gallo-Roman potters, however, and especially their novel technique, enabled Banassac to change from a local craft workshop to a true center of industrial production.

These artisans came from La Graufesenque and settled in the Urugne Valley about the middle of the 1st c. A.D.,

setting up a secondary workshop. The wares were exported as far as Budapest, Antioch on the Orontes, Poland, North Africa, and England.

The Banassac workshops were active from A.D. 60 to 190, with marked growth taking place between 70 and 120. The export area shrank little by little after 150, although Banassac ware crops up again at Javols in a stratum dating from 190.

An archaeological depot is under construction, where all the finds will be housed.

BIBLIOGRAPHY. Excavation reports: *Bull. Soc. Lozère* (1860) 47-317; Balmelle, in *Cévennes Républicaines*, 27 Feb. 1938; *Compte-rendu du groupe d'archéologie antique du T.C.F.* (mimeo 1962); *Revue du Gévaudan* (1962) 180; *Gallia* 24, 2 (1966) 482.

"Haches et monnaies romaines," *Bull. Soc. Lozère* (1839) 158; *Congrès archéologique, Mende* (1857) 29; Fabre, *Bull. Soc. Lozère* (1875) 33; (1899) 136; (1900) 62; J. Barbot, "Zigs-Zags en Lozère," ibid. (1901); J. Déchelette, *Les vases céramiques ornés de la Gaule romaine* (1904) 117; *Bull. Soc. Lozère* (1906) Chroniques et Mélanges; C. Morel, "Céramique à Strasbourg," ibid. (1947) 280; (1948) 363; id. in H. Boullier de Baranche, *Feuda Gabalarum* I, app. 1; id., "Quelques aspects des céramiques Gallo-romaines de Banassac (Lozère)," *Revue du Gévaudan* (1968) 78-86; id. & P. Peyre, "Les exportations des céramiques sigillées de Banassac en Provence et dans les pays Rhodaniens," *Provence Historique* (1968) 66-76; P. Peyre, "Autour de Banassac-La Canourgue dans des Gévaudan, Decembre 1961," ibid. (1962); id., "Exposition Gallo-romaine. Les ateliers de céramique sigillée de Banassac-La Canourgue," *Catalogue d'Exposition* (mimeo 1963); Balmelle, *Bull. Soc. Lozère* (1949) 486, bibl.; ibid. (1955) 136-61 passim; ibid. (1956) 231, 234, 251, 257; M. R. Thevenot, "Rapports commerciaux entre la Gaule et la Mauritanie tingitane," *Congrès des Sociétés Savantes, Dijon 1959* (1961) 185; M. Cavaroc, "Epigraphie inédit sur céramique de Banassac (Lozère)," *Ogam* (1961) 431[I]; id., "Les marques de potiers gallo-romains," *Revue archéologique du Centre* 10 (1964); "Banassac-La Canourge, Août 1961," *Revue du Gévaudan* (1961) 5; ibid. 162-99 passim; Merovingian coins pl. 189.

P. PEYRE

BANEASA Muntenia, Romania. Map 12. Two Roman castra ca. 25 km N of the Danube. The larger, which has been systematically investigated, was rectangular (130 x 126 m) and was constructed of burnt earth. Its main axis was oriented N-S, parallel with the limes transalutanus (late 2d-mid 3d c.), to which it belonged.

BIBLIOGRAPHY. G. Cantacuzino, "Le grand camp situé près de la commune de Băneasa," *Dacia* 9-10 (1945) 441-72.

E. DORUTIU-BOILA

BANNAVENTA Northamptonshire, England. Map 24. Identified by its position in the *Antonine Itinerary* (470.5, 477.1, 479.5) with the site on Watling Street near Whilton Lodge where traces of buildings, coins, and pottery had been recorded since the 17th c. In 1970 air photographs revealed an enclosure (ca. 225 x 112.5 m) defended by double ditches and lying athwart the Roman road. Shortly afterwards the part lying E of the modern road was bulldozed for commercial development. It has sometimes been claimed that Bannaventa is to be identified with the Bannavem Taburniae (or Bannaventa Burniae) from which St. Patrick was carried off to Ireland, but its position so far inland makes this highly improbable.

Excavation in 1971-72 revealed earthwork defenses succeeded by walls, and occupation from the 1st to the 4th c.

BIBLIOGRAPHY. *VCH Northamptonshire* I (1902) 186-87; J.K.S. St. Joseph, *Antiquity* 45 (1971) 140-41. *Itinerary*: A.L.F. Rivet, *Britannia* 1 (1970) 42, 49, 51; R.P.C. Hanson, *St. Patrick* (1968) 112-18; *Britannia* 3 (1972) 325; 4 (1973) 295-96ᴾ. A.L.F. RIVET

BANOŠTOR, *see* BONONIA-MALATA *and* LIMES PANNONIAE (Yugoslav Sector)

BANTIA (Banzi) Lucania, Italy. Map 14. A native settlement that developed in Iron Age I on a spur which commands the valley of a tributary of the Bradano river. The most numerous traces of a settlement and of the necropolis have been discovered in Via Dante and its vicinity. The pottery is Daunian, strongly influenced by Greek imports. A larger settlement, covering the entire spur, dates to the 4th c. B.C. and there are traces of life in the second half of the 5th c. B.C.

Contrary to what has occurred elsewhere, the settlement flourished during the 3d c. and the 2d c. B.C. It was similar culturally to Greek coastal centers. In the first half of the 1st c. B.C., the settlement, by this time under Roman domination, became a municipium. Its administrative systems are well known from the Tabula Bantina. A study of the last fragment of the Tabula, discovered in 1967, makes clear that it was drawn up in Latin and translated into Oscan at Rome by someone not completely familiar with the Oscan language.

The construction of the auguraculum must have started when the municipium was founded, as various fragmentary inscriptions from the monument and the archaeological materials connected with it attest. In the middle of the 1st c. B.C., the municipium received a building for the duoviri (*CIL* XI, 418). It is clear from documents found during recent excavations that the life of the municipium extended to the Christian era. A great part of the Roman settlement now lies beneath the countryside. The only area uncovered is that which extends along the S side of the spur.

BIBLIOGRAPHY. *CIL* IX, p. 43 n. 416; A. Lombardi, "Topografia ed avanzi d'antiche città nella Basilicata," *Mem. Ist. Corr. Arch.* 1 (1832) 218; *Diz. Epigr.*, IV, 715ff; E. Vetter, *Handbuch d. Ital. Dialekte*, I (1953) 14ff; M. W. Frederiksen, *JRS* 55 (1965) 186ff; C. Nicolet, *L'ordre équestre à l'époque républicaine* (1966) 557ff; M. Torelli, *RendLinc* 8, 21 (1966) 293ff; D. Adamesteanu & M. Torelli, *ArchCl* 21 (1969) 1-17. D. ADAMESTEANU

BANYAS, *see* PANEAS

BANZI, *see* BANTIA

BAOUSIOI, *see* LIMES, GREEK EPEIROS

BARA Tarragona, Spain. Map 19. A town NE of Tarragona near Torredembarra, with one of the most beautiful and best-preserved Roman arches in Spain. It lies on the Via Augusta, probably as a border marker between the Cesatanians and the Ilergetes. According to its dedication it was constructed under the will of Trajan's general Lucius Licenius Sura, consul during 102, 104, and 107. Built of stone, it has one arch framed by two pilasters with Corinthian capitals; it is 12.28 m high, 12 m long, and 2.34 m wide. Probably it once had an attic.

BIBLIOGRAPHY. J. R. Mélida, *Monumentos romanos de España* (1925)ᴵ; B. Taracena, *Ars Hispaniae* II (1947)ᴵ. R. TEJA

BARACS, *see* LIMES PANNONIAE

BARACSKA ("Iasuiones") Fejér, Hungary. Map 12. A modern village with Roman traces probably belonging to Iasuiones of Pannonia Inferior, 25 milia passum from Aquincum and the same distance from Gorsium, the next statio on this section of the road. Inscriptions on stones found in the area indicate a small statio established for military reasons. Although it is the most significant Roman site on this stretch, no traces of buildings have been found. Several stone inscriptions from the area are recorded (*CIL*). One Jupiter altar was erected by Cocceius Senecio, decurio of the Ala I Thracum; another was dedicated to the god by a veteran of Legio II Adiutrix. One of the two tombstones found on the borders of Baracska was erected in the memory of a member of the Cohors I Alpinorum. A marble Hercules and a relief depicting the Battle of Hercules and the Centaur merit special attention and suggest that a Hercules sanctuary stood here. The earliest finds are of the era of the Marcomannic wars. Most of the tombs and coins are of the 4th c.

BIBLIOGRAPHY. *It. Ant.* 264; *CIL* III, 3693 = 10362, 10369-71, 12014, 12759; A. Bauer, *AEM* 3 (1879) 25; K. Torma, *ArchErt* 3 (1883) 12; I. Tömörkényi & P. Harsányi, *Numizmatikai Közlöny* 11 (1912) 10; A. Marosi, *Székesferhérvári Szemle* 1 (1931) 7, 9, 13; J. Juhász, ibid., 4 (1934) 78; A. Graf, "Übersicht der antiken Geographie von Pannonien," *DissPan* I.5 (1936) 120; id., *RE* Suppl. IX (1926) 83-84; id., *Alba Regia* (1963-64) 225. E. B. THOMAS

BARÁTOFÖLDPUSZTA, *see* LIMES PANNONIAE

BARBOŞI Moldova, Romania. Map 12. Roman castellum on the left bank of the Danube, at the mouth of the Siret, on the site of a Dacian settlement of the early 1st c. A.D. The castellum, first constructed of earth, was later replaced by a larger castellum built of stone. A bridgehead on the left bank of the Danube across from Dinogetia, it belonged to the province of Moesia Inferior, was under the authority of the legion at Troesmis, and was placed here to protect the road along the Siret which ran through the Oituz pass into Dacia. In the middle of the 3d c. this castellum was abandoned, but in the 4th c. a small polygonal tower was built, the last phase of construction on the plateau of Barboşi. The castellum enclosed an area of ca. 5000 sq. m and was defended by a stone wall 1.1 m thick with rectangular interior towers and by a double ditch, barely visible today. In the 2d and 3d c. detachments of Legio V Macedonica, Legio I Italica, Cohors II Mattiacorum and Classis Flavia Moesica were garrisoned here. Near the castrum a civil settlement developed where many inscriptions, pottery fragments, and coins were found. Near this were cemeteries belonging to both the castellum and the civil settlement. The territory dependent on the castrum was closed by an earth vallum which crossed S Moldavia between the Prut and the Siret. Within this territory many other places with traces of Roman remains have been identified.

BIBLIOGRAPHY. V. Pârvan, "Castrul de la Poiana şi drumul roman prin Moldova de Jos," *ARMSI* 36 (1913) 11-31; G. Ştefan, "Dinogetia—a problem of ancient topography," *Dacia*, NS 2 (1958) 317-30; N. Gostar, "Unităţile militare din castellum roman de la Barboşi," *Danubius*, I (1967) 107-13. E. DORUTIU-BOILA

BARCELONA, *see* BARCINO

BARCINO (Barcelona) Barcelona, Spain. Map 19. Town in Tarraconensis whose name, known from many inscriptions, was Colonia Iulia Augusta Paterna Faventia Barcino, indicating that it was founded by Augustus. Barcino appears to be the native name of an oppidum

of the Laietani who minted silver drachmae at the end of the 3d c. B.C., imitating those of Emporion and bearing the Iberian legend BARKENOS. An allusion by Ausonius (*Ep.* 37.68) is the basis for the claim that it was founded by the Carthaginians (the family of the Barcidae). This is unacceptable, however; the name appears in Avienus (*O.M.* 5.520) in its pure Iberian form, Barcilo.

The Augustan colony spread over a small height, Mons Tabar (18 m above sea level), between two mountain streams, the San Juan to the N and La Rambla to the S. Its fields probably extended from the Baetulo river (Besós) to the Rubricatus (Llobregat). During the Late Empire it had large monuments, temples, baths, and two aqueducts, but it was burned and razed in A.D. 265 during the invasion of the Franks and the Alamanni. It was subsequently rebuilt and its perimeter reduced. The colony had been surrounded by a strong defensive wall with over 60 circular or polygonal towers which were mostly incorporated later into mediaeval structures. The extraordinary fortification of Barcino and the excellence of its port increased its importance during the Early Empire. At the beginning of the 5th c. A.D. it was occupied by the Visigoths as allies of the Romans, and King Ataulfo was assassinated there in 414. It had an active Christian community, including St. Paciano, and there are remains of a 6th c. basilica.

The Roman wall has been restored and the subsoil excavated, uncovering a large amount of reused architectural material, statues, funerary and honorific stones, and mosaics, from the destruction of the town in the 3d c. It is now possible to visit more than 200 m of the Roman town under the Gothic cathedral and the public buildings dating from the Middle Ages. The finds are in the museum on the site and the Barcelona Archaeological Museum.

BIBLIOGRAPHY. J. Puig i Cadafalch, *L'Arquitectura romana a Catalunya* (1934); L. Pericot et al., *Historia de Barcelona* (1943); A. Balil, *Las murallas romanas de Barcelona* (1961); id., *Colonia Iulia Augusta Paterna Barcino* (1964); F. Pallares, "Las excavaciones de la Plaza de San Miguel y la topografía romana de Barcino," *Cuadernos de Historia de la Ciudad* 13 (1969) 5ff.

J. MALUQUER DE MOTES

BARGASA Turkey. Map 7. Site in Caria, perhaps at Haydere, 11 km SE of Bozdoğan, in the valley of the Harpasos. The region at least is certain, both from Ptolemy (5.2.15) and from coins and inscriptions found in the neighborhood. The ruins of a town or city with a gymnasium have been found at Haydere.

BIBLIOGRAPHY. W. R. Paton, *JHS* 20 (1900) 60-61; L. Robert, *La Carie* II (1954) 273, 336, n.1. G. E. BEAN

BARGASA or Pargasa Turkey. Map 7. City in Caria, almost certainly at Gökbel near the coast, 29 km E of Bodrum. The city figures (as Pargasa) in the Delian Confederacy, usually paying 500 dr., and can have been only very small. From Strabo (656) it appears that it should be W of Keramos and close to the sea; at Gökbel, which is 18 km W of Keramos, there is a small citadel on a rocky hilltop, with a wall of rough masonry and sherds of archaic and Hellenistic date. A fragmentary Hellenistic city-decree was found here, proving the existence of a polis, and on the shore nearby another fragment referring to sacred harbors.

BIBLIOGRAPHY. W. R. Paton & J. Myres, *JHS* 16 (1896) 197; R. Kiepert, *Forma orbis antiqui* (1908-14) VII, Text p. 7; A. Maiuri, *Annuario* 4-5 (1921-22) 448-49; G. E. Bean & J. M. Cook, *BSA* 50 (1955) 135, 165.

G. E. BEAN

BARGYLIA or Andanos (Varvil) Turkey. Map 7. Town in Caria 7 km S of Küllük, never apparently colonized from Greece. Stephanos Byzantios says that the Carians, who called the city Andanos, attributed its foundation to Achilles; the alternative tradition, that it was founded by Bellerophon in honor of his friend Bargylos, is equally mythical. In the Athenian tribute lists Bargylia normally paid 1000 dr., and in the 5th c. B.C. was evidently of much less account than her neighbor Kindya. By the 3d c. the positions were reversed: Bargylia became completely Hellenized, taking over the principal deity of the Kindyans, Artemis, and sharing with Iasos the control of the gulf (Polyb. 16.12). In 201 B.C. Philip V used the city as his base, though not without discomfort (Polyb. 16.24); in 196 he was required to withdraw, and Bargylia was declared free. When Aristonikos occupied Myndos after 133 B.C. Bargylia was also in danger, but she was freed by an epiphany of Artemis Kindyas. Coinage exists from the 1st c. B.C. to the time of Septimius Severus; the principal types are Artemis and Pegasos.

The scanty ruins occupy a low hill with two summits at the angle of an inlet in the form of a reversed L; the inner part of this is now silted up. It is crossed at one point by a stone causeway. On the N summit, which formed the acropolis, were the chief buildings of the Hellenistic and Roman city, but they are in wretched condition. At the top was a Corinthian temple some 30 m long, oriented NW-SE; only the foundations survive, but some of its architectural members are strewn over the slope below. On the S slope of the hill stood a small odeion; the vaulted passage under the seats remains. The theater, somewhat better preserved, is on the E slope. An angle of the retaining wall is in excellent isodomic ashlar, slightly bossed, but the rows of seats are gone. Something of the stage building is still visible, and no doubt more is preserved underground. Farther down the slope are the foundations of a stoa. Nearby is a short stretch of a Roman aqueduct with low arches neatly formed; where the water came from is not clear. On the S summit is a mediaeval castle and a fragment of the city wall dating perhaps to the 4th c. B.C. The main necropolis is near the shore N and E of the city; the tombs are mostly sarcophagi.

BIBLIOGRAPHY. C. T. Newton, *Halicarnassus, Cnidus and Branchidae* II (1863) 604ff; id., *Travels and Discoveries* II (1865) 57-58; G. Guidi, *Annuario* 4-5 (1921-22) 359-62; G. E. Bean & J. M. Cook, *BSA* 52 (1957) 96-97; id., *Turkey beyond the Maeander* (1971) 82-87M; Epiphany of Artemis Kindyas: L. Robert, *Etudes Anatoliennes* (1937) 459ff; cf. D. Magie, *Roman Rule in Asia Minor* (1950) 1039. G. E. BEAN

BAR HILL, *see* ANTONINE WALL

BARI, *see* BARIUM

BARIUM (Bari) Apulia, Italy. Map 14. A city of the Peuceti of Roman times. There are virtually no remains of the Roman city. However the port was recognized as the most important in the area as early as 180 B.C. (Livy 40.18; Strab. 5.283). As a Roman municipium the city was enrolled in the tribus Claudia (Tac. *Ann.* 16.9). An important highway junction at the crossroads of the Via Traiana and the coast road, Bari was established as a diocese under Bishop Gervasius (A.D. 347). The 12th-13th c. Norman castle in Città Vecchia has been supposed to rest on the ancient Greek acropolis.

In the Museum of Archaeology in the Palazzo dell'Ateneo the archaic and Classical eras are represented by Apulian polychrome impasto pottery from Canosa and

Ruvesta and Attic black- and red-figure pottery; bronze arms and mirrors; cameos, gems, earrings, and fibulae; and glass and gold objects, extending down to Roman times.

BIBLIOGRAPHY. F. Carabellese, *Bari* (1909)[I].

D. C. SCAVONE

BARNSLEY PARK VILLA　Gloucestershire, England. Map 24. Roman villa near Cirencester, excavated since 1960. The chronology of the site can be summarized:

1) The pottery, including Samian, suggests activity from the early 2d c. on, but no structures have yet been found except a deep, partly stone-lined pit which may have been an abortive well, some drainage gullies, and an enclosure ditch.

2) The first series of structures consists of circular and rectangular pens, built in dry-stone walling, presumably for animals. Several had been rebuilt, and are datable from the 3d c.

3) A stone building with mortar walls in the form of a typical winged-corridor house and a large barn built ca. 360. The central area, where the main living quarters should have been, was an open space in which a small bath underwent two extensive renovations. Occupation continued until ca. 380.

4) Domestic activity ceased and the building was converted to agricultural use; this continued until the whole area was reduced to a large yard, presumably early in the 5th c.

5) Much of the field system has been traced and from the boundary ditches has come grass-tempered pottery of late 5th c. date which does not appear in the main building site.

BIBLIOGRAPHY. Interim report, *Trans. Bristol & Glos. Arch. Soc.* 86 (1967) 74-87; *Britannia* 3 (1972) 338-39[P].

G. WEBSTER

BARON-SUR-ODON　Calvados, France. Map 23. From Aregenua, the chief city of the Viducasses, a road cut through the chief city of the Baiocasses toward the English Channel. It can be recognized in the Chemin Haussé, which starts from Vieux and crosses the road from Caen at Evrecy at La Croix des Filandriers.

Substructures have been excavated 200 m from this road, in the commune of Baron-sur-Odon. The building stood on a hill overlooking, to the SE, a small valley adjoining the site of Vieux. It had 12 sides and a gallery running around an open esplanade. The first wall enclosed a polygonal area 22 m in diameter; a second wall ran exactly parallel with it, forming a gallery 2 m wide. Fragments of a third vertical structure indicate a third surrounding wall, more or less concentric with the other two, and making a corridor 3.5 m wide.

This building has been called "a somewhat unusual type of sanctuary." A large quantity of small bronze rings were found in the excavations, which may be ex-votos, suggesting that the monument is a temple—a hypothesis that seems fairly well grounded. Polygonal sanctuaries have been found in England: Silchester (Hampshire) has a six-sided temple whose greatest diameter is 20 m, and at Chewstoke (Somerset) there is a little octagonal Roman temple of the end of the 3d c. Polygonal temples have also been found in Germany: Mainz has an octagonal temple 25 m in diameter with two surrounding walls 4 m apart, while Pfuenz has an irregular 13-sided temple as much as 50 m in diameter. Such polygonal temples are rarer in France, though a 7-sided sanctuary 10 m in diameter has been found at Mur-en-Carentois (Morbihan, Brittany). The geographical position of the Baron-sur-Odon monument, however, matches that of sanctuaries found in Normandy, which are usually set on

high ground, near a spring and not far from a major highway. The 12-sided sanctuary of Baron-sur-Odon stands almost at the top of a slope; there is a well at the spot known as La Maison Blanche a few hundred m toward Evrecy, and a Roman road passes 200 m to the E.

Judging from the pottery, the temple seems to have flourished in the 2d and 3d c. A.D., but the site was occupied at an earlier period: several articles from Iron Age III have been found in the NE section of the temple cella. A rectangular complex 25 by 13 m has been uncovered E of the 12-sided monument, some 24 m from the third surrounding wall. It is roughly at right angles to the road bordering the monument and stands somewhat apart from the latter, looking toward the road. Its purpose has not yet been determined.

BIBLIOGRAPHY. Gosselin, "Fouilles aux environs de la côte 112 le long de la voie romaine partant de Vieux," *Bulletin de la Société des Antiquaires de Normandie* 52 (1952-54) 284; 54 (1957-58) 618; 55 (1959-60) 176, 389; 56 (1961-62) 588, 766.

C. PILET

BARRAFRANCA　Province of Enna, Sicily. Map 17B. A large agricultural center which, according to local scholars, may be identified with Calloniana, the statio located by Roman itineraries between Philosophiana (modern Sofiana) and Corconiana (Sommatino?). Supposedly the Roman mansio proper is to be found a few km from Barrafranca, in the Ciarfara area, where there are archaeological remains of the Roman and Byzantine periods. This hypothesis has not, however, been verified through scientific excavation.

BIBLIOGRAPHY. A. Li Gotti, "Identificazione definitiva di Calloniana," *Archivio Storico Sicilia Orientale* (1958-59) 121ff (with previous bibliography); D. Adamesteanu, *Kokalos* 9 (1963) 35ff (with previous bibliography).

P. ORLANDINI

BAR-SUR-AUBE, *see* SEGESSERA

BARZAN ("Tamnum")　Charente Maritime, France. Map 23. In the place known as Le Fâ, ca. 1000 m from the present-day N bank of the Gironde, there is a Gallo-Roman sanctuary consisting of a temple, a theater, baths, and a silted-up waterfront, the whole covering some 30 ha. The site has been identified with the ancient Tamnum mentioned in the *Antonine Itinerary* and the *Peutinger Table*, but this identification is still contested. The importance of the site is due above all to its position. It was the S port of the civitas of the Santones, a stage along the commercial route from the Mediterranean to the Atlantic by way of the Gironde, and a way-station in the coastal trade well served by its partly artificial little port. It was also a rural sanctuary for the people of the surrounding area. Its remains attest its prosperity from the 1st to the 3d c. A.D. By the time of its destruction (end of 3d c. ?) a small urban settlement had developed around the port, in the area now occupied by the La Fosse Perat marsh.

The temple: the podium is a massive circular construction 36 m in diameter and 3 m high, with three steps at the base. It is faced with small blocks. On the E side is a rectangular projection 16 m wide, the remains of the steps leading to the entrance and the vestibule, which opened behind six columns or pillars. The circular outside wall, with the steps at its base, carried a stylobate made of large slabs. It is connected by radiating walls to the wide foundation of the cella, which has an exterior diameter of 21 m, and 15.4 m on the interior. The wall of the cella was ornamented inside and outside by 14 Corinthian half-columns or pilasters, the stylobates of which have been found. The 4.5 m ambulatory surrounding the cella was covered with gray cement, and the cella was

paved with green and pink marble. An underground room lay under the pavement in the W part of the cella. The whole building lay within a rectangular peribolos composed of two parallel walls.

A forum probably existed in the axis of the temple, as at Vandeuvre or Sanxay. The forum proper must have begun outside the wall of the peribolos, 40 m from the entrance to the sanctuary. A base has been found there inscribed C. CAECILIVS / GALERIA / CIVILIS MART.

Some 60 m SE of the temple are the partially excavated baths. A large caldarium (15 x 10 m) and a square room above a hypocaust (laconicum?) flanked by two small rooms with paved tubs (frigidaria?) have been identified. Some of the supports of the hypocaust are in the form of open pyramids (cf. St. Bertrand de Comminges). A gutter runs E of the building.

Remains of a theater have been found 800 m E of the temple. Soundings have reached the base of the tiers and the stage wall. The large size of the orchestra is comparable with that at Sanxay.

An aqueduct, running E-W 300 m from the village of Barzan, consists of a vaulted gallery 2 m high and 2 m wide, with a 50 cm walkway on either side. It has a circular opening about every 30 m.

BIBLIOGRAPHY. A. Planchet et al., *Le Fâ de Talmont, port gallo-romain de Saintonge* (1944); L. Basalo, "Le temple du moulin du Fâ à Barzan, près Talmont," *Gallia* 3 (1944) 141-65; F. Eygun, *Gallia* 15 (1957) 211-13; 21 (1963) 439; 23 (1965) 355; 25 (1967) 246.

G. NICOLINI

BASEL, *see* BASILIA

BASILIA (Basel) Baselstadt, Switzerland. Map 20. Roman vicus and fort on the left bank of the Rhine (*Amm.Marc.* 30.3.1; *Not.Gall.* 9.4). The site is mainly on a spur of the alluvial terrace, the Münsterhügel between the Rhine and the Birsig. Remains of the Late Bronze age have been discovered here, and name and location indicate a pre-Roman oppidum in this part of the territory of the Raurici (another settlement of the Raurici was excavated in the early 20th c. on the right bank of the Rhine at Alte Gasfabrik; it flourished between 58 and ca. 10 B.C., probably as a river port and market).

In connection with the campaigns of Tiberius and Drusus in 15 B.C. a small fort was built on the Münsterhügel; it was again occupied by a Roman garrison from ca. 17 to 50. A vicus connected with the highway from Argentorate to Augusta Raurica developed in the 1st c. A.D., and during the 2d and 3d c. a guard (a statio of beneficiarii) must have been stationed at the bridges over the Birsig and the Rhine. After the fall of the Upper German Limes in 254-60 the Münsterhügel was fortified to an unknown extent. In the 4th c. Basilia became an important link in the defense system on the Rhine frontier as conceived by Valentinian I. The garrison left, probably in A.D. 401, but the fort must have remained the administrative center of the civitas Basiliensium. From about the 8th c. on Basilia was the seat of a bishop, who had resided earlier in Castrum Rauracense. His residence was in the Late Roman fortress, from which the mediaeval town developed.

The continuous settlement of the site has made excavation difficult, but traces of the wooden barracks of the earliest Roman fort have been found, beneath those of the 1st c. A.D. garrison, as well as a few remains of canabae. The vicus developed on both banks of the Birsig, which joins the Rhine at the W foot of the Münsterhügel; the lowest part is now the Marktplatz and the Schifflände. There must have been a bridge over the Rhine in the area of the Schifflände (a pile has been discovered on the opposite bank), and a post to guard the traffic over the bridge. But public buildings are known only through single architectural elements reused in the Late Roman walls.

The Late Roman fortress, the size of which is still controversial, included at least the Münsterplatz and its immediate vicinity. Its plan was probably trapezoidal, but the exact course of the walls is only partly known (shortest side ca. 120 m, longest ca. 240 m; area at least 3.5 ha). The Rittergasse and Augustinergasse follow the course of the Roman road. A ditch 20 m wide along the S wall of the fortress may have reused an earlier one, perhaps prehistoric. Recent excavations have increased the probability of a much larger enclosure, including the whole spur to the N. Within the fortress a two-storied granary with two rows of pillars has been partly excavated. The cemetery connected with the Late Roman fort is in the area called Aeschenvorstadt. The Historisches Museum is in the Barfüsserkirche.

See also Limes, Rhine.

BIBLIOGRAPHY. F. Staehelin, *Die Schweiz in römischer Zeit* (3d ed. 1948) 284-88, 367, 611; R. Fellmann, *Basel in römischer Zeit* (1955)[PI]; id., "Neue Funde und Forschungen zur Topographie und Geschichte des römischen Basel," *Basler Z. f. Geschichte und Altertumskunde* 60 (1960) 7-46[PI]; L. Berger, *Die Ausgrabungen am Petersberg in Basel* (1963)[PI]; id., "Die Anfänge Basels," in E. Meier, ed., *Basel, eine illustrierte Stadtgeschichte* (2d ed. 1969) 1-19[I]; id., "Das spätkeltische oppidum von Basel-Münsterhügel," *Archäologisches Korrespondenzblatt* 2 (1972) 159-63[P]; C. M. Wells, *The German Policy of Augustus* (1972) 46-49; excavation summaries: *Jb. Schweiz. Gesell. f. Urgeschichte* 47 (1958-59) 184-85; 49 (1962) 68-76[PI]; 50 (1963) 78-79[PI]; 54 (1968-69) 93; 56 (1971) 206-7.

V. VON GONZENBACH

BASILIKO, *see* SIKYON

BASILUZZO, *see under* AEOLIAE INSULAE

BAŞMAKÇI, *see* FAUSTINOPOLIS

BASSAI SW Arkadia, Greece. Map 9. A precinct sacred to Apollo Bassitas and site of the famous Doric Temple of Apollo built in the late 5th c. B.C. It is located 7 km NE of the ancient city of Phigalia and is contiguous to a second precinct, that of Kotilon, sacred to Artemis Orthia and Aphrodite. The composite sanctuary (750 m x 350 m) spreads over the S face of Mt. Kotilios: the precinct of Kotilon (elev. 1226 m) reaches the peak, Bassai lies below (elev. 1129 m). The god Pan is also attested at the site and an ancient spring in the SW area may have been sacred to him.

In 1812 an expedition led by Cockerell cleared the Temple of Apollo. Excavations at Kotilon and Bassai and restorations of the Apollo temple have been conducted intermittently since 1903. Finds show that dedications started ca. 675 B.C. and that the cults then flourished through the 5th c. B.C. By ca. 350 B.C. activity rapidly declined but persisted into Roman times.

Ca. 625 B.C. temples were constructed for Apollo, Artemis, and Aphrodite. Evidently, the temples dedicated to Apollo and Artemis were identical in design and decoration (15 x 7 m, pronaos, cella, akroterion disks, antefixes with heraldic sphinxes). The pair of Temples to Artemis and Aphrodite (ca. 9 x 6 m) in Kotilon survived throughout the history of the site; whereas the original structure in Bassai was the first of four Temples to Apollo. Ca. 575 B.C. Apollo I was rebuilt and slightly enlarged (cella 12 m x 7 m, adyton 7 m, opisthodomos 3

m) and redecorated with a new set of architectural terracottas similar in design to those on the first temple. In 1970 foundations of Apollo II were discovered 10 m S of the present temple, Apollo IV; the center lines of the earlier and later temples are on approximately the same N-S axis.

Ca. 500 B.C. a third and large-scale Temple to Apollo was constructed of local limestone. It was subsequently disassembled and its blocks were reused in the substructure for Apollo IV of the late 5th c. B.C. Apparently, many essentials in plan and outward appearance of Apollo IV were in fact derived from Apollo III of the late archaic period (proportions width to length of 1:2.6, disposition of 6 x 12 columns and thickened diameters of frontal columns).

Subtle refinements of design and construction in Apollo IV include a plan which forms an isosceles trapezoid (width of euthynteria is ca. 16 m but S is slightly wider than N, with both lateral sides exactly equal in length, ca. 40 m); in addition there are outward curvature in the stylobate, precise jointing, and decoration of all risers of the krepidoma with molded rebates at the lower edges and raised, stippled panels above. Subtle adjustments were made in column spacings and column proportions and the Doric shafts are without entasis. Metopes of the exterior Doric frieze and the two pediments were undecorated by sculpture; by contrast, a marble roof was trimmed by antefixes and a richly carved and painted raking sima; and the gables were surmounted by floral akroteria. Within the peristyle a set of reliefs filled the metopes of the Doric friezes across the pronaos and opisthodomos (preserved fragments BM 510-19 are all from the S side) and a system of elaborately carved limestone coffers adorned the ceilings of the pteromata.

The most splendid decoration of the temple was a sculptured frieze which encircled the interior of the cella, an arrangement which appears in Greek architecture for the first time at Bassai. The slabs contain scenes of a Centauromachy (BM 520-30) and an Amazonomachy (BM 531-42). The design of the interior peristyle is unique: in plan five columns of the Ionic order are engaged to each lateral wall by short spur walls, with the rearmost pair being joined by spurs which run at 45° to the lateral walls. Between this pair and on the center-line axis of the cella there was a freestanding column which bore the earliest known capital of the Corinthian order. Limestone and marble were employed alternately throughout the interior: bases and shafts in limestone, capitals in marble except for the Ionic capitals in limestone above the diagonal spurs, frieze in marble, geison in limestone, and coffered ceiling in marble.

The adyton and the cella are divided only by the Ionic entablature which is carried across the cella on the Corinthian column. Within this area a doorway opens to the E. Originally, it was closed to pedestrian traffic by a permanently fixed grill. The adyton was also coffered, but the lozenges here differed slightly in shape from the patterns used for ceilings of the cella and lateral niches.

The cult image stood before the Corinthian column; no indication of the base remains on the pavement, but in 1812 fragments of an akrolithic statue (BM 543-44) were found in this part of the cella. The adyton may have served to house a xoanon from the earlier temples.

No altar has been discovered at Bassai. However, other outlying structures have been partially uncovered and include a base at the SW corner of Apollo IV (perhaps for the 4 m bronze statue of Apollo Epikourios), a stairway in this vicinity, a rectangular foundation for a building 25 m NW of Apollo IV (perhaps to be identified as a workshop) and miscellaneous other stretches of walls in lower terraces to the SW of the temple.

BIBLIOGRAPHY. Bibliographical listings are in E. Meyer, *RE* Suppl. VII 1030-32; in W. Dinsmoor, *Architecture of Ancient Greece* (1950) 364-65, & in F. Cooper, "Temple of Apollo at Bassae: New Observations on its Plan and Orientation," *AJA* 72 (1968) 103-11; R. Carpenter, *The Architects of the Parthenon* (1970) 142ff; U. Liepmann, *Das Datierungsproblem und die Kompositiongesetze am Fries des Apollotempels zu Bassae-Phigalia,* Ph.D. diss. (1970); U. Pannuti, "Il Tempio di Apollo Epikourios a Bassai (Phigalia)," *Atti della Accademia Nazionale dei Lincei,* ser. 8, vol. 16, fasc. 4 (1971); O. zur Nedden, "Apollo Epikurios," *Aachener Kunstblatter* 41 (1971) 18-20; H. Bauer, *Korinthische Kapitelle des 4. und 3 Jahrhunderts v. Chr.* (1973) 1-80; N. Yalouris, Ἀνασκαφαὶ εἰςτὸν ἐν Βάσσαις Φιγαλείας ναὸν τοῦ Ἀπόλλωνος, *AAA* 6 (1973) 39-55.

Forthcoming: F. Cooper, "Two Inscriptions from Bassai," *Hesperia* (1975); id., *Temples of Apollo at Bassai.* F. A. COOPER

BASSE-WAVRE Commune of Wavre, Belgium. Map 21. At L'Hosté, excavations were undertaken in 1864 and again in 1904 to explore the remains of what is considered the largest and most luxurious Gallo-Roman villa ever found in Belgium. It has often been regarded as a villa urbana, an opulent country home, but it seems rather to have been located in the middle of a large fundus and to have served as the residence of the proprietor of the estate. At a little distance from the building, the foundations of one of its annexes were uncovered. In any event, in spite of its dimensions, the structure excavated served solely as a dwelling-place, and not a single trace of activity relating to agriculture, crafts, or industry has been found.

The villa appears to have been built all at one time, with a long portico flanked by buildings at its corners. Only the structure housing the baths, at the extreme W end, is built slightly askew; possibly it was a later addition.

The main facade, 130 m long, faced SE. A gallery of mixed stone and mortar construction 110 m long served the entire building. There were also less important galleries running the length of the NE facade. The plan is symmetrical. The central pavilion, flanked by two interior courtyards (or flower beds), stood opposite the main entrance. It comprised a large room, preceded and followed by rooms of smaller, equal size. The central pavilion, heated by a hypocaust, was paved in mosaic, with tesserae of red pottery, terracotta, and black marble. Numerous fragments of polychrome plaster were found in this area.

The E wing was also provided with a hypocaust. At the extreme left, a room with an area of 90 sq. m, sumptuously decorated and also heated, was built as a detached structure. Its mosaic pavement was composed of tesserae of gray, blue, black, and white marble, and the walls were revetted with marble and porphyry. The narrow windows were glazed. A small corner room adjoining this monumental room served as a kitchen.

The W wing appears to have included only service quarters. The bath installation, connected to the villa by a gallery, contained both a hot and a cold bath, separated by a small garden. In the cold bath was a semicircular pool 6 m in diameter, paved with slabs of white and gray marble.

In the course of the 3d c. A.D., the villa was destroyed by fire, possibly in one of the barbarian invasions of the second half of the 3d c.; however, the excavations conducted according to methods now outdated have not yielded a solution to this problem of chronology.

Later, at an undetermined date, a small apsidal build-

ing was erected with reused material. It is probably a mediaeval construction, but it is not possible to date it precisely.

BIBLIOGRAPHY. R. de Maeyer, *De Romeinsche Villa's in België* (1937), passim[P]; id., *De overblijfselen van de Romeinsche Villa's in België* (1940) 29-34; J. Martin, *Le Pays de Gemboux des origines à l'an mil* (1950) 55-60; M. Desittere, *Bibliografisch repertorium der oudhaidkundige vonsten in Brabant* (1963) 160-64.

S. J. DE LAET

BASTA (Vaste) Apulia, Italy. Map 14. This Messapian center was placed by Pliny (*HN* 3.100) between Hydruntum (modern Otranto) and the Japigio Promontory (modern Capo di Leuca). Its name is preserved in the village of Vaste, near Poggiardo, where there remain the ruins of megalithic city walls. Archaeological documentation of a settlement of the 9th-8th c. B.C. is preserved in the National Museum at Taranto. The Provincial Museum at Lecce contains much funerary material of the 4th-3d c. B.C. from the necropolis of the city, as well as interesting Messapian inscriptions of the same age.

BIBLIOGRAPHY. W. Smith, *Dictionary of Greek and Roman Geography*, I (1856) 380 (E. H. Bunbury); *RE* III.1 (1897) 110 (Hülsen); M. Mayer, *Apulien* (1914) 76; K. Miller, *Itineraria Romana* (1916) 223; M. Bernardini, *Panorama archeologico dell'estremo Salento* (1955) 50; O. Parlangeli, *Studi Messapici* (1960) 179.

F. G. LO PORTO

BASTI (Baza) Granada, Spain. Map 19. Town ca. 50 km NE of Guadix, mentioned in the *Antonine Itinerary* (401.8), on several occasions by Strabo, and in Livy (37.46.7) in connection with a Roman defeat by the Bastetani. It was an episcopal see during the Early Christian and Visigoth periods. The Iberian cemetery has yielded a large number of Greek vases, indicating that it was used during the 5th and 3d c. B.C. Recent finds include the so-called Lady of Baza, a seated Iberian figure still bearing traces of polychrome and dating from the 4th c. B.C.

BIBLIOGRAPHY. A. García y Bellido, *Hispania Graeca* (1948)[M].

L. G. IGLESIAS

"BATAVIS," *see* PASSAU

BATH, *see* AQUAE SULIS

"BATIAE," *see* KASTRI

BATINA, *see* LIMES PANNONIAE (Yugoslav Sector)

BATN-IHRÎT, *see* THEADELPHIA

BAUDECET Hamlet of the commune of Sauvenière, Belgium. Map 21. Vicus of the Tungri, on the Bavai-Tongres road, less than 4 km from the town of Gembloux. Systematic excavations have never been undertaken here, but the area abounds in Roman remains. Numerous archaeologists have wanted to identify Baudecet with the Geminiacum of the *Antonine Itinerary* and the Geminico vico of the *Peutinger Table*, but the distances given by the two documents are contradictory. It is possible that Geminiacum may be identified with Liberchies.

A short distance from the vicus lies the villa of Sauvenière, excavated in 1898. It is a villa with a portico, of medium importance, whose W wing was enlarged for use as a residence; it has, among others, a room heated by a hypocaust and a cellar. A rectangular annex, which served as a workshop, was found 25 m from the main building.

Two tumuli were excavated 2 km N of the vicus of Baudecet, along the road, in the Bois de Buis. The smaller (height, 1.50 m; diameter, 12 m) yielded the remains of a funeral pyre and a wooden vault with scanty burial objects. The second, three times the size of the first, contained a stone burial vault with a glass urn and two glass bottles as funerary objects. In the same Bois de Buis traces were uncovered of a quadrangular area surrounded by trenches, which may conceal the remains of a small fort of the Late Empire, similar to those of Liberchies, Taviers, and Braives; it has not yet been excavated.

BIBLIOGRAPHY. H. Van de Weerd, *Inleiding tot de Gallo-Romeinsche archeologie der Nederlanden* (1944) 13-15, 45; J. Martin, *Le Pays de Gembloux des origines à l'an mil* (1950); F. Ulrix, "Où faut-il situer Geminiacum et Perniacum?" *Helinium* 3 (1963) 258-64.

S. J. DE LAET

BAVAI, *see* BAGACUM

BAYEUX, *see* AUGUSTODURUM

BAYIR, *see* SYRNA

BAYONNE, *see* LAPURDUM

BAZA, *see* BASTI

BEARSDEN, *see* ANTONINE WALL

BEAUCAIRE, *see* UGERNUM

BEAUCAIRE-SUR-BAISE Gers, France. Map 23. From 1965 to 1968 at La Tourraque, a vast necropolis of the Barbarian and Merovingian periods was excavated. It contained more than 120 sarcophagai and was placed in the ruins of a 4th c. Roman villa whose floor was paved with a fine polychrome mosaic of geometric design.

BIBLIOGRAPHY. M. Labrousse, *Gallia* 24 (1966) 431[I]; 26 (1968) 539; 28 (1970) 415-17[I].

M. LABROUSSE

BEAUVAIS, *see* CAESAROMAGUS

BECKFOOT, *see* BIBRA

BEERSHEBA, *see* BEROSABA

BEGEĆ, *see under* LIMES PANNONIAE

"BEGORRA," *see* FARANGI

BEGUES Allier, France. Map 23. On a plateau overlooking the valley of the Sioule is a Late Bronze Age oppidum, as yet not completely explored. Fragments of imported Greek bowls of the 5th c. B.C. have been found, and plowing has revealed amphorae and traces of dwellings.

Recent excavation uncovered a cellar dating from the end of the 1st c. A.D., and proved that this was the site of a pottery. Evidence of activity from the beginning of the 1st c. A.D. is provided by a goblet mold, an imitation of Aco Ware, while a potter's kiln from the middle of the 2d c. has also been excavated.

H. VERTET

BEIKUSHSKOE, *see* MALAIA CHERNOMORKA

BEIRE-LE-CHATEL Côte d'Or, France. Map 23. The cult site in the area known locally as La Charme Tupin, W of Beire-le-Châtel, is still something of an enigma in spite of recent excavations. Two dedications, one to

the mother goddesses (Dia Matribus, Vintedo V. S. L. M.; *CIL* XIII, 11577), the other to the goddess Januaria (Deae Januariae Sacrovir, V.S.L.M., *CIL* XIII, 5619), suggest that several divinities were worshiped there, and the variety of ex-votos found on the site confirms this impression: heads of goddesses; male and female ex-voto heads in relief or modeled in the round; small-scale figures in a wide variety of attitudes and with a range of attributes; many renderings of three-horned bulls; groups of birds (doves or turtle-doves) the ritual number for which seems to be four, if it is true that those reliefs with only two or three birds are broken at the sides. Such diverse offerings surely indicate the shrines of a number of divinities.

The walls were razed, and in many cases all that is left is some traces of rubble or broken-down foundations. The impression remains, however, that these walls were not those of buildings but of enclosures, or partitions between different sacred zones. The only fresh evidence provided by the dig was the discovery of a road network around the crossroads where the sanctuary developed, unconnected with any nearby settlement. This seems to have been a sacred area where a group of divinities were worshiped at altars or in small chapels rather than in temples.

BIBLIOGRAPHY. E. Espérandieu, *Receuil général des bas-reliefs* . . . (1907-66) IV, 3620-36; G. Drioux, *Cultes indigènes des Lingons* (1934) 82-84; P. Lebel, "Quelques sculptures votives du temple de Beire-le-Chatel," *Revue Arch. de l'Est* 4 (1953) 319-28; Grenier, *Manuel* IV, 2 (1960) 643-48; R. Martin, *Gallia* 18 (1960) 338-39.

R. MARTIN

BEIRUT, *see* BERYTUS

BEIT RAS, *see* CAPITOLIAS

BEJA, *see* PAX JULIA

BEJAIA (Bougie), *see* SALDAE

BELA CRKVA, *see under* PRILEP

BELALIS MAIOR (Henchir El Faouar) Tunisia. Map 18. Eight km NE of Beja on a platform dominating the valley, the rather inaccessible site has been under excavation since 1960. At the beginning of the first campaign, an inscription was discovered which supplied the name of the settlement. The forum was brought to light in 1962, as well as the buildings which surround it, in particular the public baths. Some inscriptions on blocks reused in later walls were found during the course of the excavations: one indicates a Temple of Apollo, another is related to the cult of Jupiter Sabazius.

BIBLIOGRAPHY. A. Mahjoubi in *CRAI* (1960) 382-91; in *Africa* 2 (1967) 293-311PI. A. ENNABLI

BELBÈZE-EN-COMMINGES Haute-Garonne, France. Map 23. The quarries of Belbèze were exploited in Roman times and, notably, furnished the small stone ashlar which revetted the Roman rampart of Toulouse. Above the quarries, on the summit of Pédegas-d'en-Haut, G. Manière has found and excavated a hilltop sanctuary which was also a fountain-head shrine. The cult seems to have lasted from the 1st to the 4th c. A.D.

BIBLIOGRAPHY. G. Manière, "De l'antiquité gallo-romaine à nos jours: les carrières souterraines de Belbèze en Comminges . . . ," *Rev. de Comminges* 78 (1965) 57-70; id., "Un nouveau temple gallo-romain à Belbèze-en-Comminges (Haute-Garonne): découverte de petits vases à offrandes," *Ogam* 18 (1966) 299-301; "Un nou-

veau sanctuaire gallo-romain: le temple de Belbèze-en-Comminges," *Celticum* 16 (1967) 65-126 & pls. 26-43.

M. LABROUSSE

BELEIA, *see* VELEIA

BELENLI, *see* OLBASA

BELENLI, *see* ISINDA (Lycia)

BELETSI, *see* LIMES, ATTICA

BELEVI Ionia, Turkey. Map 7. This village in the territory of Ephesos, some 16 km NE of Selçuk, has given its name to two interesting monuments situated about 3 km to the N. One a mausoleum and the other a tumulus, these tombs stand close above the road from Belevi to Tire.

The Belevi Mausoleum consists of a great cubical core, cut from the living rock of the hillside and faced with marble on all four sides, with steps at the foot and a Doric triglyph frieze at the top. On the surface of this rock cube (ca. 15 x 24 m) stood a rectangular chamber of marble with a Corinthian colonnade. Little of this remains today, but the fragments permit an approximate reconstruction. Above the colonnade winged lions were set in pairs facing each other across a globular vase, and above the chamber there probably rose a pyramidal roof with a chariot and pair at the summit.

The grave chamber itself, however, was hidden in the rear of the rock cube, where it is separated from the hillside by only a narrow space. The chamber was formed by cutting away the entire rock cube from top to bottom, the sides tapering towards the top; in the lower part of this cut the actual grave chamber was installed, the trapezoidal space above remaining empty. The marble facade was carried right across this cut, rendering it invisible from outside. In the grave chamber stood a single large sarcophagus with the deceased shown reclining on the lid; the decoration is very elegant, showing eleven Sirens in relief. The head of the reclining figure had broken off, but was found in the chamber in somewhat damaged condition.

There is no inscription and neither the date nor the identity of the occupant is known. Antiochos II, who died in 246 B.C. at Ephesos, has been suggested but the apparently Persian influence shown in the form of the winged lions has led scholars more recently to believe that the monument dates rather to the Persian period in the 4th c. B.C.

The Belevi Tumulus stands nearby on the summit of a hill of moderate height, whose top has been converted into a tumulus tomb. On the summit itself a number of scattered squared blocks suggest that some kind of monument stood there, but no idea can be formed of its nature. A little below the summit a handsome wall of bossed ashlar has been carried round the hill and still stands in places to a height of 3 or 4 m. Close by on the SW is the quarry from which the blocks were obtained. On the S side the hill is pierced by a tunnel some 18 m long, formed not by boring through the rock but by cutting down from above; it was then roofed with large slabs and lined with masonry, and the space above filled with earth. The entrance was concealed by the ring wall, which was carried past it without interruption. The tunnel leads to two grave chambers situated one behind the other near the center of the tumulus. They were constructed in the same manner as the tunnel, with strong provision to resist the thrust from above. The inner chamber is roofed with a corbeled arch, and in the outer the span is reduced by blocks laid obliquely across the corners; over

each is a relieving chamber. There is no inscription and no trace of the actual burial, so that here again the identity of the deceased remains unknown. Dates have been proposed ranging from the earliest antiquity to Hellenistic times; recent opinion favors the 4th c. B.C.

BIBLIOGRAPHY. F. Miltner, *Ephesos* (1958) 10-12; G. E. Bean, *Aegean Turkey* (1967) 182-84. G. E. BEAN

BELGOROD DNESTROVSKII, *see* TYRAS

BELGRADE, *see* SINGIDUNUM

BELIAUS Crimea. Map 5. A fortified agricultural settlement of ca. 3500 sq. m, located 41 km NW of Eupatoria near the mouth of Lake Donuzlav, founded from Chersonesus in the late 4th c. B.C. Beliaus was apparently seized by the Scythians in the mid 2d c. B.C. and inhabited by them until the 1st c. A.D. Excavations have uncovered the remains of two stone defensive walls of the 4th-3d c. along with a corner tower composed of several rooms on the ground floor and a stairway that presumably led to a second story. Around the 2d c. B.C. a layer of rough stones was built along the outside tower walls to provide added protection against battering rams. Inside the fortifications were numerous structures of the 4th c. B.C.-1st c. A.D., the most interesting of which was a large building of at least eight rooms. North of the site was a cemetery composed primarily of crypt, pit, cenotaph, catacomb, and earthen Scythian graves of the 1st c. B.C.-1st c. A.D. One crypt was later used for a Hunnic burial of the late 4th or early 5th c.

BIBLIOGRAPHY. O. D. Dashevskaia & A. N. Shcheglov, "Khersonesskoe ukreplenie na gorodishche Beliaus," *SovArkh* (1965) 2.246-55; Dashevskaia, "Antichnaia bashnia na gorodishche Beliaus," *KSIA* 116 (1969) 85-92; id., "Dva sklepa Beliausskogo mogil'nika," *KSIA* 119 (1969) 65-73; id. et al., "Ekspeditsiia Evpatoriiskogo muzeia," *Arkeologicheskie Otkrytia 1971 goda* 352-53; id., "Raskopki gorodishcha i mogil'nika Beliaus," *Arkheologicheskie Otkrytiia 1972 goda* 277-78.
 T. S. NOONAN

"BELIGIO," *see* AZAILA

BELKIS (Pamphylia), *see* ASPENDOS

BELKIS, *see* KYZIKOS

BELLIBOL, *see* KYS

BENÇË, *see* LIMES, SOUTH ALBANIA

BENEVENTUM (Benevento) Italy. Map 17A. It lies between the rivers Calore and Sabato, ca. 65 km E-NE of Naples and was once the chief center of a Samnite tribe, almost certainly the Hirpini, who called it Malventum or something similar. The Romans fought their last battle against king Pyrrhus nearby (275 B.C.) and then made the place a Latin colony with the more auspicious name of Beneventum (268). Beneventum remained staunchly loyal in the second Punic (218-201) and Social (91-87) wars. About 90 it became a municipium and in 42 B.C. a Colonia. In the Gothic wars of the Late Empire it changed hands more than once. In 571 A.D. dissident Lombards made it a duchy and later a principality that lasted 500 years.

A key communications center, Beneventum has always been a large town. Roman roads radiated from it in all directions: N, via Bovianum to Aesernia (the Via Minucia?); S, via Abellinum to Salernum; E, via Venusia to Brundisium, and W, via Capua to Rome (the Via Appia). The emperor Trajan (98-117) built another road to Brundisium by way of Aequum Tuticum, and this Via Traiana replaced the Appia as the main highway to the E.

Repeated devastation by war, earthquake, and flood and repeated rebuilding have effaced all traces of the original town plan. The Roman successor to the Samnite settlement expanded E beyond Palazzo Pacca to the lower slope of La Guardia hill: Corso Garibaldi may correspond to its decumanus maximus. The Lombard town stretched still farther E to the Castello. The modern city has spread also N and S, across both rivers.

The poorly preserved town walls are mostly Lombard (e.g. at Porta Arsa in the SW), but some Roman masonry survives in the NE near the Torre di Simone.

The principal monument is the Porta Aurea, Trajan's well-preserved and magnificent triumphal arch (15.6 m high), at the point where the Via Traiana left the city. Its designer, who may have been Apollodorus, modeled it on the Arch of Titus. According to the inscription on each face it was dedicated in A.D. 114 presumably after Trajan passed through it en route to the Parthian war; but the reliefs in Parian marble that adorn it, depicting on the W face and in the single passageway Trajan's achievements in Italy and on the E face his activities in the provinces, probably belong to the early years of Hadrian. Other notable monuments include the Santi Quaranta, a Roman wall and cryptoporticus (part of the forum?) near S. Maria delle Grazie; the heavily restored theater SW of the Duomo (Hadrianic, but repaired by Severus); the ruins of a large building (baths?) near the Ponte Vanvitelli; a statue of Apis (in Piazza S. Lorenzo) and an obelisk erected in A.D. 88 by Lucilius Rufus (in Piazza Papiniano), both Egyptian from a Temple of Isis; the much damaged Arco del Sacramento in an archaeological zone near the Duomo. The bridge (Ponticello) by which the Via Traiana crossed a tributary of the Calore just beyond Trajan's arch still stands (Trajanic, but much repaired). There is also Roman work in the bridge (Ponte Leproso) which carried the Via Appia across the Sabato into Beneventum.

Since 1929 the cloister of S. Sofia has housed the Museo del Sannio, a remarkable collection started by Talleyrand and systematized by Mommsen.

There is an impressive array of Roman milestones from the Via Traiana in the courtyard of the Castello (Rocca dei Rettori).

BIBLIOGRAPHY. A. Meomartini, *Benevento* (in the "Italia Artistica" series) (1909)MPI; F. A. Lepper in *JRS* 59 (1969) 250-61, discussing Hassel's *Der Trajansbogen in Benevent*; I. A. Richmond, *Roman Archaeology and Art* (1969), pp. 229-38. E. T. SALMON

BENGHAZI, *see* EUESPERIDES

BENI FOUDA, *see* NOVAR [- - -]

BENKOVAC, *see* ASSERIA

BENWELL, *see* CONDERCUM *under* HADRIAN'S WALL

BERAT, *see* ANTIPATREA

BERENICE or Pernicide Portum (Madinet el-Haras) Egypt. Map 5. An ancient port on the W coast of the Red Sea 959 km SE of Cairo, noted by Strabo (16.1.5; 17.1.45) and by Pliny (6.23.103). Founded by Ptolemy II Philadelphos (275 B.C.) and named for his mother, it was a transit station for goods from Arabia and India. These goods were conveyed by camel caravan N to

Leucus Limen (present Quseir), then W towards Coptos (Justinianopolis, present Qift). Along the road, guards were posted and water provided since it was a military road where taxes were collected. The port itself was provided with a fortification to protect the city against piracy. In the center of the city a small temple was dedicated to the god Khem by the emperor Tiberius. Offerings were also presented to the goddess of the emerald mines. At a nearby mine site, Sakait, a temple hewn from living rock was dedicated to Serapis and Isis.

BIBLIOGRAPHY. M. Kammerer, *La Mer Rouge* . . . (= *Mem. Soc. R. Géographie d'Égypte*, Vol. xv,7; J. G. Wilkinson, *Topography of Thebes* (1835) 418; M. G. Daressy, "Bérénice et El Abraq," *ASAE* 22, 169-81; Porter & Moss, *Top. Bibl., VII. Nubia, the Deserts* . . . (1951) 326; D. Meredith, "Berenice Trogloditica," *JEA* 43 (1957) 56-70[MPI]. S. SHENOUDA

BERENICE, *see* EUESPERIDES

"BERENIKE," *see* KASTROSIKIA

BEREZAN Ukraine. Map 5. The first Greek colony in the N Black Sea, it is on an island in the Dnieper-S. Bug estuary. The earliest Greek pottery dates from ca. mid 7th c. B.C.

The city's most prosperous period dates from the 6th-5th c. B.C. and is represented by traces of houses, 6th c. pottery, and black-glazed bowls of the 6th-5th c. from Rhodes and Attica; also terracottas (seated goddesses or grotesques), and 5th c. coins from Olbia. There is also a necropolis. Recent excavations suggest that the site existed until the 4th c. B.C. and was inhabited again in the early centuries A.D. when various finds indicate that a sanctuary of Achilles may have existed here. The Hermitage and Odessa Museums contain material from this site.

BIBLIOGRAPHY. E. H. Minns, *Scythians and Greeks* (1913) 451-53; E. Belin de Ballu, *L'Histoire des Colonies grecques du Littoral nord de la Mer Noire* (1965) 41-43; V. V. Lapin, *Grecheskaia kolonizatsiia Severnogo Prichernomor'ia* (1966); I. B. Brašinskij, "Recherches soviétiques sur les monuments antiques des régions de la Mer Noire," *Eirene* 7 (1968) 86-87; K. S. Gorbunova, *Drevnie Greki na ostrove Berezan'* (1969).
M. L. BERNHARD & Z. SZTETYŁŁO

BERGAMA, *see* PERGAMON

BERN, *see* ENGE

BEROE (Piatra Frecăţei) Dobrudja, Romania. Map 12. A station on the limes of the lower Danube, between Carsium and Troesmis, placed by the *Tab. Peut.* (8.3) at 21 Roman miles and by the *It. Ant.* (225,1) at 18 Roman miles from Troesmis. The Cuneus Equitum Stablesianorum was stationed here (*Not. Dig.* or. 39.5). In the 6th c. the place is mentioned as an episcopal residence (531). Recent research in the cemetery has uncovered 1100 inhumation graves (2d-7th c. and 10th-12th c.). Near the cemetery was a large civil settlement. Recently traces of life from the 10th-11th c. have been discovered here, superimposed on levels from the Roman and Roman-Byzantine periods. In these earlier levels were buildings with stone walls.

BIBLIOGRAPHY. J. Weiss, *Die Dobrudscha im Altertum* (1911) 48; P. Aurelian, "Cîteva mărturii ale culturii Sintana de Mureş-Cerneahov în Scythia Minor," *Studii şi Cercetări de Istorie Veche*, 15, 1 (1964) 59-80.
E. DORUŢIU-BOILA

BEROEA (Aleppo) Syria. Map 6. A leading city of N Syria, on the caravan route between the Euphrates and the Mediterranean, Beroea was made a Macedonian city by Seleucus Nicator between 301 and 281 B.C. It was sacked by Chosroes in A.D. 540.

The plan of the Macedonian colony survives in the modern city. Traces of the original grid plan can be seen on the 25 ha area E of the tell: a series of streets, parallel or at right angles to each other, are oriented to the cardinal points and laid out with uniform space between them. An avenue 20-25 m wide, now occupied by souks, cut across the city from W to E, from the W gate to the foot of the citadel, and a monumental three-bay arch ornamented with military emblems marked the W exit. Colonnaded porticos were added to the arch probably in the 2d or 3d c. A.D. The agora was precisely in the center of the city, where the great mosque stands today, at the end of the aqueduct that pipes water from a spring 13 km to the N.

The wall that ringed the ancient city forms a more or less regular rectangle, 1000 by 950 m. On the W the rampart, flanked by wide rectangular towers, ran parallel to the streets; its E face took advantage of the hill of the citadel, which bears no traces of either the Hellenistic or the Roman periods. The mediaeval gates are probably where the ancient gates stood.

BIBLIOGRAPHY. J. Sauvaget, *Alep* (1941)[PI].
J.-P. REY-COQUAIS

BEROIA Macedonia, Greece. Map 9. An ancient city on the E slope of Mt. Bermion, which has existed continuously to the present day under the same name. It was called Karaferia by the Turks. It is situated on the crossing of the E-W road via the S of the three passes over Bermion and the N-S road across the W side of the marsh which elsewhere covers a good part of the lower Macedonian plain. According to a Macedonian myth Beroia was the daughter of the mythical king Beres: "Beres had three children, Mieza, Beroia, and Olganos" (Steph. Byz. s.v. Mieza). The Macedonians came from the W, from upper Macedonia, and settled the E slope of Bermion around 700 B.C. (see Edessa). Beroia is mentioned first in historical times in 432 B.C. in a much disputed passage of Thucydides (1.61.4) where he tells us that after the Athenians captured Therme and besieged Potidaia they attacked Beroia and other places. In 288 B.C. the Macedonians deserted Demetrios Poliorketes in front of the walls of Beroia and joined Pyrrhos of Epeiros inside the city (Plut., *Dem.* 44, *Pyrrh.* 11). After the battle of Pydna in 168 B.C. Beroia was one of the first cities which surrendered to the Romans (Livy 44.45.5). Through the whole history of Macedonia Beroia appears as second in importance to whatever city was the first, which changed in succession from Edessa to Pella to Thessalonika. After the Roman conquest it was not made capital of one of the four merides, but from the time of Augustus it seems generally accepted that it was the seat of the Macedonian Koinon and prospered as never before. The Apostle Paul fled here when he was sent out of Thessalonika in 49-50 A.D., and he founded a Christian community. In inscriptions of the 3d c. A.D. the titles of Beroia are: Ἡ σεμνοτάτη μητρόπολις καὶ δὶς νεωκόρος Βέροια, under Decius Trajan Beroia carries the fuller title of: Μητρόπολις καὶ κολωνία καὶ τετράκις νεωκόρος.

Except for a prehistoric axe which was found by itself in a building excavation, the oldest finds from graves date to the Early Iron Age. Very few finds of the Classical period have been preserved because of the continuous settlement of the town and the perishable nature of Macedonian building materials (poros stone, wood, stucco).

Moreover, these remains are hidden under a large Byzantine, Turkish, and more recent settlement.

A part of the ancient walls is preserved under later additions and repairs, especially on the road out of the city toward Thessalonika and Naousa. The older parts are constructed of large poros blocks from the Bermion quarry, as is a round tower, while the upper and more recent parts of the wall, including a complete rectangular tower, were constructed hastily in the 3d c. A.D., against some danger from the Goths or Herulians, with reused ancient marbles, various architectural fragments, altars bearing honorary and funerary inscriptions, statues, inscriptions, etc.

The remains of public and private buildings appear chiefly in the center of the modern town, on both sides of the modern Metropolis, Venizelos, and Kentrike Sts., where lay the center of the ancient town. The building material was again local poros, marble being used only in thresholds, as in the neighboring palace at Verghina. At Beroia, too, appear the double Ionic columns, the shining stucco, and the same type of terracotta tiles. The immovable remains were covered over in private residences after they were cleaned, drawn, and photographed. They are preserved below ground until some opportune time (e.g., in the residence of the brothers Karadoumane).

During the work of building the streets named above, remains of large Roman roads were discovered. The ancient roads, with small deviations, have the same course as those of today and lead to the same exits from the city: (a) the E gate to Thessalonika and Edessa-Pella, that is, to lower Macedonia; (b) the S gate to Pieria across the Halyacmon; and (c) the W gate to Elimeia in upper Macedonia, via the S of the three passes over Mt. Bermion. Of these Roman roads, which date to the period of the Tetrarchy, the one along what is now Metropolis St. was paved with slabs of hard limestone. A drain, built under the middle of it, was lined with curbstones on each side, and under the sidewalks were water pipes.

Many graves were discovered by chance and investigated near the above-mentioned three exits from the city. Some were chambers with loculi cut in the soft rock, others were cist graves, others were tile lined and covered. Most are dated to the Hellenistic and Roman periods. Most of the graves had been robbed, but some contained pottery, figurines, and other offerings. The tumuli by the S and E exits of the city, which probably cover vaulted tombs of the type called Macedonian have not been excavated.

Other small finds from Beroia were chance finds, or have been collected from the walls and courts of old houses. There have been no systematic excavations in the area of the ancient city, but only salvage ones. Therefore the collection in the Beroia Museum consists mainly of reliefs and inscriptions, although there are some other finds. Of the carvings, the most notable is an unpublished colossal Hellenistic head of Medusa from the E gate of the city wall, where it may have been placed for apotropaic purposes. The large number of very high quality Roman portraits is a reminder of the fact that in the period of the Macedonian Koinon Beroia developed a high degree of craftsmanship. Works of a family of Beroian sculptors are scattered from Thessalian Larissa and Lete near Thessalonika to Eidomene on the Greek-Yugoslav border. Most of the inscriptions are of Roman date, funerary or honorary, and decrees of the Synedrion of the Macedonian Koinon. One of the most interesting and longest texts is of the still unpublished (it was found in 1949) Law for the Gymnasiarchs of Beroia, of the

Hellenistic period. Also of interest are some manumission inscriptions of about the same period and some dedications, among which is a plaque which tells us Philip V dedicated "the stoas to Athena." Some cults are attested by inscriptions, as those of Herakles Kynagidas, Asklepios, Hermes, Zeus Hypsistos, etc.

Of the terracotta offerings from the graves the figurines and lamps make up an interesting series, as do some of the categories of pottery: Hellenistic pyxides, tear bottles (balsamaria), etc. Earlier finds from Beroia were taken to the Thessalonika Museum, where they are still kept.

A bronze in Munich, the "Kore of Beroia" should be mentioned, but most of the finds, particularly those noted above are in the Beroia Museum. This is already one of the richest museums in Northern Greece, since it has acquired interesting groups of finds both from systematic and salvage excavations in the area. The finds from Mieza (see Mieza and Lefkadia) are of the Hellenistic and Roman periods. Finally, there is a noteworthy collection of manumission inscriptions, most of them from the Sanctuary of the Autocthonous Mother of the Gods (Mother of the Autochthonous Gods) from Mt. Bermion by the Beroia-Kozani road near the town of Leukopetra. These date approximately to the period from 169 to 362 A.D. and record the ending of the ancient world in the face of the Christian-Byzantine Epoch, during which Beroia continued her brilliant life, in Macedonia second only to Thessalonika.

BIBLIOGRAPHY. C. Edson, "The Antigonids, Herakles and Beroea," *HSCP* 45 (1934) 213-46; id., "Strepsa" (Thuc. 1.61.4) *CP* 50 (1955) 169-90; M. Andronikos, Ἀρχαῖαι Ἐπιγραφαὶ Βεροίας (1950)[I]; D. Kanatsoules, Τὸ Κοινόν τῶν Μακεδόνων, Μακεδονικά 3 (1953-55) (1956) 27-102; P. Lévêque, *Pyrrhos* (1957), 154-57 and passim; A. Greifenhagen, *Das Mädchen von Beröa* (1958)[I]; P. R. Franke, Θεσσαλικά[I]; "Zwei signierte Werke des Bildhauers Euandros," *RhM* 101 (1958) 336-37; Ph. M. Petsas, Ὁ Τάφος τῶν Λευκαδίων (1966) 5-18; id., "Veria," *EAA* VII (1966) 1135-36[I]; id., Χρονικά Ἀρχαιολογικά, Μακεδονικά 7 (1967) 318-22; A. K. Andreiomenou, Ἀρχαιότητες καὶ Μνημεῖα Δυτικῆς Μακεδονίας, *Deltion* 23 (1968) Χρονικά, 345-48[I]; I. Touratsoglou, Δύο νέαι ἐπιγραφικαὶ μαρτυρίαι περὶ τοῦ Κοινοῦ τῶν Μακεδόνων κλπ.; Ἀρχαία Μακεδονία, ἔκδ. Ἑταιρείας Μακεδ. Σπουδῶν (1970) 280-90[I]. PH. M. PETSAS

BEROSABA or Beersheba Israel. Map 6. A town in the N Negev, important in the early history of the Hebrews. Remains of a Chalcolithic culture of the 5th millennium B.C. have been discovered on the banks of a wadi of the same name near the modern town, while the biblical town is being excavated at Tell Sheva (Tell es-Sebaʻ), 4.8 km to the N. To the Hellenistic and Roman periods belong fortresses built on top of the ancient mound as part of the limes Judaeae, and remains of the Byzantine period are scattered in the modern town.

Eusebios (*Onom.* 50.1) mentions Berosaba as a large village 20 miles from Hebron, where a garrison is stationed; the *Notitia Dignitatum* (73.22) also refers to it as a Roman military post. Berosaba figures in the 6th c. mosaic map at Madaba, in the Byzantine period it was part of Palestina tertia, and it is frequently mentioned in the Nessana papyri.

BIBLIOGRAPHY. F. M. Abel, *Géographie de la Palestine* II (1938) 263; M. Avi-Yonah, *The Holy Land* (1966) 120, 133; C. J. Kraemer, *Excavations at Nessana* III (1958) 119-28, 230. A. NEGEV

BERTHA Perthshire, Scotland. Map 24. Roman fort at the confluence of the Tay and Almond; the pseudo-Latin

name is a 14th c. invention. Subject to riverine erosion, it measures ca. 255 by at least 150 m, but the surviving stretch of the SE rampart is of slighter build than that on the NW, and may be a late feature reducing the area of a still larger fort. The site has not been excavated, but has produced an inscription attributable to the 2d c. A.D.

BIBLIOGRAPHY. *Proc. Soc. Ant. Scotland* 53 (1919) 145-52; *JRS* 48 (1958) 90-91.　　　　　　　K. A. STEER

BERYTUS (Beirut) Lebanon. Map 6. An ancient Phoenician city on the coast at the foot of the Lebanon mountains. It did not become important until the end of the Hellenistic period. It was made a Roman colony about 14 B.C. Herod the Great, Agrippa I and II, and Queen Berenice built exedras, porticos, temples, a forum, a theater, amphitheater, and baths here. In the 3d c. A.D. the city became the seat of a famous school of law and continued to flourish until the earthquake of A.D. 551 ravaged the city.

The Hellenistic town lay S of the port. Its streets, laid out on a grid plan, are spaced at roughly the same intervals as those of Beroea, Damascus, and Laodicea. The new Roman city spread farther S and W, with its forum near the Place de l'Etoile. On its N side was a civic basilica 99 m long with a Corinthian portico of polychrome materials (now in front of the Beirut Museum), dating from the 1st c. A.D. Some large baths have been uncovered on the E slope of the Colline du Sérail, and the hippodrome lay on the NW side of the same hill. Some villas in a S suburb facing the sea had mosaic floors (now in the Beirut Museum).

Some 12 km upstream on the Beirut river are the ruined arches of an aqueduct. The rocky spur of Deir el-Qalaa was Berytus' high place; the podium of a large temple can still be seen.

BIBLIOGRAPHY. R. Mouterde, "L'emplacement du forum de Béryte," *MélStJ* 25 (1942-43); id., "Regards sur Beyrouth," ibid. 40 (1966)[I]; J. Lauffray, "Forums et monuments de Béryte," *BMBeyrouth* 7 (1944-45); 8 (1946-48)[PI]; id., *Beyrouth, ville romaine* (1953).

J.-P. REY-COQUAIS

BERZOBIS (Berzovia) Caraş-Severin, Romania. Map 12. Roman camp and civil settlement on the Lederata-Tibiscum imperial road, on the left bank of Bîrzava river. The name appears in the *Peutinger Table* and in Priscianus (*Gram. lat.* 6.13), the only extant fragment of Trajan's commentary on the Dacian wars.

The camp (410 x 490 m) has earth walls; ditches were built after the second Dacian war (105-106) by Legio IV Flavia Felix and used probably until the time of Hadrian. The N and S sides of the camp are well preserved.

Ceramics, stamped tiles, coins, etc., are on display at the Banat Museum in Timişoara and the museum in Reşiţa.

BIBLIOGRAPHY. D. Protase, "Legiunea IV Flavia şi apartenenţa Banatului şi Olteniei de vest la provincia Dacia," *Acta Musei Napocensis* 4 (1967), 42-47; M. Moga, "Castrul Berzobis," *Tibiscus* (1970) 51-58.

L. MARINESCU

BERZOVIA, *see* BERZOBIS

BESANÇON, *see* VESONTIO

BESARA or BETH SHEARIM Israel. Map 6. A town in the Valley of Jezreel on the border of Lower Galilee. The site, known by its Arabic name esh-Sheikh Ibreiq, was identified by an inscription found on the site. It was the center of the royal estates of Berenice (Joseph. *Vit.* 24.119). By the name of Beth Shearim it is mentioned in the Talmud. In the 2d and 3d c. A.D. it was a Jewish town, and for some time the seat of the Sanhedrin and of several famous Jewish scholars, outstanding among which was Rabbi Judah the Patriarch.

The town extended over an area of 4 ha, occupying the summit of a hill, on the slopes of which was a large Jewish necropolis. The site has been extensively excavated and the five occupation levels range from the late 1st c. B.C. to Mameluke times. Of most interest are the results of the excavations in the necropolis. The number of catacombs, ranging from small family sepulchers to large public catacombs, some with more than 400 burial places, is estimated at ca. 100. Of these about 30 have been excavated. Some of the larger catacombs are arranged in two or three tiers, access to which is given by means of a deep, narrow corridor in which staircases hewn in the soft rock lead to the openings of the burial halls. Most of the catacombs are of the type just described, but two are outstanding in plan and architectural decoration. Both are preceded by spacious courts, and the facade of each is decorated by three arches. Of great interest is the decorative repertoire. On the walls of the catacombs are many representations of the menorah and of human beings. On the sarcophagi are animals (lions, oxen), various birds (mostly eagles), and even scenes taken from Greek mythology, such as the Amazonomachy and Leda and the Swan. One sarcophagus displays a head of Zeus. The art of Beth Shearim confirms what is otherwise known from that of contemporary synagogual art.

Of the many inscriptions found at Beth Shearim a great number are in Greek. Hebrew inscriptions are also quite numerous; Aramaic and Palmyrene are rarer. Some of the inscriptions reveal the social standing and occupation of the deceased. Many of the deceased were brought from the Diaspora, mostly from Phoenicia, Syria, Palmyra, and Arabia.

The extensive excavations at this site are a major source for the study of the architectural, artistic, religious, social, and economic history of the Jews of Palestine and the Diaspora in the Late Roman period.

BIBLIOGRAPHY. N. Avigad, *Beth Shearim, Volume Three: The Archaeological Excavations during 1953-1958* (1971). In Hebrew. (English edition is forthcoming.)

A. NEGEV

BESSAN ("Polygium") Hérault, France. Map 23. The site, called La Monédière, is 5 km N of Agde, on the right bank of the Hérault and at the head of the delta that the river formed in antiquity. Favored by this excellent geographical position, the site, which some historians identify as the city of Polygium mentioned by Avienus, became an important emporium in the 6th c. B.C., and a port of call for Etruscan and Greek navigators. It is also possible that Greek colonists settled Bessan before Agde was even founded. In any case, the rise of the Massaliot trading post in the 4th c. B.C. put an end to the prosperity of Bessan: the settlement was partly abandoned at that time, but had a certain revival of activity in the 1st c. A.D.

Nothing is known of the plan of the city, which covered 4 ha. Excavations have revealed some huts built either of cobwork (6th c. B.C.) or basaltic stones (4th c. B.C.). The last occupation stratum (1st-4th c. A.D.) contained a cistern, in the S section. The importance and wealth of the original city, however, can be seen from the many Etruscan, Punic, and Greek imports: Attic ware, in particular, is varied as well as of high quality, and much of it bears graffiti in Greek characters. The finds are housed in Agde and in the Institut d'Archéologie in Montpellier.

BIBLIOGRAPHY. J. Coulouma, "La station grecque de La Monédière près de Bessan," *CahHistArch* 9 (1936) 690-712; J.-J. Jully, "La céramique attique de La Monédière, Bessan." *Latomus* 124 (1973). Y. SOLIER

BETH-GUBRIN, *see* ELEUTHEROPOLIS

BETHLEHEM Jordan/Israel. Map 6. A city 9.6 km S-SW of Jerusalem, on a narrow ridge set in a fertile area. The setting of the story of Ruth and the birthplace of David and Jesus, it is mentioned frequently in the Bible, especially with reference to the Nativity (Matt. 2, Luke 2), as well as in various texts (i.e., Joseph. *AJ* 5, 7, 8; Justin Martyr *Dialogue* 78; Procop. *Aed.* 5.9).

Some ancient cisterns and several catacombs exist, and there was once a shrine, of Hadrianic date, to Tammuz (Adonis), in a grove of trees hard by the traditional site of the Nativity. The chief remaining monument is the Church of the Nativity, built first in Constantine's time (by A.D. 333). A five-aisled basilica, it was entered through an atrium and was continuous, on the opposite (E) end, with an octagonal structure placed over the grotto of the Nativity. In the 6th c. (perhaps ca. 560), the church was much rebuilt, particularly at the E, where the octagon was replaced by an expanded construction of trefoil plan; it is substantially this later work that can be seen today. In the church there are remnants of mediaeval mosaics depicting early church councils.

BIBLIOGRAPHY. R. W. Hamilton, *A Guide to Bethlehem* (1939)MP; A. M. Schneider, "Bethlehem," *RAC* (1952) 224-28P; M. Restle, "Bethlehem," *Reallexikon zur byzantinischen Kunst* 1 (1966) 599-612P.

W. L. MAC DONALD

BETH-SHEAN, *see* SCYTHOPOLIS

BETH SHEARIM, *see* BESARA

BETTIOUA, *see* PORTUS MAGNUS

BETTONA, *see* VETTONA

BEWCASTLE Cumberland, England (NY 565746). Map 24. About 9.6 km NW of Birdoswald, 24 km NE of Carlisle, an outpost fort of the Hadrianic Wall system, occupied from the reign of Hadrian (*RIB* 995) to A.D. 367. Built during or after the construction of the Wall itself, it formed one of a series of outposts (the others being Netherby and Birrens) to screen the W end of the Wall. This fort had timber buildings, but its size and plan are unknown, as are its history and garrison during the 2d c.

In the 3d c. it was probably occupied by Cohors I Nervana Germanorum (*RIB* 966). In that case, like the other 3d and 4th c. outposts at Netherby, High Rochester, and Risingham, it was occupied by a cohors milliaria equitata. Bewcastle and Netherby between them could have fielded not only something approaching 2000 infantry, but also about 480 cavalry—virtually an ala quingenaria—a formidable force, capable of dealing with considerable disturbances N of the Wall without having to call on the Wall garrison.

The 3d c. fort was (unusually) an irregular hexagon, ca. 2.4 ha. The internal plan was therefore also irregular, although little is known in detail. The headquarters building and commander's house faced E. The sunken strong-room of the headquarters building, divided in two by a central wall shortly after construction, contained material from the destruction, perhaps at the end of the 3d c., of the shrine above it. The material included two fine silver plaques dedicated to Cocidius (*RIB* 986-987). Dedication to a local and unofficial deity in the shrine of a fort is unparalleled. This fact, and the number of altars dedicated to Cocidius from the site (*RIB* 966, 985, 988-89, 993), suggests either that Bewcastle was the Fanum Cocidi of the *Ravenna Cosmography*, or that his shrine was close at hand. The fort suffered further destruction in the mid 4th c. (perhaps A.D. 343, or 360), and was abandoned after the invasion of A.D. 367.

The bath house, of apparently standard Hadrianic type but within the fort, was excavated in 1954. No fort structures can now be seen on the ground.

BIBLIOGRAPHY. E. Birley, *Research on Hadrian's Wall* (1961) 231-33. Excavation reports: I. A. Richmond et al., *Trans. Cumberland and Westmorland Ant. and Arch. Soc.* 38 (1938) 195-237; J. P. Gillam, ibid. 54 (1955) 265-67PI. J. C. MANN

BÉZIERS, *see* BAETERRAE

BIBERLIKOPF, *see* LIMES ON WALENSEE, RAETIA

BIBRA (Beckfoot) Cumberland, England. Map 24. Coastal fort S of the W end of Hadrian's Wall, for an infantry unit of 500, built of stone with internal angle towers and four gates with guard-chambers, occupied from Hadrian's reign until the late 4th c. The only known garrison is Cohors XI Pannoniorum. Ballista platforms may have been added to the defenses in the 3d-4th c.

BIBLIOGRAPHY. R. G. Collingwood, "The Roman fort at Beckfoot," *Trans. Cumberland and Westmorland Arch. Soc.* ser. 2,36 (1936) 76-84. D. CHARLESWORTH

BIBRACTE Mont Beuvray, Saône-et-Loire, France. Map 23. Situated in the Morvan region near the SE edge of the massif, 27 km from Autun. The importance of Bibracte—"by far the largest and the best provided of the Aeduan oppida" (Caes. *BGall* 1.23)—in Gaul in the last years of independence is stressed by the "council of all Gaul" held there in A.D. 52, which appointed Vercingetorix commander-in-chief of the Gaulish armies (*BGall* 7.63). Excavations carried out over a period of 30 years, to 1898, have left no doubt as to the site: the oppidum covered the more or less flat summit of Mont Beuvray, which dominates the surrounding hills and provides easy access to the Yonne, the Saône, and even the Loire. Further, despite the rampart (of the murus gallicus type) which runs nearly 5 km around the mountain, Bibracte's primary importance most probably was as a center of crafts and trade.

Excavation around a large temple, which may have been dedicated to a goddess after whom the city was named (two dedications have been found at Autun), has revealed rectangular dwellings of the Gaulish type, half buried underground and enclosed in walls of dry stone, as well as some houses with hypocausts, of the Mediterranean type. The main road, also uncovered, is lined with shops. Workshops for metalworking take up several sections; in a number of them the owner's ashes were buried beneath his forge. Objects found here are evidence of links with Marseille (coins, amphorae) and Italy (so-called "Campanian" ware with a black glaze, Arretine bowls, including some goblets signed ACCO).

The city, whose finds have served as a basis for characterizing the period as "La Tène III," was occupied at least to the founding of Augustodunum (Autun), which later took its place (5 B.C.). Thereafter the temple continued to be used, probably especially during annual fairs. In fact, only new excavations would make it possible to determine precisely which buildings and objects actually date to the period before the Roman Conquest.

BIBLIOGRAPHY. Bulliot, *Fouilles du Beuvray . . . de*

1867 à 1895 (1895); Déchelette, *L'oppidum de Bibracte* (1903) (résumé in id., *Manuel* 2.3, pp. 948-57); Vuille-mot, "Révision du matériel archéologique de Bibracte: céramique campanienne," *Mémoires de la Société Eduenne* 51 (1968) 213 ff. C. ROLLEY

"BIBRAX," *see* SAINT-THOMAS

BIEDA, *see* BLERA

"BIGESTE," *see* HUMAC

BIGNOR Sussex, England. Map 24. Site of a large Roman villa close to Stane Street, the Roman road from London to Chichester, ca. 16 km NE of the latter. Discovered in 1811, it was extensively excavated in the following years. Mosaics of high quality were revealed; preserved under small sheds, they are still open to visitors. In 1960 a small site museum was built.

The plan of the villa reveals an inner courtyard surrounded by some 60 rooms and an outer courtyard containing what appear to be farmyard buildings, the whole covering a not quite rectangular area (ca. 174 x 96 m; over 1.6 ha). It is one of the largest villas in Britain. Early excavations gave little information about the history or development of the buildings, but the plan suggested an original nucleus in the W wing. Recent excavation confirms this, but shows a complicated sequence of no less than eight phases. The earliest identified building was a timber-framed corridor house, dated by a coin of Commodus to no earlier than ca. 180-190; but since Flavian samian ware and two coins of Trajan have been found it seems probable that earlier structures remain to be discovered. The first stone house was a simple oblong, but was soon embellished with a corridor and small wings. The great enlargement around the courtyard can be presumed to belong to the 4th c.: a further enlargement to the N is contemporary with the main mosaics, which are thus likely to belong to the middle years of the 4th c.

The majority of these mosaics are grouped at the NW corner of the house and include portrayals of the head of Venus in a nimbus, Ganymede and the Eagle, a Medusa head and the Four Seasons in the angles. In the SE corner of the courtyard, the capacious bath suite belongs to the latest phases of the villa: a smaller suite attached to the back of the W wing was never completely finished.

The buildings in the outer courtyard can be theoretically identified as quarters for cattle and sheep with their attendants; they allow for some 55 cattle, 12 pair of plough-oxen, and 200 sheep. Considerations such as these and an examination of local natural boundaries suggest an estate of perhaps ca. 800 ha. Excavation has shown that the villa collapsed from natural causes; the date is uncertain but may reasonably be placed in the first half of the 5th c. Perhaps the breakdown of markets and the escape of slaves left it economically impossible to maintain so large a building.

BIBLIOGRAPHY. S. Lyson, *Reliquiae Britannico-Romanae* III (1817); S. Applebaum in H.P.R. Finberg, *The Agrarian History of England and Wales* I ii (1972) 182-84. S. S. FRERE

BILBILIS (Calatayud) Zaragoza, Spain. Map 19. Iberian settlement and Roman municipium in the Conventus Caesaraugustanus Tarraconensis, at the junction of the Jalón and Jiloca rivers and SW of the town of Zaragoza on the road to Madrid. Traces of it are visible on the hill above Bambola, 6 km from the present town of Calatayud. Excavations have yielded remains perhaps of a theater, of a temple, and of hydraulic construction. The town climbed a hillside and was of long but irregular outline. Paintings and other objects are in the local museum.

Bilbilis was the scene of the struggle between Sertorius and Metellus. The town issued native coinage and, from the time of Augustus, Imperial bronze coinage. It was famous for the temper of its weapons, as well as for being the place where Martial was born and died. Ausonius (*Ep.* 29.57), in the 4th c., includes it among the abandoned and desolate Spanish towns.

BIBLIOGRAPHY. Strabo 3.4.13; Pliny, *HN* 24.144.
M. Dolç, "Semblanza arqueológica de Bilbilis," *ArchEspArq* 27 (1954) 179-211[I]. J. ARCE

BINCHESTER, *see* VINOVIA

BINGEN, *see* BINGIUM

BINGERBRÜCK Rhineland Palatinate, Germany. Map 20. A large Roman necropolis opposite Bingen was uncovered during the construction of the railway station. The many military gravestones (today in the museums at Bad Kreuznach and Wiesbaden) covered graves with burial urns and sarcophagi, indicating that the necropolis was used from the 1st c. A.D. to the 4th. The Breucus gravestone (Bad Kreuznach Museum) records the action of Pannonian troops in the province of Germania Superior. (See also Bingium.)

BIBLIOGRAPHY. E. Schmidt, "Römische Grabdenkmäler vom Ruppertsberg bei Bingen," *BonnJbb* 28 (1860) 79-83; id., "Neue römische Inschriften vom Ruppertsberg bei Bingen," *BonnJbb* 29-30 (1860) 205-23, pl. III; G. Behrens, *Bingen* (1920) 120-52. H. BULLINGER

BINGIUM (Bingen) Rhineland Palatinate, Germany. Map 20. A Roman settlement on the right bank of the Nahe (ancient Nava) where it joins the Rhine. A bridge of the Roman Rhine valley route which crossed the Nava at this point was protected by a castellum for auxiliary troops in the first half of the 1st c. A.D. Particularly important in the Roman road network was a route from Bingen to the imperial town of Trier, which is marked in the *Peutinger Table*. Stationed at Bingen were Cohors IV Delmatarum, Cohors I Pannoniorum, and Cohors I Sagittiariorum, which is attested by gravestones, as well as the Legio XXII Primigenia Pia Fidelis. In 370 the Roman writer Ausonius mentioned that the town was surrounded by a wall which the emperor Julian had built in 359 (Amm. Marc. 18.2). There is evidence of milites Bingenses under a praefectus ca. 400.

Many graves from the civil settlement are preserved. The most notable is a doctor's grave from the beginning of the 2d c. A.D., containing a rich assortment of bronze instruments: basin, scalpel, trapan, pincers, spatula, etc. (exhibited in Burg Klopp, Bingen).

BIBLIOGRAPHY. G. Behrens, *Bingen* (= *Katalog west- und süddeutscher Altertumssammlungen* 4) (1920) 49[MPI]; id., *Die Binger Landschaft in der vor- und frühgeschichte* (1954); Como, "Das Grab eines römischen Arztes in Bingen," *Germania* (1925) 125ff; H. Klumbach, "Bingen zur Römerzeit," *Führer zu vor- und frühgeschichtlichen Denkmälern* 12 (1969) 127-30.

H. BULLINGER

BIRAN Gers, France. Map 23. The Roman mole of Mas-de-Biran, one of the best preserved in the Gers, was surveyed in 1966.

BIBLIOGRAPHY. M. Labrousse, *Gallia* 26 (1968) 539[I]; 28 (1970) 417. M. LABROUSSE

BIRDHOPE or Burdhope Northumberland, England. Map 24. A site 65 km NW of Newcastle.

1) Marching camps (NY 827988), ca. 400 m NW of and visible from Bremenium, the earlier and larger one (ca. 11 ha) with gates with claviculae, enclosing the smaller and later (ca. 3.2 ha) with gates with traverses. Now within a modern army camp, these are two of the remarkable series of camps on Dere Street in N Northumberland.

2) Native farming settlement (NY 815985), 1.6 km W of Bremenium. Five conjoined enclosures built of stone, with one or two round stone houses in each, undoubtedly occupied in the Roman period, but partly obstructed by rectangular post-Roman structures.

BIBLIOGRAPHY. 1) I. A. Richmond, "The Romans in Redesdale," *Northumberland County History* xv (1940) 116-28; 2) ibid. 77-78; G. Jobey, *Arch. Ael.* 42 (1964) 54. J. C. MANN

BIRDOSWALD, *see* CAMBOGLANNA under HADRIAN'S WALL

BIRRENS, *see* BLATOBULGIUM

BIR RICCA, *see* MELITA

BIRTEN, *see* VETERA AND COLONIA ULPIA TRAIANA

BIRŻEBBUGIA, *see* MELITA

BISERICUŢA-GARVĂN, *see* DINOGETIA

BISONTII, *see* VESONTIO

"BISTUE NOVA," *see* ZENICA

BITOLA, *see* HERAKLEIA LYNKESTIS

BITTERNE, *see* CLAUSENTUM

BIZYE (Vize) Thrace, Turkey. Map 7. The home of the mythological king Tereus (Plin. *HN* 4.47; 10.70). It was the capital city of the last Thracian dynasty of the Odrysian line, the center of the client kingdom of the Astai, which lasted until A.D. 44 (Strab. 7. frag. 47[48]).

The ancient site, still occupied by the modern town, lies somewhat N of a line between Adrianople and Constantinople, on the present N highway through Turkish Thrace. Substantial remains of fortifications still rise along the W and S sides of the acropolis. The earliest parts of the wall circuit have been dated to the Hellenistic period. The appearance of the main gateway is known from a coin of the time of the emperor Caligula (*Syll. Num. Graec.* IV; Fitzwilliam Museum, No. 1662). It shows an arched opening between two round towers and suggests that a freestanding model of a quadriga may have stood over the arch. Numerous curved seat blocks in and around the acropolis are evidence of a nearby theater.

Reused blocks from Classical buildings can be seen in many houses of the modern town, and traces of a large building of Roman date were found (1938) in the quarter called Kaledibi, but no specific identifications can be made. At some distance from the citadel, on Çömlekçi Tepe, a villa of the 2d-3d c. was found. The discovery of numerous inscriptions has facilitated the reconstruction of the complicated family relationships in the last generations of the dynasty of Rhoemetalces.

Four km S of the town, along the banks of the river (Anadere or Boğazköy Deresi), a group of nine grave tumuli have been investigated. Tumulus A, the most important of the group, contained the barrel-vaulted chamber tomb of a wealthy and distinguished personage, quite probably one of the kings of Bizye. The tomb is a rectangle (4.62 x 3.12 m). The side walls rise 1.18 m to the springing of the vault, which at its center is 2.74 m above the floor. A large doorway (1.40 x 1.17 m) was sealed by an even larger stone slab, attached to the door frame with heavy iron staples. The tomb had not been robbed. Inside the burial chamber, a stone sarcophagus (more than 2 x 1 m) was fitted with a heavy stone lid, also attached by iron staples. The sarcophagus contained the ashes of the deceased and a rich assortment of articles in gold, silver, and bronze.

In the remainder of the tomb there were bronze vessels and lamp stands and a large number of ceramic vessels. The walls of the chamber were covered with painted stucco which had been seriously damaged by damp and earthquakes. Sufficient evidence was preserved to permit a complete restoration of the tomb in the Istanbul Archaeological Museum.

To the E of the city, a rock shrine sacred to the local Thracian divinities was uncovered in 1963. It consists of a rock temple, an altar and a sacred precinct, which can probably be dated to the 6th c. B.C.

BIBLIOGRAPHY. M. Christodoulos, *Perigraphe istoriographike tes Eparchias Saranta Ekklesion* (1881) 35ff; Th. Lakidis, *Istoria Bizyes kai Medeias* (1899); R. M. Dawkins & A.J.B. Wace, "Inscriptions from Bizye," *BSA* 12 (1905-6) 175-83; R. M. Dawkins, "The modern carnival in Thrace," *JHS* 26 (1906) 191-206[I]; E. Kalinka, "Altes und neues aus Thrakien," *ÖJh* 23 (1926) Beiblatt, 118-27; "Haberler," *Belleten* 2 (1938) 494[I]; "Archäologische Funde aus der Turkei," *AA* (1939) 175; A. Müfid Mansel, "Trakya Hafriyatı. Les fouilles de Thrace," *Belleten* 4 (1940) 89-139[IP]; F. Dirimtekin, "Vize et ses antiquités," *Annual of the Aya Sofya Museum* 5 (1963) 26-36[I]; 6 (1965) 17-18; N. Fıratlı, "Brief archaeological news, Finds in Thrace," *Annual of the Archaeological Museums of Istanbul* 13-14 (1966) 228-29. T. S. MAC KAY

BLACCIACUM, *see* BLASSIACUM

BLAEN-CWM-BACH Glamorgan, Wales. Map 24. Large Roman marching camp on a moorland ridge at SS796987, 4.8 km NE of Neath. The site lies on the NE spur of Cefn Morfydd Mountain at a height of nearly 240 m. Elongated in shape (894 x 291 m; 25 ha), it is one of the largest marching camps known in Wales. Its position on the SE slope of the hill gives protection from the prevailing wind. One entrance of the titulum type survives. The camp could have held more than a legion on campaign, but the historical context is not known.

BIBLIOGRAPHY. J. K. St. Joseph, "Air Reconnaissance in Britain 1955-7," *JRS* 48 (1958) 86ff[I]. G.D.B. JONES

BLAIN Loire-Atlantique, France. Map 23. For several centuries the substratum of this little town ca. 30 km from Nantes has yielded archaeological remains dating from the Late Empire. A good deal of pottery has been uncovered, including a hemispherical bowl of terra sigillata with a molded design depicting Trajan's victory over the Daci under Decebalus. Most of the objects found at Blain are housed in the Mairie.

BIBLIOGRAPHY. J. Revelière, "Notes Archéologiques sur Blain," *Bulletin de la Société Archéologique de Nantes* (1903). M. PETIT

BLASSIACUM or Blacciacum (Plassac) Gironde, Aquitaine, France. Map 23. The site is on the right bank of the

Gironde, 9 km downstream from Le Bec d'Ambès and 3 km from Blaye (Blavia), the boundary of the civitas of the Bituriges Vivisci. Under Roman rule it was part of the pagus Blaviensis on the road from Burdigala to Talmont in the territory of the Santoni (*Antonine Itinerary*). It was a rural estate from the Late Empire to Merovingian times, at the foot of hillsides sloping to the river, with forests and vineyards nearby.

The last known proprietor in antiquity was the Merovingian deacon Waldo, who became Bertchramnus (Bertrand), bishop of Le Mans, 550-624 (cf. Gregory of Tours, *Hist. Franc.*, passim). The poet Fortunatus dedicated a poem to him in his Book IX. His will, dictated on 27 March 616, cites the existence of this family estate, inherited from his mother, a Gallo-Roman from Bordeaux. The will was copied in the 9th c. in the abbey of Couture at Le Mans (Bibl. Mun. Mans, ms. 224, published in the *Collection des Archives Hist. du Mans*, pp. 98 to 141).

The site was often mentioned in the 19th c. and the mosaic which extends under the modern church was seen on several occasions up to 1939. Excavations were undertaken in 1962 and still are in progress; they now extend over ca. 0.5 ha. Test pits have led to the partial rediscovery of the mosaic previously mentioned: it has entwined roses and polychrome, geometric central motifs. In addition, the excavations have led to the discovery, in the N part, of 10 rooms, the NW wing of the villa urbana, over three recognized levels. They indicate the existence of an earlier villa of the Late Empire, destroyed in the 3d c.

The floors of five rooms are mosaic, all polychrome and geometric, covering ca. 100 sq m. Three rooms are over hypocausts with radiating channels. They are the end rooms of the master's house, which must have extended under the modern church and beyond in a rectangular plan. To the E and W along the wings there extended two covered galleries 80 m long, enclosing a garden court and going down to the river. On these galleries opened the rooms of the villa agraria. It had a bath with hypocausts with radiating channels and small square piers. Eighteen rooms served as working buildings. The galleries are bordered by small aqueducts emptied by two spouts, still in place, 7 m above the river. The whole abuts on the S side on massive 3d c. foundations (walls 1.1 m thick, of fine ashlar construction, plastered over and marked with scribed pointing). These foundations form a rectangle 12 x 8 m, and 3.2 m deep at the rear. They are flanked on each side by two parallel walls supporting galleries coming down from the N. At a lower level, facing the river, a concave wall of large radius and earlier date lies in the massive foundations. This last group is not a private house. After systematic filling, it was used in the 5th c. villa to support two tall buildings above the river, possibly a tower and portico.

Findings—pottery, coins (bronzes from Trajan to Gratian), artifacts for adornment of bone, bronze, etc. —are on exhibit on the site.

BIBLIOGRAPHY. For Bertchramnus: L. Duchesne, *Fastes épiscopaux* (1894) II; A. de Maillé, *Origines chrétiennes de Bx* (1959); C. Higonet, *Hist. de Bx* (1970) II.

For Plassac: Hachette, *Guide Bleu* s.v. Sud-Ouest; E. Marcel, *Plassac à travers les âges Bx* (1955); Reports of excavations of 1963-1969 in *Gallia* (1965—).

G. EMARD

BLATOBULGIUM (Birrens) Middlebie, Dumfriesshire, Scotland. Map 24. The site, mentioned in the *Antonine Itinerary*, is ca. 2.4 km E of Ecclefechan, at the junction of the Mein Water and the Middlebie Burn. The visible fort, with rampart and ditches well preserved, is of Antonine or mid 2d c. date.

The S part of the area had earlier been occupied by a late 1st c. enclosure, constructed as a result of Agricola's campaigns in Scotland. It was probably ca. 70 m square, defended by a turf rampart and ditch. This enclosure was directly succeeded by a fort of Hadrianic date (stratified pottery). It had a turf rampart 6.7 m wide enclosing an internal area of ca. 1.34 ha, one ditch on the N side, and at least one ditch on the E and W sides. The S side has been eroded by the Mein Water. Barrack blocks were of timber, but the central block of buildings may have been of stone. The Hadrianic fort faced S, and was apparently an outpost fort to Hadrian's Wall. The inner of two triple-ditched enclosures visible on air photographs in the field W of the site was probably an annex.

The Hadrianic fort was leveled to make way for a new, longer fort, presumably with a larger garrison or a larger mounted contingent. The new fort (proved to be Antonine by stratified coins and pottery) had its E and W ramparts, and probably its S rampart, on approximately the same lines as the Hadrianic fort, but its N rampart lay over 18 m N of the earlier one.

The longer, Antonine fort measured ca. 153 m N-S and ca. 106 m E-W internally, an area of 1.6 ha. Its rampart (the present visible one) was of turf, set on a stone base 5.4 m wide, with six ditches on the N side, and one ditch at least on the E and W. In the interior a new central block of stone buildings was erected over the leveled debris of Hadrianic structures, and N and S of the central block were long narrow buildings also of stone, either barracks or stables. Inscriptions show that the garrison was the Cohors I Nervana of Germans, 1000 strong, with a mounted contingent.

The Antonine fort, as first built, suffered serious damage, resulting in a layer of debris and burned material. By A.D. 158, it had a new garrison, the Cohors II of Tungrians, also 1000 strong, with a mounted contingent. No alteration was made in the dimensions, but extensive repairs and rebuilding were needed in the interior. The outer of the two triple-ditched enclosures in the field W of the fort was probably an annex. Birrens, for a time at least, formed part of the system supporting the Antonine Wall between Forth and Clyde.

None of the pottery found in the 1962-69 excavations was later than the 2d c. A.D., but later Roman occupation in the vicinity of the visible fort is proved by stray finds of early 3d c. pottery from the bed of the Mein Water. These may have come from one of the structures discovered by aerial photography N and S of the fort.

BIBLIOGRAPHY. *Proc. Soc. Antiquaries of Scotland* 30 (1896) 81-199; 72 (1938) 275-347; A. Robertson, *Birrens (Blatobulgium)* (1974). A. S. ROBERTSON

BLED TAKOURART, *see* TOCOLOSIDA

BLERA Italy. Map 16. An ancient city until recently called by its mediaeval name, Bieda. The site, barely known to the Roman geographers, appears on the *Peutinger Table* as a station on the Via Clodia. The city occupied a long, narrow, curving plateau of which the modern town takes up the E end. The site is cut from the Tuscan tufa plateau by the Fosso Ricanale on the N and the Biedano on the S; at its W tip these join, and the Biedano continues past Norchia to join the Marta below Tuscania. The Via Clodia ran along this valley, crossing the streams on two bridges. The older, Ponte della Rocca, which dates from the 2d century B.C., is a single span across the Ricanale just before it joins the Biedano; the other, Ponte del Diavolo, of Imperial Ro-

man date and with three arches, spans the Biedano SE of the city.

Some thousand Etruscan tombs, both tumulus and cliff tombs, have been found here. The tumuli rimmed the high plateaus on the far side of the city's boundary streams; the cliff tombs were carved in the face of the cliffs below the city or facing it across the water.

Like the tumuli at Caere, those at Blera had a ring base, usually carved in the living rock and crowned with a series of moldings, a rock-cut burial chamber approached by a dromos, and an earth mound above. The material found in the chambers is local pottery of the late 7th and 6th c.

The cliff tombs are of two types: the rarer has the form of a house with a pitched roof, the other is flat-roofed with a massive crown of moldings. Only three gabled tombs are known, but some hundreds of die tombs. Most of these are merely a facade carved in the cliff, or a half-die projecting from its face, but the facade is always much the same: a smooth rectangle, slightly broader than high, topped with a series of moldings—hawk's beak, half round, deep fascia—above which a heavy Etruscan quarter round (the "bell") rolls back to a crowning half round and fascia. In the facade a door is carved (sometimes two) with a Doric T-shaped frame. Usually, at least at Bieda, the door is real and leads to the burial chamber, though there are some tombs with false doors like those at Norchia and Castel d'Asso. The burial chamber normally takes the form of a room with a gabled roof and heavy rooftree, with a couch on either side wall, its front carved to represent a wooden bedstead.

The flat-topped die tombs have been taken either to represent a flat-roofed house or to be designed as a funerary monument, a giant cippus. The crowning moldings are hard to explain as eaves' trim, and the fact that the grave chambers themselves have pitched roofs speaks further against the flat roof as an element in Etruscan domestic architecture.

BIBLIOGRAPHY. G. Dennis, *Cities and Cemeteries of Etruria* (3d ed., 1883) 207-218; H. Koch et al., *RömMitt* 30 (1915) 161-303[MPI]; G. Rosi, *JRS* 15 (1925) 1-59; 17 (1927) 59-96; A. Gargana, *NSc* (1932) 485-505; Å. Åkerström, *Studien über die etruskischen Gräber* (1934) 76-84; L. T. Shoe, *Etruscan and Republican Roman Mouldings, MAAR* 28 (1965) 46f. E. RICHARDSON

BLESTIUM (Monmouth) Monmouthshire, Wales. Map 24. The place name occurs in the *Antonine Itinerary*, 17.6 km from Burrium (Usk) and the same distance from Ariconium (Weston-under-Penyard). It has long been identified with Monmouth, at the junction of the rivers Wye and Monnow. This identification has yet to be corroborated by the finding of Roman structures, though pottery has been found in and near the town.

M. G. JARRETT

BLICQUY Belgium. Map 21. A vicus of the civitas Nerviorum which grew up at the point where the road going N from Bavai forks, the right fork proceeding to Velzeke and Ganda (Ghent), the left to Oudenburg. A great many scattered finds have been made there over the years, among them an arm belonging to a bronze statue that must have been ca. 1 m high, and a bronze statuette of Mars. More systematic digging has been done since 1953. In the vicus itself a rectangular structure was found, with a hypocaust; also a cellar, its walls made of large blocks of stone from a nearby quarry and its mud floor covered with a layer of sand that showed traces of many amphorae; and a storage pit simply hollowed out of the clayey soil. The main excavations concern the necropolis and the industrial quarter. The necropolis lies W of the ancient street, between the site of the vicus and the modern village of Aubechies. About 100 tombs had been cleared by amateurs before systematic excavations were started in 1960. About 400 more tombs were investigated, but a good part of the necropolis still remains to be studied. All the tombs are cremation tombs, ranging from the middle of the 1st c. A.D. to the first half of the 3d c., but they vary in structure—some are of local stone or tile, some are lined with wood, some are simple pits. The grave gifts are all very rich, each tomb averaging a dozen pottery vases (mainly local ware) as well as very fine glassware, quantities of fibulas (a good many of enamel and tinned bronze), bronze mirrors, beads of glass and clay belonging to necklaces and diadems, small boxes of bone, bronze bracelets, and, very occasionally, strigils and weapons. Some of the tombs probably were surmounted by funerary monuments decorated with reliefs but only small fragments of these remain.

Between this necropolis and the Bavai road, also to the S of the vicus, was an industrial quarter. Three potter's kilns have been found there, along with their rubbish pits, but some 20 more have been located by proton magnetometer. Recently a shaft-furnace belonging to a forge or ironworks was uncovered in the same area. The potter's kilns were in use between ca. A.D. 50 and 150. A little farther S, underneath the Romanesque church of Aubechies, was a large bath building; it was separated from the vicus by the necropolis and the industrial quarter. A hexagonal nymphaeum has been excavated there, also two rooms (tepidaria?) over a hypocaust. The fact that the Dendre spring is close by and that the baths are located at some distance from the vicus suggests that the baths had a religious purpose. In the 19th c. a bronze statuette of a pantheic god was found near this site. Lastly, it has long been known that there were several substructures at the spot called Ville d'Anderlecht, about 1 km E of the necropolis. A well has been uncovered and restored there, and quite recently a bronze-founder's furnace, trapezoidal in design; also a wooden trough where bronze objects were stored ready for recasting, among them statuettes of Mars and Mercury, handles of chests, phallic amulets, rings, and harness ornaments.

BIBLIOGRAPHY. R. De Maeyer, *De overblijfselen der Romeinsche Villa's in België* (1940) 47; S. J. De Laet & P. Moison, "Une statuette de divinité panthée découverte à Aubechies," *La Nouvelle Clio* 4 (1953) 1-4; De Laet & H. Thoen, "Etudes sur la céramique de la nécropole gallo-romaine de Blicquy," *Helinium* 4 (1964) 193-218; 6 (1966) 3-25; 8 (1968) 3-21; 9 (1969) 28-38. De Laet et al., *La nécropole gallo-romaine de Blicquy* (1972)=*Dissertationes Archaeologicae Gandenses* XIV.

S. J. DE LAET

BOBADELA Beira Litoral, Portugal. Map 19. Near Oliveira do Hospital. Neither the geographers of antiquity nor the *Antonine Itinerary* mentions this village, but three stone inscriptions which record three flamines attest its importance. An arch is preserved which seems to be an entrance to a forum or sacred enclosure rather than a gate in the fortifications or a support for an aqueduct as some authors suggest. A monumental inscription (NEPTUNALE) seems to indicate the existence of a Temple of Neptune.

BIBLIOGRAPHY. V. Correia & Nogueira Gonçalves, *Inventário Artístico de Portugal*. IV. *Distrito de Coimbra* (1952) 165-66. J. ALARCÃO

BODRUM, *see* HALIKARNASSOS

BÖHMING, *see* LIMES RAETIAE

BOIANO, *see* BOVIANUM

BOIODUNUM, *see* PASSAU

BOLJETIN, *see* LIMES OF DJERDAP

BOLOGA ("Resculum") Cluj, Romania. Map 12. Roman camp (2d-3d c.) on a plateau at the junction of the Săcueul valley with Crişul Tepede river, the westernmost point of Dacia. It is mentioned in a tabula cerata (*CIL* III, p. 924, tab.cer. I = ILS, 7215).

Excavations have revealed that the earth camp was replaced by a stone one (213 x 133 m), quadrilateral with round corners. The gates protrude in a semicircle, and the corner towers are trapezoidal in section. Both Cohors II Hispanorum Scutata Cyrenaica equitata and Cohors I Aelia Gaesatorum milliaria were stationed here. Inscriptions, stamped bricks and tiles, coins, and Dacian ceramics have been found.

BIBLIOGRAPHY. M. Macrea, "Castrul roman de la Bologa," *Anuarul Comisiunii Monumentelor Istorice. Secţia pentru Transilvania* 4 (1932-38) 195-233; N. Gudea, "Ceramica dacică din castrul roman de la Bologa, jud. Cluj," *Acta Musei Napocensis* 6 (1969) 503-8.

L. MARINESCU

BOLOGNA, *see* BONONIA

BOLONIA, *see* BAELO

BOL'SHAIA BLITZNITZA, *see* PHANAGORIA

BÔNE, *see* HIPPO REGIUS

BONN, *see* BONNA *and* LIMES G. INFERIORIS

BONNA (Bonn) Germany. Map 20. A legionary camp in Germania Inferior. Built of wood, it served in the 30s of the 1st c. A.D. for the Legio I. After A.D. 83 it was reconstructed in stone and served the Legio I Minervia. The camp was still occupied in the 4th c. Of this later camp the principia, the valetudinarium, horrea, barracks, and perhaps a fabrica are known. About 500 m S an auxiliary camp, probably built by Drusus, survived at least into the 2d c. Between the two camps was a settlement. Finds are at the Rheinisches Landesmuseum in Bonn.

BIBLIOGRAPHY. D. Wortmann, *Rheinische Ausgrabungen* 3 (1968) 323-29. H. VON PETRIKOVITS

BONONIA (Bologna) Emilia-Romagna, Italy. Map 14. A Latin colony founded in 189 B.C. where the earlier Etruscan city of Felsina had stood. In 187 it was connected to Ariminum and Placentia by the Via Aemilia Lepidi, and with Arretium by a Via Flaminia never again recorded. At the end of the Republic the community of Bononia was under the patronage of the Antonii. The city was involved, seemingly without injury in the bellum Mutinense in 43 B.C. It was recolonized by Antony and later by Octavian in 32 B.C. It acknowledged the title of parens later when it had become Augustan. Destroyed by fire in A.D. 53, it was restored and enlarged under Claudius as the result of intercession on the part of young Nero. In the Imperial age, it was recorded among the major cities of Italy. In a state of crisis during the Late Empire, the city nevertheless resisted the Visigoths of Alaric in A.D. 410. It was included in the kingdom of Theodoric, and later became part of the Byzantine ex-

archy, falling to the Lombards in 727. Bononia was a diocesan seat from at least the beginning of the 4th c.

The pre-urban antecedents of Bononia go back to the Iron Age. Huts were concentrated on the plateau at the foot of the mountains between the Aposa and the Ravone rivers, and in the surrounding territory from the Santerno to the Panaro there was a network of sparsely populated settlements. Clearly, the site was favorable for agriculture and even more so for trade, as it was at the intersection of numerous channels of communication. From Pliny (*HN* 3.5) the name Felsina is known, and its function as the capital of the area. The continuity of life at the site from the Iron Age until the 4th c. B.C. has been verified by the peripheral extension of the necropoleis. The plan of the Latin colony of 189, implemented by a force of 3000 men, was orthogonal and had perhaps a square perimeter. The successive form of the city, was rectangular. The city had as axis the principal E-W avenue, which was not entirely straight. Probably Bononia never had a circuit wall. Its development indicates dense settlement of the suburban area, with both dwellings and productive establishments. The median depth of the Roman level is only ca. 3 m. Thus continual building from the mediaeval period to the present has destroyed the major part of the Roman stratum and also lower strata. Little remains of public and private buildings except mosaics and architectural elements. It appears that the basilica may be identified with remains under the N wing of the municipal building, where Imperial portraits have also been found. Of the bath buildings constructed under Augustus, only epigraphical mention remains. A sanctuary to the Egyptian divinities existed, probably under the group of buildings making up S. Stefano, which in Roman times was in the suburban area. In this zone architectural fragments were used in later construction. Mosaics permit insight into the building history of the city from the end of the Republic to the 3d c. A.D. In Roman times Bononia lacked the dimensions of a great city but was the capital of a vast territory, still largely centuriated, with some later roads as well. It was a center of predominately agricultural and artisan activity, with indications of animal husbandry and metal working. Since many funerary markers were made here, there is opportunity for the study of workshops producing both inscriptions and sculpture.

BIBLIOGRAPHY. A. Grenier, *Bologne villanovienne et étrusque* (1912)[MPI]; P. Ducati, *Storia di Bologna, I: i tempi antichi* (1928)[MPI]; E. Andreoli, "Bologna nell'Antichità," *MemPontAcc* 3, 6 (1946) 143-82[MPI]; E. Andreoli & A. Negrioli, *Carta arch. d'Italia*, foglio 87 (1949)[MP]; *EAA* 2 (1959) 125-28 (P. E. Arias)[MP]; G. C. Susini, *Il lapidario greco e romano di Bologna* (1960)[I]; id., "Culta Bononia," *Strenna stor. bolognese* 7 (1957) 109, 133; id., "Testimonianze dei culti precristiani nel bolognese," ibid. 5 (1955) 139-51; G. A. Mansuelli et al., "Lo sviluppo urbano di Bologna," *Bologna centro storico* (1970) 21-36[MPI]; G. Gualandi, "Problemi urbanistici e cronologici di Felsina," *Atti e mem. Deputaz. di Storia patria Rom.* NS 20 (1969) 47-67; F. Bergonzoni, "Un contributo alla conoscenza di Bologna romana," ibid. 125-36[MPI]; D. Scagliarini, "L'insediamento residenziale e produttivo nel suburbio di Bologna romana," ibid. 137-92[MPI]. G. A. MANSUELLI

BONONIA-MALATA, *see* LIMES PANNONIAE (Yugoslav Sector)

BORCOVICUS, *see* HADRIAN'S WALL

BORDEAUX, *see* BURDIGALA

BORIDAVA, *see* BURIDAVA

BORSH, *see* LIMES S ALBANIA

BOSCOREALE (and Boscotrecase) Campania, Italy. Map 17A. Subdivisions of Torre Annunziata lying N and NW of Pompeii. Here a series of villas was excavated between 1894 and 1903, following the discovery of the Boscoreale Treasure of gold coins, jewelry, and silver tableware in the "Pisanella Villa." The silver (103 pieces now in the Louvre) included a patera, with an allegorical figure of Alexandria, and 16 cups, two of which are decorated with skeletons. Besides the treasure, many bronze furnishings and utensils were found, some of which are in Berlin; others, with parts of the decoration in the Fourth Pompeian Style, are in the Field Museum in Chicago.

The villa was a villa rustica producing oil, and grain, and enough wine to have two presses and 82 dolia in the court for fermentation. An apartment for the owner may have been arranged in an upper story; except for a single big triclinium in which were remains of couches, the ground floor was given over to the necessities of the farm. The plan of the villa and most of its companions varies from Vitruvius' prescription for such buildings (6.5.3) in having no atrium complex and it treats the peristyle as a utility courtyard around which other units are grouped in convenient blocks.

The Villa of Fannius Synistor of mid 1st c. B.C. is famous for its Second Style decorations, the most important a cubiculum with large architectural vistas, now in the Metropolitan Museum in New York, and an oecus, divided between the Metropolitan and the Museo Nazionale, Naples, painted with large figures whose interpretation is much disputed. Pieces from other rooms are widely scattered, and several disappeared after they were sold in Paris in 1903. Most of these are architectural decorations restricted in their development of the illusion of depth. Here only the living quarters around a peristyle were thought worth excavating, so the villa adds little to our knowledge of working farms, but it shows evidence of having been a big villa and an extensive property.

So little of the Villa of Agrippa Postumus at Boscotrecase was excavated, and the loss of the rest in the eruption of 1906 was so final, that one can only speculate about its magnificence. One suite of rooms has provided us with Third Style decorations that rank among the finest known; the varied treatment of landscape is particularly interesting. These are now divided between the Metropolitan Museum in New York and the Museo Nazionale, Naples.

Of the other villas, in Contrada Centopiedi al Tirone, in Piazza Mercato, and in Contrada Giuliana, only the last was more than sampled. Built late and decorated in the Fourth Style, it belongs in architecture and arrangements with the Pisanella Villa. Parts of its decorations are in the British Museum.

BIBLIOGRAPHY. R. Héron de Villefosse, *Le Trésor de Boscoreale* (*MonPiot* 5, Fasc. 1 & 2, 1899); A. Mau, tr. F. W. Kelsey, *Pompeii: Its Life and Art* (2d ed., 1902) 361-66; H. F. DeCou & F. B. Tarbell, *Antiquities from Boscoreale in the Field Museum of Natural History* (Field Museum Publication 152, Chicago 1912); P. W. Lehmann, *Roman Wall Paintings from Boscoreale in the Metropolitan Museum of Art* (1953); P. H. v. Blanckenhagen & C. Alexander, *The Paintings from Boscotrecase* (*RömMitt* Supplementband 6, 1962).

L. RICHARDSON, JR.

BOSCOTRECASE, *see* BOSCOREALE

BOSMAN, *see* LIMES OF DJERDAP

BOSTRA (Busrâ) Syria. Map 6. A royal Nabataean city in the Hauran plain, Bostra was annexed by Trajan in A.D. 106, becoming chief city of the Roman province of Arabia and the camp of Legio III Cyrenaica. An important Christian city in the late Byzantine period, Bostra was fortified by Justinian, then seized by the Moslem Arabs in A.D. 637.

Bostra was built of black basalt; the modern town lies over the ancient one, and many houses are constructed of reused stones. The wall surrounding the ancient city is very nearly oval. The rampart is best preserved on its W face, where it is ca. 4 m thick. The only gate still standing is that to the W, a high bay with semicircular arches, flanked by two square towers; in front of the gate there is an open place oval in shape. The main avenue is the decumanus, running from the W gate to the E end of the city. It was paved and was lined with porticos, the column shafts of which can still be seen. At the intersection of the decumanus and cardo, a tetrapylon stood in the center of a circular area. To the E, on the N side of the decumanus, was a vaulted cryptoporticus ca. 100 m long, lit by slits arranged in the steps of the porticos. Farther E is a monumental arch more than 12 m high and 18 m wide; it has a great semicircular bay flanked by two small ones; arches cut in the other direction permitted passage along the decumanus. The facade facing the decumanus has pilasters with Corinthian capitals and brackets for statues. At the N angles of the lateral faces and on either side of the central bay, to the S, are engaged columns with Ionic capitals, marking the beginning of the porticos.

At the S end of the street is a remarkably well-preserved theater, built in the second half of the 2d c. A.D. and transformed into a fortress at the end of the 8th c. It is built on level ground and strictly integrated into the city plan. The hemicycle, which is slightly over half a circle and has a diameter of more than 100 m, faces N. Its three tiers of 14, 18, and 5 rows of seats are crowned by a portico with a composite colonnade. Interior galleries, stairways, and admirably built vomitoria made for easy circulation; the direct access to the middle and upper stories and to the tribunals above the vaulted paradoi is remarkable. The orchestra is paved with stone. The scaenae frons, over 26 m high, is decorated with two rows of Corinthian columns in pink Egyptian granite, and flanked by two tall folded-back wings that have steps and loges descending laterally to the stage. Equally noteworthy are the vast side foyers, into which the paradoi are incorporated by a series of arcades. Coherent both architecturally and organically, this theater is considered the most perfect of all Roman and Italian theaters.

To the W of the theater there was probably a stadium; S of it was the hippodrome, which could accommodate 30,000 spectators. Only a few seats have been found.

To the E of the street and S of the decumanus are the ruins of baths of the Roman period, covered by modern houses, and called the S, W, or Trajan's baths. Designed on a T-shaped plan, they opened to the N through an 8-columned portico and two semicircular, arched doorways with a niche between them. The first room was the apodyterion, an 8-sided oblong hall with four semicircular recesses in the oblique sides. It was roofed with a flattened arch of volcanic scoriae. In the entrance axis was a wide arch leading to the tepidarium, and beyond that, in the same axis, to another room with a large window in its S wall. Both rooms had transverse cradle vaults. On either side, to E and W, are a series of rooms and exedras; the vaulting of the latter is still intact.

Farther along the decumanus are four tall, well-proportioned Corinthian columns with hexagonal bases, on a line diagonal to the intersection of the avenue and

a cross street. Behind them was the broad curve of the apse of a nymphaeum. On the other side of the street are tall, slender Corinthian columns, one of which carries an entablature fragment supported by a pilaster; they were part of a late monument not identified. The facade is at an oblique angle to the street plan. The cross street is edged in part by an Ionic colonnade now included in the walls of houses; it leads N to the Omar mosque. This monument, of the early Omayyad period, was built of magnificent reused marble columns with Corinthian and Ionic capitals. On the other side of the street are the baths and, some 50 m to the NE, more baths, now badly damaged.

At the top of the decumanus is the so-called Nabataean gate, with its great semicircular bay decorated with round pilasters and engaged columns surmounted by characteristic crocket capitals. Beside it, to the SE, is the building commonly known as Trajan's palace. It can be seen only from the E, where a large, well-built basalt wall decorated with two superimposed rows of semicircular niches and rectangular doors gave on to two stories of outer porticos, now gone. The palace formed an enormous rectangle with an E entrance opening onto a large porticoed courtyard. The residential wings, which were several stories high and had angle towers, were on the N and S sides. The first story in the N wing contained a spacious apartment with an entrance to the N, great apses to the E and W, and a deep rectangular exedra to the S.

To the NE is the 6th c. cathedral. Its square nave was completely covered by a large cupola supported by four semi-cupolas. Farther N is a rectangular basilica with pediments. The long S and N sides are lined with low porticos and pierced with windows; the W gable wall contains a great arch, while that to the E has an elliptical arch opening onto a semicircular apse and, in the pediment, a row of three rectangular windows with an axial window over them. Remarkably simple in design and decorated with elegant molding, this basilica, which was used as a church, probably dates from Christian times. To the N are the ruins of a little apsidal structure built in the same style and with the same methods.

To the NW inside the surrounding wall is a great oblong-shaped excavation with springs flowing at the bottom of it. It is often referred to as the Naumachia, and may have been built in antiquity.

BIBLIOGRAPHY. R. E. Brünnow & A. v. Domaszewski, *Die Provincia Arabia* III (1909)[MPI]; H. C. Butler, *PAES* Pt. II, *Architecture*. Sec. A, *Southern Syria* (1914)[MPI]; E. Frézouls, "Les théâtres romains de Syrie," *Annales archéologiques de Syrie* 2 (1952)[PI]; *Syria* 36 (1959); 38 (1961)[I]; S. Abdul-Hak, "Découvertes archéologiques récentes," *Annals archéologiques de Syrie* 6 (1956); 8-9 (1958-59); H. Finsen et al., *Le levé du théâtre romain à Bosra, Syrie* (= *Analecta romana instituti danici 6 suppl.* 1972)[PI]. J.-P. REY-COQUAIS

BOUCHEPORN Moselle, France. Map 23. About 10 km NW of St. Avold, on the Roman road from Metz to Worms. The area had long been known for its ancient ruins but the most important discovery, a pottery factory, was made in 1950. A large part of the factory has now been excavated, including 26 kilns of different shapes and a sizable quantity of ceramics.

The factory lies E of Boucheporn and covers ca. 4 ha at the spot known as the Ziegelgarten. Boucheporn must have been the earliest producer of terra sigillata in E Gaul; ordinary ware of the Belgian type was already produced there under Tiberius, and the manufacture of terra sigillata was introduced by potters from S and central Gaul in Nero's reign. Some 30 potters turned out plain sigillata and about 15 produced decorated sigillata; at first the latter was copied from imported models and even at times made in molds that the potters had brought with them. Two names may be cited from this period, Canaus and Rutanus; they made Drag. 29 vases, and the former was also noted for his plain ones. The factory was particularly active in the Flavian period; from that time on we meet such potters as Saturninus from S Gaul, Satto, and Arvernian potters such as the Master of the Shields and Helmets, the Potter of the Rosette, and the Master of the Cross-rosette. The first of these still turned out a few Drag. 29 vases, but the others concentrated exclusively on Drag. 37. Boucheporn also produced ordinary ware, glazed ware, even tiles, and work continued until ca. 160, after which it rapidly declined.

The masters Saturninus and Satto are met here for the first time, and the group of potters that grew up around them appear later in other workshops (Chémery, Blickweiler, even Mittelbronn). Saturninus started the enterprise. Besides the potters mentioned above there was a still unknown worker, the Master of the Little Horse. The large group of potters at Boucheporn suggests that it was an experimental factory.

The St. Avold museum has an archaeological collection.

BIBLIOGRAPHY. M. Lutz, *L'atelier de Saturninus et de Satto à Mittelbronn, Gallia* Suppl. 22 (1970). M. LUTZ

BOUCHETION (Rogous) S Epeiros, Greece. Map 9. On the Louros river. Founded by Bouchetos (*FHG* 3. 153, Mnaseas fr. 25), later a colony of Elis (D.7.32) near the coast (Strab. 7.7.5). The river is navigable up to this point and curves round a steep limestone hill, fortified by an inner circuit wall, ca. 800 m long and an outer circuit wall ca. 1300 m long. Pottery from the mid 6th c. onwards has been found, and there are three stages of fortification. This city controlled the main route from inland Epeiros to the W part of the Gulf of Arta and enabled the Eleans to hold the peninsula of Preveza, rich in pasture, fisheries, and olives.

BIBLIOGRAPHY. N.G.L. Hammond in Ἀφιέρωμα εἰς τὴν Ἤπειρον (1954) 26ff; id., *Epirus* (1967) 57f, 475, and 481f[PI]. N.G.L. HAMMOND

BOUKEPHALOS Corinthia, Greece. Map 11. Named both by Pliny (*HN* 4.5) and the geographer Ptolemy (3.16.12) as the next port S of Kenchreai on the Saronic coast of the Corinthia. Herodianus (*Pros.* 2) has an entry for Boukephalos as a harbor of Argolis and the name of the horse given to Alexander the Great by the Corinthian Demaratus. The Corinthian port is probably the broad, deep-water harbor now called Frankolimano at the SE edge of the Bay of Kenchreai opposite the island known in antiquity as Aspis.

BIBLIOGRAPHY. H. N. Fowler & R. Stillwell, *Corinth I, i: Introduction. Topography. Architecture* (1932) 20-23; J. R. Wiseman, *The Land of the Ancient Corinthians* (forthcoming). J. R. WISEMAN

BOULOGNE, *see* GESORIACUM BONONIA

"BOUNIMAI," *see* MONI VOUTSA

BOUPHAGION (Palaiokastro) Arkadia, Greece. Map 9. A town situated, according to Pausanias, at the sources of the Bouphagos river. It has long been identified with a fortified hill site, commanding the road from the plain of Elis to the plain of Megalopolis, near the springs of Papadaes. There are remains of inner and outer circuits, with both rectangular and round towers, and gates protected by flanking walls. The masonry, of local gray-blue limestone, is well fitted, of coursed rectangular or

trapezoidal blocks with the exception of a few large, unshaped stones; it has been dated late 4th or early 3d c. B.C. by comparison with similar work (a few large blocks remaining from the archaic period) in the S fort at Gortys. A triglyph, a limestone column drum, and a few scraps of wall are the only traces of other structures.

Not far away at Haghios Nikolaos is another small fort overlooking the same route; it lies W of Gortys above the village of Vlachorafti at the highest point of the range. There seem to be remains of two circuit walls with towers. The masonry is generally similar to that at Palaiokastro.

A third fort in the same area overlooks Gortys and Haghios Nikolaos and commands one of the few routes to E Arkadia. Natural outcroppings were supplemented with large unshaped blocks, two or three courses of which are preserved in several places. There is a cross wall at the narrowest point and a projecting rectangular tower. The remains, with the exception of three cut limestone blocks, appear to be from the archaic period, as does an inscribed stele found at the foot of the slope.

BIBLIOGRAPHY. Paus. 5.7.1, 8.26.8, 8.27.17; W. L. Leake, *Morea* (1830) II 67f, 92; J. G. Frazer, *Paus. Des. Gr.* (1898) IV 303; P. Charneux & R. Ginouves in *BCH* 80 (1956) 522f[PI]. M. H. MC ALLISTER

BOURGES, *see* AVARICUM

BOURTON ON THE WATER Gloucestershire, England. Map 24. Where the Fosse Way crosses the Windrush river, 5 km SW of Stow on the Wold and 24 km NE of Cirencester. Discoveries made here from 1875 on indicate that, beginning with a small posting station on the Roman road, a settlement extended 1.2 km E along the N bank of the river toward the pre-Roman oppidum of Salmonsbury. Many buildings and streets have been identified, dating from the 1st to the 5th c.

BIBLIOGRAPHY. H. O'Neil, *Trans. Bristol and Glos. Arch. Soc.* 57 (1935) 234-59[P]; ibid. 87 (1968) 25-55[PI]. A.L.F. RIVET

BOUTAE (Annecy-Les-Fins) Haute-Savoie, France. Map 23. A small Allobrogian settlement at the outlet of an Alpine valley. It developed into a Gallo-Roman vicus of the city of Vienne under Augustus, when construction of the route from the Little St. Bernard Pass to Geneva began (completed under Claudius by a road linking it to Aix). The center of many industries, Boutae reached its apogee in the 2d c. Destroyed in the 3d c. by the German invasions, it recovered somewhat under Constantine but was conquered by the Burgundians in the 5th c.

At its height, the vicus covered a triangular area of 25 ha, the base of the triangle corresponding to the modern Avenue de Genève. Three cardines running NE-SW were crossed by the decumani, marking off regular insulae. In the N section of the settlement, where the N decumanus crossed the W cardo, was the forum, which was paved, first under Hadrian and twice thereafter, and surrounded by porticos. Close by on the NE side is a rectangular building (46 x 22 m) uncovered in 1959-66; inside it is a peripheral portico 3.7 m wide with a wall of mortared rubble faced with small blocks; the portico encloses a hall with a nave (35 x 11 m). A rectangular room (9 x 6 m) with a tiled floor extends into the axis of the long N side facing the forum; this has been identified as the curia of the vicani Boutenses (*CIL* XII, 2532). On either side of the curia, in an unusual arrangement, is a semicircular exedra. The dimensions of the building, the strength of its foundations, its location on the edge of the forum, and the absence of domestic pottery all suggest that it may be the [basi]lica cum p[orticibus] mentioned in an inscription (*CIL* XII, 2533), a dedication dating from the reign of two emperors, perhaps Marcus Aurelius and Lucius Verus.

In the same N section of the vicus several houses have been found: the House of the Gold Coins, the House of the Galleries, the House of the Columns, and the Double House; farther S are the Hypocaust House and the House of the Fresco. A number of workshops have also been located.

To the SE are a temple attributed to Mercury and, close by it, a little theater, recognized by a fragmentary inscription (*CIL* XII, 2539) and by the discovery of some curved tiers at the edge of an open area that had sometimes been thought to be a second forum. Several pottery strata, S of the theater, have yielded quantities of potsherds from different workshops; this S section of Boutae seems to have been mainly industrial in character.

A peculiarity of this vicus is that it got its water supply not from an aqueduct but from wells; some 40 have been located.

At the W end of the vicus on what is now the Boulevard de Rocade, between the Avenue des Iles and the Avenue des Romains, is a large inhumation necropolis that was used in Roman times and again in the Burgundian era.

Terraced on the neighboring hillsides are luxurious villas. A suburb also grew up on the Thiou river around a port, indicated by the tiles frequently unearthed in the center of the modern city of Annecy, around the Rue J. J. Rousseau.

Objects found on the site are housed in the Annecy museum.

BIBLIOGRAPHY. C. Marteaux & M. Le Roux, *Boutae, vicus gallo-romain de la cité de Vienne* (1913); P. Broise, "Annecy aux temps gallo-romains," *Annesci* 3 (1955) 9-54; id., "Bilan des découvertes archéologiques aux Fins d'Annecy de 1930 à 1960," *Actes du 85ᵉ congrès national des Sociétés savantes, Chambéry-Annecy, 1960* (1962) 104-9[P]; id., "Un gisement de céramique commune aux Fins d'Annecy," *Annesci* 12 (1965) 89-90; id., "Découverte d'un édifice public sur le site gallo-romain de Boutae," *Latomus* 27 (1968) 33-44. M. LEGLAY

BOUTTOS, *see* WEST LOKRIS

BOUY Marne, France. Map 24. Near Châlons-sur-Marne in Champagne is an Iron Age I necropolis (in the area known as Les Varilles), as well as some Gallo-Roman buildings. A hoard found there was buried shortly before the Tetrarchy, and include some large and medium-sized bronzes, about 1200 small bronzes, and gold objects: five rings and a necklace with two identical medallions suspended from it.

BIBLIOGRAPHY. E. Frézouls, *Gallia* 25 (1967) 286; 29 (1971) 292f[I]. E. FRÉZOULS

BOVIANUM (Boiano) Abruzzi e Molise, Italy. Map 17A. About 210 km E-SE of Rome, the earliest settlement of the Samnites and capital of the Pentri tribe. It became a Roman municipium ca. 87 B.C., but after A.D. 70 it was the colonia Bovianum Undecimanorum with settler veterans from Legio XI.

A road winds up, past San Michele church on an ancient temple site, to Civita Superiore where one can see polygonal walls of the Samnite town. Possibly this is Pliny's Bovianum Vetus (*HN* 3.107). The view is to be rejected that Bovianum Vetus was 45 km to the N at Pietrabbondante, where spectacular remains exist of 2d c. B.C. temples and a theater.

No Roman remains survive at the site; its antiquities are housed at Chieti.

BIBLIOGRAPHY. E. T. Salmon, *Samnium and the Samnites* (1967) Index s.vv. "Boiano" and "Pietrabbondante," and plates 2, 6, 7, 8, 9[MPI]. E. T. SALMON

BOVINO, *see* VIBINUM

BOWES, *see* LAVATRAE

BOWNESS-ON-SOLWAY, *see* MAIA *under* HADRIAN'S WALL

BOZBURUN, *see* TYMNOS

BOZOVA, *see* SIBIDUNDA

BOZYAZI, *see* NAGIDOS

BRACARA AUGUSTA (Braga) Minho, Portugal. Map 19. It is mentioned by Ptolemy (2.6) and Pliny (*HN* 4.20) who refers to the city as Bracarum oppidum Augusta, and the designation as an oppidum suggests that a settlement existed before the time of Augustus. There are, however, no traces of occupation before the 1st c. A.D. except for one small fragment of Campanian C ware and some rare coins. Around the city were many forts of the Bracari, a tribe which fiercely resisted the troops of Decimus Junius Brutus (137 B.C.).

The city became the seat of one of the judicial districts of Tarraconensis, the coventus bracaraugustanus. It was already an important economic center in the first half of the 1st c. A.D. Local workshops produced a curious pottery that recalls terra sigillata in its shapes and thin-walled pottery in its fine clay and its roulette decoration. A lamp mold signed by the African potter Lucius Munatius Treptus indicates either that he had a branch here or that he sold the mold to a local potter.

The Roman city was much larger than the area enclosed by the 14th c. walls, and the two cities only partially coincide. Outside the mediaeval fortifications, in the parish of Maximinos, there is an area suggestively called cividade, covered until recently with yards. Remains of the Roman town wall and an amphitheater were still visible there in the 18th c., but the area has not been systematically excavated. Remains of the Roman town wall were also visible in the Avelar farm E of S. Geraldo Street. This wall was probably late, built to enclose an extension of the town.

Inscriptions attest the existence of monumental buildings of which no traces remain today: a temple of the imperial cult, perhaps a temple of Isis, and a market (Flavius Urbitius dedicated an altar to the genius of the place). In the cloister of the Seminary of Santiago were found remains of a structure (bath?) with a pool covered with mosaics of sea life and another pool with mosaics was excavated in the garden next to the Largo de S. Paulo. The Fonte do Ídolo on Raio street is a curious sanctuary dedicated to Tongoenabiagus: a fountain gushes out of a rocky wall fashioned by the pick, and a niche in the wall holds a bust (of the god?) and a full-length figure wearing a toga (the donor?). Inscriptions name the donor of the sanctuary as Celicus Fronto, a native of Arcobriga. The fountain was certainly outside the fortifications, not far from one of the cemeteries. In fact, some burials have been found on Raio street, and on the E side of the avenue of Marechal Gomes da Costa.

There was another cemetery to the N near the present-day Alferes Alfredo Ferreira street, and a third to the SW in the area of S. Pedro de Maximinos. At the site of the Hospital de S. Marcos there was perhaps a city gate.

Falcões street (now Hospital street) probably corresponds to the decumanus. Santa Maria street from the cathedral to the Santiago gate, in which was found a statuette of Minerva, may be the cardo.

BIBLIOGRAPHY. Contador de Argote, *Memória para a história eclesiástica do arcebispado de Braga* (1732); R. do Carmo Sampaio, "Bracara Augusta," *Lucerna* 3 (1963) 260-67. J. ALARCÃO

BRADING Isle of Wight, Hampshire, England. Map 24. The Roman villa at Morton, near Brading and 1.6 km N of Sandown, was excavated in 1879-81. It was apparently built around two courtyards of which only the inner (ca. 55 x 55 m but widening a little towards the E) has been fully defined. The dwelling house, on the W side of the inner court and looking across it towards the the sea, was a modified form of corridor villa (27 x 16.5 m) with 12 rooms. On the N side of the inner court was a large aisled building (42 x 16.5 m) which was subsequently divided internally, and on the S side was a simple rectangular building (48 x 9 m) also divided. Only one building (15 x 6 m) relating to the outer court was excavated; this lay on the S side. The dates of the building and modification of the villa were not worked out, but the coins found ranged from Domitian to Honorius, with a predominance of those later than 250.

The main house is notable for its 4th c. mosaics; the themes include Orpheus, the Gnostic deity Abraxas, Astronomy, and scenes from the Metamorphoses. At a later stage a corn-drier was cut into the pavement of the corridor of the main house, and a large collection of iron implements was found on the site. A system of so-called Celtic fields on Brading Down may be related to the villa. Parts of the buildings have been preserved and are open to inspection.

BIBLIOGRAPHY. J.E.P. & F.G.H. Price: *A Description of the Remains of Roman Buildings at Morton near Brading, Isle of Wight* (1881); *VCH Hampshire* I (1900) 313-16; mosaics: D. J. Smith in A.L.F. Rivet, ed., *The Roman Villa in Britain* (1969) 91-94; fields: H. C. Bowen, ibid. 43-44; ironwork: H. F. Cleere, "Roman Domestic Ironwork, as illustrated by the Brading, Isle of Wight, Villa," *Bulletin Institute of Archaeology, University of London* 1 (1958) 55-74. A.L.F. RIVET

BRADWELL-ON-SEA, *see* OTHONA

BRAGA, *see* BRACARA AUGUSTA

BRAIVES ("Perniciacum" or "Pernaco") Belgium. Map 21. A Gallo-Roman vicus on the road from Tongres to Bavai. This is perhaps Perniciacum, mentioned in the *Antonine Itinerary* (Pernaco in the *Peutinger Table*), but the question is still debatable because different distances are given in the two documents. Remains at the boundaries of the villages of Braives and Avennes consist of a series of wells, one of them 25 m deep; cellars of houses, built very systematically of masonry; rubbish pits; and silos. In 1960 a warehouse cellar (10 x 5 m) was discovered; it was 1.6 m deep and contained some 400 vases, most of them perfectly preserved. The warehouse seems to have been destroyed, perhaps accidentally, about A.D. 160. To the SW of the vicus is a large tumulus, 11 m high, over a wooden funerary vault that was full of objects: a glass urn, several pieces of glassware, pottery, an iron candelabra, and a folding chair, also of iron. All these finds date from the 1st, 2d, and 3d c. but the coins found there show that the site was occupied from the beginning of the 1st c. A.D. to well into the 4th. In 1964 a small castellum similar to that at Taviers was discovered and partly excavated.

It was probably built at the end of the 3d c. and enlarged in the 4th. It was surrounded by a ditch, V-shaped in profile, and a palisade, which was later replaced by a surrounding wall of masonry.

BIBLIOGRAPHY. G. De Looz, "Fouilles dans la tombe d'Avennes," *Bull. de l'Institut arch. liégeaois* 12 (1874) 190-228; W. Lassance, "Braives romain et mérovingien," *Chronique arch. du Pays de Liège* 49 (1958) 10-19; F. Ulrix, "Où faut-il situer Geminiacum et Perniciacum?" *Helinium* 3 (1963) 258-64; J. Willems et al., "Notes sur le vicus belgo-romain de Braives. Vestiges d'un magasin d'époque," *Bull. du Cercle arch. Hesbaye-Condroz* 4 (1963) 11-47; J. Willems, "Le vicus belgo-romain de Braives," ibid. 7 (1967) 5-10; J. Mertens & C. Leva, "Le fortin de Braives et le 'Limes Belgicus,'" *Mélanges d'arch. et d'hist. offerts à A. Piganiol* (1966) 1063-74[P].
S. J. DE LAET

BRAM, see EBUROMAGUS

BRAMPTON (Old Church) Cumberland, England (NY 510615). Map 24. Site of a Roman fort 13 km NE of Carlisle and 0.8 km S of the Stanegate, partly underlying St. Martin's Church. The fort was ca. 1.5 ha, with turf defenses and stone internal buildings, and faced N. It was probably of Trajanic date, and may have formed an element in a Trajanic fortified frontier road on the Stanegate. There is so far no evidence of later occupation. Kilns of Trajanic date were found ca. 1.6 km to the E, with a large quantity of ironwork. A civil site, Hawk Hirst, ca. 0.4 km SE, was occupied in the 3d and 4th c., and perhaps into the post-Roman period.

BIBLIOGRAPHY. E. Birley, *Research on Hadrian's Wall* (1961) 138-41; id., in *Studien zu den Militärgrenzen Roms* (1967) 8-9; J. C. Bruce, *Handbook to the Roman Wall* (12 ed. by I. A. Richmond, 1966) 188. Kilns: R. Hogg, *Trans. Cumberland and Westmorland Ant. and Arch. Soc.* 65 (1965) 133-68[PI]; R. L. Bellhouse, ibid. 71 (1971) 35-44. Hoard of ironwork: W. H. Manning, ibid. 66 (1966) 1-36. Hawk Hirst: ibid. 36 (1936) 179-82.
J. C. MANN

BRANCHIDAI, see DIDYMA

BRANTINGHAM E Riding, Yorkshire, England. Map 24. A Roman villa was found when two mosaic pavements were uncovered in a quarry in 1941. Subsequently tesserae were seen on the surface of a field N of the quarry and an excavation was mounted in 1962. A large mosaic pavement (10.95 x 7.65 m) was uncovered, and parts of it were moved to the Hull Museum. The pavement had a central panel of a goddess with mural crown, surrounded by eight water-nymphs in semicircular panels and bordered at each end by a row of four busts.

BIBLIOGRAPHY. *Yorks. Arch. Journ.* 37 (1951) 514-20; *Britannia* 4 (1973) 84-106.
I. M. STEAD

BRATUSPANTIUM, see CAESAROMAGUS

BRAUGHING Hertfordshire, England. Map 24. An extensive settlement between Braughing and Puckeridge which has been little explored. Most of the site has been undisturbed since Roman times, and a large area has been scheduled as an ancient monument. It lies on Ermine Street, 48 km N of London, at the junction with roads to Colchester, Great Chesterford, and Baldock. A considerable number of British coins as well as clay coin-molds suggest that it was an important oppidum before the Roman conquest, and occupation continued throughout the Roman period. Defenses, or limits to the settlement, have yet to be defined.

BIBLIOGRAPHY. *Trans. East Herts. Arch. Soc.* 13 (1950-54) 93-127; *Hertfordshire Archaeology* 2 (1970) 37-47[PI].
I. M. STEAD

BRAURON (Vraona) Attica, Greece. Map 11. Lies beside a small bay on the E coast, about 38 km from Athens.

A fortified prehistoric settlement occupied the small hill about 400 m W of the bay, flourishing from the Neolithic to the Late Bronze Age, but particularly during the period ca. 2000-1600 B.C. A few houses have been cleared, and on the NW slopes of the hill E of the acropolis, several Late Helladic chamber tombs were dug. This settlement was abandoned before the end of the Bronze Age, and in the Classical period only a sanctuary remained. It lay just to the NW of the acropolis and was active from the late 8th to the 3d c. B.C., when it was destroyed by a flood of the nearby river Erasinos. The area was deserted in Roman times, but in the 6th c. A.D. an Early Christian basilica was built about 500 m W of the sanctuary on the other side of the valley, and reused some material from the sanctuary itself.

The goddess of the sanctuary, identified with Artemis, was particularly connected with childbirth and was worshiped mainly by women. Her cult statue, presumably a primitive one, was said to have been brought from the Crimea by Iphigeneia and Orestes (Eur. *IT* 1462-67) but Pausanias (1.23.7; 1.33.1; 3.16.8) discounts the story. Iphigeneia herself was supposed to be buried there. The special servants of Artemis Brauronia were called arktoi (bears), young girls aged between five and ten, who wore saffron robes, perhaps to recall the actual bearskins of an earlier period (*Suda*, s.v. ἄρκτος ἤ Βραυρωνίοις).

Greek excavations between 1948 and 1962 revealed the main buildings of the sanctuary. Of the temple, dating from ca. 500 B.C., only the foundations remain. It was a small Doric building (ca. 20 x 11 m), but little is known of its plan. Immediately to the NW of the temple terrace is a copious spring into whose waters offerings were thrown. From the partly artificial basin of the spring, and from the bed of the stream flowing N from it, many dedications were recovered, mostly of a feminine character—mirrors, rings, gems, etc.; particularly valuable are the objects of bone and wood which luckily have been preserved in the mud. The spring seems to have been the most sacred part of the sanctuary until the late 6th c. B.C., but both it and the temple were probably destroyed by the Persians in 480.

About 10 m SE of the temple, in a cleft in the rock which was probably once a cave, stood a small temple-like building which perhaps represents the supposed Tomb of Iphigeneia. It seems to have replaced the earlier buildings to the SE, which were destroyed by the collapse of the cave roof in the mid 5th c. B.C.

The most impressive building at the sanctuary is the large Doric stoa dating from ca. 430-420 B.C., which was perhaps used by the arktoi. It was to have had three colonnaded wings facing onto a court from the W, N, and E, the temple terrace forming the fourth side. The E wing was longer than the W, and did not have rooms behind its portico as did the N and W wings. In the end, the N wing alone was completed; except for the column nearest the corner with the N colonnade, the E and W colonnades never rose above their foundations. Behind the N wing was a narrow courtyard with a small propylon at each end, and a shallow portico forming its N side.

The N colonnade of the stoa has been partially restored, using the original elements found lying in front of it. Its 11 Doric columns, with shafts of local sand-

stone and capitals of Pentelic marble, stood on a marble stylobate, which, although it has settled badly at the E end, seems to have been laid in a rising curve like that of the Parthenon. The columns were more widely spaced than in contemporary temples, so that above each span there are three metopes instead of two; the spans nearest the corners were extended a further 12 cm to allow a half-triglyph to appear in the frieze at the reentrant angle. The stoa is one of the earliest buildings where this wider column spacing is found, and where the problem of the reentrant angle had to be met; not surprisingly, therefore, the adjustment of the column spacing is not really adequate.

Behind the N and (intended) W porticos of the stoa were various rooms, the majority of them of a standard size (ca. 6 x 6 m) and equipped with 11 couches and 7 small tables. The arrangement of these rooms is best seen at the E end of the N wing, where the base blocks for several tables, as well as the holes where couch legs were fixed with lead, still survive. The rooms were entered from the porticos in front of them, and in the marble threshold of the first room from the E can be seen one of the bronze pivots for the double doors and the prism-shaped bronze projections that held the doors shut.

Besides the standard rooms, there were also in the N wing a narrow passage to the N court, and a small room at the extreme W end, which probably served as a lodge for the porter of the W gate into the N court. In the W wing, the third room from the S formed the main entrance to the stoa and its court from the W. The many wheel-marks visible here, however, belong with a rough road made of reused reliefs and architectural members and laid over the remains of the stoa, probably by people coming to remove building material from the site.

Along the central wall of the N wing, behind the rear wall of the W wing, and at the foot of the N retaining wall of the temple, there were rows of bases. On most of these bases were reliefs or inscriptions in honor of Artemis, but there were also several statues of children, mostly girls (arktoi ?), dating from the 5th and 4th c. B.C. Several fragments of the catalogue of dedications to Artemis list separately the garments dedicated to the goddess, either in thanks for successful childbirth or in memory of those who died as a result of it. The garments were perhaps displayed on the racks which appear to have occupied the narrow portico of the N court.

About 7 m W of the stoa, a bridge of the 5th c. B.C. crosses the stream which flows N from the sacred spring to the Erasinos. It is ca. 9 m long x 9 m wide, very simple in structure, and consists of horizontal slabs about 1 m long which rest on five rows of upright slabs. Not all the buildings at the sanctuary have been uncovered; an inscription mentions several others, including a palaistra and a gymnasium.

The finds from the excavations at the artemision are mostly housed in a new museum on the site.

BIBLIOGRAPHY. B. Stais, *ArchEph* (1895) 196-99; J. Papadimitriou in *Praktika* (1945-48) 81-90; (1949) 75-90; (1950) 173-87; (1955) 118-20; (1956) 73-87; (1957) 42-45; (1959) 18-20; in *Ergon* (1956) 25-31; (1957) 20-24; (1958) 30-39; (1959) 13-20; (1960) 21-30; (1961) 20-37; (1962) 25-39; "The Sanctuary of Artemis at Brauron," *Scientific American* (June 1963) 111-20MP; Ch. Bouras, *I Anastilosis tis Stoas tis Vravronos* (1967)MP.

Hdt. 6.138; Eur. *IT* 1462-67; Strab. 9.1.22; *Suda*, s.v. ἄρκτος ἢ Βραυρωνίοις. J. J. COULTON

BRAVINIUM, *see* BRAVONIUM

BRAVONIACUM (Kirkby Thore) Westmorland, England. Map 24. On the road from Eburacum (York) to Luguvallium (Carlisle). The fort, unexcavated, lies in the SE corner of a large civil settlement, probably defended in the 3d-4th c. The fort was garrisoned by a cavalry unit with an African commander in the 3d c., at another time by a numerus of Syrian archers.

BIBLIOGRAPHY. D. Charlesworth, "Recent work at Kirkby Thore," *Trans. Cumberland and Westmorland Arch. Soc.* ser. 2, 64 (1964) 64-75. D. CHARLESWORTH

BRAVONIUM or Bravinium (Leintwardine and Buckton) Herefordshire, England. Map 24. The modern village, 32 km N of Hereford, covers the 5.5 ha oblong enclosure of the late 2d c. A.D. military station. The timber-laced clay rampart, originally 6 m wide, is well preserved along the W side of the village and especially at the NW corner; along the E side its position is marked by a steep fall along a line of property boundaries which include the E side of the churchyard. The small size of the bath house excavated in an annex between the S rampart and the river Teme suggests that Bravonium was a supply base and was garrisoned by a single cohort. Laid out in the 2d c., the bath house was extended and modified in the late 2d or early 3d c., and then altered drastically, probably in the 4th c. This echoes the pattern of work inside the fort, where two early periods were separated by a lengthy gap from a final, 4th c. building phase.

Bravonium was almost central in the Welsh border, 75 Roman miles by road from the legionary fortress of Deva (Chester) and 64 from Isca Silurum (Caerleon). It was at an important river crossing where the farther W of the two N-S routes of the central Welsh border intersects routes from the W, a strategic position utilized from the beginning of the Roman occupation.

The earliest fort (Jay Lane), discovered by aerial reconnaissance, was set on a knoll NW of the village. It had a twin ditch system outside a turf rampart. The latter had been thrown down when the site was abandoned, but the post-holes of the timber gateway and of the interval and corner towers establish the dimensions of the fort within the towers as 155 by 126 m (1.9 ha). Large enough to have held an ala quingenaria, the fort was probably established by Ostorius Scapula ca. A.D. 50 and dismantled ca. A.D. 75.

While Jay Lane was in use a vicus developed along the Watling Street West between the fort and the river. Consequently, when the border defenses were being consolidated in the 70s the obvious site for a waterside successor to Jay Lane had already been used; the army was obliged to build its new fort 1.6 km to the W on a low terrace between the rivers Teme and Clun at Buckton. This fort was also discovered from the air. It was about the same size as Jay Lane, and originally had a turf rampart and timber gatehouses. Perhaps as early as A.D. 110 a stone wall was added to the rampart and stone gatehouses were built. The latter were, unusually, provided with internal staircases and so became exceptionally large for an auxiliary fort: the excavated porta praetoria is 22 by 5.8 m over-all. The construction of the stone defenses was probably accompanied by the erection of stone buildings in the central administrative insula, visible on the air photographs but not excavated. The buildings were otherwise of timber. Within its rampart the stone fort (ca. 161 x 124 m; 2 ha) was large enough to house an ala quingenaria. By ca. A.D. 140 the fort was demolished and the position left without a garrison until the construction of the late 2d c. base at Leintwardine village over the charred remains of the vicus.

Finds from the three forts are in Ludlow Museum.

BIBLIOGRAPHY. S. C. Stanford, "The Roman Forts at Leintwardine and Buckton," *Trans. Woolhope Naturalists' Field Club (Herefordshire)* 39 (1968) 222-326[MPI].

S. C. STANFORD

BRECON GAER Breconshire, Wales. Map 24. The fort at Y Gaer lies 5 km W of Brecon, on a spur overlooking the junction of the river Usk with its tributary the Yscir. The place name Cicutio has been associated with the site, on inadequate evidence. Y Gaer lies close to the road from Caerleon to Llandovery and the W; a few km to the E a road ran S to Penydarren, Gelligaer, and Cardiff, and other road-links with Castell Collen and Neath (via Coelbren) may be presumed.

Excavation has revealed a fort (204 x 154 m; 3.1 ha) with ample provision for the cavalry garrison (ala Hispanorum Vettonum c.R.) which is attested by a tombstone. The original fort, built ca. A.D. 75-80, had timber buildings and earthen defenses; the stone wall was added ca. A.D. 140. The W gate (porta praetoria) is distinguished by boldly projecting square guard-towers. The defenses are still visible, but the internal buildings have been covered over.

The main range (granaries, headquarters, and commandant's house) was of stone in the latest phase; at least two timber houses preceded the stone praetorium. The slight available evidence suggests that none of these stone buildings is earlier than ca. A.D. 140. The unusual sitting of the stone praetorium, well behind the via principalis (it covers the via quintana), suggests a plan (never completed) to abandon the retentura of the original fort and turn the axis 90°, so that the reduced fort would face N. A noteworthy feature is the spacious forehall of the principia, straddling the via principalis; it is assumed that this was a cavalry riding-school.

The barracks and stables at Y Gaer were never rebuilt in stone, and nothing is known about them. A small bath building inside the praetentura and at an angle to the line of barracks and stables is clearly a later addition though it is not precisely dated. It must belong to a period when the garrison was less than the 500 cavalry for which the fort was built. Outside the fort was a substantial civil settlement, stretching ca. 300 m along the road leading from the N gate. Most of the buildings were of timber, but there was a stone workshop. To the W of the fort, another stone building may have been a mansio. The site of the bath house was located, but not fully explored.

It is not certain that regular military occupation at Y Gaer continued beyond the end of the 2d c. A.D. though it is clear that the stone gates were rebuilt at least once. There is slight evidence for reoccupation by a small force late in the 3d c. Presumably the mansio, at least, continued in use into the 4th c. The finds from Y Gaer are now in the Brecon Museum and the National Museum of Wales, Cardiff.

BIBLIOGRAPHY. R.E.M. Wheeler, *The Roman Fort at Brecon* (1926)[PI] = *Y Cymmrodor* 38 (1926); M. G. Jarrett, "The Roman Fort at Brecon Gaer: some problems," *Bulletin of the Board of Celtic Studies* 22 (1966-68) 426-32; V. E. Nash-Williams, *The Roman Frontier in Wales* (2d ed. by M. G. Jarrett 1969) 48-51[MPI]; P. J. Casey, "Excavations at Brecon Gaer, 1970," *Archaeologia Cambrensis* 120 (1971) 91-101[MPI].

M. G. JARRETT

BREGENZ, *see* BRIGANTIUM *and* LIMES RAETIAE

BREMENIUM (High Rochester) Northumberland, England. Map 24. Roman fort of ca. 2 ha 65 km NW of Newcastle (NY 834986), on Dere Street 38 km N of Corstopitum. An occupation with turf ramparts dates to the Flavian period, with modifications under Trajan. After an interval of abandonment when Hadrian's Wall was built, the site was reoccupied under Lollius Urbicus and garrisoned by Cohors I Lingonum (*RIB* 1276). The defenses were now of stone, but little else is known of the 2d c. occupation.

The fort was reoccupied and probably largely rebuilt in the early 3d c. as an outpost of Hadrian's Wall. A fragmentary building inscription (*RIB* 1277) may date to the reign of Severus, but more extensive rebuilding is attested under Caracalla (*RIB* 1279, A.D. 216), Elagabalus (*RIB* 1280, A.D. 220) and Severus Alexander (*RIB* 1281, ca. A.D. 225-235). The two latter record the construction of catapult platforms (ballistaria), which have been found in the NW corner of the fort. Excavations in the 1850s (the first to reveal the basic anatomy of a Roman fort in Britain) showed that the fort faced N. Under the shrine in the headquarters building was a strongroom, at the entrance to which was a stone door which ran back, on small iron wheels, into a recess. The fort had a double allocation of granaries, two on either side of the headquarters building. To the S lay structures very like the rows of chalet-like houses which took the place of unitary barracks in the late Roman period at Housesteads and Great Chesters. An internal bath house occupied the SE corner of the fort. Little is now visible except for the fine single-portal W gate, a monumental construction probably of the 4th c.

The fort was garrisoned in the 3d c. not only by a miliary cohors equitata, Cohors I fida Vardullorum, but also by a unit of scouts, numerus exploratorum Bremeniensium (*RIB* 1262, 1270). Built after destruction about the end of the 3d c., the fort was destroyed again about the middle of the 4th (perhaps in A.D. 343 or 360) and not reoccupied.

BIBLIOGRAPHY. I. A. Richmond, "Excavations at High Rochester . . . ," *Arch. Ael.* 13 (1936) 171-84[PI]; id., "The Romans in Redesdale," *Northumberland County History* XV (1940) passim; E. Birley, *Research on Hadrian's Wall* (1961) 242-44.

J. C. MANN

BREMETENNACUM VETERANORUM (Ribchester) Lancashire, England. Map 24. Important fort in the Ribble valley 12.8 km E of Preston. The SE third of the fort platform has been eroded by the river and the central area is covered by the present church, museum, and vicarage. To the N the modern village lies over an extensive vicus, and the remains of a bath unit are partly visible. Ribchester is one of the best known Roman forts in the Pennines, thanks to a number of inscriptions as well as excavation.

The first fort in the Flavian period had an area of ca. 2.4 ha, which the site retained throughout its history. The clay and turf rampart was set on a timber corduroy and received a stone revetment at the end of the 1st c. At one stage in its early history the garrison was formed by the second ala Asturum; the famous parade helmet found in the river bank in the late 18th c. probably belongs to an early phase. From the mid-2d c. on much more is known from epigraphic sources. These attest the presence of an ala equitum Sarmatarum, the only unit of Sarmatian heavy cavalry epigraphically known at a British fort, although Marcus Aurelius transferred 5500 of them to Britain in A.D. 175. It is probably to this phase that the stone granaries (exposed on the N side of the museum) belong, although recent excavation shows that the barracks of this garrison were still of timber. The fort has produced dedications to Severus, Caracalla, and Iulia Domna; the latter joined in a dedication of A.D. 212, on which the name of the praetorian governor of

Britannia Inferior, perhaps the future Emperor Gordian I, was erased.

At this time, early in the 3d c. the site must by implication have gained its full name. In the *Ravenna Cosmography* it is termed Bremetennacum Veteranorum, namely a center for the Sarmatian veterans settling in the area after completion of their military service. Two inscriptions indicate that a centurion drawn from the sixth legion at York filled the role of centurio regionarius, or district officer, in charge of the administrative area concerned, either the Fylde region of the Lancashire plain or the Ribble valley. The garrison cannot have been maintained at full strength in the late 3d and 4th c. Excavation has shown that the rear of the fort did not contain barracks in the latest occupation period, when the W gate was apparently blocked and the massive W ditch cut to the size now visible.

Outside the fort to the N timber buildings of Flavian and later date have recently been excavated. They were part of the associated vicus in an area that towards the end of the 2d c. was leveled to receive an extensive dump of gravel. This is best interpreted as a parade ground, perhaps associated with the arrival of the Sarmatian heavy cavalry garrison. Farther E cremation burials belonging to an early cemetery have been found. Elsewhere remains certainly extend under most of the present village; the vicus appears to have extended along the main road to the N over Longridge Fell and the Forest of Bowland. The remains of baths follow the normal Roman pattern, with the addition of a circular laconicum. There is evidence to suggest the existence of an earlier bath house associated with the Flavian phase sealed beneath the present visible remains. An inscription also implies the existence of a substantial temple.

The length of military occupation at Ribchester attests its strategic importance, at the point where the Flavian military route from Manchester to Carlisle crossed another important road running E-W along the Ribble-Aire corridor. Evidence suggests that a signaling system, comparable with the example known across Stainmore farther N in the Pennines, existed along one or both these lines. The signal station serving Ribchester has been recognized on the crest of Mellor Hill 3.2 km S of the fort.

BIBLIOGRAPHY. D. Atkinson, *The Roman Fort at Ribchester* (1928); I. A. Richmond, "The Sarmatae, Bremetannacum Veteranorum and the Regio Bremetennacensis," *JRS* 35 (1945) 15ff; G.D.B. Jones, *Northern History* 3 (1968) 1ff; id., "Roman Lancashire," *ArchJ* 127 (1970) 237ff[MI], 277ff[P]. G.D.B. JONES

BRENTHONNE Haute-Savoie, France. Map 23. A site near Thonon-les-Bains, which shows signs of a long occupation. A luxurious building (villa?) is now being excavated. A number of pools with rubble walls coated on the inside with a mortar of broken tiles must have belonged to the baths. Judging from the material that has been found, the building dates from the 2d c. A Burgundian tomb dates from the 6th c.

BIBLIOGRAPHY. M. Leglay, "Informations," *Gallia* 26 (1968) 602-3. M. LEGLAY

BRESCIA, see BRIXIA

BREST ("Gesocribate") Finistère, France. Map 23. Ancient site probably to be identified as the Gesocribate of the *Peutinger Table*. Only a few traces of the Gallo-Roman period have been found in the substratum of the city. Brest's maritime position and its consequent vulnerability to the raids of the Saxons led to the erection of a series of fortifications at the end of the 3d c. A.D. On the left bank of the Penfeld, the isthmus is blocked by a strong wall, built with a core of mortared rubble faced with small blocks and banded with brick. Part of the present-day castle is supported by this wall.

BIBLIOGRAPHY. L. Pape, "L'Armorique gallo-romaine," *Histoire de la Bretagne* (1969). M. PETIT

BREȚCU, see ANGUSTIA

BREZA Bosnia-Herzegovina, Yugoslavia. Map 12. North of Sarajevo, the remains of Roman buildings and carved tombstones dating from the 2d and 3d c. The epitaphs mention the family names Aelius and Aurelius, indicating the period of romanization of the native population. A Christian church from the 6th c., contains a tombstone with the inscription: ". . . princeps Desitiati(um) . . .", indicating the residence here of the Desidiati, an Illyrian tribe. A pillar was found here with traces of runes associated with the Alamans.

BIBLIOGRAPHY. V. Corovic, *Glasnik Zemaljskog muzeja, Sarajevo* 25 (1913) 409-20; G. Cremosnik-Sergejevski, *Novitates Musei Sarajevoensis* 9 (1930); D. Sergejevski, *Spomenik Srpske akademije nauka* (1940) 141-43; id., *GZM Sarajevo* 55 (1943) 14-19; Bojanovski-Celic, *Nase Starine*, 12 (1969) 7-25; J. J. Wilkes, *Dalmatia* (1969). V. PASKVALIN

BRIBIR, see VARVARIA

BRIGANTIUM (Bregenz, capital of Vorarlberg) Austria. Map 20. Situated on the SE bay of Lake Constance, the settlement was first mentioned by Strabo (4.206). It belonged to the province Raetia and is listed by Ptolemy (2.12.3) among the towns of that province. It marked the most important intersection of roads near Lake Constance: here the road from Gaul via Basel intersected that leading from the S (Mediolanum) across the Alps. From here the road went via Cambodunum to the provincial capital Augusta Vindelicum. Consequently, Brigantium is mentioned repeatedly in antiquity (*It.Ant.* 237, 251, 258, 259, etc.; *Tab.Peut.* 3.5). The significance of the place is evidenced by the fact that Pliny (9.63) even calls Lake Constance lacus Brigantinus (lacus Brigantiae in Amm. Marc. 15.4.1).

The Celtic oppidum is thought to have been on the rise of the old town, whereas the Roman settlement stretched out over the terrace called Ölrain, ca. 30 m above the shore of the lake. It was an open town which developed on both sides of the wide main street, but it was also a planned settlement with rectangular insulae. The public buildings were apparently situated mainly along the lakeside edge of the terrace, while the private ones and the quarter for craftsmen were on the opposite side of the street. On the terraces toward the lake were single buildings (villas, etc.). The forum (97 x 55 m) departed from the customary arrangement in that the capitol did not face the forum but was located offside. Great baths had been constructed on the main street SW of the forum. In addition, numerous public and private buildings have been uncovered although their exact function is not easily determined. Outside the town to the NE is the principal necropolis, one of the largest Roman cemeteries of Raetia. The more than 1300 graves (1st c. to 4th) indicate through their furnishings the solid wealth of a town that must have had a certain importance as a trade center; an inscription speaks of negotiatores Brigantienses.

Brigantium possesses the oldest inscription of Raetia —an inscription from A.D. 4-14 commemorating Drusus the Younger. In Early Imperial times there were earthworks on the SW Ölrain (time of Tiberius); up to the days of Claudius a cavalry unit was garrisoned there; it was eventually shifted to the Danube.

When ca. A.D. 260 the limes collapsed, the border of the empire retracted to Lake Constance, making Brigantium a frontier town. The lower settlement gradually moved to the level of the fortified upper town. Later it became from time to time the headquarters for the commander of the Lake Constance fleet (*Not.Dign.* 35.32).

It is not known whether Brigantium had the status of a municipium. The only visible remnants of Roman Brigantium are a wall in the Protestant cemetery and a part of the Roman pier. The numerous finds are in the Vorarlberg Landesmuseum in Bregenz.

BIBLIOGRAPHY. R. von Scala, *Archiv für Geschichte und Landeskunde Vorarlbergs* 10 (1914) 29ff; A. Hild, *Jahrbuch des Vorarlberger Landesmuseumsvereins* 95 (1952) 28ffMPI; B. Saria in *EAA* 2 (1959) 170ff; E. Vonbank, in L. Franz & A. Neumann, *Lexikon ur- und frühgeschichtlicher Fundstätten Österreichs* (1965) 175ff.
R. NOLL

BRIGANTIUM (La Coruña) La Coruña, Spain. Map 19. Roman port in the NW of the peninsula, the principal monument of which is a lighthouse called the Tower of Hercules, restored in the 18th c. Its plan was square, with an outside access. It was 34.77 m high and 10.08 m wide, and was constructed by Caius Levius Lupus, probably in the time of Trajan.

BIBLIOGRAPHY. J. R. Mélida, *Monumentos romanos de España* (1925); B. Taracena, *Ars Hispaniae* II (1947)I.
R. TEJA

BRIGETIO (Szöny) Komárom, Hungary. Map 12. Legionary camp site, cannabae, and municipium on the N frontier of Colonia Pannonia, on the banks of the Danube and 38 km E-NE of Györ. Until 214 it belonged to Pannonia superior, after Caracalla's rearrangement of the borders in 214, to Pannonia inferior. Its name is frequently mentioned in documents of antiquity.

The military and economic significance of the camp and the settlement is due to their strategic location at the convergence of land and water routes of critical importance. The camp insured the defense of the province across the Vág valley, while the town was one of the main points on the limes road along the Danube.

In its topographic arrangement the settlement is typical of the camps and their attached military or civilian towns along the Rhine and Danube. The camp was adjacent to the cannabae on the S and W, later to the military town, and ca. 1.5 km farther W was the civilian settlement. The two sections of town were separated by cemeteries. On the borders of both towns significant remains of industrial quarters were discovered (pottery, bronze-smelting, glassmaking).

At the intersection of the roads was the castrum: in the E-W direction the limes road along the Danube crossed it, at its S gate the road began which led E—a few hundred meters from the gate—towards Aquincum and W towards the inner settlements of the province. Because of these roads, Brigetio was in touch with all of the more significant towns of the two Pannonias. Along the S route, leading to Aquincum, ran Brigetio's aqueduct, which brought the waters of the warm springs of Tata to Brigetio.

Comparatively few buildings can be identified. In the military town the remains of the amphitheater are clearly visible, along the S road a Mithraeum and a Dolichenum were discovered. Inscriptions mention more sanctuaries, but they cannot be located.

Across the camp, on the N bank of the Danube, somewhat farther E, a countercamp was situated: Celemantia (Leányvár, Iža-Czechoslovakia). The two camps were connected by a bridge.

The history of the camp and settlement begins with the Roman occupation of Pannonia. The first auxiliary camp must have been built in the middle of the 1st c, E of the legionary camp. There are no records of the rebuilding of the camp in stone. Building of the camp was begun ca. A.D. 100 by the vexillatio of three legions. Construction was finished in 101 by the Legio XI Claudia, Brigetio's garrison till 106 when they were relieved by the Legio XXX Ulpia Victrix from Germania, which also added to the construction. This camp, however, is not yet identical with the final camp of Legio I Adiutrix, which formed Brigetio's later garrison. It was located farther E with a different orientation. This camp was probably abandoned because of the river floods. Legio I Adiutrix arrived in 119 at the latest, and they built the final stone camp.

The camp's area (540 x 430 m) is square in plan. Gate and tower plans were square and were never changed. The lime-covered walls 2 m wide were bordered on the inside by a turf walk. Of its four gates the porta decumana can be established as having a double gate, but the E and W gates must also have been double. On the N side, facing the enemy, the gate had a single opening but was of a more massive construction than the porta decumana. Through the porta praetoria a well-built road and channel led to the Danube.

Many periods can be identified in the camp's construction. The first destruction occurred during the Marcommannic wars of Marcus Aurelius, probably between 169-72. During the rebuilding that followed, three sides of the camp walls were made thinner while the N wall—facing the enemy—was left intact. The second and complete destruction of the camp occurred during the Tetrarchy. In the subsequent rebuilding some significant changes were made in the ground plan. Also, the walls were less strongly constructed, and the gates are not as massive as during previous periods. On the evidence of the tile stamps it can be established that even Valentinian I carried out some construction in the camp, but probably very little. This period ended sometime after his death, but the exact date of the camp's final destruction is not known.

The fortress Celamantia (175 x 176 m) had gates guarded by indented, square towers, and there were towers also at the rounded corners and at half-points between gates and corner towers. Its garrison was a section of Legio I Adiutrix. Its periods agree with the main periods of the legionary camp. The camp was abandoned in the 4th c.

The camp housed many troops. In the 1st c. there is definite proof of the presence of Cohors I Britannica milliaria C.R. (ca. A.D. 80), the ala milliaria Flavia Domitiana C.R. (after 80), the ala I Pannoniorum Tampiana (around 90). In the same period Cohors I Alpinorum Equitata was there. At the beginning of the 2d c. Cohors I Itureorum sagittariorum, then the ala I Hispanorum Arvacorum came. The latter stayed until the middle of the century with Legio I Adiutrix. In the second half of the century, some vexillatio of Legio XIIII Gemina and Legio IV Flavia were there. Cohors I Thracum was there at the beginning of the 3d c.; during the time of Philip the Arab a vexillatio of Legio II Augusta came; sometime during the middle of the 3d century, the ala Osrhoen. sagittariorum.

Brigetio was also support for the military fleet of the Danube. Seals prove the role of C/lassis F/lavia H/istrica (*CIL* III, 11415); the inscription mentions a trierarchia of classis Flavia Pannoniae (*CIL* III, 4319).

Of the two settlements that developed next to the military camp, the military town played the more significant role. Not only was it larger than the civilian town farther

W, but it was most probably the one that gained the rank of municipium from Septimius Severus or Caracalla, and later, but still during the 3d c., the rank of colonia. The name of the municipium and its office holders is mentioned on numerous inscriptions. One of these (*CIL* III, 11007) mentions municipium Antoninianum. The colonia is mentioned on only one inscription (*CIL* III, 4335). An adjunct of city life in Brigetio is the appearance of various professional and religious associations. Among these are mentioned the collegium centonariorum, the collegium iuventutis, the collegium opificum and the collegium culturum Iovis.

From the 1st to the mid 2d c. the population of Brigetio consisted mainly of the soldiers' families, most of whom were of Italian or of W Pannonian origin. There were inhabitants also of Illyrian-Azalus origin but they played an unimportant role. Following the destructions of the Marcomannic wars the population changed. Settlers came from S and W Pannonia and Orientals from Syria (in many cases from Commagene). During the late 2d c. and early 3d many of the city's leaders were Syrian. It was during this period that Brigetio became one of the leading economic and cultural centers in the area of the limes. Stone carving, monument raising, and construction reached its peak. Large, decorated sarcophagi were made and many temples and public buildings were erected. From the mid 3d c., during the years of the anarchic rule of the soldier-emperors, decline began. There are again some remains of inscriptions from the age of the Tetrarchy, but they give little opportunity for study of the history of the town and its population.

Religious life at Brigetio is fairly well documented. In addition to the worship of the major Roman gods, there remain proofs of the cult of Silvanus—of local Pannonian origin—and of Oriental deities; Magna Mater and Baltis, Mithra and Iuppiter Dolichenus. The temples of the two latter gods stood next to each other near the camp. The healing deities (Aesculapius, Hygieia, Apollo, Nymphae) were worshiped and an inscription mentions the erection of a portico near Fons Salutia.

Among the objects found in Brigetio some sarcophagi and stone carvings are comparatively significant by provincial standards. Some of these are imported, some products of local workshops. A relief depicting Mithras tauroktonos is of outstanding interest.

BIBLIOGRAPHY. I. Paulovics, "Funde und Forschungen in B. Laureae Aquincenses II," *Diss. Pann.* 2.11 (1941) 118ff (previous bibliography); L. Barkóczi, "Brigetio," *Diss. Pann.* 2.22 (1951) (summary of investigations to 1944); id., *Antiquitas Hungarica* (1949) 67-77; id., *Folia Archaeologica* 13 (1961) 95-115; id., *Acta Antiqua Acad. Scient.* 13 (1965) 215-57; *TIR*, L: 34 (1968) 40.

I. TÓTH

"BRIGINN . . . ," *see* BRIGNON

BRIGNON ("Briginn . . .") Serre de Brienne, canton of Vézenobres, Gard, France. Map 23. Large and important sanctuary-oppidum of the Volcae Arecomici situated along the Gardon between Nîmes and Alès on an isolated hill rising from the plain. The site has never been systematically explored, but limited soundings and emergency excavations have uncovered architectural remains and numerous pre-Roman and Roman artifacts (fragments from buildings, statues, votive and funerary inscriptions, ceramics), and a quantity of Gallic, Massalian, and Roman coins, which testify to its cultural and commercial importance.

The site can perhaps be identified with the locality Briginn (. . .) which is mentioned in the Nîmes geographical inscription (*CIL* XII, 3362). The artifacts from the oppidum are preserved at the museums at Nîmes and Alès, and in a local archaeological collection.

BIBLIOGRAPHY. *Carte archéologique de la Gaule romaine*, fasc. VIII, Gard (1941) 189-90, no. 297; "Informations," *Gallia* 20 (1962) 630; 24 (1966) 474; 29 (1971) 390.

G. BARRUOL

BRIGOBANNE Germany. Map 20. A Roman auxiliary fort near Hüfingen, Schwarzwald-Baar-Kreis, Baden-Württemberg. This name, found only on the *Peutinger Table* (3.5), is almost certainly connected with this site and its vicus although inscriptions are lacking. The fort lies on a plateau S of the Breg, one of the two source streams of the Danube, at the place where it is crossed by the Roman road that connected the legionary camp Vindonissa (N Switzerland) and Arae Flaviae (near Rottweil am Neckar). The vicus lies a few hundred m from the fort, on both sides of this road, in a plain on the N side of the Breg.

The fort was founded from Vindonissa in the early Claudian period as the westernmost fortification for the Danube line, and secured under Claudius with forts in Upper Germany and Raetia. Originally a primitive, makeshift camp, it was expanded even before Claudius' death into a permanent camp at least 3 ha in area; and immediately after the uprisings of A.D. 69, it was enlarged to ca. 4.2 ha. Soon after the building of a road in A.D. 73-74 from Argentorate (Strasbourg) diagonally through the Black Forest to Arae Flaviae, the fort was abandoned and the troops were moved farther N.

In a small valley ca. 50 m outside the W ditch of the fort lies the garrison bath (40 x 20 m), restored in 1968-69 and now roofed. The usual rooms of a military bath are visible in their essential remains. According to some brick stamps of the Legio XI, stationed in Vindonissa from 70 until shortly after 100, the bath was built between 70 and 74 (the probable date of the evacuation of the fort). It was apparently later enlarged for the population of the vicus.

BIBLIOGRAPHY. P. Revellio, "Das Kastell Hüfingen," *Der Obergermanisch-Raetische Limes des Römerreiches* Abt. B, Band V2, no. 62a (1937)[MPI]; id. & R. Nierhaus, "Die Canabae von Kastell Hüfingen," *Badische Fundberichte* 20 (1956) 103-14[I]; R. Nierhaus, "Römische Strassenverbindungen durch den Schwarzwald," *Badische Fundberichte* 23 (1967) 117-57[M]; H. Schönberger, "The Roman Frontier in Germany: An Archaeological Survey," *JRS* 59 (1969) 154 & 192 no. 159; A. Eckerle, *Römische Badruine in Hüfingen* (1970 brochure)[PI].

R. NIERHAUS

"BRIKINNIAI," *see* MONTE SAN BASILE

BRILESSOS, *see* PENDELI

BRINDISI, *see* BRUNDISIUM

BRIORD Ain, France. Map 23. A small town on the right bank of the Rhône, on the borders of Gallia Narbonensis, Gallia Lugdunensis, and Gallia Belgica. It is near important roads and waterways, and 25 km from Augusta (Aoste). It became important in the 1st c. and continued so until the early Middle Ages, and the modern village shows many traces of ancient ruins beneath it. A large aqueduct under the Briarette hill carried water from the valley of the Brivaz. A theater (not located) is mentioned in an inscription preserved in the hamlet of Vérizieu.

The necropolis is at the foot of the Briarette hill on the plateau known as Les Plantés, 500 m from the mod-

ern village. Nearly 200 tombs from three different periods have been excavated since 1956. The earliest are pagan (1st c. and early 2d); oriented NW-SE and dug in open ground, they have no stone rings around them, but many have wooden coffins and some have votive hearths. Inhumation and incineration were both practiced. The tombs of the late Roman period (end of 3d c. and early 4th) are partly pagan, partly Christian; oriented W-E, they have tiled coffins. The latest tombs (5th-7th c.) are barbarian; they are ringed with stones or dug in open ground, and some have wooden coffins.

In the middle of the necropolis stands an Early Christian church with one aisle (10.35 x 8.65 m); it has a flattened chevet with a sacristy on either side. This cemetery church, built in the 5th c., was destroyed in the Frankish invasions of the 7th c.

There are many finds in the local museum.

BIBLIOGRAPHY. A. Grange et al., *La nécropole gallo-romaine de Briord* (*Ain*) (1960); id. et al. *La nécropole gallo-romaine et barbare de Briord* (*Ain*) (1963); id., *La nécropole gallo-romaine et barbare de Briord* (*Ain*). *Découverte d'une basilique paléochrétienne* (1965).
M. LEGLAY

BRIOU: CHATEAU DE CHATILLON Loir et Cher, France. Map 23. The site of the Chateau de Chatillon is near the E edge of the Forêt de Marchenoir, ca. 1500 m N of the village of Briou. It consists of a trapezoidal rampart very close to the rectangle (155 x 120 m) formed by a ditch and a mound. Excavations carried out since 1967 date the site with certainty from Iron Age III. It is therefore one of the many Gallic camps dating from the end of the period of independence that are to be found chiefly on the outskirts of cities, particularly in wooded areas. In this case the Forêt de Marchenoir, which seems to have existed in antiquity, marked the boundary between the Carnutes and the Turones; it is now close to the line between the departments of Loir et Cher and Loiret. Many other ramparts of the same type have been found there.

The Chateau de Chatillon, however, differs from other Celtic fortifications in one respect: inside the rampart is a large structure dating from late antiquity that has no connection with the Gallic vallum, which it partly cuts across. The building has not been fully excavated, but it is a rectangular structure with an inner colonnade set parallel on all four sides: part of the area bounded by the colonnade is covered with a somewhat crude geometric mosaic that can be dated stylistically to the 3d c. A.D. The building does not seem to be a private house; nor can it be a Christian church, although its plan puts it in the basilica family. Coins found there indicate that it was destroyed in the invasions of the second half of the 3d c. Thus it may well be a frontier basilica. From these basilicas is derived the name Bazoches, Bazoges or Bazouches, common in French toponymy.

BIBLIOGRAPHY. C. Jullian, *REA* (1923) 257-58; A. Grenier, *Manuel d'archéologie gallo-romaine* II, 1 (1934) Les routes, 200, no. 4.
G. C. PICARD

BRIVIESCA, see VIROBESCA

BRIXIA (Brescia) Lombardy, Italy. Map 14. A Roman city at the foot of a hill in the territory of the Cenomani Gauls. It had the name Colonia Civica Augusta Brixia in the age of Augustus, and was an important commercial, agricultural, and military center during the advance of the Romans into the Alpine valleys.

Of all the Lombard cities, Brescia is the richest in inscriptions and Roman architecture. The Capitol, of which notable elements remain, was constructed by Vespasian in A.D. 73 (*CIL* V, 4312). It rises above a Republican sanctuary formed of four small parallel temples and is ornamented by lordly frescos of the Second Style (Sullan age), unique in the Po valley. The city walls, which also enclosed the hill of the Arce, had a perimeter of 3 km and may be dated to the third decade B.C. The city was divided into insulae, for the most part 57 by 89 m; its forum measured 40 by 139 m. Besides the Capitol, the remains of the law court, the theater, and a temple on the hill are noteworthy. In addition there is a Republican house, which was modified in the 2d c. A.D., a villa of the 1st c. A.D. with important frescos, and a domus with a nymphaeum from the 1st c.; it includes later restorations.

Many polychrome mosaic pavements have been found, including figured examples such as that from the villa of San Rocchino; six portraits in bronze; a baldric in worked bronze; and the celebrated statue of Victory writing on a shield, inspired by the Aphrodite of Capua. These finds are preserved in the rich Civico Museo Romano.

BIBLIOGRAPHY. *Museo Bresciano Illustrato* (1838); M. A. Levi & M. Mirabella Roberti in *Storia di Brescia*, I (1963).
M. MIRABELLA ROBERTI

BROCAVUM (Brougham) Cumberland, England. Map 24. Fort and civil settlement, occupied from ca. A.D. 80 until the 5th c. Garrisons included a numerus of Stratonician cavalry and a cohort of Gauls. A late Roman tombstone gives evidence of a Christian community. The visible platform of the fort, with an unusually wide ditch, is partly obscured by a mediaeval castle.

BIBLIOGRAPHY. *RIB* 260-65.
D. CHARLESWORTH

BROCKLEY HILL, see SULLONIACAE

BROCOLITIA, see HADRIAN'S WALL

BROOMHOLM KNOWE Dumfriesshire, Scotland. Map 24. Two successive Roman forts placed at the junction of the river Esk and the Tarras Water (NY 379815) and effectively sealing Eskdale. It appears that Fort 1 was built during the Flavian occupation of Scotland (probably Flavian II, A.D. ca. 87-ca.100) and Fort 2 in the early 2d c. (Trajan or early Hadrian).

Only limited surface indications remain: the SW angle and ditches farthest N (disfigured by a later pond and accompanying drove-road banks), and the causeway of a Roman road running N from the fort's SW angle for almost 1 km. The site was discovered by aerial photography and verified by excavations in 1956 and 1961-65. It consists of two superimposed turf and timber forts with their annexes. Fort 1 measured 297 by 229.5 m (over the ramparts) with a somewhat wider annex (207 x 315 m) attached to its S side. It was destroyed, possibly by enemy action, to be replaced by a larger fort (495 x 292.5 m) with the same annex. At some date the annex ramparts were widened. Fort 2 was systematically dismantled and its gate timbers removed, probably after only a short occupation.

BIBLIOGRAPHY. "Roman Britain," *JRS* 41 (1951) 122[1]; 47 (1957) 201[1]; 52 (1962) 164[1]; 53 (1963) 128; all superseded by 55 (1965) 202.
C. M. DANIELS

BROUGHAM, see BROCAVUM

BROUGH ON FOSSE, see CROCOCALANA

BROUGH-ON-HUMBER, see PETUARIA

BROUGH-ON-NOE, see NAVIO

BROUGH-UNDER-STAINMORE, see VERTERAE

BRUCKNEUDORF, see PARNDORF

BRUGES Belgium. Map 21. It used to be held that Bruges, Ghent, and Antwerp, which played such an important economic role in the Middle Ages and after, developed in the early mediaeval era. Now it is claimed that these three cities grew up from Gallo-Roman vici. The proof is there in the case of Ghent and Antwerp, but for Bruges all the evidence is a large number of scattered finds from the Roman period made here and there in the city. However, in 1899 a fairly large Gallo-Roman settlement was uncovered at the N city limit, in the area called Fort-Lapin. Excavation was unsystematic and it is impossible to tell exactly what kind of a settlement it was. Then in 1965 an important stratum from the Roman period was struck while repair work was being done at the Burg in the heart of the mediaeval city but excavation was not possible. Thus it would seem that Bruges also owes its origin to a Roman settlement. In antiquity it was linked by road to Oudenburg (to the SW), Aardenburg (to the NE), Ganda (Ghent) and Antwerp (to the SE and E).

BIBLIOGRAPHY. M. Bauwens-Lesenne, *Bibliografisch repertorium der oudheidkundige vondsten in Westvlaanderen* (1963) 11-19. S. J. DE LAET

BRUNDISIUM (Brindisi) Puglia, Italy. Map 14. An important Roman port and embarkation point for the E. Its name derives from the shape of its twin-branched bay, which penetrates deeply into land like the antlers of a stag (Lat. brunda). Originaly a Messapian town, it became a Latin colony in 246 B.C., was taken by Caesar in 49 B.C., and was the object of a siege by Antony in 40 B.C. after which the second triumvirate was renewed by the Treaty of Brundisium. Several roads ended here, most notably the coast road from Bari and the Via Appia through Tarentum; the latter, begun 312 B.C., reached its termination here ca. 264 B.C.

At the end of the Via Appia (Via Colonne) overlooking the bay, stood two columns 19 m high, probably of the 1st c A.D. The one still in situ has a base of Attic marble, and a shaft of gray eastern marble. The fine capital depicts 12 figures: Jupiter, Neptune, Minerva (Juno?), Mars (Amphitrite?), and eight tritons. The other column fell in the early 16th c., and was transported to Lecce, where it still supports a statue of S. Oronzo. Nearby are the ruins of a Roman villa where, tradition maintains, Virgil died on his return from Greece in 19 B.C.

Since modern Brindisi lies over the ancient city, large-scale excavations are difficult. Among imperial remains are the structures beneath Piazza Duomo at the opposite end of Via Colonne and beneath the Church of S. Giovanni al Sepolcro. On Via Colombo are the so-called vasche limarie, remains of a large Roman reservoir, perhaps Trajanic. Scanty remains of baths, a Claudian aqueduct, a porticoed crypt with arched vault, and the forum can be traced. The last is mentioned in a recently discovered decree of the 1st c. A.D. in honor of a citizen, which also attests, for the first time, existence of an armamentarium at this port city.

The Museo Archeologico Ribezzo contains five rooms of local material.

BIBLIOGRAPHY. T. Ashby & R. Gardner, *BSR* 8 (1916) 170; P. Camassa, *La Romanità di B.* (1934); F. Castagnoli, *BullComm* 71 (1943-45) 5ff; C. Picard, "B., notes de topographie et d'histoire," *REL* 35 (1957) 285-303;

N. Degrassi, *Atti del III Congr. Internaz. di Epigr. Gr. e Lat.* (1959) 303-12; B. Sciarra, "Le statue di B.," *Rend-Nap,* n.s. 40 (1965) 219-26.

App. *BCiv* 5.26.104; 66.278f. D. C. SCAVONE

BRZA PALANKA, see LIMES OF DJERDAP

BŪ and SENANTES Eure et Loir, France. Map 23. The region E of Dreux is rich in Classical sites. In antiquity as in the Middle Ages it was a frontier zone where the territories of the Carbutes, the small Durocanes tribe, and the Aulerci Eburovices met.

Today Bû is a village ca. 12 km NE of Dreux, where two department roads intersect, on the edge of the Forêt de Dreux. Ca. 500 m N of the settlement an ancient monument was discovered that had been concealed by forest growth. It is a fanum with a rectangular cella 12 x 10.4 m, with a gallery 3.5 m wide around it and a crude pebble mosaic floor. This sanctuary stood in the middle of an enclosure with various other buildings and a pool; the imitation Augustan coin showing the Lugdunum Altar was found on the gallery floor, as well as terra sigillata and ordinary ware.

Senantes is about 15 km SE of Dreux, on the border of the department of Eure et Loir and the Yvelines region. There is a very large ancient complex here consisting of a fanum, square in plan, and a sizable building that might be a villa or one of the elements of a conciliabulum, perhaps a basilica. Here was discovered a curious hypogeum made up of two curved rooms connected to the surface by five shafts. Many objects were found here, particularly Lezoux ware and coins of the Antonine dynasty. The function of this hypogeum, which apparently was not a tomb, remains a mystery.

BIBLIOGRAPHY. *Gallia* 26 (1968) 324-95.

G. C. PICARD

BUBON (Ibecik) Lycia, Turkey. Map 7. Some 22 km S of Kibyra, in the region called Kabalis by Strabo, Kabalia by Pliny and Ptolemy. The earliest mention of the city is in an inscription found at Araxa, recording a war between that city and "Moagetes and the Bubonians" (*JHS* 68 [1948] 46ff; *SEG* 18.570); the date is uncertain, but may have been in the early part of the 2d c. B.C. By the early 1st c. B.C. Bubon was incorporated in a tetrapolis headed by Kibyra and including Balbura and Oinoanda. Later Kibyra was annexed to the province of Asia, the other three to the Lycian League (Strab. 631), of which Bubon thereafter continued to be a member.

Under the emperor Antoninus Pius handsome gifts of money were made to most of the Lycian cities by the millionaire Opramoas of Rhodiapolis (*TAM* II 905); Bubon was among the beneficiaries, though the sum allotted to her, 2000 denarii, is in fact the lowest of those recorded.

An inscription found recently in the theater at Bubon, at the time of writing still unpublished, contains a letter from the emperor Commodus praising the Bubonians for their zeal and courage in suppressing banditry, and confirming a decree of the Lycian League to raise Bubon to the rank of a city possessing three votes in the League assembly, that is to the highest rank.

The site was identified in 1842. The main part of the city stood on a hill of moderate height now known as Dikmen, ca. 1.6 km S of the village. Although several terraces with the prostrate remnants of public buildings, a small theater with 20 rows of seats remaining, and a fortification on the summit was reported in the mid 19th c., virtually nothing is now to be seen but isolated blocks and the hollow of the theater.

Just outside the village on the N, close above the road,

is a rock-cut temple tomb, which appears to be of early date. The porch has two rather rough Ionic columns; the door jambs and the pediment are indicated in relief. The grave chamber is roughly arched and has a stone ledge round three sides. There is no inscription.

About one hour on foot to the E of Ibecik, the road to Dirmil and Balbura crosses a pass some 1200 m above sea level. Here is a fort built of dry rubble, at the foot of which, in the pass itself, is a good-sized building; in this is lying a large base carrying a dedication to the "very great god Ares" by four men of Bubon; the date is 3d c. A.D. A similar base lying close by has a similar inscription now largely destroyed. The pass evidently marks the territorial boundary between Bubon and Balbura.

BIBLIOGRAPHY. T.A.B. Spratt & E. Forbes, *Travels in Lycia* (1847) I 264-65; G. E. Bean in *BSA* 51 (1956) 140. G. E. BEAN

BUCCINO, *see* VOLCEI

BUCHEPHALA, *see following* ALEXANDRIAN FOUNDA-TIONS, 8

BUCINUS, *see* PORT-SUR-SAÔNE

BUCIUMI Sălaj, Romania. Map 12. Roman camp of the 2d-3d c. on the road between Porolissum (Moigrad) and Bologa. Cohors I Augusta Ituraeorum sagittariorum and then Cohors II Nervia milliaria Pacensis were stationed here. The camp (167 x 134 m) is well-preserved and has been systematically investigated. It had two construction phases: one in earth and one in stone. The circuit wall had trapezoidal corner towers and an external ditch. The bastions of the gates are circular except those of the praetoria gate, on the SE side, which are quadrilateral. Inside the camp the praetorium, the principia, two horrea, and three barracks were found.

The rich and varied archaeological, numismatic, and epigraphic material are on display at the Museum of History and Art in Zalău.

BIBLIOGRAPHY. I. I. Russu, "Castrul şi garnizoana ro-mană de la Buciumi," *Studii şi cercetări de istorie veche* 10.2 (1959) 305-17; M. Macrea et al., "Castrul roman de la Buciumi," *Acta Musei Napocensis* 6 (1969) 503-8; E. Chirilă et al., *Das Römerlager von Buciumi* (1972).
 L. MARINESCU

BUCKTON, *see* BRAVIONIUM

BUDAPEST, *see* AQUINCUM

BUGOJNO Bosnia-Herzegovina, Yugoslavia. Map 12. A Roman settlement in the upper valley of the river Vrbas. There are remains of Roman buildings with traces of a hypocaust from the 2d and 3d c. On the foundations of the Roman remains an Early Christian cemeterial church was built by the middle of the 4th c., containing vaulted tombs.

BIBLIOGRAPHY. C. Patsch, *Wissenschaftliche Mitteilun-gen aus Bosnien und der Hercegovina* (1897) v, 240; *WMBH* 6 (1899) 238; *WMBH* 11 (1909) 139; Petrovic, *GZM Sarajevo, Arheologija*. NS 15 (1960) 229-34; V. Paskvalin, *Arheoloski Pregled* (1959, 1961, 1966). J. J. Wilkes, *Dalmatia* (1969) 170, 273, 277.
 V. PASKVALIN

"BUKATION," *see* PARAVOLA

BULLA REGIA Tunisia. Map 18. First the residence of Numidian princes, then an oppidum liberum in the reign of Augustus, the town probably became a munici-pium under Vespasian and a colony under Hadrian.

The abundance of grain in its territory and its strategic position for trade resulted in economic prosperity. A fer-ment of romanization contributed to its political im-portance since some of its notables were to be close associates of emperors.

The forum was excavated in 1949-52. On an area bordered on four sides by porticos lie public and re-ligious buildings and on the W side the capitol, prostyle, of which only the stylobate is extant. On the opposite side, a hall with a double apse is paved with geometric mosaics, much deteriorated. On the N side, the Temple of Apollo has a small court encompassed by a portico and opens on the forum. This temple seems probably to have been in existence in the reign of Tiberius, while the rest of the forum probably dates from the era of the elevation of the town to the rank of colony.

A monumental entrance which gave access to the forum, noted by the first investigators, was destroyed at the end of the 19th c. Important statues of the cult were found in the Temple of Apollo and its environs, now on display at the Bardo Museum in Tunis. Their removal in the ancient period and the reappearance of honorary dedications on the forum bear witness to a renewal of municipal activity in the 4th c. after the long period of decline following the troubled era of the Late Empire.

The domestic architecture is one of the singularities of Bulla Regia. Some houses have a complete under-ground story conceived as a first floor, which no doubt remained comfortable in the excessive heat of the sum-mer.

Several of these houses, conceived according to the same principle but with some variations in the plan, have been discovered and excavated. The House of the Hunt, excavated in 1904, has a central court sur-rounded by a portico supported by eight columns and a square chamber covered with a groin vault made of tubes of terracotta.

The House of Fish was excavated in 1910, as well as the House of Amphitrite or Neptune. The latter com-prised a hall vaulted also and paved by a mosaic rep-resenting the crowning of Venus.

In 1942 three new houses of the same kind were un-covered in the neighborhood of the House of the Hunt. In the third, situated 100 m to the N of the baths, some rooms were vaulted and paved with well-preserved mosaics; a treasure of 70 Byzantine pieces of gold was discovered there, showing that the house had been oc-cupied right up to that period.

Certain walls of the Great Baths, those of the frigi-darium, are still standing to an imposing height as well as certain rooms of the basement level, of which the groined vaults are still intact.

The street on which the entry to the baths opens leads to the theater. This, built in the reigns of Marcus Au-relius and Lucius Verus, was uncovered in 1960-61. In one of its annexes a group of several statues was found, among them—in an exceptional state of preservation —two of Ceres, today on exhibit in the Bardo Museum.

In addition to this theater, the 1960-61 excavations have resulted in bringing to light in this sector an en-semble of rather well-preserved public buildings, still unpublished: around the two great open squares bordered by monumental porticos, one of which is in a semicircle, are numerous halls, rectangular or basilical, several tem-ples, one with a triple cella, and also a sanctuary of Isis next to the theater. On the other side of the street are more public baths.

A vast pagan necropolis, situated to the W, was ex-plored in 1889-90, and several inscriptions were found. Among recognizable monuments in the areas not ex-

cavated are the Byzantine fortress, a series of large parallel cisterns along the road, and to the SW an amphitheater.

BIBLIOGRAPHY. A. Merlin, *Forum et Temples de Bulla Regia* (1908); P. Quoniam in *CRAI* (1952) 460-72[P]; *Tunisie* (*Guide bleu*, 1965), pp. 185-87[P]; Kotula in *MélRome* 79 (1967) 207. A. ENNABLI

BUMBEŞTI Gorj, Romania. Map 12. An important Roman rural settlement at the S opening of the Carpathian Jiu gorge, where the Drobeta and Răcari roads joined. The civil settlement developed E of the camp and has not yet been explored. It was apparently part of the territory of the town of Drobeta. The earthen camp at Vîrtop, 1 km from the stone camp of Bumbeşti is earlier, from the period of Trajan's Dacian Wars. It covers an area of 115 by 126 m and is believed to have been built by Cohors IV Cypria (to judge from stamped bricks). The camp replaced an earthen camp, built in the 2d c. A.D. by a few detachments of Legio V Macedonica and Cohors IV Cypria. Its deteriorating earthen vallum, was provided with a stone wall in 201, built by order of the governor of Dacia, Octavius Iulianus. This time the work was performed by Cohors I Aurelia Brittonum milliaria Antoniniana. The waters of the Jiu have left only one side of the camp, 167 m in length, two gates, and a part of the praetorium (finished under Caracalla by order of the governor C. Iul. Sept. Castinus). Excavations have identified a military bath installation 50 m to the S. The archaeological finds include numerous tools of craftsmen and farmers, fragments of a bronze imperial statue (Septimius Severus?), and votive monuments dedicated to Mithra and Venus. The last coin found in the camp was minted by Philip the Arab (244-249).

The objects discovered are in the Tg. Jiu Museum.

BIBLIOGRAPHY. *CIL* III, 14485 = *ILS*, 9179; 14216, 27; *AnÉpigr* (1959) 326, 327; D. Tudor, "Castra Daciae inferioris: Bumbeşti," *BCMI* 33 (1940) 18-33; id., *Oltenia romană* (3d ed., 1968) 270-72, 326; id., *Oraşe* (1968) 362-63; *TIR*, L.34 (1968) 43; G. Florescu et al., "Săpăturile arheologice de la Bumbeşti," *MCA* 4 (1957) 103-18. D. TUDOR

BURDHOPE, *see* BIRDHOPE

BURDIGALA (Bordeaux) Dept. Gironde, France. Map 23. A port on the estuary of the Garonne, 90 km from the Atlantic, this was the chief city of the Celtic tribe of the Bituriges Vivisci. It was founded in the 3d c. B.C. for the purpose of controlling the Gallic isthmus which was on the route of the tin trade. The city was almost certainly a municipium under Vespasian, then became the capital of the province of Aquitania. Still later, in the period of the Tetrarchy, it was the capital of the second Aquitania province, the vicarius of the diocese of Gaul having his residence there. The Vandals seized it in 409 and the Visigoths in 414.

Very little is known of the town plan of Burdigala or its first monuments; the original forum (on Mont Judaïque?) has not been located, and the plan of the streets is conjectural. From Ausonius' writings and from chance finds and excavations we know more about the city rampart: in the Tetrarchy it confined what had been an open city in the Early Empire (125 ha) within an area of only 31 ha. This small castrum formed an almost regular oblong. The river was connected to the inland port by the Navigère gate; the city got its water supply from a tributary of the Garonne, the Devèze, which was canalized. And according to Ausonius, a certain fountain of Divona captured the waters of a sacred spring and spewed forth abundant, swift torrents of water from its 12 bronze mouths. Both the quays and the rampart of the port had strong foundations resting on wooden piles and girders. The foundations were made from the debris of all sorts of monuments, piled up skillfully, as a precaution, into a mass 6 m high and 5 m thick. The wall proper was 3 m high and built of mortared rubble-work faced on either side with small blocks, every 10 or 12 rows being banded with three rows of brick. The rampart was strengthened by semicircular towers that were set every 50 m; the four corners were fortified by larger towers, the wall having only three gates (Porta Iovia to the W and two gates dominating the principal cardo).

Outside the rampart is the amphitheater known now as the Palais Galien, the only monument that has left any lasting trace of the monumental splendor of the Severan age; still visible in the cellars of some Bordeaux buildings today, it was ruined in the Germanic invasions of A.D. 276. Seven rings of arcaded walls of ellipsoidal plan supported the wooden tiers. These walls have a core of rubble faced with small blocks, with a triple band of brick every seven courses. The 15,000 spectators, divided among three caveae, reached their seats by a skillful arrangement of sloping corridors, wooden stairs, and passageways. On the long axis (132.30 m; small, 110.60 m) are some monumental entries over 22 m high, the design of whose inner walls recalls the frontes scenae. They led to some carceres under the podium steps. For draining the arena, which measured 69.80 x 46.70 m, there was a carefully built stone sewer which ran to the foot of the podium.

Another Severan monument, the so-called Piliers de Tutelle, disappeared in the 17th c. These piers have no connection with any temple of Tutela but look as if they belonged to the portico that ran around the Severan forum.

A Christian quarter grew up outside the Porta Iovia around the Saint-Etienne church and the necropolis, which flourished in the 4th c. Architectural and sculptural finds are housed in the Musée d'Aquitaine.

BIBLIOGRAPHY. C. Jullian, *Hist. de Bordeaux depuis les origines jusqu'en 1895* (1895); R. Etienne, *Bordeaux Antique* (1962)[MPI]; id., in *l'Hist. de l'Aquitaine* (1971) 65-127; id., *L'amphithéâtre du Palais Galien* (*Bordeaux*), in preparation. For reports since 1962, see *Gallia* 21 (1963) 505-9; 23 (1965) 413-16; 25 (1967) 327-28; 27 (1969) 343-47. R. ETIENNE

BURGAZ ("Uranion") Turkey. Map 7. Town in Caria. Near Geriş, 5 km NE of Myndos, a site of Lelegian type, with a citadel some 50 m long enclosing a tower of squared masonry; outside this on the N is a second tower and some stretches of polygonal wall evidently belonging to an outer circuit. The pottery is of archaic and Classical date. On a peak to the N is a handsome chamber tumulus. Uranion is mentioned in the Athenian tribute lists with a very small tribute, and by Diodoros (5.23), who records that after the Trojan War Carians fled from Syme to the mainland and occupied the place called Uranion. According to Pliny (*HN* 5.107) it was one of the six Lelegian towns incorporated by Alexander the Great (really by Maussolos) in Halikarnassos. The location at Burgaz is conjectural.

BIBLIOGRAPHY. W. R. Paton & J. Myres, *JHS* 8 (1888) 78f; 16 (1896) 206f; G. E. Bean & J. M. Cook, *BSA* 50 (1955) 118-20, 155. G. E. BEAN

BURGENAE, *see* LIMES PANNONIAE (Yugoslav Sector)

BURGH-BY-SANDS, *see* HADRIAN'S WALL

BURGH CASTLE, *see* GARIANNONUM

BURIDAVA or Boridava (Stolniceni) Rîureni, Vîlcea, Romania. Map 12. At first a Dacian settlement, then Roman, located on the Olt river (Alutus). Ptolemy noted a population of Buridavensioi in Dacia, and "Hunt's pridianum," dating from the period of the Dacian Wars of Trajan, mentions a detachment of the Cohors I Hispanorum veterana as being Buridavae in vexilla(t)ione. It was about halfway between Pons Aluti (Ioneştii Govorii) and Castra Traiana (Sîmbotin) (*Tab. Peut.*). The name is Thraco-Getic, and the settlement was the economic center of the Dacian tribe of the Buri, a name identical to that of the Germanic tribe from Slovakia. Archaeological excavations have disclosed the outlines of the settlement and uncovered rich archaeological material, now in the Museum of the city of R. Vîlcea and the Museum of Băile Govora. The Roman town, 1 km long and 300 m wide, consists of numerous dwellings still unexplored, built with stone originating in the Govora-Buleta quarries and paved with pieces of terracotta. A large bath establishment, not yet excavated, is in the center of the settlement. Its ruins have yielded the remains of a life-sized, bronze statue of an emperor. The silver and bronze coins cover the period from Caligula to Justinian. The pottery found in the ovens and rubbish ditches is Dacian and Roman, dating from the 1st to the 4th c.; it attests to the continuity in the area of the native population under the Roman domination. The prosperity of this locality was the result of the traffic along the Roman road (6 m wide and built with stones from the Olt river), salt exports shipped down the Olt to the Danube, and sheep raising.

As a military center, Buridava was important during the Dacian Wars of Trajan. "Hunt's pridianum" mentions the vexillatio of the Cohors I Hispanorum veterana, of which the epigraphic traces were identified in the camp near Arutela. A large stone camp (ca. 50 x 60 m) lay S of the civil agglomeration. It must have been built under Hadrian by Cohors I milliaria Brittonum. Mixed stamps on the bricks and tiles show the names of the Moesian legions, I Italica, V Macedonica, and XI Claudia, with the names of the brickmakers Iulius Aper and Cornelius Severus. The same stamps bear witness to the presence of the auxiliary troops, Cohors II Flavia Bessorum, Cohors IX Batavorum, and pedites singulares. The last constituted the personal guard of the governor of Moesia inferior, who had established his headquarters there for the purpose of preparing the second Dacian war. The troops concentrated here under his command crossed the gorge of the Olt in 105. In the meantime, the neighboring Dacian settlement of Bîrseşti was completely razed and replaced by a Roman fort. Located 3 km from Buridava, this fort was built by a vexillatio of Cohors II Flavia Bessorum and Cohors IX Batavorum. The vestiges of pottery and coins prove that after the abandonment of Dacia (A.D. 271) Buridava continued to exist until the arrival of the Slavs and the Avars.

BIBLIOGRAPHY. *CIL* III, 14216, 25; *AnÉpigr* (1964) 229; (1966) 312, 313; (1967) 420.

G. Tocilescu, *Fouilles et recherches archéologiques en Roumanie* (1900) 120; R. O. Fink, " 'Hunt's pridianum': British Museum Papyrus 2851," *JRS* 48 (1958) 102-16; R. Vulpe, "Les Bures alliés de Décébale dans la première guerre dacique de Trajan," *Studii clasice* 5 (1963) 223-47; D. Tudor, "Les garnisons de Buridava à l'époque de la conquête de la Dacie," *Akte des IV Intern. Kongress f. griechische und lateinische Epigraphik* (1964) 403-10; id., "Pedites singulares à Buridava," *Dacia*, NS, 8 (1964) 345-51; id., "Depozitul de vase dacice şi romane de la Stolniceni," *SCIV* 18 (1967) 655-60; id., "Centrul

militar roman de la Buridava," *SMIM* 1 (1968) 17-29; id., *Oltenia romană* (3d ed., 1968) 220-33, 311, 529-30; id., *Oraşe* (1968) 367-69; G. I. Petre, "Cuptor de olar cu vase dacice şi romane de la Buridava," *SCIV* 19 (1968) 147-58; I. I. Russu, *Die Sprache der Thrako-Daker* (1969) 112; M. Macrea, *Viaţa în Dacia romană* (1969) 36f, 313f; R. Syme, *Danubian Papers* (1971) 122-34; *TIR*, L.35 (1969) 68-69. D. TUDOR

BURNSWARK Dumfriesshire, Scotland. Map 24. On the E side of Annandale, 4.8 km N of Birrens, an outpost fort of Hadrian's Wall. The defenses of the largest native hill fort in SW Scotland enclose 6.8 ha of this prominent hilltop and are beset on N and S by two Roman camps of 5.2 and 3.2 ha respectively. The Roman road up Annandale skirts the foot of the hill on the W. The Roman camps have been seen as siegeworks, possibly related to an extension of troubles in Brigantia, A.D. 155-158, and the whole complex compared with the well-known and historically attested situation at Masada.

Recent excavations have shown that the hill fort was a center from as early as the 6th c. B.C. On the other hand, the latest defenses would not appear to have been standing when Roman missiles were being fired, and the so-called work of circumvallation, linking the two Roman camps in Masada fashion, is a more recent feature. All told, the Roman camps are best understood at the moment as forming part of an area devoted to military exercises, in a realistic setting which allowed the employment of supporting slingers, archers, and artillery, as well as assault troops. The S camp, with three gun platforms placed as traverses in front of the three N entrances, must be later than A.D. 140, since in the NE its defenses lie over the silted and turf-grown ditch of an Antonine fortlet.

BIBLIOGRAPHY. *Proc. Soc. Ant. Scotland* 33 (1898-99); *Royal Commission on Hist. Mon., Dumfriesshire* (1920); S. N. Miller, ed., *The Roman Occupation of South-Western Scotland* (1952); *Discovery and Excavation in Scotland* (1968-69). G. JOBEY

BURNUM (Ivoševci by Kistanje) Croatia, Yugoslavia. Map 12. The military camp of Legio XI Claudia Pia Fidelis situated over the gorge of the Krka (Titius) river just opposite the Dalmatian hill fort on the E river bank. It controlled the pass over the river on the W border of this rebellious tribe. It was mentioned by Pliny (*HN* 3.142). Legio XI left Burnum in A.D. 69 and was replaced by Legio IV Flavia until A.D. 86 when Dalmatia became a territory without legions (provincia inermis). The civil settlement of canabae attained municipal rank, most probably from Hadrian. It was destroyed by Goths in 537. Three stone arches of the praetorium still stand. Numerous finds are in the Archaeological Museum at Zadar.

BIBLIOGRAPHY. E. Reisch, "Das Standlager von Burnum," *JOAI* 16 (1913) 112-35; M. Zaninović, "Burnum from Castellum to Municipium," *Diadora* 4 (1968) 119-29. M. ZANINOVIĆ

BURRIUM (Usk) Monmouthshire, Wales. Map 24. Founded as a legionary fortress ca. A.D. 55, 18 km from the estuary of the river Usk, it was demolished and replaced by a smaller auxiliary fort ca. A.D. 75. This fort was dismantled early in the 2d c. A.D. when an extensive civil settlement grew up on the site and continued until the 4th c.

The existing evidence suggests that it was constructed by the Legio XX Valeria as a main base for the early Neronian campaigns of Quintus Veranius (A.D. 57-58) and Suetonius Paulinus (A.D. 58-61) against the

Silures (Tac. *Ann.* 14.29). Its actual construction, however, may be the work of their predecessor, Didius Gallus, governor in A.D. 52-57. The site is of great strategic importance: it commands the Usk valley, which leads from the coastal lowlands into the mountains of S Wales, at a point where it is joined by a supply road from England running along the Olway valley.

Excavations and magnetometer surveys in 1965-74 have revealed the line of the defenses on the N, E, and S sides, showing that the fortress covered an area in excess of 18.75 ha. If the plan is assumed to be symmetrical the full size would be ca. 21.25 ha. The defenses were of earth and timber with a single ditch except on the S side where it was doubled. At intervals of ca. 100 Roman feet were timber towers. The E gate, excavated in 1971, had a double carriageway flanked by twin towers and approached by a timber bridge across the ditch. With the exception of the bath all the known buildings are of timber, including 13 granaries and a series of large works or stores compounds set on the N side of the via principalis.

The site, constricted by rivers and hills, is subject to sudden, severe flooding which makes it unsuitable for a permanent fortress. Accordingly, in ca. A.D. 75 when the conquest of S Wales was completed and the strategic importance of Burrium lessened, the buildings were demolished and the fortress closed, to be replaced by a new foundation at Isca (Caerleon) 11 km downstream near the estuary of the Usk. The smaller fort which was then built at Usk appears to have been an auxiliary fort of the type found throughout Wales in the early Flavian period. It was demolished at the beginning of the 2d c. A.D. The civil settlement that occupied the site in the 2d-3d c. A.D. was an important center of iron production and may have served as a works depot for the Legio II Augusta stationed at Isca (Caerleon). Excavations are in progress.

BIBLIOGRAPHY. W. T. Watkin, "On the Roman Stations 'Burrium,' 'Gobannium,' and 'Blestium' of the XII and XIII Iters of Antoninus," *ArchJ* 35 (1878) 19-43; W. H. Manning, "Usk," in V. E. Nash-Williams, *The Roman Frontier in Wales* (2d ed. by M. G. Jarrett, 1969). W. H. MANNING

BURUNCUK ("Larisa") Aiolis, Turkey. Map 7. Ruins at 28 km N of Izmir. These ruins are usually identified with Larisa, a very old city, the principal place in the region before the coming of the Aiolian Greeks. Of the various cities of the name, this is perhaps the one referred to by Homer as fertile Larisa, home of warlike Pelasgians (*Il.* 2.840-41; cf. Strab. 620). These Pelasgians of Larisa resisted the Greeks on their arrival, but were eventually overcome, and Larisa became one of the twelve cities of the Aiolian League. After 546 B.C. she acquired the name of Egyptian Larisa owing to the settlement by Cyrus of some Egyptian allies of Croesus. In the Delian Confederacy Larisa was assessed for tribute, at least in 425 B.C., but there is no evidence that she ever paid. In 399 Larisa successfully resisted Thibron's attempt to liberate her from the Persians (Xen. *Hell.* 3.1.7). Included in the Attalid kingdom, the city at some time during the Hellenistic period lost her independence; the cause is not known. Strabo said the place was deserted; Pliny (*HN* 5.121) wrote "fuerat Larisa." On the other hand we find a Larisa still existing in the 2d c. A.D., when Aelius Aristides passed through on his way from Smyrna to Pergamum (*Or.* 51.4).

The identity of the site has been challenged in favor of another a few km to the E at Yanık Köy, previously identified with Neonteichos. The excavations have provided no evidence to decide the question.

On the hill above Buruncuk, some 100 m high, remains of three building periods have been distinguished: a pre-Greek city wall enclosing a remarkably extensive area; second, the fortification of the acropolis about 500 B.C.; and finally a complete reconstruction in the 4th c. The walls still standing, in polygonal and ashlar masonry, are of exceptionally fine construction. The main gate, on the N, is approached by a winding road up the hillside; much of the paving remains.

Among the closely packed buildings in the interior, of which only foundations survive, two temples and a palace have been identified. The houses are mainly of megaron type, converted in some cases to the form of a peristyle house. Water was in early times supplied by wells; these still survive and have been used until recently. Later, perhaps ca. 500 B.C., an aqueduct was constructed to bring water from the mountain to the E.

The necropolis, E of the city, comprised mostly tombs of tumulus type; a low ring wall of polygonal masonry was surmounted by a cone of earth, with the grave, made of stone slabs set on edge, placed in the middle. In many cases the original ring has been enlarged by the addition of one or more segments of circles. A few of the tombs are rectangular. The necropolis as a whole is dated by the sherds to the 6th c. B.C. Over 100 tumuli have been found, but only a few may be recognized today.

Yanık Köy has never been excavated; little can be seen beyond a stretch of polygonal city wall and a number of terrace walls on the hillside.

BIBLIOGRAPHY. E. Boehlau & K. Schefold, *Larisa am Hermos* (1940) (Buruncuk); J. M. Cook, *BSA* 53-54 (1958-59) 20 (Yanık Köy); G. E. Bean, *Aegean Turkey* (1966) 97-102. G. E. BEAN

BUSRÂ, *see* BOSTRA

BUTERA ("Omphake") Sicily. Map 17B. Probably the site of an ancient Sikanian center, the first to come into conflict with the Greek colony of Gela, founded in 689 B.C., ca. 20 km to the SE. Quite probably Butera should be identified with ancient Omphake, the Sikanian town which, according to Pausanias (8.46.3), was conquered by Rhodio-Cretan colonists from Gela led by its founder Antiphemos. The formidable location of this site, on a high and steep mountain that dominates the plain of Gela, explains both the presence of an important native town and the need for rapid conquest by the Greek colonists in defense of the fertile plain.

Excavation has clarified, at least partially, the history of the settlement. The large necropolis in the area Piano della Fiera contained four levels of tombs; the deepest layer (1st stratum) comprised grotto-like tombs (a grotticella) with carved covers, indigenous vases with painted or incised decoration, bronze fibulae and razors datable from the 8th c. B.C. to the early 7th. A few vessels already document Greek influence. The next layer (2d stratum) dated to the second and last quarter of the 7th c. B.C., clearly reveals contact with the Greek colonists of Gela. Most of its burials (several hundred) show close parallels with the archaic necropolis of Gela, while others are of local type, with stone enclosures and, in one case, a characteristic large "dolmen" tomb, still preserved in situ. Funerary customs are also mixed, and both inhumation and cremation occur. Frequent and typical is the custom of partial cremation, with the skulls of the dead preserved in vases. Funerary gifts include Protocorinthian, Geloan, and local pottery. That this necropolis was abandoned for over three centuries is indicated by the lack of tombs with Corinthian, Ionic, and Attic vases. The following layer (3d stratum) indicates a resumption of city life in the second half of the

4th c. B.C., probably as part of the reconstruction program carried out in Sicily by Timoleon. This phase is characterized by monumental stepped tombs surmounted by columns (epitymbia) and funerary gifts of Sicilian red-figure vases. The topmost layer (4th stratum) revealed rather poor graves of the 3d c. B.C. containing unpainted alabastra (fusiform vases).

Investigation on the slopes below the modern city has revealed a few protohistoric huts and a Hellenistic building, but the chronological gap noticed in the necropolis remains unsolved. A few more items were yielded by the excavation of a votive deposit in a rural sanctuary below Butera, in the vicinity of Fontana Calda, along the present torrent Comunelli. According to a graffito on a vase, the sanctuary was dedicated to a female deity referred to as Polystephanos Thea, probably a nymph comparable to Artemis, whom the votive figurines represent with bow and hound. Some objects from the votive deposit go back to the archaic period, but the vast majority of the offerings are vases and statuettes of the period of Timoleon (second half of the 4th c. B.C.). The cult continued, however, till Roman times, as shown by lamps of late Republican and Imperial date. Further evidence from the Greek and Roman periods can be found in various areas of the Buteran territory. Greek farmhouses datable between the 6th and 3d c. B.C. have been identified or excavated at the locations Fiume di Mallo, Priorato, Milingiana, S. Giuliano, etc. Graves of Roman Imperial date connected with farmhouses or small villages have been explored in the vicinity of Priorato e Suor Marchesa. All the material from the excavations of Butera and its territory is in the National Museum of Gela.

BIBLIOGRAPHY. D. Adamesteanu, "Butera," *MonAnt* 44 (1958); id., *NSc* 1958, 350ff; id., *Kokalos* 4 (1958) 40ff; P. Orlandini, *Kokalos* 8 (1962) 77ff; id., *Kokalos* 7 (1961) 145ff. P. ORLANDINI

BUTHROTUM (Butrinto) Epeiros, S Albania. Map 9. A city which, according to Vergil, was founded by the Trojan seer Helenos. After marrying Andromache, the widow of Hector, Helenos migrated to the shores of Epeiros where he founded a new Troy. In reality, Buthrotum must have been founded, as were Apollonia and Durazzo, by colonists from Kerkyra (Corfu). It is situated on a hill commanding a view of the coastal lagoon of Corfu—Lake Pelode in antiquity—connected to the sea by a short, natural canal. The remains of the city, which belong to the Greek, Roman, and Byzantine periods, are scattered on the acropolis hill—along its slopes and in the low-lying section along the bank of the canal—and in the entire zone between there and the base of the hill.

The city became a colony under Julius Caesar. Pompeius Atticus constructed a magnificent villa there, the Amaltheion, in the vicinity of which was found a Parian marble relief representing a winged Nike of disputed date. The acropolis is protected by three circuit walls, set out in three rows of varying height. The highest and oldest was constructed of large, rough-hewn polygonal blocks. The central wall, halfway up the hill, is also built of polygonal blocks. The third wall, at the foot of the hill, is made of ashlar masonry; occasionally the stones are very large and the wall shows traces of the restorations of different periods. This last wall, constructed between the end of the 5th c. and the beginning of the 4th c. B.C., was provided with bastions and gates. The most important of the gates are the so-called Porta Scea and the Porta del Leone. The left side of the former juts out like a large tower in such a way as to force attackers to expose their right, unshielded sides. The flat arch of the gate is made of long, narrow rectangular blocks held

in place by molded brackets. The present pavement, 5 m from the top of the gate, dates to the Byzantine period; the original paving is 1.5 m below that.

The Porta del Leone has the same structure as the Porta Scea and was so named because the top is decorated with a sculptured limestone relief of a lion tearing a bull to pieces. The work seems unfinished (but certainly archaic—6th c. B.C.) and appears to have been added to the gate after its construction.

Only the foundations of the N and W gates remain, while the Porta a Mare in the third circuit wall is partially preserved and gains its name from its geographic location. It is formed of two towers, one square and the other semicircular. At the center on the inside, each of the two large towers has a pillar which must have served to support the roofing. All the gates date to the beginning of the Hellenistic period, around the middle of the 4th c. B.C.

Among other Greek and Roman buildings partially preserved and of prime importance is the theater, which stretches along the S slopes of the acropolis. The cavea and the orchestra belong to the end of the 4th c. B.C. Thirteen rows of seats have been preserved as have the remains of at least six others, separated from the first by a diazoma and parapet. Four stairways form five sections. The horseshoe-shaped orchestra was paved in the Roman period with slabs of white limestone. The stage dates to the first years of the Empire, with but few traces of the original. The scaena is composed of the scaenae frons and the pulpitum, the first of which is formed by a wall and three arcades with niches in the pilasters, and niches also adorn the frons pulpiti. The parodoi were transformed in the Roman period into versurae by means of a vaulted roof. Many Greek inscriptions can be read on the rows and on the walls of the parodoi. On the third row is a dedicatory inscription, probably to Asklepios since proximity of a small shrine dedicated to Asklepios is nearby. Numerous statues have been discovered in the theater, among which are a copy of the Great Hercules and the so-called Goddess of Buthrotum, the latter a Hellenistic head of Apollo fitted to a female torso of the 5th c. In addition, there are two statues of warriors, one of which is signed by Sosikles the Athenian.

In the vicinity of the theater are various monuments, the most important of which are:

A Greek temple, somewhat above the theater along the S slope of the hill of the acropolis, in antis with the cella raised in the center on three steps; two mosaic pavements—one of them polychrome—have been placed over the original floor; the temple dates to the Hellenistic period.

A portico of ashlar masonry on the same axis as the theater with arcades supported by pillars; only one arch is partially preserved and the pillars have been reinforced.

A Shrine of Aesculapius, a small Roman temple built over a previous temple of the Greek period, backs onto the W side of the theater. It comprises a vestibule and a cella in which was discovered a large headless statue which must be that of Aesculapius or of his priest; some 340 vases and vase stands were found in the votive pit and inscriptions to Aesculapius were found on some of those dating to the Hellenistic period.

There are numerous buildings at Buthrotum, partially preserved, dating primarily to the Roman period. Among them are various bath complexes, the Nymphaeum, and the Fountain of Junia Rufina. The fountain, near the Porta del Leone, is a well of sulphurous water used in the Greek period and on into the Roman period. Along the parapet are limestone slabs with a Greek inscription referring to Junia Rufina, the friend of the Nymphs. The

arcaded aqueduct, near the Porta a Mare, is also noteworthy. The Baptistery was built from a circular room of the Roman period with a mosaic pavement dating to the end of the 4th c. A.D. On the pavement a baptismal font in the form of a Greek cross had been carved out of two superposed column drums. Two panels inserted in it depicted the Baptism and the Eucharist. The mosaic is polychrome and the decoration is of animal forms in bright colors.

BIBLIOGRAPHY. Dion. Hal. 1.51.1; Strab. 6.324; Ptol. 3.13.3; Caes. *BCiv.* 3.16.1; Plin. *HN* 4.4; Cic. *Ad Fam.* 16.7.

L. M. Ugolini, *Butrinto, Il mito di Enea, gli scavi* (1937); id., *Albania Antica, III: L'Acropoli di Butrinto* (1942); P. C. Sestieri, "Butrinto," *Arte Mediterranea* 1.6 (1941) 26; A. de Franciscis, "Iscrizioni di Butrinto," *RendNap* 21 (1941) 273ff. P. C. SESTIERI

BUTRINTO, see BUTHROTUM

BUTZBACH, *see* LIMES G. SUPERIORIS

BUXENTUM, *see* PYXOUS

BUXINUS, *see* PORT-SUR-SAÔNE

BUXTON, *see* AQUAE ARNEMETIAE

BYBASSOS (Hisarönü) Turkey. Map 7. Site in Caria 13 km SW of Marmaris, proved by the identification of Kastabos at Pazarlık on the mountain above Hisarönü. Bybassos was a Rhodian deme and Kastabos lay in its territory. Herodotos (1.174) observes that Knidian territory began from the Bybassian Chersonese, that is, the Loryma peninsula SW of Marmaris; Diodoros (5.62) speaks of Bubastos in the Chersonese; Pliny (*HN* 5.104) uses regio Bubassus; Mela (1.84) says that the sinus Bubasius includes Kyrnos; Stephanos Byzantios s.v. calls it a city. Bybassos was long believed to be represented by the ruins at Emecik, on the Knidian peninsula 10 km E of Datça (Reşadiye), and the Bybassian Chersonese to be the E half of that peninsula, but this is demonstrably wrong. Bybassos was among the more important of the Rhodian mainland demes, and the demotic is frequent in the inscriptions.

The ruins at Hisarönü are scanty and inscriptions lacking. The acropolis hill is about 1 km W of the village; it carries remains of a fortification wall and some stretches of terrace wall; Hellenistic sherds are abundant. Other remains in the neighborhood include a long double field wall a little to the N, some remnants of buildings on the seashore, and some evidence of the existence of a church.

BIBLIOGRAPHY. *Annuario* 4-5 (1921-22) 405; P. M. Fraser & G. E. Bean, *The Rhodian Peraea* (1954) 62-65; id., *Turkey beyond the Maeander* (1971) 162-63; J. M. Cook & W. H. Plommer, *The Sanctuary of Hemithea at Kastabos* (1966) 6-9, 11-12, 62-63.

G. E. BEAN

BYBLOS Lebanon. Map 6. On the coast at the foot of the Lebanon mountains, 60 km N of Beirut. Built on a site occupied since Neolithic times, Byblos was for 2000 years a flourishing Phoenician city that had close ties with Egypt. It was a vassal of the Persian Achaemenids, then submitted to Alexander the Great and lost its importance in the Hellenistic period. Threatened by the Itureans in the 1st c. B.C., the city rebuilt its ramparts with the aid of Herod the Great. In the Roman period it was famous for its cult of Adonis.

Byblos contains few visible remains of the Greek, Roman, or Byzantine eras. Some paved streets, a Corinthian colonnade, a theater, and a nymphaeum survive from the 2d and 3d c. A.D., along with some marble statues and polychrome mosaics.

A deep excavation in the middle of the site marks the location of the sacred spring. To the N is the acropolis, which faces the sea to the W and has a mediaeval castle on the E. There are traces of Hellenistic as well as Roman ramparts, of a large temple and a basilica, both from the Roman period, and of some Roman streets (restored Corinthian colonnade). The acropolis was approached by two stone ramps, one coming from the NW, from the port, the other from the NE, where the ramp, which dates from the Early Hellenistic period, duplicates another ramp built 1000 years earlier.

To the N, 12 m down from the acropolis, is a paved, colonnaded street coming from the NE; it dates from the end of the 2d c. A.D. On reaching the acropolis, the street turns W and climbs the hill to join the road from the port. At the bend in the road is an apsidal nymphaeum that abuts on the sustaining wall of the acropolis. Its niches were decorated with marble statues, notably a magnificent Hygeia, a group of Achilles and Penthesilea in the Classical style, and another of Orpheus charming the animals, which is Oriental in character (all now in the Beirut Museum). Water fell from the great basin of the nymphaeum into a fluted pool. The nymphaeum court was closed to the E by a four-columned portico. A staircase led up to the acropolis.

The commercial and residential sections lay mainly to the N and E. The Roman settlement developed along Hellenistic lines, until the 3d c. A.D. onward. Near the Church of St. Jean des Croisés some Roman mosaics have been found illustrating the legend of Atalanta, while a large villa to the SE contained mosaics from the 2d c. A.D. (both in the Beirut Museum). The theater, which was moved toward the sea and reconstructed, to allow deeper excavation on its original site, was SE of the mediaeval castle and oriented NW. The orchestra was decorated with a magnificent mosaic from the end of the 2d c. A.D. representing Bacchus (now in the Beirut Museum).

Some bronze coins of Byblos minted in Macrinus' reign (A.D. 217-218) show a sanctuary with a temple adjoining a huge porticoed courtyard. In the middle of the courtyard is a square-based monument built in the shape of a cone, often described as a baetyl, and with a balustrade running around it. No trace has been found of such a temple at Byblos; nearby, however, at Machnaqa in the valley of the Adonis river, there is a sanctuary often called the tomb of Adonis that has a similar plan, with a large cubical altar surrounded by columns in the middle of a porticoed courtyard.

BIBLIOGRAPHY. E. Renan, *Mission de Phénicie* (1864-74); M. Dunand, *Fouilles de Byblos* I (1937); id., "Rapports préliminaires sur les fouilles de Byblos," *BMBeyrouth* 9 (1949-50); id., *Byblos* (1968)PI; J. Lauffray, "Une fouille au pied de l'acropole de Byblos," *BMBeyrouth* 4 (1940)PI; N. Jidejian, *Byblos through the Ages* (1968)PI. J.-P. REY-COQUAIS

BYLLIACE (Plaka) S Albania. Map 12. The site is on a low ridge on the coast at the N end of the Gulf of Valona. Inland is a large lagoon which is joined to the sea on the N of the site by a channel (aulon); after this channel Bylliace was renamed Aulon, the predecessor of the modern Valona. The site is separated now from the hinterland by a waste of sandy dunes, but in Roman times it was the terminal port of the Via Egnatia which ran

from the Adriatic coast to Constantinople. Remains of walls survive on the ridge, along the shore and in the sea where there was once a built quay.

BIBLIOGRAPHY. C. Patsch, "Das Sandschak Berat in Albanien" *Schriften der Balkankommission, Antiquarische Abteilung*, III (1904) 63; N.G.L. Hammond, *Epirus* (1967) 132f, 471f, 689f. N.G.L. HAMMOND

BYLLIS S Albania. Map 12. Identified by a Latin inscription cut in rock. It lies on the right bank of the lower Aous on the hill of Gradisht, which is fortified with a circuit wall ca. 2000 m long. The remains of two theaters are visible as well as remains of the agora and a gymnasium; another fortification wall separates the higher part of the site. A limestone statue of a comic actor from Byllis is in the Museum at Valona; funerary reliefs have been found, and a rock-niche contains a dedication to Dionysos. The remains are of the Hellenistic and Roman periods, and the main Roman road up the Aous valley passed below the site. The city was the capital of the Bylliones, who issued money.

BIBLIOGRAPHY. C. Patsch, "Das Sandschak Berat in Albanien," *Schriften der Balkankommission, Antiquarische Abteilung*, III (1904) 102ff; C. Praschniker, "Muzakhia und Malakastra," *JOAI* 21-22 (1922-24) Beiblatt 68ff; P. C. Sestieri in *Rivista d'Albania* 4, 47ff; N.G.L. Hammond, *Epirus* (1967) 225ff. N.G.L. HAMMOND

BYZANTIUM later CONSTANTINOPLE (Istanbul) NW Turkey. Map 5. City at the S end of the Bosphorus. The original Greek settlement was located at the elevated E apex of a roughly triangular peninsula bordered on the S by the Propontis (the Sea of Marmara, linking the Bosphorus with the Hellespont or Dardanelles) and on the N by a grand, elongated natural harbor, the Golden Horn (Strab. 7.6.2). The peninsula was in part cut NW-SE by a stream, the Lycus. In late antique times the city expanded W across the hills and valleys of the peninsula, filling it out; the area across the Golden Horn to the N and the nearer European shores of the Bosphorus were built up somewhat, and settlements across the straits in Asia were claimed as suburbs. The commercial significance (shipping, fishing, tolls) of its location and the strategic importance it gained from its superb defensive position (Cass. Dio 75.10; cf. Paus. 4.31.5) explain the considerable role Byzantium played in Classical times and, together with its proximity to the troublesome Danubian and E frontiers, Constantine's decision to devalue Rome's functions and make of Byzantium, henceforth Constantinople, the chief city of the Roman Empire.

There is evidence for prehistoric settlement on the site, but Byzantium proper was founded, sometime in the 7th c. B.C., by Megarians who were probably assisted by groups from other Greek cities. In the late 6th and early 5th c. B.C. it was under Persian control. Subsequently it was usually an Athenian ally, and as such it strenuously resisted Philip II of Macedon in a celebrated siege (340-339 B.C.). During the 2d c. the town sided with Rome in her E wars, and thereafter strategic and economic considerations commended it to Rome's care. In the late 2d c. A.D., however, Byzantium sided with Pescennius Niger, and as a result was besieged by the forces of Septimius Severus for more than two years (Cass. Dio 75.12); after its capitulation Severus all but destroyed it. But it was too important a site to ignore, and soon afterward he began its reconstruction and even enlarged it, and subsequent rulers gave it additional buildings. During the Tetrarchy Byzantium was overshadowed by Nicomedia, but in A.D. 330, after several years of construc-

tion on a much enlarged site, it became at Constantine's direction a new and Christian city, for eleven centuries thereafter the seat of the Eastern Roman, Byzantine Empire.

Archaeological information about Greek Byzantium is scarce. Little excavation has been done and little can be, largely because of the superimposition of later structures. The perimeter of the site in Greek times, enclosing the heights upon which the Haghia Sophia and the Ottoman Serai now stand, seems to have been a little less than 2 km in length; the exact line of the walls, with their several gates and 27 towers, cannot now be established (Cass. Dio 75.10.3; cf. Paus. 4.31, and Dion. Byz. 6ff). Almost certainly the Megarian acropolis was within the limits of the Serai. Inside the city walls, chiefly in the N part of the town, there were several temples and sanctuaries, among them those of Zeus, Athena, Poseidon, and Dionysos. Near the center of the W limit of the walls was a square called the Thrakion (Xen. *Anab.* 7.1.24). Just to the N of this was a strategion. The agora was in the vicinity of Haghia Sophia Square and contained a bronze statue of Helios (Malalas 291ff), also apparently known as the Zeuxippos, a name perpetuated in the area in Byzantine times. Other Greek constructions, such as cisterns, gymnasia, and a stadium are also recorded; there seems also to have been a theater. All these monuments have disappeared, though remains of shrines to Artemis, Aphrodite, and Apollo have been found in excavations between the Haghia Sophia and the Haghia Eirene.

Equally little is known of Roman Byzantium, though it is apparent that practical and political buildings were erected by the Roman government; we hear, for example, of an aqueduct built in the time of Hadrian. The plan of the Roman town cannot be recovered, though some facts about the Severan rebuilding are known; parallels with Severus' enlargement and aggrandizement of Leptis come to mind. At Byzantium he doubled the walled area, moving the land-side N-S wall nearly half a km W of the old Greek line—its N extremity reached the Golden Horn at a point a little to the E of the present Galata Bridge. It was perhaps then that the agora was given porticos all around, gaining the name of tetrastoon. From it Severus ran a porticoed avenue W to his new wall, presumably to a gate therein. He also began a hippodrome to the SW of the tetrastoon; this, some 450 m long in its final form, was enlarged and finished by Constantine. Severus also built a theater, probably near where the Serai kitchens now stand, and baths, apparently in the style and toward the scale of the imperial baths of the capital; these were placed hard by the NE end of the hippodrome, next to the tetrastoon.

Constantine's estimate of the value and importance of the site after he besieged Licinius there in 324 was even more favorable than that of Severus. He razed the latter's walls, and from about 325 vast resources of men and money were provided to frame and pursue his goal of a new capital, an almost entirely new city five times the area of the Severan town. The new land walls were laid out some 3 km W of the Severan walls, and within this huge enclosure there progressed one of the largest and most important exercises in city-making ever undertaken by Western man, to be continued off and on by Constantine's successors for more than two centuries. In a sense Rome was the model—there were seven hills, fourteen administrative regions, a comparable building typology and an idealized distribution thereof—but there were also more specifically Hellenistic and eastern influences at work. Most of this astonishing undertaking has disappeared, but fortunately we have texts that enumer-

ate many buildings and works of art and that describe imperial ceremonies more or less topographically; also, there are precious descriptions by pilgrims and visitors made during and after Byzantine times, and drawings made relatively soon after the Turkish conquest of 1453 which record remains no longer in existence (Richter, Unger, Preger, Ebersolt, Gyllius, Freshfield, etc.).

There were provided a capitolium, a golden milestone, and two senate houses. The tetrastoon became an imperial square, an Augusteon, and Constantine added a large forum of curved plan about 600 m to the W, just beyond the line of the former Severan wall. There a great column of porphyry was erected which carried a statue showing Constantine with the attributes of Apollo; the mutilated shaft still stands (Çemberlitaş). The Constantinian city plan cannot be recovered. We know only that the new forum was connected with the Augusteon, probably by a continuation of Severus' avenue, and that to the N and W of the forum arteries fanned out to the Golden Horn and across the widening peninsula to the major gates in the new land walls.

Just N of the Augusteon a large church of basilican plan was begun, the forerunner of the celebrated Haghia Sophia of Justinian's time; Constantine began several other major churches. To the S of the Augusteon, toward the present Mosque of Sultan Ahmed (the Blue Mosque), Constantine built his palace, the Daphne, entered from the Augusteon through a bronze gate (the Chalke) and a guards' quarter. The Daphne was also connected with the hippodrome in that the elevated kathisma or imperial loge there was a part of the palace; in these dispositions (as in others in the new city) one can clearly see the inspiration of Rome, in respect to the physical and symbolic relationships there among the forum, the palace on the Palatine, and the Circus Maximus (with its loges high in the facade of the Domus Augustana above). The sphendone or curved SW end of the Hippodrome, raised on powerful piers and vaults above the ground that falls steeply towards the Marmara, was made into a cistern, as were, then and later, a number of declivities in the city, which were cut to rectangular shape and lined, sometimes vaulted over, in the Roman way.

Everywhere Constantine's people placed works of art and historical monuments brought from other parts of the ancient Graeco-Roman world. At the vast hippodrome one could see, for example, the bronze monument dedicated at Delphi by the victors of Plataiai in 479 B.C.; its spiral stem is still there, standing on the line of the spina of the race course. At the NE end of the hippodrome, near where the fountain of Wilhelm II stands today, the carceres or starting stalls were surmounted by a bronze quadriga, supposedly wrought by Lysippos, whose horses now decorate the facade of San Marco in Venice. Round about, and in the Augusteon, the new forum, and the Baths of Zeuxippos, there were scores of such trophies, giving to the new city the quality of a museum, of being the steward of the past.

After Constantine's death in 337, work on the new city slowed down. Valens (364-78) added an aqueduct, a grand nymphaeum, baths, and apparently a cistern. The aqueduct, along with the Theodosian walls the most visible of the Roman urban constructions, still stands in a section between two of the hills of central Istanbul; this great arcade is almost 1 km long. Theodosius I (379-95) and his family returned to the policies of Constantine. In the 390s a new forum, the Forum Tauri, was built about 700 m W of Constantine's, along the line of the Mese or High Street leading W from the Augusteon (today the Divan Yolu and its extensions). Supported along its S edge by vaulted substructures, the vast Forum Tauri may have been inspired by the Forum of Trajan in Rome; details are lacking. The Forum Tauri contained a huge sculptured column of the Trajanic type of which only bits and precious drawings remain. There was also an elaborate monumental gateway, perhaps in the form of a tetrapylon, of which fragments have been excavated and restored on the Ordu Caddesi in the vicinity of the modern university. Probably the best known of Theodosius' monuments in Constantinople is the obelisk he caused to be placed upon the spina of the hippodrome in the traditional manner. The shaft proper is from Heliopolis in Egypt and dates from the 18th dynasty. It stands on a tall square marble base, the four faces of which are carved in relief. In the bottom zones the circus games are shown, together with a scene of the triumphant raising of the obelisk. Above, at larger scale, the court is shown at the circus. Between are dancers, organ players, and a dense crowd of spectators. This is almost a definitive monument of late antique art, where the qualities of frontality and diagrammatic hierarchy are softened in a style that has not forgotten the humanism and classicism of the Graeco-Roman past.

Arcadius (395-408) added still another forum (in the XII Region, towards the S or Marmara limit of Constantine's land wall). Again the details are unknown, but the mutilated base of Arcadius' column there still exists, together with drawings and comments made by intrepid observers after the Conquest. It was Theodosius II (408-50) who gave Constantinople its most stupendous surviving monument, the great land walls of 413 and 447. They were built ca. 1.5 km W of Constantine's walls and nearly doubled the enclosed area of the city. Subjected to numerous earthquakes, to dilapidation, much repair, and understandable neglect, they still stand, traversing some 7 km from the upper reaches of the Golden Horn to the Marmara shore. In the first campaign the prefect Anthemius built the main wall and its massive towers; in the second the Praetorian Prefect Constantine built the outer, lower walls with their towers, and the ditch or moat. Altogether some 400 towers were constructed (including those of the sea walls). In the late 430s a stout single wall was run around the sea perimeter of the city (lengthy stretches are still visible); these Theodosian fortifications traverse in all almost 20 km.

The main curtain of the great land wall is between 3 and 4 m thick at the base and it rises to an average height of 13 m. Its 96 towers, of varying shapes, are from 16 to 20 m high. To the W of this main construction were the successively lower walls and the moat, the whole system averaging nearly 70 m in width. There were a number of posterns and ten major gates, the most celebrated and elaborate of the latter being the Porta Aurea, quite well preserved today. This, the chief ceremonial entrance to the city, is towards the S extremity of the land walls, about 500 m from the Marmara shore.

The unsculptured column of the emperor Marcian (450-57), standing in the center of old Istanbul, and the lost column of Justinian (527-65) that stood in the Augusteon, continued the imperial traditions. But the many churches, palaces, mosaics, and individual works of art of post-Theodosian date that are still to be seen in Istanbul (or are known through the writers referred to above) lie outside the scope of this article. The Museum of Antiquities, inside the Serai walls, is exceptionally rich in pre-Classical, Greek, and Roman art and finds, not only from Byzantium-Constantinople but from other sites in Turkey as well. In the courts of the Serai there are major architectural elements of the late antique period, and other fragments of the past are scattered around old Istanbul, often lodged in structures of later date. Also, a

number of portable works were removed to Venice in the 13th c.

BIBLIOGRAPHY. P. Gyllius, *De topographia Constantinopoleos libri iv* (1561; also 1632; Eng. tr. J. Ball, 1729); C. Du Fresne du Cange, *Constantinopolis christiana . . .* (1682); F. W. Unger, *Quellen der byzantinischen Kunstgeschichte* (1878); A. D. Mordtmann, *Esquisse topographique de Constantinople* (1891) [= *RevAC* 34, 22-38, 207-25, 363-83, and 463-85[P]]; P. Forchheimer & J. Strzygowski, *Die byzantinischen Wasserbehälter* (1893) [= *Byz. Denkmäler* 2[PI]]; J. P. Richter, *Quellen der byzantinischen Kunstgeschichte* (1897); *RE* III (1899) 1116-58[P], and 4 (1901) 963-1013[P]; T. Preger, ed., *Scriptores originum Constantinopolitanarum*, 3 vols. (1901-7); J. Ebersolt, *Constantinople byzantine et les voyageurs du Levant* (1919)[I]; E. H. Freshfield, "Notes on a Vellum Album . . . ," *Archaeologia* 72 (1921-22) 87-104[I]; id., "Some Sketches Made in Constantinople in 1574," *BZ* 30 (1929-30) 519-22[I]; S. Casson et al., *Preliminary Report upon the Excavations carried out in the Hippodrome . . .* (1928); *Second Report*, 1929[PI]; K. O. Dalman, *Der Valens-Aquädukt in Konstantinopel* (1933) [= *Istanbuler Forschungen* 3][MPI]; E. Mamboury & T. Wiegand, *Die Kaiserpaläste von Konstantinopel* (1934)[MPI]; G. Bruns, *Der Obelisk und seine Basis . . .* (1935) [= *Istanbuler Forschungen* 7]; A. M. Schneider, *Byzanz. Vorarbeiten zur Topographie und Archäologie der Stadt* (1936) [= *Istanbuler Forschungen* 8][MPI]; id., "Mauern und Tore am Goldenen Horn zu Konstantinopel," *NAkG* (1950) 65-107[MI]; E. Mamboury, *The Tourists' Istanbul* (1953)[MPI] [the first (Fr.) ed. was 1923]; F. Krischen, *Die Landmauer von Konstantinopel* (1938) [= *Denkmäler antiker Architektur* 6][MPI]; R. Demangel & E. Mamboury, *Le quartier des Manganes et la première région de Constantinople* (1939)[MPI]; B. Meyer-Plath & A. M. Schneider, *Die Landmauer von Konstantinopel* (1943) [= *Denkmäler antiker Architektur* 8][MPI]; C. Mango, "The Brazen House . . . ," *Arkeol.-kunsthist. Meddelelser udgivet af Det Kongelige Danske Videnskabernes Selskab* 4 (1959)[MPI]; id., "Constantinopolitana," *JDAI* 80 (1965)[I]; id., *The Art of the Byzantine Empire 312-1453* (1972)[P]; *EAA* 2 (1959) 880-919[MPI], with detailed bibliography; also see pp. 765-67; R. Janin *Constantinople byzantine*[2] (1964)[P]; W. Kleiss, *Topographisch-archäologischer Plan von Istanbul* (1965)[P]; R. Guilland, *Études de topographie de Constantinople byzantine*, 2 vols. (1969)[P]; W. Hotz, *Byzanz Konstantinopel Istanbul, Handbuch der Kunstdenkmäler* (1971)[MPI].

[For catalogues of the Museum of Antiquities in Istanbul, see *EAA* 2 (1959) 918.] W. L. MAC DONALD

C

CABANES ("Ildum") Castellón, Spain. Map 19. Site 26 km N-NE of Castellon de la Plana, with remains of a Roman arch consisting of two columns on a square base and imposts supporting the arch (ht. 5.25 m; w. 4 m). Absence of any inscription and the ruinous condition of the arch preclude knowledge of its purpose and date. Diverse Roman remains have been recorded: coins, ceramics, a milestone (*CIL* II, 4950), and an inscription (*CIL* II, 4048) from an unrecorded site.

BIBLIOGRAPHY. D. Fletcher & J. Alcacer, *Avance a una arqueologia romana de la provincia de Castellón* (1955); G. Andreu Valls, "El arco romano de Cabanes," *B. Socied. Castellonense de Cultura* 31 (1955) 149-64[MPI]. D. FLETCHER

CABELIO (Cavaillon) Vaucluse, France. Map 23. On the Durance river, capital of the Gallic tribe of the S Cavares, this was a Marseillaise city (cf. Steph. Byz.), a Roman colony under Augustus, a Latin city in Narbonnaise Gaul (Plin. 3.5) on the Domitian road where it crosses the Durance (*Peutinger Table* and Vicarello goblets).

St. Jacques' hill, which dominates the city, is the ancient oppidum of the Cavares, with vestiges of a wall of large, hewn blocks and foundations of huts carved into the cliff. Many Gallic coins have been found on the ground: drachmas, obols, and small Massilian bronzes (90 percent of the finds), coins of the Volques Arecomiques (Nimes), Samnagenses, Sequanes, Aedui, Remi, and Allobroges. There are also sump wells and storage ditches from Iron Age II, Gallic and Gallo-Roman cremation burials with funerary furniture consisting of lamps, dishes, and glass vials, groups of Gallic stelai with inscriptions in Greek letters, epitaphs of Pompeïa Helena, of a triumvir, and of an Augustan sevir, and a dedication of the Cabellienses to Diadumenianus, the son of the emperor Macrinus (in the Cavaillon Museum).

From the Roman period there remains a triumphal arch with four facades; two of the four arches are preserved, resting on pilasters decorated with scrolls of acanthus leaves with birds and butterflies. The caisson vaults are decorated with squares, lozenges, and rosettes. On the pediment, two winged victories face each other, holding a laurel crown and a palm.

BIBLIOGRAPHY. P. de Brun & A. Dumoulin, "La colline St Jacques de Cavaillon avant l'occupation romaine," *CahHistArch* (1938)[MI]; *Forma orbis romani* VII (1939); A. Dumoulin, "Les puits et fosses de la colline St Jacques de Cavaillon," *Gallia* 23, 1 (1965)[MPI]; id., *Visite des monuments et Musées de la village de Cavaillon* (1968)[MPI]. A. DUMOULIN

CABEZA DE GREGO, see SEGOBRIGA

CABILLONUM or Cabilonnum (Chalon) Saône-et-Loire, France. Map 23. On the left bank of the Saône, 140 km N of Lugdunum (Lyon) and the Rhone-Saône confluence. The chief port of the civitas of the Aedui before the Roman Conquest, it had economic importance: 24,000 amphorae found on the site of the Roman port, a large number of bronze and silver bowls, lead ingots from Britain. In the 6th c. A.D. it was one of the principal cities of the Burgundian kingdom and minted its own coins.

The mediaeval and modern city retains the plan of the Roman one, which has never been excavated to any significant degree. The existence of an amphitheater, attested in the 18th c., is still hypothetical. Some oak posts with iron tips, from the foundations of the Roman bridge, were discovered in the Saône in 1950. Only a few traces remain of the castrum, which was built at the beginning of the 4th c. A.D. The city wall, backed by the Saône, is semicircular in shape and 1300 m long, enclosing an area of ca. 15 ha. It was defended by 18 towers

and had three gates. Interspersed in the courses of masonry, which are 3.5 m thick and made of large blocks, are many remains, for example, the dedication offered to the goddess Sauconna (the Saône) by the inhabitants of the city.

BIBLIOGRAPHY. J. Dechelette, *La collection Millon* (1913)[MI]; L. Armand-Calliat, *Le Chalonnais gallo-romain* (1937)[MPI]; id., *Musée de Chalon, catalogue des collections archéologiques* (1950)[I]; id., "Le pont romain de Chalon," *Soc. Hist. et Archéologie* 33 (1952)[I].

L. BONNAMOUR

CABILONNUM, *see* CABILLONUM

CABYLE, *see* KABYLE

CÁCERES, *see* NORBA CAESARINA

CADDER, *see* ANTONINE WALL

CADEILHAN-SAINT-CLAR Gers, France. Map 23. At La Tasque a farming villa of moderate size has been excavated. The public rooms were paved with polychrome mosaics of geometric design of the 4th c. A.D.

BIBLIOGRAPHY. Mary Larrieu et al., Labrousse, "La villa de La Tasque, à Cadeilhan-Saint-Clar (Gers)," *Gallia* 11 (1953) 41-67. M. LABROUSSE

CÁDIZ, *see* GADIR

CADOULE, *see* LA CANOURGUE

CADRIEU Lot, France. Map 23. At Fontorte, near a spring arranged as a fountain perhaps as early as Roman times, a small Gallo-Roman bath establishment has been discovered and excavated.

BIBLIOGRAPHY. See preliminary study by M. Labrousse in *Gallia* (1968) 546; 28 (1970) 423-24 & fig. 32 (plan of baths); G. Foucaud, "Le site gallo-romain de Fontorte," *Bull. de la Soc. des études du Lot* 93 (1972) 241-49. M. LABROUSSE

CADURCI, *see* DIVONA

CAELIA (Ceglie di Bari) Apulia, Italy. Map 14. Strabo (6.282) places this city between Egnatia and Canusium, and Ptolemy (3.1.73) lists it among the cities of Peucetia. The *Peutinger Table* confirms the testimony of Strabo and locates it ca. 14 km from Butuntum on the Via Traiana, a distance corresponding to the position of modern Ceglie del Campo, 8 km S of Bari, where there are the ruins of the city walls. Coins with the legend Kailinon are attributed to the city. A Latin inscription indicates that Caelia was ascribed to the tribus Claudia (*CIL* VI, 2382b, 33); another records an Augustalis (*CIL* IX, 6197). Ager Caelinus also appears in the *Libri Coloniarum* (p. 262). Archaeological finds from the site are in the museums at Bari and Taranto.

BIBLIOGRAPHY. W. Smith, *Dictionary of Greek and Roman Geography*, I (1856) 464 (E. H. Bunbury); E. De Ruggiero, *Dizionario epigrafico di antichità romane*, II (1900) 5; K. Miller, *Itineraria Romana* (1916) 376; V. Roppo, *Caeliae* (1920). F. G. LO PORTO

CAELIA (Ceglie Messapica) Apulia, Italy. Map 14. An ancient center of Messapia mentioned by Pliny (*HN* 3.101) together with Lupiae and Brundisium. Its name is preserved in that of the modern town, where remains of megalithic walls break the surface of the ground. The inscriptions in the Messapian language from the necropoleis are notable and the rich funerary material from numerous tombs, dating for the most part from the 4th-

3d c. B.C. The *trozzella*, a vase typical of the Messapian area, predominates. Archaeological material from the site is in the museums at Taranto and at Brindisi.

BIBLIOGRAPHY. W. Smith, *Dictionary of Greek and Roman Geography*, I (1856) 465 (E. H. Bunbury); *RE* III.1 (1897) 1251 (Hülsen); M. Mayer, *Apulien* (1914) 75; O. Parlangeli, *Studi di Messapici* (1960) 77.

F. G. LO PORTO

CAENOPOLIS (Kyparissos), *see under* TAINARON

CAERE (Cerveteri) Latium, Italy. Map 16. A major Etruscan town on a long tufa plateau 8 km from the sea and isolated from the surrounding plain by two small rivers, the Fosso del Manganello and the Fosso della Mola. Legend attributes its foundation to Thessalian invaders (Herod. 1.167; Diod. 15.14; Dion. Hal. 1.20; 3.58), its name deriving from invasion by Tyrrhenians. The town was allied with the Carthaginians in a successful battle against Phokaians in the Sardinian Sea (ca. 535 B.C.). In spite of a sudden change of alliance with the Tarquinii in 353 B.C., the town received civitas sine suffragio from Rome for help in battling the Gauls. But in 293 B.C. (Livy 7.19.6) or 273 B.C. (Dion. Hal. fr. 33 Boissevain), a revolt of the Etruscans deprived Caere of its independence (Fest. 155L, 262L) and of half of its territory, the coastal strip where the Romans founded four colonies, Fregenae, Alsium, Pyrgi, and Castrum Novum. Caere's decline dates from this period, and by early Imperial times the once great metropolis was no more than a village (Strab. 5.2.3).

At least six temples are known, of which only two have been officially excavated: one on the N ridge (the so-called Manganello temple) and another nearby dedicated to Hera and frequented by Greek merchants as painted inscriptions indicate. Some 18th c. excavations revealed extensive Roman buildings, including a theater, a portico, and an Augusteum (now covered over). Some stretches of city walls of the 4th c. B.C. can be seen along the ridge.

Three cemeteries are known: the largest on a hilltop NW of the town (Banditaccia), another on a similar height on the other side of the town (Monte Abatone), and the third on the S slopes of the hill (Sorbo) on which the town stands.

Two Iron Age necropoleis of Villanovan type, one on Sorbo and one at Cava della Pozzalana on the Banditaccia side, contained large and rich chamber tombs, normally two rooms on the same axis, dug in the tufa rock. Of the richest graves, which show conspicuous mounds, one was partially built of huge tufa blocks and displays a corbeled vault. It contained furnishings of gold, silver, and bronze. By the mid 7th c. B.C. tomb architecture became more elaborate and in the 6th c. mounds were bordered by tufa moldings and preceded by funerary altars. Later in the same century the tufa was carved to simulate ceilings, funerary beds, thrones, and architectural moldings. During the same period an attempt was made to impose a plan on the cities of the dead with a grid of streets and long rows of facades for middle class burials. By the beginning of the 4th c. large chambers underground served for dozens of burials. Some are similar to Greek heroa, some contain niche burials. From the 3d to the 1st c. B.C. only poor graves are evident, mostly reusing older tombs.

BIBLIOGRAPHY. L. Pareti, *La Tomba Regolini-Galassi* (1947)[PI]; B. Pace et al., "Caere, Scavi di R. Mengarelli," *Monumenti Antichi Pubblicati dall'Accademia dei Lincei* 42 (1955)[MPI]; *EAA* 2 (1959) 518-21 (M. Pallottino); M. Cristofani, "Caere," *CIE* 2,1.4 (1970) 398-491[M].

M. TORELLI

CAER GYBI Anglesey, Wales. Map 24. On the low cliff on the W side of Holyhead harbor are the walls and round towers of a small fort of uncertain date. The W side is 76 m long and the N and S sides 48 and 41 m, respectively, to the points at which they disappear at the edge of the cliff. Near the NW angle the walls survive to a height of 4 m, revealing details of the rampart walk (1 m wide) and parapet. Caer Gybi is generally interpreted as a fortified beaching-point with only three sides, of a type known on the Rhine in the late 4th c. A.D. Such a fort might provide protection to vessels trading between Anglesey and the mainland at a period when piracy was a serious problem. No Roman material has been found at Caer Gybi, however, and the site may be mediaeval.

BIBLIOGRAPHY. R.E.M. Wheeler, *Segontium and the Roman Occupation of Wales* (1924) 97-101 = *Y Cymmrodor* 33 (1923); W. E. Griffiths, "Excavations at Caer Gybi, Holyhead, 1952," *Archaeologia Cambrensis* 103 (1954) 113-16; W. G. Putnam in V. E. Nash-Williams, *The Roman Frontier in Wales* (2d ed. by M. G. Jarrett 1969) 135-37[MPI]. M. G. JARRETT

CAERHUN, see CANOVIUM

CAERLEON, see ISCA

CAERSWS ("Mediolanum") Montgomeryshire, Wales. Map 24. Roman military center in the upper Severn valley, pivot of the road system controlling central Wales. The *Ravenna Cosmography* implies that its name was Mediolanum (place in the middle of the plain), a suitable description. The importance of the site is shown by the size of the successive forts based there. The first of these has recently been located on a low hill 1 km E of the present village. Over 3.6 ha in size, it is by implication pre-Flavian in date. This is because the second fort, long known to lie at the N end of the village, has produced evidence of continuous occupation from A.D. 75 when Wales was finally subjugated. The 2.8 ha fort platform can readily be recognized and is comparable in size to other large sites like the Forden Gaer and the Brecon Gaer.

A considerable vicus extended beneath the modern village to the S. A bath house lies beneath the present railway line to the W. Excavations early in this century showed that the central range of buildings in the later occupation were built of stone, while the barracks were of timber. Recent excavation showed that the defenses were of three periods. The original Flavian rampart was widened at the end of the 1st c. and did not receive a stone revetment until the middle of the 2d c.; all these changes are associated with rebuilding in the interior. The praetorium was enhanced by the addition of three rooms with hypocausts in the 3d c., and indications of continued occupation in the 4th c. have been found in both the central range and the vicus.

BIBLIOGRAPHY. F. N. Pryce, *Montgomeryshire Collections* 46 (1940) 67ff; C. M. Daniels et al., "Excavations at Caersws," ibid. 59 (1965) 112; 60 (1966) 1ff[I]; G.D.B. Jones, *The Roman Frontier in Wales* (1969) 66ff[MP]. G.D.B. JONES

CAERWENT, see VENTA SILURUM

CAESAR AUGUSTA or Salduba (Zaragoza) Spain. Map 19. A Roman tribute-exempt colony on the right bank of the Ebro, where the oppidum of Salduie (Salluie, Salduba of Pliny) formerly stood, in Sedetania (Plin. *HN* 3.24) and not in Edetania, a mistake arising from a misreading of the Leyden Codex. It was founded by veterans of legiones IV Macedonica, VI Victrix, and X Gemina, discharged after the wars against the Cantabri, ca. 24 B.C., as is shown by the coins. It was the chief town of an extensive Conventus Iuridicus and was of great importance during the time of Pomponius Mela, who stated (3.88) that the most important towns of the interior were Palantia and Numantia in Tarraconensis and, in its time, Caesaraugusta; Strabo (3.4.10, 13) adds that it was on the banks of the Ebro, about 800 stadia from Numantia. Ptolemy calls it Kaisareia Augusta.

The colony was founded as a bridgehead and remains of the stone bridge are preserved in the mediaeval and modern one. The town stood at the intersection of the roads of the Ebro (Hiberus), Gállego (Gallicus, through which passed the C. Benearnum road), Huerva (Orbia), and Salo (Jalón), 20 km away. It was also a river port, as is confirmed by finds of amphorae near the confluence of the Huerva and the Ebro. Its foundation date is controversial: 25, 19, or 15 B.C. The oppidum has also been located at Zaragoza la Vieja (El Burgo, 10 km away) and at Juslibol, on the left bank of the Ebro, but these claims are not soundly based.

The town minted Iberian bronze coins, patterned on Roman coins, and gave its name to a cavalry unit which served under Cn. Pompeius Strabo, son of Sextus and father of the triumvir. Members of the unit were granted Roman citizenship in 89 B.C. during the siege of Ascoli. Their names and the award are preserved on a copper tablet; four of them were from the town.

The plan of the Roman town is preserved in the ancient part of Zaragoza: the entire perimeter or cursum in the Coso, the decumanus maximus in the Calles de Manifestación, Mendez Nuñez, and Mayor; the Calle Don Jaime I approximates the cardo maximus, the forum was at the intersection of the two, and remains of the cloaca maxima are in the N part of the cardo. The rectangular plan had four gateways, preserved until the 19th c., the gates of Toledo and Valencia at the ends of the decumanus, that of El Angel straddling the bridge, and the supposed Cineraria, on the Coso. The wall, still visible in a few curtains flanked by fortified towers, must be a 3d c. reconstruction necessitated by the barbarian invasions; the perimeter of the town was reduced, and many shafts and bases of columns were probably reused in this wall.

There are no other remains in situ; but a number of monuments appear on coins: a statue of Augustus between Gaius and Lucius (4 B.C.), perhaps Livia seated (A.D. 15-16), and a fine hexastyle temple dedicated to the cult of Augustus (28-29), an equestrian statue of Tiberius (31), and another tetrastyle temple dedicated to the cult of Augustus (33). A number of shafts and Corinthian capitals are housed in the museum.

The mosaics of the Plaza de Santa Engracia and the Plaza del Pilar date from the 2d c. and include the triumph of Bacchus and that of Orpheus; there are also statues, one of a man from the Plaza de la Seo, a group of hetairas making music, a drunken faun from a suburban villa, and architectural fragments from the place called Piedras de Coso, almost certainly the site of ancient temples. Inscriptions are rare and of little importance.

Hispano-Roman coins are not continuous with the Iberian coins from Salduie and are the most abundant series in the Peninsula; still unknown are the coins struck when the colony was founded, ca. 24 B.C., on which must have appeared the legate responsible for the deductio and the duoviri quinquennales who conducted the census. Coins of the first series bear the head of Augustus, first bare and later with a laurel wreath, before and after 27 June, 23 B.C., the yoke of oxen led by a priest (on the asses), and a standard, a type also alluding to the foun-

dation (on the semisses). They all bear the names of the duoviri and range from the dupondius to the sextans. The issues continued in the time of Tiberius and Caius Caesar, but other types were added, bearing the standards of the legions with the numbers of the founder legions, the bull, the abbreviated name of the town, CCA, and the statues and temples already mentioned.

Finds are in the Zaragoza Museum, the National Archaeological Museum in Madrid, and a few private collections.

BIBLIOGRAPHY. M. Risco, *España Sagrada; Santa Iglesia de Zaragoza* (2d ed. 1859) passim; A. Beltrán, "Los monumentos en las monedas hispano-romanas," *Arch-EspArq* 8 (1935) 63; id., "Las monedas antiguas de Zaragoza," *Numisma* 6 (1956) 9ff; A. García y Bellido, "Las colonias romanas de Hispania," *Anuario de Historia del Derecho Español* 29 (1959) 484ff; J. Caro Baroja, "Sobre la fecha de la fundación de Caesar Augusta," *Boletín de la Real Academia de la Historia* 168 (1971) 621ff; G. Fatás, *La Sedetania y las tierras zaragozanas hasta la fundación de Caesaraugusta* (1973).
A. BELTRÁN

CAESAREA (Cherchel), *see* IOL

CAESAREA (Cilicia), *see* ANAZARBOS

CAESAREA CAPPADOCIAE (Kayseri) Turkey. Map 5. Known formerly as Mazaca, it was capital of the kingdom of Cappadocia, situated in the strategia of Cilicia immediately N of the holy mountain Argaeus (Erciyes Dağ), which appeared on many of its coins. Renamed Eusebeia by Argaeus in honor of the Hellenizing king Ariarathes V Eusebes Philopater, 163-130 B.C., it became Caesarea under Archelaus 12-9 B.C. The city was reputed to be marshy and unsuitable as a capital. It was sacked by Tigranes in 77 B.C. and the inhabitants were deported to Tigranocerta until freed by Lucullus in 69 B.C. (Strab. 12.2.7-9). It was eventually rebuilt by Pompey. Under Tiberius it became capital of the newly formed province of Cappadocia in A.D. 17. By the reforms of Diocletian the E parts of the province became part of Armenia Minor. Valens in A.D. 371-72 cut off the W cities and Caesarea remained capital of Cappadocia Prima, being the only city amid the vast imperial estates administered by the comes domorum per Cappadociam. With the decline in its importance there was apparently a decline in population, for Justinian found it necessary to replace the walls with a shorter circuit (Procop., *Buildings* 5.4.7-14). Little of the ancient city remained visible, but it is now being excavated. The citadel is Turkish and other surviving walls perhaps originally Justinianic. On the N side, towards Argaeus, is a ruin field with lumps of perhaps a gymnasium or baths. Chance finds are displayed in the Kayseri Museum.
R. P. HARPER

CAESAREA MARITIMA Palestine, Israel. Map 6. Founded in the years 22-10 or 9 B.C. by Herod the Great, close to the ruins of a small Phoenician naval station named Strato's Tower (Stratonos Pyrgos, Turris Stratonis), which flourished during the 3d to 1st c. B.C. This small harbor was situated on the N part of the site. Herod dedicated the new town and its port (limen Sebastos) to Augustus. During the Early Roman period Caesarea was the seat of the Roman procurators of the province of Judea. Vespasian, proclaimed emperor at Caesarea, raised it to the rank of Colonia Prima Flavia Augusta, and later Alexander Severus raised it to the rank of Metropolis Provinciae Syriae Palestinae. During Late Roman and Byzantine times, Caesarea was an important center of both Jewish and Christian learning.

The city flourished in the Byzantine period; its long decline began after its conquest by the Moslems in A.D. 640.

The more than 500 ha which comprise the area of Caesarea have been only partly excavated. To the N remains of houses of the Phoenician station have been discovered and remains of Jewish synagogues of Late Roman and Byzantine times, identified by dedicatory inscriptions and by capitals decorated with Jewish symbols.

In the central area, facing the ancient harbor, remains of a huge podium have been unearthed, presumably that of the Temple of Augustus and Rome, described by Josephus Flavius. It consisted of a series of five vaulted structures, each ca. 21 by 7 m, and 15 m high. To the N of it, and of approximately the same size, are a series of chambers, filled with crushed sandstone. Nothing of the superstructure remained, but reused in walls of later buildings numerous fragments of marble statues were found, belonging most probably to that temple. To the W of the podium extended the limen Sebastos. The harbor consisted of an artificially excavated basin and the harbor proper, which was protected by two breakwaters, one 250 m long, the other 600 m long. The harbor thus occupied an area of ca. 200,000 sq. m.

At the S extremity of Caesarea a Roman theater has been excavated. The earliest of its kind in Palestine, it was built by Herod the Great. Of the original building are preserved the cavea and a series of 14 superimposed floors made of fine plaster, painted in geometric, floral, and formal designs, made to resemble marble. The scaena had a rectangular central exedra, flanked by shallow, half-rounded niches. The podium and the pulpitum were also plastered and painted. The theater was rebuilt in the 2d c. A.D. The scaena took the form of a large circular exedra, flanked by two deep rectangular niches, adorned by columns. The podium and the orchestra were faced with marble. In the 3d c. a large half-rounded exedra, like that at Dugga, was added at the back of the scaena frons. In the 3d and 4th c. A.D. the theater was adapted for water games. During the Byzantine and Arab periods it formed part of a large circular fortress.

Sections of the water supply system of Caesarea, which was probably built during Herod's reign, have also been excavated. It consisted of a double, arched conduit, which conveyed the water from springs at the foot of Mt. Carmel, 12 km to the NE of the city. A lower level aqueduct conveyed water from the Crocodile river, about 10 km to the N of Caesarea.

To the Byzantine period belongs a city wall, which encircled an area of ca. 60 ha. Within the wall were discovered remains of a street, probably identical with the Roman decumanus, as well as churches and other Christian religious institutions, richly decorated with mosaics.

BIBLIOGRAPHY. A Reifenberg, "Caesarea, A Study in the Decline of a City," *Israel Exploration Journal* 1 (1950-51); M. Avi-Yonah, "The Synagogue of Caesarea," *Rabinowitz Bulletin* 3 (1963); A. Negev, "The High Level Aqueduct at Caesarea," *Israel Exploration Journal* 14 (1964); A. Frova, *Scavi di Caesarea Maritima* (1966); id., *Caesarea* (1967).
A. NEGEV

CAESAREA PHILIPPI, *see* PANEAS

CAESARODUNUM or Civitas Turonorum (Tours) Indre-et-Loire, France. Map 23. This capital city of the small tribe of the Turones, built by the Romans probably in the 1st c. A.D., was an important meeting point of roads and waterways. Destroyed by an invasion in 275, it acquired a fortified surrounding wall at the end of the 3d c. and in 374 became the chief city of Lugdunensis

Tertius and the center of a large diocese. At this time there was a vicus christianorum W of the city; Bishop Litorius (337-371) built a funerary basilica there but set up the episcopal complex within the walls. His successor St. Martin (372-397) was buried in the Christian cemetery; a basilica was built over his tomb, ca. 470, by Bishop Perpetuus.

The amphitheater, the only monument preserved, is unfortunately filled with houses or covered with earth. It was one of the largest in the Empire (143 x 124 m on the axes). The outer height may be calculated as ca. 20 m. The seats, which are cut in the natural rock to the N, rested on vaulted passageways. The walls are faced with limestone rubble with white mortar joints, often trowel-marked, and double courses of brick. Four passageways have been found, placed on the axes of the ellipse; at the entrance they are reinforced with enormous buttresses shaped like semicircular towers about 6 m in diameter. The size of the building and the moderate use of brick indicate that it dates from about the time of Hadrian (117-138). The remains can be reached through the cellars of certain houses.

The 3d c. surrounding wall, an irregular rectangle (ca. 340 x 240 m) enclosed half of the amphitheater on its S side, and formed an enormous bastion that dominated the plain (perimeter 1155 m, area 9.23 ha). The foundations were built of reused material (blocks, columns, capitals); the wall itself was 4.3-4.8 m thick, made of rubble dressed with small blocks of stone and with red mortar and double bands of brick every 7-10 courses. It was flanked with round towers filled with rubble up to the first floor, where small tegular windows were set. Remains can be seen at rue des Ursulines no. 12, the Musée des Beaux-Arts, and the N and S sides of the Cathedral.

Remains of a round temple are at no. 7, rue de Lucé. The Musée de la Société archéologique de Touraine (Hôtel Gouin, 25 rue du Commerce), the former Musée (Place Foire-le-Roi, no. 8) and the Musée Martinien (Basilique Saint-Martin) all have collections of finds.

BIBLIOGRAPHY. Grenier, Manuel I (1931) 424, 547; III, 2 (1958) 682-84; Carte archéologique de la Gaule romaine XIII, Indre-et-Loire (1960) 67ff; C. Lelong, "Note sur les vestiges visibles de Caesarodunum," Caesarodunum, Bulletin de l'Institut d'Etudes latines de l'Université de Tours (1968) 315-26. C. LELONG

CAESAROMAGUS (Beauvais) Oise, France. Map 23.

The capital of the civitas of the Bellovaci. It is not yet known whether Caesaromagus of the ancient itineraries supplanted the city of Bratuspantium, last refuge of the Bellovaci after their defeat by Caesar, or whether it was a city created by the Romans. No trace of the Gallic fortifications has been found at Beauvais, while such remains exist elsewhere in the civitas of the Bellovaci (Vendeuil-Caply, Bailleul sur Thérain), and indeed no vestiges of any kind from the Gallic period have been discovered there.

The plan of the town is not known in detail, but its limits are indicated by the Gallo-Roman necropoleis, three of which have been found: Notre Dame du Thil to the N, one to the S near the Thérain, and the third to the NE at the rue du Pressoir Coquet. The extent of the ancient city under the Early Empire seems to have been about that of the modern one. The dwellings were for the most part individual houses with porticos, widely dispersed and often remodeled (in the first two centuries A.D. the ground level rose 1-2 m).

Some of the buildings are better known. On Mt. Capron, N of the city and E of the road to Amiens, stood a temple discovered in the 18th c. which has completely disappeared although its plan is known. On the site of the modern church of Saint-Étienne stood a bath complex which was excavated at the beginning of the 19th c. A circular ensemble of the Severan period located at the chevet of the cathedral has recently been excavated. It was built between two Roman streets, on the site of an Early Empire district demolished to permit its construction. The nature of this half-ruined ensemble is uncertain, but probably it is a large semicircular portico surrounding a public square. The forum, the theater, and the circus, however, have not been located.

In the Late Empire the city was completely destroyed and a strong rampart was built. The rampart is partially preserved along with some of its towers at the rue Racine and the rue Philippe de Dreux, and its line is well known. The fortified sector represented only a tenth of the area of the Early Empire city. The wall had two gates, the Porte du Chatel to the E and the Porte du Limaçon to the W.

Artifacts were lost in the destruction of the museum in 1940, but recent excavations have uncovered a number of carved blocks reused in the Late Empire fortifications, as well as much Gallo-Roman and particularly Carolingian pottery, for which Beauvais appears to have been an important center.

BIBLIOGRAPHY. G. Archer & V. Leblond, La balnéaire gallo-romain de Beauvais (1906); V. Leblond, "La topographie romaine de Beauvais et son enceinte au IVème siècle," BAC (1915) 3-39; P. Durvin, "Un coup de sonde à travers les vestiges gallo-romains de Caesaromagus," Ogam 15 (1963) 49-64; G. Matherat, "La première campagne de César contre les Bellovaques et le geste passis manibus," Hommages A. Grenier, Latomus 58 (1962) 1134-50; E. Will, "L'activité archéologique dans les régions Nord et Picardie," Revue du Nord 199 (1968) 677-79; C. Pietri, "Informations," Gallia 29, 2 (1971) 224-26. P. LEMAN

CAESENA (Cesena) Emilia-Romagna, Italy. Map 14.

A Roman municipium ca. 19 km from Forlì and on the Via Aemilia not far from its intersection with the road that leads through the Valley of the Savio to Ravenna. The centuriation of the territory has the same orientation as that of the colony of Ariminum. The origin of the place name is pre-Roman. There is no important mention of the site in the sources during Republican or Imperial times. The city did play a part in the Gothic war at the time of Justinian. It was the seat of a bishopric, but probably not until the middle of the 6th c. A.D.

The epithet of a curve that accompanies the name of the city in the Antonine Itinerary is explained by the spur of the Garampo hill and by the route of that section of the Via Aemilia that follows the slopes of the hill to reach the ancient bridge over the Savio. The rest of the topography of the city is unknown; and it is only a hypothesis that its location was on the hill. The few remains that have been found were discovered in the level zone at the foot of the Garampo. They include strata containing ceramics of Republican age and two mosaic pavements belonging to a building of the 3d c. A.D. Inscriptions mention measures taken in favor of Caesena by Hadrian and Aurelian, baths, and cult centers.

BIBLIOGRAPHY. G. A. Mansuelli, Caesena, Forum Popili, Forum Livi (1949) MPI; Solari, "Curva Caesena," Boll.Comm.Arch.Com. Roma (1928) 138; G. C. Susini, "La liberalitas di Adriano a Cesena," Atti e Mem. Deputazione di Storia patria per le Romagne 10 (1958-59) 281; Cesena, il Museo storico dell'antichità (1969). G. A. MANSUELLI

"CAETOBRIGA," *see* TROIA

CAGLIARI, *see* CARALIS (Sardinia)

CAHORS, *see* DIVONA

CAIETA (Gaeta) Latium, Italy. Map 17A. A port included in the territory of Formiae in Roman times, made by Vergil the site of the death of Aeneas' nurse (*Aen.* 7.1-7). Livy (40.2.4) mentions a temple of Apollo there, Cicero's estate seems to have been there (*Att.* 1.3.2. and 4.3), and there are allusions to an imperial villa. The most conspicuous remains today are the monumental tombs of L. Munatius Plancus and L. Sempronius Atratinus, both of the general type of the mausoleum of Augustus.

BIBLIOGRAPHY. R. Fellmann, *Das Grab des Lucius Munatius Plancus bei Gaeta* (1957)[PI].

L. RICHARDSON, JR.

CAINO (Chinon) Touraine, France. Map 23. On the river Vienne, 16 km upstream from its confluence with the Loire at Condate (Candes, where St. Martin died about 397), and 48 km SW of Caesarodunum, capital of the Civitas Turanorum (Tours). Earlier a Gallic oppidum (Caino is a Celtic word meaning beautiful, related to German *schön*), in Roman times it was a prosperous small town. At the end of the 3d c. the castle was walled against the Bagaudes and other invaders. An important pre-Roman road linking Caesarodunum (Tours) to Lugdunum (Loudun) and Poitou, by Rotomagus (Pont-de-Ruan) crossed the Vienne at a ford 4.8 km upstream of Chinon, at Riparia (Rivière).

Excavations in 1824-26 in several parts of the castle led to the discovery of the Gallo-Roman 3d c. wall, made of huge blocks of stone, fragments of reused sculptures, funeral stelai, etc., from local monuments, and hard mortar. Under the wall were found 15 holes filled with ashes. The principal sculptures are preserved in towers of the castle and the Archaeological Museum in Tours. Roman coins of Postumus (261-267) and Tetricus (268-273) come from the same excavations.

Villas have been found in the town and on its E border, with hypocausts, fragments of columns, coins, sherds of sigillata and other wares, tiles, etc.; the principal sites are la Grange Liénard, l'Olive Guéritaude, and l'Hôtel de France. The material is preserved in the local Musée des Amis du Vieux Chinon.

BIBLIOGRAPHY. M. Duvernay, "Recherches archéologiques et découverte de matériel gallo-romain au Château de Chinon de 1824 à 1826," *Bull. trimest. de la Soc. Archéol. de Touraine* 12,2 (1900) 121-30; G. Richault, *Histoire de Chinon* (1926) 11-25; R. Mauny, "Poteries gallo-romaines trouvées à Chinon," *Bull. Soc. des Amis du Vieux Chinon* 5,1-2 (1946-47) 60-61; J. Boussard, *Carte archéologique de la Gaule romaine*, Fasc. XIII, *Indre-et-Loire* (1960) 35-37; J. Zocchetti, R. Mauny, & A. Heron, "Découverte d'une villa gallo-romaine à Chinon," *Bull. Soc. Amis du Vx. Chinon*, 6,10 (1966) 164-70.

R. MAUNY

CAISTER ON SEA Norfolk, England. Map 24. A Roman walled town on the N shore of the Yare estuary, 5 km N of Great Yarmouth. The Saxon Shore fort of Burgh Castle was 8 km away, across the estuary. The defenses of Caister, a square of 3.6-4 ha, are of two periods, a palisade of the 2d c. succeeded by a stone wall of undetermined date. At the SE angle, as presumably at the others, was an internal turret. It is unknown whether external towers were ever added to the circuit. Much of the interior is covered by modern buildings,

and the only excavated area is part of the S end, between the S gate and the SW angle. The only substantial Roman building recorded is a large structure round a courtyard or part of one. One of its wings had been divided into several small chambers, indicating that it may have been an inn or a brothel.

The position of Caister on an estuary points to its use as a port, but the associated installations have not yet been traced. It is possible, though unproven, that the place played some part in coastal defense during the late Roman period.

BIBLIOGRAPHY. *VCH Norfolk* 1 (1901) 293; J. A. Ellison, "Excavations at Caister-on-Sea 1961-2," *Norfolk Archaeology* 33 (1962) 94.

M. TODD

CAISTOR Lincolnshire, England. Map 24. Little is known of the early history of this settlement, which stood on a spur projecting from the N Lincolnshire Wolds. Probably in the 4th c., irregular polygonal defenses were built to enclose the spur (area ca. 3.2 ha). The circuit included a number of external towers, which, as at Horncastle, were built at the same time as the wall. A connection with coastal defense is to be presumed. Occupation continued after the end of the Roman period, as indicated by early Germanic burials at Nettleton and Fonaby.

BIBLIOGRAPHY. C.F.C. Hawkes, "Roman Ancaster, Horncastle and Caistor," *ArchJ* 103 (1946) 17ff; P. Rahtz, "Caistor," *AntJ* 40 (1960) 175ff.

M. TODD

CAISTOR ST. EDMUND, *see* VENTA ICENORUM

CAJARC Lot, France. Map 23. In 1968 and 1969 near Gaillac on the left bank of the Lot a Gallo-Roman potter's workshop was found and excavated. In the time of Vespasian it made terra sigillata directly inspired in its decoration by the products of Montans and La Graufesenque.

BIBLIOGRAPHY. M. Labrousse in *Gallia* 28 (1970) 426-27 & figs. 35-37; R. Pauc, "Les ceramiques sigillées rouge de Carrade à Cajarc," *Bull. de la Soc. des études du Lot* 93 (1972) 183-239[I].

M. LABROUSSE

CALAGURRIS (Calahorra) Logroño, Spain. Map 19. On the left bank of the river Cidacos near its junction with the Ebro. Mentioned by Livy (39.21) in connection with the wars of the Romans against the Celtiberians in 188-187 B.C. It is celebrated for its adherence to Sertorius and resistance to Pompey and Afranius in 76 B.C. (Sall. *H.* 3.86-87; Val. Max. 6. ext. 3). Towards the middle of the 1st c. B.C. it acquired the epithet of Nassica and later that of Julia, after Caesar. According to Suetonius (*Aug.* 49.1) both Caesar and Augustus recruited Calagurritans for their bodyguards, and Augustus accorded the privilege of coining money.

Among its remains is a circus NE of the city, some 400 paces in length and 116 in width, capable of accommodating 20,000 spectators. The highway from Caesaraugusta to Virobesca traversed the site and crossed the Ebro by a 20-arch bridge, 5-6 m high and 140 m long. There are also remains of an aqueduct and of baths with a mosaic pavement.

Calagurris was the birthplace of the orator and essayist Quintilian, and perhaps of Prudentius. According to Ausonius, at the close of the 4th c. it was a deserted town of no importance.

The local museum contains mosaics, terra sigillata, and inscribed stones.

BIBLIOGRAPHY. B. Taracena, "Restos romanos en la Rioja," *ArchEspArq* 15 (1942) 17-47[MPI].

J. ARCE

CALAGURRIS CONVENARUM (Saint-Martory) Haute-Garonne, France. Map 23. The modern site covers the ancient center of Calagurris Convenarum, located on the Garonne beside the Roman road from Toulouse to Saint-Bertrand-de-Comminges and Dax. Besides the abundant remains of dwellings, the more important discoveries include a potter's kiln, a mausoleum, and the remains of the bridge by which the Roman road crossed the Garonne.

BIBLIOGRAPHY. G. Manière, "Vestiges d'un mausolée à Saint-Martory (Haute-Garonne)," *Ogam* 18 (1966) 463-68 & pls. 123-25; id., "Voies et ponts antiques dans la commune de Saint-Martory (Haute-Garonne)," *Gallia* 27 (1969) 163-70; for other minor finds: M. Labrousse in *Gallia* 9 (1951) 129-30; 12 (1954) 216; 15 (1957) 259-60; 22 (1964) 444; 24 (1966) 422; 26 (1968) 530-31; 28 (1970) 408-9. M. LABROUSSE

CALAHORRA, see CALAGURRIS

CALAMA (Guelma) Algeria. Map 18. Some 74 km SSW of Hippo Regius, at the foot of the Mahouna massif which dominates the valley of the Seybouse River, the town occupied the site of modern Guelma and extended farther to the NE. Perhaps it was of Phoenician origin since Punic influence there has been pervasive.

Efforts to identify Calama with the town of Suthul, cited by Sallust, have proved fruitless; no doubt Jugurtha defeated the Romans nearby. Calama belonged to the Proconsular province and was a municipium under Trajan; presumably that emperor gave the statute to the town; its inhabitants were included in the Papirian gens. Calama is not mentioned in Pliny, Ptolemy, the *Antonine Itinerary*, or the *Peutinger Table*. The town was still a municipium at the death of Septimius Severus and is referred to as a colony in numerous 3d and 4th c. inscriptions. There was a Christian community at the time of Diocletian's persecution. Calama fell to Genseric in A.D. 437 but was restored by count Paulus under the orders of the patrician Solomon. It became one of the fortress towns of Byzantine Numidia and subsequently began to decline. Mentioned again in the 12th c., at the time of the French conquest (1836) it was no more than a collection of rude dwellings. Then the remains were still considerable; excavations and efforts at restoration were undertaken.

It is difficult to reconstruct the plan and general appearance of the site. The only important monuments known are the theater and the public baths. The theater was built in the first or second year of the 3d c. A.D. through the generosity of a certain Annia Aelia Restituta, who spent 400,000 sesterces on it. It was restored, indeed virtually rebuilt, from 1902 to 1918, after having served as a quarry. It is on a slope and measures 58.05 m in width. It was built of a rubble core revetted with ashlar. The tiers of seats had virtually all disappeared; they must have numbered 10 in the lower zone and 12 in the second. The orchestra was paved in marble. Behind the stage, which was flanked by two rectangular chambers, a portico with columns formed a facade.

The public baths were built of rubble and revetted with ashlar and brick. They may date as early as the 2d c. A.D. Only one large rectangular chamber (22 x 14 m), undoubtedly the tepidarium, can be described; it gave onto other rooms and onto the exterior by 11 passages. These baths were included within the Byzantine fortress, no doubt built on an earlier enclosure and defended by 13 towers. It measured 278 x 219 m.

The existence of a forum is attested by a single inscription. Likewise one can cite the remains of arcades, a small shrine dedicated to Neptune, cisterns and, outside the town, a Christian church. In 1953 a hoard of 7,499 coins was discovered; virtually all of them came from the mint at Rome; the most recent dated to the beginning of A.D. 257. Presumably the hoard was buried because of local disturbances. Most of the ancient objects recovered at Calama and from the region are preserved in the Guelma Museum.

BIBLIOGRAPHY. A.H.A. Delamare, *Exploration scientifique de l'Algérie. Archéologie* (1850) 171-187[PI]; A. Ravoisié, *Exploration scientifique de l'Algérie pendant les années 1840 à 1849* II 19-36, pls. 22-38[I]; S. Gsell, *Les monuments antiques de l'Algérie* (1901) I 194-97 et 227-28[PI]; *Atlas archéologique de l'Algérie* (1904) 9, no. 146[MP]; *Texte explicatif des planches de A.H.A. Delamare* (1912) 153-73; L. Leschi, *Algérie antique* (1952)[I]; G. Souville, "Les collections de Guelma (Note sur la constitution d'un musée régional en Algérie)," *Actes 79e Congr. nat Soc. savantes, Archéol.* (1954, 1957) 285-89; R. Turcan, *Le trésor de Guelma. Etude historique et monétaire* (1963). G. SOUVILLE

CĂLAN, see AQUAE (Romania)

CALATAYUD, see BILBILIS

"CALCARIA," see NEWTON KYME

CALEACTE (Caronia) Sicily. Map 17B. A city founded between 448 and 447 B.C. by the Sikel leader Ducetius after his defeat by the Syracusans, against whom he had revolted at the head of the Sikeloi. This is the first time a Sikel prince has founded a polis of the Greek type.

The site had already been occupied by Sikeloi, who had been exposed to Greek culture as early as the 6th c. B.C. Aerial photographs show a settlement on the terrace overlooking the modern city, and in the city itself traces of ancient habitation down to the Roman period have been found. There has been no excavation.

BIBLIOGRAPHY. A. Holm, *Geschichte Siziliens im Altertum* 1 (1870) 280; A. E. Freeman, *History of Sicily* 2 (1892) 379; B. Pace, *Arte e Civiltà della Sicilia antica* 1 (1935) 231-32 (2d ed., pp. 244-45); D. Adamesteanu, "Ellenizzazione della Sicilia ed il momento di Ducezio," *Kokalos* 8 (1962) 190-93. D. ADAMESTEANU

CALES Campania, Italy. Map 17A. A city on the Via Latina. While older settlements are attested in the area on the basis of archaeological data, the city and its present site seem to date to the late 7th c. B.C., i.e., to the period of Etruscan hegemony which would coincide with what we already know from the necropolis. It remained the city of the Ausones until the siege by the Romans in 334 B.C. Following this it was reduced to a Latin colony, the first in Campania. During the Late Republican period, when it reappeared as a municipium, the city was the seat of the quaestor of Campania. In the Late Empire, it was practically destroyed by the Vandals under Genseric, and in the Longobard period a fortress was built on the site.

The city occupied a long, narrow plain, nearly surrounded by streams that cut deep into the tufa. At its highest point, to the N, there was a citadel. In the center of the settlement, crossed by the Via Latina, was the forum and some of the major public buildings. From the forum, the two sections of the major street, intersected by cross-streets, ran N-S, according to a plan well-attested elsewhere in Etruscan-Italic environs. The fortifications, built over some of the structures preserved from the 4th c. B.C. or even earlier, underwent important restorations in the age of Sulla. This is particularly true in the vicinity of the gates, to some of which access is

gained over steep, narrow slopes in the tufa bank. Among the most notable buildings recognizable today are: the theater, in the area of the forum, of Late Hellenistic date and enlarged in the age of Sulla; the central baths and a terraced sanctuary of the Sullan period; a temple dating from the beginning of the Imperial period, not far from which were discovered votive offerings and some terracotta facings belonging to a sanctuary of the archaic period. North of the settlement are the Late Republican amphitheater (rebuilt 2d c. A.D.), and a monumental bath building of the first half of the 2d c. of the Empire. On the outskirts, in the S section, an important votive dumping area of the Hellenistic period has been partially explored.

In the W suburb, adjacent to the Via Latina, are remains of a palaestra partially incorporated into a basilica of the 5th c., as well as sure evidence of pottery shops of the Hellenistic period. Along the streets in the same area, the Hellenistic and Roman necropoleis extended, their sepulchral monuments in part dating to the 3d c. B.C. In a more N direction, there have been discovered archaic tombs, among which a sumptuous one dates to the late 7th c. with many grave gifts imported from Etruria.

Molded and decorated pottery with the potter's seal (called caleni) is attributed with certainty to Cales. The discovery of quite a number of molds has increased that certainty, and the pottery is dated between the last ten years of the 4th c. B.C. when the technique was introduced by Attic artisans, and the late 3d c. B.C. During the latter period, black glaze pottery of the commonest type began to be produced up until the first ten years of the 1st c. B.C. when gradually a high quality praesigillata was substituted.

The division of land in the territory evidently dates back to the city's reduction to colonial status in 334. Many country villas, in the plain as well as on the hillside, date to the Republican era.

BIBLIOGRAPHY. Th. Mommsen in *CIL* x, p. 451f; Hülsen in *RE* III 1 col. 1351f; W. Johannowsky in *BdA* 46 (1961) 258f; see also M. Ruggiero *Scavi di antichità nelle provincie di Terraferma* (1888) 267f and in *NSc* 1883, 1895, 1929. On the ceramics see R. Pagenstecher, *Die Calenische Reliefkeramik* (1919). On centuriation, see F. Castagnoli in *BullComm* 75 (1953-54) Suppl. pp. 34f. On the villas in the area see P. v. Blanckenhagen et al., *BSR* 33 (1965) pp. 55f. W. JOHANNOWSKY

CĂLIMĂNEŞTI, *see* ARUTELA

CALLEVA ATREBATUM (Silchester) Hampshire, England. Map 24. The cantonal capital of the civitas Atrebatum 13 km SW of Reading (Berkshire) where the collection of antiquities is housed in the borough museum, loan of the Duke of Wellington; there is a small museum near the site.

Calleva (town in the wood) was an oppidum of the Belgic Atrebates, probably as early as Commius (ca. 50 B.C.). Under the king Eppillus (ca. A.D. 5-10) it had a mint, and a high standard of living among the richer inhabitants is denoted by imported pottery. It was overwhelmed by the Catuvellauni under Epaticcus ca. A.D. 25, but after the Roman invasion of 43 became for a few years a bastion of the client kingdom of Cogidubnus (cf. Tac. *Agric.* 14). A polygonal earthwork of ca. 34 ha is attributable to this phase, while other earthworks S of the town relate to earlier periods. The town developed apace from the Flavian period on, largely because it was an important nodal point of the road system. The chief mark of transition to cantonal-capital status is the central forum-basilica of principia type (82.5 x 94.5 m). The basilica had a single row of Corinthian columns ca.

8 m high, and its apsidal aedes and other rooms were lined with imported and local marble.

Also of the transitional period is the street grid, laid out within a polygonal outer earthwork which may in part be of Cogidubnian origin; the grid (ca. 660 x 720 m) was aligned N-S, producing originally 41 insulae of different but related sizes. Of other important public buildings, the baths (*Reihentyp*, 63 x 28.5 m) were a creation of the regal period, lying at an angle to the street grid and adapted to it, like many other early buildings of lesser consequence. The earthen amphitheater on the NE (arena ca. 48 x 39 m) has not been excavated. A large official residency (praetorium?) lies on the S side of the town. Sacred buildings include three square and one polygonal Romano-Celtic temples, two in a walled temenos under the present churchyard, and the polygonal temple in another, S of the forum; simple cellas, including one in a walled enclosure, were probably also temples. There is yet another, or more probably a guild schola, on the main street; inscriptions naming a collegium peregrinorum Callevae consistentium were found in one of the Romano-Celtic fana.

Silchester has also yielded remains of a small church, ca. 12.6 m long over-all, with narthex, aisled nave, transept, and apse to the W containing a mosaic panel; there is no formal proof of its nature, though a 4th c. date is likely, and the implication of the plan is inescapable. Unlike other early churches excavated N of the Alps, this had no cemetery context, and its position next to the forum suggests that the cult had official support.

There were about 180 buildings assignable as houses or shops, the latter mainly of the strip type aligned along the main E-W street N of the forum. Some of the smallest insulae are not fully built up, and the outlying ones are largely vacant. It has been questioned whether the plan accurately represents the density of building, since the excavators undoubtedly missed some structures and could identify those of timber only with difficulty; excavation elsewhere (e.g. at Verulamium), however, suggests that the picture presented is essentially true when the results of recent aerial photography are added. It is interesting to compare Silchester with Caerwent (Venta Silurum, q.v.), where the insulae of a much smaller town are more densely built up. The houses range from cottages of two or three rooms to large establishments as much as 39 m square, often lying well back from the streets and in some cases evidently of earlier origin. About 16 larger houses were probably the residences of curiales: they have hypocausts, mosaics, and painted walls, although these are also often found in smaller dwellings. A difference between Silchester and Caerwent can be seen in the extreme rarity of the courtyard house, i.e. ranges of rooms completely enclosing a courtyard or garden. There is only one such example, and that is an organic development from a simpler building.

In general, the foundations of houses and other buildings were of flint masonry, and in many cases the superstructure was of half-timbered work filled in with clay; windows were often glazed, and the roofs were tiled (in the late period stone slabs were used in place of tiles). It is not likely that many houses had an upper story, and on the basis of the plan it seems unlikely that the townsfolk could have numbered more than ca. 2000 souls. Since Silchester occupies a somewhat elevated position at the end of a gravel spur, piped water was not so much in evidence as at Caerwent, and was probably arranged only in specific cases such as the baths. Water came from wells, and the rubbish buried in pits all over the town must sometimes have led to contamination of the supply.

At least some of the houses were farms, which ac-

counts for the unusually spacious plan. While agriculture and allied crafts were undoubtedly the main occupation of the townsfolk, retail trade and small manufacturing are also in evidence, and general trade along the roads which converged on the town probably accounts for the presence of the collegium peregrinorum. Pottery was made; an imperial tilery existed ca. 3 km S during the reign of Nero; metal-working included the refining of silver on a small scale (from argentiferous copper, probably for jewelry), pewter manufacture, and blacksmiths' work (notable finds of iron tools). Other industries included glass making (from scrap), tanning, and bone-working.

The inner defenses consisted primarily of a bank and ditch drawn polygonally around the built-up area ca. 196-197(?) during the Albinus crisis. The bank was faced with a substantial wall in the 3d c., 2.7 m thick at the base and ca. 7.5 m high—the circuit of the wall is all that can be seen at Silchester today (and the site of the amphitheater)—and a new ditch was dug farther out to accompany it. There were double gateways on E and W, single on N and S, posterns SE, SW, and NE, the latter leading to the amphitheater. In terms of standard wagonloads of 1200 librae, it can be calculated that the wall required over 126,000 loads of flint (from several km away) and 35,000 loads of oölitic bonding-stone (which had to be brought at least 56 km). Unlike the walls of Caerwent and some other Romano-British towns, those of Silchester do not appear to have acquired external bastions in the 4th c., though various gateways came to be blocked with rubble and architectural fragments at a late date.

Occupation flourished throughout the 4th c. and well into the 5th; the town at this period seems to have had a garrison of Germanic mercenaries, to judge from items of equipment found. Later still, the lands of the last Callevans were demarcated from those of Saxon settlers on the NW by an earthwork ca. 3.2 km from the town. The latest relic is a sandstone pillar, reused as a funerary monument, bearing an inscription in Irish Ogham characters, found farther E than any other (ca. 600?).

BIBLIOGRAPHY. Excavation reports: *Archaeologia* 40, 46, 50, 52-62, 92, 102 (1866-1969)[MPI]; *JRS* 52 (1962)[I]; O. Cuntz, ed., *Itineraria Romana* (1929-) 73-74; G. C. Boon, *A New Guide to the Roman Town Calleva Atrebatum* (1972)[MI]; id., *Silchester: the Roman Town of Calleva* (1974)[MPI].　　　　G. C. BOON

CALLIRRHOE (Uyun es-Sara) Jordan. Map 6. The name given to several hot springs on the NE coast of the Dead Sea. In the Roman period medical qualities were ascribed to these waters, and King Herod sought a cure there before his death (Joseph. *BJ* 1.657; *AJ* 17.171). Pliny (*HN* 5.15.72) writes: "On the same side there is a hot spring possessing medical value, the name of which, Callirrhoe, itself proclaims the celebrity of its waters." The site is marked on the Medaba mosaic map, on which three buildings are seen, a spring house, a nymphaeum, and a house through which a river is flowing. In a recent survey several buildings were observed among which are several pools into which the water of the springs is conveyed by means of channels. Remains of a nymphaeum were also observed.

BIBLIOGRAPHY. A. Strobel, *ZDPV* 82 (1966) 149-62.
　　　　A. NEGEV

CALLONIANA, see BARRAFRANCA

CALTAGIRONE Sicily. Map 17B. A Hellenized settlement in the Heraian hills W of Syracuse; the ancient name is unknown. The site had strategic importance, for it controlled the pass between the plain of Gela to the

S and the valleys of the Caltagirone and Symaithos to the NE. The earliest settlement belongs to the neolithic Stentinello culture and was located on the hill of S. Ippolito, to the NE of the modern city. During the Late Bronze Age Caltagirone was of major importance; a large necropolis of as many as 1500 chamber tombs occupied the slopes of the hill known as La Montagna to the N of town. It belongs to the Pantalica culture (ca. 1250-1000 B.C.); some of the burials are in the form of tholos tombs, suggesting Mycenaean influence, also seen in ceramic shapes. Less is known about the Early Iron Age. Greeks arrived in the early 6th c. and settled on the hill of S. Luigi, under the modern town. Only a few graves have been excavated, mostly of the 5th c. and later; the burial types are Geloan, perhaps indicating Geloan control of the site in the early 5th c. Excellent red-figure pottery of the 4th c. is also known. An archaic stele and most of the pottery from the site are in the fine local museum.

BIBLIOGRAPHY. S. Ippolito: P. Orsi, *BPI* (1928) 82ff; L. Bernabò Brea, *Sicily before the Greeks* (1966) 80ff. La Montagna: P. Orsi, *NSc* (1904) 65ff; L. Bernabò Brea, op.cit. 145f, 161f. S. Luigi: T. J. Dunbabin, *The Western Greeks* (1948) 113f; G. Libertini, *MonAnt* 28 (1922) 101ff.　　　　M. BELL

CALTANISSETTA Sicily. Map 17B. A prehistoric and Greek settlement revealed by recent excavations. Remains of huts of the Chalcolithic period, with Serraferlicchio, S. Ippolito, and Castelluccio style pottery, have been found in the area of the present cemetery and on the San Giuliano mountain which towers over the modern town. This area yielded important terracotta male and female figurines of the Early Bronze Age, very probably connected with a great prehistoric sanctuary. Other discoveries attest to the existence of a later indigenous center which from the 7th c. B.C. established contacts with the Greek colony of Gela. Traces of this settlement, with Corinthian, Geloan, and local imitation pottery, have been found on Monte San Giuliano, and tombs containing vases of Geloan type with geometric decoration have been uncovered near the present athletic field. Finally the discovery of a 5th c. B.C. Greek antefix in the castle of Pietrarossa demonstrates the presence of sacred buildings in Greek style at that time.

An archaeological museum contains all the material found in the last ten years at the ancient sites in the surrounding territory, especially Sabucina, Gibil-Gabib, Capodarso. Greek imports and colonial material predominate, thus demonstrating the progressive Hellenization of central Sicily between the 7th and 4th c. B.C.

BIBLIOGRAPHY. P. Orlandini, *Kokalos* 8 (1962) 108ff; id., *Kokalos* 12 (1966) 36ff; id., *Sicilia Archeologica* (1968) 17ff; id., *BdA* (1968) 55ff.　　　　P. ORLANDINI

CALVISSON Gard, France. Map 23. The oppidum of La Liquière, near Calvisson, is on the first hills in from the sea between Nîmes and Sommières. It is one of the five cities in the prehistoric stratum surrounding the Vaunage plain. Excavations have revealed a group of houses cut in the rock and arranged around a central hearth. There were three phases of occupation: from ca. 625 to 610 B.C. the populace engaged in vigorous trade with the Etruscans, evidenced by finds of wine amphorae and delicate Etruscan ware. In the second phase, ca. 610-590 B.C., hearths of dry clay began to appear in the center of the houses; this phase saw the first importations from Greece brought by the Phokaians, for example, a goblet of gray Ionian bucchero and two fragments of Corinthian aryballoi. At the same time Etruscan imports remained plentiful. In the third phase, 590-540 B.C., the way of life hardly changed, but many articles made in Marseille appeared.

The civilization of La Liquière is a survival developing from the late Languedoc Urnfield type.

BIBLIOGRAPHY. M. Louis, "Le village anhistorique de La Liquière de Calvisson," *CahHistArch* 12 (1937) 3-38; M. Py, "Les influences méditerranéennes en Vaunage du 8° au 1° s. av. J. C.," *Bull. de l'École Antique de Nîmes* 3 (1969) 35-86. M. PY

CAMARACUM (Cambrai) Pas de Calais, France. Map 23. The city that superseded Bavai as capital of the civitas of the Nervii. Situated on the left bank of the upper Escaut, it was at the intersection of important Roman roads: Amiens-Bavai, Cambrai-Saint Quentin, and especially Arras-Cambrai, part of the famous route from Boulogne to Bavai and on to Cologne. The fact that no Gallic remains have been found is generally taken as proof that the Romans simply created the city as part of their road and administrative system in Belgica. On the other hand, the area immediately surrounding Cambrai is well known for its important Gallic remains: Moeuvre (Iron Age I cemetery), Etrun (oppidum at the confluence of the Escaut and the Sensée). But next to nothing is known of the topography of the ancient city or its stages of development, nor are we much better informed about the Late Empire rampart. Local tradition has it that the fortified city stood on a hill on the Escaut, the Mont des Boeufs, but definitive proof is still lacking.

The only finds from which we can derive any useful information are the tombs. The first group lies at the NW exit of the city, at the foot of the Pierres Jumelles (the remains of two sunken menhirs), the other in the Rue du Grand Séminaire. These cremation tombs have yielded a large quantity of pottery, now either in the Cambrai museum or the diocesan museum. We have more detailed evidence on the environs (especially at the bends of the Arras-Cambrai and Bapaume-Cambrai roads), which were very thickly settled in the Roman period. Major villas and monumental complexes are found each year, either by excavation or by aerial photography. A hoard of coins has just been discovered at Graincourt-les-Havrincourt, famous for its remarkable finds of silver plate.

BIBLIOGRAPHY. Wilbert et Durieux, "Cambrai gallo-romain et mérovingien," *Mémoires de la Société d'émulation de Cambrai* XLVIII (1893); L. de Sailly, "Les pierres Jumelles de Cambrai," *Pro Nervia* 2 (1924) 35-40; F. Vercauteren, *Etude sur les civitates de la Belgique Seconde* (1934) 203-33; L. Chauvin & A. Tuffreau, "Recherches archéologiques récentes dans le Cambrésis," *Revue du Nord* 44, no. 202 (1969) 373-74. P. LEMAN

CAMBAZLI Rough Cilicia, Turkey. Map 6. A modern village on an ancient site, some 7 km SE of Olba on the ancient Roman paved road leading inland from Korykos. At Cambazlı the road forks, one branch leading to Olba, one apparently SW to the Seleucia-Diocaesarea road and one roughly E towards the Lamus river crossings and Lamus on the coast. The site lies on and near a steep-sided rocky promontory on the R bank of the ravine of an intermittent stream (Çukurbağ Deresi) which emerges at the coast just W of Elaeussa. The visible remains at Cambazlı are apparently of the Roman and Christian periods. The ancient name of the site is unknown; it was probably an outlying town belonging to Olba or Diocaesarea.

By the modern road ca. 1 km NE of the town are some house (?) remains. More house remains are on the tip of the promontory which juts into the ravine, and around the site are cisterns and other building remains. There are six grave temples or heroa. The most out-standing one, which is on the road leading N from the town, is in the form of a temple distyle in antis, Corinthian, on a high podium. The porch and cella measure ca. 9.5 x 5.5 m. Most of the roof has fallen, save one corner of the front pediment, and all but one column. The staircase to the porch is gone, the flanking walls remain. A doorway leads from the porch to the cella. The architrave has three fasciae, the frieze an egg-and-dart molding, the cornice is denticulated. The base of the building is hollow, vaulted, divided into two rooms corresponding to the division above, with walled-off graves along each side.

A smaller grave temple SE of the town is well preserved save for the roof and pediment. It is a small temple in antis, ca. 5 x 7 m. The architrave has three fasciae, the frieze is a plain S molding, the cornice is heavy, with lion head spouts. The ceilings are vaulted; the front pediment is missing, exposing the vault of the porch ceiling. Both grave temples are faced with heavy ashlar masonry. They probably date from the 2d or 3d c. A.D.

A well-preserved and very handsome basilica within a precinct wall lies outside the town on the road leading to Korykos.

BIBLIOGRAPHY. J. T. Bent, "Cilician Symbols," *CR* 4 (1890) 321-22, no. 12; id., "A Journey in Cilicia Tracheia," *JHS* 12 (1891) 219; E. L. Hicks, "Inscriptions from Western Cilicia," *JHS* 12 (1891) 262; J. Keil & A. Wilhelm, *Denkmäler aus dem Rauhen Kilikien*, *MAMA* II (1931) 33-43MPI; T. S. MacKay, "Olba in Rough Cilicia," Diss. 1968 (Univ. Microfilm) Appendix E. T. S. MAC KAY

CAMBODUNUM (Kempten) Bavaria, Germany. Map 20. A Raetic provincial town in the foothills of the Alps at the intersection of important roads leading from Italy to Augusta Vindelicum and to the Danube. The name originated as a major place of the Celtic Estioni but the location of the place (hardly an oppidum) has not yet been fixed for lack of characteristic finds. During the first years of the emperor Tiberius (about A.D. 17), a garrison was stationed on a plain above the banks of the Iller and a new urban settlement was developed systematically. The first representative buildings were erected under Claudius ca. A.D. 50. The economy of the town was based on commerce, agriculture, and cattle-breeding. During the turmoil of the Three Emperor Year (68-69), the town and its public buildings were largely destroyed. Reconstruction was soon started, and the public buildings were rebuilt on a larger scale. The town contained now a forum with temple, curia, basilica, and a guest-house, as well as three public baths, a walled-in area (238 x 178 m) with an altar for burnt-offerings, and a separated area with numerous small temples. The forum, of the type called a temple forum, can be compared with that of Pompeii, e.g., the basilica is comparable with measurements of 47 x 23.5 m and a middle nave 12.5 m wide. The large baths with a square ground plan of 75 m correspond roughly to the Stabiani baths in Pompeii. Streets at right angles divided the center of the town into at least a dozen insulae. Stone buildings usually had porticoes facing the street. To the N, E, and S were other sections with wooden houses. The town continued to grow in size although economic development decreased owing to a shift of trade routes after the incorporation of the limes area N of the Danube. In the second half of the 1st c. A.D. the old necropolis in the N was abandoned and built over. The town area had then a N-S extension of 1 km, and a width E-W of 0.5 km. Probably the town was elevated at the end of the 2d c. A.D. to a municipium. After 200 A.D. there existed for some time a potter's workshop, producing decorated

ceramics and sigillata like the factory in Westerndorf in the town. Numerous finds of ornaments and other traces testify to the complete destruction by the Alamanni in 233.

Another catastrophe in 259-260 caused a relocation of the town to the left bank of the Iller. There, on the isolated mountain of the Burghalde and behind strong walls, a smaller town developed. The *Notitia dignitatum* mentions in Cambodunum a praefectus legionis III Italicae who commanded that sector of the limes (*Not. dig.* [*occ.*] 35). Thus troops were stationed in the late Roman town; under their protection the settlement must have continued for some time. That the mediaeval town Campidona developed there (documented for the first half of the 8th c.) argues, together with the name, for the continuity of the settlement. The finds are in the Allgäuer Heimatmuseum in Kempten and in the Prähistorische Staatssammlung in München.

BIBLIOGRAPHY. F. Wagner, "Die römische Provinzstadt Kempten," *Allgäuer Geschichtsfreund* NF 36 (1934) 65-69[I]; W. Krämer, *Cambodunumforschungen 1953* I (1957)[MPI]; U. Fischer, *Cambodunumforschungen 1953* II (Ceramics) (1957)[I]; H.-J. Kellner, "Der Schatzfund von Cambodunum," *Germania* 38 (1960) 386-92[PI]; W. Kleiss, *Die öffentlichen Bauten von Cambodunum* (1962)[MPI]; G. Krahe, "Ausgrabungen im frührömischen Gräberfeld von Cambodunum," *Jahresber. d. Bayer. Bodendenkmalpflege* 3 (1962) 78-91[MPI]. H.-J. KELLNER

CAMBOGLANNA, *see* HADRIAN'S WALL

CAMBRAI, *see* CAMARACUM

CAMBRIDGE ("Durolipons") Cambridgeshire, England. Map 24. The Roman town of Cambridge lay on the S end of a broad ridge NW of the Cam, in the area now occupied by the mediaeval castle and the churches of St. Giles and St. Peter. The Roman name of the place is not certain. Camboritum in the *Antonine Itinerary* was earlier favored, on the grounds of its general similarity to Cambridge, but this identification is no more than specious. Durolipons, also listed in the *Antonine Itinerary*, is the most probable Roman name for the town.

The system of Roman roads around Cambridge is of some interest: two major routes cross at the site of the town itself. Akeman Street branches from Ermine Street and runs NE towards Cambridge, leading thence into the Isle of Ely. The road from Colchester (Camulodunum) can be traced over the Gog Magog hills SE of the town, and from their foot a branch road led to a crossing of the Cam at Cambridge itself and thence towards Godmanchester.

The early period of Roman Cambridge is still little known. A length of pre-Flavian ditch found beneath Shire Hall in the W part of the town has been claimed as part of the defenses of an early Roman fort, but proof is lacking. On general grounds, the siting of a fort at the crossing of the Cam is very likely. A settlement of the pre-Roman Iron Age may also be proposed, since a number of late Iron Age pottery vessels have been found in various parts of the town, but this hypothesis also has yet to be confirmed by the discovery of structural remains.

The Roman settlement was at some stage walled, and the polygonal defenses enclosed an area of 10-11.2 ha. The longer axis of the enclosure ran NW-SE; it was crossed by the Roman road leading NW towards Godmanchester (now represented by the Huntington Road and Castle Street), and SE towards Colchester, presumably crossing the Cam by a bridge a short distance below the present Magdalene Bridge. Excavated evidence for the structure and dating of the defenses is not extensive, but it suggests that there was an earth rampart of the late 2d c., in front of which a stone wall was built in the 3d c. Outside these lay a ditch some 10-12 m wide and 2.4-3.6 m deep. Neither rampart nor ditch now survives, but the outline of the defensive works can be traced with some confidence on the N, S, and W sides. A bank in the grounds of Magdalene College, formerly identified as the rampart of the Roman town, is now known to be post-Roman. The W gate, which had at least one flanking tower, has recently been excavated.

Several cemeteries have been located on the fringes of the settlement, at Girton, Coldham Common, Trumpington, and on the Huntingdon Road. Sculptured fragments found at Girton may have come from a monumental tomb. The Arbury Road cemetery, which lay along Akeman Street NE of the town, dated in the main from the 3d and 4th c., and included a large walled tomb containing two inhumation burials, one in a lead-lined stone sarcophagus.

The Roman town was the focus for a considerable agricultural population; farmsteads are attested at the War Ditch, Cherry Hinton, Manor Farm, and at several other sites close to the town. Like Cambridge itself, many of these sites appear to have been occupied in the later Iron Age. After the collapse of Roman administration, the town remained a nucleus of settlement; pagan Anglo-Saxon objects have been recovered from within the walls and from burials outside them. Finds are in the Museum of Archaeology and Ethnography.

BIBLIOGRAPHY. *Royal Commission on Historical Monuments. The City of Cambridge* I (1959) lixff[MPI].

M. TODD

CAMELON Stirlingshire, Scotland. Map 24. About A.D. 140 a Roman auxiliary fort was built 1 km N of the Antonine Wall to guard the point at which the great trunk road to the Tay and Strathmore crossed the river Carron. Occupying the corner of a plateau composed of glacial sand and gravel, the fort faced level ground on the S and W, but on the other two sides it was protected by a steep scarp some 18 m high. Excavation in 1899-1900 showed that the fort was almost square and occupied ca. 2.4 ha.

The rampart, 12.3 m thick, was made of turf and clay, underpinned with stone in many places. On the S and W sides were two ditches, and one on the W half of the N side; no ditches were observed round the rest of the circuit. The four gates were of timber, but their plans were not recovered; three of them were ca. 6 m wide, while the fourth gate, in the E side, was only half as wide. This implies three double carriageways and a single one. Inside the fort, which faced E, a number of stone buildings were identified: a headquarters building with colonnaded front courtyard, cross-hall, and regimental shrine flanked by administrative offices; the commandant's house containing a suite of baths; a granary; several barrack-blocks; and a series of long narrow buildings that may have been barracks, stables, or storehouses. Nothing is known of the garrison, but it may have been an ala quingenaria.

Outside the fort there was a small annex on the N side, and a larger one on the S defended by a rampart and multiple ditches. The latter was only partially explored and has now been almost entirely destroyed. Within it, however, was found a bath building of at least two structural periods; a considerable portion of another stone building, perhaps a mansio, containing a chamber with hypocaust; and fragmentary remains of other structures of stone or wattle-and-daub. The bath building and the

mansio are probably of Antonine date, but the discovery in the area of another series of ditches running on a different alignment from those of the fort and annexes, together with the unearthing of substantial quantities of Flavian pottery, suggests that the site of the S annex may previously have been occupied by a Flavian fort. The finds are either in the National Museum of Antiquities of Scotland or in the Burgh Museum, Falkirk. The only inscribed stone of any significance is a building record of the Twentieth Legion, discovered in the bath house.

Crop marks on air photographs W of the fort have revealed traces of five temporary camps, each defended by a slight ditch and rampart. One, 17.6 ha in extent, was capable of housing two legions on the march, while another, of only 2 ha, was comparable in size to several camps believed to have been used by troops engaged in the construction of the Antonine Wall. Two Roman burials found in a sandpit near Camelon railway station may indicate the course taken by the main road as it approached the Flavian fort.

BIBLIOGRAPHY. *Proc. Soc. Ant. Scotland* 35 (1901) 329-417; 89 (1955) 336-39; *Inventory of the Ancient & Historical Monuments of Stirlingshire* 1 (1963) 107-12.

K. A. STEER

CAMERTON Somerset, England. Map 24. The Romano-British settlement at Camerton (31/689564) is on the Fosse Way, where it crosses a small plateau E of the Mendip Hills 11.2 km SW of Bath. The site has been occupied since Neolithic times: many stone implements have been recovered, and there are two large Bronze Age burial mounds. The Early Iron Age camp with circular huts and ditches (excavated in 1930-36) covers the period from 500 B.C. to the construction of the Fosse Way in A.D. 47. The Romano-British settlement was partially excavated in 1800-37, and work in 1930-47 confirmed that the settlement was founded as a small Claudian camp on the S side when the Fosse Way was constructed. But early in the 2d c. a settlement developed on the N side of the Fosse Way. Its tripartite, corridor-type buildings faced SE and were well constructed. An inscription and other objects found in one building, which had a semicircular court, suggested a small shrine.

During the first half of the 3d c. A.D., with increasing industrial activity, the settlement was replanned on a different alignment. A number of simple rectangular buildings were erected on either side of the Fosse Way to house artisans engaged in pewter casting. Several stone molds used for casting dishes, paterae, and plates were found lying around a furnace which had been used for this purpose. This development probably arose from increasing use of coal from the out-crops in N Somerset, and from a change in the use of lead from the Mendip mines. The lead, formerly exported in the form of pigs, was now used to produce pewter, which replaced pottery to a considerable extent, and lead and tin exports were replaced by the export of plates and dishes made in Britain. This was the first indication of pewter casting found in Britain, but since then a similar industry has been discovered at Nettleton, Wiltshire, which is also on the Fosse Way. Pewter casting probably came under the surveillance of the imperially controlled lead-mining industry at Charterhouse-on-Mendip, Somerset.

After the middle of the 4th c. the settlement deteriorated; it was ultimately occupied by squatters until the early 5th c. The large Anglo-Saxon cemetery N of the settlement, excavated in 1926-30, was probably used from the later 4th c. until the 6th and 7th c.

BIBLIOGRAPHY. *Diary of the Rev. John Skinner, 1800-37* (BM Add. MSS 33633-730, 28793-95); Rev. Dom. E. Horne, "The Anglo-Saxon Cemetery at Camerton," *Proc.*

Somerset Arch. Soc. 74 (1928) 61-70; 79 (1933) 39-63; id., "The Early Iron Age Site at Camerton, Somerset," ibid. 83 (1937) 155-65; W. J. Wedlake, *Excavations at Camerton, Somerset* (1958).

W. J. WEDLAKE

CAMPAGNAC Aveyron, France. Map 23. The caves of the Ancize were occupied from prehistoric times on. In them have been found painted ware of Ionian tradition and Gallo-Roman artifacts, in particular a tiny bronze statuette.

BIBLIOGRAPHY. M. Labrousse in *Gallia* 22 (1964) 428-29 & fig. 3; 26 (1968) 516; L. Balsan, "Découverte de céramique ionienne en Rouergue," *Rev. du Rouergue* 20 (1966) 172-75.

M. LABROUSSE

CAMPONA (Nagytétény) Hungary. Map 12. A Roman camp, 16 km S of Budapest, on the Danube. Mentioned by the *Antonine Itinerary* (245.6), it was built at the beginning of the 2d c. A.D. and stood till the end of the 4th c. or the beginning of the 5th. The camp (178 x 200 m) had four gates, across from each other, with two towers each (4 x 3.5 m); in addition it had square inner towers and in the corners, in front of the inner towers, huge, fan-shaped, protruding towers were built between 322 and 333, after the devastation of the Sarmatian wars. The whole camp was surrounded by moats. During excavations the porta praetoria was unearthed, the porta principalis sinistra (preserved on site), the porta decumana, the corner towers (two of these preserved on site) and, in the center of the camp, some of the buildings of the principia. The porta principalis sinistra and dextra were blocked off by a huge, horseshoe-shaped wall during the 4th c. The ruins of canabae were discovered around the camp. The cemetery was on the E side. Numerous tombstones with inscriptions (now in the museum) and altar stones dedicated to Jupiter, Hercules, Silvanus, Sol preserve the names of the inhabitants. More than 10,000 coins are preserved in the Hungarian National Museum.

BIBLIOGRAPHY. I. Járdányi-Paulovics, *Nagytétényi kutatások* (1957); F. Fülep, "A nagytétényi római tábor," *Budapest müemlékei* 2 (1962) 643-52MPI.

F. FÜLEP

CAMPSA, *see* LIMES OF DJERDAP

CAMULODUNUM or Colonia Claudia Victricensis (Colchester) Essex, England. Map 24. On the river Colne, 16 km from the sea and 80 km NE of London. It was the tribal town of the Trinobantes, in a promontory fortress some 307 ha in area, bounded on three sides by marshy river valleys, but on the W by four or more massive linear earthworks which are believed to be mostly the work of Cunobeline. The Trinobantes were conquered by Tasciovanus of Verulamium (q.v.) shortly before A.D. 10, and his son, Cunobeline established his royal city and mint here. By A.D. 43 he was known to the Romans as King of the Britons, and his capital was the main objective of the Roman invasion of that year.

In A.D. 50 Claudius founded a Roman colonia adjacent to Cunobeline's city. An inscription preserved in Rome refers to it as: Colonia Claudia Victricensis which is in Britain at Camulodunum. The two places are thus one, and the identity of the site is beyond question. Camulos was a Celtic war god, and dunum means fortress. The new colonia, including a temple of the emperor, a theater, and a Senate house, was totally destroyed in A.D. 61 by the insurgent Queen Boudicca. After the destruction the government was probably moved to London, but the temple of the emperor seems to have remained in use as such. The town is not mentioned again in history, but one of the three British

bishops at the Council of Arles in 314 was from either Colchester or Lincoln.

The pre-Roman earthworks, largely visible, sometimes imposing, run ca. 5 km N-S. The innermost line was leveled by the Romans, who also made partial use of one other. The site of Cunobeline's city, immediately W of the modern town, was excavated in 1930-39 and 1970. There are no visible remains.

The Roman town, which had no wall in A.D. 61, may have acquired it ca. 200. Most of the wall, nearly 1800 km, remains; it encloses an area of 43 ha. This could indicate an origin as a double legionary fortress, as recent discovery in final paragraph shows. The walls are 2.7 m thick, with rounded angles, interior towers, and earthen rampart-bank. Part of the W gate, toward London, still stands to a considerable height, including two of its six vaulted archways. The size is exceptional, with two carriageways and two footways, and the plan is unique: the ground plan of each tower is a quadrant.

Within the walls the cardo maximus ran from this W gate (the Balkerne Gate) to the E gate, which was pulled down in 1675 and is alleged to have had one main arch with two smaller ones for footways. Most of this line is still the High Street of the modern town. The modern Head Street and North Hill also lie on the line of a Roman street running N-S a short distance inside the W wall. Remains of a Roman Northgate have been found on this line, and in mediaeval times the porta principalis lay at the S end, but no trace of it remains. There are, however, remains of a postern gate in the N wall near the NE angle. A fallen block of masonry, from the upper part, has preserved details which allow a close reconstruction. Curiously, no other gates have come to light in the long N and S walls. Sections cut in the earthen rampart have shown that the wall could not have been built before ca. A.D. 150, and a later date is probable. The street grid has been almost completely reconstructed, and shows a large insula occupied by the Temple of Claudius.

This temple, mentioned by ancient writers, and one of the causes of the rebellion of Boudicca, lies under the keep of the Norman castle, which is built exactly around it. The podium (24 x 31.5 m) had foundations 3.9 m deep, and its original height was probably about the same. It is not solid, but was built with four vaults filled with rammed earth to economize on stone and mortar. These vaults can be visited.

The temple stood in a court (ca. 180 x 120 m), only the S side of which has been adequately explored. There was a monumental central entrance (only part of it has been seen), built on a concrete raft 1.5 m thick and 8.4 m wide N-S. The remains (underground) stand 1.8 m high in places (i.e. 3.3 m over-all). On each side of this feature the concrete platform runs on, with a reduced width of 4.5 m, apparently for the whole length of the S side. Upon it stood a series of piers which had been cased with ashlar blocks of shelly limestone. The piers were connected by arches turned with specially made brick voussoirs. At platform level they were also connected by thin walls (ca. 0.45 m) with ornamental plaster-work on the outside, of two clearly differentiated periods. Each pier, almost certainly, had a partly engaged column before and behind. It is not possible to say whether or not the thin walls completely closed each archway.

In front of the platform was a narrow gravel footpath, which had been remade several times (as had the street) and was bounded towards the street by a small open drain. Reused material in the drain included blocks of alabaster and fragments of large fluted columns plastered to resemble white marble (presumably from the first period of the temple). In the filling were found fragments of colored marbles from all parts of the empire, some of it from wall-sheathing and some from flooring. The remains clearly belong to an architectural screen, but we have no proof that it antedates A.D. 61. Between this screen and the temple, before the S face of the keep, remains indicate a large outside altar surrounded on three sides, at a distance of 3-3.6 m, by a vaulted drain which again suggests that there was an architectural screen. To the NE and NW lay oblong masonry pedestals of a size and shape suitable for equestrian statuary.

There are no other monuments above ground. The site of the theater is almost surely under the site of St. Helen's Chapel and the adjacent burial ground. Forum, basilica, and baths have not been found, but massive foundations, so far unparalleled in plan, have come to light directly opposite the temple insula, and in the next insula to the W remains found under St. Nicholas' church are too large for private houses. Many mosaic pavements have been found in the town, and undoubted traces of the sack and conflagration of A.D. 61.

The finds are preserved in the Castle Museum in the Norman keep, and are particularly rich in pottery and other material from the extensive Roman cemeteries. This is the largest Roman collection in the provinces, and it also covers earlier periods.

Domestic occupation extended outside the walls, including villas with mosaic floors. Several temples of Celtic type have been found, and one site demands particular attention. At the S end of the earthworks some of the inner line becomes curved instead of straight, following the contour line. Within this on Gosbecks Farm there is a large Celtic temple standing within a double portico 27.87 m square. The original enclosure, however, had been a ditch 9 m wide and 2.7 m deep, with coins and pottery of Cunobeline date. The ditch probably surrounded a sacred tree, and the temple and portico were added later. A theater of most unusual plan lies to the S, and E of it a fair-ground over 240 m wide. This could well have been the tribal meeting-place of the Trinobantes, after the foundation of the colonia.

Since this entry was written, the excavators have reported the discovery of the outline of a legionary fortress under the W part of the Roman town. It was apparently of the same size as that at Caerleon, but the remains are fleeting for it was occupied for only seven years. If the colonia established in A.D. 50 occupied the area of this fortress, then the temple of Claudius, built in the same year, was built *outside* the colonia, as indeed it ought to have been.

BIBLIOGRAPHY. M. Wheeler, "The Balkerne Gate, Colchester," *Trans. Essex Arch. Soc.* 16 (1923) 7ff; id., *An Insula of Roman Colchester* (1921); id. & P. G. Laver, "Roman Colchester," *JRS* 9 (1919); F. C. Hawkes & M. R. Hull, *Camulodunum* (1947); M. R. Hull, "The South Wing of the 'Roman Forum' at Colchester," *Trans. Essex Arch. Soc.* 25 (1955) 24; id., *Roman Colchester* (1958); id., *The Roman Potters' Kilns of Colchester* (1963). M. R. HULL

CANATHA (Qanawat) Syria. Map 6. In the Hauran N of Soueida, Canatha was one of the cities of the Decapolis at the end of the Hellenistic period. The city, perched on a steep plateau bordered to the E by a deep ravine, contains many ancient monuments: temples, palaces, churches, a triumphal arch, the SW rampart gate, and tower tombs. Travelers in the past saw a dozen of the latter, still several stories high.

On a wooded slope to the NW stood a temple, a peripteral structure, with Corinthian columns and carved

pedestals and bases. The principal street led E to a flagged space bordered by columns, then some ruins of baths, and nearby a building with a vaulted hall containing inscriptions that refer to Agrippa, Hadrian, Marcus Aurelius, and Julia Domna. On the opposite side of the ravine was an odeon designed like a theater, almost entirely cut in the rock, and next to it a nymphaeum. At the highest point of the city, at the E end of a long terrace, was a portico of Corinthian columns, then an atrium that led to a basilica. The latter had a doorway framed with carved foliated scrolls and maeanders. A church is attached to the W side of the atrium by its chevet. This church is a modification of a building with a porticoed entrance to the N and a semicircular three-lobed exedra to the S, originally a praetorium. Farther S, beyond a Byzantine cistern, are the ruins of a so-called temple of Jupiter.

BIBLIOGRAPHY. R. E. Brünnow & A. v. Domaszewski, *Die Provincia Arabia* III (1909)MPI; H. C. Butler, *PAES* II, *Architecture*, Sec. A, *Southern Syria* (1916)MPI; E. Will, "La tour funéraire de la Syrie," *Syria* 26 (1949); E. Frézouls, "Les théâtres romains de Syrie," *Annales archéologiques de Syrie* 2 (1952). J.-P. REY-COQUAIS

CANDARLI, *see* PITANE

CANÉJAN Gironde, France. Map 23. Situated 15 km S of Bordeaux, on the Roman road from Bordeaux to Salles (Salomagus). The site contains ruined remains of a Gallo-Roman building of the Late Empire, partly covered by the present village church. As is frequently the case in Aquitania, this ruined Gallo-Roman monument was chosen as a burial place both in the Merovingian and the mediaeval period; 13 sarcophagi have been uncovered there. There has been no further excavation.

BIBLIOGRAPHY. J. Coupry, "Informations," *Gallia* 25, 2 (1967) 338I. M. GAUTHIER

CANNABIACA, *see* LIMES PANNONIAE

CANNAE Apulia, Italy. Map 14. A Roman city 8 km NE of Canosa on the right bank of the Ofanto (ancient Aufidus) on a hill, traditionally called Monte di Canne. In its environs have been discovered Neolithic and Bronze Age sherds, a menhir (to the S on the road to Canusium, mod. Canosa), and Iron Age and archaic Apulian burials, the latter furnished with Daunian geometric ware of the 6th-5th c. B.C. An antiquarium houses these remains and also a documentation of the battle of the second Punic war for which the city is best known, in which Hannibal's Carthaginians defeated a larger Roman army in a classic double envelopment. On the right bank of the Ofanto, generally thought to be the battle site, an immense necropolis of 23,000 sq. m was found in 1937 but has proved to be mediaeval.

A representative portion of the Roman town, including part of the wall, has also been excavated. The character of the shops, columns, and inscriptions along an uncovered ancient street indicate that the city may have served as an emporium for more prosperous Canusium through the time of Julian.

BIBLIOGRAPHY. Livy 22; Polyb. 3.107-17.

G. De Sanctis, *Storia dei Romani* (1907); M. Gervasio, "Scavi di C.," *Iapigia* 9 (1938) and 10 (1939); H. H. Scullard, *Historia* 4 (1955) 474ff; F. Tiné Bertocchi, *Ann. dell'Accad. Etr. di Cortona* 12 (1961-64). D. C. SCAVONE

CANOSA DI PUGLIA, *see* CANUSIUM

CANOVIUM (Caerhun) Caernarvonshire, Wales. Map 24. The identification of Canovium with the Roman fort at Caerhun derives from a milestone, and is confirmed by the *Antonine Itinerary* and the *Ravenna Cosmography*. The fort is at the upper tidal limit of the river Conway, close to the point where the road from Deva (Chester) to Segontium (Caernarvon) crossed the river. Another road led directly through the mountains of Snowdonia to Tomen-y-Mur and the S.

Approximately three-quarters of the fort has been excavated; the remainder lies under the church and churchyard. The fort (140 x 140 m; 1.97 ha), had a small annex of uncertain function on its S side. The original fort, built ca. A.D. 80, had earthen defenses and timber buildings in the interior. Modifications involved the building of stone angle-towers, and later of a stone wall; this was not earlier than ca. A.D. 150. Two of the gates have the usual paired guard-towers, but the portae decumana and principalis dextra have only a single tower.

Little is known of the timber buildings of the original fort; the stone ones appear to have been provided for a cohors quingenaria equitata, and since they comfortably fill the area available the original garrison was probably of the same character. The buildings in the central range consist of a pair of granaries with an enclosed space between them; the headquarters, of standard form; and the commandant's house. This last is on a very large scale, though much of its area may have been taken up with open courtyards.

Between the fort and the river lay the bath house. Originally a simple row-type structure, it later received considerable additions and must certainly have had a long life; no precise dating evidence is available. Nor does the evidence from the fort produce any clear picture. It was apparently occupied until the end of the 2d c. A.D., with no detectable intermission. The coin lists suggest that occupation continued until late in the 4th c., but no confirmation can be found in the ceramic evidence. Possibly the civil settlement continued to be occupied after the fort was abandoned. There is a suggestion that the fort may have been briefly reoccupied late in the 3d c., perhaps under Carausius (A.D. 287-293). The finds from the excavations of 1926-29 are in the Rapallo House Museum, Llandudno. The site of the fort may be detected today as a level platform raised above the surrounding fields, but no structure is visible.

BIBLIOGRAPHY. P. K. Bailie Reynolds, *Excavations on the site of the Roman fort of Kanovium at Caerhun, Caernarvonshire* (1938); W. Gardner, "The Roman Fort at Caerhun, Co. Caernarvon," *Archaeologia Cambrensis* 80 (1925) 307-41; P. J. Casey in V. E. Nash-Williams, *The Roman Frontier in Wales* (2d ed. by M. G. Jarrett 1969) 56-59. M. G. JARRETT

CANTABASA, *see* LIMES OF DJERDAP

CANTERBURY, *see* DUROVERNUM CANTIACORUM

CANUSIUM (Canosa di Puglia) Apulia, Italy. Map 14. One of the most important cities of ancient Apulia, located on the right bank of the Ofanto (Aufidus) river ca. 24 km from its mouth, at the boundary between Peucezia and Daunia. Its port on the Ofanto, perhaps navigable at that time in its lower reaches, is recorded by Strabo (6.3.9). According to legend the city was founded by Diomedes and named for his hunting dogs (Strab. loc.cit.; Hor. *Sat.* 1.5.92; *Schol. Dan. Aen.* 11.246). Its Greek origin seems to be confirmed by recent archaeological finds, as well as by the minting of coins with the

legend in Greek, which was still spoken in the Augustan age. Horace (*Sat.* 1.10.30) says "Canusini more bilinguis." The economic prosperity of the city, principally based on the production and sale of wool, is mentioned by Pliny (*HN* 8.190) and other ancient authors. In 318 B.C. Canusium was occupied by the Roman Consul L. Plautius, thus falling under the domination of Rome but conserving its right to coin money (Livy 9.26). During the second Punic war the city, remaining faithful to the Romans, took in the survivors of the rout of Cannae (Livy 22.52-54; Val.Max. 4.8.2; Polyb. 3.107). Canusium fought against Rome in the social war, together with Venosa. It took within its walls the Samnite general Trebazio, defeated in 89 B.C. on the Ofanto by the Roman praetor C. Cosconius (App. *BCiv.* 1.42, 54, 84). Canusium became a Roman municipium (*CIL* IX, 342, 343), and was ascribed to the tribus Oufentina (*CIL* IX, 336, 339, 340, 415). Under Antoninus Pius a colony was established there which was called Colonia Aurelia Augusta Pia Canusia (*CIL* IX, 344). In this period the city was enlarged by Herodes Atticus, who provided it with an aqueduct (Philostr. *VS* 2.1.5).

Recently, in the course of agricultural work, a settlement of the Neolithic Age was discovered and a necropolis with cremation burials from the Bronze Age in the zone to the NW of the modern town in the sections called Pozzillo and Toppicelli. In these areas there have also been found the remains of an indigenous habitation site from the 7th-6th c. B.C., as well as archaic vases of Greek provenience. There are indications of the city of the Hellenistic and Roman times in a number of places in the modern city, from which come marble columns, capitals, entablatures, and inscriptions that are recognizable in many churches in the city. Some have been collected and placed in the municipal building. Recent excavations have brought to light the ruins of fortifications and of a Roman road near the Early Christian baptistery. Also recently noted are the remains of a late Hellenistic temple under the basilica of S. Leucio and of a Roman temple in Via Imbriani. A statue of Jove, which came from the latter, is in the museum at Taranto. The remains of a Roman bath building are preserved in a courtyard in Via Lamarmora, while the ruins of the mediaeval castle incorporate part of the city wall and several towers of the ancient acropolis. At the edge of the city in the direction of Cerignola, along the course of the Via Traiana, is a Roman arch of brick, called Porta Romana or Porta Varrone. It is perhaps one of the many funerary monuments in the area. Among them is the so-called Torre Casieri, quadrangular in plan and built of stone blocks and brick, with a barrel-vaulted cella containing two niches for cinerary urns. There is also a mausoleum of the Augustan age with a square base, which had perhaps a circular superstructure like that of the famous tomb of Cecilia Metella on the Via Appia at Rome. There is also the so-called Monumento Bagnoli, an interesting mausoleum of the 2d c. A.D.

A Roman bridge spans the Ofanto; its arches were rebuilt in the mediaeval period. From the hypogea at Canosa, especially those from the 4th-3d c. B.C., came rich fittings including red-figure Apulian vases, characteristic plastic polychromed vases, and precious goldwork that may now be seen in the museums of Naples, Taranto, and Bari.

BIBLIOGRAPHY. W. Smith, *Dictionary of Greek and Roman Geography*, I (1856) 503 (E. H. Bunbury); *RE* III.2 (1899) 1501-2 (Hülsen); E. De Ruggiero, *Dizionario epigrafico di antichità romane*, I (1895) 83; K. Miller, *Itineraria Romana* (1916) 375; *EAA* 2 (1959) 315-17 (O. Elia).　　　　　F. G. LO PORTO

CÁPARRA, see CAPERA

CAPDENAC Lot, France. Map 23. The site of Capdenac is a promontory fort which dominates the Lot valley. It was first occupied in Gallic times and continues in use in the Roman period. Since the Middle Ages, it has often been identified with Uxellodunum.

BIBLIOGRAPHY. For modern discoveries, see M. Labrousse in *Gallia* 15 (1957) 277; 17 (1959) 435; 20 (1962) 589-90 & fig. 50; 26 (1968) 546; 28 (1970) 427-28; for identification with Uxellodunum, see A. Sors, *Capdenac en Quercy (Lot). La fontaine gauloise et la fontaine de César dans le dispositif du siège et de la bataille d'Uxellodunum* (1965); "Fouilles et découvertes à Capdenac-Uxellodunum," *Archaeologia* (1965) 68-74; "Les projectils de guerre d'Alésia et d'Uxellodunum," *Bull. de la Soc. des Et. du Lot* 88 (1967) 149-53.

M. LABROUSSE

CAPE KUTRI, see PHALASARNA

CAPE MATAPAN, see TAINARON

CAPENA (Civitùcola) Italy. Map 16. An ancient city between the Via Flaminia and the Tiber, S of Soracte on the NE rim of Lago Vecchio, an extinct crater, between two tributaries of Fosso di San Martino, the river Capenas of Silius (13.85), which flows S of Capena to Lucus Feroniae (Sacrofano) and the Tiber. The discovery in 1952 of a number of honorary inscriptions of Imperial date set up by the Capenates foederati has identified the site. Cato (ap. Serv. *Aen.* 7.697) says that Capena was a colony of Veii and that the Capenates considered themselves Etruscans but spoke a Latin dialect, like the Faliscans. Capena sided with Veii in her war with Rome but was forced to make peace in 395 B.C. (Livy 5.24.3); the Capenates who had deserted to Rome were given full citizenship (Livy 6.4). Subsequently Capena became a municipium foederatum, governed by a single praetor even in Imperial times.

Some traces of the city walls remain, presumably built during the Veientine war. The site is surrounded by necropoleis; the earliest burials are of the 8th c.; the richest, of the 7th and 6th c., have produced a wealth of fantastic impasto vases with incised decoration in an exuberant local style. The tomb goods have connections with Italic material rather than Etruscan; the Tiber highway and the Lucus Feroniae in Capena's territory may explain this.

Feronia is an Italic goddess (Varro *Ling.* 5.74 calls her Sabine), and her grove by the Tiber, honored by Latins and Sabines alike (Livy 1.30; Dion. Hal. 3.32) was the site of a great annual fair. The sanctuary was sacked by Hannibal in 211 B.C. (Livy 26.11.8). In 47-46 B.C. a colony of Caesar's veterans, Colonia Iulia Felix Lucoferoniensis, was settled here (Cic. *Fam.* 9.17.2).

The site was identified in 1952; the long Italic forum with its adjacent buildings and a small amphitheater have been excavated, and excavations are in progress. Almost everything is of Augustan date except the foundations of a large Republican temple found in 1961.

BIBLIOGRAPHY. R. Paribeni, *MonAnt* 16 (1906) 277-490; L. R. Taylor, *Local Cults in Etruria* (*PAAR* 2, 1923) 40-59; G. Foti, *NSc* (1953) 13-17; G. Mancini, *NSc* (1953) 18-28; G.D.B. Jones, *BSR* 30 (1962) 116-207, 194-95; 31 (1963) 100-58[MPI].　　E. RICHARDSON

CAPERA (Cáparra) Cáceres, Spain. Map 19. A Roman tributary city of the province of Lusitania (Plin. 4.118) in the N environs of Plasencia. Frequently cited in inscriptions (*CIL* II, 806, 810, 812, 813) and by Ptol-

emy (2.5.7), and located on the road from Emerita to Helmantica (*Antonine Itinerary* 433.7).

The city was ca. 16 ha in area and its walls were probably built in the Tetrarchic period. It had a circus, not excavated; a partially excavated theater, a temple of the Antonine period dedicated to Jupiter and another temple, both of which have been excavated. The temples stood in the forum, as did another building with a facade containing three doors; the central one has a stairway. In front of it is a four-way arch of the period of Trajan, built by a private citizen and decorated on its N side with equestrian statues, now lost. From Cáparra come a togate statue of the Julio-Claudian period, now preserved at the site, a portrait of Tiberius at about the age of 40, a portrait of Antoninus Pius, and one of the period of Gallienus, all kept in the palace of the Duke of Arión in Plasencia.

The numerous inscriptions found here are preserved in Oliva de Plasencia and in Plasencia. One of them is dedicated to the native goddess Trebaruna and dates from the end of the 1st c. There are also milestones of Trajan (*CIL* II, 4662) and Alexander Severus (*CIL* II, 4660), and several stelai of private citizens from the end of the Antonine period or the Severan period (*CIL* II, 818-21, 825, 829, 847). The excavations have produced much sub-Gallic terra sigillata of the Flavian period, Hispanic terra sigillata of the period of Trajan, and glass of the 1st c. The 1st c. necropolis has yielded glass of the 1st c. and silver cups, now in the Archaeological Museum of Cáceres.

BIBLIOGRAPHY. J. M. Blázquez, *Cáparra* I-III (1965-68)MPI; A. Garcia y Bellido, "El Tetrapylon de Capera (Cáparra, Caceres)," *ArchEspArq* 45-47 (1972-74) 45ff.

J. M. BLÁZQUEZ

"CAPE SEPIAS," *see* POURI

CAPIDAVA Dobrudja, Romania. Map 12. Roman military camp on the lower Danubian limes, between Axiopolis and Troesmis, at a crossroads of commercial and strategic routes and near the point where the road crosses the river into the Valachian plain. The first phase of construction was a rectangular castellum with interior towers, built by Trajan at the beginning of the 2d c. It was defended by a system of ditches and a vallum, which was modified by later reconstruction. After destruction by Goths in the middle of the 3d c., the fortifications were rebuilt. The walls are still visible. The plan was rectangular (105 x 127 m) with exterior towers, rectangular at the gates and circular or polygonal at the corners. There was partial rebuilding in the second half of the 4th c. and at the end of the 5th c. On the site of the old city, destroyed by the Huns, was constructed a fort defended by a narrow rampart. At this fort was garrisoned the cuneus equitum solensium (*Not. Dig.* or. 39). At that time Capidava was an episcopal center. A basilica with three apses orientated toward the E has been discovered from this period. The civil settlement developed in the interior of the old city surrounding the fort. Capidava survived until after Justinian's reign, when it was destroyed by the Avars and then abandoned. When the Byzantine Empire regained the borders of the lower Danube, the city was refortified. The last levels date from the 10th and 11th c.

BIBLIOGRAPHY. *Tab. Peut.* 7.3; *It. Ant.* 244; *Geog. Rav.* 779.3.

J. Weiss, *Die Dobrudscha im Altertum* (1911); V. Pârvan, *Descoperiri nouă din Scythia Minor* (1913) 467-73; G. Florescu et al., *Capidava. Monografie arheologică*, I (1958). E. DORUTIU-BOILA

CAPILLA, *see* MIROBRIGA TURDULORUM

CAPITOLIAS (Beit Ras) Jordan. Map 6. A city of the Decapolis in Ajlun in N Jordan. According to the *Peutinger Table* it was between Adraa and Gadara, 16 miles from each. It was an autonomous city and minted coins from the time of Nerva or Trajan to that of Macrinus. The Arabic name preserves a Hebrew-Aramaic form of Beit Reisha, mentioned in Jewish sources. Roman inscriptions found here indicate that local citizens served in the Roman army. In the late Roman-Byzantine period it was part of Palestina Secunda and its bishops participated in church councils between 525 and 536. The city wall, enclosing an area of 125 ha, can be traced on the surface, as well as remains of a colonnaded street, a Roman military cemetery, and a church.

BIBLIOGRAPHY. M. Avi-Yonah, *The Holy Land* (1966) 113, 175. A. NEGEV

CAPE MATIFOU, *see* RUSGUNIAE

CAPO DI PULA, *see* NORA

CAPO D'ORLANDO ("Agathyrnon") Sicily. Map 17B. Archaeological evidence of a habitation center of the Classical period near Capo d'Orlando between S. Martino and Bagnoli has led to speculation that it may be Agathyrnon. Diodoros (5.8) attributes its foundation to Agathyrnos, son of Aiolos, and in 210 B.C. the consul Laevinus transferred to Bruttium 4000 dissidents who had gathered at Agathyrnon (Livy 26.40; Polyb. 9.27). It is unlikely that it should be identified, as has also been suggested, with S. Agata Militello in the territory that was probably "chora" of Halontion.

BIBLIOGRAPHY. G. Parisi, "La via Valeria," *BIA* 11 (1948) 121. G. SCIBONA

CAPPUCK Roxburghshire, Scotland. Map 24. A small Roman fort which guarded the point where Dere Street crossed the Oxnam Water, 19 km SE of Newstead (q.v.). There are no surface remains, but excavation has shown that in the first two periods of occupation (ca. A.D. 80-100) it measured 87 by 65.4 m overall (0.68 ha). In the third period (ca. A.D. 140-155) it measured 90.9 by 78 m (0.72 ha), but finally (ca. A.D. 158-180) it was reduced to 78 by 75.6 m (0.6 ha). The only internal buildings identified were those of the 2d c. occupation, comprising a small granary, a bath house, and a courtyard building resembling a praetorium, all on one side of the central street, with partial remains of barracks on the other. An inscribed tablet records work done here by Legio XX.

BIBLIOGRAPHY. *Proc. Soc. Ant. Scotland* 46 (1912) 446-83; 85 (1951) 138-45. K. A. STEER

CAPRARELLA, *see* ARMENTO

CAPREAE (Capri) Italy. Map 17A. This island in the Gulf of Naples was an important center in the prehistoric period, of which there remain relatively abundant traces. According to Virgil (*Aen.* 7.73) it was reached by the Teleboi coming from Acarnania at the time of the Trojan war. The colonizers, settled both at the Marina and at Anacapri. The two centers, joined by a path worn in the slope of Mt. Solaro, remained relatively independent until the time of Augustus. Construction during the Roman Imperial epoch destroyed nearly every trace of the preceding age.

Visited by Augustus in 29 B.C., the island became the residence of Tiberius between A.D. 27 and 31. During the reign of Augustus began the construction of the imperial villas that, according to Tacitus (*Ann.* 4.67), numbered

twelve under Tiberius. Excavations in the 19th c. and again in 1935 have brought to light the remains of two large villas, the Villa Jovis on the E promontory and the Villa di Damecuta, as well as remnants of minor dwellings. The Villa Jovis surrounds a four-sided court where there are cisterns for collecting water. A ramp leading from Viale dei Mirti to the entrance hall provided access to the palace. A corridor paved in white mosaic led to a second vestibule, from which one could pass to the E to the lodgings and to the bath on the floor above. To the W a flight of steps and a ramp led to the imperial apartments, a large semicircular hall and the private quarters at the N, opening on the W toward the sea. On the N flank of the mountain is the loggia of an ambulatio, interrupted at midpoint by a residential section, and ending to the E in a perpendicular drop to the sea. On the ridge of the mountain was a lighthouse.

The Villa di Damecuta, on the promontory that juts out from the plateau of Anacapri, includes a belvedere, a residential section and an even more scenic lodging on the slope of the promontory. The building complex was buried in 79 by the cinders from Mt. Vesuvius. The remains of other villas are scarce.

The grotto of the Arsenale and the grotto of Matermania were transformed into large nymphaea. After Tiberius the island continued at intervals to be an imperial residence until the Flavian age.

BIBLIOGRAPHY. E. Petraccone, *L'isola di C.* (1913); P. Mingazzini, *ArchCl* 7 (1955) 139-63; A. Maiuri, *Capri. Storia e monumenti* (1956); id., *Capri in prehistoric times and in classical antiquity* (1959).

F. PARISE BADONI

CAPRI, see CAPREAE

CAPSA (Gafsa) Tunisia. Map 18. Situated at the point where the steppe meets the Sahara, the town occupies the pass between the jebels of Ben Younés and Orbata. This gives the city a commanding position, overlooking the great roads which, starting in the heart of Africa and going across the Sahara, converge here before branching off to the E, towards the Mediterranean coast, and towards the fertile, populous regions of the N. The many artesian wells that are to be found among the vast mountainous and desert regions encouraged the growth of palm trees and at the same time favored the development of a city around its oasis, a city enriched by caravan trade. But its prosperity goes back even further, since in prehistoric times the region was the center of a culture which gave the city its name.

It is not surprising that such a site was occupied continuously. Capsa played a spectacular role in the Jugurthine war (Sallust). Loyal to Jugurtha, it was suddenly overcome in an extraordinary raid carried out by Marius who, to impress the Africans, had destroyed the city and massacred its inhabitants. Capsa emerged from its ruins to become a prosperous town once again. A municipium under Trajan, it later became a colonia. In the Byzantine period, when Africa was divided into military districts, it was one of the two seats of the commander of Byzacena. It was also a stronghold, on the edge of the desert, responsible for guarding the frontier of the region. A dedication, fragments of which were reused to build the pools, commemorates the general Salomon's construction of the rampart in Justinian's reign, at the end of the first half of the 6th c.; the city in fact took on his surname. Capsa guarded the whole of this region until the Arab troops of Okba-Ibn-Naffa seized it in 668.

The "Roman pools" are three basins with high walls of reused ashlar. Set in the open air, around springs rising from the bottom of the pools, they are aligned E-W

according to the direction of the outflow of the water and connected by underground channels. The W pool consists of two covered rooms. The two largest pools, Ayn es-Saggaïn (15 x 6.5 m and 3.5 m high) and Aîn Sidna (19 x 16 m), are built of reused stones, some engraved with important inscriptions. From the restored text we know that there was a nymphaeum, under the auspices of Neptune, probably on the actual site of the pools. From other fragments we learn that Capsa, still a civitas in 105 but no longer one under Hadrian, became a municipium in Trajan's reign.

Throughout the whole of the Middle Ages, Gafsa remained a great metropolis in the middle of a region that had long flourished with its many villages and oases. Even today, in spite of its decline, Gafsa remains the capital of Saharan Tunisia, and the modern city stands on top of the older remains. Very little of the ancient city has survived, while certain buildings benefited from the reuse of the old stones—the mosque, which inherited many columns and capitals, the casbah, whose stones have since been removed, and especially the pools, which get their water from the hot springs.

A number of finds have been made in the casbah area; for example, a large mosaic (4.7 x 3.4 m) was found 300 m E in an undetermined monument. Now at the Bardo Museum in Tunis, it depicts an amphitheater scene.

BIBLIOGRAPHY. C. Saumagne, "Capsa: les vestiges de la cité latine," *CahTun* (1962) 519-31. A. ENNABLI

CAPUA (S. Maria Capua Vetere) Campania, Italy. Map 17A. A settlement that showed Villanovan characteristics toward the middle of the 9th c. B.C. The funerary furnishings have comparisons in the area of Etruria from Tarquinia to Bisentium. Capua became an Etruscan city during the 7th c. B.C., a period well documented by funerary paraphernalia that confirm the date of the traditional founding (Vell. Pat. 1.7.2). From this time, Capua had a prominent role in the history of ancient Italy, often in competition with Rome, and it maintained its position until the final years of the Empire.

The Etruscan city was conquered by the Samnites about the middle of the 5th c. B.C.; ca. 338 B.C. it entered into the sphere of Roman political interests. After the battle of Cannae (216 B.C.), it surrendered to Hannibal and became the center of the Carthaginian struggle against Rome. In 211 it was recaptured by the Romans and severely punished. In 83 it became a colony and regained citizenship in 58, returning to its former prosperity and maintaining it in the centuries that followed. In the 4th c. A.D., Ausonius Magnus numbered it among the great cities of the Empire, remarking that at one time it had been a second Rome (*Ordo nob. urb.* 8). In late antiquity the city was devastated and almost depopulated until, nearly destroyed by the Saracens in 840, the inhabitants abandoned it and migrated to Casilinum (Capua).

The city spreads out on a plain, as do many other Campanian centers (Atella, Acerra, Nola, Calatia). Its perimeter in the Samnite and Roman periods may be reconstructed from various elements (the necropolis and the line of the Via Appia) but without complete certainty.

We know from the literary sources the names of the two principal areas of the city, Albana and Seplasia, as well as the names of gates and of temples. The E gate on the Via Appia has been recognized in recent excavations. On the W side of the city, remains of a limestone gate decorated with a Doric frieze have recently been discovered. The most noteworthy of the monuments

which remain are: the amphitheater, built in the 2d c. A.D. and rivaling the Colosseum at Rome in grandeur and importance; the theater, of which the few ruins remaining date to at least the 2d c. B.C.; baths, with a cryptoporticus, which were incorporated in the modern jail; the Mithreum of the 2d-3d c. A.D. decorated with panels depicting the rites of initiation; an honorary arch with three brick vaults on the Via Appia in the direction of Capua Nuova; and two monumental tombs, the so-called Conocchia and Carceri Vecchie, on the Via Appia in the direction of Caserta. Excavation has often brought to light ruins of private homes, tombs, bath complexes, and suburban villas of the Samnite and Roman periods. Although the state of these ruins shows the profound upheaval and massive destruction which the city suffered after it was abandoned, it is possible from the various interesting discoveries to draw certain conclusions about the type of private buildings and their decoration and to make useful comparisons with other Campanian cities (Herculaneum, Pompeii, etc.) and with Ostia.

The inscriptions that the magistri Campani set up to commemorate the public works carried out by them are additional evidence toward a knowledge of the building development in the 2d and the 1st c. B.C. In the immediate suburb (the Patturelli area), a sanctuary was uncovered which dates at least to the middle of the 4th c. B.C. and has provided numerous architectural terracottas, Oscan inscriptions, and tufa statues—the so-called mothers. Another large sanctuary connected with the city was that of Diana on Mt. Tifata. Recent studies have identified the remaining sections of the sanctuary, today part of the Basilica di Sant'Angelo in Formis.

Tombs dating to various periods have been uncovered in the necropolis outside the inhabited area. For the first centuries of the city, the necropolis to the W of the amphitheater (in the Fornaci area) is noteworthy and excavations are still in progress. Among evidence for the Christian period are a cemetery (in the Sant'Agostino area) and a large basilical complex, probably of the Constantine period.

From various discoveries it is known that in the archaic and Classical periods Capua imported articles of Etruscan and Hellenic manufacture, but it was also an active center of production and developed its own art. Its bronzes were celebrated in antiquity and its bronze vases were produced during a long period dating at least from the 6th c. B.C. The production of architectural terracottas and vases is also local and extends from the 7th c. B.C. (Campanian bucchero) until the Roman period (black glaze ware with stamped decorations). Our knowledge of Samnite painting has been enlarged through the tomb paintings.

A local style may be discerned in the characteristic tufa sculptures of the Patturelli sanctuary as well as in the funeral stelai of the Roman period, some of which have been preserved in the local antiquarium and in the Museo Campano. Although taking its impetus from Hellenic mastery (specifically in bronze vases and in architectural terracottas), artistic skill seems to have developed along naturalistic lines (lively notations, hints of color schemes, a sense of volume) which brought it rather close to Etrurian and then to Roman art.

The discoveries made in the area have been preserved in various museums of Italy and of other countries. The major portion may be found in the Museo Campano, whose holdings include architectural terracottas, votive pottery, votive tufa sculptures, materials coming primarily from the Patturelli sanctuary, in addition to funeral stelai, inscriptions, Greek and local ceramic ware, decorative elements of the amphitheater, sculptures and mosaics of the Roman period, and coins.

BIBLIOGRAPHY. J. Beloch, *Campanien* (1890) 205ff; C. Hülsen, *RE* III, 1555ff; J. Heurgon, *Recherches sur l'histoire, la religion et la civilisation de Capoue préromaine* (1970); *EAA* 2 (1959) 335-36 (A. de Franciscis); J. Vermaseren, *Mithriaca I, The Mithraeum at St. Maria Capua Vetere* (1971); A. de Franciscis, *Templum Dianae Tifatinae* (1956). A. DE FRANCISCIS

CARACOTINUM Normandie, France. Map 23. The Gallo-Roman town was on the right bank of the Seine estuary, more or less on the site of mediaeval Harfleur. In prehistoric times, this site must have been an active port, lying as it did at the end of the overland and sea routes of the bronze trade. The first mention of the ancient port is in the *Antonine Itinerary*, on the route from Augustobonam (Troyes) to Caracotinum (Harfleur).

A temple discovered in 1840 is the most interesting monument. Constructed on a Celtic religious site W of the town, the fanum looked down on the estuary. It was square and surrounded by a simple colonnade.

Ruins of many villas have been identified on the slopes above the port. A necropolis with cremation burials was discovered NW of the town, where the present cemetery is. In 1964, a pottery workshop was discovered on a terrace at the base of Mont Cabert. Excavation uncovered tunnel-kilns, run-off trenches, and rubble heaps. Traces of the important Augustobona-Caracotinum road are still visible on the slopes to the NW. The objects found (vases, urns, jewelry, coins, statuettes) have been stored in the Harfleur city hall, awaiting installation in a local archaeological museum.

BIBLIOGRAPHY. Fallue, *Mémoire de la Société des Antiquaires de Normandie* 12 (1840)[M]; A. Naef, "Le Sanctuaire romain d'Harfleur," *S. Havraise d'Etudes Diverses* (1894)[MPI]; J. Lachastre, "Les fouilles du Mont-Cabert à Harfleur," *SNEP* 39 (1967)[I]; id., "Le sanctuaire gallo-romain d'Harfleur," ibid.[PI]. J. LACHASTRE

CARALIS (Cagliari) Sardinia, Italy. Map 14. A city in S Sardinia on the gulf of the same name. It is mentioned by Pausanias (10.17.9), by Claudianus (*De Bello Gild.* 521), in the Itineraries (*It. Ant.* 80; *Rav. Cosm.* 5.26), and in the *Peutinger Table*. From prehistoric times the hills that encircle the gulf were occupied by villages whose economy was based mainly on hunting and fishing in the nearby pools. Little is known of the Phoenician invasion of the area (7th c. B.C.), or of the Punic period. During the Roman domination of Sardinia, Cagliari was at first only a fortified center. Under Sulla it became a municipium, gaining full citizenship under Caesar (*Auct. Bell. Afr.* 98) when it was inscribed in the Quirina tribe and became the most important city on the island (Floro 1.22.35), a position which it still holds. The city was occupied and partly destroyed by the Vandals, but regained vigor in Christian and Byzantine times.

Evidence of Punic civilization is still visible in the upper part of the city, in the Castello and Stampace districts. There are large cisterns excavated in the rock, and a sanctuary of the Hellenistic age dating to the beginning of the 3d c. B.C. in the Via Malta. The latter is one of the earliest examples of the association of a temple with a theater. That the city's commercial and civic life must have been concentrated around the pool of S. Gilla, which at that time was still navigable and included in the port area, is evidenced by the ruins of Punic houses and Roman houses from the 3d c. B.C. in the Scipione section and by a deposit of terracotta figurines now preserved in the National Museum of Cagliari. The necropoleis, situated to the E and W of the city on the

hills of Bonaria and S. Avendrace, contain pit tombs dug into the rock. In the Roman epoch the city spread along the shore from Bonaria to S. Gilla. The acropolis was on the highest level of the upland, now the Castello district. An aqueduct of the 1st c. A.D. still carries drinking water to Cagliari from the mountain above Silliqua, passing through Elmas, Assemini, and Decimo. Late necropoleis have been found between the E slope of the Castello hill and the upland of Bonaria. In this area religious communities were concentrated at the time of the Vandal and Byzantine incursions, and here the nucleus of the basilica of S. Saturno was erected in the 5th c. A.D. Important public monuments have been noted in the region of Bonaria. There is a bath building, of which the caldarium with two pools is visible. It has mosaic pavements in opus vermiculatum and the interior walls are faced with marble. An amphitheater of the 2d c. A.D. is oriented NE-SW and dug into the rocky W flank of the Castello hill.

Other remains include those of a fuller's shop in Viale R. Margherita with a mosaic pavement from the Republican period; a section of the city wall in Via XX Settembre; and cisterns in Via Ospedale, Via Oristano, and Viale Trieste; as well as dwellings. There is a Roman house with a diningroom at Campo Viale, and another (Villa de Tigellio) with a tetrastyle atrium and remains of mosaics and architectural decorations. A large tomb excavated in the limestone bedrock on Viale S. Avendrace is attributed to Atilia Pomptilla and dates to the 1st c. A.D. The objects from the excavations are presently preserved in the National Museum of Cagliari.

BIBLIOGRAPHY. A. Lamarmora, *Itineraire de l'île de Sardaigne*, I (1840) 123; Fiorelli, *NSc* (1877) 285f; (1879) 160f; (1880) 105; A. Taramelli, *NSc* (1909) 135[PI]; E. Pais, *Storia della Sardegna e della Corsica*, I (1923) 351ff; D. Levi, *AJA* 46 (1942) 1ff[PI]; G. Lilliu, *Studi Sardi* 6-7 (1942-47) 252ff[I]; id., *Studi Sardi* 9 (1950) 463ff, 474ff; P. Mingazzini, ibid. 10-11 (1950-51) 161ff[P]; G. Pesce, *EAA* 2 (1959) 255ff[I]; J. A. Hanson, *Roman Theater-Temples* (1959) 32-33[P].

D. MANCONI

CARBANTORATE, *see* CARPENTORATE

CARCASO (Carcassonne) Gallia Narbonensis, Aude, France. Map 23. The ancient town was located on the site of the mediaeval city: on a steep hill 400 m from the right bank of the Aude (Atax), on the road from Narbonne to Toulouse. Pliny the elder calls it an oppidum (*HN* 3.36) and the Bordeaux-Jerusalem Itinerary calls it a castellum. On this site stood a small center fortified by the Volcae Tectosages, then by the Romans, and finally by the Visigoths who took possession of it in 436. The interior rampart of the mediaeval city is generally supposed to rest on Roman foundations, which are in places visible (at the Tour du Plo, for example), and which may date to the 3d or 4th c. The construction of this fortification is sometimes attributed to the Visigoths, but without decisive proof. It appears that the Visigoths were content to restore the Roman work. Fine monochrome mosaics have been found inside the ramparts. No building is known, although the remains of a Temple of Apollo were noted in the 17th c. The town was supplied with water by an aqueduct. Outside the ramparts funerary remains and foundations on the right bank of the Aude may attest to the existence of a suburb.

BIBLIOGRAPHY. A. Grenier, *Carte arch. de la Gaule romaine, fasc. XII, Aude* (1959)[MP]; G. Rancoule & Y. Solier, "La Cité de Carcassonne à l'âge du fer," *Bull. Soc. Etudes Scient. Aude* 72 (1972)[PI].

M. GAYRAUD

CARCASSONNE, *see* CARCASO

CARDEAN Meigle, Angus, Scotland. Map 24. On the Dean Water, 22 km NW of Dundee. The Roman fort, discovered by aerial photography, has been shown by recent excavation to have measured internally over 180 m E-W. It had a turf rampart 6 m wide, two ditches on the W side, one on the S, three on the N, and four on the E side. The ditches averaged 3 m in width except for the two outer ditches on the E, which were 6 and 8 m wide. The span of the E defenses, from the inner edge of the rampart to the outer lip of the fourth ditch was 45 m. The internal buildings were of timber.

Three of the four entrances (E, W, S) have been examined. The entrance gap in the rampart was ca. 12 m wide, and the gap in the two inner ditch-ends at E, W entrances 22.5-30 m wide. The two inner ditches combined into looped ends on either side of the E and W entrance gaps. These looped ends contained much Samian and coarse-ware pottery, and fragments of a fluted glass cup, all of the late 1st c.

Cardean was one of the screen of auxiliary forts N of Inchtuthil, the legionary fortress on the Tay. Their occupation lasted for only a few years, ending in or just after A.D. 86, the date of the six latest coins found at Inchtuthil.

BIBLIOGRAPHY. *JRS* 45 (1965) 83.

A. S. ROBERTSON

CARDIFF S. Glamorgan, Wales. Map 24. Finds from central Cardiff, close to the head of the tidal waters of the Taff, suggest Roman occupation (probably military) from the late 1st c. A.D. The earliest structural evidence is the fort built late in the 3d c. or early in the 4th. No systematic excavation has been undertaken, but the coin list runs as late as the reign of Gratian (A.D. 383-388). The fort measures 195 by 183 m inside its stone defenses, which were equipped with a series of semi-octagonal projecting bastions. An earthen bank, presumably derived from an external ditch, lay against the inner face of the wall. Metaled streets led from the single-arched gates in the N and S sides.

In the 12th c. and later, Cardiff Castle was built within the fort, reusing its fallen defenses. Some idea of the original appearance of the fort may be gained from work undertaken at the end of the 19th c. The E half of the castle is a careful restoration of the Roman walls and N gate, in which the Roman facing can be seen below the modern rebuilding; beneath the modern wall the Roman core survives in places to a height of 3 m.

BIBLIOGRAPHY. J. Ward, "Cardiff Castle: its Roman origin," *Archaeologia* 57 (1899-1901) 335-52; id., "Roman Cardiff," *Archaeologia Cambrensis* 63 (1908) 29-64[I]; id., "Roman Cardiff II," ibid. 68 (1913) 159-64; id., "Roman Cardiff III," ibid. 69 (1914) 407-10; R.E.M. Wheeler, "Roman Cardiff: supplementary notes," *AntJ* 2 (1922) 361-70; V. E. Nash-Williams, *The Roman Frontier in Wales* (2d ed. by M. G. Jarrett 1969) 70-73[MPI].

M. G. JARRETT

CARIČIN GRAD, *see* JUSTINIANA PRIMA

CARLISLE, *see* LUGUVALIUM

CARMARTHEN, *see* MORIDUNUM

CARMO (Carmona) Sevilla, Spain. Map 19. Town in Hispania Ulterior 33 km E of Seville. It belonged to the territory of the Turduli and appears to have been a municipium, appearing in Agrippa's account as oppidum civium romanorum or latinorum. Variants of the name Carmo appear (Caes. *BCiv.* 2.19.4; Strab. 3.141; Ptol.

2.4.10; App. *Hisp.* 58; *Bello Alexandr.* 57.2; 64.1; *Ant. It.* 414.2; Ravenna Cosmographer 315.5).

Carmo began to mint coins before 133 B.C., the obverse of the ass bearing the head of Mercury and of Mars or Roma, and the reverse, the name of the mint between two ears of corn; on later issues, smaller in size, the reverse type is the same but the obverse bears the head of Herakles. Surprisingly, while Caesar called it one of the most important towns in Baetica, it is not mentioned by Mela and Pliny. Its early remains are buried in the area extending from the present Ayuntamiento to the Plaza de Abastos, where there is a large dolmen. Some graves from the Carthaginian period (ca. 5th c. B.C.), with rich grave goods, have been discovered. The name of a certain Urbanibal, of Carthaginian descent, who lived during the Roman period, is preserved on a funeral urn discovered in the Roman cemetery and today in the Carmona museum.

Remains of the Roman period include part of the wall (the gates of Seville and Cordoba were modified in the Arab and mediaeval periods), a large temple, the Roman cemetery containing underground tombs such as those of Servilia, Prepusa, Postumius, and the Elephant, and the amphitheater, which is partly cut out of the rock and dates from the last quarter of the 1st c. B.C. Portraits, sculptures, and inscriptions have also been found in the town and in the necropolis.

BIBLIOGRAPHY. J. Bonsor, *Memorias de la Sociedad Arqueológica de Carmona* (n.d.); J. D. de la Rada, *Necropolis de Carmona* (1885); E. Bonsor, *An Archaeological Sketch-Book of the Roman Necropolis at Carmona* (1931); J. Hernández Diaz et al., *Catálogo arqueológico y artístico de la provincia de Sevilla* (1943); C. Fernández Chicarro, *Excavaciones del anfiteatro de Carmona* (in preparation). C. FERNANDEZ-CHICARRO

CARMONA, *see* CARMO

CARNUNTUM Austria. Map. 20. Between Bad Deutsch Altenburg (to the E) and the small town of Petronell (to the W), ca. 40 km down the Danube from Vindobona (Vienna), an important Roman military stronghold on the middle Danube. The name is of Illyrian origin. Because of its position in the road network, Carnuntum was strategically one of the chief cities on the boundary between Noricum and Pannonia. It was situated at the crossroads of two major trade routes: the ancient tribal road along the Danube and the important S-N connecting road from the Adria region (Aquileia) along the E boundary of the Alps to Carnuntum. At this point the amber route running S from the Baltic thrust out toward the Danube—a major artery from early times with the valley of the March providing a favorable passageway for invaders from the N. The geographical and political importance of the site is thus reflected in its history.

The early Illyrian-Celtic settlement of Carnuntum was situated near the Braunsberg mountain by Hainburg, on whose summit the oppidum of the Boii was set up as a center of defense. After the occupation the indigenous population settled in the Petronell territory (later to become the civilian city). Not long after the conquest of Pannonia (12 B.C.), Carnuntum became a sortie base for the military operations that Tiberius carried out against the Marcomanni under King Maroboduus. As such it is first mentioned, under the name locus Norici regni. In A.D. 14 the Legio XV Apollinaris was transferred from Emona to the stone camp here which apparently was built under Tiberius. In this period too the E boundary of Noricum, with Carnuntum, was added to

the province of Pannonia for military and administrative reasons.

In A.D. 62 Legio XV, detached to serve in the E campaign for a few years (63-68), was relieved by Legio X gemina or Legio VII Galbiana (68-69). On its return in 71, the legion once again served in Carnuntum but was replaced in the latter part of Trajan's reign by Legio XIV gemina, which was to remain in garrison here to the end of Roman domination. Under Trajan (in the years 103-107) the province of Pannonia was divided into Pannonia superior and inferior and Carnuntum was made chief city of Pannonia superior and thus the seat of the governor. Hadrian visited the city during his tour of the Danubian provinces in 124 and raised the settlement W of the camp to the rank of municipium Aelium Carnuntum. Often in difficult and dangerous times the Danube fortress was to shelter emperors within its walls. When Carnuntum, together with the Viennese basin, was overrun in the Marcomannic invasion, Marcus Aurelius began his counteroffensive from this spot. For two years (172-74) Carnuntum was his headquarters. Here, too, the emperor wrote the second book of his Meditations.

Twenty years later at Carnuntum the then governor of Pannonia superior, Septimius Severus, was promoted from soldier to emperor on the strength of his leadership of Legio XIV and the city was made colonia Septimia Carnuntum in 194. During the wars of succession in the unsettled 3d c., Carnuntum in 260 was evidently one of the centers of the usurper Regalianus. Since most of the coins of this rival emperor are to be found around Carnuntum, he presumably had his mint here. In 308 Carnuntum was the site of a meeting of the emperor Diocletian with Maximianus and Galerius on the succession to the throne. The Mithraic altar set up on this occasion has been preserved and represents the most significant historical inscription from Austria Romana. The last known time that an emperor stayed in Carnuntum was in 375. Valentian I rushed here to prepare a retaliatory strike against various Germanic tribes. By that time, however, the city had lost all its early splendor. The decline over the previous century had turned it into an "oppidum . . . desertum quidem nunc et squalens" (Amm. Marc. 30.5.2), forcing the emperor to set up his winter quarters in Savaria. As a striking illustration of this decline, about 700 inscriptions dating from the first three centuries were found on the soil of Carnuntum, but only four from the 4th c. The end of Roman domination came with the invasion of Germanic tribes in 395. The fate of both camp and city was sealed with the collapse of the boundary as far as Vindobona and the final surrender of Pannonia I to the Huns in 433. Carnuntum was last mentioned in the *Notitia dignitatum* (34.24; 26; 28).

The site comprises three complexes differing as to area, function, and administration: (a) the camp and adjacent territorium; (b) the canabae; (c) the municipium, W of the camp, also clearly separate from the canabae.

The camp is on rising ground between Petronell and Bad Deutsch Altenburg (at road km mark 42) on the banks of the Danube. It is irregular in plan, owing partly to the configuration of the ground, partly to later changes in construction (especially the bays on the E facade). The outline resembles a rhombus. The N facade has collapsed where the river has undermined the bank. The original area of the camp must have been approximately 500 by 400 m. The greater part of the surface has been excavated. The sturdy circuit wall, which is 1.8 m thick with rounded-off corners, has a trench system of differing width and is fortified at irregular intervals with inward-facing towers. The via principalis, which lay exactly where the cross-country highway runs today, had two

gates at each end with double towers and two passages; likewise the porta decumana. It is no longer possible to determine whether there was a porta praetoria. The interior plan seems fundamentally to follow the usual arrangement. On the other hand, because of the many construction changes made over the 400-odd years that the site was occupied (up to eight construction periods have been noted at certain spots), much has become unclear. Projected excavation should help clarify as far as possible the sequence of the strata and the plan of the settlement in post antiquity.

The military amphitheater is situated on the territorium legionis. Placed, unusually, only ca. 100 m E of the camp, it is nevertheless somewhat below the level of the defenses. Laid out in a depression, it measures 98 by 75 m on the outside, the arena being 72 by 44 m. In the middle of the arena is a basin (8 x 6 m and almost 4 m deep). The governor's loge is in the middle of the S side, the Nemesum by the W gate. The cavea with its wooden seats could accommodate approximate 8000. The stone building put up probably in the first half of the 2d c. A.D. on the site of an earlier wooden structure was founded by the decurio C. Domitius Zmaragdus of Antiochia (Syria). Among the buildings on the territorium legionis was a large forum-marketplace, some 100 m SE of the camp. It has two porticoed courtyards, four fountains, a portico on the N side and, with its outer dimensions (182 x 226 m), corresponds roughly to a quarter of the camp's area. This unusually large size, which takes into consideration not only the population of the surrounding region but also the neighboring Germanic tribes, testifies to Carnuntum's economic role as a center of trade. The military necropolis extended from the W camp gate to the civilian city along the Aquileia road; it contains tombs dating mainly from the 1st and 2d c. Numerous tombs were uncovered around the civilian city, but as yet we have no clear idea of their chronology.

The built-up area of the civilian city extends at least 2 km E to W, ca. 1.5 km from N to S. The center (with forum and Capitolium) has not yet been located. However, three monuments dedicated to Mithras and one to Jupiter Dolichenus have been located.

The most striking building complex is the so-called palace. The rectangular area (104 x 143 m), not completely excavated, is walled on two sides and porticoed on the other two. Especially noteworthy is the transverse wing on the S side—a rectangle (50 x 20 m) having 16 small rooms on three sides and, in the middle, two octagons each measuring 6 m in diameter and a rotunda 4 m in diameter. The strikingly large apsidal area in the N section suggested that this was an audience hall, and that the whole complex may have been designed as the legate's palace. The purpose of the complex, as well as of the individual rooms, is still undetermined. The building work visible today dates from the 3d-4th c., while the first construction period of this large-scale complex goes back to the 2d c. Houses were uncovered in another sector of the excavation, in the so-called garden walk on either side of the Schlossstrasse. The S row of houses is thought to be the business quarter and the large complex N of it, with a paved street alongside it, is interpreted as a public bath building.

Two more monuments of a public character should be noted in the civilian city, both situated in the S section of the settlement. The first is the municipal amphitheater. The plan (an irregular ellipse) measures ca. 130 by 110 m, the arena itself ca. 68 by 50 m. The monument had a seating capacity of 13,000. Thus this second amphitheater is substantially larger than that of the camp. It was presumably built under Hadrian. Of particular interest are some late structures built in the S gate of the complex. The 4th c. Christian community erected a small rectangular building here and inserted in the floor a six-sided basin made of plundered materials, in this way creating a baptisterium with a font. The second most noteworthy structure in the civilian city is the so-called giant gate (Heidentor). It is the major regional landmark, visible from far off, and the only monument still standing aboveground since Roman times. Today only two piers, with a vault between them, are preserved; formerly there were four piers set on a square plan, with a groin vault supporting a superstructure. Originally the monument stood ca. 21 m high; the remains are 14 m high. It was clearly not a roadway arch, since there is a cylindrical pedestal 1.8 m high in the middle of it. The nature and date of this monument, which was erected after A.D. 200, have not yet been determined (a sepulcher? a monument honoring Septimius Severus?).

A number of stone monuments have been preserved aboveground in the area around Carnuntum. These are, aside from the arch, the two amphitheaters, the so-called palace, part of the civilian city (garden walk), as well as an open-air lapidarium and display of mosaics. Finds from Carnuntum are for the most part in the Museum Carnuntinum in Bad Deutsch Altenburg, others in the Schloss Traun in Petronell and the Kunsthistorisches Museum in Vienna.

BIBLIOGRAPHY. W. Kubitschek & S. Frankfurter, *Führer durch Carnuntum* (1923)[MPI]; E. Swoboda, *Carnuntum. Seine Geschichte und seine Denkmaler* (1964)[MPI]; H. Stiglitz, "Carnuntum," *RE* Suppl. XII (1970) 1575ff; M. Kandler, "Die Ausgrabungen im Legionslager Carnuntum 1968-1973," *AnzWien* 111 (1974) 27ff[MPI]. R. NOLL

CARONIA, *see* CALEACTE

CAROVIGNO, *see* KARBINA

CARPENTORATE (Carpentras) Vaucluse, France. Map 23. Chief town of an arrondissement on the left bank of the Auzon river, 25 km NE of Avignon. Capital of the Gallic tribe of the Memini, neighbors of the Cavares and Voconces (referred to by Pliny in his list of Latin oppida in Narbonese Gaul: Carpentorate Meminorum, *HN* 3.36). A trading city and great marketplace, a political and religious center, it became a Roman colony under the name colonia Julia Meminorum, inscribed in the tribus Voltinia at the beginning of the Empire (epitaph of a municipal official in the Musée Lapidaire in Avignon, and inscription to the guardian spirit of the colony in the Musée de Carpentras). At the beginning of the 2d c. Ptolemy mentions the capital of the Memini as Forum Neronis, a name improvised to supplant the native place name. The latter may have been related to the local god Carpentus, and Carpentorate could mean the fortress of this god, the city where he is supposed to have had his sanctuary. The Roman city was connected by Cabelio (Cavaillon) to the Via Domitiana, by Arausio (Orange) to the great road of the Rhône Valley, and by a secondary road to Vasio, the capital of the Voconces.

Excavations in 1965 in the Lègue quarter, on a hill dominated by a plateau 2 km E of Carpentras, indicate that this area was probably the original home of the Memini. Foundations of huts hollowed out of the clay were discovered. They contained imported pottery: numerous fragments of cups with handles on the sides and gray Phokaian pottery bowls with wavy decorations, also local products with the same decoration, imitating

the Phokaian vases, and urns and basins of rough clay. Campanian pottery is also represented, as well as some bronze coins with the bull of Massalia.

From the Roman period, Carpentras possesses a triumphal arch, in the courtyard of the Palais de Justice, very similar to that at Saint-Rémy-de-Provence. The arch has a single bay, and the archivolt springs from pilasters fluted and cabled for one-third of their height. Their capitals are composite. At each corner is a broken piece of a fluted column. The ends carry bas-reliefs symbolizing the conquest of the country by the Romans. Two captives, their hands tied behind their backs, flank a trophy to which they are chained. On the E end one prisoner wears a Phrygian cap, a short tunic and long coat, and trousers wrapped around his legs by interlaced straps. The other is bearded, has naked arms and legs, and wears only a fur coat to his knees. The trophy is a tree trunk holding two horns surmounted by two quivers; two swords hang from the trunk. At the base of the trophy are a two-headed axe and a dagger with short blade and twisted haft. A round leather helmet, without a visor, hangs from a branch above each captive. The bas-relief on the W end differs in a few details. The arch dates from the 1st c. A.D., like that of Orange, the city was destroyed by the Ostrogoths, the Franks, and the Burgundians during the 5th and 6th c. A.D.

BIBLIOGRAPHY. I. Gilles, *Précis historique et chronologique des monuments triomphaux dans les Gaules* (1873); J. Liabastres, *Histoire de Carpentras, ancienne capitale du Comtat Venaissin* (1891); J. Sautel, *La Provence romaine* (1929); id. et al., *Vaucluse histoire locale* (1944); H. Eydoux, *La France antique* (1962); G. Barruol, "Une peuplade de la confédération Cavare: les Memini," *Provence Historique* 13 (1963); "Informations," *Gallia* 25, 2 (1967). A. DUMOULIN

CARPENTRAS, *see* CARPENTORATE

CARPINO, *see* URIUM

CARPOW Perthshire, Scotland. Map 24. A military base on the S bank of the Tay, used by Septimius Severus during his British campaigns in 208-11, and described by Cassius Dio (76.12f) and Herodian (3.14). Its Roman name is unknown, but it was not Horrea Classis as was believed earlier. The defenses, formed of a 6 m earth bank and two ditches, enclose an irregular quadrilateral (337.5 m E-W x 280.8 N-S; 11.16 ha). In the middle of each side was a stone gate with two passageways but no guard chambers.

Inside, near the center of the enclosure, was a stone principia (46.5 x 39 m) and the bath suite of a praetorium. Tiles were stamped by Legio VI victrix with the titles BRITANNICA PIA FIDELIS (LEG VI VIC B P F), and the Legio Augusta is attested as well by its emblems of the capricorn and pegasi on a sculpture found at the E gate. Aerial photographs have revealed legionary barracks in the praetentura, an annex at the SE, and a large temporary encampment enclosing the entire Severan complex. The base was abandoned soon after 212, when Caracalla made peace with the Britons, although a TRAIECTUS coin of that ruler showing a bridge of boats probably refers to Carpow, while a fragmentary inscription from the E gate probably dates to some time not long after 211.

BIBLIOGRAPHY. R. E. Birley, *Proc. Soc. Ant. Scot.* 96 (1962-63) 184ff[MPI]; R. P. Wright, ibid. 97 (1963-64) 202ff (inscription); *JRS* 59 (1969) 110 (aerial photographs), 203[P]; J. K. St. Joseph, ibid. 63 (1973) 220ff[MPI]. J. J. WILKES

CARRAWBURGH, *see* BROCOLITIA *under* HADRIAN'S WALL

CARREO POTENTIA (Chieri) Piedmont, Italy. Map 14. About 12 km SE of Turin and in antiquity a city of the Augustan Regio IX. Perhaps a Gracchan colony, it was built on a previous oppidum of which there is a reminder in the Roman-Celtic name (Carreo quod Potentia dicitur: Plin. 3.5.49). Its identification with Chieri is based on lost epigraphic evidence of M. Ebatius, who mentions (C)-arrei and Industriae. This is strengthened by sparse but significant discoveries. The aqueduct, which entered the city from Tetti Miglioretti, met the junction of the cardo (the Via Vittorio Emanuele) and the decumanus into which the principal cross streets ran: the road to Augusta Taurinorum with an orientation NW to SE and the road through Hasta to Forum Fulvii-Dertona (the Via Fulvia) in a NE direction. Remains of structures discovered inside the Cathedral may confirm the existence of a cult building which local tradition attributes to Minerva (the Capitolium?). Outside the building, the fortuitous discovery of a discharge tunnel, with an orientation E-W, seems to follow the straight alignment of houses and streets that run parallel to the cardo in the S sector. Sections of walls have been brought to light in Via Palazzo di Città in the course of a random excavation and may belong to the fortified circuit wall which, on this side, must have run in a straight line following the line of the modern streets.

Outside the settlement, which must have been elongated in the direction of the cardo, the necropolis spread out along the principal and secondary streets to the NE and SW. Still to the NE, 500 m from the Maddalena farm, along the old road to Cambiano, the discovery of a farmhouse with its attached equipment (a triple basin and fishpond for rain water) dating to the 2d c. of the Empire gives evidence of the population of the countryside around the urban center. Inscriptions are for the most part scattered. Some of the excavated material has been brought together in the Museum of Antiquities at Turin, and the most recent finds are housed in the small Museo Civico.

BIBLIOGRAPHY. Plin. 3.5; *CIL* v, 848, 7493ff; *Inscr. It.* IX, 1.16.

G. Cipolla, *Resti di costruzioni romane e oggetti vari*, N.S. (1890) p. 327ff; F. Gabotto, *I municipi romani dell'Italia occidentale* (Biblioteca Soc. Storica Bibiliografica Subalpina, XIII; 1908) 180; E. Pais, *Dalle Guerre puniche a Cesare Augusto* (1918) 673; R. Ghivarello, "L'acquedotto romano di Chieri," *BSPABA* (1932) 156ff; P. Barocelli, "Notiziario di archeologia piemontese," *BSPABA* (1932) 221ff; A. Cavallari Murat, *Antologia monumentale di Chieri* (1968). S. FINOCCHI

CARRHAE (Haran) Turkey. Map 5. About 40 km S of Edessa at the junction of important trade routes, this site is the Haran of the Bible and the Mari letters. It was famous in antiquity for planet worship and a provincial capital in the Assyrian empire. The Macedonians, and later the Romans, had a garrison there. Crassus was defeated nearby in 53 B.C. (Plut. *Dio Cass.*). Its temples were visited by Caracalla and Julian. The Muslims took it in 639; it declined after the Mongols sacked it in 1260.

Excavation of the Great Mosque effectively proved the identification of the site with modern Haran. Three stelae of Nabonidus were uncovered (a fourth, now at Ankara, had been found earlier at Eski Haran) and a fragment with the name Haran. The irregular direction of the NE wall of the mosque marks the presence of a pre-Muslim pagan ("Sabian"?) chapel. A ruined Chris-

tian basilica (in the SE corner of the derelict city wall) and the present citadel were built also on the site of "Sabian" temples.

Objects from Haran are housed in the museum at Urfa; they include a statue in Iranian dress. About 24 km N-NW of Haran is Sultantepe.

BIBLIOGRAPHY. S. Lloyd & W. Brice, "Haran," *AnatSt* 1 (1951) 77[MPI]; D. S. Rice, "Studies in Medieval Harran," ibid. 2 (1952) 36; C. J. Gadd, "The Harran Inscriptions of Nabonidus," ibid. 8 (1958) 35; J. B. Segal in E. Bacon, *Vanished Civilizations* (1963) 201.

J. B. SEGAL

CARRIDEN, *see* ANTONINE WALL

CARSEOLI (Carsóli) Abruzzo, Italy. Map 16. An oppidum of the Aequi on the Via Valeria ca. 65 km from Rome. In 302 or 298 B.C., it became a colony under Latin law. In 168 B.C., Bitis of Thrace was confined there. The town was devastated in the social war and subsequently became a municipium. It rose in the present district of Civita, ca. 3 km from the modern town, on a rocky spur which dominates the high plain of the Cavaliere near the course of the Tolerus river. The site, abandoned in the 13th c., has never been excavated. There are remains of the rectangular block walls, of tufa walls with limestone repairs, the podium of a temple, and a street, along the major axis, which crosses the entire settlement starting at the Via Valeria. In the vicinity, remains of an aqueduct and of a rich votive depository of the 3d c. B.C., today in the Museo di Chieti, have been found.

BIBLIOGRAPHY. B. J. Pfeiffer & T. Ashby in *PAAR* 1 (1905) 108ff; A. Cederna, *NSc* (1951) 169ff; id., *ArchCl* 5 (1953) 187ff.

G. COLONNA

CARSIUM (Harsova) Romania. Map 12. An ancient center of Getaean origin on the right bank of the Danube. It commands a shallow spot in the river which served as an important ford for merchandise for the Wallachian plain from Histria and the other colonies. Opposite Carsium, on the left side of the Danube, one of the river's major tributaries, the Jalomitza, crosses the plain and becomes an important commercial artery for the Getaean settlements located in this area.

Carsium became part of the limes before the time of Trajan and was closely linked to the other military garrisons, especially Capidava and Troesmis, by means of the great Roman road that flanked the right bank of the river. The importance of this artery may be judged by the numerous times it was repaired between the reigns of Marcus Aurelius and Diocletian.

Already from the Republican period, together with the other centers along the right bank of the Danube, Carsium became part of the governmental formation of the Odrysae, and more precisely of the Roman territorial organization named the Ripa Thraciae. A real castrum was built at Carsium in 103 during the Dacian wars, and it became part of the broader defensive system of the limes. From the age of Trajan until the fall of the Roman Empire, Carsium was continually reinforced, especially by troops of cavalry for rapid attack against the Daco-Getae who infiltrated Scythia Minor from the Wallachian plain or from Moldavia. These raids into the barbaricum were planned to end this pressure on Scythia Minor. That is to say, on the left bank of the Danube across from Carsium was a propugnaculum where a numerus Surorum sagittarium (*CIL* 3,7493) was quartered. Following this reinforcement of the garrison, small agricultural settlements such as vicus Verobrittiani, or later vicus Carporum, sprang up in the vicinity.

Nothing is known either of the form of the castrum or of the arrangement of its monuments. Architectural elements of several monuments from the Imperial age have been recognized however; and a bronze mask was found that is a copy of a Hellenistic original.

The last precise notice of Carsium appeared at the time of Diocletian when the Milites Scythici were quartered there.

BIBLIOGRAPHY. R. Vulpe, *Histoire ancienne de la Dobroudja* (1938) passim; id. & I. Barnea, *Din istoria Dobrogei*, II (1968) passim.

D. ADAMESTEANU

CARSÓLI, *see* CARSEOLI

CARSULAE Umbria, Italy. Map 16. A town on the Via Flaminia, 18 km N of Narnia, belonging to the tribus Clustumina. It figured in history only in A.D. 69 when Vespasian's army marching on Rome halted there, while the Vitellians held Narnia (Tac. *Hist.* 3.60). Its ruins are well preserved. Arches spanned the Via Flaminia at either gate; one survives. Around the forum, excavations have been in progress for the last 25 years; three sides of the trapezoidal square, including a basilica, twin temples on podia, and twin quadrifrontal arches have been uncovered; with, just to the E, an amphitheater (86 x 62 m) set in a limestone sink, and a theater. All the buildings are of similar construction and seem to belong to the Early Imperial period.

BIBLIOGRAPHY. *Forma Italiae VII.1 Tuder-Carsulae* (1938) 89-104 and pls. 35-39 (G. Becatti)[MI]; *EAA* 2 (1959) 372 (U. Ciotti)[I]; *AA* 85 (1970) 319-21 (H. Blanck).

L. RICHARDSON, JR.

CARTAGENA, *see* CARTHAGO NOVA

CARTEIA, *see* KARTEIA

CARTHAGE Tunisia. Map 18. Situated on a large peninsula, which stretched between salty lagoons to the furthermost part of the gulf of Tunis, Carthage was twice in antiquity a capital. Founded by Tyrians, who came from Phoenicia, the settlement quickly became the metropolis of an empire, at first essentially maritime. Destroyed, it was reconstructed and immediately raised to the rank of capital of the province of Africa, a position it held almost to the end of antiquity. This past, covering 15 centuries of history, has left relatively few traces which strike the imagination of the visitor of today. Since the end of the 19th c., modern life has progressively covered over much of the ancient site.

During all the centuries of abandonment which preceded, the ruins served as an inexhaustible stone quarry for Tunis and other towns as well as for present-day structures built on the site. Very few monuments have escaped this intensive exploitation. Further, the explorations of the 19th c. resulted in stripping the remains of their archeological objects for private collections and museums.

Of the first Punic city there are known only the two harbors, the tophet, the sacred area destined for cult sacrifices, and the necropoleis, which form a large strip occupying the N heights of the town. Of the Roman period, several monuments have survived which, in spite of their ruinous condition, bear witness to their original importance. To the SW, no more of the circus remains than traces of foundation; a little farther to the N was the amphitheater, of which only the arena and the substructures have survived; of the Odeon, situated on the summit of the plateau, there exists no more than the platform of the foundation; of the theater only a part of the cavea, backed against the side of the hill, is still

intact. There are also the large cisterns of Malga to the W and those of Borj Jedid to the NE, fed by the aqueduct of Zaghouan; and finally, above all, the Baths of Antoninus preserved today in a great archaeological park. This is the most imposing monument of Roman Carthage and counts among the largest of the Empire. Situated on the seashore at the foot of the hill of Borj Jedid, with one facade towards the sea and the other towards the interior, it had an alternation of projections and recesses formed by a succession of rectangular, hexagonal, and octagonal rooms. Perfectly symmetrical in plan, it was covered by an immense vault supported by enormous granite columns. The wings encircled two large palestrae with porticos of white marble. The building was surrounded by an esplanade, itself circled by porticos and building annexes of which two immense hemicycles sheltered the latrines.

In this city, subjected to incessant pillage of its materials and objects, the most indestructible monument is certainly the city plan. A large-scale work, thought out rationally and implanted by Rome even at the origins of the re-founding of the town, this plan takes as its central axis the summit of the acropolis of Byrsa and divides the area of the city into four quarters of equal importance except for the one situated to the NW. A rectilinear, regular plan of the streets determines the insulae in which are set all the monuments of the town.

The most remarkable sector in this regard is that which stretches along the slope of the hill of the Odeon. Uncovered by several campaigns since 1899, the villas included in these areas rose on successive levels up to the Baths of Antoninus. The most remarkable of these dwellings is the House of the Aviary named for a mosaic. Around a large peristyle open the rooms, which also give on an octagonal garden situated in the center of the court. Cleared at the beginning of this century, this aristocratic villa has been restored and transformed in part into an antiquarium protecting some archaeological objects of various provenance.

From the Christian era, several basilicas have been found and cleared: that of Dermech, situated in the archaeological park, that of Damous el Karita, behind the plateau of the Odeon, and to the NE on a cliff dominating the gulf, that of St. Cyprian.

Apart from the houses, which have been despoiled of their most beautiful mosaics, the most complete recovery of the lost city has been carried out in the necropoleis, which surround the town; the numerous furnishings that have been recovered from there constitute the essence of the archaeological documentation of ancient Carthage.

BIBLIOGRAPHY. Audollent, *Carthage Romaine* (1901)[P]; G. C. Picard, *Carthage* (1964; Fr. ed. 1956); *La Carthage de Saint Augustin* (1965)[PI]; Lézine, *Carthage— Utique* (1968)[PI]; M. Fantar, *Carthage, la prestigieuse cité d'Ellissa* (1970). A. ENNABLI

CARTHAGO NOVA (Cartagena) Murcia, Spain. Map 19. Built over the Iberian settlement of Massia or Mastia, capital of the Mastieni, by Hasdrubal in 226 B.C., the Punic town of Qart-Hadasat became the capital of the Carthaginian empire in SW Spain and the base of its future operations against the Romans. The new city had one of the safest harbors in the Mediterranean, rich silver-lead mines, abundant salt pans for the curing industry, and esparto grass plantations which furnished raw material for the manufacture of ships' tackle.

Scipio captured it by surprise in 209 B.C. after a short siege, and it became the site of the Roman colony named Urbs Iulia Nova Carthago, founded by Cn. Statilius Libus on behalf of Lepidus in 42 B.C. It belonged first to Hispania Citerior, then to Tarraconensis, and after 287 was the capital of Carthaginensis. Although destroyed in A.D. 425 by the Vandals, it was for a short time in the 6th c. A.D. the capital of the Byzantine empire in Spain, as evidenced by an inscription of the patrician Comenciolus praising the towers of the gateway of the city. It was frequently mentioned by Classical authors: Polyb. 2.13.1; 10.7.6; 10.10; 3.24.2; Livy 26.41-45; 26.42.2ff; Diod. 25.12; Theopomp. 2.5; Avienus 449ff.

The Roman city was adapted to the topography of the terrain, according to Polybios, who visited it in the second half of the 2d c. B.C. It stood on a promontory bounded on the N by a large lagoon or Almarjal, and on the S by the bay guarded by hills 200-300 m high; the channel joining bay and lagoon was spanned by a bridge carrying an aqueduct to the city. The mouth of the bay was protected by the island of Escombreras (from scomber or mackerel, which abound along the coast). The town lay in a depression between hills, but had on the S a level approach from the sea; the highest hill was named for Aesculapius and was crowned by a temple dedicated to him (today Castillo de la Concepción); on the E the hills of Hephaistos (Despeñaperros) and Aletes (San José) guarded the isthmus and the main landward entry; on the N Mt. Kronos (Sacro) closed the perimeter with the Arx Hasdrubalis (Mount Molinete) where stood the Punic palace, the last redoubt to surrender to Scipio.

The hills were connected by walls restored in the Roman period; an inscription mentions a Topilla or Popilla gate. Outside the walls the Tumulus Mercurii (Santa Lucía) was the site of Scipio's camp. The walls were over 3500 m long, and must have had a single gateway on the isthmus and perhaps an opening near the W bridge. The town covered more than 25 ha and had about 30,000 inhabitants. Its wealth came from the harbor, an important market, from the silver mines which in the 2d c. B.C. produced 25,000 drachmas a day for the Roman treasury, and from the export of esparto grass and cured fish.

Remains consist of columns and ashlar walls of the forum (Plaza de los Tres Reyes), streets (Calle Morería), and the amphitheater (under the present bullring); statues (head of a child, perhaps Augustus, from the Calle Cuatro Santos; headless Hermes from the Pl. San Francisco; a herm with a woman's head; a tutelary Bacchus; togate stele). The Torre Ciega, the tomb of Titus Didius, dates from the 1st c. B.C. and is rectangular. The ashes were in a crystal urn enclosed in a leaden one. The tomb stood on the road leading out of town, with other similar monuments. On San Antón a late Roman cemetery has been found. Of the temples that may have stood on the hills, there is a reference only to that of Aesculapius, but the coins show a tetrastyle Augustan temple (19 B.C.), and there are several references to the cult of Health and its symbol, a snake.

Among the inscriptions there are dedications to Hercules of Gades, the genius of the fortress, to Liber, to Victoria, and one to Mercury by the fishermen and fishmongers dedicating "columnam, pompam, ludosque" to the "Genio oppidi." Prominent persons were sometimes appointed honorary magistrates of this important colony, for example, King Iuba and King Ptolemy. The inscriptions also record the names of the family of the Numisii, Iulia Mamea, without a damnatio memoriae, and many others such as guilds of architects and masons.

There are 43 series of Latin coins, aside from the issues of the Barkedas which bear the portraits of Hannibal and his predecessors. The minting was entrusted to the duoviri quinquennales and the coins may be arranged by 5-year periods, from that of L. Fibricius and P. Atelius,

57 B.C., to the series of Caius Caesar, A.D. 39. The types vary enormously.

The finds are in the Cartagena Municipal Museum, the Murcia Provincial Museum, and the National Archaeological Museum in Madrid.

BIBLIOGRAPHY. A. Beltrán, "La conquista de Cartagena por Escipión," *Actas y Memorias de la Sociedad española de Antropología, Etnografía y Prehistoria* 21, 1-4 (1946) 101; id., *Las monedas latinas de Cartagena* (1949); id., "El plano arqueológico de Cartegena," *ArchEspArq* 25 (1952) 47ff; A. García y Bellido, "Las colonias romanas de Hispania," *Anuario de Historia del Derecho Español* 29 (1959) 470ff.　　A. BELTRÁN

CARVORAN, *see* MAGNA *under* HADRIAN'S WALL

CASALE MONFERRATO, *see* VARDAGATE

CASCIA Umbria, Italy. Map 16. A Sabine site ca. 10 km SW of Nursia where Vespasian's mother, Vespasia Polla, inherited estates (Suet. *Vesp.* 1). At Villa S. Silvestro are remains of a Late Republican tuscanic temple. This has been investigated several times since 1920, but full drawings and description have yet to be published.

BIBLIOGRAPHY. *NSc* (1938) 141-58 (G. Bendinelli)[PI]; E. C. Evans, *The Cults of the Sabine Territory*, *PAAR* (1939) 125-32, pls. 2-7[PI]; *EAA* 2 (1959) 401 (U. Ciotti)[I].　　L. RICHARDSON, JR.

CĂŞEI, *see* SAMUM

CASINUM (Cassino) Latium, Italy. Map 17A. In Crocifisso, Frosinone, 120 km E-SE of Rome, a Volscian city, Oscan in origin. It was occupied by the Samnites and then by the Romans at the end of the 4th c. B.C. (There are archaic 7th c. B.C. tombs, 4th and 3d c. B.C. Hellenistic ones, and Roman tombs of the 2d c. B.C. to the 4th c. A.D.) The city, sacked by Hannibal in 208 B.C. was reconstructed and flourished in the Imperial period, particularly through the interest of a local family, the Ummidi. It suffered decline in the late Empire and was destroyed by the Longobards in the 6th c.

There is evidence of the Roman city on the cliff of the Chiesa del Crocifisso by the Via Latina which crosses it, with the theater above and the amphitheater below, and at the center in a small level area the forum with its remains of a temple dating, in its first phase, to the Volscian period. The theater was probably rebuilt in the time of the amphitheater through a gift from Ummidia Quadratilla in the second half of the 1st c. A.D. The mausoleum of Ummidia is unique, with a cella in opus quadratum, on a central plan with a cupola, a pronaos facing E, with Italic Corinthian columns covered in stucco. Paved streets allow us to reconstruct the extent of the terraced settlement. Large remains of cyclopean walls of the Volscian period are visible on the side of the mountain and on the summit the remains of the Temple of Jupiter beneath the Abbey. There is evidence of a villa with a bath complex (noteworthy is an octagonal room known from sketches by Giuliano da Sangallo) in the valley of the Gari river—the so-called villa of M. Terentius Varro.

BIBLIOGRAPHY. G. Carettoni, *Casinum* (1940); id., "Fortificazioni medievali," *Palladio* (1952) 135ff; id., *EAA* 2 (1959) 404-6; id., Sepolcreto dell'età del ferro . . . ," *Bull. Paletn. Ital.* 69 (1960); A. Pantoni, "Pitture della chiesa del Crocifisso," *Benedictina* (1949) 230ff.　　V. SANTA MARIA SCRINARI

CASSEL Pas de Calais, France. Map 23. In the arrondissement of Dunkirk; chief town in the canton. Historians in the 18th and 19th c. long debated whether Cassel was the capital of the civitas of the Morini or of the Menapii. It is now acknowledged that Cassel, situated beyond the Aa (the river bounding the city of the Morini) was in fact the chief city of the civitas Menapiorum. It is often mentioned in the ancient itineraries of Tournai and Cologne. Few traces of the ancient city have been located, but the richness of the chance finds leads one to suppose that it was an important place: a bronze equestrian statue, a bust of Galba, also in bronze. Three ancient roads that do not appear in contemporary guides can still be seen on the terrain: the road from Cassel to Thiennes (on the Lys) and two going from Cassel to the North Sea, possibly toward the salty marshlands (we know how important the salt industry was for the Morini and the Atrebates).

The events of the 3d c. were to be fatal for Cassel. A rampart stands atop the city, a few traces of which were discovered in the 19th c. Cassel was superseded as capital of the Menapii by Tournai after Gaul was reorganized under Diocletian and Constantine. The civitas Menapiorum became the civitas Turnencensium.

BIBLIOGRAPHY. A. Schayes, "Mémoire sur le Castellum Morinorum," *Mem. de la Soc. Acad. de Morinie* 2 (1835) 133-34; M. de Symtere, "Memoire sur Cassel," *Congrès arch. de France, Session de Dunkerque* (1861) 180-241; E. Cantineau-Cortyl, "Notes archéologiques et déductions historiques à propos des constructions découvertes et des terrains reconnus pendant les travaux exécutés en avril 1904 dans la partie Est de la butte du Castellum," *Bulletin de la Commission Historique du Nord* 26 (1904) 217-22; E. Espérandieu, *Recueil général des bas reliefs . . .* (1907-55) v, no. 3975; E. Will, "Le sel des Morins et des Ménapiens," *Mélanges Grenier* (1962) 1649-57.　　P. LEMAN

CASSINO, *see* CASINUM

CASSINOMAGUS (Chassenon) Charente, France. Map 23. This commune is crossed by the D 29 road. The present village replaced the Cassinomagus of antiquity, which is mentioned in the *Peutinger Table*; it grew up beside the great Gallo-Roman monuments that had remained intact, and especially outside what we now know to have been a sacred area, although no texts or inscriptions have come down to us giving precise information. It measured ca. 600 m E-W, ca. 350 m N-S. The wall around this sacred area is still standing to the N and S; the latter section is 450 m long and 2 m high at certain points. Inside the wall were those elements necessary in a rural sanctuary, probably Celtic in tradition:

1. To the W: a temple, known locally as Montélu. Only its cella seems to have been excavated; we have a report dated 1844-48, and from a careful study of the remains of the monument it appears to be scientific and accurate. The author points out that "the plan of this curious building is an octagon forming a huge gallery that is reached by four ramps placed at the four cardinal points. . . . In the middle of the octagon is the cella; its wall is round inside and octagonal outside."

2. To the NW: an amphitheater that was badly and incompletely excavated over a century ago and which has unfortunately been used as a quarry. The 1844-48 archaeologist noted that "the plan is elliptical" and that "the great diameter of the arena is 60 m, the small one 40 m."

3. To the E: two small buildings, carelessly excavated in the past, possibly fana.

4. Equidistant (230 m) from the great temple (Montélu) and the two little fana (?), the baths, which remain nearly complete.

5. More or less in the middle, a huge esplanade or forum, probably a meeting-place for the pilgrims who came to take the waters.

Since 1958 work has gone forward on the baths, both to expose and to salvage them. Some of the walls still stand 9 m above the bed of the aqueducts, of which there is a whole network in the basements. They are double, public bath buildings, with matching rooms on either side of a central axis. Among them are the functional rooms, which are perfectly designed for their intended purposes; the furnaces, for heating by the hypocaust system; the cold pool, with its floor and facings of white marble; and part of the great swimming pool, several dozen meters long.

Vaulted and dark underground rooms occupy the greater part of the lower floor. There are ca. 20 Roman vaults, still showing traces of the planks upon which they were formed. Some of the vaults of these cellars held up the lower floor of the hypocausts, and higher ones supported the floors of the cold rooms, making it possible to pass on one level from the hot to the cold rooms. But the underground rooms clearly had another function, one that was dictated by the circulation of water, the principal element of the sanctuary. The passages linking the rooms are not only narrow and sloping, which Vitruvius recommended as the best way to decant water, but they are staggered so as to break the flow and force the impurities in the water to settle to the maximum extent. Moreover, the layer of mud, 0.8 m thick on the average, that reached the level of the aqueducts in these underground rooms confirms that water circulated in them.

The Musée de Rochechouart (Haute-Vienne) houses the finds made at Chassenon at the end of the 19th and the beginning of the 20th c.

BIBLIOGRAPHY. J.-H. Michon, *Statistique monumentale de la Charente* (1844) 175-92; J.-H. Moreau, *Recueil de textes sur les ruines gallo-romaines de Chassenon* (1958); id., *Comptes rendus annuels de fouilles et recherches à Chassenon* (11 have been published so far); id., *Description et essai d'explication d'un ensemble gallo-romain unique en France*; H.-P. Eydoux, *Resurrection de la Gaule* (1961) 251-78; M. Vauthey et al., "A propos de certaines figurines en terre blanche: ex-voto thermal réprésentant un homme le bras gauche en écharpe" (found at Chassenon), *Revue Archeologique du Centre* (1967) 59-65. J.-H. MOREAU

CASTEGGIO, *see* CLASTIDIUM

CASTEL D'ASSO, *see* AXIA

CASTELFERRUS Tarn-et-Garonne, France. Map 23. On the plateau of Saint-Genès, investigations have led to the identification of: a) a cremation necropolis of the Urnfield culture; b) a large and rich Gallo-Roman villa which has produced a good amount of coins, terra sigillata, glassware, small artifacts, bronze statuettes, etc.; c) a necropolis of barbarian times whose burials contained, among other grave goods, a perforated bronze plate-brooch and a large plate of damascened iron.

BIBLIOGRAPHY. M. Labrousse, "Marques de potiers gallo-romains trouvées à Saint-Genès, commune de Castelferrus (Tarn-et-Garonne)," *Actes du XIXᵉ Congrès d'études régionales de la Fédération des Sociétés académiques et savantes de Languedoc-Pyrénées-Gascogne tenu à Moissac, les 5 et 6 mai 1963*, pp. 11-24. Cf. *Gallia* 20 (1962)

607; 22 (1964) 471 & figs. 53-54; 24 (1966) 447-48 & fig. 40; 26 (1968) 555-56 & fig. 40; 28 (1970) 436; *Saint-Genès (Tarn-et-Garonne: 5000 ans de présence humaine en vallée de Gimone)*, Musée de Moissac (juillet-octobre 1969); M. Labrousse, "Nouvelles marques de potiers gallo-romains trouvées sur le site de Saint-Genès," *Actes du XXVIIᵉ Congrès . . . à Montauban les 9-11 juin 1972*, pp. 103-20. M. LABROUSSE

CASTEL GANDOLFO, *see* ALBA LONGA

CASTELLAMMARE DI STABIA, *see* STABIAE

CASTELL COLLEN Wales. Map 24. This Roman auxiliary fort in E central Wales is unknown to history, and its Roman name is lost, but excavation has revealed that it played a recurrent role on the W limes from its foundation ca. A.D. 75-78 until the 4th c.

The fort was in a characteristic position on a low knoll within a great bend of the river Ieithon, just off the supposed line of the N-S military road which formed the E boundary of the Welsh limes. About 2.5 km S of the fort is a major group of practice-camps. The visible remains are those of the bank and ditch of a fort ca. 125 m square, capable of holding a cohors quingenaria peditata, but this is known to have replaced an original fort of ca. 170 x 125 m; this, with twice the troop accommodation, would have been suitable for a cohors milliaria peditata. Traces of the masonry administrative buildings—principia, praetorium and horreum—are also to be seen in a dilapidated condition. The barracks and other buildings were, however, always of wood.

Minor excavations were carried out in 1911 and 1913, and more sustained excavations in 1954-57. These demonstrated a complex pattern of building, abandonment, and reoccupation. Actual dating evidence is not abundant, but the following sequence has been suggested. I, milliary fort with turf and timber defenses, ca. A.D. 75-78. II, defenses and gates rebuilt in stone; portae praetoria et principales had projecting semicircular gate-towers, the earliest known in Britain in a military context; Antonine. III, retentura abandoned and its rampart razed, new quingenary fort enclosing original administrative block and praetentura; Severan. IV, rampart and gates refurbished, ditch recut to a wide profile perhaps for artillery defense; late 3d or 4th c. Periods of abandonment, inferred from the collapse of the rampart, intervened between these building-phases. Nothing is known of the history of the internal buildings, but the single horreum would be appropriate to the reduced fort. Externally, a large bath house was explored in 1955-57. It was distinguished by a large basilica, for drill or exercise, in place of the customary changing-room. Its development ran parallel with that of the fort itself.

Among the finds now in the museum at Llandrindod Wells, Radnorshire, the most important is part of an Antonine building inscription ornamented with peltae terminating in griffins' heads. Apart from its artistic interest, this reveals that the building work of phase II was carried out by a vexillation of Legio II Augusta. There is no evidence to show what unit or units were stationed at Castell Collen.

BIBLIOGRAPHY. L. Alcock, "The defences and gates of Castell Collen auxiliary fort," *Archaeologia Cambrensis* 113 (1964) 64-96[PI]; F. H. Thompson, "The zoomorphic pelta in Romano-British art," *AntJ* 48 (1968) 47-58[I]; V. E. Nash-Williams, *The Roman Frontier in Wales* (rev. 1969)[MP]. L. ALCOCK

CASTELLEONE DI SUASA, *see* SUASA

CASTELLUM DIMMIDI (Messad) Algeria. Map 18. The Roman occupation did not extend much to the S of the Chott el Hodna, in the direction of the Ouled Naïl and the Djebel Amour. In the course of the 2d c., however, expeditions to the S were undertaken. Once the edges of the Hodna had been reached and posts had been set in the region S of Biskra (such as Gemellae, occupied under Hadrian), incursions were attempted. This is proven by the inscription of A.D. 174 found at Agueneb. Detachments of the Third Augustan Legion and of auxiliaries had then reached the heart of the Djebel Amour. But the permanent post farthest S known at present is Castellum Dimmidi, on the wadi Messad.

In 198 the legate propraetor of the Third Legion had sent legionaries there, supported by Pannonian cavalry and under the command of Flavius Superus. The installation of a permanent camp undoubtedly dates to that time. The camp was maintained until about 238, the date of the temporary disbanding of the Third Legion.

Excavations have revealed a part of the rampart which protected the soldiers' quarters. The wall was irregular in plan. Today very little can be seen on the site since the excavations were not continued and no attempt was made to consolidate the remains. The inscriptions also have almost all disappeared. They have been published and permit the reconstruction of certain aspects of the life of the camp. About 100 men relieved one another there; they were legionaries and later, after Alexander Severus, Palmyrans.

The inscriptions and the paintings (now deposited at the Algiers Museum) give an idea of the soldiers' religious life as it pertained to official and Palmyrene cults.

BIBLIOGRAPHY. G. C. Picard, *Castellum Dimmidi* (1944). 　　　　　　　　　　　　P.-A. FÉVRIER

CASTELLUM ONAGRINUM, *see* LIMES PANNONIAE

CASTELLUM TIDDITANORUM (Tiddis) Algeria. Map 18. West of Constantine the Rhummel flows in a rather wide depression between the chain of the Chettaba to the N (where various castella belonging to the colony of Cirta were located: Castellum Elephantum, Castellum Mastarense, Castellum Phuensium) and a rough area to the S (where the river must cut a narrow bed in order to reach the sea). The ruins of the center of Tiddis are located just where the Rhummel pierces the mountain of the Kheneg, about 15 km from Constantine as the crow flies. It is the Castellum Tidditanorum known from an inscription of the time of Alexander Severus.

The site has been partially excavated. Set upon the S slopes of the mountain on an upper plateau, it was a relatively strong site, easy to defend. It had at its command a fertile plain to the N and a zone of hills, whose rich soil today produces wheat.

Excavating the site was difficult. The best cleared part of the ancient town is attached to the slopes of the Kheneg. Since the slopes are steep, the streets had to wind their way up to the summit. In the steepest places these sloping ramps were replaced by stairs. Everywhere too, one had to cut back into the rock and build out with terraces in order to construct houses, and cellars were cut out of the rock. As no springs were available, cisterns, public and private, were installed throughout the built-up area in order to collect rainwater. In all of these details, Tiddis is somewhat different from other ancient sites excavated in Algeria. In seeking comparable constructions in order to visualize the town's original appearance, one turns to the Berber villages of Kabylia, with their irregular streets and houses set in tiers along the slopes.

The necropolis located outside the village is of interest in revealing the origins of Tiddis. The oldest tombs are circular bazinas, in the middle of which one or two coffers were placed and set off by slabs. The handmade pottery found in these tombs was sometimes decorated with painted motifs. This pottery and these methods of burial suggest that Tiddis was at first a native center which, because of the proximity of Cirta, very early entered into contact with wider currents of commerce. Rhodian amphoras of the 2d c., Campanian ware, inscriptions with Punic lettering of the 1st c. B.C., and finally Italic Arretine ware, all testify to the life of the center before Rome's conquest of the region and just after the foundation of the kingdom of Sittius.

The native town became Romanized just like the other towns near Cirta. Today one can cross it by following the main street as it goes from a monumental portal up between the houses, passing by the forum, a small square, and the curia. From inscriptions one knows the magistrates and decurions of the castellum. It belonged to the colony of Cirta and, with the other colonies of Rusicade, Milev, and Chullu, formed part of the confederation of the IV colonies.

Also among the public monuments cleared thus far are the public baths and cisterns (built by M. Cocceius Anicius Faustus in the middle of the 3d c. A.D.) and on top of the crag a Temple of Saturn (which produced a great number of stelae now in the Constantine Museum). On the slopes of the cliff one can see many houses and the remains of the original rampart of the castellum.

The Lollii were one of the important families of the town. Their circular mausoleum can still be seen some kilometers to the N. The monument was erected by Lollius Urbicus, prefect of the city of Rome under Antoninus Pius.

At the end of the 5th c. the town is known to have been the seat of a bishopric. Two Christian basilicas have been cleared. One was located at the entrance of the town; the other was in a more distant district and has been only partially cleared. Excavations have led to the discovery of a very large quantity of mediaeval pottery, in particular a ware which is also found at the Kalaa des Beni Hammad in the 10th and 11th c.

In the Constantine Museum one finds what pottery from Tiddis has been kept (in particular the wares from the necropolis), many artifacts from daily life (in particular pottery from potters' kilns and workshops), and tools used by the potters, as well as inscriptions and stelae dedicated to Saturn.

BIBLIOGRAPHY. A. Berthier, *Tiddis, antique castellum Tidditanorum* (1951) and reedited with bibl.; J. Lassus in *Libyca* 4 (1956) 176-80; 6 (1958) 251-64; 7 (1959) 294-301; H. G. Pflaum, *Inscriptions latines d'Algérie* II, 1 (1957) nos. 3563-4175; P. A. Lally, in *Recueil des notices et mémoires de la société archéologique de la willaya de Constantine* 71 (1969-1971) 91-121; P.-A. Février, in *Bulletin d'archéologie algérienne* 4 (1970) 41-100. 　　　　　　　　　　　　P.-A. FÉVRIER

CASTELNAUDARY, *see* SOSTOMAGUS

CASTELNAU-MAGNOAC Hautes-Pyrénées, France. Map 23. A Roman milestone in white Saint-Béat marble (preserved in the church) bears the name of Constantine and dates from 306-307. It was turned upside down and recarved to serve as a holy-water basin.

BIBLIOGRAPHY. M. Labrousse, "Un milliaire inédit de

Constantin à Castelnau-Magnoac (Hautes-Pyrénées)," *Pallas* 4 (1956) 67-86 (= P. Wuilleumier, *Inscriptions latines des Trois Gaules* [1963] 187, no. 464).

<div align="right">M. LABROUSSE</div>

CASTELNAU-MONTRATIER Lot, France. Map 23. In the valley of the Barguelonne near the Souquet mill, an imposing group of Gallo-Roman ruins has been known for a long time. They rise tier upon tier along the valley slope and cover almost 4000 sq m. Partial excavations carried out from 1962 to 1964 have brought to light what may be the platform of a temple and a series of basins and pools. Certain pieces of architectural ornamentation and the quality of the construction suggest that the site was not a villa, but rather a rural sanctuary with temple, theater, and baths, similar to several others in central and W Gaul.

BIBLIOGRAPHY. A. Viré, "Les vestiges gallo-romains dans la vallée de la Barguelonne," *Bull. de la Soc. des Et. du Lot* 52 (1931) 231-32; C.-A. Delbur, "La présence romaine dans la vallée de la Barguelonne," ibid. 84 (1963) 251-59 & 85 (1964) 161-70; M. Labrousse in *Gallia* 20 (1962) 590; 22 (1964) 458-61 & figs. 39-45; 24 (1966) 440-41 & figs. 32-33; 26 (1968) 546-47 & fig. 33 (over-all plan of ruins). M. LABROUSSE

CASTELO DA LOUSA Alentejo, Portugal. Map 19. A Roman fort (23.5 x 20 m) on the left bank of the Guadiana, 6 km SW of Mourão, established in the period of Augustus. The work, unmatched in Portugal, is important evidence for the military architecture of the period. Outside the fort, on the slope, are various structures still incompletely excavated, which may have served as lodgings for the garrison. The finds are in the Museum of Évora.

BIBLIOGRAPHY. A. do Paço e J. Bação Leal, "Castelo da Lousa, Mourão (Portugal). Una fortificación romana de la margen izquierda del Guadiana," *Archivo Español de Arqueologia* 39 (1966) 167-83[MPI]; id., "Castelo da Lousa (Mourão)," *Conimbriga* 7 (1968) 1-5[MPI].

<div align="right">J. ALARCÃO</div>

CASTIGLIONE Sicily. Map 17B. In Catania province ca. 7 km NW of Ragusa is a hill that was already inhabited during the Early Bronze Age. From the end of the 7th c. to the beginning of the 5th c. B.C. it was occupied by a Sikel settlement and again during the 4th and 3d c. B.C. On this hill some scholars would locate the Greek site of Kasmenai, though positive evidence cannot be adduced.

Excavation has brought to light a complex of rectangular rooms, some of which are aligned with a rocky street, and three circular structures that may be silos. The pottery finds belong to the mid 5th, 4th, and 3d c. B.C. Some stone tablets incised with magical signs, which can be dated to the last centuries of the Empire, suggest the presence of isolated groups of Christians, perhaps followers of heretical sects. The archaic necropolis, occupying the S and SW slopes of the plateau, consists of rock-cut cist and chamber tombs; some of the latter have a central cavity with lateral benches. This cemetery has yielded Sikel pottery mixed with Attic and Corinthian vases that range in date from the end of the 7th to the beginning of the 5th c. B.C. The finds are housed in the Hyblaean Archaeological Museum of Ragusa.

BIBLIOGRAHY. A. Di Vita, "Comiso, esplorazione parziale di una necropoli sicula del IV periodo siculo," *NSc* (1951) 335ff; id., "Breve rassegna degli scavi archeologici condotti in provincia di Ragusa nel quadriennio 1955-59," *BdA* (1959); M. Margani Nicosia, *Casmene ritrovata?* (1955); R. U. Inglieri, "Casmene ritrovata,"

ArchCl 9 (1957) 223ff; P. Pelagatti & M. Del Campo, "Abitati Siculi: Castiglione," *SicArch* (Dec. 1971).

<div align="right">M. DEL CAMPO</div>

CASTIGLIONE, see GABII

CASTLECARY, see ANTONINE WALL

CASTLEDYKES Lanarkshire, Scotland. Map 24. On a plateau overlooking the river Clyde on the S, 5 km E of Lanark. Known as a Roman site as early as the 18th c., Castledykes has been proved by recent excavation to have been occupied during the late 1st c. A.D. as a result of Agricola's advance into Scotland, and again in the 2d c. as a major fort in the network of roads and forts supporting the Antonine Wall.

The earliest Roman structure was a large temporary enclosure which was replaced by a permanent fort in the late 1st c. This fort had a massive turf rampart enclosing ca. 2.6 ha, an elaborate ditch system, and internal buildings of timber.

After an interval of at least 40 years S Scotland was reoccupied by the Romans and the rampart at Castledykes was given a new front, set on a stone base laid partly over the innermost pre-Antonine ditch, which had been filled in. The internal area of the Antonine fort remained the same, but its buildings were of stone; this fort had at least two periods of occupation. On the plateau ca. 60 m E of the fort there was an Antonine enclosure, either a construction camp or an annex to the fort.

BIBLIOGRAPHY. A. Robertson, *The Roman Fort at Castledykes* (1964). A. S. ROBERTSON

CASTLEFORD, see LAGENTIUM

CASTLE GREG Midlothian, Scotland. Map 24. A Roman fortlet midway between Castledykes and Cramond. Still in an excellent state of preservation, it is defended by a rampart and double ditches, and has a single entrance facing E. It was excavated in 1852, but the objects found were inadequately published and have since been lost. In size (0.29 ha) the fortlet resembles the 1st c. Roman fortlet at Gatehouse of Fleet, which was garrisoned by a centuria.

BIBLIOGRAPHY. *Inventory of the Ancient & Historical Monuments of Midlothian and West Lothian* (1929) 140-41. K. A. STEER

CASTLEHILL, see ANTONINE WALL

CASTLESHAW Yorkshire, England. Map 24. Roman military site in the W Riding, 20.8 km NE of Manchester and approximately midway between the auxiliary fort there (Mamucium) and that at Slack. Set at a height of ca. 270 m, it helped to guard the road between the legionary fortresses of York (Eboracum) and Chester (Deva) where it crossed the Pennine hills. Excavation has identified two successive sites.

The first was an auxiliary fort of ca. 1 ha, probably founded by Agricola ca. A.D. 80. Defended by an earth bank and ditches, its internal buildings were of timber; the garrison is not known, and after a brief occupation the site was abandoned. The second was a fortlet of ca. 0.2 ha, established within the earlier fort except on the S where the ramparts coincided. Probably built soon after A.D. 100, it was also defended by an earth bank and ditch, and the internal buildings were again of timber with the exception of a small stone bath. It is thought to have served as a small outpost of the fort at Slack, manned by troops from there (a stamped tile of Cohors

IV of ?Breuci was recovered from the Castleshaw bath house). Occupation ceased ca. A.D. 120 when the line of communication was moved to an easier route over Blackstone Edge, 8 km N.

BIBLIOGRAPHY. F. A. Bruton, *Excavations of the Roman Forts at Castleshaw: First Interim Report* (1908); *Second Interim Report* (1911); *Trans. Lancs. and Cheshire Ant. Soc.* 40 (1922-23) 154; 67 (1957) 118; 71 (1961) 163. F. H. THOMPSON

CASTLESTEADS, *see* UXELLODUNUM *under* HADRIAN'S WALL

CASTRA AD HERCULEM, *see* LIMES PANNONIAE

CASTRA CAECILIA Cáceres, Spain. Map 19. About 2.5 km NE of Cáceres, on the Roman road from Emerita to Asturica. It was established by Caecilius Metellus Pius in 79 B.C. It lost its military character but survived for a few centuries as a mere village. Nearby are the remains of houses and cemeteries. The vallum is 654 m long and 402 m wide.

BIBLIOGRAPHY. J. R. Mélida, *Catálogo Monumental de España. Provincia de Cáceres* (1924) I, 79-85; A. Schulten, *Castra Caecilia* (1932)[PI]. L. G. IGLESIAS

CASTRA CONSTANTIA, *see* ULCISIA CASTRA

CASTRA EXPLORATORUM (Netherby) Cumberland, England. Map 24. Site of an outpost fort N of Hadrian's Wall and 16 km N of Carlisle, perhaps also a port on the river Esk (NY 396716). The name castra exploratorum appears in the *Antonine Itinerary*; the place name is unknown. The site lies under Netherby House. A fort was built here under Hadrian (*RIB* 974), but nothing is known of its size or 2d c. garrison. In the 3d c. it was garrisoned by Cohors I Aelia Hispanorum (apparently assigned to Uxellodunum in the *Notitia Dignitatum*), and presumably also by a unit of scouts. An external bath house was discovered in 1732, but nothing is now visible. Finds take the occupation down to the mid 3d c., but lack of excavation makes it uncertain how long it lasted after that.

BIBLIOGRAPHY. E. Birley, *Trans. Cumberland and Westmorland Arch. and Ant. Soc.* 53 (1953) 6-39; id., *Research on Hadrian's Wall* (1961) 229-30. J. C. MANN

CASTRA REGINA (Regensburg) Bavaria, Germany. Map 20. A legionary camp on the Danube. A pre-Roman Celtic settlement is not known although an oppidum has been suspected because of the name Radasbona, which occurs in early mediaeval sources. Under the emperor Vespasian an auxiliary castellum was located on a rise above the Danube valley, a typical location for military camps in the 1st c. A.D. Only the outline of the castellum is known (ca. 160 x 137 m). Originally constructed as an earth and timber camp, it was later rebuilt in stone and provided protection for an important Danube crossing. After Trajan the Cohors II Aquitanorum equitata was stationed there. An auxiliary vicus was located to the E on the main road between Augsburg and Regensburg. There were large baths with caldarium, tepidarium, and frigidarium. To the E of the castellum part of a residential building has been found.

Following the wars against the Marcomanni, the castellum was replaced under Marcus Aurelius by a legionary camp farther N near the Danube. There is a building inscription from A.D. 179. The Legio III Italica was stationed there. The legionary legate of Regensburg was then governor of the province of Raetia; his official residence, however, remained in Augusta Vindelicum (Augs-

burg). During the invasions by Germanic tribes (3d c. A.D.), the camp was repeatedly destroyed in part. After Diocletian's army reforms in the 4th c., the legion was divided into six parts of which only one remained in Regensburg. The camp became a fortress in Late Classical times. In 357 it was probably attacked by the Juthungi. At the beginning of the 5th c. the regular Roman troops withdrew.

BIBLIOGRAPHY. F. Vollmer, *Inscriptiones Baiurariae Romanae* (1915) nos. 358ff; P. Reinecke, *Bayer. Vorgeschichtsfr.* 4 (1924) 40; id., "Das Auxiliarkastell Ratisbona-Kumpfmühl," *Germania* 9 (1925) 85ff; G. Steinmetz, "Regensburg i.d. vorgeschichtlichen u. römischen Zeit," *Verhandlg. Hist. Ver. Oberpfalz u. Regensbg.* 76 (1926) 3ff; F. Wagner, *Die Römer in Bayern* 4 (1928) 61ff; id., "Neue Inschriften aus Raetien," *Ber. RGK* 37-38 (1956-57) nos. 101ff; A. Stroh, "Untersuchungen an der Südostecke des Lagers der legio III Italica in Regensburg," *Germania* 36 (1958) 78ff; F. Ulbert, "Das römische Regensburg," *Germania Romana I: Römerstädte in Deutschland* 1 (1960) 64ff; id., "Das römische Regensburg als Forschungsproblem," *Verhandlg. Hist. Ver. Oberpfalz u. Regensbg.* 105 (1965) 7ff; K. Schwarz, "Ausgrabungen im Niedermünster z. Regensburg," *Jahresber. Bayer. Bodendenkmalpflege* 8 (1970). G. ULBERT

CASTRA TRAIANA (Sîmbotin) Dăieşti, Vîlcea, Romania. Map 12. An agglomeration between Buridava and Arutela (*Tab. Peut.*). The civil center and the camp, located on the limes Alutanus, are badly deteriorated by the waters of the Olt river. Excavations have uncovered the E wall of the camp for a length of 69.5 m. Dating from the 3d c. A.D., this structure is built over a Dacian agglomeration. The camp was equipped with an oven for the reduction of ferrous ore.

BIBLIOGRAPHY. D. Tudor, *Oltenia romană* (3d ed., 1968) 272-73; id., "Săpăturile arheologice de la Castra Traiana," *MCA* 9 (1971) 245-50; *TIR*, L.35 (1969) 66. D. TUDOR

CASTRIMOENIUM Italy. Map 16. A municipium near Marino on the N slope of the crater that encloses Lago d'Albano, perhaps a resettlement of the site of the ancient Latins called Munienses, which had disappeared before Pliny's time. It flourished from the time of Augustus to that of Marcus Aurelius, as the epigraphical record shows; it is mentioned only by Pliny (*HN* 3.69) and the *Liber coloniarum* (233). Finds in the vicinity range from a prehistoric necropolis to a number of fine Roman villas, notably that of Q. Volconius Pollio excavated in 1884, sculptures from which are now in the Museo delle Terme and the Vatican (Braccio Nuovo), but nothing of the ancient town is visible today.

Below the site, toward the floor of the campagna, are great quarries of peperino (lapis albanus), both ancient and modern.

BIBLIOGRAPHY. R. Lanciani, *BullComm* 12 (1884) 141-71[PI]; T. Ashby, *PBSR* 4 (1907) 147-53; G. & F. Tomassetti, *La campagna romana* 4 (1926) 173-279. L. RICHARDSON, JR.

CASTRO URDIALES ("Flaviobriga") Santander, Spain. Map 19. Its location is not sure. Ptolemy (2.6.8) and Pliny describe it as the first city beyond the E limit of the Cantabrian mountains, and Pliny (4.110) identifies it with Portus Amanum and describes it as a colony. It was the only colony on the Cantabrian coast and the last founded in the peninsula. Among the sites proposed (Bermeo, Portugalete, Bilbao) the most probable is Castro Urdiales. The name indicates that it was founded

by the Flavii, perhaps between A.D. 69 and 77, and probably by a deductio of veterans in Portus Amanum, to guard the recently conquered zone of N Hispania and its mineral deposits.

Coins of the 1st-2d c. have been found, and a bronze statue of Neptune(?), known as the Cantabrian Neptune, clean shaven, with a trident(?) in his right hand, a dolphin in his left, and a gold collar in the shape of a half-moon. The patera of Otañes, possibly of the Flavian period, was also found in the vicinity.

BIBLIOGRAPHY. A. García y Bellido, *Esculturas romanas de España y Portugal* (1949) no. 493, pl. 345[I]; id., "Las colonias romanas de Hispania," *Anuario de Historia del Derecho Español* 29 (1959)[M]; J. González Echegaray, "El Neptuno cántabro de Castro Urdiales," *ArchEspArq* 30 (1957) 253ff[I]. R. TEJA

"CASTRUM COLUBRI," see ALANGE

CASTRUM RAURACENSE (Kaiseraugst) Aargau, Switzerland. Map 20. Late Roman fortress on the S bank of the Rhine adjoining Augusta Raurica, 12 km upstream from Basel (*Not.Gall.* 9.9). The site was fortified under Diocletian or more probably Constantine, ca. A.D. 300, to protect the bridge at Augusta Raurica. Under Valentinian I the fort was rebuilt and a bridgehead was constructed on the N bank at Wylen by the Legio I Martia (stamped tiles). About the middle of the 4th c. a church was erected inside the fort. A bishop is recorded here in 434-44, 615, and 618. In 401, the garrison was recalled to Italy, and the fortress taken over by the local population. Cemeteries explored on the Roman highway along the river to the E indicate that the site was inhabited until well into the 8th c.

The plan of the fort is still reflected in the village and its main road: trapezoidal with its base (284 m) along the river to the N (S side 261 m; E 176; W 170; area 3.6 ha). Only one section of the N wall has been found, but the W and S walls are partly preserved. There were 16 rectangular towers (av. width 7 m) ca. 20 m apart. Much material from Augusta Raurica was reused in the foundations. The upper walls were concrete, faced with small squared masonry; tile bands were used only on the inside facing. The S gate had three passageways, and the W gate survives. The berm was 17 m wide, and the moat outside it 10 m wide. Inside the fort a granary (34.5 x 17.5 m) and probably two drill halls (30 x 15 m), have been identified. The church (17 x 11 m) had a wide apse, and a baptistery and a small bath are built against the N wall of the fortress. The bridgehead at Wylen (44.5 x 26 m) had three projecting round towers on each long side.

Finds are in the museum in Augusta Raurica, including a Late Roman silver treasure found in the fort.

BIBLIOGRAPHY. K. Böhner, "Spätrömische Kastelle und alamannische Ansiedlungen in der Schweiz," *Helvetia Antiqua, Festschrift Emil Vogt* (1966) 307-16[P]; R. Laur-Belart, *Führer durch Augusta Raurica* (4th ed. 1966) 165-72[MPI]; id., *Der spätrömische Silberschatz von Kaiseraugst* (4th ed. 1966)[I]; id., *Die frühchristliche Kirche mit Baptisterium und Bad in Kaiseraugst* (1967)[PI]; R.-M. Swoboda, "Neue Ergebnisse zur Geschichte des Castrum Rauracense," *Jb. Schweiz. Gesell. f. Urgeschichte* 57 (1972-73) 183-91[P]. V. VON GONZENBACH

CASTRUM VINDONISSENSE, see LIMES, RHINE

CÁSTULO (Cazlona) Jaén, Spain. Map 19. An Ibero-Roman city of Baetica in the environs of Linares, inhabited from the end of the Neolithic Age on and famous for the nearby silver mines of Sierra Morena. It has pro-

duced fragments of Greek black-figure vases from the end of the 6th c. B.C., red-figure vases from the first half of the 4th c. B.C., and some kraters of the same date from Italy. It was the largest city in Oretania (Strab. 3.156) and closely tied to the Carthaginian party (Livy 24.41). Nearby was the Baebelo mine, which paid Hannibal 300 pounds of silver per day (Plin. 33.96).

Castulo played a large part in the beginning of the Roman conquest (App. *Iberia* 16; Livy 26.19). The inscriptions on its coins were in native alphabets. It has contributed a few good Roman portraits, one in a toga of the Flavian period, many Hispanic sigillata and Roman gems, architectural fragments, Roman glass, and animalistic sculpture such as Iberian and Roman lions, all now in the Archeological Museum of Linares. Stelai with human figures in relief are in the Archaeological Museum of Madrid. Many inscriptions have been found there, one of them a fragment of an olive oil law of Hadrian. Iberian, Roman, and Visigothic necropoleis are well documented. Castulo was surrounded by walls and had several temples, a theater, and a circus.

BIBLIOGRAPHY. A. D'Ors & R. Contreras, "Nuevas inscripciones romanas en Cástulo," *ArchEspArq* 29 (1956) 118-27[I]; J. M. Blázquez, "Cástulo en las fuentes histórico-literarias anteriores al Imperio," *Oretania* 21 (1965) 123-28; G. Trías, "Estudio de las cerámicas áticas decoradas de la necrópolis del Molino de Caldona (Cástulo)," ibid. 10-11 (1969) 222-33[I].

J. M. BLÁZQUEZ

CATANIA, see KATANE

CATARACTONIUM (Catterick Bridge) Yorkshire, England. Map 24. A fortified settlement on the road (Dere Street) from Eburacum to Corstopitum where it crossed the river Swale. Listed in the *Antonine Itinerary* (465.2; 468.2; 476.2) and the *Ravenna Cosmography* and one of the principal coordinates for Ptolemy's survey of Britain (*Geog.* 2.3.16).

The earliest structures were related to a fort built by Cn. Julius Agricola ca. A.D. 80, S of the river and a short distance W of the main road. It seems likely that the garrison were also responsible for running a large military tannery. The fort appears to have been evacuated ca. A.D. 120. Shortly afterwards, a mansio was constructed E of the fort; the fort bath was rebuilt on a larger scale and incorporated into the new building. The fort was reoccupied ca. A.D. 160, and the mansio was demolished by the end of the 2d c. In the last 40 years of that century a vicus grew up E and SE of the fort, and more civilian development took place N of the Swale, chiefly shops and houses lining both the main road and the side road leading to the fort. It is not known when the fort was finally evacuated, but when a defensive stone wall was erected early in the 4th c. round the central part of the vicus, it was extended to include the area originally occupied by the fort. The new area covered ca. 6.3 ha.

About A.D. 370 part at least of the vicus was requisitioned for a cavalry unit, perhaps of laeti or gentiles, which led to the conversion of shops and houses into barracks and other buildings. The duration of this military occupation is not known, but it probably ended before A.D. 400. Later some rebuilding of low standard occurred, probably implying a return to civilian occupation in the early 5th c., but the settlement was deserted before the main Anglo-Saxon immigrations reached this part of Britain.

The only part of the site still visible is a section of the E defensive wall on Catterick race course. Aerial photographs (1949) showed the extent of the fortified enclosure, as well as streets and buildings within it. The

most impressive building was excavated in 1959: a small bath never completed, of early 4th c. date, constructed on the site of the demolished mansio baths. The walls in places stood 3 m high. In 1972 excavations N of the river revealed a Hadrianic fort and a small 4th c. temple.

Most of the finds are in The Yorkshire Museum, York.

BIBLIOGRAPHY. E.J.W. Hildyard & W. V. Wade, *Yorkshire Archaeological Journal* 37 (1950) 402-19[PI]; 39 (1958) 224-65[PI]; J. K. St. Joseph, *JRS* 43 (1953) 90[I]; J. S. Wacher, ibid. 50 (1960) 217-18[PI]; id., in R. M. Butler, ed., *Soldier and Civilian in Roman Yorkshire* (1971) 167-74[PI]; J. S. Wacher, *Britannia* 4 (1973) 279[P].

J. S. WACHER

CATTERICK BRIDGE, *see* CATARACTONIUM

CATULLIACUS (Saint-Denis) Seine-St.-Denis, France. Map 23. The derivation of the place-name from the feminine name Catulla can be traced to the legend of St. Denis. However, a late Gallo-Roman cemetery has been found underneath the present cathedral, as well as some Gallo-Roman architectural blocks reused in Merovingian foundations. Two of these blocks have a design of long shields (scutum) and double axes and no doubt came from a public building nearby.

BIBLIOGRAPHY. M. Fleury, *Nouvelle campagne de fouilles des sépultures de la basilique de Saint-Denis, C.r. de l'Académie des Inscriptions* (1958); P. M. Duval, *Paris antique* (1961).

M. FLEURY

CAUCA (Coca) Segovia, Spain. Map 19. A site in Tarraconensis 59 km from Segovia on the way to Valladolid. According to Pliny, it was a city of the Vaccaei (*HN* 3.3.26); it is also cited in Ptolemy (2.6.50) and Appian (*Iber.* 51.89). It was the birthplace of Theodosius I (Zosimus 4.24). There have been no excavations, and the only finds from the Roman period are two inscriptions (*CIL* II, 2727-28), the first of them on an Iberian stone pig. However, the antiquity of the settlement is confirmed by the finding of a bronze jug of the Hispano-Punic type, abundant in the S of the peninsula and related to the culture of Tartessos.

BIBLIOGRAPHY. A. García y Bellido, "Materiales de Arqueología hispano-púnica: Jarros de bronce," *ArchEspArq* 29 (1956)[I].

R. TEJA

CAURIUM (Coria) Cáceres, Spain. Map 19. Town on the Alagón river W of Plasencia, mentioned by Pliny (4.118) and Ptolemy (2.5.6). Considerable stretches of its Roman walls survive: the towers are square and the perimeter ca. 1 km. The ashlar is granite in large blocks. There are four gates, those on the S and E the most important. Little of the aqueduct survives, but sculptural and epigraphic remains have been found.

BIBLIOGRAPHY. J. R. Mélida, *Catálogo Monumental de España. Provincia de Cáceres* (1924) I, 104-14; A. Díaz Martos, *Las murallas de Coria* (1956)[MPI].

L. G. IGLESIAS

"CAUSENNAE," *see* ANCASTER

CAUTERETS Hautes-Pyrénées, France. Map 23. In 1965, above the thermal baths of Poze-Vieux, a small Gallo-Roman bathing establishment was excavated. Its discovery proves that the hot springs of Cauterets were put to therapeutic use from Roman times on.

BIBLIOGRAPHY. M. Labrousse, "Aux origines de Cauterets," *Actes du XIIIe Congrès d'études de la Fédération des Sociétés académiques et savantes de Languedoc-Pyrénées-Gascogne, Tarbes, 15-17 juin 1957*, 72-78; R. Coquerel, "Les bains romains de Cauterets," *La Nouvelle*

République des Hautes-Pyrénées (12 Jan. 1965); M. Labrousse in *Gallia* 24 (1966) 443 & fig. 35.

M. LABROUSSE

CAVAILLON, *see* CABELIO

CAVALLINO Apulia, Italy. Map 14. An ancient Messapian center ca. 6 km S of Lecce. Some have identified it with the famous Salentini site of Sybaris recorded by Pausanias (6.19.9). The remains of a great circuit wall are preserved, in which several gates have been noted. Recent excavations have brought to light, besides traces of a protohistoric settlement, conspicuous ruins of habitations and rich pit tombs, datable between the 6th and the beginning of the 3d c. B.C.

BIBLIOGRAPHY. M. Bernardini, *Panorama archeologico dell'estremo Salento* (1955) 40; F. G. Lo Porto, "L'attività archeologica in Puglia," *Atti dell'VIII Convegno di Studi sulla Magna Grecia* (1968) 193; P. E. Arias, "Vecchi rinvenimenti archeologici a Cavallino," *RömMitt* 76 (1969) 1.

F. G. LO PORTO

ÇAVDARHISAR, *see* AEZANI

CAVES INN, *see* TRIPONTIUM

CAVTAT, *see* EPIDAURUM

CAWTHORN Yorkshire, England. Map 24. Contiguous Roman forts 9.6 km NW of Pickering on the escarpment of the limestone hills overlooking the N Yorkshire Moors.

The ramparts are of turf and upcast from the ditches. There are traces of metaled roads within the ramparts. In one fort an oven was found near the gate, but not the full range of ovens necessary for a field kitchen. Moreover, there were a few pits near the ramparts but no broken pottery, so the forts were probably built for practice purposes and never occupied. Though often described as camps they are rather too large and possess features such as claviculae at the entrances, so they are better described as forts.

G. F. WILMOT

CAYLA, *see* MAILHAC

CAZÈRES Haute-Garonne, France. Map 23. The district of Saint-Cizy corresponds to the ancient center of Aquae Siccae, which was located on the Roman road from Toulouse to Saint-Bertrand-de-Comminges and Dax. Recent excavations uncovered a funerary pit of Flavian date, 11.5 m deep and almost 150 cubic m in volume; a necropolis of the Late Empire, first pagan, then Christian; and, in 1971, a baptistery, no doubt adjacent to a Christian basilica.

BIBLIOGRAPHY. G. Manière, "L'appellation antique du vicus de Saint-Cizy dans la commune de Cazères: *Aquae Siccae* ou *Aquis Siccis*," *Rev. de Comminges* 75 (1962) 161-65; id., "La voie romaine dans la commune de Cazères," ibid. 77 (1964) 1-6; id., "Un puits funéraire de la fin du Ier siècle aux *Aquae Siccae* (Cazères, Haute-Garonne)," *Gallia* 24 (1966) 103-59; id., "La nécropole de basse époque du Bantayré," *Pallas* 13 (1966) 175-91.

M. LABROUSSE

CAZLONA, *see* CÁSTULO

CEA, *see* KEOS

CECINA Tuscany, Italy. Map 14. A city at the mouth of the river Cecina, named for an Etruscan-Roman family who owned vast land tracts, clay pits, kilns, and salt beds. Rutilius Namatianus (*De reditu suo* 453-478) describes a villa (of Albinus Cecina?) in what is now

San Vincenzino, a short distance from the mouth of the river in the direction of the Marina. There, in the 18th and 19th c., remains of a Roman villa were found. The cistern under it is of typical Roman design with a covering of opus signinum and a concrete core (the actual cistern: 16.25 x 5.30 m x 4 m high; 344 cubic m, a capacity of ca. 350,000 liters). Through a system of double filters (wire mesh measuring 0.54 x 0.95 m) the water passed in a winding distribution channel (ca. 100 m long) with three wells for raising the water (for the kitchens, the laundries, and the stables) and for inspection. The vast complexity of the water works well attests to a villa on a grand scale. In the upper part of this cistern have been discovered the fittings for a bath, a small swimming pool, and remains of a mosaic peristyle, aqueducts, and farm equipment. Around the villa or farm, it is possible that an Etruscan-Roman settlement had developed. The discoveries of tombs and of Etruscan necropoleis (at Ghinchia and Le Pompe) and of Roman necropoleis (at San Giuseppe and at Campo ai Ciottoli) might indicate such a settlement. Archaeological finds are preserved in the Museo Civico at Cecina.

BIBLIOGRAPHY. L. Cipriani, *Avventure della mia vita* (1934) 25-31; G. Monaco in *FA*, vols. 18-19, and *StEtr* (Rassegna Scavi e scoperte) from 33 (1965) to 39 (1971); M. Failli, *Voce della Riviera Etrusca* vol. 3, n. 17-18, pp. 2-3; 4, n. 22-23, pp. 4-10. G. MONACO

CEFALÙ, *see* KEPHALOIDION

CEGLIE DI BARI, *see* CAELIA

CEGLIE MESSAPICA, *see* CAELIA

CEILHES Canton of Lunas, Hérault, France. Map 23. Gallo-Roman Lascours settlement, in a mountainous region particularly rich in mines (silver-bearing lead). This is indicated by Strabo (4.2.2), who boasts of the silver resources of the Cévennes, and of the territories of the Gabali, and the Ruteni. The abundant finds to date (amphorae, various ceramics, coins, fibulas, lead tesserae) show that the site was occupied from the beginning of Roman colonization (end of the 2d c. B.C.) to the middle of the 1st c. A.D.

BIBLIOGRAPHY. *Carte archéologique de la Gaule romaine*, fasc. x, Hérault (1946) 24, no. 77; "Informations," *Gallia* 27 (1969) 392; 29 (1971) 380.
 G. BARRUOL

CELAMANTIA, *see* LIMES PANNONIAE

CELEIA (Celje) Yugoslavia. Map 12. Prehistoric settlement situated on both sides of the right angle made by the river Savinja as it emerges to the SE from the fertile hollow set in the foothills of the Karawanken and so-called Savinjske Alps. It was a Celtic oppidum (the name is pre-Celtic), princely seat with its own mint, a Roman municipium walled by Claudius, and an episcopal see in late antiquity. The city is in the SE part of the territory of Noricum on the road from Aquileia to Carnuntum, which for the prehistoric period can aptly be referred to as the amber road.

The excavations, which include all periods, are made difficult by the presence of modern buildings. The finds are preserved in the local museum. An important sculpture collection includes funerary reliefs with mythological scenes, such as Luna and Endymion, and the rescue of Patrokles' body. Very little is preserved in situ.

The forum has not yet been investigated although its location, in the NW part of the city, is known from chance finds, which included a series of bases for com-

memorative statues and a row of altars. To the S above the city, the Sanctuary of Noreia-Isis and Hercules is preserved on the hillside terrace in the sacred grove along with other oriental sanctuaries. The roads leading up to it were bordered by necropoleis. To the NW are two parallel Christian churches from the 5th and 6th c. They have mosaic floors with donor inscriptions. Bishop Gaudentius, whose metrical epitaph probably dates from the beginning of the 6th c. (*AIJ* 16), came from Celeia, which was also the native city of T. Varius Clemens, who was appointed ab epistulis imperatorum in the reign of the emperors Lucius Verus and Marcus Aurelius.

Fourteen km W of Celeia, a fortress was built during the Marcomannic Wars (168-173) for Legio II Italica (the village of Ločica presently stands there). Shortly thereafter the legion was moved to Lauriacum. Two km from there in the direction of Celeia a local necropolis was excavated (1st-3d c. near the village of Šempeter ob Savinji). The architectural remains recovered during the excavations were restored and are preserved in situ. They consisted of large aediculae for politically prominent families of Celeia, richly decorated with mythological symbolism.

BIBLIOGRAPHY. J. Klemenc, "Izkopavanja na Sadnikovem vrtu v Celju," *Celjski zbornik* (1957)[PI]; id., *Rimske izkopanine v Šempetru* (1961)[PI]; V. Kolšek, *Celeia, Steindenkmäler* (1967)[PI]; id., *Šempeterska nećropola* (1971)[I]; A. Bolta & V. Kolšek, *Celjski muzej* (1970)[I]; J. Šašel, "Celeia," *RE* Suppl. XII (1970); T. Kurent, *Modularna rekonstrukcija edikul v Šempetru* (1970)[I]; G. Winkler, "Legio II Italica," *Jahrbuch des Oberösterreichischen Musealvereins* 116 (1971); J. Orožen, *Zgodovina Celja* (1971)[I].
 J. SASEL

CELEI, *see* SUCIDAVA (Romania)

CELERIS, *see* VADU

CELJE, *see* CELEIA

CELSA (Velilla de Ebro) Zaragoza, Spain. Map 19. Town in Tarraconensis, near the Ebro, and E of Quinto, key to the romanization of the valley before the foundation of Caesaraugusta. Its history is based on the many bronze coins minted in the 2d and 1st c. B.C.: first Iberian, bearing the name Celsa, and then Latin. The city was founded by Lepidus in 42 B.C. and named Colonia Victrix Iulia Lepida. After the fall of the triumvirate, its name was changed to Iulia Celsa. Its decline began after the founding of Caesaraugusta in 24 B.C. It had the only stone bridge over the Ebro in the upper third of its course up to Dertosa (Strabo: Ad Hiberum amnem est Celsa oppidum, ubi ponte lapideo Amnis iungitur); Pliny located it in the jurisdiction of the Conventus Iuridicus Caesaraugustanus and Ptolemy attributed it to the Ilergetes. Its location is certainly in the Velilla de Ebro, where there are the remains of a bridge reported in the 19th c., and ruins between the sanctuaries of San Nicolas and San José, which include a wall of opus reticulatum.

Pottery, carnelians, coins, and bronze letters of various weights have been found, and excavations have uncovered mosaics in threshing floors, terra sigillata, and painted stuccos with figurative themes. Below the San José sanctuary stand the ruins of the Roman theater with traces of the walls of the stage and of the tiers of seats of the cavea. Among finds made at an earlier period Martin Carrillo (1435) speaks of a statue, later destroyed, of a certain T. Sempronius with a scroll and staff. The name of the ancient town has been preserved in Gelsa, 4 km NW, where finds have also been made. A Roman road that crossed the Monegros from Buja-

raloz ran as far as the Val de Velilla, and stones with inscriptions have been found nearby. An area between Velilla and Gelsa is still called Puencaido, which may refer to the stone bridge mentioned by Strabo.

Celsa minted coins bearing the abbreviated names of the town or its initials. Lepida first used the head of Victory and the yoke of oxen led by a priest, the foundation type, and later the heads of Peace and of Pallas and a bull, copied from Republican prototypes. After 36 B.C. come the duoviri themselves, with the bust of Augustus and a bull, and coins continued to be minted until the time of Tiberius. Finds are in the Zaragoza museum.

BIBLIOGRAPHY. M. Risco, *España Sagrada: Santa Iglesia de Zaragoza* (2d ed. 1859) 39ff; J. Galiay, *La dominación romana en Aragón* (1946) 77; A. Beltrán, *Curso de Numismática* I (1950) 361; A. García y Bellido, "Las colonias romanas de Hispania," *Anuario de Historia del Derecho Español* 29 (1959) 472ff. A. BELTRÁN

CEMARA or Chimera (Himarë) S Albania. Map 9. The name survives from ancient times through a bishopric of Chimara. The village, situated in a strong position on the lip of a gorge, is set among the ruined fortifications of the ancient city, which was the capital of the Chaonians of this rocky, steep coast. A small plain below Chimera has an exposed beach, and the place was famous for its so-called royal spring of fresh water (Plin. *HN* 4.1.4). It was a place of refuge for shipping on the very dangerous Ceraunian coast.

BIBLIOGRAPHY. R. L. Beaumont, "Corinth, Ambracia and Apollonia," *JHS* 72 (1952) 64, 70; N.G.L. Hammond, *Epirus* (1967) 124, 679, 699. N.G.L. HAMMOND

CEMELENUM (Cimiez) Alpes-Maritimes, France. Map 23. Situated 3 km NE of Nice (Greek Nikaia, which was founded from Massilia in the 4th c. B.C. and has left few remains). The Roman town was established near the ancient oppidum of the Celto-Ligurian tribe of the Vediantii (Plin. *HN* 3.47-49; Ptol. 3.1.39), near Liguria. The choice of site was no doubt dictated both by strategic considerations (a key position on the road from Italy to Spain and at the start of the Sisteron and Alps road) and by the antiquity of the alliance between Rome and the Vediantii. Their name is not mentioned among the tribes conquered in the expeditions of 154 and 125-123, nor on the inscription of the trophy at La Turbie. The founding of the Roman establishment (whose name, Cemelenum, is of Ligurian origin) is linked to the end of the campaigns to pacify the Alpine tribes in 25-14 B.C. and to the construction of the Via Julia Augusta in 13 B.C. (cf. Tropaeum Alpium). From the Augustan period on Cemelenum became the capital of the autonomous district of Alpes Maritimae, administered by a praefectus civitatum in Alpibus Maritimis. Later it was the capital of the province of the same locality, governed by a procurator of the equestrian order. At that time the inhabitants received from Nero the jus Latii before becoming Roman citizens in the following century. Cemelenum retained this role as an administrative capital until the reforms of Diocletian. At the beginning of the 5th c. it became the seat of a bishopric dependent first on Arles (Arelate), then on Marseille. The town was abandoned in the 6th c.

The boundaries have not been definitely ascertained except to the N. Its interior arrangement cannot be specified in spite of the discovery of several stretches of streets orientated according to an orthogonal plan. But the excavation of five necropoleis, dating from the 1st to the 6th c., and above all the discovery of a huge district in the Parc des Arènes permit the reconstruction

of the history of the monuments of the city: a modest arrangement in the 1st c., growth and embellishment under the Severans, destruction in the 4th c., and Early Christian renascence in the 5th.

Few remains of the 1st c. town survive, but most of them confirm Cemelenum's military nature. There are funerary stelae of soldiers belonging to the Ligurian cohort (cf. Tac. *Hist.* 2.14), the Gaetulian cohort, or sailors. A small amphitheater (dimensions of the arena: 46 x 34.80 m) could contain ca. 500 spectators—the strength of a cohort—and probably was destined for the drills of the soldiers. Possibly there was a small circus of the type found in certain camps of the Rhine limes. It was circumscribed by a long wall with buttresses faced with regular ashlar masonry. It was contemporary with the first stage of the N decumanus. From the Claudian period there is a statue dedicated by the emperor to his mother Antonia. Finally, of two aqueducts discovered, one dates to the first years of the 1st c. A.D., the other perhaps to its end.

Two series of baths were built in the first years of the 3d c., another in the middle of the century. The ensemble is the largest and most grandiose which Roman Gaul has produced. Possibly the N baths were reserved for the procurator and the garrison. A monumental entry with a portico leads to the frigidarium (more than 10 m high), long called the Temple of Apollo. There follow a tepidarium, laconicum, and two caldaria. A vast swimming pool, a palaestra, latrines, reservoirs, and various annexes complete this monument of striking luxury. Its arrangement was changed in the second half of the century. Separated from the N baths by the decumanus I, the E baths seem to have been reserved for men. South of these, in the corner of a spacious court is found a rectangular building with an apse. Presumably it is the schola of one of Cemelenum's corporations. These (the fabri, centonarii, utricularii) are known to us from inscriptions kept in the museum. This schola is next to an older rectangular building which extended to the decumanus II. This street has preserved its stone flagging, drains, and narrow sidewalks, and was probably laid out in the 2d c. (under Hadrian ?). It is lined by private houses which were remodeled many times over five centuries. Going back towards the NW, one comes across a third bathing establishment, the W baths. It was reserved for women to judge by the many pieces of feminine ornament found in the drains. The structures are mostly hidden by Early Christian buildings. Finally, the remodeling of the amphitheater, whose cavea was enlarged, must also be attributed to the 3d c.

In the 4th c. the baths were abandoned and destroyed, and limekilns were installed, some of which are still visible. The aqueducts went out of use, and the site did not revive until the 5th c. Then Early Christian buildings were erected on the ruins of the W baths: a church, a sacristy, and a baptistery with out-buildings (small baths and vestiary). The most interesting room is the trapezoidal baptistery, adorned with eight columns. In the middle it had a hexagonal tub, at the angles of which one can see the bases of the six small columns of a ciborium.

The archaeological museum (Villa des Arènes) brings together abundant material from the region from the 8th c. B.C. until the abandonment of the town. Of note are various important funerary and epigraphic pieces.

BIBLIOGRAPHY. P. M. Duval, "Les fouilles de Cimiez," *Gallia* 4 (1946); "Chroniques des circonscriptions arch., Circonscription de Provence-Côte d'Azur," *Gallia* (1950ff); F. Benoît, *Nice et Cimiez antiques* (1968)PI.

A comprehensive description of the site by F. Benoît is forthcoming. C. GOUDINEAU

CENABUM or Genabum (Orléans) Loiret, France. Map 23. The name Orléans, still written Orlians or Orliens in the 14th c., derives from Aurelianis, which appears under the form Civitas Aurelianorum for the first time in the *Notitia Provinciarum* ca. 400.

It replaces the Gallic name Cenabum or Genabum, formed on the Celtic root *Gen*, meaning mouth, in the sense of the mouth of a small tributary of the Loire. Strabo indicates (4.2.3) that a river port was located there. The port was dominated by the oppidum, of which nothing survives except the remains of a murus gallicus found in 1902 at a depth of 13 m.

At dawn on 13 Feb. 52 B.C. the Carnuti massacred the Romans installed at Cenabum. That very evening the news reached the Arverni and provoked the general uprising of Vercingetorix.

Caesar returned hurriedly, rejoined his legions at Agedincum (Sens), captured Vellaunodunum (Chateau-Landon?) on the way, and arrived at Cenabum. His scouts warned him that the Carnuti were escaping, trying to cross the bridge over the Loire under cover of night. Caesar had the gates set on fire, took the town, and gave it over to pillage and flames. Then he crossed the Loire.

The Romans rebuilt the town, but its monuments have been destroyed. Some remains were found in 1741 and immediately buried in the foundations of the Church of Notre Dame de Bonne Nouvelle, a location now occupied by the Prefecture. Even the ruins of the theater (buried until the 19th c.) were torn down in 1821 or covered 20 years later by the fill of the Vierzon railway line.

During the crisis of the 3d c., the town underwent fires and pillagings. For defense it was surrounded by a wall of ashlar masonry with chain bondings of flat bricks. Sections of the wall can be seen in many cellars, and several towers still stand among the houses of the old town. The modern town grew up around this square castrum.

Probably in about the same period the town lost its name Cenabum and became the capital of the civitas Aurelianorum, a name which an erroneous tradition links to the emperor Aurelian. Attribution to M. Aurelius Probus (276-282) would be preferable.

In the spring of 451 the city was besieged by Attila and his Huns. The bishop Anianus (St. Aignan) went to ask help from Aetius, who finally arrived just when the town was about to fall. Be that as it may, Attila withdrew towards Troyes and was defeated at the campus Mauriacus near this town.

In the Orléans historical museum (Hôtel Cabu) are the treasures of Neuvy-en-Sullias (30 km upstream from Orléans), including six large animals of hammered bronze, one of which is the magnificent horse dedicated to the god Rudiobus, and a dozen statuettes whose style, simultaneously stripped-down, archaizing, and "modern," is world famous.

BIBLIOGRAPHY. Caesar, *Bell.Gall.* 7; Gregory of Tours, *Hist. Francorum* II 7; Buzonnière, *Histoire architecturale de la ville d'Orléans*, 2 vols. (1849); see *Bull. et Mém. de la Soc. Arch. et Hist. de l'Orléanais*, dont Mantellier, *Mém. sur les bronzes de Neuvy-en-Sullias* (1866) IX; A. Nouel, *Les origines gallo-romaines du sud du Bassin Parisien* (1968); J. Debal, "Les travaux archeologiques dans la Civitas Aurelianorum," *Actes du 93 Congrès nat. des Soc. sav.* (1968); id., "De Cenabum à Orleans," ibid. (1970); id., *Les Gaulois en Orleanais* (2d ed., 1974). J. DEBAL

CENTCELLES, see CENTUM CELLAE

CENTUM CELLAE (Centcelles) Tarragona, Spain. Map 19. Roman-Christian villa of the 4th c., in the municipality of Constantí, about 5 km from Tarragona (Tarraco), near the highway between Lérida (Ilerda) and Zaragoza (Caesaraugusta) and not far from the cemetery of S. Fructuoso. There are no ancient literary references to this place, but the mausoleum discovered here is one of the best known Early Christian monuments in the Iberian peninsula. It is mentioned in A.D. 888 in the *Cartularium* of Ripoll and was originally a church dedicated to St. Bartholomew.

Until recent excavations only two rooms were known, square on the exterior and domed on the interior, also a large baptistery room, the remains of a cella memoriae from among those dedicated to various martyrs, and traces of a basilica which perhaps had three aisles. Today, however, parts of a second phase of a large Roman villa built in the 3d and reconstructed in the 4th c. have been recognized. Out-houses with large storage jars (dolia) survive from the 3d c. villa, which was destroyed at an unknown date; a large complex was built in its place, whose most important elements were two aulae. That to the E was round in interior plan, while that to the W was quadrilobed.

The E aula had four small arched recesses at the ends of its axes. The diameter of the hall was 10.6 m and the diameter of each exedra 2.7 m. The hemispherical dome was covered with mosaic decoration (now poorly preserved). The second aula was 7 m square by 6 m high, and its exedrae 4.8 m in diameter. Despite the suggested resemblance to baths, the overall appearance is that of a mausoleum. Analysis of the brick and mortar of the dome and its mosaics permits a sure dating of the structure to the 4th c. The mosaic and pictorial decoration that entirely covers the drum and dome is unique in that the person dominating the scenes of the chase may be identified with the deceased proprietor of the tomb. The subjects of the friezes (from the bottom up) are a) wall paintings with architectural motifs and scenes of the chase; b) scenes from the Old and New Testament, including Adam and Eve, Daniel and the lions, the story of Jonah, and Noah's ark; c) cycle of the four seasons; and d) in the center of the dome, some unidentified figures.

The 4th c. date of the structure is certain, but two identifications of the person interred there have been proposed: someone belonging to the family of Constantine, e.g. Constance (a theory based on a letter from Athanasius to Constance II, giving a date of 353-358), or a rich rural landowner.

BIBLIOGRAPHY. H. Schlunk, "Untersuchungen im frühchristlichen Mausoleum von Centcelles," *Neue deutsche Ausgrabungen: Mittelmeer und vorderer Orient* (1959) 344-65MPI; id. & T. Hauschild, "Informe preliminar sobre los trabajos realizados en Centcelles," *Excavaciones Arqueológicas en España* 18 (1962)PI; id., *MadrMitt* 6 (1965) 126ffP; 8 (1967) 226ff; 10 (1969) 251ff. J. ARCE

CENTUMCELLAE (Civitavecchia) Italy. Map 16. A city on the Via Aurelia 4 miles N of Cape Linaro, the first real promontory on the Tyrrhenian shore N of the Tiber. It was founded to support a port Trajan built there ca. A.D. 106 and has owed its continuing prosperity to the excellence of its harbor. When Rutilius Namatianus sailed up the coast in A.D. 416, it was the only city of the *Antonine Itinerary* still flourishing; and it continued to flourish for four centuries. It was taken by the Saracens in 828 and the inhabitants were expelled, but 60 years later they returned. The city's name was then changed

to Civitas Vetula, which became Civitavecchia; it is still the port of Rome.

The younger Pliny (*Epist.* 6.31) is the first author to mention Centumcellae. He was summoned to the emperor's council in the "beautiful villa overlooking the sea and surrounded by the greenest of fields" where Trajan lived during the harbor's construction. The site of this is supposed to be the Belvedere, 1 km E of the present city. The foundations of the two moles of the harbor and the artificial island that lay between them, which Pliny saw under construction, form part of the substructures of the present harbor; and until the bombardments of 1943-44, one of the Roman towers at the harbor mouth was still standing. A gateway to Trajan's inner harbor, the Vecchia Darsena, with a paved road leading through it, can still be seen, as well as stretches of fine reticulate walls of the Roman warehouses built into later constructions behind the present docks. The grid of modern streets behind the harbor is based on that of Trajan's time.

A detachment of the imperial fleet was based at Centumcellae through the 2d and 3d c. The gravestones recovered regularly record the deceased's name, age, years of service, ship, and fleet (the Ravennas or the Misenensis), and often his birthplace. The Ravenna sailors were largely Dalmatians and Pannonians; the Misenense were Egyptians and Thracians. The ships were mostly triremes, but quadriremes and biremes also appear.

Little clusters of hut foundations going back to the Bronze Age have been found scattered over the territory of Centumcellae. The metal in the Tolfa mountains, of which Cape Linaro is a spur, must have been a prime reason for this early habitation, as well as the superior fishing off its rocky coast; a string of hot springs paralleling the coast a few kilometers inland may also have been an attraction. Under the Empire these supplied bathing establishments, the best preserved of which, the Terme Taurine or Baths of Trajan, lie ca. 3 km NE of Civitavecchia. The imperial buildings, dated by brickstamps to the time of Hadrian, incorporate the circular laconicum and calidarium of an earlier bath, perhaps of Sullan date. The great imperial calidarium, into which the hot spring still flows, and its adjacent rooms are in opus reticulatum and brickwork; the vaulted ceilings were constructed with ribs of brick, possibly the earliest example of such construction; walls and floors were covered with marble, and ceilings with stucchi. Adjacent to the baths are a library and a series of small rooms of uniform size arranged around a courtyard. These baths were long famous; Rutilius visited and admired them (*De reditu* 249-76).

The Museo Nazionale at Civitavecchia displays excellent plans of Trajan's harbor and the Terme Taurine, as well as epigraphical material and marbles from the neighborhood.

BIBLIOGRAPHY. S. Bastianelli, *Centumcellae, Italia Romana: Municipi e Colonie I 14* (1954) 7-92; G. Lugli, *La Tecnica Edilizia Romana* (1957) 625.

E. RICHARDSON

CENTURIPAE Sicily. Map 17B. About 35 km NW of Catania, on a strategic mountain ridge of 726 m elevation. The Sikel town was gradually Hellenized in the 5th and 4th c. B.C. Ruled intermittently by Greek tyrants (Aristoxenos, fg. 17 [ed. Wehrli]; Diod. 14.78.7), the populace was largely Sikel (Thuc. 6.94.3; Diod. 13.83.4). At other times, the town belonged to Syracuse, against whose rule it rebelled repeatedly (Thuc. 6.94.3; 7.32 [alliance with Athenians]; Diod. 16.82.4 [liberation by Timoleon]). In 312 B.C., and probably from 304 to 289 B.C., it belonged to Agathokles (Diod. 19.103.2; 20.56.3), in 270 to Hieron II (Diod. 22.13.1). Shortly thereafter, in 263 B.C., the town submitted to Rome (Diod. 23.4). Elevated to the status of civitas libera atque immunis for her strategic importance and loyalty in 241 B.C. (Cic. *Verr.* 2.3.6 [par. 13]; Sil. *Pun.* 14.240), it rose to wealth and importance; Cicero refers to it once as civitas totius Siciliae multo maxima et locupletissima (*Verr.* 2.4.23 [par. 50]). But the Verrine exploitation and the war of Sextus Pompey reduced it to a minor city again. Despite an Augustan restoration (Strab. 6.272) and sporadic periods of reconstruction in the 2d and 3d c. A.D., it sank to insignificance. An unimportant village throughout the Byzantine, Arab, and Norman periods, it was partially destroyed for insubordination by Frederick II in 1232 and completely razed by Charles of Anjou shortly thereafter. Refounded by a count of Adernò in 1548, the modern town occupies the ancient site.

The architectural remains, almost exclusively of Roman date, are scattered among the slopes and valleys surrounding the town. Beside extensive remains of ancient retaining and fortification walls, now incorporated into modern buildings, the following monuments are of most interest: 1) The so-called Roman Baths, actually an Imperial nymphaeum, NW of the town; an extensive ruin, ca. 50 m wide, containing five vaulted apses of unequal size and orientation, and adjoining rooms to the S. The building's date is disputed, as there is no inscriptional or brick-stamp evidence. 2) A Hellenistic house, N of the town; in size a modest dwelling of the 1st c. B.C., it is of interest in its unusual floor plan, with short corridors connecting symmetrically arranged rooms. Remains of incrustation-style wall decoration are extant in some rooms, as well as a floor mosaic of geometric motifs. Two pairs of terracotta satyrs and maenads, now in the Siracusa Museum, served as atlantes and caryatids in the house. 3) Remains of smaller, perhaps private, baths of Imperial date (Acqua Amara, Stalle Antiche) on the E side of the town. 4) A building, perhaps official, of Augustan date at the Mulino Barbagallo nearby; an example of representative, ambitious architecture not otherwise preserved in the town, it contains a fine marble floor and interior colonnade. In the building were found several marbles, including fragments of a colossal Julio-Claudian portrait statue. Numerous dedicatory inscriptions testify to the later use of the building in the 3d c. A.D. 5) Of interest are the "Dogana," a reservoir and fountain house, and a mausoleum (the so-called Castello di Corradino), both of the 2d c. A.D.

The town is surrounded by seven ancient necropoleis. Excavations have concentrated on the easternmost (Contrada Casino), in use from the 3d through 1st c. B.C. Besides the usual burial gifts of unguentaria and coins, the tombs have yielded substantial amounts of terracotta figurines of local manufacture, attesting to a flourishing industry during the 3d and 2d c., and polychromatic nuptial vases of the 3d c. B.C., unique testimonia to the artistic and social ambitions of the town. The most representative collections of terracottas and vases are now in the Museo Nazionale of Siracusa.

BIBLIOGRAPHY. G. Libertini, *Centuripe* (1926)MPI; id., Centuripe, *NSc* (1953) 353-68; P. Griffo, *Nuova testa di Augusto e altre scoperte di epoca Romana fatte a Centuripe* (1949); G. Rizza, Centuripe, *NSc* (1949) 190-92.

P. DEUSSEN

CEOS, *see* KEOS

CERAMIAE, *see under* PRILEP

CERNA Dobrudja, Romania. Map 12. Roman rural settlement on the road along the lower Danube between Troesmis to Arrubium. Extensive traces of stone buildings are spread over the ground, where have been found many sculptural fragments, inscriptions dating from the 2d and 3d c., tiles, pottery fragments, coins, and pithoi with cereals. The settlement was defended by a stone rampart 2.5 m in width. Remains of an aqueduct are still visible. The site developed on the territorium of Troesmis.

BIBLIOGRAPHY. P. Nicorescu, "Liber-Dionysos," *Buletinul Comisiunii Monumentelor istorice* 8 (1915) 41-45; R. Vulpe, *Histoire Ancienne de la Dobroudja* (1938) 183, 214. E. DORUTIU-BOILA

CERNAVODĂ, *see* HERAKLEIA (Romania)

"CERNE," *see* MOGADOR

CERRO DE LOS SANTOS Albacete, Spain. Map 19. Site at the municipal border of Montealegre del Castillo, occasionally confused with the nearby Llano de la Consolación. At the crown of the hill are the remains of an Iberian sanctuary. Its nucleus was a temple in antis, based on bedrock, with its plan recognizable although the structure itself had disappeared. Its dimensions are 15.6 by 9.9 m, with a doorway 2.6 m wide. Access was by two flights of steps. The walls, to judge by what was still in place a century ago, were formed by a double course of squared blocks held together by lead clamps. The building was covered with roof tiles, and may have had a pavement of rhomboidal terracotta floor tiles.

Excavations in the 19th c. uncovered some 300 pieces of stone sculpture, for the most part now in the National Archaeological Museum in Madrid, although some are in other museums and private collections. More recent investigation has shown that the deposit occupies the center of a dense pre-Roman and Roman settlement. Many of the sculptures were found on the slopes of the hill, and their poor preservation can have been due only partly to erosion as some of the pieces seem to have been broken intentionally. The statuary in the round, and to a lesser degree the low reliefs, seems to date from the 4th to the 1st c. B.C.; in the latest excavations there was not a single ceramic find from the Imperial Roman period, although there were some coins, which had doubtless been displaced in later searches for building material.

No ancient literary sources allude to the sanctuary nor can the site be identified with any ancient town. The Cerro de los Santos has none of the usual characteristics of a developed Iberian sanctuary. Apart from architectural fragments such as capitals, the sculptures in stone have the characteristics of votive offerings. Except for a few examples of animals, the subjects are human beings, almost always single figures, usually female; in only one instance is there a group. Some pieces show inscriptions in an Iberic alphabet, while a few have Latin letters (there are also a considerable number of forgeries and reworked fragments). The ex-votos accumulated over many generations. Some were produced under Roman domination and may be classed with the Roman provincial art of the Iberian peninsula, but these are few. On the basis of the jewelry carved on the female figures, the earliest sculptures should be dated as far back as the 4th c. B.C., but it is difficult to construct a chronological sequence, owing to the variety of the figures and their costumes, even when they may be contemporary.

All the sculpture was cut in soft sandstone from local quarries. This fact, combined with the absence of early excavation records, has led to the attribution to Cerro de los Santos of pieces that might have been discovered in the Llano de la Consolación or on other sites of the districts of Montealegre and Yecla. Some pieces show traces of polychrome coloring, which appears to reflect a common practice. Further, a xoanon-like quality has been postulated in these figures, although this might better be attributed to working in soft local stone.

Excluding isolated heads and fragments of busts, the female figures are statuettes with tiara-like headdress or cloak. Standing figures predominate, though some are seated on a chair or throne. In their costumes a step-like rendering of the folds is reminiscent of archaic Greek sculpture. Also reminiscent is the rendering of eyes, hair, and jewelry. The male statues show similar traits. All these wear the same costume, a girt pallium grasped by the right hand. Many have their heads uncovered, with hair worked like that on archaic Greek statues. A few wear earrings or pendant bullae, some a cap or bonnet; the only warrior is armed with a short sword.

BIBLIOGRAPHY. P. Savirón, *Noticias de varias excavaciones del Cerro de los Santos, en el término de Montealegre* (1875)MP; J. de la Rada y Delgado, *Antigüedades del Cerro de los Santos* (1875); P. Paris, *Essai sur l'Art et l'Industrie de l'Espagne primitive* (1903); id., *Promenades archéologiques en Espagne* I (1910); J. R. Mélida, *Las esculturas del Cerro de los Santos. Questión de autenticidad* (1906); J. Zuazo, *La villa de Montealegre y su Cerro de los Santos* (1915); A. García y Bellido, "De Escultura ibérica," *ArchEspArq* 16 (1943) 272, 292MP; id., "Arte Ibérico," *Historia de España* I, 3 (1955) 483-541; A. Fernández de Avilés, "Escultura del Cerro de los Santos," *ArchEspArq* 16 (1943) 361-87; id., "La colección de los Padres Escolapios de Yecla," ibid. 21 (1948) 360-72; id., *Cerro de los Santos* (1966).
 A. BALIL

CERVETERI, *see* CAERE

CESENA, *see* CAESENA

CESSERO (Saint-Thibéry) Hérault, France. Map 23. Situated on the right bank of the Hérault ca. 10 km from the mouth of the river, this settlement owed its prosperity chiefly to the fact that it stood at a crossroads. From the 7th to the 1st c. B.C. it was a simple oppidum built on a level stretch of basalt overlooking the river, which was crossed here by the road to Spain. After the Roman conquest a road station was set up at the foot of the hill on the same road, now rebuilt by Domitian at the point where, according to Ptolemy (55.10.6), it was met by another road leading to Lodève (Luteva) and Rodez (Segodunum). Mentioned in the *Peutinger Table*, the road itineraries, and the Apollinarian traveling cups, the mansio probably became an important center; Pliny ranks it among the oppida Latina.

Sporadic excavations on the oppidum summit (100 m each side) have revealed the remains of a rampart of medium-sized stones, a short section of which shows Greek influence, and some huts of dry stone that can be dated by Ionian and Attic imported wares. The post continued to be occupied after the creation of the statio. This latter is probably covered by the present-day settlement and no conclusive traces of it have yet been found. The path of the Via Domitia, at least, has been clearly established: the road crossed the Hérault downstream from Saint-Thibéry at the point where a mediaeval bridge with a flattened arch, once thought to be Roman, stands today.

BIBLIOGRAPHY. J. Coulouma & G. Claustres, "L'oppidum de Cessero, près de Saint-Thibéry," *Gallia* 2 (1943) 8-18. Y. SOLIER

CESTAYROLS Tarn, France. Map 23. Near Larroque. The heating part of a fairly rich villa, which seems to have been occupied from about A.D. 30 until the 3d c., was excavated in 1965 and 1966. Nearby some tombs of a "Visigothic" cemetery were investigated at this time.

BIBLIOGRAPHY. R. Cubaynes & F. Lasserre, "Le cimetière wisigothique de Larroque-Cestayrols (Tarn)," *Ogam* 28 (1966) 303-10 & pls. 97-100; cf. M. Labrousse in *Gallia* 24 (1966) 446 & fig. 38; 26 (1968) 553; F. & R. Cubaynes, "Le mobilier de la villa gallo-romaine de Larroque-Cestayrols," *Fédération tarnaise de spéléo-archéologie* 9 (1972) 94-102. M. LABROUSSE

CETIUM (Sankt Pölten) Austria. Map 20. A municipium on the frontier road from Vindobona to Lauriacum, twice mentioned in the *Antonine Itinerary* and in the *Passio sancti Floriani*. In inscriptions it is referred to as municipium Aelium Cetium, which means that, like Carnuntum and Ovilava, it received the rights of a city under Hadrian. It must have enjoyed a certain importance as one of the eight Roman cities in the Noricum province, especially since it was ideally placed on the route to act as a supply post for the forward Danube fortifications.

Because the site has been built over in modern times, exploration of the ancient city has barely begun. Excavations carried out after WW II near the cathedral confirm the hypothesis that Cetium was in fact in the area of the so-called cloister quarter. The accuracy of this location is confirmed by findings of graves in the area. Finds are for the most part preserved in the Staedtisches Museum at Sankt Pölten.

BIBLIOGRAPHY. G. Pascher, *Der römische Limes in Österreich* 19 (1949) 129ff; R. Noll, *Jahrbuch für Landeskunde von Niederösterreich* 36 (1964) 61ff. R. NOLL

CEUCLUM, *see* CUŸK

CEUTA ("Septem Fratres") Morocco. Map 19. The ancient city is covered over by the modern one. Repairs and construction work have uncovered some underlying ruins, as yet unidentified, in the cathedral quarter, and traces of a Roman necropolis. Among the remains are the base of a sarcophagus, carved in marble; a bronze statuette of Hercules; some coins, and a great quantity of pottery. A bishopric in the Byzantine era, Septem was the last Moroccan city to recognize the authority of the emperor at the time of the Arab conquest.

BIBLIOGRAPHY. C. Posac Mon, *Estudio arqueologico de Ceuta* (1962); "Una necropolis romana descubierta en Ceuta," *IX Congreso nacional de Arqueologia, Valladolid, 1965* (1966) 331-33. M. EUZENNAT

CEVIZLI, *see* KAGRAI

ČEZAVA, *see* LIMES OF DJERDAP

CHAHBA, *see* PHILIPPOPOLIS

CHAIKA Crimea. Map 5. Site 7 km W of Eupatoria, probably founded by Chersonesus in the 4th c. B.C. The walls surrounding the city, which had towers and date from the 4th-3d c. B.C., are partly preserved. A few traces of streets and houses can be seen. The city was destroyed in the 2d c. B.C. by the Scythians, who set up a trading center on the same site that lasted until the first centuries A.D. The famous bronze statuette of an Amazon on horseback, done in the style of Lysippos, was found here. The Hermitage and Eupatoria Museums contain material from this site.

BIBLIOGRAPHY. A. N. Karasev, "Raskopki na gorodishche Chaika bliz Evpatorii," *KSIA* 95 (1963) 33-42; id., "Raskopki gorodishcha u sanatoriia 'Chaika' bliz Evpatorii v 1963 g.," *KSIA* 103 (1965) 131-39; I. B. Brašinskij, "Recherches soviétiques sur les monuments antiques des régions de la Mer Noire," *Eirene* 7 (1968) 93-94; I. V. Iatsenko, "Issledovanie sooruzhenii skifskogo perioda na gorodishche Chaika v Evpatorii (1964-67 gg.)," *KSIA* 124 (1970) 31-38.
 M. L. BERNHARD & Z. SZTETYŁŁO

CHAIRONEIA Boiotia, Greece. Map 11. Situated at the NW entrance to the region in the narrow Kephissos plain lying between Mt. Thourion and Mt. Akontion, at the modern village of Chaironeia (formerly Kapraina).

The gateway to Boiotia, Chaironeia had a Neolithic settlement but apparently none in the Mycenaean age. Whether it is the Arne of Homer is doubtful. Chaironeia was subject to Orchomenos up to the end of the 5th c. B.C., then with Akraiphia and Kopai formed one of the 11 Boiotian districts until 387 and again, after a period of autonomy, from 371 to 338 B.C. It then enjoyed independence in the Boiotian Koinon and was granted the status of a civitas libera by the Romans. Three famous battles were fought in the Chaironeian plain: in 338 Philip II's Macedonians carried off a decisive victory over the Athenians, the Boiotians, and their allies; in 245 the army of the Aitolian League fought that of the Boiotian League; and in 86 B.C. Sulla and his 20,000 Romans crushed Mithridates' forces, over 100,000 strong, commanded by Archelaos.

The city of Chaironeia, of which there are only insignificant remains, lies at the foot of Mt. Petrachos, on top of which is the acropolis. Plutarch (ca. 46-120) was born and died here. In the Church of the Panagia can be seen a marble Roman seat, the so-called seat of Plutarch, and many inscribed stones in the walls. At the foot of the N summit of Mt. Petrachos is a little theater completely cut in the rock; its 14 tiers are arranged in two unequal blocks. Above the last tier is a dedication to Apollo Daphnaphorios and Artemis Soodina. The Chapel of Hagia Paraskevi is built on the site of a Temple of Herakles on the slopes of Mt. Thourion. The sanctuary of Sarapis, where many slaves were freed from the 3d to 1st c. B.C., has not been traced.

The acropolis occupies both summits of Mt. Petrachos and dominates the Kephissos valley from a height of 150 m. Around it is a 4th c. rampart, well preserved and built in regular courses except on the W slope where the old wall has been preserved and strengthened with cyclopean masonry. To the E a ramp cut in the rock led to the only gate. Several towers fortified the rampart.

The field where the battle of 338 took place is 2 km E of the village, between Mt. Thourion and the Kephissos, along the banks of the Haimon brook. The victorious Spartans burned their dead close by the Kephissos. Excavation of a tumulus at this spot revealed a pyre, 10 m in diameter and 0.75 m high, with bones and fragments of weapons in the ashes; it was covered over by a conical mound of earth 70 m in diameter and 7 m high. The bodies of the Sacred Band of Thebans that was crushed by Alexander were buried several days after the battle. From ancient times the "Lion of Chaironeia" was believed to be their funeral monument. Discovered in 1818, then smashed, restored, and replaced on a plinth 3 m high, the lion stands 5.50 m high; it is made of five blocks of marble, three of them hollow. It is a replica of the lion on the polyandrion of Thespiai. The monument is on the N side of a rectangular peribolos (approximately 24 x 15 m). Within this area was

found a tomb 4.30 x 3.60 m ringed by a wall 2.30 m high and containing 254 skeletons arranged in seven layers; two of the bodies had been incinerated. The weapons had been removed (the skeletons are at the National Museum in Athens, the other finds at the Chaironeia Museum).

BIBLIOGRAPHY. J. G. Frazer, *Paus. Des. Gr.* v (1898) 205-10; E. Oberhummer in *RE* (1899) s.v. Chaironeia; G. Sotiriadis in *Praktika* 1902-4, 1909; *Guide Bleu, Grèce* (1962) 664-65; E. Kirsten & W. Kraiker, *Griechenlandkunde*[5] (1967), 242-46[M]; N. Papahadjis, *Pausaniou Hellados Periegesis* v (1969) 235-45[MI]. P. ROESCH

CHALA Iraq. Map 5. A Seleucid city established on an Assyrian site. Its ruins are near modern Halvan in NW Iraq, N of the Great Zab river.

BIBLIOGRAPHY. Isodore Charax 6. D. N. WILBER

CHALANDRI (Phlya) Attica, Greece. Map 11. Once a village, now part of the almost unbroken urban development from Athens to Kephissia (and beyond), Chalandri lies slightly N of the N limits of both Hymettos and Tourkovouni, midway between them, and 4 km S of Marousi, the ancient deme of Athmonon. Thus it once occupied an important position in the Athenian plain alongside roads leading N to Pendeli and E to the Mesogaia. Many antiquities have been found in this area, for example, graves from Late Classical and Hellenistic times, an archaistic relief of Dionysos, and a Roman tomb of the 2d c. A.D., besides inscriptions and reused architectural blocks. The tomb has its vaulting intact, and, with the addition of an apse, now serves as the Church of the Panagia Marmariotissa.

Despite the lack of more specific evidence, it seems obvious that Chalandri has inherited the location of an ancient village. Because it is known that the demes of Athmonon and Phlya were in part contiguous (*IG* II[2] 2727.48-49), and because all the demes around Marousi have been identified except to the S, scholars agree that Chalandri must therefore be the site of Phlya. As such, it possessed a telesterion restored by Themistokles (Plut. *Them.* 1.3), had a tradition of mystic rites older than those at Eleusis (Hippol. *Haer.* 5.20), and was visited by Pausanias (1.34.1), who recorded several other cults.

BIBLIOGRAPHY. E. Meyer, "Phlya," *RE* Suppl. x (1965) 535-38. C.W.J. ELIOT

CHALEION, *see* WEST LOKRIS

CHALKEDON or Kalchedon (Kadıköy) Turkey. Map 5. City in Bithynia, across the Bosporus from Istanbul. The site appears to have been originally occupied by Phoenicians and Thracians; the Greek city was founded by Megarian colonists led by Archias in 685 B.C., 17 years before Byzantium. Since they overlooked the far superior site a mile or so across the water, Chalkedon became known as the city of the blind. As a member of the Delian Confederation the city paid a tribute varying between nine talents and three, and in 416 B.C., as an independent city, Chalkedon attacked and defeated the Bithynians (Diod. Sik. 12.82.2). It passed to the Persians in 387 B.C., but was liberated by Alexander and remained free until Philip V subjected it for a short time. After his defeat the city obtained freedom and an alliance from Rome, and became wholly Roman when in 74 B.C. Nikomedes IV bequeathed his kingdom to Rome. In the following year Aur. Cotta, barricaded in Chalkedon, was attacked and decisively defeated by Mithridates. A free city under the Empire, Chalkedon was raided and plundered by Scythians during the reign of Valerian (Zosim. 1.34). The coinage extends from the early 5th c. B.C. to the 3d c. A.D.

The site is described by Dionysios Byzantios (*GGM* II, 93, fr. 67). It stood on a peninsula close above a river also called Chalkedon, with a harbor on either side of the isthmus, E and W, and an oracular shrine of Apollo. The river is the stream, now mostly built over, which flows into Moda Bay; the city stood on the higher ground between the Kadıköy boat station and Moda Point. The harbors have filled up and the isthmus has disappeared. Remnants of the ancient city were still to be seen in the 16th c., but nothing remains today. Some Greek sherds have been found on Moda Point, and a few fragments of ancient wall are said to have been visible until recently, but nothing more.

BIBLIOGRAPHY. C. Müller, *Geographi Graeci Minores* (1861) II, 96; E. Mamboury, *Constantinople, Tourists' Guide* (English ed. 1924) 412-13. G. E. BEAN

CHALKETOR (Karakuyu) Turkey. Map 7. City in Caria 10 km NW of Milâs. In the Delian Confederacy Chalketor paid about one-third of a talent, but was reassessed in 425 at more than two talents. The city united in the 2d c. B.C. with Euromos, and later in a sympolity with Mylasa. The acropolis hill, now called Yaz Tepesi, carries a ring wall of masonry in Lelegian style; at its N foot was the Temple of Apollo, of which only a few blocks remain. Several inscriptions have been found here, including one in Carian. The tombs include sarcophagi, plain shallow graves, and a number of underground chambers solidly constructed of large blocks in the Carian manner. Near the neighboring village of Köşk are two forts with massive walls 3-5 m thick.

BIBLIOGRAPHY. W. R. Paton & J. Myres, *JHS* 16 (1896) 210-11; G. Cousin, *BCH* 22 (1898) 374ff, 376 no. 16, cf. Polyb. 30.5.11; A. & T. Akarca, *Milâs* (1954) 133; G. E. Bean, *Turkey beyond the Maeander* (1971) 48-49.

G. E. BEAN

CHALKIS Euboia, Greece. Map 11. The chief city of the region, situated at the narrowest part of the Euripos, where the island lies closest to Boiotia. It was a flourishing trade center throughout antiquity, known especially for pottery and metalwork. Its citizens founded colonies in Sicily in the 8th c. B.C. and along the N Aegean coasts in the 7th. Eretria to the E was a long-standing rival for control of the rich Lelantine Plain which lay between them. Chalkis supported the Greek cities against Xerxes, but turned against Athens in 446, only to be defeated and remain a tributary until 411 B.C. It was then that the Euboians and Boiotians combined to block the Euripos with moles, leaving only a narrow channel spanned by a wooden bridge, the first of many built at various times in later history. Philip II of Macedon garrisoned the city in 338 B.C. as one of his chief control points; it remained an important center until it was partly destroyed for siding with the Achaian League against Rome in 146 B.C. Few remains of the ancient city have been uncovered, but quarrying activities N of the acropolis have revealed the walls of some Late Classical structures. Dikaiarchos (26f) described Chalkis as enclosed by a wall 70 stades in length; the trace is still clear on air photographs. Among many brackish springs, that of Arethusa alone provided sufficient healthful water for all the people. There were gymnasia, theaters, sanctuaries, including that of Apollo Delphinios, squares, and stoas; an inscription mentions the Temple of Zeus Olympios. The port on the Euripos was connected by a gate to the commercial agora, which had stoas on three sides. A mile S of the town, Leake saw the ruined arches of a Roman aqueduct.

BIBLIOGRAPHY. Livy 28.6; Plut. *Tit.* 16; W. M. Leake, *Nor. Gr.* (1835) II 254-66[M]; J. Boardman in *BSA* 52 (1957) 1f. M. H. MC ALLISTER

CHALOBON, *see* BEROEA (Syria)

CHALON, *see* CABILLONUM

CHÂLONS-SUR-MARNE ("Durocatalaunum") Marne, France. Map 23. City of the Catalauni in Champagne, at the confluence of the Marne and some of its small tributaries and on the Lyon-Boulogne road. It did not become the center of a civitas, separate from that of the Remi, probably until the Late Empire. A small castrum, it has yielded no traces of public buildings and little is known of its plan.

On the other hand the abundant potsherds (especially Gallo-Belgic ware and terra sigillata), metal objects, and burial gifts (Rue Carnot, Rue St. Dominique, Rue des Vieilles Casernes, Rue des Viviers, and around the Place de la Comédie) point to a sizable settlement from as early as the middle of the 1st c. A.D. In some places the continuity of the finds goes up to the 4th c. Weights used by weavers and fishermen and iron slag indicate that craftsmen worked in the settlement, but as yet a very few architectural blocks and some marble fragments are the only signs of a settlement on a truly urban scale.

BIBLIOGRAPHY. Eutrope 9.13; Amm. Marc. 15.11.10; 27.2.4; *Not. Galliarum* 6.3.

L. Grignon, *Topographie historique de la ville de Châlons* (1889); R. Lemoine, *Mém. Soc. d'Agriculture, Commerce, Sciences et Arts du Département de la Marne* 13 (1909-10) 297-328; F. Vercauteren, *Etude sur les civitates de la Belgique Seconde* (1934); E. Frézouls, *Gallia* 29 (1971) 293f; 31 (1973) 409f.

E. FRÉZOULS

CHAMALIÈRES Puy-de-Dôme, France. Map 23. Gallo-Roman settlement just outside Clermont-Ferrand (Augustonemetum).

The most important discovery made here was of a large collection of Gallo-Roman carved wooden ex-votos near a mineral water spring, known today as La Source des Roches. The spring itself shows no signs of engineering, even of a rough kind. The ex-votos, originally stacked vertically or placed on their bases around the two drainage basins, had fallen into these basins, almost filling them. Coins and pottery found in this deposit show that it was used over a period from the end of Gallic independence, at the earliest, to the reign of Augustus' first successors, at the latest.

Over 5000 wooden ex-votos have been found, but no stone or bronze offerings. Essentially they consist of lifesize representations of legs and arms, lower sections of the body, either naked or draped, and anatomical splints. Particularly noteworthy are some statuettes of pilgrims, busts and heads of men and women (the Classical influence is noticeable here), and some badly damaged painted plaques. The carvings can be seen in the Musée Bargoin in Clermont-Ferrand.

BIBLIOGRAPHY. C. Vatin, *Gallia* 27 (1969) 320-30[I]; id., "Ex-voto de bois gallo-romains à Chamalières," *RA* (1969) 103-14[I]; id., "Wooden sculpture from gallo-roman Auvergne," *Antiquity* 46 (1972) 39-42[I]; J. C. Poursat, *Gallia* 31 (1973) 439-44[I]. J. C. POURSAT

CHAMPALLEMENT or St. Révérien Nièvre, France. Map 23. Spread over the two communes of Champallement and St. Révérien, in the area known as Compierre, the site is thickly wooded and has been partially explored; only the sanctuary area has been excavated. Some residential sections, the probable remains of a theater, and the substructures of streets have been located, but the boundaries of the site have not been determined.

The sanctuary has a surrounding wall of slightly trapezoidal shape, with a porticoed gallery on all four sides. The sides are 58.53 and 45 m long. The N, W, and S porticos are 4 m deep, but the E portico is 7 m deep and has a monumental entrance with staircase ramps and apsidal sections. The entrance was probably framed by two projecting wings.

The shrine stands far back in the W half of the courtyard and is centered on the E-W axis of the complex with its entrance to the E. Of the indigenous type, it consists of an octagonal cella with a circular interior (diam. 8.84 m). A second octagonal wall surrounds the cella, forming a gallery 2 m wide. The walls are 1.15 m thick at the reinforced corners but only 0.75 m in the sections between, which would seem to rule out a cupola roof and justify the restoration of a wooden frame supporting a tile or stone roof. Fragments of a white marble cornice have been found, probably from the cella, the molding of which would seem to indicate a date in the 2d c. A.D. The fairly large number of coins found on the site, ranging from Marcus Aurelius to Gordian III, are evidence that it was occupied over a considerable period. On the other hand, the presence of Gallic coins and the type of plan suggest that there was an earlier sanctuary, probably of wood, and roughly built, such as that found in the fanum of St. Germain-le-Rocheux near Chatillon. A number of limestone sculpture fragments and two small bronzes of Mercury have been found on the site. To judge from the offerings (baskets of fruit, cornucopias), it appears that the sanctuary may have been dedicated to a god or goddess presiding over agrarian life and fertility.

BIBLIOGRAPHY. E. Espérandieu, *Receuil général des bas-reliefs . . .* (1907-66) 2228ff; A. Koethe, "De Keltischen Bund- und Vielecktempel der Kaiserzeit," *Ber. RGKomm* 23 (1933) 66-68; L. Mirot, *Bibliographie des articles de géographie publiés dans les Revues savantes du Nivernais* (1936) nos. 256, 260; Grenier, *Manuel* IV, 2 (1960) 668-71; R. Martin, "Informations," *Gallia* 20, 2 (1962) 459; 22, 2 (1964) 325-26; 24, 2 (1966) 398; 26, 2 (1968) 490. R. MARTIN

CHAMPIGNEULLES Meurthe-et-Moselle, France. Map 23. One part of the ancient site is situated on the sides of the valley of the Meurthe, a short distance from its junction with the Moselle; another is in a smaller adjacent valley which descends from the Haye massif. The first discoveries of ancient remains were made at the end of the 19th c., at the locality named Le Noirval. These consist of fragments of stelae (now in the Musée Lorrain at Nancy) depicting divinities and probably related to an iron-working establishment exploiting the local ore; the slag piles are still visible.

In 1969 housing construction at the NW exit of the modern village (at the locality named au Sarrazin) brought to light the remains of a Gallo-Roman structure, apparently a villa rustica. The buildings are divided into two quite distinct parts. To the S are outbuildings used for farming or handicrafts, with a circular annex, possibly a dovecote. To the N are living rooms, one of which was plastered and painted in polychrome geometric motifs. In the middle a bathing pool and hypocaust were identified. At the S end in a cellar furnished with niches a very large hoard of bronze objects was found; they were no doubt rejects intended for recasting. It comprised, on the one hand, sections of pipes and faucets, pieces of harness, parts of household effects (fragments of candelabra, fittings for furniture legs, various zoomor-

phic ornaments) and, on the other, a statue of an adolescent Dionysos (height: 0.6 m). These objects are preserved in the Musée Lorrain at Nancy.

BIBLIOGRAPHY. M. Toussaint, *Répertoire archéologique Meurthe-et-Moselle* (1947) 14-15; R. Billoret in *Gallia* 28 (1970)[PI]. R. BILLORET

CHAMPLIEU Commune of Orruy, canton of Crepy-en-Valois, arrondissement of Senlis, Oise, France. Map 23. A sanctuary (ca. 150 x 250 m) on the boundary of the civitas of the Suessiones (capital Soissons) and that of the Silvanectes (capital Senlis); it contains a temple, a theater, and a bath complex.

The temple, surrounded by a portico 3.8 m wide, faces E. The classical proportions (rectangular peribolos 160 Roman feet x 120), the importance of the podium, and the motifs of the carved blocks are Roman, but certain details testify to the survival of Celtic religious features: the base of a presentation tablet in the S gallery, the orientation, and the square cella. The reliefs show Graeco-Roman mythological motifs involving Apollo, Achilles, Mercury, and Eros; all were once painted. The frequent representation of Apollo suggests that the temple may have been dedicated to him.

The theater and baths are S of the temple. The theater, adjoining the S side of the wall surrounding the temple, has a central (N-S) axis of 49 m and a radius of 35.7 m. Except for the stage wall, which has disappeared, the main features are well preserved: six passages, the entrance and steps leading to the top of the cavea, and the first tiers.

The baths, surrounded by a rectangular enclosure 53 m x 23 m, were reached by a courtyard serving as a palaestra and surrounded by a portico 3 m wide. The sequence of rooms, decorated with painted stucco and marble, followed the Roman tradition. The temple, theater, and baths are not all on the same axis. Further excavation is indispensable, and some parts of the site, such as the palaestra and the S gallery of the temple, have not yet been fully uncovered.

The importance of this frontier sanctuary was confirmed by the discovery in 1917 of four milestones dedicated to Gordian, Philip and his son, Trebonianus Gallus and Volusianus, and Diocletian. The milestone fragments are stored in the Musée des Antiquités Nationales at Saint-Germain-en-Laye.

BIBLIOGRAPHY. Grenier, *Manuel* III (1958) 407-12, 860-67; IV (1960) 333-36; G. C. Picard, "Les théâtres ruraux en Gaule," *RA* (1970) fasc. 1, 25-32; P. Wuilleumier, *Inscriptions latines des trois Gaules* (1963) 195-96. P. LEMAN

CHANDON Loire, France. Map 23. In the Sornin valley, in the area known as La Grande Terre, was a Gallo-Roman villa which yielded an enormous quantity of potsherds of many kinds: sigillata of Lezoux, everyday ware, painted Roanne ware, and many tiles and amphora fragments.

BIBLIOGRAPHY. J. Quey, "Le site gallo-romain de la Grande Terre à Chandon," *Bulletin des Groupes de Recherches archéologiques de la Loire* 1 (1960). M. LEGLAY

CHARADRA (Voulista Panayia) S Epeiros, Greece. Map 9. On the Louros river. A steep, high hill is fortified with a circuit wall ca. 450 m long. The site was inhabited, but its main function was to guard the S end of the gorge which leads into Central Epeiros. It was mentioned by Polybios (4.63.4).

BIBLIOGRAPHY. N.G.L. Hammond, *Epirus* (1967) 157, 159f. N.G.L. HAMMOND

CHARADROS (Kaledıran) Turkey. Map 6. Site in Cilicia Aspera, 25 km W of Anamur. Recorded as a city with harbor by Pseudo-Skylax in the 4th c. B.C., later a station under a Ptolemaic hegemon. It is mentioned in the *Stadiasmus* as a chorion, and about A.D. 200 as a harbor of Lamos—probably the region rather than the city (*IGR* III, 838). Virtually nothing remains of the city apart from some scattered blocks among the houses and a milestone of A.D. 137.

BIBLIOGRAPHY. R. Heberdey & A. Wilhelm, *Reisen in Kilikien* (1896) 155; G. E. Bean & T. B. Mitford, *Journeys in Rough Cilicia in 1962 and 1963* (1965) 42-43. G. E. BEAN

CHARAX Crimea. Map 5. Scythian fortress (later, Roman) of the 3d c. B.C. on the Ai-Todor promontory near ancient Chersonesus, not far from modern Yalta. A fortress of the Tauri tribe, it was ringed with thick cyclopean walls of hewn stone. The fort was seized by the Romans in the 1st c. A.D. and made into a military camp. It then acquired a second ring of walls and the area was increased to 1.5 ha.

Houses with walls of stone and brick have been uncovered, and water pipes and mosaic-floored basins (design of cuttlefish) have been found; also, there are ruins of Roman baths (25 x 15 m) and a necropolis of the 3d-4th c. Pottery and other articles are of local manufacture. The Simferopol Museum contains material from this site.

BIBLIOGRAPHY. V. D. Blavatskii, "Kharaks," *Materialy po arkheologii Severnogo Prichernomor'ia v antichnuiu epokhu* [Materialy i issledovaniia po arkheologii SSSR, No. 19] (1951) 250-91; A. L. Mongait, *Archaeology in the USSR*, tr. M. W. Thompson (1961) 203-5. M. L. BERNHARD & Z. SZTETYŁŁO

CHARAX (Iraq-Iran), see ANTIOCH

CHARLIEU Loire, France. Map 23. A Gallo-Roman site of the 1st c. in the Sornin valley (flanged tiles, pottery, coins of Tiberius). In 870 the priory church of the abbey of Charlieu was built over an earlier church, with a crypt containing an inscribed sarcophagus.

BIBLIOGRAPHY. C. Chopelin, "L'implantation gallo-romaine dans la vallée du Sornin (Loire)," *Ogam* 15 (1963) 342. M. LEGLAY

CHARTERHOUSE-UPON-MENDIP Somerset, England. Map 24. Important center of lead/silver mining; pigs bearing imperial titles from Claudius to Marcus and Verus (A.D. 49-169) are known; production continued to the end of the 4th c. Neronian and Vespasianic pigs sometimes bear the stamped names of lessees or a company; some give the Roman place-name VEB(. . .). There is little to see at Charterhouse, where most obvious traces of mining are of the 19th c. Faint irregularities in fields on either side of a lane leading to a small earthen amphitheater (at National Grid Reference ST.499/565) are resolved, from the air, into the outline of the streets and small insulae of a straggling township. Many finds from this area are in Bristol City Museum (brooches, gems).

BIBLIOGRAPHY. F. Haverfield, *VCH Somerset* I (1906, repr. 1969)[MI]; D. Elkington in J. Campbell et al., *The Mendip Hills in Prehistoric and Roman Times* (1970)[I]. Mining: G. C. Boon in *Apulum* 8 (1970)[I]; E. K. Tratman et al., *Proc. Univ. Bristol Spelaeolog. Soc.* 13.3 (1974)[PI]. G. C. BOON

CHARTRES, see AUTRICUM

CHASSENON, see CASSINOMAGUS

CHÂTEAUBLEAU Dept. Seine-et-Marne, France. Map 23. Châteaubleau, in the Provins arrondissement in the canton of Nangis, is the site of a Gallo-Roman settlement covering about 30 ha that was inhabited until the 3d c. It lies along the Roman road linking Sens to Senlis by way of Meaux and just next to the boundaries of the old dioceses of Meaux and Sens which seem to have been drawn up on the limits of the ancient cities of the Meldi and Senones.

The site has been under excavation since 1960. Finds include a water-cult sanctuary at La Tanneric, and, at Le Vois de la Vigne, a rustic theater. The sanctuary, a rectangle (31.10 x 35.65 m) with two apses on each of the long sides, still has water coming into it. Some curious ex-votos have been excavated there; carved in painted mortar, they represent eyes and ears, leading to the supposition that there was a fountain divinity that healed those organs. The middle of the sanctuary apparently had a pool in it, which has not yet been uncovered. Only pottery and 3d c. coins have been found in the sanctuary. The rustic theater has seats covered with wood and cut in the soil and is modest in size (80 x 53 m).

BIBLIOGRAPHY. M. Fleury, "Informations arch.," *Gallia* (1965, 1967). J.-M. DESBORDES

CHÂTEAUMEILLANT, *see* MEDIOLANUM BITURIGUM

CHÂTEAUPONSAC Dept. Haute Vienne, France. Map 23. A prehistoric oppidum at the place called Chegurat. Of the fortified spur type, it overlooks the Semme valley.

In 1961 a dig at the village of La Bussière-Etable revealed a Gallo-Roman settlement that was occupied from the 1st to the 3d c. A.D. When a tumulus was excavated in 1956, also at La Bussière-Etable, a chariot tomb was found dating from the time of the barbarians (3d c A.D.); it held a large number of grave gifts that can be seen at the Musée des Antiquités Nationales at St. Germain-en-Laye. At the Musée Notre Terroir at Châteauponsac can be seen burial chests and Gallo-Roman objects uncovered in the course of the various excavations in this commune.

BIBLIOGRAPHY. "Les decouvertes de la Bussière-Etable," *Bull. de la Sahl* (1950) 130; (1965) 53. P. DUPUY

CHÂTEAU-PORCIEN Ardennes, France. Map 23. Site on the Aisne near the Roman road from Reims to Cologne. Excavation has yielded traces of Neolithic occupation and, some distance away, some Gallo-Roman objects and traces of buildings. Most of the digging has been carried out at La Briqueterie, near the old Ecly road, at L'Aiguillon, and on the Nandin plateau overlooking the Aisne valley.

In the lower part of the site a well-furnished incineration necropolis has been found (terra sigillata and common ware, fibulas, bracelets and an oinochoi of bronze), some harness pieces and a horseshoe by the roadside, and traces of a Gallo-Roman villa containing frescos and mosaics. On the plateau were found not only coins (Tiberian aureus) and quantities of sherds, but also traces of craftsmen's workshops (fibula molds, bronze-founding crucibles) and the cellar of a house.

Aerial photographs show that there was a city on the plateau covering at least 20 ha, with buildings arranged on a grid plan, several of them very large. A number of complexes of individual buildings have also been located on the outskirts of the city. Work on the site itself has uncovered pits dug in the clay, the basement of a house with clay or limestone walls where many potsherds were found, and the foundations of a square fanum. The floor of this building had about a dozen pits dug in it which held a variety of objects: one pit contained about 100 bovine horns and nothing else. The pottery was varied, consisting mainly of common wares, metalized black ware, Gallo-Belgic ware, the pottery with a crackled appearance and bluish tone often found in Champagne, and a smaller quantity of imported terra sigillata. When it is possible to date them, the wares in every case go back to the 1st c. A.D., sometimes to the beginning of the century. The early finds are housed, in part, at the Musée de Rethel; recent ones are in the depot of the Service of Antiquities in Reims.

BIBLIOGRAPHY. A. Larmigny, *Bull. Soc. Arch. Champenoise* 2 (1908) 54ff; 7 (1913) 18f; 18 (1924) 13; 20 (1926) 78-80; 21 (1927) 70f; 22 (1928) 52f; 30 (1936) 33f; E. Bosse et al., *Travaux de l'Académie de Reims* 129 (1910-11) 219-26; M. Maquart, *Bull. Soc. Arch. Champenoise* 30 (1936) 18-25; *Bull. du Comité des Amis du Musée du Rethelois et du Porcien* 9 (1939) 30f; E. Frézouls, *Gallia* 27 (1969) 291ff[I]; 29 (1971) 278-80[I].
 E. FRÉZOULS

CHÂTEAURENARD Loiret, France. Map 23. The valley of the Loing, in antiquity the principal waterway linking the Loire and Seine basins, is extremely rich in archaeological sites. The Loing is navigable at least as far as Montargis, and consequently the most important sites are to be found along its valley (see Pontchevron and Montbouy). But cross-routes along the tributaries of the Loing were also used; one of the busiest of these followed the valley of the Ouanne which leads to the valley of the Loing, a little upstream of Montargis, by way of Auxerre. Montargis itself was occupied in the Gallo-Roman period, as excavations attest, and the name Conflans sur Loing at the confluence of the rivers indicates that there was another ancient site there. Going up the Ouanne, we come to Châteaurenard, where a small bath building has been found two km W of the center of the modern village, known in the area as La Bouzie. The complex consists of two main buildings; in one a frigidarium has been identified on one side, and some caldaria on the other. The second building is ca. 5-6 m E of the first; here a pool and a room have been excavated. The latest period of occupation was the 4th c. A number of rebuildings indicate that the baths were used over a long period, indeed their construction may be dated in the 2d c. We cannot yet tell whether these are private baths belonging to a villa, or public baths belonging to a vicus or conciliabulum (see Triguères and Vendoeuvre en Brenne). Some tombs have also been found.

BIBLIOGRAPHY. *Gallia* 24, 2 (1966) 241; Abbé Nouel, *Origines Gallo-romaines du Sud du Bassin Parisien*, 24, 31, 33; Mémoir inédit de M. Roncin (La vallée du Loing dans l'Antiquité). Paper on the same subject by Dr. Vauthey, Congrès des Sociétés Savantes de Reims, April 1970. G. C. PICARD

CHÂTILLON-SUR-SEINE, FORÊT Côte-d'Or, France. Map 23. The vast massif is limited to the W by the valley of the Seine, to the NE by the valley of the Ource, and to the S by the valley of the Brevon. The ravined, calcareous plateau does not retain rainwater and there are no springs in this forest. According to the most recent thought the origin of these woods does not seem to be earlier than the Merovingian period. The oldest trace of human occupation seems to be the barrow of Le Soue de Banne. It contained a cist of stone slabs which enclosed a crouched skeleton. The grave goods consisted of some flint flakes and perforated shells. Prehistoric occupation was intense mainly during the first

and second Iron Ages; the Bronze Age has left no remains. The funerary mounds are built of dry stones, without earth, and they are located on the edges of the wooded massif. Most frequently the central burial, for which the barrow was built, dates to the Late Hallstatt period (6th c. B.C.). Secondary burials dating to La Tène I (5th, 4th c. B.C.) were inserted into the body of the monument. The burial rite was always inhumation. Near the Ource valley to the east one finds the Maisey, Vanvey, and Villers-le-Duc burial groups. To the S between the Brevon and Seine valleys one can mention the barrows of Brémur, Busseaut, and Essarois. The barrows of Voisin and Aisey are found along the Seine valley to the SW.

During the Gallo-Roman period human occupation was extensive and included the entire plateau. Two fana have been identified and excavated: that of Essarois, consecrated to Apollo Vindonnus, and that of Saint-Germain-le-Rocheux. Both have produced a great quantity of votive offerings and statues. The fanum of Saint-Germain-le-Rocheux was built on the site of a wooden Gallic temple.

Up to now some 40 Gallo-Roman buildings have been identified in the Forest of Châtillon. For the most part they consist of small villas or agricultural domains clustering near the Roman roads which crossed the forest. Only one of these villas (the villa of Pepinière) has been partly excavated. It was characterized by a spacious entry-way and fine ashlar walls adorned with polychrome frescoes.

The agricultural domains include, in addition to the living quarters, barns, and stables, vast enclosures shut in by small walls. The existence of these farms in what is now the middle of the woods demonstrates that the forest had not yet grown up in the Gallo-Roman period. The absence of water sources must have necessarily limited exploitation of the area, since livestock could drink only in ponds. It appears that all of these buildings, secular and religious, were destroyed at the end of the 3d c., but only excavations can confirm this.

The grave goods from the prehistoric remains in the Forest of Châtillon, as well as the excavated assemblages from the temples of Essarois and St.-Germain-le-Rocheux are in the Musée Municipal at Châtillon-sur-Seine.

BIBLIOGRAPHY. F. Henry, *Les tumulus du département de la Côte d'Or* (1933); R. Joffroy & R. Paris, "Le tumulus du Soue de Banne," *Bull. Soc. Arch. du Châtillonnais* (1948); Joffroy, *Un tumulus à Essarois* (Côte d'Or): *le tumulus du Bas de Comet*, XVe Congr. Préhist. de France (1956); Mignard, *Hist. d'un temple dédié à Apollon, près d'Essarois*, Mém. de la Com. des Ant. de la Côte d'Or (1847-52) III; R. Paris, "Fouilles du Fanum du Tremblois," *Bull. de la Soc. Arch. du Châtillonnais* (1961-62-63-65-67). R. JOFFROY

CHAVAGNÉ Deux-Sèvres, France. Map 23. The ancient site called La Fougeoire is in the civitas of the Pictones. It was on the highway leading from Poitiers to the Sinus Pictonum, as was the sanctuary of Sanxay (Vienne). Aerial reconnaissance has revealed a vast ensemble, covering several ha, of architectural remains, trenches, and circles.

A main building, oriented N-S, the nature of which is uncertain (villa?), was worked on in two different periods, the beginning of the 1st c. and the Flavian period, when it seems to have been remodeled and enlarged. Occupation of the site goes back to Iron Age III.2 and lasted until the 3d c. A.D. Objects of Celtish design, a mold, and bronze decorations, indicate that the pre-Roman tradition long survived here.

BIBLIOGRAPHY. *Gallia* 25 (1967) 255; 27 (1969) 270-71; 29 (1971) 263-65; *Bulletin de la Société historique des Deux-Sèvres* 13 (1967) 261-68; n.s. 1 (1968) 159-79; 2 (1969) 217-32; 3 (1970) 263-71. G. NICOLINI

CHAVES, *see* AQUAE FLAVIAE

CHEDWORTH Gloucestershire, England. Map 24. Roman villa, beside the White Way 12.8 km N of Cirencester, discovered in 1864 and excavated 1864-66. The villa faces E down an attractive valley and its buildings ultimately enclosed two courtyards, with an overall size of at least 75 by 90 m, but only the inner court and the N wing of the outer court have been exposed. Most of our knowledge of its development derives from excavations in 1957-65, undertaken in connection with consolidation.

The courtyard form had been imposed on groups of buildings which were originally detached, and the earliest structure known, which was destroyed by fire in the middle of the 2d c., was in what became the S wing of the inner courtyard; in its later, rebuilt, state this wing appears to have housed the bailiff's office and to have had a kitchen at its W end. The W wing had also undergone substantial alteration, both at the turn of the 2d-3d c. and at a later date. In its final form (4th c.) it contained a heated dining room and a suite of baths, all with good mosaic floors (the work of the Corinian school of mosaicists). These baths, however, were a late development, for the original baths occupied what became the W end of the N wing, where they were ultimately replaced by a laconicum, for dry-heat bathing, as a supplement or alternative to the damp-heat baths in the W wing (the plunge baths associated with the laconicum were for a time wrongly interpreted as fulling vats). The remainder of the N wing, extending along the side of both courtyards, contained a further series of at least eight rooms, some of them with hypocausts and including a dining suite at the E end.

Water was supplied from a nymphaeum, later Christainized, just outside the NW corner of the inner court. A small Romano-Celtic temple on a high podium, dating from the 2d to the 4th c., stood 270 m SE of the villa, overlooking the Coln river. Chedworth is one of the best preserved of British villas and may be taken as typical of the rich group that flourished in the Cotswolds in the 4th c. The site was acquired for the National Trust in 1924 and the remains are open to inspection, together with a site museum.

BIBLIOGRAPHY. G. E. Fox, *ArchJ* 44 (1887) 322-36; I. A. Richmond, *Trans. Bristol and Glos. Arch. Soc.* 78 (1960) 5-23; temple: W. St. C. Baddeley, ibid. 52 (1930) 255-64; mosaics: D. J. Smith in A.L.F. Rivet, ed., *The Roman Villa in Britain* (1969) 97-102; guide: R. Goodburn, *The Roman Villa Chedworth* (1973). A.L.F. RIVET

CHELLAH, *see* SALA

CHELONES Cyprus. Map 6. On the S coast of the Karpass peninsula, about 5 km due SE of the village of Rizokarpasso. The ruins of a small town, now covered by sand dunes, extend along the shore to the E of the modern storehouses. A small bay, still used by fishermen, may have been used as an anchorage. Nothing is known of the ancient name.

Nothing is visible above the surface of the ground. A sanctuary on the shore at the E end of the town produces fragments of terracotta figurines dating from the archaic to the Graeco-Roman period. On present-day evidence the site was in existence from archaic to Early Byzantine times, when it was abandoned after the first Arab raids of A.D. 647.

Opposite the storerooms, there are a large rock in the

sea known as Aspronisi and two or three other wave-washed reefs now forming part of the recently constructed fishing shelter. Farther E there are a few more reefs with a group of small upright rocks known as Gynaikopetres. These are probably the Karpasian islands mentioned by Strabo (14.6.3), who gives the distance from Karpasia, on the opposite coast, as 30 stadia, an exact calculation as the crow flies.

Hogarth noticed to the W of the town the remains of what he believed to have been a slip for the launching of ships and suggests that the mariners of antiquity sometimes drew their vessels across the land to Karpasia or vice versa in order to avoid the dangers of Cape Dinaretum.

On the summit of Rani, a hill to the S of Chelones, are remains of a settlement with a wall protecting it from the S, the other three sides being practically inaccessible. At the NW end of the summit there is a large underground cistern supported on square piers. This fortified site may have been a lookout camp for Chelones. Both sites are unexplored.

BIBLIOGRAPHY. D. G. Hogarth, *Devia Cypria* (1889) 79-80; A. Sakellarios, Τα Κυπριακά I (1890); M. Ohnefalsch-Richter, *Kypros, the Bible and Homer* (1893) 27.
K. NICOLAOU

CHÉMERY Moselle, France. Map 23. Situated ca. 4 km S of Faulquemont, and the site of an important Gallo-Roman sigillata factory excavated in 1934-36. It was the principal pottery of Saturninus and Satto; many of their fellow-workers had previously worked at Boucheporn. Saturninus still made some Drag. 29 vases here but Satto, who took his place around 125, turned out only Drag. 37 forms, as did the other potters in the group. Plain forms were made by some 50 potters: Drag. 18, 18/31, 27, 32, 33, 35, 36, 40. This typology and the fact that certain potters moved away enable us to date the start of the enterprise ca. A.D. 90 and the end ca. 150-160.

Four potter's kilns were discovered (two rectangular, one round, and the third in the process of being rebuilt), part of the workshop, and some dumps. Chémery marks the economic success of the Saturninus-Satto group, which the former initiated and the latter expanded. Chémery had some dealings with Blickweiler ca. 125-130, and it exported over a wide area, from England to the middle Danube. The N and NW zones accounted for ca. 57 percent of the trade and the E zone 28 percent; the remainder was distributed locally. Chémery enjoyed both commercial success and prestige: the art of Saturninus and Satto influenced several generations of potters in E Gaul, especially at La Madeleine, Heiligenberg, and Rheinzabern.

The Metz museum has archaeological collections.

BIBLIOGRAPHY. E. Delort, *Les vases ornés de la Moselle* (1953).
M. LUTZ

CHEMTOU, see SIMITHU

CHENAB, see ALEXANDRIAN FOUNDATIONS, 9

CHERCHEL, see IOL

CHERSONESOS (Limani Khersonesou) Pediada District, N Crete. Map 11. On the W side of the Bay of Mallia 26 km E of Herakleion. The ancient site derives its name from the prominent peninsula, Kastri, which shelters the harbor from the N. It served as out-port of the city of Lyttos, 15 km inland (Strab. 10.4.14); but in the 4th-3d c. issued its own coinage, an indication of autonomy. Its harbor was the best on the N coast of

Crete between Herakleion and Olous, and in the Roman and first Byzantine periods it became much more important than Lyttos.

Plutarch (*De mul. vir.* 247D) narrates its foundation legend; the colonists arrived with a statue of Artemis. Strabo (10.4.14) mentions the temple of Britomartis, one of the chief Cretan deities, and the site of the temple is indicated by the find of an inscription to her of the late 2d c. B.C. on a small headland ca. 1 km E of Chersonesos, where a church of Hag. Nikolaos stands on the ruins of a Roman building with a mosaic; remains of another building lie nearby, submerged in shallow water. Britomartis is depicted on many coins of Chersonesos.

In a 3d c. inscription Chersonesos appears as a subordinate ally of Knossos; in 183 B.C. it was one of the Cretan cities which made an alliance with Eumenes II of Pergamum. In the 2d and 1st c. B.C. it seems again to have been more closely linked with Lyttos, being described in inscriptions as "Lyttos on the sea"; but this may indicate not subordination to Lyttos but the transfer of real power to the coastal city. Bishops of Chersonesos are mentioned in the 5th to 8th c.

The peninsula N of the harbor has traces of Minoan settlement: sherds appear in the NE cliff face at the bottom of a deep occupation deposit. The peninsula was probably the city's acropolis in the Classical period; it was surrounded with defense walls in Late Roman or Byzantine times, and a fine Christian basilica was built on top in the 5th or 6th c. On the NE side of the peninsula a row of three fish-tanks, now totally submerged, was cut into the E end of a rock shelf in the Roman period.

The remains of the Roman city cover an extensive area S and W of the peninsula. The theater, of the Roman period, is now almost completely destroyed, but was still well preserved in 1583 (as was an amphitheater), and was visible until 1897.

The most significant ancient remains are those of the Roman harbor works, showing the city's importance and prosperity as a seaport. The harbor was protected on the E and S by massive breakwaters of large boulders, along the inner side of which run concrete moles which served as quays. These alone provided 330 m of berthing space, and there was a shoreline quay at least in the SW corner of the harbor. The stumps of stone bollards survive in the surface of the E mole and SW quay. On the W shore of the harbor remains are visible of house walls of the Roman period. Just inland is a fountain-house with mosaics.

Inland near Potamies have been found stretches of the aqueduct which brought water to the site from Lasithi.

BIBLIOGRAPHY. T.A.B. Spratt, *Travels and Researches in Crete* I (1865) 104-7; L. Mariani, *MonAnt* 6 (1895) 238-43; Bürchner, "Chersonesos (4)," *RE* 3 (1899) 2251; S. Xanthoudides, *Deltion* 4 (1918) Parartima I, 30-32; S. Marinatos, *Deltion* 9 (1924-25) 79-84; M. Guarducci, *ICr* I (1935) 33-34; E. Kirsten, "Chersonesos," *RE* Suppl. 7 (1940) 84-90MP; A. Orlandos, *Ergon* (1956) 118-23; J. Leatham & S. Hood, *BSA* 53-54 (1958-59) 266-73IP; Hag. Nikolaos mosaic: Marinatos *ICr* I, 35 no. 4.
D. J. BLACKMAN

CHERSONESOS Crimea. Map 5. A city on the W coast of the Crimea ca. 3 km W of modern Sebastopol. It is mentioned in the ancient sources (Strab. 7.4.2-7; Plin. *HN* 4.85; Polyb. 25.2.12; Pompon. 2.1.3; Ptol. *Geog.* 3.6.2 etc.). Founded in 421 B.C. by colonists from Herakleia Pontica, perhaps on the site of an earlier Greek settlement, it rapidly became the major city of SW Crimea and the chief center in this area for international trade. In the 3d c. B.C. Kerkinitis and Kalos

Limen came under its control. In the 2d c. B.C. under attack from the Scythian king Palak, it was supported by Mithridates Eupator, king of Pontus. Although the Scythians were conquered, Chersonesos lost its independence and became one of the cities of the Bosporan kingdom.

The city covered an area of 38 ha and its defensive system is one of the major architectural monuments of the N Black Sea region. Stone walls (3.5 km long and up to 3.8 m thick), with crenellated towers and gates, were first constructed in the 4th-3d c. and rebuilt in the Hellenistic and Roman times and later. The city was laid out according to the Miletian plan with straight streets crossing at right angles. Traces of houses from the 3d-2d c. follow the same plan as those in other cities in the region. A corridor led to an inner courtyard onto which rooms opened; each house had a well or cistern and the basins were often paved with mosaics. Other architectural remains include a mint of the 4th c. B.C., several wine-making establishments, several large pottery workshops, numerous cisterns for the salting of fish; large baths of the Roman era, Christian basilicas of the 5th-7th c.; an odeum (?); a theater of the late 3d-early 2d c. B.C., which was still in use in the 4th c. Outside the walls in the Hercules peninsula excavations have uncovered the ruins of numerous fortified farmsteads, some for grape growing and others for grain.

Among the many Greek inscriptions found are the oath of the inhabitants of the city (3d c. B.C.) and the decree of Diophanes (end of the 2d c. B.C.). A fine head of an ephebus in the manner of Skopas has been discovered; also many locally made terracottas, including a torso of a statue of Herakles. The Roman period is represented by funerary monuments, with portraits, and sarcophagi ornamented with scenes of Eros, griffins, and other figures of local legend. The Cherson Museum contains material from this site.

BIBLIOGRAPHY. E. H. Minns, *Scythians and Greeks* (1913) 498-553; K. E. Grinevich, *Sto let khersonesskikh raskopok (1827-1927): Istoricheskii ocherk* (1927); G. D. Belov, *Raskopki Khersonesa v 1934 g.* (1936); id., *Otchet o raskopkakh v Khersonese za 1935-1936 gg.* (1938); "Raskopki v severnoi chasti Khersonesa v 1931-1933 gg.," *Arkheologicheskie pamiatniki Bospora i Khersonesa* [Materialy i issledovaniia po arkheologii SSSR, No. 4] (1941) 212-67; id., *Khersones Tavricheskii: Istoriko-arkheologicheskii ocherk* (1948); *Materialy po arkheologii iugo-zapadnogo Kryma (Khersones, Mangup* [Materialy i issledovaniia po arkheologii SSSR, No. 34] (1953); S. F. Strzheletskii, "Osnovnye etapy ekonomicheskogo razvitiia i periodizatsiia istorii Khersonesa Tavricheskogo v antichnuiu epokhu," *Problemy istorii Severnogo Prichernomor'ia v antichnuiu epokhu* (1959) 63-85; id., *Klery Khersonesa Tavricheskogo* [Khersonesskii sbornik, No. 6] (1961); A. L. Mongait, *Archaeology in the USSR*, tr. M. W. Thompson (1961) 185-89; C. M. Danoff, *Pontos Euxeinos* (1962) 1104-16 = *RE* Suppl. IX; E. Belin de Ballu, *L'Histoire des Colonies grecques du Littoral nord de la Mer Noire* (1965) 74-94; I. B. Brašinskij, "Recherches soviétiques sur les monuments antiques des régions de la Mer Noire," *Eirene* 7 (1968) 96-97. M. L. BERNHARD & Z. SZTETYŁŁO

CHESTER, *see* DEVA

CHESTERHOLM, *see* VINDOLANDA *under* HADRIAN'S WALL

CHESTER-LE-STREET, *see* CONCANGIUM

CHESTERS, *see* CILURNUM *under* HADRIAN'S WALL

CHESTERTON Warwickshire, England. Map 24. A small settlement on the Fosse Way near Warwick. The defenses enclose a polygonal area of ca. 3.2 ha and are of two periods. They were constructed in the late 2d c. and after the middle of the 4th c. a stone wall 3.3 m thick and gates were added. At the same time the ditches were recut, making the large single ditch to be seen on the ground today. The N gate, excavated in 1961, had a single portal, with towers projecting inwards from the wall on each side. There is evidence of interior buildings, some with stone foundations. Excavations have shown building and rebuilding from the Antonine period on, and graves on the tail of the rampart indicate continuity into the 5th and 6th c. The settlement extends for a considerable area around the enclosure, and a villa is known ca. 1.6 km to the SE at Ewe Field Farm.

BIBLIOGRAPHY. *VCH Warwickshire* 1 (1904) 234-35; gates: *JRS* 52 (1962) 170-72; 58 (1968) 188; *Trans. Birmingham Arch. Soc.* 49 (1923) 58-60; excavation reports forthcoming. G. WEBSTER

CHESTERTON (Cambridgeshire), *see* DUROBRIVAE

CHEW GREEN Northumberland, England. Map 24. Beside the Roman road from York to the Forth, a short distance before it enters Scotland, there is a fine group of Roman earthworks comprising a fortlet, a semipermanent camp, and two temporary camps. The remains are clearly not all of the same date.

Excavations in 1936 showed that the earliest occupation was an almost square temporary camp of 7.2 ha, capable of holding a legion on the march and probably built at the time of Agricola's invasion of Scotland. This was succeeded by a small fortlet (no surface traces) which produced Flavian pottery; a second temporary camp of 5.6 ha followed, whose occupants constructed the semipermanent camp. The defenses of the latter enclose only 2.4 ha but are stronger than those of the other two camps; the four gates were originally equipped with both claviculae and traverses, while on the NW the rampart was furnished with catapult platforms. Although the troops were housed in tents, roads were laid down in the interior. Finally, in the Antonine period, the early fortlet was leveled to make room for a larger one; the garrison had the task of guarding and assisting convoys negotiating the very steep inclines leading to the site. About 64.5 m square, this fortlet is protected by triple ditches on all sides except the S, which is covered by two enclosed wagon parks; the internal buildings were half-timbered structures on rubble sills.

BIBLIOGRAPHY. *Arch. Ael.* 14 (1937) 129-50.
 K. A. STEER

CHICHESTER, *see* NOVIOMAGUS REGNENSIUM

CHIERI, *see* CARREO POTENTIA

CHIETI, *see* TEATE MARRUCINORUM

CHIMERA, *see* CEMARA

CHINON, *see* CAINO

CHIOS, *see* PITYOUSSA

CHIPIONA Cádiz, Spain. Map 19. Town NW of Cádiz, near the mouth of the Guadalguivir. The Coepionis monumentum corresponds to the Kaipionis Pyrgos of Poseidonius, according to Strabo (3.140) and, better still, to the Salmedina rock on which the monument or pharos must have stood. Appian (*Hisp.* 70) states that the pharos

was built by Q. Servilius Caepio, hence its name. P. Mela (3.4) also mentions it. The town appears to have belonged to the Turduli and most of its ruins are probably under the sea. Coins, jewels, and terra sigillata vases have been found, and rock-cut pits as well as graves and their grave goods near the beach.

BIBLIOGRAPHY. A. Schulten, *Fontes Hispaniae Antiquae* IV, 123; VI, 48, 49, 150; E. Romero de Torres, *Catálogo Monumental de España. Provincia de Cádiz* (1934) 194, 259, 462, 484. C. FERNANDEZ-CHICARRO

CHIUSI, *see* CLUSIUM

CHLOE, *see* LEMNOS

CHOMA (Hacımusalar) Lycia, Turkey. Map 7. The site, 14.5 km SW of Elmalı, is first mentioned by Pliny (*HN* 5.101), then by Ptolemy and Hierokles and in the Byzantine bishop lists. In the 2d c. A.D. it received 7000 denarii from Opramoas of Rhodiapolis for a stoa and a Temple of the Augusti. Its character as a genuine Lycian city in the Classical period is proved by a rock tomb with inscription in the Lycian language in the hills a few miles to the W. It was probably included in the Lycian League in the 1st c. A.D.; the earliest coins, of the 1st c. B.C., were of nonfederal type. Otherwise coinage is confined to Gordian III.

The site was identified in 1963 on the strength of a number of inscriptions. The name alludes evidently to the mound, low but conspicuous in the flat plain, about 0.8 km from the present village. The river Aedesa, mentioned by Pliny (*HN* 5.101), is clearly the modern Akçay. Nothing whatever of the ancient city remains standing, either on the mound or in the neighborhood, and there are no tombs to be seen. The remnants of antiquity consist merely of sherds and ancient blocks in the villages of Hacımusalar and Sarılar.

BIBLIOGRAPHY. G. E. Bean & R. M. Harrison in *JRS* (1967) 40-44; Bean, *Journeys in Northern Lycia 1965-1967* (*Österreichische Akademie Denkschriften* 104, 1971) 22-23. G. E. BEAN

CHORA, *see* ASTYPALAIA

CHORAZIN (Khirbet Kerazeh) Israel. Map 6. Town in Galilee, 4.8 km N of Capernaum, mentioned in Matt. 11:20-24 together with Beth-Saida. Wheat for the service of the Temple in Jerusalem was brought from here. By the time of Eusebius (*Onom.* 174.23) it lay in ruins.

A synagogue of the Galilean type was discovered in the 19th c. and has been partly excavated: it is 20.7 by 15.3 m, built of basalt ashlar on the highest spot in the town among other public buildings. From an open court in front a grand staircase led up to three portals facing S towards Jerusalem. The interior was divided by three colonnades into a nave, 6.3 m wide, and three aisles, each 1.8 m wide, with stone benches along the walls. The columns of the interior were quasi-Ionic and quasi-Doric, but the capitals of the pilasters which decorated the exterior were Corinthian. A frieze on the upper part of the outside wall shows plant motifs as well as representations of men pressing grapes, a lion devouring a centaur, and a Medusa.

Some private dwellings, a ritual bath, and wine presses have also been found. There are indications that the town was still flourishing in the Byzantine period, which would contradict Eusebius.

BIBLIOGRAPHY. H. Kohl & C. Watzinger, *Antike Synagogen in Galilea* (1916) 41ff; F. M. Abel, *Géographie de la Palestine* II (1938) 299-300. A. NEGEV

CHOTT MARIEM, *see* THEMETRA

CHRETIÈNNE, *see* SHIPWRECKS

CHRYSOSTOMOS, *see* LASAIA

CHUR, *see* CURIA

CHYTROI Cyprus. Map 6. The ruins of a small inland town, due E of the village of Kythrea, have been identified with those of Chytroi. The town consisted of two parts, the acropolis and the lower town. The acropolis situated on a hill now called Katsourkas lies N of the town. The lower town extends to the S around the ruined Church of Haghios Demetrianos. No traces of a city wall are visible. A large necropolis extends S and SE. A Geometric necropolis to the SW of Kythrea may also belong to early Chytroi.

The town was traditionally founded by Chytros, son of Aledros, the son of Akamas. The historical town succeeded a Late Bronze Age settlement. We also know that the area around the nearby Kephalovryse, the principal spring in the island, was inhabited since Neolithic times. Even Salamis was supplied with water from this spring by an aqueduct, the remains of which still exist for part of its 56 km course.

Little is known of the history of the site. The name appears on the prism of Esarhaddon (673-672 B.C.), if the identification were beyond dispute. The prism mentions Pilagura, king of Kitrusi, identified as Pylagoras or Philagoras, king of Chytroi. Its name appears for the first time in one of Lysias' speeches in the early 4th c. B.C. After this the town is frequently mentioned by many ancient writers and is also mentioned in the list of the theodorokoi from Delphi (early 2d c. B.C.). In Early Christian times it became a bishopric and flourished down to Early Byzantine times, but was finally abandoned after it was sacked by the Arabs in A.D. 912.

Very little is known of its monuments. Inscriptions indicate that there were a gymnasium in the 2d c. B.C. and shrines to Artemis, Hermes, and Herakles but the location remains unknown. The site is still unexcavated but many casual finds have been recorded, including an over-life-size bronze statue of Septimius Severus, now in the Cyprus Museum.

On the summit of a hill called Skali, due NW of the town, are the remains of a sanctuary identified from inscriptions as that of Aphrodite Paphia. This sanctuary was summarily excavated in 1876, uncovering partially one of two rectangular temples and again in 1883. There is nothing to be seen at present, the site being badly eroded; however, fragments of sculpture are still scattered about. This sanctuary dates from archaic to Graeco-Roman times. Another sanctuary may have stood on the acropolis.

The Sanctuary of Apollo Agyates at Voni, ca. 3.2 km south of Chytroi, should be associated with this town. Excavated in 1883, it yielded a large quantity of sculpture dating from archaic to Hellenistic times. This sanctuary consisted of two courts, one inner and one outer, enclosed by walls. The inner court was probably that for burnt offerings and communicated with the outer court in which votive statues were erected. Of this sanctuary nothing survives above the surface of the ground.

The finds are in the Cyprus Museum.

BIBLIOGRAPHY. Luigi Palma di Cesnola, *Cyprus, its Ancient Cities, Tombs and Temples* (1877); M. Ohnefalsch-Richter, *Kypros, the Bible and Homer* (1893); I. K. Peristianes, Γενικὴ Ἱστορία τῆς νήσου Κύπρου (1910); K. Nicolaou, Γεωμετρικοὶ Τάφοι Κυθραίας, *Report of the*

Department of Antiquities, Cyprus (1965) 30-73[MPI];
I. K. Nicolaou, "Tombe Familiale de l'époque Hellé-
nistique à Chytroi, Chypre," *BCH* 92 (1968) 76-84[I].

K. NICOLAOU

CIBALAE (Vinkovci) Yugoslavia. Map 12. On the river
Bosut a significant prehistoric site, first mentioned as a
municipium (*CIL* III, 3267), probably in Hadrian's time,
then as colonia Aurelia Cibalae (*CIL* III, 14038, Pécs),
perhaps in the Severan period. The walls surrounded an
area 860 by 650 m. It was situated at the intersection
of roads leading to Sirmium, to Siscia, and to Mursa-
Aquincum. Here Licinius was defeated by Constantine
in 314. Presumably the town was the seat of a bishop.
It existed to the beginning of the 6th c.

Recent excavations have uncovered remains of aque-
ducts and sewers, houses with hypocausts, lead water
mains, mosaics and marble paneling. Kilns have yielded
some knowledge on domestic production of pottery and
oil lamps. The finds can be seen in the local museum and
in the Archaeological Museum at Zagreb.

BIBLIOGRAPHY. J. Brunšmid, "Colonia Aurelia Cibalae,"
VHAD 6 (1902) 117-66[PI]; V. Hoffiller, "Spomenici rim-
skog lončarskog obrta u Vinkovcima," *VHAD* 14 (1919)
186-95[I]; J. Korda, "Tragom Limesa od Vukovara do
Iloka s osobitim obzirom na Cibalae," *Limes u Jugo-
slaviji,* I (1961) 61-64[PI]; B. Vikić-Belančić, "Istraživanja
u Vinkovcima 1966. godine," *Vjesnik Arheološkog mu-
zeja u Zagrebu* 3, 4 (1970) 159-76[PI].

D. PINTEROVIĆ

ÇIGRI DAĞ, *see* NEANDRIA

CILLIUM (Kasserine) Tunisia. Map 18. On the great
highway from Gafsa toward the N, 40 km W of Sbeitla,
Kasserine is fortunate in rather rich soil and provision
of water and in its strategic location at the opening
between the two great mountain ranges, Semmama
and Chambi, which block all the region from E to W.
This gap, controlled by Cillium in antiquity, permits
passage between the south, an arid zone amenable to
nomadism, and the north, both grain-producing and rich
in pasture.

Since ancient times, this region has belonged to great
tribes of nomads: Mussulmen and Fraxii. It was to con-
quer them that Rome sent her troops, which after vic-
tory settled down in this strategic location. This explains
the great number of epitaphs of legionaries bearing the
name of the Flavii found in this town, for Cillium must
have been precisely that Flavian settlement created after
the pacification of the tribes. Provided with municipal
status and connected with the colony of Thelepte, it was
elevated in its turn to the rank of colonia probably in
the 3d c.

The ruins of the ancient town essentially cover a
plateau which extends down to the wadi Derb. The
modern village, extending from the other side of the
wadi, has thus preserved the majority of the archaeo-
logical site. Little excavation has been done, but the
interest of extant monuments suffices to class the site
among the most important of the region. Among those
monuments are two great mausolea: the one, of the
Petronii, in part destroyed; and the other, of the Flavii,
which bears a long inscription in verse. The triumphal
arch with one bay, dating from the 3d c., restored in
the 4th, has a dedication which gives the ancient name
of the town. The great dam on the wadi Derb, a long,
thick, winding barrier, probably served for irrigation of
the plain. There are also a fortress and small Byzantine
forts among buildings of the earlier era still poorly
identified.

The most important excavation on the site revealed

the theater, traces of which, discovered at the end of
the 19th c., had been lost. It is an edifice of average pro-
portions, situated on the edge of the town plateau and
against the flank which goes down to the wadi; inunda-
tions have preserved it in large part; the cavea and the
platform have also been found; the proscenium and
the scaena wall have been destroyed, probably by stone
robbers. Despite the absence of inscriptions and the
scarcity of decoration (only a corbel and a theater mask
of terracotta have been found), the edifice was probably
built at the end of the 1st c. A.D. to commemorate the
founding of the municipium.

On the summit of the plateau, excavation uncovered
a flat, paved space with a base in the center carrying a
dedication consecrated to Jupiter and Ceres. It marked
the location of a temple. A group of houses with peri-
styles, paved with mosaics, stood 100 m W of the arch.
Several of these, remarkable for their decor and their
arrangement, have also been excavated but remain un-
published. Certain of the mosaics have been transported
to the Bardo Museum in Tunis.

Numerous inscriptions, especially epitaphs and stelae,
have been discovered and marked. In 1958-60, during
the construction of a tourist hotel, an important necropo-
lis was laid waste.

BIBLIOGRAPHY. H. Desparmet, "Le théâtre de Cillium,"
Karthago 15 (1969-70) 13-66[PI]. A. ENNABLI

CILURNUM, *see* HADRIAN'S WALL

CIMIEZ, *see* CEMELENUM

CÎMPULUNG-MUSCEL, *see* JIDAVA

CIOROIUL NOU, *see* AQUAE

CIRENCESTER, *see* CORINIUM DOBUNNORUM

CIRÒ, *see* KRIMISA

CIRPI, *see* LIMES PANNONIAE

CIRTA (Constantine) Algeria. Map 18. The name
appears in texts from the 3d c. B.C. when the town
was a capital of King Syphax. Later it became Massinis-
sa's capital and the center of the kingdom which he
organized in the E part of modern Algeria and W Tu-
nisia. The town is cited by ancient authors several times,
in particular in connection with the war which Jugurtha
conducted against the Roman people. After Caesar's
victory at Thapsus in 46 B.C., the town and the territory
around it were given to an adventurer, P. Sittius, a com-
panion of Caesar and a native of Nocera in Campania.
His hold upon this prize, which extended between Africa
Nova and the territory of Bocchus, was undoubtedly
brief. Later attached to the province of Africa, to
which it belonged until the reign of Hadrian, the town
and its environs then came under the control of the
legate of the Third Augustan Legion, which was in gar-
rison at Lambaesis.

The town of Cirta had become a Roman colony,
probably as early as the time of Sittius. At the beginning
of the 2d c. it was the capital of a curious administra-
tive district, one of those anomalies common to the ad-
ministrative history of Africa. It was the capital of the
confederation of the IV colonies, the three others being
Rusicade, Chullu, and Milev. Its magistrates and munici-
pal assembly were those of the confederation. On the
other hand, Cirta itself possessed castella distributed
throughout the area of the High Plains and to the N
of the region: Castellum Mastarense, Elephantum, Tid-

ditanorum, Cletianis, Thibilis, Sigus, etc. After the dissolution of this confederation, Cirta recovered its role as a capital when it headed Numidia Cirtenses (created under Diocletian) and, later, all of Numidia. At that time it changed its name to Constantina in honor of the emperor who restored it to its splendor after a siege undertaken by the usurper Domitius Alexander.

Constantine was an important center of the Christian community as early as the 3d c. It became the chief town of an ecclesiastical district and was an important city until the end of antiquity. Although many ancient cities disappeared during the Arab Middle Ages, Constantine survived. The mediaeval built-up area, and later that of Turkish times, covered the pre-Roman and Roman constructions. The growth of the town after the French conquest was scarcely more favorable to the preservation of monuments—the entire necropolis of the Koudiat was razed in order to build new districts. What we know of the ancient town is from inscriptions and occasional chance finds rather than from surviving monuments.

The ancient town occupied a plateau of trapezoidal shape, well protected to the E and to the S by the deep canyon of the Rhummel, and to the W by another sheer slope. One approached the town from the SW by a spur which linked the center to the hill of the Koudiat. (A part of the material from the necropolis there is kept in the Constantine Museum.) However, the settlement certainly expanded beyond the plateau in ancient times. In the last few years a dwelling has been identified down towards Sidi M'cid. It is relatively well dated by Campanian pottery, and thus must have been occupied at least during the 1st c. B.C.

Outside the town, a large number of Punic and Neo-Punic inscriptions, as well as some Greek and Latin ones, found in the locality of El Hofra, demonstrate the existence of a sanctuary dedicated to Saturn and reflecting the influence of Punic civilization on the capital of the native kingdom of Massinissa. Some inscriptions are dated to years of the reign of this sovereign and of his successors; the stones are deposited in the museum.

In the town itself, little remains visible. A rampart or embankment wall built of ashlar with embossments is preserved inside the military citadel. At the time of the conquest, cisterns and temples were identified, always within the Casbah. In addition, the remains of bridges can be seen in the canyon of the Rhummel. Piers and arches of the aqueduct which fed the town stand upstream in the valley.

The Constantine Museum has collected a certain number of artifacts from the town. Also some inscriptions can be seen there. Many items in the museum collection come from sites in the vicinity (Tiddis, Kalaa des Beni Hammad, or ancient towns of the High Plains).

BIBLIOGRAPHY. S. Gsell, *Atlas archéologique de l'Algérie* (1911) 17, no. 126; H. G. Pflaum, *Inscriptions latines de l'Algérie* II (1941) no. 468; A. Berthier and R. Charlier, *Le sanctuaire punique d'El Hofra à Constantine* (1955). See also *Recueil des notices et memoires de la société archéologique de Constantine.*

P.-A. FÉVRIER

CISSA, *see* TARRACO

CISSIS, *see* TARRACO

ĆITLUK, *see* AEQUUM

CITTÀ DEL FRIULI, *see* FORUM JULII (Italy)

CITTÀ DI CASTELLO, *see* TIFERNUM TIBERINUM

CIUDAD RODRIGO, *see* MIROBRIGA VETTONUM

CIUS (Gîrliciu) Dobrudja, Romania. Map 12. Roman military settlement and port, on the road between Carsium and Troesmis. In the 4th c., a cavalry squadron (cuneus equitum stablesianorum) was stationed here. The fortress was rebuilt by Valens (369) after his victory over the Goths N of Danube. No archaeological excavations have been undertaken. Traces of walls surrounded by a ditch and a rampart are visible.

BIBLIOGRAPHY. *Ant. It.* 224.4; *Not. Dig. or.* 39.14. R. Vulpe & I. Barnea, *Din istoria Dobrogei*, II (1968) passim; *TIR*, L.35 (1969) s.v. I. BARNEA

CIVARONE, *see* CULARO

CIVAUX Vienne, France. Map 23. The ancient name of the site is unknown; in the 9th c. it was called Vicaria Excidulense. This very ancient site has yielded prehistoric remains but is known in particular for its important Merovingian necropolis.

A settlement of some importance stood on the site of the modern village in Gallo-Roman times, and one can still see traces of two Roman temples on the central square. Excavations have revealed the sites of a theater, a fortified camp, and the substructures of many villas. Cippi from the ancient Gallo-Roman cemetery are now in the Musée des Antiquaires de l'Ouest at Poitiers, and finds from recent digs in a little museum at Civaux itself.

The enigma of Civaux is its immense early mediaeval necropolis, where burials took place almost continuously from the end of the Roman period on. It contained thousands of stone sarcophagi, trapezoidal with monolithic lids that were usually decorated with a band in the middle with three bars across it, a very common motif in Poitou. The sarcophagi were placed on the ground or buried a little below the surface. Some graves of a different type have recently been discovered deeper down; these are burials in open ground, in dry-stone chests partly surrounded by stones. Why so many tombs were crowded together in this way remains a mystery. A legend has grown up that this is the resting-place of Clovis' warriors, who died fighting Alaric in 507, but texts refute it.

Besides these Christian tombs there are other remains of interest for the history of Christianity: the Merovingian apse of the present church, traces of a baptistery, a Christian epitaph of the 4th c., an ancient oratory dedicated to St. Sylvain, and an ancient place of pilgrimage.

BIBLIOGRAPHY. F. Eygun, *Gallia* 19,2 (1961); 21,2 (1963); J. C. Papinot, *Notice sur les vestiges archéologiques de Civaux* (1971). J. C. PAPINOT

CIVIDALE DEL FRIULI, *see* FORUM JULII (France)

CIVITA CASTELLANA, *see* FALERII VETERES

CIVITA LAVINIA *see* LANUVIUM

CIVITAS RIEDONUM, *see* CONDATE

CIVITAS TURONORUM, *see* CAESARODUNUM

CIVITAVECCHIA, *see* CENTUMCELLAE

CIVITÙCOLA, *see* CAPENA

CLANVILLE Weyhill, Hampshire, England. Map 24. The Roman villa here, 5.5 km NW of Andover, excavated in 1894, consisted of a roughly rectangular walled enclosure (45 x 60 m) with buildings on its N, E, and W

sides. The buildings on the N and E (54 x 9.9 m and 33 x 12 m respectively) were subdivided into several rooms but appear to have been of simple construction. That on the W, however, was an aisled building (28.8 x 15.6 m), subsequently divided into 12 rooms, several of which were provided with tesselated floors and one with a mosaic. Walls projecting from the N and S sides of the enclosure indicate that further structures remain to be discovered, perhaps including the main dwelling house.

The dates of the building and modification of the villa were not worked out, but the coins, apart from two of Domitian and one of Marcus, were all of the period 250-350. Though the site lies 3-4 km from any known Roman road, the finds included an inscription to Carinus (*RIB* 98), apparently part of a milestone and presumably brought here for reuse as building stone.

BIBLIOGRAPHY. G. H. Engleheart, *Archaeologia* 56 (1898) 2-6; *VCH Hampshire* I (1900) 295-97; J. T. Smith, "Romano-British Aisled Houses," *ArchJ* 120 (1963) 1-30. A.L.F. RIVET

CLAROS Ionia, Turkey. Map 7. The oracle and Sanctuary of Apollo Clarios was situated in Ionia, near the coast between Smyrna and Ephesos, in the prefecture of Izmir. No city is known and no coins. The sanctuary belonged to Colophon with its joint centers, which varied in importance in different periods: Old Colophon (near the village of Değirmendere), about 15 km to the N, and New Colophon, or Colophon by the Sea or Notium, which was an acropolis port at the outlet of the valley 2 km S. All the political and religious officials of the sanctuary held office in the city of Colophon and were Colophonians; there were no Clarians.

Claros was famed for its oracle, to which many literary texts bear witness (generally not in detail). The most informative of these are the Homeric Hymn to Apollo, Tacitus' account of Germanicus' consultation in A.D. 18 (Tac. *Ann.*), and Iamblichos' Treatise on the Mysteries (*De Mysteriis*). Its most flourishing period, according to the newest discoveries, was in the 2d and even the 3d c. A.D. Oracles, preserved chiefly by Christian writers, show that in this period the sanctuary officials came under certain philosophical influences and the oracle gave forth theological oracles of syncretist doctrine.

The site had been located, very approximately, in the coastal plain S of the village of Giavurköy (now Ahmetbeyli) following scattered finds of inscriptions towards the end of the 19th c. At the beginning of the 20th c. some columns and inscriptions were found which determined the exact location of what were later identified as the propylaea of the sanctuary. This latter monument was excavated almost in its entirety before the temple was discovered and exhumed. The monuments are, on the average, 4 m below the tobacco-growing plain; their bases are slightly below the phreatic water level. To the S, facing seaward, is the triple-doored propylaea or tripylon; its walls and columns are largely covered with inscriptions from the Imperial period. From there to the temple extend a series of bases honoring Roman governors of the 1st c. B.C. There was also a large sacred grove.

The temple is Doric, with five steps. In facade it measures 26 m with 6 columns, and 45.49 m deep with 11 columns. About 150 column drums have been found along with whole columns and their capitals, overturned in an earthquake after the temple had been abandoned. The present monument was probably built toward the beginning of the Hellenistic period. Around the beginning of the Imperial period changes were made to accommodate in the cella a group of three colossal statues

—Apollo seated between standing figures of Artemis and Leto. On the architrave is Hadrian's dedication of the monument, which he had finished. The altar, 27.5 m from the temple is 18.45 m wide with four steps; it was consecrated to Apollo and Dionysos. North of the temple-oracle is a small, badly damaged temple consecrated to Artemis Claria (her effigy appears on coins of the Imperial period); in front of it is an altar near which was found a Kore dedicated to Artemis by Timonax, the temple's first priest.

The special interest of the temple lies in the fine preservation of the whole oracular section below the temple. This section has two narrow staircases and passageways with seven changes of direction. A room, roofed at first then later vaulted, designed like a grotto, contained a marble omphalos, which has been recovered. A low postern gate leads to a second room where probably only the thespiod could enter; in this room was the well from which he drank the prophetic water. In front of the postern was a seat for the priest (probably the prophetes) whose task it was to note down the answers. The oracles took place on certain days, always at night. The majority of the inscriptions consist of lists of delegations in the Imperial period (2d and 3d c.)—the chronology can be established fairly readily—which came, especially from the interior of Asia Minor and the W coast of the Euxine, to consult the oracle. Certain cities sent delegations every year, others at times of public disaster. The city's official consultant, the theopropos, was often accompanied by a chorus of young men and girls from his city who came to sing hymns composed by poets, also compatriots. There are indications of mysteries and initiation in some of the texts.

BIBLIOGRAPHY. T. Macridy, *Oesterr. Jahreshefte* (1905 & 1912); id. & C. Picard, *BCH* (1915); C. Picard, *Ephèse et Claros* (1922); L. Robert, *Les fouilles de Claros* (1954); G. Klaffenbach, *Das Altertum* 1 (1955); L. Robert in C. Delvoye & G. Roux, *La civilisation grecque* I (1969) ch. "L'oracle de Claros."

Brief annual reports on the excavations in *Annuaire Collège de France, TürkArkDerg*I, *AJA, AnatSt*. Series of inscriptions in L. & J. Robert, *La Carie* II (1954); L. Robert in *Laodicée du Lycos* (1969). L. ROBERT

CLASSIS, *see* RAVENNA

CLASTIDIUM (Casteggio) Italy. Map 14. About 60 km S of Milan and 11 km S of the Po, it controls the route across the Po to Ticinum (Pavia) on the other side. It is famous as the town of the Celtic Anamares where the Republican general M. Claudius Marcellus won the spolia opima in 222 B.C. by slaying Virdumarus, the king of the Insubrian Gauls, in hand-to-hand combat. Shortly afterwards the poet Naevius celebrated Marcellus' feat in an historical play entitled *Clastidium*. After Marcellus' victory the Romans planned to use Clastidium as one of their chief bases for the conquest of the neighboring parts of Liguria and Cispadane Gaul, but they had to wait until after the second Punic war (218-201 B.C.) before they could carry out their program since at the very beginning of that struggle the town was betrayed into the hands of Hannibal (Polyb. 3.69 and Livy 21.48; 32.29,31). When the Romans finally brought Clastidium under control after 200 B.C., they made it a dependency of Placentia.

The Roman town was in the part of Casteggio known locally as Pisternile, but no Roman monuments have survived there. There are, however, remains of Roman bridges over two neighboring creeks, the Rile and the Coppa, and there is also a large block of ancient masonry at nearby Masone, the so-called Fontana di Annibale.

Roman inscriptions, coins, pottery, glass, and architectural fragments have been found at Casteggio in some quantity. The Municipio houses a few of the finds, but most have been sent to the museum of antiquities in the Castello Visconteo at Pavia, 20 km to the N.

The great Roman highway from Dertona to Placentia, the Via Postumia, served Clastidium; remains of its road station were found on the E outskirts of the modern town.

BIBLIOGRAPHY. G. Giulietti, *Casteggio: Notizie Storiche* (1890); M. Baratta, *Clastidium* (1931).

E. T. SALMON

CLATERNA (Ozzano) Emilia-Romagna, Italy. Map 14. A Roman municipium on the Via Aemilia to the E of Bononia, on the Quaderna. The site is in the Maggio section of the present town.

Excavations undertaken N and S of the Via Aemilia have brought to light mostly private buildings from the Late Republican and Early Imperial ages. Probably a vast area of cobblestone pavement discovered in connection with the Via Aemilia was the forum of the city, which seems to have had a regular plan.

BIBLIOGRAPHY. Brizio, "Claterna," *NSc* (1892) 133-45[PI]; Solari, "Claterna," *RivFC* (1930) 349; Aurigemma, "Mosaici di Claterna," *Il Comune di Bologna* (1934)[I].

G. A. MANSUELLI

CLAUDIOPOLIS (Mut) Cilicia Aspera, Turkey. Map 6. In a well-watered plain 80 km N-NW of Seleucea on the Kalykadnos. Named for the emperor, who gave it colonial status, Claudiopolis was first a city and later a bishopric. It was tentatively identified in 1800 with modern Mut by Leake, who noted that "its chief streets and temples and other public buildings may be easily distinguished, and long colonnades and porticos, with the lower parts of the columns in their original places. Pillars of verd-antique, breccia and other marbles, lie half buried in different parts. . . ." The city's identity was confirmed from epigraphic evidence at the end of the 19th c.

Little remains of Claudiopolis, apart from reused building material and inscriptions in Mut and in the walls of the 14th c. (Karamanoğlu) castle at the town's N limit. The theater, with fragments of seating and of the sculpture and column drums of its scaena, may still be recognized to the W, and S of the ancient ramparts (still visible in places as a low mound) is the necropolis with numerous sculptured sarcophagi. Of the latter, one recording the city's name has been removed for safekeeping to the precincts of Lâl Pasha's mosque.

BIBLIOGRAPHY. Ptol. 5.7.7; Amm. Marc. 14.2.5.

W. M. Leake, *Journal of a Tour in Asia Minor* (1824) 108, 117; A. C. Headlam, "Ecclesiastical Sites in Isauria (Cilicia Trachea)," *Suppl. Papers No. II of the Soc. for the Promotion of Hellenic Studies* (1893) 23.

M. GOUGH

CLAUDIOSELEUCEIA, see SELEUCEIA SIDERA

CLAUSENTUM (Bitterne) Hampshire, England. Map 24. The Roman site lies on a promontory surrounded on three sides by the river Itchen on the edge of Southampton Water. Occupation began soon after the Claudian invasion in A.D. 43 and continued until the 5th c. or later. Initially the site may have been occupied by a fort of the invasion period. From the mid 1st until the late 4th c. timber and masonry buildings spread over the site, but soon after A.D. 367 an area at the tip of the promontory was enclosed by a masonry wall ca. 2.7 m thick which followed the coastline on three sides and cut across the neck of land on the E. Earlier accounts record the presence of bastions on this E wall. It is possible that a garrison was moved to Clausentum from Portchester under the reorganization carried out by Count Theodosius. The promontory was further defended by an earthwork of late or post-Roman date.

Archaeological discoveries have been made sporadically over the last 200 years. The collection, now housed in the Gods House Tower Museum, Southampton, includes several inscriptions. The site is now largely covered by modern houses, but a small section of wall can be seen on the N side with part of an adjacent bath building.

BIBLIOGRAPHY. D. M. Waterman, "Excavations at Clausentum, 1937-8," *AntJ* 27 (1947) 151-71; id., "A Group of Claudian Pottery from Clausentum," *Proc. Hampshire Field Club and Arch. Soc.* 17 (1952) 253-63; M. A. Cotton & P. W. Gathercole, *Excavations at Clausentum, Southampton, 1951-1954* (1958).

B. W. CUNLIFFE

CLERMONT-FERRAND, see AUGUSTONEMETUM

CLITUMNUS Temple of Jupiter-Clitumnus, Umbria, Italy. Map 16. On the Clitumnus river ca. 4 km below Trebiae (Trevi), the most important of the many shrines to various divinities of the springs and waters that dotted the river's course. The god was represented not as a fluvial divinity reclining full length but standing in a purple-bordered toga praetexta. He gave oracles through leaves and foretold the future by lots. Votive inscriptions and symbols of answered prayers covered the temple's walls. Coins were commonly thrown into the water nearby. A bridge separated the sacred area from that across the stream for public use, and no swimming was allowed between it and the source. A special society, the Hispellates, was entrusted by Augustus with operating an inn and baths at the site free to all. Several villas were beautifully situated along the river's banks.

Parts of this major temple seem to be built into a Christian church of the Savior still standing at the site, apparently constructed in the 4th or 5th c. A.D.—though some consider it 8th c. Carolingian. It is in the form of a small temple in antis with four Corinthian columns, those on the outer edges contacting the antae. There is ornate molding on the architrave and pediment. The cella is lighted by two pairs of windows and contains an altar. The whole structure is elevated on a platform at the front, with an arched door beneath the facade, but it fits into the hillside at the back. There are no stairs along the front facing the river, but on either side of the cella, a third of the way back, is a door with enclosed porch and steps leading down to the ground. Some 7th or 8th c. frescos of Christ, Saints, and angels are faintly visible on the niche and altar walls. Most of the structural material is clearly ancient limestone from the Clitumnus temple.

BIBLIOGRAPHY. Verg. *G.* 2.146-48; Prop. 2.19.25-26; Stat. *Silv.* 1.4.129; Sil. Ital. 4.545-46, 8.451; Juvenal 12.13; Plin. *Ep.* 8.8; Suet. *Calig.* 43.

H. Holtzinger, "Der Clitumnus-Tempel bei Trevi," *Zeitschrift Bild. Kunst* 16 (1881) 313-18; Pila-Carocci, *Del Tempio e Fiume Clitunno* (1895); W. Hoppenstadt, *Die Basilica San Salvatore bei Spoleto und der Clitunnotempel bei Trevi*, Halle (1912); A. P. Frutaz, "Il Tempietto del Clitunno," *Rivista Arch.Crist.* 17 (1941) 245-64; *EAA* 2 (1959) 723[I].

R. V. SCHODER

CLUANA (Portocivitanova) Macerata, Marche, Italy. Map 14. A Roman municipium on the Adriatic coast (Mela 2.65; Plin. *HN* 3.13.111) at the mouth of the Chienti river. There remain in situ some inscriptions in the church of San Marone. In the territory of Cluana,

from the 1st c. A.D., a vicus Cluentensis has been attested (*CIL* IX, 5804) on a hill 4 km from the sea where Civitanova Alta now stands. The capital may have been transferred there in the Late Empire. At the end of the 5th c. there was an Early Christian diocesan seat in the town.

BIBLIOGRAPHY. *CIL* IX, p. 554; F. Lanzoni, *Le diocesi d'Italia* (1927) 393; N. Alfieri, "Cluana," *Antiquitas* 6-7 (1951-52), 14-36. N. ALFIERI

CLUJ, *see* NAPOCA

CLUNIA (Peñalba de Castro) Burgos, Spain. Map 19. Site on the Arandilla river near Coruña del Conde, ca. 30 km N of Aranda de Duero. Chief town of the Conventus iuridicus Cluniensis, province of Tarraconensis in Hispania Citerior, and a Celtiberian town of the Arevaci, mentioned during the Sertorian wars. Livy (*Per.* 72) says that Pompey besieged Sertorius in Clunia in 75 B.C., but according to Sallust (*Hist.* 2.93) Clunia hesitated between Sertorius and Pompey. It fell into the hands of Perpenna (Exuperantius 8; Florus 2.10.9), and is mentioned at the end of the Celtiberian wars when the Vaccaei were defeated by Metellus who attacked Clunia. Winter imposed an armistice in 56 (Dio Cass. 39.54). Afranius, a legate of Pompey during the triumvirate, finally subdued the Arevaci and the Vaccaei.

There is no further information about the town until the time of Galba. It was the chief town of the Conventus Tarraconensis, established by Augustus and Claudius in A.D. 41-54 (Plin. *HN*) and a large, fortified town during Galba's revolt against Nero; Galba took refuge there after the defeat of Vindex. It was undoubtedly in Clunia that Galba gave the standard to the new Legio VII Gemina on 10 June 68 (Tac., *Hist.* 2.11.1; 3.22.4; Dio Cass. 55.24; Suet., *Galba* 10). On Nero's death Galba took the title of Emperor in Clunia, as evidenced by the inscription on the sestercius minted by him with the legend HISPANIA CLUNIA SUL(picia) (s. Jucker) and the representation of Hispania or Clunia standing before the enthroned monarch offering him the pallium. The town is mentioned by Pliny (*HN* 3 and 4) in 77 B.C. and also in the *Antonine Itinerary* and by the Cosmographer of Ravenna, but Pliny does not mention it in the list of colonies in Hispania Citerior founded by Augustus. It bears the title of colony in an inscription (*CIL* II, 2780) from the time of Adrianus, A.D. 137, in the Burgos Archaeological Museum, and in the mention in Ptolemy. The presence of the quattuorviri and the aediles on the asses and the semisses from its mint in the time of Tiberius indicate that it was a municipium of free men.

The town must have been destroyed in the 3d c. during the invasions of the Franks and the Alamanni, as evidenced by the coin hoard from House 1, with mintings from the time of Galienus, Aurelianus, Florianus, Probus, Carus, Numerianus, Carinus, and Magna Urbica, up to 284. But it was rebuilt in the 4th c., as evidenced by House 1 and the forum. Nothing is known about Clunia under the Visigoths, but it must have been occupied by the Moors on their way to Amaya (Tarif) and was relieved and resettled by Gonzalo Fernández in 912 (*Anales Complutenses*). In 920 Abderramán II found it abandoned and undefended. In the 17th c. Clunia was finally located on the Alto de Castro, on a star-shaped meseta 1023 m above sea level, with an area of 130 ha. The *Antonine Itinerary* places it on the road from Caesaraugusta to Asturica. Nearby in Coruña del Conde are the remains of two small Roman bridges.

Excavations have been carried out in three stages. In the center of the town is a large forum of Imperial times; it has a rectangular basilica with two rows of columns and a small tribunal to the E perpendicular to the forum on the N side, shops on the E side and, in the corner, the entrance into the forum of a paved decumanus with a gateway that leads into the square. All the E side of the forum is known, as is the SE corner with the boundary line towards the temenos of the temple of Jupiter (not yet excavated). Near the forum on the E is a large rectangular public building ending in an exedra, with an aisle covered by a barrel vault and two triangular end rooms towards the N. The building is constructed over houses of the 1st c., one of which has been excavated. Entrance to the forum, on the N, is through a cardo which runs into the upper corner of the basilica, the line of which has deviated to the E in relation to the rectangular plan of the Augustan town indicated by House 1. This house was built during the Augustan age (Arretine pottery in the deepest levels) and lasted until the 4th c., with gardens and post-Constantine mosaics. Other urban houses recently identified include the large House of the Arches, with an extensive hypocaust and cryptoporticus. A house of the Italic type with an impluvium has been found in the Cuevas Ciegas area.

The theater, with the upper and middle rows of the cavea hewn out of the bedrock, is much damaged. Part of the frons scaenae remains but is devoid of any ornamentation, also half of the middle and upper rows of the cavea; the lowest section (ima), built of masonry, has disappeared. Excavation is now uncovering part of the substructure of the orchestra, the whole plan, and ornamental remains of the Corinthian order of the three tiers of the frons scaenae. The drainage system included an underground collector sewer, the Cueva de Roman, with an outlet to the N. The ruins have been heavily pillaged for building material and damaged by cultivation.

Among the finds are a group of freestanding statues, including a fine statue of Isis (Burgos Museum), a seated Jupiter (whereabouts unknown), and other sculpture and fragments. Other finds include stelai, inscriptions, and a tropheum in fragments.

Clunia minted native silver and bronze coins from the time of Sertorius on, as well as Hispano-Roman asses and semisses under Tiberius, and there is an unbroken series of imperial coins down to Honorius. Roman intaglios have been found, perhaps from a local workshop, and much of the pottery is Hispanic terra sigillata dating from the 1st c. on; the late types of the 4th and 5th c. are interesting. A 1st c. native potter has been identified, "the potter of birds and hares," who painted his vases in the last survival of pre-Roman ceramics. There is a museum on the site.

BIBLIOGRAPHY. *CIL* II, 2772-2813; P. de Palol, *Clunia Sulpicia, ciudad romana* (1959); id., "Excavaciones en el foro de Clunia," *Homenaje a Vicens Vives* (1965); id., "Notas en torno al teatro de Clunia," *Arquivo de Beja* 22-24 (1966-67); id., *Guía de Clunia* (3d ed. 1974); M. Trapote & M. Martín Valls, "Hallazgos monetarios en Clunia de 1958 a 1962," *Monografías Clunienses* 1 (1964); id., "Los capiteles de Clunia," ibid. 2; for sculpture see A. García y Bellido, *Esculturas romanas de España y Portugal* (1949) geographic index; coins, Vives, *La Moneda Hispanica* IV, III. P. DE PALOL

CLUPEA or Aspis (Kelibia) Tunisia. Map 18. The old town on Cape Bon rises along the slope of the hill where the fort stands, several km NW of the present town. Some recent works of construction in this sector in 1966 revealed an important residential district descending in successive tiers towards the bank. Of particular importance is a luxurious villa that contained a bust of Marcus Aurelius. This aristocratic house includes a large central garden surrounded by a peristyle,

complete on three sides, on which open the rooms. The most remarkable wing is formed of four large rooms all paved with mosaic of high quality. The wing that is perpendicular to it comprises a series of several chambers set against the hill. An ensemble of areas is situated above and beyond this wing, on a higher level, constituting a *piano nobile* offering a large panorama of the sea.

About a score of meters away at the center of the city is a capitoleum with imposing architectural elements of white marble.

BIBLIOGRAPHY. A. Ennabli & J. M. Lassus "Rapport préliminaire de la fouille de la villa romaine de Kelibia," *Africa* 3 (1969-70) 239-41. A. ENNABLI

CLUSIUM (Chiusi) Italy. Map 14. The oldest inland settlement of the Villanovans and one of the chief cities of Etruria, it lies 800 stades (ca. 130 km) N of Rome (Strab. 5.2.9) in the hilly country between lake Trasimene on the NE and the extinct volcanoes of M. Amiata and Radicofani on the SW. Its territory stretched NW to the river Ombrone and S to the Paglia. The city itself crowns an isolated hill dominating the Val di Chiana to the N. In antiquity the Clanis (Chiana) flowed S into the Paglia and the Tiber system and was navigable, so the stories of Clusium's early associations with Rome may be true. It was linked to the coastal cities by two routes: one up the Fiora, around the N end of lake Bolsena, crossing the Paglia at Acquapendente, which accounts for the early influence of Vulci, Tarquinia, and Caere on Clusium; the other route, down the Orcia to the Ombrone, which may explain coins that link its name with Populonia and Vetulonia as issues of a commercial league. The fertility of the region was famous in antiquity, it was also rich in iron and copper, and its hot springs are still appreciated.

Clusium first appears in Roman chronicles as one of five Etruscan cities that promised to help the Latins against Tarquinius Priscus (Dion. Hal. 3.51). The city's most famous son, Lars Porsenna, attacked and captured Rome in the first years of the Republic but did not restore the Etruscan Tarquins to the throne (Livy 2.9-13; Dion. Hal. 5.21-35). Its most notorious citizen, Arruns, enticed the Gauls into Etruria with his merchant's samples of figs, wine, and olive oil (Livy 5.33; Dion. Hal. 13.10-12). Whether or not the story is true, the Senones did invade Etruria and besiege Clusium in 387 B.C. Clusium sent to Rome for help, and the Romans' intervention led to the capture and sack of their city by the Gauls the same year (Livy 5.35; Diod. 14.113-14; Plut. *Vit. Cam.* 15). Clusium appears next, allied with other Etruscan cities against Rome, in the third Samnite war and was finally subdued in 295 (Livy 10.30). In 205, as an ally, it furnished timber and grain for Scipio's fleet (Livy 28.45). During the war with Marius, Sulla won a cavalry battle near Clusium (Vell.Pat. 2.28) and fought an indecisive engagement with Carbo (App. *BCiv.* 1.89). After the war, Clusium seems to have received a colony of Sulla's veterans: Pliny speaks of Clusini Veteres and Clusini Novi (*HN* 3.52), and there are inscriptions from the city referring to duoviri and one from the base of a statue erected to Sulla in 80 B.C. The city continued to exist in quiet comfort under the Empire, as many later inscriptions and a fine head of Augustus capite velato attest; the life of the city seems, in fact, unbroken from Villanovan times.

The earliest and richest of the Villanovan necropoleis was on Poggio Renzo to the N; others have been found to the SW at Fornace and Fonte all'Aia. All burials are cremation; the latest use a great dolium (ziro) as receptacle for ash urn and grave goods. Ziro burials continued

into the 6th c. B.C., the old Villanovan urn giving way to an elaborate bronze urn with a human mask fastened to the neck and still later to an urn with a lid in the form of a head. Others had standing figures on the lid, surrounded by a ring of mourners and griffin protomes. The first inhumation burials occur in chamber tombs of the 6th c., but cremation never completely disappeared at Chiusi, and "canopic jars" (urns with a head lid) appear in archaic chamber tombs as well.

Some chamber tombs of the first half of the 5th c. were painted, like those at Tarquinia. Two inhumation tombs can still be seen, the Tomb of the Monkey on Poggio Renzo and the Tomb of the Hill (or Casuccini Tomb) E of the city. Each is approached by a long dromos; the main chamber is broader than deep, the ceiling carved to represent wooden beams like those of some of the tombs at Caere. The figures are in a frieze at the top of the walls, with scenes of banqueting, funeral games, dancers, and musicians. Except that in these tombs the banqueters are all male, the repertory is the same as in Tarquinia but the carefully drawn figures lack the Tarquinian brio.

Hellenistic tombs have a very long dromos with many loculi and a small main chamber or none at all. Sarcophagi and ash urns are found together in these. One, the Tomba della Pellegrina, excavated in 1928, dates from the mid 3d to the mid 2d c. The Tomba del Granduca, discovered by chance in 1818, is coeval but of another type, a rectangular chamber roofed with a barrel vault of cut stone. The eight burials are all cremation.

Of all Etruscan territories this has produced the most sculpture, almost all of it funerary, though scattered architectural terracottas of the Classical and Hellenistic periods have been found and some fine bronzes, both votive and decorative. The funerary sculpture begins with the figured urns of the 7th and 6th c.; in the later 6th and 5th c., ash urns were carved in the soft limestone called *pietra fetida* in the form of a seated (rarely standing) man or woman. The head was carved separately and the torso hollowed out to receive the ashes.

Contemporary with these ash urns but not from the same workshop are the cippi found in many tombs. These are rectangular blocks carved in relief on all sides, often surmounted by a bulbous, onion-shaped form. The reliefs are low, with delicate details of dress and furniture; the subjects are connected with the funeral: prothesis, processions and dances, games, the funeral banquet.

Stone sarcophagi of the Classical period are sometimes carved like the cippi, but others have a reclining male figure on the lid with a female figure sitting at his feet. Sometimes she is the man's wife, as on a sarcophagus in Florence where the woman lifts her veil with the gesture of Hera as a bride; in others the figure is winged, a messenger from the other world.

Hellenistic sarcophagi, of stone or terracotta, have figures like those at Tarquinia, reclining on banquet couches. The contemporary ash urns have similar covers and a front decorated with a violent mythological scene.

Material from Chiusi can best be seen in the Museo Nazionale at Chiusi and the Museo Archeologico at Florence, but there are fine collections in the Museo Archeologico in Palermo, in Berlin, and in the British Museum in London.

BIBLIOGRAPHY. R. Bianchi-Bandinelli, *MonAnt* 30 (1925) 209-578; D. Levi, *BdA* 28 (1934) 49-75; id., *Critica d'Arte* 1 (1935) 18-26, 82-89; E. H. Dohan, *AJA* 39 (1935) 198-209[I]; E. Paribeni, *StEtr* 12 (1938) 57-139; 13 (1939) 179-202[I]; K. A. Neugebauer, *Die Antike* 18 (1942) 18-56; J. Thimme, *StEtr* 23 (1954-55) 25-147; 25 (1957) 87-160; L. Banti, *The Etruscan Cities and their Culture* (1973) 162-72. E. RICHARDSON

CLUVIAE Abruzzi, Italy. Map 14. A city of the Carricini Samnites, now identified with a locality called Piano Laroma near Càsoli in the province of Chieti. The site has previously been noted erroneously under the name of Pagus Urbanus (*CIL* IX p. 277). That the city was founded by the Carricini is attested by Tacitus (*Hist.* 4.5, the Italian region Carecina and the municipality of Cluviae), and by two inscriptions. One is from the 2d c. A.D. at Isernia, and the other is a tabula patronatus from A.D. 384 at S. Salvo. The Cluvienses Carricini figure in both. We know that the place was fortified in the 4th c. B.C. (Livy 9.31.2-3). It was a municipium assigned to the tribus Arnensis after the social war (*CIL* IX, 2999= *ILS* 6526) as noted by the *Liber Coloniarum* (260 L s.v. Clibes). It must, in fact, be identified with the first of the two municipalities that in Pliny's list (*HN* 3.106) appear as Caretini Supernates et Infernates. The city was on an upland surrounded on three sides by the Aventino and its tributaries the Laio and the Avello. The perimeter of the walls that enclosed a very limited area (ca. 42,000 sq m) remains almost completely recognizable. There are also conspicuous remains of a theater and of other buildings.

BIBLIOGRAPHY. A. La Regina in *RendLinc* 22 (1967) 87-99; id., *EAA* Suppl. (1970) 238-39. A. LA REGINA

CNIDUS, see KNIDOS

CNOSSOS, see KNOSSOS

COCA, see CAUCA

COCUSUS (Göksun, Maraş) Cappadocia, Turkey. Map 6. Important road junction with route to Germaniceia (Maraş) on highway from Caesarea Mazaca to Melitene, from which it is about 127 Roman miles. Many milestones have been recorded in the vicinity. The site is marked by a large mound which has produced sherds from the middle Chalcolithic through the Roman and Byzantine periods. Like Coxon, Cocusus lay on the route of the first Crusade.

BIBLIOGRAPHY. G. H. Brown, "Prehistoric Pottery from the Antitaurus," *AnatSt* 17 (1967). R. P. HARPER

COELBREN W. Glamorgan, Wales. Map 24. This Roman fort lies on the W margin of the Neath valley, beside the road from Neath to Brecon Gaer. It covers 2.1 ha, and its earthworks are clearly visible. Excavation revealed that the defenses were of turf, interlaced with timber, but failed to detect more than one phase in the structures. But the finds (now in the Museum of the Royal Institution of South Wales, Swansea) indicate occupation from ca. A.D. 75 to 140, so that rebuildings must have been necessary.

BIBLIOGRAPHY. W. L. Morgan, "Report on the excavations at Coelbren," *Archaeologia Cambrensis* 62 (1907) 129-74; J. L. Davies in V. E. Nash-Williams, *The Roman Frontier in Wales* (2d ed. by M. G. Jarrett 1969) 81-83MPI. M. G. JARRETT

COIMBRA, see AEMINIUM

COLCHESTER, see CAMULODUNUM

COLFOSCO Italy. Map 14. Remains of three bridges in the N Italian zone of the river Piave, ca. 20 km N of Treviso on the route of the Via Claudia Augusta, which was begun by Drusus and completed by his son, the emperor Claudius (*CIL* v, 8002, 8003). This road, which ran from Altino to the Danube, is evident at Colfosco in the remains of three small bridges. Of the first only the cobblestone paving of the shoulders is preserved; the second, partly buried, is almost intact; the third has recently been restored and is formed on a single arch (4.2 x 2.9 m) in stone blocks. The width of the road is 5.65 m.

BIBLIOGRAPHY. A. De Bon, "Rilievi di campagna," *La via Claudia Augusta Altinate* (1938) 32; B. M. Scarfì, "Colfosco (Treviso). Ponte romano sulla via Claudia Augusta," *BdA* 49.4 (1964) 398. B. M. SCARFÌ

ÇÖLKAYIĞI, see BALBURA

COLLEMANCIO, see URVINUM HORTENSE

COLLEVILLE or Koli Villa Normandy/Seine Maritime, France. Map 23. Four km E of Fécamp, in the broad and deep valley between the limestone plateaus of the Caux region. The old Church of Saint-Martin is traditionally held to have been built on the ruins of an ancient temple. Excavations during the 19th c. uncovered ruins and ancient objects (now in the museum at Rouen) at Orival, in the Colleville district, and indicate that the village was originally a vicus. Its ancient name is unknown; the present name is Danish in origin and dates back to 10th c. Norman settlements.

The ancient road began at Fécamp and climbed the valley. It is still visible at several places overhanging the modern road.

From 1962 to 1969 excavation at the place called Petit Moulin uncovered the plan of a Gallo-Roman dwelling whose dating is interesting. The U-shaped villa, open to the SW, is near the river, at the foot of the N face of the valley. The facade, without a gallery, faces in the same direction, with its back to the prevailing winds. It is flanked by two long wings; the S wing, housing the domestic baths, was a room built over a hypocaust with run-off conduits. The fourth side is open and probably had a loggia.

The building was constructed on foundation walls of flint sunk into very strong mortar. The walls were 75 cm wide and 1 m high, their lower half being the sunken foundation. On this foundation were erected walls made of wooden panels filled with daubing or adobe. There were 18 rooms, covering an area of 30 x 40 m. There seems to have been a wall enclosing the entire structure, and there must have been outbuildings.

There were two periods of habitation: the first beginning with the reign of Augustus (10-5 B.C.) and ending with a fire at the close of the 2d c. A.D. (a Saxon maritime invasion? the Septimus Severus-Albinus conflict?); the second period, when the villa was restored with poor mortar, ended toward the end of the 3d or during the 4th c. There was also a later, transitory occupation of the ruins.

Most of the objects found date from the first period, and were preserved in good condition in the earth of the second; objects ranging from the 3d to the 20th c. were dug from 40-50 cm of soil. The fact that anything of real interest must have been taken away before the excavation explains the poverty of this list: 12 bronze fibulas, a horseshoe, a silver spoon (cochlear), a wrought-bronze key, fragments of Greek marble, and several thousand pottery sherds, about 900 of them in terra sigillata. Some of the latter are Italian in origin, especially the fragments of a decorated cup of the type Drag. 11, one of which is marked with the owner's name, Attius, and a fragment of a dish signed Synhistor, a potter of Arezzo. The other sherds come from potteries in SE and central Gaul; some, extremely rare, originated in Argoune. The range of imports demonstrates that the villa enjoyed greatest prosperity from the reign of Augustus to the advent of the Flavii.

BIBLIOGRAPHY. *Gallia* (1964-66, 1968, 1970) reports; *Forum* 840 (1972), 852 (1973). R. SOULIGNAC

COLLIAS Canton of Remoulins, Gard, France. Map 23. Important pre-Roman and Gallo-Roman sanctuary at the end of a narrow, rocky, and very wild gorge, at the place called l'Ermitage de Notre-Dame-de-Laval, not far from a spring. The sanctuary has yielded, among other ancient artifacts, several Gallo-Greek and Gallo-Roman votive inscriptions. These are preserved on the spot, in the Romanesque chapel, or at the Musée de Nîmes (Aramo, Mars Budenicus, Minerva Sulivia Idennica, Jupiter). The site, which is comparable to the spring sanctuaries of Glanum, Vaucluse, and Groseau en Provence, deserves excavation.

BIBLIOGRAPHY. *Carte archéologique de la Gaule romaine*, fasc. VIII, Gard (1941) 163, no. 184.

G. BARRUOL

COLLIPO (S. Sebastião do Freixo) Beira Litoral, Portugal. Map 19. Mentioned by Pliny (*HN* 4.21) among the oppida of Lusitania, it was probably in S. Sebastião do Freixo, near Azoia and in the district of Batalha. Trial excavations have revealed a pottery kiln, the foundations of an important building, and a statue of a magistrate of the 1st c. A.D. The objects are in the Gabinete de Etnografia in Leiria.

BIBLIOGRAPHY. J. M. Bairrão Oleiro & J. Alarcão, "Escavações em S. Sebastião do Freixo (concelho da Batalha)," *Conimbriga* 8 (1969) 1-12. J. ALARCÃO

COLMIER-LE-BAS Haute-Marne, France. Map 23. On the boundary between the departments of Haute-Marne and Côte d'Or, W of Langres, is the large Gallo-Roman villa known as Les Cloisets.

The excavated section includes a rectangular arrangement of rooms with a courtyard adjoining the E side. Surrounding the courtyard on three sides is a portico, with a floor of opus signinum and the rear wall still bears coats of paint. Several of the rooms had mosaic floors with geometric or figured designs; some of the mosaics have been removed and preserved. The middle rooms contain bath installations, small pools, and chambers with hypocausts below them. To the S are some working areas, now being excavated. Foundations have been found on the side of the courtyard facing the living quarters, in the SE corner, possibly of farm buildings. Traces independent of the villa have been located at several points. The imported terra sigillata (especially Lezoux) and the few coins found on the site suggest it was occupied in the 1st and 2d c. A.D.

Colmier-le-Haut, a few km away, has yielded several late sarcophagi and a stele with an inscription. Finds are housed at the Langres museum and in the excavation depot on the site.

BIBLIOGRAPHY. A. Blanchet & G. Lafaye, *Inventaire des mosaïques de la Gaule* II (1909) nos. 1584-87; C. Auberive, *Bull. Soc. Hist. & Arch. de Langres* 13 (1964) 405ff; E. Frézouls, *Gallia* 25 (1967) 289f[P]; 27 (1969) 306ff[PI]; 29 (1971) 302f[PI]; 31 (1973) 416f; J. C. Didier & J. Harmand, *Mémoires Soc. Hist. & Arch. Langres* 10 (1969)[I]. E. FRÉZOULS

COLOGNE, see COLONIA AGRIPPINENSIS *and* LIMES G. INFERIORIS

COLONIA (Şebinkarahisar, Giresun) Armenia Minor, Turkey. Map 5. Colonia was, according to Procopius, founded by Pompey but this may be a confusion with Nikopolis. The name Colonia at least must depend on the placement of veterans perhaps from the legion at Satala.

It reaches more prominence in the Early Byzantine period and is referred to as a city by Basil. It was heavily fortified by Justinian (Procop., *Buildings* 3.4.6). Byzantine defenses are visible today. Inscriptions have been found.

BIBLIOGRAPHY. F. & E. Cumont, *Studia Pontica* II (1906) 296-302. R. P. HARPER

COLONIA AGRIPPINENSIS (Cologne) Germany. Map 20. Founded on the left bank of the Rhine by Agrippa (oppidum Ubiorum) in 38 B.C. (not 19) on a site bearing traces of Neolithic and Iron Age settlements. Later (8 B.C.? A.D. 5?) an ara Romae et Augusti was built for the future province of Germania, whence the city's name (Ara Ubiorum). Nearby was a camp for two legions, I and XX (A.D. 14; up to A.D. 9, probably XIX and XVII). Towards the end of Tiberius' reign the legions were transferred to Neuss and Bonn, but the Rhine fleet (Classis Germanica) remained near Cologne-Alteburg where its camp has been excavated. In A.D. 50 the city was made a colony (Colonia Claudia Ara Agrippinensium) at the instigation of the empress Agrippina, and acquired a city wall.

The only fortress involved in the Batavian revolt under Civilis, it was the seat of the governor of Germania Inferior, and the residence of the Gallic emperor in the 3d c. A.D., as well as a center of trade and industry (glass, pottery, goldsmiths' work, the minting of coins). In 310 Constantine erected the bridge over the Rhine with a fortified bridgehead, Divitia, on the opposite bank (now called Deutz). The city did not fall into Frankish hands until after 450; it became the residence of King Sigibert the Elder and from A.D. 507 on was part of Chlodwig's kingdom.

The site of the Roman colony in the center of the modern city has long been known, especially the city wall of the period after A.D. 50, large sections of which are still standing (a Roman tower on the NW corner and parts of the NW and S wall). Its irregular perimeter marks the limits of a natural plateau. The present-day streets correspond in large measure to the Roman ones, in particular the Hohestrasse, which lies exactly over the cardo maximus and until the 19th c. also went through the Roman N gate. The cardines are oriented directly N, but the decumani diverge several degrees to the NE, presumably in the direction that the sun rose on the birthday of the emperor Augustus.

After a peristyle house with a mosaic of Dionysus was discovered in the NE corner of the colony, at the Cathedral, further excavations revealed the entire area: streets, houses, a Mithraeum, subterranean shrines to the Matrones (indigenous female idols of mother goddess type), a temple of Mercury-Augustus, and finally the Roman and Frankish Bishop's Church beneath the cathedral. Much of these remains has been preserved below ground.

In the SW corner of the colony the capitol temple, below the church known as Maria im Kapitol, has proved to be a temple of orthodox type with its own temenos wall, built shortly after A.D. 50. The praetorium, roughly in the middle of the city's river front, lies beneath the Rathaus and may be visited. Adjoining it to the S is a large hall with a hypocaust and great apse on its long E side. This structure, which is being included in the ruins preserved underground, corresponds in size and purpose to the Palastaula (known as the Basilica) at Trier, but is ca. 100 years older (early 3d c. A.D.). The baths in the center of the city include a semicircular caldarium with a diameter of 25 m, and date from the 1st c. A.D.

The site of the Ara Ubiorum has not yet been found.

The oppidum has been presumed to be close to the colony (Tac., *Ann.* 12.27: Agrippina . . . in oppidum Ubiorum, in quo genita erat, veteranos coloniamque deduci impetrat), but the latest excavations have shown that the two-legion camp may possibly lie under the town. Discoveries include an embankment, traces of rows of tents, and the graffito PRIN(ceps) LEG(ionis) XIX.

One monument remaining from the period of the Ubii is a high pedestal, 9 by 9 m, that originally supported a column. It may have served as a lighthouse at the harbor entrance, and is the earliest example of ashlar technique N of the Alps. In A.D. 50 it was included in the SW corner of the city wall.

Monuments outside the Roman colony that can still be seen include: the E gate of the Deutz fort (early 4th c. A.D.); the extensive excavations under the St. Severin Church; a pagan and Christian cemetery on the road to Bonn with a cemetery church that developed through various stages into the present-day basilica; the St. Ursula Church on the road to Neuss, originally a cemetery basilica with 11 loculi; the St. Gereon Church in the NW part of the city, whose late Roman core can still be seen but which apparently goes back not to the time of Constantine but to that of his sons; and finally, W of Cologne on the Roman road to Jülich, the Weiden burial chamber containing a sarcophagus and busts of the deceased persons.

BIBLIOGRAPHY. R. Schultze et al., "Colonia Agrippinensis," *BonnJbb* 98 (1895); J. Klinkenberg, *Das römische Köln, Die Kunstdenkmäler der Stadt Köln* 2 vols. (1906); id., "Die Stadtanlage des römischen Köln und die Limitation des Ubierlandes," *BonnJbb* 140-41 (1936) 259ff; F. Fremersdorf, "Neue Beiträge zur Topographie des römischen Köln," *Romisch-Germanische Forschungen* (RGKomm) 18 (1950); O. Doppelfeld, "Das Praetorium unter dem Kölner Rathaus," *Neue Ausgrabungen in Deutschland* (1958) 313ff; id., "Die Ausgrabung unter dem Kölner Dom," ibid. 322ff; id., ed., *Römer am Rhein, Ausstellungskatalog* (1967); *Rom am Dom Ausstellungskatalog* (1970); P. La Baume, *Colonia Agrippinensis* (1965). O. DOPPELFELD

COLONIA ARCHELAIS (Aksaray, Niğde) Cappadocia, Turkey. Map 5. It was formerly known as Garsaoura, chief town of the strategia of Garsaouritis. Strabo (12.2.6; 14.2.29) describes it as a κωμόπολις and a πολίχνιον; it was later refounded as Archelaos by King Archelaus, and became a colony under Claudius (Plin. *HN* 6.8). The site is a large oasis SE of Tuz Gölü and 225 km S of Ancyra. No monuments survive though occasional tombstones are found. R. P. HARPER

COLONIA CLAUDIA SAVARIA (Szombathely) Hungary. Map 12. A Roman city 108 km S-SE of Vienna on the amber road from Aquileia to the Baltic Sea. From this center the basalt-paved roads branched out to Brigetio, through Mogentiana to Aquincum, and to Sopianae. The city is often mentioned in ancient documents. It was founded A.D. 43 during the reign of Claudius, ca. 18 km S of the large prehistoric center at the foot of the Alps (Velemszentvid), on the former territory of the Celtic tribe Boi. The early town developed during the reign of Domitian; its inhabitants, who had the right of Roman citizenship, were mostly settled soldiers and merchants. During this time, to judge from inscriptions, it must have been the center of the Pannonian emperor cult. The city suffered greatly during the Quadi-Marcomannic wars between 167 and 180. It was not completely destroyed because, on the evidence of inscriptions, the town's most prominent citizens of the 1st and 2d c. still lived there at the end of the 2d c. According to Aurelius Victor,

Septimius Severus, legatus of Pannonia superior, was elected emperor in Savaria in 193. During the persecutions of the Christians under Diocletian, Quirinus, the aged bishop of Siscia died a martyr's death here. St. Martin of Tours, converter of the Gauls, was born in Savaria of a military family. The emperors Constantine the Great, Constantine II, and Valentinian dated edicts from Savaria. At the beginning of the 5th c. its environs were occupied by Huns and federated German peoples. Final destruction of the town was brought about by an earthquake in 455.

The grid of streets was laid out as early as the 1st c. A.D. Under Domitian the town occupied a small territory. Known among its more important buildings are the Capitolium and the Curia, presumably in forum. The torsos of large statues of Jupiter, Juno, and Minerva have been found. At the end of the 1st c. and during the first half of the 2d, suburbs sprang up N and S of town. Cemeteries also were there, with graves containing rich gifts of glass, amber, ivory carvings, and bronze. After the Quadi-Marcommanic invasions, rebuilding was started at the end of the 2d c. during the reigns of Commodus and Septimius Severus. A city wall system was developed to include the former suburban settlements. The former Curia building in the center of town was rebuilt and enlarged. The large public bath or palaestra was built next to the cardo, and by 188 at the side of the basalt road 10 m wide and leading S, stood an Iseum. In the Iseum the levels of the altars, the marble carvings of the central sanctuary, and the foundations of the neighboring buildings remain intact. On the E side of this same road stood a sanctuary of Jupiter Dolichenus with its sacred area surrounded by a double wall. According to inscriptions, this sanctuary played an important role in the town's life in Caracalla's time. During this period a considerable number of people moved in from the east. Though the N and S cemeteries continued to expand, the W road grew in importance and rich burial grounds were developed on either side of it. On the nearby hills to the W was the theater, mentioned in the Passio Quirini. They also erected large buildings in the new E sections of town. A few mosaics indicate their richness. At the end of the 3d c., from 260 on, the city's environs must have suffered from the Gothic invasions. The settlements outside the town were destroyed, and the coin and jewelry treasures found at nearby Rábakovács and Balozsameggyes were buried during this period. In the ravaged territory the presence of the emperor, who resided in town during battles against the barbarians on the banks of the Danube, meant relative prosperity for the city. At this time the main municipal building was changed into an emperor's palace. The size of the palace's bath is mentioned by Ammianus Marcellinus, who also reports on the city walls and gates.

Especially valuable remains of four centuries of Roman rule are the inscribed marble stones that record information from the reign of Domitian to the end of the 4th c. Bronze foundries and pottery kilns were found during excavations outside the walls.

BIBLIOGRAPHY. Plin. *HN* 3.24; A. Victor, *Epitome* 5; *Ant. It.* 109, 122-24, 126; Cod. Theodos. Tit. leg. 1, Tit. 10 de petitionibus leg. 6, Libri 12. Tit. 13 lex 3, Tit. 6 de susceptoribus lex 15; Sulpicius Severus, *De vita beati Martini*, caput 2; *Amm.Marc.* 30.5.14.

S. Schoenvisner, *Antiquitatum et historiae Sabariensis ab origine usque ad praesens tempus, libri novem* (1772); V. Lipp, *Savariai fölirattanulmányok, Vasvármegyei Régészeti Egylet Évi Jelentései* (1873); I. Paulovics, *Lapidarium Savariense* (1943); *Savaria-Szombathely topográfiája* (1943); Gy. Géfin et al. *Szombathely* (1961); P. Buocz, *A szombathelyi Savaria Muzeum kőtára, A*

Savaria Muzeum Közleményei 14, 15, 16, 17, 20, 23, 24, 26, 28, 30. *Arch. Ért.* 89 (1962); *Temetők és városfalmaradványok Savariában* 2 (1964); T. Szentléleky, *A szombathelyi Isis szentély Das Iseum von Szombathely* (1965); A. Károlyi & T. Szentléleky, *Szombathely városképei és müemlékei* (1967); L. Balla, "Savaria lakossága a II. század végén és a III. század első felében," *Annales Instituti Historici Univ. Sci. Debreceniensis de L. Kossuth noninatae* 1 (1962); E. B. Thomas, "Az 500 éves szombathelyi lapidárium története," *A Vas megyei Muzeumok Értesitője I* (1963); A. Mócsy & T. Szentléleky, *Die römischen Steindenkmäler von Savaria* (1971).

T. SZENTLÉLEKY

COLONIA CLAUDIA VICTRICENSIS, *see* CAMULODUNUM

COLONIA IULIA BAETERRAE SEPTIMANORUM, *see* BAETERRAE

COLONIA JULIA AUGUSTA PARMENSIS (Parma) Italy. Map 14. A city of the eighth Augustan region, Aemilia. Originally a settlement of the Late Bronze Age between the present via della Repubblica and Borgo Valorio, it was probably developed by the Etruscans and the Gauls.

Parma became an urban center with the sending out of the colony in 183 B.C., and was destroyed by Mark Antony in 44 B.C. during the battle of Modena. The Augustan reconstruction, following the earlier city plan, must have marked an amplification and enrichment of the colonia recorded later by Pliny in his catalogue of the cities of the eighth region, and restored by Constantine.

The plan of the city, with the intersection of the main axes almost at the center, is easily recognizable today from aerial photographs and confirmed by archaeological finds. The cardo maximus corresponds to via Farini–via Cavour; the decumanus to via Mazzini–via della Repubblica, which follow the ancient via Emilia; and the central forum to Piazza Garibaldi. The perimeter of the city walls seems to correspond to a quadrangular castrum, though the city developed outside the walls, especially to the S. There the theater (60 m diam.) was built, and farther E was the amphitheater (136-106 m). Though these buildings were partly excavated in 1843 and 1846 and probed in 1933 and 1937, their plans are barely known.

A few traces remain of a suburban villa from the Republican period. There are numerous deposits of amphorae, some with painted inscriptions. Notable are the mosaics in *cocciopesto* with white tesserae. Variations include subjects such as a centaur and a warrior silhouetted in black on white, polychrome, and black-and-white geometric designs. There are several marble and bronze statues, and a funerary stele of a purpurarius with clothing and tools of his calling, documenting the flourishing wool trade in Parma. Another stele has portraits and one is aedis rotunda in form. Of great value is the 3d c. A.D. Roman gold work of Teatro Regio, and that of the Lombards found in Borgo della Posta.

The major monumental evidence of the city consists of large fragments of architectural decorations from diverse periods. Additions to the city walls, which were redrawn and restored in the time of Theodoric, are indicative of new prosperity in the city, which flourished again in Byzantine times under the name Chrysopolis. The Museo Nazionale di Antichità contains local prehistoric and Roman material, as well as Renaissance collections originating elsewhere, and Greek ceramics.

BIBLIOGRAPHY. I. Affò, *Storia di Parma* (1792); R. Andreotti, "Intorno ai primordi e allo sviluppo di P. nell'antichità," in *Bull. Com.* 56 (1929); M. Corradi Cervi, "Notizie," *Arch. St. p. le prov. parmensi* (1937ff); id., *NSc* (1942)[PI]; G. Monaco in *NSc* (1957)[PI]; A. Frova & R. Scarani, *Parma Museo Naz. di Antichità* (1965-1966)[I]; M. P. Rossignani, *Decorazione architettonica romana a Parma* (1974)[I].

A. FROVA

COLONIA JULIA EQUESTRIS, *see* NOVIODUNUM (Switzerland)

COLONIA VENERIA CORNELIA POMPEIANORUM, *see* POMPEII

COLOPHON Ionia, Turkey. Map 7. About 40 km S of Izmir, by the modern village of Değirmendere. Founded probably from Pylos (Strab. 14.1.3), the town commanded fertile land and, in its earlier days, a significant maritime establishment. It was famous for its horses and its luxury, the latter being compared to that of the Sybarites (Strab. 14.1.27-28). The poet Mimnermos came from Colophon (late 7th/early 6th c. B.C.), which was first under Lydian control and then Persian until the coming of Alexander. The town of Notion (later New Colophon), just to the S, gradually expanded its influence at Colophon's expense, and when the Colophonians resisted Lysimachos their doom was sealed. Upon their submission Lysimachos required them to emigrate to his new city of Ephesos; the tomb of those slain in the city's defense may be one of the tumuli visible near the town of Çile to the S of Colophon. After Lysimachos' death in 281 B.C. the town was reestablished, but it never recovered its former station. Pausanias mentions it several times.

The ruins are on a site composed of three hills within a walled area of approximately triangular shape and comprising about a square kilometer. The wall was strengthened by twelve semicircular towers; these fortifications apparently date from the end of the 4th c. B.C. There is not much to be seen; most of the ruins that have been identified (partly work of the 1920s) are of the 4th c. B.C. There is a paved street made of carefully fitted stones, with houses on either side. Other houses overlay archaic constructions. There was a stoa of the first half of the 4th c. with shops and offices attached. There was also a Temple of Demeter and a Roman bath building, as well as a sanctuary to the mother goddess Antaia.

BIBLIOGRAPHY. C. Schuchhardt in *AthMitt* 11 (1886) 398ff; *RE* XI (1922) 1114-18; *EAA* 2 (1959) 745-46, with house plans and bibliography; E. Akurgal, *Ancient Civilizations and Ruins of Turkey* (3d ed. 1973) 133-34.

W. L. MAC DONALD

ÇOMAKLI, *see* POGLA

COMANA CAPPADOCIAE (Şar, Tufanbeylin Adana) Turkey. Map 6. In the valley of the Sarus (Göksu), in the deep glens of the Antitauros. It is probably Hittite Kummani, religious center with goddess Hepat. By Hellenistic times Comana, with Comana Pontica, was one of the two cult centers of the Goddess Ma, equated by Strabo with Enyo. The city, chief town of the strategia of Cataonia, was ruled by the chief priest, who ranked second after the king of Cappadocia and was generally of the royal family. Strabo states that the temple servants numbered 6000 and also implies a lay population (12.2.2); an inscription by the demos honors King Archelaos and a gerousia is also attested. Roman period inscriptions refer to the city as Hieropolis. Then as in the Byzantine period it was evidently prosperous but not important.

The small town center, unwalled as befits a holy place, did not hold the whole population. The fertile valleys for

miles around bear traces of ancient occupation. Principal standing monuments are the Ala Kapı, a tetrastyle prostyle temple of the 2d c. A.D., the Kırık Kilise, 4th c. A.D. heroon of the senator Aurelius Claudius Hermodorus, a theater, and a number of churches and chapels. Outside the town are hundreds of tumulus graves. A number of sculptured and inscribed monuments are housed in the Adana Museum.

BIBLIOGRAPHY. R. P. Harper & I. Bayburtluoğlu, "Preliminary Report on Excavations at Şar, Comana Cappadociae, in 1967"[PI] and R. P. Harper, "Tituli Comanorum Cappadociae," *AnatSt* 18 (1968) 149-58 & 93-147 resp.
R. P. HARPER

COMANA PONTICA Pontus, Turkey. Map 5. Site of the temple of Ma, in the valley of the Yeşil Irmak (Iris fl.), 11 km upstream from Tokat on the road to Niksar (Neocaesarea). The cult of Ma, identified with the Roman Bellona, was derived from Comana in Cappadocia, an old Hittite sanctuary. The priest of Ma ranked second to the king of Pontus and wore a diadem; the temple had 6000 serfs, including sacred prostitutes. Comana Pontica was both a trading center for goods from Armenia and a resort. In Pompey's settlement of Pontus (64 B.C.) Comana became an independent principality, and it so remained under a succession of Roman nominees until it was annexed to Pontus Galaticus in A.D. 33-34 or 34-35. Its importance as a religious center was marked by adopting the additional name Hierocaesarea in or before the reign of Titus. Comana's territory included the plains of Kazova and Tokatovasi (Dazimonitis) on the Yeşil Irmak as well as Artova farther to the S. The natural center of this region is not Comana but Tokat (Dazimon), and after Comana had ceased to be a major religious site, with the triumph of Christianity, it lost its ancient local importance also.

The actual site of Comana Pontica is a low natural hill beside the bridge called Gömenek Köprüsü. The Kazova irrigation canal cuts through the edge of this hill. Eight columns of gray marble now supporting the porch of the 16th c. mosque of Ali Paşa at Tokat may well be derived from the tetrastyle temple of the goddess Ma. The Roman bridge and post-Roman buildings recorded at Comana in the 19th c. no longer survive. A number of inscribed stones from Comana are now in the museum at Tokat.

BIBLIOGRAPHY. W. F. Hamilton, *Researches in Asia Minor, Pontus, and Armenia* (1842) I 349-50; J.G.C. Anderson, *Studia Pontica* I (1903) 63-67; F. & E. Cumont, *Studia Pontica* II (1906) 248-53, pl. XIX.
D. R. WILSON

COMBRETOVIUM Suffolk, England. Map 24. Mentioned in *Ant.It.* 480.2 and as Convetoni in the *Peutinger Table*. It is probably to be identified with the settlement at Baylham House, 2.4 km SW of Coddenham, at the crossing of the Gipping river and the intersection of two Roman roads. Much Roman material has been found (1st-4th c.), but the limits of the settlement have not been determined. A difficulty is presented by the name, which should mean confluence, since no tributary joins the Gipping here.

BIBLIOGRAPHY. *VCH Suffolk* I (1911) 303; S. E. West, *AntJ* 36 (1956) 73; *Itinerary*: A.L.F. Rivet, *Britannia* 1 (1970) 52; name: K. H. Jackson, ibid. 71.
A.L.F. RIVET

COMISO Sicily. Map 17B. At the site of the modern city of Comiso considerable remains of an ancient settlement were found long ago, attesting to an unbroken sequence of habitation from the 5th c. B.C. down at least to the Byzantine period. Near the fountain Diana some mosaics have been found belonging to a Roman bath. Some Christian hypogaea and a Byzantine baptistery are the evidence for the later periods.

BIBLIOGRAPHY. P. Orsi, "Comiso. Necropoli greco-romana," *NSc* (1912) 368; id., "Necropoli e villaggio siculi," *NSc* (1915) 214; B. Pace, *Camarina* (1927) 119ff; id., "Comiso. Edificio termale presso il fonte Diana," *NSc* (1943) 162ff; id., *EAA* 2 (1959); L. Bernabò Brea, "Comiso. Abitato di età greca e bizantina nelle contrade di S. Silvestro e Serramenzana," *NSc* (1947) 257-58; F. Panvini Rosati, "Ripostiglio di aurei tardoimperiali a Comiso," *RendLinc* (1953) 422ff.
G. SCROFANI

COMO, *see* COMUM

COMPIERRE (Bois de) Dept. Nièvre, France. Map 23. Hidden on a small rise in the Compierre woods, between St. Révérien and Champallement, is a whole Gallo-Roman village covering an area some 900 m long and between 100 and 300 m wide.

Situated on the Entrains-Autun road, this vicus was inhabited from the beginning of the Empire to the end of the 4th c., when it was laid waste, as were most of the ancient sites in these parts, and finally abandoned. In official excavations, carried out a long time ago, the plan of the town was located; it included a theater linked by a cardo to a galleried octagonal fanum; the interior of the cella of this fanum is circular. (See Champellement for a more detailed description.)

Numerous objects have been discovered in clandestine digging, as well as many workshops and houses, some of them with cellars. Judging from the slag heaps found on the site, iron-working must have played a very active part in the economy of this large settlement which, however, is scarcely represented in the museums.

BIBLIOGRAPHY. Boniard, "Mém. sur les ruines d'une villa gallo-romaine, Clamecy, Cégrétin" (June 1842)[MP]; G. Charleuf, "Mém. sur les fouilles de Saint Révérien (Nièvre)," *Mém. de la Soc. Eduenne* (Autumn 1844) 319-36[I]; id. in *Annuaire de la Nièvre* (1845) 28-43; Barat & Duvivier, *Rapport à M. le Préfet de la Nièvre sur les ruines gallo-romaines de Saint-Révérien* (1845); Baudouin, *Rapport sur les travaux ordonnés par . . . dans les ruines gallo-romaines de Saint-Révérien*, Congrès arch. de France, 1852 (1853) 292-302; E. Harris, "Communication à l'Assemblée de la Soc. des Fouilles arch. de L'Yonne à Saint Père-sous-Vézelay" (18 Sept. 1938); id., *Mém. de la Soc. Académique du Nivernais* 41 (1939); L. Coursier, "Les fouilles de Compierre près de Saint Révérien," *Annales de Bourgogne* 20 (1948) 65-67.
J.-B. DEVAUGES

COMPLUTUM (Alcalá de Henares) Madrid, Spain. Map 19. An ancient site, 31 km NE of Madrid, on San Juan del Viso hill, near the town. It is mentioned by the ancient geographers, in itineraries, and in inscriptions (*CIL* II, 3024ff). Some architectural remains are still visible, and finds include epigraphic and numismatic material, but the site has not been excavated except for recent investigation of a villa on the lower part of the hill.

BIBLIOGRAPHY. F. Fuidio, *Carpetania romana* (1934).
L. G. IGLESIAS

COMUM (Como) Lombardy, Italy. Map 14. One of the most important Roman cities in Regio XI, it was colonized under Caesar, with the name Novum Comum, near the villages that formed the Comum oppidum of

Titus Livius. The city had a orthogonal plan covering an area 445 by 550 m. Imposing city walls in stone from the late Republican period remain. The insulae, still recognizable in the urban area, were 75 m on each side. The city was also of military importance in the late antique period. Remains are still visible of the gate called praetoria on the decumanus maximus, as well as stretches of walls and of a bath building with a library (*CIL* v, 5262) erected outside the city walls by Pliny the Younger. He, like his uncle Pliny the Elder, the naturalist, was born at Comum.

Of interest among the objects in the Archaeological Civic Museum is the material from the Ca' Morta necropoleis, which encompass the Late Bronze Age and the entire Iron Age. The collection includes a military parade cart, Greek bronze sculpture, sacred and funerary inscriptions, and a figured Early Christian mosaic.

BIBLIOGRAPHY. C. Albizzati, "Un ritratto di Licinia Eudoxia," *AttiPontAcc* 2, 15 (1921) 337ff; id., "Una scultura greca arcaica del Museo Giovio di Como," *Rend PontAcc* 3 (1924-25) 317ff; F. Frigerio, "Antiche porte di città italiche e romane," *Riv. Arch. Comense* 108-10 (1934-35) 5-52; G. Caniggia, *Lettura di una crittà: Como* (1963); G. Luraschi, "Comum oppidum," *Riv. Arch. Comense* 152-54 (1970-72) 7-154; M. Mirabella Roberti, "L'urbanistica romana di Como e alcune recenti scoperte," *Atti Convegno centenario Riv. Arch. Comense* (1973). M. MIRABELLA ROBERTI

CONCA, *see* SATRICUM

CONCANGIUM (Chester-le-Street) Durham, England. Map 24. On the Roman road from Dere Street, N of Vinovia, to Arbeia, and 12.8 km S of Newcastle (NZ 275513). Site of a Roman fort of ca. 2.5 ha. The name probably derives from that of the stream, the Cong burn, on which it lies. The 2d c. fort, probably Hadrianic, was rebuilt for a cavalry garrison in the early 3d c. (*RIB* 1049, A.D. 216). In the 4th c. a new unit was established here, a numerus vigilum. Occupation continued to the end of the Roman period. The latest defenses were of stone. Of internal buildings, only the commander's house has been located. Nothing of the fort or of the village that grew up around it is at present visible.

BIBLIOGRAPHY. E. Birley, *ArchJ* 111 (1944) 196; J. P. Gillam & J. Tait, *Arch. Ael.* 46 (1968) 75-96; B. Dobson, *Trans. Archit. and Archaeol. Soc. of Durham and Northumberland* NS 2 (1970) 37-38; J. S. Rainbird, *Arch. Ael.* 49 (1971) 101-8. J. C. MANN

CONCARNEAU Finistère, France. Map 23. Gallo-Roman villa discovered in 1964 in the village of Le Questel near Concarneau. Built towards the middle of the 1st c. B.C., it was occupied up to the 4th c. A.D. Its general plan is of the gallery-facade type common in the western Roman empire.

The villa consists of a long main section divided into three longitudinal corridors; in the center of the middle one is a semicircular structure of undetermined purpose. This main section is flanked to the E by a lateral wing of which only a few traces remain; to the W is a second main building, better preserved and containing the baths. These consist of a caldarium and tepidarium heated by a hypocaust connected to the praefurnium (a small room with a well-built flagged floor, and two semicircular windows on its W side). The frigidarium, part of which is taken up by a bath, connects with another room, presumed to be a changing room(?). In the 4th c. three small rooms (of undetermined purpose) were added to the N part of the bath complex.

Other ancient remains 2 km E of Le Questel seem to be the remains of a monumental gateway rebuilt in the 4th c.

BIBLIOGRAPHY. R. Sanquer, "L'établissement gallo-romain du Questel," *Annales de Bretagne* 72, 1 (1965); 73, 1 (1966); "Les deux établissements gallo-romains du Questel et du Vuzit," ibid. 74, 1 (1967). M. PETIT

CONCOBAR or Konkobar (Kangavar) Iran. Map 5. On the age-old highway across Iran, some 75 km E of Kermanshah, the site is marked by a Seleucid temple of ca. 200 B.C. Isodore of Charax states that there is a temple of Artemis at Concobar: modern scholars agree that it is actually a temple of Anahita. Other Classical writers call the site Konkobar, but provide no additional information.

The fragmentary remains have greatly deteriorated since they were first recorded over a century ago. It is, however, apparent that a vast square court over 200 m on each side was surrounded by a peristyle with three rows of columns. Within the court was the temple proper; a number of the lower shafts of columns and their bases set on a podium of large blocks survive. Fragments indicate that the columns carried Doric capitals with Corinthian abaci. The size of the peristyle is almost identical with that of the temple of Bel at Palmyra.

BIBLIOGRAPHY. Isodore of Charax, *Stationes Parthicae* 6; E. Flandin & P. Coste, *Voyage en Perse* (1843-54)[PI]; A. V. Williams Jackson, *Persia Past and Present* (1906) 236-42[I]; E. Herzfeld, *Archaeological History of Iran* (1935) 50. D. N. WILBER

CONCORDIA, *see* IULIA CONCORDIA

CONDATE (Condres) Lozère, France. Map 23. A statio in the commune of Saint-Bonnet de Montauroux, mentioned in the *Peutinger Table* as being 22 Gallic leagues from Anderitum-Gabalum. It is at the confluence of the Chapeauroux and the Allier, where the Lyon-Toulouse route crosses an old road linking Nîmes with the Arvennes region.

The site is spread out on both banks of the Allier and beyond its tributary, the Chapeauroux. There are extensive substructures on the left bank, including perpendicular walls, and the finds have determined the period of occupation. The earliest coin is a Gallic coin of Epadnactus, the latest a bronze one of Gallienus. Some substructures have been found on the right bank and, on both sides of the river, the subfoundations of a Roman bridge.

An even layer of pan and cover tiles was discovered during construction of the viaduct over the Chapeauroux. The few finds are housed in the Musée Ignon-Fabre at Mende. P. PEYRE

CONDATE (Northwich) Cheshire, England. Map 24. A settlement on the Roman road (Watling Street) from Deva to Mamucium, roughly midway between them. King Street passes 2.5 km E of the site, which is on the W bank of the Weaver overlooking its confluence with the Dane. Occupation began in the Flavian period probably with a fort, and continued into the Antonine period.

Redevelopment in the "Castle" area in the late 1960s enabled excavations to take place. An auxiliary fort of unknown size was established in the 70s of the 1st c. A.D. It was abandoned early in the 2d c., and then reoccupied in the Hadrianic period when the defenses were reconstructed in stone and new timber internal buildings erected. Final evacuation took place ca. 140; subsequent

civil occupation included iron roasting or smelting and some pottery production.

BIBLIOGRAPHY. F. H. Thompson, *Roman Cheshire* (1965); G.D.B. Jones, "The Romans in the North-West," *Northern History* 3 (1968) 1-26; G.D.B. Jones et al., "Excavations at Northwich," *Arch. J.* 128 (1972) 31-77.

D. F. PETCH

CONDATE or Civitas Riedonum (Rennes) Ille et Vilaine, France. Map 23. The chief city of the Riedones tribe, Condate was situated on a hillside near the confluence of the Ille and the Vilaine. That the town and its monuments flourished throughout the Pax Romana is evident from the stone inscriptions frequently found in the substratum of the modern city.

Towards the end of the 3d c. A.D. the center of Condate was ringed with a fortified circuit wall of the classic type (coarse rubblework faced on either side with small blocks and banded with brick). The foundations of this wall contain many reused architectural fragments, such as the statue bases with inscriptions recently found when a section of the rampart was uncovered. The Cabinet des Médailles et Antiques de la Bibliothèque Nationale in Paris has a very fine solid gold patera with a Bacchic design, found at Rennes in 1774. Its inner circumference contains 16 2d c. aurei set in filigree medallions. Other objects found in the excavations can be seen in the Rennes Musée Archéologique.

BIBLIOGRAPHY. A. Toulmouche, *Histoire Archéologique de l'époque Gallo-romaine de la ville de Rennes* (1847); M. Petit, "La céramique italique de Rennes," *Annales de Bretagne* 78, 1 (1971); J. Bousquet, "Les inscriptions de Rennes," *Gallia* 29, 1 (1971).

M. PETIT

CONDATOMAGOS (Millau) Aveyron, France. Map 23. 1. On the left bank of the Tarn downstream from the junction of the Dourbie is the plain of La Graufesenque, which corresponds to the ancient site of Condatomagos. In the 1st c. A.D. it was one of the largest centers of production of Gallo-Roman terra sigillata. Its potters numbered several hundred. They sold their vases on a large scale in all Gaul, in Germany, Britain, and even in Italy, Spain, and Africa. Excavations in the last few years have shown that the potters originally made a ware that was not true terra sigillata in a time of trial and error at the end of the reign of Augustus. Their first true terra sigillata vases were directly inspired by Italic types; besides the common forms, Drag. 29, 30, 37, they also produced the Drag. 11 chalice and large lagenae. Some six thousand stamps have been collected since 1965; these revise completely the list of La Graufesenque potters and illustrate the diversity of their signatures. It remains to be discovered where the first potters came from and what technical and commercial reasons dictated their settlement at the junction of the Tarn and the Dourbie. The site did not have, moreover, a monopoly of production. Kilns of late date, which fired debased sigillata, have been found on the right bank of the Tarn on the outskirts of Millau.

2. On a prominent headland of the Larzac, the oppidum of La Grinède (or La Granède) is a promontory fort which dominates from a great height the plain of La Graufesenque and the valley of the Tarn. New investigations were conducted there from 1957 to 1965. Its original, dry-stone fortifications seem to be later than the Hallstat period and contemporary to the second Iron Age. It was repaired, reinforced, and given masonry walls at the end of Roman times. Inside the enclosure occupation of the site seems to have been continuous from the end of the Iron Age culture on. A Gallo-Roman fanum with remains of mosaics and painted stuccos has been identified, as well as a building with an apse which must correspond to the mediaeval establishment of the Mas de Tolzieu.

BIBLIOGRAPHY. 1. F. Hermet, *La Graufesenque (Condatomagos)* 2 vols. (1934), an older work but still fundamental; completed by A. Albenque, *Inv. de l'archéologie gallo-romaine du département de l'Aveyron* (1947) 83-88, no. 187 & pls. II-III; id., *Les Rutènes* (1948) 48-55; L. Balsan, "Les fouilles de La Graufesenque au XIXᵉ siècle," *P.V. de la Soc. des Lettres de l'Aveyron* 39 (1968) 71-77.

Reports on excavations 1950-54: L. Balsan, "Reprise des fouilles à La Graufesenque (Condatomagos), campagne de 1950," *Gallia* 7 (1950) 1-13; A. Albenque, *P.V. de la Soc. des Lettres de l'Aveyron* 36 (1949-53) 141-49; L. Balsan, ibid. 36 (1949-53) 198-200, 248-53; 37 (1954-58) 6-15, 65-70 (= *Rev. du Rouergue*, 8 [1954] 44-51, 399-404).

Reports on excavations 1965-72: L. Balsan, "Recherches archéologiques autour de Condatomago en 1965," *Rev. du Rouergue* 19 (1965) 403-15 (= *P.V. de la Soc. des Lettres de l'Aveyron* 39 (1968)); id., "Recherches archéologiques autour de Condatomago (campagne de 1966)," *Rev. d'études millavoises*, no. 8 (1966) 23-27; id., "Observations sur quelques estampilles de potiers de La Graufesenque," *Rev. arch. du Centre* 9 (1970) 99-109; M. Labrousse in *Gallia* 24 (1966) 412-15 & figs. 3-6; 26 (1968) 517-21 & figs. 1-6; 28 (1970) 398-402 & figs. 2-9; 30 (1972) 472-76ᴵ.

Studies of graffiti subsequent to Hermet: A. Albenque, "Nouveaux graffiti de La Graufesenque," *Rev. des études anciennes* 53 (1951) 71-81 & pls. IV-V; A. Aymard, "Nouveaux graffites de La Graufesenque," ibid. 54 (1952) 93-101 & pls. VIII-IX; 55 (1953) 126-31 & pl. VI; P.-M. Duval & R. Marichal, "Un compte d'enfournement inédit de La Graufesenque," *Mélanges . . . André Piganiol* (1966) 1341-52.

2. On the promontory fort: L. Balsan in *Rev. du Rouergue* 5 (1951) 531-33; A. Soutou, "Un habitat de la civilisation des Champs d'Urnes: la Serre de la Granède," *Actes du XIVᵉ Congrès d'études régionales de la Fédération des Sociétés académiques et savantes de Languedoc-Pyrénées-Gascogne (14-16 juin 1958)* 73-79; L. Soonckindt, "Les fouilles de la Grinède," *P.V. de la Soc. des Lettres de l'Aveyron* 39 (1968) 4-10. Cf. M. Labrousse in *Gallia* 17 (1959) 410-12 & fig. 2; 20 (1962) 550-51; 24 (1966) 415.

M. LABROUSSE

CONDEIXA-A-VELHA, *see* CONIMBRIGA

CONDERCUM, *see* HADRIAN'S WALL

CONDEVICNUM (Nantes) Loire-Atlantique, France. Map 23. There are few traces of the port of Condevicnum, and no substructures have been found in situ. The city, however, had some public and religious buildings, judging from the many architectural fragments discovered here. One of these is a dedicatory inscription, now in the Hôtel de Ville, which mentions that Nantes had a corps of boatmen, the Nautae Ligerici.

At the end of the 3d c. A.D. a rampart with round towers was erected around the city, some sections of which can be seen near the cathedral. The lower courses of one of the city gates, the Porte St. Pierre, uncovered at the beginning of this century, are also visible today. The collections of the Musée Dobré in Nantes include a good many objects from ancient Condevicnum.

BIBLIOGRAPHY. Durville, "Fouilles de l'Evêché de Nantes," *BAC* (1912); P. Caillaud et al., *Nantes, son Histoire, sa Marine, ses Monuments* (1958).

M. PETIT

CONDRES, *see* CONDATE

CONGAVATA, *see* HADRIAN'S WALL

CONIMBRIGA (Condeixa-a-Velha) Beira Litoral, Portugal. Map 19. About 16 km S of Coimbra, near the village of Condeixa-a-Velha. The name means oppidum of the Conii, a tribe which inhabited the region before the arrival of the Celtic tribe of Saefes some time between the end of the 7th c. and the 5th c. B.C. Conimbriga was probably entered by Decimus Iunius Brutus at the end of the 2d c. B.C. Not far away is an encampment, which was perhaps built by Brutus, today almost destroyed by the airfield of Cernache.

Objects from the Roman Republican era at Conimbriga are rare. The first forum is from the Augustan period; next to it simple rectangular houses of Iron Age tradition survived to Flavian times. Pliny (*HN* 4.21) classifies Conimbriga among the oppida of Lusitania, and under the Flavians the city received the status of municipium and the name of Flavia Conimbriga. In the same period, the forum was replaced by another, different in plan and of larger proportions. Considerable construction took place in the first half of the 3d c. A.D. and there was a notable workshop of mosaic workers. At the end of the same century or the beginning of the 4th, the city was fortified; the amphitheater, a public bath building, and some of the richest houses were left outside; the baths and houses were razed. The latest Roman coins found in Conimbriga date from 402 to 408 and are very rare. Rome probably abandoned the region in the time of Honorius. The Cantabri, perhaps the richest family in the city, probably took over its government and defense, but in 465 they became prisoners of the Suevi. In 468, according to Idatius of Chaves, the Suevi attacked Conimbriga a second time and partially destroyed it.

The city, however, was not abandoned. By 561 it was a seat of a bishop; its own prelate Lucentius participated in the first council of Bracara, but the seat was soon moved to Aeminium. Many Visigoth coins have been found (one of Rodrigo minted in 710, the year before the Arab invasion and the downfall of the Visigoth monarchy), as well as Arab and mediaeval coins. Occupation of the site may have continued even after the Arab invasion of 711, but the absence of stones with Arab workmanship and of Moslem pottery indicates that it was no more than a hamlet.

Near the E section of the fortifications several buildings have been excavated: a rich residence with private baths, three other less extensive but luxurious houses, two public baths, an Early Christian church, and a building which served perhaps as an inn. More recently the Forum of Augustus has been discovered, the Flavian forum which replaced it, two insulae of houses and commercial buildings, and some large public baths of Trajan's time, constructed over others of the early 1st c.

The rich houses are all built around a large peristyle with a pool: in one of them the pool held more than 400 water jets. Around the peristyle was a portico paved with mosaics. Two of the larger houses have as a second central point a small atrium which opened on the sleeping quarters of the house. The mosaics discovered constitute the largest collection in Portugal, although there are others, at Torre de Palma, for example, more varied in theme and more carefully executed. The mosaics with mythological themes represent Perseus, Bellerophon, Acteon, the Minotaur in the labyrinth, and a solar chariot. Others show hunting scenes or animal life, from aquatic birds to sea dragons, the elephant, or the camel. The simplification of some of the Classical themes by leaving out some of the usual figures (Andromeda is omitted

from the mosaic of Perseus) is characteristic of the local workshops, which seem to have been particularly active in the time of the Severi.

Of the public monuments, the oldest remains are those of the Forum of Augustus. The monument was enclosed on one side by a basilica with three aisles and on the other by shops. On the N side was the temple, built over a crypt. This forum was demolished under the Flavians to make room for another (100 x 50 m) and the public square was enclosed by two monumental porticos along the E and W sides. On the S side were some small structures, now ruined, which were probably shops. The large temple with a double cella, dedicated to Rome and Augustus, dominated an esplanade at a little higher level in the N section of the forum. The esplanade was surrounded by a pi-shaped cryptoporticus with a flat roof resting on thick pillars, and above the crytoporticus stood a portico. This forum, which had neither basilica nor curia, was destroyed at the beginning or middle of the 5th c.

The amphitheater (94 x 80 m) outside the walls has not yet been excavated. It dates from the 3d c. A.D. The cavea rests in part on arcades and in part is cut out of the rocky hillside. Four public baths of different periods have so far been discovered in the city. Two of them, each with a natatio, existed during the 2d and 3d c.; both have curious circular laconica, and in the center a small pool, also round, with steps hollowed out of the pavement. At a level higher than the pool, a passageway resting on the hypocaust goes around the room. The water was brought by an aqueduct, largely underground, from a large spring ca. 3 km from the city, and was distributed to the baths and some houses in lead pipes. Water was channeled even into simple houses in which there are no traces of paving in mosaic, and which could have belonged only to small industries or small traders.

The Early Christian basilica has a cruciform apse, and the baptistery a circular basin of a depth unusual in the 7th-8th c., the period to which the building is attributed. The finds are in a museum at the site.

BIBLIOGRAPHY. J. M. Bairrão Oleiro et al., *Conimbriga. Guide to the Museum and the Ruins* (1967)MPI also in Portuguese and French; J. Alarcão et al., "Le culte des Lares à Conimbriga," *CRAI* (1969) 213-36; R. Etienne & id., "La chronologie des cryptoporticus à Conimbriga," *Actas do II Congresso Nacional de Arqueologia, Coimbra* (1971) 479-86.

The excavation report will be published in 7 volumes under the direction of R. Etienne and J. Alarcão.

J. ALARCÃO

CONLIEGE Jura, France. Map 23. Site, the ancient name of which is unknown, where several Iron Age tumuli in the place called La Croix des Monceaux have been partially excavated. One of the tumuli contained, along with two fibulas of native manufacture with false cord and small rings, two bronze objects of Etruscan origin: a ladle and an amphora the handles of which are decorated at the top with horse protomes, like the Hamburg amphora, and at the base with Sirens. These objects indicate commercial relations between the Mediterranean and this region of the Jura, as do the finds made at Château-sur-Salins and Montmorot.

BIBLIOGRAPHY. L. Lerat, *Actes du Colloque sur les influences helléniques en Gaule* (1958) 89-98; J. P. Millotte & M. Vignard, *Catalogue des Antiquités de l'Age du Fer du Musée de Lons-le-Saunier* (1962) 19-21.

L. LERAT

CONSILINUM (Padula) Campania, Italy. Map 14. A center in ancient Lucania renowned for its economic

and commercial importance. In the *Liber regionum* (p. 209), the territory dependent on that municipium is in fact indicated, with mention of the praefectura Consiline. Cassiodorus (*Var.* 8.33) records a great annual fair, with the participation of people from all the surrounding regions, held in a pleasant spot in the valley, "suburbanus quondam Consilinatis antiquissimae civitatis."

From the ancient center there are inscriptions and monumental remains, found under the modern city and on the hill known as la Civita to the SE, both on a height dominating the fertile valley of the Tanagro. Situated between the valley of the Agri, open to commerce with Metapontum, with Siri, and with Heraklea on the Ionian Sea, and the valley of the Bussento, at whose mouth was the landing place of Pixous, on the Tyrrhenian Sea, it was an important inland market of Magna Graecia.

The material found so far includes more than 13,000 objects from 1300 tombs, specifically from the archaic, Enotrian, Graeco-Italic, and Lucanian necropoleis between Padula and Sala Consilina. The finds are housed in the large new Museo Archeologico della Lucania Occidentale, instituted by the Province of Salerno in the monumental Certosa of S. Lorenzo.

The funerary material from the Enotrio-Italic tombs, containing both inhumation and cremation burials, includes Protogeometric pottery; ornamental and votive objects in amber, bronze, and iron; and impasto pottery with characteristic decoration showing Graeco-Oriental archaic influence. Tombs from the Ionic period (7th-5th c. B.C.), all contain inhumation burials and rich gifts, among which are rare examples of Geometric vases with original polychrome decoration. There is also material from the Graeco-Italic tombs of the 6th and 5th c. B.C., containing examples of Greek figured ceramics, and vases and other objects in bronze. Finds from the Lucanian tombs of the 4th-2d c. B.C. include local red-figured ceramics.

The Hellenistic and Roman material includes antefixes with protomes of Maenads and Silens, and composite figured capitals. There are also several characteristic sepulchral portraits.

BIBLIOGRAPHY. *Apollo, Bollettino dei Musei Provinciali del Salernitano* (July 1961ff); J. de la Genière, *Recherches sur l'âge du fer en Italie méridionale Sala Consilina* (1968)[MPI]; V. Bracco, *RendLinc* (1969) 238ff; K. Kilian, *Früheisenzeitliche Funde aus der südest-necropole von Sala Consilina* (1970). V. PANEBIANCO

CONSORANNI (Saint-Lizier) Ariège, France. Map 23. On a steep hillock dominating the valley of the Salat, Saint-Lizier was in Roman times the capital of the civitas of the Consoranni, whose name it bore. The only remaining visible monuments are the ramparts, which resemble those of the upper town at Saint-Bertrand-de-Comminges (Lugdunum Convenarum) and, like them, date to the Late Empire.

BIBLIOGRAPHY. R. Lizop, *Les Convenae et les Consoranni* (1931) 102-14 & pl. VI; M. Labrousse in *Gallia* 17 (1959) 409; 20 (1962) 548; 28 (1970) 397-98.
 M. LABROUSSE

CONSTANTIA, *see* COSEDIA

CONSTANTINE, *see* CIRTA

CONSTANTINOPLE, *see* BYZANTIUM

CONTIOMAGUS (Pachten) Saarland, Germany. Map 20. On the lower Saar near the mouths of its tributaries the Prims and the Nied. The river crossing of the Metz-Mainz road had been guarded in prehistoric times by a fortification on the nearby Limberg. In Roman times the place developed into a larger vicus and finally a castellum was added. Little is known of the civilian buildings, as the Roman foundations were incomplete or were destroyed by farming or the pillaging of stones. The houses, with eaves parallel to the street, had hypocausts and usually deep wells. There were no cellars because of the danger of flooding. There was a temple district in the area of the later castellum. Stone seats of a cult theater with many Gallo-Roman family names inscribed have been discovered. A large potter's workshop in the SW quarter was uncovered and remains of walls and tools indicate a bronze foundry where equipment disclosed the practice of counterfeit.

The castellum was built in the beginning of the 4th c. Its wall, enclosing a rectangular area (133 x 152 m), had 16 square towers for defense. In the foundation were the stone seats of the theater and stones from monuments to divinities, among them a sacred stone with place name. In the S part of the periphery was a large necropolis (with cremation graves) which was in use from the early 1st c. into Late Imperial times. Another necropolis is believed to have been N of the castellum, where stones with inscriptions had been used in building a Romanesque church. A significant grave inscription was found there. The church was dedicated to the missionary Maximin from Trier. The Christian inscription together with the early patrocinium and a Merovingian cemetery suggest continuous settlement from Roman times into the Middle Ages. Among the small finds is an excellent statuette of the god Mercury. Coins date from Republican times to Arcadius (A.D. 383-395).

BIBLIOGRAPHY. P. Schmitt, *Der Kreis Saarlouis unter den Römern und Celten* (1850); E. Gose, "Das Kastell Pachten an der Saar," *Trierer Zeitschrift* 11 (1936) 107-18; D. Kienast, *Die Fundmünzen der römischen Zeit in Deutschland, III: Saarland* (1962) no. 1143; W. Schleiermacher, "Kaiserzeitliche Namen in Pachten," *Germania* 41 (1963) 38-53; R. Schindler, "Neue Inschriftsteine in der spätrömischen Kastellmauer von Pachten," *Germania* 41 (1963) 28-38; id., "Bericht über die Forschungsgrabungen im römischen Pachten," *Bericht der staatl. Denkmalpflege im Saarland* 11 (1964) 5-49.
 A. KOLLING

COPĂCENI, *see* PRAETORIUM

COPIA, *see* THURII

CORA (Cori a Valle) Latium, Italy. Map 16. About 32 km NE of Anzio, a center of Latin origin, which was later occupied by the Volsci, sheltered a Latin colony preceding the foedus Cassianum (Livy 2.16). It is known that it minted silver coins and that in 211 B.C. it was already a municipium (Livy 26.7); however, it is not known whether Livy referred to the jurisdictional condition of the city in his own lifetime. Cora apparently later sided with Marius and was destroyed under Sulla (Luc. 7.392ff). Its later history is obscure.

The city developed on the W slopes of the Lepini mountains overlooking the Pontine plain, and was connected with the major transit axes of the Via Appia. The habitation area occupied a hill with steep and uneven flanks varying in height from 250 m to 403 m above sea level and isolated by two ditches. The urban plan is extremely irregular, and the network of streets, for the most part sharply curving, is often supported by massive terraces of polygonal masonry. Within the bounds of the urban system, the acropolis may be identified with the upper area, today called Cori a Monte, while the actual habitation site occupied the rest, or what is now

Cori a Valle. The city had a circuit wall, at many places still well preserved. Round towers in opus incertum were added during the first half of the 1st c. B.C. Of particular interest are the colossal foundations inside the urban area, for example, in Via Ninfina, Via Pelasga, Piazza Municipio, and those of the Doric Pozzo (well) and of the Temple of Hercules.

The Temple of Castor and Pollux is on the Via delle Colonne. Its scarce remains identify a temple on a high podium built of squared blocks of tufa. It is a six-columned prostyle Corinthian temple, partly supported by the slope of the hill. Two of the travertine columns on the front are preserved in situ with the corresponding architrave. Opening onto the pronaos was a cella divided into three naves by a double colonnade. It was flanked by two alae, at the ends of which were two small rooms. Two inscriptions pertaining to the monument (*CIL* x, 6505, 6506) indicate the divinities to whom it was dedicated and the magistrates under whom it was constructed. They date the temple to the first half of the 1st c. B.C.

On the summit of the hill, supported by massive foundations, is the temple traditionally attributed to Hercules. Dominating the horizon, the facade is fairly well preserved. It is a tetrastyle pseudo-peripteral temple in the Roman Doric order, with a deep pronaos. In the cella there remains only the entrance with the elegant moldings of the door. It was probably built in the 1st c. B.C. Votive material found there, the earliest of which dates to the end of the 4th or the beginning of the 3d c. B.C., cannot be connected to the building period of the temple. Outside the city were numerous villas, mostly of the rustic type, and a fully developed network of roads.

BIBLIOGRAPHY. S. Viola, *Memorie Istoriche dell'antichissima città di Cori* (1825); A. Nibby, *Analisi storico topografica della carta dei contorni di Roma*, I (2d ed., 1948), 487ff; A. Accrocca, *Cori, storia e monumenti* (1936); *EAA* 2 (1959) s.v. Cori; P. Vittucci, *Cori*, Quaderni Ist. Topografia Antica Univ. Roma, II (1966) 13ff; G. Schmiedt, *Atlante aerofotografico delle sedi umane in Italia*, II (1970) 98f; G. A. Mansuelli, *Architettura e città* (1970) 322.

For the Temple of Hercules. R. Delbrueck, *Hellenistische Bauten in Latium*, II (1912) 29ff; A. Von Gerkan, "Die Kruemmungen im Gebaelk des dorischen Tempels in Cori," *RömMitt* 40 (1924) 167ff. C. F. GIULIANI

CORABIA, *see* SUCIDAVA

CORBRIDGE, *see* CORSTOPITUM

CORDES-TOLOSANE Tarn-et-Garonne, France. Map 23. In the appendages of the ancient abbey of Belleperche, near the Fountain of the Monks, there existed a Gallo-Roman establishment, a villa or sanctuary. It has yielded a draped statue of a woman, carved in soft limestone, which must have been of funerary character.

BIBLIOGRAPHY. M. Labrousse in *Gallia* 20 (1962) 607 & fig. 69. M. LABROUSSE

CÓRDOBA, *see* CORDUBA

CORDUBA (Córdoba) Spain. Map 19. City of Andalusia on the Guadalquivir river, founded in 152 B.C. by the consul Claudius Marcellus on an ancient native site. It received the status of colonia shortly before A.D. 45, perhaps from Gnaius, son of Pompey the Great, and the title of Patricia from Augustus when veterans of Legiones V and X were settled there. The city flourished during the Roman period, first as capital of Hispania Ulterior, and later of the senatorial province of Baetica; it was the

most completely romanized city of the Peninsula and the seat of the juridical conventus. After the Germanic invasions, in the Moslem period, it became the center of the independent Cordovan caliphate and an important cultural center of the early Middle Ages. The remains of the Roman colony lie beneath the modern city, but the superb bridge over the Guadiana is still used, although restored.

The modern network of streets is largely superimposed on the Roman one, which divided the city into the four rectangles customary for Roman encampments. The cardo (Osario Street) ran N-S, and a Roman necropolis lay at the end of it. Traces of the forum have been found in the center of town, including a large edifice originally over 90 m long, which was undoubtedly a bath. The rooms had mosaic floors and the heating system included suspensurae for the caldarium. The area so far excavated (60 x 20 m) greatly resembles the baths in Italica; they were doubtless a standard provincial type. The exterior wall, which abuts on the plaza or site of the forum, is perhaps 2 m thick, with marble revetments on the outside. There were two entrances, marble-lined as at Italica. The thick walls seem designed to carry heavy vaults. The baths were adorned with statues, many fragments of which have come to light.

A large temple has also been identified, on the property of the present Casa Consistorial. It stood on a high podium, approached by a stairway with an altar at its foot, on the central axis. Large rough-hewn blocks have been found, laid fanwise to contain the earth fill for the temple. The building has been reconstructed as 18 by 32 m, peripteral with six columns in front and ten on each side, seven of which were attached pilasters. The Corinthian capitals (in the museum) are large and of excellent quality (ht. 1.02 m, diam. at top 1.14). There are also remains of private houses. The most interesting is the central portion of a villa or insula, comprising the N side of a hexastyle peristyle court with a garden. On each side was a gallery carried on six Doric columns. Any new building activity in the city today reveals Roman constructions and bits of architecture, which the museum direction records and fits into the plan of ancient Corduba.

A series of cemeteries line the roads ascending to the walled city: the patrician necropolis of the Puerta de Hierro where elegant lead coffins have been found, the cemetery by the Osario gate with rich stone burials, and another at the ascent to the S gate. The most important one, however, is on the old road to Almodóvar del Rio: its area is over 5000 sq. m, and the most crowded section is at the first milestone on the road from Corduba to Hispalis. Judging by the finds, this necropolis was used from Iron Age II until the Moslem era; it was the most frequented because of its location to the W and its proximity to the Guadalquivir river. Most of the finds belong to the Republican and Imperial periods. Nearby there are foundations and walls of large projecting cutstone blocks, suggesting a public building, perhaps a stadium.

The Archaeological Museum houses a wealth of architectural remains, capitals, column shafts, bits of molding of fine workmanship; abundant epigraphic material comparable only to that of Tarraco; sculptures and basreliefs, including statues from the baths; gravestones and grave goods; numerous bronze objects; Roman and Visigothic jewelry; clay figures; glass; Campanian, Arretine, and local ceramic ware.

BIBLIOGRAPHY. A. Blázquez, "El Puente romano de Córdoba," *Boletin de la Real Academia de la Historia* (1914); S. de los Santos Gener, *Guía del Museo Arqueo-*

lógico Provincial de Córdoba (1950); id., "Memoria de las Excavaciones del Plan Nacional, realizadas en Córdoba (1948-1950)," *Informes y Memorias de la Comisaría General de Excavaciones Arqueológicas* 31 (1955); A. García y Bellido, "Las colonias romanas de Hispania," *Anuario de Historia del Derecho Español* 29 (1959) 451ff; id., *Los hallazgos cerámicos del área del templo romano de Córdoba* (1970). J. M. ROLDÁN

CORFINIO, *see* CORFINIUM

CORFINIUM (Corfinio) Abruzzi, Italy. Map 14. A town of the Marsic Paelignians in the Aeternus river valley. It does not appear in the sources until the social war, 90 B.C., when Diodorus Siculus (37.2.4f) wrote that the city had recently been completed and contained a spacious forum and senate chamber. Newly named Italia, the city was to be capital of a new Italian federation intended to supplant Rome, but so remained for only a short time. In 49 B.C., under L. Domitius Ahenobarbus, the city succumbed to the siege of Caesar after a week (Caes. *BCiv.* 1.15-23: App. *BCiv.* 2.38). Seldom mentined, the city was still important in the early Empire, as evidenced by its location at the crossroads of the Via Valeria and the Via Claudia Nova built by emperor Claudius (*CIL* IX, p. 586), by the numerous inscriptions found on the site (esp. *CIL* IX, 3152, 3166-67, 3170); and by the existence of two aqueducts, largely subterranean (remains of one visible near the Church of the Madonna of Grace). The modern town (formerly Pentima) is located N of the ancient one, which in the 10th c. became the cathedral city of Valva. The curved line of houses to the NE marks the site of an ancient theater.

Among the sparse Roman ruins, chiefly on the Via Valeria toward the cathedral, excavations have uncovered several tombs with inscriptions, a bath and other buildings, and the large siege mound of Caesar. Local material is housed in the antiquarium of S. Alessandro attached to S. Pelino.

BIBLIOGRAPHY. G. Veith, "Corfinium," *Klio*, 13 (1913) 5ff; D. Ludovico, *Dove Italia nacque* (1961).

D. C. SCAVONE

CORFU, *see* KERKYRA

CORIA, *see* CAURIUM

CORI A VALLE, *see* CORA

CORINIUM DOBUNNORUM (Cirencester) Gloucestershire, England. Map 24. On the main road (Ermin Street) from Londinium to Colonia Glevensis, ca. 25.5 km SW of the latter. Mentioned by Ptolemy (*Geog.* 2.3.25) and in the *Ravenna Cosmography*. The site was occupied by a cavalry fort ca. A.D. 43-70, during which time a vicus grew up to the N. After the abandonment of the fort the vicus developed into the civitas capital of the Dobunni, and ca. 100 ha were enclosed when a wall was built in the 3d c. It is possible that it became the capital of Britannia Prima in the 4th c., and occupation seems to have continued well into the 5th c. The Anglo-Saxon Chronicle refers to the capture of the town by the Saxons after the battle of Dyrham in A.D. 577.

Most of the buildings of Corinium lie buried deep below the modern town, but excavations in 1958-68 have recovered most of the street plan, which divided the town into rectangular insulae, the circuit of the defenses, including the NE gate, much of the plan of the forum and basilica, a market hall, and a number of shops and town houses. The only principal monument above ground is the amphitheater, ca. 200 m SW of the town; it is concealed beneath grass-covered banks, but its shape and size can be appreciated. Excavations have shown that it was first constructed early in the 2d c. A.D., with timber walls retaining the cavea of piled earth; the timber was replaced by masonry later in the century.

A length of the town wall can be seen on the NE side of the circuit; in some other places it can be traced as a substantial linear earthwork concealing both the wall and the rampart behind it. The course of the river Churn appears to have been moved at an early date, from its natural position through the town center into an artificial channel running round the N and E perimeter; it was subsequently used as part of the defenses. At least four phases of fortification have been distinguished: the first, erected late in the 2d c. A.D., consisted only of a ditch and an earth bank, although interval towers and the NE gate were constructed of masonry. The bank was faced with a stone wall, 1.1-3 m thick, in the 3d c. A.D., and external towers were added later. The position of the walls at the SW end of the basilica, which, together with the forum, is known to have been erected in the late 1st c. A.D., have been marked out on the modern street surface near the junction of Tower Street and the Avenue. Both basilica and forum underwent considerable modifications in the 4th c.

A new and larger museum contains an excellent collection of sculptured and inscribed stones, pottery, metalwork, and a number of mosaics, including an Orpheus mosaic from a villa just outside the town to the N.

BIBLIOGRAPHY. Buckman & Newmarch, *Remains of Roman Art in Cirencester, Corinium* (1850)[I]; F. Haverfield, "Roman Cirencester," *Archaeologia* 69 (1920) 161-209[MI]; P.D.C. Brown et al., interim reports in *AntJ* 41-47 (1961-67)[MPI]; J.M.C. Toynbee, *Art in Roman Britain* (1962) passim[I]; J. S. Wacher, "Roman Cirencester," *ArchJ* 122 (1965) 203-6; id., *The Towns of Roman Britain* (1974) 289-315[MPI]; P. Cullen, *Britannia* 1 (1970) 227-39[MPI]; A. D. McWhirr, *AntJ* 53 (1973) 191-218[MPI]. J. S. WACHER

CORINTH (Korinthos) Corinthia, Greece. Map 11. On the S coast of the Gulf of Corinth, some 9 km W of the Isthmus of Corinth. Principal city of the region, whose territory extended W to the river Nemea (adjacent to the territory of Sikyon), E across the Isthmus to Krommyon (modern Haghioi Theodoroi), and S to an uncertain line in the mountains bordering on the lands of Mycenae and Epidauros; due N of the city, across the SE bay of the Gulf, the peninsula of Peraion (modern Perachora) with its Sanctuaries of Hera was also under Corinthian control. The ancient city lay on the slopes of its fortified acropolis (Akrokorinthos), some 3.5 km from the shore and from the harbor town of Lechaion, which served the maritime traffic to and from the West. A second harbor town, Kenchreai, 10 km distant toward the SE on the shore of the Saronic Gulf, enabled Corinth to enjoy also the benefits of trade with the East. A stone-paved portage road, built across the narrowest part of the Isthmus in the 6th c. B.C., made it possible to transport whole ships (with their cargos?) between the Gulf of Corinth and the Saronic Gulf.

Human occupation of the late Neolithic period is found at various mounds lying W, N, and E of the Classical city; on the hill of Korakou, near the shore at Lechaion, appear extensive remains of domestic habitation of all three phases of the Bronze Age. Within the area of the Classical city there is evidence of almost uninterrupted occupation from the Late Neolithic period through the Bronze and the Early Iron Age; but no significant architectural remains of those periods have yet appeared.

The earliest architectural monument is to be associated with the Bacchiad kings. About 700 B.C. a primitive

temple (middle or 3d quarter of 7th c.) was built on the so-called Temple Hill which dominates the center of the city. Its walls were of small limestone blocks from ground to eaves; the roof, hipped at one end, was covered with the earliest known Corinthian terracotta tiles. There was probably no peristyle. This temple was destroyed ca. 580 B.C., possibly in the violence attending the fall of the tyranny and the establishment of the oligarchy which was to control Corinth for the next four centuries. The temple, sacred probably to Apollo Pythios, was replaced ca. 560-540 B.C. by a larger, peripteral (6 x 15) temple of limestone; only seven columns survive in situ. The cella of the temple is divided: the smaller, W chamber contained a basis probably used for a chryselephantine or bronze image of Apollo of the 5th-4th c.; the more ancient image of Apollo (xoanon or sanis) would have been located in the larger, E chamber; a tank for holy water was located beneath the floor of the pronaos (cf. the Temple of Apollo Pythios at Gortyn in Crete).

With the construction of the second temple the Temenos of Apollo was enlarged to the N and a ramp or stairway led from the lower ground at the N up through the temenos wall to the sanctuary. SE of the temple another stair led down to the area of a shrine (Athena Hellotis?) with semicircular mudbrick altar, a sacred spring, an apsidal building (of oracular function), and a racecourse. From there a road led N past the Fountain-house of Peirene (the city's main public water supply) toward the sea and the harbor town of Lechaion. Immediately N of Peirene was a shrine, possibly of Artemis. A small Doric temple (A; distyle in antis) of the 5th c. B.C. was replaced in the 4th c. by a tetrastyle baldachino (covering a cult image?); at the same time the circular altar of the sanctuary was also covered with a baldachino. Beyond this shrine to the N lay a cleaning and dyeing works, with vats and concrete drying floors. Across the street to the W of Temple A lay a commercial building, a stoa of the 5th c., possibly a fish market. To the N of the archaic Temple of Apollo Pythios a stoa and a hot bath were constructed in the 5th c.; W of the temple a public road led NW toward Sikyon. Thus at a relatively early date constructions of civic and secular use encroached upon the great temple on the W, N, and E; to the S lay the Sanctuary of Athena Hellotis and the racecourse. The location of the civic center or agora of Greek times is by no means certain, though scholars have long tended to place it S of Temple Hill, on the site of the Roman forum. It is not clear just what civic buildings were required for the processes of the oligarchic government of Greek Corinth or what open meeting places (if any) were used by its popular assembly. A public archives must have existed for the preservation of documents on papyrus or parchment (the Corinthians appear not to have recorded public documents on stone, probably because of the lack of local marble quarries to supply a material suitable for the inscribing of long texts). None of the Greek buildings so far excavated can be associated with specifically civic functions.

During the 5th and 4th c. the irregular terrain dominated by the sacred spring and oracular building was gradually filled in until a broad floor, rising slightly toward the S, covered the whole valley that lay to the S of Temple Hill. At the S limit of this valley, a large stoa of the Doric order (165 m long) was built toward the end of the 4th c. This S Stoa consisted of a single order on the N facade; but in the rear half of the interior the 33 two-room shops were covered by as many rooms on a mezzanine level. Each of the ground-floor shops but two was provided with a well; many of these shops apparently served as establishments for eating and drinking. Broneer believes the building was constructed by Philip II after the battle of Chaironeia in order to provide food and accommodations for the delegates of the various Greek states to the meetings in Corinth of the Hellenic League which Philip founded. For the construction of the S Stoa there were sacrificed several private houses of the 5th c. and two shrines, one of Aphrodite and the other probably for a hero cult, connected with the sacred races run on the nearby racecourse.

Towards the end of the 4th c. the racecourse was redesigned, its orientation changed so as to create a wider open area N of the S Stoa. At the W end of this open area, and on a rock ledge rising about 7 m above the racecourse level, lay an old shrine, perhaps rebuilt at this time and certainly enclosed now by a large peribolos measuring about 93 x 130 m. In Roman times this temple was replaced by the heavy rubble-concrete basement of a podium temple (E) which completely obscures the Greek or Hellenistic construction.

By 300 B.C. the valley S of Temple Hill had acquired the form it was to retain until the Roman sack in 146. Meanwhile other areas of the ancient city had been developed. The fortifications of Corinth may go back in part to the 6th c.; by the 4th c. they had reached their maximum extent, enclosing an area two and one-half times as great as that of Classical Athens. From the fortress of Akrokorinthos at the S, walls extended N to enclose the city; the N city wall lay along the top of a rock ledge, which gave strategic advantage to the defenses. From the N wall two long walls (patterned after those of 5th c. Athens) extended to the sea and enclosed the harbor town of Lechaion. Within the main city enclosure were not only public buildings and residential structures, but also extensive farming and grazing lands. Cemeteries (burials of Geometric to Hellenistic times) occur at several points *within* the city. These are for the most part small; the largest cemeteries were outside the walls at the N and E.

The athletes who competed in the sacred contests on the racecourse in the center of the city had at their disposal one gymnasium (frequented in the 4th c. by Diogenes the Cynic) located in the suburb of Kraneion to the SE and another at the N, referred to by Pausanias as the "ancient gymnasium." Recent excavations on the supposed site of the latter have revealed only the constructions of the gymnasium of Roman times. Between that and the N city wall there had existed, as early as the 6th c. B.C., a Sanctuary of Apollo; in the 4th c. Asklepios took over this shrine, where a temple was constructed on a rock terrace; at a lower level to the W a colonnaded court with fitted banquet rooms and abundant water supply served the physical needs of the worshipers. Some distance to the W lay a Sanctuary of Zeus; the exact site is not yet identified, but architectural fragments from the shrine indicate a late archaic Doric temple, greater in size than any other at Corinth (or in the entire Peloponnesos). A road connected the gymnasium and Asklepieion area with the center of the city further S. Adjacent to the W side of this road lay a theater. The stone seats and stairways of the cavea (capacity ca. 15,000) and the earliest (wooden) skene were laid out at the end of the 5th or in the early 4th c. B.C.; the skene was rebuilt in stone about a century later.

Pausanias records many small sanctuaries lying beyond the center of the city; some of these clearly had their origins in Greek times. The important cult of Aphrodite had its center in a shrine on Akrokorinthos; the architectural remains are meager, but the sanctuary appears to have originated at least in the period of the tyrants. Recent excavations have brought to light one of the ten sanctuaries which Pausanias noted on the road

leading up to Akrokorinthos—the Sanctuary of Demeter and Kore. A small, popular rather than civic, shrine, it was founded in the early 7th c. B.C. It is marked by no distinctive temple building but has an open-air meeting place (seats cut as steps in the rock); a stoa below at the N perhaps constituted a skene. Several dining rooms with couches point to communal religious banquets. Extremely fine examples of terracotta sculpture of the 6th through the 3d c. have been found here. To the NW of the city, on the ancient road just outside the Sikyonian Gate, has appeared a stela-shrine where hundreds of votive terracotta figurines of the 5th and 4th c. were offered (by travelers?); many of the figurines represent groups of women dancing about a central figure of a flute player.

Residential buildings always crowded close to the civic and commercial buildings of the city. Private houses lay near the central area at E and S. East of the theater, just across the road that connected the center with the gymnasium, lie the remains of a private house with an early and unusual pebble-mosaic floor. Further W other houses of the 5th and 4th c. and of Hellenistic times are known to exist, but all have been damaged by Roman or later rebuilding and no complete Greek house plan has yet been exposed in Corinth. Ancient sources record that the suburb of Kraneion, lying to the SE of the civic center, on a hillock between the Kenchreai and Argos gates, was marked by a grove of cypresses and by luxurious residences: no excavations have been carried out here.

The Corinthians of Greek and Roman times have left many monuments of their understanding of hydraulic engineering. Rain water, penetrating the porous upper limestone beds, was trapped (at levels varying from 2 to 30 m below the surface) by the lower, impervious clay deposit. This water made its appearance naturally at many points where a vertical rock scarp exposed both the upper limestone and the lower clay. The Fountain of Peirene near the center of the city is the best example of this type of supply; another is the so-called Baths of Aphrodite below the N city wall E of the Asklepieion. At both these points tunnels dug back into the clay, just below the overlying limestone, served to augment the water supply and to draw it forward to the rock scarp. The tunnels dug for the Peirene system extend S, SE, and SW in a network well over a km in length. Manholes dug at varying distances from one another served for the initial tunnel construction and subsequently as a means of drawing water for public and private use. The Peirene tunnels may have been initiated in the period of the tyrants. From a natural water source at the foot of Akrokorinthos a tunnel, excavated in the late 5th c. or earlier, carried water NW to serve private houses, farmsteads, and small industries (a pottery?), and to provide water for irrigation. The tunnel of this system has been investigated over a length of more than 1 km. Here the manholes were dug generally at intervals of ca. 60 m. Other similar tunnels are known to have existed in the ancient city but have not yet been explored.

Cisterns of many forms were used by the Corinthians: large chambers dug into the rock (one, excavated in 1962, had a storage capacity of ca. 245,000 liters); long, narrow, rock-cut tunnels connecting two or three manholes (one such tunnel cistern had a capacity of ca. 100,000 liters); a series of tunnels intersecting in a pattern not unlike that of the so-called Hippodamian city plan; small bottle-shaped cisterns dug in rock near the surface of the ground (this type, common in Athens, is infrequent in Corinth). Although many of these cisterns and tunnels were in use in Roman times, it seems almost certain that most represent engineering feats of the Greek period. They are generally coated with a fine, creamy-yellow hydraulic cement which is typical of Greek times. Throughout the city, wells (independent of cisterns and tunnels) provided water to individual private and public buildings; the earliest so far excavated is of the Late Geometric period.

The public water supply of the center of the city was provided by the Fountain of Peirene, to the E of the archaic Temple of Apollo, and by the Fountain of Glauke, W of the same temple. Glauke consisted of a series of three storage chambers cut into the rock of the W extension of Temple Hill; the N slope of the hill provided access to an architectural facade, cut from the living rock, just in front of the storage chambers. Water was brought to the chambers in terracotta pipes from some source lying far away to the S. Another and important water supply existed on Akrokorinthos, where a natural spring welled up among the rocks. This was doubtless in use in the time of the tyrants; in the Hellenistic period the collecting basin was covered by a concrete vault, which survives today.

The building material of Greek Corinth was almost exclusively native limestone (poros). Marble, of which there was no local source, was used very rarely in Greek times, though Roman builders employed it extensively from the 1st c. A.D. Limestone was obtained from quarries some 4 km to the E of Corinth or even from the rock outcrops within the city itself. Quarrying of the W extension of Temple Hill (begun at least as early as the 4th c. B.C. and terminated in early Roman times) eventually isolated the Fountain of Glauke from the hillside of which it had been an integral part and left the monument, as it stands today, a lonely cube of living rock rising about 6 m above the surrounding terrain.

In 146 B.C. a Roman army, led by the consul L. Mummius (Achaicus), sacked Corinth, then the leading city of the Achaian League. All the citizens were killed or enslaved; the buildings, to a large extent, demolished. The site lay waste for a century; such land as was not turned over to the people of Sikyon was declared ager publicus. In 44 B.C., on the initiative of Julius Caesar, a Roman colony (Laus Julia Corinthiensis) was established at Corinth. The purpose of the foundation was in part commercial, in part political—Corinth became the administrative center of the senatorial province of Achaia.

In the first quarter of the 1st c. A.D. an extensive building program was begun. The designers made use of some Greek structures whose ruins were substantial enough to permit repair (the Temple of Apollo Pythios, S Stoa, Fountains of Peirene and Glauke, theater, Asklepieion), but otherwise they created a Roman city. Within 75 years of the foundation of the colony the plan of the new city was well established. A Roman arch (ornamental rather than triumphal) marked the S end of the stone-paved road from Lechaion, where it entered the forum. Adjacent to the arch at the W a basilica was constructed, with shops in the basement level opening out onto Lechaion Road. Two other basilicas, almost identical with one another in plan and elevation, were built at the E end and on the S side of the forum; a third similar structure apparently existed at the W. The S basilica was entered through the reconstructed S Stoa, into which were now incorporated also a horseshoe-shaped meeting room for the members of the local senate and several large administrative rooms. A row of one-story shops extending E-W through the center of the forum area was interrupted at its midpoint by a speakers' platform designated "rostra" (inscription of 2d c. A.D.) or "bēma" (Nov. Test., Act. Ap. xviii.12). All these structures served the administrative needs of the colony itself and of the provincial governor and his considerable staff. A rectangular structure built in the

early 1st c. A.D. in the SE corner of the forum has been identified tentatively as the tabularium.

Across the W end of the forum, in front of and below the peribolos of temple E (see supra), were built six small podium temples and a circular monopteros (the last, dedicated by Gn. Babbius Philinus before the middle of the 1st c., perhaps housed a statue of Aphrodite). This architectural complex, developed between the years A.D. 35 and 190, included a pantheon and Temples of Venus-Fortuna, Herakles, and the emperor Commodus. Between the NW corner of the forum and the Fountain of Glauke a Temple of Hera Akraia (?) with peribolos was built during the 1st c.

North of Peirene the Greek Shrine of Artemis was replaced in early Roman times by a peribolos, sacred to Apollo but apparently serving as a place of meeting and of business for those engaged in shipping; a row of shops separated the peribolos from the colonnaded sidewalk of Lechaion Road to the W. The N flank of Temple Hill was quarried away in the early 1st c. to create space for a large quadrangular marketplace enclosed on all sides by colonnades. Another commercial structure, of like width, opened onto the W side of Lechaion Road.

Roman Corinth boasted at least three great public baths. The thermae built by Eurykles in the late 1st or early 2d c. are probably to be identified with the ruins just N of the Peribolos of Apollo. Another great bath is being excavated at a point some 200 m N of the forum (its ground area may surpass 10,000 sq. m); it is probably the Thermae of Hadrian mentioned by Pausanias. The third large bath is located due N of the theater. At least four other small public baths of the later Roman period are known within the city.

For the entertainment of the populace the Romans rebuilt the Greek theater, constructing a typical Roman scenae frons. In later times the orchestra was redesigned for use as an arena and even for aquatic performances. A smaller odeum was constructed in the 1st c. A.D. S of the theater; a colonnaded court of trapezoidal plan joined the two structures. In the 2d c. the odeum was remodeled at the expense of Herodes Atticus (as was also the court of the Fountain of Peirene). For more typically Roman performances, an amphitheater (the only one in the province of Achaia) was laid out (3d or 4th c.) in the NE quarter of the city.

Traces of Roman private houses are found throughout the city area. Two have been excavated. One, lying some 750 m W of the odeum, was built in the early 1st c. and was remodeled several times. A dining room, redesigned in the last quarter of the 1st c. to accommodate nine couches, was provided with a splendid mosaic floor in which many tesserae of glass were employed; adjacent to this room was a small, Italianate atrium. A house of the 3d c., built just outside the city wall at the NW, beside the road to Sikyon, is distinguished by numerous well-preserved mosaics with mythological and pastoral scenes; this house, too, had an atrium. It is clear that Herodes Atticus possessed a villa in or near Corinth; it may have been N of the suburb of Kraneion. An elaborate villa near the shore, just E of Lechaion, is probably of the 3d c.; it is marked by extensive and complex provisions for the supply of water.

In Roman times the Sanctuary of Aphrodite on Akrokorinthos continued to flourish, and Romans inscribed their names on the walls of the subterranean chamber that gave access to the natural fountain on the citadel. The fortifications of the hill, however, as well as those of the lower town, demolished by Mummius, were not needed in the Early Imperial period and were not rebuilt. There is no evidence of a rebuilding prior to the invasion of the Heruli in A.D. 267; but traces of N-S lines of rubble-concrete walls some 1,000 m W and a like distance E of the forum may perhaps represent the post-Herulian fortifications of a smaller area than that covered by the Greek and early Roman city. The major repairs to the walls of Akrokorinthos are to be attributed to the Byzantines and their successors.

Excavations at Corinth were begun in 1896. A museum at the site (built 1932, enlarged 1950) houses almost all finds from the excavations as well as chance finds from the vicinity.

BIBLIOGRAPHY. *Corinth, Results of Excavations Conducted by the American School of Classical Studies at Athens* (1929—); 16 vols. in 26 parts to date, plus 3 albums of plates. Vols. I (6 parts), II, III (2 parts), V, X, XIV, XV.1, XVI deal with topography & architectureMPI; *Ancient Corinth: A Guide to the Excavations*, 6th ed. rev. (1960)MPI; Corinth, *A Brief History of the City and a Guide to the Excavations*, rev. ed. (1969)MPI.

J. G. O'Neill, *Ancient Corinth with a Topographical Sketch of the Corinthia*. Part I: *From the Earliest Times to 404 B.C.* (1930); Édouard Will, *Korinthiaka: Recherches sur l'Histoire et la Civilisation de Corinthe des Origines aux Guerres Médiques* (1955); Georges Roux, ed., *Pausanias en Corinthie* (1958)MPI; H. S. Robinson, "The Urban Development of Ancient Corinth," *Études sur L'Art Antique* (1963) 53-77 (repr. separatim 1965)MPI; C. Roebuck, "Some Aspects of Urbanization in Corinth," *Hesperia* 41 (1972) 96-127.

Reports in *AthMitt* 71 (1956) 51-59; 73 (1958) 140-45; in *Praktika* (1960) 136-43; (1962) 48-50; in *Hesperia* 29 (1960) 225-53; 31 (1962) 95-133; 34 (1965) 1-24; 36 (1967) 1-41, 402-28; 37 (1968) 299-330, 345-67; 38 (1969) 1-106, 297-310; 39 (1970) 1-39; 40 (1971) 1-51; 41 (1972) 1-42, 143-84, 283-354; 42 (1973) 1-44.　　　　　　　H. S. ROBINSON

CORINTH, ISTHMUS, *see* ISTHMIA

CORIOVALLUM (Heerlen) S Limburg, Netherlands. Map 21. Cortovallio in the *Peutinger Table*, Coriovallo in the *Antonine Itinerary* (375.7; 478.6). The town lay at the crossing of two Roman roads: Cologne to Boulogne, and Xanten to Trèves via Heerlen and Aix-la-Chapelle. Scores of pottery kilns have been found, indicating that it was a center of the coarse-ware industry, and some of the inhabitants must have been wealthy, judging by the contents of graves discovered here. Excavations have revealed the remains of a bath (ca. 40 x 50 m), several houses, Roman roads, and the ditches of a late Roman fort.

The bath was built ca. A.D. 50 and altered in the 3d c., probably because the heating system did not function properly. An inscription discovered on the site, attests a restoration ca. A.D. 250 by M. Sattonius Iucundus (cf. *CIL* VIII, 2634), a decurio of Colonia Ulpia Traiana (Xanten). In the first half of the 4th c. the bath was at least partly destroyed, and the site was incorporated into the fort by shifting the ditch to the N. The fort lasted until the beginning of the 5th c.; coins and pottery of the 4th c. have often been found. The older finds are in the Leiden and Maastricht museums, the newer ones in the municipal museum at Heerlen.

BIBLIOGRAPHY. A. W. Byvanck, *Excerpta Romana* II (1935) 85-87; III (1947) 27-36; A. E. van Giffen, "Thermen en castella te Heerlen," *AntCl* 17 (1948) 199-236MPI; W. Glasbergen, "Terra sigillata uit de Thermenopgraving te Heerlen-Coriovallum," ibid. 237-62I; J. E. Bogaers, "Heerlen, een bouwfragment met de naam van Marcus Sattonius Iucundus," *Niewsbull. Kon. Ned. Oud. Bond* (1957) 133-38; id., "Militaire en burgerlijke neder-

zettingen in Romeins Nederland (Honderd eeuwen Nederland)," *Antiquity and Survival* II (1959) 157-59.

B. H. STOLTE

CORNACUM, *see* LIMES PANNONIAE (Yugoslav Sector)

CORNETO, *see* TARQUINII

CORNUS Sardinia, Italy. Map 14. An ancient city on the W coast of Sardinia, near S. Caterina di Pittinuri. Probably founded by the Carthaginians on a nuraghic settlement, it is mentioned by the geographers (*It. Ant.* 84; *Rav. Cosm.* 5.26). Livy (23.40) writes of the city in connection with the war in 215 B.C. between the Romans and Sardinians allied with the Carthaginians under the leadership of Ampsicora. Probably the Punic city was destroyed by the victors and became a Roman city with the rank of colonia (*CIL* X, 7915). It was linked by road to Tharros and to Gurulis Nova (Cuglieri) and was still flourishing in the 3d c. A.D. In the late period its center shifted toward the acropolis on the Corchina hill, where Late Roman remains still exist. The city was abandoned after the coming of the Vandals.

The site, identified in the 16th c. by Fara, had been sacked so many times that very little could be saved from the Roman necropolis. It is at su Columbaru and consists of ditch tombs and tombs with stone coffins. The material from the necropolis is preserved in the National Museum at Cagliari.

Around Sisiddu are the remains of a villa oriented NE-SW, and around Lenaghe are the ruins of a bath building.

BIBLIOGRAPHY. A. Taramelli, *NSc* (1918) 285ff^MPI; E. Pais, *Storia della Sardegna e della Corsica*, I (1923) 369; G. Pesce, *EAA* 2 (1959) 860f. D. MANCONI

CORRE Haute-Saône, France. Map 23. Gallo-Roman site, sometimes incorrectly identified with Ptolemy's enigmatic Dittation (2.9), at the juncture of the Saône and the Coney, on an important crossroads. It has yielded numerous sculptures: a fine series of funerary stelai, a torso of Apollo, and the remains of several groups of Jupiter and an anguiped monster. Those sculptures still in existence are now in the Museum of Vesoul which, with that of Luxeuil, is the most important museum for sculpture in the Franche-Comté.

BIBLIOGRAPHY. Coudriet et Chatelet, *Histoire de la Seigneurie de Jonvelle* (1864) 4, 12-15, 19-45, 115; *CIL* XIII, 5452-59; E. Espérandieu, *Recueil général des basreliefs . . . de la Gaule romaine* (1907—) nos. 5362-68, 5370-72, 5374, 5377-79; L. Lerat, "L'archéologie au Musée de Vesoul," *Revue Archéologique de l'Est*, 16 (1965) 275-82. L. LERAT

CORSEUL, *see* FANUM MARTIS

CORSICA, *see* ALALIA

CORSTOPITUM (Corbridge) Northumberland, England. Map 24. On the river Tyne 28 km W of Newcastle, 0.8 km W of Corbridge village, 4 km S of Hadrian's Wall (NY 983647). Bridgehead site on the N bank of the river, where the Roman road from York into Scotland (Dere Street) met the road W to Carlisle (the Stanegate). The name is as given in the *Antonine Itinerary*. It is apparently not Celtic, and may be corrupt—if not pre-Celtic. The Roman occupation lasted from the Flavian period to ca. A.D. 410 or perhaps later in the 5th c.

The earliest permanent occupation probably dates to Agricola's second campaign (A.D. 79). It was a timber fort with turf ramparts of ca. 2.8 ha, and cavalry were probably included in its garrison (*RIB* 1172). This fort, after some slight modification, was destroyed by fire ca. A.D. 105, and replaced by a fort of ca. 2.5 ha, also with timber buildings and turf ramparts. Rebuilt for a short occupation under Hadrian (probably in the earliest stages of the occupation of Hadrian's Wall, ca. A.D. 122-125), the fort was reoccupied in 139 (*RIB* 1147) in support of the advance of Lollius Urbicus into Scotland. It was garrisoned (probably by auxiliaries) until ca. A.D. 160, and its timber buildings (but not its ramparts) progressively replaced by stone. The headquarters building and commander's house, both of stone, are still visible.

Some military buildings remained in use after A.D. 160. The granaries were rebuilt and reused during the Severan campaigns of A.D. 209 and 210 (*RIB* 1143, 1151) and were probably still in use in the 4th c. They are still visible N of the E-W road (the via principalis). But the construction of temples (still visible) was permitted within the former fort area, S of the E-W road. A large square monumental building of uncertain purpose (still visible) was planned and begun E of the granaries, probably in the late 2d c., but was never finished. Its S range was later converted into shops, facing on the road.

Also probably in the second half of the 2d c., two military compounds (still visible) were constructed S of the E-W road, on either side of what had been the via praetoria of the fort, ingeniously fitting in behind, but not disturbing, the existing temples. Each compound, garrisoned by a legionary detachment (*RIB* 1154), had its own headquarters building, the W one with an underground strongroom, still visible. There was iron working in the W compound, probably to supply units stationed along the Wall. A water channel, probably of 3d c. date, supplied an ornamental fountain E of the granaries. The two compounds were combined, perhaps at the beginning of the 4th c., and military occupation of the compounds and granaries apparently continued to the end of the Roman period.

Outside the fort area, a large early bath house and a later mausoleum have been excavated some distance to the W. To the S, between the fort area and the river, a large corridor house with ornamental pool (embellished with a vigorous piece of sculpture, the Corbridge Lion, now in the museum on the site), perhaps an official rest house or mansio, lay near the road from the bridge. None of these outlying buildings can now be seen, nor can the shops and houses of the town that grew up around the site (an area of ca. 14 ha, perhaps eventually enclosed by a rampart and ditches).

While the fort was still garrisoned the settlement must have been an important market center, a role it continued to fill to the end of the Roman period. The presence of legionaries probably gave the site a more sophisticated character than that of most frontier settlements, accentuated by the activities of merchants and others from as far away as Phoenicia (*RIB* 1124, 1129) and Palmyra (*RIB* 1171). Cults attested include those of the local Apollo Maponus (*RIB* 1120-22) and the Syrian Jupiter Dolichenus (*RIB* 1131), with only slight evidence of Christianity. Stones from the site were reused in the church (tower arch) and other buildings in Anglo-Saxon and mediaeval Corbridge, and in the 8th c. church at Hexham (*RIB* 1120, 1122, 1151, 1169, and 1172 are still to be seen in Hexham Priory).

BIBLIOGRAPHY. Research to 1958: E. Birley, *Arch. Ael.* 37 (1959) 8-12. Religious cults: I. A. Richmond, ibid. 21 (1943) 149-214. Christianity: ibid. 43 (1965) 214-23. 1st & 2d c.: J. P. Gillam, ibid. 37 (1959) 59-84; 49 (1971) 1-28. Bath house: C. M. Daniels, ibid. 37 (1959) 85-176. Mausoleum: J. P. Gillam & C. M. Daniels, ibid. 39 (1961) 37-61. Civilian life: P. Salway, *The Frontier*

People of Roman Britain (1965) esp. 45-60. Bridge: D. Bourne, *Arch. Ael.* 45 (1967) 17-26. Hoard of legionary armor: C. M. Daniels, ibid. 46 (1968) 115-26. Guidebook: E. Birley, *Guide to Corstopitum* (1954).

A military site was found in 1974 at NY 970651, 1.3 km W of the visible site. This clearly represents the earliest (Agricolan) occupation, contemporary with the bath.

J. C. MANN

ČORTANOVCI, *see* LIMES PANNONIAE (Yugoslav Sector)

CORTENEBRA, *see* SAN GIOVENALE

CORTONA Tuscany, Italy. Map 14. Probably a member of the Etruscan League and identical with Vergil's Corythus (after its legendary founder and father of Dardanus of Troy: *Aen.* 3.170; 7.209), Cortona's earliest remains date to the 7th c. B.C. After it was absorbed by Rome in the 4th c., it rarely appears in the sources.

Important among the 7th-6th c. remains are a group of funerary tumuli (meloni) near the town. The melone di Camucia contained gold and bronze objects and, besides imported Greek pottery, local impasto, bucchero, and painted ware from the 7th-6th c. A stone funerary bed with weeping women in low relief, now in Florence, was found inside. The 6th c. meloni del Sodo I and II and the 4th c. so-called tumulus of Pythagoras (who never resided here but at Kroton) are dated by their respective vault construction. All are built of great blocks.

The 5th c. Etruscan wall, made of roughly squared blocks of local stone, is still visible, especially near Porta Colonia. Its double gate is later. There is a Roman reservoir 18 m square.

The Museo dell'Accademia Etrusca houses Greek and Roman items with a fine Etruscan collection. A sarcophagus depicting lapiths and centaurs is in the Duomo of S. Maria.

About 16 km to the S is Lake Trasimene. Today the *malpasso*, the defile hemmed in by cliffs, scene of Hannibal's entrapment of the Romans in 217 B.C., lies 1.2 km from the shrunken NE shore line; the old shore line is still visible from the air. To the E near Tuoro are ditches in which the dead were cremated.

BIBLIOGRAPHY. A. Neppi Modona, *Cortona etrusca e romana* (1925)[I] with bibliography; L. Pernier, *MonAnt* 30 (1925); A. Minto, *NSc* (1929); E. Franchini, "Il melone di Camucia," *StEtr* 20 (1948-49); A. Donati, "Epigrafia Cortonese," *Estratto da Annuario* 13 (1965-67); H. H. Scullard, *The Etruscan Cities and Rome* (1967).

D. C. SCAVONE

CORTORIACUM (Courtrai) Belgium. Map 21. A large vicus of the civitas Menapiorum, on the Cassel-Tongres road at the place where it crosses the Lys. Lesser roads linked Courtrai to Tournai, to Ghent, and finally to Lille and Arras. The Arras road has been sectioned and studied in the middle of the modern town. It consisted of a bed of sand mixed with broken tiles, covered by a bed of gravel. The Tournai road has been traced S of the town. Since the 17th c. many finds of Roman antiquities have been noted at Courtrai and the neighboring communes of Kuurne and Harelbeke. The main finds are: coins of the first four centuries of our era; five hoards of coins (three at Courtrai, two at Harelbeke: two found in 1499 and 1610 and lost forever, two buried in the time of Marcus Aurelius, one buried ca. A.D. 267); a superb Hellenistic statuette of the 2d c. depicting Venus Anadyomene, now kept at the Mariemont museum; various substructures; wells; pottery; tombs. More systematic excavations were not undertaken until just after WW II. The present state of our knowledge indicates that there were at least three distinct areas of settlement; these almost certainly formed a single administrative unit.

1) The most ancient remains are several straight V-sectioned ditches found in the S part of the modern town, at the locality called Walle. They seem to date to the first half of the 1st c. These may represent the remains of two temporary military camps, where Caligula or Claudius would have assembled some of the troops about to take part in the conquest of England, but this is uncertain. Near these ditches remains have been found of dwellings dating to the second half of the 1st c. and to the 2d and 3d c.

2) The vicus proper was farther N, in the NW district of the modern town. It started at the main square and extended along both banks of the Lys into Kuurne. Some isolated tombs mark the limit of the vicus to the NE and NW. The necropolis of the Molenstraat has been excavated to the S. It included ca. 100 cremation tombs ranging in date from the time of Claudius to the middle of the 2d c., but they are mainly from the Flavian period. This necropolis separated the vicus from the habitation zone of Walle. In the vicus the main finds are the scanty remains mentioned above. These seem to indicate that the beginning of the settlement goes back to the Claudian period. Finds of the 3d c. are rare. A well lined with a hollowed-out oak trunk was filled with many sherds and coins of the 1st and 2d c.

3) At Harelbeke, less than 2 km from the vicus of Courtrai, the remains of another settlement have been found: several wells, traces of wooden dwellings, masonry foundations, and trenches with refuse. In these trenches were abundant remains of local ironworking. This suggests a district of ironworking crafts, somewhat apart from the vicus proper. Nearby at the hamlet of Stagem, another well made out of a hollowed-out trunk has been excavated. In 1968 the favissa of a sanctuary was found. It contained ca. 120 white ceramic statuettes, which came from the workshops of the Allier and depict various divinities. There was also a bronze statue of a wild boar.

There was probably a castellum at Cortoriacum during the Late Empire. In fact, the *Notitia dignitatum* (*occ.* 5.96; 245; 7.88) mentions milites Cortoriacenses. This force may not have originated at Courtrai, but may simply have been garrisoned there. The hoards of coins seem to indicate that Courtrai was threatened under Marcus Aurelius (the invasion of the Chauci in 172-74) and under Postumus. Apart from this, we still know nothing of the history of the vicus during the last centuries of the Roman occupation.

BIBLIOGRAPHY. J. Vierin & C. Leva, "Un puits à tonneau romain avec sigles et graffiti à Harelbeke," *Latomus* 20 (1961) 759-805; M. Bauwens-Lesenne, *Bibliografisch repertorium der oudheidkundige vonsten in Westvlaandeneren* (1963) 37-41 (s.v. Harelbeke), 59-65 (s.v. Kortrijk), and 65 (s.v. Kuurne); M. Thirion, *Les trésors monétaires gaulois et romains trouvés en Belgique* (1967) 91, 103-4; C. Leva, "L'importance des récentes découvertes romaines à Courtrai," *Annales de l'Institut arch. du Luxembourg* 92 (1967) 267-72; id. & G. Coene, "Het Gallo-Romeinse Grafveld in de Molenstraat te Kortrijk," *Arch. Belgica* 114 (1969) 96 pp.[PI].

S. J. DE LAET

CORTRAT, *see* MONTBOUY

CORTUOSA, *see* SAN GIOVENALE

COSA (Ansedonia) Etruria, Italy. Map 16. A Latin colony on a rocky promontory, rising ca. 113 m above

the sea, on the Tyrrhenian coast 139 km NW of Rome. It was founded in 273 B.C., on territory taken from Etruscan Vulci (Vell. Pat. 1.14.7; Livy *Per.* 14; Strab. 5.2.8). Its name was derived from a nearby Etruscan town, probably modern Orbetello. After the wars of the 3d c. B.C. (Livy 22.11.6; 27.10.8-9; 32.2.7; 33.24.8-9) it prospered until an unrecorded event of the 60s B.C. left it sacked, burnt, and depopulated. Partially rebuilt under Augustus, it survived as a local religious and festival center until the second quarter of the 3d c. For a century or so after 350 the ruins of the forum were occupied by the center of a large estate.

Excavations (1948-54, 1965-72) have traced the city plan, the principal buildings, the port, and have uncovered the Arx, the forum, and a number of houses. Unexcavated buildings include a bathing establishment, but no trace of theater or amphitheater has been found.

The colony's fortifications of massive polygonal masonry still surround the town site. The circuit of less than 2 km had curtains flanked by 18 square towers and was pierced by three gateways and a postern. The gateways were of the inner court type with arched outer openings closed by portcullises and inner gates. The town site, sloping northward, covered ca. 13 ha. Its principal features were twin summits with a level saddle between. Temples stood on the summits. The forum occupied the saddle. Main streets at right angles crossed the site from the gates and were directed at the forum and temple heights. Secondary streets ending in a pomerial road subdivided the site into rectangular and trapezoidal blocks.

The Arx, on the loftier summit at the S angle of the fortifications, was set off from the city by low cliffs and walls of polygonal masonry. At a broad opening on the NE front a main street widened to become a sacred way. The Arx came to be the seat of a major temple, the Capitolium (175-150 B.C.) and a minor, of Mater Matuta (?) (200-175 B.C.). The Capitolium, raised on a high podium above the terraced altar court, had a facade of four columns, reached across its full width by a flight of steps. From a deep, half-enclosed pronaos opened the three cellae of its prototype. The exterior was decorated with molded and painted revetments and pedimental sculptures of terracotta. The minor temple, beside the approach to the Capitolium, was set on a low podium of polygonal masonry, and had a single, square cella behind its deep pronaos. It, too, was adorned with terracotta revetments and pedimental sculptures.

Under the floor of the Capitolium, on the crest of the summit, were found the traces of the augural templum and sacred pit which celebrated the inauguration of the colony. Behind the Capitolium, cuttings in the rock have disclosed the outlines of the first temple on the Arx (240-220 B.C.), dedicated to Jupiter and torn down when the major temple was built. A small building, later erected on the site of its altar court and composed of atrium, meeting rooms, and kitchen, testifies to the observances of a religious confraternity and to the life of the Arx during the Empire.

The forum was a long, unpaved rectangle, entered at either end of the long axis by widened extensions of a main thoroughfare and at either side of one end by a secondary street. By 125 B.C. it had been surrounded by buildings, some of which had already passed through earlier stages. Its entrance from the center of the town was now marked by a monumental triple archway (175-150) between twin, public buildings (240-220), having the form of atria surrounded by shops and offices. One long and both short sides were lined with colonnades (175-150), behind which were the older facades, identically tripartite, of shops and offices (240-220). Along the fourth side stood a row of separate, public buildings.

The oldest of these were the comitium and curia (273-250): a circular amphitheater of steps and a covered, rectangular hall, facing a bicolumnar monument across the short axis of the forum. To one side stood a temple, with its forecourt, similar to the minor temple of the Arx, and the Aerarium (200-175). To the other stood the basilica (150-125). Along both sides of the forum ran continuous pairs of steps, in front of which toward one end small trees were planted in tub-like, rock-cut pits. A double row of smaller, square pits across this end seems to have served to secure staging for various public purposes.

The principal buildings along the one side of the forum were preserved by the Augustan revival of the town, while most of the ruined shop and office buildings were sealed off and abandoned or turned into dwellings. Between A.D. 50 and 55 the basilica was rebuilt as an odeum with seats and a stage. Later a mithraeum was installed in the basement of the curia. In the 4th and 5th c. the ruins of these buildings provided a skeleton for the estate center. One aisle of the basilica accommodated a church. One of the forum's entrances was walled up to make a pagan sanctuary.

The residential blocks of the colony were terraced lengthwise according to the slope of the town site. In each block a row of houses on either side of the median terrace wall opened on the upper or lower street. Six small houses (250-200) show the uniform plots and more or less uniform plans of the early colony. Later houses, rebuilt on two or more of the original plots, display freer plans and gardens. These plans were not of the typical atrium type but centered on covered halls or open courtyards. All the houses brought to light so far were destroyed before 60 B.C. Houses reconstructed in the early Empire had similar plans.

The port of the colony lay in the lee of the promontory. It consisted of an outer harbor offshore, connected by a ship channel with an inner harbor at the end of a coastal lagoon. The outer harbor was protected by a mole and outlying breakwaters of large limestone blocks. The embankments of the ship channel were revetted with polygonal masonry. Recent excavations have uncovered a watering dock, jutting into the channel, its fountain house and quays. Measures for keeping the outer harbor free of sand and for circulating water through the inner harbor are represented by a flux channel to the lagoon with flood gates and by a large rock-cut flush basin fed by sluices.

The finds from the excavations of Cosa are to be stored and exhibited in an antiquarium on the site.

BIBLIOGRAPHY. R. Cardarelli in *Maremma* 1 (1924) 131-42, 155-86, 205-24; 2 (1925) 3-36, 75-128, 147-213; F. E. Brown, *Cosa I, History and Topography* ("MAAR," 20, 1951)MPI; id. et al., *Cosa II, The Temples on the Arx* ("MAAR" 26, 1960)MPI; id., "Scavi a Cosa-Ansedonia (1965-1966)," *BdA* 52 (1967) 37-41MPI; F. Castagnoli, "La centuriazione di Cosa," *MAAR* 24 (1956) 147-65; L. Richardson, Jr., "Cosa and Rome: Comitium and Curia," *Archaeology* 10 (1957) 49-51PI; D. M. Taylor, "Cosa: Black-Glaze Pottery," *MAAR* 25 (1957) 65-193; A. M. McCann & J. D. Lewis, "The Ancient Port of Cosa," *Archaeology* 23,3 (1970) 200-211PI; V. J. Bruno, "A Town House at Cosa," *Archaeology* 23,4 (1970) 232-41; M-T. M. Moers, *The Roman Thin Walled Pottery from Cosa*, in *MAAR* 32 (1973). F. E. BROWN

COSEDIA later CONSTANTIA (Coutances) Manche, France. Map 23. A plausible tradition links Constantia with Constantius Chlorus, who was first Caesar then emperor in A.D. 292-306. In the 4th c. A.D. the city appears in the *Notitia provinciarum* along with those of

Lugdunensis secunda, and in the *Notitia dignitatum* as the residence of the praefectus militum primae Flaviae. With the coming of Christianity it became the seat of a diocese, still in existence. Historians identify Constantia with Cosedia, mentioned in the *Peutinger Table* and the *Antonine Itinerary*. It was in the territory of the Unelli but apparently was not their capital before the conquest or during the Early Empire. In Diocletian's reign military necessity forced Alauna (Alleaume) or Crociatonnum (Carentan) to be abandoned in favor of Cosedia, which then changed its name.

The ancient settlement was built on top of a long, fairly steep hill 91 m high, and on part of its slopes. It was not thickly settled, and the houses were built chiefly of light materials; in the 1st c. A.D. The town covered 27-30 ha, but diminished in the next centuries. Two bath complexes have been located, but no important monument; some fragments of wall frescos have been found but no statues or inscriptions. The city plan does not follow the classical pattern; the Roman road from Coriovallum (Cherbourg) to Condate (Rennes) passes through it as well as several older roads. Traces of a mediaeval rampart can still be seen, but some remains of walls found near the cathedral suggest that there was a fortified redoubt in antiquity, covering ca. 1.5 ha. Ruins of an aqueduct seem to be mediaeval; a shallow water-bearing stratum formerly fed a number of wells. Commerce was facilitated by the proximity of the sea, 12 km away, and in the 1st c. the city imported considerable quantities of delicate pottery and amphorae from Italy and southern Gaul.

BIBLIOGRAPHY. M. Le Pesant, "Les origines antiques de Coutances," *Revue du département de la Manche* 17 (1963) 6-37. M. LE PESANT

"COTTA," *see* JIBILA

COULANGES Allier, France. Map 23. Site of a Gallo-Roman pottery where excavations have revealed nine kilns.

Two important periods of activity have been identified. To the first, which dates from Tiberius' reign, belong the first chalice mold (imitation Arezzo) found in Gaul, a large quantity of imitation terra sigillata cups, and ordinary ware. The second period is Antonine, when the workshop specialized in bowls of white clay, sometimes large. The potter's name is frequently stamped on the rim of the bowl, giving us some 40 new names including AUSTERINUS, CASATUS, CORISILLUS, MASSA, SAMITUS, URBINOS. A pottery warehouse has also been found on the banks of the Loire.

BIBLIOGRAPHY. H. Vertet, "Decouverte de céramique moulée fabriquée au début du 1e siècle," *Actes du Congrès National des Sociétés Savantes* (1963).
 H. VERTET

COURTRAI, *see* CORTORIACUM

COUTANCES, *see* COSEDIA

COZZA MATRICE, *see* PERGUSA

COZZO PRESEPE Italy. Map 14. A hill 126 m high, above the river Bradano 15 km to the NW of Metaponto. It is ca. 300 by 250 m. Explorations since 1968 have led to the following noteworthy discoveries:

1) A curious wall protecting those slopes of the plateau which are not provided with a natural defense. The wall is of stone with a single or double curtain depending on the location. Along certain segments it is faced with curved tiles almost 1 m long set perpendicular to the wall. To date, no other example of such construction is known from antiquity. The wall dates from ca. 300 B.C.

2) A votive depository dating from ca. 320-370 (vases, some pinakes and numerous terracotta oscilla with impressed decoration, including one bearing the four-armed torch associated with the cult of Demeter and Kore), as well as some rather poor tombs of the same period.

3) The traces of a pre-Hellenic settlement perhaps dating back to the 9th or 8th c. B.C. The remains of huts and numerous fragments of ceramics (impasto, achromatous ceramics, and above all painted ceramics have been found, decorated with varied black or brown geometric motifs and often bearing a strong resemblance to geometric ceramics of the Iapygians).

4) Indications of light settlement in the 6th c. The site appears to have been completely abandoned in the second quarter of the 3d c., probably as a result of the Roman conquest.

BIBLIOGRAPHY. D. Adamesteanu, "Problèmes de la zone archéologique de Métaponte," *RA* (1967) 1, 3-38; id., *Atti Convegno di Taranto* 8 (1968) 167; J.-P. Morel, "Fouilles à Cozzo Presepe près de Métaponte," *MélRome* 82 (1970) 1. 73-116. J.-P. MOREL

CRAMOND Edinburgh, Scotland. Map 24. Roman fort and stores base for the Antonine Wall on the Firth of Forth, 8 km NW of the center of Edinburgh. The existence of an important site, long suspected because of numerous coin finds ranging in date from the Republic to the early 3d c. A.D., was proved by excavations in 1955-62. Three major occupations were identified, two in the Antonine period between A.D. 142 and 185, and one in the early 3d c., during all of which the overall dimensions of the site remained constant (ca. 162 x 141 m; 2.36 ha).

The defenses consisted of a thick clay rampart revetted externally by a stone wall. The fort is larger than would normally be required to house the garrisons known to have been stationed at Cramond, and although only a limited area of the interior has been explored there is evidence that the additional space was occupied by storage buildings and workshops. Altars testify to the presence of the 1000-strong Cohors I Tungrorum and the 500-strong Cohors V Gallorum, but precisely when is unknown. A bath was found outside the fort on the W, and a large extramural settlement on the S and E. Evidence of a limited (4th c.) occupation was recovered from both fort and settlement. Some of the finds are in the National Museum of Antiquities of Scotland, and others in the Huntly House Museum, Edinburgh.

BIBLIOGRAPHY. *Inventory of the Ancient and Historical Monuments of Midlothian and West Lothian* (1929) 38-41; *Britannia* 5 (1974). K. A. STEER

CRAON, *see under* MONTBOUY

CRAWFORD Lanarkshire, Scotland. Map 24. A small Roman fort on the Clyde about halfway between Castledykes and Tassiesholm. Discovered in 1938 and excavated in 1961-66, it was first occupied in the Agricolan period (ca. A.D. 80-86), and again in the Antonine period (A.D. 142-155), during both of which phases it measured ca. 114.3 by 67.5 m overall (.76 ha). For the third and final occupation, which seems to have succeeded the second almost immediately, the size of the fort was increased to 1.08 ha. At no stage was it large enough to hold more than a vexillation of an auxiliary regiment. In the 2d c. it may have been associated with the fortlet system in upper Annandale and Nithsdale.

BIBLIOGRAPHY. *Proc. Soc. Ant. Scotland*, forthcoming.
 K. A. STEER

CREISSELS Aveyron, France. Map 23. In the cave of Boundoulaou traces have been found of an occupation which lasted from the Late Bronze Age until the 5th and 6th c. A.D. This last period was marked by the presence of much stamped pottery and of a gold triens bearing the name of Anastasius.

In December 1962 near the farm of Les Cascades, some forty terracottas were found, depicting for the most part warriors and gladiatorial contests as well as other plaques representing—sometimes in relief, sometimes incised—hares, fishes, a head of Medusa, or an individual on his knees. This may be a workshop or, more simply, offerings deposited in a sanctuary.

BIBLIOGRAPHY. A. Soutou, "Monnaie en or et céramique estampée de la grotte du Boundoulaou," *Ogam* 16 (1964) 355-60 & figs. 1-5; cf. M. Labrousse in *Gallia* 22 (1964) 431-32; 24 (1966) 412.

L. Balsan, "Importante découverte archéologique à Creissels," *Rev. du Rouergue* 17 (1963) 58-66; M. Labrousse in *Gallia* 22 (1964) 431 & figs. 6-8.

M. LABROUSSE

CREMONA Lombardy, Italy. Map 14. The first colony founded by the Romans beyond the Po in Cisalpine Italy (218 B.C.). It was built on the site of a pre-Roman center. It then became an important gateway to the river to the ford on the Via Postumia between Genoa and Aquileia. Cremona was a military base for the forces of Vitellius in the civil war, which was decided by the two battles of Bedriacum in A.D. 69. The city, sacked and burned, was restored by Vespasian and remained a military garrison with a permanent parade ground that can still be noted in the urban area. The city was nearly square (500 x 520 m). The paving of several roads has been found, including one 6 m wide that ran along the walls and is still partly visible; no Roman buildings are preserved. From Tacitus (*Hist.* 3.27.3) the name of a gate, the Porta Brixiana, is known. Of particular interest are the mosaic pavements, both black-and-white and polychrome, now preserved in the Museum. In the subterranean vaults under the cathedral, mosaics of the Early Christian basilica are visible.

Other objects of particular importance in the Museum include several Roman vases in bronze, helmets of various types, and a marble bust of Q. Labienus Parthicus, son of Caesar's general who fought against the Romans in 41 B.C.

BIBLIOGRAPHY. C. Albizzati, "Due ritratti romani a Cremona," *Historia* 4 (1930) 634-40; A. Frova, "I mosaici romani di Cremona," *BdA* 42 (1957) 325-34; M. Mirabella Roberti, "Un campo militare romano sotto la cataulada di Cremona," *Atti del I Congr. Naz. di Studi bizantini* (1965) 145-51; G. Pontiroli, "Cremona e il suo territorio in età romana," *Atti del Centro Studi dell'Italia Romana* 1 (1969) 165-211.

M. MIRABELLA ROBERTI

CROCCIA COGNATA Lucania, Italy. Map 14. Near modern Oliveto Lucano is the site of a fortification of the 4th c. B.C., now largely covered by forest.

BIBLIOGRAPHY. T. Ashby & R. Gardner, "An Ancient Hill Fortress in Lucania," *JRS* 9 (1919) 211-15.

R. R. HOLLOWAY

CROCOCALANA (Brough on Fosse) Nottinghamshire, England. Map 24. This small settlement on the Fosse Way, mentioned in the *Antonine Itinerary* (Iter VI and VIII), is 4.8 km N of Newark, and known largely from air photographs. Buildings of timber and of stone lined both sides of the Fosse Way and straggled along

several irregular branching lanes. The entire settlement covered ca. 4.8 ha. At an unknown date defenses incorporating two broad ditches were built astride the main road. There has been no excavation, but the discovery of a bronze cheekpiece from a helmet suggests a Roman fort in the vicinity.

BIBLIOGRAPHY. *VCH Nottinghamshire* 2 (1910) 11ff; J. K. St. Joseph in J. S. Wacher, ed., *The Civitas Capitals of Roman Britain* (1966) 27ff.

M. TODD

CROCODILOPOLIS, *see* FAIYÛM

CROTONE, *see* KROTON

CROY HILL, *see* ANTONINE WALL

CRUCINIACUM (Bad Kreuznach) Rhineland Palatinate, Germany. Map 20. A Roman vicus on the Nahe, a tributary of the Rhine, 13 km S of Bingen. The oldest remains date from a settlement of the Late Stone Age, and there are finds from the Bronze and Iron Ages. The vicus was probably on the site of a Celtic settlement. There was a wooden bridge over the Nahe at the junction of the ancient routes from Bingerbrück, Trier, Mainz, and Alzey. A Frankish palace is first mentioned in the 9th c.

The Roman vicus, obviously a crossroads settlement during the Age of Augustus, lay to the E of the present town. Lead curse tablets found in tombs (today in the museums of Bonn and Worms) record more than 70 inhabitants of the settlement during the last quarter of the 1st c. A.D. The settlement was destroyed ca. 270, rebuilt during the Constantinian epoch, and finally razed in the middle of the 4th c. About 370 a fortification was built by Valentinian I. Only part of the E front (2 m thick) remains, the so-called Heidenmauer. The continual use of the necropolis to the SE of the fortification from the Late Iron Age to the era of the Franks, is attested by ca. 1800 Roman graves with burial urns, 70 Late Roman inhumation graves, 450 tombs without contents, and 270 Franconian tombs with grave goods. A second Franconian necropolis is on the bank of the Nahe; a third is near a Roman villa on the road to Hüffelsheim. In the villa, not yet fully excavated, was a gladiator mosaic, now in Bad Kreuznach Museum. Another mosaic, uncovered in 1966, shows a seascape with the bust of Oceanus.

BIBLIOGRAPHY. O. Kohl, *Programm des königlichen Gymnasiums zu Kreuznach: Die römischen Inschriften und Steinskulpturen der Stadt Kreuznach* (1880); W. Zimmermann, *Die Kunstdenkmäler des Kreises Kreuznach* (1935) 56-107; K. Parlasca, *Die römischen Mosaiken in Deutschland* (1959) 88-89; O. Guthmann, *Kreuznach und Umgebung in römischer Zeit* (1969); B. Stümpel, *Mainzer Zeitschrift* 63-64 (1968-69) 196-98; *Führer zu vor- und frühgeschichtlichen Denkmälern* 12 (1969) MI.

H. BULLINGER

CRUMERUM, *see* LIMES PANNONIAE

CSOPAK County of Veszprém, Hungary. Map 12. In the area of the so-called stone tomb hill on the NW shore of Lake Balaton lies an extensive building of the Roman era. Within its walls a stone, with the inscription DIANAE AVG SAC, was discovered. The majority of contemporary buildings and wine cellars of Csopak are built on Roman foundations. In 1900 a Roman wine cellar was excavated whose ground plan and organization could be established. East of the highway bridge, along the lake shore, irregularities in the ground surface indicate the presence of rooms terminating in apses. From this area come fragments of the table-like marble slabs used

among the Christians in the so-called "Agape" rite. At the edge of the marble table are carved in relief a unicorn and an archer hunting a lion. The table was made in Egypt during the first half of the 4th c. Considering the location and the circumstances of discovery of other objects of similar use, we can assume that underground lie the ruins of a 4th c. place of Early Christian worship.

BIBLIOGRAPHY. E. Thomas, "Bruchstück einer frühchristlichen Marmortischplatte mit Reliefverzierung aus Csopak," *Acta Ant.* (1955) 261-82; id., *Romische Villen* (1966) 28-32. E. B. THOMAS

CUCCIUM, *see* LIMES PANNONIAE (Yugoslav Sector)

CUEVAS DE SORIA Soria, Spain. Map 19. A Roman villa 23 km SW of Numancia. It is one of the best examples in Spain of the classical type of Hellenistic dwelling, with rooms around a central peristyle (22 x 41 m). Of the 30 apartments discovered, 22 have floors covered with polychrome mosaics in opus tessellatum, occupying a total area of 1400 sq. m. The villa probably dates from the end of the 2d c. and was inhabited until the end of the Empire.

BIBLIOGRAPHY. B. Taracena, "La villa romana de Cuevas de Soria," *Investigación y Progreso* 6 (1930)PI.
R. TEJA

CUGNO DEI VAGNI Matera, Lucania, Italy. Map 14. A large Roman villa and vicus on the last ridge of the hills descending from Rotondella toward the plain that extends along the right bank of the Sinni river (ancient Siris). The villa and the vicus occupied a zone of Hellenistic farm settlements which are documented by antefixes of the Tarentine-Heraklean type dating to the second half of the 4th c. B.C. On the slope of the terrace is set the bath complex. Its calidarium had a polychrome mosaic of the Imperial period. The entire complex obtained its water through terracotta conduits from a spring above it, which also supplied the villa.

The villa underwent various reconstructions, but the earliest section is known to have been built in opus incertum bordered in brickwork. As elsewhere in S Italy, such construction methods may be dated to the beginning of the 1st c. A.D. The best comparison is with the monuments of Grumentum, particularly with the amphitheater dated to the early years of the 1st c. A.D.

Until the 2d c. A.D., a vicus clustered around this central complex and spread over the upper terrace for more than 200 m. This arrangement is found everywhere but particularly in S Italy at the beginning of the Empire (Front., *Gromatica*, II, p. 53, 7-9 ed. Lachmann). While the vicus continued to exist after the 2d c. A.D., the villa was abandoned immediately after a series of very expensive reconstructions.

BIBLIOGRAPHY. F. Lenormant, *La Grande Grèce: Paysage et histoire*, I (1881) 212-14; M. Lacava, "Sul sito dell'antica Siri," *Arte e Storia* (1889) 17-20; U. Kahrstedt, *Historia* (1959) 100-1, 203; L. Quilici, *Siris-Heraclea* (Forma Italiae, Regio III, vol. I; 1967) 123-32.
D. ADAMESTEANU

CUICUL (Djemila) Algeria. Map 18. A colony founded by the emperor Nerva, 80 km W of Constantine, in the mountainous region that separates the high plains of the Constantinois from the coast, S of the Babors massif, about 900 m above sea level. The original town was placed on a rocky spur situated between two wadis, the Guergour and the Betame. The site is well protected and has abundant spring water. The high mountains to the N and S did not limit the extension of the city's territory. It is known that to the

S the center of Thigillava and its pagus were attached to Cuicul. Thus the town perhaps controlled the N fringe of the high plains, good wheat-growing land. To the W its domain must have extended to the Oued el Kebir (the ancient Ampsaga), the boundary between Numidia and Mauretania. To the E its boundary is not known. At any rate, it is certain that the town never was a member of the confederation of Cirta (Constantine), to which Milev (Mila), some 60 km distant, belonged.

The Roman citizens of the colony, originally veterans, were inscribed in the gens Papiria. But very early, if not from the beginning, there settled at Cuicul families from, for example, Carthage (such as the Cosinii) or from other towns of Africa (of the confederation of Cirta). This is clearly proved by inscriptions concerning 2d c. magistrates.

Through excavations conducted between 1909 and 1957 a great part of the built-up area has been uncovered, and the appearance of an ancient town can be observed. Reading the inscriptions collected in an open-air museum, studying the mosaics set on the walls and floor of a new building, strolling among the ruins, all help one to reconstruct the life of a town of moderate size in Roman Africa.

A large part of the center founded at the end of the 1st c. A.D. has been unearthed. The town was protected by a roughly polygonal enclosure, measuring 400 x 200 m. The S gate, faced with large blocks, is still visible and a part of the course of the ramparts has been traced. Within, the streets are laid out N-S with some attention to regularity; they follow the direction of the gentle slope. Transverse streets link them. The forum was placed in the middle of town, bordering on the cardo maximus. The square itself was built gradually during the course of the 2d c. Its principal components are the porticos bordering the square on two sides, the judicial basilica, the curia, the capitol, and the market placed at the lower end. The basilica was built by the flamen C. Julius Crescens Didius Crescentianus after A.D. 169. The market was donated by two brothers, L. Cosinius Primus and C. Cosinius Maximus. The former was duumvir at Cuicul after having held magistracies at Carthage, his native town. Close by the forum is a temple whose cella is situated in a porticoed courtyard.

Several large dwellings with peristyles cluster along the cardo maximus and in the neighborhood of the forum. Part of their mosaic decoration has been preserved. The names of the residences—House of the Ass, House of Castorius, House of Europa, House of Amphitrite—recall the subjects of their decoration or the name of an owner, as revealed by another paving. Most of these mosaics (the Rape of Europa, the Toilet of Venus, foliage with human figures) belong to a late period, the 4th or even the 5th c. They testify to the continued occupation by rich families of the most important houses of the 2d c., and so, after a fashion, to continuity in the urban upper class. Also within the walls are public baths and temples (one of which may have been dedicated to Bacchus). Later, around the 5th c., a Christian basilica was erected.

At an early date, the original settlement proved incapable of containing the increasing population. Construction had to be undertaken outside the walls on both sides, and later on the summit, of a hill that rose to the S. Likewise, to the N a theater was built against the existing slope. Its cavea accommodated 3,000 spectators on 24 tiers of seats. Nearby, after A.D. 169, there stood a triumphal arch. On the other side of the hill, baths were built in the time of Commodus. Later on, under

the Severans, a huge irregular plaza was laid out in front of the original ramparts. Porticos occupied two sides. To these was added a temple dedicated to the family of the Severans; it survived to most of its original height until the period of modern restoration. Close by there was a temple, presumably to Saturn, the great African deity. Under Caracalla an arch was built opening on the road to Setif. Other arches, fountains, inscriptions, and statues completed the scene.

Beginning in the second half of the 2d c., houses were built outside the walls. Thus, in one later dwelling in the vicinity of the great baths of Commodus, several decorative mosaics have survived. Little by little, the slopes of the hill were covered with buildings.

The existence of a Christian community at Cuicul is attested from the middle of the 3d c. In the first years of the 5th c. the Christians built a good-sized cluster of episcopal edifices at the top of the hill. Two basilicas were placed next to each other. Nearby was a round baptistery, as well as a bishop's mansion and a complicated group of annexes. The richest inhabitants of the town and their kinsmen holding posts in the offices of the governor of Numidia together paid for the paving of one of the basilicas. Bishop Cresconius adorned the other with mosaics, probably in the middle of the 6th c.

At the same time, the rest of the town continued to change. On the Severan square a basilica was built around 364-67, as well as a clothing market. Above all, rich houses (such as the so-called House of Bacchus) were built or decorated with mosaics in a new style. Different schools of mosaicists worked in these residences, as well as in religious buildings. The chronology of these works is still uncertain, but probably most of them are no earlier than the second half of the 4th c.; they may even be of more recent date.

The mosaics of Djemila, by their subjects and compositions, are closely linked to the mass of very original works produced in Roman Africa. Mythological themes, hunting scenes, and geometrical motifs belong to a context well-known elsewhere. But these mosaics have their own distinctive style, especially in late antiquity. The culmination is the great hunting mosaic from the so-called House of Bacchus, expert and well-conceived. Arranged in rows above one another, the scenes depict the combat of men and animals against animals.

One can also discern stylistic differences and evolution in the mosaics of the Christian basilicas. These differences permit the attribution of certain pavings to the 6th c., if not to an even later period.

Djemila is one Numidian center reconquered by the Byzantines where apparently no fortress was built. From other sources it is known that the bishops of the town attended the synod at Constantinople in 553. After that date, the town is no longer mentioned in the texts.

BIBLIOGRAPHY. Y. Allais, *Djemila* (1938); "Le quartier occidental de Djemila (Cuicul)," *Antiquités Africaines* 5 (1971) 95-120; P.-A. Février, *Djemila* (1968) with complete bibl.; see also *CahArch* 14 (1964) 1-47.

P.-A. FÉVRIER

ÇUKE, see LIMES, SOUTH ALABANIA

CULABONE, see CULARO

CULARO (Grenoble) Isère, France. Map 23. A city of Gallia Narbonensis in the territory of the Allobroges on the Isère. Apparently mentioned by Cicero (*Ad fam.* 10.23.7): Civarone (for Cularone) ex Allobrogum finibus; cited in the *Peutinger Table* as Culabone; and by the Geographer of Ravenna (4.27) as Curarore. The Celtic oppidum was probably situated on a hill close to the river. It was a customs post of the Quadragesima

Galliarum. Between 288 and 292 a rampart was built to protect the city against the barbarian invasions. Under Gratianus it became Gratianopolis, whence the modern name Grenoble (*Not. Gall.* 11.5; Sid. Apoll. *Epist.* 3.14.1).

The surrounding wall was oval and had two gateways, known by their inscriptions (*CIL* XII, 2229): one, known as the Rome gate (near the Frères Prêcheurs), was called the Gate of Jove; the other, the Vienne gate near the cathedral, was called the Gate of Hercules. They seem to mark an oblique axis oriented nearly E-W; the corresponding N-S road has not yet been found.

Slightly to the N along the Isère, the surrounding wall stood until the city was seized by the Protestant forces of Lesdiguières in 1591. A few fragments can still be seen, especially under the Treille de Stendhal (Jardin de Ville). Its circuit can be traced almost in its entirety, thanks to ancient plans. Several fragments have recently been unearthed: near the cathedral parts of the wall and two towers have been preserved, but in the Rue de la République and Rue Lafayette quarter the fragments were destroyed after excavation. The towers, three of which have been found, are 22-24.4 m apart and 7.8 m in diameter; the foundations are very solid. The walls, 4.5-5 m thick at the bottom, are faced on both sides with small rectangular mortared stones; the core consists of irregular blocks and other material bedded in a mortar of broken tiles. The foundations have four main elements: wooden supports 40-50 cm apart (which make it a wall on piles); above these a regular layer of boulders; then some rubble; and finally a course of flat stones. Outside the wall there was probably a ditch.

The main Christian monument is the Saint-Laurent crypt on the right bank of the Isère. The building has been variously dated: from the late 6th to the late 8th c. Some of the capitals follow Graeco-Roman models, others are clearly Roman, and several columns are made of reused material. A 4th c. Gallo-Roman mausoleum, destroyed at the time of the Lombard invasions in 574, and a burial vault of the same period have also been found.

The museum contains inscriptions, pottery, and architectural and sculptural fragments.

BIBLIOGRAPHY. A. Blanchet, *Enceintes romaines de la Gaule* (1907) 149[P]; R. Blanchard, *Grenoble, étude de géographie urbaine* (1912)[PI]; H. Müller, *Les origines de Grenoble* (1930)[P]; Grenier, *Manuel* I (1931) 413[P], 518, 552; R. Girard, "La crypte Saint-Laurent de Grenoble," *CahHistArch* 6 (1961) 157-63[PI]; id., *Les remparts gallo-romains de Grenoble* (1963)[PI]; M. Leglay, "Informations," *Gallia* 22 (1964) 519; 24 (1966) 509; 29 (1971) 427.

M. LEGLAY

CUMAE Campania, Italy. Map 17A. A city in Phlegraean Fields inside Cape Misenum on the Bay of Naples. This area and its original Oscan inhabitants were known to Mycenaean explorers of the 12th c. B.C., but the city was actually founded ca. 750 B.C. by colonists from Chalkis, Eretria, and the island of Pithekusai (Ischia). The site included a strong acropolis, fertile hinterland, and an attractive harbor, now nonexistent. From 700 to 500 B.C. it was a prosperous and important disseminator of Greek culture in the West through the Chalkidian alphabet, Greek cults, and several important colonies of its own. The earliest historic Cumaean, Aristodemos, repulsed an Etruscan attack in 524 B.C. and shared a leading role with the Latins and Romans in defeating the Etruscans again at Aricia ca. 505; in 474 the Cumaean and Syracusan fleets combined to crush Etruscan power in Campania. But about a half century later Cumae was conquered by the Samnites and became Oscan until 180

B.C. Samnites were not maritime-minded and did not really maintain the harbor. However, after Hannibal's failure to establish outlets to the sea at Neapolis and Puteoli, in 215 B.C. Cumae was his third—and equally unsuccessful—choice. Already a civitas sine suffragio (338 B.C.) Cumae was now granted municipal citizenship with Latin as the official language, and it became a municipium at the end of the Republic. In 37-36 Agrippa undertook a massive reorganization of the harbor facilities, adapting the lakes Lucrinus and Avernus on the bay side into Portus Julius for the construction of a fleet and the training of personnel against Sextus Pompey (battles of Mylae and Naulochos, 36 B.C.) and, on the Cumaean side, the construction of a whole new Roman port for the unloading of supplies, and two long tunnels for communication between the sea and the lakes (see below). After this great ad hoc achievement Cumae once more silted up into maritime insignificance, though Symmachos sailed from there to Formia in A.D. 383.

Cumae was most famous for its oracular Sibyl, just as her grotto is now its most spectacular monument. As shown by an inscribed bronze disk, she was giving, and declining to elucidate, responses by the middle or the late 7th c. B.C., originally for a chthonic Hera and only later for Apollo, and her famous bargaining with Tarquinius Priscus (regn. ca. 616-579) for the Sibylline Books was about contemporary. Vergil's poetic but surprisingly accurate description of her antrum (Aen. 6.9-155 for the whole incident) is clearly based on autopsy. Though restored by Augustus, the Sibyl's official cult lapsed within the next century.

The site of the Sibyl's grotto was discovered in 1932, a trapezoidal gallery (131.5 x 2.4 m and an average height of 5 m) cut N-S into a solid tufa ridge below the acropolis, overlooking the sea through six similar trapezoidal bays, with a total of nine doorways (not all now documented) and, cut back into the rock on the left (E) side, three ceremonial baths later converted into cisterns; note the repetition of triads and the Sibyl's relation to Hekate (Trivia). The splendid archaic Greek stone-cutting is attributable to the 5th c. B.C. and reminiscent of Mycenaean and Etruscan dromoi. At the extreme (S) end is an arched chamber, the inmost adyton wherein Aeneas received oral instructions from the frenzied priestess; a vaulted chamber to the E, perhaps the Sibyl's personal apartment, and a similar but smaller W chamber, probably for light and ventilation, open to left and right of the adyton. This last complex, with vertical walls and doorposts supporting semicircular arches, is a 4th-3d c. addition or alteration to the original gallery. Under the early Empire the whole floor was lowered 1.5 m to convert the entire grotto into a cistern; still later, parts were used for Christian inhumation.

The entrance to the Sibyl's grotto was part of an architectural unit including steps leading up to the Temple of Apollo (see below) and a ramp leading downward to the entrance of the so-called Cumaean Roman crypt, a long underground E-W tunnel passing under the acropolis. The operations of Narses against the Goths (A.D. 560), landslides, and quarrying have destroyed this impressive facade, but the crypt itself is undoubtedly attributable to Cocceius, the Augustan architect who also built the very similar crypt of Cocceius under Monte Grillo (see below) and the crypta Neapolitana tunnel between Puteoli and Neapolis. For 26 m the Cumaean crypt is barrel-vaulted 5 m high and then opens into an enormous Great Hall or "vestibule" 23 m high with revetment of tufa blocks and with four niches for large statues; lighting for these and the whole crypt, of which the remainder was a normal tunnel, was supplied by vertical or oblique light-shafts down through the rock. Toward the E end

enormous rock-cut storerooms and cisterns open on one side. Like the Sibyl's grotto, this crypt was eventually used for Christian burials.

Even more impressive is the so-called crypt of Cocceius itself which, passing for ca. 1 km under Monte Grillo, was wide enough for loaded wagons to pass and which, after an open interval from the previous crypt, continued the underground water-level supply route from Cumae to Agrippa's Lake Avernus base. It was partly barrel-vaulted with neat blocks; the remainder was cut through unadorned tufa. Like the other crypt it was lighted by vertical and oblique light-wells of which the deepest is 30 m. As a further tour de force, Cocceius included an aqueduct along its N side, with its own niches, ventilation shafts, and wells. But it and the Cumaean crypt were strictly military in purpose and were not properly maintained thereafter until the Bourbons cleared it for land reclamation purposes. It can still be traversed despite ruts and water due to bradyseism and deforestation. It was undoubtedly Cocceius' masterpiece.

Not all of the crypt of Cocceius and the mountain under which it passes is strictly Cumaean, but consideration of Cumae cannot ignore Domitian's cut through the crest of Monte Grillo and his filling the consequent gash with the high narrow Arco Felice of brick, not an aqueduct but apparently simply a high-level bridge from one side of the cut to the other.

The precise areas of the Greek, Samnite, and Roman territory of Cumae varied from time to time and are not entirely clear, but at least the acropolis was always the obvious center. It was originally part of a crater; much of it consists of varying qualities of tufa. Easiest access was from the S where the harbor and principal city lay with appropriate gates, but on the remaining sides it was impregnable. In Greek times it was fortified with walls of which some fine stretches remain visible, but in Roman times it was extensively occupied by private dwellings which have virtually eradicated structures (portico, cistern), but two temples remain identifiable.

The lower of these, epigraphically identified as the Temple of Apollo, built upon a still earlier sanctuary, exists only in ground plan (34.6 x 18.3 m). It was oriented N-S; in Augustan times the Cumaean Apollo received a new and presumably more elaborate E-W temple; in the 6th-7th c. this was converted into a Christian basilica, once more N-S. The Greek phase of the upper so-called Temple of Jupiter is E-W but even less recognizable than that of Apollo, though its dimensions were greater (at least 39.6 x 24.6 m). The Tiberio-Claudian phase is of characteristic reticulate masonry and is generally recognizable in its unusual plan, which was adapted to a Christian basilica in the 5th-6th c., one of the earliest such structures in Campania.

In the lower town were Temples of Jupiter Flazzus (later the Capitolium) and of Divus Vespasianus used for a committee meeting in A.D. 289, a forum (ca. 120 x 50 m) with long porticos, largely unexplored, and two 2d c. bathing establishments. At the S end of the city was an amphitheater with a major axis of 90 m, of which only parts of the outer shell remain above ground. Statius, who often refers to Cumae, refers to quieta Cyme (Silv. 4.3.65) and Juvenal calls it vacuae (3.2), but this was doubtless in contrast to Rome and busy Puteoli. Under the late Republic and early Empire Cumae was a favorite resort of upper-class Romans, vying with Puteoli and Baiae.

A large and ill-defined necropolis surrounds the city, especially to the NE where extensive plundering during the 19th c., as well as responsible excavation during the 20th c., has revealed interments of all periods including pre-Hellenic; some tombs are painted. A tholos tomb

reflecting Mycenaean tradition and a mass grave of headless skeletons are of especial interest.

Most of the finds from Cumae, including a fine marble copy of Cresilas' *Diomedes*, are in the Naples Museum.

BIBLIOGRAPHY. General: A. Maiuri, *The Phlegraean Fields* (Guide books to Museums and Monuments in Italy, 32) (3d ed. 1958, tr. Priestley)[MPI]; W. Johannowsky in *EAA* (1959)[PI]; J. H. D'Arms, *Romans on the Bay of Naples* (1970)[MI].

G. Pellegrini, "Tombe greche archaiche e tomba grecosannitica a tholos della necropoli di Cuma," *MonAnt* 13 (1903) cols. 201-96[I]; E. Gàbrici, "Cuma," *MonAnt* 22 (1913) cols. 9-871 (chiefly necropolis)[PI]; A. Maiuri, "*Horrenda secreta Sibyllae*: Nuova esplorazione dell'antro Cumano," *BStM* 3, 3 (1932-33) 21-29[I]; J. Bérard, *Bibliographie topographique* (1941) 50-52; M. Guarducci, "Un antichissimo responso dell'oracolo di Cuma," *BullComm* 72, 3-4 (1946-48) 129-41[I]; C. C. van Essen, "Etudes VI-X," *Meded* 2 XXXIII 4 (1966) (Sibyl's grotto); R. V. Schoder, S.J., "Ancient Cumae," *Scientific American* 209 (1963) 109-18[MI]; R. F. Paget, "The Ancient Harbours of Cumae," *Vergilius* 14 (1968) 4-15[PI]; id., "The Ancient Ports of Cumae," *JRS* 58 (1968) 152-69[PI]; id., "Portus Julius," *Vergilius* 15 (1969) 25-32[M].

H. COMFORT

CUMIDAVA (Rîşnov) Braşov, Romania. Map 12. Roman camp and civil settlement near the modern town. The name is mentioned by Ptolemy (3.8.4). The camp (114 x 130 m) was built of earth in the first half of the 2d c.; it was built in stone and enlarged (124 x 118 m), and rebuilt again towards the middle of the 3d c. The stone walls that enclose it had round corners defended inside by rectangular towers. Its gates were flanked by two slightly protruding bastions.

The Cohors VI nova Cumidavensium was stationed here; the soldiers were recruited from among the local population. An inscription dedicated to Iulia Mamaea was found, as well as graffiti, coins, and a quantity of Dacian ceramics.

BIBLIOGRAPHY. M. Macrea, "Cumidava," *Anuarul Institutului de Studii Clasice* 4 (1941-43) 234-61; N. Gudea & I. Pop, *Castrul roman de la Rîşnov—Cumidava* (1971).

L. MARINESCU

CUNETIO (Mildenhall) Wiltshire, England. Map 24. Mildenhall village, in the parish of that name, lies ca. 2.4 km E of Marlborough, on the river Kennet. What is called the Black Field, within the area described as the site of the Roman settlement of Cunetio, is on the S side of the river, and 0.4 km due E of Mildenhall church. The field is also the meeting point for two Roman roads running respectively E-W and N-S.

Recent air photography has disclosed the existence within Black Field of a walled township of Romano-British date, some 8 ha in extent, with at least two phases of construction. The first phase consists of a double-ditched earthwork with rounded corners, whose E, W, and S sides are visible in the photographs, measuring some 261 m E-W x 210 m. The S ditches are interrupted, probably for a small gateway. The second and later phase comprises a massive stone wall with defensive bastions spaced at regular intervals along its E and S sides. Roughly midway along the S wall crop markings disclosed a gateway with drum-ended flanking towers.

Investigations since 1957 have cut sections across the township wall on its four sides. Considerable robbing of the wall, doubtless for building stone, had taken place in antiquity, but enough of the foundation remained to show that the wall had been built of heavy flint rubble embedded in lime mortar, and its thickness at the base varied between 5.55 and 4.8 m. Coin finds from individual cuttings were imprecise, but suggest a date of A.D. 280-350 for the wall construction.

One of the stone defensive bastions observed from the air to project beyond the S wall face was also investigated. The bastion footings, standing two courses high, were formed first by heavy squared blocks of Lower Chalk laid on to the rubble platform, though not, it appears, mortared together. Sufficient of this lower course remained to show quite clearly that it was semi-octagonal in plan. Evidence clearly showed that the bastion had been bonded into the wall face, proving (also by the similarity of both wall and bastion construction) that the masonry defenses of Cunetio were of a single date. Recent research on the defenses of Romano-British townships elsewhere seems to indicate a sweeping reorganization about the middle of the 4th c. A.D., one particular feature being either the addition of projecting bastions to existing walls, or their incorporation within entirely new stone defenses. In the light of present knowledge at Cunetio, the surrounding stone wall with defensive bastions is is to be allocated to the 4th c. phase of the Roman occupation.

The latest excavation at the site proved the existence of a hitherto unknown W gateway ca. 90 m S of the NW corner of the town. A small coin hoard, dated to ca. A.D. 360, was recovered immediately above the gateway floor, at its W end. Next to the gateway, and beneath the line of the W wall, a well was excavated. The presence of early figured Samian and native wares in the well implies an early occupation of the site, within the 1st c. A.D., not inconceivably related to the Roman military advance in SW England during the initial stages of the Roman conquest. It is perhaps noteworthy that the plan of the early ditched defenses conforms precisely to the so-called playing card plan of a Roman military fortification, although it must be emphasized that these belong to a civil phase of the occupation of Cunetio.

BIBLIOGRAPHY. R. C. Hoare, *Ancient Wiltshire* II (1819) 89; C. Soames, "Coins Found near Marlborough," *Wiltshire Archaeological Magazine* 19 (1881) 84-85; M. E. Cunnington, "Notes on the Pottery from a Well at the Site of Cunetio, Mildenhall, Marlborough," ibid. 41 (1920) 151-59; J. K. St. Joseph, "Air Reconnaissance of Southern Britain," *JRS* 43 (1953) 90; F. K. Annable, "Excavations and Fieldwork in Wiltshire," *Wiltshire Archaeological Magazine* 56 (1956) 241-45; 57 (1959) 233 & (1960) 397; 58 (1962) 245; id., "A Late First Century Well at *Cunetio*," ibid. 61 (1966) 9-24.

F. K. ANNABLE

CUPPAE, *see* LIMES OF DJERDAP

CURARORE, *see* CULARO

CURIA (Chur) Graubünden, Switzerland. Map 20. Roman vicus and fort E of the Rhine in the Schanfigg valley. (The non-Roman name is mentioned in *Ant. It.* 277.7 and *Tab. Peut.*). Curia was on a military road from Italy to Lake Constance, and at the N end of the Julier, Splügen, and Septimer passes. This strategic position made the site an important administrative center of Raetia from the early 1st c. A.D. on. By the late 3d c. or the 4th its military post was turned into a fort. The settlement was then a municipium. From A.D. 451 on Curia was the seat of a bishop; it has been continuously inhabited ever since.

The vicus was mainly on the S bank of a Rhine tributary, the Plessur, and on the slopes of the Pizokel. Occupation goes back at least to the early Iron Age, and in Roman times covered an area of more than 80,000 sq. m. The Late Roman fortress, on a rocky spur of the Mittenberg on the N bank of the Plessur, lies beneath the bishop's palace and the cathedral. Its plan was tri-

angular (area ca. 9040 sq. m). Some foundations, especially at the N edge of the plateau such as those of the Marsöl tower, may belong to it. There was a cemetery in the area of the Martinskirche. The Raetisches Museum is in the Hofstrasse.

BIBLIOGRAPHY. E. Poeschel, *Die Kunstdenkmäler Graubündens* 7 (1948) 3-6; F. Staehelin, *Die Schweiz in römischer Zeit* (3d ed. 1948) 271, 331, 369-70; H. Lieb & H. Wüthrich, *Lexikon Topographicum der römischen und frühmittelalterlichen Schweiz* (1967) 51-53; C. M. Wells, *The German Policy of Augustus* (1972) 79; excavations: *Bündner Monatsblätter; Schriftenreihe des Rätischen Museums* 1- (1965-); *Jb. Schweiz. Gesell. f. Urgeschichte* 53 (1966-67) 118, 133-36; 54 (1968-69) 85; 57 (1972-73) 301-2. V. VON GONZENBACH

CUSUM, *see* LIMES PANNONIAE (Yugoslav Sector)

CUYCK, *see* CUŸK

CUŸK N Brabant, Netherlands. Map 21. Vicus on the Meuse mentioned in the *Peutinger Table* as Ceuclum, on the road from Noviomagus (Nijmegen) to Atua(tu)ca (Tongeren in Belgium). Traces of the Roman bridge have been discovered. Occupation began, probably on uninhabited soil, during the reign of Claudius (41-54): an auxiliary fort of wood and earth was built, surrounded by two ditches, to guard the river crossing. It lasted until ca. A.D. 100, and a vicus developed nearby. Several buildings have come to light on both sides of the Roman road, among them two (possibly three) temples of the Romano-Celtic type. In the 2d and 3d c. there was probably a statio of a beneficiarius consularis in or near the vicus.

In the 4th c. another fort was built, again surrounded by two ditches. There are reasons to suppose that in the last century of Roman occupation the limes in Holland was moved from the Rhine to the Waal and the crossing at Cuŷk again became strategically important. Work on the fort was probably begun under Constantine. The walls, 4-5 m thick, were constructed of wood, earth, and sod. Later, probably during the reign of Valentinianus I (364-75), a stone wall 1.5-1.9 m thick was built against the outer face of the earthen wall; semicircular towers and several buildings were constructed against the stone wall after the old one had been removed. This fort was probably a square of ca. 110 m; the E side was later destroyed by the Meuse. The end of the fort came ca. A.D. 400, in the reign of Honorius; the latest coins found are of Arcadius and Honorius, 383-402.

BIBLIOGRAPHY. A. W. Byvanck, *Excerpta Romana* III (1947) 70-72; J. E. Bogaers, "Opgravingen te Cuyk, 1964-1966," *Niewsbull. Kon. Ned. Oud. Bond* (1966) 67-72; (1967) 9-10; id., "Enige opmerkingen over het Nederlandse gedeelte van de limes van Germania Inferior (Germania Secunda)," *Ber. Rijksdienst Oud. Bod.* 17 (1967) 99-114. B. H. STOLTE

CYRENE (Shahat) Libya. Map 18. A city NE of Benghazi, ca. 176 km, and 8 km inland on the crest of the second stage of the Gebel Ahkdar, an extended limestone plateau, 144 km long and here nearly 622 m above sea level. In ancient times it was connected to its port, Apollonia, 19 km away, by a road still visible in stretches along either side of the modern highway.

Attempts to uncover traces of trading contacts between Minoan Crete and eastern Libya have not yet met with success. While the historical annals of dynastic Egypt occasionally refer to the hostile activities of Libyan tribesmen, the real history of the region commences with the Greek colonization of Cyrene ca. 631 B.C. Herodotos (4.150f) says that Delphi directed

Thera to send a small band of settlers under the leadership of Battos to found a city in Libya. After six years of living by the sea not far from the modern town of Derna (Darnis), Battos moved his people to Cyrene where they were assured of a constant supply of water and the protection of the high ground. Here the colony flourished. After a second wave of immigration from many parts of Greece organized by the grandson of the original oecist (Battos II, ca. 583-60 B.C.), the primacy of Cyrene in eastern Libya was established and a succession of Battiad kings assured. Political unrest, which had broken out with depressing frequency in the intervening period, finally put an end to the monarchy ca. 440 B.C. and a republican form of government prevailed for the next century.

After the death of Alexander the Great the entire region of Cyrenaica was annexed by Ptolemy I, who visited Cyrene in 322 B.C. Ptolemy's grandson Magas succeeded the first governor Ophellas, in 300, first as governor and then after 283 as "king," a title he retained until his death in 250. The region was thereupon reunited with Egypt. Under Ptolemaic rule the Cyrenaican cities, including Cyrene, grew in size and were equipped with permanent defensive wall systems. The old port of Barca was laid out on a magnificent scale and took the regal name of Ptolemais. Euesperides (Benghazi) was renamed Berenice, and Taucheira (Tocra) became Arsinoe. It was perhaps during this time that Apollonia, the port of Cyrene, first gained its independence and Cyrenaica came to be recognized as the Pentapolis or land of the five cities. In 96 B.C. the kingdom of Cyrenaica was willed by Ptolemy Apion to Rome.

With the arrival of the quaestor Cornelius Lentulus Marcellinus in 74 B.C., Cyrenaica began its development as a Roman province. Cyrene, like the other cities of the region, enjoyed nearly a century and a half of peace under Roman imperial rule until the outbreak of the Jewish revolt in A.D. 115. At that time, a certain Lucas or Andreas seized control of the city. Bands of his men systematically destroyed most of its public buildings. The Roman general Marcus Turbo was dispatched to suppress the rebellion, but before this could be accomplished some 20,000 persons were said to have been killed. Property losses were also severe.

Hadrian materially aided the recovery of Cyrene by restoring many of its ruined buildings and by bringing in new settlers to replenish its depleted population. In 134 it was given the title of metropolis in recognition of its importance within the province. From the time of Antoninus Pius down to Septimius Severus, the city appears to have made a nearly full recovery from the misfortunes of 115.

Decline set in during the troubled years of the 3d c. when Cyrene suffered from the attack of hostile tribesmen and a crippling earthquake in 262. Diocletian dissolved the old Province of Crete and Cyrenaica in 297 and reorganized eastern Libya into two smaller regions.

By the end of the 4th c. the most serious problem to face Cyrene's fast dwindling population was invasion from the desert. To meet this crisis the Cyreneans abandoned the line of their original Hellenistic defensive walls and drew back to improvise a new circuit. The reconquest of Africa by Justinian after 550 and his general policy of fortifying the countryside must have brought some indirect relief at least to the hard-pressed city. But the Arab invaders led by Amr ibn el-Aasi apparently encountered no armed resistance when they seized Cyrene along with the other cities of the Pentapolis in 643.

The excavated, visible remains of Cyrene today belong mainly to the Roman period and are either new constructions or remodelings of earlier buildings. Their

urban framework, however, is essentially Hellenistic, since the laying-out of the acropolis, the agora, the lower valley street, and the Sanctuary of Apollo had all been completed by Ptolemaic times. But the initial development of each of these areas was begun in the early archaic period. And conversely most of the monuments of the E third of the city, including the forum, the city center, and the cathedral area, all belong from their inception to later times. With the exception of the Zeus Temple the pre-Roman appearance of this part of Cyrene has yet to be determined.

The Hellenistic defenses, which survive in only intermittent stretches, enclose two lofty hills (max. elevation 620 m above sea level) separated by a valley dropping away to the NW. The over-all NW-SE length of the walled city is just under 1,600 m, while its maximum NE-SW width is approximately 1,100 m. The SW hill (acropolis, agora, and forum) is totally free of modern buildings. However, the NE hill is today covered by the modern town of Shahat, stands of reforested evergreens, and cultivated ploughland. As a consequence, its ancient features are still largely unexcavated and poorly known.

The ancient town was divided along its long NW-SE axis by two main roads. The valley road followed the descent of the valley between the two hills to the Sanctuary of Apollo. The road of Battos connected the acropolis with the Roman forum. A third major artery crossed the main axis of the city at right angles immediately E of the forum area. Gates in the city ramparts linked all three roads with the overland routes leading to nearby Apollonia, Balagrae, Darnis, and Lasamices (Slonta), the closest of Cyrene's ancient neighbors.

The acropolis, occupying the W end of the SW hill, has been only fractionally excavated and is still virtually terra incognita. While it seems logical to suppose the original band of Thereans settled on its heights, none of its exposed remains are earlier than the Hellenistic period.

South of the city proper, at a point across the steep wadi Bel Gadir opposite the agora, is the extra-mural Sanctuary of Demeter. The lowest levels of this precinct, which is still in the process of excavation, have already yielded pottery dating as early as 600 B.C. to document the activities of the early settlers in this area. At least two sets of walls, one dating early in the 6th c. B.C. and the other toward the century's end, comprise the earliest traces of a built sanctuary complex. These were replaced in the later 3d-2d c. by a monumental walled precinct, rising over some five terraced levels, which remained in active use until destroyed by earthquake apparently in A.D. 262.

A second extra-mural discovery of marble and bronze sculptures and architectural fragments datable to the second and third quarters of the 6th c. was recently made outside the walls at the E end of the city. The material, which represents favissa remains of an early sanctuary, may have been buried at this spot after the Persians destroyed the shrine in 515-514 B.C. The massive Temple of Zeus, which was erected late in the 6th c. as its replacement perhaps, is located about 200 m inside the walls of the NE corner of the city. Its octostyle peripteral colonnade and interior (presently undergoing restoration) were extensively repaired during the reign either of Augustus or of Tiberius. Its colonnade was overturned during the Jewish rebellion. During the ensuing hundred years its cella and porches were put back into use. These were totally wrecked by the earthquake of 365, and the temple was desecrated by Christian zealots.

The agora was cleared before the Second World War to bring to light its Hellenistic-Roman phase of development. Additional work has been conducted in this area since 1957 to expose its earlier phases. From this it has become apparent that the E edge of the agora was used from about 625 B.C. as a sacred area as well perhaps as the burial ground of Battos I. Constantly transformed over the years, this area eventually was occupied by a stoa of the Doric order and a handsome tetrastyle, prostyle Corinthian temple (early 3d c. A.D.).

Stoa constructions covered the N edge of the agora throughout most of its history. The most splendid of these was a portico (2d c. B.C.), which during the reign of Tiberius was flanked by an Augusteum, honoring the imperial family. In Byzantine times prior to the invasions of 643, both sides of the agora were transformed into impoverished private houses.

The history of the rest of the agora, an open space measuring ca. 105 x 125 m, is less well known. The N half of its W side was marked by a large stoa of mixed orders, while the S half contained a smaller Portico of the Emperors and Temple of Apollo. A Hellenistic naval monument and two commemorative tholoi were erected in its open center.

The S edge of the agora was bounded by the road of Battos, connecting the acropolis with the forum. Across the street some six civic and religious structures have been excavated, including a capitolium and a prytaneum, both as presently constructed belonging to the Roman period.

Continuing E, two complete insulae of the town plan were occupied in the 2d c. A.D. by the large House of Jason Magnus, which replaced two earlier independent structures. The W half of the house, with its central court surrounded by mosaics and triclinium richly paved in opus sectile, preserves a more public and official appearance than the E half, which appears mainly residential.

Across the road of Battos to the N is the House of Hesychius, a president of the provincial council of Cyrenaica and a devout Christian living early in the 5th c. A.D. Although small, the house attests to the continuity of urban life in Cyrene after the disastrous earthquake of 365.

The imposing Caesareum dominates the Roman forum area ca. 150 m E of the agora on a continuation of the SW hill. It was constructed as a rectangular enclosure with blank exterior walls on three sides and entered by Doric propylaea on the S and E. A complete Doric peristyle on its interior faced onto an open central court. A small temple, perhaps dedicated to the deified Julius Caesar, occupied the center of the court, while a large civil basilica lay immediately to the N. In its original Hellenistic form the complex functioned as a gymnasium, with the area taken up in Roman times by the basilica housing the traditional closed rooms. A running track, exactly one third of a stadium in length, extended W, paralleling the road of Battos. Its S facade, known as the Stoa of Hermes and Herakles, consisted of a blank curtain wall, whose upper level was pierced by windows flanked by alternating telemon figures of the two divinities providing its name. The conversion of the gymnasium to a complex honoring the dictator is attributed to the later years of Augustus' reign. The basilica, remodeled during the reign of Hadrian, was probably used for law cases. Like the Caesareum, the Stoa of Hermes and Herakles has been heavily restored. Behind it is a small covered theater or odeon, also restored. Across the road of Battos S of the Caesareum are a small Roman theater and a so-called Temple of Venus.

The valley road between the SW and NE hills descends to an open expanse of leveled ground ca. 80 m below the N edge of the acropolis, developed at an early time into

the Sanctuary of Apollo. The Fountain of Apollo, which figures prominently in Herodotos' account of the foundation of the Therean colony, still pours forth its waters from a tunnel leading under the acropolis hill. The restored remains of the Temple of Apollo rise in the center of the sanctuary ground. This impressive monument was first built as a simple megaron without external columns around 550 B.C. By the end of the century it had received its first Doric peristyle, which was subjected over the passage of time to repeated restorations. Its currently standing colonnade belongs to repairs following the Jewish revolt.

Immediately W of the temple is the conspicuous Altar of Apollo, remodeled with white marble revetment in the 4th c. B.C. The S corner of the sanctuary is occupied by the fully restored strategeion, a rectangular stone building with pedimented roof, erected in the 4th c. B.C. by victorious Cyrenean generals to honor Apollo. Nearby are the remains of the partially restored Greek propylaia, again built in the 4th c. to mark the entrance into the sanctuary from the valley road, and their later replacement, the Roman propylaia (2d c. A.D.), erected a short distance to the W.

Aside from various minor shrines and altars grouped around the main Temple of Apollo and cut into the rock-cliff face of the acropolis hill, the remaining significant monuments within the sanctuary zone are the Trajanic baths and their later Byzantine replacement. The Trajanic baths (A.D. 98) covered most of the NE corner of the sanctuary, here extended on terracing supported by a massive retaining wall in order to provide space for its frigidarium. After their destruction by earthquake the baths were replaced around A.D. 400 by Byzantine baths, which today dominate the entire NE edge of the sanctuary.

The W edge of the sanctuary is bounded by the Wall of Nikodamos, set up perhaps in the late 2d or early 3d c. A.D. to separate its sacred monuments from the profane zone of the theater. Here a large-scale Greek theater with its cavea built against the N slope of the acropolis hill was radically transformed in the Roman period into an amphitheater.

The city center was built around the intersection of the valley road with the principal N-S cardo. Its E half is still unexcavated, while much of its W half is obscured by the modern town of Shahat. A triumphal arch, raised in honor of Marcus Aurelius and Lucius Verus, marked the W entrance to this area from the valley road. A small market theater has been excavated just S of the modern road. Remains of a market building and ornate propylon are visible close by, both probably erected in Severan times, to judge from their windblown acanthus capitals and the relief sculptures from the gateway.

Several ancient structures have been identified in the area ca. 200 m long and E of the modern shops of Shahat and below the old post office. The latest is a stoa dating after A.D. 365, whose Corinthian portico ran parallel to the N curb of the valley road. Three small temples lay across the valley road to the S, occupying the front of a complete city block. The central temple housed the imperial cult, the easternmost was dedicated to the eponymous nymph Kurana, while the third is unidentified. In later times the first two were destroyed and then ritually purified by fire by Christians. In addition the city center contained two basilical churches, apparently 6th c. The first is in the SW corner of the zone; the second is found E of the intersection of the valley road with the N-S cardo.

The most important monument of the period of Christian ascendency at Cyrene is its large cathedral, situated at the E end of the city not far from the main east gate. The basilica proper was connected to a baptistery in its NE corner. Its broad nave was paved with mosaics depicting animal and rural scenes. The apse was originally placed at the E and the church entered through three doors on the W. The church was later rebuilt so that its entrance was on the S and its apse located at the W end. The entire structure was fortified with thicker and loftier walls in its final stages. During these troubled times the Byzantine circuit did not take in the cathedral, and it had to double in function as a kind of advanced phrurion to protect the E face of the city. This sector lacked the protection of rising ground and was especially vulnerable to attack from the interior. The remains of a Byzantine defensive tower (Gasr Sheghia) have survived to be excavated about 150 m to the NW. Its initial erection probably coincided with the fortification of the cathedral. It was rebuilt in Early Islamic times.

The unexcavated hippodrome lies directly N of the cathedral just within the circuit of the Hellenistic defenses. South of the cathedral and just exterior to the line of the defenses is an elaborate vaulted cistern complex, built in the Roman period.

The extensive necropoleis of Cyrene cover many square meters of territory on all sides of the walled city. Numbering in the thousands, the burials are located in four main groups. The N necropolis is found on either side of the road to Apollonia. The E necropolis occupies the rolling plain between Cyrene and the modern Beida crossroad. The S necropolis lies beside the ancient track to Balagrae (Beida). The W necropolis is built into the steep slopes of the wadi Bel Gadir either side of the Sanctuary of Demeter. The types of burials vary from one area to the next. The least complicated are the simple cist burials with stone cover slabs and the rock-cut sarcophagi with removable lids. A more elaborate form is the stepped burial, which has a stepped pedestal carrying a stele. Then there is a rich series of rock-cut chamber tombs with cut-stone masonry facades, which are occasionally decorated with the Doric or Ionic order, as well as free-standing circular and rectangular masonry tombs. All periods of urban occupation are represented, from archaic to Christian. Many of the graves in the Hellenistic period were surmounted by a bust of a veiled female figure symbolizing death. Occasionally these busts are rendered faceless. In Roman times funerary portraits of the actual deceased became extremely popular. Many examples of both classes of representations are displayed in the local sculpture museum, as is a full selection of major sculptures from all other phases of the clearance of the city.

BIBLIOGRAPHY. *Notiziario Archeologico del Ministero delle Colonie* I-IV (1915-27) passim; *Africa Italiana*, I-IV (1928-35) passim; G. Oliverio, *Gli scavi di Cirene* (1931); J. Thrige, *Res Cyrenensium* (1848), republished and translated into Italian by S. Ferri (1940); P. Romanelli, *La Cirenaica romana* (1943); F. Chamoux, *Cyrène sous les Battiades* (1953); E. Paribeni, *Catologo delle sculture di Cirene* (1959)[I]; "Cirene" in *EAA* II (1959) 655-92[MPI]; S. Stucchi, *L'agora di Cirene* (1959)[MP]; G. Traversari, *Statue iconiche femminile cirenaiche* (1960)[I]; E. Rosenbaum, *A Catalogue of Cyrenaican Portrait Sculpture* (1960)[I]; R. G. Goodchild, *Cyrene and Apollonia. An Historical Guide* (1963)[MP]; R. G. Goodchild, *Kyrene und Apollonia* (1970)[MPI].

See also S. Stucchi, *Cirene 1957-1966. Un decennio di attività della Missione Archeologica Italiana a Cirene* (1967); L. Beschi, "Divinità funerarie cirenaiche," *ASAtene* 47-48, NS 31-33 (1969-70). D. WHITE

D

DAĞ PAZARI ("Koropissos") Cilicia Aspera, Turkey. Map 6. Ca. 34 km N of Mut (Claudiopolis) and ca. 48 km SE of Karaman, this large and impressive site at ca. 1400 m above sea level is protected on three sides by steep descents towards the swift-flowing stream of the Kavak Gözü; to the N, the natural strength of its elevation above the main road was reinforced by a wall. Occupied at least from the 5th c. B.C., the place had civic status by the time of Septimius Severus and was a bishopric by the 5th c.

Circled by ramparts (1.2 m thick by 5 m high) with 9 m square towers at intervals, the highest point was defended by a redoubt. An aqueduct brought water to the city from the S, and there was a hippodrome on flat ground to the N. A columnar heroon stands S of the river, and weathered, apparently uninscribed sarcophagi flank the Mut-Karaman road. As a bishopric, Dağ Pazarı almost certainly boasted a monastery (now destroyed), a cathedral with an adjoining baptistery, a funerary church extra muros, and an ambulatory church with certain similarities to foundations at Meryemlik (Seleucea on the Kalykadnos) and Alahan, ca. 21 km NW of Mut, the last three sometimes attributed to Zeno, the Isaurian emperor.

The identification of the site with Koropissos (Coriopio in the *Peutinger Table*), on the route between Iconium and Seleucea, is supported by an inscription mentioning Koropissos which was found and copied near Mut in 1961.

BIBLIOGRAPHY. E. J. Davis, *Life in Asiatic Turkey* (1879) 325; W. Ramsay, *Historical Geography of Asia Minor* (1890) 366, 369; G. Forsyth, "Architectural Notes on Cilicia," *DOPapers* 11 (1957) 233-36.　M. GOUGH

DAIDALA Turkey. Map 7. Site in Lycia or Caria, almost certainly at Inlice Asarı, 19 km N of Fethiye and 6 km E of Göcek. Strabo (651) calls it the beginning of the Rhodian Peraea, and the *Stadiasmus* places it 50 stades from Telmessos; Livy (37.22), relating its liberation from siege by Antiochos III in 190 B.C., calls it a fortress of the Peraea. It is listed also by Pliny, Ptolemy, and Stephanos Byzantios. It stood on the border of Lycia and Caria, and is attributed now to one, now to the other. A dedication in Doric by a Rhodian official, stated to have come from Inlice, shows that this region must have been incorporated Rhodian territory in the 2d c. B.C. There is naturally no coinage, nor does the ethnic or demotic occur in any inscription.

On the main acropolis hill is a ring wall of good ashlar, and inside this a small fort and a circular cistern, also house foundations and rock-cuttings. On a ridge lower down to the E is a wall of large irregular blocks. There are several Lycian rock-tombs, a few sarcophagi, and many pigeon-hole tombs cut in the rock face, mostly inaccessible. Beside the main Fethiye road below the site is a fine Doric rock-cut temple tomb.

BIBLIOGRAPHY. C. Fellows, *Lycia* (1840) 101-4 (wrongly identified with Kalynda); Hoskyn, *Journal of the Royal Geographical Society* 12 (1842) 146; W. Arkwright, *JHS* 15 (1895) 94f; *TAM* II.1, p. 53; P. Roos, *Opuscula Atheniensia* 9 (1969) 91-92.　G. E. BEAN

DALAMA, see EUHIPPE

DALGINROSS Perthshire, Scotland. Map 24. The Ro-

man fort at Dalginross, 8 km W of Crieff, is square and measures 246 m (1.65 ha). Although unexcavated, it is presumably one of the chain of stations built in the late 1st c. A.D. to defend Strathmore against attacks by the Highland tribesmen. An earthwork, 4 ha in extent, which completely encloses the fort, may be either an annex or an earlier Flavian fort. A short distance to the S there is a large temporary camp of the Agricolan type.

BIBLIOGRAPHY. W. Roy, *The Military Antiquities of the Romans in Britain* (1793) pl. xi; *JRS* 59 (1969) 109.
　K. A. STEER

DALHEIM Luxembourg. Map 21. Vicus on the main Roman road from Metz (Divodurum Mediomatricorum) to Trèves (Augusta Treverorum), ruins of which were visible until the 17th c. The site was occupied in the Neolithic period (silex tools, food, and wells), and in Roman times there were narrow urban houses. Inscriptions dedicated to the gods (Jupiter, Minerva, Juno, Mercury, Victoria, Nemesis, Mater Deorum) and to the dead have been found, and ca. 30,000 coins from Roman times to the 5th c. A.D. Other finds include statues of the gods, bas-reliefs, animal figurines, portraits, and objects of everyday life. No visible traces are left on the site. The finds are in the Musée d'Histoire et d'Art in Luxembourg.

BIBLIOGRAPHY. A. Namur, "Le camp romain de Dalheim," *Publ. de la Section Hist. de l'Institut Grand-Ducal* 7 (1851) 121ff; 9 (1853) 89ff; 11 (1855) lxxiff; J. Vannerus, "Ricciacus et Caranusca," ibid. 62 (1928) 3ff; 64 (1930) 1ff; C. M. Ternes, *Répertoire archéologique de Grand-Duché de Luxembourg* (1971) I, 52ff; II, 38ff.　C. M. TERNES

DALI, see IDALION

DALJ, see LIMES PANNONIAE (Yugoslav Sector)

DALSWINTON Dumfriesshire, Scotland. Map 24. Three successive Roman forts guarded the crossing of the river Nith 9 km N of Dumfries. One, which has revealed two periods of occupation, lies on the flood plain and is at least 2.6 ha in extent; the other pair (3.5 and 4.5 ha), which are probably later in date, occupy the high ground immediately to the N and are superimposed. All three forts are believed to be of Flavian date.

BIBLIOGRAPHY. *Trans. Dumfriesshire and Galloway Nat. Hist. and Ant. Soc.* 3d ser. 34, 9-21; 35, 9-13; *JRS* 63 (1973) 217.　K. A. STEER

DALYAN, see KAUNOS

DAMASCUS later DEMETRIAS (Damascus) Syria. Map 6. In the interior of S Syria, between the mountains and the desert, in the midst of irrigated gardens, famous for their produce. It was conquered by Alexander the Great in 332 B.C. The Lagids and Seleucids wrangled over it, and the latter gave it the name of Demetrias. It was threatened by the Iturii and passed under Nabataean control in 85 B.C. under Aretas III Philhellene. Conquered by Pompey in 64 B.C., Damascus flourished in the Roman period. It was the birthplace of Apollodorus, Trajan's architect, and became a Roman colony under the Severans. Diocletian set up an arsenal here; Julian visited the town, and Theodosius and Arcadius built a church in honor of St. John the Baptist. Taken by the

Persians in 612, it was reconquered by Heraclius in 628 and in 635-36 by the Moslems.

The site has never been abandoned, but there are few Greek or Roman remains: notably the Temple of Damascene Jupiter and the ancient plan of the city. The Street called Straight, mentioned in The Acts of the Apostles, can still be seen.

The sanctuary of Damascene Jupiter, now occupied by the mosque of the Omayyads, was the largest of all Syrian sanctuaries. It consisted of a temple (completely destroyed in the Omayyad period) built in the middle of two concentric courts. The inner one was 150 m E-W by 100 m N-S, and surrounded by a monumental peribolos built in the first half of the 1st c. A.D. This has become the enclosing wall of the mosque. The stone walls are 14 regular courses high, capped by stepped merlons. Towers containing staircases stand at each corner; the S towers serve as foundations for two of the minarets of the mosque.

The monumental entry was to the E, where propylaea 33 m long jutted out 15 m from the line of the walls. The great stairway, which still has 15 steps, is buried to over half of its original height. Three bays led to the interior, with two small lateral rooms for the porters. On the W was a single axial bay, with a large doorway topped by an arch on each side, to admit carts and sacrificial animals. Spacious rooms (chambers and exedras) extended right and left of the E and W gates up to the towers. On both N and S sides was a triple bay adorned with sculptures and, in the W part of the S side, a gate topped by an arch. In Byzantine times three Christian inscriptions were engraved over other words on the lintels of the S gates.

The outside enclosure consisted of a massive rampart. The exterior was adorned with large pilasters and a portico was built against it on the interior. The remains of the wall and colonnade are mainly visible to the E, where a monumental gate with a triple bay lies exactly on the axis of the large propylaea of the peribolos. The axial arrangement on the W side can be seen in the souk which leads to the W door of the mosque: a pediment supported by four large Corinthian columns framed by two piers; beside these are pilasters which undoubtedly matched the colonnade of the portico. An inscription of A.D. 90-91 indicates that there was an entry for carts on the W side, as well as a gamma-shaped annex which stood against the enclosure and was supported by the town ramparts on its N side.

The exact location of the Church of St. John the Baptist within the sanctuary of Damascene Jupiter is a matter of controversy; apparently it cannot have become the Omayyad mosque.

On the axis of the E entry to the temple, a wide avenue, 240 m long and bordered with colonnades in the Roman period, led to a spacious agora. The grid of the ancient streets, which dates to Hellenistic times, has been traced in the present plan of the E part of the old town, E of the temple: the streets running N-S are spaced 45 m apart, those running E-W 100 m apart. Some irregular streets appear E of the agora, however, in a district whose popular name suggests that it was the Nabataean quarter. In the 1st c. A.D. there were so many Nabataeans in Damascus that King Aretas IV maintained an ethnarch there.

The axis of the ancient town was the Street called Straight, bordered with colonnades in Roman times. It ran from the W gate to Bab Sharqi, the well-preserved E gate with three bays with semicircular arches. The central pavement was more than 13 m wide, the lateral porticos 6 m apiece. Actually the Street called Straight had three sections with different axes, but two monu-

mental arches masked the slight changes in orientation. One arch can be seen 500 m W of Bab Sharqi; it has a lateral bay with a semicircular vault and a sturdy masonry mole. The other was 250 m farther W. Not far from the second arch, on the S side of the avenue, a hillock often called a tell may cover the ruins of a palace. A tall column bearing a huge imperial statue stood near it during the Late Empire. Farther W, S of the avenue, the curving course of the streets suggests the existence of a Roman theater. Its hemicycle opened to the N and must have had a diameter of ca. 100 m.

The ramparts of the Moslem town follow the course of the ancient walls only in a short stretch on either side of the E Gate, where the line is strictly rectilinear and perpendicular to the axis of the Street called Straight. Even there, the ancient materials are all reused. Various indications, however, have allowed a reconstruction of the course of the ancient fortification. It was a huge rectangle, and therefore must date to Roman times; the mediaeval gates mark the sites of the ancient ones. The remains of a Roman bridge over the river can be seen some m from Bab Tuma, on the axis of the gate. The citadel, W of the temple, contains nothing ancient except reused materials. On the inside, however, it preserves part of the W front of the Roman ramparts.

BIBLIOGRAPHY. J. L. Porter, *Five Years in Damascus* (1855); C. Watzinger & K. Wulzinger, *Damaskus* I, *Die antike Stadt* (1921)^MPI; J. Sauvaget, *Les monuments historiques de Damas* (1932)^P; id., "Le plan antique de Damas," *Syria* 26 (1949)^PI; K.A.C. Cresswell, *Early Muslim Architecture* I (1932)^PI; E. Herzfeld, "Damaskus, Studies in Architecture," *Ars Islamica* 13-14 (1948); H. Seyrig, "Eres de quelque villes de Syrie: Damas . . . ," *Syria* 27 (1950); N. Elisséeff, "Dimashk," *Encyclopédie de l'Islam* II (2d ed. 1962). J.-P. REY-COQUAIS

DAMLIBOĞAZ, see HYDAI

DANDARA, see TENTYRA

DANGSTETTEN, see under LIMES RAETIAE

DANILO GORNJE BY ŠIBENIK, see RIDER

"DANUM," see JARROW under HADRIAN'S WALL

DAPHNE Attica, Greece. Map 11. Separating the Athenian and Thriasian plains is Mt. Aigaleos, which the Sacred Way crosses by the same pass used by the main motor road. To the W of the watershed stands the famous Byzantine monastery. In the exonarthex can be seen a marble Ionic column and capital, probably of Hadrianic date, and in the cloister Doric capitals from Classical times. Because of the association of the name Daphne with Apollo, and because Pausanias saw a Sanctuary of Apollo at about this location (1.37.6-7), there is a strong assumption that these and other reported ancient remains should be thought of as coming from that sanctuary.

On the heights to the SW of the monastery, 10 minutes' walk away, is a cave in which Pan and the nymphs were worshiped from the 5th c. B.C. Almost 2 km W of the monastery, immediately N of the highway, is a Classical Sanctuary of Aphrodite, which Pausanias described as having before it "a wall of rough stones worth seeing" (1.37.7). Today the most prominent remain is a vertical scarp of rock pockmarked with niches for votive reliefs, part of a walled temenos that also included a shrine, stoa, and propylon. A priest's house lies to the N of the Sacred Way, at this point well preserved, while to the S is a rectangular foundation of unknown purpose,

whose extremely heavy walls may fit Pausanias' description.

BIBLIOGRAPHY. J. Travlos, Σπήλαιον τοῦ πανὸς παρὰ τὸ Δαφνί, ArchEph (1937) A 391-408[PI]; id., 'Ανασκαφαὶ Ἰερᾶς ὁδοῦ, Praktika (1937) 25-37[PI]; Travlos & K. Kourouniotes, Praktika (1938) 26-34[PI]; (1939) 39-41[PI]; A. Orlandos, Ergon (1960) 230-32[I]. C.W.J. ELIOT

DARDANOS or Dardanum Turkey. Map 7. City in the Troad, in the coastal plain of the Kalabaklı çay. The site is on a low hill (Mal Tepe, Şehitlik Batarya) which controls the coast road, as Strabo says (13.1.28), 70 stadia (13-14 km) S of Abydos. It was a member of the Athenian League, paying one talent; at some point in the Hellenistic period it was transferred to Abydos (Strabo) but in 190 B.C. was liberated by Rome (Livy 37.9; 37; 38.39). Roman Imperial coinage. In the 19th c. some Greek vases were found here. Recent excavations have yielded tiles and sherds of the 8th c. B.C. to the 2d c. A.D., but no trace of walls. A Hellenistic tumulus 1 km to the S has also been excavated. The finds are in the Çanakkale museum.

BIBLIOGRAPHY. ArchJ 16 (1859) 3 n. 1; AthMitt 6 (1881) 219; H. Schliemann, Ilios (1880) 134; id., Troja (1884) 305; W. Leaf, Strabo on the Troad (1923) 150ff[MI]; R. Duyuran, "Decouverte d'un Tumulus près de l'ancien Dardanus," Anatolia 5 (1960) 9-12[I]; Z. Taşlıklıoglou, "Dardanos şehri tümülüsde yeni bulunan Grekçe kitabeler," TurkTarDerg 13 (1963) 17-18; J. M. Cook, The Troad (1973) 57-60[I]. T. S. MACKAY

DARDANUM, see DARDANOS

DARENTH Kent, England. Map 24. A Roman villa 4.8 km SE of Dartford. It covered an area of 1.2 ha beside the river Darent. It was excavated in 1894-95. The earliest building appears to have been a double-winged corridor house (39 x 18 m) which faced S on a courtyard (ca. 64.5 x 27 m). This house was later connected with other buildings, probably aisled in their original form, one (ca. 24 x 15 m) at the NE corner of the courtyard, the other (ca. 30 x 18 m) at the NW corner, set at an angle. This last building contained baths, but they were subsequently replaced by an arrangement of tanks and hypocausts which extended to the main house and were interpreted as part of a fulling installation; water was supplied from a well outside the courtyard by way of a large tank (8.4 x 3 m) built across the courtyard itself. In a third period the tanks in and near the main house were replaced by baths, but those in the NW building continued in use.

No close dating has been suggested for any of the periods, but the coins found range from Domitian to Gratian. Reexamination of Chedworth has cast some doubt on the interpretation of Darenth, but the large tanks and the presence of many hypocausts, some of them of unusual design, do point to some form of industrial use, whether fulling or dyeing is not known. No further work has been done on the main complex, but rescue excavations in 1969 revealed a detached bath house at the SW corner of the courtyard and an aisled building 48 m long, 90 m farther to the SW, and here five periods of construction between A.D. 180 and 350 were distinguished.

BIBLIOGRAPHY. G. Payne, Archaeologia Cantiana 22 (1897) 49-84; VCH Kent III (1932) 111-13; fulling: G. Fox, Archaeologia 59 (1905) 218-32; B. J. Philp, Excavations in West Kent, 1960-1970 (1973) 119-54. A.L.F. RIVET

DARIORITUM (Vannes) Morbihan, France. Map 23. The chief city of the powerful Gallic tribe, the Veneti, Darioritum spread out over a series of small hills separated by inlets. From its site inside the Morbihan gulf, the city probably witnessed the naval encounter between the Roman fleet and that of the Veneti, in 56 B.C., mentioned by Caesar (B.Gall. 2.34; 3.7-16). Like most Romanized cities, Darioritum prospered under the Pax Romana but suffered from the troubles of the late 3d c.; according to the Notitia Dignitatum, a garrison of Moorish soldiers was installed there.

It was in this late period that a circuit wall was erected; traces of it have been found in the substratum of the modern town. Enclosing only a small part of the Roman city, the wall was more than 4 m thick and made of a coarse core of rubble faced on either side with small blocks banded with brick. Only a few sections of this Late Empire rampart can be seen today, intermixed with the mediaeval fortifications.

BIBLIOGRAPHY. P. André, "La Cité Gallo-romaine des Vénètes," Bulletin mensuel de la Société Polymathique du Morbihan (1971). M. PETIT

DASCUSA (Ağın, Elazığ) Cappadocia, Turkey. Map 5. The town was located by Ptolemy (Geog. 5.7) on the W bank of the Euphrates, N of Melitene and S of Zimara, as Dascusa in Armenia Minor or as Dagusa in strategia Melitene of Cappadocia. It is listed again in the Antonine Itinerary on the route from Satala to Samosata along the bank of the Euphrates 60 Roman miles from Zimara and from Melitene. Pliny (HN 5.83) gives distances by river, Zimara to Dascusa 75 miles and thence to Melitene 74 miles. The consonance of these distances with modern topography make it reasonably certain that the archaeological site at Ağın described below is Dascusa, though as yet (1971) no relevant epigraphic testimony has been found. Dascusa does not figure in history. An inscription attests the presence of a cohort in A.D. 82, a tombstone the settlement of a legionary veteran of Helvetian origin. The Notitia Dignitatum (or. 38.22) places the Ala Auriana in garrison there in the 4th c.

Ağın lies 5 km W of the Euphrates on a tributary, the Ağın Çay. In the valley below the town on the steep S bank is a mound called Kalecik of which the lower levels date from the Late Bronze Age. There was a walled settlement here in the Roman period and the top level was a small Byzantine fortress. On the N side, at Hoşrik, nearer Ağın, a church of the 6th c. and a granary of the 3d c. A.D. have been excavated. Also to be associated with the Roman settlement is a cemetery near the village of Pağnik at the mouth of the valley of which the use, dated by coins, ranges from Trajan to Commodus. To the NE of Ağın on the Euphrates bank, lies the hill called Kilise Yazısı Tepe. This was surrounded with a fortification wall a meter thick, strengthened with small internal rectangular towers. Coins and pottery found during the excavation indicated an occupation in the 2d-3d c. A.D. Opposite this site, on the E bank, again on a natural promontory, stands the castle called Kalaycık Tepe. This was occupied from the 3d millennium B.C. onwards. The slight occupation during the Roman period was destroyed by fire.

A vigorous mediaeval settlement seems to have lasted until the 12th c. About 3 km S of Kilise Yazısı Tepe, over very rough terrain, and 1 km N of Pağnik village stands the fort of Pağnik Öreni, again on a defensible promontory overlooking a summer ford of the Euphrates. A curtain wall 2 m thick encloses a subtriangular area of ca. 0.9 ha. It is punctuated with 11 semicircular or horseshoe-shaped towers, ranging in size from large on the landward side to small on the steep riverbank, and with four gateways, one 4 m wide, the others small posterns. This enceinte may be related to the general

strengthening of E defenses under Constantius (Singara and Amida are similar, if on differing scales). The construction and first brief occupation is dated archaeologically to the mid 4th c. At the end of the century the fort was repaired shoddily and most of the surviving internal buildings erected. The latest coin is of A.D. 402. On the Arapkır Çay, a large tributary of the Euphrates, S of Ağın, stands the fine Karamağara Köprüsü, a bridge with a Christian Greek inscription which has been dated to the 6th c. A.D. on stylistic grounds. All the sites here described will be flooded by the lake of the Keban Dam during the 1970s. The Roman signal station on the eminence of Mineyik Tepe, S of the Arapkır Çay, will remain above water. Finds from the Keban Project Excavations are housed in the Elazığ Museum.

BIBLIOGRAPHY. Reports of excavations 1968ff at Ağın and Kalaycik by Ü Serdaroğlu and at Pağnik Öreni by R. P. Harper in *Middle East Technical University, Keban Project Publications* I-IV (1970-74). R. P. HARPER

DASKYLEION

DASKYLEION Turkey. Map 5. Stephanos Byzantios records five cities called Daskyleion in W Asia Minor, one of which, according to Xenophon (*Hell.* 4.1.15; *Hell. Oxyrhynchia* 17.3), was the residence of Pharanabazus, Persian satrap of the Hellespont and Phrygia. This has been identified with the city mound called Hisartepe on the SW shore of Lake Manyas, near Ergili, where excavations have yielded many Achaemenid bullae in Graeco-Persian style bearing Aramaic inscriptions. Consequently the lake is to be identified with Δασκυλίτις Λίμνη: according to Strabo (12.575) Daskyleion lay on this lake.

Three Graeco-Persian funerary stelai found in Daskyleion are now in the Istanbul museum.

BIBLIOGRAPHY. Site: A. R. Munro, *JHS* 32 (1912) 57ff; K. Bittel, "Zur Lage von Daskyleion," *AA* (1953) 2-16; E. Akurgal, *Anatolia* 1 (1956) 20-24[I]; id., *Die Kunst Anatoliens* (1961) 170-73[I]; F. K. Dörner, *Der kleine Pauly* I (1964) 1395-96.

Inscriptions on bullae: K. Balkan, *Anatolia* 4 (1959) 123ff.

Graeco-Persian reliefs: D. Sommer, *CRAI* (1966) 44-58; E. Akurgal, *Iranica Antiqua* 6 (1966) 147-56. F. M. Gross, "An Aramaic Inscription from Daskyleion," *BASOR* 184 (1966) 7-10; G.M.A. Hanfmann, "The New Stelae from Daskyleion," ibid. 10-13; N. Dolunay, *Ann. Arch. Mus. Ist.* 13-14 (1967) 1ff; J. Borchhardt, *IstMitt* 18 (1968); J. P. Bernard, *RA* (1969) 17-28; J. Teixidor, "Bulletin d'épigraphie sémitique," *Syria* 45 (1964) 377; J. M. Dentzer, *RA* (1969:2) 195-224; H. Möbius, "Zu den Stelen von Daskyleion," *AA* (1971) 442-55; id., "Zur Datierung der Grabstelen aus Daskyleion," *Mélanges Mansel* (1974) 967-70. E. AKURGAL

DAULIA, *see* DAULIS

DAULIS

DAULIS or Daulia Phokis, Greece. Map 11. A city on the E slope of Parnassos overlooking the "schize hodos" leading to Arachova and Delphi as well as the approach to Boiotian Kephissos (Soph. *Oed. tyr.* 734).

The city goes back to the Mycenaean period and is mentioned by Homer (*Il.* 2.520). In the Median wars Daulis was burned by the Persians as were the nearby cities of Panopeus and Lilaia. In 395 the Thebans failed to seize the city (*Hell. Oxy.* 18 (13). 6) although they sacked the whole region; then in 346 it was destroyed by Philip (Paus. 10.3.1). In 220 the Aitolians tried in vain to recapture Ambrysos and Daulis (Polyb. 4.25.2) which they had lost about 225, and in 198 Flamininus seized the city from Philip V (Livy 32.18.7).

Daulis was built on a table-shaped acropolis (468 m

high). Its ramparts, which are well preserved, were quadrangular and built of polygonal masonry, and rendered the city almost impregnable (Livy 32.18; cf. Paus. 10.4.7). Daulis had a Sanctuary of Athena, a cult of Athena Soteira, for which there is epigraphical evidence, and a Sanctuary of Isis. Inside the acropolis is the Church of Haghii Theodori, built with the reused ancient stones.

Daulis is not to be confused with Daulis in Epeiros.

BIBLIOGRAPHY. J. G. Frazer, *Paus. Des. Gr.* (1895) for description of ramparts; E. Schober, "Phokis" (diss., Iena 1924) 27-28; R. Placeière, *Les Aitoliens à Delphes* (1937) 287, 289; A. Bon in *BCH* 61 (1937) 143-44[IP]; A. Philippson & E. Kirsten, *GL* (1951) I.2 431; E. Meyer in *Kl. Pauly* (1964) s.v.; R. Hope Simpson, *A Gazetteer and Atlas of Mycenaean Sites* (1965) III, no. 441; id. & J. F. Lazenby, *The Catalogue of the Ships in Homer's Iliad* (1970) 42; N.G.L. Hammond, *Epirus* (1967) 657 (for Daulis in Epeiros); for Pausanias, beyond the Frazer ed., see that of N. Papachatzis (1969) v 261-64[I], 247, plan 157. Y. BÉQUIGNON

DAX, *see* AQUAE TARBELLICAE

DCHAR JEDID, *see* ZILIS

DEA AUGUSTA VOCONTIORUM

DEA AUGUSTA VOCONTIORUM (Die) Drôme, France. Map 23. An Augustan colony of Gallia Narbonensis on the road from Valence to Briançon, in the Drôme valley, and an important religious center of the Vocontii. Christian inscriptions of the 5th-6th c. attest the presence of a community there. The city is mentioned in the *Antonine Itinerary*, the *Peutinger Table*, the *Jerusalem Itinerary*, the *Notitia Galliarum*, and by Stephen of Byzantium.

A wall 1940 m long surrounds the city; it is partly Roman and partly mediaeval but the plan and foundations of the mediaeval wall are probably Roman. Construction is of rubblework bonded with very hard cement, faced on both sides with small stones. The rampart is reinforced by round, square, and polygonal towers, some of which have bands of brick, suggesting that they were built or restored fairly late. Four gates are open, the Porte Saint-Pierre and Porte Anglaise to the W, Porte Saint-Vincent to the S, and to the E the Porte Saint-Marcel, the only one flanked by towers.

Encased in the Porte Saint-Marcel is a monumental arch, of which an arcade remains as well as the toothing stones of the adjoining sections: a barrel vault with interlace in low relief, a frieze with sacrificial scenes, a bull's head on the keystone of the archivolt, more bulls' heads on the piers, and in the corner-pieces tritons blowing horns. A stone carved with a design of pearls and spirals has been found in the oldest part of the fortified gate, and a cornice fragment carved with heart-shaped ornament was found in the body of the N tower known as the Porte Saint-Agathe. Fragments bearing inscriptions can be seen at several points in the wall and towers. These finds and the monumental arch are further evidence for a late date (4th c.?).

The city is roughly oblong, narrower in the upper (N) section that includes the Des Beaumes plateau and the area known as La Citadelle. Low arches were built in the Chastel quarter; they served as buttresses. The decumanus maximus, which corresponds to the Grande Rue (from the Porte Saint-Pierre to the Porte Saint-Marcel), as well as a secondary decumanus and the cardo maximus can still be traced in the streets of the modern town.

The water supply of Dea Augusta came from two aqueducts, one from the Rays springs in the commune of Romeyer to the NE, the other from Valcroissant to

the E, remains of which are still standing. In each case the conduit is built of cut stones, probably because of the steep slopes. Traces of the first aqueduct have been located mainly between the Rays springs and the hamlet of Moulin. The aqueduct leads to a water tower with a cistern, in the S part of the Des Beaumes plateau.

Traces of the second aqueduct have been found in a number of places, but no signs of a conduit at the source; the water must have been caught downstream from the pass, where many slabs have been discovered. The width and height of the channel varies from place to place, but the method of construction is much the same throughout: paving stones, 1 m wide, laid lengthwise form the base of the conduit. These stones form a projecting band down the middle, and on each side slabs are laid vertically to form piers. The slabs are laid close together by means of grooves, and mortared. Over the piers is a rubblework arch topped with fairly thick masonry. The conduit is in many places covered with a limestone deposit, sometimes 0.05 cm thick. Only one other example of this type of conduit is known, in an aqueduct at Bourges. It should be noted that this kind of masonry is used only in the upper sections; in the lower ones the channels are built of quarry-stones.

The water was carried farther by various piping systems; recently two such systems were found at the Nouvelle Poste, near the cathedral. The base is of tiles fitted together and laid on a bed of mortar; the sides are made of quarry stones with paving stones on top. Other pipes have been located in the Chastel and Palat quarters and in the modern cemetery.

Few public monuments have been excavated. Some baths have been identified, by remains of hypocausts and by slabs of marble and porphyry used as facing, outside the surrounding wall to the NE on both banks of the Meyrosse. Nor has anything conclusive been found NW of the rampart, in the Palat quarter, where the Carte Archéologique places a hypothetical theater (or amphitheater?) in a hollow on the hillside. However, two fragments of balustrade reused in the rampart in the Late Empire very possibly came from a theater. Outside this same rampart three Roman bridges have been located: the Meyrosse and Saint-Eloi bridges to the E and the Pont-Rompu to the S. All three have been rebuilt since the 15th c., but with Roman blocks or on Roman foundations.

Two necropoleis, to NE and NW, have yielded a number of inscribed funerary stelai and some sarcophagi. Many more stelai were reused in the rampart. Several of the inscriptions and sarcophagi are Christian.

Villas and various unidentified buildings have been located both within and outside the rampart. Columns, capitals, marble slabs, pottery, and mosaics have been found; among the latter is a floor in the SE quarter near the cathedral depicting Neptune on a sea-horse surrounded by hexagons decorated with fish. A Christian mosaic showing the four rivers of Paradise was found in the same district (now in the Salle des Archives at the Hôtel de Ville).

Die had a number of temples, known however only from altar inscriptions or religious statues: a Temple of Jupiter (*CIL* xii, 1563), a temple of Vulcan (App. epigr. of *Carte arch.*, 9), a temple of Kybele and Attis (seven altars or fragments of taurobolium altars), and a temple of Dea Augusta Andarta (*CIL* xii, 1556-60).

Monuments and objects found at Die are housed in a municipal museum.

BIBLIOGRAPHY. H. Desaye, "Notes sur l'aqueduc romain de Valcroissant à Die," *Rhodania* (1952) 8-17; id., *Die à l'époque romaine* (forthcoming); J. Sautel, *Carte arché-* *ologique de la Gaule romaine* xi, *Drôme* (1957) 44-71[PI]; Grenier, *Manuel* iv (1960) 106-11.　　　M. LEGLAY

DECEMPAGI (Tarquimpol) Moselle, France. Map 23. An important statio ca. 10 km SE of Dieuze, mentioned in the ancient itineraries as being on the road from Reims to Strasbourg. Another road led from there to the Donon mountain. At first the Roman city occupied two-thirds of the peninsula that now juts out from S to N into lake Lindre, as well as the Ile de la Folie. The lake was created in the Middle Ages, and in the Roman period the region must have been extremely marshy. Traces of the city have been found as far as contours 218 and 217 in the N part of the peninsula, and the first area is called Vieux Château.

The Reims-Strasbourg road hugged the N part of the Ile de la Folie, crossed what is now the lake, followed the main street of the modern village and ran across the E branch of the lake towards the farm of La Breidt and Assenoncourt. Excavations in the E arm of the lake produced evidence of the road, and some buildings were also unearthed. Thus in the 1st c. Decempagi was roughly a square ca. 1 km on a side; later, under the threat of invasion the city withdrew to the S part of what is now the peninsula and took shelter behind ramparts. Its area was reduced to one-fourth its former size (second half of 3d c.). We know nothing of the decline of Decempagi, but it was mentioned again in 366 by Ammianus Marcellinus when Julian won a victory over the Alemanni in the region (ad Decempagos). On the other hand, 4th c. terra sigillata has been found there as well as coins as late as the reign of Theodosius. A Merovingian necropolis underneath the church proves that the city was still there in Frankish times.

The archaeological interest of Tarquimpol was noted as early as the 18th c., and many finds were made. In 1825 fragments of cornices were found at Vieux Château, and remains of columns a little later. In 1841 and 1890 the village itself was excavated, and results of digging at Vieux Château suggested that there might be a temple there. In the gardens N of the village foundations of a Roman building were unearthed, along with columns and half-columns. More columns and capitals, of the Doric order, were excavated some distance away, but only the floors of the building remained. At this time traces of a road running NE were found, 4 m wide. This is the road that crossed the lake, passing a building (41 x 13.5 m). A rampart dating from the Later Empire was also found. It was roughly oval and ca. 1100 m around, although the N side ran in a straight line for ca. 200 m. A tower was located, beside the church. In 1892 a large villa NE of the village was unearthed, parallel to the Lindre lake, and excavations continued up to 1894.

In 1950 and 1951 more finds were made in the E part of the village, including a marble sculpture of a child's head and a hoard of about 30 articles that probably belonged to a peasant with a vineyard: two large cauldrons, a strainer, three wine-tasters, a funnel, all of bronze, and a collection of iron tools including two plowshares. The articles can be dated from the second half of the 3d c. and the beginning of the 4th. Another trial trench in the E section of the village revealed three occupation strata with a depth of 2.3 m for the 1st c. alone. Finally in 1967, just S of the same area, 20 enormous limestone blocks each weighing close to a ton were found at the base of the rampart. Probably part of a triumphal arch, they included drums and bases of columns and bas-relief carvings, many of which fit together. The trench where the blocks had been placed had encroached upon the

1st c. strata mentioned above, which were filled with fine pottery and a medium-sized bronze of Claudius.

The Sarrebourg museum has archaeological collections.

BIBLIOGRAPHY. M. Toussaint, "Tarquimpol," *Répertoire archéologique du département de la Moselle* (1950).

M. LUTZ

"DECENTIANUM," *see* DESENZANO DEL GARDA

DECUARIA, *see* PETUARIA

DEKELEIA Attica, Greece. Map 11. One of the twelve cities that under Theseus gave up their autonomy to form a new state with Athens as capital (Philochoros: *FGrHist* 328 F 94), Dekeleia remained a deme in Classical times. It was situated 120 stades from Athens (Thuc. 7.19.2), on the road that led to Boiotia around the E end of Mt. Parnes (Hdt. 9.15). In the Peloponnesian War it was captured by Agis in 413 B.C., walled, and remained a Spartan stronghold until the defeat of Athens in 404 B.C.

The city has long been associated with the ancient remains at Tatoi, on the SE slopes of Parnes, within the grounds of the once royal estate. From here, particularly in the area of the farm buildings, have come walls, pottery, sculpture, and inscriptions, one of which (*IG* II² 1237) is concerned with the phratry of the Demotionidai established at Dekeleia.

Immediately S of the farm buildings is the wooded hill called Palaiokastro, its flat top now used as a cemetery for the Greek royal family. It was once a fortified enclosure, with a circuit totaling more than 800 m of rubble wall. Much of the foundation course remains in situ but is not generally accessible. Because of its location and size, this fortified height has been rightly identified as the site of Agis's camp.

BIBLIOGRAPHY. A. Milchhöfer, *Karten von Attika. Erläuternder Text* 7-8 (1895) 2-4; Th. A. Arvanitopoulou, Δεκέλεια (1958)ᴹᴾᴵ; T.R.H. The Princesses Sophia & Eirene, Ὄστρακα ἐκ Δεκελείας (1959)ᴵ.

C.W.J. ELIOT

DELIKTAŞ, *see* OLYMPOS

DELLYS, *see* RUSUCURRU

DELMINIUM (Županac) Bosnia-Herzegovina, Yugoslavia. Map 12. On the plain near Duvno in Duvanjskopolje. The pre-Roman settlement of the same name, the capital and the largest city of the Illyrian Delmatae, was near its Roman successor at either Lib or Gradina kod Gaja. The city was besieged by the Romans in 156 B.C. under C. Marcius Figulus; a year later it was captured by P. Cornelius Scipio Nasica, its fortifications destroyed, and the surrounding country converted into sheep pasturage (App. *Ill.* 11; Florus. 2.25; Frontin. *Str.* 3.6.2; Strab. 7.5.5). Following the typical Dalmatian pattern, the later Roman settlement moved from a hilltop site to the valley as the need for fortifications passed, and the territory of the Delmatae was administered from Salona on the coast (Plin. *HN* 3.142). Roman Delminium was probably established under Augustus and survived through the 6th c. when it was mentioned as a bishopric under Pope Gregory ca. 585. Grants of Roman citizenship to the native population first appear under the emperor Hadrian. The city flourished as the agricultural center for the valley although it never regained the importance held by its Illyrian predecessor.

The major monument known from the site is the forum, partially excavated. Over three-quarters of the forum area consists of a paved open space surrounded by a wall. The principal feature within the enclosure is the building on its S end. The long axis of the building is parallel to the S edge of the forum pavement and is divided by cross walls into two larger spaces and several smaller ones. The two largest occupy the central and E part of the building and presumably served as the city basilica and senate house. The senate chamber is distinguished by the addition of a fireplace sometime after its original construction. The whole forum complex is probably contemporary with the granting of municipium status to the town, usually assigned to Hadrian or Antoninus Pius. Further building activity there is recorded during the 3d c. The relatively high concentration of Roman burials and traces of roads in the valley suggest a fairly large population for the area in the Roman period. However, the poor quality of construction in the civic center indicates that the city did not attain the same degree of prosperity under the Romans as did the former Illyrian centers at Doclea and Salona.

The finds from the site are located in the Zemaljski Musej at Sarajevo.

BIBLIOGRAPHY. D. Sergejevski, "Epigrafski nalazi iz Bosne," *Glasnik Zemaljskog Muzeja u Sarajevo*, NS 12 (1957) 109-25; E. Pašalić, *Antička naselja i komunikacije u Bosni i Hercegovini* (1960); M. Zaninović, "Delminium. Primjedbe uz lokaciju," *Vjesnik za arheologiju i historiju dalmatinsku* 63-64 (1961-62) 49-55; J. J. Wilkes, *Dalmatia* (1969)ᴹᴾ.

M. R. WERNER

DELOS Greece. Map 9. Situated in the center of the Cyclades, Delos is one of the smallest islands of the group, measuring some 5 km N-S and 1.3 km E-W at the widest. The highest point on the island is Mt. Kynthos, which measures 112 m and down which flows the Inopos.

Famous in antiquity as the birthplace of Apollo, Delos is mentioned with great frequency in ancient texts. The most important ones which refer to it are the Homeric Hymn to Apollo and Kallimachos Hymn to Delos. The oldest habitation site that has been found on the island is on the summit of Kynthos (end of the 3d millennium B.C.). The island seems to have been abandoned in the first half of the 2d millennium. Then a Mycenaean settlement was established at the future site of the Sanctuary of Apollo, which was itself founded at the beginning of the 7th c. B.C. The number of offerings between 700 and 550 indicates domination by Naxos at this period, but in the second half of the 6th c., it was Athens which attempted to control the sanctuary. Pisistratos, tyrant of Athens, intervened in the religious life of the island by "purifying" it, that is, by removing the tombs which surrounded the sanctuary. The Athenian supremacy became increasingly apparent in the 5th and 4th c., despite a short interruption from 404 to 394: Delos, then the headquarters of the maritime league directed by Athens, was administered by Athenian magistrates known as "amphictyons." In 426 it was again purified, with all the remaining tombs removed and the bones and funerary furnishings deposited at Rheneia. In 314, Delos again became independent, remaining so until 166. The administrative accounts for the sanctuary and the inventories of offerings give us a rather good idea of the civil and religious institutions of this time. In 166, by Roman decree, Delos became an Athenian possession and was administered by an Athenian epimelete. It was declared a free port, and consequently attracted a great deal of maritime traffic and many merchants from Greece, Italy, and the East. This cosmopolitanism led first to the installation of foreign deities for whom sanctuaries of a non-Greek type were built; secondly, given the influx of immigrants, the town grew

considerably. Delos was partially ravaged in 88 by the troops of Mithridates Eupator, and again in 69 by pirates of Athenodoros. These devastations together with the shift of commercial traffic to Italy as a result of the Roman conquest, led to the rapid decline of Delos. It remained a small town until the coming of Christianity, and was finally abandoned in the 7th c. A.D.

Excavations since 1873 have uncovered a very great part of ancient Delos. The ruins can be divided into seven groups: the region of the Sanctuary of Apollo, which is situated on a small plain behind the main port; the lake quarter and the theater quarter, which border on the sanctuary to the N and S respectively; the quarter of the Inopos; the Terrace of the Foreign Gods and Mt. Kynthos; finally two outlying groups, the stadium quarter, to the NE of the island, and the S region.

The sanctuary, which was established on the site of a Mycenaean settlement, began to take its present form towards the 6th c. B.C. It is reached by an avenue leading to a propylon, the avenue being flanked by two Hellenistic porticos, one of which was built by Philip V of Macedon. The propylon is contiguous with a 6th c. B.C. edifice called Oikos of the Naxians, which consists of a rather narrow room with an axial colonnade, and a four-column prostoon which was added later. Immediately to the N on the Sacred Way is to be found the base of the Naxian Colossos. Near it are three Temples of Apollo, constructed side by side and all facing W. The temple farthest N, which the inscriptions call Porinos Naos, dates to the 6th c. B.C., and appears to have consisted of a cella and a prodomos. The second building is the Athenian Temple or Temple of the Seven Statues, which was built by the Athenians ca. 425-420. It was an amphiprostyle hexastyle Doric temple which had in addition four pillars in antis. The interior of the cella was occupied by a horseshoe-shaped base which supported the statues of seven divinities whose identity is conjectural. The third Temple to Apollo, which was Doric, was the only peripteral temple on Delos. It was begun around 475-450 B.C., but not finished until the first half of the 3d c. To the N and the E of the temples are five buildings arranged in a semicircle. They are referred to as treasuries, but their actual purpose is unknown. They date from the archaic to the Classical period. To the E of the Temples of Apollo are a 6th c. B.C. edifice which may have been the bouleuterion, and the prytaneion, which was constructed in the 5th and 4th c. B.C. The latter is divided into several small rooms which inscriptions tell us included, among other things, a prodomos, a courtyard, and an archives room. Parallel to these two edifices is the Edifice of the Bulls, which is formed by a six-column prodomos, a long gallery flanked by benches, and a sort of cella reached by way of a bay framed by two supports, the pilasters of which are decorated with bull protomas. The building, which was constructed at the end of the 4th c. or the beginning of the 3d, appears to have contained a ship which was probably a votive offering.

To the W of the Temples of Apollo, on the other side of the Sacred Way, are various structures grouped around the Artemision. A first Temple of Artemis was built in the 7th c. B.C. on top of a Mycenaean edifice near which a hoard of gold and ivory Mycenaean objects has been found. This first temple was replaced in the 2d c. B.C. by a new one which incorporated it. To the E of the Artemision the Sema of the Hyperborean Maidens Laodike and Hyperoche which was mentioned by Herodotos (4.34) has been identified by some. Nearby there is an apsidal structure of uncertain purpose. Contiguous with the S face of the Artemision are the foundations in poros of a large edifice which according to

an account of the hieropoipoi was built by the Athenians in the 4th c. B.C. Blocks from the frieze represent the episodes of an epic of Theseus. Some have identified the structure, though without compelling reasons, with the Keraton mentioned in the accounts of the hieropoipoi. Parallel to its W face is the Edifice with the Hexagons, which is from the archaic period and had honeycomb decoration on at least two sides. To the N of the Artemision were the ekklesiasterion, which was remodeled several times from the 5th c. B.C. to the Imperial period, and a 5th c. building of very unusual plan which some have incorrectly identified as the Thesmophorion. It consisted of a courtyard with a Doric peristyle flanked by two symmetrical rooms whose roofs were supported by four Ionic columns. This building, along one side, borders an agora built ca. 126-125 by Theophrastos, epimeletes of Delos. A hypostyle hall built in the last years of the 3d c. B.C. opens onto this agora. Inside, 24 Doric columns and 20 Ionic columns supported a roof with a skylight.

To the N the Sanctuary of Apollo is closed by a portico constructed by Antigonos Gonatas. The gallery, with a Doric exterior colonnade and an Ionic interior one, was flanked by two projecting wings. The triglyphs of the intercolumniation were each decorated with a bull's head in high relief. In front of the facade of the portico, a Mycenaean tomb surrounded by a semicircular wall corresponds to the Theke of the Hyperborean Maidens Opis and Arge which was mentioned by Herodotos (4.35). Behind the Portico of Antigonos, the fountain Minoe consists of a square well into which one could descend by means of a wide staircase of 11 steps.

To the E the Sanctuary of Apollo is closed by a wall behind which was a residential district which has so far hardly been excavated and the Shrine of Dionysos, the latter flanked on either side by a cippa surmounted by the stump of a phallus. To the S of the Sanctuary of Apollo was the agora, a trapezoidal area surrounded by porticos built from the 3d to the 2d c. B.C. Baths were built on the agora in the Imperial period. Nearby, the basilica of St. Cyriacus is the only well-preserved Early Christian monument on Delos.

The lake quarter extends to the N of the Sanctuary of Apollo around the "trochoidal lake" mentioned by several ancient writers as one of the most notable features of Delos' scenery. In the archaic period, this region formed the Temenos of Leto, of which the lion terrace offered by the Naxians towards the end of the 3d c. B.C., and the mid 6th c. Temple of Leto, still remain. To the SW of the Letoon, the dodekatheon contained only the altars and probably the statues of the twelve gods. In the 3d c. B.C. an amphiprostyle Doric temple was added to it. To the E of the dodekatheon and the Letoon, the agora of the Italians testifies to the prosperity of Delos' Italian colony. The agora, which was paid for by the donations of various benefactors in the last years of the 2d c. B.C., consists of a large trapezoidal area surrounded by a two-story portico on which opened exedrae and niches. Except for two palaestrae, the N part of the district is formed essentially of private houses, including some of the most opulent dwellings on Delos: the House on the Hill, the House of Diadumenos, The House on the Lake, and several recently excavated insulae, in particular that of the House of the Comedians, which included a two-story tower crowned with pediments. In addition to these private buildings mention should be made of the establishment of the Poseidoniastes of Berytos. Constructed in the first half of the 2d c. B.C. by the "Association of the Poseidoniastes of Berytos at Delos, Merchants, Shippers and Warehousemen," it consists of two court-

yards, living quarters, and four shrines dedicated to Roma, Poseidon of Berytos, and two other national divinities of the Berytians, probably Astarte and Echmoun. The establishment of the Poseidoniastes and the neighboring insulae are oriented N-S and E-W and stand on straight, right-angled streets. This district, which appears to have been constructed in the second half of the 2d c. B.C. must have been laid out according to a predetermined plan.

Such is not the case, however, with the area of the theater, which extends to the S of the Sanctuary of Apollo on the side of a hill. It is the oldest residential district of Delos. It continued to grow throughout the 3d c. B.C., and appears to be without prearranged plan. Its principal axis was the narrow Street of The Theater, which begins in a large flagged square called the Agora of the Hermaistes or Agora of the Competaliastes on account of the numerous votive monuments erected there by these two Italian associations. The street, completely flagged, follows a twisting course as it rises to the theater, which was constructed in white marble in the 3d c. B.C. and could hold some 5500 spectators. The metopes of the frieze of the proskenion were decorated alternately with tripods and bucrania. The water which drained from the theater collected in a large cistern whose cover was supported by eight marble arches, which are still intact. On both sides of the Street of The Theater are houses dating in their present form from the 2d or the beginning of the 1st c. B.C. Most of them are two-story affairs. The most luxurious among them have a courtyard with marble peristyle and are decorated with mosaics. Some of them are well known: the House of Dionysos, which owes its name to a mosaic in opus vermiculatum representing a winged Dionysos (?) astride a tiger; the House of Cleopatra, in which the statues of its owners, the Athenian woman Cleopatra and her husband Dioskourides, are still to be found; the House of the Trident, whose peristyle of Rhodian type includes consoles decorated with two bull protomes and two lion protomes (probably symbols of Atargatis and Hadad), and which possesses several pictorial mosaics.

Behind the theater is a residential district which has only been partially excavated. The House of the Masks there is famous for the mosaics which decorate four contiguous rooms and which include a Dionysos on the cheetah and a series of ten theatrical masks. Almost directly across from it is the House of the Dolphins, which is almost equally famous on account of the vestibule mosaic with the symbol of Tanit and the mosaic in the impluvium, which is signed by [Askle]piades of Arados.

To the E of the theater precinct is the area of the Inopos, which is made up of public buildings and private houses along the banks of the Inopos. The waters of the stream were caught at this point in a reservoir constructed in the 3d c. B.C. The most noteworthy house in the area is the House of Hermes, which backs into a hill, and for this reason are preserved the remains of four stories. The sector includes two sanctuaries. The first is the Samothrakeion, consecrated to the Great Gods of Samothrace, Dioskouroi-Kabeiroi, and including both a temple built in the 4th c. B.C. which was enlarged in the 2d c. B.C. and the Monument of Mithridates, which Helianax, priest of Poseidon Aisios and the Great Gods, consecrated in 102-101 "to the gods of whom he is priest and to King Mithridates Eupator Dionysos." The latter building consists of a square chamber with a statue of the king, and a facade with two Ionic columns in antis. Along the top of the walls ran a frieze composed of twelve medallions with half-length portraits of Mithridates' officers and allies. A little lower

down is the Sarapeion A, the oldest of the Egyptian sanctuaries of Delos. It was built in 220 B.C. by the grandson of a priest of Memphis in obedience to a dream which is recounted in a long inscription carved on a colonnette found in the sanctuary. The sanctuary itself consists of a portico, two rooms, and a courtyard, at the far end of which stands a small temple. Some distance from the House of Hermes is the Aphrodision of Stesileos, a private organization of the 4th c. It consists of a marble temple, an altar, and five oikoi.

At the foot of the Kynthos massif extends a long terrace sometimes called the Terrace of the Foreign Gods because standing on it are the Sanctuary of the Syrian Gods and a Sarapeion. The sanctuary, consecrated essentially to Atargatis and Hadad, occupies the N half of the terrace. Built in stages during the second half of the 2d c. B.C., it was administered at first by hieropolitan priests and then as an official right by Athenian priests. It consists of a square courtyard surrounded by small rooms and shrines, and a long terrace onto which a small theater opens. Here the faithful sat during the ceremonies, as is indicated by the absence of a stage and the presence of a portico which surrounds the cavea and hid the spectacle from profane eyes. To the S is the Sarapeion C, which was under official administration from the beginning of the 2d c. B.C. A dromos bordered by porticos and small sphinxes alternating with square altars leads to a large flagged courtyard. This is surrounded by several small buildings of cultic purpose, in particular the little bluish marble Temple of Serapis and the Doric distyle in antis Temple of Isis. The facade of the latter has been reconstructed and its cella still contains the big statue of Isis. The dromos of the Sarapeion C is dominated by the Heraion. This temple, Doric distyle in antis, dates from the end of the 6th c. B.C. Its foundations enclose the remains of a much smaller, earlier temple which appears to date from the beginning of the 7th c. B.C.

The summit of Mt. Kynthos was reached by three roads which ran up the N and W sides. It was originally the site of a post-Neolithic settlement dating from the last centuries of the 3d millennium B.C. The remains of huts with generally curvilinear walls, as well as various stone and earthenware artifacts, have been found under the Sanctuary of Zeus and Athena Kynthia. This Kynthion was erected in Hellenistic times, for the most part in the 3d c. B.C. Its main structures are an oikos of Zeus Kynthios and an oikos of Athena Kynthia, both Ionic distyle in antis.

The W face of Mt. Kynthos supports two sanctuaries, that of Agathe Tyche and the Den of Kynthos; the nature of the latter has long been a matter of dispute. It consists of a natural cleft in the rock covered by a ridge-roof formed by 10 enormous blocks of granite leaning against and supporting each other in pairs. Inside is a base which bore a statue of Herakles. Although the Den was long considered to have been the original Sanctuary of Apollo, it would appear in reality to have been a Hellenistic Sanctuary of Herakles. The N face of Kynthos is occupied by several sanctuaries of oriental type, such as that of the gods of Iamneia and that of the gods of Ascalon.

The stadium area is in the NE part of Delos, running along the E coast. The stadium is bordered with tiers of seats on the W and has a tribunal on the E. It is next to a gymnasium, established there in the early 3d c. B.C. and rebuilt during the Athenian period, whose central courtyard with an Ionic peristyle is flanked by rooms on two sides only. The stadium dominates a partially explored residential quarter. Nearby on the shore was the synagogue, identified by its ground-plan and

dedications to Theos Hypsistos. It was in use until the 2d c. A.D. Halfway between the stadium area and the Sanctuary of Apollo is the Archegesion or Sanctuary of Anios, mythical archegetes and king of Delos. It dates from the 6th c. B.C. but was remodeled during the Hellenistic period.

To the S of the Sanctuary of Apollo along the W shore are various ruins which have been only partially excavated. After a group of warehouses opening on the port comes a sanctuary which might be the Dioskourion. It contains various archaic and Hellenistic structures. More to the S the Asklepieion was built between the end of the 4th and the middle of the 3d c. B.C. Among other things, a propylon, an oikos, and the Doric tetrastyle temple have been found there. To the E of this sanctuary, on the side of the hill, is the exceptionally large House of Fourni.

In 69, Delos was fortified by the legate Triarios; remains of the Wall of Triarios are to be found in various places, particularly to the E of the lake area.

Most objects found on the island are preserved in the Delos museum, with the exceptions of some exceptional pieces in the National Museum of Athens. The former thus possesses a considerable collection of archaic kouroi and korai, some pieces of Classical sculpture, and a vast quantity of Hellenistic statues and reliefs. In addition it contains fragments of murals from the houses and the altars of the Compitalia; gold and ivory Mycenaean objects; ceramics from all periods, but especially from the 1st and 2d c. B.C.; Hellenistic figurines and furnishings; and hundreds of marble inscriptions.

Rheneia, to the W of Delos, has been only summarily explored. The E coast, which is that closest to Delos, contains the necropolis of the Delians. In addition to numerous tombs and funerary stelai, there have been found a columbarium from the Hellenistic period and the mass grave where the bones and funerary offerings exhumed in the "purification" of 426 were placed. A small Sanctuary of Herakles, dating from the 2d or the 1st c. B.C. has been found near the W bank.

BIBLIOGRAPHY. M. Bulard, *Monuments Piot, XIV: Peintures murales et mosaïques de Délos* (1908)[I]; *L'Exploration arch. de Délos*, 30 vols. (1909-74)[MPI]. I: A. Bellot, *Carte de l'île de Délos* (1909); II: G. Leroux, *La Salle hypostyle* (1909); II.2: R. Vallois & G. Poulsen, *Compléments* (1914); III: L. Gallois, *Cartographie de l'île de Délos* (1910); IV: L. Cayeux, *Description physique de l'île de Délos* (1911); V: F. Courby, *Le Portique d'Antigone ou du Nord-Est et les constructions voisines* (1912); VI: C. Picard, *L'Etablissement des Poseidoniastes de Bérytos* (1921); VII.1: R. Vallois, *Le Portique de Philippe* (1923); VIII: J. Chamonard, *Le Quartier du théâtre* (1922-24); IX: M. Bulard, *Description des revêtements peints à sujets religieux* (1926); X: C. Dugas, *Les vases de l'Héraion* (1928); XI: A. Plassart, *Les sanctuaires et les cultes du Mont Cynthe* (1928); XII: F. Courby, *Les Temples d'Apollon* (1931); XIII: C. Michalowski, *Les Portraits hellénistiques et romains* (1932); XIV: J. Chamonard, *Les mosaïques de la Maison des masques* (1933); XV: C. Dugas & C. Rhomaios, *Les vases préhelléniques et géométriques* (1934); XVI: F. Chapouthier, *Le Sanctuaire des dieux de Samothrace* (1935); XVII: C. Dugas, *Les vases orientalisants de style non mélien* (1935); XVIII: W. Deonna, *Le mobilier délien* (1938); XIX: E. Lapalus, *L'Agora des Italiens* (1939); XX: F. Robert, *Trois sanctuaires sur le rivage occidental* (1952); XXI: C. Dugas, *Les vases attiques à figures rouges* (1952); XXII: E. Will, *Le Dôdékathéon* (1955); XXIII: A. Laumonier, *Les figurines de terre cuite* (1956); XXIV: H. Gallet de Santerre, *La Terrasse des lions, le Létoon, le Monument de granit* (1959); XXV: J. Delorme,

Les Palestres (1961); XXVI: P. Bruneau, *Les lampes* (1965); XXVII: P. Bruneau et al., *L'Ilot de la Maison des comédiens* (1970); XXVIII: J. Audiat, *Le Gymnase* (1970); XXIX: P. Bruneau, *Les mosaïques* (1972); XXX: M.-Th. Couilloud, *Les Monuments funeraires de Rhénée* (1974); P. Roussel, *Les cultes égyptiens à Délos* (1915-16)[PI]; id., *Délos colonie athénienne* (1916); R. Vallois, *L'architecture hellénique et hellénistique à Délos* (1944, 1966) I, II; id., *Les constructions antiques de Délos* (1953)[MPI]; Gallet de Santerre, *Délos primitive et archaïque* (1958)[MPI]; P. Bruneau & J. Ducat, *Guide de Délos* (1966)[MPI]; Bruneau, "Contribution à l'histoire urbaine de Délos," *BCH* 92 (1968) 633-709; id., *Recherches sur les cultes de Délos a l'époque hellénistique et à l'époque impériale* (1970)[MPI]; J. Marcadé, *Au Musée de Délos, étude sur la sculpture hellénistique en ronde bosse découverte dans l'île* (1969)[I].

Inscriptions: IG XI 2, 4; *Inscriptions de Délos*; F. Durrbach, *Choix d'inscriptions de Délos avec traduction et commentaire* I: *Textes historiques* (1921). Only Vol. I is published. P. BRUNEAU

DELPHI Phokis, Greece. Map 11. North of the Gulf of Corinth, with the twin peaks, the Phaidriades, above it and the valley of the Pleistos river below, the city (altitude 500-700 m) is superbly situated on the slopes of Mt. Parnassos (2459 m). From there it overlooks the meeting of the roads coming from the passes of Arachova to the E and Bralo to the W, which link the Peloponnese to the Greek mainland.

History: At the beginning of the 3d millennium the city of Krisa grew up on the sea coast, on the edge of the fertile plain formed by the deposits of the Pleistos. Removed ca. 1600 B.C. to the Kriso spur, the city was destroyed at the time of the Dorian invasion. Delphi itself was settled no earlier than the Late Bronze Age: the original city, called Lykoreia, was in the region of the Korykian cave. Mycenaean Delphi, "rocky Pytho," was sacred to Athena, Gaia, who spoke oracles through the mouth of a prophetess, and very probably also to Poseidon, Dionysos, the sacred stones (the Omphalos, the Stone of Kronos), and the hero Pyrrhos-Neoptolemos. An avalanche of rocks and mud destroyed the city at the end of the Late Bronze Age.

Delphi became prosperous once again by the 8th c. when the first archaeological evidence of the cult of Pythian Apollo appears. According to the Homeric Hymn, the god seized the Earth oracle by slaying the female dragon that guarded the prophetic spring (Kassotis). Purified of this murder by a sojourn in the valley of Tempe, Apollo spoke his oracles in the Sanctuary of Gaia through a Pythia who sat on a tripod fastened on the edge (stomion) of a chasm (chasma ges) from which issued an inspiring vapor (pneuma). Its first priests were Cretans from Knossos who disembarked at Kirrha; they introduced the cult of Apollo Delphinios (dolphin), brought with them the old wooden idol (xoanon) and probably gave Pytho the name Delphi. Toward the middle of the century Trophonios and Agamedes built the first ashlar temple. The sanctuary acquired considerable treasure, arousing the envy of Kirrha, which proceeded to levy dues on the pilgrims. In the course of the first Sacred War (600-586), Kirrha was destroyed (590) by the Amphictyony, a regional association of 12 tribes (from central Greece, Attika, Euboia, the NE Peloponnese) who previously had been grouped around the Sanctuary of Demeter at Thermopylai and probably at this time chose Delphi as the second federal sanctuary. The Amphictyony reorganized and presided over the Pythian Games, held every four years in the third year of each Olympiad, and added the chariot race. At this time Delphi

became truly the "navel of the world": the oracle played an important moral role in colonization, and its fame spread as far as the barbarians. In 548, the temple having been destroyed by fire, the sanctuary was enlarged to its present size and the temple rebuilt by the Athenian family, the Alkmaionidai, with funds collected throughout the Greek world, even from Egypt. Offerings and treasure piled up. Miraculously saved from a Persian raid (480), Delphi received tributes following the Persian Wars (treasury of the Athenians after Marathon, the colossal Apollo of Salamis, golden tripod of Plataia, portico of the Athenians, golden stars of the Aiginetans, trophy of Marmaria, etc.) and minted silver coins. During the second Sacred War (448-446), the Phokians, with the support of Athens, seized the sanctuary, but it was restored to Delphi with the aid of Sparta.

The 4th c. was another golden age for architecture (Temple and Tholos of Athena Pronaia; gymnasium; treasuries of Thebes and Kyrene stadium). The Temple of Apollo, which was ruined in 373, was rebuilt under the guidance of the naopes with funds provided by Delphi, the cities of the Amphictyonic League (which levied a poll tax —epikephalos obolos—on their citizens), and the other Greeks. The building accounts were inscribed on stelai. Philip of Macedon took advantage of the endless quarrel between Delphi and Phokis (third Sacred War, 356-346) and between the Amphictyony and the Lokrians of Amphissa (fourth Sacred War, 340-338) to establish his dominion in Greece and occupy the Phokians' two seats in the Amphictyonic League. At his instigation silver staters were minted at Delphi; on one side they showed Apollo with the Omphalos and on the other Demeter, veiled.

In 278 the Aitolians repulsed a Gallic invasion (the victory was commemorated by Soteria) and exercised hegemony over the League. The kings of Pergamon showed a pious interest in the sanctuary: Attalos I, having conquered the Gauls in Asia Minor, built a collection of monuments (a portico decorated with paintings, groups of statues, an oikos, a vaulted exedra); Eumenes II and Attalos II gave funds for the schools, for the completion of the theater, and the organization of the Eumenia and Attalaia. In 191 the Romans took the place of the Aitolians as masters of Delphi (the Romaia were instituted at this time). In spite of this powerful protection the sanctuary gradually declined; it was plundered by the Maides of Thrace in 91 and by Sulla in 86. Augustus reorganized the Amphictyony and it was probably in his reign that Delphi instituted a cult of the emperors in the Tholos of Athena. In A.D. 51 Galenus sought Claudius' aid in repopulating the impoverished, half-deserted city. Nero carried off 500 statues, but Domitian restored the temple. A priest of Apollo from 105 to 126, Plutarch strove to revive the weakened religious life of the city, as did Hadrian and Antoninus later. Herodes Atticus covered the stadium with stone tiers, and in about 170 Pausanias visited the sanctuaries, finding them already dilapidated but still rich in works of art. These, however, were later plundered by Constantine and Theodosius, whose edict of 381 dealt the cult of Apollo its coup de grace. A Christian settlement was built on the ruins.

Institutions: The Amphictyony met twice a year, in the spring (the month of Bysios) and autumn (Boucatios). Each meeting, or pyle, entailed two sessions, one at Thermopylai, the other at Delphi. Consisting of 24 hieromnemons (two to each people), who if need arose were assisted by pylagorai, the council could in emergencies hold a plenary session (ecclesia) which was open to all the citizens of the Amphictyonic cities. The Amphictyony organized the Pythian Games and, together with Delphi, administered the sanctuary.

Under an oligarchic constitution, political rights being reserved for the demiurges, Delphi was governed by a yearly college of nine (?) prytaneis (the archon eponymus being probably one of them), a Boula, or council, of 15 members in charge during six months, and a popular assembly (ecclesia). The city was responsible for the oracle; it recruited the Pythia, the two priests of Apollo, the two (?) prophets, the five hosioi; collected the consulting taxes (pelanos); assigned the privilege of the promantie (consultation priority); and organized the consultations.

The Oracle: Originally, usual consultations took place only once a year on the seventh day of the month of Bysios (February-March); then at an undetermined time they became monthly (the seventh of each month). The oracle could be questioned every day in special consultations, if the signs were favorable, by those whose cities were officially represented at Delphi by a proxenus. The suppliant first paid the pelanos and provided victims for the preliminary sacrifice and the sacred table, then, following the order fixed by protocol and the drawing of lots, was led into the megaron, in the rear of which was a gap in the stone floor through which the surface of Mt. Parnassos could be seen. This was the place of the oracle (adyton, manteion, chresterion). Here were the tripod, set over the mouth of the prophetic cleft or chasma ges, the Omphalos, the sacred laurel, the suppliants' waiting chamber, Dionysos' tomb, and the golden statue of Apollo. Purified at Castalia, having drunk the water of the Kassotis and chewed laurel leaves, the Pythia, assisted by a prophet and some hosioi, took her place on the tripod and under the influence of the pneuma gave the oracle, either in words or by cleromancy (drawing of lots).

The Monuments: These are in two zones, one E (the Sanctuary of Athena, the gymnasium) and the other W (Sanctuary of Apollo, stadium) of the Kastalian Fountain (altitude 533 m) that gushes forth from the two Phaedriades, Phlemboukos and Rhodini. Traces of two fountains can still be seen, one at the spring itself, cut in the rock, the other (6th c.) built at the edge of the ancient road.

The Sanctuary of Athena Pronaia, in the area called Marmaria, stands on a terrace that was enlarged several times. In the 4th c. the terrace measured about 150 m E-W and 50 m at most N-S. The main entrance is to the E not far from the trophy (now gone) dedicated to Zeus after the defeat of the Persians (480). Beyond altars consecrated to Athena (Pronaia, Zosteria, Ergane, Hygieia), Eileithyia, and Zeus (Polieus, Machaneus) are six monuments oriented S: the Temple of Athena, a Doric peripteral (6 x 12 columns) building of tufa, was built about 500 on the site of a 7th c. temple erected over the Mycenaean sanctuary; it was in ruins in Pausanias' time. The Doric treasury, of unknown origin (c. 480) and the Aiolic treasury of Massalia, later known as the treasury of the Massaliots and the Romans (after the capture of Veii in 394?); both of them, of marble and distyle in antis, were decorated with sculptures. About 390-380, with the "money of the sacrilegious ones" who had massacred suppliants in the sanctuary, the archaic two-cella Temple of Artemis and Athena (6th c.) was replaced by the Doric limestone temple and marble Doric tholos (with Corinthian interior); the tholos was very likely consecrated to all the gods of Marmaria and later was assigned to the cult of the Roman emperors. The hoplotheca (for arms consecrated to Athena) and the Heröon of Phylakos near the sanctuary have not been identified. The gymnasium (4th c., rebuilt in Roman Imperial times) is on two terraces, one above the other, one bearing the covered portico (xystos) 177.55 m long; the other, the

palaestra with its pool. Nearby was a Sanctuary of Demeter and the Heröon of Autonoos (not identified).

The Sanctuary of Pythian Apollo is surrounded by a trapezoidal enclosure wall (195 m maximum N-S, 135 m maximum E-W) of the 6th c. (repaired in the 5th and 4th c.). Its artificial terraces (altitude: 538-601 m approximately), which form tiers on the steep mountainside, are linked by the Sacred Way. It was enlarged in the 3d c. when the W portico (Aitolian? 74 m long) and terrace of Attalos I to the E were added. It overflowed with works of art (at least 100 statues lined the first 35 m of the Sacred Way) of marble, bronze, ivory, gold, and silver (offerings of Croesus listed by Herodotos; archaic chryselephantine statues discovered in 1938 underneath the Sacred Way; golden tripod from Plataia, etc.). These were votive offerings commemorating not only Greek victories over the barbarians (Messapii, Persians, Gauls, etc.) but also victories of Greeks over Greeks. "Treasuries" abound at the first turning of the Sacred Way: those of the Sikyonians (ca. 500), Siphnos (ca. 525; admirable sculptures), Thebes (370), Athens (post-490: fine sculptures; Syracuse, "Etruscan" treasury, etc.). Passing in front of the Rock of the Sibyl and the bouleuterion (6th c.), the Sacred Way crosses the "threshing floor," the ancient meeting-place of the ecclesia not far from the prytaneum, where the prytanes gathered. The sphinx of the Naxians and the Treasury of Corinth (end of 7th c.) stand close by the Portico of the Athenians in which were kept the bronze prows and flax cables taken from the pontoon bridge that Xerxes threw over the Hellespont. Many statues were perched on the crest of walls (20 Apollos of the Liparaians), on pillars (the Messenians, Paulus Aemilius, the kings of Pergamon, Prusias), on columns or the two-columned monuments typical of Delphi (Charixenos, the Lykos-Diokles family, etc.); they formed a "crown of bronze" over the sanctuary whose splendor dazzled the invading Gauls. The Sacred Way leads up to the Altar of Chios (6th c., repaired in the 3d and 1st c.) and the temple piazza. The latter is bounded to the N by the ischegaon (4th c., rebuilt in Roman Imperial times) and to the S by the great polygonal wall (6th c.), which is covered with over 700 inscriptions, most of them records of emancipation of slaves. The 4th c. temple, which is Doric peripteral with 6 x 15 columns, was rebuilt after 373 on the consolidated and enlarged foundations of the one before it (end of the 6th c.). In the pronaos, among other things, were the Maxims of the Seven Sages engraved on herms, and in the megaron, the Altar of Hestia, the common hearth of all Greeks, that of Poseidon, and the adyton of the oracle described above. The prophetic Fountain of the Earth and the Muses, Kassotis, part of which was incorporated in the foundations of the archaic temple, was moved for reasons of safety N of the piazza, which was ringed with offerings: the Apollos of Salamis and Sitalcas, both colossal; the tripod of Plataea, the chariot of the Rhodians (4th c.), the Column of the Dancing Maiden (end of the 4th c.), the Family of Daochos of Thessaly (by Lysippus), the chariot of Polyzalos of Gela (whence the "Charioteer," ca. 475), etc. The upper region was taken up by the theater (3d-2d c.) with its 5,000 seats, the lesche (club) of the Cnidians (5th and 4th c.), the Stone of Kronos, and the Temenos of Neoptolemos at the edge of a sacred grove. At the top of the site, a few minutes' walk from the sanctuary, is the stadium. Its 7,000 seats and 178 m of track were used for the Pythian gymnastic contests as well as musical contests before there was a theater. Chariot races were held in the hippodrome down in the plain (not found).

The excavations at Delphi have yielded one of the richest collections of epigraphic material. The museum houses the most important finds, in particular a fine collection of sculpture.

BIBLIOGRAPHY. A. Tournaire, *Fouilles de Delphes: Relevés et Restauration* (1902)[PI] (hereinafter *Fouilles de Delphes* = *FD*); E. Bourguet, *Les ruines de Delphes* (1914)[PI]; G. Daux, *Pausanias à Delphes* (1936)[P]; P. de La Coste-Messelière et G. de Miré, *Delphes* (1943)[PI].

History: E. Bourguet, *De rebus delphicis imperatoriae aetatis* (1905); *L'administration financière du sanctuaire pythique* (1905), amended by G. Roux, q.v.; G. Daux, *Delphes au II et au I^e siècle avant notre ère* (1936); P. de La Coste-Messelière, *Au musée de Delphes* (1936)[PI]; L. Dor et al., *Kirrha* (1960)[MPI]; G. Roux, "Les comptes du IV^e siècle et la reconstruction du temple d'Apollon," *RA* (1966) 245ff; id., "Problèmes delphiques d'architecture et d'épigraphie," *RA* (1969) 47-56; id., "Les prytanes de Delphes," *BCH* 94 (1970) 117-32; Cl. Vatin, "Damiurges et Épidamiurges à Delphes," *BCH* 85 (1961) 316-66; id., "Les empereurs du IV^e s. à Delphes," *BCH* 86 (1962) 229-41.

Oracle & Cults: P. Amandry, *La mantique apollinienne à Delphes* (1950)[I]; H. W. Parke & D.H.W. Wormell, *The Delphic Oracle* (1956); J. Fontenrose, *Python* (1959); id., *The Cult and Myth of Pyrrhus at Delphi* (1960); W. Fauth, "Pythia," *RE* xxiv (1963); G. Roux, *Delphi* (1971)[MPI].

Monuments: 1. Marmaria: R. Demangel & G. Daux, *FD: Les temples de tuf; les deux trésors* (1923), cf. *BCH* 63 (1939) 220-31; Demangel, *FD: Topographie du sanctuaire* (1926); J. Charbonneaux & K. Gottlob, *FD: La tholos* (1925), cf. *BCH* 64-65 (1940-41) 121-27; 76 (1952) 141-96; G. Roux, "Pausanias . . . et les énigmes de Marmaria à Delphes," *REA* 67 (1965) 48-52[P]; J. P. Michaux, *FD: Le temple de calcaire* (en préparation).

2. Gymnasium: J. Jannoray, *FD: Le gymnase* (1953).

3. Fountain: A. K. Orlandos, "La fontaine . . . à Delphes," *BCH* 84 (1960) 148-60[PI].

4. Sanctuary of Apollo: J. Audiat, *FD: Le trésor des Athéniens* (1933); J. Bousquet, *BCH* 64-65 (1940-41) 128-45; id., *FD: Le trésor de Cyrène* (1952); P. de La Coste-Messelière, "Le socle marathonien de Delphes," *RA* (1949) 522-32; id., "L'offrande des Tarentins 'du bas,'" *RA* (1942-43) 5-17; id., "Topographie delphique," *BCH* 93 (1969) 730-58; P. Amandry, *FD: La colonne des Naxiens et le portique des Atheniens* (1953); E. Hanson, "Les abords du tresor de Siphnos," *BCH* 85 (1961) 387-433; J. Pouilloux et G. Roux, *Enigmes à Delphes* (1963): contains the only complete plan of the sanctuary now published; J. P. Michaux, *FD, Le trésor de Thèbes* (1973).

Terraces, etc.: E. Bourguet, "Le char des Rhodiens," *BCH* 35 (1911) 457-71; F. Courby, *FD: La terrasse du temple* (1915-27); A. Plassart, "Eschyle et le fronton est du temple," *REA* (1940) 293-99; P. Amandry, "Notes . . . d'architecture delphique," *BCH* 70 (1946) 1-17; 73 (1949) 447-63; 78 (1954) 295-315; 93 (1969) 1-38; G. Roux, "La Terrasse d'Attale I^e," *BCH* 76 (1952) 141-96; *Delphi* (1971) 88-134[MPI]; L. Robert, "De Delphes à l'Oxus," *CRAI* (1969), 416-57.

North Region: J. Pouilloux, *FD: La région nord du sanctuaire* (1960); L. Lerat, "Fouilles à Delphes," *BCH* 85 (1961) 316-66.

Theater: G. Roux, *Delphi* (1971) 162, n. 309.

Epigraphy: List of published volumes in R. Flacelière, *FD* III, 4, 178 (1954); A. Plassart, *FD* III, 5: *Inscriptions du temple* (1970). Un *Corpus des Inscriptions de Delphes* (in preparation).

Sculptures, Bronzes, miscellaneous objects: P. Perdrizet, *FD: Monuments figurés, petits bronzes . . .* (1908)[I]; Th. Homolle, *FD: Art Archaïque* (1909); P. de La Coste-Messelière & Ch. Picard, *Sculptures de Delphes* (1926)[I];

P. de La Coste-Messelière, *FD: Sculptures des temples* (1931); id., *Sculptures du trésor des Athéniens* (1957); F. Chamoux, *FD: L'Aurige* (1955); id., "Un portrait de Flamininus," *BCH* 89 (1965) 214-24; J. Marcadé, "Sculptures inédites de Marmaria," *BCH* 79 (1955) 379-406[I]; Marcadé & P. Bernard, "Sur une métope de la tholos," *BCH* 85 (1961) 447-73[I]; P. Amandry, "Rapport sur les statues chryséléphantines de Delphes," *BCH* 63 (1939) 86-119[I]; id., "Statuette d'ivoire d'un dompteur de lion,"[I] *Syria* 24 (1944-45) 149-74; id., "Plaques d'or de Delphes," *AthMitt* 77 (1962) 35-71[I]; Ch. Le Roy et J. Ducat, *FD: Terres cuites architecturales* (1967), additional bibliography in P. Amandry, "Recherches à Delphes (1938-1953)," *Acta congressus Madvigiani* I (1958) 325-40; J. F. Crome, "Die goldene Wagen der Rhodier," *BCH* 87 (1963) 209-28[I]; id., "Die Marmor-Standbilder des Daochos-Weigeschenks," *Antike Plastik* 8 (1968) 33-53[PI]; Cl. Rolley, *FD: Les statuettes de bronze* (1969)[I].

G. ROUX

DELPHINION, *see under* PITYOUSSA (Greece)

DELVINAKION, *see* LIMES, GREEK EPEIROS

DEMA PASS Attica, Greece. Map 11. The Athenian and Eleusinian (Thriasian) plains are separated by a chain of hills, chiefly Mt. Aigaleos, that runs S from Mt. Parnes to the sea W of Peiraeus and opposite Salamis. Communication between them is largely confined to a narrow S gap, through which passes the main motor road from Athens to Eleusis past Daphne, the ancient Sacred Way, and to a wide N gap between Aigaleos and Parnes, which until recently carried only the railway and a dirt track. It was through the latter that Archidamos led the Spartans in the first year of the Peloponnesian War (Thuc. 2.19.2); Agis presumably used the same route in 413 B.C. on his way to Dekeleia (Thuc. 7.17.1).

Across this N gap, at its narrowest point, is the Dema wall, a barrier built along the line of the watershed between the two plains, and planned to oppose a force coming from Eleusis. This basically rubble fieldwork is 4,360 m long, and for the S two-thirds of that length it is made up of 53 short stretches of walling, separated by openings, which, because all but two stretches overlap each other from S to N, have the form of sally ports. The two exceptions are gateways. Throughout this section the wall is massive, with a broad rampart that at times stands as much as 2 m above the ground to the W. The N third is quite different and looks unfinished. Here the line of the rubble wall is unbroken: on the lower slopes only the foundation course is apparent; on the higher slopes there are remains of a crude breastwork.

The date of the Dema's construction cannot as yet be determined with any precision. What little evidence there is might seem to favor a date in the second half of the 4th c., but a date in the first half of the 3d must also be considered a possibility. And in this period of a hundred years several occasions, from the threat of Philip after Chaironeia to the Chremonidean War might have prompted so large an undertaking. Without new evidence a choice between this or that event is probably unjustified, especially since the wall could have been built after Chaironeia and then later manned by the Macedonians.

Thirteen m to the W of the Dema wall, at the foot of Aigaleos and immediately N of the railway are the important remains of an isolated country house of the late 5th c. B.C., now buried beneath city refuse. Low rubble walls that formed socles for mudbrick outline a large rectangular structure (22 x 16 m) with the main rooms facing S onto a court through a colonnade. Ceramic evidence shows that the house was inhabited for only a short time. Historical considerations make it likely that this habitation took place between the Peace of Nikias, 421 B.C., and the Spartan occupation of Dekeleia in 413 B.C.

Three km farther W, on the highest point of a spur that lies within the pass, are the remains of a fortified enclosure known as the Thriasian Lager. The circuit contains eight towers; within are foundations of a number of buildings; a narrow fieldwork runs from the fort SE down the slope to the line of the railway. This military complex appears to be contemporary with the Dema wall, and may have been built by a force planning to invade the Athenian plain.

BIBLIOGRAPHY. J. E. Jones et al., "TO ΔEMA: A Survey of the Aigaleos-Parnes Wall," *BSA* 52 (1957) 152-89[MPI]; J. E. Jones et al., "The Dema House in Attica," *BSA* 57 (1962) 75-114[MPI]; J. R. McCredie, *Fortified Military Camps in Attica* (*Hesperia* Suppl. XI [1966]) 63-71, 107-15[MPI].

C.W.J. ELIOT

DE MEERN Utrecht, Netherlands. Map 21. Fort on the site called De Hoge Woerd, 5.5 km W of Utrecht, on the Limes Germaniae Inferioris. It was built near a river or creek now silted up. Its size is still unknown, but it was occupied from the Claudian period until ca. A.D. 250. Part of a barrack building has been found, and the foundations of what may have been a bath. Near the river some strata with level patches of charcoal may represent ustrina or perhaps small industries. Tiles with the stamps of several army units have been found. Finds are in the Provinciaal Oudheidkundig Museum, Utrecht.

BIBLIOGRAPHY. C. W. Vollgraff & G. van Hoorn, "Verslag van eene Proefgraving op de Hooge Woerd bij De Meern," *Meded. der Ned. Ak. v. Wet.* NR 4, no. 6 (1941)[PI]; J. H. Jongkees & C. Isings, *Opgravingen op de Hoge Woerd bij De Meern* (1957, 1960); J. B. Wolters, *Archaeologica Traiectina V*. Groningen (1963)[PI]; J. E. Bogaers & C. B. Rüger, *Der Niedergermanische Limes* (1974) 55-56.

C. ISINGS

DEMETRIAS Thessaly, Greece. Map 9. A city of Magnesia. It was founded in ca. 293 B.C. by Demetrios Poliorketes as a synoecism, according to Strabo (9.436, 443), of Neleia, Pagasai, Ormenion, Rhizus, Sepias, Boibe, Iolkos, and probably Kasthanaie. From inscriptions we learn that Spalauthra, Korope, Halos, Aiole, Homolion were absorbed into it then or later. Demetrias was then and through the 3d c. B.C. a strong point and harbor for the Antigonids. In 196 B.C. it fell to Rome and in 194 B.C. was made head of the Magnesian League (Livy 34.51.3). With inside help it fell to the Aitolians in 192 B.C. (Livy 35.34) and was used by Antiochus III until his retreat from Greece. The confused city was retaken by Philip V of Macedon in 191 B.C. (Livy 36.33) and remained in Macedonian control until the battle of Pydna in 167 B.C., when its fortifications were destroyed. It continued, however, as head of the reformed Magnesian League, and flourished through the Roman period, although its most splendid days were past. It was a bishopric in the Christian period, was ravaged by the Saracens in the 9th c., and declined until its desertion by 1600.

The city was long thought to be located at Goritza across the way, but has proved to be, as Strabo (9.436) stated, exactly between Pagasai and Neleia, indeed it absorbed part of the walled area of Pagasai and probably all of Neleia. Pagasai is immediately SW of Demetrias and Neleia was probably at the tip of modern Cape Pevkakia (Tarsanas) within the wall circuit of Demetrias. Demetrias is on the W shore of the Gulf of Pagasai, 3 km SE of modern Volo. Its wall included a rocky

cape (Pevkakia) jutting E into the gulf and a hill inland to the W. The low hill of the cape and the higher one inland are separated by a flat valley through which runs the modern Volo-Halmyros road. Immediately to the S of this cape is a marsh (Halykes) which may have been the S harbor of the city, and to the N a bay (N harbor) with a marsh (Bourboulithra) at its W end.

The wall of Demetrias, ca. 7 km in circumference, is fairly well preserved to several courses high along much of its length; it has largely disappeared along the shore between the Pevkakia peninsula and the Bourboulithra marsh. The enclosed acropolis is on a high point (Palatia, 170 m) on the W hill of the city. There remain 182 projecting towers, more or less evenly spaced along the wall. The wall and towers consist of a stone socle with mudbrick upper parts, the brick represented now only by some earth covering. The socle is built of rough-faced rectangular and trapezoidal blocks laid in more or less regular courses, and varying somewhat in style depending on the material at hand. It is double with a filling of stones. In some places the remains of an outer wall (proteichisma) also furnished with towers (included in the 182) may be seen. The wall must date from the early 3d c. B.C. A few of the towers at the SW end of the city were hastily enlarged, perhaps at some time between 192 and 191 B.C. in connection with the Aitolian takeover, or Antiochus' use of the city, or in the disturbed period after his departure. These towers included painted grave stelai from a necropolis immediately outside the original wall.

Several buildings are visible within the circuit. No comprehensive excavations have ever been carried out, although in the early part of the century Arvanitopoullos excavated here and there (including the stelai towers) and some areas have been cleared or recleared recently.

The civic center of the ancient city seems to have been at least partly at the base of the peninsula. Here are the foundations of a temple, perhaps originally peripteral, excavated in 1908 and recently cleared. It is attributed to Artemis Iolkia, and apparently dates to the early 3d c. B.C. Remains of its peribolos wall can be seen to the N and S of it. It appears that at least on the W side the precinct was bounded by a stoa. Within the peribolos was a Sacred Market, known from inscriptions. Just N of this is a large (54 x 55 m) building with a square central peristyle court surrounded by rooms. Stählin thought this was a market, but by analogy with, e.g., the Macedonian palace at Verghina it has recently tentatively been identified as the Antigonid palace known to have been built at Demetrias. Partially excavated and recently cleared, it is dated to the first half of the 3d c. B.C. West of this is a flat area with the remains of a terrace wall at its W side. On the peninsula are various other ruins, including a shrine of Pasikrata excavated by Arvanitopoullos. Some remains of the ancient harbor may be seen. At the tip of the peninsula recent excavations have uncovered numerous Mycenaean remains, probably those of Neleia, and some Hellenistic remains, notably those of a purple-dye factory.

The ancient theater lay at the foot of the W hill, just across the valley from the Macedonian palace(?). It was partially excavated early in the century, and finally cleared in 1958 and 1959. The edge of the orchestra was discovered, and the first row of seats. The theater apparently dates from the period of the city's foundation. Only the foundations of the Hellenistic proskenion remain. The fairly well-preserved skene is of the Late Roman period. North of the theater are two large hollow areas, and some ancient remains including washbasins. It is presumed the hippodrome and stadium were here. On

the N harbor there is a modern lighthouse. Near this in 1912 were discovered the poros foundations of a temple.

The main Late Roman and Christian settlement was evidently in the flat valley by the N harbor. Here are numerous wall remains, the foundations of a basilica, etc. Seventy-six piers of a Roman Imperial aqueduct (now called Dontia, "teeth") cross the valley from just S of the theater. In 1962 an Early Christian (late 4th c. B.C.) basilica was excavated above the S harbor of the city.

There are few remains to be seen on the city's W hill. Above the theater is a not completely understood building partially cleared in 1961. This is a complex of rooms and terraces with a rough surrounding wall, and a roadway leading to an entrance, perhaps with propylon, on the W side. There was an altar in the center of the complex. Stählin suggested the Macedonian palace might have been here, but at present this building is considered to be a shrine.

The finds from Demetrias are mainly in the Museum of Volo; some of the objects from tombs are in the Stathatos Collection in the National Museum of Athens. Perhaps the most notable group of objects is that of the painted grave stelai from the towers. Numbering ca. 400 and dating mainly from the 3d c. B.C., they are of marble, painted with encaustic, generally with farewell scenes, or single or grouped figures. Most are faded; a few retain considerable color.

BIBLIOGRAPHY. A.J.B. Wace, *JHS* 26 (1906) 170[I]; A. S. Arvanitopoullos, *Praktika* (1907) 175-82; (1909) 137-54[I]; (1910) 235-41[PI]; (1912) 154ff[I]; (1915) 159-229[I]; id., *ArchEph* (1908) 1-60[I]; id., *Graptai Stelai Demetriados—Pagason* (1928)[MPI]; id., numerous articles in *Polemon* 1-5 (1929 to 1955), mainly on the stelai; F. Stählin, *Das Hellenische Thessalien* (1924) 69-75[P]; Stählin & E. Meyer, *Pagasai und Demetrias* (1934)[MPI]; id., *BCH* 46 (1922) 518; 53.2 (1929) 507; N. D. Papahadjis, *Thessalika* 1 (1958) 16-26[MP], 50-65; 2 (1959) 22-27; D. Theocharis, *Thessalika* 3 (1960) 57-85[PI]; id., *Deltion* 16 (1960) chron. 172-74, 183[P]; 17 (1961-62) chron. 172-74[I]; 18 (1963) chron. 139f[P]; 23 (1968) chron. 263; 24 (1969) chron. 221f; id., *Praktika* (1957) 55-69[PI] (Neleia); id., *Ergon* (1957) 31-36[PI] (Neleia).

T. S. MAC KAY

DEMETRIAS, *see* DAMASCUS

DEMETRION, *see under* PYRASOS

DEMIRCIDERESI, *see* ALINDA

DEMIR KAPIJA Yugoslavia. Map 12. The name, meaning Iron Gates, is applied to the narrow pass through which the Vardar (ancient Axius) flows, ca. 24 km S of Stobi in Macedonia. High, sheer cliffs rise above the Vardar at this point and there is a small town, also called Demir Kapija, just NW of the cliffs near the modern highway.

Stenai, mentioned by Strabo (8.329.4) and other ancient writers, may have been located here. Fortifications and house walls of the pre-Greek settlement have been found near the narrows above the right bank of the river; and walls, perhaps of a watch station, are known on the cliffs above the left bank. Near the former area, but lower along the river terrace, several graves containing Greek vessels of the 5th and 4th c. B.C. have been excavated.

The Roman and Early Christian community was a few km farther to the SW along the Bošava river where a small Christian basilica (probably 6th c.) has been excavated. A number of graves of the 4th to 6th c., as well

as burials of the mediaeval period, were excavated in the vicinity. Earlier Roman funeral monuments were also found near the basilica.

BIBLIOGRAPHY. F. Papazoglu, *Makedonski gradovi u rimsko doba* (1957); B. Aleksova, *Demir Kapija* (1966).

J. WISEMAN

DEMRE, see MYRA

DERVENTIO (Little Chester) Derbyshire, England. Map 24. Mentioned as Derbentione in the *Ravenna Cosmography* (name from the Celtic name of the river Derwent). The earliest Roman occupation of Derventio almost certainly took the form of a fort on the high ground W of the Derwent. The date of its foundation is obscure, perhaps A.D. 55-65. Later, in the governorship of Cn. Julius Agricola (A.D. 78-85), a new fort site was adopted on low ground across the river. The only certain information, from the road pattern of this area, is that the site was an important junction of N-S and E-W routes.

Occupation is attested during the Hadrianic and Antonine periods and may well have been military in character. In the 3d or early 4th c. a circuit of defenses incorporating a stone wall was built, enclosing 2.4 ha; their purpose is not clear. Outside them to the N, Ryknield Street was lined with stone buildings, presumably in an extramural vicus. A group of pottery kilns 0.8 km to the E were active in the early 2d c., producing lead-glazed vessels as well as more common wares. Finds from the area are in the Derby Museum and Art Gallery.

BIBLIOGRAPHY. W. Stukeley, *Itinerarium Curiosum* I (1776) 85; G. Webster, *Derbyshire Archaeological Journal* 81 (1961) 85ff; M. Todd, ibid. 87 (1967) 70ff.

M. TODD

DERVENTIO (Malton) Yorkshire, England. Map 24. Agricolan fort on the site of an earlier legionary fortress, partly covered by a Roman town and a mediaeval castle and mansion, and just W of old Malton Priory Church. Mentioned twice as Derventione on Iter I (*Ant. It.* and *Not. dig*). The site covered a crossing of the river Derwent. The fort wall was laid on a foundation of clay and stone, and well-preserved gates with guardrooms still stood at the time of excavation. The pits of the earlier fortress lay outside the fort, and yielded an abundance of mid 1st c. pottery and tiles. This fortress may have been built by Petcilius Cericles on his advance from Lincoln to York.

The fortress was destroyed and corn from the granaries laid along the ramparts and systematically burned. This carbonized layer divides the earlier and later periods of the fort's history. Later the fortress showed signs of decay: burials were common even in the guardrooms. The later town was built along the road to the ford and on the other bank through Norton. Workshops and stores were common, and there were potters' kilns in Norton. The earliest buildings were of wood, but some of the later buildings were of stone and had mosaic floors.

G. F. WILMOT

DERVENTIO (Papcastle) Cumberland, England. Map 24. A fort for a milliary cohort or cavalry ala, probably a Trajanic foundation with occupation continuing until the late 4th c. Inscriptions record the presence of Legio VIII and, in the mid 3d c., the Cuneus Frisonum Aballavensium Phillipianorum. There was a civil settlement.

BIBLIOGRAPHY. E. B. Birley, "Roman Papcastle," *Trans. Cumberland and Westmorland Arch. Soc.* ser. 2, 63 (1963) 96-125; D. Charlesworth, "Excavations at Papcastle 1961-62," ibid. 65 (1965) 102-14.

D. CHARLESWORTH

DERVENTUM (Drevant) Cher, France. Map 23. A village 2 km S of Saint Amand-Montron, on the Cher. The river separates it from the La Groutte spur, which was the site of a very large Campignian station; this was succeeded in the Bronze Age by an oppidum that was still inhabited in the Early Iron Age and probably in the Late Iron Age.

The name Derventum comes from the Celtic dervos, one of the words for oak. After Caesar's conquest the settlement was probably transferred from the left to the right bank of the Cher. In Imperial times Derventum acquired a forum, a theater, and two sets of baths.

The forum is roughly square, 80 m on each side, and surrounded by a portico 3 m wide that was covered with tiles and had a concrete floor. The main entrance was in the middle of the E portico, outside of which was a terrace 6 m wide, reached by a flight of steps opposite the gateway giving onto the portico. The gateway had two bays separated by a pier; the socket holes and bolt frames are still visible. The S portico had three gateways to the outside, on one level; only the middle one had a matching, vaulted entrance on the square.

At each of the four outer corners of the building was a pavilion. The two framing the main facade on the E side are rectangular and divided into several rooms. The pavilion at the SE corner probably served essentially to take the thrust of the structure since its rooms have curved walls tangent to one another like the buttresses of the theater (see below). The three rooms in the NE pavilion have doors facing N. These two pavilions flanking the E portico gave the facade an appearance similar to that of many villa facades. The two on the W face are square; the S one, which is reached from the gallery, contained a well. The N pavilion apparently had no openings.

Towards the middle of the N half of the surrounding wall was a temple. The cella was 7 m square with a gallery 3 m wide around it. The facade has two antae framing a flight of steps, and faces W. The orientation of the temple wall is different from that of the forum enclosure.

The Theater of Drevant is one of the best preserved of the rustic theaters of Gaul, because of the size of the substructures supporting the cavea. The latter surrounds a horseshoe-shaped orchestra with a podium 2.6 m high around it. Encircling the outside of the cavea is a galleried passageway with seven vomitoria, three of which descend to the praecinctio. The lower part of the structure is strongly supported by two trapezoidal masses of masonry divided on the inside into vaulted galleries. The stage is a rectangular building (20 x 5 m). Moderate in dimensions (the greatest outer diameter is 85 m), this monument is a theater-amphitheater, as the presence of a podium proves.

Derventum had two, almost contiguous, bath buildings, between the theater and the forum. Hardly any traces of them can be seen today, but the plans have been recovered. The first (ca. 50 x 35 m) belongs to the category of imperial bath buildings. Apparently there was no natatio, unless it has not yet been located, but the cella maxima, which opens onto two symmetrical frigidaria, each with an apse on the exterior, can be clearly made out, as well as the caldarium, which had three pools. In the second bath building a smaller frigidarium and the tepidarium and caldarium are aligned on one side of a vast porticoed courtyard. It has been suggested that these were double baths, intended for men

and women, but they might also be summer and winter bath buildings.

The nature of the Derventum settlement has been the subject of much discussion, particularly as to whether the large space surrounding the temple should be identified as a forum or as the temenos of a sanctuary. Derventum, however, may well belong to the series of conciliabula, the complexes at Sanxay, Tours Mirandes in Poitou, Chassenon in Charente, Champlieu S of the Forêt de Compiègne, and Genainville in Vexin, to mention only the best known. Derventum shows all the characteristics of this architectural family peculiar to central and W Gaul. It is situated on the edge of the territory of the Bituriges, in a wooded, damp area beside a river. It contains typical urban monuments but no residential settlement of any importance. We have a description of a complex of this type in the inscription at Vendoeuvre en Brenne, which shows that the nucleus of these complexes was in fact a forum. At both Sanxay and Tours Mirandes the forum is of a type very common in Gaul, and Augusta Rauracorum (Augst) has the best-preserved example. The Forum of Derventum is of a less highly developed type, like that of Champlieu.

Some scholars have taken the conciliabula to be pilgrimage sanctuaries. I would suggest, however, that they may have been civic centers designed for a rural population of small landowners, and that they had been established from the Flavian period on in the outskirts of cities, on the site of public meeting places which were semi-sacred in character and dated back to the time of independence. The Vendoeuvre en Brenne inscription referred to above contains the deed setting up one of these conciliabula which was also a part of the city of the Bituriges Cubi.

BIBLIOGRAPHY. A. Grenier, *Manuel d'archéologie gallo-romaine* II, 2 (1934) Archéologie du sol, 720-21; III, 1 (1958) L'urbanisme 359-62; II, 2, Ludi et circenses, 929-36; IV, 1 (1960) Monuments des eaux, 294-97.

G. C. PICARD

DESENZANO DEL GARDA ("Decentianum") Brescia prov., Lombardy, Italy. Map 14. A Roman villa of the mid 4th c. A.D. was found here, its principal rooms arranged on a single axis. An octagonal vestibule, a peristyle, a forceps-shaped atrium, a square hall with apses on three sides, and a nymphaeum are included. On the side are other rooms for residential purposes and an annex. All the rooms have polychrome mosaic pavements. Especially notable are scenes of hunting and fishing and the scene of the Good Shepherd. A beautiful cup of beveled glass was found in the villa. Nearby is a basilica and another large private building with a bath area.

BIBLIOGRAPHY. G. Ghislanzoni, *La villa romana in Desenzano* (1962). M. MIRABELLA ROBERTI

DEUTSCH-ALTENBURG, *see* CARNUNTUM *and* LIMES PANNONIAE

DEVA or Deva Victrix (Chester) Cheshire, England. Map 24. The site of a legionary fortress, initially garrisoned by Legio II Adiutrix p. f. Established as part of the preparations for the subjugation of Wales and Brigantia, it was strategically placed at the NW extremity of the Midland plain, astride lines of communication between Wales and the N. The fortress was built on a sandstone ridge at the head of the estuary, commanded a good ford, and was at the limit of navigation for seagoing vessels. The Flavian fortress was a semipermanent base, and its defenses therefore consisted of a turf wall 6 m thick,

augmented by timber gates and towers, and fronted by a ditch 1.5 m deep and ca. 3.5 m wide.

Buildings were in the main of timber, including the principia, and (outside the defenses) the amphitheater. A large internal bath building in the E half of the praetentura was also certainly of primary date. A building inscription from its large covered palaestra records completion in A.D. 79. Lengths of lead water pipes with molded inscriptions date the completion of aqueduct and water supply to the same year, and foundation of the fortress may therefore be as early as ca. A.D. 75. Substantial fragments of the colonnading from the exercise hall have been moved and erected close to the amphitheater. Rebuilding in stone commenced under Trajan, probably soon after A.D. 102. The garrison by this time was Legio XX Valeria Victrix (from ca. A.D. 86-90). The defenses were strengthened by the addition of a stone wall 1.83 m wide at the base, narrowing to 1.37 m above offset and plinth, and standing 5 m high to the wall walk. The most substantial fragment of this wall is to be found N of the E gate and close to the Cathedral. The ditch was enlarged at this period to a width of 6 m and a depth of 3 m. There were four gates, one in each side; the sites of the E and N ones are occupied by town gates today. Little is known of any of them. Three of the corner towers have been located and explored, and the SE one has survived. Smaller towers (22) were placed at intervals between gates and corners: six have been located but none is now to be seen.

Apart from the bath building, which was used with additions and modifications at least to the 3d c., the buildings so far located are the principia, praetorium, horrea, workshops, and barracks, and fragments of the cross-hall and sacellum of the principia have been preserved. A site immediately W of the principia and praetorium was occupied by an unidentified building of an unusual elliptical plan; on the S side of the complex was an extensive suite of baths. The three granaries were placed close to the porta principalis dextra which gave access to the harbor. Barracks so far located include those of the First Cohort in latera praetorii, another group just within the porta principalis sinistra, and others E of the bath building, N of the workshops, and across the N end of the site. Store buildings and ovens have been found just within the defenses. The fortress had the usual regular street pattern, and the viae principalis, praetoria, and decumana are still in use today. Minor streets have less consistently survived: those found by excavation have been 4-6 m wide.

Half of the exceptionally large amphitheater has been preserved and may be visited. The harbor lay W of the fortress, and part of a supposed Roman quay wall still survives. An extramural bath building on this side may have been for officers; close to this was a building identified as a stable. Other fragments of Roman buildings have been found in this area, but the principal part of the vicus lay outside the E gate, beyond the parade ground. The civilian buildings, which have been little explored, extended to ca. 300 m from the E gate. At a little over 2 km E of the fortress an altar (now at Eaton Hall) indicates the source of the aqueduct, the line of which ran along the S side of Watling Street.

Although inhumation cemeteries have been located W of the fortress, the main cemetery area was S of the river in the suburb of Handbridge. On this side of the river may also be seen Roman quarries (Edgar's Field), one of which contains a much-weathered relief thought to have been of Minerva.

Building is known to have been done in the Antonine and Severan periods, and some buildings (such as the praetorium) continued to be altered and repaired well into the 4th c. At some time after A.D. 213-222, perhaps

under Constantius Chlorus, substantial portions of the N and W walls were rebuilt on a wider gauge incorporating much inscribed material. Two well-preserved stretches, complete to cornice level, may be seen in the sector between the porta decumana and the NE corner.

The fortress was rectangular with rounded corners. The short axis measured ca. 412 m and the long ca. 591 m, giving a comparatively deep retentura in which postern gates may have been provided. The area was up to a fifth greater than other British fortresses (24.3 ha). The reason is not known, although it may be significant that the fortress was placed between two powerful and hostile tribes, the Brigantes and Ordovices.

Abandonment predates the compilation of the *Notitia Dignitatum*, and is perhaps to be attributed to Magnus Maximus. Subsequent occupation of the site by Saxon *burh* and the mediaeval city has left comparatively little in situ, and archaeological exploration has been confined largely to sites cleared for rebuilding. Most of the finds are in the Grosvenor Museum, Chester, including an unusually large collection of inscribed material.

BIBLIOGRAPHY. T. N. Brushfield, "The Roman Remains of Chester," *Journal Chester Arch. Soc.* (hereafter *CASJ*) 3 (1885) 1-126; W. T. Watkin, *Roman Cheshire* (1886); J. P. Earwaker, ed., *Roman Remains in Chester* (1886); P. H. Lawson, "Schedule of the Roman Remains of Chester," *CASJ* 27 (1928) 163-89 & "Addenda," 29 (1932) 69-72 (R. Newstead); J. P. Droop & R. Newstead, "Excavations in the Deanery Field, 1928," *Liverpool AAA* 18 (1931) 6-18, 80-113; R. Newstead & J. P. Droop, "The Roman Amphitheatre at Chester," *CASJ* 29 (1932) 1-40; G. A. Webster, "Excavations on the legionary defences at Chester, 1949-1952," ibid. 39 (1952) 21-28; 40 (1953) 1-23; id., *Short Guide to the Roman Inscriptions and Sculptured Stones in the Grosvenor Museum, Chester* (rev. 1970)[PI]; R. P. Wright & I. A. Richmond, *Catalogue of the Roman Inscribed and Sculptured Stones in the Grosvenor Museum, Chester* (1955)[I]; F. H. Thompson, *Deva: Roman Chester* (1959)[MPI]; D. F. Petch & id., "The Granaries of the Legionary Fortress of Deva," *CASJ* 46 (1959) 33-60[P]; Petch, "The Praetorium at Deva," ibid. 55 (1968) 1-6[P]; id., "The Legionary Fortress of Chester," in V. E. Nash-Williams, *The Roman Frontier in Wales* (2d ed. by M. G. Jarrett, 1969)[MP]; "Excavations on the site of the Old Market Hall," ibid., 57 (1970-71) 3-26.　　D. F. PETCH

DEYR YAKUP, *see under* ANTIOCH BY THE CALLIRHOE

DHEMATI, *see* LIMES, GREEK EPEIROS

DHERVENI Macedonia, Greece. Map 9. Situated 11 km NW of Thessalonika. It is the only viable pass from the bay of the Thermaic Gulf to the region of the Langada and Volvi Lakes (the region of ancient Mygdonia). Along the narrow way and on either side of it there are ancient ruins and several discoveries have been made from time to time, probably belonging to Lete, a very ancient town with a series of silver coins dating to before 500 B.C. The town Lete received this name according to Steph. Byz. "from the temple to Leto erected in the vicinity." A Letean cavalry troop took part in Alexander the Great's expedition. A gate on the W branch of the Thessalonika walls was called Letean. The identification of the town is made possible by a famous inscription referring to a vote of Lete in favor of the quaestor M. Annius. It was found in the village of Aïvati (now Lete) near Dherveni and is kept in the Istanbul Museum. The inscription refers to the Assembly and the People of Lete as well as to the joint administration of the rulers of the city. It is dated ca. 119 B.C.

The most important remains of the site are the Macedonian tombs, the best known of which is the tomb of Langada. Movable finds from this tomb were taken to the Istanbul Museum before the liberation of Macedonia from the Turks (1912). Another Macedonian tomb less well known and incompletely excavated is to be found in the village of Laïna. Valuable finds from the Hellenistic period (reliefs, inscriptions, etc.) from the Temple of Demeter and Kore are in the Thessalonika Museum.

Under the Turkish name for passage (dherveni) the site became world-famous particularly from 15 Jan. 1962 on when amazing artifacts were discovered accidentally and later excavated. They came from about six rectangular tombs which had not been looted. Most of them are bronze (not gilt as originally thought) or silver vessels, implements, and arms. There are also gold jewelry, clay, alabaster, and glass vessels, gold coins (among them half-drachma pieces of Philip II and Alexander the Great), a head of Herakles made of gold plate, and other small objects. An especially valuable find was a papyrus discovered among the remains of a funeral pyre. It is the only papyrus found in Greece and may be the oldest one in existence (mid 4th c. B.C.). It preserves the scholia on orphic theogony of an unknown writer. The most precious discovery of the Dherveni tombs is certainly the famous bronze krater with relief ornamentation representing dionysiac rites. An inscription, in Thessalian dialect, informs us that the krater is the property of one Astion, son of Anaxagoras, from Larissa. Because the krater has not yet been published, as well as the other finds of the Dherveni tombs, its dating and evaluation are still tentative. Some date it to the third quarter of the 4th c. B.C., others tend to bring it closer to 300 B.C. All the finds of the Dherveni tombs are kept in the Thessalonika Museum, where most are on exhibit.

BIBLIOGRAPHY. Th. Macridy, "Un tumulus macédonien à Langaza," *JdI* XXVI (1911) 193ff[PI]; Dittenberger, *Sylloge*[3] (1918) 700; cf. *AntCl* 35 (1966) 430; E. Oberhummer, "Lete," *RE* XII.2 (1925) 2138; Ch. I. Makaronas, Χρονικά Ἀρχαιολογικά, Μακεδονικά 2 (1953) 616ff, nos. 42 and 44[PI]; id., Ἀρχαιότητες καὶ Μνημεῖα Κεντρικῆς Μακεδονίας, *Deltion* 18 (1963), Χρονικά, 193ff[I]; D. Kanatsoulis, Ἡ ἀρχαία Λητή (1961); E. Vanderpool, "News Letter from Greece," *AJA* 66 (1962) 389; S. G. Kapsomenos, "The Orphic Papyrus Roll of Thessalonica," *The Bulletin of the American Society of Papyrologists* 2.1 (Oct. 1964); id., Ὁ ὀρφικὸς πάπυρος τῆς Θεσσαλονίκης, *Deltion* 19 (1964) 17ff; I. G. Daux, "Chronique des Fouilles," *BCH* (1963); Ph. M. Petsas, Χρονικά Ἀρχαιολογικά 1966-1967, Μακεδονικά 7 (1967) 293ff, nos. 46,52,87 and 88[I]; id., Χρονικά Ἀρχαιολογικά Μακεδονικά 9 (1969) 136ff, nos. 37,42,46 and 64.　　PH. M. PETSAS

DHESPOTIKON (Ilion) S Albania. Map 9. Mentioned only in the *Peutinger Table*. It controls the route from the Kalamas valley in Epeiros to the Drin valley in S Albania. The Roman road probably took this route. There are remains of a powerful circuit wall ca. 750 m long.

BIBLIOGRAPHY. N.G.L. Hammond, *Epirus* (1967) 197f, 695f and Pl. XI c.　　N.G.L. HAMMOND

DHOLIANI, *see* LIMES, GREEK EPEIROS

DHRANISTA (Ano and Kato, now Ano and Kato Ktimene) Thessaly, Greece. Map 9. A modern town above the E bank of the Papitsa river (influent to the Sophaditikos), in mountainous country between the Spercheios valley and the W Thessalian plain, ca. 9 km E-NE of Lake Xynias. Just to the W of Anodhranista is a circular fortification wall of polygonal masonry, ca. 4 m

thick and ca. 240 m around. The remains of two projecting towers are preserved. A little to the S of this circuit are short stretches of two walls concentric to it, close together, which may be terrace walls or the remains of larger circuits. To the S of these are the remains of a tholos tomb excavated in 1911, which was said to have contained Geometric sherds and to have dated from the late Mycenaean-8th c. B.C. The finds have not been published.

BIBLIOGRAPHY. A. S. Arvanitopoullos, *Praktika* (1911) 347f, 351-53ᴾ; F. Stählin, *RE²* (1936) 109, s.v. Thessalia, id., *Das Hellenische Thessalien* (1924) 148f; Y. Béquignon, *BCH* 52 (1928) 452-58ᴵ; *La Vallée du Spercheios* (1937) 331-36ᴹ. T. S. MAC KAY

DHROVJAN, *see* LIMES, SOUTH ALBANIA

DIA (Bithynia), *see under* AKÇAKOCA

DIANA VETERANORUM (Zana) Algeria. Map 18. A vicus in Numidia, 90 km SW of Constantine, it became a municipium in A.D. 162, founded for the benefit of veterans of the Third Augustan Legion. In the middle of the 3d c. there was a Christian community with a bishop. The Byzantines occupied the town.

The center covered a vast area. It is in a plain which possesses numerous oil presses and remains of farms, cisterns, and wells. An aqueduct brought water from the spring of Aïn-Soltane.

Among the monuments discovered is the forum, rectangular and paved with flagstones. On the N side at the intersection with the cardo maximus, there still stands a triumphal arch with three openings, built under Macrinus (A.D. 217). The central arch, the largest, has two small bays at the sides. The architrave and frieze are small compared to the cornice, which has complicated moldings. The dedicatory inscription appears on the attic. Another arch with one bay stands on the decumanus maximus near the forum to the NE. There is a temple, possibly dedicated to Diana, in the SE part of the town.

Three monuments date from the Byzantine period. A church was built on the forum. It has a rectangular plan (33 x 17.1 m) and is orientated NW-SE. It includes a narrow vestibule and nave with a platform at the end; there is no apse, but the platform is flanked by two rooms on each side. A small fort (20.2 x 16.8 m) was attached to the Arch of Macrinus. Finally, a fort (61 x 53 m) was built about 100 m E of the forum. There are square towers at the corners. It was built with reused material and has produced important inscriptions; recently, a white limestone statue of a lion has been found near the W gate.

Several mausolea are found W of the ruins.

BIBLIOGRAPHY. S. Gsell, *Les monuments antiques de l'Algérie* (1901) I 178-79; II 339-40; *Atlas archéologique de l'Algérie* (1911) 27, no. 62; M. Leglay, "Diana Veteranorum (Zana). Statue de lion," *Libyca* 1 (1953) 284-85; *Saturne africain. Monuments* (1966) II 76-78. M. LEGLAY

DIANIUM INSULA (Giannutri) Etruria, Italy. Map 16. Originally called Artemision, the island, cited by Pliny (*HN* 3.81), was inhabited from the Stone Age but particularly during the Roman era. There are notable remains of a Roman villa, with rich living quarters, a bath complex, stores, cisterns, and harbor equipment at Cala Maestra and at Cala Scirocco. (See also Shipwrecks.)

BIBLIOGRAPHY. C. Pellegrini, *NSc* (1900) 609-23; (1901) 6; Vaccarino, *NSc* (1935) 127ff; *EAA* 3 (1960) 871-72 (G. Maetzke); A. Olschki, *Universo* (1962)

827ff; G. Uggeri & R. Bronson, *StEtr* 38 (1970) 205-7; see also G. Monaco, *FA*, vols. 14-22 and *StEtr* (Rassegna Scavi e scoperte) 28 (1960) to 34 (1966). G. MONACO

DIBIO, *see* DIVIO

DIDIM, *see* DIDYMA

DIDYMA or BRANCHIDAI (Didim, previously Yoran) Turkey. Map 7. Lies on a limestone plateau of the Milesian peninsula to the S of Miletos, with which it was once connected by the Sacred Way. To the NW is the port of Panormos (Kovella); to the W, Cape Poseidon (Tekağac burnu). According to a late tradition, it was known just before the Ionian settlement as a fountain oracle of Apollo (Paus. 7.2.6), whose prophets were descended from the Carian Branchos, the spring having apparently belonged at one time to a local goddess, comparable to the Greek Leto. The earliest literary references are in Herodotos (e.g., 1.157; 2.159; 1.92). The dedications of Necho II and Croesus show the wide influence of the oracle in archaic times. When the Ionian rebellion collapsed in 494 B.C., the Persians burned the Temple of Apollo (Temple II), which was still under construction, and carried off to Persia the cult statue of Kanachos, the treasures (Hdt. 6.19), and the Branchidian priests (Strab. 14.1.5; 11.11.4). Our knowledge of the sanctuary in the 5th and 4th c. B.C. rests on little evidence (*SIG* 57). The oracle was first revived in 331 B.C. (Strab. 17.1.43). Probably at this time the plan for the latest Temple of Apollo (III) was completed and construction begun (Vitr. 7 praef. 16). The work continued off and on during the next six centuries (Suet. *Calig.* 21). Ancient authors mention its unfinished state (Strab. 14.1.5; Paus. 7.5.4). Even in the post-archaic period it received royal endowments. Ca. 300 B.C. the Seleucids contributed to the construction and the elaboration of the rest of the sanctuary, and returned the stolen cult figure (Paus. 1.16; 8.46). The sanctuary was further enlarged in Hellenistic-Roman times; in addition to the main temple there were other shrines, a grove, and a settlement (Strab. 14.1.5). Inscriptions testify to the existence of Sanctuaries of Artemis, Zeus, and Aphrodite, and of other structures. The oracle appears to have been used, as was that of Apollo at Klaros, to give theological answers, and was finally silenced by the Theodosian Edict of A.D. 385. Signs of decline are evident prior to A.D. 250: the Hellenistic structure was plundered to provide for the erection of new buildings. The destruction of the shrine in which the cult figure stood and of other structures provided material for the building of a Christian basilica in the adyton, which stood, in spite of several earthquakes and a fire, until late into the Middle Ages. The earthquake of 1493 brought down the "whole massive marble structure of the temple" (Knackfuss).

Temple III, which lies in a hollow, rests on a seventiered foundation and is reached on the E by steps (stylobate 51.13 x 109.34 m). There was an inner ring around the cella (8 x 19 columns) and an outer one (10 x 21 columns). The plan is based on a series of axes, with the proportions of the whole determined by a standard intercolumniation (5.3 m). The deep pronaos contains 12 columns. There is no direct entrance to the cella. In the middle of the wall of the pronaos is a portal (5.62 x ca. 14 m) with a sill too high to step over. An intervening two-columned room was so dimly lit that its interior was largely invisible. Two passageways without steps led down from the inner corners of the pronaos to the adyton, treated as a courtyard open to the sky. The lower portion of its walls are plain, the upper articu-

lated with pilasters which were of the same height as the outer colonnades. A wide flight of steps leads upward toward the two-columned room. In the parastades of this stair are the doorways leading from the tunnels. The courtyard contained the oracle spring and laurels in the W part, where Zeus and Leto celebrated their nuptials; the naiskos with the cult figure was also here. The two predecessors of Temple III lay in the W half of the courtyard or adyton: the foundations of the adyton of Temple II, begun in 550-540, consisting of limestone slabs with projections for pilasters, lie between socles and the foundations of the naiskos. This temple has been reconstructed as having a pronaos with a great portal and high sill and double colonnade with 9 columns on the back, 8 with greater intercolumniation on the front, and 7 along the side, the columns having a height of some 15 m. This plan corresponds to the greater Samian Rhoikos temple (21 columns) as the column reliefs and bases in the pronaos and on the facade do to those of the Artemision at Ephesos. To Temple II belong, on the E, the surrounding round altar, brook, protecting wall of the consecration terrace with its two treasuries (later covered by the foundations of several pedestals), and in the S the stadium (starting-blocks near the SE corner of Temple III).

The side walls of Temple I, which dates from the 7th or 8th c. B.C., lie within the adyton foundation of Temple II. It consists of blocks of poros lying on the S between the first and third foundation projection, in the N by the fourth projection. The oldest naiskos as well as a hall under the steps outside Temple II on the SW date from a period of expansion. Thus, the adyta of Temples II and III, which contained the cult image, surrounded the courtyard of their predecessor. The position of the spring and the design of Temple III indicate that there must have been steps in front of the E wall of the adyton, which was pierced by three doors, to give access from the courtyard to the two-columned room, whose narrow side contains two staircases ("labyrinths") leading to the roofed part of the pronaos. The last temple did not alter the old arrangement in front of the new building. The Sacred Way, of which a segment is visible in the NW of the site, appears to have passed here.

The chronology of individual parts of Temple III can be sketched quickly: 1) the socle wall of the adyton, the naiskos, the two tunnels and parts of the krepidoma were built until 230 B.C. up to the orthostate; 2) the 29 wall segments with pilasters of the adyton, the two staircases, the doors, and the main portal were added before 165-164 B.C. At the end of this phase of construction the columns began to be transposed (12-column room, surrounding colonnade) and the limestone was leveled to receive the foundations of the colonnade, this unfinished work being carried on almost throughout the entire Imperial period; 3) the columns of the E face; and 4) after the 2d c. A.D., the addition of the Gorgon frieze and the treasury ceiling.

The finds from Didyma are in the museums in Didyma, Izmir, Istanbul, Berlin, Paris, and London (the famous "Branchides").

BIBLIOGRAPHY. B. Haussoullier, *Études sur l'histoire de Milet et du Didymeion* (1902); E. Pontremoli & B. Haussoullier, *Didymes* (1904)[MPI]; T. Wiegand, "6., 7., 8., Vorl. Bericht über die Ausgrabungen," *AbhBerl* (1908, 1911, 1925) 32-46, 35-71, 9-25[MPI]; id. & H. Knackfuss, *Didyma, I: Die Baubeschreibung* (1941) 3 vols.[MPI]; A. Philippson, *Das südl. Ionien, Milet* III 5 (1936)[M]; A. von Gerkan, "Der Tempel von Didyma und sein antikes Baumass," *ÖJh* 32 (1940) 127-50; id., "Das Säulenproblem des Naiskos von Didyma," *IstMitt* 13-14 (1963-64) 63-72; A. Rehm, *Didyma, II: Die Inschriften* (1958);

L. Robert, "Inscriptions de Didymes et de Milet"; "Sur Didymes à l'Époque Byzantine," *Hellenica* 11-12 (1960) 440-504; F. Krauss, "Die Höhe der Säulen des Naiskos im Tempel von Didyma," *IstMitt* 11 (1961) 123-33; G. Gruben, "Das archaische Didymaion," *JdI* 78 (1963) 78-182[PI]; R. Naumann & Tuchelt, "Die Ausgrabung im Südwesten des Tempels von Didyma 1962," *IstMitt* 13-14 (1963-64) 15-62[PI]; H. Drerup et al., "Bericht über die Ausgrabungen in Didyma 1962," *AA* 79 (1964) 333-84[PI]; W. Hahland, "Didyma im 5. Jh. v. Chr.," *JdI* 79 (1964) 142-240[PI]; W. Günther, "Eine neue didymeische Bauinschrift," *IstMitt* 19-20 (1969-70) 237-47; id., *Das Orakel von Didyma in Hellenistischer Zeit, IstMitt* Suppl. 4 (1971); K. Tuchelt, "Die archaischen Skulpturen von Didyma," *IstForsch* 27 (1970)[I]; id. et al., "Didyma. Bericht über die Arbeiten 1969-70," *IstMitt* 21 (1971) 45-108[PI]; id., "Vorarbeiten zu einer Topographie von Didyma," *IstMitt* Suppl. 9 (1973)[MPI]; id. et al., "Didyma. Bericht über die Arbeiten 1972-73," *IstMitt* 23-24 (1973-74)[PI]; B. Fehr, "Zur Geschichte des Apollonheiligtums von Didyma," *MarbWPr* (1971-72) 14ff[P]; W. Voigtländer, "Quellhaus und Naiskos im Didymaion nach den Perserkriegen," *IstMitt* 22 (1972) 93ff[PI]; id., "Der jüngste Apollontempel von Didyma," *IstMitt* Suppl. 14 (1974)[I]. K. TUCHELT

DIE, *see* DEA AUGUSTA VOCONTIORUM

DIEKIRCH Luxembourg. Map 21. There are prehistoric sites on the surrounding hills, and private collections (Geiben, Herr) include objects from the Palaeolithic to the Bronze and the Iron Age. A megalith near Hardt was unfortunately restored in the 19th c. (Deiwelselter). Later Diekirch became a vicus near a Roman road. Two mosaics of the middle or end of the 2d c. A.D. were found in a villa; one of them has in its center a mask which can be viewed from top or bottom, and geometrical decorations surrounding floral motifs.

At the church of St. Laurence, excavations have brought to light the remains of several Roman rooms running N-S; the walls were covered with dark purple paint, and the main room was equipped with pipes for central heating. In Early Christian times, the room was reoriented W-E and a primitive altar (built mostly with reused Roman materials) was set up in the middle of the central heating pipes; the system had broken down because of underground water infiltration. Still later sarcophagi were stored in this room, on 11 different levels.

The local museum has objects from the Herr collection, the mosaics, and finds from the nearby Roman villa at Bigelbach. St. Laurence's and its excavations can be visited by special permission from the mayor.

BIBLIOGRAPHY. J. Herr, "La préhistoire sur les plateaux de la Sûre Moyenne," *Bull. d'Arch. Luxembourgeoise* 2 (1971) 3; C. M. Ternes, *Répertoire archéologique du Grand-Duché de Luxembourg* (1971) I, 61ff with bibl.; id. *Das römische Luxemburg* (1974) 43, 65-66.
 C. M. TERNES

DIEULOUARD-SCARPONNE, *see* SCARPONNA

DIJON, *see* DIVIO

DIKTYNNAION Kisamos district, Crete. Map 11. Temple of Diktynna on E side of what was the Tityros peninsula in antiquity, 4 km SE of Cape Spatha (ancient Psakon). On N side of Menies Bay a sheer cliff provides a sheltered anchorage; on SW side is a small coastal plain at the mouth of two streams which join just above;

on S side a short peninsula, 20 m high, projects N, with two descending flat terraces. On the lower N terrace is the main temple of Diktynna.

The site is clearly identified (*Stad.* 340-42 and inscriptions). Herodotos (3.59) ascribes the building of the temple to the Samians at Kydonia (ca. 524-519), but it was probably not the first temple. The site was probably controlled originally by Kydonia (but see Skylax 47), probably by Polyrrhenia in early 3d c. (cf. *ICr* II. 131-3 no. 1), certainly by Kydonia in the 2d-early 1st c., and by Polyrrhenia after the Roman conquest of Kydonia (69 B.C.). This was the scene of the miraculous passing of Apollonios of Tyana (1st c. A.D.: Philostr. *VA* 8.30). The site is otherwise mentioned only by geographers (Skylax 47; Strab. 10.4.12,13; Pompon. Mela, 2.113; Ptol. 3.15.5; *Rav. Cosm.* 5.21). Possible civic status (and issue of coins) in the Roman period is a matter of dispute.

The sanctuary seems to have flourished especially under Hadrian and his successors, when the road down the peninsula to the sanctuary was built or rebuilt (it can be traced still in places along the peninsula, 6 m wide, and winding down to Menies with concrete terrace walls). The work was financed from the temple treasury, as were other public works in Crete in the 2d c. (an indication of its wealth). To the Hadrianic period, and perhaps connected with an imperial visit to Crete, belongs the temple of which scanty remains have been found (1942): amphiprostyle (14 x less than 33.50 m: Welter & Jantzen; 9.17 x 27.80 m: Faure) and apparently of rather hurried workmanship, with an altar to the SW, it stood in a paved courtyard surrounded on the three seaward sides by stoas resting on the retaining walls of the terrace (55 x 50 m), and on the SW side by the higher terrace, approached by steps, on which lies a row of four massive cisterns (20.10 x 11.75 m overall). Pieces of a Doric peripteral temple, apparently planned in the Augustan period but not erected, were reused in the Hadrianic temple; the terrace probably goes back to the earlier period. By the entrance propylon at the W corner of the terrace is a Roman storage building. To the SW of this and W of the cisterns may lie the site of an earlier (late 7th c.) temple. Of this and of the late 6th c. temple only sima fragments have been found, but excavation was limited to Roman levels; the earliest find is a 9th c. sherd.

In the valley below to the W and by the bay are remains (Hadrianic or later) of buildings to accommodate pilgrims, smaller houses, an odeum(?), and an agora complex(?) with a room for the imperial cult. There are remains of an aqueduct.

BIBLIOGRAPHY. R. Pococke, *Description of the East* II.1 (1745) 244-45[M]; T.A.B. Spratt, *Travels and Researches in Crete* II (1865) 196-200[I]; J.-N. Svoronos, *Numismatique de la Crète ancienne* (1890; repr. 1972) 121-24, 343; L. Savignoni, *MonAnt* 11 (1901) 295-304[M]; G. De Sanctis, ibid., 494-98; M. Guarducci, *ICr* II (1939) 128-40; G. Welter & U. Jantzen, "Das Diktynnaion," in F. Matz (ed.) *Forschungen auf Kreta, 1942* (1951) 106-17[MPI]; E. Kirsten, "Polyrrhenia," *RE* XXI (1952) 2530-48; P. Faure, *BCH* 82 (1958) 498; R. F. Willetts, *Cretan Cults and Festivals* (1962); W. Fauth, "Diktynna," *Kleine Pauly* 2 (1969) 27-29. D. J. BLACKMAN

DILIS (Senèmes) Bouches-du-Rhône, France. Map 23. Commune of Martigues, 5 km S-SW of that city, on the Mediterranean coast, near the hamlet of Laurons. Dilis is mentioned in the *Antonine Itinerary*. Surface finds include Roman coins and numerous pottery sherds. The remains of an aqueduct 2 km long with its canal carved in the rock and lined with concrete had attracted attention to the area, and in 1968 the ruins of a sizable group of Roman buildings were uncovered.

To the S, on the edge of the paved Roman road along the coast, is a large hall with a concrete floor. It opens to the E on an exedra, is surrounded by partially destroyed smaller rooms, and seems to belong to a large villa. To the N, near the beach, a larger group of buildings includes a bathing establishment; in its SE portion is a large rectangular edifice, consisting of two courtyards each containing a well, and a series of more or less similar rooms. Noteworthy are many fragments of amphorae of the so-called Spanish type, intended for salted foods, the handles of which often bear the manufacturer's mark (27 different stamps); also sigillated pottery, mostly with hemispherical lips, lightly sigillated vases of yellow clay for liquids, glass receptacles, two 1st c. lamps, bronze nails, and coins of the 1st-4th c. The buildings seem to have been constructed at the beginning of the Empire, then destroyed, perhaps by a fire, in the 3d c., and restored in the 4th c. with modifications, especially in the area of the baths.

BIBLIOGRAPHY. I. Gilles, *Les voies romaines et massiliennes dans le département des Bouches du Rhône* (1884); "Informations," *Gallia* 27, 2 (1969). A. DUMOULIN

"DILUNTUM," see STOLAC

DIMALE or Dimallon (Krotine) S Albania. Map 9. A city on a high peak of Mt. Shpiragrit. The acropolis and the residential area were enclosed by a circuit wall ca. 2400 m long. The city commanded the route along the E side of the swampy plain of Myzeqija, which led N from Apollonia. Coins and inscriptions are of the Hellenistic period. The city was occupied by Demetrius and captured by the Romans in 219 B.C. (Polyb. 3.18 and 7.9.13; cf. Livy 29.12.3).

BIBLIOGRAPHY. C. Praschniker, "Muzakhia und Malakastra," *JOAI* 21-22 (1922) 103; B. Dautaj, "La découverte de la cité illyrienne de Dimale," *Studia Albanica* (1965) 1.65ff; N.G.L. Hammond, "Illyris, Rome and Macedon in 229-205 B.C.," *JRS* 58 (1968) 12ff. N.G.L. HAMMOND

DIMALLON, see DIMALE

DINAR, see KELAINAI

DINOGETIA (Bisericuţa-Garvăn) Dobrudja, Romania. Map 12. In the NW corner of the Dobrudja, about 8 km SE of Galaţi. Earlier a Geto-Dacian settlement, it was conquered by the Romans and changed into a boundary fortress. Ptolemy (3.8.2) places it on the left bank of the Danube (near the mouth of the Siret), while the *Antonine Itinerary* (225.5) places it on the right bank, between Arrubium and Noviodunum. Apparently an earlier Roman site of the same name was transferred from the more exposed left bank of the river in the vicinity to the later site on the right bank of a small rocky island in the Danube marshes. It is mentioned by *Notitia dignitatum* (39.24).

Thoroughly rebuilt by Diocletian, the fortress continued to play an outstanding role during the reign of Constantine the Great, as well as under his successors. The last important structures, after the crisis of the 5th c., were undertaken by Anastasius and Justinian. In 559, it was burnt down during the attack of the Kotrigurs led by Zabergan. After this invasion the site continued to the end of the 6th c., but never again flourished.

Archaeological excavations have uncovered the circuit wall and the towers, as well as a number of buildings within and outside the limits of the precinct. These ruins

were heavily damaged by a feudal site built over the Roman one.

The higher part of the island, an irregularly shaped plateau of ca. 10,000 sq. m, was protected by the circuit wall (ca. 3 m wide) erected under Diocletian. Fourteen horseshoe-shaped towers increased the defensive capacity of the fortification.

The walls were made of local stone, alternating with horizontal rows of brick. The main gate of the fortress was in the middle of the S side of the circuit wall. Two smaller gates were placed on the W and N sides. The limited area of the fortress was crowded with buildings, separated by narrow streets. The praetorium, built in the same technique as the circuit wall, was near the center of the citadel. The ruins of a large house, possibly belonging to a local aristocrat, were discovered in the vicinity of the praetorium to the E. In the SW angle of the fortress a basilica, built in the 4th c., was renovated by Anastasius (several stamped bricks, carrying the name of the emperor were found among its remains and in its pavement). Other large public buildings have not yet been completely unearthed. The ruins of a Roman bath (4th c.) were brought to light outside the precinct (ca. 100 m to SE).

Some of the small finds include bricks with the stamps of the Legio V Macedonica, Cohors I Cilicum, Cohors II Mattiacorum, cl. Fl. Moesica (2d c.) and Legio I Iovia (4th c.). A bronze balance carries an inscription with the name of Flavios Gerontios, great eparchos (praefectus) of Constantinople, during the reign of Justinian.

BIBLIOGRAPHY. G. Ştefan, "Dinogetia, I," *Dacia* 7-8 (1937-40) 401-25; id., "O balanţă romană din sec. VI e.n. descoperită în Dobrogea," *Studii şi cercetări de istorie veche*, I (1950) 152-62; id., "La legio I Iovia et la défense de la frontière danubienne au IVe siècle de notre ère," *Nouvelles études d'histoire*, I (1955) 339-46; id., "Un miliario dell'epoca di Diocleziano scoperto a Garvăn (Dinogetia)," *Dacia*, NS 1 (1957) 221-27; id., "Dinogetia. A problem of ancient topography," *Dacia*, NS 2 (1958) 317-29; id. et al., *Dinogetia*, I (1967); I. Barnea, "L'incendie de la cité de Dinogetia au VIe siècle," *Dacia*, NS 10 (1966) 237-59; id., "Les Thermes de Dinogetia," *Dacia*, NS 11 (1967) 225-52; id., *Dinogetia* (2d ed. 1969).

I. BARNEA

DIOCAESAREA (Uzuncaburç) Cilicia, Turkey. Map 6. Originally the hieron of Olba, the town around the temple was incorporated as a separate city, whose first known coins were minted under Domitian but whose foundation may have dated from ca. A.D. 72 when Vespasian made one province of Cilicia. The city's history, subsequent to its separation, is virtually unknown. It may also have been known by the native name of Prakana.

The temple town is located 23 km inland at a height of 1000 m on an ancient road, paved in Roman times, which led N from Seleucia ad Calycadnum, and from the temple NW to modern Mağara (Kırobaşı), thence probably W to Claudiopolis (Mut) and over the Tauros to Laranda (Karaman). There are heroa along the road, those around Imbriogôn Komē perhaps belonging to Seleucia, one grave tower at Ovacık, ca. 9 km S-SE of Uzuncaburç, probably to Olba or Diocaesarea. Guarding the road about halfway up to the temple are watch towers and behind them a fort (Meydan Kalesi), probably built in the Hellenistic period to defend the territory of Olba. Diocaesarea and Olba are connected by a road marked by Roman milestones, the earliest dating from A.D. 75-76, others from 197 and ca. 308. How the two cities were separated and what area each controlled is not known. On imperial coinage both claimed to be

metropolis of the Kennateis, apparently the name of the local tribe. Both also claimed to be metropolis of Cetis, probably Rough Cilicia, referring to the time when Olba was capital of the country, then called Pirindu.

The city lies in a flat area among low hills. It was walled, its area roughly oval in shape, ca. 700 m E-W, 500 m N-S. Houses of the modern town are scattered around the site. The most conspicuous remains are those of the temple and a great tower. The priests of the Temple of Zeus at Olba claimed that the temple was founded by Ajax, the son of Teucer, the hero of the Trojan war, who founded Salamis in Cyprus. At present there is no evidence to confirm or deny early settlement of any sort in this upland area, or an early shrine on this spot. The temple, the earliest datable monument in the city, is peripteral, Corinthian in style, the stylobate 33.70 x 21.20 m, 6 x 12 columns, all of which save three are standing at least in part, four with capitals in position. The columns are faceted to about one-quarter of their height, fluted above. Nothing remains of the interior walls, although in 1958 the krepis of the temple was cleared and apparently revealed something of the interior arrangement. In Christian times the temple was converted to a church, the columns tied with a wall, and the two central columns of the E end removed to give space for an apse. A high peribolos wall of regular ashlar masonry surrounds the temple except on the E. Cuttings for the roof beams of a porch can be seen along the inner face of the W peribolos wall. Here an inscription records the repair by a later priest of the roof (or dwelling) of Zeus Olbios, first built by Seleucus Nicator. What building is referred to is not clear. A date of the early 3d c. B.C. has generally been agreed on for the temple but the mid 2d c. has been suggested on stylistic grounds. The temple was dedicated to Zeus, the Greek version of the native weather god, to whom the sanctuary was no doubt originally dedicated. A coin of Septimius Severus minted at Diocaesarea (Hill, *BMCCat, Lycaonia* . . . , 72, pl. 12, 14) shows a bucranium in the pediment, Nikai (?) as acroteria.

At the N edge of the city wall is a great tower of regular ashlar masonry, not quite preserved to the top, ca. 22.5 m high, about 12 x 16 m at the base, of 5 or 6 stories, divided into various rooms. There is a door on the S side, and on the E a window with balcony on the third floor. An inscription of the late 3d or early 2d c. B.C. records its building by the priest Teucer, son of Tarkyaris. Conspicuous inscriptions record a repair, possibly of the 3d c. A.D. Nothing more of the Hellenistic city remains in place.

In the 1st c. A.D. the main streets were colonnaded. One runs E-W along the N wall of the temple peribolos, with many of the columns still standing. Across the street just E of the temple are the remains of an ornamental gateway consisting of two parallel rows, each of six columns, supporting an entablature. Five at the S end are still standing. The central intercolumniation was spanned by an arch continuing the line of the entablature. The columns are unfluted, with Corinthian capitals, and have consoles to support statues protruding from them. At the W end of the street, near the city wall, are the remains of a tychaion. A row of six unfluted, monolithic, granite columns with Corinthian capitals, of which five still remain, stands at the E end of a long, narrow platform, at the W end of which is a square cella, open to the E, nearly 34 m away from the row of columns, which has an architrave. The inscription on it, dating to the second half of the 1st c. A.D., records the donation of the tychaion to the city. East of the tychaion a colonnaded street (no columns standing) leads N to a well preserved

triple arched gate in the city wall. On this is an inscription recording a complete repair (of the wall as well as the gate?) under Arcadius and Honorius (A.D. 398-405). The gate is probably of the 2d c. A.D.

The remains of the theater are to the E of the temple, just S of the E-W street. The cavea is dug into the hill; a considerable number of seats, a diazoma, and vomitorium are preserved. No remains of the scene building are visible in place, but an architrave block probably from the proscenium has an inscription to Lucius and Marcus Verus, dated A.D. 164-65, perhaps the date of the theater. The most noteworthy of the other remains in the city is a long rectangular building of the Roman period, perhaps a gymnasium, S of the temple. Outside the city, crowning a round hill ca. 1 km to the S is a grave tower, square in plan with shallow pilasters at the corners, Doric capitals and entablature, and a stepped pyramid above. This is generally considered to be the tomb of one of the priests of the Hellenistic period.

Outside the city wall along the ancient road leading to Mağara, and along a road leading NE from the city are extensive cemeteries with rock-cut tombs and sarcophagi of the Roman and Christian periods. Besides the temple church there are the remains of two other churches, one of the 4th or 5th c.

BIBLIOGRAPHY. Strab. 14.5.10; J. T. Bent, "Cilician Symbols," *CR* 4 (1890) 321-22; id., "A Journey in Cilicia Tracheia," *JHS* 12 (1891) 221; E. L. Hicks, "Inscriptions from Western Cilicia," *JHS* 12 (1891) 262-69; R. Heberdey & A. Wilhelm, *Reisen in Kilikien, Denkschr-Wien*, Phil.-Hist. Kl. 44, 6 (1896) 84-89; E. Herzfeld, *AA* 24 (1909) 434-50; J. Keil & A. Wilhelm, "Vorlaufiger Bericht über eine Reise in Kilikien," *JOAI* 18 (1915) 34-42; id., *Denkmäler aus dem Rauhen Kilikien, MAMA* III (1931) 44-79[MPI]; Y. Voysal, *Uzuncaburç ve Ura*, Milli Eğitim Bakalığı, Eski Eserler ve Müzerler Genel, Müdürlüğü Yayınlardan, ser. 1 vol. 15 (1963)[P]; T. S. MacKay, "Olba in Rough Cilicia," Diss. 1968[MI]; C. Börker, "Die Datierung des Zeus-temples von Olba-Diokaesereia," *AA* 86 (1971) 37-54[I]. T. S. MAC KAY

DIOCAESAREA (Israel), *see* SEPPHORIS

DION Greece. Map 9. A town of Pieria at the S entrance into Macedonia, named for its proximity to a shrine of Olympian Zeus (Steph. Byz.); local tradition (Paus. 9.3) held that Orpheus died and was buried there. Town and shrine were brought into prominence by King Archelaos (Diod., 17.16.3; schol. Dem. 19.192), who instituted a dramatic festival in honor of Zeus and the Muses. Philip celebrated the destruction of Olynthos at Dion (Diod. 16.15). Alexander held a nine-day festival there (Diod. 17.16.3-4; Arr. *Anab.* 1.11.1) before the campaign into Persia, and later commissioned Lysippos' statues of the Macedonian Companions who fell at the Graniko (ibid. 1.16.4). Dion was fostered by the Antigonids, and prospered until the Aitolians sacked it in 219 B.C. (Polyb. 4.2). It had recovered by 169 B.C. (Livy 44.7), and Metellus Macedonicus found Lysippos' statues still there in 147 (Vell. Pat. 1.11.3; Plin., *HN* 34.64). In Imperial times it was resettled as Colonia Julia Diensis, and flourished while its neighbor Pydna declined. It was sacked in the late 4th c. A.D., recovered briefly in the next century, but was soon abandoned altogether.

The town lies on a gentle slope between the Aegean shore and the abrupt slopes of Mount Olympos. Until recently a dense forest and unhealthful swamps impeded serious investigation, but the site has now been cleared and drained. The first excavations concentrated on two lines of paved roadway, on a basilical church building NW of their intersection, and on several Macedonian chamber tombs in the vicinity.

The city forms a rectangle, crossed by roads running roughly N-S and E-W (actually E-NE—W-SW). The more important axis, paved with large slabs and 5-5.6 m wide, runs straight from the N to the S wall, and may continue into the sanctuary area. To the W of this road the circuit wall stands out over a large moat, which may have protected the city from flooding more than from siege. The wall is difficult to trace E of the road. The foundation courses of the S wall date from the late 4th c. It is solidly built of large rectangular blocks with numerous rectangular towers at regular intervals. In the center of the W wall, a structure that may once have served for a gate was subsequently converted into a sort of Nymphaion.

On the W side of the N-S road, towards the center of the city, there is an ornamental facade with a relief depicting shields and body armor on alternate panels. Farther S the W side is lined by shops and a bath, the latter near the passage through the S wall.

The sanctuary area extends S of the city wall, apparently along the line of the N-S road. Well to the W, towards Mt. Olympos, is a theater built on an artificial embankment, an odeion, and a stadium. Between the theater and the line of the road, near a spring, inscriptional and other evidence suggests the existence of cults of Dionysos, Athena, and Kybele. On the E side of the road excavations have brought to light naiskoi of Demeter and Asklepios, along with evidence of the cults of Baubo, Artemis, Hermes, and the Muses; farther out along the line of the road inscriptions mentioning Olympian Zeus have been found.

Finds are in a small museum in the adjacent village of Malathria (officially Dion): numerous funerary monuments, cult statues, and architectural fragments. A piece of Ionic molding dated to the 5th c. B.C. gives evidence of the embellishment of the city in the time of Archelaos.

The most impressive of the Macedonian chamber tombs in the vicinity of the theater was dated to the 4th c. B.C. but is now thought to be later. Tombs have also been found at Karitsa, N of Malathria.

BIBLIOGRAPHY. W. M. Leake, *Travels in Northern Greece* III (1835) 408-13; L. Heuzey, *Le Mont Olympe* (1860) 113-28[M]; id. & H. Daumet, *Mission en Macédoine* (1876) 267-72; G. Soteriades, Excavation reports, *Praktika* (1928) 59; (1929) 69-82[I]; (1930) 36-51 (tomb)[I]; (1931) 43-55[I]; C. Macaronas, "Neai Eidēseis ek Diou tou Pierikou, Ē Thesis tou ierou tou Dios," *ArchEph* (1937) II 527-33; id., Excavation report, *Praktika* (1956) 131-38[I]; G. Bakalakis, Excavation reports, *ArchDelt* 19, 2 (1964) 344-49[PI]; 21, 2 (1966) 346-49[I]; 23, 2 (1968) 342-44[I]; "Chronique des Fouilles," *BCH* 52 (1928) 490; 53 (1929) 510; 54 (1930) 498-500; 55 (1931) 494-95; 58 (1934) 256; 80 (1956) 311-13; 81 (1957) 597-98; 90 (1966) 862-64[P]; 94 (1970) 1060; *Ergon* (1955) 48-50, 123-25; (1956) 50-52. P. A. MACKAY

DIONYSIAS (Qasr Qarûn) Egypt. Map 5. About 42 km NW of Medinet El-Faiyûm. Originally on the SW shore of Lake Moeris (now Qarûn), it is now in the desert since the lake has receded ca. 4 km NW. Because of a Roman fortress here, the site has been identified with the Dionysias noted by Ptolemy the Geographer (A.D. 90-168). It is the Dionisiada of the *Notitia dignitatum*, which enumerates the Roman garrisons at the time of Valentinian III (A.D. 425-55). Dionysias is also well known through the Archive of Flavius Abbinaeus of the 4th c.

During the late Ptolemaic period a temple, still extant,

was dedicated to Sobek, the crocodile god of the Arsino-ite nome. Another temple, dedicated to a certain war god, was near a public bath. Excavations have yielded a number of objects related to the side activities of the military community of the garrison. Most interesting is a collection of 15,000 molds datable to A.D. 315 and probably used in the forgery of coins. Of interest also are the 4th c. Christian symbols influenced by pagan frescos.

The site is scattered with broken glass, potsherds, terra-cotta fragments, bricks, and blocks of stone. The fortress (94 x 81 m), datable to the reign of Diocletian, occupies the NW part of the area. It was built of burnt bricks. At each of the four corners stands a tower (8.2 x 9.5 m) and the wall is further fortified by five smaller towers. The thickness of the walls is 4.1 m. The only access to the interior of the fortress was through a stone entrance built into the N wall and closed by a wooden door. The central part, of basilican form, leads from the door to a raised platform reached by a stone stair. Near the end stood a statue of Tyche. To the W of the fortress is the Roman temple built of bricks and decorated inside with engaged columns. Its sanctuary has the form of an apse with a vaulted roof. A funerary chapel 40 m to the W was apparently surrounded with columns. The earliest building in the area, a late Ptolemaic temple (28 x 19 m) occupies the E quarter of the site. The sanctuary, which is divided into three small chapels, is approached through a court and a corridor flanked on both sides by 14 rooms. There is also an upper floor with many rooms.

BIBLIOGRAPHY. J. Schwartz & H. Wild, *Qasr Qârûn/Dionysias*, publications of the Institut français d'Archéologie orientale du Caire (1950) 4, VIII[MPI]; Schwartz et al., *Qasr-Qarûn/Dionysias 1950*. Fouilles Franco-Suisses. Rapports II (1969); E. Brunner-Traut & V. Hell, *Aegypten* (1966) 490. S. SHENOUDA

DIONYSIAS (Soueida) Syria. Map 6. Town in the Hauran on the road from Damascus S to Bostra. The few visible remains include four columns of a peripteral temple of Nabataean times, on the main street. Their Corinthian capitals carry figurines carved above the corbel, and the entablature is adorned with vine branches.

Farther W are the remains of a large basilica with five naves, and sections of a Roman theater now hidden under houses. There are also a monumental arch, a marble fountain (dated to the time of Trajan by an inscription), and a water tower (built under Commodus), the terminal for aqueducts coming from nearby springs. The tomb of Hamrath stood on a hill beyond the ravine crossed by the ancient bridge. The tomb is now destroyed, but a bilingual Greek and Aramaic inscription dates it to the 1st c. B.C. It was a massive cube adorned with Doric pilasters, between which were sculptured helmets, breastplates, or shields; it was crowned by a Doric frieze and a stepped pyramid. A funerary tower stood at the W exit of the town.

Numerous basalt sculptures, notably a Minerva, some winged Victories, and fine mosaics are now in the Soueida and Damascus museums.

BIBLIOGRAPHY. M. de Vogüé, *Syrie centrale, Architecture civile et religieuse* (1865-77)[I]; H. C. Butler, *AAES* Pt. II, *Architecture and other Arts* (1903)[MPI]; R. E. Brünnow & A. v. Domaszewski, *Die Provincia Arabia* III (1909)[MPI]; M. Dunand, *Le Musée de Soueida* (1934)[I]. J.-P. REY-COQUAIS

DIONYSO, *see* IKARIA (Attica)

DIOSCURIAS later SEBASTOPOLIS (Sukhumi) Colchis. Map 5. A Greek city, covered over by the mod-ern town. It was probably founded by Miletos ca. 540 B.C. on the site of an earlier native settlement dating from the 2d millennium (Strab. 9.2.16,17; Plin. *HN* 6.5). From the 6th-5th c. the population was both indigenous and Greek. The section inhabited by the Greeks was destroyed by the sea. The city flourished in the 4th-3d c.; its decline coincided with its conquest by Mithridates Eupator in the late 2d c. B.C. A century later the city was conquered by Rome under whom it became a fortified center, and its economy revived. Its decline in the 4th-5th c. was accompanied by the withdrawal of Roman troops, growing pressure from the Laz state of Caucasus, and possibly a Hunnic raid.

Most of the remains date from Hellenistic times or later. Aside from the Roman fortress, of which a section still stands, there seem to have been no prominent monuments. Among articles imported in the 6th-5th c. are Greek wares (in particular, Attic bowls with a black glaze), and amphorae from Thasos and Chios; Attic bowls of the 5th-4th c.; stamped amphorae of the 4th c. and amphorae from Sinope and Herakleia of the 4th-3d c. Local wares were produced, especially in the 4th-3d c.

The city minted its own coins in the 3d c. B.C. Attic coins of the 5th-4th c. have been found as well as Hellenistic coins of the Kolchian king Saulakos. Among the few sculptures is a funerary stele of 430-420 of Ionian origin with a relief depicting a seated woman surrounded by her family.

BIBLIOGRAPHY. M. M. Trapš, "Nekotorye itogi arkheologicheskogo issledovaniia Sukhumi v 1951-1953 gg.," *SovArkh* 23 (1955) 206-27; L. A. Shervashidze & L. N. Solov'ev, "Issledovanie drevnego Sebastopolisa," *SovArkh* (1960) 3.171-79; V. A. Lekvinadze, "Oboronitel'nye sooruzheniia Sebastopolisa," *SovArkh* (1966) 1.203-10; I. B. Brašinskij, "Recherches soviétiques sur les monuments antiques des régions de la Mer Noire," *Eirene* 7 (1968) 114-15; M. P. Inadze, *Prichernomorskie goroda drevnei Kolkhidy* (1968); G. A. Lordkipanidze, *K istorii drevnei Kolkhidy* (1970).

M. L. BERNHARD & Z. SZTETYŁŁO

DITCHLEY Oxfordshire, England. Map 24. A villa 6.4 km NW of Woodstock and 5 km N of North Leigh. Though the existence of Roman buildings in Watts Wells Field had long been known, the outlines of the villa were first clearly seen on air photographs taken in 1934, and excavations were undertaken in 1935.

The first house (ca. A.D. 80) was a rectangular timber structure (14.4 x 9.6 m) set in the upper (N) part of a ditched enclosure 90 m square, with the entrance in the middle of the S side. Early in the 2d c. this was replaced by a winged-corridor house (28.2 x 14.7 m) with eight rooms and with footings at least of stone. This was subsequently enlarged by the addition of a corridor, later divided into rooms, at the rear. A well was dug in front of the house and a circular threshing floor constructed farther W, while a range of timber buildings (84 x 21 m) was erected across the S side of the enclosure. This second house appeared to have remained in use to ca. 200 (perhaps later), when it was damaged by fire. In the subsequent rebuilding (early 4th c.?) the original plan was restored but the accommodation was increased by the provision of an additional corridor along the S front and both sides, and probably by an upper story. The buildings on the S of the enclosure were abandoned but partly replaced by a granary in the SE corner; the bank surrounding the enclosure was replaced by a stone wall.

Other features outside the enclosure, observed from the air and tested on the ground, include ditches defining the approach from the S, flanked by orchards or small fields; the size of the granary led the excavator to postu-

late a cultivated area of ca. 400 ha. But while the facade of the final building seems to have had some architectural pretensions, the total absence of baths, hypocausts, and mosaics suggests a farm administered by a bailiff.

BIBLIOGRAPHY. C.A.R. Radford, *Antiquity* 9 (1935) 472-76; id., *Oxoniensia* 1 (1936) 24-69; *VCH Oxfordshire* I (1939) 311-12. A.L.F. RIVET

DIVIO or DIBIO (Dijon) Côte-d'Or, France. Map 23. On the Ouche river 30 km W of the Saône, on the border of the civitates of the Lingones and the Haedui, a fortification of the second half of the 3d c.

Gregory of Tours (*Historiae Francorum* 3.19) attributes to Aurelian the construction of the *castrum divionense*. He places it N of the Ouche, indicates that it is traversed by a small river which supplies the moat and operates the mills, and mentions the proximity, to the W, of famous vineyards. The plan of this almost square fortification, ca. 1200 m in circumference, may be reconstructed from mediaeval texts and particularly from elements of it which have been found, although often destroyed. Many of its 33 round towers are known; bases of many of them are still in place. The river that flowed through it is the Suzon, a tributary of the Ouche. Its course has changed several times, but probably it crossed the castrum N-S, fairly close to the E wall.

The only clues to the settlement before it was fortified are the numerous architectural or sculptural blocks which were reused in the rampart: funerary sculpture, stelai, piers, or fragments of large monuments, which testify to a rich necropolis and, therefore, to an important city. Three of these fragments show the same scene, the loading of a wagon. One of them bears the inscription nauta' araricus, "sailor of the Saône," suggesting that Dijon owed its existence to its position astride several routes of communication. The city profited not only from the proximity of the Saône and the Ouche valley with its easy passage to the W, but also from a network of roads. Agrippa's great Rhine road runs a little E of the Late Empire castrum. A military milepost dedicated to Tetricus was found there. Secondary roads connected the castrum with the Rhine route, and another road went to Autun.

A number of buildings and funerary monuments have been discovered, especially to the NE between the castrum and Agrippa's road, including a necropolis at the place called Les Poussots, and a rather large edifice, with a bath, at the place called Les Petites-Roches. Some of the tombs yielded terra sigillata, but none of the buildings could be dated.

The finds are in the Musée Archéologique.

BIBLIOGRAPHY. Reports of discoveries: *Mémoires de la Commission des Antiquités de la Côte-D'Or* (1832ff). Sculptures: E. Esperandieu, *Recueil général des bas-reliefs . . . de la Gaule romaine* (1907ff) III. Castrum: E. Fyot, "Le castrum divionense," *BAC* (1920) 299-321; P. Gras & J. Richard, "Le castrum de Dijon et le Suzon," *Revue archéologique de l'Est* 1 (1950) 76-87. Roads: E. Thevenot, *Les voies romaines de la Cité des Eduens, Collection Latomus* XCVIII (1969). C. ROLLEY

DIVODURUM MEDIOMATRICORUM later METTIS (Metz) Moselle, France. Map 23. The first known settlement was a Late Bronze Age oppidum that was probably destroyed by fire in the 6th c. B.C.; the site was on an isolated hill where the Moselle and the Seille meet, called the Haut de Ste. Croix. The oppidum of the Iron Age spread farther S and W; it was burnt down during Ceasar's campaign. Both a place of refuge and an economic and religious center, Divodurum was the chief town of the city of the Mediomatrici.

The Roman city that replaced it was destroyed by fire under Tiberius. The site acquired fresh importance when roads were built from Lyon to Trèves and from Reims to Strasbourg. Their junction at the foot of the Haut de Ste. Croix determined the site of the new town: the first road became the cardo, the second the decumanus, and a grid system of streets developed. This city was built of wood and was apparently destroyed again ca. A.D. 70 (troubles at the time of Nero's death). Rebuilt in stone under the Flavian emperors, it was again destroyed about the end of the 1st c. During the Pax Romana the city grew markedly along the N-S road, where remains of wealthy villas have recently been excavated.

The section built under Trajan had rather splendid baths on the hillsides, and other public buildings. This prosperity continued until the mid 3d c., when the city suffered again, possibly as a result of the invasion of the Alemanni in 257. Metz built a rampart and became a castrum, a long, irregular polygon stretching down the Haut de Ste. Croix to the Hôtel du Gouverneur, crossing from there to the Tour Camoufle, then touching the hill again in the St. Martin quarter and the Place des Paraiges. A good part of the city (the E and SE quarters and Sablon) lay outside the fortification. Again destroyed in the middle of the 4th c., the city was rebuilt on a very different plan; it is this topography that has come down to us through the mediaeval city.

The plan of Metz in the Gallo-Roman era was based on the cardo, corresponding to the Avenue Serpenoise and its continuations, and on the decumanus, now the Fournirue. Besides being at the junction of these two roads Metz was also favored by its location on the Moselle, which linked the capital of the Mediomatrici with Trèves, Coblenz, Cologne, and the Lower Rhine, and by other roads, one of which went from Metz to Worms and the Rhine. The site of the forum is still undetermined (possibly the modern Place St. Jacques). The religious center remained on the Haut de Ste. Croix, and the rest of the city spread out on terraces leading W and SW toward the Moselle. The discovery of the suburb of Sablon and its cemeteries confirmed the growth of the city along the roads to the S. The high point was in the 2d c.; at the end of the 3d c. the threat of invasion forced the city to withdraw inside its ramparts (3500 m long).

Chief public monuments: 1) the aqueduct bringing water from Gorze was ca. 22 km long, had a gradient of 22.19 m, and was apparently built in the 1st c. The first section runs underground from Gorze to Ars-sur-Moselle; the second, the aqueduct proper, crosses the Moselle between Ars and Jouy (ca. 1100 m long, gradient 4.04 m at this point); the third section, from Jouy to Metz, is half underground. Where it crossed the Moselle the aqueduct had a basin at each end linking the parts above and below ground; the basin functioned as both a purifier and a regulator. An inscription refers to the receiving and distributing basin, or nympheum, which was assumed to be at Sablon, but discoveries in 1960-61 near the church of St. Pierre-aux-Nonnains contradict this. In 1932 part of the baths was found, and later excavations confirmed that they occupied a large part of the Haut de Ste. Croix.

2) The basilica was discovered in 1941 during excavation of the church of St. Pierre-aux-Nonnains. Foundations were unearthed, at a depth of 4 m, of a civic building (26 x 31 m) with a rounded apse; erected about 310, it in turn had replaced other older buildings, including a potter's workshop containing a kiln, a storage dump of Belgian ware, and the stamp CASICOS. More foundations, presumably those of a baptistery, were found in 1959-61.

3) The amphitheater at Sablon was completely destroyed when the goods station was erected at the be-

ginning of this century. Hurried excavations showed it to be one of the largest of its kind ever built: perimeter 427 m, N-S axis 150 m, small axis 124 m, area 1.43 ha, estimated number of spectators 25,000, and 76 entrances. Only a few substructures now exist in the cellars of the quarter. Also noteworthy is a building (21 x 14 m) in the courtyard of the old bishop's palace (now a covered market); it was presumably a workshop or supply depot, of which only some foundations remain.

The Metz museum has archaeological collections.

BIBLIOGRAPHY. M. Toussaint, *Metz à l'époque gallo-romaine* (1948); J. J. Hatt, "Fouilles stratigraphiques à Metz," *Annuaire de la Société d'Histoire et d'Archéologie de Lorraine* 68 (1958) 35ff; "Fouilles de Metz," 59 (1959) 5ff. M. LUTZ

DIVONA later **CADURCI** (Cahors) Lot, France. Map 23. First called Divona, then Cadurci, Cahors was the capital of the civitas of the Cadurci throughout the Roman period and a center of pilgrimage. It owed its existence to the holy spring of Divona (undoubtedly the Fontaine des Chartreux) and to the ford (later a bridge) which allowed the crossing of the Lot. Some remains of the Roman bridge and theater still existed in the last century, but nothing of them can be seen today. However, recent housing construction in the districts W of Cahors has uncovered an "Arch of Diana" (in reality a part of the public baths), mosaics whose number and diversity may indicate the existence of a local workshop. Dwellings and their associated assemblages have been identified, and information about the aqueduct which brought the waters of the Vers from 30 km away has been gained.

BIBLIOGRAPHY. A. Viré, "Le Quercy à l'époque romaine . . . ," *Rev. arch.* 2 (1940); Jean Thiéry, "Compte rendu des découvertes faites dans les fouilles de la rue Wilson, à Cahors," *Bull. de la Soc. Et. du Lot* 71 (1950) 130-32; id., "Contribution à l'étude de l'aqueduc romain de Murcens à Cahors," ibid. 77 (1956) 14-25; M. Labrousse, "Amiantus, briquetier de Cahors," ibid. 74 (1953) 117-19; id., "A Cahors et en Quercy au temps des Romains," ibid. 75 (1954) 81-93; id., "Une statue du Cadurque M. Lucterius Leo au sanctuaire fédéral des Gaules," ibid. 76 (1955) 114-18; id., "Mosaique gallo-romaine trouvée à Cahors rue Joachim Murat," ibid. 91 (1970) 41-55.

See also M. Labrousse in *Gallia* 9 (1951) 139; 12 (1954) 227-30 & figs. 16-19; 13 (1955) 220-23 & figs. 23-26; 15 (1957) 276 & fig. 22; 17 (1959) 435; 20 (1962) 588-89 & figs. 48-49; 21 (1963) 191-225 & figs. 1-30; 22 (1964) 457-58 & figs. 36-38; 26 (1968) 546; 28 (1970) 424-26 & figs. 33-34; 30 (1972) 497-991. M. LABROUSSE

DIYARBAKIR, *see* AMIDA

DJEMILA, *see* CUICUL

DJIDJELLI, *see* IGILGILI

DJILLAOUA, *see* THIGILLAVA

DOCLEA (Duklja) Crna Gora, Yugoslavia. Map 12. At the confluence of the Zeta and Morača 10 km N of Titograd.

The Docleatae, their capital at the later Roman city of Doclea, were conquered by Octavian in 35 B.C. (App. *Ill.* 16); Pliny (*HN* 3.143) mention them as part of the conventus of Narona. Ptolemy (*Geog.* 2.16) includes them among the inhabitants of the interior of S Dalmatia. The site of the city was already occupied in the pre-Roman period, probably by one of the dependencies of Illyrian Meteon. First a civitas, then a municipium (under the Flavians), the city became the most important center in SE Dalmatia. It retained its dominant position in Diocletian's new province of Praevalitana but under Justinian was administered by the Metropolitan See at Justiana Prima (Caričingrad), and, in the early 7th c., fell to the Avars.

The site of the city is a trapezoidal plateau, bounded on the S and W by the Morača and Zeta rivers and on the N by the mountain torrent Širalija. A stone wall with towers, dating from the Roman period, surrounds the site; the defenses of the unprotected E side were augmented with a double line of ditches.

The major buildings, known from excavations at the end of the 19th c., occupy the W half of the site along the principal E-W street. Most of the monuments date from the 2d c. A.D., the period of the city's greatest prosperity.

The main gate was in the W wall where the road from Diluntum and Narona entered the city and continued E to form the principal thoroughfare. East of the gate, beyond the foundations of a triumphal arch, lies the Temple of Dea Roma, the seat of the imperial cult transferred from Epidaurum to Doclea in the 2d c. The temple, distyle in antis with a single cella and apse, is situated within a precinct opening onto the main street. Farther E is a smaller temple, enclosed in a portico connected with an elegant town house. The building is square in plan and of unknown dedication. The adjoining house is organized around a central peristyle and contains a small set of baths on its E side. The Temple of Diana, almost identical in plan to that of Dea Roma, is on the S side of the street in a peristyle temenos.

The public baths, E of the Diana Temple, were divided into men's and women's sections sharing a common entrance on the S side of the street opposite the forum. Excavations of the men's half have revealed the usual group of hot and cold rooms and a peristyle courtyard. The forum consisted of an open area, rectangular and unpaved, bordered on the N by a row of official buildings, on the E by shops, and on the W by a basilica with its long side facing the forum. The basilica is divided into two chambers with an apsed tribunal in the N wall.

In the E half of the city a three-naved Christian basilica and a small central-plan church were built.

The finds from the site are in the Archaeological Museum at Titograd.

BIBLIOGRAPHY. G. Alačević, "Rovine ed iscrizioni di Doclea," *Bullettino di archaeologia e storia dalmata* 5 (1882) 179-83; V. Petričević, "Dukljanske starine. Doclea," ibid., 13 (1890) 99-105; P. Sticotti, *Doclea, Die römische Stadt Doclea in Montenegro (Schriften der Balkankommission. Antiquarische Abteilung* 6; 1913)MPI; D. Basler, "Problem rekonstrukcije prvobitnog isgleda antičkih hramova u Duklji," *Starine Crne Gore* 1 (1963) 139-451; J. J. Wilkes, *Dalmatia* (1969)MPI; A. Boëthius & J. B. Ward-Perkins, *Etruscan and Roman Architecture* (1970)P. M. R. WERNER

DODONA Epeiros, Greece. Map 9. A city situated S of Lake Pambotis at the foot of Mt. Tomaros (mod. Olytsikas), 22 km S of Jannina. It was famed for its Sanctuary and its Oracle of Zeus which was greatly venerated, even more than that of Apollo at Delphi, which finally took its place. Homer's heroes knew this oracle and its god. Thus Achilles prays to Zeus when he wishes to see Patroklos intervene in his stead and drive the Trojans from the ships (*Il.* 16.233). He speaks of the Selli, the prophets of Zeus, who have unwashed feet and sleep on the ground. In the *Odyssey* (14.327) Odysseus is described as having gone to Dodona to consult the priests

of Zeus who interpret the sound the wind makes in the leaves of Zeus's great oak tree. In the historic period Herodotos went to Dodona (2.52) and recalls that "the oracle at Dodona is held to be the most ancient in Greece." The cult of Zeus goes back to a period before Late Helladic III, about 1200. It may have been preceded by a goddess cult, as elsewhere in Greece (Ge?). Later, in the 8th c. we find a cult of Zeus and Dione, a female paredros. Pausanias (10.12.10) talks about a chtonian goddess and, while making it quite clear that he believes none of it, tells how every year at Pothniai in Boiotia suckling pigs were thrown into the megara, in a sacred wood consecrated to Demeter and her daughter, and that the pigs reappeared at Dodona the following year. These three elements—Zeus, Dione, cult of the oak—make up the Dodonian cult. We have evidence of the sanctuary in the god's answers, inscribed on thin sheets of lead; a certain number have come down to us. Chiefly under Pyrrhos' influence (297-272) the sanctuary acquired the form in which it now appears after excavation. It was torn down by the Aitolians in 219-218, then restored, and destroyed in 168-167 by the Romans and later, in 88 B.C. by Mithridates and his Thracians. In the Augustan period the theater was made into an arena and the emperor Hadrian visited it about 132. At the end of the 4th c. A.D. it was again in ruins; the oaks were cut down and a basilica was put up ca. the 5th or 6th c.

Compared with a sanctuary like Delphi, Dodona clearly did not benefit from the building and beautification one might expect. Probably its isolated location, far from Greece proper and from busy thoroughfares, contributed to this neglect.

Even the travelers who visited it, and later the archaeologists, did not give Dodona the stature it deserved. Excavations carried out since 1944 have revealed the appearance of the sanctuary as well as its history. The theater, located by all the travelers, has been completely uncovered and restored. It dates from Pyrrhos' reign. The cavea measures 21.9 m in diameter, the stone stage 31.2 m, and the orchestra ca. 19 m in diameter. The cavea was divided into three sections of 21, 16, and 21 rows of seats, giving it a capacity comparable to that of Epidauros. Ten radiating stairways divide the cavea into nine bays each for the first and second sections and 18 bays for the third. After the destruction in the 3d c. the wooden proskenion was replaced by one of stone. Again destroyed by the Romans, the theater was made into an arena in the Augustan period.

Above the theater and sanctuary is an acropolis ringed with walls dating from the 4th c. B.C. that have in places been preserved to a height of 3 m.

The sanctuary is situated to the E, 50 m down from the acropolis, and is partly surrounded by a wall. Inside this hieron to the E is a basilica, long mistaken for an early Temple of Zeus, then three small temples that have been identified as a Temple of Aphrodite and two of Dione. Between this group of buildings and the theater is a quadrangular monument, identified as the bouleuterion. As for the actual Sanctuary of Zeus, known as Hiera Oikia, it is possible to reconstruct its history, which is clearly divided into three periods. The first dates from the 4th c., when the sanctuary consisted of a temenos with a peribolos wall around it and a sacred oak inside it, and a small rectangular monument in one corner. Next, in the Hellenistic period, the temenos was enlarged, a stoa being put up on three of its four sides. Finally, about 200 B.C., the small naiskos was rebuilt, becoming prostyle, while a small propylaea was put up in the axis of the temple to allow for passage on the S side of the stoa. The sacred oak remained in the area of the temenos, close to the E peribolos wall.

BIBLIOGRAPHY. F.C.H.L. Pouqueville, Voyage dans la Grèce . . . I (1820); v (1821); C. Diehl, Excursions archéologiques en Grèce (1890); A. Philippson & E. Kirsten, GL (1956) II.1 85-86 (with earlier bibliography); ibid. (1962) 739-48; P. Lévêque, Pyrrhos (1957)MP; S. Dakaris, Δωδώνη, Ἱερὰ Οἶκα, ArchEph 1 (1959) 193MIP; id., Das Tauzenorakel von Dodona . . . Neue Ausgrabungen in Griechenland, suppl. I in Antike Kunst (1963) 35-49MIP; id., in BCH 84 (1960) 746-48MP; id., Τὸ ἱερὸν τῆς Δωδώνης, Deltion 16 (1960) 4-40MIP; H. P. Drögemüller, Bericht über neure Ausgr. in Griechenland, Gymnasium 68 (1961) 222-26MP; N.G.L. Hammond, Epirus (1967)MP; W. Fauth, Kl. Pauly (1970). s.v. Orakel, cols. 325-27. Y. BÉQUIGNON

DOĞANBELENI, see TEICHIUSSA

DOLAUCOTHI N. Carmarthenshire, Wales. Map 24. Site of Roman gold mines near the village of Pumsaint, on the road linking the forts at Llandovery and Llanio. The mining area, the most technologically advanced in Roman Britain, comprised both sides of the mountain spur forming the S side of the Cothi valley. The mines demarcate the principal outcropping of auriferous quartz veins. The axis of their strike is roughly NE-SW and there are four lodes of varying quality. The site was first exploited in the pre-Roman period but developed enormously in scale with the Roman conquest of S Wales ca. A.D. 74. Despite two periods of modern exploitation the mines retain substantially their Roman shape, and visible remains include aqueduct systems, reservoirs, mining galleries, and opencasts.

The complex comprises: 1) Several aqueducts running down both sides of the mountain ridge. The 11.2 km Cothi aqueduct is the longest of these, bringing ca. 9-13 million liters per day to the minehead. The other main aqueduct derived from the Annell river. 2) Opencast workings and adits: the largest group lies immediately S of Ogofau Lodge. The last modern exploitation of this area located Roman galleries drained by an elaborate pumping system over 60 m below the opencast floor. These workings are now all flooded and inaccessible. 3) Traces of a settlement associated with the mines and covering much of the valley floor in the area of Pumsaint village. A fort may be involved but the area awaits excavation. In the last century remains of a bath house were located S of the village, close to the cemetery which served the mining settlement.

BIBLIOGRAPHY. Royal Commission for Ancient Monuments, Carmarthenshire (1917) 24; G.D.B. Jones & P. R. Lewis, "Dolaucothi Gold Mines I," AntJ 69 (1969) 244ff; id., The Roman Gold Mines at Dolaucothi (1971)MPI. G.D.B. JONES

DOLOJMAN, see ARGAMUM

DOMAVIA Gradina, Bosnia-Hercegovina, Yugoslavia. Map 12. Near Srebrenica ca. 85 km NE of Sarajevo on a tributary of the Drina river.

The silver-bearing lead mines in the Drina valley were probably worked by the Illyrians before the beginning of large-scale Roman activity there in the reign of Marcus Aurelius. The city, granted municipium status sometime in the 3d c. A.D., flourished as the administrative center for the mining industry in that region. Exploitation of the mines continued through the 3d c. and into the 4th c. After the reorganization of the mines by Marcus, equestrians with the title of procurator metallorum Delmaticarum et Pannoniarum administered from Domavia the mines of both Dalmatia and the adjoining Pannonia. During the Middle Ages nearby Srebrenica took the place of Domavia as the mining center in the area.

Excavations have found extensive remains of Roman mines and settlements around the city. The mines were concentrated mostly on the NE slopes of Mt. Kvarac; connected with them were several wide canals presumably related to processing the ore. Traces of smelters were also found.

The city was located on irregularly sloping terrain in a small valley. Excavations have uncovered a bath complex, some official buildings, and two residential areas. Inscriptions mention the existence of a macellum and an aqueduct built for the baths.

The baths occupy a slightly irregular square area on the E edge of the town and show two building phases. The first produced a relatively simple structure containing waiting rooms, two cold rooms, a warm and hot room. Later, in the second half of the 3d c., a more elaborate structure was built, incorporating the rooms from the first phase. In addition to the usual bath facilities, this structure included a separate set of rooms for women, provisions for dining, and an unusually large number of small rooms, perhaps reserved for officials since no other baths were discovered in the city. The floors of two heated rooms were paved with mosaics. The baths, used throughout the 3d c. and into at least the early 4th c., are the most elaborate in the province.

The group of official buildings is near the city's center. The principal structure is rectangular with an apse at the S end of its short axis; it is flanked on the E and W by smaller buildings. The larger enclosure has been interpreted as a part of the imperial procurator's residence, the town curia, or a basilica. The lack of an open forum area in the city and the presence here of a number of dedications to the various procurators indicate a public function for the building group. Domavia's residential areas were located on two level spaces on the site. The houses consisted of small single rooms built close together in the confined space available.

The finds from the site are in the Zemaljski Muzej at Sarajevo.

BIBLIOGRAPHY. W. Radimsky, "Berichte über di Ausgrabungen von Domavia bei Srebrenica in 1892 und 1893," *Wissenschaftliche Mitteilungen aus Bosnien und der Hercegovina*, 4 (1896) 202-42PI; E. Pašalić, "O antičkom rudarstvu u Bosni i Hercegovini," *Glasnik Zemaljskog Muzeja u Sarajevo*, NS 9 (1954) 47-75; id., *Antička naselja i komunikacije u Bosni i Hercegovini* (1960); J. J. Wilkes, *Dalmatia* (1969)MP.

<div style="text-align:right">M. R. WERNER</div>

DÔME (Puy de) Commune of Orcines, Puy-de-Dôme, France. Map 23. Almost at the summit of this isolated mountain (altitude 1465 m), excavations were undertaken in 1872 and resumed from 1902 to 1906. They uncovered the ruins of a temple of imposing dimensions, its plan conditioned by the topography of the site. The only entrance found was to the SE. It opened on a staircase which gave access to a wide corridor. This ran W and broadened at the end. There, another staircase led to a terrace to the N. This group of buildings formed the base of the cella, which was surrounded by a gallery and was probably open on the E side. A bronze blade bearing a dedication to Mercury and a statuette of that god, also of bronze, indicate to what god the temple was dedicated.

No fact supports the hypothesis that the colossal statue of Mercury by Zenodoros (Plin. *HN* 34.18) was located in this high place.

BIBLIOGRAPHY. A. Audollent, "Note sur les fouilles du puy de Dôme," *Académie des inscriptions et belles-lettres, comptes rendus* (1902) 299-316; id., "Le Temple de Mercure Dumias," *l'Auvergne littéraire* IV.32 (1927)

48-58; A. Grenier, *Manuel d'arch. gallo-romaine*, 3e partie, fasc. 1 (1958) 424-31.

<div style="text-align:right">P. FOURNIER</div>

DONON Bas-Rhin, France. Map 23. Sanctuary of Mercury, ca. 737 m a.s.l. on a plateau (375 x 90 m) in the Vosges Mountains on the border between Alsace and Lorraine, 43 km W of Strasbourg. No trace remains of a circuit wall reported in 1692.

Near the entrance stands a column bearing a reconstruction, from fragments found in situ, of a Jupiter and giant group, peculiar to the Rhineland: the god, as horseman, rides down a giant symbolizing barbaric or chthonic forces. Beyond, a modern exedra displays casts of some of the 30-odd stelae dedicated to Mercury, found set in the living rock at the sanctuary's highest point. Within the precinct are the remains of three religious buildings, the earliest, pre-Roman, consisting of the post-holes of a primitive hut. A structure with the remains of windows, which may have been a priest's house, is dated by an inscription (*CIL* XIII, 4550) to Trajan's reign. The third building was roofed with stone slabs, like Trajan's trophy at Adamklisi in Romania. In front of it was found a statue of a syncretized god, wearing a lion-skin, like Hercules, but bearing fruit, like Silvanus, and carrying an ax, like Gallic Esus. He wears a sword, like Mars; the stag accompanying him is an attribute of Gallic Cernunnus. He may personify the Vosges Mountains. Northwest of the third temple a well-like cavity has been taken as the tomb of a hero worshiped here along with Mercury. A small museum formerly housed some of the finds; they are now divided between the museums of Epinal and Strasbourg.

BIBLIOGRAPHY. O. Bechstein, "Der Donon und seine Denkmäler," *Jb. für Geschichte, Sprache und Litteratur Elsass-Lothringens* 7 (1891) 1-82; E. Espérandieu-R. Lantier, *Recueil général des bas-reliefs, statues et bustes de la Gaule romaine* 6 (1915) 4570-4603I; 7 (1918) 7244-46; 11 (1938) 7813, 7816; R. Forrer, *L'Alsace romaine* (1935) 170-75; A. Grenier, *Manuel d'archéologie gallo-romaine* 4 (1960) 829-40PI; J.-J. Hatt, *Inventaire des collections publiques françaises* 9 (1964) "Strasbourg: sculptures antiques regionales," nos. 19-22, 150-186I; P. MacKendrick, *Roman France* (1972) 165-67I.

<div style="text-align:right">P. MAC KENDRICK</div>

DORA Israel. Map 6. An important city on the Palestinian coast, the capital of a satrapy in the Persian period. According to Skylax (first half of 4th c. B.C.), Dora was a Tyrian colony. By the middle of the 3d c. B.C. there was a royal fortress there (I Macc. 15:11-14). When the Seleucid kingdom of Syria began to decline, Dora and nearby Strato's Tower were ruled by the tyrant Zoilus, from whom Alexander Jannaeus obtained Dora through negotiation (Joseph. *AJ* 13.324-35). After the conquest of Palestine by Pompey in 64 B.C., Dora became autonomous and was rebuilt by Gabinius (Joseph. *BJ* 1.156, 409). During the Roman period there still was a strong fortress there (*AJ* 13.223-24.324; 14.76; 15.333). On the eve of the Revolt against the Romans, the emperor's statue was placed in the local synagogue (Joseph. *Vit.* 31). In the early 3d c. A.D. Septimius Severus annexed it to Phoenicia. In the Byzantine period Dora became part of Palestina Prima. Eusebius (*Onom.* 78.9) refers to Dora as a town in ruins, a description later confirmed by the pilgrim Paula (Hieron. *Pregr. Paulae* 5).

Its remains consist of the ancient mound. Trial excavations have produced traces of continuous occupation from the Late Bronze Age to the Persian period. The remains of the Hellenistic, Roman, and Byzantine towns are by far the most extensive and cover a large area. Close to the coast are the imposing remains of a Roman

temple and theater. The city had a double harbor, the division made by a natural cliff, on which was built a massive tower. To the Byzantine period belong remains of a large church.

BIBLIOGRAPHY. J. Garstang & J. W. Phytian-Adams, *Bulletin of the British School of Archaeology in Jerusalem* 4 (1924) 35-45, pls. I-III; 6 (1924) 65-73; G. M. Fitzgerald, ibid. 7 (1925) 80-98; M. Avi-Yonah, *The Holy Land from the Persian to the Arab Conquests (536 B.C. to A.D. 640). A Historical Geography* (1966).

A. NEGEV

DORCHESTER (Dorset), see DURNOVARIA

DORCHESTER Oxfordshire, England. Map 24. A small Roman town on the left bank of the Thames, 13 km SE of Oxford. There are Belgic settlements nearby, but the first Roman phase was the establishment of an auxiliary fort soon after A.D. 43. Military buildings have been found by excavation: they were demolished ca. A.D. 78-80, and only thereafter was the town laid out. At the end of the 2d c. it received a bank and ditch, to which a wall was added ca. 270-290. The defenses were further augmented by a flat-bottomed ditch 33 m wide, possibly in the 4th c.; later still two small V-shaped ditches were dug. An inscription (*RIB* 235) shows that the town was the seat of a beneficiarius consularis, a government agent supervising traffic and supplies. The principal local industry was pottery production: from ca. 270 on its red color-coated wares won popularity throughout the province.

Excavation within the defenses has revealed masonry buildings of which the most interesting, a small three-roomed house, dates to the early 5th c. Unusually large numbers of coins point to the importance of Dorchester at this time, while close outside the walls occur burials which may be those of foederati who were perhaps placed here to defend the rich Cotswold country. Occupation in Dorchester was uninterrupted: a 6th c. hut and later Saxon building have been excavated, and in 634 the town became the seat of St. Birinus, bishop of the West Saxons.

S. S. FRERE

DORISKOS, see TRAIANOPOLIS

DORN Gloucestershire, England. Map 24. On the Fosse Way 8 km N of Stow on the Wold. A Roman settlement here had long been inferred from finds of sculptured stones, pottery, and coins (2d-4th c.); in 1960 air photographs revealed a ditched enclosure of ca. 4 ha (faintly visible on the ground) with a system of parallel streets within it. Its situation beside, not athwart, the Roman road has suggested that it may have originated as a fort, and the modern name preserves the element "duro." A sculptured panel inscribed Dea Regina (*RIB* 125) was found in 1906 at Lemington, 0.8 km to the E.

BIBLIOGRAPHY. *VCH Worcestershire* I (1901) 221; J. K. St. Joseph, *JRS* 51 (1961) 132-33; name: A. H. Smith, *Place-Names of Gloucestershire* I (1964) 235.

A.L.F. RIVET

DOUGGA, see THUGGA

DOVER, see DUBRIS

DRABESKOS (Sdravik) Macedonia, Greece. Map 9. A town in the district of the Edonoi, about 12 km N of Amphipolis on the NE side of the Angites river plain. Here the Athenian colonists from Amphipolis were besieged and massacred by the Thracians in 465 B.C. Though lacking ancient remains, modern Sdravik now seems generally accepted as the location of Drabeskos, while Daravescus of the Roman period is identified with Drama farther to the NE.

BIBLIOGRAPHY. Thuc. 4.102; W. M. Leake, *Nor. Gr.* (1835) III 183; S. Casson, *Macedonia, Thrace and Illyria* (1926) 45f; P. Collart, *Philippes* (1937) 66f, 507.

M. H. MC ALLISTER

DRAGHOMI, see LIMES, GREEK EPEIROS

DRAGUIGNAN Var, France. Map 23. At the heart of a depression surrounded by hilltops once occupied in the Celto-Ligurian period, the mediaeval and modern town is placed in the vicinity of the mutatio of Anteae. This mutatio was on the road from Forum Julii (Fréjus) to Reii Apollinares (Riez). Its exact location has not been determined. Remains of Gallo-Roman dwellings have been revealed at various places, notably at Saint-Hermentaire where excavations have uncovered a farming villa and several rooms, a complete bath installation, and various arrangements for crafts (tubs, ore furnace, etc.). Other remains of villas have been noted. A rich cremation tomb, found inside the town itself, has produced a notable silver pyxis with reliefs. At Draguignan the Centre de Documentation Archéologique du Var contains archaeological material from the whole department of the Var.

BIBLIOGRAPHY. "Chronique des circonscriptions arch.," *Gallia* (1952ff); *Provence Hist.* 3 (1953); 4 (1954).

C. GOUDINEAU

DRAJNA DE SUS Muntenia, Romania. Map 12. Roman castellum in the Subcarpathian mountains, on the road that leads to Transylvania through the Bratocea pass. The castellum is rectangular (200 x 176 m) with stone walls and towers at the corners. Among buildings discovered inside are a praetorium and a horreum. In the castellum and in the civil settlement nearby were found many tiles with stamps of the Cohors I Flavia Commagenorum and of the legions of Moesia Inferior, I Italica, XI Claudia, and V Macedonica. On the basis of the coins discovered here, it has been established that the castellum was built between 102 and 105 during the wars against the Dacians and that it was abandoned at the beginning of Hadrian's reign, along with other Roman camps of N Muntenia.

BIBLIOGRAPHY. G. Ştefan, "Le camp romain de Drajna de Sus," *Dacia* 11-12 (1945-47) 115-44.

E. DORUTIU-BOILA

DRAMONT A, see SHIPWRECKS

DREPANA (Trapani) Sicily. Map 17B. The main city of the province that bears the same name is at the NW tip of Sicily; its name (sickle), both in Greek and Latin, derives from the shape of the narrow tongue of land on which it rises.

Remains of various prehistoric settlements, as early as the paleolithic period, have been found around Trapani but for the Classical period there is no archaeological evidence since the city did not mint coinage and no public inscription has ever been found. For this reason some would deny that Drepana became civitas during the Roman period.

The ancient sources mention it as the harbor of the Erycinians from the time of the Dionysian wars (Diod. 15.73); later it became known also as the trading center of the Erycinians (Diod. 24.11). During the first year of the Punic war, i.e. ca. 260 B.C., Hamilcar moved part of Eryx's population to "the sickles" and turned the site into a fortress (Diod. 23.9).

During the summer of 249 B.C. the Romans were defeated by Aderbal in a naval battle near Drepana but recovered their losses in the naval battle which Lutatius Catulus won in 241 B.C. near the Egadi islands. Drepana

passed under Roman control, probably as censorian city, but lived meagerly, as shown by the lack of archaeological finds and by the fact that the site always remained a complementary base of the stronger Lilybaion.

The city's National Museum Pepoli has a considerable archaeological collection, including various objects of the Classical period mostly from Eryx, Selinos, and Motya.

BIBLIOGRAPHY. G. M. Columba, *Monografia storica dei porti dell'antichità nell'Italia insulare* (1906) 264ff; V. Scuderi, *Il Museo Nazionale Pepoli in Trapani* (1965).

V. TUSA

DREPANON (Haghios Georghios tis Peyias) Cyprus. Map 6. On the W coast, due NW of the village of Peyia. The ruins of a small town spread over a headland off the extremity of which lies the small island of St. George. There is no clue to the name of this town though Sakellarios suggests Tegessos. The name of the cape, however, is given by Ptolemy the geographer as Drepanon, and this name may apply also to the town.

There are massive ruins of ancient buildings and in Hogarth's day the remains of a small theater were still visible. In the seaward face of the cliff are rock-cut tombs in two tiers. The visible remains of the town date from Hellenistic, Graeco-Roman, and Early Byzantine times, after which it was abandoned, evidently at the time of the first Arab raids of A.D. 647.

Three Early Christian basilican churches with mosaic floors and a bath establishment have been uncovered in recent years, but otherwise the site remains unexcavated.

BIBLIOGRAPHY. D. G. Hogarth, *Devia Cypria* (1889); A. Sakellarios, Τὰ Κυπριακά (1890)Ⅰ; *RE*, s.v. Drepanon.

K. NICOLAOU

DREROS Crete. Map 11. A small hilltop city on one of the S spurs of Mt. Kadiston, NW of Ag. Nikolaos and just NE of modern Neapolis, Mirabello District, N Crete. The twin hill, known as Ag. Antonios, dominates the inland plain of Mirabello to the S; to the E lie Olous and Lato.

Dreros is barely mentioned in literary sources. There is no trace of Minoan occupation; the earliest remains found are Sub-Minoan. Plentiful remains of the Geometric and archaic periods attest the city's prosperity in the 8th-6th c., and a group of archaic inscriptions includes the earliest complete constitutional law yet found in Greece. In the 3d c. B.C. Dreros was an ally of Knossos and on hostile terms with Lyttos and Milatos: this is vividly expressed in the famous oath of the Drerian epheboi (late 3d c.), which also indicates dissensions within the city. In the 2d c. B.C. Dreros seems to have ceased to exist as an independent city; it became a dependency of Knossos, or possibly Lyttos. The chief deities of Dreros were Apollo Delphinios and Athena Poliouchos; the few surviving (Hellenistic) coins of the city depict the latter and the caduceus of Hermes.

The center of the city lies on the N side of the saddle between the two hilltops, overlooking the small valley of Fourni. It has the same features of an archaic Cretan town as Lato: stepped agora, nearby temple and probably prytaneion, going back to the 8th c. These remains, with those of private houses particularly on the N slope of the twin hill, illustrate well a small provincial Greek city of the Geometric period.

The agora is a large, almost rectangular area (ca. 40 m N-S x over 20 m E-W) on the N side of the saddle. At its N end, where the ground falls away, it is bounded by a polygonal retaining wall, and at the S end by a set of stone steps, probably used as seats; at the SW corner

seven rows of seats still survived when excavated. Like the agora at Lato, it bears a striking resemblance to the theatral areas by Minoan palaces, and was probably used as a meeting place for the popular assembly and for religious spectacles. The floor was of beaten earth. The steps on the S side were rebuilt in the Hellenistic period, probably when the cistern to the S was constructed; the reused blocks included one with primitive incised designs.

Above the SW corner of the agora, and approached from it by a set of steps, lie the remains of the Geometric Temple of Dreros, one of the earliest known temples of the Greek Iron Age. It is probably the Delphinion, Temple of Apollo Delphinios, or possibly that of Apollo Pythios. Its excavation followed the discovery on the site of three curious statues of hammered bronze plating, originally covering wood: a nude male and two smaller clothed female figures, probably representing Apollo, Leto, and Artemis, and dating from ca. 650-640.

The building dates probably from the second quarter of the 8th c. The cella (ca. 10.90 x 7.20 m externally) has walls, built of small dressed stones, standing up to 2.50 m high at the SW corner. The entrance was on the N, where the wall is thicker and the facade of better masonry; between the facade and the steps leading up from the agora is a shallow pronaos of uncertain plan. There may have been another entrance on the E. Within the cella was a central rectangular hearth, sunken and lined with stones, and one or two axial columns to support the roof; a round stone column-base was found in situ between hearth and entrance. In the SW corner is a stone bench for offerings, on which were found an early 6th c. bronze Gorgoneion, vases, and terracotta figurines. Later a small stone box was built beside it against the S wall—a keraton or altar of horns; the box, formed of vertical slabs (probably covered by a low wooden table), contained goats' horns, more of which were found in front along with a stone offering-table. The three bronze figures, like the altar a later addition, probably originally stood on this altar. Most of the pottery from the area is of mid 8th to early 7th c. date, and several stones incised with goat-hunting scenes have been found.

On the W side of the temple is a terrace at a higher level, probably roofed as a portico, and on the S a group of rooms which may be the prytaneion of the city: three rooms, one containing a hearth, all entered from a common vestibule. The first divinity invoked in the Drerian Oath is "Hestia in the Prytaneion." Finds here include a stone cult vase in the Minoan tradition. The building remained in use, with alterations, into the Hellenistic period.

Below the temple to the E, and S of the Agora, an enormous rectangular cistern (13.50 x 5.50 m and nearly 8 m deep) was constructed in the late 3d century B.C. An inscription recording the work and mentioning the protection of Apollo Delphinios was found in the cistern; it is contemporary with the Drerian Oath. Two walls were built and two rock-cut; all four were plastered. The cistern was probably open to the sky, and assured the water supply of the acropolis. In the upper levels of its fill on the W were found a number of blocks, probably fallen from the E wall of the Geometric temple, with archaic inscriptions of the late 7th or 6th c., including a constitutional law, a Greek-Eteocretan bilingual text (suggesting a surviving pre-Greek element in the population) and six fragmentary religious and public texts. In the lower levels on the E side were found incised blocks, clearly not from the temple, including one with graffiti similar to Minoan script and one with hammered designs curiously similar to scenes on the Ag. Triada sarcophagus.

The E hilltop seems to have been surrounded by a wall with a gate on the W side. However, the earliest remains

found here are Roman; later ones are Byzantine and Venetian. Traces of a fortification wall of various periods have also been found on the W side of the W hill, on top of which a building (24 x 10.7 m) has been excavated which, though it was originally interpreted as a temple, may rather be an andreion or meeting place for hetaireiai; it has a deep vestibule with a side room, and a main room with a hearth and 2(4?) columns. The stele bearing the Drerian Oath was found on this hill in 1854, identifying the site.

At the foot of the N slope of the E hill part of the cemetery has been excavated: 25 graves with low stone walls and an enclosure wall on the lower side. One grave contained inhumations and Sub-Minoan pottery; the rest are of Geometric date and contain mainly cremation burials, some of them in pithoi or urns, with scanty grave goods.

BIBLIOGRAPHY. E. Bürchner, "Dreros," *RE* 5 (1905) 1699; S. Xanthoudides, *Deltion* 4 (1918) Parartima I.23-30[PI]; M. Guarducci, *ICr* I (1935) 83-88; S. Marinatos, "Le temple géométrique de Dréros," *BCH* 60 (1936) 214-85[PI]; H. van Effenterre, "A propos du serment des Drériens," *BCH* 61 (1937) 327-32; id., "Une bilingue étéocrétoise?" *RevPhil* 20 (1946) 131-38; id., "Inscriptions archaïques crétoises," *BCH* 70 (1946) 588-606; id., *Nécropoles du Mirabello* (1948)[MPI]; id., "Pierres inscrites de Dréros," *BCH* 85 (1961) 544-68; id. & P. Demargne, "Recherches à Dréros," *BCH* 61 (1937) 5-32, 333-48[MPI]; E. Kirsten, "Dreros," *RE* Suppl. 7 (1940) 128-49[MP]; P. Demargne, *La Crète dédalique* (1947); R. F. Willetts, *Aristocratic Society in Ancient Crete* (1955); id., *Ancient Crete: A Social History* (1965) esp. 68-73; C. Tiré & H. van Effenterre, *Guide des fouilles françaises en Crète* (1966) 85-88[PI]. D. J. BLACKMAN

DREVANT, *see* DERVENTUM

DRNOVO, *see* NEVIODUNUM

DROBETA or Drubeta (Drobeta-Turnu Severin) Romania. Map 12. A large Dacian city that became Roman. It is mentioned by ancient sources (Ptol., *Tab. Peut.*, *Not. dig.*) as an important center on the left banks of the Danube, near the Iron Gate.

The Dacian city was conquered in 101-2 by the Romans, who settled their veterans there. Apollodorus of Damascus built a bridge across the Danube in 103-5. (Procop. *De aed.*; Dio Cass.). It is an imposing stone structure 1135 m long resting on 20 piles connecting Drobeta to Pontes (on the right bank of the river). The arches and the floor of the bridge were of wood. Some ruins (masonry of gates and piles) are still visible. Trajan had most of his troops cross this bridge during his expedition against Decebalus in A.D. 105. This bridge is represented twice on Trajan's Column: at the time of its dedication and during the passing of the troops on the N bank of the Danube. At its N end Apollodorus built a quadrilateral stone camp (123 x 137.5 m). It too is visible in the scene of the dedication of the bridge on Trajan's Column. Four gates, each at a wing of the citadel, gave access to it. Towers guarded the corners and inside there was an imposing praetorium, two horrea, and houses for the officers and soldiers. Many legions passed through it (V Macedonica, VII Claudia, IV Flavia, XIII Gemina, Cohors I Antiochiensium, etc.), but in permanent garrison there were Cohors III Campestris (2d c.), and Cohors I sagittariorum milliaria (3d c.). The latter built a large bath building on the banks of the Danube for public and military use. In the 3d c., the soldier-brickmaker Aurelius Mercurius with a labor force of 60 soldiers, repaired it.

The ruins of the ancient city (ca. 2 sq. km) are now completely covered by the modern city. Its necropoleis were located at the places now known as Parcul Rozelor and Bariera Craiovei. During the first half of the 3d c., the city was surrounded by a moat, a vallum, and a wall, the remains of which were still visible during the last century. At the founding of Dacia inferior (118-19), Hadrian granted Drobeta the rank of municipium and ca. 198-208 Septimius Severus raised it to the rank of colonia. The inscriptions show that inhabitants of the city included Dacians, Romans, Thracians, Celts, and Orientals. It attracted veterans, who generally came from the Danube Valley garrisons and were landowners or communal magistrates. Many merchants also came, attracted by the traffic facilitated by the bridge, the port of Drobeta, and the Roman road that led along the left bank of the river. A large agricultural-grazing area surrounded the city, extending as far as the Cerna and Jiu rivers. For construction, Drobeta used stone from the quarries of the Iron Gate area and Breznița. Terra sigillata vases as well as various metal objects attest to its trade relations with all the provinces of the Empire, from Gaul to Phoenicia and Egypt. In the city there was also a collegium fabrum. An inscription of the time of Septimius Severus mentions a tabularium of a fiscal customs office directed by two servi villici. Among the most popular gods of Drobeta were Cybele (a temple), Iupiter Zbelsurdos, Mithra, and Venus. Even after the abandonment of Dacia, Drobeta remained under Roman domination since it was an important bridgehead on the N bank of the Danube.

In the 4th c., the camp was reconstructed (Diocletian? Constantine the Great?), fortified, and provided with well-defended gates and towers. But the attack of Attila against the Empire of the East was to destroy it. The disaster was so great that even the ancient Geto-Dacian name was lost and when Justinian constructed a defense tower on the ruins of ancient Drobeta, he called it Theodora.

The objects found during excavations are in the Iron Gate Museum at Turnu Severin and in the National Museum at Bucharest.

BIBLIOGRAPHY. *CIL* III, 1582-87; 6279; 8006-21; 8032; 8062-76; 14216, 1-16, 28; 14484; *AnÉpigr* (1914) 117, 118; (1939) 19, 369; (1944) 100; (1959) 309-17.

L. F. de Marsigli, *Description du Danube* (1744) passim; V. Pârvan, "Știri nouă din Dacia Malvensis," *ACRMI* 36 (1931) 1-10; A. Bărcăcilă, *Drubeta: une ville daco-romaine* (1938); G. Florescu, "Castrul roman Drobeta," *Revista Istorică Română* 3 (1933) 54-77; D. Tudor, *Drobeta* (1965); id., *Oltenia romană* (3d ed., 1968) passim; id., *Orașe* (1968) 289-303; id., *Podurile romane de la Dunărea de Jos* (1971) 53-153.

For Apollodorus, see W. L. MacDonald, *The Architecture of the Roman Empire* I (1965) 129-37.
 D. TUDOR

DROITWICH, *see* SALINAE

DRUBETA, *see* DROBETA

DRUMBURGH, *see* CONGAVATA *under* HADRIAN'S WALL

DRYMAIA or DRYMOS NW Phokis, Greece. Map 11. Probably on the frontier with Doris; located on S foothills of Mt. Kallidromos, on the side road to Glounista village. Several inscriptions are built into a church in the village (*IG* IX 1.226-23 refers to the name). Drymaia was burned by the Persians in 480 B.C.

The citadel was on a projecting spur, the lower town in the plain to the S, where the walls can be traced around an area of ca. 0.20 sq. km. Among the foundations in the

plain are some that Frazer conjectured may have belonged to a temple; Pausanias (10.33.12) mentions a temple and festival of Demeter Thesmophoros, with an archaic cult-statue. Sherds run into Roman Imperial times.

The walls are well preserved on the summit and S slopes of the hill. The masonry is massive trapezoidal; some towers still stand 7-8 m high. Loopholes preserved in the middle of the field face may have been designed for bolt-throwing artillery (oxybeleis); for the existing circuit, like many others in Phokis, seems to date from the last third of the 4th c. There is a gate (partly ancient) in the cross wall separating the acropolis from the city, and traces of another gate seem to be preserved in the E wall, at the foot of the acropolis.

BIBLIOGRAPHY. J. G. Frazer, *Paus. Des. Gr.* (1898) v 423-24; J. B. Tillard, *BSA* 17 (1910-11) 54ffM; F. Schober, *Phokis* (1924) 28; F. E. Winter, *Greek Fortifications* (1971) 36, 158I. F. E. WINTER

DRYMOS, *see* DRYMAIA

DUBRAVICA, *see* MARGUM

DUBRIS (Dover) Kent, England. Map 24. The Roman fort lies beneath the modern city in a valley between steep chalk hills, close to the sea. The site was probably continuously occupied from the time of the Roman invasion of A.D. 43. The nature of the 1st c. occupation is uncertain, but in the 2d c. a fort was constructed to house a detachment of the Classis Britannica. Part of the wall, a gate, and a series of internal buildings belonging to the fort were discovered in 1970. At a later date, probably towards the end of the 3d c., the old structure was replaced by a more substantial fort of the Saxon Shore series. Its extent is at present unknown but it must have enclosed an area of over 2.4 ha. Traces of other buildings, as well as evidence of wharves and jetties, have come to light from time to time. The finds are housed in the City Museum.

On the E hill, within what is now Dover Castle, stand the remains of a well-preserved Roman lighthouse. The structure is octagonal in plan outside but rectangular inside. Originally it would have stood ca. 24 m high with the outer face stepped back in eight stages, but only four Roman stages now remain. It was built of flint rubble faced with limestone blocks and bonded with tile courses. Its window openings and doors are well preserved. Fragments of another lighthouse survive on the W heights on the far side of the valley.

BIBLIOGRAPHY. E.G.J. Amos & R.E.M. Wheeler, "The Saxon-Shore Fortress at Dover," *ArchJ* 76 (1929) 47-58; S. E. Rigold, "The Roman Haven of Dover," ibid. 126 (1970) 78-100; B. Philp, "The Discovery of the Classis Britannica and Saxon Shore Forts at Dover. An Interim Report," *Kent Archaeological Review* 23 (1971) 74-86. B. W. CUNLIFFE

DUDURGA ASARI, *see* SIDYMA

DUEL Austria. Map 20. A hill on the S bank of the Drau between the towns of Villach and Spittal, near Feistritz-Paternion (Carinthia, Austria). In antiquity it belonged to the territory of Teurnia (Noricum). It is an elongated, isolated hill (240 x 110 m).

A strong circular wall surrounded the plateau, attached towers and pillars strengthened the fortification. A gate flanked by towers stood midway on the N front. Heated barracks for living and unheated rooms for storage were added to the interior side of the wall. The larger part of the plateau was not built up. At the S edge, where the ground rises to form a small mound, are a few isolated buildings. At the highest point is a church (21 x 14.5 m) whose unusual plan is determined by the rocky subsoil. It could be described as having a nave and two aisles, but the aisles with their varying width and height are really lateral corridors each of which connected with the nave through two passages. The apse is the full width of the nave (7.15 m); it contains a semicircular bench for the clergy and in front of that, marking the location of the altar, a trough-shaped reliquary carved out of the rock. The floor was covered with a simple layer of mortar, and the partition between the sanctuary and the rest of the church was supposedly made of wood. A building to the E, perhaps the home of the priest, contained a square baptismal font built upon a quadrifoliate ground plan. A smaller building is interpreted as the house of the commanding officer.

The spolia used as building material (e.g. a votivara for Jupiter Depulsor, a statuette of Kybele) indicate a settlement of late antiquity. The complex doubtless originated between the 5th and 6th c. and existed for some time, as indicated by two building periods of the fortification wall. The hill of Duel is an instructive example of the resourcefulness of the population in the restless times of the migrations when the Roman Empire could not muster enough military strength against enemy attacks. The peasants in the low country withdrew to an adjacent hill they had fortified, and took with them their belongings and cattle. There was ample space in the walled area, which had been kept unobstructed for that purpose. For such fortifications a small church is characteristic. The Fliehburg on the hill of Duel can serve as an illustration for the castella of the diocese Tiburnia which are mentioned once in the biography of St. Severin (Eugippius c. 25). Architecturally, the complex consisting of fortification and a church prefigures the mediaeval castle with its chapel.

When the Goths moved through the Drau valley and laid siege to Teurnia ca. 472, this site was probably destroyed as a refuge. It was still in use in the 6th c., as indicated by an Ostrogoth fibula; final destruction can be attributed to the Slavs ca. 600.

BIBLIOGRAPHY. R. Egger, "Ausgrabungen in Feistritz a.d. Drau, Oberkärnten. Der Hügel bei Duel," *JOAI-Beibl* 25 (1929) 189ffMPI; id., *Teurnia. Die römischen und frühchristlichen Altertümer Oberkärntens* (7th ed. 1973); R. Noll, *Frühes Christentum in Österreich* (1954) 100ffP. R. NOLL

DUEÑAS Palencia, Spain. Map 19. Town between Valladolid and Palencia, with a 1st c. Roman villa rebuilt in the 4th c. It had a mosaic of the age of Constantine with a horse labeled AMORIS, and a large head of Oceanus flanked by Nereids riding a sea bull and a sea leopard.

BIBLIOGRAPHY. P. de Palol, "El mosaico de tema oceánico de Dueñas, Palencia," *BSAA* 29 (1963); id., "Das Okeanos-mosaik in der römischen Villa zu Dueñas (prov. Palencia)," *MadrMitt* 8 (1967) 196-225MI; A. Revilla et al., *Excavaciones en la villa romana del "Cercado de San Isidro," Dueñas, Palencia* (1964).
 P. DE PALOL

"DUGA," *see* EL BENIAN

DUKLJA, *see* DOCLEA

DUNABOGDÁNY, *see* LIMES PANNONIAE

DUNAFÖLDVÁR County of Tolna, Hungary. Map 12. There are traces of Roman settlement everywhere in the area. The limes road of Aquincum-Mursa led through

here. In the vineyards of Nagyhegy a votive group of terracotta, made in honor of Mater Matuta, was discovered. The group, originating from the end of the 1st c. B.C. or the first years of the 1st c. A.D., came to Pannonia from the shrine of Mater Matuta at Satricum in southern Italy. In addition to being worshiped as protector of women in their first marriage and of their children, Mater Matuta was also worshiped as the goddess of dawn's light and of harbors. Her presence suggests a Roman port near Dunaföldvár on the Danube, even before the conquest by land of the province of Pannonia. The objects from the Mater Matuta shrine are kept in the museum of Szekszárd. At Dunaföldvár, in 1967, a dredge brought to the surface an iron dagger, including its sheath, of the Julio-Claudian era, decorated with gold, red enamel, and silver inlay. The find suggests that a Roman flotilla guarded the Danube limes before the land occupation. From Dunaföldvár the Hungarian National Museum acquired a Roman shield in 1966, in white metal and richly decorated. In addition to the vine and ivy leaf decorations, the edge of the shield contains several inscriptions: CASSIOPOTENTIS signifies that the first owner of the shield belonged to the Centuria of Cassius Potens; the other inscription on the edge, ANT ES CRESC PROPINQVS, shows that the second owner was Crescens Propinqus, who belonged in Antoninus' Centuria. The shield of Dunaföldvár was made in the 2d c., either in Syria or Alexandria, in the workshop of a weapon maker who worked according to Roman regulations.

BIBLIOGRAPHY. E. Thomas, "Italische Mater Matuta-Votive aus Pannonien," *Acta X. Rei Cretariae Fautorum* (1968) 56-61; id., *Helme-Schilde-Dolche* (1971).

E. B. THOMAS

DUNAKÖMLŐD, *see* LIMES PANNONIAE

DUNASZEKCSŐ, *see* LIMES PANNONIAE

DUNAUJVÁROS, *see* INTERCISA *and* LIMES PANNONIAE

DUNSTABLE, *see* DUROCOBRIVIS

DUNTOCHER, *see* ANTONINE WALL

DURA EUROPOS Syria. Map 5. Caravan center 96 km S of Deir-ez-zor on the Syrian Euphrates, founded with a Hellenistic grid plan of streets by Macedonians ca. 300 B.C. The Parthians, occupying Dura about 100 B.C., made it their frontier fortress against the Romans until Verus (A.D. 165), retreating from Seleucia on the Tigris, left it in Roman hands. After capture by Sasanians in A.D. 256, the city was abandoned.

Dura is exceptional in the character of its remains. The embankment along the circuit wall facing the desert encased religious paintings and preserved cloth, wood, parchments, and papyri. Most noteworthy are the paintings in the Temple of Palmyrene Gods, the Christian paintings, the Mithra temple in the Roman camp, and the astonishing series of paintings from the synagogue (A.D. 246). Evidences of siege operations were also preserved by the embankment. Sudden abandonment left many inscriptions and pieces of sculpture intact and in situ.

Some of the first finds are in the Louvre; the synagogue has been reconstructed in the museum of Damascus, the paintings of the Christian building and the temple of Mithra in the Gallery of Fine Arts at Yale. On the site there remain the stone walls of the circuit, the Parthian citadel, and the Redoubt palace, as well as the foundations of temples and of private and public buildings. The cliff, broken by the river, has carried away part of the citadel and the circuit wall to the S.

To the S of the main gate along the wall are a Roman bath and private houses in the first block; the Christian building (the baptistery with paintings was the NW room) in the NW corner of the second block; the Temple of Zeus Kyrios against the city wall close to the tower at the S end of the same block; and, beside the next tower to the S, the battlements above a Sasanian tunnel running beneath the fortifications. In the SW corner of the city lies the Temple of Aphlad.

In the first block N of the main gate the embankment contained a Tychaion; the synagogue was in the second, the Temple of Mithra four blocks beyond, and the Temple of Palmyrene Gods in the NW corner. In the block E of the synagogue lies the Temple of Adonis.

On the N side on the main street, the third block from the gate constituted the caravanserai. Three blocks beyond and one block to the left (N) of the main street lie the remains of the agora, with stone foundations of Hellenistic buildings beneath rubble colonnades and shops of later periods. Opposite the agora and one block S of the main street are the temples of Artemis in the W block, the Temple of Atargatis on the E. The Temple of the Gaddé lies between that of Atargatis and the main street.

Three blocks E of the agora was the Temple of Zeus Theos, and E of that one looks directly to the middle of the citadel wall. On the citadel the stone foundations of the Parthian palace lie over stone Hellenistic foundations. Parts of both were lost in the fall of the cliff.

In front of the N entrance to the citadel lies the little Roman military temple. On the S slope of the E-W wadi S of the citadel rises the Hellenistic embossed wall of the Redoubt palace. Between Redoubt and citadel were a Roman bath and private houses; to the S, behind the palace, was the Temple of Zeus Megistos. The NW section of the city contains the Roman camp with barracks, a Roman bath and, in the center, the praetorium. Behind the praetorium is the Temple of Azzonathkona. A Parthian bath lies just beside the amphitheater on the S side of the camp.

The NE corner of the city contains the headquarters of the Dux (3d c.) and the Dolicheneum. In the desert lie innumerable subterranean tombs and the foundations of funerary towers. The temple of the necropolis is NW of the main gate, and the remains of the triumphal arch of Trajan are N of the city over the former road up the river.

BIBLIOGRAPHY. F. Cumont, *Fouilles de Doura-Europos* 1922-3 (1926); id., *CRAI* (1934) 90-111 (Mithraeum); J. H. Breasted, *Oriental Forerunners of Byzantine Painting* (1924); *Excavations at Dura-Europos. Preliminary Reports* (1929-); J. Johnson, *Dura Studies* (1931); M. I. Rostovtzeff, *Caravan Cities* (1932); id., *RömMitt* 49 (1934) 180-207 (Mithraeum); id., "Dura and the Problem of Parthian Art," *YCS* 5 (1935) 155-304; id., *Dura-Europos and its Art* (1938); id., "The Foundations of Dura-Europos," *Annales de l'Institut Kondakov* 10 (1938) 99-106; id., "Res Gestae Divi Saporis and Dura," *Berytus* 8 (1943) 17-60; C. Hopkins, "Aspects of Parthian Art in the Light of Discoveries from Dura-Europos," ibid. 3 (1936) 1-31; R. O. Fink et al., "The Feriale Duranum," *YCS* 7 (1940) 1-222; R. Dussaud, "Cultes de Palmyre et de Doura-Europos," *Mana* 1, 2 (1945) 403-14; L. T. Shoe, "Architectural Mouldings of Dura-Europos," *Berytus* 9 (1948) 1-40; C. B. Welles, "The Population of Roman Dura," *Studies in Honor of Allan Chester Johnson* (1951) 251-74; id., "The Chronology of Dura-Europos," *Symbolae Raphaeli Taubenschlag dedicatae* III (1957) 467-74; R. N. Frye et al., "Inscriptions from Dura-Europos," *YCS* 14 (1955) 127-213; C. H. Kraeling, *The Excavations at Dura-Europos, Final Re-*

port VIII, pt. 1, *The Synagogue* (1957); pt. 2, *The Christian Building* (1967); E. R. Goodenough, *Jewish Symbols in the Greco-Roman Period 9-11, Symbolism in the Dura Synagogue* (1964); J. Gutmann, ed., *The Dura-Europos Synagogue. A Re-evaluation (1932-1972)* (1971).

C. HOPKINS

DURAN ÇIFTLIK ("Kallipolis") Caria, Turkey. Map 7. It is known that Kallipolis was a city of the Rhodian Peraea, subject to Rhodes though not incorporated in the Rhodian state. The site is disputed. It first appears as a stronghold occupied by Orontobates in 334 B.C., together with Myndos, Kaunos, and Thera (Arr. 2.5,7). About 200 B.C. it was visited by the Delphic theori and the name appears in three Rhodian inscriptions dating between the 2d c. B.C. and the time of Domitian. It is also mentioned by Stephanos Byzantios.

Kallipolis has generally been located at Gelibolu on the coast, near the head of the gulf of Kos, the name having survived exactly as at Gelibolu on the Dardanelles. Here there are a number of forts of varying sizes, two of them ancient, the others mediaeval, but no city site has been discovered, nor are the extant remains suggestive of urban civilization. There seem to have been one or more amphora factories on the spot, and a dedication by a Rhodian thiasos was unearthed in 1949. That Gelibolu preserves the name of Kallipolis is hardly disputable, but in other respects the site is far from satisfactory.

In 1893 an altar dedicated to Domitia by the demos of the Kallipolitans was discovered at Duran Çiftlik, some 16 km E of Gelibolu; the remains indicated that a sanctuary stood there. Less than 2 km NE, above the village of Kızılyaka and on the highest point of a range of hills, is an ancient site now largely bare but thickly covered with Roman sherds and loose building blocks; the circuit wall has disappeared, but its line is clearly traceable by a shelf in the hillside. On the summit is a tower of inferior masonry, and close by are a rectangular enclosure with walls well built of small blocks, a spring, and a few simple graves. This site supports the suggestion that Kallipolis was in the neighborhood of Duran Çiftlik; the name must have been transferred to Gelibolu at some mediaeval date for unknown reasons.

It is likely, though not proved, that Kallipolis replaced the ancient city of Kyllandos.

BIBLIOGRAPHY. E. Hula & E. Szanto, "Reise in Karien," *SBWien* 132 (1895) 34; *BCH* 45 (1921) 6; G. Guidi, *Annuario* 4-5 (1921-22) 379f; L. Robert, *Études Anatoliennes* (1937) 491-500; P. M. Fraser & G. E. Bean, *Rhodian Peraea* (1954) 71; Bean & J. M. Cook, *BSA* 52 (1957) 65-66, 75, 81-85; Bean, *Turkey beyond the Maeander* (1971) 155-56. G. E. BEAN

DURAZZO, *see* EPIDAMNOS

DURETIA (Rieux) Morbihan, France. Map 23. The ancient city, situated near Redon at an important ford, was spread out on both banks of the Vilaine. The ford was elevated, on a masonry foundation that allowed one to cross on foot at low tide. Originally, there was also a wooden bridge, no trace of which remains. Nothing is left today of the ancient city except for debris strewn over the fields.

Excavations on the right bank in the last century uncovered a quadrangular fanum with a gallery around it and a central cella containing a basin. The facade faced E and was framed by antae. Against the SE wall, on the outside, was added a small construction open to the E. About the same time traces of a large villa were found on the left bank. It had a sizable bath building with six rooms, one of them over 100 sq m in area.

BIBLIOGRAPHY. L. Maitre, *Les villes disparues de la Loire-Inférieure* (1893); Grenier, *Manuel* IV, 797-99P.

M. PETIT

DURISDEER Dumfriesshire, Scotland. Map 24. The best preserved of the series of Roman fortlets established in upper Annandale and Nithsdale ca. A.D. 140. Defended by a 9 m thick rampart and a single rock-cut ditch, it measures 51 x 36 m externally (0.19 ha), and the entrance is protected by a titulum. Excavation in 1938 showed that one half of the interior had been occupied by a timber barrack-building, while areas of flagging in the other half may indicate the presence of stabling.

BIBLIOGRAPHY. S. N. Miller, ed., *The Roman Occupation of South-western Scotland* (1952) 124-26.

K. A. STEER

DURNOVARIA (Dorchester) Dorset, England. Map 24. The town lies 9.6 km inland from Weymouth Bay, 3.2 km N of the Iron Age hill fort of Maiden Castle. Occupation probably began in A.D. 44 immediately following the destruction of Maiden Castle by Legio II Augusta under the command of Vespasian. There is some evidence to suggest the presence of a military garrison on the site, but by A.D. 70 civilian development had superseded it and Durnovaria became the cantonal capital of the Durotriges. It flourished as a Roman town into the early 5th c. and has continued to be occupied until the present day.

In the 2d c. the town was defended by an earthen bank and ditch system, strengthened in the 3d c. by the addition of a stone wall. The core of the wall is visible at only one point, near the W gate, but the line of the defenses, which enclosed some 28-32 ha, can still be traced. The defended area is now heavily built upon and largely unavailable for excavation, but parts of a regular street grid have come to light together with fragmentary evidence for a number of town houses.

The most substantial area to be explored lies in the NW corner in Colliton Park (excavations 1937-39, 1961-63). Parts of nine buildings have been exposed together with a street and a substantial culvert. Most of the structures were industrial (stores and workshops), and were provided with ovens, hearths, and a smithy. Only one building was definitely a dwelling: it was a house of some quality adorned with seven mosaic pavements. Excavation in the SW quarter (1969-70) has shown that here too industrial buildings predominated. Although structural evidence from elsewhere in the town is fragmentary, and no public buildings have yet been identified, the general impression is that of a densely built-up area containing closely packed buildings most of which were, by the 4th c., constructed in masonry. Stylistic consideration of the mosaic pavements has suggested the presence of a school of mosaicists working in the area in the early years of the 4th c.

The town was served by an aqueduct over 19 km long (the longest in Britain). It was an open leet following the contours of the hills W of the town, entering the walled area in the vicinity of the W gate; thereafter its course is unknown. The amphitheater lay 0.4 km outside the S gate, close to the road to Weymouth Bay. The earthwork had originally been constructed in the Neolithic period as a henge monument. Roman modification entailed lowering the arena floor and heightening the bank, together with the construction of a fenced passage around the arena and chambers for beasts and performers.

Large inhumation cemeteries are known on all sides of the town, particularly outside the E and W gates. At the Poundbury cemetery (W of the town) some of the

burials were in stone sarcophagi and lead coffins; one was in a mausoleum with elaborately painted walls. It is likely that some, at least, of the burials here are Christian. Other evidence of Christianity consists of a hoard, found in Somerleigh Court, containing more than 50 siliquae, five spoons, and a ligula, deposited ca. A.D. 400. One of the spoons is inscribed AVGVSTINE VIVAS and another bears the sign of a fish.

While the main function of the town was to serve as the administrative center of the Durotriges, its economic importance is clear. Purbeck stone, marble, Kimmeridge shale, and pottery from the New Forest and Poole Harbour production centers all passed through its markets.

BIBLIOGRAPHY. C. D. Drew & K. C. Collingwood Selby, "The Excavations at Colliton Park, Dorchester," *Proc. Dorset Nat. Hist. and Arch. Soc.* 59 (1938) 1-14; 60 (1939) 51-65; R.A.H. Farrar, "The Roman Wall of Dorchester," ibid. 75 (1953) 72-83; Royal Commission on Historic Monuments (England), *An Inventory of Historical Monuments in the County of Dorset* II, *South East* (Part 3) (1970) 531-92. B. W. CUNLIFFE

DUROBRIVAE (Chesterton) Cambridgeshire, England. Map 24. On the S bank of the Nene, where it is crossed by Ermine Street. The name (attested in the *Antonine Itinerary*, the *Ravenna Cosmography* and on local potters' stamps) was given originally to an auxiliary fort guarding the river crossing. The town of Durobrivae developed in the 2d c. from the civil settlement attached to the fort. It was walled in the 3d c. and continued to flourish as an agricultural and industrial center until at least A.D. 450.

The 2 ha fort visible from the air is unexplored, but may be dated by analogy to the mid 1st c. Little can now be seen of the town, except its defensive circuit (enclosing an area of ca. 17.6 ha) and the embankment of Ermine Street, which is its main thoroughfare. Excavation in 1957 showed that the defenses consisted of a stone wall, backed by a clay rampart, at least three gateways, and a ditch. Within the town aerial photographs reveal an irregular street plan and close-packed rectangular buildings, which are combined workshops and dwellings.

No excavation has taken place here since about 1840. There are extensive industrial suburbs on three sides of the town and across the river.

BIBLIOGRAPHY. E. T. Artis, *The Durobrivae of Antoninus* (1828); J. K. St. Joseph, *JRS* 59 (1969) 127.
 J. P. WILD

DUROBRIVAE (Rochester) Kent, England. Map 24. A Belgic settlement on the river Medway 38 km from London (Londinium) and 37 from Canterbury (Durovernum). It was important enough to have a mint in the period immediately prior to the Roman invasion. The name Durobrivae (which only occurs in the *Antonine Itinerary*, but the identification is certain) means "fortress by the bridges," which may suggest the existence of a Belgic oppidum. During the 1st and 2d c. a straggling development occurred along the line of Watling Street, but in the last quarter of the 2d c. the first defenses, a clay-faced earth rampart and a ditch, were constructed. A massive stone wall replaced the rampart early in the 3d c., enclosing an area of 9.2 ha. In A.D. 604 Rochester was still of sufficient importance for St. Augustine to make it the seat of the second cathedral under Justus.

The only Roman remains now visible are parts of the city wall, which survives to the height of 5.1 m at the SE corner, with fragments elsewhere incorporated in the mediaeval defenses. Little is known of the internal plan of the Roman city, though the High Street and Northgate Street mark its principal axes and the existence of four gates is attested by references in Anglo-Saxon charters.

BIBLIOGRAPHY. G. Payne, "Roman Rochester," *Archaeologia Cantiana* 21 (1895) 1-16; A. C. Harrison & C. Flight, "Roman and Medieval Defences of Rochester," ibid. 83 (1968) 55-104; id., "Excavations in Rochester," ibid. 85 (1970) 95-112; id., "Rochester East Gate, 1969," ibid. 87 (1972) 121-57. A. C. HARRISON

"DUROCATALAUNUM," *see* CHÂLONS-SUR-MARNE

DUROCOBRIVIS (Dunstable) Bedfordshire, England. Map 24. Firmly identified from its place in the *Antonine Itinerary* (471.2, 476.9, 479.7) with Dunstable, on Watling Street. Though many chance finds of Roman material had been found in the town, and a substantial villa had been excavated at Totternhoe, 3.2 km to the W, little was known of the actual settlement until 1967-68 when excavations on the site of the Dominican friary revealed the foundations of a large timber building, at least 30 m long, a well 27.5 m deep, and a kiln.

BIBLIOGRAPHY. *VCH Bedfordshire* II (1908) 6-7; C. L. Matthews, *Ancient Dunstable* (1963); *JRS* 59 (1969) 220, 243. A.L.F. RIVET

DUROCORNOVIUM (Wanborough) Wiltshire, England. Map 24. A site at the junction of a road from Cunetio and the road from Calleva to Corinium. It is mentioned in the *Antonine Itinerary* (485.5). Little is known of its history. A military occupation immediately after the Roman conquest might be expected, but evidence is lacking. A settlement centered on the road junction began to grow in the later decades of the 1st c.; it extended during following centuries over a considerable area, and reached its maximum in the 4th c. Most of the buildings flanked the roads. The name would suggest fortifications, but none have yet been found. Excavations since 1966 have shown that the main roadside development consisted of shops and workshops, although comfortable dwellings, some with mosaics, were built farther away and were served by well-metaled side streets. The discovery of a large number of late coins suggests an occupation continuing well into the 5th c.

Nothing of the site is visible. The finds from the excavations will go to Swindon Museum, Wiltshire.

BIBLIOGRAPHY. M. E. Cunnington, *Wiltshire Archaeological Magazine* 45 (1930-32) 207; E. Greenfield, *JRS* 57 (1967) 196; 58 (1968) 201; 59 (1969) 230; J. S. Wacher, *Britannia* 1 (1970) 300. J. S. WACHER

DUROCORTORUM (Reims) Marne, France. Map 23. Gallo-Roman city on the N boundary of Champagne, on a flat site bordering on the marshy valley of the Vesle, a tributary of the Aisne that runs N alongside the Montagne de Reims. Durocortorum succeeded a Celtic settlement that was apparently surrounded for several km by a broad, deep trench, with a second circumvallation some 800 m inside. A fair number of traces from the period of independence have been found outside this fortification but practically none inside it, which may suggest that the settlement was not a permanent one. On the other hand, identification of this site with the center of the independent Remi, Caesar's Durocortorum Remorum, is not certain: the latter is often placed 17 km away at Vieux-Reims, a site more than 100 ha in area.

After the conquest the Remi, who were loyal allies of Rome and a federal civitas, built a town on the site of the original oppidum which became one of the leading cities in the province and the residence of the governor

of Belgica. However, the earliest known structures, aside from a hypothetical Caesar's camp, appear to lie outside the inner Gallic wall, to the NE and especially the S, in the St. Rémi quarter. A series of cellars and potters' workshops have been found in this section dating from the first half of the 1st c. A.D., and, close by, a necropolis obviously of the same period. At first, new quarters were possibly set up beside the old settlement, and city planning on the Roman model—which involved filling in the trench of the smaller Gallic wall—did not come until a later period, difficult to pinpoint but somewhere between the Flavians and the second half of the 2d c. A.D.

At the height of its prosperity the city whose center occupied the space within the smaller Gallic wall gradually spread out over the area bounded by the outside wall. The cardo, oriented SE-NW, is recognizable (Rue du Barbâtre, Rue de l'Université, Cours A. France), as is the decumanus (Avenue J. Jaurès, Rue Cérès, Rue Carnot, Rue Muirron-Herrick, Rue de Vesle). This plan is confirmed by the four so-called triumphal arches that straddled the two axes at the edge of the monumental quarter forming the city center: to the N the Mars Gate, relatively well preserved; to the S, the arch erroneously called the Bacchus Gate, of which only incomplete traces remain (Rue de l'Université, along with the adjoining section of the Late Empire rampart); and to E and W the two decumanus maximus arches attributed, for no valid reason, to Ceres and Venus. These last two are destroyed, but ancient descriptions and the discovery of some foundations almost certainly locate them.

The secondary cardines and decumani that have been excavated point to an orthogonal plan, although it is not possible to determine the exact size of the blocks. The soil also contained many fragments of water pipes and sewers: at least part of the water supply came from the Suippe through an aqueduct 40 km long.

Local tradition places the forum near the crossroads of the two main axes, and this seems to be confirmed by the presence of a cryptoporticus with three wings. The central wing is much longer than the other two, which are symmetrical. Only one of the latter and the adjacent section of the middle wing have been uncovered. They have two aisles separated by a row of piers, and the interior of the open area was lighted by vents. The walls were decorated with niches and painted. The entrance stairway has recently been found at the end of the lateral wing, along with the beginning of the stairway leading to the upper story, which is completely destroyed. No other public building is preserved, but place names and some ancient references indicate that there was an amphitheater near the decumanus, at the W edge of the city center.

Many chance finds show that the settlement was dense and its domestic architecture fairly luxurious: architectural fragments, especially in the sector called the Three Piers; mosaics (Rue Voltaire, Rue de Mars, Cour de l'Archevêché, several dozen in all, including the Bellerophon, Gladiators, and Circus mosaics, but most of them have now disappeared); walls covered with frescos. Since the city was laid waste many times the numerous cellars are the only parts still intact. Aside from some potters' workshops (a group of kilns near St. Rémi is exceptionally well preserved), crafts are represented by work in bone, of which there is evidence in several places.

The boundaries of the Early Empire city are not clear: the necropoleis that surrounded it to the NE, N, NW, SW, and SE are often too far away, judging from the excavated sections, to pinpoint the perimeter of the city. Only the necropoleis to the N and W appear to coincide with the boundaries of the settlement, which extended almost 1 km in each direction from the four arches.

Traces of destruction and fire as well as caches of coins (several of which date no later than the period of Gallienus or Tetricus) provide evidence of the upheavals of the second half of the 3d c.: Durocortorum certainly suffered from the invasion of A.D. 275, perhaps also from those of 252-54 and 259-60. The settlement was reduced in size; workshops were concentrated in the center, and a surrounding wall (difficult to date) was built, apparently linking the four earlier arches; much Late Empire material was reused in the wall. Outside the walls, the settlement, sporadic in growth, did not develop beyond the mid 4th c. In contrast, the necropoleis spread out.

The first Christian monuments, frequently combined with sepulchers, from the end of the 3d and beginning of the 4th c. A.D., were the chapels of St. Sixtus and St. Clement (the latter was subsequently replaced by the Oratory of St. Christopher, then by the St. Rémi basilica), and later the churches of St. Timothy and St. Agricola. All these monuments were in the S section of the city. The only church intra muros before St. Nicaise built the original cathedral was that of St. Symphorien, which was erected in the first half of the 4th c. The chief city of Belgica Secunda, the city was henceforth known as Remorum urbs or Remi.

Most of the finds are in the Musée St. Rémi.

BIBLIOGRAPHY. Caes., BGall. 1.1-6; Strab. 2.3-4; Tac., Hist. 4, 5; Hier., Ep.

C. Loriquet, Reims sous la domination romaine d'après les inscriptions (1860); N. Brunette, Notice sur les antiquités de Reims (1861); A. Blanchet, Les enceintes romaines de la Gaule (1907); E. Espérandieu, Recueil général des bas-reliefs . . . v, 1 (1913)[1]; F. Vercauteren, Etude sur les civitates de la Belgique Seconde (1934); J. Leflon, Histoire de l'église de Reims du Ier au Ve siècle (1941); H. Stern, Recueil général des mosaïques de la Gaule I, 1 (1957)[1]; P. M. Duval, Gallia 12 (1954) 97f[P]; 17 (1959) 37-62; J. & F. Lallemand, Bull. Soc. Arch. Champenoise (1969) 18-34[PI]; E. Frézouls, Gallia 27 (1969) 303[PI]; 29 (1971) 295-97; 31 (1973) 410-14.

E. FRÉZOULS

"DUROLIPONS," see CAMBRIDGE

DUROVERNUM CANTIACORUM (Canterbury) Kent, England. Map 24.

At a crossing of the river Stour. The name is recorded by Ptolemy and later ancient sources. Caesar had crossed the river here or nearby in 54 B.C., but occupation of the site began only ca. A.D. 1, when a large oppidum grew up on each bank. Canterbury has been continuously inhabited ever since, but opportunity for large-scale excavation occurred only after WW II as a result of bombing.

The Belgic oppidum was found to cover a wide area with sporadic huts and gulleys; it was probably a regional capital and a silver coin of Voicenos attests an otherwise unknown ruler. Soon after A.D. 43 gulleys were filled in and a Roman street-grid laid down; thus Durovernum was one of the earliest civitas capitals to be developed, and presumably reflects the pro-Roman character of the region. The Cantiaci were not a single tribe; their name, derived from Cantium, suggests a Roman amalgamation of small groups to form an administrative area of convenient size. The earliest buildings were of half-timber and/or clay; masonry structures began to appear ca. A.D. 100. About this time a theater or amphitheater was built; it was entirely remodeled as a large classical theater with vaulted substructure in the early 3d c. Two bath buildings are known.

The town lacked defenses until ca. 270, when a wall and bank were constructed enclosing 52 ha. The defended area was confined to the E bank of the Stour, and

occupation ceased on the other side. Excavation has yielded evidence for a regular settlement (early 5th c.) by Germanic immigrants using Anglo-Frisian pottery and living in *Grubenhäuser* that are probably of the period of Hengist. Another important discovery was a late 4th c. silver treasure carrying Christian symbols, which had been concealed just outside the walls near the river. It reminds us of the Christian churches which, according to Bede, could still be identified by St. Augustine.

BIBLIOGRAPHY. S. S. Frere, *Roman Canterbury* (3d ed., 1962); id., "The end of towns in Roman Britain," in J. S. Wacher, ed., *The Civitas Capitals of Roman Britain* (1966); id., "The Roman Theatre at Canterbury," *Britannia* I (1970) 83-113 ; K. Painter, "A Roman Silver Treasure," *Journal of the British Archaeological Association* ser. 3, 28 (1965) 1-15. S. S. FRERE

"DUROVIGUTUM," *see* GODMANCHESTER

DYRRACHION, *see* EPIDAMNOS

DYSTOS Euboia, Greece. Map 11. The ancient site is to be associated with a rocky outcrop of conical shape, some 300 m high, along the main road from Chalkis to Karystos (ca. 20 km SE of Aliveri). It is prominently located in the middle of a marshy basin which is partially transformed into a lake during the rainy season. (There is some evidence to indicate that efforts were made to drain the basin in antiquity.)

Dystos is thought to have been founded by the Dryopians, early inhabitants of S Euboia, but little is known of its subsequent history. Surface reconnaissance has shown that the site was occupied in prehistoric and Classical times, and there is epigraphical evidence to indicate that it had become a deme of Eretria at least by the mid 4th c. B.C. It continued to be occupied in the Hellenistic and Roman periods, and substantial remains of a Venetian castle are to be found at the crest of the hill.

Impressive remains of the Classical town can still be seen on the lower slopes of the hill. These remains were partially surveyed and subjected to brief excavation by a German expedition in 1895. A fortification wall of large stone masonry, about two-thirds of whose circuit is preserved, enclosed the town. One of the best preserved stretches is that at the E where, in the neighborhood of the main city gate, the wall stands to a height of about 3 m. Numerous buildings thought to be largely residential in character still can be seen at several points within the fortifications. The largest of these is House J, near the wall in the SE part of the town. Its plan is complete, and its well-dressed stone walls are exposed to a level above that of the ground floor. This and other houses here have been dated to the 5th c. B.C. and, therefore, are among the earliest known examples of domestic architecture of the Classical period in Greece. The extent and preservation of the walls and other buildings render this site worthy of further archaeological investigation.

BIBLIOGRAPHY. T. Wiegand, "Dystos," *AthMitt* 24 (1899)[PI]; F. Geyer, *Topographie und Geschichte der Insel Euböa* (1903); L. Sackett et al., "Prehistoric Euboea: Contributions Toward a Survey," *BSA* 61 (1966)[M]. T. W. JACOBSEN

E

EAST BRIDGEFORD, *see* MARGIDUNUM

EAUZE, *see* ELUSA

EBBA KSOUR, *see* ALTHIBUROS

EBCHESTER, *see* VINDOMORA

EBORA (Évora) Alentejo, Portugal. Map 19. Mentioned by Ptolemy (2.5), Mela (3.1), Pliny (*HN* 4.22), and in the *Antonine Itinerary*. It was also called Liberalitas Iulia, a name received from Julius Caesar or Octavian before 27 B.C. The name Ebora is Celtic, but nothing is known of the prehistoric town. According to one tradition Sertorius established his base of operations in the peninsula here. From Caesar or Octavian it received the Latium vetus and from Vespasian the status of municipium.

In the center of the town and on one of its two highest points stands one of the best-preserved temples in the peninsula, the so-called Temple of Diana. It is peripteral and hexastyle, and a temple of the imperial cult. The foundations of opus incertum measure 25 by 15 m and are 3.5 m high. On the N side are preserved six original granite columns 7.68 m high, with capitals of local marble. The colonnades of the W and E sides are incomplete, and the facade has disappeared completely. Some stones with bucrania and paterae, in the museum of the city, perhaps belong to the frieze.

At Praça do Giraldo there appears to have been a triumphal arch (perhaps the only one in Portuguese Lusitania), demolished in 1570. The circuit of the fortifications, erected at the end of the 3d c. A.D., can be entirely reconstructed. Many sections are still visible, especially on the Largo das Portas de Moura, the Largo dos Colegiais, and the streets of Menino Jesus and of Alcárcova. This Roman city had the largest number of families of Roman origin: Julia, Calpurnia, Canidia, and Catinia. The Julian family at the beginning of the 3d c. had a rich villa ca. 15 km from the city in a place now called Nossa Senhora da Tourega.

BIBLIOGRAPHY. Túlio Espanca, *Inventário Artístico de Portugal*. VII. *Concelho de Évora* (1966)[PI]; A. Gracía y Bellido, "El recinto mural romano de Évora (Liberalitas Iulia)," *Conimbriga* 10 (1971) 85-92[PI]. J. ALARCÃO

EBORACUM or Eburacum or Eburaco (York) Yorkshire, England. Map 24. A legionary fortress and colonia. (Ptol. *Geog.* 2.3.16; *It. Ant.* 466.) The revolt of the Brigantes against their pro-Roman Queen Carturandua deprived the Roman province of Britain of a friendly buffer state on the N, and in the emergency the governor and commander in charge Pet. Pius Cerialis advanced Legio IX Hispana from its base at Lincoln to a position on the E bank of the Ouse. Roman remains still standing are the W corner tower of the 4th c. fortress and the curtain wall facing the river in the Museum gardens, portions of the 4th c. NW wall in the garden of the Public Library and off Exhibition Square, and the 2d c. E corner tower behind the Merchant Taylors' Hall in Aldwark. Most of the fortress lies some 6 m below modern ground level and is covered by later buildings, but the modern streets are based on the fortress plan: Petergate is the via principalis, and Stonegate the via

praetoria. Portions of a large headquarters building have recently been discovered below York Minster, and there are foundations of a 4th c. bath house below the Mail Coach Inn in St. Sampson's Square.

The original fortress, covering some 200 ha, had an earthen rampart faced with turf; it was later strengthened by Julius Agricola, who constructed a clay rampart faced with turf which probably had wooden interval towers. Under Trajan the three British fortresses were rebuilt in stone; the rebuilding of York can be dated to 107-8 by an inscription found in King's Square and now in the Yorkshire Museum. This is the last dated record of Legio IX (though mortaria stamps found at Nijmegen suggest that it was moved to the Lower Rhine); ca. 120 it was replaced by Legio VI Victrix. In the early 3d c. the emperor Severus made Eboracum his headquarters, and died here in A.D. 211. He strengthened the defenses of the fortress with a stone wall 1.8 m thick, and the barrack blocks within the fortress seem also to have been rebuilt in stone at this time. There was another rebuilding at the end of the 4th c. by Constantius I, who also died here. The towers were replaced by projecting bastions; towards the end of the century the defenses became neglected and the protective ditch was used by squatters.

Very little is known of the history of the colonia on the W bank of the Ouse, though the inscription on the altar dedicated by M. A. Lunaris to the Guardian Spirit of Bordeaux shows that it existed as a colony by A.D. 237. There was a Temple of Mithras (altarpiece in the Yorkshire Museum) and a Temple of Serapis. Outside the colonia lay the cemeteries.

BIBLIOGRAPHY. S. Wellbeloved, *Eburacum* (1842); S. N. Miller, *JRS* (1925) 176ff; I. A. Richmond, *Arch. Journ.* (1946) 74ff; for headquarters building under York Minster, see *JRS* 11 (1921) 102. G. F. WILMOT

EBURACUM, *see* EBORACUM

EBURODUNUM (Yverdon) Vaud, Switzerland. Map 20. Vicus and fort at the S end of Lake Neuchâtel, on the Thièle river (*CIL* XIII, 5064; *Tab. Peut.*). There was probably an oppidum of the Helvetii on the site, but no traces earlier than 50 B.C. have yet been found. It was important in Augustan and Tiberian times as a harbor and market on the water route from the Rhône to the Rhine, like Lousonna to the S. Destroyed by the incursions of Germanic peoples in 260-65, it was only partly rebuilt. The Castrum Ebrodunense (*Not. Gall.* 9.6), in its center, was built under Valentinian I in the 4th c. as a link in the series of strongholds protecting the waterway, like Salodurum, Ollodunum, and Altenburg. Eburodunum was the seat of a bishop, and settlement continued into the Early Middle Ages.

The site is mostly covered by modern buildings and excavation has been possible only inside the fort, used today as a cemetery. The vicus, just S of the mediaeval center, stretched along the lake shore (which was farther S than it is today), and developed on both sides of the highway from Aventicum to Ariolica. Inside the later fortress the 1st c.(?) baths, possibly used as late as the 5th c., were partly preserved until 1821. Their main features were large twin rooms with hypocausts and apsidal pools; votive inscriptions to the healing deities were found there. The sulphur springs nearby are still used. The fort is a slightly irregular rhomboid (140-130 m on a side, area 1.95 ha) with round towers at the corners and semicircular ones in between. Incorporated into the E gate (6 m wide) is much reused material from the vicus, and portions of the wall can still be seen in the cemetery. There is also a massive apsidal structure

(18 x 10 m), which may have been turned into a granary in the 4th c.

The Musée du Vieil Yverdon is in the town hall.

BIBLIOGRAPHY. V. H. Bourgeois, "Le castrum romain d'Yverdon," *AnzSchweiz* 28 (1924) 213-32[PI]; F. Staehelin, *Die Schweiz in römischer Zeit* (3d ed. 1948) 303-4, 616[P]; A. Kasser, "Vestiges au début de l'époque romaine découverte en 1955," *Ur-Schweiz* 19 (1955) 51-59[PI]; G. Kasser, "Yverdon: *Eburodunum*," ibid. 33 (1969) 54-57[P]; summaries: *Jb. Schweiz. Gesell. f. Urgeschichte* 16 (1924) 85-86; 47 (1958-59) 132-35.
 V. VON GONZENBACH

EBUROMAGUS (Bram) Gallia Narbonensis, Aude, France. Map 23. The village was a vicus located at the crossroads of the Roman road from Narbonne (Narbo) to Toulouse (Tolosa) and of a road from the Montagne Noire to the Ariège. It already existed in the 2d c. B.C., and must be assimilated to the Cobiomagus referred to by Cicero (*Font.* 9.19). Thus, it was one of the stops where the Italian wines bound for Toulouse paid a tax in 76-74. The most abundant finds are tombs, coins, and amphorae. Aerial photography, however, has revealed the existence of a checkerboard plan under the circular structure of the mediaeval village. Furthermore, an inscription indicates that the magistri vici built, with their own money, a theater which was associated with a Sanctuary of Apollo. As yet, however, this monument has not been found.

BIBLIOGRAPHY. J. Soyer, "Un village à structure double: Bram," *Photo-Interprétation*, no. 6 (1963) fasc. 7, 8[P]; M. Passelac, "Le vicus Eburomagus. Eléments de topographie. Documents arch.," *Rev. arch. de Narbonnaise* 3 (1970)[PI]; M. Gayraud, "L'inscription de Bram (Aude) et les toponymes Eburomagus, Hebromagus, Cobiomagus en Gaule méridionale," *Rev. arch. de Narbonnaise* 3 (1970)[M]. M. GAYRAUD

ECBATANA (Hamadan) Iran. Map 5. This very important city of the Achaemenid empire was taken over by the Seleucids. Pliny states that it was founded by Seleucus, the first Seleucid ruler, while Strabo writes that the existing Achaemenid palace was an occasional residence of the Seleucid kings.

BIBLIOGRAPHY. Plin. 6.43; Strab. 11.13.6.
 D. N. WILBER

ECCLES Kent, England. Map 24. The site of the Roman villa lies on the E bank of the river Medway, ca. 8 km S of the Roman town of Rochester (Durobrivae) and 6.4 km N of the reputed settlement at Maidstone. Excavations were begun in 1962.

A system of ditches, probably for irrigation, indicates the first occupation ending ca. A.D. 55, with the building of a small granary and other buildings which, in A.D. 65, were superseded and/or incorporated in the construction of the first baths and dwelling, containing several rooms with tessellated and mosaic floors. After the burning of these baths, ca. A.D. 120, a new bath house and extensions to the dwelling were built, and continued in use until ca. A.D. 180; a third and more extensive bath suite was then erected, and the house once more remodeled by the addition of a rear corridor and new tessellations, as well as a new wing with a channeled hypocaust. A final reconstruction took place after ca. A.D. 290, when the rear corridor was converted into a suite of rooms with hypocaust.

The size of the villa (so far, 135 rooms of various periods are known) and its early foundation suggest the possibility of some official connection between its owners and the Roman provincial government.

BIBLIOGRAPHY. A. P. Detsicas, "Excavations at Eccles, 1962," *Archaeologia Cantiana* 78 (1963) 125-41, and following volumes. A. P. DETSICAS

ECDIPPA or Achzib (ez-Zib) Israel. Map 6. Town on the Mediterranean coast, 9.4 km N of Acre. It was autonomous in the Persian period, and possibly occurs in Skylax' list. Pliny (*HN* 5.75) mentions Ecdippa, a town on the Phoenician coast and Eusebius refers to it as a road station 9 miles N of Acre on the road to Tyre (*Onom.* 30.13). In Jewish sources it appears as a place on the N boundary of the Holy Land. Excavations have revealed six occupation levels, from the 9th to the 3d c. B.C., and Persian and Phoenician cemeteries outside the town.

BIBLIOGRAPHY. F. M. Abel, *Géographie de la Palestine* II (1938) 237; M. Avi-Yonah, *The Holy Land* (1966) 28, 130. A. NEGEV

"ECHETLA," see GRAMMICHELE

ECHTERNACH Luxembourg. Map 21. Site on the Sauer river occupied from palaeolithic times to the Middle Ages, and surrounded by other prehistoric sites (palaeolithic grottos, tools, skeletons; wall- and rock-engravings survive in the so-called Müllerthal). It was connected with the Ferschweiler plateau on the opposite bank of the river. A Roman vicus developed here which was in contact with Altrier and the Eifel; a Roman road connected it with the highway from Trèves to Bitburg and Cologne. Transportation on the Sauer river is attested by the epitaph of one Arecaippus buried near Bollendorf, a few km away. At nearby Weilerbach is a monument dedicated to Diana by Q. Postumius, which reused a megalith. There were remains of at least five Roman houses on the site called Schwarzacht in the 19th c.; two of them were investigated and proved to have central heating, baths, and marble mosaics with geometrical designs. Roman walls have been found under the Benedictine abbey built in the time of Willibrordus.

Excavations on the little hill where a 10th(?) c. church to SS. Peter and Paul had been built over a 7th c. monastery revealed that a Late Roman fortification wall of irregular circular form surrounded the partly artificial hill; the wall had a gate on each side, and the N and E sides had been specially reinforced. A pit 14 m deep provided the castellum with fresh water; it contained various objects dating from the Roman period on. Finds from Echternach include two winged genii holding a laurel crown built into one of the pillars of a bridge crossing the Sauer (Ausonius' Sura), an inscription dedicated to the god Intarabus and the Genius Patrum, the head of a marble statue, bas-reliefs showing a kitchen with several people preparing food in big bronze dishes, and a gold-framed cameo depicting Tiberius and giving the name of the artist: Herophilos, son of Dioskourides. The cameo came from the Echternach abbey, and is now in the Kunsthistorisches Museum in Vienna.

BIBLIOGRAPHY. J. P. Brimmeyr, "Observations sur quelques anciens bâtiments de la ville d'Epternach," *Publications de la Section Historique de l'Institut Grand-Ducal* 5 (1849) 65ff; 6 (1850) 74ff; C. M. Ternes, *Les Inscriptions Antiques du Luxembourg* (1965) no. 70; id., "Le camée d'Hérophilos," *Hémecht* 22 (1970) 2; id., *Répertoire archéologique du Grand-Duché de Luxembourg* (1971) I, 65ff; II, 49ff; id., *Das römische Luxemburg* (1974) 54ff, 171ff. C. M. TERNES

ECHZELL Kreis Büdingen (Hessen) Germany. Map 20. A castellum ca. 35 km NW of Frankfurt a.M. on the frontier of Germania Superior. One of the largest limes castella in this province, it was built here shortly after the rebellion of the upper Germanic legate L. Antonius Saturninus (A.D. 88-89) and existed until the collapse of the upper Germanic limes in the middle of the 3d c. A.D. The garrison consisted of auxiliary troops, among them some cavalry.

The Roman buildings are known only from the excavations. The castellum had the customary rectangular ground plan with rounded corners and four gates with an interior area of 5.2 ha. Several building periods have been established. The first fortifications and interior buildings were of wood. Under Hadrian a stone wall was erected. Destructions occurred in the second half of the 2d c. A.D. and ca. 233. Among the most important finds are frescos, which were found in the officers' quarters of a barracks in the castellum. Their origin can be dated between 135 and 155. An almost completely preserved wall shows three two-figure scenes with gods and mythical figures within the frame of an architectural painting, presently in the Saalburgmuseum, Bad Homburg v.d.H.

BIBLIOGRAPHY. D. Baatz, "Römische Wandmalerein aus dem Limeskastell Echzell, Kr. Büdingen (Hessen)," *Germania* 46 (1968) 40-52PI. D. BAATZ

ECLANO, see AECLANUM

EDESSA Macedonia, Greece. Map 9. Very ancient city of Emathia on the NE slope of Mt. Vermion. The first inhabitants of the area were the Bryges, a Thracian tribe known under the name of Phrygians in Asia Minor, where they finally took refuge after being driven back by the Macedonians coming from the W, from the mountains of Pindus, and from Upper Macedonia, ca. 700 B.C. (Hdt. 8.137; Just. 7.1). Linguistically the word Edessa is considered Phrygian (from vedy-water), and it survived over the centuries, alternating at times with the word Aigai, a common name for many Greek towns. Edessa was the first capital of the Macedonians in historical times, until King Archelaos (413-399 B.C.) transferred his seat to Pella.

Under the name of Aigai (Diod. 16.3, 92, 19.52, 22 frag. 12; Just. 7.1; Arr. 1.11.1; Plin. *HN* 4.33; Steph. Byz. s.v. Aigai), the city was closely associated with the palace and the royal cemetery, both of which remained fairly important even after the transfer of the capital to Pella. It was there that religious ceremonies and festivals, weddings, and funerals took place; there that Philip was assassinated in the city theater while celebrating the wedding of his daughter Cleopatra with King Alexander of the Epirots. Members of the royal family were buried in the royal cemetery of Aigai according to the instructions of the head of the Temenid dynasty Perdikka, in order to maintain the dynasty (Just. 7.1). Only Alexander was buried far from Aigai and decline set in. But even after Alexander's death, Kassander buried the monarchs Philip Arridaios and Eurydice, as well as Eurydice's mother Kynna, in Aigai with royal honors.

The city is found under the name Edessa in Polybios (5.97), Diodoros (31.8.8), Strabo (7.223 and 10.449), Appian (*Syr.* 57), Plutarch (*Vit. Pyrrh.* 10, 12), Polyaenus (2.29.2), Ptolemy (13.39 and 8.12.7), Hierokles, and other Byzantine writers. In later Byzantine years and during the Turkish occupation the Slavic name of the city, Vodena, became more common. Today the city is called Edessa again.

The acropolis extended over the great plateau where the modern city is situated with its famous cataracts. Its position is well fortified and strategically important because, of the three passes over Mt. Vermion, it dominates the one farthest N. Through it came the most im-

portant road that connected lower Macedonia on the coast with upper Macedonia and the Adriatic with the Aegean. During Roman times Edessa was a post on the Via Egnatia.

Few remains are preserved from the acropolis of Edessa because of the continuous life of the city and the perishable nature of the building materials in the area (poros and wood). The lower city, on the contrary, has valuable ruins. During the years 1923 to 1924 limited excavations were started, and from 1967 to the present extensive research has been carried on in the whole area of the lower city. The wall enclosure has been established and partly uncovered, as well as gates and rectangular towers. The first period of the walls, characterized by the technique of building with stones of unequal sizes, goes back to the 4th c. B.C., but extensive repairs are noticeable until the later Byzantine years, during which gates, as well as towers, were walled in or rearranged during successive additions and modifications. None of the monuments mentioned by ancient writers (temples, palace, theater, royal tombs, etc.) have yet been found. The artifacts which can be removed are mostly marble architectural fragments, inscriptions, and sculpture, the majority of them dating from the Roman period. An old Christian basilica was also excavated, as well as parts of other Byzantine monuments. The finds are kept in the Edessa Museum and the Thessalonika Museum.

BIBLIOGRAPHY. S. Pelekides. Ἀνασκαφή Ἐδέσσης, *Deltion* 8 (1923) 259-69[PI]; F. Geyer, "Makedonia" (Topographie) *RE* 14.1 (1928) 658; J. M. Cormack, *Inscriptions from Macedonian Edessa and Pella* II (1953) 374-81; id., "Inscriptions from Macedonia," *BSA* 58 (1963) 20-24; P. Lévêque, *Pyrrhos* (1957) 147ff passim; M. Karamanole-Siganidou, Χαλκῆ χείρ Σαβαζίου ἐξ Ἐδέσσης, *Deltion* 22 (1967) 149-55[I]; M. Michaelides, Παλαιοχριστιανική Ἔδεσσα, Ἀνασκαφή Βασιλικῆς Α, *Deltion* 23 (1968) 195-220[PI]; Ph. M. Petsas, Χρονικά Ἀρχαιολογικά 1966-67, Μακεδονικά 9 (1969) 175-77[I]; id., Αἰγαί-Πέλλα-Θεσσαλονίκη, Ἀρχαία Μακεδονία, ἔκδ. Ἑταιρείας Μακεδονικῶν Σπουδῶν, Θεσσαλονίκη (1970) 203-19[MPI]; N.G.L. Hammond, *A History of Macedonia* I (1972). PH. M. PETSAS

EDESSA (Turkey), *see* ANTIOCH BY THE CALLIRHOE

EGETA, *see* LIMES OF DJERDAP

EGITANIA (Idanha-a-Velha) Beira Baixa, Portugal. Map 19. On the banks of the Pônsul, ca. 50 km from Castelo Branco. The Roman town existed at least from 16 B.C., when it received a sun dial from Quintus Ialius Augurinus. At that time it was governed by four magistrates, all with Celtic names, and was not yet a Roman municipium. Romanization proceeded up to the time of Claudius, when Roman citizenship was conferred on Lucius Marcius Avitus, commander of the ala I Singularium civium Romanorum, stationed here from at least A.D. 41 to no later than 69. Perhaps the mineral wealth of the region justified the presence of a military detachment, which was transferred at least by A.D. 69 to Germany. Egitania became a municipium in the time of the Flavians. Various inscriptions call the city civitas Igaeditanis, Igaeditanorum, or simply Igaeditania. Almost all the Visigoth kings from Recaredo (586-601) to Rodrigo (710-711) minted coins here. The fortifications, preserved in almost their entire circuit, include numerous inscriptions and worked Roman blocks; they date from the end of the 3d or the beginning of the 4th c. A.D.

The cardo corresponds to the present-day Castelo and Guimarães streets; the decumanus to Rua Nova. The mediaeval tower is located on the podium of a Roman temple, perhaps the Temple of Venus, known from an inscription of the first half of the 1st c. A.D. and erected by a certain Modestinus. He may be the Gaius Cantius Modestinus who built a temple in Midões to the Genius of the city and another to Victoria (*CIL* II, 401-2). He was probably a citizen of Celtic origin, a wealthy landowner in the region developed by the road from Emerita to Egitania.

The cathedral, which may lie over a temple to Mars, has three aisles; it dates from the 6th or 7th c. but has been much altered. In front of its main door at a lower level which may be that of the original Christian church, was a baptistery. The rectangular basin had two other basins, much smaller and shallower, used for infants.

Outside the walls to the W are traces of a Roman bath. A Roman bridge nearby crosses the Pônsul. The road from Emerita to Egitania, which runs across the bridge, and its extensions to Asturica and Viseu, seem to have been constructed in A.D. 5 or 6, when Augustus set the limits of the civitates of the region: those of the Igaeditani, the Lancienses Oppidani, the Mirobrigenses (Ciudad Rodrigo), Bletisa and Salmantica. Egitania was thus an important road center. But it was also in a region where gold was mined, as is attested by an inscription which Tiberius Claudius Rufus, made a Roman citizen perhaps in the time of Claudius, dedicated to Jupiter to thank the god for 120 pounds of gold.

The finds are for the most part in the local museum. The 200 or more inscriptions constitute the largest collection in Portugal, and include the oldest inscription found in Lusitania: that of Quintus Ialius Augurinus already cited.

BIBLIOGRAPHY. Fernando de Almeida, *Egitania. Arqueologia e História* (1956)[MPI]; id., "O baptistério paleocristão de Idanha-a-Velha (Portugal)," *Boletim del Seminario de Estudios de Arte y Arqueologia* 31 (1965) 134; id., "Templo de Venus em Idanha-a-Velha," *Actas e Memórias do I Congresso Nacional de Arqueologia* II (1970) 133-39. J. ALARCÃO

EGNATIA, *see* GNATHIA

EGNEŞ, *see* KORMASA

EGUILLES Bouches-du-Rhône, France. Map 23. Situated 5 km W of Aix-en-Provence. Near the modern village is the oppidum of Pierredon. Incompletely excavated, the site was occupied in the Iron Age and abandoned, like the other Provencal sites in the same category (Entremont, Constantine), at the end of the 2d c. B.C., when the Salyes were defeated by the Roman legions. A circuit wall of dry stone has been found, of the same type as that at Entremont, with gates and an interior cross-wall but without projecting towers; there are also remains of dwellings. The objects found are mainly indigenous but include a few Campanian sherds. Also noteworthy are some fragments of carved limestone similar to those found at Entremont. F. SALVIAT

EIBEOS (Payamalanı) Turkey. Map 5. Site in Phrygia 7 km NE of Sebaste, on the W slope of Mt. Bulkaz. Previously known as Paleo Sebaste or Leonna, it has now been identified as Eıbeos from an inscription found in 1973. Today there are only a few houses on the site, and the nearest village is Eldeniz. Remains of ancient walls, among which only a Byzantine church can be distinguished, can be seen between Eldeniz and Payamalanı. The necropolis has been pillaged, but some fragments of sarcophagi and door stelai are in the Selçikler (Sebaste) Museum Depot, and in the Uşak and Afyon museums.

BIBLIOGRAPHY. W. M. Ramsay, *JHS* 4 (1883) 412; id., *The Cities and Bishoprics of Phrygia* II (1897) 584, 597; N. Fıratlı, *TürkArkDerg* 19, 2 (1970) 118-19.

<div align="right">N. FIRATLI</div>

EILEITHYIA later LUCINA (El-Kâb) Egypt. Map 5. A city, noted by Strabo (17.1.47), 85 km S of Thebes on the E bank of the Nile. The Egyptian name of the city was Nekheb. It was an important religious center, the capital of the third nome of Upper Egypt and a station for the gold mines. The patron goddess of the province, Nekhbet, was identified by the Greeks with their moon goddess Eileithyia and by the Romans with Lucina. The site was renamed after the two goddesses in turn. Ptolemy VII restored the chapel that had been erected by Amenophis III and added a monumental pylon. The small temple that is hewn in the rock was begun by the same Ptolemy and completed under Ptolemy X and his successor.

BIBLIOGRAPHY. K. Michalowski, *L'Art de l'Ancienne Égypte* (1968) 541-42MP.

<div align="right">S. SHENOUDA</div>

EINING, *see* ABUSINA

EINÖD, *see* SCHWARZENACKER

ELAEUSSA later SEBASTE (Ayaş) Rough Cilicia, Turkey. Map 6. Now a village on the coast between Korykos and Lamus. The city may have been founded about the 2d or 1st c. B.C. Under the Romans it was given perhaps to Tarcondimotos some time before 31 B.C., and in 20 B.C. with Korykos and other areas of Rough Cilicia to Archelaos I of Cappadocia, who changed the name to Sebaste in honor of Augustus. A son of Archelaos by the same name may have succeeded, and in A.D. 38 Antiochos IV of Commagene took over. He died in A.D. 72, at which time or soon after both Cilicias were formed into one province under a legatus pro praetore. Elaeussa flourished during the Roman period in spite of various setbacks; it was apparently prosperous in the 6th and 5th c. A.D., although its harbor had silted up by the 6th. It seems not to have recovered from the period of Arab invasions, and has been more or less deserted since.

Elaeussa is situated on the sandy shore of a shallow bay with an island in the center, now a peninsula, which in antiquity sheltered the harbor. On the island Archelaos built a palace in which he spent much of his time. There are numerous ruins on the island including the remains of a church, but all are apparently later than the palace. An aqueduct led to the island, and the remains of two more span the ravine to the W of the city (Cambazlı or Çukurbağ Deresi). A well-preserved water course and arched aqueduct runs along the coast from the Lamus river to Elaeussa and Korykos; a building inscription on it dates not earlier than A.D. 400.

The theater cavea is cut in the rock slope a little inland opposite the island, facing S. The seats have been robbed, but the bedding for them can be seen. Some remains of the stage building are preserved, and just S of them parts of another building (stoa?) with some column bases preserved along its S side; in 1818 there were said to be 16 of them. On a high tongue of land at the W end of the bay are the conspicuous remains of a Roman peripteral temple, oriented NW-SE, the entrance at the NW. The columns, 6 x 12, are fluted, five are left standing higher than their bases, but none is complete. The stylobate measures 17.60 x 32.94 m and is set on a podium where the ground falls away on all sides but the NW. The capitals are described as a cross between the Composite and Corinthian orders. The architrave has three fasciae, the one remaining frieze block is decorated with

a dolphin rider and hippocampus. No trace of the original cella remains. In the Early Christian period a church was built on the temple stylobate, at right angles to it, the apse at the NE side of the stylobate, with an adjoining enclosure filling the NW end of the temple. The columns of the S half of the SW side of the temple and all the columns of the SE side were removed, leaving an open platform. Part of the E end of the church and the apse is paved with a fairly well-preserved garden and animal mosaic, very similar to some at Antioch dated to the 5th c. A.D. West of the temple and near the two aqueducts across the stream are the remains of a large building of opus reticulatum with four barrel-vaulted rooms, perhaps a bath.

The inhabitants of Elaeussa eventually lived by a forest of tombs, which fill almost every available space along the ancient shore road, the majority dating from the 2d c. A.D. into the Christian period. There are sarcophagi, freestanding and rock-cut, some decorated with garlands and inscriptions. There are rock-cut and masonry chamber tombs and mausolea. From the 2d or 3d c. A.D. there are eight or more heroa of the Corinthian order, faced with ashlar masonry. Some of these are rectangular with pilasters at the corners and vaulted interiors; others are tetrastyle prostyle podium temples with narrow doorless porches. In the necropolis along the road NE of the city is a sarcophagus under an elaborate baldachino.

From near the theater an ancient paved road leads NW to a site called Çati Ören (skeleton ruins) in a plain where are a (Hellenistic?) fortress of polygonal masonry, a Temple of Hermes and an early basilica, and nearby a cave temple to Hermes. To the NE about 1.5 km is another (Hellenistic?) fort on the edge of a ravine, with club symbols carved on it. Both these sites might have belonged to Olba in the Hellenistic period and later. At Çati Ören an inscription of ca. the Augustan period mentions a dynast, possibly Archelaos of Elaeussa or Polemo, dynast of Olba in the 1st c. A.D. Northeast of Elaeussa, ca. 3 km inland, is the town of the Kanytelleis or Kanytelideis, which was a deme of Elaeussa in the Roman period, but was in Olban territory in the late 3d c. B.C. On the roads leading from this site to the coast and inland are necropoleis, including heroa; on the road to Elaeussa are numerous rock-cut tombs and reliefs. The main area of the site is around a large rectangular depression, a natural limestone cave whose roof has collapsed. At the edge of this is a large rectangular tower of polygonal masonry, with an inscription dedicating it to Zeus Olbios, by the priest Teucer son of Tarkyaris, presumably the same man who built the great tower at Uzuncaburç. There are house remains here and there and five churches, some well preserved.

BIBLIOGRAPHY. F. Beaufort, *Karamania* (1823) 241-43; for Beaufort's plan of Elaeussa see U.S. Naval Chart (Hydrographic Office, Washington, D.C., 1954) no. 4254, *Plans on the South Coast of Turkey*, H; C. L. Irby, *Travels in Egypt and Nubia, Syria and Asia Minor During the Years 1817 and 1818* (1823) 510-20; L. de Laborde, *Voyage dans l'Asie Mineure* (1838) 133f; V. Langlois, *Voyage dans la Cilicie* (1861) 220-33; J. T. Bent, "A Journey in Cilicia Tracheia," *JHS* 12 (1891) 208-11; E. L. Hicks, "Inscriptions from Western Cilicia," *JHS* 12 (1891) 226-37; R. Heberdey & A. Wilhelm, *Reisen in Kilikien, DenkschrWien,* Phil.-Hist. Kl. 44, 6 (1896) 51-67; G. L. Bell, "Notes on a Journey through Cilicia and Lycaonia," *RA* 7 ser. 4 (1906) 398-412; J. Keil & A. Wilhelm, *Denkmaler aus dem Rauhen Kilikien, MAMA* III (1931) 220-28MP; M. Gough, "A Temple Church at Ayas," *AnatSt* 4 (1954) 49-65MP; A. Machatschek, *Die Nekropolen und Grabmaler im Gebiet*

von Eleiussa Sebaste und Korykos, DenkschrWien, Phil.-Hist. Kl. 96, 2 (1967)ᴹᴾᴵ. T. S. MAC KAY

ELAIA (Kazıkbağları) Turkey. Map 7. Town in Aiolis 24 km SW of Bergama. Said to have been founded by the Athenian Menestheus at the time of the Trojan War (Strab. 622), but not a member of the Aiolian League. Assessed in the Delian Confederacy at one-sixth of a talent, Elaia acquired importance in the Hellenistic period as the port of the Pergamene kings. Coins are known from the 5th and 4th c. B.C., and from the time of Augustus to the 3d c. A.D. Later it was a bishopric under the metropolitan of Ephesos.

The ruins are scanty. Of the city wall, originally 3 m thick and built in 234 B.C., only a few stray blocks can now be seen. The acropolis hill is barely 20 m high. The sea has receded since antiquity; harbor works were formerly visible, but all that now remains is a solid wall some 200 m long running out into the mudflats. Nothing survives above ground in the necropolis to the N. Some ancient stones turned up by the plough can be seen at the local coffee-house.

BIBLIOGRAPHY. C. Schuchhardt, *Altertümer von Pergamon* I, 1 (1912) 111-13; G. E. Bean, *Aegean Turkey* (1966) 112-14. G. E. BEAN

"ELAIOUS," *see* MELIANI

ELASSONA, *see* OLOSSON

ELATEIA Phokis, Greece. Map 11. The first city of the ancient region, not counting the Delphic sanctuary. Controlling the natural route from the N into the Kephisos valley, Elateia was repeatedly attacked, sacked, burned, occupied; earthquakes destroyed what enemies had spared. The one attempt at excavation of the Classical town revealed few remains; only the Temple of Athena Kranaia, located some 3 km SE of the city, yielded important remains. Numerous inscriptions, including grave stelai from plundered cemeteries, complement the textual evidence concerning Classical Elateia. However, the well-watered valley attracted primitive men and many mounds attest their early settlements. Those near modern Drachmani, below ancient Elateia, were explored early in this century and one of these mounds was again excavated in 1959. Occupation here began about 6000 B.C. and lasted the three millennia of the Neolithic Period, establishing stratigraphically its three main phases.

BIBLIOGRAPHY. Pierre Paris, *Élatée. La ville. Le temple d'Athéna Cranaia* (1892); id., *RE* V 2236-37; id., *Praktika* (1904) 53-56; (1906) 140-42; (1910) 160-61; id., *AthMitt* 30 (1905) 135-40; 31 (1906) 397-402; id., *REG* 25 (1912) 263, 270; S. S. Weinberg, "Excavations at Prehistoric Elateia, 1959," *Hesperia* 31 (1962) 158-209.
 S. S. WEINBERG

"ELATRIA," *see* PALIOROFORON

ELBA, *see* ILVA

EL-BAHNASA, *see* OXYRHYNCHUS

EL BENIAN ("Duga") Morocco. Map 19. Camp 20 km SE of Tingi, measuring 183 x 140 m, built at the end of the 3d c. A.D. and occupied up to the end of the 4th c. It has sometimes been identified with Duga, the garrison of the cohors II Hispanorum mentioned in the *Notitia Dignitatum* (occ. 26).

BIBLIOGRAPHY. M. Tarradell, "El Benian, castellum romano entre Tetuan y Tanger," *Tamuda* 1 (1953) 302-9ᴹᴾᴵ; M. Ponsich, *Recherches archéologiques à Tanger et dans sa région* (1970) 352-55. M. EUZENNAT

ELCHE, *see* ILLICI

EL DJEM, *see* THYSDRUS

ELEA later VELIA, Campania, Italy. Map 14. A city of the Ionian Phokaians on the coast of Lucania, founded 540-535 B.C. Following their mass flight from submission to Persia, the Phokaians first sought refuge in their colonies of Alalia (on Corsica) and Massalia (Marseilles), but the sea battle of Alalia, in which they triumphed over a combined force of Etruscans and Carthaginians, led them to abandon Alalia for a place in Magna Graecia. After a stop and reinforcement at Rhegion they sailed N along the coast to Elea, a site in the mountainous country between Cape Palinurus and Poseidonia (Hdt. 1.163-67). The foundation prospered and eventually counted among its ornaments Parmenides, the 5th c. philosopher and statesman who gave the city its constitution, and the Eleatic school of philosophy. Like Naples and Tarentum it never fell to the assault of Italic tribes (*Strab.* 6.254). In 387 B.C. it was a member of the Italian league against Dionysios I of Syracuse and subsequently became a faithful ally of Rome, furnishing her with ships in the Punic wars and affording a stronghold in S Italy against Hannibal. Cicero tells us that the cult of Ceres, Liber, and Libera at Rome was Greek, and that Velia was one of two cities that furnished priestesses for it (*Balb.* 55). In 88 B.C. it became a municipium and was inscribed in the tribus Romilia. In the civil war of 44 B.C. Brutus, who had a villa there, made it one of his bases. Thereafter we know of it only as the native city of the father of Statius and the grammarian Palamedes and famous for its school of medicine founded on Parmenides' principles. It was always fiercely independent and determinedly Greek, as the archaeological record also attests, and persisted in writing Greek well into the Imperial period. Its decline was due to isolation from the main routes inland and the silting up of its ports. Its economy had probably always been fragile, dependent on the sea traffic and fishing; there is little good agriculture in the vicinity.

The city occupied the end of a spur of the Apennines between two rivers, the Palistro and the Fiumarella S. Barbara, with an acropolis overlooking a considerable bay. Landward from this the city spread to either side over the slopes descending to the plain and the river ports, the S quarter much more important than the N. The fortifications are extremely complicated and confusing, the walls with a base in blocks of the local limestone and sandstone and upper parts in two- and three-ribbed construction bricks that are a characteristic of the city. The walls made at least two, and probably three, circuits that could be separated from one another in emergency, the largest circuit embracing the S and E quarters of the city, another around the N quarter, and probably a third enclosing the acropolis and the slope SE of it, the heart of the old city. There are some scant remains of polygonal masonry of "Lesbian" type, presumably of an early fortification, to be seen at places along the crest of the spur, but most of what can be seen today is work of the Hellenistic period, with towers protecting the gates and at fairly regular intervals along vulnerable stretches of the curtain, and a fortress at the high point inland that pains were taken to include. But the setting of certain towers still wants explanation; and the function of Porta Rosa, Velia's most conspicuous monument—both a gate between the N and S quarters and a viaduct connecting the acropolis with the inland fortifications—needs further clarification.

Excavations have been carried out on the acropolis and its adjacencies, in an area known as the agora, and in the neighborhood of Porta Marina Sud, as well as around

Porta Rosa and its approaches and at scattered points in the S and E quarters. On the acropolis the most important remains are those of a large Ionic temple, now reduced to its foundations (32.50 x 18.35 m) partially covered by a mediaeval castle. This dominated the view, and around it were later constructed the terraces and porticos of an extensive sanctuary. The earliest material is of the 6th c., but the temple building is early 5th. Under it is a stretch of fine archaic work.

On the S slope of the acropolis, in part buried by a terrace wall of the early 5th c., are foundations of small buildings in "Lesbian" polygonal masonry. These seem to be remains of the first settlement, or possibly (on the evidence of pottery found here) a still more ancient station going back to the early 6th c. It is interesting that these all seem to have faced E and were aligned with a regular grid of streets.

Along the crest of the main spur a number of temples and sanctuaries of a wide range of dates have been explored. The most important are a long, narrow temenos on the minor acropolis where a stele to Poseidon Asphaleios was found and a vast terrace (ca. 110 x 100 m) near the summit of the city with a long altar (25.35 x 7 m) reminiscent of that of Hieron at Syracuse.

The agora area, on the slope S of Porta Rosa, consists of a small public square surrounded by colonnades under which passes an elaborate channel, best examined uphill from the square, that drained the surrounding slopes, taking the water to the sea. To the E are remains of a series of buildings that may be dependencies of the agora. The terrain here is steep and broken, and the area was repeatedly rebuilt, but the original plan seems to have been of high antiquity, though what can be seen today is for the most part Hellenistic and Roman. The drain is dated to the beginning of the 3d c. B.C.

In the vicinity of Porta Marina Sud a considerable area has been cleared. Here the most interesting remains are a building with cryptoporticus that fills a whole insula, apparently headquarters of a medical association, where a number of sculptures and inscriptions were recovered, and a bothros which was found full of votive material, possibly dedicated to Eros. A number of small houses belonging to the Roman period have been found in this area; these are all of peristyle plan, no atrium house being known on the site.

The excavators believe that the city was devastated by catastrophes toward the beginning of the 3d c. B.C., toward the middle of the 1st c. A.D., and toward the end of the 5th c. After the first two the city was rebuilt along its original pattern, but after the last no rebuilding was undertaken.

BIBLIOGRAPHY. P. C. Sestieri, "Greek Elea-Roman Velia" *Archaeology* 10 (1957) 2-10[I]; *La Parola del Passato* 25 (1970) 5-300, 21 (1966) 153-420 (articles by various authors on "Velia ed i Focei in Occidente"); M. Napoli, *Guida degli scavi di Velia*, Cava de'Tirreni (Di Mauro) (1972)[MP]. L. RICHARDSON, JR.

ELEPHANTINE, see SYÊNÊ

"ELESIODUNUM," see MONTFERRAND

ELEUSIS Attica, Greece. Map 11. A small hilly site about 22 km to the W of Athens, lying at the head of the Thriasian plain and on the coast of a lake-like sea bordered by Salamis. Because of its location, it has been inhabited from the Early Bronze Age to the present. Its periods of fame were due to the secret cult of Demeter, known as the Eleusinian Mysteries, celebrated once a year. The cult, introduced during the Mycenaean Age, became Panhellenic in the 6th c. B.C. and acquired uni-

versal status in Roman Imperial times. In the Classical period the township was identified with the Sanctuary of the Goddess. It was devastated first by the army of Xerxes in 480-479 B.C., then by the Kostovoks in 170 B.C., and finally by the hordes of Alaric in A.D. 395. The first two destructions were followed by rebuilding; the site never recovered from the last destruction and by the end of the 5th c. it was completely ruined by the Christians.

Excavations, continuous since 1882, have revealed the ruins of the famous Sanctuary of Demeter. For privacy its area was surrounded by fortifications in successive eras, in Geometric and archaic times, in the days of Peisistratos, Kimon, and Perikles, and in 380-370 B.C. Surviving in good length, they prove that an ever increasing popularity of the cult was followed by enlargements of the sanctuary area.

At its N edge is the outer court, 65 x 40 m, paved in Roman times. Along the E side of the court we find the remains of a fountain-house, 11.30 m in length, dating from the Roman period. At its two corners, the SE and the SW, triumphal arches identical to that of Hadrian in Athens were erected after A.D. 129. The SW arch, now being restored, is better preserved. Above its single archway we read the inscription, "All the Greeks to the Goddesses and the Emperor." That arch opened to a road running along the peribolos wall of Kimon, strengthened in Roman times. On its N side survive remnants of buildings in which the initiates once could find temporary accommodations.

On the paved court stands the high podium, made of Roman concrete, of the Temple of Artemis of the Portals and Father Poseidon. Built of Pentelic marble before the reign of Marcus Aurelius, it had a front and rear portico with Doric columns. Beyond its NE corner is a well-preserved, unique ground altar of baked brick set in a rectangular court, dating from Roman times. To the S and E the outer court was blocked by the Greater Propylaia and by a fortification wall of Peisistratean times, which was continued to the SE to enclose the township of Eleusis.

The Greater Propylaia face NE, toward Athens, and form the main entranceway to the sanctuary. They stand on a stepped platform rising 1.70 m above the floor of the court. Of Pentelic marble, they are an exact duplicate of the central section of the Periklean Propylaia of the Acropolis, with an inner and an outer portico fronted by Doric columns. The outer portico, 15.24 m in depth, uses six Ionic columns in two rows in its depth. The inner portico, facing the sanctuary, is only 7.36 m in depth. The cross-wall between the porticos was pierced by five doorways. The floor has survived, as have fragments of the entablature, and even some blocks of its pediment decorated with a bust of its builder, Marcus Aurelius, in a shield. The lowermost step on the E side was interrupted to allow access to one of the sacred landmarks of Eleusis, a well rebuilt by Peisistratos and since then known as the "Kallichoron."

To the S of the Greater stand the Lesser Propylaia. They were built of Pentelic marble after 50 B.C. by the nephews of Appius Claudius Pulcher in fulfillment of his vows over the Peisistratean Gate, the N Pylon, whose flanking tower can be seen under its platform of Roman concrete. At the depth of a forecourt (9.80 x 10.35 m) paved with large slabs, is the doorway, 2.95 m wide. It was sheltered by a prothyron on the outside and a vestibule on the inside. The prothyron, 4.40 m in depth, has two Corinthian columns whose bases and elaborate capitals with winged animals among the corner tendrils have survived. The entablature has an Ionic architrave, on which is cut the Latin dedicatory inscription, and a frieze of triglyphs and metopes embellished with cists, bukrania,

and stylized double poppies. The inner vestibule, facing the sanctuary, was fronted by two Caryatids set on high podia. One of these is in the local museum, the other in the Fitzwilliam.

To the SW of the Lesser Propylaia, separated by a wall built by Valerian, are foundations of structures which served the functionaries of the sanctuary.

From the Lesser Propylaia begins the ascending Sacred Way, paved in Roman times, which terminated to the S at the Temple of Demeter known as the Telesterion, since in it was completed the Telete, the initiation service. Immediately to the right of the Sacred Way is a cave within which survive the foundations of a 4th c. B.C. temple (2.98 x 3.77 m) dedicated to Pluto. Built of poros stone in the form of a templum in antis, it stands in a triangular court retained by a wall of poros stone. Adjacent to the cave on the S is a stepped platform cut out of the rock, 10.50 x 6.25 m, which perhaps served as a stand from which the initiates followed an act of the sacred pageant, for somewhere in front of it was the Mirthless Stone, another sacred landmark. Above its S side stood a small treasury, some 6 x 2.90 m, by the side of which, still to be seen, is a boulder used as a donation box for small gifts.

Next to the platform on the S is a deep cutting in the rock in which can be seen the foundations of a building, 14.10 x 11.20 m, whose front was built over an artificially constructed terrace. It was in the form of a templum in antis with a wide stairway in its front elevation. The building was at first identified as the pre-Persian Temple of Demeter, but it is proved to have been constructed in Roman times and perhaps was dedicated to Sabina, the New Demeter. Between this temple and the Telesterion exists a narrow stairway cut in the rock, an ascent to another Roman temple built on the hill.

No building was constructed along the E, or left-hand side of the Sacred Way. Beyond its edge and limited by the Kimonian wall can be seen remains of the Peisistratean peribolos composed of a stone socle surmounted by a mudbrick wall, as well as foundations of a variety of buildings. Most important of these is a triangular structure of Periklean times with three rows of square pillars: the famous Siroi, or magazines, where the tithes to the goddess were stored. Again on the left-hand side, as we approach the Telesterion, we can see the retaining walls built in the Geometric, archaic, and Periklean periods and in the 4th c. B.C. to support the terrace on which were constructed the successive Telesteria of Demeter.

On that terrace, above the Mycenaean remains, a fragment of an apsidal wall, built ca. 750 B.C., seems to belong to the earliest Telesterion of the historic period. To that temple and terrace access was obtained through a stairway on the S side near which remains of sacrificial pyres attest to the sacred character of the terrace and its building. Around 600 B.C. a larger Telesterion, known as the Solonian, was built over the same area of the slope, but on an enlarged terrace. Its SW corner survives, proving that at least the lower part of the temple was built of bluish-gray Eleusinian stone in the Lesbian polygonal style. The temple had an oblong plan, 24 x 14 m, with a double sloping roof ending in triangular pediments. In front of it spread a triangular court where the altars of the goddesses stood. Below the terrace to the NE a stepped platform faces a lower court bordered by an altar and a well. In the archaic period it served the initiates to follow the sacred dances held in front of the well in honor of the goddess.

In the days of Peisistratos and his sons, 550-510 B.C., the Solonian Telesterion was replaced by a larger one, built of well-cut poros stone over the same area of the slope. Its foundations of hard limestone were lowered to rock level. The temple possesses an almost square naos or cella, 25.30 x 27.10 m, fronted on the E side by a prostoon with perhaps 10 Doric columns in its facade. The roof of the naos was supported by 22 Ionic columns. In the SW section of the naos was the anaktoron, a separate shrine, where the hiera were kept. On three lengths of its walls, interrupted only by the shrine, rose tiers of nine steps from which the initiates could follow the rites. Three doors opened from the naos to the prostoon. The entablature was of poros stone, but its raking cornice and the simas, with ornamental rams' heads at the corners, were of Parian marble.

The Peisistratean Telesterion was devastated by the Persians in 480-479 B.C. Using its foundations, Kimon began the building of a new Telesterion whose scanty remains prove that it was never completed. Literary (Vitruvius, Strabo, Plutarch) and epigraphical evidence indicates that two different buildings were attempted in the Periklean Age. One was designed by Iktinos and its construction was begun but soon abandoned. The few surviving remains, especially foundations of columns, indicate that it was composed of an almost square naos whose roof, supported by 20 columns, had an opaion or lantern in the center. Its W side was cut deeply into the rock of the hillside. The second building was designed and executed by Koroibos, Metagenes, and Xenokles. It was burned in 170 B.C. and was rebuilt by Marcus Aurelius. The only change made in the original plan was to increase the length of the naos by 2.15 m. What we can see today belongs to the rebuilt temple.

The Telesterion designed by Koroibos was composed of a square naos, ca. 51 m in length (increased to ca. 53 m in Roman times) and ca. 51 m in width. A good part of its W section was cut out of the living rock. The roof was supported by 42 columns arranged in seven rows of 6 columns in each row. The floor columns supported a second tier of lighter columns and in the middle of the roof there was an opaion. Under the opaion in the naos was the anaktoron, scanty traces of which have been recently recognized; at its NE corner stood a niche containing the throne of the Hierophant. Tiers of eight steps for the initiates were arranged along the walls on all four sides of the naos, interrupted by two doorways on each of three sides, the N, E, and S. In the 4th c. B.C. a portico was built in front of its E side, known as the Philonian Stoa from the name of its architect. Today we have the foundations of the stoa, the stereobate or its floor, some drums of its columns, and parts of its superstructure, all built of Pentelic marble, while the foundations were of poros stone. The stoa measures 54.50 x 11.35 m. The exterior aspect of the naos with its unbroken wall of gray-blue stone unrelieved by columns, solemn and austere, must have been awe-inspiring, well suited to its mystic function.

Behind the Telesterion, some 7.35 m above its floor, a terrace, 11.45 m in width, is cut in the rock. This terrace, as well as the narrow stairway to the N and the broad stepped platform cut in the rock to the S, are of Roman date. The terrace led to a stepped approach of a Roman temple built on the NE extremity of the hill. The temple had a cella, 18 x 12 m, roofed by a vault and a portico, ca. 4.5 m in depth, with four columns in antis. Perhaps it was dedicated to Faustina the elder, who also had the title of New Demeter. The terrace and the temple extended to the wall—known as the diateichisma, few remains of which survive—that separated the sanctuary area from the summit of the hill.

The broad stepped platform to the S of the Telesterion faced the S court, where perhaps the rites of the balletys, the pelting with stones, was performed and was witnessed

by people standing on the platform. The S court to the E is bound by fortification walls built by Perikles and extended in 370-360 B.C. to the SE and S. The 4th c. wall, averaging 2.55 m in thickness, is the best-known example of Greek fortification walls. Along its inner side was built a long structure divided by cross-walls into six compartments. Its use is problematical; perhaps it served important members of the personnel, or was used for storing the tithes. Along the S section of the 4th c. B.C. wall, where we find the well-preserved Gate to the Sea, exist the foundations of a 3d c. building identified as the bouleuterion, where the City Council, and occasionally the 500 of Athens, met. Farther W from the Gate to the Sea scanty remnants of a long stoa survive, dating perhaps from the 4th century B.C.

The sanctuary area, cleared to the rock, has yielded remains that enable us to piece together the history and the architectural activity of the site. Of the village itself very little survives. Most important are the remains of the Peisistratean fortification wall that surrounded the N section of the village with its gate toward Athens, the Asty Gate. On the S slope of the hill a well-known relic in the form of a vaulted round chamber with a passage attached to its E side, was taken to be a tholos tomb of Mycenaean times. It has been proved to be a cistern of the 4th c. B.C. belonging to the village.

BIBLIOGRAPHY. "Eleusinische Beitraege," *AthMitt* 24 (1899); P. Foucart, *Les Mystères d'Éleusis* (1914); F. Noack, *Eleusis, die baugeschichtliche Entwicklung des Heiligtumes* (1927); K. Kourouniotes & J. N. Travlos, Τελεστήριον καὶ ναὸς τῆς Δήμητρος, *Deltion* 15 (1933-1935); K. Kourouniotes, Ὁδηγὸς τῶν ἀνασκαφῶν καὶ τοῦ Μουσείου (1934); "Das eleusinische Heiligtum von den Anfaengen bis zu vorperikleischen Zeit," *ArchRW* 32 (1935); K. Kourouniotes & J. N. Travlos, Συμβολὴ εἰς τὴν οἰκοδομικὴν ἱστορίαν τοῦ Ἐλευσινιακοῦ Τελεστηρίου, *Deltion* 16 (1935); K. Kourouniotes, *Eleusiniaka* I (1937); G. E. Mylonas, *The Hymn to Demeter and Her Sanctuary at Eleusis* (1942); J. N. Travlos, "The Topography of Eleusis," *Hesperia* 18 (1949); Τό ἀνάκτορον τῆς Ἐλευσῖνος, *Ephemeris* (1951); G. E. Mylonas, Ἐλευσὶς καὶ Διόνυσος, *Ephemeris* (1960); *Eleusis and the Eleusinian Mysteries* (1961); Τὸ δυτικὸν νεκροταφεῖον τῆς Ἐλευσῖνος (1975).

G. E. MYLONAS

"ELEUTHERAI," *see* GYPHTOKASTRO

ELEUTHEROPOLIS Israel. Map 6. A city in Idumaea, 40 km NW of Jerusalem, which began to flourish after the destruction of its rival Marissa by the Parthians in 40 B.C. Pompey conquered it in 64 B.C., and settled veterans of his legions there. Septimius Severus made it a polis in A.D. 200, and conferred ius italicum on its citizens; he also changed its Semitic name, Beth-Gubrin, to Eleutheropolis, the city of the free men. At that time it began to mint coins, dated by its own history. The city appears on the *Peutinger Table*, and its first bishop participated in the Council of Nicaea in A.D. 325. Eleutheropolis ruled over a large area, including most of Idumaea and reaching the Dead Sea near Engeddi. There were many Jewish villages in the S part of its territory. In the early Arab and mediaeval periods it lost its importance. The site has been little explored. Among the few finds are the remains of a Late Roman villa decorated with mosaics of hunt scenes, and a marble capital with a representation of a seven-branched candlestick, probably from a synagogue of the Byzantine period.

BIBLIOGRAPHY. F. M. Abel, *Géographie de la Palestine* II (1938) 272; UNESCO World Art Series, *Israel Ancient Mosaics* (1960)[I]; M. Avi-Yonah, *The Holy Land* (1966) 96, 115, 159-62.

A. NEGEV

ELEWIJT Belgium. Map 21. A Gallo-Roman vicus N of the civitas Nerviorum on the Namur-Baudecet-Rumst road. It is on the boundary between the sandy Campine province and the more fertile Brabant, at the spot called Zwijnbeer, a hill to the N of the modern village. Excavations show that the vicus covered an area of some 27 ha. Important finds of Roman antiquity have been made since the 17th c. and many amateurs have carried out scattered excavations. An undisturbed section of the vicus was systematically excavated in 1947-53.

There were three periods of occupation. The earliest clue is the mark of a rectilinear ditch, which has been traced over 60 m. Its profile is V-shaped, as is characteristic of Roman camps. This camp (Augustan?) was just a temporary one, and the ditch was very soon filled in. The vicus started to grow during the reign of Claudius when a large part of the road network of N Gallia was built. At that time Elewijt was linked by road to the vicus of Asse and also to Bavai. It was half rural and half industrial. Traces of an ironworks have been found there, along with a potter's kiln that produced everyday pottery in the local tradition. In the 1st c. A.D. the buildings were still of wood and of wattle and daub. They were gradually replaced by stone structures, of which a cellar still remains. It was at that time, no doubt, that a sanctuary was built, dedicated to a divinity that was patron of horses (this same divinity had another sanctuary at Asse). At Elewijt, as at Asse, a whole series of statuettes of horses was found, made of white Allier pottery. The thymiaterion used in this sanctuary was also discovered, and part of the foundations of the structure may have been unearthed in the course of excavation. Potsherds of terra sigillata, of which a great many have been found, show that the vicus had trade links with S and central Gallia as well as with the E and the Rhineland.

Toward the end of the 2d c. the settlement was almost completely destroyed. It was rebuilt on an entirely different plan: thereafter the houses were oriented on a NW-SE axis. A large building, erected in the middle of the vicus, had several rooms, heated by hypocaust and walls decorated with friezes. A number of wells date from this period. It is not known how the vicus disappeared. It may be that it was ravaged during the invasions of the second half of the 3d c. In any case there are few traces of the 4th c. In the 19th c. the necropolis of the vicus was located at the section called Heidendries, but little is known about it.

BIBLIOGRAPHY. F. Vaes & J. Mertens, *La céramique gallo-romaine en terre sigillée d'Elewijt* (1953); J. Mertens, "De Romeinse Vicus te Elewijt," *Handelingen van de Kring voor Oudheidkunde van Mechelen* 47 (1953) 21-62[PI]; M. Desittere, *Bibliografisch repertorium der oudheidkundige vondsten in Brabant* (1963) 45-48.

S. J. DE LAET

EL-GABALEIN, *see* APHRODITOPOLIS

EL GOUR (Souk el Jemaa el Gour) Morocco. Map 19. A large indigenous mausoleum, cylindrical and made of ashlar, 30 km SE of Meknès. In the absence of any reliable chronological evidence, its date may range from the 2d c. B.C. to the Late Empire.

BIBLIOGRAPHY. G. Camps, "Un mausolée marocain: la grande bazina de Souk el-Gour," *Bulletin d'Archéologie Marocaine* 4 (1960) 47-92[MPI]; A. Jodin, "La datation du mausolée de Souk-el-Gour," ibid. 7 (1967) 221-61[MPI].

M. EUZENNAT

EL-HALIL, *see* HEBRON

ELIMBERRIS, *see* AUCH

"ELINA," *see* PERDHIKA

ELINIKO, *see* AIPION

ELIS Peloponnesos, Greece. Map 9. The city lies in the NW part of the region, in the middle of the E Peneios plain, where the river emerges from the mountainous interior into the plain, between the modern villages of Paliopolis and Kalyvia. In the NE section of the city rises the hill Kaloskopi (mediaeval Belvedere) or Paliopyrgos (400 m), where the ancient acropolis was. The site was inhabited from at least as early as the Early Helladic period and from then on through to the end of the Byzantine period. According to some ancient philological sources, Elis in the Mycenaean period was one of the four or five most notable towns in the realm of the Epeioi (*Il.* 2.615f, 11.671f; *Od.* 4.635) and controlled only the area around the city. Excavation of the site was undertaken in 1910-14, and has continued since 1960.

In the Early Helladic to Geometric period, judging by the extent of the finds and the numerous tombs of this period, the settlement was located on the peak of the acropolis and on its NW slope toward the Peneios, where the theater was later placed. In the archaic period the city was extended to the SW. At that time the Temple of Athena was probably erected on the acropolis (Paus. 6.26.2). Numerous painted terracotta simas and stone architectural fragments indicate the existence at that time of many monumental structures.

In the Classical and Hellenistic period the city area was extended to surround the acropolis over an area bounded by Paliopolis to the S, the village of Kalyvia to the W, and as far as the outskirts of the village of Bouchioti and the banks of the Peneios. Part of the city extended to the right bank opposite. The principal necropolis of this period was discovered SW of Kalyvia. Another was found at the NW foot of the acropolis. The city, or at least the acropolis, was fortified at the end of the 5th c. B.C. (Paus. 3.8.5). In 313 B.C. Telesphoros, the general of Antigonos, refortified the acropolis (Diod. 19.74.2, 87). At its N foot a substantial section of this wall was uncovered, and other remains of the ancient wall have been found on the W slope. In this period were constructed numerous civic buildings, as well as temples and shrines in the agora and the area around, where they stood quite close together (Paus. 6.23.1f). Some of these have been uncovered and identified by the excavations to date: the agora, including a part of the stoa of the Hellanodikai which is Doric, with a triple colonnade, the Hellanodikaion which is a small rectangular building to the N of the stoa, two gymnasia and the palaestra in the W section, and in the S section of the agora the Korkyraion or South Stoa, which is a double stoa in the Doric style. The whole theater has been uncovered to the N of the agora. Its first phase dates to the 4th c. B.C., with alterations in the Hellenistic and Roman periods. Other buildings which Pausanias saw, but which have not yet been located, are: the Temple of Aphrodite with a chryselephantine statue of the goddess by Phidias, the Temenos of Aphrodite Pandemos with a statue of her with a goat by Skopas, the Temple of Hades, the Sanctuary of Artemis Philomeirax, the Cenotaph of Achilles, the Temple of Tyche and Sosipolis, the Temple of Silenos, etc.

In the Roman period the city extended to the E, S, and W. In the S and W parts of the agora several new villas and baths were constructed, many on the foundations of older, Classical buildings. These buildings are close to each other, with rather narrow roads between and a complete water and drainage system. In the Late Roman and Early Christian periods only a part of the city was inhabited, while other sections, such as the agora and the area around it, were transformed into a large cemetery, apparently after a major destruction of the city, possibly by the Herulians (A.D. 267).

In the Byzantine period some settlement remained as indicated by an Early Christian basilica with noteworthy mosaics which was built over the South Stoa, and by numerous Christian graves in various parts of the ancient city. In the Frankish period the kastro (castle) was built on the acropolis with material from ancient buildings.

Elis: the state. The first organization of Elis into a city-state probably came about after the Dorian invasion, according to ancient tradition under Oxylos, who at the head of the Aitolo-Dorian tribes created the first synoecism in Elis (Ephor. frg. 29; Strab. 463f; Paus. 5.4.1-4). After Oxylos, the name of the settlers remained Eleians. In the 11-10th c. B.C. the state of Elis spread into the plain of the Peneios, so-called Koile-Elis (Hollow Elis). Shortly afterwards Elis annexed neighboring Akroreia and part of Pisa with the sanctuary of Olympia, and thereafter took over direction of the Olympic Games. From the 26th Olympiad (676 B.C.) and throughout the 7th c. it appears the Pisans with the help of powerful allies (Pheidon of Argos and the Dymaians) recovered their independence and with it the management of the Olympian sanctuary. But after the second Messenian war Elis, with Sparta as an ally, recovered Pisa and the sanctuary (580 B.C.). After that Elis must have annexed a part of Triphylia (Paus. 5.6.4, 6.22.4). From then to the late Hellenistic period the boundaries of Elis appear at times as the river Neda to the S (the boundary of Messenia), the foothills of Erymanthos and the river of the same name to the E (the boundary of Arkadia) and the Larisos river to the N (the boundary of Achaia). To the N and NE the boundary was the Ionian Sea. In 570 B.C. the state was reorganized and the oligarchic ruling body which had now become more moderate, took on more members (the kingship had been abolished early, possibly at the beginning of the 8th c.). The city of Elis was the main political and religious center, but nevertheless the demes appear to have retained considerable self-government. The peaceful existence which Elis led thereafter, its neutrality in the quarrels of the other Greek states, the "truce" and the designation of the country as sacred ground, were the cause of her prosperity and good laws (Paus. 4.28.4, 5.6.2; Polyb. 4.73.6f; Ephor. frg. 15, in Strab. 8.358, see also 8.333). Elis took no active part in the Persian wars and participated only in the fortification of the Isthmus in 480 B.C. (Hdt. 8.72, 9.77). In 471 B.C. a new synoecism was achieved in Elis (Diod. 11.54; Strab. 8.336; Paus. 5.9.5), which thereafter continued as one of the largest cities of the Peloponnesos. Under pressure of the period's democratic tendencies the oligarchs made considerable concessions, and by degrees lost their absolute authority to a popular government. The life of the country was now directed entirely from Elis, with its council (boule) and assembly (demos) and the higher officers who were elected from among all the free citizens. In the Peloponnesian War Elis abandoned her former neutrality and the "Sacred Life" she had led up to that time (Polyb. 4.73.9f) and allied herself first with Sparta, then Athens, and later with other cities. The subsequent involvement of Elis in the collisions of the Greek world cost her dear by invasions and plundering of her territory and repeated fluctuations of her boundaries. In 191 B.C. the incorporation of Elis in the Achaian League put an end to her independent political life. In 146 B.C., after the sur-

render of Greece to Rome, Elis was included in the Provincia Romana.

The territory of Elis was one of the most thickly settled areas in Greece. Finds of the last decade throughout the Eleian land (Hollow Elis, Akroreia, Pisatis, Triphylia) have brought 120 settlements to light, and surface finds have allowed the location of 160 more sites. Nevertheless, most of these settlements and sites, which date from the Paleolithic to the Byzantine period with no break, must have belonged to small villages, hamlets, or isolated farms since Strabo tells us (8.336) that the land was settled in a pattern of small villages. But even the small settlements of the Eleia (ancient sources tell us of 49 together with the sanctuaries) were wealthy communities although the only urban center was the capital, Elis. This was due to the self-sufficiency of a country rich in rivers and springs (annual rainfall 90-110 cm) and blessed with a mild climate (temperature extremes 10°-11° C.), which pushed the Eleians into a life of agriculture and herding rather than one of craftsmanship and trade (Polyb. 4.73.7f).

BIBLIOGRAPHY. J. S. Stanhope, *Olympia* (1824)[MPI]; Blouet, *Expedition scientifique de Morée* (1831-38) II[MPI]; W. M. Leake, *Peloponnesiaca: A Supplement to Travels in the Morea* (1846)[M]; J. Belock, *Die Bevölkerung der griechisch-Römischen Welt* (1886); E. Curtius, "Sparta und Olympia," *Hermes* 14 (1879) 129ff; G. Papandreou, Ἡ Ἠλεία διά μέσου τῶν αἰώνων (1924); H. L. Bisbee, "Samikon," *Hesperia* 6 (1937) 525ff[PI]; M. Sakellariou, an article in *Mélanges à Octave Merlier* (1953) 1ff; id., Τό ὅρια τῆς χώρας τῶν Ἐπειῶν, *Peloponnesiaka* 3 (1959) 17ff; E. Meyer, *Neue Peloponnesische Wanderungen* (1957)[MPI]; U. Kahrstedt, *Das wirtschaftliche Gesicht Griechenlands in der Kaiserzeit* (1954) passim; Fr. Kiechle, "Pylos und der pylische Raum in der antiken Tradition," *Historia* 9 (1960) 1ff; N. Chavaillon et al., "Une industrie paleolithique du Peloponnese: le mousterien de Vasilaki," *BCH* 82 (1948) 616ff[MPI]; id., "Industries Paleolithiques de L'Elide," *BCH* 91 (1967) 151ff[MPI]; W. McDonald & R. Hope Simpson, *AJA* 65 (1961) 221ff[M]; id., "Further Exploration in SW Peloponnesus," *AJA* 73 (1969) 123ff[MI].

Elis, city-state: U. Kahrstedt, *Das wirtschaftliche Gesicht Griechenlands in der Kaiserzeit* (1954) passim; E. Meyer, *Neue Peloponnesische Wanderungen* (1957)[MPI]; Fr. Kiechle, "Pylos und der pylische Raum in der antiken Tradition," *Historia* 9 (1960) 1ff; W. McDonald & R. Hope Simpson, *AJA* 65 (1961) 221ff[M]; id., "Further Exploration in SW Peloponnesus," *AJA* 73 (1969) 123ff[MI]; R. Hope Simpson, *A Gazetteer and Atlas of Mycenaean sites* (1965)[M]; Leroi-Gourhan, "Decouvertes Paléolithiques en Elide," *BCH* 88 (1964) 1ff[MI]; N. Yalouris, Μυκηναϊκός τύμβος Σαμικοῦ, *Deltion* 20 (1965) 6ff[PI]; id., Παπαχατζῆς, Παυσανίου Ἑλλάδος Περιήγησις, Μεσσηνιακά–Ἠλειακά (1965)[MPI]; id., Πύλος Ἠμαθόεις, *AthMitt* 82 (1967) 68ff[I]; C. M. Kraay & M. Hirmer, *Greek Coins* (1966) 342f[I]; Meyer in *Kl. Pauly* (1967) 2, 249ff, s.v. Elis; A. Hönle, *Olympia in der Politik der Griechischen Welt* (1968); Reports in *BCH* 83 (1959) 649ff[I]; 85 (1961) 719ff[I]; 86 (1962) 741ff[I]; 87 (1963) 791ff[I]; 88 (1964) 755ff[I]; 89 (1965) 749ff[I]; 90 (1966) 830f[I]; 91 (1967) 666f[PI]; 92 (1968) 832ff[MI]; 94 (1970) 1002ff[MI]; 95 (1971) 901ff[I].

Elis city: E. Curtius, "Der Synoikismos von Elis," *Sitz. d. Kon. Preuss. Akad. d. Wiss.* 26 (1895); Fr. Tritsch, "Die Agora von Elis und die altgriechische Agora," *JOAI* 27 (1932) 64ff[MPI]; N. Yalouris, "The City-state of Elis," *Ekistics* 33 (1972) 95f.

Reports in *JOAI* 14 (1911) 97ff[MPI]; 16 (1913) 145ff[P]; 17 (1914) 61ff[PI]; 18 (1915) 61ff[PI]; 45 (1960) 99ff[I]; (1961-63) 33ff[I]; 47 (1964-65) 43ff[PI];

48 (1966-67) 45ff[PI]; in Ἐργον (1960) 129ff[I]; (1961) 177ff[I]; (1962) 144ff[PI]; (1963) 115ff[I]; (1964) 116ff[PI]; (1965) 71ff[PI]; (1966) 110ff[PI]; (1967) 14ff[I]; (1969) 80ff[PI]; (1970) 132ff[PI]; in Πρακτικα (1960) 171ff[I]; (1961) 180ff[I]; (1962) 122ff[PI]; (1963) 137ff[I]; (1964) 136ff[PI]; (1965) 99ff[PI]; (1966) 133f[PI]; (1967) 20f[I]; (1969) 70f[PI]; (1970) 142ff[PI]; Δελτιον 16 (1960) 134f[I]; 17 (1961-62) 124ff[I]; 18 (1963) 101ff[PI]; 19 (1964) 180ff[I]; 20 (1965) 211ff[PI]; 21 (1966) 170ff[I]; 22 (1967) 208ff[I]; 23 (1968) 160ff[MPI]; 24 (1969) 146ff[PI]; 25 (1970) 187ff[I]; *AAAthens* (1968) 128ff[I]; (1969) 15ff[PI]. N. YALOURIS

ELIZAVETOVSKOE Russia. Map 5. A major Graeco-Scythian commercial center of the early 5th-3d c. B.C. in the Don River delta 17 km SE of Tanais. The settlement, which was primarily native, covered an area of almost 40 ha and was protected in the 3d c. by two concentric walls. The interior wall enclosed the acropolis. The wealthier classes apparently lived on the acropolis where there are remains of stone dwellings with painted plaster walls and tile roofs. Clay-walled houses predominate in the region between the interior and exterior walls. Recent excavations have uncovered a large stone building perhaps used as the warehouse of a Greek or Hellenized merchant. In addition to trade, fishing and craft production were important in the economy, which appears to have reached its height in the 4th-1st half of the 3d c. B.C. The city slowly died during the second half of the 3d c. probably owing to competition from Tanais, which was founded in the first half of the century. The decline of the site has also been attributed to the silting up of its channel into the Sea of Azov. The settlement is surrounded by a large kurgan necropolis of the 5th-3d c. B.C. with some of its graves containing rich burial goods.

BIBLIOGRAPHY. T. N. Knipovich, "Opyt kharakteristiki gorodishcha u stanitsy Elisavetovskoi po nakhodkam ekspeditsii Gos. Akad. istorii material'noi kul'tury v 1928 g.," *Izvestiia Gosudarstvennoi Akademii istorii material'noi kul'tury* 104 (1934) 111-201; V. P. Shilov, "Raskopki Elizavetovskogo mogil'nika v 1959 g.," *Sov-Arkh* (1961) 1.150-68; id., "Ushakovskii kurgan," *Sov-Arkh* (1966) 1.174-91; I. B. Brašinskij, "Recherches soviétiques sur les monuments antiques des régions de la Mer Noire," *Eirene* 7 (1968) 104-5; id. & A. I. Demchenko, "Issledovaniia Elizavetovskogo mogil'nika v 1966 g.," *KSIA* 116 (1969) 111-17; id., "Raskopki skifskikh kurganov na Nizhnem Donu," *KSIA* 133 (1973) 54-61.
 T. S. NOONAN

EL-JĪB, *see* GIBEON

EL-KĀB, *see* EILEITHYIA

EL KANTARA, *see* MENINX

EL-KHALASA, *see* ELUSA

EL-KITHARA, *see* PRAESIDIUM

EL-LAJJUN, *see* LEGIO

ELMALI ("Kyllandos") Turkey. Map 7. Site in Caria, not conclusively established. Kyllandos figures in the Athenian tribute lists, down to 446 B.C., as paying the remarkably high tribute of two talents. It is mentioned by Stephanos from Hekataios, but despite its apparent prosperity is otherwise unrecorded, apart from a Rhodian inscription of about 200 B.C. which refers to the recovery by Rhodes of the Kyllandia. Various locations have been proposed, most recently a site at Elmalı 11 km E of the

head of the gulf of Kos. Here, on a hill some 150 m high, is a citadel with tower and an outer wall circuit, house foundations, and sherds of Classical date. Just E of Elmalı village is a pair of architectural rock tombs similar to those at Idyma. Roman remains appear to be lacking, and it is likely that the site was abandoned quite early and the city refounded, under the name of Kallipolis, on the commanding site above Kızılyaka a little to the S.

BIBLIOGRAPHY. G. E. Bean & J. M. Cook, *BSA* 52 (1957) 75, 84-85.

G. E. BEAN

ELMALI Lycia, Turkey. Map 7. City and plain 64 km N of Myra and Limyra, with Classical sites. Two tumuli with built and painted tomb chambers, both anciently plundered, were discovered in 1969-70. At Kızılbel, 3.2 km SW of Elmalı, a gabled chamber (2 x 2.45 x 2.3 m) had multiple friezes in archaic style of ca. 530 B.C. The colors are red (various shades), blue, and black, painted directly on the stone. Represented are mythological subjects (Gorgons, Medusa, birth of Chrysaor and Pegasos), and ceremonial or biographical scenes (a warrior's departure by chariot; processions of soldiers, horses, chariots, offering bearers; a boar hunt in the marshes; a lion hunt; a sea voyage). The second painted tomb chamber, Karaburun, 4.8 km NE of Elmalı, is larger (2.61 x 3 x 2.66 m). It has one frieze painted in Graeco-Persian style of ca. 480 B.C.; the colors here are red (various shades), blue, purple, green, white, and black, on a white plaster over intonaco. The main scene shows the deceased, bearded and reclining on his couch, attended by his wife and servants with vessels, fans, a towel, fillets, and alabastra. The lateral walls have the ekphora with a chariot procession and a battle scene in which the deceased and the native warriors fight Greeks. The drawing is expert and of Greek inspiration; the proportions and general design are non-Greek. Both tombs are documents of native schools of Anatolian wall painting of the archaic period.

BIBLIOGRAPHY. M. J. Mellink, "The Painted Tomb near Elmalı," *AJA* 74 (1970) 251-53; id., "Excavations at Karataş-Semayük and Elmalı, Lycia, 1970," *AJA* 75 (1971) 247-55; id., "Excavations . . . 1971," *AJA* 76 (1972) 261-69; id., "Excavations . . . 1972," *AJA* 77 (1973) 297-303.

M. J. MELLINK

EL-MANDARA, *see* TAPOSIRIS PARVA

EL-MANSHÂH, *see* PTOLEMAIS HERMIOU

ELNE, *see* ILLIBERIS

ELORO, *see* HELOROS

ELOUNDA, *see* OLOUS

EL RAMALETE Navarra, Spain. Map 19. Mid 4th c. Roman villa on the Ebro near Tudela. Only the well-preserved baths have been excavated. The floor mosaics, one of which represents the owner(?), Dulcitius, on horseback spearing a stag, are in the Pamplona museum and in the National Archaeological Museum in Madrid.

BIBLIOGRAPHY. B. Taracena & L. Vazquez de Parga, "La 'villa' romana del Ramalete (Término de Tudela)," *Príncipe de Viana* 10 (1949)[PI].

R. TEJA

ELST Guelders, Netherlands. Map 21. Village between Arnhem and Nijmegen, in the Betuwe, homeland of the Batavi. After WW II when the parish church was being restored two temples were discovered beneath it, both of Romano-Celtic type. Temple I was a rectangle (11.6 x 8.7 m), probably entirely built of stone and originally covered by a saddle roof. The inner walls were decorated with painted plaster imitating marble. This temple was built ca. A.D. 50 and may well have been the national sanctuary of the Batavi. It was probably destroyed by fire in the Batavian revolt of 69-70, but shortly after the peace of 70 was rebuilt on a much larger scale.

Temple II consisted of a cella (15.9 x 12.85 m) surrounded by a colonnade and covered by a lean-to roof. The cella stood on a podium 30.9 by 23.1 m, and 1.2 m high. The steps up to the podium extended along the full width of the temple front, which faced S. The inner walls of the cella were again decorated with paint. The columns were fluted, had Corinthian capitals and were ca. 7 m high. This temple was the second largest of its kind, and was used until the Germanic invasions. In the 7th c. a Christian chapel was built on the ruins by St. Werenfried. The remains of both temples and of the chapel are now visible beneath the church. Some of the finds are on view there, the rest in the Ryksmuseum Kam at Nijmegen. Remains of three other stone buildings have been found, probably dating from the period of Temple II; the connection of temple and buildings is not clear.

BIBLIOGRAPHY. J. E. Bogaers, *De Gallo-Romeinse Tempels te Elst in de Over-Betuwe* (1955)[MPI] summaries in German and English; id., "Een Romeins gebouw aan de Dorpstraat te Elst (O.B.)," *Numaga* 17 (1970) 102-7[MPI].

B. H. STOLTE

EL-TÔD, *see* TUPHIUM

ELUSA (Eauze) Gers, France. Map 23. The town now covered by the modern district of Cieutat was the metropolis of Novempopulania. Occasional investigations have led to the discovery, in 1948-49, of part of a sewage network and, in 1968, of three potter's kilns, in which during the 4th c. A.D. a ware very similar to terra sigillata clara was produced.

BIBLIOGRAPHY. M. Labrousse, "Recherches arch. à Eauze (1948-49)," *Bull. de la Soc. arch. du Gers* 52 (1951) 201-13; id. in *Gallia* 28 (1970) 417-18; 30 (1972) 495f.

M. LABROUSSE

ELUSA (El-Khalasa) Israel. Map 6. A town in the central Negev, mentioned for the first time by Ptolemy (*Geog.* 5.15) as one of the towns of Idumaea W of the Jordan, certainly referring to Nabatea. It appears on the *Peutinger Table* at a distance of 71 Roman miles from Jerusalem and 24 from Oboda. In the same period, the 4th c. A.D., the city is mentioned in two of Libanius' letters. Elusa played an important part in the development of Early Christianity in the Negev, and two of its bishops participated in the councils of Ephesos (431) and Chalcedon (451). However, pagan deities were still worshiped there in this period. In the 6th c. Elusa formed part of Palaestina Tertia and was an important station on the Pilgrims' Road to Sinai.

Save for a trial trench sunk in 1938 there have been no archaeological investigations at the site. Much of its building material has been removed to provide for construction at Gaza. Little of the ancient town now remains above ground. At the beginning of our century a Nabatean inscription of the first half of the 2d c. B.C. was found, as well as numerous pre-Christian and Christian inscribed tombstones. The surface pottery indicates settlement in the Hellenistic, Roman, Byzantine, and Early Arab periods. For the later phases of the town we have the evidence of the papyri found at neighboring Nessana. In these documents Elusa is referred to as the district

capital of the central Negev. It seems to have been founded in the 3d c. B.C. by the Nabateans as one of their first caravan halts in the central Negev, on the Petra-Gaza road; and it seems to have shared the same fate as the other Nabatean towns about which we are better informed. Possibly in the Late Roman period it became the capital of the central Negev, which it certainly served in the Byzantine and Early Arab periods. It was abandoned before A.D. 800. In survey excavations made in 1973 the Nabatean town was located. Remains of a temple, a theater, and an elaborate water supply system were found there.

BIBLIOGRAPHY. E. Robinson, *Biblical Researches in Palestine* (1867) 201-2; F. M. Abel, "Epigraphie Grecque Palestinienne," *RBibl.* 18 (1909) 89-166; C. L. Woolley & T. E. Lawrence, "The Wilderness of Zin," *Palestine Exploration Fund Annual* 3 (1914-1915); T. J. Collin Baly, *Quarterly of the Department of Antiquities of Palestine* 8 (1938) 159; G. E. Kirk, "The Negeb, or the Southern Desert of Palestine," *PEQ* (1941) 62; A. Negev, "Elusa," *RBibl* 81 (1974). A. NEGEV

"ELUSIO," *see* MONTFERRAND

ELVIRA, *see* ILIBERRIS

ELY Glamorgan, Wales. Map 24. Roman villa, 3.2 km W of Cardiff, excavated in 1894 and 1922. The earliest building (2d c.) was a small winged-corridor house facing S, linked by a boundary wall to a simple rectangular building set at an obtuse angle to it on the SW. The latter building was subsequently extended by the addition of baths to its S end. The complex was enclosed by banks and ditches on the N and W. In the final stage (early 4th c.?) the outbuildings were abandoned and the reconstructed main house was completely enclosed by a new bank and ditch. The earthworks were interpreted as defensive, but were more probably designed to define and drain the area enclosed.

BIBLIOGRAPHY. R.E.M. Wheeler, *Trans. Cardiff Naturalists Soc.* 55 (1922) 19-45; id., *Prehistoric and Roman Wales* (1925) 257-58; R. G. Collingwood & I. A. Richmond, *Archaeology of Roman Britain* (2d ed., 1969) 137. A.L.F. RIVET

EMATHIA, *see* LEFKADIA

EMBESOS, *see* LIMES, GREEK EPEIROS

EMESA (Homs) Syria. Map 6. Town near the Orontes, between Palmyra and the sea. It was the capital of the Emesene Arabs, whose dynasts (called Jamblichus, Sohaem, or Samsigeram) were vassals of the Romans from the 1st c. B.C. to the 1st c. A.D. It was the native town of the emperor Elagabalus, and of Julia Domna, wife of Septimius Severus. Emesa was raised to colonial status and flourished at the beginning of the 3d c. A.D. It was famous for its temple of the Sun and the cult of its black stone. It declined with the fall of Palmyra, but became an important Christian metropolis.

There are few ancient remains. The great mosque occupies the site of the temple. Coins show that the temple had sculptured columns of a rare type. The necropoleis have produced fine basalt stelai with portraits of the dead (in the Damascus museum). The main monument (replaced by the railway station) was a tall, square, funerary tower with two stories, adorned with engaged columns, a frieze of wreaths and ox-bucrania, and capped by a tall pyramid. It was the mausoleum of Caius Julius Sampsigeramus, who died in 78 or 79. The same necropolis has produced a funerary mask with attached helmet in chased silver, parade weapons, pieces of armor, and jewelry (in the Damascus museum). The countryside around Homs shows traces of centuriation.

BIBLIOGRAPHY. L. F. Cassas, *Voyage pittoresque de la Syrie, de la Phénicie* (1799)[I]; C. Watzinger, "Das Grabmal des Samsigeramos," *Kunsthistorische Sallskapets Publikation* (1923)[I]; H. Seyrig, "Antiquités de la nécropole d'Emèse," *Syria* 29 (1952); 30 (1953)[I]; id., "Caractères de l'histoire d'Emèse," ibid. 34 (1959)[M]; W. J. Van Liere, "Ager centuriatus of the Roman colonia of Emesa," *Annales Archéologiques de Syrie* 8-9 (1958-59). J.-P. REY-COQUAIS

EMMAUS later NICOPOLIS (Amwas) Palestine. Map 6. A town 32 km N of Jerusalem in N Judea, on the border of that country in the Persian period. It was fortified by Bacchides at the beginning of the Hasmonaean uprising, and Judas Maccabeus defeated Gorgias there in 166 B.C. After the middle of the 1st c. B.C. Emmaus became the capital of a district. According to Luke (24:13ff) Jesus met the disciples at Emmaus after the Crucifixion. After the destruction of Jerusalem Vespasian settled veterans of the Roman army there. In A.D. 221 it was given a status of polis by Elagabalus, who renamed it Nicopolis.

Excavations have revealed settlements of the Hellenistic, Roman, Byzantine, and later periods. Remains of a Samaritan synagogue have been found, and a Byzantine church, built above an earlier structure which is believed to have been the house of Cleophas.

BIBLIOGRAPHY. L. H. Vincent & F. M. Abel, *Emmaüs, sa basilique et son histoire* (1932); M. Avi-Yonah, *The Holy Land* (1966) 84, 95, 115, 159. A. NEGEV

EMONA (Ljubljana) Yugoslavia. Map 12. The present capital of Slovenia was originally a prehistoric village with river port which became a Roman defense point, Augustan colonia, and an episcopal see of late antiquity. It is at the juncture of the Gradaščica and the Ljubljanica, on the N bank of a morass reaching in the S to the Karst-Highs of Inner Carniola. The city is on the only road joining the Apennines to the Balkan peninsula, and from prehistoric times to the barbarian migrations and beyond it bore almost all the traffic between Italy and the provinces of Pannonia, Moesia, Dalmatia, and Noricum. In antiquity there was already a legend that associated the foundation of the city with the wintering here of the fleeing Argonauts.

On the river bank an Iron Age necropolis was found. The settlement with which it was connected has not yet been found. Sporadic La Tène finds and references of ancient authors indicate that Celts (Tauriscians) settled here in the 2d and 1st c. B.C. The city was raised to the rank of colonia in the Augustan period, and received a circuit wall (523 x 425 m) with towers, fortified gates (the porta praetoria has been excavated and preserved, as has the S wall) and a city plan of five cardines crossing seven decumani at right angles. Of the 48 insulae into which it was divided, two in the center were used for the forum and its buildings (basilica, religious center, porticos with shops). Some elements of it are preserved. The insulae had drains leading to the cloacae which ran under the decumani and into the navigable Ljubljanica. Insulae were remodeled from time to time and even razed. The one that stood on the SE corner of the city, today called Jakopičev Vrt, has been preserved and put on view. In the NW part of the city Christians met for prayer in a private dwelling in the 3d c. The complex that resulted was rebuilt in the course of the 4th c. as a public center for sacred activities. A large segment of it including an

octagonal baptistery with portico, floor mosaics with donor inscriptions, and the building's inscription have been uncovered (preserved in situ; late 4th c.). The religious center is contemporary with St. Jerome, who carried on a lively correspondence with friends in the city.

The roads to Aquileia, Celeia, and Siscia were flanked by necropoleis. The grave goods (1st-5th c.) illustrate the material level of day-to-day life known by the inhabitants, concerning whom we are also relatively well informed by inscriptions. The city was in the midst of relatively rich surroundings and had its own water supply. The inhabitants lived for the most part from river and road traffic.

Simplicius, vicarius Urbis in 375, came from Emona. As the sources show, few political events bypassed Emona, which was particularly involved with Maximinus Thrax (238), Theodosius (388), and Alaric (401).

BIBLIOGRAPHY. W. Schmid, "Emona," *Jahrbuch für Altertumskunde* 7 (1913)[MPI]; *Zgodovina Ljubljane* 1 (1955)[MPI]; J. Šašel, "Emona," *RE* Suppl. XI (1968)[P]; L. Plesničar, *Jakopičev Vrt* (1968); id., *Katalog severne emonske nekropole* (1972)[PI]; S. Petru, *Emonske nekropole* (1972)[PI].

J. SASEL

EMPORIAE, *see* EMPORION

EMPORIO, *see under* PITYOUSSA (Greece)

EMPORION or Emporiae (La Escala or Ampurias) Gerona, Spain. Map 19. A Greek trading settlement inhabited by the Phokaians from Massalia, at the end of the Gulf of Rosas on the Costa Brava; it is 3 km from the village of La Escala and 40 km NE of Gerona. It is first mentioned in the Periplus of the Pseudo-Skylax and in Skymnos. Its location has been known from the time of the Renaissance since it gave its name to an entire district, the Ampurdan, was an episcopal see in the Middle Ages, and one of the counties of the Marca Hispanica.

The Greeks originally occupied the small islet of San Martin, now joined to the mainland, which was subsequently known as Palaiapolis (Strab. 3.4.8). They soon spread to the nearby coast and used the mouth of the Clodianus (Fluvia) as a trading port. The town was founded a little after 600 B.C. (date of the foundation of Massalia) and throughout the 6th c. was a mere trading settlement, a port of call on the trade route from Massalia (Marseille), two days' and one night's sail distant (Pseudo-Skylax 3), to Mainake and the other Phokaian foundations in S Iberia which traded with Tartessos. Because it was frankly a mart the Greek settlement grew rapidly, and probably received fugitives from the destruction of Phokaia by the Persians (540) and after the Battle of Alalia (537), also Greeks from Mainake and other cities in the S destroyed by the Carthaginians.

In the 5th c. Massalia declined, and Emporion, which was already independent, became a polis ruled by magistrates; it developed a brisk trade with the Greek towns in S Italy, the Carthaginian towns, and the native settlements in the interior, on which it had a profound Hellenic influence. Emporion then minted its own coins, first imitating those of the towns with which it traded, including Athens and Syracuse, and later creating its own currency in fractions of the drachma. The types were copied from those of both Carthage and Syracuse, and the currency system continued to be separate from that of Massalia until Emporion was Romanized in the 2d c. The 5th-3d c. were those of its greatest wealth and splendor.

The town built temples, foremost among which was that dedicated to Asklepios, for which a magnificent statue of Pentelic marble was imported. Outside the town a native settlement developed, which soon became hellenized. It was called Indika (Steph. Byz.), an eponym of the tribe of the Indiketes. In the course of time the two towns merged, although each kept its own legal status; this explains why, in Latin, Emporion is referred to in the plural as Emporiae. In the 3d c. commercial interests arising from its contacts with the Greek cities in Italy made it an ally of Rome. After the first Punic war the Roman ambassadors visited the Iberian tribes supported by the Emporitani, and in 218 B.C. Cn. Scipio landed the first Roman army in Hispania to begin the counteroffensive against Hannibal in the second Punic war.

The war years were prosperous for the city's trade, but when the Romans finally settled in Hispania, difficulties arose between the Greeks and the native population, which were accentuated during the revolt of 197 B.C. In Emporion itself the Greek and native communities kept a constant watch on each other through guards permanently stationed at the gate in the wall separating the twin towns (Livy 34.9). In 195 B.C. M. Porcius Cato established a military camp near the town, rapidly subdued the native tribes in the neighborhood, and initiated the Roman organization of the country. As the result of the transfer to Tarraco of the Roman administrative and political sector, Emporion was eclipsed and became a residential town of little importance. The silting-up of its port and the increase in the tonnage of Roman vessels hastened its decline. The town became a municipium and during the time of C. Caesar received a colony of Roman veterans.

The Roman town, which was surrounded by a wall, was ruined by the invasion of the Franks in 265 and Rhode became the economic center of the district. However, a few small Christian communities established themselves in Emporion and transformed the ruins of the town into a necropolis which extended beyond the walls. Mediaeval sources claim that St. Felix stayed in Emporion before his martyrdom in Gerona in the early 4th c.

The enclosure of the Greek town has been completely excavated. To the S is a temple area (Asklepieion and temple of Serapis), a small agora, and a stoa dating from the Roman Republican period. It is surrounded by a cyclopean wall breached by a single gate, confirming Livy's description. On top of the Greek town and further inland is a Roman town, ten times larger and surrounded by a wall built no earlier than the time of Augustus. Inside is a forum, completely leveled, on which stood small votive chapels. To the E, facing the sea, are two large Hellenistic houses with cryptoportici, which contained remains of wall paintings and geometric mosaics. Many architectural remains are in the Barcelona Archaeological Museum and in the museum on the site. Among the finds are a statue of Asklepios, a Greek original; the mosaic of Iphigeneia, an archaic architectural relief with representations of sphinxes; Greek pottery (archaic Rhodian, Cypriot, and Ionian; 6th-4th c. Attic, Italic, and Roman). Several cemeteries near the town have also been excavated.

BIBLIOGRAPHY. Excavation reports, *Anuari de l'Institut d'Estudis Catalans* (1907-27); J. Puig i Cadafalc, *L'Arquitectura romana a Catalunya* (1934); A. García y Bellido, *Hispania Graeca* (1948); M. Almagro, *Las fuentes escritas referentes a Ampurias* (1951); id., *Las inscripciones ampuritanas. Griegas, Ibericas y Latinas* (1952); id., *Las Necropolis de Ampurias* (1953-55).

J. MALUQUER DE MOTES

ENDIŞEGÜNEY, *see* ANTIOCHEIA AD CRAGUM

ENGE (Bern) Bern, Switzerland. Map 20. Vicus ca. 3 km from the center of Bern, in a loop of the Aare river. The ancient name is unknown. It succeeded two oppida of the Helvetii in a naturally fortified position on a three-lobed spit with steep banks. The older oppidum flourished 150-58 B.C.; the later one, built by the Helvetii after their defeat by Caesar at Bibracte in 58 B.C., developed into the Roman vicus. A 1st c. military post also attests the importance of this site, on the shortest road to Italy over the Lötschberg and Simplon passes. A destruction level may reflect the events of A.D. 69 (Tac. 1.67). The settlement flourished until menaced by the Alamanni ca. A.D. 260, when it was abandoned.

Oppidum I enclosed the entire peninsula within its ramparts (150,000 sq. m); the defenses are still visible. The settlement was in the S part. Oppidum II (ca. 80,000 sq. m) occupied the N spit only, and access to it was protected by a new rampart across the neck. The fortifications were not kept up after 52 B.C. The vicus spread along the main road on the plateau (1.5 km long) and has been partly explored. The houses, on both sides of the road and to the W, had no uniform plan except for a portico facing the street, and were usually very simple. Workshops were numerous, including bronze foundries and a sizable potters' quarter. A small bath has also been found. At the S end of the settlement were three small temples of Gaulish type (the largest 19 x 18 m), possibly part of a larger precinct. Still farther S (behind the new Matthäuskirche), and built against the late ramparts, stood a very small amphitheater (27.5 x 25.3 m). The seats were earth terraces with a low stone retaining wall next to the arena.

There is a small exhibit at the Kirchgemeindehaus; all other finds are in the Bernisches Historisches Museum in Bern.

BIBLIOGRAPHY. H. Müller-Beck & E. Ettlinger, "Die Engehalbinsel bei Bern und ihre wichtigsten vor- und frühgeschichtlichen Denkmäler," *Jb. des Historischen Museums in Bern* 39-40 (1959-60) 367-82[MPI]; id., "Die Besiedlung der Engehalbinsel bei Bern auf Grund des Kenntnisstandes vom Februar des Jahres 1962," *RGKomm* 43-44 (1962-63) 107-53[MPI]; id., Ein helvetisches Brandgrab von der Engehalbinsel," *Jb. Schweiz. Gesell. f. Urgeschichte* 50 (1963) 43-54[PI]; V. von Gonzenbach, *BonnJbb* 163 (1963) 111-12; summaries: *Jb. Schweiz. Gesell. f. Urgeschichte* 46 (1957) 121-23; 54 (1968-69) 192. V. VON GONZENBACH

ENGEDI Israel. Map 6. The capital of one of the districts of Herod's kingdom (Joseph. *BJ* 3.55; 4.402-4), on the W shore of the Dead Sea. During the time of the Second Revolt of the Jews against the Romans, it was the seat of Bar Kohba, the leader of the revolt. On account of its fertile soil and copious spring, the oasis of Engedi was highly praised in antiquity. Its palm groves were famous (Plin. *HN* 5.17), and still more important was its grove of balsam (Joseph. *AJ* 9.7; Plin. *HN* 12.118), still known in the Late Roman period (Eus. *Onom.* 86.1.19) when Engedi was still a large village.

The site was excavated between 1961 and 1965. Four main occupation levels were observed, ranging from the end of the Iron Age to the Roman and Byzantine periods. To the Persian period (5th-4th c. B.C.) belongs a large dwelling (24 x 26 m). It contained 23 rooms and storerooms built around central courtyards. Part of the house was two stories high. Some rooms contained industrial installations, probably for the perfume industry. To the Hellenistic period (3d-2d c. B.C.) belong fragmentary re-

mains of a trapezoidal fortress, which occupied the higher part of the mound. In the Herodian period (1st c. A.D.) an oblong fort was built on the mound, with walls 2 m thick. In the 2d c. A.D. a bath of the usual Roman type was built, probably by a Roman garrison which was stationed on the site.

BIBLIOGRAPHY. B. Mazar et al. "En-Gedi, The First and Second Seasons of Excavations, 1961-1962," *Atiqot* v (1966); id. & I. Dunayevski, "En-Gedi, Fourth and Fifth Seasons of Excavations. Preliminary Report," *Israel Exploration Journal* 17 (1967) 133-43. A. NEGEV

"ENGYON," *see* GANGI *and* TROINA

ENNA Sicily. Map 17B. Principal city of the province of that name located 950 m above sea level on a wide rocky plateau in central Sicily. Cicero called it "Umbilicus Siciliae" and accurately described the town and its environs in a famous passage of his orations against Verres (4.107), which stresses the altitude, isolation, abundance of water, pastures, groves, and lakes in the entire area. A few necropoleis of the 9th-8th c. B.C. with rock-cut tombs imitating natural grottos (*tombe a grotticella*) near Calascibetta and Pergusa constitute the only remains of the original Sikel settlement. Ancient Greek sources state that Enna was founded by Syracusans in 664 B.C. (Stephanos of Byzantium) or in 552 B.C. (Philistos). These dates may not refer to an actual foundation; they reflect however a phase of Syracusan penetration of the site during the 7th-6th c. B.C. In its Greek period, and even more so in its Roman period, Enna was famous for its cult of Demeter and Kore. Not only did Enna possess one of the most renowned sanctuaries of the two goddesses, but according to the poetic tradition related by Cicero (loc. cit.) and Diodorus Siculus (5.32) it was in the vicinity of Enna, on the shores of present-day Lake Pergusa, that Hades, dashing with his chariot from a dark cave, snatched Kore-Persephone away to the Underworld. The urban sanctuary, which contained highly revered statues of Demeter, Kore, and Triptolemos, must have been located on the high spur of rock still called Rock of Ceres, in front of the mediaeval Castle of Lombardy. The only extant traces of the shrine are a few steps, cuttings, and storage pits carved in the natural rock. Coins represent the only real archaeological evidence for the cult; the earliest are silver litras from the middle of the 5th c. B.C., with a youth sacrificing at an altar on the obverse, and Demeter in a quadriga on the reverse. In 396 B.C. Enna fell under the rule of Dionysios I of Syracuse. It recovered its freedom when the tyrant died, but fell again under Agathokles in 307 B.C. In 277 it must have been under Carthaginian control since it was liberated by Pyrrhos during his brief expedition to Sicily. In the first Punic war Enna sided with Rome against the Carthaginians, but during the second Punic war, in 214 B.C., it attempted to revolt against the Romans. The rebellion was cruelly suppressed by Pinarius, who slaughtered the citizens gathered in assembly within the theater. From that day Enna lost its privileges of civitas libera atque immunis and became civitas decumana. Between 136 and 132 B.C. Enna was the center of the revolt of the slaves, led by Eunus of Apamea. Eunus was proclaimed king and around him gathered slaves and freedmen from all parts of Sicily. The Roman army was in great danger and in vain the Consul L. Calpurnius Piso attempted to capture Enna. This was accomplished by Consul P. Rupilius in 132 B.C.; Eunus was captured and killed. Archaeological evidence for this war is provided by the numerous lead sling-shots, inscribed with the name of the Consul Piso or the symbols of the slaves, which

have been found around Enna. In 70 B.C., when Cicero went to Enna to gather proof of the thefts and robberies committed by Verres, Enna must still have been a city of notable size and importance, especially as a pan-Sicilian religious center. The city must have declined fairly rapidly in the course of the 1st c. B.C., since Strabo, at that time describes Enna as "a town of few inhabitants." Enna recovered its importance only after the Arab conquest and in the Middle Ages, when it took the name of Castrogiovanni.

BIBLIOGRAPHY. V. Amico, *Dizionario Topografico della Sicilia* (1855); P. Ziegler in *RE* XV, s.v. Henna; P. Orsi in *NSc* (1915) 232; B. Pace, *Arte e civiltà della Sicilia antica* (1935-49) 1-3, passim; G. E. Rizzo, *Monete greche della Sicilia* (1946) 164, 265, pl. 59; G. V. Gentili in *EAA* 3 (1960); M. Guido, *Sicily: an archaeological guide* (1967) 131ff. P. ORLANDINI

ENOZ, see AINOS

ENSÉRUNE Hérault, France. Map 23. Oppidum of S Gaul, on a hill 118 m high between Béziers and Narbonne, ca. 12 km from the Mediterranean. The earliest imported wares (Etruscan and Greek) found on the site indicate occupation from about the mid 6th c. B.C.; the latest ware (Arretine) show that it was abandoned in the first half of the 1st c. A.D.

Characteristic features of autochthonic life (mud huts, silos cut in the rock) are preserved intact in a first village (up to ca. 425 B.C.) spread out over the plateau. Ensérune II (ca. 425-220 B.C.) was a more orderly city; its stone houses, clustered in the E, or highest point of the hill, are laid out on a grid. A rich incineration necropolis extends W of the settlement. The ashes of the dead were placed in loculi along with their arms, ornaments, and bowls, one of which served as an ossuary while others contained mainly foodstuffs offered as a funerary feast. These bowls are extremely varied (indigenous, Celtic, Iberian, Greek red-figured ware, and much Campanian). A rampart was erected in the first half of the 4th c. B.C.; remains of it can be seen particularly on the N side. The second city of Ensérune was destroyed, either in the invasion of the Volcae or by Hannibal, who passed through the region in 218 B.C.

The city was immediately rebuilt and in the third and final phase of its life enjoyed even greater prosperity than in the past. It spread out to the W on the site of the early, now unused, necropolis, and to the S on the slopes of the hill beyond the wall of the earlier settlement. It was again destroyed ca. 100 B.C., either by the Romans, who founded Narbonne in 118 B.C., or by invading Cimbri; nevertheless the city continued to grow. The inhabitants became somewhat Romanized, but the indigenous character of their civilization persisted to the end in the continuing use of Iberian script and in the absence of the large public and cultural monuments of other Roman cities.

The architectural remains, fairly poor, belong almost exclusively to private houses or craftsmen's workshops. Among the most interesting are a complex of silos discovered on a terrace E of the oppidum, another group of silos used as cisterns and forming a water tower on the S slope, and a number of stone cisterns bonded in Roman fashion. The most characteristic residential quarters extend N, along the rampart, and W, on the site of the old necropolis. Another section is partially preserved in the basement of the museum, which also contains objects found in the houses, and finds made in the necropolis.

BIBLIOGRAPHY. J. Jannoray, *Ensérune, contribution à l'étude des civilisations préromaines de la Gaule méri-dionale* (1955)MPI; H. Gallet de Santerre, "Ensérune, An Oppidum in Southern France," *Archaeology* 15 (1962) 163-71; id., "Fouilles dans le quartier Ouest d'Ensérune," *Rev. Arch. Narbonnaise* 1 (1968) 39-83; J. Giry, *Guide du Musée d'Ensérune* (1971).
 H. GALLET DE SANTERRE

ENTRAINS, see INTARANUM

ENTREMONT Bouches-du-Rhône, France. Map 23. Situated 3 km N of Aix-en-Provence (Aquae Sextiae Salluviorum), at the crossing of the natural routes, E-W from Italy to Spain, N-S from the Durance to Marseille. It was the capital of the Celto-Ligurian confederation of the Σάλυες or Salluvii, which controlled a vast territory bordered by the Rhône, the Durance, the lower Argens valley, and the Mediterranean. We do not know the ancient name of this polis (Diod. 24). The date of its founding no doubt goes back to the 4th c. B.C. It was probably destroyed during the campaigns carried out between 125 and 123 B.C. by the Roman legions commanded first by M. Fulvius Flaccus, then by C. Sextius Calvinus. Entremont's king, Teutomalius, took refuge among the Allobroges; its inhabitants were deported, except for a small pro-Roman party which may have included 900 native (Diod. 24; Appian, *Hist. rom.* 4.12; Livy, *Ep.* 61). This dating of Entremont's destruction has sometimes been questioned in favor of a later one (90-80 B.C.).

The oppidum occupies a triangular plateau, with an area of some 35,000 sq m, protected by two cliffs. The N side, a gentle slope, is protected by a strong rampart 380 m long. The walls consist of two fairly regular ashlar faces, tending towards opus quadratum. They are filled with earth and rubble and are more than 3 m thick. At regular 19 m intervals, rounded towers were attached to the rampart. A second wall, in the S corner of the plateau, encloses a quadrilateral about a ha in area, slightly higher than the rest of the oppidum. It is not known if this "acropolis" corresponds to the earliest stage of the settlement (which later would have expanded) or if it consists of a quarter separated from the rest of the town (an aristocratic quarter?).

Excavations have brought to light a regular town plan, arranged with respect to the orientation of the ramparts. The cobbled streets are relatively wide and have ruts attesting the passage of carts. Near the enceinte a system of stone channels crossed under the walls and let the run-off water out. The dwellings were arranged in blocks, and they too had stone walls. Mostly they were long, narrow (5-8 x 2.50-3.50 m) structures with a hearth and dolium. Some, however, are larger and consist of two to five rooms. Some pieces of decoration have been found: remains of a paving with a crude mosaic, clay plaques decorated with fluting and triglyphs. Oven apertures, pieces of oil presses, millstones, spindles, and various tools record farming and crafts. Many Massaliot coins, wine amphorae, and imported pottery indicate extensive commerce with Massalia.

A large dwelling, in the form of a portico, dating to the last period, reutilized parts of older buildings: a pillar with representations of human heads with closed eyes, a lintel of the same kind, but also including sockets in which the mummified heads of vanquished enemies were placed, according to the rite reported by Diodoros (5.29) and Strabo (4.4,5). Moreover, skulls with spikes have been found on the floor of this building. In the fill of the main street of the oppidum, which passed in front of this portico, important pieces of statuary have been found, pillars carved in relief depicting severed heads

(but with a much less crude technique) and a horseman. Most important are the remains of statues in the round: heroes crouching in the position seen at Roquepertuse and Glanum (St. Rémy de Provence), heads, torsos adorned with a breastplate and the Gallic torque, etc. The Helleno-Etruscan influence on this art is evident. All these features show that Entremont, a political capital, offered its heroes a cult, probably of an oracular nature. These sculptures are now on exhibit at the Musée Granet at Aix-en-Provence.

BIBLIOGRAPHY. F. Benoît, *Gallia* 5 (1947) 81-98; 26 (1968) 1-31[P]; id., *Entremont* (1957); id., *L'Art primitif méditerranéen dans la vallée du Rhône* (1955).

C. GOUDINEAU

EPAMANTADURUM or Epomanduodurum (Mandeure, Mathay) Doubs, France. Map 23. The *Peutinger Table* and the *Antonine Itinerary* mention it simply as a way-station on the road from Vesontio (Besançon) to the Rhine. The locality appears later in the Ravenna Cosmographer as Mandroda. It stood on both banks of the Doubs on the site of the present-day Mandeure and Mathay, where milestones of the Roman road have been found. Its history is unknown. Bricks bearing the stamp of the Legio I Martia suggest the presence of a military detachment in the 4th c.

The widespread ruins have been excavated since the 16th c. The artifacts, numerous and of good quality, have been widely dispersed (museums of Montbéliard, Besançon, Belfort, Epinal, Mulhouse, Colmar, Basle, Stuttgart, Berlin, etc.). The buildings discovered have been arbitrarily named.

The only edifice visible today is the theater, still only partially excavated and one of the largest in Gaul (exterior diam. 142 m). It appears to have been related to a sanctuary which lay along its axis and consisted of a circular wall surrounding a temple, inside which artifacts of Iron Age III have been found. The presence of a commemorative arch is indicated by fragments of sculpture. Baths have been discovered in the place called Muraille-Bourg (with a dedication by the person who faced them with marble) and at Courcelles-les-Mandeure. Recent digs in various areas have for the most part unearthed private dwellings.

Votive inscriptions are dedicated to Jupiter Optimus Maximus, Bellona, Castor, and Mithra. The Celtic cult of the three-horned bull is attested by small bronzes.

BIBLIOGRAPHY. Morel-Macler, *Antiquités de Mandeure* (1847); C. Duvernoy, "Le pays de Montbéliard antérieurement à ses premiers comtes," *Bull. Soc. Emul. Montbéliard*, 2d sér., 4 (1875); *CIL* XIII, 5408-22; E. Espérandieu, *Recueil général des bas-reliefs . . . de la Gaule romaine* (1907—) nos. 5290-98; H. Stern, *Recueil général des mosaïques de la Gaule romaine* I, 3 (1960) nos. 323-30; *Catalogue des collections archéologiques de Besançon* II. *Les fibules* (L. Lerat) III. *Les bronzes figurés* (P. Lebel); *Catalogue . . . de Montbéliard* I. *Les fibules* (L. Lerat); II. *Les bronzes figurés* (P. Lebel). Recent excavations: L. Lerat, "Informations," *Gallia* 6 (1948) 230-31 and later issues.

L. LERAT

EPANO PALEOKASTRO, *see* POLYRRHENIA

EPFACH, *see* ABODIACUM

EPHESOS Turkey. Map 7. The city, in the delta region of the Kayster, was in ancient times the most important metropolis in Ionian Asia Minor, and the most important of the seven Apocalyptic cities. It was founded on an older settlement of Carians and Leleges, which had a

sanctuary to the Mother Goddess of Asia Minor. Under King Androklos immigrants from the Greek mainland built the first fortified city 1200 m W of the Artemision, on the slopes of Panayir-dağı, and erected a shrine to Apollo Pythios. Under Croesus the first town on the Koressos harbor was abandoned before the mid 6th c. B.C. and a second founded inland, near the earlier Artemision. About 290 B.C., because of land subsidence, the town was moved by Lysimachos to the area between the mountains of Bülbül-dağı and Panayir-dağı. It was fortified with a turreted wall over 9 km long and laid out on the Hippodamian system; the only deviation was the so-called Kouretes Street, which follows an older path. Lysimachos' city, called until his death after his wife Arsinoë, remained inhabited until ca. A.D. 1000; The Byzantine-Selçuk city, which grew up on and around the Ayasouk hill (Selçuk), was captured in 1426 by the Ottoman Turks.

The Artemision. The scanty remains of this temple, one of the Seven Wonders of the World, lie today on a swampy plain NE of the city, from which the sea receded only ca. 1000 B.C. The earliest shrine, at the beginning of the 6th c. B.C., consisted of two platforms, the W one with an altar, the E one with the goddess's cult image and possibly a naos open to the W. A hoard of votive offerings, found under the limestone paving, is now in the Istanbul Museum. After its destruction by invading Kimmerians, the platforms were enlarged and surrounded by a wall; later they were united to form the podium of a small temple, and finally the building became a roofless temple in antis, possibly prostyle, around a freestanding central core. About 560 B.C., the great Artemision was built by the Cretan architects Chersiphron and Metagenes. On the stylobate, 115.14 by 55.1 m, stood the sekos, probably roofless, with the goddess's image in the center, surrounded by two rows of columns with a third across the front. In the pronaos were four pairs of columns, the lowest drums with reliefs like those of the entrance facade (some of them donated by Croesus). The columns, with superb, painted volute capitals, supported the first marble architrave in the Greek world, bridging the widest span yet mastered (the middle architrave weighed 24 T); the inner architrave, ceiling cofferings, and roof beams were of cedar. This temple is the only early Ionic building securely dated (completed ca. 500 B.C.), and almost entirely capable of reconstruction on paper.

In 356 B.C. the temple was burnt by Herostratos, and subsequently rebuilt by the Ephesians, after they had refused the help of Alexander the Great. The original dimensions were retained, new columns and walls rose upon the old, but on a base 2.68 m higher; the form of the older column bases and their sculptural decorations were also retained. Such artists as Skopas and Apelles collaborated in the work; the altar ornament was reputed to be the work of Praxiteles. The building was completed toward the middle of the 3d c. B.C., except for isolated elements. It was burnt in A.D. 263 by plundering Goths, and completely destroyed in the Christian era. Architectural remains from both temples are in the British Museum. The goddess's cult statue from the older temple was said to be the work of the Athenian Endoios, at the end of the 6th c. B.C. Surviving copies, all Roman, show an archaic type, but with richly jeweled ornament which would not have been part of the prototype. The recently discovered foundation of the altar (39.7 m wide), lying W of the temple and on its axis, is U-shaped and closed on the E. It consists of two courses of polygonal limestone blocks. Beneath the stone bedding of the altar court, which is paved with polygonal marble slabs,

lie fragments of the columns of the archaic temple. There are also two separate archaic foundations within the court, approached by an open ramp of later date.

The route followed below leads from the Magnesian Gate to the State Agora. A short diversion to a N-S street W of the Agora passes in front of the Temple of Domitian. The route then proceeds NW along Kouretes Street as far as the Library of Celsus and N along Marble Street to the Theater and the Theater Baths, where it turns W past the great market or Commercial Agora, along the Arkadiane to the Harbor Baths complex. Returning to Marble Street it goes N past the Stadium and the Baths of Vedius. The theater, which is a frequent point of reference, is set against a cliff at the W side of the hill called Panayir-dağı (Mt. Pion), which occupies the NE quarter of the city.

The bounds of Lysimachos' city, with ruins of Hellenistic and Roman times, are indicated by two city gates: to the W the Koressos Gate (which led to Koressos, the quarter supposedly located on the site of the old town near the Artemision; see below, Baths of Vedius), and SE of this, on the road to Magnesia, the Magnesian Gate. A stretch of the 3d c. wall constructed by Lysimachos can be seen on the slope of Panayir-dağı, and a longer one on Bülbül-dağı; the Magneseian Gate lies between them. According to an inscription on the E wall of the S theater entrance, the Festival procession proceeded from the Artemision to the Magnesian Gate, thence to the theater, next to the Koressos Gate and back to the Artemision. The Magnesian Gate consisted of three entrances, the central one for wheeled traffic; flanking these were two fortification towers. The superstructure of the gate, which survives in part, probably dates according to its inscription, from Vespasian. Inside the gate to the SW is the so-called Tomb of Luke, originally a round building faced with marble with 16 niches on the exterior, and later changed into a church.

The East Gymnasium lies to the N, a splendid complex open to the public with exercise rooms and halls for social gatherings. In front of the main building was a palaestra with an auditorium to the E, and another room, comparable to the so-called Imperial chamber of the Baths of Vedius (see below), with a statue of Septimius Severus in an apsidal niche. This was apparently built by the Ephesian Sophist Flavius Damianus and his wife Phaedrina, members of Vedius' family.

The State Agora was over 160 m long, bounded on S and E by marble benches and on the N by a basilica, which was 20 m wide excluding its S steps. In its central nave were columns with deeply set foundations and Ionian bull's-head capitals, between which additional support was provided in the Late Empire by Corinthian columns set directly on the stylobate. To the W was the Chalcidicum of the basilica, a rustic building. The dedication of the basilica to Artemis of Ephesos, the Demos, and Augustus and Tiberius, is recorded on a partly preserved Greek and Latin inscription in bronze letters set into the wall. Later eradication of the goddess's name testifies to the building's survival into the Christian era. Its donors were possibly C. Sextilius Pollio and his wife Offilia Bassa, builders of the aqueduct in Dervend Dere. Beneath the basilica are the remains of a Hellenistic stoa as long as the basilica, 8.60 m deep, with a single nave; older remains were also found beneath the Chalcidicum and the Bouleuterion.

Just N of the basilica is the *Prytaneion*, the religious and political center of the city, with the sanctuary of Hestia Boulaia and the state apartments. Here were found three statues of Artemis of Ephesos, now in the museums of Selçuk and Izmir. The sanctuary of Hestia,

with the base of the hearth for the sacred flame, dates from the Augustan period, but was remodeled in the 3d c. A.D. by the addition of corner columns with Composite capitals. The Doric portico facade with six columns in antis dates from the first phase. In front of this lies a courtyard; E of it is a peristyle with Ionic stoas on three sides and a podium approached by a monumental stair. This podium, formerly known as the state altar, has now been identified as a podium with two small prostyle temples built by Augustus in 29 B.C. for Divus Iulius and Dea Roma; it was destroyed in the 4th c. A.D. Luxurious private houses with frescos and mosaics lay N of the peristyle, on both sides of the steps leading up the hill.

Adjoining the Prytaneion on the E is the Bouleuterion (formerly called an odeion), a small building ca. 46 m wide with a semicircular auditorium for 1400 persons built on two levels; its upper tier consisted of reddish granite columns. In addition to the radial stairways, two covered stairs led from the parodoi to the center corridor. Originally no skene was planned. According to the building inscription, the donors—at least of the two-storied scaenae frons—were P. Vedius Antoninus and his wife Flavia Papiana, in the mid 2d c. A.D. There were several gates leading into the Agora, and between the Bouleuterion and the basilica were an open passageway (for reasons of safety) and a channel to carry off water from the roofs of both buildings. From this were recovered heads and parts of colossal statues of Augustus and Livia, and a copy of Lysippos' Eros with the bow. Adjacent to the basilica on the E was the so-called *Bath of Varius*. Still standing are the S wall of the caldarium with seven heated basins, and E of that other rooms for bathing purposes. The long room on the S side was perhaps a hot room. The building was erected in the 2d c. A.D. South of the complex a mosaic floor of the 5th c. A.D., belonging to a stoa, has recently been excavated.

At the E end of the State Agora a section of the archaic necropolis lies beneath the Roman level, with sarcophagi made of stone, clay (Klazomenian), or slabs, and a burial without a sarcophagus dated by the grave gifts to the mid 6th-5th c. B.C. There is also, among the interments of the residents of the second Greek city 3.25 m below the present ground level, a section of the foundations of a street predating Lysimachos' city; it is 3.5 m wide and bordered by a dry wall. The necropolis lay on both sides of it.

On the S side of the Agora was the processional street, running W-E to the Magnesian Gate; S of that and opposite the Bouleuterion was a large fountain, sometimes called the Great E Nymphaeum, fed by water from the Marnas river in the Dervend mountains by means of an aqueduct. The original structure, enlarged in the 2d c. A.D., had a central building, wings, and projecting walls between which was a large basin with a dipping pool in front of it. It was repaired in the 4th c. under Constantius II and Constans.

The Hydrekdochion (fountain) erected ca. A.D. 80 by the proconsul C. Laecanius Bassus stood at the SW corner of the State Agora, where the processional street makes a right angle to pass E of the terrace of the Temple of Domitian. This alley is called Domitian Street. The plan of the fountain resembles that of the Fountain and Nymphaeum of Trajan (see below): a two-storied building with a collecting basin in front and, in front of that, a dipping pool, the dimensions of which were later reduced. The decorations included tritons, seahorses, and river-gods. Adjoining it to the N, near the junction of Domitian Street with Kouretes Street, is the monument in honor of C. Sextilius Pollio, erected by C. Offilius

Proculus in the Augustan period and enlarged in A.D. 93 by the addition to the S of a columned apsidal nymphaeum, joined to it by a common entablature. Its late Hellenistic statuary group portraying Odysseus' encounter with Polyphemos was adapted into fountain figures by the addition of a system of pipes. Just N of this is the Chalcidicum of the basilica (see above) with rusticated walls still standing to a fair height and three doors to the W. On the N side of this the Clivus sacer, now a footpath, leads through a gate with two socles decorated with reliefs showing scenes of sacrifice (Hermes leading a ram, youth with a goat, tripod with Omphalos); the path runs from Kouretes Street directly to the precinct of the Prytaneion.

Temple of Domitian. On the opposite side of Domitian Street is the terrace of the temple, with shops in its substructure on N and E, and a monumental approach from an open square to the N. The temple, built upon ancient foundations and further transformed in post-Domitianic times, had 8 by 13 columns, and four across the front; only the foundations remain. Before it stood an altar with socle reliefs of trophies and scenes of sacrifice, now in the museum at Selçuk. The temple was originally dedicated to Domitian by the Province of Asia (the first Neokorie of Ephesos) and after his damnatio memoriae rededicated to his father Vespasian. The head and one arm of a colossal statue of Domitian, thrown down after the damnatio memoriae, were found in the cryptoporticus and are now in the museum at Izmir. In the square before the temple is the foundation of a star-shaped podium, to which perhaps belonged a cylinder with a frieze of bucrania and a conical roof. It may be compared with the more or less contemporary structure next mentioned.

Kouretes Street bends, at its junction with Domitian Street. The monument here was erected in honor of C. Memmius, grandson of Sulla, and has been partly reconstructed. It consists of a socle, surmounted by a story(?), with niches and benches on the W, S, and E sides; in front at the sides are animated female figures in relief, and the whole is surmounted by an attic ornamented with reliefs. Adjoining it is a Hydreion (fountain) of the 1st c. A.D., remodeled in the early 3d c. In front of it are four pedestals on which stood statutes of Diocletian and the Tetrarchs. Further along Kouretes Street, beyond a late antique propylaneum is the *Nymphaeum of Trajan* (Hydrekdochion) on the N side, dedicated before A.D. 114. The main basin is surrounded on three sides by a two-storied wall resembling a scaena with columns in the Composite order in the lower story and aediculae with Corinthian columns above. In the middle, two stories high, was a colossal statue of Trajan; its base with globe and feet has been restored. The pool was on the street side.

Next to this was the *Temple of Hadrian*, a little porticoed temple with two columns in antis. Its barrel vaulted cella holds the pedestal for the cult statue, and over its door is a relief of Hadrianic date with a female figure rising from acanthus rinceaux. The building was restored after earthquakes between A.D. 383 and 387, and the relief frieze in the pronaos showing the legend of the founding of the city was added at that time. This frieze, originally made for another, unidentified building (it was cut down to fit its present setting), is possibly one of the latest of antique temple friezes. According to the inscription of P. Quintilius, the temple was dedicated to the emperor during his lifetime; after the Temple of Domitian, it was the city's second Neokorie (a provincial sanctuary designated as an Imperial temple). In front of the facade stood memorial pedestals with the statues of the Tetrarchs: the Augusti in the center flanked by the Caesares (cf. the bases by the Hydreion).

Behind the Temple of Hadrian, at the SW foot of Panayir-dağı, are the sprawling *Baths of Scholastikia*, originally of the 2d c. A.D. and rebuilt ca. 400 by a Christian, Scholastikia, whose statue, with an inscription, stands in the entrance chamber. Much reused material, especially from the Prytaneion, was employed. This bath belongs to the ring- or gallery-type and includes an apsidal apodyterium with changing-cubicles on the sides; the sockets for the curtain-rods are still in place. In its N section, accessible from Marble Street, is a Paidiskeion or brothel.

Opposite the Baths of Scholastikia are two splendid private houses still being excavated. They rise in several stories against the hillside, and while the front rooms of the lower stories are aligned with Kouretes Street, the upper ones are laid out orthogonally, parallel to a street in back which runs at an acute angle from the Square of Domitian to Kouretes Street. There were shops in the lower story, and three flights of steps led from the street to the upper levels. There is a fine peristyle court in the third story of the E house, with marble floors, wall veneer, and a pool of later date with marble revetment. Ten main periods are represented, from the Augustan age until destruction in the early 7th c. Adjoining on the S is a square chamber with three niches on the W side. In House 2 to the W there are apartment suites, each grouped around a peristyle court; the surrounding rooms have an upper story (dwelling space of 964 sq. m); several rooms are decorated with two layers of paintings representing Muses (3d c.), the figure of Socrates with an inscription (1st c.), theater scenes (the *Sikyonioi* and the *Perikeiromene* of Menander, and the *Orestes* of Euripides), the Combat of Hercules and Acheloos, more Muses, and Erotes. Also found here were a bronze statuette 0.38 m high of a "Sem" priest with inscribed cartouches of Psammetich II (590 B.C.), a little ivory head of the 3d c. A.D., other figures and reliefs, and even a frieze, of ivory. From the niche-vault of one of the peristyle courtyards comes a glass mosaic of the 5th or 6th c. A.D. Some of the finds are in the Selçuk museum.

To the NW on Kouretes Street are two related buildings, perhaps heroa from the 1st c. B.C. or A.D.: the *Nymphaeum* consists of a massive marble base with Doric half-columns on three sides surmounted by Ionic ones, and a frieze decorated with garlands. It was rebuilt as a Nymphaeum in the Christian era; the water flowed into a pool with crosses inscribed on the slabs of its brim. The *Octagon* is similar: a marble socle surmounted by an 8-sided structure. The massive core, with false door, is surrounded by a Corinthian colonnade; above the entablature is to be reconstructed a stepped pyramid terminating in a cone. The base encloses a tomb chamber which held a marble sarcophagus containing bones. In A.D. 371-372 decrees were inscribed on the socle slabs. Also related to these buildings is the Round Building on the SW cliff of the Panayir-dağı: a square dado surmounted by a two-storied round structure, perhaps a memorial to the governor P. Servilius Vatia Isauricus, 46-44 B.C. Beside the two buildings mentioned above, the Processional Way (called Marble Street as far as the theater) turns to the N; on its S continuation across Kouretes Street, leading up to the cliff, lies a gateway with pedestals and bases of pillars in situ: a unique combination of half- and three-quarter columns and pilasters. The second story had a delicate columnar structure comparable to the nearly contemporary Gate of Hadrian in Athens. Beyond this gate lay a marble-paved square.

The Library of Celsus lies W of the square. A flight of nine marble steps 21 m wide leads up to the richly-articulated facade with indented and reentrant paired columns and aediculae. The niches held female figures, allegorical personifications of the four cardinal virtues, now in Vienna. Behind this was a large chamber, built on vaulted substructures and surrounded by an isolating passage (for dryness); the inner walls and floor were originally veneered with variegated marble slabs. Around the walls ran three superimposed rows of 10 cupboard-niches for manuscripts. Opposite the center entrance was an apse beneath which lay the tomb chamber, accessible from the N, with the sarcophagus of the Senator Tiberius Iulius Celsus Polemaeanus, Consul in A.D. 92. The Library, which thus also served as a heroon, was dedicated by his son C. Iulius Aquila, Consul in A.D. 110, and completed by his heirs. In the Christian period a pool was added in front of the facade, bearing relief plaques of a monument in honor of Emperor Lucius Verus; these are now in the Neue Hofburg in Vienna. Opposite the library stood a building, probably a lecture hall, now almost totally destroyed; and the socle of a round building (heroon?) of late Hellenistic or early Roman date. In the square in front of the library was an entrance down to the Commercial Agora, through the Gate of Mazaeus and Mithridates. The inscription on its attic identifies the donors as two freedmen of Agrippa who erected the gate in 4-3 B.C. in honor of Augustus, Livia, Agrippa, and his daughter Julia. It has three entrances between richly articulated side walls, and the attic was crowned by statues of the Imperial family.

The Agora or *Lower Marketplace* is a square 110 m on a side, surrounded by double-aisled stoas with shops behind them. In the center was a horologion, a water clock and sundial combined. In the 3d c. A.D. the Agora was rebuilt, and in subsequent alterations much earlier building material was reused. On the E outer wall, leading to Marble Street, lies a double-aisled Doric colonnade of the time of Nero. In front of the W side of the Agora stretches a large street-like open space, ca. 160 by 24 m with colonnades along both long sides; at the W end is a gate and on the E another entrance to the market, an exedra-like structure with projecting wings. An open stairway between the wings led up to the level of the Agora; ramps were added during later alterations.

To the W of the Agora, S of the street-like area, similar steps lead up to a square surrounded on three sides by arcades. On the S side of the square lies the *Temple of Serapis*, of the 2d c. A.D., set on a podium approached by a monumental stair. The porch in front of the barrel-vaulted cella is formed by eight monolithic Corinthian columns ca. 15 m high; immense blocks of marble were also used for the richly decorated entablature, gables, and door frame. A gigantic door on casters led into the cella.

Marble Street (S part, see above under Kouretes St.; farther N below). Named for the pavement given in the 5th c. A.D. by Eutropius, whose portrait is in Vienna, the street lies E of the Commercial Agora, and is reached by the Neronian arcade mentioned earlier. It runs N to the theater, past a late antique arcade on the E side, and on to the stadium.

The Theater, site of the Ephesians' protest, "Great is Diana of the Ephesians!" against the Apostle Paul (Acts 19:34), is set into the W cliff of the Panayir-dağı and dates in its present state from the Roman era. It was begun under Claudius, completed under Trajan, and received later additions. The auditorium seated 24,000 on three levels of 22 rows each (the lowest 6 were later removed); vaulted stairways led from outside to the up-

per levels. The well-preserved scenae frons had three stories; in front of it was the Roman logeion. There are also some remains of the pre-Roman stage structure. Built into the W terrace-wall is a fountain house of the 3d or 2d c. B.C.: a niche with two Ionic columns in antis, with the water flowing from three lions' heads in the back wall. To the N of the square in front of the theater was the *gymnasium*, dating from the Empire and today in ruins; the galleried court in front served as a palaestra.

The Arkadiane ran from the theater to the harbor, a street over 500 m long with a central lane for wheeled traffic 11 m wide, and colonnades 5 m deep on each side. The colonnades had mosaic floors, and shops in the inner walls. The remains visible today date from the time of Emperor Arcadius (A.D. 395-408). According to an inscription, the street was lighted. About halfway along it is a structure of the 6th c. A.D. consisting of four columns with Composite capitals on pedestals. The columns probably held statues of the four Evangelists. At the harbor end, the Arkadiane terminated in an early Roman Harbor Gate, with Ionic architectural features which were decorative rather than functional; its level is 0.6 m lower than that of the later street. On the parallel street to the S lay another two-storied portico of ca. 200 B.C., leading to the harbor. The wall of the Byzantine period, which still exists E of the Stadium and Theater, runs down to the harbor S of the Arkadiane.

The Great Baths (Harbor Baths, Harbor Gymnasium, or Porticos of Verulanus) lay N of the Arkadiane. The site had been set aside for this purpose in the plans for Lysimachos' city and it was originally the only bath complex. The palaestra was surrounded by the various sports facilities; to its S was the fine Marble Hall, and in front of it to the E a great square with triple colonnades. These consisted of an unroofed central lane between two narrow, roofed halls, and apparently constituted the xystus for running practice. The marble revetments of Hadrianic date were added by Pontifex Maximus Claudius Verulanus. The bath building itself and the swimming pool were rebuilt in the 2d and 4th c. A.D. The bronze statue of the Apoxyomenos in Vienna came from here.

The Council Church, also called the Church of the Virgin Mary, is N of this complex. There had previously been a building with three aisles and apsidal ends, erected over an older structure more than 260 m long. Then, in about the 4th c. A.D. a triple-aisled columnar basilica with narthex was built on the site; it had a large colonnaded atrium at the W end and a Baptistery on the N side. This was the great Church of St. Mary where in A.D. 431 the Third Ecumenical Council was held. The E section of the old building was apparently used as a Bishop's palace. Later a domed church was built on the site, and finally a triple-aisled pillared church with galleries.

The Stadium. Marble Street, E of the preceding complex, runs N from the theater to the stadium on the NW slope of the Panayir-dağı, where festivals, athletic contests, and horse- and chariot-races were held. The tiers of seats on the S were partly built into the hillside, but all seats were removed in the Middle Ages. The W facade with seven entrances and the gateway in front of it to the S belong to a rebuilding in the 3d or 4th c.; the older wall still preserved on the N dates from the extensive reconstruction under Nero, according to an inscription to Artemis of Ephesos and to Nero. At its E end was a round field for gladiatorial contests and wild beast fights. Adjoining the Stadium to the N are the baths built by P. Vedius and his wife Flavia Papiana in the mid 2d c., dedicated to Artemis, Antoninus Pius, and the City of Ephesos. The plan is symmetrical. On the E is a colonnaded courtyard, and a lavatory with marble seats at its

SW corner. On the W side of the court is the Imperial cult-chamber with a two-storied interior colonnade, a niche for the emperor's portrait and, in front of it, an altar. Adjoining this is a bath building, which was adorned with copies of famous statues now in the museum in Izmir. The Koressos Gate stood at the E end of the baths.

At the N foot of the Panayir-daği was the sanctuary of the Mother Goddess, with niches in the mountainside and votive reliefs showing the Mother Goddess of Asia Minor. In the N slope was the Grotto of the Seven Sleepers; a church with catacombs was built here over an older grave area, site of the legend of the resurrection of seven youths during the period of persecution of the Christians. In the valley of Dervend-Dere (Marnas) is the aqueduct built in A.D. 4-14 by C. Sextilius Pollio, a striking series of arches in two stories and one of the best examples of Roman aqueducts in Asia Minor. Recently part of the remains were carried away by a flood. The Panayīa Kapīlī (House of Mary), a shrine to the Virgin on the Aladağı S of the Bülbül-dağı, is thought by some scholars to date from the Byzantine period.

In Selçuk are the ruins of the Byzantine aqueduct and of the Gate of the Persecution, probably built in the 6th c. A.D.; in front of it a grave of the Mycenaean period has been excavated. Here also is the Church of St. John, originally a mausoleum over the saint's grave, then a church with a wooden roof. The church was replaced with a domed basilica in the 6th c. A.D. by Justinian. The citadel on the summit, of the Christian-Byzantine period, has a fortification wall with 15 towers and a single gate. The Mosque of Isa Bey, SW of the Church of St. John, is the most important Islamic building in Ephesos, built in 1375 by an architect from Damascus. There are 14 other small mosques, sepulchers, and baths; there is an excellent museum in Selçuk where the finds since WW II are kept, and there are two in Izmir.

BIBLIOGRAPHY. *RE* V (1905) 2773ff; *RE* Suppl. XII (1970) 248ff, 297ff, 1588ff; C. H. Picard, *Ephèse et Claros* (1922); F. Miltner, *Ephesos, Stadt der Artemis und des Johannes* (1958); W. Alzinger, *Die Stadt des 7. Weltwunders* (1962)[MPI]; id., "Augusteische Architektur in Ephesos," *Sonderschriften d. ÖAI* 16 (1972)[MP]; (1972)[MPI]; id. & D. Knibee, *Ephesos, Ein Rundgang durch die Ruinen* (1972)[PI]; J. Keil, *Führer durch Ephesos* (5th ed. 1964)[MPI]; E. Akurgal, *Ancient Civilizations and Ruins of Turkey* (1969) 142-71[PI].

Excavations:

J. T. Wood, *Discoveries at Ephesos* (1877); D. G. Hogarth, *The Archaic Artemisia* (1908); Österr. Arch. Inst., *Forschungen in Ephesos* (1906) I, 237ff; "Vorlaufige Berichte," *AnzWien* 98 (1961) passim.

Monuments:

M. Bieber, *Die Denkmäler zum Theaterwesen im Altertum* (1920) 43ff; id., *The History of the Greek and Roman Theater* (1939) 226ff, 267, 370-71[I]; A. Boëthius & J. B. Ward-Perkins, *Etruscan and Roman Architecture* (1970) 387[I] (aqueduct), 399-403 (baths); G. Sotiriou, *Deltion* 7 (1921-22) 89ff (Church of St. John); F. Fasolo, *Palladio* (1956) 1ff (Council Church); G. Grüben, *Griechische Tempel und Heiligtümer* (1961) 243ff (Artemision); W. Alzinger, *Festsch. F. Eichler* (1967) 1ff (Koressos); A. Bammer, *AA* (1968) 400ff (altar of Artemision). V. MITSOPOULOU-LEON

EPHYRA (Ephyre) or Kichyros W Epeiros, Greece. Map 9. In Elis of Thesprotia, 800 m N of the junction of the Kok(k)ytos river with the Acheron, 4.5 km E of the bay of Ammoudia where ancient Glykys Limen (Strabo 7.7.5) or Eleas Limen (Ps. Skylax 30; Ptol. 3.14.5) were located, and into which the Acheron flows.

Thucydides (1.46.4) says that near the Cheimerion promontory (modern Glossa) which shelters the bay on the N "there is a harbor, and above it lies a city away from the sea in the Eleatic district of Thesprotia, Ephyra by name. Near it is the outlet into the sea of the Acherusian Lake." Strabo (7.7.5) gives the same information and adds that in his time Ephyra was called Kichyros.

Neoptolemos landed at Ephyra on his return from Troy (Pind. *Nem.* 7.37-39) and Odysseus came there later to get poison for his arrows (*Od.* 1.259f). Theseus and Perithoos came to snatch away Persephone, the wife of Aidoneus the king of Ephyra. These were none other than Persephone and Hades, the gods of the underworld, who had a shrine and an oracle at Ephyra (Paus. 1.17.4-5, 9.36.3; Plut. *Theseus* 31.35).

The site of Ephyra is confirmed by the excavation of the ancient oracle of the dead on the hill of Agios Ioannis near the village of Mesopotamos, 150 m N of the junction of the Kok(k)ytos with the Acheron. The remains of three ancient wall circuits are preserved, 600 m farther N, on the limestone hill of Xylokastro (elev. 83 m). The outer one, surrounding an area of 4.2 ha, is cyclopean; its circumference is 1120 m and one gate in the S side is 2.3 m wide.

The central sanctuary building of the oracle of the dead is surrounded by a very thick (3.3 m) polygonal wall. The building is divided into three sections, a central aisle without divisions (beneath which is a great vaulted crypt), and two side sections each divided into three rooms. The walls stand to a height of 3.5 m; they show damage from a fire that destroyed the sanctuary and buried the offerings. In the side rooms were great piles of wheat and barley, pithoi which had contained cereals and liquid, perhaps honey. Various iron implements such as plows, shovels, and sickles were also found. In the first room on the left were two busts of Persephone in terracotta (ht. 0.2 m). The first room to the right contained eight pithoi around the walls, many vases, and much carbonized grain. The second room contained piles of bowls, overturned amphorae, a marble basin, and again much carbonized grain. In one of the corridors outside were traces of pyres and of pits with the bones of sacrificed animals—sheep and goats, bulls, and a few pigs.

The existing monumental remains date from Hellenistic times, but the location of the sanctuary and the types of sacrifices attested by the remains correspond closely with Homer's description (*Od.* 10.508ff; 11.24ff; cf. Paus. 1.17.5).

The finds within the acropolis, chiefly sherds of local pottery of the Bronze Age and Mycenaean sherds of LH III A-B, together with the worship of the pre-Hellenic chthonic goddess Persephone and the local name (Kichyros), indicate that a native settlement of the Bronze Age was resettled in the 14th c. B.C. by colonists most probably from the W Peloponnese.

After the surrender of the Elean colonies in Kassopaia to Philip II of Macedon in 343-342 B.C. (Dem. 7.32) and their subjection to the Thesprotians, Ephyra appears to have reverted to its pre-Hellenic name, Kichyros, which had been kept alive in some neighboring Thesprotian settlement (Kichyros, the former Ephyra: Strab. 7.7.5, 8.3.5). Some finds, chiefly pottery of the 1st c. B.C., confirm the statement of Pausanias (1.17.5) that Kichyros was in existence in his time.

BIBLIOGRAPHY. A. Philippson, *RE* 6, 1 (1907) 20, No. 7; id. & E. Kirsten, *Die Griechischen Landschaften* II, 1 (1956) 104, 106, 242, 280; S. Dakaris, Ἀνασκαφικαί ἔρευναι εἰς τὴν Ὁμηρικὴν Ἐφύραν καὶ τό Νεκυομαντεῖον τῆς ἀρχαίας Θεσπρωτίας (1958) 107-13; id., "Das Taubenorakel von Dodona und das Totenorakel bei Ephyra,"

AntK (1963) Beih. 1, 35-54^{MP}; id., Θεσπρωτία (1972) 62-63, 74, 80, 95, 133-34, 199-200; N.G.L. Hammond, *Epirus* (1967) 369, 372, 379, 393, 478, 483.

S. DAKARIS

EPHYRE, *see* EPHYRA

EPIDAMNOS or Dyrrachion (Durazzo) Albania. Map 12. A city, ca. 30 km W of Tirana, founded in 627 B.C. by Corinth and Kerkyra. The name Dyrrachion is found on coins; in the Roman period it was prevalent (changed to Dyrrachium). Since the modern city is built over the ancient town, it is primarily on the basis of inscriptions and occasional finds that some idea of its monuments has been formed.

Inscriptions offer evidence on the following monuments: an aqueduct constructed by Hadrian and restored by Alexander Severus (the inscription comes from Arapaj, a short distance from Durazzo: *CIL* III, 1-709); the Temple of Minerva; the Temple of Diana (*CIL* III, 1-602), which is perhaps the one mentioned by Appian (*BCiv.* 2.60); the equestrian statue of L. Titinius Sulpicianus (*CIL* III, 1-605); the library (*CIL* III, 1-67). The last inscription mentions that for the dedication of the library 24 gladiators fought in pairs. The conjecture that there was an amphitheater in the city is confirmed by a passage from the *Vita di Skanderbeg* by Marino Barlezio: amphitheatrum mira arte ingenioque constructum.

As a result of occasional discoveries, the following data are available: a 3d c. mosaic pavement with the representation of a female head found at a depth of 5 m (the head, surrounded by garlands of vegetables and flowers, brings to mind those painted on Apulian vases); remains of houses covered by other layers, the lowest of which, of the Greek era, was found at a depth of 5 m.

Columns with Corinthian capitals and marble facing, discovered on the nearby hillside at Stani, belong probably to the Temple of Minerva or to the Capitolium. The necropolis is E of the hills that stand above the city. The Stele of Lepidia Salvia, a sarcophagus (now at Istanbul) with a scene of the Caledonian boar hunt, and numerous Roman tombs were found in the necropolis.

BIBLIOGRAPHY. Strab. 5.283; 6.316,323,327; Ptol. 3.12; Dion. Cass. 41.49; Paus. 6.10.8; Pompon. 2.56; Plin. *HN* 3.145; 4.36; 6.217; 14.30; 19.144; 32.18.

C. Praschniker, "Muzakhia und Malakastra," *JOAI-Beibl* 21-22 (1921) col. 203ff; L. Rey, "Albania," *Cahiers d'Archeologie, d'art et d'Histoire en Albanie et dans les Balkans* 1 (1925) 26ff; P. C. Sestieri, "Vita pubblica e monumenti di Durazzo in età romana, attraverso le inscrizioni," *Epigraphica* (1942) fasc. 3, pp. 127ff; id., "Sculture romane di Apollonia e Durazzo," *Bull. del Museo dell'Impero* (1942) 3ff. P. C. SESTIERI

EPIDAUROS Peloponnesos, Greece. Map 11. A city in a recess of the S arm of the Saronic Gulf. Its territory reached to the Gulf of Argos on the W, on the N to the boundaries of Corinth, and on S and E to Hermione and Troezen. In its few well-watered valleys the vine flourished ("vine growing Epidauros" in Hom. *Il.* 2.561).

The city was founded on the rocky hill of the small peninsula of Akte (Nisi) near modern Palaia Epidauros. There are remains on the acropolis of the peninsula (walls and houses), in the sea (submerged remains of the ancient harbor and several buildings belonging to the lower city), and in the neighboring area at Nea Epidauros. Numerous prehistoric and Geometric finds have come from these areas.

Epidauros took part in the Trojan War (*Il.* 2.561) and was a member of the Kalaurian Amphictyony during the 7th and 6th c. B.C. (Strab. 8.374). At the end of the

6th c. B.C. its ruler Prokles married his daughter Melissa to Periander, the tyrant of Corinth, who murdered her and annexed Epidauros (Hdt. 3.50-52; Paus. 2.28.8). In the Persian Wars Epidauros sent eight ships to the sea battle off Artemision, 800 men to the battle of Plateia, and ten ships to the battle of Salamis (Hdt. 8.2, 43, 72; 9.28, 31). Afterwards the city was consistently unfriendly to Athens and continued steadfastly in alliance with Sparta throughout the Peloponnesian War and later on, even after the battles of Leuktra (371 B.C.) and Mantinea (369 B.C.). Epidauros was involved in the Lamian War (323-322 B.C.: Diod. Sic. 18.11.2), and in 243 B.C. was a member of the Achaian League (Paus. 2.8.5; Plut. *Arat.* 24). From 115-114 B.C. on, Epidauros was allied to Rome as a friend. The last mention of Epidauros is in the 6th c. A.D. when it was included in the Synekdemos of Hierokles.

The Sanctuary of Asklepios. This was always under the management of the city. It lies SW of it, in the middle of the Argolid peninsula, near the modern town of Ligourio (9 km by the old road, 18 km by the new highway). It comprises 160 sq km in the verdant valley enclosed by Mt. Arachne together with the lower peak of Titthion which lies in front of it, and by Mts. Koryphaion and Kynortion. Here in archaic, perhaps even in prehistoric, times the god or hero Malos or Maleatas was worshiped. He had his own sanctuary, which is a little outside the Sanctuary of Asklepios on the slope of Mt. Kynortion above the theater. Long before the cult of Asklepios and his father Apollo was established the inhabitants of the area gathered at the Sanctuary of Malos in spring to celebrate the regeneration of nature and the end of winter. These festivals, as in Delphi and Delos, were associated with teleological and metaphysical ideas as well as with the operation of the temple as an oracle. The evident relation of this cult to that of Apollo very early allowed a merging of the two. In historic times, Apollo, already the dominant god in the precinct, took on the surname Maleatas.

Asklepios, the mythical hero-doctor, son of Apollo and Korone, learned medicine from the centaur Chiron. It is not known when the worship of Malos was superseded by that of Apollo and Asklepios. The contention of the Epidaurians that the worship of Asklepios was autochthonous there and not introduced from Trikka in Thessaly, a view which the poet Isyllos also tried to promote in the 4th c. B.C., is not proved. When other places, like Messenia, however, claimed the oldest cult, the temple of Delphi ruled for the Epidaurians (Paus. 2.26.7). Nevertheless, up to the present, the finds from the excavations in the Asklepieion are not older than the end of the 6th c. B.C.

In the last quarter of the 5th c. B.C. the cult of Asklepios enjoyed a sudden upsurge in Epidauros, to reach its peak in the 4th c. B.C. The Panhellenic Games and horse races, the Asklepieia, which were traditionally held every four years, were enriched around 400 B.C. by poetry and music contests (Pl. *Ion* 530). At that time the cult spread throughout the Greek world, so that more than 200 new Asklepieia were built, the most notable being in Athens (420 B.C.), in Kos, in Pergamon (4th c. B.C.), and in Rome (293 B.C.)—all under the patronage of the sanctuary in Epidauros. In the 4th c. B.C. the Hellenistic world, under the influence of radical internal and external changes now clung with especial fervor to this new philanthropic god, a healing doctor and savior. The manifest reverence towards the god resulted in the metamorphosis of the sanctuary's enclosure, which had been unadorned up to the 5th c. B.C., into a place filled with countless offerings and monuments, most of them remarkable examples of 4th c. B.C. Greek art. The pros-

perity of the sanctuary continued through the Hellenistic period. Treasures and choice works of art were ceaselessly heaped up in it. The treasures were looted by Sulla in 87 B.C. (Plut. *Sull.* 12.6; Paus. 9.7.5) and again by pirates in 67 B.C. (Plut. *Pomp.* 24.5).

The sanctuary enjoyed a new flowering in the 2d c. A.D. when, because of the reigning climate of spiritual anxiety, there grew a strong inclination towards religious salvation. In consequence of this inclination new gods were introduced into the sanctuary: Ammon, Sarapis, and Isis, as evidenced by the discoveries there of dedicatory inscriptions. In A.D. 163 the senator Sextus Julius Antoninus give generously for the repair of many ruined buildings and for the erection of new ones to meet the needs of the sanctuary and of the worshipers. Among these was the Temple of Apollo and Asklepios under the Egyptian epithet (Paus. 2.27.7). It is worthwhile to note that even in the great days of the sanctuary in the 4th and 3rd c. B.C., and again in the 2d c. A.D., while the religious buildings were all of small dimensions, the buildings necessary for visitors and patients (enkoimeterion, baths, gymnasium, katagogeion, stoas, etc.) were two-storied and large, thus surrounding and hiding the others. In A.D. 395 the Goths under Alaric raided the sanctuary. The triumph of Christianity ended the sanctuary's rites in mid 5th c., but Christ and the saints took the place of the healer-god. In the N part of the sanctuary a five-aisled early Christian basilica was built in the end of the 4th c. A.D. Religious healing evidently continued there.

Ancient literary sources and relevant inscriptions found in the sanctuary give a great deal of information about the cures. Therapy was based on the belief that, since an individual's sickness had a psychosomatic origin, the power to restore health was likewise to be sought within him (Democr.: Diels, *Dox. Graec. Vorsokr.* II 183.7; 192.4; Galen: Diels II 339.5). The therapy of the doctor-priests, therefore, aimed at the rousing and augmentation of an inner power of restoring health, which was, in fact, the harmony of soul and body (Diels I 451; II 463.25). This type of therapy was also practiced by the Pythagoreans, whose founder was held to be the son of Apollo. Although this therapy often led to superstition, it nevertheless presented a basis for scientific medicine and proved the importance of psychosomatic factors in the control of health. Consequently, in the Hellenistic and Roman periods, although the practice of medicine was generally taken away from religious control, doctors traced their lineage and inspiration to Asklepios, and called themselves his descendants.

The Excavations. From the middle of the 17th c. travelers came to see the sanctuary. A systematic excavation of it was undertaken in the 19th c., during which most of the remains now preserved were uncovered, as well as important literary inscriptions on stone, among them the Paean of Isyllos. In 1946 a small trial excavation was made in the sanctuary and a small part of the Temple of Apollo Maleatas was studied.

In the sanctuary a museum houses the fragments of the most noteworthy buildings (the tholos, and the Temples of Asklepios and Artemis) and much of the sculpture, although the rest of the sculpture, particularly that from the Temples of Asklepios and Artemis is in the National Archaeological Museum in Athens.

The Temple of Asklepios 380-375 B.C. Only the foundations are preserved, but the architectural fragments discovered and an inscription concerning the building of the temple allow the reconstruction of its original form. It was the work of the architect Theodotos, and

although it was one of the smallest Doric peripteral temples in Greece (6 x 11 columns; 23.06 x 11.76 m) with no interior colonnade and no opisthodomos, still it was one of the most splendidly ornamented, with a floor of black and white marble slabs, and inlays of ebony, ivory, gold, and other precious materials on the door and elsewhere. In the temple stood the chryselephantine statue of Asklepios by Thasymedes of Paros (Paus. 2.27.2).

In the W pediment was an Amazonomachy. In the E pediment was the Sack of Troy, apparently with 22 figures, 11 male and 11 female, which were perceptibly larger than those of the W pediment. The two groups are basically of a different technique. The figures of the W pediment, although in active conflict, have a soft and flowing form. On the other hand, the figures of the E pediment with their harshly geometrical articulation and forceful constriction, with their drapery schematically rendered in deep folds and sharp-edged ridges or planar surfaces, create an intense chiaroscuro effect.

The W acroteria, filled out by new fragments, have a central Nike figure, as may be inferred from a new fragment with feathers carved in relief which fits into her left shoulder. The two lateral acroteria are Aurai. The central acroterion on the E side must have been a group of male and female figures, the females represented now only by a left hand. This group must be placed in this position since, unlike all the others, it is worn on all sides, and does not have the cutting necessary for fixing it to the tympanum of the pediment. The corners of the pediment must have been occupied by figures of Nike.

The above observations on the sculpture are reinforced also by the building inscription discovered in the sanctuary. According to this inscription, Timotheus did the "typoi," which must be interpreted as small models of the statues. The making of one pedimental group was entrusted to Hektorides, the other to a man whose name is not preserved. It is also noted that one of the two acroterial groups was entrusted to Timotheus, and the other to a sculptor of whose name only the first three letters, Theo . . . , are preserved. Unfortunately the inscription does not specify which end of the temple each of these men worked on.

Temple of Artemis. Late 4th c. B.C. The temple is small, Doric, hexastyle prostyle. Ten columns, which ran around the inside of the temple, were Corinthian. The gutter spouts, of marble like the roof, took the form of dog heads.

The Tholos or Thumele. A circular building whose underground center is labyrinthine (diameter ca. 13.36 m), composed of three concentric walls, each of which has a door and beside it a partition running crosswise, closing off the circular passageway in one direction. To get from the outside to the center one must traverse the whole circuit of each passageway, and reverse direction in the next. This building, whose purpose remains unknown, was built in the 6th c. B.C. and is closely associated with the cult of Asklepios. In the years 360-320 B.C. the Argive architect and sculptor Polykleitos the Younger enlarged the building and encircled the original part with three concentric rings (diameter 21.68 m). The outer ring is a Doric peristyle, the next is the wall of the building, and the inner one a Corinthian colonnade. In the center the well-like opening was left. The peak of the conical roof was crowned by an exquisitely worked acanthus. In this new version of the tholos there was abundant use of black and white marble as well as poros. The numerous floral and geometric decorations in the paneling, the orthostates, the para-

stades, the doors, and the cornice establish this building as one of the most beautiful and most representative of 4th c. architecture. The interior was decorated with painted panels, the work of the painter Pausias.

Enkoimeterion or Abaton. A large poros porticoed building of the 4th c. B.C. (70 x 9.50 m), which is divided near the middle into two sections: the E had a single story; the W, which was a little later, had two stories owing to the steep slope of the ground. The building was closed off at the rear by a wall, and in front an open colonnade of 29 Ionic columns supported the roof. An inner row of columns divided the building in two lengthwise; the interspace between the columns was filled by a wall. The sleeping-in of believers took place in this closed-off inner room, which communicated with the open portico through doors. The sleeping-in also took place in the lower floor of the W section. In the SE corner of the enkoimeterion was discovered a well filled with inscribed tablets describing miraculous cures. A square structure at the W end was a fountain of the 4th c. B.C.

Epidoteion. This sacred building, known from inscriptions of the 4th and 3d c. B.C., seems to have been rebuilt by the senator Antoninus (Paus. 2.27). It may have been the temple-style building W of the Temple of Artemis.

Anakeion. This was a sanctuary dedicated to the Dioskouroi, which is known from inscriptions of the Roman period. Some authorities place it near the Temple of Artemis, others to the NE of it.

The Old Abaton. An almost square building (24.30 x 20.70 m) of the second half of the 6th c. B.C., with closed passageways surrounding it on three sides.

Baths of Asklepios and the Library. Located at the NE corner of the enkoimeterion, they were probably built by the senator Antoninus.

Temple of Aphrodite (?). This name is applied to a temple which is unique in the Peloponnese. It is pseudoperipteral, set on a krepidoma of four steps. Across the front are four Ionic columns, and in back of each corner column is another single column. Around the outside of the cella walls ran a row of columns connected to the wall like pilasters. They were placed one at each corner of the E wall, four along the W wall, and five each on the N and S walls. The columns which ran around the inside of the cella were Corinthian. The fine workmanship and the decoration of the architectural members were clearly inspired by those of the tholos, and date this building to the end of the 4th or the early 3d c. B.C. The statue of Aphrodite with a sword, which was found in the sanctuary, may have stood by this temple. It is Hellenistic, possibly the work of Polykleitos the Younger.

The Cistern. This is Hellenistic. The baths are NW of it and W of them is a large building of unknown purpose, consisting of a portico, a peristyled court, and a room.

The Propylaia. This lies on the NW side of the sanctuary, where the Sacred Road from Epidauros comes in. The sanctuary, however, was not enclosed by a peribolos wall, and only in the 4th c. A.D. was it protected by a double wall. To the E of the propylaia, a villa was built in the 5th c. A.D. and an Early Christian basilica at the end of the 4th c. The five-aisled basilica with a narthex was dedicated to St. John. To the N of the propylaia was the necropolis of the sanctuary.

A Large Porticoed Building. Of the Classical Greek period, with two colonnades, the outer Doric and the inner Ionic. It was repaired by Antoninus (Paus. 2.27.6). West of it were baths built in the Roman period. SW

of these is the Sanctuary of the Egyptian Gods (?), which is a square building with a portico on the front and a square court with three entrances behind. Near this shrine was a house of the Late Roman period.

Palaistra (?). A rectangular structure of the Classical period with a four-sided interior courtyard. The stoa along its N side was perhaps the Stoa of Kotys (Paus. 2.27.6).

The Gymnasium or Palaistra. A square building with an inner peristyled court and porticos and rooms along the four sides, like the palaistra at Olympia. The entrance is through a monumental propylon on the NW side. An odeum was constructed in Roman times on the site of the gymnasium.

Baths of the Classical Greek Period. A rectangular building poorly preserved.

The Katagogeion. A two-storied hostelry for the use of visitors to the sanctuary. It contained 160 rooms arranged around four peristyled courts. It is of the 4th c. B.C.

The Theater. This is the best preserved theater in Greece, celebrated in antiquity for its beauty and harmonious proportions. The elliptical cavea in the lower story with 34 rows of seats, the entrances to the paradoi, the proskenion, and scene-building, the sloping steps, and the orchestra in the form of a full circle were built of local limestone in the second half of the 4th c. B.C. by Polykleitos the Younger of Argos (Paus. 2.27.5). In the 2d c. B.C. the cavea above the diazoma was added, which, with the lower section, makes 55 rows of seats, giving about 14,000 places. The acoustics of the theater are remarkable, and spectators in the highest seats can hear the actors clearly. At this period additions and changes were made to the scene-building. The W parados entrance was restored with the original materials, while some new material was incorporated in the E.

The Stadium. The length is 181 m. It was built in the later 5th c. B.C. and underwent numerous changes and additions from then to the Roman period. At both ends of the track the two stone starting posts are preserved. In the lower part of the sides of the stadium, in the middle, are rows of stone seats dedicated by private individuals, and also the remains of seats for judges and officials of the games. In the N side is an underground passage for athletes. The hippodrome lies SW of the stadium about an hour's walk away. It has not been excavated. To the W of the stadium are the remains of a house of the Later Roman period with peristyled courts.

The Sanctuary of Apollo Maleatas. This is much older than the Sanctuary of Asklepios. Its site was inhabited from the Early Helladic period. The finds show a continuous inhabitation to historic times. The Mycenaean finds from a deposit (a steatite rhyton with the representation of a procession, terracotta idols, etc.) show that even at that period the site was sacred. The excavated structures, include a large Temple of Apollo and two smaller buildings (treasuries?) of the 4th c. B.C., a stoa of 300 B.C., an altar and a fountain of the Roman period, etc. The latest of these other buildings was erected by the senator Antoninus.

BIBLIOGRAPHY. *City-state*: A. Mau et al., *Katalog der Bibliothek des Kais. Deutschen Archaol. Instituts in Rom* (1900-1932) passim; A. Frickenhaus & W. Müller, "Epidauria," *AthMitt* 36 (1911) 29ff; U. Kahrstedt, *Das Wirtschaftliche Gesicht Griechenlands in der Kaiserzeit* (1954) 175ff; A. Philippson & E. Kirsten, *Die Griechischen Landschaften* (1959) III 1, 105ff; K. Syriopoulos, Προϊστορία τῆς Πελοποννήσου (1964) passim; R. Hope

Simpson, *A Gazetteer and Atlas of Mycenaean sites* (1965) 20f.

Sanctuary—Excavations, Restorations: P. Kavvadias, *Fouilles d'Epidaure* (1891)[PI]; id., Τό ῾Ιερόν τοῦ ᾿Ασκληπιοῦ ἐν ᾿Επιδαύρῳ καί ἡ θεραπεία τῶν ἀσθενῶν (1900)[MPI]; H. Lechat & A. Defrasse, *Epidaure* (1895)[PI]; B. Martin & H. Metzger, *BCH* 66-67 (1942-43) 327ff[I]; A. Orlandos, *Praktika* (1955) 339[I]; (1956) 269[PI]; (1959) 243; (1960) 342[I]; (1961) 227 (theater)[I]; id., *Atti VII Congresso Int. Arch. Classica* (1961) 1,100.

Excavations at Maleatas: J. Papadimitriou, *Praktika* (1948) 90ff[PI]; (1949) 91ff[I]; (1950) 194ff[I]; (1951) 204ff[PI]; id., *BCH* 73 (1949) 361ff[PI], 530ff; 74 (1950) 303ff[I]; 75 (1951) 113f; 76 (1952) 221.

Architecture: P. Foucart, "Sur la Sculpture et la date de quelques édifices d'Epidaure," *BCH* II (1890) 589ff; G. Sotiriou, Αἱ παλαιοχριστιανικαί Βασιλικαί τῆς ῾Ελλάδος, *Arch.Eph.* (1929) 198ff[P]; L. Shoe, *Profiles of Greek Mouldings* (1936) passim[I]; W. Dilke, "Details and Chronology of Greek Theatre Caveas," *BSA* 45 (1950) 42ff; B. Berard, "Notes Epidauriennes," *BCH* 85 (1951) 400ff; E. Fabricius, *RE* XXI[2] (1952) 1720ff, s.v. Polykleitos; J. Delorme, *Gymnasium* (1960)[P]; G. Roux, *L'architecture de l'Argolide aux IV et III siècles avant Jésus Christ* (1961)[PI]; H. Berve & G. Gruben, *Griechische Tempel und Heiligtümer* (1961), 53ff, 157ff[PI]; M. Bieber, *The History of Greek and Roman Theater* (2d ed., 1961), passim[PI]; A. von Gerkan & W. Müller-Wiener, *Das Theater von Epidauros* (1961)[PI]; R. Ginouvès, *Balaneutike* (1962), passim; A. Burford, "Notes on the Epidaurian building inscriptions," *BSA* 61 (1966) 254ff; id., *The Greek Temple Builders at Epidauros* (1969)[PI]; C. Weickert et al., *Künstlerlexikon* 27 230, s.v. Polykleitos II.

Sculpture: Ch. Picard, *Manuel*, vols. III, IV passim[I]; U. Hausmann, *Kunst und Heiltum* (1948)[I]; J. F. Crome, *Die Skulpturen des Asklepiostempels von Epidauros* (1951)[PI]; N. Yalouris, *Arch.Delt.* 19 (1964) 179[I]; id., *BCH* 90 (1966) 783ff[I]; id., Τά ἀκρωτήρια τοῦ ναοῦ τῆς ᾿Αρτέμιδος, *Arch.Delt.* 22 (1967) 25ff[PI]; B. Schlörb, *Timotheos*, Ergänzungsheft 22 (1965) of *JdI*[I]; Sh. Adam, *The technique of Greek Sculpture in the archaic and classical period* (1966), passim[I]; B. S. Ridgway, "The two reliefs from Epidauros," *AJA* 70 (1966) 217ff[I]; G. Heiderich, "Asklepios," Dissertation (1966); M. Bieber, "Bronzestatuette des Asklepios in Cincinnati," *Antike Plastik* 10 (1970) 55ff[I].

Cult and healing: R. Herzog, *Die Wunderheilungen von Epidauros*, *Philologus* Suppl. XXII.3 (1931); R. Nehrbass, *Sprache und Stil der Iamata von Epidauros*, *Philologus* Suppl. XXVII.4 (1935); F. Robert, *Thymele* (1939) passim[PI]; E. J. & L. Edelstein, *Asklepios* (1945), 2 vols.; B. Kötting, *Peregrinatio religiosa* (1950) passim; id., *RAChrist.*5 (1961) 531ff, s.v. Epidauros; K. Kerenyi, *Der Göttliche Arzt* (1956)[I].

History, Topography: J. G. Fraser, *Paus. Des. Gr.* (1898) III 234; *IG* IV I[2]; W. Peck, *Inschriften aus dem Asklepieion von Epidauros*, Abh.Sächs.Akad.Wissen.zu Leipzig, 60 (1969); B. Kötting, *RAChrist.*5 (1961) 531ff, s.v. Epidauros; E. Kirsten & W. Kraiker, *Griechenlandkunde* (1967) I 335ff[MP]; E. Meyer, *Kl.Pauly* II 203ff, s.v. Epidauros; B. Conticello, *EAA* 3 (1960), 358, s.v. Epidauros; N. Yalouris, *EAA* (Suppl.), s.v. Epidauro.

N. YALOURIS

EPIDAUROS LIMERA Lakonia, Greece. Map 9. On the E coast, beside the bay dominated by the rock of Monemvasia. The epithet, of doubtful meaning even in antiquity, distinguishes the city from Epidauros in the Argolid. According to Apollodoros (Strab. 368) limera meant "of the good harbor" (= limenēra), but others ex-

plained the word as signifying "parched" or "deficient" (Schol. Thuc. 7.26). Pausanias (3.23.6) alleges that the city was founded from the Argolic Epidauros. There was a cape (ἄκρα, Paus. 3.23.11) with a fort (Strab. 368) called Minoa; this may have been the promontory of Monemvasia, which, however, is now an island. The city overlooks a long stretch of coastline and the E end of the easiest route from Sparta to the E coast of the Peloponnese. Athenian raids during the Peloponnesian War are mentioned by Thucydides (4.56.2, 6.105.2, 7.26.2). The city became a member of the Eleutherolakonian League (Paus. 3.21.7).

The acropolis is enclosed by a Hellenic fortification wall. Ancient towers and terrace walls are also visible; there is a leveled surface on the acropolis, perhaps for a temple. Mycenaean sherds have been noted near the summit. Inland, a series of chamber tombs yielded pottery extending in time from Late Helladic II to Late Helladic IIIC. Some of the earliest vases from the burials suggest Minoan connections.

BIBLIOGRAPHY. Topography: W. M. Leake, *Morea* I (1830) 211-17; F. W. Hasluck in *BSA* 14 (1907-8) 179-82; H. Waterhouse & R. Hope Simpson in *BSA* 56 (1961) 136-37. Cults (Zeus Soter by the harbor; Athena on the acropolis; Aphrodite, Asklepios; Artemis Limnatis beside the road to Boiai; and a pool of Ino): J. G. Frazer, *Paus. Des. Gr.* (1898) III 387-90. Inscriptions: *IG* v i 174-75, 306. Tombs: A. Ch. Oikonomakos, ἡ ᾿Αρχαία ᾿Επίδαυρος Λιμηρά (1957); K. Demakopoulou in *Deltion* 23A (1968) 145-94.

G. L. HUXLEY

EPIDAURUM (Cavtat) Croatia, Yugoslavia. Map 12. On a headland 12 km SE of Dubrovnik, a settlement of Illyrians, whose trade here with Greeks is confirmed by coins of Apollonia and Dyrrachion. In 47 B.C. settlers from Italy fought on Caesar's side (*BAlex.* 44). Pompey's fleet attacked the town and it was rescued by P. Vatinius, who arrived from Brundisium. Not long after, a colony was founded—most probably by Caesar to reward his allies. Traces of the centuriation can be seen in Konavle valley to the E. The ancient settlement developed toward the S and SW on the peninsula.

The site has not been explored. The walls of a villa can be seen on the W point of peninsula where the surface is covered with ancient tiles, also found in the surrounding gardens. There are traces of baths (?) beyond the Franciscan Monastery. The necropolis extended toward Tiha bay to the NW where, at a place called Obod, a ruined aqueduct tower is visible. Graves have been found here and at the other places near the town. The bishop from Epidaurum attended the church council at Salona 533 A.D. About 615 the town was destroyed by the Avars and Slavs. The refugees founded Rausium (Dubrovnik). Inscriptions and pottery are in the Bogišić collection in Cavtat and in the Town Museum at Dubrovnik.

BIBLIOGRAPHY. G. Novak, "Quaestiones Epidauritanae," *Rad Jugoslavenske Akademije* 339 (1965) 97-140; A. Faber, "Prilog topografiji ilirsko-rimskog Epidaura," *Opvscvla archaeologica* 6 (1966) 25-37.

M. ZANINOVIĆ

EPIEIKIA Corinthia, Greece. Map 11. The Spartan army invaded the Corinthia by way of Epieikia in 394 B.C. to fight the opening battle of the Corinthian War along the nearby Longopotamos river. Two years later Epieikia was fortified by the Spartan Praxitas following another invasion of the region (Xen. *Hell.* 4.2.14, 4.13). The site is probably to be identified with the ruins of a small outpost above the E side of Kondita Ravine, where the Corinthian stream farthest W is located.

BIBLIOGRAPHY. W. K. Pritchett, *Studies in Ancient Greek Topography II: Battlefields* in U. of Calif. Publications: Classical Studies IV (1969) 80-81; J. R. Wiseman, *The Land of the Ancient Corinthians* (forthcoming).
J. R. WISEMAN

EPIPHANEIA (Oiniandos) Cilicia Campestris, Turkey. Map 6. Mainly identified with large site 91 km SE of Adana and ca. 6 km W of Erzin on the right side of railroad track to Iskenderun. The otherwise unknown native town of Oiniandos was renamed for Antiochos IV Epiphanes at the beginning of the 2d c. B.C. After a short-lived autonomy, Epiphaneia was colonized with ex-pirates by Pompey and adopted 68/7 B.C. as its era date. A coin of A.D. 113/4 suggests that the city was honored by Trajan with his name, but Epiphaneia's history is otherwise obscure apart from its claim, with many other places, to be the birthplace of St. George.

The extensive ruins of the city, constructed almost entirely of black basalt, were enclosed by a wall 2 m thick with large square towers at intervals throughout its length. Very conspicuous is the long aqueduct of which numerous arches still remain, with a part of the watercourse still draining into a cistern with walls nearly 1.5 m thick. The theater, with a diameter of ca. 87 m, has been robbed of its seating, but retains its upper promenade of 12 m width, this upper part being strengthened by buttresses at intervals of 5.5 m. There are two ruined churches, both apparently of the 5th or 6th c.; one of these may have been originally a pagan building with walls of stone orthostats to which a concrete apse had later been added at the E end of the rectangle.

BIBLIOGRAPHY. App. *Mith.* 96; Plin. *HN* 5.93; *Tab. Peut.* 10.4.

R. Heberdey & A. Wilhelm, "Reisen in Kilikien," *Wien. Denkschr.* 44 (1896) 23; D. Magie, *Roman Rule in Asia Minor* (1950) 280, 300, 397, 595, 1159; A.H.M. Jones, *Cities of the Eastern Roman Provinces* (2d ed. 1971) 201, 203, 436.
M. GOUGH

EPISKOPI, *see under* KOURION

EPITHEROS, *see* PTOLEMAIS THERON

EPOMANDUODURUM, *see* EPAMANTADURUM

EPOREDIA (Ivrea) Italy. Map 14. Established as a military outpost during the Roman penetration into the valley of the Dora Baltea about 100 B.C., the city belonged to the eleventh Roman region in the territory of the Salassi, and was the last of the colonies civium romanorum ascribed to the tribus Pollia. Eporedia was recorded in the late Republic in the letters of Cicero (*Fam.* 11.20). It was also mentioned by Strabo (4.6.7), Velleius Paterculus (1.15), Pliny (3.17; 21.20) and Ptolemy (3.1.34); and cited by Tacitus among the firmissima Transpadanae municipia (*Hist.* 1.70). It was the seat of a bishopric and the quarters of a garrison of Sarmati during the late Empire.

The name is of Celtic origin, perhaps meaning "station of the horse carts," and proves the existence of an ancient indigenous settlement at the mouth of the Dora valley along the natural route between the Po valley and the transalpine passes. In the organization of the Roman city on the pre-existing nucleus, the connection between the city's internal development and the principal territorial crossroad is still clearly perceptible. Coming from the E, the Via di Vercellae passed over a brickwork bridge, of which there remains an arch inserted in the modern bridge over the Dora, and continued toward the SW. During this period one may suppose that the forum developed in the upper part of the city, and that the enclosing walls followed an approximately rectangular course, forming one of the elements of major relief in the configuration of the city plan. Within the walls recent excavations have uncovered the remains of a building of the Republican era along the paved circumvallation road inside the walls. Outside the walls other impressive remnants including private homes and a large apsidal wall serve to document the expansion of the community in the early centuries of the Empire.

The building of a theater, perhaps during the age of Hadrian, at the center of the inhabited area, entailed the demolition of pre-existing buildings. On the flank of the hillside the remains of the cavea, with a diameter of 70 m, and of the straight scena, almost 50 m wide, are preserved in the basements of houses in Via Cattedrale and Via Peana.

Outside the fortified perimeter the period of major expansion is documented by the construction of the amphitheater (arena: 67 x 42 m). It is characterized by embankments of earth carried back between annular retaining walls. It very probably had linear steps, double-arched passages, and a subterranean passageway with a central chamber. The building rises on the ruins of an earlier construction, perhaps a villa, of which there remain several frescoed rooms of the early Empire. It indicates the range of the suburban expansion, 700 m from the E side of the wall along the Via di Vercellae.

Several stretches of the aqueduct's channel have been found (0.6 x 0.5 m in section), and its route has been reconstructed, with its origin at the Viona stream on the slopes of the Mombarone.

Necropoleis extended along the principal roads to Augusta Taurinorum, Augusta Praetoria, and Vercellae. One km past the amphitheater to the W are the remains of an extensive rectangular structure built of river pebbles and broken quarried rocks. It probably belonged to an agricultural establishment of the late Imperial age.

The material found during excavation is housed in the local Museo Civico and in the Museo di Antichità at Torino.

BIBLIOGRAPHY. C. Promis, "Memorie sugli avanzi del teatro romano di Ivrea," *Atti Soc. Piem. Arch.* (1883) 85ff; G. Borghesio & G. Pinoli, "L'acquedotto romano di Ivrea," *Boll. Soc. Piem. Arch.* (1919) 49ff; P. Barocelli, *Carta Archeologica*, F. 42 pp. 28ff; id., "Appunti di epigrafia eporediese," *Atti Acc. Sc.* (1957-58); P. Fraccaro, "La centuriazione di Eporedia," *Annali Lavori Pubblici*, 79 (1941); C. Carducci, *I più recenti risultati della Sopr. alle Ant. del. Piemonte* I (1959) pp. 26ff; id., *Piemonte romano* (1968); A. Perinetti, *Ivrea romana* (1968).

Cic. *Ad. Fam.* 11.20.23; Strab. 4.6.7; Vell. 1.15; Plin. 3.17.123; Tac. *Hist.* 1.70; Ptol. 3.1.34; *Not. Dig.* 121; *It. Ant.* 282, 345, 347, 351; *Tab. Peut.*; *Rav. Cosm.* 4.30; *CIL* v, 715, 750f, 6777ff; *Inscr. It.* 2,1ff.
S. FINOCCHI

ERBIL, *see* ALEXANDRIA OF MYGDONIA *under* ALEXANDRIAN FOUNDATIONS, 1

ERCOLANO, *see* HERCULANEUM

EREĞLI, *see* HERAKLEIA (Pontus)

EREMOUPOLIS, *see* ITANOS

ERESOS, *see* LESBOS

ERETRIA Euboia, Greece. Map 11. The ancient city is partially covered by the modern village of the same name, some 18 km SE of Chalkis on the S-central coast

of the island. The site is dominated by a prominent acropolis at the N and extends over an area of more than 80 ha, roughly delimited by the course of the ancient city walls. The archaeological remains are the most extensive in Euboia.

First mentioned in the Homeric Catalogue of Ships (*Il.* 2.537: Eretria), there is a growing body of evidence to indicate that the site was occupied throughout most of the Bronze Age. Problems related to the location of Strabo's "Old Eretria" (9.2.6)—now thought by some to be at the nearby site of Lefkandi—still remain unsettled. With the dawn of the historical period, Eretria—along with its neighbor, Chalkis—appears among the leading cities of Greece in establishing colonies abroad. This contributed to a bitter rivalry between Chalkis and Eretria, manifested at home in a war over the control of the fertile coastal strip centering upon the Lelantine plain. The Lelantine War, which seems to have taken place at or near the end of the 8th c. B.C., may have resulted in a certain decline in the status of Eretria. But recent excavations have brought to light considerable evidence of occupation on the site in the 7th and 6th c. Near the end of the 6th c., Eretria supported the revolt of the Ionian Greek cities from Persian subjugation. This resulted in the destruction of the city at the hands of the vengeful Persians in 490 (Hdt. 6.43-44). Herodotos (6.99-101, 119) tells us that the temples were plundered and burned and many of the inhabitants taken captive and carried off to Persia. The city seems to have recovered somewhat for it managed to contribute both ships and men to the Greek forces in 480-479. After the Persian Wars, Eretria became a member of the Delian Confederacy and generally remained loyal to Athens until 411. At that time the Euboian cities revolted, and there is some evidence to indicate that they formed a league with Eretria at its head. Eretria supported Sparta through the balance of the Peloponnesian War but was back on good terms with Athens by the early 4th c. Thereafter its allegiance vacillated between Athens and Thebes until—by the end of the 4th c.—it had come under the thumb of the Macedonians and was to remain so for the next 100 years or more. Eretria came to be the most important city in Euboia in the late 4th and early 3d c., by which time its influence extended over most of S Euboia. The city flourished in the 3d c. and was the home of a well-known school of philosophy under the direction of Menedemos. But the great days of Eretria came to an end with a major destruction at the hands of a Roman-Pergamene coalition in 198 B.C. (Livy 32.16). Although the city was rebuilt and the site continued to be occupied for some time thereafter, no major monuments can be assigned to this period and it does not seem to have regained its old importance.

Sporadic excavation has been carried out since the later 19th c. These investigations have uncovered the remains of numerous graves (including a well-built tomb of the Macedonian period a short distance to the W of the ancient town), large stretches of the city wall, a theater, a gymnasium, a Thesmophorion, a bathing establishment, a fountain-house, a tholos, a number of houses, and several temples or shrines (dedicated to Apollo Daphnephoros, Dionysos, and Isis), as well as lesser monuments. No clear-cut remains of the agora have yet been reported.

The current excavations have been largely confined to the areas of the temple of Apollo Daphnephoros near the center of the ancient town and a major gate in the NW sector of the city. The Temple of Apollo—now visible only in its foundations—was first exposed around the turn of the century, but recent investigations have clarified its chronology and many details of construction. A peripteral temple of the Doric order, it seems to have been erected in the late archaic period (530-520 B.C.) but was razed shortly thereafter in the Persian destruction of 490. It is to this structure that the well-known pedimental group of Theseus and Antiope in the Chalkis Museum belongs. Recent excavation has shown that the 6th c. temple had several precursors including an early archaic hecatompedon of the Ionic order (670-650 B.C.), and a small apsidal "shrine" of the 8th c. The latter is the earliest building yet found at Eretria. All of the structures in this sequence are thought to have served in the worship of Apollo Daphnephoros.

One of the most striking monuments at Eretria is the ancient theater, lying at the SW foot of the acropolis. A noteworthy feature of the complex is a subterranean vaulted passage which led by means of a stairway from the center of the orchestra to the stage building. It is thought that such an arrangement facilitated the sudden appearance of actors from the underworld. This structure seems to have been erected in the late 4th c. and serves as one of the best examples of the Greek theater during the Hellenistic period. The remains of a small temple and altar of Dionysos lie a short distance to the S of the theater.

The site is dominated by the acropolis, from which the visitor gains a magnificent view of the S Euboian Gulf and the mainland beyond. Of particular interest here are the walls and towers which represent some of the best preserved examples of Classical Greek masonry. Although there is some evidence of the use of the acropolis during the Mycenaean period, the fortifications probably range in date from no earlier than the archaic period through Hellenistic times.

A line of fortification can be traced intermittently from the acropolis along the W side of the city to a point just SW of the theater. Here lies a major gateway (W Gate) through which the ancient road to Chalkis and the Lelantine plain must have passed. The most recent excavators have concentrated much of their efforts upon the investigation of the W Gate and its environs. These investigations have shown that the major gate of the early Classical period (ca. 480 B.C.) overlay a gate and fortifications of the 7th c., which are among the earliest known fortifications of post-Bronze Age Greece. To the S of the W Gate, a complex of burials (both inhumation and cremation) within a modest architectural setting has been identified as a heröon. The rich finds from this area, whose foundation goes back to the 8th c., testify to the far-flung commercial activities of Eretria at that time. The heröon seems to have been incorporated into a Hellenistic structure of palatial proportions ("Palace I"), which may have belonged to the descendants of those who were buried in the heröon. An even larger and more impressive complex ("Palace II"), probably of the 4th c. B.C., has been exposed farther to the S.

Apart from the pedimental sculpture from the Temple of Apollo Daphnephoros in the Chalkis Museum, all of the finds from the excavations at Eretria are now housed in a small museum on the site.

BIBLIOGRAPHY. F. Geyer, *Topographie und Geschichte der Insel Euböa* (1903); K. Schefold et al., preliminary reports on current excavations in *AntK* 7 (1964)[PI]; K. Schefold, "The Architecture of Eretria," *Archaeology* 21 (1968)[MPI]; P. Auberson, "Temple d'Apollon Daphnéphoros," *Eretria* 1 (1968)[PI]; I. Metzger, "Die hellenistische Keramik in Eretria," *Eretria* 2 (1969)[I]; P. T. Themelis, Ἐρετριακά, *ArchEph* (1969, publ. 1970)[PI]; C. Bérard, "L'Héroon à la Porte de L'Ouest," *Eretria* 3 (1970)[PI]; P. Auberson & K. Schefold, *Führer durch*

Eretria (1972)[MP]; L. Sackett & M. Popham, "Lefkandi: A Euboean Town of the Bronze Age and Early Iron Age," *Archaeology* 25 (1972)[MI]. T. W. JACOBSEN

ERICE, *see* ERYX *and* RAMACCA, LA MONTAGNA

ERNES, *see* ARNEAI

EROME Drôme, France. Map. 23. Two archaeological sites in Gallia Narbonensis. The first is Les Orpaillots, which has traces of a large fanum and a number of tombs with grave goods (everyday pottery and some Campanian sherds). The other is Notre-Dame-de-la-Mure, a chapel destroyed in 1970; beneath it were found traces of a Gallo-Roman villa (late 3d c.) and an early church with a crypt (Burgundian era). M. LEGLAY

ER-RABBA, *see* RABBATHMOBA

ERYMNA (Ormana) Turkey. Map 7. In Pamphylia or Pisidia 18 km W of Akseki. The site is proved both by the survival of the name (Orymna in Hierokles and the *Notitiae*) and by an inscription found on the spot. Erymna is thought to have been in earlier times a member of the tribe of Katenneis mentioned by Strabo (570); later it was an independent city with a normal Greek constitution, though it never issued its own coinage.

The extant ruins are very scanty. The acropolis hill is peaked but not high; at its foot are the foundations of a columned building constructed of very large blocks. Otherwise there are only a sarcophagus and various architectural stones in the village, including the identifying inscription.

BIBLIOGRAPHY. G. Hirschfeld, *MonatsberBerl* (1875) 142-43; H. Swoboda et al., *Denkmäler aus Lykaonien . . .* (1935) 48-50. G. E. BEAN

ERYTHRAI (Greece), *see* WEST LOKRIS

ERYTHRAI (Ildırı) Turkey. Map 7. Site 20 km NE of Çeşme. The four islands in the gulf opposite the city were called Hippoi (Strab. 14.644). Inscriptions mention the Aleon river, noted by Pliny, but the coins of Erythrai represent a river god named Axos. Actually there is only one stream in Erythrai, which flows into the gulf.

According to Pausanias (7.3.7), Erythrai was founded by Cretan settlers under the leadership of Erythros the Red, son of Rhadamanthys, and at the same time inhabited by Lycians, Carians, and Pamphylians, later reinforced by Ionian colonists under Kleopos, or Knopos (Strab. 14.633), a descendant of the legendary Athenian king, Kodros. Erythrai was governed for a time by members of the Athenian royal house; Aristotle mentions an oligarchy of Basilidae at Erythrai (*Pol.* 1305b). It belonged to the Panionion, the political league of Ionian cities, founded in the 9th c. B.C., and, together with Teos, Erythrai sent noblemen of Ionian descent to reinforce the Ionic settlement at Phokaia (Paus. 7.3.8). The local historian, Hippias, who probably lived in the Hellenistic period, reported that Knopos was dethroned by the tyrants Ortyges, Iros, and Echaros, friends of the tyrants Amphiklos and Polyteknos of Chios; they were expelled by the brother of Knopos and died during their flight. This king, whom Hippias probably confused with the legendary Knopos, must have lived in the 7th c. B.C. From ca. 560 B.C. on Erythrai was under Lydian domination, and after 545 was subject to the Persians.

The city sent eight ships to the battle of Lade (494 B.C.), and its tribute to the Delian Confederacy was the considerable sum of seven talents; it left the Delian League perhaps ca. 453. Together with Chios, it revolted against the Athenian hegemony in 412 B.C. and served as a base for the Peloponnesians. Later it was allied alternately with Athens and Persia. About the middle of the 4th c. the city became friendly with Mausolos: in an inscription found on the site he is called a benefactor of Erythrai. About the same time the city signed a treaty with Hermias, Tyrant of Assos and Atarneus, based on reciprocal aid in the event of war. In 334 the city regained its freedom through Alexander the Great who, according to Pliny (*HN* 5.116) and Pausanias (2.1.5), planned to cut a canal through the peninsula of Erythrai to connect Teos bay with the gulf of Smyrna. Erythrai was later associated with Pergamon and with Rome, and after the death of Attalos III in 133 B.C., when the Pergamene kingdom was bequeathed to the Romans, it flourished as a free city attached to the Roman province of Asia.

The landward fortification is still well preserved; it is of fine ashlar masonry 4-5 m thick, with several gateways. Three inscriptions found on the site indicate that the city wall was built either at the end of the 4th or the beginning of the 3d c. B.C. Near the coffee-house in the village, part of a Hellenistic pebble mosaic of griffins is still in situ. The theater, cut into the N slope of the acropolis hill, is badly damaged. The aqueduct S of the acropolis crosses the Aleon(?) from N to S, and dates from Byzantine times.

The site of the Herakleion, sanctuary of the Tyrian Herakles, is not known. A cult statue of Egyptian type was described by Pausanias (7.5.4) and depicted on the city's coins. Herophile, the prophetic sibyl of Erythrai, enjoyed a great reputation in the ancient world, second only to the sibyl of Kyme in Italy. A building claimed to be her sanctuary was discovered at Ildırı, a structure resembling a nymphaion with a number of inscriptions, one of which records the Erythraian origin of Herophile. This building, however, has not yet been identified.

Finds from recent excavations are in the Archaeological Museum in Izmir. Trenches on top of the acropolis have yielded much pottery and small offerings in bronze and ivory of ca. 670-545 B.C. The pronounced Cretan and Rhodian style of the ivory statuettes confirms Pausanias' statement that Erythrai was originally founded by Cretans and inhabited by Lycians, Carians, and Pamphylians. The city was apparently destroyed by the Persians shortly after the mid 6th c. B.C.

According to a graffito on a bowl of the early 6th c., the offerings belonged to the Temple of Athena Polias (Paus. 7.5.8). The small lion figurines in bronze, of the first half of the 6th c. B.C., strongly resemble the lion statue from Bayındır now in the Izmir Museum; they are the earliest Ionian examples of a lion type which served as a model for Etruscan artists. From the same trench on top of the acropolis came a monumental archaic statue of a woman (also in the Izmir Museum); the head is missing, but the folds on the chiton recall such Samian sculptures as the Hera of Cheramyes in the Louvre and the statues by Geneleos. The Erythraian statue is the work of an Anatolian artist of ca. 560-550 B.C.

BIBLIOGRAPHY. Dittenberg, *SIG* 229; Bürchner, *RE* VI 1, 575-90; D. Magie, *Roman Rule in Asia Minor* (1950) 79; E. Akurgal, *Ancient Civilizations and Ruins of Turkey* (1970) 231-33; H. Englemann & R. Merkelbach, *Die Inschriften von Erythrai und Klazomenai* I & II (1972-73). E. AKURGAL

ERYX (Erice) Sicily. Map 17B. Remains of an ancient site on Monte San Giuliano at Erice 12 km NE of Trapani. Fragments of Neolithic and Bronze Age ob-

jects have been found at the foot of the mountain and at its summit a sanctuary dedicated first to the Phoenician Astarte and then to Aphrodite and Venus, whom the Romans called "Erycina ridens." Ancient sources differ on the origins of the cult (Diod. 4.78; Dion. Hal. 1.53) but all agree that Eryx was founded by the Elymians of W Sicily, who were centered at Segesta. The Elymians, especially those of Eryx, always maintained close relations with the Punic Phoenicians both during the various wars against the Greeks and in peace. The Spartan Dorieus at the end of the 6th c. B.C. managed to found a Greek center, Heraklea, at the foot of Eryx, but the site was immediately destroyed by a coalition of Elymians and Phoenicians. During the first Punic war, in 249 B.C., Eryx was occupied by the Romans for the first time, reconquered by Hamilcar in 244 B.C. but lost by the Phoenicians after the battle of the Egadi islands in 241 B.C. when almost all of Sicily passed under Roman domination. Rome always looked on Eryx with favor since it, like Rome, traced its origin back to Troy through Aphrodite and Aeneas.

The few remains of the sanctuary, with the exception of sporadic fragments of the 6th-5th c. B.C., belong to the Roman Imperial period, perhaps when the temple was rebuilt under the emperor Claudius. Long stretches of the city walls are well preserved though full of restorations and rebuildings of various periods, including some of recent date. Recent excavations have revealed that this circuit of fortifications with its towers and gates, had two distinct building phases. During the first (8th-mid 6th B.C.) the lower courses were built in the megalithic technique; to this phase must be attributed the many sherds of painted pottery typical of various Elymian centers in W Sicily, and specifically of Segesta. During the second (mid 6th-mid 3d B.C.), that is, from the period of greatest Punic influence on Eryx to the Roman conquest, the upper courses were built. Punic influence is well attested by the numerous Phoenician characters inscribed on many blocks of the walls.

The small Museo Civico houses various objects, almost all found at Eryx, which attest ot the presence of non-Greek peoples at the site; they consist mostly of statuettes, amulets, scarabs, terracotta vases which reflect a Cypro-Phoenician influence during the 6th c. B.C. as well as a persistence of Punic culture until the Hellenistic-Roman period.

BIBLIOGRAPHY. M. G. Guzzo-Amadasi, *Le iscrizioni fenicie e puniche delle colonie in Occidente* (1967) 53, 58, 77-79; A. M. Bisi, "Catalogo del materiale archeologico del Museo A. Cordici in Erice," *Sicilia Archeologica* 8 (1969) 7ff; id., "Una necropoli punica recentemente scoperta ad Erice," *Sicilia Archeologica* 11 (1970) 5ff, with previous bibliographyᴾᴵ; A. Tusa-Cutroni, "La collezione numismatica del Museo Cordici de Erice," *Sicilia Archeologica* 12 (1970) 49ff; id., "Anelli argentei e tipi monetali di Erice," *Sicilia Archeologica* 13 (1971) 43ff. V. TUSA

ESCHATE, *see* ALEXANDRIA ESCHATE *under* ALEXANDRIAN FOUNDATIONS, 6

ESCLAUZELS Lot, France. Map 23. On the left bank of the Lot, in the cave of Le Noyer, was found a large amount of stamped pottery, red in color, which dates to the Late Roman Empire, lying above prehistoric levels with abundant Late Bronze Age pottery.

BIBLIOGRAPHY. M. Labrousse in *Gallia* 26 (1968) 546ᴾ.
 M. LABROUSSE

ESCOLIVES-STE.-CAMILLE, *see* SCOLIVA

ESGAIR PERFEDD Radnorshire, Wales. Map 24. Marching camp of 6.2 ha, 4.8 km NW of Rhayader. The site lies at 420 m elevation on a moorland ridge flanking the S side of the Gwynllyn valley at SN927699. The sloping hillside prevented a completely regular plan. The entrances are represented by four internal claviculae and the camp could have held up to 4000 men under canvas on campaign. The objective of their march must by implication have lain in the upper Elan valley, which offers an easy descent through the Ystwyth valley into the coastal area of central Wales.

BIBLIOGRAPHY. G.D.B. Jones, "The Roman Marching Camp at Esgairperfedd," *Bulletin of the Board of Celtic Studies* 22 (1967) 274. G.D.B. JONES

ESKI ANAMUR, *see* ANEMURIUM

ESKI ANTALYA, *see* SIDE

ESKIHISAR, *see* STRATONIKEIA

ESKI KÃHTA, *see* ARSAMEIA

ESKI MALATYA, *see* MELITENE

ESPEJO, *see* UCUBI

ES-SALT, *see* GADARA

ESSAROIS Côte d'Or, France. Map 23. Sanctuary near the source of the small Cave river dedicated, according to inscriptions (*CIL* XIII, 5644-46), to Apollo Vindonnus and Apollo of the Springs.

Recent excavations have corrected earlier accounts, and have demonstrated that the temple was not a single building with a double cella, but consisted of two distinct structures with no wall connecting them but similar in plan. There are two fana, each of which contained a rectangular cella with a gallery around it, set in a court. The cella of the NW temple was 7.4 m on the N side, 7.6 on the S, 6.6 on the W, and 6.95 on the E; the gallery was 2.6 m wide to the N and 3.2 m to the W. Pottery and coins found on the site, combined with an investigation of the soil and strata, have pinpointed more precisely the histories of the buildings. A large part of the pottery is still in the local tradition (coarse blackish paste with scour), and with the pottery were found many Gallic coins (25 pewter; four silver; Roman coins from the end of the Republic or beginning of the Empire). Apparently in the beginning there was a wooden monument to the S, a few elements of which have been found buried beneath the first floor of the S cella (phase 1); then about the middle of the 1st c. B.C. a stone cella was built (phase 2) N of the first, closer to the springs. Phase 3 is apparently represented by a second stone temple erected during the 1st c. A.D. to replace the early wooden one, which had been destroyed in a fire of which there are some traces. It is possible that temple II was rebuilt after being abandoned for a time.

The abundant ex-votos link the sanctuary of Essarois with that of the Sources of the Seine. They include thin bronze slabs representing eyes and breasts, ex-votos of wood, ex-votos of stone (legs, arms, torsos), proving that Apollo Vindonnus, with the aid of the springs associated with him, had assumed the character of a healing god. The ex-votos are frequently pathological (deformed limbs, highly developed genitals, a head with closed eyes). Also worthy of note are the statuettes of infants in swaddling clothes, as well as an odd stele with five women's heads in a group. Most of these sculptures are in the Musée de Chatillon.

BIBLIOGRAPHY. P. Mignard, *Description d'un temple dédié à Apollon au cirque de la Cave, près d'Essarois* (1851); *Mémoires de la Commission des Antiquités de la Côte d'Or* III (1847-52) 111-205; E. Espérandieu, *Recueil général des bas-reliefs . . .* (1907-66) III, 3411-39; G. Drioux, *Cultes indigènes des Lingons* (1934) 20-24; Grenier, *Manuel* IV, 2 (1960) 639-44; R. Martin, *Gallia*, 22, 2 (1964) 311-13[I]; 24 (1966) 390-92[I].

R. MARTIN

ES-SOULEM, *see* SELAEMA

ESTEPA, *see* ASTAPA

ESZTERGOM, *see* LIMES PANNONIAE

ESZTERGOM-HIDEGLELŐSKERESZT, *see* LIMES PANNONIAE

ETALLE Belgium. Map 21. A vicus of the civitas Treverorum, on the Trier-Rheims road, situated at the point where the road fords the Semois. The site has never been excavated systematically, but ancient remains abound. In the 17th c. ruins of Roman buildings were still visible, and coins, tombs, weapons, and a gold bracelet were discovered. The Arlon museum has three glass vases found ca. 1848 that date from the late 4th c. In the mid 1950s a Roman building was located and other important remains of the vicus were found over a wide area. Potsherds found at that time date from the 2d and 3d c. Some earthworks, found on a hill overlooking the river, are possibly remains of a castellum of the Late Empire. At Fratin, 1 km from the vicus, a tomb was uncovered, with contents that date from the end of the 4th c.; it suggests the tomb of a German auxiliary (one of the Laeti mentioned in the *Notitia dignitatum* [*occ.* 42.38] as being stationed near Epoisso [Carignan], not far from Etalle). If in fact it is, this would confirm the existence of a small temporary fort at Etalle in the 4th c. However, the most important remains from Etalle have been recovered at Buzenol, 3 km to the S. There, on the Montauban hill, is an Iron Age oppidum that was reoccupied at the end of the 3d c. A.D. and changed into a fortified keep. The spur formed by the hill was blocked by a wall; in front of the keep is a forecourt surrounded by a palisade. The walls were built in workmanlike fashion and a great amount of embankment work had to be done to fortify the site. Huge blocks, taken from funerary monuments, were used for the wall foundations; almost certainly these carved blocks came, for the most part, from the necropolis at Etalle. It is not known whether the Buzenol fort was built at the initiative of the public authorities or was commissioned by a local landlord. Carved blocks were taken from the wall foundations in the 17th c., then again in the course of excavations in 1913 and finally in 1958. These funeral carvings indicate the wealth of the inhabitants of Etalle at the time of the Late Empire. Among the most interesting remains found at Buzenol is a milestone with a legend stating that the Rheims-Trier road was built under Claudius in A.D. 44; also a relief showing the vallus, a mechanical harvester of Gallic invention.

BIBLIOGRAPHY. M. E. Mariën, "Monuments funéraires de Buzenol," *Bull. des Musées royaux d'Art et d'hist.* 15 (1948) 2-10, 58-69, 104-14; 16 (1949) 28-36, 59-70; J. Mertens, "Le refuge antique de Montauban-sous-Buzenol," *Le Pays Gaumais* (1954) 1-32[PI]; id., "Sculptures romaines de Buzenol," *Le Pays Gaumais* (1958) 17-124[I]; id., "Römische Skulpturen von Buzenol," *Germania* 36 (1958) 386-92; id., "La moissonneuse de Buzenol," *Ur-Schweiz* 22 (1958) 49-53; id., "Le refuge protohistorique de Montauban-sous-Buzenol," *Celticum* III (1962) 387-400[PI]; id., "Quelques aspects de la romanisation dans l'ouest du Pays gaumais," *Helinium* 3 (1963) 205-24; id., "Le Luxembourg méridional au Bas-Empire," *Mélanges A. Bertrang* (1964) 191-202; K. D. White, *Agricultural Implements of the Roman World* (1967).

S. J. DE LAET

ETAM Jordan/Israel. Map 6. A town of Biblical Judea, 20 km S-SW of Jerusalem, in ancient times as now the site of a rain- and spring-fed source of water for that city. It is mentioned by Josephus (*AJ* 8.246) and is thought to be the cool and watered place, with gardens, to which Solomon so enjoyed retiring (*AJ* 8.186, and cf. Eccles. 2:6; extant pools are called by his name). A major aqueduct from Etam to Jerusalem was constructed, or renovated, by Pontius Pilate, Prefect of Judea (A.D. 26-36).

BIBLIOGRAPHY. W. Smith, ed., *A Dictionary of Greek and Roman Geography* 1 (1873; repr. 1966) 854-55.

W. L. MAC DONALD

ETAPLES Pas de Calais, France. Map 23. In the Montreuil arrondissement; chief town in the canton. A little port at the mouth of the Canche. In 1842 excavations were carried out on the site of the chateau: several layers of tombs were unearthed as well as many foundations of rectangular houses dating from the Roman period. The excavators' plans show the site as a sizeable vicus. Furthermore, the foundations of a very large Roman tower have been interpreted as belonging to a fortification built in Diocletian's reign; these may be remains of a Late Empire castrum. A large number of fibulas were discovered in chance finds as well as hoards of coins. More recently a collection of coins was discovered by chance N of Etaples, along the Boulogne road (liards); now in the Quentovic museum in Etaples, it consisted of 3791 coins ranging from Septimus Severus to Postumus. The area called Les Sablins S of the city has been under excavation since 1965, and several isolated rectangular houses have been unearthed. Pebble floors and some large collections of shells have been found beneath the sand, and two wells have been located. The settlement appears to have lasted no later than the 2d c. To the N is a small cremation necropolis where some beautiful specimens of pottery with animal motifs, of the Castor type, have been found. Although these digs have made it possible to locate the vicus of Les Sablins they have not produced a decisive argument in favor of the thesis that Etaples was Quentovic.

BIBLIOGRAPHY. G. Souquet, *Histoire chronologique de Quentovic et d'Etaples* 1 (1863); "Rapport sur les fouilles d'Etaples," *Bull. de la Com. des Mon. Hist. du Pas de Calais* 2 (1866) 270; A. S. de Ricci, "Note sur quelques antiquités romaines trouvées à Etaples," *BAntFr* (1897) 338-50; J. B. Giard, "Le trésor d'Etaples," *RN* 6 ser., 7 (1965) 206-24.

P. LEMAN

ETENNA (Sırt) Turkey. Map 7. Town in Pamphylia or Pisidia, 22 km N of Manavgat. Polybios (5.73.3) records that Etenna in 218 B.C. furnished 8000 troops to Garsyeris; he speaks of it as lying in the Pisidian mountain country above Side. It is not mentioned again before the Council of Ephesos in A.D. 341. There is, however, a handsome silver coinage of the 4th c. B.C., and the bronze coins extend from the 1st c. B.C. to the 3d c. A.D. The site at Sırt is determined by the preponderance of coins of Etenna found there, and confirmed by sherds of the Classical period—such sherds being very rare on the

inland sites of this region. The previous location of Etenna at Gölcük, farther E beyond the river Melas, is thus disqualified.

The ruins occupy the slopes of a steep hill some 250 m high, N of the village. The ring wall, of irregular ashlar of good quality, is standing in part; the S slope, less steep than the others, is covered with overgrown remains of buildings for the most part unidentifiable. They include however a church, a rock-cut reservoir, and a roofed cistern; a spring of good water supplies the village below. On the N slope are numerous rock-cut tombs, said to number 52 in all. Two statues of women, about life-size, are lying on the hillside, and some half-dozen inscriptions of the Roman period have been seen. There is no theater, and no temple has been recognized.

BIBLIOGRAPHY. G. Hirschfeld, *MonatsbBerl* (1875) 132; K. Lanckoronski, *Die Städte Pamphyliens* (1892) 185-86; H. Swoboda et al., *Denkmäler aus Lykaonien, Pamphylien und Isaurien* (1935) 51-53; G. E. Bean, *Klio* 52 (1970) 13-16. G. E. BEAN

EUESPERIDES later BERENICE (Benghazi) Libya. Map 18. The settlement lay on a low hill, now partly occupied by a cemetery, between salt marshes that were then lagoons linked with the sea by the present inner harbor of Benghazi. Probably settled from Cyrene early in the 6th c. B.C., it was replaced ca. 247 by a new city, on the coast a little to the SW, named Berenice in honor of the wife of Ptolemy III. The change of location is almost certainly due to the silting-up of the lagoons. Berenice ceased to exist by the 11th c. A.D., and Benghazi (named after a holy man, Ibn-Ghazi) did not arise until the 15th c. During the period 1835-1911, when Benghazi was expanding under Turkish rule, many stones from Euesperides were removed. In 1946 Hellenic potsherds were found beside the salt marshes, and in 1950-51 a collection of surface sherds was made. The ground plan of an ancient city, with streets, insulae, and houses, extending between the Muslim cemetery on the top of the hill and the salt marshes, was revealed by air photography, which also shows parts of the city walls, enclosing an area ca. 750 x 350 m. The quantities of Hellenic pottery excavated in 1969 confirmed the rediscovery of Euesperides. Stratified levels were found going back from the Early Hellenistic period to the 6th c. B.C. Most of the houses were of mudbrick on stone foundations.

Occasional finds of mosaic floors, etc., attested the position of Berenice under Benghazi and its cemeteries. Excavations (1971-74) in the old Turkish cemetery of Sidi Khrebiesh revealed remains of buildings and pottery from Hellenistic until Byzantine times and part of a late town wall. A stele of the 1st c. B.C. found in 1972-73 refers to civil disturbance and attacks by pirates. Inscriptions of the 1st c. A.D., found previously, mention the separate magistrates of the Jewish community and a synagogue.

Near Benghazi are several sites of legendary interest. The Hesperides with their golden apples were said to have occupied a luxuriant sunken garden for which several natural hollows in the plain about 10 km E of Benghazi provide a plausible setting. One of them has an underground pool, which possibly accounts for the location of the river Lethe there. Lake Tritonis is thought to be Ain es-Selmani, and it has been suggested that the hill of Euesperides itself between the lagoons might represent the island mentioned by Strabo (17.3.20).

BIBLIOGRAPHY. Sethe, "Berenike," *RE* III (1897); R. G. Goodchild, "Euesperides, a Devastated City Site," *Antiquity* 26 (1952) 208-12; *Benghazi, The Story of a City* (1962); C. H. Kraeling, *Ptolemais* (1962) 43-44P; G.D.B. Jones & J. H. Little, "Coastal Settlement in Cyre-

naica," *JRS* 61 (1971) 65-67; J. H. Lloyd et al., *SLS Ann. Rpts.* 3-5 (1971-74); J. M. Reynolds, ibid., 5 (1973-74). O. BROGAN

EUHIPPE (Dalama) Turkey. Map 7. In Caria near the S bank of the Maeander, 20 km E-SE of Aydın, mentioned only by Stephanos s.v. and Pliny (*HN* 5.109). The city had associations with Alabanda, which is said to have been named after Alabandos son of Euhippos; the rare coins, ranging from Hellenistic times to that of Maximin, bear in some cases the type of Pegasos. The site at Dalama was identified from an inscription found there. It is much denuded; the city wall is traceable in part and the hollow of a theater is recognizable.

BIBLIOGRAPHY. L. Robert, *CRAI* (1952) 589-99. G. E. BEAN

EUMOLPIA, *see* PHILIPPOPOLIS (Bulgaria)

EUPALION, *see* WEST LOKRIS

EUPATORIA later MAGNOPOLIS Pontus, Turkey. Map 5. At the confluence of the Yeşil Irmak (Iris fl.) and the Kelkit Çayi (Lycus fl.), 12 km NW of Erbaa. Founded by Mithridates VI Eupator of Pontus under the name Eupatoria, and refounded as Magnopolis by Pompeius Magnus in 64 B.C. Pompey restored the city, which had been devastated by Mithridates himself in revenge for opening its gates to Lucullus in 70 B.C., and gave it a territory including the fertile plain of Taşova (Phanaroia). Magnopolis then disappears from history. Presumably it was presented to Polemon I of Pontus by Mark Antony and became eclipsed by its neighbor Diospolis Sebaste, which was the capital of Polemon's successor Pythodoris.

No significant trace remains visible. The nucleus of the city seems to have been a rocky hillock on the right bank of the Yeşil Irmak shortly before the river enters its gorge to pass through the coastal mountains to the sea.

BIBLIOGRAPHY. J.G.C. Anderson, *Studia Pontica* I (1903) 74-78. D. R. WILSON

EUPATORIA (Crimea), *see* KERKINITIS

EUROMOS (Ayaklı) Turkey. Map 7. Town in Caria, 13 km NW of Milâs. It figures in the Athenian tribute lists as Hyromos or Kyromos, with a tribute of 2500 drachmae, raised in 425 B.C., no doubt unrealistically, to 5 talents. In Herodotos (8.133-35) the Carian Mys is described as a man of Europos, and Stephanos also records a Carian city of Europos; in these and other cases Euromos seems certainly to be meant. The place was occupied by Philip V during his Carian campaign, but in 196 B.C. he was required by the Senate to withdraw his garrison. When Mylasa revolted in 167 against Rhodian suzerainty, she began by seizing the cities in Euromos; from this expression of Polybios it appears that Euromos controlled a considerable area. By the end of the 2d c. we find Euromos in a sympoliteia with Mylasa which, however, was not of long duration; quarrels arose and the Euromans found it necessary to turn to the Romans and Rhodians. About this time an inscription records an alliance with Iasos. After this the city is barely mentioned; Strabo calls it a peripolion of Mylasa, and Pliny lists it in the form Eurome. A coin of the late 5th c. B.C. inscribed ΥΡΩ, with the head of Zeus, seems clearly to belong to Euromos; otherwise the coinage begins in the 2d c. B.C. after the liberation from Rhodes, and continues to the 1st c. A.D.

The city stood on flat ground, encircled by a wall which also enclosed the lower slopes of the hills to the E.

The wall is of good ashlar masonry, apparently of Classical date, with towers at intervals; it is best preserved on the hillside. On the same hillside was a good-sized theater facing W, but only a few rows of seats and some fragments of the stage building survive. On the level ground is the agora, surrounded by a stoa with one or two columns still standing. But the most striking monument is the temple, just outside the city wall on the S and visible from the present road—one of the best preserved temples in Asia Minor. It had a peristyle of 11 by 6 columns in the Corinthian order, 16 of which are standing complete with architrave; all but four are fluted, and 12 of them carry a panel with an inscription recording their presentation by individual citizens. Recent excavations have brought to light an altar in the usual position on the E, and a decree of Hellenistic date revealing that the temple was dedicated to Zeus Lepsynos (known at Miletos) and was not the first temple erected to him here; in its present form it dates from the 2d c. A.D. Close to the temple on the SW is a group of underground tomb chambers solidly built and roofed with large blocks in the Carian manner.

BIBLIOGRAPHY. R. Chandler, *Travels in Asia Minor* (3d ed. 1817) 226-27 (repr. 1971) 119-20[I]; C. Fellows, *Asia Minor* (1839) 261-62[I]; L. Robert, *Villes d'Asie Mineure* (1935) 59; A. Laumonier, *Cultes Indigènes en Carie* (1958) 164-74 (with more complete bibl.); G. E. Bean, *Turkey beyond the Maeander* (1971) 45-48.

G. E. BEAN

EURYMENAI (Kastritsa) Epeiros, Albania. Map 9. An early and important city (*EphArch* [1956] 1f; D.S. 19.88), most probably identified with the largest site in the plain of Ioannina, a craggy limestone ridge called Kastritsa on the S side of the Lake of Ioannina. It was defended by a massive circuit wall ca. 3000 m long and was densely inhabited. The fortifications were extended at various periods and include gateways and towers of different kinds. It stands at a nodal point in the communications of Epeiros. The area has yielded Prehistoric, Classical, and Hellenistic pottery.

BIBLIOGRAPHY. S. I. Dakaris in *PAE* (1951) 173ff; (1952) 362ff; id. in *ArchDelt* 20 (1965) *Chron.* 348, 21 (1966) *Chron.* 288, and *PPS* 33 (1967) 30ff; N.G.L. Hammond, *Epirus* (1967) 173f, 291f, 527f, Plan 15 and Pl. XI *a*; I. Vokotopoulou in *ArchDelt* 23 (1968) *Chron.* 291f.

N.G.L. HAMMOND

"EUTHENA," *see* ALTINSIVRISI

EVDIR HAN, *see* LAGON

ÉVORA, *see* EBORA

EVRAIONISOS, *see* ASPIS

EVREUX, *see* MEDIOLANUM AULERCORUM

EWHURST Surrey, England. Map 24. Roman villa at Rapsley, 11.2 km SE of Guildford, discovered in 1956 and excavated 1956-68. Five periods were distinguished, from ca. A.D. 80 to ca. 350.

The first was identified only by the presence of Flavian pottery, and there was no sign of pre-Roman occupation. In the second period (ca. 120-200) a timber build-ing (9.9 x 4.8 m) was erected and enclosed by a ditch. In the third period (ca. 200-220) this was replaced by structures with footings at least of stone, comprising a bath block (20.4 x 11.4 m) separated by a fence from an aisled building (30 x 12 m); there was also a small apsidal building (nymphaeum?), and the whole complex was defined on the S by a boundary wall and ditch. The main house does not appear to have been located. In the fourth period (ca. 220-280) the aisled building was reconstructed and another aisled building (22 x 10 m) erected at right angles to it; the bath block was converted into a dwelling house and one room in it was given a geometric mosaic. In the fifth period (ca. 280-330) a small building was attached to the outside of the boundary wall and three new rooms were added to the house. No late 4th c. pottery was found and only one 4th c. coin.

The fact that the design of the mosaic is closely similar to one from Silchester suggests a link with the Atrebates rather than the Regni. Cattle raising was important, but the villa was evidently connected with the tile kiln excavated in 1936 at Wykehurst Farm, 0.4 km to the S, and much kiln waste was found. The finds included fragments of a pottery mural crown.

BIBLIOGRAPHY. Villa: R. Hanworth, *Surrey Archaeological Collections* 65 (1968) 1-70; Wykehurst kiln: R. G. Goodchild, ibid. 45 (1937) 74-96.

A.L.F. RIVET

EXCISUM (Eysses) Commune of Villeneuve-sur-Lot, Dept. Lot-et-Garonne, France. Map 23. An important way-station situated N of Agen (Aginnum) at the ancient crossroads of ways linking Bordeaux to Lyon and Bourges to Auch, Eysses produced various finds in the course of the 19th c., in the neighborhood of a monument known as the Tour d'Eysses, which is still partially preserved. It consists today of a circular structure (diameter, 11 m; average height, 10 m), its walls an average of 1.1 m thick. The two dressed faces of these walls were covered with rows of small masonry, among which remain the iron clamps which served to hold in place a marble revetment. The same characteristics may be seen on the tower of Vésone in Périgueux. The monument at Eysses belongs, like the latter, to a series of indigenous temples made up of a cella surrounded by an ambulatory gallery, erected in the center of a large esplanade surrounded by a peribolos.

Soundings made since 1970 have revealed remains of buildings in the neighborhood of this sanctuary, which date, according to amphorae and coins, to the first half of the 1st c. A.D. These recent discoveries have narrowed the proposed date for the temple's construction to the 1st to 2nd c. The furnishings from earlier excavations (including a Celtic bronze horse's head) and recent finds, are divided between the museums of Agen and Villeneuve-sur-Lot.

BIBLIOGRAPHY. J. F. Boudon de Saint Amans, *Essai sur les antiquités du département du Lot-et-Garonne* (1859) 61ff; Grenier, *Manuel d'arch. gallo-romaine* III. 1 449[I].

M. GAUTHIER

EXETER, *see* ISCA DUMNONIORUM

EYSSES, *see* EXCISUM

EZ-ZIB, *see* ECDIPPA

F

FABARA Zaragoza, Spain. Map 19. About 13 km E of Caspe. Not mentioned in ancient sources. A large tomb in the shape of a rectangular temple has survived, prostyle tetrastyle, with shallow pronaos and naos. The four columns of the facade are of the Tuscan order, with smooth shafts carrying an Ionic entablature with frieze decorated with garlands. The lateral walls have attached pilasters. Only a portion of the pediment is preserved, bearing an inscription stating that the monument is dedicated to the shades of Lucius Aemilius Lupus (*CIL* II Supp., 5851). Construction is in large stone blocks bound by iron clamps. In the interior at the left of the naos a stairway descends to a vaulted sepulchral crypt. The date of the monument is uncertain.

BIBLIOGRAPHY. J. R. Mélida, *Monumentos Romanos de España* (1925) 134-36[1]; Puig i Cadafalch, *L'Arquitectura romana a Catalunja* (1934). J. ARCE

FABRÈGUES Hérault, France. Map 23. The oppidum of La Roque is on the La Gardiole hill W of Montpellier, on the edge of the coastal plain and 2 km S of the Via Domitia. The ancient texts contain no mention of the site, which is a barred spur with natural defenses on three sides. The fourth side is closed by three ramparts of dry stone, and in several places these ramparts are peculiar in having a triple-faced wall. The fortification can be dated between 425 and the first half of the 3d c. B.C.

A stratigraphical study of the pre-Roman site has distinguished three periods of occupation: La Roque III (end of the 5th to the beginning of the 4th c. B.C.) La Roque II (middle of the 4th c.) and La Roque I (end of the 4th c. to 250-230 B.C.). A few soundings revealed traces of Iron Age I. The destruction of the settlement should probably be attributed to the Volcae invasion in the 3d c. The most interesting finds are the altar-hearths —large slabs of baked clay decorated with geometric motifs which were placed in the middle of certain rooms in the settlement. These rooms also contained trivets and pots with pierced bottoms.

Excavation has revealed two residential sections, built of stone and laid out on a square or rectangular plan. Neither the necropolis nor any public monuments has yet been located.

BIBLIOGRAPHY. *Gallia* 12 (1954) 422-23; 14 (1956) 599-608; 17 (1959) 462-64; 20 (1962) 623-24; 22 (1964) 491; 24 (1966) 466; P. Larderet, "L'oppidum préromain de La Roque, commune de Fabrègues (Hérault)," ibid. 15 (1957) 1-39; id., "Les découvertes archéologiques de l'oppidum de La Roque (Hérault)," *RStLig* 23 (1957) 71-89. J.-C.M. RICHARD

FAENZA, see FAVENTIA

FAESULAE (Fiesole) N. Etruria, Italy. Map 14. A town on the hill that dominates Florence. With the exception of the geographers (Plin. 3.52; Ptol. 3.1.43), it is rarely mentioned in the literary sources, and does not even appear in the Itineraria. It is mentioned for the first time in connection with the Gallic invasion in 225 B.C. (Polyb. 2.25); then by Polybios (3.80.82) and by Livy (22.3) during the second Punic war when Hannibal's army camped in the fertile Fiesole countryside. From that time on, the citations increase.

Fiesole participated in the social war and was devastated in 90 B.C. by Lucius Porcius Cato (Florus, *Ep.* 2).

Later on, the victorious Sulla established a colony of veterans there (Cic. *Cat.* 3.14; Sall. *Cat.* 28). The Fiesolani revolted in 78 B.C.; and in 63 took part in Catiline's conspiracy (Sall. *Cat.* 24.27.30; App. *BCiv.* 2.3).

The few fragments that survive from the archaic period indicate that the area must already have been inhabited in the Early Iron Age. The city must have developed at a much later period, even though certain stretches of the encircling wall on the upper part of the hill of S. Francesco and near Borgunto seem to date from the 5th c. B.C., while the major part of the wall dates from the 3d c. B.C. Various building techniques, with some stretches in polygonal work, confirm that the wall was built in stages with some rebuilding in the Roman period.

Inside the walls, which extend for ca. 3 km, the most significant building yet excavated is a temple dedicated to a healing divinity, constructed with separate annexes probably for the use of pilgrims. The temple has a peculiar plan, consisting of a cella against the far wall and two lateral wings. The entrance between two columns was reached by a stepped ramp. Excavations in progress in the area immediately in front of the temple have brought to light the altar belonging to the Etruscan temple, a drain from the same period, and another at a lower level from an earlier period (5th to 4th c. B.C.). This suggests an urban system preceding the Hellenistic. The necropolis, with chambered tombs, in the area called Bargellino to the N of the wall, contains no funerary material earlier than the 3d c. B.C. In the fields around Fiesole nevertheless several stelai have been found that date as far back as the 6th c. B.C. They come from isolated tombs, often far apart. Near the Villa Marchi, inside the Etruscan wall on the slope that overlooks Florence, a shrine was found with a votive stipe that offers a rich sampling of small bronzes.

Fiesole was at its height under Augustus. To this time, according to the latest stratigraphic tests, belong the theater, the baths, and perhaps the rebuilding of the Etruscan temple, destroyed by fire at the beginning of the 1st c. B.C. and reconstructed with its annexes at a higher level with a slightly amplified plan.

The central part of the cavea of the theater rests against the hill while the lateral sections are carried by vaults. The theater must have been refurbished during the Roman Imperial age, as can be seen from the plaques on the pulpitum, which show noticeable stylistic and chronological discrepancies. Since the Fiesole hillside is made up of sloping terraces, the forum was probably in the modern Piazza Mino da Fiesole where, at a more elevated position, the Capitolium must have been under the present church of S. Maria Primerana. The theater, of several levels, linked the forum and the buildings in front on the lower terrace built against the wall, the temple, and the baths. The latter have a very simple plan with natatoria at the entrance, then the tepidarium flanked by two apoditeria, to the right the caldarium, and to the left the frigidarium with the swimming pool. Behind the caldarium are two earthenware furnaces. The water for the baths came from Montereggi, where the beginning of the Roman aqueduct has been traced. The baths show rebuilding during the Imperial epoch up until the Severian age.

Numerous barbarian tombs have been found during excavation in the archaeological zone. Fiesole again appears in the histories at the beginning of the 5th c. when

Stilicone defeated the Goths under Radagaiso near Fiesole (Oros. 7.37), and in 539 when Fiesole was occupied by Belisarius (Procop. *Goth.* 2.23,24,27). Under Pope Gelasius I (492-96) a notice of an episcopus faesulanus shows that Christianity had already reached Fiesole.

BIBLIOGRAPHY. "Faesulae" in *PW* 6C; *EAA* 3 (1960) with biblio. (G. Maetzke); A. De Agostino, *NSc* (1940) 180ff. Per la necropoli: G. Maetzke, *NSc* (1957) 267ff. Per l'ara: F. Castagnoli, *BullComm* 77 (1959-60) p. III[I]; P. Bocci, *St. Etruschi* 29 (1960) 421ff; id., *NSc* (1961) 52ff. P. BOCCI PACINI

FAGIFULAE (Montagano) Molise, Italy. Map 14. A center of the Pentri Samnites and a Roman municipium (Plin. *HN* 3.107). The name appears in that of the church of S. Maria di Faìfoli in the valley of the Biferno (ancient Tifernus). The site has never been excavated. It is doubtful that it is to be identified with the center mentioned by Livy (24.20.5).

BIBLIOGRAPHY. *CIL* IX, p. 237; H. Nissen, *Italische Landeskunde* 2 (1902) 792; A. Degrassi in *MemLinc* 2 (1950) 323ff = *Scritti vari* 1 (1962) 150ff; E. T. Salmon, *Samnium and the Samnites* (1967) 299.

 A. LA REGINA

FAIYÛM Egypt. Map 5. An oasis 103 km SW of Cairo and 38 km W of the Nile, with which it is connected by Bahr Yusuf. Its name has survived through Coptic from the New Kingdom name meaning sea, referring to Lake Moeris (now Qarûn) at the edge of the oasis. The Greeks called it Limné, which formed the twenty-second nome of Upper Egypt. Situated on a lake, it has always attracted hunters and fishermen. Owing to the interest of Ammenemes III (1842-1797 B.C.) in irrigating this district, the nome became one of the most fertile parts of Egypt. Its capital was Shedit (consecrated to Sobek, the crocodile god); the Greeks therefore called it Crocodilopolis (Herod. 2.148-50). Here Ptolemy II Philadelphos organized his Greek and Macedonian veterans as farmers and when his sister-wife Arsinoë Philadelphos died, she was decreed to be the patron deity of the nome. Its capital, the present El-Faiyûm, bore the name of Arsinoë while the nome began to be called Arsinoite (Strab. 27.1.38). The Moeris Lake Papyrus depicts a plan of the whole nome.

The ruins of the Egyptian temple in the old city indicate that it was dedicated to Sobek and to Renenutet, goddess of harvest, by Ammenemes (Amenemhat) III, and that it was also in use during the Ptolemaic period. Apart from the great number of papyri found here or in the neighborhood, the most important finds from the Roman period are the portraits executed in tempera or encaustic on mummy wrapping or on wooden boards over the faces of the dead bodies. The technique of these portraits reached its zenith in the Byzantine period. The Christian Copts of the 2d c. A.D. made of Arsinoë an important center of the new religion and, under Commodus, it was inhabited by more than 10,000 monks. It is from here that most of the Coptic sculpture and reliefs come.

BIBLIOGRAPHY. B. Grenfell et al., *Fayoum Towns and Their Papyri* (1900); E. Kiessling, "Zum Kult der Arsinoë in Fayûm," *Aeg.* 13 (1933) 542-46; H. Ranke, "The Egyptian Collection of the University Museum," *Univ. Mus. Bull.* 15.2-3 (1950) 59, 90-91[I]; J. Bingen, "Anses d'amphores de Crocodilopolis Arsinoë," *Chronique d'Égypte* 30 (1955) 130-32[I]; H. Riad, "Le Culte d'Amenemhat III au Fayoum à l'epoque ptolémaique," *ASAE* 55 (1958) 203-6[I]; A. F. Shore, *Portrait Painting from Roman Egypt* (1962)[I], with bibliog; E. Brunner-Traut & V. Hell, *Aegypten* (1966) 485ff[M]; K. Michalowski, *Aegypten* (1968) 494-95[M]. S. SHENOUDA

FALERII NOVI (Santa Maria di Falleri) Italy. Map 16. The site to which the people of Falerii Veteres were moved after their surrender to Rome in 241 B.C. (Zonar. 18.8). It lies on the left bank of the Rio Purgatorio ca. 5 km W of the old city. A trapezium in plan, its longest side the S above the low cliffs of the river, it had walls of tufa blocks furnished with 50 towers and 9 gates. The circuit approaches 2.4 km in length, with the towers regularly spaced except on the S, where the river gorge gives added protection. The W gate, flanked by towers, the Porta di Giove, is the best preserved. The entrance is a single arch of 19 long, narrow voussoirs, the extrados finished with a heavy molding, a youthful head carved on the keystone. With the possible exception of the walls of Paestum, this is the finest Hellenistic fortification in Italy.

There is little else. The theater, excavated in 1829, is a mere ghost now. A statue of Livia as Concord and statues of Gaius and Lucius Caesar were found in it; presumably it was of Augustan date. An amphitheater N of the city walls has faded like the theater. The city plan was examined in 1903; apparently it was a rectangular grid with the main streets crossing at the center.

Many imperial inscriptions have been found here. It was a municipium under the Early Empire and given the status of a colonia, "Iunonia quae appellatur Faliscos" (*Lib. Colon.* 217.5-6), in the 3d c. (The name Junonia indicates that Juno was still the chief goddess here as she had been at Falerii Veteres.) Three inscriptions refer to a "pontifex sacrarius Iunonis Curritis," another has to do with the restoration of a sacred way "from the chalcidicum to the grove of Juno Curritis." It must have been along this that Ovid watched the procession in honor of the goddess (Ovid *Am.* 3.13).

Down to the Early Empire, the citizen of Falerii Novi still buried his dead in a chamber tomb with a rock-cut facade preceded by an arched portico. Dennis describes a number of these and remarks that only here has he seen a cornice of masonry atop a rock-cut tomb facade; a tomb excavated in 1903 had architectural elements that had been carved separately and applied to the facade in the same way. The tombs' inscriptions are in Latin, but in one case, as Dennis points out, the man's mother's name is given as well as his father's, an Etruscan tradition. Later tombs are built in the Roman manner along the roads leading from the city. The most important of these is the Via Amerina, which becomes the axial N-S street inside the city.

BIBLIOGRAPHY. L. Canina, *l'Antica Etruria Marittima* (1846-51) pls. 5-16[MPI]; G. Dennis, *Cities and Cemeteries of Etruria* (3d ed., 1883) I, 97-114[MI]; M. Frederiksen & J. B. Ward-Perkins, *BSR* 25 (1957) 155-62; L. Banti, *The Etruscan Cities and their Culture* (1973) 63f.

 E. RICHARDSON

FALERII VETERES (Civita Castellana) Italy. Map 16. The easternmost city of the tufa region of Etruria and the most picturesque in site. It lies on a long, narrow tongue where several tributaries of the Treia unite to flow N to the Tiber; the Rio Maggiore and its tributary the Purgatorio bound it on the N, the Rio Filetto on the S. Its sheer red cliffs are some 90 m high except on the W; the gorges of the streams are narrow and now choked with vegetation.

It was the chief city of the Faliscans, a people who considered themselves Etruscan though their language was akin to Latin. In the wars between the Etruscans and Rome in the late 5th c., Falerii was allied with Veii, Capena, and Fidenae, her near neighbors (Livy 4.17.12; 5.8; 5.13.9-11); and when Rome besieged Veii, only Falerii came to her help (Livy 5.17.6-10; 5.18.7-11),

for which it was attacked by Camillus and fell the year after Veii's fall (Livy 5.26-27; Plut. *Vit. Cam.* 1; Val. Max. 6.5.1). Later it was allied with Tarquinia (Livy 7.16.17) but in 351 made a 40 years' truce with Rome, changed to a foedus in 343 (Livy 7.22; 7.38.1). With other Etruscan cities it rebelled in 293 (Livy 10.46.5) and again in 241 (Polyb. 1.65). This time Rome sent both consuls against the Faliscans; in six days they were forced to surrender (Livy *Epit.* 20), having lost 15,000 men (Eutropius 2.28; Oros. 4.11). They were punished by the sequestration of half their territory (Eutropius 2.28; Zonar. 8.18), and later they were forced to leave their ancient and impregnable city for a site more accessible (Zonar. 8.18). Although this fact is recorded only by Zonaras, it is confirmed by the grave goods from the necropoleis, which include nothing later than the 3d c. B.C. The new city, Falerii Novi (S. Maria di Falleri) lay 4.8 km W of the old, on the left bank of the Rio Purgatorio.

The most extensive necropoleis are on the hills of Montarano and Celle to the NE of the city and Penna and Valsiarosa to the SW. The earliest graves are cremation burials of the early 7th c.; the latest, chamber tombs of the 4th-3d c. with rock-cut facades. The early material is like that from Narce: dark impasto with incised decorations and a partiality for ducks and horses drawn in lively shorthand; red-slipped ware, local painted ware and imported Protocorinthian and Corinthian pieces. Falerii's wealth in the 6th and 5th c. is attested by the many fine Attic vases, both black- and red-figure. Late in the 5th c. S Italian red-figure vases appear, and about 400 B.C. a local school began to turn out specimens so close in style to Attic work of the early 4th c. that the first Faliscan painters may have been Athenian immigrants; this workshop was active through the 4th c.

The original settlement may have been on the hill of Vignale NE of the present city, to which it is joined by a saddle; the Rio Maggiore sweeps around it to the W and N; the Treia, reinforced by the Filetto, on S and E. Its steep cliffs provide good natural defense; and late archaic terracottas, apparently from two temples, were found there in 1896. But the city that surrendered to Rome in 241 was on the site of Civita Castellana. Stretches of its walls are preserved, of rectangular blocks of tufa like those of the nearby Roman colonies of Sutrium and Nepet, probably built in answer to theirs. There is still an ancient gate (now in the convent of S. Maria del Carmine) on the N, serving a path that led down to the bed of the Maggiore. The path took advantage of a gap in the cliff; the wall was carried over it on a tall, narrow corbeled vault. This is the only reasonably complete Etruscan city gate earlier than the introduction of the arch to central Italy.

Three more temples are known; one at Lo Scasato is within the city walls on the S side of the plateau. The terracottas divide into two groups: one of fragments of the complete series of revetments for a large Hellenistic temple; these must date from the early 2d c. The second series is made up of figures of two sizes modeled by hand; the smaller were parts of antefixes, the larger perhaps pedimental but more probably from columen and mutule plaques. They are in an eclectic style that suits the late 2d c. better than the 4th, to which they are usually assigned, and they are exceptionally handsome. Both series, certainly to be dated later than 241 B.C., indicate that the temples were not abandoned when the city was transplanted.

Two other temples in the valley of the Maggiore also survived after 241. One, at Sassi Caduti on the left bank of the stream, was apparently a Temple of Mercury. The attribution is based on the evidence of 14 black-glaze sherds inscribed TITOI MERCVI EFILES from a Hellenistic votive deposit, and the lower part of a statue of the god, apparently an acroterion. The oldest terracottas, of the early 5th c., include an acroterion representing two fighting warriors and antefixes showing pairs of silens and maenads; the later terracottas, including the Mercury, are Hellenistic; and some fragments of Campana plaques bring the date of the temple's survival down to the time of Augustus.

The other temple, at Celle on the left bank of the Maggiore where it turns E above Vignale, is usually identified as the Temple of Juno Curritis (Ovid *Am.* 3.13), the chief divinity of the city. Excavated in 1886, its foundations were the first Etruscan temple foundations known: a great platform of rectangular tufa blocks supporting a massive wall at the rear, from which five walls project forward. These are taken to be the remains of a triple-cella temple with alae, like the Capitolium at Rome. This was built over an older temple, and votive finds from the site are older still, going back to the Bronze Age. The temple terracottas preserved date from the 5th to the 1st c.

Mount Soracte, on the fringe of the Apennines W of the Tiber, lay in Faliscan territory (Plin., *HN* 7.19). A cult of Apollo Soranus (Varro, *ap.* Servius, *Aen.* 11.787) is attested by one inscription found near Falerii recording a dedication to the god; otherwise our knowledge of him is purely literary.

The temple terracottas and much of the tomb furniture from Falerii are at the Museo di Villa Giulia at Rome.

BIBLIOGRAPHY. M. Taylor & H. C. Bradshaw, *BSR* 8 (1916) 1-34; L. R. Taylor, *Local Cults in Etruria* (*PAAR* 2, 1923) 60-96; L. A. Holland, *The Faliscans in Prehistoric Times* (*PAAR* 5, 1925); A. Andrén, *Architectural Terracottas from Etrusco-Italic Temples* (1940) 80-148; J. D. Beazley, *Etruscan Vase Painting* (1947) 70-112, 149-62; M. Frederiksen & J. B. Ward-Perkins, *BSR* 25 (1957) 128-36. E. RICHARDSON

FALERIO Marche, Italy. Map 16. A considerable town near Falerone in Picenum on the left bank of the river Tinna ca. 25 km from the sea. Its territories bordered on those of Firmum. Its history is obscure; almost all that is known is that it received a colony of veterans under Augustus and belonged to the tribus Velina. The people were called Falerienses ex Piceno or Falerionenses.

Ruins of buildings include a reservoir, called Bagno della Regina, an amphitheater, and a theater, the last excavated in the 19th c. and maintained as a monument. An inscription informs us that it was built A.D. 43. Antiquities from the site are kept in the Museo Civico, Palazzo Comunale, Falerone.

BIBLIOGRAPHY. *AdI* (1839) 5-61 (G. De Minicis); H. Nissen, *Italische Landeskunde* (1902) 2.423; *EAA* 3 (1960) 570f (G. Annibaldi). L. RICHARDSON, JR.

FALERONE, *see* FALERIO

FAMARS, *see* FANUM MARTIS

FANO, *see* FANUM FORTUNAE

FANUM FORTUNAE (Fano) Italy. Map 16. An Umbrian town on the Adriatic just N of the mouth of the Metaurus at the point where the Via Flaminia reaches the Adriatic after crossing the Apennines. Nothing is known of its early history or the reason for its name; it is first mentioned as occupied by Caesar after the crossing of the Rubicon (*BCiv.* 1.11.4). It received a veteran colony of Augustus, the colonia Iulia Fanestris,

and was inscribed in the Tribus Pollia. An inscription (*CIL* XI, 1.6218-19) records that Augustus gave the city its walls, and since the Via Flaminia became one of the main axes of a regular street grid, it seems likely that he gave it its city plan as well. By the end of the 4th c. it was called colonia Flavia Fanestris.

Its most conspicuous remains are its fortifications, in a rectangle with blunted corners on the landward front; a substantial stretch of the NW sector can be examined inside and out. The curtain is of concrete faced with thin, brick-like slabs of yellow sandstone. There are round towers, their facing in bond with the curtains, except on the sea front. These are placed to protect gates, angles, and dangerous approaches, but have the appearance of occurring at roughly regular intervals. A secondary gate is built in large blocks of the sandstone, used elsewhere for dressing; but the main gate, the Arco di Augusto, is of sandstone faced with fine limestone. It is very elegant, a large central arch trimmed with moldings at imposts and extrados, flanked by small plain arches for foot traffic. Above the central arch runs a pseudo-epistyle carrying the inscription commemorating Augustus' gift of A.D. 9-10. Above this, in a second story, a graceful loggia of seven windows, tall and arched, was framed within an engaged Corinthian order, architecture reminiscent of the tabularium in Rome. Towers projecting boldly to either side and rounded in front complete the harmony.

Vestiges of Roman life and construction have come to light at many places within and without the fortifications, and a wealth of inscriptions and statuary has been collected, but there are no other important ruins, and no certain trace of the basilica that Vitruvius tells us he built here (5.1.6-10) has ever been located though it has been repeatedly sought.

BIBLIOGRAPHY. E. Brizio, *NSc* (1899) 251-59; *Atti del XI Congresso di Storia dell'Architettura* (Centro di Studi per la Storia dell'Architettura, Rome 1965) 48-51, 67-68 (G. Annibaldi); 95-99 (F. Pellati); 101-4 (G. A. Mansuelli). E. RICHARDSON

FANUM MARTIS (Corseul) Côtes du Nord, France.

Map 23. The ancient city, the center of which is now occupied by the small township of Corseul, was one of the chief towns of the Coriosolites tribe, and became the capital of the new civitas under Augustus. Built on a N-S and E-W grid plan, the city grew in the Claudian period and flourished under the Antonines. After uncertainty and economic recession in the 3d c. the city shrank in size, and many quarters were abandoned. In the 4th c., however, with the renaissance under Constantine, it came to life again although it had lost its title of capital to Aleto (St. Servan sur Mer), and the abandoned quarters were once more occupied.

To the E and outside the limits of the ancient city stands the most important monument, the temple of Le Haut-Bécherel. All that is left of this edifice—in area, the greatest religious monument in all Armorica, even in all Gaul—is the impressive remains of the cella. Excavations ca. 1868 traced the general plan of the temple (110 x 101 m). A huge central court, rectangular in shape, was open to the E and lined on the other three sides by a gallery formed by two parallel walls, the first of which probably supported a colonnade. The sanctuary proper, to the W, consisted of a hexagonal cella built of mortared rubble faced with small blocks and with iron joints, surrounded by an ambulatory. The sanctuary was reached by a monumental entrance opening on the W colonnade. On either side of the sanctuary, in the outer gallery wall, were two small rectangular rooms, and there were two other identical rooms in the N and S passageways. In the NE and SW corners of the courtyard were two quadrangular structures projecting into the interior; they had sturdy buttresses on their outer corners. The E wall of these structures extends to close off part of the great central court. It is not certain to what divinity this temple was dedicated, but the name would indicate that it was the god Mars.

Recent excavations have uncovered a residential sector, in particular the plan of a villa urbana from the Claudian period. Actually a country house in an urban setting, the building is of the so-called horseshoe type. The main building, rectangular and facing S, is flanked to the W by a wing at a right angle, forming a courtyard that is closed to the E by a wall. The courtyard, which contains a well, is lined on three sides by a portico and opens to the S on one of the paved streets of the ancient city. Excavation also revealed the substructures of a bath building erected in the 4th c. when this section of the city was reoccupied.

Most of the objects found can be seen at the Corseul Mairie, but some are in the museums of Rennes and Dinan. The Corseul church contains a fine funerary inscription dedicated to a woman from the Roman provinces of Africa.

BIBLIOGRAPHY. E. Fornier, "Rapport sur les fouilles du Haut-Bécherel en Corseul," *Bulletin de la Société d'émulation des Côtes du Nord* (1870); "Informations," *Gallia* 27, 1 (1969) 248-51; 29, 2 (1971). M. PETIT

FANUM MARTIS (Famars) Nord, France. Map 23.

In the Belgica province of Gaul. Situated on a narrow strip of land extending N-S between the marshy valley of the Escaut and the Rhonelle, 5 km S of Valenciennes. This spot, which had previously been the site of a Celtic settlement (Gallic coins) was a crossroads on two ancient routes from Tournai and Mons. In the first half of the 1st c. A.D., at the latest, two monuments were erected here: a temple dedicated to Mars, after whom the site was named, and a large group of bath buildings. In the Late Empire the baths were damaged by fire, probably during the Germanic invasions of the second half of the 3d c., and partly torn down to serve as the foundations of a castellum. This fortress was a purely military installation, not a rampart designed for an existing civilian settlement; the seat of the praefectus laetorum Nerviorum (*Not. Dig.* 11.2), it also provided quarters for some of the troops under the magister peditum praesentalis. The invasion of Clodion, king of the Franks, which led to the capture of Tournai and Cambrai in 431, probably signified the end of the Roman presence at Famars.

The sanctuary has not been located, but excavations carried out in the early 19th c. and resumed during WW I have uncovered the remains of the bath buildings and part of the Late Empire walls. Part of the rampart can still be seen. The dimensions and plan of the complex suggest that these were public bath buildings connected with the Temple of Mars. Various structures have been identified: the heated rooms, cold pools, draining channels, and great sewer and, especially in the W section, some very large basins. The finds made at Famars (terra sigillata, fibulas of the first half of the 1st c.) indicate that the Roman occupation of the site goes back to the beginning of the Empire; the baths, which were restored on several occasions, are probably later (2d c.). The water supply may have come from the aqueduct at Artres (9 km S of Famars).

The remains of the W part of the castellum are still standing (the wall is preserved to a height of 2.5 m, and the tower was reused in the corner tower of the Chateau de Pailly). The study of these remains and the continuing excavations give a fairly clear idea of the general plan of the rampart. It was more or less square (105 m

to the N, 140 m to the E, 110 m to the S, and 165 m to the W where the wall becomes slightly convex, probably allowing for the presence of buildings next to the baths), and enclosed an area of ca. 1.8 ha. The rampart includes an original wall, relatively narrow (less than 1.8 m), the foundations of which are laid on large quarry-stones and reused architectural blocks.

This first rampart is duplicated over a large part of the original perimeter by a second one, wider (2.3 m) and more carefully built (a mortar of crushed bricks). At the same time some semicircular towers were put up which projected on the outside (every 24 m on the N side). The first wall, hastily built, was probably a makeshift, but the second seems to have been erected according to a systematic design. The fact that the baths, now destroyed, were not yet filled in by the beginning of the Constantinian period (coins) means that the construction of the castellum in its first form dates at the earliest from the end of this period, a time of relative peace when elaborate fortifications were not necessary. On the other hand, we may date the reinforcing of the castellum from the middle of the 4th c., when the recurring Germanic invasions forced Julian, and especially Valentinianus I, to put the defenses of the Empire in order—or, less likely, at the very beginning of the 5th c., the period of the penetration of the Rhine (406).

BIBLIOGRAPHY. H. Guillaume, "L'aqueduc romain de Famars," *Revue du Nord* 42 (1960) 353; G. Bersu & W. Unverzagt, "Le castellum de Fanum Martis," *Gallia* 19 (1961) 159. C. PIETRI

FARANGI ("Begorra") W. Macedonia, Greece. Map 9. A site in the vicinity of Farangi. There is no ancient reference to a Begora or Begorra, but the name has long been accepted as a necessary basis for the name Begorritis lacus, by which Livy (42.53.5) identifies Lake Ostrovo. The true form of the name appears to be Βοκερία as it is found on a milestone of ca. the 3d c. B.C. This milestone points to a site near Kelemiş (mod. Farangi) along the E shore of the lake, where black-glazed pottery was found in 1959-60.

Begorra/Bokeria was apparently a station on the Macedonian royal road through Eordaia, the road which later became the Via Egnatia. The town lost all importance during the Roman period, and was replaced by a station at Cellae, near Novigrad (officially Vegorra). This latter site was for a long time flooded by Lake Ostrovo, but has recently reappeared. It has been the subject of some informal investigations.

Excavations in the summer of 1960 revealed a small apsidal structure, along with some suggestions of rectangular buildings. One inscription, a 2d c. A.D. funereal monument, probably reused, had been found. Two pieces of sculpture, a headless male figure and the head of a youth (size not reported) were taken to the museum at Florina, along with figurines and architectural fragments. Coins were found ranging in date from Augustus to Valens, with a particular concentration around the time of Constantine.

The finds suggest that special attention was paid to the Via Egnatia in the period of the 2d tetrarchy, and support the argument that the Via Egnatia passed S through the Kirli Derbend pass and around the S of Lake Ostrovo. Gradište, a site just N of Katranitsa (mod. Pyrgoi), along the E side of the lake, probably marks another station on the Via Egnatia.

BIBLIOGRAPHY. W. M. Leake, *Nor. Gr.* (1835) III 316-17; C. Edson, "The Location of Cellae and the Route of the Via Egnatia in Western Macedonia," *CP* 46 (1951) 1-16M; G. P. Aziz, *Lebaia, City of the Ancient Macedonians* (1958)I, report of excavations, in modern

Greek; G. Daux, "Chronique des Fouilles 1960," *BCH* 84 (1960), 766-67, with fig. 6 & fig. 12.1; *RE*, s.v. Begorritis lacus; *ArchDelt* 17.2 (1961-62) 216, with pl. 253.
 P. MACKAY

FARO, *see* OSSONOBA

FAUROUX Tarn-et-Garonne, France. Map 23. Near Saint-Romain, at Le Sas de Marty, is a large Gallo-Roman villa of the Late Empire. Several of its rooms were adorned with 4th c. polychrome mosaics of geometric design.

BIBLIOGRAPHY. M. Labrousse in *Gallia* 9 (1951) 137-38P. M. LABROUSSE

FAUSTINOPOLIS (Başmakçı, Niğde) Cappadocia, Turkey. Map 6. Formerly a village called Halala, it was raised to the status of colony by M. Aurelius. His wife Faustina the Younger died there on the journey from Syria in A.D. 176. It was a city and bishopric of Cappadocia Secunda according to Hierokles and the *Notitiae*. The town, in the foothills of Tauros on the main Tyana-Cilician Gates route, was identified by an inscription honoring Gordian III. The ruins include a rocky acropolis.

BIBLIOGRAPHY. M. H. Ballance, "Derbe and Faustinopolis," *AnatSt* 14 (1964) 140-42. R. P. HARPER

FAVENTIA (Faenza) Emilia-Romagna, Italy. Map 14. A Roman city on the Via Aemilia near the Lamone river, and ca. 29 km SW of Ravenna. It was founded in the course of Roman settlement of the region in the Late Republican period. The city was involved in the events of the civil war at the time of Sulla. It had a certain economic importance as the center of an agricultural area that produced linen and wine; and also as a crossroads. Faventia was a rather early diocesan center.

The city had an orthogonal plan, still largely conserved; and an earlier circuit wall of limited extent in opera quadrata. The city developed outside the wall in the Imperial period, including also several irregular traces of a suburb. The orientation is the same as that of the centuriation axial on the Via Aemilia. Even though no buildings of any importance remain, Faventia is one of the best documented cities of the region.

BIBLIOGRAPHY. Medri, *Faenza romana* (1947); Monti, "Archeologia faentina," *Studi faentini in memoria di G. Rossini* (Soc. di Studi romagnoli, 1966) 67-174MPI.
 G. A. MANSUELLI

FAVIANIS (Mautern) Austria. Map 20. Established as a cohors milliaria on the Danube opposite Krems. It is one of the castella between the legionary camps at Vindobona and Lauriacum in the chain of Noricum's border fortifications. Possibly a smaller construction preceded it in the second half of the 1st c. A.D. Repair work from the time of Valentinian indicates that the structure remained unchanged in size into late antiquity. Excavations as well as the plan of the modern town give some idea of the location and extent of the castellum. The W wall is partly preserved in its N section; the E front is indicated by a rise in the ground. Proximity to the river may have made necessary two fortification ditches of masonry on the N front. Details of the inner plan cannot be ascertained because the area is built over. Maximum dimensions of the castellum were ca. 270 by 180 m. The cohors I Aelia Brittonum is known to have been the garrison in the 2d c. A.D. In the 4th c. part of Legio I Noricorum, which Diocletian had reorganized, was stationed here. In the *Notitia dignitatum* (34.41) a "praefectus legionis Liburnariorum primorum Noricorum, Fafianae," is mentioned, the first reference to the place in ancient literature.

Around the castellum an extensive camp village developed over the years, of which several villas, domestic buildings, etc., are known. There are several well-preserved cellars with slot-shaped windows and wall niches. At the edge of the settlement are extensive necropoleis, especially from the late period, some with rich offerings. Some of the graves are clearly Christian. The inscription on a curse tablet found in one necropolis suggests that a small sanctuary there may have been dedicated to Dispater and Aerecura.

Two large buildings at the edge of the ancient town were discovered in 1958-59: the first, a rectangular building (14.5 x 21 m) contained the characteristic semicircular clerics' bench with the altar in front of it and was probably a hall church; the second, a rectangular building (21 x 36 m), equipped for heating, is assumed to be the "monasterium . . . iuxta muros" mentioned by Eugippius (c. 22.4). These buildings are very likely connected with the activities of Severinus, in the record of whose life as recorded by Eugippius, Favianis is the place name that occurs most frequently. Here Severinus built the largest of his monasteries and to this place he brought refugees from the upper Danube. Favianis became an evacuation center when Noricum Ripense was evacuated by military orders from Rome in 488.

BIBLIOGRAPHY. H. Stiglitz, "Römische Lager und frühmittelalterliche Siedlungen am norischen Limes," *JOAI-Beibl* 46 (1961-63) 158ff[PI]; id., *Führer durch das römische Mautern an der Donau* (1963)[PI]; R. Noll, *Eugippius: Das Leben des heiligen Severin* (1963) passim.

R. NOLL

FELSINA, *see under* BONONIA

FENAKET, *see* PHOINIX

FENDOCH Perthshire, Scotland. Map 24. The Roman auxiliary fort at Fendoch, 8 km NE of Crieff, lies at the mouth of the Sma' Glen, guarding an important natural route to the upper Tay valley. It was one of a series of forts built by Agricola, probably in A.D. 83, to protect Strathearn and Strathmore from invasion by the Highland tribes, but it was evacuated and systematically demolished after only a few years' occupation.

Today there are virtually no surface traces of the fort, but excavation in 1936-38 showed that it was defended by a turf rampart 5.1 m thick, and one or two ditches; internally it measured 169.2 by 88.5 m, its proportions adapted to the site. The four gateways were all of timber. Three of them had twin towers flanking a carriageway 31.5 m wide, while the S gate, which led to an annex, had a single tower over the gateway passage. The internal buildings were also of timber, and the complete plan was recovered by tracing the foundation trenches and post-holes. In the center was the principia (24 x 30 m, including a front portico). It comprised a colonnaded forecourt flanked by long rooms, probably armamentaria; a cross-hall; and, at the back, the regimental chapel and four other rooms. On the left of the principia was the praetorium (20.4 x 30 m externally), consisting of a series of rooms ranged around an open court. The side wings were occupied by service quarters and bedrooms, while the dining room was at the rear. On the right of the principia was a pair of granaries (each 16.8 x 9 m). The floors were carried on cross-beams at intervals of 0.9-1.5 m, thus allowing ample space for the circulation of air. It is thought that each granary contained 10 bins, one for each of the 10 cohorts in the garrison, and that altogether they held more than a year's supply of corn.

Behind the principal buildings, and fronting on the via quintana, were a hospital and several smaller buildings, probably workshops or cart sheds. The hospital (31.8 x 12 m) consisted of a long central corridor with eight rooms on one side, and a ward or reception hall flanked by offices on the other. The rest of the space within the fort was occupied by 10 barracks for a cohors milliaria, and by two long sheds, one on either side of the via praetoria. The barracks were of uniform design, a typical example measuring 46.2 by 9.6 m. At one end the centurion's quarters occupied the whole width of the building for 10.2 m, and the remaining 51 m were devoted to 10 mess units with a verandah in front. A longitudinal partition divided the mess units into vestibules for kit, and inner rooms for living quarters.

No angle towers or interval towers were found, but five ovens were discovered at the back of the rampart, and their disposition in relation to the barracks makes it evident that each century originally had one oven. Since it was not practicable to dig wells, water was brought to the fort by a wooden pipeline, using a siphon system to overcome the rise in the ground as the pipe approached the defenses; once inside the fort, the water was distributed in pipes or open wooden gutters to tanks installed below ground level. The finds are in the National Museum of Antiquities of Scotland.

On the S side of the road to Amulree, 1.2 km W of the fort, a small signal station, commanded the view up the Sma' Glen.

BIBLIOGRAPHY. *Proc. Soc. Ant. Scotland* 73 (1939) 110-54[P].

K. A. STEER

FERENTINO, *see* FERENTINUM

FERENTINUM (Ferentino) Latium, Italy. Map 16. A Hernican hill town on the Via Latina (modern Casilina) about 75 km SE of Rome. It was taken by the Romans in 361 B.C., remained faithful to Rome in the Hernican revolt, and defied Hannibal in the second Punic war, for which he laid it waste (Livy 7.9.1; 9.42.11; 26.9.11). It is famous for its fortifications and its monumental acropolis.

The walls are of local limestone, large polygonal blocks approaching rectangles with much coursing, the two surviving gates, Porta Stupa and Porta Sanguinaria, capped with arches of regularly cut voussoirs. The walls, much rebuilt in mediaeval times, can be followed around a winding circuit that avoids acute angles and sites the gates with some sophistication, but is towerless.

The acropolis had its own fortifications, which come tangent to the city walls at the N corner and probably joined them there, but the NE side cannot be traced. The most important front is the SW, overlooking the town, where a bold rectangular outwork juts forward at the S corner. At its base this is of roughly trapezoidal blocks of limestone in rough coursing set in a deep footing trench cut into the stone of the hill. There is some effect of bossing and a marked batter, and this work is carried as coigning part way up the superstructure, which is of travertine cut in long thin blocks laid in regular courses of unequal height. The superstructure houses a system of concrete vaults, an interior substructure of well-developed plan and ingenious fenestration that carried at the level of the top of the acropolis a rectangular building raised a meter above a surrounding terrace, perhaps a temple. It is known only that it faced NE, away from the town, and had walls of, or faced with, travertine, files of Ionic or Corinthian columns on a raised plinth down either side of a central nave, and curious small windows evenly spaced just above the plinth. The approach and pronaos, if there was one, are completely lost. Some have thought the whole might have been roofed with a vault. A num-

ber of advanced building techniques were employed: concrete vaulting, relieving arches over lintels, a segmental arch where there was not room for a full semicircle. The whole structure is adorned with four building inscriptions of the censors A. Hirtius and M. Lollius (*CIL* x, 5837-40). The date is much debated, but the architectural sophistication inclines the majority to the early 1st c. B.C. The whole complex is of a build with the rest of the acropolis fortifications, though variations in masonry appear in other stretches.

Just NE of the supposed boundary of the acropolis is a well-preserved market building of Republican date, a vaulted hall along one side of which open five vaulted shops, an important predecessor of the basilica of the Mercati di Traiano in Rome. There are poor remains of a theater, and at nearby Terme Pompeo are cold sulphur baths that were used in antiquity.

Ferentinum has yielded a great many inscriptions, some of which are housed in the Raccolta d'Arte Comunale, but the most famous is the will of Aulus Quintilius of the time of Trajan, carved in the rock outside Porta Maggiore, in which he left income from lands to the community (*CIL* x, 5853).

BIBLIOGRAPHY. T. Ashby in *RömMitt* 24 (1909) 28-48; A. Bartoli in *BdA* 34 (1949) 293-306[MPI]; G. Gullini in *ArchCl* 6 (1954) 185-216 & pls. 44-63; L. Benevolo & F. Fasolo in *Istituto di Storia dell'Architettura* 10 (1955) 8-11[PI].

L. RICHARDSON, JR.

FERENTIUM (Ferento) Italy. Map 16. A town 88 km NW of Rome and 7.5 km W of the Tiber, in a region scarred by deep ravines and lying about 300 m above sea level. Rome wrested control of the district from the Etruscans ca. 265 B.C. Etruscan Ferentium (7th-5th c. B.C.) lay on a site slightly SW of the later Roman town: excavation has recently laid bare its necropolis, temples, and houses with terracotta decoration.

Roman Ferentium was already a flourishing municipium by the time of Augustus, and it remained such down to the Late Empire. Its most famous native son was Otho, the ephemeral emperor of A.D. 69, whose family sepulcher was found immediately NE of the site in 1921. Flavia Domitilla, wife of Vespasian and mother of the emperors Titus and Domitian, may also have come from Ferentium (Suet. *Vesp.* 3). In the Late Empire Ferentium dwindled to a village, but it retained its own bishops down to the 7th c. Neighboring Viterbo finally destroyed the place in 1172.

Its temples to Fortune and Salus, recorded by Tacitus (*Ann.* 15.53), have disappeared, but its theater, in the S section of the site, is one of the best preserved anywhere. Apparently it was built under Augustus, or slightly earlier, and was later restored (perhaps under Septimius Severus). Explorations in 1901 and 1927-28 revealed that it conforms closely to the theater norms recommended by Vitruvius (*De Arch.* 5.6), who may have been living at the time of its original construction. The scaena, ca. 40 m long, was adorned with marble statues of Apollo, the Muses, and a winged Pothos, copied from originals by Skopas: these are now in the Museo Archeologico in Florence. The rear wall of the scaena, lofty as usual, seems to belong to the later reconstruction: it is largely of brick and was pierced by 11 exits (seven survive) leading to an ambulatory. The stage proper was on the N side of the scaena: its surviving foundations, built of a local peperino commended by Vitruvius (*De Arch.* 2.4.7), show that it was 5 m deep and ca. 1.5 m high; the customary three doors linked the proscenium with the scaena. The orchestra has a diameter of 28 m, is paved with the local peperino, and is reached by parodoi faced with opus reticulatum. The

cavea was originally divided into six sections: little remains of its original stone seating, but 13 rows have been recently restored in cement. A spectacular semicircle of massive stone pilasters, 60 m in diameter, runs round the cavea: the 28 pilasters are 4 m apart and are linked by arches, 25 of which (one of them restored) still stand, their voussoirs holding themselves in place without cement. Surviving fragments of the marble cladding further attest the sumptuous appearance of the theater.

Next to the theater on the E are extensive ruins of baths, mostly of brick but with some opus reticulatum: fragments of marble, of stucco veneer, and of white and black mosaic paving also survive. The date seems Augustan, but there were later rebuildings. Investigation in 1908-9 revealed that the baths covered ca. 4000 sq. m, provided separate accommodations for men and women, and had the tepidaria and calidaria at the S end as usual. They, too, apparently adhered to Vitruvian canons.

An inscription on a marble slab used for repairing the baths in the Late Empire indicates that the forum was monumentalized, in either A.D. 12 or 18, with an Augusteum, as yet unidentified, which housed over 50 statues.

Blocks from the E end of the town wall and traces of the defensive agger at its W end also survive, as well as a well-preserved stretch of the decumanus maximus that ran W to join the Via Cassia some 4 km away. Excavation will probably reveal much else, especially in the NE part of the site where remains of an amphitheater are clearly visible.

Several ancient bridges cross the nearby ravines, the most notable being the lofty Ponte Funicchio of ca. 100 B.C. immediately to the SW.

Many of the archaeological finds are now at Viterbo in the Museo Civico (the convent of S. Maria della Verità). They include an altar front with bas reliefs (from the Augusteum ?), a female statue (headless but beautifully draped), and numerous inscriptions (one of them honoring Otho).

BIBLIOGRAPHY. A. Garzana, *Ferento: Guida degli Scavi* (1935); M. E. Blake, *Ancient Roman Construction in Italy* (1947) 221, 224, 240; pl. 26 fig. 2; P. Giannini, *Ferento* (1971)[MPI], with good bibliography.

E. T. SALMON

FERENTO, *see* FERENTIUM

FERMO, *see* FIRMUM PICENUM

FERRANDINA Lucania, Italy. Map 14. An isolated crest on the slopes that dominate the right bank of the Basento river, about 60 km from the plain on which Metapontion stood. The crest was divided into two plateaus. At the base of the plateau to the E, scattered tombs have been discovered (8th-3d c. B.C.). On the smaller one to the W, Croce Missionaria, destroyed today, a native settlement has been brought to light comprising ovoid and rectangular huts dating from Iron Age I to the end of the 7th c. B.C. when the original inhabitants came into contact with the Greek habitations along the coast.

At the edge of Croce Missionaria, in the present-day Piazza Mazzini, various tombs (late 8th-early 7th c. B.C.) have been discovered. The grave gifts include mixed vases (small sacrificial bowls), and uncommon riches in bronzes with geometric designs. Other furnishings (late 8th-early 3d c. B.C.) include pendants, brooches, bracelets, and a belt richly decorated with incised bands of so-called wolf teeth, with swastikas and rhombuses.

Greek contact is also characterized by the presence of a series of skyphoi and cups thought to be original to the area of Metapontion. These vases indicate that the native population of Ferrandina was also part of the zone of

influence of Metapontion (proschoros) along the borders of this colony. During the second half of the 4th c. B.C. the rich grave gifts include vases of the Painter of Pisticci, Apulian vases in the ornate style. The local production had completely disappeared.

At the beginning of the 3d c. B.C., habitation on the two hills was abandoned, but in the Republican period large farms appeared and continued to exist until the late Roman era. These farms are situated in the Macchia region toward the mediaeval fort of Uggiano.

BIBLIOGRAPHY. E. Bracco, *NSc* (1947) 153f; (1953) 383-89; G. F. Lo Porto, *NSc* (1969) 157-65.

D. ADAMESTEANU

FERRERE Hautes-Pyrénées, France. Map 23. A votive altar dedicated to the deified Mountains, to Silvanus, and to Diana (*CIL* XIII, 382) was found at a height of ca. 1100 m in the forest of Salabé in the clearing of the Cortail de Tous. It is now kept at the Musée Saint-Raymond at Toulouse.

BIBLIOGRAPHY. M. Labrousse, "Etat-Civil d'un autel votif gallo-romain de la Barousse," *Rev. de Comminges* 71 (1958) 1-7; cf. P. Wuilleumier, *Inscriptions latines des Trois Gaules* (1963) 39, no. 123. M. LABROUSSE

FERRERE and SOST Hautes-Pyrénées, France. Map 23. On top of the Montlas, at a height of 1729 m, have been found several small votive altars of white Saint-Béat marble. They mark the site of a summit cult.

BIBLIOGRAPHY. M. Labrousse in *Gallia* 7 (1949) 146; G. Fouet, "Cultes gallo-romains de sommets dans nos Pyrénées centrales: le Montlas," *Rev. de Comminges* 76 (1963) 8-11. M. LABROUSSE

FETHIYE, *see* TELMESSOS (Lycia)

FEURS, *see* FORUM SEGUSIAVORUM

FIESOLE, *see* FAESULAE

FIĞLA, *see* POGLA

FILICUDI, *see* AEOLIAE INSULAE

FILYOS, *see* TIOS

FINIK, *see* PHOINIKE

FIRENZE, *see* FLORENTIA

FIRMUM PICENUM (Fermo) Marche, Italy. Map 14. A Picene town 6 km inland from the Adriatic, S of the river Tinna; its port was called Castellum Firmanum (or Firmanorum). Site of a settlement from the Early Iron Age, Firmum became Roman in the conquest of Picenum and had a Latin colony as early as the beginning of the first Punic war. It remained faithful to Rome in Hannibal's war and was a stronghold of Rome against the Italians in the social war. In the civil war of 48 it sided with Caesar, and in 44 with the Republicans against Antony, for which it had to accept a colony of veterans. It belonged to the tribus Velina. It declined under the Empire, and fell to Alaric in 408.

Remains of fortifications in large rectangular blocks, once thought Etruscan, are now assigned to the Latin colony. The most interesting antiquity is the piscina epuratoria, built between A.D. 41 and 68, a chain of cisterns of which 24 have been explored and 6 put to use as a reservoir. There are also ruins of a theater and interesting Early Christian remains above a pagan temple in the cathedral. A small museum of antiquities, including material from the Early Iron Age necropolis is kept in the Palazzo degli Studi.

BIBLIOGRAPHY. H. Nissen, *Italische Landeskunde* (1902) 2.423-25; *EAA* 3 (1960) 624-25 (G. Annibaldi)P.

L. RICHARDSON, JR.

FISCHAMEND, *see* LIMES PANNONIAE

FISHBOURNE Sussex, England. Map 24. The Roman building complex lies at the head of Chichester harbor 1.6 km W of the town. Excavations in 1961-69 have revealed traces of occupation from the Roman invasion in A.D. 43 until the early 4th c. In the first phase (43 to 50) a group of timber store buildings were erected on either side of the stream which flowed into the harbor. They are of military type and probably represent part of a military supply base erected at the time of the invasion for use in the conquest of SW Britain. In the early 50s the military buildings were replaced by timber houses of a civilian type, roads were remetaled, and bridges built. During the 60s the main timber residence was replaced by a masonry building (the protopalace), which consisted of a range of rooms attached to a colonnaded garden with elaborate Corinthian columns. At one end of the building range was a substantial bath suite. The rooms were originally decorated with mosaics, opus-sectile, marble veneering, and wall paintings. Another masonry building, apparently unfinished, lay W of the protopalace.

About A.D. 75 work began on a large building which incorporated the protopalace in its SE corner. The main part of the palace consisted of four wings enclosing a large central garden. To the S of the S wing lay another garden stretching down to the sea, where wharfs and jetties were constructed. On the N side of the N wing was an enclosed yard for various domestic activities such as milling and baking. The entire E side of the complex was flanked by a road, joined at right angles by the main road from Chichester. The N garden with its enclosing ranges was laid out on an E-W axis continuing the line of the approach road. Astride the axis, in the E wing, lay an entrance hall that opened onto a central pathway lined with bushes leading across the garden to an audience chamber in the center of the W wing. The main complex was largely symmetrical about this axis, except for the E wing which incorporated the protopalace.

On the N side of the entrance hall, in the E wing, were two colonnaded gardens flanked by suites for visitors. The NE corner was occupied by a large aisled hall, possibly an assembly hall with religious connotations. The N wing consisted of a series of rooms arranged in an E, with small colonnaded gardens between the short arms; the entire S side was closed by a continuous colonnade opening on to the main garden. All the rooms originally had mosaic pavements, of which substantial parts survive. The planning of the range suggests provision for visitors in sumptuous self-contained suites.

Only the N part of the W wing has been excavated. Its rooms were large and public, increasing in size towards the central audience chamber; all were once floored with mosaics. The audience chamber was a square room with a bench-lined apsidal recess set in one wall. It was originally roofed with a stucco vault and approached by a flight of steps from the garden. Little is known of the S wing, which lies beneath modern houses and a main road, but it would appear to have been the owner's private residence. The identity of the first owner is uncertain, but it is a strong possibility that the palace was built for the local client king, Tiberius Claudius Cogidubnus.

Throughout the 2d and 3d c. the building continued in

use but was drastically modified by demolitions, additions, and the laying of several polychrome mosaics. In the late 3d c. it was destroyed by fire and never rebuilt. The N half of the palace is now open for inspection: the N wing is entirely exposed beneath a protective building and the garden has been replanted according to its Roman plan. A site museum houses the archaeological collection.

BIBLIOGRAPHY. B. Cunliffe, *Excavations at Fishbourne 1-2* (1971); id., *Fishbourne: A Roman Palace and its Garden* (1971). B. W. CUNLIFFE

FIUMICINO, *see* SHIPWRECKS

FLAVIA NEAPOLIS (Nablus) Jordan/Israel. Map 6. Between Mt. Gerizim and Mt. Ebal, a colony of Roman veterans founded by Vespasian after the Second Temple was destroyed. The new town was built on the site of an earlier one, of which only the name, Mabartha, is known (Joseph. *BJ* 4.449). Pliny (*HN* 5.69), mentioning Samaria, gives the earlier name in a corrupted form, Mamorta. In A.D. 72 the city established an era of its own, by which it dated its coins to the middle of the 3d c. A.D. On many of the coins the temple on Mt. Gerizim is portrayed. In A.D. 244 Philip the Arab raised the town to the rank of a colony, naming it Colonia Iulia (or Sergia) Neapolis.

Christian sources refer frequently to Neapolis. It was the seat of a bishop, and two of its bishops participated in the councils of Ancyra (314) and Nicaea (325). In the Early Byzantine period the majority of the inhabitants of Neapolis were, however, Samaritans, who oppressed the Christian minority. In the 4th c. the Samaritans built a synagogue. In the 6th c. Neapolis is still described as a large city on the Medaba mosaic map, where its walls are shown with a gate on the E, opening on a large market. From the market one colonnaded street, intersected by another, passes through the middle of the town. At the intersection of the two streets a domed building rested on four columns. A nymphaeum and a large church are also shown in other quarters of the city. The remains of the ancient town are still hidden below the modern town of Nablus, a name which has preserved the ancient form. There have been no excavations.

BIBLIOGRAPHY. F. M. Abel, *Géographie de la Palestine* II (1938) 396-97; M. Avi-Yonah, *The Holy Land from the Persian to the Arab Conquests (536 B.C. to A.D. 640). A Historical Geography* (1966). A. NEGEV

FLAVIA SOLVA (Steiermark) Austria. Map 20. In the SE corner of Noricum ca. 35 km S of Graz. It was on the ancient road which led from Poetovio up through the Mur valley to Ovilava and the Danube limes. A bit off the main roads, the Noric main road in the W and the Amber road in the E, Flavia Solva is mentioned neither in the *Peutinger Table* nor in the itineraries. The name, perhaps Illyrian, continues in modern river and land names.

According to Pliny (*HN* 3.146), Flavia Solva was founded by Vespasian (A.D. 69-79) and was called Municipium Flavium Solvense. It never became a colonia as asserted in older literature, nor was it ever a garrison. Being distant from the major traffic arteries, it was historically unimportant. It was a quiet country town with considerable prosperity as evidenced by numerous stone monuments. Flavia Solva suffered heavily during the Marcomannic wars, but experienced toward the end of the 3d c. A.D. a certain renaissance. It was finally destroyed at the beginning of the 5th c.

The town was well situated on an elevated terrace on the right bank of the river Mur, near Klein Wagna, ca. 2 km SW of Leibnitz. Excavations have been supplemented since 1950 by occasional test and emergency digging. Nothing excavated is above ground. A considerable part of the built-up area (ca. 600 x 400 m) is known today. The settlement was not walled in. It consisted of regular house blocks of different sizes, some of which have been excavated. The larger insulae, located in the center, are separated by wide streets crossing at right angles. Strangely enough, there was no sewage system and no aqueduct. A large insula (71 x 60 m) N of the decumanus maximus, formerly identified as a forum, was probably only an elegant villa. No public building at all is known. At the SW edge of the town is the amphitheater (3d c. A.D.); for the arena (80 x 35 m) use was made of a natural basin; its ground plan is still recognizable in the terrain. The roads leading out of the town are paralleled by necropoleis with hundreds of tumuli from the Late Bronze Age to the Marcomannic wars.

More than a hundred stone inscriptions and tombstone reliefs are built into the wall of the court of the nearby castle Seggau, which is thus transformed into an outdoor museum. Other finds from the municipium are in the castle Graz-Eggenberg, which contains an outdoor lapidarium.

BIBLIOGRAPHY. Flavia Solva: E. Diez, *Flavia Solva. Die römischen Steindenkmäler auf Schloss Seggau bei Leibnitz* (2d ed. 1959); id. in *EAA* 3 (1960) 704f; W. Modrijan, "150 Jahre Joanneum 150 Jahre Forschungen in Flavia Solva," *Schild von Steier* 9 (1959-61) 13ff[MPI]; id., "1900 Jahre Flavia Solva," *Schild von Steier, Kleine Schriften* 11 (1971)[MPI].

Frauenberg: W. Modrijan, *Frauenberg bei Leibnitz. Die Frühgeschichtlichen Ruinen und das Heimatmuseum* (1955); Graz-Eggenberg: W. Modrijan & E. Weber, *Die Römersteinsammlung im Eggenberger Schlosspark, 1. Teil: Verwaltungsbezirk von Flavia Solva* (1965).
 R. NOLL

"FLAVIOBRIGA," *see* CASTRO URDIALES

FLAVIOPOLIS (Kadirli) Cilicia Campestris, Turkey. Map 6. Almost certainly identifiable with modern Kadirli on the river Savrun at the NE corner of the plain and ca. 160 km from Adana. Kozan (120 km NE of Adana) is out of the question since it has virtually no pre-Armenian remains and no trace of an ancient road thither from the ruins of Anazarbos (Anavarza) 35 km S. According to the *Antonine Itinerary*, however, Flaviopolis was the first city from Anazarbos on the road N to Kokossos (Göksun), and a stretch of this road, with milestones in situ, still exists. Also, ca. 5 km N of Anavarza, a Roman bridge spans the Savrun at Tozlu and a number of inscriptions were found there in 1949. Most scholars agree on the identification of Flaviopolis with Kadirli, for epigraphic evidence there proves the existence of a city whose magistrates were demiurgi.

Flaviopolis was founded in A.D. 74 by Vespasian, as part of an imperial program for the urbanization of the Cilician Plain. Until then the rural hinterland, as well as the city of Anazarbos, was probably administered by the Tracondimotid dynasty from Hieropolis Castabala. Some mosaic floors, inscriptions, and building blocks have been found at Kadirli, and a 6th c. church has been excavated. Flaviopolis was bishopric of Cilicia Secunda in the Christian era.

BIBLIOGRAPHY. *It.Ant.* 212.2; J. T. Bent, *JHS* 11 (1890) 223-26; R. Heberdey & A. Wilhelm, "Reisen in Kilikien," *Wien. Denkschr.* 44 (1896) 32-33; H. Bossert & B. Alkım, *Karatepe, Second Prelim. Report* (1947) 17ff; M. Gough, *AnatSt* 2 (1952) 93-95. M. GOUGH

FLAYOSC Var, France. Map 23. Four km W of Draguignan are many traces of a Gallo-Roman settlement in the vicinity of Saint-Pierre chapel. There are floors in opus signinum, pieces of dolia, drums of columns, pottery, millstones, inhumation burials under tiles, and the funerary inscription of one C. Iulius Asiaticus (*CIL* 12,288). A mediaeval settlement is mentioned by 11th c. texts. The material is deposited at the Centre de Documentation Archéologique du Var at Draguignan.

BIBLIOGRAPHY. L. Laflotte, "Flayosc," *Provincia* (1923); *Forma Orbis Romani*: Var. (1932).

C. GOUDINEAU

FLEURY Canton of Coursan, Aude, France. Map 23. Gallo-Roman establishment S of Béziers, on a small rocky butte near the coast at the locality called La Fount de Rome. The platform of less than 1 ha on which the buildings were located is shored up on the S and E by strong supporting walls faced with regular small blocks. Only the S wing of the establishment has as yet been excavated; it consists of several rooms and probably some baths. The artifacts discovered cover the entire Gallo-Roman period. This ensemble, small but original in form, may have had a cultic purpose.

BIBLIOGRAPHY. "Informations," *Gallia* 27 (1969) 383.

G. BARRUOL

FLIESSEM Germany. Map 20. The villa of Fliessem lies on a SE slope ca. 5 km N-NE of Bitburg (Beda Vicus) and 800 m E of the Roman road from Trier to Cologne. About 380 x 133 m in area, it comprises a manor house and walled farmyard with stalls, barns, and servants' quarters. The site of the ruins, known locally as Weilerbusch, was exposed in 1825 and revealed, in addition to a settlement of the Late Iron Age, a villa with 66 chambers, halls, and rooms, partly heated by hypocausts. Originally a porticoed villa with wings, it was enlarged before the 4th c. by rebuilding and additions. On the W, S, and E sides it was provided with projections and corner pavilions, while on the valley side the ground was artificially terraced and a cryptoporticus built with a colonnade above it, so that the building offered richly articulated facades on three sides. In the area NW of the house were a small bath and a larger, later bath complex 100 sq. m in area, with apodyterium, frigidarium, tepidarium and caldarium, sudatorium and praefurnium. Three of the larger rooms in the E tract were heated and had mosaic floors with geometric ornaments—rosettes, rhomboids, volute-panels—severe in composition and delicately colored. Of 13 original mosaics, four are preserved in situ. On the slope opposite, in the entrance hall, is a sanctuary with two rectangular Gallo-Roman temples with ambulatories, dedicated, according to votive coins, to Diana and Minerva. After its flowering in the 2d c. (as dated by the mosaics), the estate remained under cultivation to the end of the Roman period. Destroyed in the 5th c., the community was resettled by the Franks as indicated by a Frankish stone sarcophagus found in the villa.

BIBLIOGRAPHY. E. Gose, "Der Tempelbezirk von Otrang bei Fliessen," *Trierer Zeitschr.* 7 (1932) 123; P. Steiner, "Das römische Landgut bei Fliessem," *Führungsblätter des Landesmuseums Trier* 8 (1939).

H. CÜPPERS

FLORANGE-DASPICH-EBANGE Moselle, France. Map 23. A view SW of Thionville. Ancient workshops were discovered here: 1) potteries (in the middle of Daspich) centered W of the Daspich-Terville Roman road (roughly corresponding to modern N 412); native and Belgian ware was produced from the end of the Gallic period to the 3d c. 2) E of the road mentioned

above, forges and metallurgical works dating from the middle of the 1st c. to the 3d c. The settlement was apparently twice destroyed by fire in the 1st c. A statuette of Epona was discovered in 1964.

The Thionville museum has an archaeological collection.

M. LUTZ

FLORENTIA (Firenze) Tuscany, Italy. Map 14. A Roman colony, established probably about the middle of the 1st c. B.C., following the devastation of the area in the Catilinarian conspiracy and its aftermath, and reinforced by a new draft of colonists under the first triumvirate (*Lib.Colon.* 1.213). It stood on the N bank of the Arno near its junction with the Mugnone, a site already long inhabited, guarding a river crossing and destined to become an important road center. The colony was inscribed in the tribus Scaptia, and the town was given a castrum plan (ca. 480 x 420 overall) with brick-faced fortifications that employ round towers. The city throve, showing special prosperity and growth under Hadrian, and early became a bishopric; it seems never to have ceased to be inhabited.

The most interesting remains of the ancient city discovered to date are the marble-paved forum with an imposing triple-cella capitolium dominating its length. There have also been found remains of a Temple of Isis, two bath complexes, a theater and amphitheater, and two Early Christian basilicas, as well as numerous dwellings and tombs. Little that is ancient is visible in situ today, but the archaeological record has been scrupulously kept and the finds housed in the Museo Archeologico.

BIBLIOGRAPHY. A. K. Lake in *MAAR* 12 (1935) 93-98; G. Maetzke, *Florentia* (*Italia Romana: Municipi e Colonie* 1.5) (1941)MP; id. in *NSc* (1948) 60-99.

L. RICHARDSON, JR.

FLORENVILLE-CHAMELEUX Belgium. Map 21. An important station on the Rheims-Trier road. The site was excavated in 1954-56, and in 1966 the remains of the buildings were made into an archaeological zone. Digging made it possible both to see how Roman roads were built in N Gallia and to study an official statio of the cursus publicus. The road from Rheims to Trier was built under Claudius, as is shown by a milestone (found at Buzenol, not far from the Chameleux station) which probably originated in the vicus of Etalle, from which remains were carried to Buzenol as building material. When the road was built, the site was first cleared down to virgin soil and a ditch dug to mark the axis of the road. Next, two more ditches, one at each side, were hollowed out and the earth shifted to the middle so as to fill the middle ditch and make the first layer of the road surface. This latter was made of stone, carefully placed edgewise to a thickness of 25 cm. On top of this a layer of gravel was placed, 10-20 cm thick, as surface. The Roman roads of northern Gallia do not seem to have been paved with stone. The width of the surface was 5.8 m (20 Roman feet); counting the side ditches the total width of the road came to 14 m. The road was restored and strengthened at different times with the addition of fresh layers of gravel, so that in places the gravel was ultimately more than 2.5 m thick.

The statio proper existed from the middle of the 1st c. A.D. to the beginning of the 5th. It consisted of a number of buildings arranged on either side of the highway. These structures were rebuilt several times, as traces of fire and floods at several levels reveal; however, it seems likely that the damaged buildings were, for the most part, rebuilt on the same locations and according to the same plans. The earliest buildings were of wood;

later ones had masonry walls of fairly irregular blocks bonded with strong mortar. Most of the structures were built on oblong plans, a narrow side (8-10 m wide) fronting the street, along which extended a wooden colonnade. There were no party walls, the houses being separated by roofless passageways to lessen the danger from fire. The hearth was sometimes in the middle of the main room, sometimes backed up against a wall. Most of the buildings had a small cellar reached by a wooden staircase; often there are traces of half-buried amphorae on the floor. The largest building (24 x 10 m) had a wide entrance leading to a central courtyard on either side of which were sheds for vehicles; at the back of the courtyard was the main part of the building: this was most likely the mutatio where the vehicles of the cursus publicus changed horses.

After the invasions of the second half of the 3d c. the principal vici of the Rheims-Trier road, such as Carignan and Arlon, were fortified. It was then that a rectangular fort was built on the hills overlooking the statio of Chameleux (the Williers hills, on the other side of the present Franco-Belgian frontier); the ruins of the wall surrounding it can still be seen. The fort may have been occupied by a detachment of Germanic Laeti; in fact the *Notitia dignitatum* (*occ.* 42.38) mentions some Laeti being at Epoisso (Carignan), only a few km from Chameleux.

BIBLIOGRAPHY. J. Mertens, "Quelques aspects de la Romanisation dans l'Ouest du Pays Gaumais," *Helinium* 3 (1963) 205-24; id., "Le Luxembourg méridional au Bas-Empire," *Mémorial A. Bertrang* (1964) 191-202; id., *Le relais romain de Chameleux* (1968) 36 pp.[MPI]

S. J. DE LAET

FOÇA, *see* PHOKAIA

FOCE DEL SELE Italy. Map 14. Near the mouth of the Sele, which flows through the plain N of Paestum, a sanctuary of the archaic period dedicated to Argive Hera (Strab. 6.252; Plin. *HN* 3.70; Solin. 2.12; Plut. *Vit.Pomp.* 24.3). Since the sources are unanimous in attributing the foundation of the sanctuary to Jason, it has been conjectured that the Heraion may have been founded by Thessalians, as was Posidonia. However, this hypothesis fails to find confirmation in more recent archaeological evidence (Treasury I) on the basis of which rapport with Sybaris is apparent as far back as the archaic period. The Heraion was abandoned in late antiquity and became a source of limestone for mediaeval buildings.

The numerous terracotta votive objects permit a reconstruction of the type of Hera of the sanctuary. At the end of the 7th c. or at the beginning of the 6th the goddess is already represented seated, with a polos, supporting a child with her left arm, and carrying a pomegranate in her right hand.

The sanctuary flowered mainly in the archaic period, specifically during the 6th c. Treasury I was constructed between 570 and 550, and at that time the first series of metopes was made. The octastyle temple was erected toward the end of the century. Between the end of the 5th c. and the second half of the 4th the buildings were gravely damaged and the treasury was probably destroyed. The architectural elements and the metopes were reused in a stoa of the 4th c. The finding of numerous votive objects indicates that the sanctuary flourished at the end of the 4th c. and during the Hellenistic age.

Between the end of the Republican epoch and the 1st c. A.D. the sanctuary declined rapidly. An earthquake, perhaps in 63, probably destroyed the octastyle temple. The eruption of Vesuvius in 79 buried the Heraion, and every trace of life seems to have disappeared from the area by the beginning of the 4th c.

Treasury I: Few elements of the building are preserved in situ. Of the naos there remains the end wall to the W and the long walls to a maximum height of four courses. There is no trace of a pronaos nor of a wall between it and the naos. Thus reconstruction remains substantially hypothetical. Of 38 metopes belonging to the treasury, three are illegible. On the basis of material discovered within the foundation of the building, and from a stylistic examination of the reliefs, it has been possible to date the metopes to ca. 570. The erection of the treasury has been attributed to the Sybarites, and its incompleteness to the destruction of their city. Two metopes and various fragments have been ascribed to two different buildings called Treasury II and Treasury III, the foundations of which have not yet been traced.

Heraion: An octastyle temple (18.7 x 38.9 m) with 17 columns on the long sides. The stereobate is preserved to its entire height in a few places. The instability of the terrain dictated the placing of four courses under the peristasis and two under the cella in the points of greatest pressure by the superstructure. The axes of the cella walls are aligned with those of the corresponding columns of the peristasis, following the Ionic usage. The cella is composed of a pronaos, naos, and adyton. The lateral walls had columns instead of antae. The pteroma widens greatly on the E side, equaling the dimensions of three interaxials. The remains of the columns are constructed of drums of sandstone conglomerate, all with eighteen flutes, to which correspond two groups of capitals, diverse in profile. A multiple molding crowned the architrave with neither taeniae nor regulae. On both sides of the course there was a Doric cyma in place of the Ionic. The moldings of the external faces bear a plastic decoration with Lesbian leaves, egg and dart, and bead and reel. The normal Doric geison was formed above the frieze by a multiple molding bearing from top to bottom a Lesbian leaf, an Ionic leaf, and a small cyma reversa surmounted by an astragal. Above runs a cyma ornamented with lions' heads. Of the frieze there remain three fragments of triglyphs and twelve figured metopes of unequal height and tapering toward the bottom.

The temple was entered by means of a ramp abutting the crepidoma on the E front. The altar is situated at a distance of 34.1 m from the E front.

The sacred area was delineated at the N by two stoas of rectangular plan. The NW stoa seems to be, from the discovery of proto-Corinthian oinochoai under the floor level, the most ancient building of those yet explored. The NE stoa dates to the epoch succeeding the construction of the sanctuary, between the first and the fourth quarter of the 4th c. B.C. Almost contemporary with the NE stoa, and connected with it, is a third stoa to the E. This one is a more irregular structure built with reused material from Treasury I and from the octastyle temple.

In the area between Treasury I and the octastyle temple, and S of them, bases have been found for donations, for votive columns, and for a bronze lebes. To the SE of the octastyle temple area a square tower has been found, constructed in the 3d c. exclusively of reused material, including many metopes.

The most recent discovery at the mouth of the Sele is a building situated to the E of the Heraion. It was constructed a little after 400 B.C. in the center of a larger space on a ditch dug for the laying of the foundation and serving also as a dump for votive objects, datable between 575 and 425, coming from the destroyed treasury. In spite of the square plan and the opening to the S, it appears to have been a cult building, destroyed in

connection with the sending out of the colony from Paestum and not intended to be used again.

BIBLIOGRAPHY. P. Z. Montuoro & U. Z. Bianco, *Heraion alla foce del Sele* I-II (1951-54); P. Z. Montuoro in *Atti e memorie della Società Magna Grecia*, NS 2 (1958) 8ff; 3 (1960) 69ff; 5 (1965) 57ff; 6-7 (1965-66) 24ff; 8 (1967) 7ff; S. Stucchi in *Annuario della Scuola archeologica italiana di Atene*, NS 14-16 (1952-54) 41ff.

F. PARISE BADONI with P. H. SCHLÄGER-STOOPS

FOLIGNO, *see* FULGINIA

FONDI, *see* FUNDI

FONTAINE-VALMONT Belgium. Map 21. A Gallo-Roman vicus on the Bavai-Trier road immediately to the E of the point where the road fords the Sambre. The settlement developed on a site of more than 25 ha, at the place called Champ des Castellains, at the boundary between the Nervii (to the W) and the Tungri (to the E). In the Early Empire this boundary between two civitates would become the frontier between the provinces of Belgica secunda and Germania inferior. Many important finds have been made here: some substructures, a cellar, architectural fragments, a life-size horse's head of marble, and coins that form a continuous series from Augustus to Gallienus and Postumus. A little farther E, at Le Castia, more substructures were found but not excavated (villa? castellum of the Late Empire?). Here also a necropolis was uncovered that had a luxurious tomb (a vault made of marble slabs, containing a beautiful urn of white marble from the mid 2d c.).

Systematic excavations at Champ des Castellains started in 1955, uncovering the foundations of a double sanctuary in the Celtic tradition, with a square cella and a peribolos, inside one surrounding wall. The twin temples were mounted on a podium with steps and are oriented to the E. Built toward the middle of the 1st c. A.D., they appear to have been destroyed by fire in the 3d c. Some 400 m from this sanctuary, baths were excavated. In the complex (38.35 x 35.4 m) were found hypocausts for the caldarium and sudarium, a palaestra, an outdoor pool to the N of the buildings, and a second pool that had a tile roof on wooden posts. A small altar stood at the entrance to the baths. The complex was built over the substructure of a forge that probably dates from the late 1st c. A.D. or the early 2d c. The baths appear to have been destroyed by fire in the 3d c. Not far from them was a large burial site made up of a dozen enclosures. In the middle of each was a solid mass of masonry, sometimes square, sometimes round, that marked a burial vault and was very likely the base of a funerary monument. In each case smaller tombs were arranged inside the enclosures around the monument. So far there is no evidence that the vicus was still inhabited in the 4th c.

BIBLIOGRAPHY. R. De Maeyer, *De overblijfselen van de Romeinsche Villa's in België* (1940) 60-62; G. Faider-Feytmans, "Les fouilles du site romain de Fontaine-Valmont," *Mém. et publ. de la Soc. des Sciences du Hainaut* 71 (1957) 13-65; id., "Le site sacré de Fontaine-Valmont," ibid. 74 (1960) 3-47[MPI]. S. J. DE LAET

FONTENAY-SOUS-VÉZELAY, *see* VÉZELAY

FONTES TAMARICI (Velilla de Guardo, or Velilla del Rio Carrión) Palencia, Spain. Map 19. Site near Guardo. Pliny (31.23-24) describes the spring, which still exists. Its flow is irregular, as Pliny reports. Its bed was excavated during a period of drought, and large ashlar courses delimiting the tank were discovered below the more modern concrete structure that rises above the water level. The few finds dating from the Roman period included common ware, a bronze coin minted during the reign of Tiberius and bearing the effigy of Augustus, and a small fragment of an Hispano-Roman stele.

BIBLIOGRAPHY. A. Fernández de Avilés, "Prospección arqueológica en las *Fontes Tamarici* (Velilla-Palencia)," *Revista de Archivos, Bibliotecas y Museos* 69 (1961) 263-68[I]; A. García y Bellido & id., "Fuentes Tamaricas," *Excavaciones Arqueológicas en España* 29 (1964)[PI]. L. G. IGLESIAS

FONTVIEILLE Bouches-du-Rhône, France. Map 23. Situated 9 km NE of Arles. In antiquity the area E of Arles was covered with marshes in which a few tall rocks formed islands. One of these is Le Castelet, 2 km SW of Fontvieille; it was occupied from the Bronze Age on. The Phokaians of Marseille, moving toward the Durance, made it a trading post which was very prosperous in the 6th and 5th c. B.C., as shown by the great variety of pottery found on the site: Etruscan (bucchero nero), Ionian (with painted bands and a black glaze), Aeolian (gray with incised bands), gray Phokaian, Attic (black- or red-figured) and micaceous Massaliot sherds. The indigenous glazed vases were inspired by Greek models. A long period of decline ended with the Roman conquest, and Le Castelet was abandoned. Its latest pottery is Campanian A. All the material is synchronous with that of the Greek finds of Marseille and Arles. Deserted in the Gallo-Roman period, Le Castelet was not occupied again until the Middle Ages when the Benedictines settled on the nearby island of Montmajour. At Fontvieille the quarries of Les Taillades provided stone for the amphitheater at Arles; two Roman reliefs have been found there, the Altar of the Shell and an apotropaic composition. In the surrounding area the indigenous sanctuary of the Arcoule spring, at Le Paradou (6 km E) has disappeared, as has the aqueduct of the Roman mill of Barbegal (4 km S). The remains of a rutted road at the Mas du Prêcheur, 3 km N, mark the Via Aurelia.

BIBLIOGRAPHY. *Gallia* (1954) 430; (1960) 305; (1967) 403; (1969) 423. H. MORESTIN

FORDEN GAER Montgomeryshire, Wales. Map 24. This Roman fort lies on the E bank of the Severn a short distance N of Montgomery, and covers an important crossing of the river. The defenses were originally of earth, subsequently revetted with a timber-laced rampart of clay. Some internal buildings may have been of stone. The fort was established ca. A.D. 75-80 and was not finally abandoned before the reign of Valentinian I (A.D. 364-378). The finds are in the Powysland Museum, Welshpool.

BIBLIOGRAPHY. F. N. Pryce & T. D. Pryce, "Excavations of the Powysland Club at the Forden Gaer," *Archaeologia Cambrensis* 82 (1927) 333-54; id., "The Forden Gaer. Second Interim Report," ibid. 84 (1929) 100-39; id., "The Forden Gaer. Third Interim Report," ibid. 85 (1930) 115-30; P. J. Casey in V. E. Nash-Williams, *The Roman Frontier in Wales* (2d ed. by M. G. Jarrett 1969) 85-88[MPI]. M. G. JARRETT

FORDONGIANUS, *see* FORUM TRAIANI

FORÊT DE CHÂTILLON, *see* CHÂTILLON-SUR-SEINE (Forêt de)

FORLÌ, *see* FORUM LIVI

FORLIMPOPOLI, *see* FORUM POPILI

FORMENTERA, *see* OPHIOYSSA

FORMIA, see FORMIAE

FORMIAE (Formia) Latium, Italy. Map 17A. A coastal town ca. 4 km N-NE of Gaeta, exceptionally beautiful in situation and benign in climate. It faces S over the bay of Gaeta. It is uncertain whether its origin was Ausonian or Volscian; it appears first in history in 338 B.C. when it remained neutral in the Latin war and was rewarded by Rome with citizenship sine suffragio (Liv 8.14.10). Suffrage came in 188 B.C. when it was inscribed in the tribus Aemilia (Livy 38.36.9). Under Hadrian it received a colony and was designated Colonia Aelia Hadriana Augusta. It seems to have flourished until it was destroyed by the Saracens in 859. It owed its prosperity to its situation on the Via Appia, its abundant water, and the excellence of its agriculture, especially its fruit, and its attractions as a resort. It was among the earliest of the sites preferred by rich Romans for seaside villas, and it continued to draw them at least as late as the time of Symmachus. Its most famous frequenters were Pompey and Cicero, who was assassinated at his villa there while attempting to flee from the proscription of the triumvirs in 43 B.C. (Plut. *Vit. Cic.* 47-48). It may also have been the home of Vitruvius, the architect.

The town plan is hard to discern. Some walls in massive trapezoidal blocks and others in Roman concrete appear at various points. These must include remains of its fortifications and perhaps terrace walls of private villas. One circuit seems to have enclosed the arx of the city (Castellone); another, more fragmentary, can be completed as a larger triangle. An amphitheater and theater can be recognized inland and uphill from the waterfront. But Formiae's great glory is its ring of villa remains stretching from the Peschiera Romana in the Nuovo Porto, to the Porto di Caposele on the confines between Formiae and Gaeta. From Formiae to Gaeta the line of villas is, in effect, unbroken.

The most conspicuous of the remains are those in Villa Rubino, attributed without basis to the villa of Cicero, including an important nymphaeum and remains of substructions decorated with painting and stuccos, Villa Irlanda (a cryptoporticus with stuccos), and Villa Caracciolo (a great court surrounded by rooms and other constructions). From them have been removed a great many marbles, the majority of which are in the Museo Nazionale in Naples; the most famous are a fine pair of Nereids mounted on sea monsters. There are collections of antiquities gathered largely or entirely locally in Villa Rubino, the park of Piazza della Vittoria, and the antiquarium of the municipio.

In the vicinity of Formiae along the Via Appia are ruins of a number of monumental tombs of interesting architecture. The most imposing of these, 24 m high, is given the name Tomba di Cicerone.

BIBLIOGRAPHY. S. Aurigemma & A. De Santis, *Gaeta-Formia Minturno* (1955) 21-35, 80-88[MPI].

L. RICHARDSON, JR.

FORMIN, *see* RAMISTA

FORUM CLAUDII VALLENSIUM, *see* OCTODURUS

FORUM CLODII (San Liberato) Latium, Italy. Map 16. A station near Bracciano on the Via Clodia on the W side of Lake Bracciano. It was seat of a praefectura Claudia Foroclodi by the Augustan period and later an early bishopric. Abundant ancient remains, including many inscriptions, have come to light in agricultural work on the site, and much ancient material is built into the church of San Liberato, but systematic excavations have yet to be undertaken.

BIBLIOGRAPHY. A. Pasqui, *NSc* (1889) 5-9.

L. RICHARDSON, JR.

FORUM CORNELII (Imola) Emilia-Romagna, Italy. Map 14. The site of a Roman municipium 32 km SE of Bologna on the Via Aemilia. The site is in an area inhabited since prehistoric times, though little is known of the continuity. Monte Castellaccio, directly S of the town, was a way station in the Bronze Age and not the only example of such early development. The Roman center was certainly built in connection with the Via Aemilia and the name reflects restructuring of the region under Sulla. The centuriation has the Via Aemilia as an axis, and the cardo (Via Selice) crosses it in relation to the E part of the urban area. The town was an early diocesan seat. The economy appears to have been largely agricultural.

The plan of the city is very irregular in the E section where the Via Aemilia itself could not be straight because of the terrain. It is probable that there were two urban phases, with an expansion to the W characterized by a regular orthogonal system still partly preserved. It is documented by the discovery of paved streets and the remains of buildings. The civic center was definitely established in this area, at the intersection of the two principal axes. The plan of the city is notably elongated along the route of the Aemilia, with rectangular city blocks elongated in the same direction. The history of building construction is largely documented by the remains of extensive private houses. They include a domus in Via S. Pier Crisologo from the first Imperial age, which has polychrome mosaics, and the much earlier suburban villa with large rooms in Viale Rivalta. It also has mosaics. But the period of great building activity continued at least through the 3d c. A.D. The only public monument known today is the amphitheater, to the W of the city and parallel with the Via Aemilia. It was explored in 1929 and then covered over. Its axes measure 108 m x 81 m and it has a circular foundation of cemented brick and radial walls with opposing arches. It was dug into the earth, with earth packed inside the masonry sustaining the tiers. The arena was, in fact, much lower than the level of the plain in ancient times. The chronology of the building is not clear; possibly it dates from the early Imperial period. It is so large that it must have served the inhabitants of an extended area.

The extensive population of the countryside around the town is indicated by the relative number of large villas, especially in the natural amphitheater formed by the hills to the S of the city. Excavation of several villas has revealed the existence of establishments for farming. Elsewhere in the plain, kilns for the production of ceramics have been identified. The necropoleis are along the access roads and have not been noted in any detail. From the Ponticelli necropolis to the S came the remains of a large monument with leonine ornamentation. To the W is a suburban necropolis in use until late antiquity. In that area the first Christian center developed around the Church of S. Cassiano.

The modern name is probably pre-Roman, as attested by the late sources, and was revived in mediaeval times.

BIBLIOGRAPHY. Mancini et al., *Imola nell'antichità* (1957)[MPI].

G. A. MANSUELLI

FORUM DOMITII (Montbazin) Canton of Mèze, Hérault, France. Map 23. Important market created by the

proconsul Cn. Domitius Ahenobarbus two or three years before the founding in 118 B.C. of the provincial capital of Narbonne. The market was established on the great interprovincial road that was to bear his name, the Via Domitiana, exactly halfway between Nîmes and Narbonne, the two most important native cities in that part of the province and on the right bank of the Rhône.

The stopping place designated under this name in all ancient itineraries should be located in the area around Montbazin. The area has never been systematically explored, but important substructures have been found in different sectors on both sides of the ancient road, the line of which is still easily recognizable in this flat region. Moreover, numerous Gallo-Roman objects have been discovered in the surrounding area.

BIBLIOGRAPHY. *Carte archéologique de la Gaule romaine*, fasc. X, *Hérault* (1946) 16-17, no. 41; P.-M. Duval, *Gallia* 7 (1949) 227; "Informations," *Gallia* 22 (1964) 494; 29 (1971) 385. G. BARRUOL

FORUM HADRIANI (Arentsburg) S Holland, Netherlands. Map 21. Country seat in the village of Voorburg, near The Hague, where Roman remains have been found since the 16th c.: foundations, mosaic floors, tiles, pottery, glass, jewelry, coins, and bronze and iron objects of all kinds. The site was first identified with Forum Hadriani of the *Peutinger Table*, after the discovery of a heavy wall and some stone buildings.

Later several gates were identified, and the W wall found to be ca. 400 m long, the N wall ca. 200. The E side could not be located and to the S a wall never existed, as the W wall ended on the banks of the Vliet canal, which was probably the Roman Fossa Corbulonis (Tac. *Ann.* 11.20; Cass. Dio 60.30.6). Inside the walls traces of wooden buildings were interpreted as barracks, and this time the complex was thought to be an auxiliary fort and a base of the Classis Germanica identified with Praetorium Agrippinae of the *Peutinger Table*. This is incompatible, however, with the distances given by the *Peutinger Table* and the *Antonine Itinerary* (368.3ff) on the N road between Lugduno and Noviomagi. Moreover, the so-called barracks do not resemble ground plans known elsewhere, the walls and buildings are differently oriented, and the dimensions far too large for an auxiliary fort. The military character of Arentsburg is not proved by the tiles with military stamps, nor do the tiles with the stamp C(lassis) G(ermanica) P(ia) F(idelis) prove that it was a base for the fleet. Furthermore, few military objects have been found. The first identification was correct.

Arentsburg is the most important Roman site in W Holland and the only one where nonmilitary inscriptions have been discovered (*CIL* XIII, 8807-8). Pottery from the site indicates that some kind of settlement (of the Cananefates) existed in the first half of the 1st c. It was enlarged considerably after the Batavian revolt of 69-70, especially under Domitian, and became the capital of the civitas Cananefatum. The first stone buildings were probably erected in 120-60. Hadrian gave it the ius nundinarum in 120 or 121, after which it was called Forum Hadriani. Before 162 it was made a municipium, probably by Marcus Aurelius, and the settlement lasted until 260-70. It was perhaps reoccupied for some time a little later, as suggested by coins of Gallienus, Postumus, Claudius II, Constantine, Constantius II, and some late Roman fibulas. The finds are in the Rijksmuseum voor Oudheden in Leiden.

BIBLIOGRAPHY. J. W. Holwerda, *Arentsburg* (1923)MPI; A. W. Byvanck, *Excerpta Romana* II (1935) 204-17; 507-8; III (1947) 144-46; J. E. Bogaers, "Civitas en stad van de Bataven en Canninefaten," *Ber. Rijksdienst Oud. Bod.* 10-11 (1960-61) 263-317MPI; id., "Forum Hadriani," *BonnJbb* 164 (1964) 45-52MI; id., "Civitates und Civitas-Hauptorte in der nördlichen Germania Inferior," ibid. 172 (1972) 310-32MPI. B. H. STOLTE

FORUM JULII (Fréjus) Var, France. Map 23. Placed near the sea, the town is located at the mouth of the Argens valley. It is on the highroad from Italy to Spain and at the start of the N road to Reia Apollinaris (Riez). Although the Argens valley and neighboring hilltops have revealed traces of settlement from the Palaeolithic to the Celto-Ligurian period, the site of Fréjus was not occupied on a regular basis until the time of Caesar. The first mention of Forum Julii occurs in Cicero's correspondence (*Fam.* 10.15.3 and 10.17.1) in 43 B.C. Therefore, one can attribute to Caesar (perhaps at the time of the siege of Massilia in 49 B.C.) the creation or expansion of this stopping-place, which was both a market and a provisioning center. The port apparently was laid out during the Triumvirate, since Tacitus (*Ann.* 4, 5) says that Octavius sent Antony's fleet there after capturing it at Actium (31 B.C.). No doubt the port had already been used in the campaigns against Sextus Pompeius.

During the reign of Augustus, it was one of the major naval bases of the Empire, on the same footing as Misenum and Ravenna; later its role declined. Also in the Augustan period, probably shortly after Actium, a detachment of veterans of the 8th legion turned Forum Julii into Colonia Octavanorum. According to Pliny the Elder (*HN* 2.35) the town was also called Pacensis and Classica. In spite of the loss of its military role, the town remained a fairly important and prosperous administrative and economic center until the end of antiquity; it became the seat of a bishop at the end of the 4th c.

Linked to the sea by a canal which must have been ca. 1 km long and 50-80 m wide, the port is now completely filled up. Wharfs can be recognized to the W and S over a length of more than 500 m, and the area of the basin can be estimated at some 20 ha. The entry was defended by two towers linked to a wall which met the town ramparts. A small hexagonal monument was built on the ruins of one of these towers after ancient times. It was 10 m high, probably served as a signal platform, and is still visible. At the inner end of the port at the level of the S wharf are the remains of what was long thought to be a lighthouse with three stories, of the same type as those at Ostia and Ravenna, but it was probably nothing more than a tower.

Important vestiges of the ramparts of the colony have remained in place. The walls, Augustan in date, formed an irregular polygon more than 3.5 km long, giving the town an area of ca. 40 ha. More than 2.50 m thick on the average, the walls are faced with ashlar masonry with rubble fill. Here and there opus reticulatum was used. Several towers survive in part to the E and, above all, to the N, where one of them has two stories. The first floor is pierced with loopholes; the second is furnished with windows under a semicircular arch and is connected to the chemin de ronde of the fortifications. Two gates are still visible: the E Rome Gate and the W Gate of the Gauls. Both are set back from the ramparts, at the center of a semicircular wall and flanked by two round towers (the same type is known at Aquae Sextiae and Arelate). These two gates are at the ends of the decumanus maximus. The location of the gates of the cardo is known to the N, but has not been found to the S.

The S sector of the ramparts includes two natural

hillocks which dominated the port: the Saint-Antoine hill to the SW and the Platform to the SE. The former was defended by three towers. On the W side the rampart was reinforced on the inside by semicircular buttresses, intended to contain the pressure of the earth. A group of buildings arranged around a central court has been brought to light on the terreplein. They are set up on artificial fill designed to level the hillock. Ceramic material permits the fill to be dated to the last third of the 1st c. B.C. Under this fill have appeared the remains of a private dwelling of an earlier period. These are all that is left of Caesar's Forum Julii. The second level, the Platform, was also leveled off by a fill and by the construction farther down the slope of seven large, vaulted chambers, which acted as a base and support. A vast courtyard, into which there opens a cistern with three intercommunicating, vaulted chambers, is at the center of a series of living rooms with a peristyle and baths. The S side remained bare of all construction, to leave unobstructed the view of the port and the sea. The function of these buildings found on the two hills has been variously interpreted: a citadel and a praetorium? It is hard to settle this discussion with any certainty, but their construction in the Augustan period (that is to say, at the time when the naval port expanded) leads one to believe that they played an important role in the organization of the naval base.

Apart from some sections of streets and water mains and of some mosaics and various pieces collected in the museum, the only important structure excavated inside the fortifications is a theater. It had its back against a gently sloping hill in the NE part of the town and faced S. Its design was simple and it was little decorated. Apparently it too was Augustan.

The amphitheater was situated outside the NW corner of the walls and almost in contact with them (during the Middle Ages it served on more than one occasion as a fortress for attackers besieging Fréjus). It dates to a later period, to Flavian or even Antonine times. Its axes measure 113.85 m and 82.60 m respectively. It had only one story and its 16 tiers of seats accommodated ca. 10,000 spectators, or ca. half the capacity of the Arles and Nîmes amphitheaters.

The following are also to be noted outside the ramparts: to the SW the remains of public baths; a necropolis, of which there remains a mausoleum called La Tourrache; the bridge of the Esclapes, with its three arches; and, to the S, near the old port and close by the ramparts, the Golden Gate, the remains of a large vaulted chamber with three openings, whose nature has not been determined (a basilica? a large room in public baths?), but whose date is certainly later than the 2d c. A.D.

The aqueduct which fed Forum Julii is in an exceptionally good state of preservation. It can be followed over almost 40 km beginning at the foot of Mons hill, where it is a surface ditch. It then continues by underground canal, 3 m wide and vaulted. Arcades and tunnels take it to the Roman Gate. From there it follows the ramparts to the N, cuts across their NE corner, and meets the water tower to the W.

On the town hall square, the group of episcopal buildings comprises the cathedral, which originated in the renewal and transformation of an Early Christian church; the baptistery, whose first state goes back to the 5th c.; and the episcopal palace, which shelters the municipal museum (Gallo-Roman collections).

BIBLIOGRAPHY. A. Donnadieu, *La Pompéi de la Provence, Fréjus* (1927); P. A. Février, "Fouilles à la Citadelle méridionale de 'Forum Julii,'" *Gallia* 14 (1956)[P]; A. Grenier, *Manuel d'arch. gallo-romaine*, III: *l'Architecture* (1958)[PI]; id., "Fouilles a la Plateforme," *Gallia* 20 (1962)[P]; id., "Forum Iulii: Fréjus," *Itineraires ligures* 13 (1963)[MPI]. C. GOUDINEAU

FORUM JULII (Cividale del Friuli) Italy. Map 14. A city in the Natisone river valley ca. 17 km from Udine. There are remains from the Neolithic, Bronze, and Iron Ages and traces of contact with the nearby early Veneti though here these peoples were overcome by a Carni invasion so threatening as to induce the Romans to establish the Latin colony of Aquileia in 181 B.C. A hypogeum, with remains of sculpture (three large stone masks of the type of the celebrated "Têtes coupées" in S France), shows traces of long use. This and persistent echoes in the local toponymy are the only remains of this population that was conquered in 115 B.C. by the consul M. Emilius Scaurus.

A sign of increasingly intense exchange with the Romans are coins found in tombs or in treasure hoards, all from the first half of the 1st c. B.C. The open position saved the area from the threatening raids of the Giapidi. The true pacifier of the area, as of all N Italy, was Julius Caesar, who united the region with Rome, making it a base for the conquest of transalpine Gaul. Forum Julii probably began as a forum or fortified place (the precise date is still under discussion) on an existing road already important for military and commercial traffic. It was not far from Tricesimo at the opening of the Tagliamento valley, where the senate of Aquileia at about this time constructed the gates and walls of a castello recorded by an inscription (*CIL* I, 2648).

Very soon, perhaps by 49 B.C., when the Lex Julia Municipalis gave Roman citizenship to the Cisalpine population, the settlement became a municipium, governed still by quattuorviri (and not according to the later use of duoviri), and was assigned to the tribus Scaptia. However, some connect the development of the site with the systematization of the roads of the region under Augustus in 2 B.C.

In order to distinguish this from other homonymic centers in Gallia Narbonese and in Liguria, Pliny (*HN* 3.130) called the inhabitants Forojulienses cognomine Transpadani. Ptolemy calls it a colony (3.120), but his testimony is not universally accepted.

Following the work of pacification of the whole Alpine area under Augustus, the region grew in importance. By virtue of its position and climate it became a vacation area for the rich of Aquileia and Trieste, and therefore dotted by spas, villas, and various other buildings though no traces of these remain above ground today. Inscriptions are neither particularly important nor numerous. It may be noted that the gentes mentioned are almost all of Roman or of central or S Italian origin.

The cults are recorded only by inscriptions and by small bronzes. They include Herakles, Jupiter, Fortuna, Augusta, Silvanus, Mercury, and the god Beleno, the best known among the local deities of the region and connected with a Gallic cult. It is possible that several columns of varicolored marble, fragments of doorposts and of architraves from an earlier temple were reused in the celebrated church of S. Maria in Valle. Inscriptions also indicate the existence of a Pontifex, of sexviri, and of Augustales. Unlike Aquileia, no record of artisan or agricultural activity is preserved here.

Excavations carried out at various times and stray finds have confirmed at Forum Julii the customary network of roads found in Roman cities, though of course with variations imposed by the geographical situation. The forum or center of the city must have corresponded to the present Piazza Duomo, where the cardo maximus intersected with the decumanus. Here have been found under the Palladian Palace of the Pretorio (itself con-

structed on the ruins of a patriarchal palace) the remains of a basilican building with two naves, an unusual type also found in the nearby center of Julium Carnicum (Zuglio).

The beautiful private houses, interesting for their varied plans, must have been richly decorated with mosaics. Many of these, conserved at the museum, date from the 1st to the 3d c. A.D. The museum contains a particularly tasteful head of Oceanus from the baths, judged to be from the Antonine age.

The walls offer some interesting problems. It is probable that the earliest city wall, constructed at the same time as the first forum, defended a center corresponding roughly to two-thirds the area enclosed by the later wall. The slightly later wall started from the Natisone, circled, and returned there, thus incorporating the steep bank of the river into the defensive system. The course of the wall has been securely established, and its average thickness is 2.4 m. Its remains have been found in the cellars of the houses constructed above. The wall was rebuilt or restored in great haste at the time of Marcus Aurelius when the center, menaced by the invasion of the Quadi and the Marcomanni, had to prepare a military defense. The Emperor, in fact, must have included the center in the defensive system he created with the praetentura Italiae et Alpium.

From that point on, all imperial interest in the area ceased and it again became the outpost it had been at the time of Julius Caesar, leaving no evidence of the succeeding phases it passed through. We know only that Forum Julii was hardly touched by the Goths, became a part of the Byzantine Empire, and was overrun by the Lombards when they crossed the Alps in 568.

There is scant evidence of the primitive Christianity that must have been practiced here and probably gave impetus to new construction, at least by the 4th c. A.D. The flowering of religious art came with the establishment of the first Lombard Duchy in Italy, at first Arian and then orthodox, especially after the transfer to Cividale of the Patriarchy of Aquileia, now in ruins.

With the patriarchal government ends the ancient history of the Forum Julii of Caesar. The necropoleis, placed as usual outside the gates (one to the S along the road from Aquileia, a second to the NE, and a third to the N), contain both cremation burials and the later inhumations of the barbaric period.

BIBLIOGRAPHY. S. Stucchi, *Forum Julii* (1951); A. Degrassi, *Il confine nord-orientale dell'Italia romana* (1954) 26-36; G. B. Brusin, "Tessellati di Cividale," in *Memorie Storiche Forogiuliesi* 40 (1960-61) 1-23; B. Forlati Tamaro *EAA* (1959); P. S. Leicht, *Breve storia del Friuli* (4th ed. 1970). B. FORLATI TAMARO

FORUM LIVI (Forlì) Emilia-Romagna, Italy. Map 14. A Roman municipium 64 km SE of Bologna on the Via Aemilia between the Ronco and the Montone rivers. Its origin may be connected with the laying of the road, which provides the orientation for the centurial network of the territory. It became a diocesan seat rather early.

The archaeological finds are of no assistance in the reconstruction of the city's urban plan. It seems to have been irregular, probably because the area was crossed by streams at times of high water. Perhaps there were public buildings along the winding course of the Via Aemilia. Outside, to the W, were the workshops of potters.

BIBLIOGRAPHY. G. A Mansuelli, *Caesena, Forum Popili, Forum Livi* (1948) 80-103MPI. G. A. MANSUELLI

FORUM POPILI (Forlimpopoli) Emilia-Romagna, Italy. Map 14. A Roman municipium 8 km SE of Forlì

on the Via Aemilia between Caesena and Forum Livii. It was a diocesan seat at least from the 6th c. A.D.

Numerous private buildings with mosaics from various periods have been discovered, which conform to the plan of the modern town and confirm the regularity of the ancient city's plan, axial on the Via Aemilia. The necropolis of Melatello, to the NE of the city, probably belonged to a vicus. The territory shows three different orientations in the centuriation.

BIBLIOGRAPHY. Aurigemma, "Forlimpopoli, "*NSc* (1940), p. 5PI; G. A. Mansuelli, *Caesena, Forum Popili, Forum Livi* (1948) 64-67MPI. G. A. MANSUELLI

FORUM POPILLII (Polla) Province of Salerno, Campania, Italy. Map 14. An important station on the Via Popilia from Capua to Reggio Calabria, on the N pass of the upper valley of the Tanagro at the confluence of the trans-Apennine routes from the interior areas of Campania, Sannio, Apulia, Lucania, and Bruzio.

The name is documented by the *Peutinger Table* and by the geographer of Ravenna. Mommsen has proposed that the same designation existed for the road since a well-known inscription, the lapis Pollae (*CIL* x, 6950), still exists in the same place as the Forum itself, where it must have been attached as an autoelogium to the base of an honorific statue. It states that the person to whom the monument was dedicated, but whose name is unknown though it must have been recorded on the plinth of the no longer extant statue, not only constructed the "Forum . . . heic," but also the road from Reggio to Capua.

BIBLIOGRAPHY. V. Panebianco, "Il 'lapis Pollae,' e le partizioni di 'ager publicus' nel II sec. a.C., nel territorio dell'antica Lucania," *Rassegna Storica Salernitana*, 24 (1963) 3-22MPI; V. Bracco, "Il luogo di 'Forum Anni' (In margine all'Elogium di Polla)," *Arch. Stor. per la Calabria e la Lucania*, 34 (1965-66) 151-63.

V. PANEBIANCO

FORUM SEGUSIAVORUM (Feurs) Loire, France. Map 23. Chief city of the Segusiavi, between Saint-Etienne and Roanne. The city is mentioned by Ptolemy (*Geog.* 4.8). Several Celtic oppida have been located in the region, at Le Crêt-Chatelard, Essalois, Le Châtelard de Chazi. Situated in the center of the Forez plain, Forum Segusiavorum became an important market in Roman times, lying as it did at the junction of roads from Lugdunum to Rodumna and Augustodunum, from Lugdunum to Burdigala, and from Lugdunum to Tolosa.

The city extended along the Loire from N to S, between the river to the W and a Roman cemetery to the E that lies left of the road running from La Boaterie to the railroad. In the La Boaterie district traces of a building (temple?) have been found, and 12 granite pedestals arranged in two rows. To the E of these were the remains of a rectangular building (25 x 11.5 m) with a double portico in front and a smaller building to N and S.

Under the church are the ruins of a Roman building that may be connected with an inscription built into the chevet, honoring the Numen Aug[usti] and the god Silvanus and made by the corporation of carpenters, the fabri tignuar[ii].

The city had a theater, as yet undiscovered; an inscription (*CIL* XIII, 1642) mentions that under Claudius the wooden structure was replaced by one of masonry. In the N sector of the city there were probably some baths. Several sections of aqueducts have been found.

The local museum has inscriptions, pottery, and statues. There are also some finds at the Musée de la Diana at Montbrison.

BIBLIOGRAPHY. Roux, *Recherches sur Forum Segusia-*

vorum et l'origine gallo-romaine de la ville de Feurs (1851)[PI]; R. Périchon, *Feurs à l'époque gallo-romaine* (1971)[PI]. M. LEGLAY

FORUM SEMPRONI (Fossombrone) Umbria, Italy. Map 16. Probably a foundation of C. Sempronius Gracchus, ca. 3 km NE of Fossombrone on the river Metaurus near S. Martino al Piano. It belonged to the tribus Pollia. It commanded the approach from the Adriatic to the Gola del Furlo, through which the Via Flaminia passes, and to this owed its prosperity. Ruins may be seen at the site, and material from excavations is in the Museo Vernarecci in the Palazzo delle Scuole at Fossombrone.

BIBLIOGRAPHY. *EAA* 3 (1960) 728 (G. Annibaldi).

L. RICHARDSON, JR.

FORUM TRAIANI (Fordongianus) Sardinia, Italy. Map 14. In W central Sardinia on the left bank of the Tirso river, a Roman way station where the most important roads of the island converged and a military center of notable importance to central Sardinia. Mentioned in the *Peutinger Table* and in the Itineraries (*It. Ant.* 82), the locality has been known since ancient times for its hot springs (Ptol. 3.3.7). Procopius (*De Aedif.* 6.7.12-13) relates that the center was enclosed by walls under Justinian, but not a trace of them remains.

Of the few remains, only the bathing establishments have been explored. They were constructed on the left bank of the Tirso and arranged on several levels. It is not possible to reconstruct the general plan. The lower level is covered by a vaulted ceiling, and on the long sides are porticos, also covered by vaults and illuminated by skylights. The lower level is built of squared masonry, the upper of brick.

The scattered tombs in the surrounding countryside at Is Ortus and Sa Senora are few and late.

BIBLIOGRAPHY. Fiorelli, *NSc* (1881) 175ff; A. Taramelli, *NSc* (1903) 469ff[PI]; G. Maetzke, *Boll. del Centro per la Storia dell'Architecttura* 17 (1961) 54.

D. MANCONI

FOSSOMBRONE, *see* FORUM SEMPRONI

FOX-AMPHOUX Var, France. Map 23. Located slightly S of the border between the territories of the civitas of Forum Julii (Fréjus) and that of Reii Apollinares (Riez), the area of the Logis and of Clastre (commune of Fox-Amphoux) was crossed by an ancient road and may have included a mansio. Excavations have brought to light an agricultural villa with living and work rooms arranged around a peristyle. South of this villa, at the back of a vast courtyard (80 x 40 m) there is a temple (18 x 14 m) with a pronaos, cella, and appended chambers. It is, perhaps, a sanctuary ad fines, dedicated to the Capitoline triad. Indeed, a head of Minerva in white marble has been found there. A cremation necropolis is located nearby. There seems to have been regular occupation of the site from the time of Augustus until the first decades of the 3d c. A.D. In contrast, pottery of the Late Empire is scantily represented.

The archaeological material is collected in the Centre de Documentation Archéologique du Var at Draguignan.

BIBLIOGRAPHY. "Chronique des circonscriptions arch., circonscription de Côte d'Azur-Corse," *Gallia* (1964ff).

C. GOUDINEAU

FRAGA Lérida, Spain. Map 19. Some 30 km SW of Lérida (Ilerda), and not mentioned in the sources. The Villa of Fortunatus, so called because the name occurs on one of its mosaics, is ca. 5 km to the N. A broad peristyle surrounded the various cubicula, which have mosaics with animal motives very unusual in Spain. Built in the 2d c. A.D., enlarged in the 3d and 4th, and abandoned in the 5th, it was a place for recreation rather than a source of economic development.

BIBLIOGRAPHY. J. Serra Ráfols, "La Villa Fortunatus de Fraga," *Ampurias* 5 (1943) 5ff. J. ARCE

FRANCOLISE Italy. Map 17A. An area of the ancient Ager Falernus for which the mediaeval castle and village of Francolise, beside the modern Via Appia 16 km NW of Capua, furnishes a convenient reference point. There were good natural communications with Cales, Sessa Aurunca, and Teanum, as well as with the Via Appia, which in antiquity passed some way to the S. The natural fertility of the soil made it an early goal of Roman agricultural settlement. Of the many villas in the area two have been exhaustively excavated.

The villa of San Rocco, on a limestone spur ca. 450 m SE of the village with fine views over the Falernian plain, was built around the second quarter of the 1st c. B.C. Though designed from the outset as a residence, the initial plan was simple, consisting of a rectangular terraced platform on which the living rooms were grouped loosely about what was probably an atrium. The agricultural installations occupied a lower terrace below the main platform. Some 25 years later the villa was greatly enlarged to the SW and SE so as to incorporate a peristyle courtyard, with the formal entrance to the villa set in the middle of the SE side. The original residence was extensively remodeled and redecorated, taking full advantage of the fine views to S and W, and a lavish water supply was assured by the addition of two large vaulted cisterns. About the middle of the 1st c. A.D. half of the NW wing was converted into a bath building. Apart from its sequence of mosaics the main interest of this villa lies in the well-preserved agricultural installations, which occupied a separate terraced enclosure beside the main access road opposite the main entrance to the residence. Here are olive presses of two periods with a number of vats for the separation of the oil, a threshing floor, and a brick kiln. As well as a residence this was the center of a substantial estate of which oil was, it seems, the principal product.

The Posto villa lay at the foot of the same slopes 1170 m SE of the village, immediately beside the modern Via Appia at kilometer 185. Built between 120 and 75 B.C., unlike the San Rocco villa it was essentially a working farm, the center of an agricultural property managed by a resident bailiff. The original buildings comprised a rectangular terraced enclosure with lean-to farm buildings and, along the N side, the scanty remains of the bailiff's house. During the last quarter of the 1st c. B.C. the house was considerably enlarged; large new vaulted cisterns were installed and a single vat, in the courtyard, for separating oil suggests operations on a modest scale. About the middle of the 1st c. A.D. the farmyard was enlarged to the S, the W part of the house was converted to a simple bath building and the E part was shut off and converted into an area for processing the oil on a much grander scale. Then in the second half of the 2d c. the site was deserted, presumably as the results of the absorption of the estate by some wealthy neighbor. A partial re-occupation is of the late 5th to early 6th c.

The two villas afford what is at present uniquely documented insight into the agricultural exploitation of N Campania at the end of the Republic and under the early Empire. The villa of San Rocco is preserved and accessible. Of Posto, only the site, the cistern, and the terrace can now be seen.

BIBLIOGRAPHY. P. v. Blanckenhagen et al., "Interim Report on Excavations at Francolise," *BSR* 33 (1965) 55-69. J. B. WARD-PERKINS

FRANKFURT AM MAIN, *see* NIDA

FRANKFURT-HÖCHST, *see under* LIMES G. SUPE-RIORIS

FRÉJUS, *see* FORUM JULII (France)

FRIGIDAE (Azib el Harrak) Morocco. Map 19. Station of the *Antonine Itinerary* (7.3), situated 18 km S of Lixus, also mentioned in the *Notitia Dignitatum* (occ. 26). The site contains remains of a Roman castellum (95 x 75 m) and traces of an ancient system for piping the waters of the nearby Aïn el Hammam.

BIBLIOGRAPHY. R. Cagnat, *L'Armée romaine d'Afrique* (1912) 673-74[MP]; L. Chatelain, *Le Maroc des Romains* (1944) 67-69; M. Euzennat, "Les voies romaines du Maroc dans l'Itinéraire Antonin," *Hommages à Albert Grenier*, coll. *Latomus* 58 (1962) 605-6.
 M. EUZENNAT

FROCESTER COURT Gloucestershire, England. Map 24. A Roman villa 16 km S of Gloucester. A 1st c. farmstead surrounded by a double ditch was extended ca. A.D. 275 and a new dwelling erected outside the old perimeter. This was a winged-corridor villa, to which was added, ca. A.D. 360, a wing with bath block. In its final stages it measured 44 by 31 m and contained 19 rooms. Occupation continued until the end of the 5th c., by which time crude, grass-tempered pottery had replaced the better quality Romano-British wares. The center block was burnt down after the bath suite had been abandoned. Finds are in Gloucester City Museum.

The main room in the center block had been divided by light partitions forming kitchen, dining room, and a small storeroom. Among the other rooms were an office with an ironbound chest sunk in one corner, corn-drying room with T-shaped corn drier, smithy with forge, heated and unheated living rooms, and a large workroom. The whole was built of local stone and the massive foundations of the center block strongly suggest that it had two stories. Mosaics in the corridor were laid by workmen of the Corinian School. The corridor front was approached by a heavily metaled road which expanded into a turning area. A courtyard on this front was used for domestic purposes and contained a small formal garden.

BIBLIOGRAPHY. D. R. Wilson, "Roman Britain," *JRS* 58 (1968) 198[P]; H. S. Gracie, "Frocester Court Roman Villa," *Trans. Bristol & Glos. Arch. Soc.* 89 (1971) 15-86[PI]. H. S. GRACIE

FULGINIA (Foligno) Umbria, Italy. Map 16. A late unwalled praefectura on the Via Flaminia. It prospered under the Empire, owing to its situation at a crossroads and its connections with Perusia and Picenum by the pass of Plestia. It was inscribed in the tribus Cornelia.

The ancient town lies under the modern one; the most significant remains are four Roman bridges, close together. Remains of an amphitheater lie E of the town site. There is a Museo Civico in Palazzo Trinci.

BIBLIOGRAPHY. *EAA* 3 (1960) 718 (U. Ciotti); P. Gazzola, *Ponti romani* (1963) 2.61-64[PI].
 L. RICHARDSON, JR.

FUNDI (Fondi) Italy. Map 17A. An Auruncan town astride the Via Appia in a fertile triangular valley opening on the sea. It is first known in 338 B.C. (Latin war). It won full Roman citizenship in 188 B.C. and was inscribed in the tribus Aemilia. Many important Romans of the Late Republic had villas in the neighborhood, and its wine was esteemed (Pliny *HN* 14.65).

Much of the ancient city plan survives in the modern town; the insulae seem to have been small and squarish, while two main streets cross at right angles at the center of town next to the forum. There are excellent remains of the fortifications, laid out in a square, with at least one gate of sophisticated plan, flanked by towers and provided with a portcullis. The original construction (3d c. B.C.) is of large polygonal blocks of the local limestone, well fitted on the outer face, but without snecking, with coursing and arching for short stretches. The inner face is less finely finished. The rectangular towers are in bond with the curtain, and beds at joints and corners are usually level. Subsequently (1st c. B.C.) the walls were extensively rebuilt in opus incertum with round towers.

The town was known for a cult of Hercules (Porphyrion on Hor. *Epist.* 1.1.4), but no remains of the temple have been traced. There are ruins of numerous monumental tombs along the Appia nearby and many villas. A bath has been discovered just outside the SE gate and partially excavated.

BIBLIOGRAPHY. C. F. Giuliani, *Studi di urbanistica antica* (Quaderni dell'Istituto di Topografia Antica della Università di Roma 2, 1966) 71-78[MPI]; E. L. Caronna, *NSc* (1971) 330-63. L. RICHARDSON, JR.

FURFOOZ Belgium. Map 21. The rocky massif of Hauterecenne at Furfooz dominates the Lesse river. In it are numerous caves that were inhabited in the Paleolithic age and served as burial grottos in the Neolithic era. In the second half of the 1st c. A.D. some small baths (15 x 5 m) were built on the mountain slopes, not far from the summit. They consist of a caldarium with hypocaust beneath, a rectangular pool, an apsidal sudarium, and a frigidarium with a semicircular pool. Built far away from any settlement, these baths probably had a religious purpose (lustration?) and some connection with the cult of springs. They were restored around 1957. In the 4th c. the summit of the Hauterecenne massif was made into a fortified keep: earthworks were formed and two walls built to block access to the fort. The few remains found in the redoubt seem to show that it was occupied mostly in the second half of the 4th c. and at the beginning of the 5th. The garrison that occupied it was made up of German soldiers in the service of Rome (probably Laeti), whose tombs have been found. Despite the fact that the baths were still working well when they arrived there, the soldiers destroyed the building to build a few huts at the foot of the rocks, along the banks of the Lesse, and to make a necropolis in the ruins of the baths. Apart from two cremation burials, these are inhumation tombs: the bodies lie between the short hypocaust piers, generally in a N-S orientation (although some tombs face E-W). In one instance, the skull of the deceased, severed from the body, had been placed between the feet. The rich grave gifts found inside the tombs included pottery of the 4th c., glassware, bone combs, an occasional bronze basin, and a wooden bucket with a bronze handle. The military character of these tombs is illustrated particularly by the inclusion of swordbelts with buckles, frogs, and applied ornaments decorated in champlevé enamel (Kerbschnitt), with geometric and animal motifs. Unlike the regular army's dead (as, for example, in the Oudenburg necropolis), the dead of the German auxiliaries of Furfooz were buried with their arms: ar-

rowheads, spearheads, battle-axes, knives. The necropolis of Furfooz has proved of major importance in the study of the civilization of the transition period between antiquity and the Early Middle Ages.

BIBLIOGRAPHY. A. Bequet, "La forteresse de Furfootz," *Annales de la Soc. arch. de Namur* 14 (1877) 399-417; R. De Maeyer, *De Oberblijfselen der Romeinsche Villa's in België* (1940) 252; J. Nenquin, "La nécropole de Furfooz," *Diss. Arch. Gandenses* I (1953)MPI; J. Breuer & H. Roosens, "Le cimetière franc de Haillot," *Annales de la Soc. arch. de Namur* 48 (1956) 171-376 (see especially the supplement by J. Werner); K. Böhner, "Zur historischen Interpretation der sogenannten Laetengräber," *Jahrbuch d. Römisch-German. Zentralmuseums Mainz* 10 (1963) 139-67; S. J. De Laet, "Note sur les thermes romains de Furfooz," *Helinium* 7 (1967) 144-49; A. Dasnoy, "La nécropole de Furfooz," *Annales de la Soc. arch. de Namur* 55 (1969) 121-94. S. J. DE LAET

G

GABALA (Jeble) Syria. Map 6. A small coastal town 20 km S of Laodicea ad Mare. Gabala was a Phoenician city of the confederation of Arados and became independent in the 1st c. B.C. Pausanias mentions one of its sanctuaries, dedicated to a Nereid, and in the 5th c. A.D. Theodoretos of Cyrrhos declared it to be a charming little town.

The town was built on a grid plan, probably dating from the Seleucid period. Its main monument is a theater, erected in the center of the town during Roman times. It was still well preserved in the 19th c. and has now been partially cleared. It was built on flat ground and oriented N-NE. The hemicycle has a diameter of 90 m, and its three tiers of seats are entirely supported by vaults. There are no vomitoria, but a series of outside entryways under the arcades of the facade and two interior corridors leading to the parodoi guaranteed easy circulation. The elegant profile of the tiers of seats, the delicacy of the sculptured decoration of the scaenae frons, the polychromy of the imported marbles and granites, all indicate Hellenistic influence. The ramparts are of Roman date. The port is of a type frequent in Phoenicia: a beach behind an opening in the sandstone barrier which forms the coast, with an outer harbor.

BIBLIOGRAPHY. E. Frézouls, "Les théâtres romains de Syrie," *Annales archéologiques de Syrie* 2 (1952)I; P. J. Riis, "Activités de la mission archéologique danoise . . . ," ibid. 10 (1960); H. Seyrig, "Questions aradiennes, 1. Gabala," *RN* 6 ser. 6 (1964)MI. J.-P. REY-COQUAIS

GABALUM, see ANDERITUM

GABIA LA GRANDE Granada, Spain. Map 19. An underground chamber 4.1 m square was found here, ca. 6 km S of Granada, accessible through a long dromos with steps leading to the exterior. The chamber was roofed with a round cupola and had an octagonal nymphaeum at its center. Plan and elevation give an impression of a Roman cryptoporticus combined with a bath. However, traces of decoration suggest a structure of the 4th c., so it may be connected with a Christian cult.

BIBLIOGRAPHY. M. Gómez Moreno, *Misceláneas* (1949) 386ff. J. ARCE

GABII (Castiglione) Italy. Map 16. An ancient city of the Latins, founded, according to one tradition (Verg. *Aen.* 6.773), by Alba Longa, on the E shores of Lago di Castiglione, a small, shallow crater lake, probably drained in antiquity as it is today. It lay on the Via Praenestina at the twelfth mile, about halfway from Rome to Praeneste. Gabii is said to have had close ties with Rome from the time of the Tarquins and it stood in peculiar relation to Rome, ager gabinus being neither romanus nor peregrinus but having auspices of its own (Varro *Ling.* 5.33), the cinctus gabinus was a special way of draping the toga that left both arms free (cf. Livy 8.9.9); the terms of the treaty of alliance between Rome and Gabii were inscribed on a wooden shield covered with the hide of the sacrificial ox and kept in the Temple of Semo Sancus (Dion.Hal. 4.58.4; Festus 48L s.v. clipeum). From its flourishing state in the early period, Gabii declined in the course of time, and Cicero and the Augustan poets use it as the example of a city whose glory is only a memory. But it survived as a municipium as late as Elagabalus, as excavations have shown.

The site was ransacked in 1792 by Gavin Hamilton, who explored the forum and the area around the great temple, the ruins of which are still a landmark. The forum survives only in a plan by Visconti, which shows a rectangular space opening off the Via Praenestina, surrounded on the three remaining sides by colonnades connected by a low pluteus. Off this open various chambers, of which only those at the far end were completely explored; these seem to include the curia of the city and an Augusteum. The inscriptions show that Hadrian was regarded as a special benefactor of Gabii and built or restored its aqueduct.

Between the forum and the Lago di Castiglione, facing toward the forum, the so-called Temple of Juno stood in the middle of a large, artificially leveled platform. Along the rear half of its sides and along the back, were Doric colonnades, behind which on the sides were lines of shoplike rooms, partly rock-cut. In front descended a great hemicyclical stair of 11-13 steps, which may have served as a theater in some way. Behind, Visconti shows three doors opening to a street running behind the temple. Cut in the rock of the open area around the temple are many square pits of fair size, some of which make patterns, possibly the scrobes of a planation of trees.

The temple itself (17.83 x 23.93 m exclusive of the stair) was of lapis gabinus (sperone) and rose on a podium trimmed at base and crown with nearly identical cyma moldings. It was a single-cella temple with alae, the back wall being continuous, with colonnades of six columns each across the front and down the flanks. The remaining fragments of column bases show that the order was Ionic or Corinthian. The walls still rise in 13 courses of blocks of constant height but irregular length. The temple can hardly be earlier than the 2d c. B.C., and the architectural terracottas Delbrueck recovered are more likely 1st c. Though the arx of Gabii at Torre di Castiglione may be identifiable, owing to its height, it is impossible to make out any more of the city plan.

Around the site of Gabii are extensive quarries of lapis gabinus, the handsome gray tufa of the Tabularium and Forum of Augustus in Rome, prized in antiquity for its resistance to fire. To prove Gabii's high antiquity as a habitation center, a tree-trunk burial of the 8th c. B.C. came to light in the neighborhood in 1889; the material

from this grave is now in the Museo della Villa Giulia. The harvest of sculptures and inscriptions recovered by Hamilton is now divided between the Villa Borghese and the Louvre.

BIBLIOGRAPHY. E. Q. Visconti, *Monumenti gabini della Villa Pinciana* (Società Tipografica de' Classici Italiani, Milan 1835); T. Ashby, *PBSR* 1 (1902) 180-97; G. Pinza, *BullComm* 31 (1903) 321-64; R. Delbrueck, *Hellenistische Bauten in Latium* 2 (1912) 5-10, pls. 4-6.
L. RICHARDSON, JR.

GADARA (es-Salt) Jordan. Map 6. This a village NE of Jericho, near Tell Gedur, which preserved the ancient name of the place. Obodas I, king of the Nabateans, defeated Alexander Jannaeus here (Joseph. *AJ* 13.356). From the 1st c. B.C. on it was part of the Jewish region of Peraea, and also its capital. It was conquered by Vespasian in A.D. 63, but Jews still lived there in the Byzantine period.

BIBLIOGRAPHY. F. M. Abel, *Géographie de la Palestine* II (1938) 324; M. Avi-Yonah, *The Holy Land* (1966) 84, 156, 179.
A. NEGEV

GADARA (Umm Qeis) Jordan. Map 6. City N of the Yarmuk river, in N Jordan, a Ptolemaic foundation. The *Peutinger Table* places it 16 miles from both Tiberias and Capitolias. In the Hellenistic period it was an important cultural center, and Meleager, Menippus, and Philodemos were born here (Strab. 16.759). It was the capital of the district of Galaaditis (Gilead), but became part of the Seleucid kingdom after the victory of Antiochus III. At that time it was also called Antiochia and Seleucia. It was conquered by Alexander Jannaeus, but freed by Pompey in 64 B.C. (Joseph. *AJ* 13.356). The city was rebuilt and joined the Decapolis. It minted coins from the time of Augustus to that of Gordian III, dating them from the time of Pompey. Augustus presented Gadara to Herod, but it was annexed to Syria after the monarch's death and ruled directly by a Roman proconsul. Matthew (8:28) mentions it as the place in which Jesus healed the demoniac. A late Roman inscription found on the site gives the name of the town as Colonia Valentiniana Gadara. In the territory of the city were well-known hot springs (Euseb. *Onom.* 74.10), and in the Byzantine period a synagogue was built nearby.

BIBLIOGRAPHY. E. L. Sukenik, *Ancient Synagogues in Palestine and Greece* (1934) 81-82; F. M. Abel, *Géographie de la Palestine* II (1938) 323; M. Avi-Yonah, *The Holy Land* (1966) 40, 51, 69, 76, 80, 84, 89, 96, 102, 174.
A. NEGEV

GADIR (Cádiz) Cádiz, Spain. Map 19. Originally a small island, long since much enlarged by silting and joined to the mainland by a bridge (the Isla de Léon), and a larger long island now the peninsula. Gadir was founded, according to tradition, by Phoenicians from Tyre in 1100 B.C. (Strab. 3.5.5; Vell. Pat., *Historia Romana* 1.2.3). To the Phoenicians Gadir meant a fortress or walled area, but Pliny (4.120) and Silinus (23.12) wrote that the Carthaginians called it Gadir, meaning redoubt, as did Avienus (268) and St. Isidorus (*Etym.* 45.6.7). Martial (1.61.9, 5.78.26) employs the plural in referring to Gades, perhaps in imitation of the Greek (Hdt. 4.8). Pliny (4.119) states that, according to Polybios, it was 12,000 paces long and 3000 wide; the part closest to the mainland was less than 213 m from it, but the remainder was more than 2135 m away. Strabo (3.5.3) says that the city was on the W part of the island, and that the Temple of Moloch was on the end that projected toward the smaller island. The temple of Hercules was on the other side, Sancti Petri, where the island was

separated from the mainland by a channel only one stadium wide; the sanctuary was ca. 19 km from the city.

The most ancient Greek material is a proto-Attic oinochoe, in the Copenhagen Museum, which is thought to have been found in the city and dates from the 7th c. B.C. Parts of Carthaginian necropoleis, ca. 150 hypogea from the 5th-3d c. B.C., have been discovered; many gold jewels were found in the tombs, and Etruscan bucchero of the 6th c. B.C. On the other hand, there are few terracottas, coarse ceramics, ostrich eggs, lamps, and necklaces, as in Ibiza, and no Greek vases or Campanian ceramics. A gold masked figurine is now in the National Archaeological Museum in Madrid, and an anthropoid sarcophagus of the 4th c. B.C. in the Cádiz Museum. The graves are impersonal and independent, made of huge stone blocks.

Nothing is known of the plan of the city, whose inhabitants were primarily interested in trade and fishing. In the beginning of the 1st c. B.C. they controlled tin mining and the tin trade (Strab. 3.5.11). Strabo (3.5.3) also writes that Cádiz had the most sailors and the best ships, both in the Mediterranean and the Atlantic. However, up to 500 horsemen were counted in a census. When the city became crowded Galbus the Younger built a second one, and from both cities Didyme arose (Strab. 3.5.3). Towards the end of the Republic, it had a theater, perhaps of wood, of which no trace remains (Cic. *Ad fam.* 10.32.1). An underground tomb from this period yielded many ceramic vases, a polychrome plate, and two engraved gold rings, all now in the Cádiz Museum.

The city also minted coins at an early date and bronzes without inscriptions, of Greek type. It initiated its series of coins with the Phoenician Hercules on the obverse and the tuna, symbol of its fishing wealth, on the reverse. The silver coins came somewhat later, a result of the Barcine domination, mining operations, and military necessity. The obverse, bearing a head of Hercules with a club on his shoulders, is taken from Greek coins. Drachmas and half-drachmas were minted. With the Roman conquest appear asses of Roman metrology bearing a Phoenician inscription. Infrequently, the reverse bears the caduceus and the trident. The smaller units continue the same series, with tuna fish and dolphins. Other mintings do not follow the Roman pattern, but are of barbaric design with neo-Carthaginian inscriptions. Under Augustus, great commemorative medals appear, reminted coins characteristic of the coinage of Cádiz, which continued until the time of Claudius, and always had a Phoenician, never a Roman, inscription. On the obverse they bore the Hercules of Gadir and priestly attributes in honor of Balbus, the builder of the new city, as Pontifex. Others have Augustus on the obverse and Caius and Lucius on the reverse, or Agrippa represented as praefectus classis. These medals were rapidly demonetized. The city also had an arsenal.

In 49 B.C. Caesar bestowed Roman citizenship on the city (Livy *Per.* 110). Many inscriptions of the 1st c. have been found. Discoveries, including a heroic statue of an emperor from the first half of the 2d c., are in the Archaeological Museum of Cádiz. The city also had a statue of Alexander (Dion. Cass. 37.52). The most important personages during the change in era in Cádiz were the Balbi. The oldest was Caesar's banker; the nephew triumphed over the Garamantes and was the first consul from the provinces possessed by Rome and the first provincial who earned the honors of a triumph. During the 1st c. the puellae gaditanae, variety hall artists, were famous and were mentioned by Strabo (2.3.5) and others (Mart. 3.63; 5.78; 14.203; Juv. *Sat.* 11.162; Pliny, *Ep.* 1.15).

The Temple of Hercules, one of the most famous

sanctuaries of the ancient world, was visited by Hannibal (Sil. 3.1), Fabius Maximus (App. *Hisp.* 65), Caesar (Dio. Cass. 37.52), whose future power was foretold by the priests, and Apollonius of Tiana (Philostr. *VA 5.5*). Its ritual was always typically Semitic. There was no image of the god, and only the priests were permitted to enter the sanctuary. On the doors, which can be no earlier than 500 B.C. (Sil. 3.32-44), were represented the labors of Hercules. The temple contained fabulous riches, stolen by Mago in 206 B.C. (Livy 28.36.2). In 49 B.C. Varro ordered that the treasure and decorations of the temple be transported to Cádiz (Caes. *BCiv.* 2.18,2). There was still, in 60 B.C., a Temple to Moloch where human sacrifices were made, a custom which Caesar abolished (Cic. *Balb.* 43), and altars to poverty and the arts, services to Menestheus, veneration for Themistocles and other heroes and demigods. There were services and an altar to old age, and a special worship of death, and it was said that while the ocean tides were high the souls of the sick did not expire (Philostr., *VA* 5.2-4). Towards the end of the 4th c. B.C., when Avienus visited it, the city was in ruins, except for the Temple of Hercules.

BIBLIOGRAPHY. L. Rubio, "Los Balbos y el Imperio Romano," *Anales de Historia Antigua y Medieval* (1949) 69-83; A. García y Bellido, "Iocosae Gades," *Boletín de la Real Academia de la Historia* 129 (1951) 73-121[PI]; id., *Historia de España, España Protohistórica* (1952) 289-417[MPI]; id., *La Península Ibérica en los comienzos de su historia* (1953) 467-89; id., "Hercules Gaditanus," *ArchEspArq* 36 (1963) 70-153[PI]; id., "Sobre los athloi hercúleos de la puerta del Herakleion de Cádiz," *Estudios Clásicos* 7 (1963) 307-10; J. M. Blázquez, "El Herakleion gaditano, un templo semita en Occidente," *I Congreso Arqueológico del Marruecos Español* (1954) 309-18[I]; A. M. Guadan, "Gades como heredera de Tartessos en sus amonedaciones conmemorativas del Praefectus Clasius," *ArchEspArq* 34 (1961) 53-89; M. Jiménez, "Miscelánea epigráfica. Inscripciones funerarias gaditanas inéditas," *Emerita* 30 (1962) 294-304[I].
 J. M. BLÁZQUEZ

GAETA, *see* CAIETA

GAFSA, *see* CAPSA

GAGAI (Aktaş) Lycia, Turkey. Map 7. About 11 km SE of Kumluca. First mentioned by pseudo-Skylax in the 4th c. B.C. The foundation was attributed to Rhodes; according to the story certain Rhodian sailors arriving in Lycia called out "ga, ga," either as a request to the natives for land or on sighting land in a storm; they then founded a city and called it Gagai. Opramoas of Rhodiapolis bestowed on Gagai 8000 denarii and undertook to pay for baths and certain oracular shrines; of these latter nothing is heard elsewhere. The coinage includes Hellenistic issues of Lycian League type and imperial issues under Gordian III.

The ruins are not abundant. The acropolis hill is on two levels; apart from a fort on the upper level, all the walls and buildings are of late date. There are no Lycian tombs. At the N foot of the hill is a small theater, poorly preserved. A single inscription has been found on the site, an honorific decree for a Gagatan.

BIBLIOGRAPHY. T.A.B. Spratt & E. Forbes, *Travels in Lycia* (1847) I 183-87. G. E. BEAN

GALAVA (Ambleside) Westmorland, England. Map 24. At the head of Lake Windermere, which may have been used for transporting supplies from the S, on roads from Alone (Watercrook) and Brocavum (Brougham) to the W coast at Glannoventa (Ravenglass). A road N possibly existed. The first fort was an irregular four-

sided area defended by two ditches with a palisade between them and a clay rampart. Nothing is known of the internal buildings. Its date may be Trajanic. It probably proved too wet for permanent occupation so a clay and gravel platform was constructed over part of it, on which a new fort was built, defended by a stone wall backed with an earth rampart. Double ditches were traced on its N and E sides, apparently without a causeway at the gates. Of the four gates only the Porta Praetoria is double. At each angle is an internal tower.

The principia was carelessly laid out, with the entrance to the courtyard off-center; two L-shaped weapon-stores flank it. The cross-hall, roofed with local slate, has a rostrum in its NW corner, and the back range comprises three rooms with a sunken strongroom in the center room. The granary N of the principia is a square, buttressed building with vent holes in the N and S walls only, divided into three sections. In the N and S sections low walls were built to carry the suspended floor. In the center the three incomplete walls, at right angles to those of the other section, are too widely spaced to take a floor. In the E section charred wheat was found, lying on oak boards thought to be the remains of a bin. The praetorium S of the principia is a courtyard building only partially excavated. Little is known of the timber barrack blocks except that those examined had at one time been destroyed by fire. This fort is probably Hadrianic, and was occupied to the end of the 4th c. Part of the civil settlement NE of the fort has been discovered, on low-lying wet ground. One tombstone records the deaths of a retired centurion and of a record clerk, killed in the fort by the enemy.

BIBLIOGRAPHY. R. G. Collingwood, "Report on the exploration of the Roman fort at Ambleside," *Trans. Cumberland and Westmorland Arch. Soc.* ser. 2, 14 (1914) 433-65; 15 (1915) 1-62; 16 (1916) 57-90; M. E. Burkett, "Recent Discoveries at Ambleside," ibid. 65 (1965) 86-101. D. CHARLESWORTH

GALAXIDI, *see* CHALEION *under* WEST LOKRIS

GALERA, *see* TUTUGI

GALICEA MARE Dolj, Romania. Map 12. An important Roman vicus 10 km from statio Aquensis. A stone statue of a lion was discovered here, a monetary deposit of 800 coins (Antoninus Pius—Philip I) in a vase buried during the period of the Carpic invasion of 245-47, and a votive altar. An inscription is dedicated to Diana regina by Dioscurus Ianuari and his wife (contubernalis). He was probably a servus villicus of Iulius Ianuarius (157-69), an Illyrian customs farmer. The vicus was integrated in the large agricultural territorium of which Aquae was the capital.

The finds are preserved in the Museum of Craiova.

BIBLIOGRAPHY. *AnÉpigr* (1963); D. Tudor, "O nouă inscripţie privitoare la sclavii din Dacia," *AUBIst* 10 (1961) 7-11; id., "Comunicări epigrafice I," *Studii şi cercetări de istorie veche* 13 (1962) 116-19; id., *Oltenia romană* (3d ed., 1968) 127, 154-55, 220, 230; id., *Oraşe* (1968) 513-14; B. Mitrea, "Descoperiri de monede antice şi bizantine," *SCIV* 13 (1962) 220; id., "Monnaies antiques et byzantines découvertes plus ou moins récemments en Roumanie," *Dacia*, NS 6 (1962) 537; *TIR*, L.34, 59. D. TUDOR

GALLIPOLI, *see* KALLIPOLIS

GAMZIGRAD Yugoslavia. Map 12. The ruins of a Roman castrum on a plateau at the SW edge of a village 11 km W of Zaječar near the Bulgarian border. The

ancient name of the site is unknown although the center must have played an important role in the region as the juncture of the routes Bononia-Castra Martis-Horreum Margi (Čuprija) and Aquae-Timacum Minus-Naissus (Niš). It was part of Dacia Ripensis after the organization of that province by Aurelian in the 3d c. During that century the castrum was founded, and it presumably served as the administrative center for the mining, gold-panning, and quarrying operations in the area. The two phases of destruction detected have been attributed to the Hunnic invasion of 441 and the Slavic invasions of the late 6th c.

The plan of the town is an irregular trapezoid ca. 300 by 230 m. The town walls, constructed of opus mixtum, are 4 m thick and exceptionally well-preserved for the entire perimeter. Six round towers, counting the corner towers twice, are located on each of the four sides. The wall may have been constructed as late as the reign of Justinian when there was other rebuilding on the site.

Excavations have noted traces of walls belonging to 10 buildings, but the campaigns concentrated on one large building near the center of the town in the NW quadrant. The building, or rather complex of structures, is a rectangle (54 x 34 m) and was built in the 3d c. The S and W exterior walls were revetted with multicolor marble plaques, using serpentine and porphyry, and were further elaborated with marble pilasters. The interior walls were covered with marble on their lower extent; fresco covered the rest of the walls, separated from the marble revetment by a stuccoed molding. The chief entrance was from the marble-paved street to the E through a colonnaded gateway and into a long vestibule. An octagonal room with a hypocaust lies to the N which communicates, via a descent of two steps, with a large room on the N. This room has an apse on the E with a raised floor reached by two broad steps.

The mosaic pavement of the vestibule is a highly colorful tapestry pattern with a series of octagonal fields bearing a variety of geometric motives. A room opening to the S from the vestibule has as one main panel a hexagonal trompe l'oeil with town gates at the angles connected by representations of city walls crowned by ramparts; a gadrooned kantharos fills the NE corner.

The apsidal room has mosaics with geometric motives along the side walls and, in the center, a masterly representation of venatores and panthers in a large panel framed by a guilloche border. Other animal scenes, less well preserved, were also in the central area. The mosaics in the apsidal room have been dated to the 4th c., probably also the date of those in the vestibule.

The function of the building is not known; the excavators suggest that it was either a praetorium or a bath. It was built over in the mid 6th c. by a smaller apsidal construction, and there is some evidence of renewed use in the 9th-10th c. The earliest material reported from the site is a group of 3d c. funeral monuments.

Finds from Gamzigrad are in the museums in Zaječar and Negotin.

BIBLIOGRAPHY. Djordje Mano-Zissi, "Le castrum de Gamzigrad et ses mosaiques," *Archaeologia Jugoslavica*, 2 (1956) 67-84; Vladimir Popović, "Antički Gamzigrad," *Limes u Jugoslaviji* I (1961) 145-53; M. Čanak-Medić, "Kasnoantička Palata kod Gamzigrada," *Velika Arheo-loška Nalazišta u Srbiji* (1974) 61-76[MPI]. J. WISEMAN

GANDA (Ghent) Belgium. Map 21. A Gallo-Roman vicus of the city of the Menapii, at the confluence of the Lys and the Escaut. Nothing was known of it until excavations were started in 1960. The name, appearing only in mediaeval sources, is pre-Roman and means "meeting of rivers." On the site of the vicus a settlement with necropolis was found, dating from the Late Bronze and Early Iron Age (from the end of Ha A to the end of Ha D), but so far no remains have been discovered of an Iron Age settlement that would have preceded the Gallo-Roman vicus. The beginnings of the vicus go back to the mid 1st c. A.D. The settlement spread out for 2 km on a narrow strip of land surrounded by marshes on the left bank of the Escaut: to the W, from the point where the two rivers meet; to the E, up to the modern village of Destelbergen. At the W end of the vicus, in the ruins of the mediaeval abbey of St. Bavon, great quantities of Roman pottery were found ca. 1930, but thorough excavations have taken place only at the E end of the settlement. Isolated finds were made in between these two spots. The excavations, which were carried out at the edge of present-day Ghent, revealed that the part of the vicus studied was half rural in character (with orchards, meadows, and paddocks for cattle, but no fields) and half industrial (with significant traces of iron-smelting works, limonite from nearby boglands being used for ore). No fewer than ten wells, with wooden linings, were found; most probably they were related to the iron-smelting operation. To the SE of the vicus a large necropolis was found with from 1000 to 2000 tombs, most of them from the 3d c. Among these tombs, which are of the incineration-pit type, is one that is unique in the archaeology of the NW provinces of the Roman Empire. This is a collective tomb (13.3 x 1.4 m) in which were found the charred bones of about twenty deceased—men, women, and children. The rich grave gifts, placed on the pyre along with the bodies, had been severely damaged. Among the objects were sherds of 700 to 800 pottery vases, 25 coins, about 50 fibulas (some 20 of them enameled), a perfume flask of bronze, rings, hairpins, glass and bone articles. The tomb is generally taken as evidence that an epidemic raged through the vicus, in the course of which a large number of its inhabitants perished.

Ganda was linked to Bavai by a road that passed through the vici of Velzeke and Blicquy. Other roads probably connected it to the settlements of Aardenburg to the W and Hofstade and Asse to the E. The vicus was certainly still inhabited in the 4th c. There is some evidence, from topography and the study of local place names, that there was a castellum at Ganda in the 4th c.; its site has not yet been definitely located.

In the 7th c. a Merovingian settlement took the place of the Gallo-Roman vicus; its inhabitants were evangelized by St. Amand, who built an abbey there (later dedicated to St. Bavon). By the 8th and 9th c. the town had become a port of some economic importance, but was completely destroyed at the time of the Viking invasions in the 9th c. When the Vikings left, another port which developed farther W, between the Lys and the Escaut, kept the name of the old vicus. Ghent (Fr. Gand) became one of the leading cities of the Middle Ages, although the site of the original vicus had become by then completely rural.

BIBLIOGRAPHY. S. J. De Laet, "Oudheidkundige vondsten en opgravingen in Oostvlaanderen," *Kultureel Jaarboek voor de Provincie Oostvlaanderen* 12, 1958 (1961) 38-52; 17, 1963 (1964) 27-71; 19, 1965 (1967) 10-31, 129-70; id., "Les fouilles de Destelbergen et les origines gallo-romaines de la ville de Gand," *Archeologia* 30 (1969) 57-69[MPI]; id. & A. Van Doorselaer, "Lokale ijzerwinning in westelijk België in de Romeinse tijd," *Mededelingen van de Kon. Vlaamse Academie v. Wetenschappen v. België, Klasse der Letteren* 31.2 (1969) 73 pp.; id. et al., "La tombe collective de la nécropole gallo-romaine de Destelbergen-lez-Gand," *Helinium* 10 (1970). S. J. DE LAET

GANGI ("Engyon") Enna, Sicily. Map 17B. A Sikel city mentioned by Diodoros (4.79-80 and 16.72), Plutarch (*Marc.* 20), Cicero (*Verr.* 3.43), and Pliny (*HN* 3.91). From Diodoros we learn that it was 100 stades from Agyrion. It was colonized by Rhodio-Cretans, who brought with them the cult of the Great Mother. Some scholars have identified this city with modern Troina, others with Gangi or Nicosia. The most likely hypothesis seems to be the identification with Gangi, where traces of walls and buildings are preserved. The identification with Troina is unlikely because this modern town is quite far from the borders reached by Rhodio-Cretan penetration in this direction, and, moreover, the archaeological finds there are no earlier than the 5th c. B.C.

BIBLIOGRAPHY. A. Holm, *Storia della Sicilia* I (1896) 159. A. CURCIO

GANNAT Allier, France. Map 23. The city, whose ancient name is unknown, is in a small basin ringed with hills. Two streams run through it. Traces of dwellings have been found, but also near the St. Etienne church the remains of a large building that has marble veneers and a remarkable stele 1.45 m high and 1.68 m wide. It has a niche containing a figure with a mallet in his left hand and a goblet(?) in his right; at his feet is a little barrel. A stele of Epona was found on the same spot.

A pottery that turned out molded bowls with a lead glaze, fine ware, and statuettes(?) has been excavated, and some clay architectural fragments have also been found. H. VERTET

GARAGUSO Lucania, Italy. Map 14. A native settlement on the left bank of the Salandrella river (ancient Chalandrum) on the Ionian Sea. To the N, the settlement bordered on the valley of the Basento river and therefore on Metapontion territory. The first traces of life date to the end of the 8th c. B.C. Recent excavations indicate that the first settlement is beneath the present town, and its necropolis is in the public gardens. There are also traces of habitation in the districts of Filera and S. Nicola, and in the district of Fontanelle there are remains of an ancient sanctuary in a ravine.

Contact with the Greek world occurred in the 6th c. B.C. and much is to be learned from the votive depository of the sanctuary. During the last quarter of the 6th c., late archaic Greek ware appeared: one alabaster statuette and a small marble model of a temple, both discovered in the Filera district. The period of greatest prosperity, to judge from ex-voto offerings in the depository, falls between 550 and 470 B.C. No traces of life during the second half of the 5th c. B.C. have been found. During this period, Greek coastal influence, well documented on coins, almost completely destroyed the native production, which was primarily represented by a type of kantharos decorated by a broken line that started on the body and terminated at the top with the symbol of a hand. The colors are very lively in the local ware in contrast to native production elsewhere.

In the middle of the 4th c., there is evidence of renewed activity. The first half of the 3d c. B.C. marked the end of all life in the settlement. A similar pattern is encountered in nearly all the inland Lucanian centers.

BIBLIOGRAPHY. C. Valente, *NSc* (1941) 252-57; M. Sestieri Bertarelli, "Il tempietto e la stipe votiva di Garaguso," *Atti e Mem. Soc. Magna Grecia* (1958) 67-78; D. Adamesteanu, *Atti IV Convegno Taranto* (1965) 138-39; *Popoli anellenici in Basilicata* (1971) 36-38.

D. ADAMESTEANU

GARDHIKAQ, *see* LIMES, SOUTH ALBANIA

GARDHIKI, *see* RADOTOVI

GARIANNONUM (Burgh Castle) Suffolk, England. Map 24. The Roman fort is situated on high ground overlooking the river Waveney. It was probably built in the middle of the 3d c. against the threat of pirates. The *Notitia Dignitatum* refers to its mid 4th c. garrison as Equites Stablesiani Garrianonenses. Occupation continued well into the Saxon period, as shown by the continuous use of a burial ground outside the fort. A monastery was probably established within the Roman fort by St. Fursa soon after A.D. 630.

The fort is quadrangular, covering 2 ha. On all but the W side the wall is very well preserved: it is built of flint rubble faced with flint, with triple tile courses every 1.5-1.8 m. Particular interest attaches to the external bastions: they were added during construction, after the wall had reached a height of 2.1 m. Thus the lower part of the bastions are butted against the wall while the upper courses are bonded into it. It also appears that internal corner towers were begun but never finished. The evidence therefore strongly suggests a change in the style of defensive architecture while the fort was being built. The main entrance lay in the middle of the E wall; partial excavation suggests the existence of internal gate towers.

BIBLIOGRAPHY. A. J. Morris, "The Saxon Shore Fort at Burgh Castle," *Proc. Suffolk Institute of Archaeology* 24 (1947) 100-20. B. W. CUNLIFFE

GARKUSHI ("Patraios") Kuban. Map 5. A settlement of the 6th c. B.C.-14th c. A.D. along the N shore of the Taman Gulf near the village of Garkushi has often been identified with Patraios (Strab. 11.2.8; Steph. Byz. s.v. Patrasus ?). Excavations have led to the discovery of a Greek agricultural settlement of the 6th-5th c. B.C. 250 m W.

On the hill part of the site, excavations revealed the remains of a fortress (ca. early 1st c. A.D.) composed of a rampart, defensive walls, a moat, and a thick clay platform which covered the horizontal interior surface. A stone roadway of the Late Hellenistic era found under the platform indicates that the fortress was built over an earlier site. The gate of the acropolis was flanked by two rectangular pylons made of adobe bricks. The monuments and artifacts found inside the fortress date from the 1st c. A.D. to mediaeval times. The rectangular dwellings, which had adobe brick walls, were rebuilt several times but the original plan and orientation were preserved. In one area, the dwellings formed whole blocks which bordered both sides of a narrow street. Excavations suggest a comparatively dense habitation inside the fortress during the 1st-3d c. when the population also expanded onto the adjoining plain and the city developed its own wine and pottery industries. Two winemaking establishments of the 2d-3d c. were uncovered, one of which had several side areas for pressing by foot and a central area for secondary pressing with a lever press. A large circular pottery kiln of the 2d-3d c. was found in one dwelling.

BIBLIOGRAPHY. Iu. S. Krushkol, "Raskopki drevnego Patreia v 1949 g.," *VDI* (1950) 2.231-33; id., "Raskopki drevnego Patreia v 1950 g.," *Vestnik drevnei istorii* (1951) 2.225-28; A. L. Mongait, *Archaeology in the USSR*, tr. M. W. Thompson (1961) 200; A. S. Bashkirov et al., "Otchet o raskopkakh drevnego goroda Patreia (1961-1962 gg.)," *Uchenye Zapiski Moskovskogo Pedagogicheskogo Instituta* 217 (1964) 236-49; id., "Iz istorii Patreia v III-I vv. do n.e. (Po materialam Tamanskoi arkheologicheskoi ekspeditsii 1949-1951 gg.)," *Zapiski*

Odesskogo Arkheologicheskogo obshchestva 2(35) (1967) 90-98; N. I. Sokol'skii, "Raskopki v severo-zapadnoi chasti Tamanskogo poluostrova," *Arkheologicheskie Otkrytiia 1965 goda* 127-28; V. S. Dolgorukov et al., "Raboty Tamanskoi ekspeditsii," *Arkheologicheskie otkrytiia 1970 goda* 121. T. S. NOONAN

GASK RIDGE Perthshire, Scotland. Map 24. The ridge runs for 25 km at ca. 60-90 m above sea level, NE towards Perth. There have been excavations recently on the Roman road running along this ridge and at three of the Roman signal stations, Gask House, Parkneuk of Roundlaw.

Gask House had a wooden tower ca. 3 m square, enclosed within a clay bank with a ditch outside. There was only one entrance causeway, in the N side of the ditch, facing the Roman road. The plan of the Parkneuk signal station was almost an exact duplicate. No pottery was found at Parkneuk, but Gask House yielded a mortarium fragment undoubtedly of late 1st c. date.

At least 11 signal stations, ca. 1.3 km apart, are now known on the Gask Ridge. Earlier and recent excavations suggest that they all had a similar plan. Some lay on the N side of the Roman road, some on the S, but they each had an entrance facing the road, which was over 5 m wide. They formed a chain of signaling towers installed in connection with or as a result of Agricola's campaigns in Scotland, A.D. 80-84.

BIBLIOGRAPHY. *Discovery and Excavation, Scotland* (1966) 37; (1967) 37; (1968) 28-29; (1969) 38; (1942) 33. A. S. ROBERTSON

GASTIAIN Navarra, Spain. Map 19. Village in the municipality of Valle de Lana on the border of the province of Alava. It was apparently a Roman vicus. A later sanctuary dedicated to San Sebastian incorporated many funerary inscriptions, which provide data on primitive naming systems (*CIL* II, 2950-57). The sanctuary has recently been demolished and the inscriptions have been moved to the Museo de Navarra in Pamplona.

BIBLIOGRAPHY. B. Taracena & L. Vazquez de Parga. "Epigrafía romana en Navarra," en *Excavaciones en Navarra* I (1947) 95ff; *Principe de Viana* (1947).

J. MALUQUER DE MOTES

GATCOMBE ("Iscalis") Somerset, England. Map 24. A small Romano-British town of ca. 6.4 ha, 6.4 km SW of Bristol. The earliest occupation is mid-1st c. A.D., and both 2d c. timber buildings and early 3d c. cremations have been recovered. The walled town was built in the late 3d c. and occupation continued into the 5th c.

The town is surrounded by a wall almost 5 m wide, the thickest in Roman Britain. Excavations, concentrated in the NE quarter, have revealed more than a dozen buildings which all seem to have been stores or workshops. At least three of the largest buildings have been identified as bakeries. The purpose of the town has not yet been established, but it may have been related to the extensive potteries believed to have been situated on the Somerset Levels in the late 3d and 4th c.

BIBLIOGRAPHY. E. K. Tratman, "Some Ideas on the Roman Roads in Bristol and North Somerset," *Proc. Univ. of Bristol Spelaeological Soc.* 9 (1967) 173-75; B. Cunliffe, "Excavations at Gatcombe, Somerset, in 1965 and 1966," ibid. 11 (1967) 125-60MPI; K. Branigan, "The North-East Defences of Roman Gatcombe," *Proc. Somerset Archaeol. and Nat. Hist. Soc.* 112 (1968) 40-53; id., *Roman Gatcombe* (1969); id., *The Romans in the Bristol Area* (1969); id., "Gatcombe," *Current Archaeology* 25 (1971)PI. K. BRANIGAN

GAUJAC Locality of Saint-Vincent, Gard, France. Map 23. The excavations conducted at the oppidum since 1963 have led to the identification of four periods of occupation. The oldest goes back to the second half of the 5th c. B.C., and does not seem to have lasted beyond the 4th c. The second period begins at the end of the 2d c. B.C. and lasts until the end of the 1st c. Then the settlement was Romanized. It was abandoned at the end of the 1st c. A.D., but was partially reoccupied at the end of the 4th c. under the impulse of the barbarian invaders. To the first, so-called Celto-Ligurian period belong an altar of ashes (an open area cult site) and some sections of a rampart. Two dumps at the NE and SE ends of the site are of the second, Gallo-Hellenic period. An architectural ensemble, including dwellings and a monumental public square built of quarrystone carefully chipped with a double-pointed hammer, belongs to the 3d period. In the final Early Christian and Christian period there was a street lined with dry stone-walled huts and a Romanesque chapel.

The finds are deposited at the museum and the archaeological storage depot at Bagnols-sur-Cèze (Gard).

BIBLIOGRAPHY. J. Charmasson, Reports of the excavations (1963-69)PI; id. in *Gallia* 22 (1964); 24 (1966); 27 (1969)I; id., "Les inscriptions gallo-grecques de Gaujac (Gard)" in *Cahiers Rhodaniens* 12 (1965) 41-52MI; id., "L'oppidum de Saint-Vincent à Gaujac," in *Archéologia* (Sept.-Oct. 1969) 70-79MPI; id., "Cultes antiques et Monument chrétien de Gaujac," in *L'Ecole Antique de Nîmes* (1970)I. J. CHARMASSON

GAULOS (Gozo), *see under* MELITA

GAUTING, *see* LIMES RAETIAE

GÂVUR ÖREN, *see* HADRIANI

GAZA Israel. Map 6. An important city on the coast of Palestine from earliest times. It was a halt on the Via Maris, the main highway connecting Egypt with Syria, Mesopotamia, and Asia Minor. In the earlier periods of its existence, Egypt and the N empires fought for control of it and it was only in the Persian period that the city enjoyed limited independence. After a siege of five months Gaza was taken by Alexander the Great (Arr. *Anab.* 2.26ff) and for more than a century Gaza was under Ptolemaic rule. After 200 B.C. it was conquered by the Seleucids.

Shortly after the conquest of Gaza by Alexander the Nabateans apparently began using its port as their main emporium for the export of spices and aromatics, brought by land caravans from Arabia. In 96 B.C. Alexander Jannaeus attacked Gaza (Joseph. *AJ* 13.357) and the city was taken by the Hasmonaean monarch (Joseph. *AJ* 13.360-64). As a result of this conquest the Nabateans had to abandon their system of caravan halts in the Negev for almost a century. After the conquest of Palestine by Pompey in 64 B.C., Gaza regained independence and was subsequently rebuilt by Gabinius (Joseph. *AJ* 13.75-76). Herod the Great acquired Gaza early in his reign (Joseph. *AJ* 15.217; *BJ* 1.196). It was then that it was detached from Judea, and formed a special district under Cosbaras, the governor of Idumaea (Joseph. *AJ* 15.254). After Herod's death Gaza was placed under the charge of the proconsul of Syria.

During the Roman period Gaza was prosperous, and the Roman emperors conferred many favors on it, helping to build temples and other public buildings. The chief temple of the city was dedicated to Marnas. There also were temples of Zeus Helios, Aphrodite, Apollo, Athena,

and of the local Tyche. The pagan temples were destroyed after the Christianization of the inhabitants of Gaza by bishop Porphyrios (A.D. 396-420). In this period a famous school of rhetoricians flourished there, and one of the most famous of its scholars was Procopius, the historian of emperor Justinian. During the Byzantine period there was a large Jewish community, and remains of its synagogues are still to be seen embedded in the walls of modern mosques. Remains of a mosaic pavement of another synagogue were recently discovered close to the Mediterranean coast, where lay the port Maiumas Gaza. On this mosaic is depicted King David playing the lyre. There have been no systematic archaeological investigations.

BIBLIOGRAPHY. F. M. Abel, *Géographie de la Palestine* II (1938); G. Downey, *Gaza in the Early Sixth Century* (1963); M. Avi-Yonah, *The Holy Land from the Persian to the Arab Conquests (536 B.C. to A.D. 640). A Geographical History* (1966). A. NEGEV

GAZIPAŞA, *see* SELINOS

GEISLINGEN, *see* LIMES G. SUPERIORIS

GELA Sicily. Map 17B. A Greek city founded in 689 B.C. by colonists from Rhodes and Crete led by Antiphemos and Entimos. It occupied part of a long and low sandy hill parallel to the seashore, which was already inhabited by Early Bronze Age Sikanian villagers during the second millennium B.C. The city acropolis developed near the source of the river Gelas after which the new colony was named. After long struggles against the indigenous populations to secure possession of the fertile inland plain, the Geloans began a policy of commercial and political penetration along the coast and toward the interior of the island. In 582 B.C. they founded Akragas and extended their domination to a large part of central and S Sicily. Under the tyrant Hippokrates, at the beginning of the 5th c. B.C., Gela's power reached also into E Sicily, up to the straits of Messina. Hippokrates was succeeded by Gelon, who moved to Syracuse in 483 B.C. and defeated the Carthaginian army in the battle of Himera in 480 B.C. Under the rule of Gelon's successors, the Deinomenids, Gela's political importance declined although it remained an artistic and cultural center. The tragic poet Aeschylos spent his last years in Gela, dying there in 456 B.C. And in 424 B.C. was convened there the peace congress in which the Syracusan Hermokrates, in the face of the threatening Athenian power, proclaimed the autonomy of the Sicilian colonies. In 405 B.C., despite the help of Dionysios of Syracuse, Gela was conquered and completely destroyed by the Carthaginian army led by Himilco. The city remained uninhabited for many years. It was rebuilt and repopulated with new colonists after 338 B.C. by the Corinthian Timoleon, who restored peace and democracy in Sicily. After a period of prosperous tranquility Gela was again conquered by the new tyrant of Syracuse, Agathokles, who in 311-310 B.C. used Gela as his military base against the Carthaginians. After 310 B.C. the city shrank to the W part of the hill, and at an undetermined date between 285 and 282 B.C. was destroyed by the Akragan tyrant Phintias, who transferred its population into the new city of Phintias (Licata). The hill of Gela remained deserted until 1233, when Frederik II of Swabia built on the ancient ruins the fortified city that was first called Herakleia and later Terranova until 1927, when the original name was restored.

Excavations in 1900 brought to light large sections of the Greek necropoleis and the remains of two temples on the acropolis. In 1948 the accidental discovery of fortifications in the area of Capo Soprano inspired a new series of systematic excavations still in progress.

A section of the archaic and Classical acropolis antedating the destruction of 405 B.C. has been uncovered on the modern hill of Molino a Vento where, according to Thucydides, were built the first fortifications, which the colonists called Lindioi. On the S side of the acropolis one can see the foundations of the archaic Temple of Athena, famous for its architectural terracottas (at present in the Syracuse Museum), and the foundations of a second Doric temple of the 5th c. B.C., of which remain some blocks for the underpinning of the cella and one of the columns of the opisthodomos. On the N side excavation has uncovered a section of living quarters of the 4th c. B.C. (the age of Timoleon), with ruins of houses and shops on terraces built over the remains of the earlier sanctuaries and the archaic fortifications destroyed by the Carthaginians. The area of the ancient town to the W of the acropolis is now totally occupied by the modern city. But architectural, votive, and domestic finds of great importance and aesthetic appeal have been made almost everywhere, and a Sanctuary of Hera has been identified in the area of the present City Hall. Numerous sanctuaries outside the town have been excavated around the hill; most of them were dedicated to Demeter and Kore. The Sanctuary of Demeter Thesmophoros on the small Bitalemi hill, at the mouth of the river Gelas, has yielded thousands of votive objects perfectly stratified. Another sanctuary, near the present railway station, contained a splendid hoard of over a thousand archaic silver coins.

Before 405 B.C. the polis ended at the level of the present Pasqualello valley, where the necropoleis began, and filled the entire W section of the hill. When Gela was rebuilt by Timoleon shortly after 338 B.C., habitation expanded over the necropolis area; and the entire hill, over 4 km long, was enclosed by a new circuit of walls. The Capo Soprano walls, excavated and restored between 1948 and 1954, represent the W end of these fortifications and are among the most perfect examples of Greek walls. They were built in two media, the lower part of elegant ashlar blocks of sandstone, the upper part of unbaked mud bricks, by use of a technique widely diffused in the Graeco-Oriental world. In the preserved section one should note a postern gate with a false pointed arch, a gate for wheeled traffic, remains of towers and stairways. These fortifications were soon covered by sand and the Geloans were forced to raise them at least twice in 50 years, probably at the time of Agathokles and again when they were finally conquered by Phintias. These superimposed layers are clearly visible in the best-preserved section of the walls which, through these additions, reach at some points a height of 8 m. In order to protect the unbaked mud bricks, an expensive covering with tempered glass panes and plastic roofing has been devised. Inside the walls test excavations have uncovered houses and military quarters of the time of Agathokles; the structures, built of unbaked bricks, have been temporarily covered over.

Throughout the W section of the city, foundations of houses and shops were found with evident traces of destruction and fire. These are the houses that, according to Diodorus Siculus, the Akragan tyrant Phintias razed to the ground together with the walls. Among the preserved monuments of this last period (338-282 B.C.) one should note public baths, with two groups of tubs and the furnaces for heating the water. It is the oldest public bath found in Italy thus far. It was originally built with terracotta tubs which were in the process of being re-

placed with cement troughs at the time of the final destruction.

All the archaeological finds from the new excavations are now in the National Museum, next to the acropolis area. They are displayed with the material coming from excavations and soundings in the interior (Manfria, Butera, Monte Bubbonia, Sofiana, etc.). The Museum also houses a local collection of Greek vases, especially Attic (Navarra collection). The material from the 1900-6 excavation is in the National Museum of Syracuse.

BIBLIOGRAPHY. J. Schubring, "Historische topographische Studien über Altsizilien," *RhM* (1873); L. Pareti, "Per la storia e la topografia di Gela," *Studi siciliani ed italioti* (1914) 199f; D. Adamesteanu & P. Orlandini, "Gela—scavi e scoperte," *NSc* (1956) 203-401; (1960) 67-246; (1962) 340-408 (with bibl.); P. Orlandini, "Lo scavo del Thesmophorion di Bitalemi e il culto delle divinità ctonie a Gela," *Kokalos* 12 (1966) 8ff; id., "Gela: topografia dei santuari e documentazione archeologica dei culti," *RivIstArch* (1968) 20f; H. Wentker, "Die Ktisis von Gela by Thukydides," *RömMitt* (1956) 129f; P. Griffo, *Gela* (ed. Stringa, 1963). P. ORLANDINI

GELDUBA (Krefeld-Gellep) Germany. Map 20. An auxiliary castellum of the lower Germanic limes. Pliny (*HN* 19.90) mentions Gelduba as a castellum Rheno impositum in an agriculturally rich area. The legate Vocula constructed a camp here during the uprising of the Batavi. It was occupied a short time and surrendered under pressure from Civilis (Tac. *Hist.* 4.26, 32, 35, 36, 58). After A.D. 70 an auxiliary castellum was built (*It. Ant.* 255.3) of which so far the principia have been excavated. There was a vicus SE of the auxiliary castellum. There are traces of ditches, possibly of a camp, and areas surrounded by strong fences where Roman weapons have been found. From Flavian times until the 3d c. A.D. Gelduba seems to have been the garrison of an ala; in Late Roman times, perhaps of limitanei. The graves date from Neronic to Merovingian times.

Most of the finds are at the Niederrheinisches Landschaftsmuseum in Krefeld-Linn; some at the Rheinisches Landesmuseum in Bonn.

BIBLIOGRAPHY. R. Pirling, *Das römisch-fränkische Gräberfeld von Krefeld-Gellep* (1966) 2 vols.; K.-H. Knörzer, "Über die Gelleper Rüben," *Niederrheinisches Jahrbuch* 10 (1967) 48-51; G. Alföldy, *Die Hilfstruppen der römischen Provinz Germania inferior* (= *Epigraphische Studien* 6) (1968) 152ff; W. Piepers & D. Haupt, "Gelduba," *Rheinische Ausgrabungen* 3 (1968) 213-315; I. Paar & C. Rüger, "Kastell Gelduba," *Rheinische Ausgrabungen* 20 (1970) 30.
 H. VON PETRIKOVITS

GELIDONYA, *see* SHIPWRECKS

GELLIGAER Mid Glamorgan, Wales. Map 24. Two Roman forts NW of the present village, in a commanding position close to the road from Cardiff to Brecon Gaer. Their defenses are clearly visible, though no detail is extant. Of the larger and earlier (179 x 136 m; ca. 2.4 ha) little is known. It was built ca. A.D. 75, and its timber buildings are of two periods. Occupation presumably ended with the building of the adjacent stone fort (123 x 120 m; ca. 1.5 ha). Defenses and internal buildings were of stone from the first. Fragments of three inscriptions from the gates reveal that it was built in the period A.D. 103-111. It was excavated in 1899-1901 and a complete plan is known. The six barracks indicate that it was occupied by a cohors quingenaria peditata, the smallest auxiliary unit in the Roman army. In

addition to the barracks, the accommodation includes headquarters, commandant's house, granaries, hospital, workshop, store-buildings, and (probably) stable. The defenses are unusual, consisting of an earthen bank faced internally and externally with stone; the corner and interval turrets were built within the thickness of the bank.

A roughly paved area NE of the fort was presumably the parade ground. To the SE lay the bath house; various modifications to its structure indicate a long life. In a late stage of the occupation it was enclosed within an annex which also included other buildings of uncertain function. Occupation at Gelligaer continued into the 4th c., though it is not clear whether it was military or civilian.

BIBLIOGRAPHY. J. Ward, *The Roman Fort at Gellygaer* (1903)[PI]; G. C. Boon in V. E. Nash-Williams, *The Roman Frontier in Wales* (2d ed. by M. G. Jarrett 1969) 88-91[MPI]. M. G. JARRETT

GENABUM, *see* CENABUM

GENAINVILLE, *see* PETROMANTALUM

GENAVA or Genua (Geneva) Genève, Switzerland. Map 20. At the W end of Lake Geneva, on the left bank of the Rhone. (Caes., *B.Gall.* 1.6; *Ant. It.* 347.12; *Tab. Peut.*; *Not. Gall.* 9.4). Oppidum, then vicus of the Allobroges, and belonging to the civitas Viennensium centered on Vienna (Vienne, France). It was in this area, on the border between the provincia Narbonnensis and the Helvetii, that in 58 B.C. Caesar warded off the attempt of the latter to force their way into the Roman province. Vienna became a colonia in A.D. 14, and the inhabitants of Genava received Roman citizenship in A.D. 40, together with the rest of the civitas. Because of its strategic position at the entrance to the Swiss plateau, where the main roads to Italy and the Narbonnensis met, and because of its two harbors, Genava grew into a wealthy urban settlement despite the fact that legally it was only a vicus. The flourishing traffic on the waterways, managed since pre-Roman times by transportation corporations, made Genava also a toll station of the quadragesima Galliarum, and a military post manned by beneficiarii guarded the bridge over the Rhone. Destroyed during the raids of the Alamanni in 260-65, the settlement was again fortified by the end of the 3d c. By the early 5th c. it was the seat of a bishop.

The oppidum was on a promontory (the later Cité or Haute Ville) surrounded on three sides by the lake, the Rhone, and a tributary, the Arve, which joins the Rhone near the tip of the spur. Timber and earth defenses enclosed an area of 5 ha. The main road along the ridge of the spur was closed off by two gates: the E gate at the neck (now the Bourg de Four), the other at the tip of the spur (Fusterie), leading to the Rhone bridge. The pre-Roman wooden bridge crossed the river a little beyond the modern Pont de l'Isle, using an island in midstream as a support. Not until the 2d c. A.D. was it reinforced by wooden piles.

The Roman vicus retained the road system and replaced the wooden structures by buildings of stone and mortar. Three distinct quarters developed along the lake: the official center on the oppidum hill, with sanctuaries (under the cathedral and surrounding churches) and the main forum (Bourg de Four); the commercial quarter connecting the river port with the lake harbor; the residential quarter on the plateau beyond the hill (Tranchées). The river port was connected with the larger lake harbor (Longemalle) by a paved road, and near

this harbor lay a secondary forum with a basilica and a temple of Maia (Madeleine church). The residential section was laid out on a regular grid. One of the suburban villas on the lake is partly preserved in the Parc de la Grange.

The Late Roman city walls followed the course of the pre-Roman walls, but two gates replaced the earlier ones. The E gate, flanked by rectangular towers (Porte du Bourg de Four), was still visible in the 19th c. The walls (av. thickness 2.75-3 m) are built of large stone blocks and much reused material; portions of them can still be seen near the Cathedral. Inside the walls the remains of a large 4th c. praetorium with peristyle and atrium have been found on the edge of the forum.

Finds are in the Musée d'Art et d'Histoire.

BIBLIOGRAPHY. L. Blondel, "Le développement urbain de Genève à travers les siècles," *Cahiers de Préhistoire et d'Archéologie* 3 (1946) 16-30PI; id., "Le pont romain de Genève," *Genava* NS 2 (1954) 205-9PI; F. Staehelin, *Die Schweiz in römischer Zeit* (3d ed. 1948) 38-41, 150-53, 286-88, 614-15; M. R. Sauter & C. Bonnet, "Nouvelles observations sur l'enceinte romaine tardive de Genève," *Jb. Schweiz. Gesell. f. Urgeschichte* 56 (1971) 165-72PI. V. VON GONZENBACH

GENDEVE, *see* KANDYBA

GENEVA, *see* GENAVA

GENÈVE, *see* GENAVA

GENOA, *see* GENUA

GENOVA, *see* GENUA

GENUA (Genoa) Liguria, Italy. Map 14. A port city destroyed by Hannibal and restored by the Romans for use as a military base against the Ligurians. From Livy (21.32) it is known that it was under Roman domination by 218 B.C. Little remains from pre-Roman times except Greek vases, mostly 4th c. imports, and Etruscan bronzes, both from the necropolis. Excavations have so far revealed no evidence before the 4th c. of a settled colony on the hill overlooking the oldest center of habitation at the harbor (S. Maria di Castello) although sherds testify to the traffic that might be expected around a harbor. The position of the modern city over the Roman town has made exploration impossible but the Roman grid is discernible in the regularity of the present city's street plan.

BIBLIOGRAPHY. R. Paribeni, "Necropoli arcaica rinvenuta nella città di Genova," *Ausonia* 5 (1910) 13ff; N. Lamboglia, *Liguria romana* I (1938) Ch. v; id., *La Liguria antica* (1941); L. Bernabò Brea & G. Chiappella, "Nuove scoperte nella necropoli preromana di Genova," *RStLig* (1951) 163ff; T. Mannoni, "Le ricerche archeologiche nell'area urbana di Genova," *Boll. Ligustico* 19 (1967) 9ff; T. O. De Negri, *Storia di Genova* (1968). A. FROVA

GEOAGIU, *see* GERMISARA

GERAISTOS (Helleniko) Euboia, Greece. Map 11. The site of a Sanctuary of Poseidon, near Platanistos in the S part of the region. The name was also used for the cape, now called Mandeli, and a harbor 3 km to its N at Porto Kastri. As the only good harbor on the S coast, the town was visited by merchant ships throughout antiquity. The sanctuary, of pre-Hellenic origin, is mentioned by Homer and Strabo. Bursian and others have located it at Helleniko 5 km N of the harbor, as no remains have been found at Porto Kastri, though Geyer thought the cape itself would be a more appropriate location. Bursian found a terrace with traces of walls around the remains of a white marble temple, and cited an inscription mentioning Artemis Bolosia.

BIBLIOGRAPHY. Xen. *Hell.* 3.4.4, 5.4.61; Strab. 10.1.7; C. Bursian, *Geographie von Griechenland* (1872) II 434ff; F. Geyer, *Topographie und Geschichte der Insel Euboea* (1903) III; A. Philippson, *GL* (1950-59) I 629; L. Sackett et al. in *BSA* 61 (1966) 82f. M. H. MC ALLISTER

GERASA (Jerash) Jordan. Map 6. About 48 km N of Amman/Philadelphia in the hills of Gilead S of the Hauran. It was transformed from a village into a considerable town in Hellenistic times, perhaps by Antiochos IV Epiphanes (175-164 B.C.), and was known then as Antioch on the Chrysorhoas. Early in the 1st c. B.C. it was annexed by Alexander Janneus to Jewish territory, and in 63 B.C. Pompey in his reorganization of the East assigned it to Roman Syria as one of the towns of the Decapolis; in the 3d c. A.D. it was elevated to the rank of colony. As a provincial agricultural, mining, and caravan town Gerasa flourished under the Roman Empire, remaining relatively prosperous until in the 7th c. it was captured first by the Persians (614) and then by the Arabs (635). One of the few ancient writers to mention Gerasa is Josephus (*BJ* 1.104, 2.458, etc.); however, several hundred inscriptions, chiefly of Imperial date, have been found on the site. Considerable excavation and restoration has taken place since 1920.

In plan the town is divided N and S into two inward-sloping, unequal parts by the Chrysorhoas. There is a perennial spring within the walls; N of the site in Roman times a reservoir was built from which an aqueduct ran to the town. The chief gates are N and S and they received the main roads of the area, which were among those much renovated and augmented in the East in Trajan's time. The town walls, so slight as to be almost cosmetic, are sprinkled with small towers and enclose ca. 100 ha. Perhaps ten or fifteen thousand people lived in Gerasa in the early 2d c. A.D.

What can be seen today is post-Hellenistic in date and consists almost entirely of principal streets and public buildings; few private or domestic remains have been uncovered. The architecture of Gerasa is richly worked and in some ways baroque, a successful synthesis of the Hellenistic and Roman Imperial styles. Also, much of the monumental building typology of imperial towns is represented; Gerasa is a significant site in these respects. This is clearly shown by a huge triumphal arch, a large part of which still stands outside the town walls to the S. It was probably erected to commemorate a visit by Hadrian during the winter of 128-29. About 37.5 m wide, it is divided into five bays characterized by niches, aediculae, orders at three different scales, and decorative architectural sculpture of floral motifs. Beside this arch stood the town stadium.

A street plan approximately orthogonal, at least with regard to the major thoroughfares, was laid upon the site apparently in Early Imperial times. The southernmost portion of the town, however, is not subject to this grid: the S gate gives obliquely onto a large paved area of irregularly oval plan surrounded by an Ionic colonnade (ca. 66 x 99 m, and built ca. A.D. 300; there was a rather similar plaza at Palmyra). Nearby, and also independent of the orthogonal system, is a large Temple of Zeus (begun ca. A.D. 22 but finished in the 160s). It is of typical Romano-Syrian type, with unfluted peristyle columns arranged 8 by 12, the whole raised on a broad and high podium. The cella wall is decorated wtih scalloped niches on the exterior and broad pilasters on the interior.

Nearby is the S theater, first constructed in the 1st c. A.D. but later rebuilt. Its elaborate scaenae frons, now partly restored, consists of projecting and retreating pavilions and aediculae, with orders of varying scales.

The main street runs N from the oval plaza. To the E of this street bridges carried the main cross streets over the Chrysorhoas ravine. The main street and many of the subsidiary streets were colonnaded; sometimes the Corinthian order was used, sometimes the Ionic. Two of the major intersections with the main street were marked by tetrapyla; of these the S one was set in a large circular space with tabernae round about. Some of the column shafts along the streets carry brackets for sculpture, in the Palmyrene manner, and in order to emphasize the locations of entrances to major buildings the height of the colonnade was from time to time raised above the standard level. Along the main N-S street were placed a large, scenically designed nymphaeum and propylaea to the (later) Cathedral and to the Temple of Artemis.

The last-named is an elaborate system of architectural screens and openings articulated by aediculae and a rich profusion of decoration. It is centered upon a majestic staircase that rises up the W slope of the town to give onto the immense, walled precinct of Artemis (all from the mid 2d c. A.D.). This complex, one of the major monuments of Roman religious architecture in the Near East, measures ca. 240 by 120 m. The temple proper is ca. 52.5 m in length and stands in a colonnaded temenos. In design it is rather similar to that of the Temple of Zeus but with columns disposed 6 by 11. The podium is high, the porch deep, and the order Corinthian (some columns stand—they are unfluted and carry a suggestion of double entasis; this is the order that appears in so many Gerasa buildings).

To the E of the main N-S street are the remains of two baths; in the N ruins there is a large, well-preserved room roofed by a true pendentive dome made of stone (2d c. A.D.?). To the W of this, across the main street, there is a second (N) theater, set beside a handsome rectangular plaza. Outside the town to the N, beside the reservoir, there is a third, smaller, theater.

Early Christian remains at Gerasa are important. At least 13 churches are known (seven from the time of Justinian), and their plans and to a degree their elevations can be recovered. Both basilican and centralized designs were built, largely from materials taken from earlier structures. Almost all these churches can be dated, and some excellent mosaics have been revealed. Three examples of Gerasa churches may suffice. The Cathedral, of the second half of the 4th c., was approached from the main N-S street by way of a colonnaded, monumental staircase. The building, of the three-aisled basilican type, was erected on the site of a Temple to Dionysos, parallel to and slightly below the precinct of the great Temple of Artemis. Just beyond the Cathedral, to the W, was a courtyard centering on a miraculous fountain. Farther to the W, in the center of a complex of three churches, was the Church of St. John the Baptist, built in 529-33. It was planned as a circle inscribed in a square, with the corners of the latter receiving deep niches; this is a variant on the slightly earlier Cathedral at Bosra, to the N. At the Church of the Prophets, Apostles, and Martyrs of the 460s the plan consists of a cross inscribed in a square, with the remaining corner rectangles walled off into all but discrete volumes. All of these churches had apses projecting toward the E.

By the late 8th c. people were still living around the S tetrapylon circle and in the oval plaza. Today, some of Gerasa's mosaics are still in situ; other materials from the site can be seen in the archaeological museum in Jerusalem and at the Yale University Art Gallery.

BIBLIOGRAPHY. M. I. Rostovtzeff, Caravan Cities: Petra and Jerash, Palmyra and Dura (1932)[I]; id., Social and Economic History of the Roman Empire 2 (2d ed., 1957) references on p. 784; R. O. Fink, "Jerash in the First Century A.D.," JRS 23 (1933) 109-24; C. H. Kraeling, ed., Gerasa, City of the Decapolis (1938)[PI]; J. W. Crowfoot, Early Churches in Palestine (1941)[MPI]; EAA 3 (1960) 840-42[P]; G. Lankester Harding, The Antiquities of Jordan (2d ed., 1967) 79-105[MPI]; M. Restle, "Gerasa," Reallexikon zur byzantinischen Kunst 2 (1970) 734-66[P]. W. L. MAC DONALD

GERGA Turkey. Map 7. Carian village near Ovacık, 12 km S-SE of Çine. It is unknown to history, identifiable by the fact that the name is written on the rocks and buildings more than 20 times. The village center is on the E hill, which carries a remarkable group of monuments. Most conspicuous is a small but well-preserved temple, with a roof constructed in imitation of woodwork; the pediment over the door is inscribed with the name Gergas. Close by are two tapering stelai over 3 m high, again inscribed Gergas, between which stood a colossal statue now overthrown. A little to the W is another statue, 4 m high, lying on its face. Not far away is a group of ruined houses and a street lined with walls.

Lower down is a curious sloping rock with flat top, inscribed Gerga Enbolo, which was perhaps a speaker's platform. On the W hill is a third fallen statue, also over life-size, inscribed on the breast with the name Gerga. A number of small square buildings about 2 m high, roofed and open in front, have been thought to be tombs, but are perhaps more probably fountain houses. It is supposed that Gergas is the name of a local deity.

BIBLIOGRAPHY. G. Cousin, BCH 24 (1900) 28-31; A. Laumonier, ibid. 58 (1934) 304-7; 60 (1936) 286-97; G. E. Bean, AnatSt 19 (1969) 179-82; id., Turkey beyond the Maeander (1971) 201-7. G. E. BEAN

GERGOBIA, see GERGOVIA

GERGOVIA or Gergobia Commune of La Roche-Blanche, Puy-de-Dôme, France. Map 23. Mountain ending in a plateau (altitude 730 m) dominating the valley of the Allier by ca. 350 m. When Gaul was independent, the plateau was used as a citadel by the agricultural population living on the level areas on the slopes and at the foot of the mountain. In 52 B.C. Caesar besieged the fortress but failed to take it. The Roman administration tried to establish an urban center on the plateau, but failed in less than a century and the inhabitants settled once again on lands more favorable to agriculture.

Excavations have been conducted on several occasions. Those in the 18th c. are poorly known, but in 1862 the ditches of Caesar's two camps were uncovered. Other excavations in 1861, in 1933-38, and in 1941-49, have analyzed the composition of the rampart and excavated a temple of Celtic type with two cellae, a small blast furnace, and private dwellings. The artifacts collected are shared by a small museum on the plateau and by the Musée Bargoin at Clermont-Ferrand.

BIBLIOGRAPHY. Stoffel, in Napoléon III, "Hist. de Jules César" (1865-66)[M]; O. Brogan & E. Desforges, "Gergovia," AJA 97 (1941); Hatt & Labrousse, "Les Fouilles de Gergovie," Gallia 1 (1943) 71-124; 5 (1947) 271-300; 6 (1948) 31-95; 8 (1950) 14-53; Balme & Fournier, Gergovie (1962); A. Noché, Gergovie, vieux problèmes et solutions nouvelles, Collection Roma aeterna, VI (1974). P. FOURNIER

"GERMANICOMAGUS," see Les Bouchauds

GERMISARA (Geoagiu) Hunedoara, Romania. Map 12. Health resort, camp, civil settlement, and necropolis, situated a few km apart. The name, of Thraco-Dacian origin, is mentioned in ancient sources (Ptol. 3.8.4; *Tab. Peut.*; and by *Rav.Cosm.* 4.7) and attests to the use of the hot springs even before the Roman conquest.

The camp, not yet systematically investigated, is situated between Cigmău and Geoagiu. The ancient bath is 5 km N of the camp, at the modern health resort. Germisara was probably a pagus included in the territory of Ulpia Traiana Sarmizegetusa.

Important archaeological discoveries include a basin (7.59 m in diameter) dug into a rock and filled with thermal waters through a terracotta pipe; many inscriptions, sculptures, and coins. Remains of walls and buildings have also been found.

Many of the inscriptions, dedicated to the healing gods or to the nymphs, were ordered by prominent patients. Among them were the governors of Dacia Superior: M. Statius Priscus (*CIL* III, 7822) and P. Furius Saturninus. A dedication in hexameters to the nymphs (*CIL* III, 1395) has been found. The funeral monuments, carved in stone supplied by the neighboring quarry, offer a variety of representative figures. An aedicula wall represents a child with two penholders and a satchel for school supplies.

BIBLIOGRAPHY. N. Gostar, "Inscripţii şi monumente din Germisara," *Contribuţii la cunoaşterea regiunii Hunedoara* (1956) 57-99; D. Tudor, *Oraşe, tîrguri şi sate în Dacia romană* (1968); V. Wollmann, "Monumente sculpturale din Germisara," *Sargetia* 5 (1968) 109-219.

L. MARINESCU

GERONA, see Gerunda

GEROUSSENS Tarn, France. Map 23. Since 1960 the vicinity has been systematically explored. Some fifteen Roman sites have been found, mostly consisting of villas and, at Les Martels, a Visigothic necropolis of about sixty tombs, some of which have yielded fairly rich grave goods.

BIBLIOGRAPHY. M. Labrousse in *Gallia* 20 (1962) 600-602 & fig. 64; 22 (1964) 468 & figs. 50-51; 24 (1966) 446; 26 (1968) 553-54 & fig. 37; 28 (1970) 435.

M. LABROUSSE

GERPINNES Belgium. Map 21. A large Gallo-Roman villa, ca. 10 km SE of Charleroi. The main building and annexes were excavated in 1875 but did not yield valid data for precise dating. The construction of the main building shows signs of several phases of occupation. Originally it had a large rectangular room in the middle, flanked by two projecting corner rooms joined by a portico. The corner room on the E side was built over a cellar. Later, a series of smaller rooms was added to the E, W, and S sides, but a large passageway was made in the SE corner that led to the great central hall; it probably housed vehicles and tools. The W wing rooms very likely were used as stables. The living quarters— originally the two projecting corner rooms—were moved to the N wing: a number of fragments of a mural plaster decorated with frescos were found there. None of the rooms in this central building had a hypocaust. To the S of the main building by the banks of the Biesme, which ran along the edge of the estate, some bath buildings were erected, with caldarium, tepidarium, and frigidarium. A little farther away, the solid foundations of a small rectangular building were discovered; this may have been a barn, shaped like a tower. Gerpinnes lies in a region rich in quarries and iron-ore deposits; thus it seems likely that the occupants of the villa engaged not only in agriculture and stock farming but in iron smelting and stone quarrying. Not far from the villa, but on the other side of the Biesme, a burial vault was unearthed in 1960. It was made of small limestone rocks (60 x 70 cm) and contained a relatively large quantity of grave gifts: a dozen pottery vases, fibulas, and four coins. Perhaps originally built under a tumulus, the tomb dates from the end of the 2d c.

BIBLIOGRAPHY. R. De Maeyer, *De Romeinsche Villa's in Belgie* (1937) passim, esp. pp. 85-87ᴾ; id., *De overblijfselen der Romeinsche Villa's in Belgie* (1940) 62-65; R. Brulet, "Gerpinnes: sépulture gallo-romaine," *Helinium* 8 (1968) 269-76.

S. J. DE LAET

GERULATA, see Limes Pannoniae

GERUNDA (Gerona) Gerona, Spain. Map 19. Town in the province of Tarraconensis at the confluence of the Ter and the Onyar. Chief town of the Gerundenses who, according to Pliny (*HN* 3.23), had Latin rights. It was an oppidum of the Ausetani who controlled the defile of the Ter which separated them from the Indiketes and from Emporion's area of influence. Stretches of the pre-Roman cyclopean wall, which was strengthened during the Republican era, still survive; the wall of the Imperial age, rebuilt on the same perimeter, dates from the end of the 3d c. The town is on the main Roman road from Tarraco to Narbo and is mentioned in ancient sources (*Ant.It.* 390; Ptol. 2.6.9). Like all of Tarraconensis it was invaded by the Franks but, thanks to its fortifications, it subsequently acquired greater importance under the Late Empire (*Rav. Cosm.* 307.4; 341.13).

From an early time it had a large Christian community and was a bishopric (Martyr. Felix peristeph. 4.29). The Church of San Felix contains pagan and Christian sarcophagi. Roman villas outside the town have yielded the mosaic of Ball-lloch and others, now in the Barcelona and Gerona museums; the mosaic of Sarria de Ter is now being excavated. A local museum is being built, which contains prehistoric, Iberian, and Greek materials from Rosas and Ampurias, in addition to Roman remains.

BIBLIOGRAPHY. Comision de Monumentos de Gerona, *El mosaico romano descubierto en la Torre de Ball-loch* (1876); J. Martorell y Peña, *Recintos fortificados* (1881); E. Bonnet, "Les sarcophages chrétiens de l'église Saint Felix de Géronne et l'Ecole Arlésienne de sculpture funéraire," *BAC* (1911); J. Puig i Cadafalch, *L'Arquitectura romana a Catalunya* (1934)ᴵ.

J. MALUQUER DE MOTES

"GESOCRIBATE," see Brest

GESORIACUM BONONIA (Boulogne) Nord, France. Map 23. In the Belgica province of Gaul. The history of the city that grew up around the two sites is characterized by the alternation of the names Bononia and Gesoriacum, as the city's center of gravity shifted from one place to the other. The name Bononia was probably used to designate the Celtic oppidum and was still used by Tiberius, who stayed there in A.D. 4. But the name Gesoriacum, first mentioned in the text of Florus (2.30; between 12 and 9 B.C.), had already appeared by this time, and the city had probably also begun to take on the function of a harbor, as Caesar had foreseen (Portus Itius). For over three centuries only Gesoriacum was important—the lower city that developed around an expanding port. Gesoriacum acquired a famous lighthouse under Caligula, who came here in A.D. 40 to stage a simulated embarkation for Britain; and it was from here in 43 that the fleet actually sailed. From that time on,

Gesoriacum, home of the Classis Britannica, was the port linking the continent with Roman Britain.

At the end of the 3d c. the name Gesoriacum was replaced by Bononia; after the catastrophes of the mid 3d c. the city withdrew to the high fortified ground to the NE and a large part of the Empire city was abandoned. The construction of the city walls and founding of the upper city may probably be attributed to Carausius, commander of the fleet responsible for protecting the litus Saxonicum against pirates. In 293 Carausius' forces, revolting against the authority of the Tetrarchy, were besieged by Constantius Chlorus; after the transfer of power, he named the upper city Bononia, thereby acknowledging himself to be the usurper.

Nevertheless, at the beginning of the 4th c. the military port was in full operation (bricks stamped Classis Britannica, from the Constantinian period). The end of Bononia oceanensis, as it is called on coins, dates from the beginning of the 5th c.; the city is mentioned one last time as the base of the usurper Constantine III, who disembarked there with troops being recalled from Britain. The abandonment of that province was fatal for Boulogne, which is not included in the Notitia Dignitatum and was not to come to life again until Charlemagne's time. All that can be seen on the site are a few remains of a barbarian settlement and some Merovingian tombs.

Systematic excavation is recent and has produced no spectacular results. The site and area of expansion of the Empire city, Gesoriacum, are roughly marked by its necropoleis: three cemeteries—to the NW (between the Vallon des Tintelleries and the hill on which the upper city stands), E (N of the modern Rue du Viell-Atre) and S (at the gates to the suburb of Brequerecque)—bound an urban area of 40-50 ha. Thus Gesoriacum spread out along the shore; in antiquity it was a cove but it silted up in the Middle Ages and was drained in the 17th c. This so-called Anse de Brequerecque was the site of the Roman port, S of the upper city, not NW in the Vallon des Tintelleries where the mediaeval port developed. This location is confirmed by the discovery of traces of buildings belonging to the naval base near the Rue de la Port Gayole and the Rue Saint-Marc, and of a large quantity of tiles and bricks stamped with the fleet's seal in the same sector. The residential areas grew up around the harbor installations, the wealthiest houses probably occupying the higher ground to the NE, away from the marshes.

The upper city, which was to become the essential city center in the 4th c., was occupied at least from the Flavian period on; this is attested by the recent discovery of a series of basins and by a 19th c. reference to some remains under the church large enough to have belonged to an important building (still not properly identified). But the city was still sparsely settled; the center of activity was farther down, near the right bank of the river. The orientation of certain mediaeval and modern streets suggests a grid plan, but it is not certain that the grid covered the whole city, especially around the ancient port. As to Caligula's lighthouse, it was partially preserved up to the 18th c. (the Tour d'Ordre) and stood outside the city, to the NW. According to ancient descriptions, it was built of alternating courses of stone and bands of brick. Finally, the Empire city does not appear to have had a surrounding wall, judging both from the lack of archaeological evidence and from the vulnerability of the city and the various installations of the classis which were burnt down, probably in the 3d c. invasions.

In the Late Empire, on the other hand, a system of ramparts was erected; the upper city was ringed with a wall which can still be detected at certain points. The mediaeval rampart (c. 1231), which is still visible, rested on Roman substructures on the NW and NE, as proved by excavation; on the SW and SE the mediaeval wall was apparently some distance behind the line of the Roman wall, whose plan is incompletely known. Essentially the upper city rampart formed a rectangle ca. 450 x 300 m, enclosing a citadel of ca. 13 ha. The towers and gates cannot be precisely located. This system of fortification was completed when two parallel ramparts were built in the Late Empire. Starting from the SW Bononia wall, the ramparts probably extended from the upper city down to the shore, ensuring protection of an area of ca. 20 ha. This second system of defenses, built to protect old sections of the Empire city, indicates that this part of the lower city (its boundaries are marked by a few late cemeteries) was still active as a city and harbor in the 4th c. The archaeological finds are housed in the Boulogne municipal museum.

BIBLIOGRAPHY. J. Heurgon, "Les problèmes de Boulogne," REA 50 (1948) 101; 51 (1949) 324; id., "De Gesoriacum à Bononia, Hommages Bidez-Cumont," Coll. Latomus II (1949) 127; E. Will, "Les remparts romains de Boulognes-sur-mer," Revue du Nord 42 (1960) 363; id., "Recherches sur le développement urbain sous l'empire romain dans le nord de la France," Gallia 20 (1962) 79; id., "Boulogne et la fin de l'Empire . . . ," Mél. Renard, II (1969) 820. C. PIETRI

GHAZNI, see ALEXANDRIAN FOUNDATIONS, 4

GHENT, see GANDA

GHERLA Cluj, Romania. Map 12. Roman camp, flourishing civil settlement, and necropolis, now covered by modern buildings. Two military diplomas were discovered here, dated 123 and 133, testifying to the existence of Dacia Porolisensis.

The earthen camp (162 x 169 m) was later rebuilt in stone. Ala II Pannoniorum, which also built the baths situated 200 m away, was stationed in this camp.

The archaeological material, including inscription, fragments of architecture and sculpture, weapons, bronze statuettes and coins, are to be found at the History Museum in Gherla, the Museum of History of Transylvania in Cluj, and the Museum of History of the Socialist Republic of Romania.

BIBLIOGRAPHY. V. Christescu, Istoria militară a Daciei romane (1937) 135-36; C. Daicoviciu & D. Protase, "Un nouveau diplôme militaire de Dacia Porolissensis," JRS 51 (1961) 63-70; I. I. Russu, Dacia şi Pannonia inferior în lumina diplomei militare din anul 123 (1973).

L. MARINESCU

GHIACCIO FORTE Grosetto, Tuscany, Italy. Map 16. An Etruscan site in the first stages of exploration. On a hill overlooking the Albegna river, it is ca. 14 km SE of Scansano. A complete circuit of city wall almost 1 km long defines a town—as yet unidentified—which was ca. 3.4 ha in extent and 8-shaped. Only the substructure of the city wall (ca. 4 m thick) remains, through which at least three city gates penetrated at strategic and convenient points. The inhabited area reveals a regular urban plan with paved streets, drainage system, and houses composed of multiple rooms and open courts.

Together with the pottery finds, bronze pins, vessel handles, etc., there has come to light an impressive votive deposit chiefly comprised of bronze and terracotta sculpture. Although the deity or deities to whom the ex-votos were offered has not yet been determined, there doubtlessly existed an important cult at Ghiaccio Forte. The

terracotta sculpture represents human and animal figures and anatomical models. The bronze sculpture is limited to bronze statuettes of nude and semi-nude youths (several with a falx or pruning-knife, and one with its original stone base), draped women, bulls, and a boar.

Although the widespread signs of destruction can be placed to the Hellenistic period (late 4th and early 3d c. B.C.) and correlated with the Roman conquest of Vulci (280 B.C.), there is evidence of earlier occupation—reused architectural blocks, a female terracotta head of Classical appearance, and an unquestionably archaic bronze statuette of a kouros.

BIBLIOGRAPHY. M. Del Chiaro and A. Talocchini, "A University of California, Santa Barbara Excavation in Tuscany," *AJA* 77 (1973), 327-31; 78 (1974).

M. A. DEL CHIARO

GHIGEN, *see under* OESCUS

GHIRZA Libya. Map 18. A Romanized Berber settlement on the left bank of the wadi Ghirza 10 km above its confluence with the wadi Zemzem, ca. 250 km SE of Tripoli. The settlement contained over 40 substantial buildings, five of them large two- or three-story structures with interior courtyards; lesser houses had one room, or two or three end to end. They are built of small, roughly squared masonry, and entrances are on the E or SE. Water was collected in cisterns; two wells were found. There are large middens on the site. One building was a temple of native type with porticos round a courtyard, a sanctuary on the W, and an entrance on the E. Over 20 small altars were found (ht. 20-24 cm), three with inscriptions in the Libyan alphabet. The temple was burned (6th c.) and later (10th c.?) rebuilt as a house. The settlement depended on its crops, flocks and herds, and hunting. Over 3 km of the wadi had transverse walls, 40-50 m apart, to slow down flash floods and to preserve the silt. Barley, a little wheat, and olive trees could be grown between the walls.

There are two major cemeteries, each with monumental tombs of large dressed stones. The earliest tomb (A) in the N cemetery is in the form of a small Doric temple (10.20 x 7.40 m) with debased Ionic capitals. It has tomb chambers under the podium and within the cella. There are sculptures on the E and S walls of the cella, which had a false door (now gone) facing E and, above it, a Latin inscription. The five principal tombs remaining (B-F) have external columns with Corinthian capitals which carried arch-heads cut from single stones. They stand on high podia, their cellas are solid piers, and the larger ones have false doors. Tombs B and C have 4th c. inscriptions. The tomb chambers are under the podia and offering-ducts led into them from the exterior. Above the arcades are friezes with barbarous sculptures showing the life of the departed and the common funerary symbolism of the Late Roman world. Names on the inscriptions are all Libyan except for the family name Marcius. The S cemetery has one of the tall, obelisk-like tower tombs that are characteristic of Tripolitania; its upper stories are now fallen. The other mausolea resemble tombs B-F of the north cemetery, but are generally smaller; the smallest has been re-erected in the Tripoli Museum.

Of the pottery found in the settlement, a few sherds can be dated to the 2d and 3d c. A.D. but the largest quantity belongs to the 4th c., the most prosperous period, continuing in diminishing volume into the 6th c. There is no sign of Christianity save for a few pieces of "Christian" lamps. Early Fatimid sherds and coins were found in the Berber house, which seems not to have survived the 11th c.

BIBLIOGRAPHY. D. Denham and H. Clapperton, *Travels and Discoveries in North and Central Africa, 1822-24* (1826) 305 (Hakluyt Society ed. 1964); H. Méhier de Mathuisieulx, *Nouvelles Archives des Missions* (1904) XII; G. Bauer, *Africa Italiana* (1935) VI, 61; O. Brogan, *ILN* (Jan. 22 and 29, 1953)[I]; D.E.L. Haynes, *Antiquities of Tripolitania* (1955) 154; O. Brogan and D. J. Smith, "The Roman Frontier Settlement at Ghirza," *JRS* 47 (1957) 173[MPI]; E. Vergara-Caffarelli, "Ghirza," *EAA* (1958)[I]; for inscriptions, see J. M. Reynolds et al., *Inscr. of Roman Tripolitania* (1952) nos. 898ff; *BSR* 22 (1955) 135; *Antiquity* 32 (1958) 112ff. O. BROGAN

GHOR EL-FEIFEH, *see* PRAESIDIUM

GIANNUTRI, *see* DIANIUM INSULA *and* SHIPWRECKS

GIAT ET VOINGT Puy-de-Dôme, France. Map 23. A Gallo-Roman site (ruins of the Puys de Voingt, also known as the Beauclair ruins) on the Roman road from Lyon to Saintes, 45 km W of Clermont-Ferrand. The site was occupied at least from the beginning of Roman domination to the end of the 4th c. A.D.

The chief monument is a temple set on a hill with a spring close by. It is of the fanum type, with a cella 12 m square, the walls of which still bear traces of paintings at the bottom. The cella is surrounded by a gallery, which is backed to the S and W by solid walls and on the other two sides by a wooden colonnade. The temple facade faced NE. Remains of an earlier temple with the same orientation have been found under the cella.

Next to the temple were some outlying buildings; to the N was a large adjoining room again with traces of paintings on its walls, while a wall to the E may be the remains of a surrounding wall.

Excavations on the remainder of the site, which covers ca. 28 ha, have revealed the foundations of huts, shops built of light materials, and forges and workshops belonging to craftsmen (especially bronze-founders) whose work may have been connected wtih the sanctuary. A few larger structures were apparently farm buildings. Traces of a water supply system have been uncovered: an ancient water-catchment connected to a spring and the remains of a small aqueduct. E of these buildings were two necropoleis, largely despoiled in the 19th c.

BIBLIOGRAPHY. A. Tardieu & F. Boyer, *La ville gallo-romaine de Beauclair* (1882)[MPI]; G. Charbonneau, "Les ruines gallo-romaines des Puys de Voingt," *Gallia* 15 (1957) 117-28[M]; id., "Nouvelles fouilles aux Puys de Voingt," ibid. 19 (1961) 226-31; Grenier, *Manuel* IV:2, 594-98. J. C. POURSAT

GIBEAH Israel. Map 6. A town on the main road that passed through the mountains of Judah and Ephraim, prominent in the Biblical story of the times of the Judges and during the kingship of Saul and the later kings of Judah. By the name of Gabath Saul (Saul's Hill) it was known to Josephus, who wrote that it was 30 stadia distant from Jerusalem and that Titus camped there on his way to that city (*BJ* 5.51). Gibeah is identified with Tell el-Ful, a hill N of Jerusalem and 750 m above sea level. Excavations here have revealed a succession of fortresses dating from the 12th c. B.C. and later. Hellenistic and Early Roman remains are scanty. The site was apparently destroyed in A.D. 70 by the emperor Titus.

BIBLIOGRAPHY. W. F. Albright, *AASOR* 4 (1924); id., *BASOR* 52 (1933) 6-12; L. A. Sinclair, *AASOR* 34-35 (1960) 1-52; id., *Biblical Archaeologist* 27 (1964) 52-64; P. W. Lapp, *Biblical Archaeologist* 28 (1965) 2-10. A. NEGEV

GIBEON (el-Jīb) Occupied Jordan. Map 6. Town 13 km N of Jerusalem, mentioned 45 times in the Bible. It was prominent in the account of the conquest of Canaan (Josh. 9:3-15; 10:9-14), the battle between Joab and Abner at the pool of Gibeon (II Sam. 2:13-17), the sacrifice of the seven descendants of Saul (II Sam. 21:1-6, 8-10), and the holocausts of Solomon (I Kings 3:4-6, 9-13). Josephus mentions the encampment there of Cestius in his attempt to take Jerusalem in A.D. 66 (*BJ* 2.545-46). The site was identified by the discovery of 24 jar handles inscribed with *gb'n* in Hebrew.

Gibeon was occupied principally in the Early Bronze, Middle Bronze, Iron I and II, Persian, and Roman periods. Within the Iron Age fortification was a rock-cut pool, 11.1 m in diameter and 10.5 m deep, equipped with a spiral staircase of 79 steps that continued downward for another 13.5 m to the fresh water table. A second access to water was provided by a rock-cut tunnel with 93 steps reaching from inside the ramparts to a spring at the base of the hill. Evidence for a winery and dwellings belonging to the Iron Age was found, as well as tombs of the Early Bronze, Middle Bronze, Late Bronze, and Roman periods. Artifacts are divided between the National Museum in Amman, Jordan, and the University Museum in Philadelphia.

BIBLIOGRAPHY. J. B. Pritchard, *Hebrew Inscriptions and Stamps from Gibeon* (1959); *The Water System at Gibeon* (1961); *Gibeon, Where the Sun Stood Still* (1962); *The Bronze Age Cemetery at Gibeon* (1963); *Winery, Defenses and Soundings at Gibeon* (1964).

J. B. PRITCHARD

GIBIL GABIB Sicily. Map 17B. A mountain on the right side of the valley of the river Salso, a few km S of Caltanissetta. The name is a corruption of the Arabic name Gebel Habib (Mountain of the Dead), referring to numerous prehistoric and Greek graves dug into the rock. An indigenous settlement on the S slope of the mountain dates to the Chalcolithic period. During the 7th c. B.C. this center came into contact with the Greek colonists of Gela, who utilized the valley of the Salso (fl. Himera) as the main route for their commercial and political penetration toward the interior of Sicily. The vases, painted with lines and concentric circles, are undoubtedly of Geloan inspiration, but imitation of Corinthian pottery is also present. As in other centers in the Salso Valley, Greek influence was fully established in Gibil Gabib during the second half of the 6th c. B.C. when Attic pottery is predominant, together with terracottas from Gela and Akragas. At the end of the 6th c. the S slope of the mountain was barred by a fortification wall, probably indicating that Greek colonists were in complete possession of the center. The few houses so far excavated have a simple rectangular plan with two rooms. The center, abandoned at the end of the 5th c. B.C., was repopulated in the second half of the 4th c., as part of the general reconstruction of Sicily sponsored by Timoleon. It was finally abandoned ca. 310 B.C., perhaps after the war which Agathokles, tyrant of Syracuse, waged against cities and fortresses of the interior (Diod. Sic. 19.72). The finds from Gibil Gabib are in the museums of Gela and Caltanissetta.

BIBLIOGRAPHY. D. Adamesteanu, *NSc* (1958) 387ff (with previous bibliography); P. Orlandini, *Kokalos* 8 (1962) 99ff; id., *RendLinc* (1965) 459. P. ORLANDINI

GIGLIO, *see* AEGILIUM INSULAE

GIGTHIS Tunisia. Map 18. On the Gulf of Boughrara opposite the island of Jerba, 30 km NE of Medenine and E of the road leading to Jerba through Ajim. The ruins are spread out on the foothills going down to the coast, with hills to N and S of them and the road on the hinterland side.

The importance of the site is due both to its size—almost 50 ha—and to the extent and significance of the area excavated. Its fame also owes much to Constans' remarkable monograph on the history and archaeology of the site, but, it has been virtually abandoned since the original excavations except for a few sporadic restorations.

Gigthis was one of the most flourishing emporia of the Syrtic gulf. Its foundation was probably Phoenician, the city's position enabling it to trade with both Greece and Egypt. Under Numidian rule after the fall of Carthage, Gigthis then probably declined. On becoming Roman with the creation of Proconsular Africa, it prospered for a time, mainly because of the olive groves in the hinterland and trade with Ostia, the port of Rome. This economic progress encouraged political development. The political and administrative center of gravity of a Numidian tribe of the "natio" of the Chinithi, Gigthis was at first a civitas peregrina. It was promoted to the rank of municipium by Antoninus Pius after those of its distinguished citizens who had acquired individual Roman citizenship were permitted by the emperor to grant their city the ius Latii. This enabled the most deserving of its members to become Roman citizens and opened the way for all its members to be Latinized. This prosperous period was marked by an extension of the city plan and architecture, as is shown by the traces that remain today. Nevertheless, owing to its origins and its position on Syrtis Magna, Gigthis always retained the stamp of Carthage as well as its links with the East through Egypt and Libya. This influence was felt not only in the Alexandrine religious cults, strictly speaking, but also in architecture, decoration, and especially in Carthaginian traditions.

The forum stands on a hill near the shore beneath the Temple of Isis and Serapis. Measuring 60.6 x 38.5 m, it is oriented WSW-ENE, like the first general orientation of the city, and has a large paved esplanade (32 x 23.5 m) surrounded on three sides by a spacious portico 7 m wide with a Corinthian colonnade (19 x 11 columns). A whole series of buildings and annexes open onto the portico. Two more large buildings flank the SW and NW corners of the forum, on the side facing the principal temple. They are arranged symmetrically on either side of the entrance, which is continued along an axial street. One of the buildings is dedicated to Liber Pater, the other apparently is a civil basilica.

The forum is, therefore, complete in design and provided with the customary appurtenances. Some statues and dedications that adorned it tell its history. Begun under Hadrian, it was completed at the beginning of Marcus Aurelius' reign and embellished under the Severi, remaining in use up to the end of the Empire. Certain outlying buildings were rebuilt and a few structures, in particular the two large ones on the W side, were made into private houses.

The capitol stands W of the forum on a podium 3.3 m high. Hexastyle, prostyle, and pseudo-peripteral, it is of the Corinthian order (12 fluted columns of gray-green marble) and is reached by a monumental staircase divided into two flights of steps. It is built of large limestone blocks with bands of opus africanum and faced with painted stucco. A colossal head of Zeus Serapis that belonged to a religious statue was found in the cella, making it possible to identify the temple, not at all as the usual sort of capitol but as that of the Alexandrian god. Many other fragments of sculpture and bas-relief, frequently of stucco, have been found in the temple. The

temple wing, which opens onto the N portico, consists of an alignment of rooms and sanctuaries, several of which have been identified either from their plan or by the inscriptions and objects found inside them.

Proceeding from the NE corner, one first comes upon a Sanctuary of Hercules (3.7 x 5 m), identified by a head of a statue found there. It is built of ashlar painted with stucco. Next is an unidentified temple, built of large blocks on a podium 2.4 x 3 m. According to an inscription it was built under Hadrian. A Sanctuary of Concordia Panthea comes next, identified from a statue of the goddess and an epigraphic frieze, then on the other side of the gate a Sanctuary of Apollo, dedicated in 162-64. Next is a fountain with its reservoir and several large rooms whose function is undetermined. On the other S side is a large paved room, the only structure occupying the SW corner of the portico. A head of Augustus was found there (now in the Bibliothèque Nationale in Paris), which enables us to identify the sanctuary as that of the cult of the gens Augusta; beside this is the Temple of Liber Pater, built under Marcus Aurelius. It stands in the middle of a large court (23.5 x 14.7 m) surrounded on three sides by a portico 3.5 m wide, which it dominates. The cella (10 x 10.5 m) has a naos and pronaos.

Opposite it across the street is another building—traces of its three parallel naves can be seen today—identified as the civil basilica. As large as the monument just mentioned, in the Byzantine period it was made into private houses. Other structures are grouped along the S side. Among them is a great temple (not identified) that has a rectangular court (20 x 8.3 m) surrounded on three sides by a portico 4.3 m wide (6 x 9 Ionic columns) which is dominated on the W side by a cella, of which only the foundations remain. The sculptured head of an unidentified god was found there. On the S side of this temple is an open courtyard, possibly a public square (6.3 x 12 m), ringed with a portico 2.25 x 3 m wide (4 x 6 Doric columns). Nearby are some badly ruined houses. Next is the Temple of Aesculapius, 7 x 4 m, built of large blocks. Then there is another small square near the harbor. Next comes a jetty (17 x 140 m) which terminates in a rounded, colonnaded mole. It dates from the first half of the 2d c.

The baths in the center of the city comprise two groups of buildings, with rooms paved with mosaics. The baths and palaestra to the W are situated 200 m W of the forum. This complex is made up of two elements covering a vast rectangle (104 x 66 m) oriented ENE-SSW. The luxurious complex consists of the baths on one side, and on the other a vast circular courtyard, inside an area 66 m square, which has been taken to be the palaestra. These buildings were put up during the period of feverish urban construction in the 2d c., then were presumably abandoned at a fairly early date.

The market is 150 m SE of the forum. Oriented in the same direction as the forum, it measures 19 x 32 m and consists of a courtyard surrounded by a portico with stalls aligned around it. First built on a rectangular plan, it was thereafter partly redesigned as a semicircular series of stalls. In the middle is an aedicula with a fountain.

Behind the market is a complex of structures with mosaic floors. One of them, fortified on the outside and containing a series of troughs, was designed as a fortified farm. In view of its position in the city it may be an inn. Two other houses with troughs and mosaics have been noted in this sector.

The Byzantine citadel stands on the cliff to the N. It measures 60 m square and has square bastions in the middle of the E and W walls. The approach to the interior was staggered. During the excavation three inscriptions were discovered, one of them in Greek. Excavations

in the same sector, still unfinished, have revealed more structures from the Roman period that were fortified in the Byzantine period. One of these had rooms with mosaic floors and included some private baths.

The Temple of Mercury stood on a hill at the SW end of the site. Its plan consisted of a peribolus 34.5 x 22 m built of a masonry of large stones, with a portico (7 x 7 columns) on three sides surrounding an esplanade. In the middle of the esplanade stood the cella of the temple. It had a pronaos 1.15 x 2.6 m fronted by two columns and a naos 2.6 m square. Behind was a wing consisting of several rooms and chapels. In front, to the W, the facade is preceded by a porch. The temple, which was identified by an inscription and a statue of a god, is now at the Bardo Museum in Tunis. It was built at the end of the 2d c. A.D. Its decoration consisted of veneers of polychrome marble, stucco, and bas-reliefs.

A huge suburban villa overlooking the beach to the S was found to have a second story, from which fragments of mosaic flooring remain. It was laid out around a peristyle of 20 stuccoed columns onto which the rooms opened. These had mosaic floors and walls decorated with painted stuccos and various bas-reliefs, among them a satyr's head now in the Bardo Museum.

A necropolis was discovered to the N-NW of Gigthis, W of the palaestra, when route 108 was being laid from Medenine to Boughrara. A great many tombs were excavated as a result, and were found to contain an abundance of grave gifts including some glass vases. Three streets oriented NNW-SSE were also uncovered at that time. While work was continued on the same road, another grave vault was discovered 200 m W of the tombs previously excavated. Its grave gifts are now preserved at the Bardo Museum. Also, 250 m NW of this vault, a group of houses was found belonging to the suburb NW of Gigthis. They were designed on a uniform plan: a double main section on either side of a courtyard. Still farther along the road, a semirural dwelling was uncovered. It had a sandy floor paved with mosaics, also some private baths.

BIBLIOGRAPHY. L. A. Constans, "Gigthis," *NouvArch* (1916) 1-116.　　　　　　　　　　　　A. ENNABLI

GILAU Cluj, Romania. Map 12. Roman camp and civil settlement at the junction of the Someşul Mic river and Căpuşul valley, W of the town of Cluj (Napoca). The camp (210 x 138 m), originally of earth, was rebuilt in stone in the middle of the 2d c. A.D. The Ala I Siliana was stationed here.

In the civil settlement, S of the camp, traces of walls have been found, sculptures, various coins minted in the period between Marcus Aurelius and Phillip the Arab, and a military diploma of 164 A.D. The funeral monuments with ornaments of typical provincial style were made on the spot. The large number of Dacian ceramics attest to Roman-Dacian synthesis. The archaeological material is displayed by the History Museum of Transylvania in Cluj.

BIBLIOGRAPHY. M. Rusu, "Cercetări arheologice la Gilău," *Materiale şi cercetări arheologice* 2 (1956) 687-713; D. Protase, *Problema continuităţii în Dacia în lumina arheologiei şi numismaticii* (1966) 33; D. Tudor, *Oraşe, tîrguri şi sate în Dacia romană* (1968) 232-33.
　　　　　　　　　　　　　　　　L. MARINESCU

GILDA (Souk el Arba de Sidi-Slimane) Morocco. Map 19. Ancient city of the S region of Mauretania Tingitana, mentioned in the *Antonine Itinerary* (23.4), Mela, and Ptolemy. Its name appears stamped on some tegulae found at the Souk el Arba of Sidi-Slimane, 1.5 km S of the village, where remains of a Roman settlement were

discovered in a loop of the wadi Beth. The extent of these ruins and their topography are undetermined, but chance finds and some digging have revealed two funerary inscriptions, a number of bronze statuettes and fragments, coins, and an abundance of pottery. At the village of Sidi-Slimane a Libyan inscription has been found, and a tumulus tomb dating from the 3d-2d c. B.C. was uncovered in early excavations.

BIBLIOGRAPHY. A. Ruhlman, "Le tumulus de Sidi Slimane (Rharb)," *Bulletin de la Société de Préhistoire du Maroc,* 12 (1939) 37-70; L. Chatelain, *Le Maroc des Romains* (1944) 124-26; M. Euzennat, "Les voies romaines du Maroc dans l'Itinéraire Antonin," *Hommages à Albert Grenier,* coll. *Latomus* 58 (1962) 599-600; C. Boube-Piccot, *Les bronze antiques du Maroc I* (1969) 238-39. M. EUZENNAT

GILINDIRE, *see* KELENDERIS

GIOIA TAURO, *see* MATAUROS

GIRESUN (Armenia Minor), *see* COLONIA

GIRESUN (Pontus, Turkey), *see* PHARNAKEIA KERASOUS

GÎRLICIU, *see* CIUS

GISACUM (Le Vieil-Evreux) Eure, France. Map 23. A Roman town 8 km SE of Evreux on a plateau 133 m high and covering an area of ca. 140 ha in the communes of Le Vieil-Evreux, Miserey, Cierrey, and La Trinité. The site mentioned in the 9th c. Life of Saint Taurinus, was identified when the name was found on two inscriptions discovered at Le Vieil-Evreux in 1828 and 1837. Gallic coins and some strata of Iron Age II found near the sanctuary, baths, and water tower make it clear that there was a large settlement in pre-Roman times. From the beginning of the 1st c. A.D. huge monuments were put up, including a sanctuary which was soon burned down, perhaps at the end of the same century, and never rebuilt. Gisacum flourished through the 2d c., but in the 4th c. only a small area near the baths seems to have been occupied. In the Middle Ages the village of Le Vieil-Evreux grew up around the sanctuary and theater.

The site has been excavated since the early 19th c.: first the theater, the baths, a large building with mosaics, and the aqueduct were found, then the sanctuary, which contained two large bronze statues and an inscription on a bronze tablet. Further excavations in the first half of this century have clarified the plans of the sanctuary and the baths. In 1934-39 a site thought to be the necropolis of Le Vieil-Evreux was identified as a spring-sanctuary that became a cemetery in the Merovingian period. It is a square fanum in a sacred enclosure, a type common in Normandy; it exhibits two types of construction, the earliest from the Gallic period. Although close to Gisacum (Cracouville), the fanum is independent of it.

Gisacum is quadrilateral in shape: three sides have a fairly narrow (100-200 m) strip of houses around the edge which becomes noticeably wider near the baths. The E side is ca. 950 m, the N one 1650 m, while the W side, 1250 m long, abuts on the baths and continues 550 m S. The sanctuary and theater are aligned on the 1200-m S side, which is backed by the baths. The building known as the Champ des dés is 200 m NE of the baths; part of the site is strewn with cubes of mosaic. Immediately N of this building aerial photography has revealed strips of paving in a grid pattern, marking off plots of land; there are no traces of buildings, but many potsherds and oyster shells. The ground also shows traces of a huge

rectangle. The area may have been a fairground with an esplanade for public meetings. The center of the quadrilateral shows no signs of occupation, and the complex of sanctuary, theater, and Champ des dés building is isolated from the residential areas. An aqueduct carried the waters of the Iton river from ca. 30 km away; it started above ground but ran for the most part underground, ending near the baths. Here it split into branches which carried water to all the built-up areas. Ancient roads from Evreux and Lisieux, Rouen, Amiens, Paris, Sens, Chartres, Le Mans, and Tours met at Gisacum.

The sanctuary (incorrectly called a basilica) was built in a vast enclosure, incompletely explored, and had a facade 155 m long. It consisted of three rectangular cella temples facing E, linked by a 35 m wide complex of rooms and galleries. The temples at the N and S ends are 28 x 20 m, the middle one is 35 x 25 m. The sanctuary seems to have been richly decorated: the ruins have yielded a mask made of sheet bronze dating from the first half of the 1st c. B.C., some later (end of 1st c. A.D.) bronze statues of Jupiter and Apollo, and a fragment of a bronze tablet with an inscription in Latin and Gallic.

The theater, of the theater-amphitheater type, faced E. The facade was 100 m long, the radius of the cavea 26 m, and that of the orchestra 22 m. Access was by the axial aisle and six vomitoria. The tiers were apparently made of earth rather than stone. The baths were 100 m long. In front of the E section is a porticoed courtyard 75 m square. The building of the Champ des dés stretches over ca. 205 m; it consists of courtyards and rooms of various sizes, some of them paved with geometric mosaics.

The greater part of Gisacum still awaits excavation: the plan of roads and aqueducts has not been determined, nor the date and function of the sanctuary. The unexplored residential area includes several well-constructed buildings apparently of the 2d c.

During Gallic independence Gisacum was the religious and spiritual center of the Aulerci Eburovices and the other Aulerci tribes, the Cenomanni and Diablintes, and as such it probably continued to play an important role for part of the 1st c. A.D. After the Romans set up an administrative capital at Mediolanum, pilgrimages provided the only activity at Gisacum. It never really became a city.

BIBLIOGRAPHY. F. Rever, *Mémoire sur les ruines du Vieil-Evreux* (1827); T. Bonnin, *Antiquités gallo-romaines des Eburoviques* (1860); E. Espérandieu, "Les fouilles du Vieil-Evreux," *Bulletin de la Société française des fouilles archéologiques* 3 (1913); 4 (1921); J. Mathière, *La civitas des Aulerci Eburovices à l'époque gallo-romaine* (1925); H. Lamiray, "Le Vieil-Evreux. Fouilles de la basilique de 1911 à 1914," *Bulletin de la Société normande d'études préhistoriques* 27 (1931); M. Baudot, "Premier rapport sur les fouilles de Cracouville-Le-Vieil-Evreux," ibid. 30 (1936); id., "Historique des fouilles d'Alexis Robillard et de Théodose Bonnin au Vieil-Evreux (1835-1842)," ibid. 31 (1939); id., "Le problème des ruines du Vieil-Evreux," *Gallia* 1 (1943); J. Le Gall, "Utilisation de la couverture photographique aérienne de la France: l'aqueduc du Vieil-Evreux . . . ," *Gallia* 12 (1954); H. Bellenger, "Le prolongement de l'aqueduc du Vieil-Evreux au delà de Coulonges," *Bulletin de la Société normande d'études préhistoriques* 38 (1965). M. LE PESANT

"GITANA," *see* GOUMANI

GIVRY Belgium. Map 21. A Gallo-Roman settlement on the road from Bavai to Tongres and Cologne, situat-

ed at the point where the road crosses the Trouille. The settlement seems to consist of two parts: on the road and N of it is a little roadside settlement (a mutatio?), which has not been excavated systematically but where many coins have been found, ranging in date from the end of Augustus' reign to the middle of the 4th c. Nearby is the base (14.2 x 9.6 m) of a large funeral monument, now gone. The vicus proper lies more than 1 km to the S of the highway, on the left bank of the Trouille, at a place called Vieille Bruyère. Substructures have been located there covering an area 1 km long and 400 m wide. Among the most notable finds is a hidden storage place containing a great many bronze objects: a statuette of Jupiter, one of Mercury, and three of Mars. One of the latter, although of local make, is an elegant imitation of a Hellenistic model. There are also cauldrons, ewers, dishes, and bowls of tinned bronze. It will be recalled that Pliny (*HN* 34.160-62) described the tin-plating of bronzes as a Gallic invention. In the 4th c. an Iron Age keep, the Castelet of Rouveroy, 2 km from the vicus, was fortified so as to provide a place of refuge for the inhabitants. Two forts, one hexagonal and the other quadrangular, were built back to back and surrounded by a rampart 1200 m long with an interior wall.

BIBLIOGRAPHY. R. De Maeyer, *De Overblijfselen der Romeinsche Villa's in België* (1940) 65-67.

S. J. DE LAET

GLANNOVENTA (Ravenglass) Cumberland, England. Map 24. Once thought to be Agricola's base for an invasion of Ireland, but probably a Hadrianic foundation. It controls a safe river anchorage. The fort, unexcavated, was cut by the railway in the 19th c. The only visible feature is the external bath house, standing 3.6 m high, with some window openings and a niche preserved. The internal walls were coated with pink plaster.

BIBLIOGRAPHY. E. B. Birley, "The Roman fort at Ravenglass," *Trans. Cumberland and Westmorland Arch. Soc.* ser. 2, 58 (1958) 14-30.

D. CHARLESWORTH

GLANON later GLANUM (Saint-Rémy-de-Provence) Bouches-du-Rhône, France. Map 23. About 12 km from the Rhône, 25 km NE of Arles, and 1 km from St-Rémy, a site occupied successively by a native village, a Hellenistic settlement, and a Gallo-Roman station which was granted the ius Latii (Plin. *HN* 3.4.5). Situated close to the two roads leading from the Rhône to Italy and linked to them, Glanum is mentioned by Ptolemy (*Geog.* 2.10) and in various itineraries (*Antonine Itinerary*, Vicarello cups, *Peutinger Table*). It owed its prosperity both to its position and to the religious character of the site.

Remains on the slopes nearby indicate continuous occupation from the Eneolithic to the Iron Age. At the S end of the site are some rectangular huts of dry stone, partly cut in the rock, on either side of a wide stairway leading to a natural cave. At the foot of the cave is a basin hollowed out of the rock which collected water from the spring: this is probably an early place of worship. The imported pottery (gray Phokaian ware with a wavy design, pseudo-Ionian ware, black-figure Attic ware), and Massaliote coins, besides local objects, prove that from the 6th c. B.C. on the natives traded with the Phokaians of Marseille.

In the 2d c. B.C. Glanon had many Greek features. A silver drachma was struck bearing the legend ΓΛΑΝΙΚΩΝ and structures of Hellenistic plan and technique were erected. Several houses of the Delian type were grouped around a peristyle: the Maison des Antes and the Maison d'Atys, on either side of a three-galleried portico which may have had shops opening on to it. These three build-

ings are grouped on a long island between two streets. Other houses are found farther E, below the Maison d'Epona and the Roman baths and forum (houses IV and XI). To the S is an important monument (LVII) consisting of porticos surrounding a paved trapezoidal courtyard; rooms with opus-signinum mosaic open onto the galleries; some column bases with a double torus have been found in situ as well as several capitals decorated with baskets containing plants and human or gods' heads, male and female. These date from the 2d or 1st c. B.C. In the same sector are three apparently contemporary monuments: a building with three rooms of indeterminate purpose, an exedra, and a rectangular room with tiers that recalls the plan of a Greek bouleterion. Finally, an E-W rampart with postern and tower and a double gateway barred access to the cult center in the gorge. In technique it resembles the Saint-Blaise rampart and some Sicilian constructions: masonry of large blocks and rounded merlons. This design is continued on the inside by two walls of the same construction which mark a street. The W wall joins an earlier structure and the original staircase; here a niche contains two female statues: a later inscription identifies them as the Matres Glanicae, with whom is associated the god Glanis. On the opposite side the E wall is interrupted by a lane, a continuation of the original staircase. The lane leads to the spring, transformed into a monumental nymphaeum: a staircase of three flights leads to a basin lined with large stones fed from a water-catchment gallery.

Certain native remains, however, modify the picture of a thoroughly Hellenized city. Piers with cavities hollowed out of them were designed to hold severed heads; a capping stone of Greek workmanship was even altered for this purpose. Human skulls with holes bored through them have been found on the floor of monument LVII, and in two places statues of crouching figures like those at Roquepertuse and Entremont have been discovered.

The city was perhaps damaged at the end of the 2d c. B.C. (either by one of the revolts of the Salyes, who provoked Roman intervention in 125, or by the Teutoni and Ambroni who passed through the region in 102?). In the following period (Glanum II) certain houses were rebuilt with changes, and new ones were erected (IV, V, XII, XVI). One of these (XII), very simply laid out and without a peristyle, is noteworthy for its mosaic floors and painted stucco. A geometric mosaic has an inscription CO. SVLLAE showing the name of the owner, and a graffito on a stucco gives an exact consular date (28 March, 32 B.C.) as well as the name of the writer, Teucer. The Maison du Capricorne (IV) contains mosaics with emblemata. The religious sector apparently underwent no changes of any significance. The characteristic masonry of this period is of irregular quarry-stones bonded with a mortar of lime or clayey soil.

From the beginning of Augustus' reign Glanum enjoyed its period of great prosperity and acquired many monuments. At the entrance to the city are a cenotaph known as the Mausoleum of the Julii, placed at the extreme edge of the pomerium, and a triumphal arch, both apparently of early date. The arch, the oldest in Gallia Narbonensis, has a single bay; each face is decorated with two groups of Gaulish prisoners and the archivolt with swags of foliage and local fruits. The mausoleum, which is in three sections, has a square podium rather like a sarcophagus, decorated with four bas-reliefs, a tetrapylon with corner columns, and on top a rotunda with a conical roof and two statues inside it. An inscription states that three Julii—Lucius, Sextus, and Marcus—dedicated the monument parentibus suis. It has often been supposed that this dedication was ad-

dressed to Gaius and Lucius, who died in 2 and 4, but neither the cenotaph nor the arch can be dated to a definite year in Augustus' reign.

Many changes were made in this period (Glanum III) inside the city, giving it an appearance it would retain up to the 3d c. Sanitation was improved by an aqueduct and great sewers. The sacred quarter acquired new monuments: a small prostyle temple dedicated by M. Agrippa to Valetudo was erected on the N wall of the restored nymphaeum, and votive altars were consecrated to the same goddess, to Apollo, and to Fortuna Redux. A little farther S is a small two-roomed fanum of Hercules, identified by a statue in the local style, and some altars dedicated to the hero.

In the old Hellenistic quarter to the NE some baths were built, of a core of mortared rubble faced with small blocks. The original plan, recalling that of the forum baths at Pompeii, was changed by the erection of a large palaestra, perhaps at the beginning of the 2d c. An enormous platform (ca. 80 x 40 m) was put up about 25-20 B.C. S of the baths, to level the slope. Houses IV, XI, XII, and XVI, and building LVII were buried beneath it, and replaced by a monumental complex that may be the forum. The larger part of the complex is a vast paved space, bordered to E and W by Corinthian porticos and to the S by a great facade with an exedra decorated with columns and statues of satyrs. On the N side a stairway, running from one portico to the other, leads to a rectangular monument (ca. 45 x 22 m) supported on 25 piles (the superstructure has disappeared). Adjoining was a second monument; it was apsed and built over two underground rooms. The purpose of these buildings is uncertain.

The forum gave onto a second, paved platform to the S; smaller than the first, it had a well with a basin and a fountain with triumphal decoration. To the W a great double-square peribolos surrounds two temples. A number of architectural fragments from them have been found, along with a statue of a youth and marble heads of Octavia and, possibly, Julia. Here the temples may be supposed to have been consecrated to Rome and Augustus. Between the temples and the nymphaeum the exedra (XXXI) was redesigned, and a long graffito on its wall is apparently a drawing of the forum monuments. Then came a Doric portico (for receiving pilgrims?) and, opposite it, a small Corinthian building containing votive altars.

The residential quarter was also modified. The Hellenistic market (VII) was given over to the cult of Kybele, to whom the dendrofori Glanici put up an altar; the remodeled House of Atys, adjacent to it, may have housed the priests of the goddess. Few houses from Glanum III have been uncovered—the quarter was probably moved, to keep the center for public buildings.

The end of Glanum dates from the Germanic invasion, ca. 270. A few buildings were erected on its ruins in the late Middle Ages, and then the city vanished beneath an alluvial mass that came down the hillside, burying everything save the arch and the mausoleum, which became known as Les Antiques.

There is an important collection of finds at the Hôtel de Sade in St-Rémy-de-Provence.

BIBLIOGRAPHY. H. Rolland, "Inscriptions antiques de Glanum," *Gallia* 2 (1944) 167f[I]; id., *Fouilles de Glanum, Gallia* Suppl. 3 (1951)[MPI]; id., "Un temple de Valetudo à Glanum," *RA* 46 (1955) 27f; id., *Fouilles de Glanum 1947-1956, Gallia* Suppl. 16 (1958)[MPI]; id., *Glanum* (1960); id., *Le mausolée de Glanum, Gallia* Suppl. 21 (1969)[PI]; R. Bianchi Bandinelli, *Storicità dell'arte classica* (1950) 90f, 218f[I]; F. Chamoux, "Les Antiques de Saint-Rémy-de-Provence," *Phoibos* 6-7 (1951-

55) 97f[I]; G. C. Picard, "Glanum et les origines de l'art roman-provençal. 1. Architecture," *Gallia* 21, 1 (1963) 111f; id., "2. Sculpture," *Gallia* 22, 1 (1964) 109f[I]; "Informations," *Gallia* (1956-74) passim[PI].

C. GOUDINEAU

GLANUM, see GLANON

GLAPHYRAI Thessaly, Greece. Map 9. A town near Lake Boibeïs, mentioned in Homer but not by later authors; it belonged to Magnesia. The site is now generally taken to be the hill N of the village of Kaprena near modern Glafira. Leake was able to trace the full circuit of the walls, built of roughly shaped blocks in irregular courses, and reported considerable remains of walls inside. Inscriptions found there indicate that the town continued to be inhabited in the Classical period.

BIBLIOGRAPHY. Hom. *Il.* 2.712; W. M. Leake, *Nor. Gr.* (1835) IV 431-33; A.J.B. Wace in *JHS* 26 (1906) 162.

M. H. MC ALLISTER

GLENLOCHAR Kirkcudbright, Scotland. Map 24. Air photography has disclosed a large group of Roman works comprising an auxiliary fort, four or five temporary camps, and minor structures, 3.2 km NW of Castle Douglas. No surface remains are visible. The fort is 3.2 ha in extent, with a triple-ditched annex on the N side, and its street plan suits a cohors milliaria equitata. Excavation in 1952 showed three structural periods, one Flavian and two Antonine; there was also evidence of an Agricolan fort in the immediate vicinity.

BIBLIOGRAPHY. *Trans. Dumfriesshire and Galloway Nat. Hist. and Ant. Soc.* 3d ser., 30, 1-16.

K. A. STEER

GLEVUM (Gloucester) Gloucestershire, England. Map 24. Between Calleva and S Wales, at the crossing of the Sabrina (Severn). Excavations in 1966-69 in the center of the modern city distinguished structures of three periods: 1) a Claudio-Neronian ditch system of unknown extent, possibly indicating hiberna; 2) a Flavian timber fortress of 17.2 ha, presumably that of the Legio II; and 3) the colonia (coterminous with fortress) which is known from inscriptions to have been founded under Nerva (A.D. 96-98). Originally provided with a series of barrack-like dwellings, probably of timber on stone footings, the colonia was rebuilt during the 2d or 3d c. with large masonry houses; the central forum was probably rebuilt at the same time. The site was falling into ruins in the 5th c. and was captured by the Saxons in A.D. 577.

The only visible monuments are portions of the colonia wall incorporated into modern basements beneath the City Museum and beneath buildings in King's Square. Vertical joints separate masonry of the 3d c. from that of the 4th, which includes large reused blocks. The City Museum contains much excavated material including that from Kingsholm, a 1st c. military site 0.8 km to the N.

BIBLIOGRAPHY. L.E.W.O. Fullbrook-Leggatt, *Roman Gloucester* (1968)[MPI]; "Roman Britain," *JRS* 49 (1959) 126; 57 (1967) 194-95; unpublished work of H. R. Hurst.

J. F. RHODES

GLOUCESTER, see GLEVUM

GLOUSTA, see LIMES, GREEK EPEIROS

GLYPHA, see WEST LOKRIS

GNATHIA (Egnatia) Apulia, Italy. Map 14. A city between Bari and Brindisi. Ancient sources place it on the border between Messapia and Peucezia and identify it as a maritime freight station and crossroads for land traffic (Strab. 6.282; Ptol. 3.1.15; Mela 2.4; Plin. 2.107,

3.102). Horace (*Sat.* 1.5.97ff.) passed through Gnathia in 38 B.C. on his voyage from Rome to Brindisi.

The earliest evidence of organized life comes from the acropolis and dates to the Bronze and Iron Ages. About the 4th-3d c. B.C. the site acquired the appearance characteristic of a Messapian city, surrounded by powerful walls on its three landward sides. From this period date rich tombs, often containing painted ornaments and furnished with valuable vases.

In the Roman period, especially during the early centuries of the Empire, the city prospered because of its location on the principal transit route to the Orient. In A.D. 109 the Emperor Trajan, in order to facilitate communication between the capital and Brindisi, improved the old pack road cited by Strabo and Horace. A stretch of this paved road, the Via Traiana, and traces of the gate of Egnatia have recently been discovered in the course of systematic excavation. In the Christian epoch the city was the seat of a bishopric. A bishop of Egnatia, Rufentius, participated in the Council of Rome, convened in the early years of the 6th c. by Pope Symmachus I. The causes of the city's destruction and end at the beginning of the Middle Ages remain unknown.

The first systematic excavations were undertaken in 1912 and 1913 and have continued at intervals since then. The city was defended on the landward sides by a circuit wall, almost 2 km long, preceded by a wide ditch. The wall was of double curtain construction built of large blocks of tufa in isodomic courses, with interior rubble fill. The best-preserved stretch of this wall is visible near the sea. The acropolis was also defended by walls. Traces of the port establishments are preserved underwater as a result of gradual changes in the relative level of land and sea. Between the acropolis and the Via Traiana, was the Roman forum. It was paved with regular blocks of tufa and enclosed by a portico with Doric columns, covered with limestone. The Hellenistic agora was also surrounded by porticos, later turned into shops. Not far from the two forums is a large ellipsoidal plaza, perhaps intended as a place for spectacles. A monument with a dedicatory inscription (sacerdos Matris Magnae et Syriae deae) documents the existence of an Oriental cult widespread in Italy at the beginning of the Empire. The Via Traiana, which runs parallel to the sea, divides a zone of public buildings at the foot of the acropolis from an area of rather modest private houses. They are quadrangular in plan, occasionally show traces of white mosaic pavements, and almost always are furnished with catch basins to collect rainwater. Among the ruins of more recent monuments are those of two Christian basilicas with mosaic pavements that date from the early mediaeval period when the city was the seat of a bishopric.

The earliest necropolis lay outside the acropolis in an area that was later included in the Roman urban plan. Sumptuous chamber tombs were often painted and richly provided with ceramics. In the Hellenistic age the ceramics are of the overpainted type, called vases of Gnathia because they were discovered here in abundance for the first time.

BIBLIOGRAPHY. L. Pepe, *Notizie storiche ed archeologiche dell'antica Gnathia* (1883); *RE* VII.2 (1912) 1478-79 (Weiss); *EAA* 3 (1960) 167-71 (C. Drago); *L'antica Egnazia*, a cura della Soprintendenza alle Antichità della Puglia (1965). F. G. LO PORTO

GOBANNIUM (Abergavenny) Monmouthshire, Wales. Map 24. The Roman fort has not been precisely located, but must lie beneath the modern town of Abergavenny, on the N bank of the Usk. A bath is known near the castle, and a cemetery to the NE. Excavations in the town center have produced a quantity of Roman pottery of the period A.D. 75-150, with enough Claudian and Neronian pottery to indicate occupation in the period A.D. 50-60. The finds are in the Abergavenny Museum.

BIBLIOGRAPHY. L. A. Probert et al., "Excavations at Abergavenny, 1962-1969," *Monmouthshire Antiquary* 2 (1965-69) 163-98; J. L. Davies in V. E. Nash-Williams, *The Roman Frontier in Wales* (2d ed. by M. G. Jarrett 1969) 45-46M. M. G. JARRETT

GÖDENE, see KOTENNA

GÖD-ILKAMAJOR, see LIMES PANNONIAE

GODMANCHESTER ("Durovigutum") Huntingdonshire, England. Map 24. Probably the Durovigutum of the *Ravenna Cosmography*, close to the Great Ouse ca. 1.6 km S of Huntingdon. Here Ermine Street, from London to Lincoln, crossed the river and was joined by roads from Colchester and Verulamium. The position was guarded by a fort in the mid 1st c.; the later settlement developed from the vicus or traders' settlement adjacent to a military post, which acted as a local market center and also prospered from road and river traffic.

It has been claimed that the town was divided into a series of regular plots aligned with Ermine Street, 135 Roman feet square and with posts marking the corners, but no plan is yet available. In the Hadrianic period a large inn was built near the center, over part of the abandoned fort; it was a courtyard building of 32 rooms and evidence of staircases to an upper story. Nearby was a bath building provided with water by a leat. The establishment may have had an official character as part of the imperial posting system. A late 2d c. ditch and palisade has been claimed to represent the construction of a new fort under Severus, probably to counter the danger of sea-borne raids penetrating the river system, but confirmation of the military character of the remains is still lacking. During the 3d c. the settlement was walled, but despite this it was sacked ca. A.D. 300. In the 4th c. there was a partial recovery: the latest levels have yielded early Saxon pottery.

BIBLIOGRAPHY. M. Green, *Current Archaeology* 16 (1969); "Roman Britain," *Britannia* 2 (1971) 264. S. S. FRERE

GÖKÇELER, see PEDASA

GÖKSUN, see COCUSUS

GOLDEN KURGAN, *see under* PANTIKAPAION

GOLDSBOROUGH Yorkshire, England. Map 24. Roman signal station, farthest N of the system, at the S end of Runswick Bay on the headland known as Kettleness. A rectangular bank with outer ditch surrounds a square stone enclosure with a gate on its S side. This wall, 31.5 m square, has semicircular bastions or turrets at intervals. The interior courtyard is unpaved, but contains a stone-lined well and the foundations of a strong stone tower 2.6 m square. Socket stones in the interior suggest that wooden pillars supported the first story, and the tower may have stood 27-30 m high. Inside all was confusion: an open hearth in the corner contained the skeleton of a man, another skeleton lay with a dog's head at its throat, while the bones of 15 individuals as well as two breeds of cattle and two breeds of dogs were found in the well. Coins of Honorius, 395-4-233, and quantities of the latest Roman coarse ware were also found. G. F. WILMOT

GOLGOI Cyprus. Map 6. Inland ca. 1.6 km NE of the village of Athienou and 17 km N-NW of Kition. The ruins cover a sizable area on a hill sloping gently N to S in the direction of the village. Remains of the ancient city wall can still be traced in almost all its course. According to Sakellarios, who was the first to identify this site, the perimeter of the circuit was 7 stadia. The necropolis lies to the S within the village and to the SE. Two important temples excavated in the 19th c. lie outside the walls by the Church of Haghios Photios about 3 km SE of the village. The area of the city itself is now a field of ruins under cultivation.

The traditional founder of the town was Golgos from Sikyon in the Peloponnese. This connection is further illustrated by an archaic limestone block found here, now in the Metropolitan Museum, New York. Carved in relief on this block is a Chimaera, the symbol of Sikyon which appears on its coins. Golgoi must have succeeded the nearby Late Bronze Age settlement at Bamboulari tis Koukouninas, due N of Athienou. Nothing is known of the history of Golgoi although it is mentioned by several ancient authors. Inscriptions attest an Aphrodite Golgia whose worship was, according to Pausanias, earlier than the cult of Aphrodite at Paphos. And although we know nothing about the existence of a kingdom of this name some coins have been attributed to it. On the evidence of recent excavations near the E gate the city seems to have flourished to the end of the 4th c. B.C. but another sector of the town must have been inhabited down to Early Christian times.

Excavations on the site were started for the first time in 1969 and were confined to the E sector by the E Gate, where a number of private houses and workshops dating mainly from the 4th c. B.C., came to light; the lowest strata, however, produced sherds of the archaic and Early Classical periods. Part of the city wall is preserved to a height of 2.50 m; its lower course consists of rubble with mudbricks above. The E Gate with steps leading up into the town has also been cleared.

From a tomb comes a late archaic stone sarcophagus with low relief decoration, now in the Metropolitan Museum of Art, New York. One of the long sides shows a hunting scene; the other, a banquet scene of four couches on which recline one older and three younger men.

One of the short sides shows Perseus carrying off the head of Medusa followed by his dog; the other, a four-horse chariot with a beardless driver conveying an elderly man, who probably represents the occupant of the sarcophagus. The cover is in the form of a gable with four crouching lions at the ends.

BIBLIOGRAPHY. Luigi Palma di Cesnola, Cyprus, its Ancient Cities, Tombs and Temples (1877); A. Sakellarios, Τὰ Κυπριακά I (1890); I. K. Peristianes, Γενικὴ Ἱστορια τῆς νήσου Κύπρον (1910); Olivier Masson, Les Inscriptions Chypriotes Syllabiques (1961) 275-301ᴵ; id., "Kypriaka IX: Antiquités de Golgoi," BCH 95 (1971) 305-34ᴹᴵ; K. Nicolaou, "Archaeological News from Cyprus, 1969," AJA 74 (1970) 396-97ᴵ; 76 (1972) 314; 77 (1973) 56, 429-30; V. Karageorghis, "Chronique des Fouilles à Chypre en 1969," BCH 94 (1970) 269-72ᴵ; 95 (1971) 403-6; 96 (1972) 1073-74; 97 (1973) 673.
K. NICOLAOU

GÖLHISAR, see KIBYRA MAIOR

GOLUBAC, see LIMES OF DJERDAP

GOMPHOI Thessaly, Greece. Map 9. One of the principal cities of the region and an important site in military history, Gomphoi lies 2 km NE of the modern village of Muzaki and about 15 km SW of Trikkala. It guarded the route to the Pindos and was used as a rallying point by Philip V of Macedon. The principal cult was that of Dionysos Karpios, but inscriptions also mention Zeus Palamnios. The walls are the principal architectural remains on the triangular acropolis, which is hollowed out on one side like a natural theater.

BIBLIOGRAPHY. Strab. 9.5.17; Livy 38.1.2; W. M. Leake, Nor. Gr. (1835) IV 519; F. Stählin, Das hellenische Thessalien (1924) 125f.
M. H. MC ALLISTER

GONCALI, see LAODICEA AD LYCUM

GONDECOURT Nord, France. Map 23. In the arrondissement of Lille, canton of Seclin. Situated on the W edge of the chalky plateau of Le Mélantois and the marshy valley of La Haute Deule, on the boundary of the cities of the Atrebates and the Menapii, this little commune has not been excavated systematically. Thus no trace has been found of any prehistoric occupation, whereas the nearby communes of Houplin, Seclin, and Allennes les Marais have yielded important remains of every period. Toponymy is of no help in providing archaeological sources, with the exception of the area known as Pré à Motte, on the edge of the Deule marshes, an indication that there was once a feudal mound here (it has disappeared). The only archaeological find, made in 1934, was a Roman interment. Near the skeleton, which faced N-S, was an urn and some Hadrianic coins.

BIBLIOGRAPHY. C. T. Leuridan, "Gondecourt, son histoire féodale et notes pour sa monographie," Bulletin de la Société d'Etudes de la Province de Cambrai 19 (1914) 143-229ᴾ; C. Liagre, "Découverte d'une sépulture romaine à Gondecourt," Bulletin de la Commission Historique du Nord 35 (1938) 790.
P. LEMAN

GONNOS or Gonnoi, Gonnoussa Thessaly, Greece. Map 9. An important city of Perrhaibia, located on the left bank of the Peneois river, at the W entrance to the Tempe pass. It controlled the pass and the S end of a route which led from Macedonia to Thessaly over the E shoulder of Olympos via Lake Askyris. Xerxes came by here in 480 B.C. (Hdt. 7.128, 173). The area was settled in prehistoric times, and the city evidently prospered in the archaic and Classical periods. Owing to its position, it was important to Macedon in the Hellenistic period, and it played a part in wars between Rome and various Hellenistic kings. Philip V collected stragglers here on his way back to Macedonia in 197 B.C. after Kynokephalai (Livy 33.10; Polyb. 18.27.12). It was freed and important after the Roman liberation of 196 B.C. Antiochus III, advancing N in Thessaly in 191 B.C., was frightened back to Demetrias by Appius Claudius who came down from Macedonia to the heights above Gonnos (via the Askyris route? [Livy 36.10]); Perseus in 171 B.C. took the city and strengthened its fortifications with a triple ditch and rampart, and left a garrison there which remained until Pydna (Livy 42.54, 67; 44.6). The city prospered thereafter, but seems to have dwindled in importance in the Roman provincial period.

The ruins of the site are on the end of a ridge of lower Olympos which stretches down into the Peneios plain 1 km from the river and ca. 3 km from the W end of the Tempe pass. The ancient town is almost 2 km SE of modern Gonnoi (formerly Dereli). The end of the ridge is broken into three separate hills aligned in a half-moon shape facing SE. Along the NW side of the ridge is a deep ravine. In the archaic period the NE hill was circled by a wall made of small, flat, roughly squared stone

slabs laid in fairly regular courses; part of it is still preserved to 6 m high. In Hellenistic times the city wall was extended along the ridge to include the other two hills, and then across the wide, theater-shaped slope between the SE hill and the acropolis. The line of the wall along the ridge (ca. one course high) can be traced; the stretch across the valley has largely disappeared. The wall between the middle hill and the SE one, and around the SE hill was fortified by some 12 projecting towers. In the middle of this stretch of wall was a gate flanked by towers. Another gate could be seen in the middle of the stretch crossing the valley, and outside this gate Arvanitopoullos in 1910 saw a ditch and earth rampart he took to be the fossa triplex built by Perseus.

The archaic acropolis was inhabited since Neolithic times. On the summit, excavations in 1910-11 uncovered the foundations of an elliptical temple of small stones with an entrance to the SE. It probably had two poros columns in the door; fragments of an archaic Doric capital were found. The temple seems to have been built with a stone socle and mudbrick upper parts. Fragments of archaic painted terracotta antefixes and cornice were found here. The temple was rebuilt on the same plan in the 4th-3d c. B.C.: Hellenistic terracottas and roof tiles were also found. Three half-round terrace walls support the slope to the S of the temple, which Arvanitopoullos called the Temple of Athena Polias. Foundations of another building, possibly a temple, were discovered and excavated at this time just inside the NW gate. Dedications to Artemis were found near it. To the E of the city walls, in the plain, are the foundations of a temple (partially excavated in 1914) perhaps to Asklepios. South of this are the foundations of another temple.

Arvanitopoullos supposed the agora of the city to be on the gentle slope at the S foot of the acropolis hill, where he saw the remains of a large building. Just outside the wall here he saw the remains of a Roman (?) building. He discovered a water channel just to the N of the acropolis, which brought water from a spring called Manna on the peak of Lower Olympos called Solio, where there was said to be (1910) a cemented reservoir. South of the walled city is a mound in the plain called Besik Tepe, which was a prehistoric site. Around the mound are traces of a (period?) wall, and on the summit remains of buildings of small stones. Ancient graves have been found at this tepe, outside the N gate of the city, and outside the S gate. The site of Gonnos has yielded a rich quantity of inscriptions, some sculpture and other remains.

BIBLIOGRAPHY. W. M. Leake, *Nor. Gr.* (1835) III 388f; *AM* 34 (1909) 84; A. S. Arvanitopoullos, *Praktika* (1910) 241-54[MPI]; (1911) 253-56, 315-20[P], 347; (1914) 208-10; id., *ArchEph* (1911) 123ff; F. Stählin, *Das Hellenische Thessalien* (1924) 32-36[PI]; E. D. Van Buren, *Greek Fictile Revetments in the Archaic Period* (1926) 36f; *AA* (1960) 173; W. K. Pritchett, "Xerxes' Route over Mt. Olympus," *AJA* 65 (1961) 369-75[I]; H. Biesantz, *Die Thessalischen Grabreliefs* (1965) 125[I].

T. S. MAC KAY

GORDION Phrygia, Turkey. Map 5. A city near the confluence of the Sangarios and Tembris rivers in Anatolia, about 96 km SW of Ankara. Situated on a natural route from the sea to the central Anatolian plateau, it was already settled in the Early Bronze Age. Throughout the Hittite period it was evidently an important provincial town. It reached its greatest development in Phrygian times during the Dark Age following the fall of the Hittite Empire (9th and 8th c. B.C.).

The Phrygian city was sacked at the time of a Kimmerian raid dated to the opening decades of the 7th c.

It was rebuilt in the 6th c., probably by Alyattes the Lydian king, as a market and garrison town. In the early years of the Persian Empire, Darius reorganized the ancient route to the Aegean sea by creating the Royal Road, of which stretches have been uncovered at Gordion. Visits by a number of travelers following the Royal Road are recorded: by the Satrap Pharnabazos in 411; by Agesilaos in 395; and by Alexander, who is alleged to have cut the Gordian knot during his visit in 333. Later the king of Bithynia settled Galatians who had crossed into Asia in the region subsequently known as Galatia. In B.C. 189 Manlius Volso, leading a Roman army to chastise the Gauls for their depredations, found the city deserted. It was never resettled as a place of importance; Strabo speaks of the old Phrygian capital as a mere hamlet in his time.

The Phrygian city, burned about 690 B.C., was surrounded by a massive wall of coursed masonry pierced by gates at E, N, and W. The E gateway, completely cleared, still stands to a height of 9 m and comprises a ramped central passageway with the gate itself at the inner end and flanking courts at either side. Within the city the palace occupied a large area shut off from the rest of the town by its own enclosure walls. A number of separate buildings grouped around a central plaza have been cleared. All were laid out on the same "megaron" plan of inner room with round central hearth, entered only through a vestibule in front. The buildings were all constructed of stone or of crude brick strengthened by frameworks of timber and covered by gable roofs of clay spread over reed beddings. In the largest megaron, which had a width of more than 15 m, two rows of wooden posts helped support the roof. At least three of the buildings were adorned by floors of pebble mosaic laid in geometric patterns; the walls of one were scribbled over by graffito drawings which illustrate the contemporary 8th c. scene. On a terrace to the S of the plaza a long building of eight adjoining rooms housed the service area of the palace. There were clearly several phases and successive building periods of the town which must extend well back into the 9th c. B.C.

The cemeteries lay around the city on higher ground above the river valley. Royalty and the wealthy had tumuli heaped over their graves. The greatest tumulus, 53 m in height, covered a tomb constructed of wood with gabled roof, admirably preserved. The sole occupant must have been a king, probably the predecessor of King Midas. With him were buried Phrygian inlaid wooden furniture and many bronze vessels. The finds from tombs and city are shown at the local Gordion museum and in the Ankara Museum.

BIBLIOGRAPHY. G. & A. Korte, *Gordion*, JdI suppl. v (1904); M. J. Mellink, *A Hittite Cemetery at Gordion*, University Museum Monograph (1956); R. S. Young, "Early Mosaics at Gordion," *Expedition* 7 (1965) 4-13; id., "Gordion on the Royal Road," *ProcPhilSoc* 107 (1963) 348-64[MPI]; id., *Gordion, A Guide*, Archaeological Museum of Ankara (1969); id., "Old Phrygian Inscriptions from Gordion," *Hesperia* 38 (1969) 252-96.

R. S. YOUNG

GORGIPPIA (Anape) Kuban. Map 5. A city on the Taman peninsula mentioned by Strabo (11.2.10). It dates to the 6th c. B.C. The Greeks set up an emporium on the site, which was inhabited by the Sindi (Ps.-Scymn. *Periplus* 72), and named it in honor of a member of the Spartocid dynasty. In the 3d c. A.D. it was destroyed by the Goths but it made a brief recovery before its final decline in the 4th c.

With an area of 20 ha, the city was almost equal in importance to Phanagoria, whose prosperity like

Gorgippia's derived from the wheat trade. The city's most prosperous period was the 3d c. B.C. Excavations have revealed remains of dwellings, two wine-making establishments, a potter's kiln, a main street. Greek inscriptions prove that the city aristocracy was Hellenized to a considerable extent: the names of the native victors of the agones, held in honor of Hermes, are Greek, as is shown in the list from the 3d c. B.C.

The necropolis, which dates from the 4th c. B.C., consists of simple tombs and a series of kurgans lining the roads to the city. The burial chambers were roofed with a false cupola of stone. Archaeological finds include Attic red-figure and black-glazed ware, Bosporan ware decorated with watercolor, and hand-thrown vessels produced locally. Particularly noteworthy are the portrait of an inhabitant and some funerary reliefs of local origin. The Hermitage Museum contains material from the site.

BIBLIOGRAPHY. A. L. Mongait, *Archaeology in the USSR*, tr. M. W. Thompson (1961) 201; C. M. Danoff, *Pontos Euxeinos* (1962) 1137-38 = *RE* Suppl. IX; I. T. Kruglikova & G. A. Tsvetaeva, "Raskopki v Anape," *KSIA* 95 (1963) 66-71; id., "Raskopki Gorgippii," *KSIA* 108 (1966) 82-88; E. Belin de Ballu, *L'Histoire des Colonies grecques du Littoral nord de la Mer Noire* (1965) 128-29; G. A. Tsvetaeva, "Raskopki nekropolia Gorgippii v 1964 g.," *KSIA* 109 (1967) 136-39; id., "Novye dannye ob antichnom sviatilishche v Gorgippii," *VDI* (1968) 1.138-48; id., "Okhrannye raskopki v Anape v 1965 g.," *KSIA* 116 (1969) 105-10; I. B. Brašinskij, "Recherches soviétiques sur les monuments antiques des régions de la Mer Noire," *Eirene* 7 (1968) 110-11; A. I. Salov & T. M. Smirnova, "Novye nakhodki v Anape," *KSIA* 130 (1972) 53-57.

M. L. BERNHARD & Z. SZTETYŁŁO

GORGO, *see* AD AQUAS GRADATAS

GORITSA ("Orminion") Thessaly, Greece. Map 9. An ancient site on a ridge just SE of modern Volo. The ridge stretches down from the mass of Pelion to the sea, and cuts off the plain of Volo from that of (modern) Agria to the SE; thus the site on it controls the road from Thessaly along the inner coast of Magnesia. This site and Demetrias across the way control shipping into the innermost recess of the Gulf of Pagasai, now the harbor of Volo. The site used to be thought Demetrias but Stählin suggested that it was Orminion. Strabo (9.438) says Orminion is 27 stades (ca. 5 m) distant from Demetrias by land, and 20 (ca. 4 km) from the site of Iolkos, which is on the road between the two. This is approximately correct for equating Orminion with Goritsa. Orminion was one of the cities incorporated into Demetrias in 293 B.C., but otherwise nothing is known of its history.

A considerable amount of the wall circuit remains on the hill, in form an oval with pointed ends running roughly SW-NE, and ca. 2,480 m around. The NW long wall runs along the irregular spine of the ridge, and the SE wall along its sloping side, close above the sea. The old road from Volo to Agria ran through the center of the walled city, but a new road has been built along the shore, below the walls. The wall is double faced, with tie blocks, the interior filled with earth. The faces are built of large rectangular or trapezoidal blocks laid in fairly regular courses. Like the fortifications of Demetrias, the wall consisted of a stone socle and upperworks of earth or mudbrick. The wall was furnished with 26 projecting square towers. The highest point of the ridge, about in the middle of the long wall, is enclosed to make a fortified acropolis of very small area; this now contains a Church of the Panaghia. Here are a cistern and, before the rebuilding of the church, the foundation of a building

14 x 10 m. In 1931 some tests in the church foundations revealed ancient blocks (part of this foundation?). The city wall presently visible is successor to an earlier one of much the same construction. A stretch of this earlier wall is visible outside the later one to the S of the city's W gate, another section at the middle of the long SE wall where the earlier wall lies along the edge of a ravine, partly outside and partly inside the later one. The original wall included a small hill at the NE end of the city, which the later wall excluded. The later wall had gates well protected by towers at the SW end of the circuit, a N gate between the acropolis and the outlying hill mentioned above, a SE gate at the head of a ravine just above the W end of the Agria plain (where there used to be a marshy area, perhaps an ancient boat landing or harbor, but then by the 1930s a cement factory) and a narrow gate at the head of the ravine where the earlier wall is visible, in the middle of the SE wall. At the NE end of the circuit where the later wall was built considerably inside the line of the earlier one are the remains of a powerful bastion built to protect this rather accessible section. This bastion was partially excavated in 1931, but only described in 1956. It consisted of a thick stretch of wall flanked by two projecting rectangular towers with half-round outer faces. The towers inside had each a rectangular room; the outer semicircle was solid. There was a door into each tower from the city, and small entrances into each from the outside, at the corner between the tower and the wall between them. The whole bastion is ca. 34 m wide and 14 m deep.

In the center of the city is a square level area 61 x 61 m, probably the ancient agora. A water channel cut in the rock and covered with slabs can be seen along the N side, and for a little way down the E side. Near the NE corner of this area is a small (9 x 6 m) foundation, probably of a temple. The street pattern of the ancient town was a grid, oriented NS by EW. Streets and house remains can be made out in many places.

Outside the walls, above the modern road from Volo to Agria, on the slope of the hill, a private excavation in 1931 revealed some ancient tombs—one containing objects of silver, bronze, and alabaster—of the Hellenistic period, now in the Volo Museum. In 1962 a cist grave of the same period was excavated here. In the SE end of the Volo plain under the Goritsa hill, and near the beach could be seen (1930s) some Roman and/or Byzantine wall remains.

It has been suggested by Meyer that the fortifications of the city were constructed at the same time as those of Demetrias as part of the same scheme. The later wall is of problematic date, but may, with the bastion, have been constructed by Antiochus III in 192-191 B.C., in connection with his use of Demetrias as a headquarters in his war with the Romans.

BIBLIOGRAPHY. E. Dodwell, *A Tour Through Greece* (1819) II 90; W. M. Leake, *Nor. Gr.* (1835) IV 363, 375; R. Kent, *AJA* (1905) 166-69[P]; C. Fredrich, "Demetrias," *AM* 30 (1905) 221-44 (with notes by A.J.B. Wace)[PI]; A. S. Arvanitopoullos, *Praktika* (1907) 171-74; F. Stählin, *Das Hellenische Thessalien* (1924) 75-77; *BCH* 55 (1931) 489-91[I]; E. Meyer in Stählin & Meyer, *Pagasai und Demetrias* (1934) 251-57[MPI]; id., *RE* (1939) s.v. Orminion; id., "Goritza," *AM* 71 (1956) 98-100[PI]; A. P. Wrede, *AA* (1932) 151; T. Papazaphiri, "An Hellenistic Cist Grave from the Neighbourhood of Volo," *Thessalika* 4 (1962) 28-34[PI].

T. S. MAC KAY

GORSIUM later HERCULIA Hungary. Map 12. A settlement 16 km S of Székesfehérvár on both sides of the Sárviz river. About A.D. 50 a military camp was con-

structed at the crossroads. It was garrisoned by the ala I Scubulorum for several years. After the departure of the mounted unit a civilian settlement was formed in the area of the castrum and probably raised to municipal rank under Hadrian. At the end of the 1st c. another military camp was constructed S of the city. This was garrisoned by the cohors Alpinorum equitata. After the partition of Pannonia in 106 Gorsium became the religious center of Pannonia inferior. The construction of its capital and forum was begun under Trajan; the former contained the ara Augusti Pannoniae inferioris. The city was devastated by the Sarmatians in 178 and by the Roxolans in 260. After the first catastrophe rebuilding was completed under Septimius Severus, who dedicated the reconstructed shrine of the capital in person. Following the entire destruction in 260, the city was rebuilt in the period of Diocletian and its name changed to Herculia. The history of the settlement may be followed to the middle of the 5th c., but the center of the city at the important crossing, persisted to the middle of the 16th c.

Excavations have uncovered the entire extent of the settlement. The forum, established at the crossing of the decumanus and the cardo, was closed by a colonnade on the N. Three long stairs interspersed with nymphaea once led to the buildings of the capital. Among these the apse of a large hall to the W contained the ara Augusti, with a sacrificial altar in front of it. The central stair represented the entrance to the shrine of the capital, to which access was given by a colonnaded area. The E side of the capital was occupied by an edifice that was perhaps the site of the consilium provinciae. The capital, devastated in 260, was occupied by a new city center in the 4th c.; its forum was moved somewhat to the N and an Early Christian basilica was raised at the crossing of the cardo and the decumanus at the beginning of the same century. Later another Early Christian basilica was constructed along the decumanus, to the NE corner of which a baptismal chapel was added at the beginning of the 5th c., fashioned from the reshaping of an ancient public fountain. In the first third of the 4th c. a palatium was raised along the decumanus in the neighborhood of the second basilica. During the 4th c. a row of tabernae stood on the S side of the decumanus, opposite the palatium. They were all built on the ruins of buildings destroyed in 260. Among the earlier edifices was a large horreum in the E part of the palatium and a building possibly of eastern derivation below the level of the second basilica, richly ornamented with wall painting and stuccos. The city center was surrounded by extensive city quarters among which excavations have been carried on only to the S.

Under Domitian a second military camp was established at a distance of 300 m from the crossing of the cardo and the decumanus, and beside it a minor vicus with simple huts dug into the ground and houses made of adobe bricks. This settlement survived the dissolution of the military camp; the potters' quarter of the city was here. At the beginning of the 4th c., during the largest extension of the city, stone buildings were raised here, among them a major, villa-like edifice. It was constructed at the end of the rule of Constantine the Great and was abandoned by the owner under Valentinian, as were the other dwellings of the neighborhood. On the site of this abandoned city quarter a cemetery appeared at the end of Valentinian's rule and was used by the impoverished inhabitants of Gorsium as late as the 5th c.

Till the Marcomannic wars the inhabitants of the city were Celtic Eraviscans with a number of Italian merchants and veterans. After the war Italians decreased; in the mass of the new settlers—partly Thracian, partly oriental—the local population was pushed into the background and finally disappeared.

BIBLIOGRAPHY. E. B. Thomas, "Die römerzeitliche Villa von Tác-Fövenypuszta," *Acta Arch. Hung.* 6 (1955) 79-152; J. Fitz, "Gorsium," *Székesfehérvár* (1960); id., "Gorsium," *RE* Suppl. 9 (1962) 73-75; id., "Gorsium," *Székesfehérvár* (1964); id., "Gorsium, Excavations in a Roman Settlement of Lower Pannonia," *Acta Arch. Carpathica* 10 (1968) 287-90; id., "Gorsium," *Székesfehérvár* (1970); Zs. Bánki, "Villa II von Tác," *Alba Regia* 4-5 (1963-64) 91-127.　　　　J. FITZ

GORTYN Kainourgiou, Crete. Map 11. The most important Graeco-Roman city of Crete stood on the N edge of the plain of Mesara, 15 km E of the great Bronze Age palatial site at Phaistos. Prehistoric remains at the site are scarce, although some evidence of Neolithic and Minoan occupation was found nearby at Mitropolis, and a little Late Minoan material has been found at Gortyn itself. References to the city in the *Iliad* (2.646) and *Odyssey* (3.294) suggest that there was probably a Late Bronze Age settlement somewhere in the vicinity of the Graeco-Roman city. The foundation of the city is variously ascribed to Lakonians (Konon, *History* 36), Tegeans (Paus. 8.53) and to Minos (Strab. 10.476-7), but the beginnings of the Graeco-Roman city can best be ascribed to the Geometric or early archaic period. The earliest inscriptions from the site date from the later 7th c., and the oldest of the temples was either a Geometric or archaic foundation. By the 3d c. B.C. it had become one of the major cities of Crete, and had conquered Phaistos and taken over its harbor at Matala. In 221 B.C., however, civil war broke out in the city between those who favored an alliance with Knossos and those who preferred alliance with Lyttos. The result of the war is uncertain, but there followed a long period of intermittent hostilities with Knossos, which were really ended only by the Roman conquest of Crete in 68 B.C. Gortyn allied with Rome, and while Knossos was destroyed, Gortyn became the capital of the new province of Crete and Cyrene. The city was finally destroyed by the Saracens in A.D. 824.

The city was built on either side of the Lethaios River, but there are few surviving remains to be seen to the W of the river. Immediately W of the river, however, is the acropolis with traces of its ancient wall and with the early temple mentioned above. This was a slightly oblong building with a cella, toward the back of which was a bothros flanked by two repositories. The building was restored in Classical, Hellenistic, and early Roman times. At the foot of the acropolis, by the river, are the remains of a theater.

Immediately opposite the theater, on the E bank, is the odeion, which was built in the late 1st c. B.C. and, after being damaged by an earthquake, was restored by Trajan. Behind the brick-floored stage was a facade with three portals and four built niches, while on the N side, incorporated into the foundations, were the 12 stone blocks carrying the famous law code. These had been built into an earlier, Hellenistic building which may well have been a law court, but the inscription was first cut in the first half of the 5th c. B.C. The code itself undoubtedly contains much that is archaic and indeed Minoan.

To the S of the odeion lay the agora and the Temple of Asklepios, about both of which little is known, although the cult statue from the temple is preserved in the Herakleion Museum. South of the agora, and close to the modern road, is the Church of Haghios Titus. It was probably built in the 6th c. A.D., but much of what survives certainly belongs to later repairs and additions.

Originally there appear to have been transeptal apses and flanking chapels on either side of the great central apse and altar.

To the S of the modern road are several other important public buildings. Close together stand the Temple of Apollo Pythios and the Temple of Isis. The former is said to have stood at the center of the city and to have been its most important temple. Its foundation date is uncertain but it was restored and enlarged during the Hellenistic period, when a pronaos was added, with six half-columns of the Doric order. Between the columns were placed inscribed blocks carrying the treaties made between Gortyn and other Cretan cities during the 2d c. B.C. In the cella two rows of four Corinthian columns, the bases of which are still in situ, divided the interior into three aisles. Other subsequent additions included the great stepped altar which stood before the pronaos and was built during the Roman period. The Temple of Isis, just N of the Temple of Apollo, is known from an inscription to have been dedicated in fact to Isis, Serapis, and various Egyptian deities. The altar stand on the E wall, opposite the entrance, was in fact divided into three and took statues of Isis, Serapis, and Anubis. Niches for further statues were situated in the other walls and a number of inscriptions were recovered from the site.

East of the Temple of Apollo was a small nymphaion built at the end of the 2d c. A.D., and subsequently (6th-7th c. A.D.) made into a reservoir and fountain. A similar fate befell a second nymphaion, built perhaps a little earlier, and situated some distance S of the first. Immediately S of the N nymphaion is the building known as the Praetorium, and identified as the residence of the governor of the province. It was originally built at the beginning of the 2d c. B.C. during the reign of Trajan and may then have been a domestic residence for the governor and little more. Rebuilding following earthquake damage in the 4th c., however, saw the construction of the great basilican hall, which signifies that the building was now, if not before, used as an administrative center.

To the W, and close to the Temple of Apollo is a small brick-built theater of the Roman period. Some distance S of it are the remains of a substantial building of the Roman period which is almost certainly the main public baths. East of the baths is the brick and masonry amphitheater, another of the buildings erected early in the 2d c. A.D. The oval cavea is partially taken up by a built stage for theatrical performances, while on the outside wall of the building built niches were originally embellished with statues, one of which (of Antoninus Pius) is still preserved—the trunk on the site and the head in the Heraklion Museum. Fragments of other sculptured pieces survive in the vicinity of the amphitheater. South of it some of the supporting arches of the great circus or stadium can be seen.

During the Roman period water was supplied to the city by a built aqueduct which ran from a source somewhere along the line of the Lethaios river.

Finds from the site are on display in the Heraklion Archaeological Museum, and in the small museum on the W outskirts of the village of Haghia Deka where a number of statues and inscriptions are displayed.

BIBLIOGRAPHY. Hom. Od. 3.294; Il. 2.646; Strab. 10.476; F. Halbherr, "Relazione Sugli Scavi del Tempio di Apollo Pythio in Gortina," MonAnt 1 (1892) 9-76; D. Comparetti, "Nuovi Frammenti d'Iscrizioni Arcaiche Trovati nel Pythion," MonAnt 1 (1892) 77-120; S. Ricci, "Il Pretorio di Gortyna, Secundo un Disegno a Penna e Manoscritti Inediti del Secolo XVI," MonAnt 2 (1892) 317-34; L. Savignoni et al., "Nuovi Studii e Scoperte in Gortyna," MonAnt 18 (1907) 177-384[I]; L. Pernier & L. Banti, Guida degli Scavi Italiano in Creta (1947)[MI]; D. Levi, "Atti Della Scuola," Annuario NS 19-20 (1958) 389-94; R. F. Willetts, The Law Code of Gortyn (1967)[I]; G. Rizza & V. Santa Maria Scrinari, Il Santuario Sull' Acropoli di Gortina (1968)[PI].

K. BRANIGAN

GORTYS or KORTYS (e.g. Hesychius) Arkadia, Greece. Map 9. An ancient city of Kynouria, lay on the banks of the Gortynios river, ca. 7 km N of present-day Eliniko. Little is known of the history of the place. After the founding of Megalopolis (Paus. 8.27.3) Gortys had to give up some of its population, and sank to the status of a village. It nonetheless had enough power, and was prestigious enough, to build its imposing fortifications and to hire Skopas to do the sculpture for one of the two Asklepios temples. Later a member of the Achaian League, it was no more than a village in Pausanias' day (8.28.1).

After crossing a bridge to the W side of the river, one finds one's self in a Sanctuary of Asklepios. The sanctuary included a large temple (23.6 x 13.2 m) with pronaos but no opisthodomos. The building dates from the 4th c., and if the marble fragments of Doric columns found in the vicinity belong, this was the temple for which Skopas did the sculpture. To the S on the banks of a ravine, and partially destroyed by the ravine, are the remains of a smaller temple. Nearby there are also the remains of a bathing establishment with hypocausts and pool. The structure was first built in the 4th c. B.C. on the plan of a large house around a court containing a large bathing pool. The second stage of the building, with hypocausts, dates from the first half of the 3d c. To the S of the ravine are the remains of a portico and a watch tower. About 40 m SE of the portico, across a second ravine, are remains of houses in use from the 4th c. B.C. to the 1st or 2d A.D.

Following the course of the river S, one comes upon the acropolis of Gortys. There are two sections, completely separate and distinct from each other: a N acropolis and a S fortress. The acropolis runs SE-NW for ca. 425 m, and varies in width between 100 and 160 m. There are three gates preserved, and five round towers, these latter in the W corner, the best preserved portion. The N-NE section had no towers, but was built with a more or less saw-toothed design. This portion of the walls seems to be of 4th-3d c. date, while the rest of the circuit is earlier 4th c. The S fortress, on the high banks of the Gortynius, has square towers, and seems later, possibly 3d c. It seems that the two fortifications did not coexist, and that the blocks of the S fort may well have come from the SE wall of the acropolis, no trace of which is to be found today.

To the SW of the S fortification there are the remains of still another Sanctuary of Asklepios, also inscriptionally assured. The sanctuary contained the foundations of a temple (27.09 x 13.5 m) of 5th-4th c. date, a bath, and an adyton. A deposit of military-related equipment was also found in the sanctuary.

BIBLIOGRAPHY. J. G. Frazer, Paus. Des. Gr. (1898) IV 307-11; Reports in BCH 64-65 (1940-41) 274-86; 66-67 (1942-43) 334-39; 71-72 (1947-48) 81-147 (walls)[MPI]; 75 (1951) 130-34; 76 (1952) 245-49; 77 (1953) 263-71; 79 (1955) 130-34; 80 (1956) 399-406; R. Ginouvès, L'établissement thermal de Gortys d'Arcadie (1959)[PI]; F. W. Winter, Greek Fortifications (1971) passim.

W. F. WYATT, JR.

GOSPODJIN VIR, see LIMES OF DJERDAP

GOSTAVĂŢ, see SLĂVENI

GOUMANI ("Gitana") S Epeiros. Greece. Map 9. A meeting place of the Epirote League (Livy 42.38.1). A spur near Philiates between the Kalamas river and a N tributary is fortified with a circuit wall ca. 3000 m long, and the acropolis has a fine semicircular tower. A small theater, towers, and gateways are visible. The Kalamas may have been navigable to this point.

BIBLIOGRAPHY. N.G.L. Hammond, *Epirus* (1967) 83f, 651f, Plan 10 and Pls. IV *a*, XIX *b*, and XXV *b*.

N.G.L. HAMMOND

GOURYIANA, see LIMES, GREEK EPEIROS

GOURZON Haute-Marne, France. Map 23. Gallo-Roman city on the Châtelet hill overlooking the valley of the Marne between Fontaines and Bayard, and at the intersection of two Roman roads. One of these followed the Marne valley while the other, from Naix (Nasium), led W. The city, ca. 20 ha in area, replaced a Celtic oppidum (foundations of huts, pottery, fibulas, bracelets, statuettes, and coins), which in turn had succeeded a Neolithic settlement (about 100 axes of flint, quartz, and jadeite, arrowheads, knives, cutters, and scraping tools).

The site has yielded a number of finds since the 18th c., but has never been systematically explored until the recent excavation of a suburban quarter. In the section originally investigated, which today is covered with vegetation, a network of roads and squares was uncovered, a temple, some baths, many houses (most of them with cisterns and stone roofs), and part of an inhumation necropolis. A number of reliefs and sculptures and some architectural fragments have been found, a considerable quantity of pottery (especially terra sigillata—Centre, Alsace, Argonne), as well as arms, fibulas, jewelry, glassware, bronze and silver grave gifts, tesserae of bone and ivory, and over 10,000 coins, including several hundred gold pieces. The Gallo-Roman settlement apparently developed uninterruptedly from the 1st to the 5th c. A.D.

BIBLIOGRAPHY. Grignon, *Bulletin des fouilles faites, par ordre du roi, d'une ville romaine sur la montagne du Châtelet* (1774); Phulpin, *Notes archéologiques sur le Châtelet* (1840); R. Colson, *Pro Alesia* (1921) 161ff; id., *Bacth* (1923) 20ff; (1927) 337, 343; id., *Les amphores du Châtelet* (1930); P. Colson & id., *Mém. Soc. des Lettres, des Sciences, des Arts de Saint-Dizier* 23 (1935); G. Drioux, *Cahiers Haut-Marnais* 19-20 (1949) 160; Y. Gaillet, ibid. 77 (1964) 49, 81; (1965) 90; P. Ballet, *La Haute-Marne antique* (2d ed. 1971) 131-35, 144-49.

E. FRÉZOULS

GÖZLÜ KULE, see TARSUS

GRAČANICA, see ULPIANA

"GRACCHURRIS," see ALFARO

GRADO, see AD AQUAS GRADATAS

GRAGNANO Campania, Italy. Map 17A. A small agricultural center not far from Stabiae. It was buried in A.D. 79. Several country villas and a farm with one of the best preserved and most advanced grain mills have been uncovered so far. A bath connected with one of the villas was decorated with stucco reliefs depicting boxers, Psyche, harpies, Narcissus, and Pasiphai. A second villa dating from the Republican period contained a large kitchen and five non-adjoining rooms. A third villa, built during the Flavian period, preserves the en-

trance and two day rooms on the N, a medium-sized kitchen with an oven and apotheca on the E, a storage area on the W, a triclinium with walls decorated in the Fourth Style (including paintings of the Triumph of Bacchus, Bacchus and Ariadne, Neptune and Amymone; bacchantes) on the S, and finally, next to the triclinium, two smaller rooms, one with erotic paintings and the other with a painting of Pomona. Like other buildings in the complex, it was built in opus incertum. In addition a pre-Roman necropolis with almost 200 tombs has been found nearby. The finds from there and from the villas are in the National Museum of Naples and the Antiquarium of Castellamare at Stabiae.

BIBLIOGRAPHY. *NSc* (1887) 155-56, 251-52; *NSc* (1892) 204-5; A. Liguori, *Gragnano; memorie, archeologiche e storiche* (1955) esp. 30-45; *FA* 16 (1961) no. 2737, 4747; *FA* 18-19 (1963-64) no. 7377.

J. P. SMALL

GRAMMENO Epeiros, Greece. Map 9. A hill in the Jannina plain W of the village of the same name, ca. 17-18 km from Dodona. The remains of a small temple (17.5 x 12.8 m), probably dating from the 4th c. B.C., have been excavated. The temple faces S and has a pronaos and a sekos. In the 2d-3d c. A.D. two houses were put up on its site, all the stones of the temples being used to build them. Articles of daily use were found in the remains of one of the houses (bronze fibulae, potsherds). The presence of ashes and animal bones suggests that there was a sacrificial altar here. The masonry of the temple is isodomic.

BIBLIOGRAPHY. *BCH* 79 (1955) 267; Suppl. to *JHS* 75 (1955) 13; M.S.F. Hood, the report of E. Vanderpool in *AJA* 59 (1955) 227; A. Philippson & E. Kirsten, *GL* II.2 (1958) 667 n. 87a; N.G.L. Hammond, *Epirus* (1967) 168[M7]; ibid. 183; ibid. 700[M18].

Y. BÉQUIGNON

GRAMMICHELE ("Echetla") Sicily. Map 17B. Ca. 6.4 km NW of Grammichele in the Terravecchia district are the remains of a substantial town of the 6th-3d c. B.C. The settlement lies at the very edge of the Heraian hills on four defensible hilltops, overlooking the valley of the river Caltagirone where the town's fields must have been. Early Iron Age habitation is indicated by a necropolis in the Madonna del Piano district, an elevated plateau at the foot of the four hills. The settlement belongs to an early phase of the Cassibile culture (ca. 1000-850 B.C.) and is associated with the Ausonian habitation at Lipari and Milazzo by the unusual burials (both pithos and fossa graves). The tombs contain some of the earliest iron yet found in Sicily, in the form of finger rings. Later, chamber tombs were cut into the slopes. Greek occupation of the hilltops began about 600 B.C.; the earliest remains are architectural terracottas. No buildings have been excavated. In the upper slopes of the easternmost hill (Poggio dell'Aquila) were found favissae of a Sanctuary of Persephone; they include a fine series of Severe Style terracotta busts. Another earlier favissa at Madonna del Piano contained a seated terracotta goddess and a fragmentary kouros. These finds indicate a Greek population, perhaps of Chalkidian origin; Leontinoi is the closest city. An indigenous substratum is indicated by Sikel pottery in contemporary tombs. The site has been identified on tenuous evidence as Echetla (Diod. 20.32.1; Polyb. 1.15.10); it was inhabited until 1693, when the town, called Occhiolà, was destroyed by earthquake. The finds are mostly in Syracuse; the recently excavated Iron Age material is at present in Lentini.

BIBLIOGRAPHY. P. Orsi, "D'una città greca a Terravecchia," *MonAnt* 7 (1897) 201-74[MPI]; id., "Anathemata di una città siculo-greca," *MonAnt* 18 (1908) 121-74;

id., *BPI* (1905) 96ff; id., *NSc* (1920) 336f; E. D. Van Buren, *Archaic Fictile Revetments in Sicily and Magna Graecia* (1923) 21, 137. Gianformaggio, *Occhiolà* (1928); T. J. Dunbabin, *The Western Greeks* (Oxford, 1948) 122-25; L. Bernabò Brea, *Sicily before the Greeks* (New York, 1960) 164f, 170; id. et al., *NSc* (1969) 210-76. M. BELL

GRAND Vosges, France. Map 23. This was an important Gallo-Roman town of the civitas Leucorum, its ancient name is not now known. Possibly Grand was the locality cited in the *Peutinger Table* under the name of Andesina.

The built-up area, of indisputably urban character, is situated on a forested plateau, away from major strategic and commercial routes of the Empire. Grand undoubtedly owed its growth to the existence of a cult to a native healing deity (Grannus?), which was replaced after the Roman conquest by a Sanctuary to Apollo. A passage of the *Alethia* (3.204-9) by Claudius Marius Victor (5th c.) very probably alludes to the divinity of Grand. Perhaps the emperor Constantine came to pray to the Apollo of Grand when, according to the *Panegyric* of 310 (*Paneg. lat.* 7.21), he made a detour to visit "the world's most beautiful temple" and to receive the prophetic vision which revealed to him his future power. One may suppose that, from the end of the 1st c., a center of national independence and resistance developed around the temple of Celtic origin. Essentially for this reason the Romans chose to make Grand an example of the town-making which was the sign of their presence and authority. Although excavations have shown that the town was destroyed several times, there was no break in occupation from the time of Gallic independence to the Merovingian period.

Today one can still see the remains of a certain number of monuments at the ancient site. The great mosaic, preserved in situ, was discovered in 1883. The excavation of 1961-62 proved that it formed part of a basilica of eastern type. The proportions of the basilica are about the same as those of the one built by Vitruvius at Fano (*De Arch.* 5, § I), but it is of smaller size. The walls were built of small, regular, quarry-stone ashlars with buttresses on the other side and interior compartments. They were faced with marble slabs, several of which are still in place. Possibly the floor was paved in marble too. Fragments of fluted columns and of capitals of composite Classical style have been discovered. The building was roofed with limestone slabs, using the technique alluded to by Pliny the Elder (*HN* 1.36). A large thoroughfare passed in front of the basilica; possibly it was the town's cardo. It appears to us as a covered gallery giving access to both sides of the facade and forming with it a large monumental ensemble.

On the other side of this thoroughfare was built a monument whose plan and purpose are still little known. However, the nature of the remains found with it and its location at the official center of the ancient town suggest that, if it was not the very Temple of Apollo to which the town owed its fame, it was at least an important part of a great cult complex lasting until the present-day church. To date only the NW corner of a platform has been excavated. On the platform were raised bases apparently intended to carry the decoration of marble and of stone sculpture. Indeed, all around the masonry there extended a layer of broken soft stone in which more than 1500 sculptural and architectural fragments of all sizes were gathered. A great number of them present the usual motifs of Graeco-Roman decorative sculpture. Some small figures in medium or high relief seem to have formed part of a retinue of Bacchus, with his customary acolytes and animals. Certain sculptures are of larger size, in particular a child's head presumed to be a portrait of Geta, son of Septimius Severus. Finally, a very few pieces belonged to a colossal statue, most notably a left hand whose gesture recalls the imperial posture known from statues and medals. The presence of such a statue in the monument or its immediate vicinity leads to the supposition that an imperial personage, perhaps one of the Severans, took an interest in the Grand sanctuary. In this connection one must recall the monumental inscription found in the 19th c. (*CIL* XIII, 5940). In any event, the style of all these sculptures and their expert technique, unrelated to provincial products, prove that this is an imported, commissioned work, intended as propaganda, no doubt to consecrate the memory of a political event and to serve as an accessory to the imperial cult.

Recent excavations inside the village have further revealed foundations and sculptures which perhaps belonged to the public baths. A large network of water channels and wells has been discovered, as well as the course of a rampart very carefully built with small ashlars.

At the E end of the village is the monument usually called the amphitheater. It is really a hybrid edifice intended to combine two functions, originally different in intention and characteristics: on the one hand, a theater reserved for dramatic productions; on the other, an amphitheater with an arena designed for the maneuvers of gladiators and hunts of wild animals. The long axis measures 149.5 m, the short, ca. 65 m. Inexpensively built, the cavea takes advantage of the slope (ca. 15 m) of a small valley. Eight vomitoria open in the interior wall. The cavea is divided into three sectors by two radiating walls. Three zones are set off by two boundary walls bordered by a terrace. At the bottom of the small valley the elliptical arena communicates to the exterior by two monumental corridors furnished with buttresses, the ones to the W built of large ashlars, the ones to the E made of small regularly hewn quarry stones. The tiers of seats passed above these corridors and were held up by the arches decorating the monument's N facade. Only two of these arches survive today. Two masonry blocks, symmetrical with respect to the arena, contained carceres, which opened in the N walls of the two corridors. Below these corridors and the arena itself ran a sewer. Recent excavations have contributed evidence that the theater was no longer in use after 170-80.

The artifacts recovered before 1960 are deposited in the Epinal Museum. Those collected since then are kept at Grand, in cases around the mosaic, pending the construction of a local museum.

BIBLIOGRAPHY. J.B.P. Pollois, *Mémoires sur quelques antiquités remarquables du département des Vosges* (1843) 1-58, pls. 1-16MPI; M. Toussaint, "Grand à l'époque gallo-romaine," in *Pays Lorrain* (1933) 529-48PI; id., *Répertoire archéologique Vosges* (1948) 79-130; R. Billoret, *Grand la Gallo-Romaine* s.l.n.d. (1965)MPI; id., "La basilique de la ville antique de Grand," in *Comptes-rendus de l'Académie des Inscriptions* (1965) 63-74PI; id. in *Gallia* 24 (1966); 26 (1968); 28 (1970)PI; 30 (1972); E. Salin, "Aperçu général de la ville antique de Grand" in *Comptes-rendus de l'Académie des Inscriptions* (1965) 75-86. R. BILLORET

GRAND CONGLOUÉ, see SHIPWRECKS

GRANITSA, see LIMES, GREEK EPEIROS

GRATIANA, see under MURIGHIOL

GRATIANOPOLIS, *see* CULARO

GRAVINA DI PUGLIA, *see* SILVIUM

GRAVISCA or Graviscae Latium, Italy. Map 16. Port of the Etruscan town of Tarquinia on the coast 8 km E of its metropolis. The site of the town, often cited in connection with a colonia civium Romanorum founded there in 181 B.C. (see Bibl.), was disputed until excavations in 1969 uncovered it near the ruins of the Papal harbor called Porto Clementino.

These excavations have revealed substantial parts of the Roman settlement, established according to a regular plan of insulae, half actus (= 60 roman feet) wide. Three insulae have been partially explored, mostly at late Roman levels and have given clear evidence of an extensive fire which, from the discovery of a coin hoard of 174 solidi from Valentinianus I to Honorius, can be attributed to the Gothic invasion of 408-10. A bronze altar of Isis and Serapis was buried at the same time against the arrival of the barbarians. Even after such destruction life must have continued on the site, for a bishop of Gravisca is known in 504.

Late Roman life (3d-5th c.) is known from a luxurious domus, property of a family of potentiores. It had an extensive nymphaeum, a large marble-paved hall with a terminal apse and a small bathing annex. To Roman times also (2d-4th c.) belong a cemetery with tile-built tombs and a rectangular mausoleum E of the town on the road to Tarquinia. Trial trenches under Imperial and Republican strata have brought to light conspicuous remains of the Etruscan town, larger and richer than the Roman colony, and with a somewhat different street grid.

The most important discoveries have been made 200 m SE of the Roman insulae, well outside the limits of the colonia, but in close connection with the Etruscan city, on the borders of the ancient seashore. There a road, possibly the Etruscan coastal road to Caeretan harbors, which cuts into a large sanctuary, whose latest phase can be dated 450-250. Surface exploration has revealed three rectangular buildings containing altars, bases of statues, and a considerable number of votive objects, some of which are inscribed with dedications to the Etruscan goddess Turan (Venus). At least one of these buildings was constructed upon remains of a previous shrine (dated ca. 590-480), perhaps a sacred precinct in the open air with earth altars of which three have been found. This archaic shrine belonged to Hera, and was frequented almost exclusively by East Greeks, as attested by ca. 40 graffiti on sherds, dedications to Hera in the East Greek alphabet and in Ionian dialect; one inscription is on a marble block, a votive gift (ca. 500 B.C.) in the form of an apotropaic and aniconic cult image to Apollo of Aegina, presented by a certain Sostratos, most probably a renowned merchant mentioned by Herodotos (4.152). Much pottery of high quality (Attic, East Greek, Laconian, some Corinthian) and ca. 1000 Greek lamps witness the importance of the emporion for the archaic Greek trade with Tarquinia.

BIBLIOGRAPHY. M. Torelli et al., "Gravisca," *NSc* (1970)[MPI]; id., "Il sanctuario di Hera a Gravisca," *La Parola del Passato* 136 (1971) 44-67[MPI]. M. TORELLI

GREAT CASTERTON Rutland, England. Map 24. On Ermine Street, 17 km N of Durobrivae and 35 km S of Ancaster, where the Roman road crosses the little river Gwash. Its Roman name is unknown.

There is no trace of any considerable Iron Age site in the vicinity; the settlement developed from the vicus of an auxiliary fort of the conquest period. The fort itself was discovered from the air in 1959, and excavation showed that there were two main phases in its occupation. The defenses of the original area of 2.4 ha included a turf rampart and two widely spaced ditches, defining a fire-trap into which attackers might be lured and dispatched. The SE side had a third ditch of lesser dimensions, placed within the fire-trap. The defenses were a rectangle with smoothly rounded corners, and there were gates in three of the four sides (there was no porta decumana). The internal buildings, all of timber, have been only briefly explored; their complete plan cannot be reconstructed, but the praetorium and at least two barracks can be identified. The date of this first phase is from ca. A.D. 45 to ca. A.D. 70-75.

The second phase of occupation involved a reduction in area to ca. 2 ha by shortening the longer sides and by building a new length of defenses across the SE quarter of the earlier fort. The internal buildings were drastically remodeled, presumably for a unit of different size. This occupation was short, ending ca. A.D. 80, when the fort was abandoned, although civilian life continued in the vicus at the river crossing. This village may have been founded during occupation of the fort. By the 3d c. it had defenses; a stone wall 2.4 m wide, an earth rampart, and at least one ditch. The circuit was an irregular polygon of seven or eight sides. Few buildings have been located within the walls. The earliest is a late 1st c. bath in the S corner, which may have been associated with an inn. There was little or no attempt at internal planning and no grid of streets was laid out.

In the late 4th c., probably ca. A.D. 370, the defenses were modified by the addition of small projecting towers at the points where the wall changed direction. To accommodate these towers, the early ditch was filled up and a much broader ditch dug farther out; this can still be traced on the N and E sides. The settlement probably survived into the 5th c. Evidence for such survival comes from a villa 0.8 km to the NE, originally established in the mid 4th c. and refurbished and enlarged after ca. A.D. 370. It was occupied well into the 5th c. before being damaged by fire and abandoned. The ruins were still put to agricultural use, however, by men living within the defended site nearby. A small number of early Anglo-Saxon cremation burials outside the N defenses also attests mid-5th c. occupation.

Great Casterton provides a clear instance of a civilian settlement developing from the vicus outside an early fort. Here for the first time the structural sequence of small town defenses was fully adumbrated, as was the close association of the small town with the surrounding countryside. Finds are in the Rutland County Museum, Oakham.

BIBLIOGRAPHY. P. Corder, *The Roman Town and Villa at Great Casterton, Rutland* I (1951); II (1954); III (1961); M. Todd, *The Roman Fort at Great Casterton, Rutland* (1968). M. TODD

GREAT CHESTERFORD Essex, England. Map 24. A Roman walled town on the E bank of the Cam, 63 km N of Londinium (London) and 52 km NW of Camulodunum (Colchester). A fort, dating from the early years of occupation, appears to be the first Roman installation on the site, but only a short sector of the defenses has been revealed. The fort probably lay N of the later town. Of the civilian settlement that followed the military phase, the best recorded remains are those of the town wall, 3.6 m thick, which defined a roughly oval area of 14.4 ha. This wall, without a rampart behind it, appears never to have had external or internal towers and was not erected until ca. A.D. 300 at the earliest. The only gate thus far examined, the N gate, had a single portal

flanked by rectangular towers. This entrance was later blocked, and then restored by cutting back the curtain wall to the W and leaving the blocking in situ.

Within the walls a large area has been investigated at the N end, but relatively few buildings have been discovered. The largest is a house, resembling a farmhouse in plan, with a main range of rooms served by a portico. This area, however, was examined in 1845-60, and structures in timber may have eluded the excavator. The most significant find is a great hoard of ironwork, probably a smith's stock-in-trade, uncovered in 1854. This includes more than 90 items: scythes, plough coulters, hammers, chains, shackles, an anvil, and a pair of shears for cropping wool. Finds from the area are in the Cambridge University Museum of Archaeology and Ethnology, the Chelmsford Museum, and the Saffron Walden Museum.

BIBLIOGRAPHY. R. C. Neville, *Antiqua Explorata* (1847); id., *ArchJ* 13 (1856) 1; *VCH Essex* 3 (1963) 72ff; W. Redwell, *Britannia* 3 (1972) 290. M. TODD

GREATCHESTERS, *see* AESICA *under* HADRIAN'S WALL

GREAT WELDON Northamptonshire, England. Map 24. A Romano-British villa, N and E of the present village. The first structure was a small farmhouse consisting of four rooms with a verandah along either side. Though unpretentious, its furnishings included imported glassware and Samian pottery, indicating occupation ca. A.D. 150-200. This house was burnt down and replaced by a longer house with more rooms, and a single verandah with simple bath suite at the S end.

During the 4th c. the house was embellished with mosaic pavements, a kitchen was added, also a projecting wing at the N end of the verandah, and the bath suite was greatly enlarged. In front lay an extensive walled courtyard or garden, flanked on the N by a barn, twice burnt down and containing quantities of carbonized grain, and on the S by another building. Two 4th c. burials were found N of the barn. Coins attest occupation at least to the late 4th c., probably into the 5th. The finds will be deposited in the Central Museum, Northampton.

BIBLIOGRAPHY. Plan, showing the mosaics, engraved by Messrs. Lens and Cole, 1739; *VCH Northamptonshire* I (1902) 192; D. J. Smith, "The Roman villa at Great Weldon, Northamptonshire," *Trans. Ancient Monuments Society* NS 1 (1953) 74-76; "Roman Britain," *JRS* 44 (1954) 93, 95; 45 (1955) 135; 46 (1956) 131, 133; A.L.F. Rivet, ed., *The Roman Villa in Britain* (1969) 72 n. 5, 79-80, 107-8, 122, 132-33, 271. D. J. SMITH

GREAT WITCOMBE Gloucestershire, England. Map 24. Roman villa on Cooper's Hill Farm 8 km E-SE of Gloucester. Pre-Roman occupation of the site is represented by an Iron Age ditch, and continuity is suggested by 1st and 2d c. pottery; a simple rectangular building discovered and destroyed ca. 1819 "in front of" the later villa may have been related to this period.

The main part of the extant structures was built ca. 250-270. This consisted of two parallel ranges of buildings (each ca. 31.5 x 6.6 m) extending NW-SE, which were linked at a point 12 m from their NW ends by a corridor (33.6 x 4.8 m) so as to enclose a courtyard on the SE side; a rectangular room (6.6 x 4.5 m) projected from the middle of the corridor on its NW side. Extensive alterations and additions to this plan were made between 270 and 400: the room off the corridor was replaced by another of octagonal plan, many rooms were added to the NE wing, and extensive baths to the SW wing. Occupation appears to have persisted well into the 5th c. The slope on which the villa is built presented

considerable problems, and buttresses and terracing were extensively used. Most of the mosaics are geometric but one in the baths has a design of fish, and a threshold shows a town gate. The site is in the care of the Department of the Environment.

BIBLIOGRAPHY. S. Lysons, *Archaeologia* 19 (1821) 178-83; E. M. Clifford, *Trans. Bristol and Glos. Arch. Soc.* 73 (1954) 5-69PI; *Britannia* 1 (1970) 294-95P.

 A.L.F. RIVET

GREENSFORGE Staffordshire, England. Map 24. A site on the Smestow brook, 8 km SW of Wolverhampton, with a sequence of military establishments. There are two permanent forts on adjacent sites, and indications of marching camps and other works. Excavations have produced coins and pottery of Claudio-Flavian date, but little is known as yet about the two forts. The fact that there are two sites may indicate a break in occupation, or a change of unit during the advance towards Wales and the subsequent withdrawal during the revolt of A.D. 60. Fort A, farther N, is the larger (1.7 ha), and has a turf-fronted rampart. Fort B is ca. 1.2 ha and occupies a somewhat stronger position overlooking the brook. The size suggests an infantry cohort, but excavations have produced items of cavalry equipment. It is not known which fort was the earlier.

BIBLIOGRAPHY. *William Salt Arch. Soc.* (1927) 185; *JRS* 48 (1958) 95; 53 (1963)I; 63 (1973) 233; *Trans. Birmingham Arch. Soc.* 80 (1965) 82-83; *Antiquity* 40 (1966) 300-4. G. WEBSTER

GREMNOS, *see* ARGURA

GRENOBLE, *see* CULARO

GROBBENDONK Belgium. Map 21. A Gallo-Roman site discovered in 1908 and interpreted as being a villa. More thorough excavations, begun in 1956, show that it was a vicus. In the course of these excavations a well was found, foundations of masonry buildings (of which no plan has been yet published), quantities of potsherds, and a variety of objects—including iron tools and surgical instruments. From a close study of the plentiful terra sigillata, it is clear that the vicus dates to the first half of the 1st c. A.D., that it was at the height of its expansion in the reign of Claudius, and that it remained inhabited up to about the middle of the 3d c. In 1956 a tomb was discovered near the vicus and in it some fairly rich grave gifts consisting of 23 pieces—terra sigillata, pitchers, goblets of glazed ware, and a glass bottle. The tomb dates from the end of the 2d c. or the beginning of the 3d. Very probably it was originally covered over with a tumulus, now leveled. Close to this rich tomb was found a small necropolis. Its tombs, which are far poorer, date from the 2d and 3d c.

BIBLIOGRAPHY. J. Mertens, "Gallo-Romeins grafuit Grobbendonk," *Arch. Belgica* 53 (1961) 14 pp.; M. Bauwens-Lesenne, *Bibliografisch repertorium der oudheidkundige vondsten in de provincie Antwerpen* (1965) 54-64; P. Janssens, "Het gallo-romeins grafveldje van Grobbendonk," *Noordgouw* 6 (1966) 53-71; H. Thoen, "De Terra Sigillata van Grobbendonk," *Noordgouw* 7 (1967) 105-60. S. J. DE LAET

GRUMENTO, *see* GRUMENTUM

GRUMENTUM (Grumento) Lucania, Italy. Map 14. In the upper valley of the Acris (Agri), the city is known to history as the scene of actions during the second Punic war and social war. The theater was excavated in 1956-57 and restored in 1964-67. The cavea dates from

the 1st c. A.D.; the scene building was constructed in the 2d c. and was rebuilt in the 4th c. The theater is located between two major N-S streets, which have been exposed by excavation.

BIBLIOGRAPHY. *EAA* 3 (1960) 1064 (G. Colonna); D. Adamesteanu, "Grumento (Potenza) Teatro romano," *BdA* 52 (1967) 44-45. R. R. HOLLOWAY

"GRYNCHAI," see NEOCHORI

GRYNEION (Temaşalık Burnu) Turkey. Map 7. City in Aiolis, 30 km S of Pergamon, a member of the Aiolian League. Its settlement by Greeks is not recorded, and legend spoke of an earlier town founded by the Amazon Gryne. The city was enrolled in the Delian Confederacy, with a tribute of 1000 to 2000 dr. In 335 B.C. Gryneion was captured from the Persians by Parmenio and its people enslaved. During the Hellenistic period the city fell to the status of a dependency of Myrina.

Gryneion was noted chiefly for the temple and oracle of Apollo, described by Strabo (622) as a costly temple of white marble; Pausanias (1.21.7) spoke of a beautiful grove of Apollo. Pliny (*HN* 5.121), on the other hand, says there is nothing now but a harbor where Gryneion once existed. Surprisingly little is known of the oracle of Gryneian Apollo, and it has been doubted whether it functioned at all after the Classical period. However, a consultation by the men of Kaunos about 200 B.C. and the visit by Aelius Aristides in the 2d c. A.D. (*Or.* 51.7-8) show that its activity did in fact continue.

Virtually nothing now remains on the site. The tiny promontory at Temaşalık is largely occupied by a large rectangular mound which is supposed to have carried the temple, but no convincing remains of it have been found. The city must have stood on the mainland, but here again nothing is to be seen. A small excavation brought to light only several sarcophagi of about 500 B.C. and a late Roman mosaic pavement. The harbor mentioned by Pliny is in fact of poor quality.

BIBLIOGRAPHY. C. Schuchhardt, *Altertümer von Pergamon* I, 1 (1912) 98; G. E. Bean, *JHS* 74 (1954) 85, no. 21 (oracle); id., *Aegean Turkey* (1966) 110-12.
 G. E. BEAN

GUADIX, see ACCI

GUBBIO, see IGUVIUM

GUELMA, see CALAMA

GUEUGNON Saône-et-Loire, France. Map 23. Situated on the Arroux, a tributary of the Loire, 50 km downstream from Autun. In the Arroux Valley, at the place called Le Vieux Fresne at Gueugnon, is a very large complex of potters' ovens, which has been under excavation since 1966. Products from this pottery supplied Autun, in particular. The site was occupied from the Augustan period but the first ovens found are slightly later. The potters were active at least up to the end of the 3d c. Manufacture especially of sigillate ware is well attested through the middle of the 3d c. The many signatures found make it possible to follow the production at this center and the way in which it spread. White clay figurines were also manufactured. Most of the kilns were sufficiently well preserved for a study of their type and function.

BIBLIOGRAPHY. "Informations archéologiques," *Gallia*, 24 (1966), 26 (1968), 28 (1970), 30 (1972); articles signed "Groupe archéologique de Gueugnon-Montceau," *La Physiophile* (Montceau-les-Mines, Saône-et-Loire) 66 (1967) and following; id., *Les statuettes en terre cuite de l'officine céramique gallo-romaine du Vieux-Fresne,* Gueugnon (1974). C. ROLLEY

GUIPAVAS Finistère, France. Map 23. The commune of Guipavas, around the villages of Cosquerou, Beuzidel, and Kergevarec, contains a huge Gallo-Roman agricultural complex. Many remains of walls, made with a core of mortared rubble faced with small blocks, can be seen in the fields. Traces have also been found of a large rectangular building oriented NW-SE and, a little farther off, of another smaller structure oriented N-S.

BIBLIOGRAPHY. "Informations," *Gallia* 25, 2 (1967) 226. M. PETIT

GULASHKIRD, see ALEXANDRIAN FOUNDATIONS, 13

GÜLEK BOĞAZI, see PYLAE CILICIAE

GÜMÜŞLÜK, see MYNDOS

GÜNEY KALESI ("Kibyra Minor") Cilicia Tracheia, Turkey. Map 6. Very probably at Güney Kalesi, about 19 km NW of Alânya, 48 km E of Side and 11 km from the coast. Kibyra is mentioned as a city of Pamphylia by pseudo-Skylax in the 4th c. B.C.; it is named in the *Stadiasmus*, and Strabo places "the coastland of the Kibyrates" close to Side. The site has long been sought, as the indications given by the ancient geographers are not consistent. The only precise location is that in the *Stadiasmus* (§ 212-14), which places it 109 stades E of Side, and this agrees with Strabo's indication.

Coinage began in the 2d c. B.C. but did not continue into Imperial times, and apart from a mention by Ptolemy the city only reappears in the authorities in the 10th c. as giving its name to the Cibyrrhaeotic thema, extending from Miletos to Seleuceia. Constantine Porphyrogenitus (*De Them.* 14) calls it "a cheap and undistinguished township," and observes that the thema was called after it by way of insult rather than praise, because of a haughty and self-willed attitude towards the imperial commands.

The ruins at Güney Kalesi, discovered in 1964, occupy two summits some 750 m above sea level, but are not well preserved. The city wall, of inferior masonry, stands in part some 6 m high, but the buildings within it are utterly ruined. The inscriptions, however, refer to a Caesareum and to games; they show also that the city possessed civic status down to the 3d c. A.D. Beyond the city wall to the W a third summit carries some tombs. The water supply was dependent on cisterns, spring water being scarce.

BIBLIOGRAPHY. G. E. Bean & T. B. Mitford, *Journeys in Rough Cilicia 1964-1968* (1970) 59-66. G. E. BEAN

GÜZELÇAMLI, see PANIONION

GÜZELHISAR, see TRALLES

GYNAIKOKASTRO, see PROERNA

GYŐR, see ARRABONA and LIMES PANNONIAE

GYPHTOKASTRO ("Eleutherai") Greece. Map 11. Some scholars think that this city in Attica corresponds to modern Gyphtokastro (Paus. 1.38.8-9; 2.6.3; 9.2.1-3). Others identify Gyphtokastro with the site of ancient Panakton (Thuc. 2.18.1-2; 5.3.5). It has also been suggested that Eleutherai was located at Myupolis, E of Gyphtokastro, a location proposed by others as the site of Oinoe. The first of the theories seems perhaps the most acceptable; in any case the problematic fortified castle of Gyphtokastro was a site of primary strategic importance on the road that connected Athens, Eleusis, and Thebes.

The well-preserved circuit wall delimits the summit of a hill, describing an ellipse ca. 330 m long and half as wide, with an average thickness of 2.6 m. There are four gates. The towers, of which eight remain at the N, were two stories high and had doors, windows, and stairways. Three diverse phases in the technique of the wall have been recognized: polygonal with roughhewn face in the remains of an isolated construction inside the N flank of the wall; trapezoidal isodomic with fluted face; and isodomic with smooth face having oblique junctures of the blocks. The polygonal technique would date from ca. the middle of the 5th c. B.C. (it has been called Boiotian), and would therefore precede the construction of the whole circuit, which would then date from the last 30 years of the 4th c. B.C.

BIBLIOGRAPHY. G. Beloch, *Klio* 11 (1911); L. Chandler, *JHS* 46 (1926); U. Kahrstedt, *AthMitt* 52 (1932); W. Wrede, *Attische Mauern* (1933); R. L. Scranton, *Greek Walls* (1941); R. E. Wycherley, *How the Greeks Built Cities* (1949); N.G.L. Hammond, *BSA* 49 (1954); R. Martin, *Urbanisme dans la Grèce antique* (1956); A. W. Lawrence, *Greek Architecture* (1957); L. Beschi, *I.B.I., Atti VIII Congr.* (1968). N. BONACASA

GYROULAS, *see* NAXOS (Greece)

GYTHEION or Gythion Lakonia, Greece. Map 9. Town and port at the back of the Gulf of Lakonia. It is to the W of the mouth of the Eurotas and some 45 km from Sparta (Strab. 8.5.2; Paus. 3.21.6). Legend says it was founded jointly by Herakles and Apollo, reconciled after their quarrel over the Delphic tripod. It is on the small island of Kranai, ca. 100 m from the shore and to the S of the ancient city, that Paris is supposed to have first united with Helen (*Il.* 3.445). And in fact, it is there that the most ancient archaeological remains have been found (Mycenaean sherds, obsidian laminae). Nothing is known of the town in the archaic period. Protogeometric vases, doubtless from a necropolis, have been found on the Mavrovouni mound 3 km to the SW. A text of a religious prohibition was cut into the rock in the 6th c. (*IG* v.1, 1155). Gythion must have been used by Sparta from a rather early time as both a port and arsenal. It is mentioned as such in all the conflicts in which Sparta was involved. It was ravaged in 456-455 by the Athenian admiral Tolmides (Thuc. 1.108.5; Diod. 11.84; Paus. 1.27.5), closely watched by Alkibiades in 408 (Xen. *Hell.* 1.4.11), and having been taken in 369 by the Thebans of Epaminondas (ibid. 6.5.32) after a three day siege, it was recaptured by the Spartans shortly before 362 (Polyaen. 2.9). In 218, Philip V of Macedon devastated the surrounding countryside but did not attack the city itself (Polyb. 5.19.6). In 195, Nabis concentrated his fleet there and made the town a point of strategic support. But attacked by Flamininus, the garrison surrendered in exchange for permission to withdraw to Sparta (Livy 34.29). In the treaty concluded shortly afterwards the city was given autonomy, and the title of "savior" was consequently conferred on Flamininus (*IG* v.1, 1165), Nabis attacked the city again in 193, and took it in 192. After his death it appears to have been under Achaian control until 146 B.C. Then it was a member of the Eleutheriolakonian League. In 72-71 M. Antonius Creticus taxed it heavily for his campaign against the pirates (*IG* v.1, 1146). Under the Empire it instituted a festival in which divine honors were rendered to Augustus, Livia, Flamininus, and Tiberius, despite the fact that the latter at first refused them. Gytheion struck bronze coinage under Septimius Severus, Caracalla, and Geta, and appears to have been prosperous up to the 4th c. A.D.

The only excavations—and these have been only very summarily published—have been of the theater and its surroundings, where a Kaisareion must have been located. The tiers of the theater are well preserved. The modern town has covered the ancient one, and certain monuments visible in the 19th c. are no longer so today, as, for example, the great niche cut into the rock and bearing an inscription mentioning Zeus Terastios (*IG* v.1, 1154). A few remains of Roman buildings are to be seen on the hill to the N of the theater. Walls can be made out under the sea at the point where the shore turns to the NE. A small museum has been installed in the local college, but several important pieces disappeared shortly before 1939, and others have been taken to the museum at Sparta.

BIBLIOGRAPHY. Reports of Travelers: Cyriacus of Ancona (ed. Sabbadini), *Fontes Ambrosiani* (repr. from *Miscellanea Ceriani*) II 29-30; *Voyage de Dimo et Nico Stéphanopoli en Grèce* (1800) 225-46; J. Morritt (ed. R. Walpole), *Memoirs relating to Turkey* (1820) 57; Bory de Saint-Vincent, *Expédition de Morée: Relation* (1829) 440-46; W. M. Leake, *Morea* (1830) I 234-48; E. Puillon-Boblaye, *Recherches . . .* (1835) 86-90; A. Blouet, *Expéd. Morée: Architecture* (1838) III 50-53; Ph. Le Bas, *Voyage archéologique . . .* (1847-68) pl. 26MP; J. Frazer, *Paus. Des. Gr.* (1897) III 376-80; E. S. Forster, *BSA* 10 (1906-7) 218-37.

Studies and Excavations: G. Weber, *De Gytheo* (Diss. Heidelberg 1833); A. Skias, *Praktika* (1891) 27-34; id., *Deltion* (1891) 113; id., *ArchEph* (1892) 60-64, 185-204PI; I. Patsourakos, *Pragmateia peri tou archaiou Gytheiou* (1902); F. Versakis, *ArchEph* (1912) 193-96PI; W. Kolbe, *IG* v.1 (1913), no. 1143-1213; J. J. Hondius, *BSA* 24 (1921-22) 141-43; S. B. Kougeas, *Ellenika* 1 (1928) 7-42, 152-57; H. Waterhouse & R. Hope Simpson, *BSA* 56 (1961) 114-18; P. Giannacopoulos, *To Gytheion* (1966). C. LE ROY

GYULAFIRÁTÓT-POGÁNYTELEK County of Veszprém, Hungary. Map 12. A Roman villa ca. 1 km W of the community of Rátót in the Pogánytelek fields. A Roman road here led toward Arrabona through the Bakony. The excavations extended over an area of 10 ha. The villa was occupied from the end of the 1st c. to the end of the 4th. The main building, during its first period, was built as an atrium, and later, adjusting to the cold climate of Pannonia, a heating system and bath were added. During the 3d c. several buildings of the settlement were equipped with corner towers against the increasing number of barbarian attacks. A separate bath building was fed by the numerous springs nearby.

At the end of the 4th c. the complex became a fortified Roman settlement. The legacy of the migrations following the Roman era is revealed in the buildings, as well as in the traces of tall buildings used for drying and storing grain. In one building an iron plate (for the cover of a small chest), decorated with silver and bronze inlay, was discovered. Its inscription preserves the name M.FLAVIVS. ANTHV. F. B. The villa had a potter's kiln where leaden sacred objects were also manufactured. The votives depict the goddesses of fertility, Silvana Silvannae and Isis Conservatrix. The finds are in the museum at Veszprém.

BIBLIOGRAPHY. G. Rhé, "Ös- és ókori nyomok Veszprém körül," *Spuren aus der Vorzeit und dem Altertum in der Gerend von Veszprém* (1906); E. Thomas, "Monuments votivs en plomb sur le territoire de la Pannonie: La Fonderie de plomb de Pogánytelek," *Arch. Ért.* (1952) 32-38; id., *Römische Villen . . .* (1964) 34-49. E. B. THOMAS

H

HABITANCUM (Risingham) Northumberland, England. Map 24. Roman fort of 1.8 ha, 23 km N of Corstopitum, where Dere Street crosses the river Rede (NY 891862). The name is known only from one inscription (*RIB* 1225). The platform and a little stonework are visible. There is no evidence for occupation before the mid 2d c., and little for the fort built then. The rebuilt fort of the reign of Severus probably faced S, with a striking single-portal S gate with projecting towers (*RIB* 1234, A.D. 205-207). From the reign of Caracalla on, the fort served as an outpost to Hadrian's Wall, garrisoned by a milliary cohors equitata, Cohors I Vangionum, with a unit of scouts and one of spearmen, all attested by *RIB* 1235 of A.D. 213.

The garrisons of Habitancum and Bremenium together could field a formidable striking force for minor military operations, including 500 cavalry, without calling on the Wall garrison. The headquarters building was rebuilt, probably in the early 4th c., facing W towards a new gate inserted in the W wall. Of other internal buildings, only a bath house in the SE corner is known. The fort was destroyed in the mid 4th c. (probably either A.D. 343 or 360) and was abandoned after further destruction in 367.

BIBLIOGRAPHY. I. A. Richmond, *Arch. Ael.* 13 (1936) 184-98; id., "The Romans in Redesdale," *Northumberland County History* XV (1940) passim; E. Birley, *Research on Hadrian's Wall* (1961) 235-40; J. K. St. Joseph, *JRS* 59 (1969) pl. III. J. C. MANN

HACIMUSALAR, see CHOMA

HADRIA (Atri) Teramo, Abruzzo, Italy. Map 14. A city of the S Piceno region, ca. 20 km from the Adriatic coast, between the Vomano river to the N and the Matrino to the S. The first evidence of the name is from coins datable to the 3d c. B.C.

The inscriptions (*CIL* III, 14214.10; VII, 101; IX, 5016-5157) and the authors (Spartianus, *Vita Hadriani* 1.1; 19.1) refer constantly to Hadria, ethnically "hadrianus" as in Polybius (3.88.3) and Livy (22.9.5-27; 10.7-34; 45.8-1.c. p. 227). According to Livy (*Per.* 11), Hadria was a Latin colony in 290 B.C. In 209 B.C. Hadria was among the cities which offered aid to the Romans against Hannibal (Livy 27.10.7). It was perhaps about that time that the ancestors of the Emperor Hadrian moved to Spain from the Picenian city to which the Emperor traced his origin (Spartianus 1.C.I.1). Following the granting of Roman citizenship, presumably directly after the social wars, Hadria was ascribed to the tribus Malcia. It is supposed that another colony, but of "Roman right" was founded there by Sulla or by Augustus, which on that occasion received the title of Veneria.

As was usual in the colonies, Hadria had duoviri. A quinquennalis has been noted, and the office was also offered to Hadrian in recognition of his origins. The presence of a prefect is not certain and the presence of quaestors is hypothetical. The senate and its components are documented (*CIL* IX, 5013, 5016, 5017), as is the body of the Augustali (*CIL* IX, 5020, 5016). There is evidence of a Curator Muneris Publici (*CIL* IX, 5016).

Hadria issued fused coins (aes grave), probably soon after the founding of the colony, between 289 and 270 B.C. The complete series, from the asse to the Semuncia, has been noted.

In the area surrounding Atri, at the foot of Mt. Pretara and the hill of the Giustizia, were discovered two necrop-

oleis. The funerary material found in them is similar to that found in the mid Adriatic necropoleis of Campovalano and in the analogous phase of the necropoleis of Alfedena. It is impossible, however, to date the material earlier than the second half of the 6th c. B.C.

Not many remains of the Roman city have been noted. By far the most important is the hypogeum under the cathedral. Thought to be a piscina limaria (25 x 28 m), it has walls in isodomic work datable to the Republican epoch. Perhaps in the 2d or 3d c. A.D. the area was divided into five naves by means of a series of pillars sustaining cross-vaults. The basin may be connected with a large bath building to which may be attributed the remains of a mosaic pavement brought to light during restoration of the cathedral. Another hypogeum, also thought to be for hydraulic use, is under the municipal building.

Recently the remains of a building, perhaps a private house, with mosaic pavements have been identified near the cathedral.

BIBLIOGRAPHY. *CIL* IX, p. 480-85; L. Sorricchio, *Hadria Atri*, I (1911); E. J. Haeberlin, *Aes Grave* (1910) 203-11; F. V. Duhn, *Italische Graberkunde* (1924) p. 586; *EAA* 1 (1958) 885-86. V. CIANFARANI

HADRIANI (Gâvur Ören) Turkey. Map 7. Site in Pisidia near Karacaviran, 25 km S of Burdur, at one time identified with Kormasa. The true identification depends on a dedication by the Council and People of Hadriani to the Emperor Verus found near the village of Kozluca some 8 km W-SW. Apart from this one inscription the name of Hadriani occurs only in the Byzantine bishopric lists. No coins are known.

The site at Gâvur Ören is extensive though ruined; apart from a large building of unknown purpose the chief remains consist of tombs, including handsome sarcophagi and some impressive mausoleums now reduced to little more than a heap of blocks. The city's territory must have extended into the valley of the Lysis on the W, with a smaller area to the E. Whether Hadriani was a new foundation in the time of Hadrian or a refounding of an earlier town remains uncertain.

BIBLIOGRAPHY. W. M. Ramsay, *Cities and Bishoprics* I (1895) 327 n.1; G. E. Bean, *AnatSt* 9 (1959) 108-10.

G. E. BEAN

HADRIAN'S WALL England. Map 24. A barrier crossing N England from Tyne to Solway. The late Roman name was Vallum (*Not. Dig.* and *Ant. It.*). Begun ca. A.D. 120-125 (S.H.A.: *Had.* 11.2) as a continuous curtain with small fortlets (milecastles) and towers (turrets) only, it was modified to include larger forts moved from the Stanegate, and a wide continuous ditch to the S. A reduction in thickness also occurred. It was probably finished ca. A.D. 132 and abandoned ca. 140, on the advance into lowland Scotland; it was reoccupied ca. 163?, or ca. 180 (much disputed), and held until 387, or a little later. The Wall was damaged by enemy action on three attested occasions: A.D. 197 (disputed, alternatives 180 or 208), 296 (traditional date), and 367.

The barrier consists of a triple running line of wall-ditch (6 m wide x 4 m deep) a curtain wall, and a further ditch to the rear (today known as the vallum). The curtain wall, now nowhere standing above 3 m high, was originally ca. 5 m to the rampart walk, with a parapet and merlons rising an additional 2 m. Its thickness varied

from 2 to 3.5 m (7-10 Roman feet). The whole was stone built with ashlar faces, although the 49.6 km to the W were originally of turf, later replaced by stone. The vallum ditch was 6 m wide by 3 m deep with a continuous mound 6 m wide set back 9 m from each lip: the whole was 1 actus wide. The S mound was continuous, but the N mound was broken at intervals of a Roman mile (1500 m) to allow access for patrols. Crossing points, each controlled by a gateway manned from the N, lay S of each milecastle and major fort. Later those S of the milecastles were removed.

On flat ground the vallum was as close as 30-40 m to the curtain wall, but where the Wall rides up onto the Whin Sill it may be as much as 700 m to the S. At regular intervals of a Roman mile a milecastle was built against the S face of the Wall; it had a gateway through its N and S walls and contained a small barracks, or sometimes two. The N gateway was topped by a stone tower at least 10 m high, carrying an inscription recording the emperor Hadrian, his governor A. Platorius Nepos, and the legion that built the structure. Between each pair of milecastles were two turrets 500 m apart. These were of stone, 6.5 m square and partly recessed into the thickness of the curtain. They were probably as high as the milecastle towers and, like them, flat-roofed (disputed). A military way connected turrets and milecastles with each other and with the larger forts.

At intervals varying from 3 to 9 Roman miles larger forts were placed either on the Wall or adjacent to it. In plan these were mostly of a playing-card shape, divided internally into thirds. Barracks and stables occupied the inner and outer sections, and the headquarters building, storehouses and granaries, hospital and commandant's house the central portion. Each fort was surrounded by a wall with four principal gateways, each consisting of a double portal flanked by a pair of towers and topped by an upper chamber. Normally the N gate was through the Wall itself, but many forts lay astride the Wall, with three of their principal gates to the N. Outside the fort lay its military bath house, official rest-house, parade ground, temples, and cemeteries, beside which a vicus or civil settlement grew up. Originally these were kept S of the vallum ditch, but from the early 3d c. on they were allowed to surround the fort itself. In form they were vigorous villages of taverns, shops and workshops, dwelling houses, and brothels—everything to cater for those aspects of life not covered by the army.

The Wall ran from Wallsend on the Tyne to Bowness-on-Solway, 80 Roman miles, and formed the principal part of a larger system which began at South Shields (the mouth of the Tyne), and continued along the Cumberland coast for 40 Roman miles beyond Bowness, in the form of freestanding towers and mile fortlets, with larger forts at Beckfoot, Maryport, Burrow Walls, and Moresby. Outpost forts lay to the N at High Rochester, Risingham, Bewcastle, Netherby, and Birrens, and a depot (Corbridge) and supporting forts to the S.

Arbeia (South Shields: NZ 365679). A fort (ca. 189 m N-S x 109 m E-W; 2.1 ha) defended by two ditches. The gates, sections of the walls, and several interval towers are known, also the headquarters building and other parts of the central range, and several barracks of the primary plan. In the early 3d c. the interior was converted into a stores base, of which some 22 granaries are now known. The headquarters building and parts of 10 granaries, with underlying earlier buildings, are exposed to view.

Jarrow ("Danum," not located). Presumably the next fort.

Segedunum (Wallsend: NZ 301660). A fort (138 m N-S x 120 m E-W; 1.6 ha), defended by a single ditch 6.3 m wide. The NE angle tower, parts of all four gate-ways, and a portion of the headquarters building have been located, also the branch Wall from the fort to the river Tyne and an external bath house. All is now completely overbuilt.

Pons Aelius (Newcastle: NZ ?250369). A fort is attested here (*Not. Dig.*) but it is uncertain whether the remains discovered under the Moot Hall and Keep are from it or its vicus. Traces of the Roman bridge have been located on the site of the present Swing Bridge.

Condercum (Benwell: NZ 216648). A fort lying astride the Wall (ca. 177 m N-S x ca. 119 m E-W; 2.1 ha) defended by a ditch, or possibly two. The S wall, S gate and angle towers, most of the commandant's house, part of the headquarters building and two granaries, most of the hospital, two barracks, and parts of the stabling have all been excavated. The external bath house has been located. All is now covered, with the exception of the vallum crossing S of the fort and a small temple in the vicus.

Vindobala (Rudchester: NZ 113676). A fort lying astride the Wall (151 m N-S x 118 m E-W; 1.8 ha). The four principal gates and one subsidiary postern, a granary, part of the headquarters building and commandant's baths have been located, and a temple of Mithras has been excavated in the vicus. Nothing is now visible.

Onnum or *Hunnum* (Halton Chesters: NY 997685). A fort lying astride the Wall (138 m N-S x 124 m E-W; 1.6 ha). An enlargement of ca. 0.3 ha was added to the W side, S of the Wall, in the 3d c. The main N, E, and W gates, a forehall attached to the headquarters building in the 3d c., a granary, and another building in the central range have all been excavated, as well as barracks and stables in the NE area. An internal bath house is known as well as 3d c. buildings in the extension.

Cilurnum (Chesters: NY 912703). A fort lying astride the Wall (177 m N-S x 132 m E-W; 2.4 ha), apparently defended by two ditches. All four main and two subsidiary gates, most of the interval and angle towers, and parts of the walls are on view, also the headquarters building and most of the commandant's house and baths. Portions of stables and barracks are on view, and others have been located. The external bath house is exposed and a considerable (but unexcavated) vicus lies S and E of the fort.

Brocolitia (Carrawburgh: NY 859712). A small fort totally S of the curtain wall (ca. 128 m N-S x 100 m E-W; 1.4 ha). An inscription fragment suggests that it was not built until A.D. 130-132, later than all other forts. Parts of the W wall and W and S gates are known, as is the external bath house. Part of the headquarters building has been excavated, also an external Mithraeum, a shrine to the Nymphs, and the sacred spring of the goddess Coventina.

Borcovicus, or perhaps *Vercovicium* (Housesteads: NY 790688). A fort wholly S of the curtain wall (186 m E-W x 112 m N-S; 2.1 ha). The walls, towers, and all gates stand to varying heights. The commandant's house, headquarters building, granaries, and hospital are all visible, as well as an internal communal lavatory and some of the barrack blocks, one of which displays rebuilding as independent two-room units, after A.D. 296. Excavation and aerial photography have revealed a large vicus to the S and E, and a late gateway through the Wall at the Knag Burn, E of the fort. Various temples, including a Mithraeum, and cemeteries are known, also a large unexplained enclosure to the W. The 2d c. vicus lay S of the vallum ca. 100 m from the fort.

Vindolanda (Chesterholm: NY 771804). A fort 1500 m S of the Wall (and the vallum) (155 m N-S x 93 m E-W; 1.4 ha). As a Stanegate fort that continued in use as part of the Wall system Chesterholm was oc-

cupied from ca. A.D. 80 on, with rebuildings in the 160s and the early 3d c. on sites beneath or adjacent to the present fort (built ca. A.D. 300). Little of the anatomy of the earlier occupation remains, but the side gates and headquarters of the 3d c. fort have been located. The walls, gates, headquarters building, and part of the commandant's house of the 4th c. fort are exposed. The vicus has been partly excavated: it includes strip houses and shops, a bath house, and an official rest house.

Aesica (Greatchesters: NY 704668). A fort wholly S of the curtain (128 m E-W x 108 m N-S; 1.4 ha); four ditches are known on the W side. The principal S and W gates, the NW and SW angle towers, and several buildings against the W and S walls are to be seen. Also known are parts of the headquarters building and commandant's house, fragments of a granary, portions of barrack blocks, and the external bath house. Epigraphic evidence suggests a date of A.D. 128 or later.

Magna, or possibly *Banna* (Carvoran: NY 666657). A fort of ca. 1.8 ha lying 250 m S of the Wall and vallum. The NW angle tower is visible and part of an internal bath house has been located. Its original occupation was possibly pre-Hadrianic.

Camboglanna (Birdoswald: NY 615663). The fort (177 m N-S x 122 m E-W; 2.1 ha), originally lay astride the Wall but, after a realignment of the curtain, was placed wholly behind it. The walls and most towers and gates are on view, and parts of the headquarters building, commandant's house, a granary, and barracks have been excavated or are known.

Uxelodunum or *Axelodunum*, but uncertain (Castlesteads: NY 513635), lies 400 m S of the Wall but is enclosed by a detour of the vallum. It is apparently ca. 122 m square (1.5 ha). Only the E and W gateways and an angle tower are known. Possibly an earlier fort lies under the visible one.

Petriana (Stanwix: NY 402572). A fort (213 m E-W x 177 m N-S; 3.8 ha) entirely S of the curtain. Parts of the S wall and a granary and barracks are known, but the site is now completely built over. There was apparently a considerable vicus.

Aballava (Burgh-by-Sands: NY 328592). A fort lying astride the Wall (apparently ca. 158 m N-S x ca. 125 m E-W; 1.9 ha). Only the E wall and external bath house are known.

Congavata (Drumburgh: NY 265599). A fort wholly S of the curtain (93 m E-W x 82 m N-S; 0.76 ha). Little is known of the anatomy but a granary in the NW corner suggests an unusual plan.

Maia (Bowness-on-Solway: NY 223627). Terminal fort (ca. 191 m E-W x 119 m N-S; 2.8 ha), entirely S of the curtain and defended by at least one ditch. The W gate has been located and an external bath house to the S. A branch wall ran down to the river W of the fort.

Wall, ditches, turrets, and milecastles. The surviving stretch of the Wall farthest E is Turret 7b (Benwell, NZ 198656); the next is at Heddon (NZ 137669). From Heddon to Rudchester some intermittent lengths of the vallum can be seen, and from Milecastle 18 (NZ 048684) to Downhill (NZ 006685) a very informative stretch survives, especially the 800 m E of Downhill. The Wall ditch is visible intermittently over the same sector and for the next 4.8 km the vallum and Wall ditch survive clearly. At Planetrees (NY 929696) a fragment of Wall stands 2.25 m high. Nearby at Brunton Bank (NY 922698), Turret 26b and a length of Wall can be seen. From Tower Tie (NY 892709) to Limestone Bank Top there is a stretch of curtain including Turret 29a (Black Carts); the vallum is also clear. At Limestone Corner (NY 875716) the ditch is rock-cut, and to the W, as far as Milecastle 33 (NY 823705), a particularly fine length

of the vallum survives, with several stretches of the wall ditch. At Milecastle 33 the modern road leaves the line of the Wall; from here the vallum is generally visible (with some exceptions) as far as Carvoran fort and, intermittently, to Poltross Burn (NY 634663). Some turrets and milecastles can be seen between Milecastle 35 and Housesteads fort; thereafter, the Wall rides along the crags in a most imposing fashion (with some gaps) as far as the Tipalt Burn (NY 659661). Many milecastles (especially 37, 39, and 42) and turrets (45a) are on view, and a good length of curtain survives on Walltown Crags. The military way is also visible for long stretches between Milecastle 34 and Walltown. West of Poltross Burn, Milecastle 48 is informative, and stretches of the curtain wall run from there to Willowford Bridge abutment (NY 624665). One of the most upstanding stretches of curtain lies between Milecastle 49 and Birdoswald fort, and W of the fort the only surviving stretch of the Turf Wall can be seen. Apart from this, with a very few exceptions (Turret 52a), there is little between here and Carlisle, or W of the river Eden. Bridge abutments may be seen on the Irthing (Willowford) and North Tyne (Chesters). At Chesters the 3d c. stonework of the E abutment incorporates a pier of Hadrianic date.

The principal Wall museums are at Newcastle (Museum of Antiquities), Chesters (Clayton Memorial Museum), Carlisle (Tullie House Museum) and South Shields, with others at Housesteads and Wallsend.

BIBLIOGRAPHY. J. Collingwood Bruce, *The Roman Wall*[3] (1867); id., in *Handbook to the Roman Wall*[12], ed. I. A. Richmond (1966)[MPI]; E. B. Birley, *Research on Hadrian's Wall* (1961); *Map of Hadrian's Wall* (Ordnance Survey[2] 1972)[M]; C. E. Stevens, *The Building of Hadrian's Wall* (1966); A. R. Birley, *The Ninth Pilgrimage of Hadrian's Wall* (1969)[P]. C. M. DANIELS

HADRUMETUM (Sousse) Tunisia. Map 18. An ancient coastal city, situated on the bay of Hammamet and at the edge of the fertile region of Sahel, Hadrumetum drew its fortune from the advantages its position provided: the agriculture of its hinterland and Mediterranean commerce.

A town constantly inhabited and always lively, to judge from the vestiges of antiquity buried under the accumulation of strata, it offers to the visitor today only a few ancient monuments: some paved with mosaics, especially the catacombs, as well as some traces brought to light by chance.

Few of the ruins have survived but the objects (ceramics, statues, inscriptions, and especially the mosaics) have been preserved in the Bardo Museum at Tunis and principally the Sousse Museum.

A Punic settlement, the city developed along the edge of its harbor; only the tophet has been located. It was partially excavated in 1944; the stelae and funerary urns are exhibited in a room of the museum. Several Punic tombs have also been discovered.

Having abandoned Carthage at the time of the last Punic war, Hadrumetum was rewarded by Rome with the status of free town. For its support of Pompey, it was heavily fined by Caesar after his victory at Thapsus. With the Empire, it experienced great economic development, evidence of which is found in the richness of its houses and more particularly in its mosaics. The Vergil mosaic is the most famous. This prosperity is explained by the elevation of the town to the status of colony under Trajan.

BIBLIOGRAPHY. L. Foucher, *Hadrumetum* (1964)[PI]; *La maison des masques à Sousse* (1965)[PI]; *Guide du musée de Sousse*[2] (1967)[I]. A. ENNABLI

HAELEN-MELENBORG, *see* ROERMOND

HAGHIA EFTHYMIA, *see* MYANIA *under* WEST LOKRIS

HAGHIA IRINI, *see* KEOS

HAGHIOS GEORGHIOS TIS PEYIAS, *see* DREPANON

HAGHIOS KHARALAMBOS, *see* MESOPOTAMON

HAGHIOS NIKOLAOS, *see under* BOUPHAGION

HAGHIOS PHLOROS Messenia, Greece. Map 9. A village about 8 km E of Messene. A group of warm and cold springs at a site 1 km to the N have been recognized from antiquity as the sources of the Pamisos river. Pausanias mentions annual sacrifices to this river, as well as springs where children were cured. Archaeological excavations have uncovered the remains of a small Doric temple with cella and pronaos, connected by a ramp to an open-air altar. Masonry predating the temple surrounded an opening at the back of the cella, presumably a sacred spring, and many small dedicatory objects were found in the earth floor. Two inscriptions recorded dedications to Pamisos. At the end of the excavation season, the remains were re-covered and the finds taken to the National Museum in Athens.

BIBLIOGRAPHY. Paus. 4.3.10, 31.4; M. N. Valmin, *The Swedish Messenia Expedition* (1938) 419fMPI.

M. H. MC ALLISTER

HAGHIOS VLASIS, *see* PANOPEUS

HAIDRA, *see* AMMAEDARA

HAJDUČKA VODENICA, *see* LIMES OF DJERDAP

HALAI E or Opuntian Lokris, Greece. Map 11. Located near Haghios Theologos, on a deep sheltered bay on the E side of the gulf below Atalandi (Opus). Like many other coastal sites, Halai was evidently heavily damaged by the great earthquakes of 426-425 (Thuc. 3.89; Diod. Sic. 12.59). In Late Classical or Early Hellenistic times it passed into the Boiotian orbit, and was sacked by Sulla in 85 but immediately resettled (Plut. *Sulla* 26.3ff). The city area beside the sea, and the cemeteries to the N and E, were excavated between 1911 and 1935. The lower levels of the site yielded Bronze Age and Neolithic material.

Iron Age Halai may have been one of the strongholds of the notorious Lokrian pirates. The sheltered deepwater harbor would have been an excellent pirate's nest, the existence of which would account both for the modest size of the settlement and for its having been heavily fortified at quite an early period.

The fortified area is not an acropolis in the normal sense, for it lies on virtually level ground right on the seashore, with the highest point only a few meters above the ancient sea level. As a result of the rise in sea level since antiquity, the preserved lower courses of some of the walls are now under water. Clearly the natural strength of the site was less important than ready access to the sea. The wall circuit in its final form was approximately a rectangle, measuring about 325 m E-W and 160 m N-S.

The main entrance was always at the NE corner; there was also a secondary gate towards the W end of the N wall. Two distinct styles of construction are represented. The first circuit seems to have been built in the early 6th

c. and remodeled towards the end of the century. The second wall, of massive ashlar with internal cross walls, is probably early Hellenistic work; it had additional towers, of square plan except for the S tower of the NE gate, and enclosed additional territory at the SE corner. The NE gate was rebuilt on a much larger scale.

From this gate a street always led W towards the Temenos of Athena Poliouchos, located just inside the W wall of the citadel (identified by votive inscriptions). The first temple and altar were built soon after the first wall circuit. The temple was quite small, with very flat archaic Doric capitals. Abundant deposits of pottery, terracottas, sculpture, and other objects came to light, including an inscribed base in the form of an archaic Doric shaft and capital.

The second temple, built ca. 510, was apparently destroyed in the earthquakes of 426-425. The surviving elements were broken up and spread over the temenos as part of a new pavement, and a third temple then constructed. Unlike its predecessors, which were rather rough provincial work, Temple III was built in good late 5th c. style and technique.

Also excavated were the E and W buildings, on either side of the street leading in from the N gate. The latter building was built in the late 4th c., and remodeled in the early 2d. In late Roman times a small bath was built over the ruins of the NE corner defenses.

The N and E cemeteries probably flanked roads leading out from the N and NE gates. The graves yielded a long series of terracottas ranging in date from the late 6th c. to ca. 200 B.C.

BIBLIOGRAPHY. A. L. Walker & H. Goldman, *AJA* 19 (1915) 418ffI, and 438ff (inscriptions—Goldman); K. Lehmann-Hartleben, *Antike Hafenanlagen* (1923) 78; Goldman, *Hesperia* 9 (1940) 381ffMPI; Goldman & Jones, *Hesperia* 11 (1942) 365ff (terracottas). F. E. WINTER

HALAI ARAPHENIDES Attica, Greece. Map 11. Ancient sources (Strab. 9.1.22; Steph. Byz. s.v. Ἁλαὶ Ἀραφηνίδες καὶ Ἁλαὶ Αἰξωνίδες), make it clear that this deme was situated on the E coast, N of Brauron, S of Marathon, and presumably near the township whose name it shares, Araphen, modern Raphina. It was famous for a sanctuary dedicated to Artemis Tauropolos. According to Euripides (*IT* 1447-61), this cult, with a statue of the goddess taken from Taurus, was established by Orestes at Athena's command, and included among its rites a ceremonial act of atonement in which a drop of blood was drawn from a man's throat with a knife, and a midnight revel (Men. *Epit.*).

Nineteenth c. topographers realized that this deme had to lie between Vraona and Raphina in the neighborhood of the salt lake, now at Loutsa, and the ruined village and hill of Velanideza, ca. 3 km to the W. The name suited the former; from the latter had come the two archaic grave reliefs of Lyseas and Aristion. In this century, however, attention has focussed on Loutsa. In 1926 a deme decree of the inhabitants of Halai was found SW of the salt lake, near the sea, in the remains of a Roman building. It was to be set up in the Sanctuary of Artemis Tauropolos. A second deme decree, found a few years later to the S of Loutsa, was to be displayed there also. Finally, in 1956, the remains of a small temple were uncovered in the same vicinity, S of the salt lake among the pines that fringe the sea.

The material of the temple is hard, gray poros. All of the bottom step is preserved, and most of the second, but of the stylobate there are only a few blocks in place, enough however to allow measurement of the temple area at this level: 19.30 x 12.20 m. Above this, nothing is in situ, but a peristyle of Doric columns, a few poros

fragments of which have been found, can be restored on the stylobate. From the evidence on this course, it would seem that the temple had the unusual design of eight columns on the short sides, twelve on the long. Within the columns was a cella divided into two unequal rooms, the inner to the W presumably an adyton, but of all this only foundations survive, the temple having been thoroughly pillaged. Thus its date cannot be ascertained. Pottery and figurines of the archaic and Classical periods were recovered around it. The original excavator identified this seaside temple as that of Artemis Tauropolos. The suggestion is most persuasive, for the position exactly suits the evidence bearing on the temple's location.

Artemis was not the only divinity worshiped at Halai. A recently discovered inscription, found half a km W of her temple, records the holding of games during the Dionysia celebrated in the deme. One can therefore assume that a sanctuary once existed dedicated to Dionysos, perhaps among the extensive remains of ancient buildings where the inscription was discovered. Philochoros' enigmatic (and defective) fragment concerning Dionysos (*FGrHist* 328 F 191) may yet be shown to apply to Halai Araphenides.

BIBLIOGRAPHY. A. Milchhöfer, *Karten von Attika. Erläuternder Text* 3-6 (1889) 6-7; A. Conze, *Die attischen Grabreliefs* (1893) I, nos. 1-2, 3-5; N. Kotzias, Δημοτικὸν ψήφισμα Ἁλῶν τῶν Ἀραφηνίδων, *ArchEph* (1925-26) 168-77; Ph. Stauropoullos, Τιμητικὸν ψήφισμα Ἁλῶν τῶν Ἀραφηνίδων, *ArchEph* (1932) Ἀρχαιολογικὰ χρονικά, 30-32; J. Papadimitriou, Ἀνασκαφαὶ ἐν Βραυρῶνι, *Praktika* (1956) 87-89; (1957) 45-47[PI]. C.W.J. ELIOT

HALAISA Sicily. Map 17B. A city on the N coast of Sicily between Kalakta and Kephaloidion (district of S. Maria, Commune of Tusa, Province of Messina). It is located on a large hill overlooking the sea to the N and the valleys of the rivers Halaisos (modern Tusa) and Opikanos (modern Cicera) to the W and E respectively. It was founded in 403 B.C. by Archonides of Herbita and peopled with Sikels and Greeks who had fled to the site during the wars waged by Dionysios I (Diod. 14.16). Around the middle of the 4th c. the city minted its own coinage in the name of a federation in which it occupied a position of prominence (Head, *HN* 125). At the beginning of the first Punic war it was the first Sicilian town to side with Rome (Diod. 23.4); it was therefore made libera et immunis and was one of the main cities of the island until the 1st c. B.C. (Cic. *Verr.* 3.6.13). Having achieved the status of municipium in the Augustan period, it enjoyed considerable prosperity through the 2d and 3d c. A.D. During the Byzantine period it declined and was abandoned after the Arab invasion.

Excavation tests have shown that the urban plan is largely preserved, and systematic excavation was begun in 1970. The circuit wall (Hellenistic in date) built in isodomic masonry with curtains between piers, is among the most complete in Sicily. The E and N sides (which include an expansion downhill and an imposing terracing with buttresses uphill) are the best preserved; near the S gates, at regular intervals, are set square towers, which at times reach a height of ca. 2 m. The main urban center lies on the E plateau and shows a street system based on quasi-orthogonal principles: onto a cardo ca. 6 m wide, open decumani, all well paved with small stone blocks, which create insulae. An insula near the agora has yielded numerous Hellenistic architectural elements from a peristyle house and Roman mosaics from another. On the highest part of the hill have been found the substructures of two temples, one of which is almost certainly that of Apollo. The main monument is the agora. The square is paved with bricks and contains bases for monuments and the podium for speakers, in opus reticulatum. On its W and N sides it is bordered by an L-shaped portico with double nave and columns of stone and terracotta, which on epigraphic evidence has been identified as the basilica. Against the (rear) wall of the portico (5 m high) are small shrines containing altars and an abundance of marble floors and moldings, honorary inscriptions, and pieces of sculpture. The first plan of the agora, which was modified during Imperial times, goes back to the Hellenistic period; it was abandoned presumably after the Constantinian age. In the late Byzantine period the agora, already covered over, became the site of a poor cemetery.

BIBLIOGRAPHY. G. F. Carettoni, *NSc* (1959) 293[MPI]; id., *NSc* (1961) 266[MPI]. G. SCIBONA

HALIARTOS Boiotia, Greece. Map 11. A city in the central part of the region, near modern Haliartos, 20 km W of Thebes on the Levadhia road, at the edge of ancient Lake Kopais.

Founded before the Mycenaean period and contemporary with Orchomenos, the city very soon passed under the control of Thebes; it was one of the first to mint silver coins bearing the Boiotian shield, the emblem of the Confederacy (6th c. B.C.). Spared by the Persians in 480, it became one of the 11 Boiotian districts, with Koronea and Lebadeia, from 447 to 387 and then from 371 to 338. At the beginning of the Corinthian War (395) Lysander and the Spartan army joined battle with the Boiotians under the walls of Haliartos, and he was killed there. During the Third Macedonian War Haliartos joined forces with Perseus against Rome: the praetor C. Lucretius razed the town, destroyed the garrison, and sold 2,500 citizens as slaves. Its territory was given to Athens, which administered it through an epimeletes and sent colonists there. The city was never rebuilt.

The acropolis is on a low hill to the W of the modern town between the highway and the railroad; it controlled traffic between N and S Greece. The Mycenaean acropolis (ca. 250 x 150 m) is situated at the highest point of the hill; its rampart is well preserved to the S and W. On the W side of the hill is a second type of wall composed of large quadrangular blocks laid in more or less horizontal courses; it dates from the 7th c. B.C. On the S slope and at the SE corner are remains of two towers; the masonry here is polygonal and very workmanlike, the stones being laid on one or two courses of wide, flat rectangular blocks. It possibly dates from the end of the 6th or beginning of the 5th c. A fourth type of wall, of which only the foundations remain, was made of blocks of crumbly red or yellow limestone (tower near the SW corner). To the W, 100 m from the NW corner, was a gate 3.50 m wide. Built in the 4th c., this rampart was razed by the Romans in 171 B.C. On its surface can be seen significant traces of an Imperial or Byzantine wall made of small rocks bonded with mortar.

At the very top of the acropolis, excavations have uncovered (1926-30) a Temple of Athena surrounded by a peribolos wall, a large building, and the passageway that served both; everything had been razed, no doubt in 171 B.C. The temple, which was built in the 6th c., was distyle in antis; it was of the archaic elongated shape (7.10 x 18 m) and open to the E. Several regular courses of limestone have been preserved, on poros foundations. Fragments of poros columns and some architectural terracottas were found to the E. Along

the N wall are the foundations of an earlier temple (7th c.?). The peribolos wall, which is rectilinear to the S (36 m) and a flat semicircle to the N, is of fine polygonal masonry laid in horizontal courses. To the S of the temple is a large building (21 m N-S, 8.90 m E-W) with polygonal walls of the same type, dressed on both sides. Two doorways opened in the E wall. Inside the building four wooden pillars on square stone bases supported the roof. Its purpose is unknown. A large store of vases, lamps, and terracottas at the W foot of the peribolos shows that the Temple of Athena was used from the 6th to the beginning of the 2d c. B.C. A small necropolis, SE of the acropolis, provides evidence that the site was occupied in Roman times.

E of Haliartos, on the chain dividing Lake Kopais from the Teneric Plain, was the very ancient Temple of Poseidon Onchestios; it was the center of the Boiotian Confederacy from 338 to 146.

BIBLIOGRAPHY. J. G. Frazer, *Paus. Des. Gr.* v (1898) 139-40; R. P. Austin in *BSA* 27 (1925-26) 91-99, 268-70; 28 (1926-27), 128-40; 32 (1931-32), 180-212[PI]; P. Roesch, *Thespies et la Confédération béotienne* (1965); N. Faraklas in *ArchEph* (1967) *Chronika* 20-29[PI]; N. Papahadjis, *Pausaniou Hellados Periegesis* v (1969) 194-201[MPI]; R. Hope Simpson & J. F. Lazenby, *The Catalogue of the Ships in Homer's Iliad* (1970), 28-29.

On Onchestos: G. Roux, *REG* (1964) 6-22; E. Touloupa, *Chronika* in *Deltion* 19 (1964) 200-201, pl. 237.

P. ROESCH

HALIEIS

HALIEIS Argolid, Greece. Map 11. On an excellent harbor near the S tip of the peninsula. Occupied from Protogeometric times, it enters recorded history with Athens' unsuccessful attack in 460 B.C. Not long before, refugees from Tiryns in the Argive Plain had settled here, probably without displacing the natives. Sometime before 431 B.C. the town was captured by Sparta but with the outbreak of the Peloponnesian War it was subject to further raids by the Athenians to whom the use of acropolis and harbor was granted in 424-423 B.C. by treaty. In the next century Halieis appears as a Spartan ally through 370-369 B.C., after which there is no sure historical reference. Under the name Tirynthioi coinage was issued in the 4th c. as from an independent city-state. The site was abandoned near the end of the century. Scattered remains, including a calidarium built on classical fortifications, testify to some occupation in late Roman times.

The town is located on the slopes and shore below a low hill on the S side of the circular harbor, across from the modern village of Porto Cheli. From at least the 8th c. B.C. mudbrick walls enclosed a small acropolis, the site of the shrine of an unidentified goddess. The military role of the hill is shown by a series of fortifications and associated structures, culminating before the mid 4th c. in an impressive semicircular tower. By the shore a settlement from at least the early 7th c. had a separate wall. In the Classical period a circuit with no less than four gates and a number of rectangular and round towers ran down from the acropolis to, and along, the shore. Private houses and workshops of mudbrick on stone socles have been found over the whole site, affording a rare glimpse at the plan of a provincial town. Changes in sea level have covered up to 50 m of the town along the shore; there appears to have been a small war harbor enclosed within the circuit of the walls.

On the E side of the bay, some 500 m from the city, a Sanctuary of Apollo has been found at a depth of ca. 2 m below sea level. A temple (27 x 4 m) divided into three chambers was probably in existence by ca. 675 B.C.; it has yielded quantities of metal and votive pottery

and much of a marble statue of the god. To the S of the temple are the foundations of a long altar and a stadium with two stone starting lines, 167 m apart. The temple appears to have been destroyed near the mid 5th c., perhaps in the Athenian attack, and never rebuilt on that site. Athletic activities occasioned the construction of various other buildings and flourished until close to the end of the city's life. Finds from the city, sanctuary, and necropolis are kept in the Nauplion Museum.

BIBLIOGRAPHY. M. H. Jameson, "Excavations at Porto Cheli and Vicinity, Preliminary Report, I: Halieis, 1962-68," *Hesperia* 38 (1969) 311-42[MPI] and reports for subsequent years in *Deltion & Chronika.* M. H. JAMESON

HALIKARNASSOS

HALIKARNASSOS (Bodrum) Turkey. Map 7. City in Caria on the N coast of the gulf of Kos. Originally one of the three mainland members of the Dorian hexapolis, founded according to tradition by Anthes or one of his descendants from Troezen. Later the city was expelled from the hexapolis, ostensibly because of the misconduct of her citizen Agasikles, who took home the tripod he had won at the Triopian games instead of dedicating it on the spot to Apollo (Hdt. 1.144). Strabo (653) observes that after the death of Kodros, king of Athens, Knidos and Halikarnassos were not yet in existence, though Rhodes and Kos were. By the 5th c. the city had become wholly Ionian; the inscriptions are in Ionic, and Herodotos and Panyassis wrote in that dialect. At the same time there was a strong Carian element in the city; the citizens' names are equally divided between Greek and Carian, and the two are often mixed in the same families. Vitruvius (2.8.12) records a tradition that the Carians, driven to the hills by the Greek settlers, were later attracted down to the city by the excellence of the water of Salmakis, a suburb where a Greek had set up a tavern, and so became civilized.

After the Persian conquest in the 6th c. Halikarnassos was ruled by a Carian dynasty, represented at the time of Xerxes' invasion of Greece by the queen Artemisia, who joined his forces in person and was regarded by him as one of the wisest of his advisers (Hdt. 8.68-69, 101-3). She took part in the battle of Salamis in her own ship (Hdt. 8.87-88). In the Delian Confederacy Halikarnassos was assessed at one and two-thirds talents, indicating her modest importance in the 5th c. Towards the middle of the century, as an inscription shows (*SIG* 45), the government was in the hands of the tyrant Lygdamis II, grandson of Artemisia, but the decree was issued at the same time by the Council of the Halikarnassians and Salmakitans, apparently a first step towards a modified democracy. This Lygdamis was subsequently expelled, with the help, it is said, of the historian Herodotos.

Halikarnassos became of real importance when Mausolos, satrap of Caria from 377 to 353, made it the capital of his satrapy in place of Mylasa. The city was rebuilt, with a wall over 4.8 m long, and manned by the forcible transplantation of the inhabitants of six of the eight Lelegian towns on the Myndos peninsula (Strab. 611). The Carian element in the city was in this way considerably strengthened. Mausolos was succeeded by his sister-wife Artemisia II, who built (or at least completed) his tomb, the Mausoleion. When the Rhodians attacked Halikarnassos in an attempt to take Caria, Artemisia defeated them and retaliated by capturing the city of Rhodes (Vitr. 2.8.14-15). On her death in 350 she was followed in quick succession by the other children of Hekatomnos, Idrieus, who married his sister Ada, and Pixodaros, who expelled Ada to Alinda and shared the rule with the official Persian satrap Orontobates.

Halikarnassos was one of the few places which re-

sisted Alexander in 334. After much fierce fighting the defenders set fire to the city and withdrew to the headlands on either side of the harbor. Alexander sacked the city and passed on to Lycia, leaving the task of blockading the headlands to Ada, with whom he had previously had friendly dealings. When they surrendered, she was appointed ruler of the whole of Caria (Arr. 1.20-23; Diod. 17.24-27). Pliny (*HN* 5.107) states that Alexander incorporated six towns in Halikarnassos; their names are those of the neighboring Lelegian towns. This however seems to be a confusion with the Mausolean synoecism.

After Alexander's death the city came into the possession of the Ptolemies until 190; after Magnesia she was left as a free city, and seems to have remained so thereafter. Plundered by Verres in 80 B.C., restored by Quintus Cicero in 60, plundered again by Brutus and Cassius, the city prospered less than most under the Empire; the Imperial coinage is somewhat scanty and the title of neocorus does not appear. Later the bishop of Halikarnassos ranked 21st under the metropolitan of Staurupolis (Aphrodisias).

Distinguished citizens included the historians Herodotus and Dionysios, Herakleitos the epigrammatist, and Phormio the boxer, Olympic victor in 392 B.C. but found guilty of corruption four years later.

The ruins have been almost entirely obliterated by the town of Bodrum, though much of the city wall is still standing; the masonry varies between polygonal and a somewhat irregular ashlar. On the W side two solid towers remain from the tripylon mentioned in Arrian's account of the siege by Alexander; the present road to Myndos passes this point. On the NE, outside this line of wall, is a stretch of exterior wall apparently belonging to an earlier scheme of defense that was soon abandoned; this was probably the wall attacked by Alexander. The Mylasa gate must have been in this region, but has not survived. The acropolis hill, now called Göktepe, rises to a height of 160 m; on its SE slope is the theater, still fairly well preserved in 1815 but now completely denuded, with only a few blocks of the seats remaining. In 1857 the substructures of the Mausoleion and some of the sculptures were discovered; the site was subsequently buried, but recently excavation has begun again. Apparently the peribolos and associated buildings were never completed. Of the other buildings investigated in the 19th c. virtually nothing remains, though the modern town is full of ancient stones, many of them sculptured or inscribed. Tombs are mostly rock-cut chambers; these are numerous on the slopes of Göktepe, frequently arranged in groups.

Vitruvius gave a picture of the city in antiquity in the passage already cited. He compared it to the cavea of a theater, with the agora by the harbor representing the orchestra, and a wide street running across halfway up, like a diazoma; at the middle point of this was the Mausoleion. On the summit of the acropolis was a shrine of Ares with a colossal statue, on the right horn, by the fountain of Salmakis, a temple of Aphrodite and Hermes, and on the left horn the palace of Mausolos. From this palace there was a view to the right over the agora, harbor, and wall circuit, while below it on the left, "hiding under the hills," was a secret harbor, to which the king could issue commands from the palace without anyone being aware of it.

Apart from the Mausoleion, no building mentioned in this passage has been located. The shrine of Ares (fanum, which need not have been a full-scale temple) should be on the summit of Göktepe, where there is nothing now but an oblong platform. Salmakis is placed with near certainty on Arsenal Point on the W side of the

harbor. The fountain is now under water; fresh water rises in the harbor a short distance off the point, but there is no sign of the temple. The street and agora have long since been obliterated, and no trace of the palace has been found on or near the headland (originally called Zephyrion) which forms the E horn of the harbor and now carries the castle of the Knights of St. John. The smaller secret harbor played a part in Artemisia's defeat of the Rhodians; hiding her ships in it, she led them by a canal (fossa facta) into the main harbor to seize the Rhodian ships. This canal is apparently the river referred to by Pseudo-Skylax (98); there is no river, or even stream, at or near Bodrum. The position of this second harbor is a puzzle. "Under the hills" is in any case unintelligible, and sub montibus has been emended to sub moenibus, but even so no secret harbor is discoverable in the region of the castle headland. There is a line of submerged wall on the E side of the main harbor which has been attributed to it, but a situation actually inside the harbor is obviously inappropriate. It seems that the secret harbor must be merely the open roadstead on the E side of the headland, with a canal across the isthmus to the main harbor. Mausolos' palace would then have stood on the landward side of the isthmus; looking S, the main harbor would be on the right and the second harbor on the left.

The territory of Halikarnassos adjoined that of the independent cities of Myndos on the W and Theangela on the E, but the exact boundaries are not determinable.

The great castle of the Knights of St. John was built in the 15th c., largely of materials taken from the Mausoleion and other ancient buildings; much of the stone came from quarries still to be seen at Koyunbaba a few miles N of Myndos. The castle houses three small museums containing objects from the surrounding countryside, including some from recent underwater explorations.

BIBLIOGRAPHY. W. J. Hamilton, *Travels in Asia Minor* (1842) 32ff; C. T. Newton, *A History of Discoveries at Halicarnassus, Cnidus and Branchidae* (1863)MI; id., *Travels and Discoveries in the Levant* (1865); L. Ross, *Reisen auf den griechischen Inseln* IV (1852) 33-39; G. E. Bean & J. M. Cook, *BSA* 50 (1955) 85-171MI; Bean, *Turkey beyond the Maeander* (1971) 101-14. Mausoleion: W. B. Dinsmoor, *Architecture of Ancient Greece* (1950) 257-61. G. E. BEAN

HALMYRIS, *see* MURIGHIOL

HALONTION (S. Marco di Alunzio) Sicily. Map 17B. A city in the province of Messina between Apollonia (Steph. Byz.) and Agathyrnon (Plin. 3.90), on a steep hill of the Crasto massif, near the coast. Historical information is scant; it was civitas decumana and contributed one ship to the fleet against pirates in the 1st c. B.C. (Cic. *Verr.* 3.43.103; 5.39,86); it was municipium in the early Imperial period (*IG* 14.367).

Its most important monument is the small Hellenistic temple at the entrance to the modern village, locally called a temple of Hercules; it has a rectangular plan (ca. 20 x 7 m), entrance on the E side and isodomic construction. It was built extra moenia on a rocky cliff and owes its preservation to its transformation into a Christian church. Remains of the Hellenistic city walls (in isodomic blocks of local marble) are to be seen near the mediaeval gate of S. Antonio, uphill to the E of the temple. The original city plan can no longer be deduced from the few fragmentary archaeological remains recently uncovered (apsidal room near the Chiesa Madre; architectural fragments under the Castle); the steepness of the hill and the dense, at times spasmodic, expansion of the mediaeval-modern village suggest that the ancient

system must have been closer to the irregular one of to-day than to the regular system prevalent in the Hellenistic world (orthogonal, with successive terraces).

BIBLIOGRAPHY. A. Salinas, *NSc* (1880) 191[P].

G. SCIBONA

HALOS Thessaly, Greece. Map 9. A city of Achaia Phthiotis, situated on the W side of the Gulf of Pagasai, 3 km from the shore by a deep bay (modern Sourpi) which is sheltered except from the N by Cape Zelasion (modern Halmyrou, or Perikli). The city lay on the rough shore road which runs from the Gulf of Pagasai to the Maliac gulf around the foot of Mt. Othrys. It controlled the S part of the fertile coastal plain (Krokion); the part around it being called Athamantion. Halos was a seaport (the main one?) for Thessaly in the 5th c. B.C., issued coinage in the 4th, was taken by Philip II of Macedon in 346 B.C. and given to Pharsalos. The city issued coinage again in the 3d c., being probably then free of Pharsalos, and was important in the post-196 B.C. Thessalian League (Hdt. 7.173, 197; Strab. 9.432, 433; Steph. Byz. s. v.; Dem. 19.36, 163; 11.1).

There are city walls above the coastal plain on a spur projecting N from a N peak (Haghios Elias) of Mt. Othrys. On a peak (208 m) near the end of the spur are the walls of a small round fort of Cyclopean masonry, 2 m thick. Around this peak and around the end of the spur to the NE are Classical walls, built of rectangular and trapezoidal blocks of irregular heights, preserved in places to two courses high. There were towers irregularly spaced along the circuit. The NE end of the circuit is missing. A wall of polygonal masonry runs N from the circuit wall down towards the plain, and one of rectangular blocks down to the E, but the ends of these walls cannot be seen. Leake thought they joined the city walls on the hill with those in the plain (see below). The walls on the hill are probably of the 4th c. B.C. No remains of buildings are visible within this circuit.

At the N foot of the spur is a copious, brackish spring (Kephalosis). In the plain five minutes E of the spring are city walls in the form of a rectangle, 750 x 710 m, aligned roughly N-S. The walls are of good Hellenistic masonry, double faced and stone filled, the faces constructed of heavy, rough-faced rectangular blocks laid in regular courses. The wall is some 3 m thick, and had 15 square projecting towers on a side, not including the tower at every corner. The E wall and much of the N is missing; the W and S walls are in good shape, preserved to two to three courses high (1924). There are no gates in the W side; the S and N sides each had a gate flanked by towers and small portals (one? in the N, two in the S). The stream from the spring Kephalosis flows by the N wall and may be the ancient river Amphrysos referred to by Strabo (9.433) as being in this position, although elsewhere he says it flows through the middle of the plain (Krokion), a position better described by the modern Platanos river. The area inside the walls is thick with sherds, and, according to Leake, foundations of buildings. The ruins on the hill are probably those of the Halos of the Trojan War (*Il.* 2.282), taken in 346 B.C.; the walls in the plain, those of a refounding of the city, possibly connected with Demetrios Poliorketes' activities in Thessaly.

In the plain to the NE of the acropolis, N of the Kephalosis stream, are several tumuli. One of these was excavated in 1912 and contained burials of the Geometric period. NE of the city, on the shore by Paralia 2 hours SE of Halmyros, were visible, according to Vollgraff in 1906, the scanty ruins of a large building of the Classical period within a rectangular temenos wall, apparently a temple belonging to Halos. A brief trial excavation turned up black-glazed sherds.

BIBLIOGRAPHY. N. I. Giannopoulos, Τὰ Φθιωτικά (1891) 50ff; id., *ArchEph* (1925-26) 183ff[I] (bronze 8th c. B.C. statuette of Zeus Laphystios?); F. Stählin, *AM* 31 (1906) 23-27[MI]; id., *RE* (1912) s.v. Halos; id., *Das Hellenische Thessalien* (1924) 177-80[P]; *BCH* 48 (1924) 483; W. Vollgraff, *BSA* 14 (1907-8) 225; A.J.B. Wace & M. S. Thompson, "Excavations at Halos," *BSA* 18 (1911-12) 1-30[I]; G. Bendinelli, *RFC* 33 (1955) 294-300 (gold medallion supposed to have come from the site); H. Biesantz, *Die Thessalischen Grabreliefs* (1965) 135, 138[I] (4th c. B.C. Artemis torso, bronze Zeus).

T. S. MAC KAY

HALTERN Kr.Recklinghausen, Land Nordrhein-Westfalen, Germany. Map 20. Several Roman fortifications dating to the earliest period of the occupation under Augustus: 1) the so-called field camp (*Feldlager*), 2) the great camp (*Grosses Lager*), 3) the fortlet St. Annaberg, 4) the fortified harbor installations (*Uferkastelle*). They lie on the NW bank of the Lippe, just over 50 km from the main legionary base at Xanten (Birten)—Vetera on the Rhine. All the installations at Haltern had defenses of earth and timber and wooden buildings inside.

The field camp was probably the earliest. Its area of 36 ha could probably accommodate two legions, but it was in use for only a short time. It was soon replaced by a permanent fortress of 20 ha, large enough to accommodate a legion. Over the years much of the interior of this fortress has been stripped and examined, but by no means all of it. The principia and praetorium, a valetudinarium, and various barrack blocks are known. As at Oberaden, one must assume that this fortress was in use for many years. From time to time a complete legion (which was otherwise on duty on the Rhine) may have been stationed here. But sometimes only large detachments of legions or auxiliary units were in occupation and changed often according to the needs of the military situation. It is not known whether the small fortlet on the St. Annaberg belongs to the same period as the field camp. Measuring 6.7 ha in extent, it lies ca. 1.5 km SW of the field camp and the great camp on a hill that governed the plan of its defenses. Its purpose is not at all clear. The harbor installations lie not far E of the field camp and the great camp on an old tributary of the Lippe. They show evidence of several building phases, of which the majority can be dated to the same period as the great camp.

The finds from Haltern—particularly the "Italian" terra sigillata—suggest that the military installations were erected later than those at Oberaden. It is possible that they were built a few years after the death of Drusus (9 B.C.) when Oberaden, as a result of military reorganization, had already been given up. To judge from the coins, which shed some light on the end of the occupation, Haltern was evacuated at the time of the reoccupation of the key sites on the right bank of the Rhine after the defeat of Varus in A.D. 9. Haltern cannot, therefore, be the Aliso mentioned by Tacitus (*Ann.* 2.7).

BIBLIOGRAPHY. *Mitteilungen der Altertumskommission für Westfalen* 5 (1909); *Bodenaltertümer Westfalens* 6 (1943); K. Kraft, "Das Enddatum des Legionslagers Haltern," *BonnJbb* 155-56 (1955-56) 95ff; H. Aschemeyer in *Germania: Anzeiger der Römisch-Germanischen Kommission* 37 (1957) 287ff; S. v. Schnurbein, "Die römischen Militäranlagen bei Haltern," *Bodenaltertümer Westfalens* 14 (1974).

For an area plan see *Saalburg-Jahrbuch* 19 (1961) 5,2; in general see H. Schönberger, "The Roman Frontier

in Germany: an Archaeological Survey," *JRS* 59 (1969) 144ff with Map A. H. SCHÖNBERGER

HALTON CHESTERS, *see* ONNUM *under* HADRIAN'S WALL

HALTWHISTLE BURN and Haltwhistle Common, Northumberland, England. Map 24.
1) Fortlet (NY 715662) on the Stanegate 53 km W of Newcastle, 0.8 km S of Milecastle 32 on Hadrian's Wall. Large fortlet (0.32 ha) at the crossing of the Haltwhistle Burn, with stone-faced earth ramparts, two main gates on the E and S sides (the W postern being finally blocked) and stone internal buildings, including at least one barrack and a granary. Occupation dates in the first half of the 2d c. and was very short; the fortlet probably served as an element in the detailed control of the Stanegate as a fortified frontier road in the later part of Trajan's reign and the early years of Hadrian's; it was abandoned and carefully demolished when Hadrian's Wall was built.
2) Undershot watermill, on the burn just S of the Wall (NY 712665).
3) Series of temporary camps: one just N of fortlet, 1 ha, one entrance on S side; a second just to the E, ca. 0.25 ha, with annex of 0.25 ha on S, entrance on S side. These two camps were probably connected with the construction of the fortlet or of the bridge over the burn. Two large camps, 2.8 and 0.8 km W of the fortlet, on Haltwhistle Common, and another 0.8 km E, were cut by the line of the Stanegate, and were perhaps of Flavian date. Some others in the area were probably related to the building of Hadrian's Wall; others may be practice works.
BIBLIOGRAPHY. 1) J. P. Gibson & F. G. Simpson, *Arch. Ael.* 5 (1909) 213-84; J. C. Bruce, *Handbook to the Roman Wall*, 12th ed. I. A. Richmond (1966) 141-42; E. Birley, *Research on Hadrian's Wall* (1961) 145-46. 2) *Proc. Soc. Ant. Newcastle* ser. 3, 4 (1909-10) 167. 3) *Arch. Ael.* 5 (1909) 259-63; *Proc. Soc. Ant. Newcastle* ser. 3, 7 (1915-16) 125-26, 196-97; Ordnance Survey, *Map of Hadrian's Wall* (1964); J. K. St. Joseph, *JRS* 59 (1969) 105. J. C. MANN

HALVAN, *see* CHALA

HAMADAN, *see* ECBATANA

HAMAXIA (Sinekkalesi) Turkey. Map 6. Town in Pamphylia, 6 km W-NW of Alânya. Hamaxia is mentioned only by Strabo (668) and in the *Stadiasmus* (208: Anaxion); Strabo calls it a katoikia and the *Stadiasmus* a chorion, and it appears from the inscriptions that the place did not attain city status before the early 3d c. B.C. Strabo places it E of Korakesion (Alânya), the *Stadiasmus* to the W; it is generally agreed that the latter is in this case the better authority.
The site is on a high hill above the village of Elikesik and is heavily overgrown. The circuit wall, of respectable ashlar masonry but not of early date, is preserved in large part. In the interior some remains of two temples, one of Hermes, have been identified, also two exedras facing one another, presumably across a street. A church has also been noted. Inscriptions are numerous, almost without exception of the 1st-2d c. A.D. The personal names are mostly epichoric, and Roman names are rare. The principal necropolis was on the N slope outside the wall, and contained many built tombs.
According to Strabo Hamaxia had an anchorage on the coast, "where the shipbuilding timber is brought down." This is perhaps to be identified with the Aunesis recorded in the *Stadiasmus*, but it has not been located with certainty.

BIBLIOGRAPHY. R. Heberdey & A. Wilhelm, *Reisen in Kilikien* (1896) 137-40; Wilhelm & J. Keil, *ÖJh* 18 (1915) 9; H. Rott, *Kleinasiatische Denkmäler* (1908) 71; G. E. Bean & T. B. Mitford, *AnatSt* 12 (1962) 185-91; id., *Journeys in Rough Cilicia 1964-1968* (1970) 78-94. G. E. BEAN

HAMBLEDEN Buckinghamshire, England. Map 24. Roman villa between Henley and Marlow, 360 m from the N bank of the Thames, discovered in 1911 and excavated 1911-12. The remains included a dwelling of H-shaped plan (28.8 x 24.6 m in its developed form) with corridors to front and rear and incorporating baths. In front of this was a trapezoidal yard (135 x 60 m). On either side of the yard were two buildings, evidently of aisled construction: one (22.5 x 12 m) built against the yard wall on the N; the other (26.4 x 13.5 m) some meters in from the wall on the S. A small building, possibly a shrine, lay NE of the house and between it and the N aisled building.
The skeletons of three adults and two children were found in a pit near the N building and 97 infant burials at various places in the yard. The pottery and coins (over 800 examples) ranged from the 1st to the late 4th c., but although modifications to the buildings were noted, no coherent scheme of development was suggested. It is, however, probable that the dwelling began as a simple rectangular building (19.5 x 6.6 m) similar to those at Lockleys and Park Street and that the corridors and baths were later additions. The villa was not luxurious and a notable feature was the presence of some 14 corn-driers, some built into the aisled buildings, others both inside and outside the yard. The animal bones indicate that stock raising was also important.
BIBLIOGRAPHY. A. H. Cocks, *Archaeologia* 71 (1920-21) 141-98[PI]; R. G. Collingwood & I. A. Richmond, *The Archaeology of Roman Britain*[2] (1969) 135, 138-39. A.L.F. RIVET

HAMMAM GUERGOUR, *see* AD SAVA MUNICIPIUM

HARAN, *see* CARRHAE

HARDKNOTT, *see* MEDIOBOGDUM

HARFLEUR, *see* CARACOTINUM

HARĪT, *see* THEADELPHIA

HARLOW Essex, England. Map 24. The site, 33.5 km NE of London and known for its temple, lies on a low hill in the valley of the river Stort and seems to have been sacred as early as the Belgic period; 79 pre-Roman coins, mainly of Tasciovanus and Cunobelin, have been recovered from below the temple and its vicinity although no structure could be identified. Later the hill was surrounded by a ditch to form the temenos, and a masonry temple of Romano-Celtic type was erected on the summit. The cella was 7.4 m square with a surrounding portico 16.4 m overall. The entrance lay to the SE; at a later date it was flanked by wings, each containing a small room with a tessellated floor. On the axis of the approach stood an altar base; nearby and possibly derived from it lay an inscribed fragment of stone dedicated NVM]INI A[VG—to the divinity of the emperor.
Some 7 m N of the temple part of an outer portico has been traced: this probably surrounded the temple on all sides to form an inner temenos. Like many pagan shrines in Britain the temple reached its greatest prosperity in the 4th c.; the building itself was probably

erected late in the 3d c., and the problem of continuity from the pre-Roman period is best explained by the previous existence of a sacred grove on the summit of the hill. S. S. FRERE

HARSOVA, see CARSIUM

HASTA (Asti) Piedmont, Italy. Map 14. About 48 km SE of Turin and in antiquity a colony in the Augustan Regio IX. Like other colonies enrolled in the tribus Pollia, it is believed to have been founded prior to the social war. Cited in the itineraries, mentioned by Varro, Pliny, Ptolemy, Claudian, and Cassiodorus, the city was famous along with Pollentia in the Imperial period for its ceramic ware. Developing at a crossroads (the Via Fulvia, from Augusta Taurinorum through Carreo Potentia to Dertona, and the road through Alba-Pollentia), the city was a fortified center with a regular urban plan. The walls, which have disappeared, had a rectangular perimeter and must have extended as far as Piazza San Secondo to the E and Piazza Santa Caterina to the W, Piazza San Giuseppe to the S and Via Testa to the N. At the entrance to the road to Turin, there remains a Roman tower with brick facing. It is today attached to the Church of Santa Caterina but originally belonged to a city gate. Other elements of the fortification system, every trace of which has been lost, are traditionally mentioned under the names of Castello dei Varroni, Castrum Vetus, and Castelletto. Corso Alfieri still represents, as it moves from E to W, the ancient decumanus maximus, crossed at a right angle by the cardo (the axis of Via Balbo - Via Tribunale) at the top of the forum (the modern Piazza Roma). The destruction suffered by the city in 480 during the Burgundian invasions explains the loss of records regarding the most important public buildings. There is no documentation for the remains of buildings and of streets which have been uncovered in the past in the course of excavations. The existence of a temple, perhaps the Capitolium, may be supposed in the area of the modern Cathedral, where Corinthian capitals seem to have been reused. However, the cemeteries are known to have lined the major arteries of communication. In the most extensive, outside the Porta Santa Caterina and about 300 m from the city walls, have been discovered rich objects in glass, bronzes, and vases, which are today in the museum at Turin. Numerous inscriptions, for the most part funerary, have been preserved along with other finds in the Museo Archeologico Comunale at Asti.

BIBLIOGRAPHY. Varro Rust. 11.15; Plin. 3.49; Ptol. 3.1.45; Claud. Cons. Hon. 202; Cassiod. Var. 11.15; Tab. Peut.

CIL v, 7555ff; G. Fantaguzzi, Ritrovamenti vari ad Asti, N.S. (1881) 150; (1882) 124; (1884) 136; F. Gabiani, Asti nei suoi principali ricordi storici (1927); P. Barocelli, Dalla capanna neolitica ai monumenti di Augusto (1933) III, p. 24. S. FINOCCHI

HASTA REGIA or Asta (Mesas de Asta) Cádiz, Spain. Map 19. Town near Jerez de la Frontera, which belonged to the Conventus Hispalensis (Plin. 3.11; Mela 3.4; Ant. It. 409.4) and was a Turdetanian settlement. It was called Asta in Strabo (3.140), elsewhere Hasta (Livy 39.21; Bellum Hisp. chs. 26, 36; Ravenna Cosmographer 4.43). In 187 B.C. C. Caius Atinius captured it and it was conquered by Caesar in 45 B.C.

The city minted coins during the Imperial age; and from a small bronze coin with the legend P. COL. ASTA RE. F on the reverse, it appears to have been called Colonia Asta Regia Felix. It was the third stage on the military road from Cádiz to Cordoba via Seville, and its ruins

were known in ancient times. Finds made during the 19th c., now lost, included a granite lion, a headless togate statue, a bust, and several inscriptions.

Excavations have uncovered material from phase I of the Mediterranean Bronze Age which document an Ibero-Saharan culture showing central and E Mediterranean influences, as evidenced by its incised, burnished, reticulated, painted, and decorated pottery. Abundant stone objects include knives, sickle blades, scrapers, bone and even bronze utensils. The existence of an Iberian settlement is confirmed by Iron Age decorated pottery of the Andalusian type, cinerary urns, Ibero-Roman coins, fragments of Punic amphorae, glass paste necklace beads, Italo-Greek and Campanian pottery. Material from the Roman period includes stucco fragments, thin-walled and Arretine ware, terra sigillata, lamps, coins, and Roman and Early Christian inscriptions. Finally, sherds of Byzantine, and especially of Caliphat, pottery as well as dirhems, and the remains of the foundations of a house or perhaps of a farmhouse have been found. All the finds are in the Jerez de la Frontera Archaeological Collection.

BIBLIOGRAPHY. E. Floréz, Medallas de España (1775) II, Tab. II, No. 7; E. Romero de Torres, Catálogo Monumental de España. Provincia de Cádiz (1934) 198, 203, 260-61; M. Esteve Guerrero, Excavaciones de Asta Regia (Mesas de Asta Jerez) (1945); A. García y Bellido, "Las colonias romanas de Hispania," Anuario de Historia del Derecho Español 29 (1959) 460f.

C. FERNANDEZ-CHICARRO

HATRA Iraq. Map 5. About 88 km S-SW of Mosul, in the westernmost part of ancient Assyria, somewhat W of the right bank of the Tigris. Hatra was the capital of a semi-independent frontier principality chiefly of Semitic, Aramaic-speaking population. It flourished as a caravan city on the route between the Persian Gulf and N Syria during the first two and a half centuries A.D. and was normally in the orbit of the rulers of Persia. Hatra's considerable archaeological importance derives from its position on the border between the Classical and the Iranian worlds: Hatran art and architecture (the sculpture is particularly significant) show the influence of both. Trajan and Septimius Severus both besieged the town without success (Dio Cass. 68.31; Amm. Marc. 25.8.5); later, after a brief period as an ally of Rome, it fell to the Sassanians under Shapur I (ca. A.D. 245). The site was deserted when Ammianus saw it in 363.

What can be seen is chiefly later Parthian in date (1st and 2d c. A.D.). A defensive ditch and towered wall (of circular plan, probably in imitation of Ctesiphon) enclose ca. 320 ha. There is no regular street plan. The houses, built around courtyards, are of crude brick; each has an iwan (a vaulted chamber or hall with one side open to a court). At the center of the city was a walled rectangular enclosure (ca. 300 x 450 m), pierced by seven gates and divided into two unequal parts by a transverse wall. Within this precinct were a number of sanctuaries, each of one or more iwans, and perhaps the city administrative center as well.

The chief monument in the enclosure is a great Temple to Shamash, the god of the sun (formerly called the palace, but inscriptions found in it would seem to guarantee its religious function). One inscription records that it was under construction in A.D. 77. The plan is Parthian, the structure Romano-Syrian. Major and minor iwans, the largest spanning ca. 21 m, were vaulted with stone voussoirs, and the walls are of dressed stone facing mortared rubble cores; it is the only known building of this period in Mesopotamia to be constructed in this manner. Molding forms appear that are common to Hatra and Baalbek. Capitals specifically Ionic and Corin-

thian were used, and there is a garlanded frieze featuring the forequarters of bulls and lions that is unmistakably of Achaemenid origin. Next to the Shamash iwans is a fire temple or platform of square plan with vaulted galleries around it.

The synthetic nature, however creative, of Hatran art is seen also in the sculpture (relief, freestanding, and items of personal adornment). Greek, Neo-Iranian, and Roman Imperial elements mingle here, though the eastern mode predominates (frontality, stylization, patterning). This sculpture can be seen chiefly in the Iraqi Museum at Baghdad and in the Mosul Museum.

BIBLIOGRAPHY. W. Andrae, *Hatra*, 2 vols. (1908-12)[MPI]; *RE* VII (1912) 2516-23; H. Ingholt, *Parthian Sculptures from Hatra* (1954)[I]; J. Bradford, *Ancient Landscapes* (1957) 71-75[I]; *EAA* 3 (1960) 1116-22[I]; R. Ghirshman, *Iran: Parthians and Sassanians* (1962) passim[MPI]; D. Homès-Fredericq, *Hatra et les sculptures Parthes* (1963)[I]; J. B. Ward Perkins, "The Roman West and the Parthian East," *ProcBritAc* 51 (1965) 175-99[I]. See also the journals *Sumer* (1951ff), *Syria* (1955ff), *RA* (1964), and *Phoenix* (1965ff). W. L. MAC DONALD

HATRIA, *see* ADRIA

HAUTE-YUTZ Moselle, France. Map 23. Situated SE of Thionville, between route D 1 and the Moselle river. The site was destroyed when the course of the Moselle was changed in 1960, but traces remain in the military area between the new riverbed and route D 1. The site was hurriedly excavated in 1960 when remains of a pottery were uncovered during work on the riverbed, and traces of a large shed and three kilns were brought to light. The stratigraphy revealed two occupation levels with a hiatus between them.

Two storage dumps were found, one for goblets, the other (apparently never used) for molds. The first dump dated from the earliest period of activity and contained two batches of terra sigillata, apparently by different potters: the first batch was probably made by one hitherto unknown man, now called the Moselle Master or the Master of the Little Man. The second batch can be attributed to a group that undoubtedly had ties with Lavoye. The second generation of potters had strong ties with Trèves, in particular Censor, Comitialis, and especially Alpinus: according to recent studies (Huld-Zetsche) he started working in Haute-Yutz and from there influenced the Trèves potters from the end of the 2d c. to the beginning of the 3d c., which is the second period of activity at Haute-Yutz. The first may be placed around 130. Haute-Yutz also turned out a good deal of plain sigillata, notably Drag. 40, 38, 18/31, 32, 33, 43, 45, 44 and various other forms with a dozen potters' stamps.

The Thionville museum has an archaeological collection.

BIBLIOGRAPHY. G. Stiller et al., "Découverte d'une officine de céramique gallo-romaine à Haute-Yutz (Moselle)," *Annuaire de la Société d'Histoire et d'Archéologie de Lorraine* 60 (1960) 5. M. LUTZ

HAVZA, *see* THERMAI PHAZEMONITON

HAYITLI, *see* ISTLADA

HEBRON or Kiryat Arbah (el-Halil) Occupied Jordan. Map 6. One of the oldest cities in the mountains of Judea, on the main road from Jerusalem to Beersheba. Possibly it was called Kiryat Arbah because it consisted of four quarters, one of which was Mamreh (Gen. 23:17). It was here that Abraham bought the Cave of Machpelah in which Abraham, Isaac, Jacob, and their

wives were buried, and David was anointed king at Hebron. The city was resettled in the Persian period, when Hebron was in Idumaea. The city was later conquered by the Hasmonaeans, and since then has formed part of Judea. After the destruction of the Second Temple it was given to the Roman Legio X Fretensis, who made it a military base in the rear of limes Palestinae. In the late Roman period Hebron had a Jewish community and a synagogue.

The enclosure built over the Cave of Machpelah by Herod survives to its original height: the walls, built of large ashlar blocks, some of which are 1.5 by 6.3 by 1.5 m, enclose an area of 46.8 by 27 m. Flat pilasters decorated the exterior.

BIBLIOGRAPHY. F. M. Abel, *Géographie de la Palestine* II (1938) 345-46; M. Avi-Yonah, *The Holy Land* (1966) 53, 163. A. NEGEV

HEDDERNHEIM, *see* NIDA

HEERLEN, *see* CORIOVALLUM

HEKATOMPEDON (Lekel) S Albania. Map 9. Mentioned by Ptolemy (3.14) as an inland city of Chaonia. The site is defended by cliffs on two long sides and by strong walls of ashlar masonry, strengthened with towers, on two short sides; the circumference of the defensible area was some 1700 m. The masonry and the use of bonding cross-walls within the circuit wall date the site to ca. 295-290 B.C., and it is likely that Pyrrhos founded it and Antigonea at the same time. The site has great strategic importance: it commanded the entry from the N into the Drin valley and lay close to the mouth of the Aous pass (Aoi Stena), leading towards Macedonia. The two rivers join just N of Lekel.

BIBLIOGRAPHY. N.G.L. Hammond in *JRS* 56 (1966) 47ff, and 61 (1971) 114; id., *Epirus* (1967) 212f, 699.
 N.G.L. HAMMOND

HELENENBERG, *see under* MAGDALENSBERG

"HELIKRANON," *see* KHRISORRAKHI

HELIOPOLIS (Baalbek) Lebanon. Map 6. The site on the elongated high plain, between the mountain chains of the Lebanon and the Antilebanon E of Beirut, was occupied from prehistoric times on, but Heliopolis did not become important until late Hellenistic times. It was the holy town of the Ituraean tetrarchs of Chalcis in the 1st c. B.C. Under the Roman Empire it was a flourishing colony, and during the Byzantine period remained a center of pagan resistance. It was conquered by the Moslems in A.D. 637; the sanctuaries were transformed into a citadel, and Sultan Suleiman the Magnificent ordered some of the columns to be brought to Istanbul to build his mosque. In 1759 an earthquake damaged the ruins.

The site, known since the 17th c., consists primarily of the complex of the great sanctuary of Heliopolitan Jupiter and the so-called Temple of Bacchus which adjoins it to the S. They were built on imperial initiative, perhaps begun by Augustus himself. Enlargements and improvements were carried out over three centuries. The dimensions are vast and the decoration sumptuous. The architectural and decorative forms belong largely to the repertory of Roman art of the W, but the plan (with its successive enclosures and the importance given to the courts), the cult installations, and the arrangement of the cellas conform to ancient Oriental traditions.

On a single E-W axis almost 400 m long, the sanctuary of Heliopolitan Jupiter includes monumental propylaea, a hexagonal court, a large rectangular court, and the

temple proper, where the cult idol was enthroned under a canopy in the cella.

The sanctuary occupies an ancient tell, artificially enlarged by enormous works of terracing and masonry. At the W end near the N corner, the supporting walls contain three colossal quadrangular stones, called the trilithoi, each one nearly 20 by 4.5 by 3.6 m. Another even larger stone was left in a quarry at the foot of the hill W of the town. Two long vaulted galleries running E-W correspond at the basement level to the peristyle of the central court. They are open at the ends and joined by a transverse gallery. Some of their keystones carry Latin inscriptions. The S gallery is matched on its outer side by rooms and a large square exedra, which open on the court of the so-called Temple of Bacchus. These arrangements date from the 2d c. A.D.

The propylaea consisted of a colonnade of 12 columns of Egyptian granite, flanked to N and S by a tall tower adorned on the outside by pilasters. The coins of Heliopolis struck under Philip (A.D. 244-249) show the central intercolumniation wider than the others and topped by a semicircular Syrian facade, which broke the horizontal line of the entablature, and by a triangular pediment. This arrangement can be observed in the other porticos on all the intercolumniations on the long axis of the sanctuary. A great stairway, bordered by two massive antae forming parapets, gave access to the colonnade over its entire width. Inscriptions on three bases indicate that the columns supported Corinthian capitals with acanthus leaves of gilded bronze, dedicated under Caracalla (A.D. 212-217).

A monumental gate and two narrow lateral corridors led from the propylaea to the flagged hexagonal courtyard. A stylobate, two steps higher, encircled the court, supporting porticos beneath which were exedras. This remodeling of an originally square plan dates to the middle of the 3d c. A.D.

The rectangular court in front of the temple in its final state probably dates from the 2d c. A.D. On its N, E, and S sides it was surrounded by porticos with 128 columns of pink Egyptian granite, raised three steps above the paving of the courtyard. Only the NE corner of the peristyle, which has been restored, still stands. Exedras, alternately rectangular and semicircular, opened beneath the porticos; they are separated by large masonry blocks adorned with two superimposed niches between corner pilasters with Corinthian capitals. The walls of the exedras are decorated with two stories of niches, conch apses, and shallow niches with straight lintels and either triangular or segmental pediments.

In the middle of the courtyard, which corresponds to the middle of the ancient tell, stood a great altar, a four-story tower 18 m. high. Only the lowest parts are now visible, with the door jambs, the corridors, and the beginning of two interior staircases which led to the terrace where the sacrifices were offered. The outside walls were covered with marble slabs, the doors with bronze.

To the W of the great altar stands a smaller and older one with a niche on each side, on the inside (which was found filled with ashes from sacrifices) a staircase ascends to the top. The location of the altar is visible and also of the gutters, which run along one of the walls and over the flagging of the court to drain water and the blood of the victims.

On each side of the court is a large lustration basin with delicately carved edges, and on each side of the great altar stands an isolated column on a high base. The columns are Egyptian granite, the S one pink, the N one gray. Because of an oracle of Heliopolitan Jupiter, a statue was erected on the S column, probably in the Severan period. Small votive chapels and statues—of emperors from Titus and Vespasian to Diocletian, kings, and other important personages—also stood in the courtyard. Their bases, with dedicatory inscriptions, can still be seen.

A great staircase with three divisions or flights leads to the temple, W of the court. The 38 steps are made of enormous limestone blocks, which bear traces of the apse of a Christian basilica set up in the court during the 5th c. (its remains were removed by modern archaeologists).

The great temple was peristyle, 10 columns by 19; only the six columns to the S still stand. They have considerable entasis and consist of only three drums. They are 19 m high with Corinthian capitals and a carved entablature: heads of bulls and lions alternate between the acanthus leaves of the frieze, above a Greek key pattern and a cable molding. Construction was started possibly as early as the time of Augustus and was well on the way to completion in the reign of Nero, as a graffito dated A.D. 60 demonstrates. The temple was probably inaugurated under Vespasian. It replaced a Hellenistic building, which seems to have had a crepis, a peristyle with more numerous and smaller columns, a double portico for a facade, and a larger cella. The sanctuary was never finished: the terrace which should have surrounded the temple was not built.

Another temple, built in the Antonine period, stands to the S, lower than the Temple of Jupiter. It is remarkably well preserved and is usually called the Temple of Bacchus. It stands on a high podium, approached from the E by a staircase with three flights between two antae. The peristyle consists of 8 by 15 Corinthian columns with unfluted shafts. The portico of the facade included a double colonnade. The walls of the cella ended in pilasters with Corinthian capitals. The severity of the exterior contrasts with the magnificence of the interior decoration. The stone ceilings of the peristyle, still largely in place, consist of compartments of sculptured limestone in which busts of divinities and mythological scenes appear in a network of hexagons, lozenges, and triangles on a field covered with scroll patterns and interlacing figures.

The cella is reached by a huge door, by two shallow, delicately carved bands. One has vine scrolls in which individuals and animals frolic (especially Dionysiac panthers). The other depicts kantharoi from which birds drink and poppies and ears of wheat (the attributes of the great divinities of Heliopolis) emerge. The soffit of the enormous lintel depicts an eagle holding a caduceus in its claws between two winged Cupids displaying garlands. On each side of the large entryway a smaller door led to a small staircase, inside the partition walls, leading to the upper parts of the building. Above the N side door a sculptured frieze illustrates episodes in the life of Dionysos.

On the inside the cella is a square chamber with the W side ending in a staircase going up to the adytum. The first three steps extend along the S and N walls, along which fluted, engaged Corinthian columns stand on high pedestals, which carry heavy blocks on their capitals. Two rows of shallow niches open between the columns, the lower ones topped by segmental arches, the upper by triangular pediments. In the middle, the staircase goes up to the platform of the adytum; on each side the wall of the podium is adorned by sculptured friezes illustrating the legend of Dionysos. At the ends two small doors lead to a vaulted crypt extending under the entire length of the adytum. The temple was undoubtedly used for the celebration of mysteries and for ceremonies of initiation. There was no access from the Temple of Jupiter; the court was reached by staircases to the E,

where the level of the ancient streets and squares was ca. 3 m below present ground level.

A stretch of a wide, flagged street bordered by porticos has been partially cleared SE of the sanctuaries; at right angles to it another street with porticos, of late date, has a mosaic pavement. In this area there is also a small 3d c. A.D. temple of central plan. Wide staircases with three flights ascend to a high podium on which is a circular cella open to the NW. The outside walls are decorated with five apsidal niches, framed by six Corinthian columns which stand well out from the cella wall. Their bases and entablatures form five concave bays tangent to the central rotunda. The door opens onto a porch bounded by two antae that end in engaged columns. Along the entire width of the facade, a portico of four columns carried a pediment whose roof joined the dome of the cella. This last was crowned by a cone or small pyramid.

To the SW in the Bostan el-Khan gardens, between the great sanctuaries and a tall isolated column which bore an honorific statue, is a colonnade of 12 tall Corinthian columns with a Syrian arch over the central intercolumniation. It stands between two walls which end in pilasters cut out from superimposed niches with sculptured decoration. To the E a part of the colonnade with a semicircular arch returns towards the S, where a high wall meets the long colonnade. The wall is pierced by two gates extended by four columns on each side. Not far to the NW a sort of small theater may be the council hall or Senate.

The hippodrome must be under the orchards farther to the NW. To the S, against the hill dominating Baalbek, a theater lies under modern buildings. A temple of Mercury stood on top of the hill outside the ramparts. A long staircase led up to it from the town, as is shown on coins of Heliopolis struck under Philip. Remains of the temple, the line of the staircase, and parts of its parapet have been found.

A huge statue of a seated female divinity of Roman empress (now in the Istanbul museum) was found E of the town. A temple of Venus was also in that area: inscriptions on rocks mark the boundaries of its property.

In a suburb to the SE between river and vineyards, a series of houses and villas has produced fine mosaic floors (in the Beirut museum). They date from the middle of the 3d c. A.D. to the end of the 4th. Some are in Classical style (Socrates, Kalliope, and the Seven Wise Men, the Seasons), others in an orientalizing style (illustrating the childhood of Alexander the Great).

A well-preserved Roman gate stands at the N end of the town: it has three bays and a figure of Hercules on the central lintel. From there to the E the mediaeval ramparts run parallel to the axis of the great sanctuary. This may be their ancient course, but the ramparts of the Roman town are not precisely known. The necropoleis, which have produced a few stelai, have not been excavated. Fragments with inscriptions and sculptured decoration were collected long ago on the NW slope of the hill which dominates Baalbek. They came from a mausoleum of the family of the tetrarchs of Chalcis and Abilene.

BIBLIOGRAPHY. R. Wood, *The Ruins of Baalbec* (1757, repr. 1971)[I]; T. Wiegand, *Baalbek, Ergebnisse der Ausgrabungen und Untersuchungen 1898-1905* I-III (1921-25)[MPI]; D. Schlumberger, "Le temple de Mercure à Baalbek-Héliopolis," *BMBeyrouth* 3 (1939)[I]; C. Picard, "Les frises historiées autour de la cella et devant l'adyton, dans le temple de Bacchus à Baalbek," *Melanges syriens offerts à René Dussaud* I (1939)[I]; R. Amy, "Temples à escaliers," *Syria* 27 (1950); P. Collart & P. Coupel,

L'autel monumental de Baalbek (1951)[PI]; H. Seyrig, "Questions héliopolitaines," *Syria* 31 (1954); M. Chéhab, "Mosaïques de Liban," *BMBeyrouth* 14-16 (1958-60)[I]; A. von Gerkan, *Von antiker Architektur und Topographie, Gesammelte Aufsätze* (1959)[PI]; J. Lauffray, "La Memoria Sancti Sepulchri du Musée de Narbonne et le Temple Rond de Baalbeck," *MélStJ* 37 (1962); R. Saïdah, "Chroniques, Fouilles de Baalbeck," *BMBeyrouth* 20 (1967); J.-P. Rey-Coquais, *Inscriptions grecques et latines de la Syrie.* VI. *Baalbek et Beqa* (1967)[MI].

J.-P. REY-COQUAIS

HELLENIKO (Euboia), *see* GERAISTOS

HELLENIKO (W Lokris), *see* VELVINA

HELLÍN, *see* ILUNUM

HELMANTICA (Salamanca) Salamanca, Spain. Map 19. Originally a fort inhabited by the Vetones tribe, Helmantica later belonged to the Roman province of Lusitania and is frequently mentioned in the sources. It was conquered by Hannibal (Polyb. 3.13.5-14, 9; Livy 21.5; Polyaenus 7.48, Σαλματίδες Ptol. 2.5.7; *Ant. It.* 434.4; *Ravenna Cosmographer* 319.7).

It has a bridge of the Augustan period and mediaeval walls built over Roman walls dating from the end of the Republic. Incorporated in the mediaeval wall were various Roman funerary inscriptions of the Severan period which are unpublished and kept in a private collection. There are two boundary markers between Helmantica and Mirobriga, one in a private collection in Ciudad Rodrigo and the second in the Ledesma Church in Salamanca. No terra sigillata has been found, only pre-Roman pottery.

BIBLIOGRAPHY. V. Bejarano, "Fuentes antiguas para la historia de Salamanca," *Zephyrus* 6 (1955) 89-119.

J. M. BLÁZQUEZ

HELOROS (Eloro) Siracusa, Sicily. Map 17B. Ancient remains at a small city on a low hill near the coast SE of Noto on the left bank of the river Tellaro. The literary sources give scanty information on the ancient site, which was connected to Syracuse by the Helorian Road. In 493 B.C. Hippokrates defeated the Syracusans on Helorian territory, and in 263 B.C., by virtue of the peace treaty between Hieron II and Rome, the city passed under Syracusan control; it surrendered to Marcellus in 214 B.C.

Two excavation campaigns have brought to light long sections of the ancient walls, a small temple, and some Hellenistic houses on the S slope of the modern city, where part of the theater cavea was also identified.

A Sanctuary of Demeter and Kore has been explored on the shore immediately to the N of the city, at a short distance from the fortification walls. The sanctuary flourished from the archaic to the Hellenistic period and proved very rich in votive offerings; a complex of rooms in front contained several bothroi.

In the S section of the urban area, a Sanctuary to Demeter has been found, dating from the second half of the 4th c. B.C. In this district, previously residential, a temple was built. Its stereobate is almost entirely preserved (20 x 10.5 m). Besides the temple, the sanctuary contained a few rectangular structures for the storage of votive offerings, a practice attested also in the extramural Koreion mentioned above. In the early 2d c. B.C. the sacred complex was delimited by a monumental stoa which has now been completely excavated. It is a long pi-shaped portico (stoa with paraskenia) with two naves, Doric columns on facade, and square pillars in the inte-

rior. The greatest length of the building is ca. 68 m, the greatest width, at the center, 7.4 m. It is one of the most important Hellenistic examples of this type of structure in Sicily. During the Byzantine period the E side of the sanctuary was occupied by a basilica with three naves, apse, and narthex, built with blocks taken from earlier buildings. The most recent excavations in the area of the sanctuary have also yielded the earliest documentation for Greek occupation at Heloros. Stratigraphic tests have produced (from the archaic levels) Protocorinthian Geometric sherds and remains of house walls of the early archaic period.

These finds suggest that Heloros was not a relatively late foundation connected with the Syracusan expansion within the SE triangle of Sicily, but was instead one of the first outposts on the coastal zone S of Syracuse, in an area agriculturally very rich and strategically very important (the mouth of the Tellaro) especially with regard to the sites defended by the native populations.

Among the important finds of the recent campaigns are the discovery of the S city gate and the identification of the major traffic artery within the city, which ran N-S and connected the N gate, already excavated, with the newly discovered gate.

In Helorian territory, approximately 2.5 km to the W of the city, some polychrome mosaic floors have recently been discovered. They probably belong to a Roman Imperial villa, and are in good state of preservation; they seem of high artistic quality. A section of a vast portico is paved with a motif of medallions with geometric patterns surrounded by large and elegant laurel wreaths. The other mosaics belong to rooms opening onto the portico; the most important shows a banquet scene with people around a table set under a tent, a well-known motif which occurs also in the Little Hunt Mosaic of the Villa near Piazza Armerina. The varied and vivid polychromy, the elegance and richness of the compositons, the particular efficacy of the figured scenes make these mosaics, dating from the 4th c. A.D., a major discovery for our knowledge of the late Roman period.

BIBLIOGRAPHY. A. Holm, *Storia della Sicilia*, III:1 (1901); P. Orsi, *NotSc* (1899) 241-44; B. Pace, *Arte e civiltà della Sicilia antica*, I-III (1953) passim; G. V. Gentili, *EAA* 3 (1960) s.v. Eloro; A. Di Vita, "La penetrazione siracusana nella Sicilia sud-orientale" *Kokalos* 2 (1956) 9ff; M. T. Currò et al., *MonAnt* 47 (1956) cols. 207-340; G. Voza, *Kokalos* 14-15 (1968-1969) 360-62; id. *EAA* s.v. Eloro (supplementary volume in preparation). G. VOZA

HENCHIR BESSERIANI, *see* AD MAIORES

HENCHIR BOTRIA, *see* ACHOLLA

HENCHIR EL FAOUAR, *see* BELALIS MAIOR

HENCHIR HOURI, *see* THELEPTE

HENCHIR KASBAT, *see* THUBURBO MAIUS

HENCHIR LORBEUS, *see* LARES

HENCHIR MAKHREBA, *see* UZITTA

HENCHIR SIDI AMARA, *see* AGGAR

HENCHIR THINA, *see* THAENAE

HEPHAISTIA, *see* LEMNOS

HERAKLEIA (Ereğli) Pontus, Turkey. Map 5. A natural haven on the S coast of the Black Sea (Pontos Euxeinos), the first of any importance E of the Bosporus. Herakleia was a Megarian colony founded ca. 558 B.C. in Mariandynian territory on the E margin of Bithynia. It founded colonies of its own in the late 6th c. at Kallatis and Chersonnesos on the opposite shore of the Euxine, as well as emporia along the coast W towards the Bosporus. In addition, it established a small land empire by reducing the Mariandynoi to helotage and subjecting the small Greek cities of Sesamos, Tios, and Kieros. In the early 3d c. B.C. this subject territory seceded, but was restored to Herakleia ca. 278 B.C. by Nikomedes I of Bithynia. In the early 2d c. this same territory was lost to Prousias I of Bithynia, though Herakleia itself was still independent when Bithynia was annexed by Rome in 74 B.C. It proceeded to slaughter a group of Roman publicani and submitted to Mithridates VI Eupator of Pontus, but was captured by Cotta and devastated in 70 B.C. In Pompey's settlement of the joint province of Bithynia-Pontus (64 B.C.), Herakleia was transferred from the Bithynian to the Pontic portion and was henceforth known as Herakleia in Pontus. A colony was established there by Julius Caesar, and the remainder of the city presented by Antony to a Galatian prince, Adiatorix, who massacred the coloni and was removed by Octavian. Under the Empire Herakleia became metropolis of the coastal cities of Pontus.

Herakleia's mythical founder Herakles was said to have reached the underworld through a cavern on Baba Burnu (Acherousia pr.), a headland 2 km NW of Ereğli. The harbor, praised by Strabo (12.542), lay close in under this headland, which protected it from NE storms. There were two moles, and the lighthouse, known from coins, presumably stood (like its modern counterpart) on the tip of Baba Burnu. The Greek city lay on the flat ground beside the harbor, with a citadel rising on the SE side. All but one short length of the walls has disappeared, as has the Roman temple seen by Ainsworth. The area of the harbor and much of the Greek city are made inaccessible by a Turkish naval base; and the citadel, similarly, by a Turkish shore battery. The modern town, on the S and W slopes of the citadel hill, contains many Roman and Byzantine inscribed and sculptured stones, but its walls are mediaeval. It is not clear whether the Roman city lay here or on the site of the original Greek colony. Farther SE another Roman temple was visited by Ainsworth and von Diest, and an aqueduct was visible to Perrot. The amphitheater (shown on coins) has not been located.

BIBLIOGRAPHY. W. F. Ainsworth, *Travels and Researches in Asia Minor, Mesopotamia, Chaldea, and Armenia* (1842) I 38-41; G. Perrot et al., *Exploration Archéologique de la Galatie . . .* (1872) 15; W. von Diest, "Von Pergamon über den Dindymos zum Pontus," *PM* 20 (1889) suppl. vol. XX 79-81; K. Lehmann-Hartleben, "Die antiken Hafenanlagen des Mittelmeeres," *Klio* suppl. 14 (=NF 1) (1923) 130-31; W. Hoepfner, *Herakleia Pontike-Ereğli* (1966; = Oesterr. Ak. der Wiss. phil.-hist. Klasse, Bd. 89). D. R. WILSON

HERAKLEIA later AXIOPOLIS (Cernavodă) SE Romania. Map 12. On a hill, divided in two, that dominates the right side of the Danube, ca. 51 km N-NW of Constanţa, a fortified center probably founded at the time of the expedition of Alexander the Great on the Danube. Because the site dominates not only the route between the Wallachian plain and Scythia Minor but also the natural road that leads from the Danube to the port of Tomi on the Black Sea, the hill was of great strategic importance in the life of Scythia Minor (Dobrogea) from Hellenistic times until the 5th-6th c.

Excavations have brought to light evidence of habita-

tion as early as Neolithic times. In the Bronze Age, on the hill called Sofia in Cernavodă arose the first habitation site. It was defended by one or more ditches. Its domestic implements and ceramics testify to diverse cultural currents, that have been identified as Cernavodian culture. During the late phase of the Iron Age (4th c. B.C.) a habitation center developed that had Hellenistic necropoleis. The funerary material contains as many local products of the Getaean type as imported objects from the Greek world on the coast of the Black Sea: Histria, Tomi, and Kallatis. The local ceramics assume forms that are directly linked with the Greek products. Thus the hill, always important because of its position as a crossroads, became involved with the Hellenistic Macedonian world through the commercial expansion of the Greek colonies on the coast of the Black Sea, and perhaps also through their territorial expansion.

During the Roman period Axiopolis was already a center of a certain importance because of the ease of reaching Tomi by the Roman road that followed the right bank of the Danube along a bypath rebuilt several times. Being part of the customs system and used for the quartering of the naval military forces that defended the line of the lower Danube, Axiopolis was the seat of a Collegium nautae universi Danubii. Nothing, however, is known of the arrangement of the Roman civitas of this period. The first indications of fortification are, very probably, from the 5th-6th c. To this period may be dated at least one of the great ramparts in earth and stone that join Axiopolis to Tomi. The hill where the inhabited zone of the 5th-6th c. arose is rectangular in form with an incline toward the N. On this side is found a line of first defense formed by a wall that has been rebuilt several times. On the S flank are two other citadels, incorporating remains of other earlier fortifications, which have also been rebuilt repeatedly until the 9th-10th c. Axiopolis' greatest flowering was in the 6th c. and corresponds to a general well-being in all of Scythia Minor. To the same period belongs the basilica near the S gate.

BIBLIOGRAPHY. G. Tocilescu, "Fouilles d'Axiopolis," *Festchrift zu Otto Hirschfeld* (1903) 354-59; R. Netzhammer, *Aus Rumänien*, I (1909) 275-94; R. Vulpe, *Histoire ancienne de la Dobroudja* (1935) passim; id. & I. Barnea, *Din istoria Dobrogei* (1968) passim; D. Berciu, *Contribuţii la problemele neoliticului României in lumina noilor cercetari* (1961) 9ff, 511ff; D. M. Pippidi & D. Berciu, *Din istoria Dobrogei* (1965) 29-66.

D. ADAMESTEANU

HERAKLEIA (Policoro) Lucania, Italy. Map 14. On the Gulf of Taranto at the mouth of the river Acris (Agri). The city was colonized from Tarentum in 433-432 B.C. Excavation, however, has shown that the acropolis (site of the Renaissance castle) was first occupied by Greek settlers at the end of the 8th c. B.C. Scattered potters' works, identified by the remains of kilns, have revealed a mixture of Greek and indigenous wares paralleled by the mixture of burial rites (cremation and inhumation in pithoi) found in the archaic necropolis. The E Greek character of much of the material of this settlement makes it possible to interpret it as an outpost of Siris. Following the Tarentine foundation, Herakleia became the meeting place of the representatives of the Italiote Greek League and remained so until the 330s B.C. One of the battles between King Pyrrhos of Epeiros and the Romans was fought in the vicinity in 280 B.C. In the 1st c. B.C., following the slave insurrection of Spartacus, the area occupied by the city was reduced once again to the acropolis, where a settlement persisted until the 5th c.

Long famous because of the discovery there of an inscribed text of the Lex Julia Municipalis and inscribed bronze tablets recording partitioning of temple properties (found in the river Acris), Herakleia has been the site of intensive archaeological investigation since 1959. The city is situated on a long low hill oriented NW-SE with the acropolis at the SE end toward the sea. The rectangular city plan was laid out at the time of the founding of the Tarentine colony. Three entire city blocks have been excavated. The city walls, traced largely from air photographs, belong to the 4th c. B.C. and were strengthened after construction. There are remains of a coroplastic industry in the form of kilns and dumps of terracotta figurine fragments and molds. The foundations of a temple of the 4th c. B.C. have also been uncovered. The excavation of the extramural Sanctuary of Demeter and Kore has resulted in the discovery of a large group of dedications, largely miniature vases and terracotta figurines. These, together with the distinguished group of later 5th c. S Italian red-figure vases from a chamber tomb excavated in 1963, are displayed in the new museum adjoining the site.

BIBLIOGRAPHY. B. Neutsch et al., *Archäologische Forschungen in Lukanien II Herakleia-Studien, RM* suppl. vol. 11 (1967)[MPI]; L. Quilici, *Forma Italiae, Regio III, 1 Siris-Heraclea* (1967); D. Adamesteanu, *Siris-Heraclea* (1969); A. D. Trendall, "Archaeology in South Italy and Sicily, 1967-69," *Archaeological Reports for 1969-1970*, 38. R. R. HOLLOWAY

HERAKLEIA (Spain), *see* KARTEIA

HERAKLEIA UNDER LATMOS Caria, Turkey. Map 7. Though a Carian town, it was on the Ionian coast. It is some 25 km W of Miletos and about 10 km N of the village of Bafa. Now at the W end of Lake Bafa it was on a gulf of the Aegean at least until Early Imperial times (Strab. 14.1.8). The town lay on a fairly steep lower slope of Mt. Latmos (Beş Parmak, ca. 1400 m) where it met the gulf. First called Latmos, and a member of the Delian League, it fell to Mausolos in the 4th c. B.C. and his philhellene policy accounts for its change of name. In time Miletos overshadowed it, and the gulf on which it stood was gradually converted into a lake by the action of the Maeander. Herakleia was celebrated as the locale of Endymion (Paus. 5.1.5). There are several Early Christian monuments in and near the site, including a Byzantine fortress at the S end of the town.

Either Mausolos or, less probably, Lysimachos in the 280s B.C. built the 6.5 km of walls which still stand in great part (later the enclosed area was reduced by about a third). There were 65 towers, and the maximum dimension of the city, N-S, was slightly more than 2 km. The walls, one of the major monuments of Classical fortification, were carefully built. Cuttings in bedrock were often made for the foundation courses and can be seen where the wall has fallen. All of the detail of such a system can be observed: access stairs, parapets, windows, and roofs. Several of the gates and posterns are preserved, particularly in the S portions. At the N the walls follow the terrain to a height of some 500 m above the level of the lake, marching up the stony site in a manner reminiscent of the Byzantine-Venetian walls of Kotor.

The port lay on the SW side of the town. Within the walls, at least in the S half of the city, the plan was orthogonal on the Hippodamian model rather like the plan of Miletos. The streets were oriented to the cardinal compass points, and the resulting rectangular blocks determined the orientation and alignment of most of the public buildings. An exception to this is the Temple of Athena (an inscription identifying it survives), which

stood in a commanding position on a hill above and behind the harbor area. It was a carefully built structure of simple plan: a cella with a pronaos, the two of approximately equal dimensions (the walls of the cella stand nearly intact). To the NW of the Temple of Athena, beyond the agora, are the remains of the bouleuterion, which was similar in plan to that at Priene—a rectangle with the seats, on three sides, parallel to the enclosing walls. Apparently the upper part of these walls featured engaged Doric columns; fragments of a more or less canonical Doric entablature have also been found.

The agora, of Hellenistic date, measures about 60 x 130 m. Its S retaining wall is well preserved, and one can see there two levels of shops, the lower entered from the outside below the agora. Details of windows, doors, and structural niceties are all visible. Farther to the NW are a nymphaeum and a theater, neither well preserved; the latter is of Roman date. There are also the remains of a Roman bath building, between the bouleuterion and the theater, and there are at least three temples in addition to that of Athena; none of these has so far been identified.

In the S part of the site, about 200 m on a line from the Byzantine fort to the Athena temple, is an unusual building which has been identified as a Sanctuary of Endymion. Over-all the building measures about 14 x 21 m. It consists of pronaos of six unfluted columns set between two square piers at the ends of the facade; behind this porch there was an almost horseshoe-shaped cella intruded into by the natural rock and featuring two widely but irregularly spaced internal columns. The building faces the SW and thus is oblique to the orthogonal grid; its design reminds one of certain later sanctuaries and temples in Roman North Africa.

At the very S end of the site, where the walls nearly reach the water, is a cemetery of tombs cut from the living rock along the steep slopes. These tombs had separate lids in the Carian fashion; some are now submerged, as the level of the lake has risen since ancient times.

BIBLIOGRAPHY. *RE* VIII (1913) 431-32; F. Krischen, *Die Befestigungen von Herakleia am Latmos* (1922); = *Milet* III.2[PI]; G. E. Bean & J. M. Cook in *BSA* 52 (1957) 138-40; id., *Aegean Turkey* (1966) 252-58[MPI]; *EAA* 3 (1960) 390-91 with bibliography[PI]; E. Akurgal, *Ancient Civilizations and Ruins of Turkey* (3d ed. 1973) 240-41[P]. W. L. MAC DONALD

HERAKLEIA LYNKESTIS (Bitola) Macedonia, Yugoslavia. Map 12.

At the W edge of the modern city lies the ancient one, founded by Philip V, probably after one of his early campaigns against the Illyrians either in 359-58 or 356 B.C. It was situated on a low hill at the juncture of two ancient routes, one leading from the Adriatic coast through Lychnidos to Thrace, and a second extending NE through Pelagonia to Stobi in the Vardar valley. The former route became the Via Egnatia in 148 B.C. This location on important highways made Herakleia strategically important, and it became the principal town and administrative center of the district of Lynkestis, a fertile plain surrounded by wooded mountains.

Herakleia figured in the campaigns of Julius Caesar during the civil wars as a supply depot, and inscriptions of veterans who settled there date as early as the turn of the era. Although the town is seldom mentioned in ancient literature its importance during the Early Empire is attested by numerous private and official inscriptions.

The names of bishops from Herakleia are known from the 4th, 5th, and 6th c. The town was sacked by Theodoric in 472 and, despite a large gift to him from the bishop of the city, again in 479. Herakleia was restored in the late 5th and early 6th c. and conquered by the Slavs in the late 6th c.

Excavations have revealed several sections of the fortification wall on the acropolis and two basilicas in the main part of the settlement below to the S. Both basilicas had well-preserved mosaics of the 5th to 6th c. B.C., depicting geometric and figured motives. Test trenches, dug in the vicinity of the basilicas, revealed streets and parts of buildings of the 4th-5th c.

Part of the ancient theater on the slopes of the acropolis has been excavated, but work has been concentrated in the larger of the two basilicas found earlier and in the area to its W and S. The smaller basilica and a small baptistery have been partially restored as well as some sections of the earlier buildings.

Mosaics were found in numerous buildings near the large basilica but the most interesting of the new mosaics, remarkable for its size and arrangement, was found in the narthex of the large basilica. It is a rectangle (over 21 x 4.7 m) with a broad rectangular border containing 36 octagonal panels in which fish and water birds are depicted; the panels are linked by intricate meanders. The mosaic dates to the late 5th-early 6th c.

There is a small museum at the site and a large museum in Bitola.

BIBLIOGRAPHY. F. Papazoglu et al., *Héraclée I* (1961); *Heraklea II* (1965); G. Tomašević & M. Medić, *Heraklea III: The Mosaic in the Large Basilica* (1967); Tomašević & Tome Janakijevski, *Herakleja Linkestis* (1973).

J. WISEMAN

HERAKLEIA MINOA Sicily. Map 17B.

The remains of the ancient city on the S coast of Sicily, between Agrigento and Selinus, on the plateau dominating Capo Bianco, at the mouth of the river Platani (fl. Halykos). Minoa is the earlier component in the city's double name; the name Herakleia was probably added in the second half of the 4th c. B.C. when the city appears to have been repopulated by colonists from Kephaloidion (Cefalù). Ancient authors connected the name Minoa with Minos, and this name may go back to an Early Minoan settlement, of which however no archaeological evidence has as yet been found. During the second half of the 6th c. B.C. Minoa was violently disputed between Selinus, of which it formed the E outpost, and Akragas, which wanted to invade the valley of the Platani river. The city was also briefly occupied by Spartan exiles who took part in the abortive expedition of Dorieus to Sicily (Herod. 5.46). During the whole of the 5th c. B.C. Minoa remained under Akragan control. After 406 B.C. and until the Roman conquest at the end of the second Punic war (210 B.C.) Minoa was under Carthaginian domination, with the exception of brief and sporadic periods of freedom between Timoleon's time and Pyrrhos' expedition (339-277 B.C.). After becoming civitas decumana, the city was destroyed during the first Servile war and was recolonized by the consul Rupilius. It also suffered from Verres' abuses and was visited by Cicero (*Verr.* 5.112. 129). At the end of the 1st c. B.C. the city seems to have been completely abandoned.

Excavations have not yet revealed positive traces of the archaic city, which must have occupied the E part of the plateau. However a necropolis of the second half of the 6th c. B.C. has been partially brought to light near the mouth of the Platani river. The present remains belong to the Hellenistic-Roman period. The fortification wall has been cleared along the N limit of the city. It is built of chalky stone with sun-dried brick superstructures and is reinforced by square towers with gates and posterns. The most imposing stretch is seen where a powerful wall of masonry and mud brick extends be-

tween a square bastion and a round tower that was probably added during the 3d c. B.C. Here the fortifications stop at the edge of the great landslide into the sea which, through the centuries, has eroded a great part of the town. A second fortification wall was rebuilt twice and lies now in the interior of the city, near the theater and along the houses. It represents a narrowing of the urban area during the Punic and Servile wars.

The theater, recently cleared and protected with plastic material, dates from the end of the 4th c. B.C. Its cavea is oriented to the S and divided into nine sectors (kerkides); it retains ten rows of seats in friable marly stone. Both the orchestra and the strong retaining walls of the cavea (analemmata) are well preserved. Nothing remains of the stage building except the holes for a wooden platform; some Roman buildings were erected against the orchestra. The foundations of a temple and a shrine have been excavated to the N of the theater. To the S excavations have uncovered parts of the Roman habitation quarter during the Republican period, in two superimposed layers. The upper stratum must be connected with Rupilius' recolonization. The lower level (3d-2d c. B.C.) retains two particularly notable and well-preserved houses on parallel streets, with square plan and rooms gathered around a central atrium. One of the houses had two stories; its high mud brick walls and *cocciopesto* floors are well preserved. The second house still retains its lararium with altar and walls painted in incrustation style (First Pompeian Style).

A small antiquarium in the archaeological area houses part of the excavation finds and attempts to reconstruct and illustrate the various phases of the city's life. The remainder of the archaeological material from the site is displayed in the National Museum of Agrigento.

BIBLIOGRAPHY. B. Pace, *Arte e artisti della Sicilia antica* (1917) 25ff, with previous bibliography; G. Caputo, *Dioniso* (1930) 86ff; id., *La parola del passato* (1957) 439ff; P. Griffo, *Bilancio di cinque anni di scavi nelle province di Agrigento e Caltanissetta* (1954) 14ff; G. Schmiedt, *Kokalos* 3 (1957) 25ff; id., *X Congress of International Society of Photogrammetry* (1964) 16; E. De Miro, *NSc* (1955) 262ff; (1958) 232ff; id., *Kokalos* 4 (1958) 69; 8 (1962) 144; id., *L'antiquarium e la zona archeologica di Eraclea Minoa* (1965—Its. Poligrafico dello Stato). P. ORLANDINI

HERAKLEIA TRACHINIA Central Greece. Map 11. A city situated at the beginning of the Malian plain on the gulf of the same name and on the road from Brallo to Lamia, slightly W of the gorge of the Asopos, S of Lamia.

Founded in 426 B.C. by the Spartans as a strategic post on the Pass of Thermopylai (Thuc. 3.92), Herakleia dominated the low valley of the Spercheios, replacing ancient Trachis where Herakles had taken refuge in exile. It was named after the Dorian hero. Its neighbors (Boiotia) contended with Sparta for the city, which thereafter was attacked and razed by Jason of Pherai in 371 (Xen. *Hell.* 6.4.27; Diod. 15.57.2). It joined the Delphic Amphictyony, then the Aitolian League, aiding Antiochos in his struggle against Acilius Glabrio.

The site is established by *IG* IX.2.1 and by Vardates' manumission. It lay in the plain between the ravines of the Asopos and Skliphomeli, where sections of the rampart have been found and even 10 isodomic courses of a wall. Inside it is a 55 m stretch of aqueduct; the gymnasium (Liv. 36.22) apparently was situated near the road to Brallo. Neither the tomb of Deianira (Paus. 2.23.5) nor the Sanctuary of Artemis (Liv. 36.22) has been located. Both sides of Skliphomeli are hollowed out in many places, the cavities serving as rock tombs.

BIBLIOGRAPHY. F. Stählin, *Das hellenische Thessalien* (1924, repr. 1967) 207[P]; Y. Béquignon, *La Vallée du Spercheios* (1937) 243-60[MPI]; G. Daux, *BCH* 58 (1934) 156-67; W. K. Pritchett, *Ancient Greek Topography* (1965) I 81-82. Y. BÉQUIGNON

HERAKLEION (Iraklion) Temenos district, Crete. Map 11. A small city on N coast of Crete. The city is barely mentioned by ancient sources other than geographers. Together with and eventually superseding Amnisos, it served as the port of Knossos which lay 5 km inland (Strab. 10.4.7; 10.5.1; cf. Ptol. 3.15.3; *Stad.* 348-49). The location of ancient Herakleion has been much debated, but Platon has solved the main problem which lay in a reference in Pliny (*HN* 4.12.59): the name Matium results from a misunderstanding by Pliny, and ancient Herakleion does lie under modern Iraklion, once called Candia.

Slight epigraphic evidence shows that the city was a satellite of Knossos in the Hellenistic period. No coins are certainly known.

At Katsaba in E Iraklion by the mouth of the Katsaba (ancient Kairatos), which flows past Knossos, are Neolithic remains and a considerable Minoan site. The later city seems to have been under the modern city center, but little is known of its plan: scattered remains, mainly of tombs, have been found of the Geometric period to 7th c. A.D.

BIBLIOGRAPHY. R. Pashley, *Travels in Crete* I (1837; repr. 1970) 189-90; T.A.B. Spratt, *Travels and Researches in Crete* I (1865) 27ff, 66f; L. Mariani, *MonAnt* 6 (1895) 218-22[M]; Bürchner, "Herakleion (1)," *RE* VIII (1913) 499; M. Guarducci, *Historia* 7 (1933) 370-73; N. Platon, *KretChron* 1 (1947) 14-21; 5 (1951) 386-87; St. Alexiou, *Praktika* (1955) 311-20; id., *Isterominoikoi taphoi limenos Knosou (Katsaba)* (1967); S. G. Spanakis, *Crete* I (n.d.) 117ff[M]; *Deltion* 20 (1965) *Chronika* 3, 562; 21 (1966) *Chronika* 2, 408-9; 24 (1969) *Chronika* 2, 418-20. D. J. BLACKMAN

HERAT, see ALEXANDRIAN FOUNDATIONS, 2

HERBITA, see TROINA

HERCULANEUM (Ercolano, formerly Resina) Italy. Map 17A. The ancient city, buried by the eruption of Vesuvius in A.D. 79, lies a short distance from the sea, not far from Neapolis (Naples) and from Pompeii. The earliest ancient writer to mention the city is Theophrastos (6th c. B.C.).

The Roman historian Sisenna in the 1st c. B.C. described Herculaneum as an inhabited center located in an elevated position near the sea between two watercourses. Archaeological excavation substantially confirms the description, even though the site underwent several transformations during the eruption of A.D. 79.

Legend says that the city was founded by Herakles, and it is probable that the origins of Herculaneum go back to the remote past. According to Strabo the city was inhabited by Oscans, Tyrrhenians, and Pelasgians. We may presume that in the archaic and Classical ages the city, like nearby Pompeii, greatly increased in population owing to an influx both from the Greek colonies in the area, especially from Cumae, and from Etruscan Capua. Toward the end of the 5th c. B.C. when Campania was occupied by the Samnites, Herculaneum also became Samnite and afterwards was probably involved in the wars between the Samnites and the Romans. Later the city participated in the social war. It was conquered by T. Didius, legate of Sulla, and in 89 B.C. became a Roman municipium. Herculaneum suffered serious dam-

age in the earthquake of A.D. 62; and soon thereafter, like Pompeii, Stabiae, and Oplontis, was a victim of the Vesuvian eruption of A.D. 79. It is still not known whether Christianity spread to Herculaneum: a mark on the wall plaster in the Casa del Bicentenaio has sometimes been interpreted as the outline of a Christian cross.

The eruption of Vesuvius inundated the city with a torrent of mud, which covered it completely and solidified into a compact layer with a consistency similar to that of tufa. The average ground level was raised by ca. 15 m. While the buildings were badly damaged, organic material, especially wood, was preserved so that the excavations at Herculaneum are unique in this respect.

Casual discoveries that served to fix the site of the ancient city were made at the beginning of the 18th c., after which more or less systematic excavation began. In the first phase of research ancient Herculaneum was explored by means of digging wells and underground tunnels and carrying to the surface paintings, mosaics, sculpture, and various other objects that were collected in a Herculanean Museum prepared in the royal palace in nearby Portici. At the same time, the excavators succeeded in delineating the plan of the city and of its principal buildings. The discoveries aroused intense interest for their exceptional historic, antiquarian, and artistic value.

In the following century the research was resumed, adopting more up-to-date and scientific criteria. With an open excavation and with the attentive recovery of all the buried elements, the excavations are continuing at present, employing methods always more modern and precise.

The approximate plan of Herculaneum is known from what has been brought to light, which is about a quarter of the urban area, and from the outlines traced by the excavators in the Bourbon age. The city, which must have been enclosed by walls for at least a part of its circumference, developed over an area of ca. 370 by 320 m and was regular in plan. Streets meet at right angles (decumani in an E-W direction and cardines leading N-S) forming insulae that contain one or more buildings. Usually the houses are entered from the cardines. In the last period of the city's life it developed further. On the S section of the enclosing wall, which by then was no longer functional or necessary after the peace established by Augustus, were built luxurious and panoramic houses. Outside the walls a sacred area was constructed, as well as a large bath. In addition, the countryside around the city must have become populated by suburban and rural villas. In one of these, the famous Villa of the Pisoni, was found a library and a collection of sculpture.

The center of the city's life is constituted by the decumanus maximus, a wide street closed to vehicular traffic, from which there is access to many public buildings. Thus it appears that the decumanus had the function that in other cities is usually served by a forum. On the N side of the decumanus rose a large public building, probably the basilica, which is known only through the accounts and drawings made at the time of the Bourbon excavations. Several remains of its pictorial decoration are in the National Museum in Naples.

Recent excavations have revealed that in front of this building extended a portico faced with marble and with stucco. At the extremities of the portico arose two four-sided arches with decorations in stucco and honorific bronze statues, of which there remain the bases, and traces of the statues themselves. In the part excavated to the N of the decumanus there extends another portico with shops and with at least two upper stories. To the E of the street is a palaestra, with rooms on several levels and with a large peristyle, at the center of which is a large pool. The pool was fed by a bronze fountain that represents the Lernaian Hydra twisted around the trunk of a tree, evidently an allusion to Herakles, and thus to the name of the city. To the S of the decumanus is a chapel dedicated to Herakles, which perhaps also fulfilled the functions of the seat of civic administration; and another monumental building of unknown use, only partly excavated.

The theater is in the NW sector of the inhabited area. Beside it were other public buildings. Along the decumanus inferior are the baths, of the usual type, with separate sections for men and women. Outside the S wall of the city is a sacred area and another large bath that is notable for the development of its plan and for its decorations in stucco and marble. Here the division into two sections does not exist; the building seems to date to the last years of the city.

The private dwellings of Herculaneum vary widely in plan. There is a rare example of a house containing small rental apartments, each independent and with a small central courtyard. The Casa del bel cortile has a central courtyard from which a flight of steps leads to the upper stories.

There are notable examples of houses built around an atrium, Italic in type, several of which go back to relatively ancient times. They include the Casa sannitica with beautiful decoration in the first style, the Casa del tramezzo di legno and the Casa di Neptuno and the Casa di Anfitrite. Other houses recall the Italic scheme but are amplified in plan. The villas built along the S edge of the city are distinctive in plan. In these houses the traditional plan is modified. An axial arrangement is abandoned, and while the typical rooms such as the atrium are oriented by the fact of their facing the cardines; the peristyles, the gardens, the salons and the other annexes are oriented toward the S, in such a way as to exploit the panoramic position of the site with its view toward the sea. To the houses are annexed the shops, which reveal the various aspects of everyday life of Herculaneum and of its socio-economic environment. Worthy of mention is a shop on the cardo IV, where is preserved the wooden counter with the amphorae of the wine merchant in position on it, and the large containers of cereal grains. Also preserved are some shops on the decumanus maximus, one of which has a painted sign, and another of which must have belonged to a metal worker. In another shop on the decumanus maximus has been found a group of glass objects still enclosed in their wrappings. Very often the front of the insulae was preceded by a portico, and the houses reveal in many cases the presence of one or even two upper stories. It is not easy to calculate the population of Herculaneum, but possibly it had ca. 5000 inhabitants.

A short distance from the city is the grandiose and celebrated Villa dei Papiri (or dei Pisoni). Constructed in the middle of the 1st c. B.C., it was undergoing renovation at the time of the catastrophe in A.D. 79. The villa belonged, according to many scholars, to L. Calpurnius Piso Caesoninus, the father-in-law of Julius Caesar and a politician and patron of the arts. In the villa was found a remarkable library, largely of Epicurean philosophy that appears to be the work of the philosopher Philodemos; and a notable collection of sculpture that constitutes the only surviving example of a private collection in antiquity. It contains works in marble and in bronze in the Hellenistic and neoclassical manner, and a series of portraits of philosophers, Hellenistic princes, and orators.

In public buildings and houses numerous sculpted works have also been found, for the most part portraits of emperors and of citizens of Herculaneum, and even an Egyptian statue. Painting in Herculaneum is in the Pompeian style but often more finely executed and more tastefully composed. Excellent taste is also shown in domestic furnishings such as vessels of bronze or terracotta, votive statuettes, lamps, etc.

The works of art and the furnishings found at Herculaneum were collected in the Herculanean Museum at Portici and then transported to Naples at the end of the 18th c. when the great National Museum was created. A few pieces found their way abroad during the Bourbon period. A large proportion of the wall paintings and some examples of domestic furnishings are preserved in situ.

BIBLIOGRAPHY. C. Waldstein & L. Shoobridge, *Herculaneum Past, Present, and Future* (1908; A. Cippico, 1910); E. R. Backer, *Buried Herculaneum* (1908); *RE* 8 (Gall) 532-42; A. Maiuri, *Ercolano* (1932); id., "Nuovi studi e richerche intorno al seppellimento di Ercolano," *RendAccIt* 7, 2 (1940); id., *I nuovi Scavi di Ercolano*, I (1958); A. W. van Buren, *A Companion to the Study of Pompeii and Herculaneum* (1938, 2d ed.) with bibliography; D. Mustilli, "La Villa pseudourbana ercolanese," *RendNap* (1957)　　　A. DE FRANCISCIS

HERCULIA, *see* GORSIUM

HERDONIA (Ordona) Italy. Map 14. Some 25 km S of Foggia above the Apulian plain on the S bank of the river Carappelle. The Roman city has the form of an elongated lozenge (730 x 300 m). It stood on the site of a much larger native settlement which included necropoleis and dwellings.

Although the name of the town is perhaps to be found on 5th and 4th c. coins, it appears in literary sources only in the 3d c. in the accounts given by ancient authors of the events of the Punic wars in S Italy. In 214 and 212 the Roman army was beaten there by Hannibal, who burned the city and deported the population in 210. Herdonia appears to have received the title of municipium under the Republic. Strabo describes it as a way station on the road from Brindisi to Benevento (*Geog.* 6.3.7). Pliny mentions it, but for Silius Italicus it is only a poor, abandoned spot (8.567). Included in the II Augustan region, the city underwent a remarkable renaissance in the 1st c. A.D. when it became an important crossroads on the Via Traiana. In this capacity it is mentioned in the majority of the itineraries. In the 5th c., it appears to have been an episcopal see. The mediaeval town, a pale reflection of the ancient one, lived meagerly on one of the hills of its predecessor. The townspeople buried their dead in a series of chapels set up in the ancient buildings. On the acropolis was erected a fine early church, which was soon transformed into a fortress. Coins and ceramics show that the site was occupied until the 17th c.

Among archaeologists, Ordona is known principally for its rich necropoleis, which have furnished artifacts illustrating the native civilizations of Apulia, particularly that of Daunia. The first official explorations were made there in 1872, followed by others in 1902. The Roman city was touched for the first time in 1954-1955, and in 1962 systematic study of the site was undertaken. This recent work has led to the complete excavation of the public buildings of the city center, as well as a detailed study of the city wall and the examination of a part of the necropolis.

It is now clear that towards the beginning of the 3d c.

B.C. a sector of the native settlement was surrounded by a wall composed of an earthen rampart almost 13 m thick reinforced by a wall of sun-dried bricks. This rampart was restored on many occasions with the addition of towers and bastions. At the beginning of the 1st c. B.C., under the threat of the civil wars, Herdonia was surrounded by a new wall of more solid construction. The old wall of sun-dried bricks was enclosed in fine facings of opus incertum masonry. At the beginning of our era, the rampart was dismantled, and an amphitheater erected in the moat. Inside the city, the first attempts at city planning took place from the end of the 2d c. B.C. A temple of Italic tradition was built in the artisan sector, which was destined to become the monumental center of the city. During the reign of Augustus a magnificent basilica (41 x 27 m) was erected. The laying out of the forum (59 x 35 m) necessitated considerable terracing. Along a vast esplanade stood shops, a cryptoporticus, and a market. During the 1st c. A.D., the aediles of Herdonia were extremely active: the original shops were replaced, a second temple built across from the basilica. The Via Traiana was flagged for the whole of its length within the city. This flowering was short-lived. From the 3d c. on, many of the public buildings were abandoned or transformed. Small Christian chapels appeared in the ancient edifices; the population concentrated increasingly in the N sector of the town, at the farthest extremity of which a great Christian basilica with three naves was soon to be built. Two noteworthy coin hoards have been found: the first, dating from the 5th c., shows that the center of the town continued to be occupied under the Late Empire. The second, from the end of the 10th c., is composed of gold coins struck in imitation of Arab money, and is a valuable contribution to knowledge of numismatics of early mediaeval Italy.

Although the most recent excavations have centered in the Roman city, they have furnished important information on the native pre-Roman settlement, such as the fact that the tombs and the dwellings were mingled together indiscriminately with no separation of city of the dead from that of the living. In the tombs, the deceased was placed in a squatting position, surrounded by rich grave goods.

The excavations have furnished a particularly rich and varied quantity of artifacts: coins, lamps, sculptures, inscriptions, ceramics. Among the latter should be noted the local pottery, with its polychrome geometric decoration. It is an important contribution to our knowledge of the native Italic civilizations of S Italy.

BIBLIOGRAPHY. A. Chieffo, *Herdoniae* (1948); *EAA* 5 (1963) 725-26 (N. Degrassi); J. Mertens, *Ordona* I. Rapport provisoire sur les travaux de la mission belge en 1962-64 (Etudes de philologie, d'archéologie et d'histoire anciennes publiées par l'Institut historique belge de Rome VIII, 1965); id., *Ordona* II (Etudes IX, 1967); id., *Ordona* III (Etudes XIV, 1971); *Herdonia. Chantier archeologique belge en Italie* (1969); G. Alvisi, *La viabilità romana della Daunia* (Società patria per la Puglia. Doc. et Monografie XXXVI, 1970); M. D. Marin, *Topografia storica della Daunia antica* (Civiltà della Daunia I, 1970) 31-137. For a study of the lamps and coins, see *Ordona* IV (1973).　　　J. MERTENS

HERMIONE or Hermion Argolid, Greece. Map 11. It is found in the Argolic Akte between Troizene and Halieis. Its remote location tended to keep it out of the mainstream of Hellenic affairs, and Lasos is the only even minor notable to have originated there. Reputed to be one of the Dryopian cities of the Peloponnese (Hdt. 8.73.2), it was part of Diomedes' realm in heroic times

(*Il.* 2.560), and was a member of the Kalaurian amphictyony (Strab. 8.6.14). Hermione sent three ships to Salamis (Hdt. 8.43) and 300 men to Plataia (Hdt. 9.28.4). During the 5th c. Hermione was a member of the Peloponnesian League, and as a result had its territory plundered by the Athenians in 430 (Thuc. 2.56.5). It remained faithful to Sparta during the 4th c. (and perhaps later), but in 229 was forced to join the Achaian League by Aratos (Strab. 8.7.3). Little is known of Hermione later, though Plutarch (*Pomp.* 24) tells us that the Temple of Demeter Chthonia was plundered by pirates, and we know from Pausanias (2.34.9-35) that in his time the older part of the town was no longer inhabited.

The ancient city was located on a promontory separating two harbors, but by Pausanias' time had moved W, to approximately the location of the modern town, at the foot of a hill anciently called the Pron. Three stretches of the ancient circuit wall (late 5th c.) of polygonal masonry are preserved, the most easily visible being that on the Kranidi road on the right as one enters the town. The best preserved stretch extends ca. 19 m. Other walls, to be found on the seaward end of the promontory, prove that it was the only defended portion of the city, and that the higher Pron to the W was outside the ancient fortifications. On the promontory there is preserved the euthynteria course of a temple with polygonal joints, probably of the late 6th or early 5th c., and almost certainly to be identified with the Temple of Poseidon mentioned by Pausanias. The Temple of Athena, also mentioned by Pausanias, may have stood on a large conglomerate foundation about 50 m SE of the modern quay. Most of the other sanctuaries mentioned by Pausanias have now disappeared, but it is a highly reasonable assumption that that of Demeter Chthonia lay roughly in the area of the Church of Haghii Taxiarchi on the Pron where there is preserved, both in the church wall and across the street, a wall of ashlar masonry, possibly a peribolos wall. The E portion, preserved only in part, is ca. 10 m from the N portion which extends W at a height of two to three courses for ca. 20 m. Some 25 m N of the church and forming the N wall of the Koinotiko Grapheio, there is preserved to a height of ca. 3 m approximately 20 m of a wall of polygonal ashlar masonry. Another stretch has been reported, which would yield a total length of ca. 95 m. It has the appearance of a retaining wall and seems to be of late 4th c. date, but some scholars assign it a 5th-4th c. date, and connect it either with the Demeter sanctuary or with the Echo Colonnade. There are a number of Late Roman and Early Byzantine mosaics in the area of the municipal school, as well as a section of a Roman brick aqueduct to the N of the Pron. The Mycenaean settlement seems to have lain to the W, near the sea, on a small mound known as Magoula.

BIBLIOGRAPHY. A. Philadelpheus in *Praktika* (1909) 172-81; A. Frickenhaus and W. Müller, "Hermionis," *AthMitt* 36 (1911) 35-38[M]; *RE* 15 (1912) 835-41; V. B. & M. H. Jameson, "An Archaeological Survey of the Hermionid" (1950), unpublished paper deposited in the library of the American School of Classical Studies in Athens[MPI]; M. H. Jameson in *Hesperia* 22 (1953) 160-67 (on border of Hermionid); M. H. McAllister, "A Temple at Hermione," *Hesperia* 38 (1969) 169-73[PI], with an historical note (184-85) by M. H. Jameson.

W. F. WYATT, JR.

HERMONASSA Bosporus. Map 5. Ionian colony near Taman on the S shore of the Gulf of Taman. It is mentioned in the ancient sources (Eust. ad Dion, l. 549; Strab. 11.2.10; Plin. *HN* 6.18). Founded in the mid 6th c. B.C.,

it reached its zenith in the 4th-3d c. B.C. Many ancient buildings and streets have been uncovered, including a large dwelling of the 4th c. B.C. with an interior peristyle courtyard; remains of archaic structures; grain pits; and a hearth. There are also remains of buildings of the 1st-4th c. A.D., some along a paved street, and evidence of extensive replanning and construction in the 2d c. A.D.

The necropolis, which dates from the 6th-5th c. B.C., contains tumulus tombs. There is a fine marble sarcophagus from the beginning of the 3d c. B.C.; the lid is shaped like a pitched roof and has acroteria. The sides of the sarcophagus are decorated with a frieze of rosettes. The Hermitage and Kiev Museums contain material from the site.

BIBLIOGRAPHY. I. B. Zeest, "Raskopki Germonassy," *KSIIMK* 58 (1955) 114-21; id., "Raskopki Germonassy," *KSIIMK* 74 (1959) 58-63; id., "Arkhaicheskie sloi Germonassy," *KSIA* 83 (1961) 53-58; V. P. Gaidukevich, "Tamanskii nekropol' (raskopki 1931, 1938 i 1940 g.)," *Nekropoli Bosporskikh gorodov* [Materialy i issledovaniia po arkheologii SSSR, No. 69] (1959) 154-87; N. P. Sorokina, "Raskopki nekropolia Germonassy v 1956-1957 godakh," *KSIA* 83 (1961) 46-52; A. L. Mongait, *Archaeology in the USSR*, tr. M. W. Thompson (1961) 200-201; E. Belin de Ballu, *L'Histoire des Colonies grecques du Littoral nord de la Mer Noire* (1965) 129-31; I. B. Brašinskij, "Recherches soviétiques sur les monuments antiques des régions de la Mer Noire," *Eirene* 7 (1968) 109-10.

M. L. BERNHARD & Z. SZTETYŁŁO

HERMONTHIS (Armant) Egypt. Map 5. A city, noted by Strabo (17.1.47), ca. 25 km S of Thebes on the W bank of the Nile. Both the Greek and Arabic names refer to a vanished temple dedicated to the Egyptian god Mont, the falcon god of war. Its chief object of worship was, however, the bull Buchis. During the Graeco-Roman period, when the city was the capital of the Hermonithite nome, a great new temple was constructed from material taken from older temples. Here was the abode of the bull Buchis. Towards the end of the Ptolemaic period, Cleopatra built the Mammisi shrine in order to celebrate the birth of Caesarion. Building activity continued during the Roman period and the discovery of the Bucheum, the necropolis of the bulls, proves the continuity of the cult of Buchis down to the time of Diocletian. The necropolis of the mother cows, Baqaria, has also been discovered. During the Coptic period, the town was the center of a large administrative area and a seat of a bishopric.

BIBLIOGRAPHY. R. Mond, O. H. Myers, et al., *The Bucheum* (1934) 3 vols.; Mond, *Temples of Armant* (1940); K. Michalowski, *L'Art de l'Ancienne Égypte* (1968) 538-39.

S. SHENOUDA

HERMOPOLIS MAGNA (Ashmûnein) Egypt. Map 5. On the borderline between Upper and Middle Egypt, 6 km W of the left bank of the Nile, opposite Antinoöpolis. Pliny referred to it as the Town of Mercury (5.9.61). The site and ruins have been surrounded with three villages, of which one, El-Ashmûnein, has preserved the Egyptian name Shmunu meaning the four couples personifying the pre-Creation elements of the Universe. These, according to the Hermopolitan school of religion, were conquered, in a very remote period, by Thoth, identified with Hermes. Thus the city dedicated to Thoth was called Hermopolis. While it must have guarded its importance as a religious center during the Ptolemaic period and still more in the 3d c. A.D. with the rise of Neoplatonism in Alexandria when Thoth or Hermes was termed Trismagistus (thrice great), it was certainly a very active center of Christianity. According to tradition, the Holy Family reached the end of its journey here.

There continued for some time to be a bishop here, but by the end of the 13th c., as the city declined, the seat of the bishop was moved elsewhere.

Most of its architectural remains were reused in the building of mosques. The 29 monolithic columns of red granite with their fine Corinthian capitals are almost all that is left of the basilica (A.D. 410-440) which covered an area of 1195 sq. m. The stylobate and the foundations of the basilica were built of reused blocks of stone from different periods. Most important among them are the remains of the Ptolemaic sanctuary. The inscription on the five blocks of its Doric architrave informs us that the statues, the temple, and other objects within the sacred enclosure and the portico, had been dedicated to Ptolemy III Euergetes and his wife, Berenike, by cavalry troops who were settled in Hermopolis. Some of the Corinthian capitals, now beneath the N side of the basilica, still retain their original color. Farther to the W are the bases of the marble columns of the portico of the temple dedicated to Alexander the Great and Philip Arrhidaeus. Underneath the foundation of the temple were found two colossal sandstone statues of the baboon with the cartouches bearing the name of Amenophis III. They are now erected in front of excavation headquarters. Another temple, in the Egyptian style and dedicated to Nero, lies a short distance to the E.

BIBLIOGRAPHY. G. Meautis, *Hermopolis-La-Grande* (1918); J. Schwartz, "Herméracles" *ASAE* 45 (1947) 37-50; 47 (1949) 233-47; G. Roeder, *Ein Jahrzehnt deutscher Ausgrabungen in einer ägyptischen Stadtruine* (1951); S. Gabra & E. Drioton, *Peinture à Hermopolis Ouest* (1954); A. El-Khachab, "Numismatica," *ASAE* 53,2 (1955) 251-78[I]; A. Badawy, "The Cemetery at Hermopolis West," *Archaeology* 11 (1958) 117-22; A.J.B. Wace, *Hermopolis Magna* (1959)[PI]; J. Leclant, "Fouilles et Travaux en Égypte, 1957-1960," *Orientalia* 30.1 (1961) 176-99; E. Brunner-Traut & V. Hell, *Aegypten* (1966) 509-16[P]; K. Michalowski, *Aegypten* (1968) 540ff.
S. SHENOUDA

HERODIUM (Jebel Fureidis) Jordan/Israel. Map 6. A town ca. 8 km SE of Bethlehem with a fortified acropolis, founded toward the end of the 1st c. B.C. by Herod the Great (Joseph. *BJ* 1.265, *AJ* 14.360; cf. Pliny *HN* 5.15.70). It was the capital of a toparchy; Herod was buried there in 4 B.C. (Joseph. *BJ* 1.673; *AJ* 17.199). It figured prominently in the first Romano-Jewish war (*BJ* 4.555, 7.163), and seems to have been Jewish headquarters in the winter of A.D. 132-33 during the second war. Later, Byzantine monks recorded their presence in the citadel by graffiti.

The rather elaborate town, which apparently was given over to the members of Herod's court, was built on a plain below and around the citadel. Josephus, in a fairly detailed description, twice declares the hill upon which the fortress was built to have been artificial (*BJ* 1.419-21; cf. *AJ* 15.323-25). Access was by a steep flight of rock-cut steps encased in marble, and water was brought from a considerable distance. The fortress was circular in plan, with stoutly built walls and four towers, one round and three semicircular. Recent Italian excavations within the walls tend to bear out Josephus' declarations of magnificence. There was an elaborate bath building more or less on the Roman model, with the usual divisions by functional rooms (apodyterium, frigidarium, etc.; these were all vaulted). A number of mosaic floors and mural paintings of geometric design have been uncovered, as well as an elaborate exedra and many graffiti. The citadel is the best-preserved Herodian construction in Palestine.

BIBLIOGRAPHY. V. Corbo, "L'Herodion de Gebel Fureidis," *Liber Annus Studii Biblici Fransciscani* 13 (1962-63, pub. 1963) 219-77[PI]; id., "Chronique archéologique," *RBibl* 71 (1964) 256-63[P]. W. L. MAC DONALD

HERONBRIDGE Cheshire, England. Map 24. A civil settlement on the left bank of the Dee a little over 2 km S of Deva. The Roman road (Watling Street) which crossed the site N-S was lined by buildings for a distance of at least 200 m. Occupation began in the late Flavian period with timber (or timber and stone) buildings which yielded evidence of corn-drying and bronzesmithing. Shortly after ca. A.D. 130 rebuilding in stone took place: structures of this period consist of strip buildings 9-12 m wide and over 30 m long, arranged in groups of three or four. In some cases occupation did not outlast the 2d c.; in others it is known to have continued into the 3d and 4th c.

The distance from the fortress suggests that the site was an extramural settlement dependent on the military base. The proximity of river to Roman road has also suggested the possibility that tiles and pottery coming downriver from the works depot at Holt could have been unloaded here. A stream running through the site was found to have been deepened and reveted with masonry. Initially identified as a dock, this was perhaps the leat for a water mill.

BIBLIOGRAPHY. W. J. Williams, "Watling Street at Heronbridge," "Roman Ditch at Heronbridge," "Bovium," *Journal Chester Arch. Soc.* 30 (1933); J. A. Petch, "Excavations at Heronbridge," ibid. 5-49; B. R. Hartley, "Excavations at Heronbridge, 1947-48," ibid. 39 (1952) 1-20; id. & K. F. Kaine, "Roman Dock and Buildings," ibid. 41 (1954) 15-38; F. H. Thompson, *Deva: Roman Chester* (1959); id., *Roman Cheshire* (1965). D. F. PETCH

HERRERA DE PISUERGA, *see* PISORACA

HIENHEIM, *see* LIMES RAETIAE

HIERAPETRA, *see* HIERAPYTNA

HIERAPOLIS (Pamukkale) Turkey. Map 7. Town in Phrygia, 18 km N-NE of Denizli. Founded during the Hellenistic period, probably by the Pergamene kings, and most likely by Eumenes II; the earliest inscription found there is a decree in honor of his mother Apollonis. The earliest coins, down to the time of Augustus, give the city's name as Hieropolis, which suggests that the site was previously occupied by a temple village. Stephanos Byzantios, although he quotes the name as Hierapolis, explains it by the many temples in the city. A derivation from Hiera or Hiero, wife of Telephos, has been suggested, but this idea was evidently not current in antiquity.

Hierapolis has virtually no history, apart from a series of earthquakes and visits from the emperors. The worst earthquake occurred under Nero in A.D. 60, and seems to have necessitated extensive rebuilding. Christianity was introduced early, and the apostle Philip ended his life at Hierapolis, where his martyrium has recently been rediscovered. Coinage extends from the 2d c. B.C. to the emperor Philip, though alliance coins continue a little later.

The white cliffs of Pamukkale (Cotton castle), like petrified cascades, have long been famous. They were and are being formed by heavily lime-charged streamlets issuing from a hot pool fed from the hill above. The city lies on the plateau above the cliffs, and stood in large part not on soil but on the calcareous mass deposited by the streams. Its cardinal feature is a straight street over

a mile long, running N-S through the center. At either end stood a monumental three-arched gateway flanked by round towers; that on the N is still well preserved, and is dated by its dedication to Domitian in A.D. 84-85. These gates stoood some 150 m outside the city wall, in which was a second, simpler gate. The wall itself surrounds the city except on the side of the cliffs; it is low and of indifferent masonry, no earlier than the Christian era. The original city was apparently protected only by its sanctity.

The great baths, close to the edge of the cliffs, stand almost to their original height. In front is an open courtyard flanked on each side by a chamber entered through a row of six pilasters; behind this is a complex of a dozen rooms, with arches up to 16 m in span, and an even larger central arch. Identification of the individual rooms is hindered by the stonelike floor deposited since antiquity. In many places the walls show the holes for fixing the marble veneer, and traces of stucco are visible on the arches. The hot pool, commonly called the sacred pool, has a temperature somewhat under blood heat. In it lie numerous ancient blocks and column drums. The streamlets issuing from it deposit their lime as they go, forming self-built channels 0.3 m or more wide which change their position from time to time. Along the N part of the main street they have formed walls up to 2 m high.

Up the slope E of the pool is the Temple of Apollo, newly excavated. In its present form it is no earlier than the 3d c. A.D., but it appears to have replaced an earlier building. The SW front, approached by a flight of steps, stands on a podium about 2 m high; the back part rests on a shelf of rock. It contains a pronaos and cella, and had a row of columns, probably six, on the front only.

Adjoining the temple on the SE is the Plutoneion, which constituted the city's chief claim to fame. It was described by Strabo (629-30) as an orifice in a ridge of the hillside, in front of which was a fenced enclosure filled with thick mist immediately fatal to any who entered except the eunuchs of Kybele. The Plutoneion was mentioned and described later by numerous ancient writers, in particular Dio Cassius (68.27), who observed that an auditorium had been erected around it, and Damascius ap. Photius (*Bibl.* 344f), who recorded a visit by a certain doctor Asclepiodotus about A.D. 500; he mentioned the hot stream inside the cavern and located it under the Temple of Apollo. There is, in fact, immediately below the sidewall of the temple in a shelf of the hillside, a roofed chamber 3 m square, at the back of which is a deep cleft in the rock filled with a fast-flowing stream of hot water heavily charged with a sharp-smelling gas. In front is a paved court, from which the gas emerges in several places through cracks in the floor. The mist mentioned by Strabo is not observable now. The gas was kept out of the temple itself by allowing it to escape through gaps left between the blocks of the sidewalls.

Just N of the temple is a large nymphaion, of familiar form, with a back wall and two wings enclosing a water basin, and a flight of steps in front. Five semicircular recesses in the walls are surmounted by rectangular niches; in the central niche is a pipe-hole. The walls were decorated with moldings, statues, and reliefs.

Higher up the slope to the E is the theater. This is large for the size of the city, reflecting the large numbers of visitors to the warm baths and the Plutoneion. The cavea, ca. 100 m wide, is well preserved, with some 50 rows of seats, one diazoma, a semicircular Royal Box, and a vomitorium on either side. The stage building is also standing in large part; it had three rows of columns one above another, and was adorned with statues and a Dionysiac frieze, but most of the decoration has fallen.

The stage itself was rather less than 4 m high. The orchestra, some 20 m in diameter and surrounded by a wall ca. 2 m high, is being cleared of the mass of fallen masonry. The building as a whole is of Graeco-Roman type, dating from the Roman period; some vestiges of an earlier Hellenistic theater may be observed in a hollow of the hill N of the city.

Farther up the hill to the NE is a rectangular walled reservoir, and beyond this again is the newly excavated and elaborate martyrium of St. Philip. This is a square building, approached from the SE by a broad flight of steps; it has an octagonal central chamber containing the semicircular synthronos; from this six other chambers open off, and round the exterior are rows of smaller chambers entered from the outside. The apostle's tomb has not been discovered. The building is supposed to have been used for commemorative services on the saint's feast day; it dates from the early 5th c. A.D.

The necropolis, containing well over 1000 tombs, has two main groups, one on the hillside beyond the city wall on the E, the other lining the street outside the city on the N. The earliest are of tumulus type, with a circular wall at the base, a cone of earth above surmounted by a phallos stone, and the burial chamber in the interior with its own door; some also have a door in the semicircular wall. There are some house tombs, but most of the tombs are simply sarcophagi, set in many cases on a solid substructure; there are also a few large built tombs. The tomb of Flavius Zeuxis stands W of the N monumental gate; the inscription records that Zeuxis had made 72 voyages round Cape Malea to Italy.

BIBLIOGRAPHY. R. Chandler, *Travels in Asia Minor* (1817; repr. 1971) 186-92; C. Fellows, *Asia Minor* (1839) 283-85; C. Humann et al., *Altertümer von Hierapolis* (1898)[MI]; excavation reports, *Annuario* (1961-); G. E. Bean, *Turkey beyond the Maeander* (1971) 232-46.

G. E. BEAN

HIERAPYTNA, later Hierapetra (Ierapetra) Greece. Map 11. City on the S coast of Crete, on the S side of the narrow isthmus which forms the shortest and easiest route across the island from the Gulf of Mirabello on the N coast. There is little evidence of prehistoric habitation. The city was a Doric Greek foundation, with probably a considerable Eteocretan element. Almost nothing is known of its early history. It was supposedly founded by Kyrbas; the name indicates a Rhodian link, as do two of its early names, Kyrba and Kamiros (Steph. Byz.). It struck coins from the 4th c. on. Much of our knowledge of its history is derived from inscriptions, mainly treaties showing its growing influence in the 3d c., and its pro-Macedonian policy at the end of the century. In the war of certain Cretan cities supported by Macedon against Rhodes and her allies (204-201), the powerful Hierapytnian fleet, which was probably active in piracy, attacked Kos and Kalymnos. After the war the city changed sides and made a treaty with Rhodes (201-200), indicating that Rhodes needed her support in suppressing piracy.

Between 145 and 140 Hierapytna expanded to the E, destroying the neighboring city of Praisos, and occupied its territory, including the Temple of Dictaean Zeus (at Palaikastro on the E coast). There followed a long boundary dispute and hostilities against Itanos; despite Roman mediation these were not settled until 112-111. During Metellus' conquest of Crete (68-67) Hierapytna was the last city to surrender (Dio 36.19.1ff). That the town prospered in the Imperial period is clear from the remains which once existed, the continuing inscriptions, and Servius' remark (on *Aen.* 3.106) that only Hierapytna and Knossos, of the 100 cities of Crete, survived in

his day. The latest inscription is a copy of Diocletian's price edict (301). The city was later a bishop's see; it was destroyed by the Saracens in 824 and probably rebuilt by them.

The main deities were Zeus, Hera, Athena (Polias and Oleria) and Apollo; Egyptian cults also flourished.

Travelers in the 15th-19th c. saw considerable remains: a 16th c. visitor reported two theaters, an amphitheater, baths, and an aqueduct. Today there are only a few remains of one theater and the amphitheater on the E side of the town, and a few scattered traces of other buildings. A number of tombs have been found in the necropoleis E and W of the city, but the city site has not been excavated. The harbor was an impressive construction, with an inner and an outer basin; the inner one is now marsh and the outer basin is mostly under the modern town. The final form of the harbor, particularly the outer basin with two curving moles of rubble and concrete, must date from the Imperial period. The harbor gave the city importance, but the site was low-lying and difficult to defend.

Larisa, Oleros, and Chryse island (now Gaidharonisi) were in the territory of Hierapytna. The site of Larisa is not certain, but it lay inland to the N; the likeliest candidates are Kedri, just N-NE, which has LM remains, and Kalamafka to the NW, with remains of MM to Byzantine date. The people of Larisa were transferred to Hierapytna in a synoecism. Oleros, probably to the N at Meseleri, E of Kalamafka, had a temple of Athena Oleria. By the Hellenistic period it belonged to Hierapytna, but it had once been independent, and perhaps had controlled the latter as its port.

On the coast to the W, near the modern Myrtos, are remains, including a Roman bath building, of a Graeco-Roman harbor town whose ancient name is not known. It seems to have been within the territory of Hierapytna in the Hellenistic period (see Myrtos).

BIBLIOGRAPHY. T.A.B. Spratt, *Travels and Researches in Crete* I (1865) 253-88[I]; L. Mariani, *MonAnt* 6 (1895) 319-21; Bürchner, "Hierapytna," *RE* VIII (1913) 1405-7; K. Lehmann-Hartleben, "Die antiken Hafenlagen des Mittelmeeres," *Klio* Beih. 14 (1923) 201-2[P]; M. Guarducci, *ICr* III (1942) 18-74, 131-33; E. Kirsten, "Oleros," *RE* XVII, 2 (1937) 2451-53; H. van Effenterre, *La Crète et le monde grec de Platon à Polybe* (1948); R. F. Willetts, *Aristocratic Society in Ancient Crete* (1955); id., *Cretan Cults and Festivals* (1962); S. Spanakis, *Crete: A Guide* I (n.d.) 269-70, 363-67[M]; S. Spyridakis, *Ptolemaic Itanos and Hellenistic Crete* (1970).

D. J. BLACKMAN

HIEROPOLIS CASTABALA Cilicia Campestris, Turkey. Map 6. About 24 km NE of Osmaniye in a valley about 3 km from N of River Ceyhan (Pyramus). First mentioned in literature as oppidum Castabalum at which Alexander the Great made a stage before the Battle of Issos, it was known from the period of Antiochos Epiphanes (175-64 B.C.) until the principate of Valerian (A.D. 253-60) either as Hieropolis on the Pyramos or as Hieropolis Castabala. In the 1st c. B.C., Hieropolis was the capital of a local dynasty that controlled the hinterland of the E plain of Cilicia. Its first ruler, Tarcondimotus, an inept politician, survived taking the side of Pompey against Caesar, only to die at Actium fighting for Antony against Octavian. Despite this second error of political judgment, the dynasty was temporarily restored though the city and its dependent territories seem to have been incorporated into the Empire before the death of Augustus. Hieropolis was also famed as a sanctuary of Artemis Perasia, and a number of honorific inscriptions have

been found at the site (Bodrum) or near it, at the village of Kazmacılar. In the later empire, the city was a Christian bishopric but fell to the Arabs in the 7th c. and was not reoccupied afterwards. As a fortified outpost, however, the acropolis may have survived until the destruction of the Kingdom of Little Armenia by the Mamelukes of Egypt towards the end of the 14th c.

The ruins of Hieropolis Castabala, identified in 1890, are extensive and well preserved. A colonnaded street (the cardo) may be traced for over 200 m, its level rising gradually from S to N. The Corinthian columns of red conglomerate are fitted, as they are at the neighboring sites of Anazarbos, Soli-Pompeiopolis, and Uzuncaburç (Diocaesarea?), with brackets to support sculpture. The decumanus, however, is marked now only by a series of inscribed plinths for imperial statuary and has apparently no colonnade. The stone-built and largely freestanding theater faces W, and the vomitoria and seating are still generally well preserved, but the orchestra is rather deeply buried. Part of the scaena still stands, its frieze decorated with tragic and comic masks suspended from foliate swags. Farther up the valley are a brick and concrete bath building, and the foundations of a temenos with a rectangular marble structure (almost certainly the Temple of Artemis Perasia) within it. The downward slope of the wadi into the city is very abrupt, so that sustaining walls were built across it at intervals to prevent silt washing down in the rainy season into inhabited areas. Water was obviously rather scarce, however, and plaster-lined concrete reservoirs were built in the lower city as well as on the acropolis.

From the early bishopric of Hieropolis two important churches survive, of which the one to the S is specially well preserved. Like its N neighbor, it is probably of 5th c. date. It is a three-aisled basilica with its external polygonal apse flanked, in the Syrian manner, by a chamber to either side of it. Ancient material, especially frieze blocks of apparently 3d c. inhabited scroll-work, are extensively reused in its construction. Outside the city ramparts is a large necropolis with ruined heroa and rock-cut tombs. The number of inscriptions, dating from the 1st c. B.C. until the 5th c. A.D. still remains to be properly recorded.

After the Islamic conquest of Cilicia only the acropolis was occupied, and it was still used as a stronghold and look-out post during the later and relatively short-lived periods of Byzantine and Armenian suzerainty. The site is now totally deserted.

BIBLIOGRAPHY. J. T. Bent, "A Journey in Eastern Cilicia," *JHS* 11 (1891) 234ff; A.H.M. Jones, *Cities of the Eastern Provinces* (2d ed. 1971) 202-5; P. Verzone, "Hieropolis Castabala, Tarso, Soli-Pompeiopolis, Kanytelleis," *Palladio* 1 (1957) 54-68. M. GOUGH

HIGH CROSS, *see* VENONAE

HIGH ROCHESTER, *see* BREMENIUM

HIGH WYCOMBE Buckinghamshire, England. Map 24. Roman villa in Great Penns Mead, discovered in 1723 and excavated in 1863, 1932, and 1954. It is now destroyed. The buildings consisted of a dwelling of double corridor type (31.2 x 21 m) and a detached bath house, 28.5 m long, to the E. These were set in a walled enclosure (at least 108 x 84 m); the gate, flanked by two rooms identified as a porter's lodge, was on the E side, just N of the bath house. A small building of uncertain use abutted on the outside of the enclosure wall farther S. Occupation commenced in the second half of the 2d c., and the baths were substantially modified in the early

4th c. Little change was made in the dwelling however, which contained two mosaic pavements, badly preserved but interesting as rare examples of 2d c. mosaic work in a villa.

BIBLIOGRAPHY. B. R. Hartley, *Records of Bucks* XVI (1953-60) 227-57; D. J. Smith in A.L.F. Rivet, ed., *The Roman Villa in Britain* (1969) 77-78. A.L.F. RIVET

HILDESHEIM (Niedersachsen) Germany. Map 20. A Late Hellenistic and Early Imperial silver treasure, found by chance in 1868 by soldiers setting up a rifle-range 0.5 km SE of Hildesheim at the foot of the Galgenberg. The treasure consists exclusively of silver tableware, mostly dishes and drinking vessels. These objects had been packed into a pit (ca. 1.2 x 0.9 m at the top and ca. 2.5 m deep), the smaller vessels hidden inside the larger ones. Later investigations have made almost certain that this was not a grave hoard but hidden treasure.

There is nothing now to be seen at this place, which lies ca. 250 km as the crow flies from the Roman Rhine border, in a district of Germania Libera which remained outside Roman domination except during the Roman offensive war E of the Rhine (11 B.C.-A.D. 16). Considering the geographical location of the find spot, it is tempting to connect the treasure with these offensive wars and to view it as originally the property either of P. Quinctilius Varus, killed in A.D. 9, or of Germanicus, who campaigned there in A.D. 14-16. More recent investigations have shown, however, that the latest pieces of the treasure were produced ca. mid 1st c. A.D. Concerning the assembling of the various pieces of the treasure and the occasion for their burial, nothing is known. The treasure is now in the Staatliche Museen, Stiftung Preussischer Kulturbesitz, in West Berlin.

BIBLIOGRAPHY. E. Pernice & F. Winter, *Der Hildesheimer Silberfund* (1901)[MI]; W. John, "P. Quinctilius Varus, VI: Der Hildesheimer Silberfund," *RE* XXIV (1963) 965ff; D. E. Strong, *Greek and Roman Gold and Silver Plate* (1966); U. Gehrig, *Hildesheimer Silberfund* (1967) (= Bilderhefte der Staatlichen Museen Berlin, 4)[I]; K. Lindemann, *Der Hildesheimer Silberfund—Varus und Germanicus* (1967); R. Nierhaus, "Der Silberschatz von Hildesheim. Seine Zusammensetzung und der Zeitpunkt seiner Vergrabung," *Die Kunde* NF 20 (1969).
 R. NIERHAUS

HIMARĖ, see CEMARA

HIMERA Sicily. Map 17B. A colony founded in 648 B.C. on the N shore of the island (Ptol. 3.4.3) by the Myletidai (perhaps Syracusan refugees, guests of the people of Zankle) by the Chalkidians of Zankle and of Mylai, and by an ethnic group probably originating from Euboia (Thuc. 6.5.1; Diod. 13.62.4; Strab. 6.272). The leaders were Euclid, Simon, and Sakon. The Ionic-Chalkidian culture of Himera, mixed with Doric elements, was subverted in 476 B.C. by Theron of Akragas who, to avenge his son Thrasideos, exterminated the Ionic inhabitants of the city and replaced them with Doric colonists (Herod. 7.165ff; Thuc. 7.58.2-3; Pind. *Ol.* 12; Diod. 11.48.6-8 and 49.3-4). In 480 B.C. Himera was the site of the famous battle between a league of Sicilian Greeks and the Carthaginians who, having been utterly defeated on that occasion (Herod. 7.165-67; Diod. 11.20ff and 13.62.1-4), returned to attack the Doric cities of Sicily in 409 B.C. Himera was razed to the ground and abandoned (Diod. 11.49.4; 13.62.4-5; 13.79.7-8 and 114.1), and Graeco-Carthaginian political interests to the West with the foundation of Thermai Himeraiai (Thermae Himerenses: Cic. *Verr.* 2.35.86).

In antiquity the city and its territory occupied a large portion of the coastal plain to the W of the river Grande (the N stretch of the ancient river Himera) and the two adjacent hills which dominate the plain to the S (cf. Thuc. 6.62.2 and 8.58.2; Herod. 7.165ff; Pind. *Ol.* 12.26-27). In 1929-30 a large Doric temple was excavated—the so-called Temple of Victory, which had been erected near the river, perhaps in commemoration of the victorious battle fought in 480 B.C. It is hexastyle peripteral (55.9 x 22.4 m) with 14 columns on the sides, rising on a four-stepped crepidoma, and having pronaos, naos, and opisthodomos; small stairways cut into the anta walls between naos and pronaos gave access to the roof; the splendid sima with lion-head water spouts (of which 56 units have been recovered) deriving from two different sculptural conceptions, was carved by several masters.

Uphill, on the Himera Plain, campaigns from 1963 to 1972 led to the identification of a sacred area with three temples, an altar, and traces of the temenos wall, some blocks of the ancient habitation quarters, three sections of a necropolis, and some stretches of the archaic city walls. The three temples are of pre-Doric type, without peristasis. An archaic shrine (15.7 x 6 m), which has yielded a rich votive deposit, was built in the decades immediately after the foundation of the colony. A new and more elaborate sacred building (30.7 x 10.6 m) incorporated within its structures the remains of the archaic shrine, undoubtedly for religious reasons. The long life of the new temple, from the middle of the 6th c. until 409 B.C., is attested by a very large number of terracotta reliefs (metopes, pediments, akroteria) and by numerous and diverse elements of architectural terracotta decoration. The third temple (14.3 x 7.1 m) is toward the N border of the sacred area. The monumental altar (13.1 x 5.6 m) lies to the E on the axis of the main temple. The urban system and the typology of the houses show that the city was planned as a whole and at one time (early 5th c. B.C.) on the Himera Plain, with full adherence to a single and strictly orthogonal system, to replace an older and irregular archaic plan. The necropolis contains inhumations in terracotta sarcophagi with grave goods dating from the second half of the 5th c. B.C. The finds from the early excavations are housed in the National Museum of Palermo and in the Civic Museum of Termini Imerese; those of the recent campaigns will be exhibited at Himera, in an antiquarium soon to be erected.

BIBLIOGRAPHY. L. Mauceri, "Cenni sulla topografia d'Imera e sugli avanzi del tempio di Buonfornello," *MonAnt* 18,2 (1908)[MPI]; P. Marconi, *Himera* (1931); A. Adriani et al., *Himera I*, excavation campaigns 1963-65 (1970)[MPI]; *Quaderno Imerese, Studi e Materiali* 1 (1972)[MPI]. N. BONACASA

HINTON ST. MARY Dorset, England. Map 24. Roman villa 1.6 km N of Sturminster Newton, discovered in 1963 and excavated in 1964-65. The buildings, apparently grouped around a courtyard, were in general badly preserved, but two adjacent 4th c. mosaics were recovered almost intact and are now in the British Museum. The smaller (4.95 x 2.4 m) shows Bellerophon slaying the Chimera, while the central roundel of the larger (5.1 x 4.35 m overall) is a representation of Christ, backed by the Chi-Rho monogram and flanked by pomegranates. This association of Bellerophon with Christian symbolism recurs at Lullingstone and probably at Frampton, Dorset. The pavements are the work of the Durnovarian school of mosaicists.

BIBLIOGRAPHY. K. S. Painter, *Proc. Dorset Nat. Hist. and Arch. Field Club* 85 (1964) 116-21; 87 (1966) 102-

3; mosaics: J.M.C. Toynbee, *JRS* 54 (1964) 1-14; D. J. Smith in A.L.F. Rivet, ed., *The Roman Villa in Britain* (1969) 86-88, 109-13; Christian aspects: J.M.C. Toynbee in M. W. Barley & R.P.C. Hanson, eds., *Christianity in Britain 300-700* (1968) 177-92.　　A.L.F. RIVET

HIPPONION later VIBO VALENTIA (until 1928 called Monteleone di Calabria) Italy. Map 14. A city of the toe of Italy dominating from the S the modern Tyrrhenian Golfo di S. Eufemio. As a colony of Lokroi Epizephyroi it had the name Hipponion, which may contain an element of an older name; at all events a connection with horses is hard to find. Its foundation date is uncertain; no very early material has been found, and it has even been suggested that it was founded as a consequence of the destruction of Sybaris in 510 B.C. But Medma, its sister colony, existed before the middle of the 6th c., and a late 7th c. date for both seems the most probable.

Hipponion revolted from its mother city in 422 (Thuc. 5.5); prior to this time owing to protection by the tyrants of Syracuse, it seems to have flourished (Ath. 12.542a). Being well developed and fortified, it now made a successful but short-lived bid for independence. A little later (388 B.C.) it took part with other cities of Italy in the battle of the Helleporus against Dionysios of Syracuse because Lokri had allied itself with him (Polyb. 1.6.2; Diod. 14.103-7). Following Dionysios' victory, Hipponion was destroyed and its citizenry moved to Syracuse, while its lands were given to Lokri (Diod. 14.107). In 379 the Carthaginians, being at war with Syracuse, helped the Hipponiates rebuild their city (Diod. 15.24). But the destruction of Dionysios' empire in 356 opened the way to the Bruttii, who moved down from the mountains to attack the Greek cities. Hipponion was one of the first to fall, sometime between 356 and 345 (Diod. 16.15). Thereafter the Bruttii held the place and seem, from the evidence of coins and inscriptions, to have thrived until the Romans sent a Latin colony there in 192 B.C. (Livy 34.53.1; 35.40.5-6). This was composed of 3700 infantry and 300 cavalry under the tresviri Q. Naevius, M. Minucius, and M. Furius Crassipes; each infantryman received 15 iugera of land, each cavalryman 30. The colony took the name Valentia, later Vibo Valentia, the first element possibly the Bruttian corruption of the name of Hipponion.

In its Romanized form the city was governed by quattuorviri, responsible to a senate. It coined its own money and prospered. After the social war it was inscribed in the tribus Aemilia. We hear of it from time to time in the civil wars, especially in connection with Octavian's war against Sextus Pompey when it was one of his most important bases of operations. Owing to the proximity of the great Sila forests, Vibo seems to have been a center of ship-building during the Empire as well as an important exporter of timber.

During excavations in 1916-17 and 1921, a stretch of the N front of the fortifications was laid bare for 225 m, and the foundations of two temples and a sanctuary were brought to light. The walls are of large squared blocks of calcareous sandstone laid in alternating courses of headers and stretchers, built solid in the curtains, an average of 2.8 m thick. They are interrupted at regular intervals of ca. 40 m by semicircular towers mounted on square bases, ca. 10 m on a side. One tower, at a point where the wall turns, is two-thirds of a circle, and one guarding a sally port virtually a full circle. In front of the walls was found a fossa 4.5 m wide, 3.25 m deep. Four periods of construction have been construed in what is preserved. The earliest, not earlier than the 4th c., is perhaps best ascribed to the time when Agathokles of Syracuse briefly seized the city back from the Bruttii in 294 B.C. (Diod. 21.8). The second wall, of rubblework imbedded in clay mortar with facings of rough stonework, has been ascribed to the Bruttii. The third, that with the semicircular towers and isodomic curtains, must then be the wall of the Latin colony of 192; its high sophistication will permit no earlier date. And the fourth, a repair or remodeling of the third, must then belong to the 1st c. B.C., the troubled times of the Roman revolution.

Substantial remains of two temples were found. The one on the height of the Belvedere (or Telegrafo), dominating the sea, was reduced to only a portion of its foundations, but the plan could be recovered. It was peripteral (37.45 x 20.5 m in over-all dimensions) with a shallow pronaos and a squarish adyton or opisthodomus. It seems to have been Doric with terracotta revetment of the roof, notably a lateral sima with lion's-head spouts. Votive material was scarce but ran from the archaic period to the Hellenistic.

The second temple, also peripteral (27.5 x 18.1 m in over-all dimensions) was found on the height known as Cofino. The cella was relatively short and can have been preceded by only a token pronaos. Fragments of the columns and their bases showed that it was Ionic, and this was confirmed by the style of the lateral sima in fine limestone. A 5th c. date for this has been proposed.

A third sacred building was discovered at Coltura del Castello on the presumed acropolis of the city, the substructions of a small temple together with a mass of figured terracottas; the presence of a large temple nearby was indicated by fragments of a colossal terracotta gorgoneion, 1.10 m in diameter.

Vibo was some distance from the sea and must have had its port at the site now known as Porto S. Venere, but little is known about it. At the site of Torre Galli, ca. 16 km W of Vibo, a necropolis has come to light that shows a native population in contact with the Greeks from the late 7th c. (Late Protocorinthian vases) and a gradually increasing hellenization down into the second half of the 6th c., when the graves stop. This makes an illuminating example of the influence Hipponion exerted and an interesting study in itself.

The Collezione Capialbi in Vibo was formed locally, and the majority of the material belongs to the site and its dependencies; the Collezione Cordopatri, also made chiefly at Vibo, is now in the Museo Nazionale at Reggio Calabria.

BIBLIOGRAPHY. P. Orsi, *NSc* (1921) 473-85; id., *MonAnt* 31 (1926) 5-212; G. Saeflund, *OpusArch* 1 (1935) 87-107; T. J. Dunbabin, *The Western Greeks* (1948) 163-70.　　L. RICHARDSON, JR.

HIPPO REGIUS (Annaba or Bône) Algeria. Map 18. First and foremost a seaport, this city of Proconsular Africa overlooks a deep, sheltered bay where from earliest times ships could put in. Confusion between Hippou Acra, its original name, and Hippo Zarytus (Bizerta) makes it difficult to interpret the oldest texts. Also, topographical study is complicated because alluvial deposits of the Seybouse, or Ubus, have changed the landscape. In 1935 the site of the Roman city was identified S of the Arab town, which was built nearer the cape, to the N, after Hippo was destroyed. The Roman and Early Christian city was excavated in part and at least some stages of its history revealed. However, nothing remains of the very earliest buildings of a town that has been described as "without doubt of Phoenician origin" (G. Camps).

The city that has been excavated lies in the plain between the vale of St. Augustine and the old coastline

and was apparently not inhabited until 200 B.C. Even the famous cyclopean walls, which were believed to be of Punic origin, go back only to about 40 B.C. Wherever they have been uncovered, the early strata reveal light structures of rough brick, while those monuments that have been preserved can generally be attributed to the Roman period. Nevertheless, one may assume that a town already existed there before the Romans came and that Roman builders followed the earlier plan, not modifying it until later, for example, when the forum was laid out. This was a huge rectangular area 76 m long, around which city blocks were laid out more or less at right angles. Built under Vespasian for the proconsul C. Paccius Africanus, this forum had been preceded by another: the base of a statue with the name of the emperor Claudius has been found there, also a magnificent bronze trophy 2.5 m high, which has been linked with Caesar's decisive victory that brought about the suicide, at Hippo, of Metellus Scipio and his ally Juba I (46 B.C.). An Ionic capital found in the curia, similar to those of the Tomb of the Christian, points to a similar date—the middle of the 1st c. B.C. Even if no Punic or Numidian remains have been preserved, the city as excavated has nevertheless stood for nine centuries: both its plan and its monuments seem to date from various periods and to have gone through many modifications.

As one goes from W to E, the first monument is the theater, built against the St. Augustine hill. Measuring 100 m in width, it is perhaps the largest in Africa. All that is left of it are the eight lowest tiers; the orchestra, surrounded by a deep drain; part of the very long (40 m) stage with its proscenium decorated with reliefs, and part of the platform, flanked with two wide parascenia.

Nearby is the forum, which can be dated from an inscription carved in the paving stones: the dedication of C. Paccius Africanus. The forum is 76 x 42 m (that of Timgad is 50 m long), not including the porticos that lined three sides. To the S, it gave onto a smaller courtyard of indeterminate purpose. Beside the open square stood a series of monuments: a little temple to the W, then three aligned pedestals, one of them rectangular, the second with concave sides and supporting four columns, while the third most probably held a statue. Three small, indeterminate monuments are on the N side. Inscriptions indicate other statues, now disappeared. Besides the bronze trophy, which belonged to the old forum, such fragments as the head of a member of Augustus' family and a very fine head of Vespasian give an idea of the quality of these statues.

On the two long sides were porticos, the columns of which have been partially recovered, and behind these a series of small rooms some of which no doubt were shops while others held religious statues. To the W, the first room to the N is thought to be the curia.

To the N of the forum, beyond the E corner, is a fountain where roads coming from the N forked before skirting the square. The entrance was on the E side at the end of a long, almost straight road from which transverse roads ran off to right and left marking off unequal, irregular blocks, the whole forming a rough checkerboard pattern. Beyond the first blocks, to the N, is the market. It consists of a courtyard 15.88 m square with stalls on all sides and in the middle the remains of a small, circular temple. Then it widens into another rectangular courtyard paved with mosaics. According to an inscription, this dates from the reign of Valens and Valentinian (364-67). The square courtyard, of earlier date, apparently goes back to the 1st c. A.D.

Immediately to the E of the market is a large, irregularly shaped block of buildings that measures about 100 m diagonally. This is the so-called Christian quarter; its chief monument, which fills half the E section, is in fact a large basilica with three naves.

The basilica is built on top of earlier monuments— a house decorated with mosaics, at the axis of the nave, and farther E a large cistern that, like the rest of the church, was later covered over with tombs. The oldest elements are some tub-shaped cisterns found deep down under the W wall; similar cisterns have been excavated at Constantine and Cherchel, in pre-Roman strata. The church has outlying buildings to the E. The baptistery has a number of rooms with mosaic floors in secular designs—muses, cherubs gathering grapes. Earlier, these rooms belonged to a peristyle house that was later made into an entrance to the basilica. A group of workshops were later added to the N section of the complex; they extended to the courtyard. The dates are uncertain. The basilica may possibly date from the end of the 4th c.

To the E, across the street, is a section of the city that seems to have been gradually retrieved from the sea. Its huge walls, mentioned above, with their drafted construction, were clearly designed to protect the buildings from storms. At the same time they served to strengthen the soil, which was damp and frequently flooded.

The oldest of these walls predate the 1st c. A.D. Beyond them were villas that have numerous layers of mosaic floors, suggesting successive invasions. In the last period these villas were joined along their facades by a long corridor. This very probably had a gallery looking out over the sea and gave unity to the ensemble.

Farther N and a little W, though still parallel to the sea, is a building incorrectly called "the basilica with five naves." It is a patio with concentric colonnades, erected over earlier buildings.

Continuing N, the street reaches the Platea Vetus. This marble-paved courtyard bears the remains of a temple dating from the early years of the 1st c. Behind the square rise the great N baths, still majestic. Apparently built in the Severan era, they held a number of religious statues and inscribed pedestals. The lower floors and the hydraulic and heating installations are well preserved.

Finally, an area S of the Gharf el Artran hill, where the museum is, has been partially excavated. Among the finds are a curious multi-storied house, built against the hill, and a huge platform showing the same impressive masonry technique as the great W walls. It bears an inscription to the Dii Consentes. Other baths—the S baths—have also been excavated. They closely resemble the great baths of Djemila. A dedication to Julia Domna has also been found here. Toward the W some more, smaller baths have been discovered. One hall is decorated with a large, beautiful mosaic showing a labyrinth with a bust of the Minotaur in the center.

A large surface area has been set aside for research and still remains to be excavated. But the discoveries made up to now are very significant. To these should be added the richness of the statues, mainly those of the baths and forum; the quality of the mosaics, which range from the 2d to the 5th c. A.D.; and the importance of the many inscriptions. Captured by the Vandals in 431, when its bishop Augustine had just died there, and laid waste by the Arabs, the city was used as a cemetery in mediaeval times. It is strewn with coffin tombs laid on the ancient floors. Fortunately, the site was not covered over by the modern town.

BIBLIOGRAPHY. A. Ravoisié, *Exploration scientifique de l'Algérie pendant les années 1840-42* (1846); A. Papier,

Lettres sur Hippone (1887); S. Gsell, *Monuments antiques de l'Algérie* (1901); *Atlas archéologique de l'Algérie* IX (1902); F. G. de Pachtère, "Les nouvelles fouilles d'Hippone," *MélRome* 31 (1911) 328; E. Marec, "Les nouvelles fouilles d'Hippone," *Bulletin de l'Académie d'Hippone* 36 (1925-30); *Hippone-la-Royale* (1954); *Monuments chrétiens d'Hippone* (1958); O. Perler, "L'eglise principale et les autres sanctuaires chrétiens d'Hippone la Royale d'après les textes de saint Augustin," *Revue des études augustiniennes* 1 (1955) 299; "La découverte des monuments chrétiens d'Hippone," *Rev. d'Hist. eccl. suisse* 54 (1960) 177; H. Masson, "La basilique chrétienne d'Hippone d'après les dernières fouilles," *Revue des études augustiniennes* 6 (1960) 109; *EAA* 2 (1959); J. P. Morel, "Céramiques d'Hippone," *Bulletin d'archéologie algérienne* 1 (1962-65) 107; "Recherches stratigraphiques à Hippone," ibid. III (1968) 35; see also *Bulletin de l'Académie d'Hippone*; *Libyca* 1 (1953) to 8 (1960) (articles by E. Marec and annual résumés). J. LASSUS

HISARBURNU, *see* AMOS

HISARÖNÜ, *see* BYBASSOS

HISPELLUM (Spello) Umbria, Italy. Map 16. A hill town on the Via Flaminia, made colonia Julia (*CIL* XI, 5278) probably under the triumvirate; it belonged to the tribus Lemonia. Augustus was fond of it and gave it the baths of the Clitumnus (Plin. *Ep.* 8.8.6). It throve under the Empire and probably received a further draft of colonists under Constantine, when it became colonia Flavia Constans with the privileges of a temple to the Gens Flavia and regional festivals (*CIL* XI, 5265).

Spello's glory is its walls, probably of a single build and early Augustan, despite differences in style and technique; they may be compared with the walls of Fanum Fortunae and Mevania. The core is concrete faced with small blocks of the local limestone with gates in larger ashlar. Three gates are well preserved, Porta Consolare and Porta Venere (triple archways, the latter flanked by dodecagonal towers) and Porta S. Ventura, a decorative single arch, simplified and set flush in the wall. The poorly preserved Arco di Augusto seems also to have been of this type.

Within the city are traces of the ancient terracing of the site, and in the plain below are remains of a large amphitheater (108 x 82 m). Antiquities from the site are kept in the Palazzo Comunale.

BIBLIOGRAPHY. A. L. Frothingham, *Roman Cities in Northern Italy and Dalmatia* (1910) 188-96; *JRS* 23 (1933) 163-64 (I. A. Richmond)[I]; *JdI* 57 (1942) 100-101 (H. Kähler)[P]; *EAA* 7 (1966) 438-39 (U. Ciotti); *AA* 85 (1970) 326 (H. Blanck). L. RICHARDSON, JR.

HISSARLIK, *see* TROY

HISTIAIA (Orei) Euboia, Greece. Map 11. The ancient site can be associated quite confidently with the prominent terraced hill (Kastro) situated at the very E limits of the modern village of Orei on the N coast of the island. In later antiquity the town came to be known more commonly as Oreos (e.g., Strab. 10.1.3), the name of an old deme in the neighborhood (probably Molos, a small headland located a few km to the W of Orei).

Histiaia was the most important Classical town in the region. Its importance was based not only on its strategic position overlooking the narrows leading to the North Euboian Gulf but on its control of the large and fertile coastal plain on which the city lay. Trial excavation and surface reconnaissance have demonstrated that the site

was already flourishing in the Bronze Age, and Homer (*Il.* 2.537) testifies to the fertility of the surrounding plain by describing it as "rich in vines." Surface finds suggest that it continued to be occupied during the Early Iron Age, probably by the Aiolic-speaking Ellopians or Perrhaibians who seem to have replaced the Homeric Abantes. In 480 B.C. the city and its environs were overrun by the Persians (Hdt. 8.23). After the Persian Wars it became a member of the Delian Confederacy, contributing the rather modest sum of 1/6 talent. In 446 the Euboians revolted and were promptly reduced by Athens (Thuc. 1.114.3); but Histiaia was treated more severely than the other Euboian cities. (Plut. *Per.* 23 attributes the severity of the punishment to the Histiaian seizure of an Athenian ship and the murder of its crew.) Perikles sent off the existing population of the city to Macedonia and replaced them with a cleruchy of 1000 (Diod. 12.22) or 2000 (Theopompos in Strab. 10.1.3) Athenians who may have temporarily settled at the old site of Oreos. In any event, the city was commonly referred to by that name thereafter. The exiled population probably returned home at the end of the Peloponnesian War in 404; thereafter they seem to have been largely under the control of Sparta until they joined the Second Athenian Confederacy in 376-375. Although the city appears to have become a member (for the first time) of the reconstituted league of Euboian cities in 340, its allegiance during most of the 4th c. seems to have vacillated between Athens and Macedonia. It was almost exclusively pro-Macedonian during the 3d c., as a result of which it was attacked in 208 and captured in 199 by a Roman-Pergamene force (Livy 28.6, 31.46). The Roman garrison was removed in 194, and—to judge from the wide distribution of its coinage—Histiaia-Oreos prospered during the first half of the 3d c. Thereafter little is known of its history, yet surface finds indicate that the site continued to be inhabited in Roman, Byzantine, and later times. Considerable remains of the later fortifications incorporating a number of Classical blocks can still be seen at Orei, while evidence of ancient harbor installations have been observed at Molos.

There has been little excavation at Orei. A small trial excavation produced Early Helladic pottery; a segment of a house wall, a small cist-grave and pottery, all probably of Middle Helladic date; and Late Helladic pottery. The foundations of a Late Byzantine church were also exposed at the S foot of the mound in 1954.

BIBLIOGRAPHY. F. Geyer, *Topographie und Geschichte der Insel Euböa* (1903); A. Georgiades, *Les Ports de la Grèce dans l'Antiquité* (1907)[P]; L. Pernier & B. Pace, "Ricognizioni archeologiche nell' Eubea settentrionale," *Annuario* 3 (1921)[M]; A. Philippson, *GL* I.2 (1951); W. Wallace, *The Euboean League and its Coinage* (1956); L. Robert, "Circulation des monnaies d'Histiée," *Hellenica* 11-12 (1960); L. Sackett et al., "Prehistoric Euboea: Contributions Toward a Survey," *BSA* 61 (1966)[M]. T. W. JACOBSEN

HISTRIA, *see* ISTROS

HOD HILL Stourpaine, Dorset, England. Map 24. A large Iron Age hill-fort and the well-preserved earthworks of a Roman fort of the conquest period 5.2 km NW of Blandford. A remarkable air photograph (1928) shows extensive remains of Iron Age huts and streets, except where destroyed by 19th c. ploughing, but extended cultivation during WW II destroyed much of these. The 3 ha still preserved have been mapped by the Royal Commission on Historical Monuments and selective excavations in 1951-58 have shown that from perhaps the 4th c. B.C. on the hill-fort had a long history of

development during which the defenses were elaborated. It was captured by the Romans ca. A.D. 44.

The interior contained at least 200 huts, some with attached yards outlined by banks. Some contained hoards of slingstones. Two huts appear to have been the object of concentrated fire from Roman catapults, which must have been mounted on a siege tower at least 15 m high, the position of which can be calculated. The Roman assault came before the strengthening of the defenses could be completed, and the absence of destruction at the gates suggests that the fort surrendered after bombardment. The inhabitants were evacuated. A Roman fort of ca. 2.8 ha was built in the NW corner, but was held for only 5-10 years. Equipment discovered in earlier ploughing and the plan of the internal timber buildings, recovered by excavation, both suggest that the garrison was a mixed force consisting of a cohort of legionaries supplemented by a detachment of seven turmae from an auxiliary cavalry regiment.

The fort is divided by viae principalis and praetoria. This plan and the absence of a via or porta decumana are features found at other Claudian forts; at Hod the plan is partly controlled by topography, there being no porta principalis sinistra for this reason, while the precipitous slope scarped by the Stour river would make useless a porta decumana in the normal position. Instead, a gate was built in the NW angle to facilitate the fetching of water from the river below. The principia, of simple plan, occupies the normal place; two praetoria were provided, one for the legionary centurion in charge, the other for the cavalry commander. Six barracks and three storage buildings in the rear range S of the principia are identifiable as the quarters of the legionaries. Stables lie to the N, while the troopers' barracks are found in the praetentura together with a hospital, cavalry praetorium, and a granary.

The Roman defenses on the S and E sides of the fort comprised a chalk rampart faced with turf and almost certainly laced with horizontal timber-framing; in front lay a Punic ditch system 27 m wide, designed as a firetrap. The porta praetoria was a double gate with projecting six-poster towers; the porta principalis sinistra was a single carriageway below a tower, as was the NW gate. A ballista platform flanked the two main gates, and the terrain shows that a range of ca. 180 m was anticipated. The approach to each causeway is broken by tituli, unusual at a fort; behind these the causeways themselves are subtly designed in a V-shape which is not immediately apparent, the purpose evidently being to disrupt a rush on the gates by causing many of the attackers to jostle each other into the accompanying side-ditches. No other site illustrates the skills of Roman military science in such illuminating detail.

BIBLIOGRAPHY. Crawford & Keiller, *Wessex from the Air* (1928) pl. I; I. A. Richmond, *Hod Hill* II (1968); Royal Commission on Historical Monuments, *Dorset* III, 2 (1971) 263MP. S. S. FRERE

HOFSTADE-LEZ-ALOST Belgium. Map 21. This vicus in the N part of the civitas Nerviorum was linked by secondary roads to Ganda, Velzeke, and Asse. The site was partly excavated from 1947 to 1951. It is located on a slight rise that dominates a brook, the Vondelbeek, which has its source 800 m away. In 1946 a trench was accidentally found which was filled with a large quantity of potsherds, pieces of glass goblets, a white terracotta statuette depicting the Spinario, and the sword of a Roman legionary. The collection can be precisely dated to the Flavian period. Following this discovery, the foundations of a small dwelling (ca. 21 x 22 m) were brought to light. The irregular plan recalls that of villas with the rooms that jut out at the corners linked by a portico. Sherds date this dwelling to A.D. 150-250. The remains of a small rustic sanctuary, excavated ca. 100 m distant, consisted of a plain square cella surrounded by a large temenos shaped like an irregular trapezoid. The fanum itself (6.8-7.1 m square), faces E, and it too can be dated ca. A.D. 150-250. Probably there was a link between the two buildings. Excavations proved that an older sanctuary had existed on the same spot. It was built about A.D. 60 and was destroyed by fire a little before 150. The 1946 find, reevaluated in this context, consisted of a favissa of the first sanctuary. After the fire, the burnt debris of this fanum was buried in large trenches, in order to avoid the use of the remains of this consecrated building for profane purposes. Besides architectural fragments bearing traces of the fire, one of these trenches produced some jewelry, sherds of small libation paterae, and a series of bronze and terracotta statuettes depicting Minerva, Venus, Kybele, and a Mater suckling twins. This group of divinities belongs to the Roman, Graeco-oriental, and native pantheons. They reflect the interpretatio romana, which identified with various Classical goddesses the great native divinity of fertility and springs. One may suppose that the brook passing near the sanctuary was dedicated to her. The excavations also led to the discovery of remains of several small buildings. These seem to have been shops where souvenirs of the sanctuary (statuettes, paterae, etc.) were sold to pilgrims.

BIBLIOGRAPHY. S. J. De Laet, "Romeinse oudhedengevondente Hofstade bij Aalst," *AntCl* 16 (1947) 287-306; id., "Opgravingen op de Steenberg te Hofstade bij Aalst," *Kultureel Jaarboek v. de Provincie Oostvlaanderen* 2 (1948) 141-64; id., "Un sanctuaire gallo-romain à Hofstade," *La Nouvelle Clio* 1-2 (1949-50) 231-37; id., "Een Gallo-Romeins heiligdom op de Steenberg te Hofstade bij Aalst," *Kultureel Jaarboek v. de Provincie Oostvlaanderen* 4 (1950) 269-314; id., "Le fanum de Hofstade-lez-Alost et le culte de la déesse gauloise de la fécondité," *Latomus* 11 (1952) 45-56MPI; M. Bauwens-Lesenne, *Bibliografisch repertorium der oudheidkundige vondsten in Oostvlaanderen* (1962) 89-92. S. J. DE LAET

HOMOLE, *see* HOMOLION

HOMOLION or Homole, Homolos Thessaly, Greece. Map 9. It was the city of Magnesia (and Hellas) farthest N, at the borders of Macedonia, situated on the slopes of Ossa where the Peneios emerges from the Tempe gorge (Strab. 9.443; Scylax 33; Steph. Byz. s.v. ὁμόλιον). It lay on a route to Thessaly from Macedonian Dium (Livy 42.38) and controlled both the E end of the Tempe pass and the N end of a more difficult route which led around the shoulder of Ossa, along the E coast of Magnesia, and back between Ossa and Pelion into the interior of Thessaly. It seems to have been one of the most important Magnesian cities in the 4th c. B.C. With the rest of Magnesia, it was made subject to Macedonia from 352 B.C. It lost importance when Demetrias was founded in 293 B.C., but continued to issue coinage in the 3d c. There are indications it was something of a center of resistance against the power of Demetrias, but it was apparently absorbed into that city in 117 B.C.

The scanty, rarely visited or described ruins of ancient Homolion lie on the slopes of Ossa just above the Peneios plain, by the modern town of Laspochori, which is just at the edge of the plain. Some of the city walls remain. The acropolis, a rocky ridge ca. 220 m above the plain, is surrounded by a circuit wall of small flat stones laid in more or less regular courses. From the acropolis the

remains of the city walls run down towards the plain, just inside and above two parallel ravines.

The N wall of the city lies a little above the plain. The remains of a cross wall can be seen dividing the lower city not far below the acropolis. Within the acropolis, under a chapel of Haghios Elias, the remains of a temple were excavated in 1911. It had probably been constructed of mudbrick and wood, and was perhaps elliptical, like the temple at Gonnos. There were fragments of archaic terracotta revetment, and some from a later (4th-3d c. B.C.) rebuilding, and some Hellenistic stamped tiles. The temple had apparently had two periboloi; SE of the outer one were the remains of another building. Here was found the right foot (sole ca. 1 m long) of a colossal terracotta statue, possibly of Zeus. The objects from the excavation are in the museum at Volo. By the W wall of the lower city are visible the cavea of the theater hollowed into the hill, and the remains of some other buildings (described in 1910). In the middle of the lower city is a cave with carvings by it. Outside the city to the E of the acropolis are some graves of the Geometric period, and other graves have been discovered in the area. Some Protogeometric and Classical graves have been excavated recently, and a tomb containing some very handsome 4th c. B.C. jewelry (finds in the Volo Museum).

Outside and to the N of the city walls the modern road from Laspochori to Tempe comes very close to the Peneios about one km W of Laspochori. Here (1911) are the remains of an ancient bridge and above it on a hill called Kokkinokoma, sherds and some marble slabs. On a hill called Dapi Rachi part of a wall of large stones, perhaps of the 4th c. B.C., was discovered in 1961. The territory of Homolion seems to have adjoined that of Gonnos to the W (cf. Hiller von Gaertringen) and apparently extended N of the Peneios, since a sales contract (stele, now in Volo) of the 3d-2d c. B.C. found near modern Pyrgeto (on the lowest slopes of Olympos just W of the Peneios plain) indicated that the city of Homolion had purchased land in that area (see Arvanitopoullos in *RevPhil*).

BIBLIOGRAPHY. Hiller von Gaertringen, *Berl. Philol. Wochenschr.* no. 49 (1910); A. S. Arvanitopoullos, *Praktika* (1910) 188-90; (1911) 284-87[P]; id., *RevPhil*, NS 35 (1911) 132, no. 36; *AJA* 17 (1913) 108; F. Stählin, *RE* (1913) s.v. ὁμόλη 1 and 2; id., *Das Hellenische Thessalien* (1924) 46f; E. D. Van Buren, *Greek Fictile Revetments in the Archaic Period* (1926) 41; D. Theocharis, *Deltion* 17 (1961-62) chron. 175-79[I]; 20 (1965) chron. 319[I]; H. Biesantz, *Die Thessalischen Grabreliefs* (1965) 130-31.　　　　　　　　　　　T. S. MAC KAY

HOMOLOS, *see* HOMOLION

HOMS, *see* EMESA

HORNCASTLE Lincolnshire, England. Map 24. This defended site of the Late Empire lies at the S end of the Lincolnshire Wolds. During the Early Empire, Horncastle was probably no more than an open agricultural settlement. At an undefined date, probably in the 4th c., a massive defensive circuit incorporating projecting towers was thrown round an area of 2.4 ha. These defenses have long provoked controversy. Their massive character and the fact that, as at Caistor, the towers were built at the same time as the wall, suggest that their role was military. If so, Horncastle was connected with defense of the coastlands in the 4th c.

BIBLIOGRAPHY. C.F.C. Hawkes, "Roman Ancaster, Horncastle and Caistor," *ArchJ* 103 (1946) 17ff.
　　　　　　　　　　　　　　　　　　　　M. TODD

HORZUM, *see* KIBYRA MAIOR

HOSN SOLEIMAN, *see* BAETOCECE

HOUSESTEADS, *see* BORCOVICUS *under* HADRIAN'S WALL

HOWARDRIES Belgium. Map 21. A large archaeological zone has been found in the region defined by the modern villages of Howardries, Bléharies, Hollain, Taintignies, and Rumes (province of Hainaut), in the SE part of the civitas Nerviorum, S of Turnacum (Tournai). In Roman times it was essentially industrial. Excavations there, however, have never been systematic, so that it is not yet clear whether the zone was a vicus or an area of dispersed settlement. Dwellings have been noted and excavated at Taintignies, Hollain, Bléharies, and Rumes. Some of these were heated by hypocausts. At Bléharies a well has also been excavated.

The most interesting finds, however, are industrial remains. Numerous potter's kilns, excavated at Howardries and Taintignies, were in active use mainly during the second half of the 1st c. A.D. A tile-maker's kiln has been excavated, also at Howardries. Important remains of an ironworks have been discovered at Howardries and Taintignies. At Howardries gutters for washing the iron ore have been excavated. Among the most interesting discoveries are iron artifacts of local manufacture (pieces of carts, tools, knives, picks, gravers), thousands of sherds coming from dumps, and a bronze statuette of a household god. A leveled barrow was excavated at Rumes. The funerary chamber, with slabs of stone from Tournai, had been pillaged.

All these industrial establishments were destroyed during the invasions of the Chauci under Marcus Aurelius. After this period the industrial activity of the region slackened greatly. Three hoards of coins were found at Howardries. The first two were buried around A.D. 263, the third around 268. They indicate that the region was ravaged a second time during the invasions of the Franks in the second half of the 3d c.

BIBLIOGRAPHY. M. Amand, "La romanisation du Tournaisis," *Annales de la Fédération arch. et hist. de Belgique* 36 (1955) 155-66; id., "Contribution à l'étude de la voirie antique au sud-ouest de Tournai," *Hommages à W. Deonna* (1957) 49-58; id., "Fouille d'une habitation d'époque romaine à Taintignies," *Latomus* 17 (1958) 723-30; id., "Nouveaux aspects de la romanisation en Pévèle belge," *Hommages à Albert Grenier* (1962) 104-20; M. Thirion, *Les trésors monétaires gaulois et romains trouvés en Belgique* (1967) 97-99.
　　　　　　　　　　　　　　　　　　　S. J. DE LAET

HUELVA, *see* SHIPWRECKS

HUESCA, *see* OSCA

HULTEHOUSE Moselle, France. Map 23. A statio 10 km S of Phalsbourg. Although Roman, it was of the Celtic tradition called the civilization of the summits of the Vosges: many traces of it were left on the W slopes of the Vosges in the beginning of our era.

The people exploited both the high-quality sandstone and the wood of the area, exporting them to regions close by. They lived in clusters of huts usually set up around a quarry or stone-cutting works. Excavation has revealed some bas-reliefs of gods, especially of Mercury and the "rider of the serpent." The necropoleis contain only ashes placed in urns of glass, terracotta, or sandstone; grave gifts in the men's tombs consisted mainly of hunting weapons (knives, boar-spears, and hatchets),

while the women's tombs contain fibulas, usually enameled. Pottery in the tombs consisted of ordinary ware and terra sigillata imported from S Gaul. The pottery and coins show that the summits of the Vosges were occupied from the time of Claudius and Nero to about the end of the 2d c. when disorders in E Gaul apparently cut off the inhabitants from the valleys and ended their civilization.

The museums at Strasbourg, Metz, Saverne and Sarrebourg have archaeological collections.

BIBLIOGRAPHY. A. Fuchs, *Die Kultur der keltischen Vogesensiedlungen* . . . (1914); E. Linckenheld, *Les stèles funéraires en forme de maison chez les Médiomatriques* (1927); id., *Répertoire archéologique de l'arrondissement de Sarrebourg* (1929); M. Lutz, "Considérations sur la civilisation dite 'des sommets vosgiens' . . .," *Annuaire de la Société d'Histoire et d'Archéologie de Lorraine* 64 (1964) 25ff. M. LUTZ

HUMAC ("Bigeste") Bosnia-Herzegovina, Yugoslavia. Map 12. A Roman castrum on the road from Narona to Salona. Tombstones of soldiers and veterans indicate that a camp of Roman military units may already have existed there in Augustan times. The inscriptions indicate that at first the garrison of the camp consisted of infantry units and, later on, of the calvary cohorts.

Stamped bricks give information about the legions, whose minor units were stationed in the camp. There is evidence that in the 1st c. A.D. the Cohors III Alpinorum equitata was stationed here; Cohors I Lucensium Hispanorum equitata, Cohors I Bracaraugustanorum, Cohors VIII voluntariorum; also the units of the legions I Ad(iutrix) and II Ad(iutrix). The Cohors I Belgarum equitata was stationed here in the 2d c. A.D.

In the 1st c. A.D. the broad fields near the camp were inhabited by the veterans of the Legio VII and the Legio VII Claudia Pia Fidelis. An inscription on one of the buildings indicates that there was a temple dedicated to Libera Patra. Cylindrical stone urns for the ashes of the dead have been found.

BIBLIOGRAPHY. C. Patsch in *WMBH* 1 (1893) 330-31; 5 (1897) 338-40; 12 (1912) 131-37; id., *Zur Geschichte und Topographie von Narona* (1907) 27-80; J. J. Wilkes, *Dalmatia* (1969). V. PASKVALIN

HUMELICĖ, *see* LIMES, SOUTH ALBANIA

HYBLA GELEATIS (Paternò) Catania, Sicily. Map 17B. The site lies on the slopes of a volcanic hill containing the remains of different periods, ranging from the Bronze Age to the Greek, Hellenistic-Roman, Byzantine, and Early Mediaeval periods. The identification with modern Paternò was suggested after the discovery of an altar with a dedication to Venus "Victrici Hyblensi" (*CIL* 10,2,7013), at present in the Museo Comunale of Catania. The altar has been connected with the sanctuary dedicated to the goddess Hyblaia mentioned by Thucydides (6.94.2). The finds were published in the first decade of this century. Other finds have been made in the cemetery discovered in the district of Castrogiacomo, to the SW of the hill of Paternò; they consist of vases, lamps, and terracottas, datable between the 5th and the 3d c. B.C. These finds, at present in the Siracusa Museum, will soon be displayed in the antiquarium which is being prepared within the old Norman Castle.

BIBLIOGRAPHY. P. Orsi, "Paternò," *NSc* (1903); id., "Paternò. Reliquie sicule," *NSc* (1909); id., "Paternò. Tesoro di argenterie greco-romane," *NSc* (1912); id., "Paternò. Rispostigli monetali," *NSc* (1915); G. Savasta,

Memorie storiche della città di Paternò (1905); G. Rizza, "Scavi e ricerche nel territorio di Paternò," *NSc* (1954); id., "Necropoli greca e rinvenimenti vari in contrada Castrogiacomo," *NSc* (1957). C. BUSCEMI INDELICATO

HYBLA HERAIA (Ragusa) Sicily. Map 17B. The ancient Roman itineraries locate the site between Akrai and Calvisiana. It must have been an indigenous site of considerable importance and, from the first half of the 6th c. B.C., one which came into friendly contact with Greek colonists. This is attested by grave goods of mixed nature which are found in the Greek cemetery in the Rito district to the S of Lower Ragusa. The site of the Sikel city must have corresponded to the height of the Castello near Lower Ragusa, while Sikel graves, the earliest of which belong to the so-called Finocchito culture (750-630 B.C.), were discovered in the nearby grottos of Molino and S. Maria delle Scale. In the Pendente district have been found traces of the Greek settlement, whose necropoleis occupied a large strip of the plateau which faces Ragusa to the S. On the height of Rito 76 Greek graves, dating between 570 and 490 B.C., were explored; together with the often considerable grave gifts, the fragmentary statue of a lion was found. Other sculptural fragments, always in the area of the Greek cemeteries, were found near the present railroad station of Upper Ragusa.

Not only the importance in the late Roman period of the road that passed through Hybla and joined Akrai at the ford of the Dirillo attests continuity of life in this ancient center, but especially the cemeteries of the Hellenistic, Roman, and Byzantine periods, found in large numbers on the plateau to the S of the habitation center. Of these necropoleis one can visit the Latomia in the district Tabuna.

The recently established Archaeological Museum in Ragusa houses the finds from the site of Hybla and from the entire province.

BIBLIOGRAPHY. P. Orsi, *NSc* (1892) 321-22; id., *NSc* (1899) 402ff; T. Ziegler, "Hybla," *RE* IX.1 (1914); B. Pace, *Arte e Civiltà della Sicilia antica* 1 (1935) 196; A. Di Vita, "Recenti scoperte archeologiche in provincia di Ragusa," *Arch. St. Sir.* 2 (1956) 30ff; A. M. Fallico, "Esplorazione di necropoli tarde," *NSc* (1967) 407ff; G. Uggeri, "La Sicilia nella 'Tabula Peutigeriana,'" *Vichiana* (1968); P. Pelagatti, "Il Museo Archeologico di Ragusa," *Sicilia Archeologica* 11 (1970). G. SCROFANI

HYDAI or Kydai (Damlıboğaz) Turkey. Map 7. In Caria, 7 km W of Milâs, in the valley of the Sarıçay, the ancient Kybersos. The city appears in the Athenian tribute lists, with a normal tribute of only one-fifteenth of a talent, but reassessed at one-third in 425 B.C. Later Hydai was united in a sympolity with Mylasa. A handmade jug found there is dated to the 3d millennium. The extant remains consist only of a ruined circuit wall, a few plain rock tombs, and on the plain below a collapsed building which has been thought to be the Temple of Apollo and Artemis, the principal deities of the city.

BIBLIOGRAPHY. L. Robert, *RA* (1935; 2) 159; A. & T. Akarca, *Milâs* (1954) 130-31; G. E. Bean, *Turkey beyond the Maeander* (1971) 49-50. G. E. BEAN

HYDATA, *see under* AQUAE (Călan)

HYDISOS (Karacahisar) Turkey. Map 7. 20 km S of Milâs. The city appears (the name only partially preserved) in the early Athenian tribute lists, with a tribute of one talent, and is recorded by Pliny and Ptolemy. The coins are Imperial only. The position is a strong one on

two summits, defended by a wall with towers well pre-
served in parts, of early Hellenistic date. The location of
the theater is recognizable between the summits, also
that of the agora adjoined by stoas. The site is identified
by an inscription and coins found on the spot.

BIBLIOGRAPHY. L. Robert, *AJA* 39 (1935) 339-40.

G. E. BEAN

HYIA (Incirli)　Turkey. Map 7. Town in Pisidia, 5 km
S of Bucak. The site and name, previously unknown,
have been identified by an inscription; the termination of
the name is uncertain. The ruins are on a hill above a
pass. The circuit wall, of coursed polygonal masonry, is
preserved in part up to 4 m high. On the S slope is a
building with three sides of masonry, the fourth consist-
ing of a rockface 4 m high in which are a number of
niches of varying size. Outlines of other buildings are
discernible, and the hillside is covered with many squared
blocks, architectural fragments, and sherds of Roman
date.

BIBLIOGRAPHY. G. E. Bean, *AnatSt* 10 (1960) 80-81.

G. E. BEAN

HYLLARIMA　Turkey. Map 7. Site in Caria, near the
villages of Mesevle and Kapraklar, 20 km S of Bozdo-
ğan. The identity of the site, and the existence of the
city at least as early as the 3d c. B.C., are proved by an
inscription found in 1934. Hyllarima came under Rho-
dian domination between 189 and 167 B.C., and even
after that time the inscriptions continue to show evidence
of Rhodian influence. The city had in its territory a
number of isolated rural sanctuaries, of which the most
notable is that of Zeus Hyllos. The coinage is of Imperial
date. The extant ruins are considerable, including an
agora, a theater, and a synagogue.

BIBLIOGRAPHY. A. Laumonier, *BCH* 58 (1934) 356,
515-16; id., *Cultes Indigènes en Carie* (1958) 452f; L.
Robert, *Villes d'Asie Mineure* (1935) 147.

G. E. BEAN

HYMETTOS, Mt.　Attica, Greece. Map 11. Separating
the S end of the plain of Athens from that of the Meso-
gaia to the E is the mountain range of Hymettos. About
20 km long, and broken into two parts by a pass that
crosses E-W from N of the civil airport at Helleniko to
Koropi, ancient Sphettos, the larger N section reaches a
height of over 1000 m along its whale-back ridge, while
the S, also called Anhydros (waterless), consists of sev-
eral peaks, the highest being 774 m.

In antiquity Hymettos was famous for honey and
marble, and the scars of the worked-out quarries can be
seen concentrated for the most part on the W slopes for
a distance of 3 km S from Kaisariani. The bare summit
performed a different function: even as today, it gave the
Athenians a reliable indication of weather by the pres-
ence, or absence, of threatening clouds (Theophr. *De
sign. temp.* 20). Less than a km N of the highest point,
excavations have disclosed two crude rectangular founda-
tions, possibly for altars, the one probably dedicated to
Herakles, the other most likely to Zeus. Near the latter
was a pit full of sherds, the bulk either Geometric and
archaic or Late Roman. A large stele was also found
with cuttings for a small bronze statue, perhaps that of
Zeus Hymettios mentioned by Pausanias (1.32.2). As for
the altar ascribed to Zeus, its location makes it a suitable
candidate for that of Zeus Ombrios described in the
same passage. The altar of Zeus Epakrios (*Etym. Magn.*
s.v. Ἐπάκριος Ζεύς) should have been on the very sum-
mit. All ancient remains, however, have been recently
obliterated by military building operations.

Another, and better preserved, pair of foundations

has been cleared at the Church of Prophet Elias, a little
more than 3 km due S of the summit, on the E slopes
of the peak Zeze, overlooking the Mesogaia, with the
ancient deme of Sphettos immediately to the E below.
Beneath the church are the remains of a small temple,
consisting of a cella with pronaos and opisthodomos.
Twenty-five m away another temple of similar size and
general disposition was discovered. Both were built in
the 6th c. B.C. The one on the site of the church was
apparently destroyed at the beginning of the 5th, re-
stored in the second half of that century, and survived
until Roman times. The other was destroyed in the 3d c.
B.C. About midway between the two temples is a promi-
nent natural rock, several m high, which may have served
as an altar. No evidence exists for a firm identification
of either temple.

Finally, there are two caves that deserve notice. Near
the N end and on the mountain's E flank, 4 km from
Liopesi, is the Lion Cave. Classical and Roman sherds
found within it testify to its long use in antiquity; per-
haps Pan was worshiped here. No doubt surrounds the
deity honored in the second cave, the famous one of
Pan on the S slopes overlooking Vari. Inscriptions, sculp-
ture, votive reliefs, and pottery make obvious the popu-
larity in Classical times of this cult of Pan, Apollo, the
Nymphs and Graces. Chief among the worshipers was
Archedemos of Thera, a man of the 5th c. B.C. "caught
by the Nymphs," who carved in low relief an image of
himself as a sculptor carrying pick-hammer and square.
A millennium later, this cave was taken over by the
Christians.

BIBLIOGRAPHY. C. H. Weller et al., "The Cave at Vari,"
AJA 7 (1903) 263-349[PI]; R. Young, "Excavation on
Mount Hymettos, 1939," *AJA* 44 (1940) 1-9; N. Kotzias,
Ἀνασκαφαὶ ἐν Προφήτῃ Ἀλίᾳ Ὑμεττοῦ, *Praktika* (1949)
51-74[PI]; (1950) 144-58[PI]; E. Vanderpool, "Pan in Pai-
ania . . . ," *AJA* 71 (1967) 309-11[M].

C.W.J. ELIOT

HYPATA　Aitolia, Greece. Map 9. A city of Ainis,
which first appears when it issued coinage of the Aini-
anes ca. 400-344 B.C.; from 302 B.C. it was in the Aito-
lian League. In 191 B.C. it was an Aitolian strong point
and its territory laid waste by M' Acilius Glabrio. It re-
mained with the Aitolians after 189 B.C., but after 168
B.C. was part of the free League of Ainis, which was
finally joined to Thessaly by Augustus in 27 B.C. (Livy
28.5.15; 36.14.15, 16.4, 26.1, 27.4, 28.8, 29.5; Polyb.
20.9.6, 10.13, 11.5; Livy 37.6.2, 7.1; Polyb. 21.2.7, 3.7,
3.13). The city prospered in the Roman Imperial period
(Apul., *Met.* 1.5) and was the site of a bishopric in
Christian times. It came to be known as Neai Patrai, an
important mediaeval city.

Hypata is located above the Spercheios valley, on the
N slope of Oeta, on a hillside flanked on the W by the
Xerias river and on the E by a ravine. The acropolis hill
is a small, rocky peak (661 m) which falls away steeply
on all sides. It is connected to the main mass of Oeta to
the S by a narrow saddle. A road led S over Oeta to Kal-
lipolis. On the acropolis are some remains of the ancient
wall circuit, although these have largely disappeared un-
der later Byzantine and Frankish walls. Stählin saw some
of the ancient wall on the S side with a gate giving on
the saddle which connects the hill to Oeta. The wall was
ca. 4 m thick, of good 4th-3d c. B.C. masonry. Béquignon
noted an ancient Hellenic wall inside the acropolis on
the SE side at right angles to the circuit wall, perhaps
the foundation of some building. Modern Hypati is set
on a terrace on the steep N face of the hillside, below
the acropolis. It occupies the site of the ancient city.
Stählin saw traces of the ancient city walls on the N and
E sides of this terrace. Inscriptions and various ancient

blocks have been built into the modern houses. Béquignon saw a marble head and a mutilated relief, and other pieces of sculpture have been seen. In 1921 a late Roman (?) mosaic was found near the church of Haghios Nikolaus in the town. Graves have been discovered in the vicinity, particularly outside the city to the W. At the beginning of the century Giannopoullos reported an ancient Greek naiskos at Rigoziano (Rogozinon) on the left bank of the Xerias opposite Hypata's acropolis; this has apparently not been checked since. Several inscriptions exist relative to Hypata's boundaries (see Stählin) which included a considerable amount of the river plain.

BIBLIOGRAPHY. W. M. Leake, *Nor. Gr.* (1835) II 18f, 23; L. Stephani, *Reise durch Einige Gegenden des Nordlichen Griechenland* (1843) 52; *IG* IX 2.56: inscription concerning the building of a gymnasium in 131 B.C.; N. I. Giannopoullos, Ἁρμονία 1 (1900) 633-45; id., *ArchEph* (1914) 89-90[I]; *BCH* 45 (1921) 524; F. Stählin, *RE* (1914) s.v. Hypata; id., *Das Hellenische Thessalien* (1924) 220-22[I]; Y. Béquignon, *La Vallée du Spercheios* (1937) 307-12[MPI]. T. S. MAC KAY

"HYPPANA," *see* MONTE CAVALLI

HYRCANIA (Khirbet Mird) Occupied Jordan. Map 6. A fortress ca. 14.4 km NE of Jerusalem built, according to Josephus, by Alexander Jannaeus, and named after his grandfather John Hyrcanus (*BJ* 1.161). It was conquered by Gabibius, Pompey's general and procurator of Syria (*BJ* 1.167). Herod conquered the fortress in 32 B.C. and made it a prison for political offenders; they were executed here and buried secretly (*BJ* 1.364). St. Saba founded a monastery in 492 and named it Castellion. A survey has identified a double wall, an aqueduct, and remains of buildings of the Roman and Byzantine periods.

BIBLIOGRAPHY. F. M. Abel, *Géographie de la Palestine* II (1938) 350; M. Avi-Yonah, *The Holy Land* (1966) 73, 101, 156. A. NEGEV

HYRIA, *see* URIA

HYRIUM, *see* URIUM

HYSIAI Argolis, Greece. Map 11. An Argive border citadel S of the modern village of Achladokampos on the road between Lerna and Tripolis. The town was destroyed by the Lakedaimonians in 417 B.C.; following the defeat, the Argive dead were buried at Kenchreai. The ruins of Hysiai were seen by Pausanias and the walls were described by Curtius as polygonal on ashlar foundations, and flanked by round towers.

See also Limes, Attica.

BIBLIOGRAPHY. Paus. 2.24.7; E. Curtius, *Peloponnesos* (1851-52) II 367[P]; J. G. Frazer, *Paus. Des. Gr.* (1898) III 214. M. H. MC ALLISTER

I

IACCA (Jaca) Huesca, Spain. Map 19. Town of the Vascones in Hispania Tarraconensis, ca. 70 km N of Huesca on the main road to France. Livy (21.23) mentions the inhabitants, the Iacetani, in connection with Hannibal's march through the Pyrenees on his advance against Rome. Menioned also by Sallust (2.5) and Plutarch (*Sert.* 4). We know that it minted coinage and that it was a station on the highroad to Caesaraugusta (*Rav.* 309.7). Remains of walls and buildings were visible as late as the 19th c.

BIBLIOGRAPHY. A Schulten, s.v. Iaca, *RE* IX:1, 545. J. ARCE

IADER (Zadar) Croatia, Yugoslavia. Map 12. A settlement on the Zadar Peninsula dating from the 9th c. B.C. Early Greek imports from the end of the 8th c. B.C. have been discovered. In the civil wars between Caesar and Pompey Caesar's naves Iadertinae took part (*BAlex.* 42). About 33 B.C. the settlement attained colonial rank under Octavian and the rich land was distributed to veterans. The heaps of stone piled at the edges of fields still preserve the orthogonal grid pattern of centuriation visible in the aerial photos. An inscription names Augustus as the "parens coloniae" who donated to the city the walls and towers (*CIL* III, 13246).

The town had an area of 136 ha enclosed by a circuit wall with three gates. It had a regular street grid of five cardines and more decumani with insulae. Mosaics have been found in the house foundations. The forum was situated in the W corner of peninsula. It was a double precinct (ca. 180 x 130 m) of which the E half was an open market area surrounded by colonnaded porticos with tabernae and shops. The basilica was on the S side. To the W was a sacred precinct peribolus with altars and the capitolium on a podium 3 m high. The three-aisled temple had six fluted columns in front. Before the temple stood the altar for sacrifices. Two high columns stood before the precinct. This forum is Iulio-Claudian or possibly Augustan.

The stone paving of the city is found in many places in the town to be from 0.5 to 1.5 m deep. The baths are found in the center of the city.

Outside the city to the E was the amphitheater, destroyed in the 17th c. The necropoleis (1st-4th c.) are to the E. There are many villae rusticae in the environs. The aqueduct brought water from the Vrana lake region 40 km distant. Early Christian remains are few. The town suffered a great cataclysm (earthquake, fire ?) in the 6th c. A.D.

The finds from archaeological excavations are preserved in the Archaeological Museum at Zadar.

BIBLIOGRAPHY. V. Brunelli, *Storia della città di Zara*, I (1913); M. Suić, "The Limitation of Roman Colonies on the Eastern Adriatic Coast," *Zbornik Instituta za historijske nauke u Zadru* 2 (1956-57) 13-50; id., "O imenu Zadra," *Zbornik Zadar* (1964). M. ZANINOVIĆ

IALYSOS, *see* RHODES

IASOS later IASSOS (Kiyi Kişlacik) Turkey. Map 7. City in Caria on the gulf of Mendelia opposite the port of Güllük. In modern times it has been called Asin Kalé and later Asin Kurin. It occupies a small peninsula joined by an isthmus to the mainland, where the necropolis lies. Strabo (14.658) calls it an island, and remarks on its harbor and commercially important fishing. According to tradition it was a colony of Argos (Polyb. 16.12), but excavations indicate that it was inhabited, probably by tribes from Caria, from the Early Bronze Age on, and that in the Middle Bronze Age a Cretan colony was established there as at nearby Miletos. During the first part of the Late Bronze Age it apparently

came under Achaean influence; to that period may probably be dated its contacts with Argos and the report of Peloponnesian, probably Mycenaean, origin. After the Mycenaean period the Carian element seems again to have become dominant.

Discoveries attest that Iasos was a fairly important center, tied to Rhodes and the Dodecanese. It was probably an ally of Ionia against Darius (Hdt. 1.174-75) in the battles in which Heraklides from nearby Mylasa distinguished himself (Hdt. 5.121). In the 5th c. Iasos appears on the tribute lists of the Delian League, first as contributing one talent, then three or four. In 412 it was captured and sacked by the Peloponnesian fleet (Thuc. 8.26-28), then destroyed by Lysander (Diod. 13.104.7). The city was rebuilt, probably with the help of Knidos, as coins of 394 B.C. attest. After the peace of Antalkidas it must have belonged to the satrapy of Caria under Hekatomnos, father of Mausolos, and then to the kingdom of Caria under Mausolos. It was liberated by Alexander the Great, in whose army two citizens from Iasos reached high rank (*CIG* 2672). Iasos was still independent after 168 B.C., but in 125 it was incorporated into the province of Asia along with all of Caria. Inscriptions and monuments indicate prosperity under Hadrian and throughout the entire 2d c. Later it was probably destroyed by the Heruli, but was rebuilt; basilicas were built in the first centuries of the Christian era, and one of its bishops took part in the Council of Chalkedon in A.D. 451. The city was inhabited throughout the Byzantine period, and in the Middle Ages it was the seat of a fortress of the Cavalieri.

Iasos has two circuit walls. One of the Classical period, of bossed ashlar with towers and gates of various types, surrounds the city on the peninsula and appears to have been used again against the barbarian invasions. The other, which is larger, in trapezoidal isodomic work with a large gate on the land side, numerous postern gates, and semicircular elongated towers, surrounds the landward end of the peninsula where the modern town lies. Excavations have revealed that the wall is actually one continuous circuit, and that within it there were several buildings. Probably it was a defensive wall for a garrison guarding the gulf of Iasos.

Few buildings were identified before excavation. The 4th c. B.C. theater, set on the slope of the hill toward the NE, is preserved to the top of the embankment wall, with an inscription which records its restoration. The marble seats, however, were carried off in the last century for use in Istanbul. The summa cavea was reached on the level from the W, but on the E side there was a staircase. The orchestra is well preserved and the stage shows successive Hellenistic remodelings. The Roman proscenium was decorated with niches and engaged columns.

Beside and below the theater the hill is less steep. The inhabited areas here preserved approximately the same orientation from archaic times to the late Imperial period. On the S side, towards the open sea, there is an imposing terraced complex, beside a central covered stairway. In the plain to the NW, near the main harbor, which is presumed to have been in the cove between the peninsula and mainland, is the agora; on the S side is the bouleuterion, still preserved up to the top of the cavea, and also a second public building with three rooms on the E side. A large gate with a propylon, near the SW corner, gave access to the agora from the shore, and a second gate with three vaults on the E side communicated with the rest of the city. In the NE corner was a nympheum. Beneath the agora of Imperial date excavations have revealed the arrangements of the Classical and Hellenistic periods. On the W side, a necropolis of large cist tombs from the Protogeometric period

appears to indicate that the settlement was then perhaps farther inland. In the Bronze Age, however, the inhabited area spread below the agora and into the plain, to W and E and over the hill.

Of the sanctuaries mentioned in inscriptions, that of Zeus Megistos has been located in the plain to the NE as the result of the discovery of an oros on the E gate of the circuit wall. The sanctuary of Artemis Astiades, with its exedras and the stoas restored under Commodus, is behind the Bouleuterion to the W. The necropolis, on the mainland contains Early Bronze Age tombs built of rock slabs of the Carian type, chambered tombs with both flat roofs and barrel vaults, and funeral monuments and sarcophagi of the Imperial period. The large building known as the Fish Market has been shown to be a mausoleum, with a small tetrastyle temple above the burial chamber surrounded by a courtyard and a portico. The so-called Clock Tower is the only remaining example of a group of Roman tombs with two stories and a cupola supported on arches. The necropolis, on the edge of which an agricultural-industrial complex was established in the Roman period, is crossed by an aqueduct which probably continued as far as the peninsula.

There are several basilicas and other Christian buildings, particularly in the E section of the peninsula, and two basilicas have been found at the summit of the hill, near the fort of the Cavalieri.

Finds are in the Smyrna museum, but an antiquarium is being built on the site, in the N portico of the Roman mausoleum.

BIBLIOGRAPHY. C. Texier, *Description de l'Asie Mineure* III (1849)[PI]; E. L. Hicks, "Jasos," *JHS* 8 (1887); 9 (1888); W. Judeich, *AthMitt* 15 (1890); F. Krischen, *ArchAnz* (1913); G. Guidi, *Annuario* 4-5 (1921-22)[I]; G. Jost, *Iasos in Karien, ein antikes Stadtbild* (1935); G. E. Bean & J. M. Cook, *BSA* 52 (1957); recent excavations: D. Levi, *Annuario* 39-40 (1961-62); 43-44 (1965-66); 45-46 (1967-68); 47-48 (1969-70); C. Laviosa, *III Congr. Internaz. Cretologico* (1971).

C. LAVIOSA

IASSOS, *see* IASOS

"IASUIONES," *see* BARACSKA

IATINUM (Meaux) Dept. Seine-et-Marne, France. Map 23. Chief city of the Meldi, the Gallo-Roman city of Iatinum lies 45 km from Lutetia in a bend of the Marne (Matrona), which has since been cut back. The Gallo-Roman and Gallic sites lie one on top of the other; the Gallic capital covered roughly 60 ha in the period before the barbarian invasions of the 3d c., but in the 4th c. it was reduced within the walls to an area of less than 10.

The city's geographical position, ringed as it was on three sides with a fine network of navigable waterways, at once suggests that it was well suited to be a center of river-borne trade. Like many other Gallic capitals, Iatinum was set up at the junction of two naturally complementary regions: the grain-producing Multien plateau and the forests of Brie.

The city's monuments have almost all disappeared, even their location being uncertain. Meaux had a theater, which stood to the N of the city. It is mentioned in an inscription, no doubt dating from the 1st c., that has disappeared. The city also had its aqueduct, which was excavated at the end of the 19th c. in the suburban commune of Villenoy. No trace has been found of the forum, which is presumed to be on the site of the cathedral and its surrounding area. Indeed, all that remains today are some sections of the surrounding wall of the Late Empire, especially to the N along the Boule-

vard Jean-Rose; it was rebuilt and altered in the 14th c. There are more traces of it in cellars in the Rue Bossuet and Rue Tronchon. The Rue Notre-Dame and Rue Saint-Rémy may possibly correspond to the cardo maximus and decumanus maximus.

BIBLIOGRAPHY. J.-M. Desbordes, "Le site de Meaux antique," *RA* (1970). J.-M. DESBORDES

IBECIK, see BUBON

ICIODURUM (Yzeures) Indre et Loire, France. Map 23. On the right bank of the Creuse, at the S tip of Indre et Loire, which at this point forms a wedge between Vienne and Indre. The boundaries of the modern districts in this area are roughly the same as those of the Gallic cities: Indre et Loire corresponds to the territory of the Turones, Vienne to that of the Pictones, and Indre to that of the Bituriges Cubi. Iciodurum was thus a frontier post belonging to the Turones.

The church of Yzeures was built in the late 19th c., replacing a 12th c. chapel which had been erected over the foundations of a Merovingian church. In 1895-96 the foundations of one of the walls of the Merovingian church were found and dismantled; they were built of large stones, many of them carved, taken from a Gallo-Roman sanctuary. (The same is true at Vienne en Val in Loiret and Saint Ambroix in Cher.) In 1965 further excavations revealed the presence of other Gallo-Roman blocks in the foundations of the N wall of the modern church, which is built upon a Merovingian wall.

The 95 blocks unearthed in 1895-96 are now displayed under cover close to the church. They include architectural elements (architraves, friezes with acanthus carvings, and pilasters, similarly decorated); there are also 20 stones ornamented with figures in bas-relief, 18 of which may be regrouped to form two large rectangular masses, carved on each surface. The most important one judging by its size showed on one side Jupiter wielding his thunderbolts, and on the other Mars in majesty with a heap of arms beside him, flanked by Vulcan and Apollo of the Lyre. The second represents, on the front and back, Minerva and Mars fighting snake-legged giants, while the sides depict Herakles delivering Hesione and Perseus delivering Andromache. An octagonal tambour, half of which has been preserved, bears the figures of a satyr, Apollo, Leda, and one of the Dioscuri. Some carved blocks cannot be included in this list, in particular a large stone with a bust of the warrior Minerva. Two large slabs bear an inscription identifying an aedes of Minerva built by the Petronii. It was recognized that the two rectangular dados and the octagonal tambour formed the base of a pillar similar to the columns of Jupiter and the serpent, and this was confirmed by the structural resemblance of the Yzeures pantheon to that at Vienne en Val. In both cases, the hierarchy of the gods begins with Jupiter, followed by Minerva. Mars and Vulcan are directly associated with Jupiter. At Yzeures this triad is completed by Apollo, who takes the place Venus holds at Vienne en Val. On the second dado described above at Yzeures, Venus is probably represented by the naked torso of a woman who has also been interpreted as a female captive associated with Mars.

The pillars of Yzeures and Vienne en Val belong to the W series of this family of monuments: not as prolific as the Rhenish series, but excelling in these two cases at least in the spaciousness and richness of the sanctuaries. The archetype of the two families has been identified as the Nautes pillar in Paris, and the pillar of Mavilly is another early example.

The aedes of Minerva built by the Petronii was probably not the only sacred monument at Yzeures. It is likely that the sanctuary had a vast porticoed temenos in the middle of which stood the pillar and altars (the crowning of one of them has been preserved) as well as the cellas. The problem is whether the Petronii donated the whole complex or only the temple—or chapel—of Minerva. The sculptures are homogeneous and probably came from the same workshop. Perhaps Petronius the Elder had dedicated the greater part of the monuments and at his death all that remained was to build the aedes of Minerva.

The formula, numinibus Augustorum, with which most of the religious dedications in this part of Gaul begin indicates, as a rule, that the dedication was made in the reign of joint rulers, that is, under Marcus Aurelius and Lucius Verus at the earliest. The style of the sculptures belongs to the end of the 2d c. or the first years of the 3d c. The inscription is engraved in square capital letters, but the G has the rounded form rarely found in Gaul until the 3d c.

The ruins of La Guérinière, 3 km NW of Yzeures, were explored in 1964-65. This is an important, wealthy villa with baths. A statuette was found representing an adolescent god sitting on a goat. The god is certainly Mercury; the Gauls very often represented him seated. This preference may have been inspired by Greek prototypes, but the explanation is probably to be found in the connection between Mercury and Cernunnos, who is often depicted in a sitting or crouching position. We have seen that Mercury does not appear on the pillar of Yzeures, and his absence is not due to chance (see Vienne en Val). The Yzeures finds point to the coexistence, in the same region, of divergent religious ideas.

BIBLIOGRAPHY. F. Cumont, *RA* 2 (1912) 211-15; E. Espérandieu, *Recueil général des bas-reliefs, statues et bustes de la Gaule* (1907-55) IV, nos. 2996-99. *CIL* XIII, 3075; A. Grenier, *Manuel d'archéologie gallo-romaine* III, 1 (1958) 414-16; *Gallia* 23 (1965) 279-84; 24 (1966) 256. G. C. PICARD

ICOSIUM (Algiers) Algeria. Map 18. A Punic settlement, placed on four islets and a narrow coastal strip and protected by a natural acropolis. The name is known from Solinus (25.17), from a Punic stela, and especially from a hoard of 158 lead coins bearing the name IKOSIM. The town was chosen by Roman colonists even before the annexation of Mauretania; at that time it was connected to the colony of Ilici in Spain. It became a Roman colony under the Flavians, grew in the 2d and 3d c., but never became an important town. A Christian community existed in the 4th c. and three bishops are known in the 5th. The town was sacked in 373 during the revolt of Firmus. The Ziridian prince Bologguîn founded a new town on the site in 960.

Facing the islets in the bay, the Roman town stretched out along the coast with the hill behind it. It was protected by a rampart with towers. Parts survive today in several places. The walls were often reused in the Berber defenses of the 10th c. and the Turkish ramparts of the 16th. Thus, the fortifications enclosed part of the modern kasbah to the SW and the Bab-el-Oued district to the NE. They extended as far as the former Bresson square to the SE. Outside, villas surrounded by gardens were located on the coastal plain and, more often, on the sides of the hills. The villas have produced sculptures: two female heads, a statue of Pomona, another statue of a female deity, a head of the emperor Hadrian; all are in the Algiers Museum. Inside the lower town, which was densely populated, a network of streets at right angles to each other formed insulae. Their plan can often be traced in the modern urban grid. The decumanus maximus followed the modern Bab-Azoun street.

The water supply was provided at least in part by wells; for example, at the so-called Nave well there are stacks of pottery dating from Punic to mediaeval times.

Of the monuments discovered or noted inside the town, the public baths are of particular importance. Four cisterns placed side by side and two ornamental mosaics indicate that a first bath building was under the old cathedral. A second was located under the former church of Notre Dame des Victoires. A third has been discovered in the suburbs to the SE, near the Jardin d'Essai. According to the inscription (*CIL* VIII, 9256), a mithraeum no doubt existed. No church is known, but two capitals and a fenestella confessionis (at the Algiers Museum) indicate the presence of an edifice for Christian worship.

The main necropolis was located NW of the town along the extension of the decumanus. Funerary stelae, cinerary urns, rock-cut tombs, and burials under roof tiles have been discovered. In addition, there were tombs in the form of vaulted cellars; entering by an underground passage, one reached the burial chamber, where niches cut into the walls sheltered cinerary urns. Abundant grave goods have been found, in particular terra sigillata and intact glass vases. One enameled glass goblet was decorated with a scene of gladiators. There was another necropolis SE of the town at the other end of the decumanus. There are isolated tombs at the periphery.

BIBLIOGRAPHY. S. Gsell, *Atlas archéologique de l'Algérie* (1911) 5, no. 12; M. Leglay, "A la recherche d'Icosium," *Antiquités Africaines* 2 (1968) 7-52[MPI].

M. LEGLAY

IDALION Cyprus. Map 6. Inland by the river Yialias 22 km NW of Kition. The ruins of the ancient city extend to the S of the modern village of Dali. The city consisted of three parts: two acropoleis and the lower town. The acropoleis occupied two hills, Moutti tou Gavrili to the E and Ambelleri to the W. These acropoleis bounded the city to the S and the lower town extended on their N slopes and on the flat land right up to the S outskirts of the modern village, which lies near the river. The city wall can still be traced along the N ridge of the E acropolis and past the Church of Haghios Georgios, where it disappears in the plain. It can also be traced along the ridge of the W acropolis, where it was partly excavated, and then disappears in the plain below. The necropolis extends E and W. Tombs of the Late Bronze Age and of Geometric times lie in the E necropolis; those of the archaic, Classical, Hellenistic, and Graeco-Roman, in the W one.

Idalion, one of the ancient kingdoms of Cyprus, was, according to tradition, founded by Chalcanor. Excavations have shown that the city was inhabited towards the end of the Late Bronze Age, when the W acropolis became a fortified stronghold with a cult place. This later became the place of the Temenos of Athena, whom the Phoenicians identified with their own Anat. On a terrace below the top of the W acropolis are remains of the royal palace, uncovered by trial excavations. The summit of the E acropolis was occupied by a Temenos of Aphrodite and in the narrow valley between the two acropoleis was the Temenos of Apollo, whom the Phoenicians identified with their Reshef. The Sanctuaries of Aphrodite and of Apollo, summarily excavated at the end of the 19th century, yielded a series of sculptures of stone and terracotta dating from the archaic, Classical, and Hellenistic periods. The W acropolis was excavated in 1928.

Little is known of the history of Idalion but the name appears on the prism of Esarhaddon (673-672 B.C.) and the sequence of its kings from the beginning to the middle of the 5th c. B.C. is fairly well fixed. The city fell in the siege by the Persians and the Kitians and thereafter was governed by Kition, which was itself ruled by a Phoenician dynasty. The presence of Phoenicians at Idalion after its fall is witnessed by inscriptions. The city continued to flourish throughout the Hellenistic and Graeco-Roman times and, unlike other cities of Cyprus, seems to have had in the 5th c. B.C. a constitution with some democratic element. Before falling to the Kitians it issued its own coins, the first of which date from shortly before 500 B.C. These coins show on the obverse a sphinx and on the reverse a lotus flower.

Very little survives in the way of monuments, the principal one being the remains of the Temple of Athena on the summit of the W acropolis. Of the Sanctuaries of Aphrodite and of Apollo nothing is to be seen. In the necropolis a number of tombs were excavated but only one tomb can now be viewed within the W necropolis.

The Temple of Athena was enclosed by the fortification wall, which at the same time served as a peribolos wall of the temenos. The first temenos belongs to Late Cypro-Geometric times but several additions and rebuildings were made during the Cypro-archaic period until it was finally abandoned at the beginning of the Cypro-Classical period. Originally it consisted of a chapel and an altar, the first being a room of the liwan type. Along the SW fortification a hall was built later which was entered through a gateway opening in the wall and communicated with the outer temenos. Simultaneously a wall was built to screen the area of the chapel, which thus became the inner temenos, in the N part of which another altar was built like the one in the cult chapel. In its final phase it underwent only minor alterations. Many ex-votos were discovered in these successive sanctuaries.

An archaic tomb in the W necropolis lies close to the road to Dali from Nisou. A long, narrow stepped dromos cut into the rock leads to the chamber, which is built with well-dressed stones and has a saddle-shaped roof. The tomb, although looted in the past, yielded a number of vases and metallic objects.

Casual finds turn up frequently but the most important is an inscribed bronze tablet, now in the Bibliothèque Nationale in Paris, which was reported to have been found accidentally in 1850 or before in the Sanctuary of Athena on the W acropolis. Other finds are in the Cyprus Museum, Nicosia.

BIBLIOGRAPHY. Luigi Palma di Cesnola, *Cyprus, its Ancient Cities, Tombs and Temples* (1877); R. Hamilton Lang, "Narrative of Excavations in a Temple at Dali (Idalium) in Cyprus," *Transactions R. Soc. Lit.*, II, Ser. XI (1878) 30-79; id., *Cyprus* (1878); M. Ohnefalsch-Richter & E. Oberhummer, "Idalion," *The Owl*, nos. 6,7,8,9 (1888)[MI]; Ohnefalsch-Richter, *Kypros, the Bible and Homer* (1893); A. Sakellarios, Τὰ Κυπριακά I (1890); I. K. Peristianes, Γενικὴ Ἱστορία τῆς νήσου Κύπρου (1910); Einar Gjerstad et al., *Swedish Cyprus Expedition* II (1935)[MPI]; K. Spyridakis, "Συμβολὴ εἰς τὴν Ἱστορίαν τῆς Πολιτείας τοῦ Ἀρχαίου Ἰδαλίου," Κυπριακαί Σπουδαί A (1937) 61-78; Olivier Masson, *Les Inscriptions Chypriotes Syllabiques* (1961) 233-52; id., Kypriaka—Le sanctuaire d'Apollon à Idalion," *BCH* 92 (1968), 386-402[I]; V. Karageorghis, "Excavations in the Necropolis of Idalion," *Report of the Department of Antiquities, Cyprus* (1964) 28-84[MPI]; id., *Nouveaux Documents pour l'Etude du Bronze Récent à Chypre* (1965).

K. NICOLAOU

IDANHA-A-VELHA, *see* EGITANIA

IDEBESSOS Lycia, Turkey. Map 7. Near Kozağacı, 900 m up in the mountain country 21 km N-NW of Kumluca and not easy to reach. The city is not mentioned before the Imperial age, at which time it was a member of a sympolity headed by Akalissos and belonging, as the inscriptions show, to the Lycian League. As a junior member of the sympolity Idebessos issued no coins in its own name. In the Byzantine bishop lists the name appears in the corrupted forms Lebissos and Lemissos.

The extant ruins and inscriptions are all of the Roman period. They include some remains of a city wall, a small theater, poorly preserved, a bath building, a church, but above all a great number of sarcophagi, many of them very rich and handsome.

BIBLIOGRAPHY. T.A.B. Spratt & E. Forbes, *Travels in Lycia* (1847) I 168-69; E. Petersen & F. von Luschan, *Reisen in Lykien* (1889) II 146-47; *TAM* II.3 (1940) 301-2MI. G. E. BEAN

IDFU, *see* APOLLINOPOLIS MAGNA

"IDOMENAE," *see* MARVINCI

IDYMA (Kozlukuyu) Turkey. Map 7. City in Caria 18 km S of Muğla. It first appears as a member of the Delian Confederacy, until ca. 440 B.C. At this time it was ruled by a dynast Paktyes, and then or a little later struck silver drachmas with the head of Pan and a fig leaf. At some time before 200 B.C. the city became subject to Rhodes; later it separated again, but was recovered by the Rhodian general Nikagoras (*SIG* 586).

The acropolis is on a spur of the mountain ca. 300 m above the village, and may be reached from the main road which passes above it. The fortification wall, of variable quality, encloses an oval space some 200 m long; there are remains of a small fort on the central part of the crest, but little else in the interior. On the S side are traces of an outer circuit enclosing a much larger area, which was evidently the inhabited part of the site. Lower down is a group of rock tombs including a fine architectural tomb in Ionic style, and at the foot of the mountain, beside the present road W of Kozlukuyu, is another group of five, of which two are Ionic temple tombs; the others are simpler. These architectural tombs probably date from the dynastic period around 400 B.C.

BIBLIOGRAPHY. G. Cousin & C. Diehl, *BCH* 10 (1886) 428-30; G. Guidi, *Annuario* 4-5 (1921-22) 370ff; L. Robert, *Études Anatoliennes* (1937) 472-90; G. E. Bean & J. M. Cook, *BSA* 52 (1957) 68-72. G. E. BEAN

IERAPETRA, *see* HIERAPYTNA

IEROMNÏMI, *see* LIMES, GREEK EPEIROS

IESI, *see* AESIS

IGEL Germany. Map 20. The village of Igel with its Roman funerary monument of a cloth-merchant family of Celtic origin called the Secundinii lies on the left bank of the Moselle some 8 km S of Trier. The family villa has not yet been explored. It probably lay up river from the monument, where the village church now is, or 400 m farther E on the Königsacht tributary. The monument has survived because by the early Middle Ages it had become associated with St. Helena, the mother of Constantine, and was regarded as a monument to the wedding of Helena and Constantius Chlorus. It has often been reproduced in engravings.

The monument was erected about A.D. 250 by the two brothers Lucius Secundinius Aventinus and Lucius Secundinus Securus for themselves and some seven or eight relatives. On the main relief, which has a partially preserved inscription, are portrayed six individuals, three full-length and three in medallions. The scene shows the brothers taking leave of a son of the Secundinii. In the medallions are three deceased family members. The remaining reliefs, which cover all four sides of the monument, are based on two themes: the religious-mythological, and the family's professional and daily life. The mythological scenes deal with life after death: apotheosis of Hercules and Ganymede (coronation), the death of Rhea Silvia for the sake of love, and the death of Hylas; Eros as a symbol of the omnipotence of love; Achilles being dipped in the Styx; Perseus with the head of Medusa. The scenes from daily life show the Secundinii at work: textile shop, textile factory, the transportation of the cloth by wagon and ship, are all shown, along with the kitchen, and the family eating and drinking. Other reliefs show the social standing of the Secundinii. They were great property owners, who farmed out some of their lands to tenants (coloni), and received their rent in the form of money, produce, or manufactured goods (cloth). The monument was a memorial to the dead of the family, but also served to document the importance and prestige of the family and firm.

The name Igel does not come from the Latin aquila, but from the mediaeval Latin agulia, which was used in Rome in the Middle Ages to refer to ancient obelisks. The word was brought N by the clergy, and became the High German Igel in Trier, and Eigelstein in Cologne and Mainz. The monument is 23 m high overall. It is built of red and red-gray sandstone that was originally painted.

BIBLIOGRAPHY. H. Dragendorff & E. Krüger, *Das Grabmal von Igel* (1924) summary of older literature; F. Drexel, "Die belgisch-germanischen Pfeilergrabmäler," *RömMitt* 25 (1920) 27ff; id., "Die Bilder der Igeler Säule," ibid. 83ff; J. Vannérus, "Le Mausolée d'Igel," *Les Cahiers Luxembourgeois* (1930) 457ff; H. Kähler, "Die rheinischen Pfeilergrabmäler," *BonnJbb* 139 (1934) 145ff; E. Krüger, "Die Igeler Säule," *Führungsheft des Rhein. Landesmuseums Trier* 9 (1934); id., *Die Kunstdenkmäler der Rheinprovinz, Landkreis Trier* (1936) 163ff; H. Eichler, "Zwei unbekannte Bilder des Grabmals von Igel," *TrZ* 18 (1949) 235ff; F. Oelmann, "Die Igeler Säule und die Eigelsteine als Problem der Nameskunde," *BonnJbb* 154 (1954) 162ff; E. Zahn, "Die Igeler Säule bei Trier," *Rheinische Kunststätten* 6-7 (1968); (1970); id., "Die neue Rekonstruktionszeichnung der Igeler Säule," *TrZ* 31 (1968) 227ff; H. Cüppers, "Arbeiten und Beobachtungen an der Igeler Säule," ibid. 222ff. E. ZAHN

IGILGILI (Djidjelli) Algeria. Map 18. First a Carthaginian trading post and then a Roman colony in Mauretania Caesariensis, the site is on a low peninsula and a small coastal plain enclosed by a ring of hills, about half-way between Bône and Algiers. The Roman colony, founded by Augustus (Plin. *HN* 5.21), is mentioned by Ptolemy (4.2.2), in the *Antonine Itinerary*, the *Peutinger Table*, and the Ravenna Geographer. It was a fairly important port until the Byzantine period. Six roads went out from it.

The monuments found date mostly to the Punic period. Essentially, these consist of necropoleis cut into the rock coastline up to 2 km to the W of the peninsula. There are graves at ground level and rock-cut tombs. The vaults average 2 x 1.50 x 1.25 m. Entries are

shut by slabs. The varied grave goods which they contain (amphorae, jewelry, pottery) were once attributed to the 6th and 5th c. B.C., but now have been brought forward to the 4th c.

The remains of town walls (which have now disappeared) belonged to the Roman period. An aqueduct comes from the S. To the SE of the knoll of St. Ferdinand were public baths. They have produced Dionysiac and ornamental mosaics, now at the Skikda Museum (formerly Philippeville), and sculptures (a satyr's head at the Algiers Museum). Other artifacts include statuettes, lamps, and votive stelae (at the Skikda Museum and the Louvre).

BIBLIOGRAPHY. S. Gsell, *Atlas archéologique de l'Algérie* (1911) 7, no. 77; J. and P. Alquier, "Tombes phéniciennes à Djidjelli (Algérie)," *RA* 31 (1930) 1-17; M. Astruc, "Nouvelles fouilles à Djidjelli," *Revue Africaine* 80 (1937); M. Leglay, *Saturne Africain. Monuments* (1966) II. M. LEGLAY

IGUVIUM (Gubbio) Umbria, Italy. Map 16. A hill town on the upper Tiber system, it originally commanded an important highway through the mountains and minted its own coins. Under the Romans it served in 167 B.C. as a place of detention for the Illyrian king Gentius; after the social war it was inscribed in the tribus Clustumina. But the running of the Via Flaminia in 223 B.C. several miles E of Iguvium had sealed its fate, and its decline through Imperial times was steady.

The theater, SW of the city, was always known; systematic excavations and drawings of it were made as early as 1789, and it is maintained as a monument. Its date is disputed, but the size, the sophisticated plan, and the rustication of the exterior suggest that it is not earlier than Claudius. Nearby is the core of a large tomb, a cylindrical base surmounted by an hourglass-shaped story, perhaps representing a giant mill.

More famous are the Tabulae Iguvinae, seven bronze tablets of three sizes found in 1444 near the theater. The two largest and part of one smaller one are inscribed in the Roman alphabet, the remainder in an Umbrian alphabet akin to Etruscan. They contain instructions for ceremonies of the Atiedan Brothers, a college of priests, with a wealth of information about topography and cults. They and other antiquities are kept in Palazzo dei Consoli.

BIBLIOGRAPHY. *Dioniso* 7 (1939) 3-16 (P. Moschella)PI; J. W. Poultney, *The Bronze Tables of Iguvium*, American Philological Association (1959)I; *EAA* 3 (1960) 1067-68 (U. Ciotti). L. RICHARDSON, JR.

IKARIA Attica, Greece. Map 11. On the N side of Mt. Pendeli, in a valley between it and the peak Stamatovouni farther N, lies the village of Dionyso, just E of which are the remains of the public center of the deme of Ikaria (or Ikarion), the reputed home of both drama and Thespis (Ath. 2.40 and Suidas, s.v. Θέσπις), the identification made certain by the discovery of several deme decrees.

The excavated area is small, and most of the remains are tenuous. But one can make out an open area, the agora, with public buildings—one a pythion—and monuments grouped about. To the S of the agora is a small theater, its rectangular orchestra limited on one side by five stone prohedriai and bases for stelai, and on the other by a terrace. These austere arrangements may belong to the 4th c. B.C., or possibly earlier because an inscription of the 5th c. B.C. (*IG* I² 186-87) attests the existence at that time in Ikaria of organized festivals. Further associations with Dionysos can be seen, not only

in the name of the village, but in two archaic marble sculptures—a mask and a seated figure of the god, both from the excavated area.

BIBLIOGRAPHY. C. D. Buck, "Discoveries in the Attic Deme of Ikaria in 1888," *AJA* 4 (1888) 421-26; 5 (1889) 9-33, 154-81, 304-19, 461-77; W. Wrede, "Der Maskengott," *AM* 43 (1928) 67-70; O.A.W. Dilke, "Details and Chronology of Greek Theatre Caveas," *BSA* 45 (1950) 30-31. C.W.J. ELIOT

IKARIA (Nikaria) Greece. Map 7. The island is one of the Anatolian Sporades group, W of Samos. According to legend the name of the island derives from the fall of Ikaros, son of Daidalos, who plunged to earth there after his fatal flight. According to Pausanias (9.11.5) his tomb was on the island. Archaeological remains are extensive near the modern village of Kalpos, and have been identified with ancient Oinoe; fragments of inscriptions and funerary reliefs have been reused in the walls. Remains of walls have been discovered on the hill of Ag. Irini, and the remnants of a Byzantine church lie over the foundation of an ancient basilica. Perhaps the ancient city was on the sea, as a necropolis of the 5th and 4th c. B.C. extends S from the coast. At Raches a Greek necropolis of the same date has been discovered. At Nas, on the W coast, there was perhaps a small port. Walls there date from the Classical period, and foundations of two small buildings and one larger one have been discovered. The material found includes fragments of Greek-Oriental ceramics which indicate that the area was frequented from the 7th to 5th c. B.C. Marble pieces, statuettes, and inscriptions on ceramic fragments indicate that they belong to the Sanctuary of Artemis Tauropolos, recorded in the sources.

In the ancient center of Thermai there are remains of bath buildings. Kataphygion, the ancient acropolis, occupied the summit of a mountain, not precisely located, which was called Kastro and which dominated the coast and the sea. Near the modern village of Kataphygion a necropolis has been excavated, containing tombs dating from the beginning of the 5th c. on.

BIBLIOGRAPHY. E. Bürcher, *RE* 9 (1916) c. 973 s.v. n.2; id., *ArchAnz* 53 (1938) 581; (1939) 284; (1942) 191; G. Becatti & L. Banti, *Enciclopedia Italiana, Appendice* (1938-48) s.v. Grecia; G. B. Montanari, *EAA* 4 (1961) s.v. Icaria (G. B. Montanari).

G. BERMOND MONTANARI

ILCHESTER ("Lindinis") Somerset, England. Map 24. The Roman town, whose ancient name may have been Lindinis or a form allied to it, lay on the Fosse Way where it is joined by a road from Durnovaria (Dorchester). The site has long been known but has not yet been extensively examined. In the mid 1st c. A.D. a settlement of simple circular huts was surrounded by a bank and ditch. In the 4th c. an area of ca. 12.8 ha was enclosed by a wall 0.9 m wide; this defensive work was perhaps added to an earlier clay bank. The S gate has been identified and one of its towers excavated. On the evidence of two inscriptions from Hadrian's Wall which mention Durotriges Lindinienses (or Lendinienses), it has been suggested that Lindinis was an administrative center of the civitas Durotrigum, equal in status with Durnovaria.

BIBLIOGRAPHY. *Proc. Somerset Archaeological Society* 46 (1951) 188. M. TODD

ILDIRI, see ERYTHRAI

"ILDUM," see CABANES

ILERDA (Lérida) Lérida, Spain. Map 19. Town on the W bank of the Sicoris (Segre) river in Tarraconensis, named for the Ilergetes. It was the most important pre-Roman town N of the Iber (Ebro). Its silver coins, imitating Massalian oboli and the drachmas of Emporion, were inscribed in Iberian letters. Allied with the Carthaginians, Ilerda tenaciously opposed the Romans under the leadership of its chiefs, Indibil and Mandonius, until they were captured in 205 B.C. According to Pliny the town was inhabited by the Surdaones and had Roman rights (*HN* 3.24), and nearby Julius Caesar won a famous tactical victory over Pompey's forces in 49 B.C. (*BCiv* 1.38; App. 2.42). Under the Romans it minted coins according to the Roman system (denarii and asses) during the 2d and 1st c. B.C.

Situated on the Roman road from Tarraco to Osca, it always retained its importance (*Ant.It.* 391.2; Auson. 23.4): it was a municipium attached to the Conventus Caesaraugustanus and an Islamic center during the late Middle Ages. No Roman monuments are visible but Roman inscriptions, marbles, pottery, and glassware are frequently found. Excavation in the cellars of the town hall has produced strata covering 2000 years.

BIBLIOGRAPHY. E. Hübner, *Monumenta Linguae Ibericae* (1893) no. 30a; G. Hill, *Notes on the Ancient Coinage of Hispania Citerior* (1931); *Fontes Hispaniae Antiquae* V (1940). J. MALUQUER DE MOTES

ILIBERRIS (Elvira) Granada, Spain. Map 19. The exact location of this Baetic town W of Granada is not known and there is no archaeological evidence. About A.D. 309 19 bishops and 24 presbyters met here in a Council which promulgated 81 canons, notably no. 36, prohibiting images and paintings in the churches.

BIBLIOGRAPHY. Z. G. Villadda, *Historia Eclesiastica de España* (1929). J. Vives, *Concilios visigodos e hispano-romanos* (1963). J. ARCE

ILIDŽA, *see* AQUAE S.

ILION (Albania), *see* DHESPOTIKON

ILION (Troy) Turkey. Map 7. Equidistant (about 5 km) from the Aegean and the Dardanelles. A gap of 400 years separates Troy VIIb, the final phase of the Bronze Age citadel, from the beginning of Troy VIII, when the site was reoccupied, apparently by Greek settlers, traditionally described as Aitolian, shortly before 700 B.C. To judge from the archaeological remains, Troy enjoyed a moderately active existence in the 7th and 6th c., and declined into comparative stagnation in the 5th and 4th c. In Hellenistic-Roman times (Troy IX) its fortunes were livelier. The town benefited substantially from the favor of Alexander and Lysimachos, and later from that of Caesar and Augustus, to say nothing of subsequent emperors, but there were also reverses, notably during the Mithridatic war, when Troy was captured and sacked by the Roman legate Fimbria in 85 B.C. Before deciding to locate his new capital on the Bosphoros, Constantine considered Troy as a possible site. The latest known Classical reference to the town is an account of a visit by the emperor Julian in A.D. 355.

The physical remains of Troy VIII are meager. The buildings of this period which originally occupied the hilltop were largely destroyed in Troy IX when the central part of the hill was leveled to provide a precinct for the cult of Athena Ilias. Though Troy VIII extended beyond the limits of the Bronze Age citadel, its people, for a time at least, relied for defense on the great wall of Troy VI, which they repaired and strengthened at vari-

ous places. In the NE sector a wall was built to enclose a flight of steps that gave access to a well outside. At the SW, again outside the circuit of the VI wall, two sanctuaries of modest size lie adjacent to each other. They were founded in the mid 7th c., and continued into Troy IX.

Though Troy IX was larger and more prosperous, its remains are scarcely abundant. The plan of the great Sanctuary of Athena, which included a propylon and colonnades, has been determined, occupying an area almost half as large as all of Troy VI. Scattered fragments of a Doric temple have been recovered. The best preserved metope depicts Helios driving his chariot. Though its date is disputed, the temple is probably Early Hellenistic; its construction is ascribed by Strabo (13.1.26) to Lysimachos. Elsewhere about the hill are remains of theaters or theatral buildings, a palaestra, and sections of the extended city wall.

The bulk of the finds from Troy are housed in the Archaeological Museum in Istanbul.

BIBLIOGRAPHY. W. Dörpfeld, *Troja und Ilion* (1902)[P] (see pp. 1-17 et passim for references to Schliemann's reports); W. Leaf, *Strabo on the Troad* (1923); C. W. Blegen et al., *Troy: Settlements VIIa, VIIb, and VIII* (1958)[PI]; A. R. Bellinger, *Troy: The Coins* (1961); F. W. Goethert & H. Schleif, *Der Athenatempel von Ilion* (1962)[PI]; D. B. Thompson, *Troy: The Terracotta Figurines of the Hellenistic Period* (1963); B. M. Holden, *The Metopes of the Temple of Athena at Ilion* (1964); W. Hoepfner, "Zum Entwurf des Athena-Tempels in Ilion," *AthMitt* 84 (1969) 165-81. C. BOULTER

ILKLEY, *see* OLERICA

ILLIBERIS (Elne) Pyrénées-Orientales, France. Map 23. Iberian oppidum built on an isolated butte in the plain of Roussillon, near the coastal river Iliberis (Strab. 4.1.6), now the Tech, at the foot of the Albère Massif. The importance and prosperity of the town is said to have declined under the early Empire (Plin. 3.32), but under Constantine it regained its role as a fortified place guarding the principal routes across the E Pyrenees. At this time it took the name of Castrum Helenae (Elne) in honor of the mother of Constantine. It was the see of a diocese from the 6th c. on.

The ancient settlement is directly under the mediaeval and modern town, and there is evidence of continuous human occupation since the 6th c. B.C. Recent emergency excavation has uncovered modest structures and pre-Roman storage pits in the upper town, and in the lower town a necropolis of the Early Christian era. The archaeological artifacts are preserved nearby in a museum in the cathedral buildings.

BIBLIOGRAPHY. E. Espérandieu, *Répertoire archéologique des Pyrénées-Orientales* (1936) 28-29; "Informations," *Gallia* 20 (1962) 611; 22 (1964) 473; 29 (1971) 369. G. BARRUOL

ILLICI (Elche) Alicante, Spain. Map 19. A settlement 2 km from Elche on the Dolores road, on the estate of La Alcudia. It is mentioned in ancient sources (Plin. 3.20; Mela 2.93; Diod. 25.10; Ptol. 2.61). The settlement occupied some 10 ha on a rise ca. 4 m higher than the surrounding plain. In the Bronze Age it bore a tiny village (stratum G), above which were a series of towns: Iberian (F, E), Republican Roman (D), destroyed about the middle of the 1st c. B.C.; Imperial Roman (C), razed by the Frankish invasions and subsequent revolts; Late Roman (B), much reduced in size and destroyed by barbarian peoples; and finally the Visigothic-Byzantine

stratum (A), after which the hillside was abandoned and its inhabitants settled the site of modern Elche.

In 43-42 B.C. Illici was raised to the status of colonia immunis under the name of Colonia Iulia Illici Augusta and issued Roman coinage with more than 20 variant types between 43 B.C. and A.D. 31. The town walls, surveyed in 1565, had a perimeter of 1400 m (now largely destroyed). Since 1752 excavation has uncovered such architectural remains as baths and an amphitheater. Stratum C (mid 1st c. B.C. to mid 3d c. A.D.) yielded houses larger than those in stratum D, with impluvium, bath and drain, admirable statuary, coins from the Empire. Stratum B (3d-4th c.) produced remains of a building identified as a synagogue, built in the 4th-5th c., enlarged in the 7th c., and containing a mosaic with a Greek legend indicating where the people, the magistrates, and the elders assembled for prayer.

Finds from the site include sculpture—most notably the so-called Lady of Elche (4th-3d c. B.C.) now in the National Archaeological Museum in Madrid—coins, inscriptions, mosaics, ceramics. There is a museum on the site.

BIBLIOGRAPHY. A. Ibarra, *Illici, su situación y antigüedades* (1897); P. Beltrán, *Las primeras monedas latinas de Ilici* (1945); A. García y Bellido, *Las colonias romanas de Valentia, Carthago Nova, Libisosa e Ilici* (1962); A. Ramos Folqués, *Estratigrafía de La Alcudia de Elche* (1966). D. FLETCHER

ILOK, *see* CUCCIUM *under* LIMES PANNONIAE (Yugoslav Sector)

ILUNUM (Hellín) Albacete, Spain. Map 19. City of Tarraconensis 59 km S of Albacete (Ptol. 2.6.61). The principal finds are a magnificent Roman mosaic of the 2d c. A.D. showing the seasons and months of the year, and an Early Christian sarcophagus of ca. A.D. 380. Both are in Madrid, the mosaic in the National Archaeological Museum and the sarcophagus in the Royal Academy of History.

BIBLIOGRAPHY. A. Fernandez de Avilés, "Un nuevo mosaico descubierto en Hellín (Albacete)," *ArchEspArq* 14 (1940)[1]; P. de Palol, *Arqueología cristiana de la España romana* (1967) 302-3[1]. R. TEJA

ILURATUM Bosporus. Map 5. Fortified agricultural settlement 17 km SW of Kerch, dating from the 1st to the 3d c. A.D. It is mentioned by Ptolemy (3.6).

Spread out over a 2-ha area, the city has a rectangular plan. It was surrounded by sturdy walls—very well preserved—more than 6 m thick and 2.5 m high, and fortified with six towers. A necropolis SE of the site has been excavated.

The residential area, which is fairly well preserved, consists of houses rectangular in plan, each having a small inner courtyard with rooms arranged around it. The houses are contiguous and are supported by the fortress walls. The stairways go from the courtyard to the first story, or directly onto the ramparts. Iluratum is an example of a fortress designed to protect agricultural settlers against nomads.

The finds—local hand-thrown wares with an incised design, terracotta figurines—are typical of Scytho-Sarmatian civilization, free of any Greek influence. Among the most noteworthy is a figurine of a goddess with outstretched arms, one arm in the shape of a tree trunk. The goddess had a nimbus around her head. The Hermitage Museum contains material from the site.

BIBLIOGRAPHY. V. F. Gaidukevich, "Ilurat. Itogi arkheologicheskikh issledovanii 1948-1953 gg.," *Bosporskie goroda*, II [Materialy i issledovaniia po arkheologii SSSR,

No. 85] (1958) 9-148; A. L. Mongait, *Archaeology in the USSR*, tr. M. W. Thompson (1961) 198-99; I. B. Brašinskij, "Recherches soviétiques sur les monuments antiques des régions de la Mer Noire," *Eirene* 7 (1968) 99-100; I. G. Shurgaia, "Raskopki v iugo-zapadnoi chasti Ilurata v 1966 i 1968 gg.," *KSIA* 124 (1970) 61-68; M. M. Kublanov, "Issledovanie nekropolia Ilurata," *KSIA* 128 (1971) 78-85; id., "Raskopki nekropolia Ilurata v 1969 g.," *KSIA* 130 (1972) 83-88.
M. L. BERNHARD & Z. SZTETYŁŁO

ILVA (Elba) Etruria, Italy. Map 14. Named Aithalia by the Greeks, the island is cited by Greek writers (from Polybius to Strabo, Ptolemy, and Diodorus Siculus) and by Latin writers (from Vergil to Pliny and Rutilius Namatianus) primarily for the mining of iron, first by the Greeks, then by the Etruscans and the Romans. A large number of discoveries have been made on land and in the sea (an abandoned ancient ship at Procchio). Inhabited from the Stone Age into the Roman era, the island offers even now the sight of two large Roman villas, one at Grotte di Portoferraio and the other at Cavo di Rio Marina. Archaeological finds are in the museums of Florence, Livorno, Rome, Reggio Emilia, and in depositories on Elba (Portoferraio, Marciana, and Porto Azzurro).

BIBLIOGRAPHY. *NSc* (1880) 77-78 and (1878) 62; *ArchAnthrop* (1924) 89-116; V. Mellini with G. Monaco, "Memorie storiche Isola Elba," *Repertorio archeologico e Bibliografia sistematica* (1965); G. Monaco in *FA* from 12 (1959) on and in *StEtr* (Rassegna Scavi e scoperte) from 27 (1959) to 41 (1973); id., *Atti I & II, Convegno Storia Elbana* (1974-75); id. & M. Tabanelli, *Guida all'Elba archeologica* (1974-75). G. MONACO

ILYAS Turkey. Map 7. Site in Pisidia, whose ancient name is unknown, directly across the lake from Burdur. The city stood on two hills with stretches of rough wall at the foot. The ancient road from the NE is spanned by a triple-arched gateway in poor condition, and at one point are the ruins of a small temple. The numerous inscriptions and cut blocks are of unusually good quality for this region; mention of Council and People is proof of city status, but no clue to the name has yet appeared. A milestone (not in situ), showing one mile, indicates that the city at Ilyas was the caput of a road, perhaps a short branch joining the main road on the other side of the lake. In view of the quality of the ruins their anonymity is surprising.

BIBLIOGRAPHY. J.R.S. Sterrett, *Wolfe Expedition* (1888) 415-24; W. M. Ramsay, *Cities and Bishoprics* I (1895) 322-23, 332-34; G. E. Bean, *AnatSt* 9 (1959) 81-82.
G. E. BEAN

IMACHARA, *see* TROINA

IMMURIUM (Moosham) Austria. Map 20. A vicus in Lungau not far from present-day Mauterndorf, 110 km S-SE of Salzburg and 1100 m above sea level. It was in the Noricum province and part of the territorium of Teurnia (St. Peter im Holz). Mentioned in the *Peutinger Table*, it was a mansio on the road from Virunum (Zollfeld) to Iuvavum (Salzburg), established at the time the road was built in the early Imperial period. It was important economically for the mining and working of iron.

The settlement was not disturbed by the Marcomannic assaults in Marcus Aurelius' reign. In A.D. 201, when a new road was built from Teurnia to Immurium, the vicus became a crossroads statio. About 275 it was at least partially destroyed by the Alemanni. There is no evidence that the city was finally destroyed in late antiquity,

but it seems instead to have been abandoned earlier by its inhabitants.

In 1950 a Mithraeum, probably dating from the early 3d c. A.D., was found. Excavations (1964-70) have uncovered the following: mansio I with two separate buildings and courtyard; a large house with bronze foundry; a bath building with apodyterium, caldarium, tepidarium, frigidarium; houses, some poorly preserved; a large house with wall paintings, with a sepulcher for multiple burials added; mansio II with inner courtyard. The finds are in the Museum Tamsweg.

Recently, remains of houses of the 1st and 2d c. A.D. have been excavated in Steindorf, 1.5 km N of Immurium.

BIBLIOGRAPHY. M. Hell, "Das Mithräum von Moosham im Salzburger Lungau," *Mitteilungen der Gesellschaft für Salzburger Landeskunde* 105 (1965) 91ff[I]; R. Fleischer, "Immurium-Moosham. Die Grabungen 1964 und 1965," *ÖJh* 47 (1964-65) 105ff[MPI]; 48 (1966-67) 165ff[MPI]; 49 (1968-71) 177ff[MPI]; id., "Die Grabung in Steindorf 1971." *ÖJh* 49 (1968-71) 235ff[MPI].

<div align="right">R. FLEISCHER</div>

IMOLA, *see* FORUM CORNELII

IMUS PYRENAEUS (Saint-Jean le Vieux) Pyrénées Atlantiques, France. Map 23. Only the *Antonine Itinerary* mentions the mansio of Imus Pyrenaeus, situated at the foot of the Bentarte and Ibañeta passes leading to Pamplona (Pompaelo). The itinerary places it on the road from Bordeaux to Astorga (Asturica Augusta).

The original site, which goes back to the last third of the 1st c. B.C., was a rectangular castrum (200 x 115 m) ringed by a strong vallum, well preserved on two sides. Inside this rampart a fairly regular city plan can be made out; its axis is the N-S cardo leading to the only gate opening S. The finds from the earliest stratum indicate that the city enjoyed sudden prosperity at the end of the 1st c., probably connected with Valerius Messala's campaigns against the Pyrenean tribes, which ended in 27-26 B.C.

In the 1st c. A.D. the settlement was rebuilt, but retained the same plan and the same defensive circuit wall. A little forum was built, consisting of a small, square, windowless building and some shops grouped around a little temple, whose oblong cella (7.2 x 4.8 m) suggests that it may have been divided into three sections. The construction technique remained very primitive—an inferior mortar was used in all but a few cases. Real prosperity did not come until the last quarter of the century when there was an influx of goods from Spain, and Gallo-Roman imports were stopped almost completely. At this time the city expanded and developed. At the beginning of the 2d c. A.D. the original rampart was split and a new vicus built, using only part of the earlier buildings around the forum. No appreciable change was made from that time until the second half of the 3d c. A.D. when there is evidence of massive destruction, related to the first waves of Germanic invaders moving toward Spain. After a brief period of abandonment at the end of the 3d c. the ruins were leveled and the ancient defenses of the castrum probably restored. Restricted in plan, Imus Pyrenaeus vegetated and the site was finally abandoned, probably before the barbarian invasions of the early 5th c. A.D.

BIBLIOGRAPHY. J. Coupry, "Informations," *Gallia* (1967) 372[PI]; (1969) 378-80[I].

<div align="right">J. L. TOBIE</div>

INARIME, *see* AENARIA

INCEALILER, *see* OINOANDA

INCHTUTHIL Perthshire, Scotland. Map 24. An isolated plateau on the N bank of the Tay, 8 km SW of Blairgowrie, is the site of a complex group of Roman remains, comprising a 20 ha legionary fortress, almost square in plan; a temporary camp of about the same size; a linear earthwork cutting off the approach to the fortress from the SW; a stores compound of nearly 2 ha; and a residential compound for senior officers supervising the construction work. The linear earthwork and the outlines of fortress and stores compound are still partly discernible, but the other works have been completely buried.

Excavation in 1952-65 showed that the fortress was begun by Agricola, probably in A.D. 83, and abandoned in an unfinished state, probably in A.D. 87. The defenses consisted of a turf rampart fronted by a stone wall 1.5 m wide, a ditch 6 m across, and an external upcast mound with obstacles on the crest. The N gate had been destroyed by the erosion of the scarp on which it stood, but the other three gates were of the same design, twin carriage-ways flanked by timber towers each 6 m square. The internal buildings were almost entirely of wattle-and-daub in timber framing. In the center was the headquarters building, 48 m square, its courtyard bordered at the front and sides with internal and external colonnades. Behind the courtyard was the cross-hall, and then a row of administrative rooms on either side of a central shrine. In the NE quarter the principal building was a hospital, containing 60 wards in two ranges separated by a corridor. The complementary position in the NW quarter was occupied by a large construction shop, a courtyard building with workshops on three sides and a row of five rooms on the other. Before the evacuation a quantity of worked iron, including 12 tons of unused nails, had been buried in the front range to prevent it from falling into the hands of the native tribesmen. Also in this quarter of the fortress there were four centurion's houses, with a larger house for the primus pilus.

The main roads were bordered on both sides by colonnaded storerooms, but on the E side of the via praetoria the line of storerooms was interrupted by a drill hall, an elaborate building with porch, nave, aisles, and ranges of rooms at the sides and back. Four tribune's houses were identified in the praetentura, two on either side of the via praetoria, while distributed throughout the fortress were 64 large barracks for the 54 centuriae of nine quingenary cohorts and ten centuriae of one milliary cohort. Six large granaries were also found, carried on dwarf walls with a portico at each end. Although the accommodation for the legionaries had thus been completed, much still remained to be done. The legate's house, which was to have stood on the E side of the principia, had not been begun, although the site had been leveled in preparation for it. Two more tribune's houses and probably two more granaries awaited erection, while the area behind and around the principia was undeveloped. Moreover, a small bath house built for the use of officers in the residential compound still lacked its hot water system. Evidently, therefore, the headquarters staff had not yet left their old location when work was suspended. There is no proof of the garrison for whom the fortress was intended, but it was almost certainly the Legio XX. When the site was evacuated the fortress was deliberately dismantled, the main timbers removed for use elsewhere, the stocks of pottery destroyed, and the drains and sewers filled up. The finds from the excavation, and from earlier exploration in 1901, are in the National Museum of Antiquities of Scotland.

BIBLIOGRAPHY. *Proc. Soc. Ant. Scotland* 36 (1902) 182-242; annual summaries in *JRS* 43-56 (1953-66).

<div align="right">K. A. STEER</div>

INCIRLI, *see* HYIA

INCIRLIHAN Pisidia, Turkey. Map 7. About 5 km W of Bucak. References by Diodoros (18.44, 47) and Polybios (5.72) show that Kretopolis must have been in this neighborhood, but it is doubtful that the remains at Incirlihan are sufficient to represent a city. Travelers have noted only a large building, various scattered fragments, and a votive dedication to Demeter; few or no sherds. It has been suggested that Kretopolis was identical with the city of the Keraitai.

BIBLIOGRAPHY. K. Ritter, *Die Erdkunde . . .* XIX (1859) 706; H. Rott, *Kleinasiatische Denkmäler* (1908) 21, 360; G. E. Bean, *AnatSt* 10 (1960) 52-53; A.H.M. Jones, *The Cities of the Eastern Roman Provinces* (2d ed. 1971) 125. G. E. BEAN

INCORONATA (Pisticci) Basilicata, Italy. Map 14. An ancient center near the town, set on a small, elongated hill overlooking the river Basento. The settlement, isolated on every side, may be reached only from the E where it looks out over the sea. It is 6 km from the center of the Greek colony of Metapontion and W of the line of defense of the Achaean colony.

The site is defended not only by its precipitous position but by an irregular stone and earthen agger (ca. 1 m wide). Within the fortification line, on a level stretch that slopes gently upward to the E, are traces of dwellings, rectangular or circular, with plinths of irregular sandstone rocks coming from the Basento river. Scattered here and there throughout the area, they are built of clay mixed with straw and ash and reinforced with tree trunks and branches. Inside the dwellings, Greek pottery mingled with local ware was found. The oldest vases are the proto-Corinthian bulging aryballoi and the pyre-shaped vases with friezes of running dogs. This series of small proto-Corinthian vases is associated with the series in gray clay. The larger vases are represented by locally produced amphorae and by black, painted amphorae, probably imported, and by a series of double-handled Chian orientalizing vases. These have geometric decorations in imitation of the insular and Rhodian techniques. The local ware comprises large decorated vases or imported Iapygean ware mingled with large dishes, small sacrificial bowls, and urn-shaped amphorae. The total array of extant pottery suggests coexistence between Greeks and native peoples, beginning in the second half of the 8th c. B.C.

In the lowest levels of the site are ceramic fragments dating from the last years of the Bronze Age or perhaps of the Apennine culture. Even though the levels are often mixed because of a succession of buildings, this much has become clear in the chronology which extends until the end of the 7th c. B.C. Thus far, no other evidence has been found prior to this period. Some vases show traces of graffiti, among the oldest known to date in the area of Metapontion.

The archaic Greek pottery discovered in this site antedates, in very large part, the finds thus far made in the lowest levels at Metapontion. Everything gives the impression of a site which predates the founding of Metapontion, and which was abandoned toward the end of the 7th c. B.C. Antiochos of Syracuse (Strab. 6.1.15) speaks of another site which existed in the area of Metapontion but which was abandoned before Metapontion was founded. Perhaps his words should be reconsidered in this context.

BIBLIOGRAPHY. D. Adamesteanu, "Problèmes de la zone archéologique de Métaponte," *RA* (1967) 28-29, fig. 35; id., *Popoli anellenici in Basilicata* (1971) 18-20.
 D. ADAMESTEANU

INDUSTRIA (Monteu da Po) Piedmont, Italy. Map 14. A Roman colony of the Augustan Regio IX, perhaps contemporary with Valentia, Pollentia, and Hasta, all of which were enrolled in the tribus Pollia. It seems to have had assigned to it all the districts of Roman citizens in Cisalpine Gaul before the social war. The settlement, dating to the century prior to the social war, developed on either side of the road which follows the right bank of the Po and led from Augusta Taurinorum to Vardagate and from there to Valentia and Vercellae. The Ligurian name of Bodincomago by which Industria was called earlier, according to Pliny (3.5.20, 21), demands the existence on the same spot of a pre-Roman settlement, but evidence is lacking.

The regularity, which has been seen from an examination of the known elements (few remains of poorly identified buildings and streets) and the military considerations attendant upon building a city on one of the major roads of access to W Cisalpine Gaul, make it possible to conjecture a regular grid plan and the existence of a fortification wall. The existence of the wall would appear to be confirmed by the discovery of a tower, closed by a double wall of loose rubble core with facing in opus incertum. A complex erroneously thought to be a theater has recently been identified as a cult building, a sanctuary extra moenia dedicated perhaps to Isis and dating to the 2d c. of the Empire. From there come valuable bronze figures, some produced in local shops, now in the Museo di Antichità in Turin. The imposing monumental remains, the richness and the value of the recovered figures, and the numerous inscriptions document the floruit of urban life in the centuries of the Empire. We do not yet know the extent of the settlement which, beyond the road to Casale, must have joined the ancient bed of the Po river, 1 km S of the present course. The necropolis has also been tentatively placed; a late tomb was set over the ruins of a sanctuary of Isis on its S edge.

BIBLIOGRAPHY. E. Fabretti, "Dell'antica città di Industria detta prima Bodincomago," *ASPABA* (1880) 44ff; F. Gabotto, "I municipi romani dell'Italia occidentale," *Biblioteca Soc. Storica Bibliografica Subalpina* 33 (1908) 280; E. Durando, "Scavi archeologici nel sito dell'Antica città di Industria," *ASPABA* (1913) 117ff; P. Barocelli, "Monteu da Po: scoperte nel territorio dell'antica Industria," *NSc* (1914) 185, 441; U. Erwin, "The early colonisation of the Cisalpine Gaul," *BSR* (1952) 54ff; P. Fraccaro, "Un episodio dell'agitazione agraria dei Gracchi," *Studies . . . D. M. Robinson* (1953) 884ff; M. Barra Bagnasco et al., *Scavi nell'area dell'antica Industria* (Memorie Acc. Scienza Torino; 1967) 4, n. 13; id. et al., "Notizia degli scavi nell'area dell'antica Industria," *BSPABA* (1968) 47ff. S. FINOCCHI

INEBOLU, *see* ABONUTEICHOS

INESSA later AITNA Catania, Sicily. Map 17B. A Sikel settlement between Catania and Centuripe (Thuc. 6:94.3); it was later occupied by Aitneans who changed its name into Aitna (Strab. *Geog.* 6.2). The identification with the district Città, between Paternò and S. Maria di Licodia, has been suggested by some scholars, but has been disproved by recent excavations in that district. As a result, it has been proposed that Inessa was in the Poira district, on the right bank of the river Simeto, halfway between Paternò and Centuripe; this location would be in agreement with the sources as well as with the *Antonine Itinerary* and the *Peutinger Table*, which place the site 19 km from Catania.

In the area one can see remains of ancient walls from houses and fortifications. Recently some rock-cut cham-

ber tombs have been discovered; they are rather irregular in shape and contain material of the 6th and 5th c. B.C., soon to be published.

BIBLIOGRAPHY. G. Rizza, "Scavi e ricerche nel territorio di Paternò," *BdA* (1954); id., "Paternò, Città siculo-greca in contrada Civita. Scoperte fortuite nella necropoli meridionale," *NSc* (1954); id., "Scoperta di una città antica sulle rive del Simeto: Etna-Inessa?" *La Parola del Passato* 69 (1959). C. BUSCEMI INDELICATO

INICOS, see PHINTIAS

INNERPEFFRAY Perthshire, Scotland. Map 24. Two Roman marching camps on the N bank of the Earn opposite Strageath fort. The camp to the E (ca. 630 x 420 m), visible only as crop marks on air photographs, belongs to a group averaging 25.2 ha in extent which are thought to have been built during the early Severan campaigns. The second camp (ca. 810 x 570 m; 48 ha) probably dates to the later Severan campaigns; part of its N side survives in Innerpeffray Wood.

BIBLIOGRAPHY. *JRS* 48 (1958) 90; 49 (1959) 116-19.
K. A. STEER

INTARANUM (Entrains) Dept. Nièvre, France. Map 23. The site is halfway between Cosne-sur-Loire and Clamecy-sur-Yonne. The ancient name is attested by a marble marker discovered at Autun, the capital of the Aedui. Roads radiated from Entrains to Auxerre, Autun, and Bourges through Mesves or Cosnes and to Orléans through St. Amand and Neuvy-sur-Loire. The city was built on an overhanging rock where the valleys of the Trélong and the Nohain meet, along the edge of which are two parallel fault lines. These valleys also bounded the cities of the Aedui, Biturigi, and Senoni, and constituted a border region that, in turn, came under the authority of Autun, Auxerre, then Nevers.

Although no ancient monument has been preserved, the modern city bears traces of an amphitheater, some baths, and many temples. Inhabited since Gallic times but built up chiefly from the 2d c. onward, Entrains has yielded 120 carved stone fragments—more than the whole of the Nièvre territory combined. Colossal limestone statues of Apollo (2.65 m) and very probably of Jupiter, Mithraic bas-reliefs as well as a great many traces of indigenous cults testify to the religious fervor of the inhabitants, who also included in their pantheon the gods Borvo and Candidus, as is shown by a bronzeworkers' dedication. Still, Entrains was not just a city of temples; at the same time it was an active commercial and industrial center. Spanish amphorae have been found there, along with terra sigillate ware from S and central Gallia, Argonne pottery decorated with the pestle, gray crackleware from la Villeneuve au Châtelot, and even ocellated ware that shows how Celtic decorative motifs still persisted in the 1st c. Also in the region were sculptors' and weavers' workshops; work in bronze and iron was also extremely important. Since 1965 excavations at the "chantier Chambault" have uncovered an insula belonging to ancient Intaranum. A blacksmith's forge, some vaults, a well, cesspools, and ancient roads have also been discovered. Stratigraphical studies and an examination of the objects found on the site make it possible to date the period of activity of this district between the 1st c. and the end of the 4th.

BIBLIOGRAPHY. J. Bollandus et al., *Acta sanctorum quot toto orbe coluntur*, 49 vols. in fol. (1643-1769): *Passio Perigrini*, 3; J. F. Baudiau, *Histoire d'Entrains*, with appendix by M. Héron de Villefosse on the antiquities of Entrains (1879); E. Thevenot, "Le culte des eaux et

le culte solaire à Entrains," *Ogam*, no. 31 (1954) 9-20; J.-B. Devauges, "Entrains gallo-romain," doctoral dissertation, 3d cycle, Faculté des Lettres de Dijon (1970)MPI.
J.-B. DEVAUGES

INTERAMNA NAHARS (Terni) Umbria, Italy. Map 16. The modern city, 73 km N-NE of Rome, is near the confluence of the Nera (ancient Nar) and the Serra, which may have changed course since antiquity. The ancient city must have been encircled by the rivers.

According to an inscription (*CIL* XI, 4170) the city was founded in 672 B.C. It lay along an alternate route that left the Flaminia at Narni. Terni was a flourishing Roman municipium ascribed to the tribus Clustumina.

The Nera valley appears to have been a rather important center during the Iron Age. This is documented particularly by the finds from the large necropoleis of the Acciaierie (at the foot of the Pentima hill) and of S. Pietro in Campo (near the railway station), topographically and chronologically a continuation of the former. The protohistoric necropoleis developed largely from the 10th to the 8th-7th c. B.C., but there are also tombs dating to the 4th c. B.C. It is not possible to establish the habitation site related to the protohistoric necropoleis.

The Roman settlement, covered by the center of the modern city, must have been about the size of the mediaeval city. A rather extensive stretch of the Roman city wall of limestone, which probably encircled the whole city, is visible below the Public Gardens.

The most important preserved monument is the amphitheater at the SW extremity of the city, near the wall, It is dated, on the basis of an inscription, to the age of Tiberius. Exploration under the Church of S. Salvatore, earlier believed to overlie a Roman temple, has shown that the Roman structures underneath belong to a lordly domus independent of the church.

Archaeological material from the city and its environs is preserved in the Civic Museum of Terni.

BIBLIOGRAPHY. *EAA* 7 (1966) 721-23 (Feruglio) with bibliography; H. Blanck, in *AA* (1970) 326. U. CIOTTI

INTERAMNIA PRAETUTTIORUM (Teramo) Abruzzi, Italy. Map 14. This Roman city was founded near the confluence of the Tordino and Vezzola rivers in the territory of the Praetutti. It was assigned to Regio V (Picenum) under the Augustan territorial arrangement.

Inhumation burials found mostly to the W of the city demonstrate that a primitive indigenous settlement must have existed before the foundation of the Roman city. The Romanization of the Praetutti territory goes back to the beginning of the 3d c. B.C. In the age of Sulla the city was already designated a colonia, and in the course of the 1st c. B.C. its double status of municipium and colonia is documented (*CIL* IX, 5074). A reflection of this double administrative structure may perhaps be traced in the characteristics of the urban plan, whose orthogonal arrangement is complex, with two zones juxtaposed and diversely oriented. The general lines of the urban network were partially followed in the plan of the mediaeval streets. The urban area was almost rectangluar (ca. 440 x 240 m). Among the public buildings the most conspicuous today are the theater and part of the amphitheater in the W sector of the city. A zone of suburban settlement may be recognized in the modern Largo della Madonna delle Grazie section outside Porta Reale. Roman burials have been found near the railroad station and near the Messato bridge. The latter is 3 km from the inhabited center along a stretch of the road that led

to Amiternum, where there exists a row of funerary monuments from the 1st c. A.D.

Three stelai with boustrophedonic inscriptions from the 5th c. B.C. are attributable to the S Picene group (also called Old Sabellic or E Italic). They were found in the Valley of the Vomano, near Penna S. Andrea, to the SE of Teramo.

BIBLIOGRAPHY. *CIL* IX, p. 485ff; F. von Duhn, *Italische Gräberkunde*, I (1924) 583ff; M. E. Blake in *PAAR* 8 (1930) 135-37; *EAA* 7 (1966) 712-13 (A. La Regina) with bibliography; G. Cerulli Irelli, *Edizione archeologica della Carta d'Italia* 140 (1971) with a city plan.

A. LA REGINA

INTERCISA (Dunaujváros) Hungary. Map 12. About 46 Roman miles S of Aquincum, on the limes of Pannonia inferior (*It.Ant.* 245.3), a castrum and vicus at the highest point of the plateau, on the Danube. Its E side, facing the river, was partially destroyed by the collapse of the river bank, but the other three sides are still identifiable from the ground plan. The castrum (175 x 240 m) probably had three gates on the Danube side.

The first camp was built of wood. The fragment of a diploma, issued in 98, has been discovered. The camp was established at the end of the 1st c. A.D. The territory was most probably occupied during the Dacian wars of Domitian and was destroyed during the Jazigo wars in 117-118. The area and vallum of the burned and partially demolished wooden camp were filled in and the stone camp built 20 m back. The stone camp in its first period had smooth, rounded corners, without towers. Its gates were three-quarters recessed, the walls were 1.4 m thick, and a double moat surrounded it. After its destruction ca. 178 at the time of the Marcomannic-Sarmatian wars of Marcus Aurelius, the walls were removed and the stones used for the new building.

The rebuilding of the stone fort must have begun during the years following the end of the wars and the signing of peace in 180. The gates and towers were repaired but no fundamental changes were made in the position of the towers or walls. Inside the camp, however, significant changes took place. One excavation of this period unearthed a house, decorated with frescos and stucco work. There must have been partial destructions during the second period, at the time of the Roxolan attack in 260. There are traces of construction from the Tetrarchic era, but the fundamental changes—fan-shaped towers on the corners, the fan-shaped enclosure of the porta decumana—date from the time of Constantine the Great, between 325-330. This period saw only alterations and repairs on the camp's inner buildings. The remains of several iron helmets were discovered in one of these buildings.

During the 4th c. many repairs were made on the inner buildings. The last of these occurred under Valentinian I. The excavations show no definite proof of the castrum's complete destruction and abandonment. The end of traffic in coins under Valentinian and Gratian does not signify the end of the settlement as well, since its survival can be shown as far as the second and third decades of the 5th c., on the basis of grave excavations.

The vicus, belonging to the wooden camp and to the stone camp's first period, developed S of the castrum. Remains of houses on stakes, of mud walls, frescos, terra sigillata of the Po valley, and coins of the 1st c were discovered here.

After the Marcomannic-Sarmatian wars the settlement grew considerably, even onto the hills N and W of the camp. The vicus, already established S of the camp, developed further. This is where the Mithras sanctuary must have stood. During the 4th c. there were already burials in the cannabae, so that area was no longer used for settlement.

Excavations have uncovered here the largest Pannonian cemetery. Apart from smaller grave clusters N and W of the camp, the majority of graves are to be found S of it. One group is found on both sides of the road leading out of the camp, the other E of this, on the Danube side. Cremation burials, typical of the end of the 1st c. and the beginning of the 2d, are found here. One of the burial customs of the 2d and 3d c. is the placement of ashes in cremation graves. From the beginning of the 3d c. inhumation became general. During the last few years six burials in sarcophagi came to light, with mummified bodies. Two tomb chambers, graves of built stone, and many brick graves have been discovered.

Military occupation can be placed in the last decade of the 1st c. A.D., during the campaigns of Domitian. The camp's garrison was the ala I Thracum veteranorum for a long period during the 2d c. At the end of the 2d c. and during the 3d, the cohors I milliaria Hemesenorum civium Romanorum was stationed in the camp, a troop of 1000 archers, recruited from the Syrian Emesa. They may have been brought here by Marcus Aurelius in 175-76 from the eastern wars, but perhaps later. An inscription antedating the autumn of 183 shows that this cohors participated in the rebuilding of the camp, destroyed under Marcus Aurelius. They can be shown to have been the camp's garrison for over 80 years. The majority of the ca. 500 inscriptions can be attributed to this troop. The membership of the troop was always supplemented from the east.

A significant Syrian settlement developed in the cannabae, surpassing both in numbers and riches the natives, who moved into the vicus and its vicinity. The Syrians became the leading social class and preserved their traditions and religious ideas. Among the territory's gods a special place was preserved for Deus Sol Elagabalus and Diana Tifatina, according to local inscriptions, and the cohors' temple was built for the pair in 202.

After the murder of Severus Alexander (A.D. 235) Intercisa's decline coincided with the decline of Pannonia. We hear no more of the Syrian cohors after the middle of the century. An inscription from the last decade of the 3d c. names the numerus Equitum scutariorum as the camp's garrison. The scattered remains of the cohors of Hemesa served in this troop. After the military reorganizations of Diocletian the camp's garrison was the Equites sagittarii. During the ravages of the Sarmatae under Constantine the Great this troop also must have been destroyed because in the third period the rebuilding was done by the cuneus equitum Dalmatarum. One more troop is known in the 4th c., the cuneus equitum Constantianorum, which must have arrived ca. 357.

Since agriculture has destroyed the upper layer, nothing further can be established of the camp's last decades. Repairs made inside the castrum under Valentinian and grave findings indicate that life continued, though somewhat changed, during the second and third decades of the 5th c.

See also Limes Pannoniae.

BIBLIOGRAPHY. Intercisa I: "Geschichte der Stadt in der Römerzeit," *Archaeologia Hungarica* 36 (1954); Intercisa II: "Geschichte der Stadt in der Römerzeit," *Archaeologia Hungarica* (1957). L. BARKÓCZI

INVERESK Musselburgh, Scotland. Map 24. Roman fort and settlement guarding a harbor at the point where the roads from York and Chester converged on the Firth of Forth. In 1565 part of a structure with a hypocaust and an altar dedicated by an imperial procurator were discovered, and later an external bath house E of the

parish church, but it was not until 1946 that excavation in the graveyard located the fort itself.

Measuring ca. 182 by 144 m over-all (2.7 ha), it was defended by a massive clay rampart and a single ditch, and faced W towards the crossing of the river Esk; the internal buildings, including barracks and stables, were of stone. Occupation appears to have begun ca. A.D. 140 and to have continued, with one brief intermission, until the late 2d c. The planning of the barracks and stables suggests that an ala quingenaria was in garrison. The bulk of the extramural settlement lay S and E of the church, probably as a ribbon development along streets leading to the E gate of the fort. Air photography has also revealed several temporary camps, as well as a Romano-British field system, SE of the settlement.

BIBLIOGRAPHY. *Inventory of the Ancient & Historical Monuments of Midlothian and West Lothian* (1929) 90-93; *JRS* 38 (1948) 81-82. K. A. STEER

IOL, later Caesarea (Cherchel) Algeria. Map 18. Capital of Mauretania Caesariensis, Iol—100 km W of Algiers—was one of the small ports that the Carthaginians established on the coast of the Maghreb from Carthage to the present South Morocco, to serve as ports of call for their ships and at the same time as centers of commerce. The site includes a small island very close to the shore which assured it the kind of protection that a seawall would have given it. Another seawall connected to a row of reefs closed the harbor towards the E.

The Punic town no doubt achieved some importance; after the fall of Carthage it was under the control of African dynasties and became the capital of one of their kings, Bocchus, in the time of Julius Caesar. When he died in 33 B.C., Rome annexed his kingdom and then entrusted it to a Berber prince raised in Rome, Juba II, son of an ally of Pompey sent as hostage to Rome, who became a Roman citizen. King of Mauretania, he married Cleopatra Selene, the daughter of Cleopatra of Egypt.

In the course of his reign of some fifty years, he remained faithful to Rome. Cultured, a traveler, an indefatigable writer, he was interested in the arts and applied himself to making Iol, which became Caesarea, a Graeco-Roman town.

After the death of his son and successor Ptolemy, assassinated in Lyon by Caligula in A.D. 40, the town became the capital of the E part of Mauretania, the province of Caesarian Mauretania, and received the rank of colony under the emperor Claudius. The effort undertaken by Juba for its embellishment was continued, and one could see there all the monuments that were the pride of a Roman town—temples, baths, theater, amphitheater. The encircling wall, 7 km in circumference, restored several times, was perhaps begun in the time of Juba. A lighthouse in the form of an octagonal tower was constructed on the islet; the port was prosperous, and the town included numerous inhabitants and foreign visitors.

Of this splendor, unfortunately, not much remains. The town was conquered and plundered at the time of the revolt of Firmus in 364, then in 429 by the Vandals. The modern town, built in the middle of the ancient one, has been an obstacle to systematic research. However, since the beginning of the French occupation, the site with its sculpture and mosaics, found in great numbers, have been the subject of many publications.

In spite of these efforts, the town remains insufficiently known. There are a few indications of the checkerboard city plan, thanks to the preliminary efforts for protection undertaken in the course of recent years. The town walls, studied in 1946, pose more problems; and the monuments are more often simply marked than completely known. The amphitheater, which has been excavated, remains unpublished; the very large hippodrome, which appears clearly on aerial photographs, is known only through old borings. The temples, which have been found on a spur of the mountain to the E of the central esplanade, on the edge of the route from Ténès to the W of the modern town, are too much destroyed to warrant publication even of plans. The baths along the edge of the sea, rather majestic, are also badly preserved. One would scarcely recognize several houses recently excavated. Grouped around peristyles with vast triclinia, they are readily adapted to the terrain and are constructed on terraces on the lower slopes or on the edge of cliffs with views over the sea. They often are preserved for us only in a late form—4th c. A.D.—and traces of the era of Juba are found only in the lower strata. The theater is an exception; still well-preserved in 1840, it has since served as a quarry. It was set against the slope of the mountain. At the back of the scaena towards the N was a portico, covered over today by a street, where Gsell saw the S side of the forum. Of the rich scaenae frons there remain only traces and several statues, of which two are colossal muses. The orchestra had later undergone great modification which had resulted in the disappearance of the platform of the stage: an oval arena had been built, intended for hunting spectacles, and a wall was raised between the first row of seats and the cavea to protect spectators from the wild beasts. The sumptuously decorated monument is consequently very much mutilated, but is of interest specifically because of its complex history.

The amphitheater, in the E part of the town, was erected in flat open country. It was not oval but rectangular, with the short sides rounded. The tiers of seats, for the most part missing, were carried on ramping vaults, and the arena floor was cut by two perpendicular passages intended for beasts. It is in this arena that St. Marciana was martyred.

The small island of the lighthouse, which has been excavated in part, has revealed a confused jumble of walls of very different structures and periods. It was surrounded by a robust defense wall. Within were found some traces of Punic occupation, walls and tanks, various remains of houses with mosaics dating from the 1st c. B.C. to the 3d c. A.D., and the pharos, the sturdy octagonal base of which was carefully built of dressed stone and concrete, above a grotto made in the cliff to serve as a sanctuary.

All around the city wall were spread necropoleis where were mingled monumental tombs, sometimes made of opus reticulatum, individual tombs, half-column tombstones and altars for cremation, sarcophagi, and tombs under tiles for inhumation. They have yielded stelae, often simple unpolished blocks set up in front of an urn, sometimes limestone or sculptured slabs with reliefs or inscriptions.

Lastly, the town was provided with water by several aqueducts, subterranean and above ground, one very fine unit of which remains above a valley SE of the town; it comprises three tiers of arcades for a maximum height of 35 m. The whole system is in process of study as is the agricultural organization of the region.

Christianity left few traces. Of one Christian complex that vanished without yielding a plan, there is extant a fine mosaic from an apse—vase, peacocks, and birds—which has been taken to the museum.

Fortuitous discoveries have enriched, in rather exceptional fashion, the Cherchel Museum and also the Algiers Museum. These are principally statues and mosaics, some of which are of very high quality. The whole

allows one to perceive something of the splendor of the town until the arrival of the Vandals.

BIBLIOGRAPHY. A. Ravoisié, "Exploration scientifique de l'Algérie," *GBA* 3 (1846) pl. 21.52; P. Gauckler, *Musée de Cherchel* (1895); S. Gsell, *Atlas archéologique de l'Algérie* IV (1902, 1911) no. 16; in *Dictionnaire d'Archéologie chrétienne et de Liturgie* III, s.v. Cherchel; *Cherchel, Antique Caesarea* (1952); M. Durry, *Musée de Cherchel, Supplément* (1924); P.-M. Duval, *Cherchel et Tipasa: Recherches sur deux villes fortes de l'Afrique Romaine* XLIII (1946).

For recent discoveries, see: *Libyca* (1953-1960) and P. Leveau in *Revue d'histoire et de civilisation du Maghreb* 8 (1970).

For mosaics, see A. Brühl in *MélRome* 48 (1931), and J. Bérard in ibid. 52 and 53 (1936), and J. Lassus in *Bulletin d'archéologie algérienne* 1 (1962-65).

J. LASSUS

IOMNIUM (Tigzirt) Algeria. Map 18. In spite of the location of a small modern village at Tigzirt, the history of the site is relatively well known through early and recent excavations and through the discovery of inscriptions.

A native town, then a municipium, the ancient center occupied a flat area on a point jutting out into the Mediterranean. What seems to have been the administrative center of the settlement is found near the end of this point. It undoubtedly included the forum as well as a very well-preserved building, a temple dedicated to the tutelary spirit of the neighboring town of Rusucurru (Dellys) by a municipal magistrate on the site of his house. A portion of the district has been cleared. It has two streets crossing each other at right angles and a small Christian basilica. Excavation of this part of the site indicates that it was occupied until the end of antiquity.

Nearby a Christian basilica was cleared and restored in the last century. The building has three naves with galleries over the aisles. There was a baptistery of polyfoil plan to the NE. Nearby public baths and an ornamental mosaic can still be seen. Inscriptions and statues are found scattered in the modern town.

The town of Dellys is dominated by a large hill to the E. Where the modern village of Taksebt is located, there stood a large ancient settlement. One can still see some of its remains, in particular part of a large mausoleum. This site must no doubt be identified with Rusippisir, which was a municipium and possibly a colony. Perhaps there existed an administrative link between the two localities of Rusippisir and Iomnium.

BIBLIOGRAPHY. E. Frézouls and A. Hus in *MélRome* 66 (1954) 147-63; M. Euzennat, ibid. 65 (1953) 127-28 and 69 (1957) 75-80; S. Lancel, ibid. 66 (1956) 293-333.

P.-A. FÉVRIER

IONOPOLIS, *see* ABONUTEICHOS

IOTAPE (Aidap) Turkey. Map 6. City in Cilicia Aspera, 9 km NW of Gazipaşa. Founded by Antiochos IV of Kommagene, but otherwise unknown to history. It is listed by Ptolemy, Hierokles, and the *Notitiae*, and perhaps by Pliny (*HN* 5.92). The name Aidap is applied solely to the site and evidently preserves the ancient name. The ruins are on a small promontory defended by a circuit wall and on the shore of a small bay below it to the E; the present highway passes through the site.

Conspicuous is a double row of large honorific statue bases facing each other across an ancient street. Numerous buildings, for the most part of poor quality, surviving in various states of collapse, include a structure with a number of vaulted rooms. A small stream, dry in summer, enters the bay. Above this on the E, beside the modern road, are the foundations of a modest temple dedicated by an inscription to Trajan. On the higher ground to the E is an extensive necropolis; most of the tombs are of squared blocks originally covered with stucco. They usually have a main chamber and antechamber and are in some cases enclosed in a peribolos.

BIBLIOGRAPHY. R. Heberdey & A. Wilhelm, *Reisen in Kilikien* (1896) 147-48; R. Paribeni & P. Romanelli, *MonAnt* 23 (1914) 174f; J. Keil & A. Wilhelm, *JOAI* 18 (1915) *Beibl.* 111; G. E. Bean & T. B. Mitford, *Journeys in Rough Cilicia in 1962 and 1963* (1965) 24-29; id., *Journeys in Rough Cilicia 1964-1968* (1970) 149-52.

G. E. BEAN

IOULIS, *see* KEOS

IRAKLION, *see* HERAKLEION

IRCHESTER Northamptonshire, England. Map 24. A settlement in the middle valley of the Nene, 16 km NE of Northampton, continuously occupied from the Iron Age into the Roman period. In the late 2d c. a pentagonal area of 7 ha was enclosed by an earth rampart, which was later cut back to accommodate a stone wall. There has been little examination of the interior. Air photographs indicate a central N-S street with at least two branches to E and W. Several architectural fragments suggest buildings of some pretension. The most important find was a hoard of bronze vessels, dating from ca. A.D. 400.

BIBLIOGRAPHY. D. N. Hall & N. Nickerson, "Excavations at Irchester, 1962-3," *ArchJ* 124 (1967) 65ff; J. Knight, "Excavations at the Roman Town of Irchester, 1962-3," ibid. 100ff; D. Kennett, "The Irchester Bowls," *Journ. Northampton Museum & Art Gallery* 4 (1968) 5ff.

M. TODD

IRGENHAUSEN Zurich, Switzerland. Map 20. Best preserved Late Roman fort in the NE, in a dominant position on a hill above the Pfäffikersee, 1 km SE of Pfäffikon. The ancient name may have been Cambodunum, which probably survives in that of nearby Kempten. The fortress was built under Diocletian or more probably later in the 4th c. under Valentinian I to guard the military road from Raetia via the Walensee and Zurichsee to Vitudurum, where it joined the W-E highway from Vindonissa to Brigantium. The castrum was abandoned probably in A.D. 401, when Stilicho called most Roman troops N of the Alps back to Italy.

The fort was square (average length of a side 61 m), with four square towers at the corners and one in the middle of each side. The walls included much reused material. The main gate was in the middle tower of the E wall, and inside are remains of barracks. Beneath the fort are some remains of a villa of the 1st c. A.D., sacked during the raids of the Alamanni in 259-60. Finds are in the Ortsmuseum in Pfäffikon.

BIBLIOGRAPHY. O. Schulthess, "Das römische Kastell Irgenhausen," *Mitt. Antiquarischen Gesellschaft Zürich* 27, 2 (1911); F. Staehelin, *Die Schweiz in römischer Zeit* (3d ed. 1948) 274-75, 615; H. Lieb & R. Wüthrich, *Lexikon Topographicum der römischen und frühmittelalterlichen Schweiz* 1 (1967) 84-88; E. Meyer, "Das römische Kastell Irgenhausen," *Arch. Führer der Schweiz* 2 (1969) MPI; R. M. Swoboda, *Jb. Schweiz. Gesell. f. Urgeschichte* 57 (1972-73) 187.

V. VON GONZENBACH

IRUN ("Oiarson") Guipúzcoa, Spain. Map 19. There is scant mention of this place, 18 km E of San Sebastian, in ancient sources. Strabo (3.4.10) gives Oiasuna (Οἰασοῦνα) as the terminus of Augustus' highway, which ran from Tarraco through Pompaelo and ended here (cf.

Ptol. 2.5.10). The region was noted for its mines. Recent excavations have yielded terra sigillata and the remains of a Roman ship (now in course of publication).

J. ARCE

IRUÑA, *see* VELEIA

ISACCEA, *see* NOVIODUNUM (Romania)

ISARA, *see* ISAURA VETUS

ISARNODURUM (Izernore) Ain, France. Map 23. A Gallic oppidum, later a Roman vicus of the city of the Ambarri, in the middle of a large plateau on a road leading to Lugdunum. It flourished from the Augustan era on. A stratum of debris apparently reflects the disorders of 68-69. In spite of destruction in 276, at the time of the invasions, the site was occupied to the mid 5th c. It has been frequently excavated since 1730, especially a Temple of Mercury which has a rectangular cella (18 x 12 m) surrounded by a wide columned gallery. The simple cella, with no pronaos, places the temple in the Gallic tradition, while its classic peripteral arrangement mark it as Roman. Nearby are some baths, covering ca. 30 x 25 m.

A section of the early vicus has been found NW of the modern village, also traces of roads and various structures. Among these is a large building, clearly a farm and workshop (a foundry and potter's kiln have been excavated there). To the SE is the villa known as de Bussy, Gallo-Roman with a galleried facade that faces W towards the Izernore plain. In its hypocaust system a symmetrical series of low walls, covered with limestone slabs, edges the flow channels. This villa was occupied from the second half of the 1st c. to the end of the 3d c.

In the center of the village a rubbish dump and some banks of earth reflecting several periods of occupation have yielded much material, including a gold ring with the intaglio design of Diomedes carrying off the Palladium. The local museum, recently rebuilt, houses the finds.

BIBLIOGRAPHY. Grenier, *Manuel* III (1958) 403-6; P. H. Mitard, "Les monnaies de la villa gallo-romaine de Perignat," *Le Bugey* (1965) 128-34; M. Leglay, "Informations," *Gallia* 24 (1966) 488; 26 (1968) 560-62; R. Chevallier & C. Lemaître, "Note sur une bague d'Izernore," *Hommages à M. Renard, Coll. Latomus* 3 (1969) 124-45.

M. LEGLAY

ISAURA VETUS or Isauria or Isara Turkey. Map 6. City of Isauria on a hill (Zengibar Kalesi) near Ulu Pınar, 10 km E of Boskir (Silistat). It was the main fortress of Isauria when Perdiccas took it in 322 B.C. (Diod. 18.22), was destroyed by Servilius Isauricus in 75 B.C., and later restored by Amyntas of Galatia who died when the wall was under construction (Strab. 12.6.3; 14.3.3). It appears on Roman Imperial coinage as metropolis of the Isaurians.

The wall around the hill is ca. 3.8 km long. Parts of it are well preserved, including two well-fortified gates and 14 polygonal towers. The masonry is pseudo-isodomic. The small acropolis is on a rise at the SE end of the city. Inside the walls remains still standing include arches to Hadrian, Marcus Aurelius, and Severus Alexander, a well-preserved church, and an octagonal chapel. Outside the walls are some elaborate rock-cut graves and heroa, apparently of the 2d-3d c. A.D.

BIBLIOGRAPHY. W. J. Hamilton, *Researches in Asia Minor* II (1842) 327f; J. S. Sterrett, *Papers Am. Sch. of Classical Studies Athens* 3 (1884-85) 97, 105f; J. Jüthner et al., *Vörlaufiger Bericht über eine Archäolo-*gische *Expedition nach Kleinasien* (1903) 44-50MPI; Jüthner et al., *Denkmäler aus Lykaonien, Pamphylien und Isaurien* (1935) 69-92, 119-42MPI; D. Magie, *Roman Rule in Asia Minor* (1950) esp. 1170 n. 22, 1171 n. 24; F. E. Winter, *Greek Fortifications* (1971) 136, 190f, 194, 200-2PI.

T. S. MACKAY

ISAURIA, *see* ANEMURIUM

ISAURIA, *see* ISAURA VETUS

ISCA (Caerleon) Monmouthshire, S Wales. Map 24. The base fortress of Legio II Augusta, which had participated in the invasion of Britain, A.D. 43; founded by Julius Frontinus during the conquest of Wales (Tac. *Agric.* 17) in 74-75. Now a village on the river Usk, 4.8 km upstream of Newport (Mon.), Caerleon has been extensively excavated since 1926. Most of the plan can be reconstructed, but only the amphitheater and a centurial barrack in the W corner, together with parts of the adjacent defenses, are visible today.

The fortress occupies a position very similar to that of Legio XX V. V. at Chester—at the roots of the Welsh peninsula, on a navigable estuary for ease of supply, but above danger of flooding. Between them, the two fortresses maintained the military occupation of Wales, and some of the auxiliary forts at important valley junctions provide evidence of a legionary connection (brick stamps, inscriptions). The tactical position of Caerleon is particularly good since it lies in a wide bend of the Usk and is additionally protected by a small tributary on the E. To the NW rises a hill crowned by a late Iron Age hill-fort. Running water was carried by 20 cm lead pipes from an unknown source.

The fortress is a rectangular enclosure with rounded corners, oriented NW-SE and 90 by 18 m. an area of 20.6 ha. The defenses first consisted of a clay bank formed of upcast from a single ditch 9 m wide; the rampart was strengthened with timbering, but nothing is known of the gateways and turrets of the initial period. In the 2d c. the bank was cut back, and a wall (still in parts visible) built, with a double gateway in each side; there were internal turrets at intervals of ca. 45 m. Extensive rebuilding at the S corner of the wall may be related to damage sustained during a revolt of the Silures while the legion was supporting Albinus in Gaul, in 196-197.

The interior is divided into three lateral zones by the via principalis (between the NE and SW gates) and the via quintana. In the center of the middle, or administrative zone stood the headquarters (principia): it is mostly under the present church, but part of the basilica (64.8 x 26.85 m internally) was excavated in 1968-69. The roof was supported by lofty colonnades of Bath stone, in front of the N row of which there had been inscribed plinths for statues, two of bronze (only scraps remain): cf. the statues erected in a similar position at Lambaesis. The building was dismantled at the end of the 3d c. On its right side, three of the five houses for primi ordines centurions, together with parts of the corresponding 10 barracks for the milliary first cohort, have been excavated. On the left side, parts of six barracks for a quingenary cohort are known, together with stabling for the 120 equites, or scouts, of the legion. Behind the principia lay the palace of the legate (praetorium), with an internal oval court as at Xanten, but approached through a large basilica for public audience. On the right side of the praetorium is a great basilica exercitatoria, for drill in wet weather; adjacent are some rows of magazines. The nature of buildings in an insula farther SW are as yet unknown. On the left side of the prae-

torium is a large courtyard building identified as workshops, consisting of large halls or stores; residential accommodation projects into the courtyard. The contents of an insula farther NE are unknown.

The retentura is entirely given over to centurial barracks arranged longitudinally and accommodating two quingenary cohorts; 12 barracks, on either side of the decumanus, led to the NW gate. The barracks measured ca. 72 by 12 m, about a third allocated to the centurion and the rest divided into 12 double cubicles for the men.

The praetentura is bisected by the via praetoria leading from the SE gate to the headquarters. Inside the SE defenses another long range of 24 barracks completes the accommodation for the 10 cohorts of the legion. The remaining ground on the SW side of the praetentura has not been much explored; it is likely that granaries occupy part of it. On the NE side, recent excavation has revealed parts of the hospital and the large internal baths, both of which were demolished about the end of the 3d c. The hospital consists of rows of small wards arranged around three sides of a square court, with a second concentric range within; a large operating theater projected into the court from the fourth and SE side. The baths comprised a large basilica (63.3 x 23.4 m) opening from the via principalis, a frigidarium with several piscinae, and heated accommodation, the most important elements of which (calidarium, etc.) are inaccessible. On the SW lay a palaestra with porticos on three sides, containing a pool (40.5 x 5.4 x ca. 1.2 m) reminiscent of the palaestra of Herculaneum.

The entire block of internal buildings is divided from the defenses by a wide street. Various turrets had cookhouses built in front of their ground-floor entrances and numerous rampart magazines are known. Latrines have been excavated in the S and W corners and probably existed on the E and N. Some of the principal buildings were erected in stone from the beginning, but the barracks and the hospital were first built of timber on cobble footings. The stone replacements are of 2d c. date, and there was widespread rebuilding and repair in the early 3d c.

The environs of the fortress include elements of a small vicus cannabarum on the SW, which seems never to have reached urban proportions, perhaps because the cantonal capital of the Silures (Venta Silurum) was not far distant. Shops, a mansio(?), and other buildings are known, while temples of Mithras, Jupiter Dolichenus, and Diana are epigraphically attested. The area is divided by a continuation of the main street down to the Usk, where 3d c. wharves have been excavated; the civil settlement is separated from the fortress, NW of this road, by a walled parade ground (ca. 150 x 207 m), and on the SE side by the amphitheater (80.1 x 66.6 m; the arena, 55.2 x 40.95 m). The structure is partly set into the ground, the upcast being revetted by stout walling as a basis for the wooden seating. There are four principal entrances, two on the short axis with boxes above, and four subsidiary ones; all, except the two that led directly into the arena, had dens at the level of the arena. A large bath house is adjacent, and another is known on the SE side of the fortress. On the S side of the Usk and along roads leading W and NE there were cemeteries, including at least two mausolea belonging to burial clubs; cremation was the predominant rite.

The finds are housed in the Legionary Museum of Caerleon (branch of the National Museum of Wales) and at the National Museum in Cardiff.

BIBLIOGRAPHY. J. E. Lee, *Isca Silurum* (1862)[I]; G. C. Boon & C. Williams, *Plan of Caerleon* (1967) with bibl.[MP]; Boon, *Isca: the Roman Legionary Fortress at Caerleon, Mon.* (1972)[MPI].

See also excavation reports: *JRS* 16ff (1926ff) summaries[PI]; *Archaeologia* 78 (1928) amphitheater[MPI]; *Archaeologia Cambrensis* 84ff (1929ff)[MPI]; *Monmouthshire Antiquary* 1 (1961-64)[PI]. G. C. BOON

ISCA DUMNONIORUM (Exeter) Devonshire, England. Map 24. The cantonal city of the Dumnonii, the Iron Age tribes inhabiting the modern counties of Cornwall, Devon, and West Somerset. The city was named from the river Exe, Celtic Eisca, Wysc, meaning river abounding in fish. The position is given in road-books in the 2d c.: *Antonine Itinerary*, Iter xv, in the *Peutinger Table* fragment, and is twice mentioned in the *Ravenna Cosmography*. Excavation has demonstrated that the site began as a Claudian military post, a fort, probably of 2.4 ha, S of the later city and supplemented by a lookout fortlet on the crest of Stoke Hill, 3.2 km NE. About A.D. 47-48 this was replaced by a legionary fortress, probably the headquarters of the Second Augustan legion. Remains of roads, timber barracks, workshops, officers' houses and an imposing stone bath building have recently been identified in the center of Exeter. A reduction in the garrison took place during the reign of Vespasian, when the caldarium of the baths and the barracks were altered. By A.D. 80 there was a general military withdrawal from the SW consequent on the need to garrison Wales and the North, and the fortress was converted for civilian use. The military bath house became part of the municipal offices with a new entrance and an extensive forum. New public baths, of which a plunge bath in the frigidarium and a stone conduit for the waste have been located, were built on an adjacent site.

The defenses, a rampart and ditch with stone gates, were begun after A.D. 160 and supplemented by a massive stone wall during the early 3d c. The 3.2 km circuit of the wall mostly survives, apart from the gates, enclosing a city of 36.8 ha. The Roman masonry consists of a facing of rectangular blocks of local volcanic stone on a core of grouted rubble 3 m thick; a chamfered plinth indicates the Roman ground level. Bastions were added in mediaeval times, and there is much later repair with different stone.

The road grid, only partly known, is irregular because of the hilly character of the interior. Little is known of domestic buildings; 10 tessellated pavements have been recorded but fragments of only two with geometric designs survive. Trade with the Mediterranean in the 3d c. is indicated by Alexandrian coins, and the existence of a Christian community by a Chi-Rho inscribed on a cooking-pot sherd.

The forum was in disuse by A.D. 375 and the coin series ends effectively with Gratian A.D. 383. Finds of imported amphorae show that part of the municipal offices were altered and occupied into the 5th or 6th c. It is likely that an impoverished city was still inhabited when the Saxons arrived in the mid 7th c. The finds are in a museum in Rougemont House, Exeter.

BIBLIOGRAPHY. A. Fox, *Roman Exeter* (1952); "Roman discoveries in Exeter 1951-52," *Proc. Devon Arch. Soc.* 4 (1951) 106; "Excavations in Bear Street, Exeter," ibid. 5 (1953) 30; "Excavations at the South Gate, Exeter," ibid. 26 (1968) 1; *Exeter in Roman times* (rev. ed. 1973). A. FOX

"ISCALIS," *see* GATCOMBE

ISCHIA, *see* AENARIA

ISERNIA, *see* AESERNIA

ISINDA (Belenli) Turkey. Map 7. Site in Lycia 6 km NE of Kaş, not mentioned by the ancient writers and known only from inscriptions as a minor member of a sympoliy under Aperlai. The site is on a hill ca. 90 m above the village; the masonry of the ring wall is of poor quality and much repaired. On the summit are remains of buildings, including a stoa with steps and projecting wings, and many large worked blocks. The tombs include three rock tombs with Lycian inscriptions and a pillar tomb with reliefs.

BIBLIOGRAPHY. R. Heberdey & E. Kalinka, *Bericht über zwei Reisen* (1896) 30-32. G. E. BEAN

ISINDA (Kışla) Turkey. Map 7. Site in Pisidia close to Korkuteli (Istanoz), now thought to be Isinda rather than the site at Yazır, formerly so identified. The situation is an important one, on the route from Pamphylia to Caria. In 189 B.C. Manlius Vulso, on his march through Asia, found the Isindians besieged by the Termessians; at their request he raised the siege and fined the Termessians 50 talents.

The remains are scanty. On a high craggy hill on one side of a glen are rock cuttings and a rock tomb without inscription; on the lower hills in the vicinity are the ruins of extensive walls of soft stone and burnt brick. An inscription in Kışla village mentions a Clarian festival; this agrees with the claim of Isinda, on her coins, to be an Ionian colony.

BIBLIOGRAPHY. T.A.B. Spratt & E. Forbes, *Travels in Lycia* I (1847) 246; W. M. Ramsay, *AthMitt* 10 (1885) 340; A. M. Woodward & H. A. Ormerod, *BSA* 16 (1910) 83. G. E. BEAN

ISKENDERUN, *see* ALEXANDRIA AD ISSUM

İSMIT, *see* NICOMEDIA

ISNA, *see* LATOPOLIS

ISORBRIGANTIUM (Aldborough) Yorkshire, England. Map 24. The *Antonine Itinerary* places it half way between Eboracum (York) and Cateractonium (Catterick); it also appears in the *Ravenna Cosmography*. The Roman town covered 24 ha, one-sixth the size of Roman London.

There are traces of the town wall N of Aldborough Hall, and a number of buildings on the W side of the village street (entrance through Museum). The wall is of friable local red sandstone, with bastions at the corners, and has in part been built over an earlier ditch. The street plan is a simple cross, with the forum probably at the intersection, the present village green. The name is probably derived from Isira, which may have been the original name of the Ure which runs N of the town. The buildings in the town are in poor condition. There are some mosaic pavements, but the best one, showing Romulus and Remus with the she-wolf, is in the Leeds City Museum.

G. F. WILMOT

ISSA (Vis) Croatia, Yugoslavia. Map 12. A town on an island of the same name in the central Adriatic. It was settled by Illyrians, who were under the domination of Liburni from the 8th to the 6th c. B.C. At the beginning of 4th c. B.C. it was colonized by Syracusan Greeks as part of a plan of Dionysios the Elder to control the Adriatic. During the 3d c. Issa founded the emporia Tragurion (Trogir) and Epetion (Stobreč) on the Illyrian mainland. Its predominance in the region lasted until the first Illyro-Roman war 229-219 B.C. when it became a pawn in the battles of greater powers. In the civil war it sided with Pompey and consequently lost its priv-

ileges and autonomy in 47 B.C. when it was reduced to the rank of the oppidum civium Romanorum and dependent on the newly founded colony at Salona. As a polis Issa minted its own money, and these coins of many types had wide circulation.

The town, situated on a slope on the W side of a large bay, was defended by strong Hellenistic walls, still visible in an irregular quadrangle (265 x 360 m) that enclosed an area of 9.8 ha. The street grid and foundations of houses have been found. The necropolis has yielded many pieces of the pottery, including some from S Italy. The wall of the cavea of the theater, built in the Roman period, is incorporated into the present Franciscan Monastery. It could seat about 3000 persons.

Inscriptions, statues, coins, and pottery are preserved in the archaeological museums at Split and Zagreb.

BIBLIOGRAPHY. M. Nikolanci, "Helenistička nekropola Isse," *Vjesnik za arheologiju i historiju dalmatinsku* 63-64 (1961-62) 57-90; G. Novak, *Vis* (1961); B. Gabričević, *Antički spomenici otoka Visa, Viški spomenici* (1968) 5-60 (English summary). M. ZANINOVIĆ

ISTANBUL, *see* BYZANTIUM

ISTHMIA Corinthia, Greece. Map 11. In ancient literature, the name refers to the Isthmian Festival, held every two years in the Sanctuary of Poseidon on the Isthmus of Corinth. As a geographical designation "Isthmia," with accent on the second syllable, is a modern form.

The Corinthians credited their king Sisyphos with the founding of the Isthmian Games at the funeral of the boy Melikertes-Palaimon, who was drowned in the Saronic Gulf and brought to the Isthmus on the back of a dolphin; the Athenians claimed that their hero Theseus was the founder. In the 49th Olympiad, 582-578 B.C., the games were reorganized as a Panhellenic festival and were thenceforth held biennially in the spring, in even years B.C. and in odd years A.D. The Corinthians had charge of the games except for a time after the destruction of Corinth in 146 B.C., when the Sikyonians assumed management and possibly transferred the games to Sikyon.

The cult of Poseidon was established as early as the 8th c. B.C. The first temple, built about 700 B.C., was a Doric building with 7 x 19 wooden columns. The walls were of stone, with painted panels on the exterior. East of the temple was a large sacrificial area, now strewn with ash, burned animal bones, and smooth pebbles, the latter probably brought by worshipers to be used for symbolic participation in the slaying of the victims. The archaic temple was destroyed by fire about 470 B.C. and a new temple, also Doric, with 6 x 13 columns, was erected before 450 B.C. Severely damaged by fire in 390 B.C., it was restored and remained standing until Early Christian times. A marble torso of a colossal female figure, found in the temple, is probably from a cult statue of Amphitrite, worshiped together with Poseidon. A later cult group, described by Pausanias, consisted of chryselephantine statues of Poseidon and Amphitrite standing in a four-horse chariot flanked by tritons. There was also a statue of Palaimon nearby. An altar, 40 m long, stood E of the temple. Pebbles like those from the sacrificial area of earlier times lie scattered along the front of the altar foundation.

A little to the SW of the temple but outside the precinct proper, is an immense well, ca. 5 m in diameter and nearly 20 m deep. Abandoned as a well about the middle of the 5th c. B.C., it was subsequently used as a refuse pit.

Little remains of the precinct wall from the Greek

period except foundations of two propylons, one on the E, the other on the N. In the 1st c. A.D. a precinct of smaller size was built with a gateway at the E end and probably one at the W. A new altar of more modest dimensions was then constructed. Still later the temenos was enlarged as a quadrangle with stoas of the Ionic order on the S, E, and W, and a precinct wall on the N. No altar from that period has been discovered; it may have stood on the earlier altar foundation close to the temple. There was a monumental propylon in the SE corner and two smaller gateways, one at the E end, the other at the W.

Adjacent to the SE corner of the Precinct of Poseidon was the Palaimonion, an extensive cult area covering the NW end of the abandoned earlier stadium. All the buildings are of Roman date. The precinct contained three sacrificial pits and a circular temple, underneath which is a crypt in which oaths were administered. Terracotta lamps, found scattered in front of the temple, would have been used in the nocturnal rites of the mystery cult, at which black bullocks were sacrificed to the hero. In the temple was a statue of Melikertes-Palaimon lying on a dolphin.

The earlier stadium, which was close to the Temple of Poseidon, measured ca. 192 m in length. It had 16 lanes with unique starting gates (balbides) of wood erected on a stone sill. In its second period the racecourse was shortened to ca. 181 m. A new starting line was made of stone with a single groove and with wooden posts set in lead. In Hellenistic times this stadium was abandoned and a new stadium built in a natural hollow some 250 m from the Precinct of Poseidon.

The theater is located some fifty m to the NE of the Precinct of Poseidon. Its original construction, with rectilinear orchestra, goes back to about 400 B.C. It was twice rebuilt in Greek times and twice by the Romans, first probably for Nero's visit in A.D. 67 and again a century later. Both Roman reconstructions remained unfinished.

Above the theater is a cult cave divided into two compartments, each provided with dining couches. The chambers were entered through open courts in which meals were prepared to be served inside, probably to members of some sacred guild. The cave fell into disuse about 350 B.C. In the NE corner of the Poseidon precinct was a similar cave, also with two chambers, and close to it a raised area which probably held an altar. West of the Temple of Poseidon are the W waterworks, containing a small room with a water tank; this may have functioned as a baptisterion in some cult of Chthonic deities. There is a well-preserved underground reservoir a little NW of the temple. South of the sanctuary is a prominent ridge, on which are ruins of a textile establishment dating from Hellenistic times.

Some 400 m SW of the Poseidon precinct was the Sacred Glen, which contained shrines of Artemis, Dionysos, Demeter and Kore, and Eueteria. About 2 km W of the temple is a pi-shaped foundation which must have supported some unroofed structure, perhaps the cult place of some deity or hero worshiped in connection with the horse races. The hippodrome may have been close to the monument.

The movable finds from the excavations are to be exhibited in a museum, now being constructed close to the modern road S of the Precinct of Poseidon. It will house the antiquities from the Isthmian sanctuary as well as those from Kenchreai and from other nearby sites. Among the sculptures from Isthmia is a large marble bowl, perirrhanterion, carried on the heads of four female figures, each standing on a lion and holding its tail in one hand and a leash in the other. This sophisticated piece from about 650 B.C. stood at the entrance

into the archaic temple and served worshipers and priests for the ritual washing of hands.

BIBLIOGRAPHY. Paus. 1.1.3-2.2; Philostr. *Imag.* 2.16; P. Monceaux, *Gazette Archéologique* (1884) 273-85, 354-63; J. G. Frazer, *Paus. Des. Gr.* (1898) I 70-72, III 4-16; J. H. Jenkins & H. Megaw in *BSA* 32 (1931-32) 68-69[MI]; H. N. Fowler, *Corinth I: Topography* (1932) 59-71[MPI]; O. Broneer in *Hesperia* 22 (1953) 182-95[PI]; 24 (1955) 110-41[PI]; 27 (1958) 1-37[PI]; 28 (1959) 298-343[MPI]; 31 (1962) 1-25[PI]; in *Klio* 39 (1961) 249-70[PI]; O. Broneer, *Biblical Archaeologist Reader* II 393-420[PI]; id., Χαριστήριον εἰς 'Α. Κ. 'Ορλάνδον Γ, 61-85[PI]; *HThR* 64 (1971) 169-87; *Isthmia I, Temple of Poseidon* (1971); *Isthmia II, Topography and Architecture* (1973) (other volumes are in preparation); E. R. Gebhard, *The Theater at Isthmia* (1973). O. BRONEER

ISTHMUS OF CORINTH Corinthia, Greece. Map 11.

Neck of land, 5,857 m wide at its narrowest point, joining the Peloponnesos to the mainland of Greece. Neolithic and Bronze Age pottery discovered in several places there shows early occupation of the area. East of it an inscribed stele marked the boundary between Corinth and Megara. Mythology tells of a dispute between Poseidon and Helios for possession of the land; Briareos, who was appointed arbitrator, decided in favor of Poseidon.

The Isthmus formed a bridge for land traffic and a barrier to E-W shipping, and attempts were made early to facilitate passage from sea to sea. In the 6th c. B.C. a causeway (diolkos), 3.60-4.20 m wide, was constructed, the pavement of which has been exposed for a distance of nearly 1 km near the Corinthian Gulf. On it ships were hauled on cradles, as shown by deep wheel ruts, 1.50 m apart. The diolkos was still in use in the 9th c. A.D.

Plans to dig a canal were conceived by Periander, Demetrios Poliorketes, Julius Caesar, Caligula, Nero, and Herodes Atticus. Nero broke ground for a canal during his visit to Greece in A.D. 67. Two of his trenches, 2,000 and 1,500 m long but nowhere reaching water level, and several pits, 37-42 m deep, were clearly visible before the modern canal was dug in 1881-93. Traces of Nero's work still remain.

To protect themselves and the Peloponnesos from attacks by land, the Corinthians fortified the Isthmus. The earliest of the walls, which dates back to about 1200 B.C., may have been planned to stem the recurrent waves of "Dorian" invaders at the end of the Mycenaean period. It was probably left unfinished when the decisive invasion took place. The next line of defense, built in haste in 480 B.C. against an expected Persian attack that never materialized, has left no sure traces. There are extensive remains of a later fortification, built probably in 279 B.C., when the Gauls, who overran the N of Greece, threatened invasion of the Peloponnesos. This wall crossed the Isthmus so far to the W as to leave the Precinct of Poseidon (see Isthmia) and large parts of Corinthian territory open to the attackers. There are also references to a wall built in the reign of Valerian (A.D. 253-60). The "Wall of Justinian," which can be followed through most of its course, had originally 153 towers on the N side, spaced at intervals of about 40 m. Near the E end, close to the Sanctuary of Poseidon, there is a massive fortress whose walls abut against the trans-Isthmus wall. The fortress and much of the Isthmus wall are constructed largely out of reused material from the sanctuary. Recent excavations (1967-69) tend to show that these walls are earlier than Justinian; if this is correct, they must have been rebuilt during his reign. The fortress has three gates: the NE Gate, incorporating an earlier Roman gateway; the S Gate, built or repaired by Justin-

ian's engineer Victorinus; and a smaller gate in the W wall. Repairs were again made in the reign of Manuel II (1391-1425). Until the fall of Constantinople in 1453, the trans-Isthmus wall and the fortress remained a bulwark against invasions from the N.

BIBLIOGRAPHY. J. H. Jenkins & H. Megaw in *BSA* 32 (1931-32) 68-89[PI]; H. N. Fowler, *Corinth I: Topography* (1932) 46-71[MPI]; N. M. Verdelis in *AthMitt* 71 (1956) 51-59[PI]; 73 (1958) 140-45[I]; A. Philippson-E. Kirsten, *GL* III, Part I: *Der Peloponnes* (1959); O. Broneer in *Antiquity* 32 (1958) 80-88[MI]; id., *Atti del Settimo Congr. Intern. di Archeologia Class.* I (1961) 243-49[MI]; id., *Hesperia* 35 (1966) 346-62[MPI]; 37 (1968) 25-35[MPI]; J. R. Wiseman in *Hesperia* 32 (1963) 248-75[MPI]; B. v. Freyberg, *Erlanger Geologische Abhandlungen, Heft 95, Geologie des Isthmus von Korinth* (1973). See also Isthmia, with Bibliography. O. BRONEER

ISTLADA (Hayıtlı) Turkey. Map 7. Small town in Lycia 9.6 km W-SW of Myra, unknown except from its inscriptions, in which the termination of the name is uncertain. The ruins consist of houses, comparatively well preserved though not of early date, and some 20 Lycian sarcophagi with so-called Gothic lids, all exactly alike.

BIBLIOGRAPHY. E. Petersen & F. von Luschan, *Reisen in Lykien* (1889) I, 30-31; II, 47. G. E. BEAN

ISTROS (Histria) Romania. Map 12. Situated on the W coast of the Black Sea, about halfway between the mouth of the Danube and the present-day city of Constanţa. The city was founded in the 7th c. B.C. by the Milesians within a gulf that was later made into a lagoon. Lasting until the beginning of the 7th c. A.D., it apparently was abandoned by its inhabitants, probably as a result of the invasion of the Avari in 587. The site has never been reoccupied.

In the course of its long history Istros experienced periods of prosperity interrupted by crises that more than once imperiled its existence. Laid waste for the first time at the end of the 6th c. B.C. (probably by the Scythians), it was again sacked at the end of the 4th c. (perhaps by Lysimachos), then about the middle of the 1st c. by the Getae of Byrebistas and once more about the middle of the 3d c. A.D. by the Goths. Made part of the Roman Empire toward the end of the 1st c. B.C., it later was included in the imperial province of Moesia and, from Docletian's reign, in the new province of Scythia.

Excavations have revealed the latest circuit walls, erected after the Goths had laid waste the city. Since then other walls have been found and more or less completely uncovered: the first one dating from the archaic period, the second from the Hellenistic period, and the third from Early Roman times.

To this last period of its existence (4th-6th c.) belong most of the monuments excavated inside the late circuit wall. The rampart itself, which is fairly well preserved on its W and S sides, recalls the dramatic conditions in which it was built: all along the walls can be seen architrave blocks, columns, architectural fragments, even inscriptions used as building materials.

A seemingly official quarter of the city has been excavated inside the rampart, to the right of the main gate. It contains several large civic basilicas, a commercial pavilion, a small porticoed square and a bath building, fairly well preserved. Farther off, to the S and SE, can be seen a section containing poor dwellings and workshops, probably a later addition to the city. This section of Istros is linked by a street paved with broad slabs to a residential quarter set at the highest point of the city. Here can be seen several large houses with inner courtyard and more than one story; one of them (which has

a private apsed chapel) seems to have been a bishop's residence. All these remains (including those of several Christian basilicas, with or without crypt) belong to the last phase of the city (4th-6th c.). Far more ancient are those monuments found in what is now known as Istros' Sacred Zone, situated on the water in the NE part of the city. Excavations have revealed the foundations of a temple dedicated to Zeus Polieus (built in the 6th c. B.C. and rebuilt in the first half of the 5th); a few anonymous altars dating from the same period; important fragments of a small Doric temple of Thasos marble, dedicated to Theos Megas (3d c. B.C.); and sizable fragments of a Temple of Aphrodite (Hellenistic period), still being excavated.

Other scattered ruins have been uncovered on different occasions outside the city to the W in the area between the early rampart and the first Roman rampart. Among these ruins is a second bath building, dating from the 2d-3d c., a Christian basilica with a cemetery around it (5th-6th c.), and remains of scattered houses and fragments of streets from the Hellenistic period.

Farther off, in the same direction, on the other side of the neck of water separating the ancient site and the cultivated areas, is a large cemetery. In addition to Greek tombs (6th c. B.C.-3d c. A.D.), it was found to contain several tombs belonging to chiefs of the Getae who were buried according to barbarian ritual, surrounded by human victims and skeletons of horses.

BIBLIOGRAPHY. V. Pârvan, *An. Acad. Rom., Mem. Sect. Ist.* 38 (1916) 533-732; III, t. II, mém. 2 (1923); S. Lambrino, *Dacia* 3-4 (1927-32) 378-410; *Histria. Monografie arheologică*, I (1954), II (1964); E. Condurachi, *Dacia*, NS 1 (1957) 245-63; P. Alexandrescu & V. Eftimie ibid. 3 (1959) 143-64; D. M. Pippidi, ibid. 6 (1962) 139-56; id., *Epigraphische Beiträge zur Geschichte Histrias* (1962); id., *Contribuţii la istoria veche a României* (2d ed., 1967); id., *I Greci nel Basso Danubio* (1971).

D. M. PIPPIDI

ITALICA (Santi Ponce) Seville, Spain. Map 19. City 8 km NW of Seville, settled by Scipio in 206 B.C. with wounded survivors of the battle of Ilipa. It had no special status. Between the time of Julius Caesar and that of Augustus, however, it attained the category of municipium; under Hadrian, at the request of the city itself, it was raised to the rank of colonia, with the title Aelia Augusta Italicensium. It was one of the more urban communities of the Roman world, with a busy port on the Guadalquivir, but the ruins known today are those of a creation ex novo by Hadrian. Damaged by the invasions of the third quarter of the 3d c. A.D., the city continued to exist through the Visigothic period, only to be destroyed during Arab domination in the 9th-10th c. The village of Santi Ponce was built on its ruins.

The wall enclosed an area of some 30 ha. The wide streets, intersecting at right angles, paved with large stone blocks, and lined with porticos, sometimes reached a total width of 16 m. A surviving sector of the city wall near the amphitheater, with an entrance gateway and two towers, dates perhaps from the end of the 2d or the beginning of the 3d c. A.D. The amphitheater was one of the largest in the Empire, 160 by 197 m. It was built of large blocks of hewn stone and brick faced with marble and could accommodate some 25,000 spectators. Much of the cavea is preserved with its corridors and vomitoria still usable, and the underground service passages of the arena are in perfect condition. The amphitheater took advantage of a natural slope, although all of it rose above ground. A theater has also been excavated recently, located like the amphitheater outside the city wall.

There are two baths, the Baths of the Moorish Queen to the W and The Palaces to the E. They are roughly equal in size, date from the same general period, and are very similar in plan. The former includes a swimming pool 21 m long, various rooms (two of them vaulted), and on the N a large underground chamber with three aisles. On the S is a porticoed street, onto which one of the entrances to the baths (presumably the principal one) opens. This entrance had three aisles besides a columned vestibule. The Palaces had a somewhat smaller swimming pool (15 m), various rooms and passageways, and an underground section with vaults of medium size, from which came some of the best sculpture found on the site. Both baths were built of broken rubble coated with brick and sometimes faced with marble. The floors are of opus signinum with large two-foot slabs, and mosaics with tesserae of colored marble.

The drainage system was admirable, a network of drains and catch basins constructed in accordance with the street plan. Water was brought in by an aqueduct, portions of which are still visible, from Tucci (Escacena del Campo) some 40 km to the W. The elevated portions of the aqueduct were carried on piers and low arches. In addition, 18th c. sources mention a water mill built of rubblework and hewn stone, now vanished.

Near the cemetery of Santiponce, N of the ancient city, is an interesting group of spacious houses of the domus type, rectangular and of identical plan. They lie in a rectangular area formed by four streets, and most of them have porticos. Axial in plan, they usually have two patios, with a cistern and well, surrounded by covered ways on which the rooms open. Several patios have fountains, and pools with mosaics of fish. Construction is of rubble, faced with brick and ornamental marble or colored stucco. The floors are of mosaic in the main rooms and of opus signinum in the remainder. Noteworthy examples are the House of the Birds, of the Labyrinth, of Hylas, and particularly the House of the Exedra, which covers an area of some 3000 sq. m. It consists of two basic elements: one a mansion or de luxe residence with a porticoed patio in the center; the other formed by two adjacent, parallel walk-ways, the more important one terminating in a large apse.

The only burial ground yet excavated lies along the N edge of Santiponce, where there was a structure with three aisles terminating in a semicircular apse, perhaps a Christian martyrium. Other monuments include the graves of Antonia Vetia and of Valeria. A great many lead coffins have been found, some with partially ornamented lids, and an enormous number of mosaics; some of these are still in place, the remainder are in the archaeological museum of Seville or in private hands. They have colorful figured or geometric designs, which have inspired names such as the mosaic of the Bird, Bacchus, Hylas and Hercules, the pygmies and cranes, a marine thiasos, Ganymede, and Pan.

There is a superb collection of sculpture from the excavations in the Archaeological Museum of Seville. Noteworthy are the heads of Alexander the Great, Augustus, Nero, and Galba(?), there is also a bust of Hadrian, and a colossal heroized Trajan, beside individual portraits, reliefs of deities, and mythological themes. The smaller finds, carved gems, glass, and ceramics are dispersed among various museums and private collections, notably the Archaeological Museum of Seville, the Lebrija Collection, and the museum of the Hispanic Society in New York. There is also a new museum in Italica itself, where future finds will be shown.

BIBLIOGRAPHY. D. de los Ríos, *Memoria arqueológico-descriptiva del Anfiteatro de Itálica* (1862); F. de Collantes Terán, *Catálogo arqueológico y artístico de la Provincia de Sevilla* IV (1955); A. García y Bellido, "Colonia Aelia Augusta Italica," *Bibliotheca Archaeologica* II (1960); id., "La Italica de Hadriano," in *Les empereurs romains d'Espagne* (1965) 7ff; C. Fernandez Chicarro, *Catálogo del Museo Arqueológico de Sevilla* (1969). J. M. ROLDÁN

ITANOS (Eremoupolis) Greece. Map 11. Town in Sitia province, E Crete; on a now deserted bay just S of the NE point of Crete, Cape Sidhero (ancient Samonion) and N of Palaikastro and Cape Plaka (ancient Cape Itanon). Traces of Minoan occupation have been found, and at Vaï 1.6 km to the S an LM IA building has been excavated. Much more evidence has been found of occupation in succeeding periods: Protogeometric(?), Geometric, and archaic sherds from unstratified deposits, and many Classical and Hellenistic sherds. But the visible remains are mostly of Roman or Byzantine date.

Apart from the archaeological evidence little is known of the city's history before the 3d c. B.C. The traditional founder was Itanos, a son of Phoinix or bastard son of one of the Kouretes (Steph. Byz. s.v.). This and the possibly Semitic origin of the name have been adduced as evidence of Phoenician links or even settlement, but concrete evidence is lacking. The Theran colonists of Kyrene (Hdt. 4.151) were guided by an Itanian purple-fisherman, Korobios (possibly to be identified with the marine deity on some Itanian coins). Itanos was one of the first Cretan cities to strike coins, in the 5th c.

Much of the detail of its history in the 3d and 2d c. comes from inscriptions. In the early 3d c. an oath of loyalty was imposed on all citizens, a probable indication of internal political instability and the threat of revolution, clearly arrested (perhaps by reforms leading to a moderate democracy). In the 260s Itanos sought Ptolemaic help against its aggressive neighbor Praisos (perhaps also against the threat of revolution). An Egyptian garrison was established, maintained until about the end of the 3d c., and renewed briefly in the mid 2d. This led to increasing Egyptian influence in Cretan politics and provided a base for recruiting mercenaries. When Hierapytna destroyed Praisos (145-140), she became a neighbor of Itanos, and the two cities, though formerly allies, came into conflict over Hierapytnian control of the Sanctuary of Dictaean Zeus (at Palaikastro) and Leuke island (Kouphonisi). The dispute was finally settled in 112-111. The later history of Itanos is obscure; it was not a bishop's see and is not listed by Hierokles. Coins, inscriptions, and ruins indicate continued occupation in Roman times, and many Byzantine remains survive, including two churches and baptisteries. The date of final abandonment is uncertain.

In the 19th c. the site was first thought to be Hetera, but later correctly identified. In the center of a small bay, protected from the N and NW winds, a low hill forms the ancient acropolis. On its W side is a large church, on the S traces of a circuit wall with towers, and on the summit remains of small late buildings; sherds, however, go back to the Geometric period. Inland to the W, on a second hill, stands a fine Hellenistic terrace wall, but few other remains. On low ground between the hills are large domestic buildings of Byzantine date overlying earlier levels. To the N is the necropolis, to the W ancient quarries, and on the S edge of the city a circuit wall surrounds a hill, perhaps for the Ptolemaic garrison. Part of the ancient city may now lie under water; this coast has been submerged by some 2 m since antiquity. Ancient remains have been found on the offshore island of Elasa (ancient Onysia), still an anchorage.

BIBLIOGRAPHY. T.A.B. Spratt, *Travels and Researches in Crete* I (1865) 193-205[I]; F. Halbherr, *Antiquary* 24 (1891) 202-3, 241-45; L. Mariani, *MonAnt* 6 (1895) 312-18; A. J. Reinach, "Inscriptions d'Itanos," *REG* 24 (1911) 377-425; Bürchner, "Itanos," *RE* IX, 2 (1916) 2286-88; J.D.S. Pendlebury et al., *BSA* 33 (1932-33) 97-98[M]; M. Guarducci, *ICr* III (1942) 5-17, 75-130; H. van Effenterre, *La Crète et le monde grec de Platon à Polybe* (1948); C. Tiré & id., *Guide des fouilles françaises en Crète* (1966) 93-94; H. Gallet de Santerre, "Recherches archéologiques dans la région d'Itanos," *RA* 38 (1951) 134-46[MI]; J. Deshayes, "Tessons géometriques et archaïques d'Itanos," *BCH* 75 (1951) 201-9 (cf. 190-98); Brit. Adm. Chart 1677 (1969)[M]; S. Spyridakis, *Ptolemaic Itanos and Hellenistic Crete* (1970). D. J. BLACKMAN

ITHACA Greece. Map 9. An island in the Ionian Sea NE of Kephalonia. Homer speaks of a maritime power formed by four islands: Ithaca, Dulichio, Same, and Zacinto (*Od.* 9.31). Ithaca, the mythical homeland of Odysseus and capital of his kingdom, was identified by Classical authors with the island of the same name which today is called Ithaki or Thiaki. Test trenches had been dug at various points on the island in 1868 and 1878, and excavations since 1930 have given ample credence to this identification.

Near the village of Stavros in the N of the island, on a hillside dominating the Bay of Polis in the locality called Pelikate, a settlement surrounded by a Cyclopean wall and an ancient Helladic necropolis have been discovered. The necropolis also contains pottery from the middle Helladic and Mycenaean phases. Traces of a rather large building and some Mycenaean pottery were found in 1937 at Tris Langadas, also in the vicinity of the Polis valley. A cavern excavated in the Bay of Polis contained finds from the Bronze Age to the 1st c. A.D., the most interesting are from the Geometric period, including bronze votive tripods. This was a grotto sanctuary in which a fragment from the 3d c. B.C. indicates that the Nymphs were venerated, while a fictile mask from the 1st c. A.D. significantly bears the name of Odysseus. The islet Daskalio offshore from Polis could be the Homeric Asteris, where the Proci awaited the return of Odysseus. Near Stavros there are also the remains of a necropolis with tombs from the 5th and 4th c. B.C. above a Bronze Age settlement.

Farther N, near Exoghi, the chapel of Haghios Athanasios is built on the ruins of a tower with archaic polygonal masonry. It is popularly called the School of Homer and the original plan, two rooms, is still recognizable. There are remains of a polygonal wall, within which votive objects have been found NE of the church. The wall probably enclosed a temple or an archaic sanctuary. Near the village of Exoghi one might locate the domain of Laertes; and a fountain brings to mind Melanthydros in the Odyssey. On the summit of Mt. Aetos, on the narrow strip of land that joins the N and S parts of the island, an archaic polygonal enclosing wall and other remains may be identified with Alakomenai, mentioned by Strabo.

On the slopes of Mt. Aetos, near a tower of the 5th c. B.C., a large sanctuary with a massive terracing wall has been found, and a deposit of local Geometric and imported Corinthian vases. Moreover, there are confused remains of tumuli of the LH III period, with ceramics from the 12th c. B.C. After the middle of the 8th c. W Greek and Cretan influence is evident in the ceramics from Mt. Aetos. The ceramic votive offerings seem to cease in the 4th c. B.C., but there are numerous terracottas from later epochs. Vathy, the modern capital of the island, is identified with the ancient port of Phorkys

where Odysseus embarked. The grotto of Marmarospilia would be the grotto of the Nymphs, while the plain of Marathia would be the location of the stalls of Eumelus (*Od.* 14.6), and the fountain of Perapighadi may be the Arethusa. There is a small museum at Vathy.

BIBLIOGRAPHY. F. Schuchardt, *Schliemanns Ausgrabungen* (1891) 359ff; W. Vollgraff, "Fouilles d'Ithaque," *BCH* 29 (1905) 153ff[PI]; W. Dörpfeld, *Alt Ithaca* (1927)[MI]; V. Bérard, *Ithaque et la Grèce des Achéens* (1927); W. A. Heurtley, "Excavations in Ithaca, IV," *BSA* 40 (1939-40) 1ff; M. Robertson, "Excavations in Ithaca, V," *BSA* 43 (1948) 1ff[PI]; id., *BSA* 50 (1955) 37[PI]; H. Waterhouse, "Excavations at Stavros, Ithaca, in 1937," *BSA* 47 (1952) 227ff; S. Benton, "Further Excavations at Aetos," *BSA* 48 (1953) 255ff[PI]; D. Levi, *EAA* 4 (1961) 249-50; A. Wace-F. Stubbings, *A Companion to Homer* (1962) 398-421[M]. M. G. PICOZZI

ITHOME (Phanarion) Thessaly, Greece. Map 9. A town in the Hestiaiotis region, within a rectangle formed by the fortified cities of Gomphoi, Trikka, Pelinnaion, and Metropolis; it merged with the last of these in the 4th c. B.C. The site was located by Leake on a ridge between Metropolis and Gomphoi, now marked by a Byzantine-Turkish castle. The only remains of the ancient city are the ashlar blocks in the NW part of the fortification wall.

BIBLIOGRAPHY. Strab. 9.5.17; W. M. Leake, *Nor. Gr.* (1835) IV 510; F. Stählin, *Das hellenische Thessalien* (1924) 129. M. H. MC ALLISTER

IULIA CONCORDIA Veneto, Italy. Map 14. A city of the tenth Augustan region, the Venetia et Histria, on the Via Annia constructed in 131 B.C. by the praetor T. Annius Rufus. At first it was a vicus administered by four magistri, but it grew quickly because of its favorable position between Altino and Aquileia. The name of the city is linked to the memory of Julius Caesar and of Octavian and celebrates the entente in 42 B.C. between the triumviri. The colonia of Concordia, assigned to the tribus Claudia, enjoyed full political rights.

Following the social war in 89 B.C., Italy S of the Po obtained the formerly Roman city. Concordia owed its development to the importance of the roads passing through it. Besides the Annia, it was connected through Opitergium (Oderzo) with the Postumia (148 B.C.), and with the regina viarum of N Italy, which ran from Genova on the Tyrrhenian Sea to Aquileia on the Adriatic. In A.D. 167 the Quadi, the Marcomanni, and other tribes invaded the Venetia region, besieging the bulwark of Aquileia and advancing across the Concordia zone to the territory of Opitergium. Marcus Aurelius drove back the barbarians beyond the Alpine passes. In 180 the hoards were driven to Vindobona (Vienna). Concordia, like Aquileia, was finally destroyed by the Huns of Attila.

On the left bank of the Lemene is a military necropolis from the late 4th c. and early 5th c. During the late Roman period Concordia had a considerable garrison of militia made up of Germanic stirpi (Heruli, Batavi, and Mattiaci); and the Gallic stirpe (Brachiati). The inscriptions from the sarcophagi are in the museum, but nothing else from the necropolis survives.

In 1950 exploration between the baptistery and the cathedral led to the discovery of a trichora, constructed toward the end of the 4th c. By the first half of the 5th c. a small basilica had been added to the trichora. The basilica, domnorum apostolorum, recorded by the inscription of sanctus Maurentius presbiter, had relics of St. John the Baptist, and of the apostles John, Andrew, Thomas, and Luke. Thus in the second half of the 4th c. the church of Concordia received the relics of the saints,

had a bishop who was perhaps Eusebius, the brother of Cromazius, and was the seat of the bishopric. The transformation of the basilical trichora probably took place in the first half of the 5th c., resulting in a double basilica similar to that at Aquileia.

Material on view at the National Museum of Concordia, in addition to the inscriptions from the military necropolis mentioned above, are stelai with portraits, an interesting sarcophagus with a nuptial scene, and a polychrome mosaic showing the Three Graces.

BIBLIOGRAPHY. R. Egger, "Der heilige Heragoras," in *Carinthia I, Mitteil. d. Geschichtsvereins für Karnten* (1947) 14-58; G. Brusin & P. L. Zovatto, *Monument romani e cristiani di Iulia Concordia* (1960) 242 and fig. 135; B. Scarpa Bonazza et al., *Iulia Concordia dall'età romana all'età moderna* (1962); P. L. Zovatto, *Guida del Museo e della Città di Portogruaro* (1965).

G. BRUSIN

IULIA TRADUCTA (Tarifa) Cádiz, Spain. Map 19. Town 22 km SW of Algeciras, which Strabo (3.140) calls Ioulia Ioza, and others Iulia Ioza. Ioza is the Latin equivalent of Transducta or Traducta (Ptol. 2.4.6; Marcianus 2.9; Ravenna Cosmographer 305.12). P. Mela (2.96), however, places Tingentera in this place.

The town was founded in the Augustan period as Colonia Iulia Traducta, since some of the inhabitants of Zelis (Algiers) and Tingis (Tangiers), in North Africa, had been transferred to it. However, since Pliny (5.2) states that Tingis was named Traducta Iulia by the emperor Claudius when he converted it into a colony, some scholars have concluded that the population that came from the African coast returned home in the time of Claudius. The town of Iulia Traducta minted coins only in the Imperial age; the obverse carried the head of Augustus or produce such as tuna, grapes, or wheat, and the reverse the name of the mint, IVL TRAD.

Fragments of ancient pottery and coins have been found in Tarifa, but until recently its surroundings have been explored more than the town itself. Copper Age graves have been found in the Algarbes area, near Tarifa; grave goods, now in the Seville Archaeological Museum, include handmade pottery in the form of a tulip; also arrow points and flint knives, polished axes, some bronze pieces, bone objects used for ornament or as pendants, and a fragment of a gold sword hilt with checkerboard decoration. Remains from the same period have been found throughout the course of the Ebro.

Tarifa probably forms part of an ancient tell. Fragments of Campanian pottery indicate that excavation would be worthwhile.

BIBLIOGRAPHY. E. Romero de Torres, *Catálogo Monumental de España. Provincia de Cádiz* (1934) 171, 230, 270-71, 310, 356, 361-62, 460, 549; A. García y Bellido, "Las colonias romanas de Hispania," *Anuario de Historia del Derecho Español* 29 (1959) 493ff.

C. FERNANDEZ-CHICARRO

IULIOBRIGA (Retortillo) Santander, Spain. Map 19. In the Cantabrian mountains 3 km E of Reinosa, in one of the best passes from the plateau to the sea. It was the first Roman establishment in Cantabria and the main one, settled probably between 29 and 19 B.C. Its name indicates its founding by Augustus, perhaps during the Cantabrian wars. Pliny (*HN* 3.21) calls it an oppidum, meaning that it enjoyed privileges similar to those of a colony. It was the principal Roman city in the limes of N Hispania, and was probably destroyed during the invasions of the 5th c.

It must have occupied ca. 1 sq. km, but only a small part has been excavated. The principal discovery is a building (79.4 x 29.5 m) whose SE side consisted of an enclosed portico, probably a loggia or private gallery rather than a porticoed street. The building has two parts each ca. 40 m long, one a residence with rooms around a peristyle, the other apparently an outbuilding with servants' quarters and storerooms. The finds are in the Museum of Prehistory in Santander.

BIBLIOGRAPHY. A. García y Bellido, *Iuliobriga, ciudad romana de Cantabria. Las nuevas excavaciones* (1953); id., "Excavaciones en Juliobriga y exploraciones en Cantabria. II Relación. Campaña de 1953 a 1956," *ArchEspArq* 29 (1956); id., *Excavaciones y exploraciones arqueológicas en Cantabria* (1970).

R. TEJA

IULIPA (Zalamea de la Serena) Badajoz, Spain. Map 19. Between Don Benito and Belmez. It is not mentioned by ancient geographers, but its Roman name is given in *CIL* II, 2352. Remains include a Roman cistern and a distyle funerary monument. The cistern forms part of a longitudinal suite of rooms separated by a double arch; the surviving portion is more than 10 m long, and its maximum depth is 4.44 m. The sepulchral monument, of the 1st or 2d c. A.D., is of a type well known in Syria: a podium with two columns which probably supported a section of architrave. The upper part of the monument, which is missing, would have measured ca. 24 m.

BIBLIOGRAPHY. A. García y Bellido & J. Menéndez Pidal, *El distylo sepulcral romano de Iulipa (Zalamea)* (1963) MPI.

L. G. IGLESIAS

IULIUM CARNICUM (Zuglio) Friuli, Italy. Map 14. A Roman settlement, probably part of the defense of Cisalpine Gaul following the attack of the Giapidi in 52 B.C. It was built on an indigenous center as a vicus dependent on Aquileia. Under Augustus it was granted autonomy; as a municipium it controlled a large amount of territory on the road that led from Aquileia to Aguntum in Noricum. It was designated a colonia, perhaps in the second half of the 1st c. A.D., at the same time Aquileia received that designation.

Nothing is known of the site during the barbaric invasions nor of its destruction. The first documented destruction, of a building to the N of the bath building, is datable to the end of the 4th c. or perhaps in connection with the descent of Alaric in 401-408. A little later the center in the valley was abandoned and the inhabitants took refuge on the hill of San Pietro. The Bishopric of Juliensis, founded at the end of the 4th c., was absorbed in the 8th c. by the diocese of Aquileia.

Numerous inscriptions document the life of the center. We know the names of magistri vici, duoviri jure dicundo, decuriones, a quaestor, and a curator reipublicae. Inscriptions of divinities also occur, including Jove, Mithra, Fortuna, Silvanus, Hercules, and Beleno.

As the result of excavations, the remains of a number of monuments have come to light. The forum (40 x 85 m) was constructed on an existing pre-Roman quarter. It had a portico around the entire interior. In the center there was the temple, probably faced with marble, of which only the podium remains. It was tetrastyle with three columns on the sides, built according to Vitruvian rules and proportions. The temple, of the 1st c. A.D., was probably a Capitolium, and not a temple dedicated to the Carnican God Beleno, as might be inferred from a Republican inscription of unknown provenance that records the rebuilding of a temple at the instigation of several magistri vici. There is a rectangular hall at the S end of the forum, opposite of the temple. It is divided into two naves by a series of eight columns, and it probably had a second story. This building may have been a law court; it has parallels at Cividale, Aquileia,

and Rome. Numerous architectural fragments, inscriptions, and particularly a portrait considered to be a work from the age of Trajan, date this building to the 1st c. A.D.

The bath complex is notable for its large swimming pool. There are remains of a Temple to Hercules, an aqueduct, sewers, and private houses with mosaics and provision for heating. The cemetery basilica, typically Early Christian in plan, had a fine mosaic pavement. On the E side were two service rooms. Similarities are evident between this Early Christian basilica and the buildings constructed under Theodoric and slightly later at Aquileia, as well as with Christian architecture in Noricum. Recently the apse possibly of another basilica has come to light. Both would probably date to the 4th or 5th c.

BIBLIOGRAPHY. C. G. Mor, "Recenti scavi nei due Fori Giuli Friulani," *Atti V Congr. naz. Studi Romani* II (1940) 23ff; S. Stucchi, "Il ritratto romano di Costantino del Museo di Cividale," *Studi goriziani* 13 (1950) 45ff; G. Daltrop, *Die stadtrömischen männlichen Privatbildnisse, traianischer und hadrianischer Zeit* (1958); L. Bertacchi, "Il Foro romano di Zuglio," *Aquileia nosta* 30 (1959) 50-58; *EAA* 7 (1966) coll. 1290-91 (L. Beschi); *CIL* v, 172-78. L. BERTACCHI

IUNCARIA (La Junquera) Gerona, Spain. Map 19. The last stage on the Via Heraclea linking Gadir (Cadiz) with Rome before reaching the Pyrenees, 18 km N of Figueras, mentioned in the *Antonine Itinerary* and a station on the traveling vases of Vicarello. Strabo (3.4.9), speaking of the textile industry of the Emporitani, calls the marshy area of the upper Ampurdan Iounkarion since it provided a kind of reed which he confuses with esparto.

BIBLIOGRAPHY. A. García y Bellido, *La Peninsula Iberica en los comienzos de su Historia* (1953).

J. MALUQUER DE MOTES

IUNCI, *see* MACOMADES MINORES

IUVAVUM (Salzburg) Austria. Map 20. One of the five oldest towns of Noricum, it was, according to Pliny (*HN* 3.146), founded during the reign of Claudius (A.D. 41-54) as Municipium Claudium Iuvavum. The name is pre-Roman but it is uncertain to which prehistoric population it should be ascribed. It should be noted that of these five towns, Iuvavum was situated farthest N, in the foothills of the Alps, yet still behind the frontier, ca. 90 km from the Danube. This is evidence that Roman rule extended beyond the Alps around the middle of the 1st c. A.D.

Iuvavum was on the Salzach river (Isonta, Ivarus) at the point where it enters the plain (Flachgau), and on the Salzach road which led N from Teurnia or Virunum across the Radstädter Tauern Alps. It was an important traffic junction a) for the continuation of the Salzach road N in the direction of Castra Regina (Regensburg) and b) for the Noric road in the direction of Ovilava (Wels) and Lauriacum (Lorch-Enns) on the Danube limes.

The territory of the settlement was circumscribed by the island mountains of the Salzburg basin: the Mönchsberg, Festungsberg, and Nonnberg on the left bank, and the Kapuzinerberg on the right bank of the Salzach. The steep slope of the mountains offered ideal possibilities for defense, increased by the formerly divided river which was forced into a narrow trough at the foot of the Kapuzinerberg. Here was the best place for crossing the river or building a bridge. The swampy plain offered added security as did the extensive moors (Untersberger

moor in the W, Schall moor in the E). The center of the prehistoric (Celtic) settlement was located on the Rainberg, as evidenced by a concentration of finds there. The Roman settlers, as usual preferring the plain, chose the area confined by the Salzach and the arc of the Stadtberg.

Almost nothing is known of the history of the town. Whether it suffered in the Marcomannic wars is debatable. Iuvavum never was a garrison and did not have walls, but it must have been a flourishing and prosperous town. This is indicated by the finds, which are more numerous and impressive here than in many other municipia of Noricum. Roman pulchra habitacula were still known around A.D. 700 when the Franconian bishop Rupert took up residence there. Excavation of Iuvavum has been hampered by the fact that the mediaeval town completely covered the center of the municipium and the deep cellars largely destroyed the Roman ruins. The center of the Roman settlement was situated on the left bank of the Salzach, in the bay formed by Mönchsberg, Festungsberg, and Nonnberg. From the 1st c. A.D. on, a larger section of the town developed on the right bank, its lesser density indicating a suburban character. Both parts were connected by a bridge at the narrowest part of the river. On the right bank large necropoleis were located, as usual, on roads leading out of the town (Bürglstein, N rim of the Kapuzinerberg).

The plan of the site cannot be reconstructed as only occasional remains of buildings have been found. The exact location of the town center (with forum and capitol) is not known but can be assumed to have been in the area of the cathedral. This is suggested by fragments of inscriptions in the mediaeval cathedral, referring to a building erected in honor of Septimius Severus, of which possible remains were discovered during the 1958 excavations in the Residenzplatz. These remains have been interpreted as the foundations of a Roman triumphal arch (quadrifrons). This would establish the first public civilian structure. The discovery on the Residenzplatz of an altar to Jupiter and all the gods, and of remains of large buildings in the interior of the cathedral argues for locating the forum on this site. Nearby a block was found with a fragment of an inscription which also points to a monumental structure from the time of Septimius Severus. At what probably was the E edge of the forum, the foundations of a large temple (29.6 x 45.4 m) were recently excavated which may have been a Temple of Asklepios since many pertinent sculptures have been found in this area (statuettes of Asklepios, of Hygieia, a votive altar for Asklepios Augustus, a Serapis head). An inscription in honor of a mayor also indicates that the area was part of the public center of the municipium, a place for official tributes to emperors and other persons of merit.

Building remains found in many parts of the town indicate residential dwellings. Their luxurious appointments and beautiful mosaic floors are characteristic of Iuvavum. They confirm the prosperity of the town as does the quantity of sculptures, whose stone came partly from the marble quarries, already used by the Romans, of the nearby Untersberg. Also at the edge of the town notable building remains exist: e.g. a small native peripteral temple in Salzburg-Gnigl, and in Salzburg-Liefering the first Roman country estate known in this area. Also in the Loig fields SW of the town there is a Roman villa with a well-known Theseus mosaic (now in the Kunsthistorisches Museum, Vienna).

Hardly anything is known of the Late Roman period of Iuvavum. We know from Eugippius (*Vita Sancti Severini* 13 and 14) that there existed in the second half of the 5th c. a monastery with a basilica. However, the

Christian character of architectural finds in the town section on the right bank, attributed to a hypothetical church, is as questionable as the Christian origin of the so-called catacombs in the Mönchsberg.

The numerous finds from Iuvavum are primarily in the Museum Carolino Augusteum in Salzburg, which was reopened in 1967.

BIBLIOGRAPHY. Synopses: O. Klose & M. Silber, *Iuvavum* (1929); L. Eckhart in *EAA* 4 (1961) 278ff; Cathedral area excavations: H. Vetters in *Beiträge zur Kunstgeschichte und Archäologie . . . (Akten zum VII. Internationalen Kongress für Frühmittelalterforschung, 21-28 Sept. 1958)* (1962) 217ff; Temple of Asklepios; M. Hell, *Mitteilungen der Gesellschaft für Salzburger Landeskunde* 100 (1960) 29ff; "Basilica": id., ibid. 107 (1967) 71ff; Catacombs: R. Noll, *Österreichische Zeitschrift für Kunst und Denkmalpflege* 10 (1956) 13ff.

R. NOLL

IUZHNO-DONUZLAV Crimea. Map 5. This coastal settlement, 28 km NW of Eupatoria near the village of Popovka, was founded in the late 4th c. B.C. by Chersonesus. It was seized by the Scythians in the mid 2d c. B.C. and ceased to exist in the late 1st c. A.D.

Thus far no remains of fortifications from the Greek period have been uncovered. In the central part of the site is a round Scythian fortress-citadel built in the 2d c. B.C. and consisting of a thick embankment and deep ditch with an external facing of up to 18 rows of rough stone. A stone wall, now destroyed, stood atop the rampart. These fortifications enclosed an area of ca. 130 by 45 m, which was smaller than the original Greek settlement. By the 1st c. A.D., the settlement had spread outside the defensive system and had even extended beyond the boundary of the earlier Greek area. The chief monumental remains excavated are numerous dwellings and horrea; these are rectangular and built of stone. A number of stone walls and palisades connected and delineated the various buildings and helped to enclose several flagstone courtyards. The remains of a Scythian *iurta* (nomadic tent) from the 1st c. A.D. were found at one spot outside the fortress. Two crude stelai uncovered in the NW part of the site, outside the walls, suggest the presence of a Scythian cemetery during the last period of the settlement's history.

BIBLIOGRAPHY. O. D. Dashevskaia, "Raskopki Iuzhnogo Donuzlavskogo gorodishcha v 1960 g.," *Kratkie soobshcheniia Odesskogo universiteta i Odesskogo arkheologicheskogo muzeia v 1960* (1961) 51-58; id., "Raskopki Iuzhno-Donuzlavskogo gorodishcha v 1961-1962 gg.," *Kratkie soobshcheniia Odesskogo arkheologicheskogo muzeia v 1962 g.* (1964) 50-56; id., "Raskopki Iuzhno-Donuzlavskogo gorodishcha v 1963-1965 gg.," *KSIA* 109 (1967) 65-72; id., "Raskopki Iuzhno-Donuzlavskogo gorodishcha v 1966-1969 gg.," *KSIA* 130 (1972) 62-69.

T. S. NOONAN

IVOŠEVCI BY KISTANJE, *see* BURNUM

IVREA, *see* EPOREDIA

IXWORTH Suffolk, England. Map 24. Roman buildings were excavated 9.6 km NE of Bury St. Edmunds in 1849 and 1948, and air reconnaissance shows that an early fort, possibly of the Boudiccan period, was succeeded by a considerable civil settlement. The main concentration lies S of the modern village.

BIBLIOGRAPHY. *VCH Suffolk* I (1911) 311-12; D. N. Riley, *Antiquity* 19 (1945) 152; I. E. Moore, *Proc. Suffolk Institute of Archaeology and Nat. History* 24 (1948) 167, 174; ibid. 25 (1951) 213; J.K.S. St. Joseph, "Air Reconnaissance of Southern Britain," *JRS* 43 (1953) 82; 59 (1969) 127-28 & pl. II.2.

A.L.F. RIVET

IZAUX Hautes-Pyrénées, France. Map 23. In the plain of La Neste near the vanished Chapel of Notre-Dame-des-Barthes. Since 1967 a 4th c. Gallo-Roman villa has been excavated. After it went to ruin it still sheltered a very poor dwelling, converted to use as a necropolis before the chapel's cemetery came into being.

BIBLIOGRAPHY. R. Coquerel, "Recherches sur le site gallo-romain d'Izaux: stage de fouilles de 1967," *Ogam* 20 (1968) 67-94; cf. M. Labrousse in *Gallia* 24 (1966) 444; 26 (1968) 551; 28 (1970) 431-32.

M. LABROUSSE

IZERNORE, *see* ISARNODURUM

IZMIR, *see* SMYRNA

IZNIK, *see* NICAEA

IZVOARELE, *see* SUCIDAVA

J

JABNEH, *see* JAMNEIA

JACA, *see* IACCA

JAFFA, *see* JOPPA

JAJCE Bosnia-Herzegovina, Yugoslavia. Map 12. Remains of an ancient brick-works, Roman buildings, traces of a 4th c. necropolis and a sanctuary of the god Mithras ca. 48 km S of Banja Luka. In the temple were found Roman coins (2d-4th c.) and artifacts. On a massive rock inside a small spelaeum is a likeness of Mithras. The altars excavated in the sanctuary bear no inscriptions.

BIBLIOGRAPHY. C. Patsch, *WMBH* 8 (1902) 108-9; D. Sergejevski, *GZM Sarajevo* 49 (1937) 11-18; id., *GZM Sarajevo* (1938) str. 61; V. Paškvalin, *GZM Sarajevo, Arheologija* NS Sv. XXV, 29238; J. J. Wilkes, *Dalmatia* (1969).

V. PASKVALIN

JALALABAD, *see following* ALEXANDRIAN FOUNDATIONS, 8: Nikaia

JAMNEIA or JABNEH (Yavneh) Israel. Map 6. A Philistine town on the NW border of Judea. In the Persian and Early Hellenistic periods it was part of Idumaea and for some time the seat of the governor of that region (I Macc. 4:15). In 147 B.C. Jonathan and Simon won a decisive victory there over a large army led by Gorgias, but it was John Hyrcanus I who annexed it to the Hasmenaean kingdom (Joseph. *AJ* 13.324, but cf. 13.215). To the Greek writers Jabneh was known as Jamneia (Strab. 16.2.28). After the conquest of Palestine by Pompey in 64 B.C., the town was returned to its former inhabitants and was rebuilt by Gabinius (Joseph. *BJ* 1.166). After Herod's accession to the throne the town was given to him and after his death, to Salome (*BJ* 2.98). Later it seems to have passed to Agrippa I. Vespasian conquered it and gave it autonomy (*BJ* 4.130).

For some time after the destruction of the Temple it was the seat of the Sanhedrin. An important place also in Late Roman and Byzantine times, Eusebius (*Onom.* 106.22ff) knew it only as a small town. It figures both on the *Peutinger Table* (4th c.), and on the Madaba Map (6th c.) and was the seat of a bishop.

According to Pliny (*HN* 5.14) there were two sites named Jamneia: one inland and the other on the coast. The first is identified with the village of Yibnah (today Yavneh), and the other with Minet Rubin to the W of it on the coast. There have been no archaeological researches at either site, save for trial digs at the coastal town, where the mound of the earlier periods was excavated.

BIBLIOGRAPHY. M. Avi-Yonah, *The Holy Land from the Persian to the Arab Conquests (536 B.C. to A.D. 640). A Historical Geography* (1966). A. NEGEV

JARROW, *see* HADRIAN'S WALL

JAULNAY-CLAN Dept. Vienne, France. Map 23. Situated near and on the Tours-Poitiers road on the left bank of the Clain. Important remains were first noted in 1875 and have been excavated on different occasions since then. The Jaulnay church seems to have been built on the site of a huge bath building whose floors were paved with mosaics in black and white geometric designs: lozenges framed in rectangles or with borders. The tesserae are 6-8 mm on each side. Some large substructures were uncovered on the site in 1953 S of the church when mains were being laid, but they could not be explored further. There were walls of mortared rubble with a facing of small blocks, and some arched drains. The walls were decorated with frescos with a design of stylized palmettes and bouquets of eglantine. The walls had a glazed surface, apparently to give a watertight bond to rooms intended to hold water.

What may have been baths belonging to a villa, or Roman foundations, were discovered in 1888 some 800 m away, on the other side of Route Nationale No. 10.

The foundations of a peripteral temple 7.70 m sq have also been excavated. The cella was ringed with 12 fluted and cabled columns, one of which is still standing at the side of the road; it came from the site of the temple, 250 m to the W. Four steps led to the temple entrance, which was to the E.

BIBLIOGRAPHY. *Gallia* 12.1 (1954) 177-81[IP]. F. EYGUN

JÁVEA Alicante, Spain. Map 19. About 5 km SE of Denia, sometimes arbitrarily identified with ancient Alonai. In the parish of La Lluca was found a treasure consisting of a diadem, a fibula, and chains, all of gold, and a silver bracelet (4th c. B.C.). From other spots have come amphorae, Punic coins, and Roman objects, notably a marble relief of a horseman preceded by a man wearing a toga and followed by a soldier with shield and spear (Aracil Collection, Javea). On Punta del Arenal the remains of a fishery have yielded architectural fragments and ceramic material.

BIBLIOGRAPHY. A. García y Bellido, *Hallazgos griegos en España* (1936); G. Martin & M. Serres, "La factoria pesquera de Punta de l'Arenal y otros restos romanos de Jávea (Alicante)," *Trab. Varios del S.I.P.* 38 (1970).
 D. FLETCHER

JAVOLS, *see* ANDERITUM

JEBAL SERAJ, *see* ALEXANDRIA-AD-CAUCASUM *under* ALEXANDRIAN FOUNDATIONS, 5

JEBEL FUREIDIS, *see* HERODIUM

JEBEL OUST or Bab Khaled Tunisia. Map 18. The site is situated halfway between Tunis and Zaghouan, on the road that runs along the foot of the mountain of the same name. Occupying a spur on the NE side of the mountain, it dominates the surrounding valley. The reason for the settlement and for the various appurtenances of this ancient watering place, not yet identified, is to be found in the healing qualities of its hot spring. The bath complex is well preserved. It consists essentially of a great rectangular hall surrounded by columns (still standing) and a circular room with a pool ringed by 10 columns, six of which still had their capitals when excavations were begun in 1907. The baths were made up of rooms and pools (a third one is rectangular) designed for bathing, as well as their annexes, designed for healing and lodging.

The spring that fed the baths flowed at the bottom of a grotto designed before the baths were erected. Above it is a tripartite building for worship, dedicated to the healing gods. Heads of statues of Aesculapius and Hygiea were found there in the Christian era when the sanctuary was taken over as a baptistery of a church with three naves surrounded by a necropolis.

The bath building itself was occupied for a long period, as can be seen from the many examples of rebuilding and enlargements of the architecture, construction, and decoration; changes are especially apparent in the mosaic floors. A stylistic study of the mosaics enabled the excavator to set up a chronology beginning in the middle of the 2d c. and resuming, after a gap in the 5th c., in the Byzantine period. Essentially local, the design of these mosaics is geometric or floral, and polychrome. The only floor decorated with figures is one with square emblemata, four of which contain busts of the seasons. Some statues, in particular of Aesculapius, Mercury, and Hygiea, and a small bust of Mercury, have been found as well as some architectural fragments, including Tuscan capitals.

Aside from these main buildings, a number of hydraulic monuments were scattered over the site. Among them were two large reservoirs on the hillside. Almost identical (30 x 30 m), they were joined together by a conduit.

Three hundred m E, down river, is a complex of public cisterns. These consisted of a series of seven rectangular compartments built of rubble and measuring 4.5 m x 12 m, extended thereafter to a length of 20 m. In front of them is a large basin 30 m square which served to pipe off the waters. It was fed by water collected on the hillside slopes.

A little sanctuary, noted for its remains, now at the Bardo Museum in Tunis, was discovered on the side of a hill overlooking the ruins. Excavations in 1907 uncovered a paved vestibule as well as some small rooms paved with white mosaic with a design of red crosses throughout (*IMT* 464). A small stela was found with an inscription which, when deciphered, made it possible to identify the sanctuary as that of Mercury Silvanus. The excavators also noted a number of potters' kilns. The sherds from these filled a whole quarter of the city.

BIBLIOGRAPHY. M. Fendri, "Evolution chronologique et stylistique d'un ensemble de mosaiques dans la station thermale de Jebel-Oust," *Mosaique greco-romaine* (1963) 157-73. A. ENNABLI

JEBLE, *see* GABALA

JELALPUR, *see* BUCHEPHALA *following* ALEXANDRIAN FOUNDATIONS, 8

JEMELLE Belgium. Map. 21. A Gallo-Roman villa, excavated at the end of the 19th c. It is one of the largest

known in Belgium. The complex consists of a dwelling, an enclosure for livestock, six appended buildings, and a necropolis. The central building (ca. 100 x 30 m) includes to the S a bath building that seems to have been a later addition. Originally (mid 1st c.), the villa was symmetrical in plan, with porticos all along the E and W facades, and a large central hall with lesser rooms on either side. To compensate for the slope of the ground, an artificial terrace was built first and reinforced at various places by semicircular buttresses. None of the rooms of the villa was heated by a hypocaust. Three rooms were built above cellars. The bath mentioned above included a caldarium, sudatorium, tepidarium (all three above hypocausts), apodyterium, and frigidarium with pool. A long, narrow corridor connected the bath with the dwelling itself. On the NE side of the dwelling is a walled enclosure (8160 sq m) for livestock. The appended buildings were probably a stable, a workshop, and an ironworks. The necropolis was located some 150 m from the dwelling.

The villa had a rather turbulent history. Ruined for the first time under Marcus Aurelius during the invasion of Chauci, it was rebuilt and then destroyed for a second time under Aurelian (270-75). Once again restored, it was one of the very few villas in Belgium to remain in use during the 4th c. Its owner, who must have been a member of the aristocracy of great landed proprietors of the time, ordered the construction, at the end of the 3d c., of a fortified refuge on a hill that dominates the villa. Here the remains of an oppidum of the Iron Age was blocked off by an earthworks preceded by a ditch. About 35 m behind this, the promontory was once again blocked by a transverse wall (80 x 6 m) standing in front of a ditch 14.5 m wide, which precedes an exterior rampart flanked by five semicircular towers, two of which flank the entry into the refuge. Another wall, located 140 m behind the preceding one, divides the refuge into two unequal parts. Circumvallation protects the S side of the refuge; the N side is protected by steep cliffs. In the two parts of the refuge one can still see the foundations of two buildings.

BIBLIOGRAPHY. R. De Maeyer, *De Romeinsche Villa's in België* (1937) passim, esp. pp. 87-93[P]; id., *De Overblijfselen der Romeinsche Villa's in België* (1940) 258-63; Y. Graff, "Oppida et castella au pays des Belges," *Celticum* 6 (1963) 125-26.　　　S. J. DE LAET

JERASH, *see* GERASA

JERUSALEM, *see* AELIA CAPITOLINA

JIBILA ("Cotta") Morocco. Map 19. An important fish-salting and garum-manufacturing center S of the Ras Achakar, 15 km SW of Tingi. Built in the 1st c. B.C. and occupied until the end of the 3d c. A.D., it preserves remains of workshops, a tank, an oil-mill, a house, and some baths; also a necropolis. There is no evidence to support the suggestion that the site is Cotta, the pre-Roman oppidum mentioned by Pliny (5.2). Other fish-salting works lie 15 km to the S, on the left bank of the wadi Tahadart.

BIBLIOGRAPHY. M. Ponsich and M. Tarradell, *Garum et industries antiques de salaison dans la Méditerranée occidentale* (1965) 40-68[MPI]; M. Ponsich, *Recherches archéologiques à Tanger et dans sa région* (1970) 206-12, 283-90; 301-2, 313-35[MPI].　　　M. EUZENNAT

JIDAVA (Cîmpulung-Muscel) Romania. Map 12. The strongest Roman camp of the limes Transalutanus; its ancient name is unknown. It is in the part of the city called Pescăreasa. Built of stone, this camp guarded the access to Valachia through the Bran-Rîşnov (Cumidava) pass. The citadel is quadrilateral and covers an area of 98.65 by 132.25 m. It has four gates and square towers at the corners and the curtains. The wall, 1.8 m wide, is preserved to a height of 2 m. Inside the wall were found a praetorium, a horreum, bath establishments, and dwellings for soldiers. The excavations identified four dwelling areas (2d-3d c.) and determined that the camp was destroyed under Gordian III—Philip the Arab, at the time when the Romans lost all the limes Transalutanus. Recent excavations have yielded Roman pottery of the first half of the 3d c. Many bricks and tiles show writing exercises and signatures of several soldiers, thus revealing the composition of the garrison (legionary and auxiliary detachments). Chance discoveries of Roman coins of the 2d-4th c. were made in the civil settlement next to the Roman camp.

The finds from the excavations are preserved in a museum constructed on the site and in museums at Piteşti, Cîmpulung-Muscel, and Bucharest.

BIBLIOGRAPHY. CIL III, 12531-32; *AnÉpigr* (1959) 336. L. F. de Marsigli, *Description du Danube* (1744) II, 69; D. Tudor, "Castrele romane de la Jidava lîngă Cîmpulung-Muscel," *Bucureştii* 2 (1936) 89-117; id., "Ştiri noi despre castrul Jidava," *BMMN* 4 (1940-41) 98-101; id., "Arme şi diferite obiecte din castrul Jidava," *BCMI* 37 (1944) 77-82; id., *Oltenia romană* (3d ed., 1968) 293-96; E. & E. Popescu, "Castrul roman de la Jidava—Cîmpulung (Observaţii preliminare)," *Studii şi comunicări Muzeul Piteşti* 1 (1968) 69-79; *TIR*, L.35 (1969) 57.　　　D. TUDOR

JOPPA (Jaffa) Israel. Map 6. An ancient Canaanite port on the Mediterranean coast. The earliest mention of it in a Classical text is in the *Periplus* attributed to Skylax of Karyanda, now thought to be of the second half of the 4th c. B.C. He wrote that at Joppa "Andromeda was abandoned to the sea-monster." In Persian and Early Hellenistic times Joppa belonged to the Sidonians. Under the Ptolemies it became autonomous (Diod. 19.93.7) and a local mint was established there. The Hasmoneans conquered the city and replaced its original population with Jews (I Macc. 13:11). It became the main harbor of their kingdom. After Pompey's conquest of Palestine in 63 B.C., Joppa became autonomous again, but it returned to the Jews after a short time (Joseph. *AJ* 14.205). After the accession of Herod the Great the city became part of his domain (Joseph. *AJ* 14.396). At the time of the Jewish War Vespasian granted autonomy to the city, naming it Flavia Joppe. The city flourished also in Late Roman and Byzantine times.

The ancient mound was excavated in the years between 1955 and 1966. The earlier occupation levels belong to the Late Bronze and Iron Ages; the latest to Late Roman and Byzantine times. Since the area is still densely populated, excavations were restricted. To the Persian period belongs part of a city wall, unearthed over a length of 12 m. It was dated by imported Attic pottery. To the Hellenistic period is dated a fortress of considerable size. From the Early Roman period and later, scanty remains of dwellings and burial caves were discovered.

BIBLIOGRAPHY. J. Kaplan, "Jaffa," *Israel Exploration Journal* 6 (1956) 259-60; 12 (1962) 149-50.　　　A. NEGEV

JUBLAINS, *see* NOIODUNUM

JULIA DERTONA (Tortona) Italy. Map 14. Probably the oldest colony under Roman rule in the westernmost section of the Po valley. The founding of the city dates

to ca. 118-123 B.C., and the principal motivation was its geographical position. The Via Postumia merged within the city's borders with the Via Aemilia Scauri to become the great road so valued by Augustus and called the Via Julia Augusta.

The central axis of the city plan is the present Via Aemilia, which crosses the city SW to NE and quite probably retraces the route of the Roman decumanus. Little is known of the inner plan of the ancient city and only occasional investigations permit the supposition of cardines minores.

The city was thought at one time to have lacked a protective circuit wall, but recent investigations on the castle hill have identified a segment of the fortification wall. It had a loose rubble core with rough-hewn stones, and there are remains of a rectangular tower. The curtain wall, following with a stepped incline the natural slope of the land, seems to date to the earliest years of the colony.

Roman influence on this colony, which at the time of Augustus could be considered one of the major centers of the Po valley, is also apparent in the large tombs along the principal road and in the great aqueduct that carried water from the nearby Scrivia river along the Via Postumia and into the city.

Numerous inscriptions found in the area of Dertona identify men who attained high public office, and furnish details of their rise in the senatorial and equestrian orders. Recent discoveries of Veronese marble statue bases, some with dedicatory inscriptions, demonstrate that the city honored its most famous citizens with portrait statues. These were probably mingled with statues, commissioned and donated by Rome, of imperial officials.

Numerous mosaics and remains of marble lintels indicate that the city had sumptuous buildings with sophisticated decorations. The splendid sarcophagus of Publius Aelius Sabinus was found in the territory of Tortona, and the funeral stele of the bootmaker Publius Latinius belongs among the funeral stelai produced in the Po valley. In the territory of Marengo, adjacent to Tortona, a celebrated silver treasure was discovered and is today preserved in the Museum of Antiquities in Turin.

Dertona became the oldest episcopal center of Piemonte S of the Po river.

BIBLIOGRAPHY. P. Barocelli, "Julia Dertona," *Bollettino della Società Piemontese di Archeologia e Belle Arti* 15 (1931) 94 nn. 3-4; 16 (1932) 168 nn. 3-4. C. CARDUCCI

JULIOBONA (Lillebonne) Seine-Maritime, France. Map 23. Chief city of the Caletes, on the S boundary of Gallia Belgica. The Seine was the frontier. To the E were the Veliocasses and to the S, across the river, the Lexovii. Caesar (*BGall* 7.75) notes that the Caletes provided the Armorican line with 10,000 men, besides sending a detachment to the relief force during the siege of Alesia.

The city was built in the 1st c. A.D. on an inlet of the Seine, sheltered from the W winds by a cliff ca. 100 m high, which provided a safe roadstead for unloading ships coming down the river. Sea-going vessels could then follow the estuary to the Channel and the S coast of Britain. The cargoes came by the Rhône-Saône-Seine route, bringing Mediterranean products to the English Channel—a long inland waterway with, midway, a short portage overland between the Saône and the upper valley of the Seine (Strab). In the 2d c. Ptolemy mentioned the name and function of the city and its imperial foundation. The *Antonine Itinerary* also mentions the Juliobona relay stage and its distance from the stages nearest it, on both the decumanus and the cardo. The *Peutinger Table* places Julio-

bona on the route from Caracotinum (Harfleur) to Augustobonam (Troyes); an extensive network of roads connected the city with the interior of the region.

Two valleys converged near the ancient port, one lying N-S, the other E-W. When the great tides came, the harbor waters could spill over into the N valley, which was flatter. Two hills commanded the port to the W. On the farther hill the first Roman castrum was built for defense, replaced later by a series of forts. The hill nearer the port was cut away considerably, to accommodate the amphitheater. The city grew around the forum (modern Place de l'Eglise) along the cardo and decumanus, and on the outskirts villas sprang up along these roads. A temple stood on the left side of the cardo, NW of the forum, on the site of the present-day church (which explains its unorthodox N-S orientation).

The port occupied the lower part of the valley between the chalk cliffs that sheltered it to W and E. Its site can still be seen, since the shifting soil in the area has prevented any building. Towards the city, a quay built of large stones, and with a few mooring rings, marked the boundary of the port. It varied in depth, and ships were able to beach at low tide. Objects dropped overboard have often been found on the site of the port.

The number of potsherds excavated at Lillebonne, out of proporion for residential areas, proves that the city had warehouses and carried on vigorous trading. An ingot of stamped lead weighing 43.5 kg found in 1840 came from the Charterhouse mines, in the Mendip Hills in Somerset, while the large number of amphorae shows that Juliobona imported wines, oil, and olives from the Mediterranean regions. One of the amphorae had a Spanish trademark. Quantities of oyster shells of the Ostrea type have been found in the soil all over the city, evidently brought in from the Channel coast. Manufactured products indicate a variety of craftsmen: a lead casket containing a funerary urn (now in the museum) is evidence of metalworking activity, together with the lead ingot referred to above. The presence of goldsmiths is shown by a silver salver, its edge decorated with animals from the local fauna.

The extant monuments are a theater, two bath buildings, two villas, and part of the city rampart. The theater, outside the city SW of the forum, is backed against a hill, which was cut out to accommodate the foundations. Originally it was an elliptical amphitheater designed for games, combats of gladiators and wild beasts, and 48 m long. It was built in the 1st c. A.D. (walls with courses of brick) close to the port, from which it was separated by the cardo. After the city was completely destroyed, in the middle of the 2d c., the increase in the Latin-speaking population made it possible to turn the building into a theater where plays could be given at less cost than amphitheater entertainments. The tiers and upper boxes were built on a circular plan S of the original ellipse, and were designed to seat perhaps 6000 people. The erection of the theater may be attributed to Hadrian who, according to his putative biographer, aedificavit theatra in plerisque civitatibus. The emperor passed through the region on his way to Britain, as we know from an inscription on a monument he built at Elbeuf. Destroyed in the barbarian invasions of 273, the theater was made into a stronghold: the exits were barricaded, wells were dug, and baths put up in the arena. Later still, when the great forts on the English coast were being built (Portchester), Carausius' fleet, which was based at the port of Juliobona, used one of the theater boxes as a warehouse.

A few meters N of the theater stood the public baths. The statue of a goddess found there is now in the Musée des Antiquités in Rouen. Another bath building in the

Alincourt quarter had rich facings of marble. Also discovered in the 19th c. was the great gilded bronze statue of Apollo, now in the Louvre.

A villa outside the city walls, below the decumanus, was also found in the 19th c., and a tomb near it contained luxurious grave gifts: 45 articles, four of solid silver (these finds are now in the Lillebonne museum).

A second villa was discovered a few meters from the N quay of the port, beside the decumanus. The mosaic (now in the Rouen museum) found there shows hunting scenes around a central allegorical medallion. It bears the names of two artists, T. SEN FILIX, C. PUTEOLANUS (citizen of Pozzuoli) and AMOR C. K. DISCIPULUS (his pupil Amor of the city of the Kaletes).

A few traces of the rampart that ringed the upper part of the city can still be seen. It was built of large stones, some of them reused gravestones with inscriptions. Everything indicates hurried construction in time of invasion.

BIBLIOGRAPHY. F. Rever, *Mémoire sur les ruines de Lillebonne* (1821); J.B.D. Cochet, *Mémoire sur une remarquable sépulture romaine trouvée à Lillebonne* (1866); id., *Répertoire Arch. du Départ. de la Seine Inférieure* (1971); R. Lantier, *La Villa romaine de Lillebonne* (1913); A. Grenier, *Le Théâtre de Lillebonne* (1956); M. Yvart, *Découverte du rempart gallo-romain de Lillebonne* (1959); L. Harmand, *La Villa de la Mosaïque de Lillebonne* (1965); H. P. Eydoux, *Les terrassiers de l'Histoire* (1966) 157-93[I]. M. YVART

JULIOMAGUS, *see* ANGERS

JUPA, *see* TIBISCUM

JURANÇON Basses-Pyrénées, France. Map 23. The valleys and hillsides of this commune, adjacent to the city of Pau on the left bank of the Gave, have long been noted for their fine vineyards: ever since antiquity inhabitants of neighboring towns have chosen this region for their country seats. In Roman times citizens of Beneharnum (Lescar), one of the chief cities of Novempopulania, built villas there. A Roman road leading to Spain through the Ossau valley crossed the area, and traces of Roman occupation can be found along its path, especially at Bielle (a mosaic, columns, capitals). For over a century Roman remains have been discovered in the neighborhood and the sites of villas and baths identified. Two of the latter are worth describing.

1) In 1850 a huge public building, probably a bath, was summarily excavated near the Oly bridge on the W bank of the Néez, a tributary of the Gave. It was known chiefly for its mosaics, which have now disappeared. The published plan is difficult to interpret, as the position of the doorways is uncertain. Two sets of rooms, four to the S and nine to the N, with independent heating and water supply systems, were arranged on either side of an atrium. A mosaic with fish motifs covered the bottom of the pool in the atrium, and there was a fountain fed by lead pipes. The outer rear wall curves in a huge apse, opposite which are two doors giving on to a porticoed gallery 30 m long. Opening towards the river, this gallery also leads to two groups of rooms bordering the atrium. The N group is a set of baths: the heated rooms and alvei can be identified. Besides the usual geometric motifs the mosaic floor shows a Neptune with a trident surrounded by fish and Nereids.

In the S complex the floors are heated by hot-air radiating pipes, the furnaces of which have been found. These may also be bath buildings; if so, the monument may be a double establishment with one side for men and the other for women. Fragments of columns and elements of marble wall facings suggest that it was a luxurious building. Traces of outbuildings have also been found.

2) In 1958 a fine mosaic, noted in the 19th c. but forgotten, was rediscovered in the area known as Las-Hies. Partial excavation made it clear that the mosaic was the floor of the frigidarium of some small baths standing alone. Their plan is similar to that of two baths found at Sorde l'Abbaye. There were four main rooms. The apodyterium, to the SE, served the two heated rooms. The caldarium had two baths. In the frigidarium, to the SW, the mosaic is geometric in design.

On the hillside of the chapel of Rousse, between the Pont d'Oly and Las-Hies, near the Château Montjoly, a mosaic was discovered on what is probably the site of a large villa.

BIBLIOGRAPHY. C. Lecoeur, *Mosaïques de Jurançon et de Bielle* (1856); id., *Le Béarn, Histoires et Promenades archéologiques* (1877) 146-63[I]; G. L. Lafaye, *Inventaire des mosaïques de la Gaule* (1909-25); J. Coupry, "Informations," *Gallia* 19 (1961) 397-98[I]; copies in color of the mosaics of Pont d'Oly are in the Archives des Monuments Historiques in Paris. J. LAUFFRAY

JUSTINIANA PRIMA (Caričin Grad) Yugoslavia. Map 12. The remains of an important city of the Early Christian period near the village of Caričin Grad, ca. 30 km SW of Leskovac in S Serbia.

The city occupies a long, high ridge in a fertile, hilly district and was founded early in the reign of Justinian. The city walls cover an area over 500 m N-S and ca. 215 m E-W. There are additional fortifications around the inner acropolis near the NW limit of the city and another E-W wall with a gate separates the N and lower S areas of the community.

There is a circular forum near the N end of the city and paved, colonnaded streets extend from it in four directions; the one to the E leads directly to a large gate through the city wall and the W street enters the acropolis. On the acropolis is a large basilica of two stories with a ground plan that includes a nave with two side aisles and three apses at the E. There is a complex of building N of the basilica and a large, quatrefoil baptistery with a cruciform piscina on the S.

There were at least five other churches in the ancient city, all dating to the 6th c. Of special interest is a long basilica in the S area which has a tripartite transept and a colonnaded atrium. Mosaics on the floor of the narthex and in the naos are well-preserved and depict in large panels scenes of the Good Shepherd, hunters and savage beasts, centaurs, and amazons. The excavators point to analogies for the style and symbolism to mosaics in the imperial palace in Constantinople and to mosaics in Nikopolis. The architectural decoration of the basilica suggests a date of 525-50.

An unusual martyrium is located in the NE quarter of the city where most of the shops and industrial works may be found. The martyrium is a three-aisled basilica with an apse. The crypt, like the basilica above, has three aisles, all vaulted, extending the whole length of the church. Another smaller basilica with a nave separated from the two side aisles by arcades is S of the acropolis. Outside the central gate on the E is a large bath with a hypocaust and an apodeuterium that is triconchial in plan. Another church lies to the S which has apses on the N and S as well as on the E.

The city was probably Justinia Prima which Justinian founded near his birthplace of Tauresium. Justiniana Prima, earlier thought to have been at Scupi (modern Skopje), was the seat of the archibishop in Dardania and was the principal city in the region during the 6th c.

It was destroyed in the late 6th or early 7th c., but archaeological evidence shows that it was revived in the 9th and 10th c.

The principal excavations were conducted from the 1940s to the 1960s. Many of the architectural fragments can be seen at the site; most of the smaller finds are in the museum in Leskovac.

BIBLIOGRAPHY. A. Grabar, "Les monuments de Tzaritchingrad," *CahArch* 3 (1948) 49-63; N. Spremo-Petrović, "Bazilika sa kriptom u Caričinom Gradu," *Starinar* 3-5 (1952-53)[PI]; D. Mano-Zissi, "Iskopavanje na Caričinu Gradu 1949-1952 godine," ibid., 3-5 (1952-53) 127-68[MPI]; id., "Terme kraj srednje u suvurviumu Caričina Grada," ibid., 20 (1969) 205-12[PI]; A. Deroko, "Excavations at C-G in 1947," ibid., 1 (1950) 119-42[PI]; C. A. Raleigh-Radford, "Justiniana Prima . . . ," *Antiquity* 28 (1954) 15-18[I]; D. Mano-Zissi, "Caričin Grad," *Velika Arheološka Nalazišta u Srbiji* (1974) 78-88[MPI].

J. WISEMAN

JUSTINIANA SECUNDA, *see* ULPIANA

JUSTINOPOLIS, *see* ANTIOCH BY THE CALLIRHOE

JUZ-OBA, *see* PANTIKAPAION

K

KABIRION Boiotia, Greece. Map 11. A sanctuary of the Kabeiroi situated about 8 km W of Thebes on the Thebes-Levadia road. Before the crossroads going to Vagia, Leondari, and Thespies there is a bypath that leads to the site.

The origin of these deities is still unknown. Pausanias says nothing about their nature or their mysteries (9.25.5), merely stating that, according to the Thebans, there was a city whose inhabitants were called Kabeiroi. Demeter, who came to the region, revealed some mystery to Prometheus, one of the Kabeiroi, and Aetnaios, his son. Pausanias could not disclose Demeter's words. The mysteries were one of Demeter's gifts to the Kabeiroi, who had been chased out of their country by the Argives. Demeter's wrath toward men was implacable, as was shown by the punishment of the Persians who came with Mardonios and dared to enter their temple and pillage it, and later, after Alexander seized Thebes, when the Macedonians who had entered the sanctuary of the Kabeiroi were all killed by thunderbolts. The Kabeiroi were said to be guardians of vines and the fertility of animals (over 1400 representations of animals have been found, also over 700 representations of the pais, either the son or an accompanying slave).

The sanctuary was discovered in 1887-88 and excavation was resumed in 1955 and the years following. Today the remains of a rectangular temple have been located, the earliest traces dating to the 6th c. It was followed by two more monuments oriented E-W. A theater of the Hellenistic period was built in the axis of this temple (orchestra: 26 m in diameter). It had no skene, but had 10 kerkides as well as an altar in the middle of the orchestra. The diameter of the theatron is 60 m. Southeast of the theater is a stoa (40 x 6 m) which may possibly have been used in the cult. A circular building from the 4th c., between the stoa and the temple, may have been used for sacrifices.

There was also a Sacred Grove of Demeter Kabeiria and Kore, where Demeter is supposed to have revealed the mysteries.

According to Pausanias (9.22), just near the center of the city of Anthedon NE of Thebes there was a sanctuary of the Kabeiroi related to a cult of Demeter and Kore.

BIBLIOGRAPHY. F. Chapouthier, *Les Dioscures au service d'une déesse* (1936) 155, 170, 175 & n. 2; P. Wolters & Gerda Bruns, *Das Kabirenheiligtum bei Theben* I (1940)[MIP]; B. Hemberg, "Die Kabiren" (diss., Upsala 1950); M. P. Nilsson, *Gesch. gr. Relig.* I (2d ed. 1955); H. P. Drögemüller, *Gymnasium* 68 (1961) 219-22[MP]; Gerda Bruns, "Kabirenheiligtum bei Theben," *Arch.Anz.* (1964) 231-65[MIP]; (1967) 228-73[MIP]; *Pausanias*, ed. N. Papachatzis (1969) v 150-59.

Y. BÉQUIGNON

KABYLE (or Cabyle) Bulgaria. Map 12. On the right bank of the river Tonzos (modern Tundza) near the city of Yambol, a settlement of the Bronze Age (2d millennium B.C.). The Thracian city was conquered by the Macedonians in 342-341 (Dem. 8.44; 10.15). It was an economic and trade center of the state of the Thracian king Seuthes III (323-311 B.C.) (Theopomp. fr. 246; Harp. s.v.; Strab. 7.320; Steph. Byz. 346.1). It was conquered by Rome in 72 B.C. (Eutr. 6.10), and it became a city in the Roman province of Thracia. The territory of the city included the middle reaches of the river Tonzos. In A.D. 378 a battle was fought between the Romans and the West Goths nearby (Amm. Marc. 31.15.5). It was a rest stop on the road to Adrianopolis (Edirne) and Anchialus (Pomorie). In the 4th c. it was the seat of a bishop but disappeared in the 6th c.

In the 3d c. B.C. the city minted its own coins. There was an agora, a temple of Artemis-Hekate-Phosphorion and a temple of Apollo (*IG Bulg.* III/2, n. 1731). In A.D. 145 immigrants from Perinthos erected votive inscriptions to Herakles Agoraios. Excavations have uncovered a large basilica of late antique date and parts of the defense wall. The finds from Kabyle are in the Regional Museum of Yambol.

BIBLIOGRAPHY. E. Oberhummer, *RE* 10 (1919) col. 1455ff; D. P. Dimitrov, *Latomus* 28 (1957) = *Hommages à W. Deonna* 185-89; Head, *Hist. Num.* 278; T. Gerasimov, "The Alexandrine tetradrachmes of Kabyle in Thrace," *Centennial Volume of the American Numism. Soc.* (1958) 273; id., "Sur la numismatique de la ville de Cabyle (bulg.)," *Bull. Inst. arch. bulg.* 32 (1972) 113-19.

V. VELKOV

KADIKÖY, *see* CHALKEDON

KADIRLI, *see* FLAVIOPOLIS

KADYANDA (Üzümlü) Lycia, Turkey. Map 7. About 19 km NE of Fethiye (Makri). Of the ancient authorities only Pliny (*HN* 5.101) mentions the city, but the name is evidently of high antiquity, and the monuments and inscriptions go back to the 5th c. B.C. The Lycian name was Kadawanti. Despite the city's obscurity the ruins are quite impressive though of comparatively late date. The site is on a steep mountain over 900 m above sea level and 300 m above the village. It was defended by a ring wall which survives chiefly on the S side. In the city center is an open space 9 m wide, running straight for over 90 m, with six rows of seats on one side; this is recognized as a stadium from the numerous agonistic inscriptions found in it; two local athletic festivals are mentioned in these and other inscriptions. Adjoining this on the S is

a building identified by an inscription lying close by as the baths built by Vespasian, and on the N a Doric temple badly ruined. Farther to the S is a stoa some 100 m in length, which may have been part of the gymnasium mentioned in an inscription, and at the S end of the site is a small but attractive theater, facing S, with 18 rows of seats. The masonry is mostly Roman, and the cavea forms an exact semicircle; but some of the masonry seems older, and the stage building is largely of polygonal work.

Tombs are very numerous. Many close to the city have the vaulted form characteristic of Olympos in E Lycia, but not of Lycia as a whole. Of the others, three in particular are remarkable. Two of these are at the foot of the mountain about 1.6 km E and SE respectively from Üzümlü. The first is a pillar tomb of Lycian type, as at Xanthos and elsewhere; the grave chamber at the top is lacking. It carries an inscription in Lycian, now badly weathered and largely illegible. The second is a tomb of house type hewn entirely from an outcrop of rock and standing free on all four sides. All sides except the back carry reliefs, in which the figures are accompanied by their names in Lycian and Greek; on the flat roof is a broken sarcophagus, also decorated with reliefs. The third tomb is on the slope of the mountain towards Üzümlü; it too is cut solidly out of a huge boulder, now tilted over, and has reliefs on the long sides. These tombs are dated to about 400 B.C. or a little earlier.

BIBLIOGRAPHY. C. Fellows, *Lycia* (1840) 115-22[I]; E. Petersen & F. von Luschan, *Reisen in Lykien* (1889) I 141-44; *TAM* I (1901) 28-32; *TAM* II.2 (1930) 240ff[MI].

G. E. BEAN

KAFACA, *see* OLYMOS

KAGRAI (Cevizli, formerly Kâğras) Turkey. Map 6. Small town in Pisidia, 55 km N of Manavgat and unknown to history. The site had been visited several times and inscriptions found there; but the ancient name was discovered only in 1965, when two inscriptions giving it were found. The name obviously survived almost unchanged until recently. The inscriptions show that Kagrai had close connections with Selge.

The ruins are on a low rocky hill above the village, approached by a rock-cut stairway. On the SE side a high wall and solid bastion support a platform on which are the scanty remains of a temple, identified by inscriptions as dedicated to Zeus. A pediment block, a few fluted column drums, and some other architectural fragments survive.

BIBLIOGRAPHY. H. A. Ormerod, *JRS* 12 (1922) 53f; G. E. Bean & T. B. Mitford, *Journeys in Rough Cilicia 1964-1968* (1970) 22-28.　　　　G. E. BEAN

KÂĞRAS, *see* KAGRAI

KÂHTA, *see* ARSAMEIA

KAIMS CASTLE Perthshire, Scotland. Map 24. Roman fortlet midway between the forts of Ardoch and Strageath. It measures ca. 29 by 26 m over the ramparts, and was further defended by two ditches and a counterscarp bank. When excavated in 1900 the interior was found to contain an extensive area of well laid paving, but no traces of buildings. No datable material was recovered, so that the relationship of this fortlet to the nearby signal posts is uncertain.

BIBLIOGRAPHY. *Proc. Soc. Ant. Scotland* 35 (1901) 18-21.　　　　K. A. STEER

KAISARIANI Attica, Greece. Map 11. To the E of Athens on the W slopes of Mt. Hymettos, at an altitude

of 350 m, is the famous Kaisariani monastery set within a sequestered glen. In the outer face of the surrounding E wall is a spring, with water flowing through a marble ram's head. This sculpture, insofar as comparison is possible, is similar to the fragments of a water spout found on the Athenian Acropolis belonging to the Old Temple of Athena, ca. 525 B.C. Architectural pieces of Roman date can be found in the principal church, courtyard and refectory, and in the walls of two ruined churches half a km to the W.

It is extremely tempting to identify Kaisariani as Κύλλου Πήρα, "a place on Hymettos," according to Suidas, "with a sanctuary of Aphrodite and a spring, drinking from which women have easy delivery and the childless become fertile." But the spring called Kallopoula, half a km to the E, is another possible candidate. However, it is only at the monastery that one can visualize Ovid's setting for the tragic death of Prokris in the arms of her faithful Kephalos (*Ars Am.* 3.687-746).

BIBLIOGRAPHY. A. Milchhöfer, *Karten von Attika. Erläuternder Text* 2 (1883) 23-25; T. Wiegand, *Die Archaische Poros-Architektur der Akropolis zu Athen* (1904) 125; A. A. Papagiannopoulos-Palaios, Καισαριανή (1965)[I].

C.W.J. ELIOT

KAISERAUGST, *see* CASTRUM RAURACENSE

KAITSA (Kypaira?), *see under* RENTINA

KAKOSI, *see* THISBE

KAKOSOULI, *see* LIMES, GREEK EPEIROS

"KAKYRON," *see* MONTE SARACENO

KALAMAKI, *see* SCHOINOUS

KALAMI, *see* KISAMOS

"KALAMYDE," *see* PALAIOKHORA

KALARRITAI, *see* LIMES, GREEK EPEIROS

KALAURIA (Poros) Map 11. Island in the Saronic Gulf to the NE of Troizen. It was known as Καλαυρία (Strab. 8.6.14) and Καλαύρεια (Apoll. Rhod. III 1243) in antiquity. Chanddler (*Voy. As. Min. Grèce* I 228) identified Poros as Kalauria. The ancient city was located at the highest part of Poros. At first it was independent, with a high magistrate called ταμίας but later came under the dominion of Troizen. The area was inhabited from the Early Helladic period. The city preserves sections of the Hellenistic walls, a contemporary stoa and an unidentified heröon that lie at the agora. The harbor of the city was named Pogon. A street led from it to the Temple of Poseidon through a propylon. The cult on the area dates to the beginning of the 8th c. B.C. The temple, enclosed in a peribolos, is a Doric peripteros (6 x 12 columns) and dates to ca. 520 B.C. Between the temple and the propylon there were three stoas dating in the 4th c. B.C. and a fourth dating ca. 420 B.C. Another long stoa and a rectangular building lie SW of the hieron. The latter has been associated with the convention of the maritime amphictyony of Kalauria (Strab. 8.6.14). The tomb of Demosthenes, who poisoned himself at the sanctuary in 332 B.C., was still preserved in the time of Pausanias (2.33.3).

BIBLIOGRAPHY. S. Wide & L. Kielberg, *AM* 20 (1895) 267-326; G. Welter, *Troizen and Kalaureia* (1941)[MP]; Ch. Callmer, *Opus. Athen.* I (1953) 208-23; B. Stucchi, *EAA* IV (1961) 295-96, s.v. Kalauria; E. Kirsten & W.

Kraiker, *Griechenlandkunde* (1967) I 307-8; II 879 (bibliography). D. SCHILARDI

KALAVRYTA, *see under* KYNAITHA

KALCHEDON, *see* CHALKEDON

KALEDIRAN, *see* CHARADROS

KALENJI, *see* LIMES, GREEK EPEIROS

KALIANE ("Aiane") Greece. Map 9. City between Servia and Kozani on the N bank of the Haliakmon, in the vicinity of Kaliani, which may echo the ancient name. Stephanos of Byzantium called it a city of Macedonia, named after Aianos son of Elymos, king of the Tyrrhenoi who immigrated to Macedonia, thus indicating that it belonged to Elimeia. Two walled enclosures have been noted, one NW of the village of Kteni, the other W of the village of Kaisaria; both have been identified as Aiane.

Kteni was chosen on the basis of inscriptions found there, especially a dedication. The badly damaged relief represents Pluto and Kerberos. There is also a funeral stele showing a man wearing the Macedonian kausia, poorly executed, but possibly Hellenistic. On the other hand the walls at Kaisaria have been identified with Aiane; one of several inscriptions found there mentions the city, and there is some evidence of the cults of Zeus and Herakles. More recent discoveries, however, suggest that the site is very close to Kaliani itself. No systematic excavation has been done except for salvage of burial sites. Earlier finds were sent to Kozani, but recently an archaeological collection has been established in Kaliani.

There are a number of burial sites in and around Kozani itself, still within the territory of Elimeia, though there is as yet no evidence for the habitation site, and no satisfactory evidence for giving a name to the place. Excavation of a large cemetery in the town has yielded finds ranging from late Mycenaean to Classical times: the 8th through the 5th c. are well represented in an assortment of metal objects ranging from pins and ornaments to weapons, furniture, and much funerary pottery. The finds are in the Kozani museum.

On a hill NE of Kozani is a shrine of Zeus Hypsistos.
BIBLIOGRAPHY. W. M. Leake, *Travels in Northern Greece* III (1835) 304-5; L. Heuzey, "La ville d'Éané en Macédoine et son Sanctuaire de Pluton," *RA* 18 (1868) 18-28[MI]; L. Heuzey & H. Daumet, *Mission en Macédoine* (1876) 285-98[MI]; A. Keramopoullos, "Anaskaphai kai ereunai en tē Anō Makedonia," *ArchEph* (1933) 38-51[MI]; "Chronique des fouilles," *BCH* 84 (1960) 782-86[I]. Principally Kozani: C. Macaronas, "Ek tēs Elimeias kai tēs Eordaias. Arkhaiologikē Syllogē Kozanēs," *ArchEph* (1936) 7-14; B. Kallipolitis, "Nekropolis Klassikōn Khronōn en Kozanē," ibid. (1948-49) 85-111; (1950-51) 184[PI]; id., Excavation reports, *Praktika* (1950) 281-92[PI]; (1958) 96-102[PI]; P. Petsas, Excavation reports, ibid. (1960) 107-13[PI]; (1963) 55-58; (1965) 24-35 (Zeus Hypsistos)[MPI]; *Ergon* (1958) 85-90; (1960) 96-102; "Khronika," *ArchDelt* 17, 2 (1961-62) 216; 19, 2 (1964) 361; 22, 2 (1967) 413-15; 23, 2 (1968) 349. P. A. MACKAY

KALIVO, *see* LIMES, SOUTH ALBANIA

KALLATIS (Mangalia) SE Romania. Map 12. A Greek colony on the left bank of the Black Sea ca. 43 km S of Constanța in a fertile area where cereal grains were grown. Ancient sources (Prudent. *c. Symm.* 761-64) indicate the Megaran origin of the colony and the date of its foundation. Colonists from Heraklea Pontica founded the Doric city in the 6th c. B.C. On the spot where Kallatis developed there must have been an earlier center of Getaean origin (Plin. *HN* 4.18.5), the name of which is preserved in the form of Acervetis or Carbatis. Some scholars date the foundation of the city to the middle of the 7th c. B.C., but the earliest archaeological indications found thus far go back only to the 4th c. B.C. There has been, however, a lack of systematic excavation and the modern center of Mangalia is superimposed on the perimeter of the ancient city. Several stretches of fortifications are preserved on the N side of the city, but they date to the 2d-3d c.

Several necropoleis (4th-2d c.) have large tumuli containing chambered tombs. They contain rich grave gifts including well-preserved clay statuettes of the Tanagra type. The necropoleis occupy such a large area around the colony that they may be considered, as at Histria, to have belonged to indigenous or Greek settlements in the environs of the city.

From inscriptions it is known that in addition to public buildings intended for meetings of the various public bodies, the city also had a theater, which has not yet been identified.

In the 4th c. B.C. the city struck coins that bore the head of Herakles and the symbols of his power, as well as an ear of grain or barley. These coins clearly indicate that the city supplied grain, put aside for Athens in the name of the whole League, not only from the Bosphoran kingdoms but also from the other colonies rich in cereals and in possession of their own vast territories or dominating the local populations of those territories.

During the expansion of Macedonian power the city suffered the same fate as all the other colonies of the Pontus Sinistrus. They were subject to heavy contributions required by Lysimachos from which they could escape only at the end of the reign of the Diadochi. Both in 313 and in 310 B.C., the city posed the major resistance to the troops of Lysimachos.

In the 3d and 2d c. there was pressure from the indigenous peoples of the area, with repercussions that involved all the colonies of Pontus Sinistrus and of N Pontus. The inscriptions and the ancient text, such as Polybios (*Hist.* 5.6; 4.45.7-8), indicate the changed conditions of life here and in other colonies. They were obliged by native rulers to put themselves under the protection of their naval forces. For this protection they had to pay sums that were rather large for cities already weakened by wars, domestic struggles, and the uncertainty of the harvests. In Kallatis we now know of a number of Scythian tribes under the command of a whole series of princes mentioned on a series of coins. But even under these conditions Kallatis was able to maintain a high economic and cultural level, as is documented by numerous inscriptions found in the city or in other cultural or religious centers of the metropolitan Greek world.

When the city joined in the struggles of Mithridates against the Romans and in the consequent Roman siege, the period of its splendor waned. The foedus Kallatianum signaled the passage of the city from a free state to an ordinary Roman civitas. The conquest by Burebistas of all the colonies of the Pontus Sinistrus was a further blow. Later the city became part of Moesia Inferior, and under Diocletian, of Scythia Minor.

After the invasion of the Costoboci, Kallatis fortified itself ca. 172; but the subsequent invasions, which lasted throughout Moesia until the time of Trebonianus Gallus, weakened the city more and more. A period of revival is evident only during the era of Diocletian and his successors. In the Byzantine age, under Anastasius, the fortifications and other public buildings were reconstructed.

The same buildings were reconstructed under Justinian (Procop. *De aed.* 4.11).

To the 4th-6th c. belongs a Christian basilica of Syrian type which indicates the relations of the city with that distant region at a very difficult time not only for the city itself, but for the whole area. After this period, following more invasions, it began to decline, as did all the other coastal and internal cities.

BIBLIOGRAPHY. B. Pick, *Die antiken Münzen Nord-Griechenlands—Dacien und Moesien*, I, 1 (1898) 83-124; V. Parvan, "Gerusia din Callatis," *Mem. Sect. Ist. Aca. Romàna* 2, 39 (1920) 51-90; T. Sauciuc-Saveanu," "Callatis," *Dacia* 1 (1924) 108-65; 2 (1925) 104-47; 3-4 (1927-32) 411-82; 5-6 (1935-36) 247-319; 7-8 (1937-40) 223-81; 9-10 (1941-44) 243-47; O. Tafrali, "La cité pontique de Callatis," *Arta si Arheologia* 1 (1927) 17-55; R. Vulpe, *Histoire ancienne de la Dobroudja* (1938) passim; E. Condurachi, "Cu privire la raporturile dintre autohtoni si greci in asezarile sclavagiste din Dobrogea," *Studii si ceretari de Istorie veche* 2, 2 (1951) 49-59; G. Bordenache, "Antichità greche e romane nel nuovo Museo di Mangalia," *Dacia*, NS 4 (1960) 399-509; C. Preda, "Date si concluzii preliminare asupra tezaurului descoperit la Mangalia in anul 1960," *Studii şi cercetări de istorie veche* 2 (1961): id., *Callatis* (1963); D. M. Pippidi, *Contribuţii la istoria veche a României* (2d ed., 1967) 32-67; 222-41; 260-69; 329-37; 528-34.

D. ADAMESTEANU

KALLIPOLIS (Gallipoli) Apulia, Italy. Map 14. A city on the Gulf of Taranto, 48 km from the Japigio Promontory. Considered by the ancients to be of Greek origin (Mela 2.4), it was founded by the Lakedaimonian Leukippos, perhaps with the assistance of the Tarentines, for whom it became an important port (Dion. 19.3). According to Pliny (*HN* 3.100) its Messapian name would have been Anxa, but certainly the ancient city must have occupied the site of modern Gallipoli. In the Roman period it had municipal regulation and was perhaps ascribed to the tribus Fabia (*CIL* IX, 7-9). Archaeological finds are in the Museo Civico.

BIBLIOGRAPHY. W. Smith, *Dictionary of Greek and Roman Geography*, I (1856) 481 (E. H. Bunbury); E. De Ruggiero, *Dizionario epigrafico di antichità romane*, II (1895) 38; J. Bérard, *La colonisation grecque de l'Italie méridionale et de la Sicile* (1941) 188 F. G. LO PORTO

KALLIPOLIS (Spain), *see* TARRACO

"KALLIPOLIS" (Turkey), *see* DURAN ÇIFTLIK

KALLITHEA Greece. Map 11. A district between Athens and Phaleron. Modern building operations have exposed parts of a cemetery dating from the 8th c. B.C. Reliefs, including an Amazonomachy, from later monuments, are now in the Peiraeus Museum.

BIBLIOGRAPHY. D. Callipolitis-Feytmans in *BCH* 87 (1963) 404ff I; E. K. Tsirivagos, *AAA* 1² (1968) 108ff I.

M. H. MC ALLISTER

KALOI LIMENES (now also Kaloi Limniones) Kainourgio District, Crete. Map 11. A bay on the S coast of Crete, 7 km E of Cape Lithinon, 2 km W of Lasaia and 10 km W of Lebena; the bay is well protected from the sudden N winds and offers good anchorage except from the SE winds of winter; offshore islands provide protection from the SW.

The site is famous only for the visit of St. Paul on his voyage to Rome in ca. A.D. 47 (Acts 27:8): one of the offshore islands is known as St. Paul's Island. The words used in Acts ("we came to a place called Fair Havens,

near which is the city of Lasaia") make it clear that Fair Havens was not a city but a locality, and imply that it was in the territory of Lasaia, which seems certain. The point is confirmed by the *Stadiasmus* (322), which mentions Halai (= Lasaia) but not Kaloi Limenes.

On the promontory hill which bears the chapel of St. Paul and encloses the bay from the W, a considerable scatter of sherds attests occupation in the Roman and Late Roman periods. There is no visible evidence of earlier occupation, and no remains of harbor installations in the bay except to the E at Lasaia. Just NW of the modern village, on a rounded hill, stand the foundations of a Roman farmstead with an enclosure wall, and close by to the NW are two Early Minoan tholos tombs and traces of a Minoan and Roman settlement.

Farther inland from Kaloi Limenes are considerable remains of occupation of the Minoan and Graeco-Roman periods. The remains are concentrated in the valley of a stream which runs W from Pigaïdakia in the Asterousia mountains past the deserted villages of Gavaliana and Yialomonochoro, and then, joined by a tributary running S from the Odigitria Monastery, turns S past the chapel of Hag. Kyriaki and reaches the sea 2 km W of Kaloi Limenes, through the gorge of Agiopharango.

Besides a number of isolated farmsteads of the Minoan and Roman periods, there are important groups of Early Minoan tombs and Early to Late Minoan settlements at Hag. Kyriaki and at Megaloi Skoinoi to the NE. At Hag. Kyriaki there are also considerable remains of a settlement of the late 5th to 1st c. B.C.; remains can be distinguished of a large courtyard house and a (probably public) building (over 18 x 8 m). On the opposite (E) bank of the stream is a farmstead with an enclosure wall, occupied in the Roman and Late Roman periods, and just to the N a settlement of the Hellenistic and Roman periods. A clay tablet inscribed with a dedication to Asklepios was found at Hag. Kyriaki.

The area seems to have had little or no occupation between the end of the Bronze Age and the late 5th c. B.C., and from the Late Roman period until after the Arab occupation of Crete (824-961).

BIBLIOGRAPHY. T.A.B. Spratt, *Travels and Researches in Crete* II (1865) 1-7 I; Bürchner, "Kaloi Limenes," *RE* 10, 2 (1919) 1756-57; J. Sakellarakis, *Deltion* 20 (1965) *Chronika* 3, 562-64; St. Alexiou, *Deltion* 22 (1967) *Chronika* 2, 482-84; C. Davaras, *Deltion* 23 (1968) *Chronika* 2, 405-6; D. J. Blackman & K. Branigan, "An archaeological survey on the south coast of Crete," *BSA* forthcoming MP I; see also Brit. Adm. Chart 1633 M; Asklepios dedication: M. Guarducci, *ICr* I, 106 no. 3.

D. J. BLACKMAN

KALOI LIMNIONES, *see* KALOI LIMENES

KALOKHORI, *see* LIMES, GREEK EPEIROS

KALO PIGADI, later Kallopigadi Attica, Greece. Map 11. About 1 km E of the sanctuary of Eleusis, at the place where the National Highway departs from, and crosses over, the Athens-Eleusis road, there are remains of the best preserved bridge of its kind in Greece. Mostly built of hard poros from Peiraeus, the bridge consists of four arches, measuring 50 x 5.30 m, the two central higher and wider than the two lateral. Against the force of the river, the three supporting piers are protected to the N by semicircular projections. To E and W, ramps, each with a length of 10 m, lead up to the bridge.

Although the general style of the bridge is reminiscent of the Classical period, close study of the masonry, clamps, and letters shows it to be Roman, very similar

to work done in Athens on buildings associated with Hadrian. Since it is known from literary sources that the emperor had a bridge built over the Eleusinian Kephissos because of severe flooding, probably on the occasion of his first visit to Greece in A.D. 124-125 when he was initiated into the Mysteries, it is therefore a most likely (and economic) conclusion that the bridge at Kalo-Pigadi is Hadrian's, and carried the Sacred Way across the Kephissos.

BIBLIOGRAPHY. P. Graindor, *Athènes sous Hadrien* (1934) 35-36; J. Travlos, Ἀνασκαφαὶ ἐν Ἐλευσῖνι, *Praktika* (1950) 122-27PI; A. Kokkou, Ἀδριάνεια ἔργα εἰς τὰς Ἀθήνας, *ArchDelt* 25 (1970) A. Μελέται 171-73PI.

C.W.J. ELIOT

KALOS LIMEN Crimea. Map 5. Greek city and port near Chernomorskoe along the NW Crimean coast. It was founded in the late 4th-early 3d c. B.C. by Chersonesus. A fortress against the Scythians, it was built well into enemy territory. It was captured by the Scythians ca. mid 2d c. B.C. and occupied by them until the early centuries of our era.

Excavations have revealed remains of fortifications, made of beaten earth, and ruins of stone dwellings dating from the 1st c. B.C. to the 2d c. A.D. The finds include pottery and other articles of local make, non-Greek in influence.

BIBLIOGRAPHY. M. A. Nalivkina, "Raskopki Kerkinitidy i Kalos Limena (1948-1952 gg.)," *Istoriia i arkheologiia drevnego Kryma* (1957) 264-81; id., "Torgovye sviazi antichnykh gorodov Severo-Zapadnogo Kryma (Kerkinitida i Kalos Limen v V-II vv. do n.e.)," *Problemy istorii Severnogo Prichernomor'ia v antichnuiu epokhu* (1959) 183-94; id., "Kerkinitida i Kalos Limen," *Antichnyi gorod* (1963) 55-60; M. L. Bernhard, "Kalos-Limen. Fouilles Polonaises en Crimée, URSS, 1959," *Bulletin du Musée National de Varsovie* 2 (1961) no. 1; A. N. Shcheglov, "Issledovanie sel'skoi okrugi Kalos Limena," *SovArkh* (1967) 3.234-56.

M. L. BERNHARD & Z. SZTETYŁŁO

KALOYERITSA, *see* LIMES, GREEK EPEIROS

KALPALI, *see* ORCHOMENOS

KALYDON Greece. Map 9. An ancient city in Aitolia near the N coast of the gulf of Patras, at the entrance to the gulf of Corinth, on the S ridges of Mt. Arakynthos. It is mentioned in the *Iliad* where it is the scene of the struggle between Herakles and the river god Acheloos, and of the hunt for the Kalydonian boar.

The city lay on a hill with two summits and in the valley below. There are a few remains of the circuit walls dating from the beginning of the 3d c. B.C.; the perimeter was ca. 4 km and there were occasional towers. The acropolis, to the NW, was well fortified and had a double gate flanked by two towers; inside this was a large inner courtyard. The road to Stratos, the ancient capital of Akarnania, left the city through that gate. The W gate was also handsome and well fortified; it was on the axis of the Via Sacra, 400 m long, which led to Laphrion, the sacred precinct situated on a narrow plateau and probably dedicated in the 8th c. B.C. to the worship of Artemis and Apollo.

Various periods of construction in Laphrion are distinguishable. Two Doric temples in antis date from the end of the 7th c. B.C.; Temple A was dedicated to Apollo (or Dionysos?) and Temple B to Artemis. Remains of Temple B include terracotta decorations (sima, antefixes, akroteria, and metopes). Between the first decade and the second half of the 6th c. these two temples were refaced. To that period belongs a series of terracotta metopes from Temple A, painted with mythological figures whose Corinthian origin is confirmed by letters in the Corinthian alphabet incised before the metopes were fired. From Temple B in the same period come antefixes with anthemia, an akroteria with sphinxes, and metopes that depict the Labors of Herakles. About 500 B.C. Temple B was enclosed by a portico. Two other small buildings belong to the 6th c.; one of them, an apsidal structure, yielded numerous votive offerings to Artemis and Dionysos.

At the beginning of the 4th c. B.C. the entire zone was remodeled and buttressed by massive ramparts. A portico was built to the SE, with six columns along the front, and ca. 360 a peripteral Doric temple in poros, with 6 by 13 columns, arose on the site of the Temple of Artemis. It had a marble roof, gutters with spouts representing dogs' heads, and sculptured metopes (only a single undecipherable one remains). In the cella, which probably had 20 channeled Ionic columns, stood the chryselephantine statue of Artemis, the work of Menaechmos and Soidas of Naupaktos (460 B.C.) mentioned by Pausanias (7.18.10). This statue is believed to be represented on some coins of Patras. An altar, an exedra, and an entrance propylon are of the same date as the temple. In the Hellenistic period, N of the sacred precinct, a large square was built; it had a long stoa with two aisles, probably further divided into different lanes and decorated at the ends by two large semicircular niches (3d-2d c. B.C.). To the W of the square stairs led to the valley of the Kallirhoe river.

In the remaining area, limited to the N by the city gate and to the S by a slope, the remains of a series of small archaic thesauroi have yielded abundant terracotta objects and some Hellenistic tombs. The most important of these, in a valley to the SE, is the heroon, also called the Leonteion after its owner, Leon of Kalydon. It is a rectangular building (37.5 x 34.4 m) dating from ca. 100 B.C., with rooms on three sides, and promenades, around a square peristyle (16.78 m on a side). The largest room, to the N, has at least 11 large medallions on the walls, on which are carved the gods and heroes of the legendary history of Kalydon. An arch on the N side of the room leads to a small chamber below which is the hypogeum, with a barrel vault and marble sarcophagi in the form of beds. A second heroon has been discovered in the valley of the Kallirhoe.

The decline of Kalydon began in the Roman era during the struggle between Caesar and Pompey, when the city was occupied by Pompey's followers. In 30 B.C. the inhabitants of Kalydon were transferred to Nikopolis. The major terracotta finds, marvelous documents of archaic Corinthian painting, are in the National Museum at Athens. The stone gate of the crypt of the heroon is also there.

BIBLIOGRAPHY. Geisau, *RE* x (1919) 1763-66; W. M. Leake, *Travels in Northern Greece* III (1835) 534ff; W. J. Woodhouse, *Aetolia* (1897) 91ff; K. Rhomaios, "Die Ausgrabungen in Thermos und Kalydon," *Bericht über die Hundertjahrfeier* (1930) 254-58; id., Οἱ κέραμοι τῆς Καλυδῶνος (1951); H. Payne, *Necrocorinthia* (1931); E. Dyggve et al., *Das Heroon von Kalydon* (1934)PI; id., *Das Laphrion, der Tempelbezirk von Kalydon* (1948)PI; id., "A Second Heroon at Calydon," *Studies in Honor of David M. Robinson* (1951) 360-64.

L. VLAD BORRELLI

KALYMNOS (Κάλυμνος) The Dodecanese, Greece. Map 7. An island situated to the N of Kos. Kalymnos was settled by Dorians. Together with the adjacent islands it appears in the Catalogue of Ships of the *Iliad* (2.676-

77). After the Persian Wars it became an Athenian ally. Before the end of the 3d c. B.C. it was annexed to Kos, to constitute a deme. Numerous ancient sites testify to its importance in antiquity. The main centers of occupation in Classical times seem to have flourished at Vathy. At Embolas, to the N of the valley of Vathy, is preserved a circuit wall belonging to a town. A Hellenistic tower known as Phylakai is to the SE. The crag of Kastellas is protected by a Hellenistic (?) rubble wall. At Pothaia to the S a sanctuary may have existed. An Ionic Temple of Apollo has been investigated at Christos tes Jerousalem. The cult goes back to the archaic period. A cemetery with chamber tombs has been located at Damos. Sykia, on the W side of the island, has limestone quarries. On the N, in the area between Emporion and Argeinonta, various remains have been reported, such as pottery, coins, and tombs.

BIBLIOGRAPHY. L. Ross, *Reisen auf den griechischen Inseln des Aegaeischen meeres* II (1843) 96ff; C. T. Newton, *Travels and Discoveries in the Levant* I (1865) 226, 252, 285ff; Bürchner, *RE* X² (1919) 1768-71, s.v. Kalymna; B. D. Meritt, *ATL* I (1939) 494; M. Segre, *Ann. Atene* 22-23 (1944-45); G. E. Bean & J. A. Cook, *BSA* 52 (1957) 127-33ᴹ; R. H. Simpson & J. F. Lazenby, *BSA* 57 (1962) 172-73ᴹ. D. SCHILARDI

KALYNDA (Kozpınar) Turkey. Map 7. City in Caria or Lycia, ca. 4 km E of Dalaman, 32 km NW of Fethiye. Kalynda appears in the Athenian tribute lists with a tribute of one talent, and is mentioned twice by Herodotos: from 1.172 it appears that it lay close to Kaunos, and in 8.87-88 it supplies one ship to Xerxes' fleet. From the Zeno papyri it appears that in the 3d c. it was in Ptolemaic hands, and it was still independent about 200 B.C. when the Delphian theori paid it a visit. Before 164 B.C. it had come under the control of Kaunos, from which it revolted in that year and was given to Rhodes by the Roman Senate. The rare Kalyndian coins are of late Hellenistic date; none seem to have been issued under the Empire, and it is probable that by that time the city was incoporated in Kaunos. In the 1st c. A.D. it was attached to the Lycian League, and in the 2d was among the beneficiaries of Opramoas of Rhodiapolis; earlier it is reckoned a Carian city. It is listed by Pliny, Ptolemy, and Stephanos, but does not appear in the Byzantine bishopric lists.

The site at Kozpınar agrees well with the ancient notices; in particular, Strabo (651) places it 60 stades from the sea; the actual distance is 9.6 km. The hill, of moderate height, is enclosed by a ring wall of rather rough polygonal masonry, topped in places by a mediaeval wall. The style varies, but some parts at least seem to date to the early Hellenistic period. At the N end is a tower or small fort divided into two chambers; the masonry is good regular Hellenistic ashlar, with a door on the N side. There are two or three other towers in the wall circuit. No remains of public buildings are in evidence, but a great many building blocks, cut and uncut, are strewn over the whole area, and house foundations are discernible in many places. The absence of Roman remains is noticeable, and agrees with the history of the place as it appears from other evidence.

BIBLIOGRAPHY. E. Davies & W. Arkwright, *JHS* 15 (1895) 97; G. E. Bean, *JHS* 73 (1953) 25-26ᴵ; P. Roos, *Opuscula Atheniensia* 9 (1969) 72-74ᴵ. G. E. BEAN

KALYVES, *see under* KISAMOS (Kalami)

KAMARI, *see* OLUROS *under* PELLENE

KAMARINA Sicily. Map 17B. On a promontory ca. 20 km SW of Ragusa, a colony founded by Syracuse in 598 B.C. (Thuc. 6.5). It was at the limit of the Syracusan territorial expansion, near the territory of Gela and under its influence. The history of the city is associated with that of Syracuse and of Gela, but in its affairs one finds numerous attempts at independence from both cities. During its early years the city established with the Sikels a peaceful rapport which, according to Philistus, amounted to a true alliance. The Sikel settlements were on the Dirillo plain and in the Iblei mountains. The city, destroyed in 553 by the Syracusans, was rebuilt by Hippokrates of Gela in 492. It was destroyed a second time by parties from Gela in 484 and again rebuilt by Gela in 461 B.C. With its power consolidated, the city's influence grew over a radius so great that even the city of Morgantina was allotted to it in the agreements with Gela in 424 B.C.

Allied with the Chalkidian city of Leontinoi and therefore with Athens, Kamarina was abandoned by Syracuse in 405 B.C. to the Carthaginians, who must have destroyed its fortifications. In 396 B.C. its citizens returned to it, but only under Timoleon in 339 B.C. was the city completely reconstructed. A period of splendor ended with the sack by the Mamertines in 275 B.C. and destruction by the Romans in 258 B.C. The survival of several sectors in the 2d and 1st c. B.C. has been verified by the discovery of the House of the Altar, documented by several inscriptions. Probably during the period of Augustus the site was abandoned. The only building still standing in the area is a small church with a cemetery built into the Temple of Athena at the center of the ancient city, on the summit of the hill.

Exploration of the necropoleis was begun at the end of the last century, but the habitation area has been the object of systematic excavation only for the last ten years. The city walls, 7 km in length, enclosed an area of ca. 200 ha. The urban plan is of the grid type advocated by Hippodamos, with streets that intersect at right angles and delimit blocks 35 m square. It is probable that three principal arteries about 10.7 m wide crossed the city longitudinally from E to W, cut orthogonally by numerous parallel streets 5 m wide running N-S. This grid of streets ignores the uneven terrain, which varies in level by as much as 50 m, although in the time of Timoleon almost the entire urban area was occupied by buildings.

Walls belonging to buildings from the archaic age have been identified in the W area of the city and show the same orientation as the buildings from the age of Timoleon. Groups of city blocks have been discovered from this phase in the SE zone. These include the House of the Merchant and the House of the Inscription. In the latter has been found the contract for the purchase of a house, inscribed in Greek on lead. It gives information about the organization of the citizens, who appear to have been subdivided into classes or tribes, and it alludes to a Sanctuary of Persephone in the neighborhood.

A stretch of cella wall of the Temple of Athena, exposed from ancient times to the present, is recognizable in the drawings of 18th c. travelers. A cella in antis, without peristasis, it dates to the 5th c. B.C. and is situated on the highest point on the promontory (ca. 55 m). Recent excavations have uncovered a conspicuous stretch of the walls on the S side near the Oanis river (Rifriscolaro). It is faced with crude bricks of the type used in the walls at Gela. The use of crude bricks at Kamarina appears to be confirmed by the sources (scholia to Pind. *Ol.* V).

Extensive necropoleis surround the city on three sides. To the N the necropoleis of Scoglitti date to archaic and Classical times; to the E the necropoleis of Rifriscolaro,

Dieci Salme, and Piombo date from the archaic, Classical, and Hellenistic periods; to the S is the necropolis of Passo Marinaro, in which kraters from the 5th c. B.C. have been found, and the necropoleis of Cozzo Campisi and Randello from the Classical and Hellenistic times. Of the more than 2500 tombs systematically excavated to date 500 are at Passo Marinaro and 480 at Rifriscolaro. The tombs in the latter necropolis largely date from the first 30 years of the 6th c. B.C. and contain much mid Corinthian material. They may be attributed to the first generation of Syracusan colonists.

A deposit of fictile figurines and molds has been found outside the city near the Hipparis river near several kilns that constitute a quarter of vase-makers and modelers active in the 5th and 4th c. B.C. The figurine types reveal contact with the production at Gela. Representations of Demeter with the piglet are common (there was certainly a sanctuary to Demeter near the Oanis), Artemis on the stag, and Athena Ergane. The last has been found previously in Sicily only at Scornavacche, an anonymous habitation site nearby.

The earliest in the series of coins from Kamarina dates from ca. 461 B.C. Among the master die cutters was Exekastidas.

The material from the site is displayed in the museums at Syracuse, Ragusa, and in the Antiquarium near the Temple of Athena at Kamarina.

BIBLIOGRAPHY. G. Schubring in *Philologus* 32 (1873) 490ff; P. Orsi in *Mon. Ant. Lincei* 9 (1899) col. 201ff; 14 (1904) col. 783ff; B. Pace, *Camarina* (1927); T. J. Dunbabin, *The Western Greeks* (1948) 105ff; A. Di Vita in *BdA* (1959) 347ff; P. Orsi, ed. P. Pelagatti, in *Arch. St. Sir.*, 12 (1966) 120ff; J. Brunel in *Rev. Et. Anc.* 73 (1971) 327ff; P. Pelagatti in *BdA* (1962) 251ff; id., in *Kokalos* 14-15 (1968-69) 353ff; 18 (1972) (Atti III Congresso Sicilia Antica).　　　　P. PELAGATTI

KAMATERO, *see* SALAMIS (Greece)

KAMBOS, *see* ALAGONIA

KAMEIROS, *see* RHODES

"KAMIKOS," *see* SANT'ANGELO MUXARO

KANDIANIKA Messenia, Greece. Map 9. About 80 stadia from ancient Koroni (at Petalidi, cf. p. 463) was located (Paus. 4.34.7) the ancient Sanctuary of Apollo Kory(n)thos, where two cult statues of the god were displayed. During the excavations of Versakis, which were held N of the Kandianika village, a part of this sanctuary was discovered. The cult of Apollo started during the early archaic period and continued until the end of the Roman era. Four temples were built, of which the 3d (γ) peripteral with 6 x 12 columns dating back to the archaic period was erected on the spot of the 1st (δ). The 4th (α), built close to the 2d (β), during the Hellenistic period, survived through the Roman period. There was a guesthouse and, at least during the Roman period, a triclinium. On the site of the 3d temple was built an Early Christian basilica and later the St. Andreas Church.

Among the bronze finds of the sanctuary should be mentioned archaic and Classical idols (one depicting a hoplite), and especially swords and spear-butts with engraved dedications to Athena and Apollo (Apollo may originally have been worshiped as a warlike god, though later he was greatly honored as healer of diseases).

BIBLIOGRAPHY. F. Versakis, Τὸ ἱερὸν τοῦ Κορύνθου

'Απόλλωνος, *Deltion* 2 (1916)[PI]; M. N. Valmin, *Bull. de la Soc. des lettres de Lund* (1928-29) 146ff; id., *Etudes topographiques sur la Messénie ancienne* (1930) 172ff; M.L.H. Jeffery, *The Local Scripts of Archaic Greece* (1961) 203ff[I].　　　　G. S. KORRÈS

KANDYBA (Gendeve) Lycia, Turkey. Map 7. On a mountain top a two-hour walk W of Kasaba. The foundation was attributed in ancient times to a fictitious eponymous hero Kandybos, whose father Deucalion is represented on a coin of Kandyba of the reign of Gordian III. The antiquity of the city is, however, proved by two epitaphs in the Lycian language found on the site. Kandyba (in the corrupted form Kondyka) is ascribed by Ptolemy to the Milyas, though it lies well outside the limits of that region as defined by Strabo (631). Pliny (*HN* 5.101) mentions "Kandyba, where the woodland Eunias is highly spoken of." Coins are very rare; two specimens only seem to be known at present, both of the time of Gordian III. Later, the bishop of Kandyba ranked twenty-second of those in Lycia.

The site is now severely denuded and its monuments broken or dilapidated. The acropolis, to which an ancient road leads, is long and narrow, and enclosed by a ring wall of mediaeval construction; in the interior Spratt believed he saw the ruins of a church. Otherwise the site has nothing to show beyond a number of Lycian tombs of house type, originally handsome but now much damaged, and some Lycian sarcophagi. A hollow in the hillside is suggestive of a theater, but of this there are no visible remains.

BIBLIOGRAPHY. T.A.B. Spratt & E. Forbes, *Travels in Lycia* (1847) I 90-95; *TAM* II.3 (1940) 277; L. Robert in *Hellenica* 10 (1955) 219-22.　　　　G. E. BEAN

KANGAVAR, *see* CONCOBAR

KANLI DIVANE Cilicia Aspera, Turkey. Map 6. About 5 km W of Lamas and 3 km inland from the Mediterranean by a paved Roman (?) road. Apparently unrecorded by ancient geographers, the town belonged in the 2d c. B.C. to the priestly dynasty at Olba (Uzuncaburç/Ura?), as proved by the inscription of a king Teucer, built into a lofty tower of polygonal masonry and dedicated to Olbian Zeus. The ancient town was built round a limestone depression, ca. 60 m deep, and measuring ca. 200 m from E to W by ca. 170 m from N to S. Since the sides of the cavern are almost sheer, except at the SW corner where one Bias paid for the engineering of a path to the bottom, retaining walls were built at dangerous points near the brink. Architectural fragments, including column drums, on the floor of the cavern suggest a possible shrine, as does the relief of a seated man and woman, attended by four children (possibly a votive) carved on the S face. Two well-preserved heroa, sarcophagi, and arcosolia with scenes in high relief along the Via Sacra leading W from the town also suggest religious associations, as do four basilican churches of the 5th (?) c. which are poised on the very lip of the cavern.

Inscriptions refer to "the people," but not to "the Council," so that Kanli Divane was not a city. One refers to the "people of Kanytel(l)a." In the mid 19th c., the name had been rationalized to Kanideli (Kannidali), but by 1891 was already known as Kanlı Divane.

BIBLIOGRAPHY. J. T. Bent, "A Journey in Cilicia Trachea," *JHS* 12 (1892) 208-10; M. Gough, "A Temple and Church at Ayaş," *AnatSt* 4 (1954) 54 n. 1; P. Verzone, "Hieropolis Castabala, Tarso, Soli-Pompeiopolis, Kanytelleis," *Palladio* 1 (1957) 54-68.　　　　M. GOUGH

KARA-ALI-BEY ("Maiandria") S Albania. Map 9. On a hill in marshy ground near the coast, inland from Buthrotum, are remains of a powerful circuit wall with massive well-cut blocks, similar to that at Phoinike and built probably ca. 325-320 B.C. The name was attributed to Trojans who settled here en route to Latium. Pliny (*HN* 4.1.4) mentions it as being on the coast of Epeiros; it was probably on the Roman road, which followed the coast.

BIBLIOGRAPHY. N.G.L. Hammond, *Epirus* (1967) 98f, 659, 678, 699. N.G.L. HAMMOND

KARABAVLI, *see* ADADA

KARACAHISAR, *see* HYDISOS

KARAKOÇ KÖYÜ Turkey. Map 7. Site 5 km N of Kırklareli, in Turkish Thrace. The only ancient monument is a tumulus E of the village. Excavation brought to light a circular tomb chamber with a false dome of the 4th c. B.C. Bronze vessels, iron weapons, ceramics, and terracotta lamps found in the tumulus are in the Istanbul Archaeological Museum.

BIBLIOGRAPHY. N. Fıratlı, "Explorations in Thrace," *Annual of the Archaeological Museums of İstanbul* 11-12 (1964) 211ff; A. M. Mansel, *Belleten* 145 (1972).
 N. FIRATLI

KARAKUYU, *see* CHALKETOR

KARANIS (Kôm Aushim) Egypt. Map 5. About 28 km N of Arsinoë in the Faiyûm, systematic excavation has revealed remains of an important and active village. A lintel of the late Ptolemaic temple, dedicated to the local god Petesuchos and to the crocodile god Pnepherôs, was inscribed with the cartouche of Nero. The papyri, ostraca, lamps and other utensils, in addition to the houses and granaries that the excavation yielded, give us a clear picture of the Politai, certain nonresident landowners, and their place in the agricultural life of Arsinoite nome during the last phase of the Roman period. Apparently the site was abandoned by the 5th c. A.D.

BIBLIOGRAPHY. D. Hogarth & B. Grenfell, *Cities of the Faiyûm, Archaeological Report* (1895-96) 14-19; B. Grenfell et al., *Faiyûm Towns and Their Papyri*, 30-32; J. G. Milne, *A History of Egypt* (1898) 35 and passim[I]; A.E.R. Boak, *Karanis* (1931); id. & E. Peterson, *Karanis* (1931); Boak, "Politai as Landholders at Karanis in the Time of Diocletian and Constantine," *JEA* 40 (1954) 11-14; D. B. Harden, *Roman Glass from Karanis*, University of Michigan Studies XLI (1936); H. C. Youtie, *Michigan Papyri VI: Papyri and Ostraca from Karanis* (1944); W. B. Schuman, "Two Unpublished Inscriptions from Karanis," *Hesperia* 16 (1947) 267-71[I]; E. M. Husselman, "The Granaries of Karanis," *TAPA* 83 (1952) 25-79[I]; L. A. Shier, "Roman Lamps and Lamp Makers of Egypt," *AJA* 57 (1953) 110-11. S. SHENOUDA

KARATAŠ, *see* LIMES OF DJERDAP

KARAVASSARAS, *see* LIMNAIA

KARBASYANDA, *see* KIZILTEPE

KARBINA (Carovigno) Apulia, Italy. Map 14. An ancient Messapian center ca. 25 km N-NW of Brindisi. It was destroyed in 473 B.C. by the Tarentines (Diod. 11.52.5; Ath. 12.552 d). Karbina probably corresponds to the city of Carbinium which the *Cosmographia Anonymi Ravennatis* cites near Brindisi; and it may certainly be identified with modern Carovigno, where remains of the ancient walls are preserved. From the necropolis came funerary material and inscriptions in the Messapian language, which are now in the museums at Lecce and Brindisi.

BIBLIOGRAPHY. W. Smith, *Dictionary of Greek and Roman Geography*, I (1856) 515 (E. H. Bunbury); K. Miller, *Itineraria Romana* (1916) 220; *RE* X.2 (1919) 1930; O. Parlangeli, *Studi Messapici* (1960) 61.
 F. G. LO PORTO

KARDAKI, *see under* KERKYRA

KARDHIQ, *see* LIMES, SOUTH ALBANIA

KARDHITSA, *see* AKRAIPHIA

KARMYLESSOS Lycia, Turkey. Map 7. Mentioned only by Strabo (665), who calls it an occupied site in a ravine on Mt. Antikragos. No real evidence has been found for the exact location. The elevated plain between Fethiye and Kaya (formerly Makri and Levisi) has been suggested. Here there are a number of rock-cut tombs and sarcophagi of Lycian type, but no sign of an ancient town.

BIBLIOGRAPHY. *TAM* II.2 (1930) 36. G. E. BEAN

KARPASIA (Haghios Philon) Cyprus. Map 6. On the N coast of the Karpass peninsula ca. 3 km from the village of Rizokarpasso. The ruins of the town, nearly 3 sq km in area, are now largely covered with sand dunes; the rest is under cultivation. The town extended mainly along the shore but also inland as far as the foot of the high plateau. The town had a harbor; its ancient moles are still visible. Traces of a city wall, which begins and ends at the base of the two moles, can be followed for its whole course. This wall, however, built to protect only a small part of the town on the N side, should date from Early Byzantine times. Nothing is known so far of a bigger circuit. The necropolis extends W at the locality Tsambres.

Karpasia was founded, according to tradition, by Pygmalion. Present archaeological evidence precludes an earlier date than the 7th c. B.C. for its founding. Little is known of its history. The first mention of it dates from 399 B.C., when a man from there led the mutiny of Conon's Cypriot mercenaries at Kaunos. It is mentioned in the list of the theodorokoi at Delphi, and appears on inscriptions of the 2d c. B.C. Among early writers the town is frequently mentioned (Skyl. *GGM* 1.103; Diod. 20.47.2; Strab. 14.682; Steph. Byz.; Plin. *HN* 6.30; Ptol. 5.14.4; and in the *Stadiasmus*). Karpasia is better known in history as the place where Demetrios Poliorketes, coming from Cilicia, landed his forces in 306 B.C. He stormed Karpasia and Ourania and, leaving his ships under sufficient guard, marched on Salamis. The town flourished in Classical, Hellenistic, Graeco-Roman, and Early Christian times, when it became the seat of a bishop. It was finally abandoned in Early Byzantine times after the first Arab raids of A.D. 647.

There is no evidence so far for the worship of any deities in Karpasia, but there can be no doubt that sanctuaries existed. The remains of marble columns, now covered by sand, to the S of the town may well belong to a temple. Further evidence comes from casual finds of sculptures, among others a sandstone head of Tyche of the Late Classical period. From an inscription found in recent years we know that there was a gymnasium to be located at a short distance to the SW of the Church of Haghios Philon. Apart from minor excavations car-

ried out in the 1930s around this church, when remains dating from Early Christian times were uncovered, the town site is unexcavated. The principal monuments now visible, apart from the church and the excavated remains of an Early Christian palace attached to it, are the harbor and some important rock-cut tombs in the W necropolis.

The two moles in the harbor are the most considerable works of their kind in Cyprus. That of the E side can be followed for about 100 m from its base on the shore; it is made for the most part of large well-dressed rectangular blocks of stone rivetted to each other by clamps of lead. The outer end had been reinforced in later times with more blocks including fragments of columns of marble and basalt. These walls rest on natural rock. The width of the mole was about 3 m; its original height cannot be determined. It projects W from the shore towards the point of the other mole which runs due N. This latter mole, built in a similar manner, extends from the shore to a large rock in the sea known as Kastros. This W arm is longer than the E one, measuring ca. 120 m including the rock. The town was supplied with water from springs W of Rizokarpasso. Remains of the aqueduct still survive in many parts.

The W necropolis occupies a large area extending from the cliffs at Tsambres to the plain below as far as the shore. In the cliff of Tsambres itself there is a series of fine rock-cut tombs with unusual features. The chambers of the tombs are of the usual type but their facades seem to be unique in Cyprus. The face of the rock is carefully scarped and on the right or left of the tomb doors plain stelai are cut in relief, either simply or in groups of two or three. Sometimes they are of the conventional shape with pediment or they are anthropoid. These stelai were not inscribed but were probably painted. The tombs may be dated to the Late Classical or Early Hellenistic period.

Finds from the excavation of the necropolis are in the Cyprus Museum, Nicosia, but certain tomb groups have been allocated to the Ashmolean Museum in Oxford, to the Museum of Classical Archaeology in Cambridge, and to the Institute of Archaeology in London.

BIBLIOGRAPHY. D. G. Hogarth, *Devia Cypria* (1889); A. Sakellarios, Τὰ Κυπριακά I (1890); E. Dray & J. du Plat Taylor, "Tsambres and Aphendrika," *Report of the Department of Antiquities, Cyprus* (1937-39) 24-123[MPI]; T. B. Mitford and K. Nicolaou, "An inscription from Karpasia in Cyprus," *JHS* 77 (1957) 313-14[I]; I. Michaelidou-Nicolaou, ". . . Inhabitants of Ronas," *Vestigia* 17 (Acta des VI Internationalen Kongresses für Griechische und Lateinische Epigraphik, 1972) 559-61[M].

K. NICOLAOU

KARPATHOS Greece. Map 7. An island in the S Aegean. According to Diodorus (5.54.4) it was a Minoan domain, later colonized by the Argives. We know the names of three cities from the Classical age: Karpathos, Arkaseia, and Brikous; and the locality of the Eteokarpathioi. The cities paid tribute to the Delio-Attic League, and at the end of the 5th c. B.C. came under Rhodian domination. Potidaion, the port of Karpathos, is identified with modern Pighadia on the SE coast, where tombs have been found containing Minoan (MM IIIB and LM IA) and Mycenaean (LH IIIA-B) ceramics. The site of Karpathos is uncertain; at Arkaseia, on the SW coast, the Cyclopean walls of the acropolis are visible, and at Brykous, on the NW coast, sections of the enclosing walls of the 4th-3d c. B.C.

BIBLIOGRAPHY. R. M. Dawkins, "Notes from Karpathos," *BSA* 9 (1902-3) 176ff; L. Bürchner, *RE* x, 2 (1919) 2000-4; R. Hope Simpson & J. F. Lazenby,

"Notes from the Dodecanese," *BSA* 57 (1962) 154ff[MPI]; id., *BSA* 65 (1970) 68-69; G. Susini, "Supplemento epigrafico di Caso, Scarpanto ecc.," *ASAtene* 41-42 (1963-64) 225ff[MI]; S. Benton & H. Waterhouse, "Excavations in Ithaca: Tris Langadas," *BSA* 68 (1973)1ff[PI].

M. G. PICOZZI

KARPUZLU, *see* ALINDA

KARTEIA or Herakleia Cádiz, Spain. Map 19. Town on the Cortijo de El Rocadillo near the Guadarrangue area, in the S Roque district on the bay of Algeciras, the S coast of Hispania Ulterior. Although it is Phoenician or Punic in origin, as its name indicates, there are few remains of these cultures. In antiquity it was called Karteia and Herakleia, since its foundation was attributed to Herakles according to Timosthenes of Rhodes. Strabo (3.1.7-8) stated that in Timosthenes' time, ca. 280 B.C., its circuit wall and arsenals were visible.

Part of this wall has been uncovered, as well as Campanian ware A, B, C, and Hispano-Carthaginian silver coins. However, most of the remains are Roman, the oldest from the Republican period. The Roman foundation dates from 171 B.C. when it was called Colonia Libertinorum (Livy. 28.30.3). There are frequent references to the city, some stating that it was the site of the legendary Tartessos (Strab. 3.151; Paus. 6.19.3; Mela 2.96; Plin. 3.7; and Sil. *Pun.* 3.396). The port was of great importance in both the Iberian and the Imperial age according to Strabo and the author of *De Bello Hisp.* (26.1-37.1-2), who calls it navale presidium. In 46 B.C. the squadron of Accius Varo took refuge in Karteia when pursued by Caesar's ships under Caius Didius, and Cn. Pompeius embarked in the same port after the defeat at Munda (*De Bello Hisp.* 26.1-17, 1-2), when the partisans of Caesar in Karteia compelled him to leave the city. On the death of Cn. Pompeius, Sextus Pompeius returned to Baetica, and Karteia, which had declared itself for Pompey, again surrendered to him (Cic. *Ep.* 15.30.3).

Remains include the Roman wall, the theater, the baths, part of a monumental building with Corinthian columns and bull protomes (apparently a temple); the supposed Capitolium; remains of the salting basins for the manufacture of garum; and finds of sculptures, inscriptions, coins, and pottery.

BIBLIOGRAPHY. E. Romero de Torres, *Catálogo Monumental de España. Provincia de Cádiz* (1934) 174, 223-27, 270, 533, 537; A. García y Bellido, "Las colonias romanas de Hispania," *Anuario de Historia del Derecho Español* 29 (1959) 450ff; D. Woods et al., *Carteia* (1967).

C. FERNANDEZ-CHICARRO

KARTEROS ("Amnisos") Pediada, Crete. Map 11. Ancient site on N coast 7.5 km E of Iraklion. Homer (*Od.* 19.188-89) refers to its difficult harbor and to the Cave of Eileithyia; a later tradition made it the port of Knossos under Minos (Strab. 10.4.8, probably a deduction from Homer rather than a genuine surviving Minoan tradition, despite the considerable Minoan remains now revealed). Ancient sources (see Guarducci) refer only to the Amnisos river (now Karteros), the harbor, the plain, and the cave and sanctuary of Eileithyia. There is no clear evidence that a city called Amnisos ever existed: no coins or public inscriptions of Amnisos are known, and the main coastal settlement (Palaiochora) may have been called Thenai.

A sandy beach runs E for 2.5 km from the mouth of the Karteros. Half way along it is a rocky hill (Palaiochora), on which there was a fortified village (Mesovouni) in the Venetian period, probably abandoned during the Turkish attacks of the mid 17th c.; Minoan

remains have been found beneath the ruined houses of this period.

At the E and N foot of the hill and W of the hill are Minoan remains, and traces of occupation on the W in the early post-Minoan period also, though the evidence is confused. In the archaic Greek period an open-air sanctuary was built over and into the Minoan ruins, which were at least partly visible: in front of a long wall fronted by steps was an altar, over and around which were found large numbers of archaic votives, and faience objects imported from Egypt. A coastal recession deposited a deep layer of sand over the site, probably in the Classical period. The sanctuary was rebuilt with roofed buildings over the sand layer by the end of the 2d c. B.C. A dedication to Zeus Thenatas indicates the identity of the cult practiced here (or one of them), which lasted until the 2d c. A.D. at least.

Farther W, towards the river, lay the impoverished settlement of LM IIIB, with traces of post-Minoan occupation. The Minoan harbor must have lain in the river mouth, then much less silted, but still rather exposed to the NW wind.

The Cave of Eileithyia (Neraidospilios or Koutsouras) lies 1 km inland, in the ridge on the E side of the Karteros valley. First identified and briefly excavated in the 1880s, it was fully excavated, with the coastal site, in the 1930s. The cave (62 m long, 9-12 m wide and 3-4 m high) was entered from the E. Roughly in the center of the cave are a large and small stalagmite (clearly objects of cult) and a simple altar, surrounded by a low wall (probably Minoan or Geometric); water dripping at the back of the cave may have been connected with the (probably kourotrophic) cult, which seems to have flourished in LM III-Archaic and Hellenistic-Roman times. The remains are mostly of pottery, ranging in date from Neolithic to 5th c. A.D.

Regarded in antiquity as the birthplace of Eileithyia, the cave was her chief cult place. Her cult may also have been later practiced in the coastal settlement, whose origin may have been due to the cult rather than the harbor.

BIBLIOGRAPHY. T.A.B. Spratt, *Travels and Researches in Crete* I (1865) 66-67; J. Hazzidakis, *Parnassos* X (1886-87) 339-42; Hirschfeld, "Amnisos (1)," *RE* I (1894) 1871; L. Mariani, *MonAnt* 6 (1895) 223; S. Marinatos, *Praktika* (1929-38, except for 1931 and 1937)[PI]; Summaries in *AA* (1930-37 and 1939) and in *BCH* (1929-30, 1933-36, and 1938); M. Guarducci, *ICr* I.2 (1935); E. Kirsten, "Amnisos," *RE* Suppl. VII (1940) 26-38; R. F. Willetts, *Cretan Cults and Festivals* (1962); P. Faure, *Fonctions des cavernes crétoises* (1964)[I]; S. G. Spanakis, *Crete*, I (n.d.) 52-56, 95-97, 128-29[MP].

D. J. BLACKMAN

KARTHAIA, *see* KEOS

KARUN, *see* SELEUCIA ON THE EULAEUS

"KARYANDA," *see* SALIHADASI

KARYSTOS S Euboia, Greece. Map 11. At modern Palaiochora under Castel Rosso hill, over a km inland from the N shore of the great bay. Sparse Neolithic and Early Helladic finds occur at half a dozen nearby spots. The Dryopian town probably dates from the Dark Ages. It stood Persian siege in 490 B.C. (the alleged traces of city walls are uncertain), but in 480 contributed to Xerxes' fleet, and so was ravaged by the Greeks. Karystos entered the Delian League after war with Athens, and revolted with the other Euboians in 411. The only Classical remains are the walls at Platanisto. In 411 or after

the Lamian War the town probably lost territory to Eretria and by ca. 290 joined the Euboian League. Later 3d c. coins show a pro-Macedonian tyrant and in 196 B.C. Karystos shared Eretria's fall to Rome.

The vogue at Rome for greenish Karystian marble, begun possibly by Mamurra, revivified the area, its prosperity rising to a peak under Hadrian. Dozens of quarries are known, though mostly for local stone, especially NW of Marmari (Strabo's Marmarion) and above Karystos where unfinished columns 13 m long may still be seen near Myloi. Monumental buildings spread now if not before to the coast. A four-stepped heptastyle peripteral Ionic temple of the 2d c. has been excavated there. Many marble and poros blocks, including a battered Roman pedimental relief, were built into the 14th c. Venetian coastal fort, the Bourtzi.

The port of Geraistos to the E, with its Sanctuary of Poseidon, was on the main route from the Euripos SE and from Athens NE, and probably had an Athenian clerouchy. It is referred to from Homer to Procopios, and finds continue to be made.

The region's most dramatic monument is the megalithic place of worship atop Mount Ocha, the Dragon House, where the excavators found sherds inscribed in archaic Chalkidian script outside, and Classical and Hellenistic pottery inside. The building is a rectangle ca. 10 x 5 m, interior dimensions, with a door and two windows in the S side. The roughly isodomic walls are ca. one m thick. In the interior the blocks are smoothed; on the exterior many show a curious rustication. The roof consists of four superimposed layers of great blocks corbeled inward, but not meeting, at least today, in the center. (Cf. Styra.)

Other, comparatively undatable, remains have been found at Philagra and at Archampolis (perhaps associated with iron mining), and on promontories in the Karystos and Geraistos bays. Late Roman columnar members are found in churches near Marmari, Metochi, and Zacharia.

BIBLIOGRAPHY. F. Geyer, *Topographie und Geschichte der Insel Euboias* (1903); G. A. Papabasileiou, "Anaskaphai en Euboiai," *Praktika* (1908) 101-13, cf. 64; F. Johnson, "The Dragon-Houses of Southern Euboea," *AJA* 29 (1925) 398-412[I]; K. A. Gounaropoulos, *Historia tes Nesou Euboias* (n.d.); W. P. Wallace, "The Euboian League and its Coinage," *NNM* 134 (1956); N. K. Moutsopoulos, "To Drakospito tes Oches," *To Bouno* 217 (1960) 147-63[I]; V. Hankey, "A Marble Quarry at Karystos," *BMBeyrouth* 18 (1965) 53ff; L. H. Sackett et al., "Prehistoric Euboia . . . ," *BSA* 61 (1966) 33-110[MP]; W. P. Wallace, "A Tyrant of Karystos," *Essays in Greek Coinage* (ed. C. M. Kraay & G. K. Jenkins, 1968) 201-209; H. J. Mason & M. B. Wallace, "Appius Claudius Pulcher and the Hollows of Euboia," *Hesperia* 41 (1972) 128-40; D. Knoepfler, "Carystos et les Artemisia d'Amarynthos," *BCH* 96 (1972) 283-301; A. Choremes, "Eideseis ex Euboias," *AAA* 7 (1974) 27-34.

Hom. *Il.* 2.539, *Od.* 3.174-79; Hdt. 4.33, 6.99, 8.7, 66, 112, 121, 9.105; Thuc. 1.98, 3.3, 4.42-43, 7.57, 8.69, 95; Strab. 444-46; Livy 31.45, 32.16-17; Diod. 4.37, 18.11, 19.78; Plin. *HN* 4.51, 63-65, 36.48; Dio Chrys. *Or.* 7; Ptol. 3.15.25; Arr. *Anab.* 2.1.2; Procop. *Goth.* 4.22.27.

M. B. WALLACE

KAŞ, *see* ANTIPHELLOS

KASAI (Asar Tepe) Turkey. Map 6. City in Cilicia Aspera or Pamphylia, near Gündoğmuş, 30 km N of Alânya. The ethnic of Kasai seems to occur in an inscription of Alexandria in the 3d c. B.C., and the city is listed by Ptolemy, Hierokles, and the *Notitiae*. Georgios Kyprios records a klima of Kasai (*Not. Dig.* 1.854), and the

city appears to have been among the most important of the region. Its coinage is of the 3d c. A.D.

The site is on a steep hill, the end of a ridge of the Taurus, with deep gorges on either side. It is approached by a saddle on the N. The remains are ruined and hardly impressive; no public building can be identified apart from a large church, parts of the walls of which, including two arched doorways, are still standing. On the outer face of the church, at the SE corner, covering the apse and the adjoining wall, is a long inscription; it apparently dates from the late 5th c. and comprises a letter from the Emperor, a prostagma of the magister officiorum, and an edict of the provincial governor, all concerning a point of law. It shows that Kasai was in full vigor at that time, and had city status.

BIBLIOGRAPHY. L. Robert, *RevPhil* 32 (1958) 36, n.3 (Alexandrian inscription); G. E. Bean & T. B. Mitford, *Journeys in Rough Cilicia 1964-1968* (1970) 48-59.

G. E. BEAN

KASARA (Asardibi) Turkey. Map 7. Town in Caria, near the tip of the Loryma peninsula SW of Marmaris. Kasara was (at least after 408 B.C.) a Rhodian deme which included Loryma and much of the S end of the peninsula. Whether it also included the island of Syme is more doubtful. As a deme it was attached to the city of Kamiros, not Lindos.

The site occupies a low hill in a valley running across the peninsula. The remains consist merely of a stretch of circuit wall in bossed ashlar, and two specimens of the curious stepped pyramidal bases which appear to be found exclusively in the immediate neighborhood; their purpose remains uncertain.

BIBLIOGRAPHY. J. T. Bent, *JHS* 9 (1888) 82-83; 10 (1889) 46ff; P. M. Fraser & G. E. Bean, *Rhodian Peraea* (1954) 59, 140; G. P. Caratelli, *Studi Classicie Orientali* 6 (1957) 72f (attachment to Kamiros); J. M. Cook, *JHS* 81 (1961) 60.

G. E. BEAN

KASIANON Constanța, Romania. Map 12. Along the deep valley of the Casimcea, 2 km from the present-day village of Seremet are rocks with Greek inscriptions, at each end of a gorge in the steep mountain overhanging the site. These inscriptions mark the boundaries (horoi) either of a rural settlement whose inhabitants called themselves Kasianoi, or of a sacred enclosure dedicated to Zeus Kasios. In the first case, the name of the vicus in question certainly must have been Kasianon; in the second case, the site probably was rather a community of worshipers that took their name from that of the god who was venerated on these mountains. Up to the present time no systematic digging has been done to settle the question.

BIBLIOGRAPHY. V. Pârvan, *An. Acad. Rom., Mem. Sect. Ist.* 35 (1913) 532-37, 549-50.

D. M. PIPPIDI

KASMENAI Sicily. Map 17B. The remains of an archaic city on the plateau of Monte Casale, ca. 12 km to the W of Palazzolo (ancient Akrai). A colony of Syracuse, it was founded, according to Thucydides (6.5.3), 90 years after the mother city, ca. 643 B.C. Herodotos (7.155) reports that ca. 485 B.C. Gelon removed the Syracusan Gamoroi from this city and brought them back to their home city, from which they had been expelled by the people in league with the slaves. A fragment of Philistos (Jacoby, 3 B.559, fr. 5), as emended by Pais, affirms that Kasmenai sided with Syracuse during its struggle against the rebellious Kamarina and its Sikel allies in 553-552 B.C. And in 357 Dion, after landing at Heraklea Minoa, seems to have recruited troops at Kasmenai on his way to Syracuse (Diod.Sic. 16.9.5). Insignificant men-

tions of the colony occur also in Stephanos of Byzantium and in scholia to Thucydides (ed. Didot, p. 102).

On a plateau at the edge of Monte Casale are the ruins of a circuit wall built with enormous blocks only roughly shaped. It was ca. 3400 m in length, 3 m thick, with external rectangular towers. Within the circuit the city comprised at least 38 parallel streets (ca. 3 m wide), running from NW to SE, with blocks usually no wider than 25 m. The E-W traffic utilized alleys of irregular width since the houses were aligned only along their N side. This system appears at first glance comparable to what is usually called per strigas, but it should be noted that, although stenopoi are amply attested, this settlement lacked proper orthogonal streets and especially major traffic axes, the typical plateiai of the Hippodamian cities. The four plateiai believed to have been identified through aerial photography have not yet been confirmed by systematic excavation. For the present the city must be considered, on the basis of the test excavations, pre-Hippodamian in type, with a plan that can be dated, to the second half of the 7th c. B.C.

The importance of the town's urban system for the studies of Greek and particularly Sicilian city planning lies in the very fact that it allows us to pinpoint between the end of the 7th and the first half of the 6th c., the transition, at least in the W, from the system with parallel streets to the more sophisticated Hippodamian type, such as we see it at Selinus, Akragas, Metapontion, and Poseidonia.

If in fact the Sicilian Greeks had already known the system per strigas during the second half of the 7th c., it seems logical that they would have employed it at Kasmenai, which started as a military colony and was therefore almost "prefabricated," thus offering the most favorable conditions for realizing on the ground the ideal model for urban planning.

The colony was started here on the natural penetration route of Syracuse toward the interior of the island purely for military reasons, as is amply attested by the powerful wall circuit already mentioned and by the large quantity of iron weapons from the temenos of a temple which excavations have brought to light in the W corner of the plateau. From this early temple, part of the architectural and sculptural decoration in polychrome terracotta have been recovered and at least three inscriptions from the 6th c. In the necropolis the cist and chamber tombs are typically Greek. The city's main function as a military colony ceased rather early and it apparently ceased to exist at the end of the 4th c. B.C.

BIBLIOGRAPHY. A. Di Vita, "La penetrazione siracusana nella Sicilia sud-orientale alla luce delle più recenti scoperte archeologiche," *Kokalos* 2 (1956) 177ff, 186-196 with previous bibl.; id., *EAA* 4 (1961) 329-30; id., "Un contributo all'urbanistica greca di Sicilia: Casmene," *Atti del Settimo Congresso Internazionale di Archeologia Classica* 2 (1961) 69-77; id., "Per l'architettura e l'urbanistica greca d'età arcaica: la stoa nel témenos del Tempio C e lo sviluppo programmato di Selinunte," *Palladio* 17, 1-4 (1967) 46-47 and n. 183; L. H. Jeffery, *The Local Scripts of Archaic Greece* (1961) 268, pl. 54, n. 15; D. Adamesteanu, "Contributo della aerofototeca archeologica del Ministero della Pubblica Istruzione alla soluzione di problemi di topografia antica in Italia," *Tenth Congress of International Society of Photogrammetry*, Commission VII (1964) 62-63 fig. 11; G. Voza, *Kokalos* 14-15 (1968-69) 359-60.

A. DI VITA

KASSAR ("Krastos") Sicily. Map 17B. Fortifications on the mountain overlooking the village of Castronovo. The Arab name, which dates from mediaeval times, means castle or fortified area. The fortifications have been part-

ly explored. They date from the end of the 6th or the beginning of the 5th c. B.C. Some archaeological evidence connected with the Greek world has been found, while no documentation remains of a possible settlement by Sikeloi or Sikani.

Since the site commanded the large communication route between Akragas and Himera, this fortified center could well have been an Akragan outpost on the road to Himera. On the basis of a papyrus (*Oxyrh.Pap.* 4.665, ll. 1-7), which recounts the raids of Syracusan mercenaries in central Sicily during the second quarter of the 5th c. B.C., this fortified site could well be identified with the city of Krastos.

From the same area come various small bronzes in the shape of knucklebones, some surmounted by snakes, birds, or bulls. These bronzes have generally been considered comparable to many others found on the fringes of the territory belonging to the Greek colonies in Sicily, but a recent theory suggests that they represent the pre-coinage stage of the Sikel-Sikan culture. No evidence of life after the end of the 4th c. B.C. remains at the site.

BIBLIOGRAPHY. L. Tirrito, "Sulla città e sulla comarca di Castronovo," *Giornale di Scienze, Lettere, Arti per La Sicilia* 28 (1875); A. De Gregorio, *Su taluni bronzetti arcaici di Sicilia* (1917); P. Marconi, *NSc* (1930) 555-57; B. Pace, *Arte e Civiltà della Sicilia Antica* 1 (1936) 208-9; D. Adamesteanu, "Monte Saraceno e il problema della penetrazione rodio-cretese nella Sicilia meridionale," *ArchCl* 8 (1956) 139-40; A. T. Cutroni, "Osservazioni sui bronzetti di Castronovo: contributo agli studi sull'origine della moneta," *Kokalos* 9 (1963) 129-36.

D. ADAMESTEANU

KASSERINE, *see* CILLIUM

KASSOPE Greece. Map 9. Located in SW Epeiros, above the modern village of Kamarina. The city was apparently the result of a συνοικισμός of the Kassopaians in the 3d c. B.C. although some earlier remains, notably roof tiles, may indicate prior settlement on the site. Kassope may not have been severely damaged in the destructions attendant on the Roman conquest. In any event, there is evidence that it flourished at least up to the founding of Nikopolis. The site of the ancient city is extensive: its circuit wall has been calculated to be 2800 m long. A large theater, a smaller theater in the agora, the foundations of a temple, and the remains of a grid plan agora have been recorded.

A portion of the city has been excavated. Most interesting is a large building (33 x 30.3 m) constructed of ashlar and polygonal masonry, with upper courses built of baked brick set into a wooden superstructure. The building contains 17 rooms grouped around an interior courtyard, with an entrance through an 18th room which served as a doorway for the building on the S. The courtyard was surrounded by a colonnade of 26 octagonal Doric columns. There was also an upper story in the building on three of its four sides, perhaps allowing enough space for a total of 30 rooms. The rooms in the upper story must have been accessible by wooden ladders, while those on the lower one show some evidence for hearths and foundations for tables. The building has been identified as a katagogeion or guest house, and apparently some destruction in the 1st c. B.C. was followed by repairs.

A street 4 m wide runs to the S parallel to the katagogeion; to the SE lies the small theater, and to the SW a rectangular building so far unexplored. On the other side of the street is a long Doric stoa (63.1 x 11.3 m) which faces N; its construction is similar to that of the katagogeion. Opinions differ as to dates: 1) the kata-

gogeion is placed in the first half of the 4th c., primarily on the basis of early roof tiles, and the katagogeion in the 3d c.; 2) the stoa and the katagogeion are more or less contemporary, constructed in the second half of the 3d c. when the agora itself was laid out.

BIBLIOGRAPHY. W. M. Leake, *Travels in Northern Greece* I (1835) 244-53[P]; *RE* 10 (1919) 2332-34 (Bürchner), Suppl. vol. 4 (1924) 879-80; S. I. Dakaris, Ἀνασκαφὴ εἰς κασσωπὴν-πρέβεζης, *Praktika* (1952) 326-62[PI]; (1953) 164-74; (1954) 201-9; (1955) 181-86; N.G.L. Hammond, *Epirus* (1967) passim[MPI]; *Der kleine Pauly* (1969) 149.

W. R. BIERS

KASSOS Greece. Map 7. An island in the S Aegean near Karpathos, cited in the *Iliad* (2.676) among the participants in the Trojan War. In historic times a Doric dialect was spoken there; and Kassos appeared in the tribute lists of the Delio-Attic League. During the 3d c. it came under the domination of Rhodes. Several villages now occupy the site of the ancient city of Kassos (Strab. 10.5.18); near one of them, Poli, are remnants of walls and necropoleis with burials indicated by inscribed lenticular discs, mainly from the 4th and 3d c. B.C. Near Haghia Marina the mouth of a grotto, Ellinokamara, is closed by a wall of isodomic blocks with two gates. The grotto has yielded ceramics of various periods, including the Mycenaean.

BIBLIOGRAPHY. L. Bürchner, *RE* x, 2 (1919) 2268-69; G. Susini, "Supplemento epigrafico di Caso, Scarpanto ecc.," *ASAtene* (1963-64) 204ff[MI]; R. Hope Simpson & J. F. Lazenby, "Notes from the Dodecanese," *BSA* 57 (1962) 168; 65 (1970) 69[MPI]; 68 (1973) 169.

M. G. PICOZZI

KASTABOS (Pazarlık) Turkey. Map 7. City in Caria above Hisarönü, 13 km SW of Marmaris. Until the site was identified in 1960 Kastabos was known only from three sources: 1) a Rhodian inscription found on the island of Megista; 2) a Rhodian decree, found at Gölenye near Marmaris, which locates Kastabos on the territory of the deme of Bybassos; 3) a passage of Diodoros (5.62-63) which places the sanctuary of Hemithea at Kastabos in the Carian Chersonese. The site at Pazarlık was visited in 1860, and a temple, theater, and other remains including a female statue were reported; it was supposed to be the grove of Leto mentioned in Strabo (652). Excavation after WW II revealed an inscription recording that the temple was dedicated to Hemithea, proving that Kastabos was at Pazarlık and that the fortified site at Hisarönü is Bybassos.

Diodoros' account is remarkably detailed. The sanctuary, he says, in the course of time became highly esteemed and visited by pilgrims from far and near who made splendid sacrifices and rich offerings so that the place was filled with dedications although not protected by guardians or any strong wall. Such was its reputation that neither the Persians nor the pirates touched it, vulnerable as it was. The goddess had great powers of healing, especially for women in childbirth; standing over the sleeping patients she treated them in person and had cured many desperate cases. The Gölenye inscription confirms this popularity, recording that the crowds were so great that they could not be accommodated in the existing buildings, and revenue was being lost.

The temple stood on a platform; it succeeded a simple shrine about 5 m square on the hilltop, the sanctuary which had been spared by the Persians. The platform and temple were apparently constructed in the latter part of the 4th c. The platform, some 53 by 34 m, is supported by high walls of local limestone with masonry varying from ashlar to coursed polygonal. The temple was Ionic,

with a peristyle of 12 columns by 6, a cella, and a deep pronaos with two columns in antis; there was no opisthodomos. The cella door seems to have been decorated with engaged columns and stood on a high threshold necessitating steps up from the pronaos. Close to this threshold, in the middle of the pronaos and blocking direct approach to the cella door, was a puteal consisting of a circular plinth surmounted by a round monument adorned with half-lifesize figures in relief. Judging from its position this is probably a later addition to the pronaos. At the back of the cella stood a small naiskos 1.22 m wide, which evidently housed the cult statue. Of the whole temple hardly more than the foundation survives.

Round three sides of the platform ran a screen wall, poorly preserved; along this at intervals were placed at least five small buildings, aediculae, of unequal size and uncertain purpose. And on the E, adjoining the outer side of the screen wall, were two larger buildings, also of unequal size; the larger could possibly have served for purposes of incubation, but more likely both rooms were intended for the personnel of the temple. Built into a wall of the larger building, facing the temple, was an inscription recording the dedication of the temple to Hemithea by a man of Hygassos; another inscription from the screen wall named the architects, two men of Halikarnassos.

Outside the temple platform a few foundations are recognizable, but the only identifiable building is the theater, a short way down the slope to the SW. The cavea, facing approximately W, was roughly constructed, but only a small part has been excavated.

We learn from the Gölenye inscription that in the first half of the 2d c. B.C. considerable improvements were made to provide for the crowds and to render the sanctuary more worthy of the goddess; but in the damaged condition of the text it is not clear what steps were taken. Soon after this the sanctuary began to decline, no doubt largely because of the contemporary decline of the Rhodian state itself, and by the Roman period there is little evidence to suggest that the cult of Hemithea continued even to exist.

BIBLIOGRAPHY. T.A.B. Spratt, *Archaeologia* 49 (1886) 351-54; H. Collitz, *Sammlung d. griechischen Dialektinschriften* III (1899) 4332; P. M. Fraser & G. E. Bean, *The Rhodian Peraea* (1954) 24-27; Bean, *Turkey beyond the Maeander* (1971) 162-65; J. M. Cook & W. H. Plommer, *The Sanctuary of Hemithea at Kastabos* (1966)[MI].

G. E. BEAN

KASTANOCHORION, see KRAMBOVOS

KASTELLI KISAMOU, see KISAMOS

KASTELLORIZO, see MEGISTE

KASTHANEIA Thessaly, Greece. Map 9. Mentioned by Herodotos in the account of the storm that wrecked part of the Persian fleet on the E coast of the Magnesia peninsula. Locations both N and S of Cape Pori have been proposed, but the name is probably correctly assigned to an acropolis near Keramidhi. The walls are preserved to a maximum height of seven courses.

BIBLIOGRAPHY. Hdt. 7.188; A. Philippson, *GL* (1950) I 144,306; W. K. Pritchett in *AJA* 47 (1963) 1f[MI].

M. H. MC ALLISTER

KASTRI ("Batiae") S Epeiros, Greece. Map 9. Probably a colony of Elis (Strab. 7.7.5 and *FGrH* 115 [Theopompos] F 206). A limestone outcrop is ringed with a circuit wall ca. 2100 m long. Gateways and towers are visible.

BIBLIOGRAPHY. N.G.L. Hammond in Ἀφιέρωμα εἰς τὴν Ἤπειρον (1954) 27ff; id., *Epirus* (1967) 55f and 478, Plan 3 and Pl. II *b* and *c*. N.G.L. HAMMOND

KASTRION ("Argos Ippatum") Greece. Map 9. In the Acherusian plain of Epeiros, a large limestone hill is fortified with circuit walls of polygonal masonry built in two phases and some 2500 m long. The site dominates the plain and controls the bridge over the Acheron river which may have been navigable from here to its mouth. Ampelius mentions it (*Lib. Mem.* 8).

BIBLIOGRAPHY. N.G.L. Hammond, *Epirus* (1967) 67f and 540, and Plan 6. N.G.L. HAMMOND

KASTRIOTISSA, see LIMES, GREEK EPEIROS

KASTRORACHI ("Sperchieiai") Thessaly, Greece. Map 9. Sperchieiai was apparently included in Dolopia rather than Ainis as it was under Macedonian, not Aitolian, control in 198 B.C. The Aitolians crossed Oeta, and, entering the Spercheios valley near Hypata, ravaged Sperchieiai and Makrakome on their way N to Thessaly proper (Livy 32.13.10; see Dhranista, Metropolis). It is presumed that the city was in the Spercheios valley, near and to the NW of Hypata, on the way to the Yiannitsou pass, which is the presumed route of the Aitolians over the mountains to Thessaly. In this area are three possible sites so far discovered. South of the river, there is a site at Kastrorachi on an isolated hill (314 m) on the river's edge, opposite to modern Vitoli. Its N side is washed by the Spercheios, the W by an influent, the Papagourna. The circuit wall which follows the form of the hill is in the shape of a long oval N-S with an abrupt square extension jutting out of the E side. The wall is intermittently preserved to a height of ca. 2 km. The masonry is of rectangular and nearly square rough-faced blocks of varying heights, but laid in fairly regular courses.

At Helleniko is another fortress. This is 1½ hours S of the last site, on the N slope of Oeta, above the villages of Phteri and Kato Phteri and Palaiovracha, and between them and Ano Phteri, on a height of ca. 600 m. Here a wall circuit, perhaps 3d-2d c., of triangular shape surrounds two peaks.

Above Varibobi (now Makrakomi) on the left (N) bank of the Spercheios is the third site. This commands the entrance to the Yiannitsou pass. Its walls surround the peak of the hill N of the modern town. The hill is called Kastri, and on the summit (285 m) is a Chapel of Haghios Elias. The walls are in the shape of a long, irregular oval running N-S, the perimeter about 1550 m. The identity of none of these sites is certain but probably Sperchieiai was at Kastrorachi or at Varibobi.

BIBLIOGRAPHY. F. Stählin, *Das Hellenische Thessalien* (1924) 223-24[P] (Varibobi plan); id., *RE*[2] (1929) s.v. Sperchieiai, Sosthenis; Y. Béquignon, *BCH* 52 (1928) 444-52[I]; id., *La Vallée du Spercheios* (1937) 313-22[MPI] (no plan of Hellenika); G. Daux, *BCH* 58 (1934) 157-67 (Sosthenis); A. Philippson, *GL* I 1 (1950) 244; G. Roux, "Notes sur les Antiquités de Macra Come," *BCH* 78 (1954) 89-94[MI]. T. S. MAC KAY

KASTROSIKIA ("Berenike") Greece. Map 9. On the seaward side of the Preveza peninsula. There are indications of an acropolis, some tombs and architectural remains, and a sheltered anchorage. The city was founded by Pyrrhos and named after his mother-in-law (Plut. *Pyrrh.* 6). It is possible that the city stood instead on the E side of the peninsula at Mikhalitsi, where some rich burials from the 5th c. B.C. onwards have been excavated.

BIBLIOGRAPHY. S. I. Dakaris in *ArchDelt* 17 (1961-62)

2.187f and 19 (1964) 2.305f; N.G.L. Hammond, *Epirus* (1967) 49-51, 578f; I. Vokotopoulou in *ArchDelt* 23 (1968) 2.295. N.G.L. HAMMOND

KASTRITSA, *see* EURYMENAI

KASTRIZA, *see* LIMES, GREEK EPEIROS

KATANE (Catania) Sicily. Map 17B. A Greek colony founded by the Chalkidians of Naxos during the second half of the 8th c. B.C. (ca. 729). During the archaic period the city enjoyed complete autonomy and lived intensely both politically and intellectually. At the beginning of the 6th c. B.C. it adopted a law code drafted by Charondas.

From the early 5th century B.C. the city was under Syracusan control; in 475 B.C. Hieron invaded it, expelled the Chalkidians, and repeopled the city with 10,000 Dorians; the name of the town was changed to Aitne. The Chalkidians returned there in 461 B.C. During the Sicilian expedition the city favored the Athenians. It was occupied by Dionysios in 403 and remained within the sphere of Syracusan politics. It was conquered by the Romans in 263 B.C. Throughout the 2d and 1st c. B.C. it was civitas decumana; it became a Roman colony under Octavian and progressively gained an importance that it retained until the Byzantine period. At the beginning of the war against the Goths it was invaded by Belisarius. The Emperor Maurice Tiberius (582-602) established a mint there which functioned for ca. 50 years. It was one of the earliest and most important Christian communities in Sicily, as attested by rich and interesting epigraphic material.

The first Greek colony must have settled on the hill that always remained the city's acropolis, presently occupied by the Benedictine monastery. The area has yielded proto-Corinthian sherds slightly later than the foundation date. In 1959 a chance find led to the fortunate discovery of a rich votive deposit (6th-4th c. B.C.) at the foot of the S side of the acropolis, in the Piazza di San Francesco; the deposit was probably connected with a sanctuary of Demeter.

During the Roman period the city must have expanded considerably toward S and E into the plain. The major civic monuments belong to this phase. The theater, which together with the nearby odeion rests against the S slope of the acropolis hill, has been recently cleared of the modern structures that crowded over the cavea and the area of the stage building. Of the original Greek construction only a large wall remains under the level of the cavea; the extant portions of the building date from the Roman period. The cavea was divided into nine cunei by means of eight stairways, and its lower section rests against the slope of the hill, while the upper section is supported by three concentric corridors which give access to the seats; the uppermost corridor opens outwards into a portico with piers. In the interior, a colonnaded portico crowned the cavea; orchestra and seats were revetted with white marble, while the euripos and the stairways were built of lava.

The odeion was joined to the W side of the theater, and its orchestra opened toward the S at the same level as the theater's uppermost corridor. The cavea, built in small blocks of lava, was supported by a structure resting on 18 radial walls sloping toward the interior of the building and connected to one another by a series of barrel vaults; two stairways divide the auditorium into three cunei. The radial walls formed 17 units opening outwards. The building, revetted by lava blocks, was crowned by a simple cornice.

On the NE slope of the hill of the acropolis and separated from it by a narrow passage was the amphitheater; its N end is partly visible in Piazza Stesicoro, while to the S its corridors lie under the foundations of modern buildings. The preserved portion of the amphitheater is built on two concentric corridors connected by radial passageways.

There are numerous remains of baths. Under the cathedral some units of the Achellian Baths are still visible, their vaults finely decorated with stucco reliefs; a large square hall supported by four pilasters and flanked by a corridor is still preserved; the building continues under the level of present Piazza Duomo. Not far from there other baths (Terme dell'Indirizzo) in the Piazza Currò, with ca. 15 units, both large and small, are preserved up to their original height including their vaulted ceilings. On the acropolis hill, to the N of the theater, one can see the Rotunda Baths, so called because of a large circular hall that was later transformed into a Christian church. To a bath complex belong the ruins of seven rooms in Piazza Dante, opposite the Benedictine monastery. Remains of many other buildings of this type have been identified within the city area.

Under the level of the Via V. Emanuele, where it meets the Via Transito, lies a large rectangular podium delimited by two steps and a fine molding, which local tradition calls the Arch of Marcellus. There are numerous remains of a large aqueduct which brought the waters from S. Maria di Licodia.

The NE border of the city must have coincided with the edges of the acropolis, and with the approximate course of the Via Plebescito and the Via Etnea (S of the Piazza Stesicoro). This is shown by the fact that within this line only structures of a civic nature have been found, while outside of it lie several funerary buildings and cemetery areas.

In the N section, a large rectangular tomb of the Roman period is preserved near the Via Ipogeo, while another is to be found in the Modica estate, along the Viale Regina Margherita. To the NE of the amphitheater, within the present caserina Lucchese-Palli, is the so-called Tomb of Stesichoros, a funerary structure probably belonging to the Classical period. A group of graves of Roman date is preserved in the basement of the Rinascente store, and represents a portion of the cemetery complex uncovered in the Via S. Euplio and extending up to the area presently occupied by the Post Office building. A subterranean tomb with remains of inhumation and cremation can also be seen in Via Antico Corso, where it is incorporated into one room of the building erected by the Istituto delle Case Popolari.

The most important group of graves has been uncovered along the Via Androne and in the area crossed by Via Dottor Consoli. The continuity of this burial ground is attested from the Hellenistic into the late Roman period, and offers a good example of a pagan necropolis which slowly became transformed into a Christian cemetery. It contains numerous mausolea, cist graves, hypogaean (underground) chambers; a grave with wall paintings and barrel vault is preserved under the level of Via Dottor Consoli. In some places the graves were contained within precincts surrounded by low walls and interconnected: these were mostly graves characterized by an abundance of Christian inscriptions; in some precincts the graves were built above ground level in several stories.

In the largest precinct yet discovered, along the Via Dottor Consoli, an Early Christian funerary basilica was found superimposed on the level of the graves; a large polychrome mosaic with figured scenes covered the floor. The mosaic (20 x 10 m), which is at present in the Museo Comunale, can be dated to the middle of the 6th c.

A.D., and is to be attributed to an Oriental workshop. Of the basilica only the apse is preserved, and can be seen under the Lombardo dwelling.

To the same period can be attributed a large trichora uncovered and preserved under Via S. Barbara, and the small Basilica of Nesima.

The finds from excavations and accidental discoveries within the city of Catania are housed in the Museum of Castello Ursino, where are also gathered the collections once in the Museo Biscari, the Benedictine Museum, and the Antiquarium Comunale.

BIBLIOGRAPHY. A. Holm & G. Libertini, *Catania Antica* (1925) with previous bibliography; G. Libertini, "Catania. Basilichetta bizantina nel territorio di Catania," *NSc* (1928) 241-53; id., "I principali problemi intorno all'antico teatro di Catania," *Rivista del Comune* 1 (1929) 9-18; id., *Il Museo Biscari* (1929); id., "Catania. Scoperte varie," *NSc* (1932) 367-72; id., "Catania nell'età bizantina," *Arch. St. Sic. Or.* 28 (1932) 142-66; id., "Catania. Scoperta di un sepolcreto romano. Avanzi romani nel cortile del Palazzo del Governo," *NSc* (1937) 75-82; id., *Il Castello Ursino e le raccolte artistiche comunali di Catania* (1937); id., "Scoperte recenti riguardanti l'età bizantina a Catania e provincia. La trasformazione di un edificio termale in Chiesa bizantina (La Rotonda)," *Atti VIII Congr. Int. studi biz.* (1953) 166-72; id., "Catania. Necropoli romana e avanzi bizantini nella via Dottor Consoli," *NSc* (1956) 170-89; G. Rizza, "Mosaico pavimentale di una basilica cemeteriale paleocristiana di Catania," *BdA* (1955) 1-11; id., "Necropoli romana scoperta a Catania in Via S. Euplio," *Arch. St. Sic. Orientale* 54-55 (1958-59) 249-51; id., "Stipe votiva di un santuario di Demitra a Catania," *BdA* (1960) 247-62; id., "Un Martyrium paleocristiano di Catania e il sepolcro di Julia Florentina," *Oikoumene* (1964) 593-612; id., *Scavi e scoperte archeologiche a Catania nell'ultimo decennio* (1964); S. Lagona, "L'acquedotto romano di Catania," *Cronache di Archeologia* 3 (1964) 39-86. G. RIZZA

KATARRAKHTIS, see LIMES, GREEK EPEIROS

KATO KLITORIA, see KLEITOR

KATO PAPHOS, see PAPHOS

KAUKANA Sicily. Map 17B. An anchorage mentioned by Ptolemy and known also as base of Belisarius' fleet before his departure for Malta during the Greek-Gothic war (535-536 A.D.). The site is in the neighborhood of Cape Scalambri, modern Punta Secca, ca. 10 km to the W of the Greek city of Kamarina. Within an area that stretches for some hundreds of m along the coast and ca. 200 m inland, ruins of 25 buildings had been visible before excavation. Coins, lamps of African type, sherds (of undecorated ware and of impressed terra sigillata chiara), and technical details of the masonry indicate continuity of life from the second half of the 4th c. to the beginning of the 7th c. A.D.

Structures of one group, rather simple in plan, with rectangular outline comprising two or more rooms of considerable size, were most likely used as storerooms. Elsewhere the plan is more complex with spacious courtyards, sometimes circular, closed toward the outside. These courtyards provide access to the ground floor rooms and to those of the upper story by means of large staircases built in masonry. These are country houses but grandly conceived; being independent and often at considerable distance from one another, they could even have been fortified farms.

At the E end of the habitation quarter, in the center of a complex of buildings, a small cemetery church has been identified, with three naves paved with poorly preserved mosaic floors. Numerous terracotta lamps with chrismon and the beautiful bronze lamp handle with the same motif within a laurel wreath follow an iconography which goes back to the 4th c. A.D.

The structures of Kaukana accessible to visitors are within a fenced area opening onto the Provincial Route for Marina di Ragusa-Punta Secca; other edifices are along the seashore. The creation of an archaeological park is in progress.

The finds (pottery, bronzes, glass) are exhibited at the Archaeological Museum of Ragusa.

BIBLIOGRAPHY. Ptol. *Geogr.* 3.4-7 (ed. C. Mueller); Procop. *Vand.* 1.14.

B. Pace, "Sul sito di Kaukana," *RivStAnt* 12 (1908) 267ff; P. Orsi, *Sicilia Bizantina,* ed. G. Agnello (1942); S. L. Agnello, *Corsi di Cultura sull'Arte Ravennate e Bizantina* (1962) 102ff; G. V. Gentili, *La Basilica bizantina della Pirrera di S. Croce Camerina* (1969); P. Pelagatti in *ArchStSir* 12 (1966) 23ff; id. in *Kokalos* 14-15 (1968-69) 355ᴾ. P. PELAGATTI

KAULONIA Bruttium, Calabria, Italy. Map 14. On the E coast between Krotone and Lokroi Epizephyroi near modern Punta Stilo and the town of Monaterace Marina. Founded from Kroton in the 7th c. B.C., it became a center of Pythagoreanism and was destroyed by Dionysios I of Syracuse in 389 B.C. Rebuilt in the 4th c. B.C., it is mentioned in connection with events of the second Punic war, but by the 1st c. B.C. the site had already been abandoned.

Excavations conducted early in this century established the perimeter of the city walls and led to the discovery of houses of the Hellenistic period and the foundations of a peripteral temple in the Castellone district. There is an important deposit of architectural terracottas from the acropolis.

BIBLIOGRAPHY. P. Orsi, "Caulonia," *MonAnt* 22 (1915) 686ff; S. P. Noe, *The Coinage of Caulonia* (Numismatic Studies, 9, 1958); G. Schmiedt & R. Chevalier, *Caulonia e Metaponto* (1959; also in *Universo* 39 [1959]); G. Foti in *Santuari di Magna Grecia, Atti del Quarto Convegno di Studi sulla Magna Grecia* (1965) 143-46.
 R. HOLLOWAY

KAUNOS (Dalyan) Turkey. Map 7. City in Caria by the lake of Köyceğiz. Kaunos was purely Carian in origin; its earliest appearance in history is in the 6th c. B.C., when the city was captured by the Persian general Harpagos after a defiant resistance. In the Athenian tribute lists Kaunos paid the surprisingly low tribute of half a talent; in the assessment of 425 B.C. this was suddenly and probably unrealistically raised to ten talents. In the Peloponnesian war both sides used Kaunos as a port. In the 4th c. the city was still called Carian by Pseudo-Skylax, but from the time of Mausolos on it began rapidly to acquire a Greek character, and by the 3d c. was fully Hellenized.

During the wars of the Diadochi, Kaunos changed hands a number of times, passing in turn to Antigonos, Ptolemy, Antigonos, Demetrios, Lysimachos, and Ptolemy. Early in the 2d c. it was purchased by Rhodes from the generals of Ptolemy for 200 talents, and remained unwillingly Rhodian until 167 B.C., when the Senate declared it free. Included in the province of Asia in 129, Kaunos supported Mithridates VI in 88 and took part in the slaughter of the Roman residents; for this she was given back to Rhodes, but by the end of the 1st c. B.C. was again free, though it seems from Dio Chrysostom (31.125) that the Rhodians later regained some sort of

control. In Byzantine times, when Kaunos was attached to Lycia, her bishop ranked 15th under the metropolitan of Myra. Known coins begin in the 4th c. and continue through the Hellenistic era, with the exception of the period of Rhodian domination from 189 to 167; no Imperial coinage seems to be known.

Herodotos distinguishes the Kaunians from the Carians and from the Lycians, and believes them to be indigenous, though they themselves claimed to have come from Crete. Their language, he says, is similar to, but not identical with, the Carian; and in fact a Carian inscription found at Kaunos includes characters which do not occur in those from other parts of Caria. The earliest Greek inscriptions found at Kaunos are those on the bases of statues of Hekatomnos and Mausolos. The later inscriptions reveal a thoroughly Hellenic city, not one of whose citizens bears a Carian name.

Throughout her history Kaunos suffered from two permanent troubles. It was notoriously unhealthful owing to the prevalence of malaria from the mosquito-infested marshes surrounding the city. These marshes, caused by the deposits of the river which leads from the Kaunian lake (now the lake of Köyceğiz) to the sea, produced the second trouble, the silting-up of the harbor, which is now 3 km from the coast. A donation of 60,000 denarii by private citizens in the 1st c. A.D. for the remission of harbor dues reflects the increasing seriousness of the problem. Kaunian exports included fruit (especially figs), salt, fish, resin, and slaves.

According to Strabo (651) Kaunos had a closed harbor and dockyards, with the river Kalbis flowing nearby; above, on a height, was the fort Imbros. The harbor is now a small round lake below the acropolis hill; the Kalbis must be the present Dalyan Çayı connecting the lake with the sea, though its course has probably changed since antiquity; Imbros is a large fort on the summit of Ölemez Dağ just N of the city; the position of the dockyards remains uncertain. The acropolis hill is in two parts, a higher and a lower, corresponding respectively to the Heraklion and Persikon mentioned in Diodoros' account (20.27) of the capture by Ptolemy in 309 B.C. A ruined fort still exists on the higher summit, but nothing remains of the Persikon.

The city wall is in two unequal parts. The shorter connects the two acropolis hills S of the harbor; the other, some 3 km long, runs from the other side of the harbor over the hills to N and E, ending at a precipice above the river. Of this vast area only a small part by the harbor and acropolis was inhabited. The masonry of the wall shows great variety; the earliest part is the most remote from the city and dates apparently from the time of Mausolos; the lower parts near the city are Hellenistic and presumably represent one or more rebuildings.

The theater stands on the lower slope of the main acropolis hill, facing W across the slope, and has recently been cleared. The cavea is more than a semicircle and has 34 rows of seats and one diazoma; it is entered on the N side by two arched entrances. There is no entrance on the S where the theater is cut out of the hillside. The foundations of the stage building exist, but have not yet been excavated. On the ridge N of the theater three buildings stand in a row, a church, baths, and a building of uncertain character; all are fairly well preserved and are being excavated.

The main area of occupation was close to the harbor. A building near the water's edge carrying the long customs inscription mentioned above has proved to be not a customs-house as previously supposed, but a nymphaeum. It has been completely restored with its own blocks, with the inscription on the outer face of the S wall. The building measures ca. 8 by 5 m, and was approached on the W by three steps. A dedication to Vespasian was found in front of it.

Not far from the nymphaeum is a stoa of rather poor quality, and a circular building of unusual form and uncertain purpose. This has a sunken floor surrounded by a double row of columns, with a platform on one side raised on steps and in the middle a curious round flat stone. A reservoir or bathing pool has been suggested. Elsewhere the existence of at least four temples has been determined; these are not yet excavated.

Tombs at Kaunos are in general either rock-cut or built of masonry; there is one group of Carian type, sunk in the rock with separate lids, but sarcophagi are rare if not unknown. Most conspicuous is the splendid series of tombs cut in the face of the cliff between the site and Dalyan village: no less than 150, of which some 20 are temple tombs with columns and pediments; most of these have two Ionic columns, but one unfinished tomb has four. Pottery found in these temple tombs dates them to the 4th c. B.C. They have a passage cut all round them in the rock, and were usually closed by a door slab imitating a studded wooden door working on a hinge. The pediments have akroteria, but except in one case no decoration in the tympanon. The interior normally has a flat roof, and benches on three sides hollowed out in sarcophagus form. The smaller tombs are plain rock-cut chambers; most of them had originally elegant doorframes and door-slabs. Epitaphs are remarkably scarce; three of the temple tombs are inscribed, but the inscription in every case relates to a reuse of the tomb at a much later date.

BIBLIOGRAPHY. M. Collignon, *BCH* (1877) 343ff; A. Maiuri, *Annuario* 3 (1921) 266ff; G. E. Bean, *JHS* 73 (1953) 10-35; 74 (1954) 85-110; id., *Turkey beyond the Maeander* (1971) 166-79; P. Roos, *Opuscula Atheniensia* 8 (1968) 149-66; 10, 5 (1971) 25-30. G. E. BEAN

KAVALA, *see* NEAPOLIS (Greece)

KAYSERI, *see* CAESAREA CAPPADOCIAE

KAZIKBAĞLARI, *see* ELAIA

KEA, *see* KEOS

KEDREAI Turkey. Map 7. City in Caria, on the island of Şehiroğlu or Sedir Ada, 16 km N of Marmaris. The city was independent in the 5th c. B.C., paying a tribute of half a talent, later reduced to a third, in the Delian Confederacy. In 405 it was attacked by Lysander, who captured it at the second attempt and enslaved the inhabitants; these are described by Xenophon (2.1.15) as semi-barbarian. At an uncertain date in the Hellenistic period Kedreai was incorporated into the Rhodian Peraea, and formed one of the more important Rhodian demes. So far as is known the independent city issued no coinage. The principal deity was Apollo, with the epithets Pythios and Kedrieus.

The island is less than 1 km long, divided in the middle by a narrow isthmus. The W half is bare; the E is surrounded, just above the water, by a strong ashlar wall with towers. Near the summit stood a Doric temple, apparently that of Apollo, but only the foundations are preserved; it stands on a terraced platform with a solid wall. The site was later occupied by a Christian church. On the N slope is the theater, well preserved but overgrown and partly buried; the cavea had nine cunei but no diazoma. The agora also is overgrown, but its supporting wall remains in fine condition. On the mainland opposite the island, across some 200 m of water, is a fairly extensive necropolis comprising built tombs and sarcophagi. The stadium whose existence is implied by

the agonistic inscriptions has not been located. Like most of the Peraean demes, Kedreai was neglected by the ancient geographers, though Stephanos quotes it from Hekataios, and it does not appear in the Byzantine bishopric lists.

BIBLIOGRAPHY. E. Diehl & G. Cousin, *BCH* 10 (1888) 423-28; G. Guidi & A. Maiuri, *Annuario* 4-5 (1921-22) 378-84; P. M. Fraser & G. E. Bean, *The Rhodian Peraea* (1954) 67, 95-97; Bean, *Turkey beyond the Maeander* (1971) 156-57. G. E. BEAN

KÉKKÚT County of Veszprém, Hungary. Map 12. In the Balaton highlands a large Roman settlement with villas built close together. In addition to villas, living quarters, and agricultural buildings, the site shows traces of public buildings. Most typical of these are two Early Christian basilicas. At the E end of the village, in the hollow of Maktyán, at the left side of the road leading to Kövágóörs, the outlines of one (37.5 x 16.5 m) are distinguishable. This rectangular structure was divided lengthwise into three sections by wooden pillars, standing on small stone bases. The pillars next to the walls were decorated with carved, red standstone columns. The small dimensions of the columns (trunk 88 cm, head 23 cm high) indicate that they served a strictly decorative function. The interior division of this structure was made of wood. It was built in the second half of the 4th c. The other building, larger and more elevated, stood 85 m away. Its three aisles were built at different levels, terrace-like. The building is atypical in ground plan. The excavations have established that an earlier villa was made into the Christian basilica during the first half of the 4th c. Two large, lattice-work tiles with Christ monograms were also discovered; they must have served as apertures to admit light. Near the basilicas, on the S side of the road to Kövágóörs, are mineral springs which were also used during the Roman era. Some of the many stone monuments from the settlement are found in the National Museum of Budapest and in the Balaton Museum of Keszthely.

BIBLIOGRAPHY. L. Nagy, *Pannonia Sacra* (1939) 80 pp.; K. Sági, "Die spätrömische Bevölkerung der Umgebung von Keszthely," *Acta Arch. Hung.* (1960) 187-256; E. Thomas, *Römische Villen* (1964) 52-60. E. B. THOMAS

KELAINAI later **APAMEIA** (Dinar) Phrygia, Turkey. Map 7. Founded at the junction of the roads that still join Ionia to the East, and Phrygia to Pamphylia, as in antiquity. In 333 B.C. Alexander the Great marched to Kelainai on his expedition through Asia Minor and left there as satrap of Phrygia one of his best generals, Antigonos. This was the opening move in the maneuver for succession that culminated in 301 in the events that led to the battle of Ipsos (Paus. 1.8.1; Diod. 20.107.2-4), in which Seleukos I was victorious. His son Antiochos Soter (324-261 B.C.) moved Kelainai to the plain, rebuilt it, and named it after his mother. The meeting place of the conventus iuridicus in the Roman period, the city later became a bishopric. There are no remains in situ except the old and new city walls. Fragments of columns and architraves, as well as some inscriptions can, however, be seen in some gardens of the town.

BIBLIOGRAPHY. M. Ramsay, *The Historical Geography of Asia Minor* (1890); id., *The Cities and Bishoprics of Phrygia* (1895-97); C.H.E. Haspels, *The Highlands of Phrygia: Sites and Monuments*, I (1971) 147f.
C. BAYBURTLUOĞLU

KELEMIŞ, *see* PATARA

KELENDERIS, later Gilindire (Aydıncık) Rough Cilicia Turkey. Map 6. On the coast 46 km W of the modern Anamur and the center of a region known to Pliny (*HN* 5.92) as Kelenderitis. Said by Apollodoros to be a foundation of Sandokos of Syria and therefore presumably of native origin, Kelenderis was colonized, doubtless in the 8th c. B.C., by Samians. Included in the Delian League between 460 and 454 as a way station on the route to Egypt, with an assessment probably of one talent, it thereafter has no recorded history. Its coinage began in the mid 5th c. and continued until the time of Decius. Survival into the 5th c. of our era is attested by Hierocles and the *Notitia*. Of the recorded inscriptions, nearly all funerary and datable to the 2d and 3d c., not one is now to be seen.

The ruins today are overlaid by the expanding modern village. Fortifications may still be detected, nevertheless, around the modern lighthouse on the small promontory which forms and commands the harbor; but the chief harbor was undoubtedly the fine, landlocked bay with its famous spring 1.6 km to the W at Soğuk Su. Here there are ancient ruins, notably a bath at the head of the bay and archaeological debris on the peninsula at its mouth. The most notable monument is the great built tomb among olive trees to the E of the modern town. There are handsome but much destroyed rock-cut tombs at Duruhan 9.6 km to the N.

BIBLIOGRAPHY. R. Heberdey & A. Wilhelm, "Reisen in Kilikien," *DenkschrWien* 44 (1896) 1-168; A.H.M. Jones, *Cities of the Eastern Roman Provinces* (1937); B. V. Head, *Historia Numorum* (2d ed. 1911) 718; *Sylloge Nummorum Graecorum, Deutschland, Sammlung v. Aulock, Kilikien* (1966) pl. 190.
T. B. MITFORD

KELIBIA, *see* CLUPEA

KEMER, *see* PARION

KEMERARASI, *see* TERMESSOS (Lycia)

KEMERHISAR, *see* TYANA

KEMPTEN, *see* CAMBODUNUM *and* LIMES RAETIAE

KENCHESTER, *see* MAGNIS

KENCHREAI Argolis, Greece. Map 11. Probably to be identified with a site SW of Argos near the village of Paleo Skaphidaki, where Frazer saw marble fragments and foundation walls. Pausanias speaks of several polyandreia near Kenchreai, mass graves of the Argives fallen in the battle against the Spartans at Hysiai. The so-called Pyramid of Kenchreai at Helleniko near Cephalari has frequently been proposed as one of these tombs; it was apparently converted in antiquity into a fort or guard post. About 8.6 x 14.7 m, the limestone walls are preserved in some places to their full height of 3.4 m. The masonry is polygonal, arranged more or less in courses; above a low vertical base, the outer surface is dressed to a plane surface in the shape of a truncated pyramid. The interior was divided into rooms with an entrance passageway at one side; the outer and inner doors were barred on the inside and there are cuttings at the top of the wall for ceiling or roof beams.

Pausanias specifically describes another pyramid near the church of Haghia Marina 1.5 km W of Ligourio on the ancient road from Argos to Epidauros. There are only two courses remaining, also of limestone, but both show the slope of the pyramid; the plan, about 12.5 x 14 m overall, is similar to that at Helleniko. Pausanias says it was decorated with carved shields of Argive (round) shape. The masonry of both tombs has been dated in the 4th c. B.C. and the unusual shape explained by the tradi-

tional close connection between Egypt and the Argives from the time of their legendary conqueror Danaos, king of Libya; that 3000 Argive mercenaries were sent to Egypt in 349 B.C. is still more persuasive evidence.

BIBLIOGRAPHY. Paus. 2.24.7, 2.25.7; J. G. Frazer, *Paus. Des. Gr.* (1895) III 212; L. Lord in *Hesperia* 7 (1938) 496fMPI; Y. Béquignon in *RA*, sér. 6.14 (1939) 48f.

M. H. MC ALLISTER

KENCHREAI Corinthia, Greece. Map 11. On the E coast of the Isthmus of Corinth about 11 km E of the center of ancient Corinth and 4 km S of the Isthmian Sanctuary of Poseidon at the E end of the modern Corinth Canal. It was the port of Corinth communicating with the Aegean and the East. References to it in Greek literature are few and slight. It is mentioned twice in the New Testament, especially in the conclusion of the Epistle to the Romans, which speaks of one Phoebe, a "diakonos" of the church at Kenchreai. It figures colorfully in Apuleius' *Metamorphoses* as the site of the transformation of Lucius from ass to man and his further spiritual regeneration in a Sanctuary of Isis there. It suffered violently from earthquakes in A.D. 365 and 375, and perhaps in the Avar invasions of the end of the 6th c., but survived at least as a vestigial port until the present day.

Topographically the site consists of a triangular alluvial plain about 600 m deep facing on a broad straight beach about 500 m long. Along the N side of the valley is a steep bluff, which extends E beyond the beach. In the cove formed by the beach and the bluff are remains of ancient moles forming a small harbor about 250 m in diameter. At various points on the slopes and top of the bluff are numerous marks of quarrying, slighter remains of construction, and many tombs, chiefly Roman.

There is reason to suspect that the alluvial plain marks the site of the harbor in Greek times; to what extent it may have silted up by Roman times is moot. Investigation of the harbor, whose moles are visible in the sea, and its periphery on land, have been made by excavation both on land and underwater. The study of the results has not been completed, and the following account must be taken as tentative. Most of the features examined, so far as explored, are of Roman date.

Among the points of interest is the evidence for the rise and fall of the land on several occasions during historic times. Most conspicuously, it is clear that along the present shore the land is today some 2 m lower in relation to the sea than it was in the time of Christ.

The harbor was artificially improved by the construction of two moles, now totally submerged, one extending S from the NE end; the other, about E from the SW end. These moles, so far as has been determined, are simply masses of broken rock and earth, rising at the harbor mouth some 30 m above the harbor bottom. The SW mole springs from a broad artificial pier of similar construction, whose seaward end was a complicated system of fish tanks. Thence NW, facing the harbor, a homogeneous block of warehouses extended for more than 200 m. Along the NW side of the harbor were other, less homogeneous, commercial structures, facing on a broad quay. On the N was a plain stoa facing on a plataia beside the harbor.

On the pier, S of the warehouses, there developed through the Roman period a complex assumed to belong to a Sanctuary of Isis. A prominent feature of the complex was a sunken apsidal structure, with mosaic floor and a fountain, beside what has been taken to be a temple with a cellar. At the NE end of the harbor was a series of complexes, the earliest from perhaps the 4th c. B.C., the latest a large, handsome structure of

brick of Roman Imperial times with features in its plan resembling a palatial house—though at least half of it has been lost to the sea. It is tentatively thought that throughout its history this site may have been a Sanctuary of Aphrodite.

After the earthquakes of A.D. 365 (or 375, or both) most of the structures dwindled in extent, but an ecclesiastical complex began to grow over the Sanctuary of Isis, reaching an acme in the 6th c., after which it too declined.

In the apsidal basin of the Isis sanctuary were found remains of over 100 panels of glass opus-sectile, dating from ca. A.D. 370. The panels (the largest ca. 1 x 2 m) are made of a kind of plaster; and the glass, in various colors and shapes, is affixed to it to make formal designs or representational pictures. The latter include scenes of buildings along the sea, swamps with flowers and birds, human figures in large scale—up to about half life-size. The panels were intended to be mounted as the decorative facing of the walls of some building, but had never been installed. They were found in shipping crates, presumably delivered but abandoned because of some catastrophe. In the fill covering them were many pieces of wooden furniture, some veneered with engraved tortoise shell, and quantities of carved ivory. In the cellar of the temple were quantities of building materials and tools.

BIBLIOGRAPHY. Robert Scranton & Edwin S. Ramage, "Investigations at Corinthian Kenchreai," *Hesperia* 36 (1967) 124-86MPI; Robert Scranton, "Glass Pictures from the Sea," *Archaeology* 20 (1967) 163-73PI.

ROBERT SCRANTON

KEOS (Ceos, Cea, Zea; now officially Kea, but called Tzia) one of the Cyclades, Greece. Map 9. Near the tip of Attica, the island is favorably situated on principal shipping lanes. It has more water than most islands and once bore a second name, Hydrousa. Small plains and terraced slopes provide arable land and there are deposits of useful minerals, including miltos. Not surprisingly, it has been inhabited since Neolithic times. The word Keos (with omega) is almost certainly not Greek, presumably pre-Greek.

In Early Classical times there was a tetrapolis, but in the days of Strabo (10.5.6; C486) the cities were only two, Ioulis having taken over Koressia and Karthaia having absorbed Poieessa. The history and antiquities of the island have been examined sporadically by modern scholars but few sites have been systematically excavated and much remains unknown.

Koressia (originally Koressos, another Prehellenic name), at the W end of the great natural harbor on the NW coast of the island, was and is now the principal port. Ancient walls are visible on the rocky heights behind it, and on an upper terrace are remains of a temple. Among chance finds in the town are bits of excellent Attic pottery and a fine kouros of the third quarter of the 6th c. (National Museum 3686).

Ioulis, the most important of the Classical poleis and the chief modern town (Kea, "Chora"), is inland, high on the steep hillsides S of the harbor. Parts of walls are exposed, architectural fragments and pieces of marble sculpture and inscriptions have been found, but the place has not been excavated. About a km NE of the town a mighty figure of a reclining lion, carved in high relief on a rough boulder, rests isolated on the slopes. It is 9 m long; a work probably of the early 6th c., seen undoubtedly by Simonides and Bacchylides, who were natives of Ioulis.

Karthaia, on the SE coast at the foot of deep gorges which descend from the highlands, is now called Poles and is all but deserted. Parts were investigated by Brönd-

sted in 1812. There are massive walls of masonry and remains of various buildings, among which are a Temple of Athena in excellent style of the early 5th c. and one of Apollo.

Poieessa (Poiessa, Poiassa; now Poises) was on the W coast, above a small, rich valley. Ancient walls can be seen on the rocky hills; it has not been excavated.

Between Poieessa and Koressia there were Temples of Apollo Smintheus and Athena Nedousia, the latter said to have been founded by Nestor on his voyage homeward from Troy (Strabo 10.5.6). A big watchtower, probably of the 4th c. B.C., shaken but remarkably well preserved, stands at the village of Haghia Marina. At many places along the coasts and on the high ground in the interior potsherds, bits of roof tiles, and building blocks testify to extensive occupation in Greek and Roman times.

The promontory of Haghìa Irini at the inner (E) end of the great harbor, was the site of a flourishing town in the Bronze Age. In it was a free-standing building, a temple, which served religious purposes from the Middle Helladic period onward. Destroyed by earthquake in the 15th c. B.C., it was rebuilt and modified repeatedly in Mycenaean times and thereafter. One of the small rooms became a shrine and in it, around 700 B.C., was carefully preserved the head of one of the large terracotta female statues which had stood in the temple some eight centuries earlier. Graffiti and small votive offerings show that the shrine was sacred to Dionysos from the 6th c. The area seems to have been revered at least until late Hellenistic times.

BIBLIOGRAPHY. P. O. Bröndsted, Reisen und Untersuchungen in Griechenland (also in French, Voyages . . .) (1826) I[1]; A. Meliarakes, Hypomnemata perigraphika ton Kykladon neson (1880) 184-263; F. Halbherr, "Iscrizioni di Keos," Museo Italiano di Antichità Classica 1 (1885) 191-219; A. Pridik, De Cei insulae rebus (1892); L. Savignoni, "Archaiotetes tes Keo," ArchEph (1898) 219-48; P. Graindor, "Fouilles de Karthaia," BCH 29 (1905) 329-61[1]; K. Storck, Die ältesten Sagen der Insel Keos (1912); I. N. Psyllas, Historia tes nesou Keas (1920); L. Bürchner in RE (1921); G. Welter, "Von griechischen Inseln," AA (1954) 48-93; J. L. Caskey, excavation reports in Hesperia 31 (1962), 263-83[1]; 33 (1964), 314-35; 35 (1966), 363-76; 40 (1971), 358-96; D. Lewis, "The Federal Constitution of Keos," BSA 57 (1962) 1-4; C. G. Doumas, "Kea," Deltion 18 (1963) Chronika B2, 281-82[1]. J. L. CASKEY

KEPHALE Attica, Greece. Map 11. A deme belonging to the tribe Akamantis. Inscriptions found in Keratea, about 19.32 km N of Sounion, place the township in that area, most probably to the NW of the modern village, where Frazer reported ancient walls. A boundary stone and a dedication respectively indicate Sanctuaries of Hera and Asklepios. The Altar of Aphrodite mentioned by Isaios (2.31) presumably lay in the precinct marked by a boundary stone found between Keratea and the E coast of Attica at Kaki Thalassa. No trace has been reported of the Sanctuary of the Dioskouroi, although Pausanias (1.31.1) thought it the most important at Kephale.

BIBLIOGRAPHY. J. G. Frazer, Paus. Des. Gr. (1898) II 402. M. H. MC ALLISTER

KEPHALOIDION (Cefalù) Sicily. Map 17B. An ancient center midway between Himera and Halaesa on the N shore. In spite of its Greek name, referring to the promontory around which the city presumably developed, the site is not among the Greek colonies in N Sicily mentioned by Thucydides. Its origins and early history are unknown. There is no positive evidence for a Phoenician origin, which seems implied by the legend RSMLKRT

on some coins. Diodoros (14.56.2) relates that in 396 B.C. Himilco made an alliance with the inhabitants of the phrourion. After various events (Diod. 14.78.7; 20.56.3; 77.3) the site was conquered by the Romans, through treason, in 254 B.C. (Diod. 23.18.3). Within the Roman province of Sicily it was civitas decumana (Cic. Verr. 2.128ff). It is mentioned in the Antonine Itinerary.

Few remains are visible today. Within the modern town and along the shore stretches of the cyclopean walls are preserved, but of uncertain date. The most important monument, the so-called Temple of Diana, is on the peak. It was erected with large boulders around a rock-cut cistern, and it may have been a pre-Hellenic sanctuary. In the center of the cistern a column of three large drums supports a dolmen-like roof. Excavation tests have suggested a date in the 9th-8th c. B.C. In the 6th-5th c. B.C., the original plan of the sanctuary was augmented by the addition in polygonal masonry; its doors identify it as Greek.

A Museum belonging to the Mandralisca Foundation contains Greek and Italic vases, largely from the Aeolian islands, and a rich collection of coins.

BIBLIOGRAPHY. P. Marconi, NSc (1929) 273ff[PI]; E. Gabrici, "Alla ricerca della Solunto di Tucidide," Kokalos 5 (1959) 1ff[1]. V. TUSA

KEPHELLENIA, see SAME

KEPHISSIA Attica, Greece. Map 11. One of the original twelve cities that formed the union of Attica under Theseus (Philochoros: FGrHist 328 F 94), Kephissia remained a deme in Classical times, on the site now occupied by the suburb of the same name. Its most famous resident was Herodes Atticus, whose elegant villa is described by Aulus Gellius (NA 1.2.2). Herodes' presence there has been amply documented not only by inscriptions, but also by the discovery in 1961 of his portrait bust and that of his favorite Polydeukion, possibly from the villa itself. These finds came from a lot behind the Church of the Panagia (Xydou).

From the same period as Herodes is the long-known Roman tomb on the S side of Plateia Platanou. When found it still contained four sarcophagi. Although nothing of the tomb has survived in place above the level of the orthostate course, it can be convincingly restored with a vaulted roof on the basis of the almost similar tomb at Chalandri. About half a km E of this square, a deme decree of the 4th c. B.C. was recently found, recording the thanks of the citizens of Kephissia towards someone who had repaired their palaistra. This constitutes the only reference to a privately organized palaistra outside of Athens.

BIBLIOGRAPHY. A. Tschira, "Eine römische Grabkammer in Kephissia," AA 63-64 (1948-49) 83-97; E. Vanderpool, "News Letter from Greece," AJA 65 (1961) 299-300; id., "A Palaistra in Kephissia," ArchDelt 24 (1969) A. Μελέται 6-7. C.W.J. ELIOT

KEPOI Kuban. Map 5. A Miletian colony founded in the mid 6th c. B.C. on the Gulf of Taman NE of Phanagoria, on the site of a Kimmerian (?) settlement (Strab. 11.2.10; Diod. 20.24; Plin. HN 6.112). At first the city, of mixed population, subsisted on farming and trade with Asian Greeks and local tribes, paying taxes to the Bosporan kings. The inhabitants prospered from the wheat trade between the 4th c. B.C. and the 1st c. A.D., but from the 2d c. A.D. the city was increasingly barbarized by the Sarmatians. The Huns destroyed it in the 4th c.

The Greek city, originally 20-25 ha, covered a small hill and extended down the slopes to the seashore. Much

of the coastal part of the site is now under water. Remains of a house of the mid 6th c. B.C. have been found and some of the numerous graves from several necropoleis can be dated to the same period, but other architectural remains date to the 1st c. A.D. or later. From the 1st c. are ruins of a temple in antis dedicated to Aphrodite; the terracotta ex-votos found nearby represent the goddess. The remains of houses from this century reflect the high standard of living. The foundations are of stone, the walls of brick, often imported from Sinope as were the roof tiles; there are traces of water pipes. There are also remains of baths from the 1st c. A.D. and two wine-making establishments (1st-3d c.).

Finds include not only Klazomenai wares, Classical and archaic Attic bowls, terracotta figurines of local manufacture (4th c. B.C.), imported Syrian glassware and Egyptian scarabs, but a headless marble statue 0.53 m high known as the Aphrodite of Taman (1st half of the 2d c. A.D.) and a head of Aphrodite from a workshop near the Pergamon school of the 2d c. B.C.

The Hermitage Museum contains material from the site.

BIBLIOGRAPHY. N. I. Sokol'skii, "Kepy," *Antichnyi gorod* (1963) 97-114; id., "Sviatilishche Afrodity v Kepakh," *Sovetskaia Arkheologiia* (1964) 4.101-18; id. & N. P. Sorokina, "Raskopki goroda Kepy i ego nekropolia v 1957-1963 gg.," *Ezhegodnik Gosudarstvennogo istoricheskogo muzeia, 1963-1964* (1966) 28-49; id., "Vinodelie v aziatskoi chasti Bospora," *SovArkh* (1970) 2.75-92; E. Ia. Nikolaeva, "Raskopki gorodishcha Kepy v 1964 g.," *KSIA* 109 (1967) 94-100; N. P. Sorokina, "Raskopki nekropolia Kepy v 1962-1964 gg.," *KSIA* 109 (1967) 101-7; I. B. Brašinskij, "Recherches soviétiques sur les monuments antiques des régions de la Mer Noire," *Eirene* 7 (1968) 105-6.

M. L. BERNHARD & Z. SZTETYŁŁO

KERAME (Vionnos) Haghios Vasilios, Crete. Map 11. Twenty-five km W of Timbaki, a Classical and Hellenistic city. Traces of Minoan, Geometric, and archaic occupation of the site have been found, but the most extensive settlement and most of the visible remains belong to the 5th to the 3d c. B.C. An inscription from the site, assigned to the late 4th c. B.C., carries the implication that the city was at that time an independent state.

The city was situated on a small hill and the E slopes below it and, to judge from surviving house and terrace walls, covered an area of about 1.5 hectares. The defenses of the city are still clearly visible on the N side, where a massive wall 3 m thick runs straight for over 100 m. From it project two semicircular towers, each about 6 m in diameter and 40 m apart. At the W end of the wall is another circular tower, twice the size of the central towers, while the E corner tower is rectangular in shape and of a different build.

BIBLIOGRAPHY. M. Guarducci, *ICr* II (1939) 310f; E. Kirsten, in F. Matz, *Forschungen auf Kreta 1942* (1951) 124-26; M.S.F. Hood & P. Warren, "Ancient Sites in the Province of Ayios Vasilios, Crete," *BSA* 61 (1964) 173-74.

K. BRANIGAN

KERAMOS (Ören) Turkey. Map 7. City in Caria, on the Ceramic Gulf about 40 km S-SE of Milâs. It appears to be Carian in origin; no Greek settlement is recorded, but archaic statuary of Greek type has been found on the site. Keramos paid a tribute of 9000 dr. in the Delian Confederacy, and was later an important member of the Chrysaoric League (Strab. 660). From 189 to 167 B.C.

it was under the domination of Rhodes, and shortly afterwards, in difficulties in its relations with a neighbor, probably Stratonikeia, appealed to Rhodes for an alliance. By the first century she had fallen under the control of Stratonikeia. The chief deity of Keramos was Zeus Chrysaoreus, who appears on some coins together with a young god, apparently a local deity.

The site is partially occupied by the modern village, and the ruins have been much despoiled. The city wall, enclosing an extensive area, followed the hills to the N and E and took in much of the flat ground on the S. The masonry is for the most part polygonal, in some places with an upper part in squared blocks, little of which now remains. The numerous gates are mostly arched. The best-preserved stretch is high up on the mountain to the E. The wall as a whole appears to be of Hellenistic date.

The earliest remains have been found at a spot called Bakıcak, on a low hill: a platform supported by an ashlar wall carries the foundations of a temple, probably that of Zeus Chrysaoreus. Nothing remains of the temple itself except three large blocks scattered on the hillside, but a block with a relief of a double axe was found nearby, and at Bakıcak itself a handsome marble head of archaic date and kouros type was uncovered. It has been thought that this head may represent the youthful deity who appears with Zeus on the coins. Below the platform on the W is a complex of terrace walls joined by crosswalls, and a row of six large niches.

Outside the city on the E was a second temple, now known as Kurşunlu Yapı, which stood on a platform with a supporting wall 6 m high surmounted by a cornice; only a few steps can be made out. The supporting wall still stands, in handsome masonry, but the cornice has been recently destroyed. Architectural members of the temple, in the Corinthian order, are strewn about, and two clipeae rotundae, with their inscriptions, can still be seen.

The tombs at Keramos were placed, in the usual fashion, beside the roads leading to the gates; a number of sarcophagi and several so-called Carian tombs are still in evidence.

BIBLIOGRAPHY. C. Michel, *Receuil d'inscriptions grecques* (1900) 658; G. Guidi, *Annuario* 4-5 (1921-22) 386ff; A. & T. Akarca, *Milâs* (1954) 170-74; G. E. Bean, *Turkey beyond the Maeander* (1971) 53-57.

G. E. BEAN

KERASOUS Pontus, Turkey. Map 5. A tributary colony of Sinope, on the S coast of the Black Sea (Pontos Euxeinos), in Colchian territory; visited by Xenophon and the Ten Thousand in 400 B.C. (*Anab.* 5.3.2). From here Lucullus took the cherry (κερασός) to Rome. The city had ceased to exist by the early 2d c. A.D., and its name was transferred to Pharnakeia.

The site lies on the W side of Yeros Burnu (Hieron Oros), presumably at the mouth of the Kireşon Deresi (Kerasous fl.), 3 km NE of Vakfikebir. No remains are known.

D. R. WILSON

KERCH, *see* PANTIKAPAION

KERESSOS Greece. Map 11. NW of Thespiai, a fortified post in the Valley of the Muses N of Mt. Helikon. About the middle of the 6th c. B.C. the Thespians withdrew to the site at the time of the Thessalian invasion; the victory of the Boiotians liberated Greece. After the battle of Leuktra (371 B.C.) the Thespians again took refuge in Keressos, which Epaminondas succeeded in capturing. There is no further mention of the site.

Keressos has been placed, variously, on the hill of Erimokastro immediately above Thespiai (Ulrichs), in the village of Neochori 4 km W of Thespiai (Leake, Boelte), on Mt. Marandali above Neochori (Fimmen) and even on the hill of Listi, 2 km N of Mavromati (Buck). It is most commonly identified with the limestone hill of Palaeopyrgos (493 m) ca. 2 km NW of Palaeopanagia, at the entrance to the Valley of the Muses. On top of this hill is a ruined mediaeval tower; the W slope of the hill bears traces of mediaeval houses. However, this hill with its gentle, never steep slopes is not a natural fortress; there are no traces of ancient buildings, and the few potsherds that have been found are late Roman or Byzantine (author's observations). Perhaps the fortress should be placed on the "mountain of Askra," which has a 4th c. fort on its summit; this steep, strongly fortified hilltop could have served as an acropolis retreat to the citizens of Askra as well as to the inhabitants of the Valley of the Muses and Thespiai. The abandonment of the site would account for Pausanias' and Plutarch's silence on the subject of Keressos, according to Papahadjis.

BIBLIOGRAPHY. Paus. 9.14.2-3; Plut. Cam. 19; W. M. Leake, Nor. Gr. (1835) II 500; A. Conze, Philol. 19 (1863) 181[M]; P. Decharme, ArchMiss 2d sér. IV (1867) 174; J. G. Frazer, Paus. Des. Gr. (1898) V 53-54; D. Fimmen in NJbb (1912) 529; Bölte in RE (1921), s.v. Keressos; G. Roux in BCH 78 (1954) 22; E. Kirsten & W. Kraiker, Griechenlandkunde[5] (1967) 238; N. Papahadjis, Pausaniou Hellados Periegesis V (1969) 95, n. 3; 166-67; 172, n. 2[MI]; R. J. Buck, Proceedings of the Ist International Conference on Boiotian Antiquities, Montreal 1972 (Teiresias, Suppl. 1) 31-40[M]. P. ROESCH

KERILEN Finistère, France. Map 23. Gallo-Roman site in the commune of Plounéventer, first located in the 19th c. and excavated since 1962. Stratigraphical studies show that the ancient city was inhabited from the time of Gallic independence to the end of the 3d c. A.D., when the site was probably abandoned.

The substructures uncovered appear to be fairly well built. The many furnaces and hearths as well as the various scoria found in situ indicate that the area excavated was a sector of artisans' workshops. The objects discovered, mainly terra sigillata and profusely decorated domestic ware, are housed in the archaeological laboratory of the Faculté des Lettres et Sciences Humaines of Rennes.

BIBLIOGRAPHY. Miorcec de Kernadet, Notice sur l'Ancienne ville d'Ocismor (1829); L. Pape, "Premières considérations sur le site de Kérilien en Plounéventer," Annales de Bretagne 70, 1 (1963); id., "Les fouilles de Kérilien en Plounéventer" ibid. 71, 1 (1964); 72, 1 (1965); 73, 1 (1966); 74, 1 (1967). M. PETIT

KERINTHOS Euboia, Greece. Map 11. Listed in Homer's catalogue of ships, the city was known to Ptolemy and Strabo, though it was no longer of any importance, having early lost its independence to Histiaia. The site has been identified with a hill N of modern Mantudi, near the Bay of Peleki, at the mouth of the Boudoros river. The acropolis drops abruptly to the sea in a 30 m cliff. The fortification wall on the N side is of irregular polygonal blocks roughly dressed, and probably belongs to the 6th c. city, the destruction of which Theognis attributed to the Kypselids. The wall on the S side is double-faced, of trapezoidal blocks in courses, with a square tower of regular isodomic masonry: these sections are probably Hellenistic. Pernier reported the remains of a large rectangular building on the highest ground, with other buildings of rough limestone blocks, along streets laid out according to the cardinal points of the compass. No finds have been reported from the Roman period.

BIBLIOGRAPHY. Theog. 891-94; W. Vischer, Kl. Schr. (1877) 597[P]; L. Pernier in ASAtene III 1916-20 (1921) 273-76[I]; L. Sackett et al. in BSA 61 (1966) 43f[M].

M. H. MC ALLISTER

KERKINITIS (Eupatoria) Crimea. Map 5. An ancient Greek colony along the NW Crimean coast. It was founded in the late 6th-early 5th c. B.C., perhaps by Heraklea Pontica, on the site of a pre-Greek settlement. Kerkinitis came under the control of Chersonesus in the late 4th c. and enjoyed a period of prosperity. As a center for the surrounding agricultural area, it provided Chersonesus with grain and had trade relations with the Scythians of the interior. It also issued its own coins from the mid 4th to the 2d c. B.C. The Scythians captured it in the mid 2d c. and occupied it until the early centuries A.D. (Hecateus, Fr. 153; Herod. 4.55, 4.99).

At its height, the settlement covered an area of 8 ha. By the late 4th c., stone defensive walls and towers encircled the site. The walls were partially rebuilt and strengthened in the 3d c. The earliest dwelling, a two-room house with stone walls, a beaten clay floor, and an adobe hearth, dates to the late 6th-early 5th c. B.C. Other remains uncovered in limited excavations include a stone house of the 4th-3d c. with a cellar, a house of the late 3d-early 2d c. with stone walls and floors, a large stone-paved drain cutting N-S across the site and leading to a stone-lined reservoir, and a round stone structure of the 4th-3d c., 6.2 m in diameter, whose purpose is not clear. The necropolis, located NW of the site, had burials of the late 6th-2d c. B.C. including some rich graves of the 4th-3d c. It is now completely destroyed.

BIBLIOGRAPHY. Ellis H. Minns, Scythians and Greeks (1913) 490-92; M. A. Nalivkina, "Raskopki Kerkinitidy i Kalos Limena (1948-1952 gg.)," Istoriia i arkheologiia drevnego Kryma (1957) 264-81; id., "Torgovye sviazi antichnykh gorodov Severo-Zapadnogo Kryma (Kerkinitida i Kalos Limen v V-II vv. do n.e.)," Problemy istorii Severnogo Prichernomor'ia v antichnuiu epokhu (1959) 183-94; id., "Kerkinitida i Kalos Limen," Antichnya gorod (1963) 55-60; O. D. Dashevskaia, "O proiskhozhdenii nazvaniia goroda Kerkinitidy," VDI (1970) 2.121-28. T. S. NOONAN

KERKYRA or Korkyra (Corfu) Greece. Map 9. Situated at the extreme NW boundary of Greece, the site has often been identified because of its peripheral position with the fabled Scheria, according to the Homeric account, seat of the Phaiakian people (Thuc. 1.25). It was originally inhabited by Illyrian and Apulian populations, until in 734 B.C. it was occupied by Corinthian colonists under Archias or Chersikrates, both of the Bacchiadai family. They settled on the E coast and called their city Kerkyra or Korkyra from a corruption of Gorgon, the demon routed by the Corinthian hero Bellerophon. The pre-Corinthian name would have been Drepane. Conflicts with the mother country began soon. In 664 B.C. the revolt of Kerkyra provoked the fall at Corinth of the Bacchiadai and the ascent of the Kypselids; in 435-431 there were new encounters occasioned by the war of Epidamnos which brought democracy to power in 425 B.C. Kerkyra participated in the Peloponnesian War as an ally of Athens, and at the beginning of the 4th c. fell under the hegemony of Sparta. It later joined the second Athenian confederation in 373 B.C.; became the prey of Agathokles in 300 B.C.; and finally passed to Epeiros.

From 229 B.C. it was under the protection of the Romans and served them principally as a naval base.

The earliest traces of human settlement are found in the NW zone of the island. At Sidari and on the small island of Diaplo these go back to the Mesolithic period and to the first Neolithic age (VI millennium), and show notable similarity to the Campanian culture in Italy; while in the same places there are Bronze Age strata that appear, instead, different from the corresponding Italic facies. At Aphiona an Early Neolithic deposit has been found from the late III–early II millennia with two types of pottery. One is coarse and red; the other is finer and brown with black paint and incised decorations of the geometric type, classified as Molfetta and belonging to the Apulian pottery type. The site has been located at a village of the Middle and Late Bronze Age (II millennium) excavated at Kapo Kephali or instead, farther to the S in the zone where, on the hill of Ermones, 500 m from the sea, there has recently been discovered another prehistoric habitation with fragments of clay slabs that must have served as roofs for mud huts.

The city founded by the Corinthian colonists rose a little to the S of the modern capital of the island, on the rocky peninsula of Palaiopolis that projects between the sea and a lagoon. The acropolis was situated on the height of Analipsis. Here Euboian settlers had already made a way place on the road to the W. The peninsula narrows to the N into an isthmus barred by walls of Hellenistic age. At opposite ends are the two ancient ports. That on the W, on the lagoon, is perhaps the older naval port called the Hyllaiko; while that to the N was connected with the name of Alkinoos. The inhabited area was between the two ports, but very few remains of the civil buildings survive. Two gates from the city walls have been identified, constructed of marble and poros blocks, and partly incorporated in the Venetian fortifications. A third port was perhaps dug out farther N, in an inlet near the oldest Venetian fort. In the Monrepos park, on the seaward side of the Analipsis height, remains of a sanctuary have been found, and recent excavations permit a reconstruction of its history. At the beginning of the Corinthian colonization at the end of the 8th c. B.C. there arose a large sanctuary probably dedicated to a divinity protective of Kekyra and the other cities of W Greece. A century later, at the end of the 7th, the sanctuary was closed by a peribolos, and a large temple was built with columns and part of the superstructure in local limestone. The roof was in terracotta, richly decorated with gutters in the form of leonine protoma and gorgoneia vividly painted, analogous to those of Thermos and Kalydon. At the end of the 6th c. other cults were established around the temple to the great divinity. That of Apollo had a hypaethral enclosure with an altar, and Aphrodite and Hermes were remembered by two small temples, parts of whose terracotta roofs remain. Evidence of the cults lasts until the end of the 5th c. when a fire destroyed the sanctuary. At the beginning of the 4th c. a new temple in limestone with a marble roof arose on the ruins of the archaic temple. New building activity took place in the 3d c. Still at Monrepos, near the Kardaki spring, are the remains of a temple discovered in 1822. This is a Doric building of singular construction, dating to about 510 B.C., and perhaps dedicated to Apollo (Timaios). The cella, in crude bricks, was circled by a peristasis of 6 by 11 monolithic columns, amply and uniformly spaced. The entablature bore no frieze with triglyphs, although it had an architrave crowned with ovoli, cornice, and kyma. These elements bring to mind Ionic influence similar to that which is encountered in some architectonic forms, the so-called achaian of S Italy. Several fragments of a Nike in terracotta belong to the acroterion of the temple.

Not far from the temple a deposit of clay figurines, coins, tiles, and inscribed fragments from the middle of the 6th c. has been found. The same formal characteristics may be recognized in the temple at Kardaki as in the most prestigious monument of Kerkyra, the Sanctuary of Artemis, discovered near the Monastery of St. Theodore in the region of the Garitza. In the sacred area, enclosed by a peribolos wall, rose the stone temple measuring ca. 47.9 x 22.4 m, with 8 by 17 columns. It is the most archaic pseudoperipteral Doric temple, datable to about 585 B.C. The cella was very narrow and divided into three naves by two rows of columns. The original gutter was in terracotta, replaced during the second half of the 6th c. by marble elements. The importance of this temple is above all centered on the decoration of the tympanum, where for the first time there appears in that position a mythical representation, although the thematic unity which later becomes the norm is lacking. On the 21 slabs in poros stone of the W pediment (of which 12 remain), a gigantic Gorgon was shown at the center in high relief. Her function was clearly to keep away malign influence, and she was flanked by her two offspring, Chrysaor and Pegasos, between two panthers. On the sides there were two groups: to the left Priam being killed by Neoptolemos, and to the right Zeus battling a giant, while a fallen warrior filled the corner of the pediment. An analogous scene, but of uncertain identification because of the meager remains, occupied the E pediment. The figures are carved according to the archaic scheme, through parallel planes, in the ornate taste common to all orientalizing production. These are in the Corinthian tradition, but show strong Doric influence. Also preserved are several fragments of a frieze from a metope with Achilles and Memnon. Before the temple, and joined to it by a ramp, rose the altar (25.4 x 2.7 m), decorated with a frieze, metopes, and trygliphs.

In the Palaiopolis zone, before the entrance of Monrepos park, is the Church of Haghia Kerkyra. It is a large Early Christian basilica with five aisles, double narthex, and transept. On the mosaic pavement is inscribed an epigram of Archbishop Govianus from the middle of the 5th c. A.D. Soundings made under the pavement have brought to light the remains of an apsidal building, a Hellenistic bouleuterion or ecclesiasterion. Below that level have been found sherds ranging from the pre-Corinthian and Geometric periods up until the end of the 4th c., fragments of sculpture from the middle of the 5th c., and remnants of a foundation wall from the 8th c. Leaning against the N side of the basilica is a small building constructed of reused material from the 5th c. B.C. To the W, near the apse, is another small building with a mosaic pavement a meter higher than the floorlevel of the basilica. It was probably constructed after the period of Vandal destruction in the 6th c. A.D. The basilica arose on the site of the ancient city, which also included Hellenistic habitations in the neighborhood, and on which a Roman bath was built in A.D. 100. Between the basilica and the point of Kanoni, at the extreme SW of the peninsula, a house has been discovered that preserves traces of two building periods; that is, of the 4th c. B.C. and of the Middle Helladic age. The recovery at Kanoni of a deposit of terracottas ranging in date from the 8th to the 5th, with the figure of Artemis, leads to the supposition that here was another sanctuary dedicated to that deity. A little farther to the N, near the cloister of Panaghia Kassiopitra, there remain traces of a temple of the 6th c. B.C., possibly to Poseidon. The ancient necropolis is near the region of the Garitza, to the N and NW of the city. Among the more notable monuments is that of Xenvares, which is formed of a Doric column with a capital of the so-called Achaian type (see

the capitals of Paestum), datable to the middle of the 6th c. B.C. by reason of a dedicatory inscription; and the cenotaph of Menekrates on a round base, that bears a metric inscription in Corinthian characters, of ca. 600 B.C. Next to it has been found a life-size statue of a lion in limestone on a quadrangular base, stylistically and chronologically close to the felines on the pediment of the Temple of Artemis. Its immediate precedent is represented by the plastic lions of the pre-Corinthian aryballoi from the middle of the 7th c. Recent excavations have turned up numerous fragments of archaic ceramics.

The monumental sculpture and the other finds from the pre-Christian era are in the archaeological museum of the modern city.

BIBLIOGRAPHY. J. Stuart & N. Revett, *Ant. Ath.*, suppl. (1830) plates 1-5; W. Dorpfeld in *AthMitt* 39 (1914) 161-76; id. in *Arch.Anz.* 28 (1913) 105-9; L. Bürchner in Pauly-Wissowa, *RE* (1922) 1400-16, s.v.; P. Montuoro, *L'origine della decorazione frontonale* (1925); C. Weickert, *Typen der arch. Architektur* (1929); H. Payne, *Necrocorinthia* (1931); H. Bulle in *AthMitt* 59 (1935) 147-240; F. P. Johnson & W. B. Dinsmoor in *AJA* 40 (1936) 46-56; I. F. Crome in *Mnemosyne Th. Wiegand* (1936) 47-53; G. Rodenwaldt, *Die Bildwerke des Artemistemples v. Korkyra* (1939); J. Papadimitriou in *Praktika* (1939) 85-99; id. in *ArchEph* (1942-44) 39-48; H. Schleif et al., *Der Arthemistempel-Korkyra* (1940) E. Lapalus, *Le fronton sculpté en Grèce* (1947); F. Matz, *Gesch. Griech. Kunst.* (1950) 205-10, 367-70; R. Matton in *Ergon* (1959) 77-82; id., *Corfou* (1960); B. Kallipolitis in *Praktika 1955* (1960) 187-92; *1956* (1961) 158-63; *1957* (1962) 79-84; B. Daux in *BCH* 89 (1965) 751-60; 91 (1967) 670-72; 1 (1968) 66-69; G. Dontas in *BCH* 93 (1969) 39-55; A. Sordinas, *Stone Implements from Northwestern Corfu* (1970) J. P. Michaud in 94 (1970) 1011-17.　　　L. VLAD BORRELLI

KERYNEIA Cyprus. Map 6. On the N coast 23 km E of Cape Kormakiti. The ruins cover a large area now occupied by the modern town. The town site is situated on the shore, but its limits are difficult to define. The town had a harbor, used to this day by small craft, whose ancient breakwaters are still visible behind Kyrenia Castle. The necropolis extends W along the shore.

One of the ancient kingdoms of Cyprus, Keryneia was traditionally founded by Kephios from Achaia in the Peloponnese. Evidence for the arrival of the Mycenaeans in the area occurs at the villages of Kazaphani and of Karmi, both very near the site. Archaeological evidence for the town itself, however, does not at present support a date earlier than the Geometric period for its founding. In Early Christian times it became the seat of a bishop. The ancient town flourished down to Early Byzantine times when it was sacked during the first Arab raids of A.D. 647.

Very little is known of the history. Kelena, identified with it, appears in a list of names in the temple at Medinet Habu in Egypt of the time of Rameses III (12th c. B.C.) but this reading is not to be trusted. The name of the Classical town is mentioned for the first time by Skylax in the mid 4th c. B.C., by Diodoros, and later by Ptolemy, Pliny, and Pompeius Melas, but strangely enough it is omitted by Strabo. It is also mentioned in the list of the theodorokoi at Delphi (early 2d c. B.C.) and at Kafizin the ethnic occurs in the time of Ptolemy III, Euergetes I (second half of the 3d c. B.C.).

It is conjectured that Themison, the Cypriot king to whom Aristotle dedicated his "Protreptikos," was a king of Keryneia, who must have reigned during the second half of the 4th c. B.C. Its last "dynast," possibly Themison, suspected of being on the side of Antigonos, was arrested in 312 B.C. by Ptolemy.

From inscriptions we learn of the worship of Aphrodite and of Apollo but nothing is known of the position of the sanctuaries. From inscriptions also we learn that there was a gymnasium, but again its site remains unidentified. And from an inscription of the time of the emperor Claudius we are informed that water was carried to the town by an aqueduct from a source at Limnai. No coins have been attributed to Keryneia. The town site itself is still unexcavated but many casual finds have been recorded.

Practically nothing survives in the way of monuments except for some rock-cut tombs in the W part of the town, looted long ago. In a sanctuary in the upper part of the town many statuettes of terracotta and of limestone were found, dating from the archaic to the Hellenistic period. In the same area some other buildings also came to light but nothing is visible today. More recently a number of fragmentary limestone statues and of terracotta figurines were accidentally found in a bothros within the town. They date from Classical and Hellenistic times and obviously belong to a nearby sanctuary. Recent rescue excavations have also brought to light a number of tombs dating mainly from the Classical and Hellenistic periods.

The finds are in the Keryneia and Nicosia Museums.

BIBLIOGRAPHY. I. K. Peristianes, Γενικὴ Ἱστορία τῆς νήσου Κύπρου (1910); id., "A Cypriote Inscription from Keryneia," *JHS* 34 (1914) 119-21; id., *A Brief Guide to the History and Ancient Monuments of Keryneia Town and District* (1931) 3-6; George Hill, *History of Cyprus* I (1949) in passim; V. Karageorghis, "Chronique des Fouilles et Découvertes Archéologiques à Chypre," *BCH* 89 (1965), 257-60[I]; 90 (1966), 339-41[I]; 95 (1971) 362f; 96 (1972) 1032; 97 (1963) 624-26; M. Katsev, "The Kyrenia Shipwreck," *Expedition* 11 (1969) 55-59[I]; 12 (1970) 6-14[I].　　　K. NICOLAOU

KESTER Belgium. Map 21. A large Gallo-Roman vicus of the civitas Nerviorum, at the intersection of the Bavai-Asse-Antwerp-Utrecht road and the Casel-Courtrai-Tongres road. Systematic excavations have never been undertaken there. Our only information comes from discoveries made in the course of large public works. The built-up area spread over several hectares. The occupation seems to go back to the beginning of Roman times since Iron Age bracelets and pottery are among the most significant finds. Among these discoveries, are numerous sherds of terra sigillata, coins, and a large series of white terracotta statuettes. This last find suggests that there was a sanctuary of Celtic tradition in the vicus. The necropolis, located W of the vicus, has likewise been found but has never been excavated systematically. The tombs date to the 1st and 2d c. A hoard of coins in a bronze vase was found at Kester as early as 1574. It consisted of about 600 silver coins, the most recent of Philip II (244-49). This seems to indicate that the vicus was ravaged during one of the very first invasions of the 3d c.

BIBLIOGRAPHY. M. Desittere, *Bibliografisch repertorium der oudheidkundige vondsten in Brabant* (1963) 76-77; M. Thirion, *Les trésors monétaires gaulois et romains trouvés en Belgique* (1967) 101.　　　S. J. DE LAET

KESTRIA (Aetos) S Albania. Map 9. On an isolated limestone hill in the plain S of Buthrotum. The site was defended by a double circuit wall, mainly in polygonal masonry, of which a part, containing a gateway, has been excavated. The quarry from which the masonry probably came has been identified.

BIBLIOGRAPHY. L. M. Ugolini, *Butrinto* (1937) figs. 136, 137; N.G.L. Hammond, *Epirus* (1967) 94f, 677, 699.

N.G.L. HAMMOND

KESTROS (Macar Kalesi) Turkey. Map 6. City in Cilicia Aspera 6 km S-SE of Gazipaşa. It is mentioned by Hierokles and in the *Notitiae*, and apparently also by Ptolemy (5.7.5: Kaystros); Imperial coins of the 2d c. are known but not common. The site is on a hill above the village and is identified by inscriptions. A circuit wall of indifferent masonry is best preserved on the E side. The agora lay on the saddle dividing two modest eminences; on its N side stood a temple of Antoninus Pius and on the S a temple of Vespasian. On the N summit is a fortified enclosure, and below this a long terrace carrying numerous honorific statues. Outside the city on the E hillside are two cemeteries, which include a handsome built tomb.

BIBLIOGRAPHY. A. Wilhelm, *Neue Beiträge* 4 (1915) 62-64; G. E. Bean & T. B. Mitford, *AnatSt* 12 (1962) 211-16; id., *Journeys in Rough Cilicia 1964-1968* (1970) 155-70.

G. E. BEAN

KHALKOPOULOI, *see* LIMES, GREEK EPEIROS

KHAMALEVRI ("Allaria") Rethymno, Crete. Map 11. A Minoan and Graeco-Roman settlement about 12 km E of Rethymno. The site seems to have been first occupied during the Middle Bronze Age, and occupation in the Late Bronze Age, Geometric, and archaic periods is suggested by pottery recovered from the site. More intensive occupation, and most of the surviving and visible remains, however, belong to the Hellenistic and Roman eras.

The main Graeco-Roman city was situated on the rising ground E of the modern course of the stream and just above the shore. Apart from Roman house walls visible in the cliff face by the shore, there is little to be seen of the city itself. Tombs belonging to its cemeteries during the Roman period, however, can be seen to both E and W. A third cemetery area lies to the SW where groups of rock-cut chamber tombs and rock-cut graves can still be seen.

Outlying remains of some interest include traces of a Late Minoan sanctuary, which continued to be used as a sacred site during the archaic and Classical periods, situated on the hill of Kakavella, 400 m SW of the city.

Material from the site is stored both in Rethymno and the Herakleion museums, and there are also some interesting finds in the collection of Khamalevri School.

BIBLIOGRAPHY. P. Faure, "Nouvelles recherches de spéléologie et de topographie Crétoises," *BCH* 85 (1960) 202-5; M.S.F. Hood, P. Warren, & G. Cadogan, "Travels in Crete, 1962," *BSA* 59 (1964) 62-66.

K. BRANIGAN

KHAMISSA, *see* THUBURSICU NUMIDARUM

KHANIA, *see* KYDONIA

KHENCHELA, *see* MASCULA

KHERBET OULED ARIF, *see* LAMBIRIDI

KHERBET RAMOUL, *see* PORT ROMAIN

KHIRBET EL-KERAK, *see* PHILOTERIA

KHIRBET EL-MAIN ("Menois") Israel. Map 6. A site which may be Menois 16 km S of Gaza and known from the late Roman period and later. Eusebius (*Onom.* 130.7) identified Menois, "a small town near Gaza," with biblical Madabana (Josh. 15:31), and in the same corrupted form (Madmenah is correct) it appears on the Madaba mosaic map. According to the *Notitia Dignitatum* a cohort of Illyrian cavalry was stationed there.

The accidental discovery of a mosaic floor led to excavation of a synagogue: a basilica (15.3 x 13.5 m) with an apse to the NE, towards Jerusalem. On the mosaic in the nave was an amphora flanked by peacocks, from which emerged a vine that formed 54 medallions arranged in five rows; the medallions were filled with animals and birds. Specific Jewish symbols such as a seven-branched candlestick, a shofar (ram's horn), and a lulab (palm branch) were portrayed only near the apse, and here also was a dedicatory inscription in Aramaic. The floor is dated on stylistic grounds to the first half of the 6th c. A.D.

BIBLIOGRAPHY. F. M. Abel, *Géographie de la Palestine* II (1938) 384; S. Levi et al., *Rabinowitz Bulletin* 3 (1960) 6-40; M. Avi-Yonah, *The Holy Land* (1966) 161-62.

A. NEGEV

KHIRBET ET-TANNUR Jordan. Map 6. A Nabatean sacred compound on an isolated mountain named Jebel et-Tannur, 495 m above sea level. The site is N of Petra, capital of the Nabatean kingdom, SE of the Dead Sea, and about 0.8 km off the main road, the King's Way of biblical times, Via Nova Traiana of the Romans.

A narrow path runs from the base of the mountain, where there is a spring and a nymphaeum, to the flattened mountain top, whence a broad flight of steps leads up to a gate in the E wall of the compound. Within the gate is the outer court, 14.1 square, paved with flagstones and with porticos on the N and S sides. On the N side of the court, closer to the E than the W wall, stood an altar, near a small pool for water used in the ritual. A gate on the W side of this court led to an inner court in which stood the shrine. The W wall of the court was decorated with pilasters and attached columns with niches between them, all surmounted by a frieze and a gable. The frieze was of triglyphs and rosettes, instead of metopes. A relief of Atargatis as the goddess of vegetation, above the main gate to the outer shrine belongs to a later period, a change of style also evident in the substitution of Corinthian capitals for the original Nabatean ones.

Within the inner court (the outer shrine), 9.3 by 8.55 m and paved with flagstones, stood the inner shrine, or holy of holies, facing E. Unlike other known Nabatean temples, this shrine was a solid construction, with access to a flat roof by a flight of steps attached to its W wall. Pilasters decorated the E facade of the inner shrine, and the corner ones bore reliefs of Atargatis as the goddess of dolphins and of corn. The W facade had a frieze of rosettes, egg-and-dart, vine trellis, and leaves; above the frieze was a decorated arch. Perhaps the relief of Zeus-Haddad and another one of Atargatis came from here. In front of the inner shrine and built into the floor of the outer one were two receptacles covered by a slab of stone, for the bones of sacrificed animals. The Nabatean ritual included burning of incense, animal sacrifice, and a sacred meal. The incense was possibly burnt on an altar on top of the inner shrine, the sacrifices were offered in the court, and the sacred meal was taken in triclinia N and S of the outer court, where there were also lodgings for pilgrims and priests.

A large relief of Tyche supported by a winged victory has been found. Around the Tyche the symbols of the zodiac are arranged in a way suggesting that the Nabateans celebrated the New Year both in spring and autumn.

The temple had three periods of activity: end of the 2d c. B.C., possibly late 1st c. B.C., and early 2d c. A.D., to which most of the sculpture is attributed.

BIBLIOGRAPHY. N. Glueck, *Deities and Dolphins* (1965) passim. A. NEGEV

KHIRBET FAHIL, *see* PELLA

KHIRBET FASAIL, *see* PHASAELIS

KHIRBET KERAZEH, *see* CHORAZIN

KHIRBET MIRD, *see* HYRCANIA

KHIRBET QUMRÂN Jordan/Israel. Map 6. A site on the NE shore of the Dead Sea, above the left bank of wadi Qumrân. After the discovery of the Dead Sea scrolls in the nearby caves, the site was extensively excavated between 1951 and 1956. The habitation of one of the Dead Sea sects, it is well defended on all sides by gorges of wadis which cut their way to the Dead Sea in the soft marl. The earliest building remains on the site belonging to the Iron Age II, the 8th to the 6th c. B.C. The remains of the walls of this settlement were incorporated in those of the later enclosure, measuring some 75 m square. The entrance to the enclosure was by a massive tower on the N three stories high. A narrow passage led from the tower to the different parts of the settlement. The more important installations were to the S of the gate. Of these the excavators identified one as a scriptorium. To the E of it was a small court surrounded by the kitchen, laundry, and several reservoirs covered by a thick layer of plaster. South of this complex was a large assembly hall (19.5 x 10.5 m), close to which were a potter's workshop and a storage room in which were found hundreds of pottery vessels. The potter's workshop contained two kilns: one for the firing of ordinary kitchenware, the other for the jars in which the scrolls were kept. In the W part of the settlement were stores, workshops, a mill, a baking oven, granaries, and a stable for eight horses. There were also additional water reservoirs in this quarter. The whole water supply of the village depended on a dam which was built across wadi Qumrân from which an aqueduct and an intricate system of channels conveyed the water to each reservoir. To the E of the settlement was a cemetery containing no less than 1106 burials.

The earliest occupation level was that of the Iron Age II, probably to be identified with the City of Salt (Josh. 15:62). The next phase of occupation is attributed to John Hyrcanus I (135-104 B.C.). It is believed that the occupants of this settlement were the Essenes or the "Dead Sea sect." The dating of this and the next phases depends mainly on coins. In the next phase, still in the Hellenistic period, the settlement assumed its final form. This settlement suffered severe destruction by fire and an earthquake, possibly in 31 B.C., to which Josephus alluded (*AJ* 15.141-47; *BJ* 1.370-80). In ca. 4 B.C., during the reign of Archelaus, the site was rebuilt along the original plan, but it was destroyed in A.D. 68 during the War against the Romans (*JB* 4.449). After that time a Roman garrison was stationed on the site. Coins from the time of the Bar Kohbah revolt bespeak a short-lived occupation of the site by Jewish refugees, after which the site was completely abandoned.

BIBLIOGRAPHY. J. T. Milik, *Ten Years of Discovery in the Wilderness of Judaea* (1959); R. de Vaux, *L'archéologie et les manuscrits de la Mer Morte* (1961). A. NEGEV

KHIRBET TEDA, *see* ANTHEDON

KHOJAND, *see* ALEXANDRIAN FOUNDATIONS, 6

KHRISORRAKHI ("Helikranon") Epeiros, Greece. Map 9. The steep side of a high ridge is fortified with a circuit wall ca. 900 m long. It commands the entries from the NW toward the plain of Ioannina. It is mentioned by Polybios (2.6.3).

BIBLIOGRAPHY. N.G.L. Hammond, *Epirus* (1967) 194, 596 and Pl. XIII *a*. N.G.L. HAMMOND

KHURHA Iran. Map 5. Near Qum on the road between Qum and Arak are the remains of a Seleucid temple. Two columns of the peristyle stand intact. Smooth stone shafts, 11 diameters in height, stand on two high plinths and a still higher torus: the capitals are rather poorly understood Ionic. The temple awaits excavation. Set in a region of vineyards, the area is strewn with the sherds of wine jugs and it has been suggested that the temple was dedicated to Dionysos.

BIBLIOGRAPHY. E. Herzfeld, *Archaeological History of Iran* (1935) 50-51[1]. D. N. WILBER

KIATO, *see under* SIKYON

KIBYRA MAIOR (Horzum [Gölhisar]) Phrygia, Turkey. Map 7. About 59 km S of Denizli. According to Strabo 631, the Kibyrates were said to be descended from certain Lydians who occupied the Kabalis and were driven by the neighboring Pisidians to the site which became their permanent home. Strabo adds that Kibyra prospered by reason of its good government, which he calls a moderate tyranny, and controlled a wide territory extending from Pisidia and Milyas as far as Lycia and the Rhodian Peraea.

At some time during the 2d c. B.C. a tetrapolis was formed under the leadership of Kibyra, comprising the neighboring cities of Bubon, Balbura and Oinoanda. This tetrapolis was finally broken up after the first Mithridatic War. A principal industry at Kibyra was metallurgy; Strabo remarks it as a peculiarity of the region that iron was easily worked there. We hear also of a guild of cordwainers.

In A.D. 23 the city was visited by a severe earthquake. Tiberius came to the rescue with a remission of taxation for three years, and assistance in the rebuilding was given by Claudius; in gratitude Kibyra added the name of Caesarea to her own, instituted Caesarean games, and began a new dating era from the year 25. In A.D. 129 Hadrian, on his journey through the eastern provinces, visited Kibyra and conferred "great honors" on the people (*IGRR* I 418). Coinage began after 167 B.C. and continued down to Gallienus. The population was divided into tribes, apparently five in number, named after individual citizens who are thought to have been their presidents for the time being.

The site was first identified in 1842. It stands about 1050 m above sea level, half an hour's walk from the village. The site is extensive but unimpressive, occupying a low ridge E-W, which seems never to have been enclosed by a wall in antiquity though there are remnants of a mediaeval wall around the city center.

In the upper (W) part of the city is the theater, facing a little S of E, in very fair preservation. It is somewhat above average size, with something over 40 rows of seats and a single diazoma. The seats are largely preserved, though overgrown and buried in the lower part. The stage building has collapsed; of the doors leading onto the stage two are preserved, and the uprights of a third. An arched entrance survives at orchestra level, and a smaller rectangular entrance near the top of the cavea.

The top ten rows of seats seem to have been added later than the others. The theater is of Graeco-Roman type, with the cavea rather more than a semicircle.

Some 90 m to the S of the theater is the odeum, also in good preservation. It forms a segment of a circle with diameter of 17 m. The front wall stands complete up to its cornice, and is surmounted by a row of large windows partially preserved. It is pierced at ground level by five arched doors, the middle one larger than the rest, and a rectangular door at either end. The curved wall of the auditorium projects slightly at each end beyond the front wall; in the projection is a small window high up, and just inside the building is another window. The presence of these windows suggests that the odeum was roofed over. Spratt counted 13 rows of seats visible at that time; there are certainly more buried. Nothing is now to be seen of any stage or platform for performers. In front of the odeum is a long terrace wall some 24 m high, of irregular ashlar masonry.

Below the theater to the E is the city center, but the numerous public buildings are now utterly destroyed and none has been identified. Lower down, at the E end of the city, the stadium survives in fair condition, running approximately N-S. The S end is rounded; at the N end was a triple-arched entrance. The seats on the W side rest on the slope of the hill, but are much overgrown; the arcade at the top remains in part. On the E side a low embankment, faced with a rough wall, carried a few rows of seats. The stadium is of full length, with an arena 197 m long.

On the E a fine paved street of tombs led up to the city, entering by a triumphal arch in the Doric order. The tombs are mostly sarcophagi, one or two of which are decorated with gladiatorial combats in relief. At the W end of the city a ruined Christian church reminds us that the bishopric of Kibyra ranked first among those of the eparchy of Caria under the metropolitan of Staurupolis (Aphrodisias).

BIBLIOGRAPHY. T.A.B. Spratt & E. Forbes, *Travels in Lycia* (1847) I 253-60; E. Petersen & F. von Luschan, *Reisen in Lykien* (1889) II 186-92; G. E. Bean in *BSA* 51 (1956) 136-49.　　　　　　　　　　G. E. BEAN

"KIBYRA MINOR," *see* GÜNEY KALESI

KICHYROS, *see* EPHYRA

KIDRON Israel. Map 6. A valley in Jerusalem, to the E of the Temple Mount, also known by the name of the Valley of Joshaphat. In the lower course of the valley several monumental tombs were carved from rock in the Late Hellenistic and the Early Roman periods. The earliest in this group is the Tomb of the Priests of the House of Hezir, a family of priests known also from the scriptures. It has a Doric porch which rests on two freestanding columns and two attached pilasters, behind which is the rock-cut burial cave. It is dated by the funerary inscription to the end of the 2d c. B.C. To the S of this tomb is the monolithic monument, the so-called Tomb of Zechariah, in the form of a cube decorated by Ionic attached columns and corner pilasters, and surmounted by an Egyptian cornice with a pyramid above. No burial cave connected with this monument has been discovered. The northernmost monument, the most elaborate, is the so-called Tomb of Absalom. It consists of an Ionic cube decorated by a Doric frieze and an Egyptian cornice set on a podium. Above the cornice is a square base for the built part of the monument, which is otherwise cut out of the rock. This square base supports a steep-sided cone. The monument is 22.5 m high and contains a small burial chamber, probably for the fathers of a noble family, the

remaining members of which were buried in a nearby burial cave, the so-called Cave of Joshaphat. The gable above the portal of this cave is decorated with an acanthus scroll. The three monuments last mentioned are dated to Herodian times.

BIBLIOGRAPHY. K. Galling, "Die Nekropole von Jerusalem," *Palästinajahrbuch* (1936) 73-101; N. Avigad, *IEJ* 1 (1950-51) 96-106; id., *The Ancient Monuments of the Kidron Valley* (1954). (In Hebrew.)　　A. NEGEV

KILINÇLI, *see* APOLLONIA (Lycia)

KIMMERIKON Bosporus. Map 5. Greek city 50 km S of Kerch, founded in the 6th c. B.C. by Greek colonists from Miletos (Hekataios 1.164; Strab. 11.2.5).

The city is situated on the SW slope of Mt. Opuk along the coast of the Black Sea, where there was a Cimmerian settlement before the arrival of the Greeks. Traces of houses, rectangular in plan, have been found dating from the 6th-5th c. B.C. Ionian ware and amphorae from Chios were found inside them, together with local hand-thrown wares. In the 4th c. B.C. the city was ringed with fortifications and became an important fortress in the defense system of the Bosporan kingdom against the Scythians. The city walls are 2.5 m thick, those of the acropolis, 3.5 m. The city reached its height in the 1st-2d c. A.D. when the walls were enlarged and the houses built of stone. Toward the end of the 3d c. A.D. the city was destroyed by fire. The Kerch Museum contains material from the site.

BIBLIOGRAPHY. I. T. Kruglikova, "Raskopki drevnego Kimmerika," *Arkheologiia i istoriia Bospora*, I (1952) 55-73; id., "Kimmerik v svete arkheologicheskikh issledovanii 1947-1951 gg.," *Bosporskie goroda*, II [Materialy i issledovaniia po arkheologii SSSR, No. 85] (1958) 219-53; A. L. Mongait, *Archaeology in the USSR*, tr. M. W. Thompson (1961) 197-98; E. Belin de Ballu, *L'Histoire des Colonies grecques du Littoral nord de la Mer Noire* (1965) 127-28.　　M. L. BERNHARD & Z. SZTETYŁŁO

KIMOLOS Cyclades, Greece. Map 9. A small island of volcanic origin in the S Aegean, separated by a narrow channel from the island of Melos to the S. In antiquity Kimolos was best known as a source of kaolin (ἡ Κιμωλία γῆ), a fine white clay still quarried as a component of porcelain and for other commercial uses.

Very little is known about the history of the island. Limited archaeological exploration has indicated that it was inhabited during the Bronze Age. After the fall of the Mycenaean civilization the island—along with its neighbor Melos and other islands of the S Aegean—came to be occupied by Doric-speaking Greeks, and it is likely that its early history was closely connected with that of Melos. As Dorian islands, Kimolos and Melos were not members of the Delian Confederacy and, therefore, not tributary to Athens. As a result of the fall of Melos to Athens in 416-415 B.C. (Thuc. 5.84ff), Kimolos seems to have achieved (perhaps by the early 4th c. at the latest) a certain independence. But, at least by the last half of the 3d c., it—along with many of the other Aegean islands—came under the influence of the Macedonian kings. Thereafter its history is unknown.

Archaeological exploration and excavation have indicated that the ancient town lay on the SW coast of the island, in an area known today as Ellinika (Limni). Here a large cemetery of Late Mycenaean, Early Iron Age, Classical, and Hellenistic times has been found. Of special interest was the discovery of some 20 cremation burials containing over 200 vases of the 9th and 8th c. B.C., one of the richest collections of Geometric pottery

from the Aegean islands. The site has been partially submerged owing to a change of sea level since antiquity. Walls and other indications of ancient habitation can be seen in the shallow water along the shore as well as on the offshore islet of Haghios Andreas (Daskalio), which was once part of the mainland. It is possible that Haghios Andreas was the site of the Sanctuary of Athena, apparently the principal religious center of Kimolos, at least during Hellenistic times. Evidence of ancient and mediaeval (or later) occupation has also been noted on the height of Palaiokastri, located N and E of Ellinika.

BIBLIOGRAPHY. A. Miliarkis, Ὑπομνήματα Περιγραφικὰ τῶν Κυκλάδων Νήσων κατὰ μέρος: Κίμωλος (1901)[M]; "Archaeology in Greece, 1953," JHS 74 (1954) 165; C. Mustakas, "Kimolos," AthMitt (1954-1955)[M]; Κίμωλος, Deltion 20 (1965) Chronika 514-15; T. W. Jacobsen & P. M. Smith, "Two Kimolian Dikast Decrees from Geraistos in Euboia," Hesperia 37 (1968).

T. W. JACOBSEN

KINDYA (Sığırtmaç) Turkey. Map 7. Town in Caria 20 km SW of Milâs. It was of some importance in the 5th c., when it paid one talent in the Delian Confederacy, but later, apparently in the 3d c., was absorbed into Bargylia. Herodotos (5.118) mentions a Pixodaros, son of Mausolos of Kindya, presumably an ancestor of the Hekatomnids. Strabo (658) speaks of it as no longer existing. The city was chiefly notable for its principal deity, Artemis Kindyas, whose temple was believed to be immune from rainfall; she later became a chief deity of Bargylia.

The ruins are on a steep hill above the village. The city wall enclosed an area some 450 by 200 m, but large stretches of it are now destroyed. On the crest is a citadel ca. 120 m long in dry rubble masonry, with a gate at the NW end and a smaller fortification at the SE end. Traces of ancient buildings extend some distance down the SW slope. Surface pottery includes sherds of 4th c. date, but nothing recognizably later.

The site of the temple has been determined by inscriptions and architectural fragments at a spot near the village of Kemikler some 2 km to the NE, but virtually nothing is now to be seen above ground.

BIBLIOGRAPHY. W. R. Paton & J. Myres, JHS 16 (1896) 196; A. & T. Akarca, Milâs (1954) 165-66; G. E. Bean & J. M. Cook, BSA 52 (1957) 97-99; G. E. Bean, Turkey beyond the Maeander (1971) 82-83. G. E. BEAN

KINGSWESTON Bristol, England. Map 24. Near Avonmouth, ca. 7.2 km from the city center. Substantial remains of the moderate-sized, stone, late 3d c. Roman villa were excavated in 1948-50. The finds are in the City Museum, Bristol.

The site, at the landward edge of the alluvial plain of the Severn, with a steep limestone ridge rising to the S, is ca. 2.4 km from the small town of Abone (Sea Mills), which probably served as the market of the villa. Three or four buildings and scattered occupation E and W of the site perhaps mark tenant farms. The villa probably originated in the 2d c.; remains (now covered) immediately W of the visible building are incompletely known, but were used as farm buildings in the 4th c.

The main block of the house was destroyed when a new road was built, leaving an E and W wing (each ca. 15 x 6 m) connected by a colonnade (later an arcade) containing the central main entrance and looking N on a courtyard (ca. 16.5 x 7.5 m). Flanking the W wing is a small bath suite of four rooms and lobby. The baths and wing rooms had geometric mosaics: two in the baths and one in the W wing are preserved under a roof,

but another in the W wing belonged to a villa excavated at Brislington, Bristol, in 1899. The inserted composite hypocaust in the E wing is a good example; in it the skeleton of a man slain in Post-Roman times was discovered. The monolithic thresholds of several rooms, grooved for stone jambs, are noteworthy, as are fragments of chip-carved side tables preserved with other Bath stone material on the site.

BIBLIOGRAPHY. G. C. Boon, excavation report, Trans. Bristol and Gloucestershire Arch. Soc. 69 (1950) 5-58[PI]; guidebook, id., Kings Weston Roman Villa (1967)[PI].

G. C. BOON

KIONIA, see TINOS

KIRKBUDDO Angus, Scotland. Map 24. A Roman marching camp 6 km SE of Forfar. Still visible in part, it measured ca. 705 by 330 m, and belongs to a group of camps ca. 25 ha in extent which have recently been assigned to the early Severan campaigns in N Britain. It is, however, more elongated than the other members of the series. All the six gates were protected by titula, and a small structure was attached externally at the SE angle.

BIBLIOGRAPHY. O.G.S. Crawford, Topography of Roman Scotland (1949) 97-100; JRS 59 (1969) 116-18.

K. A. STEER

KIRKBY THORE, see BRAVONIACUM

KIRKINTILLOCH, see ANTONINE WALL

KIRRHA (Xeropigadi) Phokis, Greece. Map 11. The port city of Delphi, confused even in antiquity with Krisa, leading to speculation in modern times as to whether there were indeed two separate cities. Krisa was known to Homer and Pindar; it has been identified with fortification walls at Haghios Georgios on a mountain spur near modern Chryso, several km from the sea. Pindar locates the hippodrome, also seen by Pausanias, at the foot of the acropolis; although he refers to the Kirrhan Games, the plain and gulf continued to take their names from Krisa. Since excavation it has been concluded that Haghios Georgios was occupied only in the prehistoric period, except for small sanctuaries indicated, for example, by a double altar with an archaic dedication to Hera and Athena. Kirrha is known to have thrived in the 7th c. B.C., levying tolls on pilgrims to Delphi until the city was destroyed by the Amphictyonic League in the First Sacred War about 600 B.C. The site of the archaic city has not been located; it was probably close to the shore between the modern towns of Itea and Kirrha (formerly Xeropigadi) to the E. Excavations at Kirrha produced nothing earlier than the second quarter of the 6th c., when the necessity for a port presumably resulted in the rebuilding of the town. At Magoula, on the N or landward side of Kirrha, excavations produced material from early prehistoric periods as well as remains of the 4th c. wall. A large sanctuary, surrounded by colonnades providing accommodations for pilgrims, may be the Temple Precinct of Apollo, Artemis, and Leto seen by Pausanias at Kirrha. Various naval buildings and Roman baths have been discovered near the sea.

BIBLIOGRAPHY. Pind. Pyth. 10.15, 11.12; Paus. 10.37.4; J. Jannoray in BCH 61 (1937) 33f[MP], 457f[I]; L. Lerat in RA, sér. 6.31-32 (1948) 621-32. M. H. MC ALLISTER

KIRYAT ARBAH, see HEBRON

KISAMOS (Kalami) Apokoronas district, Crete. Map 11. The existence of two cities of this name on the N coast of Crete on either side of Kydonia is proved by

the *Peutinger Table*, which mentions both and puts this one 8 miles E of Kydonia. This one must be the Kisamos referred to by Strabo (10.4.13) as the harbor of Aptera. Although it is usually located at or close to Kalyves, 4.5 km E-SE of Aptera, where Roman and later sherds have been found, a strong case has now been made for locating it at Kalami, on the coast by the former Fort Izzedin, immediately below Aptera and just inside (W of) the now sunken *porporella* (the Venetian harbor defense mole). Kalami is 8 miles (12.8 km) from Kydonia, nearer to Aptera than Kalyves and more sheltered, and has house foundations, traces of quays, and Classical as well as Roman sherds. A dependency of Aptera, the city had no history of its own. (The Kalyves site may be ancient Tanos.)

BIBLIOGRAPHY. R. Pashley, *Travels in Crete* I (1837; repr. 1970) 48-49, 54-55; Bürchner, "Kisamos (2)," *RE* XI (1922) 516; M. Guarducci, *RivFC* (NS) 14 (1936) 158-62; J.D.S. Pendlebury, *Archaeology of Crete* (1939) 21-22; M. Guarducci, *ICr* II (1939) 9-11; P. Faure, *KretChron* 13 (1959) 184, 201; id., *BCH* 84 (1960) 206-9; id., *KretChron* 17 (1963) 24; S. G. Spanakis, *Kriti* II (n.d.) 190, 192-93 (in Greek); Brit. Adm. Chart, 1658.

D. J. BLACKMAN

KISAMOS (Kastelli Kisamou) Kisamos district, Crete. Map 11. Harbor town on the rich alluvial plain (Nonnus 13.237) at the head of the Gulf of Kisamos (ancient Myrtilos). The port of Polyrrhenia, 5.6 km inland to the S, Kisamos probably became an independent city only in the 3d c. A.D., when it gradually superseded Polyrrhenia (not mentioned thereafter). The town probably benefited most from proximity to the flourishing Diktynnaion sanctuary, from exploiting the rich plain, and from continuing trade. It was the only see in the area: bishops are attested from 342-43 to the 9th c.

The town is not mentioned before Pliny (*HN* 4.12.59) and is referred to only in geographical sources (e.g. *Stad*. 339: a city on the gulf, with harbor and water), Hierokles (650.13), records of Ecumenical Councils and the *Notitiae Dignitatum*. No coins are known (those once attributed to Kisamos belong to Tenos); a number of inscriptions have been found, mostly Christian epitaphs of the 3d-6th c.

Ancient remains, almost entirely of the Roman period, have been found under the modern settlement or reused in its walls or in the castle. A number of wall remains, mainly of brick and rubble and mortar, architectural members, and mosaic floors were seen by 19th c. travelers S and W of the castle and village; part of the aqueduct was just visible above the ground. Buondelmonti (1422) reported seeing the city walls (now disappeared), a stone bridge, a fountain, and remains of a "huge palace with columns and marble slabs." Onorio Belli (1586) reported ruined remains of a theater and amphitheater, and more remains of one of these seem to have been found in 1862. Recent excavations have revealed parts of a fine bath complex with marble floors and revetments; part of the aqueduct (coming from Krya Vrysi 2 km SW of the town) and of the main city drain; part of the theater complex; a house of the later 3d c. with 15 rooms, including two with mosaic floors of a quality hardly paralleled in Crete, and evidence of reoccupation in the 4th-5th c.; another house with mosaics and a similar history.

West of the town on a small bay (Mavros Molos) lies the ancient harbor, protected by a short rubble breakwater on the E and a longer one with a right-angle turn on the W and N. Because of coastal uplift (of just over 5 m since antiquity) much of the harbor is now dry land; and because of this uplift and the resulting coastal ac-

cretion, the shoreline to the E is well N of the ancient site. West of the harbor, Pococke (1745) saw foundations of large buildings, possibly warehouses.

Remains of the archaic to Hellenistic periods are scanty, and it has been suggested that the main settlement (apart from the actual port) was then some distance to the W at Selli above Cape Nisi where Theophanidis found an LM III shrine and where a house of the Classical period and walls are visible. The site at Selli has also been identified as Korykos, Elaea, and Agneion.

BIBLIOGRAPHY. R. Pashley, *Travels in Crete* (1837; repr. 1970) I.54-55, II.43-44; T.A.B. Spratt, *Travels and Researches in Crete* II (1865) 216-19; L. Savignoni, *MonAnt* 11 (1901) 304-14; Bürchner, "Kisamos (1)," *RE* XI (1922) 516; M. Guarducci, *ICr* II (1939) 94-101; V. D. Theophanidis, *ArchEph* 81-83 (1942-44) *Chronika* 1-17; E. Kirsten, "Polyrrhenia," *RE* XXI (1952) 2535-38, 2544-45; P. Faure, *KretChron* 13 (1959) 182, 184n, 201, 212; 17 (1963) 25; K. Davaras, *Deltion* 22 (1967) *Chronika* 2, 498-99; J. Tzedakis, *Deltion* 23 (1968) *Chronika* 2, 416-17; 24 (1969) *Chronika* 2, 431-32; 25 (1970) *Chronika* 2, 471P; S. G. Spanakis, *Kriti* II (n.d.) 209-14 (in Greek)M.

D. J. BLACKMAN

KIŞLA, *see* ISINDA

KISTENE, *see* MEGISTE

KITAION Bosporus. Map 5. A Greek city on the N coast of the Black Sea 40 km SW of Kerch near Zavetnoe. It probably dates to the 4th-5th c. B.C. (Ps. Skyl., 10.68; Plin. *HN* 4.86).

In the 4th-3d c. the city was surrounded by walls 2.5 m thick and these were reinforced in the Roman period by a second circle of ramparts. The city was a fort of major importance against the Scythian nomadic tribes. On the outskirts is a kurgan necropolis belonging to the Hellenized Scythians who inhabited the city. Another necropolis from the Roman period (2d-3d c.) contains tombs decorated with frescos representing warriors, teams of horses, and ships. Particularly noteworthy are a sundial of the 2d c. A.D. with a relief of a bull's head in the center (Kerch Museum); from the 3d c. A.D. an offering table of stone with a Greek inscription containing a reference to a temple; and several other Greek funerary inscriptions with non-Greek names. The Hermitage and Kerch museums contain material from the site.

BIBLIOGRAPHY. Iu. Iu. Marti, "Raskopki gorodishcha Kiteia v 1928 g.," *Izvestiia Tavricheskogo obshchestva istorii, arkheologii i etnografii* 3 (1929) 116-30; V. F. Gaidukevich, "Sklepy nekropolia Kiteia," *Nekropoli Bosporskikh gorodov* [Materialy i issledovaniia po arkheologii SSSR, No. 69] (1959) 223-38; N. S. Belova, "Arkheologicheskie razvedki v Kitee," *KSIA* 83 (1961) 83-90; A. L. Mongait, *Archaeology in the USSR*, tr. M. W. Thompson (1961) 197; S. S. Bessonova & E. A. Molev, "Raskopki Kiteia," *Arkheologicheskie Otkrytiia 1972 goda* 258.

M. L. BERNHARD & Z. SZTETYŁŁO

KITION (Larnaca) Cyprus. Map 6. The ruins cover a large area now occupied by the modern town. The city site, on the S coast, is situated on a hill sloping gently S. The acropolis is NE of the city, but unfortunately very little of it survives. The port lay on the E side below the acropolis. At this end the sea penetrated inland and reached the foot of the acropolis and then turned a little to the S. This inlet formed a natural harbor, the enclosed harbor of Strabo. All this is now silted up and the present coast line is ca. one-half km away. Traces of the city wall and of the moat, which fol-

lowed the edge of the plateau, are still visible, particularly on the W side. A vast necropolis extends N, W, and S. The tombs date from the Early Bronze Age to Graeco-Roman times.

The city was founded, according to archaeological evidence, in the Late Bronze Age but the site was already occupied in the Early Bronze Age. Recent excavations have shown that the founders were Mycenaeans coming from the Peloponnese. The Phoenicians arrived at Kition at the end of the 9th c. B.C. at first as traders during their expansion to the W, and later as settlers; yet the vast population of the city must have remained Greek, as the archaeological evidence testifies. Later, however, with the help of the Persians, the Phoenicians established a dynasty which ruled the city in the 5th and 4th c. B.C.

There is no positive evidence as to the earlier kings of Kition but a memorial stele of Sargon II, erected here in 709 B.C., mentions that the Cypriot kings submitted to the Assyrian king and paid him tribute. The inscription mentions seven kings of Ya, a district of Yatnana, which seems to be the cuneiform rendering of "the isles of the Danai," i.e. the land of Greeks. Therefore the king of Kition, where the stele was found, must have been at that time a Greek. Unfortunately the names of the kings are not mentioned. The Greek rulers must have remained in power down to the very end of the 6th c. B.C. for at the time of the Ionian Revolt (499-498 B.C.) Kition joined the revolt against Persia.

The failure of the revolt and the support which the Persians gave the Phoenicians, especially after the battles of Marathon and Salamis, soon brought them to power. In the year 479 a Phoenician dynasty had been established, which ruled Kition until it fell to Ptolemy I Soter in 312 B.C. The Phoenician dynasty, however, was broken for a short period in 388-387 B.C. by the installation at Kition of King Demonikos at the time when most of Cyprus was liberated by King Euagoras I of Salamis with the help of the Athenian general Chabrias.

Kition was the birthplace of Zeno, the Stoic philosopher and of the physician Artemidoros. From a metrical epitaph of the 2d c. A.D. we learn that Kilikas, a native of Kition, was a teacher of the Homeric poems. According to other epigraphical evidence quinquennial games were held at Kition in Graeco-Roman times.

Systematic excavations were conducted in 1894, when a number of tombs and a sanctuary were investigated. Later, in 1913, the Bamboula hill, i.e., the acropolis, was explored. In 1930, on the same acropolis, the Temple of Herakles-Melkart was excavated. And since 1959 excavations in the N extremity of the town have been carried out. Most of the ruins, however, remain unexcavated and the task of exploring them is a very difficult one because the modern town is built over them.

The principal monuments uncovered to the present time include, in addition to those mentioned above, part of the fortifications of the Mycenaean city and a large Phoenician temple in the N part of the city. The city wall of the Classical period can be traced for most of its course, particularly on the W side, and the site is known of the ancient harbor, now silted up. The site of the Hellenistic gymnasium and that of the Temple of Artemis Paralia is also known, while the site of a theater may be conjectured. A Temple of Aphrodite-Astarte may have stood on the acropolis side by side with that of Herakles-Melkart. And from inscriptions we know of the worship of Zeus-Keraunios, Asklepios and Hygeia, Aphrodite, Esmun-Adonis, Baal Senator, and Esmun Melkart, the last by the Salt Lake.

Substantial remains of the city wall of Mycenaean Kition, later of Classical Kition as well, can be seen on the N extremity of the ancient town. Houses of the Geometric period were built in this part of the city above the Mycenaean remains and follow the architecture of the previous period, for in most cases the older foundations were reused. The Temple to Astarte was built towards the end of the 9th c. on the foundations of an earlier Mycenaean temple which had fallen into disuse ca. 1000 B.C. when this part of the Mycenaean town was abandoned. It is an imposing rectangular building measuring 35 x 22 m. The walls were constructed of large ashlar blocks, some of them measuring as much as 3.50 m in width and 1.50 m in height. Two parallel rows of columns, six in each row, supported the roof of the temple. The adyton stood at the W side and in front there is a large courtyard with two entrances. Four rows of wooden columns, of which only the stone bases survive, supported the roof of the porticos on each side of the courtyard. The temple suffered many changes—four successive floors were recognized—during the five centuries of its life until its final destruction in the year 312 B.C., when Ptolemy I Soter put to death Pumiathon, the last Phoenician king of Kition, and burned the Phoenician temples of the town.

A bath establishment of the Hellenistic period was recently uncovered at Chrysopolitissa. It consisted of two tholoi within which were a series of cemented basins around the hall. One of the rooms was circular with a column in its center; the other was rectangular. Nearby was found a mosaic floor of the Graeco-Roman period, composed of geometric and floral patterns in black and white.

Four built tombs (archaic) can be seen in the W necropolis of Kition. The tomb of Haghia Phaneromeni contains two chambers, one behind the other. The outer chamber is rectangular in shape; the interior, square with one corner rounded. The roofs of both the chambers are vaulted, and are formed by huge blocks hollowed out and covering the whole width of the chambers. The so-called Cobham's tomb contained three chambers entered by a dromos leading down to them. The first chamber had a very fine coffered ceiling, the second and third were provided with barrel roofs with real vaults. The third room was quite small, more or less a recessed space to contain the sarcophagus. The walls between the chambers were provided with moldings in the shape of pilaster capitals on both sides of the doorways. Close by is the Evangelis Tomb, which was damaged in late times. It may originally have had a similar plan to the Phaneromeni Tomb, with a dromos leading down to a large rectangular chamber with a second one behind. Both chambers had corbel vaults and were constructed of large, well-dressed blocks.

The finds are in the Nicosia and Larnaca Museums.

BIBLIOGRAPHY. Luigi Palma di Cesnola, *Cyprus, its Ancient Cities, Tombs and Temples* (1877); A. Sakellarios, Τὰ Κυπριακά I (1890); John L. Myres, "Excavations in Cyprus 1894: Larnaca," *JHS* 17 (1897), 152-73[I]; id., "Excavations in Cyprus 1913: The Bamboula Hill at Larnaca," *BSA* 41 (1940-45) 85-69[PI]; I. K. Peristianes, Γενικὴ Ἱστορία τῆς νήσου Κύπρου (1910); V. Karageorghis, "Fouilles de Kition 1959: Etudes sur les origines de la ville," *BCH* 84 (1960), 504-88[MPI]; id., "Chronique des fouilles et découvertes archéologiques à Chypre," *BCH* 84 (1960), 283-86[I]; 90 (1966), 362-65[PI]; 91 (1967) 315-24[I]; 92 (1968) 302-11[PI]; 93 (1969) 517-27[PI]; 94 (1970) 251-58[PI]; 95 (1971) 377-90[PI]; 96 (1972) 1058-64[PI]; 97 (1973) 648-53[I]; id., "New Light on the History of Ancient Kition," *Mélanges K. Michalowski* (1966) 495-504[I]; K. Nicolaou, Κίτιον Ἑλληνὶς *Kypriakai Spoudai* 15 (1961) 19-39[MI]; id., "Archaeological News from Cyprus 1966," *AJA* 71 (1967) 401; 72 (1968)

374-75; 74 (1970) 73, 393-94; 76 (1972) 313-14; 77 (1973) 53-54, 427. K. NICOLAOU

KIYI KIŞLACIK, *see* IASOS

KIZILKAYA, *see* OKTAPOLIS

KIZILTEPE Turkey. Map 7. A fortified site on the hill of this name in Caria, ca. 1.6 km SW of Kaunos. It is possible that this was the site that appears in the Athenian tribute lists as Karbasyanda by Kaunos, with a tribute of one-sixth of a talent; in the inscriptions of Kaunos the name is spelt with a pi. It is not otherwise mentioned. For a time in the Hellenistic period it was a deme of Kaunos. There is no direct evidence for placing it at Kızıltepe.

BIBLIOGRAPHY. G. E. Bean, *JHS* 63 (1953) 15, 21, 24; P. Roos, *Opuscula Atheniensia* 9 (1969) 61-62.

 G. E. BEAN

KLAZOMENAI (Klazümen) Ionia, Turkey. Map 7. At the scala of Urla, 36 km W of Izmir. (The modern name has only lately been in use; the ancient name survived until recently 9 km to the E at the village of Kilisman, now Kızılbahce.) The main site, though not the original site, is on a small island joined to the mainland by a causeway. Pausanias (3.8.9) records that a band of Ionian settlers built a city on the mainland, but later they crossed to the island from fear of the Persians. From the sherds found on the site it appears that this move came not after the fall of Sardis in 546 but rather at the time of the Ionian Revolt. The city remained in Persian hands until the formation of the Delian Confederacy. By the King's Peace of 386 B.C. all the cities of Asia were surrendered to the Persians, and "of the islands Cyprus and Klazomenai." Persian rule ended with Alexander, who displayed some interest in the city. By the treaty of Apamea in 188 B.C. Klazomenai was granted immunity by the Romans. At the end of the first Mithridatic War, about 84 B.C., Klazomenai is mentioned by Appian (*Mithr.* 63) together with other cities as having been sacked by pirates "in Sulla's presence." Klazomenian coinage began (apparently) in the 6th c. B.C. and continued to Gallienus; standard types are the winged boar and the swan.

The most distinguished citizens of Klazomenai were the philosophers Anaxagoras and Scopelianus.

Not much remains of the city today, and of the original mainland site virtually nothing apart from the well-known sarcophagi of painted terracotta which have been found over a wide area near the coast, but not on the island. The causeway survives alongside its modern replacement, but normally only a few blocks are visible above water. On the island the ring wall stands only for a short stretch at the N end; the masonry is ashlar, the blocks on the small side. There are some remains of a harbor on the W shore, and the emplacement of a theater facing N. Near the SW corner is a cave comprising four chambers, most of which has now collapsed; it contains a well, and may be the "cave of Pyrrhos' mother" referred to by Pausanias (7.5.11).

BIBLIOGRAPHY. J. M. Cook in *ArchEph* (1953-54)ᴹ; G. E. Bean, *Aegean Turkey* (1967) 128-36. G. E. BEAN

KLAZÜMEN, *see* KLAZOMENAI

KLEIN WAGNA, *see* FLAVIA SOLVA

KLEITOR (Kato Klitoria) Arkadia, Greece. Map 9. This was the first city in Arkadia to produce coins, the mint being active from ca. 500 to 460 B.C. The site has been identified with ancient remains at the point where the Kleitor River joins the Karnesi. The acropolis wall is double-faced of bulging, roughly quadrangular blocks, and is strengthened with semicircular towers. There are remains of more walls and towers in the plain on the N and W; the other sides are bounded by the two streams. The cavea of a theater is preserved on the W slope of the acropolis. Pausanias saw Sanctuaries of Demeter, Asklepios, and Eileithya at Kleitor, which Curtius and Leake identified at three locations occupied by churches built with ancient blocks. West of the city, the foundations of a large building with columns may belong to Pausanias' Temple of the Dioskouroi. The Temple of Athena Koria he described as on the top of a mountain 30 stades (5.77 km) distant: it probably lay to the N.

The relief of the soldier-historian Polybios found at Kleitor has been separated from its inscription and is now less well preserved than a cast in the Berlin Museum.

BIBLIOGRAPHY. Paus. 5.23.7, 8.4.5, 8.18.8, 8.21.1; Polyb. *Hist.* 4.288; Vitr. 8.3.21; E. Dodwell, *A Classical and Topographical Tour through Greece* II (1819) 447f; W. M. Leake, *Morea* (1830) II 257fᴾ; E. Curtius, *Peloponnesos* (1851-52) I 377; J. G. Frazer, *Paus. Des. Gr.* (1898) IV 266; R. T. Williams, *The Confederate Coinage of the Arcadians* (1965). Sculpture: H. Mobius in *JdI* 49 (1934) 52fᴵ; M. Bieber, *Sculpture of the Hellenistic Age* (1955) 161f. M. H. MC ALLISTER

KLEONAI Chalkidike, Greece. Map 9. A city on the peninsula of Akte whose exact location is not known. It is likely, however, that it lay on the S coast near the monastery of Xiropotami. According to Herakleides (*FHG* II p. 222, fr. 31) it was founded by the Chalkideans. The city makes its first appearance in the Athenian Tribute Lists in 434-433 (*ATL* I 464).

Historically, little is known of the activities of the city as it seems to have been dominated by its more powerful neighbors, either Dion or Thyssos. During the first years of the Peloponnesian War Kleonai was on the side of the Athenians but shifted alliance to Brasidas in the winter of 424-423 (Thuc. 4.109). It was apparently regained for Athens by Kleon. Its loss in power and significance is indicated by the sharp drop in tribute from 500 drachmai (from 434-433 to 429-428) to only 100 in the year 421. After 421 the only references to Kleonai are geographical.

No excavations have been carried out in the area and archaeological exploration is not permitted on the peninsula now occupied by the monasteries of Mount Athos. Ancient sources, however, clearly place it on the Akte peninsula (Hdt. 7.22; Strab. 7.331, fr. 33, 35; Scyl. 66; Mela 2, 30; Plin. *HN* 4.37) and from the order of listing of sites in the area it is likely that it lay on the S coast. Although there are no extant remains which would conclusively fix its position, Demitsas' report of certain remains of ancient construction near the monastery of Xiropotami suggest that area as a possible site.

BIBLIOGRAPHY. W. M. Leake, *Nor. Gr.* (1835) II 149-52; M. Demitsas, Ἡ Μακεδονία (1896) 619; E. Oberhummer, "Kleonai," *RE* XI (1921) 729; M. Zahrnt, *Olynth und die Chalkidier* (1971) 194. S. G. MILLER

KLIMA, *see* MELOS

KLIMATIA, *see* LIMES, GREEK EPEIROS

KLOKOTO, *see* PHARKADON

KLOS ("Amantia") Albania. Map 9. On the right bank of the lower Aous, a steep-sided hill is fortified with a circuit wall ca. 1900 m long. An ancient road enters the city between two towers of ashlar masonry and foundations of houses are visible inside. Some magistrates of the city are named on an inscribed block in a house of the modern village. Religious and funerary reliefs of Hellenistic and Roman times come from the site. Literary evidence suggests that it was Amantia, the chief city of the Amantes, who issued coins.

BIBLIOGRAPHY. C. Patsch, "Das Sandschak Berat in Albanien," *Schriften der Balkankommission, Antiquarische Abteilung*, III (1904) 118ff; C. Praschniker, "Muzakhia und Malakastra," *JOAI* 21-22 (1922-24) Beiblatt 84ff; P. C. Sestieri in *Rivista d'Albania* 4.197; N.G.L. Hammond, *Epirus* (1967) 224f, 233ff, 698ff.

N.G.L. HAMMOND

KLOSTERNEUBURG, *see* LIMES PANNONIAE

KNEŽEVI, *see* LIMES PANNONIAE (Yugoslav Sector)

KNIDOS (Cnidus) Caria, Turkey. Map 7. On the SW coast opposite Nisiros and Telos. The three cities of Rhodes—Lindos, Kamiros, and Ialysos—together with Kos, Halikarnassos and Knidos formed the Dorian Hexapolis. Every four years the Dorian federation met at Knidos to celebrate the Dorian Games. According to Herodotos, Knidos was colonized by Lakedaimonians, but Diodoros mentions an earlier settlement by Triopas. The main objects and ruins uncovered so far date from at least the 7th c. B.C. to the 7th c. A.D. when the city was abandoned. Strabo describes Knidos as a double city consisting of an island, the main residential section, which was joined to the mainland by moles. Two harbors were thus created, a commercial one, and a smaller naval harbor capable of berthing 20 triremes. The city was eventually laid out on a grid plan both on the island and mainland sections. The latter was divided by seven main N-S stepped streets which intersected four main E-W streets at right angles.

To the E of the street farthest E remains of a Hellenistic house have been excavated. Fragments of handsome figured wall paintings and architectural stuccos imitating Doric, Ionic, and Corinthian orders, which once decorated the upper story, were recovered. To the N of the Hellenistic house are a number of rooms of a large Roman house. To the SE of this complex a small structure, formerly called an Odeion, has been re-excavated; this roofed building with a colonnade probably served as a bouleuterion. A partially excavated, well-preserved theater, originally constructed during the Hellenistic period with restorations, modifications, and additions, such as the stage buildings during the Roman period, lies to the E of stepped street 3. To the W of this street is a large 5th c. Byzantine church built on top of and reusing materials of an Ionic temple. On a terrace above this monument are the remains of a small tetrastyle prostyle distyle in antis Hadrianic Corinthian temple. An imposing Doric stoa, perhaps the ambulatio pensilis designed by Sostratos, lies to the S. South of this is a well-preserved monumental Byzantine church. Its aisles and narthex were decorated with mosaics. To the W of stepped street 1 and N of the trireme harbor is the agora and a small Byzantine church. To the N is a Doric temple dedicated to Apollo Karneios. This may have been the site where the ceremonies of the Dorian Games were celebrated. A stadium lies outside the W city wall. A junction between stepped street 1 and the main E-W street has been uncovered; here the E-W street termi-

nated at an Ionic building, which may have served as a propylon.

High on the terrace farthest W is the sanctuary of Aphrodite Euploia. Her gardens, described by Pseudo-Lucian, probably lay to the E of the temenos. The famous cult statue by Praxiteles stood in the center of a handsome marble monopteros facing her altar to the E. To the W are a well-preserved treasury, an altar to Athena, and a rectangular shrine. To the NW is a complex of rooms, at least two-storied, of the Byzantine period, residential in character. To the S on an intermediate terrace is a theatron which may be associated with a monumental marble altar below and a large Roman building to the W. Perhaps this area was used for the celebration of mystery rites in honor of Aphrodite and/or Adonis, or even of Demeter. The Temenos of Demeter is located high on the terrace farthest E of the city. Immediately to the E of the city walls is the necropolis extending some 10 km. It has produced a variety of sarcophagi, altars and tombs (rock-cut, temenos, and chamber). The astronomical observatory of Eudoxos and the medical school have not yet been located. The objects excavated since 1967 are in the museums of Izmir and Bodrum.

BIBLIOGRAPHY. Society of Dilettanti, *Antiquities of Ionia* III 2ff, v 23ff; Sir C. Newton, *A History of Discoveries at Halicarnassus, Cnidus, and Branchidae* II (1865); E. Akurgal, *Ancient Civilizations and Ruins in Turkey* (2d ed. 1970) 252-53; I. C. Love, Preliminary Reports of the Excavations at Knidos, 1969-1971: *AJA* 74 (1970) 149-55, *AJA* 76 (1972) 61-76, *AJA* 76 (1972) 393-405. Plin. *HN* 36.12.18; Lucian *Hist. conser.* 62.

IRIS LOVE

KNIDOS Cyprus. Map 6. The ruins of a small Hellenistic and Graeco-Roman town on Cape Elaia, due S of the village of Haghios Theodoros in the Karpass peninsula, have been identified with Knidos. The identification comes from a funeral inscription, which gives the name of Symmachos, captain of a trireme, from Knidos. Tzetzes (*Chil.* 1.84) says that the physician Ktesias came from the Cyprian Knidos; Suidas calls the same physician a Knidian but without specifying to which town of that name he belonged. Knidos is also mentioned by Ovid (*Met.* 10.530). The cape, on which the ruins of the town extend, is called by Ptolemy Elaia.

There are still considerable ruins of ancient buildings extending around a small bay, which may have served as an anchorage, and inland for some distance. Sakellarios in the 19th c. saw the gates of the town and traces of the N and NW town wall as well as remains of an aqueduct. In Hogarth's day there were still many traces of houses and of the town wall and in particular a small rectangular building. The ruins, however, have suffered since that time from the hands of quarrymen and the tombs have been looted. The site is still unexplored.

BIBLIOGRAPHY. D. G. Hogarth, *Devia Cypria* (1889) 65-67[I]; A. Sakellarios, Τὰ Κυπριακά (1890) 168[I].

K. NICOLAOU

KNOSSOS Temenos, Crete. Map 11. Graeco-Roman city some 5 km S of Herakleion. The site is best known for its great Minoan palace and deep Neolithic deposits, but it was a flourishing city in the Geometric and archaic periods and during the Classical and Hellenistic eras it was again the principal city of the island. In the 4th and 3d c. it was frequently at war with Lyttos, and after the destruction of Lyttos in the late 3d c. B.C., it was intermittently at war with Gortyn. The Roman invasion, which Knossos resisted, resulted in the elevation

of Gortyn to be capital of the island, but Knossos was made a colony (Colonia Julia Nobilis) in 36 B.C., and was occupied as a prosperous city continuously up to the early Byzantine period. There is some evidence for a temporary decline in the early 3d c. A.D.

The Geometric and archaic cities were situated N of the Minoan palace and settlement, and the Classical, Hellenistic, and Roman cities remained in this same area, eventually covering a little less than a square km. Little is known of the Classical and Hellenistic towns, although temples on the old palace site, on Lower Gypsades, and on or near the foot of the acropolis hill all seem to belong to the 5th or 4th c. That by the acropolis hill is known mainly from a fine metope relief showing Herakles and Eurystheus. The agora too, lying at the center of the city, was probably already sited by the Classical period.

In the Roman period the agora was flanked on the W by a large basilica, while to the S stood another public building often identified as a temple but possibly the public baths. The basilica, like much else at Knossos, may not have been built until the 2d c. A.D. Northwest of it, the remains of a small amphitheater are known, now partially overlain by the modern road. To the W of this road, and S of the amphitheater is the so-called Villa Dionysus. This is the best-known and -preserved example of the wealthier Roman town houses at Knossos, most of which are known only from fragmentary remains of walls and ill-recorded mosaics. The villa is built around a peristyle courtyard, to the W of which is a large square room with a mosaic showing the heads of Dionysus and maenads in medallions. In the SW quarter of the building is a small household shrine. Recent excavations suggest that the main period of occupation was in the 2d c. A.D. Contemporary houses of a lower quality have recently been excavated immediately N of the Minoan "Little Palace." Earlier Roman houses, built in the Neronian period, were found beneath them, and around them were stretches of the narrow paved streets which served them.

On the N edge of the city a Christian church with an E apse, nave, and two aisles was built in the late 5th or early 6th c. It was erected over an earlier cemetery which included tombs of the 2d to 4th c. A.D. Other cemeteries were situated to the W and S of the city, and both dug and built tombs have been discovered. In the S and SE slopes at the foot of the acropolis hill, rock-cut Roman chamber tombs can still be entered.

Water was supplied to the city by an aqueduct coming from the S. Finds from the site are found in the Herakleion Archaeological Museum and the Stratigraphical Museum, Knossos.

BIBLIOGRAPHY. H. G. Payne, "Archaeology in Greece, 1934-35," *JHS* 55 (1935) 164-67[I]; S. Benton, "Herakles and Eurystheus at Knossos," *JHS* 57 (1937) 38-43; M.S.F. Hood & J. Boardman, "A Hellenic Fortification Tower on the Kefala Ridge at Knossos," *BSA* 52 (1957) 224-320[I]; M.S.F. Hood, *Archaeological Survey of the Knossos Area* (1958)[M]; W. C. Frend & D. E. Johnston, "The Byzantine Basilica Church at Knossos," *BSA* 57 (1962) 186-238[PI]; J. Boardman, "Archaic Finds at Knossos," *BSA* 57 (1962) 28-35; J.V.S. Megaw, "Archaeology in Greece, 1967," *Archaeological Reports 1967-68* (1968) 21-22[I]. K. BRANIGAN

KOBLENZ, *see* AD CONFLUENTES

"KODRION," *see* RRMAIT

KOKOTI Thessaly, Greece. Map 9. An isolated hill S of Halmyros, crowned with the remains of Macedonian fortifications. The ancient name is unknown. The walls are of double construction in ashlar masonry with rubble fill, and strengthened with towers and rectangular projections. The site was inhabited in the prehistoric as well as Classical and Hellenistic periods.

BIBLIOGRAPHY. F. Stählin in *AthMitt* (1906) 33f[PI]; F. Stählin, *Das hellenische Thessalien* (1924) 135.

M. H. MC ALLISTER

KOLI VILLA, *see* COLLEVILLE

KÖLKED, *see* LIMES PANNONIAE

KÖLN, *see* COLONIA AGRIPPINENSIS

KOLOBAISĒ, *see under* PRILEP

KOLYBRASSOS (Ayasofya) Turkey. Map 6. City in Cilicia Aspera or Pamphylia, on Susuz Dağ, 20 km N of Alânya and 12 km S of Gündoğmuş, some 1000 m above sea level. The site is proved by an inscription, not yet published, in which the city names itself in honoring Trajan. This remote town is listed by Ptolemy and the *Notitiae*, though not by Hierokles, and Imperial coinage is known.

The circuit wall is well preserved only on the SW, where a stairway leads up to the city gate; the masonry is a good ashlar. Two temples are still fairly well preserved, and an odeion and exedra have been recognized. The necropolis is on the S side, with several freestanding sarcophagi and a handsome rock tomb.

BIBLIOGRAPHY. A. Albek, *Belleten* 22 (1958) 247-49; G. E. Bean & T. B. Mitford, *Journeys in Rough Cilicia in 1962 and 1963* (1965) 9-21; id., *Journeys in Rough Cilicia 1964-1968* (1970) 69-77. G. E. BEAN

KOM ABOU BELLOU, *see* TERENUTHIS

KOMAMA (Şerefönü) Turkey. Map 7. City in Pisidia near Ürkütlü, 45 km S of Burdur, which first appears in the late Hellenistic period when it issued autonomous bronze coins. It belonged no doubt to the commune Milyadum mentioned by Cicero (*Verr.* 1.95), and may have been its capital. A colony was planted by Augustus about 6 B.C., entitled Colonia Julia Augusta Prima Fida Comama. As the site is on flat ground and completely unfortified, it seems to have been intended not so much to repress the unruly Pisidians as to serve as a market town spreading Roman influence by peaceful means; it was well situated near the junction of several important thoroughfares. The colonial coinage is of the 2d and 3d c. A.D.

The surviving ruins are scanty. They lie on and around a hillock and consist merely of scattered blocks, some of which are inscribed and confirm the site. Nothing is standing. Many other cut blocks and inscriptions have been removed to neighboring villages.

BIBLIOGRAPHY. W. M. Ramsay, *AJA* 4 (1888) 263; A. Woodward, *BSA* 16 (1909) 85; G. E. Bean, *AnatSt* 10 (1960) 53-55. G. E. BEAN

KÔM AUSHIM, *see* KARANIS

KOM GIÉIF, *see* NAUKRATIS

KOMINI (Municipium S.) Yugoslavia. Map 12. In N Montenegro, near the small city of Pljevlja. It was probably an Illyrian settlement, which in the course of the 1st c. A.D. developed into a city, received municipal rights in the middle of the 2d c., and survived until the middle of the 4th c. The population included romanized natives

from the coast (Risinium) as well as immigrants from N Italy and Greek freedmen.

Excavations have been oriented mainly toward the city's two burial sites. The older one (1st-early 2d c.) is on a plateau; the other (2d-4th c.) is on the slope of the mountain underneath the original settlement, in the direction of the river Vezišnica. At the older site were found only cremation burials in clay urns, pits, or chests. The urns come from a prehistoric tradition, and the grave offerings are uniform and modest.

At the other site were found eight monumental tombs that consist for the most part of large stone blocks. They contained coffers made of stone slabs. Above each coffer was a cippus with an inscription and relief decoration. Both cremation and interment were practiced in the cemetery, even into the late 3d c. The grave types are in the prehistoric tradition, but construction and monuments are completely Roman.

The monuments are the work of local stonemasons. Most of them adopted Roman symbolism but the influence of the local Illyrian-Celtic tradition is marked.

BIBLIOGRAPHY. A. Evans, *Antiquarian Researches in Illyricum*, III-IV (1885) 6-43; A. Cermanović-Kuzmanović, "Die Ergebnisse der archäologischen Forschungen auf dem Gebiete des Municipium S. bei Pljevlja," *Actes IV, VII Congrès des archéologues yougoslaves* (1967) 77-84; id., "Le municipium S. et ses problèmes observés sous la lumière des monuments archéologiques et épigraphiques," *Starinar* 19 (1969) 101-9.

A. CERMANOVIĆ-KUZMANOVIĆ

KOM-OMBO, *see* OMBOS

KONJIC Bosnia-Hercegovina, Yugoslavia. Map 12. On the upper Neretva river ca. 50 km SW of Sarajevo.

The mixed Illyrian-Celtic population of the area had relations with the Greek Adriatic colonies in the 3d and 2d c. B.C. With the Roman occupation, the valley prospered agriculturally from the 1st c. A.D. through the 4th and supported a large population: some 19 Roman sites have been identified in the valley with Konjic as their center. Grants of citizenship were first made in the 2d c. A.D.

Konjic and its environs have been the object of intermittent archaeological investigation since the end of the 19th c. In Konjic itself a Roman necropolis and various house remains have been found, and a Mithraeum excavated. Outside the settlement the principal remains are those of villae rusticae; the most notable group of these is located near the town of Lisičići. The finds from the area are at the Zemaljski Muzej in Sarajevo.

BIBLIOGRAPHY. D. Basler, "Dolina Neretve od Konjica do Rame," *Glasnik Zemaljskog Museja u Sarajevo*, NS 10 (1955) 219-29; I. Cremosnik, "Nova antička istraživanja kod Konjica i Travnika," ibid., NS 10 (1955) 107-36; P. Andjelić, Tragovi prehistorijiskih kultura u okolini Konjica," ibid., NS 12 (1957) 277-83; E. Pašalić, *Antička naselja i komunikacije u Bosni Hercegovini* (1960); J. J. Wilkes, *Dalmatia* (1969)M. M. R. WERNER

KONKOBAR, *see* CONCOBAR

KONTICH Belgium. Map 21. A Gallo-Roman vicus on the Bavai-Asse-Antwerp-Utrecht road. This road was sectioned at Kontich in 1895 during the construction of a railroad line. At the vicus itself stray finds of pottery and various artifacts have often been noted. At least five wells have been examined. Two were made of hollowed-out oak trunks; the rest had square wooden linings. The center of the vicus was located at the locality of Kazernen, where systematic excavations have been

undertaken since 1964. An important archaeological level has been found: refuse pits, stone foundations, traces of wooden buildings, and finally the foundations of a Celto-Roman sanctuary with a nearly square cella surrounded by a peristyle (17 x 20 m). The pottery and coins indicate that the site was occupied from the middle of the 1st c. A.D. until the middle of the 3d c. A burning level indicates that the vicus was ravaged at that time. The necropolis of the vicus may have been at Blauwen Steen, where some cinerary urns, now lost, were found around 1761.

BIBLIOGRAPHY. M. Bauwens-Lesenne, *Bibliografische repertorium des oudheidkundige vondsten in de provincie Antwerpen* (1965) 87-91; F. Lauwers, "Kontich: Romense vicus," *Archeologie* (1967, 2) 53-55PI; (1969, 2) 63-64. S. J. DE LAET

KONTOPOREIA Corinthia, Greece. Map 11. One of the most important passes leading S from the Corinthia (Polyb. 16.16.4-5). Ptolemy Euergetes recorded that he drank from a spring "colder than snow" at the top of the pass although his soldiers were afraid of being frozen if they drank from it (Ptol. apud Athenaeus: *FGrH* 234 F6). The road through the pass, which connected Argolis and the Corinthia, was evidently steep in parts since the Κοντοπορεία ("staff-road") implies that a walking staff would be useful.

The Kontoporeia has been identified by most commentators as the pass of Haghionorion which leads S from ancient Tenea, but that route is in no part steep. The Kontoporeia is more likely the track that ascends a narrow gorge under the walls of the Frankish castle of Haghios Vasileios to the W of the pass of Hagionorion. At the top of the pass is the spring of Kephalari whose copious waters are cold even in midsummer. Near the spring is a polygonal tower and the ruined walls of what was probably a small military station or border post in the 5th-4th c. B.C. The route S descends from the spring to Mycenae and the Argive plain.

BIBLIOGRAPHY. Geiger, *RE* XI (1922) 1343-44, s.v. Kontoporeia; J. R. Wiseman, *The Land of the Ancient Corinthians* (forthcoming). J. R. WISEMAN

KONURALP, *see* PRUSIAS AD HYPIUM

KOPAI Boiotia, Greece. Map 11. A city on the N bank of the former Lake Kopais, now Topolia, to the NW of the Mycenaean fortress of Gla.

A small town living on the rich pasture lands of the Kopais and eel-fishing in the Melas river, Kopai made up one of the 11 Boiotian districts from 447 to 387 and 378 to 338, together with Akraiphia and Chaironeia. Thereafter it was autonomous in the Boiotian League. Its territory consisted of all the NE section of the Kopais up to Cape Phtelio at the foot of Akraiphia, where an inscription engraved in the rock marks the boundary of the two territories. At the end of the 4th c. Krates of Chalkis attempted to drive a tunnel to carry off the waters of the Kopais to the sea; the beginnings of galleries and a line of well-shafts are still extant. The hill of Kopai, broken off from the shore of the ancient lake, is linked to it by a raised causeway some 100 m long; it formed a peninsula in the dry season and an island in times of flood. Made of large stone blocks, the causeway was joined to a surrounding wall, part of which is preserved to the N. To the E of the road, Frazer saw a broken bit of wall "built of rough and rather small stones"; to the W the wall was polygonal, made of roughly bonded stones of different sizes. Nothing can be seen of it today. The acropolis, on the hilltop, was underneath the modern village; the walls of the latter con-

tain many ancient stones, architectural blocks, and inscriptions, especially the Church of the Panagia. A 6th c. B.C. relief of an Amazon and a metric epitaph of the 5th c. are in the Thebes Museum. Kopai had a Sanctuary to Demeter Tauropolos (the bull is represented on its coins), one to Dionysos, and one to Sarapis. The necropolis is N of the causeway, on the mainland side. No excavations have been carried out at Kopai.

BIBLIOGRAPHY. J. G. Frazer, *Paus. Des. Gr.* (1898) v 131-32; Geiger in *RE* (1922), s.v. Kopai & Kopais[M]; P. Roesch, *Thespies et la Confédération béotienne* (1965) 64-65[M]; S. N. Koumanoudis, *AAA* 2 (1969) 80-83[I]; N. Papahadjis, *Pausaniou Hellados Periegesis*, v (1969) 144-45; S. Lauffer, *Deltion* 26 (1971) *Chron.*, 239-45[I]; Th. Spyropoulos, *AAA* 6 (1973) 201-14[MI]. P. ROESCH

KOPRINKA, *see* SEUTHOPOLIS

KOQINO LITHARI, *see* LIMES SOUTH ALBANIA

KORAKESION (Alânya) Turkey. Map 6. City in Cilicia Aspera, recorded by Pseudo-Skylax in the mid 4th c. B.C., but never a place of much importance. About 197 B.C. it successfully resisted capture by Antiochos III, and in the mid 2d c. was used as headquarters by Diodotos Tryphon (Strab. 668). Later it was the scene of the decisive sea battle in which Pompey defeated the pirates, who had used the place as a major stronghold. Korakesion and the neighboring area were presented by Antony to Cleopatra to supply timber for shipbuilding (Strab. 669). Coinage begins under Trajan.

Very little remains of the ancient city. The walls of the citadel erected on the great rock by Keykûbad I in the 13th c. stand in part on the Hellenistic walls, which are of regular ashlar masonry. Otherwise only scattered ancient blocks and a few inscriptions have been found in the suburbs of Alânya.

BIBLIOGRAPHY. R. Heberdey & A. Wilhelm, *Reisen in Kilikien* (1896) 136-37; G. E. Bean, *Turkey's Southern Shore* (1968) 101-2. G. E. BEAN

KORESSIA, *see* KEOS

KORINTHOS, *see* CORINTH

KORION (Melambes) Haghios Vasilios, Crete. Map 11. Fifteen km S of the small Greek city of Sybrita. There is no evidence for either Minoan or Roman occupation of the same site, and the city seems to belong only to the Classical and Hellenistic periods. Evidence from the summit of the acropolis suggests that here, at least, abandonment may have followed violent destruction by fire.

The focus of the settlement is a small, flat-topped acropolis around which there are traces of walls, probably of a retaining nature rather than defensive. On the top of the acropolis there are the remains of a building which Hood suggests may have been the Temple of Athena, whose presence is indicated by an inscription found in the city below. The principal area of settlement below the acropolis appears to have been to the E, where house walls may be traced. The city's water supply, almost certainly the spring 100 m W of the acropolis, therefore seems likely to have lain outside the occupied area of the city.

BIBLIOGRAPHY. N. Platon "Chronika," *Kretika Chronika* 13 (1959) 391; M.S.F. Hood & P. Warren, "Ancient Sites in the Province of Ayios Vasilios, Crete," *BSA* 61 (1966) 169-70. K. BRANIGAN

KORKYRA, *see* KERKYRA

KORMASA (Egneş) Turkey. Map 7. City in Pisidia 36 km SW of Burdur. Captured, with much booty, by Manlius on his march in 189 B.C. (Polyb. 21.36, cf. Livy 38.15; Polybios gives the name as Kyrmasa). The city is mentioned also by Ptolemy (5.5.5) and is shown on the *Peutinger Table* between Themisonion and Perge. It seems never to have struck coins. The site is determined by an inscription in the neighboring village of Boğaziçi (*SEG* XIX, 777).

The ruins consist of great quantities of uncut building stones, a few cut blocks, and abundant sherds of Roman date; these extend for 1.5 km, but almost all the better stones have been removed to the surrounding villages. The town was apparently never fortified. The necropolis lies on the slopes above and covers a wide area. Just above the plain is a rock-cut chamber tomb, and higher up is a second, together with numerous rock-cut sarcophagi. On the slope between is a group of 20 or more stone circles from 5 to 8 m in diameter, now mostly consisting of a single course of stones; in at least one place, however, there is evidence of three or more courses, and a large ornamented pediment block 1.72 m wide indicates that the buildings must originally have been quite substantial. Nothing similar is found elsewhere in this region, but there seems no reason to suppose that these grave circles are of any great antiquity.

BIBLIOGRAPHY. L. Duchesne, *BCH* 3 (1879) 480f; G. E. Bean, *AnatSt* 9 (1959) 91-97. G. E. BEAN

KORMI Lycia, Turkey. Map 7. Near Karabük, close to the E bank of the Alagırçayı, about 17 km N of Kumluca. The name, of uncertain termination as inscribed, appears to be Greek. However, the city is not mentioned by any ancient writer, and our only knowledge of it comes from the few inscriptions, of which the earliest date to the 1st c. B.C. As a junior member of a sympolity headed by Akalissos, Kormi struck no coins in her own name.

The site is small, comprising an acropolis hill with a ring wall, inside which are a few inscribed bases and other stones; the inscriptions include a Sullan senatus consultum and an honorific decree for a citizen who did good service to the Lycian League apparently at the time of the war with Zenicetes. The usually numerous Lycian sarcophagi are lacking.

BIBLIOGRAPHY. *TAM* II.3 (1940) 323. G. E. BEAN

KORONEIA (Koroni) Attica, Greece. Map 11. A headland which closes the S side of the bay of Porto Raphti on the E coast. It lay in the territory of the deme of Prasiai but was sparsely inhabited, if at all, except during the Chremonidean War, 265-261 B.C., when it served as a fortified camp and base of operations for the Ptolemaic fleet, which, under the admiral Patroklos, came to aid Athens against its Macedonian besiegers. The fleet departed unsuccessful, and Koroneia, like the Ptolemaic bases at Patroklos' Island, at Rhamnous, and elsewhere, was abandoned (Paus. 1.1.1; 1.7.3; 3.6.4-6).

Remains investigated in 1960 illustrate well the features of a Greek fortified military camp (cf. Polyb. 6.42). The peninsula, ca. 1 km in length and width, is a naturally strong position, connected with the mainland only by a low, sandy isthmus. Its center rises to a natural acropolis, ca. 120 m high, from which steep, inaccessible slopes fall off to the NW, the N and the E. A long ridge forms a boundary to the peninsula at the S, toward the isthmus; at its W it is separated from the acropolis by a valley, sloping gently to the sea, while at the E it is joined by a broad saddle to the acropolis.

The camp was defended by two lines of fortifications. A dry-rubble wall 2.25 m thick and ca. 950 m long runs the entire length of the ridge, protecting the pen-

insula on the landward side. Nine towers strengthen its lower, W portion, but there are no gates, and the camp was evidently supplied by sea. A second wall, 1.50 m thick and standing in places to its original height of over 2 m, encircles the acropolis. One tower commands a view of the S part of the peninsula and of the sea lanes to Keos. Three narrow posterns on the N and three wider passages on the S gave access through the wall to the acropolis.

Within the acropolis and on the saddle are the roughly built structures of the garrison. They were constructed of rubble with no regular plan and roofed with reused tiles. A small house near the peak consisting of a main room and anteroom, may have served the officer of the watch. A larger structure nearby, with five rooms, to judge from its profusion of plates and bowls, may have been an officers' mess. Small storerooms lined the inner face of the acropolis wall. On the saddle, a complex of more than 20 rooms was probably a barrack, with rough, stone benches for beds.

Furnishings were utilitarian—kantharoi and plates, cooking ware, and wine amphorai to store and carry water on a site unprovided with wells or cisterns. Much of these furnishings may have been requisitioned from neighboring demes. There is a variety of fabric and shape among the pots, but the pervasive coins of Ptolemy II are consistent and confirm both the date and the character of the site.

BIBLIOGRAPHY. H. G. Lolling, "Prasiä," *AthMitt* 4 (1897); E. Vanderpool, J. R. McCredie, & A. Steinberg, "Koroni: A Ptolemaic Camp on the East Coast of Attica," *Hesperia* 31 (1962)[MPI]; "Koroni: The Date of the Camp and the Pottery," *Hesperia* 33 (1964); G. R. Edwards, "Koroni: The Hellenistic Pottery," *Hesperia* 32 (1963); G. R. Edwards & V. R. Grace, "Notes on the Amphoras from the Koroni Peninsula," *Hesperia* 33 (1964); J. R. McCredie, *Fortified Military Camps in Attica, Hesperia* Suppl. Vol. XI (1966).

JAMES R. MC CREDIE

KORONI (modern) Messenia, Greece. Map 9. A large building, 4.8 N of modern Koroni, which was probably "the villa of a rich man or a gymnasium," can be dated in the Early Imperial period. It had three rooms, while a fourth room was situated ca. 30 m farther to the E. In the first room (5.7 m each side) a superb mosaic was discovered, which is now preserved in the Benakeion Museum at Kalamata. The stones of the mosaic vary in size, shape, and color. In the center of a simple sixfold frame was a quadrangular field (3.1 x 3.1 m) divided by plaited borders into a central circle, four semicircles, and four quarter circles, the last in the corners. In the central circle are depicted a Satyr, a panther, and, between them, Dionysos. In the four surrounding semicircles are painted scenes from the amphitheater (bull with gladiator), lion with gladiator, the scene of a tiger-hunt, and a hunter (ill-preserved). Between the central circle and the corners are square fields with theatrical masks hung from red ribbons (two male, one female, one lost) while in the NW, SW corners are painted kantharoi surrounded by branches, and in the NE a running female panther. The fourth one (SW), probably occupied by another panther, is entirely lost. The mosaic themes of the other rooms form ornamental compositions.

BIBLIOGRAPHY. M. N. Valmin, *The Swedish Messenia Expedition* (1938) 467-75[I]; D. Levi, *Antioch Mosaic Pavements* (1947) 42; B. Kallipolitis in *Deltion* 17 (1961-62) A, 14, n. 12; M. Chatzidakis, in *Deltion* 22 (1967) 19ff[I]; P. Themelis, in ibid. 206[I].

G. S. KORRÈS

KORONI (Petalidi) Messenia, Greece. Map 9. Ca. 30 km W-SW of Kalamata. Koroni was a town under Mt. Mathia (now Lycodemon), on Koronaeus Bay in the NW part of the Messenian Gulf. It is generally accepted (except for one scholar who believes that the present Koroni occupies the site of the ancient one) that Petalidi village corresponds to the site of ancient Koroni. Petalidi Bay is the safest of all Peloponnesian ports and was called "port of the Achaeans." Parts of the ancient dock can still be seen in the sea. The older name of Koroni was Aipeia (Paus. 4.34.5) or Pedasos (Strab. 8.360). The name of the town refers to the Boiotian Koroneia whence came the founder Epimelides, who fortified the city ca. 365 B.C. The poros wall was 1.5 m thick and 2 km long.

In the 2d c. B.C. Koroni was either autonomous (191) or associated with the Achaean League or Sparta. The earliest known coins of the city with the head of Athena and the inscription AXAIΩN KOPΩNAIΩN date from this period.

On the acropolis hill and outside of the village have been found the foundations of the fortification wall and of various buildings, as well as sarcophagi, inscriptions, and sculptures. Classical remains have been found especially on the NE side of the acropolis, including five Doric capitals possibly belonging to a small temple of Early Classical date. Near the village were ruins of baths and an aqueduct, and 10 km to the NW are remains of Roman baths. On the acropolis in Pausanias' lifetime there was a bronze statue of Athena holding a bird. There was a bronze statue of Zeus the Savior in the agora, and temples of Artemis Paidotrophos (Children's nurse), of Dionysos and Asklepios, with marble statues of Dionysos and Asklepios.

BIBLIOGRAPHY. Head, *Hist. Num.* 433; Pieske, Korone, *RE* 11, 1422-24; R. Valmin, *Etudes topographiques sur la Messénie ancienne* (1930) 175ff; id., *BLund* (1934-35) 44ff; R. Hope Simpson, *BSA* 52 (1957) 249, fig. 10; A. Philippson & E. Kirsten, *Die griech. Landschaften* III (1959) 396; *Der kleine Pauly* III, c. 308-9 (E.M.).

G. S. KORRÈS

KORONI (Attica), *see* KORONEIA

KOROPE Thessaly, Greece. Map 9. City and site of the oracular Shrine of Apollo Koropaios. The god was one of the Magnesian triad; the sanctuary was in existence from at least archaic times. The city was incorporated into Demetrias on its foundation in 293 B.C., but the oracle continued to function through Roman times. The site is located on the right bank of the (modern) river Bufa, ca. 20 km S of Volo on the shore road which runs along the inner coast of Magnesia. A small modern settlement is presently known as Korope. The site was identified in 1882 by the discovery of a decree of Demetrias relating to the management of the shrine. In 1906 and 1907 the area of the sanctuary was discovered and partially excavated. This is on level ground above the modern road and just below a hill called Petralona. The excavation has now entirely filled in. Parts of the base of the NW corner of the peribolos (?) wall constructed of rough stones was found, and joining the W wall another wall (E end not found) parallel to the N peribolos wall and 8 m away, perhaps belonging to a stoa. Numerous terracotta figurines and black-glazed and black-figure sherds of the 7th-6th c. B.C. were found, and a number of pieces of the handsomely painted archaic terracotta revetment of the temple (?) and part of the wing of a lateral acroterion, a gryphon or sphinx. Some terracottas and fragments of terracotta revetment were also found. The finds from the excavation (unpublished) are in the Volo Archaeological Museum.

On a peak of the hill Petralona (175 m) above and ca. one km to the E of the sanctuary are traces of habitation in the form of roof tiles, sherds, etc. To the SE of the peak, at the edge of a flattish area is a semicircular retaining wall about one to two m high, built of polygonal masonry. Between the peak of the hill and the sanctuary are two ancient tombs. There is no sign of acropolis or city defense walls. The remains on the hill date from the archaic through the early Hellenistic periods. By the shore, SW of the sanctuary are remains of a Roman tomb, and a floor probably of the Roman or Christian period. Late Hellenistic and Roman sherds are commonly found in this area, indicating that the settlement of Korope moved from the hill to the shore.

BIBLIOGRAPHY. *IG* IX² 1109; H. G. Lolling, *AM* 7 (1882) 71; A. S. Arvanitopoullos, *Praktika* (1906) 123-25; (1907) 175; (1910) 225; F. Stählin, *RE* (1922) s.v. Korope; id., *Das Hellenische Thessalien* (1924) 53f; id., *AM* 54 (1929) 219-20; E. D. Van Buren, *Greek Fictile Revetments in the Archaic Period* (1926) 44ᴵ; N. D. Papahadjis, "Korope and its Sanctuary," *Thessalika* 3 (1960) 3-24ᴹᴾᴵ. T. S. MACKAY

KOROPE (Attica), *see* SPHETTOS

"KOROPISSOS," *see* Daǧ Pazari

KORTRIJK, *see* CORTORIACUM

KORTYS, *see* GORTYS

KORYDALLA Lycia, Turkey. Map 7. About 1 km W of Kumluca. The city is recorded by Hekataios (ap. Steph. Byz.) and by several later writers. Pliny (*HN* 5.100) calls it a city of the Rhodians; and probably, like its neighbors Rhodiapolis, Gagai, and Phaselis, it was founded from Rhodes. On the other hand, a bilingual inscription in Lycian and Greek, recently found at Kumluca, shows it to have been a genuine Lycian city. It was among the beneficiaries of Opramoas in the time of Antoninus Pius. The rare coins all belong to the 3d c. A.D. Korydalla was the seat of a bishop in Byzantine times.

The city stood on two hills some 90 m high; the site is identified by inscriptions. The ruins previously visible have in recent years been utterly destroyed and the stones carried away.

BIBLIOGRAPHY. T.A.B. Spratt & E. Forbes, *Travels in Lycia* (1847) I 163-64ᴹ; *TAM* II.3 (1940) 359.
 G. E. BEAN

KORYKIAN (Corycian) CAVE Phokis, Greece. Map 11. This grotto on Mt. Parnassos (altitude 1360 m), 2½ hours' walk from Delphi, owed its name to its "knapsack" shape (korykos). Described by Pausanias (10.32.2), it was sacred to Pan and the nymphs (dedication of a peripolarkos of Ambrysos engraved on the rock to the right of the entrance) and no doubt also to Dionysos (mention of the Thyads, the Delphic bacchantes, in a second, barely legible, rock inscription), whose biennial festival (Trieteris) was celebrated by torchlight by the Thyads of Delphi and Athens on the plateau close by. Excavations by the French School of Athens (1970) have shown that the grotto, which had two chambers (the first some 70 m long), was consecrated to the cult from the Neolithic Age. Another Korykian Cave was in Cilicia, near the town of Korykos.

BIBLIOGRAPHY. J. G. Frazer, Paus. *Des. Gr.* (1913) v 399-400; L. Rabert, *Etudes Anatoliennes* (1937) 108ff; M. Launay, *Recherches sur les armées hellénistiques* (1949) 1010; J. Fontenrose, *Python: a Study of Delphic Myth*

and Its Origins (1959) 409-12ᴹ. The finds of the recent excavations will be published in *BCH* and *FD*.
 G. ROUX

KORYKOS Rough Cilicia, Turkey. Map 6. A city 3.5 km W of Elaeussa. First mentioned as taken by Antiochos III from Ptolemaic control in 197 B.C., it minted autonomous coinage in the 1st c. B.C. and shared the fate of Elaeussa under the Romans until ca. A.D. 72. It was noted as a port in Roman times, and was extremely important in the Byzantine and mediaeval periods. Taken by the Turks in 1448, it slowly declined in importance as a port until the 19th c. when it was practically deserted. Its ancient name was never lost.

The scanty remains are apparently confined to two small peninsulas ca. 425 m apart and a narrow gentle slope inland from them. On the E peninsula and inland are some undescribed remains of buildings. The W peninsula is filled by a large Armenian castle and has a mole extending from it, protecting a small harbor to the W. Incorporated in the SE wall of the castle is a well-preserved single-arched Roman gateway, which led from the quay probably to a market, which may lie under the castle. East of the castle about 100 m are the foundations of two buildings, perhaps temples, with column fragments and wall blocks lying around. A line of bases, perhaps from a colonnaded street or stoa, is oriented NW-SE, about 100 m NE of the temples (?).

Inland from the city, along the ancient road from Elaeussa, and along the steep slope a little way inland is the ancient necropolis, clusters of sarcophagi and rock-cut chambers, numerous inscriptions, and one conspicuous relief of a warrior with sword and spear. One grave chamber constructed of polygonal masonry may be Hellenistic or Roman; the rest of the necropolis is of the Roman and Christian periods.

The Byzantine (?) city wall can be traced in an arc from the shore 1.25 km E of the castle to the slope 375 m NW of the castle. Just S of the modern road to the E of the wall can be seen the ancient water course leading from Elaeussa and Lamus. Inside the wall and out are a number of churches, some very well preserved, of the 5th and 6th c., and one of the Armenian period. About 0.75 km S of the mainland castle and close to shore is a small island (ancient Krambusa?) with a well-preserved Armenian castle of the 13th c., built perhaps over a Byzantine predecessor.

About 3 km from the site on an ancient road to Kambazlı are two watchtowers and behind them a cluster of buildings within a wall of polygonal masonry, just above the sheer wall of the Şeytan Deresi (Verev D. or Karyağdı D.) gorge. The towers and fort (?) may be part of a Hellenistic Olban defense system, or a retreat for Korykians. Below the fort (?) are several rock-cut memorial reliefs of the Roman period and an inscription probably of the 3d c. B.C.

Five km W of Korykos, 1 km inland, is the Korykian Cave, a natural limestone pit, opening out as a cave. Above it is a Temple of Zeus, perhaps amphiprostyle, with a peribolos wall of elegant polygonal masonry. An inscription on the temple gives a list of priests (?), the first name apparently of the late 3d or early 2d c. B.C. A myth concerning Zeus and Typhon was localized at the cave; the original Hittite or Luvian myth and cult may have been placed here as early as the 2d millennium B.C. In the mouth of the cave at the bottom is a well-preserved chapel to the Virgin, perhaps of the 4th c. Less than a kilometer N of the cave another Temple of Zeus was reported.

BIBLIOGRAPHY. V. Langlois, *Voyage dans la Cilicie*

(1861) 197-209 (= *RA* 12 [1855] 129-47); J. T. Bent, "A Journey in Cilicia Tracheia," *JHS* 12 (1891) 212-16; E. L. Hicks, "Inscriptions from Western Cilicia," *JHS* 12 (1891) 238-58, 272; R. Heberdey & A. Wilhelm, *Reisen in Kilikien, DenkschrWien*, Phil.-Hist. Kl. 44, 6 (1896) 67-79; E. Herzfeld & S. Guyer, *Meriamlik und Korykos, MAMA* II (1930) 90-189[MPI]; J. Keil & A. Wilhelm, *Denkmäler aus dem Rauhen Kilikien, MAMA* III (1931) 118-219[PI]; G. H. Forsyth, "Architectural Notes on a Trip through Cilicia," *DOPapers* 11 (1957) 225f[I]; A. Machatschek, *Die Nekropolen und Grabmäler im Gebiet von Elaiussa Sebaste und Korykos, DenkschrWien*, Phil.-Hist. Kl. 96, 2 (1967)[MPI]; T. S. MacKay, "Olba in Rough Cilicia," Diss. 1968 (Univ. Microfilm) Appendix E; L. Budde, *Antike Mosaiken in Kilikien* II (1972) 95-103[MI]; O. Feld, "Bericht über eine Reise durch Kilikien," *IstMitt* 13-14 (1963-64) 99-107; id. & H. Weber, "Tempel und Kirche über der Korykischen Grotte," *IstMitt* 17 (1968) 254-67.

T. S. MAC KAY

KOS Greece. Map 7. An island of the S Sporades group. The *Iliad* (2.676) speaks of the participation of Kos in the Trojan War under the leadership of the Heraclidae Phidippos and Antiphos; they are to have succeeded the first dynasty of the island, which was Thessalian. In archaic times Kos was a Doric oligarchy; it became part of the political and religious union that included Lindos, Kamiros, Ialysos, Knidos, and Halikarnassos. At the end of the 6th c. B.C. Kos fell under Persian domination, but rebelled after the Greek victory at Cape Mykale in 479 B.C. In 477 the island entered the Delio-Attic League, and during the Peloponnesian war it participated in the expedition to Sicily as an ally of Athens. In 410 B.C. Alkibiades left an Athenian garrison on the island, and it was subsequently occupied by the Spartans under Lysander. Only after Knidos had done so did Kos become re-allied with Athens in 394 B.C., and the island was also a member of the Second Maritime League.

Following a synoecism, probably promoted by the family of the Asklepiads of Isthmos in the W part of the island, the capital was transferred from Astypalaia to the site of the modern city (Diod. 15.762; Strab. 14.657). In 357 B.C. the island fought against Athens in the social war, and passed under the control of Mausolos, King of Caria. After the victory of Alexander the Great at Halikarnassos in 334 B.C., Kos became part of the Macedonian domain. After 309 B.C. Kos was linked to the dynasty of the Lagidi until the naval battle of 260 B.C. in which the Ptolemies were defeated by Antigonos Gonatas, King of Macedonia. Later the island came under the influence of Rhodes, but from the beginning of the 2d c. B.C. entered into the Roman orbit. Kos was occupied and sacked by Mithridates in 88 B.C., but continued to have good relations with Rome and was a civitas libera of the province of Asia. In A.D. 53, under Claudius, the island was declared immunis. Antoninus Pius aided in its recovery after the terrible earthquake in 142. In the time of Diocletian Kos was part of the Provincia insularum, and later was annexed to the Eastern Empire. In this period the island suffered two violent earthquakes, in A.D. 469 and 554. The latter destroyed the city.

Excavations in the city and elsewhere on the island were begun in 1900-1904 and continued in 1922-43. The site of the modern city was occupied in very ancient times. In the zone called the Seraglio in the S central part of the city a habitation site from the Bronze Age has been explored, in which the earliest identifiable strata belong to the Middle Bronze Age and the most recent to the end of the Late Bronze Age. Related to

this habitation site are the necropoleis of Eleona and Langada SW of the modern city, which were excavated in 1935 and 1940. Material from the three phases of Late Bronze Age III included imported Mycenaean pottery and locally made imitations.

Above the Mycenaean habitation site is a protogeometric necropolis, but the settlement has not been found. The latest tombs in the necropolis date from the end of the 8th c. B.C. Later finds are scarce and sporadic, and apparently the site was not reoccupied until 366 B.C. when the city was founded after the synoecism. On the other hand, the sources (Thuc. 8.41.2; Diod. 13.42.3) speak of Kos Meropis during the Classical period, a city which must have been situated on the sea near the new Kos of 366, but which was probably not a center of major importance. The new city of 366 B.C., with a geometric plan following the principles of Hippodamos, was enclosed by a wall of volcanic stone, of which several sections have been found. Its perimeter is calculated as 3-4 km. The port was left outside the wall to the N, but was protected by two sections of wall that were detached on the E and W from the principal wall. In the 2d c. B.C., in connection with a general restoration of buildings in the city for which white marble from local quarries was freely used, the wall was restored with limestone worked in boss-like projections.

Some interesting monuments have been brought to light in the port area, including a shrine from the 2d c. B.C. with a rectangular plan. A few courses of the marble superstructure survive, on an earthen foundation that seems to be older; it is surrounded by a 3d c. A.D. building with a series of rooms on four sides. There are also remains of a travertine stoa, built in the 4th-3d c. B.C. and remodeled in the 3d c. A.D., which are visible between the foundation walls of a basilica built above it in the 5th c. A.D. The basilica had three aisles preceded by an atrium and a narthex, and a square baptistery. The principal monument in this area is a sanctuary, of which the foundations remain: a Doric quadriporticus on a high podium with two propylaea in front, and an internal esplanade with two matching tetrastyle temples which have high flights of steps in front. The sanctuary, attributed to Aphrodite Pandemos and Pontia, was erected in the 2d c. B.C. and must have been the first monumental structure seen by those arriving by sea. At the extreme NW of the port area a bath building from the 3d c. A.D. has been found.

The agora, ca. 82 m wide, was built against the N side of the N city wall, extending out from its E part. It was enclosed by its own wall on the other three sides, and a section of the W side, built in the 4th-3d c. B.C., remains. A road circled the wall on the outside. The inside of the walls formed the backs of wide porticos which were reconstructed in marble in the 2d c. B.C., with Doric columns fluted for two-thirds of their height. The pavement, remade in the 2d c. B.C., was of regular slabs of marble. The S side, recently excavated, extended as far as the altar of Dionysos and a Doric temple in antis, both of the 2d c. B.C. In the Roman period the walls on the N side, which had fallen in the earthquake during the reign of Antoninus Pius, were rebuilt with a monumental entrance. The opening had three large arches, which on the interior corresponded to rooms with barrel vaults decorated with plaster. In front of the arches a grand marble staircase descended to the area of the port.

In the N part of the W zone of the city are the badly damaged remains of large bath buildings datable to the 3d c. A.D. There is also a stadium built against the E slope of a small hill. Its original plan, with simple

benches in travertine, is attributable to the first phase of the city. The aphesis, of which the stylobate and several bases of semi-columns in marble built against pilasters survive, belongs to the 2d c. B.C. The W tribune dates to the Roman age, the 3d c. A.D. Farther S, but still in the W section, is a monumental complex including a gymnasium of the 2d c. B.C., the xyston of which has been partly restored; E of the gymnasium were large baths. After the earthquake of A.D. 469, which destroyed the baths, the frigidarium and several other rooms were transformed into a basilica. Mosaic pavements in ornate geometric designs have been found. Another church with a baptistery was built in the caldarium.

On the E the baths were bounded by the cardo maximus, and its paving of large irregular slabs, of the 3d c. A.D., is preserved under the level corresponding to the Early Christian basilicas. Part of a travertine portico of the 4th-3d c. B.C. survives E of the cardo, and S of the portico is a public latrine, also contemporary with the baths, which has been entirely reconstructed. It has a square plan with an interior gallery on three sides; the sewer ran along the back wall. The gallery consists of Ionic columns surmounted by arches in brick with vaults. On the fourth side of the latrine is a fountain with three niches and basins, and behind that an access corridor with the entrance to the cardo. Farther S the cardo intersects the decumanus, 150 m of which have been brought to light towards the W. It is ca. 10.5 m wide, including the sidewalks, had porticos on both sides, and also dates from the 3d c. A.D.

Near the intersection of cardo and decumanus is the Odeion, with rectilinear walls enclosing the cavea, which is supported by two semicircular vaulted galleries. The circular orchestra was decorated in opus-sectile with a design of intertwined squares. Three open doorways in the scena lead to a room behind. A loggia probably ran above the summa cavea. A last large public building, not yet completely excavated, is the theater, dating like the Odeion from the 3d c. A.D. Near the S walls of the city, it has a semicircular orchestra and cavea with the marble tiers built against a hillside. Especially to N and S of the decumanus there are interesting private houses, arranged in regular city blocks.

At the corner of the decumanus and the cardo is the House of the Mosaic of Europa, which constitutes an entire block. The house has a trapezoidal plan and a central porticoed courtyard, from which open various rooms. Another block S of the decumanus is occupied by a large so-called Roman house, with two peristyles and a courtyard with windows. Many mosaics have been found in the houses, featuring figured scenes and geometric designs. In the House of the Mosaic of Silenus, for example, mosaics of a boar hunt and of a battle between gladiators, datable to the 2d-3d c. A.D., have been found, in addition to the mosaic for which it is named. A nearby house has mosaics of the 3d-4th c. A.D., showing the Muses and Eros depicted as a fisherman. Among mosaics worth mentioning from the W zone of the city are Orpheus and the animals, Hunting and Fishing, and The Judgment of Paris, of the early 3d c. A.D.

Near the city of Kos is the sanctuary of Asklepios. The healing god was venerated from the earliest times on the island, which was also the home of Hippokrates, the most famous physician of antiquity. In the beginning the sanctuary had only an altar in the place which had originally been the sanctuary of Apollo Kyparissios. Only after the death of Hippokrates, about the middle of the 4th c. B.C., was the construction of the Asklepieion begun, and its completion and embellishment took a long time. The first plan consisted of the temple of the god with the altar decorated by the sons of Praxiteles,

and of the abaton, the room in which the sick awaited the god. The sanctuary, excavated in 1901, in its final form consisted of four terraces joined by stairways, with heavy foundation walls. In the lower quarter is a small Roman bath building, from which one may ascend to the large baths added in the 3d c. A.D. to the E part of the third terrace, with an apsidal basilica and frigidarium. The principal access to the third terrace, enclosed by porticos on three sides, was by a Doric propylaion; its foundations and a wide stairway are preserved. From the porticos opened various rooms for the sick. At the center of the second terrace the foundation of the altar of Asklepios is visible. To the right is the Ionic temple of the god, of the early 3d c. B.C., in which votive offerings were deposited. To the left is another temple of the Imperial age. Nearby are the remains of a lesche with a portico. An exedra and a building to house the priests, of which little remain, were located at the foot of the stairway to the terrace above. The uppermost terrace was constructed during an enlargement of the complex in the 2d c. B.C. It contains the six-columned Doric peripteral temple of the god, enclosed by porticos.

In the S part of the island not far from the village of Kephalos, on an upland near the church of the Panaghia Palatiane, are the remains of polygonal walls. These belong to the site of ancient Astypalaia, the principal city of the island before the synoecism, which was probably founded after the Doric invasion. Ceramic material from the 9th c. B.C. found at the site support the identification. Near Kephalos there are two small Doric temples in antis and a Hellenistic theater with a semicircular orchestra and seats of trachyte. Not far away, near the SE coast, excavations in the grotto of Aspripetra have brought to light a cult place active from the Neolithic period until the 4th-3d c. B.C., when Pan and the Nymphs were venerated there. A Hellenistic theater built against a hill has been excavated near Kardamena; the cavea is preserved to the height of three tiers of seats. In the same area inscriptions attest that ruins near the church of Haghia Theotes belonged to a sanctuary of Apollo. In the center of the island, at Pyli, a vaulted hypogeum in which are incorporated elements of Doric entablature from the Hellenistic age has been found under a village church. It is popularly identified as the Heroon of Charmylos, a local mythological hero. There is a tract of Cyclopean wall near the abandoned medieval fortress of Palaio Pyli, and Mycenaean pottery fragments from the area may indicate a Bronze Age settlement. Between Pyli and Asfendiu is a sanctuary of Demeter and Kore, with a little Hellenistic temple in which marble votive statues were found.

Both in the city of Kos and elsewhere on the island are interesting Early Christian basilicas, with splendid mosaics, that date from the period between the earthquakes of A.D. 469 and 554. The sculpture and ceramics from the excavations are preserved in the archaeological museum at Kos.

BIBLIOGRAPHY. R. Herzog, *AA* (1901) 131ff; (1903) 1ff; (1905) 1ff; id. & P. Schazmann, *Kos* I, *Asclepieion* (1932)MPI; D. Levi, "La grotta di Aspripetra a Cos," *ASAtene* 8-9 (1929) 235ffPI; L. Laurenzi, "Nuovi contributi alla topografia storico archeologica di Coo," *Historia* 5 (1931) 603ffMPI; id., "L'Odeion di Coo," ibid. 592ffPI; id., *EAA* 3 (1959) 795ff; H. Balducci, *Basiliche protocristiane e bizantine a Coo* (1936)MPI; L. Morricone, "Scavi e ricerche a Coo, 1935-43," *BdA* 35 (1950) 54-75, 219-46, 316-31MPI; id., "Eleona e Langada; sepolcreti della tarda età del bronzo a Coo," *ASAtene* 27-28 (1965-66) 5ff; J. D. Kondis, Αἱ ἑλληιστικαὶ διαμορφώσεις . . . (1956)MPI; G. E. Bean, "The Carian Coast III," *BSA* 52 (1957) 119ff; id., "Kos," *Ergon* (1959) 131ff;

G. Pugliese Caratelli, "Il damos coo di Isthmos," *ASAtene* 25-26 (1963-64) 147ff; A. Orlandos, *ArchEph* (1966) 1-103; R. Hope Simpson & F. Lazenby, "Notes from the Dodecanese," *BSA* 57 (1962) 169ff[M]; 65 (1970) 55ff[MPI]; 68 (1973) 170ff.　　M. G. PICOZZI

KOSSURA (Pantelleria) Trapani, Sicily. Map 17B. A volcanic island 110 km SW of Sicily and 70 km from Africa. The island has been inhabited since the Neolithic period, from which there are remains of a village and of a fortification wall in the district of Mursia, as well as dome-like constructions with rubble walls called sesi, which were used as graves.

Within the historical period, beginning with the earliest phases of Phoenician colonization within the W Mediterranean, the island was probably reached by Phoenician traders. Even at a later time (4th c. B.C.) Pseudo-Skylax (Müller, 1885, φ 111) mentions the island to relate that it was one navigation day away from Lilybaion. Until the middle of the 3d c. B.C. it remained within the Carthaginian sphere. It was occupied for the first time by the Romans in 254 B.C. (Zonar. 8.14), perhaps only briefly, but in 217 B.C. the island was seized by the Romans (Polyb. 3.96). However, Punic culture survived on the island until at least the 2d-1st c. B.C., as attested by coins bearing a Punic legend. The island was still fortified as late as the 1st c. A.D. Pliny the Elder (5.7) describes it as "Cossura cum oppido," and Roman presence, even if only for strategic reasons, is attested in the island by remains of structures with mosaic floors datable to the late Imperial period.

The archaeological remains from the historical period of the island consist primarily of some stretches of the wall in the areas of Santa Theresa and San Marco, where the acropolis was most likely located, but nothing permits attribution of these walls to the Punic period. There are, however, some terracotta female heads and busts of Punic type with a *klaft* hairstyle or fillet, which are reported to have been found at Bagno dell'Acqua where there was once a sanctuary of Punic type. An early Corinthian aryballos was found there, datable to the 6th c. B.C. A few other items from the Punic period (jewelry, necklaces, coins) provide archaeological evidence for a long Phoenician-Punic cultural phase within the island, but at the same time they strongly suggest that Punic penetration was somewhat limited.

BIBLIOGRAPHY. P. Orsi, "Pantelleria," *MonAnt* 9 (1889)[MPI]; A. Verger, "Pantelleria nell'antichità," *Oriens Antiquus* 5.2 (1966) 249ff[MPI]; C. Tozzi, "Relazione preliminare sulla I e II campagna di scavi effettuate a Pantelleria," *Rivista Scienze Preistoriche* 23.2 (1968) 315ff[I]; A. M. Bisi, "In margine ad alcune terrecotte puniche arcaiche di Pantelleria," *Sicilia Archeologica* 10 (1970) 17ff[I].　　V. TUSA

KOSTOLAC, *see* VIMINACIUM

KOTENNA (Monteşbey, formerly Gödene) Turkey. Map 6. City in Pamphylia or Pisidia 12 km W of Akseki. The site is determined both by the survival of the name and by a decree of the Council and People of the Kotennians found on the spot. Kotenna is not recorded in the literary authorities before the 4th c. A.D. (Hierokles, *Notitiae*), but is proved by inscriptions to have had city status at least by the 2d c. The name is likely to be a variant of the name of the tribe of Katenneis, mentioned by Strabo (570) as occupying the mountain country above Side and Aspendos.

Not much survives on the site. A circuit wall with bastions surrounds part of the hill, with a rock-cut stairway leading to the summit; no buildings are standing, but numerous cut blocks, some inscribed or carved with reliefs, are lying around.

BIBLIOGRAPHY. G. Hirschfeld, *MonatsbBerl* (1875) 143f; H. Swoboda et al., *Denkmäler aus Lykaonien, Pamphylien und Isaurien* (1935) 50; G. E. Bean & T. B. Mitford, *Journeys in Rough Cilicia 1964-1968* (1970) 29-33.
　　G. E. BEAN

KOTOR, *see* ACRUVIUM

KOTYORA (Ordu) Pontus, Turkey. Map 5. A tributary colony of Sinope in Tibarenian territory, on the S coast of the Black Sea (Pontos Euxeinos). The citizens were transferred to the new city of Pharnakeia, ca. 48 km farther E, by Pharnakes I of Pontus (ca. 180 B.C.). Kotyora itself declined into a small village. Traces of the port, cut in solid rock, were formerly visible at Kiraz Limani, on the N side of Ordu.

BIBLIOGRAPHY. W. J. Hamilton, *Researches in Asia Minor, Pontus, and Armenia* (1842) I, 267.
　　D. R. WILSON

KOUDIAT ROSFA, *see* RUSPE

KOUKLIA, *see* PAPHOS

KOURION Cyprus. Map 6. On the SW coast, about 16 km W of Limassol. The ruins cover a large area on a bluff overlooking the sea to the S. Kourion was surrounded by a city wall but of this very little survives; the rocky scarp on the E and S sides has been vertically cut. There was probably no proper harbor but the remains of a jetty, about 80 m long, are still visible at low tide to the W of the town and Strabo mentions the existence of an anchorage. The necropolis extends E and S.

One of the ancient kingdoms of Cyprus, Kourion was founded by the Argives (Hdt. 5.113; Strab. 14.683). The connection between Kourion and Argos is further illustrated by the worship at Kourion of a god called Perseutas. Excavations have yielded evidence of an Achaian settlement in the 14th c. B.C. at the Bamboula ridge at the nearby village of Episkopi. A tomb within the necropolis of Kourion yielded material of the 11th c. B.C. including the well-known royal gold and enamel scepter which is now in the Cyprus Museum. The name of Kir appears in an Egyptian inscription at Medinet Habu of the time of Rameses III (1198-1167 B.C.), if the correlation with Kourion were beyond dispute. The name is also mentioned on the prism of Esarhaddon (673-672 B.C.), where the reading Damasu king of Kuri has been interpreted as Damasos king of Kourion.

During the revolt of Onesilos against the Persians at the time of the Ionian Revolt King Stasanor of Kourion, commanding a large force, fought at first on the Greek side but at the battle in the plain of Salamis (498 B.C.) he went over to the Persians and his betrayal won them the day. Nothing is known of the other kings of Kourion until Pasikrates, probably its last king, who sailed in the Cypriot fleet, which went to the aid of Alexander the Great at the siege of Tyre in 332 B.C.

The city flourished in Hellenistic and Graeco-Roman times. It was badly hit by the severe earthquakes of A.D. 332 and 342, which also hit Salamis and Paphos, but it was soon rebuilt. Before this time Christianity was well established at Kourion and one of its bishops, Philoneides, had suffered martyrdom under Diocletian (A.D. 284-305). Zeno, a later bishop, was instrumental in securing at the Council of Ephesos (A.D. 431) a favorable decision on the claims of the church of Cyprus to independence. As a bishopric the city flourished once more until it was gradually abandoned after the first Arab raids of A.D. 647.

Kourion was the birthplace of the poet Kleon, who wrote *Argonautica*, from which Apollonios Rhodios, in his epic of the same theme, was accused of copying; it was also the birthplace of Hermeias, a lyric poet.

The principal monuments uncovered to date include the House of Achilles, the House of the Gladiators and the House of Eustolios, all paved with mosaics of the 4th and 5th c. A.D., a theater, an Early Christian basilican church, and, near the city, the stadium and the Temple of Apollo Hylates.

The existence at Kourion of a gymnasium is attested by inscriptions but its location is not known at present. The worship of Hera, Dionysos, Aphrodite, and the hero Perseutas has also been attested by epigraphical evidence but again nothing is known of the site of the sanctuaries. The Sanctuary of Demeter and Kore, also attested by inscriptions, has been located on the E side of the Stadium.

The remains of the House of Achilles lie on the N part of the city close to the main Limassol-Paphos road. The house consists of an open courtyard with rooms on either side and a colonnaded portico on the N. In the portico, whose floor is paved with mosaics, a large panel depicts in lively manner Achilles disguised as a maiden at the court of King Lykomedes of the island of Skyros unwittingly revealing his identity to Odysseus on the sounding of a false alarm. In another room a panel shows Ganymede being carried by the Eagle to Mt. Olympos.

The House of the Gladiators, farther S, consists of a complex of rooms and corridors with an inner court, probably an atrium. Some of its rooms were paved with mosaics, including figure representations. In one of these rooms are two panels depicting gladiatorial scenes. The first panel shows two gladiators fully armed with helmets, shields, and swords facing each other and ready to strike. Above them are indicated their names or nicknames, ΜΑΡΓΑΡΕΙΤΗC and ΕΛΛΗΝΙΚΟC. The second panel shows again two gladiators facing each other but with an unarmed figure between them. The left-hand figure is called ΛΥΤΡΑC, the central one ΔΑΡΕΙΟC; of the right-hand figure only the initial Ε survives.

At the SE end of the bluff are the remains of a large house paved with mosaics, commanding a splendid view over the fields and the sea beyond. It is known as the House of Eustolios and includes a bathing establishment. In one of the porticos an inscription gives the name of Eustolios, the builder of the baths, and refers to Phoebus Apollo as the former patron of Kourion; another inscription specifically mentions Christ, an interesting commentary on the gradual transition from paganism to Christianity. The bathing establishment lies on higher ground to the N. Its central room has its floor paved with mosaics divided into four panels, one of which depicts Ktisis in a medallion.

To the W of the House of Eustolios lies the theater built on a slope overlooking the sea to the S. The theater consists of the cavea, a semicircular orchestra, and the stage-building. A vaulted corridor around the back of the theater provided access through five gangways to the diazoma. Access was also effected from the parodoi lower down. The orchestra is paved with lime cement. Of the stage-building only the foundations survive. The theater as it stands today dates from Graeco-Roman times, but the original one, smaller and on a Greek model, was built in the 2d c. B.C. The orchestra at this period was a full circle and the cavea encompassed an arc of more than 180 degrees. The theater provided accommodation for ca. 3,500 spectators; it has been recently reconstructed up to the diazoma.

The stadium lies to the W of the city on the way to the Temple of Apollo. The outline of its U-shaped plan is well preserved. Its total length is 233 m and its width 36 m. Its total capacity was ca. 7,000 spectators. The stadium was built in the 2d c. A.D. during the Antonine period and remained in use until about A.D. 400.

The Sanctuary of Apollo Hylates, about 3 km W of the city, displays a large group of buildings. The precinct is entered by two gates, the Kourion Gate and the Paphos Gate. The remains of the long Doric portico extend the whole way between the two gates. South of this portico is the S Building consisting of five rooms entered from the portico and separated from each other by corridors. Each room had a raised dais on three sides, divided from a central paved area by Doric columns. The inscription set in the front wall over one of the doors tells us that two of the rooms were erected by the emperor Trajan in A.D. 101. A room of similar design is the NW Building, reached by a broad flight of steps. The function of these rooms is not certain but they may have been used to display votives or to accommodate visitors.

The main sanctuary lies to the N of the precinct. From the Doric portico a paved street leads straight to the Temple of Apollo. The temple stands on a high stylobate reached from the Sacred Way by a flight of steps occupying the whole width of the temple. It consisted of a portico with four columns and of two rooms, the pronaos and the opisthodomos. At the E of the precinct lie the baths. At the SE, by the Kourion Gate, lies the palaestra, which is composed of a central peristyle rectangular court surrounded by rooms.

The worship of Apollo at this site began as early as the 8th c. B.C. There are still a few remains of the archaic period but most of the ruins seen now date from the Graeco-Roman period or ca. A.D. 100, having been restored after the disastrous earthquakes of A.D. 76-77. These new buildings were themselves destroyed during the severe earthquakes of A.D. 332 and 342, when the sanctuary seems to have been definitely abandoned.

Finds are in the site museum at Episkopi village and in the Cyprus Museum, Nicosia.

BIBLIOGRAPHY. Luigi Palma di Cesnola, *Cyprus, its Ancient Cities, Tombs and Temples* (1877); A. Sakellarios, Τὰ Κυπριακά I (1890); J. F. Daniel & G. H. McFadden, "Excavations at Kourion," *The University Museum Bulletin, University of Pennsylvania* 7 (1938) 2-17; J. F. Daniel, *The University Museum Bulletin, University of Pennsylvania* 13 (1948), 6-15; G. H. McFadden & De Coursey Fales, Jr., *The University Museum Bulletin, University of Pennsylvania* 14 (1950), 14-37[PI]; G. H. McFadden, "A Late Cypriote III Tomb from Kourion, Kaloriziki no. 40," *AJA* 58 (1954) 131-42[MPI]; Richard Stillwell, "Kourion: The Theatre," *Proc. Phil. Soc.* 105 (1961) 37-78[MPI]; Robert Scranton, "The Architecture of the Sanctuary of Apollo Hylates at Kourion," *TAPA* 57 (1967), 3-85[MPI]; Anonymous, *Kourion: A Guide* (1970); T. B. Mitford, *The Inscriptions of Kourion* (1970); M. Loulloupis, "Ἀνασκαφαὶ εἰς Κούριον 1967-1970," *RDAC* (1971) 86-116[PI]; *RE*, s.v. Kurion[M]; J. L. Benson, *The Necropolis of Kaloriziki* (Studies in Mediterranean Archaeology, 36; 1973)[MPI].

K. NICOLAOU

KOURNO Lakonia, Greece. Map 9. This site in the peninsula of Maina, 18 km to the N of Cape Tainaron and 570 m above sea level, can be reached by a two and a half hour climb on foot from the small port of Nymphi. It is not mentioned by any ancient author, and its name in antiquity is unknown. The ancient establishment is 500 m from a plentiful spring near which a convent stands, in the place called Ta Kionia (The Columns).

It has never been systematically explored. The principal buildings recognizable are two Doric shrines. The first, peristylar, with a proportion of seven columns to six, measures ca. 8.4 x 9.2 m on the stylobate. The second, with two columns in antis, measures some 7 x 5 m. The roofs bore a round acroterium. No inscription or sculpture allows us to guess to whom these shrines were dedicated. Some of the architectural fragments, above all the capitals, are said to have been taken to Kythera in the 19th c. To the S of these shrines was doubtless a third sanctuary. A cliff relief shows three figures, of which two are still distinct: in the center, a woman holding a cornucopia (Rome?) and to the left a standing warrior. All around are the remains of several ancient buildings. Everything appears to date from the Imperial period.

BIBLIOGRAPHY. E. Puillon-Boblaye, *Recherches géographiques . . .* (1835) 89; Ph. Le Bas, *Voyage archéologique* (1847-68), *Arch. Pélop.* 2, pls. 1-11; A. M. Woodward & E. S. Forster, *BSA* 13 (1906-7) 253-55.

C. LE ROY

KOUTSI, *see* LIMES, GREEK EPEIROS

KOZAĞACI, *see* TORIAION

KOZANI, *see* KALIANE

KOZLUKUYU, *see* IDYMA

KOZPINAR, *see* KALYNDA

KRAMBOVOS (Kastanochorion) Arkadia, Greece. Map 9. Locality on the road from Isoma to Ano Karyes, E of Mt. Lykaion. The peribolos of a settlement, a small thesauros or cistern (3 x 2 m), and a temple have been identified with Kretea and a Sanctuary of Apollo Parrhasios located in its neighborhood (Paus. 8.38.2-8). On the remains of the archaic temple a later building was erected, which survived in poor condition. The finds include fragments of Geometric vases and iron and bronze objects, and are in the National Museum at Athens.

BIBLIOGRAPHY. K. Kourouniotes, Κρητέα—Ναὸς Παρρασίου 'Απόλλωνος, *ArchEph* (1910) 29ff[1]; J. Hejnic, *Pausanias the Perieget and the Archaic History of Arcadia* (1961) 11, 20ff.

G. S. KORRÈS

KRANNON (Palaio-Larisa) Thessaly, Greece. Map 9. The ancient city lay on a plateau in the hills of the central part of the region. Successor to pre-Thessalian Ephyra, it was important only in the 6th and 5th c. B.C., after which time it was absorbed by Larissa to the E. As one of the eight principal Thessalian cities, it was already issuing coins in 480 B.C. Literary references mention cults of Helios, and Sarapis and Isis, while the state archives were said to be kept in the Temples of Athena and Asklepios. Present-day remains are limited to the foundations of the upper city wall on a height called Paleokastro, and a number of grave mounds and built tombs.

BIBLIOGRAPHY. Strab. 7, fr. 14, 16; 8.5; 9.5.21; Paus. 10.3.4; W. M. Leake, *Nor. Gr.* (1835) III 361f; cf. I 446. Also: E. Protonotariou-Deilaki in *Thessalika* 3 (1960).

M. H. MC ALLISTER

"KRASTOS," *see* KASSAR

KREFELD-ASBERG, *see* ASCIBURGIUM

KREFELD-GELLEP, *see* GELDUBA

KREMNA Pisidia, Turkey. Map 7. Near the village of Çamlik in the district of Bucak in the province of Burdur. The village is situated on the Tauros 60 km SE of Burdur and 15 km from Bucak. According to Strabo (12.569), Kremna and the other cities of Pisidia were first captured by Amyntas, the commander of the Galatian auxiliary army of Brutus and Cassius, who became king of Galatia and Pisidia on going over to the side of Antonius. Octavian allowed him to remain king until his death in 25 B.C., after which Kremna (*Mon.Anc.* 28; Strab. 12.569) was made into a Roman colony (Colonia Iulia Augusta [Felix] Cremnena, *CIL* III, 6873). Coins of the Imperial period were first minted at Kremna during the reign of Hadrian. The donatio given by the emperor Aurelian (270-75) was followed by a period of brilliant prosperity in Kremna, but not long after, in A.D. 276, during the reign of the emperor Probus, the acropolis was occupied by the Isaurian bandit leader Lydios, who used it as a fortress against the Romans, and was thus able to hold out for a considerable time (Zosimos 1.67). Kremna was included in the Byzantine province of Pamphylia, and it is clear that settlement continued there uninterrupted, though on a smaller scale. In 787 Kremna sent a representative to the Second Council of Nicaea. Meanwhile the inhabitants had probably left the steep slopes and settled in what is now the village of Çamlik, which had been a village or suburb of the ancient city, bringing the name of their city with them. Thus Girme, the old name of the Turkish village, is derived from Kremna. According to the last information regarding the city (*Not. Dig.* 10) Kremna was the administrative center of the province.

In 1874 the site was definitely identified as Kremna by the discovery of a dedicatory inscription containing the name. Excavations were begun in 1970.

Kremna is situated on a hill dominating the valley of the Kastros (Aksu) and extending from E to W across a plateau 1000 m above sea level. The hill is 250 m above the level of the plateau, with sheer slopes on the N, E, and S, so that the city can be approached only from the W. Although on this side it is connected with the plateau by gentle slopes the hill is isolated by a deep ravine formed by flood waters. Thus the topographical situation of the acropolis makes it almost impregnable. The acropolis itself is not level for there are a number of small hills on the N, E, and SE. Most of the public buildings are concentrated within two small valleys, the forum and the basilica situated at the junction of the two valleys. To the N of the forum are cisterns, and to the S the library (?). The theater is situated on the slopes of the E hill, with the stoa and the gymnasium to the E of this. To the NE of the gymnasium lies the macellum, to the W of the forum a colonnaded street, and to the W of the basilica a monumental propylon. There are temples on the high hills on the acropolis, while houses are scattered around the center of the city and other suitable parts of the site. Churches of the Christian period are to be found both inside and outside the city. Tombs are outside the city, especially on the W and S slopes of the acropolis. The finest and best-preserved rock tomb is to be found on the S. The W city gate is in ruins, and only sections of the W defense walls and towers are still standing. The second gate of the city is a gate with courtyard in a better state of preservation. Walking from here towards the E, one reaches first arcades and later a second theater. Kremna was built on a grid plan. The uneven surface of the acropolis is unsuitable for the application of such a plan, but instead of leveling the ground the main buildings were placed in the valleys, while the perpendicularly intersecting streets were led straight over the hills.

Very few of the buildings of the ancient city are still standing, most of them now consisting of mere heaps of stone and architectural fragments. The coins and sculp-

ture found in Kremna are preserved in the Burdur Museum.

BIBLIOGRAPHY. F.V.J. Arundell, *Discoveries in Asia Minor* (1834) II 74ff; R. N. Waddington, *RN* (1853) 371; G. Hirschfeld, "Bericht über eine Reise in Südwestlichen Kleinasien," *Zeitschrift der Gesellschaft für Erdkunde* (1878) 279; J.R.S. Sterret, "The Wolfe Expedition to Asia Minor," *Papers of the American School of Classical Studies at Athens* 3 (1884-85) 319-26; K. Lanckoronski, et al., *Städte Pamphyliens und Pisidiens* (1892 repr. ca. 1965) II 161ffᴹᴾ; W. Rüge, *RE* XI, 1708; H. Rott, *Kleinasiatische Denkmäler* (1908) 18ff; M. H. Ballance, "The Forum and Basilica at Cremna," *BSR* (NS 13) (1958) 167ffᴾᴵ; J. Inan, 1970 Cremna Excavation Report, *Turkish Archaeological Journal* 19.2, in press. J. INAN

KRENIDES, *see* PHILIPPI

KREUSA (Livadhostro) Boiotia, Greece. Map 11. In antiquity, the market town for Thespiae. The site is on the N slope of Mt. Korombili, near the modern town of Livadhostro. The harbor, protected from the violent local storms by a mole in ancient times, had no importance of its own in the Classical period, but served as a port for Thebes, and maintained close relations with Corinth. During the war against Antiochos, the Romans used the town as a base of operations. Pausanias saw nothing there worth reporting; the site is now marked by the remains of walls with towers, and a gate 3 m wide. A bronze statue known as the Livadhostro Poseidon, now in the National Museum, was found in the sea off nearby Haghios Vasilios at the end of the 19th c.

BIBLIOGRAPHY. Paus. 9.32.1-2; Livy 36.21.5, 44.1.4; Ptol. 3.14.5; W. M. Leake, *Nor. Gr.* (1835) II 406, 505, 520. M. H. MC ALLISTER

KRIMISA (Cirò) Calabria, Italy. Map 14. According to tradition the site was founded by Philoktetes. An indigenous Iron Age settlement is represented by two small grottos containing skeletons, pottery, and small bronzes. In the early archaic period a temple dedicated to Apollo Alius on the Punta d'Alicia was constructed. The pronaos was omitted; instead the cella began with two columns in antis and had four interior columns along the central axis. Four columns or posts (2 x 2) stood in the adyton. The terracotta revetments on the raking cornices carried antefixes and two superimposed architrave taenias with staggered regulae and guttae. Towards the end of the 5th c. B.C. or the beginning of the 4th, a peristyle (8 x 19) was added on a slightly higher level, leaving the cella lower. Most of the architectural terracottas from the site belong to this last phase and show Tarentine influence. Among the finds is an acrolithic seated Apollo playing a lyre. Conjectures as to the date range from the mid 5th c. B.C. into the Hadrianic period, with an early date generally preferred. This and the other objects are in the National Museum of Reggio Calabria.

BIBLIOGRAPHY. Lycoph. *Alex.* 913; P. Orsi, "Templum Apollinis Alaei ad Crimisa promontorium," *AttiMGrecia* (1932) 7-182; J. Bérard, *Bibliographie topographique des principales cités grecques de l'Italie méridionale et de la Sicile dans l'antiquité* (1941) 48; *EAA* 2 (1959) 693-94; G. Foti, "La ricerca archeologica," *Almanacco calabrese* (1963) 33-42; C. Turano, "L'Acrolito di Cirò," *Klearchos* 6 (1964) 61-72. J. P. SMALL

KROMNA Corinthia, Greece. Map 11. The ancient town on the Isthmus is mentioned by Kallimachos (Σωσιβίου Νίκη, l. 12; cf. Tzetzes schol. on Lycophron 532). It is located at the base of Haghios Dimitrios Ridge, W of the Isthmian Sanctuary of Poseidon, where extensive habitational ruins were discovered in 1960. There are also large cemeteries nearby and chance finds have led to the excavation of several burials. An inscription found in the area records the name of Agathon Kromnites. Pottery from the cemeteries and the town site dates from the mid 7th c. B.C. to the 4th c. A.D. Ancient stone quarries extend from Kromna some 2 km W to the modern town of Examilia.

BIBLIOGRAPHY. *SEG* XXII 219; J. R. Wiseman, "A Hellenistic Trans-Isthmian Fortification Wall," *Hesperia* 32 (1963) 271-73; id., *The Land of the Ancient Corinthians* (forthcoming). J. R. WISEMAN

"KROMYOYSSA," *see* MAJORCA

KROTINE, *see* DIMALE

KROTON (Crotone) Calabria, Italy. Map 14. On the E coast of the toe of Italy some 246 km NE of Reggio di Calabria, the city stands on a promontory which forms two defensible ports. In accordance with the Delphic oracle, Myskellos of Rhypai founded an Achaian colony there (Strab. 6.1.12) in 710 B.C., ten years after the establishment of Sybaris. The city soon spread into the fertile plains to the S, and in ca. 675 B.C. it initiated the foundation of another Achaian colony, Kaulonia. In the middle of the 6th c B.C. Kroton attacked Lokroi with an army of 120,000 men (Just. 20.2-3) but was decisively defeated at the river Sagra (perhaps the modern Allaro). A period of decline set in, from which the town was aroused by the arrival from Samos in ca. 530 B.C. of Pythagoras, who remodeled the constitution. The city became famous as the home of athletes, doctors, and philosophers. In 510 B.C. Kroton became embroiled in a war with Sybaris and defeated it in a single battle near the river Krathis. Kroton now became the most powerful city in S Italy. During the 4th c. B.C. it suffered from attacks by the Lucanians and Bruttians and became further exhausted during the campaigns of Pyrrhos. The final blow came when Hannibal made it the center of his desperate retreat from Italy. In 194 B.C., when the Romans planted a colony on the site, it ceased to be a place of importance.

No traces of the ancient city remain. The harbor still exists although much changed by modern construction. The site of the acropolis is marked by the castle built in A.D. 1541 by Don Pedro di Toledo. Attempts have been made to trace the city walls, which Livy (24.3.1) says extended 12 Roman miles. It is likely that the walls ran in a NW direction from the harbor, crossing the Esaro river, and that the town lay facing the sea, half on one side of the river and half on the other.

Excavations have taken place in the important Sanctuary of Hera Lakinia, which stood on a promontory (the modern Capo Colonna) some 10 km to the S. Here processions and games took place in a yearly assembly of the Italian Greeks. The interior of the temple contained paintings, the most celebrated of which was a picture of Hera by Zeuxis. A single Doric column out of 48 now remains, together with the stereobate in the NE corner; the rest was carried away by Bishop Lucifero of Crotone at the beginning of the 16th c. The peristyle (hexastyle x 16) had columns inclining inwards. There was a double colonnade across the E front in the old Sicilian fashion, and the porches were distyle in antis. The temple was remarkable for its marble decoration—roof tiles, interior cornices, and pedimental sculpture of Parian marble, fragments of which have been found. The present temple dates to the second quarter of the 5th c.

B.C., but an earlier one of the 7th c. had once stood on the site. Other buildings of the temenos also survive. The peribolos wall exists and in places rises to a height of 7 m. In the E side is a monumental propylon, which has been cleared and repaired. Nearby two buildings have been discovered. One has a central court surrounded by rooms, and on its exterior runs a portico with stone columns faced with stucco. The other consists of a corridor dividing two series of rooms. Other edifices include priests' dwellings and treasuries. Crotone has a museum which contains finds from the area.

BIBLIOGRAPHY. G. Abatino, "Note sur la Colonne du Temple de Héra Lacinia," MélRome 23 (1903) 353-61; P. Orsi, "Croton," NSc (1911) Suppl. 77-124[I]; E. D. van Buren, Archaic Fictile Revetments in Sicily and Magna Graecia (1923)[I]; D. Randall-MacIver, Greek Cities in Italy and Sicily (1931); T. J. Dunbabin, The Western Greeks (1948)[MP]; M. Guido, Southern Italy: an Archaeological Guide (1972) 166-70. W.D.E. COULSON

KROTOPOLIS, see under INCIRLIHAN

"KRYA," see TAŞYAKA

KSAR-EL-KÉBIR ("Oppidum novum") Morocco. Map 19. The station of Oppidum novum (It. Ant. 24.2) is generally placed at Ksar-el-Kébir, but this location is not absolutely certain. All that has been found in the town are two funerary inscriptions, one Greek, the other Latin, reused along with other Roman-looking ashlar blocks in building the Great Mosque, and a bronze statuette of a bacchante, which has since disappeared. However, there are quite a large number of Roman remains on the outskirts of the settlement, notably to the N and W. Moreover, the site has an extremely favorable strategic position at the crossing of the wadi Loukkos.

BIBLIOGRAPHY. L. Chatelain, Le Maroc des Romains (1944) 109-12; C. Moran and G. Guastavino Gallent, Vias y poblaciones romanas en el Norte de Marruecos (1948) 16-18; M. Euzennat, "Les voies romaines du Maroc dans l'Itinéraire Antonin," Hommages à Albert Grenier, coll. Latomus 58 (1962) 599-600.
 M. EUZENNAT

KSAR LEMSA Tunisia. Map 18. At the foot of the Jebel Serj chain, which borders the valley of the wadi Mahrouf to the W, the citadel of Lemsa, set up on a small plateau backed against the Jebel Bouja, occupied a position of strategic importance. On the one side, it overlooked the S-N passage from the Ousseltia basin to that of the Siliana along the plain of the wadi Mahrouf, and on the other the more difficult passage which, crossing it at right angles, comes from the E by way of the Ouchtetia and Guelfel passes.

This fine fortress with its strikingly well-preserved walls (except for the SE side) can be seen from afar dominating the valley in the middle of a field of ruins. A gushing stream flows down the mountainside next to it. The citadel probably was built by the patrician Salomon in the reign of Justinian, who established his country-wide system of fortifications in the first half of the 6th c. Built with materials from the monuments of the ancient city, it is a modestly proportioned fortified castle. Almost square, it measures roughly 29 m N-S and over 31 m E-W on the inside and has square projecting towers at the corners; the battlements are still standing. A nearly axial entrance on the N side is the only way into the interior: 1.84 m wide and framed by two projecting bastions, it is staggered, as recent excavations show.

Inside and around the fort, especially in the W part of the rampart, there is a group of somewhat crude, late buildings. Outside the citadel, at the foot of the ruined SE wall, was found a large, well-constructed basin measuring 28.4 x 11.25 m. Its sides were 1.1 m thick, one of the long ones having served as the base of the wall, now destroyed. The basin, 1.4 m deep, was fed by pipes from the nearby spring, along the N side. Older in construction than the building it supports, it continued to serve as an extra support, perhaps even a fortification, for the fortress: blocks from the ruined wall have been found at the bottom of the basin, which they helped to fill. During the excavation of the basin and piping system some reused dedicatory blocks were found, among them some honorary and religious funerary inscriptions, one dedicated to Mercury. Some of these have been published, and they illuminate the city's history before Byzantine times. Five hundred m down from the citadel on the other side of the road is a small theater, backed against the hillside. Its seats are well preserved.

BIBLIOGRAPHY. C. Diehl, "Rapport sur deux missions archéologiques dans l'Afrique du Nord," NouvArch 4 (1893) 389-597[P]; K. Belkhodja, "Ksar Lemsa," Africa 2 (1966) 313-29[PI]. A. ENNABLI

KSAR PHARAOUN, see VOLUBILIS

KSAR TOUAL ZAMMEL, see VICUS MARACITANUS

KTIMENAI, see ANODRANITSA under RENTINA

KTIMENE, see DHRANISTA

KTISMATA, see LIMES, GREEK EPEIROS

KÜNZING, see LIMES RAETIAE

KURNUB, see MAMPSIS

KYANEAI (Yavu) Turkey. Map 7. City in Lycia, 18 km E of Kaş (Antiphellos), 5 km from the coast. It is listed by Pliny and Hierokles, but otherwise unknown except from coins and inscriptions. It was nevertheless the principal city in the region between Antiphellos and Myra and possessed a considerable territory. The coinage is of Lycian League type and of Gordian III. There are also coins of Rhodes countermarked with a lyre and the letters KY; these belong presumably to the period of Rhodian possession of Lycia, 189-167 B.C., and were intended for circulation in the central area. In Byzantine times the bishop of Kyaneai ranked 36th and last under the metropolitan of Myra.

The ruins are on a high, steep hill directly above the village. Most of the circuit wall is well preserved; it is of irregular ashlar of moderate quality and late date. Many buildings remain in ruined condition and heavily overgrown, including a large bath building, a library, and many wells and cisterns. The theater, on a lower summit to the W, is of medium size, with 25 rows of seats and one diazoma; the retaining wall is of small polygonal blocks, collapsed at either end. Of the stage building only scanty traces remain. There are countless Lycian sarcophagi everywhere, and in the precipitous S face of the hill is a well-preserved temple tomb with a single fluted Ionic column in the porch; farther E in the same face is a pleasing group of two fine sarcophagi and two house tombs.

BIBLIOGRAPHY. T.A.B. Spratt & E. Forbes, Travels in Lycia I (1847) 112-17; E. Petersen & F. von Luschan, Reisen in Lykien II (1889) 18-22; G. F. Hill, BM Catalogue of the Greek Coins of Lycia, Pamphylia and Pisidia (1897) lv. G. E. BEAN

KYDAI, see HYDAI

KYDONIA (Khania) Crete. Map 11. On the gulf of the same name in the W part of the island, it is one of the three greatest and most famous cities of Crete. It is mentioned in many ancient sources (Scylax 47; Strab. 10.4.7-8, 11-13; Pompon. Mela 2.113; Plin. *HN* 4.12.59; Ptol. 3.15.5; *Stad.* 343-44; *Tab. Peut.* 8.5; *Rav. Cosm.* 5.21). It had a good harbor and controlled a fertile plain. Founded traditionally by Minos or Kydon (*Marmor Parium* 21f; Diod. 5.78.2; Paus. 8.53.4), it was the principal site in the territory of the Kydones. Herodotos (3.59) tells of its foundation or refoundation in 524 by Samian exiles, who built the temples visible in the 5th c.; they were defeated and enslaved by Aeginetans (with Cretan support), who then settled there (Strab. 8.6.16) and remained a significant part of the population. The city was attacked unsuccessfully by an Athenian force in answer to an appeal from its small neighbor Polichna in 429 B.C. (Thuc. 2.85) and by Phalaikos the Phokian mercenary commander in 343 B.C. (Diod. 16.63; Paus. 10.2.7.).

It had good relations with Athens and probably with Macedon in the later 4th and 3d c. It was allied with Knossos in mid 3d c., but forced to abandon this alliance in 220 by Polyrrhenia (Polyb. 4.55.4). Increasing prosperity from the 4th c. made Kydonia predominant in W Crete by the 2d c.; it subjected Phalasarna, but was forced by Ap. Claudius to restore its freedom (Polyb. 22.15) in 184 B.C.. It stayed out of the Cretan League and the alliance with Eumenes II (183 B.C.), but made a separate alliance with him, invoked in 170 or 169 when Gortyn threatened it, counterattacking in reprisal for the city's atrocities against Apollonia (destroyed 171; Polyb. 28.14-15; Diod. 30.13). For long periods it controlled the Diktynnaion. It led Cretan resistance to Rome in the 1st c. B.C., supported Octavian against Antony, and was rewarded with freedom (30 B.C.; Dio Cass. 51.2). It was prosperous under the Empire and one of the few Cretan cities then issuing its own coinage, which had begun in the early 5th c. B.C. The seat of a bishop, the settlement continued until the Arab Conquest in the early 9th c.

Recent excavations on Kastelli Hill by the harbor have revealed a very important Minoan settlement, mainly MM-LM (esp. LM III), but with also EM and post-Minoan sherds (esp. Geometric). From the Bronze Age onwards this was clearly the main settlement in the area; theories that Kydonia or early Kydonia lay W or SW of Khania must be rejected. Of the post-Minoan city very little has been found, but it probably occupied Kastelli Hill (presumably the acropolis) and the area below to the S. Remains of buildings with mosaics of the Roman period (mainly 2d c. A.D.) have been found just S of the Cathedral (Metropolis; two rooms of bath complex and part of hypocaust); by Venizelos Sq. S of the Market; and in Nea Katastimata to the SW (mosaic depicting Poseidon and Amymone). Tombs of MM, LM, archaic, Classical, Hellenistic, and Roman date (the Minoan mainly chamber tombs and the later mainly cist graves or hypogaea) have been found in the E and SE of the city: in the area of the Public Park, Stadium, Law Courts (Mazali), Bolaris and Khalepa. Minoan remains have also been found to the SW. The ancient harbor (closable according to Skylax; with reefs at entrance according to the *Stad.*) was below Kastelli to the N, the harbor used later by the Venetians, whose mole along the reef probably covers an ancient mole. Belli saw remains of the theater (being demolished in 1585 by the Venetians for improvements to their fortifications), an aqueduct, and a temple with a Doric portico. The Venetian walls clearly contain much ancient material and provide the main reason for the lack of visible ancient remains.

BIBLIOGRAPHY. R. Pashley, *Travels in Crete* I (1837; repr. 1970) 11-17[M]; T.A.B. Spratt, *Travels and Researches in Crete* II (1865) 137-42[I]; J.-N. Svoronos, *Numismatique de la Crète ancienne* (1890; repr. 1972) 96-119; L. Mariani, *MonAnt* 6 (1895) 170, 201-7; Bürchner, "Kydonia (1)," *RE* XI (1922) 2306-7; S. Paraskevaidis, *Deltion* 10 (1926), Parartima 44-48[P]; M. Guarducci, *ICr* II (1939) 104-27; V. D. Theophanidis, *ArchEph* 84-85 (1945-47) 37-46; id. 86-87 (1948-49), Parartima 12-19[P]; H. van Effenterre, *La Crète et le monde grec de Platon à Polybe* (1948); U. Jantzen, "Die spätminoische Nekropole von Kydonia," in F. Matz (ed.), *Forschungen auf Kreta, 1942* (1951) 72-81; id., "Protogeometrisches aus Westkreta," *Festschr. E. von Mercklin* (1964) 60-62; N. Platon, *KretChron* 13 (1959) 392; R. F. Willetts, *Aristocratic Society in Ancient Crete* (1955); id., *Cretan Cults and Festivals* (1962); P. Faure, *Fonctions des cavernes crétoises* (1964); M.S.F. Hood, *BSA* 60 (1965) 109-10; S. G. Spanakis, *Kriti* II (n.d.) 231-36, 396-416 (in Greek) n.d.[M]; *Deltion*, 20ff (1965ff) esp. *Chronika* 21, 428; 22, 497-98; 25, 465-67; *BCH* 94 (1970) 1156; 95 (1971) 1063, 1067; 96 (1972) 805; 97 (1973) 409ff; *AAA* 3 (1970) 100-2; 4 (1971) 223-24; 5 (1972) 387-91; 6 (1973) 430-48. D. J. BLACKMAN

"KYLLANDOS," *see* ELMALI

KYME Euboia, Greece. Map 11. One of the chief towns of the region in the archaic period, joining with Chalkis in the 8th c. B.C. to found Cumae in Italy. There was a tendency in later times, when the Euboian city was overshadowed by Chalkis, to confuse it with the far more important Aeolian Kyme in Asia Minor. The location of the archaic city is not certain, but it is presumably to be found on the E slope of Mt. Dirphys near the E coast town of Koumi. No ancient remains other than inscriptions have been found at the modern town; the ancient acropolis was probably on the height of Palaiokastri at Potamia, now marked by a mediaeval fortress. Bursian reported 4th and 3d c. B.C. graves NE of Koumi; a small temple has been excavated at Oxylithos not far to the S.

BIBLIOGRAPHY. C. Bursian, *Geographie von Griechenland* (1872) II 427; G. A. Papavasiliou in *Praktika* (1907) 117; A. Philippson-Kirsten, *GL* (1950-59) I 618; L. Sackett et al. in *BSA* 61 (1966) 76. M. H. MCALLISTER

KYME (Namurt Limanı) Turkey. Map 7. City in Aiolis, 40 km N of Smyrna. Founded, according to Strabo (621), by Greek colonists after the Trojan War and after their capture of Larisa from the Pelasgians. Kyme contributed ships to Dareios in 512 B.C. and to Xerxes in 480 (Hdt. 4.138; 7.196). The city was assessed in the Delian Confederacy at the very high figure of nine talents, and is called by Strabo the biggest and best of the Aiolian cities. Kebren and Side are said to have been her colonies. The coinage extends from the 7th c. B.C. to the 3d c. A.D., but the city has virtually no history in the Hellenistic and Roman periods.

Little remains of the ancient city. It occupied two hills, of which the S one was defended by a circuit wall of polygonal masonry; almost nothing of this is now to be seen. The hollow of a theater is visible at the foot of the N hill, but its stones are gone. A small Ionic temple of Isis, once excavated, is now undiscoverable. In the valley between the hills are the remains of a monumental building of late date with two rows of unfluted columns. To the N a stream identified with the Xanthos enters the sea; another stream to the S has converted the valley into a marsh. On the shore are two harbor-moles; the S one is reasonably well preserved,

though now under water. The whole site is virtually deserted.

BIBLIOGRAPHY. C. Schuchhardt, *Altertümer von Pergamon* I, 1 (1912) 95; G. E. Bean, *Aegean Turkey* (1966) 193-96. G. E. BEAN

KYNAITHA Arkadia, Greece. Map 9. A city in Anzania founded probably during the archaic period near the town of Kalavryta. According to Polybios (4.18-21) the Kynaithaians far surpassed other Greeks in cruelty and wickedness. During the War of the Allied (220-217) the city was destroyed by the Aitolians. It was reinhabited and, during the Roman era, its citizens gained the right to issue coins. In the marketplace were altars of the gods, including an image of Zeus Olympias.

BIBLIOGRAPHY. B. V. Head, *HN* (2d ed. 1911) 447; E. Meyer, *Peloponn. Wanderungen* (1939) 107ff; J. Hejnic, *Pausanias the Perieget and the Archaic History of Arcadia* (1961) 21; E. Mastrokostas in *Deltion* 17 (1961-62) B, 130ff[I]; E. Kunze, *Olympia-Bericht* VIII (1967) 119; E. Meyer in *Kl. Pauly* III 398.

G. S. KORRÈS

KYPAIRA, *see* KAITSA *under* RENTINA

KYPARISSOS, *see under* TAINARON

KYRENIA, *see* KERYNEIA *and* SHIPWRECKS

KYRRHOS Syria. Map 6. Town founded by the Macedonians, 70 km N-NW of Aleppo, an important strategic position at the beginning of the Hellenistic period and later under Roman rule. It was sacked by the Sasanians in A.D. 256. In the 5th c. it experienced a brief renascence as a center of pilgrimage under its bishop Theodoretus. In the 6th c. Justinian fortified and adorned the town, and in A.D. 637 it yielded to the Moslems.

It is at a bend of a tributary to the Afrin, not far from their confluence. It forms a rough triangle, from the acropolis to the W to the high cliff above the river to the E. Bridges, ramparts, a great avenue, Christian sanctuaries, a theater, and a mausoleum are the principal ancient remains.

The Byzantine bridges are still in use S of the town: they cross first the Afrin, then its tributary. To the N the bridge over the river is in ruins, but the ancient road is visible beyond it.

The ramparts have square or semicircular towers and date from the Byzantine period. An inscription on a gate of the citadel gives the names of Justinian, Theodora, Belisarius, and the domestikos Eustathius. The vast enclosure is of Hellenistic date, as are the polygonal blocks preserved in various sectors. The acropolis was roughly rectangular, with a gate to the outside and a gate to the lower town. The lower town itself had three gates, to the N, S, and E.

The orthogonal street plan dates from Hellenistic times; the main axis is a wide street from the S to the N gate, bordered by porticos. A spacious rectangular enclosure has the ramparts to the W, and on its S and E sides two monumental gates flanked by rectangular towers; two other towers stand at the corners of the E side, parallel to the great avenue. Inside this space (once mistaken for an agora) was a church with three naves and a narthex to the W; it has ancient fluted columns and is built of materials of many colors. To the NE of this sanctuary and E of the colonnade are the remains of a large Christian basilica with several apses.

The theater is ca. 60 m from the avenue; it backs against the hill of the acropolis and faces E. Only the 24 rows of the lower tier of seats survive; the upper tier

has disappeared. There are seats with backs in front of the diazoma, and those next to the radial staircases have elbow rests in the form of dolphins. The scaenae frons had five doors, opening onto alternately rectangular and semicircular exedras. The theater reveals the influence of Antioch and Daphne and may date to the middle of the 2d c. A.D.

The best-preserved necropolis is to the NW. A large hexagonal mausoleum, reused as a Moslem sanctuary, has pilasters at the corners of the ground floor. It is crowned with an entablature, decorated with lions' heads, that supports a skylight with windows which have archivolts and Corinthian pilasters. The skylight is capped by a slender pyramid, with a capital adorned with acanthus leaves at the top. The capital is big enough to carry a statue.

BIBLIOGRAPHY. D. van Berchem, "Recherches sur la chronologie des enceintes de Syrie et de Mésopotamie," *Syria* 31 (1954)[PI]; E. Frézouls, "Recherches historiques et archéologiques sur la ville de Cyrrhus," *Annales archéologiques de Syrie* 4-5 (1955)[MPI]; id., "Les théâtres romains de Syrie," *Syria* 36 (1959); 38 (1961).

J.-P. REY-COQUAIS

KYS (Bellibol) Turkey. Map 7. City in Caria, 30 km S of Bozdoğan. It was recorded by Stephanos Byzantios in the form Kyon, formerly called Kanebion. An inscription informs us that it also at one time was called Palaiopolis, a name which has survived in the modern village. The rare coins are dated to the 1st c. B.C. The city was in a commanding position in the mountain country between the valleys of the Marsyas and Harpasos. The acropolis is on a height above a deep rocky gorge with a stream at the bottom. The seats of a theater can be seen in the village but the stage building has disappeared.

BIBLIOGRAPHY. G. Cousin & G. Deschamps, *BCH* 11 (1887) 305f; A. Laumonier, *Les Cultes Indigènes en Carie* (1958) 463. G. E. BEAN

KYTHERA Greece. Map 9. An island S of the Peloponnesos. The sources (*Il.* 10.268; Paus. 3.23.1) speak of the ancient port of Skandia, which is probably modern Kastri. The island belonged to Argos, but in Classical times on was under Sparta. The ancient city of Kythera is identified with the summit now called Palaiokastro, at the center of the island, where traces of an enclosing wall, probably archaic, are visible. Near the church of Haghios Kosmas, on the SW slopes of the mountain, rose the sanctuary of Aphrodite (Hdt. 1.105.3). Near Kastri on the SE side of the island was a Minoan settlement, begun toward EM I-II, with Mycenaean pottery in the ultimate phase. At Kastraki there have been finds of EH I-II. There is a small museum at Khora.

BIBLIOGRAPHY. V. Stais, *Deltion* 1 (1915) 191ff; L. Bürchner-Maull, *RE* XII, 1 (1924) 207-18; H. Waterhouse & R. Hope Simpson, "Prehistoric Laconia, Part II," *BSA* 56 (1961) 148ff[PI]; G. L. Huxley & J. N. Coldstream, "Kythera, First Minoan Colony," *ILN* 6630, 249 (1966) 28-29; id., *Kythera, Excavations and Studies* (1972)[MPI]; *EAA* Suppl. (1970) 227.

M. G. PICOZZI

KYUSTENDIL, *see* PAUTALIA

KYZIKOS (Belkis or Balkız) Turkey. Map 7. City on the isthmus of the peninsula Arktonnesos (Kapu Dağ) on the SW coast of the Sea of Marmara. Arktonnesos was originally an island, but it became a peninsula by means of two parallel dykes and accumulations of sand. Kyzikos, according to tradition, was the earliest colony in the Propontis founded by Miletos (Strab. 14.635; Plin. *HN* 5.142). Eusebios (*Chron.* 2.81.87) says that Kyzikos

was twice colonized, in 756 and 679 B.C., but a Greek settlement in the mid 8th c. on the Propontis is unlikely —Miletos was not in a position to found colonies there before the beginning of the 7th c. Indeed nothing has been found in the whole Pontos area dating from before the middle of the 7th c. In Byzantium, which was a Megarian colony, the earliest pottery found is late Protocorinthian in style, of the third quarter of the 7th c., while a Late Geometric sherd, the oldest pottery discovered in Daskyleion, dates from ca. 680-670 B.C. Thus Kyzikos must have been founded about 700 B.C. at the earliest.

On the trade route between Pontos and the Aegean, Kyzikos was an important center from the beginning, and the Κυζικηνοῦ στατῆρες χρυσίου were the most important coins of the E Greek world from the 6th to the 4th c. B.C. The city took part in the Ionian revolt, belonged to the Delian League, and during the Peloponnesian war it was held alternately by Athens and Sparta. In 411 B.C. the Athenians defeated the Spartan fleet under Alcibiades near Kyzikos. In 387, however, it became subject to Persia, like the other Greek cities in W Anatolia, under the Peace of Antalcidas. Incorporated in the Pergamene kingdom about 190, it passed to Rome in 133 B.C.

The earliest sherds found at Kyzikos are of the orientalizing style, but there must have been older pottery; the archaic layer lies below sea level and the lower strata are hard to reach. Noteworthy is a big fragment of a columna caelata, mid 6th c. B.C., which represents a young woman dancing between two youths (in the Archaeological Museum in Istanbul). It reflects some Milesian influence, but is a local creation. The archaic statue of a young man with arms and legs missing, also in the Istanbul Museum, was likewise made in Kyzikos after Milesian models. Many other finds from Kyzikos and the neighborhood are in the same museum, others are in the Erdek Open-Air Museum.

All that exists today of the Temple of Hadrian, in the SW district of the city, is the vaulting that supported the platform. The temple was dedicated to the emperor as the 13th Olympian god; in the late Roman era it was accepted as one of the seven wonders of the world. In 1431 Cyriacus of Ancona saw the whole upper part of the building with 33 columns intact; his engravings have made it possible to identify a piece of one of the temple columns, now in the Erdek Museum.

BIBLIOGRAPHY. F. W. Hasluck, *Cyzicus* (1910); *RE* XII 1 (1925) 228-33; D. Magie, *Roman Rule in Asia Minor* (1950) 81; B. Ashmole, "Cyriac of Ancona and the Temple of Hadrian at Cyzicus," *JWarb* 19 (1956) 76-91; E. Akurgal, "Recherches faites à Cyzique," *Anatolia* 1 (1956) 15-20[I]; id., *Die Kunst Anatoliens* (1961) 234-39, 257, 262[I]; id., "Neue archaische Bildwerke aus Kyzikos," *AntK* 8 (1965) 99-103[I]; P. Laubscher, "Zwei neue Kouroi," *IstMitt* 13-14 (1963-64) 73-80; id., "Zum Fries des Hadrianstempels," ibid. 17 (1967) 211-17.

E. AKURGAL

L

LA ALMUNIA DE DOÑA GODINA, *see* NERTOBRIGA

LABASTIDE D'ARMAGNAC Landes, France. Map 23. An Early Empire Gallo-Roman settlement, rebuilt in the Late Empire and partly covered in modern times by the Chapelle de Géou. The Late Empire villa covers an area of more than 2 ha; in it were found a gallery (2.85 x 15.3 m) with a mosaic floor (geometric design of squares and eight-pointed stars) opening onto an inner court, also a room with a hypocaust on low piers with a mosaic floor in the same style.

BIBLIOGRAPHY. Dufourcet et al., *Aquitaine Historique et Monumentale* I (1890) 338; J. Coupry, "Informations," *Gallia* 19, 2 (1961) 392[I]. M. GAUTHIER

LA-BASTIDE-DU-TEMPLE Tarn-et-Garonne, France. Map 23. In the Notre-Dame district, the ruins of a Gallo-Roman establishment were excavated in 1956. A 4th c. polychrome mosaic with geometric decoration was found. It is now kept at the Musée Ingres at Montauban.

BIBLIOGRAPHY. M. Labrousse, "Mosaique polychrome gallo-romaine découverte à La-Bastide-du-Temple (Tarn-et-Garonne)," *Pallas* 5 (1957) 71-82; cf. *Gallia* 15 (1957) 273-74 & figs. 18-19. M. LABROUSSE

LA-BASTIDE-L'ÉVÊQUE Aveyron, France. Map 23.
1. Ancient marble heads are preserved in the castle of Requista, one of a faun or satyr, one of an old man. They may come from 19th c. excavations in the region of Villefranche-de-Rouergue.
2. At the Rivière farm, a Gallo-Roman votive altar has recently been discovered. It is 0.9 m high, hewn and carved from local sandstone.

The finds of sculptures are no doubt connected to the intensive exploitation of veins of lead containing silver in the region of Villefranche (*CIL* XIII, 1550), from the beginning of the Empire on.

BIBLIOGRAPHY. A. Albenque, *Les Rutènes* (1948) 168-72; M. Labrousse, "Exploitations d'or et d'argent dans le Rouergue et l'Albigeois à l'époque romaine," *Actes du XIV*e *Congrès d'études régionales de la Fédération des Sociétés académiques et savantes Languedoc-Pyrénées-Gascogne 14-16 juin 1958*, 99-103; id. in *Gallia* 22 (1964) 432-33 & figs. 10-11; 28 (1970) 398 & fig. 1.

M. LABROUSSE

LABOVË ("Omphalion") S Albania. Map 9. A precipitous ridge, overlooking the gorge of the Suhë river, is fortified with a circuit wall and powerful towers. The site controls the entry from the Drin valley to the high plateau of Poliçan, the territory probably of the Omphales, a Chaonian tribe. It is mentioned by Ptolemy (3.13.5).

BIBLIOGRAPHY. N.G.L. Hammond, *Epirus* (1967) 209, 660, 680, 699f. N.G.L. HAMMOND

LABRAUNDA or Labraynda, Labranda Caria, Turkey. Map 7. An important religious center, a sanctuary rather than a town, about 48 km SW of Miletos and 13 km N of Mylasa (under whose control Labraunda usually was). It was the seat of the cult of Zeus Stratios or Labraundos, a local Mylasan deity. The site was occupied in archaic times, and Herodotos speaks of a large grove of sacred plane trees there (5.119). The first cult temple seems to have been erected in the 5th c. B.C., and the site was much embellished by the Hecatomnids, particularly by the brothers Mausolos and Idrieus, in the next century. Strabo (14.2.23) mentions the temple and the Sacred Way from Mylasa, and Aelian (*NA* 12.30) describes a basin at Labraunda stocked with tame and bejeweled fish. The Hecatomnid complex remained more or less unchanged until buildings were added to it in Julio-Claudian times. Perhaps the main buildings were destroyed about the middle of the 4th c. A.D. There are

remains of a Byzantine church built of reused materials.

Part of the paved Sacred Way up from Mylasa is still visible. About 7.5 m wide, it runs straight, being partly constructed by cut-and-fill. The site, well supplied with water, is steep; the several terraces and numerous buildings were connected by ramps and stairs. Apart from the sanctuary there is an acropolis ca. 90 m in length, and on the slopes above the sacred precinct there are the fragmentary remains of a stadium. The Hecatomnids seem to have had a palace at Labraunda.

There were many tombs around the sanctuary and along the Sacred Way, usually cut from the living rock, room-style, or sunk into it. Of particular interest is one N of the temple, built up of carefully finished cut stone. Two rooms are vaulted with projecting corbel-stones, the undersides of which, however, are cut back to form the impression and surface of a true, curved vault. Above both chambers is a low second story, roofed with monolithic stone slabs up to 5 m in length. The doorway to the inner chamber was originally closed by a six-ton stone; the whole may be of the 4th c. B.C. There are fragments of two sarcophagi in the outer chamber, and three well-preserved sarcophagi in the inner chamber.

The original Temple of Zeus Stratios was a small structure in antis of megaron-like plan in part preserved by the Hecatomnid builders, who added to it an Ionic peristyle (6 x 8 columns); part of Idrieus' dedicatory inscription has been found. He and his brother constructed two interesting and all but identical androns or religious meetinghouses, one W and one S of the temple terrace. These were well built of local stone, with rectangular plans and numerous large windows. Each had a porch with two columns in antis (recalling the plan of the original Temple of Zeus) and a large main room lit not only by side windows but also by windows in the thick wall separating the room from the porch. Both buildings have broad niches at the ends of their interior chambers, rectilinear in plan and elevated, shelf-like, from the floor. In the 1st c. A.D. a third andron was built, just S of the Hecatomnid one farther S. East and S of the temple are the remains of several priests' houses, one with a porch of four Doric columns. Flanking the broad terrace to the E of the temple were two stoas, the N one built for Mausolos, the S one for Idrieus. By the N one there is an exedra, perhaps of Roman date; beyond this was another large house. Below the S colonnade is a fairly elaborate well-house, probably of the 1st c. A.D. East of this are sizable ruins which may well be of the Hecatomnid palace.

About 45 m SE of the well-house two staircases, one a grand, well-preserved structure nearly 12 m wide, lead to a lower courtyard faced on two sides by grand propylaea; it was to these that the Sacred Way led. Here stood a house with a facade of Doric columns which was later incorporated in a Roman bath building. Nearby, and also between the two propylaea, are the remains of the Byzantine church, a three-aisled basilica with a narthex and a deep apsidal sanctuary flanked by side chapels. Still farther SE, alongside part of the precinct wall, was an unusual two-story building partly constructed of granite columns. It has been suggested that Aelian's pool was here, that the fish were sacred to the god and were connected with those oracular functions for which there is some evidence at Labraunda (the use of fish as oracular agents is well attested in the ancient world).

There are several small, ruined fortresses of ancient date in the general vicinity. Some Labraunda finds can be seen in the Archaeological Museum in Izmir.

BIBLIOGRAPHY. *RE* XII (1924) 277-82; A. Laumonier, *Labraunda, Swedish Excavations and Researches* (1955ff)[PI]; id., *Les cults indigenes en Carie* (1958) 45-101; *EAA* 4 (1961) 440-42[P]; A. Westholm, *Labraunda* (1963); G. E. Bean, *Turkey Beyond the Maeander* (1971) 56-68[MPI]; E. Akurgal, *Ancient Ruins and Civilizations of Turkey* (3d ed. 1973) 244-45.　　w. l. mac donald

LABURDUM, *see* LAPURDUM

LA CANOURGUE or Cadoule　Lozère, France. Map 23. A Gallo-Roman site known as Ron de Gleïso in the commune of La Canourge, in the NW section of the Sauveterre plateau on the top of a hill 850 m high. One km from the site is an ancient road linking Banassac-La Canourgue to Chanac and Grèzes.

The site consists of dwellings scattered on the summit and the W and S slopes of the hill. The dwellings are rectangular and divided into two sections along the long axis of the settlement. One section is for artisans, the other, which is subdivided, is simply residential. The walls here are of a regular masonry, mortared rubble faced with small blocks. Traces of an earlier occupation have been noted below these remains and elsewhere. The site was inhabited at the beginning of the 1st c. B.C. and finally abandoned at the end of the 4th c. A.D. There is a distinct hiatus in the 3d c.

A number of fibulae of the Late Iron Age, a bowl fragment with a repeated inscription, CATTIOS, bowls with a white slip and geometric decoration, and coins of the Arveni provide evidence of the first occupation. Among the finds of the Roman period are a lifesize sculpture of the head of a woman, many bowls of terra sigillata from Banassac, various bronze and bone objects, and coins. All these objects are in the archaeological depot at La Canourgue.

BIBLIOGRAPHY. "Chantier de Cadoule," in H. Vigarié, *Fouilles du groupe d'archéologie antique du Touring Club de France*; "Banassac-La Canourgue, Août 1961," *Revue du Gévaudan* (1961) 30; ibid. (1963) 80, 167, 190 (Roman villa); P. Peyre, *Les habitats de "Ron de Gleïso," commune de La Canourgue, Lozère* (mimeo 1966); id., "Ensemble Gallo-romain de Ron de Gleïso, Cadoule," *Revue du Gévaudan* (1968) 99-135; *Gallia* 27, 2 (1969) 413-14.　　p. peyre

LA CHAPELLE-MONTBRANDEIX　Dept. Haute Vienne, France. Map 23. In 1880 a Gallo-Roman settlement with two hypocausts, was discovered at Artimache. Two skeletons were found in a room 2 m sq, lying on a pink concrete floor.

An important Gallo-Roman site is just now being excavated at the place called Les Couvents. Thanks to this work, begun in 1968, the underlying ruins of a Gallo-Roman settlement have been unearthed as well as a potter's oven, perfectly preserved.

From the finds made so far it is evident that the site was occupied from the 1st c. A.D. Objects found there can be seen at the town hall of Chapelle-Montbrandeix.

BIBLIOGRAPHY. "Le site gallo-romain des 'Couvents' et son contexte arch.," *Forum* (1971).　　p. dupuy

LA CHAPELLE-VAUPELTEIGNE　Yonne, France. Map 23. Situated in the valley of the Serein, a tributary of the Yonne. The richness of the Yonne and Saône valleys in the Gallo-Roman period has long been recognized from scattered remains of settlements and the presence of large villas. The Serein valley was probably no less rich, as is evident in particular from two recently excavated villas, one at Noyers-sur-Serein (the area known as La Tête de Fer) and the other at La Chapelle-Vaupelteigne (Les Roches). The second villa, the only one that has been excavated thoroughly, comprises a large porticoed courtyard with rooms arranged around

it according to a regular plan. To the E, on the facade, is a large ditch between two towers or square rooms. The various stages of the buildings range from the end of the 1st c. A.D. to the beginning of the 4th c. A few fragments of decorative figured reliefs, made of limestone, give an idea of their richness.

BIBLIOGRAPHY. Abbé Duchâtel, "L'établissement gallo-romain des Roches à La Chapelle-Vaupelteigne (Yonne)," *Rev. Arch. de l'Est* 21 (1970) 261-330; id., *Noyers et son territoire dans l'Antiquité* (1966); *Gallia* 22 (1964) 331-32[P]. C. ROLLEY

LACOBRIGA (Lagos) Algarve, Portugal. Map 19. Mentioned by Mela (3.1) and by Ptolemy (2.5), it was situated at the foot and on the top of Monte Molião on the outskirts of the present city. Only trial excavations have been made; the finds are in the museum of Lagos.

BIBLIOGRAPHY. A. Viana et al., "Alguns objectos inéditos do Museu Regional de Lagos," *Revista de Guimarães* 62 (1952) 133-42; id., "De lo prerromano a lo arabe en el Museo Regional de Lagos," *Archivo Español de Arqueologia* (1953) 113-38. J. ALARCÃO

LA COCOSA Badajoz, Spain. Map 19. A Roman villa 16 km S of Badajoz has been excavated, dating from the 4th c. A.D. but modified during the Christian era. Pottery from the 1st and 2d c. and coins from Agrippa to Arcadius have also been found. The original building consists of a large peristyle, a number of rooms, three of which had mosaic pavements, and baths. The finds are in the Badajoz Archaeological Museum.

BIBLIOGRAPHY. J. de C. Serra Ráfols, *La "villa" romana de la dehesa de "La Cocosa"* (1952)[MPI].
L. G. IGLESIAS

LA CORUÑA, see BRIGANTIUM

LACTODORUM (Towcester) Northamptonshire, England. Map 24. Identified from its position in the *Antonine Itinerary* (470.6, 476.11). The name (corrupted to *Iacodulma* in the *Rav. Cosm.* 5.31) means town of dairymen. Many chance finds are known from this town on Watling Street and in 1954 limited excavation revealed some details of the defenses. The wall, of the late 2d c., lay over some 1st and early 2d c. buildings. In the 4th c. it fell into the ditch and was not repaired, though new buildings continued to be erected.

BIBLIOGRAPHY. *VCH Northamptonshire* I (1902) 184; "Roman Britain," *JRS* 45 (1955) 135; 59 (1969) 219; *Itinerary*: A.L.F. Rivet, *Britannia* 1 (1970) 42, 49; meaning of name: K. H. Jackson, ibid. 75. A.L.F. RIVET

LACTORA (Lectoure) Gers, France. Map 23. The town of Lactora was first part of the province of Aquitaine, then of Novempopulania. It was the capital of the civitas of the Lactorates and one of the high places of the cult of Cybele. Recent investigations, outside the original oppidum, have led to the following discoveries: 1) On the Lamarque plateau there are a series of funerary pits of the 1st c. B.C. 2) In the district of Pradoulin a dwelling which was devastated by the invasions and troubles of the 3d c. has produced three hoards of coins buried under Aurelian and Probus. In the 4th c. it was covered by a group of workshops where potters produced a rather rough red ware decorated with appliqué. 3) In the same district an inhumation necropolis of the Late Empire has produced, among others, an adorned sarcophagus of the School of Aquitaine. 4) At La Payroulère there is a barbarian necropolis of late date.

BIBLIOGRAPHY. R. Etienne, "La chronologie des autels tauroboliques de Lectoure," *Bull. de la Soc. arch. du Gers* 60 (1959) 35-42; M. Labrousse, "Les lampes romaines du Musée de Lectoure," ibid. (1959) 43-67; 65 (1964) 25-30; Mary Larrieu, "Céramiques romaines du Musée de Lectoure," ibid. 60 (1959) 69-83; M. Larrieu, "Découverte à Lectoure d'un nouveau sarcophage sculpté de l'Ecole d'Aquitaine," *Cahiers archéologiques* 18 (1968) 1-12.

For reports on recent excavations see M. Labrousse in *Gallia* 5 (1947) 476-77 & figs. 10-11; 7 (1949) 138; 24 (1966) 433-35 & figs. 23-26; 26 (1968) 540-43 & figs. 27-29; 28 (1970) 418. M. LABROUSSE

LADENBURG ON THE NECKAR, see LOPODUNUM

LAERTES Turkey. Map 6. City of Cilicia Aspera or Pamphylia, almost certainly at a site high up on the mountain of Cebelireş, 17 km E of Alânya and ca. 750 m above sea level. The 40 inscriptions found on the spot do not name the city, but the position agrees reasonably well with the location of Laertes in the *Stadiasmus* (207) as 100 stades from Korakesion (Alânya), and Alexander Polyistor ap. Steph. Byz. s.v. speaks of a mountain and city of Laertes. Strabo (669: the passage is confused) also places Laertes E of Korakesion. The coinage is Imperial only, of the 2d and 3d c., but the city is not mentioned either in Hierokles or in the *Notitae*.

The city lay on a shoulder of the mountain at the foot of the summit peak, which rises some 600 m higher. It is approached by a gully from the SE; this route is defended by two spaced towers, and by a stretch of wall where it reaches the city. The remainder of the site seems never to have had a fortification wall, but at the SE corner there is a good-sized fortress, below which is an underground building consisting of three vaulted passages, perhaps a storehouse. On the N side of the site are remains of a long paved street originally lined with numerous statues, many of Roman emperors. On the S side of this street stood a building approached by steps, possibly a council house; here also were numerous statues. Farther W is an open space, perhaps an agora, bordered by a long pavement; at the N end of this is an exedra and at the S end a large building with an apse at its W end, comprising a complex of halls. This part of the site is covered with ruins of houses and other buildings. The main necropolis is on the mountain slope S of the city.

BIBLIOGRAPHY. G. E. Bean & T. B. Mitford, *AnatSt* 12 (1962) 194-206; id., *Journeys in Rough Cilicia 1964-1968* (1970) 94-105. G. E. BEAN

LA ESCALA, see EMPORION

LAGASTE, see POMAS-ET-ROUFFIAC

LAGATORA, see LIMES, GREEK EPEIROS

LAGBE Turkey. Map 7. Near the village of Ali Fahrettin on the NE shore of Karalitis (Söğüt Lake) in Phrygia. There are few ancient building remains at this site first identified through an inscription. It was a bishopric in the 3d c.

BIBLIOGRAPHY. M. Ramsay, *The Cities and Bishoprics of Phrygia*, I-II (1895-97); D. Magie, *Roman Rule in Asia Minor*, I-II (1950). C. BAYBURTLUOĞLU

LAGENTIUM or Lageolium (Castleford) Yorkshire, England. Map 24. The *Antonine Itinerary* places Lageolium between Danum (Doncaster) and Eboracum (York). It is also mentioned in the *Ravenna Cosmography*, but it seems never to have been more than a roadside settlement.

Coins and the remains of walls have been found at

intervals just S of Castleford Church. Graves have also been found, and a milestone, now in the Yorkshire Museum, York, erected by the emperor Annius Florianus ca. 276, comes from the site. G. F. WILMOT

LAGEOLIUM, see LAGENTIUM

LAGINA Turkey. Map 7. Site, in Caria, of the famous temple of Hecate. Near Turgut (formerly Leyne), 15 km NW of Yatağan. Lagina was a village in the territory of Stratonikeia, but the name is not used in the inscriptions, and the village appears to have been called Hierakome. The cult is not attested before the period of Rhodian domination in 189-167 B.C., but was no doubt much older. The sanctuary was joined to Stratonikeia by a sacred way, of which virtually nothing is now to be seen. Numerous festivals were celebrated at the site, notably the annual Hekatesia, to which a quadrennial Hekatesia-Romaia was added after the Mithridatic war, also the annual Bearing of the Key, and the Birthday Festival. Personnel included the priest (a priestess not before the 3d c. A.D.), the Key Bearer (a young girl), the neokoros, the president of the mysteries, and the eunuchs.

In 88 B.C. Stratonikeia resisted Mithridates but was taken by force; it was rewarded by Sulla with an alliance of friendship with Rome and confirmation of the inviolability of the sanctuary at Lagina; this was inscribed on the temple itself. In 40 B.C. Labienus revenged himself for his failure to take Stratonikeia by sacking the temples, including that of Hekate; the damage was repaired with the help of Augustus, as is acknowledged in an inscription on the lintel of the propylon.

The temple lies at present in a flat heap heavily overgrown, but its plan is clear and many of the architectural features remain. It was pseudodipteral, in the Corinthian order, with a peristyle of 11 columns by 8; the pronaos and cella were of almost equal dimensions, and there was no opisthodomos. The building faced E. Elements still in position include the steps on the E front, the antae of the pronaos, some of the orthostats of the cella wall, three column bases at the rear, and part of the paving of the peristyle. Much of the frieze and numerous inscriptions were removed by 19th c. excavators. The frieze covered all four sides of the building, with scenes representing the birth of Zeus, a battle of gods and giants, and a scene of reconciliation between Greeks and Amazons; Hekate features in all of these. On the S side was a series of figures which seem to have represented Carian cities and deities. Estimates of the date vary from ca. 125 B.C. to the end of the 1st c.

The precinct surrounding the temple was ca. 150 by 135 m. It was enclosed by a stoa in the Doric order, the S side of which was raised on a flight of 11 steps, with a staircase at the W end; but little of this can now be made out. At the E end of the S stoa was a propylon; the gate still stands, with jambs and inscribed lintel complete.

The inscriptions indicate that there was much else in the precinct: "three stoas in the sacred house" (presumably living quarters for the clergy), a provision market, and a sacred grove of trees maintained by the eunuchs. One inscription forbids flocks to be pastured in the sanctuary.

BIBLIOGRAPHY. C. T. Newton, Halicarnassus . . . II (1863) 554; Hamdi Bey & J. Chamonard, CRAI 19 (1891) 272, 290; (1892) 147, 304; id., BCH 19 (1895) 235ff; G. Mendel, Catalogue des sculptures grecques, romaines et byzantines (Istanbul Museum) I (1912) 428ff; A. Laumonier, Cultes Indigènes en Carie (1958) 344-425; G. E. Bean, Turkey beyond the Maeander (1971) 94-98. G. E. BEAN

LAGON (Evdir Han) Pamphylia, S Anatolia. Map 7. Referred to as Lagbon in Livy. The city was founded on a plain surrounded with pine forests. It is 17 km from modern Antalya. Canals passed through the city. As the remains show, both sides of the canals were adorned with richly ornamented altars and porticos. The ancient city was probably on the road from the N to Antalya. This idea is supported by Seljuk caravanserais seen along the road at regular intervals. Very near the center of the ancient city is a small prostyle tetrastyle temple of the 2d c. A.D., which is the best-preserved structure on the site. Around the city are to be seen rock-cut graves and grave monuments. Artemis was especially honored. The site has not been excavated.

BIBLIOGRAPHY. Pace, "Escursioni in Licia," Annuario 3 (1916-20) 65; Moretti, "Rovine di Lagon," Annuario 3 (1916-20) 135-41. U. SERDAROĞLU

LAGOS, see LACOBRIGA

LA GRAUFESENQUE, see CONDATOMAGOS

LAINO, see LAINUS

LAINUS (Laino) Cosenza, Italy. Map 14. Now connected with the two towns, Laino Castello and Laino Borgo. Strategically located in the Laos valley, settlement extended from the 9th c. B.C., represented by an indigenous necropolis, through the 6th and connections with Sybaris, into the Hellenistic period. In Laino Borgo have been found the remains of a wall, a kiln, and terracotta figurines from the Hellenistic period. In the area between S. Primo and S. Gadda are Lucanian tombs from the Hellenistic period. Thus far no Roman remains have been found. The finds are in the Museo di Reggio.

BIBLIOGRAPHY. P. Orsi, NSc (1921) 469; Phillip in RE XII¹ (1924) c. 467, s.v. Lainus; E. Galli, in AttiMGrecia (1929) 155ff; (1933) 155ff; N. Catanuto, NSc (1931) 655ff; T. J. Dunbabin, The Western Greeks, 205 n. I and 459; EAA 4 (1961) 457-58 (with bibliography). J. P. SMALL

LA JUNQUERA, see IUNCARIA

LAKHANOKASTRO, see LIMES, GREEK EPEIROS

LALLA DJILLALIA, see TABERNAE

L'ALMANARRE, see OLBIA (France)

LALONQUETTE Basses-Pyrénées, France. Map 23. Halfway between Beneharnum (Lescar) and Vicus Julii (Aire-sur-l'Adour), near a Roman road that linked these two cities and continued N towards Burdigala (Bordeaux) and S towards Spain are ancient remains on the edge of the river Gabas around the area called Lou Gleyzia. They cover several hectares. To the E, on the national highway from Pau to Bordeaux, can be seen a building the central part of which has been excavated, and some outlying farm buildings that were added W of the road. Noteworthy among the latter is a water mill with a dam, penstock, and tail-lock.

The site has been known since 1843. In 1959 deep excavations revealed some 4th c. mosaics. Houses had been burnt down and rebuilt on the site several times from the end of the 1st c. to the 5th and possibly 6th c., when the inhabitants left for the hills. The earliest architectural strata, now being excavated, can be dated by pottery (terra sigillata decorated with aquatic plants), and 1st c. coins. These strata mark the site of a semi-rural settlement consisting of a few public buildings, separated from one another. Among them is a finely built bath

building, a huge rectangular room with an apse on one of the long sides, heated by a hypocaust on low piers, and perhaps a small temple. These buildings survived throughout the whole of the 2d c., and additional buildings were placed around a little square with a well in the middle. The walls are not thick, but are solidly built and decorated with paintings. A large marble basin, incongruous in a purely agricultural building, denotes a certain wealth.

To the W is a large hall opening onto a portico; it can readily be dated by a store of 63 coins from the period from Claudius to Commodus, including 19 from Hadrian's reign. The settlement seems to have flourished in the 3d c. under the Tetrici (46 coins with their names). Various changes seem to have been made at this time: the square became a porticoed courtyard, the bath building was given a new raised hypocaust, and there is a columned atrium against the S wall, although this may date from the preceding period. To the S, a kind of rectangular cella was built on the axis of a large courtyard ringed with buildings. Outside this complex are some rooms filled with piles of metal slag, a sign that craftsmen worked there. To the N the buildings are set closer together; they were all heated by a network of pipes radiating hot air under the mosaic floors. The buildings were destroyed in a severe fire.

In the 4th c. a luxurious villa was built over the original settlement; its walls were erected on the leveled walls from the previous period. The baths were rebuilt, the apsidal hall modified, and both were incorporated in an elaborate complex, with many apses and vistas, arranged around the 3d c. peristyle courtyard, which was raised. The mosaics were restored and the well replaced by a pool sheltered by a sort of tetrapylon. An oecus was added, opening to the E, and a gallery 30 m long was built on the banks of the Gabas with an apse at either end. From the SE corner of the courtyard a series of vestibules of various shapes—octagonal and square— all richly decorated with somewhat carelessly executed geometric mosaics, led to a portico opening to the S on gardens (created on top of buildings razed in the 3d c.). Another collection of 57 coins, 46 of them from the reigns of Constantine and his sons, was found S of the baths under a mosaic that was added at the end of the 4th c. The same date probably should be assigned to the gallery mosaic and especially to that in the oecus, the theme of which is very common in Dalmatia, Palestine, and North Africa in the early 5th c.

The villa apparently survived the Visigoth invasions. Later a modest building, possibly a chapel, was erected on its ruins. In front of its E wall is a solid mass of stone resembling an altar. It is surrounded by tombs, but no grave furnishings have been found.

BIBLIOGRAPHY. P. Courteault, "Bibliographie des mosaïques gallo-romaines du Béarn IV: Lalonquette," *REA* 11 (1909) 162ff; J. Lauffray, "Note sur les mosaïques de Lalonquette," *Bulletin de la Sté des Sciences, Lettres et Arts de Pau* 20 (1959); id., "Lalonquette, Nouvelles découvertes archéologiques," *REA* 24 (1963); J. Coupry, "Informations," *Gallia* 17, 1 (1959) 407[1]; 19, 2 (1961) 396-98; 21, 2 (1963) 535-36; 23, 2 (1965) 441; 27, 2 (1969) 376-78. J. LAUFFRAY

LAMBAESIS (Lambèse or Tazzoult) Algeria. Map 18. Eleven km SE of Batna and 140 km from Constantine, the settlement was the headquarters of the legate of the Third Augustan Legion from the 2d c. A.D. When the province of Numidia was officially created in 197-198, it became the capital. Its name is known from inscriptions, from secular texts (*Antonine Itinerary*, Julius Honorius), and from religious texts (the Hieronymian Martyrologist, the Acts of the Synod of Carthage in 256, and St. Cyprian). The town is built 622 m above sea level in the plain and on the spurs of the Djebel Asker. To the E a road went out towards Thamugadi, Mascula, and Theveste; to the N in the direction of Cirta; to the NW to Sitifis; and to the W and S to the Saharan regions. Two km to the NW was found the inscription recording excerpts of addresses delivered by the emperor Hadrian when he reviewed the troops in July 128. This camp is scarcely visible except by aerial photography. It has been wrongly called the "camp of the auxiliaries." Probably it was a camp built by the soldiers for the imperial visit. We know now that an earlier camp, dating to A.D. 81, existed in the district called the civilian town, S of the modern built-up area. The N district was mainly occupied by the large camp (500 x 420 m). This camp was greatly damaged when in 1851 a penitentiary was built in the SW part; the village built later on was also constructed on the ruins.

Two streets, one running E-W, the other N-S, divided the large camp into four parts of unequal size. At the intersection is a rectangular building (36.6 x 23 m) called the praetorium. It forms a sort of quadruple arch of triumph. On the outside it is adorned with pilasters and Corinthian columns; it has large arched openings. South of this building extended a flagged court (65 x 37 m) surrounded on three sides by a portico onto which a series of rooms opened. To the S, a supporting wall circumscribes a basilica of Hellenistic type (52 x 30 m). This is divided into three naves by two colonnades of 12 columns each. The large S wall of the basilica is bounded by apses used for cult purposes. In addition, there are several cellars below ground.

Barracks and dwellings are placed along the streets. From the E gate of the camp a street passes under an arch with one bay, built under Commodus, and continues to the amphitheater. The tiers of seats have disappeared, but the major entryways and the foundations have survived, with a system of counterbalancing machinery for letting the beasts into the arena. The monument dates to A.D. 169 and was restored during the ten years following. Another street leaving the camp passed under an arch with three bays of the Severan period and went by the large baths with their vast public latrines. Continuing S one reaches, on one side, industrial buildings of late date and, on the other side, the camp of A.D. 81, remodeled at various times and only partially excavated. One continues on a long avenue bordered by square chapels, dedicated to various Latin and oriental deities, and each with an apse at the end. The avenue reaches a semicircular temple with two chapels beside it. This group of buildings was built in 162 and was consecrated to Aesculapius and Salus, as well as to Jupiter Valens and Silvanus. Behind and in the vicinity were swimming pools and baths, probably devoted to the care of the invalids who came to supplicate the deities. There was also a mithraeum with benches.

To the S, a capitol, enclosed by a rectangular porticoed court (mistakenly identified as a forum), was built around 246 and restored in 364-67. This temple is distinctive in having two instead of three cellae. To the E another temple is enclosed by a court which adjoins the court of the capitol. North of this temple are the so-called Chasseurs baths, named after the soldiers who began to excavate them. To the E are two monumental gates. The nearer one has three bays and is built in large part of reused inscriptions. The farther one, dating to the time of Commodus, has one bay and leads to the nearby market town of Verecunda. South of this district are the spring of Ain Drinn and the sanctuary of Neptune, god of springs. The dwellings of the ancient

city are covered by the modern village and the gardens that extend from the camp to the district of the temples. Recent work has brought to light fine mosaics at several places. A small Byzantine fort was placed on a hillock about 700 m E of the modern village. The town was completely surrounded by cemeteries. The one on the hill overlooking the camp from the E was undoubtedly the largest. That necropolis covered more than 15 ha, and one can still see there two mausolea with second stories. The most famous is 3 km N of the large camp. It is the mausoleum of a prefect of the Third Legion and was built under Alexander Severus. As an inscription from 1849 testifies, the building was restored by the French army. A similar mausoleum is W of the village. To the S is a necropolis where one can still see rock-cut tombs.

Although it is poorly organized, the museum in the village is extremely rich. The visitor will remark statues of Aesculapius and Hygieia, as well as a fine head of the child Commodus. There are mosaics with geometric and floral designs. Another, depicting Venus and her retinue on the sea, was signed by a Greek artist, Aspasios. There is also a Dionysiac mosaic. A fragment depicting a female figure at a spring is of very unusual workmanship. Flat tints were used to render the foliage in the style of fresco painting. Above all, the museum contains an exceptional epigraphic collection. In spite of the lack of systematic excavations at the site, the inscriptions permit one to understand Lambaesis' history and are an important contribution to the history of Roman institutions.

The history of the Third Augustan Legion, appearing in the inscriptions preserved in the epigraphic garden, provides information on changes in the recruitment of soldiers. Oriental predominance in Hadrian's time gave way, little by little, to African elements from the Proconsular province and Numidia, until these provided all the legionaries. Inscriptions tell us of the campaigns in which the legion took part. Others inform us of the re-establishment of the legion at Lambaesis in 257, after it was condemned and disbanded for its support of the emperor Maximian against the Gordians in 238. The punishment was put into effect by the chiseling away of the name of the legion. Other texts elucidate numerous obscure aspects of the army and its hierarchy. The rules of an association of noncommissioned officers have shed new light on military social life. This text was inscribed in hemicycles flanked by pilasters. In the middle, after a dedication to the reigning emperors, the establishment of a schola and of a college is indicated; there follow the rules of the association. The founding members are listed on the pilasters. This foreshadows the mutual security increasingly sought from the time of Septimius Severus on. Inscriptions also tell us what divinities were worshiped at Lambaesis, not merely the deities of the official Pantheon (the Capitoline trinity, Janus, Mars, Mercury, Aesculapius and Salus, Apollo, Diana, Pluto, Neptune, Ceres, Venus, or Hercules), but also (apart from the deified abstractions) foreign gods (Jupiter Depulsor, Dolichenus, or Heliopolitanus, Isis, Serapis, Liber and Libera, Cybele, Iorhobol, Malagbel, Medauros, or Mithra) and the African gods (the dii Mauri, Caelestis, Africa, and above all Saturn). A series of stelae found in different parts of the ruins and kept at the museum show how important Saturn must have been in African surroundings. The rarity of Christian remains is notable: a piece of an inscription, some Christian symbols, a sarcophagus depicting the Good Shepherd. It is to be hoped that one day the monuments known only from inscriptions (Temple of Jupiter Dolichenus, septizonium, nymphaeum, market, curia, various aqueducts) will actually be found.

Certain monuments from Lambaesis, first kept at the Louvre, are now deposited in Algiers: the monument of Hadrian's speech and the rules for the college of the legionary non-coms. At the Algiers Museum are a bronze statuette of the Child with the Eaglet, a bronze inkwell with a silver inlay depicting a retinue of Bacchus, and a cast of an inscription on the main square at Bougie (Saldae). In this text an engineer of the legion proudly tells how he set up and brought to fruition the project of piercing a mountain in order to bring water to Saldae as ordered by the governor procurator of Mauretania Caesariensis. The work began in 137 and ended in 152. Other monuments were included in the wall of the penitentiary and are no longer visible.

BIBLIOGRAPHY. S. Gsell, *Atlas archéologique de l'Algérie* (1911) 27, nos. 222-24M; Cagnat, *Musée de Lambèse* (1895)P; L. Leschi, *Algérie antique* (1952) 88-101P; M. Leglay, *Saturne Africain. Monuments* (1966) II 80-113 and pls. XXIII-XXIVP; M. Janon, "Recherches à Lambèse," *Antiquités Africaines* 7 (1973) 193-254MP.

J. MARCILLET-JAUBERT

LAMBAGIANA (Philanoreia, Philanorion?) Argolis, Greece. Map 11. A valley W of the modern village of Phournoi in the S part of the region. It has been identified with the Philanoreia found in inscriptions; Pausanias mentions Philanorion. About 200 m from the Argolic Gulf, the watchtower of a small border fort is preserved to a height of several courses, with traces of adjoining structures. The large blocks of coursed polygonal masonry suggest a date in the late 5th or 4th c. B.C.

BIBLIOGRAPHY. Paus. 2.36.3; M. H. Jameson, "Inscriptions of the Peloponnesos," *Hesperia* 22 (1953)MI.

M. H. MC ALLISTER

LAMBÈSE, see LAMBAESIS

LAMBIRIDI (Kherbet Ouled Arif) Algeria. Map 18. This Roman town in Numidia is mentioned in the *Peutinger Table* and by the Ravenna Geographer and Julius Honorius. It became a municipium in the 3d c. and had a Christian community. Bishops are known in the 5th c.

The ruins cover 21 ha on both sides of the wadi Chaba, 10 km SW of Batna. On the site remains once existed of an arch, several oil presses, and a church (46.3 x 19.3 m). In front of the church was a portico with columns. There were three naves ending in an apse flanked by two sacristies. In addition, a small fort of late date has survived; it was connected to a large enclosure. There are also several mausolea, near which have been found statues of persons in togas. Particularly noteworthy are a large room with an Invidus mosaic and a tomb containing three sarcophagi (one with an inscription) standing on a very curious mosaic. At the corners of it four snake-footed spirits hold up an emblema in which are depicted two personages seated on stools. One looks like a skeleton; the other is in full health. The latter feels the former's pulse and touches his feet. This scene was first interpreted as hermetical (Asklepios ensuring the health of the deceased), and then as historical (Hippokrates attending to the Macedonian prince Perdiccas).

BIBLIOGRAPHY. S. Gsell, *Les monuments antiques de l'Algérie* (1901) I 172; II 244-45; *Atlas archéologique de l'Algérie* (1911) 27, no. 120; J. Carcopino, "Sur les traces de l'hermétisme africain," *Aspects mystiques de la Rome païenne* (1942) 207-314; F. Chamoux, "Perdiccas," *Hommages à A. Grenier* (1962) I 386-96.

M. LEGLAY

LA MONÉDIÈRE, see BESSAN

LAMOS (Adanda) Turkey. Map 6. City in Cilicia Aspera, 14 km SE of Gazipaşa. The site is not proved by inscriptions, but may be regarded as virtually certain. The city is listed by Hierokles and the *Notitiae*, but other ancient mentions seem rather to refer to a city and river of the same name farther E in Cilicia Pedias. Lamos was the center of the region Lamotis, with a harbor at Charadros.

The ruins are on a high hill above the village, some 600 m above the sea, and on a second summit to the E. The more conspicuous remains are on the W hill; they consist almost entirely of walls, including part of a circuit wall of poor quality masonry and evidently late date. The main gate, however, is standing, and carries a fine lintel block with a dedication to Gallienus and a relief of an ox's head on which an eagle stands. Just inside the gate is a large underground reservoir. On the saddle between the two summits is a large building of uncertain purpose; one wall is standing nearly to a man's height. On the E hill is a small temple of Vespasian and Titus, badly ruined, and higher up numerous built tombs, some originally very handsome. Less than 1 km to the E is a stadium of rather less than full length, with rows of seats on either side and two entrances in its N side.

BIBLIOGRAPHY. R. Paribeni & P. Romanelli, *MonAnt* 18 (1915) 148; G. E. Bean & T. B. Mitford, *AnatSt* 12 (1962) 207-11; id., *Journeys in Rough Cilicia 1964-1968* (1970) 172-75. G. E. BEAN

LAMPOUSA, *see* LAPETHOS

LAMPSAKOS (Lapseki) Turkey. Map 7. City of the Troad (Mysia) originally called Pityussa, on the S shore of the Hellespont opposite Kallipolis. It had a good harbor (Strab. 13.1.18), and was said to have been founded by the Milesians or the Phokaians. During the 6th and 5th c. B.C. it belonged to Lydia, and then to the Persians; it joined the Athenian League, paying 12 talents, and was an object of contention among the Athenians, Spartans and Persians from 411 B.C. until the Hellenistic period. It allied itself with Rome in 190 B.C. and prospered thereafter. No ruins have been visible for some time, but in the 19th c. there were walls and some architectural remains. Some objects from Lampsakos are in Istanbul.

BIBLIOGRAPHY. J. Spon, *Voyage de l'Italie et du Levant* I (1678) 211f; De Castellan, *Lettres sur la Morée . . .* I (1820) 240ff[PI]; A. Sorlin-Dorigny, "Une Patère d'argent emaillée trouvée à Lampsakos," *GazArch* 3 (1877) 113f, 215[I]; Bürchner, "Lampsakos," *RE* XII 1 (1924) 591; W. Leaf, *Strabo on the Troad* (1923) 93-97[M]; L. Robert, *BCH* 52 (1928) 158-78, cf. *JHS* 50 (1930) 253f. T. S. MAC KAY

LANCASTER England. Map 24. A Roman fort site at the N end of the Lancashire plain. Occupation began in the Flavian period with the construction of an auxiliary fort on top of the hill now occupied by the Castle and St. Mary's Church. Recent excavation shows that the fort underwent at least four periods of occupation extending into the late 4th c. when a disaster occurred, presumably ca. A.D. 367. By the later periods the site had changed in character and the so-called Wery Wall appears to represent the defenses of a coastal station comparable to a Saxon Shore fort. Finds are in the local museum.

BIBLIOGRAPHY. I. A. Richmond, "Excavations on the Site of the Roman Fort at Lancaster," *Trans. Hist. Soc. Lancs. and Ches.* 105 (1953) 1ff; G.D.B. Jones, "Roman Lancashire," *ArchJ* 127 (1970) 237ff[MI]. G.D.B. JONES

LANCHESTER, *see* LONGOVICIUM

LANCIA (Mansilla de las Mulas) León, Spain. Map 19. Asturian town on the Esla 20 km S-SE of León. It was on the highway from Caesaraugusta to the Septima Legio (*Ant.It.* 395.4), and the last stronghold of the Astures in Augustus' campaign. Captured by T. Carisius, as recorded by Florus (2.33), Dio Cassius (53.25.8), and Orosius (6.21.10). According to Ptolemy (2.6.28) it was inhabited by the Lankiatoi. Little excavation has been done, but a small bath has been found.

BIBLIOGRAPHY. *RE* XII:1, 620; J. Jordá & E. García Dominguez, *Excavaciones en Lancia* (1961); F. Jordá, *Exc. Arq. en España* 1 (1962). P. DE PALOL

LANGRES, *see* ANDEMATUNUM

LANGTON E Riding, Yorkshire, England. Map 24. The village is 4.8 km SE of Malton. The Roman buildings on East Farm, 1.2 km to the E, were discovered in 1899, and excavated in 1926 and 1930-31. The earliest feature on the site was an oblong ditched enclosure of 0.12 ha, originally interpreted as a military fortlet but more probably a farmstead of native type. This was succeeded by a series of Roman buildings which included a small dwelling, a small so-called bath house (probably a corn-drier), various farm buildings, a well, corn-drying kilns, and a circular platform which was interpreted as a threshing floor. The complex was contained within a system of ditches covered by the latest buildings.

The first version of the dwelling was a simple structure (15.6 x 5.9 m) succeeded by a second house (29.8 x 7.6 m), built 3 m farther N. This was later modified by the addition of two rooms with hypocausts. The excavators dated their so-called fortlet to ca. A.D. 80-120 and the beginning of the villa to ca. 200 with the period of maximum prosperity in the 4th c., but a recent reinterpretation, taking the fortlet as a farm, suggests continuous development from ca. 150 until the end of the 4th c. and possibly later. Further Roman buildings, with tesselated floors, were recorded in 1863 in a field 0.4 km to the W, and it seems probable that the excavated remains formed part of a much larger complex. Nevertheless the excavation and recording set a new high standard, and Langton has been widely taken as the type site for the simpler kind of Romano-British villa developing somewhat later in the N than in the S.

BIBLIOGRAPHY. P. Corder & J. L. Kirk, *A Roman Villa at Langton, near Malton, E. Yorkshire* (1932); reinterpretation: G. Webster in A.L.F. Rivet, ed., *The Roman Villa in Britain* (1969) 246-48. A.L.F. RIVET

LANSARGUES Canton of Mauguio, Hérault, France. Map 23. Prehistoric site at the locality called Camp Redon at the mouth of the Viredonne, a small coastal river which runs into the Étang de Mauguio at the point farthest N on the coast of the Gulf of Lion. This site on the lagoon coast of Languedoc consists of a small natural mound surrounded by a man-made canal. Preliminary explorations have indicated continuous occupation from the Middle Bronze Age to the Gallo-Roman period, and above all occupation during all of Iron Age I (numerous ceramics from the urnfield civilization). Exploration of the site, which in both topography and the artifacts of the older levels recalls the terramare of N Italy, is making an important contribution to our knowledge of the Mediterranean coast of Languedoc, which was more heavily inhabited during the last millennium B.C. than was formerly realized.

BIBLIOGRAPHY. "Informations," *Gallia* 29 (1971) 381. G. BARRUOL

LANUEJOLS Lozère, France. Map 23. A Roman settlement 18 km from Mende; a mausoleum is of particular interest. The plan of the monument, which was completely buried, was drawn up in the 19th c. A square structure 5.35 m on a side in the interior, it was flanked to the N, E, and S by three niches 1.3 m deep and 2.75 m long. The W facade contained an opening 2.57 m wide. The lintel above this opening, 2.2 m above ground, carried an honorary inscription (*CIL* XIII, 1567).

The semicircular bay over the doorway and lintel is surmounted by an arch. The archivolt is decorated with winged spirits, amorini, vine leaves, and bunches of grapes. The niche opposite the entrance terminates in a flattened arch, the archivolt of which has a design of goblets of fruit surrounded by doves. The four corners of the building are decorated with pilasters. Near this monument, as the inscription indicates, is another building, badly damaged at the subfoundation level.

The recent discoveries of a limestone statue in the neighboring village of Langlade and of a large house at Rouffiac prove that there was an important settlement here in the Roman period. Several inscriptions have also been found in the village of Lanuejols: DIVUS JOVIS; D. M. MEMEROS; IOVI OPTIMO MAXIMO.

BIBLIOGRAPHY. *Journal de la Lozère* 745 (25 July 1813); *Mémoires de la Société de Mende* (1841-42) 137-58; Tourelle, "Rapport sur le monument romain de Lanuejols," *Congrès archéologique de France* (1857) 200-8; T. Roussel, "Notes sur le monument romain de Lanuejols," ibid. 17-29; id., *Bull. Soc. Lozère* (1859) 27ff; de Caumont, *BMon* 24 (1858) 295; id., *REpigr* 3 (1890) 39, no. 828; F. Gerner & Durant, "Note sur le monument de Lanuejols," *Bull. Soc. Lozère* (1881) 170-74; E. Reisser, *Notice sur le tombeau romain de Lanuejols* (1900); id., *Bull. club cévenol* (1904) 281-84; Louvreleul, *Mémoire historique sur le pays du Gévaudan* 112.

P. PEYRE

LANUVIO, *see* LANUVIUM

LANUVIUM (Lanuvio) Latium, Italy. Map 16. A city on a S extremity of the Alban Hills ca. 30 km SE of Rome. It was an independent member of the Latin League and a participant in the foedus Cassium, 493 B.C. Loyal to Rome until the Latin war of 340 B.C., it then received Roman citizenship and Rome received a share in the city's cult of Juno Sospita (Livy 8.14). It flourished as a municipium during the Empire until sacked by barbarians, and was revived in the 11th c. as Civita Lavinia, through confusion with ancient Lavinium.

The modern city is built over the ancient one except for the arx (the hill of S. Lorenzo) to the N, where lie the most important remains. This was surrounded by a tufa circuit wall, sections of which still stand. Elaborate ramparts guarded the N and S entrances, though no trace of the N rampart remains. Later, arched Doric porticos were built along the W and S sides of the wall. A fine equestrian group in marble, from the 2d c. A.D., probably adorned the S entrance. Portions of these armored riders are now in the British Museum and at the City Museum in Leeds.

The arx also holds remains of a temple in antis, perhaps associated with the famous Temple of Juno. Of the earliest structure (ca. 500 B.C.) little remains. More is extant of the two later phases built ca. 330 B.C. and in the 3d c. B.C.

Near the arx, amid modern vineyards, are remains of several Roman villas, one of which is ascribed to Antoninus Pius.

In the modern city the ancient cardo can be traced. The Palazzo Comunale contains objects from the Temple of Juno. The wall facing the Palazzo is built over remains of a Roman theater. In the modern Largo del Tempio d'Ercole far S of town can be seen temple ruins of the 2d c. B.C.

BIBLIOGRAPHY. A. M. Woodward, *BSR* 7.2 (1914); G. B. Bendinelli, *MonAnt* 27 (1921); A. Galieti *BullComm* 61 (1928) and 66 (1938); A. E. Gordon, *The Cults of Lanuvium* (1938).

D. C. SCAVONE

LAODICEA Iran. Map 5. A Seleucid city adjacent to modern Nihavand. According to Pliny, it was founded by Antiochos I. Chance finds include a stele with an inscription of 193 B.C. of Antiochos III in behalf of a cult of his queen, and a round altar with ribbons carved in relief and bronze statuettes of Zeus, Athena, Apollo, and Demeter. Furthermore, at Magnesia in Asia Minor a stone was found bearing a decree passed at Laodicea during the reign of Antiochos III. The site may also have been known as Antioch-in-Persis.

BIBLIOGRAPHY. Plin. 6.116; Strab. 11.13.6; E. R. Bevan, *The House of Seleucus* I (1902) 265; L. Robert, *Hellenica* VII (1949) 1-30; R. Ghirshman, *Persian Art. The Parthian and Sassanian Dynasties, 249 B.C.-A.D. 651* (1962) 18¹.

D. N. WILBER

LAODICEA AD LYCUM (Goncalı) Turkey. Map 7. City in Phrygia, 6 km N of Denizli, founded by Antiochos II of Syria in honor of his wife Laodice between 261 and 253 B.C. An alternative tradition, recorded by Stephanos Byzantios, that the foundation was made by Antiochos I in response to a dream, and the city named after his sister Laodice, is generally discredited, no sister of that name being known. According to Pliny (*HN* 5.105) the site was previously occupied by a place called Diospolis; this may be correct, as Zeus was the chief deity of Laodicea.

The city has little history. Achaios was crowned there in 220 B.C. (Polyb. 5.57). In the first Mithridatic war Laodicea opposed the king and was besieged by his forces; the defense was conducted by Quintus Oppius (App. *Mithr.* 20). Chosen as the capital of the conventus of Kibyra, the city resisted the Parthians under Labienus in 40 B.C. at the instigation of a citizen named Zeno (Strab. 660). It was damaged by an earthquake in A.D. 60, but recovered without help from the emperor. The title of neocorus was granted by Commodus, taken away after his death and damnatio, then restored by Caracalla. Christianity was introduced by Epaphras, the companion of St. Paul, though in Revelations the Laodiceans are rebuked as lukewarm. Later the city was the seat of the metropolitan of Phrygia Pacatiana. A disastrous earthquake in 494 ended all prosperity, though the city continued to exist until the Turkish conquest.

The site occupies a low flat-topped hill 10 km S of Hierapolis, on the other side of the river Lykos. The whole city was contained within the circuit wall, of which only a few traces remain on the E side. The three gates were called the Ephesian Gate, the Hierapolis Gate and the Syrian Gate, though only the last of these names has ancient authority; it is also the best preserved. Two small but perennial streams, called in antiquity the Kapros and Asopos, run close below the hill, one on each side.

The two theaters, both above average size, are in the NE slope of the hill. The larger one faces NE, with most of its seats preserved; the lower parts of the stage building also survive, though only the front wall is at present visible, with a large shallow niche in the middle. The smaller one faces NW, but only the upper parts of the seating remain. The stadium, at the S end of the plateau, is hardly better preserved; it is exceptionally long, about 370 m, and rounded at both ends. A few of the rows of seats survive. Inscriptions call it the amphitheatral sta-

dium, and it was dedicated to Vespasian in A.D. 79 by a wealthy citizen. At its SE end is a large ruined building, in solid masonry, which has been variously identified as a gymnasium or, with greater probability, as a bath building; it was dedicated to Hadrian and Sabina. Just outside this building are the remains of a water tower still some 5 m high; the pipes are visible running up in the mass of the masonry.

An aqueduct coming from the S connected with this tower; its course may be traced for several km towards Denizli. Immediately S of the water tower the channel consists of a double row of blocks pierced through the middle. Some blocks also have a funnel-shaped hole from the upper surface to the central pipe; these were normally plugged with round stones. The purpose was evidently to enable a stoppage to be located. The pipes tended to become choked with a lime deposit; when this occurred the plug would be removed to see whether the channel was dry at that point. On the next hill to the S was a clearing basin, where the water coming from the S ceased to flow by the force of gravity and began to cross the intervening hollow to the city under pressure. Farther S the water was carried partly in aqueducts built of masonry, partly in a rock-cut channel. The source was the spring now called Başpınar, in the town of Denizli; the fall from there to Laodicea is ca. 105 m.

Near the center of the plateau is a recently excavated nymphaeum, the only excavation yet conducted on the site. In its original form, dating apparently to the 3d c. A.D., it consisted of a square water basin with a colonnade on two sides adjoined by semicircular fountains; these were fed from chambers above by water brought from the tower near the stadium. Later the basin was converted into a closed room approached by steps on one side and used for Christian purposes. The fountains were walled off and troughs placed in front of them. Among the finds was a life-size statue of Isis.

Little remains of other public buildings on the hill. About 100 m N of the stadium is a small odeum or council chamber, in which five or six rows of seats are visible. The city's tombs were placed in the usual fashion beside the roads leading to the city gates; most of them are sarcophagi.

BIBLIOGRAPHY. W. M. Ramsay, *Cities and Bishoprics of Phrygia* I (1895) 32-83; J. des Gagniers, *Laodicée du Lycos: le Nymphée* (1969); G. E. Bean, *Turkey beyond the Maeander* (1971) 247-57. G. E. BEAN

LAODICEA AD MARE Syria. Map 6. With Seleucia, Antioch, and Apamea, one of the four great towns which Seleucus I Nicator (301-281 B.C.) founded in N Syria. Conquered by Pompey and declared by Caesar to be a free town, it suffered badly during the Roman civil wars. It was sacked by Pescennius Niger at the end of the 2d c. A.D., restored by Septimius Severus, and continued to be an active city during Byzantine times and after the Moslem conquest.

There are few remains of what was a rich and wellbuilt town (Strab. 16.2.9): colonnades, a monumental arch, sarcophagi, all within the modern town. The sanctuaries, public baths, amphitheater, hippodrome, mentioned by ancient authors or by Greek inscriptions, and the rampart gates depicted on coins, have all disappeared.

The town occupies a rocky promontory, bounded to W and S by the sea and to the E by two hills. Earthquakes and sieges have left no trace of the ramparts, but the confines of the ancient town can be determined by topography and by the two large necropoleis to the E and N. Including the port, its area was ca. 220 ha, and the plan of the Seleucid town can be recognized under the modern streets. Those running E-W were spaced 100 or 120 m apart, those running N-S ca. 60 m apart. A wide avenue, bordered with porticos in Roman times, ran N-S across the town, from the tip of the peninsula to the gate where the road to Antioch started; perpendicular to this, three colonnaded streets ran from E to W. The one to the N was centered on the entry to the citadel on the high hill to the NE. The central one came from the E gate, where the Apamea road reached the city. The street today is occupied by the great souk, where there is still an alignment of 13 monolithic granite columns. A tetrapylon marked the crossing of this thoroughfare with the N-S avenue. The S street began at the port and ended to the E at the long steep hill to the SE, where a monumental four-way arch, erroneously called a tetrapylon, closed off the view. This arch consists of four semicircular arches, one on each side, supporting a stone cupola. Columns engaged in pilasters serve as buttresses at the corners of the four masonry moles. Not far away, inside a mosque, is the corner of a Corinthian peristyle, with capitals and entablature. Virtually nothing remains of the theater, which was built against the SE hill and whose cavea had a diameter of ca. 100 m.

The port was a basin, now silted up, E of the modern port, and not long ago the huge marble blocks used to pave the wharfs could be seen there. Coins of the Imperial period depict the lighthouse: it stood on the basin's N breakwater, where the small modern lighthouse is located. It was a round or polygonal tower with two stories, the upper one set back; it stood on a base with two steps and was topped by a statue.

Several large marble statues of Hellenistic style have been found in Laodicea or its vicinity (now in the Damascus museum).

BIBLIOGRAPHY. E. Renan, *Mission de Phénicie* (1864-74); M. de Vogüé, *Syrie centrale, Architecture civile et religieuse* (1865-77)[I]; J. Sauvaget, "Le plan de Laodicée-sur-mer," *BEO* 4 (1935)[MPI]; H. Seyrig, "Le phare de Laodicée," *Syria* 29 (1952) (*Antiquités syriennes* IV)[I].
 J.-P. REY-COQUAIS

LAPANOUZE-DE-CERNON Aveyron, France. Map 23. At Le Pas-de-la-Selle near the *cami ferrat* in the valley of the Cernon on the Causse du Larzac, excavations have uncovered an enclosure (110 x 90 m). It contained a small rectangular building (0.6 x 4.6 m) with walls of dry stone and a tile roof; it was no doubt a fanum. The material collected includes some terra sigillata from La Graufesenque, some engine-turned pottery, and above all a large amount of stamped pottery of the Late Empire.

BIBLIOGRAPHY. A. Soutou, "Trois sites gallo-romains du Rouergue: II Le fortin-sanctuaire du Pas-de-la-Selle," *Gallia* 25 (1967) 127-45 & figs. 25-57; cf. Jacqueline Rigoir, "Sigillées paléochrétiennes grises et orangées," *Gallia* 26 (1968) 214, 217, 221-24, 226, 228, 231, 232, 239. M. LABROUSSE

LAPETHOS (Lampousa) Cyprus. Map 6. On the N coast, E of the Monastery of Acheiropoietos and 10 km W of Keryneia. The ruins cover a large area along the seashore. Substantial remains of a harbor with its breakwaters still survive and the city wall can be traced for most of its course. The necropolis extends E.

The site extends mainly along the shore for a considerable distance, but also inland. Part of it may lie under the cultivated land. The rest of the site is now a field of ruins overgrown with scrub. A rocky hill near the center of the city may have been its acropolis. The site has been badly damaged by looters in search of stone and treasure. Lampousa is well known for its Early

Byzantine silver treasure, most of which is now in the Metropolitan Museum of Art in New York.

It appears that there was originally a rocky ridge running E-W a little farther back from the sea. It began at the rock-cut chapel, probably a tomb, at Acheiropoietos on the W, included the acropolis about halfway, and extended E to the Troulli hill. In this mass of rock there were tombs dating probably from the 6th and 5th c. B.C., an indication that the earlier city was still nearer the coast and that when it expanded in later Classical and Hellenistic times this part was also inhabited so that most of the tombs were then quarried and destroyed.

Lapethos, one of the ancient kingdoms of Cyprus, was, according to tradition, founded by Praxandros from Lakonia in the Peloponnese. Excavations on the acropolis have shown that the city was inhabited during the Late Bronze Age, which accords well with its traditional origin. A Late Bronze Age settlement has also been located higher up within the modern village of Lapethos while Early Geometric tombs surround the village.

Little is known of the history. The name appears for the first time in 312 B.C. when its king Praxippos, who was suspected of being on the side of Antigonos, was arrested by Ptolemy. From coins, however, we know the names of some of its kings of the 5th and 4th c. B.C., and the name is mentioned by Skylax the geographer (mid 4th c. B.C.). After that it is frequently mentioned by other ancient authors. Lapethos seems to have flourished mainly from archaic down to Early Byzantine times, when it became a bishopric. The city was gradually abandoned after the first Arab raids of A.D. 647.

To Lapethos are attributed coins of the mid 5th c. B.C. with Phoenician legends and heads of Athena. Some of them name a king Sidqmelek, thus indicating a temporary Phoenician rule. Earlier coins show Athena and Aphrodite. To the later king Praxippos are attributed coins with the head of Apollo on the obverse and a krater on the reverse. The temporary Phoenician rule, however, does not prove the existence of Phoenician settlers in Lapethos.

From inscriptions we learn that there was a gymnasium, and it is possible that there was a theater, but nothing is known of the location of either. It seems strange that no evidence has been forthcoming so far of the existence at Lapethos of sanctuaries nor do we know anything of the worship there of any deity. Lapethos is one of the Cypriot cities mentioned in the list of the theodorokoi from Delphi (early 2d c. B.C.). According to epigraphical evidence quinquennial games were held at Lapethos. These were known as the Aktaion games, held in celebration of the victory at Aktion.

Very little survives in the way of monuments and only minor excavations were carried out on the city site. Part of the acropolis was investigated in 1913; and in 1915 a small excavation was carried out at Troulli hill; the results in both cases, however, were disappointing.

The upper part of the acropolis was of solid rock deeply dissected by house basements with rock-cut doors and staircases; there were chamber tombs on the E face and deep quarries on the N.

The results of the excavations at Troulli hill were much the same. Again chambers had been cut in the solid rock and rubble walls. One such chamber had a long and thick wall resting on solid rock. Opposite this wall, the rock, 11 m high, had its side cut straight so as to form the other parallel wall of a long and narrow chamber, 4 m wide, with the door at the broader side opening to a small antechamber.

Probably the best preserved remains are those of the harbor, where both the ancient breakwaters still survive for a considerable distance. The W arm measures about 155 m; the N one is shorter, measuring about 40 m. In this way was created a small but safe harbor protected from the N winds. This is undoubtedly the anchorage for small craft mentioned by Strabo. The breakwaters were recently reinforced with new blocks of stone in order to make a safer fishing shelter.

To the E of the city lie a group of ancient fish tanks right on the rocky coast, all cut in the solid rock. They communicate directly with the sea or with one another by canals. The largest one 30 x 13.25 m and ca. 1 m deep, is fairly well preserved. It communicates directly with the sea by three side oblique canals and by a front (sea side) system of openings and sluices of complicated mechanism.

BIBLIOGRAPHY. A. Sakellarios, Tὰ Κυπριακά I (1890); I. K. Peristianes, Γενικὴ Ἱστορία τῆς νήσου Κύπρου (1910); Menelaos Markides, "Excavations at Lampousa," *Annual Report of the Curator of Antiquities* (1915) 11-12; John L. Myres, "Excavations in Cyprus, 1913: Lapethos," *BSA* 41 (1940-45) 72-78[PI]; *RE*, s.v. Lapethos; A. Stylianou & K. Karmanta, *Karavas* (1969) especially ch. I[I].
K. NICOLAOU

LAPSEKI, *see* LAMPSAKOS

LAPURDUM or Laburdum (Bayonne) Pyrénées Atlantiques, France. Map 23. The origins of Lapurdum are still unknown. At the end of the 4th(?) or the beginning of the 5th c. A.D.(?) the *Notitia dignitatum* (occ. 42.18f) refers to Lapurdum as the residence of the Tribunus cohortis Novempopulaniae. Sidonius Apollinaris (*Epist.* 8.12.7) mentions it in the 5th c., and in 587 the site is designated as a civitas in Gregory of Tours text of the Treaty of Andelot between Gontran and Childebert II (*Hist.Franc.* 9.20).

The ancient site stood on a hill overlooking the confluence of the Nive and the Adour and was ringed by a rampart probably erected during the 4th c.(?). Originally the rampart, a few towers and some wall sections of which are still standing, formed a more or less quadrangular polygon ca. 1120 m in perimeter. It is a masonry wall ca. 3 m thick, with facings of cubes of stone intersected by bands of stones cut to the size of bricks. This use of stone in place of the brick is fairly rare in this type of construction. The other peculiarity of this rampart is that apparently no earlier architectural fragments went into the building of it, as is the case in most of the Gallic ramparts built in the Late Empire. The wall is flanked at the corners and at irregular intervals on its perimeter by half-projecting round towers; it seems to have had three main gates.

No remains of ancient houses have been revealed in recent excavations inside the walls, and only a few potsherds have been found to indicate that the site was first occupied no earlier than the 4th c. A.D. Although ancient coins found here and there in the substratum may argue in favor of an earlier original settlement, there is every reason to believe that this settlement was extremely small. The absence of any reused fragments in the building of the wall is to some extent evidence that Lapurdum, founded at a late period, was in the Late Empire a fortress rather than a true city with a municipal and urban life.

BIBLIOGRAPHY. J. E. Dufourcet & G. Camiade, "Bayonne, notice historique et archéologique," *Aquitaine historique et monumentale*, III (1897) 1-72; Blaÿ de Gaïx, *Histoire militaire de Bayonne* 2 vols. (1899-1908); C. Jullian, "L'origine de Bayonne," *REA* 7 (1905) 147-54; A. Blanchet, *Les enceintes romaines de la Gaule* (1907) 192-94; E. Lambert, "Bayonne, enceintes et châteaux,"

Congrès archéologique de France, CIIème session, Bordeaux-Bayonne 1939 (1941) 506-14. J. L. TOBIE

LARACHE, *see* LIXUS

LARA DE LOS INFANTES Burgos, Spain. Map 19. Town of the Conventus Cluniensis in Tarraconensis, 18 km from Salas. Pre-Roman castrum with three walled enclosures. In one, called La Muela, rectangular and circular houses with pottery and bronzes have been excavated. Near the present village was a Roman settlement, rich in funerary inscriptions (*CIL* II, 2850H), characteristically beveled. Nearby is the 7th c. church of Quintanilla de las Viñas.

BIBLIOGRAPHY. *CIL* II, 391; J. L. Monteverde, "Los Castros de Lara (Burgos)," *Zephyrus* 9 (1958) 191; B. Osaba, "Catálogo arqueológico de la Provincia de Burgos," *Noticiario Arqueológico Hispánico* 6 (1962) 247, 259, 275. P. DE PALOL

LARDIERS Alpes de Haute-Provence, France. Map 23. The oppidum-sanctuary of the Chastellard, at an altitude of 1000 m in the S foothills of Mt. Lure. It was far from any important road, but on the dividing line between the two Gallic tribes of the Vocontii and the Albici. It was heavily occupied from the end of Iron Age I to the Late Empire.

In a first phase, from the 6th c. B.C. to the first years of the Christian era, an indigenous Celto-Ligurian village occupied the summit of the hill, which offers a view to the S of all inland Provence. It is surrounded by two, and in places three, strong walls in dry masonry. Each of these walls is 4 m thick and consists of a double facing of large rough-hewn limestone blocks, with rubble fill. The area encompassed by the walls is some 8 ha. Systematic searches since 1961 have revealed only pre-Roman habitations, thoroughly leveled in the 1st c. A.D. when they were replaced by new construction. But abundant and varied remains of Iron Age I and II habitations have been discovered in all the sectors explored.

In the early years of the Christian era the inhabitants of this high, fortified village profited from the Pax Romana, which was late in coming to these mountainous regions of the Provincia Narbonensis. They abandoned the village in favor of the great rural estates in the two valleys which enclose the oppidum to W and E. Many of these estates have been identified and some partially explored. At the same time, the beginning or middle of the 1st c. A.D., à large sanctuary was built on the leveled dwellings of the pre-Roman settlement inside the old walls, which thus became a sacred enclosure. The sanctuary was built on an old native cult site, the ritual center of which has not yet been certainly identified.

Exploration of this sanctuary, apparently unique in Narbonese Gaul, has yielded segments of a long sacred way, lined with cult niches, which led up the hill to an E-facing temple: a square cella (6.05 m) stood alone in a courtyard which was surrounded by a covered gallery 24.8 m overall on a side. Near this cult site was a portico (32 x 4.7 m), and some small oratories and adjoining rooms. Excavation of this ensemble has brought to light architectural fragments, inscriptions, and thousands of artifacts, mostly votive: coins, gold and bronze jewelry (rings, brooches, fibulas), rings and pierced plates of bronze (ca. 15,000), metal mirrors, some small bronze reliefs, some fragments of metal vases, glass and ceramic goblets, and especially terracotta lamps. A midden outside the walls has yielded several tens of thousands, both imported and of local manufacture. These multitudinous offerings, from the 1st c. A.D. to the end of the 4th, testify

to the great crowds at this pilgrimage center, which was consecrated to one or several gods not yet identified.

The artifacts found at the site are on display at the Musée Archéologique d'Apt (Apta Julia), Vaucluse.

BIBLIOGRAPHY. H. de Gérin-Ricard, "Un pélerinage gaulois alpin," *Bulletin Archéologique du Comité* (1913) 193-205; Grenier, *Manuel* IV, 2 (1960) 527-28; H. Rolland, "Informations," *Gallia* 20 (1962) 655-56[I]; 22 (1964) 545-50[I]; F. Salviat, ibid. 25 (1967) 387-93[PI]. G. BARRUOL

LARES (Henchir Lorbeus) Tunisia. Map 18. An extensive site 15 km SE of Le Kef on the road from Le Kef to Thala, the ancient city at several troubled periods played a strategic role. A fortified town which served as a military base for Marius against Jugurtha, it immediately became on the creation of Nova Africa an important crossroads which served in particular Sicca Veneria. It was undoubtedly a colony under Hadrian. Considered the gateway of the grain fields of the N, it again played an important role at the end of antiquity. Justinian fortified it with an encircling wall flanked by towers, round ones at the angles and square on the sides. In the interior were included numerous edifices, among them a basilica converted later into a mosque.

BIBLIOGRAPHY. P. Salama in *Mélanges de Carthage* (1964-65) 97-115[PI]. A. ENNABLI

LARINO, *see* LARINUM

LARINUM (Larino) Molise, Italy. Map 14. About 39 km N-NE of Campobasso, it was a city of the Frentani, perhaps at one time a part of Daunia. It dominates the valley of the Biferno river. Famous for its bronze coins of the 3d c. B.C., it was the birthplace of L. Cluentius, an Italian commander during the social war. It became a municipium and was inscribed in Regio II.

The ancient city rose ca. 1 km E of the modern one, in an area now near the railroad station in the district of Piano San Leonardo. The most notable remains are the amphitheater, the baths, and some polychrome mosaics which came to light in 1948-50. One of the mosaics represents the Lupercal; all are preserved near the town hall.

BIBLIOGRAPHY. G. D. Magliano, *Larino* (1895); H. Nissen, *Italische Landeskunde*, II (1902) 783; Head, *Hist. Num.* 28ff; *EAA* 4 (1961) 485 (V. Cianfarani). G. COLONNA

"LARISA," *see* BURUNCUK

LARISA (Thessaly), *see* LARISSA

LARISCUS (Skhira) Tunisia. Map 18. Revealed in 1958 when a petroleum port was being built at the outlet of the Edjélé pipeline, the site is situated slightly W of the Cap de Skhira Kedima, 45 km from Maharès, in the Gulf of Gabès. The site has been identified as Lariscus, where Troglita and Antalas fought in 548.

Explored and partially excavated in 1958 and 1959 along the pipeline, it was found to contain several pagan and Christian necropoleis and two basilicas. The larger of these latter stands on the edge of the site surrounded by other as yet unexplored remains. Built of materials of mediocre quality (unbaked bricks covered with coats of paint), it is nevertheless interesting because of its architecture and mosaic floors. Oriented SW-NE, the monument had five naves formed by four rows of nine columns and a quadratum populi (25 x 20.5 m) with a W apse (3.5 m x 4.7 m), and a facade fronted by a portico

3 m wide with two trefoil-shaped columns in front of the opening to the central nave. It had a wood and tile roof. The building underwent a number of changes, the chief one being the construction of a counter-apse in place of the first entrance (3.5 m deep and 5.4 m in diameter), and the addition of the mosaic floor. A mosaic in the apse shows a large chalice, with two symmetrical scrolls of vine leaves curling out of it. The panels of a raised platform beside the altar are decorated with medallions of deer and lambs.

Four m behind the apse and joined to the church by a vestibule is a baptistery. Its hall (11 x 9 m) consists of a double row of six columns supporting three naves. The basin, which is shaped like a Greek cross in an octagon inside a square, was surmounted by a cupola supported on four pillars. The floor of this room was paved with mosaic. Its panels, of various sizes and shapes, were decorated with geometric motifs except for the four panels opposite the entrance, which had a design of deer and jeweled Latin crosses.

Another, smaller basilica has also been excavated. Oriented N-E and measuring 20 x 11.35 m, it had three eight-bayed naves, a central apse, and a facade to the SE. Several tombs have been found inside and around this monument.

BIBLIOGRAPHY. M. Fendri, *Basiliques chrétiennes de la Skhira* (1961) (Publication de l'Université de Tunis, VIII). A. ENNABLI

LARISSA or Larisa or Pelasgis Thessaly, Greece. Map 9. A city of Pelasgiotis on the right bank of the Peneios river, approximately in the center of the E Thessalian plain. Through it ran the major routes from S Greece to Macedonia, and routes across Thessaly and to the Gulf of Pagasai. The city and the plain around it were settled in prehistoric times, and its name must be early, but it is first mentioned in connection with the aristocratic Aleuadai, whose home it was. It flourished during the 5th c. and was a considerable artistic center, but was weakened by party dissensions by the end of the century. It was the leader of the resistance against the tyrants of Pherai, but felt it necessary to call in first Thebes and then Macedon to help. In 344 B.C. Philip II of Macedon directly annexed Thessaly, and from then to 196 B.C. Larissa was under Macedonian control. It was the capital of the post-196 B.C. Roman-organized Thessalian League and flourished during the Republic and Empire. Justinian refortified the city.

Very few visible remains of the ancient city are left in place. The Peneios bends in a rough arc around the N side of the city. A Turkish earth embankment (still visible in places) makes a wide arc around the S side. It is supposed the Turkish wall may lie on the line of the ancient one; if so, the circuit of Larissa (counting the river) would be approximately 7 km. There are no visible remains of the city wall, however. In the NW part of the city, close to the river, is a hill (96 m) which was the ancient acropolis. It was fortified in Byzantine times. No ancient wall is to be seen. The ancient theater, which dates to the later Hellenistic period, was dug into the S side of this hill. The seats are marble, and some have the names of notables of the city carved on them.

East of the acropolis hill, in modern Demeter St., a large, 4th c. B.C. votive stele, dedicated to Poseidon, was discovered in situ in 1955.

The agora of the ancient city was probably located near the center of the modern city, S of the citadel. Here, at the crossing of Roosevelt and Papakyriazis Sts., three large Doric poros column drums, two pieces of triglyph, and other architectural fragments were discovered

recently. In the area were a row of statue bases and immediately W of them a massive 4th-3d c. B.C. foundation, which has been identified as some building of the agora, or possibly the Temple of Apollo Kerdoios, which is known to have been in the lower city. Near this were some Late Roman or Early Christian foundations. In this general area, in 1910, Arvanitopoullos discovered a few curved seats and a foundation which he ascribed to an odeion and dated to the 4th c. B.C. Stählin suggested it might have been a bouleuterion. What appear to be remains of a Classical temple lie just N of the Metropolis cathedral, N of the E end of the bridge which leads across the river to the W. Part of an Athena head and other statues of the Roman period have been found here.

Ca. 5 km S of the city at Palaiochori Larissis or Siïti, a Hellenistic underground vaulted chamber tomb has been excavated. At Kioski, across the river, a short way along the road leading to ancient Argura, a tomb containing two silver skyphoi was discovered. Hellenistic graves (terracotta comic masks) and a head of Dionysos were discovered at the airport SE of the city.

Numerous small finds, sculptures (6th c. B.C. through Roman), inscriptions giving a good deal of information about the ancient city, etc., have been found in Larissa and its vicinity. These, and objects from the Nome of Larissa are mainly housed in the local museum, a restored mosque E of the city center. Some are in the Volo Museum.

BIBLIOGRAPHY. A. S. Arvanitopoullos, *ArchEph* (1909) 24-44[I]; id., *Praktika* (1910) 174f; (1920) 26f; F. Stählin, *Das Hellenische Thessalien* (1924) 94-99[PI]; id., *RE* (1924) s.v. Larisa 3 (Larisa Pelasgis)[P]; Y. Béquignon, *Mel. Oct. Navarre* (1935) 1-10; N. I. Giannopoulos, *ArchEph* (1945-47) chron. 16f; T. D. Axenidis, Ἡ πελασγὶς Λάρισα I, II (1947); N. M. Verdelis, *Praktika* (1955) 147-50[I]; id., *Thessalika* (1958) 28-38[I]; *BCH* 80 (1956) 308f[I]; H. Biesantz, *AA* (1959) 90-108[I]; D. Theocharis, *Deltion* 16 (1960) chron. 174f, 184f[I]; 20 (1965) chron. 316f; 21 (1966) chron. 254; G. Chourmouziadis, *ArchAnalekta* 2 (1969) 167-69[I]. T. S. MAC KAY

LARNACA, see KITION

LA RONCE, see under MONTBOUY

LAS Lakonia, Greece. Map 9. Town mentioned in the Catalogue of Ships (*Il.* 2.585). Legend gives it an eponymous founder (Paus. 3.24.10) and adds that it was captured by the Dioskouroi (Strab. 8.5.4) and that the Heraklidai used its port after their victory. The importance of this port in historic times is illustrated by the fact that the Spartan fleet called there in 411 (Thuc. 8.91-92) and that the Lakedaimonians attacked it in 189 (Livy 38.30-31) in order to obtain access to the sea. Under the Empire, it was sufficiently prosperous to coin money under Septimius Severus, Caracalla, and Geta.

The site of the Homeric city was supposed to be Mount Asia, which is identified with the hill of Passava, on which is built a Frankish castle with large blocks of ancient masonry visible in its walls. But one cannot be sure, given the absence of any Mycenaean sherds. On the other hand, numerous chance finds from the Hellenistic and Roman periods have been made on the plain. The port may have been situated either at Vathi, on the coast, or a little to the S at Ayeranos, which can be identified as the site of the Arainos mentioned by Pausanias together with Las.

BIBLIOGRAPHY. E. Puillon-Boblaye, *Recherches géographiques . . .* (1835) 87; W. M. Leake, *Travels in the Morea* I (1830) 255-57; *Peloponnesiaca* (1847) 174;

E. S. Forster, *BSA* 13 (1906-7) 232-34; H. Waterhouse & R. Hope Simpson, *BSA* 56 (1961) 118; R. Hope Simpson & J. F. Lazenby, *The Catalogue of Ships in Homer's Iliad* (1970) 79. c. LE ROY

LASAIA (Chrysostomos) Kainourgiou, Crete. Map 11. An extensive Graeco-Roman city 8 km W of Lebena. The earliest remains in the vicinity are two Early Minoan tholos cemeteries and an Early Minoan settlement, but there are no other remains earlier than the late 5th c., at which time the city appears to have been founded. The site was then occupied continuously as a harbor and city until at least the late Roman period, and was at its most prosperous and extensive during the period of the Roman occupation.

The site is a small headland, opposite the offshore island of Nissos Traphos, flanked by two small bays with sandy beaches. An ancient mole, possibly of Roman date, which runs from the foot of the headland almost to Traphos ensured calm water in either one of the bays, depending on the direction of the wind.

The late 5th and 4th c. occupation of the site seems to have been concentrated on the slopes and the flat summit of the low hill which rises immediately behind the headland. Buildings on the summit include one with foundations entirely of white blocks, situated right on the seaward edge of the hilltop, overlooking the whole site. In later periods occupation spread over the whole of the headland, and along the steep slopes overlooking the bay to the W. Further buildings were erected to the E of the headland. Over the whole of this area the remains of the city are still clearly visible, both as a dense spread of broken pottery and as a mass of stone walls, built of red, green, white, and brown blocks used haphazardly.

On the headland three buildings of some importance can be traced. In the center of the headland are the remains of a substantial building whose main feature is an oblong court measuring 27 x 10 m. On the N side it is flanked by a long narrow hall or corridor 5 m wide, and on the S by a corridor 3 m wide, which continues along the E and possibly the W sides of the court also. At either end of the S corridor, against the courtyard wall, is a built altar or statue base. Beyond the S corridor are suites of almost square rooms. The building seems likely to have fulfilled a public rather than a private function but its precise identity is uncertain.

Southwest of the building described the headland has been terraced to form a natural podium for a temple. A flight of six steps, 10 m wide, survive, flanked by massive side walls. Set back 3 m from the top of the steps are two square altar bases, one on either side of the entrance to the cella. Two walls of the cella survive and show it to have been approximately 5 x 8 m.

Toward the S tip of the headland are the remains of a Christian church, one corner of which has been lost by erosion of the cliff edge. At the N end of the building is an apse 8 m in diameter. The nave is of a similar width, and flanking it are two narrow aisles. Beyond the nave and aisles there may have been a narrow narthex.

The city was supplied with water by a built aqueduct which ran across the hill slopes to the E to reach a spring source about a km away. On the NE extremity of the city the aqueduct appears to have emptied into a large built cistern with plastered walls. The city's cemeteries lay to the W of the settlement. In the late Classical and Hellenistic periods burials were in dug graves and cists on a small headland. Roman burials were in built barrel-vaulted tombs a little farther W.

BIBLIOGRAPHY. T. B. Spratt, *Travels and Researches in Crete* (1865) II 8; D. J. Blackman & K. Branigan, "An Archaeological Survey on the South Coast of Crete," *BSA* 70 (1975)[PI]. K. BRANIGAN

LATARA or LATERA (Lattes) Canton of Montpellier, Hérault, France. Map 23. Lagoon port on the lower coast of Languedoc, halfway between the mouths of the Rhône and the Hérault, and on a small coastal river, the Lez, behind the Étang de Lattes (Plin. *HN* 9.29). It was in the territory of the Volcae Arecomici, and was later made part of the civitas of Nîmes. Oriented towards the sea, it was engaged in commerce from pre-Roman times with the greatest ports of the Mediterranean, especially Marseille, for which it was a way station or even a trading post. But it was also a river port, at the mouth of a splendid access route, and played an important commercial role in relation to the oppida of the interior, particularly Sextantio (Castelnau-le-Lez) on the Via Domitiana. The site of Lattes, a meeting-place for maritime, river, and road traffic, is one of the most important on the Gulf of Lion.

The name of the settlement is known from literary sources (Pliny, Pomponius Mela, Anonymous of Ravenna) and inscriptions (recent discoveries). It covered almost 10 ha in the locality known as Saint-Sauveur, near the modern village of Lattes. The site consists of a mound some five m high, permeated with water owing to its proximity to sea-level.

Excavations, which are only beginning, have disclosed nine layers of habitation from the 7th c. B.C. (with traces of an earlier occupation) to the Roman period. The pre-Roman settlements consisted primarily of huts with cobwork or stone walls, hearths, and floors of broken amphorae, and port installations (landing stages on piles). The artifacts, which are both imported and of local manufacture, are abundant and of very high quality (Late Bronze Age, Etruscan, Phokaian, Ionian, Attic, Ibero-Punic, local ceramics). Three large hoards of coins of the 2d and 1st c. B.C. (coins from Massalia and of the Volcae) have also been found.

The Gallo-Roman town, which was of greater extent and included wide streets, shows a more developed but as yet little known level of urban life: larger houses, mosaic floors, etc. To the NE of the ancient town are the remains of a small sacellum to Mercury (statues, inscriptions, architectural fragments), and a large and well-furnished incineration cemetery of the Early Empire; 160 tombs, containing an abundance of artifacts (ceramics, glassware, bronze objects) and 34 epitaphs have been excavated.

The artifacts are currently at the Dépôt archéologique in Montpellier.

BIBLIOGRAPHY. *Carte archéologique de la Gaule romaine*, fasc. x, Hérault (1946) 8, no. 23; E. Demougeot, "L'inscription de Lattes," *REA* 68 (1966) 86-100; J. Arnal et al., "Lattes," *Archéologia* 31 (1969) 68-72[I]; "Informations," *Gallia* 22 (1964) 491; 24 (1966) 467[I]; 27 (1969) 393-95[I]; 29 (1971) 381-83[I]; 31 (1973) 491-92[I]; E. Demougeot, "Steles funeraire d'une necropole de Lattes," *RAN* 5 (1972) 49-116; J. Arnal et al., *Le port de Lattara* (in press)[MPI]. G. BARRUOL

LATERA, *see* LATARA

LATIMER Buckinghamshire, England. Map 24. A villa 24 km W of Verulamium, erected in ca. A.D. 150 over the remains of a Belgic farm. After a short period of abandonment in the late 3d c. the villa was reoccupied until the late 4th c. when its rooms were progressively abandoned. Thereafter four stratified levels of post-villa occupation and structures carry the history of the farm into the second half of the 5th c.

The villa began with a small baths, long rear corridor and about eight living rooms; it was later extended and in the 4th c. had a large enclosed courtyard and projecting side wings. The villa is notable for its 2d and 3d c. mosaics. The latter, though badly damaged, provide three of the four 3d c. villa mosaics known in Roman Britain. Among the most notable of the post-villa buildings is a cruck-building 17 m long. This and other features of the post-villa occupation, suggest that the farm may have fallen into the hands of a Germanic auxiliary and his family.

BIBLIOGRAPHY. B. Burgess, "The Romano-British Villa at Latimer," *Records of Bucks* 3 (1866) 181-85; K. Branigan, "The Development and Distribution of Romano-British Occupation in the Chess Valley," ibid. 18 (1967) 136-49; id., "The Origins of Cruck Construction—A New Clue," *Medieval Archaeology* 12 (1968) 1-11; id., "The Latimer Roman Villa," *Current Archaeology* 20 (1970) 241-44; id., *Latimer (Belgic, Roman, Dark Age and Early Modern Farm)* (1971)[MPI].

K. BRANIGAN

LATO Crete, Greece. Map 11. The city is situated on the Gulf of Mirabello in E Crete. It was bounded to the N by the Oxa mountain chain, marking the frontier with Olonte, to the W by the foothills of the Lasithi mountains and to the S by the territories of Arkades, Malla, and Hierapytna. Lato had a port, Lato pros Kamara (mod. Haghios Nikolaos) and a number of inland plains suitable for agriculture, the largest of which however is no more than a few km square.

The name appears on several Mycenaean tablets at Knossos. But up to the present time only a few objects and sherds of Late Minoan III have been found on the site, and then always at the surface. The earliest structures to be excavated date from the 7th c.

Excavations in 1899-1900 yielded an abundance of terracottas showing oriental influence: female figures, sphinxes, Daidalian heads. Digging carried out in 1968 near the great temple revealed a pottery dating from the same period.

Objects found in these digs are now divided between the Heraklion, Mallia, and Haghios Nikalaos museums.

Lato's ruins are situated ca. 8 km from the sea. Scattered over the whole site can be seen the remains of several terrace walls and walls of houses. The latter are designed on an interesting plan: built lengthwise, they sometimes have a courtyard with a cistern, a large room with a hearth and one or more secondary rooms. Although not all the houses have been explored, the masonry of the walls shows that they date from different, and in some cases quite early, periods. The plan of the city was governed by the nature of the site, which is hilly. The presence of large numbers of cisterns can be explained by the shortage of water.

During excavations carried out in 1899 and 1900, then again from 1967 to 1971, the city agora was uncovered on the W pass as well as some civic and religious buildings nearby and a section containing fortified houses between the agora and the W city gate.

1. Agora and prytanaion: Along the E side of the agora is a terrace wall, the earliest stage of which may go back to the 7th c. In the center of it is a small ruined temple that may date from the archaic period. The square is lined to the W by a portico and to the S by an exedra. On the N side is a flight of steps leading to the prytanaion. Lato's principal civic building is made up of two sections: a peristyle court to the E, and to the W the area where the cosmes (council of city magistrates) took their meals together. The steps leading to the prytanaion apparently served as a meeting place for an enlarged assem-

bly. Indeed, the manner in which they are laid out—three flights of steps 30-40 cm high separated by two series of lower stairways—resembles the plan of theaters in mainland Greece. E and W of the steps are two massive structures, rectangular in plan, whose appearance is reminiscent of military rather than civic architecture. They were designed to support the platform on which the prytanaion stood. Between the steps and the W bastion is a gap of a few m, now occupied by a peasant's hut, which in antiquity may have held two rooms of still indeterminate purpose.

Recent studies have shown that the main city buildings date at the earliest from the second half of the 4th or 3d c. B.C. Only then, apparently, was a vast building plan carried out in the city center.

2. Sanctuary and theater S of the agora: The city's principal religious monument (10.1 x 6.5 m) stands on a terrace connected to the agora by a winding road. Rectangular in plan, it consists of a pronaos and a cella. It is not known to what deity the temple was consecrated.

The temple terrace is supported by a fine wall of polygonal masonry with bosses ca. 40 m long. The 1968-69 excavations uncovered an interesting complex at the foot of this terrace consisting of straight tiers of steps and a rectangular carefully built exedra. The tiers and the exedra make up the cavea of a sort of rustic theater, the stage being formed by a platform ca. 8 x 30 m. What kind of ceremony, religious or civic, this complex was designed for we do not know.

3. Fortified houses: The first excavations revealed a street that climbs gradually from the W fortified gate to the agora. To the S it is lined with a series of stalls and workshops backed against a late rampart. Traces of various kinds of crafts: pottery, iron-working, dyeing have been found here. To the N, at the end of the rows of terraces spread out over the sides of the acropolis, are some sturdy walls with one gate per terrace cut in them. The resultant passageways open onto either a house or a pathway leading to the N quarter. Study of these individual fortifications, set side by side yet separate from each other, shows that the methods used in them are more and more complex. Certain houses, the latest ones, are veritable towers with zigzag entrances. When the S rampart was put up the complex lost its usefulness.

In the 2d c. B.C. the inhabitants of Lato seem to have abandoned the high city and settled by the sea, at Lato pros Kamara. Numerous inscriptions dating from this period found at Haghios Nikolaos show that the city enjoyed renewed activity at this time.

BIBLIOGRAPHY. A.J.A. Evans, "Goulas, The City of Zeus," *BSA* 2 (1895-96) 169-94; J. Demargne, "Les ruines de Goulas ou l'ancienne ville de Lato en Crète," *BCH* 25 (1901) 282-307 & pls. XX-XXI; id., "Fouilles à Lato en Crète 1899-1900," *BCH* 27 (1903) 206-32 & pls. IV-V; P. Demargne, "Terres cuites archaïques de Lato," *BCH* 53 (1929) 382-429 & pls. XXIV-XXX; E. Kirsten, "Lato," *RE* suppl. VII (1940) 342-65; P. Ducrey & O. Picard, "Recherches à Lato, I. Trois fours archaïques," *BCH* 93 (1969) 792-822; id., "II. Le grand temple," *BCH* 94 (1970) 567-90; id., "IV. Le théâtre," *BCH* 95 (1971) 515-31; id., "V. Le prytanée," *BCH* 96 (1972) 567-92; Vanna Hadjimichali, "III. Maisons," *BCH* 95 (1971) 167-222.

P. DUCREY & O. PICARD

LATOPOLIS (Isna) Egypt. Map 5. On the W bank of the Nile, 53 km S of Thebes. The Greek name Latopolis (Strab. 17.1.47) refers to the fish Latus that was venerated here, mummified, and buried in its special necropolis in the mountains. The city gained its importance through being the terminus of the caravan road that ran through the oasis of Kurkur to Derr in the Sudan.

Under the Ptolemies and Romans it became the capital of the third nome of Upper Egypt. In the heart of the modern city, in a hollow 10 m deep, stands the great Roman hypostyle hall of 24 columns constructed by Claudius and Vespasian. Its symmetry, its almost complete state of preservation, and the variety and originality of its capitals make it one of the most beautiful hypostyles in Egypt. The numerous texts that are carved on the walls and columns and which consist of important religious works were mostly carved in the time of Trajan and Hadrian.

BIBLIOGRAPHY. G. Posener, *A Dictionary of Egyptian Civilisation* (1962) 81; E. Brunner-Traut & V. Hell, *Aegypten* (1966) 627, 629-30; K. Michalowski, *L'Art de l'Ancienne Égypte* (1968) 546-47; C. C. Walters, *Monastic Archaeology in Egypt* (1974). S. SHENOUDA

LATRESNE Gironde, France. Map 23. Traces of a building were uncovered in 1955-57. Only the foundations (one corner) remain, along with three column bases belonging to a portico which was walled in at a later period. A limestone votive stele was also found (26 cm high, 9 cm thick), broken on the right side. A figure carved on it holds in its left hand what may be a purse (?) above a sort of altar (Mercury?).

BIBLIOGRAPHY. J. Coupry, "Informations archéologiques," *Gallia* 13 (1955) 190-92, figs. 3-5; 15 (1957) 250. L. MAURIN

LATTES, *see* LATARA

LA TURBIE, *see* TROPAEUM ALPIUM

LAUBENDORF Austria (Carinthia). Map 20. On a high plateau N of the Lake of Millstatt, ca. 200 m above it. Here an Early Christian church was discovered in 1957 and by 1960 its main elements, which are all now visible, had been excavated. The complex differs in characteristic details from other early churches in S Noricum, being a single-naved church with recessed apse, in which the semicircular synthronon is not, as usual, freestanding but built directly into the wall of the apse. Also unusual is another built-in bench running along the N wall of the nave. The main entrance was on the W, a secondary entrance on the corner of the N wall at the start of the apse. There was no architectural ornament of any distinction, a fact not surprising in view of the area's isolation in Early Christian times, and no important finds made within the church. Its main significance is in the fact that because of its out-of-the-way location it documents the intensity of Christianization in the Roman alpine provinces. Whether one may see in it also the refuge of the Bishop of Teurnia, about 3 hours distant, is questionable.

BIBLIOGRAPHY. H. Dolenz, *Festschrift Gotbert Moro* (1962) 38ff[MPI]; R. Egger, *Teurnia. Die römischer und frühchristlichen Altertümer Oberkärntens* (7th ed. 1973). R. NOLL

LAUDUN Locality of Camp-de-César, Gard, France. Map 23. The present state of research suggests that human occupation of the Camp-de-César began at the end of the 2d c. It continued without a break until the 2d c. A.D. The site was resettled at the time of the barbarian invasions at the end of the 4th c. The Gallic town was particularly large and well defended. In Roman times the city, although smaller, still covered ca. 15 ha and had a high population density. The most important monument is a Cyclopean Celtic rampart. It was 3.5 to 4 m thick and ran N-S, protecting the W side of the Gallic town. It is built of large limestone blocks, often more than a meter

on a side, arranged as facing for a rubble fill. To the SE on both sides of the entrance, the Romans built a wall of squared-off quarrystone, held together with lime mortar. Elsewhere, the natural abruptness of the terrain was enough to defend the settlement. Remains of different periods—a tower, house walls, pits, architectural fragments, hummocks hiding buildings, a chapel—are visible here and there over the whole plateau.

The main finds are in the Musée Calvet at Avignon, the Nîmes museum, and the museum at Bagnols-sur-Cèze (Gard).

BIBLIOGRAPHY. L. Alegre, *Le Camp-de-César de Laudun près Bagnols* (Gard) (1865) I; V. Luneau, "La numismatique au Camp-de-César de Laudun," in *Compte rendu du LXIVème Congrès Archéologique de France* (1897) I; L. Rochetin, "Le Camp-de-César de Laudun," in *Mémoires de l'Académie de Vaucluse* (1899) 41ff; P. Raymond, *L'Arrondissement d'Uzès avant l'histoire* (1900) I passim. J. CHARMASSON

LAURENTUM, *see* LAVINIUM

LAURIACUM (Lorch) Austria. Map 20. In Roman times in Noricum. The Celtic name (documented A.D. 791 as Lorahha) continues in the modern name. There was possibly an earlier settlement, but it has not yet been discovered. As the name of a station, Lauriacum is mentioned several times in the *Peutinger Table* (4.4; misspelled as Blaboriciaco), in the *Notitia dignitatum*, and also in several other sources (Ammianus Marcellinus, *Vita Sancti Severini, Passio Floriani*).

The geopolitical significance of the place is characterized by its location: a) on the important Danube road parallel to the Noric-Pannonic limes (Carnuntum-Vindobona-Castra Batava); b) at the terminal of the Noric Trans-Alpine Road leading from the Adriatic area (Aquileia) via Virunum-Ovilava to the Danube; c) at the mouth of the Enns, which paralleled an important commercial road; d) opposite the Aist valley (Freistädter Steig) which approaches the Danube on the left bank and constitutes an advantageous gate for invasions from the N.

The history of Lauriacum can be reconstructed only partially, primarily on the basis of finds. Soon after the occupation of Noricum (15 B.C.) the border at the Danube and mouth of the Enns was secured by a small fortification. There were earthworks (71.4 x 124.3 m) surrounded by a double trench. Because of its small size the castellum can have had only a small garrison (Alen-Centuria?). It was probably constructed in the first half of the 1st c. A.D. South of it were located the canabae. This first military installation was destroyed during the Marcomannic wars (170-71), necessitating the transfer of legionary troops to Noricum. Under Marcus Aurelius the Legio II Italica was stationed at the Danube frontier, at first at Albing, E of the mouth of the Enns. Since the terrain there was unsuitable (danger of floods), Albing was soon abandoned, and W of the Enns a new legionary camp was erected under Commodus (191) or, more likely, under Septimius Severus (205).

Lauriacum is in the corner formed by the Danube and the left bank of the Enns, on a terrace of the Enns Stadtberg. Since 1904 about four-fifths of the camp has been excavated. Its ground plan is a rhomboid (ca. 539 x 398 m) and therefore larger than the camp at Carnuntum. The reason for the oblique angle is not clear. The surrounding wall with trenches was ca. 2 m thick and had four pairs of gate towers, four corner towers, and 24 towers interspersed on the inside of the wall. In the interior the via principalis with principia and sacellum, numerous barracks, scamnum tribunorum, camp baths,

and valetudinarium are known. A few areas which were not built up might have been intended to harbor civilian refugees, making this the first Roman camp designed to serve as a refuge.

Until the end of the Roman rule, the Legio II Italica remained as its garrison. About later times the *Notitia dignitatum* reports: praefectus legionis secundae Italicae (34.39), praefectus classis Lauriacensis (34.43), lanciarii Lauriacenses (5.259 = 5.109 = 7.58) fabrica Lauriacensis scutaria (9.21). The transfer of legionary troops to Noricum also caused a change in the provincial status, for the legion commander became the governor of the province. At the time of the construction of the camp a civilian town 200 m W (for security reasons) was planned and built. Large parts of it have been systematically excavated from 1951 to 1960, including the adjoining cemeteries; publication is still incomplete. The town plan is regular and directed toward the camp. Streets at right angles form insulae 90 m square; the total built-up area is ca. 500 m square. The original dwellings were of timber; the public buildings were of stone. At the E edge was a large square surrounded by pillared halls, the forum venale, headquarters of Lauriacum's commercial companies. Adjoining on the W side stood a one-nave basilica, equipped for heating. In the S part of the town large baths have been discovered, in the W mainly private dwellings. The forum is considered to have been in the area of St. Laurenz church and its surrounding cemetery; years ago an altar for the Capitoline gods was found there. The first great building period of the town was from the time of Septimius Severus to about the time of Alexander Severus, but almost all buildings were rebuilt several times. The cemeteries were in a large surrounding area; more than 20 have been found so far. Graves containing ashes exist in an uninterrupted sequence to mid Imperial times. Graves of Late Classical times contain skeletal remains and are occasionally richly decorated. Some show Christian origin.

The civilian town must have developed rapidly, for under Caracalla (212) it became a municipium. It was the last town founded by the Romans in Noricum. Some fragments of a bronze tablet inscribed with the town law constitute a valuable memento of this historic occasion. Lauriacum suffered repeatedly after the time of Alexander Severus from Allemannic invasions and was burned down several times, e.g. under Gallienus and Aurelianus. Three strata reflecting the destruction and subsequent rebuilding have been ascertained. Under the Constantinian dynasty the town experienced a brief renaissance, evidenced by increased building activity. In the 4th c. the emperors Constantius II (341) and Gratian (378) stayed within its walls. Perhaps also Valentinian I (374) was there when the defense of the limes was reorganized. Literature and finds give evidence of Christianity in Lauriacum in this same century. Florianus, the former head clerk of the chancery under the governor of riparian Noricum, is a well-documented figure who died a martyr's death (the only one known in Austria Romana) during Diocletian's persecutions of the Christians ca. 304. Architecturally, Christianity is represented by a small church which was discovered in 1936 on a tract of the valetudinarium.

Eugippius gives a lively description of conditions in the 5th c. in his *Vita Sancti Severini* (c. 18,27,28,30,31); this is the latest available information. The vita does not mention any military function for the town but reports it as a bishopric. The camp was already a refuge for the population which was always threatened by attack. Because of the continuing invasions of the Alemanni and other Germanic tribes into the urban settlements on the upper Danube, this area had to be evacuated, and Lauriacum at first served as a refuge. But it could not resist the superior strength of the enemy. Under the leadership of St. Severinus, the town was given up and the population was evacuated to Favianis farther down the Danube and was put under the protection of the king of the Rugii. Thus Lauriacum fell without a struggle into the hands of the Germanic aggressors. Germanic huts and graves document a resettlement of the place after Roman rule.

Finds from Lauriacum are mostly in the museum of the town of Enns, finds from earlier decades are also in the Oberösterreichisches Landesmuseum in Linz.

BIBLIOGRAPHY. A. Gaheis, *Lauriacum. Führer durch die Altertümer von Enns* (1937)[MPI]; R. Noll, *Römische Siedlungen und Strassen im Limesgebiet zwischen Inn und Enns* (1958) 46ff; H. Vetters in *EAA* 4 (1961) 506ff[P].
R. NOLL

LAURION Attica, Greece. Map 11. In antiquity, even as now, Laurion was understood as Attica's SE corner, the place of the silver mines, a clearly identified system of low hills stretching N from Cape Sounion for a distance of ca. 17 km. For most of this length, Laurion has a single backbone marked by a succession of peaks, the highest of which, Vigla Rimbari, located near the chain's midpoint, has a height of 372 m; but to the S, where it reaches a maximum width of 10 km, the system is divided by the Legraina valley. Along the E coast, other cultivatable valleys penetrate the hills, especially at Thorikos, where the low, flat land is large enough to constitute a small plain and, for millennia, to have helped support a settled community. Otherwise, most of Laurion's 200 sq. km is rugged and waterless, and would have given little to Athenian economy had it not been for the early discovery, particularly in the hills on its E side, of rich deposits of ore—mixed sulphides of lead, zinc, and iron—from the first of which silver could be profitably extracted.

Exploitation of this mineral wealth may have begun as early as the Middle Helladic period, but the evidence admits of no assessment of the extent, or continuity, of the industry in the Bronze and Early Iron Ages. By the archaic period, however, from the time of Peisistratos' tyranny (Hdt. 1.64) and with the issuance of Athens' silver coinage, the mines of Laurion had assumed political as well as economic significance. And in the 5th c. B.C. this importance increased with deeper mining and the discovery of the ore bodies of the "third contact" (Arist. *Ath.Pol.* 22.7). But progress was halted by the placing of the Spartan fort at Dekeleia in 413 B.C. (Thuc. 6.91 & 7.27), and recovery may have been slow, for Xenophon (*Vect.* 4) makes clear that even in the middle of the 4th c. the industry still needed encouragement. Despite this setback, the Classical period marks the heyday of the Laurion mines. Thereafter the story is one of decline, accompanied by a slave revolt (Ath. 6.272), and by Strabo's time men had ceased to go underground but were now reworking the slag-heaps (9.1.23). Even this activity is missing from Pausanias' description of the place as one where "the Athenians once had silver mines" (1.1.1).

Of this ancient and extensive industry, particularly from the Classical period, the remains that survive throughout Laurion are almost beyond count, many still to be properly cleared and studied. A fair sample of them may be seen alongside any of the roads that serve the mining area: the mines themselves, some nothing more than a rudely hacked horizontal passage, others a complex system of deep galleries linked to the surface by well-cut shafts as much as 100 m deep; milling and washing establishments, the latter with nearby cisterns for the storage of water; furnaces (the excavation of a

heavy-walled building containing a bank of them was begun in 1971 near Megala Peuka); slag and other waste; living quarters and cemeteries; roads and culverts. But to some Laurion did not mean only mining: there are also, in some less accessible places, instructive examples of farmhouses and marble quarries, in one of which one can see where column drums were removed. Finally, at the top of Vigla Rimbari there is a rubble enclosure wall, perhaps a direct answer to Xenophon's suggestion (*Vect.* 4.43-44) that the area needed a third stronghold, in addition to those at Anaphlystos and Thorikos, to protect in war one of the city-state's most valuable assets.

BIBLIOGRAPHY. E. Ardaillon, *Les Mines du Laurion dans l'Antiquité* (1897)[MPI]; G. P. Marinos & W. E. Petraschek, Λαύριον (1956)[MPI]; J. H. Young, "Studies in South Attica, Country Estates at Sounion," *Hesperia* 25 (1956) 122-46[PI]; R. J. Hopper, "The Laurion Mines: A Reconsideration," *BSA* 63 (1968) 293-326; H. F. Mussche et al., *Thorikos* 1-5 (1968-71)[MPI].

C.W.J. ELIOT

LAURO, *see* LEIRIA

LAUROLAVINIUM, *see* LAVINIUM

LAUSANNE-VIDY, *see* LOUSONNA

LAUZE and SAINT-PROJET Tarn-et-Garonne, France. Map 23. At the W end of the military camp of Caylus, in the district of Cantayrac has been found a site thought by some to be that of Uxellodunum (see Luzech), which was besieged and taken by Caesar in 51 B.C. The evidence, however, seems to attest only an occupation in the 1st c. B.C. and during the Roman Empire.

BIBLIOGRAPHY. Commandant Reveille, "En Bas Quercy ... Cantayrac, dernier bastion de la résistance gauloise," *Rev. hist. de l'Armée* (1958) no. 3; R.P.A. Noché, "Uxellodunum = Cantayrac," *Les Etudes Classiques* 27.1 (1959) 1-20; id., "Où ce haut lieu: Uxellodunum?," *Gaule* 10 (1965) 91-99; Emile Thévenot, "A la recherche d'Uxellodunum," *Rev. arch. de l'Est* 10 (1959) 342-43; M. Labrousse in *Gallia* 11 (1951) 138-39; 13 (1955) 217; 17 (1959) 449; 26 (1968) 556-57.

M. LABROUSSE

LAVANT East Tyrol, Austria. Map 20. At the S edge of the Lienz basin, ca. 4 km S of the ruins of the Roman town of Aguntum and near Lavant, the Kirchbichl, a hill with steep slopes on all sides, rises to a height of ca. 800 m. The ascent is possible only on the N side by a serpentine path. On its peak (W) stands the Church of St. Peter; midway on the S side, the Church of St. Ulrich. Excavations have disclosed evidence not only of Early Imperial civilization but also of the fact that the hill served as a fortified refuge in Late Classical times. The only natural access had been blocked at a sharp turn of the road by a gate with tower, closed on both sides by heavy walls ca. 875 m long, which encircled the hill and encompassed an area of ca. 30,000 sq. m. The terraced interior was largely left free of building.

Under St. Peter's choir, square foundations were discovered which are interpreted as the remains of a rectangular Celtic-Roman temple. This pagan cult building was changed in Early Christian times into a chapel through the addition of a semicircular clerics' bench. The most important structure was found SW of St. Ulrich's: an unusually long building (10 x 41 m), which proved to be the largest Early Christian church in Noricum. The long architectural history of the whole complex, with many modifications over the centuries, is very complicated; and the reuse of building materials makes establishing a chronology difficult. It is doubtful that the unusually large building represents a unified concept. Probably the E section belongs to the oldest part of the building and was erected soon after the construction of the fortification (ca. 400 A.D.).

West of St. Ulrich's the ruins of an extensive dwelling complex were found, part of which was equipped for heating and may have been the residence of the bishop.

The historical significance of Kirchbichl is that ca. A.D. 400 a fortified refuge was established here to protect the population of the surrounding area in the troubled times of the migrations, and that at the same time a fortified residence for the bishop (probably the Bishop of Aguntum) was created. It is of interest that the place outlasted the big invasion by the Slavs and Awari ca. 600. For this reason the impressive church ruins have been preserved.

BIBLIOGRAPHY. W. Alzinger, *Aguntum und Lavant. Führer durch die römerzeitlichen Ruinen Osttirols* (1974) 44ff[MPI].

R. NOLL

LAVATRAE (Bowes) Yorkshire, England. Map 24. A fort on the river Greta (from the gorge of which the name perhaps derives). It guards the E end of the Stainmore pass across the Pennines which carried the Roman trunk road from York to Carlisle, and was garrisoned in the 2d c. by Cohors IV(?) Breucorum and in the 3d c. by Cohors I Thracum. The first fort, with timber-faced rampart revetted with turf at the rear, was built by Julius Agricola ca. A.D. 78, or possibly a few years earlier by Julius Frontinus, as part of the system for controlling the newly conquered Brigantes. A polygonal annex was provided on the N side, presumably to protect transport encamped for the night, but this was leveled early in the 2d c.

There has been little excavation within the fort, though complicated sequences of structures have been found in the vicinity of the principia and show that it was held without significant interruption for some 320 years. Inscriptions (*RIB* 739-40) indicate reconstruction under Hadrian and Severus. The defenses were renewed on at least five occasions, the latest at the end of the 4th c. In the pass above the fort there are traces of a system of signal towers which is thought to have been used for communication between York and Hadrian's Wall, and 3.2 km S in a remote glen were found two shrines containing altars to Silvanus Vinotonus erected by a 3d c. prefect and centurion respectively.

S. S. FRERE

LAVDHANI, *see* LIMES, GREEK EPEIROS

LAVELLO Potenza, Lucania, Italy. Map 14. A center on the right bank of the Ofanto river 12.8 km from Melfi. It was inhabited from the beginning of the Iron Age. The larger hill, La Gravetta, of the two small hills on which it stood was the site in Classical and Hellenistic time of a settlement with defensive works and an urban plan.

Traces of Early Iron Age huts and tombs are in evidence at some distance from La Gravetta, but during the 6th c. B.C., the growing necropolis spread in this direction.

Late archaic and Classical antefixes from sacred buildings have been unearthed, specifically from the area of the modern cemetery. These are of the Tarentum-Metapontion style and resemble those of Daunia, particularly those at Arpi. The Gorgon is the typical decorative motif, handled in a rather sketchy fashion. Other Classical motifs represent bulls or flowers, bearing little resemblance

<table><tr><td>to Lucanian or Apulian antefixes and even less to those of the Greek coastal colonies.</td></tr></table>

to Lucanian or Apulian antefixes and even less to those of the Greek coastal colonies.

The first Greek products, the so-called Ionic cups and bronzes, appeared in the settlement and its necropolis in the second half of the 6th c. B.C. Daunian pottery also appeared, as well as helmets of the Apulian-Corinthian type and a few examples of pottery used in central Lucania. There is only slight evidence for the use of Greek products through the second half of the 5th c. but it increases in the 4th c., particularly during the second half. The tombs of this period usually exhibit a roofing of rubble and a long dromos as at nearby Melfi and Arpi.

The center began to decline in the 3d c. B.C., the inhabitants scattering to the large farms and villages of Gaudiano and Boreano and to the area today called Chiesa del Diavolo.

BIBLIOGRAPHY. C. Valente, *NSc* (1949) 107; D. Adamesteanu, *Atti IV Convegno Taranto* (1965) 139-40; id., *Atti VI Convegno Taranto* (1967) 259; J. de La Genière, *Recherches sur l'âge du fer en Italie Méridionale* (1968) 109, 122; *Popoli anellenici* (1971) 129-32.

D. ADAMESTEANU

LA VIENNE, see LIGUGÉ

LA VILLENEUVE-AU-CHÂTELOT Aube, France. Map 23. Potters' kilns, discovered near the Seine valley and the Roman road from Troyes to Senlis, and fairly close to a necropolis of the Iron Age and another from the Merovingian period, have led to the excavation of a pottery center.

About a dozen kilns varying in size and orientation, with walls made of tiles or vases, were found within a small area. Close by was pottery stored ready for shipment, a cellar full of varied wares including imported terra sigillata (Lezoux, Lavoye, Argonne), and a number of wells and rubbish pits. The pottery made on the site often, though not exclusively, has the crackled appearance and bluish tone found in many Gallo-Roman settlements in Champagne. La Villeneuve exported this pottery, but also other types of ware, particularly an imitation terra sigillata with varied and often original forms. A huge number of sherds have been recovered as well as many intact or restored vessels (over 1300 different pieces in a single year). Both the coins and the La Graufesenque terra sigillata show that the workshop was active from the middle of the 1st c. A.D., perhaps even earlier. A hoard of bronze and silver Gallic and Roman coins was recently discovered a few hundred m away. Consisting entirely of coins from the 1st c. B.C., it provides evidence that the site was occupied and had far-flung trade links as early as the first years after the Roman conquest.

A part of the early finds are in the Saint-Germain Museum (Musée des Antiquités Nationales); the recent ones are in the Nogent-sur-Seine museum.

BIBLIOGRAPHY. A. Brisson & A. Loppin, *BAC* (1936-37) 262-65; id., *Bull. du Groupe Archéologique du Nogentais* 4 (1965) 5-20; P. Benoît & R. Guéry, ibid. (1963) 4-5, 11-18; Guéry, ibid. 19-28; Tessier & Boisset, ibid. 29f; R. Martin, *Gallia* 22 (1964) 297; E. Frézouls, ibid. 25 (1967) 281-83[1]; 27 (1969) 299; 29 (1971) 285-88[1]; 31 (1973) 407.

E. FRÉZOULS

LAVINIUM (Pratica di Mare) Latium, Italy. Map 16. A city 28 km S of Rome. It was founded by Aeneas, fugitive from Troy, and named for his wife Lavinia, daughter of Latinus, king of the Aborigeni. So goes the legend in the liberal poetic version of Virgil, in Livy (1.1.4ff), Dionysius Halicarnassensis (1.59.1ff), Dio Cassius (1. Fragm. 1.3ff), *Origo gentis Romanae* (10.5ff) and in other sources. The earliest testimony of the legend is in Timaeus, ca. 300 B.C., who speaks of the

Penates of Troy preserved in Lavinium. The people of Lavinium are mentioned in the first treaty between Rome and Carthage (Polyb. 3.22). The city was the center of the Laurens ager, from which the inhabitants of the city are also called Laurentes; and thus the city itself is sometimes called Laurentum or Laurolavinium. Lavinium was part of the Latin League (Cato, in Prisc. *Inst.* 4) and was the seat of the League's sanctuary. At the conclusion of the Latin war in 338 B.C., Lavinium probably became a federated municipium. Strabo (5.3.5; 100.232) connected the city's decline with the Samnite ravages, that is, with the actions of Marius' force in 82 B.C. Nevertheless, a particular religious significance preserved Lavinium's importance throughout the ancient period. It was the seat of the cult of the Penates, from which the Romans borrowed the official cult (Macrob. 3.4.11, etc.) of the beginning of the Roman peoples called Latins (*CIL* X, 797). It is in consideration of this cult and in the acceptance of the legend of their Trojan origins that Varro (*Ling.* 5.144) could write: "Oppidum quod primum conditum in Latio stirpis Romanae, Lavinium: nam ibi dii penates nostri." Other cults of Lavinium mentioned in the sources include Vesta, closely connected as at Rome, with the Penates; Indiges (also called Jupiter Indiges or Aeneas Indiges), Venus Frutis, Iuturna, Anna Perenna, Liber, etc. From epigraphic evidence it is known that Castor and Pollux were venerated at Lavinium ca. 500 B.C. and Ceres during the 3d c. B.C.

The city was linked to Rome by the Via Laurentina, on lightly rolling hills in sight of the sea, from which it is 4 km distant as the crow flies. On the coast near the mouth of the Numicus (now called the Fosso di Pratica) was Troia with a Sanctuary of Jupiter Indiges. In this spot legend places the embarcation of Aeneas. The limits of the city are clearly determinable. Above the hillside where today stands the village of Pratica di Mare is the nucleus of the earliest settlement, indicated by the Iron Age tombs found around it. In the 6th c. the city grew to the S and the W, while the older nucleus must have assumed the functions of an acropolis. Various stretches of city wall have been found, the earliest datable to the 6th c. Inside the city are preserved various remains from archaic, Republican, and Imperial times, among them the bases of statues of Lavinia and of Silvius Aeneas, honorific inscriptions, a bath building renovated by Constantine, etc.

Outside the city, toward the E, a temple from the 5th c. has been found; and to the S near the little church of Santa Maria delle Vigne, which is of Early Christian origin, elements of a large sanctuary have been discovered. The latter contains a particularly interesting series of 13 large altars, all aligned, the earliest from the 6th c. B.C. and the most recent perhaps from the 2d c. B.C. Besides many votive terracottas the excavation has brought to light local and imported ceramics from the 6th and 5th c., small bronzes of kouroi similar to those of the Niger Lapis (about 500 B.C.), a very fine bronze statuette of Kore in the Greek oriental style, and the aforementioned Latin inscription of Castor and Pollux datable to ca. 500 B.C. These discoveries are interesting for the testimony they provide of direct contact with the Greek world, probably through maritime trade; and they also contribute new evidence concerning the function that Lavinium may have had in transmitting Greek influence to Rome, particularly in religious matters. Another important discovery made in the same area, about 100 m N of the others, is that of a tomb of the 7th c. B.C., covered by a tumulus. It was transformed in the 4th c. into a Heroon and can be identified as the Heroon in the form of a tumulus seen by Dionysius

Halicarnassensis (1.64.5) near Lavinium, not far from Numicus; and believed to be the tomb of Aeneas.

BIBLIOGRAPHY. R. H. Klausen, *Aeneas und die Penaten* I-II (1839-40); A. Nibby, *Analisi . . . della Carta de' dintorni di Roma* (2d ed., 1848) II, 206ff; J. Carcopino, *Virgile et les origines d'Ostie* (1919); G. B. Trovalusci, *Lavinium. Pratica di Mare* (1928); G. Bendz, "Sur la Question de la ville de Laurentum," *Acta Instituti Romani Regni Sueciae* 4 (1935); B. Tilly, *Vergil's Latium* (1947); A. Alföldi, *Early Rome and the Latins* (1965); G. K. Galinsky, *Aeneas, Sicily, and Rome* (1969); F. Castagnoli, *Lavinium* I (1972).

On recent excavations: F. Castagnoli, "Dedica arcaica lavinate a Castore e Polluce," in *Studi e Materiali Storia e Religioni* 30 (1959) 109ff; id., "Sulla tipologia degli altari di Lavinio," *Bullettino Commissione Archeologica del Comune di Roma* 77 (1959-60) 3ff; id., *I luoghi connessi con l'arrivo de Enea nel Lazio, ArchCl* 19 (1967) 1ff; P. Sommella, "Lavinium. Rinvenimenti preistorici e protostorici," ibid. 21 (1969) 18ff; id., "Heroon di Ena a Lavinium: il contributo dei recenti scavi a Pratica di Mare," *RendPontAcc* 44 (1971-72) 47-74. F. CASTAGNOLI

LAZU Dobrudja, Romania. Map 12. Roman settlement in the rural territory of Tomis, 8 km S of Constanţa on the road to Mangalia. Here and in the Turkish cemetery nearby were found many coins and architectural, sculptural, and epigraphic fragments from the 2d to the 7th c. From here comes the latest Latin inscription found in Scythia Minor. It is a funerary inscription, in the Latin vulgate, inscribed on a limestone cross (late 6th-early 7th c.). The name of the ancient settlement is unknown although an identification has been proposed with Vicus Amlaidina, mentioned on an inscription discovered in the area and on the map painted on the shield from Dura Europos.

BIBLIOGRAPHY. E. Popescu, "Descoperirile arheologice de la Lazu," *Studii Clasice* 7 (1965) 251-61.

E. DORUTIU-BOILA

LEÁNYVÁR, *see* LIMES PANNONIAE

LEBADEIA (Levadhia) Boiotia, Greece. Map 11. Capital city of the nome, situated at the mouth of the gorges of the Herkyna on the foothills N of Mt. Helikon and near the W end of Lake Kopais.

The city was famous from the 6th c. B.C. for its Oracle of Trophonios, which, together with those of Delphi, Abai in Phokis, Dodona, and the Amphiareion, was one of the five great Greek oracles. It was consulted by Croesus (550 B.C.), Mardonios (480), and later by Paulus Aemilius (168 B.C.). Pausanias describes it in detail (9.39.5-13). Together with Koroneia and Haliartos, the city formed one of the 11 Boiotian districts from 447-387 and from 371-338 B.C., then became an autonomous city in the Boiotian Confederacy. It was sacked by Lysander in 395 B.C., then again by Mithridates' forces in 86 B.C. Flourishing once again from the 2d c. A.D., it developed in the Byzantine period, thanks to its strategic position and its cotton industry.

The ancient city, very little of which remains, was situated on the right bank of the Herkyna, N of the modern town, at the foot of the acropolis which has been placed at Trypolithari. In recent excavations some 4th c. buildings have been discovered at Levadhia. The river Herkyna flows S of the town in a deep narrow gorge between Mt. Haghios Ilias to the W and Mt. Granitsa (formerly Laphystios) to the E. There are several abundant springs on both sides of the valley;

people consulting the oracle drank the waters of Lethe and Mnemosyne. In the rock on the left bank are hollow niches for statues and a square chamber (4 m each side, 3 m high) with two seats, possibly the Sanctuary of Agathos Daimon and Agathe Tyche. At the W end of the gorge the lower tower of the mediaeval fortress is apparently built over the Temple of Trophonios.

On Mt. Haghios Ilias, on whose slopes the Catalans built a fortress in the 14th c. that can still be seen, was the Sacred Grove, near the Chapel of the Panagia, the Oracle of Trophonios, and the Temple of Zeus Basileus. Recently discovered by Greek archaeologists, the site of the oracle is a few m SW of the Temple of Zeus. It consists of a well ca. 4 m deep and 2 m in diameter (approximately the dimensions given by Pausanias). At the bottom of the well, in the middle, is a cavity the width of a man's body; it extended toward the SW underneath the wall of the well. The cave was sealed with a rough stone. In its present state the somewhat careless construction looks as if it dates from the 3d c. A.D. The identification seems certain.

The Temple of Zeus Basileus, which was never finished, is in almost complete ruin. The E foundations and some carved blocks have just been uncovered. Construction was begun, or perhaps resumed, between 175 and 171 B.C. with money offered by Antiochos IV Epiphanes, king of Syria. Several inscriptions give the building plan in detail. It was apparently a large Doric temple, peripteral, oriented E-W, with an apse in the rectangle of the sekos and a cross-wall with three doors in it. It may have been intended for ceremonies involving processions around an inner altar. The Boiotian Confederacy started the Basileia festivals at Lebadeia, to commenorate the Spartans' defeat at Leuktra in 371; held in Panamos month (August-September), they included athletic contests and horse races. Foreign delegations, notably from Athens, took part in the religious ceremonies.

BIBLIOGRAPHY. Pieske in *RE* (1924) s.v. Lebadeia; A. Bon in *BCH* 61 (1937) 194ff (château médiéval); Radke in *RE* (1939) s.v. Trophonios; J. Jannoray in *BCH* 64-65 (1940-41) 36ff, 274; J. A. Bundgaard, *ClMed* 8 (1946) 1-43; G. Roux, *MusHelv* 17 (1960) 175-84[P]; N. Papahadjis, *Pausaniou Hellados Periegesis* V (1969) 224-34[MPI]; E. Vallas & N. Faraklas, *AAA* 2 (1969) 228-33[PI]. P. ROESCH

LEBEDOS Turkey. Map 7. City in Ionia, on the Kısık (formerly Xingi) peninsula 36 km NW of Ephesos. Founded according to tradition by a son of Kodros named variously as Andraimon or Andropompos. The city was among the poorest of those in the Ionian League; in the Delian Confederacy it was assessed at first at three talents, but this was soon reduced to one. Antigonos, ca. 303 B.C., planned to transfer the inhabitants of Lebedos to Teos and to merge the two cities into one, but the plan was never carried out; instead, Lysimachos used the populations to man his new city at Ephesos. About 266 B.C. Ptolemy II refounded Lebedos under the name of Ptolemais, but the old name soon revived. The Ionian branch of the Artists of Dionysos, originally settled at Teos, moved finally to Lebedos in the 2d c. B.C. Horace's reference to Lebedos as a deserted village is plainly an error; the coinage continues down to the time of M. Aurelius, and a bishop of Lebedos is recorded in the Byzantine lists.

The little peninsula, low and flat, is surrounded by a wall of regular ashlar 2 m thick, with four towers and three gates; a rock-cut ramp leads up from the water to the SE gate, but little else survives. Some foundations of buildings may be discerned on the peninsula, but the acropolis hill is on the mainland opposite. Here sherds

are abundant, and there are numerous fragments of unidentifiable walls and foundations.

There are thermal springs on the shore W of the city and at a spot called Karakoç to the N, where substantial ruins of ancient baths are still standing.

BIBLIOGRAPHY. G. Weber, *AthMitt* 29 (1904) 228; *SIG* 344; G. E. Bean, *Aegean Turkey* (1966) 149-53.

G. E. BEAN

LEBENA (Lendas) Kainourgiou, Crete. Map 11. On the Libyan Sea, a small Hellenistic and Roman settlement centered around the medicinal springs. The settlement was founded in the 4th c. B.C. probably as a spa, but during the Roman period it grew and prospered as one of the two harbors of Gortyn. It was probably not abandoned until the 9th c., some time after the building of a Byzantine basilica which was later covered by the church of Haghios Joannis.

Several of the principal buildings of the settlement can still be seen, most of them directly connected with its function as a spa. Overlooking the center of the harbor is a close-set complex of buildings dominated by the Temple of Asklepios. The cella, with a floor of marble slabs and mosaic panels, retains its altar and the two columns which stand immediately before it. North of the temple is the building known as the Treasury, built in the 2d or 1st c. B.C., and fronted by a monumental marble staircase. At right angles to the staircase and the temple was a long abaton, at the E of which was situated the Temple of the Nymphs. The temple complex formed an angle around the source of the healing waters while S of the complex were two basins for medicinal bathing.

Closer to the shore, traces of other buildings can be seen. The largest is a long, narrow building which seems to have been subdivided into many small rooms, each with an apse overlooking the harbor. This seems likely to have been the main hostel for visitors to the spa. Whether or not the large building to the S also served as a hostel is less certain. Walls belonging to much smaller buildings situated on the opposite, E, side of the harbor are identified as the remains of domestic houses.

A number of inscriptions from the site, mainly relating to the cures obtained there, are kept in the Herakleion museum together with the rich array of Early Bronze Age material recovered from five circular communal tombs excavated in the vicinity of Lebena.

BIBLIOGRAPHY. F. Halbherr & I. Piginoni, *Rendiconti dell' Academia Lincei* (1901) 291ff; G. Gerola, *Le Antiche chiese di Lebena a Creta* (1915); L. Pernier & L. Banti, *Guida degli Scavi Italiano in Creta* (1947) 67-75MP.

K. BRANIGAN

LE BOSSENO Finistère, France. Map 23. This luxurious villa near Carnac is one of the rare houses of this type of which we know the general plan. It was excavated in the 19th c. but only a few traces remain today. The huge complex was erected in the second half of the 2d c. A.D., flourished in the first half of the 4th c., then vanished completely around the beginning of the 5th c.

There are three distinct parts. To the E is the owner's house, a large rectangle with walls built of mortared rubble faced with small blocks with alternating bands of brick. This building is divided into two sections: the house proper, consisting of 11 rooms decorated with frescos, and a small bath building. To the NW, on the other side of a central courtyard, is a square sanctuary with a cella and ambulatory. To the SW and SE are two far simpler complexes, probably the farm buildings of the estate. The whole area was originally ringed with a pro-

tective circuit wall, now apparent as a bank of earth with a vallum. The wall was probably built towards the end of the 4th c. for defensive purposes.

BIBLIOGRAPHY. J. Miln, *Fouilles faites à Carnac* (1887); L. Pape, *Documents d'Histoire de Bretagne* (1971).

M. PETIT

LE BRUSC ("Tauroention") Var, France. Map 23. Located on the seacoast ca. 50 km E of Marseille, Le Brusc was very probably (in spite of contrary assertions: cf. Saint-Cyr sur Mer) the site of the port of Ταυροεντιον (or Ταυροεις), cited by Strabo (4.1.9) as a Massaliot establishment like Olbia, Antipolis, and Nikaia. Later the name was Romanized as Tauroentum. The Hellenistic and Roman town occupied the site of the modern Citadelle district. It was surrounded by a rampart of tufa in opus quadratum; old excavations found traces of it. The town was fed by an aqueduct, a good-sized section of which has been discovered. Floors of dwellings have been uncovered; they are made of clay, limestone, and crude mosaics of Hellenistic date. The coins and the ceramic material date from the 3d c. B.C. to the 3d c. A.D. continuously. They thus lead one to date the founding of Tauroention to the same period as that of Olbia. The island of Les Embiez which faces Le Brusc has produced more ancient remains (5th c. B.C.).

BIBLIOGRAPHY. L. Fiessinger, *Les fouilles du Brusc* (1898); E. Duprat, *Tauroentum* (1935); *Gallia* 6 (1948) 215.

C. GOUDINEAU

LECCE, *see* LUPIAE

LECHAION Corinthia, Greece. Map 11. The port of Corinth on the Corinthian Gulf ca. 3 km N of the ancient city and joined to it by double long walls and a broad paved avenue. Established by at least the time of the Kypselid tyrants and a thriving port in the Roman period, it was one of the largest harbors in Greece, occupying an area of ca. 10 hectares. Two outer harbors protected by moles lay on the shore and communicated with a spacious inner harbor through a narrow channel bordered by stone jetties. In the middle of the W half of the inner harbor stands the masonry core of a Roman monument. The prominent mounds of sand near the shore were probably heaped up by Roman engineers when clearing out the inner harbor. At the town of Lechaion there were shipsheds (Xen. *Hell.* 4.4.12) and Sanctuaries of Poseidon (Paus. 2.2.3) and Aphrodite (Plut. *Mor.* 146 D). The site has never been excavated and our best evidence for its ancient buildings is a coin of Corinth under Caracalla. A small Classical cemetery and a Roman villa have been excavated to the S of the ancient harbor.

BIBLIOGRAPHY. F. Imhoof-Blumer & P. Gardner, *A Numismatic Commentary on Pausanias* (1887) 115, no. 11; J. Paris, *BCH* 39 (1915) 5-16P; K. Lehmann-Hartleben, *Klio* Beih. 14 (1923) 53, 148-52; W. Zschietzchmann, *RE* Suppl. V, 542-45P; J. W. Shaw, *AJA* 73 (1969) 370-72MPI.

R. STROUD

L'ECLUSE Canton of Céret, Pyrénées-Orientales, France. Map 23. Imposing fortifications of the Late Empire, now covered with vegetation. They stand on either side of the L'Ecluse defile, which is the only route leading to the Perthus pass—the lowest of the E Pyrenees—and the route of the great Roman road that joined Gaul with Spain. The structures, large, strong, and preserved to a relatively great height, consist of curtain-walls, towers, barracks, and a cistern. They extend on the E side of the valley (right bank of the Rom) to the hamlet of L'Ecluse-Haute, and on the left bank to the

hill called Château des Maures. The road, which is cut into the rock, follows the bottom of the defile, skirting the stream. At the fortified point it cuts between two walls which are designed to carry portcullises to block it. Recent soundings in some of these structures have uncovered ceramics characteristic of the Late Empire. This fortified ensemble (clausurae), which was placed at the easiest place to watch and defend (not at the Perthus pass itself but at the last mountainous passage before the plain of Roussillon), was intended to control the passage of travelers, impose tariffs on merchants, and even check the advance of invaders. Efforts were made here to prevent passage during the troubled times of the Late Empire and the Early Middle Ages.

BIBLIOGRAPHY. E. Espérandieu, *Répertoire archéologique des Pyrénées-Orientales* (1936) 34; "Informations," *Gallia* 22 (1964) 473; 24 (1966) 449[I]; 27 (1969) 381. G. BARRUOL

LECTOURE, *see* LACTORA

LEDERATA, *see* LIMES OF DJERDAP

LEDRAI or Ledroi, Ledra, Ledron (Leukosia) Cyprus. Map 6. Remains of this ancient town extend S of the Venetian walls of Nicosia as far as Haghioi, Omologitai. The necropolis extends W and S. In the light of recent discoveries, the earlier identification of Ledrai with Leondari Vouno, some 6 km SW of Nicosia, should now be dismissed.

Practically nothing is known of the origin of this town except that it succeeded a Late Bronze Age settlement which has been discovered on the S boundary of Nicosia and especially on either side of the Venetian fortifications. Here were found quantities of Mycenaean pottery. The necropolis of this period was at Haghia Paraskevi, which also yielded Mycenaean material. From present-day archaeological evidence it is clear that Ledrai itself was in existence from the Geometric period down to Early Christian times, when it became a bishopric. The area, however, has been inhabited since Neolithic times and owed its prosperity to the river Pediaios and to the fertile land of the surrounding plain.

Very little is known of the history. On the prism of Esarhaddon (673-672 B.C.) we find the name Unasagusu, king of Ledir, identified as Onasagoras(?), king of Ledrai. The recent study of graffiti in the Temple of Achoris at Karnak has revealed the presence in Egypt, at the beginning of the 4th c. B.C., of several Cypriotes from Ledrai. The ethnic Ledrios appears also on a sherd from Kafizin, a hill near Nicosia, of the end of the 3d c. B.C. We hear no more about the site until A.D. 52, when St. Mark took refuge there on his way from Salamis to Limenia. The next reference is in the 4th c. when Triphyllios was its bishop.

From inscriptions we learn of the worship of Aphrodite at Ledrai but nothing is known of the site of the sanctuary. A sanctuary, possibly dedicated to Apollo, has been located at the locality Haghios Georgios on a hill at the back of the modern Civil Servants Club. The town site is unexplored but many casual finds have been recorded.

BIBLIOGRAPHY. I. K. Peristianes, Γενικὴ Ἱστορία τῆς νήσου Κύπρου (1910); George Hill, "Two Toponymic Puzzles," *Journal of the Warburg Institute* 2.4 (1939) 379-81; Olivier Masson, *Les Inscriptions Chypriotes Syllabiques* (1961).

R. C. Lipsius & M. Bonnet, *Acta Apostolorum Apocrypha* II₂, p. 301, para. 25; A. Papageorghiou, Ὁ Ἅγιος Αὐξίβιος (1969) 18, para. 7. K. NICOLAOU

LEFKADIA (Emathia) Macedonia, Greece. Map 9. Village about 18 km N of Verroia, near Naoussa. Between the town of Naoussa and the villages of Kopanos and Lefkadia stretch the ruins of a town previously thought to have been Citium, referred to once in Livy (42.51), but lately attributed with great probability to Mieza. This town, the cave with stalactites near it, and the nymphaion (in which was located Aristotle's "school," where he taught Alexander and his fellow students from 343/342 B.C.) are referred to by Stephanos Byzantios (q.v. Mieza; see also Veres and Verroia), by Ptolemy (3.13.39), by Plutarch (*Alex.* 7), by Pliny (*HN* 31.30 & 4.34), and others. In a Delphic catalogue of city ambassadors, dated 190 to 180 B.C., Mieza is mentioned between Verroia and Edessa. From Arrian we learn about the Miezan trierarch Peukestas and his brother Amyntas, son of Alexander.

The ancient remains of the region are mostly artificially constructed tombs of the Hellenistic period, the so-called Macedonian type, some carved out of the rock in the shape of a chamber, and others simpler. They have been known only partially for many years. Among the sculpture found in the area, a Roman marble bust of the mythical hero Olganos is most valuable. Of the inscriptions, the most important is one recording deeds of purchase and sale of property, dating from the second half of the 3d c. B.C. Ruins of buildings, houses and villas with mosaic floors, a Christian basilica, a bathhouse, workshops, etc. were found and partly excavated in the areas of Tsifliki and Baltaneno in the early 1960s. They belong to the Roman and Early Christian periods.

Ruins of the Classical and Hellenistic periods, more or less contemporary with the above-mentioned Macedonian tombs, were uncovered from 1966 on in the area of Kefalobryso, where there are gushing springs, between Naoussa and Kopanos. But the most important of the known monuments of the region remain the Macedonian tombs, subterranean, vaulted, and tumulus-type monuments. One of these, long known and excavated during the Turkish occupation, is dated in the 3d c. B.C., and is best known for its fresco representing a Macedonian on horseback spearing a barbarian on foot.

Another Macedonian tomb was excavated in 1942. Its importance is also based on the painted decoration of the interior and on the inscriptions, from which we learn the names of three dead brothers (Evïppos, Lyson, Kallikles), sons of Aristophanes, of their wives, and even of the descendants of Lyson and Kallikles down to the third generation. This tomb is dated ca. 200 B.C.

The third and most important of the great Macedonian tombs was discovered by chance ca. 1954. It is the largest and, as a monument of architecture, painting, and sculpture, the most important of all the Macedonian monuments in existence. The construction materials are poros stone and mortar. The tomb has a two-story facade with pediment which conceals a high, wide prothalamos and smaller death chamber, both arched. The height and width of the facade is ca. 8.65 m. It is about the same as the total length of the two chambers combined. The facade below has four engaged half-columns of Doric style between pilasters on either side and a simple wide entrance opening in the center. The Doric entablature ends in a cornice with a sima. The metopes have a painted representation of centaur battles. On the second level six engaged half-columns stand on a continuous base, also between pilasters. They support an Ionic entablature with cornice. Between the columns and the pilasters seven representations of windows are carved in relief. Only portions of the pediment have been pre-

served, but it is possible to restore it by reconstruction. Additional importance is given to this architectural monument by the painted and written ornamentation of the architectural details (triglyphs, cornices, moldings, simas, etc.).

The movable finds of the region are kept in the Museums of Thessalonika and Verroia.

BIBLIOGRAPHY. K. F. Kinch, "Le tombeau de Niaousta, tombeau Macédonien," *D. Kgl. Danske Vidensk. Selsk. Schr., 7 Raekke, Hist. og Filos. Afd.* IV.3 (1920) 283ff[PI]; I. Lenk, "Mieza," *RE* 15 (1932) 1548; B. Kallipolitis, "Buste d'Olganos, héros éponyme d'un fleuve macédonien," *Mon Piot* 46 (1952) 85-91; X. I. Μακαρόνας, Χρονικά Ἀρχαιολογικά, Μακεδονικά 2 (1941-52 [1953]) 634-36[PI]; Εὐστ. Στίκας, Ἀνασκαφή Λευκαδίων Ναούσης, *Praktika* (1959) 85-89[PI]; Ph. M. Petsas, "Macedonian Tombs," *Atti Sett. Congr. Intern. de Arch. Classica* I (1961) 401ff[PI]; id., Ὠναί ἐκ τῆς Ἡμαθίας, *ArchEph* (1961) 1-55[I]; id., Ἀνασκαφαί Ναούσης, *Praktika* (1963) 58-79[PI]; (1964) 24-34[PI]; (1965) 36-46[MPI]; id., Ὁ τάφος τῶν Λευκαδίων, ἐκδ. Ἀρχαιολογικῆς Ἐταιρείας (1966)[MPI]; id., Χρονικά Ἀρχαιολογικά, Μακεδονικά 7 (1967) 333-41[PI]; 9 (1969) 196-97[PI]. PH. M. PETSAS

LEGIO later MAXIMIANOPOLIS (el-Lajjun) Israel. Map 6.

A site in the Valley of Jezreel, called Kefar Otnay in the Jewish sources, in which Legio IV Ferrata camped after the Bar Kohbah revolt (Ptol. 5.15.3). Eusebius gives the name as Campus Maximus Legionis (*Onom.* 110.21). When the legion left in the time of Diocletian, the town was renamed Maximianopolis, in honor of the emperor's friend Maximianus Herculius (*Onom.* 14.21 and later sources). In the Byzantine period Legio was the seat of a bishop.

A rectangular altar dedicated by an officer of the legion in the time of Elagabalus has been discovered. On two sides of it Roman legionary eagles with wreaths in their beaks, stand on thunderbolts; the other sides have dedicatory inscriptions.

BIBLIOGRAPHY. F. M. Abel, *Géographie de la Palestine* II (1938) 175, 201; M. Avi-Yonah, *The Holy Land* (1966) 122-23, 141, 171. A. NEGEV

LEGIO (León) León, Spain. Map 19.

City at the foot of the Cantabrian mountains in Tarraconensis. Its name refers to its status as a camp of the Legio VII Gemina. According to recently discovered inscriptions on tablets from Villalís, the legion was founded in A.D. 68, and was permanently stationed there from 72 until the end of the Empire. It was the main body of the Roman forces in the limes of N Spain and controlled the operation of the mines of the region. The city had the rectangular plan with rounded corners typical of Imperial Roman camps; it was 570 by 350 m, an area of 19 ha. It is strategically located on a hillock well supplied with water between the Bernesga and Torío rivers.

Excavation is difficult because the modern city is built over the ancient one: the roman strata lie ca. 3-4 m below the surface. The finds have been scanty: the city was apparently only a simple camp, with its greatest development during the reign of Trajan. The double walls, however, are largely preserved: an exterior wall 5.25 m thick, and directly inside it another wall 1.8 m thick with an inside face of well-cut blocks and carefully framed and raised joints. This system was completely covered by the wall now visible. The 1.8 m wall must have been constructed toward the end of the 3d or beginning of the 4th c., in time of peace, carefully and without pressure. However, the outside wall was hastily built of reused material, probably under threat of inva-

sion, towards the end of the 4th or beginning of the 5th c.

The baths are under the present cathedral but, since they were larger than the latter, some parts have been excavated, including three hypocausts separated by walls 1.2 m thick. The piles of the suspensura are square, of brick, and 80 cm high. These baths must have been part of the residence of the Legatus Augusti of the Legio VII, and some stamped bricks seem to indicate that they date from the period of Antoninus Pius.

The Early Christian building of Marialba, recently discovered outside the city, was a church dedicated to the martyrs, the largest in the peninsula and the most important Early Christian building in N Spain. The walls are preserved to a height of 1-2 m, enclosing a space 23.44 by 13.6 m. At one end is a horseshoe-shaped apse 9.55 m in diameter. The church was constructed in two phases, the middle of the 4th c., and the end of the 4th or beginning of the 5th.

There are few other finds in the city: inscriptions, funeral stelai, terra sigillata, and a large number of bricks stamped with various honors obtained by Legio VII.

BIBLIOGRAPHY. M. Gómez Moreno, *Catálogo Monumental de España. Provincia de León* (1925)[I]; I. A. Richmond, "The Town-walls in Hispania Citerior," *JRS* 21 (1931)[PI]; A. García y Bellido, *Nueve Studios sobre la Legio VII Gemina y su Campamento en León* (1968)[MPI]; id., "Estudios sobre la Legio VII y su Campamento en León," *Legio VII Gemina* (1970) 569-601[PI]; T. Hauschild, "Die Märtyrer-Kirche von Marialba bei León," ibid. 511-23[MPI]. R. TEJA

LEICESTER, see RATAE CORITANORUM

LEINTWARDINE, see BRAVONIUM

LEIPSYDRION, see LIMES, ATTICA

LEIRIA or Lauro (Liria) Valencia, Spain. Map 19.

City of Tarraconensis 25 km NW of Valencia, at the foot of the Cerro de S. Miguel and site of an important Iberian settlement, the successor to Iberian Edeta, capital of Edetania. It was besieged and burnt by Sertorius in 78 B.C. and, according to tradition, its inhabitants were transported to Collipo in Portugal, whence the latter took the name of Leiria.

More probably the Sertorians founded a new settlement, at first of little importance, in the area today known as the Pla de l'Arc from the still visible remains of a Roman arch. *CIL* II, 3786, an inscription discovered in the district of S. Vicente, reveals that Q. Sertorius Sertorianus and his wife Sertoria dedicated a temple to the Nymphs in honor of the Edetani, and Ptolemy (2.6.63) identifies Edeta with Leiria. The new town enjoyed the Latin right (Plin. *HN* 3.23). Greater difficulty attaches to the identification of Edeta with the Lauro mentioned by Frontinus (2.5.31), Appian (1.109), Plutarch (*Sert.* 18 and *Pomp.* 18), and Orosius (5.23.6), in connection with the Sertorian war. Perhaps these writers, who wrote long after the disappearance of the native town, confused Lauro with the Edeta which Sertorius burned. There are other towns named Lauro, one in Baetica and another N of the Ebro, which issued native coinage.

Roman finds in the area of Liria are plentiful, particularly in the Pla de l'Arc, and 65 inscriptions, whole or fragmentary, from Liria or elsewhere, refer to the town (*CIL* II, 3786-3818, 3874-75, 3989, 4251, 6012-17). Some of the inscriptions in the Museum of Fine Arts in Valencia, the C'an Porcar in Liria; 4251, cited as in Tarragona, is

missing, but a copy is preserved in the Casa Pilatos in Seville. A hoard of 992 republican and imperial Roman coins is now in the University Library in Valencia. Among ceramics there is abundant thin-walled ware, Arretine terra sigillata, S Gallic, and Hispanic; amphorae and lamps; there are also a marble oscillum with a tragic mask on one face and a captive hare on the other (Prehistoric Museum, Valencia); architectural remains: capitals, shafts, the arch mentioned above with a column 3 m high; mosaics. One mosaic, in the National Archaeological Museum in Madrid (5.4 x 4.6 m), depicts the Labors of Hercules and dates from the end of the 2d c. A.D. or beginning of the 3d. Recent excavation has uncovered terraces, houses, stairways, streets, and water conduits.

Study of the finds invalidates the theory that the city was founded in the plain by the Sertorians after their capture and burning of the town on the hill, for on the lower site no Campanian ware B has been discovered and the earliest ceramic material is from Augustan times. This leaves a gap of some 50 years. Perhaps this indicates merely that the original foundation was small and unimportant, although there is abundant material from the 1st c., less from the 2d, a marked falling off in the 3d, and practically nothing datable to the 4th and 5th c. The city did not disappear, although it became smaller and impoverished during the revolts in the latter half of the 3d c.

BIBLIOGRAPHY. D. Fletcher, "El poblado ibérico de San Miguel de Liria," *AMSEAEP* 16 (1941); G. Martin & M. Gil, *Romanizacion en el campo de Liria* (1969); L. Marti, *Lápidas romanas de Liria* (1971). D. FLETCHER

LE KEF, *see* SICCA VENERIA

LEKEL, *see* HEKATOMPEDON

LE LANGON Ille et Vilaine, France. Map 23. In the center of the village is a small building of Gallo-Roman origin whose original purpose is unknown. Known as the Chapelle Sainte-Agathe, it is a large rectangular room with a semicircular vaulted apse at its W end.

The walls, fairly well built, consist of a core of mortared rubble faced with small blocks and having alternating bands of brick. The sides of the apse are decorated with frescos representing Venus Anadyomene. The goddess is shown rising from the sea beside a winged Cupid who is riding a dolphin. Fish of all kinds abound in the water. Although the frescos are faded, the color scheme of the whole composition can still be distinguished. Apparently the side walls of the building were originally separate from those of the apse, so that each element was isolated. When the monument became Christian, the open space between the side walls and the exedra was closed with a wall pierced by a semicircular doorway, and small bays were added to the N and S walls as well as to the apse.

BIBLIOGRAPHY. A. Ramée, "Notes sur le Monument gallo-romain de Langon," *RA* (1866); F. Dauce, "Historique des recherches sur le Monument gallo-romain de Langon," *Annales de Bretagne* 68, 1 (1961). M. PETIT

LEMANIS (Lympne) Kent, England. Map 24. A Roman fort on the side of a hill overlooking Romney Marsh; originally a navigable inlet flanked its S side. Occupation in the 2d and 3d c. is attested by the presence of fragments of tiles stamped CL BR (Classis Britannica) and by the discovery of an altar, reused in the later foundations, dedicated by one Aufidius Pantera Prefectus Classis Britannicae. These fragments hint at the existence of an early naval base in the vicinity. The fort now visible was built towards the end of the 3d c. and remained in use until the late 4th c. when it appears to have been abandoned, possibly as part of the reorganizations carried out by Count Theodosius.

The walls are now distorted by landslips, but in their original form they enclosed an irregular area of 4-4.4 ha. They were 3.6 m thick, 6 m high, built of rubble with a limestone facing bonded at intervals with tiles, and had a series of external D-shaped bastions. One gate, in the E wall, has been excavated: a simple opening 3.3 m wide, flanked by two solid bastions. The W wall was pierced by a narrow postern gate.

Internally, two buildings have been identified, a principia set back in the N part of the fort, and a small bath suite close to the E gate.

BIBLIOGRAPHY. C. Roach Smith, *Richborough, Reculver and Lymne* (1850); id., *The Roman Castrum at Lymne* (1852). B. W. CUNLIFFE

LE MANS, *see* SUBDINUM

LEMNOS Island of the NE Aegean, Greece. Map 9. About 475 sq. km in area, rugged, and of volcanic origin. The main sites have been excavated. The two principal Classical cities are Hephaistia and Myrina, on its N and W coasts respectively. It contains several important Bronze Age sites, notably Poliochni (on the E coast), whose culture is closely related to that of Troy. The pre-Classical inhabitants were described as Tyrsenoi, associated by ancient writers with the Etruscans of Italy. The Athenian Miltiades took the island at the end of the 6th c. B.C. After brief occupation by the Persians it remained Athenian throughout antiquity, receiving cleruchs from Athens ca. 450 B.C. and with intermittent occupation by Hellenistic kings.

Hephaistia, the main city, occupies a peninsula site beside an almost wholly landlocked harbor. The only above-ground remains explored are of a Graeco-Roman theater, with its stage buildings and some houses of late antiquity, but the excavations have recovered much of its pre-Greek "Tyrsenian" period. This includes a large cremation cemetery, which is succeeded by Classical Greek burials in the 5th and 4th c. B.C. and votive deposits from a pre-Greek sanctuary including terracottas in a partly Hellenized style.

Myrina occupies a rocky peninsula site, with good harbors. There are traces of its Classical fortifications, an archaic and Classical cemetery, and inscriptions indicate a Sanctuary of Artemis.

Northeast of Hephaistia, at modern Chloe, a Sanctuary to the Kabeiroi has been discovered, with inscriptions ranging in date from the 5th c. B.C. to the 3d A.D. The sanctuary occupies two semicircular terraces within a circuit wall. On the S terrace a three-roomed building is identified as the early telesterion, with a structure in the central room surrounded by offering bases, probably intended for the display of sacred objects to initiates. The upper terrace is mainly filled by a large Hellenistic building, probably the later telesterion, with a 12-column Doric facade, faced by a monumental stoa. Southwest of Hephaistia, at Mosychlos, were the sources of Lemnian earth.

At Kaminia in the SE part of the island was found a stele (now in the National Museum of Athens) inscribed in the Lemnian language, related by some to Etruscan. At Komi, inland in the E half of the island, are remains of a Temple of Herakles, referred to in an inscription.

The finds from Lemnos are in the National Museum of Athens and the museum at Kastro (Myrina).

BIBLIOGRAPHY. C. Fredrich, "Lemnos," *AthMitt* 31

(1906); *IG* XII[8] & XII, Suppl.; F.L.W. Sealy, "Lemnos," *BSA* 23 (1918-19); *Annuario d. Scuola archeologica di Atene* X-XII (1931); XIII-XIV (1933); XV-XVI (1942[PI] [Hephaistia]); XVII-XVIII (1942 [Hephaistia theater, Chloe]); L. Bernabò-Brea, *EAA* III (1960), s.v. Efestia; IV (1961), s.v. Lemno[MI]. J. BOARDMAN

LE MOULIN, *see* PEYRIAC-DE-MER

LENDAS, *see* LEBENA

LENTIA (Linz) Austria. Map 20. On a bay of the Danube opposite which old roads from the N approached the river. The town, belonging to the province of Noricum, is mentioned only in the *Notitia dignitatum* 34.32 (equites sagitarii, Lentiae) and 34.38 (Praefectus legionis secundae Italicae partis inferioris, Lentiae). This testifies to the military role of Lentia in Late Classical times. On the one hand, it was a defense outpost opposite the route of invasion from the N; on the other, it was a link in the chain of fortifications on the river frontier. In the first half of the 1st c. there was an auxiliary earthworks within the area to be used later for the theater. The ground plan is trapezoidal (78.5 x 79.0 m; 87.6 x 79.9 m). Later (under Hadrian?), it was replaced by a larger stone castellum, only parts of which have been excavated. The earliest garrison mentioned is Ala I Pannoniorum Tampiana Victrix (ca. A.D. 200).

The center of the settlement was W of today's main artery Hauptplatz-Innere Landstrasse. Since the Roman area was completely built over by the modern city, Classical remains were discovered only during reconstruction of sections destroyed in WW II. Besides dwellings (some with cellars, some with timber frame construction), in the old sector of the town is a sacred precinct. Of this a mithraeum is known with numerous offerings (reliefs, inscriptions, coins, etc.); also a "temple of the two gods," and finally a capitolium, with a Gallo-Roman peripteral temple in the vicinity. The so-called Römerberg NW of the old quarter does not seem to have been a settlement center, and it is questionable whether St. Martin's on the Römerberg includes Late Roman parts. In the W of the town, on the Freinberg, where the Celtic oppidum Lentia is supposed to have been, foundations of a building of uncertain use have been found.

The largest of the known necropoleis is the one located in the S (near the Kreuzschwestern) from the 1st and 2d c. It contains, almost exclusively, graves showing evidence of cremation, which suggests a relatively prosperous population. Only small groups of graves with skeletal remains have been found, mainly along the Lentia-Ovilava road.

The finds are in the Oberösterreichisches Landesmuseum in Linz.

BIBLIOGRAPHY. R. Noll, *Der römische Limes in Österreich* 21 (1958) 50ff; L. Eckhart in *EAA* 4 (1961) 645ff; P. Karnitsch, *Die Linzer Altstadt in römischer und vorgeschichtlicher Zeit* (1962)[MPI]; id., *Die Kastelle von Lentia* (1970-72)[MPI]. R. NOLL

LENTINI, *see* LEONTINOI

LENZBURG Aarau, Switzerland. Map 20. Vicus about 8 km E of Aarau, whose ancient name is unknown. The settlement arose at an intersection in the military road system around the legionary camp of Vindonissa, ca. 13 km to the NE. Lenzburg was a collecting center for produce from farms run by the army, and flourished from the time of Tiberius until the incursions of the Alamanni, ca. A.D. 259-60.

A military lookout during the 1st c. A.D. and a road post are attested by legionary stamped tiles and military bronzes. The settlement developed along a highway 6 m wide for at least 400 m. The predominant type of house is familiar: rectangular with the narrow side (ca. 12 m) on the road, with or without a portico. They combined shops, workshops, and living quarters and were at first built of timber and earth on a stone foundation. A large building (19 x 11 m) with two gateways may have been an army storehouse. A stone theater (restored) without a stage building seated 4-5000 persons (cavea 74 m wide; area 2750 sq. m). Parts of the 1st and 2d c. cemetery along the highway leading E have also been explored. Finds are in the Heimatmuseum in Lenzburg.

BIBLIOGRAPHY. F. Staehelin, *Die Schweiz in römischer Zeit* (3d ed. 1948) 616 with bibl.; V. von Gonzenbach, *BonnJbb* 163 (1963) 113-14; H. Wiedemer & T. Tomasevič, "Die Ausgrabungen in der römischen Siedlung auf dem Lindfeld bei Lenzburg," *Jber. Gesell. Pro Vindonissa* (1964) 51-60[PI]; (1967) 63-82[PI]; Wiedemer, "Das römische Theater auf dem Lindfeld bei Lenzburg," ibid. (1966) 32-50[PI]; summaries: *Jb. Schweiz. Gesell. f. Urgeschichte* 41 (1951) 112-13; 43 (1953) 94-96; 54 (1968-69) 91, 93; 56 (1971) 220.
 V. VON GONZENBACH

LEÓN, *see* LEGIO

LEONTINOI (Lentini) Sicily. Map 17B. A Greek colony founded at the S edge of the Campi Leontini (modern piana di Catania). First inhabited by the Sikels, in the second half of the 8th c. B.C. (ca. 729), it was occupied by the Chalkidians of Naxos led by the Oikistes Theokles; Thucydides (6:3) mentions that the Sikels were forcibly expelled (cf. Polyaenus, *Strat.* 5:5.2).

For the entire archaic period Leontinoi was autonomous. It was conquered by Hippokrates in 495 B.C., and was restored to freedom only after 466 B.C. In 427 it asked for Athenian help against Syracuse (Diod. 12:53) and was Athens' ally during the Sicilian expedition. Occupied by the Syracusans in 422 B.C., it regained independence for brief intervals but was virtually dominated by the Syracusan rulers throughout the 4th and 3d c. B.C. It was conquered by the Romans in 215 B.C.

The ancient city lay beyond the hills to the S of present-day Lentini in Valle S. Mauro, which is flanked by two series of steep rises sloping from S to N. Polybios (7:6), in describing the city's topography, locates the agora within the valley with a city gate at either end, the Syracusan Gate to the S and the gate leading to the Campi Leontini to the N.

In 1950, at the far end of the Valle S. Mauro the S gate of the city was discovered. One phase dates to the beginning of the 6th c. B.C., the other to the middle of the 5th c. At the end of the century it was demolished together with the surrounding fortifications, and during the 4th and 3d c. it lay under the rising ground level and was covered by a necropolis. A third defensive work, following the plan of the earlier gate, was hastily built at the end of the 3d c. over the cemetery strata.

The gateway opened at the center of a pincer-like fortification whose projections to the E and W embraced the edges of the overhanging hills of Metapiccola and S. Mauro. The circuit wall has been uncovered for a few hundred meters and is still in an excellent state of preservation. The various chronological phases are reflected in the different construction techniques. On S. Mauro, besides the structures connected with the various phases of the gate, an earlier wall has been uncovered; it was built with large blocks set as headers, and belongs to the time when the city extended only over S. Mauro or part of it.

Some archaic houses have been identified within the

walls, and the summit of the hill, near the Aletta dwelling, has yielded numerous architectural terracottas from a temple now no longer visible.

On the opposite hill (Metapiccola) remains of houses and the foundations of an archaic temple have been found. On the plateau at the summit of the hill were identified the remains of a Sikel village of the Iron Age.

Two native cemeteries have been identified and explored in the Valle S. Eligio to the E, and in the Valle Ruccia to the W. The graves are in the shape of small artificial grottos and are largely preserved.

The finds from the excavations carried out since 1950 are housed in the Archaeological Museum of Lentini, where they are arranged chronologically and with specific reference to the major phases of the city's life.

BIBLIOGRAPHY. P. Orsi, "Scavi di Leontini-Lentini," *AttiMGrecia* (1930) 7-39 with previous bibliography; P. Griffo, "Lentini. Campagna Topografica e scavi in località varie," *Le Arti* 3 (1940-41) 212; G. Rizza, "Note di topografia lentinese," *Sic. Gym.* (1949) 276-84; id., "Gli scavi di Leontini e il problema della topografia della città," *Sic. Gym.* (1951) 190-98; id., "Scavi e ricerche nella città di Leontini negli anni 1951-1953," *BdA* (1954) 69-73; id., "Leontini. Campagne di scavi degli anni 1950-1952: la necropoli nella valle S. Mauro; le fortificazioni meridionali della città e la porta di Siracusa," *NSc* (1955) 281-376; id., "Leontini. Scavi e ricerche degli anni 1954-1955," *BdA* (1957) 63-73; id., "Precisazioni sulla cronologia del primo strato della necropoli di Leontini," *ArchCl* 11 (1959) 78-86; id., "Siculi e Greci sui colli di Leontini," *Cronache di Archeologia* 1 (1962) 1-27; id., "Stipe votiva sul colle di Metapiccola a Leontini," *BdA* (1963) 342-47; D. Adamesteanu, "Lentini. Scavo nell'area sacra della città di Leontini," *NSc* (1956) 402-14. G. RIZZA

LEONTION Peloponnesos, Greece. Map 9. It is located in Achaia at the N foot of Erymanthos (Olonos), ca. 3 km from the modern village of Vlasia, at the 51st km on the Patras-Kalavryta road. It lies on a hill (present Kastritsi) 750-800 m above sea level, flanked by two parallel ravines to the E and NW. This site commands the roads from Aigion to Psophisa and from Patras to Kleitoria. The ruins, which were already known to 19th c. travelers, were investigated in 1954, 1957, and 1958.

The walls of Leontion, carelessly made of local limestone in polygonal masonry (beginning of the 3d c. B.C.) are preserved along most of their length in the lower layers, and to some height particularly along the NW side. They are strengthened at intervals by several rectangular towers and one semicircular one. In one of the gates, which was excavated with a section of wall, the carbonized remains of the wooden door leaves were found together with the metal sheathing of iron plates and iron nails with wide, disk-shaped heads. In the stone of the threshold were found the bronze sockets for the door pivots. These are, with the rest of the finds, in the Patras Museum. Inside the walls are preserved a number of terrace walls, the foundations of several monumental buildings, a temple (?), a small theater, and numerous house remains. Most of the pottery sherds were Classical and Hellenistic, but some archaic and prehistoric pottery was also found.

The best preserved building, the theater, touches the N corner of the wall. The lower part of the cavea was partially dug from the living rock and partly built up of hewn blocks. The walls of the parodos and scenebuilding are preserved to a height of 1.50 m. The theater must be dated to the end of the 4th c. B.C. In the area

of the ancient city were found tombs of the Roman period, which, with the carbonized door excavated in the gate, show that the city was destroyed in the Hellenistic period and was thereafter used as a cemetery. The settlement seems to have moved a little to the S where evidences of its existence have long been known. Leontion may have been destroyed in 217 B.C. by the Aitolians when, as allies of the Eleians, they invaded and plundered Achaia (Polyb. 5.94). In Classical times Leontion was not independent, but probably belonged in the territory of Rhypai. It seems to have become autonomous only in the Hellenistic period, and was a member of the Achaian League (Polyb. 2.41.8). In 275 B.C. Antigonos Gonatas refounded the city (Strab. 8.7.5, p. 388).

BIBLIOGRAPHY. Duhm, *AthMitt* (1878) 70ff; M. F. Bölte, "Leontion in Achaia," *AthMitt* 50 (1925) 71ff[M]; id., *RE* Suppl. IX 390, s.v.; E. Meyer, *Peloponnesische Wanderungen* (1939) 111ff[MPI]; id. in *Kl. Pauly* (1969) s.v.; Reports in *BCH* 79 (1955) 252; 82 (1958) 725; 83 (1959) 620; in *AJA* 62 (1958) 323. N. YALOURIS

LEPCIS, *see* LEPTIS MAGNA

LE PEGUE Drôme, France. Map 23. An oppidum on the W edge of the Alpine foothills bordering the plain of the Rhône, between Nyons and Dieulefit. The site lay at the crossing of several prehistoric roads leading to the Rhône valley by way of the Drômois plateau, to the Po valley through the pass of La Madeleine, to the Massif Central by Donzère, Viviers, and Alba, to Marseille and the Mediterranean by way of the hills bordering the Rhône, and to Languedoc through Roquemaure.

The oppidum was built on a promontory surrounded by two valleys, now called the Colline Saint-Marcel. Excavations since 1955 have revealed successive periods of habitation from the Bronze Age to the Middle Ages.

From the 6th c. B.C. come some very fine vases (oinochoai, cups) of pseudo-Ionian ware; some fragments of black-figure Attic cups and imitation Phokaian ware; fragments of pithoi. About 500 B.C. a great fire, probably connected with the Gaulish invasions (Livy 5.34), left a thick layer of debris. In the 4th c. B.C. some terraces were rebuilt, yielding red-figure Attic potsherds, fragments of pre-Gnathian cups and black-glazed vases. A settlement in the plain took the place of the one on the hill (on the site of the modern village school of Le Pègue); in 380-370 B.C. it was destroyed once again. New terraces were built, as well as an aqueduct and cisterns. Quantities of potsherds of Campanian ware and Massaliot obols come from the 3d to the middle of the 2d c. B.C. After 150 B.C., the site was once more partly abandoned, although fibulas and Campanian ware, sometimes with Gaulish graffiti in Greek characters, are evidence of some human activity. In the early Gallo-Roman period (50 B.C. to the end of Augustus' reign) there was some occupation (lamp fragments). In the Late Empire and the Middle Ages traces of walls and a few objects (potsherds, bone pins) indicate occupation at least until the 12th c.

The local museum has a fine collection of pottery and fibulas.

BIBLIOGRAPHY. A. Perraud, *Le Pègue, préface de Marseille?* (1955)[I]; J.-J. Hatt et al., "Le Pègue, habitat hallstattien et comptoir ionien en Haute Provence," *Atti del settimo Congresso intern. di Arch. classica* (1961) III, 177-86[PI]; M. Leglay, "Informations," *Gallia* 22 (1964) 526-31; 24 (1966) 512-15; 26 (1968) 589-91; 29 (1971) 431. M. LEGLAY

LEPREON Triphylia, Arkadia, Greece. Map 9. About 7 km from the coast, on a steep hill N of Strovitsi village.

The hill falls sharply to the N. It is said to have been founded by Minyans, who drove out the original Kaukonians (Hdt. 4.148). Although the Triphylians claimed to be part of Arkadia, Lepreon was dependent upon Elis through much of its history (Paus. 5.5.3). From the early 4th to the mid 2d c. it was drawn at various times into the orbits of Sparta, the Arkadian League, Philip V, and, finally, the Achaian League. In 146 it was permanently assigned to Elis, and was of little importance in Pausanias' day. Men of Lepreon fought at Plataia (Hdt. 9.28,31; Paus. 5.23.2).

There are considerable remains of the fortified citadel, with several towers, and an enclosed "keep" at the NE corner. On the W, traces of a wall descend towards the valley. The walls include several styles of masonry, but probably only two periods are represented; the earlier of these may be 4th c. work, but the remains are mostly Hellenistic.

Rectangular foundations, probably of two temples, have been observed on the citadel hill. Numerous tombs have been found by peasants in the valley to the S around Strovitsi; and there is an ancient well below the "keep" to the N.

BIBLIOGRAPHY. Blouet, *Expédition de Morée* I (1831) pls. 50-52MPI; J. G. Frazer, *Paus. Des. Gr.* (1898) III 473ff; Fiehn, *RE* Suppl. V (1931) 550ff; R. L. Scranton, *Greek Walls* (1941) 106, 169, 172, 180. F. E. WINTER

LEPTIS MAGNA, or Lepcis Libya. Map 18. On the coast 120 km E of Tripoli (Oea), the farthest E of the three cities (treis poleis) that gave the region its name. Originally a Punic settlement, established not later than 500 B.C. beside a small natural harbor at the mouth of the wadi Lebda, the city flourished and rapidly expanded under Augustus and his successors, reaching a peak of prosperity in the reign of Septimius Severus, who was himself a native of Leptis. The subsequent decline, accelerated by the growing strength of the tribes of the interior and by the Vandal conquest of ca. A.D. 455, was compounded by disastrous winter floods and by the incursion of the mobile sand dunes which finally covered (and in so doing preserved) the site. After Justinian's reconquest in A.D. 533, a relatively small area around the port was refortified. The Arab conquest of A.D. 643 put an end to effective urban life.

The excavations of the 1920s and 1930s uncovered large stretches of the street plan and many of the principal public monuments, but relatively little of the domestic and commercial quarters. The Punic settlement lay on the W side of the mouth of the wadi and still awaits systematic examination. The Roman town grew outwards from this nucleus, its growth shaped largely by the lines of two pre-existing roads: the road that linked the harbor with the rich olive-growing country in the hills to the S, curving gently up the low watershed to the N and W of the wadi, and the main coastal road, which at this point passed some 800 m to the S of the early settlement.

The initial development took the form of a series of orthogonally gridded quarters laid out in rapid succession along the first of these roads (the so-called Via Trionfale) which thus became the main axial street of the imperial town: the first, including the Forum Vetus, immediately adjoining the Punic settlement (ca. 30-20 B.C.?); next, an extension S to the market (last decade of the 1st c. B.C.); and subsequently (late Augustan-Tiberian), a further extension S towards, and orthogonal to, the coast road, which thus became the main transverse street (the "Decumanus") of the later imperial town. The area to the S of this street awaits excavation, as does also most of the area to the E of the wadi, which

seems largely to have retained a residential, semisuburban character. The main attested urban development in the later 1st and 2d c. lay to the W, where the formal grid of streets extended at least as far as the Hunting Baths.

The Forum Vetus, stripped of its Byzantine accretions, presents an unusually complete picture of an early imperial forum complex. The 1st c. buildings were all built of the fine local limestone in a provincial style that incorporated many pre-Roman details. The irregular alignment of the NE side reflects the orientation of the pre-existing settlement. Along the NW side are three temples: one, dedicated to Liber Pater, an early Augustan building standing on a lofty podium; next to it, and linked with it at podium level to form a single platform, a temple of Rome and Augustus (Tiberian), the find spot of a large group of Julio-Claudian statuary now in the Tripoli Museum; and at the N corner, a smaller temple of unknown dedication, dated between 5 B.C. and A.D. 2. The opposite, SE side was occupied by the Basilica Vetus (Tiberian or Claudian), and in A.D. 53 the whole open area was paved and enclosed on three sides by porticos. Three more temples occupied the SW side: one to Magna Mater (A.D. 72); one of Trajanic date, later converted into a church; and, at the W corner, a small courtyard-shrine in honor of Antoninus Pius (A.D. 153). The curia, obliquely opposite the entrance to the basilica, was added in the early 2d c., during the course of which most of the earlier buildings, both here and elsewhere in the city, were partly rebuilt in marble.

The market, built in 9-8 B.C. on what was then the outskirts of the growing city, was an enclosed, porticoed structure with two octagonal pavilions, one original and one rebuilt in the early 3d c. The many surviving fittings include the market benches and the official tables of weights and measures. Nearby, on the site of a Punic cemetery, is the theater (A.D. 1-2). At the head of the magnificent limestone cavea stood a small Temple of Ceres (A.D. 35-36) and a (later) portico. The pavement of the orchestra replaces an earlier floor of elaborately painted stucco, and the marble scaenae frons is of Antonine date. Beyond it is a well-preserved, quadrangular porticus post scaenam enclosing a central temple of the Di Augusti (A.D. 43). Between the theater and the main street, much altered by later structures, lay a large porticoed enclosure, along the frontage of which ran a monumental chalcidicum (A.D. 11-12) containing offices and a small Shrine of Venus Chalcidica. Two honorary arches masked the change of alignment of the main street, one recording the paving of the streets in A.D. 35-36, the other a quadrifrons erected in honor of Trajan in A.D. 110. Yet another, in honor of Vespasian (A.D. 77-78), was demolished to make way for the Byzantine Gate.

Continuing S down the main street, one arrives at the crossing of the Decumanus, the center of the expanded city where, shortly after 200, an ornate quadrifrons arch was erected in honor of Septimius Severus. The sculpture from this arch is now in the Tripoli Museum. It includes four large relief panels from the attic, two portraying triumphal processions, one a sacrificial scene, and one symbolic of the solidarity of the imperial family. A second set of eight figured panels adorned the inner face of the arch. The carving throughout is the work of sculptors from Asia Minor and their local pupils.

To the W of this point recent excavations have uncovered a courtyard building with two apses, thought to be a schola, a small late bath, and a 2d c. temple. Beyond this the west gate of the 4th c. walls incorporates

a monumental arch (perhaps of Antoninus Pius; the inscription is lost) and beyond this again are the remains of a fine quadrifrons arch in honor of M. Aurelius (A.D. 173).

In the opposite direction, E of the Severan Arch, one passes through a quarter of which the blocked doorways attest a period in late antiquity when only the main streets were kept open. Beyond it, angled in beside the wadi, lie the Hadrianic baths, a huge symmetrical building, completed in A.D. 127 on the model of the great imperial baths of Rome and later several times remodeled, notably under Commodus. The monumental porticoed palaestra in front is an Antonine addition.

The accession of Septimius Severus was predictably the signal for an outburst of building activity. In addition to the quadrifrons arch, a possible enlargement of the circus, and the construction of new cisterns and of an underground aqueduct from the wadi Caam, 20 km to the E, the next three decades saw the completion of a vast building program, comprising a new, enclosed harbor, a colonnaded street leading up from it to a monumental piazza beside the Hadrianic baths and, beside the street, a grandiose new forum and basilica. Much of the land for the program was reclaimed from the former wadi bed.

Before Severus the harbor seems to have consisted largely of quays and warehouses alongside the sheltered natural anchorage afforded by the wadi mouth, mainly along the W bank. The new scheme saw the creation of an artificial basin, some 21 ha in extent, with a narrow entrance between two projecting, artificial moles. Along the W mole there were warehouses (unexcavated) and at the seaward extremity a lighthouse; along the E mole, a signal tower, a small temple, and a row of warehouses fronted by a portico with an upper gallery. Facing out across the harbor, on a high, stepped podium, was a Temple of Jupiter Dolichenus. The arrangements for berthing the individual ships, with steps down and mooring rings, are unusually well preserved.

The colonnaded street was 366 m long, with a central carriageway about 21 m wide. The flanking porticos were raised on tall pedestals, with columns of green Karystos marble, carrying arches instead of the usual architraves. Off the NW side opened the basilica and forum, ingeniously sited so as to minimize the differences of alignment imposed by the irregularities of the site available. The basilica itself was a grandiose rectangular hall, measuring about 30.48 m from floor to ceiling and flanked by lateral aisles with galleries over them; at either end of the central nave was a large, concrete-vaulted apse, incorporating a pair of engaged columnar orders, and beside each apse stood a pair of pilasters carved with scenes from the stories of the city's patron divinities, Herakles (the Punic Melqarth) and Dionysos (Shadrap or Liber Pater). The forum was a huge open space, nearly 60 m wide, enclosed on three sides by tall, arcaded porticos, similar to those of the colonnaded street; and on the fourth side, facing the basilica from the head of a lofty podium and fronted by a spreading flight of steps, was an octastyle temple in honor of the Severan family. The columns of this, which stood on sculptured pedestals of Pentelic marble, were of red Assuan granite, as also were those of the basilica. A feature of both forum and basilica is the large number of marble workers' signatures, all in Greek. In the 6th c. the basilica was converted into a church and the forum into a barracks.

At the head of the colonnaded street, where it met, at a variety of angles, the Hadrianic baths and palaestra, the main street from the theater, and a second colonnaded street running up the wadi behind the baths, the original design envisaged a circular piazza enclosed within a portico. This axially neutral scheme was, however, dropped in favor of the establishment of a new dominating axis by the construction on the E side, symmetrically between the two colonnaded streets, of a huge scenographic fountain building. Half of the central hemicycle has fallen outwards, but the rest of it is still standing to its full height, together with considerable remains of the engaged marble orders that decorated it. The Severan complex was originally planned to include other buildings beside the colonnaded street, but though the ground was cleared the only one to be built was a hemicyclical exedra on the N side of the piazza. The adjoining church dates from the 6th c., when a section of the Byzantine city wall was built across the piazza itself.

The many outlying buildings include, near the NE corner of the town, a large amphitheater (A.D. 56) built into a disused quarry and, between it and the sea, a circus. To the W of the Old Forum are the "new excavations" (1955-60), of which the most conspicuous monument is a late, unfinished bath of "imperial" type, with a hexagonal caldarium. Beyond this lie the 4th c. walls, and beyond these the Hunting Baths, a 3d c. concrete-vaulted building of which the structure, paintings, and mosaics were found almost intact beneath the sand dunes. To the S, up the wadi Lebda, are two large cisterns and a massive dam built to divert the flood waters of the wadi round the city. The suburban villas include the rich Villa del Nilo (mosaics in Tripoli Museum). The cemeteries have not been systematically explored. The small museum is primarily a lapidary collection. All the finer sculpture is in Tripoli.

BIBLIOGRAPHY. P. Romanelli, *Leptis Magna* (1924); "Leptis Magna," *EAA* IV (1961) 572-94; R. Bartoccini, *Le Terme di Lepcis* (1929); "L'arco quadrifronte dei Severi a Lepcis," *Africa Italiana*, 4 (1931) 32-152; "Il Porto Romano di Leptis Magna," *Bollettino del Centro Studi per la Storia dell'Architettura* 13 (Suppl. to 1958) (1960); J. B. Ward-Perkins, "Severan Art and Architecture at Leptis Magna," *JRS* 38 (1948) 59-80; idem & J.M.C. Toynbee, "The Hunting Baths at Leptis Magna," *Archaeologia* 93 (1949) 165-95; N. Degrassi, "Il mercato romano di Leptis Magna," *Quaderni di Archeologia della Libia* 2 (1951) 27-70; D.E.L. Haynes, *An Archaeological and Historical Guide to the pre-Islamic Antiquities of Tripolitania* (1955) 71-106; R. Bianchi Bandinelli, E. Vergara Caffarelli and G. Caputo, *Leptis Magna* (1964); M. F. Squarciapino, *Leptis Magna* (1966). J. B. WARD-PERKINS

LEPTIS MINOR Tunisia. Map 18. So named to distinguish it from Leptis Magna in Libya, this is a sheltered site on a cove between Hadrumetum and Thapsus on the shore of the Sahel hinterland, known for its rich agriculture. It was linked to Thysdrus, the olive capital in the center of the region. This situation on the border of a fertile, well-populated region favored the establishment and growth of the city. Originally a Carthaginian trading post, it became the important city mentioned by the ancient writers, its extensive ruins bearing witness to its prosperity.

No systematic excavations have ever been undertaken. Moreover, the present-day village of Lemta being close by, the ruins have continuously been pillaged or destroyed. The site lies between the ravines of the wadi Lemta and the wadi Bou Hajar, and stretches down to the coast. Among the remains that can be recognized by their construction or by inscriptions are an amphitheater, a theater on the side of a hill, baths, large cisterns (some of them fed by an aqueduct, others by a dam and reser-

voir on the wadi Bou Hajar), quays and a long jetty and, especially, the forum, which can be identified by a number of dedicatory bases. From these bases, too, we learn of a cult of Liber Pater which was organized in the municipal curiae. Another important ruin called El Knissia—presumably, therefore, a church—with fine columns of cipolino did not survive destruction, and hardly any trace remains of the necropolis that surrounded it. Finally, on the shore there is a monument built of a masonry of large stones and with a big round tower, possibly a Byzantine fortress that was later turned into an Arab ribat.

The sectors that have suffered the most despoiling are the necropoleis, whose grave gifts (a lamp and pottery)—which are all that remained—bear witness to the great antiquity of the site and the prosperity of the region up to the end of the Classical era.

BIBLIOGRAPHY. G. Hannezo & L. Molins, "Notes archéologiques sur Lemta," *BAC* (1897) 290-95.

A. ENNABLI

LÉRIDA, *see* ILERDA

LE ROCHOIR, *see* PONTCHEVRON

LEROS Greece. Map 7. One of the Sporades, lying between Patmos and Kalymnos, ca. 40 km from the Anatolian coast (Caria). The island was inhabited in prehistoric times and again at least from the 7th c. B.C. A close, though not exactly definable, political relationship with Miletos is attested epigraphically and by statements of Herodotos (5.125) and Thucydides (8.26-27) from at least the early 5th c. to Roman times. It has been suggested that Leros was a deme of Miletos in Hellenistic times, a cleruchy earlier. Habitation of the island apparently continued uninterrupted into Byzantine times.

There have been no systematic excavations. The principal ancient town may have been located on the site of the modern Ayia Marina, where remains, of a few unidentified Classical structures are visible. However, the places where various inscriptions have been found suggest that the administrative center was Parthenion in the N part of the island. The temple of Parthenos (Artemis) mentioned by Athenaeus (*Deipnosophists* (14.655,b,c) and in inscriptions has not been located, but is presumed to have been in the locality now known as Partheni (Metochion). At the S end of the island, on top of the hill of Xerokampos, are the remains of a wall probably built in the late 4th c. B.C., usually thought to be part of a tower. This, and a similar tower at Partheni, may link Leros to the precautions taken by Miletos on its peripheral islands, in order to control the sea in Hellenistic times. Architectural fragments of Classical date are built into later structures, especially churches, in various parts of the island (Smalu and Lakki), implying widespread habitation in Classical times. Inscriptions and some ancient objects are in the Archaeological Hall in the Library at Platanos.

BIBLIOGRAPHY. L. Bürchner, *Die Insel Leros* (1898); R. M. Dawkins & A.J.B. Wace, "Notes from the Sporades: Astypalaea, Telos, Nisyros and Leros," *BSA* 12 (1905-6) 172-74; G. E. Bean & J. M. Cook, "The Carian Coast III," ibid. 52 (1957) 134-35; J. L. Benson, *Ancient Leros*, GRB Monographs No. 3 (1963)[MPI]; G. Manganaro, "Le Iscrizioni delle Isole Milesie," *Annuario* 25-26 (1963-64) 296-317; R. Hope Simpson & J. F. Lazenby, "Notes from the Dodecanese II," *BSA* 65 (1970) 52-54.

J. L. BENSON

LE ROZIER Lozère, France. Map 23. On the SW boundary of the department where the Tarn and Jonte rivers meet, 20 km from La Graufesenque and 30 km from Banassac. A large quantity of terra sigillata was found here, and excavations in the early 20th c. located several furnaces. Molds, trinkets, and many bowls were found; they are now in the Musée Fenaille at Rodez. Recent excavations have identified ceramic types and a number of potters.

As at Banassac, the earliest strata contain evidence of the manufacture of painted ware with a white slip. Terra sigillata is the most plentiful; it has a delicate, homogeneous paste and the varnish is similar to that of La Graufesenque. The bowls have thin sides. The turned forms are: 15, 18, 22, 24, 27, 33, and 46. Carinated bowls predominate in the molded forms, their profile and decoration dating them from Tiberius to the Flavians. Cylindrical bowls of Form 30 are less plentiful, and appear to date from Claudius' reign. A few hemispherical bowls of Form 37 mark the decline of the workshop.

A cylindrical form with a decorated footstand occurs frequently, and 12 different ovolos have been listed, all of them on molds; they also occur at La Graufesenque and Banassac. The potters include Arcani, Bio, Celsi, Elvi, Felic, Germani, Martialis, Paullus, Sabin, Caelus, and Bassus. The Le Rozier factory appears to be contemporary with La Graufesenque and strongly influenced by the Rutenian potters.

BIBLIOGRAPHY. Weyd, "Un atelier de céramique du Ier siècle," *Bull. Soc. Lozère* (1903) 104-5; (1904) 14, 60-61; F. Hermet, *La Graufesenque* (1934); P. Peyre, *Les ateliers du Rozier* (mimeo 1968). P. PEYRE.

LE RUBRICAIRE ("Robrica") Mayenne, France. Map 23. A Roman statio (3d-4th c. A.D.) 11 km from Jublains on the slopes of Mont Rochard. Its function was unquestionably military. At the site can be seen a square defensive rampart 200 m on each side, with towers at the corners. In the S section of this wall and inside it is a round tower generally considered to be a watchtower. Outside the rampart, built against its W wall, are the substructures of houses, stables, and shops.

Excavation outside the rampart and close to it has uncovered a small, fairly well-preserved bath building of the Classical type: a large rectangular structure flanked at the W corner by a rectangular room with an apse to the SW. The hot rooms and service rooms occupy the central building, but the cold baths are in the W annex, where a curved bench follows the contour of the apsed section. The walls on three sides of the building still retain their original height, ca. 5 m.

BIBLIOGRAPHY. Grenier, *Manuel* I, 463. M. PETIT

LES BOLARDS Côte d'Or, France. Map 23. At Nuits Saint Georges, ca. 20 km from Dijon, the remains of a Gallo-Roman vicus covering ca. 10 ha. Three km W of a major Roman road (Lyon-Chalon-Langres-Trêves), the vicus is on the northernmost boundary between Eduens and Lingons. It was a center of commerce and manufacture related to religious sanctuaries, which attracted crowds of pilgrims. Apparently these sanctuaries were directly connected with the therapeutic effects of the mineral hot springs at Courtavaux ca. 2 km away at Premeaux.

Despite the fact that the site has provided an almost inexhaustible amount of material for more than a century, epigraphy has so far given no clue to the ancient name of the Les Bolards region, which lies on a bend in the Meuzin river. The first remains were discovered in 1836, but not until 1964 was organized restoration of the vicus begun, using aerial photography. Stratification uncovered six stages, from the 1st c. B.C. to the beginning of the 5th c. A.D.: a very dense layer of Gallic

occupation (Iron Age); an early Gallo-Roman habitation, which flourished during the Julio-Claudian and Flavian dynasties and reached its apogee under the Antonines; a layer of demolition corresponding to the destruction contemporaneous with the disturbed reign of Septimius Severus. During this period began the decline of the vicus, destroyed during the invasions. More than 700 coins found at the site recount its history, from the time of the Gauls to the reign of Arcadius.

To date, excavation has uncovered a decumanus, a cardo, a street provided with gutters and lined with artisans' or merchants' shops, a cellar, its floor paved with six large rectangular tiles, and its walls pierced with niches (ca. A.D. 98-138); a 2d c. cellar with holes for seven amphoras. Many rubbish heaps and eight perfectly constructed wells yielded an important cache of pottery from Gallic workshops (La Graufesenque, Lezoux). There is evidence of ritual sacrifice in the layers of bones, an altar, a ritual knife, a libation cup, an ex voto of oolithic limestone (a hand holding an offering of fruit and flowers), a little stele of Epona, a head of a mother goddess, a stele of a man suffering from ophthalmia, a bronze statuette of Minerva. In the same area were found sanctuary rooms with monumental entries: two stylobates and the shaft of a column, a pilaster support, mosaic debris, painted plasterwork. Also there is the storehouse, or favissa, of a maker of ex votos. On the site of one shop are statuettes in the faience of the Allier region representing Mercury; the mother goddess, Venus, and equestrian figures. An important Mithraeum (all its mutilated sculptures now in the archaeological museum at Dijon) has been uncovered.

On exhibition in the belltower of Nuits Saint Georges is a collection of intaglios, jewels, toilet articles, ceramics, bronzes, funerary or votive stelai, and coins.

In 1969, excavation was extended toward the thermomineral springs. An apsidal building was uncovered, and in its center a white marble basin, covered with pink plaster and provided with a run-off channel. Aerial photography has shown that it was part of a large group of substructures for which exploration is planned.

BIBLIOGRAPHY. E. Thevenot, "La station antique des Bolards," *Gallia* 6 (1948) 289-347; R. Martin, "Informations archéologiques," *Gallia* 24 (1966) 380; 26 (1968) 482; E. Planson & A. Lagrange, "La statuette de Minerve des Bolards," *RA* (1970).

Work on the Dijon-Beaune highway since 1972 has revealed the important necropolis, including a large number of infant burials in half-round tiles called imbrices. There are also stelai recording the activities of the deceased. E. PLANSON

LESBOS Greece. Map 7. An island at the NE corner of the Aegean Sea, at the entrance to the Gulf of Adramyttion (Edremit) in Asia Minor. Its shape is notable for two gulfs with very narrow mouths. The Gulf of Kalloni (ca. 20 km long) was called in antiquity Pyrrhaios Euripos. The Gulf of Geras was ancient Hiera (ca. 13 km long). Lesbos, according to tradition, was named for son of Lapithos, the descendant of Deucalion and Hellen, and grandson of Aiolos, founder of the Aiolian tribe.

The significant number of Mycenaean sherds found on the surface in 1970 at the extensive ruins of Kourtir, on the gulf of Kalloni, near the town of Lisvori, and the numerous sherds from ruins of other periods, testify to continuous occupation of the site from at least the Late Neolithic to the Geometric period.

The island reached its zenith in the archaic period, but even before 700 B.C. Mytilene controlled the Aiolian cities on the shore of Asia Minor opposite the island

and in the Troad up to the Hellespont. Because of this the Mytilenaians came into collision with the growing sea power of the Athenians, who disputed their possession of the Aiolian colony, Sigeion.

Lesbos paid tribute to the Persians under Cyrus. In 499 B.C. Lesbos joined the Ionian revolt against the Persians, and in 494 took part in the battle of Lade with 70 triremes. After the defeat at Lade, Lesbos was subject to the Persians, but was freed after the Persian defeat at Mycale in 479 B.C. It then joined the Athenian Alliance, from which the Mytilenaians revolted in 428 B.C., although the Methymnians remained loyal to Athens and found themselves opposed to a confederation of the other large cities of the island. In 427, after a siege, the Athenians gained control of Mytilene, and divided a large section of the island among 2700 Athenians cleruchs, after harshly punishing the instigators of the revolt. In 405 B.C. the Spartan admiral Lysander became master of the entire island after his victory at Aigos Potamoi on the Hellespont. After the success of Konon, Mytilene once more joined the Athenian Alliance in 392 B.C., and the Athenian general Thrasyboulos restored the rest of the island to Athenian control. Lesbos was made autonomous by the Peace of Antalkidas in 387, but in 385 came again under Spartan domination. The island broke away in 369 and joined the second Athenian Confederacy. In 357 B.C. it was obliged to recognize Persian domination and to establish an oligarchical constitution. Lesbos finally broke away from the Persians and the oligarchs when Alexander the Great invaded Asia in 332 B.C. After Alexander's death it came into the hands of those of his successors who controlled the Aegean.

In 167 B.C. the Romans destroyed Antissa because it was allied to Perseus, the king of Macedon. Lesbos joined the Greek revolt against Rome in the Mithridatic war and in 88 B.C. the Romans destroyed Mytilene and extended Roman domination over the whole island. Pompey later gave Mytilene autonomy, which the Emperor Vespasian revoked in A.D. 70, but which the Emperor Hadrian later restored. Life remained peaceful on Lesbos until the 8th c. A.D. when attacks of various barbarian peoples against the island began.

The most notable cities of Lesbos were Mytilene, Methymna, Antissa, Eresos and Pyrrha. The city of Arisba was independent before the time of Herodotos, but was soon taken over by Methymna.

Mytilene. The older city of Mytilene was located on an islet on which a fortress of the Byzantine period, repaired under the Genoese and the Turks, is now preserved. This original city later expanded onto the main part of Lesbos. Excavation of the ancient theater began in 1958, although the first trial findings were made in the 19th c. The orchestra has a diameter of 25.26 m and is almost perfectly circular, which shows this to be one of the oldest theaters in Greece. The theater of Mytilene was so beautiful that Pompey copied the plan when he built the first great stone theater in Rome.

Excavation of mosaic pavements dating to the beginning of the 4th c. B.C., which have representations of scenes from Menander's plays, was begun in 1961 near the ancient theater, in an area now called Khorafa. Other mosaic pavements of the Roman period have been uncovered in front of the entrance to the church of Ag. Therapon, and a striking portion of a Classical structure (probably an aqueduct) of the beginning of the 4th c. B.C. was found NW of this church. At the same site a road of the early Hellenistic period was discovered, made of soft brown limestone, preserved to a width of 3.6 m.

Twenty minutes walk NE of the village of Moria (ca. 7 km NW of Mytilene) one can see the best-preserved

section of the Roman aqueduct which appears to have brought water to Mytilene from the Megali Limni (Great Lake) which has now been drained. Portions of the same aqueduct are preserved W of the village of Lambou Myloi (Mills of Lambos) and there are other traces of it along its route. About 500 m S of the Spa of Thermi and near the village of Pyrgoi Thermi, on the shore, is a part of the remains of the prehistoric town of Thermi, dating to the Bronze Age (3d and 2d millennium B.C.) now covered with earth.

Ancient Hiera should theoretically be located on the shore in the area of the modern villages of Gera, Papados, Plakados, Paliokipos, Skopelos, and Mesagros, N of the harbor of Perama, on the site called Khalatses.

A small marble Doric temple on the peninsula of Agios Phokas in S Lesbos has been identified as the Temple of Dionysos Bresagenes. It was incorporated in a church of the Christian period, and was uncovered in 1971 when the church of Ag. Phokas was moved to clear the area of the ruins, first noted in the 19th c. On the E side of the peninsula is an inlet with the remains of ancient harbor works.

On the E shore of the Gulf of Kalloni, NW and W of the market town of Polichnitos, settlements of various periods were discovered in 1960, mainly at the sites called Khalakies, Ara, Perivola, Ampelia, and Nyphida. The most ancient of these appears to be at Khalakies.

Excavation of the prehistoric settlement at Kourtir, dating from the Late Neolithic to the Geometric period, started in 1972. On the shore at Kourtir are ancient harbor works under water which have not yet been described in detail. They may be the more ancient of the two Pyrrhas mentioned by Pliny (*HN* 5.139): "of these Pyrrha is swallowed by the sea . . . there remain Eresos, Pyrrha and free Mytilene."

The area which preserves the ancient name of Pyrrha, ca. 6 or 7 km NE of the ruins at Kourtir of Lisvori, has a fortified circuit wall and the remains of Classical and Roman buildings. About 5 or 6 km N of Pyrrha of Akhladeri in the place called Mesa, near Kryoneri, there are remains of an ancient temple, perhaps identified with the temple erected by the Achaean-Aeolians to Zeus, Hera, and Dionysos when they first arrived in Lesbos. It has been suggested that this temple at Mesa was the federal shrine of the Lesbians, in which the assemblies and councils of the Federation of Lesbian Cities were held, and federal law cases tried.

About 5 km NW of the market town of Ag. Paraskevi, at the place called Klopedi, are the remains of an archaic and Classical temple, possibly the Temple of Apollo Napaios mentioned by Strabo (9.426) from which Pelops sought an oracular pronouncement.

The remains of the acropolis of ancient Arisba, which was taken over by Methymna before the time of Herodotos (1.151), are NE of the market town of Kalloni and N of the village of Nea Arisba. There are houses of megaron form, and a large section of wall built of Lesbian masonry, with an entrance and tower.

Methymna (Molybos) is at the N end of Lesbos, ca. 61 km NW of Mytilene. It was the next most powerful city state on the island after Mytilene. During the war between Athens and Sparta Methymna always opposed Mytilene and tended to resist the hegemony of whichever side was favored by Mytilene. Before the time of Herodotos Methymna had taken over Arisba by force, and in 167 B.C. when the Romans destroyed Antissa, they gave her territory to Methymna. Some archaeological discoveries were made in Methymna in the 19th c., and after WWI traces of an ancient settlement dating from as early as the 7th or possibly 8th c. B.C. and continuing

to Roman times were found at Dambia, NW of the present town.

Antissa is believed to be NW of the modern town of Skalokhori, on the peninsula called Nisi, Ovriokastro, or Kastro ton Genoveson, E of the place where the river Voulgaris issues into the Tsamourliman (Mud Harbor) and ca. 9 km NE of the modern market town of Antissa which was called Telonia during the Turkish period and up to the 1930s. There are smaller ruined settlements W of Skalokhori, near Liota on the bay of Gavathas, and also farther W between the bay of Pokhi and Orphikia in the area of Lapsarna. The site of Antissa, which was excavated before WWII, may also be the location of the Byzantine castle of Ag. Theodoroi whose name appears in old maps. During its independent period, Antissa was rarely on friendly terms with the neighboring state of Methymna, but those who survived after the destruction of the city in 167 B.C. were forced to incorporate with the Methymnians.

Eresos. The remains of the ancient city are near the Skala (harbor) of the modern inland town of Eresos, ca. 92 km from Mytilene. Strabo (13.618) mentions this site. The chief preserved antiquities are a part of the pre-Hellenistic and Hellenistic isodomic circuit wall, some remains of buildings, and the ruins of the ancient harbor. In 1931 a local archaeological collection was begun, which includes finds of various periods.

BIBLIOGRAPHY. R. Koldewey, *Die antiken Baureste der Insel Lesbos* . . . (1890); E. Ledyard-Shields, *The Cults of Lesbos* (1917); W. Lamb, *Excavations at Thermi in Lesbos* (1936); G. Mihailov, *Annuaire Univ. Sofia, Fac. hist. phil.* 46 (1949-50); L. Robert, *REA* 62 (1960) 285ff; J. D. Quinn, *AJA* 65 (1961) 391ff; C. Picard, "Où fut à Lesbos, au VII^e siècle, l'asqle temporaire du poète Alcée?" *RA* (1962) 2, 43-69; M. Paraskevaïdis, "Pyrrha auf Lesbos," *RE* (1963) 1403-20; M. Treu, *Alkaios Lieder* (2d ed. 1963) 130-203; J. M. Cook, "Greek Settlement in the Eastern Aegean and Asia Minor," *CAH* II (rev. ed. 1964) C. XXXVIII; E. Kirsten & W. Kraiker, *Griechenlandkunde* (5th ed. 1967); S. Charitonidis et al., "Les mosaïques de la maison du Menandère à Mytilène," *AntK* 6. Beih. (1970).

TITLES IN GREEK ONLY. Δημ. Μαντζουράνη, Οἱ πρῶτες ἐγκαταστάσεις τῶν Ἑλλήνων στή Λέσβο (1949); Σ. Γ. Παρασκευαῖδου, Ἐπιβίωσις τοῦ ἀρχαίου Ἑλληνικοῦ βίου ἐν Λέσβῳ (1956); Μ. Παρασκευαῖδη, ἄθρον "Λέσβος," εἰς Ἐγκυκλοπαιδικόν Λεξικόν Ἐλευθερουδάκη-Συμπλήρωμα 8 (1964) 925/1077—926/1078; "Νέες ἀρχαιολογικές ἐνδείξεις γιά τή Λέσβο," εἰς Δελτίον τῆς Ἑταιρείας Λεσβιακῶν Μελετῶν-Λεσβιακά 5 (1965) 198-219; Μ. Παρασκευαῖδη, ἀρχαιολογικά καί βιβλιογραφικά περί Λέσβου εἰς τό βιβλίον τοῦ Κώστα Μάκιστου (Παπαχαραλάμπους) Ἡ Σελλάδα τῆς Ἁγίας Παρασκευῆς Λέσβου (1970) 241-69; Γεωργίου Δουκάκη, Ὁ τουρισμός τῆς νήσου Λέσβου (διδακτορική διατριβή διά τήν Ἀνωτάτην Βιομηχανικήν Σχολήν Ἀθηνῶν) (1959); Γιάννη Λάσκαρι, "Τά λείφανα τῆς ἀρχαίας Ἐρεσοῦ," εἰς Δελτίον τῆς Ἑταιρείας Λεσβιακῶν Μελετῶν-Λεσβιακά" (1959) 67-74; Ἰωάννου Φουντούλη, Γαβριήλ Μητροπολίτου Μηθύμνης, Περιγραφή τῆς Λέσβου (κατά τό 1636-41) (1960); Ἰωάννου Μουτζούρη, "Μεσαιωνικά κάστρα τῆς Λέσβου" εἰς Δελτίον τῆς Ἑταιρείας Λεσβιακῶν Μελετῶν-Λεσβιακά (1962), 50-68; Σερ. Χαριτωνίδη, "Παλαιοχριστιανική τοπογραφία τῆς Λέσβου" εἰς Ἀρχαιολογικόν Δελτίον 23 (1968) 10-69; Δέσποινας Χατζῆ, ἀνυπόγραφου ἄρθρον "Λέσβος" εἰς "Δομή, ἐγκυκλοπαίδεια ἔγχρωμη" 9 (1971) 324-29; Γιάννη Κοντή, "Τά κατά Δάφνιν καί Χλόην τοῦ Λόγγου καί ἡ Λέσβος," εἰς περιοδικόν Αἰολικά Γράμματα 2 (1972), τεῦχος 9. M. PARASKEVAÏDIS

LES BOUCHAUDS ("Germanicomagus") Charente, France. Map 23. Gallo-Roman theater in the commune of St. Cybardeaux. The site is sometimes referred to as

Germanicomagus, a Latin name very similar to that of a statio mentioned in the *Peutinger Table* and located in the region but not identified. This is an unconfirmed hypothesis.

The theater, 23 km from Angoulême, is built against the NW side of a hill dominating the surrounding countryside—a religious hilltop site of the Celtic period. The site contains neither a city nor fortifications; it was a rural sanctuary like Chassenon (Charente) or Sanxay (Vienne). However, some wells and a few dwellings can be discerned to the S at the foot of the hill opposite the theater, where a road branches off from the Roman roads and climbs towards the site.

The base of the stage wall is impressive. Its 105 m facade is surpassed by Lyon (108 m), Vienne (130 m) and Autun (147 m), but is greater than Fréjus (83 m), Vaison (96 m), Arles (102 m), and Orange (103 m). The stage wall was 1.3-1.4 m thick at the base, and was supported, halfway up the slope of the hill, by a thick sustaining wall and by a number of buttresses of different size and placement. On the inside the customary three doorways of the stage building served as supports, as did their projecting sections. The reason for these extravagant precautions, as well as for the thickness of the wall, can be found in the size of the structure, which has been estimated as 22.4 m high.

The forepart of the stage, in front of the doorways, was 35 by 4.5 m. A straight wall bare of any decoration bordered it on one side. The stage projects considerably into the orchestra, but is only slightly raised above it. The orchestra, in spite of its 23.8 m radius, probably served only as an aisle for distinguished citizens who had reserved seats in the first three rows. The walls lining the tiers on either side are straight and parallel to the great wall. These tiers, forming a semicircle 52.5 m in radius, were probably partly of stone and partly of wood. They were divided by six aisles that provided access to the seats; there was no central passageway, but there may have been a double entrance at the rear. Remains of walls outside the semicircle would seem to be evidence of access stairways at the side gates. The spectators sat facing N, as was the custom, and were protected at least partially by a canopy: the bored stones that used to hold up the poles have been found.

This is a standard Roman theater with few deviations. It particularly resembles the theater at Champlieu (Oise), which is of exactly the same type with the same restricted entrances. The W corner of the theater was apparently rebuilt; the absence of bands of brick and the excellence of the masonry date the whole structure from the 1st c. A.D. It has been claimed that the theater could seat 8500.

On top of the hill were several buildings. Farthest W was a large portico surrounding a rectangular area (40 x 27 m) which may have replaced a Celtic burial ground. To the E was a Classical temple, a rectangular building with two rooms, one 5.70 m square and the other 5.70 by 2.45 m. Ringing this central section was a corridor which apparently served as a Celtic gallery, allowing for ritual processions. There is also an enormous foundation block still standing in the theater axis, which probably supported a little temple, as at Lyon, not a statue. The theater was obviously attached to the sanctuaries.

The Les Bouchauds monuments were destroyed, or at least badly damaged, in 276 in one of the first barbarian invasions. The invaders were easily led there by the network of roads serving the site. There is no comprehensive collection of finds from Les Bouchauds in any museum; everything has disappeared.

BIBLIOGRAPHY. C. de la Croix, "Études sur le théâtre gallo-romain des Bouchauds (Charente) et sur son dé-
blaiement," *Bulletin et Mémoires de la Société Archéologique et Historique de la Charente* 8 (1908) 65-172[1].

J. PIVETEAU

L'ESCALE Basses-Alpes, France. Map 23. A Gallo-Roman settlement (1960-62) in the Le Bourguet quarter of the commune of Escale revealed by building excavations. On the left bank of the Durance at a point where the river narrows and can be forded, the settlement was a crossroads for the route from the Rhône to Italy through Mont-Genèvre and the secondary Riez-Digne-Sisteron route.

The settlement was built on terraces covering ca. 5 ha, from the river up to a hill that was occupied in the Iron Age and the Middle Ages. The city, probably built in the Augustan period (Italic sigillate and La Graufesenque ware), was destroyed in the 3d c., then again inhabited up to the 5th c. The buildings discovered do not indicate a strict city plan: the streets are narrow, the ground plan irregular. The walls are of quarry stones bonded with mortal. Floors of the houses are simple, but painted stuccos and some fragments of marble facing have been found. No complete house plan has been recovered. Many coins were discovered (including one extremely rare denarius of Maximianus Hercules minted in Lyon in 293 for the decennalia of Diocletian), and a few bronze statuettes. A funerary inscription mentioning a sepulcher built at the expense of the public treasury of the Vocontii proves what has long been disputed, that the civitas of Segustero (Sisteron) belonged to the confederation of the Vocontii and that the latter occupied the left bank of the Durance.

BIBLIOGRAPHY. "Informations," *Gallia* 20 (1962) 657f; 22 (1964) 550-51; 25 (1966) 393.

C. GOUDINEAU

LES CARS Corrèze, France. Map 23. Situated at the edge of the communes of Perols and Saint Merd-les-Oussines.

Three buildings have been located, excavated in 1936-38 and 1952-53: a temple and a mausoleum, forming a complex, and a villa 500 m E. Coins found on the site indicate occupation from Hadrian's time to that of Aurelian.

The temple, built entirely of large blocks of granite, conforms to the Graeco-Roman type. A rectangle oriented E-W (11.3 x 8.3 m), the entrance is to the E; the W end terminates in an apse 2.2 m deep. It was approached by a flight of three steps extending along the whole E facade. The roof was made of slabs of granite. Besides the podium, some huge blocks with ornamental molding are scattered on the ground.

A slightly smaller and less well-built monument, 12 m N of the temple, is aligned with it. An incineration burial has been found in the middle of it, suggesting a mausoleum. The two buildings are enclosed by a wall.

A monolithic tank of granite lies 500 m to the E, in the NE corner of a building of 15 rooms, six of them heated by hypocaust. Some have taken it for a bath building, but it is probably a house or inn. Two building periods can be distinguished: 1) six rooms arranged in a rectangle, the walls made of rubble bonded with mortar and faced with small blocks; 2) eight rooms and a gallery were added to the S around a courtyard. The walls here are not so carefully built; the large room at the S end had a mosaic with a design of triangles of red and gray sandstone, and a pool with a fountain.

BIBLIOGRAPHY. L. Prieur & F. Delage, "Fouilles effectuées au 'Château des Cars,'" *Gallia* 5 (1947) 47-79; M. Vazeilles, *Station gallo-romaine des Cars* (1962).

G. LINTZ

LES FUMADES, *see* ALLEGRE

LES GRANGES-GONTARDES, *see* Novem Craris

LESH, *see* Lissos

LES MARTYS Canton of Mas-Cabardès, Aude, France. Map 23. Ore refinery N of Carcassone in the Montagne Noire (considered a part of the Cévennes in antiquity), in a region rich in mineral resources and marked by numerous traces of ancient and mediaeval mining operations. The best known site (Domaine des Forges) consists of large and widespread ancient deposits of iron dross, worked in recent decades for the sake of the metal. The site is marked at various points by the remains of walls belonging to Gallo-Roman industrial buildings. The artifacts that are found mixed with the dross consist largely of metal tools, ceramics, glassware, coins, and other objects.

The ores of Les Martys consisted of haematite and limonite, which could be worked for iron but seem to have been exploited primarily for the gold and silver they contain, a fact which explains the enormous mass of dross covering several ha. To judge from the surviving artifacts, the main period of activity was from the 1st to the 2d c. B.C.

BIBLIOGRAPHY. M. Labrousse, "Exploitation d'or et d'argent dans le Rouergue et l'Albigeois," *Fédération Historique du Languedoc et du Roussillon* (1958) 91-106; "Informations," *Gallia* 20 (1962) 615; 31 (1973) 478-79[I]. G. BARRUOL

LES MESNULS Dept. Seine-et-Oise, France. Map 23. La Millière is a wooded site in the commune of Les Mesnuls in the canton of Rambouillet, on the edge of the state forest, the Forêt de Rambouillet. Its name may be a reminder that a milestone stood here in ancient times which has now disappeared. Excavations carried out here since 1965 have uncovered a villa with a galleried facade forming a rectangle 30 x 25 m.

The base of the walls is still covered with frescoes showing life-size people with birds, flowers, and plants. The building may be dated from the 2d c. and the first half of the 3d c.

BIBLIOGRAPHY. M. Fleury, "Informations arch.," *Gallia* (1967). J.-M. DESBORDES

LES PUYS-DE-VOINGT, *see* Puys-de-Voingt

LETE, *see under* Dherveni

LETOCETUM (Wall) Staffordshire, England. Map 24. A roadside settlement on Watling Street which began as a sequence of military establishments. The largest is a Claudian fort, which may have been the fortress for part or all of Legio XIV before it moved to Wroxeter in A.D. 57. Later there were smaller forts on the hilltop, ending in one of 0.8 ha of early 2d c. date. The civil settlement seems to have been extensive, spreading at least 3.2 km along the road, with a cemetery to the W.

The only building which has been studied is the bath, now under Government guardianship. The first building, late 1st c.-early 2d c., was not finished, but by the late 2d c. it was enlarged. In its final stage the rooms appear to have been used as dwellings. Adjacent and connected by an entrance is a courtyard house which may have been the mansio, but it has not been adequately excavated and recorded. The modern name, Wall, was derived from the presence of a massive wall 3.3 m thick which enclosed an area of early 4th c. settlement, with no indication of buildings inside. The name appears in the *Antonine Itinerary* and *Ravenna Cosmography*.

BIBLIOGRAPHY. Military aspects: *Trans. Lichfield & S. Staffs. Arch. Hist. Soc.* 8 (1966-67) 1-38; burgus: ibid. 5 (1963-64) 1-50; bath: *Trans. Birmingham Arch. Soc.* 74 (1956) 12-25; *JRS* 63 (1973) 233. G. WEBSTER

LETOUM Lycia, Turkey. Map 7. A city 4 km SW of Xanthos, near the W bank of the river, and 3 km from the present coastline. The site was occupied from the 8th c. B.C., but archaic and Classical levels are beneath the modern water table. There are early dedications to Leto, Artemis, Apollo, and the Nymphs; and later inscriptions indicate that the federal sanctuary of the Lycian League was established here. Since 1962 it has been the scene of annual excavation, which in 1973 yielded a lengthy trilingual inscription in Aramaic, Greek, and Lycian.

The main temple is an Ionic peripteros (6 x 11) of local limestone, facing S and datable to 150-100 B.C. A similar temple is E of it, slightly smaller and later in date. Between the two temples, and much earlier than either, is a small oblong building enclosing a rocky outcrop. The precinct is delimited on W and N by stoas, on the E by rising ground; to S and W the ground drops sharply, and excavation (below the water table) has disclosed a large Nymphaeum (3d c. A.D.), which replaced a Hellenistic building, both evidently providing the architectural framework around a water supply fed by the sacred spring (cf. Ov. *Met.* 6.317-81). North of the precinct a theater of Hellenistic form and date was built against the hillside; there is no trace of a stage building, and access to the cavea is by two barrel-vaulted passages. The stadium (known from inscriptions) has not yet been found, and the limits of the settlement have not been defined.

The sanctuary became the site of a small Christian community, and there is evidence that the main temple was deliberately destroyed. Column drums from it were subsequently incorporated in a 6th c. (monastic?) church, whose outbuildings partly overlay the Nymphaeum. There is no evidence for occupation after the mid 7th c., a time of Arab raids. There is a small museum on the site.

BIBLIOGRAPHY. O. Benndorf & G. Niemann, *Reisen in Lykien und Karien*, I (1884) 118f; *TAM* 2, 1, 118f and 2, 2, 180f; G. E. Bean, *JHS* 68 (1948) 45; H. Metzger, "Fouilles du Létoon de Xanthos (1962-65)," *RA* (1966) 101f; id., "Fouilles du Létoon de Xanthos (1966-1969)," *RA* (1970) 307-22; id., annual reports in *TürkArkDerg*, *AnatSt*, and (apud M. J. Mellink) *AJA* since 1963.

For the trilingual inscription, cf. *CRAI* (1974) 1. 82-93, 115-25, 139-49. R. M. HARRISON

LEUCARUM (Loughor) W. Glamorgan, Wales. Map 24. The Roman fort lies beneath the modern village of Loughor, close to the tidal estuary of the Loughor river. The total area of the fort is uncertain, as the W side has not been located, but it measured 124 m N-S. The earth and timber fort built ca. A.D. 75-80 subsequently received a stone wall 1 m wide. It is not certain that military occupation continued later than ca. A.D. 140, though the mention of Leucarum in the *Antonine Itinerary* implies at least a mansio in later years.

BIBLIOGRAPHY. R. & L. A. Ling, "Excavations at Loughor, Glamorgan," *Archaeologia Cambrensis* 122 (1973) 99-146[MPI]. M. G. JARRETT

LEUKAI (Üç Tepeler) Turkey. Map 7. Ionian city 30 km NW of Smyrna. Founded, according to Diodoros (15.18; cf. 92), by the Persian Tachos. After his death it passed into the possession of the Klazomenians, who obtained it by a trick against the Kymaians. Leukai supported the pretender Aristonikos after 133 B.C. and was

used by him as a base (Strab. 646). The coins, with the normal type of a swan (as at Klazomenai), are exclusively of the 4th c. B.C.

Üç Tepeler lies in a prohibited zone and cannot normally be visited. The site, formerly on a headland, is now some distance from the sea. Available reports suggest that little is now to be seen apart from some remains of a circuit wall of Classical date.

BIBLIOGRAPHY. D. Magie, *Roman Rule in Asia Minor* (1950) 1035; G. E. Bean, *Aegean Turkey* (1966) 125-27.
　　　　　　　　　　　　　　　　　　　　　G. E. BEAN

LEUKAS Greece. Map 9. An island almost joined to the Akarnanian coast of Greece, and in ancient times a peninsula. According to Strabo (10.451) the isthmus that joined it to land was cut by Corinthian colonists, who founded the city of Leukas about the middle of the 7th c. B.C. The island had been inhabited from the Neolithic period until the Bronze Age, but the theory that Leukas was the Homeric Ithaca now has little support. From the 5th to the 3 c. B.C. Leukas had its own coinage. Probably in the 1st c. B.C. the isthmus was cut anew and a bridge, now submerged, was built to the mainland.

Excavations in circular tumuli in the plain of Nidri on the E coast have uncovered burials in pithoi, in rectangular pits, or in cist tombs, as well as Early and Middle Helladic pottery. Remains of a large building were also identified. In the ancient city of Leukas part of the polygonal enclosing wall of the acropolis survives, some of the enclosing wall of the lower city, and part of the theater. The necropolis was SW of the city. Near the church of Haghios Yoannis Rodaki in the S part of the island the foundations of a Doric temple have been found, and there are remains of several Greek lookout towers in various parts of the island. At Cape Leukatas, the S end of the island, on the perpendicular cliff overlooking the sea that gives the island its name, are the remains of the Temple of Apollo cited by Strabo (10.452). It was from this point, according to tradition, that Sappho threw herself. There is a small museum at Nidri in what was once the home of Dörpfeld.

BIBLIOGRAPHY. L. Bürchner, *RE* XII, 2 (1925) 2213-57; W. Dörpfeld, *Alt Ithaca* (1927)[MPI]; E. Janssens, "Leucade et le pays des morts," *AntCl* 30, 2 (1961) 381-94; A. Wace & F. Stubbings, *A Companion to Homer* (1962) 410ff; B. E. Frangoules Λευκάς, ἡ ὁμηρικὴ Ἰθάκη (ἡ θεωρία τοῦ W. Dörpfeld) (1972)[MPI].
　　　　　　　　　　　　　　　　　　　M. G. PICOZZI

LEUKOLLA (Protaras) Cyprus. Map 6. The sea battle of 306 B.C., in which Demetrios Poliorketes defeated Ptolemy, is said to have been fought off Leukolla, tentatively identified with a site at Protaras on the coast S of Famagusta. A small but safe bay, known in the time of Sakellarios as Konnos, may be the harbor of Leukolla mentioned by Strabo, who places it between Arsinoe (Ammochostos) and Cape Pedalion (14.682).

The ruins of a small town above this bay may belong to the place mentioned by Athenaios from whom we learn that the trireme of Antigonos with which the generals of Ptolemy were defeated at Leukolla was dedicated to Apollo in that town. It is characteristic that among the ruins noted above was found a Hellenistic inscription dedicated to Apollo. An excavation in 1877 uncovered a building, obviously a sanctuary, which produced some fragments of sculpture in stone.

The site is unexplored.

BIBLIOGRAPHY. Luigi Palma di Cesnola, *Cyprus: Its Ancient Cities, Tombs, and Temples* (1877) 191-92; A. Sakellarios, Τὰ Κυπριακά I (1890) 186-87.
　　　　　　　　　　　　　　　　　　　K. NICOLAOU

LEUKOSIA, *see* LEDRAI

LEUKTRA Boiotia, Greece. Map 11. A village 6 km SE of Thespiai. It is situated slightly N of a hill (modern village of Parapoungia or Lefktra) overlooking the fertile plain bounded by the Oeroe river to the S, the Permessos to the W, and the Thespios to the N. To the E, on a hill, was the important Mycenaean city of Eutresis. Leuktra and Eutresis were komai in the Thespian territory; the former was situated on one of the roads leading from Thespiai to the port of Kreusis, at the mouth of the Oeroe. No trace of it has been found up to the present time.

In 371 B.C., to force Thebes to grant the Boiotian cities their independence in accordance with the Peace of Antalkidas (386), Kleombrotos I, king of Sparta, advanced his army from Phokis to Thebes. Held up near Koroneia, he walked across Mt. Helikon, reached the shore of the Gulf of Corinth at Kreusis and once again climbed up toward Thebes. With his 11,000 men he met 6,000 Boiotians under Epaminondas in the plain of Leuktra. Epaminondas' victory ensured the hegemony of Thebes. He had a trophy built on the spot. At the beginning of the 3d c. this trophy was replaced by a monument that figured on silver Boiotian coins in the period 288-244 B.C. The Greek archaeologist A. Orlandos discovered some of the stones used in this monument and rebuilt it on the original site. On a round base rebuilt of Domvraina limestone he replaced the 0.68 m-high frieze of triglyphs and metopai, three fragments of which had been preserved; above a cornice 0.26 m high are the eight trapezoidal blocks, placed in circular courses, each of which has a round shield about one m in diameter carved in relief on the outer, parabolically curved face. All these blocks were found in the vicinity of the trophy.

BIBLIOGRAPHY. B. Head, *British Museum Catalogue of Greek Coins, Central Greece* (1884) pl. VI, 2; Wrede in *RE* (1925) s.v. Leuktra 1; J. Kromayer, *Antike Schlachtfelder* IV (1926) 290ff; A. Orlandos in *Praktika* (1958) 43-44; (1961) 225ff; in *Ergon* (1958) 48-52; (1960) 222-24; (1961) 229-31; "Chronique des Fouilles" *BCH* 83 (1959) 675-79[I]; W. K. Pritchett, *Studies in Ancient Greek Topography* I (1965) 49-58[MI]; N. Papahadjis, *Pausaniou Hellados Periegesis* V (1969) 90-95[MPI].
　　　　　　　　　　　　　　　　　　　P. ROESCH

LEUSONNA, *see* LOUSONNA

LEVADHIA, *see* LEBADEIA

LE VIEIL-EVREUX, *see* GISACUM

LÉZAT-SUR-LÈZE Ariège, France. Map 23. All around Lézat, in the valley of the Lèze and on the slopes which enclose it, the location of seven Gallo-Roman establishments have been identified. One of these is situated on the very place where the abbey was built. Another has produced a golden penny of Valentinian III.

BIBLIOGRAPHY. Urbain Gondal, "Essai d'inventaire des sites gallo-romains de Lézat-sur-Lèze," *Annales du Midi* 81 (1969) 245-61; cf. *Bull. de la Soc. ariégeoise des Sciences, Lettres et Arts* 24 (1968) 278-79; M. Labrousse in *Gallia* 22 (1964) 427; 26 (1968) 515.
　　　　　　　　　　　　　　　　　　　M. LABROUSSE

LEZOUX Puy de Dôme, France. Map 23. Site in the arrondissement of Thiers, whose ancient name is not known. Excavation has shown that it was an important industrial vicus. In Tiberius' reign the potters imitated wares imported from Italy, selling their counterfeits all over Gaul, and even in Germany and Britain. They were

influenced by Arezzo, Lyon, and La Graufesenque. Then a recession set in and activity diminished for a while, but there was a period of expansion from the end of the 1st c. A.D. until the beginning of the 3d. Production continued into the 4th c.

Among the finds are potters' kilns, workshops, wells, tombs—isolated or in necropoleis—and storehouses for the bowls. The products consist mainly of terra sigillata, both plain and molded, but also include applied reliefs, lamps, thin-sided bowls, ewers, antefixes, architectural fragments, and andirons in the form of rams' heads.

BIBLIOGRAPHY. J. A. Stanfield & G. Simpson, *Central Gaulish Potters* (1958). H. VERTET

LEZUZA, *see* LIBISOSA

LHOSPITALET Lot, France. Map 23. Near Granéjouls in the vale of Bellefont, a polychrome mosaic has been found in the ruins of a Gallo-Roman villa. The geometric design of the mosaic has the peculiarity of including animal, fish, and crustacean motifs.

BIBLIOGRAPHY. For provisional reports, see M. Labrousse in *Gallia* 20 (1962) 592; 26 (1968) 548 & fig. 35. M. LABROUSSE

LIA, *see* LIMES, GREEK EPEIROS

LIAPOKHORI, *see* LIMES, GREEK EPEIROS

LIBARNA Piemonte, Italy. Map 14. An important way station in the valley of the river Scrivia, at the confluence of the mountain stream Borbera between the present Serravalle and Arquata Scrivia. Today it is in Piemonte, but in Roman antiquity in Regio IX, Liguria, about halfway between Genua and Dertona, on the Via Postumia. It is mentioned by Pliny (*HN* 3.7.3), by Ptolemy (*Geog.* 3.1.45), in the *Antonine Itinerary* (ed. Wesseling, p. 294; ed. Cuntz, I, p. 44), in the *Peutinger Table* (ed. Miller, segm. 3, n. 5), by Sotiomenos (*Hist. Eccl.* 9.12), by Anonymous of Ravenna (*De Geographia* 4.33) and by many mediaeval documents. The site is perhaps pre-Roman, at least according to its trading habits (tombs of the first period of the Iron Age in nearby Arquata; Gallic materials from Libarna itself, as well as fragments of bucchero ware from Chiusi). Beginning in the 2d c. B.C., Libarna gained great commercial and military importance (even before the Via Postumia had been built in 148 B.C.) as a crossroad. This topographic importance, owing essentially to its natural position on the only clear road between the mountains, in a gorge of the river Scrivia, has remained fixed from mediaeval times to the present. Definite traces of a Republican settlement are available from coins of the 2d c. and 1st c. B.C. Following the struggles of the Romans against the Ligurians, Libarna was taken over by the Romans.

It became a municipium according to the Lex de Gallia Cisalpina of 45 B.C. and subsequently was enrolled as part of the Mecia tribe in two enrollments beginning at the end of the 1st c. B.C. (*CIL* V, 7425, 7430). It became a colony in the 1st c. A.D., between 75 and 96-98. It gained great importance between the 1st c. and 4th c. A.D. as a center with ample territorial limits. Libarna fell and was abandoned between the 5th c. and the 7th c. Intermittent excavations between 1820 and 1921, undertaken because of work on the highways and railroads, brought to light significant segments of the settlement. Systematic excavations in 1937, and from 1950-52 on, have identified the decumanus maximus (at whose S end was certainly a city gate if not a triumphal arch),

along with the decumanus minor and the forum and some cardines minores, if not the cardo maximus. The theater and the amphitheater were uncovered along with remains of bath buildings. Notable remains of private dwellings have been discovered with mosaics (2d c.) and fresco decorations, as well as the remains of aqueducts, even on the outskirts of the city, and of necropoleis, probably of the late Imperial period.

The best-preserved monument is the theater. The theater cavea has been identified as well as the parodoi (there are three instead of two, one in the center and the other two on the sides), the orchestra, and the postscenium. Beyond the inner ring of the amphitheater, a notable section of the arena foundations and of the cavea has been preserved. In the city, inscriptions, coins dating from the Republican era to the reign of Valentinian III (425-455), small bronzes, and marble sculptures, and amber figurines have been found. The greater part of the movable finds are kept in the National Museum of Antiquities in Turin and in the Civic Museum in Genova Pegli, as well as in Pavia, Noviligure, Stazzano, and Alessandria.

BIBLIOGRAPHY. *CIL* V, 6425, 7424-41; A. Bottazzi, *Osserv. storico-critiche sui ruderi di Libarna* (1815); G. Moretti, *NSc* (1914) 113-32; P. Barocelli, *NSc* (1922) 362-68; *RE* XXV (1926) 13; G. Monaco, *Forma Italiae, Libarna* (1936); C. Carducci, *NSc* (1938) 317ff; (1941) 29ff; (1950) 221ff; id., Dioniso (1938) 302ff; M. Guasco, *NSc* (1952) 211-13; A. Neppi Modona, *Il teatro greco-romano* (1960) 116-17; G. Forni, *Encic. dello Spettacolo*, I (1960) 589, and 9 (1962) 748; G. Schmiedt, *Atlante aereo-fotografico delle sedi umane in Italia*, II (1971). G. MONACO

LIBERCHIES Belgium. Map 21. Vicus of the civitas Tungrorum on the Bavai-Tongres road. The vicus has sometimes been identified with the Geminiacum of the *Antonine Itinerary* (378) and the Geminico vico of the *Peutinger Table*. However, the distances given by the two documents are contradictory. It is just as likely that Geminiacum was located at Baudecet. The vicus of the Early Empire was situated at the modern Les Bons Villers on either side of the Bavai-Tongres road. It is on a well-orientated plateau which dominates the surrounding region; it has a spring, now called La Fontaine des Turcs, which provides abundant water. The settlement must have grown up during the period of Augustus, when the road was built. The road was flanked on both sides by boundary ditches about 20 m from the middle of the road. These very probably were used to establish the land survey register. Later on these ditches no longer were preserved, at least inside the vicus itself. Inside the vicus some streets have been traced which were parallel and perpendicular to the road. The foundations of several dwellings have been brought to light, some made of fine masonry, some of wood and of wattle and daub. Some dwellings were provided with porticos facing the street. Several cellars have been excavated. The vicus had a certain number of wells, three of which have been excavated. The lower part of one was lined with wood and above this with calcareous stones placed on top of one another without mortar. The well was abandoned during the first invasions of the Franks in the 3d c. In it have been found a spearhead, the butt of a javelin, a boss of a shield, and a pair of leather sandals with six rows of nails in each sole. The potter's district was located in the E part of the vicus. To date five kilns have been excavated there. They are circular or oval in plan and have thick bottoms of terracotta pierced with holes. They had the rather exceptional diameter of 2.5 m. They were in use at the end of the 2d

c. and the beginning of the 3d, producing large quantities of ordinary wares for daily use.

The talus of the spring of La Fontaine des Turcs was protected by a collection of horizontal beams and it was surrounded by a rather wide pavement. It may be safe to suggest that here was a small sanctuary dedicated to a native divinity of springs.

Not far away a vase was found on whose foot is a graffito reading MER(curio) ET APOL(lini), indicating that the vase was an offering to the two gods. Another sanctuary was located on the N outskirts of the vicus. In the middle of a rectangular enclosure (100 x 76 m) stood a fanum with a square cella, 13 m on a side. The fanum was surrounded by a peristyle with columns of white stone and an interior width of 4 m. Pieces of plasterwork with painted decoration in red, green, yellow, and white come from the interior decoration of the cella. A piece of an altar discovered in the foundations of the castellum of Brunehaut (see below) may come from this temple. In that case, it would have been dedicated to Jupiter. A hoard of 368 gold coins from Nero to Lucius Verus seems to have been buried some years after A.D. 166.

The large number of finds made at Liberchies attest to the prosperity of the vicus during the Early Empire. However, it was ravaged during the first invasions of the Franks in 253-55, as many traces of fire attest. Immediately after these invasions, the Roman authorities (probably the emperor Postumus) ordered the construction of a burgus straddling the roadway in the vicus itself. It formed a quadrilateral (66 x 80 m), surrounded by a moat 14 m wide. Inside the moat, ca. 2 m from the top, was a solid wooden palisade. Four m farther toward the interior of the fort, an earthen bank was erected. It was reinforced with stakes and supported a second palisade. If Liberchies is Geminiacum (see above), one may suppose that the Geminiacenses mentioned in the *Notitia dignitatum* (*occ.* 5.97; 246; 7.87) owed their name to the fact that they had been stationed as the garrison of this burgus. Nevertheless, the burgus was destroyed shortly afterwards, during the Frankish invasions of the year 268 or 275. A new castellum was built 2 km farther W at the hamlet of Brunehaut on a hillock protected to the N and E by swampy meadows. Thus, it occupied a much better strategic position than the preceding burgus. This new fortification was ca. 200 m square. It was surrounded on its S and W flanks by a moat 12 m wide and 4.5 m deep. The area thus protected was surrounded by a palisade. Under Constantine the structure of the castellum was changed and the palisades replaced by thick stone walls. This new fort (56.5 x 45 m) was much smaller than the earlier one. The corners were provided with big round towers jutting out from the ramparts. The foundations of the ramparts were made of blocks taken from the ruined buildings of the vicus (for example, the altar mentioned above). The ramparts themselves were 2.8 m thick. A rubble core drowned in yellow-brown mortar is pressed between two facings of small, white sandstone blocks. The cheek-piece of a helmet was found in a trench. East of the fort, between the wall and the swamp, was erected a small basilica-shaped building with an apse at one end. We do not know whether it was a bath building or a Christian sanctuary.

BIBLIOGRAPHY. R. De Maeyer, *De Overblijfselen van de Romeinsche Villa's in België* (1940) 77-78; H. van de Weerd, *Inleiding tot de Gallo-Romeinsche archeologie der Nederlanden* (1944) 74-75; P. Claes & E. Milliau, "Liberchies-les Bons Villers," *Bull. de la Soc. royale belge d'anthropologie* (1958) 67-74[PI]; Claes, "Les fossés-

limites de la chaussée Bavai-Cologne dans la région de Liberchies," *Helinium* 9 (1969) 138-50[PI]; Y. Graff, "Découverte d'un fortin romain aux Bons-Villers, Liberchies," *Documents et rapports de la soc. arch. de Charleroi* 50 (1955-60) 41-63[PI]; E. Milliau, "Les monnaies romaines de Brunehaut-Liberchies," *Rev. de numismatique* 109 (1963) 11-36; M. E. Mariën, *Par la Chaussée Brunehaut* (1967) 41-52[PI]; R. Brulet, "Essor commercial et développement économique du vicus de Liberchies," *Rev. des arch. et historiens d'Art de Louvain* 2 (1969) 39-46; id., "Fossés d'époque augustéenne à Liberchies," *Documents et Rapports de la Soc. arch. de Charleroi* 54 (1969) 43-54; M. Thirion, *Le trésor de Liberchies* (1972)[MPI]. S. J. DE LAET

LIBIDA (Slava Rusă) Dobrudja, Romania. Map 12. Mentioned by Procopius (*De aed.* 4.7) as Ibida, but Theophylactus Simocatta (*Historiae* 1.8) uses the name Libidinon polis. A recently found Latin inscription (ca. A.D. 200) seems to confirm that the correct name was Libida.

The large late Roman site (4th-6th c.) was built over the ruins of an earlier Roman settlement (2d-3d c.). During excavations remains of a Christian basilica (6th c.) were uncovered.

BIBLIOGRAPHY. *TIR*, L.35 (1969) s.v. Ibida and Slava Rusă; A. Aricescu, "Despre numele aşezării antice de la Slava Rusă," *Buletinul Monumentelor Istorice* 40.3, (1971) 58-60. I. BARNEA

LIBISOSA (Lezuza) Albacete, Spain. Map 19. This must have been the Augustan colony of Hispania Citerior named Colonia L. Forum Augustana. A portrait of Agrippina Minor was found there, but the site has not been excavated.

BIBLIOGRAPHY. A. Beltrán, "Cabeze femenil, de tipo claudiano, en el Museo de Albacete," *Anales del Seminario de Historia y Arqueología de Albacete* 1 (1951) 19-21; A. García y Bellido, "Las colonias romanas de Hispania," *Anuario de Historia del Derecho Español* 29 (1959) 494-95. A. BALIL

LICATA, *see* PHINTIAS

LICODIA EUBEA Catania, Sicily. Map 17B. The site is bounded by the Castello Hill to the SW and Mt. Calvario to the NE. Identified by some scholars with Euboia, colony of Leontinoi mentioned by Herodotos (7.156), Strabo (6.272.6; 10.449.15), and Pseudo Skymnos (vv.283-90), it was probably a Sikel settlement. Various excavations have brought to light necropoleis in the districts of Calvario, Perriera, Orto della Signora, Bianchette, Sarpellizza, as well as a hypogaeum in via Providenza, all datable between the end of the 7th c. and the middle of the 5th c. B.C. The tombs are rock-cut chambers, cists and pit graves; they contained a type of pottery which is named after the site itself; it is wheel-made, decorated with mat paint in dark tones, brown or dark reddish on a light slip. On the Castello Hill Christian cemeteries have been found.

BIBLIOGRAPHY. V. La Ciura, "Memoria sull'antica Eubea, oggi Licodia," Appendis to Biscari, *Viaggio per le Antichità della Sicilia* (1817); P. Orsi, "La necropoli di Licodia Eubea ed i vasi geometrici del IV periodo siculo," *RömMitt* (1898); id., "Sepolcri siculi dell'ultimo periodo," *NSc* (1902); id., "Contributi alla Sicilia Cristiana," *Röm. Quartalschrift für Christl. Altertumskunde* (1904); id., "Sepolcri Siculi e piccole Catacombe Cristiane," *NSc* (1905); id., "Ipogeo siculo-grecizzante di Licodia Eubea," *RömMitt* (1909); V. Cannizzo, "Topografia archeologica di Licodia Eubea," *Arch. St. Sic. or.* 6 (1909). C. BUSCEMI INDELICATO

LIEDENA Navarra, Spain. Map 19. A large Roman villa SE of Pamplona, near Sangüesa. It occupies an elevated site on the right bank of the Irati opposite the impressive Foz de Lumbier, and covers an area 168 by 76 m. There were two major phases and several reconstructions.

The original villa, of uncertain date, covers an area 112 by 48 m; only the hypocaust system and the baths on the E side are visible. In the 4th c. (pre-Constantine), it was completely rebuilt: The villa was enlarged, a peristyle was built with paved galleries and geometric mosaics, a cistern (27 x 5.5 m) of unknown purpose was added, and the position of the hypocaust was changed to the W. Later two wings were added towards the S with ca. 50 rooms. It is basically a villa rustica devoted to the cultivation of vines and olive trees at the N limit of these crops. In the early period it was of military importance since it was on the access road towards the grain-growing areas of Sangüesa and the Cinco Villas and might have had troops stationed there. Finds are in the Pamplona Museum.

BIBLIOGRAPHY. B. Taracena & L. Vazquez de Parga, "Excavaciones de la villa de Liédena," *Excavaciones en Navarra* II, *1947-1951* (1956) 43-107[I]; M. A. Mezquiriz, "Ceramica de Liédena," ibid. 107ff; id., "Mosaicos de Liédena," ibid. 189ff. J. MALUQUER DE MOTES

LIFFOL-LE-GRAND Vosges, France. Map 23. A small Gallo-Roman center on the route of a diverticulum linking Grand to the great Roman road from Langres to Trier. In 1830 public works at the locality called Le Rupt-de-Villet led to the discovery, amid ancient foundations and other debris, of a small square mosaic (1.7 m on each side), half of which is preserved today in the Epinal Museum. New excavations undertaken at the same place in 1966 revealed the existence of a large rural villa. It is surrounded by a rectangular colonnaded portico with a perimeter of ca. 540 m. Near the NE corner of this enclosure several living rooms were studied. One of these was in the shape of a T with three arms of equal length. It was paved with a mosaic with a square emblema of geometric type whose design could be reconstructed. Another room was also adorned with a mosaic, with a central opus sectile motif, of which only the edge and scattered pieces of various marbles remain.

Near the ancient diverticulum, at the top of a hillside dominating the site, a building apparently used for farming was discovered. It had a large central room, flanked at the NE and SE corners by two identical small rooms. The artifacts collected, as well as the pottery and coins, belong to two distinct periods: the end of the 1st c. and the 3d and 4th c.

BIBLIOGRAPHY. M. Toussaint, *Répertoire archéologique Vosges* (1948) 130-31; R. Billoret in *Gallia* 24 (1966); 26 (1968); 28 (1970). R. BILLORET

LIGARIA, see LIMES, GREEK EPEIROS

LIGUGÉ (La Vienne) France. Map 23. A Benedictine Abbey 7 km S of Poitiers. The oldest monastery in the Latin West, it was founded and presided over by Martin from 361 to 371. Archaeological discoveries have been made there since 1953 and work continues. The excavations have revealed a unique series of monuments in eight stages, dating from A.D. 100 to 1100. Many elements exist in elevation. Two sites, 40 m apart, are known: 1) a small three-room house with hypocaust and reused Gallo-Roman material; with a large exedra 32 m in diameter centered on the razed house; an ensemble replaced by a 5th c. funerary well (St. Martin's cell and votive exedra?). 2) A 2d c. villa rustica destroyed in 276. Within

a horreum (30.4 x 5.4 m) stood St. Martin's church. At the E end of the horreum, an unexcavated monument shows a facade with rough-hewn bases for columns, perhaps a baptistery. In front of the church, a 4th c. cruciform martyrion (S arcade is 5 x 4 m).

BIBLIOGRAPHY. Fr. Eygun, *Gallia* 12 (1954) 2.380-89; 21 (1963) 2.461-66; 25 (1967) 2.260-62; J. Coquet, *Revue Mabillon* (1954) 43-94; id., *Bull. Soc. nat. des Antiquaires de France* (1956) 98 (also see T. Sauvel and J. Hubert in same issue); id., *Revue Mabillon* (1955) 75-147; (1958) 245-48; id., *Revue du Bas-Poitou* (1958) 95-105; id., *Revue Mabillon* (1960) 109-14; (1961) 54-75; id., *Bull. Soc. nat. des Antiquaires de France* (1961) 184-86 (see also Jean Hubert and J. Doignon in same issue); (1964) 95-96; (1965) 39-40; (1966) 71-72; id., *L'intérêt des fouilles de Ligugé* (1968); id., *Pour une nouvelle date de la crypte Saint-Paul de Jouarre, Abbaye de Ligugé* (1970). DOM. J. COQUET

LIKOURESI, see MESOPOTAMON

LILAIA Phokis, Greece. Map 11. At the N foot of Parnassus. It is mentioned in the Homeric Catalogue of Ships (*Il.* 2.523). It was sacked in 346, during the Third Sacred War (Paus. 10.3.1), but was reconstructed after Chaironeia.

Pausanias mentions (10.33.3-5) a theater, baths, and temples. A well-preserved fortification wall ascends from the plain to the citadel on the W side of the site. Some towers stand in part to the second story, and portions of the stepped curtain and screen-wall are almost intact. On the E side of the hill remains of buildings are recorded in the ravine below the E cliffs, as well as farther N at the edge of the plain. The W wall certainly continued some 150-200 m into the plain. The large tower at the SW corner of the citadel may have served as barracks for the garrison.

About 2 km E of Lilaia is a spring identified since Homeric times as the source of the Kephisos (see *Il.* 2.523; also Paus. 10.33.5). A shrine and dedications to the river god were found here; and the priest of Kephisos was eponymous magistrate of Lilaia. Near Suvala village, farther N from the spring, Karouzos found a Sanctuary of Demeter; material excavated ran from the 5th to the 2d c., and included bricks stamped "of the Lilaians."

BIBLIOGRAPHY. *IG* IX[1] 232, 233; J. G. Frazer, *Paus. Des. Gr.* (1898) V 410-15[P]; J. B. Tillard, *BSA* 17 (1910-11) 60ff[PI]; F.W.G. Foat, *BSA* 23 (1918-19) 108; F. Schober, *Phokis* (1924) 35ff; Ch. Karouzos, *ArchAnz* (1928) 576; F. Winter, *Greek Fortifications* (1971) 141[I].

F. E. WINTER

LILLEBONNE, see JULIOBONA

LILYBAION (Marsala) Trapani, Sicily. Map 17B. On the extreme W tip of Sicily stood a well-fortified outpost of Carthaginian power in Sicily. It was the only city which Pyrrhos could not conquer when, in 267 B.C., he had succeeded in invading all of Punic Sicily, including Panormos. It was founded after the destruction of Motya in 397-396 B.C. Although there is some slight evidence that the territory of Lilybaion was inhabited in prehistoric times, there is no indication of a regularly established settlement until after the above-mentioned date. It was conquered by the Romans after the battle of the Egadi islands in 241 B.C.; even during the Roman period its importance, both military and commercial, was so considerable, that it was made the seat of one of the two quaestores of Sicily.

Exploration of the ancient habitation center is difficult because it lies under the modern city. The site was surrounded by substantial walls except for the side along

the seashore, and a wide moat was part of the fortification system. The cemeteries (4th c. B.C.-2d c. A.D.) which lie to the W of the city have been thoroughly explored. The typical rock-cut Punic graves either have a vertical shaft leading into one or more funerary chambers, or consist of a rectangular cist. For cremation, amphoras of various shapes were used or urns made of local stone called *lattimusa*; and for burial, limestone sarcophagi. The grave goods included vases of various types and periods, often undecorated, some Hellenistic pottery, and considerable Punic ware. Stelai, some of typical and traditional shape and others in the shape of naiskoi, have been found and display features clearly Punic within a context not unfamiliar with Classical motifs. The later stelai, probably to be dated to the 1st-2d c. A.D. on the basis of the epigraphical data, are more properly defined as funerary aediculae in the shape of small buildings with small pediments and columns either prostyle or in antis, often in the round, or with pillars and antae. They are carved out of limestone often coated with a thick layer of white stucco on which vivid colors are applied; the paintings depict banquet scenes, flower garlands, inscriptions in Greek, and finally the symbol of Tanit with the caduceus.

At the extreme W tip, called Capo Boeo, a part of the ancient city has been uncovered which in its latest phase belongs to the 3d-4th c. A.D.; it represents a rich and elegant complex including a small bath. Some rooms of this insula are decorated with polychrome mosaics that seem to reflect motifs and influences from nearby N Africa and its mosaic repertoire. In other parts of the city mosaics include one with Theseus and the Minotaur (1st c. A.D.) and one with the Four Seasons (2d c. A.D.). The city had its own mint after the Roman occupation.

BIBLIOGRAPHY. I. Marconi-Bovio, "Marsala: Villa romana," *Le Arti* 2 (1940) 389-90; id., "Origine della città di Lilibeo," *Lumen* 2.2-3 (1949) 1ff; G. Schmiedt, "Contributo della fotografia aerea alla ricostruzione della topografia antica di Lilibeo," *Kokalos* 9 (1963) 49ffMPI; A. M. Bisi, "La cultura antica di Lilibeo nel periodo punico," *Oriens Antiquus* (1968) 95ff; id., "Ricerche sulle fortificazioni puniche di Lilibeo," *ArchCl* 20 (1968) 259ff. V. TUSA

LIMANI KHERSONESOU, *see* CHERSONESOS

LIMASSOL, *see* NEAPOLIS (Cyprus)

LIMENIA (Limnitis) Cyprus. Map 6. On the NW coast. The remains of a town to be identified with this site cover a small coastal plain which lies some distance W of Vouni Palace. The town is mentioned by Strabo who, however, places it inland. It is also mentioned as the town of embarkation of St. Mark when he left the island. It is also recorded in the *Acta Auxibii*, where it is given both as Limne and Limnites, thus indicating that this town possessed a harbor. It was in this small town that Auxibios landed on his arrival in Cyprus. Here he was ordained bishop of Soloi by St. Mark, when they met ca. A.D. 52.

A number of antiquities of various kinds turn up occasionally dating mainly from the Graeco-Roman period, while very close to the shore a sanctuary was excavated in 1889. It yielded various sculptures in bronze, limestone, and terracotta dating from the archaic to the Hellenistic period.

BIBLIOGRAPHY. H. A. Tubbs, "Excavations at Limniti," *JHS* 11 (1890) 82-99MI; Alfred Westholm, *The Temples of Soloi* (1936), in particular pp. 17-19; Athanasios Papageorghiou, Ὁ Ἅγιος Αὐξίβιος (1969) 3-28M; *RE*, s.v. Limenia. K. NICOLAOU

LIMES, ATTICA Greece. Map 11. The sites mentioned below may be considered as fortresses; however, their purpose seems to have been not so much to halt an enemy invasion as to forestall it by signaling the approach of a hostile army, hampering its movements, or slowing it down by harassment. In short, their role was one of dissuasion. Occupation of the sites varies, sometimes going back to the Mycenaean period, but in most cases only to Hellenistic times. This occupation gives an idea of the frontier between Attica and Boiotia but no more than an idea since there was never any line of demarcation in the modern sense of the term: the notion of a frontier or plotted border was always foreign to the Greeks, for whom a mountain or valley, very rarely a stream or, most often, the limits of a city marked a boundary.

Aphidna. An Attic deme N of Tatoi, on the Athens-Oropos road near the Chapel of Zoodochos Piyi, not far W of the artificial Lake Marathon, on the hill called Kotroni (125 x 40 m). Aphidna was one of the 12 townships of Kekrops. According to legend, Theseus hid Helen there after carrying her off from Sparta; this provoked the Tyndarid War and the Dioskouroi's destruction of Aphidnai (Hdt. 9.73; Plut. *Thes.* 31-32). The city was occupied by the Spartans in 412, with the result that Athens suffered a serious wheat supply crisis (Thuc. 7.28).

Beletsi. A limestone shelf in the region of Aphidnai, near Kiourka (Haghios Meletios); ht. 841 m.

Hysiai. Thought to be situated on the road from Eleusis to Thebes, on the N slope of Mt. Kithairon near Kriekouki on the Pantanassa peak. Noted as early as Kleomenes' invasion in 507 B.C., it played an important role in the Plataians' invasion (Hdt. 5.74, 6.108). It was in ruins in Pausanias' day (9.1.6; 2.1; cf. Strab. 9.2.12).

Leipsydrion. A fort S of Mt. Parnes, situated N of Menidi on the Boiotian border. The Alkmeonides took refuge there in 513. The site is rarely mentioned in Athenian history. The walls have been preserved to a height of ca. 1.2 m.

Masi. A fortified site on the Thebes-Eleusis road, SE of Gyphtokastro, linked with Myoupolis.

Melaina. A fortified deme on the N slope of Mt. Kithairon, considered to be Korynokastro. It is rarely mentioned in the ancient texts. A gushing stream near Haghios Meletios would seem to explain Statius, *Theb.* 12.619: viridesque Melaenae, linked to Panakton.

Nisaia. The port of Megara; linked to Megara from 411 on by ramparts, and disputed between Athens and Megara.

Pagai. A fortified port on the Gulf of Corinth near Alepokhori on a hill overlooking the sea (ht. 15 m). A rampart was erected by Athens in 460.

Paliochori and *Plakoto.* Two forts dominating the Thriasian Plain and the road from Eleusis to Oinoe.

1. On the hill N of what is known as the Sarantapotamos valley is a trace of ramparts 1.8 m high and 1.8 m thick, built of roughly squared masonry. The site is also called Palaiokastro.

2. A fortress near the one mentioned above, 21 x 36 m; with a circular tower (2.9 m) and SW wall.

Panakton. A fort on the N flank of Mt. Kithairon on the frontier between Attica and Boiotia. It is usually placed near Kavasala, which is easily recognized by its mediaeval tower. The fort measures ca. 300 m around. Inside are the remains of two towers joined by a wall (6th c. ?). The fort dominates the Skourta plain, through which runs the road from Athens to Thebes by way of Phyle. Some scholars identify as Panakton the fortress popularly known as Eleutheres (Gyphtokastro), which should rather be placed at Kaza.

Varnava. Two well-preserved towers guarding the road from Marathon to Oropos.

BIBLIOGRAPHY. L. Chandler, "The Northwest Frontier of Attica," *JHS* 46 (1926) 1-21; U. Kahrstedt, "Die Landgrenzen Athens," *AthMitt* 57 (1932) 8-28; A. Philippson & E. Kirsten, *Die griechischen Landschaften* I, 3 (1950) 971-1064; N.G.L. Hammond, "The main road from Boeotia to the Peloponnese through the Northern Megarid," *BSA* 49 (1954) 103-22; J. R. McCredie, "Fortified Military Camps in Attica," *Hesperia* Suppl. 11 (1966); Y. Garlan, *RA* (1967) 2, 291-96; id. in J. P. Vernand, *Problèmes de la guerre en Grèce* (1968) 245-60.

Aphidna: Chandler, 16-17[M]; W. Wrede, *Attika* (1934) 22-23; J. Pouilloux, *La forteresse de Rhamnonte* (1954) 58[M]; *GL* I, 3, 784-85, 975; R. Hope Simpson, *A Gazetteer . . . of Mycenaean Sites* (1965) 109, no. 380; McCredie, 81-83 wih bibl.; E. Meyer, *Der kleine Pauly* 2 (1967) s.v. *Leipsydrion*: Chandler, 15[M]; *GL* I, 3, 873 n. 2; McCredie, 58-61[MI]; Meyer, *Der kleine Pauly* 3 (1968) s.v., bibl. *Masi*: W. Wrede, *Attische Mauern* (1933) 24-25 & no. 58; id., *Attika* 32; McCredie, 89-90. *Melaina*: Chandler, 7-8[M]; McCredie, 84, 91 n. 14. *Nisaia*: *GL* I, 3, 944-48; Meyer, *Kl. Pauly* s.v., complete bibl. *Pagai*: Meyer, *Kl. Pauly* s.v., complete bibl. *Paliochori & Plakoto*: 1) Chandler, 13-14[I]; McCredie, 74-75[PI]; 2) Chandler, 14-15[MI]; *GL* I, 2, 530, 975; Kahrstedt, 828, placed Oinoe here, probably wrongly; McCredie, 72-74[M]. *Panakton*: for two opinions see Kahrstedt, 10ff & Hammond, 120-22[M]; see also excavation reports in *Praktika* (1939) 44; *BCH* 62 (1938) 458; 63 (1939) 295; 64-65 (1940-41) 240, which report a temple of Dionysos, oriented E-W, 16.55 x 8.76 m, ca. 300 B.C. (and two basilicas). *Varnava*: Chandler, 19[M]; McCredie, 89-90.

Y. BEQUIGNON

LIMES OF DJERDAP Yugoslavia. Map 12. The organization of defense against various barbarian tribes had begun along the right bank of the Danube by the middle of the 1st c. A.D. At the same time the oldest military camps were being refurbished, and roads were being carved in the steep slopes of the Djerdap canyon. Road construction began during Tiberius' reign as inscriptions of Tiberius, Claudius, Domitian, and Trajan attest. After Trajan conquered Dacia, Apollodorus from Damascus bridged the Danube. This bridge connected Kostol (Pontes) and Turn Severin (Drobeta). Today at low water, some remains of the piers can be seen. After Aurelian lost Dacia, the first reconstruction of the limes was undertaken; the second reconstruction was under Anasthasia and Justinian. The presence here of the following legions has been attested: IV Scythia, V Macedonica, VII Claudia, and IV Flavia. The following cohorts have been mentioned: I Antiochensium, I Sugambrorum veterana, I Raetorum, I Lusitanorum, III, IV, V, VII, VIII Galorum, and I Cisipadensium.

The significant fortresses on this part of the limes are as follows (an asterisk indicates those that have been sunk by the construction of a hydroelectric plant): *Sapaja**** (an island close to Ram)—remains of Roman camp (120 x 80 m), with civil settlement; *Ram (Lederata) E*—Roman camp (ca. 140 x 200 m), a garrison equites sagitarri; *Zatonje E*—camp with civil settlement, built at the end of the 1st c. A.D.; *Veliko Gradište (Pincum) E*—Roman camp with civil settlement, flourished under Hadrian; *Golubac (Cuppae) E*—camp (ca. 180 x 160 m) late 1st c. A.D.; *Čezava (Novae)****—camp (150 x 140 m) 1st-6th c.; *Saldum (Cantabasa)****—camp (43 x 31 m) late 1st-6th c.; *Bosman****—camp (94 x 47 m) 6th c.; *Gospodjin Vir****—Roman guard post (9 x 3.8 m) 1st-2d c. with inscriptions of Tiberius, Claudius, and Domitian

nearby; *Pesača****—Roman guard post (7.1 x 7.1 m) 3d-4th c.; *Boljetin (Smorne)****—camp (50 x 60 m) 1st-6th c.; *Ravna (Campsa)****—camp (45 x 43 m) mid 3d-6th c.; *Veliki Gradac (Taliata)****—camp (134 x 126 m) with civil settlement, 1st-4th c.; *the mouth of the Poreč river****—Roman camp, 1st-3d c. and a boundary rampart 170 m long, reinforced with towers, 3d-6th c.; *Malo Golubinje D****—camp 3d-6th c.; *Hajdučka Vodenica****—camp (50 x 70 m) 4th-6th c., controlled shipping through the *Sip Channel,**** which was built on the Danube at the end of the 3d c. A.D.; *Karataš (Caput Bovis?) D*—fortress (150 x 130 m) with civil settlement, 1st-4th c.; *Brza Palanka (Egeta) E*—two camps with civil settlements, 1st-6th c.; *Prahovo E*—reinforced settlement (ca. 840 x 485 m) 1st-6th c.

Trajan's inscription was preserved with a part of the road. Until the construction of a museum, the finds are being kept at the Archaeological Institute in Belgrade.

BIBLIOGRAPHY. *Notitia dignitatum*, ed. O. Seeck (1875); *Novellae Iustiniani*, x, ed. R. Schöl & G. Kroll (1895); E. Swoboda, *Forschungen am obermoesischen Limes* (1939); M. Mirković, *Rimski gradovi na Dunavu u Gornjoj Meziji* (1968); *Stare Kulture u Djerdapu* (1969).

L. ZOTOVIC

LIMES GERMANIAE INFERIORIS Germany. Map 20. The fortified military border of the Roman Empire in the province of Lower Germany extended along the Rhine from Vinxtbach by way of Bad Breisig to the North Sea, a distance of some 300 km as the crow flies. The Limes road connecting the fortified areas followed the windings of the river along its lowest terrace. The placing of fortifications and their troop strength were determined by the character of the mountains and streams on both sides of the river.

A first stage in the formation of the limes was the establishment of stand-by and supply bases for the offensives against the Germans living between the Rhine and the Elbe, ca. 15 B.C.-A.D. 15. These bases included Vectio (Vechten), Noviomagus (Nijmegen), Vetera (Xanten), Asciburgium (Moers-Asberg), Novaesium (Neuss), Colonia Agrippinensis (Cologne), and Bonna (Bonn). After Tiberius recalled Germanicus from the Rhine and abandoned the idea of military occupation of the right bank of the river (the territory of the Frisians excepted), the bases on the left bank became the frontier defenses. From A.D. 10 until the 90s four legions were stationed on the Rhine; Hadrian reduced the number to two. At different periods the legions were stationed at Noviomagus, Vetera, Novaesium, Colonia Agrippinensis, and Bonna; Vetera and Bonna served the longest.

From the end of the offensive against the Germans (A.D. 16) until the middle of the 3d c. the peace of the limes was disturbed only twice: during the Batavian rebellion (69-70) and by an attack by the Chauci under Marcus Aurelius. Since the Germans hardly menaced the limes for a long time, the troops there were reduced between the reign of Tiberius and the mid 3d c. from 42,000 to 21,500 men. From the year 256 or 257 on, however, the Franks often broke through the line, which led to numerous military counteractions by Gallienus and others up to the end of the 4th c. The removal of strong units to take part in struggles for the throne greatly weakened the line from 387 on, and from 406 on its right flank was threatened by the breakthrough of Germans into neighboring provinces. No details are known of the end of the limes in the 5th c.

The limes consisted of only one line along the left bank of the Rhine; there was no defense in depth, and no reserves. Its strength rested on the legions and auxiliaries quartered in fortified bases. The auxiliary troops

of the limes included a cohors milliaria and all three kinds of quingenarian auxiliaries, but no ala milliaria. In the 3d c. there were also a few numeri. So far, 25 auxiliary bases have been identified or suggested, and some small forts and towers have also been found. The distribution and strength of the troops on the limes in the Late Roman period have not yet been fully investigated. (In the *Notitia Dignitatum* the list is missing for Germania II.) The garrisons communicated with each other by means of the limes road and the Rhine, which was guarded by the Classis Germanica and could be crossed in several places by permanent bridges. Of the legionary bases only Novaesium, and of the auxiliary bases only Valkenburg have as yet been fully excavated. In addition to the permanent bases of the limes several temporary camps and training camps have been found, and more workcamps are expected to turn up.

The troops were supplied partly by deliveries from the more protected provinces, and partly by their own products. Raw materials and land for agriculture or manufacture was available on both sides of the Rhine. From the second half of the 3d c. on supply stations were built on the main highways of the interior (e.g. the Belgian Limes).

The development of the fortifications on the limes follows a pattern common to the Rhine and the Danube. The wooden camps of Augustus' time often had more than four sides, and the sides were often bent inwards. Construction in wood continued until the time of Claudius, in some cases until the Batavian rebellion (A.D. 69-70), but from the Flavian period on stone was used. After the breakthroughs of the Franks many fortifications were strengthened, modified, or rebuilt, particularly by Constantine, Julian, and Valentinian I.

BIBLIOGRAPHY. H. v. Petrikovits, *Limes-Studien. Vorträge des 3. Limes-Kongresses* (1959) 88ff; id., *Das römische Rheinland* (1960) 14ff; id., *Die römischen Streitkräfte am Niederrhein* (1967; also in Spanish)[MP]; J. E. Bogaers, *Ber. van de Rijksdienst voor het Oudheidkundige Bodemonderzoek* 17 (1967) 99ff[M]; id., ibid. 18 (1968) 156f[M]; H. Schönberger, *JRS* 59 (1969) 144ff[M]; troop distribution: E. Ritterling & E. Stein, *Die kaiserlichen Beamten und Truppenkörper im römischen Deutschland . . .* (1932); Bogaers in *Studien zu den Militärgrenzen Roms* (1967) 54ff; H. Nesselhauf, *BonnJbb* 167 (1967) 268ff; G. Alföldy, *Die Hilfstruppen der römischen Provinz Germania inferior* (1968); D. Hoffmann, *Das spätrömische Bewegungsheer und die Notitia Dignitatum*, 2 vols. (1970); E. B. Birley, in R. M. Butler, ed., *Soldier and Civilian in Roman Yorkshire* (1971) 71ff; temporary camps: F. Münten, et al., *Rheinische Ausgrabungen* 10 (Beiträge z. Archäologie des römischen Rheinlandes II) (1971) 7ff[P]; logistics & supply: v. Petrikovits, *Das römische Rheinland* 63ff; id., *BonnJbb* 161 (1961) 477ff; C. B. Rüger, *Germania inferior* (1968) 51ff; W. Sölter, *Römische Kalkbrenner im Rheinland* (1970); fortress architecture: see under Vetera, Novaesium, Bonna, Asciburgium, Gelduba, & v. Petrikovits, *JRS* 61 (1971) 178ff (late Roman)[MP].

H. v. Petrikovits, "Römisches Militärhandwerk," *Anz-Wien* 111 (1974) 1ff; id., *Die Innenbauten römischer Legionslager in der Prinzipatszeit* (1975).

H. V. PETRIKOVITS

LIMES GERMANIAE SUPERIORIS Germany. Map 20. The Roman limes with its many forts dates to the end of the 1st c. A.D. But a hundred years earlier Roman armies were already operating from the Rhine deep into Germania. After the conquest of Gaul by Julius Caesar the earliest Roman forts on the Rhine itself, so far as we can trace them today by archaeological methods, were founded under the emperor Augustus in 19 or 16 B.C. From 12 B.C. on Augustus' stepson Drusus launched attacks on the Germans both from the Rhenish legionary fortresses, Xanten (Birten)–Vetera and from Mainz-Mogontiacum. After Drusus' death (9 B.C.) his brother Tiberius took over the Rhine command. After the defeat of Varus in A.D. 9, most of the sites on the right bank of the Rhine were probably given up by the Romans. Then followed the punitive campaigns, above all in the years 14-16, of Germanicus, who was recalled by the emperor Tiberius. The emperor was now primarily concerned with securing the line of the Rhine.

Roman fortifications connected with the above-mentioned campaigns against Germania have hitherto been found only on the Lippe and N of Frankfurt in the Wetterau. The forts of Oberaden (q.v.) and Rödgen (q.v.) belong to the early phase under Drusus, the military installations at Haltern (q.v.) belong to a somewhat later phase.

In the reign of Tiberius several additional forts were added on the Rhine between the existing ones. On the right bank, in the sphere of influence of the Mainz legionary fortress, the forts at Wiesbaden and probably also at Kastel and Frankfurt-Höchst continued to be occupied. In the 40s Claudius did not press farther across the Rhine but built a number of auxiliary forts on the river line itself after he had removed, among others, the Legio II Augusta from Strasbourg to take part in his invasion of Britain in A.D. 43. At about this time the earth and timber fort at Hofheim am Taunus, N of the Rhine, was built to serve as a bridgehead for the legionary fortress at Mainz.

The year 69-70, after the death of Nero, marks a decisive turning point. The revolt of the Batavians in the N and the fighting among the troops of Galba, Otho, Vitellius, and Vespasian led to destruction in almost all civil settlements and forts from the North Sea to the Upper Danube. After Vespasian became emperor in A.D. 70, he began a comprehensive reorganization of the Rhine and Danube frontier. Above all, roads were built E of the Rhine to make possible swift communication between Mainz-Mogontiacum and Augsburg–Augusta Vindelicum, the provincial capital of Raetia. Forts were established in the area of the Upper Neckar at Rottweil, Sulz, Waldmössingen, and perhaps also on the Häsenbühl near Geislingen on the Riedbach.

The war which the emperor Domitian waged against the Chatti in 83-85 from his base at Mainz led to the construction for the first time of an actual limes. The first structures were built in the Wetterau, N of Frankfurt: a patrol road with wooden watchtowers and fortlets guarding the most important road crossings. But in the winter of 88-89 the legate of the army at Mainz made a bid for the throne. The Chatti turned this revolt to their advantage and destroyed a whole series of military installations in the Wetterau. The rebellion was soon crushed, but Domitian was compelled to withdraw large contingents of troops which he needed for the war against the Marcomanni and Quadi on the Danube, and the war against the Chatti came to a complete halt. About A.D. 90 the newly fortified positions in the Wetterau were linked with the forts that had been established under Vespasian on the Upper Neckar. A military road was constructed from the Main S through the Odenwald and protected with fortlets of only 0.6 ha. The line of forts farther S then followed the Neckar upstream as far as Köngen.

The emperors Trajan and Hadrian carried out further

construction on the limes. Complete auxiliary units were now brought up to the limes itself. Near the forts vici soon developed. The largest vicus which we yet know is at the fort of Zugmantel in the Taunus. To the emperor Hadrian can be ascribed the building of a wooden palisade which was erected everywhere in front of the patrol road.

The province of Upper Germany received a final, but only slight, increase in territory when the forts on the Neckar were advanced 20-25 km farther E in ca. 150. At this period also the last wooden forts were rebuilt in stone, and everywhere the earlier wooden watchtowers were replaced with stone ones. At about the same time the centurion's quarters of a barrack block in the fort at Echzell were decorated with a series of superb wall paintings depicting Theseus and the Minotaur, Fortuna and Herakles, Daidalos and Ikaros. They were discovered in 1965 and show that even in the far N of the empire the military buildings were not as simply furbished as one might expect.

The period from the end of the 1st c. to the death of Antoninus Pius (A.D. 161) was the most peaceful period that Upper Germany enjoyed; soon after this the first enemy incursions began. In 162 and again ca. 170 the Germans penetrated deep into the province. Some later building activity can be attributed to the emperor Commodus (180-92): the fort at Niederbieber was a new foundation to take two numeri; Osterburken and possibly Butzbach were enlarged.

At the beginning of the 3d c. (if we accept the current view) the Romans built a ditch and rampart behind the wooden palisade, which itself continued to be maintained. These features are still clearly visible today for long stretches.

A number of hostile incursions are recorded in the 3d c. in the time of Severus Alexander, the most serious in 233. Various coin hoards from the interior of the province afford particularly striking evidence of these attacks. After the death of Severus Alexander, his successor Maximinus Thrax restored order once more and some forts were reconstructed. The discontinuance of coin hoards, however, makes it probable that the Upper German limes simply died out. Some forts may have been evacuated earlier, some later, depending on their strategic position. By 259-60 at the latest the territory behind the limes on the right bank of the Rhine was finally given up.

A new line of Roman forts was built on the Rhine about the end of the 3d c. They were more like castles or redoubts than forts with regular garrisons. This defensive system was considerably strengthened by Valentinian I (364-75) and, in contrast to the earlier limited military zone, embraced also the hinterland.

BIBLIOGRAPHY. W. Schleiermacher, *Der römischen Limes in Deutschland (Ein archäologischen Wegweisen)* (2d ed. 1961)[MPI]; H. Schönberger, "The Roman Frontier in Germany: an Archaeological Survey," *JRS* 59 (1969) 144ff with maps A-C; D. Baatz, *Der romische Limes. Archäologische Ausfluge zwischen Rhein und Donau* (1974). H. SCHÖNBERGER

LIMES, GREEK EPEIROS Fortified town and village sites which are not identified with any ancient name are numerous and justify the ancient tradition that the area was heavily populated in Hellenistic times. They are as follows: Agrilovouni, Ammotopos, Artsista, Artza, Ayia Trias, Baousioi, Delvinakion, Dhemati, Dholiani, Draghomi, Embesos, Glousta, Gouryiana, Granitsa, Ieromnïmi, Kalarritai, Kalenji, Kalokhori, Kaloyeritsa,

Kastriotissa, Kastriza, Katarrakhtis (2), Khalkopouloi, Klimatia, Koutsi, Ktismata, Lagatora, Lakhanokastro, Lavdhani, Lia, Liapokhori, Ligaria, Makrinon, Marmara, Megale Gotista, Mesoyefira, Palea Goritsa, Paleokoula, Paliokhori Botsari, Pirgos (Peria), Pramanda, Psina, Sinou, Sirouno, Sistrounion, Skamneli, Sosinou, Terovo, Thiriakision, Toskesi (2), Tsamanda, Tsourila, Uzdina, Veliani, Vereniki, Vourta, Vrousina, Yiatelio, Zalongon. (N.G.L. Hammond, *Epirus* [1967] 659-61, Index, Plans 7, 9, 13, 14, 17, 19, 20-23, and Pls. IV *b*, V *a* and *d*, IX *a* and *c*, XII *b*, XIII *b*, XIV, XVI *b* and XX *d*.)

Forts not intended for habitation, are found only in Thesprotia: Arpitsa, Kakosouli, Louro, Mouri, Smoktovina. (N.G.L. Hammond, *Epirus* [1967] 47ff with Map 3, and 661f.) N.G.L. HAMMOND

LIMES PANNONIAE (Austria, Hungary, Yugoslavia). Map 12. The limes played a decisive role in the life of the Empire's NE border province, Pannonia: the life and history of the province are inseparable from the history of the limes. During the 1st and 2d c. the limes was important in furthering Rome's expansionist policies. In the 3d and 4th c. it played an increasingly defensive role. Its development was actually completed during the 4th c. when a seemingly impenetrable chain of fortifications—consisting of new camps, numerous small forts, guard towers, and bridgeheads—was built on the banks of the Danube.

The building of the limes began during the 1st c., following the Roman conquest, with temporary earth and timber camps to protect the major crossings of the Danube. During the last third of the 1st c. the camps were rebuilt in stone, and in the sections between them the system of auxiliary field camps was developed. The rebuilding in stone of the whole system took place at the end of Trajan's reign and at the beginning of Hadrian's. The fortifications of the limes were heavily damaged during the barbarian invasions of the second half of the 2d and 3d c., but they were always rebuilt after the wars. During the rebuilding at the beginning of the 4th c., the camps were reinforced with large bulwark towers. On the most vulnerable stretches new camps and bridgeheads were added, and during the last third of the century defense was strengthened with the erection of dozens of guard towers. Probably under Constantine there was dug in the forefront of the limes, at the border of the Sarmatian settlement, a skein of trenches under Roman supervision, connecting at either end with the Danube limes, to insure the stone fortress system along the Danube. The limes of Pannonia lost its defensive role and significance during the first decades of the 5th c. following the Hun invasion; the fortresses were abandoned and slowly fell into ruin.

The heart of the fortress system was in the four legionary camps of the territory, all of them built on the N front. Vindobona (Vienna) was the headquarters of the Legio X Gemina, Carnuntum (Deutsch-Altenburg) of the Legio XIV Gemina, Brigetio (Szöny) of the Legio I Auditrix, Aquincum (Budapest) of the Legio II Auditrix. The most completely excavated among them is the camp of Carnuntum (400 x 450 m), but there have been significant excavations at the sites of the other camps as well.

Most of the auxiliary camps have now been identified. Naming them in the order in which they line the Danube as it flows towards the sea, they are Cannabiaca (Klosterneuburg), Ala Nova (Wien-Schwechat), Aequinoctium (Fischamend), Gerulata (Oroszvár-Rušovce), Ad Flexum (Magyaróvár), Quadrata (Barátoföldpuszta), Arrabona

(Győr), Ad Statuas (Ács-Vaspuszta), Ad Mures (Ács–Bum-bunıkut), Celamantia (Leányvár), Azaum (Almás-füzitő), Crumerum (Nyergesujfalu), Tokod, Solva (Esztergom), Esztergom-Hideglelőskereszt, Castra ad Herculem (Pilismarót), Visegrád, Cirpi (Dunabogdány), Ulcisia castra (Szentendre), Göd-Ilkamajor, Budapest-March 15 Square, Budapest-Albertfalva, Campona (Budapest-Nagytétény), Matrica (Százhalombatta), Vetus Salina (Adony), Intercisa (Dunaujváros), Annamatia (Baracs), Lussonium (Dunakömlőd), Alta Ripa (Tolna), Alisca (Őcsény), Ad Statuas (Várdomb), Lugio (Dunaszekcső), Altinum (Kölked), Ad Militare (Batina), Teutoburgium (Dalj), Cornacum (Šotin), Bononia (Banoštor), Castellum Onagrinum (Begeć), Rakovac, Cusum (Petrovaradin), Acumincum (Slankamen), Rittium (Surduk), Burgenae (Novi Banovci), Taurunum (Zemun). The auxiliary camps built during the 2d c. usually were regular in ground plan, rectangular, measured ca. 150-175 by 200-250 m, and were surrounded by a double trench. The camps built during the 4th c. had an irregular base, and were built mostly on elevations or mountain tops. Significant excavations have been made in the camps at Cirpi, Ulcisia castra, Albertfalva, Budapest-March 15 Square, Campona, Vetus Salina, and Intercisa.

The early remains of the chain of guard towers between the camps are still unknown. The location of the wooden guard towers, depicted on Trajan's Column, has not yet been found. Only a few of the stone guard towers built in the 2d and 3d c. are extant, but a comparatively large number of inscribed building slabs from the time of Commodus have come down to us. More is known about monuments of the 4th c., especially about those in the era of Valentinian I. The guard towers vary in ground plan, some being round, others 10 m square. The bridgeheads and small square fortresses represent still another variation in ground plan. The best-known guard towers are on the section around Carnuntum and Brigetio-Aquincum. Many of these also have been excavated.

See also Limes Pannoniae (Yugoslav sector) for Ad Militare, Teutoburgium, Cornacum, Bononia, Cusum, Acumincum, Rittium, Burgenae, Taurunum.

BIBLIOGRAPHY. E. Fabricius, "Limes," *PWRE* 13; A. Mócsy, "Pannonia," *PWRE* 9 (Suppl.); A. Graf, *Übersicht der antiken Geographie von Pannonien* (1936); id., *Der römische Limes in Österreich; Limes u Jugoslaviji* I (1961); S. Soproni, "Limes Sarmatiae," *Archaeologiai Értesitö* 96 (1969). S. SOPRONI

LIMES PANNONIAE (the Yugoslav Sector) Map 12.

The fortification system on the frontier of the Roman Empire had already been organized in Pannonia along the right bank of the Danube in the time of Claudius. The archeological investigations on the Yugoslav part of the Pannonian limes to the present time are insufficient to determine as precisely as has been done in the N (cf. A. Mócsy, Pannonia, *RE* IX [1962] col. 632ff, with biblio.) the stages of building and rebuilding of the military camps in the first centuries A.D. However, as a result of the systematic surveying and excavating of several sites in the last two decades (Teutoburgium, Bononia, Cusum, Acumincum, Burgenae, etc.), it is possible to reconstruct the fortification scheme of defense and to identify the places which protected the frontier for ca. 300 km, from Ad Militare in the N to Taurunum in the SE. Since the Danube was in itself an efficient natural frontier, the limes in Pannonia consisted of a series of individual fortifications (castella, turres, specula, etc.) built on strategically favorable sites within view of each other to ensure easy communication and signaling. The road connecting these fortifications was solely of military importance and was documented from the archeological finds and from the milestones. The road followed the bank of the Danube, except from Ad Militare to Teutoburgium, where it ran inland due to an alluvial and swampy zone along the river bed. From N to S downstream on the Danube, the following important fortifications have been documented on the Yugoslav part of the Pannonian limes:

Ad Militare (Batina). An important fortress on the hill called Gradina, the temporary residence of Cohors II Asturum et Callaecorum. In the 4th c. A.D. a division of the Flavian cavalry—equites Flavienses—was stationed here. Also documented are a civil settlement, a cemetery, and many incidental finds—a milestone, brick stamps, etc.

Ad Novas (Zmajevac). A castellum (ca. 150 x 120 m), on the site Gradina. It was an important crossroads from which a road leads through Sopiana to the S. In late antiquity Auxilia Novensia and equites Dalmatae were stationed here. Incidental finds include building material, brick stamps (Legio IV Herculia), implements, arms, pottery, coins. Two golden scabbards from the period of the great migration and a gold coin of Theodosius II were found here. A necropolis with built tombs is also documented.

Teutoburgium (Dalj). One of the most important fortresses situated close to a brick factory in the village Dalj. The first army units stationed here were ala II Hispanorum et Arvacorum and ala praetoria civium Romanorum. The *Notitia Dignitatum* mentions Teutoburgium as the seat of the prefect of the Legio V Herculia and later of cuneus equitum Dalmatarum and of equites promoti. Excavations in 1966 unearthed architectural remains, arms, implements, pottery, coins, etc., dating from the 1st to the 4th c.

Cornacum (Sotin). A small fortress on a steep hill on the banks of the Danube, the tribal capital of Cornacates. Brick stamps (exercitus Pannoniae inferioris, Legio VI Herculia) were found here. In late antiquity cuneus equitum scutariorum and equites Dalmatae are mentioned here. Arms, pottery, coins, etc., were found here.

Cuccium (Ilok). A small fortress almost completely destroyed, where mediaeval fortress was built later. According to *Notitia*, it was the residence of cuneus equitum promotorum and equites sagittarii. The remains of an aqueduct, inscriptions, and small objects have been discovered.

Bononia-Malata (Banoštor). An important fortress which served as a port for Sirmium on the Danube. Here also there was a bridge over the river. The site was excavated in 1965 and 1970-71. The remains of houses dated 1st-4th c., baths, an Early Christian church with cemetery are well preserved. Architectural remains and objects from the migration period (5th-6th c.). According to *Notitia*, Bononia was the residence of some units of Legio V Iovia. The fortress and the settlement Onagrinum on the left bank of the Danube, opposite Bononia, protected the bridge over the Danube. Architectural remains of military and civil buildings together with numerous and various archeological material were found there.

Cusum (Petrovaradin). A smaller fortress destroyed to build a mediaeval castle. The residence of equites Dalmatae. A milestone indicating the mileage from Malata to Cusum XVI milia passuum was discovered as well as other archeological material.

Acumincum (Stari Slankamen). An important castellum on Gradina hill, civil settlement, and necropolis. In the time of the Domitian wars against the Dacians and Jazigi, the Cohors I Cantabrorum was stationed here. According to *Notitia* cuneus equitum Constantium and equites sagittarii were also here. Excavations have un-

covered several Roman buildings (1st-4th c.). On the site called Dugorep, close to Gradina part of fortification with strong circuit walls was discovered.

Rittium (Surduk). A larger fortification (300 x 400 m), on the Gradina hill. Architectural remains, pottery, and other small finds were discovered, as well as two arae dedicated to Jupiter Dolichenus and brick stamps (Cohors II Asturum and Cohors II Ituraeorum). In late antiquity this was the residence of equites Dalmatae.

Burgenae (Novi Banovci). An important fortification (500 x 600 m), the residence of Cohors I Thracum civium Romanorum, civil settlement, necropolis. In late antiquity, according to *Notitia*, cuneus equitum Constantianarum, a part of Legio V Iovia as well as equites Dalmatae were stationed here. The site has been excavated.

Taurunum (Zemun). A fortress, the residence of several units of Legio VII Claudia. Brick stamps (exercitus Pannoniae, classis Flavia Pannonica) arms, implements, pottery, and coins were found here. According to *Notitia*, equites promoti were stationed here in the 4th c.

In addition to these sites, archeological investigations have been conducted at other fortifications. For the order of importance of the material, we mention here: Kneževi vinogradi, Nemetin, Šarengrad, Neštin, Rakovac, Čortanovci.

BIBLIOGRAPHY. J. Klemec, "Limes u Donjoj Panoniji," Limes u Jugoslaviji, I (1961) 5-34; id., "Der Pannonische Limes in Jugoslawien," *Quintus Congressus Internationalis Limitis Romanis Studiosorum* (1963); D. Pinterović, "Limesstudien in der Baranja und in Slawonien," *Archaelogia Iugoslavica* 9 (1968); D. Dimitrijević, "Istraživanje rimskog limesa u istočnom Sremu, s posebnim osvrtom na pitanje komunikacija," *Osiječki zbornik* 12 (1969). P. PETROVIC

LIMES RAETIAE Germany. Map 20. The Roman limes of the province of Raetia joins the limes Germaniae Superioris (q.v.) at Lorch in Württemberg. Then, running in a gentle curve N of the Danube, it bends round the S part of the present-day Middle Franconia and N Swabia. It reaches the Danube at the village of Hienheim and follows the river as far as the mouth of the Inn—that is, to the boundary of the province of Noricum. The adoption of this line does not date back beyond the end of the 1st c. A.D.—indeed part of it is not earlier than the middle of the 2d c. For at the beginning of the Roman occupation, no one thought of laying out a military frontier in this manner.

Before Drusus in 12 B.C. launched his attacks on Germania in the W, secure routes had to be opened across the Alps in the S. This led to the campaign of 15-14 B.C. in the Alps and the subjugation of the Alpine tribes. But on the approaches to the Alps we still know of no military site which belongs to these years. Only in the SW (outside the limits of the later province of Raetia) has a legionary fortress been found in recent years, that at Dangstetten in S Baden, which may be connected with the campaign of 15 B.C. Somewhat later, in the last years of Augustus' reign or the first years of Tiberius', a series of military posts was established a long way S of the Danube. We do not know how large most of these were, and their existence can often be presumed only from finds. The sites involved are: Bregenz, Kempten, Auerberg, Augsburg-Oberhausen, Lorenzberg bei Epfach, and Gauting.

The last legion was withdrawn from Vindelicia in 16-17 at the latest, and from then on no legion was stationed in this area for ca. 150 years. The province of Raetia was founded not later than A.D. 50. The Via Claudia was extended along the Lech to the Danube and soon afterwards the military posts mentioned above were moved up to the S bank of the Danube itself. Most of them, like the civil settlements in the hinterland, were totally destroyed in the upheavals of 69-70 (q.v. Limes Germaniae Superioris). But this is clearly not true of all of them; for during the excavations of 1968-69 in the fort at Oberstimm, for example, not the slightest trace of destruction was encountered.

After the reorganization of the imperial frontiers by Vespasian, the forts that now lay immediately S of the Danube were rebuilt and remained occupied for some years. About A.D. 85 they were moved N across the Danube to the Schwäbische Alb. Soon afterwards the 200 km gap which had hitherto existed downstream from Oberstimm to Linz in Upper Austria was closed. In this connection the excavations that have been carried out in recent years at Künzing on the Danube have yielded important results. This fort showed evidence over-all of four successive building phases.

A number of Roman forts were built toward the end of the 1st c. far to the N of the Danube (at Munningen, Aufkirchen, and Unterschwaningen). Their purpose is at the moment obscure. The province of Raetia, like Upper Germany, attained its greatest extent under the emperor Antoninus Pius about the middle of the 2d c. Above all in W Raetia the forts were again moved forward some distance in order to link up with the limes in present-day Württemberg, which had similarly been moved forward at this time. As in Upper Germany, so too in Raetia, the actual frontier barrier consisted of a wooden palisade.

The province was comparatively quiet in the period 160-70, but some forts were destroyed in the wars against the Marcomanni. Böhming, for example, had to be rebuilt in A.D. 181, as a building inscription tells us. As a result of the Marcomannic wars, a legion, the Legio III Italica, was now stationed in the province for the first time in ca. 150 years. It took over the newly built fortress at Regensburg in A.D. 179. A number of well-preserved stretches of defensive wall are still visible today at various points in the city. Augsburg–Augusta Vindelicum remained the seat of the civil administration of the province.

The limes in Raetia, as in Upper Germany, was strengthened again at the beginning of the 3d c. if we accept the current view. Instead of the wooden palisade (which, by contrast, was *not* abandoned in Upper Germany) a wall was erected, about the height of a man, with interval towers bonded into it. The ruins of this barrier can still be seen on the ground in many places today. In the first three decades of the 3d c. there are no signs of violent destruction of the limes fortifications. The series of Alemannic invasions did not begin here until A.D. 233 under Severus Alexander. The fort at Pfünz was probably destroyed at that time and not rebuilt. Other forts may not have been finally given up until several years later. Among these one may cite as an example the fort at Künzing on the Danube limes in Bavaria, where in 1962 excavation brought to light a great hoard of weapons and iron tools and not far away a coin of 242-44. In the hinterland the last inscription from the W part of the province comes from Hausen ob Lontal and is dated to ca. 256. All the evidence points to the conclusion that here, as in Upper Germany, the last forts were finally evacuated under Gallienus (259-60).

From what we know today it was apparently the emperor Probus (276-82) who saw to the building of a Late Roman limes, and after him Diocletian and Valentinian I. The outer line of Late Roman forts ran from

Lake Constance to the Iller, and along the Iller valley to the Danube, where it turned downstream.

BIBLIOGRAPHY. H. Schönberger, "The Roman Frontier in Germany: an Archaeological Survey," *JRS* 59 (1969) 144ff with maps A-C. H. SCHÖNBERGER

LIMES, RHINE Switzerland. Map 20. Between Basel and Lake Constance. After the abandonment of the defensive system E of the Rhine and Danube, known as the Upper German-Raetian Limes between A.D. 254 and 260, the Rhine as far as Lake Constance again became a boundary of the Roman empire. A new frontier system was built after the end of the 3d c. A.D. In its Swiss section more of the forts and the smaller structures between them have been preserved than exist below Basel.

Literary (esp. *Amm. Marc.* 27-30 passim) and epigraphical sources indicate that this system was built in two periods: under Diocletian and Constantine (*CIL* XIII, 5249, 5256: Castella Vitudurum, Tasgaetium, A.D. 294), and under Valentinian I (*CIL* XIII, 11537-38 = Howald-Meyer nos. 339-40, pl. 40: Burgi Summa Rapida, Rote Waag, A.D. 371). It is probable that the Rhine limes was completed in 368-71, before the Raetian and Pannonian limes on the Danube.

The system proved effective until the main body of Roman troops was withdrawn to Italy in A.D. 401. Some of the units garrisoned along this part of the limes have been identified: Legio I Martia (stamped tiles in Castrum Rauracense); Legio VIII [August] anensium (building inscriptions in Summa Rapida and Rote Waag); Cohors Herculea Pannoniorum (Arbor Felix, *Not. Dign. Occ.* 35.34); Numerus barcariorum Confluentibus sive Brecantia (both harbors on Lake Constance, *Not. Dign. Occ.* 35.32).

Fundamentally the Rhine limes was intended to hold the frontier by multiplying the fortifications on the left bank and by safeguarding the waterways as a supply line for the frontier troops. To achieve this various structures were erected: 1) larger forts at the main crossings of the Rhine (often strengthened by a fortified bridgehead on the right bank), as well as on trunk roads; 2) fortified landing places for boats supplying the army; 3) signal towers and watchtowers assuring communication between the larger forts; 4) fortified supply depots near the main waterway. These 4th c. structures varied greatly in plan and size, and cannot be more precisely dated; moreover, some of them were earlier installations renovated on the same site. Archaeological evidence, however, indicates that building activity in the earlier phase concentrated on the larger forts on the Rhine and the trunk roads; in the Valentinian phase on the bridgeheads on the right bank of the Rhine, the landing places, watchtowers, and supply depots.

The larger forts on the Rhine from Basel upstream were Basilia, Castrum Rauracense, Tenedo, Tasgaetium; on the military road from Basel to Raetia, Castrum Vindonissense, Vitudurum, Ad Fines, Arbor Felix; on Rhine tributaries and adjacent roads, Salodurum, Ollodunum, Altenburg (on the Aare), Turicum (on the Limmat). Fortified landing places have been identified at Tenedo, Tasgaetium(?), Arbor Felix, and Salodurum. Known supply depots are two identical structures in Mumpf and Sisseln which have semicircular annexes on the narrow sides of buildings 25 x 15 m, possibly towers. Over 40 watchtowers on the Rhine have been identified, most of them excavated, and some preserved. They were usually at the edge of the river and often as little as 1.2-1.5 km apart. Built of stone, they varied in size, but the majority were square and 8-10 m on a side (max.: 18 x 18; 18 x 26 m). The walls, on the average, were 1.5 m thick

(2.5-3.5 m in the larger ones). A peculiarity is the strengthening timber pilework in both foundations and walls. The towers had several stories, supported by wooden post(s); they also had windows and wooden galleries. The entrance was from the river. Each was surrounded by a rampart (sometimes enclosing wooden outbuildings), a wide berm, and a ditch. Small landing facilities for boats can be assumed.

BIBLIOGRAPHY. F. Staehelin, *Die Schweiz in römischer Zeit* (3d ed. 1948) 267-315[MPI]; K. Stehlin & V. von Gonzenbach, *Die spätrömischen Wachttürme am Rhein von Basel bis zum Bodensee* 1 (1957)[MPI]; J. Garbsch, "Die Burgi von Meckatz und Untersaal und die valentinianische Grenzbefestigung zwischen Basel und Passau," *Bayerische Vorgeschichtsblätter* 32 (1967) esp. 51-82[M]; H. Schönberger, "The Roman Frontier in Germany, an Archaeological Survey," *JRS* 49 (1969) esp. 177-97[M]; E. Vogt, "Germanisches aus spaetroemischen Rheinwarten," *Provincialia, Festschrift R. Laur-Belart* (1968) 632-42. V. VON GONZENBACH

LIMES, SOUTH ALBANIA Forts. A wall of rectangular blocks with some clamps spans the neck of the peninsula of Buthrotum; it was built by a sea power, probably Kerkyra, in the 5th c. to enclose annexed territory (Thuc. 3.85). Small forts nearby at Çuke, Qenurio and Malahuna may be Kerkyrean also. Other small forts at Bençë, Kardhiq, Nivicë Lopes, and Humelicë were probably control posts in the Hellenistic period, while others at Luneçi and Memalaj by the crossings of the Aous river were control posts on the Roman road. Roughly fortified places of refuge, probably of the Hellenistic period, are at Gardhikaq, Koqino Lithari, Dhrovjan, Pepel, Poliçan, Skorë and Zimnec. A fine fortification of the Hellenistic period at Vagalat controls the entry into an inland plain. None of these were made for permanent habitation. (N.G.L. Hammond, *Epirus* [1967] Pls. V *c*, VII *b*.)

Fortified sites of unknown identity. Usually within a day's walk of the coast they range from Ploçë in the N with a circuit wall exceeding 2 km to Malçan in the S, about half as large. Others are at Borsh and Kalivo. (N.G.L. Hammond, *Epirus*, index, for descriptions and references.) N.G.L. HAMMOND

LIMES, ON WALENSEE, RAETIA Glarus and St. Gallen, Switzerland. Map 20. This defense line along the Walensee comprises a series of fortified towers to protect the route from Italy to the Rhine on the stretch between the upper Rhine valley in Raetia and the E end of Lake Zurich. Most of the towers were built in 20-15 B.C. (dated by pottery and weapons), during the early Augustan campaigns which eventually led to the establishment of the provincia Raetia et Vindelici et vallis Poenina. They also protected the S flank of an army approaching Lake Constance via Basilia and Vitudurum. The towers were abandoned ca. A.D. 10.

Three of the seven towers have been excavated. They lie on both sides of the Walensee and in the plain between it and Lake Zurich, either on elevations or on the lake shore. They are spaced 3-6 km apart so that signaling was possible. The towers were built against the wall of an irregular court (area ca. 400 sq. m). They were square (9-13 m to a side) and two or three stories high, the lower 5-6 m of stone, with wood and stone above. The foundations have five or six steps (width at the bottom 2.5 m). There were windows 0.3 m wide, and an entrance from a wooden sentry walk at the level of the second floor. Three towers may be visited: 1) Voremwald, 1 km W of Filzbach, at the top of the Kerenzerberg pass, on the S side of the lake; 2) Stralegg, near

Betlis, on the N shore of the lake; 3) Biberlikopf, near Ziegelbrücke, on a spur of the Schänerberg.

The Museum des Landes Glarus is in Näfels, and the Neues Museum in St. Gallen.

BIBLIOGRAPHY. *Ur-Schweiz* 24 (1960) 3-24, 51-67, 67-71[PI]; *Jb. Schweiz. Gesell. f. Urgeschichte* 48 (1960-61) 151-60; 49 (1962) 53-56[PI]; 53 (1966-67) 151-56[PI]; 54 (1968-69) 78-79; E. Meyer, "Die geschichtlichen Nachrichten über die Räter und ihre Wohnsitze," ibid. 55 (1970) 119-25; C. M. Wells, *The German Policy of Augustus* (1972) 54-55. V. VON GONZENBACH

LIMNAIA (Amphilochia, formerly Karavassaras) Akarnania, Greece. Map 9. Small harbor town at the head of a deep bay in the SE corner of the Gulf of Arta. Mentioned in the literature (Thuc. 2.80.8; Polyb. 5.5.12-6.5), it owed its importance to its good harbor and its position astride the main road from Stratos to Ambrakia (Arta). The Albanian adventurer Ali Pasha, in the early 19th c., repaired the ancient citadel and founded a new town within its walls.

Limnaia must have extended down to the sea; but modern building has erased all ancient remains near the harbor. About 50 m from the shore can be seen the first fragments of the E long wall, one of two linking the citadel to the harbor area. This wall ascends the NE nose of the citadel hill, which it then encircles on the E, S, and W. Where the ground begins to fall on the NW a cross wall returns E, completing the enclosure of the hilltop, while the W long wall angles down the steep slopes towards the modern road and the harbor. The whole system of fortifications seems to be Hellenistic.

There are extensive remains on the hilltop, but most of these belong to Ali Pasha's now deserted settlement.

BIBLIOGRAPHY. L. Heuzey, *Le Mont Olympe et l'Acarnanie* (1860) 320ff[MPI]; R. L. Scranton, *Greek Walls* (1941) 82-83; A. W. Gomme, *Historical Commentary on Thucydides* II (1956) 426-28; N.G.L. Hammond, *Epirus* (1967) 246-47, esp. on identification.

F. E. WINTER

LIMNAION Thessaly, Greece. Map 9. A place mentioned by Livy alone among ancient authors, presumably a temporary refuge in time of war or flood without continuous occupation; there are no known coins or inscriptions. It has been identified with a rocky hill called Petromagoulo rising 250 m above the marshy plain, 2 km NW of Kortiki and on the opposite side of the Karditsis river. Double walls of rough polygonal masonry filled with rubble surround the acropolis at the highest point. There was a tower on the N side and a lower wall of ashlar work.

BIBLIOGRAPHY. Livy 36.13,14; C. D. Edmonds in *BSA* 5 (1898-99) 22[M]. Also F. Stählin, *Das hellenische Thessalien* (1924) 83f. M. H. MC ALLISTER

LIMNITIS, *see* LIMENIA

LIMOGES, *see* AUGUSTORITUM LEMOVICUM

LIMONUM PICTONUM (Poitiers) Vienne, France. Map 23. Originally known as Lemonum or Limonum, in the 4th c. B.C. the city became Pictavis, from the name of the Pictones or Pictavenses, the tribe whose chief city it had become. It is situated on the left bank of the Clain, where it meets the Boivre, on a steep rocky spur. The site was occupied early (dolmen of La Pierre Levée). After Alesia it sided with Caesar and then became part of the province of Aquitania set up by Augustus. It was sacked by the barbarians in A.D. 276. After Diocletian

it became part of Aquitania Segunda, and it fell into the hands of the Visigoths about 418.

There are few traces left of its monuments. The amphitheater was one of the largest in Gaul; most of its remains lie beneath private houses, but two tiers of arcades are still standing, over 20 m high. A 1699 watercolor shows a third tier of blind arcades outside the circular gallery of the summa cavea. At ground level, two ring-shaped galleries have been located, and another on the next story which has radiating galleries supporting the seats; also a vomitorium, some fairly wide stairways, and some carceres. The podium surrounding the arena was 3 m high, and the arena at least 155 m long. The masonry consisted of a core of rubble faced with small cubes of stone, and the arcades were built of two rows of bricks. Of the decoration only some cornice fragments remain. The plan of the monument can still be discerned in the arrangement of the streets in the modern quarter, one of which has kept the name Rue des Arènes.

The city was amply supplied with water: three aqueducts have been located. The network spread out over at least 37 km, but the channels do not seem to have been built at the same time. Their sinuous path followed the lie of the ground but was not always skillfully planned: at certain points the bends were too sharp and the slopes too abrupt. The masonry of the piping was excellent: the conduit was coated with a very fine, smooth, and extremely hard mortar and covered over with a vault of large stones or stone slabs coated with concrete. Three arcades of one aqueduct are still standing in a garden at the entrance to the city; they are built of solid masonry but have only a narrow span and have been stripped of their facing. The aqueducts brought the city an average flow of 12,000-15,000 cu. m of excellent water.

Two public baths have been located, the most important one, covering close to 3 ha, near the old Eglise St. Germain. The water came from a reservoir fed by a private aqueduct. The walls are extremely thick, 0.9-1 m, and built of highly porous tufa (a stone that does not expand in heat, oxidize, or split) with a facing of opus reticulatum. The decoration was probably very rich: pilasters and archivolts of colored marble, stucco painted with branches, flowers, and arabesques, mosaics of shells and mother-of-pearl on the floor and walls. A Claudian coin (A.D. 51-66) was found in a block of masonry.

Nothing is left of the temples except a long wall of carefully built reticulated masonry under the presbytery of the Eglise St. Porchaire, probably the subfoundation of a large temple that stood on one side of the forum. Dedications suggest that there were one or two temples of Mercury, in one of which the god is referred to as Adsmerius.

Several necropoleis have been found, one on the hills in the Faubourg des Roches et du Porteau, another near the modern St. Cypryen bridge, and one at Les Dunes. The last contained ca. 400 tombs: stone sarcophagi, either sealed with flat stone slabs, or with two-leafed lids, or curved and with no carving or ornamentation; others made of lead; pits sealed with flanged or curved tiles; individual and collective incineration graves; urns of stone, terracotta or glass.

The city suffered severely in the first barbarian invasion of A.D. 276. A rampart was built, a few sections of which can be seen today near the Palais de Justice and in the Rue des Carolus. It formed an irregular circle 2600 m in circumference. The walls were 4-6 m thick, and probably lower in the steep areas. The subfoundations were made of large blocks from destroyed monuments, frequently fitted without mortar, and the main foundations consisted of rubble with a facing of small stones.

Round projecting towers were set at varying intervals along the wall.

Excavations have revealed houses, pottery, and coins ranging from the 1st to the 5th c. A.D. not far from the St. Jean baptistery. From the Christian era come the old parts of the baptistery itself: the original baptismal basin, the channels by which water was brought in and out, and the walls up to the first cornice.

Among the works of art found at Poitiers the following are noteworthy: a marble statue of helmeted Minerva, a Roman copy of a Greek original of the early 5th c. B.C.; two quadrangular altars with an effigy of a god—Apollo, Mercury, Hercules, Minerva, or Cybele—on each face; the base of a statue to the Numini Augustorum et Tutelae Apollonis Matuicis decorated with cupids, dolphins, and a winged serpent; groups of two mother-goddesses; stelai, rougher in style, representing local people—a man holding his son by the hand, a woman holding a child in her arms; the funeral epitaph of Julia Maximilla with a mirror engraved on its upper part reflecting a human face, and an ascia below; remains of the decoration of a triumphal arch, Victory holding a palm; and some Corinthian columns of excellent workmanship.

A theater is being excavated in the ruins of Vieux-Poitiers at Naintré, 20 km to the N.

BIBLIOGRAPHY. *RE* XII:2 col. 1930 (Lemonum); XXI col. 1203 (Pictones-Pictavi); *DACL* s.v. Poitiers; Bourgnon de Layre, "L'amphithéâtre ou les arènes de Poitiers," *Mém. Société des Antiquaires de l'Ouest* (1843) 137; Duffaud, "Notice sur les aqueducs romains de Poitiers," ibid. (1854) 55; R. P. de la Croix, "Découvertes des thermes romains de Poitiers," *BMon* (1878) 462; E. Espérandieu, *Epigraphie romaine du Poitou et de la Saintonge* (1889); id., *Recueil général des bas-reliefs de la Gaule romaine* (1907-) II, 294; A. Blanchet, *Congrès des Sociétés Archéologiques de France, Angoulème* (1912) II, 104; Grenier, *Manuel* I, 489-504; III:2, 679; IV:1, 290; F. Eygun, *Gallia* 9 (1951) 102; 19 (1961) 401; 21 (1963) 468; id., "Le cimetière gallo-romain des Dunes," *Mém. Soc. Ant. de l'Ouest* 11 (1953); id., *L'Art du Pays de l'Ouest* (1965) 11-48; R. Thouvenot, "Poitiers gallo-romain," *Bull. Soc. Ant. de l'Ouest* (1966) 7-22; G. Dez, *Histoire de Poitiers* (1969) 9-21.

Théâtre de Naintré: E. Fritsch, *Bull. Soc. Ant. de l'Ouest* (1971). R. THOUVENOT

LIMYRA Lycia, Turkey. Map 7. To the NE of Finike. It developed out of an old Lycian dynastic seat. A fortress, in part well preserved, stands on a spur (318 m high) of the Tocak-Daği (1216 m high). Numismatic evidence shows that the citadel, with the epichoric-Lycian name of Zẽmu(ri), existed in the 5th c. B.C.

In the first half of the 4th c. the Lycian king Perikles, whose likeness is known from coins, resided here. He had his tomb built in the middle of the S wall of the lower citadel, which stands at 218 m on a terrace cut into the cliffs. Inspiration for the heroon came from the Porch of the Maidens of the Erechtheion, which stands over the grave of the attic king Kekrops in Athens, and the Nereid monument in Xanthos. The foundations included a burial chamber; above them rose a structure with the form of an Ionic temple of amphiprostyle design. Instead of columns there are caryatids, two of which have been re-erected and are now to be seen inside a protecting repository on the N side of the terrace. There also are blocks from a frieze which decorated the walls of the cella. It shows King Perikles setting out in his war chariot followed by a mounted guard and foot soldiers.

The gables were decorated with figurative acroteria. Only the theme of the N acroterion (Perseus and Me-

dusa) can be reconstructed. All the fragments of the acroteria are now in the archaeological museum of Antalya.

The economic basis of the city was in the rich alluvial land stretching between the Kara-Cay and Alakir-Cay. The modern Finike developed from the old port for Limyra.

The wealth and power of the Lycian king Perikles are documented in the four large necropoleis. Ten tombs decorated with reliefs have been found to date. A third of all epichoric-Lycian funerary inscriptions are to be found in this city, the farthest E of the area occupied by Lycian culture. In necropolis IV an inscription has been found in Aramaic, the chancellery script of the Persian empire. To the E of the theater, some 20 m to the other side of the road, stands the tomb of Xñtabura, which was built ca. 350 B.C. Three sides of the hyposorion, which takes the form of a Lycian tomb-niche with a flat roof, are decorated with reliefs. On the W side, the deceased stands before the judges of the other world; on the S side, a priest sacrifices a bull. The badly damaged relief of the N side shows a trip by chariot. The sarcophagus is decorated with an Ionic Cyma. On the gables crouch eagles guarding the tomb. Sphinxes with wings, and a statuette of a horseman, once stood on the roof of the tomb. The gable of another sarcophagus, decorated with reliefs of gorgons, hunting scenes, and a bull sacrifice, and dating from the same period, is to be found in the museum of Antalya.

It is in necropolis II to the W of the pyramidal mountain of the citadel that the greatest number of cliff-tombs decorated with reliefs are to be found. Most noteworthy is the tomb of Tebursseli, running around the top of which is a relief showing battle scenes which are explained by accompanying inscriptions in Lycian. Tebursseli is shown fighting back to back with King Perikles against Arttum̃para, a dynast who ruled in the Xanthos valley, and against Arttum̃para's soldiers. A well-preserved relief showing a single combat decorates the cliff-tomb of the wet nurse of the later dynast Trbbenimi of Limyra. To the W of the theater are numerous cliff terraces with houses, and cult-niches served for the worship of the twelve Lycian gods.

In Hellenistic-Roman times the original peasant settlement at the foot of the eminence on which the citadel stood began to take on the features of a city. Numerous ruins have been found on either side of the river Limyros. Recognizable are the E city gate and beneath a late Byzantine castle in the W city, the stylobate of a temple.

Near the S wall of the W city is the core of a tower-like structure which was a cenotaph for Gaius Caesar, adopted son of Augustus, who landed in Finike on his way back to Rome from Syria and died in Limyra in A.D. 4.

Following an earthquake in A.D. 141 the theater was completely reconstructed at considerable expense by the Lyciarch Opramoas. An impressive bridge 400 m long led in Roman times across the Alakir-Cay to the E.

From the Byzantine period there remain of the diocesan city of Limyra a ruined church in the lower citadel and the palace and church of the bishop inside the E city.

BIBLIOGRAPHY. E. Petersen & F. von Luschan, *Reisen in Lykien* (1884); Milya & Kibyratis, *Reisen im südwestlichen Kleinasien* (1889) II 65ff; J. Borchhardt, "Das Heroon von Limyra—Grabmal des lykischen Königs Perikles," *AA* (1970) 353ff; id., "Ein Totengericht in Lykien," *IstMitt* 19/20 (1969/70) 187ff[I].

J. BORCHHARDT

LINCOLN, *see* LINDUM COLONIA

"LINDINIS," *see* ILCHESTER

LINDOS, *see* RHODES

LINDUM COLONIA (Lincoln) Lincolnshire, England. Map 24. The major part of the Roman and later development here lies on top of the escarpment N of the Witham, though suburbs and cemeteries existed also S of the river. The Roman name is derived from the Celtic name for a marshy place. Two major Roman roads, Ermine Street and Fosse Way, met on the S side of the valley, across which Ermine Street continued to Lindum and N to York. Thus Lindum's position, commanding two of the major routes of Roman Britain, made it important in the conquest and settlement; and Ermine Street was to the end of the Roman period the major route from London to the N, hence Roman Lincoln's continued importance. It lay within the lands which had belonged to the Coritani, but which under Roman rule were administered from Leicester (Ratae Coritanorum).

Historical summary. The history of the Roman settlement at Lincoln comprises military installations succeeded by a colonia, one of four such chartered towns known to have existed in the province of Britannia (the others were Colchester, Gloucester, and York). From inscribed tombstones it is known that Legio IX Hispana and Legio II Adiutrix served here. The rectangular legionary fortress, shown by excavation to be ca. 16.4 ha in area, occupied the hilltop. Its defenses, consisting of an earth rampart faced and retained by timbers, have been traced on all four sides; one internal tower of timber is known on the W side, and on the E, part of the gateway structure has been found. Only slight traces have yet been found of the timber buildings within the defenses. The fortress seems not to have been built until the 60s, before which Legio IX may have been billeted in newly discovered campaign forts in the area. But it is likely that some form of military holding was established at Lincoln by the late 40s, perhaps an auxiliary fort.

Legio IX moved on to York in A.D. 71, and Legio II Adiutrix then briefly occupied Lincoln before it was moved, perhaps in 74-75, to build the new fortress at Chester. After ca. 20 years, at the end of the 1st c., a colonia was founded on the same rectangular hilltop site. It had defenses of stone, with internal towers added at intervals to the wall. Perhaps at the same time the town developed down the slope towards the river. The slope is known to have been walled as well, making an eventual defended area of 34.8 ha. Excavations have shown a sequence of defenses down the hill: 2d c. walls were refurbished and strengthened in the 4th c., when a gate with a single roadway was created. This is now preserved and open to the public.

Major visible remains. The most notable remains still to be seen in the hilltop colonia are those of the N gate, Newport Arch, which consisted originally of a central roadway 4.5 m wide, flanked by footways. It is still used today.

At the E gate, the N tower has been completely excavated and elements of three main phases can be seen. The front range of the post-holes of the legionary gateway, 0.3 m square, received a stone fronting in the late 1st or early 2d c. with the foundation of the colonia. Not earlier than the 3d c. the whole gateway was rebuilt on a monumental plan, with semicircular bastions projecting beyond the line of the wall. In this version the gate had two roadways, and may well have been the main gate of Lincoln by that time, if not earlier.

Parts of only one internal building within the colonia are visible in situ: a portion of a massive colonnade preserved in a house in Bailgate on the W side of the main Roman N-S street, in the central area. The so-called Mint Wall, visible nearby, probably formed part of the N wall of this colonnaded building. Architectural cornices, from demolished monumental buildings, were also found here and are preserved in the museum with many other finds.

Other notable discoveries. Sections of an aqueduct approaching the NE corner of the hilltop site have been excavated. Collared pipes, sheathed with a heavy concrete jacket, carried the water from its presumed source some 2.8 km from the town. But the gradient runs counter to the course of the pipeline, so staged force-pumps may have been used.

A number of local pottery kilns supplying everyday needs from the early 2d c. until the 4th are known. Something of an industrial area seems to have grown up at Swanpool and Bootham, ca. 3.2 km SW of Lincoln, where pottery making was concentrated in the late 3d and 4th c.

Oölitic limestone of fine quality was quarried locally; a likely source is N of the colonia on Ermine Street where stone was later quarried for Lincoln cathedral. Another quarry at Greetwell 2.4 km E of Lincoln is still in use, and a large Roman house or houses have been recorded nearby.

Suburbs were strung out across the valley along Ermine Street, and possibly also along the Fosse Way. Cemeteries are ill-defined, but military burials have been found close to Ermine Street where it crosses the Witham valley S of Lincoln, and civilian burials mainly W, N, and E of the walled area. Most discoveries were in the 19th c., however, and were not well recorded.

BIBLIOGRAPHY. Ptolemy *Geog.* 2.3.20; *Memoirs illustrative of the History and Antiquities of the County and City of Lincoln* (1848); *Roman Lincoln, 1945-46* (1946); *ArchJ* 103 (1946) 26ff & bibl.; *AntJ* 27 (1947) 61ff; *JRS* 39 (1949) 57-78; 40 (1950) 99; *ArchJ* 140 (1954) 106-28; *Ten Seasons' Digging, 1945-54* (1955); Ordnance Survey, *Map of Roman Britain* (1956); *ArchJ* 117 (1960) 40-70; *RIB* 1; J. B. Whitwell, *Roman Lincolnshire* (1970) 17-43 & bibl.; interim reports, *Britannia* passim. J. B. WHITWELL

LINZ, *see* LENTIA

LIPARA, *see* AEOLIAE INSULAE

LIPARI ISLANDS, *see* AEOLIAE INSULAE

LIRIA, *see* LEIRIA

LISBON, *see* OLISIPO

LISIČIĆI, *see under* KONJIC

LISIEUX, *see* NOVIOMAGUS LEXOVIORUM

LISOS or Lissos Greece. Map 11. A small city on S coast of W Crete, on a remote bay named after the chapel of Ag. Kyrkos, Selino district; it is E of Kastelli Selinou and W of Souyia. Its early history is unknown. In the early 3d c. B.C. it had a coinage alliance with its neighbors Elyros, Hyrtakina, and Tarrha. By the mid 3d c. it was a member of the league of People of the Mountains (Oreioi) and probably the chief city; the league lasted until the late 3d or early 2d c. The city is mentioned in ancient coastal pilots ([Skylax] 47; *Stadiasmus* 332f) and geographies (Ptol. 3.15.3; *Tab. Peut.* 8.5; Geogr. Rav. 5.21); later sources show it was a bishop's seat until the 9th c. (Hierokles 650.16; *Not. gr. episc.* 8.239; 9.148). Coins of the 4th-3d c. and the treaty of the Oreioi with King Magas of Kyrene indicate that the main divinity of Lisos was Dictynna, but excavation has now revealed an important Sanctuary of Asklepios.

Lisos was once thought to lie at Kastelli Selinou, but the correct site was identified in the 19th c., and proved by discovery in the wall of the chapel of Agios Kyrkos of a stone inscribed with the treaty between the Oreioi and Magas. On the slopes W of the stream that crosses the small coastal plain are remains of the necropolis, including many freestanding barrel-vaulted built tombs; E of the stream are the ruins of the city, which was inhabited from at least the Classical to the First Byzantine period, but apparently not reoccupied after the Arab conquest. In antiquity the relative sea level was probably some 7.8 m higher; there would then have been the natural harbor attested by Skylax, which could have served as one of the ports of inland Elyros (the main one being Syia).

Remains have been found of an aqueduct, a theater only 23.4 m in diameter, and a large Roman bath building near the chapel of Agios Kyrkos at the back of the plain. Under this chapel and that of the Panagia near the shore are the remains of Early Christian basilicas. The city was small; it had little cultivable land and was barely approachable except by sea.

The Sanctuary of Asklepios, however, which arose because of a spring of curative water, is strikingly large. It was rediscovered after the unearthing of votive statues near the chapel of Agios Kyrkos, and is the only area of the city to be systematically excavated. The temple is a small, simple Doric temple with walls of well-dressed polygonal masonry below and pseudo-isodomic above. It has no pronaos, and the cella, paved with a fine polychrome mosaic, has a marble podium at its rear for the cult statues. The water from the spring ran under the paving to a fountain in the cella. In front of the building is a forecourt, and on the W side an entrance portico from which steps led up to the temple. The building seems to have been destroyed in an earthquake; parts of its superstructure were found widely scattered. Nearby was a building used by priests or visitors. The spring itself was approached by steps from the terrace; beside it was a large cistern.

This site has produced more sculpture than any in Crete except Gortyn. Many of the heads of statues and statuettes were found in a heap some distance away from the torsos; most of them represent Asklepios or Hygieia, or girls and boys (presumably consecrated to the god). They are of Hellenistic and Roman date, but the types are mostly Classical. A number of statue bases bear dedications to Asklepios and Hygieia. The finds are in the Chania and Herakleion museums.

BIBLIOGRAPHY. R. Pashley, *Travels in Crete* II (1837; repr. 1970) 88-97; T.A.B. Spratt, *Travels and Researches in Crete* II (1865) 240-41; L. Savignoni, *MonAnt* 11 (1901) 448-59¹; G. de Sanctis, ibid. 509-10; Bürchner, "Lisos," *RE* XIII, 1 (1926) 730; M. Guarducci, *ICr* II (1939) 210-15; E. Kirsten, "Orioi," *RE* XVIII, 1 (1942) 1063-65; H. van Effenterre, *La Crète et le monde grec de Platon à Polybe* (1948) 120-26; *KretChron* 11 (1957) 336-37; 12 (1958) 465-67; 13 (1959) 376-78; 14 (1960) 516; *BCH* 82 (1958) 799; 83 (1959) 753-54; 84 (1960) 852-53; R. F. Willetts, *Cretan Cults and Festivals* (1962) 191-92; S. G. Spanakis, *Kriti* II (n.d.) 247-50.

D. J. BLACKMAN

LISSA Turkey. Map 7. Site, now deserted, in Lycia; on the mainland N of Kapı Dağı, on the W side of the gulf of Fethiye, some 3 km inland from Sarsıla Iskelesi. Lissa is mentioned only by Pliny (*HN* 5.101; see Kalinka and Robert in bibl.). There is no coinage. The name and site are established by inscriptions found on the spot; these are decrees of the 3d c. B.C. dated by the regnal years of Ptolemy II. The site is close to a large lake, now reduced to a marsh; the acropolis is fortified

by a wall and tower. There are a number of tombs, some rock-cut, some built, some sarcophagi.

BIBLIOGRAPHY. J. Bent, *JHS* 10 (1889) 50ff; R. Heberdey & E. Kalinka, *Bericht über zwei Reisen* (1896) 19; *TAM* II, 1 (1920) 51; L. Robert, *Villes d'Asie Mineure* (1935) 161ff.

G. E. BEAN

LISSOS (Lesh) Albania. Map 12. An important Illyrian city on the left bank of the Drin where it enters the marshy coastal plain of the Adriatic Sea. The site is a steep-sided high hill, overlooking the river. There are remains of prehistoric and later settlements on the hill, but the extensive fortifications date from the late 4th c. B.C., the styles of the masonry being polygonal and trapezoidal. Later repairs and additions were made in the 1st c. B.C.; Caesar (*BCiv* 3.29.1) mentions them, and an inscription preserves the names of the magistrates who were in charge of the work. The acropolis on the hilltop is defended by a circuit wall; the lower town, extending down to the bank of the river, was itself fortified by a circuit wall appended to that of the acropolis. Dionysius of Syracuse and later Philip V of Macedon laid claim to the city (D.S. 15.13.4 and 15.14.2; Polyb. 8.15). In antiquity the main bed of the Drin lay farther N and Lissos itself was a port of some consequence because it gave access not only to the hinterland but to the route via the White Drin into the Central Balkan area. Lissos issued coinage.

BIBLIOGRAPHY. C. Praschniker & A. Schober, *Archäologische Forschungen in Albanien und Montenegro* (1919) 14ff; R. L. Beaumont in *JHS* 56 (1936) 184f, 202f, and ibid., 72 (1952) 68ff; J.M.F. May in *JRS* 36 (1946) 48-56; H. Ceka, *Probleme të numismatikës ilire* (1965) 93ff; F. Prendi & K. Zheku, "Qyteti ilir i Lisit origjina dhe sistemi i fortifikimit të tij," *Studime Historike* (1971) 1.155-205.

N.G.L. HAMMOND

LISSOS (Greece), *see* LISOS

LITERNUM Italy. Map 17A. A Campanian town founded as a colonia maritima in 194 B.C., to the left of the Liternus, which was the outlet of the Literna marsh (today the Lago di Patria) in an area which forms the prime section of the ager Campanus. Among the colonists was L. Cornelius Scipio Africanus, who remained there to the end of his days and whose villa was well preserved even to the time of Seneca.

The settlement, of limited size, developed on relatively high ground. The forum with its adjacent public buildings, which in its original form dates to the time of the founding of the town, has been excavated. The main square, which preserves the tufa paving, was encircled by porticos which were rebuilt in the late Flavian period. These porticos were interrupted at the center of the W side by the projecting podium of a temple, most likely a Capitolium. While this temple was restored in the 1st c. of the Empire, the basilica which flanks it on the S dates in its present form to the time of Sulla. The theater, to the N, is built upon an earlier structure and separated from the portico in the late Antonine period. Finally, N and S of the main square were some tabernae separated by the two major entrances.

Beyond the town, to the S, remains of the amphitheater are preserved. Resting partly on the natural slope and partly on an embankment, the amphitheater was also constructed in the Republican period. Remains of funerary monuments are preserved and, toward the SE, a late mediaeval church has been excavated.

BIBLIOGRAPHY. J. Beloch, *Campanien* (2d ed. 1890) 377ff; A. Maiuri, *Passeggiate Campane* (1950) pp. 57ff; id., *I campi Flegrei* (1958) 160ff.

W. JOHANNOWSKY

LITTLE CHESTER, *see* DERVENTIO

LIVADHOSTRO, *see* KREUSA

LIVERDUN Meurthe-et-Moselle, France. Map 23. This market town, situated on a rocky spur dominating the Moselle ca. 15 km downstream from Toul (Tullum Leucorum), has produced a few ancient remains. But its immediate vicinity has contributed considerable evidence for a fairly dense occupation from prehistoric to Merovingian times. In 1967 excavations during the building of a private house at the locality called Rupt-Chaudron brought to light the foundations of a fairly large Gallo-Roman villa. A cellar, which perhaps served as a sanctuary, was explored first. It was finished with two air vents and one niche filled with abundant constructional debris and artifacts: painted plaster, small marble slabs, pieces of a table and a column, iron tools for handicrafts, a small bronze vase, fibulae, bone pins, 3d c. coins, and an interesting medallion with an effigy of Antinoüs (on the reverse, a bull). Near this cellar a small building contained a hypocaust with 42 small brick piers. To the S was a hemicycle, no doubt for a heated pool. Also to the S was a small rectangular structure (1.2 x 1.8 m), the walls of which were lined with a row of bricks covered with waterproof cement. This was no doubt a cold bathing pool. The whole of this establishment seems to have been destroyed during the invasions of the mid 3d c.

BIBLIOGRAPHY. R. Billoret in *Gallia* 28 (1970).

R. BILLORET

LIXUS (Larache) Morocco. Map 19. Ancient city of W Mauretania on the right bank of the Lixus (wadi Loukkos) opposite Larache. The name of the city, which was often mentioned by writers from Hanno's Periplus to the Geographer of Ravenna, is confirmed by the legend on its coins and by an inscription.

Situated roughly 4 km from the sea, the city stands on the Tchemmich hill, 80 m above the marshes through which the Loukkos flows. The ancients believed this to be the site of the Garden of the Hesperides and of a sanctuary of Hercules, more ancient than the one at Cadiz (Pliny *HN* 19.63). However, there are no grounds for the claim that Lixus was founded at the end of the second millennium. The earliest traces found so far go back no earlier than the 7th-6th c. B.C.; moreover, the potsherds that have been found show that the site was occupied only sporadically since, with the possible exception of the first stage of Temple H of the sanctuary (provided the date suggested for it is correct), no distinct contemporary structure has been found. The oldest buildings, in fact, apparently date from the 4th c., while the only ones that have been excavated go back just to the 3d-2d c. B.C.: Temple A of the sanctuary; in the W quarter, two-story houses without atrium or peristyle, similar to those at Tamuda; and a stone rampart, well preserved for the most part, dated variously between the 4th c. and the end of the 1st c. B.C.

At the top of the acropolis was a large sanctuary, which it is tempting to believe is that of Hercules-Melqart. Eight temples have been excavated here, the largest of which (Temple F), standing in the middle of a porticoed courtyard, covers 1500 sq m. It appears to have been put up no earlier than the reign of Juba II: the city, which was probably destroyed in the first half of the 1st c. B.C. either during Sertorius' Mauretanian expedition or in the struggle between Caesar and Pompey, was in fact rebuilt in this period. Also at this time a small amphitheater with a semicircular cavea was built some 300 m E and a group of fish-salting and garum-manufacturing workshops at the foot of the S slope of the hill. Some necropoleis dating from before the Roman conquest have been found E and W of the settlement; the oldest tombs appear to be no earlier than the 3d-2d c. B.C.

Lixus was sacked once again during the troubles that befell Mauretania after Ptolemy was assassinated. Thereafter Claudius granted the city colonial status and it recovered rapidly. Wealthy homes—the Mars and Rhea House and the Helios House on the hill and House of the Three Graces in the lower section—are evidence of its prosperity in the 2d and 3d c. A.D., as is the revival of the salting workshops. In the middle of the 3d c. the city was ravaged for the third time. Rebuilt inside a smaller rampart on the crest and S slope of the hill, it enjoyed only limited activity from then on, serving as garrison to the cohors I Herculea in the 4th c. then disappearing in the 5th-6th c. Later, a Moslem village was set up on the site; its little mosque has been mistaken for a Christian church.

The only noteworthy objects found in excavations, besides a few mosaics from the houses of the Roman period, are a very fine mask of Oceanus and two bronze groups representing Hercules struggling with Antaeus and Theseus fighting the Minotaur.

BIBLIOGRAPHY. M. Tarradell, *Lixus, historia de la Ciudad. Guia de las ruinas y de la sección de Lixus del Museo arqueologico de Tetuán* (1959)MPI; *Marruecos púnico* (1960) 131-80; M. Euzennat et al., "Chroniques," *Bulletin d'Archéologie Marocaine* 4 (1960) 538-44MPI; 5 (1964) 367-76; 6 (1966) 539-40; 7 (1967) 655-57; M. Ponsich, "Lixus 1963," *BAC* (1963-64) 181-97; id., Fouilles puniques et romaines à Lixus," *Hespéris-Tamuda* 7 (1966) 17-22.

M. EUZENNAT

LJUBLJANA, *see* EMONA

LLANDOVERY Carmarthenshire, Wales. Map 24. The Roman fort occupies an important strategic position overlooking the valley of the Towy but close to the headwaters of the Usk. It lies at the junction of roads from Carmarthen to Castell Collen and from Becon Gaer to Llanio. It probably covers an area of ca. 2.4 ha, though its exact size is uncertain.

Excavation revealed four main phases. The first, apparently destroyed by fire, was of earth and timber, and may be pre-Flavian. The second phase probably dates to ca. A.D. 75, and had clay defenses laid on a base of brushwood. Not earlier than ca. A.D. 105 a stone wall was added, and some internal buildings (probably those of the central range) were rebuilt in stone. Later the fort was reduced in area, probably to a fortlet in the NW corner of the original area. Nothing indicates occupation later than ca. A.D. 160. Cremation burials have been noted to the E, and a bath house (or a mansio) W of the fort was destroyed in the 18th c.

BIBLIOGRAPHY. V. E. Nash-Williams, *The Roman Frontier in Wales* (2d ed. by M. G. Jarrett 1969) 95-96MPI.

M. G. JARRETT

LLANDRINDOD COMMON Radnorshire, Wales. Map 24. The largest known group of Roman practice camps on the common S of Llandrindod, associated with the fort of Castell Collen N of the present town. In 1811 18 camps of roughly square shape were found on the common; they were recognized as practice camps in 1936 when other parallels had become available. The camps can be divided into four major groups: the first has been destroyed by the growth of the modern town, the second lies on its S edge, while the third and fourth are farther S on the common.

Camps VI-XIV form the third and most important group on the highest part of the area. All lie on the E side of

the road running S from Castell Collen. They vary in size from 14 to 30 m square and, although most are badly damaged, they exhibit certain common features. There were four tituli (short ditch protecting the entrance) at each camp, with the exception of Camp XIV, where an inturned clavicula appears to have been combined with each titulus. Structurally little is known about the camps. The ramparts varied between 3 and 4.5 m in thickness, with a narrow berm in front of a single ditch 1.5-2 m wide. By analogy with other examples the ramparts were principally composed of turf with an admixture of earth. Of the 18 camps originally recorded only nine are still visible; five have been destroyed and four are visible only as crop marks from the air.

BIBLIOGRAPHY. G.D.B. Jones, *The Roman Frontier in Wales* (1969) 126ff[MP]; C. M. Daniels & Jones, "The Roman Camps on Llandrindod Common," *Archaeologia Cambrensis* 118 (1969) 125ff[PI]. G.D.B. JONES

LLANIO Cardiganshire, Wales. Map 24. The fort at Llanio, often assumed (without good cause) to be the Bremia of the *Ravenna Cosmography*, lies on a terrace above the W bank of the river Teifi, some 12 km N of Lampeter. It was linked by road to the fort at Trawscoed to the N and to Dolaucothi and Llandovery to the E. A road to Carmarthen has been postulated but not proved.

Recent excavations have revealed three periods of timber barracks in the interior, with a stone principia. In the last phase of occupation a ditch cut across the site of the principia, perhaps marking the reduction of Llanio to a fortlet. The remains of the bath house are still visible S of the fort, and a civil settlement enclosed by a bank lay to the SW. No objects later than ca. A.D. 150 were found either here or in the fort, and copious Flavian pottery indicates the foundation of the fort ca. A.D. 75-85. Oak piles in the bed of the Teifi probably mark the site of the bridge or ford by which the road crossed the river. Two practice camps at Pant-teg Uchaf, farther S, were presumably built by the garrison of Llanio; at some stage this was Cohors II Asturum. The finds will be deposited in the National Museum of Wales, Cardiff.

BIBLIOGRAPHY. W. H. Davies, "The Romans in Cardiganshire," *Ceredigion* 4 (1960-63) 85-95; V. E. Nash-Williams, *The Roman Frontier in Wales* (2d ed. by M. G. Jarrett 1969) 97-98[MI]. M. G. JARRETT

LLANO DE LA CONSOLACIÓN Albacete, Spain. Map 19. Site 2.5 km from Montealegre del Castillo and 5 km from the Cerro de los Santos. The site is extensive and crescent-shaped, with a maximum length of 400 m. At the horns of the crescent are the Iberian settlements of Cerro de los Castellares and Cerrico de Don Rodrigo. The finds, from sporadic excavation of only a small part of the site, are mostly in the National Archaeological Museum in Madrid, the Louvre, and the Albacete Archaeological Museum. The oldest finds, such as an archaic Greek bronze representing a satyr, date from the 6th c. B.C.

Originally the Llano de la Consolación appears to have been occupied by the graves of the inhabitants of the Cerro de los Castellares and of the Cerro de Don Rodrigo. Of the graves excavated in 1946 and 1947, the oldest contain no objects earlier than the 4th c. B.C. but fragments of Iberian statues were reused in their construction. Habitation sites, which do not appear to have been established earlier than the 3d c. B.C. continued into Imperial times. The Roman settlement is documented by finds of Roman incineration graves and of many inhumation graves, dating from the Early Empire.

None of the fragments of Iberian sculpture or architectural elements were found in their original locations; they had been reused as building material either in the Iberian cemeteries or in Roman constructions. Among the sculptures there are more human than zoomorphic representations, and more males, usually warriors, than females. All are busts with the exception of one relief, now in the Murcia Archaeological Museum, representing a native goddess, protectress of horses, a pre-Roman cult well documented in SE Spain.

BIBLIOGRAPHY. P. Serrano, "La Plaine de la Consolación et la ville ibérique de Ello," *Bulletin Hispanique* 1 (1899) 11-19[M]; J. Zuazo, *Trabajos arqueológicos en Montealegre del Castillo* (1920); A. García y Bellido, *La Dama de Elche y el conjunto de piezas arquelógicas reingresadas en España en 1941* (1943); J. Sánchez Jiménez, *Excavaciones y trabajos arqueológicos en la provincia de Albacete, de 1942 a 1946* (1947); id., "Llano de la Consolación (Albacete)," *Noticiario Arqueológico Hispánico* 1 (1952) 92-96; A. Fernández de Avilés, "Excavaciones en el Llano de la Consolación," *Archivo de Prehistoria Levantina* 4 (1953) 195, 209[MPI].

A. BALIL

LLANTWIT MAJOR Glamorgan, Wales. Map 24. Roman villa at Caermead, 1 km NW of the village, discovered in 1887 and excavated in 1887-88, 1938-39, and 1948. The buildings were grouped around a courtyard (ca. 30 x 36 m) and an outer yard (ca. 24 x 51 m) which opened off it and extended N to form an L-shaped enclosure. The dwelling house was of winged-corridor plan (36 x 12 m) forming the N side of the courtyard, with the W wing extended to form its W side. The S side of the courtyard proper was bounded only by a wall, and the E side was open to the outer yard. This outer yard was bounded on the S by an aisled building (30 x 15 m) and on the E by further ranges of buildings, while more small buildings again extended from the rear of the E end of the dwelling house to form its NW corner. Traces of earthworks were found enclosing the whole complex.

The excavations appeared to show that all the main buildings were constructed about the middle of the 2d c. and that the villa reached its greatest prosperity in the 3d c., after which the house and baths were abandoned and occupation was restricted to the aisled building until the end of the 4th c. It was, then, the occupants of the aisled building who, becoming Christianized, used the area of the abandoned buildings as a cemetery (the graves in this cemetery were oriented and devoid of grave goods and so presumably Christian). Reconsideration of the pottery and the sections, however, has suggested that the earlier chronology should be revised, and selective excavation in 1971 has led to further re-evaluation. The probable sequence now appears to be: a pre-Roman homestead in a ditched enclosure; an early Roman timber building (late 1st-early 2d c.); a stone building without corridor (mid-late 2d c.); decline in the early 3d c.; extensive building in the mid 3d c., with additions ca. 300 and the insertion of a mosaic ca. 350; gradual decline in the late 4th c.; and burials much later, not associated with any occupants of the villa.

BIBLIOGRAPHY. W. E. Winks, *Archaeologia Cambrensis* 5 (1888) 413-17; V. E. Nash-Williams, ibid. 102 (1953) 89-163[MIP]; revision: G. Webster in A.L.F. Rivet, ed., *The Roman Villa in Britain* (1969) 238-43; *Britannia* 3 (1972) 300; RCAHM (Wales): *Glamorganshire* (forthcoming). A.L.F. RIVET

LOČICA, see CELEIA

LOCKLEYS Hertfordshire, England. Map 24. The Roman villa 0.8 km to the E of the Belgic and Roman settlement at Welwyn on the Roman road from Verulamium to Braughing. It was discovered in 1930 and excavated in 1937. Two Belgic periods (only the earlier was related to any structural remains) and three Roman ones were distinguished.

In the first Roman period (dated to A.D. 60-70) a rectangular house (21.6 x 7.5 m) was erected and divided into five rooms; the footings were of mortared flint and there were stone bases for a timber verandah not quite parallel with the W front. In the second period (dated to ca. 160) this was enlarged by the replacement of the verandah with a corridor and the addition of rooms at the N and S ends, to produce a typical winged-corridor house at least 30 m long; the wing room at the N end was of two stories. After minor modifications this house was destroyed by fire early in the 4th c. and after a break, in the fourth period (ca. 340), new buildings were erected over the S end. Though no subsidiary buildings were located, a ditch evidently enclosed a considerable area around the house.

Along with Park Street Lockleys has been taken as a type site for the smaller class of villa common in SE Britain, but recent reexamination of the pottery has cast doubt both on the continuity of Belgic and Roman occupation and on the dating of the two earlier Roman phases, both of which, it is argued, should be placed much later.

BIBLIOGRAPHY. J. B. Ward Perkins, *AntJ* 18 (1938) 339-76; reassessment: G. Webster in A.L.F. Rivet, ed., *The Roman Villa in Britain* (1969) 243-46.

A.L.F. RIVET

LODÈVE, *see* LUTEVA

LÖFFELBACH Steiermark, Austria. Map 20. About 3 km W of Hartberg, a complex of ca. 50 x 60 m was uncovered in 1961-62. Its core is a rectangular villa with separate baths, of the 1st-2d c. A.D. It was considerably enlarged, probably in the late 3d c., by the addition of representative annexes, among others a "basilica" (18 x 9 m). The entrances now lead through great octagonal chambers with anterooms of horseshoe-shaped, square, or hexagonal plan. This very complicated ground plan recalls, on a smaller scale, that of the villa at Piazza Armerina.

BIBLIOGRAPHY. W. Modrijan, *Der römische Landsitz von Löffelbach* (3d ed. 1971)^MPI.

R. NOLL

LOKROI EPIZEPHYRIOI Reggio Calabria, Italy. Map 14. The settlement was founded from Lokris in Greece though it is not certain whether by the Opuntii or by the Ozolai, at the beginning of the 7th c. B.C. It is in the vicinity of modern Bortigliola, Locri, and Gerace.

The city flourished during the 6th and 5th c., extending its dominion over territory from the Ionian to the Tyrrhenian seas, including the cities of Metauroo, Medma, and Hipponion. It defeated Kroton in the battle of the Sagra shortly after the middle of the 6th c.

Lokroi was allied with Sparta, Taras, and Syracuse, and aided Dionysios I in the struggle against Rhegion and the Italic league. In 356 it welcomed Dionysios II, sent out from Syracuse, but was soon forced to expel him. During the war between Rome and Pyrrhos, Lokroi changed sides several times. It surrendered to Hannibal in 216 and was conquered by Scipio in 205. Included in the orbit of Rome, Lokroi increasingly diminished in importance until in the course of the 8th and 9th c., following the incursion of the Saracens, it ceased to exist.

Not all of the area inside the encircling wall, which dates to the 4th-3d c. B.C., was occupied by buildings.

Several stretches of the wall, with round and square towers, have been found. The outlines of the walls that regulated the watercourses crossing the city are clear. Neither the location of the port nor the situation of the acropolis has been identified. An urban complex just inside the city wall in the locality now called Centocamere, was laid out in large city blocks separated by roads. It contains remains of water conduits, and in some places kilns for the production of small terracotta objects. A second nucleus of habitations has been located in the section of the city now called Caruso, and this also is characterized by modest buildings with kilns and millstones. Above the modern road to the hill is the theater, with its tiers resting against the natural incline of the terrain. Several parts of the steps and the parodoi were rebuilt by the Romans, with the respective part of the analemma. The plan of the scena is recognizable, with parascenia, and it is probable that behind this was a portico.

Not far from the theater, in the locality now called Casa Marafioti, the remains of a Doric temple have been discovered. It may perhaps be identified with a temple of Olympian Zeus referred to on bronze tablets found a short distance from the theater and from the dromos. Belonging to this temple is an akroterion in terracotta with a horseman and a sphinx below, very similar to contemporaneous akroterial groups from Marasà.

In the little valley between the hills of the Abbadessa and those of the Mannella a deposit of votive objects has been found, particularly pinakes and dedicatory inscriptions. The latter must refer to the Sanctuary of Persephone (Diod. 27.4.3), which flourished especially during the 6th and 5th c. In the vicinity is a treasury building. No trace remains of the temple itself, which numerous clues indicate was on the summit of the hill called Mannella.

Near Marasà a temple has been discovered. It is not certain to which divinity it was dedicated. In its earliest phase, at the end of the 7th c., it was an elongated cella subdivided into two naves. Belonging to it are terracotta slabs with meander motifs. During the 6th c. the cella was embellished by a peristyle, probably hexastyle. In the last third of the 5th c. there was built on the ruins of the archaic temple another larger temple (19 x 45.4 m) with a slightly different orientation. It had a cella, pronaos, opisthodomos, and peristyle in the Ionic order. It was hexastyle with 17 columns on the long sides, and furnished with a gutter having leonine heads in stone, and with akroterial decoration in marble, at the center of which a Nereid between Dioskouroi mounted on horses is sustained by Tritons.

To the NE of the city in the Lucifero section is a necropolis with tombs largely from the 6th and 5th c., but with some later burials. A necropolis from the 7th-6th c. has been found in the Manaci section of the city. Roman tombs found in the area of the hill indicate a shrinking in the city's area.

BIBLIOGRAPHY. A. De Franciscis, "Ancient Locri," *Archaeology* 11 (1958) 206-12; id., "Gli acroteri marmorei del tempio Marasà a Locri Epizefiri," *RM* 67 (1960) 1-28; id., "L'archivio del tempio di Zeus a Locri," *Klearchos* 3 (1961) 17-41; id., "L'archivio del tempio di Zeus a Locri, 2," *Klearchos* 4 (1962) 63-83; 7 (1963) 21-36; 6 (1964) 73-85; 9 (1967) 157-81; id., *Ricerche sulla topografia e i monumenti di Lokri Epizefiri* (1971); E. Barillaro, *L'Akropolis di Lokroi Epizephyrioi* (1960); id., *Lokroi Epizephyrioi, Guida storico archeologica* (1966); id., *Locri e la Locride* (1970); E. Lissi, "Gli scavi della scuola nazionale di archeologia a Locri Epizaefiri" (1950-66) in *Atti VII Congresso Internazionale di*

Archeologia Classica (1961); P. Zancani Montuoro, "Persefone e Afrodite sul mare," *Essays in Memory of K. Lehmann* (1964) 386-95; G. Foti, "Un nuovo documento dell'archivio locrese," *Klearchos* 10 (1968) 109-13; M. Guarducci, "Cibele in un epigrafe arcaica di Locri Epizefiri," *Klio* 52 (1970) 133-38. F. PARISE BADONI

LOMBEZ Gers, France. Map 23. In the Galane district a very large pottery workshop has been excavated. In the 1st c. A.D. it produced many vases with thin walls and sanded, paste, or molded decoration.

BIBLIOGRAPHY. P. Mesplé, "L'atelier de potier gallo-romain de Galane, à Lombez (Gers)," *Gallia* 15 (1957) 41-71; id., "L'atelier de potier de Galane, à Lombez (Gers): fouilles de 1964," ibid. 24 (1966) 161-87.

M. LABROUSSE

LONDINIUM (London) England. Map 24. The largest town in Roman Britain. The site does not appear to have been occupied in pre-Roman times, but owed its importance to its position at the lowest point where the roads built by the imperial government could cross the Thames by bridge, and to its suitability as a terminal for maritime trade with the Rhine, Seine, Loire, and Garonne estuaries. It is probable that Julius Caesar crossed the river here in 54 B.C., and Aulus Plautius in A.D. 43. There was, however, a subsidiary crossing at Westminster, at which the Kentish and Hertfordshire Watling Streets both aim; as these roads are clearly early in date it is possible that the Roman army had a depot at Westminster in 43. No certain trace of a fort of the conquest period there or in London itself has yet been found, but it is inconceivable that the crossings were not guarded.

London itself is described by Tacitus in connection with the rebellion of A.D. 60 as an important center for merchants and merchandise (*Ann.* 14.33); it is likely that a large traders' settlement had sprung up around an army stores-depot—a normal development. Though at that date it had no official urban status, it is probable that already the site's advantages had attracted the offices of the provincial procurator, for Catus Decianus was not in Colchester when the rebellion of Boudicca broke out (Tac. *Ann.* 14.32), and certainly his successor, Julius Classicianus, who appears to have died in office, was buried not at Colchester but in London. At what date the governor's headquarters also migrated to London is uncertain; but that it was there in the 2d c. and probably earlier is suggested by a dedication by the legatus iuridicus giving thanks for Trajan's Dacian victory, and by inscriptions mentioning speculatores and legionaries from all three British legions.

London's importance as a center of population ever since Roman times has limited opportunities for excavation, while continual rebuilding and digging of pits and wells has ensured that excavated remains will be fragmentary. Only since WW II, when many areas of the city were destroyed by bombing, has planned exploration been possible, but even so commercial interests have on the whole proved inimical to careful investigation. The earliest buildings were almost all of timber framing packed with clay, which burnt easily when the settlement was sacked in A.D. 60. A map of these burnt remains indicates that of the two low hills occupied by the later city only the one to the E was originally settled, with some development along the main road to the W. The Wallbrook stream which divides the hills was the effective limit of occupation. The debris of a later fire, however, which destroyed London in Hadrian's reign, ca. A.D. 130, is much more widely distributed on each side of the stream. By this date, though the city

was still unwalled, a large fort of ca. 4.8 ha had been built on the NW outskirts, another indication of the exceptional importance of London in the British province.

A town wall was at length provided early in the 3d c., incorporating two sides of the existing fort and enclosing an area of 132 ha. No trace has yet been discovered of any earlier earthwork surrounding the city, though the majority of Romano-British towns were thus defended late in the 2d c. before walls were added; it is possible, however, that such a defense, if it existed, enclosed a more constricted area. At 132 ha within its walls Roman London was 40 ha larger than either Cirencester, Verulamium, or Wroxeter, its nearest rivals, and in size compares favorably with the majority of towns in the W provinces. The wall was provided with external towers along part of the circuit probably ca. A.D. 370 (into one of which was built much of Classicianus' tombstone); the purpose of these towers was to make greater use of artillery in the defense of the wall and thus save manpower. Thereafter, with successive restorations, the Roman wall continued to defend and bound the city throughout the mediaeval period.

By Hadrianic times, if not some 30 years earlier, a very large forum and basilica had been erected; recent excavations have confirmed that it succeeded a smaller courtyard structure on the same site (also probably a forum), built soon after Boudicca's rebellion. Since the forum-with-basilica is usually found only in administrative centers, it can be deduced that the city gained self-governing status in the 1st c., and as it was not the capital of a tribal civitas it was probably created a municipium. There were also offices of the provincial government, as shown by tile-stamps and a wooden writing-tablet stamped by the procurator's office, and by the recent excavation of a large building in Canon Street, overlooking the Thames, which is best interpreted as the governor's praetorium. The first stages of this building go back to the reign of Domitian. There is, indeed, much other evidence for developments in the later 1st c., including part of a public baths at Huggin Hill; the most illuminating perhaps are the wooden tablets of this date which illustrate the thriving commercial life of the city. Remains indicating the presence of gold- and bronze-smiths have been found, and the cutler Basilis, several of whose knives have been found in London, also almost certainly worked there. Pottery kilns were unearthed by Wren during the rebuilding of St. Paul's Cathedral. The city also certainly served as the main importing and distributing center for the extensive trade in Gaulish terra sigillata, and probably also for Rhineland glass.

Excavation has shown that the Wallbrook stream, which divided the city, was not the extensive harbor once imagined: its bed was only 4.5 m wide, but the margins were subject to extensive flooding. At first the banks were revetted with timber, and continual sinkage led to dumping earth to maintain the levels. Vast quantities of well-preserved metal objects have been preserved in the mud; they suggest a market in the vicinity, though some may be votive offerings. Towards the end of the 2d c. a small Mithraeum was built on the E bank which attracted wealthy worshipers; excavation has recovered some distinguished sculptures in imported marble which had apparently been buried during the reign of Constantine I, perhaps as a precaution against Christian persecution. The building itself continued in use for another generation. The Severan period was also prosperous: a large bath structure in Lower Thames Street is now known to have formed part of a residence built ca. A.D. 200. The city wall erected a little later was built of Kentish ragstone, quarried probably in the vicinity of

Maidstone and brought by barge to London. Part of a river barge with a cargo of this stone was excavated in 1962 at Blackfriars Bridge: the boat seems to have foundered when its cargo shifted.

During the 3d c., after the Severan reorganization, London served as capital of Britannia Superior. At the end of the century a mint, established there by the usurper Carausius, continued to issue coins until 326; in 383 another usurper, Magnus Maximus, reopened the mint for the issue of gold and silver. In 296 the struggle between Carausius' successor and the legitimate regime culminated in the rescue of London by the forces of Constantius I from the danger of looting by the defeated mercenaries of Allectus. The event is immortalized on a large gold medallion of the conqueror which was found at Arras, France, in 1922. It depicts a city gate and the kneeling figure of Lon(dinium) welcoming the mounted Caesar and a galley-load of his men. The recovery of Britain in 296 resulted in reorganization after the pattern of Diocletian. London, which perhaps in 306 received the title Augusta, became the capital of Maxima Caesariensis, one of the four new provinces into which the island was divided, but was also almost certainly the seat of the vicarius Britanniarum, who represented the praetorian prefect in the Diocese of Britain. The *Notitia Dignitatum* tells us that it was also the seat of the Treasury.

Of the fate of the city in the 5th and 6th c. little is known. There is some evidence from the distribution of early Anglo-Saxon cemeteries that an effort was made to defend its approaches by settlements of barbarians who may represent foederati. A 5th c. Saxon saucer-brooch was found in the ruins of the Lower Thames Street bath block, suggesting that this building did not become ruinous much before 500. Other finds earlier than the 7th c. are rare. Though London may never have become completely depopulated, its surviving population shrank considerably. The recovery of its prosperity, which has always depended upon commerce, occurred only with the return of more settled conditions under the established Saxon monarchy.

BIBLIOGRAPHY. R. Merrifield, *The Roman City of London* (1965); id., *Roman London* (1969); W. F. Grimes, *The Excavation of Roman and Mediaeval London* (1968); "Roman Britain," *JRS* 11-59 (1921-69); *Britannia* (1969-). S. S. FRERE

LONDON, *see* LONDINIUM *and* SHIPWRECKS

LONGANE Sicily. Map 17B. A city in the province of Messina 5 km from the coast in the Peloritan mountains between Mylai and Tyndaris. It is on the plateau above the villages of Rodi and Milici between the valleys of the rivers Termini and Mazzarrà. The site seems to have been unknown to the ancient authors, who mention only the river Longanos (river of Termini) on the banks of which the Mamertines were defeated by Hieron II in 268 B.C.; but the name and the existence of Longane are attested by the ethnic on a silver coin (Poole, *Sicily* p. 96) and a bronze caduceus (Roehl *IGA* no. 522) now in the British Museum.

The excavations have identified a settlement and a necropolis of the Middle Bronze Age (18th-15th century B.C.), a necropolis of the Iron Age (9th-8th century B.C.), and considerable remains of a native settlement hellenized by Zankle-Messene, which was destroyed and definitely abandoned in the 5th c. B.C. A complex rectangular structure in stone (sanctuary?) is visible near the d'Alcontres dwelling; remains of pre-Hellenic fortifications in megalithic technique are found on the S hill (Cocuzza or Pirgo), and the acropolis has been identi-

fied to the N on Mt. Ciappa; it is surrounded by a long fortification wall with projecting square towers. The finds are in the Aeolian Museum in Lipari.

BIBLIOGRAPHY. L. Bernabò Brea, "La necropoli di Longane," *BPI* 76 (1967)[MPI]; D. Ryolo & L. Bernabò Brea, *Longane* (1967)[I]. G. SCIBONA

LONGOVICIUM (Lanchester) Durham, England. Map 24. Roman fort of ca. 2.2 ha, 17 km N of Vinovia on Dere Street (NZ 159469). It was probably first occupied under Hadrian or Antoninus Pius, and garrisoned by Cohors I fida Vardullorum ca. A.D. 175 (*RIB* 1083). Reoccupied and rebuilt in the 3d c., perhaps from the reign of Gordian III (*RIB* 1091-92), when it was garrisoned by Cohors I Lingonum and also by a vexillatio Sueborum (*RIB* 1074). But in the 4th c. the garrison was a numerus identified only by the name of its station (numerus Longovicianorum). Metal-working was prominent in the village which grew up around the fort.

BIBLIOGRAPHY. K. A. Steer, *Trans. Archit. and Archaeol. Soc. of Durham and Northumberland* 7 (1936) 200-15; 9 (1939) 112-22; E. Birley, *ArchJ* 111 (1944) 220-21; B. Dobson, *Trans. Archit. and Archaeol. Soc. of Durham and Northumberland* NS 2 (1970) 38.
 J. C. MANN

LONGTHORPE Near Peterborough, Northamptonshire/Huntingdonshire, England. Map 24. Site of a 1st c. Roman fortress discovered by aerial photography in 1961. Though no surface features survive, crop marks show two successive Roman enclosures, the outer and larger surrounded by two ditches and the inner by one. Excavation has shown that the inner is the later of the two, for its ditch is dug through traces of the wooden buildings of the larger enclosure (Fortress I). The evidence of pottery and coins suggests that Fortress I was occupied ca. 43-60 and Fortress II after 60 for a short period. The N gate of Fortress I consisted of two timber towers of six posts each, flanking two portals. The gates thus stood at the rear of a short court protected by towers on each side and by the gate-structure itself at the back. The N gate of Fortress II was simpler, a single 3.6 m portal, perhaps supporting a tower above.

Traces of buildings inside Fortress I consist of narrow rock-cut trenches for wall posts. The buildings do not, for the most part, conform to later Roman army standard types, but two granaries and one auxiliary barrack block as well as the principia and a legionary barrack block have been identified. Fortress I, ca. 10.8 ha, about half the area of a full legionary fortress, belongs to a new class of military site of which seven, all belonging to the 1st c., have been discovered since 1946. The evidence suggests that Longthorpe may have been the fortress from which Petillius Cerialis made his march to Colchester in A.D. 60, and to which he retired after defeat.

BIBLIOGRAPHY. S. S. Frere & J. K. St. Joseph, "The Roman Fortress at Longthorpe," *Britannia* 5 (1974) 1-129. S. S. FRERE

LOPODUNUM (Ladenburg on the Neckar) Germany. Map 20. Situated 10 km NW of Heidelberg in the low plains of the upper Rhine. Suebi settled here directly outside of the Roman Rhine frontier in the 1st c. A.D., prior to the Roman occupation. That the Germanic tribe was already under Roman influence can be documented archaeologically. Probably these Suebi had signed a foedus with the Romans which assured them participation in the defense of the Roman border. A Suebian settlement has been verified, which under Vespasian was directly controlled by Romans. At that time a Roman auxiliary castellum was built and a vicus grew

up, probably in part going back to the Suebian village. After the upper Germanic limes had been constructed under Domitian, the settlement was in the interior of the province Germania Superior created by Domitian. It so quickly became romanized that Trajan allowed the Suebian population self-administration within a civitas (Civitas Ulpia Sueborum Nicretum) and auxiliary troops were withdrawn. In place of the castellum and its vicus a small town named Lopodunum developed as the center of the new civitas. Legally, the town remained a vicus; it did not obtain a municipal statute as a colonia or a municipium.

Among the most important buildings are a forum with a relatively large basilica and a theater. The existence of a large temple has been deduced from column fragments. The living quarters were simple and not extensive. The public buildings also had to serve the rural population of the civitas, which evidently was of considerable importance. Several villas of the Roman type have been discovered. The threat of Germanic invasions led in the first half of the 3d c. A.D. to the construction of a defensive wall, enclosing an area of ca. 35 ha which in part was not built up. In the middle of the 3d c. A.D. Lopodunum fell to the Alamanni. The town was destroyed and the Rhine once more became the border of the Roman Empire. Around A.D. 368 under Valentinian the region reverted for a short time to Roman rule but Lopodunum was not rebuilt. From this time dates the only mention in Classical literature (Auson. *Mos.* 423f). Germanic finds of the 4th c. A.D. come from Ladenburg. It cannot be assumed, however, that there has been a continuous settlement since Roman times, in spite of the name continuity. The mediaeval town (Lobdenburg, Ladenburg) developed out of a royal court which preceded the present Bischofshof.

Very little remains of Classical Lopodunum. The walls of a Roman basilica with three naves are exposed in the crypt of the St. Gallus and also outside the church. The ground plan of the church is in part determined by the basilica. The Roman building was, however, considerably larger than the church. Some ruins of Roman town houses and a gate tower of the auxiliary castellum are visible from the Bischofshof, where there is a museum.

BIBLIOGRAPHY. H. Mylius, "Die römische Marktbasilika in Lopodunum," *Germania* 30 (1952) 56-69[P]; D. Baatz, *Germania* 39 (1961) 87-93; id., *Lopodunum-Ladenburg a.N.* (1962) [*Badische Fundberichte*, Special Issue 1]; R. Nierhaus, "Das Swebische Gräberfeld von Diersheim," *Römisch-Germanische Forschungen* 28 (1966) 185-88; B. Heukemes, *Badische Fundberichte*, Special Issue 10 (1967) 30-33; id., "Die römischen Funde von der St. Sebstianskapelle in Ladenburg am Neckar," *Saalburg-Jahrbuch* 28 (1971) 5-14. D. BAATZ

LORCH, *see* LAURIACUM *and* LIMES RAETIAE

LORENZBERG BEI EPFACH, *see* LIMES RAETIAE

LOT-ET-GARONNE, *see* NÉRAC

LOUGHOR, *see* LEUCARUM

LOUPIAC Dept. Gironde, France. Map 23. This Gallo-Roman villa is on the banks of the Garonne, 40 km upriver from Bordeaux. The first traces (a mosaic) were discovered in 1844; excavation was recommenced in 1953-56, then suspended. The site is now covered over. Over a surface of ca. 1 ha there was first identified a building ensemble, ca. 70 x 70 m sq, divided into a higher and a lower section, with traces of mosaics here

and there. The baths, connected to the villa, have been partly excavated: a pool surrounded by mosaic-floored porticos was apparently the frigidarium. The pool, a rectangle 12.20 x 8 m with a maximum depth of 1.4 m, had ladders for climbing down in the N and E corners. It was surrounded on all four sides by a stylobate ornamented between the column bases with geometric mosaics (checkerboards, imbrication); the decoration of the portico pavements was based on some similar themes (imbricated patterns, cruciform motifs of interlocking circles, checkerboards, diabolos), but also with a few nature motifs (water lilies, ivy leaves, rinceaux). The walls of the porticos were apparently covered with painted plaster; a few fragments ornamented with fish have been recovered. It is difficult to date this luxurious villa precisely, which some have wished to identify as one of Ausonius' "little villas." It must, however, be included among the numerous large rural villas built during the course of the 4th c., and which survived in Aquitaine at least into the 7th or 8th c.

BIBLIOGRAPHY. R. Dezeimeris, *Note sur l'emplacement de la Villula d'Ausone* (1869); J. Coupry, "Informations arch.," *Gallia* 12.1 (1954) 209; 15.2 (1957)[PI] 250. M. GAUTHIER

LOUPIAN Canton of Mèze, Hérault, France. Map 23. A large and luxurious Gallo-Roman dwelling situated at the locality of Les Près Bas near the N bank of the Étang de Thau and about 1 km S of the Via Domitiana. Current excavations have uncovered five rooms completely and four others partially. Almost all these rooms have polychrome mosaic pavements in geometric and storied design; they are very late and laid above more sober Early Empire mosaic floors. This sumptuous villa was mainly occupied in the Late Empire, in the 4th and 5th c. A.D. The architectural remains are protected and on view.

BIBLIOGRAPHY. "Informations," *Gallia* 22 (1964) 493[I]; 27 (1969) 395; 31 (1973) 494-95[I]. G. BARRUOL

LOURO, *see* LIMES, GREEK EPEIROS

LOUSOI Arkadia, Greece. Map 9. Originally an independent town, it later came under the jurisdiction of Kleitor; the site lies between the modern villages of Sudena and Chamaku. According to one legend, it was at a rock spring there where the daughters of Proitos were purified and cured of madness by Melampos; in gratitude their father established the Sanctuary of Artemis Hemerasia, which was surrounded by a deer park. A draught of the spring water was supposed to result in a permanent aversion to wine. Although Pausanias found nothing left at Lousoi, 19th c. travelers reported numerous springs in the area; excavations in 1898 uncovered a fountain-house, bouleuterion, propylaia, and temple. These structures appeared to be of the late 4th or early 3d c. B.C. although other finds indicated that the sanctuary had been in use as early as the 6th.

BIBLIOGRAPHY. Paus. 8.18.7; J. G. Frazer, *Paus. Des. Gr.* (1898) IV 258f; W. Reichel & A. Wilhelm in *JOAI* 4 (1901) 1-89[MPI]; W. B. Dinsmoor, *Greek Architecture* (1950). M. H. MC ALLISTER

LOUSONNA or Leusonna (Lausanne-Vidy) Vaud, Switzerland. Map 20. Vicus on the upper N side of Lake Geneva. The name (*CIL* XIII, 5026) belonged to an oppidum of the Helvetii on the hill between the Flon and the Louve rivulet, where the cathedral now stands. The vicus on the shore (now Vidy) was founded ca. 15 B.C.,

and became an important harbor and market on the waterway from the Rhone to the Rhine, and station on the road from Genava and the Great St. Bernhard pass to Aventicum and Ariolica. It flourished until the incursions of the Alamanni in A.D. 260-65. The harbor remained in use well into the 4th c., but the center of habitation was moved back to the hilltop before A.D. 400, and partly fortified.

The vicus on the shore was laid out on a grid. The decumanus maximus, explored for over 800 m, ran ca. 100 m from the shore, with cardines giving access to the quays. Oblong lots ca. 12 m wide lined the porticoed streets. Public buildings include a forum with basilica and scholae, a main temple, smaller sanctuaries, and a bath. The basilica (over 60 x 23 m) closes off one side of the forum; it probably had an apsidal tribune on one short side. Built against one side of the basilica and opening on the forum were 12 shops. They were probably scholae of corporations such as the nautae l[ac]us Lemanno and nautae Louson[nenses,] attested on inscriptions found in the neighborhood. The forum temple of Gaulish type, square with a surrounding portico (13.6 m on a side), was perhaps dedicated to Jupiter. Three smaller sanctuaries in an enclosure (20 x 15 m) were dedicated to Neptune, Hercules, and an unknown deity.

The residential area was on the inland side of the decumanus towards the hills. One villa has been made into the local museum. One tower of the late Roman fortifications is visible inside the cathedral. Most finds are in the Musée Romain de Vidy.

BIBLIOGRAPHY. F. Gilliard, "Un quartier de Lousonna," *Fouilles de Vidy* 1 (1939); E. Howald & E. Meyer, *Die römische Schweiz* (n.d.) nos. 152-54 (inscriptions); L. Blondel, *Les origines de Lausanne* (1943)[PI]; F. Staehelin, *Die Schweiz in römischer Zeit* (3d ed. 1948) 40-41, 616-19; H. Bögli et al., "Lousonna," *Bibl. Hist. Vaudoise* 42 (1969)[PI]; summary: *Jb. Schweiz. Gesell. f. Urgeschichte* 54 (1968-69) 141-42[P]. V. VON GONZENBACH

LOUTRA, *see* AIDEPSOS

LOUTSA, *see* HALAI ARAPHENIDES

LOW BORROW BRIDGE Westmorland, England. Map 24. Roman fort 16 km NE of Kendal (NY 609013). The platform is visible on the main N road W of the Pennines, 32 km S of Brocavum, and occupies ca. 1.2 ha. It was occupied, probably continuously, from the Flavian period to the early 5th c., and the stone defenses date from the reign of Hadrian or Antoninus Pius.

BIBLIOGRAPHY. E. Birley, *Trans. Cumberland and Westmorland Ant. and Arch. Soc.* 47 (1947) 1-19; E.J.W. Hildyard & J. P. Gillam, ibid. 51 (1951) 40-66.
 J. C. MANN

LOW HAM Somerset, England. Map 24. Roman villa 10.4 km NW of Ilchester, discovered in 1938 and excavated 1945-55. Beginning with a modest house built ca. A.D. 200 it was extended in the late 3d c. and again ca. 330 into a large and luxurious complex, with ranges of buildings facing on a courtyard 30 m across. The main interest centers on a mosaic pavement, 3.9 m square, with scenes from the story of Dido and Aeneas (*Aen.* 1 & 4). It has been suggested that the design was taken from a mosaicist's copybook imported from Africa, but this is disputed and a purely local origin is possible. The pavement is now in Taunton Museum.

BIBLIOGRAPHY. C.A.R. Radford, *Somerset and Dorset Notes and Queries* 25 (1947) 141-43; id. & H.S.L. Dewar, *The Roman Mosaics from Low Ham and East*

Coker (1964); Dewar, *Somerset . . . Queries* 27 (1955) 58-61; J.M.C. Toynbee, *Art in Roman Britain* (2d ed., 1963) 15-16, 203-5; D. J. Smith in A.L.F. Rivet, ed., *The Roman Villa in Britain* (1969) 90, 117.
 A.L.F. RIVET

LUCA (Lucca) Tuscany, Italy. Map 14. Situated on an island in the Serchio river and commanding its valley, early Ligurian Luca reached the Arno to the SE and hence the Etruscan frontier. Occasional discoveries of Ligurian and Etruscan material in the environs of Luca point to the 5th c. B.C. confrontation of the two cultures, probably with alternating Ligurian and Etruscan occupations.

Luca entered history in 218 B.C. after the battle of the Trebbia (Livy 21.59). Established as a colony in 177 B.C., it became a municipium by the Lex Julia municipalis of 90 B.C. (Cic. *Fam.* 113-14). In 56 B.C. it was the scene of Caesar's meeting with Pompey and Crassus at which the first triumvirate was revived. It again became a colony, probably shortly before the battle of Actium, 31 B.C., through the agency of Octavian (*CIL* VI, 1460; Plin. *HN* 3.5). From the time of the late Republic, Luca's importance derived from its location at a crossroads connecting it with Placentia, Luna, Pisae, Florentia and— by way of the Via Cassia—even with Rome. From Diocletian's time, the city's state-run factory engaged in the production of swords.

Luca's Roman remains are considerable. Its rectangular plan is discernible in the extant portions of the circuit wall of the 3d c. B.C., with gates, and later, Roman towers conforming to the usual character of a castrum. A number of great square blocks comprising the wall form part of the foundation of the Church of S. Maria della Rosa and can be seen in the church oratory.

Just outside the wall to the N was an amphitheater of the 2d c. A.D., the oval of which is still traced by the houses built over it in the Middle Ages and by the Via dell'Anfiteatro which circles its perimeter. The several arched gates which interrupt the row of houses must have been entranceways.

Still outside the N wall near the Church of S. Augustine to the W the outline and parts of the substructure of a Roman theater are traced in the modern Piazza delle Grazie. In the Piazza S. Maria Forisportam is a column called *colonna mozza*, which once may have served as the meta of a race course. The church in that piazza incorporates some columns and reliefs from a Roman private building. The ancient forum (Piazza S. Michele), in the center of town, has produced a granite column with an inscription, traces of a portico, a statue of a consul, and various other material.

The National Museum in the Villa Guinigi includes Roman and Etruscan antiquities.

BIBLIOGRAPHY. *EAA* 4 (1961) 701, especially bibliography; M. Lopez Pegna, "L'origine di L," *Giornale Storico della Lunigiana e del territorio Lucense*, n.s. 13 (1962).
 D. C. SCAVONE

LUCENTUM (Alicante) Alicante, Spain. Map 19. A Contestan city on the E coast (Plin., *HN* 3.20, Mela 2.6.93, Ptol. 2.14.14). It was once thought that the name derived from the phrase Ἄκρα Λευκή given in the Classical texts, but that town is more probably Tossal de Manises or Benacantil. Towards the end of the 19th c. the urbanization of the suburb of Benalúa, E of Alicante, uncovered the remains of a Roman city and a fragment of a stone tablet (since disappeared) with the inscription . . .ONINUS L . . ./ . . .S.AVGG.GER.SAR. . ./MVNICIPI LVCENTINI . . ., apparently part of a dedication of the municipium

of Lucentum to Antoninus Pius and to Commodus (A.D. 176-180), thus locating it in the Els Antigons area.

At its height, the city occupied an area of 1 km by 200-400 m along the coast; it was smaller after the crisis in the 3d c., and the W part was used as a necropolis during the Late Empire. Excavation has uncovered a group of buildings identified as a trading post for salt fish, fine wall tiles from Arezzo, S Gaul, and Spain, amphorae, chandeliers, sculptural remains, and Republican and Imperial coins, most of which have been lost. Lucentum was apparently founded in the 1st c. B.C., suffered upheavals in the 3d c. A.D., survived precariously until it disappeared in the 8th c. with the Arab invasion when the town was moved to its present location at the foot of Benacantil.

BIBLIOGRAPHY. D. Fletcher & E. Pla, *Bibliografía arqueológica de Lucentum* (1964); M. Tarradell & G. Martin, *Els Antigons-Lucentum* (1970)MPI.

D. FLETCHER

LUCERA, *see* LUKERIA

LUCINA, *see* EILEITHYIA

LUCUS AUGUSTI (Lugo) Lugo, Spain. Map 19. Roman city of Tarraconensis, in the NW. It was founded by Augustus at the end of the Cantabrian wars, probably as headquarters for cohorts of veterans. Among other sources, it is referred to in Pliny (*HN* 3.3.28; 4.34.111), Ptolemy (2.6.24) and often in inscriptions (*CIL* II, 2570ff). It was the seat of the Conventus Lucensis, one of the three into which Gallaecia was divided. Although the present city is built over the Roman one, the ancient plan, showing traces of a primitive encampment, is recognizable: the cardo and decumanus, and an area of 250 by 350 m capable of lodging five cohorts, or 2500 men. The population gradually clustered around the camp, forming the city enclosed within the walls.

The Roman walls are the most complete and best preserved in Spain, and some of the best in the Empire, although they have undergone several restorations which have partially altered their original appearance. Their strong resemblance to the walls of Aurelian in Rome seems to date them to the 3d c. A.D. Theoretically rectangular in plan, in reality they are in an irregular ellipse because of the terrain. The perimeter is 2130 m, the thickness 6 m, and the height 11-14 m. The walk along the top extends the whole circuit. There are 70 semicylindrical towers. Two of the present gates are Roman and almost intact: they consist of round arches between two towers. All the towers were crowned with three orders of arcades enclosed above by round arches. The construction material is slate and, on the gates, masonry.

The bridge over the Miño river dates from the period of Trajan, but various repairs have destroyed almost all its Roman character. Of the baths there remain only three vaulted rooms built of ashlar and brick. One of the rooms was the apodyterium: a series of niches in the walls covered with round arches must have been used for checking clothes. In several parts of the city there are ruins of water tanks and conduits, made of brick masonry and rip-rap vaults and 1.5 m high. A lost inscription mentioned the existence of a temple to the goddess Celeste, the Carthaginian Venus, which is believed to have been in the present Plaza de Aureliano J. Pereira.

Discoveries of sculpture have been few, but there is a female head in bad condition. Mosaic fragments from the Temple of Diana, patron goddess of the city have been found, and many funeral tablets with reliefs and inscriptions continue to appear in the walls. Most of the discoveries are in the Lugo Provincial Museum.

BIBLIOGRAPHY. J. R. Mélida, "Informe sobre las mu-rallas de Lugo," *Boletín de la Academia de Bellas Artes* (1921)I; id., *Monumentos romanos de España* (1925)I; I. A. Richmond, "The Town-walls in Hispania Citerior," *JRS* 21 (1931)PI; M. Vazquez Seijas, *Lugo bajo el Imperio Romano* (1939)I; id., *Fortalezas de Lugo y su Provincia* (1955)PI; F. Vazquez Saco & id., *Inscripciones romanas de Galicia.* II. *Provincia de Lugo* (1954)I.

R. TEJA

LUGDUNUM (Lyon) Rhône, France. Map 23. Federal capital of the Tres Galliae (Lugdunensis, Aquitania, Belgica), at the confluence of the Saône and the Rhône. When Gallic independence came to an end there were two Celtic settlements: an oppidum on the morainal hill of Fourvière (on the right bank of the Arar, mod. Saône) that grew up around the sanctuary of Lug, the Gallic god of light(?); and a village in the plain at Condate, between the Rhône and the Saône (Strab. 4.186). A Roman colony was founded in 43 B.C. (Tac. *Hist.* 1.65.2). In 12 B.C. it became the seat of the provincial concilium of the 60 Gallic civitates and the federal center of the imperial cult. Seneca (*Ep.* 91) calls it "maxima et ornamentum trium provinciarum." After a fire in A.D. 65 and the disorders of 68-69, the colony flourished again, especially under Hadrian. Partly destroyed in 197 during the war between Septimius Severus and Clodius Albinus, it declined, to the benefit of Trêves. The colony had been extremely important economically because it was the center of Agrippa's road system, and because of the commercial activity on the two rivers. Oriental cults took root there in the 1st c., followed by Christianity in the 1st-2d c. In 470 the Burgundians occupied the town and in 725 it was plundered by the Saracens.

A large number of monuments have been located and preserved, particularly on the Fourvière hill. Vienne (in Gallia Narbonensis) and Lyon are the only cities in Gaul that possess two theaters: a large theater and an odeum. The theater, the oldest in Gaul, was located in 1914 and excavated 1933-50. It was built under Augustus in 16-14 B.C. with stones imported from Glanum; it was 90 m in diameter, had two maeniana, and could accommodate 4500 spectators. Under Hadrian the addition of a third maenianum (108.5 m in diameter), increased its capacity to 10,700. The stage was rebuilt and embellished with columns and statues, and a pit was provided to receive the curtain (a model of the mechanism is in the museum). The cavea, against the hill and facing E, is supported by two galleries of 25 arches and by concentric or radiating walls. A balustrade of green cipollino marble separates the cavea from the orchestra; the latter is 25.5 m in diameter and has four rows of low tiers with a polychrome floor paved with green cipollino, pink breccia, and gray granite in front of them. Two great lateral corridors, vaulted and paved, link the orchestra to the outside. At the rear of the stage (56.5 x 6.25 m) three semicircular exedras took the place of the customary doorways.

Near the theater, on the other side of a square, is the odeum. Used for music and recitations, it was partly roofed, hence the wall, 6.45 m thick, surrounding the cavea. The semicircle (73 m diam.) includes two maeniana, seating 3000. Built against the same hill and supported by vaults in the same manner as the theater, the cavea also faces E, but around the orchestra there are just two low tiers, faced with white marble. Remains of the stage area include the front wall of the pulpitum; the pit into which the curtain was lowered, which was covered with 11 slabs with a square hole cut through them; the hyposcaenium (3.85 m wide) and the base of the scaenae frons which still rises ca. 7 m from the bottom

of the facade. A street encircled the upper section of the cavea; entrance to the theater from this side was by five monumental doors and in the lower section by two passageways that still have their white marble floors and stucco-faced walls on either side. Under the street at the upper level is a large vaulted sewer, the wooden lining of which is amazingly well preserved. Elegantly luxurious, with its orchestra paved with 11 different materials including polychrome marbles, its carved balustrade, its pulpitum of white marble decorated with vines and cherubs gathering grapes, and its outer two-story portico built against the scaena wall, this little theater dates from the time of Hadrian.

Lugdunum had a circus, as we know only from a number of inscriptions and a mosaic of a chariot race; according to an 18th c. drawing it must have been in the Trion district.

The federal amphitheater, however, has been partly excavated on the Croix-Rousse hillside. Built in A.D. 19 under Tiberius by C. Julius Rufus, a priest of Rome and Augustus and a native of Saintes, the amphitheater had only one maenianum at that time; the seats were reserved for the delegates of the Gallic tribes and marked with their names. Entrance was by stairways leading from the upper level to the lower tiers, which held the spectators' seats. The cavea was ringed with a continuous outer wall. The arena was leveled out of the rock and the podium built partly on the ground, partly on an annular vault. This vault, half-circular in plan, is interrupted at the doors and is built right on the ground, a design that occurs only in the reigns of Augustus and Tiberius, never in an amphitheater of the Republican period. In its original form, this building was closely linked with an Ara Romae et Augusti and had an essentially federal and religious purpose. It was enlarged under Hadrian and underwent important changes. Great radiating arches were built to support new tiers of seats: the quarry-stone piers of these arches have leveling courses of double rows of brick (at Lyon, an indication of Hadrianic work). At that time the structure measured 135 x 115.5 m and the arena 59 x 39.5 m. It was here that the martyrs of 117 met their deaths, notably Bishop Pothinus, Attalus, Maturus, and Blandina.

Close to the amphitheater was the Altar of the Imperial Cult (Ara Romae et Augusti), inaugurated in 12 B.C. by Drusus. It is known from a brief description by Strabo (4.3.1) and from its representation on the reverse of coins minted in Lugdunum from 12 B.C. on. The altar stood on a pedestal bearing the inscription ROM·ET·AVG· decorated in front with a crown of oak leaves flanked by two laurels and tripods topped by crowns. Framing the altar were two columns, each supporting a Victory 3.5 m high. Originally 10.5 m high and made of Egyptian granite from Syene, these columns now stand (sawn in half) in the church of Saint-Martin d'Ainay, where they have supported the baldacchino since the 11th c. The Victory statues have disappeared, but a small model in bronze was found in 1886 in the Saône (now in the Fourvière museum). An element from the crowns that the figures held aloft in their right hands was discovered in 1961: it is a half-crown 0.46 m in diameter, consisting of 10 rows of triple spear-shaped leaves in gilded bronze. This form of the altar represents a Hadrianic embellishment.

Lugdunum had two forums. On the hill is the Augustan forum known as Forum Vetus (whence the modern name Fourvière). Built on the flattened summit, it had powerful subfoundations, remains of which are still standing. According to calculations, as yet unconfirmed, it measured 140 x 61.5 m. Under Hadrian this forum was restored and enlarged, along with its two temples: a colossal temple with columns 20 m high (the Capi-

tolium?) and what was probably the municipal Temple of Augustus. Several inscriptions, by Augustan seviri or relating to the imperial municipal cult, suggest this identification. This temple stood on an esplanade supported by a terraced wall (known today as the Mur Cléberg, from the name of the street where it was found); 48 m long and 15 m high, the wall is braced by strong buttresses of quarry stones with double layers of brick. A little later, under Antoninus Pius, the Forum Novum, was built on the nearby plateau called La Sarra; excavated since 1957, it measures 120 x 90 m. Architectural remains, the fragment of an inscription, an ex-voto to Jupiter Optimus Maximus, and the head of a statue of a god make it appear certain that a colossal Temple of Jupiter stood in the middle of the forum.

Behind the great theater and overlooking it, on the other side of the street that runs around the cavea, was a large Temple of Cybele, whose E facade, over 53 m wide, is still standing. Its main elements were located in 1965: a surrounding wall (82.88 x 50.32 m); a monumental porch (12 x 5 m) in the middle of the W facade, reached by a great stairway; and on the axis of the building, in front of the cella in the middle of the E facade, the base of the altar. From the size and the plan of this complex, which covers 4200 sq. m, we may identify this monument as the Campus Matris Deum and compare it to that at Ostia. A ceramic medallion showing Cybele seated on her lion, and four taurobolium altars plus two fragments had already been found at Lugdunum, two of them in this archaeological zone: the earliest, dated December 160, was offered for the welfare of Antoninus and his sons.

Other temples have been located, if not excavated: a Temple of Mercury on the La Sarra plateau (from the time of Claudius), a Temple of the Mother Goddesses on the Montée Saint-Barthelemy on the Fourvière plateau, a Temple of Diana or of the Spirit of the Saône beside that river, a Temple of Mars, and one dedicated to the Matres Augustae in the Choulans quarter.

A bronze plaque excavated in 1524 (now in the Fourvière museum), contains part of a speech given by Claudius before the Senate in A.D. 47 or 48. In it the emperor supported the request of the leaders of the Tres Galliae for eligibility to Roman magistracies and therefore access to the Senate.

The first colony was established by L. Munatius Plancus S of Fourvière around a decumanus (today the Rue Clébert) rediscovered between 1942 and 1965—a fine granite-paved street 312 m long and 8.88 m wide—and a cardo, also paved with granite and 7.7 m wide, part of which has been excavated. The first city grew up in the Les Minimes quarter around these axes; it was protected by a rampart, some remains of which have been identified. Excavations in front of the theater have revealed an open space containing a nearly square building (57 x 55 m); it was razed in the Augustan era (praetorium of Plancus?).

In the 1st and 2d c. A.D. the city developed at three points: the first and most important was on the E flank of the Fourvière hill and the adjacent La Sarra plateau. Some houses have been located or excavated here in a number of places: under the Temple of Kybele and on the plateau, where a residential quarter was built in the 2d c. In 1913-14 the villa of S. Egnatius Paulus, also known as the Villa of the Mosaics, was discovered. It is remarkable both for its mosaic floors and for its plan: a narrow corridor runs between two shops to a great hall, 14 x 12 m (a kind of atrium), inlaid with mosaics. The hall opens directly on a peristyle 22 m square, on the N side of which are seven rooms; the largest one (14 x 7.3 m), in the middle, is decorated with frescos

and a polychrome geometric mosaic in 91 panels. Also noteworthy, on the N slope of the Fourvière hill toward the Saône, in the area called Clos de la Solitude or Clos des Maristes, is a room (6.25 x 5 m) known as the Hall of the Gladiators after graffiti found on the wall frescos. In 1965-67 another housing section came to light in the same area; dating from the 2d c., it is remarkable chiefly for a house with well-preserved frescos called the House of the Sea-Horses, and a nymphaeum that probably belongs to a large estate.

The second urban nucleus is on both banks of the Saône, between the river and the amphitheater which occupies the W flank of the Croix-Rousse hill, and also at the foot of the Fourvière hill. In this area were villas and baths and, at the foot of the cliff, the old settlement of Condate. Here, in 1965-66, an industrial area was found in the Quai de Serin with the workshops and ovens of potters, bronze-founders, and glassmakers built side by side for over 500 m. The potters' kilns are square (Gallo-Roman kilns hitherto located have been round or oval), and recall those of Arezzo; many of the names of the Lugdunum potters are also found at Arezzo. Their products, which date from the beginning of our era, were exported everywhere. Lugdunum at that time was clearly an essential link between the potteries of N Italy, particularly those of Arezzo, and the workshops of S Gaul (Montans, La Graufesenque) and of the Massif Central (Lezoux). In the 2d c., Lyon, like Vienne, probably specialized in the manufacture of vases with appliquéd medallions.

The third urban nucleus is in the Island of the Canabae (now the Ainay quarter and Place Bellecour), which owed its name either to the hutments and military depots of the time of the Gallic Wars or to the storehouses and depots that filled the area in the Roman period. The island was crossed from W to E by a road that bounded, on the S, a section full of wealthy villas which have yielded a large number of mosaics, among them the circus mosaic. On the N side of the road lay a quarter of inns, shops, and storehouses, where many amphorae have been found, made by potters working on the edge of the river. Opposite this section and farther S, on the W bank of the Rhône, another very populous quarter grew up in the Choulans district, which lies at the head of the Rhône waterway at the point where the Narbonne road rejoined the river. Here was the first port of the Rhône merchants and, close by, the docks which have yielded layers of dolia, rivaling those of Marseille. This first port seems to have been abandoned in Hadrian's reign and moved about 1 km upstream, around Saint-Georges, where it was within closer reach of the commercial centers of the Canabae. The docks were moved in the same way.

The urban development of Lugdunum was intimately connected with the growth of its water supply. Two aqueducts were built under Augustus, that of Yzeron (also called Craponne) which fed the hill town of Fourvière, and that of Mont-d'Or which supplied the riverside sections. A third, La Brévenne, built under Claudius, brought water into the low-lying quarter of Les Minimes; remains of it can still be seen, especially of the 25 arches of the lower tier, some of them 20 m high. A fourth, the aqueduct of the Gier, was built under Hadrian to carry water from Mont Pilat, 25 km away, to the La Sarra plateau. Its piers and arcades have been preserved in many places, as have several large reservoirs linked by siphons: the most impressive remains are at Chaponost and Beaunant, and at Lyon itself at the Saint-Irénée Fort.

On the outskirts of the city were several necropoleis, where almost 550 epitaphs have been found. The oldest, possibly pre-Roman, is in the old Saint-Jean quarter, near the Marseille road; a fine bronze oinochoe is one of the most notable finds. The earliest necropolis from the Roman period was developed under Augustus beside the Aquitanian road in the upper city; it extended into the Trion valley over an area 400 m wide and almost 1 km long. Here tombs covered with tiles, blocks of stone topped by cremation urns, sarcophagi, and monumental mausoleums lay side by side. Another necropolis bordered the road that ran NW from Trion, towards Vaise. A third was at Saint-Clair on the banks of the Rhône; here were buried those killed in the amphitheater. Towards the NE the Rhine road was also edged with tombs, as was the road to Italy to the E, in the territory of the Allobroges, where the mausoleum of the Acceptii with its Dionysiac sarcophagus was found. To the S, in the Choulans section, the Narbonne road crossed another large necropolis, which remained in use in the Merovingian era. The stelai from this cemetery often show an ascia with an engraved inscription ending with the words ET SVB ASCIA DEDICAVIT; the meaning of this symbol is still much disputed.

Places of Christian worship soon sprang up in these necropoleis. It is not known where the members of the first community met, but we know that the first Christian cemetery was on the Saint-Irénée hill, a small rise at the W end of the Trion valley. There St. Irénée was buried together with the martyrs Epipodus and Alexander, on the site of a pagan funerary basilica erected to the memory of an infant whose epitaph has been preserved. The saints' tomb was probably a simple memoria, remodeled by Bishop Patiens into a vaulted, half-sunken chamber. Later a basilica was raised over it.

Near the Saint-Irénée hill was the Basilica of the Maccabees (Septem fratrum Macchabaeorum et martyrum gloriosissimorum), consecrated to Bishop Justus, who died in 390 and was buried in the crypt. This church has disappeared, but Sidonius Apollinaris (*Epist.* 5.17) describes it as large and surrounded with cryptoportici; beside it was a receptorium. In the 4th c. a number of churches stood on the banks of the Saône, at the foot of the Fourvière hill, including one embellished by Bishop Patiens ca. 470 which probably became the episcopal church, consecrated to St. John. According to Sidonius Apollinaris (*Epist.* 3.18), it faced E, with two porches, one with three arcades of Aquitaine marble and a second in line with the first, leading to an atrium and a nave with many marble columns. Excavations in 1935 in the substructure of the present Cathedral of Saint-Jean revealed the semicircular apse of the 5th c. building and a few remains of the mosaic floor. On the right bank of the Saône were three more churches, and two on the left bank. Finally, the Saint-Laurent church (discovered 1947) was built on the right bank, at Choulans, on the edge of the Narbonne road. Probably built in the 5th c. on the plan of the Syrian churches, enlarged in the 6th and used most frequently in the mid 7th c., the church and the land around it served as a necropolis in the Merovingian era; 82 sarcophagi have been found, some with inscriptions from the mid 6th to the mid 7th c.

The museum (now under construction on the Fourvière hill near the theater) has, besides the finds already mentioned, several statues. These include a great imperial statue, two draped statues of women, and a torso of Apollo. There are portraits, among them Hadrian and the prefect of the praetorium, Timesitheus; several fine bas-reliefs, particularly those from the Altar of the Confluence, the theater, and the odeum; and some sarcophagi, two of them Dionysiac. Among the toreutic and gold- and silver-plate exhibits are some bronze statu-

ettes, oinochoai, appliquéd ornaments, and a silver goblet with religious decoration (Mercury, Cernunnos, and various symbols). The pottery is abundant and varied: Lyon pottery of the Arezzo type, Aco vases, pottery in relief from La Graufesenque and Lezoux, appliquéd medallions (with mythological, religious, historical, and erotic subjects). Over 100 mosaic floors have been excavated in the Lyon region; they are among the most beautiful in Gaul, and remarkable for their documentary value (the circus mosaic), their rich decoration, and the variety and originality of their geometric motifs.

BIBLIOGRAPHY. C. G. de Montauzan, "Les fouilles de Fourvière," *Ann. Univ. Lyon* 25, 28, 30 (1912-15); id., "Les fouilles archéologiques de Fourvière à Lyon depuis la guerre," *Bull. Ass. G. Budé* (July 1931) 11-24; P. Wuilleumier, *Fouilles a Fourvière à Lyon, Gallia* Suppl. 4 (1951)MPI; id., *Lyon, métropole des Gaules* (1953)MPI; A. Audin, *Essai sur la topographie de Lugdunum* (1958)MP; id., *Lyon, miroir de Rome dans les Gaules* (1965)PI; id. and M. Leglay, "Découvertes archéologiques recentes à Lugdunum, métropole des Gaules," *BAntFr* (1966) 95-109; A. Bruhl & M. Leglay, "Informations," *Gallia* (1962-73).

Monuments: C. G. de Montauzan, *Les aqueducs antiques de Lyon* (1908)MPI; P. Wuilleumier, "Etudes d'archéologie romaine," *Annales Ecole Htes. Etudes de Gand* 1 (1937) 127ff; id. & A. Audin, *Les médaillons d'applique gallo-romains de la vallée du Rhône* (1952)I; A. Duçaroy & A. Audin, "Le rideau de scène du théâtre de Lyon," *Gallia* 18 (1960) 57-82; A. Audin & P. Quoniam, "Victoires et colonnes de l'autel federal des Trois-Gaules; données nouvelles," *Gallia* 20 (1962) 103-16; J. Guey & A. Audin, "L'amphithéâtre des Trois-Gaules à Lyon," *Gallia* 20 (1962) 117-45; 21 (1963) 125-53; 22 (1964) 37-61; H. Stern, *Recueil général des mosaïques de la Gaule* II, *Lyonnaise* 1, *Lyon* (1967)MPI; A. Audin & M. Leglay, "L'amphithéâtre des Trois-Gaules à Lyon," *Gallia* 28 (1970) 67ff; A. Audin, "L'hemicycle de l'Odéon de Lyon," *Hommage à F. Benoît* IV (1972) 110.

Churches: A. Coville, *Recherches sur l'histoire de Lyon du Ve s. au IXe s.* (1928); W. Seston & C. Perrat, "Une basilique funéraire païenne à Lyon," *REA* 49 (1947) 139-59; P. Wuilleumier et al., "L'église et la nécropole Saint-Laurent," *Inst. Et. Rhod., Mémoires et Documents* 4 (1949). M. LEGLAY

LUGDUNUM CONVENARUM (Saint-Bertrand-de-Comminges) Haute-Garonne, France. Map 23. The oppidum of the Volcae Tectosages was conquered by Pompey in 72 B.C. It became the capital of the civitas of the Convenae, which was successively part of the Provincia, of Aquitania, and of Novempopulania. The town obtained first Latin, then colonial status. It was ravaged by the Germanic invasions and was destroyed in 585 by the Franks of Gontran.

Lugdunum commands the valley of the Garonne as it emerges from the Pyrenees. The ancient oppidum was placed on the heights and under the Empire was a double town; it was protected by a rampart in the Late Empire and now bears the Cathedral of Saint-Bertrand. The lower town was built on the plain in a checkerboard pattern, from the beginning of the Empire on.

The lower town has been excavated from 1920 on. It included a number of public monuments: a vast forum built of limestone in the 1st c. A.D., of marble in the 2d; two large bathing establishments, the Baths of the Forum and the Northern Baths; a large basilica turned into a market in Flavian times; squares and porticos, some of which date as late as the 4th c.; a hexastylic temple, no doubt consecrated to Roma and Augustus; attached to this last, an Augustean trophy erected in 25 B.C to celebrate the emperor's victories on land and sea; an amphitheater; etc.

The pieces of the trophy, the inscriptions, the statues, and all the artifacts collected during the course of the excavations are kept on the site at the museum of Comminges.

BIBLIOGRAPHY. R. Lizop, *Les Convenae & Les Consoranni* (1931) passim, esp. 72-101; id. in *Mém. de la Soc. arch. du Midi de la France* 17 (1930) 57-117; 18 (1932) 5-39, 129-90; 19 (1933-39) 5-75, 89-140; 20 (1940-43) 39-99, 205-46; 21 (1945-47) 53-135; A. Aymard, "Remarques sur des inscriptions de *Lugdunum Convenarum*," ibid. 20 (1940-43) 131-88; G. Picard, "Trophée d'Auguste à Saint-Bertrand-de-Comminges," ibid. 21 (1947) 5-52; B. Sapène, "Au Forum de *Lugdunum Convenarum*: Inscriptions du début du règne de Trajan," ibid. 19 (1939) 174-201; "Contribution à l'histoire de l'urbanisme de *Lugdunum Convenarum*: le carrefour du temple," ibid. 24 (1956) 17-31; B. Sapène, "Saint-Bertrand-de-Comminges" (*Lugdunum Convenarum*), *centre touristique d'art et d'histoire, s.l.* (1962). Cf. Michel Labrousse in *Gallia* 5 (1947) 475; 9 (1951) 134; 12 (1954) 216; 13 (1955) 204-5; 15 (1957) 261-64; 17 (1959) 427; 20 (1962) 564-66; 22 (1964) 443-44; 24 (1966) 422-23; 26 (1968) 529-30; 28 (1970) 408; A. Grenier, *Manuel* . . . III.1 (1958) 496-505.

M. LABROUSSE

LUGIO, *see* LIMES PANNONIAE

LUGO, *see* LUCUS AUGUSTI

LUGUVALIUM (Carlisle) Cumberland, England. Map 24. On the river Eden 85 km W of Newcastle and ca. 0.8 km S of Hadrian's Wall (NY 398560). A Roman town developed on the site of a Roman fort, which was at the point where the main road into Scotland W of the Pennines crossed the Eden and met the Stanegate from Corstopitum.

The fort, under and to the N of the cathedral, was occupied from the Flavian period to about the middle of Hadrian's reign. Military occupation of the site was rendered unnecessary by the construction of a fort at Stanwix on Hadrian's Wall, just across the river, ca. A.D. 125. Thereafter the site attracted increasing civilian settlement. Finds under the modern city suggest that the town reached a size of at least 28 ha, within stone walls which still stood in the 7th c. It was the largest town N of York, and it probably achieved city status and became the seat of a bishop. Virtually nothing is visible of the town now, but there is an important collection of material in the Tullie House Museum.

BIBLIOGRAPHY. R. C. Shaw, *Trans. Cumberland and Westmorland Ant. and Arch. Soc.* 24 (1924) 95-109; E. Birley, *Research on Hadrian's Wall* (1961) 136-37; P. Salway, *The Frontier People of Roman Britain* (1965) 41-45. Spelling of name: K. Jackson, *JRS* 38 (1948) 57.

J. C. MANN

LUKERIA (Lucera) Apulia, Italy. Map 14. A city of the Daunii ca. 19 km N-NW of Foggia. According to legend, like Arpi and Canosa, it dates to Diomedes, who carried the Palladion to the site (Strab. 6.264; Plin. 3.102). There is no historical mention of the city prior to 326 B.C. when during the second Samnite war it appears as an ally of the Romans, to whom the city gave aid following the disaster of the Caudine Forks (Livy 9.2). After falling twice into the hands of the Samnites, the city was retaken by the Romans in 314 B.C. (Livy 9.26; Diod. 19.72). The earliest coinage of the city goes back to this date. During the second Punic war the Romans established winter quarters here (Livy

22.9). In the last years of the Republic it was considered one of the most important cities of Apulia (Cic. *Clu.* 69) and played a role in the civil war between Caesar and Pompey (Caes. *BCiv.* 1.24). Lukeria was ascribed to the tribus Claudia (*CIL*, p. 74). The rather uncertain notice of the sources (Plin. 3.104), according to which Augustus established a colony there, appears definitely to be confirmed by the discovery of an inscription in the amphitheater of Lukeria, dedicated to the living Emperor by M. Vecilius Campus.

The recently restored amphitheater (131.4 x 99.2 m) is the best-preserved monument in the city. Some ruins of the ancient city wall remain near the Swabo-Angevin fort, but the remains of a circus and of the theater have been lost. An inscription documents a Temple of Apollo (*CIL* IX, 823). In the Museo Civico are preserved fragments of inscriptions and of statues from the Hellenistic-Roman period, mosaics from a bath building, and from San Salvatore a rich votive deposit which indicates the probable existence of a sanctuary to the chthonian deities.

BIBLIOGRAPHY. W. Smith, *Dictionary of Greek and Roman Geography*, II (1857) 210 (E. H. Bunbury); *RE* XIII.1 (1927) 1565f (Philipp); *EAA* 4 (1961) 706-7 (G. Cressedi).　　　　　　　　F. G. LO PORTO

LULLINGSTONE Kent, England. Map 24. The site of the Roman villa, on the W bank of the Darent river 9.6 km S of Dartford, was first recorded in the 18th c. and excavated in 1949-60. Pre-Roman occupation is attested by finds of pottery and of two coins, but the earliest Roman buildings date from the late 1st c.

The first house was a simple but well-constructed building (at least 21 m N-S x 13.5 E-W) with a projection at the N end and incorporating a cellar. A small circular temple, 4.5 m in diameter, was added at the beginning of the 2d c. on a terrace behind the house. Towards the end of the 2d c. the house was substantially modified by the addition of a suite of baths at the S end and by the conversion of the cellar, now decorated with a painting of three water nymphs, to ritual use. At the same time a second cult room, with a plan similar to that of a small Romano-Celtic temple and with a central receptacle for water, was added N of the cellar; tiled steps led down to these cult rooms. Finally, a detached kitchen (9 x 6 m) containing two ovens, was built 3 m behind the center of the house; it was erected over the foundation burial of an infant. This second and richer phase appears to have been of short duration for, although the kitchen was converted into a tannery, the main house lay derelict from ca. 220.

When occupation was resumed ca. 280 much rebuilding was necessary: the baths were refloored and substantial alterations made to the N end of the house, the stairs to the cellar were blocked, and in part replaced by a hypocaust which also obliterated the second cult room; the cellar itself, redecorated, became the repository for two marble busts, possibly portraits of the earlier 2d c. occupants. Also in the late 3d c. a large granary (24 x 10.5 m) with elaborate underfloor ventilation, was erected S of the house.

Occupation was continuous throughout the 4th c., but further additions and alterations were made. A temple mausoleum, similar to a normal Romano-Celtic temple but containing the burials of a young man and a young woman in lead coffins, was built on a terrace behind the house, S of the earlier circular temple, which was then dismantled. In the house, an apsidal triclinium was built into the W side and both there and in the adjoining room figured mosaics were laid—in the former, Europa and the Bull (with the inscription INVIDA SI TAURI VIDISSET

IUNO NATATUS / IUSTIUS AEOLIAS ISSET AD USQUE DOMOS), in the latter, Bellerophon slaying the Chimera.

Later still (ca. 360-370) the room over the cellar was converted into a Christian chapel, approached through an antechamber and a vestibule with a separate entrance on the N side of the house. The chapel was identified by piecing together the wall plaster which had fallen into the cellar below. Reassembly of the fragments showed that one wall of the chapel had been decorated with a frieze of orantes standing between pillars, while a second wall of the chapel and one of the antechamber each had a design of a Chi-Rho surrounded by a floral wreath. Shortly afterwards the baths were dismantled and the granary reduced to a cart-standing, but the Christian rooms at least continued in use until the early 5th c. when the house was finally destroyed by fire.

Lullingstone does not compare in size with the great houses of the Cotswolds (cf. North Leigh, Chedworth, Woodchester), nor even with neighboring Darenth, but it may be taken as typical of the second class of British villas and has been more thoroughly examined than any other. The religious aspects are of especial interest, and the recovery of the designs on the wall plaster was an important development in archaeological technique. The remains are in the care of the Department of the Environment and substantial parts of the house are open to inspection.

BIBLIOGRAPHY. Excavation reports: G. W. Meates, *Archaeologia Cantiana* 63 (1950) 1-49; 65 (1952) 26-78; 66 (1954) 15-36; 70 (1956) 249-50; id., *Lullingstone Roman Villa* (1955); mausoleum: id., *JRS* 49 (1959) 132-33P; temple: id., *JRS* 51 (1961) 189-90; site guide: id., *Lullingstone Roman Villa* (1963); wall-plaster: K. S. Painter, *BMQ* 33 (1968-69) 131-50; mosaics: D. J. Smith in A.L.F. Rivet, ed., *The Roman Villa in Britain* (1969) 117-18; J.M.C. Toynbee, *Art in Roman Britain*² (1963) 200-1; busts: ibid. 126-28; Christian aspects: id. in M. W. Barley & R.P.C. Hanson, eds., *Christianity in Britain 300-700* (1968) 177-92.　　　A.L.F. RIVET

LUNA (Luni) La Spezia province, Liguria, Italy. Map 14. A Roman colony founded in 177 B.C. W of the Magra river and subsequently part of the Augustan Regio VII. Because of its position at the border between Liguria and Etruria, the city is variously cited by the sources. Portus Lunae has been placed in the gulf of La Spezia by some scholars and by others at the mouth of the Magra river. Passages from ancient sources (particularly Strab. 5.2.5) may be variously interpreted. There is no extant archaeological proof of an Etruscan Luna, even though Etruscan elements in the Ligurian border territory are naturally not excluded. In La Spezia, there is no archaeological evidence of a pre-Roman or Roman center prior to Luni where, on the contrary, in addition to the existence of the ancient city, the presence of a harbor pier, which has since disappeared because of coastal bradyseism, has been verified. Aerial photography has revealed the ancient coastline about 2 km inland from the modern shore. The founding of the colony assured the Romans of possession of the Ligurian coastal zone and guaranteed a base for military expeditions. The oldest epigraphic document from Luna is a dedicatory inscription to M. Acilius Glabrio, the conqueror of Antiochos at Thermopylai. A later dedicatory inscription appears on a statue base at Luni (*CIL* XI, 1339) to M. Claudius Marcellus, consul for the second time and conqueror of the Ligurians in 155 B.C. The city was part of the tribus Galeria and is always mentioned as a colonia. Augustus was responsible for a second settling of the colony (*CIL* XI, 1330).

The major source of the city's wealth came from the

nearby marble quarries. The marble was loaded at Luni and exported widely throughout the Roman world. The quarries were originally a part of the colony of Luna, but by A.D. 27 they had become imperial property. Strabo notes that the Magra river transported to the city large trees that were excellent as construction beams. Luna shipped out the large Luna cheeses, mentioned by Pliny and by Martial, and the renowned Luna wine was considered by Pliny the best in Etruria. Numerous inscriptions give ample testimony to civil and religious offices, boards, and Roman and oriental cults throughout the Imperial period.

Activity did not cease with the fall of the W Roman Empire since the city remained outside the great invasion routes. Luna was the center (even more important than Genoa) of Italia Maritima, held by the Byzantines, and was the seat of Aldius the magister militum, and of a bishop who had administrative and political power in addition to religious authority. The city was to participate during the 7th and 8th c. in important councils (such as the one at Milan in 649) and represented, under Longobard sovereignty, the rights of the city, coined its own money, although of base alloy. With the Norman and Saracen invasions, with the gradual silting of the harbor, and above all with the spread of malaria, Luna fell and was abandoned.

Archaeological excavations were initiated during the reign of Carlo Alberto in 1837, but only in the last few years has large-scale scientific exploration been undertaken.

The city plan is square, irregular only on the E side toward the sea. The surrounding walls vary in structure: large masses of rock are followed by brickwork, belonging to different phases, but today covered over. The E gate has been partially excavated. The Via Aurelia, formerly the Aemilia Scauri, according to Strabo built by the censor Aemilius Scaurus in 109 B.C., probably over an already existing road, crosses the city and constitutes the decumanus maior. The cardo maximus, totally excavated, a major artery of communication with the harbor, stops in the central sector near a large square paved with large marble slabs. A public building in the square looks toward the forum, which is skirted by the Via Aurelia. In that area, near the ruins of the so-called Temple of Diana and the remains of a deposit of dolia defossa, a large hall has been discovered along with an area of fountains with rich architectural decorations and a monument with fragments of a large dedicatory inscription and a splendid marble portrait in relief of Augustus wearing the crown of the city. A fine villa is being excavated here. The ruins of two large temples are visible. From the one near the N walls the recovery in 1842 of terracotta facade groupings and architectural decorations dating to the 2d c. B.C., suggested at the time that the building was the Capitolium. These terracottas are no longer considered Etruscan but neo-Attic, produced in the Roman milieu. The second temple is in the center between a portico which opens on the Via Aurelia and a short side of the forum along the axis of the cardo. The polygonal substructures of this temple remain; a few terracottas and bronzes buried with the inscription "Fulgur conditum" give evidence that the temple was struck by lightning. This building is now believed to be the Capitolium. It is set in a large, unified plan including the porticoed forum and the adjacent areas. The best documented artistic periods are the Augustan and the Julio-Claudian represented by the regular urban plan itself, by portraiture, by statuary, and by architectural decorations. Evidence from pottery and coins is quite ample during the whole period of the Empire.

The theater has been discovered in the NE corner. It is of modest dimensions and badly preserved. Beyond the walls is the large amphitheater. In the city, a house with mosaics has been uncovered and the remains of a basilica was partially excavated in the last century. From the basilica comes a series of bases with inscriptions of magistrates and emperors of the 3d c. and 4th c. A.D.

The archaeological finds are, for the most part, preserved in the Civic Museum at La Spezia, in the Archaeological Museum in Florence, at the Academy of Fine Arts in Carrara, and in the National Museum at Luni. However, much material has been scattered throughout Italy and other countries.

BIBLIOGRAPHY. C. Promis, *Dell'antica città di Luni e del suo stato presente* (2d ed., 1857); G. Sforza," Bibliografia storica della città di Luni e suoi dintorni," *Memorie Acc. Scienze* 60 (1910); L. Banti, *Luni* (1937); R. U. Inglieri, *NSc* (1952) 20ff; M. Lopez Pegna, *Luni, il golfo di Selene, la via Emilia di Scauro* (1964); P. M. Conti, *Luni nell'alto medioevo* (1967); G. Schmiedt, *Atlante degli insediamenti umani in Italia*, II (1971) tav. 123; A. Frova, ed., *Scavi di Luni* (1973)^{MPI}. A. FROVA

LUNEÇI, see LIMES, SOUTH ALBANIA

LUNI (Luni sul Mignone) Italy. Map 16. Acropolis at the foot of the Tolfa mountains near the river Mignone, ca. 24 km inland from Tarquinia. The site was probably inhabited without interruption from Neolithic times to the 14th c. A.D. when it was abandoned, possibly as a consequence of the Black Death. The name Luni can be traced back to the 8th c. A.D. (Liber Pontificalis, pontificate of Gregory II, 715-731) and was almost certainly also the ancient name of the place. The tufa plateau (550 x 140 m), separated from its surroundings by deep river-eroded valleys, is a natural fortress. Excavations have brought to light a small Neolithic settlement of the Sasso-Fiorano culture (ca. 3500 B.C.), huts of the Chalcolithic Rinaldone culture (ca. 2000 B.C.), and above all a village of the Apennine Bronze Age culture (ca. 1300-800 B.C.). The Bronze Age settlement consisted not only of huts but also of houses, the largest (5 x 42 m), sunk into the tufa bedrock to 2 m of depth. Five sherds of imported Greek pottery (Mycenaean III A:2-III C) were found in stratigraphic context in the houses. They are the northernmost Mycenaean finds so far known in Italy and of basic importance for the chronology of Latium and S Etruria during the second half of the 2d and the early 1st millennium B.C. In the Iron Age there was a large village of huts on the acropolis. A remarkable building of the same period has been found on the W point of the hill. It is of monumental dimensions (ca. 9 x 18 m) and sunk into the tufa bedrock to a depth of 6 m. This building, so far unique, was probably the residence of the leader of the village and possibly also a cult center. Superimposed was a small sanctuary, dated to the 5th c. B.C., with a temenos and a cave. A Christian chapel was erected over the sanctuary. In the Etruscan period Luni was one of Tarquinia's fortresses at the S border of its territory. It was fortified at the end of the 5th c. B.C. with a city wall of tufa ashlars and a small castle. Remains of dwellings of the archaic period have been found. The remains of the Roman and mediaeval periods are scanty.

BIBLIOGRAPHY. C. E. Östenberg, "Luni sul Mignone. Prima campagna di scavi," *NSc* 15 (1961) 103ff; id., "Luni and Villa Sambuco," *Etruscan Culture* (1962) 313ff; id., *Luni sul Mignone e Problemi della Preistoria d'Italia* (*Acta Instituti Regni Sueciae*, 4, XXV; 1967); id., "Edificio monumentale dell'età del ferro scoperto a Luni sul Mignone" (Atti del primo simposio di protostoria d'Italia; 1967) 157ff. Of the final publication, *Luni sul*

Mignone. Results of excavations conducted by the Swedish Institute at Rome and the Soprintendenza alle Antichità dell'Etruria Meridionale (Acta Instituti Romani Regni Sueciae, 4, XXVII) Vol. II, fasce. 1 is in print: Torgun Wieselgren, The Iron Age Settlement on the Acropolis. C. E. ÖSTENBERG

LUNI (near La Spezia), see LUNA

LUNI SUL MIGNONE, see LUNI

LUPIAE (Lecce) Apulia, Italy. Map 14. An ancient city of Salento on the Via Traiana ca. 40 km S of Brindisi. Strabo (6.282) places it, along with Rudiae, among the cities of the interior as does Pliny (*HN* 3.101), but Ptolemy (3.1.12) considers it a coastal town, even though it was ca. 12 km from the sea. In a passage (6.19.9) which has posed not a few perplexing questions, Pausanias says that the city was originally called Sybaris, perhaps confounding Lupia or Lopia with the Roman colony of Copia in Lucania. However, it appears certain that the city now covered by modern Lecce was originally a native center whose founding has been attributed by the ancients to the king of the Salentini, Malennius, the son of Dasumnus (Iul. Cap. M. Ant. 1). The Romans probably founded Lupiae after the capture of Brindisi in 267 B.C. Octavian spent some time there on his return to Italy after the death of Caesar (App. *BCiv.* 3.10). The city was enrolled in the tribus Camilia, was raised to the status of a municipium at an unknown date, and under the Antonines it had the title of a colony. According to Pausanias (6.19.9), the harbor was most likely constructed by Hadrian and must have been along the beach at San Cataldo where the remains of a pier are visible.

Precise evidence for the first settlement comes especially from tombs which date from the 5th c. to the 3d c. B.C. An Attic black-figure kylix (late 6th c. or early 5th c.) found at Lecce is, at the present stage of investigations, the most ancient document of the commercial contacts of the city with the archaic Greek world. Beginning in the second half of the 5th c. B.C. and particularly in the 4th c., the city came under Tarentine influence, as attested by the relief frieze of the well-known Palmieri hypogeum and by the frequency of the proto-Italic and Apulian pottery finds of Tarentine workmanship. However, the language remained Messapic, to judge from the numerous inscriptions gathered from the necropolis.

Imposing monuments of the Roman city have been preserved, such as the amphitheater, the theater, and scattered remains of public and private buildings from which have come marble statues, inscriptions, and mosaics. The amphitheater, constructed between the 1st and 2d c. A.D., measured 102 by 83 m, with an arena of 53 by 34 m. It had a seating capacity of ca. 25,000. Partially set into the tufa and partially raised on arches in opus quadratum, it was of impressive proportions. It had a double order of maeniana, largely restored today only on the lower order, which was separated from the arena by a high wall with a parapet decorated in relief (mostly preserved) with lively scenes of combat between men and animals. Among the marbles which come from this monument, a copy of the Athena of Alkamenes is noteworthy. It is kept in the Museo Castromediano. The theater is perhaps of the Hadrianic period and not very large, measuring 40 m in diameter outside the cavea. It is well preserved and had a seating capacity of 5,000. Also well-preserved are the orchestra, paved with large, regular stone slabs, and one of the parodoi. The stage, 7.7 m deep and 0.7 m above the orchestra floor, must have been richly decorated. Some fragmentary marble sculptures have been found, generally copies of Greek origi-

nals, such as the torso of an Amazon of the Berlin type, another torso of the Borghese Ares, a likeness of Athena-Roma with a shield, and other works collected in the Museo Provinciale.

BIBLIOGRAPHY. C. De Giorgi, *Lecce sotterranea* (1907); K. Miller, *Itineraria Romana* (1916) 222; *RE* 13.2 (1927) 1842; M. Bernardini, *Il Museo Provinciale di Lecce* (1958); id. *Lupiae* (1959); O. Parlangeli, *Studi messapici* (1960) 134; *EAA* 4 (1961) 522 (M. Bernardini); G. Susini, *Fonti per la storia greca e romana del Salento* (1962) 138; P. Zancani Montuoro, *RendLinc* 28 (1973) 1ff. F. G. LO PORTO

LURG MOOR Renfrewshire, Scotland. Map 24. Roman fortlet on Lurg Moor, probably a survivor of a chain of posts built ca. A.D. 140 to guard the W flank of the Antonine Wall. Rectangular with rounded corners, it measures 48 by 42 m over the rampart and single ditch. The gate is in the center of the S side and a road can be traced S from it. Antonine pottery has been found immediately SW of the fortlet, and there are indications of a possible annex.

BIBLIOGRAPHY. *JRS* 43 (1953) 105. K. A. STEER

LUSSONIUM, see LIMES PANNONIAE

LUTETIA PARISIORUM later PARISIUS (Paris) France. Map 23. Chief city of the Gallic civitas Parisiorum in Lugdunensis Quarta, becoming Parisius in the 5th c. A.D. The Gallic oppidum was on the Ile de la Cité, which at that time was smaller than it is today and was linked to the riverbanks by two bridges; it seems to have been occupied by the Parisii ca. 250-225 B.C. During the Gallic Wars the inhabitants burned the bridges (52 B.C.). The Gallo-Roman city was rebuilt on the island but it developed mainly on the hill on the S bank of the river (the Montagne Sainte-Geneviève); here public buildings were put up, the N plain, low-lying and in part easily flooded, remaining uninhabited in the Early Empire, the city's prosperous period. Laid waste by the barbarians ca. A.D. 275, the city acquired a fortified keep when a surrounding wall was built on the Ile de la Cité. Nevertheless, contrary to what has long been stated, the Gallo-Roman city almost certainly was not confined to the island in the Late Empire; on the contrary, a sizable part of the S bank continued to be inhabited. Lutetia played an important military role in the 4th c. Julian and Valentinian stayed there, and later Clovis made it the cathedra regni.

During the Early Empire, the cardo, which was oriented N-S, joined the road leading in one direction to Senlis and in the other to Orléans—the route the Rue Saint-Martin and Rue Saint-Jacques follow today. Paving from the period of the Early Empire has been found underneath the latter street. Several decumani branched out from it to the S as well as some diagonal roads, necessitated by the slope of the ground. It is not certain whether in the Late Empire a road was built to the W leading to Saint-Denis, parallel to the N section of the cardo. The Ile de la Cité has kept hardly any coherent remains from the Early Empire: its topography was first completely changed and the ground level raised during the rebuilding after the rampart was built in the Late Empire, then it was destroyed. What remains are the foundations discovered in the Palais de Justice in 1848, those uncovered in 1847 at the Parvis Notre-Dame, and in the same area a paved floor and some walls excavated in 1965-70. There is nothing to prove there was a temple underneath the present Cathedral of Notre Dame, the Nautae pillar—discovered below the chancel in 1711—being made of reused blocks. The

Early Empire necropolis, which used to be known as fief des Tombes and was partially investigated in the 19th c., was excavated again in 1957-60. Situated to the S alongside the Orléans road, it contained no tombs later than the end of the 3d c. All the public monuments were on the S bank, the Montagne Sainte-Geneviève, while the new buildings spread down the hill, not up it away from the island as used to be thought.

The forum, which was excavated in the 19th c. and whose S section was again studied in 1970, seems to have replaced a circular building of the 1st c. A rectangle 782 x 100 m, it gave onto the Orléans road on its small E side and had a central platform, which no doubt served as the base of a temple or basilica, with an open area around it edged by a wall; backed against the wall were stalls with a portico above them. Graffiti make it possible to date the retaining wall of the central platform from the beginning of the 2d c. at the latest. This wall had a gallery, which was painstakingly filled in from the time it was built along the greater part of its length.

Lutetia had three baths. Those to the N, the Cluny baths, are still well preserved. They were built on a rectangular plan, the long side lying perpendicular to the cardo, and measured 100 x 65 m on the exterior. Inside, the rooms were laid out according to the circular type. The frigidarium still has its groined vault; it is supported partly by large consoles representing ships' prows, no doubt a link with the guild of the nautae parisiaci that put up a votive pillar in Tiberius' reign, some elements of which were found to have been reused in the Cité. Judging from their method of construction (walls of mortared rubble faced with small blocks and banded with brick), these baths seem to go back to the last quarter of the 2d c. or the first quarter of the 3d c. (excavations carried out in the 19th c. and in 1946-56).

The E baths, which are close by but to the E of the cardo, were slightly smaller (75-80 x 68 m), with circular hot rooms. Excavated in the 19th c. and from 1935 to 1938, they are incompletely known. Built very probably a little earlier than the N baths, they replaced an earlier building. Finally there are baths, measuring 60 x 40 m, a little S of the forum. Long believed to be a villa, when they were excavated in the 19th c. they were found to be decorated with painted walls and marbles. They were built on the site of an earlier building and seem to be later than the forum. They got their water from an aqueduct coming from the S, which was 16 km long, with a 330 m bridge; traces of piers are still to be seen. To the E was an amphitheater with a stage. Its oval arena measured 52 x 46 m. A 1st c. monument, it was discovered in the 19th c. and restored. Some of the original parts are still standing, and some drums of the half-columns decorating the cavea have been found. A small theater (72 x 49 m) was also built, probably shortly after the N baths, W of the amphitheater near what is now the Jardin du Luxembourg, which probably was the wealthiest section of the city. Seventy-three Gallo-Roman votive deposits were excavated in 1972-73. The suggestion that there was a circus, at least to the E on the banks of the Seine (the old Halle aux vins), must in all reasonableness be rejected.

During the Late Empire, after the invasions of the late 3d c., a fortified keep was built in the Cité. About 300 the Cité was enclosed in a rampart; its foundations have been located to the N, E, and S (in the 19th c. and from 1965 to 1970). They were probably composed of layers of quarrystone bonded with mortar and overlaid on top with a dry masonry of more or less recut blocks, many from the monuments of the upper city (stelae, architectural fragments). Treasure dating from ca. 275 was

discovered in 1970 on the S side of the city outside the rampart. The island buildings were replaced by new ones erected on the risen earth, which caused the ground level to rise from 0.80 to 2 m. Various fragments of these buildings have been unearthed: two rooms heated by a hypocaust are preserved in the Parvis Notre Dame along with the furnace (excavations of 1965-70), and in particular, a well-built wall of mortared rubble faced with small blocks and flanked by five large buttresses; it stands at one end of the S bridge (the Petit Pont) and looks as if it had once been part of a public building.

A Christian cemetery was located on the S bank, to the extreme E (Saint-Marcel), when the area was excavated. A late hypocaust floor was discovered in the Jardin du Luxembourg in 1957. These finds, together with a study of the building of sanctuaries in the Merovingian period, have recently led to the conclusion that Lutetia still remained on the S bank in the Late Empire while some construction started to develop on the N bank. In the Early Empire a sanctuary dedicated to Mercury stood outside the city, on the Montmartre hill, and next to it some buildings and a small necropolis.

BIBLIOGRAPHY. P. M. Duval, *Paris antique, des origines au III^e siècle* (1961), with critical bibliography; id., *Inscriptiones antiques de Paris* (1961); id., "Lutece gauloise et gallo-romaine," *Paris: croissance d'une capitale* (1961); M. Fleury, "Paris du Bas-Empire au début du XIII^e siècle," in *Paris: croissance d'une capitale* (1961); id., "Informations arch.," *Gallia* (1967, 1970); id., "Comptes rendus de fouilles," *Procès-verbaux de la Commission du Vieux Paris* (1961ff); id., *Carte arch. de Paris* (1^{er} sér., 1971); id., *Annuaire de la IV^e Section de l'Ecole pratique des Hautes Etudes* (1972-73); id., *Paris monumental* (1974). M. FLEURY

LUTEVA (Lodève) Hérault, France. Map 23. A town of Narbonese Gaul which for a while bore the name of Forum Neronis (Plin. 3.37), given to it in 45 B.C. by Tiberius Claudius Nero. In the Late Empire, it became the capital of a civitas, then the see of a diocese. The town, at the edge of the plain of Languedoc and at the foot of the Causses, was a way station on the road that ran from Agde to Rodez by way of Cessero (St-Thibéry), Piscenae (Pézenas), and Condatomagus (Millau), and for this reason played a considerable role in the economy of the province. Luteva was an important market for export of the ore of the Cévennes, resin from the Causses, wool produced intensively in the interior and worked especially at Pézenas (Plin. 8.191), and the ceramics of La Graufesenque (near Millau) and Banassac.

The modern town masks the ancient one, which has been localized, however, by some chance discoveries. At the edge of the town, recent exploration has uncovered the large blocks of a structure thought to have been a mausoleum.

BIBLIOGRAPHY. *Carte archéologique de la Gaule romaine*, fasc. x, Hérault (1946) 22, no. 71; "Informations," *Gallia* 22 (1964) 491-93¹. G. BARRUOL

LUXEUIL, *see* LUXOVIUM

LUXOR, *see* THEBES

LUXOVIUM (Luxeuil) Haute-Saône, France. Map 23. The name appears only in the 7th c. in the *Vita Colombani* of the monk Jonas, but two Roman dedications to a god Luxovius or Lussoius, who must have been the eponym of the place, are known. In them he is associated with a goddess Brixta or Bricta (not Brixa-Bricia, as has been incorrectly read).

The site is rich in hot and cold springs, used since antiquity. Antique catchments and the remains of a Gallo-Roman bath house have been discovered. The cult of the springs is attested by hundreds of traditional Gallic votive statuettes made of oak, as well as by dedicatory inscriptions made not merely to the divine pair mentioned above, but also to the healing divinities Apollo and Sirona, associated as at Hochscheid. Another religious artifact is a curious group representing Jupiter on horseback, the anguiped monster, and a third person attached to the horse.

From perhaps the end of the 1st c. on, Luxeuil had a workshop producing terra sigillata, but its output was not used very widely. The numerous stone monuments found on the site and now in the museum at Luxeuil (classic funerary stelai and house-shaped stelai) should likewise be considered as local products.

Situated at the extreme N of the territory of the Sequani, at the foot of the Vosges which supply the sandstone for its monuments, Luxeuil appears to have been oriented more towards the Vosges region than towards the Jura.

BIBLIOGRAPHY. J. Roussel, *Luxovium ou Luxeuil gallo-romain* (1924); L. Lerat, "Le nom de la parèdre du dieu Luxovius," *Revue Archéologique de l'Est* (1950) 207-13; id. & Y. Jeannin, "La céramique sigillée de Luxeuil," *Annales littéraires de l'Université de Besançon* 31 (1960); id., *118è Congrès Archéologique de France* (1960) 98-104. L. LERAT

LUZECH Lot, France. Map 23. L'Impernal de Luzech, which some believe to be Uxellodunum, was an oppidum of 8 to 10 ha, defended by a Gallic rampart with timber beams. It was a high place consecrated by a square temple of Celtic tradition. At the end of the Gallic period and in the 1st c. of the Empire, it enjoyed genuine commercial and metallurgical activity. Its abandonment seems to date to the beginning of the 2d c. A.D.

BIBLIOGRAPHY. A. Viré, *B.S.P.F.* 10 (1913) 687-711 & figs. 1-16; 18 (1921) 82-83; 20 (1923) 56-76 & figs. 1-13; *Les oppida du Quercy et le siège d'Uxellodunum (51 av. J.-C.)* (1936) 22-26 & figs. 11-17; M. Labrousse in *Gallia* 9 (1951) 139-40; 12 (1954) 230; 15 (1957) 277; 17 (1959) 436-37 & figs. 34-35; 20 (1962) 592; 22 (1964) 462; R. Tardieu, "Fouilles de l'Impernal: Bâtiment VI, vestiges d'industrie métallurgique," *Bull. de la Soc. Et. du Lot* 75 (1954) 203-15; id., "Fouilles de l'Impernal (suite)," ibid. 88 (1967) 85-95; H. Pélissié, *De la Barbacane au Pont du Diable. Guide du touriste et de l'archéologue à Luzech* (rev. ed. 1967) 81-120.

For the identification with Uxellodunum, cf. E. Albouy, *Un point d'histoire gallo-romaine particulièrement controversé: Uxellodunum, essai d'identification* (1958). M. LABROUSSE

LYCHNIDOS (Ochrid) Yugoslavia. Map 12. An Illyrian city at the NE end of Lake Ochrid in Macedonia.

It first appears in history in Polybios' accounts of the wars between Rome and Macedonia. It was the W terminus in Macedonia of the Via Egnatia, one of the most important highways in the Roman Empire. The town was part of the province of Macedonia until the organization of the province of Epeiros under Diocletian and it became a part of Illyricum during the reign of Theodosius. The city was sacked in 479 by Theodoric and the Goths and was devastated by an earthquake in 514. It was represented by bishops at numerous ecclesiastical conferences in the 4th to 6th c.

Part of the ancient theater has been revealed near the E wall of the mediaeval citadel and parts of two Early Christian churches have been found, one of them below the Church of Saint Sophia. The mediaeval and modern town lies directly above the ancient site. The National Museum in Ochrid houses inscriptions, sculpture, and a variety of burial gifts from both early and late Roman graves found in the vicinity. Some of the more recent discoveries from the nearby necropolis of Trebeništa are also in the museum.

BIBLIOGRAPHY. V. Lahtov, *Problem Trebeniške Kulture* (1965)MPI. J. WISEMAN

LYDAI Turkey. Map 7. Site in Lycia, on the promontory of Kapı Dağı, on the W side of the gulf of Fethiye. The name Lydai is abundantly proved by inscriptions found on the spot, although the city is mentioned only by Ptolemy (with variant Chydae) and in the *Stadiasmus* (where it is assigned to Caria) in the form Clydae. A silver coin of the 4th c. B.C. inscribed ΛΥ has been ascribed to Lydai, but this is doubtful; otherwise there is no coinage.

The site is approached from the shore on the E by an ancient paved road still surviving in part. The extant ruins, of Roman and Byzantine date, lie in a valley running N-S in the center of the headland; on the acropolis hill, at the S end, is a small fort. A late wall bars the isthmus on the N, but there is no city wall. The site of the agora is recognizable, and on the hillside to the W the hollow of a theater is visible, though of the building itself nothing remains. Otherwise the ruins consist almost entirely of tombs, including a number of large and handsome mausoleums, fairly well preserved; there is one tomb of Lycian type. The N part of the site, according to inscriptions, constituted the deme of Arymaxa.

BIBLIOGRAPHY. J. Bent, *JHS* 9 (1888) 83ff; 10 (1889) 51ff; *TAM* II, 1 (1920) 41, 49; P. Roos, *Opuscula Atheniensia* 9 (1969) 75-83. G. E. BEAN

LYDNEY Gloucestershire, England. Map 24. Roman temple and settlement founded after ca. 364-367 in the SW part of an Iron Age hill fort, in private grounds 0.3 km W of the town; application to view must be made in advance to the Agent, Lydney Park.

The Roman buildings comprise a) the temple; b) the long building or dormitory adjacent; c) the guest house, now covered; and d) the baths. All were enclosed within a precinct wall. A small iron mine of Roman date can be seen to the NE. The temple (ca. 27 x 19.5 m) faces SE. The oblong cella, reached by steps, was originally arcaded, but later, after subsidence, made solid; at the NW end is a triple sanctuary. Surrounding the cella is a wide ambulatory, the outer wall containing five large recesses or chapels, two on either side and one behind the sanctuary; they are unusual and may have served for incubation, as subsequently did the long building on the NW with its dozen or so cubicles.

A mosaic pavement in the cella, now destroyed, had an inscribed panel giving the name of the god worshiped here, Nodens. The dedicator was an officer in charge of the (Bristol Channel?) fleet supply-depot, acting through an interpreter on the governor's staff. Other inscriptions also name Nodens, whose cult seems to have been principally concerned with healing, to judge from the numerous ex-votos found. The Lydney Dog, a small bronze figurine housed with other finds in the private museum at Lydney Park, is one of the finest known from Roman Britain.

The guest house was a courtyard building (ca. 42 x 39 m) containing numerous rooms in three ranges; the fourth side, facing the NE side of the temple, was devoted to a large hall or concourse. Many of the rooms had mosaic floors of geometric type, as did those in the baths to the NW. The bath house, of the normal *Reihen-*

typ, seems extremely large (36 x 21 m) in relation to the guest house, and it is possible that ritual bathing formed part of the sequence of rites. The water supply was derived from a stone reservoir outside the temenos.

Though not built until A.D. 364-367, the temple and its associated buildings do not seem to have been long in use; occupation declined markedly in the latter years of the 4th c., and a 5th c. brooch indicates a subsequent frequentation of the site, possibly connected with a refurbishment of the Iron Age ramparts.

BIBLIOGRAPHY. W. H. Bathurst & C. W. King, *Roman Antiquities at Lydney Park, Glos.* (1879) color ills. of mosaics[PI]; R.E.M. & T. V. Wheeler, *Report on the Excavation of the Prehistoric, Roman & Post-Roman Site in Lydney Park, Glos.* (1932)[PI]; summary, G. C. Boon in Royal Archaeological Institute, *Programme of the Summer Meeting at Cheltenham 1965* (1965)[P] with other refs.; Lydney Dog, see also J.M.C. Toynbee, *Art in Britain under the Romans* (1964) pl. xxxivb-c.

G. C. BOON

LYKAION Arkadia, Greece. Map 9. The Sacred mountain of W Arkadia, site of the Lykaian Games, was famed as the birthplace of Zeus and the home of Pan (Paus. 8.38.2-6). There are two peaks; the slightly lower one to the S is more prominent. Between these two peaks at a height of ca. 1200 m there have been found the remains of an early Hellenistic or Roman hippodrome, a stoa, a stadium, and other service buildings. Fifteen minutes SW, is the Sanctuary of Zeus Lycaios on the S peak. There are to be found traces of the precinct of the god which no man was to enter, and the bases of two columns on which originally stood gold eagles. The entire summit of the peak is composed of the great ash altar on which human sacrifice was practiced even in Classical times (Pl. *Min.* 315c). Pausanias also mentions a Sanctuary of Parrhasian Apollo on the E side of the mountain.

BIBLIOGRAPHY. K. Kuruniotis in *ArchEph* (1904) 153-214; (1905) 161-78 (all on Lykaion); (1910) 29-36 (Apollo Sanctuary); id. in *Praktika* (1909) 185-200[PI]; *RE* XIII (1927) 2235-44; G. Mylonas, *Classical Studies in Honor of William Abbott Oldfather* (1943) 122-33.

W. F. WYATT, JR.

LYKOSOURA Arkadia, Greece. Map 9. The ruins are 7 km W of Megalopolis. The only source for the city is Pausanias' reference (8.37-38) to the Sanctuary of Despoina, a very ancient Chthonic divinity identified with Persephone-Kore, whose date was confirmed by excavations undertaken in 1889 and later. To the E and to the N foundations of a Doric portico have been found, before which, from E to W are arranged three altars consecrated to Demeter, Despoina, and the Great Mother. The temple was 15 m from the altar farthest to the W, and was perhaps constructed in the 4th c. B.C. It is a Doric prostyle temple, with a hexadic facade of marble, on three steps, oriented to the E. Recognizable are a pronaos and a cella, the major part of which was occupied by a pedestal which supported a group of cult statues in marble. These were the work of Damophon of Messene, active around the middle of the 2d c. B.C. They represented Demeter, Despoina, Artemis, and Anytos. During the excavation many fragments of sculpture recognizable as belonging to the group were found, which permitted its reconstruction after a coin of Megalopolis. Despoina and her mother Demeter were seated, while Artemis and Anytos were standing. The remains of the group are in the National Museum at Athens. One exited from the temple to the outside through a lateral door in the S wall. In the cella are the remains of a

mosaic, and before the temple there are two bases for bronze statues. Several tiles with the inscription "Depoinas" have come from the excavation, and date between 74 and 66 B.C. To the S of the pronaos several bases for offerings have been found, while the N part of the temple has been under discussion, even to the foundations. The temple dates, according to the latest interpretation, to the 2d c. B.C. On the N side in a spot called "megaron" by Pausanias, the remains of a large monumental altar have been found. The ancient city was located at the head of the plain of Terzi, to the W of the sanctuary. There the city walls have been identified, dating from the 5th-4th c. B.C., and the foundation of a temple has been found under a Byzantine chapel.

BIBLIOGRAPHY. B. Kavvadias, Ἀρχ. Δελτίον (1889) 122, 153, 170, 202, 225; (1890) 87ff, 99, 113; id., *Fouilles de Lycosoura* (1893); B. Leonardos, Ἀνασκαφαὶ τοῦ ἐν Λικοσούρᾳ ἱεροῦ τῆς Δεσταινας Πρακτικα, 1895, 1896, 1897, 1898, 1903, 1906, 1907; J. Dickins, Damophon of Messene, *BSA* XI (1905-6); Ch. Tallon, "The Date of Damophon of Messene," *AJA* 10 (1906) 302ff; K. Kouroniotis, κατάλογος τοῦ Μουσείου λυκοσούρας, Βιβλιοθήκη Ἀρχαιολογικῆς Ἑταιρείας (1911); Meyer, in Pauly-Wissowa XIII (1926) 2417-32; W. B. Dinsmoor, *The Architecture of Ancient Greece* (1950) 287; M. Bieber, *The Sculpture of the Hellenistic Age* (1955) 158; P. W. Lehmann, "The Technique of the Mosaic at Lykosoura," in Lehmann, *Essays*, 190-97; E. Lévy, "Sondages a Lykosoura et date de Damophon," *BCH* 91 (1967) 518ff.

G. BERMOND MONTANARI

LYMPNE, see LEMANIS

LYNE Peeblesshire, Scotland. Map 24. An auxiliary fort that guarded the Roman road from Trimontium to Castledykes, in a bend of the Lyne Water, 6 km W of Peebles. Recent reconsideration of the pottery found during excavations in 1900 and 1959-63 has indicated that it was built ca. A.D. 140, at the time of the Antonine advance into Scotland. Substantial remains of the defenses, a turf rampart and up to three ditches, are visible, as well as the sites of three of the four gates. The size of the fort, 2.2 ha, is appropriate for a cohors milliaria equitata. The principal buildings were of stone, the barracks and stables of timber, and there were large annexes on both the N and S sides. Water was brought to the fort by an aqueduct and distributed into wood-lined tanks sunk in the ground.

Air photography has revealed several other Roman works in the vicinity, of which no traces survive above ground. Two of them, a fortlet and a temporary camp of 19.6 ha, are on the same side of the river as Lyne fort; another fort of 1.4 ha is on the opposite bank, at Easter Happrew. Examination of the latter in 1956 showed that it was built in the late 1st c. A.D., probably during the Agricolan invasion of Scotland. The finds from both forts are in the National Museum of Antiquities of Scotland.

BIBLIOGRAPHY. *Inventory of the Ancient & Historical Monuments of Peeblesshire* 1 (1967) 169-75; *Proc. Soc. Ant. Scotland* 35 (1901) 154-86; 90 (1956) 93-101; 95 (1961) 208-18.

K. A. STEER

LYON, see LUGDUNUM

LYONS-LA-FORÊT Dept. Eure, France. Map 23. Situated 100 km W-NW of Paris and 32 km SE of Rouen. Since the 18th c. traces of the Roman occupation have been found in the lower section of the modern town close to the church (fragments of sculpture, columns, coins of the 2d c.).

From 1910 to 1969 ruins of a Gallo-Roman theater

were excavated on the S side of the Lieure valley, at mid-slope, in the Bout de Bas quarter. The theater wall, which runs W-E, was uncovered over a 50 m length; originally it must have been 82 m long. Thirty m along its S face it is joined by the orchestra wall, which starts to curve from the 5th m. The scena, which is 12.30 x 4.10 m, extends from the great theater wall from the 34th to the 47th m. The wall surrounding the cavea has a doorway in its lower section; it is built up the hillside and curves to the E. This wall has been excavated to a length of 30 m.

The theater is rustic in construction. Building materials are of local origin (flint or chipped limestone blocks embedded in yellow mortar). The remains of plaster can still be seen on the inner faces of the walls. The floors of both the orchestra and the scena are of beaten earth, unpaved. The tiers most probably were cut in the earth of the hillside or made of wood. The theater appears to have been built some time in the 1st or late 2d c., then reused as a farm or country house. Sigillate ware from Lezoux, and everyday pottery in the 2d c. style have been found on the site; also bronze, enameled peacock's tail fibulae (3d c.), writing styli, and a small bronze plaque with inscriptions and the figure of a god (Sucellus?). Coins range from Trajan to Valens. Six newborn-infants' tombs were discovered in the floor of the orchestra and scena; one of them contained a glass oil flask, another a coin of Constantine II. Many food remains were also found there. This theater can still be seen; it is in the process of being excavated. The objects found there are kept at Lyons-la-Forêt. Remains of Gallo-Roman dwellings have also been uncovered in the same part of the city, opposite the church.

In the Lyons section 3 km to the S, in Forêt de Lyons (Canton du Gouffre), a 2d c. dwelling with hypocaust was excavated from 1951 to 1954. Scattered over a 1-ha area around it is a large quantity of everyday pottery of the 2d c., gray or pinkish, suggesting that there was a potter's workshop in the area and that the excavated house was his.

In Forêt de Lyons (Canton du Robinet Cuit) a treasure store of 1st and 2d c. coins was found at the end of the 19th c. The collection is at the Musée des Antiquités de Rouen.

BIBLIOGRAPHY. M. A. Dollfus, "Etude arch. du Canton de Lyons la Forêt," *Bull. Soc. Normande d'études préhist.* 25 (1922-24) 126-48; id., "Découverte d'habitat gallo-romain à Lyons la Forêt (Eure)," *Rev. des Stés sav. de Haute Normandie*, 2 (1956) 41-46; id., "Découverte d'un balnéaire gallo-romain au canton du Gouffre en Forêt de Lyons," *Bull. Soc. Normande d'études préhist.*, vol. 37.2, pp. 34-37; id., "Compte rendu des fouilles gallo-romaines du quartiér du Bout de Bas à Lyons la Forêt," ibid., 39.2 (1968) 72-75; id., "Le Théatre gallo-romain de Lyons la Forêt," *Sté Nationale des Antiquaires de France* (March 1970); Dollfus & A.

Guyot, "Sepultures de nouveau-nés dans les fouilles de Fleurheim à Lyons la Forêt," *Annales de Normandie 18e année* 4 (1968) 283-300M. M. A. DOLLFUS

LYSINIA (Üveyik Burnu) Turkey. Map 7. City in Pisidia, near Karakent on the W shore of the lake of Burdur. It is first mentioned as one of the places passed by Manlius on his march through Asia Minor in 189 B.C. (Polyb. 21.36; Livy 38.15); it surrendered to him voluntarily. Polybios and Livy give the name as Lysinoe; Ptolemy has Lysinia, Hierokles the corrupt form Lysenara. The coins and inscriptions confirm the form Lysinia. The site is identified by a statue base of Hadrian still in situ, erected by the Council and People.

The ruins are on a rocky hill directly above the lake. Numerous short stretches of terrace wall are to be seen, but the city was not apparently defended by a fortification wall. On the summit are two platforms, artificially leveled. The S slope and foot of the hill are covered with sherds of Roman date and loose building blocks; outlines of buildings are discernible, and several rock-cut sarcophagi, but nothing but the statue base is standing. Other ancient stones are in the village of Karakent, including a milestone of Constantine showing three miles, and a handsome phallos stone.

BIBLIOGRAPHY. G. E. Bean, *AnatSt* 9 (1959) 78-81. G. E. BEAN

LYTTOS (Xydas) Pedhiadha, Crete. Map 11. An important Classical and Roman city ca. 25 km SE of Herakleion. Although said by Polybios to be the most ancient (Dorian) town of Crete, the earliest material from the site is of the archaic period. The city rose to prominence in the 4th c. and was occupied by Knossos in 343 B.C. When Lyttos resisted the Knossian conquest of the rest of the island in 221-219 B.C. it was captured and razed. Subsequently rebuilt, the city was again overwhelmed when it resisted the Roman occupation. The city is situated on a hill with three small peaks, the largest of which seems to have formed the acropolis. At the foot of this acropolis hill the theater probably stood, built into the slope of the hill. Fragmentary remains of houses have been noted on the S slopes of the remaining two hills, and on the peak of the W hill are traces of a substantial structure which might have been a temple. Traces of the aqueduct which brought its water supply from Kournia can still be found. The port for Lyttos was Chersonisos. Two marble statues from the site (of Marcus Aurelius and Trajan) are in the Herakleion museum.

BIBLIOGRAPHY. Diod. Sic. 16.62; Polyb. 4.53-55; T. B. Spratt, *Travels and Researches in Crete* (1865) I 89-94; A. Taramelli, "Richerche archeologiche cretesi," *MonAnt* 9 (1899) 387M; M.S.F. Hood & J. Boardman, "Archaeology in Greece, 1955," *Archaeological Reports* (1956) 30. K. BRANIGAN

M

MAASTRICHT Limburg, Netherlands. Map 21. In the Meuse valley N of the foothills of the Ardennes, where the Roman highway from Boulogne-sur-Mer via Bavai and Tongeren to Cologne crossed the Meuse. The Roman name is not known. Gregory of Tours (6th c.) speaks of the urbs Trajectensis, and names such as Trajectum Superius, Trajectum ad Mosam, and Mosaetrajectum oc-

cur in later sources. Although it might be expected that the origin of Maastricht, like that of Tongeren en Heerlen, went back to Augustan times, the oldest material yet found dates from the Claudian period.

The settlement lay on both sides of the river, but mainly on the W bank. Various Roman cellars and hypocausts are known, but the plan of the town is by no

means complete. The only construction certainly identified is a complex of baths of the 2d and 3d c. A.D. Where and how the river was crossed in this period is not certain; possibly at a ford N of the 4th c. bridge. At that time the center of the inhabited area (Stokstraat quarter) was fortified by a wall, three round towers of which have been recovered. The bridge which crossed the river from the city center incorporated many fragments of grave monuments and buildings. S. Servatius, who died at Maastricht in 384, is said to be buried nearby; his church lies W of the Roman settlement and just S of the Roman road. Its cemetery has been used ever since the 3d c. Farther W, near the road, was found a sarcophagus for two persons with rich grave goods (2d c. A.D.). The Roman government abandoned the area in the early 5th c.

BIBLIOGRAPHY. To 1961: J.J.M. Timmers, "Romeins Maastricht," *Bull. Kon. Ned. Oud. Bond* 14 (1961) 97-108; excavations 1963-65: Stokstraat quarter, *Nieuwsbull. Kon. Ned. Oud. Bond* (1963) 158-61, 210-14, 233-34; (1964) 33-34; 104-5; 140; (1965) 76, 122; bridge, ibid. (1963) 161-64, 182; (1964) 102-4 (1965) 44; sarcophagus (1964) 63-66, 105-10, 138-39; J.H.F. Bloemers, "Twenty-five Years ROB Research in Roman Limburg," *Berichten van de Rijksdienst voor het Oudheidkundig Bodemonderzoek.* Proceedings of the State Service for Archaeological Investigations in the Netherlands 23 (1973). J.H.F. BLOEMERS

MABLY Loire, France. Map 23. A site near Roanne on the banks of the Loire, linked with the road from Roanne to Autun and with the traffic that crossed the river at the ford. A number of Gallo-Roman dwellings were noted in 1824. One of them, excavated 1962-68, is a single room (9 x 5.5 m), its floor covered with a mortar of broken tiles. The walls, which have a pebble-dash finish of lime, are decorated with polychrome coatings in geometric designs. The finds (sigillata and everyday ware, coins of Faustina the Elder) date the village from the 2d c. A.D.

BIBLIOGRAPHY. M. Leglay, "Informations," *Gallia* 24 (1966) 492-93; 26 (1968) 566-67. M. LEGLAY

MACAR KALESI, *see* KESTROS

MACHAERUS (Mukawar) Jordan. Map 6. One of the fortresses built by Alexander Jannaeus (Joseph. *BJ* 3.417) E of the Dead Sea, in the region previously conquered by John Hyrcanus. It was destroyed in 64 B.C. by Pompey. Pliny (*HN* 5.72), who states that Machaerus was one of the important fortresses of Judea, is possibly referring to the newer fortress built by Herod the Great and described by Josephus (*BJ* 7.173-77); he mentions the strong walls, the beautiful palace, the cisterns for the collection of water, and the stores of arms and food. John the Baptist was decapitated in the palace (Matt. 14; Mark 6; Joseph. *AJ* 18.116-19). After Herod's death Machaerus became part of the Peraea, and the fortress was finally destroyed by the Romans after a long siege (*BJ* 7.190ff). It was on a mountain called el-Musheneq, where remains of Herod's fortress, the walls, the Roman siege works, and an aqueduct have been identified.

BIBLIOGRAPHY. F. M. Abel, *Géographie de la Palestine* II (1938) 371-72; M. Avi-Yonah, *The Holy Land* (1966) 73, 101, 180. A. NEGEV

MĂCIN, *see* ARRUBIUM

MACOMADES MINORES later IUNCI (Younga) Tunisia. Map 18. Situated 45 km S of Sfax and 10 km SE of Maharès, the site extends for nearly 3 km along the shore, its sandy mounds of ruins dominated by an imposing fortress. Visited by 19th c. travelers, the site remained little explored; only the citadel and a vaulted cistern had been located before the excavation of three Early Christian basilicas. Yet this city had a long history. On the shore of Syrtis Minor, alongside the Carthage-Tacape highway, at the intersection where the major inland route from Sufetula reached the sea, the city owed its importance to its position on a crossroads opening onto a port that was well known and reputable in antiquity.

First noted in the 1st c. B.C., it passed uneventfully through the period of the Empire and was mentioned in the lists of bishops attending the councils of 411 and 523. It played a strategic role when Byzantine emperors gave it a rampart, then a citadel, which provided a refuge for Jean Troglita's defeated troops; and in the Arabian period when the Aghlabite emirs, as part of their policy of defending the African coastline, occupied and reinforced the fortress in the 9th c.

Long believed to be Macomades Minores (in contrast to Macomades Maiores in Sirtus Major), its identification was confirmed by the discovery of a milestone in situ. The name of the site was changed probably in the Late Empire to Iunci, and according to some historians is the Qsar-er-Roum described by El Bekri and El Idrisi.

Excavation has revealed three Early Christian monuments of interest. The first church, 300 m NE of the fortress, is oriented E-NE–W-SW. Rectangular in plan, it measures 55 x 32 m and terminates at either end in an apse. The E apse projects outside the general framework of the building; the W counter-apse is integrated in a rectangular space. The quadratum populi consists of five naves separated by rows of columns and pillars (28.5 x 25.7 m) opening to the S through a triple doorway onto a narthex. Parallel to the latter is another narthex which opens onto three aligned rooms, the middle one (9.8 x 8.8 m) containing the counter-apse at the rear. In front of this apse is the choir; it is raised over a vaulted crypt (2.45 x 1.3 m and 2 m high), in the arcosolium of which was found a small broken reliquary that had held a pyxis of ivory (badly damaged) decorated with religious scenes. The whole complex—the two nartheces and the other rooms—was paved with geometric mosaics. The most noteworthy of these is an emblema 2.8 m square in the second narthex, opposite the room with the counter-apse; the foreground shows a semicircular facade out of which flow the Four Rivers of Paradise.

On the other side, to the E, in front of the apse, was the presbyterium dais. Measuring 6.3 x 5.5 m and raised 0.35 m, it was paved with a geometric mosaic (double axes) with the epitaph (1 x 0.4 m) of Bishop Quodbuldeus inscribed in black characters on a white ground above his tomb. The epitaph is now preserved at the Bardo Museum in Tunis.

Scattered fragments of a mensa of the Coptic type were found, probably in this same basilica. A number of fragments of painted or architectural stucco have been found on the floor of this monument.

The second church is situated 300 m from the shore, 450 m from the fort to the W. With its annexes it measures 78 x 35 m and is 1.5 m below ground. Oriented NW-SE, it consists of a central nave 8 m wide flanked by two lateral naves 5.5 m wide that are terminated on one side by three great projecting apses (the axial ones with a 7.9 m span and 5.25 m deep; the lateral ones, 6.8 m in span and 7.2 m deep). The trefoil arrangement of these apses in relation to the transept is an original combination of the Romano-African tradition and Byzantine influence. In the axis of the basilica, opposite the central apse and 20 m from the choir platform, is a semicircular exedra 6.7 m in span and 4.5 m deep designed for the

synthronon. This space was complemented by three rooms opening onto the NE side. One of them was a memoria (10.6 x 4 m), also terminating in a raised apse; it contained a reliquary with the mensa above it, a fragment of which, in ivory-colored marble, has been recovered.

The different floors of this complex were paved with a variety of mosaics. The central apse (5.25 m deep and 7.9 m in span) was decorated with a mosaic (now in the Bardo Museum) depicting a tracery of vine leaves curling out of medallions that contained various birds and bearing the inscription CUIUS NOMEN DEUS SCIT VOTUM SOLBIT. Likewise, the choir platform, which measured 7.1 x 15.3 m and was raised 0.5 m, was covered with a mosaic of 6 x 5 panels containing animals and human figures or geometric motifs with stylized palms, the whole edged with a floral design. The architectural fragments apparently were recovered a long time ago.

The third monument, another basilica designed around a baptistery, is 30 m S-SE of the first. Measuring 32.15 x 10.86 m, it has a quadratum with three naves fronted by a narthex 4 m wide with a facade built of a masonry of large blocks, and terminating on the other side in an apse. In front of the latter, inside the church, is a choir platform which widens out to measure 2.7 x 6.4 m and 0.55 high. The baptistery was in the rear of the apse and was oriented N-NE–S-SW, on the same axis as the monument. Measuring 3.75 x 1.37 m, it had four steps. A fragment of a marble mensa has been recovered along with a frustum of a small column, and a stone slab with a design of a Latin cross surmounted by a globe. Many stuccos and paintings were also found on the mosaic floor of the presbyterium and choir; most of these are now in the Bardo Museum in Tunis.

BIBLIOGRAPHY. G. L. Feuille, "Le baptistère de Iunca," *CahArch* 3 (1948) 75-81; P. Garrigue, "Une Basilique byzantine à Iunca en Byzacène," *MélRome* 65 (1953) 173-96[P].
　　　　　　　　　　　　　　　　　　　　　　　A. ENNABLI

MACON, *see* MATISCO

MACTAR, *see* MACTARIS

MACTARIS (Mactar) Tunisia. Map 18. The very extensive site occupies a plateau which rises 900 m above the valley of the wadi Saboun in the central massif of the Haut Tell. The capital of a vast agricultural zone, it was on an important route of passage between the region of dry steppes to the S and the region of vast grain-producing plains to the N.

A city of the kingdom of the Massylii, not conquered by Carthage but profoundly influenced by it, it fell under Roman domination. This transformed and developed it still more but without entirely destroying its strong Punic-Numidian character. Political, artistic, and religious elements of this Romanization are found throughout the remains scattered over the site. It was elevated to the rank of colony under Marcus Aurelius. From this period date the largest and grandest of its monuments, which bear witness to its prosperity.

After the crisis of the 3d c., the effort at restoration begun by the emperors was followed by the Christian ferment; the restored monuments which have been converted in the cult areas are numerous. With the Byzantines, life revolved around the several improvised fortresses in the midst of the ruins of the city. With the arrival of the Hillalians, life contracted markedly because of insecurity.

Since there is no mention of the site in ancient sources, only the study of the archaeological remains permits the retracing of the history of the city. Abandoned since the 11th c., the site was pointed out and visited by the great travelers: Temple, Pelissier, Guerin, Tissot, Cagnat, and Saladin. It was excavated only intermittently in 1893-94, in 1902 and 1912, but more intensively between 1944 and 1956. Several excavations were undertaken towards 1960, and the conservation of several monuments is now in progress.

The pre-Roman remains that have been discovered include the tophet and sanctuary consecrated to Baal Hammon, erected near the ravine of Bab el Aïn and overturned either during the construction of the arch of that name or simply by natural erosion; many stelae engraved with Libyan and Punic inscriptions were found there. Several megalithic necropoleis were scattered in various places on the site.

Along the periphery of the site, but at a distance from one another, are a pyramidal mausoleum and the mausoleum of the Julii, both built on a grand scale. Between them is an important necropolis which extends to the foot of the arch of Bal el Aïn, a triumphal gate with one bay marking the N entrance of the town and dominating the wooded ravine of a stream. It is presently in process of restoration. Next to the arch is an amphitheater of moderate size, recently excavated, next to the so-called Church of Rutilius, which has almost entirely disappeared. Within the town two forums were excavated between 1947 and 1956: the first an old square, vast and without porticos, limited on two sides by streets, one of which led to the second forum 100 m E. Paved, surrounded by a portico, it was dominated by a monumental arch dedicated to Trajan. This arch gives access on the S side to another small area, said to be of the Severan era, which marks the bounds of the quarter of houses contiguous to the basilica of Hildeguns, from the name engraved on an epitaph found on the ground of the central nave.

The Temple of Liber Pater faces the old forum, which it dominates. An irregular trapezoid in plan, it was built on an earlier edifice, and on it was erected a Christian church. It is known to have been elevated on a podium which shielded a double superimposed crypt, the one hollowed out of the rock, the other built in a cradle-vault. The sanctuary was probably prostyle. A frieze on the architrave, on which were sculptured some illustrated scrolls of an episode of the Bacchic cycle and of statues of Dionysos, identified the temple.

The neo-Punic sanctuary of Hathor Miskar, identified by several long inscriptions which commemorated the dedication of the temple by an association of citizens called Mizrakh, was excavated in 1893. To the NE of the forum of Trajan this sanctuary rose on a podium with a crypt, and consisted of a cella preceded by a pronaos and surrounded by a portico built in grand style. It was ultimately converted into a Christian building.

The Temple of Apollo and Diana at the W periphery of the site, N of the pyramidal mausoleum, was excavated in 1947. In the midst of a vast precinct surrounded by a rectangular portico, this peripteral temple stood facing E; constructed before the reign of Marcus Aurelius, it no longer exists except for the sub-foundations.

The existence of temples and cults of other divinities is attested by inscriptions or sculptures, such as those of Magna Mater, Neptune, Rome and Augustus, and Ceres, whose documents have been found in divers locations on the site.

The quarter called the School for Youths, excavated in 1946-55, is an ensemble of structures that are complicated by numerous transformations. A large paved vestibule gives access to a court surrounded by a portico of

the Corinthian order carrying an inscribed frieze. On the sides and to the N open areas with mosaics. On the W side is a basilica-shaped hall with three naves and an apse, also paved with mosaic, next to a group of structures among which are small baths. To the S a narrow passage opens on a quatrefoil building with troughs, and a mausoleum of Julia Bennata, which is preceded by a mosaic court and surrounded by a small Christian cemetery. The School for Youths, an association aristocratic and military in character, having Mars as patron but distinct from the army, was influential in the Romanization of the city.

Several public baths have not been completely excavated; the great baths to the SE including a palaestra in the process of restoration and the baths to the N.

Apart from these edifices of known function, several other monuments of unidentified use have been uncovered. One "with apses and arcades" was investigated in 1909-10 and mistakenly described as a water-tower in connection with the huge aqueduct which rises to the W. Another vast structure of three well-preserved rooms paved with geometric mosaics, including troughs in two semicircular walls, was probably a market.

An archaeological museum recently built at the approaches to the site houses numerous objects (mosaics, sculptures, inscriptions, and ceramics) found in the course of the excavations.

BIBLIOGRAPHY. G. C. Picard, *Civitas Mactaritana* (1958)[PI] (=*Karthago* 8; of 1957, but pub. 1958).

A. ENNABLI

MADABA Jordan. Map 6. A town in Moab, E of the Dead Sea, taken by the Israelites from Sihon king of the Amorites, and later conquered by Mesha king of Moab. In the Hellenistic period the town was in the hands of the sons of Iambre (I Macc. 9:36). John Hyrcanus conquered it early in his reign (Joseph. *AJ* 13.255; *BJ* 1.63). It was subsequently ceded to the Nabateans, in whose hands it stayed until their kingdom was annexed by the Roman Empire when it became one of the cities of the newly founded Provincia Arabia. At this period Madaba minted coins. It flourished also in the Byzantine period.

The earliest remains at Madaba were discovered in a natural cave that had served as a burial ground for many centuries. The earliest burials go back to about 1200 B.C. In the Roman period Madaba was a fortified city with a wall and seven gates. Outside one of the gates was a pool 94 m square. The city itself has hardly been investigated, but a paved colonnaded street and remains of a Roman temple are discernible. On the acropolis a public building and a bath were observed. Here and there houses of the Byzantine period were investigated. Some of these houses had mosaic floors decorated with scenes from Greek mythology. To the same period also belong ten churches, situated in different quarters of the city. Most important is a church situated close to the N gate. The outstanding feature of this church is the mosaic pavement on which is depicted the earliest known map of the Holy Land. It shows the natural landscape of the country, against which are marked towns, villages, holy places, and fortresses. In the more important towns one may identify buildings known from ancient sources or from archaeological finds. In the compilation of the map Roman road maps and the *Onomasticon* of Eusebius were used. The Madaba mosaic map is now a major source for the study of the geographical history of the Holy Land in the Byzantine period. Another church, the Church of the Apostles, dated to 578-579, has been excavated.

BIBLIOGRAPHY. S. J. Saller & B. Bagatti, *The Town of Nebo* (1949) 80-82, 147; G. L. Harding, *Palestine Exploration Fund Annual* 6 (1953) 27-33; S. J. Isserlin, ibid., 34-37; M. Avi-Yonah, *The Madaba Mosaic Map* (1954); V. R. Gold, *Biblical Archaeologist* 21 (1958) 50-70; Lux, *ZDPV* 84 (1968) 106-29; M. Noth, ibid., 130-42.

A. NEGEV

MADARA Sciumen, NW Bulgaria. Map 12. A village a few km from Pliska, the capital of the first Bulgarian kingdom, whose environs have been inhabited since Neolithic times because of abundant springs. These gush forth at the foot of the rocky upland, on which was built a fortress. It is constructed of large blocks of stone and has a large gate flanked by two pentagonal towers and an internal court with two gates. Into the rocky summit, which reaches an elevation of over 100 m, is carved a large relief, called the Cavalier of Madara.

This relief of the cavalier with a dead lion at the feet of his horse is carved 23 m above ground level. Excavations have brought to light remains from the Thracian-Roman, proto-Bulgarian, and Byzantine periods. On the building stones are found the characteristic pictograms. There are many articles fashioned of metal and clay, including painted ceramics, as well as proto-Bulgarian jewelry.

BIBLIOGRAPHY. R. Popov et al., *Le cavalier de Madara* (1925); G. Feher, *Les monuments de la culture proto-bulgare* (1932); B. Filow, *Geschichte der altbulgarischen Kunst* (1932) 11; V. Velkov et al., *Madarskijat Konnik* (1956); N. Mavrodinov, *Starobulgarskoto Izkustvo* (1959) 65ff.

A. FROVA

MADAUROS (Mdaourouch) Algeria. Map 18. Twenty-five km from Thagasta and 900 m above sea-level, the town is built on undulating terrain. According to Apuleius, a native, Madauros was founded in the 3d c. B.C. It belonged to King Syphax and subsequently formed part of Massinissa's realm. A colony of veterans was established there; it was probably called Colonia Flavia Augusta Veteranorum Madaurensium and already existed under Nerva. Dependent on the legate of the Third Legion, Madauros was assigned to Carthage during the Late Empire. It became an important intellectual center with numerous schools—St. Augustine studied there—but not a city of great size. The patrician Solomon ordered the construction of a Byzantine fortress (A.D. 535).

In spite of the excavations from 1905 to 1923, it is difficult to reestablish the plan of the site, much disturbed by Byzantine and Berber constructions. There are numerous monuments: forum, theater, two baths, mausolea, basilicas, four arches, some ten sanctuaries, churches, the Byzantine fortress, and important oil-pressing establishments.

The forum is rectangular, almost square (32.4 x 27 and 28.5 m). It is surrounded by paved porticos and built on a gentle slope, so earth fill had to be brought and retaining walls built. The limestone flagging was renewed in the 3d c. Nearby was a basilica with one nave (19.9 x 7.8 m), of Late Empire date.

The theater was built in the immediate vicinity of the forum against its W portico; thus, an arcade-lobby was not required. Contrary to frequent practice in antiquity, the convex part of the edifice is on the downhill side of the natural slope of the terrain; the semicircle had to be supported by a large wall and the tiers of seats placed on a completely artificial core. Accordingly, in spite of its small size (width: 33 m) it cost 375,000 sesterces. The theater was built through the generosity of the flamen M. Gabinius Sabinus, and probably dates from Severan times. It has a central entry at the same level as the orchestra, an arrangement unique in North Africa

but found at Ostia. A portico borders the top of the cavea. The stage is 20.25 x 4 m deep; on either side is a parascenium of ashlar paved with flagstones.

Two public baths, very carefully constructed, are found near one another to the N of the town. The walls are of carefully cemented quarry stone; all rooms were vaulted. The large baths measured 39 x 41 m and included a vestibule, hallway, semicircular latrines, frigidarium, caldarium, two bathing pools, and several other rooms of various sizes. The small baths, 15 to 25 m to the NW of the above, measured 30.2 x 33.8 m. These are no doubt summer and winter baths respectively and probably date to the beginning of the 3d c. A secular basilica was discovered near the large baths.

A Christian basilica (34 x 7.8 to 8.1 m) is found 120 m to the SE of the large baths. Another basilica was situated outside the Roman town. Both are no earlier than the 5th c.

The Byzantine fortress is well preserved, standing in places as high as 10 m. It was partly built on the forum with materials from it.

BIBLIOGRAPHY. S. Gsell, *Atlas archéologique de l'Algérie* (1906) 18, Souk-Arrhas, no. 432[MP]; and C. A. Joly, *Khamissa, Mdaourouch, Announa* (1922)[PI]; L. Leschi, *Algérie antique* (1952)[MI]; E. Frézouls, "Teatri romani dell'Africa francese," *Dioniso* 15 (1952) 95-96.

G. SOUVILLE

MADINET EL-HARAS, *see* BERENICE

MADNASA Turkey. Map 7. Town in Caria, probably at Upper Göl, 13 km NE of Myndos. In the Delian Confederacy the Madnasans paid a tribute of two talents, later reduced to one. The name is not otherwise known, but is undoubtedly identical with the Medmasa (or Medmassa or Medmasos) quoted by Stephanos Byzantios from Hekataios and included by Pliny (*HN* 5.107) among the Lelegian towns incorporated by Alexander (really by Mausolos) in Halikarnassos. The site at Göl is some 300 by 90 m, with a wall of dry rubble or polygonal masonry; at the highest point is a tower in regular ashlar. Cisterns and numerous house foundations are to be seen, and a few simple rock tombs at the W end. The sherds are mainly of the 5th and early 4th c. B.C. For an alternative site at Burgaz, 4 km N of Myndos, see Uranion.

BIBLIOGRAPHY. W. R. Paton & J. Myres, *JHS* 14 (1894) 376ff; *ATL* I (1939) 514; G. E. Bean & J. M. Cook, *BSA* 50 (1955) 121-22, 155.

G. E. BEAN

MAGALAS Canton of Murviel-les-Béziers, Hérault, France. Map 23. Oppidum on the hill of Montfo, near the modern village, and occupied from the 6th c. B.C. to the Roman period. The oldest dwellings explored are rustic, built of baked bricks, raw clay, or stone, and accompanied by storage pits dug in the soil. They have yielded a large quantity of first-class ceramics which testify to the important commercial role played by this little settlement throughout Iron Age II. In the 2d and 1st c. the settlement extended to the foot of the oppidum, where recent excavation has turned up stores of amphorae and carefully constructed buildings.

BIBLIOGRAPHY. M. Clavel, *Béziers et son territoire dans l'Antiquité* (1970) 69, 94; "Informations," *Gallia* 6 (1948) 175-77[I]; 24 (1966) 486[I]; 27 (1969) 396; 29 (1971) 384; 31 (1973) 495.

G. BARRUOL

MAGDALENSBERG Austria. Map 20. A mountain 14 km NE of Klagenfurt, the capital of Carinthia. It rises to a height of 1058 m from the plain of the Zoll-

feld, once the site of Virunum, capital of the Province of Noricum. On its peak stands a small Late Gothic church, dedicated to St. Helena and St. Magdalena, with Roman marble blocks here and there in its walls. The mountain, called Mons Sanctae Helenae in mediaeval documents, and then Helenenberg until the beginning of the 20th c., is today generally called Magdalensberg. It has long been known for its Roman antiquities and was once a favorite area for illicit digging. In a ruin field at the remarkable height of ca. 1000 m with an estimated area of 3.5 sq. km and slightly below the summit, there was found in 1502 the bronze statue of the "Helenenberg youth." It is a life-size Roman copy of a statue of a Greek athlete from the 5th c. B.C. It is today located in the Kunsthistorisches Museum in Vienna.

At one time it was thought that the settlement had been a sort of summer resort for wealthy Romans from Virunum, the neighboring provincial capital. The first scholarly excavations of the temple shed no light, but systematic excavations, begun in 1948 and continued annually, have produced definitive insights. The unexpected and unique results of these excavations on the Magdalensberg (easily reached today by car) justify calling them the most important archaeological undertaking in Austria since WW II.

The peak of the mountain (only parts of which have been investigated) had been fortified by the indigenous Celtic population before the Roman occupation. A double ring of walls with an earth filling between them (from about 100 B.C.) protected the large oppidum. Here, among other structures, was probably a temple where supposedly the above-mentioned statue resided, transformed through the addition of new attributes into the Celtic war god Mars Latobius. Everywhere the terrain is elaborately terraced. The Roman settlement started on the S slope, ca. 100 m below the peak, and it contains the oldest Roman buildings in Austria. These are built of stone and date from different periods. They partly replace pre-Roman wooden structures. The forum is located on a plaza (ca. 114 x 55 m), an artificial leveling of the curved, rocky slope of the mountain. Midway toward the mountain is the temple area (54.6 x 45.3 m), within which rises a podium temple (31.2 x 17.6 m), one of the largest of its kind in the E Alpine area. The sizable cella (21 x 11 m) has a cellar whose three sections are interpreted as treasure rooms of the Roman authorities. The temple was dedicated to Roma and Augustus and was the center of the emperor cult on the mountain. The building was started under the reign of the emperor Tiberius but was never finished; only the foundations remain. On the W side it was connected with a room exactly 100 Roman feet long, which was surrounded on three sides by halls. On the narrow W side a marble-faced platform had been built with steps leading up to it from both sides. Such a platform served as the official seat of the representative of Rome for meetings and court procedures. The building should therefore probably be designated as the praetorium. Behind the tribunal—on the second floor—was a conference room, its walls decorated with simple frescos of Augustan times. This room was part of a N-S oriented building complex with a definite threefold structure. Extending toward the mountainside, it rose at least three floors to a height of ca. 12 m. The middle section is of the greatest interest and has been called by the excavators the Repraesentationshaus. There is no comparable structure in the Imperium Romanum. Through a corridor and an anteroom one reaches a square room (6 x 6 m). Here the black and white mosaic floor is almost completely preserved, and the

walls have been preserved to a height sufficient to disclose provision for 13 niches. This odd number has been related to the 13 poleis (civitates) which Ptolemy (*Geog.* 2.13.3) mentions in his description of Noricum, and thus the room has been designated as the archive (tabularium) of the 13 tribes with a niche for each tribe's archives on the wooden scroll racks (armaria). The assumption that this was an official building was confirmed from 16 fragments of splendid slabs of imported marble containing remains of inscriptions. These inscriptions honor members of Augustus' family, one for his wife Livia, two for his daughter Julia. The inscriptions, dating from between 11 and 2 B.C., represent a tribute from eight Noric tribes; the Norici, Ambilini, Ambidravi, Uperaci, Saevates, Laianci, Ambisontes, and Elveti. The Repraesentationshaus can justifiably be considered the seat of the Noric council (conventus Noricorum).

From the archive room, and only from there, one reaches a curiously furnished hall (11.6 x 5.8 m) of representational character. It has a hypocaust and on the long side a low platform, which was probably a bench; its pillow-like, mosaic-covered back is decorated with the old symbol of the hippomorphic Celtic god of war, in a boat which rests on a sled. That we deal here with Celtic civilization is confirmed by the broad apse on the narrow side of the room. It contained the sacred fountain, a normal part of Celtic places of worship. This room may have been the meeting place of the Noric council.

To the N and higher than the complex including the Repraesentationshaus were dwellings or workshops, located on terraces. They were accessible from the forum by staircases.

To the S and separated by an ancient road was a palatial villa from Tiberian or Claudian times, its supporting walls jutting from the slope. It contained several residential terraces, a peristyle, kitchen, bakery, and a luxurious bath. In excavating one of the terraces valuable fragments of frescos were found, probably deposited here as rubble from a dismantled house. It was possible to reconstruct a few figures, e.g., Iphigeneia holding in her arm the idol of the Tauric Artemis, a female dancer holding in her hands a flower garland, and the torso of a youthful Dionysos. The paintings had been composed as separate varicolored panels, separated from each other by pilasters and columns. Artistically, these frescos from the Magdalensberg are comparable to those from Pompeii. On the basis of style, they must date from ca. 20 B.C., i.e., before the occupation of Noricum by the Romans (15 B.C.). They are an important historical and cultural document testifying to the importance of the town on the Magdalensberg in preRoman times.

One might have expected to find in the E part of the forum structures similar to those W of the temple area. However, the excavations indicate that the settlement of the Italic merchants, dating from Republican times, was located here. This settlement had once extended far to the W, into the vicinity of the Repraesentationshaus. At one time the whole forum must have been a business quarter. Many rebuildings and additions indicate a long duration, from the early 1st c. B.C. on. When the houses to the E were rebuilt, their terraces were extended out from the slope. The lower rooms were stores and workshops, which had been erected over older wooden structures. Many calculating stones and labels for money bags (tesserae nummulariae) found there furnish interesting information about the business of this trade center. Especially informative were two cellar rooms in each

of which a niche was dedicated to Mercury. The walls of these cellar rooms were completely covered with graffiti, over 300 of them, referring to the extensive trade and financial transactions on the Magdalensberg. They referred also to the arrival of customers and local suppliers, indicating that the mountain town was a center for the trade in Noricum iron and metal goods. The transalpine importance of the Magdalensberg is evidenced by the home addresses of the buyers: they came not only from Aquileia and other country towns in Italy, but also from Rome, even from Africa (Volubilis). Ancient writers praised the ferrum Noricum which was a major item of trade. In the earlier layers a number of smelting furnaces were found and metallurgical analyses confirm the excellent quality of the ferrum Noricum which had already been produced in the earliest period on the mountain. In this context the consecration of the bronze youth is understandable. The donors who had their names engraved on the right thigh of the statue were from Aquileia, one of them belonging to the wellknown merchant family of the Barbii: their business relations with this trade center were obviously close and profitable. The consecration is also noteworthy because it took place before the occupation of the country by the Romans (15 B.C.) and is proof of the early and intense trade relations between Italy and Noricum.

A necropolis of the Magdalensberg, the "Lugbichl," was on a ridge that branches off to the SE. Burial chambers for cremation remains are situated on both sides of a road 700 m long. Unfortunately most of the chambers suffered from pillaging and unprofessional excavations in the last century, and are thus not very informative. However, a considerable number of tombstones were preserved. Not only are they among the oldest found in the Noric Alps, but are interesting because they belong to the indigenous population. These stones indicate that a small occupational force was stationed on the mountain. Some of the soldiers belonged to the Eighth Legion, which was stationed in Poetovio, some to the cohors I montanorum, recruited from the local population.

The name of this mountain town is unknown. It came to an end when the provincial capital Virunum was founded about A.D. 45. Such a relocation of an old center situated in a high place to a new one in the plain was characteristic of Roman administration. After 60 years of occupation, the town on the Magdalensberg became deserted and desolate.

The excavated ruins are, in large part, preserved and transformed into a beautiful outdoor museum. The finds are in the museum on the Magdalensberg and in the Landesmuseum für Kärnten in Klagenfurt.

BIBLIOGRAPHY. H. Vetters, "Virunum," *RE* IX A 1 (1961) 262ff; R. Egger, "Die Stadt auf dem Magdalensberg ein Grosshandelsplatz. Die ältesten Aufzeichnungen des Metallwarenhandels auf dem Boden Österreichs," *DenkschrWien*, Phil.-Hist. Kl. 79 (1961); id. in *EAA* 4 (1961) 772f; id. et al., *Führer durch die Ausgrabungen und das Museum auf dem Magdalensberg* (17th ed. 1974)ᴹᴾᴵ; H. Kenner, "Wandmalereien," *Magdalensberg-Grabungsbericht* 13 (1973) 209ff, and continuous reports in *Carinthia* from 139 (1949). R. NOLL

MAGIOVINIUM Buckinghamshire, England. Map 24. Located by its position in the *Antonine Itinerary* (471.1, 476.10, 479.6) on Watling Street between Fenny Stratford and Little Brickhill, near the place where the road crosses the Ouzel river. Several finds of Roman material have been recorded and part at least of the settlement seems to have lain in an area called Auld Fields,

near the farm called Dropshort. Recent excavations between the road and the right bank of the river have revealed a stone and timber building and cobbled floors associated with 4th c. pottery and coins, but the extent of the settlement has not yet been defined.

BIBLIOGRAPHY. G. Lipscombe, *History and Antiquities of Bucks* IV (1847) 29-30; F. Haverfield, *Proc. Soc. Ant. London*² 24 (1911-12) 36; *JRS* 58 (1968) 192; *Itinerary*: A.L.F. Rivet, *Britannia* 1 (1970) 42, 49, 51.

A.L.F. RIVET

MAGNA, *see* HADRIAN'S WALL

MAGNAC-LAVAL Dept. Haute Vienne, France. Map 23. A number of Gallo-Roman dwellings have been found in this commune. That at La Valette, located in 1965, was found to contain several hypocausts and a pool. The town alms-house (Hôpital hospice) has an important collection of Gallo-Roman stones that includes a milestone dedicated to Tetricus, two funerary stelae with carvings of people, a statue of Jupiter with a wheel, burial chests, etc.

BIBLIOGRAPHY. J. Mathevet, "Le site gallo-romain de la Valette," *Bull. Soc. Arch. Hist. du Limousin* (1968) 274.

P. DUPUY

MAGNESIA AD MAEANDRUM Turkey. Map 7. Ionian city 4 km S of Ortaklar, beside the road to Söke, founded by Aiolians from Magnesia in N Greece, and accordingly not accepted into the Ionian League. Magnesia was taken by Gyges, King of Lydia, and afterwards suffered heavily from the Kimmerians; later it fell to the Persians. The city was presented by Artaxerxes to Themistokles to supply him with bread (Diod. 11.57), and was chosen by him as his home in his last days. Magnesia was not a member of the Delian Confederacy. Captured by the Spartan Thibron from the Persians, the city was transferred by him to a new site under Mt. Thorax, where the village of Leukophrys with a temple of Artemis had been (Diod. 14.36). The original site is not known. In the Mithridatic war Magnesia remained loyal to Rome, was rewarded with freedom, and continued to prosper under the Empire.

Little remains today. Excavations in the 19th c. revealed a large part of the city center, but the site is inundated annually by the river, the ancient Lethaios, and everything that was then uncovered is now reburied. Of the city wall on the hills S of the site, however, two or three courses and a single tower are still standing. On the SW the wall descends into a swamp, where ten courses of regular ashlar are preserved under the mud. On the plain the wall is entirely lost, having been replaced in Byzantine times by the rough wall now standing.

The Temple of Artemis lies in a flat heap near the road. It was built by Hermogenes in the late 3d c. B.C., replacing an earlier temple which stood on the spot in Themistokles' time. It is in the Ionic order and stands on a platform some 67 by 41 m. The peristyle is pseudo-peripteral, with 15 columns by 8. The temple faces W. The plan is remarkable for the number of interior columns: in the pronaos two in antis and two in the interior, six in the cella, and two in antis in the opisthodomos. The altar stood before the W front. The temple was enclosed in an extensive temenos, bounded on the W by the agora.

A number of unidentified buildings were excavated in the agora. At its SE corner was an odeon, and in the W center of the city stood a Roman gymnasium. On a wall of a hall in the agora were found some 70 inscriptions recording the acceptance by various cities of the inviolability of Magnesian territory, and of an invitation to the newly founded festival of the Leukophryena. This was in consequence of an epiphany of Artemis about 220 B.C., and a subsequent declaration by Apollo at Delphi of the sanctity of the city. All this is now buried.

The theater is in the S slope of a hill W of the site. It is small, with a cavea slightly over a semicircle, and dates from the 3d c. B.C. The stage building consists of five rooms with a long room at the back approached by steps on one side; from its front a tunnel led out into the center of the orchestra, where it branched right and left. The tunnel still exists, but has been filled in; only a small part of the cavea wall, in regular ashlar, and a few blocks of the stage building are now visible.

The stadium lay higher up and to the S. It was renovated with marble in the early Roman period, but the seats are now buried and nothing is visible but the shape of the hollow in the hill.

The necropolis lay outside the E and W gates of the city. This too is buried, but there is a well-preserved tumulus grave near Moralı railway station.

Magnesia was supplied with water by an aqueduct from the SW, but this has virtually disappeared.

BIBLIOGRAPHY. C. Humann, *Magnesia am Maeander* (1904)ᴹᴵ; W. B. Dinsmoor, *The Architecture of Ancient Greece* (3d ed. 1950) 274-76; G. E. Bean, *Aegean Turkey* (1966) 246-51. (Artemisium)

G. E. BEAN

MAGNESIA AD SIPYLUM (Manisa) Lydia, Turkey. Map 7. About 32 km NE of Izmir. Founded, together with Magnesia ad Maeandrum, by the Thessalian Magnetes, it was situated in the fertile valley of the Hermos river at the nexus of important road systems. Here in 190 B.C. the Romans decisively defeated Antiochos III of Syria, and the Magnesians sided with Rome in the struggle with Mithridates. When Sulla reordered the province of Asia, Magnesia was made a civitas libera. In A.D. 17 the area was struck by a terrible earthquake; the Roman authorities seem quickly to have reconstructed the town. In later Byzantine times it was an important political and military center.

There are some statues and small finds, and fragments of ancient buildings are preserved in Turkish structures, but the Classical town proper is unknown. However, in the vicinity are monuments of considerable significance, some of them apparently marking the westernmost limits of Hittite influence or control (dates and identifications have not been established conclusively in all cases). Pausanias came from the area, and his references to it and its traditions are numerous.

Just outside the SW limit of Manisa is the Rock of Niobe (Paus. 1.21.3; cf. Hom. *Il.* 24.615, and Soph. *Ant.* 806-16), a large natural rock formation rather in the shape of a woman weeping. What had formerly been taken to be Niobe's Rock is seen at Akpınar 6 km E of Manisa: a rock-cut figure of a seated woman shown frontally in a niche. This figure (Taş Suret) is probably Pausanias' Mother Goddess (3.22.4), that is, Kybele. It is in high relief and well over life size; though badly worn, it is surely Hittite in origin (13th c. B.C.). Beside it is a panel thought to contain a hieroglyphic inscription.

In the vicinity of the Taş Suret are monuments that may well be the ones that Pausanias associated with Pelops and Tantalos (2.22.3 and 5.13.7). The Tomb of Tantalos, long thought to be just N of Old Smyrna, can be sought at the tomb known as that of S. Charalambos, 1 or 2 km E of the Taş Suret. Pausanias' Throne of Pelops may be the same as a large rock-cutting in the shape of an altar or a seat that exists high up on the slopes of Mt. Sipylos between the Taş Suret and the S. Charalambos tomb. Pausanias' Sanctuary of the Plastene

Mother (5.13.7) has been identified a little way from the Taş Suret in the plain of the Hermos. In the general vicinity of these monuments are Lydian constructions (houses and cisterns?) of the 7th and 6th c. B.C., some of sun-dried brick.

About 20 km S of Manisa, in the Karabel gorge, is a rock-cut relief of a standing ruler or war-god. Here also are the badly worn remains of what was once a hieroglyphic inscription. This is probably one of the reliefs that Herodotos identified, at second hand, as one of the XII dynasty pharaohs named Sesostris (2.106). In fact the carving is Hittite, and is known locally as Eti Baba.

Some sculptures and other finds can be seen in the local Manisa museum, and there are a few pieces in the Istanbul Archaeological Museum.

BIBLIOGRAPHY. *RE* XIV (1930) 472-73; G. E. Bean, *Aegean Turkey* (1966) 53-63MI; E. Akurgal, *Ancient Civilizations and Ruins of Turkey* (3d ed. 1973) 132-33I.
W. L. MAC DONALD

MAGNIS (Kenchester) Herefordshire, England. Map 24. A small walled town of ca. 8.8 ha with a roadside suburb to the S in which there is a temple. Excavations and aerial photographs show that the town grew up along the main E-W road in the Wye valley.

The site undoubtedly owes much to military strategy in the 1st c. Objects of military use were found in the excavations of 1912-13 and 1924-25 in the center of the town, which produced plans of fragments of buildings, many at an angle to the main road. This haphazard development, in contrast to the grid plans of the tribal capitals, has been confirmed by subsequent aerial photographs. Excavations of the defenses, which were kite-shaped in plan with the main street as the long axis, show the usual two-phase construction. A ditch system and earth bank was built at the end of the 2d c.; a stone wall faced on both sides with substantial bastions, and with gates, was added in the late 4th c. Molded stones from the foundations of one of the bastions evidently came from a monumental structure demolished for the purpose. The name is given in the *Antonine Itinerary* and the *Ravenna Cosmography*.

BIBLIOGRAPHY. Excavations: *Woolhope Nat. Hist. Field Club* (1916 & 1926); defenses: ibid. 35, 2 (1957) 138-45; 36, 1 (1958) 100-16; 37, 2 (1963) 149-78; aerial reconnaissance and suburb: ibid. 38, 3 (1967) 192-95.
G. WEBSTER

MAGNOPOLIS, see EUPATORIA

MAGYARÓVÁR, see LIMES PANNONIAE

MAHDIA, see SHIPWRECKS

MAHMUDIA, see SALSOVIA

MAIA, see HADRIAN'S WALL

"MAIANDRIA," see KARA-ALI-BEY

MAIDEN CASTLE Dorset, England. Map 24. The hill fortress of Maiden Castle, one of the most imposing of Iron Age defensive works surviving in W Europe, lies 4.8 km SW of Dorchester. This region contains a greater number of large hill-forts than any other in Britain and Maiden Castle dominates them all. The site is a saddle-back hill on chalk, overlooking the valley of the Frome to the N. Its height is not commanding; it is the vastness of the defenses which gives the fortress its peculiar strength.

The hill was first occupied by a Neolithic settlement covering ca. 4.8 ha. Later an enormous Neolithic barrow, 537 m long, was erected on the long axis of the hilltop. Abandoned at the beginning of the Bronze Age, the hill was next used by settlers in the Early Iron Age. At the E end of the saddleback they constructed a fortification with a single timber-fronted rampart, enclosing an area of 6 ha. Later, the whole hilltop, some 18 ha, was surrounded by a rampart and ditch, with double gates at the E and W ends. These entrances were shortly afterwards provided with protective hornworks. Later still, probably in the latter part of the 2d c. B.C., the defenses were greatly increased in height and an outer rampart and ditch were added. These massive works were again enlarged in the 1st c. B.C. and there were further changes before the Roman invasion in A.D. 43. The most impressive works of the later Iron Age are still extremely well preserved, notably the powerfully defended W entrance.

This powerful stronghold of the local population, the Durotriges, was attacked and taken by a Roman force, probably under the command of the future emperor Vespasian. A relic evocative of this contest is a cemetery where some of the defenders were buried, amid the outworks of the E gate. The subsequent history of Maiden Castle was more placid. The population left the fortress well before the end of the 1st c. A.D., many of them drawn to the new nucleus of Durnovaria (Dorchester). Others perhaps settled in a peasant village near the stronghold. Within the old defenses the latest known ancient installation is a small Romano-Celtic temple and an associated dwelling, erected about A.D. 370. The finds are in the Dorset County Museum in Dorchester.

BIBLIOGRAPHY. R.E.M. Wheeler, "Maiden Castle," *Dorset Research Reports of the Society of Antiquaries of London* 12 (1943).
M. TODD

MAILHAC Aude, France. Map 23. Some 20 km N of Narbonne, the oppidum of Cayla (altitude 144 m) near the village of Mailhac is an isolated link in a chain of hills connecting the Corbières with the Cevennes. Cayla contains the ruins of five superimposed villages, the first four of which were fortified. The rampart enclosed an area of ca. 6 ha.

The chronology of the site appears to be as follows: Cayla I: 880-700 B.C.; Cayla II: 600-475 B.C.; Cayla III: 475-300(?) B.C.; Cayla IV: 300(?)-75 B.C.; Cayla V: 75 B.C.-A.D. 200. The first imports (Etruscan and Greek) belong to the Cayla II settlement, but Greek ware is also represented in the next occupation periods. The first two cities had houses of wood and clay; those of the last three were built of stone at the base and of unbaked clay bricks above. The necropoleis and the 7th c. B.C. village spread out in the plain between the hill and the village, in the areas known as Le Moulin and Le Grand-Bassin.

The finds, including both native and imported pottery, are housed on the site, in the Taffanel Collection.

BIBLIOGRAPHY. M. Louis, O. & J. Taffanel, *Le Premier âge du Fer Languedocien*, 3 vols. (1955-60); O. & J. Taffanel, "Les civilisations préromaines dans la région de Mailhac," *Revue d'Études Roussillonnaises* 5 (1956) 7-29, 103-30; id., "Deux tombes de chefs à Mailhac," *Gallia* 18 (1960) 1-37.
O. TAFFANEL

MAILLEN Belgium. Map 21. Two of the largest Gallo-Roman villas ever excavated in Belgium were discovered in the jurisdiction of this township. The first, near Ronchinnes, was investigated in 1894. It consisted of a main building and four subsidiary buildings, the whole extending over a length of ca. 400 m. The first stage of the villa goes back to the middle or even

the first half of the 1st c. A.D. At that time, it was a rather modest rectangular building, containing six rooms flanked on the S side by a portico. Later, it was enlarged on both sides (with the construction of a complete thermal installation, including frigidarium with labrum, sudatorium, and caldarium). In its final state, the villa was a long, narrow, rectangular ensemble, with a portico along the whole S facade, about 110 m long. Part of the villa was heated by hypocausts, and there were at least two very carefully built cellars with niches arranged in the walls. Apparently the villa must have suffered under Marcus Aurelius during the invasions of the Chauci and perhaps also during the invasions of the Franks in the second half of the 3d c. However, it was one of the few agricultural establishments in Belgium which remained in use throughout the 4th c. Of the subsidiary buildings one was a brewery, with a malthouse, fermentation room, depot. Another was an ironworks. Iron was already being produced on an industrial scale in the Entre-Sambre-et-Meuse in Gallo-Roman times.

The second villa was excavated near Al Sauvenière in 1889. Less extensive than the villa of Ronchinnes, it is similar in plan: a large quadrangular ensemble. The rooms opened onto a portico, extending ca. 73 m, the whole length of the S facade. The W wing, where fragments of fresco and window glass were found, served as a dwelling. The E wing was intended for agricultural use. The two wings were separated by an interior court. North of the court was a complete bath building, with praefurnium, caldarium, tepidarium, frigidarium, and latrine. A subsidiary building was located 45 m from the main building. The villa was in use from the first half of the 1st c. until the end of the 4th.

BIBLIOGRAPHY. R. De Maeyer, *De Romeinsche Villa's in België* (1937) passim, esp. 93-99; id., *De Overblijfselen der Romeinsche Villa's in België* (1940) 267-72.
S. J. DE LAET

MAINAKE Málaga, Spain. Map 19. A Greek colony E of Málaga. According to Avienus 425-35, Mainake was located near Cape Barbetium and the Malacha river. Opposite the city was a marshy island dedicated to Noctiluca, with a port. According to a text of Ephorus, preserved in the Pseudo-Skymnos (147-50), it was the most remote Greek colony in the Occident, a Massaliote city near one of the islands that made up the Pillars of Hercules.

BIBLIOGRAPHY. A. García y Bellido, *Hispania Graeca* II (1948) 3-19[MPI]; id., *Historia de España. España Protohistórica* (1952) 523-26[MPI].
J. M. BLÁZQUEZ

MAINZ, see MOGONTIACUM *and* LIMES G. SUPERIORIS

MAJORCA ("Kromyoyssa") Baleares, Spain. Map 19. One of the Balearic islands. It has yielded much Greek material. It is probably the island mentioned by Stephanos Byzantios (Jacoby, frag. 51), who cites Hekataios.

BIBLIOGRAPHY. A. García y Bellido, *Hispania Graeca* (1948)[MI]; G. Trías, *Cerámicas griegas de la Península Ibérica* (1967) 287-92[MI].
L. G. IGLESIAS

MAKARIA (Moulos) Cyprus. Map 6. On the N coast. The ruins of a small town identified by Hogarth with this site cover the Moulos headland, E of Keryneia. The necropolis lies S. The small bay to the E may have served as an anchorage.

Nothing is known of the founding of the town but it was occupied for the first time during the Late Bronze Age. Among surface finds of this period are fragments of Minoan and Mycenaean pottery. It is mentioned by Ptolemy the geographer but otherwise nothing else is known of its history. It seems to have flourished from Hellenistic to Early Christian times when it was gradually abandoned after the first Arab raids of A.D. 647. The town site is now under cultivation and is thus far unexcavated.

BIBLIOGRAPHY. D. G. Hogarth, *Devia Cypria* (1889) 102-4. I. K. Peristianes, Γενική Ἱστορία τῆς νήσου Κύπρου (1910) 506-9; H. W. Catling & V. Karageorghis, "Minoika in Cyprus," *BSA* 55 (1960) 115, 120-21, nos. 16, 29-31; E. Oberhummer, *RE*, s.v. Kypros[M].
K. NICOLAOU

MAKHREBA, see UZITTA

MAKISTOS, see SAMIKON

MAKLJENOVAC Bosnia-Herzegovina, Yugoslavia. Map 12. A Roman castrum at the mouth of the river Usora near Doboj. Here were found inscriptions of soldiers and veterans dating from the time of Septimius Severus (193-211). Units of the Cohors I Belgarum provided the troops for the garrison of the castrum. Beside the castrum there was a settlement of veterans dating from the end of the 2d or the beginning of the 3d c.

BIBLIOGRAPHY. W. Radimsky, *WMBH* 1 (1893) 262-72; C. Patsch, *WMBH* 5 (1897) 226-28, *WMBH* 6 (1899) 253-57.
V. PASKVALIN

MAKRA KOME Ainis, Greece. Map 9. A city N of Spercheios, NE of the modern village of Varibopi (less than an hour on foot), and S of Platystomon. It is mentioned by Livy (30.13.10-14) when he tells how the Aitolians invaded Thessaly, which had been abandoned by Philip V in 198 after his defeat on the Aoos. The city was destroyed at this time.

The acropolis, which is elongated in shape, measures 620 m in the NS axis and 280 m in the WE axis and has a total perimeter of 1550 m (ca. 8 stadia or 185 m). It is protected by a rampart that follows the outer curve exactly at a constant level of 440 m. Well preserved to N and S with two to four courses in elevation, the wall is flanked by square towers 5 m each side, spaced 20-29 m apart. There may have been a gate to the W and another one symmetrical to it to the E. Inside the rampart are several walls of unknown purpose; halfway up the hillside are the remains of a necropolis. The city spread out on the NE side of the hill; four inscriptions, one of which is a dedication to Isis, have been found on its outskirts. The fortress had strategic value and overlooked the approach to the valley. From it one can see as far as Hypata.

BIBLIOGRAPHY. F. Stählin, *Das hellenische Thessalien* (1924) 224; Pauly-Wissowa, *RE* s.v., col. 808; Y. Béquignon in *BCH* 52 (1928) 450-52[I]; id., *La vallée du Spercheios* (1937) 316-22[MPI]; G. Roux in *BCH* 78 (1954) 89-94[PI]; E. Meyer in *Kl. Pauly* s.v.
Y. BÉQUIGNON

MAKRINON, see LIMES, GREEK EPEIROS

MAKRYSIA, see SKILLOUS

MAKTORION, see MONTE BUBBONIA

MAKYNIA, see WEST LOKRIS

MALACA (Málaga) Málaga, Spain. Map 19. Roman city of Baetica on the S coast founded by the Carthaginians, perhaps in the early 5th c. B.C. The classical authors call the inhabitants of the area Libyphoenicians (probably the Carthaginian colonists). The Roman name preserves the Punic Malaka, which meant trading post or commercial settlement. The first documentation of the

city comes from its minting of Carthaginian coins, the earliest of which date from 200 B.C. The first literary reference is in Strabo (3.4.2), who states that its plan is of the Phoenician (Carthaginian) type and that it had an important salt meat and fish industry. Mela (2.6.94) describes it as an unimportant city, and Pliny (*HN* 3.8) states that it was federated with Rome. However, the principal written document, the Lex Malacitana, is a bronze tablet, discovered in 1851 near the city, containing chapters 51-69 of the city's law after it was made a Latin municipium by Vespasian (Municipium Flavium Malacitanum). It is written on five columns dating from 81-84, and is in the National Archaeological Museum in Madrid. A bishop of Málaga first appears in the Council of Elvira.

The theater has features similar to those of the Mérida and Djemilla theaters. It is well preserved but has not been completely excavated. The Augustan character of the inscriptions found date it from this period. The theater must have been abandoned in the 3d c. since it was covered with a dump, rich in small finds, of the 3d-4th c. The upper part of the stage was not covered, and its material was reused by the Arabs in the Alcazaba. Many finds have come from the slopes of this fortress: the oldest is a bronze handle of a Greek oinochoi showing an ephebos leaning on a palm tree and two sirens carrying on their shoulders a creature with a bull's head. It dates from the beginning of the 5th c. B.C. and is probably the work of a Peloponnesian studio.

From the theater have come two statues of Attis, and a large silver patera. From the vicinity of the city comes a bust of Antoninus Pius. All these finds are in the Archaeological Museum of Málaga, which also houses the collection of the Marqueses de Casa-Loring, much of which probably come from Málaga.

BIBLIOGRAPHY. M. Rodriguez Berlanga, *Monumentos Históricos del Municipio Flavio Malacitano* (1864); A. García y Bellido, *Fenicios y Cartagineses en Occidente* (1942); id., *Esculturas romanas de España y Portugal* (1949)[I]; id., "Novedades Arqueológicas de la Provincia de Málaga," *ArchEspArq* 36 (1963)[I]; M. Casamar Perez, *El Teatro romano y la Alcazaba de Málaga* (1963)[I]; A. Blanco Freijeiro, "Ein figürlich, verzierter bronzener Oinochoenhenkel aus Málaga," *MadrMitt* 6 (1965)[I]. R. TEJA

MÁLAGA, *see* MALACA

MALAHUNA, *see* LIMES, SOUTH ALBANIA

MALAIA CHERNOMORKA formerly Beikushskoe, Ukraine. Map 5. A Greek settlement dating from the first half of the 6th c. to the mid 5th c. B.C. at the junction of the Berezan and Beikush rivers, near the entry of the former into the Dnieper estuary. The triangular site, uncovered in modest excavations, contained several rectangular semisubterranean dwellings, at least one surface structure, and grain pits. Among the artifacts were numerous amphorae sherds with Greek graffiti connected with the cult of Achilles.

BIBLIOGRAPHY. A. S. Rusiaeva, "Raskopki v raione Berezanskogo limana," *Arkheologicheskie issledovaniia na Ukraine 1965-1966* (1967) 141-42; id., "Raskopki Beikushskogo poseleniia bliz Ol'vii," *Arkheologicheskie issledovaniia na Ukraine v 1967 g.* (1968) 146-50; L. M. Slavin, "Raboty Ol'viiskoi ekspeditsii," *Arkheologicheskie Otkrytiia 1969 goda* 250-51. T. S. NOONAN

MALAIN, *see* MEDIOLANUM (Côte d'Or, France)

MALANDRINO, *see* PHYSKEIS

MALÇAN, *see* LIMES, SOUTH ALBANIA

MALLOS Cilicia Campestris, Turkey. Map 6. The probable site, discovered in 1950 at the junction of the old and new beds of the river Ceyhan (Pyramos), is 29 km SW of Mopsuestia near modern Kızıltahta. A city coin type of two river gods swimming in opposite directions was a useful clue to identification; for while the Ceyhan now flows E into the Gulf of Issos, the city's port of Magarsos is almost certainly the walled settlement near Karataş, at the mouth of the river's original (though now dry) W course. Near Kızıltahta were found a Roman bridge, an inscription referring to the city of Mallos, and very numerous carved blocks in secondary use.

Mallos' claim to Amphilochos, son of Amphiaraos, as founder was partly substantiated by long and vigorous tradition and partly by Alexander's remission of tribute after his conquest of Cilicia in recognition of the city's Argive origin. For its fidelity to the Seleucid cause, Mallos became Antioch on the Pyramos under Antiochos IV, but dropped the title in the 2d c. B.C. to enjoy a limited autonomy. In 67 B.C. it was among the cities settled by Pompey with ex-pirates, and under the empire piled up honorific titles to keep up with its rivals. It even engaged in a ridiculous boundary dispute with Tarsus, metropolis of Cilicia Prima. It duly became a bishopric, but disappeared from history after the Arab conquest.

BIBLIOGRAPHY. Hdt. 3.91; Skylax 102; Arr. Anab. 2.5; Strab. 14.676; App. *Mith.* 96; Dio Chrys. *Or.* 34.44-45.

H. T. Bossert, *Belleten* 14, 664ff; A.H.M. Jones, *Cities of Eastern Roman Provinces* (2d ed. 1971) 192, 196-97, 199-200, 202, 206-7. M. GOUGH

MALO GOLUBINJE, *see* LIMES OF DJERDAP

MALTA, *see* MELITA

MALTON, *see* DERVENTIO

MAMPSIS (Kurnub) Israel. Map 6. A small town in the central Negev 40 km SE of Beersheba, on the way to the Dead Sea. The name Mampsis appears for the first time in the first half of the 2d c. A.D. (Ptol. *Geog.* 5.15.7), where it is referred to as a place in Idumaea. Eusebius (*Onom.* 8.8) states that it was situated at a distance of one day's march on the way from Hebron to Aila. It is further mentioned in numerous sources of the Byzantine period, such as the Madaba mosaic map and the Nessana papyri. The site has been extensively excavated. The earliest settlement on the site is Nabatean (first half of the 1st c. A.D.). The remains of this town were almost completely covered by the extensive Nabatean town of the early 2d c. A palace, an administrative complex of buildings centered around a large tower, two private dwellings, a public reservoir have been uncovered, and water storage devices in nearby wadies. Typical of the period is the excellent quality of the masonry and of the architectural decoration. Both the palace and the private dwellings were built as self-contained fortresses, with rooms around central courts. Each unit had only one entrance, and the outside walls were solid with narrow slots high up on the wall. All houses had at least two stories, and those above ground level were reached by means of towers in which the stairs were built around a heavy pier. A balcony surrounded the court. The private dwellings were provided also with storerooms and stables of a type hitherto known only from the Hauran and S Syria. The roofing system was based on arches with coverstones. There was at least one cistern for each house. The public reservoir (18 x 10 m and 3 m deep) was roofed over by arches resting on piers. The water

storage consisted of series of dams, in which flood waters were transferred to public and private reservoirs in the town.

To this period also belong two necropoleis, discovered near the town. One was civilian, the other military. Two inscriptions identify a centurion of the Legio III Cyrenaica, and an eques of Cohors I Augusta Thracum respectively. Burial in the civilian necropolis was in a cist 2-4 m deep. The bottom was lined with ashlar, and here a wooden coffin was placed. Over the cover stone of the grave closely packed stones were placed. Above the ground rose a stepped pyramid. One of these survives. Some of the tombs contained drachmas of Trajan, and one had seal impressions of Petra, Characmoba, and Rabatmoba from the time of Hadrian. A great quantity of gold jewelry was found in some of the tombs. One tomb was dated by a Nabatean denarius to A.D. 44. Many Nabatean pottery vessels represented both burial periods. The dead in the military necropolis were cremated.

Mampsis was settled also in the late 2d and 3d c. Since all Nabatean houses were still in a good state of repair, no new building was needed. In one of the houses a hoard of 10,500 Roman silver coins was found. Of these ca. 2500 were drachmas and tetradrachmas of the period from Vespasian to Hadrian, while the remainder belonged to the Severii. In the same house frescos depicting men, women, Eros and Psyche, Leda and the Swan, etc., were discovered. To this period possibly belongs a bath building built on the normal Roman plan. Around 300 A.D. the town was surrounded by a wall. No other changes were apparent in the town, and there was no interruption in settlement between the periods.

In the Byzantine period the number of inhabitants increased greatly. The need for more living space was met by repartitioning the older Nabatean houses, and by building annexes to these houses in the broad streets. The two churches which belong to this period were squeezed into the town by destroying parts of the town wall. As in the earlier periods the architecture of Mampsis in the Byzantine period was superior to that of the neighboring towns. Both churches were built on an identical plan: a basilica of one apse and two side rooms. Each had a spacious atrium, but no narthex. One church was a complex covering an area of 55 by 25 m, while the other was only 27 by 10 m. Both had mosaic floors.

At ca. 634-36 Mampsis was overrun by Arabs, who occupied it for a period long enough to destroy the site, leaving a few graffiti on the stones of the apse of the large church.

BIBLIOGRAPHY. A. Negev, "Kurnub dans le Néguev," *Bible et Terre Sainte* 90 (1967) 6-17; id., "Mampsis, A Town in the Eastern Negev," *Raaqi, Journal of Art History and Archaeology* 7. 3-4 (1967) 5-28; id., "Oboda, Mampsis and the Provincia Arabia," *Israel Exploration Journal* 17 (1967) 46-55; id., *Cities of the Desert* (1967); id., "A City of the Negev," *ILN* 14 and 21 Sept., 1968; id., "The Chronology of the Middle Nabatean Period," *PEQ* 101 (1969) 4-15; id., "Mampsis, eine Stadt in Negev," *Antike Welt* 3, 4 (1972) 13-28.
A. NEGEV

MAMUCIUM (Manchester) Lancashire, England. Map 24. Site of an important fort and civil settlement at a major road junction. It has long been known that an auxiliary fort once lay at the W end of Deansgate in Manchester. The position of the 2.4 ha cite was typical, protected on three sides by the confluence of the Irwell and Medlock rivers. Recent demolition has allowed excavation along the N wall. The N gateway, the position of which shows that the via principalis ran on the E side of the principia, revealed two phases, one of timber, the other

of stone, but a section across the defenses in 1966 suggested three phases. The turf front of the Flavian rampart was partly dismantled to fill the inner ditch when the (presumably Trajanic) stone revetment was added. A second stone phase later replaced the first, perhaps in the Severan period. Modern disturbance makes it difficult to interpret the late history of the fort, but Manchester's position at the hub of a communications network must have maintained its importance. Sporadic finds made in the last century along the line of Deansgate indicate an extensive civil settlement E of the fort. As at Bremetennacum Veteranorum (Ribchester), an inscription implies that a centurio regionarius of the sixth legion from York was in command in the later empire, when Mamucium lay in Britannia Inferior. Finds from the military and civil sites are housed in various museums in Manchester.

BIBLIOGRAPHY. F. A. Bruton, *The Roman Fort at Manchester* (1909); G.D.B. Jones, "Roman Lancashire," *ArchJ* 127 (1970) 237ff^{MPI}.
G.D.B. JONES

MAMURT KALE Turkey. Map 7. On the Yunt mountain between Kaikos (Bakırçay) and Hermos (Gediz), to the S of Kınık and near the village of Ortülü. There are no remains on the plateau except the Temple of Demeter and the portico around it. However, in the SE part of the plateau are dwellings for priests and other personnel. A Doric temple in antis, with an altar on its axis, was aligned NW-SE in the middle of the N portico of a sacred area 67 m square. An inscription on the architrave blocks dates it to the time of Philetairos. The E porticos, which are a little longer, are U-shaped and open to the SE.

BIBLIOGRAPHY. A. Conze & P. Schazmann, "Mamurt-Kaleh," *JdI* suppl. vol. 9 (1911).
C. BAYBURTLUOĞLU

MANCETTER, *see* MANDUESSEDUM

MANCHESTER, *see* MAMUCIUM

MANCHING, *see* VALLATUM

MANDEURE, *see* EPAMANTADURUM

MANDUESSEDUM (Mancetter) Warwickshire, England. Map 24. The name appears in the *Antonine Itinerary*. In and around here are Roman sites which can be summarized as follows:

1) At the village of Mancetter is at least one fort, datable to the period of Nero.

2) A civil settlement lies along the Roman road (Watling Street) and has been traced for at least 1.6 km.

3) Over a large area S of the road there was a large-scale pottery industry; its peak of activity was in the second half of the 2d c., continuing into the 3d c. A variety of vessels was produced for the Midland markets, including mortaria. The potters Gratinus, Minomelus, Iunius, Sennius, Maurus, Vitalis IV, and Sarrius and G. Attius Marinus are known to have worked here. The industry extended as far as the high ground at Hartshill where stone quarrying has destroyed many kilns over the last 100 years. A small glass furnace has also been found.

4) A small defended enclosure with a wall bank and ditch system was established early in the 4th c., similar to others along Watling Street.

BIBLIOGRAPHY. Pottery industry: *Institute of Archaeol. Bulletin* 5 (1965) 25-43; *Trans. Birmingham Arch. Soc.* 84 (1971) 18-44; 85 (1973) 211-12.
G. WEBSTER

MANDURIA Ionio, Apulia, Italy. Map 14. A Messapic city ca. 35 km SE of Tarentum. Its name first appears in

connection with the death, beneath its walls in 338 B.C., of king Archidamos of Sparta, who had been summoned to help the Tarentines against the Messapians and the Lucanians (Plut. Ages. 3.2). There is another mention of the city. During the second Punic war, according to Livy (27.15), the city gave passage to Hannibal in 212 B.C. and in 209 B.C. Q. Fabius Maximus sacked it, taking 3000 prisoners and a great deal of loot. From that point on, the city declined and never regained the status of a Roman municipium. Pliny (*HN* 3.11) in his listing of the cities in this part of Italy, makes no specific mention of it but elsewhere in another passage (2.106.226) concerning the existence of a celebrated lacus he calls Manduria an oppidum. The name of the city appears in the *Peutinger Table*, which places it 20 Roman miles from Tarentum, a distance shorter than the actual one.

The most ancient evidence of life in the city comes from the necropolis, where some funerary objects were uncovered along with Corinthian pottery of the first ten years of the 6th c. B.C. and associated with local, Early Geometric vase production. It is probable that the first circuit walls of the city are to be dated to the beginning of the 5th c. B.C. The walls are about 2 km long and constructed of large, irregular blocks and fronted by a ditch which had been filled even in antiquity and recently have been revealed in the course of excavations. A second circuit wall, built outside the first, is well constructed of regular blocks. Set partly over the ditch of the first wall, it was constructed to enlarge and reinforce the wall. It dates to the 4th c. B.C. and was probably connected with the war against Tarentum and the death of Archidamos. The last and strongest circuit wall, with a perimeter of more than 5 km and a breadth of 5.5 m, faced inside and out with large blocks over a rubble core and fronted by a large ditch, was constructed in the 3d c. B.C., perhaps in the period of the Hannibalic war. The wall, in fact, was set over tombs whose grave gifts date to the second half of the 3d c. B.C. (pottery of Gnathia of the gadroon type). Outside the walls and in particular relation to the gates, often well preserved, and along the sides of the streets that lead from the gates, numerous rock-carved tombs have come to light. The richest of these (4th-3d c. B.C.) testify to the prosperity enjoyed by the city in that period. Numerous furnishings have been discovered comprising local geometric ware, among which the typically Messapic "trozzella" predominates, Gnathian and black glaze ware, and some bronze objects which are now preserved in the National Museum at Tarentum. Numerous Messapic inscriptions survive. The so-called Fountain of Pliny, is set in a large, natural grotto, was artificially adjusted and furnished with a stairway of 40 steps. The constant level of the water is unique and perhaps corresponds to the lacus mentioned above by Pliny.

BIBLIOGRAPHY. W. Smith, *Dictionary of Greek and Roman Geography*, II (1857) 259 (E. H. Bunbury); L. Tarentini, *Cenni storici di Manduria antica* (1901); *RE* 14.1 (1928) 1046 (Philipp); K. Miller, *Itineraria Romana*, 362; N. Degrassi, "La documentazione archeologica in Puglia," *Atti del I Convegno di Studi sulla Magna Grecia* (1961) 235; *EAA* 4 (1961) 815 (F. Coarelli); O. Parlangeli, *Studi Messapici* (1960) 112.

F. G. LO PORTO

MANFRIA Sicily. Map 17B. A hilly area on the S coast of Sicily, ca. 10 km N of Gela. Because of its favorable position Manfria was inhabited continuously from the Early Bronze Age to the 5th c. A.D., and again in the 13th c. at the time of Frederick II. The prehistoric necropoleis with oven-shaped, rock-cut tombs were explored around 1900. In 1960 a new excavation on the slope under the present "houses of Manfria" brought to light a whole Early Bronze Age village with elliptical houses and numerous ovens and hearths. More recently, remains of Greek farms have been identified in several places. One of them, in the location called Mangiatoia, dates from the second half of the 4th c. B.C., and contained a large deposit of Sicilian black-glaze and red-figure vases in the style of the Manfria Painter. Under the farmhouse Greek material of the 7th and 6th c. B.C. was recovered, attributable to an earlier archaic settlement by Geloan colonists. According to numismatic evidence, the Greek farmhouses of Manfria were destroyed during the war between Agathokles and the Carthaginians in 310 B.C.

New farms were established in this area during the Roman Imperial period, in connection with a settlement in the valley of the torrent Comunelli, W of Manfria, where ruins emerge here and there in the area called Monumenti.

All the archaeological material found at Manfria during the recent excavations is in the Gela Museum.

BIBLIOGRAPHY. P. Orsi, *BPI* 27 (1901) 159ff; P. Orlandini, *Kokalos* 6 (1960) 26ff; id., *Il villaggio preistorico di Manfria presso Gela* (1962); D. Adamesteanu, *NSc* (1959) 290ff; (1960) 220; id., *Kokalos* 4 (1958) 59ff; id., "Vasi dipinti del IV secolo di fabbrica locale a Manfria," *Miscellanea G. Libertini* (1958) 25ff; A. D. Trendall, *The red-figured vases of Lucania, Campania, and Sicily* (1967) 592ff.

P. ORLANDINI

MANGALIA, see KALLATIS

MANISA, see MAGNESIA AD SIPYLUM

MANSILLA DE LAS MULAS, see LANCIA

MANTINEA E. Arkadia, Greece. Map 11. Located in the plain N of modern Tripolis and off the road to Olympia. Mentioned as "lovely" by Homer (*Il.* 2.607), it was formed by the synoecism of five villages at some unknown date (Strab. 8.3.2). As an ally of Sparta, Mantinea took part with 500 hoplites in the battle of Thermopylai (Hdt. 7.202), but came too late for Plataia (Hdt. 9.77). Mantinea split with Sparta in 420 (Thuc. 5.29) when interests collided, and was disbanded by Sparta in 385. After the battle of Leuktra in 371 the city was reconstituted, and was a member of the Arkadian League until 362 (Xen. *Hell.* 7.5), at which time it returned to friendship with Sparta. In 223 Antigonos Doson destroyed the city which was then refounded under the name of Antigoneia, a name which it retained until Hadrian's time. Numerous battles took place in the vicinity (418: Thuc. 5.64-81; 362: Xen. *Hell.* 7.5; 207: Polyb. 11.11-19). Pausanias describes the city (8.8.3-8.12), thus disproving Strabo (8.8.2), who included it among states no longer extant.

The 4th c. city—the most ancient site was at Ptolis, securely identified with the hill Gourtsouli—is located nearly in the middle of the plain, and was originally bisected by the Ophis river. Later, after Agesipolis had taken the city in 385 (Xen. *Hell.* 5.2.4-7) by damming the river and thus causing the sun-dried bricks of the walls to collapse, the river was diverted so as to flow around the city. The circuit of the walls, 3942 m long and roughly oval in shape, is preserved for nearly its entire extent. Originally built up in mudbrick, only the socle of the inner and outer curtain remains, at a height varying between 1-1.8 m with a width of 4.2-4.7 m. Over 100 towers (estimates vary as to the original number) are built out from the wall, and there are at least nine, and possibly ten, gates. Most of the gates are so constructed that one is forced to approach through towers into a passage between sections of the wall. Excavators have cleared the

agora (85 x 150 m) with colonnades around it, and the remains of a 4th c. theater at its W end. Though rebuilt and remodeled at various times, it may well be one of the earlier Greek theaters.

BIBLIOGRAPHY. G. Fougères, *Mantinée et l'Arcadie orientale* (1898); *RE* 14 (1930) 1290-1344; R. Scranton, *Greek Walls* (1941) passim; O. Dilke in *BSA* 45 (1950) on theater, with references; R. Martin, *Recherches sur l'agora grecque* (Paris, 1951) passim; T. Karagiorgas in *Deltion* 18.2 (1963) 88-89 (Gourtsouli); W. K. Pritchett, *Studies in Ancient Greek Topography, Part II* (1969) 37-72; F. W. Winter, *Greek Fortifications* (1971) passim.

W. F. WYATT, JR.

MANTOCHE Haute-Saône, France. Map 23. A site on the right bank of the Saône near two fords. Its importance as a crossing place from prehistoric times on is attested by finds made whenever the river is dredged. Tumuli have yielded four 6th c. Greek amphorae. From the Roman era there is a large villa between the canal and the Saône, only partially excavated, where a mosaic with marine motif was found; a factory which produced tiles and ordinary pottery; a cemetery in which a sarcophagus was found with a lid bearing a bust of the deceased in the center and tragic masks at the corners.

BIBLIOGRAPHY. A. Gasser, *Bulletin de la Société Grayloise d'Emulation* (1898) 89-93; (1900) 236-45; (1901) 165-283; (1904) 81-131; F. Villard, *La céramique grecque de Marseille* (1960) 129, no. 5; L. Lerat, "Informations," *Gallia* 20 (1962) 540-43; H. Stern, *Recueil général des mosaïques de la Gaule romaine* I, 3 (1960) no. 363.

L. LERAT

MANTOVA, *see* MANTUA

MANTUA (Mantova) Lombardy, Italy. Map 14. Named for a legendary founder, Manto, the city is of Etruscan origin (*Aen.* 10.204). Etruscans were superseded by Gauls, probably ca. 400 B.C., and later by Romans, who made it first a colony, then a municipium with Latin status after the social war. Full citizenship was granted in 49 B.C. The town was invaded by Alaric and again by Attila in the 5th c.

The modern city is virtually divided into two islands separated by the narrow marshy channel of the Mincio. Little remains of the ancient town beyond some inscriptions and a geometrically decorated mosaic found near the Ducal Palace.

A fine collection of Classical sculpture, acquired from many sources by the Gonzagas in the 16th c., may be seen in the Ducal Palace, now a museum.

BIBLIOGRAPHY. A. Levi, *Sculture greche e romane del Palazzo Ducale di M.* (1931). D. C. SCAVONE

MARAŞ, *see* COCUSUS

MARATHI ("Minoa") Kydonia district, Crete. Map 11. A small harbor town near Sternes on SE side of Akrotiri peninsula, N side of entrance to Suda Bay, opposite Aptera. It is generally thought to have been the second port of Aptera, but from the 3d c. at least it was controlled by Kydonia. It may once have been independent, but since no coins are known, it was probably no longer so by the 4th c. It is mentioned only by geographers (Plin. *HN* 4.12.59; Ptol. 3.15.5; *Stad.* 344).

Remains have been excavated (1939) of a building with 12 rooms, a cistern, and a well (1st-2d c. A.D.) behind a shore embankment and promenade, incorporating much reused material, which run for a further 60 m to the W, with traces of other buildings on the landward side. This is only part of a larger settlement occupying at least the E half of the Marathi valley, and supplied

with water by an open aqueduct. Pre-Roman settlement is shown by the reused material. In the hillside bordering the plain on the N, by the rock shelter of Marathospilio, was an important open-air sanctuary (of Diktynna?) from at least archaic to Roman times (Faure).

An alternative location was suggested by Spratt: Limni, S of Sternes, where on the peninsula enclosing from the S a shallow, almost circular bay there are houses, Classical-Roman sherds and tombs of the Roman period; on the ridge above to the E is a circular tower (lighthouse or watch-tower) of Classical date, connected to the shore by a fortified road 500 m long. A small fishing settlement and probably dependent on the Marathi site, it may possibly have been early Minoa. But it may first have been made into a harbor by the Venetians (Porto Nuovo, 1594).

BIBLIOGRAPHY. R. Pashley, *Travels in Crete* I (1837, repr. 1970) 42-53; T.A.B. Spratt, *Travels and Researches in Crete* II (1865) 130-31; Fiehn, "Minoa (4)," *RE* XV.2 (1932) 1858; M. Guarducci, *RivFC* NS 14 (1936) 158-62; id., *ICr* II (1939) 10-11; V. D. Theophanidis, *ArchEph* 89-90 *Chronika* (1950-51) 1-13PI; P. Faure, *Fonctions des cavernes crétoises* (1964) 186-87.

D. J. BLACKMAN

MARATHON NE Attica, Greece. Map 11. A coastal plain inhabited from very earliest times down to the end of antiquity. Home of the Marathonian Tetrapolis (Philochorus *FGH* 328 F 94, 109), it is best known as the site of the famous battle of 490 B.C. (Hdt. 6.102-16), though Peisistratos also landed there ca. 545 (Hdt. 1.62). Pausanias described the area in the 2d c. A.D.

The remains date from the following periods: Neolithic (cave of Pan, Nea Makri), Early Helladic (Tsepi), Middle Helladic (Vrana), Late Helladic (tholos tomb), archaic and Classical down to Roman (Plasi) at the presumed site of the ancient deme. Many of the landmarks of the great battle have been securely located, the most conspicuous of which is the soros, the tomb of the Athenians; also, the Herakleion, the trophy, the tomb of the Plataians in Vrana (?), the charadra, the great marsh, the Makaria spring. The estate of Herodes Atticus, or better of Regilla, has also been found.

BIBLIOGRAPHY. B. Stais in *AthMitt* 18 (1895) 46-63 (soros); J. G. Frazer, *Paus. Des. Gr.* (1898) II 431-35; E. Stikas in *Praktika* (1954) 114-22; (1958) 15-17; A. Orlandos in *Ergon* (1958) 15-22 (cave of Pan) & 23-27; id. in *Hesperia* 35 (1966) 93-106M (trophy); E. Vanderpool in *AJA* 70 (1966) 319-23 (Herakleion); N.G.L. Hammond in *JHS* 88 (1968) 13-57, with references (battle); W. K. Pritchett, *Studies in Ancient Greek Topography* (1969) II 1-11, with references (deme); S. Marinatos in *AAA* 3 (1970) 14-20 & 153-66; id. in *Praktika* (1970) 5-28, with references (Vrana & Tsepi)MPI; id. in *AAA* 4 (1971) 99-101; id. in *Ergon* (1971) 5-11.

W. F. WYATT, JR.

MARATHOS (Amrît) Syria. Map 6. Site on the coast, 5 km S of Tartus, the ancient Antaradus. In the time of Alexander the Great Marathos was the principal mainland city of the Phoenician confederation of Arados. Captured by Arados at the end of the Hellenistic period, it declined during Roman times.

The ruins show Phoenician traditions combined with Egyptian, Persian, and Greek influences. Near the tell is a rock-cut sanctuary, the *maabed*. A small cubic chapel, open on one side only, stands in the middle of a pool fed by a spring; it served as a canopy for the cult image. Porticos, supported by monolithic limestone pillars, encircled the basin on three sides. The monument dates from the 4th c. B.C.

To the N the stadium, dating from the 3d c. B.C., is likewise cut in the rock, and to the S the necropolis has many rock-cut tombs. Some of them are topped by towers, placed along the axis of the stairs which descend to the sepulchral vaults. The towers are round or square and sometimes capped by domes or pyramids. The most remarkable of these funerary monuments (which date from the 4th c. B.C.) are the two high *meghazil* (spindles), and the *borj el-bezzak* (the snail tower), farther SE. One of the spindles has a cubic base, the other a cylindrical base cantoned by the foreparts of four lions. The snail tower is a cube without a top.

BIBLIOGRAPHY. E. Renan, *Mission de Phénicie* (1864-74); E. Will, "Le tour funéraire de la Syrie," *Syria* 25 (1949); M. Dunand & N. Saliby, "Le sanctuaire d'Amrit," *Annales Archéologiques de Syrie* 11-12 (1961-62); N. Saliby, "Essai de restitution du temple d'Amrit," *Annales archéologiques arabes syriennes* 21 (1971).

J.-P. REY-COQUAIS

MARBELLA Málaga, Spain. Map 19. On the Mediterranean coasts SW of Málaga. Not mentioned in literary sources. Some 6.4 km W of the town are the remains of a Roman villa. Among its mosaics is one with representations of culinary themes: a simpulum (small ladle), a batillum (chafing dish), a tripod, oinochoai, a hearth; also spits, onions, rabbits, game, and fish. The mosaic dates from the first half of the 2d c.

BIBLIOGRAPHY. A. García y Bellido, "El mosaico de tema culinario de Marbella," *Hommages à Marcel Renard* III, *Latomus* (1969) 240-46[PI].

J. ARCE

MARCELLINO, *see* ROCCANOVA

MARGERIDES Corrèze, France. Map 23. Thick, well-preserved limestone walls were discovered about 20 years ago during plowing at Les Pièces Grandes. Many tiles and a number of potsherds were also found.

Excavations since 1965 have revealed a large religious complex. It consists of a fanum, two small subsidiary structures, and three altars. A surrounding wall ca. 22 m E of the temple facade leads to a rectangular building. To the N, some distance from this complex, is a badly damaged monument with a gallery on its N side. Objects found include 180 coins, evidence that the site was occupied from the 1st to the 4th c. A.D.; two statues of the Mother Goddess, one of them mutilated; another mutilated statue, and a bronze statuette resembling the god Cernunnos.

The cella walls of the fanum were ca. 7 m on a side, 0.48 m thick, and are preserved to an average height of 0.5 m. They were built of an irregular medium-sized masonry of gray granite; the inner and outer surfaces were carefully constructed of small stones bonded with mortar, and were coated with limestone. The walls, now uneven in height, stand on a thicker foundation that forms a redan at its base. The floor is a regular checkerwork of different types of small stones, most of them granite, however, and consists of just one layer varying in thickness from 0.1 to 0.15 m. The stones are laid on a fairly compact sandy floor.

The gallery walls, 12.8 m on a side, 0.49 m thick, and standing to an average height of 0.8 to 1 m, are well preserved on two sides. The inner surface has an irregular medium-sized masonry with a flat facing, while the outer one consists essentially of regular rows of small granite blocks 0.09 m square.

BIBLIOGRAPHY. "Informations," *Gallia* 25 (1967) 299-301[PI]; 27 (1969) 318[P]; 29 (1971) 311-12[I].

A. SIRAT

MARGIANA, *see* ALEXANDRIAN FOUNDATIONS, 8

MARGIDUNUM (East Bridgeford) Nottinghamshire, England. Map 24. The *Antonine Itinerary* (Iter VI and Iter VIII) locates Margidunum midway between Ratae (Leicester) and Lindum (Lincoln) on the Fosse Way. The earliest occupation of the site was a military post, established ca. A.D. 55-60. No structural evidence for a fort has been recovered, but finds of military equipment indicate the presence of an army unit. After the abandonment of the site by the army, A.D. 70-80, a civilian settlement grew up along the Fosse Way, a number of simple rectangular buildings straggling along the road for ca. 1 km. There were two villas within 3 km of the settlement and other humbler farms in the surrounding area.

In the late 2d c. an earthwork defense, an irregular polygonal circuit, was provided for the central part of Margidunum (area 2.2 ha). Later, perhaps in the 3d c., a stone wall 2.7 m wide was added to the front of the earth rampart and two broad ditches were dug outside it. Within this small defended area relatively few buildings were erected. The most elaborate was a corridor house resembling a small villa. Occupation continued until ca. A.D. 500.

BIBLIOGRAPHY. F. Oswald, "Margidunum," *JRS* 31 (1941) 32ff; id., *The Commandant's House at Margidunum* (1948); id., *Excavation of a Traverse of Margidunum* (1952); M. Todd, "The Roman Settlement at Margidunum," *Trans. Thoroton Soc.* 73 (1969).

M. TODD

MARGNY Ardennes, France. Map 23. Gallo-Roman villa on the Franco-Belgian frontier SE of Sedan. Rectangular in plan, it has a N gallery running the length of a complex of rooms lying on either side of a large central hall with a hearth. One of the doors of this hall opens onto a balneum with a hypocaust. Many metal objects have been found (bronze doorknobs with a lion design), as well as pottery, particularly amphorae and dolia. The villa had a slate roof. There were several levels of occupation, dating apparently from the 2d and 3d c. A.D.

BIBLIOGRAPHY. R. Devis, *Annales Sedanaises d'Histoire et d'Archéologie* 56 (1967) 4-8; E. Frézouls, *Gallia* 27 (1969) 294[I]; 29 (1971) 281ff; 31 (1973) 398f.

E. FRÉZOULS

MARGUM (Dubravica) Yugoslavia. Map 12. The Roman municipium Aurelium Augustum Margum in Moesia Superior near the mouth of the Morava (ancient Margus) river. In antiquity it lay between Singidunum and Viminacium.

Margum is first mentioned (Ptolemy) as the winter quarters of Legio VII Claudia in A.D. 169. The Roman prefect of the Danube fleet had his headquarters here in 400. The town was represented by a bishop from the early 5th c. It recovered sufficiently from the Hunnic invasion of 441 to become in 505 the residence of the magister militum of the province of Illyricum.

Excavations have revealed that the Roman town was founded on the site of an extensive prehistoric site of the Late Neolithic Age and the Bronze Age. Parts of several Roman houses were uncovered, in some of which parts of mosaic floors and wall paintings were preserved; one of the houses had floors heated by a hypocaust.

BIBLIOGRAPHY. M. & D. Garašanin, *Arheološka nalazišta u Serbiji* (1951) 183-84.

J. WISEMAN

MARIANA Commune of Lucciana, Corsica, France. Map 23. Located 20 km S of Bastia and 3 from the coast, the site which surrounds the Romanesque cathedral of La Canonica corresponds to the position of a settlement

of the Roman period. It goes back perhaps to the beginning of the 1st c. B.C. It would be the site where Marius chose to install the Colonia Mariana cited by Ptolemy. Various ancient remains have been recognized there. Excavations have led to the discovery of an Early Christian church and baptistery. The latter is adorned with mosaics with Christian symbols and has a font converted from a stepped swimming pool. Nearby, a large dwelling of Classical type underwent some alterations. The hypothesis has been advanced that it represents the episcopium of the 4th c. The excavations have also led to the discovery of the Early Christian church which preceded the San Parteo church. Its plan is offset with respect to that of its successor. Three necropoleis have produced cremation and inhumation tombs. These contain grave goods dating from the 1st to the 4th c. A.D. continuously. There is a small excavation warehouse near the church of La Canonica.

BIBLIOGRAPHY. "Chronique des circonscriptions arch., circonscription de Cote d'Azur-Corse," *Gallia* (1954ff).

C. GOUDINEAU

MARION later ARSINOE (Polis) Cyprus. Map 6. On the NW coast near the sea. The ruins cover a large area, part of which is now occupied by the village of Polis. Marion was founded on two low plateaus, both commanding a wide view over the narrow plain below and the Bay of Chrysochou beyond. Thus there was an E and a W city, the former being the first to be inhabited. Similarly its vast necropolis extended E and W. Remains of the ancient harbor still survive at Latsi.

Archaeological evidence indicates that the city was founded at the beginning of the Geometric period. The site of the earliest city should be located on a low hill E of the village of Polis. This is the E city. It is now a field of ruins under cultivation except for part of its S side, which is occupied by the modern gymnasium and Technical School of Polis. Close by is the E necropolis with tombs dating mainly from the Geometric and the archaic period. In late archaic times Marion spread to the W on a low hill called Petrerades, due N of Polis. This is the W city. This site too is now under cultivation or partly inhabited. South of it extends the W necropolis, dating from Classical and Hellenistic times.

The name Aimar appears in an Egyptian inscription at Medinet Habu of the time of Rameses III (1198-1167 B.C.), if the correlation with Marion were beyond dispute. The earliest known historical event mentioning Marion belongs to the Classical period, when in 449 B.C. the Athenian general Kimon freed the city from the Persians. On coins of the 5th and 4th c. B.C. are given in syllabic script not only the name of the king but also the name Marieus. Skylax the geographer (probably mid 4th c. B.C.) speaks of this city as Μάριον Ἑλληνίς (*GGM* 103).

After Alexander the Great, Stasioikos II, the last king of Marion, sided with Antigonos against Ptolemy and in 312 B.C. the city was razed by Ptolemy and the inhabitants transferred to Paphos. About the year 270 B.C. a new town, renamed Arsinoe (q.v.), was founded on the ruins of Marion by Ptolemy Philadelphus. This town flourished once more during the Hellenistic and Graeco-Roman periods and in Early Christian times it became the seat of a bishop.

Marion was one of the ancient kingdoms of Cyprus and we know the names of most of its kings from the 5th and 4th c. B.C. The city grew in importance at an early date, drawing its wealth from the nearby copper mines at Limne and from an intensive trade with Athens. The necropolis has produced large quantities of imported Attic pottery, an indication that there were close commercial and cultural relations with Athens. These tombs are also rich in gold jewelry. A fine marble kouros, now in the British Museum, also comes from Marion.

The earliest coins attributed to Marion date to the second quarter of the 5th c. B.C. These were struck by Sasmaos son of Doxandros. Coins were also minted by Stasioikos I (after 449 B.C.), Timocharis (end of the 5th c. B.C.), and Stasioikos II (330?-312 B.C.). Nothing is known of the kings between Timocharis and Stasioikos II.

Marion produced a large number of syllabic inscriptions dating from the 6th to the 4th c. B.C. They are inscribed on stelai found in tombs so that they are all funerary. None has been found so far on the city site. Alphabetic inscriptions occur also but they are Hellenistic and later.

Apart from some soundings made in 1929 and in 1960 in the W sector of the city no excavations were ever carried out within the city site. A large number of tombs, however, were excavated in the necropolis but none is now accessible. A general survey of the city site and its immediate surroundings was carried out in 1960 with interesting results. Surface finds dating from the Protogeometric period down to Hellenistic times were found at Peristeries, thus supporting the theory that the site of the earliest Marion should be sought here. The soundings at Petrerades N of Polis simply proved that at least part of the late archaic and Classical city is buried below the remains of Hellenistic Arsinoe.

The site of a sanctuary is known at the far end of a small ridge at Maratheri between the E and W cities. Casual finds date it from the archaic to Graeco-Roman times. This sanctuary may well be that of Zeus and Aphrodite, known from an inscription of the time of Tiberius which almost certainly came from this site. Strabo (14.683) speaks of a Sacred Grove to Zeus. It is interesting to note that some coins of King Stasioikos II show on the obverse the head of Zeus and on the reverse that of Aphrodite.

The harbor of Marion-Arsinoe lies ca. 4 km W of Polis and still shelters fishing boats. A massive breakwater still survives for a considerable length; it must have been much longer in antiquity, since a large part of the harbor has silted up. It was from this harbor that the trade with the West passed, especially the exportation of copper.

The finds are in the Nicosia and Paphos Museums.

BIBLIOGRAPHY. Paul Herrmann, *Das Gräberfeld von Marion auf Cypern* (1888); A. Sakellarios, Τὰ Κυπριακά I (1890); J.A.R. Munro & H. A. Tubbs, "Excavations in Cyprus 1889," *JHS* 11 (1890) 1-82[MPI]; J.A.R. Munro, "Excavations in Cyprus—Third Season's Work: Polis tis Chrysochou," *JHS* 12 (1891) 298-333[PI]; M. Ohnefalsch-Richter, *Kypros, the Bible and Homer* (1893)[MPI]; I. K. Peristianes, Γενικὴ Ἱστορία τῆς νήσου Κύπρου (1910); Einar Gjerstad et al., *Swedish Cyprus Expedition* II (1935)[MPI]; K. Nicolaou, Ἀνασκαφὴ Τάφων εἰς Μάριον, *Report of the Department of Antiquities of Cyprus* (1964) 131-88[MPI]; V. Wilson, "A Grave Relief from Marion," *Report of the Department of Antiquities, Cyprus* (1969) 56-63[I].

K. NICOLAOU

MARISSA (Tell Sandahana) Israel. Map 6. Ancient Mareshah, in the lower hill country of Judea. In the Hellenistic period, when it was inhabited by Hellenized Sidonians, it was known by the name of Marissa. It is first mentioned in this period in the Zenon papyri (*Pap. Zenon* Cairo 59006, 59015, 59537) when it was a center for slave trade with Egypt and was the capital of W Idumaea. During the Hasmonaean wars, Marissa was the center for maneuvers against Judea. It was ravaged by

the Hasmonaeans but not conquered (Joseph. *AJ* 12. 353). John Hyrcanus later conquered the city and converted its inhabitants (*AJ* 13.257; *BJ* 1.63). After the conquest of Palestine by Pompey, Marissa was restored to its former inhabitants (*AJ* 14.75; *BJ* 1.156). It was later rebuilt (*AJ* 14.87; *BJ* 1.166). After its destruction by the Parthians in 40 B.C. (*AJ* 14.364; *BJ* 1.265), it was apparently handed over to Herod together with the whole district.

Only the uppermost level, the Hellenistic, has been fully excavated. The Hellenistic town occupied an area of 15 ha. The general plan formed a rectangle, 158 m long from E to W and 152 m from N to S. The wall, built of blocks of limestone, was strengthened with rectangular towers on all sides, except at the N where there was a large structure, probably the gate, adjacent to the wall on the inside. The streets were laid out according to the Hippodamian plan. Two parallel streets running from E to W were intersected by three at right angles. The streets were 2-6 m wide. Most of them were paved and provided with a sewage system. They formed twelve blocks of houses. A large block close to the E wall was probably an administrative, military, and religious center, while another large block served as the commercial quarter of the town. Most of the private houses were built around a central court. Others were a simple agglomeration of rooms. The administrative-military center was 45 m square and consisted of a large open court surrounded by numerous halls and rooms. In the center of the court was a large building (3 x 9 m), possibly the local temple. The commercial quarter consisted of two adjoining courts: the paved one was probably a market; the other, surrounded by porticos, was probably a caravan-serai. A large house adjoined the first court. The remains of architectural decoration and capitals show both local and Hellenistic influence. At a later period, the course of the straight streets was changed and rooms were built where formerly there were streets. This change must have been made either after the ravaging of the town by the Hasmonaeans or after the Roman conquest.

During excavation numerous pottery vessels were found, including hundreds of imported Rhodian wine jars, 16 small lead figurines connected with witchcraft, and 51 limestone plaques, written in Hebrew, Greek, and in an unidentified script, possibly Coptic-Demotic. Those deciphered contained invocations to unidentified deities, which are named "fatherly, motherly ghosts," or the "Virgin of the Nether World." Other plaques contain incantations. The names of the persons involved were Semitic, Roman, Egyptian, or Greek. Of the 63 caves discovered around the mound some were used as dwellings, others contained wine and olive presses. In some of the caves columbaria were discovered, the purpose of which is uncertain. A large number of caves were bell-shaped, with stairs along the walls leading down into them.

In the local necropolis, most important were two painted tombs. The larger (22 x 17.5 m) consisted of a dromos, a decorated entrance, and a long hall, which opened on three burial chambers. The wall around the entrance at the far end of the hall was painted to depict the facade of a Greek temple. Along the walls of the hall were painted a hunting scene, with various animals, birds, and fishes, real and imaginary. Some scenes are identified by inscriptions in Greek. The form and art of these tombs bear close resemblance to contemporary Ptolemaic funerary art in Egypt, mingled with Phoenician-Oriental elements.

BIBLIOGRAPHY. F. J. Bliss & R.A.S. Macalister, *Excava-*
tions in Palestine During the Years 1898-1900 (1902); J. P. Peters & H. Thiersch, *Painted Tombs in the Necropolis of Marissa* (1905).　　　A. NEGEV

MARKOUNA, *see* VERECUNDA

MARKOV GRAD, *see under* PRILEP

MARMARA, *see* LIMES, GREEK EPEIROS

MARMARIS, *see* PHYSKOS

MARONEIA Thrace, Greece. Map 9. A prosperous Kikonian city on the coast, not far from the modern town of Maronia. It was traditionally founded by Maron, priest of Apollo at Ismaros and grandson of Dionysos. Together with the other Kikonian cities of Ismaros and Xantheia, it was already in existence in the 7th c. The principal cult was devoted to the triad of Zeus, Dionysos, and Maron. A fine local coinage began in the 6th c. and continued until the union of Thrace with Macedonia. The city was especially noted for its strong wine, like that which was given by Maron to Odysseus, who used it to intoxicate Polyphemos. Reinach reported many Byzantine and Venetian remains as well as architectural fragments of white marble. A small marble theater was destroyed early in the 20th c.

BIBLIOGRAPHY. Hom. *Od.* 9.196; Hdt. 7.109; Plin. 4.43, 6.217, 14.6.54; Strab. 7, fr. 44 (45); S. Reinach in *BCH* 5 (1881) 87f; 8 (1884) 50; C. Avezou & C. Picard in *BCH* 37 (1913) 141f; S. Casson, *Macedonia, Thrace and Illyria* (1926)MI.　　　M. H. MC ALLISTER

MARQUEFAVE Haute-Garonne, France. Map 23. South of the ruins of the Church of Saint-Hippolyte on the left bank of the Garonne have been found the structures of a large Gallo-Roman villa, incineration tombs, and an Early Christian necropolis.

BIBLIOGRAPHY. G. Chapeau, "Le site de Marquefave," *Rev. de Comminges* 77 (1964) 97-101; 78 (1965) 120-23; M. Labrousse in *Gallia* 20 (1962) 561-62; 22 (1964) 440; 26 (1968) 526; 28 (1970) 406.　　　M. LABROUSSE

MARRUVIUM (San Benedetto dei Marsi) Aquila prov., Abruzzi, Italy. Map 16. This was the capital of the Marsi to the E of Fucinus Lacus, which is now dried up. The boundaries of the city have been determined but not the interior plan. Parts of several public buildings, including the amphitheater, remain visible, and parts of two large sepulchral monuments whose nuclei, in mortared masonry, are preserved.

Much archaeological and epigraphic evidence from the Republican period comes from the urban area and from the surrounding countryside. The territory of the Marsi, like that of the Paeligni, was rich in minor settlements having the character of vici. In the last centuries of the Republic, Marruvium must have prevailed over the others since in the course of the 1st c. B.C. it obtained the designation municipium.

BIBLIOGRAPHY. C. Letta, *I Marsi ed il Fucino nell' antichità* (1972).　　　A. LA REGINA

MARSA, *see under* MELITA

MARSALA, *see* LILYBAION

MARSA SUSA, *see* APOLLONIA

MARSEILLE, *see* MASSALIA *and* SHIPWRECKS

MARTELANGE Belgium. Map 21. A small vicus located on the Arlon-Tongres road where it crosses the Sûre, a tributary of the Moselle. Foundations have been discovered there, but they have never been excavated systematically. The vicus probably subsisted on the mining and trading of slate. It probably also provided a market for the many villas that have been noted in the locality. One of the most remarkable finds was made in the vicinity of Hohdoor: a quadrangular building (14 x 19 m), flagged with marble, with painted stucco plinths. About 100 terracotta statuettes (Jupiter, Mars, Minerva, Venus, and Fortuna) were found there. The edifice must have been a small sanctuary or a lararium. In the vicinity "auf Baulig" a workshop was found which produced votive terracotta statuettes and loomweights. The statuettes were mainly of the mother goddess as well as of civilian and military figures. Cremation tombs and two barrows with fairly rich grave goods were found. A bronze statuette of Mercury is a typical piece of Roman provincial art.

BIBLIOGRAPHY. V. Balter & C. Dubois, "Contribution à la carte archéologique de la Belgique," *Annales de l'Institute archéol. du Luxembourg* (1936) 65-73; G. Faider-Feytmans, "Le Mercure de Martelange," *Mélanges A. Bertrang* (1964) 69-73. S. J. DE LAET

MARTIGNY, *see* OCTODURUS

MARTINHOE Lynton, N. Devonshire, England. Map 24. A 1st c. fortlet on the edge of the 210 m cliffs, commanding an extensive view of the Bristol Channel coasts. The double earthwork, much reduced by ploughing and erosion, is of concentric plan similar to that at Old Burrow and undoubtedly the work of the same army group. The inner enclosure, 27 m square, was designed for semipermanent occupation by a detachment of 65-80 men, a century.

The garrison was housed in a pair of timber barracks on either side of a metaled road leading in from the gate. Each barrack had five contubernia facing the rampart for the men and two rooms for their officer, and there were three additional rooms with a separate entrance at the end of the W barrack for the centurion in charge of the unit. Cooking was done in eight small field ovens in the intervallum. There was also a smith's workshop in a separate building with a forge and anvil stone. Remains of a signal beacon are on the cliff edge in the outer enclosure. The fortlet was occupied during the reign of Nero (A.D. 54-68), probably succeeding Old Burrow because it was a more habitable site. Its purpose was similar, to maintain a watch on the Roman flank during the wars with the Silures in S Wales, and to signal to the fleet in the Channel. The finds are at the Athenaeum, Barnstaple.

BIBLIOGRAPHY. A. Fox & W. Ravenhill, *Antiquity* 39 (1965) 253; id., *Proc. Devon Arch. Soc.* 24 (1966) 3. A. FOX

MARTIZAY Indre, France. Map 23. A village in the valley of the Claise, a small tributary of the Creuse. In antiquity it probably was still part of Bituriges territory, close to the point where it joined the territories of the Turones and the Pictones. Along with Vendoeuvres en Brenne and Mézières it is one of the stations marking the N boundary of the Brenne. But Vendoeuvres was the site of a conciliabulum, while Martizay seems to have originated as a manorial villa, the ruins of which are at the W end of the village, on the banks of the Claise. The site is called Saint Romain, and has been excavated for some years. A number of buildings may be distinguished: some baths beside the river, and higher on the slope of

the left bank some buildings the plan of which is much confused by restorations. Most interesting is the discovery of elements of wall paintings of the second Pompeian style. Even allowing for a local cultural lag, these paintings place the origin of the villa at a very early period since they belong to the second phase of pictorial decoration. Judging by the earliest pottery found on the site, construction of the villa should be dated ca. mid 1st c. B.C. The estate was occupied throughout the Empire; the last occupation dates from the Merovingian era when the buildings were completely demolished and partly taken over by tombs.

BIBLIOGRAPHY. A. Barbet, *Gallia* 26, 1 (1968) 171-72. G. C. PICARD

MARTRES-TOLOSANE Haute-Garonne, France. Map 23. 1. At Chiragan on the left bank of the Garonne, 19th c. excavations brought to light a large and sumptuous Gallo-Roman villa, which contained an exceptional series of imperial busts and genre sculptures, for the most part inspired by Classical Greek or Hellenistic art. These sculptures are now kept in the Musée Saint-Raymond at Toulouse. The most likely hypothesis is that they constituted a private collection assembled in the 3d c. by a rich connoisseur.

2. In the center of the village of Martres, there existed in the 4th c. another Roman villa, which was ruined around the end of the century or a little later. In its place was built the original Church of Sancta Maria de Martyribus, around which grew an Early Christian necropolis. This has produced several adorned sarcophagi of the School of Aquitaine.

BIBLIOGRAPHY. 1. L. Joulin, *Les établissements gallo-romains de la plaine de Martres-Tolosanes. Mém. présentés par divers savants à l'Académie des Inscriptions et Belles-Lettres*, 1st ser., XI.2 (1901)[IP] (a fundamental work, but dated in regard to sculptures and esp. the imperial busts, the study of which has been revived by F. Braemer); G. Astre, "Sur l'origine des sculptures gallo-romaines de la villa de Chiragan, à Martres-Tolosane," *Annales du Midi* 45 (1933) 307-9; A. Grenier, *Manuel . . .* II.2 (1934) 832-37, 850-58, & figs. 304-5, 313-16; for some recent discoveries, see M. Labrousse in *Gallia* 17 (1959) 422.

2. J. Boube, "La nécropole paléo-chrétienne de Martres-Tolosane (Haute-Garonne)," *Pallas* 3 (1955) 89-115; id., *Cahiers archéologiques* 9 (1957) 33-72; for report on recent discoveries, see M. Labrousse in *Gallia* 26 (1968) 526-27. M. LABROUSSE

MARUSI, *see* AMAROUSION

MARVINCI ("Idomenae") Yugoslavia. Map 12. A village on the left bank of the Vardar ca. 25 km N of Gevgelia. The site of ancient Idomenae probably is on the ridge Isar Kale in its territory. Excavations there in 1961 revealed the marble front (9.7 m wide) of an Ionic prostyle temple dedicated by the Macedoniarch in A.D. 181, according to an inscription on the fallen epistyle. A gate and part of the Roman city wall were cleared NE of the temple. Much pottery and two sculpted reliefs of the late Hellenistic period were also found.

BIBLIOGRAPHY. B. Dragojević-Josifovska, "Rapport sur les fouilles près du village de Marvinci," *Živa Antika* 19 (1967) 307-49. J. WISEMAN

MARYPORT, *see* ALAUNA

MARZABOTTO, *see* MISANO

MARZAMEMI, *see* SHIPWRECKS

MARZOLL District Berchtesgaden, Bavaria, Germany. Map 20. An extensive villa rustica ca. 9 km SW of the municipium Iuvavum (Salzburg). Settlement began in the middle of the 1st c. B.C. (according to finds) with a Celtic agricultural establishment. Two Roman building periods using wood construction have been established for Augustan times. About the time of Hadrian the estate with its auxiliary buildings was rebuilt in stone. The main building was then 52 m long; its two wings with several stories formed an inner courtyard 22 x 25 m. On the fourth side the courtyard was closed by a wall with a centrally located entrance gate. A thorough rebuilding took place in the second half of the 2d c. A.D. The wings which previously had dominated the building were reduced in size and length giving greater importance to the central two-story building. About 170-180 the new main building was richly decorated with wall and ceiling frescos, using plant motifs, and with floor mosaics. The study of the mosaics revealed that they were created by a group of workshops which had produced for Iuvavum and its region until the 3d c. A.D. and now finally could be identified. About the middle of the 3d c., all the buildings were destroyed by fire, probably caused by a raid of the Alemanni. The settlement was then relocated in a more protected place close at hand, as indicated by a number of late Roman finds and by the name of the place, which in documents from the end of the 8th c. is called Marciolae. Mosaics, frescos, and smaller finds are in the Prähistorische Staatssammlung in München.

BIBLIOGRAPHY. R. Christlein, "Ein römisches Gebäude in Marzoll," *Bayerische Vorgeschichtsblätter* 28 (1963) 30-57[MPI]; H.-J. Kellner, "Die römischen Mosaiken von Marzoll," *Germania* 41 (1963) 18-28[PI]. H.-J. KELLNER

MASADA Israel. Map 6. A naturally fortified rock on the W shores of the Dead Sea. According to Josephus (*BJ* 7.285), a fortress was built at Masada by "the high priest Jonathan." This could have been either the brother of Judas Maccabeus, or Alexander Jannaeus, whose Hebrew name was Jonathan. In 42 B.C., when it was conquered by Malichus, an antagonist of Antipater, Herod's father, Masada was still referred to as a fortress (*BJ* 1.237). In 40 B.C. Herod established his family at Masada before leaving for Rome (*AJ* 14.280-303; *BJ* 1.238, 263-66). After Herod's accession to the throne, the fortress was completely rebuilt. Josephus, who must have seen this place in the years preceding the Roman siege, described it in minute detail (*BJ* 7.280-300). Little is known of what happened at Masada in the years following Herod's death. At the beginning of the war of A.D. 66, the place was occupied by a Roman garrison (*BJ* 2.408; 7.297). It was soon conquered by the Zealots, who held it until A.D. 73, when it was conquered by the Romans after long siege (*BJ* 7.303-6). The fortress of Masada is scarcely mentioned by other Classical writers. The region is described by Strabo (16.2.24), and the fortress is mentioned by Pliny (*HN* 5.15.73).

The first extensive excavations (1963-65) uncovered scanty remains of pre-Herodian times. Some sherds of the Chalcolithic period were found in a cave on the slope, and a very few Iron Age sherds were found on the mountain itself. Coins of Alexander Jannaeus were found. The earliest building remains discovered belong to Herod's fortress. The upper plateau of Masada has the form of a ship (600 x 300 m). The whole perimeter of the rock was surrounded by a casemate wall 4 m wide. There were 110 towers, from 6 to 35 m apart. Wall and towers were coated with white plaster. There were three gates: one on the E, where the snake path terminated; another on the W, not far from the W palace, and a water gate on the NW. Herod's buildings occupy the N half of the rock surface and the N slope, where stood the buildings identified by the excavators as the northern palace. It consists of three rock terraces. The lowest terrace is situated 35 m below the top of the rock, and was built on the brink of the abyss. By surrounding the rugged rock with huge retaining walls a platform 17.6 m square was formed. On this platform a rectangle (10 x 9 m) of low walls was erected. The inner side of the outer and inner walls on the platform had attached half columns, thus forming porticos all around. There were small rooms attached to the terrace on the E and on the W. On the E a miniature bath contained all the essential components; on the W a staircase tower led to the terrace above. The spaces between the columns were plastered and painted to resemble multicolored marble.

The middle terrace, 15 m higher, is also supported by massive retaining walls, consisting of two parallel circular walls, with an outer diameter of 15 m. They are smooth on top, so as to receive a cover of wood. Both walls probably supported columns to form a tholos. The rock wall to the S of this construction was smoothed, decorated with projecting pilasters, and plastered and painted with the same patterns as on the lower terrace. A staircase tower led from this to the highest terrace. This terrace included a large semicircular platform on the N, 9 m in diameter with, to the S, a dwelling of four rooms, arranged on two sides of a court. There was probably a portico in the court on the N. The rooms were paved with black and white mosaics, of simple geometric patterns.

A thick, sloping wall separated the northern palace from the rest of the buildings. Behind the wall was an open square, to the S of which stood a public bath. The building (11.6 x 10 m) contained the regular components of a Roman bath, of which the largest and most elaborate was the caldarium (6.8 x 6.5 m, with walls 2.6 m thick) covered by a barrel vault. The hypocaust consisted of a thick brick floor, on which stood 200 square and round brick colonnettes. The floor above was laid with opus sectile, and the walls were plastered and painted. To the N of the bath building was its court (17.8 x 8.4 m), the floor of which was paved with mosaics. The complex measured 25 by 20 m.

To the E and S of the bath extends the large complex of the two units of storerooms, to which Josephus made reference (*BJ* 7.295-96). The S block contains eleven oblong halls (each 27 x 4 m), all opening on a central corridor, which separates the two units. The second unit consists of four storerooms (20 x 3.8 m). Fragments of numerous storage jars were found in the rooms.

To the W of the S block of storerooms extends a building (30 x 25 m) in plan typical of the Herodian buildings at Masada. It has a large open court in the center, with many rooms around it; on the S side is a double row of rooms. Three large storerooms abut the building on the S and W.

To the S of this building is another (37.5 x 27.5 m), also having a large rectangular open court, around which are apartments. Most of these consist of a small forecourt with two small rooms at the back. Another small building with a raised platform in front of it stood in the center of the court. Because of its plan, the building has been identified as a barrack. To the SW extends the large complex of the so-called western palace. The whole complex (70 x 50 m) consists of three units: 1) The SE block (33 x 24 m), which served as the palace for the king himself; 2) the NE block (34 x 23 m), which contained workshops and servants' quarters; 3) a complex of storerooms and several additional units (70 x 20 m).

The SE block has a central court (12 x 10.5 m), below which is a large cistern with a capacity of 120 cu. m. The S part of the court opens into a large hall that has two columns between two antae on its front. At the back of this hall stood the king's throne. On three sides of this hall were rooms, in some of which were colored mosaics of geometric and floral designs. The complex included a pool cut into the rock. Another room contained a bathtub. Three staircases found in this complex attest the presence of a second story. The NE block consisted of a central courtyard with rooms around it. The storerooms in the third complex were similar in form to those on the N. There were two other smaller buildings to the E of western palace.

The synagogue (15 x 12 m) was built against the NW section of the wall and in it two phases of construction were observed. In its original Herodian phase it had two rows of three columns each supporting the roof. The entrance was on the E. During the period of the Revolt a room was built into the NW corner of the building. Along the walls benches were built, thus eliminating two of the columns. The excavators believe that this building was originally built as a synagogue in the Herodian period, and that it was certainly used as a prayer house in the times of the Revolt.

Josephus described the abundant water supply at Masada (*BJ* 7.290-91). In order to contain the water of the wadi to the N of the rock of Masada, a dam was built across the wadi, from which an aqueduct led the water to 12 reservoirs cut into the rock. The capacity of these cisterns is 36,000 cu. m. From these cisterns the water was conveyed in jars to the bath buildings and cisterns on the rock itself.

To the period of the Revolt were attributed numerous small finds and remains of temporary dwellings in the casemate wall and most of the other buildings at Masada. There were also fragments of scrolls—Biblical, apocryphal, and sectarian. Most important of these was a long scroll of Ben-Sirah. There also were numerous ostraca containing names or referring to tithes. The remains of the period of the Roman garrison, which was stationed at Masada after its conquest, are quite scanty.

According to Josephus (*BJ* 7.303-19), the Roman commander, Silva, surrounded the whole mountain by a siege wall and also built earthworks on the W, on which he placed a high tower close to the road leading up to the palace. The Roman siege works are in reality much more complicated than those referred to by Josephus. There were six camps built around Masada. Three were on the E: the largest (175 x 135 m) and two others to guard the E approach to the mountain. A fourth was on the N, where a path led up to the commander's camp, which was situated on high ground, opposite the NW part of Masada. To the S of this camp was another, thought to be the lodgings of the merchants, etc., who accompanied the Roman army. But it is hardly possible that outsiders should have been allowed to live within the siege works of the army. Two more small camps were situated on the high ground to the SW of Masada. All of the small camps were built on the line of the wall, while the two larger ones were outside. The wall was further strengthened by numerous towers. The latest finds, discovered in a series of trials, were of the early 2d c., i.e., before the Bar Kohba Revolt, in which Masada played no part. In the Byzantine period a small church, consisting of an atrium and one nave, was built close to the western palace. Other traces of habitation in this period were found elsewhere.

BIBLIOGRAPHY. A. Schulten, "Masada die Burg des Herodes und die römische Lager," *ZDPV* 56 (1933) 1-179; M. Avi-Yonah et al., "The Archaeological Survey of Masada, 1955-1956," *Israel Exploration Journal* 7 (1957) 1-60; Y. Yadin, *The Excavations of Masada 1963-1964. Preliminary Report* (1965).　A. NEGEV

MASCULA (Khenchela) Algeria. Map 18. In the course of occupying the region N of the mountains, the Third Augustan Legion marched from Ammaedara (Haïdra) and Theveste (Tébessa) and then encamped in Mascula before reaching Lambaesis. The chronology is uncertain. Situated N of the gap between the Nementcha and Aurès mountains, by Badiae, the site had considerable strategic importance. Another route toward the N reached Cirta by way of Bagae. Mentioned in the *Antonine Itinerary*, the city doubtless had been a municipium since Trajan's reign, or at any rate under the Severi. Inscriptions suggest that Cohors II Gemella Thracum and VII Lusitanorum were garrisoned there, as was a detachment of the legion under Septimius Severus. Several bishops of Mascula are named in the conciliar records of Carthage. And, according to Diehl, the city was fortified by a wall, like Theveste, in the Byzantine period.

The ancient city has disappeared. Today it is covered over by a sizable, densely populated settlement built some 3 m above the original surface; as soon as the old walls were uncovered, they were destroyed and reused. Only an occasional chunk of wall can be seen.

The subprefecture has a collection of stelae dedicated to Saturn, some sarcophagi, fragments of sculpture and bas-reliefs, some capitals, carved pillars, and columns. Numerous inscriptions are being assembled.

Thanks to a chance discovery in 1960, a number of rooms belonging to a luxurious villa were found beneath some houses under construction toward the E edge of the town. The house was built around a peristyle, with a cistern in the middle bordered by carved limestone dados with a design of dolphins; they were connected by stone slabs ornamented with plant motifs, some stylized. Opening out of the peristyle was a spacious triclinium with a mosaic showing the Triumph of the Marine Venus, a favorite theme in Africa. In the same villa 14 other mosaic floors have been found, only one of which, of later date, is decorated with figures. This shows a charioteer riding in triumph in a shower of roses. The other floors have geometric designs that are expertly worked and astonishingly varied. For the most part they do not belong to the repertoire of Timgad or Theveste. The over-all impression is one of luxury, suggesting the wealth of the villa and the high quality of the artists employed there. The mosaics are signed by an inscription inside that of the peristyle: Ex oficina Junioris, B(onis) B(ene). Altogether, these works apparently date from the second half of the 4th c.

Five km W of Khenchela, at Henchir el Hammam, an antique bath building, Aquae Flavianae, is still in operation. Under Vespasian and Titus, the hot spring (70°) was channeled in A.D. 76, and the monument restored and enlarged in 208 under Septimius Severus, Caracalla, and Geta. It then became known as Aquae Septimianae. A statue of Aesculapius has been found there as well as the base of a statue of Hygeia and some dedications to Frugifer and the nymphs. Then, as today, the establishment consisted of two juxtaposed bathing-pools, one rectangular (13.80 x 10.05 m) with porticos along two sides, the other circular (7.15 m in diameter) and vaulted. Round the pools were several rooms, restored somewhat arbitrarily. The water was carried by pipe from the hot spring; it was cooled by water from the wadi. The restoration work carried out under Severus was entrusted to a detachment of the Third Legion garrisoned at Mascula. Despite a number of differences—in

particular, the absence of a sanctuary—the history of these baths is reminiscent of those of the Aqua Septimiana Felix, discovered beneath the Byzantine fort of Timgad.

BIBLIOGRAPHY. S. Gsell and Graillot, "Ruines romaines au Nord de l'Aurès," *MélRome* 13 (1893) 516; S. Gsell, *Atlas archéologique de l'Algérie* 28, nos. 137, 138; J. Birebent, *Aquae Romanae* (1962) 219; J. Lassus, in *La Mosaïque gréco-romaine* (1965) 175 and in *Recueil de Constantine* 71 (1971); M. Leglay, *Saturne Africain* (1966) II 163. J. LASSUS

MASHKID, *see under* ALEXANDRIAN FOUNDATIONS, 12

MASI, *see* LIMES, ATTICA

MASSACIUCCOLI Tuscany, Italy. Map 14. The site of a Roman Imperial habitation center with a well-preserved bath complex built in the middle of the 1st c. A.D; the ancient name is unknown. The baths, of asymmetrical plan but of advanced engineering and design, show an interesting stage in the evolution of bath architecture. Whether they belonged to a large villa or a station on the Via Aemilia Scauri is disputed.

BIBLIOGRAPHY. A. Minto in *MonAnt* 27 (1921) 405-48; D. Levi, *NSc* (1935) 211-28; A. Neppi-Modona, *Pisae* (*Forma Italiae*, Regio VII, vol. 1) (1953) 54-59, pls. 13-17MPI. L. RICHARDSON, JR.

MASSALIA or Massilia (Marseille) Bouches-du-Rhône, France. Map 23. Situated on the coast, E of the Rhône delta, Massalia was founded in 600 B.C. by Greek colonists from Phokaia, in Asia Minor. The marriage between Phokis, leader of the Greeks, and Gyptis, the daughter of the Ligurian king Nannus, sealed the agreement that made the settlement possible.

A favored base for the trade in rare metals, the city rapidly grew prosperous, and set up outposts in Spain (Ampurias, Hemeroskopion, Mainake), Languedoc (Agde), on the Ligurian coast (Monaco, Antibes), and in Corsica (Aléria). Becoming perhaps less prosperous in the 5th c. owing to the expansion of Carthage, it flourished once again after Pytheas' exploration of the British Isles and the Baltic (end of the 4th c.). In the Hellenistic period Massalia supported Rome against the Barcides and increased its territorial domain with the help of the Roman generals. It fortified Saint-Blaise and created a trading post at Olbia. Independent until the 1st c. A.D., Massalia was governed by a body of 600 councillors, and strict laws in the Ionian tradition. The city also kept its original religion with the cults of Artemis of the Ephesians, Apollo Delphinios, Kybele, and Leukothea, and ancient festivals such as the Anthesteria and Thargelia. Silver and bronze coins were struck with the effigies of Artemis and Apollo. In 49 B.C., after siding with Pompey, Massalia was besieged and forced to open its gates to Caesar and his lieutenant, Trebonius; yet under Roman rule it remained relatively independent. Christianized fairly early, the city preserved its Greek language until the 5th c. A.D., and remained an active cultural and commercial center.

The ancient city was N of the Lacydon (the Old Port); it straddled the rocky spur that now borders on the Eglise St. Laurent and the Hôtel-Dieu. Strabo (4.1.2) writes that the temples of Artemis and Apollo stood on this ridge. Several traces of archaic occupation have been located: at the Eglise de la Major; at the Fort St. Jean, where many sherds of Attic, Corinthian, Aiolian, and East Greek wares have been found under the 18th c. embankments. The earliest of these date from the period when the city was founded. After WW II an ancient theater in the Greek style, a few tiers of which are still standing, was found S of the Old Port, and a dock area of the Roman period with dolia still lodged in the ground (Musée des Docks Romains). A Sanctuary of Kybele has been located: some 40 stelai—archaic naiskoi with the effigy of the seated goddess—were found in the old Rue Négrel.

A fortified rampart encircled the city, passing around the Butte des Carmes to the E, from behind the Old Port to the S to the bay of La Joliette to the NW. Excavations near the Bourse confirmed this line, at least for the period from the 3d c. B.C. on, and Caesar (*BCiv.*) and Lucan (*Pharsalia*) describe such a rampart.

The necropoleis lay outside the city walls, S of the Old Port (excavations at the careening basin and lighthouse), E of the city (Rue du Tapis Vert), and along the ancient road leading N to Aix.

The principal remains now visible are on the Bourse site. To the E and S the tongue of land on which the ancient port stood has been excavated, together with a sturdy quay made of squared stones that still show the line of the ancient water level. This construction apparently dates from the 1st c. B.C. Near the quay to the S are the foundations of a warehouse from the 2d c. A.D., a huge shed with interior pillars. The bases of dolia that were stored there have been found in situ. Near the tip of this tongue of land was found a large square basin made of ashlar dating from the 1st c. A.D. It collected water for the ships; this came from a nearby spring, perhaps the spring which gave the Lacydon its name. The Rome road ended N of the basin; one of its milestones has been found.

This road entered the city on the axis of the present-day Grande Rue, through a gate flanked by two square towers. Only the foundations of one tower remain, but the other still retains part of its facade. Between the towers were, first, the axial gate, then, toward the city, two identical gates. The line follows that of a road paved with hard Cassis stone in the Roman period, which bears the marks of chariot wheels.

Both the gate and the towers probably date from the 2d c. A.D. The fortification adjoining at this point was built in the same period and of the same pink stone from Cap Couronne. To the S, near the present-day Palais de la Bourse, can be seen some curtain walls (now worn down, although their plan is still discernible) and the S tower (the best preserved of the towers) where one can still see the loop-holes from which catapults were fired. To the N near what is now the Butte des Carmes are some curtain walls with several embrasures and a well-preserved bastion. Its facing was erroneously called Crinas' wall. At the base of this wall can be seen the trademarks of the Greek contractors who delivered the stone.

In front of this fortification, in the S section, is the broken line of a forewall partly built of reused blocks; most of it was erected in the Late Empire. Behind the fortification, on the other hand, can be seen the remains of some white limestone foundations belonging to an earlier Hellenistic structure; they are now buried in the embankment.

Some remains have been found S of the city, at the Abbaye de Saint Victor. The mediaeval buildings were superimposed on a quarry of the Hellenistic period, and on an ancient monument, a necropolis, and some Early Christian churches. These last remains can be seen in the crypt of the modern church, along with some carved sarcophagi from the 4th and 5th c. A.D. which were found in situ.

Most of the archeological finds made before 1967 are housed in the Musée Borély in Marseille.

BIBLIOGRAPHY. Grosson, *Receuil des antiquités et monuments marseillais qui peuvent intéresser l'histoire et les arts* (1773); W. Froehner, *Catalogue des antiquités grecques et romaines du Musée de Marseille* (1897); C. Jullian, *Histoire de la Gaule* I-III (1908); G. Vasseur, "L'origine de Marseille," *Annales du Musée d'Histoire naturelle de Marseille dans l'Antiquité* 13 (1914); M. Clerc, *Massalia, Histoire de Marseille dans l'Antiquité* I (1927); II (1929); F. Benoît, *Carte archéologique de la Gaule romaine* V (1936); F. Villard, *La céramique grecque de Marseille* (1960); for excavations since WW II see "Informations," *Gallia* 5 (1947), following vols., and index with vol. 20; Bourse excavations: M. Euzennat & F. Salviat, *Les découvertes archéologiques de la Bourse à Marseille* (1968); *Gallia* 27 (1969) 423-30[Pl.].

F. SALVIAT

MASSA MARITTIMA Grosseto, Italy. Map 14. The environs of this city are rich in mines of silver-bearing lead ore. Along with mediaeval pits, other pits have been found which date from the Etruscan age. These pits are different in construction technique from those of more modern date, and Etruscan material has also been found near them.

In the neighborhood of Massa Marittima several prehistoric habitation sites dug into the cliffs have come to light. The necropolis near the little lake of Accesa has produced material similar to that from Vetulonia, now on exhibit together with prehistoric material at the Museo Civico in the Palazzetto delle Armi di Cittanova at Massa Marittima.

BIBLIOGRAPHY. P. Bocci in *EAA* 4 (1961) 918-19; G. Monaco, *Comune di Massa Marittima. Museo Civico. Collezione Archaeologica* (1964). P. BOCCI PACINI

MASSILIA, *see* MASSALIA

MASTIA, *see* CARTHAGO NOVA

MASTRAMELA, *see* SAINT-BLAISE

MASTRU, *see* PAIANION

MATALA or Matalon or Metallon Pyrgiotissa district, S Crete. Map 11. Lies on a tiny bay 8 km N of Cape Lithinon on the Gulf of Matala. Now a small fishing village, it was in Roman times one of the two outports or epineia of Gortyn, the other being Lebena. In prehistoric and Classical times it may have served as the port of Phaistos, the alternative site for the prehistoric port being Kommos, just beyond the headland to the N. Matala is described by Strabo as 130 stades from Gortyn and 40 stades from Phaistos (10.4.11,14); mentioned by Ptolemy (3.15.3) as Matalia and by the *Stadiasmus* (323-24) as a city with a harbor. Near Matala was the "lisse petra" where Menelaus' ships were wrecked on his journey home from Troy (*Od.* 3.293ff): probably Cape Nysos, the cape between Matala and Kommos, but possibly Cape Lithinon itself.

Subject to Phaistos in the 3d c. B.C., Matala was captured in ca. 219, along with Lebena, by young Gortynian exiles at war with their elders (Polyb. 4.55.6); and when Phaistos came under the control of Gortyn in the mid 2d c. B.C., Matala became a second port for Gortyn.

On the N and S sides of the bay are over 100 chambers cut at several levels in the calcareous sandstone cliffs. Many of these certainly served as tombs, with benches and side-niches for offerings cut in the rock, and a floor level below the entrance level. Some chambers investigated recently contained lamps of the 1st and 2d c. A.D. On the S side of the bay some of the chambers are now submerged, with their floors 1.8 m and their thresholds 1.5 m under water (Lembesi), which shows that there has been a relative rise in sea level, at least partly owing to land subsidence; Evans' estimate of a relative rise of 5 m is, however, excessive. At the SE corner of the bay there is a deep cutting in the cliff, 5.8 m wide and at least 38 m long, with a rock-cut floor and side-chamber: a slipway, probably covered, for a warship; probably Graeco-Roman in date, but possibly later. The stumps of rock-cut bollards of uncertain date line the seaward edge of the rock shelf along the S side of the bay. No other remains of harbor installations can now be seen; in antiquity ships would have moored, as today, in the S part of the bay, protected from the prevailing SW wind. The sandy E shore of the bay is exposed and pounded by surf; an apparent platform in its center is a natural formation of beach rock.

The ancient settlement lay mainly on the hill S of the bay, where Spratt saw "vestiges of a small walled fortress, built with mortar and small stones." An inscribed base of the 2d-3d c., of a statue of Artemis Oxychia, was found here recently, and marble fragments, columns, and foundations, perhaps of granaries or warehouses, in the plain at the head of the bay. The visible ancient remains are almost entirely of the Roman period, but remains of the Classical period may be assumed to lie beneath; tombs of the 4th c. B.C. have been found in the vicinity. No coins of Matala are known, and very few inscriptions. There is little trace of Bronze Age occupation at Matala, but Kommos has evidence of occupation in the Neolithic and Bronze Ages, and also in the Geometric period.

BIBLIOGRAPHY. T.A.B. Spratt, *Travels and Researches in Crete* II (1865) 20-23; A. Evans, *PM* II (1928) 86ff[M]; Creutzburg, "Matalia," *RE* 14, 2 (1930) 2179; M. Guarducci, *ICr* I (1935) 239-40, 269; G. Crile & C. Davaras, *Kret. Chron.* 17 (1963) 47-49; A. Lembesi, *Praktika* (1969) 246-48; D. J. Blackman, "The *neosoikos* at Matala," *Proc. 3d Cretological Congress, 1971* (1973) 14-21; see also Brit. Adm. Chart 1633[M]. D. J. BLACKMAN

MATAUROS or Metauros (Gioia Tauro) Calabria, Italy. Map 14. On the Tyrrhenian Sea about 100 km N of Reggio Calabria. A settlement of Chalkidians of Rhegion was occupied at the beginning of the 6th c. B.C. by Lokrians in the course of their W expansion. Between the 5th c. and the Roman period there are few records: the settled life must have moved S of the Petrace river (ancient Matauros) into the ancient center of Taurianon. The poet Stesichoros was most likely a citizen of Matauros and from there moved to Himera.

In the area of Due Pompe, excavations have revealed a necropolis, which was used during three major periods. The oldest period (cremation) comprised the 7th c. and the first half of the 6th c. B.C., and provides late proto-Corinthian ware; Ionic ware (Ionic cups B1 and B2); Greco-oriental ware (alabaster on grey bucchero and glazed figured vases); Attic black-figure ware (a kotyle of the painter KX). The middle period (inhumation) lasted from the middle of the 6th c. until the beginning of the 5th c. B.C. The final period (covered tombs) spans the period from the 2d c. to the 3d c. A.D.

In the area of Masseria Fava, an imperial villa has been partially excavated, along with its attached bath complex. Occasionally, a cache of Carthaginian and Neapolitan coins of the Hellenistic period is discovered. Related to the construction of a temple are the remains of a terracotta equestrian group, perhaps an acroterion of the Lokrian type, dating to the beginning of the 5th c. B.C. and contemporary with other terracotta finds.

The city itself, of which nothing is known, is probably covered over by the present settlement. The finds are preserved in Reggio Calabria and in New York.

BIBLIOGRAPHY. P. Orsi, "Gioia Tauro (Metaurum). Scoperte varie," NSc (1902) 126-30; Oldfather, "Matauros," RE XIV (1930); T. J. Dunbabin, The Western Greeks (1948) 168-69; G. Procopio, FA, XI (1956) n. 2070; N. W. van Buren, "New Letters from Rome," AJA 62 (1958) 421; E. Gagliardi, "Il gruppo equestre fittile di Metauro," AttiMGrecia, n.s. 2 (1958) 33-36; G. Vallet, Rhégion et Zancle (1958) 135-37, 261; U. Kahrstedt, Die wirtschaftliche Lage Grossgriechenlands in der Kaiserzeit (1960) 42-45; A. de Franciscis, "Μέταυρος," AttiMGrecia, n.s. 3 (1960) 21-67; J. Berard, La Magna Grecia (1963) 206.
On Taurianum. S. Settis, "Tauriana (Bruttium): note storico-archeologiche," RendLinc (1964) 117-44.

P. GUZZO

MATÉLICA, see MATILICA

MATILICA (Matélica) Umbria, Italy. Map 16. A municipium on the upper Aesis; under Rome it was inscribed in the tribus Cornelia. Little is known of it historically or archaeologically, and the site is still occupied by a thriving community. A few antiquities from the area are kept in the Museo Piersanti.

BIBLIOGRAPHY. EAA 4 (1961) 927-28 (G. Annibaldi).

L. RICHARDSON, JR.

MATISCO (Macon) Saône-et-Loire, France. Map 23. Situated on the Saône 70 km N of Lyon, in the civitas of the Aedui. Caesar (BGall 7.90) mentions the oppidum of Matisco, which has become better known through recent excavations. In the Tène III Age the principal settlement was moved from the Ile Saint-Jean on the top of a limestone bar on the right bank of the river, to the middle of what is now the city. A rampart of the murus gallicus type has been found there, with a ditch outside it. Although, being on the Via Agrippa, the city in the High Empire was the starting point of a road to Autun, it seems to have had little importance, much less than Cabillonum (Chalon-sur-Saône). The principal find is the necropolis. A castrum was built in the 4th c. A.D., for which period the finds are more plentiful.

BIBLIOGRAPHY. Jeanton, Le Mâconnais gallo-romain (3 vols. 1926, 1927, 1931); Barthélemy, "L'oppidum de Matisco," Rev. Arch. de l'Est 24 (1973) 307-18. See also Annales de l'Académie de Mâcon, passim.

C. ROLLEY

MATRICA, see LIMES PANNONIAE

MAUBEUGE Nord, France. Map 23. In the arrondissement of Avesnes; chief town in the canton. The ancient site of Maubeuge, now a sizable industrial city on the Sambre, was farther N on the Roman road from Bavai to Trèves; the road has been investigated and can still be seen E of the Meubeuge-Mons road at the spot known as Le Petit Camp. A villa at Le Bois Brûlé has also been excavated: five corner rooms with a gallery have been uncovered as well as a room with a hypocaust, a little farther back. The rooms have been identified as a forge, a kitchen, and a workshop. It is uncertain as yet whether the complex was a villa or a rural vicus. The objects found there—a fibula with an enameled design, coins, pottery, Roman farm tools—are now in the city museum. Ever since the early 18th c. many chance finds have been made, generally in the suburb of Mons, through which runs the Roman road from Bavai to Trèves. Many coins have been found at the S end of the

forest; in fact, the Roman road is known locally as the road of the coins.

BIBLIOGRAPHY. Dictionnaire archéologique de la Gaule II (1878) 171; Jennepin, Histoire de Maubeuge, 3 vols. (1879); C. Croix, L'Avesnois préhistorique, gaulois, gallo-romain et franc (1956); E. Will, "Informations archéologiques," Gallia 25, 2 (1967) 195; "L'activité archéologique dans la circonscription des Antiquités historiques des régions Nord et Picardie," Revue du Nord 195 (1967) 773.

P. LEMAN

MAUER AN DER URL Niederösterreich, Austria. Map 20. In the province of Noricum on the limes road Vindobona-Lauriacum. A fortification at this location could serve to protect the limes road and, because of its location near the confluence of Url and Ybbs, to block the two river valleys, preventing the legionary camp at Lauriacum from being outflanked on the E. On the right bank of the Url a castellum was excavated in 1907-10; its NW part had already been washed away by the Url. The ground plan had the form of an oblique parallelogram (ca. 200 x 160 m). The surrounding wall was ca. 4 m thick. At both the W and E sides were gates with two towers. The S side had no gate but was strengthened by four intermediate towers. Nothing is known of the destroyed N side. The castellum was situated directly on the limes road which traversed the fortified area from the E gate to the W. These gates were not centered in their walls but, probably owing to the formation of the ground, had been built considerably to the S. The last building phase, largely obscured by modern buildings and soil movement, probably represents the situation in the 4th c. A.D. (coins to the time of Theodosius). But small finds (terra sigillata from Lezoux and especially Rheinzabern, coins, etc.) indicate that the castellum had existed for a long time, and possibly was established in the time of Trajan or Hadrian. Two clearly characterized building periods are separated by a destructive fire which cannot be fixed chronologically (3d c. A.D.?). So far no one has been able to determine the ancient name of the place.

The real importance of Mauer an der Url rests on the discovery of a large metal deposit. In 1937 a pit covered with stone slabs was found ca. 40 m S of the castellum. It contained a surprisingly large number of metal objects (silver, bronze, iron). It was the carefully hidden treasury of a Sanctuary of Jupiter Dolichenus, and its abundance and variety make it unique. It consisted of almost 100 pieces which fall clearly into two categories: cult objects proper and, from the triclinium or cenatorium of the temple, implements that had been used for cult banquets (bronze dishes, etc.). Noteworthy among the cult objects are: the first almost undamaged bronze statuette of Jupiter Dolichenus; a unique bronze group of the god and Juno Regina; a statuette of Victoria, the product of an indigenous artist. Also there are two votive reliefs, obviously copying a type of field insignia and the first intact examples of this kind. Finally, the most valuable group of objects comprise 28 votive gifts made of sheet silver, arrow-shaped, with palmate ends, frequently carrying dedicatory inscriptions. The temple treasury must have been hidden in the first half of the 3d c. A.D. because of a Germanic invasion. The sanctuary itself has not yet been found.

The older finds from the castellum are in part in the Stift Seitenstetten. The Dolichenus find is in the Kunsthistorisches Museum in Vienna.

BIBLIOGRAPHY. On the castellum: M. Nistler, AnzWien 47 (1910) 146ff; G. Pascher, Der römische Limes in Österreich 19 (1949) 82ff. On the treasury: R. Noll, Der

grosse Dolichenusfund von Mauer a. d. Url (3d ed. 1941); P. Merlat, *Répertoire des inscriptions et monuments figurés du culte de Jupiter Dolichenus* (1951).

R. NOLL

MAURESSIP Gard, France. Map 23. The oppidum of Mauressip, situated atop and around a hill dominating the Vaunage plain in the commune of St. Come between Nîmes and Sommières, is a medium-sized fortress occupied for a long period in prehistoric times. Apparently founded in the last years of the 6th c. B.C., it had its greatest growth at the end of the 5th c. and during the 4th. It was inhabited until 120 B.C. and again in the Augustan era.

The first huts were made of perishable materials set up on the rock. They contained local ware and West Greek pottery. The second period saw the erection of stone houses dating from the 5th, 4th, and 3d c. B.C., and local, Massaliote, Attic, and Italiote wares were abundant. A tower (5 x 5 m) was built at the highest point on the site probably at the end of the 4th c. It was faced on the inside with local stone and on the outside with imported stone, fitted by a Hellenistic technique. It was destroyed during the 2d c. B.C. The civilization represented by the finds at Mauressip was Gallo-Greek, of the lower Rhone type.

BIBLIOGRAPHY. "Informations," *Gallia* 22 (1964) 504; 24 (1966) 419; M. Py, "Les influences méditerranéenes en Vaunage," *Bull. de l'École Antique de Nîmes* 2 (1969) 35-86.

M. PY

MAUTERN, *see* FAVIANIS

MAUVES Loire Atlantique, France. Map 23. The site, on a hill overlooking the Loire and covering an area of more than 20 ha, marks a small Gallo-Roman city that was inhabited from the 1st to the 4th c. A.D.

A number of luxurious villas has been uncovered, and the richness of the materials used to decorate the walls and floors (green, pink, and white marble, painted walls and stucco, mosaics) is evidence of the wealth of the inhabitants. In the 19th c. the remains of a theater were found on the city's N boundary. It is built, not on a slope as recommended in the Classical treaties, but on the top of the Coteau de Mauves overlooking the Loire and the surrounding countryside. The semicircular wall is built of mortared rubble faced with small blocks and having iron joints; it consists of broken sections placed end to end to form a series of 20 oblique walls. The diameter of the theater at the level of the stage wall is 44.2 m. The seats and the actual stage must have been of wood, since no traces of them have been found.

Some of the finds made in the early excavations are housed in the Musée de Nantes, more recent ones are for the most part at the Touring Club de France in Nantes.

M. PETIT

MAVROMATI, *see* MESSENE

MAXIMIANOPOLIS, *see* LEGIO

MAZACA, *see* CAESAREA CAPPADOCIAE

MAZARA (Mazara del Vallo) Trapani, Sicily. Map 17B. On the S shore, 20 km SE of Marsala, to the left of the river Mazaro, an emporion (Diod. 13.54.6) and border fortress (Diod. 23.9.4) for the city of Selinus. It was destroyed during Hannibal's march against Selinus in 409 B.C. (Diod. 13.54.6), but probably recovered since Diodoros (23.9.4) speaks of its destruction by the Romans at the beginning of the first Punic war. Pliny (*HN* 3.90) mentions the oppidum of Selinus; some ar-

chaeological remains also document the existence of a habitation center during the Roman period. The site is mentioned in the *Antonine Itinerary*.

Several inscriptions have been found at Mazara (*CIL* x, pp. 739ff. and nos. 7702, 7205, 7211, 7221). Three Roman marble sarcophagi and a funerary urn are preserved in the modern Cathedral.

BIBLIOGRAPHY. A. Castiglione, *Cose antiche di Mazara* (1878); L. Bonanno, *Il porto antico di Mazara* (1931); id., *La Romanità di Mazara* (1933); V. Tusa, *I sarcofagi romani in Sicilia* (1957) nos. 29, 30, 31 I.

V. TUSA

MAZI N KALESI, *see* AMYZON

MAZZARINO Sicily. Map 17B. A modern village in S central Sicily in the environs of which are ancient settlements of different periods. To the SE rises Mt. Bubbonia, on whose summit there developed a settlement which replaced sporadic earlier habitation. It lasted from the end of the 7th c. to the beginning of the 3d c. B.C. This settlement came into contact with the Rhodio-Cretan world of Gela around the end of the 7th c. or the beginning of the 6th c. B.C., but the strongest evidence of Greek influence is from the second half of the 6th c. Probably the agger fortification, and a smaller fortification of the same type which defended the acropolis, go back to this period as well as the acropolis with its prominent archaic shrine. This small temple has a masonry base in the Greek manner and was decorated with gorgon antefixes of the second half of the 6th c. of Geloan type. On the N side, but outside the walls, a votive deposit has been identified and partly excavated; it has proved rich in archaic statuettes and bronzes. The figurines are mostly Geloan in type but of local manufacture. From the necropoleis scattered on the E side of the mountain come grave goods reflecting contact with Gela toward the end of the 7th c. The site, therefore, joined the Geloan chora at the end of the 7th c. or the beginning of the 6th c. B.C. Quite likely during the 6th c. it also adopted a city plan per strigas, as if it were a sub-colony. Its name was probably Maktorion.

In the Sofiana district on the E border of the territory is the statio Philosophiana, which dates to the first half of the 1st c. A.D. To this period belongs the first phase of the bath complex, which was, however, repeatedly altered down to the 4th c. A.D. At the time of the *Antonine Itinerary* the statio is mentioned on the large Roman traffic artery connecting Catane with Agrigentum. Settlement at Sofiana actually goes back to the 4th c. B.C. when in the same area there already existed a Hellenistic farm.

At the SW border of the habitation area, toward the end of the 4th c. A.D., an Early Christian basilica with three naves and prothyron was built, and around it spread rich cemeteries which continued in use until the 10th c. Other necropoleis connected with the settlement stretch in all directions, but the earliest are those to the E and to the N.

Since the statio lies near the great imperial villa of Piazza Armerina, some connection between the two monuments might be postulated. Brick stamps found at Sofiana carry the inscription FIL (O) SOF, and it is probable that we are dealing with a Praedium Philosophianum, similar to that of Calvisianus in the Geloan plain.

BIBLIOGRAPHY. Mt. Bubbonia: P. Orsi, "Città e necropoli sicule dei tempi greci," *NSc* (1905) 447; (1907) 497; (1912) 454; D. Adamesteanu, *ArchCl* 7 (1955) 179-86; id., *RA* 49 (1957) 165-69; P. Orlandini, *Kokalos* 8 (1962) 85-88; D. Adamesteanu, *RendLinc* 11, pp. 1ff; id., *EAA* 7, pp. 265-67.

Sofiana: P. Griffo, *Bilancio di cinque anni di scavo nelle Provincie di Agrigento e Caltanisetta* (1955) 33-38; D. Adamesteanu, "I primi documenti paleocristiani della Sicilia centro-meridionale," *RendLinc* 10 (1955) 569-71; id., "Due problemi topografici del retroterra gelese: Phalaroin-stazioni itinerari e bolli laterizi," *RendLinc* 10 (1955) 199-210; id., "Vaso figurato del retroterra di Gela," *BdA* 2 (1956) 158-61.　　D. ADAMESTEANU

MDAOUROUCH, *see* MADAUROS

MDINA, *see* MELITA

MEAUX, *see* IATINUM

MEDELLÍN, *see* METELLINUM

MEDINACELI, *see* OCILIS

MEDINA SIDONIA, *see* ASIDO

MEDINET-EL-KEDIMA, *see* THELEPTE

MEDIOBOGDUM (Hardknott) Cumberland, England. Map 24. A fort on level ground on the W side of a mountain pass, which controls the road from Galava (Ambleside) to Glannoventa (Ravenglass) and commands an extensive view over the Irish Sea. It was built in Hadrian's reign and garrisoned by Cohort IV Dalmatarum. The occupation probably lasted only some 60-70 years. Thereafter road maintenance gangs or a caretaker unit may have used the site. It is built on uneven rocky ground. The plan is square with a tower at each angle, which can only have been entered from the level of the rampart walk; there are four gates, each with a double portal except the decumana, which is single and has a steep drop into the valley outside. The gate arches were of dressed red sandstone, quarried near the coast some 24 km away. The remainder of the walls were of rough local stone.

The central range of buildings is visible, the principia with two L-shaped rooms on either side of a courtyard, a cross-hall with a rostrum and three rooms in the back range; a double granary, which shows signs of alteration, and an unfinished praetorium. There is space for a courtyard building, but only one range has been built and a wing wall extends forward from it. The granary is built entirely of stone, but the other two buildings probably had only stone sills and were half-timbered. No barrack block has been fully dug but one, of timber, was found to have a thick mortar floor. In the retentura, under peat, a large collection of leather, including shoes and pieces of clothing, was found in 1968. There were also iron smelting fires. A parade ground was constructed by cutting and filling with enormous boulders, NE of the fort. The bath house lies to the S, a single row of three rooms with a tiled flue at one end and the remains of a hypocaust in two rooms. The third room, a combined apodyterium and frigidarium, had a small plunge bath. Beside this with a separate entrance is a circular laconicum.

BIBLIOGRAPHY. R. G. Collingwood, "Hardknott Castle," *Trans. Cumberland and Westmorland Arch. Soc.* ser. 2, 28 (1928) 314-52; D. Charlesworth, "The granaries at Hardknott Castle," ibid. 63 (1963) 148-55; R. P. Wright, "Hadrianic building inscription from Hardknott," ibid. 65 (1965) 169-75.　　D. CHARLESWORTH

MEDIOLANUM (Malain) Côte-d'Or, France. Map 23. Situated 20 km W of Dijon, in the civitas of the Lingones. On the boundary of the present-day villages of Ancey and Malain, near the River Ouche, were found some carved blocks from the city. One of them bears a dedication to Litavis and Cicoluis. Recent excavations have uncovered a fanum consisting of a square temple with a gallery surrounding it and an adjacent courtyard, outside the settlement. We now have evidence of the latter in a large block of houses, regular in plan, arranged on two levels on a slope. The lower level comprises some stone cellars, which are remarkably well preserved. On the upper level is a large room opening on a portico, which had a religious purpose, at least at a certain point in its history. The buildings, of Roman type, are superimposed on thick strata corresponding to structures with wooden posts, built in the Celtic style, which the Roman ones succeeded in the Claudian period. Occupation of the site in the valley may not have taken place until the Roman Conquest; future excavations may show whether, as it appears, a hill settlement on the nearby Butte de Mesmont was moved to a more favorable site, then occupied once more in the early Middle Ages.

BIBLIOGRAPHY. Roussel, "Fanum des 'Froidefonds' sur le site de Mediolanum (Malain)," *Rev. Arch. de l'Est* 20 (1969) 179-91; id., "Fouilles de Malain, lieu-dit 'La Boussière,' parcelle 22," ibid. 22 (1972) 127-54.　　C. ROLLEY

MEDIOLANUM (Milano) Lombardy, Italy. Map 14. A Ligurian and then a Celtic center at the junction of important prehistoric roads from the plains and from the Alps. In the age of Caesar the center had a strong circuit wall in stone and brick, which was enlarged by Maximianus at the end of the 3d c. when the city became the Western Roman capital. The city had a circus, a mint, a horreum, and an imperial mausoleum, octagonal and fortified. The older city covered an area of ca. 9 ha which later increased to 15 ha. In addition to the monuments already mentioned there are remains of a theater, from the Augustan age; an amphitheater, the only one in Lombardy; from the age of Maximianus a 24-sided tower and the Baths of Hercules; and 16 large columns of a temple of the 2d c. A.D. There are also remains of a number of basilicas from the age of St. Ambrosius, who lived at the end of the 4th c. A.D. They include San Simpliciano, San Nazaro, the octagonal baptistery, the memorial chapel of San Vittore and, from the first half of the 5th c., the basilica of San Lorenzo with a symmetrical plan.

The imperial presence favored the development of the applied arts. Outstanding examples of craftsmanship include ivories such as the casket of Brescia and the diptych of Monza, works in silver such as the patera of Parabiago and the reliquary of San Nazaro, and sarcophagi such as that in Sant'Ambrogio and that of Cervia Abundantia. A few sculptures in marble have survived, such as a torso of Hercules of the Farnese type and a draped statue. Only a few Early Christian mosaics have survived, including those in San Vittore in ciel d'oro and in San Lorenzo. Many mosaic pavements are in the Civic Archaeological Museum.

BIBLIOGRAPHY. A. Calderini in *Storia di Milano*, I (1953); M. Mirabella Roberti, *Milano romana e paleocristiana* (1972).　　M. MIRABELLA ROBERTI

MEDIOLANUM (Whitchurch) Shropshire, England. Map 24. Site of a Roman town known from both the *Antonine Itinerary* and the *Ravenna Cosmography* although confirmation of its location at Whitchurch awaited excavations in 1965-66. These demonstrated that the line of the present High Street marked the line of the Roman road from Wroxeter to Chester and formed the axis of the Roman settlement. The various phases may be summarized.

1) Initial occupation in the form of timber buildings probably predating A.D. 75 and associated with the period of legionary occupation at Wroxeter, which ended in deliberate dismantling. 2) Flavian auxiliary fort from ca. A.D. 75 on, identified by discovery of the W defenses. Demolished shortly after A.D. 100. 3) Gradual development of the site as a civilian settlement. By the mid-2d c. much of the excavated area was covered by timber buildings, many of an industrial character. 4) The town's prosperity reached its height in the 3d c. when substantial stone structures testify to the expansion of the town area. 5) By the later 4th c. the site was in decline. Settlement appears to have contracted along the line of the present High Street and recognizable urban life does not appear to have survived the end of the century. The area of Sedgeford S of the town marks the site of a 1st and 2d c. cemetery. A skeleton of a young man with a trepanned skull was found inserted beneath a floor of a building in the town; it dates to the first quarter of the 4th c. Finds from the excavation and earlier discoveries are housed in the Manchester University and Whitchurch museums.

BIBLIOGRAPHY. G.D.B. Jones & P. V. Webster, "Excavations at Whitchurch," *ArchJ* 125 (1968) 193ff.MPI.

G.D.B. JONES

"MEDIOLANUM," *see* CAERSWS

MEDIOLANUM AULERCORUM (Evreux) Eure, France. Map 23. The name is of Gallic origin, and the site is mentioned in the *Geography* of Ptolemy, the *Antonine Itinerary*, and the *Peutinger Table*, along with the cities of Lugdunensis Secunda, as the chief city of the Aulerci Eburovices. In the 4th c. A.D. the old name was replaced by that of the tribe: the *Notitia provinciarum* refers only to the civitas Ebroïcorum, which after the region was Christianized by St. Taurinus became a diocesan see which exists to this day.

The site lies at the bottom of the Iton valley. The left side of the valley, which is very steep, shows traces of a prehistoric settlement (spur of the Câtelier with trench and earth rampart), but the area is too small to have held a population of any size. The other side was less steep and conditions were more favorable. The original settlement was probably on a natural terrace on this side, around what is now the Boulevard Pasteur; Gallic coins have been found here. The settlement spread rapidly towards the river so that the whole of the Mediolanum site, ca. 100 ha, seems to have been inhabited by the beginning of the 1st c. A.D. The town was built of light materials and was not very densely settled.

Then, for political reasons, probably the same reasons that caused the fall of Gisacum, the Romans made Mediolanum an administrative capital in the second half or end of the 1st c.; probably a town-planning scheme contributed to the change. The marshy parts of the valley were filled in. A conduit (it still exists as the canal de la reine Jeann) piped the waters of the Iton, a few km upstream, over an earth-bank to the foot of the hill. A system of secondary conduits served the whole of the lower city and also carried the waste water back to the river. From that time on the center of the city's activity was at the bottom of the valley, around the forum and near the baths, while the theater was erected on the hillside halfway from the original site. Roads to Lisieux, Rouen, Amiens, Paris and Sens, Chartres, Le Mans, and Tours originally ran around the terrace settlement, but when the city was changed the roads were changed also, and the road junction was apparently aligned on the axes of the new forum.

Mediolanum flourished in the 2d and 3d c. In the city center (now the quarter of the Cité de l'Evreux) were the forum and some large buildings: these are still buried 4-5 m deep and little is known about them. Traces of a bath building and a floor covered with a geometric mosaic have been found in the Rue de la Petite Cité, but the best evidence of the importance and quality of the monuments is the architectural fragments (capitals) that were reused in the surrounding wall. Some fairly large buildings have also been located, with clay walls covered with frescos and built on masonry foundations. Most of the houses were built of light materials; stone was used only for public buildings. The city owed its prosperity not only to its administrative and political importance but also to industry: the quantities of iron slag found in digs are evidence of metalworking, while an inscription referring to the fullers' guild and a fine fulling tank, discovered recently, indicate cloth-making. The Iton boasted a small port; olive oil from Baetica and ware from potteries in central Gaul were imported in quantity.

The city was almost completely destroyed by fire in the Germanic invasions of the late 3d c. It was then, presumably, that the great heap of treasure found in 1889 on the site of the modern Hôtel de Ville was buried: 300 kg of coins, the most recent bearing the likeness of the emperor Probus (A.D. 276-282). As a defense against further invasion a fortified keep ca. 8 ha in area was built in the city center, which remained a key element in the defense of Evreux to the end of the Middle Ages. It was surrounded by a rampart with one gate and a moat supplied with water from the conduit. The erection of this rampart made it necessary to change the line of the main roads, which from then on ran to N and W outside the walls. In the 4th c. the site shrank considerably and its population, now probably much smaller, took refuge within the fortified city or close to it. The monuments whose materials had been reused in the rampart were not rebuilt.

Mediolanum has now almost completely vanished; only the rampart can be seen today. It forms a quadrangle ca. 1 km around; some large wall sections are still standing on the S, W, and N sides but none of the round towers that flanked it has survived. The wall is 3 m thick. The lower courses are made of reused materials (sarcophagi, large blocks of masonry, architectural elements) laid without mortar; they are topped with a rubble-work of flint faced with opus-quadratum with bands of tile.

The ruins of the theater are ca. 500 m SE of the city; known in mediaeval times as the Castel Sarrazin, they served for a long time as a quarry. They were excavated in 1843, but later razed by the owner of the property. Dating from Claudius' reign (A.D. 41-54), according to an inscription, the building followed the natural slope. The facade is 75 m long and oriented to the N, the radius of the cavea is 24 m and that of the orchestra 12 m.

The baths lay at the foot of the hill ca. 100 m N of the theater. Their ruins were destroyed at an unknown date, but the foundations have been traced for 75 m. Their size would indicate a monument larger than the baths at Gisacum, and the archaeological context dates them no earlier than Vespasian's reign (A.D. 69-79).

Outside the site is a large area bordering the Sens road, now known as Le Clos-au-Duc. In antiquity it was a cemetery covering several ha, and many incineration burials have been found there. Some Gallo-Roman sarcophagi have been discovered in the same sector but closer to the town. Both caskets and lids are simple and without decoration.

BIBLIOGRAPHY. T. Bonnin, *Antiquités gallo-romaines des Eburoviques* (1860); J. Mathière, *La civitas des Aulerci Eburovices à l'époque gallo-romaine* (1925); M.

Baudot, "Le réseau routier antique du département de l'Eure," *Normannia* (1932); id., "Dernières découvertes dans l'Evreux gallo-romain," *Bulletin de la Société normande d'études préhistoriques* 24, 4 (1947-48); M. Le Pesant, "Les fouilles de la rue de l'Horloge à Evreux," *Annales de Normandie* (1951). M. LE PESANT

MEDIOLANUM BITURIGUM (Châteaumeillant)
Cher, France. Map 23. The Mediolanum of the *Peutinger Table* between Néris (Aquae Nerii) and Argenton (Argentomagus) can be identified with the modern Châteaumeillant. Five Roman roads met there, including one coming from the Rhône valley and the Argenton road leading W. The oppidum covered 18 ha. It was protected to the S by a wall, to the E and W by two small rivers, and to the N, above the junction of the rivers, by a ditch, which can be recognized, crossing the mediaeval town.

The old finds (material filling ancient pits and ditches, massive stores of amphorae) were attributed without distinction to the Roman period. Excavations were begun in 1956 in the settlement and in the sloping rampart; they demonstrate the importance of the Gallic town. New trenches were found with amphorae aligned in them: some of them were simply stores of empty or used receptacles; others were wine cellars which had been abandoned suddenly. All the amphorae found in groups at Châteaumeillant are Republican: Dressel IA Italic types and variants of the Graeco-Italic types with wide or elongated bodies. There were small pieces of floors and remains of diggings, with abundant pottery dating from the end of La Tène II to about 30 B.C.; dumps of the time of Augustus and the Julio-Claudians in the dug-out bottoms of earlier dwellings; and pits filled with trash of the earlier Empire. Under the sloping rampart there was a murus gallicus with posts notched together and with stone facings. It contained preconquest pottery with polished features. The murus was already damaged when it was covered by the sloping construction, probably at the beginning of the Gallo-Roman period.

Mediolanum provides one of the richest deposits of amphorae on land. It played an important part, either as a stopping point or a market, in the Italian wine trade from the end of the 2d c. B.C. until the period of the conquest (and perhaps later, since its destruction in 52 B.C. is not certain). This trade ended before the appearance of the large amphorae of the time of Augustus, rare at Mediolanum. An earth wall covered the ruined murus at that time. The settlement was active in the 1st c. A.D., but retained clay dwellings of traditional type. It continued to exist in the 2d c., but no public monument of Roman type was built. It seems to have suffered during the invasions of the 3d c. and vegetated in the Late Empire. This idiosyncratic history and the exceptional potential for studies of pottery, both before and after the conquest, are among the major points of interest at the site of Mediolanum.

The local museum has on exhibit remains of the murus gallicus, a bust of a god with a torque found in a ritual pit of the time of Augustus, and a first-class ceramic collection. The Bourges museum has a part of the old finds.

BIBLIOGRAPHY. E. Chenon, *Hist. de Châteaumeillant* I (1940); J. Gourvest & E. Hugoniot, "Un emporium gaulois à Châteaumeillant," *Ogam* 9 (1957); id., "L'oppidum de Mediolanum" (Actes du 1er colloque d'Etudes Gauloises), *Ogam* (1960); C. Picard, "Informations arch.," *Gallia* 17 (1959); A. Cothenet, "Les trouvailles monétaires gauloises de Châteaumeillant" (Actes du 3eme colloque) *Ogam* (1962); E. Hugoniot, "Un nouveau dépôt d'amphores à Châteaumeillant," ibid. E. HUGONIOT

MEDIOLANUM SANTONUM (Saintes) Charente-Maritime, France. Map 23.
Halfway up the Charenter river in the heart of the civitas of the Santoni or Santones, and the chief town of that tribe, this city was the first capital of the Augustan province Aquitania and flourished in the 1st c. A.D.; it was then eclipsed by its two powerful neighbors, Limonum Pictonum and Burdigala.

Built before the Roman conquest on an oppidum (the Colline de l'Hôpital) overlooking the crossing of the Charente, under the Empire the city spread out like a fan on the slopes of the left bank. At the same time a suburban street developed on the right bank, where Agrippa's great road linking Lyon to Saintes ended. Today the boundaries of the ancient town are marked by the Charente, the ruins of the amphitheater (to the SW), the Saint-Vivien cemetery (to the NE) and the Sables hill (to the N).

The Lyon road crossed the Charente by a bridge destroyed in 1843. The bridge was approached by a double-bay arch erected in A.D. 19 in honor of Tiberius, Germanicus, and Drusus the Younger by C. Julius Rufus, who at the same time gave Lyon its Amphitheater of the Tres Galliae. The extension of this road on the left bank formed the decumanus maximus: its path has been clearly located, as have certain parts of the roads parallel or perpendicular to it. Apart from the arch (which was moved and restored in 1843-50), those public monuments still in situ are the amphitheater and, N of the city, the Baths of Saint-Saloine. The plan of the amphitheater, according to an inscription, may date from Claudius' reign, while the section of the baths that has been excavated reveals an asymmetric plan that was popular in Gaul. The Saint-Vivien bath buildings N of the town by the river were torn down in the first half of the 19th c., as was a monument with a Doric frieze built on the decumanus maximus in the city center, on the N slope of the Colline de l'Hôpital. Later, the sub-foundations of two large monuments were also destroyed on this hill. Finally, we possess the elements of a great frieze from a theater, not located; also, excavations carried out in 1944 N of the city may have uncovered the site of a circus. Water was brought to Saintes from the hills on the right bank of the river, at Le Douhet and Vénérand, by an aqueduct 11 km long; some underground sections are well preserved but no traces of it have been found in the city.

At the beginning of the 4th c. the city erected ramparts that, essentially, enclosed the original acropolis. Excavation of these walls (to the N and W), mainly in 1887-88, enriched the Musée Archéologique. The pottery, everyday articles, and sculpture are interesting though not exceptional, but the architectural collection is of extremely high quality: it includes many monuments, some of them dating from the beginning of our era, judging from the style of the capitals or of certain friezes.

BIBLIOGRAPHY. F. Bourignon, *Recherches topographiques . . . sur les antiquités gauloises et romaines de la province de Saintonge* IX; A. Chaudruc de Crazannes, *Antiquités de la ville de Saintes et du département de la Charente-Inférieure* (1820); E. Proust & Ch. Dangibeaud, *La ville de Saintes à la fin du XIXe siècle* (1900); Ch. Dangibeaud, *Mediolanum Santonum* I: *Le municipe*, II: *Les ruines, le musée* (1933); Keune, *RE* 1A, col. 2889-2301 s.v. Santoni; J. Michaud, "Le développement topographique de Saintes au Moyen-Age," *Bull. philologique et hist. du Comité* (1961) 23-29. L. MAURIN

MEDMA (Rosarno) Bruttium, Calabria, Italy. Map 14.
On the W coast, ca. 43 km N of Reggio Calabria.

The history of the settlement, founded from Lokroi Epizephyrioi, is little known. Remains of several sanctuaries have been reported from the site, and recent work has revealed remains of the Hellenistic and Roman periods. Especially important is the deposit of terracotta votive statuettes found at Piano delle Vigne in 1912 and 1913.

BIBLIOGRAPHY. P. Orsi in *NSc* supplement (1913) 55-144; *EAA* 4 (1961) 959-60 (P. E. Arias); G. Foti in *La Città e il suo Territorio, Atti del settimo Convegno di Studi sulla Magna Grecia* (1968) 233-34.

R. HOLLOWAY

MEDRACEN Algeria. Map 18. A large mausoleum in the Batna region, 9 km S-SE of Aïn Yagout, excavated in 1873. The general form is that of indigenous tombs of the type known as cylindrical-based bazina. It is made up of a cone comprising 23 steps, .54 to .58 m high, set on a cylindrical base 59 m in diameter. The total present height is 18.5 m; at the summit is a circular platform, which seems to have supported an aedicula. The cylinder is relatively low (4.43 m) and of fine masonry; it has 60 engaged Doric, unfluted columns, built of five courses of which the last forms the capital. The unadorned architrave is crowned by a cornice with concave Egyptianate molding, separated from it by a series of projecting bosses with beveled sides. Between the columns, at three points equally spaced around the monument, there survive horizontal bas-reliefs, moldings, cyma recta, and fillet. A recent investigation disclosed there the remnants of the entablatures of false doors framed by three recessed flat moldings. A simple fillet above the lintel carries a broad entablature, which varies slightly from one door to the next. This building style, with its mixture of Egyptian and Greek reminiscences is characteristic of Carthaginian monumental architecture.

To the W of the monument an antechamber, now completely in ruins, once probably accommodated the ceremonies of a funerary cult. On its axis, at the level of the third step of the tomb, opens a gallery beginning with an 11-step stairway and leading to a small funeral chamber in the center of the monument. It is furnished with a narrow bench 0.3 m high along the walls. During the excavations of 1873, a reddish revetment was visible on the floor and walls of the gallery and of the room itself. In 1970 a new exploration revealed that the platform of the gallery was made of cedar logs, of which 17 are in a perfect state of preservation. When submitted to radiocarbon dating tests samples taken from these beams gave dates of 220 and 330 B.C. This confirms chronological conclusions drawn from the moldings. Numerous circular tumuli surround the monument; a dry-stone boundary wall perhaps marked the limits of the necropolis; a Moslem cemetery continues the tradition.

This mausoleum, princely in character (the nearby lake was called lacus regius in the Roman period), has been assigned sometimes to Syphax and sometimes to Masinissa or his successors. Syphax would have had his tomb built in Massaesylian territory in W Numidia and not in this region; in any case, he was not buried here since he died in exile at Tibur. We believe that it was erected by a Massilian king before the reign of Masinissa; it was perhaps commissioned by Gaïa, who died before A.D. 205.

BIBLIOGRAPHY. C. Texier, "Exploration de la province de Constantine et des Zibans," *RA* 1st series, 5 (1848-49) 129; A. Cahen, "Le Medracen, rapport de fouilles," *Recueil des Not. et Mém. de la soc.arch. de Constantine* 16 (1873-74) 1; Brunon, "Mémoire sur les fouilles exécutées au Medracen," ibid. 303; S. Gsell & R. Graillot, "Exploration archéologique dans le département de Constantine," *MélRome* 14 (1894) 17-86; G. Camps, *Aux origines de la Berbérie, Monuments et rites funéraires protohistoriques* (1961) 201, see bibl. p. 583; id., "Nouvelles observations sur l'Architecture et l'Âge du Medracen, Mausolée royal de Numidie," *CRAI* (1973) 470-517.

G. CAMPS

MEDUN, *see* METEON

MEGALE GOTISTA, *see* LIMES, GREEK EPEIROS

MEGALOPOLIS Arkadia, Greece. Map 9. Founded after the battle of Leuktra and before Mantinea by Epaminondas as part of his Sparta-containing policy, and by the Arkadians of small villages which had heretofore been defenseless against Spartan attack. It took part in the battle of Mantinea (Xen. *Hell.* 7.5.5), but subsequently suffered from Spartan hostility (353-352, 331), the tendency of its inhabitants to return to their villages, and the jealousy of other Arkadian cities. Megalopolis during the 4th c. moved closer to Philip, was attacked unsuccessfully by Agis of Sparta (331) and in 318 by Polyperchon, at which time there were but 15,000 male inhabitants, free and slave, in the city. The 3d c. saw the tyrannies of Aristodemos and Lydiadas, the latter of whom joined Megalopolis to the Achaian League, of which it remained a member until 146 (Polyb. 2.44.5). Kleomenes caused great destruction there in 223 (Polyb. 2.55), but under Philopoimen (fl.223–184-183), the "last of the Greeks," the city was again powerful. After 146 and until his death in 117-116 Polybios mitigated the wrath of the Romans against his native city, and indeed saw to it that needed repairs were made. In Augustan times a bridge was built (*IG* v 2.456), and under Domitian a stoa was constructed (*IG* v 2.457). In the time of Pausanias (8.27.1-16, 30.2-33) Megalopolis lay mostly in ruins.

The ancient city lies ca. 1.6 km N of the modern town of the same name on the road to Andritsena. The walls, visible only sporadically, have been calculated by excavators, both from extant remains and from general considerations of terrain, to have been ca. 8.8 km in extent. They were formed of two parallel lines of stone with rubble in between, and were probably carried up in mudbrick. The town proper is divided by the Helisson river into two sections. To the N lay the agora, described by Pausanias, whose description has been in large part confirmed by excavation. The Sanctuary of Zeus Soter lies in the SE corner near the river, and has in part been washed away by the river. It consists of a rectangle (originally 47 x 53.5 m) with a square open court in the middle surrounded by a double colonnade. The temple was on the W, and cut through the colonnade. In the center of the court there stood a large base, identified by some as the base of the statue group mentioned by Pausanias (8.30.10): it is more likely, though massive, to have been an altar. The N side of the agora was enclosed by the massive Philippian Colonnade (155.5 m long x 20 m deep), with wings projecting on the E and W ends. The building should date from the end of the 4th c. (Paus. 8.30.3), but the style of architecture points to a later date (Frazer IV. 322). The E side of the market place was marked off by a long stoa of mid 3d c. date identified usually with Myropolis (Paus. 8.30.7). Other insignificant remains include the council house (?), a gymnasium (?), and the government offices. All of the above buildings are in a ruinous state, barely discernible,

and are of more archaeological and historical than aesthetic interest.

The business of the Arkadian League took place to the S of the river, where are to be found the remains of a theater, the largest in Greece (Paus. 8.32.1), and the Thersileion, the council house of the 10,000. Of the theater there are preserved the lowest bench for dignitaries (with inscriptions) and the first several rows of seats. For the most part the theater utilizes the natural contours of the hill, but since the hill proved too small, there are retaining walls to E and W, and it is likely enough that the cavea was carried up higher than the present top of the hill. Estimates of capacity vary between 17,000 and 21,000 spectators. The ruins of the extant stage are of Roman date, and are built over the remains of an earlier foundation with sockets and grooves which originally supported either scenery or a stage, more likely scenery. There are no traces of a permanent 4th c. stage or scene building. Scenery and props were stored in the skanotheka just to the W under the W retaining wall of the theater.

The thersileion, of which only foundations and footings for columns remain, was a large rectangular hypostyle hall, constructed in the interior in the form of a theater. The speaker's platform, though in the center on the N-S axis, was closer to the S wall, and was lower than both a platform behind it and the seats for spectators, which rose gradually to the exterior walls on all sides but the S. The columns supporting the roof were so arranged that they radiated out from the center of the speaker's platform, thus affording the spectators an unimpeded view of the platform. It is unclear how the roof was constructed and the building lighted, but the assumption of a clerestory over the speaker's platform is reasonable. At some point the roof seems to have collapsed, for there is evidence of repair to the building and the addition of extra columns at the point of greatest stress, the third row of columns counting from the center. There is no evidence for a stone floor, but scholars have assumed a wooden one. The portico to the S facing the theater is almost exactly the length of the width of the orchestra, and was probably used as a backdrop for dramatic performances. At some point three additional lower steps were added in order to adjust the level of the portico to that of the orchestra. The building was destroyed by Kleomenes and never rebuilt.

BIBLIOGRAPHY. E. A. Gardner et al., *Excavations at Megalopolis 1890-1891* (1892)[MPI]; E. Benson & A. Bather in *JHS* 13 (1892-93) 319-37 (thersilion)[P], 356-58 (theater); J. G. Frazer, *Paus. Des. Gr.* (1898) IV 317-49; *RE* v (1931) 127-40; O. Walter in *AA* (1942) 148-49 (Zeus sanctuary); O. Dilke in *BSA* 45 (1950) 47-48, with references (theater); R. Martin, *Recherches sur l'agora grecque* (1951) passim (see index, s.v.). F. E. Winter, *Greek Fortifications* (1971) passim (see index, s.v.). W. F. WYATT, JR.

MEGARA Greece. Map 11. Located W of Eleusis on the Saronic Gulf, forming a buffer between Attica and the Corinthia. The city may have been of some importance in the Bronze Age. It emerges from the Dark Ages as a Dorian state. During the period of colonization, it was in the forefront, founding important colonies including Megara Hyblaea, Selinus, Chalcedon and Byzantium. The city experienced a tyranny under Theagenes in the 7th c. B.C. and later came into direct collision with Athens over Salamis. She did, however, for a short time in the 5th c. ally herself with her formidable neighbor to the E, and built long walls to connect the city with the port. The rapprochement with Athens was only temporary and Megara went back to her Dorian compatriots,

only to suffer Pericles' Megarian Decree of 432 B.C. Comparatively little is known of Megara after the 5th c. B.C.; with a few exceptions her later history is uneventful.

The ancient city lies on two hills and the saddle between them. Unfortunately the modern town overlies the ancient remains and no systematic clearing has been undertaken. The only major monument even partially brought to light is a large fountain-house, apparently mentioned by Pausanias and assigned by him to the tyrant Theagenes. The building, as cleared, is a rectangle (13.69 x ca. 21 m) consisting of two parallel water reservoirs and draw basins. The front, or S, of the structure is still under modern houses, but it probably carried a Doric porch from which a fragmentary triglyph has been identified. The roof over the water reservoirs, which was probably flat, was carried on five rows of seven eight-sided Doric piers. The two reservoirs are separated by a thin orthostat wall which runs down the center of the building on the middle line of piers. Each reservoir has a separate inlet and outlet into two separate dip basins, and the parapet wall of the latter is worn by the friction of countless amphoras. Recent studies indicate that the building in its present form was constructed at the end of the archaic period and thus cannot be associated with Theagenes. There is evidence for some damage in the 3d c. A.D., perhaps associated with the Herulian invasion of 267, and a final destruction in the late 4th c. A.D.

To the W of the fountain-house lies another building, only the corner of which has been cleared. Its orientation is thought to suggest that it may be contemporary with the fountain-house. Recent archaeological work at Megara has been confined to chance finds and rescue operations, and some studies have been undertaken on the city's fortifications.

BIBLIOGRAPHY. E. L. Highbarger, *The History and Civilization of Ancient Megara* (1927)[MPI]; *RE* 15 (1932) 152-205 (E. Meyer); K. Hanell, *Megarische Studien* (1934); G. Gruben, "Das Quellhaus von Megara," *Deltion* 19 (1964) A, 37-41; *Der kleine Pauly* (1969) 1143-47; O. Alexandre, Τὸ Ἀρχαῖον Τειχος τῶν Μεγάρων, *AAA* 3 (1970) 21-29[PIM]; G. Nikopoulou, *Deltion* 25 (1970) Chron. 2, 99-120[PI]. W. R. BIERS

MEGARA HYBLAEA Italy. Map 17B. A city on the E coast of Sicily, 20 km N of Syracuse. It was founded by the Megarians ca. 750 B.C. to judge from recent discoveries. Literary tradition dates it to 728 (Thuc. 6.4). A century later it was the metropolis of Selinuntia (Thuc. ibid.). It was destroyed in 483 B.C. by Gelon (Herod. 7.156). With the exception of a fortification built by the Syracusans at the time of the Athenian expedition (Thuc. 6.49 and 94), the site remained unoccupied until the foundation of a new colony under Timoleon ca. 340 B.C. This new city was in turn destroyed by the Romans during the second Punic war ca. 313 B.C. (Livy 24.35). A rural settlement, founded among the ruins, existed until the 6th c. A.D. when the site was abandoned.

The first systematic explorations began at the end of the 19th c., in a necropolis. At the beginning of this century part of the wall and the remains of a large sanctuary were uncovered. (The latter is now again buried.)

The superposition of three settlements (greatest height preserved under the ground 2.5 m) makes the interpretation of the remains difficult. The aerial photographs show the topography clearly: two plateaus standing above the sea and separated by a depression. There is no acropolis or natural defense. The area excavated is confined to a part of the N plateau. The archaic wall constructed at the end of the 6th c. encompasses both plateaus, but

the fortification erected around 215 B.C., prior to the Roman attack, defended only the E portion of the N plateau. The last settlement did not extend much beyond the area of this Hellenistic fortification.

Although the most ancient necropoleis are not known, three great necropoleis of the 6th and 7th c. in the N, W, and S have been explored. From the N necropolis comes the great kourotrophe (second quarter of the 6th c.) and from the necropolis to the S comes the mid 6th c. kouros, both of which are today in the museum at Syracuse. The necropoleis from the Hellenistic town are more dispersed and more fragmentary.

From a historical point of view, the three phases of settlement are not of equal importance. For the last period (after 214 B.C.) may be noted some houses (numerous remains of agricultural activity). The main buildings of the preceding period (340-214 B.C.) are situated next to the agora. On its N side are the foundations of a great portico from the time of Timoleon (second half of the 4th c. B.C.) with the remains of a Doric temple in antis behind it. Elements of Ionic decoration were added to this Doric temple, which was probably dedicated to Aphrodite. To the S of the agora is a bath house from the end of the 3d c. B.C., with a round room, installations for water heating, and mosaics. To the SE are the remains of a small, square, 3d c. sanctuary with small basins for votive purposes. The most impressive structure from this period remains the powerful fortifications erected in haste to ward off the Roman menace and containing many blocks taken from buildings of the archaic period. Noteworthy are the rectangular towers and the gates, particularly the great gate on the S side with its tenaille.

The most important phase of habitation is the archaic period, as is indicated by the size of the agora (80 x 60 m), more than twice that of the Hellenistic agora. This agora and the buildings surrounding it date from the second half of the 7th c. It is enclosed on three sides and bordered on the fourth by a great street running N-S. The principal buildings, none of which is preserved above the level of the foundations, include: on the N side, a stoa (42 x 5.8 m) with an opening (three columns) in the back wall allowing the passage of a N-S street towards the agora; on the E, the remains of another, very fragmentary stoa; to the S, two temples, one (2.5 x 7.5 m) in antis with an axial colonnade, the other (16 x 6.5 m) very ruined. All these buildings date from the second half of the 7th c. The fourth side of the agora consisted of an ensemble of structures on the far side of the street which bordered it. There were numerous remodelings here throughout the archaic period. A "heroon" from the second half of the 7th c. (13 x 9.8 m) is composed of two cellae opening on the agora, with basins for offerings, and a frontal stylobate with cupulae for libations. Farther S, the prytaneum (14 x 11 m) dates from the end of the 6th c. It consists of three rooms and a big courtyard, and was built on the site of an older building.

This agora is the hinge, so to speak, between two residential districts of regular but differing orientation. There are precise characteristics common to the whole of the archaic city: streets 3 m wide running parallel and equidistant from one another at 25 m, with the insulae which they create divided along their length by median walls. In addition, two nonparallel streets 5 m wide across the site from E to W. There is also a single N-S street of the same width. The entire plan (agora, streets, and dwellings) dates from the second half of the 7th c. It is the oldest example we yet know of ancient Greek town planning. It should be noted that neither of those two districts is orthogonal and their differing orientation creates another element of irregularity.

The museum contains, in addition to its presentation of the plan of the archaic city, the most important fragments of 6th c. architecture: an altar balustrade of eolic style with large volutes (first half of the 6th c.), a fragment of carved pediment (first half of the 6th c.), a metope with a carving of a two-horse chariot (around 520), and marble architectural fragments of purely Ionic style (last quarter of the 6th c.). This 6th c. presence of Ionic in Dorian colonies (cf. the Ionic temple of Syracuse) is one of the most important discoveries of recent years. Another new element provided by the recent excavations is the presence at Megara of splendid polychrome ceramics whose production flourished above all in the first half of the 6th c. The finest examples of this Megarian ceramic are displayed at the museum at Syracuse.

Another room in the museum at Megara is given over to a reconstruction of the upper part of the facade of a 4th c. temple situated to the N of the agora.

BIBLIOGRAPHY. *The first excavations*: P. Orsi & F. Cavallari, *Mon. Ant. Lincei* 1 (1892) 689-950; id., *Megara Hyblaea* (1917-1921): "Villaggio Neolitico, Tempio greco arcaico . . . ," *Mon. Ant. Lincei* 27 (1922) 109-80; *NSc* (1877) 225; (1880) 37-42; (1892) 124-32, 172-83, 210-14, 243-52, 278-88; (1920) 331; (1925) 313.

Historical problems: F. Villard & G. Vallet, "Les dates de fondation de Megara Hyblaea et de Syracuse," *BCH* 76 (1952) 289-346; id., *Bull. Inst. hist. belge de Rome* (1965) 199-214; id., "I problemi dell'agora arcaica," *BdA* (1967) 33-37; G. Vallet, "Le repeuplement du site de Megara à l'époque de Timoléon," *Kokalos* 4 (1958) 3-9; id., "Megara Hyblaea," *Kokalos* 14-15 (1968-1969) (Atti del secondo congresso int. di studi sulls Sicilia antica) 468-75; id. et al, "Expériences coloniales en Occident et urbanisme grec: les fouilles de Megara Hyblaea," *Annales* (1970) 1102-13.

Publication of the excavations: Among supplements to *MélRome* are volumes 2 and 4—G. Vallet & F. Villard, *Megara Hyblaea 2. La céramique archaïque* (Suppl. 1, 1964); id., *Megara Hyblaea 4. Le temple du IVe siècle* (Suppl. 1, 1966). See also articles appearing in *MélRome*: 63 (1951) 7-52; (1952) 7-38; (1953) 9-38; (1954) 13-38; (1955) 7-34; (1958) 39-59; (1962) 61-78; (1964) 25-42; (1969) 7-35; id., "Les fouilles de Megara Hyblaea," *BdA* (1960) 263-72 (for the years 1949 to 1959); G. V. Gentili, "L'arte di Megara Hyblaea nei nuovi reperti," *La Giara* (Assess. P.I. Reg. Sicil., III, no. 2, 1954) 21-38.

Related problems. The tombs: S. L. Agnello, *NSc* 3 (1949) 193-98; G. V. Gentili, *NSc* 8 (1954) 80-113, 390-402; 10 (1956) 163-69. *The sculpture and ceramics*: P. Orsi, "Sur une très antique statue de Megara Hyblaea," *BCH* 19 (1895) 307-17; id., "Sculture greche del Museo archeologico di Siracusa," *RendLinc*, 5th series, 6 (1897) 301-12; id., "Piccoli bronzi et marmi inediti del Museo di Siracusa," *Ausonia* 8 (1913) 44-75; P. Arias, "Ritratto romano dalle vicinanze di Megara Hyblaea," *BullComm* 62 (1934) 37-39; L. Bernabò Brea, "Kouros arcaico di Megara Hyblaea," *Annuario Atene* 24-26, pp. 59-66; F. Villard, "Un four de potier archaïque à Megara Hyblaea," *CRAI* (1952) 120-21. G. VALLET

MEGISTE or Kistene (Kastellorizo) Greece. Map 7. An island in the E Mediterranean off the S coast of Lycia, mentioned by Strabo (14.666). From the middle of the 4th c. B.C. on it was incorporated in the Rhodian domain. Inscriptions speak of ἐπιστάται ῥοδῖ here. In the vicinity of the mediaeval castle of the Knights of Rhodes there was probably also a fortification in Classical times.

On the nearby upland called Palaiokastro, traces of a fortified settlement with an internal wall are recognizable

under the remains of mediaeval houses and monasteries and the later church of the Panaghia. Remains include remnants of a massive tower built of large rectangular blocks placed head to foot, and another external wall with at least three towers, a few courses of which are left. The fortification is of Hellenistic date and probably is the Pyrgos of which Strabo speaks. Below the castle is a chambered tomb cut into the rock; it is rectangular, with a platform around the interior perimeter and a Doric facade. The tomb dates from the beginning of the 4th c. B.C. Numerous inscriptions from the island are in the museum of Mytilene.

BIBLIOGRAPHY. N. Kyparissis, *Deltion* 1 (1915) 62ff; Zschietzschmann & Ruge, "Megiste," *RE* xv, 1 (1931) 331-32; M. R. Savignac, "Monuments funéraires et religieux de Castellorizo," *RBibl* (1917) 520ffPI; A. J. Janssen & id., *L'île de Castellorizo, il Cairo* (1917); G. Susini, "Iscrizioni greche di Megiste e della Licia al Museo di Mitilene," *ASAtene* 30-32 (1952-54) 340ff; R. Hope Simpson & F. Lazenby, "Notes from the Dodecanese II," *BSA* 65 (1970) 73ffMPI.　　　M. G. PICOZZI

MEHADIA ("Ad Mediam") Caras Severin, Romania. Map 12. Roman camp and civil settlement tentatively identified with Ad Mediam (*Tab.Peut.*). The camp (116 x 142.6 m), 3 km N of Mehadia was restored in the 3d c. under Severus and in the 4th c. probably under Constantine the Great. Close to it are baths. The Cohors II Delmatarum was stationed here. Among excavated finds is an inscription in honor of Valerian and Gallienus (*CIL* III, 1597).

BIBLIOGRAPHY. M. Macrea, *Săpăturile dela Mehadia, Studii*, II, 1 (1949) 133; D. Tudor, *Oraşe tîrguri şi sate în Dacia romană* (1968) 30-32.　　　L. MARINESCU

MEKYBERNA Chalkidike, Greece. Map 9. The port town of Olynthos. The mound lies close to the shore, controlling two coves with wide beaches separated by an artificial mole. Early archaic remains were found in houses destroyed by fire, perhaps by retreating Persians in 479 B.C. Although the later row-houses along the N-S oriented streets were simple in plan, without courts or paved floors, the finds in them were fully comparable to those from contemporary Olynthos. The town was occupied by Philip before 348 B.C., but was probably not abandoned until the inhabitants moved to Kassandreia, soon after that town was founded in 316 B.C.

BIBLIOGRAPHY. G. E. Mylonas in *AJA* 47 (1943) 78MPI.　　　M. H. MC ALLISTER

MELABRON Cyprus. Map 6. On the NW coast of the island W of the village of Haghia Irini. The ruins of a small town, now covered by sand dunes, extend along the shore but also inland for a considerable distance. A small bay below the ruins may have served as a summer anchorage. The necropolis extends mainly inland to the E of the town, but also along the rocky shore, where Late Bronze Age tombs occur.

Nothing is known of the founding of this town except that it succeeded a Late Bronze Age settlement which is to be located on the same spot. The Late Bronze Age tombs recently excavated on the shore produced among others fine Early Mycenaean pottery. Two small sanctuaries have been known on the site and the foundations of a circular building are still visible. Present-day evidence indicates that the town has been in existence from archaic to Graeco-Roman times. The well-known Sanctuary of Haghia Irini lies inland near the village.

The coastal town must have been of some importance but nothing is known of its history. Its identification too presents difficulties. The *Stadiasmus* (310f) mentions a

summer anchorage called Melabron, the distance of which is given as 50 stadia from Cape Krommyon. Since the ruins mentioned above are the most important in the area and seem to agree with this distance, it is tempting to identify these remains with Melabron, a name to be applied not only to the roadstead but also to the town itself.

The identification of these ruins with a town called in Byzantine times Kirboia (Hierokles, 7th c.), later Kerbeia or Kermia (Constantine Porphyrogennitus, 10th c.) has also been proposed, but this ought to be dismissed. Kermia is equated with Leukosia by Porphyrogennitus himself and we know that this town was in existence in his day, whereas archaeological evidence shows that the town at Haghia Irini ceased to exist after the Graeco-Roman period. Therefore Melabron has better claims for the name of this important little town.

Excavations were begun here in 1970. During this campaign a number of private houses of the Hellenistic and Graeco-Roman periods were excavated, some of them with wells, bathrooms, workshops with querns and storage jars. Part of the N town wall of the same period was also uncovered. The tombs excavated by the shore belonged to the Late Bronze Age and to the archaic and Classical periods. Of the sanctuaries nothing survives above ground, except fragments of terracotta figurines.

The finds are in the Cyprus Museum, Nicosia.

BIBLIOGRAPHY. A. Sakellarios, Τὰ Κυπριακά I (1890) 138; I. K. Peristianes, *A Brief Guide to the History and Ancient Monuments of Kerynia town and District* (1931) 17-18; Einar Gjerstad et al., *Swedish Cyprus Expedition* II (1935) 642-824PI; George Hill, *A History of Cyprus* (1949)I 262 n. 5; V. Karageorghis, "Chronique des Fouilles et Découvertes Archéologiques à Chypre en 1961," *BCH* 86 (1962) 365-71I; id., "Archaeological News from Cyprus, 1970," *AJA* 76 (1972) 317; 77 (1973) 55, 428-29; V. Karageorghis et al., *Studi Ciprioti e Rapporti di Scavi* I (1971) 11-170.　　　K. NICOLAOU

MELAINA, *see* LIMES, ATTICA

MELAMBES, *see* KORION

MELANDRA CASTLE ("Ardotalia") Derbyshire, England. Map 24. Auxiliary fort, probably to be identified as Ardotalia, near Glossop. The 2 ha site lies on the tip of a spur overlooking the Etherow river and is almost square; the fort faces N. Excavation early in this century revealed much of the plan, including the principia and several barracks. Historically the fort follows the pattern familiar in the area. After foundation in the Flavian period the timber and earth fort was rebuilt in stone in the Trajanic period. Throughout its life three widely spaced ditches guarded the less protected S side.

Further excavation of the area of the vicus in 1966-69 defined the line of the road to the S and showed that the whole vicus area had been protected by a ditch and rampart cutting off the whole N end of the spur on which the fort stands. Originally the exit of the road to the S was guarded by an inturned clavicula. Beside the road within the enclosure lay a complex series of timber buildings of Flavian and later date, while farther S cremation burials mark the site of a cemetery. Another road led round the head of a small gully towards an imposing timber building 50 m long. A plausible parallel has been seen in the mansio at Benwell. The building was deliberately demolished rather than destroyed ca. A.D. 140, and the same thing may have happened in the fort proper. The site may thus have been abandoned with the Antonine reconquest of lowland Scotland.

BIBLIOGRAPHY. G.D.B. Jones, "The Romans in the

North-West," *Northern History* 3 (1968)[MI]; P. V. Webster, "Excavations at Melandra Castle," *Derbyshire Archaeological Journal* (1971)[M]. G.D.B. JONES

MELEK CESME, *see* PANTIKAPAION

MELENDUGNO, *see* ROCAVECCHIA

MELFI Lucania, Italy. Map 14. City of NE Lucania. Cemeteries under excavation have important archaic tombs. Finds will be displayed in the museum to be installed in the Castle.

BIBLIOGRAPHY. *Enciclopedia Italiana* 22 (1934) 805-6 (Ciasca); D. Adamesteanu in *Letteratura e Arte Figurata nella Magna Grecia, Atti del Sesto Convegno di Studi Sulla Magna Grecia* (1967) 256-59. R. R. HOLLOWAY

MELIANI ("Elaious") S Albania. Map 9. Mentioned as an inland Chaonian town by Ptolemy (3.14). It is the only place in the Drin valley where olives are grown and the ancient name means "olive town." There are remains of a circuit wall ca. 1400 m long on a low ridge and of a temple where the Muslim monastery now stands.

BIBLIOGRAPHY. N.G.L. Hammond, *Epirus* (1967) 207f, 699f. N.G.L. HAMMOND

MELIBOIA Thessaly, Greece. Map 9. One of the chief cities of Magnesia, most probably located near modern Polydendri and perhaps Skiti. It was on the coast (Strab. 9.436, et al.), N of Kasthanaic (Mela 2.35) and apparently between Ossa and Pelion on a route from Macedonia to Demetrias (Livy 46.13.2). It was subject to Philoktetes (Homer B. 717, and elsewhere). Part of Xerxes' fleet washed up here after being dispersed by a storm (Hdt. 7.188). The city issued silver and bronze coinage in the 4th c. B.C. It was allied to Pherai, but its inhabitants were killed or sold into slavery by Alexander of Pherai in the course of his struggle with the Thessalian League (Plut. *Pel.* 29). Magnesia was occupied by the Macedonians under Philip II, and remained virtually Macedonian until the Roman liberation of Greece in 196 B.C. Meliboia is not mentioned as being part of the Magnetian synoecism which created Demetrias in 293 B.C. It was besieged by the Romans in 169 B.C. so as to facilitate a siege of Demetrias, but the siege was relieved (Livy 44.13). It was captured and plundered by the Romans the next year, at the time of, or after the battle of Pydna (Livy 44.46.3). The city was noted for its purple dye (Vergil *Aen.* 5.251; Lucr. 2.500).

At Palaiokastro (by Kato Polydendri) on the coast near the modern town of Polydendri (whose center is some 2 km inland) are the ruins of an ancient town. These are on a rocky hill which makes a promontory at the S end of a long beach (Aguiokampos) extending from Cape Kissavos. The promontory is just S of the mouth of the river Bourboulithra. Scanty remains of the ancient city wall, apparently of good 4th c. construction, have been noted above an overgrown ravine at the S edge of the hill. Some sections of the W wall were seen by Stählin (writing in 1931). The area of the hill enclosed by the wall must have been very small. On the end of the promontory are quarried areas and rock-cut steps. To the N and S of the point are inlets which might serve as harbors. On the hill the foundations of a large rectangular building were noted in 1957. Good black-glazed sherds have been found here. Walls of modern houses in the vicinity contain ancient blocks. A tile fragment with the name of the Meliboians stamped on it was found at the "Kastro" of Polydendri, apparently identical with this site (see Woodward), which makes the identification most likely. From this area came an early 5th c.

B.C. marble head of a young man, and two male and one female marble torsos of the 4th c. B.C. (now in Volo).

About 6 km inland, W of Palaiokastro and a little N of modern Skiti there is another ancient site. This is on a high bluff to the S of and overlooking the river Potamia or Aguiokampos which flows between the masses of Ossa and Pelion. The bluff falls off steeply to W, N, and E, so the only easy access is along the neck from the S. A city wall, ca. 1,250 m in circuit, ran around the bluff. It is best preserved where it was originally strongest, on the S, where one rectangular tower is preserved; the rest of the wall is somewhat zigzagged, but was apparently built without towers. The wall is about one m thick, built of rough field stones laid in fairly regular courses, cemented with mortar. Here and there some bigger stones are incorporated. In the SW part of the enclosure are the remains of a stuccoed cistern, and Leake reported some remains of buildings. The site at Skiti controls the only practicable route from the N along the Magnesian coast and inland to Larissa or the Gulf of Pagasai. It is argued by Pritchett that the site at Palaiokastro is Herodotos' Meliboia, and the site at Skiti the Meliboia of 169 B.C. The date of the Skiti site, however, remains uncertain, although evidently late. It has been suggested that it might be Byzantine Kentauropolis, a fort said to have been restored by Justinian (Procop. *De aed.* 4.3.13).

BIBLIOGRAPHY. A. M. Woodward, *AAA* 3 (1910) 157f, nos. 11, 12 (cf. *JHS* 33 [1913] 313, n. 2); W. M. Leake, *Nor. Gr.* (1835) IV 412f (site at Skiti only, not identified with Meliboia); F. Stählin, *Das Hellenische Thessalien* (1924) 49-51[M]; id., *RE* (1931) s.v. Meliboia 2 (had visited both sites); N. I. Giannopoulos, *ArchEph* (1930) 169ff[I]; (1931) 175; (1932) parart. 19 (statues and inscriptions); F. Brommer, *AM* 65 (1940) 105-7[I] (5th c. head); H. Biesantz, *AA* (1957) 57[I]; (1959) 78-82[I] (site at Skiathá-Palaiokastro); id., *Die Thessalischen Grabreliefs* (1965) 129-30[I] (statues); W. K. Pritchett, *AJA* 67 (1963) 2[I] (both sites). T. S. MAC KAY

MELIGALA Arkadia, Greece. Map 9. The chief town of Upper Messenia, already occupied in prehistoric times. Not far to the W is the Mavrozoumenos Bridge, just above the confluence of the Leukasia and Amphitos (Vivari) forming the Pamisos river. The triple bridge spans the two streams and runs back as a causeway on the low-lying tongue of land between them. There are seven arches and one rectangular opening, which is ancient. Below the Turkish masonry, the foundations of the piers and six courses of one arch are also ancient; the stones are not voussoirs but are corbeled to the arch shape.

BIBLIOGRAPHY. Paus. 4.33; W. F. Leake, *Morea* (1830) I 480f[P]; J. G. Frazer, *Paus. Des. Gr.* (1898) III 3.441. M. H. MC ALLISTER

MELILLA, *see* RUSADDIR

MELITA (Malta). Map 18. A small island 96 km S of Capo Passero. It was a Phoenician trading post until the Carthaginians colonized the island for strategic reasons in the 6th c. B.C. Its Punic tradition persevered throughout the Classical period. Malta was annexed by Rome in 218 B.C. and incorporated into the province of Sicily, with whom it had formed strong trading ties over the previous century. Cicero, in citing the Maltese as victims of the despoliations by the Quaestor of Sicily, Q. Verres, draws a picture of quiet prosperity at the beginning of the 1st c. B.C. The island declined in the following troubled years of piratical raids and the civil wars from which, despite the appointment of a Procurator by Augustus, it was unable to recover until the mid 1st c. A.D. By the early 2d c., Malta and the neighboring island

of Gozo (Gaulos) were granted municipal status, but their history in the later Empire is obscure; under Justinian they became once again part of Sicily and in 553 are mentioned as a bishop's see from the suffragio of Syracuse.

The Carthaginians founded capital towns on commanding inland positions on each island, but owing to continuous occupation of these sites ever since, little now can be seen. Of the town of Melita, present-day Mdina and Rabat, apart from a short section of the town wall, only the site of a large town house is preserved as the "Roman Villa" Museum, which contains the majority of Punic and Roman finds to be seen on Malta. In its earlier phases the house dates to the 3d and 2d c. B.C., but it was extended in the Augustan period with a set of rooms arranged on a peristyle atrium, decorated with sculpture, architectural ornament, and mosaics to Roman taste. The numerous tombs of the period that honeycomb the rock along the roads leading S from the town do, however, attest the size of the population. Most notable are the extensive catacombs, the largest and most elaborate of which, St. Paul's and St. Agatha's, are predominantly Christian, of the 4th and 5th c. A.D. Smaller, finer ones in country districts—at Salina Bay and Mintna—are earlier. Purely pagan complexes exist at Ħal Barca and Taċ Ċagħqi, near Rabat. Of the town of Gaulos, modern Victoria, on Gozo, only the general plan of the ancient grid of streets may be traced in the warren of Arab alleys, but the small museum on the citadel contains several fine pieces of sculpture and chance finds from the town.

The original Phoenician trading settlement and later Carthaginian port lay on the shores of Marsascirocco Bay in the S of Malta, but in the 3d c. B.C. trade with Magna Graecia led to the development of harbor facilities at Grand Harbor which faces NE. During drainage operations in the 18th c. on the silted-up inner basin at Marsa, large warehouses and evidence of a wharf (1350 m long) were found. Further wharves and storehouses were excavated in the same region in 1947 and 1959. Other rich finds, among them large baths with polychrome mosaics of fishes indicate a wealthy port.

Although a corresponding decline in the importance of Marsascirocco may be inferred, the sanctuaries that grouped around the old harbor flourished into the 1st c. A.D. Temples to Melqart (Herakles) and Astarte (Hera) are attested by many chance finds; and the site of the latter at Tas Silġ, on the ridge of the Delimara promontory, has been excavated (1963-68). A Copper Age megalithic temple was taken over in the 6th c. B.C. as the sanctuary of the Punic temple, entered from the W through a finely paved colonnaded courtyard. In the 3d c. B.C. this courtyard was surrounded with a further portico and a high "temenos" wall, 28 m of which survive on the S side. A complex of ancillary buildings was laid out to the N, and the large cistern at Bir Ricca was probably constructed to supply the site. Despite evidence of repairs made in the 1st c. A.D. the temple appears to have fallen into disuse soon after; a Christian basilica was built within the colonnaded court in the 4th c.

At Ras-il-Wardija, on the edge of cliffs 90 m high on the extreme SW tip of Gozo, another sanctuary was discovered in 1965-67. A small inner chamber was cut into a low rock face, fronted with a monumental facade, in the 3d c. B.C. A deep rectangular pool with rock-cut steps down one side lies to the right of the entrance, and the forecourt was terraced down to the cliff edge, with associated rooms to the W. Like Tas Silġ the site shows strong Hellenistic influences but remains essentially Punic in character. It was abandoned in the 1st c. A.D.

The islands were famed for their fine textiles, and the widespread production of olive oil is evident. The late Punic villa at Birżebbuġia, overlooking Marsascirocco Bay, was built round a small central court which covered a cistern, with a staircase leading off to an upper story, which probably contained the living quarters. The ground floor houses the press-beds and rooms for processing olive oil, and there is possible evidence for the production of cloth. A small plunge bath was added in the Roman period. The villa at Ras-ir-Raħeb, near the W cliffs of Malta, though fragmentary, appears to have been a larger version of the same plan. San Pawl Milqi, on the slopes above Bur Marrod close to Salina Bay, is traditionally the site of Publius' villa where the shipwrecked St. Paul was received in 60 A.D. The main constructional phase on the site is a large residential and agricultural complex, laid out regularly around a peristyle courtyard; it has produced fine architectural fragments of the 2d c. B.C. Beneath the court are traces of an earlier phase. In the 1st c. A.D. this area was damaged by fire and in the rebuilding the living quarters were extended to the W where the walls are decorated with painted wall plaster. The olive oil processing rooms are well preserved. The excavators believe that the Pauline tradition can be confirmed by the special treatment given to one room of the villa in the later Roman period, providing several extra entrances and a small antechamber to the W. A series of later chapels was built over the spot, ending with the present 16th c. chapel of San Pawl Milqi. A double defensive wall was built round the villa, probably in the 3d c.; its foundations can be seen on the S side.

Near Għajn Tuffieħa, an abundant spring on the S side of the fertile Puales Valley, a set of Roman baths was excavated in 1929. Their size has suggested a municipal establishment or at least a large villa, dated to the late 1st or early 2d c. A.D. They comprise an open-air natatio, a set of small changing rooms with mosaic and hexagonal tiled floors, a tepidarium with a fine shield mosaic, a caldarium with a hypocaust of arched brick pilae, and a nine-seat marble latrine.

A surprising survival is the tower of a 3d c. B.C. "towered" house of the type popular in Hellenic Egypt, preserved to the height of the overhanging cornice as part of the parish priest's house at Żurrieq. Other interesting monuments include the circular defensive towers built on the approaches to the town of Melita. Their date is problematic: those of Ta Gawhar, Ia Wilġia, Ta Ċieda L'Imsierah, and the Santi Gap may belong to the 3d c. A.D.; but others, it-Torriet and Misraħ Hlantun, certainly reflect earlier crises.

BIBLIOGRAPHY. *Valletta, Reports of the Museum Department* (1904) (in progress)[PI]; A. Mayr, *Die Insel Malta im Altertum* (1909); E. Becker, *Malta Sotteranea* (1913); T. Ashby, "Roman Malta" *JRS* 5 (1915) 23-49[P]; M. Cagiano de Azevedo et al., *Missione Archeologica Italiana a Malta, Rapporti Preliminare delle Campagne di Scavi 1963-68* (1964-69)[MPI]; D. H. Trump, *Malta, An Archaeological Guide* (1972).

A. CLARIDGE

MELITEIA Thessaly, Greece. Map 9. A city of Achaia Phthiotis, it lies on the edge of the plain N of Othrys watered by the Europos (Buziotikos) and the Elipeus (Chiliadhiotikos) just above the plain on the N end of a N spur (Xerovouni) of Othrys. Modern Meliteia (formerly Avaritsa) lies at the W edge of the ancient city. It issued coinage in the 5th c. B.C. when it was associated with Pherai, was a chief city of the Achaians, was joined to the Aitolian League probably from 265 B.C. Philip V failed to take it in 217 B.C. (Polyb. 5.97.5f; 9.18.5-9). It belonged to the Thessalian League after 189 B.C.

The wall circuit is visible, but poorly preserved. It included an acropolis ca. 180 m above the plain, thence the walls included a triangular section down to the plain. The walls down the hill are flanked by ravines. A cross-wall divided the city into upper and lower halves. The wall where preserved is built of irregularly sized rectangular blocks. It had a circuit of ca. 4 km. There is a late 3d c. B.C. building inscription in the E wall. A cloister of Haghia Triadha lies a little S of the acropolis, built partly on an ancient temple (?) foundation. Meliteia's neighbor to the S was Narthakion; on the track there, 25 minutes S of the city is a small fort. Forty minutes further is a church of Haghios Georgios, probably on the site of a temple. Meliteia controlled a considerable area; a good deal of inscriptional evidence exists for its boundaries. Its area has been estimated at ca. 462 sq. km (Stählin, *RE*).

BIBLIOGRAPHY. *IG* IX² 208; F. Stählin, *AM* 39 (1914) 83-103ᴹᴵ; id., *Das Hellenische Thessalien* (1924) 162-64ᴾ; id., *RE* (1931) s.v. Meliteia; G. Daux & P. de la Coste-Messelières in *BCH* 48 (1924) 351fᴹ (boundary with Xynias); *Deltion* 19 (1964) chron. 263; *ArchEph* (1925-26) 185. T. S. MAC KAY

MELITENE (Eski Malatya) Cappadocia, Turkey. Map 5. Chief town of the strategia of the same name, formerly part of a Seleucid satrapy, annexed to the kingdom by Ariarathes III. In A.D. 70 Legio XII Fulminata was stationed permanently on this sector of limes (Joseph. *BJ* 7.1.3-18: *Not. Dig. or.* 38.14). In A.D. 114 Trajan gave it the rank of city. Under Justinian the walls, which survive, were built. No trace of a Hellenistic/Roman town or fortress has yet been found although Procopius (*De aed.*, 3.4.15-20) implies they were on the same site.
 R. P. HARPER

MELLI ("Milyas") Turkey. Map 7. City in Pisidia, 20 km SE of Bucak. Milyas is recorded only by Ptolemy, who places it in Pamphylia, subsection Kabalia; some scholars have doubted whether it really existed. The location at Melli depends solely on the similarity of name.

The ruins lie on a hill ca. 1.6 km SE of the village. The circuit wall of coursed polygonal masonry is fairly well preserved and probably of early Hellenistic date. On the NE is a theater; the rows of seats, partly cut in the rock wall, are few for the size of the cavea. The stage building has collapsed; behind it is a long narrow building still 6 m high, with regular courses of bossed ashlar and seven doors in its outer face. The N slope is covered with a mass of stones from ruined buildings, including a number with inscriptions. On the adjoining hill to the NW is a handsome rock-cut monument reminiscent of early monuments in Phrygia; it is probably a cult facade rather than a tomb. It carries no inscription.

BIBLIOGRAPHY. V. Bérard, *BCH* 16 (1892) 434ff; G. E. Bean, *AnatSt* 10 (1960) 76-80. G. E. BEAN

MELLIEHA, *see* SHIPWRECKS

MELOS Greece. Map 9. One of the islands in the Cyclades, constituted of a volcanic massif whose radius was probably an ancient crater. From the written tradition we know that the island was anciently inhabited by a Phoenician population. Excavation testifies to a flourishing prehistoric civilization. Thucydides (5.112,116) places the Doric invasion 700 years before the Athenian conquest, about the 13th c. B.C. The Athenians took Melos in 416 during the Peloponnesian War and subsequently lost it. It was liberated by Sparta, then fell under the Macedonians, was eventually conquered by Rome, and was abandoned in the 5th c. A.D.

In the W part of the island there are traces of prehistoric settlements. The remains of three such settlements have been found at Phylakopi, on a promontory dominating the sea. The first dates from the Ancient Minoan period (2600-2000), and was a center of commerce in obsidian. The second dates from the Middle Minoan I-III (ca. 2000-1700) and the Late Minoan I and II (1600-1500) and has houses decorated with frescoes, the most famous of which is of fish and is now at the National Museum in Athens. This settlement was destroyed by fire. The third (1500-1000) underwent Mycenaean influence and has a walled palace which represents the height of Cycladic civilization on Melos. It was destroyed by the Dorians who settled on the island. A vast necropolis, contemporary with the third settlement, has rock-cut tombs forming large niches, with double chambers and small dromoi. The hill of the Prophet Elias constituted the acropolis of ancient Melos, where there remain a few traces of ancient walls and of the city. The theater, now in a poor state of preservation, was rebuilt by the Romans. Adjacent to it there were walls belonging to either a stadium or a gymnasium. Near the port a portico has been uncovered on the site of the Sanctuary of Poseidon, where the famous statue of the god (mid 2d c. B.C.), now in the National Museum at Athens, was discovered. A sanctuary dedicated to Asklepios has been found, from which came a head of the god, now in the British Museum in London. Near the theater remains of catacombs include a large room with sarcophagi, from which open four smaller galleries with Christian tombs, including some ornamented by frescoes.

Production of the so-called Melian reliefs is attributed to the island of Melos. Over a hundred examples have been noted of these small reliefs in terracotta, dating from between 480 and 440-30 B.C., and coming largely from tombs. A single tablet was found in the Sanctuary of Demeter and Kore at Kos. The clay tablets were stamped in molds, and were probably reproductions of clay models. They have holes, which leads to the supposition that they were used as a covering, perhaps on wooden caskets. They are the modest work of artisans, important because they show the influence of Ionic art and of the great painters, particularly Polygnotos. After the middle of the 5th c. Attic influence is felt instead. The figurative cycle is composed of mythological scenes and scenes of daily life.

Klima, founded about 700 B.C., took up the role formerly held by Phylakopi until its destruction, after a hiatus of 4 c. The ancient remains are few, though in 1820 a Greek peasant found here, in pieces, the famous statue of Aphrodite in Parian marble that was bought by the French ambassador to Istanbul as a gift for Louis XVIII, and since 1821 has been on display at the Louvre. During excavations undertaken at Melos in 1828 a base was found with part of a signature (. . . andros), datable to about 100 B.C., which was tried as a support for the instable statue of Aphrodite.

Zephiria, today known as Paleokora, was a rather prosperous city served by two ports, one on the Bay of Haghia Triada, and the other on the Bay of Paleokora. Only traces of the ancient foundations have been found under successive constructions. In 1204 the Venetians occupied the island, holding it until the arrival of the Turks in 1537. Zephiria, because of its position, suffered numerous epidemics, and was finally abandoned in 1793.

BIBLIOGRAPHY. C. Bursian, *Geographie von Griechenland* (1868-72) II 496ff; K. Ehrenburg, *Die Inselgruppe von Milos* (1899); Atkinson et al., *Excavations at Philakopi in Melos*, Suppl. Papers Soc.Prom.Hellenic Studies

(1904) IV; Reports in *Arch.Anz.* (1928, 1930, 1939) c.263; P. Jacobsthal, "Die Melischen Reliefs" in *Zeits.f.-bild.Kunst*, LVI, NS XXXII (1931) 94-104; id., *JHS* 59 (1939) 65ff[1]; G. M. Richter, *Archaic Greek Art* (1949) 30, 35, 95, 100; J. D. Beazley, *AJA* 45 (1941) 342; C. Karouzou, *JHS* 71 (1951) 104ff; J. W. Graham, *AJA* 62 (1958) 313; B. Shafton, *BCH* 82 (1958) 27ff; M. Bieber, *The Sculpture of the Hellenistic Age* (1955) 159ff.

G. BERMOND MONTANARI

"MELOYSSA," *see* MINORCA

MEMALIAJ, *see* LIMES, SOUTH ALBANIA

MEMPHIS (Mit Riheina) Egypt. Map 5. About 32 km S of Cairo, a short distance E of El-Bedreshein, the first capital of the united Upper and Lower Egypt (cf. Diod. 1.50 et passim; 16.48-51). Menes (ca. 3000 B.C.) had founded a fortress here, the White Wall (Mennofer), which became Memphis in Greek and later also Pephis (Hierocles, *Synecdemus*, ca. A.D. 535). The city venerated the god Ptah, who in his capacity as a creator of the universe, was identified with the Grecian Hephaistos. Consequently, the Egyptian temple was known as the Hephaisteion. Herodotos (ca. 450 B.C.), wrote at length (2. passim; 3.27) about the city and her kings, mentioning a chapel, dedicated to Aphrodite the Refugee, which was erected within the court of the Palace of King Proteus (cf. Hom. *Od.* 4.384ff). This Aphrodite is not the goddess, wife of Hephaistos, but Menelaus' wife (Herod. 2.11f), who, having been rescued from Paris, resided with the king until she was claimed by her husband. In 332 B.C., when Alexander the Great conquered Egypt, he celebrated his victories here in the Greek manner. On his return from the Oasis of Ammon (Siwa), he was crowned Pharaoh in the Hephaisteion and when he died in 323 B.C., his body was kept here until his tomb was completed in Alexandria. Politically, Ptolemy I transferred the capital to Alexandria, but Memphis continued to be the religious capital (cf. the decree of the Rosetta Stone) with Ptah, however, losing his importance and prestige to Serapis. The Bull Apis, the incarnation of Osiris, resumed his functions as symbol of the new official god Serapis and, consequently, the burial place of the sacred bulls has since been known as the Serapeion. Imitating Alexander, the Ptolemies were crowned in the Temple of Ptah, a custom that survived until Ptolemy Physkon ca. 171-130 B.C. (Diod. 33.13). When Strabo visited Egypt (ca. 25 B.C.), Memphis still attracted visitors. They saw (Strab. 17.31) the Temple of Apis room and the Hephaisteion. They could amuse themselves by watching the bullfight until an edict of Theodosius in A.D. 389 put an end to all such diversions. In 640, when Fustat was chosen to be the capital of Arabic Egypt, it was built out of the ruined blocks of the edifices of Memphis. The colossal statue of Ramses II, now erected in front of Cairo Railway Station, was probably the one seen by Strabo at Memphis. Although there is little now to be seen at Memphis, its necropolis, Saqqara, reflects its lost prosperity. This lies a short distance to the W, where the site is easily recognized by the Step Pyramid. Apart from the rich tombs of the Old Kingdom, the sanctuaries and the labyrinth of subterranean galleries related to Imhotep, there are the Serapeion and the Exedra of the poets and philosophers. The Serapeion, N of the Step Pyramid, contains in its subterranean passages the granite and basalt sarcophagi of 24 sacred bulls. These sarcophagi were kept in separate rooms, hewn in either side of the passage. The latest sarcophagi were in use until the late Ptolemaic period. The approach to the Serapeion was flanked by a long corridor of sphinxes, confirming what Strabo had seen (17.32), and nearby in the Exedra were set up statues of ten of the Greek poets and philosophers arranged in a semicircle around Homer. They date from the reign of Ptolemy I.

BIBLIOGRAPHY. A. Mariette, *Le Serapeum de Memphis* (1857); Porter & Moss, *Top. Bibl., III. Memphis* (1931); C. Picard, "La Statue-portrait de Démetrius de Phalère au serapeion de Memphis: exèdre des poètes et des sages," *Mon Piot* 47 (1953) 77-97[PI]; id., "Autour de Serapeion de Memphis," *RA* 47 (1956) 65-77[I]; J. P. Lauer, "Fouilles et travaux effectués à Saqqarah de novembre 1951 à juin 1952," *ASAE* 53 (1955) 153-66[I]; W. Emery, "Excavation at Saqqara," 35,2 (1939); 36,2; E. Brunner-Traut & V. Hell, *Aegypten* (1966) 452-66[MP]; K. Michalowski, *Aegypten* (1968) 452-53, 462-64[MPI].

S. SHENOUDA

MENAI later MENAINON (Mineo) Catania, Sicily. Map 17B. In the W foothills of the Hyblaei Mountains, an archaic settlement on a high peak that dominates from the E the valley of the river of Caltagirone or of the Margi. This settlement belonged to the indigenous culture of Licodia Eubea (6th c. B.C.). The city, under the name of Menai, flourished especially during the 5th c. B.C. when, in 459 (Diod. 11.78.5) it was refounded by the leader Ducetius, who was a native of the place. In 453 B.C. its inhabitants were moved to the nearby center of Paliké near the well-known sanctuary of the Palici (Diod. 11.88.6). No traces of life survive between the second half of the 5th c. B.C. and the end of the 4th c. B.C. The city, under the name of Menainon, began once more to flourish in the Hellenistic period, as attested by its rich necropoleis. After the Roman conquest the city minted its own coinage. Its existence during the Roman period is attested by Cicero (*Verr.* 3.22.55; 3.43.102) and Pliny (*HN* 3.91). The site continued to be inhabited until the Arab Conquest and again during the following centuries.

The archaic settlement is evidenced by an agger wall with a pottery dump of the culture of Licodia Eubea, which has been uncovered next to the ruins of the mediaeval castle, and by some archaic graves found in the districts of Pietre Nere and St. Ippolito. Necropoleis of the end of the 4th c. B.C. are in the districts of Acquanova and Calvario, of the Hellenistic period (St. Ippolito, Porta Udienza, contrada Pietra Catona and Piano delle Forche) and of the Roman period (St. Ippolito). Within the habitation center the finds consist only of two red-figure lekythoi with painted female heads typical of the end of the 4th c. B.C., and of some archaic and Hellenistic terracottas now in the National Museum of Syracuse. The only architectural monuments preserved within the village, besides the archaic wall, are a nymphaeum datable to the middle of the 3d c. B.C. and a bastion, probably mediaeval, both in the district of St. Agostino. The village is preparing an antiquarium near City Hall. At a distance of 3 km from the village, in the district of Caratabia, there is a pair of rock-cut funerary chambers whose walls are decorated with an incised frieze of riders and deer, attributable to the culture of Licodia Eubea.

BIBLIOGRAPHY. P. Orsi, *NSc* (1899) 70; (1901) 347; (1903) 438; (1904) 373; (1920) 337; W. Kroll, *RE* 15.1 (1931); G. V. Gentili, "Fontana-ninfeo di età ellenistica nella zona detta Tomba Gallica," *NSc* (1965) 192ff; A. Messina, "Grotta con graffiti nella campagna di Mineo," *Cronache di Archeologia* 4 (1965) 30ff; id., "Menai-Menainon ed Eryke-Paliké," *CronArch* 6 (1967) 87ff.

A. MESSINA

MENAINON, *see* MENAI

MENDE Chalkidike, Greece. Map 9. A city on the peninsula of Pallene located on the Thermaic Gulf near the modern village of Kalandra. According to Thucydides (4.123.1) it was founded by Eretria probably in the 8th c. It later founded colonies of its own: Neapolis on the E coast of Pallene (*ATL* I 354) and Eion (Thuc. 4.7). An important trading city, Mende's best known commodity was its wine which was famed (Athen. I 29,d,e) and sent out all over the Mediterranean. It is likely that Mende also dealt in grain and wood.

Mende's wealth is indicated by the high amounts of tribute paid to the Delian Confederacy: 8 talents until 451-450 and then again after 438-437 with fluctuations in between of from 5 to 9 talents. In the Peloponnesian War Mende originally sided with Athens, then on the urging of the oligarchs went over to Brasidas (Thuc. 4.123), but eventually returned to Athens (Thuc. 4. 129ff). It is not mentioned in connection with the Peace of Nikias. From 415-414 Mende again appears in the Athenian Tribute Lists. By 404 the city was minting copper on the Phoenician standard.

Little is known of the city in the 4th c. except that it engaged in a war with Olynthos (Arist., *Oec.* 2.1350a. 11ff). The city was not destroyed by Philip II but lost its importance with the founding of Kassandreia nearby in 315. Livy (31.45.14) calls Mende a "maritimus vicus" of Kassandreia.

Mendean amphoras, which carried its famed wine, have been found throughout the Mediterranean. Silver coinage began in Mende in the 6th c. on the Euboic standard and featured various Dionysiac symbols.

Mende's most famous citizen was the renowned 5th c. sculptor Paionios if, as seems likely, the "Mende in Thrace" which Pausanias (5.10.8) gives as that artist's home is in fact the Chalkidean city.

No systematic excavations have been carried out at the site nor are there any substantial remains preserved. The section of fortification wall seen in 1923 by B. D. Meritt is no longer to be found and the blocks have reportedly been carried off for reuse by villagers. The outline of the acropolis is unmistakable, however. There is a sheer drop on the S to the sea, a steep decline on the E, a ravine on the W, and a gentler but discernible slope off to the N. A few architectural blocks and quantities of pottery from archaic to Hellenistic date at the site are the chief indications of ancient habitation.

BIBLIOGRAPHY. W. M. Leake, *Nor. Gr.* (1835) III 155; B. V. Head, *Catalogue of Greek Coins, 5, Macedonia* (1879) 80-83; A. Struck, *Makedonische Fahrten* I (1970) 53; B. D. Meritt, "Scione, Mende, and Torone," *AJA* 27 (1923) 447-60[IM]; G. P. Oikonomos, Μίνδη-Μένδη ἡ Πατρὶς τοῦ Παιωνίου, *ArchEph* (1924) 27-40; S. P. Noe, "The Mende (Kaliandra) Hoard," *Numismatic Notes and Monographs* 27 (1926); B. Lenk, "Mende," *RE* xv (1931) 777-80 (bibliography); P. E. Corbett, "Attic Pottery of the Later Fifth Century," *Hesperia* 18 (1949) 336-37; I. B. Brashinsky, "From the History of the Commerce between the North Black Sea Region and Mende in the Fifth and Fourth Centuries," *Numizmatika i Epigrafika* 3 (1962) 45ff; M. Zahrnt, *Olynth und die Chalkidier* (1971) 200-03. S. G. MILLER

MENDENITSA ("Pharygai") Boiotia, Greece. Map 11. The site of the mediaeval fortress of Boudonitsa, which incorporated elements of Hellenic construction, including a massive gateway. The remains have been identified by some as those of ancient Pharygai, a town traditionally founded by Argives who brought with them the worship of Hera Pharygaia. Philippson disagreed on the grounds that Pharygai is not known to have been an important Greek fortress as these ruins would suggest. Naryka,

also suggested for this site, is now thought to be at Rengini.

BIBLIOGRAPHY. Strab. 9.4.6; N. S. Papadakis in *Deltion* 6 (1921) 141.3; W. Miller, *Essays on the Latin Orient* (repr. 1969) 257[I]; W. A. Oldfather in *RE* 19² (1938) 1872; V. Burr in *Kieo* (Neon Katalogos) (1944) 35; A. Philippson-Kirsten, *GL* (1950-59) I² 345, 718. M. H. MC ALLISTER

MENINX (El Kantara) Tunisia. Map 18. On the tip of the island of Jerba, facing the mainland, it lies on the Syrtic gulf, on whose shore each successive culture set up an emporium. The growth of the site was favored by vigorous trading between the interior of the region and the eastern Mediterranean; also, like all the cities in this area, it came under Eastern and Hellenistic influence. Its position enabled it to profit from these widespread contacts; but its prosperity (attested by Pliny) came strictly from the richness of the island which it dominated and from the ancient causeway linking it with the continent and the famed purple industry. Vibius Gallus and Volisius were proclaimed emperor there in 251.

Situated in the SW part of the island on a bay formed by the point of Castille Fort to the E and that of Tabella to the W, the vast ruins form mounds of wavy sand strewn along the shoreline over an area 2.5 km x 300-700 m. Excavated at the start of the French occupation and then sporadically until 1943, the site is abandoned today and threatened by encroaching tourism on the island. Those sections or monuments that have been uncovered (none completely) are left to the erosion of the elements or human depredation.

The causeway linking the island and the mainland across an arm of the sea was built in the Roman period and rebuilt in recent years. This chain of land touches the island midway along a bend in the coastline to the N, where the city with its warehouses and markets first starts to spread out. A large esplanade 70 m from the shore, presumed to be the forum, was very soon explored. Several pillars of reddish stone were found, carved with Victories and Barbarians; some of them were removed either to the Louvre or, on two occasions, to the Bardo Museum in Tunis. These sculptures presumably belonged to a monumental colonnade (of which 12 bases were excavated as well as a statue identical to another discovered previously), suggesting that a monument of a rare Hellenistic type once stood on that spot.

In 1881 excavations of the same monument uncovered six columns of pink white-veined marble, aligned and ringed with a second colonnade of green marble, as well as a large Corinthian frieze fragment of the same marble taken to belong to the frieze of the monument. A great basilica with three mosaic-paved naves, long known by its cruciform baptistery in the Bardo, was incompletely excavated in 1901. Another, smaller basilica, 400 m from the mosque, was discovered and partially excavated.

Some baths were explored in 1900, and a few inscriptions found. The buildings were paved with mosaics.

In 1942 more baths, situated NE of the city 500 m from the forum, were excavated and a room was disclosed with a frieze depicting scenes. Several other monuments and remains have been noted without being studied, or excavated without being identified. The many cisterns and hydraulic installations should also be added to this list.

Excavations, and especially the open trench dug along the shore, have laid bare a great number of houses with rough-cast rooms, some paved with mosaics. One mosaic covered an area of 10 x 3 m and terminated in a semicircular apse; another with a design of four plumed horses was found inside the French military camp when

it was being set up. Still another mosaic, representing a nereid, formed the floor of an indeterminate building near the shore close by the borj. Another house had walls covered with paintings. A five-room building excavated in 1934 disclosed an inscription now preserved in the Bardo.

The necropolis lies 1500 m NW of the city, near a great basilica. In it was a large funerary vault cut in the tufa; it was excavated in 1941. Lastly, there is an amphitheater near the city.

BIBLIOGRAPHY. P. Gauckler, "Fouilles en Tunisie," *RA* (1901) 403; P. M. Duval, "Recherches archéologiques à Meninx," *CRAI* (1942) 221-24.　　　　A. ENNABLI

"MENOIS," *see* KHIRBET EL-MAIN

MENTESA ORETANORUM (Villanueva de la Fuente) Ciudad Real, Spain. Map 19. Site near Valdepeñas. Livy (36.17.41) calls the town Mentissa: it was a tributary city of the Oretani belonging to the Conventus Carthaginiensis (Ptol. 2.6.59). It is also mentioned in the *Antonine Itinerary* (445.4), and was 24 Roman miles from Libisosa and 83 from Castulo according to the vases of Vicarello. Some inscriptions have been found there, a few of which mention a libertus Augusti, M. Ulpius, who fulfilled the functions of tabularius vigesimae hereditatium and was also tabularius of the provinces of Lugudunensis, Aquitania, and Lusitania (*CIL* II, 3235). Another inscription mentions a P. Licinius, prefect of the Cohors VII Equitata and tribunus militum of the Legio XXII Primigenia.

It is not identical with the Mentesa of the Bastetani (Plin. 3.25).

BIBLIOGRAPHY. *CIL* II, pp. 434-35.　　　　J. M. BLÁZQUEZ

MÉRIDA, *see* AUGUSTA EMERITA

MERSIN, *see* ZEPHYRION

MÉRTOLA, *see* MYRTILIS

MERV, OASIS OF, *see* ALEXANDRIAN FOUNDATIONS, 8

MESAD HASHAVIAHU Israel. Map 6. A fortress of the end of the Iron Age, ca. 1.6 m to the N of Jabneh, close to the Mediterranean coast. The site, the ancient name of which is not known, was excavated in 1960. It is L-shaped and extends over an area of 1.5 ha. Among the outstanding finds are a long letter in Hebrew written by a wronged peasant to the commander of the fortress, and some Greek pottery decorated in the Middle Wild Goat style of the late 7th c. B.C. From this pottery it is assumed that Greek mercenaries were stationed here. The destruction of the fortress is ascribed to the campaign of Pharaoh Necho in 609 B.C.

BIBLIOGRAPHY. J. Naveh, *IEJ* 10 (1960) 129-39; 12 (1962) 27-32.　　　　A. NEGEV

MESAS DE ASTA, *see* HASTA REGIA

MESOPOTAMON (Likouresi, Haghios Kharalambos) Epeiros, Greece. Map 9. A site in Thesprotia lying E of the promontory known as Χειμέριον, downstream from the confluence of the Acheron and Kokytos rivers and N of the Acherusian marshes. The hill of Xylocastro with the Chapel of Haghios Joannis Prodromos (18th c.) on top of it dominates the village to the N, which is also called Ἐφύρα (Thuc. 1.46). In excavations carried out from 1958 to 1961, the nekyomanteion or oracle of the dead, which was famous in antiquity, was uncovered. Legend has it that Theseus and Herakles passed this way on their descent to Hades and that here Odysseus also passed to consult the prophet Tiresias.

In the historic period, Periander, tyrant of Corinth (early 6th c.), who had killed his wife Melissa (Hdt. 3.50), nevertheless wanted to find out from her where she had placed a certain sum of money when she was alive. He twice sent to consult Melissa's shade (Hdt. 5.92, end).

Strabo says that already in his day the appearance of the landscape had changed owing to the alluvial deposits of the Acheron (7.7.7), but the hill of Xylocastro had preserved the sanctuary almost intact. It consists of a rectangular temenos with an entrance to the N, bounded by a polygonal wall (3.2 m high and 3.3 m thick) measuring 62.4 x 46.3 m. Inside the temenos is a central monument, square in plan (21.8 x 21.3 m) which, in turn, encloses the nekyomanteion proper. This is a central building (15.3 x 4.4 m) with walls 1 m thick standing more than 3 m above ground. The middle bay was erected over a crypt whose roof was supported by arches on pillars; there was no entrance. This apparently was the House of Hades, Aidos doma. The way into the rooms lay along a kind of corridor in the form of a maze, no doubt illustrating the wanderings of the soul in Erebus. The consultant, after first undergoing incubation and purification, reached the sanctuary proper where he made his offerings; traces of these have been found (cereals, carbonized chick peas, small bowls, etc.). Figurines of Persephone (3d c.) ca. 22 cm high can be taken to confirm the purpose of the sanctuary, which still confronts the visitor with the sinister image of death. It is not known how the souls appeared to the consultant and were able to converse with him.

The complex was probably destroyed in 168 in the Roman invasion; indeed, the objects found on the site match this date (second half of the 2d c.). Pausanias (1.17.5) says that Homer must have seen the place, and that the Kokytos was a dismal stream.

BIBLIOGRAPHY. A. Philippson & E. Kirsten, *GL* (1956) II.1 104; *BCH* (1959) 665-69; (1961) 729-33; S. Dakaris, "The Dark Palace of Hades," *Archaeology* 15 (1962) 85-93; id., "Das Taubenorakel von Dodona und das Totenorakel bei Ephyra, Neue Ausgrabungen in Griechenland," *AntK* I suppl. (1963) 51-54[MIP]; R. Hope Simpson, *A Gazetteer and Atlas of Mycenaean Sites* (1965) 93, no. 318; N.G.L. Hammond, *Epirus* (1967) 64, 478, & passim[MP]; E. Meyer in *Kl. Pauly* s.v. Acheron, Ephyra, Orakel.　　　　Y. BÉQUIGNON

MESOYEFIRA, *see* LIMES, GREEK EPEIROS

MESSAD, *see* CASTELLUM DIMMIDI

MESSENE or Ithome (Mavromati) Messenia, Greece. Map 9. The name Messene anciently referred to the area of Messenia (Hom. *Od.* 21.15), and only gradually came to denote the city founded after the battle of Leuktra. The city was in ancient times as it is today called Ithome, and lies in and around the modern town of Mavromati. The building of the city was begun in early 379 (Paus. 4.27.9), and Messene was stable enough to take part in the battle of Mantinea in 362 on the Theban side (Xen. *Hell.* 7.5.5). Never strong enough by itself to withstand Spartan hostility, it later sided with Philip (Paus. 4.28.2), who increased Messenian territory by adding Denthaliatis and the area from Pherai to Leuktron (Polyb. 9.28.7, Strab. 8.4.6). Messene remained more or less allied to Macedon into the 3d c. About 244 the city formed an alliance with the Aitolian League, but fear of Kleomenes brought it closer to the Achaian

League (223-222), which in turn brought about plundering by the Aitolians in 220 (Polyb. 4.3.5-6.12). Civil unrest in 215-214 brought the intervention of Philip V (Polyb. 7.10-14) and a return to the Aitolian League (Polyb. 9.30.6). It was attacked by Nabis of Sparta in 201 (Polyb. 16.13.3, 16.16-17), then allied itself with Antiochos in 192 against the Achaian League and Rome. After the defeat of Antiochos Messene was compelled to join the Achaian League (Livy 36.31.1-9) from which it revolted in 183/182 (Polyb. 23.12). Forced to rejoin the league it nonetheless sent no troops to the war against Rome in 146 (Polyb. 38.16.3). Prosperous but not powerful thereafter (*IG* v 1.1432-33), the last emperor it honored inscriptionally was Constantine (*IG* v 1.1420), though sculptural finds date even from the 5th c. Pausanias (4.31.4-33.4) visited the area in the 2d c. A.D.

The glory of Messene is its walls, the best preserved in Greece, and the strongest of antiquity (Paus. 4.31.5). They enclose an area of 9 km, including the summit of Mt. Ithome, are constructed entirely of stone, and consist of a curtain wall (2-2.5 m thick) and towers, square for the most part, at various intervals. They are best preserved in the N and W sides. Four gates are known, of which the Arkadian on the N is the best preserved and the architecturally most remarkable. It consists of an outer gate (5.32 m wide) flanked by towers (6.5 m wide) opening into a nearly circular area (19.7 m wide) which could be controlled by soldiers standing on the walls above. There are two niches on the N side of the court, one recording repairs by Q. Plotius Euphemion. Some scholars have felt that the gate may be later than the rest of the walls, though there is dispute even as to whether the main part of the wall was constructed in the early 4th c. or later, perhaps in the late 3d.

The acropolis, i.e. the peaks of Mt. Ithome, contains remains of earlier walls dating either from the third Messenian War or from the foundation of the city in the 4th c. The Sanctuary of Zeus Ithomatas is now covered by the abandoned Vourkano monastery. On the slopes of Ithome are the remains of the Temple of Artemis Limnatis of the Ionic order (17.2 x 10 m) and a spring, identified by some with the Klepsydra. Others identify the Klepsydra with the spring in the center of Mavromati.

Below the modern village there is to be found a Sanctuary of Asklepios (epigraphically assured), a site which was for many years identified with the agora: the agora remains to be located. The Aesklepieion consists of a large court surrounded on all four sides by stoas with an internal colonnade (dimensions: 66.8 x 71.8 m measuring from the rear wall of the stoa). In the middle of the court on the N-S axis, and facing due east, there are the foundations of a Hellenistic temple of Doric order (13.6 x 27.9 m) of excellent workmanship which replaces an earlier, 4th c. temple. The altar, constructed in two chronological phases, lies to the E. The rear walls of the stoa are pierced in a number of places to allow access to rooms connected with the worship of Asklepios. The E wall is bisected by propylaea, to the N of which is a small theater; to the S, entrance is gained to a square room with benches running around three sides, formerly identified with the synedrion, but more likely to have been a library. On the W side there are five small rooms, all apparently devoted to religious purposes, the northernmost of which was a small Temple of Artemis Orthia. It is divided into three sections by two sets of two columns on either side of the entrance. The N wall of the court contains three stairways, the middle one of rather monumental proportions, leading to an upper level, on which was the sebasteion, the area in which the worship of the Roman emperors took place. In the NE corner

of the stoa there is a small room, perhaps originally designed as a fountain-house, but in Imperial times used for the display of a large statue. Outside the S wall, and not integrally connected with the interior, are to be found a small heroon (with four graves) and a house with a peristyle court. Excavation in the area of the Asklepieion continues. Other insignificant remains in the vicinity include a stadium and a theater.

BIBLIOGRAPHY. Reports in *Praktika* (1909) 201-5; (1925-26) 55-66; (1957) 121-25; (1958) 177-83; (1959) 162-73; (1963) 122-29; (1964) 96-101; (1969) 98-120; (1970) 125-41[PI]; M. N. Valmin, *Études topographiques sur la Messénie ancienne* (1930); C. A. Roebuck, *A History of Messenia from 369 to 146 B.C.* (1941); Reports in *Ergon* (1963) 88-102; (1964) 102-12; (1969) 97-132; (1970) 100-131; (1971) 144-73; E. Kirsten & W. Kraiker, *Griechenlandkunde* (5th ed. 1967) 422-28; F. E. Winter, *Greek Fortifications* (1971) passim.

W. F. WYATT, JR.

MESSENE (Sicily), see ZANKLE

MESSINA, see ZANKLE

MESUA (Mèze) Hérault, France. Map 23. Pre-Roman settlement on the N bank of the Étang de Thau on a promontory almost entirely surrounded by water (Mel. 2.5.6). Soundings carried out on this little cape, on which was located a port active in antiquity, have revealed that it was occupied from the 6th c. B.C. to the Roman period.

Isolated finds made in the depths of the Thau basin, and in the wrecks which have been discovered there, testify to its frequent use by ancient shipping. It was through the small ports marking the N side of this basin (of which Mèze was the most important) that maritime commerce was connected with the great axis formed by the Via Domitiana, which crosses the territory of Mèze ca. 5 km N of the town. Numerous and important Gallo-Roman estates were situated between the Étang de Thau and the Via Domitiana.

BIBLIOGRAPHY. *Carte archéologique de la Gaule romaine*, fasc. x, Hérault (1946) 17, nos. 44-45; "Informations," *Gallia* 27 (1969) 396; 29 (1971) 384.

G. BARRUOL

"METALLA," see ANTAS

METALLON, see MATALA

METAPONTION (Metaponto) Lucania, Italy. Map 14. On the Gulf of Taranto between the mouths of the Bradanus and Casuentus rivers (modern Bradano and Basento). Famed for the fertility of its farm land, Metapontion was settled by Achaean Greeks in 773-772 B.C. according to Eusebius, but in the late 8th or 7th c. according to modern scholars. It was the last home and burial place of the philosopher Pythagoras. It supported the Athenian expedition to Sicily (415 B.C.). The city was abandoned during the second Punic war in 207 B.C.

The rectangular city plan has been reconstructed on the basis of air photographs. It is connected to a vast subdivision system of the countryside where Greek farmsteads, the earliest belonging to the 6th c. B.C., have been excavated. The original urban nucleus was augmented in the 5th c. to create a new agora in the area of the Temple of Apollo Lykeios, which previously had been outside the walls. This area of the city, its NE section, is currently the scene of study and excavation. The foundations of the Temple of Apollo Lykeios belong to an early archaic building with an exterior colonnade (9 x 18 col-

umns). It is comparable in plan to the basilica (Temple of Hera I) at Paestum. The order was Doric. The temple was modified on various occasions, notably with the addition of pedimental sculpture in the late 6th c. B.C. but was already in a state of dilapidation in the 4th c. To the W of the Temple of Apollo are the foundations of a still earlier temple dating to the end of the 7th c. and to the E are the foundations of a third temple. North of the city near the Bradanus river and beside the modern Taranto-Reggio Calabria highway is the Doric temple long known as the Knights' Tables (Tavole Paladine) but probably dedicated to Hera. It was erected in the late 6th c. B.C. Of the colonnade (6 x 12 columns), 15 columns are still standing. West of the temple is the extensive necropolis. Nearby is the antiquarium where material from the new excavations is displayed. Material from early excavations, including architectural terracottas from the Temple of Hera and the marble kouros from the Temple of Apollo Lykeios, is in the museum at Potenza.

BIBLIOGRAPHY. M. Lacava, *Topografia e storia di Metaponto* (1891); T. J. Dunbabin, *The Western Greeks* (1948); W. B. Dinsmoor, *The Architecture of Ancient Greece* (1950) 97 ("Knights' Tables"); G. Schmiedt & R. Chevalier, *Caulonia e Metaponto* (1959; also in *L'Universo* 39, 1959); D. Adamesteanu, "Metaponto (Matera) Appunti fotointerpretativi," *NSc* (1965) suppl. 179-84[P]; id., "Metaponto," *BdA* 52 (1967) 46-47[MPI]; M. Napoli, *Civiltà della Magna Grecia* (1969) 238-44; A. D. Trendall, "Archaeology in South Italy and Sicily, 1967-69," *Arch. Reports for 1969-70,* 38-39.
R. R. HOLLOWAY

METAPONTO, *see* METAPONTION

METAUROS, *see* MATAUROS

METCHLEY Warwickshire, England. Map 24. This site, discovered in 1934 and partially excavated in 1967-69, lies below various buildings of the University of Birmingham. It consists of a number of forts on the line of Ryknield Street. The first fort was Claudian (4.2 ha) with substantial timber buildings. An annex (1.6 ha) was later added, and after an apparent period of abandonment a fort (2.5 ha) was built inside the earlier one in the Flavian period, which appears to have lasted into the early 2d c.

BIBLIOGRAPHY. *Trans. Birmingham Arch. Soc.* 58 (1934) 68-83; 72 (1954) 1-4.
G. WEBSTER

METELLINUM (Medellín) Badajoz, Spain. Map 19. Town on the S bank of the Guadiana, ca. 43 km E of Mérida. The date of its foundation as a colony is not known, but its name is derived from that of Q. Caecilius Metellus, who was consul in 80-79 B.C. It was administratively part of the province of Lusitania and is mentioned by Pliny (4.117), Ptolemy (2.5.6), in the *Antonine Itinerary* (416.2), and by the Cosmographer of Ravenna (315.8). The road from Augusta Emerita ran through Metellinum, crossing a bridge of which parts still survive, although it is not certain that these pillars date from the Roman period.

Some sections of the defensive wall have been identified, and some stretches of the foundations of the mediaeval wall are probably of Roman origin. A small theater on the side of the hill crowned by the mediaeval castle is being excavated. The top of the cavea has been seriously damaged, but its total diameter appears to be ca. 60 m. A number of Roman inscriptions have been unearthed (*CIL* II, 605ff). Excavations, not yet published, have identified pre-Roman native settlements yielding Greek pottery.

BIBLIOGRAPHY. J. R. Mélida, *Catálogo Monumental de España. Provincia de Badajoz* (1926) I, 367-71; M. Almagro Gorbea, "La necrópolis de Medellín," *Noticiario Arqueológico Hispánico* 16 (1971) 161-202[I].
L. G. IGLESIAS

METEON (Medun) Crna Gora, Yugoslavia. Map 12. In a mountainous region ca. 15 km NE of Titograd. The site is mentioned twice in ancient sources. Polybios (29.2.3) identifies it as the city of the Labeates where the envoy of the Macedonian king Perseus met with the Illyrian king Gentius to conclude an alliance in 168 B.C. Livy repeats this (44.23) and later (44.32) adds that in the same year, after the praetor L. Anicius Gallus captured Scodra, the capital of King Gentius, the king's brother, wife and children were apprehended here. Meteon was probably a dependency of nearby Scodra. After the defeat of Gentius, the Labeates were forced to pay tribute to Rome; with the Roman pacification of Dalmatia, the site lost its importance and its people were absorbed into the population of Roman Scodra.

The city is on a ridge, protected on the S by the steep side of the ridge and on the N by a cyclopean wall (ca. 3d c. B.C.) with projecting towers. Parts of the wall still stand and are typical of Greek-influenced megalithic construction in Illyria during the Hellenistic period. Imported Greek pottery has been found on the site, but there have been no large-scale excavations.

BIBLIOGRAPHY. C. Praschniker & A. Schober, *Archäologische Forschungen in Albanien und Montenegro (Schriften der Balkankommission. Antiquarische Abteilung* 7; 1919)[PI]. I. Zdravković, "Grad Medun kraj Titograd," *Zbornik zaštite spomenika kulture* 3 (1952) 127-32[PI]; J. J. Wilkes, *Dalmatia* (1969)[MP].
M. R. WERNER

METHONE Macedonia, Greece. Map 9. A city on the coast of Pieria, it is distinguished from other cities of the same name by being called "Methone of Macedonia" (Dem. 50.46) but more usually "Thracian Methone" or "the one in Thrace" since in Classical times the N shore of the Aegean up to the Thermaic gulf was still called Thrace, whence Thracian tribute, etc. According to Plutarch (*Mor.* 293B) it was colonized by the Eretrians, but the site had an earlier founder, Methon, "ancestor of Orpheus," which indicates an original foundation by Thracians who were driven from here by the Macedonians (see Edessa). Methone was a member of the first Athenian Alliance, included in the Thracian tribute lists. It was under pressure from the kings of Macedonia until 354 B.C. when Philip II destroyed it and distributed its land among his Macedonians. During this siege Philip lost his right eye. Methone thereafter is not heard of as a flourishing city, although it is mentioned by later writers (Skyl. 66; Strab. 7. frag. 20, 22). They place Methone generally N of Pydna, at 40 stades distance, according to Strabo. Travelers and archaeologists locate it near modern Eleutherochori. There have never been any systematic excavations. Some surface discoveries and small finds have been made in the area, but not sufficient to settle the question indisputably. Among the finds are inscriptions referring to the tomb of Olympias. The small finds are in the Thessalonika Museum and in the Archaeological Collection of Katerini.

BIBLIOGRAPHY. Lenk, "Methone," *RE* 15.2 (1932); B. D. Meritt et al. in *ATL* I (1939), III (1950); H. B. Mattingly, "The Methone Decrees," *CQ* 11 (1961) 154-65; Γέρας Α. Κεραμοπούλλου, ἔκδ. Ἑταιρείας Μακεδονικῶν Σπουδῶν (1953).
PH. M. PETSAS

METHONE (Mothone, Modon) Messenia, Greece. Map 9. A town on the site of Homeric Pedasos at the SW tip of the Messenian peninsula. A mole, first built in the 2d c. A.D., reinforced the bar which runs out to the rocky islet of Mothon and protects the natural harbor; the islet is now occupied by the ruins of a mediaeval fort. There are ancient blocks in the town wall on the side toward the harbor as well as in the foundation of the bridge which provides the only approach from the land side. The acropolis was more than 2 km to the E. Pausanias reported seeing a Temple of Athena Anemotis and a Shrine of Artemis, as well as a spring of water mixed with pitch, but none of these has been identified. Marble fragments and coins from the area attest to the continued existence of the town and its status as a free city in the time of Trajan. In 1962, some of the many wrecks off Methone were investigated by underwater archaeologists; the material brought up by the divers was taken to the Pylos museum. (See also under Shipwrecks.)

BIBLIOGRAPHY. Paus. 4.35; J. G. Frazer, *Paus. Des. Gr.* (1898) III 452; P. Throckmorton & J. Bullitt, *Expedition* 5.2 (1963) 17f. M. H. MC ALLISTER

METHYMNA, *see* LESBOS

METROPOLIS Thessaly, Greece. Map 9. A city of Hestiaiotis located at the foot of a low spur of the Pindus Mts., some 9 km SW of Karditsa, in the W Thessalian plain. It was formed from a synoecism of various towns, perhaps represented by ruins at Pyrgos, Vunesi, Portitsa. It was one of the corners of the square formed by Trikka, Metropolis, Pelinna, and Gomphoi (Strab. 9.437-38). It is first heard of in the 4th c. B.C. and issued coinage ca. 400 to 344 B.C. and again ca. 300 to 200. Its outlying farms were attacked in 198 B.C. by the Aitolians when it was under Macedonian control (Livy 32.13.11, see also Sperchieiai, Dhranista) and in the same year it surrendered to Rome (Livy 32.15.3). It seems to have been prosperous and an important member of the post 196 B.C. Thessalian League. Justinian renewed its walls (Procop. *De aed.* 4.3.5).

The remains of the ancient city (site confirmed by inscriptional evidence) are few. Modern Mitropolis (formerly Palaiokastro) occupies the site. The city wall, poorly preserved, is of rough-faced blocks, ca. 2 m thick, and seems to be 4th-3d c. B.C. in date. The wall forms a circle some 5 km around, encompassing an isolated hill in the plain, which in Leake's time at least, had part of a wall preserved around it. Arvanitopoullos thought there were traces of two narrower circuits within the outer city wall. In the center of the ancient city, near the present Church of Haghios Georghios, were in Leake's time assorted architectural fragments and pieces of sculpture, in part brought from the surrounding fields. Here in 1911 Arvanitopoullos cleared ca. 10 m of a stereobate without discovering its full dimensions. He found coins and sherds (now in the Volo Museum) said to be of the 5th-3d c. B.C. and speculated that the foundation might be of a temple, specifically the Temple of Aphrodite Kastnia, who was the chief goddess of the city.

In 1909 at a place called Kalamia, apparently within the (outer?) wall circuit, a tomb was opened which contained a rich assortment of silver and bronze vessels and gold jewelry. The jewelry is of the first half of the 2d c. B.C.; some of the other objects are earlier. Most of the finds were divided between the Museums at Athens and Volo, but some of the jewelry is in the Hamburg Museum. Arvanitopoullos excavated some more graves here in 1911. A Roman necropolis on the road to Karditsa was excavated in the late 1920s.

BIBLIOGRAPHY. W. M. Leake, *Nor. Gr.* (1835) IV 506-12; L. Heuzey & Daumet, *Mission Archéologique en Macédoine* (1876) 421[I]; A. S. Arvanitopoullos, in *Praktika* (1909) 171; (1911) 337-45[P]; id., "Eine Thessalischer Gold- und Silberfund," *AM* 37 (1912) 73-118[I]; *BCH* 52.2 (1929) 507f; F. Stählin, *Das Hellenische Thessalien* (1924) 128-29; id., *RE* (1932) s.v. Metropolis 1; H. Hoffman & P. Davidson, *Greek Gold* (1965) 278-86[I] (jewelry in Hamburg, and bibliography on treasure).

T. S. MAC KAY

METTET Belgium. Map 21. A Gallo-Roman villa in the vicinity of Bauselenne. The ruins were badly disturbed in the Middle Ages during the construction of the neighboring abbeys of Fosses, Brogne, and Oignies. Much of their building material came from the villa. In spite of this, excavations have yielded the plan of the villa and its subsidiary buildings. The central building, of the same type as the villas of Maillen-Al Sauvenière, Maillen Ronchinnes, and Jemelle, is rectangular and ca. 90 m long with two porticos that extend along the entire length of the NE and SW facades; a series of rooms open onto these porticos. The rooms had concrete paving and some were heated with a hypocaust. Apparently, these were the residential quarters. Two walls extend the lateral facades and enclose a garden with a pool in the middle. Against the NE wall of this garden was a rectangular building that opened onto a second enclosure and probably served as a stable or sheepfold. On the other side of the residential quarters, to the S, a series of buildings arranged around a third rectangular enclosure included a complete bath building, an ironworks, a stable, and barns. A portico that extends along one side of the brewery is built as an exact prolongation of the SW portico of the dwelling. The whole complex covers an area of ca. 10 ha. The villa was provided with water from springs located more than 2 km away. The water, brought by an aqueduct, poured off into five successive pools located some distance apart from one another along the whole length of the aqueduct. The conduits of the aqueduct were largely underground and were sloped to render the flow as regular as possible.

In spite of the disturbance of the site during the Middle Ages, the finds indicate the prosperity of this farming estate. The walls of some rooms were covered with slabs of native, French, and Italian marble. The beginning of the villa goes back to the first half of the 1st c. A.D. It probably suffered under Marcus Aurelius during the invasions of the Chauci in 171-74. It resumed operation, however, and lasted until ca. 270 when it was pillaged during one of the invasions of the Franks. The site was not reoccupied in the 4th c.

BIBLIOGRAPHY. R. De Maeyer, *De Romeinsche Villa's in België* (1937) passim, esp. pp. 99-103 & 195-200[P]; id., *De Overblijfselen der Romeinsche Villa's in België* (1940) 273-80. S. J. DE LAET

METTIS, *see* DIVODURUM MEDIOMATRICORUM

METZ, *see* DIVODURUM MEDIOMATRICORUM

MEVANIOLA Emilia, Italy. Map 14. A city in the valley of the Bidente (Vitis) 30 km from Forlí. The city was a Roman center of Umbrian origin, founded by the inhabitants of Mevania (Bevagna), and was included in the sixth Augustan region (Plin. *HN* 3.113). Inscriptions mark the construction of a municipal building for a quatturovirale magistracy, which perhaps followed the social war with the assignment of the people to the tribus Stellatina. Excavations, mainly between 1958 and 1962, in the area called Monastero in the Pianetto section of

the Comune of Galeata, have uncovered several monumental complexes that make up part of an urban establishment still only partially explored. They include an aqueduct with earthenware piping and a large cistern; and a large bath building with apsidal halls and basins, whose foundation is dated by an emblem of mosaic with an inscription of the decade between 50 and 40 B.C. There is also a theater (mid 1st c. B.C.) constructed in opus testaceum with orchestra tangent to the proscenium, the scena a straight platform, showing characteristics of the Hellenistic theater. Outside the urban area a brick furnace has been found, with combustion chambers and praefurnium.

BIBLIOGRAPHY. Cluverio, *Italia antica* (1659) 623; *CIL* XI, 6603, 6606; A. Alessandri, *I Municipi di Sarsina e Mevaniola* (1928); E. Contu, *NSc* (1952) 6-19; C. Pietrangeli, *Mevania* (Bevagna) (1953); G. C. Susini, "Profilo di Storia Romana della Romagna," *Studi Romagnoli* 8 (1957); id., "Fonti Mevaniolensi," *Studi Romagnoli* 10 (1959) 1; G. B. Montanari, "Mevaniola," *Studi Romagnoli* 10 (1959) 35; *EAA* 4 (1961); id., "Fornaci romane rinvenute in Emilia," *ArchCl* 14, 2 (1962) 162; id., "Mevaniola," *Arte e civiltà romana nell'Italia settentrionale* (1962) 568; id., *NSc* (1965) Supplement, pp. 83-99. G. BERMOND MONTANARI

MEZA, *see* MIEZA

MÈZE, *see* MESUA

MEZEK SE Bulgaria. Map 12. A village near Svilengrad, important for the presence of numerous Thracian funerary tumuli. Excavations have uncovered two grandiose chambered tombs. The tomb of Mal Tepè, built entirely in squared stone blocks, has an access corridor 21 m long, two quadrangular chambers, and a large round chamber with a cupola. The latter is 3.3 m in diameter and 4.3 m high. In it were found in place a bronze door and a stone bed. Among the funerary material, particularly noteworthy are the jewelry, a bronze candelabra with a statuette of a dancing Hellenistic satyr from the end of the 4th c. B.C., decorated bronze vases, and coins. The tomb of Kurt-Kalè is constructed in the same technique, but without a dromos. It is composed of a quadrangular chamber covered in a singular way with squares and rhomboids fitted one to the other, communicating with the tholos. These Mycenaean architectural techniques still in use in the Classical age, when Greece had centuries before abandoned this type of construction, suggest a more ancient indigenous tradition that remained popular under direct Mycenaean influence, as is also indicated by much Thracian decorative art.

BIBLIOGRAPHY. O. Hamdy, "Le sanglier de Mezek," *RevArch* (1908) 1-3; B. Filov, "Die Kuppelgräber von Mezek," *Izv. Bulg. Arch. Inst.* 11 (1937) 1-116; I. Welkov, "Die Ausgrabungen bei Mezek und Svilengrad," ibid., 117-70; A. Raschenov, "Die Festung von Mezek," ibid., 171. A. FROVA

MICIA (Veţel) Hunedoara, Romania. Map 12. Roman camp, port, and customs control center on the river Mureş, several kilometers from the town of Deva.

The earth camp (360 x 180 m), which barred the admission to the province from the W, was rebuilt in stone under Antoninus Pius (138-61). Cohors II Flavia Commagenorum was stationed here permanently, and temporarily ala I Augusta Ituraerorum Sagittariorum, ala I Hispanorum Campagonum, and Numerus Maurorum Miciennsium, a vexillatio of Legio XIII Gemina.

A civil settlement—pagus Miciensis—belonging to the territory of Ulpia Traiana, developed round the camp. In its immediate vicinity are the baths and the amphitheater. The baths spread over an area of more than half a hectare. They were built in the middle of the 2d c. and rebuilt under Septimius Severus (193-211) and again under Severus Alexander (222-35). The Amphiteatrum castrense, elliptical in shape, has an arena 31.60 by 29.50 m. A stone wall, 104 m in circumference, had four entrances, separating the arena from the wooden stands for spectators.

The ruins of the port and of the commercial district have been discovered N of the camp, and to the E private buildings and a group of five furnaces for ceramics and building materials. To the S was a temple of the Moorish gods and a temple of Jupiter Erapolitanus. In the E part of the settlement is a necropolis where an impressive number of funeral monuments, worked in the Micia workshop, have been discovered.

Archaeological material from the 4th c., both epigraphic and numismatic, are in the History Museum of Transylvania in Cluj, the Deva-Hunedoara county Museum, and the History Museum of the Socialist Republic of Romania, Bucharest.

BIBLIOGRAPHY. C. Daicoviciu, "Micia, Cercetări asupra castrului," *Anuarul Comisiunii Monumentelor Istorice Secţia pentru Transilvania* 3 (1930-31) 1-43; id., "Templul Maurilor," *Sargetia* 2 (1941); O. Floca & V. Vasiliev, "Amfiteatrul militar dela Micia," *Sargetia* 5 (1968) 121-51. L. MARINESCU

MIDDLEWICH, *see* SALINAE

MIEZA (Myeza, epig.: Meza) Macedonia, Greece. Map 9. A city known mainly from Steph. Byz., Ptolemy, Plutarch, and Pliny, and by others. In these sources and in the catalogue of the Delphic Theorodokoi (receptionists for the envoys sent to consult the oracle), it is located between Beroia and Edessa. Lately, noteworthy remains near Lefkadia in the district of Naoussa have been assigned to Mieza. Especially important was the nymphaion near Mieza where Philip established the school in which Aristotle taught Alexander and his fellow pupils for three years, beginning in 343-342 B.C. Plutarch is the chief source for this (*Alex.* 7): "Philip set up a school and residence for Aristotle and Alexander around the Nymphaion of Mieza, where to this day the stone chairs of Aristotle are pointed out, and his covered *peripatos*." Near the nymphaion must have been the caves with stalactites which Pliny (*HN* 31.30) mentions: "water dripping in caves hardens into stone—called Corycideum—at Mieza in Macedonia this hangs even in the rooms themselves."

Since 1966 remains have been uncovered between Naoussa and Kopanos which are attributed to the nymphaion, near one of the numerous gushing springs in the area. For a distance of hundreds of meters, along a rock face that is sometimes 10 m high, there are remarkable stone-cuttings: caves with artificial entrances, passage ways, niches, arrangements of steps which result in part from quarrying on site for building material, and remains of stoas. Noteworthy among the small finds are various architectural fragments, terracotta simas painted with floral motifs, and the heads of gorgons and lions, etc. These mainly date to the 4th c. B.C. The excavations are continuing. The small finds are housed in the Veroia Museum.

BIBLIOGRAPHY. Ph. M. Petsas, Ἀνασκαφή Ναούσης, *Praktika* (1938) 65-71PI; id., Ὁ Τάφος τῶν Λευκαδίων (1966) 7-18MPI; id., Νιάουστα-Γλυτουνιαύστα, Μακεδονικά 7 (1967) 81-93; id., Χρονικά Ἀρχαιολογικά, Μακεδονικά 7 (1967) 333-41PI. PH. M. PETSAS

MIGLIONICO Basilicata, Italy. Map 14. A region of ancient settlement, still occupied today, on the eminence that separates the river valleys of the Bradano and the Basento. The remains indicate that the site was inhabited during the first part of the Iron Age and continuously thereafter until the end of the 4th or beginning of the 3d c. B.C.

The characteristics of this first occupation are typical of sites throughout the S and E parts of the region. The first contacts with the Greek world took place at the end of the 7th c. and throughout the 6th c. B.C. The imported archaic vases resemble those found at Metapontion and its environs. The rich funeral offerings of the 6th and 5th c. included imported Greek bronzes, as well as local pottery decorated with imitations of Greek motifs. One vase from the archaic period is decorated with running horses reminiscent of Greek black-figure vases. The local geometric vases tend to be more highly colored than those of adjacent centers. Among the bronze finds are some anthropomorphic patera handles of Italiote production.

BIBLIOGRAPHY. G. F. Lo Porto, *BdA* 2-3 (1968) 111-14; D. Adamesteanu, *Popoli anellenici in Basilicata* (1971) 34-35; F. G. Lo Porto, Civiltà indigena e penetrazione greca nella Lucania orientale," *MAL* 48 (1973) 195-205. D. ADAMESTEANU

MIKHAILOVKA Bosporus. Map 5. A Hellenized agricultural settlement 20 km W of Kerch by the modern village. The site, located in a hilly area along the dried-up bed of a river that once flowed into Lake Churbash, consists of a citadel, the surrounding agricultural region, and a necropolis. The settlement probably arose in the 4th-3d c., the period in which most of the crypt and stone box kurgan graves in the necropolis were erected. Aerial photos and ground studies indicate, however, that the entire area was divided into farmsteads of 10.2 ha rectangles even before the kurgans were made.

Excavations have shown that the main settlement atop the central hill had four strata extending from the 2d c. B.C. to 3d c. A.D. A powerful stone defensive wall, quadrangular in plan, was constructed in the second half of the 1st c. A.D. about the time when most of the settlement was destroyed by fire. A second similar defensive wall surrounded the settlement in the 2d-3d c. The citadel of the 1st-3d c. probably formed part of the defensive system of the Bosporan state. The remains of numerous dwellings and other structures were uncovered inside the citadel.

BIBLIOGRAPHY. B. G. Peters, "Raskopki gorodishcha u s. Mikhailovka v 1963 g.," *KSIA* 103 (1965) 119-24; id., "Raskopki antichnogo poseleniia v vostochnom Krymu," *Arkheologicheskie Otkrytiia 1971 g.* 348-49; G. M. Efimova et al., "Okhrannye raboty na kurgannom mogil'nike u s. Mikhailovka," KSIA 130 (1972) 97-104.
 T. S. NOONAN

MIKHALITSI, *see under* KASTROSIKIA

MILANO, *see* MEDIOLANUM

MILÂS, *see* MYLASA

MILAZZO, *see* MYLAI (Sicily)

MILDENHALL, *see* CUNETIO

MILETOS (Balat) Turkey. Map 7. A harbor city in SW Asia Minor at the mouth of the Maiandros river and now 9 km from the sea. According to Strabo (14.1.6;

634f) it was founded by Cretans from Milatos (E Mallia) and then resettled by Ionians under Neleus. These reports have been confirmed by the excavations.

Between the founding and refounding of the city, Mycenaean Achaeans occupied it, and to this period belong the great bastioned walls perhaps erected against the Hittites and destroyed by the Carians, who led Milesian troops against the Greeks in the Trojan War (Hom. *Il.* 2. 868ff).

Early in the 1st millennium B.C. Miletos was the most important and probably the largest settlement in the league of the 12 Ionian cities, and it was surpassed in this role by Ephesos only after the Ionian rebellion and the destruction by the Persians (Hdt. 6.18ff) in 494 B.C. After a decisive sea battle in front of Miletos near the island of Lade (Batmas), the city was destroyed (Hdt. 6.11ff).

In archaic times Miletos extended from the Kalabak tepe 60 m high, presumed to be the seat of the tyrants, to the NE and the so-called Harbor of the Bay of Lions, one of the harbors mentioned by Strabo (loc. cit.). The center was situated from the earliest times around the Athena temple in the NW between the so-called Theater Harbor and the large bay (Athena Harbor) that extended to the Kalabak tepe. Following the Persian wars, the center shifted to the so-called N market on the Bay of Lions whence in the spring of each year processions made their departure from the Sanctuary of Apollo Delphinios to the Apollo temple of Didyma, 18 km distant. The first section of the processional route was transformed in Roman times into a magnificent street: halls of columns, a three-story fountain structure, the Nymphaeum, and a two-story gate on the N side of the still unexcavated S market.

The excavations have so far produced only an initial evaluation of archaic Milesian art work: whether ceramics, plastic arts, or architecture. Concerning architecture and city planning, however, it is certain that the system of streets intersecting one another at right angles and named after the Milesian, Hippodamos, had already been used in the archaic period. Perhaps the system was developed in the city's colonies, of which it is supposed to have sent out 90—especially on the Marmara and Black Sea (cf. Strab. loc. cit.; Plin. *HN* 5.112). With the reconstruction begun in 479 B.C. by Hippodamos, the system was carried out throughout his native city.

The reconstruction of the city, which began with the shrines of Athena and of Apollo Delphinios, extended over a long period. Built upon at least two earlier edifices from archaic and prehistoric (Mycenaean) times, the Classical Athena temple received a new orientation from S to N and took the form of an Ionic peripteros with a double vestibule laid out upon a terrace. It has not been definitely determined whether the Delphinion had any pre-Persian predecessors. Not until the time of Alexander the Great were the city walls completed. Independent not only from the Persian king, but also from its own tyrants, Miletos became a member of the Attic League in the 5th c. B.C. and maintained its alliance with Athens in the Peloponnesian war until Alkibiades succeeded in withdrawing Athens in 412 B.C. (Thuc. 8.17ff). Thereafter and until its subjugation by Alexander the Great in 334 B.C. (Arr. 1.18f), Miletos was the base of the Persian king or of Persian Satraps (Maussolos ?) and important because of its maritime position.

In the confusion among Alexander's successors the city was a point of dispute, especially between the Diadochs and the Epigones, but it was also possessed by local tyrants such as Asandros (314-313 B.C., cf. Diod. 19.75) or by Timarchos, the Aetolian (mound grave on the E

slope of the theater hill ?). The city was freed from Timarchos by Antiochos II, who was for this reason named "Theos" (cf. App. *Syr.* 65).

Whether Asandros is connected with Miletos through the founding of Heraklea at Latmos, whose fortifications were most likely completed by Pleistarchos, is a question that must remain unanswered until the excavation of the city. [In the "Results of the Excavations and Investigations, etc." only the fortifications and the Christian cloisters of Heraklea are discussed (M III 1 and 2).] It is also uncertain whether the Milesian brothers Timarchos and Herakleides, who built the bouleuterion for Antiochos IV Epiphanes, are descendants of the tyrant Timarchos. The design is important in the history of art as an early axial symmetrical composition: it includes a building at right angles to the main axis with an audience room similar to a theater and covered with an extensive wooden ceiling without center support, and in front of it a court hall with a Corinthian columned vestibule.

Along with the Seleucids, especially the Attalid Eumenes II of Pergamon stands out as a builder, founding the Gymnasium and most likely also the stadium and honored by a gilded bronze statue upon a large round basis. The Gymnasium, preserved only in a Roman reconstruction, has not been excavated. Older predecessors of the stadium have as yet not been established. The plan of the W gate is in any case by Eumenes with eastern characteristics and of the period of late antiquity. Its drainage system is still readily recognizable today.

Miletos' relationships with the Romans were less fortunate. The city was late with its introduction of the cult of Roma, namely, after the establishment of the Province Asia 133 B.C. Consequently, even under Tiberius in A.D. 26, Miletos was regarded as inferior to Smyrna as the choice for the site of a temple for the emperor (cf. Tac. *Ann.* 4.56). The city ranked below Ephesos, the seat of the governor, and also below Pergamon, the site of the emperor cult [cf. author, *Das römische Milet* (1970) 119f].

At the time of Mithridates VI Eupator, Miletos was apparently unreliable and consequently deprived of its freedom, which the city first recovered from Mark Antony in 38 B.C. A retrogression in its development is also indicated by the fact that after 100 B.C. a new strongly fortified city wall crossed directly through the old housing section, which thus appears to have been reduced by half.

A new blossoming was achieved first under Trajan, who dedicated to his father the grandiose Nymphaeum with its tabernacle-type architecture inspired by theater facades. He also completed the processional street from the sanctified gate in the S of the city up to Didyma (100-101). Above all, the city was indebted to Marcus Aurelius' wife Faustina. Most likely because of her sojourn there in A.D. 164, she made generous donations for the baths named after her and perhaps was also concerned with the completion of the large Roman theater—both the best-preserved ruins in the city. The Baths of Faustina, because of their asymmetrical spatial composition, are especially noteworthy by comparison with the corresponding baths in Rome and elsewhere in the west. The theater, repeatedly reconstructed, was designed for at least 15,000 spectators. The third upper level was removed for use in a mediaeval castle.

Clearly belonging to the late period of antiquity is the Serapeum lying next to the S market; in its design it anticipated the Early Christian churches—the Basilica of St. Michael and the so-called Bishop's Church. These in themselves attest to the importance of the post-Classical Miletos, which built its Gothic and Justinian

walls upon those of the Hellenistic city and as a final Byzantine bulwark the theater castle Palati (Balat).

Since the description in this entry is chronological, a few directions to help locate the various monuments follow. From the theater, the most conspicuous landmark, one looks E and S over the area of the North Market with the Delphinion, Baths of Capito, Nymphaeum, Bouleuterion, South Market, and adjacent buildings. To the S of the theater lies the Stadium; and the W, the West Market and the Temple of Athena. Between the South Market and the stadium are the Baths of Faustina.

The three markets have a natural relationship with the four harbors of the town, yet it does not follow that the oldest market is situated at the oldest harbor, that of the theater. Moreover, market does not necessarily mean market-place. To what an extent Miletos was a harbor town even in comparison with Ephesos can be learned from the role of its markets. Accordingly, at the planning of the new town an important area was set aside for what we call the North Market. It is the oldest market-place, the oldest known agora of Miletos.

The West Market. The long market-place N of the Athena Temple, oriented E-W, is the latest of the Milesian market complexes so far known. It was built at a time when it could encroach on the great Athena Temple, cutting at last into its terraces. The architectural forms suggest a date at the end of the Hellenistic period.

The North Market. In the new planning after the Persian destruction, space was left for the North Market. To begin with only stoas, sheds, and other related buildings arose beside unbuilt areas. The so-called Blood Inscription was erected in the North Market.

The South Market. The largest of all yet known agoras, not only of Miletos but also of the entire Greek world, has unfortunately only been investigated by soundings however intensive these have been. Whether the huge area of 33,000 sq. m was planned from the very beginning as the official market is doubtful.

The complex was used in the Roman period especially for formal functions and underwent important reconstruction. Thus in the oldest part, the E portico, statue bases were set up in front of the interior columns. Even the latter also belong to the reconstruction. In addition, the market became for Roman emperors a place for numerous dedications as it had been for Hellenistic rulers.

The E portico is a trading house laid out to utilize best the space available. From its revenue the building of the Didymaion was supposed to be financed. An inscription found in Didyma in which a στοά σταδίαια "in the town" (that is, in Miletos), is mentioned is obviously to be connected with it. Its exterior length measures 196.45 m, its interior 189.20 m, and thus it corresponds in size to a stadium.

Gates closed off only in later times the road entrances, which are characteristic of Greek agoras. The S gate, of which no trace remains today, is Roman. A simple passage, its width must have been spanned by an arch.

The Market Gate has become world famous through its reerection in the Pergamon Museum in Berlin. In situ only the three originally open passageways can be recognized between the four socles of the Corinthian columns of the superstructure. The facade measures ca. 29 m in length.

A tower of the wall of Justinian was placed in front of the S side of the W passage. This late fortification rested on the N and W walls of the South Market.

The gate rose two stories high over three steps in contrast to the adjoining stoas of the market. It was con-

ceived wholly as a facade. A passage for vehicles does not seem to have existed here earlier as far as can be told today. However the shift in relation to the Sacred Way and the widening of the place in front of the market gate, both already in existence, were now utilized to increased effect.

The date derives not only from the style of the acanthus ornament but also from the figural decoration of the upper story. Here the figure of an emperor in cuirass attracts attention. Next to it kneels a barbarian in trousers, obviously a Parthian, which suggests the campaign of Lucius Verus (162-165), the co-emperor with Marcus Aurelius.

The Athena Temple. This sanctuary, the oldest in the town, is in the area that was settled first, just S of the Late Hellenistic tomb building which still stands high above on the peninsula between the harbors of the Theater and Athena. The massive foundations on this high ground are of unwieldy gneiss from the Latmos mountains and reveal an important temple of ca. 30 x 18 m.

The orientation N-S is unusual. In front of the cella (naos), there is a pronaos, in front of which again the otherwise single peristyle was doubled. In the publication the temple is reconstructed on a podium with an open stairway in front instead of the double colonnade. It is only certain that the complex rose above a terrace.

The Delphinion. The procession that passed each spring in the month of Taureon from Miletos to Didyma departed from the Sanctuary of Apollo, the so-called Delphinion, by the harbor of the Bay of Lions. Here Apollo was worshiped as god of the harbor, the Delphinios of Cretan origin who had come across the sea. He was thus called because he was supposed to have shown the way to Delphi in the form of a dolphin. As protector of seafaring, be became in this form naturally the god of the colonial settlers. He has been identified, for instance, in the Milesian settlement of Olbia on the Black Sea.

Of the period before the Persian destruction there remains only an inscription and some round altars which may have been brought to the present site from elsewhere since the first architectural remains are not even of the 5th c. These remains indicate nothing more than a sort of peristyle court in Doric style, a "sacred area" which only in the course of time was enlarged to the size of two house units (ca. 50 x 60 m). Originally it was only half this size and limited to the part on the W side. Only in the Early Hellenistic period was the portico with two rows of columns laid out in horseshoe shape along the N, S, and E sides. The W entrance side had only a single colonnade. In the court itself were set up so-called exedrae next to the altars, that is, semicircular benches together with other votive offerings.

Only in Roman times did the complex receive an architectural center in the form of a round temple or monopteros. Originally the area was planned as a place for sacrifice and for the gathering of the procession with the priests and singers which led it. In later Imperial times the porticos were once again reorganized and now into single colonnades, probably because the court was then all too obstructed. The marble colonnades were now crowned with Corinthian-composite capitals. Moreover a vestibule or propylon was added to which are ascribed the Corinthian capitals which were lying nearby.

The Bouleuterion. Always one of the most important buildings of a town, the bouleuterion occupies a central space in Miletos as elsewhere. It was exceeded in importance only by the theater, the place of the citizens' assembly and perhaps too the place of the meeting of the council before the bouleuterion was built. However in both cases we know nothing of pre-Hellenistic predecessors.

The bouleuterion has a unified plan containing council building, peristyle court, and propylon. Totally apart from its secure date, the building is of importance for art history as an early example of an axially symmetrical plan. It is dated by the votive inscription carved on the epistyle of the council building and repeated on the vestibule. The blocks belonging to this have been re-erected at the entrance of the court. The inscription states that two brothers, Timarchos and Herakleides, erected the building for Antiochos IV, Epiphanes.

The historians Polybios (33.18[16].6), Diodoros (31.27a) and Appian (*Syr.* 45ff) give additional information which permits the building of the bouleuterion of Miletos to be dated between 175 and 163 B.C. One would like to know whether the bouleuterion in the Syrian capital, Antioch on the Orontes, which was [also] founded in the name of [Antiochos IV] had something to do with the Milesian building. The ornament of the latter, however, appears to be wholly in the Milesian tradition.

The council building (34.84 x 24.29 m) is set across the rear of the courtyard. It could also be entered from the street by two doors at its rear side. One could then pass up two stairs to the upper rows of seats.

The Gymnasium of Eumenes II (197-160/59 B.C.). The complex, considered to be the oldest gymnasium, juts out between the West Market and the stadium, not far from the Athena Temple. In Roman times, it was altered considerably. Close by was found the round base of Eumenes II which today is preserved in Berlin. A decree of the people of Miletos honoring Eumenes II was inscribed on the anta of the gate building which led from the stadium up into the gymnasium. Unfortunately it is not completely preserved. Today one can barely find the exact location of the gate. This gate building consisted of an Ionic vestibule with two columns in antis above seven steps. It was situated precisely on axis with the stadium, which it took into consideration in other respects as well. Steps intended for visitors flanked the vestibule. Parts of the superstructure were found during the old excavation, especially fragments of an anta capital now lost. Since they were published only in drawings, it is difficult to judge their style. They appear, however, to be still in the tradition of the naiskos of Didyma and are in any case finely worked, although perhaps a Roman reconstruction.

The Stadium. The orientation of the stadium fits the regular plan of the town. One would like to deduce from this that the room for it was already provided in 479 B.C. at the time the town was newly laid out. It can be stated with certainty only that the W gate of the preserved stadium, which connects with the Gymnasium of Eumenes II, was planned in relation to the stadium and because of its inscription cannot have been built after Eumenes II. The arena is 29.56 m wide and probably was 192.27 m long, like the stadium at Olympia. Two starting gate systems are preserved, the second still of the Hellenistic period. In the E both are still partly visible while in the W by the Gymnasium of Eumenes only the second could be identified. The older system consisted of 13 stones with holes of which the one in the middle and the two on the extreme ends were larger and specially formed. The rest were simpler. As in the older gate system at Priene, which the Milesian example recalls, the evidence is not sufficient to clarify the details of how the system worked.

The Nymphaeum. So much of the city fountain is still standing and so much preserved that a reconstruction of at least the lowest of the three levels of this splendid

monument would be very worthwhile. Of the marble blocks 333 were excavated and drawn, most of which are still on the site. A small part of the sculptural decoration was taken to Istanbul and Berlin; most of it, however, remained in Miletos. Since the destruction of both depots which Th. Wiegand had built against the E slope of the theater hill, the latter have disappeared: under-life-sized statues, mostly of gods and demi-gods, which decorated the niches of the theater-like facade.

The whole is divided into waterworks and decorative monuments which are set back to back with common masonry. Of the decorative facade's lowest story are preserved the middle and two of the four adjoining arched niches to the S. The plan of these is alternately semicircular and rectangular. Water flowed from the total of nine niches into a basin (16.15 x 6.39 m) in front of which was a smaller drawing-basin.

To the level of the smaller basin project two wings of two stories each, the lower levels of which continue the gableless pattern of columns and pilasters of the main facade. Equally in the second level the so-called tabernacle system of the center building with its triangular and volute gables is repeated. The center building is only distinguished by a third story which employs a similar but off-set tabernacle system of gables.

The columns were monolithic and unfluted; the pilasters were partly fluted and partly decorated in relief. The frieze with vine decoration was carried forward over the columns and pilasters in rectangular plan. The decoration is clearly related to that of the Baths of Capito and its facade colonnade, but the details appear smaller and weaker. It is no equal of the Flavian style in the capital, Rome.

The epistyle of the lowest story bears an inscription in Latin, which probably refers to the father of the later emperor Trajan, who among other duties was proconsul of Asia under Titus in the year 79-80. The inscription was, however, inscribed during the reign of his son.

The inscription of the upper epistyle is written in Greek and speaks of the adornment of the Nymphaeum under the emperor Gordian III in the years 241-244. It is doubtful whether this refers to the entirety of the statues of the facade as has been suggested in the publication.

South of the Nymphaeum are located the remains of a small monument (11.4 x 6.63 m) on a foundation of brown poros blocks below and gneiss above. On the E short side are preserved four marble blocks of the lowest course of the superstructure. If it was a temple, a naiskos (perhaps with four columns on the facade), then the entrance must have been from the W on account of the character of these marble blocks.

Farther W between the Bouleuterion and the Nymphaeum, in the square paved with limestone slabs, is located the foundation of another small monument. Its major axis lies N-S. Parts of the upper courses have been preserved as well as most of the blocks of the lower and a large number of the second level of the marble steps. These are notable for their numerous setting marks.

The Theater. The hill against which the theater is set is over 30 m high and it formed, at least in Classical and Hellenistic times, the acropolis of Miletos. It juts into the sea between the Bay of Lions and the Bay of the Theater "like a spur." The importance of the building corresponds with the commanding location.

What is preserved and determines one's impression of the structure is a Roman plan with a frontal length of 140 m, probably the largest theater of Asia Minor, calculated for over 15,000 spectators. The auditorium or cavea originally consisted of three tiers each containing 20 rows of seats. The lowest tier is divided into five wedges by stairs. The second tier, on the other hand, has 10 wedges; a third tier, which fell victim to the mediaeval citadel, had 20. In the middle of the first tier a so-called emperor's box was set up, utilizing four columns reused from elsewhere. Two of these columns are still in situ; two were reerected in the orchestra.

To this Roman cavea, with benches which probably date to the Hellenistic theater, belonged a skene two stories high and ca. 40 m wide. It was again remodeled in later Imperial times. A third story was added, while at the same time the skene underwent considerable enlargement including one in depth. From this rebuilding of the rear side of the skene come no doubt the figural friezes which we owe to the School of Aphrodisias.

The Hellenistic stage wall itself can be recognized clearly in its lower part behind the three rows of pillars upon which rested the Roman stage. The oldest skene was only 15 m wide and belonged therefore to a smaller and probably older theater than is preserved at Priene.

The Baths of Faustina. This largest and best-preserved building, the latest of the baths and palaestra complexes to be dealt with here, still dominates, together with the theater, the general aspect of Miletos.

It deviates from the plan of the rest of the town, which is uniformly oriented to the cardinal points of the compass at the edge of Theater Bay but in the middle of the town. The sequence and grouping of the rooms, anything but axial or symmetrical, are determined by the form of the bay.

The palaestra with its almost square colonnade (62 x 64 m) seems to be at the starting point of the whole plan. It adjoins the stadium on the W; on the E the baths rest against it. Furthermore, the latter are connected directly through another portico with the stadium which links the whole complex with the Gymnasium of Eumenes.

The remarkably long room (over 80 m) with 13 chambers along each long side was originally basilical and spanned by a vault. It was entered through a narrow door and a vestibule. Above a socle (of which various remains of marble incrustation can still be seen) can be recognized on the spur walls of the chambers rectangular pilasters which are set before the poros masonry of the wall.

The chambers themselves (2-3 m wide) were vaulted at a height of 4 m. They were designed for the use of couches or klinai. These could be reached only over a continuous socle, almost 1 m high, which made footstools necessary. The benches now visible are only a later addition. It remains to be asked whether this room, and not the transverse room adjoining to the S with its niches, served as apodyterion from the beginning, as is commonly believed. Its basin (piscina) was added later.

The Serapeion. Reflecting more the greatness and importance of the Imperium Romanum than the religious life of Miletos, the temple belongs to late antiquity both in plan and method of construction. The naos (ca. 22.5 x 12.5 m) has three aisles. The columns are Ionic but unfluted and no capitals have been preserved. Before the inner chamber is a much narrower pronaos which is actually no more than a tetrastyle propylon and indeed appears to have been added only later. It bears a dedicatory inscription which expressly speaks of a "pronaos" and names Julius Aurelius Menekles as the dedicator. The name and form of the letters indicate the 3d c. A.D., perhaps already the time of the emperor Aurelian (270-275), one of the strongest patrons of the cult of the sun.

The architecture of the pronaos is richly decorated.

The columns have composite capitals, the epistyle vines in characteristic openwork and an arched frieze.

The coffers of the "vestibule" carry busts of deities in relief. They have been laid out now in the interior of the main building. A fragment with the Apollo of Didyma by Kanachos is stored in the museum of Balat.

BIBLIOGRAPHY. T. Wiegand, *Milet, Ergebnisse der Ausgrabungen und Untersuchungen seit dem Jahre 1899* (1906ff) 18 vols.; A. G. Dunham, *The History of Miletus down to the Anabasis of Alexander* (1915); G. Kleiner, *AltMilet* (1966); id., *Die Ruinen von Milet* (1968); id., "Stand der Erforschung von Alt-Milet," *IstMitt* 19-20 (1969-70) 113-23; id., *Das Römische Milet, Bilder aus der griechischen Stadt in römischer Zeit* (1970); id. & W. Müller-Wiener, "Die Grabung in Milet im Herbst 1959," *IstMitt* 22 (1972) 45-92; C. Weickert et al., "Die Ausgrabung beim Athena-Tempel in Milet 1957," *IstMitt* 9-10 (1959-60) 1-96; P. Hommel, "Archaischer Jünglingskopf aus Milet," *IstMitt* 17 (1967) 115-27; A. Mallwitz & W. Schiering, "Der alte Athena-Tempel von Milet," *IstMitt* 18 (1968) 87-160. G. KLEINER

MILLAU, *see* CONDATOMAGOS

MILREU Algarve, Portugal. Map 19. A Roman villa near Estoi, 9 km N of Faro. The villa is arranged around a peristyle, the N side of which is unfortunately beneath modern construction; W of the peristyle are baths. The mosaics are plentiful but damaged; those in the baths represent sea life.

To the S are the ruins of a temple built on a low podium revetted with wall mosaics of fish and shells, and set in the center of a walled courtyard. The cella (7.5 m sq.) ends in an apse. Although the temple has been interpreted as a temple of Venus, it was surely dedicated to aquatic deities. It appears to date from the first half of the 4th c. A.D., and was transformed into a Christian church in the same century. The finds have been scattered between the museums of Lagos and Faro, and the National Museum of Archaeology in Lisbon. A portrait of Gallienus, found here, is in the Lagos museum.

BIBLIOGRAPHY. M. Lyster Franco, "As ruínas romanas de Milreu," *Boletim da Junta de Província do Algarve* 1 (1942); T. Hauschild, *Der Kultbaus neben dem römischen Ruinenkomplex bei Estoi in der Provincia Lusitania* (1964)MPI. J. ALARCÃO

"MILYAS," *see* MELLI

MINARE KÖYÜ, *see* PINARA

MINEO, *see* MENAI *and* PALIKÉ

"MINOA" (Ierapetra District, Crete), *see* PACHIA AMMOS

"MINOA" (Kydonia District, Crete), *see* MARATHI

MINORCA ("Meloyssa") Baleares, Spain. Map 19. One of the Balearic islands. It has yielded Greek material. It is probably the island mentioned by Stephanos of Byzantium (Jacoby, frag. 52), who cites a reference in Hecateus.

BIBLIOGRAPHY. A. García y Bellido, *Hispania Graeca* (1948)MI. L. G. IGLESIAS

MINORI Campania, Italy. Map 17A. The site of a major villa on the Amalfi coast ca. 11 km W-SW of Salerno. It is on the left bank of the torrent Regina Minor, which supplied its nymphaeum and fishpond. Rooms in two stories have been explored and in part cleared. On the lower level these are disposed along the landward side of a large rectangular arcaded court that presented a blind facade toward the sea broken only by a great central arch on the axis of the nymphaeum, but there may have been other terraces below. The rooms W of the nymphaeum were living rooms, barrel vaulted, except for one with a shallow oval dome of particular interest. The painted decorations are in the Third and Fourth Pompeian styles. An equivalent wing E of the nymphaeum, including baths, has been explored but is not accessible. The nymphaeum itself is a formal grotto paved with mosaics showing sea creatures, with water stairs at the end and high lateral basins. The W stair leading to the upper story employs an interesting effect of forced perspective, but of the rooms on this level almost nothing survives. A foundation in the Julio-Claudian period is indicated, with survival only to the time of the Flavians. Probably the villa was buried by one of the landslips to which the region is subject.

Remains of other villas have been discovered in the neighborhood, and underwater exploration has brought up a number of amphorae and anchors, now kept in the antiquarium of the great villa.

BIBLIOGRAPHY. V. Panebianco in *Palladio* (1939) 129-33PI; A. Maiuri in *RendNap* NS 29 (1954) 87-92; N. Franciosa, *La Villa romana di Minori* (1968)P. L. RICHARDSON, JR.

MINTURNAE (Minturno) Italy. Map 17A. On the right (and left) bank of the Liris river separating Latium from Campania, 2 km from the sea. Minturnae was originally an Ausonian town (7 c. B.C.) of which no archaeological traces have been found, but it was presumably on or near the Roman site. Roman sources first mention it in 340 B.C. (Livy 8.10). In 313 it was captured by Rome with great slaughter. Two years later the Via Appia was laid through the (unoccupied?) present site, and in 295 a Roman colony was settled on the right bank astride the Appia in a rectangular castrum (ca. 3 ha) with a polygonal limestone wall of which some bedding remains. The castrum itself is essentially unexplored, but the area seems too small to accommodate an intramural forum; possibly its earliest forum (63 x 50 m) lay slightly W of the castrum and opened S onto the Appia.

Before 207 B.C., perhaps in connection with the Hannibalic wars, the city had been greatly extended W and S by a new ashlar tufa wall with square and pentagonal towers 14.7 m apart, and a W gate.

Meanwhile, after the presumed fire of 191 the forum was rebuilt with a double colonnade on E, N and W. In the W half a freestanding three-cella temple, presumably the Capitolium, now faced S onto the Appia. This forum and a considerable additional area were again destroyed by fire later than 65 B.C. but before ca. 45; an important expiatory bidental was consecrated in the forum; the Capitolium, now in limestone, and the colonnade were rebuilt by a presumed colonization of Julius Caesar's veterans, perhaps as early as the First Triumvirate though possibly not for some years; and a new single-cella Temple B in tufa, with a large colonnaded temenos, was built E of the forum astride the foundations of the old castrum wall. Later a small temple was placed E of Temple B and another was installed at the S end of the W temenos colonnade with consequent suppression of the pomerial streets.

Augustus again colonized veterans, and he or Tiberius added the most conspicuous present monuments of Minturnae, the aqueduct which entered the city at the W gate bringing water from the Monti Aurunci 11 km away, and a theater for about 4600 persons. The theater was located in an open area immediately N of the forum, of

which the outside of the N wall now served as the scaena, and the cavea extended out across the Hannibalic (?) ashlar N city wall, of which traces are found under the theater arches.

At the same time or perhaps as late as A.D. 30 Temple A, perhaps dedicated to Rome and Augustus and embellished with a statue of Tiberius or Augustus was placed in the E half of the forum, likewise fronting S onto the Appia; the revetment of its podium included a unique series of 29 reused dedicatory inscriptions (altars?), mostly datable between 90 and 64 B.C., listing freed and slave magistri and magistrae of several local cults.

At some point the Republican forum was outgrown and a larger imperial forum was installed opposite it across the Via Appia. This area is unexcavated except for a long E colonnade and the so-called L Street leading to the vaulted substructures of an otherwise unidentified Temple L of the late 1st c. A.D., and except for a small area in the center which yielded a deposit of wasters of a Campanian potter of ca. 200 B.C., and except for extensive baths and shops near the NW corner, fronting on the Via Appia, and some shops on the rear (S) side across L Street from Temple L. These last groups and some other details result from post-WW II excavations. During Hadrian's reign alterations modernized and embellished the scaena of the theater and well-houses were installed at the S ends of the E and W colonnades of the Republican forum, which was now wholly closed to traffic by walls and a propylon.

In 1966-67 and 1971 underwater excavations and land explorations showed wooden pilings and concrete rubble remains of Cicero's pons Tirenus (or Teretinus?) carrying the Appia over the Liris directly from the castrum, and another road (to Arpinum?) turning N from the castrum by a long causeway on the right bank toward another Roman bridge and cemetery. A variety of concrete blocks, amphorae, etc. was found upstream from the modern bridge; downstream an area 250 m long off the right bank was characterized by a ledge of concretion containing some marble sculpture of no outstanding interest, terracottas including votive offerings, common pottery and sigillata, sufficient keys and bolts to suggest a locksmith's shop nearby, an astounding amount of lead, hooks, and weights connected with fishing, and 2229 coins (270 B.C.-ca. A.D. 450, with heaviest representation between 27 B.C. and A.D. 192). All this is evidence of a busy quay during several centuries.

About 1 km downstream the sanctuary of dea Marica dates back to Ausonian times. A tufa temple in Italic, not Greek, tradition was built ca. 500 B.C.; ex votos, however, become common only ca. 350 B.C., with a hiatus between ca. 200 and 100 B.C.—fluctuations attributed to varying prosperity. Toward the end of the 1st c. A.D. the temple was rebuilt and perhaps dedicated to Isis; it was apparently abandoned after Marcus Aurelius.

Marius escaped to, and from, Minturnae. Cicero often passed through it. It is mentioned frequently in ancient sources, though rarely after Tacitus, with final mentions by Procopius regarding A.D. 548 and by Gregory I regarding the Langobard destruction in 590. From the 8th c. on it served as a quarry for Traetto nearby, and later for Cassino.

Major unexcavated and/or unpublished monuments include the imperial forum, walls, and gates (see Richmond's discussion), the amphitheater, Temple B, ca. 200 m of reticulate docks and shipways on the Liris, the theater (except for Aurigemma's description and plans), the aqueduct (except for Butler's description and photographs), and the left-bank dependencies of the city.

Sculptures are now at Zagreb, Philadelphia, and a small museum on the site; other objects are in the Naples Museum.

BIBLIOGRAPHY. H. C. Butler, *AJA* 5 (1901) 187-92 (aqueduct); J. Brunsmid, *Vjesnik Hrvatskoga Arheoloskoga Drustva* 7-9 (1903-7) and 11-12 (1910-12) (sculptures)[I]; G.-Q. Giglioli, *Ausonia* 6 (1911) 60-71 (sanctuary of Marica); J. Johnson, *Excavations at Minturno* II, pt. 1 (1933) (magistri inscriptions and literary testimonia)[I]; id., *Excavations at Minturno* I (1935)[PI] (Republican forum; coins by I. Ben-Dor; reviewed by L. R. Taylor, *AJA* 40 [1936] 284-85 and I. A. Richmond, *JRS* 27 [1937] 291-92); id., "Minturnae" in *RE* Suppl. VII (1940) 458-94; E. T. Newell, "Two Hoards from Minturno," *NNM* 60 (1933)[I]; I. A. Richmond, *JRS* 23 (1933) 154-56 (west gate)[P]; L. Crema, *BStM* 4 (1933-34) 22-44 (sculptures)[I]; A. K. Lake, "Campana Supellex, The Pottery Deposit at Minturno," *BStM* 5 (1934-35) 97-114[I]; A. Adriani, *NSc* (1938) 159-226 (sculptures)[I]; P. Mingazzini, *MonAnt* 37 (1938) 696-983 (sanctuary of Marica)[I]; H. Comfort, *AJA* 47 (1943) 313-30 (terra sigillata)[I]; S. Aurigemma, "Gaeta-Formia-Minturno," *Itinerari dei Musei, Gallerie et Monumenti d'Italia* no. 92 (1964)[PI]; Bro. S. D. Ruegg, *AJA* 72 (1968) 172; B. W. Frier, *Historia* 18 (1968) 510-12 (pons Teretinus); id. & A. Parker, *NC* 7 (1970) 89-109.
H. COMFORT

MINTURNO, *see* MINTURNAE

MIRANDE Gers, France. Map 23. The ruined moles of Betbèze were surveyed in 1965 and excavated in the following years. They are in the middle of a funerary enclosure occupied first by incineration, then by inhumation burials. The moles have produced several religious reliefs.

BIBLIOGRAPHY. M. Labrousse, provisional reports in *Gallia* 24 (1966) 435-36 & figs. 27-29; 26 (1968) 542-43 & fig. 30; 28 (1970) 419.
M. LABROUSSE

MIRMEKION Bosporus. Map 5. A Greek city on the N coast of the Black Sea, 5 km NE of Kerch. It was founded by Ionian colonists in the mid 6th c. B.C. (Strab. 7.4.5; Plin. *HN* 4.86-87; Ptol. *Geog.* 6.1). In the 5th c. the city issued its own coins, and a sanctuary temple of Demeter dates to the 5th-4th c.

In 480 B.C. it became part of the monarchy of Archeanaktides. In the 4th c. B.C. when the city was at the height of its prosperity, it acquired a rampart and its houses were built of stone and brick (remains of monumental architecture, paved streets, water pipes). Several great wine-making establishments flourished in the 4th-3d c. B.C. Among the traces that have been uncovered are large cisterns, and stamped amphorae from Rhodes, Sinope, Chidos, Chersonesus, and Thasos. Attic wares predominate from the 4th B.C. on (red-figured bowls, West Slope, etc.), the pottery of Rhodes, Alexandria, and Pergamon being the most plentiful in the Hellenistic period. Terracottas were imported mainly from Myrina and Amissos; here the figures of Demeter and Kybele and the great masks of Dionysos are most frequently found. The coins are predominantly Bosporan. From the 3d c. B.C. on the city declined, reviving only in the Early Roman period; it never regained its former prosperity. Its final decline dates from the end of the 1st B.C., and it was laid waste by the Huns in the 4th c. Among the most noteworthy finds are a terracotta statuette of Kybele (0.58 m) and a marble Roman sarcophagus with scenes from the legend of Achilles found near the city. The Hermitage Museum and the Warsaw National Museum contain material from the site.

BIBLIOGRAPHY. V. F. Gaidukevich, "Bosporskie goroda Tiritaka i Mirmekii na Kerchenskom poluostrove (Po raskopkam 1932-1936 gg.)," *VDI* (1937) 1.216-39; id. et al., "Raskopki severnoi i zapadnoi chastei Mirmekiia v 1934 g.," *Arkheologicheskie pamiatniki Bospora i Khersonesa* [Materialy i issledovaniia po arkheologii SSSR, No. 4] (1941) 110-48; id. & M. I. Maksimova, eds., *Bosporskie goroda*, I: *Itogi arkheologicheskikh issledovanii Tiritaki i Mirmekiia v 1935-1940 gg.* [Materialy i issledovaniia po arkheologii SSSR, No. 25] (1952); id., "Raskopki Tiritaki i Mirmekiia v 1946-1952 gg.," *Bosporskie goroda*, II [Materialy i issledovaniia po arkheologii SSSR, No. 85] (1958) 185-218; A. L. Mongait, *Archaeology in the USSR*, tr. M. W. Thompson (1961) 193-94; id., "Mirmekiiskie zol'niki-eskhary," *KSIA* 103 (1965) 28-37; C. M. Danoff, *Pontos Euxeinos* (1962) 1124-26 = *RE* Suppl. IX; E. Belin de Ballu, *L'Histoire des Colonies grecques du Littoral nord de la Mer Noire* (1965) 132-34; I. B. Brašinskij, "Recherches soviétiques sur les monuments antiques des régions de la Mer Noire," *Eirene* 7 (1968) 99.
M. L. BERNHARD & Z. SZTETYŁŁO

MIROBRIGA (Santiago do Cacém) Alentejo, Portugal. Map 19. About 138 km SE of Lisbon. Mentioned by Pliny (*HN* 4.22), who refers to them as "mirobricenses qui Celtici cognominantur," by Ptolemy (11.5), and in the *Antonine Itinerary*.

On the acropolis is a sanctuary with a temple, possibly of Aesclepius, that dominates a paved open square. The buildings N and S of it are not completely excavated so that their purpose is still unknown. Access to the square is by two paved ways on the SW side, on one of which stands another temple with an apsidal end, possible dedicated to Venus. Two inscriptions to Venus and the remains of a statue of the goddess support the attribution of this second temple to her, but unfortunately the exact finding place of inscriptions and statue is unknown. Another inscription refers to festivals in honor of Aesclepius, and a fourth, found on the acropolis, mentions Mars. Well-paved streets, bordered by shops lead down from the sanctuary to some baths at the bottom of the hill. The baths are small but fairly well preserved; beside them is a small Roman bridge.

About 1 km farther along the road is the circus (360 x 74 m), the only one preserved in Portugal. No residential areas have yet been discovered, and no forum, basilica, or curia. Thus the question arises whether Mirobriga was a city or simply a rural sanctuary, although the reference in the inscription of Aesclepius to a splendidissima ordo and its classification as an oppidum by Pliny argue in favor of a city. Some of the finds are in an unused chapel near the ruins and some in the Municipal Museum of Santiago do Cacém.

BIBLIOGRAPHY. D. Fernando de Almeida, "Nota sobre os restos do circo romano de Miróbriga dos Célticos," *Revista de Guimarães* 73 (1963) 147-54; id., *Ruínas de Miróbriga dos Célticos (Santiago do Cacém)* (1964)MPI.
J. ALARCÃO

MIROBRIGA TURDULORUM (Capilla) Badajoz, Spain. Map 19. Town W of Almadén (Pliny 3.14). It has not been excavated, but casual finds have been made.

BIBLIOGRAPHY. L. Vázquez de Parga, "El togado de Capilla en el Museo Arqueológico de Badajoz y la localización de Mirobriga," *Memoria de los Museos Arqueológicos Provinciales* 8 (1947) 33-36MI. L. G. IGLESIAS

MIROBRIGA VETTONUM (Ciudad Rodrigo) Salamanca, Spain. Map 19. Town on the Agueda river, ca. 35 km E of the Portuguese border. It has yielded architectural, sculptural, and epigraphic material (*CIL* II, 857-58).

BIBLIOGRAPHY. R. Martín Valls, "Investigaciones arqueológicas en Ciudad Rodrigo," *Zephyrus* 16 (1965) 71-98PI.
L. G. IGLESIAS

MISANO (Marzabotto) Emilia-Romagna, Italy. Map 14. In the Reno valley 49.6 km S of Bologna the remains of an Etruscan city, first noted in the 16th c. It seems probable that the city was founded during the Etruscan expansion in N Italy after the middle of the 6th c. B.C., together with Felsina and Spina. The city was occupied by the Boii in the 4th c. B.C., and in the course of that century practically ceased to exist, probably because of poverty. During Roman times there were only sporadic traces of an agricultural settlement, and the important center of the valley moved farther N, to the vicus of Saso Marconi. The date of the landslide that destroyed the S part of the inhabited area is not known.

Two urban phases have been recognized. The first dates from the end of the 6th c. and consists of simple dwellings and many traces of metal working. To the end of that phase, ca. 500 B.C., may be attributed the small sanctuary of the springs in the N sector. This is the oldest architectural building known in N Italy. Later, during the early decades of the 5th c., the city assumed a regular form with orthogonal streets. Four of these are 15 m wide and perfectly oriented according to the cardinal points. The system of streets is founded on the wide N-S road, intersected by three other streets and parallel to numerous minor streets 5 m wide. Cippi have been found at the intersections of the major avenues, one of which bears an indication of the astronomical orientation. They were set up when the major axes of the city were laid out and later covered by road ballast. All of the streets are flanked by one or two drainage canals. The whole urban network consists of city blocks nearly uniform in size and elongated N-S. Probably not all of the area divided up by the orthogonal system was actually occupied by buildings. Workshops of smiths and smelters and kilns for the manufacture of ceramics lined the principal N-S avenue of the city, and have also been found elsewhere. The houses, some of which included a workshop facing the street, had a central courtyard with a well. The springs on the hillside behind the city, intercepted and channeled, appear to have been used by the ceramicists.

The hillside to the NW, called Misanello, was occupied by sacred buildings. Among them are remains of three temples. The podium of one has a double cornice in opera quadrata. The orientation of the temples is the same as that of the streets and front due S. The upper part of the temples, like that of the houses, was constructed in wood and crude bricks. The roof was of fired tiles, many of which were decorated with painted geometric and vegetal motifs on the visible parts.

The city wall has not been found, but the remains of two gates have been recognized, to the E and N, which correspond with the most extensive necropoleis of the 4th-5th c. These consist mainly of ditch tombs covered by stone slabs and surmounted by simple markers of pebbles, sepulchral pillars, or columns. In the period of Gaulish occupation a third necropolis was established on the S slopes of the arc of hills, not far from an aqueduct of the Etruscan period.

Study of the territory proves that the Etruscan city was located at the intersection of important longitudinal and latitudinal lines of communication in the valley. It also appears that the worked metal was indigenous to the area.

BIBLIOGRAPHY. Brizio, "Relazione sugli scavi eseguiti a Marzabotto presso Bologna," *MonAnt* 1 (1890) 249-

426[MPI]; P. E. Arias, "Contributo allo studio della casa etrusca a Marzabotto," *Atti e Memorie Deputazione di storia patria prov. Romagna* (1953) 98; G. A. Mansuelli, "La città etrusca di Misano," *Arte antica e moderna* 17 (1962) 14; id., "La cité étrusque de Marzabotto," *CRAI* (1962) 62-84; id., "Una città etrusca nell'Appennino settentrionale," *Situla* (1965) 154-70; id., "La casa etrusca di Marzabotto," *RömMitt.* 70 (1963) 44-62; *Guida alla città etrusca e al Museo di Marzabotto* (1971)[MPI]. G. A. MANSUELLI

MISENUM Campania, Italy. Map 17A. A high promontory forming the NW termination of the bay of Naples, S of Baiae, Avernus, and Cumae. Vergil ascribes its name to Aeneas' trumpeter Misenus, who was buried there "monte sub aerio"—and its shape is indeed rather like a great tumulus. It served as the harbor of Cumae for centuries, an asset to the city's power and wealth. Hannibal devastated the port in 214 B.C. when repulsed by Cumae. Several splendid Republican villas were built in its panoramic setting, most notably that of Marius, appropriated by Sulla and later bought by Lucullus for two and a half million sesterces, then taken over as imperial property—Tiberius died in it on his way to Naples in A.D. 37.

Augustus turned the area into a large military complex, the chief naval base of the Roman fleet in the West, stationing there the ships which defeated Antony and Cleopatra at Actium.

The steep headland, 167 m high, provides a fine view of Ischia, Puteoli, Naples, and far-off Vesuvius. Ruins of a mediaeval lighthouse at its base are probably on Roman foundations. An immense cistern (Grotta Dragonara) hollowed out of the W cliff, with cruciform galleries and 12 pillars supporting its vault, probably functioned as water supply for the fleet base and perhaps also for the great Villa of Lucullus, which was probably in this sector. On the lower slope to the N are remains of a theater fitted into the hillside, with a passage cut through the hill behind for easy access from the port. Nearby are ruins of baths and of buildings which probably housed naval officers; a small town spread beyond. Recently discovered is a sacred complex dedicated to the cult of the Emperors. The Templum Augusti is at the back, with three halls—the central one (the best preserved) perhaps being the chapel, with a tetrastyle marble facade. On both sides of its courtyard are porticos with small rooms behind. Statues of divinities stood here on bases bearing dedicatory inscriptions and honorific decrees relating to the Augustales. Other statues found inside the halls include a bronze of Nerva on horseback and two colossal statues: of Vespasian and of Titus.

Here in A.D. 79 Pliny the Elder was Admiral of the fleet when Vesuvius erupted; he lost his life aiding Pompeii.

A fine double harbor lies N and W of the promontory. In 31 B.C., Agrippa developed this for Augustus into a major naval base in conjunction with the Portus Julius at nearby Lucrinus and Avernus, and the status of colonia was granted. The outer (E) harbor was improved by construction of two breakwaters—a double one from the S running toward the projection opposite (Punta Pennata), where some ruins may mark a sumptuous villa of Mark Antony and his ancestors. The N mole was shorter, with three pillars jutting southward from the Punta Pennata arc. This outer harbor was for the active fleet and for training exercises.

To the W, behind a dividing strip of land, lay the inner harbor, a circle wholly enclosed except for the canal cut across the dividing strip for access from the main harbor. An inscription refers to a wooden bridge across this gap.

Here in complete protection was the reserve fleet and ships undergoing fitting or repair, and refuge for the rest from winter storms. Around its edges must have been the arsenals and barracks. Over 400 inscriptions record names of sailors, officers, and ships of all sizes from this *Classis Praetoria Misenensis.*

A most impressive adjunct is the great Piscina Mirabile, a fresh-water reservoir cut into the hillside N of the outer harbor, toward Bacoli. This is like a huge subterranean basilica, with 5 naves and 48 arches 15 m high in 4 rows of 6 supporting the vaulted roof. A sunken channel (piscina limaria) across the middle was for settling impurities, periodically cleaned out. Stairs lead down at both ends to reach the water at whatever level it stands. Some windows above provide light and air. The walls are faced with opus reticulatum and coated with waterproof opus signinum (ground terracotta mixed in cement). This vast underground tank (25.5 x 70 m), had a capacity of 12,600 cubic m—providing 315,000 gallons of drinking water for the fleet. It is one of the more awesome Roman structures.

Strabo thought that the Laestrygonians of the *Odyssey* inhabited Misenum. The Saracens destroyed what remained of the great Roman fleet base in their 915 attack.

BIBLIOGRAPHY. Verg. *Aen.* 6.162-235; Strab. 1.2.9; 5.4.3,5,9; Plin. *Ep.* 6.20; Pompon. Mela 2.4.9; Tac. *Ann.* 6.50; *Hist.* 3.57; Suet. *Tib.* 72-73.

V. Chapot, *La Flotte de Misène* (1896); A. De Franciscis, *Atti Taranti* (1920) 631ff; C. Starr, *The Roman Imperial Navy* (1941) 14-20, 36-7, 84-6; A. Maiuri, *The Phlegraean Fields* (3d ed., 1958) 91-100[P]; K. Lehmann-Hartleben, *Die Antiken Hafenanlagen des Mittelmeeres,* Aalen (1963) 176-7; J. D'Arms, *Romans on the Bay of Naples* (1970). R. V. SCHODER

MISTRETTA Sicily. Map 17B. It is not certain whether the ancient site here is the site mentioned by ancient authors as Amestratos or Mytistratos (Diod. 23.9.3; Polyb. 1.24; Plin. *HN* 3.91; Cic. *Verr.* 3.39.43; Steph. Byz.; Sil. *Pun.* 14.267) or whether both names referred to this site. Stretches of polygonal walls were once visible but have now disappeared as a consequence of land slides. In Piazza del Popolo a Roman grave was recently discovered, perhaps dating from the Republican period.

BIBLIOGRAPHY. L. Mauceri, *Sopra un'acropoli pelasgica . . .* (1896)[MP]; S. Pagliaro-Bordone, *Mistretta antica e moderna* (1906). V. TUSA

MIT RIHEINA, *see* MEMPHIS

MITTELBRONN Moselle, France. Map 23. Situated 3 km W of Phalsbourg. A pottery was discovered here in 1952 and excavated in 1953-59. The factory turned out both plain and decorated terra sigillata, ordinary and glazed ware, as well as tiles. Four kilns, two of them for tiles, have been excavated along with a shed and several adjoining structures. The greater part of the decorated terra sigillata manufactured at Mittelbronn bears the stamp of Satto, the rest that of Cibisus and the Master of the Shields and Helmets. Form Drag. 37 is the only one made. Some 20 Mittelbronn potters also turned out plain vases, mainly in forms Drag. 18/31, 32, 33, and 40 but also Drag. 38 and 46 as well as a few Ludowici forms. It is not likely that Satto was still working himself at Mittelbronn, but his stamp was apparently being exploited. On the other hand, we find five potters who had previously worked at Chémery turning out plain vases at Mittelbronn (identical stamps), thus there was continuity between the two potteries. Cibisus had previously worked at Ittenviller, where his output seems to have been considerable; it was lower at Mittelbronn where,

judging from the style of his ornamentation, he arrived ca. 150-160. It is interesting to find Satto and Cibisus vases made in the same workshop since it shows that Satto vases were still being turned out ca. 160-170; this was proved when a Satto decorative stamp was found on a Cibisus vase at Mittelbronn as a result of a firing accident. Mittelbronn stopped producing terra sigillata ca. 175, and was abandoned until the beginning of the 3d c. After that only ordinary ware and tiles were manufactured.

The museum at Sarrebourg has an archeological collection.

BIBLIOGRAPHY. M. Lutz, *L'atelier de Saturninus et de Satto à Mittelbronn, Gallia* Suppl. 22 (1970).　M. LUTZ

MOBOLLA (Muğla)　Caria, Turkey. Map 7. The town belonged in Hellenistic and Imperial times to that part of the Rhodian Peraea which was subject to Rhodes but not incorporated in the Rhodian state. It was perhaps a member of the koinon of the Tarmiani mentioned by Livy (33.18.3) and in several inscriptions found at or near Muğla. On the hill immediately above the modern town some insignificant remains no doubt represent the site.

BIBLIOGRAPHY. P. M. Fraser & G. E. Bean, *The Rhodian Peraea* (1954) 73-74.　G. E. BEAN

MOCHLOS Sitia, Crete. Map 11. Roman settlement with possible traces of Greek occupation, on both the offshore island and the adjacent stretch of coast, 18 km W of Sitia. The island was first occupied in the Early Bronze Age and excavations destroyed much of the overlying Roman town in order to trace Minoan structures.

Of the town itself we therefore have very few details, although we know that it covered areas both on the island and on the opposite strip of coast, and that it produced coins of 2d to 4th c. date. On the mainland shore, both rock-cut tombs and a stone quarry are assigned to the main period of Roman occupation.

The main visible remains of the post-Minoan occupation of the island are the walls and towers of a fortified position situated on the summit. Along the edge of the cliffs on the N side a wall can be traced with a tower at either end and a larger central one. From the W tower a curtain wall descended to the shore on the S side of the island—the only suitable landing place on the island. A similar wall presumably ran S from the E tower as well.

Mochlos' importance in the Roman period, as in the Bronze Age, would have been as a good harbor. By the Roman period the spit of land connecting the rocky promontory to the mainland had subsided and the island had been formed, but the water on either side would still have been protected from the worst effects of the winds. Traces of harbor works noted by Plato would certainly belong to the Roman period.

BIBLIOGRAPHY. R. B. Seager, "Excavations on the Island of Mochlos, Crete, in 1908," *AJA* 13 (1909) 275-76; N. Platon, "Chronika," *Kretika Chronika* 9 (1955) 564.　K. BRANIGAN

MODENA, *see* MUTINA

MODON, *see* METHONE

MOGADOR ("Cerne")　Morocco. Map 19. Thanks to chance finds made in 1950 and excavations carried out from 1956 to 1958, we know that the small, now uninhabited island that lies about 2 km offshore opposite the town of Essaouira (Mogador) was visited in antiquity and occupied on several occasions for varying periods of time.

To the SE of the island a large dump revealed a great many potsherds dating back to the 7th and 6th c. B.C.: red-glazed pottery from Cyprus and Phoenicia as well as amphorae, tripods, and ordinary vases of the same origin, several of them carrying Punic graffiti. There were Ionian and Attic amphorae, and painted pottery in the Ionian tradition. On the other hand there are very few traces of houses, just stone or tamped clay floors and large hearths which some say show traces of the fires by which, according to Herodotos (4.196), Carthaginian merchants announced their arrival to the natives. These remains suggest that the site was a temporary, probably seasonal, stopping-place for sailors and merchants from Phoenicia, Carthage, or Gades, whose visits to the island ceased, however, after the 6th c. A single amphora neck from the 3d-2d c. B.C. shows that they passed that way in this period, but then the island remained uninhabited until the Augustan era.

At that time a villa, built of mud and unburnt brick on stone foundations, was put up on the E slope facing the nearby shore. Later, at the end of the 2d c. A.D., it was reused and enlarged; a cistern, water supply, and tanks were added. It appears to have been still inhabited in the 4th c., when one of the rooms was decorated with a mosaic showing two peacocks confronted; however, this depends on the accuracy of the date suggested for the mosaic. But the over-all building plan cannot be discerned today; remains are limited to some 20 rooms aligned N to S over a length of more than 100 m, all the E part of the villa having been swept away by erosion of the shoreline. Excavations have revealed a great deal of Roman pottery, from Etrusco-Campanian black to late Roman D terra sigillata; also of note is a very fine Arretine vase, almost intact, from the hand of the potter P. Cornelius. Coins range from the 1st c. B.C. to the middle of the 5th c. A.D.; through them we know for how long the island was visited, if not permanently occupied. A necropolis has been uncovered N of the villa; it seems to correspond to the last period, and contained a Latin funerary inscription, all but undecipherable.

According to M. Jodin, the settlement was created under Juba II (33 B.C.-A.D. 17) for the purpose of manufacturing purple, and the discovery of a heap of purpura haemastoma and murex shells near Essaouira would seem to justify this interpretation. On the other hand, the identification of the island of Mogador with Cerne appears equally likely: as a port of call for Punic sailors and no doubt the limit of their navigation, it answers the description Pliny (6.199) gave of the island after Polybios and Cornelius Nepos.

BIBLIOGRAPHY. M. Tarradell, *Marruecos punico* (1960) 184-96; L. Galand, J. Février & G. Vajda, *Inscriptions antiques du Maroc* I (1966) 109-23; A. Jodin, *Mogador, comptoir phénicien du Maroc atlantique* (1966)MPI; *Les Etablissements du roi Juba II aux Iles Purpuraires (Mogador)* (1967)MPI.　M. EUZENNAT

MOGONTIACUM (Mainz)　Germany. Map 20. The name goes back to a Celtic god Mogon or a dea Mogontia, but no important Celtic settlement has been found in Mainz. During the reign of Augustus, two legions built a fortified camp here on a rise opposite the mouth of the Main, between 15 and 12 B.C. From then on it was one of the important military bases for Roman campaigns against the Germanic tribes. Two legions were always stationed in Mogontiacum up to the time of Domitian. The garrison was reduced to one legion after the Saturninus rebellion of 88-89. It has been proved that

the Legio XXII Primigenia Pia Fidelis was stationed in Mogontiacum from A.D. 92 until the first half of the 4th c. Abandoned no later than the middle of the 4th c., the camp is mentioned several times in literature (Tac. *Hist.* 4 passim). Archaeological exploration of the camp has been very limited though the outline of the fortifications is known (area ca. 36 ha). Except for a few minor ruins, only the military bath buildings are known within the interior. From Augustan to Flavian times the fortifications and interior buildings were of wood; several building periods can be established. Later, the fortifications and inner buildings were rebuilt in stone. Today nothing can be seen of the legionary camp.

A civilian settlement around the camp developed during the 1st c. A.D. and was subdivided into several vici. In the reign of Domitian, Mogontiacum became the main town of the province Germania Superior and the seat of the governor, a legatus Augusti pr. (pr. with the rank of consul). The center of the civilian settlement was between the legionary camp and the Rhine, under what is today the old town of Mainz. Until the 4th c., it did not have municipal status although it developed early the appearance and functions of a town. The excavated amphitheater (no longer visible) was comparable to the largest in Gaul. Not until about 355 did Mogontiacum become a municipium. A wall around the civilian settlement was built in the middle of the 4th c., parts of it possibly earlier. The wall surrounded an area of ca. 120 ha. Because this area is completely built-up today, archaeological excavations are not feasible. The Roman bridge from Mogontiacum across the Rhine is shown on a Late Classical lead medallion. None of it exists, but the bridge piers had been investigated before their destruction in the 19th c.

In the second half of the 4th c. the town was the seat of the dux Mogontiacensis, who was the military commander of a sector of the Rhine frontier (*Not. Dig.* occ. 41). Roman occupation ended in 406 when the Roman troops abandoned the Rhine frontier. However, the town continued, although greatly reduced, as bishopric.

Today the so-called Römersteine, pillars of an aqueduct that provided water for the camp (probably of Flavian times), can be seen in Mainz-Zahlbach. In the modern citadel of Mainz is a large Roman tombstone, the Eichelstein; it is probably that of the cenotaph of Drusus mentioned by Eutropius 7.13. A part of the old town wall still exists on the Kästrich, in part modified by mediaeval reconstructions. The Late Roman foundations of the town wall show spolia, among them stone inscriptions and fragments from various buildings (the so-called octogon building, the Dativius Victor Arch, reliefs from a Flavian victory monument). The most important finds are in the Mittelrheinisches Landesmuseum in Mainz; among them are numerous military and civilian stone inscriptions and the large Jupiter column. Worth mentioning also is the Römisch-Germanisches Zentralmuseum, an archaeological research center.

BIBLIOGRAPHY. D. Baatz, *Mogontiacum, Limesforschungen* 4 (1962)MP; H. v. Petrikovits, "Mogontiacum— das römische Mainz," *Mainzer Zeitschrift* 58 (1963) 27-36; *Mainz, Führer zu vor- und frühgeschichtlichen Denkmälern* 11 (1969) [publ. by Römisch-Germanisches Zentralmuseum, Mainz]MPI. D. BAATZ

MOGORJELO ("Ad Turres") Bosnia-Hercegovina, Yugoslavia. Map 12. By the Neretva river, near Čapljina. Possibly the site can be identified with Ad Turres, a station on the Roman road between Narona and Diluntum (*Tab.Peut.*)

The principal remains are Roman, dating from the last half of the 3d c. A.D. and continuing in use through the 4th c. Fortification walls of opus mixtum enclose the site on all four sides, forming a slightly iregular rectangle. Towers protect the walls at each corner and flank each of the three gates. A single rectangular tower projects from the middle of the SW wall. The space within the walls is occupied by a residential area in the SW and a work area in the N quarter. Adjoining the inside of the NW, NE, and part of the SE walls is a row of small cubicles with internal dimensions of about 4 m on a side. These functioned either for storage or as sleeping quarters for servants or soldiers. The residential area, extending over the entire SW half of the complex, consists of a long row of rooms running the length of the SW wall. Its interior side, facing the center of the complex, is screened by a columnar portico. On the analogy of the nearly contemporary palace of Diocletian at Split, a long ambulatio was restored on the second story of the residence along its entire SW side, lighted through an arcade in the SW perimetral wall. The formal dining and receiving rooms were also placed in the second story behind the ambulatio.

The workyard contains, in addition to a storage shed with dolia set into the ground, two rooms with hypocaust floors (incorporated from an earlier building on the site) and a large oil press. Parallel to the perimetral walls in the E quarter stood an arcaded portico facing the work area.

The remains of an unfortified rectangular villa rustica of the 1st c. A.D., were found beneath the later complex. During the 5th c., twin Christian basilicas were built over the S end of the residential part of the villa. These buildings, representing the last phase of occupation of the site, face towards the W, and one of them contains a cruciform baptismal basin.

A building of the 4th c. has been variously interpreted as a castrum, a palace or castle, or simply a fortified villa or villa rustica. The building's connections with agriculture are obvious, but whether it was the center of a large private estate or formed part of the imperial properties in the regions administered from the palace at Split, is still speculative.

Excavations were begun in the 19th c. and preservation of the walls and buildings have proceeded since 1948, but no detailed analysis of the finds have been published.

BIBLIOGRAPHY. E. Dyggve, "Drei Paläste vom gleichen Fassadentypus aus dem jugoslawischen Künstenland," *Festschrift Karl M. Swoboda* (1959) 83-90; id., "Mogorilo Kastell oder Palast," *Akten des XI. internationalen byzant. Kongresses* (1960) 131-37; id. & H. Vetters, *Mogorjelo. Ein spätantiker Herrensitz im römischen Dalmatien* (*Schriften der Balkankommission. Antiquarische Abteilung* 13; 1966)MPI; H. Vetters, "Zum Bautypus Mogorjelo," *Festschrift für Fritz Eichler* (1967) 138-50; I. Bojanovski, "Mogorjelo: Rimsko Turres," *Glasnik Zemaljskog Muzeja u Sarajevu*, NS 24 (1969) 137-63I.
 M. R. WERNER

MOIGRAD, see POROLISSUM

MOIO DELLA CIVITELLA Lucania, Italy. Map 14. Near Vallo di Lucania, an ancient fortified outpost of Velia with walls of the late 5th or 4th c. B.C.

BIBLIOGRAPHY. M. Napoli, *Civiltà della Magna Grecia* (1969) 150. R. R. HOLLOWAY

MOISSAC Tarn-et-Garonne, France. Map 23. The Church of St.-Martin at Moissac was built, at least in part, on top of a Gallo-Roman building, of which there remains a fairly well-preserved hypocaust.

BIBLIOGRAPHY. M. Labrousse in *Gallia* 5 (1947) 476; 9 (1951) 136-37 & fig. 10. M. LABROUSSE

MOLYBOS, *see* Methymna *under* Lesbos

MOLYKR(E)ION, *see* West Lokris

MONASTERACE MARINA, *see* Kaulonia

MONASTERI, *see* Perachora

MONG, *see* Alexandrian Foundations, 8: Nikaia (India)

MONI VOUTSA ("Bounimai") Zagori, Epeiros, Greece. Map 9. Appropriate for a summer assembly of the Epeirotes. There are remains of a walled area and inscribed reliefs have been found there (*StBiz* s.v. and *SGDI* 1339).

BIBLIOGRAPHY. N.G.L. Hammond, *Epirus* (1967) 262f, 649, 708. N.G.L. HAMMOND

MONMOUTH, *see* Blestium

MONSÉGUR Dept. Gironde, France. Map 23. A Gallo-Roman villa of the early Empire, its presence indicated by mosaics found in the 19th c., has been excavated here since 1966. Construction dates from the end of the 1st c. A.D., with some buildings reconstructed in the 4th c., but conserving recognizably the original basilican plan of the villa. Holes had been made in its floor to accommodate a series of burials. Around this building and among its ruins a Merovingian necropolis was later installed.

BIBLIOGRAPHY. J. Coupry, "Informations arch.," *Gallia* 27.2 (1969) 355ᴵ; 25.2 (1967) 346. M. GAUTHIER

MONS-ET-MONTEILS (Vié-Cioutat) Cantons of Vézenobres and Alès, Gard, France. Map 23. Important pre-Roman and Roman oppidum on an eminence that dominates from the N the valley of the Droude, a tributary of the Gardon. The settlement, which occupies almost 3 ha at the edge of a plateau, is surrounded by a dry stone wall. The site has yielded numerous finds in the past, and has been systematically explored since 1966. It was occupied from the end of the 6th c. to the end of the 4th c. B.C., and again, after being abandoned for a long time, from the end of the 2d c. B.C. to the middle of the 2d c. A.D. The architectural remains so far uncovered are unpretentious, but several dwellings and streets of the Gallo-Roman town have already been identified. The finds are for the most part preserved at the museum at Alès.

BIBLIOGRAPHY. *Carte archéologique de la Gaule romaine*, fasc. VIII, Gard (1941) 194-95, no. 314; "Informations," *Gallia* 12 (1954) 424; 27 (1969) 405; 29 (1971) 393; B. Dedet, *Cahiers ligures de préhistoire et d'archéologie* 17 (1968) 178-97ᴹᴾᴵ; id. *RAN* (1973) 1-71ᴹᴾᴵ. G. BARRUOL

MONTAGANO, *see* Fagifulae

MONTAGNA DI MARZO Enna, Sicily. Map 17B. A city 44 km from Piazza Armerina, dating to the 6th c. B.C. A stretch of the walls is still visible on the E side, preserved to a height of several meters for a length of 107 m. It is built with dry masonry of small, uncut stones; a postern gate remains. On the acropolis is a shrine of which only the perimeter is preserved; it belongs to the Hellenistic period and shows traces of destruction by fire. To the same period belong remains of houses, with traces of plaster, arranged according to a grid system. At a distance of 400 m from the hill is a sacred area dating from the time of Hieron; it contains remains of an altar surrounded by votive deposits, and is enclosed by a wall. The necropolis (dating from the 6th c. B.C. to the late Roman period) lay all around the city. Notable among the grave goods are vases with Sikel inscriptions written in Greek script.

BIBLIOGRAPHY. A. W. Van Buren, "Newsletter from Rome," *AJA* 67 (1963) 397-409; L. Mussinano, "Montagna di Marzo: Relazione preliminare," *Cronache Arch. Storia d'Arte* 5 (1966) 55-66. A. CURCIO

MONTANS Tarn, France. Map 23. On the left bank of the Tarn, Montans was in the 1st c. A.D. one of the largest and oldest centers for the production of Gallo-Roman terra sigillata. The original excavations in 1860 have been supplemented by many surface finds and by more systematic investigations, between 1967 and 1973, which have added some new names to the list of Montans potters and have identified the workshop of L. Eppius. Around the beginning of the 2d c. A.D., in order to mitigate the decline of sigillate ware, the potters made for a short time lamps molded on Italian models.

BIBLIOGRAPHY. Mme Durand-Lefebre, "Etude sur les vases du Musée Saint-Raymond de Toulouse," *Gallia* 4 (1946) 137-94; id., "Etude sur la décoration des vases de Montans," ibid. 12 (1954) 73-88; M. Labrousse, "Lampes romaines de Montans aux musées de Toulouse et d'Albi," *Mém. de la Soc. arch. du Midi de la France* 28 (1962) 9-39 & pls. I-III; id. in *Gallia* 20 (1962) 603; 22 (1964) 469; 26 (1968) 554-55 & figs. 38-39; 28 (1970) 435 & fig. 40; F. Meunier, "Estampilles de potiers gallo-romains provenant de Montans," *Fédération tarnaise de spéléo-archéologie. Travaux et recherches*, no. 4 (1965-66) 58-74. M. LABROUSSE

MONTBAZIN, *see* Forum Domitii

MONT BEUVRAY, *see* Bibracte

MONTBOUY (Cortrat, La Ronce, and Craon) France. Map 23. The commune of Montbouy is situated on the left bank of the Loing ca. 25 km due N of Briare; the sites listed above are nearby. The Loing valley was the principal link between the Loire basin and that of the Seine and the meeting-point of the territories of the Senones and the Carnutes (see Pontchevron, St. Maurice sur Aveyron, Triguères). A day's journey N of the Loire, Montbouy was probably an essential stage on the Loire-Seine portage route. However, the center of the settlement must have been shifted periodically. In the Early Iron Age it seems to have been 5 km farther S, in the commune of Ste. Geneviève des Bois, a station on the transverse road that cuts across the Loing valley and joins St. Maurice sur Aveyron farther E. A necropolis with ca. 15 tumuli lies immediately above the slope of the valley, at the spot called La Ronce. The largest of these tumuli, a mound 65 m in diameter and 4 m high, has been excavated since 1953. It contained a tomb, perhaps a royal one, dating from the early 5th c. B.C., protected by a barrow; the ashes were in a Greek bronze urn, with an iron knife and a glass vase beside it. Two generations later a second tomb was hollowed out of the tumulus; the cinerary urn in this case is a stamnos of bronze wrapped in a cloth held with a golden clasp.

During Iron Age I the settlement of Cortrat, on the other side of the river ca. 3 km N of Montbouy toward Montargis, grew in importance. In 1965 a cemetery was discovered; in it were ca. 15 flat tombs containing seven swords, a spear, some torques, bracelets, and fibulas. Excavations in 1958-62 on the same site had unearthed a cemetery dating from late antiquity that consisted of 39 trench and cist tombs; beside the bodies were vases

of pottery or glass and a variety of jewelry: necklaces made of beads of amber, coral, or glass paste; a gold ring; fibulas of various types—the most remarkable are silver and bell-shaped. Also noteworthy, in a woman's tomb, is the presence of a wooden casket and a bronze basin. It has been shown that these grave gifts are characteristic of the tombs of the Zetes, barbarian auxiliaries who were part of the Roman army in the 4th c. whose tombs are usually to be found in Artois and Picardy. The Cortrat cemetery is dated by a follis of Valentinian I; the bell- and kidney-shaped fibulae of Cortrat are of Pannonian origin, which suggests that the detachment garrisoned here in the late 4th c. was recruited in Central Europe. Cortrat retained its importance throughout the Early Middle Ages; the tympanum in its church is decorated with a remarkable quasi-abstract composition of uncertain date.

Craon, nearer the present-day village of Montbouy than the previous sites, is situated on the river itself. The name Craon may be derived from Carantomagus. The adjective Carantos appears in many Celtic hydronyms, the best known being Charente, and implies that the waters are sacred. The waters in question here belong to a spring which rises in the Loing valley and which became part of an architectural complex in the Imperial period. The spring still flows into a round basin 7 m wide and 1.6 m deep, with a black and white mosaic floor; to avoid clogging, the catchment flows into a section of the basin separated from the rest by two radial walls. The remainder of the basin served as a pool; three steps lead down to it. Around this pool was an octagonal wall 25 m in diameter, which in turn was enclosed by a rectangular portico (71 x 61 m). Water from the pool flowed into two channels oriented to E and W respectively. The first (5 m wide) turns N after leaving the octagonal building and pipes the water into a second pool outside the rectangular wall. This pool was quadrangular and was protected by a building of the same shape. The channel to the W, partly underground, supplied water to baths; two cold pools have been found.

The sacred character of these structures is shown by the many ex-votos found on the site. In 1861 some wooden statues were discovered, apparently in the pool into which the spring flowed. Similar to those found in recent years at the sources of the Seine and at Chamalières in the Puy de Dôme, they are carved of oak and have no arms or legs. Comparison with ex-votos found at the sites just mentioned dates them in the 1st c. A.D. In the 2d c. the wooden ex-votos were replaced by terracotta statuettes, some of them representing Venus. Coins found here range from the Augustan era to that of Constantine.

Besides this main temple, two other important architectural complexes have been located at Craon, probably also sanctuaries. The first, now covered by a sand-pit, had been noted in 1862. Apparently it was a square temple with a double surrounding wall (32.7 x 27.2 m) with the cella (14 x 12.5 m). A round temple with a triple concentric surrounding wall, whose greatest diameter was 90 m, has also been found.

The demi-amphitheater of Chennevières is connected with the sanctuary, although it is relatively far away. Its elliptical arena measures 48.3 (E-W) by 31.8 m; one-third of its S side is dominated by a cavea built against a small hill. Around the arena is a wall that forms a podium 2.7 m high. This wall has three gateways, placed at the free ends of the axes. Opposite the N gate is a small rectangular room hollowed out below the cavea; it looks out underneath the arena. The cavea had a radius of 28 m, its tiers being built flush with the hillside; however, it is impossible to tell to what extent the ground was cleared or filled in. Apparently some seats were still in situ in the middle of the 18th c. and an early 19th c. archaeologist rearranged 19 tiers into two maeniana. On the outside, the high ground supporting the cavea is surrounded by a wall that widens out at the base and is matched on the exterior by a second concentric wall. The two walls were separated by a drainage ditch. It is clear from some holes in the stonework that scaffolding holding up the upper gallery of the cavea was supported on these walls, as at Argentomagus and Champlieu. The whole complex is carefully built of a core of mortared rubble faced with small stones, with iron joints but no layers of brick, which justifies dating it well toward the end of the 1st or the beginning of the 2d c.

BIBLIOGRAPHY. Chennevières: A. Grenier, *Manuel d'archéologie gallo-romaine* III, 2 (1958) Ludi et Circenses, 921-24; La Ronce: "Tumulus de la Ronce," *Gallia* 17, 2 (1959) 317-22; M. Dauvois, *Rev. Arch. de l'est et du Centre Est* 11, 3 (1960) 177-203; A. Nouel, *A la Recherche des Civilisations disparues* (1964); Craon: Grenier, *Manuel* IV, 2 (1960) Villes d'eaux et sanctuaires de l'eaux, 730-33; Cortrat: A. France Lanord, *RA* 1 (1963) 15-36. G. C. PICARD

MONTCARET Dordogne, France. Map 23. A villa excavated from 1921 to 1968, with several interruptions. The work area lies limited to a large, wealthy residential section beneath a modern road and the village church, so that only one large complex (79 x 56 m) has been excavated. North of the church is a huge room (17.75 x 16.12 m) connected by a bay to the S with a semicircular apse 9.95 m wide and 5.64 m deep. The floor of this room was covered with a rich geometric mosaic. Heat was distributed through a bellows-chamber system probably unique in Gaul. At the N end of the room was a peristyle. To the W two doorways opened into a rectangular room with a slightly arched apsidiole on either side; the floor was covered with a mosaic with a design of crescent-shaped shields. All these rooms were encircled by gutters 0.36 m wide. A circular wall (perhaps part of a reservoir) is half-embedded under the road NW of the large room.

To N and S of the church and partly covered by it two galleries can be seen. They lead from the first set of rooms to another complex behind the apse. The first room is rectangular, well bonded and with iron joints; it is surrounded by other remodeled rooms. Among these can be seen traces of a hypocaust and a pool, the bottom of which is covered with a mosaic (intact) decorated with panels of octopi, fish, and shells, separated by cable molding. The facing of the upper part of the walls is of marble and paint, that below water level of small squares of terracotta; the water was drained off in lead pipes.

All these buildings were constructed in the 1st c., rebuilt after the first invasion of 276, and again after the great 5th c. invasions. The principal room of what must have been one of the great villas of Aquitania was used at that time as a basilica, with the vestibule as the narthex. Countless Merovingian tombs have been discovered in the floor and walls, and the place has never ceased to be a center of worship.

The finds—fragments of architecture and sculpture, stuccos, and painted wall coatings, ancient and Merovingian pottery, glass, coins, and an enameled crucifix (with the Byzantine inscription IC.XC.NHK.A.)—are housed in the Musée P. Tauziac at Montcaret.

BIBLIOGRAPHY. J. Formigeé, "Fouilles de Montcaret de 1921 à 1938," *Congrès Archéologique de France en 1939* (1941) 182-95; J. Coupry, "Informations archéologiques," *Gallia* 25, 2 (1967) 350-53¹. A. BLONDY

MONT-DORE (le) Puy-de-Dôme, France. Map 23. At a height of 1050 m in the valley of the Dordogne, cut deeply into the massif of the Monts Dore, the mineral springs of Le Mont Dore were exploited in Roman times. Work carried out near them in the 19th c. uncovered some buildings. Beside what may be considered a bath, there was a rectangular edifice, surrounded by a gallery and preceded by a colonnade, which seems to have been a temple. Pieces of sculpture are located in the modern bath and the Clermont-Ferrand museum.

BIBLIOGRAPHY. Bertrand, "Note sur des antiquités découvertes au Mont-Dore," *Annales scientifiques . . . de l'Auvergne* 16 (1843) 488-503; Marie Durand-Lefèvre, "Les Vestiges antiques et le culte des sources au Mont-Dore" (1926). P. FOURNIER

MONTE ADRANONE Sicily. Map 17B. Remains of a Hellenized indigenous center which developed probably between the 8th and 4th c. B.C. on Monte Andranone, N of Sciacca, between Agrigento and Selinus. The mountain, which dominates the plane of the Carboi and the village of Sambuca di Sicilia lying at its foot, is inaccessible on three sides because of steep ravines, and slopes abruptly on the S.

Recent excavation of the center has begun to clear the massive fortification wall blocking access to the city along the S side. The wall was built with large blocks without mortar and was defended by square towers flanking a large gate and a flight of steps that led into the city. On the E terrace, within the walls, a large building with rooms grouped around a central courtyard has been uncovered; almost certainly these are military barracks connected with the last phase of the city's existence. Remains of the 8th c. B.C. huts and incised sherds of the Polizzello culture have been found under the structure.

Outside the walls excavations have concentrated on a rich necropolis containing numerous burials in pithoi, sarcophagi, and chamber tombs. Among the last, the so-called Tomb of the Queen, already known during the 19th c., is notable especially for its entrance with a false pointed arch. The funerary gifts range from the 6th to the 4th c. B.C. and include, besides a few painted local vessels, numerous Attic black-figure and red-figure vases of excellent quality as well as Italiote and Sicilian wares. Bronze objects can be attributed to Greek workshops of S Italy; among them a large "frying pan" (shallow bowl) has a handle in the shape of a kouros. These finds are at present exhibited in the National Museum of Agrigento. In the 17th c. this site was believed to be Adranon, a city of W Sicily quite distinct from the Aetnean city of the same name and mentioned by Diodorus Siculus in connection with some events of the first Punic war. This identification has as yet found no confirmation in present archaeological finds. However, the possibility that the Hellenistic-Roman quarters were moved farther S cannot be excluded.

BIBLIOGRAPHY. E. De Miro, *Kokalos* 13 (1967) 180ff.
P. ORLANDINI

MONTE BUBBONIA Sicily. Map 17B. The seat of an indigenous center. The mountain, ca. 20 km to the N of Gela and on the left side of the national highway to Piazza Armerina, is now almost entirely covered by oak and eucalyptus woods. The center, which under Greek influence can perhaps be identified with Maktorion, is mentioned by Herodotos as being near Gela (7.153). Excavations have uncovered parts of the necropoleis and of the ancient town. On the peak of the acropolis (529 m high), at the W end of the mountain, the foundations of a small shrine were found, together with some of its

beautiful polychrome antefixes in the shape of a Gorgon. The foundations are built with large blocks and closely resemble those of the Athenaion in Gela. The terracotta antefixes, datable to the middle of the 6th c. B.C., are also of Geloan type.

The city was protected by a dry stone wall that followed the edge of the mountain for ca. 5 km. This wall probably dates as early as the 6th-5th c. B.C. A defensive wall barring access to the acropolis must on the other hand date from the end of the 4th c. B.C. The inhabited quarter occupied the long E plateau, where aerial photography clearly shows a system of regular streets oriented N-S. An archaic kiln in good state of preservation has also been found near the walls.

The necropolis has yielded some native graves of the 8th-7th c. B.C., followed at the end of the 7th c. onward by tombs purely Greek in typology and grave goods, comprising exclusively Corinthian, Ionic, Attic, and Geloan vases. Most of the material from the excavations is in the National Museum of Gela.

BIBLIOGRAPHY. P. Orsi, *NSc* (1905) 447ff; (1907) 497; D. Adamesteanu, *RendLinc* (1956) 5ff; id., *ArchCl* 7 (1955) 179ff; id., *RA* 49 (1957) 165ff; id., *Atti V Convegno Nazionale di Fotogrammetria e Topografia* (1957); P. Orlandini, *Kokalos* 7 (1961) 145ff; id., *Kokalos* 8 (1962) 85ff. P. ORLANDINI

MONTE CAVALLI ("Hyppana") Palermo, Sicily. Map 17B. Remains of an ancient settlement on the plateau of a mountain (1000 m high) with the modern village of Prizzi 3 km to the S. On the basis of ancient sources (Polyb. 1.24.10; Diod. 23.9.5), some scholars have suggested that the settlement could be identified with ancient Hyppana, but this identification has not met with general approval.

Recent excavations have confirmed the presence of a habitation center and have uncovered stretches of the circuit walls and the remains of houses and of a small theater. These remains and the other archaeological finds are datable from the 4th c. B.C. onward. Sporadic finds of painted and incised pottery of a much earlier date suggest the presence of an earlier settlement, perhaps Elymian.

The finds give evidence of contact with the Phoenicians and the Greeks. A terracotta plaque bears a 12-line inscription in Greek, perhaps a dodekatheon. This tablet belongs to the latest known phase of the city. It is not known when it ceased to exist.

BIBLIOGRAPHY. V. Tusa, "Il centro abitato su Monte Cavalli è identificabile con Hippana?" *Kokalos* 7 (1961) 113ff[PI]; E. Manni, "Hippana, Sittana o Hipana?" *Kokalos* 7 (1961) 122ff; S. Ferri, "La ΕΥΧΗ ΔΩΔΕΚΑΘΕΟΣ di Monte Cavalli (Palermo)," *La Parola del Passato* 91 (1963) 302ff[I]. V. TUSA

MONTE DESUSINO ("Phalarion") Sicily. Map 17B. The seat of a fortified site at a height of 428 m on a large summit plateau. The mountain is on the S coast, between Gela and Licata. The circuit wall of the site, cleared in 1954, was 2 m in thickness and built entirely of stones without mortar. It surrounded the entire upper plane except on the N side, which was defended by the natural drop of the rock. On the S and E sides of the walls two gates protected by rectangular towers have been cleared; a third gate has been recently identified on the W side as well as a stretch of the ancient access road cut into the rock. It is probable that these walls go back to the 6th c. B.C., but it is certain that the system of gates and towers dates from the end of the 4th c. B.C.

Excavational evidence and Monte Desusino's position, which dominates both the Geloan plain and the mouth

of the river Salso with Monte Eknomos, have prompted the suggestion that this fortified site be identified with Phalarion, the phrourion founded by the Akragan tyrant Phalaris in Geloan territory (Diod. Sic. 19.108). Phalarion was fortified a second time by Agathokles of Syracuse, who in 311 B.C. utilized the stronghold as a base against the Carthaginians. Agathokles' troops, defeated at the mouth of the Salso, fled toward Phalarion which, according to Diodorus (19.109) was at a distance of 40 stades (ca. 7 km) from the battlefield. This fact strengthens the hypothesis identifying Monte Desusino with Phalarion.

BIBLIOGRAPHY. D. Adamesteanu, *RendLinc* (1955) 199ff; id., *NSc* (1958) 335ff; E. De Miro, *La Parola del Passato* (1956) 269 n. 2. P. ORLANDINI

MONTEFIORE Ascoli Piceno, S Etruria, Italy. Map 16. A chamber tomb accidentally discovered in 1960 22 km N of Rome in a tufa quarry. The tomb is Etruscan in form with five burial alcoves each containing a funeral bed on which were placed four burial urns. The measurements and decoration, however, are Roman. The ceilings are the only completely extant ceilings of the Second Style. They are divided into painted coffers. In the lunettes over the alcoves are birds, a lion (?), and two monsters. The tomb is either of the second half of the 1st c. B.C. or from the Vespasianic period.

BIBLIOGRAPHY. P. Bonvicini, "Le grotte sepolcrali di Massignano e Montefiore dell'Aso," *Studi Picena* 28 (1960) 112-14; A. Laidlaw, "The Tomb of Montefiore: A New Roman Tomb Painted in the Second Style," *Archaeology* 17 (1964) 33-42; W.J.T. Peters, "Prille keur: Een nieuwe vondst te Montefiore," *Hermeneus* 35 (1964) 242. J. P. SMALL

MONTELEONE DI CALABRIA, see HIPPONION

MONTE NAONE, see MONTE NAVONE

MONTE NAVONE or MONTE NAONE ("Nakona") Enna, Sicily. Map 17B. In the commune of Piazza Armerina. This is probably the site of the Greek city of Nakona. The archaeological zone consists of two distinct areas, one of which is surrounded by an agger still visible on the S slope of the hill. The city developed from E to W along an axis coinciding with a still recognizable street. The necropolis for this habitation center includes graves of the so-called Licodia Eubea type, with grave goods comprising imported Corinthian or Attic vases and locally made pottery of Licodia type.

BIBLIOGRAPHY. G. V. Gentili, *FA* (1955) n. 2580. A. CURCIO

MONTE SAN BASILE ("Brikinniai") Sicily. Map 17B. A fortified hilltop above the modern town of Scordia, controlling the junction of the plain of Leontinoi and the valley of Katane. The site was first occupied by a village of the Castelluccio culture (ca. 1800-1400 B.C.); oval huts have been excavated. Later Sikel occupation is indicated by rock-cut tombs. In the early 5th c. the hilltop was fortified by Greeks, probably from Leontinoi across the plain; stretches of the wall and a handsome stone cistern survive. A necropolis of the 4th-3d c. B.C. occupied the E slope; one tomb contained a bronze cuirass, weapons, and a Sikeliote amphora of ca. 340 B.C. The site (also called Monte Casale and Monte San Basilio) has been plausibly identified with the Brikinniai held by Leontinoi in 424 B.C. (Thuc. 5.4).

BIBLIOGRAPHY. De Mauro, *Sul colle di San Basilio* (1861); P. Orsi, *NSc* (1899) 276f; id., "Insigne scoperta

a Monte Casale presso Scordia," *Aretusa*, 15 June 1922; T. J. Dunbabin, *The Western Greeks* (1948) 121f.

M. BELL

MONTE SAN MAURO Sicily. Map 17B. A few km S of Caltagirone is the site of an indigenous village over which, in the second half of the 7th c. B.C., there developed a Greek center. Rightly considered a true sub-colony of Gela, it was needed to control the valley of the river Maroglio and the nearby mountain range of Caltagirone. This center was destroyed at the beginning of the 5th c. B.C., probably during the wars between Gela's tyrant Hippokrates and the Sicilian and Chalkidian towns.

The archaic Greek settlement, with simple two-room houses of rectangular plan, stretched across the slope of a natural depression closed on one side by five small hills. On one of these, polychrome terracotta revetments from a small shrine were found, of typical Geloan shape and manufacture. On another hill was uncovered a rectangular structure once believed to be a pre-Hellenic anaktoron of the 8th c. B.C., but now considered a small shrine of Greek type dating from the 6th c. B.C. This building contained the fragments of a bronze plaque with a well-known inscription giving legal instructions in Chalkidian alphabet and dialect, a document which testifies to the relations existing between the Rhodio-Cretan area of Gela and the neighboring Chalkidian colonies. The necropolis was totally Greek, both in the type of its graves and in the funerary gear, which included Corinthian, Ionic, and Attic black-figure vases. This site is also the source of a well-known limestone relief with sphinxes and a dance scene, at present in the Caltagirone Museum. The material from the excavation is in the Syracuse Museum.

BIBLIOGRAPHY. P. Orsi, *MonAnt* 20 (1911) cols. 729ff; E. Pais, *RendLinc* (1895) 279f; T. Dunbabin, *The Western Greeks*, 115ff; D. Adamesteanu, *ArchCl* 7 (1955) 183ff; P. Orlandini, *Kokalos* 8 (1962) 89f. P. ORLANDINI

MONTE SANNACE ("Thuriae") Apulia, Italy. Map 14. An ancient settlement on the Murge hills (382 m above sea level), ca. 5 km NE of Gioia del Colle. Because of the size of its territory, closed within a series of circuit walls which date to the 4th or 3d c. B.C. and are 8300 m long, it is one of the most important centers of Peucezia. Its name is still unknown. The identification with Apulian Thuriae, captured in 303 B.C. by the Spartan Kleonymos is not confirmed.

The zone was inhabited in the prehistoric period to judge from the discovery of grotto-tombs with depressed entrances from the Early Bronze Age. Scattered evidence of life in the archaic period comes from some grave gifts, among which 7th and 6th c. B.C. Corinthian and Attic vases are to be seen beside the native geometric pottery. The walls that close off the acropolis on the summit of the mountain are probably to be dated to the second half of the 5th c. B.C., a period to which may be assigned the first real urban plan, under the influence of Tarentum on the inland population. In the necropolis of the same date, frequently appears the first Apulian red-figure ware, produced at Tarentum. The fortification works of the acropolis were partially adapted to the mountainous conditions of the site and partially constituted a regular wall of tufa blocks. The second circuit of the walls, which closed off the level zone to the W of the acropolis (thereby enlarging the inhabited area in the course of the 4th c. B.C.), has a median thickness of 4 m and is composed of two facings, the outer of tufa blocks and the inner of less regular stones. On many of the blocks the cutters'

signs are Greek letters. The oblique orientation of a gate opened in the N section of the walls facilitated its defense. The third circuit of the walls closes off the acropolis and the W zone into one urban area. The complex is perhaps to be dated to the late 4th c. B.C. as are the fortifications of many other centers of Apulia and of Lucania. The fourth circuit of the walls seems to close off the zone to the E of the mountain within the perimeter of the city. Extensive recent excavations have brought to light numerous dwellings in the area of the acropolis, as well as a public building with a portico, and a group of large rooms rising over the site of more ancient tombs. The urban plan and the technique of construction recall those of the two insulae discovered in the plain to the W of the acropolis, where a large inhabited quarter is crossed by streets not always oriented in a straight line, thereby requiring buildings of different shapes. In the simplest houses two buildings are aligned on a single axis or several rooms face an elongated courtyard. The tombs are scattered everywhere and often next to houses. The most common form of burial is the sarcophagus with the body contracted, according to the custom in Peucezia. The grave goods are very rich and contain valuable geometric ware locally produced and red-figure Apulian pottery produced at Tarentum. These articles are in the Museo Archeologico del Castello di Gioia del Colle.

BIBLIOGRAPHY. *EAA* 6 (1965) 1112, with bibliography (E. A. Scarfì); id., "L'abitato peucetico di Monte Sannace," *NSc* 6 (1962). F. G. LO PORTO

MONTE SARACENO ("Kakyron") Sicily. Map 17B. A fortified center ca. 20 km N of Licata on the right shore of the Salso river (fl. Himera). It seems to have been in existence from the end of the 7th to the end of the 4th c. B.C. Excavations have brought to light a stretch of the E wall, with small towers added at the time of Agathokles. Within these towers were built reused architectural elements in stone with painted decoration, a few altars with similar decoration, and blocks with late archaic inscriptions. These items probably belonged originally to a sanctuary on a hill outside the walls, which still preserves the foundations of a rectangular shrine (8 x 14 m). This small temple, originally decorated with archaic terracotta revetments, was probably rebuilt during the second half of the 4th c. B.C. with the architectural elements which, a few decades later, were re-employed in the fortification towers. The votive deposit of the sanctuary has yielded pottery, terracotta figurines, and bronzes dating from the beginning of the 6th to the end of the 4th c. B.C. The foundations of three more sacred buildings of the archaic period have been recently identified on the mountain top plateau.

The total absence of local wares and the typical Geloan-Agrigentine form of the architectural terracottas, of some of the pottery, and of figurines and inscriptions, show that this center was a Greek sub-colony, founded as a consequence of the penetration of Geloan and Agrigentine colonists into the Salso valley from the second half of the 7th c. B.C. This center was destroyed by the Carthaginians in 311 B.C. after they had defeated Agathokles' army in the battle of the Eknomos at the mouth of the river Salso (Diod. 19.110).

This site should perhaps be identified with ancient Kakyron, the city which Ptolemy (3.4.6) locates to the NW of Phintias (modern Licata) and, between 463 and 461 B.C., the refuge of the Syracusan mercenaries who fled to Geloan-Agrigentine territory after the fall of the Deinomenids (*Oxyrh. Pap.* 4.665, lines 1-7). The archaeological material from the site is in museums in Palermo, Gela, and Agrigento.

BIBLIOGRAPHY. P. Marconi, *NSc* (1928) 499ff; (1930) 411ff; P. Mingazzini, *MonAnt* 36 (1938) cols. 621ff; D. Adamesteanu, *ArchCl* 8 (1956) 121ff; P. Orlandini, *Kokalos* 8 (1962) 96ff. P. ORLANDINI

MONTEŞBEY, *see* KOTENNA

MONTEU DA PO, *see* INDUSTRIA

MONTFERRAND ("Elesiodunum" or "Elusio") Canton of Castelnaudary, Aude, France. Map 23. Small bath complex of late date, necropolis, and Early Christian basilica at St-Pierre-d'Alzonne (at the foot of the eminence on which Montferrand stands) near the Naurouze ridge, and along the Aquitanian road linking Narbonne to Toulouse and Bordeaux. The funerary basilica (20 x 10 m) faces E, lopsided in form with three aisles. The central aisle extends E into an apse with a room on each side. Excavation has produced some remains of the facings of polychrome marble, the painted plaster, and the mosaics with which the interior was decorated. In the crypt and the area immediately surrounding the basilica were found 51 sarcophagi of sandstone or marble, local work with little decoration, as well as many burials in amphorae and in open ground. Some of the jars contained the remains of several individuals. The funerary furnishings are limited to splendid earrings and jewels of the 4th to the 7th c., a period during which the Visigoths extended their domination over the entire region. A few late epitaphs have also been discovered.

It would seem that this site, still only partly explored, should be identified with the way station of Elesiodunum or Elusio, which Cicero describes as a toll-point and the ancient itineraries as an overnight resting-place. The artifacts discovered are preserved on the site.

BIBLIOGRAPHY. "Informations," *Gallia* 17 (1959) 456-57[P]; 20 (1962) 615-16; M. Labrousse, *Toulouse antique* (1968) 140, 340. G. BARRUOL

MONTGÓ Valencia and Alicante, Spain. Map 19. Fortifications on a mountain group that follows the coast from Sagunto to Denia. One of the peaks, the Alto de Benimaquia, was fortified with a wall and six rectangular towers which guarded a large area of the coast; a section 125 m long, dating from the 5th and 4th c. B.C., is still standing. The Pico del Aguila has three stepped walls of the 3d and 2d c. B.C.

BIBLIOGRAPHY. H. Schubart et al., *Excavaciones en las fortificaciones del Montgó cerca de Denia (Alicante)* (1962)[MPI]; id., "Untersuchungen an der iberischen Befestigungen des Montgó bei Denia (Prov. Alicante)," *MadrMitt* 4 (1963) 1-85[MPI]. J. M. BLÁZQUEZ

MONT-LASSOIS (Vix) Côte-d'Or, France. Map 23. Hill dominating the village of Vix and the Seine. Mont-Lassois, also called Mont-Saint-Marcel and Mont-Roussillon, consists of two plateaus. The higher of the two, at a height of 100 m above the valley, has remains of prehistoric occupations. On the lower plateau a necropolis of the 7th c. A.D. is the only archaeological vestige. The importance of the site was revealed in 1929 by excavations which, after being interrupted in 1939, were resumed in 1947, and continue today. Mont-Lassois was inhabited from Neolithic to Merovingian times, but it was the site of an intensive occupation at the end of the first Iron Age, during the 6th and 5th c. B.C. At that time the site was strongly fortified. A ditch with triangular section, 5 m deep and 19 m wide at the top, surrounded the mountain over a length of 2.7 km. Behind this ditch stood a strong vallum, still more than 3 m high in places. This vallum is characterized by the

presence of an internal facing consisting of an ashlar wall. Several large banks of earth led to the river and to spring, thereby protecting access to sources of water. The dwellings on the summit are poorly known because they are too disturbed, but remains of buildings have been excavated on the sides of the hill. The cabins were built on small terraces with their backs against the rock wall. They were made of plastered wattling and their floors were carefully smoothed; stone was not used. After being abandoned during the 4th, 3d, and 2d c. B.C., the site was reoccupied during La Tène III and a rampart of murus gallicus type enclosed the summit of the upper plateau. Gallo-Roman dwellings on this plateau and a Merovingian cemetery on the other attest to the permanency of human occupation.

Mont-Lassois' interest lies in the abundance and significance of the archaeological material which has been collected there. Almost all fibula types of the end of the first Iron Age are represented there. More than 2 million potsherds dating to about 500 B.C. have been recovered, including 40,000 with geometric barbotine decoration. The remains of more than 50 black-figure Greek vases attest to the existence of a vast commercial flow between the Celtic and Mediterranean worlds.

In 1953 an exceptionally rich princely tomb was found at the foot of Mont-Lassois. Originally it was a large barrow with a diameter of 40 m. In the middle, in a funerary chamber cut into the ground and lined with planks, lay the dismounted remains of a wagon in whose chassis the body of a young woman had been placed. The grave goods consisted of an enormous bronze crater 1.65 m high, weighing 208 kg, two Attic bowls, a silver vial with a gold navel, three bronze basins, and a bronze wine jug of Etruscan manufacture. The jewelry included bronze and iron fibulas adorned with gold, amber, and coral; a bronze torque, amber beads, a schist bracelet, and bronze ankle bracelets. A gold diadem weighing 480 gr, of Graeco-Scythian workmanship, still rested on the head of the deceased. This tomb has been dated to 500 B.C. It should be compared to the two barrows of Sainte-Colombe, located 1 km away, which also contained wagon burials attributable to the princes of Vix.

The location of the necropoleis corresponding to the settlement still is not known. However, in the vicinity of the tomb of the princess at Vix, recent excavations have revealed numerous circular enclosures, funerary structures contemporary to that tomb.

Mont-Lassois' importance can be explained by its geographical position. It is located next to the Seine, just where it ceases to be navigable. Thus, it effectively controlled passage through the valley and commercial traffic, including the tin trade.

All the archaeological material collected on the site is deposited in the Musée Municipal at Châtillon-sur-Seine.

BIBLIOGRAPHY. R. Joffroy, *La tombe de Vix*, Monuments et Mém. (fondation Piot) (1954); *L'Oppidum de Vix et la civilisation hallstattienne finale dans l'Est de la France* (1960); *Les Influences méditerranéennes dans l'oppidum de Vix et dans l'Est de la France à la fin du 1er âge du Fer*, Institut de Préhist. et d'Arch. des Alpes Maritimes (1960). R. JOFFROY

MONTLAUZUN Lot, France. Map 23. On the Penchant de Majonelle there existed a large Gallo-Roman establishment, no doubt a villa. It was occupied until very late times, as is attested by the discovery on the site of a Byzantine coin of Phokis.

Near the fountain and vanished hamlet of Frascati, an ancient kiln has been discovered in which glazed pottery was fired under oxidizing conditions.

BIBLIOGRAPHY. R. Montagnac, "Four antique de potier à Montlauzun," *Bull. de la Soc. des Et. du Lot* 87 (1966) 31-36; M. Labrousse in *Gallia* 24 (1966) 442 & fig. 34; 26 (1968) 549-50; 28 (1970) 430. M. LABROUSSE

MONTMAURIN Haute-Garonne, France. Map 23. From 1947 to 1960 a rich Gallo-Roman villa on the left bank of the Save has been excavated and restored. Its presence at the center of a vast agricultural domain probably goes back to the middle of the 1st c. A.D. In the time of Constantine it was transformed into a luxurious rural residence which combined the pursuit of comfort with the opulence of adornment with marbles and mosaics.

One km downstream on the same side of the Save, a sanctuary of the waters was built around the deified spring of La Hillère. It had cult sites, a caravansary, and a market. The sacred character of the place lasted into the Christian period and until the present.

The villa is open to the public, as is a small museum in the village of Montmaurin.

BIBLIOGRAPHY. G. Fouet, *La villa gallo-romaine de Montmaurin*, *Gallia* suppl. XX (1969), rev. by O. Brogan in *AJA* 75.4 (1971) 457. For La Hillère: M. Labrousse in *Gallia* 13 (1955) 207 & fig. 8; 22 (1964) 440-42 & fig. 8; 24 (1966) 420-21ᴾ; 26 (1968) 526-28 & figs. 10-11; 28 (1970) 407. M. LABROUSSE

MONTREAL-DU-GERS Gers, France. Map 23. Excavation at Séviac of a Gallo-Roman villa has produced a remarkable series of 4th c. polychrome mosaics of geometric design.

BIBLIOGRAPHY. Mme Aragon-Launet, *Bull. de la Soc. arch. du Gers* 60 (1959) 85-92; 63 (1962) 322-28; M. Labrousse in *Gallia* 17 (1959) 416-17 & fig. 7; 20 (1962) 581-83 & figs. 38-40; 22 (1964) 452-54 & figs. 29-31; 24 (1966) 437; 26 (1968) 544 & fig. 31; 28 (1970) 419-22 & figs. 27-30. M. LABROUSSE

MONTSÉRIÉ Hautes-Pyrénées, France. Map 23. The Sanctuary of Erge at Mont Martau has been the object of new investigations in recent years. The bronze mask in the Tarbes museum comes from the sanctuary. It does not seem to be a prehistoric work of the 3d c. B.C., but rather a Gallo-Roman product of archaizing style.

BIBLIOGRAPHY. J.-F. Soulet, "Le sanctuaire gallo-romain de Montsérié (Hautes-Pyrénées)," *Rev. de Comminges* 77 (1964) 105-43; R. Coquerel, "De l'âge et de l'origine du masque de bronze de Tarbes," *Celticum* 9 (1963) 281-89; cf. Espérandieu-Lantier, *Recueil . . .* 13 (1949) 17 & pl. XXI, no. 8132. M. LABROUSSE

MOOSHAM, *see* IMMURIUM

"MOPSION," *see* BAKRAINA

MOPSUESTIA Cilicia Campestris, Turkey. Map 6. Some 19 km E of Adana and sited at a most important crossing of the Ceyhan (Pyramos) where the foothills of the Jebel-i-Nur most nearly approach the river. Two km NE it is dominated by the limestone outcrop crowned today by the 12th c. castle known as Yılan Kale, a fortress of the Little Armenian kingdom.

Its legendary founder Mopsos, whose wanderings in Cilicia and Syria are an early feature of Greek mythology, appears in the literary sources and may have been a historic figure. Mopsukrene, near the Cilician Gates, adds substance to the legend. The city was in Persian hands until Alexander's time, and was later renamed Seleucea on the Pyramos for Seleucus IV Epiphanes. It was issuing semiautonomous coinage by the 2d c. B.C.,

and in 67 B.C. adopted a new era to celebrate Pompey's conquest of the Cilician pirates and their resettlement in such established cities as Mopsuestia. It joined in the intercity rivalry of Roman Cilicia, styling itself "free" and the center of "holy, ecumenical games," as well as "Hadriane" in honor of the emperor. Captured by the Parthians in 260, it later became a Christian bishopric, the see of the famous Theodore, declared a heretic after the Council of Chalcedon (451).

A magnificent Roman bridge, a theater, stadium, and colonnaded street still exist, while W of the city mound is a huge basilican church with mosaics (5th c?).

BIBLIOGRAPHY. Theopomp. *FHG* 1.296; Callinus *apud* Strab. 14.668.

N. Hammond, *CAH* II 23-24; R. D. Barnett, "Mopsus," *JHS* 73 (1953) 140-43; B. V. Head, *Hist. Num.* (2d ed. 1911) 721, 725; D. Magie, *Roman Rule in Asia Minor* (1950) 273, 620. M. GOUGH

MOPTH [---] Algeria. Map 18. The settlement is on the top of a rocky hill, at the foot of a tall mountain, in a high valley of tributaries to the Oued el Kebir (ancient Ampsaga), on the road from Cuicul to Sitifis in Mauretania. Very probably it was founded by the emperor Nerva.

Partial excavations carried out on the site have brought to light a capitol, built by the res publica Mopth(ensium?) between A.D. 209 and 211. Nearby another building has been recognized. Both are in an enclosure with a portico on the inside. Also, there are stelae dedicated to Saturn in a style also found from Sitifis to Cuicul.

The presence of a bishop is attested in the 5th c. In the Byzantine period a fortress seems to have been built on the site.

BIBLIOGRAPHY. S. Gsell, *Atlas archéologique de l'Algérie* (1911) 16, no. 196; P. Ginther, *Bull. de la soc. hist. et géogr. de la région de Sétif* 2 (1941) 73-88; L. Galand, *MélRome* (1949) 35-91; P.-A. Février, *Les Cahiers de Tunisie* 15 (1967) 51-64. P.-A. FÉVRIER

MORGANTINA (Serra Orlando) Sicily. Map 17B. Five km E of the commune of Aidone on a ridge known locally as Serra Orlando. The city commanded a strategic position controlling the ancient roads that led from Gela on the S to Messina on the NE and up from Katane on the E. The original Sikel settlement dates from the third millennium B.C. The name of the city reflects an influx of the Morgetes from south central Italy ca. 1200 B.C. (Strab. 6.2.4). Greek settlers from the E coast, and later from the S, merged apparently without conflict with the local inhabitants until Morgantina became essentially a Greek outpost at the edge of the hinterland to the W. In 459 B.C. Ducetius, king of the Sikels, sacked the town in his campaign to wrest Sicily from Greek domination (Diod. Sic. 11.78.5), and in 425 Morgantina was assigned to the city of Kamarina (Thuc. 4.65.1). In 397 Dionysios of Syracuse brought the city back into the sphere of Syracusan interests (Diod. Sic. 14.78.7). Agathokles began an extensive renewal and building program, which continued under Hieron II of Syracuse, and from the middle of the 3d c. Morgantina prospered as the center of an extensive grain-producing area. It was also the center of a considerable production of terracottas. Coincident with Marcellus' capture of Syracuse in 211 B.C. the city was sacked and all but destroyed. A senate decree granted the Hispanic allies of Marcellus the right to issue their own coinage, but this seems not to have been exercised until after the middle of the 2d c. Little new building exists from that period, save for a large macellum in the center of the original agora. Repairs to the houses converted many rich dwellings into middle class houses—centers for small industry or makeshift apartments. Cicero (*Verr.* 2.3.23§56) speaks of the injuries to a worthy citizen of the place. Strabo (6.2.4), writing ca. 25 B.C., says that what once was a city is no more. The excavations, begun in 1955 and still continuing, have confirmed this, and the scarcity of coins found of Julius Caesar and of Augustus are evidence for the extinction of Morgantina. Apparently there was no final sack; the abandonment is due, rather, to the failure of the grain market and the general impoverishment of the area.

The walled area of the town measures from E to W 2.4 km by 580 m to as little as 140 m. Approach from N and S is very steep, but gates on those sides gave access to the central market area. A W gate gave access to a street that ran the length of the town. To the E on an isolated hill (Cittadella), whose walls do not join with those of the rest of the city lay the earlier settlement, almost an acropolis. A long narrow shrine (dedication unknown) and a substantial series of foundations for four adjacent square rooms were perhaps the principal monuments, and in the same area was a small hieron of Persephone and Kore.

The civic center lies not far from the mid-point of the ridge, in a hollow between two low hills. It was flanked to E and W by stoas (the W one never completed) and on the N lay a gymnasium with bath and running track, and a council house. The agora was on two levels, separated by a monumental series of steps forming a little less than half of a hexagon. On the lower level a course of stone outlines what must have been a speaker's platform. The steps served both as a retaining wall to prevent the erosion of the upper area and to accommodate a standing audience for large popular assemblies. The original plan for a fourth side of this comitium was curtailed by the presence of the area, described below, sacred to the underworld gods. South of the W stoa is the theater, seating 2-3000. On the E side of the agora, continuing the stoa to the southward, is a prytaneion and a long, narrow building (92.85 x 7.60 m) designed as a granary and conveniently located near the S gate. A large kiln for brick and tile completes the E side. Within the agora before it had taken its final form stood a small naiskos, with an altar, and two or three other small altars. One of these was preserved into later times and incorporated in a rectangular macellum with shops, dating from the 2d c. The most important sanctuary, however, was one dedicated to the gods of the underworld: a circular altar, an abaton for the dedication of offerings, small vases and lamps, and a small naiskos, together rooms where worshipers might shelter. Several lead curse tablets were found here, and the sanctuary seems to have survived well into the 1st c. B.C.

East and W of the agora the town was laid out in a grid pattern, with blocks averaging 37.5 m by 60.0 m. Several rich houses have been excavated, with fine cocciopesto or mosaic floors, especially two in the House of Ganymede high above the granary E of the agora. The mosaic of Ganymede and the Eagle, which gives the house its name, dates from the middle of the 3d c. B.C. and is one of the earliest examples of tesselated mosaic known. The House of the Official, in a shallow valley 250 m W of the agora, shows the Vitruvian division of a Greek house into separate areas for men and women, with two separate peristyles. The House of the Arched Cistern on the hill immediately W of the market is also of the same type.

No temples properly so called have been found. Instead there are at least four shrines of Demeter and Kore, characterized by an inner room, or adyton, furnished

with a place for ablution. The abundant remains of terracotta figurines leave no doubt to whom the holy places were dedicated. All these sanctuaries were violently destroyed in the sack of 211 B.C. and never rebuilt. About 400 m W of the House of the Official are the remains of a bath of the 3d c. B.C., with circular rooms covered by domical vaults made of hollow terracotta tubes. The extreme E end of the ridge, before reaching the depression separating it from Cittadella, was occupied by a large structure, either a barracks or a series of apartments of poorer sort. Nearby lay an early shrine, long and simple, of the 6th-5th c. Little is to be seen of the walls of the city, but they have been traced for nearly the entire perimeter. As is to be expected they show much rebuilding of different dates.

Three cemeteries lie just outside the town. The earliest, of the 6th and 5th c., is on a steep slope just below the E edge of Cittadella. The tombs were cut into the rock in the form of chambers, with sarcophagi in the walls or graves in their floors. A second burial area lies close against the S wall, below the depression in which was the House of the Official. These are of the Epitymbion type, and the vases date from ca. 330 to 210 B.C. A later cemetery with rock-cut shafts, covered by stone slabs and dating mainly from the 2d c., lies ca. 100 m W of the city, along the road leading to the W gate.

BIBLIOGRAPHY. Preliminary reports by E. Sjoqvist or R. Stillwell appear in consecutive volumes of *AJA*: 61-68 (1957-1964). All of these reports are illustrated and the report contained in volume 64 (1960) is accompanied by a contour map of the site.

K. Erim, *AJA* 62 (1958) 79-90; K. M. Phillips, Jr., "Subject and Technique in Hellenistic-Roman Mosaics, A Ganymede Mosaic from Sicily," *AB* 42 (1960) 243-62[I]; R. Stillwell, "The Theater of Morgantina," *Kokalos* 10-11 (1964-65) 579-88[I]; id., *AJA* 71 (1967) 245-50[I]; H. L. Allen, "Excavations at Morgantina (Serra Orlando) 1967-69," *AJA* 74 (1970) 354-83[I].

R. STILLWELL

MORIDUNUM (Carmarthen) Wales. Map 24. Cantonal capital of the Demetae of SW Wales. Its name (sea fortress) is attested in the *Antonine Itinerary* and aptly describes its position at the tidal limit of the Towy estuary, much used by shipping until the late 19th c.

There is no evidence of a pre-Roman settlement. The first occupation appears to have been an auxiliary fort founded ca. A.D. 74 on the elevated area overlooking the river crossing, now demarcated by Spilman and King Streets. The probable S side of the defenses is close to the Ivy Bush Hotel and clearly belong to the Flavian period. The vicus of the fort would by implication have grown up to the NE in the area of St. Peter's church; timber buildings of early 2d c. date, laid out in random fashion, were located here in 1969. Eventually this area was formalized into the tribal capital of the Demetae.

This was a small town of ca. 6 ha, with a massive stone-faced rampart and an internal street grid. Changes in modern street levels and building subsidence in Priory Street suggested the position of the SW and NE ramparts, and the line of the NW rampart, the best preserved of the four, was suggested by the line of a visible bank behind Richmond Terrace (confirmed by excavation in 1968-69). Only the fourth side has not been determined precisely, owing to modern buildings, but there is the hint of a rampart through the garden of the present vicarage. The original rampart proved to have been ca. 6 m wide; it still stands nearly 2 m high in places. The turf and clay bank was fronted by a V-shaped ditch of roughly the same width and 3 m deep. The ditch of the first period was filled in and the front of the rampart extended, to allow the construction of a stone face in the second period. Extensive dumping to the rear brought the width of the defenses to 18 m. The town wall thus underwent the normal development familiar in Romano-British civil defenses. A terminus post quem for the construction of the original rampart was provided by Antonine Samian.

Excavation in 1969 showed that creation of the street grid also belonged to the Antonine period, and timber structures were shown to have lain on either side of the decumanus farthest N. By the 3d c. stone structures had become more common and the buildings more complex. A large town house built at that time continued in use till after A.D. 320, when the area was leveled again for the construction of an even larger building ca. A.D. 353. Allowing this structure a normal life (there was no sign of violent destruction), this must extend urban life in the cantonal capital farthest W in Roman Britain into the last quarter of the 4th c., lending some credence to Welsh mythological associations between Carmarthen and Maxin Wledig (Magnus Maximus, emperor A.D. 383-388).

At 150 m outside the presumed position of the E gate lies a large oval depression partly cut into a hillside. Excavation in 1968 disclosed the site of an amphitheater; the arena floor was covered with up to 2 m of silt. It was constructed by cutting into the hill and using the excavated soil to create the S bank of the cavea. The arena is 46 by 27 m, the circumference of the cavea ca. 92 x 67 m. The arena wall was nearly 2 m thick and built in the 2d c. Seating, however, was in timber with elaborate sub-frames to maintain the units in position on the hillside. The site of a bath house is also known on the Parade on the SE edge of the town. Finds are housed in the local museum.

BIBLIOGRAPHY. G.D.B. Jones, "Excavations at Carmarthen," *Carmarthenshire Antiquary* 5 (1969) 1ff; 6 (1970) 1ff[MPI].

G.D.B. JONES

MORLANWELZ Belgium. Map 21. A vicus of the civitas Nerviorum on the Bavai-Tongres road in the locality of Château-des-Sarrasins. The site seems to have been badly disturbed during the construction of the Château de Mariemont in 1546. Besides pottery of the first three centuries A.D., bases and capitals of columns have been found, as well as conduits, fresco fragments, iron agricultural tools, etc. A short distance away, 50 m N of the ancient road, a 4th c. burgus (ca. 40 m square) was excavated in 1931. It is the first of a series of blocking forts built along the Bavai-Tongres road at the end of the 3d c. or the beginning of the 4th. To date, others have been found at Liberchies, Taviers, and Braives. It was protected by a palisade and moat; in the middle there was probably a wooden watch tower. The burgus was occupied throughout the 4th c.

BIBLIOGRAPHY. R. De Maeyer, *De Overblijfselen der Romeinsche Villa's in België* (1940) 86-87; H. Van de Weerd, *Inleiding tot de Gallo-Romeinsche Archeologie der Nederlanden* (1944) 78-79.

S. J. DE LAET

MORPHOU Cyprus. Map 6. On the NW coast, 6-7 km from the sea. Remains of an extensive settlement can be seen on both sides of the main Morphou-Myrtou road due N of the village of Morphou. On the evidence of surface finds the settlement can be dated from the archaic period down to Early Byzantine times. A necropolis with tombs ranging in date from the Geometric to the Hellenistic period extends W from Ambelia. The sites of both the settlement and the necropolis are now planted with orange trees.

Nothing is known of the founding of this important settlement or of its ancient name. It succeeded the nearby Late Bronze Age settlement at Toumba tou Skourou.

Rescue excavations, carried out in recent years, have brought to light the remains of a Hellenistic sanctuary probably dedicated to Aphrodite. It may be noted that at Sparta Aphrodite bore the epithet Morpho and that the Lakonians, the traditional founders of Lapethos (q.v.), may also have settled in the area of Morphou.

From the necropolis at Ambelia come a funerary inscription of the 4th c. B.C. in the Cypriot syllabary and some pottery of the Geometric to the Hellenistic periods. An alphabetic inscription of the 3d c. B.C. honoring a Ptolemaic official and his family is also reported to have been found at Morphou. And on a marble sarcophagus of the early 3d c. A.D., now in the Church of Haghios Mamas at Morphou, is an epigram of Artemidoros in hexameter.

The finds are in the Cyprus Museum, Nicosia.

BIBLIOGRAPHY. A. Sakellarios, Τὰ Κυπριακά I (1890) 138; K. Nicolaou, Ἱερὸν Ἀφροδίτης Μόρφου, *Report of the Department of Antiquities, Cyprus* (1963) 14-28[MPI].

K. NICOLAOU

MOTHONE, *see* METHONE

MOTYA (St. Pantateo) Trapani, Sicily. Map 17B. An ancient Punic city on a small island (ca. 45 ha) less than 1 km from the nearest point of Sicily (Spagnola), but 8 km from Marsala (Capo Boeo). Historical information is slight. A well-known passage in Thucydides (6.2) relates that when the Greeks arrived in Sicily the Phoenicians retreated to Motya, Soluntum, and Palermo. On the basis of the foundation dates for the Greek colonies in Sicily, it can reasonably be assumed that Motya was founded between the end of the 8th and the beginning of the 7th c. B.C. We have no exact information on the history of Motya between its foundation and its destruction in 397 B.C., which Diodoros (14:47-53) describes in great detail. It is certainly probable that Motya was involved in the major historical events that took place around Motya itself, that is, the expeditions of Pentathlos and Dorieus at the beginning and at the end of the 6th c. respectively.

About the siege and consequent destruction of the city in 397 B.C., Diodoros says that Dionysios, leaving Syracuse, moved directly against Motya because he was convinced that its conquest would be a grave blow to Carthaginian power in Sicily; from this we can infer Motya's importance in respect to the other Punic cities in Western Sicily. Diodoros tells us that Motya's survivors went to found Lilybaion. On the basis of this information it had been assumed that life ceased in Motya after its destruction, but recent excavation has shown that it continued, though on a reduced scale.

When excavation began in 1906, extensive ruins were already visible, including the N gate. Since that time there have been excavations at the site called Cappiddazzu, where a sacred structure was uncovered; also in the archaic necropolis, in the so-called House of the Mosaics, within the habitation center, and along certain stretches of the walls.

The earliest evidence for the historical period has been found in the archaic necropolis in the NW part of the island; it is composed mostly of cremation burials within amphoras placed in rock-cut pits or in large rectangular cists made of stone slabs; at a higher level there are a few inhumation burials in stone sarcophagi. Funerary goods are mostly represented by archaic Punic pottery, oinochoai, bottle-shaped vases with wide lip, various types of jugs. Sometimes imported wares are found mixed with local pottery; in the earliest phases they are mostly E Greek cups or Corinthian Geometric skiphoi, which can be dated to the end of the 8th c. B.C. This necropolis was in use until the beginning of the 6th c. B.C.; after that

time, contemporary with the construction of the walls, the burials were transferred to another cemetery in Sicily called Birgi. It is probably for this purpose that the underwater causeway, still preserved and used today, was constructed to connect Motya with Birgi.

The entire perimeter of the island (ca. 2 km) is delimited by walls which may have been constructed at the beginning of the 6th c. B.C., perhaps at the time of Pentathlos' expedition. They are built with irregular, roughly squared blocks of local limestone, with the exception of short stretches built in Greek fashion with isodomic blocks of imported tufa. At more or less regular intervals the walls are reinforced by square towers and probably had four gates, of which only the N and the S gates are clearly visible; the former is flanked at the entrance by bastions set at an angle to the line of the walls. It contained six passageways which, in three pairs, controlled access to the city. The two bastions of the S gate are perfectly aligned with the course of the walls. Near this gate is the so-called kothon, a small quadrangular bay (51 x 37 m) which has been considered the island's harbor; recent excavation has shown, however, that it is a small artificial dock.

In the NW part of the island is the sacred area of Phoenician-Punic culture, the tophet, recently excavated and found well preserved; several layers of deposit dating from the 6th to the 3d c. B.C. consists of urns of different types containing the burnt remains of sacrifices. Within the tophet ca. 700 stone stelai have been found, mostly with figured decoration, together with some terracotta female masks perhaps depicting a divinity. Some stelai carry dedicatory inscriptions to Baal-Hammon.

The Cappiddazzu sanctuary is a rectangular enclosure (27.4 x 35.4 m) datable to the 6th c. B.C., within which must have stood several small shrines; inserted into one side of this enclosure, as usual in Phoenician-Punic areas, are the foundations of a large building with three naves, which certainly postdates not only the precinct wall but also the destruction of Motya in 397 B.C.

After this time also dates the section of the habitation center so far uncovered. It is composed primarily of a wide street and a few rooms that belong to a sacred complex similar to some found in Selinus and Soloeis during the 4th and 3d c. B.C.

A house which still retains the peristyle court typical of Hellenistic-Roman houses after the 4th c. B.C. is also reminiscent of Soloeis; in Motya, however, the house has a feature unique in Sicily, a mosaic floor made with black and white pebbles which, besides decorative patterns of clear Greek derivation (such as the maeander), depicts animal fights, a popular subject in the Middle and Near Eastern repertoires.

Motya minted its own coinage as early as the 5th c. B.C., with both Greek and Punic legends. The island has a museum which contains, besides various finds from Lilybaion, all the archaeological material excavated on the island itself, and is therefore one of the indispensable tools for our knowledge of Punic civilization in the Mediterranean.

BIBLIOGRAPHY. J. Whitaker, *Motya. A Phoenician Colony in Sicily* (1921)[MPI]; B. Isserlin et al., "Motya, a Phoenician-Punic site near Marsala, Sicily," *Annual of Leeds University Oriental Soc.* 4 (1962-63) 84ff[I]; P. Cintas, "La céramique de Motyé et la date de la fondation de Carthage," *BAC* (1963-64) 107ff[I]; A. Ciasca et al., *Mozia*, I-VII (1965-71)[MPI]; A. Tusa-Cutroni, "Mozia, monetazione e circolazione," *Mozia*, III (1967) 97ff[I]; S. Moscati, "Iconografie fenicie a Mozia," *RStO* 42 (1967) 61ff[I].

V. TUSA

"MOTYON," *see* VASSALLAGGI

MOUCHAN Gers, France. Map 23. Excavations at Gelleneuve in 1955 and 1956 have uncovered a 4th c. Gallo-Roman villa. After it was abandoned and destroyed, it served as a necropolis in the Merovingian period.

BIBLIOGRAPHY. G. Fouet, "La villa gallo-romaine de Gelleneuve," *Mém. de la Soc. arch. du Midi de la France* 27 (1961) 8-33; M. Labrousse in *Gallia* 13 (1955) 214-16 & figs. 15-16; 15 (1957) 271. M. LABROUSSE

MOULAY YAKOUB, *see* AQUAE DACICAE

MOULIS Ariège, France. Map 23. An architectural survey of the Gallo-Roman mole at Luzenac was done in 1965. The monument is preserved to a height of 6.4 m and is very similar to the mole of La Barthe-de-Rivière (Haute-Garonne) and mole I of Betbèze, at Mirande (Gers).

BIBLIOGRAPHY. R. Lizop, *Les Convenae et les Consoranni* (1931) 454-55; M. Labrousse in *Gallia* 26 (1968) 515. M. LABROUSSE

MOULOS, *see* MAKARIA

MT. APESAS (Mt. Phoukas) Corinthia, Greece. Map 11. The mountain was also called Aphesas because the horse races in the Nemean Games began at its base. The Nemean lion was said to have roamed its slopes and the high summit was known also in legend as the place where Perseus first sacrificed to Zeus Apesantios. (The chief ancient sources are Hes. *Theog.* 327-31; Plin. *HN* 4.17; author of *de fluv.* 18.5; Paus. 2.15.3; Stat. *Theb.* 3.461; *Etym. Mag.* and Steph. Byz.)

The remains of the great ash altar of Zeus are located near the E edge of the summit and pottery sherds in the vicinity date from the Geometric period to the 4th c. B.C. The mountain rises above the Nemea river and separated the Corinthia from the territory of Kleonai.

BIBLIOGRAPHY. E. Meyer, *Peloponnesische Wanderungen* (1939) 16-18; J. R. Wiseman, *The Land of the Ancient Corinthians* (forthcoming). J. R. WISEMAN

MT. ATABYRION, *see* RHODES

MT. CAPODARSO, *see* SABUCINA

MT. MAISKAIA Bosporus. Map 5. Greek site on a small hill near Phanagoria, dating to the 4th-3d c. It contains foundations of two 4th-3d c. buildings, the one best preserved being a monument in antis, probably a temple. Both monuments were destroyed by fire in the 2d c. B.C. Not far from the temple was found a favissa containing a great number of terracotta half-figure ex-votos of Demeter, Aphrodite, and Artemis from the late 6th-3d c. as well as several dozen coins. The Pushkin Museum, Moscow, contains material from the site.

BIBLIOGRAPHY. I. D. Marchenko, "K voprosu o kul'takh aziiatskogo Bospora," *VDI* (1960) 2.101-7; id., "Novye dannye ob antichnom sviatilishche vblizi Fanagorii," in *50 let Gosudarstvennogo muzeia izobrazitil'nykh iskusstv im. A. S. Pushkina: Sbornik statei* (1962) 121-33; id., "Nekotorye itogi raskopok na Maiskoi gore," *KSIA* 95 (1963) 86-90; I. B. Brašinskij, "Recherches soviétiques sur les monuments antiques des régions de la Mer Noire," *Eirene* 7 (1968) 109.

M. L. BERNHARD & Z. SZTETYŁŁO

MT. OCHA Euboia, Greece. Map 11. This is the site of perhaps the best known of a series of stone-built structures first recognized in the rugged country of S Euboia, where peasants call them Δρακόσπιτια (Σπίτια or Σέντια τοῦ Δράκου). Frequently mentioned in the reports

of 19th c. travelers, these structures have certain architectural characteristics in common. All are built of a local gray-green schist which readily splits into flattish slabs that were laid (without mortar) in basically horizontal courses, sometimes with indications of polygonal masonry and "stacking." There is very little evidence of the use of wood in the construction; even the floors and roofs were of stone. The latter are particularly interesting since, when sufficiently preserved, they reflect the use of corbeling.

Although some 40 Dragon Houses have been reported, the best known examples are three in the neighborhood of Styra and one on Mt. Ocha. The latter is located near the crest of the mountain, some 1,400 m above sea level, and can be reached only after a difficult climb from Karystos (preferably in the company of a guide). It is a simple one-roomed structure (interior dimensions: ca. 5 x 10 m), entered by means of a single door in one (S) of the long sides. Two small windows flank the door. Although some of the earliest visitors mention an altar or offering table, there are no extant indications of special features inside the building. It is not certain whether the roof was entirely corbeled or only partially so, thus leaving a small opening through which smoke could escape.

No excavation had been carried out at any of these sites until 1959, when a small investigation was conducted in the Dragon House on Mt. Ocha. The results indicate that the building itself had been used at least in Classical and Hellenistic times and the site had been frequented at least since the archaic period. There is no evidence of prehistoric occupation. The finds tend to support the early theories attaching a religious significance to this building, but no concrete evidence of the deity (or deities) worshiped here has yet been reported.

In spite of the new information about the date and function of the Dragon House on Mt. Ocha, there is no reason to assume that all structures of this type in S Euboia ought to be regarded similarly. It is quite possible that some served no religious purpose at all and were nothing more than dwellings. (Those near the marble quarries of Styra, for example, may have been merely quarters for the officials or laborers in the quarries.) Nor is it necessary to regard all of them as of similar date, for village houses in the neighborhood are still being made of the same materials today. Although their architectural style has been termed "Dryopian" after the name of the early inhabitants of the region, it should perhaps be noted that structures of comparable style can be found in geologically related areas elsewhere, e.g., Andros, Tenos, Keos, and Mt. Hymettos in Attica. This suggests that local building materials played a more important role in the resulting architecture than has usually been recognized.

BIBLIOGRAPHY. T. Wiegand, "Der angebliche Urtempel auf der Ocha," *AthMitt* 21 (1896)[PI]; F. P. Johnson, "'Dragon Houses' of Southern Euboea," *AJA* 29 (1925); N. K. Moutsopoulos, Τὸ Δρακόσπιτο τῆς Ὄχης, *To Bouno* 217 (1960)[PI]; L. Sackett et al., "Prehistoric Euboea: Contributions Toward a Survey," *BSA* 61 (1966)[M].

T. W. JACOBSEN

MT. OETA Thessaly, Greece. Map 9. "A gigantic limestone wall" (Sion) that runs ca. 15 km in a SE direction parallel to Mt. Othrys and forms the S boundary of the Valley of the Spercheios. It has two peaks, Oeta proper (2116 m) and Pyrgos (2153 m). Several massifs can be discerned in the chalk face which rises S of Lamia and measures altogether 35 km from Liascovo to above Thermopylai. Mt. Oeta can be crossed by byroads, as Strabo says (9.4.14), either W of Hypati, whence the

summit can be reached in 6 hours, or else by way of the valley of the Asopos and Mavrolithari. M. Acilius Glabrio's action in 191 B.C. provides a clear example: after taking Heraklea he advanced into the interior of Mt. Oeta and sacrificed at Herakles' funeral pyre. The legend states, that after defeating Eurytos and seizing Oechalia, Herakles wished to sacrifice to Zeus and sent his faithful companion, Lichas, to ask Deinaira for a fresh garment. Deinaira then learned that Herakles, who was madly in love with Iole, Eurytos' daughter, was in danger of forgetting her, and she stained the tunic in the blood of Nessos the centaur. This was supposed to be a love potion, but in fact it was a poison that devoured Herakles' flesh. Deinaira killed herself at Trachis. Herakles, for his part, entrusted Iole to Lichas' care, then left Trachis and had a funeral pyre built for himself on Mt. Oeta. Philoktetes finally set it alight. During the fire thunder was heard: it was Zeus summoning Herakles up to Olympos.

The site of the pyre was discovered in 1919-21, 1800 m up the mountainside and a 2-hour journey from Pavliani, less than an hour from Trachis. One can see the hexagonal-shaped funeral pyre (15-20 m each side) as well as a little Doric temple and the remains of small monuments. 150 m from the pyre is a stoa (32.5 x 5 m deep) where the faithful and priests could take shelter from storms, which are frequent in the region. Finally, a small monument may possibly be a Philokteteion: the hero Philoktetes is said to have consecrated near the funeral pyre his offering of part of the booty he had seized after the sack of Troy (Soph. *Phil.* 1431-33).

Archaeological finds are at the Thebes museum in Boiotia.

BIBLIOGRAPHY. N. Pappadakis in *Deltion* 5 (1919) 25ff[M]; F. Stählin, *Das hellenische Thessalien* (1924) 193; Y. Béquignon, *La vallée du Spercheios* (1937) 206-16[MI]; A. Philippson & E. Kirsten, *GL* (1951) I.2 331; E. Meyer in *Kl. Pauly* s.v., 265-66. Y. BÉQUIGNON

MT. PHOUKAS, *see* MT. APESAS

MOURI, *see* LIMES, GREEK EPEIROS

MOURIÈS, *see* TERICIA

MOUZON Ardennes, France. Map 23. Gallo-Roman sanctuary on the Flavier hill on the boundary between the departments of Ardennes and Meuse, S-SE of Sedan. The sanctuary stood in a rectangular enclosure, three sides of which have been cleared. The cella is surrounded by rough stone paving of two different periods, and has a floor of stone aggregate with a pit in the middle. The entrance is to the NE; the opposite wall of the enclosure, to the SW, was the rear wall of a portico. A number of coins have been found in the cella, and hundreds of miniature arms (swords, daggers, shields, all ex-votos offered to the presiding god) against the outer walls and scattered about the courtyard. Pottery is similarly abundant. The sanctuary had two main periods of activity, the 1st and the 3d-4th c. A.D. The finds are in the Sedan museum.

BIBLIOGRAPHY. P. Congar, *Annales Sedanaises d'Histoire et d'Archéologie* 57 (1967) 36-41; id., *Rev. Hist. Ardennaise* 5 (1971) 1-12; 7 (1972) 1-10; E. Frézouls, *Gallia* 25 (1967) 273; 27 (1969) 295[P]; 29 (1971) 281f[I]; 31 (1973) 400f. E. FRÉZOULS

MUELA DE GARRAY, *see* NUMANTIA

MUĞLA, *see* MOBOLLA

MUKAWAR, *see* MACHAERUS

MULTAN, *see* ALEXANDRIAN FOUNDATIONS, 9

MULVA, *see* MUNIGUA

MUMRILLS, *see* ANTONINE WALL

MUNICIPIUM FLAVIUM MUNIGUENSIUM, *see* MUNIGUA

MUNICIPIUM S., *see* KOMINI

MUNIGUA or Municipium Flavium Muniguensium (Mulva) Sevilla, Spain. Map 19. In the district of Villanueva del Rio y Minas, ca. 50 km NE of Seville and 15 km NE of Cantillana. Excavations have revealed that there was an Iberian town before the Roman settlement: food and material furnishings have been found in chronological contexts from the 3d to the 1st B.C. During the Romanization of Baetica Munigua developed rapidly; in the mid 1st c. A.D. it received the Latin right from the emperor Vespasian and became a municipium (attested by inscriptions).

Wealth derived from local mines made possible a number of monuments, the most remarkable of which is the terraced sanctuary on the slope of the hill. Reinforced by buttresses at the rear, it has the appearance of a fortress and later became known as the castle of Mulva. The main facade faced E towards the city and access to the sacred precinct was by two separate roadways ascending to a N and a S gate. Thence two symmetrical ramps led to a terrace, from which in turn two stairways ascended to a higher terrace carrying the apse, cella, and dependencies of the sanctuary. The entire construction measures 35.20 by 54.43 m. The plan seems to have been taken from the temple of Fortuna Primigenia at Praeneste in Italy, or perhaps from a Hellenistic structure. Of its cult nothing certain is known, though it may have been that of Fortuna Crescens Augusta or possibly Hercules Augustus, divinities whose names appear on inscriptions from other parts of the city (now in the archaeological museum of Seville with the other finds from Munigua).

Other remains of interest include the foundations of a temple at the base of the hill and a rectangular aedicula with a small exedra in front. Its altar, still in situ, was consecrated by a certain Ferronius to a divinity whose name is indecipherable. In front of the temple were found architrave and frieze blocks, a granite column, two capitals, bits of a base, and part of a dedication to Mercury. The monument dates from the first half of the 2d c. B.C. There are also remains of a large portico of the forum, the municipal baths, a large mausoleum, and the necropolis.

Among the inscriptions on altars, pedestals, cippi, and other blocks are: 1) a bronze tablet recording agreement concluded between a Sextus Curvius Silvinus and the Muniguan authorities, from the first quarter of the 1st c.; 2) a letter from the emperor Titus, on bronze, dictated on the VII Ides of September, A.D. 79, rescinding a fine of 50,000 sesterces imposed by Sempronius Fuscus in a lawsuit between the authorities of Munigua and the collector of municipal taxes, Servilius Pollio. Votive inscriptions, besides those to Fortuna Crescens and Hercules Augustus, refer to Mercury, Bonus Eventus Augustus, Ceres Augusta, Pantheus Augustus, and Dis Pater. Honorary inscriptions mention Vespasian, Titus, Domitian, Nerva, and Hadrian; also for accomplishments on behalf of Munigua, Quintia Flaccina, Lucius Valerius Firmus, and Lucius Aelius Fronto.

The sculptures found in Munigua are of provincial or general Roman style: 1) a head of Hispania, identified

by her resemblance to the Hispania on the obverse of a denarius of Aulus Postumius Severus of 82 B.C.; 2) a head of the deity Bonus Eventus and the pedestal for the statue; 3) a headless statue of the nymph Anchyrrhoe, discovered in a nymphaeum added to the baths. There are also numerous Greek, Iberian, Roman, and Arab vase fragments.

Munigua flourished under the emperor Hadrian, but declined towards the close of the 3d c. That the city was in ruins in the 4th c. is attested by the incursion of burials into the center of the town. There are traces of the Visigothic period, but none of the Arab phase.

BIBLIOGRAPHY. W. Grünhagen, "Hallazgos epigraficos de la excavación de Munigua," *Actas del VI Congreso Nacional de Arqueología Nacional de Oviedo* (1959) 214ff; id., "Die Ausgrabungen der Terrassenheiligtums von Munigua," *Neue Deutsche Ausgrabungen in Mittelmeergebiet und im vorderen Orient* (1959) 340ff; id., "Ein Frauenkopf aus Munigua," *Pantheon* 19, 2 (1961) 53ff; H. Nesselhauf, "Zwei Bronzeurkunden aus Munigua," *MadrMitt* 1 (1960) 142ff; T. Hauschild, "Munigua. Die Doppelgeschossige Halle und die Ädikula im Forumgebiet," ibid. 9, 2 (1968) 263-88[PI]; id., "Excavaciones en Munigua en el año 1966," *Actas del X Congreso Nacional de Arqueología, Mahón 1967* (1969) 400ff; F. Collantes de Terán & C. Fernández-Chicarro, *Epigrafía de Mulva* (in press). C. FERNANDEZ-CHICARRO

MUNNINGEN, *see* LIMES RAETIAE

MÜNSTER-SARMSHEIM Rhineland Palatinate, Germany. Map 20. A mosaic floor from a Roman villa (now covered by a house at Römerstrasse 2) has been partly excavated. The middle field of the mosaic (18.9 x 13.7 m) depicts Sol standing on a quadriga. He is surrounded by the signs of the Zodiac. The remaining surface is covered with black-and-white geometric patterned squares; a frieze of tendrils forms the border. The middle field of the mosaic is in Bonn (Landesmuseum); parts of the black-and-white mosaic are in Bad Kreuznach Museum and in the parish church of SS. Peter and Paul, Münster-Sarsheim. Preserved under this church is a section of the aqueduct that supplied water to the Roman villa, now buried.

BIBLIOGRAPHY. K. Parlasca, *Die Römischen Mosaiken in Deutschland* (1959) 86-89, pl. 85,2; F. J. Hassel, "Das Sol-Mosaik aus Münster-Sarmsheim," *Führer zu vor- und frühgeschichtlichen Denkmälern* 12 (1969) 137-38.
 H. BULLINGER

MUNZACH Baselland, Switzerland. Map 20. Villa estate 1.2 km NW of Liestal, in the territory of Augusta Raurica now called Munzach, the ancient name Monciacum is mentioned in a document of A.D. 825. It was built in the middle of the 1st c. A.D. and sacked by the Alamanni in 259-60, but part of it was inhabited into the 4th c.

The estate comprised a rectangular enclosure (over 300 x 150 m); the villa itself, built in several periods, had geometric and figured mosaics (partly destroyed) of the late 2d c. A separate bath building and a small sanctuary have been identified at a nearby spring, also several outbuildings (barns, workshops) built against the enclosure wall. There is a museum on the site, and the Kantonsmuseum Baselland is in Liestal.

BIBLIOGRAPHY. T. Strübin & R. Laur-Belart, "Die römische Villa von Munzach bei Liestal," *Ur-Schweiz* 17 (1953) 1-16[PI]; id., "Monciacum, der römische Guts-hof und das mittelalterliche Dorf Munzach bei Liestal," *Baselbieter Heimatblätter* 21 (1956) 1-40[PI]; V. von

Gonzenbach, *Die römischen Mosaiken der Schweiz* (1961) 142-49[PI]; *Jb. Schweiz. Gesell. f. Urgeschichte* 56 (1971) 220. V. VON GONZENBACH

MURIGHIOL Dobrudja, Romania. Map 12. Station on the right bank of the lower Danube, 9 km E of Salsovia (Mahmudia). Recent research has identified here two Traco-Getic cemeteries containing cremation graves from the 3d and 2d c. B.C. At 2 km E of the village are the ruins of a Roman city with strong walls of stone and a defense ditch. In the interior are traces of stone buildings, tiles, pottery fragments, and coins from the Roman Republican and Imperial periods. The ancient name of the settlement is not known but both Halmyris (*It. Ant.* 226.4) at 8 Roman miles from Salsovia, and Gratiana (Procop. *De aed.* 4.11) have been suggested.

BIBLIOGRAPHY. C. Moisil, *Buletinul Comisiunii Monumentelor Istorice* 2 (1909) 98; V. Pârvan, *AA* (1914) 434-35; E. Bujor, "Santierul arheologic Murighiol," *Materiale şi Cercetări Arheologice* 5 (1959) 373-77.
 E. DORUTIU-BOILA

MURLO, *see* POGGIO CIVITATE

MURO LECCESE Lecce, Apulia, Italy. Map 14. An ancient Messapic center of which few traces remain; no mention is made of it in the literary sources. The double circuit wall is reminiscent of the walls of Manduria. In 1859 the remains of a circular temple were discovered. Its small altar bore a Messapic inscription of the 5th c. B.C. with a dedication to Aphrodite and a bronze statuette of the goddess. Both statuette, of Greek workmanship, and inscription are in the Museo Castromediano at Lecce.

BIBLIOGRAPHY. M. Bernardini, *Panorama archeologico dell'estremo Salento* (1955) 49; O. Parlangeli, *Studi Messapici* (1960) 195; G. Delli Ponti, *I bronzi del Museo Provinciale di Lecce* (1973) 16. F. G. LO PORTO

MURO TENENTE, *see* SCAMNUM

MURSA (Osijek) Yugoslavia. Map 12. On the right bank of the river Drava, where traces of neolithic and metal age cultures have been evidenced. It is generally assumed that Hadrian was the founder of the colonia Aelia Mursa (Steph. Byz. 458 M; *CIL* III, 3279) and that it was founded in 133 (*CIL* III, 3280). According to inscriptions in which the duoviri, decuriones, a quaestor, an augur, and even a procurator Augg. (*CIL* III, 3281) are mentioned, urban life flourished in the 2d and 3d c. At least temporarily Legio II Ad and in Late Imperial times Legio VI Herc were garrisoned here, and it was the seat of the praefectus classis Histricae (*Not. Dig.* occ. 32, 52).

Mursa was the scene of violent battles in 260 when Gallienus defeated Ingenuus, and in 351 when Constantius overcame Magnentius. In the course of the 4th c. the city was the seat of bishop Valens, known as the most zealous follower of Arius. It suffered destruction by Goths, Huns, Avars, and Slavs.

It is known that Mursa had important public buildings: 50 tabernae with double colonnades (*CIL* III, 3288), other buildings thought to have been erected by Hadrian (*CIL* III, 3280), a synagogue, a stadium outside the city gates (Zosimos II 50.2) and a chapel dedicated to martyrs outside the city walls. Being at a crossroads, it was connected with Aquincum, Sopianae-Savaria, Poetovio, Siscia, Cibalae-Sirmium, and the Limes. In the river bed are still lying columns that supported a stone bridge, important for trade and traffic with the Danubian Limes. The area of the town measured 760 by 680 m.

Of importance are inscriptions on altars and tombstones, sarcophagi, sculptures of gods and goddesses (Her-

cules, Mercury, Kybele). Jupiter, Hercules, and Silvanus were specially worshiped and a hieroglyphic inscription mentions Osiris and Isis.

The collections of small finds are rich in terra sigillata, oil lamps, bronze and terracotta statues, fibulae, glass, and masses of coins. The finds are exhibited in the Muzej Slavonije at Osijek and in the Arheološki muzej at Zagreb.

BIBLIOGRAPHY. P. Katancius, *Dissertatio de columna milliaria ad Essekum reperta* (1782)[1]; D. Pinterović & M. Bulat, "Izvještaj o arheološkom ispitivanju na terenu Murse u 1968," *Osječki zbornik* 13 (1971)[MPI].

See numerous articles on Mursa with English summaries by M. Bulat in ibid. 6 (1958) 73-88[1]; 7 (1960) 5-11[1]; 9-10 (1965) 7-24[1]; and by D. Pinterović in ibid. 5 (1956) 55-94[MP]; 6 (1958) 23-63[1]; 7 (1960) 17-42[1]; 8 (1962) 71-122; 9-10 (1965) 61-74[1] and 77-95[1]; 11 (1967) 23-65 and 67-81[1]. D. PINTEROVIĆ

MURVIEL-LES-MONTPELLIER Hérault, France. Map 23. The oppidum of Le Castellas is situated on the foothills NW of Montpellier 6 km N of the Via Domitia. The ancient texts contain no mention of the site, but in the Middle Ages it was known as Altimurium. The oppidum is set on a hill and protected by three circuit walls; these are joined, and probably represent successive enlargements. The walls date from between the end of the 3d c. and the 1st c. B.C.

The site covers an area of 20 ha. Several houses have been uncovered in different areas, as well as a section of the upper rampart and some isolated tombs. Le Castellas was apparently occupied continuously from the 3d c. B.C. to the Late Empire, and perhaps both earlier and later. The early excavations revealed remains of large monuments (columns, fragments of monumental sculpture) that have not yet been uncovered. Nor have the few tombs explored so far clarified the funerary customs. The archaeological depot at the site shows an abundance of material from the 1st c. B.C. and the 1st c. A.D., which seems to have been the golden age of Le Castellas.

BIBLIOGRAPHY. *Gallia* 12 (1954) 423; 17 (1959) 466-67; 20 (1962) 625-26; 22 (1964) 494; 24 (1966) 468-70; 27 (1969) 397; 29 (1971) 385-86. J.-C.M. RICHARD

MUSES, SANCTUARY OF, *see* SANCTUARY OF MUSES

MUT, *see* CLAUDIOPOLIS

MUTINA (Modena) Emilia Romagna, Italy. Map 14. A Ligurian settlement ca. 36 km W-NW of Bologna. It came under Etruscan and Boian rule before passing to Rome ca. 218 B.C. It became a citizen colony of Cisalpine Gaul in 183 B.C. (Livy 21.25; Polyb. 3.40). The object or scene of many battles, including especially the bellum Mutinense of 43 B.C., the town's position on the Via Aemilia marked it for military, political, and commercial importance and prosperity to at least the late 4th c. A.D. (Amm. Marc. 31.3; Ambros. 2.8).

Since the modern city lies over the ancient town, excavation has been broad but not systematic. The site is surmised to have covered an area ca. 950 by 550 m. The chief artery was Via Aemilia; the N wall probably ran along the line of the Piazza Roma and Via S. Giovanni del Cantone. Of public buildings, only the amphitheater has been tentatively identified, under the modern Camera di Commercio.

Neither the local ceramics industry (Plin. *HN* 35.12.-101) nor the general economic prosperity are attested by the finds. The necropolis of Piazza Matteotti has produced a sarcophagus whose mixed style reflects its origin

in the 2d c. A.D., and its later use in the 4th c. Provincial art of the 1st c. A.D. is seen in the stelai of the Novii and of the Apollinares, ministers of the imperial cult of Augustus. Excavations along Via Aemilia near S. Lazzaro have revealed some funerary monuments of the 1st c. A.D.

The Museo Lapidario contains a collection of Roman and Christian epigraphy; the galleries of the Palazzo museums house prehistoric material and a few interesting Greek and Roman sculptures.

BIBLIOGRAPHY. M. Corradi-Cervi, "Mutina," in *St. e Doc. dep. St. patria per l'Emilia e Romagna*, sez. di M. I (1937) fasc. III, 137-664; id., "*L'anfiteatro rom. di M.*," ibid. 5 (1941) 3-6; G. Mancini, *Em.Rom.*, II (1944) 67-73; P. E. Arias, "Necropoli rom. di pz. Matteotti," *NSc* (1948) 26-43; G. C. Susini, "Testi epigrafici Mutinensi," *Epigrafica* 21 (1959) 79-96. D. C. SCAVONE

MYANIA, *see* WEST LOKRIS

MYEZA, *see* MIEZA

MYCENAE Argolid, Greece. Map 11. Located in the NE corner of the region, some 135 km SW of Athens, it experienced its greatest period of prosperity in the Late Bronze Age. In the Geometric period only a few people had their small houses on the summit of its acropolis. Conditions improved in the archaic period (ca. 650-500 B.C.) when a temple was built on the summit and on a terrace whose retaining wall is preserved. Of the temple, only a part of the E wall and fragments of sculptured metopes survive. The Mycenaeans fought at Thermopylai and Plataia, but ca. 468 B.C. their acropolis was destroyed by the Argives, who after 300 B.C. transformed it into a township. The fortification walls were then repaired in the polygonal style of masonry, samples of which can be seen by the Lion Gate. The acropolis itself was filled with buildings, now preserved in scattered fragments, and a large temple constructed on the summit was dedicated either to Hera or Athena. The foundations and part of the floor of the temple survive. Below the acropolis, a lower city was surrounded by fortification walls, fragments of which exist along the N periphery. In the lower city remains of a fountain built in poros stone near the Lion Gate and a theater constructed across the dromos of the Tomb of Klytemnestra date from this period of reoccupation. Of the theater only a few seats can be seen today. A small number of graves and fragments of lamps prove that the site was sparsely inhabited to the end of the 3d c. A.D.

BIBLIOGRAPHY. A.J.B. Wace & C. A. Boethius, *BSA* 25 (1921-23); A.J.B. Wace, M. Holland, & M. S. Hood, *BSA* 48 (1953); G. E. Mylonas, *Ancient Mycenae Capital City of Agamemnon* (1957). G. E. MYLONAS

MYGDONIA, *see* ALEXANDRIAN FOUNDATIONS, 1

MYKALESSOS (Rhitsona) Boiotia, Greece. Map 11. A town belonging to the earliest Boiotian League, flourishing from the 6th c. until its destruction and the massacre of its inhabitants by the Athenians in 413 B.C. Strabo classed it as a village belonging to Tanagra. There are a few remains of undated walls at Rhitsona, which is generally accepted as the site of Mykalessos. Excavations have concentrated on graves, largely of the 6th c., but also 5th c. and Hellenistic, which produced material of considerable importance for the history of Greek ceramics. Pausanias mentions a Sanctuary of Mykalessian Demeter on the shore of the Euripos, which was probably near the modern village of Megalovouno above Aulis. The ancient wall which appears on both

sides of the road through the Anaghoritis pass marks the Chalkis-Thebes boundary. Frazer suggested a nearby location for the Hermaion mentioned in Thucydides' account of the Athenian attack, while locating Livy's Hermaion on the Euripos at a ferry terminus.

BIBLIOGRAPHY. Thuc. 4.93.4, 7.29.30; Strab. 9.2.11; Livy 25.50; Paus. 1.23.3, 9.19.4; J. G. Frazer, *Paus. Des. Gr.* (1898) v 66f; *BSA* 14 (1907) 226f; S. C. Bakhuizen, *Salganeus and the Fortifications on its Mountains (Chalcidean Studies* III, 1970). M. H. MC ALLISTER

MYKONOS Greece. Map 7. Island in the Aegean Sea, one of the Cyclades, close to and NE of Delos. Mentioned only in passing by ancient authors. The people were Ionians and had legendary ties with Athens. Datis stopped there in 490 B.C. on his return from Marathon (Hdt. 6.118), and the island is named as a Persian possession in Aeschylus' *Persians* 885. It was a member of the Delian League, and paid a tribute of one and a half talents, later reduced to one talent (*ATL* 1.346). It was also a member of the second Athenian League from 376 B.C. on (*IG* II², 43 A 19) and of the league of the Islanders in the early 3d c. (*IG* XI, 4.1040-41). The people "had a bad name for greed and avarice because they were poverty stricken and lived on a wretched island" (Ath. 1.8). Baldness was prevalent (Strab. 10.5.9). There were close ties with Delos. Many Mykonians are mentioned in inscriptions of Delos, and the Temple of Apollo had lands on the SW promontory of Mykonos.

There were originally two towns (Skylax 58), but they were merged into one ca. 200 B.C., as we learn from an important inscription recording a calendar of sacrifices (*SIG³* 1024). The principal town was perhaps on the site of the present town but there are few remains. A burial of the 7th c. B.C. in the center of the modern town, ca. 200 m from the waterfront, suggests that the ancient town was less extensive, since the burial was probably outside the town limits. This burial was in a large pithos with relief decoration, the Wooden Horse on the neck, scenes from the sack of Troy on the body. It is in the local museum. The location of the other town is not known. There are three towers in the SW, which probably belonged to farms.

BIBLIOGRAPHY. *AthMitt* 50 (1925) 37-44; J. H. Kent, *Hesperia* 17 (1948) 286-89; 25 (1956) 145; J. Belmont & C. Renfrew, "Two Prehistoric Sites on Mykonos," *AJA* 68 (1964) 395-400. E. VANDERPOOL

MYLAI (Mylae, Milazzo) Sicily. Map 17B. A small city in the province of Messina at the isthmus of a narrow peninsula that extends ca. 6 km toward the Aeolian islands. It was a sub-colony of Zankle founded in 717-716 B.C., and it probably never enjoyed political autonomy since its destiny depended on that of Zankle-Messene, of which it was considered a stronghold. In 426 B.C. the Athenian Laches (Diod. 12:54), and again in 315 B.C. Agathokles (Diod. 19:65), before attacking Messene, occupied Mylai. In 260 B.C. Caius Duilius obtained in its waters the first Roman naval victory against the Phoenicians; again near Mylai, in 36 B.C., Octavian defeated Sextus Pompey. Excavations have revealed a continuous series of cemeteries: from the Middle Bronze Necropolis (15th-13th c. B.C.) in the Sottocastello district to that of the Iron Age (11th-9th c. B.C.) in Piazza Romana, which is a true urnfield of Villanovan type, to the Hellenistic cemetery in the S. Giovanni district. No traces remain of the habitation center, which must surely have occupied the acropolis on which later rose the mediaeval castle. A Roman mosaic is preserved in the St. Francis' Monastery. A rare type of Byzantine grave in

the shape of an aedicula can be seen at the entrance to the highway called the Strada Panoramica. Finds and reconstructions of the cemeteries are at the Museum in Lipari.

BIBLIOGRAPHY. L. Bernabò Brea & M. Cavalier, *Mylai* (1959)MPI. G. SCIBONA

MYLAI Thessaly, Greece. Map 9. A city captured and burned by Perseus, identified by Stählin with the steep hill between Damasi and Damasouli near Phalanna. There are remains of a wall around a small acropolis at the W end, and a larger circuit of rough polygonal blocks of yellowish limestone. There were round towers at three corners and probably at the fourth. Much of the wall now visible belongs to Byzantine rebuilding. The Hellenistic remains are chiefly in the stretch of wall N of the E tower. The identification was questioned by Philippson-Kirsten on the grounds that the site seemed typically mediaeval. In support of the identification, Stählin reported a dedicatory inscription found in Damasi which refers to the Mother of the Gods of Mylai.

BIBLIOGRAPHY. F. Stählin in *RE* 15² (1893) 1038P; F. Stählin in *AthMitt* 52 (1927) 88f; A. Philippson-Kirsten, *GL* (1950-59) I¹ 85, 274. M. H. MC ALLISTER

MYLASA (Milâs) Turkey. Map 7. One of the three inland Carian cities reckoned noteworthy by Strabo (658). The city was in existence in the 7th c. B.C. (Plut., *Quaest. Graec.* 45), and between 500 and 480 was ruled by the tyrants Oliatos and his brother Herakleides (Hdt. 5.37.121). In the Delian Confederacy Mylasa paid a tribute of one talent or rather less, and in the 4th c. was the seat of the Hekatomnid satraps, until Mausolos transferred his capital to Halikarnassos. In the 3d c. Mylasa was claimed first by the Ptolemies, then taken and declared free by Antiochos II. Friendly relations with Antigonos Doson and Philip V ended in 200 B.C., and Mylasa reverted to the Seleucid Antiochos III. When Caria was given to Rhodes after Magnesia in 189, Mylasa was exempted from payment of tribute. Rhodian control ended in 167 and Caria was left free. During the 2d c. Mylasa entered into sympolity with the smaller cities in the neighborhood as the dominant partner. In the 1st c. the city was led by two demagogues, Euthydemos and Hybreas; the latter offered resistance to Labienus in 40 B.C., and the city was sacked by the Parthians (Strab. 659-60). Prosperity was restored with the help of Augustus.

It has recently been suggested, with considerable probability, that the original seat of the Hekatomnid satraps was not at Milâs itself but on the hill of Peçin some 5 km to the S, where there are remains of a temple which may be that of Zeus Karios mentioned by Herodotos (1.171) and Strabo (659).

Little remains at Milâs of the ancient city. The city wall has disappeared, though one of its gates survives intact. It is now called Baltalı Kapı, and is a handsome arched gateway with broad-and-narrow masonry; the piers supporting the arch are decorated with a row of palmettes under a row of flutes. On the keystone of the arch on the outer side is a double axe in relief. This gate dates perhaps from the reconstruction of the city after the sack by Labienus, or it may be later. Subsequently an aqueduct was carried upon it.

In the middle of the town is one column and part of the foundation of a Corinthian temple. The column stands on a podium 3.5 m high, and has a panel for an inscription which seems never to have been written. The temenos is extensive; its E wall stands for 100 m and has 11 courses in regular ashlar. A fragmentary inscrip-

tion indicates that the temple was dedicated to Zeus, probably Zeus Karios.

The temple of Zeus Osogos, which contained a spring of salt water, stood outside the city on the SW. Nothing remains of the temple itself, but a part of the temenos wall is standing, in massive polygonal style, up to 3 m high. Formerly a row of columns could be seen, belonging to a stoa of Roman date which ran around the temenos; in some cases they were inscribed to Zeus Osogos Zeus Zenoposeidon, but these too have now disappeared. A temple of Rome and Augustus, still standing in the 17th c., was described as of marble; it had six Ionic columns on the front with leaf moldings at top and bottom, and the dedication on the architrave.

The hollow of a theater is visible on a low hill NE of the city, outside the wall, but nothing of the building survives. On the same hill excavation has revealed remains of a shrine of Nemesis.

There are numerous tombs of Hellenistic and Roman date W of the city, one of which still stands complete at a spot called Gümüşkesen. It has two stories, with masonry and decoration similar to that of the Baltalı Kapı and probably of similar date. The upper story carries an open colonnade, with partially fluted double half-columns and a square pilaster at each corner. The roof consists of five layers of blocks in pyramidal form, with each layer placed diagonally across the corners of the layer below; the underside is carved and was originally painted. The grave chamber is in the lower story, with four pillars supporting the floor of the upper one; in this floor is a small funnel-shaped hole, apparently for the pouring of libations.

On the Hıdırlık hill W of the town is a separate fortification, compensating for the weak situation of the city on the plain (Strab. 659). The greater part of an oval enclosure, with a wall of rough and irregular ashlar 2.5 m thick, still stands up to 2.5 m high. No buildings are visible in the interior.

At Süleyman Kavağı, 3 km S of Milâs, is a handsome architectural rock tomb cut in the face of a hill looking E. The facade has two Doric half-columns between pilasters, with a false door surmounted by a pediment; below this, and separately entered, is the actual grave chamber, with stone benches on right and left, and a recess at the back. The suggestion has been made that this may be the tomb either of Hekatomnos, father of Mausolos, or of his father Hyssaldomos.

BIBLIOGRAPHY. J. Spon & G. Wheler, *Voyage d'Italie . . .* I (1675) 275; R. Chandler, *Travels in Asia Minor* (1817; repr. 1971) 111-16; C. Fellows, *Asia Minor* (1839) 257-61; L. Robert, *Études Anatoliennes* (1937) 567-73; A. & T. Akarca, *Milâs* (1954, in Turkish), 76ff; A. Laumonier, *Cultes Indigènes en Carie* (1958) 39-140; J. M. Cook, *BSA* 56 (1961) 98-101 (Peçin); G. E. Bean, *Turkey beyond the Maeander* (1971) 31-44MI.

G. E. BEAN

MYNDOS (Gümüşlük) Turkey. Map 7. Carian city 18 km W of Bodrum. This, however, was not the site of the original Lelegian town of Myndos, which was a small place paying one-twelfth of a talent in the Delian Confederacy and contributing one ship to the fleet of Aristagoras about 500 B.C. (Hdt. 5.33). That is probably to be located at Bozdağ, a modest Lelegian site on a hilltop about 3 km to the SE, where there remains a circuit wall and the foundation of a tower. According to Strabo (611) Mausolos incorporated six of the Lelegian towns in Halikarnassos, but "preserved" Syangela and Myndos. In fact he refounded Myndos on a much larger scale on a new site at Gümüşlük; the old site was

later remembered as Palaimyndos (Plin. *HN* 5.107; Steph. Byz. s.v. Myndos). The new city claimed in Roman times to have been colonized, like Halikarnassos, from Troezen, but this is palpably false.

Unsuccessfully attacked by Alexander, Myndos later passed into the hands of the Ptolemies, and about 131 B.C. was temporarily occupied by Aristonikos. In 43 it sheltered the fleet of Cassius. Under the Empire, though Myndians are frequently found abroad, the city seems to have been less prosperous than most of the cities of Asia. Coinage begins in the 2d c. B.C., but Imperial coins are rare.

The harbor at Gümüşlük, sheltered from the prevailing NW wind by a headland, is one of the best on the coast; a small island in the mouth leaves only a narrow entrance passage. The city wall was originally some 3.5 km long, enclosing the headland as well as a large area on the mainland, but the headland portion has disappeared since the 19th c. On the mainland it still stands in large part, in regular ashlar 3 m thick; on the more vulnerable SE side it is strengthened with towers. Another wall runs down the spine of the headland; this also is about 3 m thick, but built of larger blocks less regularly fitted. It has been called the Lelegian wall, but this is plainly a misnomer; its masonry is not Lelegian in style, nor was this the site of the Lelegian town. It appears to belong to an earlier scheme of fortification.

Nothing survives of the other ruins seen by early travelers, including a theater and a stadium. Even in antiquity a large part of the area enclosed was unoccupied (Diog. Laert. 5.2.57). Rock cuttings may be seen in various places on the hillside, and a few tombs have been noticed outside the walls. Inscriptions are remarkably scarce.

BIBLIOGRAPHY. C. T. Newton, *Halicarnassus, Cnidus and Branchidae* II (1863) 574-78; W. R. Paton, *JHS* 8 (1888) 66; 20 (1900) 80; G. Guidi, *Annuario* 4-5 (1921-22) 365-67; G. E. Bean & J. M. Cook, *BSA* 50 (1955) 108-12; G. E. Bean, *Turkey beyond the Maeander* (1971) 116-19.

G. E. BEAN

MYOUPOLIS, *see* OINOE (Attica)

MYOUS Turkey. Map 7. Town in Ionia, near Avşar, 16 km E-NE of Miletos. One of the least important of the 12 cities of the Ionian League. Tradition said that the site was taken from the Carians by a son of Kodros, Kyaretos (Paus. 7.2.10) or Kydrelos (Strab. 633). According to Diodoros (11.57.7) and Strabo (636) Myous was presented by Xerxes to Themistokles to supply him with fish in his retirement. At the battle of Lade in 494 B.C. Myous contributed three ships to the Ionian fleet. In the Delian Confederacy the city was assessed at the modest sum of one talent. In 201 B.C. Myous was given away for the second time. Philip V received a quantity of figs from the Magnesians, and by way of payment, when he captured Myous, he presented it to them (Polyb. 16.24.9). The city was gradually cut off from the sea by the silting of the Maeander, and by degrees lost her independence to Miletos; by Strabo's time the two cities were in actual sympolity, and Myous could only be reached by sailing 30 stades up the river in small boats (Strab. 636). Finally the Maeander converted an inlet of the river to a lagoon, which bred such swarms of mosquitoes that the inhabitants were forced to remove themselves and their possessions to Miletos (Paus. 7.2.11).

The site, half an hour's walk NW from the village of Avşar, is now deserted, and the extant remains are scanty. A low hill, crowned by a Byzantine castle, stands

beside the river; in its lower slope two terraces have been constructed. On the lower of these are the foundations of the Temple of Dionysos noticed by Pausanias; it was Ionic, 30 by 17 m, with a peristyle of (apparently) 10 columns by 6, a deep pronaos and cella, but no opisthodomos. It dated from the mid 6th c. and faced W. All that can now be seen is a single column drum of white marble. The upper terrace carried a larger temple in the Doric order, probably that of Apollo Terbintheus, the principal deity of Myous. Only a part of the foundation remains. Between the two terraces is a supporting wall of large irregular blocks, with a shallow recess and a number of cuttings. No other buildings survive, though on the hill to the E, which seems to have carried the main occupation, there are traces of rock-cut houses, tombs, and cisterns.

The almost total absence of any sculptured, inscribed, or even worked stones on an excavated site is remarkable; it seems that they must have been taken by the inhabitants when they moved to Miletos.

BIBLIOGRAPHY. D. Magie, *Roman Rule in Asia Minor* (1950) 883-84; H. Weber, *AnatSt* 17 (1967) 31; G. E. Bean, *Aegean Turkey* (1966) 244-46. G. E. BEAN

MYRA (Demre; Kale) Lycia, Turkey. Map 7. About 20 km W of Finike. Although the city is not mentioned in the literary authorities before the 1st c. B.C., the monuments and inscriptions in the epichoric language and script show it to have been, from the 5th c. at least, among the important cities of Lycia. It is not mentioned by pseudo-Skylax, and the *Stadiasmus* refers only to the port of Andriake. Strabo (666) describes it as standing 20 stades from the sea on a high crest, and records that it was one of the six cities of the highest class, possessing three votes in the assembly of the Lycian League. The name was popularly connected with the Greek word for myrrh; the Lycian name appears to have been the same.

In 42 B.C. Lentulus Spinther, in the course of collecting money for Brutus, was sent to Myra, where he compelled the city to meet his demands; Appian mentions that he forced an entrance to the harbor at Andriake by breaking the chain which closed it. Under the Empire Myra received numerous benefits from imperial families; on the occasion of a visit in A.D. 18 Germanicus and his wife Agrippina were honored with statues erected at Andriake. In A.D. 60 St. Paul, on his voyage to Rome, changed at Myra—that is at Andriake—from a ship of Adramyttium to one of Alexandria. In the 2d c. the city had the rank of metropolis, and was the recipient of handsome gifts of money from Licinius Longus of Oinoanda, Opramoas of Rhodiapolis, and Jason of Cyaneae. It was made capital of Lycia by Theodosius II, and continued to flourish long afterwards, enjoying a considerable reputation as the see of St. Nicholas, bishop of Myra in the 4th c. Constantine Porphyrogenitus (*De Them.* 14) refers to "that Lycian city breathing sweet unguents, thrice blessed, where the great Nicholas, servant of God, sends forth myrrh in accordance with the city's name." Despite this testimony Myra does not appear to have been noted for the production of unguents; neither Pliny nor Athenaeus mentions her in this connection, and the only product that seems to be recorded is rue (Ath. 2.59).

Coins were perhaps struck at Myra under the dynasts as early as the 5th c., but became common under the Lycian League after 168 B.C. Imperial coinage, as elsewhere in Lycia, is virtually confined to Gordian III; the standard type is the epichoric goddess Eleuthera.

In Imperial times, as we learn from an inscription (*OGIS* 572), there was a municipal ferry service between Myra and Limyra.

The ruins lie rather less than 5 km inland. The present landing-stage is on the coast S of the city, separated from the village by an expanse of sand; the ancient harbor of Andriake is some 4 km to the W and 5 km from the city. The ancient site is now known as Kocademre.

The acropolis hill rises steeply behind the city; the summit is approached by an ancient road with steps, but now reveals nothing beyond a wall of late and inferior construction. At the S foot of this hill is the theater, of Roman type, measuring some 120 m in diameter. The cavea is supported on two concentric vaulted galleries, of which the outer is in two stories. Most of the seats and the vomitoria are in good condition. There is one diazoma, at the middle point of which is a projection from the wall with steps leading to the upper seats on either side; on the front of this projection is a figure of the Fortune of the city carrying rudder and cornucopia. On this same wall of the diazoma are painted names, apparently indications of reserved seats. Much of the stage building also survives.

The well-known Lycian rock tombs of Myra are in two main groups. Just to the W of the theater the steep face of the hill is honeycombed from top to bottom with closely packed clusters of tombs, showing a great variety of types, from the simplest to elaborate tombs of house and temple form decorated with reliefs in color. The greater number are not inscribed. Most of the inscriptions that do exist are in Lycian, a few in Greek. The other group, similar but less extensive, is in the E face of the hill looking towards the river valley. Here two tombs in particular are remarkable for their reliefs; one of them shows as many as eleven persons, male and female, adult and child, the members of the household of the deceased. Both the background and the figures themselves are colored, though the colors are now faded. To obtain the advantage of sunlight this E group should be visited in the morning.

On the E of the city the Myrus, now the Demre Çayı, reaches the sea; its wide stony bed is used as a road to the country around Kasaba. Though over 40 km in length, the stream dries up in summer. Water, supplied to the city by an aqueduct in the form of an open channel cut in the rock of the hillside some 3 m above the level of the valley, is said to come from a great distance. The valley, flanked on either side by high hills, narrows at the N end to an impressive gorge. Close to this N end, at Dereağzı, are the ruins of a large and handsome church, recently investigated.

The harbor of Andriake is little used nowadays. On its N side a short but abundant stream reaches the sea. There are numerous tombs cut in the rocks, but these are not of house or temple form and few if any date before the Imperial period. The well-preserved granary of Hadrian (60 x 30 m) is a 10-minute walk from the shore. It comprises eight chambers, long and narrow, communicating by doors, the two end chambers on the W smaller than the rest. Each chamber opens on the N facade through a door with a pair of windows above it. Between the windows and the door is a cornice with projecting consoles. Above the windows a shallow pediment is only partially preserved. At each end of the granary a small projecting chamber has an arched door at right angles to the others. The Latin inscription over the doors survives in part and contains the name of Hadrian; the building is identified as a granary by a late inscription in the front wall recording the construction of standard weights and measures for the cities of Myra and Arneai in accordance with specifications sent from Byzantium. Also in the front wall are busts of Hadrian and Faustina and a relief depicting two gods,

apparently Pluto and Sarapis, dedicated in obedience to a dream by a superintendent of the granary. The ruins of Andriake include also several large Roman buildings to the N of the granary and a tower on the headland to the W.

Some distance to the W of Myra, close beside the road to Sura, is a large and impressive built tomb still complete except for its roof. It dates from Roman times, but preserves the tradition of the Lycian tombs in having a bench round three sides of the interior and a basement corresponding to the hyposorium of the Lycian sarcophagi. It has no inscription.

At the W edge of the village of Demre stands the well-known Church of St. Nicholas of Myra. The only part which may date from the time of the bishop himself is the crypt, now considerably below ground level.

BIBLIOGRAPHY. C. Fellows, *Lycia* (1840) 194-202; T.A.B. Spratt & E. Forbes, *Travels in Lycia* (1847) I 125-34; E. Petersen & F. von Luschan, *Reisen in Lykien* (1889) II 23-38; G. Rickman, *Roman Granaries* (1971) 138-40P. G. E. BEAN

MYRINA Turkey. Map 7. City on the coast of Aiolis, about 37 km SW of Pergamon. Apart from a legendary foundation by Myrina, queen of the Amazons, nothing is known of the city's origin or of its settlement by Greeks. Its history also is almost a blank. Two earthquakes are recorded; in A.D. 17 Myrina was one of twelve cities destroyed in a night and rebuilt with help from Tiberius, and in A.D. 106 a second earthquake was again followed by rebuilding. Otherwise Myrina is known almost solely for the famous temple and oracle of Apollo at Gryneion.

The ruins are scanty. The city was built on two hills of modest height at the mouth of the river Pythikos or Titnaios, now the Güzelhisar Çayı. The main occupation was on the larger E hill, where there are slight remains of a polygonal circuit wall and more conspicuous remains of a Byzantine wall. At the W foot of this hill is a hollow which probably held a theater, though nothing visible survives. The smaller hill is terraced and was evidently occupied in antiquity, but here again nothing is standing. On the shore are remains of an ancient quay, interesting for the projecting blocks pierced with a round hole by means of which vessels were moored.

Over 4000 graves in the necropolis on the N slope of the larger hill and the S slope of the adjacent hill to the N were excavated in the 19th c., but nothing can now be seen. In general they were simple rectangular graves holding a single body, though there were also a few cinerary urns. The inscriptions, on tombstones or on bronze tablets, date the necropolis as a whole to the later Hellenistic period. The tomb contents were of great variety: small bronze coins for Charon's fare, plates and bottles for the dead man's food and drink, mirrors, needles, lamps and other objects of daily use, and over 1000 terracotta figurines rivaling those of Tanagra.

There are also a number of rock-cut tombs on the neighboring hills. One of them, now known as İntaş, comprises a central chamber with ten niches.

BIBLIOGRAPHY. E. Pottier & A. J. Reinach, *La Necropole de Myrina* (1887); C. Schuchhardt, *Altertümer von Pergamon* I, 1 (1912) 96-98; G. E. Bean, *Aegean Turkey* (1966) 106-10. G. E. BEAN

MYRINA, *see* LEMNOS

MYRTILIS (Mértola) Alentejo, Portugal. Map 19. Mentioned by Pliny (*HN* 4.22), Mela (3.1), Ptolemy (2.5), and referred to in the *Antonine Itinerary*. Myrtilis was the port of embarcation on the Guadiana for the copper mined in the neighboring mines of S. Domingo. Good examples of sculpture are preserved from the period of Roman domination. Six huge columns on the bank of the river have been thought the remains of a Roman bridge, but they are more likely the remains of an aqueduct of the Muslim period.

BIBLIOGRAPHY. L. F. Delgado Alves, "Aspectos da Arqueologia em Myrtílis (Mértola)," *Arquivo de Beja* 13 (1956) 21-104I. J. ALARCÃO

MYRTOS Hierapetra, Crete. Map 11. A small Roman settlement situated about 15 km W of Hierapetra, on the S coast. Minoan predecessors to the Roman settlement are sited 4 km E of Myrtos (Fournou Korifi, EM II), and on a high, conical hill immediately overlooking the Roman site (Pyrgos, EM III). In a circular building (shrine?) of Hellenistic date over the LM villa at Pyrgos was found a broken votive inscription to Aphrodite, Hermes, and all the gods (?). This suggests that the area was then part of the territory of Hierapytna, for the cult of Aphrodite is known in E Crete only there.

The visible Roman remains are concentrated on the W side of the modern village, on and immediately above the shore. The largest building to survive seems to have served as a cistern, and a circular plastered and buttressed structure NE of it may have fulfilled the same function. It may, however, be part of a bath building, and immediately W of it are extensive traces of a building with hypocaust heated rooms and at least two polychrome mosaics. This building, probably of 2d c. date can be seen to overlie earlier Roman remains. Fragmentary walls and surface finds can be traced over most of the area of the present village and the area immediately W of it and suggest a settlement of no more than 2 hectares. Finds from the site are mainly kept in the village school.

BIBLIOGRAPHY. L. Mariani, "Antichita Cretesi," *MonAnt* VI (1895) 321; S. Xanthoudides, "Paratema," *Deltion* 2 (1916) 25; M. Guarducci, *ICr* III (1942) 69, no. 39; 72, nos. 53, 54. K. BRANIGAN

MYTILENE, *see* LESBOS

MYTISTRATOS, *see* MISTRETTA

N

NABLUS, *see* FLAVIA NEAPOLIS

NAĞARA POINT, *see* ABYDOS

NAGES and SAINT-DIONISY Gard, France. Map 23. The great fortress known as Roque de Viou is situated in the communes of Nages and St.-Dionisy, between

Nîmes and Sommières. The site is a huge plateau (400 x 200 m) overlooking the Vaunage plain to the W and joining the hills of Langlade and Nages to the E.

Two main phases have been revealed. The first period of occupation covers the 8th and the beginning of the 7th c. B.C., the date of a group of primitive huts found on the site. Pottery and other articles have identified the first

inhabitants of Roque de Viou as the late Languedoc Urnfield people of the Mailhac 1 (department of Aude) type. The second period is in the 4th c. B.C. when a dry stone rampart more than 500 m long was erected on the most vulnerable side of the plateau. From the plan of the rampart wall it is clear that the oppidum was a barred spur. Inside the rampart were built stone houses, simple in plan, which contained quantities of local, Massaliot, Attic, and Italiot ware.

Roque de Viou was abandoned in the first years of the 3d c. B.C. The inhabitants moved 100 m E, to the Castels hill at Nages, at the foot of which is a gushing spring. Here they founded the first city of Nages, traces of which have been found—a circular rampart with a triple wall, and a few houses. The objects found here match the most recent finds at Roque de Viou. The first city of Nages was destroyed between 250 and 230 B.C., possibly by the Volcae Arecomici.

The second city, founded ca. 230 B.C., represents remarkable progress in city planning. It had a new rampart with a double wall, and one gate was protected by two enormous towers. Inside the rampart the city was laid out on an elaborate plan, with insulae and parallel streets of uniform dimensions. Between 200 and 175 B.C. the insulae were enlarged at the expense of the streets, which narrowed from 5 to 2.5 m. The second city shows the growing influence of Italic trade, as represented by vases with black varnish and Campanian amphorae. The local products, however, belong to a traditional civilization typical of the Rhone valley. This second city was partly destroyed between 120 and 100 B.C. and was superseded by a third, with a fortified area four times as large. A 1200 m rampart with many towers and gates encircled the hill, and the settlement grew considerably and became a regional capital. A tall temple was erected about 70 B.C. Roman influence was felt chiefly in trade; the actual civilization of the third city was Gallo-Greek.

The oppidum seems finally to have been abandoned ca. A.D. 10. The temple was burnt down and the inhabitants resettled in the plain around a villa of the Gallo-Roman type. Finds made at Roque de Viou and Nages are now housed in the Nages municipal museum, in the town hall.

BIBLIOGRAPHY. E. Flouest, "L'oppidum de Nages," Comptes rendus des Congrès scientifiques de France (1868) 339-44; Marignan, "L'habitat protohistorique de la Roque de Viou," Rhodania (1929) 194ff; "Informations," Gallia 20 (1962) 631-32; 22 (1964) 500-2; 27 (1969) 406; M. Aliger, "Nages, Gard, des origines à la fin de l'Ere antique," Celticum 16 (1967) 1-64MPI; M. Py, "Quelques précisions sur le site de Roque de Viou, prélude à la fouille méthodique du site," Ogam 20 (1968) 25-38; id. & F. Py, "Contribution à l'étude des remparts de Nages, Gard," Revue Archéologique de Narbonnaise 2 (1969) 97-121MPI.　　　　M. PY

NAGIDOS (Bozyazı) Turkey. Map 6. On the coast of Cilicia Aspera, 18 km E of Anamur. Colonized by the Samians according to Mela (1.77), but the eponymous founder Nagis (Steph. Byz. s.v.) is likely to be mythical. The city flourished in the 5th and 4th c., when it issued silver coinage, and is recorded by Hekataios (ap. Steph. Byz.) and Pseudo-Skylax, together with an island called Nagidussa. In later times little is heard of it, but it is mentioned by Strabo (670) as the first city E of Anemurion, and sherds and an inscription show that the site was occupied down to the 2d or 3d c. A.D.

The ruins are on a low hill just E of the village. An early circuit wall of mixed polygonal and ashlar masonry, with large blocks, still stands to a man's height for much of its extent. There are some pieces of similar wall in the interior, but no buildings are recognizable. An ancient road has been identified on the neighboring plain, and a small island close offshore evidently corresponds to the ancient Nagidussa; it is covered with ruins of late date.

BIBLIOGRAPHY. R. Heberdey & A. Wilhelm, Reisen in Kilikien (1896) 159; G. E. Bean & T. B. Mitford, Journeys in Rough Cilicia 1964-1968 (1970) 191-93.
　　　　G. E. BEAN

NAGYDÉM County of Veszprém, Hungary. Map 12. A hoard, found NE of the village, containing objects from a house shrine: a bronze lid, three bronze oil-lamps, a pitcher with decorated handle, and statues of Lar and Apollo. The Lar statue is 32 cm high and depicts a male figure clothed in a tunic. He wears a laurel wreath and holds a horn of plenty in the left hand and originally a patera in the extended right. The tunic displays the narrow stripes—clavus augustus—indicating the rank of knight. The statue may be dated to the first decade of the 1st c. A.D. and comes from southern Italy. The Apollo (38 cm including base) is a fully developed example of the type in Hellenistic art. It was probably made during the first half of the 1st c., during the time of Augustus, in a workshop of Hellenistic tradition. The bronze pitcher (20.4 cm high) is undecorated; the cast bronze handle depicts a Dionysian scene. It came to Pannonia from a workshop in Gaul at the beginning of the 2d c. Two of the oil lamps are typical of Early Roman types of the end of the 1st c. and the beginning of the 2d c. The third lamp depicts the head of a Nubian slave, the opening for the flame placed in the mouth. The oil lamps are 2d c., of North African origin, but such forms were also produced in Gaul during the 2d c. The bronze pan used to conceal the objects was found in bad condition. It is decorated with three grapeleaf-shaped handles. Such pans appeared in Pannonia during the 2d c. The motive for hiding the objects can be connected with the Marcomannic invasions (second half of the 2d c.). The museum at Bakony has the finds at the Lararium of Nagydém.

BIBLIOGRAPHY. E. Thomas, "Lar angusti Clavi," Folia Archaeologica (1963) 21-42; id., A nagydémi lararium. Das Lararium von Nagydém (1965) 31 pp.; id., "Apollo von Nagydém," Arch. Funde (1956) 230-31; id., Römische Villen . . . (1964) 282-87; I. Éri, "Geschichte der Erwerbung der Nagydémer Larariums," Veszprém Megyei Muzeumok Közleményei (1963) 27-38.
　　　　E. B. THOMAS

NAGYTÉTÉNY, see CAMPONA

NAISSUS (Niš) Yugoslavia. Map 12. The birthplace of Constantine the Great and Constantius III on the Nišava river 239 km S of Belgrade (Singidunum).

Following a Roman victory over the Dardani who occupied the region, the town was founded in the late 1st c. B.C. as a central base for Roman legions. When the province of Moesia Superior was organized in A.D. 15, Naissus became an increasingly important commercial and military center. Claudius II defeated the Goths near Naissus in A.D. 269.

Constantine I returned often to Naissus during his reign (A.D. 306-37) and the city profited by his visits. He founded Mediana as a small suburb of Naissus 4 km from the city on the road to Serdica (modern Sofia) and often stayed there himself. Constans, Constantius II, and Julian all passed some time in Naissus and Mediana and it was visited by many of the succeeding emperors (Amm. Marc. 21.10.5, 12.1; 26.5.1). The city was destroyed in the Hunnic invasion of 441. After a brief revival during the reign of Justinian, the city passed into Slavic hands in the late 6th c.

Part of the royal residence with mosaic floors has

been excavated at Mediana and a small museum built around one of the rooms. A bath has also been uncovered as well as parts of other residences. A late Roman cemetery was excavated recently within the confines of the Turkish fortress at Niš where part of the city wall of Naissus can still be seen. Four Early Christian churches and a number of vaulted tombs with Christian wall paintings (4th-6th c.) are in the suburb of Jagodin Mahala.

The Archaeological Museum at Niš has a moderately large and varied collection of antiquities from the region.

BIBLIOGRAPHY. Lazar Mirković, "La nécropole paléochrétienne de Niš," *Archaeologia Jugoslavica* 2 (1956) 85-100.
 J. WISEMAN

NAIX-AUX-FORGES, *see* NASIUM

NAKHSHAB, *see* ALEXANDRIAN FOUNDATIONS, 7

"NAKONA," *see* MONTE NAVONE

NAMUR, *see* NAMURCUM

NAMURCUM (Namur) Belgium. Map 21. A Gallo-Roman vicus of the civitas Tungrorum. Diverticula linked this center to the Bavai-Tongres road to the N and to the Bavai-Trier road to the S. At the end of the Iron Age a rather poor village existed at the foot of the modern citadel at the junction of the Sambre and the Meuse. Its humble remains have only recently been discovered. The village was located on the territory of the Atuatuci. It has been suggested that the oppidum Atuatucorum, besieged and taken by Caesar in 57 B.C., was located on the plateau of Le Champeau, with an area of 70 ha, at the spot where Vauban ordered the construction of the citadel in 1692. However, no Iron Age remains have been found on the plateau. The "Vieux Murs," destroyed by Vauban during the building of the citadel, probably were not Gallic but should rather be dated to the time of the Late Empire. It seems more likely that the oppidum of the Atuatuci should be identified with the hill of Hastedon, 5 km from Namur, where there are still remains of an enclosure built according to the murus gallicus technique. In any case, the vicus of Namurcum already was of some importance in the time of Augustus, as proved by sherds of Arretine terra sigillata (very rare in Belgium) found with other remains of the time of Augustus in 1967 during the construction of a house. This importance is understandable because Namur was the economic center of the Entre-Sambre-et-Meuse, a very fertile region where rich villas abounded (for example, Anthée, Gerpinnes, Maillen, Mettet, Rognée, etc.) and where there was a large ironworking industry. Since the vicus is located under the modern town, systematic excavations are impossible. However, stray finds and minor excavations occasioned by public works show that while the built-up area of the Early Empire had its center between the Sambre and the Meuse it also extended to Salzinnes and La Plante on both sides of the Champeau plateau. There was probably even a bridgehead on the right bank of the Meuse at Jambes. Necropoleis with incineration tombs of the first three centuries A.D. have been found on the outskirts of the built-up area, notably at La-Motte-du-Comte, Saint-Servais, Salzinnes, La Plante, and Jambes. Thus, it seems that the built-up area of Roman times was as extensive as the mediaeval town. The street network of the vicus is barely known, but since the old quarter of Namur has a checkerboard plan rather unusual for a mediaeval town, one may suspect that this regular network goes back to Roman times. Besides, that no large

Roman road passed through Namur suggests that water routes played a key role in the economy of the center and that there was a river port. The enormous quantities of Roman coins found in the Sambre near its junction with the Meuse probably is related to the existence of this river port. As far as remains of the vicus itself are concerned, apart from stray finds, the foundations of one large dwelling should be noted. It was brought to light in 1931 during public works in the Rue du Bailli. Two large rooms were cleared: the first was pierced on the inside by 5 semicylindrical and vaulted niches 1 m high; the second was above a hypocaust. In the fill there were bases of columns in white stone and small Tuscan columns 50 cm high. Supposedly these would have been on top of the niches just mentioned.

The vicus was sacked during the Frankish invasions of the second half of the 3d c. Traces of fire are found everywhere in the subsoil. Many hoards of coins found in Namur and neighboring villages were buried between 258 and 273. After the disaster, the town was rebuilt, but over a much more limited area. It was restricted to the space between the Sambre and the Meuse. It may have been fortified. Perhaps the Vieux Murs of the Champeau, mentioned above, date to this period and barred the isthmus between the two rivers. Nevertheless, all that is known of this period are a large number of coins and some inhumation tombs, notably at the Place d'Armes and La Plante. Nothing is known about Namur's fate at the end of the Later Empire and about the town's transition to the Early Middle Ages.

BIBLIOGRAPHY. R. De Maeyer, *De Overblijfselen der Romeinsche Villa's in België* (1940) 283-85; R. Demeuldre, "Le développement de la ville de Namur des origines aux temps modernes," *Annales de la Soc. arch. de Namur* 47 (1953) 1-156PI; F. Rousseau, *Namur, ville mosane* (2d ed. 1958); id., *Namur* (1965) 295-310P.
 S. J. DE LAET

NAMURT LIMANI, *see* KYME (Turkey)

NANSTALLON Bodmin, Cornwall, England. Map 24. A 1st c. fort of 0.8 ha, on an interfluvial spur at a height of 60 m on the left bank of the river Camel, SW of Bodmin. The defenses of three sides of the fort are incorporated in the present field banks, and the fourth side was leveled in the 19th c. Excavation, limited to the E half of the fort, has shown it was defended by a turf rampart and ditch, timber angle-towers and gates, and had the customary road system. The timber-framed gates were without towers, but had dual carriageways bridged by a superstructure carrying the rampart walk, as at the Lunt and Brough-on-Humber forts.

All buildings were of timber; the principia, the commander's house (praetorium), and a fenced enclosure containing a latrine, faced on the via principalis. Barrack blocks had seven double cubicles for the men and four or five rooms for officers, indicating a cavalry detachment. There were only small buildings between the barracks and the rampart, some workshops, a smithy, and stables, probably because the fort was intended for a larger garrison. The fort was built during the reign of Nero, probably after A.D. 60, and was abandoned ca. A.D. 80 at the time of Agricola's campaigns. The finds are at the Royal Institution of Cornwall Museum, Truro.

BIBLIOGRAPHY. A. Fox & W. Ravenhill, "The Roman fort at Nanstallon, Cornwall: excavations 1965-1969," *Britannia* 3 (1972) 56-111; Fox, "New light on the military occupation of South West England," *Congress of Roman Frontier Studies*, ed. E. Birley (1974).
 A. FOX

NANTES, *see* CONDEVICNUM

NAPLES, *see* NEAPOLIS

NAPOCA (Cluj) Romania. Map 12. An important Roman town on the Someş river. The mediaeval and modern towns built over the ancient ruins have almost entirely destroyed them.

The name, mentioned in ancient sources (Ptol. 3.8.9; *Tab.Peut.; Rav.Cosm.* 4.7), indicates that Roman Napoca developed on the site of a Dacian settlement.

The Roman settlement has been epigraphically attested since the time of Trajan (*CIL* III, 1627). Situated in the middle of a fertile agricultural area and on the main commercial and strategic road which crossed Dacia from S to N, Napoca developed as a commercial and handicrafts center. Hadrian, on the occasion of his visit to Dacia, made it a municipium (*CIL* III, 1454), and Marcus Aurelius, or Commodus made it a colonia (*CIL* III, 963). After the administrative reform of Hadrian in 124, Napoca became the capital of Dacia Porolissensis. The inhabitants were given the ius Italicum.

In the course of modern construction, the topography of the ancient town was clarified. Part of the town's inside wall (2.20 m thick) was discovered to the S. The town covered an area of 32 ha and the forum coincides with the present center of the town.

Archaeological, epigraphic, and numismatic material discovered over the centuries may be seen at the History Museum of Transylvania in Cluj.

BIBLIOGRAPHY. I. Mitrofan, "Contribuţii la cunoaşterea oraşului Napoca," *Acta Musei Napocensis* 1 (1964) 197-214; D. Tudor, *Oraşe, tîrguri şi sate în Dacia romană* (1968) 222-42; M. Macrea, *Viaţa romană în Dacia* (1969) 123-25. L. MARINESCU

NARBO (Narbonne) Gallia Narbonensis, Aude, France. Map 23. Narbo is at the crossroads of the via Domitia, which came from Béziers and went on to Spain, and the Aquitaine road, which led to Toulouse. It was 19.2 km from the sea near the outlet of the Aude (Atax) into the lacus Rubresus. The original town, which Avienus calls Naro (*Or. Mar.* 587), began early in the 6th c. B.C. on the hill of Montlaurès 4 km NW of the modern built-up area, which covers the Roman town. It was the main market and the capital of the tribe of the Elysicii. In spite of various vicissitudes, notably destruction ca. 400 B.C., it preserved its independence until the invasion of the Volcae in the 3d c. The town was then destroyed, but was rebuilt and continued to be occupied until the beginning of our era. Before the decline precipitated by the founding of the Roman colony, Naro was a flourishing center, thanks to the trade in British tin (Diod. 5.22, 38). A coin issued by the town in the 3d and 2d c. testifies to its prosperity. At the time of the Roman conquest, a very dense settlement had grown into two distinct parts over an area of ca. 30 ha. The upper town was built in terraces on the hill. It consisted of quadrangular huts cut into the rock, some standing free, some touching one another. The lower town was located around the acropolis down to the level of the lagoons. In it there clustered huts, first built of clay in the 6th c., then built of stone.

In 118 B.C. the Romans founded Colonia Narbo Martius (Vell. Pat. 2.7.8), undoubtedly on the site of the emporium of the city just mentioned. It played a military role during the invasion of the Cimbri, the campaigns of Pompey against Sertorius, the conquest of Gaul by Caesar, and the civil war. In 45 Caesar established a new colony on behalf of the veterans of the 10th Legion (Suet. *Tib.* 4). It then became Colonia Julia Paterna Narbo Martius Decumanorum. The first two centuries witnessed the town's zenith. In 27 B.C.

Augustus presided there over a general assembly of all Gaul. It received the title of Claudia, no doubt from Claudius. Trajan gave Narbo a fountain, and Hadrian stayed there in 121. Antoninus Pius restored the public baths, porticos, and basilicas destroyed by a serious fire in 145. At this time too Narbo was commercially prosperous. The port was divided into several sectors. At Narbonne itself there was only a river port, no doubt at the place known as Les Barques. But numerous wharfs were distributed in the nearby lagoons, on the islands of Sainte-Lucie and l'Aute, at Saint-Martin and La Nautique, whose peak in the first century coincides with the export of pottery from La Graufesenque.

Beginning at the end of the 2d c. Narbonne declined. It was severely affected by the fire of 145. Besides, it was off the increasingly important Rhône-Rhine axis, and its ports silted up. It escaped the invasions of the 3d c., but the Visigoths entered in 413. Their king, Athaulf, married Galla Placidia there in Jan. 414. The Visigoths were expelled before the end of the year and installed themselves in 418 in a territory extending from Toulouse to Bordeaux. From there they attacked Narbonne on several occasions, and finally, in 462, took it, thanks to the treachery of Count Agrippinus. Narbonne still preserved its monuments in the 5th c. (Sid. Apoll. *Carm.* 23.57.47).

Most of these monuments are known only by literary or epigraphic texts or by chance finds. On account of its military role the colony probably was surrounded by ramparts from the time of its foundation. It is not known, however, whether these were destroyed or enlarged at the time Caesar founded the Roman colony. Perhaps this first enclosure has been discovered N of the town near the gate called the Porte de Béziers in the Middle Ages. If so, it was provided with square towers 6 m on a side. To the S, the Aude served as a moat in all periods. However, the town of the Early Empire extended amply beyond the original perimeter and extended over ca. 100 ha. The best known rampart belongs to the smaller city of the Later Empire and dates no doubt to the end of the 3d c. It had a perimeter of 1,600 m and protected the center of the town and its main monuments (except for the amphitheater), covering an area of 30 ha.

The general topography can only be reconstituted by studying the plan of the mediaeval city. Its regularity reflects the cardines and decumani of the ancient town, located on the left bank of the river. The Via Domitia constituted the cardo maximus. It has been located, with its sewer, under the course of the Rue Droite, between the Pons Vetus (apparently of Roman origin but greatly rearranged) and the Place Bistan, the site of the forum. The latter, 85 m wide and 60 deep, was bordered by a portico. It was adorned by statues, whose dedicatory inscriptions have been found, and by an altar, which established the rules and calendar for the festivities in honor of Augustus (*CIL* XII, 4333). The Capitol stood N of the forum on the low hill of Les Moulinassès. This exceptionally important monument is known from excavations. It dates to the 2d c., no doubt later than the fire of 145. It stood on a podium more than 3 m high and measured 48 x 36 m. It was pseudodipteral, with 8 columns on the front and 11 on the sides (9 of the latter were engaged). From the pieces which have been found, the columns stood 18 m high and were of the Corinthian order. There was a spacious peribolus (127 x 87 on the outside) around the temple. The peribolus was surrounded on three sides by a double gallery. This was divided in the middle by pillars with two convex and two concave sides. The 4th side of the peribolus joined up with the portico of the forum. On the S side

near the crossing of the decumanus and the main cardo, the forum was bordered by underground constructions. Apparently these were horrea rather than cryptoporticos. The exact size of the building remains to be determined. The part investigated forms a regular quadrilateral (50 x 37 m) around a solid block. Each side included a corridor with a continuous semicylindrical vault; the corridor was flanked by cells to the left and right. The building was constructed under Augustus and underwent important modifications during the Middle Ages. Other underground galleries were also probably built at the same time, 150 m E of the forum at the intersection of a cardo and the main decumanus (Rue Garibaldi). They no doubt were the cellar-warehouses of one of Narbonne's markets.

The center of the town included other monuments which have left no traces, but which are known from Sidonius Apollinaris and from various inscriptions. Thus, there existed several bathing establishments, one of which was built E of the town in the 1st c. by the sevir Chrysanthus. The Temple Kybele stood in the same district. The bridge was framed by two monumental arches decorated with friezes of Gallic arms, preserved in situ at the Musée de Lamourguier. The theater has not been found, but the amphitheater (121 x 93 m) is located on the E outskirts of the town, ca. 500 m. from the ramparts of the Later Empire. It was bordered to the W by a spacious portico, 160 x 107 m. There, in a pool, the lex concilii provinciae Narbonensis was found; it fixes the privileges and obligations of the flamen of the province (CIL XII, 6038). This group, which included the amphitheater, porticos, public baths, and no doubt a market, was built perhaps in the Flavian period. It is believed to have been the provincial seat of the imperial cult.

This complex was separated from the center of the town by a district of urban villas. Several of these have been located by chance finds (walls, mosaics, inscriptions, statues). Built at the beginning of the 1st c. A.D., they were ravaged by a violent fire and abandoned during the course of the 3d c. Identical villas were located N and W of the center. Several necropoleis extended along Narbonne's outskirts. The main ones were on the Via Domitia, N of the town, and on the Aquitaine road to the SW. A 3d c. mausoleum has been found about 300 m from the right bank of the river next to the modern Church of Saint-Paul. It consisted of a rectangular chamber (6 x 5 m) with an apse on the E side. The Christians reutilized the mausoleum in the 5th c. by placing sarcophagi under the floor, because it stood not far from the spot where Paul, Narbonne's first apostle, was buried at the beginning of the 3d c. Other Christian burials have been found all around. The Christians of Narbonne first gathered together in a private house. This was succeeded by a basilica of the time of Constantine, located in the modern Cour de la Madeleine in the archbishop's palace. It was destroyed by invasions and replaced in turn by a basilica which Bishop Rusticus built from 442 to 445.

A large number of epigraphic documents come from the necropoleis. Together with all the finds from the town, they are kept in the very large lapidary museum installed in the Church of Notre-Dame de Lamourguière (1300 documents) and in the archaeological museum in the archbishop's palace.

BIBLIOGRAPHY. Bull. de la Commission Arch. de Narbonne (1890); 32 (1970); P. Helena, Les origines de Narbonne (1937)[I]; C. H. Benedict, A History of Narbo (1941); P. M. Duval, "A propos du milliaire de Cn. Domitius Ahenobarbus trouvé dans l'Aude en 1949," Gallia 7.1 (1949); V. Perret, "Le Capitole de Narbonne," Gallia 14.1 (1956)[P]; A. Grenier, Carte arch. de la Gaule romaine, fasc. XII, Aude (1959)[MPI]; Y. Solier, "Fouilles et découvertes à Narbonne et dans le Narbonnais," Bull. Com. Arch. Narbonne (1968) 30; (1965) 28[PI]; J. Giry & A. F. Mare, Narbonne, son Hist., ses Monuments (1969)[PI]; M. Gayraud, "Temple municipal et temple provincial du culte impérial à Narbonne," Mélanges Fernand Benoît, Rev. des Etudes Ligures (1970)[P]. M. GAYRAUD & Y. SOLIER

NARBONNE, see NARBO

NARCE Italy. Map 16. A Faliscan city on a triangular plateau on the right bank of the gorge of the Treia ca. 9.6 km S of Falerii Veteres. The Mola di Magliano joins the Treia at the N point of the site; the nearest town is Calcata, just N of this junction. The site is the center of extensive tomb fields. The tomb contents are like material from Falerii. The earliest graves, cremation burials of the early 7th c., contain vases of dark impasto; the ash urn is ovoid, never the characteristic biconical Villanovan shape. Cremation and inhumation graves of the orientalizing period produced wheel-made pottery, a characteristic red-slipped ware, local painted ware, and imported vases as well as many bronzes. This was Narce's great period. The rare burials of the 6th and 5th c. are usually chamber tombs, sometimes with a framed doorway carved in the cliff face. A few Attic black- and red-figure vases were found in these. Faliscan red-figure pots of the 4th c. are very rare, and there is nothing later.

Material from the tombs is in the Museo di Villa Giulia at Rome and in the University Museum at Philadelphia.

BIBLIOGRAPHY. A. Della Seta, Museo di Villa Giulia (1918) 88-103; E. H. Dohan, Italic Tomb Groups in the University Museum [University of Pennsylvania] (1942) 7-80; J. M. Davison, Seven Italic Tomb Groups from Narce (1972). E. RICHARDSON

NARNI, see NARNIA

NARNIA (Narni) Umbria, Italy. Map 16. A site set high above the gorge of the river Nar, the gateway from the Tiber valley into Umbria. The Umbrian town, called Nequinum, was taken in 299 B.C. by the Romans, who put a Latin colony here with the name Narnia. As a key point in the defense of Latium it had military importance throughout the Republic; the Via Flaminia passed through the town and branched here, the longer line running E through Interamna and Spoletium, the other to Carsulae and Mevania, to rejoin at Forum Flaminii. Narnia belonged to the tribus Papiria and was the birthplace of Nerva.

Nothing is known for certain about the topography of the ancient town, now overlain by later habitation, but the mountains here made the engineering of the Via Flaminia arduous. Several cuts and sculptures in the rock belong to this, while over the Nar itself just below the town one of the greatest of all Roman bridges, the Ponte d'Augusto, carried the road at a height of more than 30 m a distance of 160 m. Only the first of four arches is now whole, of concrete faced with blocks of travertine. The second arch, 32 m in span, ranked as one of the largest in Roman bridge building, and the whole work can be compared only to Trajan's bridge at Alcántara in Spain. It is unusual in that it lacks cutwaters. There are also three other Roman bridges near Narnia.

BIBLIOGRAPHY. PBSR 19 (1951) 91-100 (M. H. Ballance)[I]; P. Gazzola, Ponti romani (1963) 2.46, 57-59, 88-89[PI]; EAA 5 (1963) 352f (U. Ciotti). L. RICHARDSON, JR.

NARONA (Vid by Metković) Croatia, Yugoslavia. Map 12. An ancient site at the mouth of the Neretva (Narenta) river, whose valley served in all periods as the route for an exchange of the goods between the Mediterranean and the interior of the Balkans. Theopompus (Strab. 7.5.5) mentions it as a port of exchange between the Greeks and Illyrians in the 6th c. B.C. It served as a center for several Roman military campaigns in 156, 77, and 44 B.C. against the Delmatae and other Illyrians whose trading community was established there in the late 2d c. B.C. A seat of conventus iuridicus for the S part of the province of Dalmatia, Narona became the Colonia Iulia Narona between 47 and 27 B.C. The development of Salona in the 1st and 2d c. A.D. overshadowed Narona, whose commercial traffic was lost to the capital of province. A silting of the river mouth and marshes probably hastened this decline. It is last mentioned when its delegates attended Salona church councils in 530 and 533. After that it was probably destroyed by the Avaro-Slavic invasion.

To the NE of the village of Viol parts of the city walls and towers from the colonial period can be seen. The town was built partly on the hill, partly in the plain. Many inscriptions, and architectural and sculptural fragments are built into the walls of the village houses. In the gardens at many places foundations of the architecture with mosaics have been found. Systematic excavations are obstructed because marsh covers the greater part of the site. In the village cemetery some sarcophagi and fragments of sepulchral monuments can be seen. There is a local archaeological collection and also a number of finds in the Archaeological Museum at Split.

BIBLIOGRAPHY. C. Patsch, "Narona," *Zur Geschichte und Topographie von Narona (Schriften der Balkankommission, Antiquar. Abteilung,* Heft 5; 1907); id., "Aus Narona," *JOAI* 16 (1912) 75-82; I. Marović, "Novi i neobjavljeni nalazi iz Narone," *Vjesnik za arheologiju i historiju dalmatinsku* 54 (1952) 153-73. M. ZANINOVIĆ

NARYKA or Naryx (Rengini) Lokris, Greece. Map 11. A city in the E part of the region known chiefly as the site of the cult of Ajax Stammheros. It was destroyed by the Phokians in 352 B.C. during their war against Boiotia, but was rebuilt perhaps as early as 335 B.C. and survived at least until the time of Hadrian. An inscription found in excavating a late temple at Haghios Ioannis, below the mediaeval castle of Rengini, has fixed the location, thought by Bursian to be the predecessor of Pharygai at modern Mendenitsa. The Classical city, which had an outlet to the sea at Thronion, would have commanded the route from N to central Greece. There are a few visible remains of the Roman and Christian periods, with traces of Hellenic walls on the E slope of the acropolis.

BIBLIOGRAPHY. Strab. 9.4.2; Diod. Sic. 14.82, 16.38; C. Bursian, *Geographie von Griechenland* (1872) I 190; N. S. Papadakis in *Deltion* 6 (1921) 141.3; W. A. Oldfather in *RE* 16² (1935) 1772; A. Philippson-Kirsten, *GL* (1950-59) I² 345, 718ᴹ. M. H. MC ALLISTER

NASIUM Naix-aux-Forges and Saint-Amand-sur-Ornain, Meuse, France. Map 23. A large center, no doubt the richest of the civitas Leucorum. It is mentioned by Ptolemy (2.9.12) and also by the *Antonine Itinerary*; it appears on the *Peutinger Table* (Nasio). Nasium is situated on the course of the Ornain, at the foot of the prehistoric oppidum of Boviolles, at the crossroads of two large roads, one coming from Andematunnum (Langres), the other going from Durocortorum (Reims) to Tullum (Toul).

During the course of the 19th c. excavations were car-

ried out on the site of the ancient town. They brought to light the foundations of many public buildings, houses, and villas, some of which were decorated with marble and wall paintings. There were mosaics, one of which, depicting the rape of Europa, was almost immediately destroyed, only a drawing surviving. There were also public baths, a system of water channels, and a smithy. Today there is no trace in situ of these discoveries. The excavations at least established that the Gallo-Roman town had been mostly destroyed during the invasions of the 3d c. Most of the sculptures, the inscriptions, and the more valuable objects discovered during the course of these investigations and afterward, as a result of various public works projects, were taken to the Bar-le-Duc museum. These included fragments of architecture and ornamental sculpture (capitals, cornices, friezes), funerary stelae, and above all a statue depicting a "mother goddess" (height: 1.57 m) sitting in a backed chair, with fruit in her lap and accompanied by two other women and a dog.

Other ancient remains from Nasium are kept at the museums at Metz (a votive altar dedicated to Epona and the tutelary spirit of the Leuci), Verdun (stelae and inscriptions), and Nancy (a bronze domestic altar adorned with an owl, a bust of Hygeia, and a tutelary spirit, all likewise in bronze; a monumental letter R, apparently belonging to a metal inscription; etc.). The site also produced two very rich hoards of coins: one of 300 aurei was dispersed; the other contained gold jewelry, including a necklace adorned with a cameo of Julia Domna, as well as Severan aurei, and is preserved at the Cabinet des Médailles of the Bibliothèque Nationale. Of the innumerable small finds (statuettes, pottery, cameos, and intaglios, gold and bronze rings, coins), some were kept in museums, mostly at Bar-le-Duc, but the great majority were sold to private collectors.

Since 1967 new archaeological investigations have been conducted on the Mazeroy plateau overlooking the ancient town. They have resulted in the discovery of a large, square (24 m to a side), raised monument, probably a temple. It must have been very carefully built and adorned to judge from the architectural and decorative fragments which have been collected: marble slaps and moldings, sculptured fragments apparently belonging to a decorative frieze, especially pieces depicting small human figures, animals (birds, rabbits, a bull) among twining vegetal motifs. A portico extended around the building; its walls have been found as well as the bases of the colonnade. Further exploration of this edifice is now in progress.

BIBLIOGRAPHY. Cl.-F. Denis, *Essai archéologique sur Nasium* (1818); F. Liénard, *Archéologie de la Meuse* (1881) I 9-36ᴹᴾᴵ; L. M. Werly, "Note sur diverses antiquités récemment découvertes à Naix," *Bull. arch. du Comité des travaux historiques* (1885); M. Toussaint, "Le long de l'Ornain: Naix-aux-Forges et son passé gallo-romain" in *Pays Lorrain* (1937) 106-24ᴵ; id., *Répertoire archéologique Meuse* (1946) 13-40; R. Billoret in *Gallia* 26 (1968); 28 (1970); 30 (1972). R. BILLORET

NAUKRATIS (Kom Giéif) Egypt. Map 5. About 65 km SE of Alexandria on the W or Canopic branch of the Nile, near the modern village of El-Niqrash. After recruiting Greek mercenaries to assist him in driving the Ethiopians from Upper Egypt, Psammetichos I (664-610 B.C.) settled the mercenaries at Daphnai, on the E branch of the Nile and, at the same time, apparently permitted Greek traders from Miletos to form a station at Naukratis (Herod. 2.97 et passim). Under Amasis (570-526 B.C.), the city became the most important commercial town and the trading center with the west.

It was the only place where Greeks were allowed to dwell when they were in Egypt for business. The town contained separate quarters for Milesians, Samians, and Aeginetans, each with its sanctuary (for Apollo, for Hera, and for Zeus respectively). Other Greeks shared a concession (temene) which they called the Helleneion. The city continued to flourish through the Saitic period. When Alexander the Great arrived in Egypt (332 B.C.), he was undoubtedly welcomed by the Greeks of Naukratis. On leaving the country six months later, he appointed Kleomenes, a resident of Naukratis, as both financial governor of Egypt and contractor for the building of Alexandria. With the establishment of the Ptolemaic capital in Alexandria, Naukratis ceased to be the only commercial emporium in Egypt. It continued, however, to serve as a transit station for all imported and exported goods. Moreover, Naukratis was then the only city to strike her own coins both in silver and bronze. The first Ptolemies at least did not completely neglect the old city: inscriptions found on the site show that buildings were erected under Ptolemy I Soter and Ptolemy II Philadelphos. The limestone stela (Damanhur Stela), decree of the year 23 of Ptolemy V Epiphanes, with a copy of the hieroglyphic text of the Rosetta Stone, was found here and was probably from the Great Enclosure. During the Roman Conquest, the city steadily declined, and the excavations have yielded nothing that dates after the 2d c. A.D. Although the city continued to appear in travelers' records for some time, even its locality was hard to identify. At the present time, vegetation has covered the whole site. Many of the finds are to be found in the Graeco-Roman Museum in Alexandria.

BIBLIOGRAPHY. W. M. Flinders Petrie & E. A. Gardiner, *Naukratis* I, II (1886-88)MPI; R. M. Cook, "Naukratis" *JHS* (1937) 227ff; A.J.B. Wace, "A Grave Stele from Naucratis," *BSRAA* 36 (1943) 26-32; A. Zaki, "A Dedicatory Stele from Naucratos," *Etude de Papyrology* 7 (1943) 73-92; J. J. Dunbabin & D. L. Page, "An inscribed sherd from Naukratis," *BABesch* 24-26 (1949-51) 52-53; F. W. von Bissing, "Naukratis," *BSRAA* 39 (1951) 33-82. S. SHENOUDA

NAUPAKTOS, *see* WEST LOKRIS

NAUPLIA Argolid, Greece. Map 11. The name derives from the legends associated with the original Nauplius of tradition, son of Amymone and Poseidon. The two imposing rocks of the peninsula, Its Kale and Palamedi, face one another across an inner bay of the Gulf of Argolis. The town is on the flat N side of the harbor, with N-S streets which climb by steps to the higher S level. Pronoia is on the E land side of the strong fortress of Palamedi which can now be approached by a motor road, though formerly only by steps (857).

Archaeology: The Classical acropolis was presumably on Its Kale. Blocks from the original walls, ca. 300 B.C., the earliest now visible, some polygonal, have been reused in later fortifications and there are traces of cuttings and steps. The earliest excavations in the Pronoia area revealed Mycenaean chamber tombs and recently work there has added rich examples. In the 1950's Geometric finds outnumbered Mycenaean. In 1970-71 excavations in the area produced evidence of Neolithic and of Early and Middle Helladic occupation. The presence of cavernous holes seems to confirm Strabo's reference to a "man-made labyrinth" and "caves." Continued excavation here may well prove this region to have been an important center of the EH period.

History and Chronology: Nauplia was a member of the Kalaurian Maritime League, but in the 7th c. B.C. was conquered by Argos, its natural rival. Its succeeding

history, disturbed by conflicts, is meager. It includes a transference of population during the Messenian Wars; Pausanias found the site deserted.

BIBLIOGRAPHY. Paus. 11.38; Strab. 369.373; R. & K. Cook, *Southern Greece* (1968); Archaeological Reports in *BSA* (1971) 11; Deilaki in *AAA* 1 (1971) 10-11; H. Wace, *Nauplia*, 3d ed. (1971); id., *EAA*, s.v. Nauplia (q.v. for bibliography). H. WACE

NAVIO (Brough-on-Noe) Derbyshire, England. Map 24. Roman auxiliary fort controlling the Peak district. The Buxton milestone shows its Roman name. There are four periods on the site: 1) An initial Flavian earth and timber fort lasting to ca. A.D. 120. 2) Reoccupation ca. A.D. 154-158, attested by an inscription of the governor Iulius Verus found reused in the sacellum of the later principia. While the latter was presumably of stone, the granaries and barracks were of timber and the orientation of the fort had been reversed. 3) Severan rebuilding in stone of at least the granaries and the principia, with remodeling of the timber barrack-blocks. 4) Early 4th c. reconstruction of the barracks as half-timbered structures, and rearrangement of the granary and praetorium. The end of the military occupation appears to have occurred shortly after A.D. 350, with no trace of a disaster.

The Antonine inscription was found early in this century, but excavations began only in 1938-39. They revealed a Flavian fort dismantled in the late Trajanic-early Hadrianic period, probably in the prelude to the construction of Hadrian's Wall. The Flavian site seemed to show considerable differences in alignment from its Antonine successor; and this was confirmed in 1966-69 with the excavation of much of the praetentura of the later fort. The Flavian plan faced in the opposite direction from that of its successors. Elements of the Flavian praetorium and granaries, for instance, appeared in the later praetentura on the N side of the Antonine via principalis. This implies that the early fort faced SW. The defenses on that side lying within the later retentura had already been discovered. At the NE end Flavian construction trenches were found sealed beneath the mass of the Antonine rampart, indicating that the Flavian defenses must have extended farther N. The N side of the fort must therefore have been subject to erosion from the Noe river during the 30 or so years between the abandonment of the original fort and the Antonine reoccupation. The reconstructed dimensions of the Flavian site would therefore make it at least 1.24 ha, large enough, like Castleshaw, to accommodate a small infantry cohort.

Less is known of the middle periods of the fort's history. The Severan reconstruction fits in with developments elsewhere in the Pennines, although continuous occupation throughout the 3d c. cannot be proved. The fourth and final phase, however, is more fully documented. The praetentura of the fort was occupied by six buildings, the outside pair of which were certainly stables aligned per strigas. They measure 40.5 by 8.4 m, with the weight of the roof carried on the outside walls and a wall running down the center; mucking-out drains prove that they were stables. The other half of the building in the area excavated appeared to be a workshop or smithy rather than living accommodation. Coin evidence points to the beginning of this occupation period as shortly after the reign of Carausius, and continuing to the middle of the 4th c. By implication, of course, the garrison in the late period must have been at least partly mounted, but it is not known whether the first cohort of Aquitanians known in the Antonine period was still stationed here.

A postern was apparently created in the E defenses in the early 4th c., but its function is not clear. Like the E

gate, it led to the side of the hill on which the vicus lay, close to the line of the Batham Gate, the Roman road leading S to Buxton. A bath building probably lay close to the Noe at the E edge of the vicus.

BIBLIOGRAPHY. G.D.B. Jones & J. P. Wild, Annual Reports in *Derbyshire Archaeological Journal* (1965-69); id., "The Romans in the North-West," *Northern History* 3 (1968) 1ff[MP]; id., "Excavations at Brough-on-Noe," *Derbyshire Archaeological Journal* (1970) 99ff[PI].

G.D.B. JONES

NAXOS Greece. Map 7. Largest island of the Cyclades, E of Paros and S of Delos.

In the 3d and 2d millennia B.C. it was a center of Cycladic culture and art. The graves of this period, which are found all over the island, testify to a dense population, but very few remains of houses have been excavated. The graves indicate that Naxos was the chief center for the production of the marble Cycladic idols which were the forerunners of Greece's great sculpture. One of the local natural resources was emery, which was used to smooth the surface of the large-grained Naxian marble. Naxos was preeminent also in the Mycenaean period (LH III). The tradition that Dionysos was born in Naxos (his cult was transferred to Paros, according to Archilochos), the story of Ariadne, the capture of the island by the Thracians, the establishment there of the cult of Otos and Ephialtes, all reflect the importance of the island at that time.

The Protogeometric and Geometric periods (11th-8th c. B.C.) are richly represented, but from the 7th c. on we can follow the development of the island in literary sources as well. It was a rival of Paros and joined the Chalkidian forces during the Lelantine war (8th-7th c. B.C.). With Chalkis, Naxos joined in the colonization of Sicily, where Naxos (founded 735 B.C.) took its name from the island. During the war with Paros, which may be considered a part of the Lelantine war, a Naxian killed Archilochos. The differing directions taken by their art illustrate the lack of accord between the two islands, as well as their respective fields of colonization: Paros in the Aegean and Naxos in the W. The power of Naxos during the 7th and 6th c. is witnessed by the number of Naxian dedications at Delos, but Naxian hegemony over the Cyclades is unlikely.

The tyrant Lygdamis (ca. 540-524 B.C.), a friend and ally of the tyrants Peisistratos and Polykrates, put an end to the aristocratic constitution of Naxos. The ten-year naval supremacy of the island (thalassocracy) is attributed to him, but his tyranny was ended by the intervention of the Spartans.

Naxos was the first to resist the advance of the Persians, ca. 500 B.C. The Persians were helped by the island's old enemy, Miletos, in their attempted expansion to the W, but Naxos, with luck and strength (8000 hoplites, numerous ships, strong walls, and the betrayal of the Persian plans by Miletos, according to Hdt. 5.28f) repulsed the attack. The island did not long escape subjection, however, and her city and shrines were destroyed during the campaign of Datis and Artaphernes in 490 B.C. During Xerxes' campaign the four Naxian ships joined the Greek fleet. A member of the Athenian Alliance, it was the first city which was subjugated by the Athenians (470) and later received Athenian cleruchies (ca. 450 B.C.).

After the Peloponnesian war, Naxos regained her independence, but had lost the power to pursue her own policies against successive domination by the great powers (Spartans, Athenians, the Hellenistic kings, etc.) in the Aegean. The island, however, retained a measure of importance because of its situation and size.

The few monuments preserved are scattered throughout the island. The polis lay on a hill commanding the harbor; the acropolis was probably under the modern town, Kastro. On the shore to the N (Grotta) portions of the Cycladic, Mycenaean (LH III) and Geometric city (several successive layers, all below sea level) are still being excavated. Inland a part of a square building ca. 60 m on a side has been uncovered. It has four colonnades on the sides and bases for dedications in front of it. This was perhaps the agora for the city of the Early Hellenistic period. Across the torrent bed, which cuts off the plain of the lower city, the hill of the Haplomata extends NE. On it is a necropolis notable for its finds, chiefly Cycladic and Mycenaean chamber tombs, in spite of destruction during expansion of the city in the Late Hellenistic period. A little nearer the shore at a site called Kaminaki, important finds have been made: pottery, jewelry, and a part of an archaic kore, from an unknown shrine. Its building has probably collapsed into the sea. Finds have demonstrated the existence of a shrine of Demeter behind and E of the present Gymnaseum of Naxos.

A huge marble doorway (h. 7.9 m including the lintel, w. ca. 6 m) has always been visible on the hill called Palatia left of the modern harbor entrance. Excavation has shown this to be the door to the cella of an archaic Ionic temple from the time of Lygdamis (ca. 530 B.C.), the foundations of which are preserved. It was a peripteral temple with a double colonnade on the short sides (a form simpler than that of the great dipteral temples of Ionia) with a pronaos, cella, and opisthodomos, and it was never finished. During its conversion into an Early Christian basilica the floor was lowered, and the ancient flooring was destroyed along with the whole form of the temple. There is a jamb under a garden wall near the quarry of Phlerios which resembles those on the hill of Palatia and was destined for the temple. Very few architectural fragments have been preserved. The temple may have been dedicated to Apollo.

Not far from the city, in the little valley of the Phlerios near the village of Melanes, among the marble rocks on the slope lies a kouros, ca. 5 m long, dating to the early years of the 6th c. B.C., which was abandoned shortly before the work was completed. There is another without a face, from the same period, a little higher up. From this point to Potamia there are numerous marble quarries.

At the quarry on the N end of the island, on the promontory of Apollo, there is a colossal archaic statue (h. 10.05 m) a little above the sea. It still occupies the spot where work on it was begun. It is a male, bearded, clothed figure with right hand extended. It dates from ca. 570 B.C. and may represent Dionysos. The area is dedicated to Apollo, as is evident on a rock-cut inscription a short distance away: "Boundary of Apollo's sacred territory."

At the site called Gyroulas or Marmara, near the village of Sangri, are the remains of a square temple (13 m on a side) which was transformed into an Early Christian basilica. It was lengthened by an apse at the E, the entrance was moved from the S to the N side, the floor was lowered, and the inner columns moved down from the original stylobate into two rows of depressions cut in the living rock (these depressions may have belonged to an earlier building period). Three columns of each row can be made out, and each row was terminated at either end by a parastade of a simpler type than in the doorway at Palatia. The column bases are preserved, each with a two-banded scotia, also numerous fragments of the superstructure (beams, geison, etc.). The temple was square in plan, with a round bothros in front, and

numerous dedicatory inscriptions which indicate the temple should be interpreted as a Thesmophorion.

On a second acropolis at Epano Kastro is a Venetian fortress; under its S side is a portion of an ancient wall. This acropolis is probably connected with a series of tombs of the Protogeometric and Geometric periods close to the nearby town of Tsikalario. Beside the tombs are huge, upright, unworked stones (marking stelai or stelai semata).

About a three-hour drive SE of Philoti is the almost completely preserved round tower of Cheimarros. Most of the Cycladic tombs of the island have been found in the now uninhabited SE area of Naxos, but only minimal signs of Cycladic dwellings. There is a square granite tower in the area of Plaka near Agiersani.

The museum of the city of Naxos has been much enriched by recent excavations, most notably its collection of Cycladic, Mycenaean, and archaic remains (pottery and plastic arts). A smaller museum at Apeiranthon houses Cycladic idols and pottery of the area, curious stones, and primitive carvings.

BIBLIOGRAPHY. G. Colonna s.v. Nasso, *EAA* (1963); R. Herbst s.v. Naxos, 5 *RE* (1935); Temple on Palatia: G. Gruben & W. Koenigs, *AA* (1968) 693ff; (1970) 135ff; Unfinished Kouroi: C. Blümel, *Bildhauerarbeit* (1927) 5f; V. Massow, *AA* (1932) 264 (inscription to Apollo); Sanctuary of Demeter at Sangri: *Praktika* (1954) 330ff; Tower of Cheimarros: Γ. Δημητροκάλλης, Ὁ ἀρχαιοελληνικός πύργος τοῦ Χειμάρρου στή Νάξο, *Τεχνικά Χρονικά* (1964) 52ff.

Archil. frag. 115 *Anth. Lyr.* = *PGL* II 388, 17; Horn. *Hymni* I 44; Herod. 1.61.64, 5.28-34, 6.95, 8.46.

N. M. KONTOLEON

NAXOS (Punta di Schisò) Sicily. Map 17. The first colony founded by the Greeks in Sicily, in 734-33 B.C. according to Thucydides (6.3). The site, in the district of Giardini, is on a level area of lava flow from the Moio volcano between the mouth of the Santa Venera stream (SW) and a small bay NE which was favorable as a landing. The area, closed in by the ridges of Monte Tauro, where Taormina is situated, is ca. 1 km from the Alcantara river, which must have constituted the only important means of communication with the inland areas.

The site appears to have been inhabited from prehistoric times. Remains of neolithic huts have been isolated as has a flourishing settlement of the Bronze Age (with pottery in the style of Thapsos). For the period immediately preceding colonization, traces of the presence of the Sikels have been found who, according to Strabo, were in the area when the Greeks arrived. The founders of Naxos were primarily Chalkidians, but Ionians were also involved, and their leader was Thoukles.

Notices regarding life in the colony in the 7th and 6th c. B.C. are sparse. The only notable episode in this period is the foundation of Kallipolis. At the beginning of the 5th c. B.C., Naxos, together with other Chalkidian cities, was attacked by Hippokrates of Gela and the citizens expelled. Only after 460 B.C. did life in the city begin again. In the war between Syracuse and Athens, Naxos was on the side of Athens. Some years after the defeat of Athens, Dionysios of Syracuse took the city (404-403 B.C.) through a ruse, according to Polyainos (5.2.5), destroyed it, and gave its territory to the Sikels, while the citizenry was dispersed (Diod. 14.87). In the second half of the 4th c. B.C., a new city arose over the destroyed one and coined its own money. Recently, some of its tombs have been discovered. A small nucleus of homes must have survived around the bay down to the Roman and Byzantine periods.

In addition to large sections of the perimeter of the walls, excavations have brought to light elements of the urban plan from the archaic and Classical periods. To date, two phases have been recognized: one dating to the 7th-6th c., and the second corresponding to the reconstruction of 460 B.C. There is particular interest in the first phase of the settlement for the study of Greek city planning, since it is part of a colonial foundation which precedes the work of Hippodamos of Miletos. Some quarters have been partially explored including the N sector, a group of dwellings N of the W sacred precinct, and the E sector.

The sacred precinct in the extreme SW corner of the city near the Santa Venera has been uncovered almost entirely. This is perhaps the temenos epithalassion of Aphrodite mentioned by our sources (App. *Bell. Civ.* 5.109). There is also a trapezoidal enclosure built in two periods (between the end of the 7th c. and the middle of the 6th c. B.C.). It contains the foundations of two buildings: Temple A, the oldest (about 600 B.C.) and Temple B (525 B.C.). There are also a square altar with three steps and two kilns for architectural terracottas and pottery of the same date as Temple A.

The walls which enclose the temenos are imposing and were constructed of lava rock of quite accurate polygonal workmanship, comparable to the walls at Delphi and at Smyrna. They constitute one of the the most interesting examples of such workmanship in the W Mediterranean area. That technique, in fact, is rarely encountered in this area in the archaic period (cf. the examples at Velia and at Lipari).

To the two sacred buildings have been attributed two architectural terracotta friezes of which numerous examples are extant collected in a storeroom near the N wall of the temenos (wall E). The most recent series, belonging to Temple B, is composed of simas and chests with molded and painted decorations. There is a frieze of lotus and palm leaves, evidently based on Ionic models.

The series of Silenos antefixes must have adorned smaller buildings and are of various types, from one very old example with a counterpart in Samian models dating to the second half of the 6th c. to more recent ones from the mid 5th c. B.C. The materials found in the sacred precinct comprise terracotta figurines (usually standing female figures with a dove or flower on the breast), various types of pottery, and numerous spear and sword points. These materials were found deposited in trenches or in thysiai, together with the bones of sacrificed animals, often near stones which were set upright and used as stelai. These thysiai were set out around the altar.

The potters' quarter has been extensively explored. It was situated on the edge of the city, in the N sector in the vicinity of Colle Salluzzo. There is also a complex of three kilns, two circular and one square, which were active in the 6th and 5th c. B.C. Remains of buildings have been brought to light which were used for the working of pottery and as depositories for equipment, among which the molds for Sileni antefixes and for figurines have been discovered. The site of the altar of Apollo Archagetes is not known, but it was nearby that the Greeks united before their expeditions and, according to Thucydides (6.3), it was outside the city.

In the necropolis a group of tombs dating to the 6th-5th c. B.C. have been recovered W of the Santa Venera, ca. 600 m from the river, while 4th c. tombs have come to light in the immediate environs of the river as well as over the slopes of the hill on which the modern cemetery is located.

The renowned coinage of Naxos (6th-5th c. B.C.)

shows consistently the head of a bearded Dionysos in profile, crowned with ivy and grape clusters hanging from vine shoots. Later, other subjects were substituted, such as the crouching Silenos raising a kantharos on high.

Naxos produced pottery of distinctive character particularly in the 8th c. and 7th c. B.C. It is distinguished from the other Sicilian shops (those at Syracuse and at Megara Hyblaia) by decorative motifs which nearly always recall the influence of Euboean-Cycladic pottery.

The initial dig in the archaeological zone has already been opened to the public and the site will, as time goes on, extend over a large part of the city. Today, it includes the Sanctuary of Aphrodite, the W stretch of the city walls, and the quarter of the vase makers in the district of Salluzzo. An Antiquarium situated on Punta di Schisò is now being built.

BIBLIOGRAPHY. P. Rizzo, *Naxos siceliota* (1894); H. Cahn, *Die Münzen der sizilischen Stadt Naxos* (1944); G. V. Gentili, "Naxos alla luce dei primi scavi," *BdA* (1956) 326ff; P. Pelagatti in *Cronache di Archeologia e Storia dell'Arte* 4 (1965) 326ff; id., in *Kokalos* 14-15 (1968-69) 350ff; id., "Relazione preliminare della campagne di scavo 1961-64," *BdA* (1964) 326ff; id., "Naxos II, ricerche topografiche e scavi 1965-70," *BdA* (1972) 211ff. P. PELAGATTI

NEA ANCHIALOS, see PYRASOS

NEANDRIA (Çigri Dağ) Troad, Turkey. Map 7. The Greek name Korone, referring to the territory of the city, is arbitrary. Though sources are scarce, some information appears in Strabo (*Geogr.* 13.604), Pliny (*HN* 5.30.122) and Xenophon (*Hell.* 3.1.16). Its name appears from 454 to 431 in the tribute lists of the Attic maritime league. From 399 Neandria fell under the satrapy of Mania, and at her death, under Dercyllidas (Xen. *Hell.* 3.1.16). In 310 B.C. the population of the city was transferred by Antigonos to Antigoneia (later *Alexandria Troas*) (Strab. *Geogr.* 13.593,597,604,607). At the end of the 4th c. B.C., with the synoecism of the work of Antigonos, one may consider the history of the city closed.

The ruins of Neandria are at a height of 500 m on a granite crest of Çigri Dağ near the sea, to the S of the river Skamandros and of Troy. The walls have a continuous socle and average 3 m in thickness. They enclose an irregular polygon, with a perimeter of 3200 m. The enclosure has 11 towers and as many openings; 4 principal towers, at the extremities of the perimeter, are built to double size, jutting out to protect recessed gates joined to the wall by large angle-walls. The arrangement described has been assigned to the 5th c. B.C. on the basis of the masonry technique, which is of the irregular trapezoidal type. However, to the principal tower on the S side a section of wall was added in trapezoidal isodomic technique with squared facings, datable to the 4th c. B.C.; while at the SE corner of the enclosure there is a section constructed of overlaid rough stones, certainly from the 6th c. B.C. A long section of wall on the W side of the city may be assigned to the beginning of the same century. A road crosses the city from N to S, lined with groups of houses constructed of accurately squared blocks, datable to the 5th c. B.C. Remains of archaic houses are to the W of the road. To the N of houses from the Classical period, between them and the city wall, is a large space recognizable as the site of the stadium. About 1 km outside the encircling wall to the S there is a square area where inscriptions have been found attesting to the existence of a sanctuary of Zeus. Necropoleis have been found to the N, NE, E, S, and

SW of the walls. The burials are between slabs of terracotta, in pithoi, in caskets made of slabs, in monolithic sarcophagi, or in sarcophagi constructed of slabs. Several tombs on the S side are marked by miniature tumuli of earth. An actual tumulus ringed with large stones has been identified to the S of the principal tower on the S side of the city wall. Within the walls, on an esplanade in the center of the city, a Temple to Apollo has been found. On the terrace of the substructure (12.87 x 25.71 m) rises the true cella, a rectangle 8.04 x 19.82 m. The entrance is at the NW, the longitudinal axis of the temple being oriented NW-SE. Along its length, aligned inside the cella, is a row of seven columns that divide the temple into two aisles. The entire construction is in local limestone. The columns rested on socles, without bases, and had smooth and highly tapered shafts. Each column was surmounted by a so-called Aiolian capital (sometimes called proto-Ionic) consisting of two elements. A low, shallow abacus rises from a palmette that flowers between two spiral volutes which constitute the echinus; the true capital is separated from the shaft by two foliated rings (so-called water lilies), between two convex moldings. The columns sustained the principal beam of the roof, which must have been sloping, forming pediments on the short sides. The covering was of tiles with sima and antefix of terracotta, several decorated fragments of which have been found. The capitals, whose elements vary from example to example, were reconstructed (by Koldewey). The graphic reconstruction and restoration of the fragments have been accepted in general, but contrary opinions have been expressed. On the basis of comparison with capitals recently discovered at Thasos, some feel the foliated elements of the Aiolian capitals at Neandria should be considered apart. Abutting the short SE side of the temple's podium an inscribed base has been discovered that mentions a statue of Apollo. A little farther S are the foundations (4.8 x 4.1 m) of the altar of the temple. The coins of Neandria, almost entirely in silver with the head of Apollo on the obverse, are datable between 430 and 310 B.C., but throw little light on the final period of the city's life.

BIBLIOGRAPHY. F. Calvert, *ArchJ* 12 (1865); C. T. Newton, *Travels and Discoveries in the Levant* I (1865); R. Koldewey, "Neandria," *51 Winckelmannspr.* (1894); W. Andrae, *Die ionische Säule* (1933); R. L. Scranton, *Greek Walls* (1941); W. B. Dinsmoor, *The Architecture of Ancient Greece* (1950); A. Ciasca, *Il capitello detto eolico in Etruria* (1962); A. v. Gerkan, *Neue Beitr. z. Klass. Altert.* (1954); R. Martin, *Etudes d'Arch. Class.*, I (1955-56); E. Akurgal, *Anatolia* V (1960).

For the coins: W. Wroth, *British Mus. Coins, Troad, Aeolis, and Lesbos* (1894). *For the inscriptions*: L. Robert, *Villes d'Asie Mineure* (2d ed. 1962). N. BONACASA

NEA PHLOGITA, see APHYTIS

NEA PLEURON, see PLEURON

NEAPOLIS (Limassol) Cyprus. Map 6. On the S coast in Greek Lemesos. Remains of a sizable town, whose limits are difficult to define, are largely covered by the modern town. The necropolis lies E and N.

Practically nothing is known of the founding of this town except that it must have succeeded a Late Bronze Age settlement located N of Limassol. On present-day evidence the town was in existence from Geometric to Roman times but the area had been inhabited since the Early Bronze Age and after the Roman period. Nothing is known of its early history and by the time this place is known by a name we are already in post-Roman times. By the 5th c. A.D. it was a town of some impor-

tance with an established episcopal see. It was then known by several names such as Neapolis, Theodosias, or Theodosiana. By the following century this had become Nemesos. The name Neapolis, however, might be earlier (Βίος Αὐξιβίου 13). The Life informs us that Tychicos I was consecrated to the see of Neapolis in the time of St. Paul.

The name appears in an inscription of the second half of the 3d c. B.C. This inscription, which was acquired in the village of Gypsos in the hinterland of Salamis, honors Nikandros, commandant of Neapolis, but as no other town of that name can be found within Cyprus it may well refer to the predecessor of Limassol.

It has also been suggested that this Neapolis might be identified with Kartihadast but since this name applies rather to Kition this view must be dismissed. Moreover nothing Phoenician has been found so far in Limassol.

The town site is unexplored but many casual finds have been recorded.

BIBLIOGRAPHY. George Hill, "Two Toponymic Puzzles," *Journal of the Warburg Institute* 2.4 (1939) 375-79; V. Karageorghis, "Chronique des Fouilles et Découvertes Archéologiques à Chypre," *BCH* 84 (1960), and thereafter every year, under the chapter "Musée régional de Limassol." K. NICOLAOU

NEAPOLIS or NEA POLIS (Kavala) Thrace, Greece.

Map 9. A coastal city, a colony of Thasos, on the site of the modern city of Kavala. It seems to have been founded ca. the middle of the 7th c. B.C. in this very strategic position through which pass the ancient coast road which joins Asia and Europe, and the road which leads from the shore to gold-bearing Mt. Pangaeum and the proverbial land of Datos.

After the flight of the Persians from Greece, Neapolis was a member of the first Athenian League, and from 454-453 B.C. on it is entered in the Athenian Tribute Lists with an unvarying tribute of 1000 drachmai a year. Close ties of friendship and alliance bound the city to Athens, as shown by two Athenian honorary decrees of 410 and 407 B.C. which praise the Neapolitans and give them several privileges in the sanctuary of Parthenos.

Around 350 B.C. Philip II of Macedon, who had captured one after another of the Greek cities in Thrace, took Neapolis also and used it as the harbor for Philippi. At the battle of Philippi (42 B.C.), the harbor of Neapolis was used as a base by the Republican generals, Brutus and Cassius. It kept its importance as a station on the Via Egnati through the Imperial and Early Christian periods.

The remains and known traces of the ancient city are scanty. Of its walls, which probably date to the early 5th c. B.C., a few large sections are preserved, chiefly on the N side of the Kavala peninsula, where the ancient town was, but some also on the E and W. The wall, built of granite blocks of varying sizes, is in places preserved to a height of ca. 2 to 4 m.

Notable was the sanctuary of the patron goddess of Neapolis, the Parthenos, probably a Hellenized figure of the Thracian Artemis Tauropolos or Bendis. An archaistic figure of the goddess is known from a bas-relief on an Athenian decree of 356-355 B.C. (National Museum 1480). Investigation in the area of the sanctuary, which is approximately in the middle of the ancient town, in the years 1936-37 and 1959-63, uncovered sacred hearths, building walls, parts of the peribolos or a supporting terrace wall, and deposits of pottery and figurines. In the beginning of the 5th c. B.C. an Ionic peripteral temple built of Thasian marble was constructed in the sanctuary area (column capitals of excellent workmanship and architectural fragments from the temple are in the

Kavala Museum). No houses or other buildings have been uncovered. The well-preserved and very impressive aqueduct of the city is the work of Sultan Suleiman the Magnificent.

The pottery found in the excavations comes from the workshops of Asia Minor, Chios, Lesbos, the Cyclades, Attica, Corinth, and Lakonia. Among the most interesting pieces are a "Melian" amphora with representations of Peleus, Thetis, and the Nereids; a Chian krater with a representation of the Chalydonian boar hunt; and an Attic black-figure amphora by the painter Amasis. On the site or in the area of the Parthenon sanctuary three votive inscriptions were found (4th-2d c. B.C.), a marble naiskos-treasury, and a bas-relief of the mid 4th c. B.C. with the representation of a sphinx facing an amphora (Kavala Museum).

BIBLIOGRAPHY. *IG* I² 108; T. Bakalakis, Νεάπολις-Χριστούπολις-Καβάλα, *A.E.* (1936) 1ff; a description of the excavations conducted under state auspices, ΠΑΕ (1937) 59ff; id., Ἐκ τοῦ ἱεροῦ τῆς Παρθένου ἐν Νεαπόλει *A.E.* (1938) 106ff; ΑΔ (1960) 219ff; (1961-62) 235ff; (1963) 257; (1964) 370ff; (1967) 417; P. Collart, *Philippes ville de Macédoine* (1937) 102ff; J. Pouilloux, *Recherches sur l'histoire et les cultes de Thasos* I (1954) 109ff and 152ff; D. Lazarides, Νεάπολις-Χριστούπολις-Καβάλα, Ὁδηγός Μουσείου Καβάλας (1969). D. LAZARIDES

NEAPOLIS (Naples) Campania, Italy. Map 17A. On the

W coast of Italy some 241 km SE of Rome, the city stands overlooking the Tyrrhenian sea in the N part of the Gulf of Naples. To the E lies the silhouette of Mt. Vesuvius, and to the W stretches a fertile area known to the ancients as the Phlegraean Fields because of the mineral springs, sulphur mines, and small craters it contains. To the SW is the Posillipo (the ancient Mons Pausilypos), a large hill which ends in a promontory and separates the Gulf of Naples from the Gulf of Pozzuoli.

Neapolis was founded ca. 650 B.C. from Cumae. Ancient tradition records that it had originally been named after the siren Parthenope, who had been washed ashore on the site after failing to capture Odysseus (Sil. *Pun.* 12.33-36). The early city, which was called Palae(o)polis, developed in the SW along the modern harbor area and included Pizzofalcone and Megaris (the Castel dell'Ovo), a small island in the harbor. Megaris itself may have been the site of a still older Rhodian trading colony (Strab. 14.2.10). Owing to the influx of Campanian immigrants, the town began to develop to the NE along a Hippodamian grid plan. This new extension was called Neapolis, while Palae(o)polis became a suburb. Incited to a war with Rome by the Greek elements, the city was captured in 326 B.C. by the proconsul Quintus Publilius Philo (Liv. 8.22.9), and the suburb ceased to exist. Neapolis then became a favored ally of the Romans; it repulsed Pyrrhos, contributed naval support during the First Punic War, and withstood the attacks of Hannibal. Even though it suffered the loss of its fleet and a massacre of its inhabitants in 82 B.C. during the Civil War (App. *BCiv.* 1.89), it became a flourishing municipium and enjoyed the favors of the Julio-Claudian emperors. Subsequently it was damaged by the eruption of Vesuvius in A.D. 79.

Remains of both the Greek and the Roman cities are scarce since the modern town has been built on top. Stretches of the Greek city walls have been found in various locations, and it has been possible to reconstruct the entire ring of fortifications. In the N the walls stretch from S. Maria di Constantinopoli to SS. Apostoli. Some blocks were found when the Ospedale degli Incurabili at the Piazza Cavour was demolished. On the E they run along the course of the Via Carbonara, by the Castel

Capuano, and down the Via Maddalena to the church of S. Agostino alla Zecca. In the area of the former convent of the Maddalena have come to light the remains of a tower measuring 10.8 m on each face with traces of rebuilding associated with the siege by Belisarius in A.D. 536. In the S they go from S. Agostino, by the University, and finally reach S. Maria la Nuova. Under the Corso Umberto I, in the stretch between the Via Seggio del Popolo and the Via Pietro Colletta, large portions have appeared, dating from the 5th c. B.C. to the Hellenistic period. On the W side, sections were uncovered at the Piazza Bellini. Outside the ring of fortifications, in the vicinity of the Via S. Giacomo, a wall, constructed in blocks of tufa, has been discovered. It dates to the 6th c. B.C. and probably belongs to the older city of Palae(o)polis.

It is also possible to reconstruct some of the street system of Neapolis, since it is likely that many modern streets run over their ancient counterparts. Three main E x W decumani can be distinguished: the Via S. Biagio dei Librai, the Via Tribunali, and the Via Anticaglia. These were crossed at right angles by about 20 narrower N x S cardines having an average width of 4 m and forming some 100 house blocks. A stretch of one of these cardines has been located under the church of San Lorenzo Maggiore. In the Via del Duomo have been found the foundations of a small sacred edifice dating to the 5th c. B.C. and rebuilt completely in the 1st c. of our era. Parts of Greek houses have been uncovered on the Via del Duomo and on the Via Nilo in the W part of the town. Graves of the Greek period are scattered throughout the city. In the region of Pizzofalcone on the Via Nicotera, part of a necropolis, belonging to the original city of Palae(o)polis, has come to light with pottery dating from the 7th and 6th c. B.C. A second early cemetery lay in the spot now occupied by the Piazza Capuana.

Evidence for the Roman buildings of Neapolis is more abundant. The church of S. Paolo Maggiore contains building materials from an earlier temple, identified by means of an inscription as sacred to the Dioscuri and of the time of Tiberius, but standing on the site of an older sanctuary. The temple itself was Corinthian hexastyle. Its front faced S and looked over the decumanus maximus (Via Tribunali). On the Via Anticaglia, between the Via S. Paolo and the Vico Giganti, are the remains of a theater, dating to the early empire. The cavea opens S towards the harbor and has a diameter of some 102 m. Beneath the level of the Early Christian basilica under San Lorenzo Maggiore have been uncovered the foundations of a large public building of the 1st c. A.D., perhaps the aerarium of the city. In various locations there are remnants of baths. Roman houses appear at the NE end of the Corso Umberto I, near the section of wall found there, and in the Via del Duomo. The cryptoporticus of a villa belonging to the 1st c. A.D. has emerged in the vicinity of the Via S. Giacomo. The Castel dell'Ovo can be identified with the site of Lucullus' villa and famous fish ponds (Plin. HN 9.170).

The most direct route from Neapolis to Puteoli (modern Pozzuoli) was along a coast road named the Via Puteolana. This road passed through the Posillipo hills by means of a tunnel, the Crypta Neapolitana, located in the region of Mergellina. The crypta, built by Augustus' architect Cocceius but many times restored and remodeled, now measures 700 m in length. A second ancient tunnel, now called the Grotta di Seiano, was built at the extreme tip of the Posillipo promontory. It led from the villa of Vedius Pollio (later given to Augustus) to the Puteoli road and is a little larger than the crypta. On the Posillipo itself are the remains of a small Augustan odeum once connected with a private villa, perhaps Pollio's. Near the entrance to the crypta is a sepulcher identified by some as the tomb of Virgil, which according to Donatus (Vita Virg. 36) was located before the second milestone on the Via Puteolana. Others argue that the present tomb is too far away and that the second milestone, calculated from the Porta Puteolana, would lie on the modern Riviera di Chiaia; furthermore, they assert that the present tomb resembles a family columbarium rather than a poet's sepulcher. The grave, belonging to the Augustan period, is in the form of a columbarium, built in the opus caementicium technique. It is circular and stands on a square podium; inside are ten niches (loculi) for cinerary urns.

The Museo Archeologico Nazionale in Naples off the Piazza Cavour is one of the finest in Italy and contains extensive collections of mosaics, paintings, and sculpture.

BIBLIOGRAPHY. J. Beloch, Campanien (1890)[M]; F. von Duhn, "Der Dioskurentempel in Neapel," SBHeidelberg Phil.-Hist. Kl. (1910) 3-20; H. Philipp, "Neapolis," RE 16 (1933) 2112-22; H. Achelis, Die Katakomben von Neapel (1936)[I]; J. Bérard, Bibliographie topographique des principales cités grecques de l'Italie méridionale et de la Sicile dans l'antiquité (1941) 71; M. Napoli, Napoli greco-romana (1959)[PI]; W. Johannowsky, Problemi archeologici napoletani (1960)[PI]; A. G. McKay, Naples and Campania (1962) 109-20; M. Napoli & A. Maiuri, "Napoli," EAA 5 (1963) 332-40[PI]; M. Guido, Southern Italy: an Archaeological Guide (1972) 48-63[MP].

W.D.E. COULSON

NEAPOLIS Sardinia, Italy. Map 14. An ancient city on the W coast of Sardinia below Cape Frasca, near the present church of S. Maria di Nabui. It is mentioned by Ptolemy (3.3.2) and by the Itineraries (It. Ant. 84; Rav. Cosm. 5.26), which place it on the Via Karalibus-Othocam. A milestone (CIL x, 8008) attests that Neapolis was linked with the colony of Uselis. Cited by the agronomist Palladius for the richness of its fields (De Agr. 3.16), the city must have been in an area of large landed estates mainly engaged in the cultivation of cereals, to judge from the numerous ruins of villas. Scholars of the last century describe the solidarity and size of the private buildings; the encircling walls; the well-paved roads; and the aqueduct, whose ruins are still visible, which carried water to the city from Landa de Giaxi, eight Roman miles away. Its territory must have bordered Cagliari's, as is shown by the mention of "water from Neapolis" (Ptol. 3.3.7) in the territory of Sardara. The city declined during the invasions of the Vandals and the Saracens.

Excavation undertaken in 1951 near S. Maria di Nabui brought to light a small bath building of brick, with a caldarium to the S, an apodyterium to the N, and a frigidarium. To the E are several modest houses and a Late Roman necropolis with tufa sarcophagi and masonry tombs. At S' Anžrarža, near the sea, another bath building of considerable size has an anterior gallery from which one enters a large hall with a polychrome mosaic pavement.

BIBLIOGRAPHY. G. Spano, Bull. Arch. Sardo 5 (1859) 20[PI]; E. Pais, Storia della Sardegna e della Corsica, I (1923) 366ff; G. Lilliu, Annali Fac. Lettere di Cagliari 21.1 (1953) 3 n. 1; G. Pesce, EAA (1963) 388.

D. MANCONI

NEAPOLIS SCYTHICA Crimea. Map 5. The chief city of the Scythians from the 3d c. B.C., situated E of modern Simferopol (Strab. 7.4.7). It ceased to exist in the 3d c. A.D. when the Crimea was overrun by Sarmatians, Alans, and Goths.

Although the capital of the Scythian state in the

Crimea, there is evidence in the remains of considerable Greek influence, and graffiti suggest the possibility of a permanent Greek settlement in the city. Covering an area of ca. 20 ha, the city was surrounded in the 3d c. B.C. with stone walls bonded with mortar. The walls are 2.5 m thick, later reinforced to a thickness of 11-12 m in some places, and have been preserved to a height of ca. 2.7 m. The main gate, in the middle of the S wall, was protected on either side by towers. There were two other gates. Architectural remains within the city include a large stone structure opposite the main gate with two porticos, columns with Doric capitals, and a tiled roof; a rich dwelling of the 3d-2d c. with a semi-cellar, tiled roof, and plastered and painted walls; Hellenistic dwellings with rooms opening onto paved courtyards.

The city's funerary architecture was monumental. Most noteworthy is a mausoleum built on a rectangular plan (8.65 x 8.10 m). Its walls, which consisted of slabs of stone, have been preserved up to 3 m. Inside were 72 richly furnished tombs, probably belonging to dynastic kings buried between the 2d c. B.C. and the 2d c. A.D. A wooden sarcophagus with feet carved in the shape of fantastic animals is especially remarkable. The sides of the sarcophagus are decorated with garlands, acanthus leaves, flowers, and pine cones. Gold rings, earrings, etc., and Scythian arms have been found here. The necropolis has also been excavated, on the outskirts of the city. Cut in the rock, the tombs are small square chambers containing niches. On the walls are painted friezes depicting scenes of everyday Scythian life (leaving for the hunt; a Scythian drawing his bow; also houses and huts). Some Greek inscriptions have been uncovered (including one mentioning King Skylurus) and a relief from the 3d c. B.C. showing Palakos on horseback. The Simferopol Museum and the Pushkin Museum, Moscow, contain material from the site.

BIBLIOGRAPHY. P. N. Shul'ts, *Mavzolei Neapolia skifskogo* (1953); id., "Issledovaniia Neapolia skifskogo (1945-1950 gg.)," *Istoriia i arkheologiia drevnego Kryma* (1957) 61-93; V. P. Babenchikov, "Nekropol' Neapolia skifskogo," *Istoriia i arkheologiia drevnego Kryma* (1957) 94-141; N. N. Pogrebova, "Pogrebeniia v Mavzolee Neapolia skifskogo," *Pamiatniki epokhi bronzy i rannego zheleza v Severnom Prichernomor'e* [Materialy i issledovaniia po arkheologii SSSR, No. 96] (1961) 103-213; A. L. Mongait, *Archaeology in the USSR*, tr. M. W. Thompson (1961) 162-63; E. Belin de Ballu, *L'Histoire des Colonies grecques du Littoral nord de la Mer Noire* (1965) 193-99; O. A. Makhneva, *Neapol' skifskii: Putovoditel'* (1968); D. S. Raevskii, "K istorii Greko-Skifskikh otnoshenii (II v. do n.e.-II v. n.e.)," *VDI* (1973) 2.110-20. M. L. BERNHARD & Z. SZTETYŁŁO

NEA POTEIDAIA, see POTEIDAIA

NEATH, see NIDUM

NÉGRINE, see AD MAIORES

NEMAUSUS (Nîmes) Gard, France. Map 23. The name of the city is that of the god of the sacred spring, whose sanctuary, which predates the Roman conquest, had led to the creation of several settlements in the vicinity. Nemausus was the capital of the Volcae Arecomici (Strab. 4.1.12; Plin. *HN* 3.37) and at the time of its first development it was in the zone of influence of Massilia (Marseille), owing its importance to its position on the road from Italy to Spain, the future Via Domitiana. It was under Roman control from 120 B.C. on, and received the Latin right between 51 and 37. Then in 27 B.C. Augustus conferred on it the title of Colonia Augusta Ne-

mausus, Voltinia tribu. At about the same time Egyptian Greeks, probably from Antony's army, were settled there. The city, in which the imperial house took an interest, appears to have been prosperous throughout the Early Empire. There are even several indications that the residence of the proconsul of Narbonese Gaul was transferred to Nemausus from Narbo Martius (Narbonne) after the old provincial capital was partially destroyed by fire in the reign of Antoninus Pius. Nemausus reached its apogee at the end of the 2d c. A.D., but from the mid 4th c. on a large part of the urban area appears to have been uninhabited. In 396 a synod met there; the first mention of a bishop of Nîmes comes in 506.

The town developed at the base of an amphitheater of hills. The Via Domitiana, which makes a right-angle turn inside the city, plays the role of both decumanus maximus and cardo maximus in the SE section. Little remains of the Augustan wall, principally the Porte d'Auguste at the E end of the decumanus. Its inscription (*CIL* XII, 3151) dates it to 16-15 B.C. It was originally flanked by two towers and had four arcaded passages. The Porte de France, at the S end of the cardo, appears to be much later. It is a single arch with a high attic decorated with pilasters in relief. In an indented angle of the NW part of the wall stands the structure called the Tour Magne. It is an impressive octagonal monument, with several stories, a central cella, an inside staircase, and semicircular rooms. The techniques used in its construction date it from the beginning of the Empire, but it is still uncertain whether it was a trophy, a watchtower, a Celtic sanctuary, or a mausoleum.

The forum, at the heart of the Augustan colony where the decumanus and the cardo intersected, was dominated by the Maison Carrée, perhaps the best preserved of all religious edifices of the Roman world. It is a Corinthian, pseudoperipteral hexastyle temple (measuring 31.8 x 14.95 m on the outside). Its pycnostyle pronaos is three intercolumniations deep. The temple, oriented towards the N, was surrounded by a vast peribolos which was partially excavated at the beginning of the 19th c. All that remains of the dedicatory inscription are the bedding-holes on the N frieze and architrave for the letters of gilded bronze, which have disappeared. It has long been thought that this inscription was of two periods: first a dedication to Agrippa of 16 B.C., and then at the beginning of our era an inscription to C. and L. Caesar, principes iuventutis, but only the second should be accepted. Examination of the architectonic decoration indicates that the temple, executed from designs taken for the most part from those for the Forum of Augustus at Rome, was built by regional construction crews at the very end of the 1st c. B.C. or the beginning of the 1st c. A.D.

The amphitheater is also remarkably well preserved. The axes of its external perimeter (133.38 x 101.4 m) and those of the arena (69.14 x 38.34 m) measure substantially the same as those of the amphitheater at Arles, placing it in size between the amphitheaters of Verona and Pola. Built of dressed stone, it held some 25,000 spectators. The cavea is supported by two series of arcades framed on the ground floor by Doric pilasters and on the next level by engaged columns. Above ran an attic marked by pilasters in low relief. The most recent studies place its construction at the end of the 1st c. A.D. or the beginning of the 2d c.

In the NW part of the city the great complex called the Fountain Sanctuary consists of several buildings of different dates. The spring, which flowed out of the base of the hill against which the theater is built, first fed baths, then entered a pool surrounded by porticos with a quadrangular kiosk in the center; its base, decorated

with a frieze of foliated scrolls, supported four spiral columns. The kiosk was a sort of nymphaeum and dates from the beginning of the reign of Augustus. Fragments of pediment, belonging to a 2d c. A.D. temple and found to the S, have been collected in the peribolos of the Maison Carrée. To the W still stands the Temple of Diana, a rectangular edifice composed of a barrel-vaulted niched central room. Facing its axial entrance and against the back wall is a square aedicula with a dais, flanked by two rooms leading to a peripheral corridor, also barrel vaulted.

Other ancient structures have now vanished: a circus, a Temple of Augustus, baths, and a basilica built by Hadrian in honor of Plotinus (Spartianus, *Vita Hadriani* 12.2; Dio 69.10.3; *CIL* XII, 3070). The museum at Nîmes contains important collections of ceramics, mosaics, coins, and architectural fragments.

BIBLIOGRAPHY. History: F. Mazauric, *La civilisation romaine dans le Gard (Nîmes et le Gard)* I (1912) 285-335; O. Hirschfeld, "Die Krokodilmünzen," *Kleine Schriften* (1913), 40f; E. Bondurand, "Le tracé de la voie Domitienne dans Nîmes," *Mém. Acad. Nîmes* 40 (1920-21) 11-37; F. Benoit, *Nîmes, Arles et la Camargue* (1936); M. Louis & A. Blanchet, *Carte archéologique de la Gaule romaine*, VIII, *Gard* (1941) 32-133; Grenier, *Manuel* I (1931) 314f and III, 1 (1958) 143f; J.-Ch. Balty, "Colonia Nemausus," *RBPhil* 38 (1960) 59f.

City walls: R. Schulze, *BonnJbb* 118 (1909) 299f; E. Espérandieu, *La Tourmagne, Notice sommaire* (1922); Grenier, *Manuel* I 316f. Maison Carrée: E. Espérandieu, *La Maison Carrée à Nîmes* (1929); J.-Ch. Balty, *Etudes sur la Maison Carrée de Nîmes, Coll. Latomus* 47 (1960); R. Amy, "La Maison Carrée," *Actes du VIIIe Congrès International d'Arch. Class.* 1963 (1965) 639f; W. D. Heilmeyer, in *Korinthische Normalkapitelle* (1970) 109f; id., "L'inscription de la Maison Carée de Nîmes," *CRAI* (1971) 670f; P. Gros, "Traditions hellénistiques d'Orient dans le décor architectonique der temples romains de Gaule Narbonnaise," *La Gallia Romana* (Acc. Naz. Lincei, 1973) 167ff; F. S. Kleiner," Gallia Graeca, Gallia Romana and the Introduction of Classical Sculpture in Gaul," *AJA* 77 (1973) 379ff.

Amphitheater: A. Pelet, *Description de l'amphithéâtre de Nîmes*[3] (1866); F. Mazauric, "Les souterrains des arênes de Nîmes," *Mém. Acad. Nîmes* 33 (1910) 1-35; F. Mazauric, "La date des arênes de Nîmes," *CRAI* (1937) 236-38; Grenier, *Manuel* III, 2, 613f; G. Lugli, "La datazione degli anfiteatri di Arles e di Nîmes in Provenza," *RivIstArch* NS 13-14 (1964-65) 145-93; R. Etienne, "La date de l'amphithéâtre de Nîmes," *Mél. Piganiol* 2 (1966) 985-1010. Fountain sanctuary: R. Naumann, *Der Quellbezirk von Nîmes, Denkmäler antiker Architektur* IV (1937); Grenier, *Manuel* IV, 2 (1960) 493f. P. GROS

NEMEA Argolid, Greece. Map 11. The site of the Panhellenic Games, of which the Sanctuary of Nemean Zeus formed the dominant element, lies at the head of the valley of the Nemea river, ca. 19 km N of Argos and 18 km from the Gulf of Corinth. Originally the games were local and under the control of Kleonai. In 573 B.C. the games were incorporated into the Panhellenic schedule and held every other year. By the middle of the 5th c. the games were presided over by Argos. In the first half of the 4th c. the games appear to have been transferred to Argos itself. Aratos of Sikyon tried to restore the games to their original site on the Nemea river in 235 B.C., but without success (Plut. *Arat.* 28). In 145 B.C. Mummius appears to have revived the games on their original site; Argos succeeded in becoming, however, the home of the games during the Roman period. There is no archaeological evidence that winter games were held within the limits of the ancient Nemean sanctuary during the Hadrianic period. The site of Nemea was reoccupied in the 4th and 5th c. A.D. by the Christians, when a basilica and baptistery were erected there, largely with blocks from the Temple of Zeus.

The site has been excavated intermittently since 1884. The pottery and small finds are stored in the archaeological museum in ancient Corinth; coins from the early American excavations are in the National Museum of Athens.

The 4th c. Temple of Zeus lies on the E bank of the Nemea river. It is built of limestone, on the foundations of the S side of an earlier temple, probably erected in the archaic period. The later temple, of which three columns still stand, was completed in the twenties of the 4th c. It is peripteral, with 6 columns across the ends, 12 along the flanks. The columns are extremely attenuated, with a height 7.34 times their lower diameter. The temple had no opisthodomus. Inside, the cella had freestanding Corinthian columns along both side walls and across its W end. These were surmounted by Ionic half-columns applied to piers. The cella had a reserved area or adyton at its W end, in which stairs led down into a crypt. The floor of the crypt appears to have been the ground level of the earlier temple. The only marble used in the temple was the sima, in design slightly resembling that of the Temple of Athena Alea at Tegea. There are other stylistic resemblances between the two temples; these are not strong enough, however, to demand the conclusion that a single architect designed both buildings.

To the E of the temple lies the foundation of an altar 41 m long, which extends N beyond the limits of the N side of the 4th c. temple. The altar appears to have been built in two phases; apparently the early altar was centered on the long axis of the earlier temple and then extended S to go with the later temple.

Between 33 and 42 m S of the temple is a line of three buildings; the one farthest E has not been completely excavated. Only foundations of these structures are preserved. The building farthest W, a large rectangular structure with two interior columns, may have been a lesche. The two buildings at its E have wide foundations on their N ends, designed to carry columned facades. The two buildings may have been treasuries facing the temple.

Farther to the S, about 72 m from the temple, is a building 86 m long, separated by a space of about 9 m from a rectangular building at its W. The W structure is a three-roomed bath. The SW corner room still has its basins and plunge preserved. The room has been roofed and now serves as an archaeological storeroom for the site. The long building at the E appears to have been divided into five units which opened onto a roadway running along the S. Each of these units held facilities for drinking and eating; the building probably served as a xenon. Both bath and xenon were built in the second half of the 4th c., immediately after the construction of the later Temple of Zeus. (The xenon was built over a kiln that made the roof tiles for the temple.) Both xenon and bath were aligned with the roadway rather than with the temple.

A Christian basilica was erected over the remains of the W end of the xenon. In form the church is a nave with both N and S side aisles, apse at the E, and narthex with subsidiary rooms at the W. The baptistery lies against the N wall of the basilica and has a circular baptismal basin in the center of the floor.

The roadway at the S of the xenon led to the E slope of the valley on which today stands the ruin of a Turkish fountain-house. Slightly farther up the E slope is the

water source that once fed it and which is identified as the Fountain of Adrastos. Here, according to legend, Opheltes, a babe yet unable to walk, was left by his nurse so that she could draw water for the Seven Warriors on their way to Thebes. The child was killed by a marauding serpent; the Nemean Games were then initiated in honor of the dead child. Pausanias (2.15.2-3) mentions a Temenos of Opheltes in which were altars to the hero, close by which was a tumulus for Lykourgos, his father. These probably stood close to the fountain. No physical remains, however, have been identified. A pit filled with votive pottery and terracotta figurines of the archaic period, apparently dedications to Demeter, was found on the slope farther to the S.

The stadium for the games was built in a hollow in the E slope of the Nemean valley, SW of the fountain-house and about 500 m SE of the temple. This is now partially excavated. The long axis of the stadium is N-S, with the S end of the track dug into the hillside, the N end built out on an artificial terrace. The course was lined with water channels and settling basins. Seats for the spectators appear, however, never to have been built.

BIBLIOGRAPHY. G. Cousin & F. Dürrbach, "Inscriptions de Némée," *BCH* 9 (1885) 349-56; C. W. Blegen, "The American Excavation at Nemea, Season of 1924," *Art and Archaeology* 19 (1925) 175-84; id., "The December Excavations at Nemea," ibid. 22 (1926) 127-34; id., "Excavations at Nemea, 1926," *AJA* 31 (1927) 427-40; M. Clemmensen & R. Vallois, "Le temple de Zeus à Némée," *BCH* 49 (1925) 1-20, pls. I-IV; C. K. Williams, *Deltion* 18 (1963) 81-82, pl. 94; 20 (1965) 154-56, pl. 138; G. Daux, "Chronique des fouilles en 1964," *BCH* 89 (1965) 703-7; D. W. Bradeen, "Inscriptions from Nemea," *Hesperia* 35 (1966) 320-30; B. W. Hill, L. T. Lands, & C. K. Williams, *The Temple of Zeus at Nemea* (1966).

C. K. WILLIAMS

NEMETACUM later ATREBATUM (Arras) Pas de Calais, France. Map 23. Mentioned by Caesar in the *Gallic Wars*, in the 4th c. it adopted the name of the civitas, Atrebatum, of which it was chief town. Situated on a high plateau, it has no navigable waterway; the Scarpe, at the N boundary of the city, is navigable only below Douai. At the confluence of the Gy and the Scarpe, W of Arras, was an important oppidum, the so-called Camp de César at Etrun, which is still remarkably well preserved.

The city is divided into three unequal sections: the city proper, the Baudimont quarter, which was ringed with a rampart in the Late Empire; the sector separated from the city by the Grinchon creek, which appears to represent the Roman city at its period of greatest expansion under the Empire; and finally the Méaulens quarter to the NW, at the confluence of the Scarpe and the Baudimont creek, where the Cassel and Therouanne roads apparently met in Roman times. There is no trace of any place of amusement or prestige monument, no theater, basilica, or forum. Some sections of streets were located in the 19th c., but it was not until 1946 that systematic excavations began, in particular in the Baudimont quarter. These excavations have located houses along with their cellars, determined the extent of the city and, especially, uncovered a late 2d c. stratum destroyed by fire, perhaps as a result of the Chauci invasion of 172-174.

Salvage work in the last few years has clarified certain elements of the topography of the ancient city. In 1965 an important fragment of the wall of the Late Empire city was discovered under the Prefecture, tucked away in the center of the strongly fortified city of Baudimont. This would indicate a castrum with a total area of 8 ha,

and the discovery of a trench E of the castrum confirms its boundaries.

At Les Blancs Monts on the Saint Polsur Ternoise road a complex of potter's kilns was found accidentally, and nearby several ditches of early date. A tomb of the Late Iron Age has also been located. All the finds are now in the Arras museum. The textile industry of the Late Empire is known to us chiefly from texts, no archaeological remains having been found. Finds made below ground suggest that building stones were quarried here. Very recently an aerial survey has located some ancient agricultural complexes E of Arras.

BIBLIOGRAPHY. A. Terninck, *Arras Gallo-romain* (1866); *CIL* XIII, 3531; F. Verçauteren, *Etudes sur les civitates de la Belgique Seconde* (1934) 181-204; G. Bellanger, "Fouilles du site gallo-romain de la cité d'Arras," *Revue du Nord* 29 (1948) 207-12; J. Heurgon, "Arras, Fouilles en 1952 de M. Bellanger et du Dr Bourgeois à Baudimont," *Gallia* 12 (1954) 135-36; M. Wheeler & K. Richardson, *Hill-Forts of Northern France* (1957) s.v. Etrun; A. Leduque, *Recherches topo-historiques sur l'Atrébatie* (1966) 43-56; G. Jelski, *Bull. Com. Départ. Mon. Hist. Pas de Calais* 9 (1971); *Septentrion* 17 (1974) 13-20.

C. PIETRI

NEMETIN, see LIMES PANNONIAE (Yugoslav sector)

NEMI, see SHIPWRECKS

NEMRUD DAGH Turkey. Map 6. Mountain in the E Taurus range, in S Turkey near modern Adiyaman. It was the highest peak (2232 m) in the Hellenistic kingdom of Commagene, and at its very summit is the great monument of Antiochos I of Commagene (reigned ca. 69-ca. 38). It consists of four main parts: at the summit a huge tumulus ca. 50 m high and built of broken rock, flanked by leveled terraces to E and W, and at the E end of the E terrace the stepped platform of a great altar. Aside from tumulus and altar, the monuments consist of sculpture, usually inscribed. In what follows the E terrace sculptures are described, but these were duplicated on the W terrace in almost all (perhaps originally all) cases, with minor variations in disposition, style, wording, and of course preservation.

The sculptures are of five main groups: 1) a group of nine colossal figures backing against the tumulus; 2) a group of five huge stelae, four showing Antiochos being received by his gods, the fifth a horoscope; 3) flanking the terrace on the N, a row of fifteen stelae representing his Iranian (paternal) ancestors; 4) at the S, a similar row showing his Seleucid (maternal) ancestors; 5) supplementary stelae depicting (presumably) various relatives and, more important, one showing the king's investiture. The colossi, built of sculptured ashlar, represent, from N to S, lion and eagle; then, seated on sketchily indicated thrones, Artagnes (Verathragna)-Herakles-Ares, Apollo-Mithras-Helius-Hermes, Zeus-Oromasdes (Ahuramazda), Commagene (personified as a Tyche-Abundance figure), and Antiochos himself; finally eagle and lion. The height of Zeus-Oromasdes is ca. 9 m. The reception reliefs show Antiochos being received by each of the above gods.

The direct paternal ancestors of Antiochos were Iranians who had been satraps of Armenia in Achaemenid times, then moved down into Commagene (first as satraps, later as kings): the Orontids. But what especially impressed the king was that one of these (Aroandas = Orontes) had married a daughter of Artaxerxes II, while his own father, Mithradates I, married a daughter of Antiochos VIII Grypos. Hence the ancestor reliefs. The Persian shows five Achaemenid kings, from Darius I

to Artaxerxes II, then the Orontids down to Mithradates I, while the Seleucid line begins (perhaps) with Alexander the Great, goes on to Antiochos VIII, and ends with several queens. The supplementary reliefs are difficult to identify securely. Across the great ashlar wall formed by the backs of the thrones of the colossi is the long inscription of Antiochos, setting forth details of his life and aims and containing a sacred law. Finally, the horoscope shows a lion (Leo) in relief and studded with stars; it also shows three planets, presumably in conjunction, which are identified as Herakles, Apollo, and Zeus, i.e. Mars, Mercury, and Jupiter. It must commemorate an important event in the life of Antiochos, and also explains the three male gods he worshiped and their strange combinations of names.

All the inscriptions are in Greek. The style of the sculptures is also Greek in general, but the trappings of the male gods (with one exception) and of the Iranian ancestors is Persian. The exception is Herakles: when shown as a colossus he is depicted in his Iranian manifestation as Verathragna, but on the reliefs he is Herakles, stark naked save for lion-skin and contrasting strangely with the muffled Persian figures. Notable iconographically is the Armenian tiara of Antiochos (shown also on his coins), the pointed tiara of the Orontids, and the leather apron worn alike by Orontids and the Persian gods.

BIBLIOGRAPHY. K. Humann & O. Puchstein, *Reisen in Kleinasien und Nordsyrien* (1890); L. Jalabert & R. Mouterde, *Inscriptions Grecques et Latines de la Syrie* I (1929). J. H. YOUNG

NENNIG Germany. Map 20. A Roman villa, ca. 40 km up the Moselle from Trier. Discovered in 1852 near the village church, it was excavated between 1866 and 1876. After WW II the main mosaic was cleaned and newly set, and the shelter with its galleries for visitors was renovated and enlarged. The villa complex included spring houses, small pavilions, and other accessories of an extensive park, with a necropolis to the S and a workshop or farm courtyard to the N. Of the necropolis only one of the two tumuli survives.

The facade (140 m long) of the main building was designed in the manner of a porticoed villa with its two-storied, colonnaded front framed by three-storied tower wings with massive walls. Beyond these, at either side projected a pair of flanking buildings, single storied, with temple-pedimented superstructures. Roofed colonnades 8.5 m wide, terminating at each end in round pavilions, augmented the facade by 250 m each way to SW and NE, without obscuring the view of the main building. The three architectural elements totaled 600 m in length. At the end of the SW colonnade lay the bath building. This complex (32 x 29 m) with five apses had dressing rooms, frigidarium, anointing room, tepidarium, a heated swimming pool or caldarium 65 m square, as well as a sudatorium. The symmetry of the overall plan of the villa demanded a small subordinate building at the end of the NE colonnade to balance the bath; its foundations, however, lie hidden under the houses of the modern village and hence, like the larger part of the NE colonnade, could not be investigated.

The main building was entered via an open stair (5 m wide) which led into the colonnade (77.5 m long) of the central structure. Two loggia-like rooms, painted red, flanked the cellared portico with its fluted columns of limestone from the Jura. The cryptoporticus (2 m deep) could be reached from two rooms inside the building and through an entrance under the SW loggia. Beyond the central vestibule three large doorways opened into the mosaic-decorated main hall with its fountain. The

great mosaic itself is dominated by geometric shapes and framed by a black-and-white ornamental border. The pictorial medallions, depicting scenes of hunting and gladiatorial contests, are of exceptional interest. Narrow passages divided the hall from the other rooms, most of which could be reached through an outer corridor that surrounded the main building and its wings on three sides. To the NE of the main hall was a large columnar peristyle with a semicircular pool and adjoining tablinum. Of the peristyle columns, three bases and one capital were found in situ; the positions of the other columns were indicated by remaining socles for the bases. The height of the columns was estimated to be 3.14 m. The containing walls of the peristyle were painted Pompeian red; at dado level were black panels with galloping horses mounted by riders, perhaps Amazons. Farther NE were bedrooms toward the mountain side and beyond these a row of rooms of various uses were grouped around an atrium. There were various connecting corridors and a N entrance to the villa. The bedrooms and the tablinum were rebuilt in post-Roman times and provided with hypocausts. Little could be learned about the inner structure of the NE corner tower and the flanking building since these are in the built-up area of the modern village and its cemetery. However, these elements of the complex must have balanced the corresponding elements to the SW in function and inner articulation.

The apartments to the SW of the main hall were organized around a corridor which bent at right angles and a courtyard surrounded by a passage. The dining hall (24 x 3.5 m) opened on the main portico. Among the rooms farther SW was one with a mosaic floor and a furnace room, which apparently also served as a kitchen. The semicircular terminal room to the front was also decorated with mosaic and a stairway led from the adjoining corridor to the upper story of the projecting tower wing. The SW flanking building, separated from the main structure by a passage and with its inner organization aligned along the corridor, is remarkable only in that in contrast to the main building two particularly large rooms were heated.

All the rooms in the villa had plastered walls, polished, painted, and enhanced with depictions of dolphins, small landscapes, etc. The ceilings were painted white or blue with egg-and-dart decoration in stucco on the moldings. The roofs were probably tiled, the outer walls plastered and painted red.

Coins from the time of Nero were reported to have been discovered in the foundation layers, and stamps of the emperors Gallienus, Constantine, and Valentinian in the later levels. A coin of Commodus (struck ca. 192), found in the fine stone bedding under the mosaic during the excavations of 1960, dates the construction of the villa to the end of the 2d c. or the beginning of the 3d c. A.D. Other finds of that season brought to light evidence for an earlier building which—in confirmation of the coins of Nero—could have been Early Roman or even, according to the finds of pottery sherds, pre-Roman. Further material for dating came from the subterranean service entrance to the fountain in the mosaic hall. Two levels of use were revealed, containing Middle and Late Roman material. The two levels were separated by a uniform flood deposit layer without finds. This layer may possibly represent the disturbed times of the Germanic invasion in the second half of the 3d c.

BIBLIOGRAPHY. J.-N. von Wilmowsky, "Bericht über Nennig," *Jahresbericht der Gesellschaft für nützliche Forschungen Trier* (1853-54) 54-61; id., *Die Villa von Nennig und ihr Mosaik* (1864); A. von Behr, "Die römische Villa in Nennig" (containing excavations by Seyf-

farth from 1878, with appendices and illustrations), *Zeitschrift für Bauwesen* 59 (1909) 314; P. Steiner, *Römische Landhäuser im Trierer Bezirk* (1923); id., "Die römische Pracht-Villa von Nennig," *Führungsblatt Provinzialmuseum Trier* (1924); H. Mylius, "Die Rekonstruktion der römischen Villen von Nennig und Fliessem," *BonnJbb* 129 (1924) 110-20; K. Parlasca, *Die römischen Mosaiken in Deutschland* (1959); R. Schindler, "Restaurierung und Ausgrabungen am römischen Mosaik in Nennig," *Bericht der Staatlichen Denkmalpflege im Saarland* 8 (1961) 66-72; id., "Das römische Mosaik von Nennig," *Führungsblatt* (1961) 16 pp.; L. Hussong, *Hebung, Festigung und Wiederverlegung des Mosaiks der römischen Villa in Nennig* (1961) 73-79.

R. SCHINDLER

NEOCAESAREA (Niksar) Pontus, Turkey. Map 5. About 103 km inland by mountain road over the coastal range (Paryadres Mons), overlooking the plain of the Kelkit Çayi (Lycus fl.). This is probably the same site as Kabeira, a treasury and hunting lodge of Mithridates VI Eupator of Pontus, where Pompey in 64 B.C. founded the city of Diospolis. This was subsequently presented by Antony to Polemon I of Pontus, whose widow and successor Pythodoris made it her capital under the name Sebaste. The later name Neocaesarea may mark a refoundation by Nero when the Pontic kingdom was annexed to Galatia in A.D. 64-65. Neocaesarea remained the chief city of the region, being metropolis first of Pontus Polemonianus and then of Pontus Mediterraneus. In Diocletian's reorganization it was metropolis of Polemoniacus.

The site is dominated by a largely mediaeval castle, which crowns a long spur projecting S from the foothills of the Paryadres. Part of the walls may be Roman or earlier; and a rock-cut tunnel-stairway, like those at Amaseia, is certainly pre-Roman. Other mediaeval walls enclose the old Turkish town, which lies below the castle on the S, perhaps on the site of the Roman city. Earthquakes in A.D. 344 and 499 may well have destroyed most of the Roman walls and buildings.

BIBLIOGRAPHY. J.G.C. Anderson, *Studia Pontica* I (1903) 56-59; F. & E. Cumont, *Studia Pontica* II (1906) 259-70.

D. R. WILSON

NEOCHORI ("Grynchai") Euboia, Greece. Map 11. Southwest of this modern village in E central Euboia is a naturally fortified site with the most extensive visible remains in the region. The acropolis can be approached only on the E, where there are rock-cut steps for pack animals. The circuit wall of irregular masonry has some ashlar blocks, especially at the corners, and some Venetian repairs. Within the walls Ulrichs found many foundations for houses and large buildings. In a grotto with a spring-fed pool, he saw a rock-cut altar; fragments of marble columns and Ionic capitals were in the debris of two ruined chapels. The ancient name of the city is unknown; Grynchai, known from the Athenian tribute lists, has been proposed, but has also been located at Episkopi, now marked with a mediaeval fortress.

BIBLIOGRAPHY. H. N. Ulrichs, *Reisen und Forschungen in Griechenland* (1863) II 244f; A. Philippson-Kirsten, *GL* (1950-59) I² 617.

M. H. MC ALLISTER

NEON, *see under* TITHOREA

NEONTEICHOS, *see under* YANIK KÖY

NÉRAC (Lot-et-Garonne) France. Map 23. Situated in the SW of the département on the Baïse, this territory in Celtic Gaul was included in the civitas of the Nitiobrigi.

In the Roman period, there was probably no city there, or at most a Gaulish vicus.

Excavations carried out after 1832 brought to light a large ensemble of buildings grouped at the SE exit of the present agglomeration. The archaeological study was then disrupted and subsequently the site was reburied. Soundings and excavations in 1963, 1967, and 1970 have made rediscovery possible.

The ensemble is divided into two series of buildings. The first, running along the right bank of the Baïse, extends ca. 200 m into the public gardens of the Garenne and includes several blocks of buildings with various orientations: the first to the N consists of several rich chambers with mosaic pavements and marble revetments, niches, fountain, and reservoir pool; the second, behind it, is composed mainly of a 75 m long gallery running along the riverbank, provided with fountains and preceded by rectangular or octagonal rooms, equally richly decorated. These two blocks are themselves superimposed upon earlier buildings.

The second series is situated around the Nazareth road which crosses the slope overhanging the Garenne. It consists of an insula with facade ca. 80 m long. Its mosaics, found in 1970, fit a circular room with a great rosette formed by concentric wreaths of realistic vegetal motifs, and one of the great rectangular chambers with semicircular apse that frame it (the latter with half-rosette in the apse and squares with geometric motifs). To the W of these buildings the foundations continue, making a right-angled turn to the NE.

This complex seems to be the reconstruction on a larger area (which the excavations of 1967 have extended even farther NE) of an earlier edifice, itself already fairly luxurious, which may date from the 2d half of the 1st c. After having undergone numerous restorations, the whole building, in its most recent and luxurious state, seems to date from the end of the 3d and beginning of the 4th c., and was destroyed during the invasions of the 5th c.

The ensemble constituted a very rich Gallo-Roman villa, with the living areas in the upper section and the outbuildings running along the riverbank (private bath or nymphaeum, porticos, etc.).

At present only a few fragments of this important site are visible: a part of the mosaics under a niche, in the Garenne; another in the courtyard of a tavern on the Nazareth road, and numerous sculptural fragments and mosaics in the museum of Nérac.

BIBLIOGRAPHY. F. Jouannet, *Rapport fait à l'Académie Royale de Bordeaux sur Nérac et ses antiquités* (1834)ᴾ; Y. Marcadal, "Les origines de Nérac," *Rev. de Nerac* (1964) 2ᴾ; J. Coupry, "Informations arch. (Lot-et-Garonne)," *Gallia* 25 (1967) 2ᴵ.

M. KLEFSTAD-SILLONVILLE

NERIS LES BAINS, *see* AQUAE NERI

NEROMANA ("Phystyon") Aitolia, Greece. Map 9. A city known only by references in inscriptions to its citizens and to the widely-known Temple of Aphrodite Syria Phistyis at ancient Hieridai. It is usually identified with the fortress at Neromana below the town of Soboniko on the N side of Lake Trichonis, between Paravola and Thermon. The walls and towers, of which four or five courses are preserved, resemble those at Thermon, and are dated by comparison at the end of the 3d c. B.C. The identification rests chiefly on the proximity of the site to Hieridai, which is above Tsakonina near Kryonero. A 6th c. antefix, now in the museum at Agrinion, was found there in excavating at the Church of the Madonna, and attests to the antiquity of the sanctuary. The cult of

Syrian Aphrodite is known only from inscriptions found there and elsewhere in the region, all dated late 3d or 2d c. In the light of the modest circuit of walls at Neromana, some have preferred to place Phistyon at Paravola. There are numerous traces of ancient buildings, largely Hellenistic, throughout the fertile land on the north side of the lake.

BIBLIOGRAPHY. J. Woodhouse, *Aetolia* (1897)[I]; O. Soteriades in *Praktika* (1908) 98; E. D. van Buren, *Greek Fictile Revetments* (1925) 59[I]; E. Kirsten, in *Arch. Anz.* (1941) 114[I]; in *RE* 20 1297.

M. H. MC ALLISTER

NERONIAS, *see* PANEAS

NERTOBRIGA (La Almunia de Doña Godina) Zaragoza, Spain. Map 19. The present town 50 km SW of Zaragoza, NE of Calatayud, was constructed on the ruins of a Roman villa excavated a few years ago which, from its mosaics, can be dated to the 3d c. A.D.

The exact location of the Celtiberian city and the mansio on the Roman road is uncertain, in spite of an attempt to identify it with Roman ruins, probably villas, near Calatorae. Recent excavations in Cabezo Chinchón, between Calatorae and Almunia, have unearthed a prehistoric settlement of the 6th and 5th c. B.C., but no Celtiberian establishment. The indigenous city, often referred to in military events of the 2d c. B.C., which minted coins bearing the inscription NERTOBIS in the Iberian alphabet, must lie in the Ricla-Calatora-La Almunia triangle.

BIBLIOGRAPHY. A. Beltrán, "Sobre la situación de Nertóbriga de Celtiberia," *VIII Congreso Nacional de Arqueología. Sevilla-Málaga, 1963* (1964) 277-85; id., "Mosaicos romanos de La Almunia de Doña Godina (Zaragoza)," *Noticiario Arqueológico Hispánico* 10-12 (1966-68) 325-27.

A. BALIL

NESACTIUM (Vizače) Croatia, Yugoslavia. Map 12. Near the village of Valtura 12 km NE of Pula. Situated on a deep bay, it was the chief stronghold of the Illyrian tribe of the Histri. It was burned by Romans in 177 B.C. after a bloody battle in which they defeated the last king of the Histri, Epulo (Livy 41.11.1). Later the settlement was rebuilt and regained its former importance. In the Augustan era it was a praefectura of the neighboring colony at Pola. In the 3d c. A.D. it was an autonomous respublica Nesactiensium with municipal dignitaries, aediles, and duoviri (*Inscr. It.* 10.1.672). The plan of settlement in the Roman period preserved the former pattern of the hill-fort settlement. The Illyro-Roman walls, still extant, encircled the hill on whose top was the forum with public buildings and statues. The houses were built on the terraces surrounding the hill. The site did not survive the destruction of the 7th c.

Nesactium has yielded some of the most important finds of the protohistoric sculpture in Europe, most probably from the native sanctuary. Many slabs ornamented with meander and spiral patterns are reminiscent of Mycenean art. Rich necropoleis from the Bronze Age to the Roman period have been excavated. The foundations of two Early Christian basilicas are still visible.

The finds are in the Archaeological Museum of Istria at Pula.

BIBLIOGRAPHY. A. Gnirs, *Istria praeromana* (1925); J. Mladin, *Umjetnički spomenici prethistorijskog Nezakcija* (with German summary) (1964); Š. Mlakar, *Die Römer in Istrien* (1966).

M. ZANINOVIĆ

NESSANA (Auja el-Hafir) Israel. Map 6. A town in the W part of the central Negev, on the border of Sinai. From papyri found at this place its ancient name was identified. Although not mentioned in Greek sources, the travel account of Antonine of Placentia (A.D. 570) contains a reference to the "fortress in which the inn of St. George was, at a distance of twenty miles from the city of Elusa."

Situated on the road leading from Beersheba to Sinai, Nessana was visited by early travelers. During the second half of the 19th c. the remains of the ancient town were explored and some Greek inscriptions were discovered. In 1936 the site was partly excavated. Since the lower town lay completely in ruins, the excavators concentrated on the acropolis, where a citadel and two churches were in a better state of preservation.

In the Byzantine period Nessana consisted of a lower town, built along the banks of a small wadi, occupying an area of ca. 18 ha, and the acropolis, which occupied a hill above the town to the W. Both parts of the town were connected by built steps. The earliest remains found on the hill (150 x 40-50 m) were pottery sherds and coins of the 2d and 1st c. B.C. To this period the excavators have attributed a small fort, but the typically Nabatean architecture suggests the first half of the 1st c. A.D., as does the typically Nabatean and Early Roman pottery found around this fort. To the same period should be dated a large ashlar-built cistern on the middle of the acropolis, which the excavators had dated to the Byzantine period.

Most of the remains on the acropolis are, however, of the Byzantine period. In the center of the hill stood a citadel (95 x 45 m), protected by towers, and with a gate on the S. The citadel had rooms on the E and W. To the N and S of the citadel were two churches; the one on the N was identified by an inscription as the Church of SS. Sergius and Bacchus. In both of these churches were discovered 150 papyri—Greek, Latin and Arabic. These include a small number of literary papyri, i.e., a Latin classical text, Latin-Greek glossaries, and literature of the New Testament. The larger group of papyri consisted of archives, dealing with personal, legal, and economic matters. It is in this group that the name of the town, along with the names of other towns in the Negev, is mentioned. From these documents we learn that during the late 4th and 5th c. a military unit, "The Most Loyal Theodosians," was stationed at Nessana, and formed the greater part of the landowners. These documents, which have not yet been fully studied, contain a great amount of information on the economic and political life of the towns of the Negev in the Byzantine period, and after their conquest by the Arabs in A.D. 636.

BIBLIOGRAPHY. L. Casson & E. L. Hettich, *Excavations at Nessana, II: The Literary Papyri* (1950); C. J. Kraemer, Jr., ibid., *III: Non-Literary Papyri* (1958).

A. NEGEV

NEŠTIN, *see* LIMES PANNONIAE (Yugoslav Sector)

NETHERBY, *see* CASTRA EXPLORATORUM

NETTLETON SCRUBB West Kington, Wiltshire, England. Map 24. Romano-British settlement in a small valley in the Cotswold hills, on the Fosse Way N of Bath (Aqua Sulis). The small Broadmead brook forms the ancient boundary between Nettleton and West Kington parishes.

A stone relief of Diana and her hound, now in the Bristol City museum, was found here in 1911. Excavations in 1956-70 have uncovered a small Roman camp built on the hillside when the Fosse Way was constructed in A.D. 47 or soon after, and a small circular shrine dedicated to Apollo, dated a little later, on a knoll overlooking the river.

Before A.D. 230 a large building of basilican type was erected on the river adjoining the circular shrine. This probably accommodated the pilgrims attending anniversary feasts or a Brotherhood in connection with the shrine. Soon after 230 a large octagonal podium was constructed around the circular shrine, and the shrine was enclosed by a precinct wall with an entrance. A shop and a priest's house were also built within the precinct, and nearby, beside the road approaching the shrine, a large square hostelry with an internal courtyard provided accommodation for visiting pilgrims.

About A.D. 250 the circular shrine was destroyed by fire, probably by Irish raiders who came by way of the Bristol Channel. An elaborate octagonal shrine ca. 21 m in diameter replaced it, built on the octagonal podium which was strengthened for the purpose. The octagonal shrine was surrounded by an ambulatory, which had a pent roof supported by pillars with pilasters at each angle. Access to the shrine and ambulatory was by way of a small vestibule on the E side. Inside the building eight radial walls from each angle of the outer octagonal wall converged towards the center, forming a central octagon surrounded by eight arches which supported a central vaulted roof. The eight chambers formed by the radial walls were also vaulted. The walls and all the vaulted roofs were plastered and painted in various colors; they carried human representations, and floral and linear designs.

The central altar bore an inscription to the god Apollo, as did a small votive bronze plaque. Towards the middle of the 4th c. A.D. the shrine fell into disrepair, probably because of the decline of the pagan religion, and evidence suggests that the building was later used by Christians.

After A.D. 340 the settlement became industrialized: iron and bronze smelting were introduced, and a pewter casting industry for the production of paterae, dishes, and plates. Towards the end of the 4th c. the settlement was subjected to two devastating raids, presumably by Irish raiders. The raiders may have settled at Nettleton Scrubb. A small Christian cemetery lends support to this theory, but other evidence suggests a temporary resurgence of pagan rites in the former shrine.

The settlement came to an abrupt end when the inhabitants were massacred after A.D. 402. Many human bones bearing sword marks and axis vertebrae indicating decapitation, found within the former shrine, bear witness to the massacre. The many finds are an important part of the Romano-British gallery in the Bristol City museum.

BIBLIOGRAPHY. "Roman Britain," *JRS* 29 (1939); 52 (1962); 59 (1969). W. J. WEDLAKE

NETUM (Noto) Siracusa, Sicily. Map 17B. Originally a Sikel center which, during the Greek period, was under Syracusan domination. The city, which extended over the Hill of the Alveria, was ca. 1 km in length. Its remains were destroyed by the earthquake of 1693. Of the monuments, more than 500 graves in the shape of artificial grottos (10th-7th c. B.C) are still preserved in the crags to the W; the grave goods are in the Museo Civico of Noto, in Siracusa, Agrigento, and Palermo. Of the Greek monuments remain the gymnasium (which is located to the SE and comprises two large units connected by a small rock-cut stairway), and two rock-cut heroa. From the gymnasium comes an inscription (*CIG* 240), at present in the Museo Civico.

BIBLIOGRAPHY. P. Orsi, *NSc* (1897); L. Bernabò Brea, *La Sicilia prima dei Greci* (1959); V. La Rosa, *Archeologia sicula e barocca per la represa del problema di Noto Antica* (1971). A. CURCIO

NEUSS, *see* NOVAESIUM *and* LIMES G. INFERIORIS

NEUVY EN SULLIAS, *see* VIENNE EN VAL

NEVIODUNUM (Drnovo) Yugoslavia. Map 12. City 6 km to the S of the present town of Krško, on a dry tributary of the Sava. Although archaeology shows the region of Lower Carniola, in which Neviodunum is located, to have been heavily populated from prehistoric times, the city itself was, as its name indicates, a new Celtic foundation of commercial character. Its economic basis was the river traffic. The city was associated with the Celtic tribe of the Latobici. Excavations have uncovered rich necropoleis along the roads to Emona and Siscia and in the dry tributary of the Sava have revealed the quay and large warehouses (both preserved). In the area of the W suburb ceramics workshops and a factory producing earthen water pipes have been discovered. The extent of the city (ca. 300 x 100 m) is known, as is the water supply system, the spring and cistern for which are on hillocks to the SE. The plan of the city is not known in detail. It received municipal status from Vespasian. Its fertile ager is still known for its richness.

In late antiquity the fortress of Velike Malence was built 10 km to the SE to guard against entry from the W into the plain around the city. The fortress, which includes an early church, is partly preserved.

BIBLIOGRAPHY. B. Saria, "Neviodunum," *RE* 17 (1936); P. Petru et al., *Municipium Flavium Latobicorum Neviodunum* (1961)[I]; id. et al., "Poročilo o raziskovanju suburbanih predelov Nevioduna," *Arheološki vestnik*, 17 (1966)[PI]; id., *Hišaste žare Latobikov* (1970)[PI]. J. SASEL

NEWCASTLE, *see* PONS AELIUS *under* HADRIAN'S WALL

NEWSTEAD, *see* TRIMONTIUM

NEWTON KYME ("Calcaria") Yorkshire, England. Map 24. A Roman town, first disclosed by air photography, ca. 3.2 km N of Tadcaster. Excavation has shown it to be of the simplest type, rectangular in plan with earthen rampart and outer ditch. The pottery of signal station type is late 4th c.

The *Antonine Itinerary* places Calcaria at a distance from Eboracum (York) that would seem to place it at Tadcaster, and the name Calcaria (limestone quarries) would be suitable to this location since Tadcaster lies close to a ridge of magnesian limestone that has been worked for centuries. However, since finds of Roman date here are limited to a few odd coins from the churchyard, identification of the site with Newton Kyme now seems more appropriate. G. F. WILMOT

NICAEA (Iznik) Bithynia, Turkey. Map 5. In legend, the God Dionysos was Nicaea's founder; according to record, some inhabitants of a small town of the same name near Thermopylai may have colonized it (Nonnus *Dion.* 15.170; 16.403-5; Dio Chrys. *Or.* 39.1 & 8). Moreover, in that locality is noted an ancient military camp of Bottiei; and the city was named Elikore, Ankore, when in 316 B.C. Antigonos Monophthalmos founded Antigoneia there (Strab. *Geogr.* 12.565; Eust. *Il.* 2.863). After the battle of Issos, in 301 B.C., Lysimachos conquered the city and refounded it with the name of his wife, daughter of Antipater. In 282-81 B.C. Nicaea came under the rulers of Bithynia and regained great importance (App. *Mith.* 6 & 77). It was only in 72 B.C. that Bithynia came under Roman domination at the conclusion of the Mithridatic war (App. *BCiv.* 5.139.1). Em-

bellished under Augustus to the point of contending with Nicomedia for the seat of the provincial governor, Nicaea became the first city of the eparchy under Claudius, as we know from the coinage. Pliny the Younger, governor under Trajan, further enlarged the city. Hadrian visited Nicaea in 123 and undertook works of fortification that were finished in the 3d c. A.D. under Claudius II (Gothicus), after the Goths had already caused serious damage to the city in 258. Constantine continued the work of embellishment of his predecessors, and held the first council at Nicaea in 325. Justinian took particular interest in the city (Amm. Marc., 26.1.3.5; 2.2; 22.9.5), which was again chosen in 787 for the second council.

The geographical situation of Nicaea was particularly fortunate (Plin. *HN* 6.34.217; Strab. *Geogr.* 2.134; Ptol. *Geogr.* 5.1.3). Its position on the shore of Lake Ascania (Iznik Gölü), on level and fertile ground, with wide roads for traffic that radiated from the city, made Nicaea a great Hellenistic center. Strabo (*Geogr.* 12.565) minutely described the foundation of the new Lysimachan city: It had a square plan 700 m to a side; the roads were arranged with perpendicular axes, following the perfect regularity of the rectangular scheme; two large arteries crossed at right angles at the center of the inhabited area; the extensions of the roads led to the four gates of the city, visible from a fixed stone placed at the center of the gymnasium, a building that thus must be supposed at the heart of the urban plan.

The following monuments are listed by written history and inscriptions: a theater, a Sanctuary of the goddess Roma and of Caesar (built under Augustus), an Apolloneion, a market (built under Hadrian), an aqueduct, and churches and a palace erected by Justinian (Procop. *De aed.* 5.3). The coinage, from the period of Marcus Aurelius onward, commemorates a number of other monuments, among them the temples of Asklepios, of Dionysos, and of Tyche. The theater was to the SW of the city, though little remains of the building itself. Its recognizable dimensions reach a maximum of 85 x 55 m, and only part of the cavea is conserved; the orchestra and the skene have been lost. Its plan must have been Hellenistic but has been repeatedly modified (Plin. *Ep.* 10.48). A curious monument, the obelisk of C. Cassius Philicus, rises barely outside Nicaea on the road to Nicomedia, and must have been a family tomb. The obelisk, triangular in section, is 12 m tall, and is placed on a rectangular base 2 x 3 m. The Byzantine city, which rendered unrecognizable with its new constructions the ancient Nicaea, overlaid the Hellenistic-Roman city plan. The imposing earlier walls had by the 5th c. A.D. already undergone major renovation. This Byzantine construction has two aspects. The gates, with triple openings, and several towers, seem still to follow the Roman plan; but often the superstructures are Byzantine, and the definitive system is Turkish. The principal churches of Nicaea included the Cathedral of Haghia Sophia, originally a basilica with three aisles of the 5th c., that underwent repeated restoration until the 14th c.; and the Church of the Dormition of the Virgin, whose controversial chronology varies between the 6th-7th and the 8th-9th c., with the earlier more probable. Of notable interest were the rich mosaics of the cupola and the narthex, destroyed during the Graeco-Turkish War, known only from photographs and watercolors made at the beginning of this century.

BIBLIOGRAPHY. C. Texier, *Description de l'Asie Min.* I (1839); M. Schede, *Führer durch Iznik (Nikaia)* (1935); N. Firatli, *Istanbul Arkeoloji Müzeleri Yilliği* 11-12 (1964); C. Artuk, *VI Türk Tarih Kongresi, Ankara 1961* (1967).

For the Graeco-Roman city: A. Fick & K. O. Dolman, *AA* 45 (1930); A. M. Schneider, *Forsch. und Fortschritte* II (1935); id. in *Antiquity* 12 (1938); id. with W. Karnapp, *Die Stadtmauern von Iznik* (*Istanb. Forsch.* 9, 1938). N. BONACASA

NICOMEDIA NW Turkey. Map 5. About 91 km E-SE of Istanbul at the head of the Gulf of Nicomedia; the modern İsmit. Nicomedia was founded about 264 B.C. by Nicomedes I of Bithynia (Strab. 12.4.2) on the site of the Greek colony of Olbia. First the capital of the Bithynian kingdom (Memnon 20.1), and later of the Roman province of Bithynia, Nicomedia was astride the great highroad connecting Europe and the East, and was a port as well; Nicaea was its rival. It is mentioned frequently in the *Letters* of the younger Pliny (esp. Book 10) and by Dio Cassius (esp. in Books 73, 78, and 79). Sextus Pompeius, in flight, halted there in 36 B.C. (Dio Cass. 49.18.3); a few years later Octavian allowed the Bithynians to consecrate a precinct to his name in the town (Dio Cass. 51.20.7). Passages in Dio Chrysostom (*Or.* 38, and 47.16) evoke a prosperous and growing metropolis, and the city's buildings and water supply came repeatedly to the attention of Trajan and Pliny when the latter was governor of Bithynia. Emperors visited and wintered there (Dio Cass. 78.18-19, and 79.8 and 35), a garrison existed (Plin. *Ep.* 10.74), and the city, a major one in later antiquity, housed a statio of the imperial post and a fleet headquarters. Sacked by the Goths in A.D. 256, Nicomedia became, in Diocletian's time, the much adorned E capital of the Empire (Lactant. *De mort. pers.* 17.2-9), but the foundation of Constantinople and severe earthquakes in the 4th and 5th c. greatly reduced its importance (Amm. Marc. 22.9.3). Something of a renaissance resulted from the care of Theodosius II (A.D. 408-50). There is a varied and important coinage.

Little excavation has taken place, and much that could be seen in the last century is no longer visible. Vestiges of a Hellenistic building of unknown function have come to light. Along the contours of Nicomedia's hilly site exist stretches of the Roman walls (with Byzantine and Turkish restorations and additions); they are of late antique construction—rows of brick alternating with rows of stone. At their NE limit are the remains of a high tower, and beside this is the gate to the road leading N to the Euxine. Parts of the harbor wall, which could be seen until a generation ago, were of typically Roman brickwork. Marble elements of a very large nymphaeum of the 2d c. A.D. have been found (İstanbul street), and E of the city there are the remains of two if not three aqueducts (Plin. *Ep.* 10.37), one of which appears to rest on foundations of Hellenistic date (Libanius, *Or.* 61.7.18, speaks of the copious supply of water to Nicomedia in the 4th c. A.D.). In the E district of the city, at the old Jewish cemetery, there are the ruins of a late Roman cistern of considerable size, built of reduplicated bays roofed with saucer domes of brick carried on piers. Major ancient drains were in use in İsmit until 1933.

Inscriptions, coins, and texts record, among others: a Temple of Roma (29 B.C., the meeting place of the provincial assembly); a Temple of Demeter, and satellite structures, in a large rectangular precinct on the hill visible from the harbor; a theater nearby; a colonnaded street (a few bits were once seen) probably leading from Demeter's precinct to the harbor; a forum (Plin. *Ep.* 10.49); a Temple of Isis and a hall for the Gerusia (10.33); a Temple of Commodus (Dio Cass. 73.12.2); and, for Diocletian, a palace, an armory, a mint, and new shipyards were built. Evidence of necropoleis

abounds, and about 8 km N of the city are tumuli which may be the tombs of the Bithynian kings. One coin hails Hadrian as Restitutor Nicomediae.

Pliny (and Justinian and Suleiman the Magnificent after him) hoped to finish the canal, long proposed, between the Propontis and the Euxine via Nicomedia, the Sabanja Göl (Lake Sunonensis in Amm. Marc. 26.8.3) and the Sangarios system (*Ep.* 41 and 61); the project was never realized. There is a modest museum in the town, and objects from Nicomedia can be seen in the archaeological museums of Istanbul and Izmir.

BIBLIOGRAPHY. *RE* XVII (1937) 468-92; D. Magie, *Roman Rule in Asia Minor* (1950, repr. 1966); F. G. Moore, "Three Canal Projects, Roman and Byzantine," *AJA* 54.2 (1950) 97-111[MPI]; M. Firlati, *İzmit rehberi* (1959; shorter French version 1964)[PI]; *EAA* 5 (1963) 455-57[I]; A. M. Sherwin-White, *The Letters of Pliny* (1966) refs. on p. 798. W. L. MAC DONALD

NICOPOLIS, *see* EMMAUS

NICOPOLIS AD ISTRUM (Nikup) N Bulgaria. Map 12. A city 20 km from Tarnovo beside the river Rossitza which empties into the Jantra, a tributary of the Danube, at the foot of Mt. Haemus. The city was founded by Trajan at the junction of the roads to Danubium and to Philippopolis. It was raised to the status of a municipium by Hadrian, coined its own money from the reign of Antoninus to that of Gordian III, flourished particularly under Septimius Severus, was captured by the Goths, reconstructed by Justinian, and finally abandoned. The city was Greek in tongue and in its constitution, with many foreign settlers and a large number of religious cults.

The city was formed on a regular grid plan of which some axis streets have been brought to light. It was encircled by walls and round towers with an appendage, also walled, in the form of an irregular pentagon, on broken ground—much like a defensive castellum. The gates and towers are represented on coins.

The central area has been excavated, including the forum (55 x 42 m) surrounded on three sides by a colonnade of Ionic columns. On the W side of the forum are the bouleuterion and other structures (perhaps the praetorium) and a colonnaded peristyle opening on one side onto the forum portico. On the other side it opened onto the great propylaea, which presented a facade of four columns supporting a frieze that contained a dedicatory inscription to Trajan. Beside the grandiose peristyle is a small Corinthian-style theater or perhaps an odeion. It had a perfectly semicircular orchestra (9.3 m in diam.). The cavea (21.8 m in diam.), was raised on brick vaults. The theater was inscribed in a rectangle which comprised a series of rooms, rectangular and square (tabernae ?), which opened on the decumanus behind the cavea. Many statue bases have been found, as well as altars, honorary inscriptions (one in honor of Marcus Aurelius and Lucius Verus mentions games given by a high priest and by his daughter), facades with shields and lances, and friezes. An aqueduct, canals, cisterns, and paved roads have been brought to light.

In the architecture of Nicopolis, Hellenistic elements from Asia Minor predominate. Many architectural pieces are fragmentary. Among the sculptures, a statue of Eros is most noteworthy. It is a Roman copy of the 2d c. A.D. of the Eros of Praxiteles at Paros. There are many religious reliefs (the relief of the gods which is a unique provincial work), a beautiful bronze head of Gordian III (now in the National Museum of Sophia), and many small bronzes.

BIBLIOGRAPHY. G. Seure, "Nicopolis ad Istrum," *RA* (1907) 257, (1908) 33; B. Filov, "Erosstatue aus Nicopolis ad Istrum," *JdI* 24 (1909) 60[I]; S. Bobcev in *Iz. Bulg. Arch. Inst.* 5 (1928-29) 56[MPI] (architecture); G. Kazarov in *RE* XVII (1936) 518-34; D. Zoncev, "Monuments de la sculpture romaine en Bulgarie meridonale," *Latomus* 39 (1959)[I]. A. FROVA

NICULIŢEL Dobrudja, Romania. Map 12. Rural Roman settlement. An altar dedicated to J.O.M. Dolichenus and an inscription in honor of Julian the Apostate have been discovered. Limited archaeological explorations have identified the remains of several Roman buildings and an aqueduct. A martyrium for the relics of the martyrs Zotikos, Attalos, Kamasis, and Philippos (4th-5th c.) have been uncovered under the ruins of a basilica.

BIBLIOGRAPHY. *TIR*, L.35 (1969) s.v.; V.-H. Bauman, "Nouveaux témoignages chrétiens sur le limes nordscythique: la basilique à martyrium de basse époque romaine découverte à Niculiţel (dep. de Tulcea)," *Dacia*, NS 16 (1972) 189-202. I. BARNEA

NIDA (Frankfurt am Main – Heddernheim) Germany. Map 20. For the Heidenfeld on the N shore of the Nidda, tributary of the Main, only epigraphic sources are known. Earthworks under Vespasian on the line of advance along the Wetterau, were followed under Domitian by a stone citadel (of the Ala I Flavia Gemina), which was abandoned under Trajan. From the camp settlement there developed the vicus Nida, capital of the Civitas Taunensium, and its area (45 ha) was enclosed by a hexagonal wall at the beginning of the 3d c. With the fall of the limes, A.D. 259-60, the town was destroyed by the Alemanni and lay in ruins for a thousand years. The ruins deteriorated rapidly after the Late Middle Ages, and today no remains are visible. Excavations were begun in 1823 and have continued over the years. Finds are in the museums of Frankfurt and Wiesbaden.

Between the two roads leading W from the citadel there was a triangular market place, surrounded by stone buildings (baths, temples, praetorium, barracks) and half-timbered row houses. Under the civilization layer 1 m down, much stone sculpture was discovered, five Mithraea, and several Jupiter columns. There were necropoleis to the W and N.

BIBLIOGRAPHY. F. G. Habel, "Die römischen Ruinen bei Heddernheim," *Nassauische Annalen* 1 (1827) 45-86; *Mitteilungen über römische Funde in Heddernheim* I-VI (1894-1918); K. Woelcke, "Der neue Stadtplan von Nida-Heddernheim," *Germania* 22 (1938) 161-66; U. Fischer, "Grabungen im Lager Heddernheim," *Germania* 38 (1960) 189-92 (Fundchronik Land Hessen); id., *Aus Frankfurts Vorgeschichte* (1971); id., "Grabungen im römischen Steinkastell von Heddernheim 1957-59," *Schriften des Frankfurter Museums für Vor- und Frühgeschichte* 2 (1973); *Fundberichte aus Hessen* 1 (1961ff). U. FISCHER

NIDUM (Neath) W. Glamorgan, Wales. Map 24. The Roman fort discovered in 1949 overlooks the point where the road from Isca (Caerleon) to Moridunum (Carmarthen) crossed the tidal reaches of the Neath. Its area was ca. 2.4 ha. The earlier fort, built in A.D. 75-85, was of earth and timber, and little is known of it. It lay over traces of earlier occupation, perhaps of a temporary character. After a period of abandonment, not precisely dated, a new fort was built on the same site in ca. A.D. 120-125. This fort had stone defenses, and a stone latrine is also known. The pottery evidence suggests that the fort was abandoned ca. A.D. 140, though the mention of Nidum in the *Antonine Itinerary* implies that a posting

station existed in later centuries. Virtually nothing of the fort is now visible. The finds are deposited in the National Museum of Wales, Cardiff.

BIBLIOGRAPHY. V. E. Nash-Williams, "The Roman Stations at Neath (Glam.) and Caer Gai (Mer.)," *Bulletin of the Board of Celtic Studies* 13 (1948-50) 239-45; id., "The Roman Station at Neath. Further Discoveries," ibid. 14 (1950-52) 76-79; B. Heywood in V. E. Nash-Williams, *The Roman Frontier in Wales* (2d ed. by M. G. Jarrett 1969) 98-101[M]. M. G. JARRETT

NIEDERBIEBER, *see* LIMES, G. SUPERIORIS

NIEDERSACHSEN, *see* HILDESHEIM

NIGRUMPULLUM (Zwammerdam) S Holland, Netherlands. Map 21. Roman castellum on the Old Rhine ca. 20 km E of Leiden. Three periods are to be distinguished in its development. Little remains of the oldest settlement, which was built, judging from the pottery, in the middle of the 1st c. A.D. as part of the reorganization of frontier defenses by Corbulo (Tac. *Ann.* 11.20). A thick burnt layer, however, recalls its violent end during the rebellion of the Bataves in A.D. 69 (Tac. *Hist.* 4.15).

In Flavian times the castellum was rebuilt (134.4 x 76.4 m); the wall, portae principales, and two ditches have been found. The broad facade of this fortress is striking. The material for bricks was supplied by Legio X stationed at Nijmegen and Legio XXII Primigenia stationed at Xanten. In 2d c. repairs, however, roof tiles produced by vexillarii of the army of Lower Germany were used. At this time a civilian settlement developed to the SW; the houses lie on a road parallel to the wall of the fort.

About A.D. 175 the castellum was rebuilt in stone (140.6 x 86 m). Most of its roof tiles were made by the exercitus Germanicus inferior on the Holdeurn near Nijmegen. A few pieces bear the names of the later emperor Didius Iulianus, governor of Germania inferior ca. A.D. 178, and of the unknown consularis Iunius Macr. Some time afterwards the principia was replaced by a stone building (42 x 27 m), distinguished from the standard type of headquarters by a facade with columns. The stone wall of the fort, four gates, and three ditches have been found, and the two main roads intersecting at right angles, the via principalis and the via praetoria. Outside the fort are the foundations of a bath house(?).

On the N the castellum was protected by the Rhine, following a course now silted up. Here several embankments were found, which appear to correspond to the building phases of the fort. In part of the last embankments were six remarkably well-preserved ships showing different types of boats evolved from the simple dugout canoe.

The garrison probably consisted of all or part of a cohors equitata. The latest known coin dates from Severus Alexander or perhaps Tacitus (275-276), and the pottery of the last period is very similar to that from Niederbieber (A.D. 190-260). A final date after the 2d quarter of the 3d c. therefore seems likely.

BIBLIOGRAPHY. H. K. de Raaf, "De Romeinse nederzetting bij Zwammerdam," *Ber. Rijksdienst Oud. Bod.* 8 (1957-58) 31-81; W. Glasbergen & J. K. Haalebos, "Zwammerdam," *Nieuwsbull. Kon. Ned. Oud. Bond* (1968) 94-97; (1970) 53-55; (1971) 20-21; Haalebos, "Opgravingen te Zwammerdam," *Jb. Geschiedenis en Oudheidkunde van Leiden en Omstreken* (1969) 175-80; id. & J. E. Bogaers, "Een schildknop uit Zwammerdam-Nigrum Pullum, Gem. Alphen (Z.H.)," *Helinium* 10 (1970) 242-49 and 11 (1971) 34-47; id., *De Romeinse castellate Zwammerdam* (diss. 1973); id., "Enkele opmerkingen over de versierde Trierse terra sigillata uit Zwammerdam, Gem. Alphen (Z.H.)," *Westerheem* 22 (1973) 178-84; L. H. van Wijngaarden-Bakker," Dierenresten uit het castellum te Zwammerdam," *Helinium* 10 (1970) 274-78; M. D. de Weerd & J. K. Haalebos, "Schepen voor het opscheppen," *Spiegel Historiael* 8 (1973) 386; J. E. Bogaers & C. B. Rüger, *Der Niedergermanische Limes* (1974) 49-52. J. K. HAALEBOS

NIHAVAND, *see* LAODICEA (Iran)

NIJMEGEN, *see* NOVIOMAGUS BATAVORUM

NIKAIA (Jelalabad), *see following* ALEXANDRIAN FOUNDATIONS, 8

NIKAIA (Nice), *see under* CEMELENUM

NIKAIA (near Mong), *see following* ALEXANDRIAN FOUNDATIONS, 8

NIKARIA, *see* IKARIA

NIKONION (Roksolany) Ukraine. Map 5. Greek settlement, probably a colony of Istria, on the E shore of the Dniester liman near Odessa (Ps. Skyl. 68). It was founded in the mid 6th c. B.C. The settlement, 4 ha in area, was burned in the mid 4th c. B.C., after which it became an agricultural village. In the 2d c. B.C. it was destroyed by a natural disaster but recovered and existed into the 4th c. A.D. It imported mainly Attic wares from the 6th-4th c. along with some rare specimens of wares from Corinth and Chios. Coins of Istria predominate from the 5th-4th c. and, sporadically, coins of Olbia (6th-5th c.) and Tiras (4th c. B.C.). Particularly noteworthy are some stamped amphorae from Thasos, Chersonesus, Herakleia and Sinope. Terracottas (Ionian, 6th c.; Attic, 5th c.) are predominantly figurines of Demeter and Aphrodite. From the 1st c. A.D. imported articles disappeared, being replaced by those of local manufacture. The Odessa Museum contains material from the site.

BIBLIOGRAPHY. M. S. Sinitsyn, "Raskopki gorodishche vozle s. Roksolany Beliaevskogo raiona Odesskoi oblasti v 1957-1961 gg.," *Materialy po arkheologii Severnogo Prichernomor'ia* 5 (1966) 5-56; P. O. Karyshkovskii, "K voprosu o drevnem nazvanii Roksolanskogo gorodishcha," *Materialy po arkheologii Severnogo Prichernomor'ia* 5 (1966) 149-62; I. B. Brašinskij, "Recherches soviétiques sur les monuments antiques des régions de la Mer Noire," *Eirene* 7 (1968) 84. M. L. BERNHARD & Z. SZTETYŁŁO

NIKOPOLIS (Palioprevesa) Epeiros, Greece. Map 9. On the peninsula opposite Aktion and separating the Ionian Sea from the Gulf of Arta. The city was founded by the emperor Augustus after 31 B.C. on the site occupied by his army during the Battle of Aktion. In addition to serving as a monument to this victory, Nikopolis was a synoecism of older cities (Strab. 10.2.2; Paus. 5.23.3) providing an administrative center to replace the Aitolian and Akarnanian Leagues. It was, from the beginning, a free city, minted its own coinage and was the site of games in honor of Apollo Aktios. In A.D. 94, the Stoic philosopher Epiktetos established his philosophic school in the city after being forced to leave Rome. In the Christian period, Nikopolis served as the metropolitan seat of W Epeiros. The city was damaged by earthquake in A.D. 375 and probably by the inroads of Goths, Huns, and Vandals in the century which followed. The emperor

Justinian had the fortifications of the city rebuilt in A.D. 550. The 10th century witnessed the gradual decline of the city with the influx of Bulgars into the area. Eventually its inhabitants drifted away to nearby Prevesa.

According to Strabo (7.7.6), the city had two harbors and a temenos sacred to Apollo in the suburbs. The temenos contained a sacred grove, a stadium, and a gymnasium. The stadium is visible in the area N of the city, as are a large theater and a bath structure. North of the sanctuary area is a hill (modern Michalitzi) where Augustus is said to have established his field headquarters during the battle. After his victory the site was consecrated, according to Strabo and Dio Cassius (51.1.3), to Apollo, according to Suetonius (*Aug.* 18), to Neptune and Mars. Excavations carried out by Greek archaeologists uncovered remains of a large structure of uncertain form, and fragments of a Latin inscription referring to Neptune.

The city proper is enclosed by a polygonal circuit of walls, presumably those of Justinian. Inside the walls are a large peristyle building identified as some sort of public building or administrative palace, and three Early Christian basilicas. Basilicas A (second quarter of the 6th c. A.D.) and B (5th c.) are of the tripartite transept variety. To the W of Basilica A, especially noted for its figural mosaic pavements, is another peristyle complex known as the episcopal palace. Basilica C, located to the N near the circuit wall, is triple-apsed and dated to the period after Justinian.

In the region W of the circuit walls are an odeion, a stretch of aqueduct with associated reservoirs and bath, and many brick-vaulted tombs and single burials. An apsidal building, also containing several graves, has been identified as a church dedicated to the Holy Apostles. The area S of Nikopolis contains an amphitheater, more tombs and graves, and a second, probably Augustan, stretch of wall. A third transept basilica (D, dated late 5th-early 6th c. A.D.), similar to Basilica A, has been excavated here as well as the mediaeval church of the Resurrection and part of a 5th c. villa. A fourth transept basilica, similar to those in Nikopolis, has been partially excavated 4 km SE of the city, outside modern Prevesa (mid- to third quarter of the 6th c.). Museum on site.

BIBLIOGRAPHY. P. Frourike, "Nikopolis-Prevesa," *Epeirotika Chronika* 4 (1929) 117-59; A. Baccin & V. Ziino, "Nicopoli d'Epiro," *Palladio* 4 (1940) 1-17MPI; E. Kitzinger, "Mosaics at Nikopolis," *DOP* 6 (1951) 83-122; E. Kirsten & W. Kraiker, *Griechenlandkunde. Ein Fuhrer zu klassischen Statten* (1967) II, 751-55M; Excavation reports in *Praktika* 1913-16, 1918, 1921-24, 1926, 1929-30, 1937-38, 1940, 1956, 1961; *ArchEph* 1913-14, 1916-18, 1922, 1929, 1952 and various articles, 1964-65, 1967, 1970-71; *Deltion* 1960-65, 1968-69.　　A. WEIS

NIKOPOLIS (Yeşilyayla, Suşehri, Sivas) Armenia Minor, Turkey. Map 5. Founded by Pompey in 72 B.C., it was given by Antony in 36 B.C. to Polemon, and incorporated in the Empire in A.D. 64. It was the metropolis of Armenia Minor and had by the 3d c. become a colony with the ius Italicum. It was destroyed by earthquake in A.D. 499. A smaller circuit of walls of Justinianic date can be seen on the site built over a more widespread ruin field.

BIBLIOGRAPHY. F. & E. Cumont, *Studia Pontica* II (1906).　　R. P. HARPER

NIKSAR, see NEOCAESAREA

NIKUP, see NICOPOLIS AD ISTRUM

NÎMES, see NEMAUSUS

NIN, see AENONA

NIŠ, see NAISSUS

NISA Lycia, Turkey. Map 7. Near Sütleğen, in the mountains ca. 25 km N of Kaş. Mentioned only by Ptolemy and Hierokles and in the episcopal *Notitiae*. There is no evidence that Nisa was ever a member of the Lycian League; her one known coin (*Sammlung von Aulock* no. 4373), of the 2d c. B.C., is of nonfederal type.

The ruins are quite considerable but poorly preserved. They include a theater and a stadium; above the latter is a paved agora with a stoa and a number of inscribed bases. The city wall is partly preserved, in good squared blocks. The necropolis, outside the wall on the W, contains sarcophagi and a few built tombs.

BIBLIOGRAPHY. R. Heberdey in *Festschrift für H. Kiepert* (1898) 153-58; *TAM* II.3 (1940) 271.　　G. E. BEAN

NISAIA, see LIMES, ATTICA

NISCEMI Sicily. Map 17B. A modern village on the terraces that dominate the E side of the Geloan Fields. In its environs, and especially on the plain, are numerous traces of settlements of the Iron Age and of the Hellenistic and Roman periods. From somewhere in this area comes a rich deposit of bronze objects datable between the end of the 10th and the 8th c. B.C. The deposit comprises axes, javelin or arrow heads, tips of spits, pieces of daggers and short swords, a razor, and other bronze fragments.

At the foot of the terrace in the Petrusa district, toward the N, a pagus of the late Republican or early Imperial period has been identified but has not yet been excavated. Farther N, on a small hill dominating the E side of the Plain of Gela, in the district of Piano Tenda, a large Hellenistic farm has been found but has not yet been investigated. In the area closer to the territory of Gela, in the district Piano della Camera, another small settlement of Roman Imperial date has been recognized.

All the settlements on the Geloan plain must obviously have belonged to the Plaga Calvisiana (Praedium Calvisianum).

BIBLIOGRAPHY. L. Bernabò Brea, *La Sicilia prima dei Greci* (2d ed., 1960) 189-92; D. Adamesteanu, *RendLinc* 10 (1955) 200-10.　　D. ADAMESTEANU

NISTA ("Torone") Greece. Map 9. On the coast of Epeiros at the head of Plataria Bay, where there is a small fortified acropolis. Ptolemy mentions it (3.14).

BIBLIOGRAPHY. N.G.L. Hammond, *Epirus* (1967) 80, 688.　　N.G.L. HAMMOND

NISTOS and SACOUE Hautes-Pyrénées, France. Map 23. Excavations in 1956 disclosed on top of Mont Sacon at the peak of Tourron a summit sanctuary 1541 m high. The sanctuary had many small votive altars of white Saint-Béat marble. It seems to have been dedicated to Jupiter and was undoubtedly destroyed after the spread of Christianity.

BIBLIOGRAPHY. G. Fouet, "Cultes gallo-romains de sommets dans nos Pyrénées centrales: le Mont Sacon," *Rev. de Comminges* 76 (1963) 13-16; G. Fouet & A. Soutou, "Une cime pyrénéenne consacrée à Jupiter: le Mont Sacon (1541 m.)," *Gallia* 21 (1963) 275-94.

M. LABROUSSE

NISYROS Greece. Map 7. An island of the S Sporades group. It is cited in the *Iliad* (2.676) as a participant in the Trojan War, led by the sons of Thessalos. In historic times Nisyros spoke the Doric dialect and belonged for

a time to the Delio-Attic League. In 200 B.C. it was incorporated into the Rhodian domain. The ancient city was at the NW tip of the island, above modern Mandraki. Remains include sections of the encircling wall with towers built of trapezoidal blocks, perhaps from the 4th c. B.C., and, at the SE corner, a gate with an access ramp. In the valley below a necropolis was excavated in 1932; it yielded material from the 7th and 6th c. B.C., as well as a tomb datable to the 5th c. B.C.

BIBLIOGRAPHY. R. M. Dawkins, "Notes from the Sporades," *BSA* 12 (1905-6) 165ff; G. Jacopi, "Scavi e ricerche di Nisiro," *Clara Rhodos* 6-7 (1932-33) 471ff[PI]; G. E. Bean & J. M. Cook, "The Carian Coast III," *BSA* 52 (1957) 118-19; R. Hope Simpson & J. F. Lazenby, "Notes from the Dodecanese," *BSA* 57 (1962) 169[PI].
M. G. PICOZZI

NIVICĖ LOPES, *see* LIMES, SOUTH ALBANIA

NOCERA SUPERIORE, *see* NUCERIA ALFATERNA

NOCERA TERINESE, *see* TERINA

NOCERA UMBRA, *see* NUCERIA CAMELLARIA

NOEPOLI Basilicata, Italy. Map 14. An Oenotrian center and later a Lucanian settlement between the Sinni river (ancient Siris) and its tributary the Sarmento, on a height covered now by the modern town. Because of its total isolation, it probably never had fortifications although it existed from the 8th c. to the first decade of the 3d c. B.C.

Nothing is known of the town itself, but there have been investigations in the archaic, Classical, and Hellenistic cemeteries, which occupy the area between the fork in the national highway from Noepoli to Cimitero. The oldest tombs brought to light belong to the end of the 8th c. and the 7th c., all systematically set around the fork. The cemeteries of the 4th c. are all found near Cimitero. The most ancient funerary items comprise cone-shaped vases with hanging decorations and large-holed brooches. Compared to the other cemeteries, those in the N area are poorer in Greek ware.

BIBLIOGRAPHY. D. Adamesteanu, *Popoli anellenici in Basilicata* (1971) 56.
D. ADAMESTEANU

NOIODUNUM (Jublains) Mayenne, France. Map 23. Mentioned by Ptolemy, and situated at the SE end of a huge granite plateau, Noiodunum seems to have been one of the leading cities of the Diablintes tribe from the 1st c. B.C. on. In the Imperial period it was made a chief city, becoming the economic and administrative center of the new civitas. After more than two centuries of prosperity the city was heavily damaged towards the end of the 3d c., managed to survive, and was finally abandoned about the end of the 6th c.

Excavations show that Noiodunum was laid out on a checkerboard plan oriented SE-NW from the decumanus. Only a few monuments on the outskirts can be seen today. The theater, at the S city exit, is more than a semicircle—an arrangement fairly frequent in N Gaul. There is no podium. The temple, known as the Temple of Fortuna, is N of the city. It was rectangular, ringed with a peristyle, and the cella was approached by a stairway still visible in the E part of the monument.

The most interesting complex is called the burgus. It consists of a central building with an earthwork vallum around it, and a great circuit wall. The principal monument, which dates from the 1st c. A.D., is rectangular and flanked by four square pavilions to which little rooms were added towards the end of the 3d c. In the center

of the building is a large rectangular atrium with an impluvium in the middle. The S wall has a doorway of cyclopean masonry; its jambs have deep grooves in them—traces of the closing mechanism. Two small similarly constructed doorways give onto the outside from two of the corner pavilions, while the latter are connected to the atrium by doorways with semicircular brick arches. The outer walls, 2.1 m thick and built with a core of mortared rubble faced with small blocks, have a subfoundation of large squared stones.

The building was unquestionably a defensive one; the earthwork vallum was originally duplicated by a trench, triangular in cross-section, which had a wide gate with masonry jambs in the SE corner. Finally, there are two small baths outside the central building, in the NE and SW recessed corners of the vallum. The huge trapezoidal rampart surrounding the complex was built in the second half of the 3d c.; it has 13 towers, an entrance gate to the E, and two posterns in the corners. The masonry is of the Classical type: coarse rubble between two carefully laid facings divided every seven rows by a triple layer of bricks. In the foundations are many reused architectural fragments.

Objects found in the excavations are in a storehouse recently built near the fortress. Other finds are in museums in Laval, Mayenne, and St. Germain-en-Laye.

BIBLIOGRAPHY. Grenier, *Manuel*: defenses I, 454-63[PI]; theater III:2, 964-66[P]; temple IV:2, 777-86[MP].
M. PETIT

NOLA Campania, Italy. Map 17A. An ancient city, already known to Hekataios as an Auruncan foundation. It was an important station on the inland highway from Etruria to Poseidonia that subsequently became the Via Popilia, lying in the valley between Vesuvius and the first ridges of the Apennines roughly halfway between Capua and Nuceria. Cato (Vell. Pat. 1.7.3) called it Etruscan, and it was likely enough colonized from Capua. After the collapse of the Etruscan dodecapolis in Campania in the early 5th c., Nola seems to have reached the apogee of its wealth and power. It fell to the Samnites at the end of the 5th c., but in its Samnite period, when it was called Novla, it was friendly to Naples and not only coining money of Neapolitan type and weight, but willing in 327 B.C. to send a force of 2000 men to help Naples in its struggle against Rome (Livy 8.23.1). In 312 B.C. it fell itself to the Romans (9.28.3-6). In the second Punic war it remained loyal to Rome and was a staging center for Roman operations against Hannibal in S Italy. In the social war, on the other hand, it was taken by the Samnites in 90 B.C. despite the presence of a Roman garrison, had to suffer siege by Sulla in 88 and again in 80, and was eventually taken by storm. Sulla evidently settled a colony of veterans there, for it was inscribed in the tribus Falerna and carried the name colonia Felix Augusta. In 73 Spartacus' men overran the place once more (Florus 2.8.5). This was the end of its troubles for a while. It received a colony of Augustus, who died here in A.D. 14 on a family property that Tiberius made a temple (Cass. Dio 56.46). Later, both Vespasian and Nerva settled veterans here (*Lib. Colon.* 236). In the days of bishop Paulinus of Nola (409-431) it became a center of monastic life but was plundered by the Goths under Alaric in 410 and more savagely by the Vandals under Genseric in 455.

Little is known of the topography of Nola; traces of an amphitheater with brick facing are to be seen, and there are records of, and an inscription belonging to, a theater with marble revetment. The fortified urban area appears to have been small, somewhat displaced toward the SW from the present center of the town. In fact Livy (9.28.

3-6) tells us that in the 4th c. B.C. the walls of Nola were already surrounded by a belt of suburban building, and we have notice in inscriptions of four outlying pagi: Agrifanus, Capriculanus, Lanita, and Myttianus. There are comparatively few monumental Roman tombs in its vicinity.

Nola's great fame comes from its necropoleis, which were systematically ransacked from the late 18th c. through the first half of the 19th. A wealth of vases has been removed and enriches the museums of the world. It goes back as far as geometric and italo-geometric, but its concentration is within the span of Attic black- and red-figure wares. From the beginning of the second quarter of the 5th c. there is scarcely an Attic painter of quality not represented in the Nolan finds.

BIBLIOGRAPHY. J. Beloch, *Campanien* (1890) 389-411, 472; M. B. Jovino & R. Donceel, *La necropoli di Nola preromana* (1969); E. La Rocca, *Introduzione allo studio di Nola antica* (1971). L. RICHARDSON, JR.

NORA Sardinia, Italy. Map 14. An ancient city SW of Cagliari on the promontory that ends in Capo di Pula. It is mentioned by the geographers (Ptol. 3.3.3, *It. Ant.* 85, *Tab. Peut.*), Pausanias (10.17.5); and Solinus (*Coll. Rer. Memorab.* 4.2) attributed the foundation of the city to Iberians under the guidance of the mythical king Norace. An inscription from the end of the 9th c. B.C., however, preserves a record of the city's founding by Phoenicians coming from Cyprus. Like the rest of N Sardinia, Nora fell to the Carthaginians at the end of the 6th c. B.C., and in the 3d c. B.C. to Rome. Both in the Punic period and in Roman Republican times Nora's preeminence among Sardinian cities was unchallenged until Cagliari assumed the official title of municipium Iulium and became the residence of the governors of the island. In Imperial times Nora was a municipium ruled by quattuorviri iure dicundo and by decurions. The city declined during the Vandal invasions and was last mentioned by the Ravenna Geographer (5.25).

The Punic necropolis, on the isthmus that joins Capo di Pula with the island, contains pit tombs cut in the rock and is rich in funerary material. Near the beach behind the present church of S. Efisio, is a tophet from Hellenistic times. The habitation zone extended along the peninsula, with houses lining the present beach. On higher ground in the center of the peninsula is the square foundation of a temple dedicated to Tanit, and lower down another sacred zone is indicated by a foundation in squared masonry. Under Roman domination the plan of the habitation area became more precise, although the irregularity of the street axes which follow the routes of earlier paths persisted. Roman streets coming from the various sectors converge toward the Tanit temple. The forum is near the sea in the depression that extends to the E of the cliff of Coltellazzo. The theater (1st c. A.D.) is built of sandstone. Its cavea is divided into four radial sections and two maeniani. The orchestra has a mosaic pavement and the front of the pulpitum is articulated in curved and squared niches. In the hyposcenium are preserved four large jars used as part of the acoustical equipment. Nothing remains of the frons scaenae; the porticus post scaenam looked out on one of the city streets. There are also a nymphaeum and two large bath complexes. Only the major bathing establishments have been completely excavated. Although they were constructed on a grandiose scale and richly decorated, the plan is not clearly articulated. The rooms are arranged in a circular pattern; and the frigidarium, the tepidarium, and the apoditerium have mosaic pavements. Along the shore to the NW were luxurious houses,

for example, the tetrastyle House of the Atrium. There is a complex of sanctuaries of various periods at Sa punta de su coloru, from which comes a Hellenistic period votive stipe from the 2d c. B.C. An aqueduct existed of which very little remains. The material from the excavations is housed in the National Museum at Cagliari.

BIBLIOGRAPHY. G. Patroni, *Mon. Ant. dei Lincei* 14 (1904)[MPI]; G. Pesce, *Nora* (1957)[MPI]; id., *EAA* 5 (1963) 540ff; G. Maetzke, *Boll. del Centro per la Storia dell Arch.* 17 (1961) 53,56. D. MANCONI

NORBA (Norma) Italy. Map 16. A Latin colony in Volscian territory of 492-491 B.C. (Livy 2.34.6) set in a very strong position on a limestone height on the edge of the Monti Lepini overlooking the Pontine plain. The original colony may have occupied only a small part of the site since little has come to light that can be dated so early. The city plan is keyed to the layout of walls and gates, and the systematization of the terraces of the two acropoleis is normal to the orientation of the street grid. From material recovered in excavations in footing trenches and in the fill of the walls, it is clear that the whole scheme is not to be dated before the 4th c. B.C.; and in view of the exceptional strength of the walls, a date after the devastation of the colony by the Privernates in 342 B.C. (Livy 7.42.8) is to be preferred. The strength of the walls was Norba's glory and its undoing, for it dared to remain faithful to Rome in the second Punic war, and in 82 B.C. dared challenge Sulla's armies in the social war, even after the fall of Praeneste. When the city was betrayed by treachery, some citizens killed themselves, while others closed the gates and set fire to the town (App. *BCiv.* 1.94). It was utterly destroyed, and any survivors must have gone elsewhere; Pliny (*HN* 3.68-69) names Norba as a city of the past.

The walls form an irregular ring following closely the brow of the hill, but dipping in the SW sector to the best line of defense. Their total length is 2662 m. Three gates are well preserved, one at the N point, two in the SE sector; there may have been one or two more in the W sector. The walls are of terrace character, the outer face of large polygonal blocks of limestone quarried within the city with some variation in style in different stretches. Almost everywhere one finds a strong batter and coursing for short stretches. Two of the gates are given protective bastions but they are not highly sophisticated; and the only tower, the rectangular "loggia," stands free of the curtain at the point from which attack was likeliest to come.

Within the walls, the town is laid out in ample terraces rising to an acropolis at the SE corner and a larger one NE of the center of town. The minor acropolis held two temples at right angles to one another, the major acropolis the Temple of Diana, which was surrounded on three sides by a portico. Another temple, that of Juno Lucina, with its temenos and an adjacent paved area surrounded on three sides by a portico, is set on a terrace to dominate the view to the SW. These were excavated in 1901-2. They are all single-cella temples set on bases of polygonal masonry, and while a little of the material found in votive deposits is as old as the late 6th and early 5th c., the great majority of it and all the terracotta revetments associated with the temples must be dated close to the city's destruction. The material from the excavations is in the Museo delle Terme in Rome.

In addition there are numerous traces of building and terracing on the site; walls and cisterns abound amid a litter of tile fragments and potsherds. The forum seems to have lain E of the center of town, just below the major

acropolis and in communication with it; the main area of habitation probably lay SW of the forum.

BIBLIOGRAPHY. L. Savignoni, *NSc* (1901) 514-59; R. Mengarelli, *NSc* (1903) 229-62; L. Cesano, *NSc* (1904) 403-30; A. L. Frothingham, *Roman Cities in Northern Italy and Dalmatia* (1910) 80-97; A. Andrén, *Architectural Terracottas from Etrusco-Italic Temples* (1940) 385-89, pl. 117; G. Schmiedt & F. Castagnoli, *L'Universo* 37 (1957) 125-48. L. RICHARDSON, JR.

NORBA CAESARINA (Cáceres) Cáceres, Spain. Map 19.

Town established as a colony ca. 35 B.C. by the proconsul C. Norbanus Flaccus, which received the cognomen Caesarina in memory of Julius Caesar. It is mentioned by Pliny (4.117), Ptolemy (2.5.6), and in an inscription (*CIL* II, 694).

Some stretches of the Roman wall and parts of its towers were incorporated into the later Moorish wall, and the E gate of the cardo maximus survives almost intact. The Roman wall consisted of large granite ashlar blocks, not all regular, but well dressed, especially the voussoirs of the E gate. The lower half of the circular tower at the NE corner of the wall is Roman. Just E of the gate is a small bridge over the Marco gully; the original plan is Roman, as are a number of its ashlar blocks. Cáceres also contains small cemetery areas of different periods. Sculpture and inscriptions are housed in the Archaeological Museum, and Roman materials incorporated into later buildings are still visible in the town.

BIBLIOGRAPHY. J. R. Mélida, *Catálogo Monumental de España. Provincia de Cáceres* (1924); A. García y Bellido, "Dictamen sobre la fecha fundacional de la Colonia Norbensis," *Boletín de la Real Academia de la Historia* 49 (1966) 279-92; C. Callejo, "La Arqueología de Norba Caesarina," *ArchEspArq* 41 (1968) 121-49MPI. L. G. IGLESIAS

NORCHIA Italy. Map 16.

A cliff tomb city in the territory of Tarquinii, at the confluence of three streams —Fosso di Pile, Acqualta, and Biedano—downstream ca. 16 km from Blera. The site of the city is a long, narrow plateau, surrounded by water except on the S where a deep fossa has been cut to separate the city from the rest of the high plain. There are no certain remains of ancient occupation.

One principal tomb field is on the N cliffs of the Acqualta; the other extends for a considerable distance along the E cliffs of Fosso di Pile, a zone called "la Stallonara," directly opposite the town. This area is now being cleared and one can see, from the town site, a panorama of over 50 tombs, arranged in rows at two levels, the larger and more monumental tombs being above. Most are facade tombs with a false door and a dromos opening below; some are two-storied, as at Castel d'Asso; there are also two porch tombs of a type found only here. These are half-die tombs with an exterior stair on either side; the false door is protected by a deep roof which has carefully carved roof tiles and was originally supported by two pillars. Two very large tombs open on a portico once supported by six columns, a palatial variant of the two-story facade.

The most famous of Norchia's tombs, the two "Doric Tombs" of the Acqualta area, furnish our best illustrations of a Hellenistic Etruscan temple facade. The columns were apparently Doric; the entablature is a Hellenistic Doric with Ionic elements; the pediments are closed and filled with figures in high relief, but the angle mutules, ornamented with gorgoneia, are still present, a legacy from the old Etruscan open pediment.

BIBLIOGRAPHY. G. Dennis, *Cities and Cemeteries of Etruria* (3d ed., 1883) 193-205; G. Rosi, *JRS* 15 (1925) 1-59; 17 (1927) 59-96; Å. Åkerström, *Studien über die etruskischen Gräber* (1934) 92-94; A. Gargana, *NSc* (1936) 268-88. E. RICHARDSON

NORCIA, *see* NURSIA

NORMA, *see* NORBA

NORTH LEIGH Oxfordshire, England. Map 24.

Roman villa 4.8 km SW of Woodstock and 1.2 km S of Akeman Street, excavated in 1813-16 and 1908-11. The visible buildings cover an area ca. 90 m square and form three sides of a courtyard, with a gatehouse in the middle of the fourth (SE) side. The earliest buildings occupied the NW side and consisted of a dwelling (ca. 24 x 18 m) with a separate bath house to the NE. This house was then joined to the baths and extended, first along the whole length of the NW side, and later by the building of wings along the other two sides of the courtyard. Other modifications were made, including the construction of two more sets of baths, and seven rooms were equipped with mosaic floors, but the succession has not been fully worked out; the pottery, however, suggests that the first house was occupied in the 2d c. and the coins extend to Arcadius.

These buildings have been preserved and are open to inspection, but they do not represent the full extent of the villa. Aerial photography has revealed large ranges of rooms on the SW side of the visible remains and part of a wall which presumably enclosed the whole complex, and a track can be seen leading to quarries 180 m to the SW; but none of these features has yet been checked by excavation.

BIBLIOGRAPHY. H. Hakewill, *An Account of the Roman Villa discovered at Northleigh* (1826); *VCH Oxfordshire* I (1939) 316-18; D. N. Riley, *JRS* 34 (1944) 81. A.L.F. RIVET

NORTHWICH, *see* CONDATE

NOTION Turkey. Map 7.

Town on the coast of Ionia S of Kolophon, 55 km S of Smyrna. Called by Thucydides (3.34) Notion of the Kolophonians, the city was assessed in the Delian Confederation at one-third of a talent, separately from Kolophon. The two cities were always closely connected, and by Aristotle's time were politically fused into one; Notion was called in Hellenistic times Kolophon on Sea or New Kolophon. The city was never very prosperous in its own right and seems never to have struck coins.

The site is on a hill directly above the sea, at the mouth of a small stream, the Halesos or Ales. It occupies two summits enclosed by a circuit wall of Hellenistic or earlier date some 3 km long, with at least four gates; much of this wall is still in fair condition. On the W summit are the foundations of a small temple, identified by an inscription as that of Athena; the altar is on the E front. Lower down to the E is the site of the agora, adjoined on the E by a rectangular building with seats on three sides, perhaps a council chamber. The theater lies at the W foot of the E hill; it is small, with 27 rows of seats, of Greek form but reconstructed in Roman times. Part of the retaining wall and a vaulted passage survive. The stage building is buried. Above the theater is a second agora. The necropolis was on the next hill to the N; the tombs are mostly rock-cut or sunk in the ground, only a few being constructed of masonry.

BIBLIOGRAPHY. R. Demangel & A. Laumonier in *BCH* 47 (1923) 353f; G. E. Bean, *Aegean Turkey* (1966) 185-90. G. E. BEAN

NOTO, see NETUM

NOVAE (Staklen) Lower Moesia, Bulgaria. Map 12. At the S extremity of the Danube near Svištov, the station of Legio VIII Augusta from A.D. 46 to 69. Thereafter until the end of the Empire it was the station of Legio I Italica. Beginning as a village, it became an important economic and military center. It was a municipium from the time of Marcus Aurelius on, a rest stop on the Via Danubiana, and port of the Danube fleet. In A.D. 250 the Goths under Kniva fought near there (Iord. Get. 101), and the town is mentioned in connection with the invasion of the Huns in 441. In the reign of the Emperor Zenon it was the residence of the Goths under Theodoric (477-483). The town, well fortified after the 2d c. A.D., was retaken by Justinian (Proc. De aed. 4.11). It was the seat of a bishop in the 5th and 6th c. and an important fort and base of the Byzantine army in its battles against the Slavs and Avars (Theoph. Sim. 7.1.1).

Excavations have cleared large sections of the late antique fortifications as well as basilicas (5th-6th c.) and the foundations of public buildings. Many inscriptions, votive stelai, and sculptural monuments have also been found. The finds are in the museum of Svištov.

BIBLIOGRAPHY. Polaschek, RE 17 (1937) col. 1125-29; B. Gerov, Akte des IV intern. Kongr. für Griech. und lat. Epigraphik (1964) 129-33; D. P. Dimitrov et al., Bull. Inst. arch. bulg. 26 (1963) 133ff; 27 (1964) 217ff; 28 (1965) 43ff; 29 (1966) 99ff; 30 (1967) 77ff; 32 (1970); K. Maiewski et al., Klio 39 (1961) 319ff; 51 (1969) 329ff; Archeologia Polona 9 (1966) 149ff; 13 (1972) 279-305. V. VELKOV

NOVAESIUM (Neuss) Germany. Map 20. The legionary camp and civilian settlement were on the left bank of the Rhine. Camp A, more than 6.5 ha in area, seems to have been built at the beginning of Augustus' campaign against Germania (12 B.C.). Camp B (ca. 40 ha) seems not to have been of great importance to judge from the inside buildings. Only after Varus' defeat and under Germanicus was a very large camp (C) established with substantial buildings inside and with a capacity possibly of several legions. Under Claudius the Legio XVI was transferred to Novaesium, defeated in the fighting against Civilis, and disbanded after the suppression of the revolt of the Batavi (A.D. 70). The camp, which had been burned down in the Batavi revolt, was rebuilt by the Legio VI victrix, and existed until after A.D. 104 as a legionary camp. An auxiliary camp was maintained within the area of the closed legionary camp in the 2d and 3d c. The camp was possibly used once again in the 4th c. Novaesium is mentioned for the last time in 388.

So far, 10 chronologically successive camps have been investigated (A-F, H1-3, and J), also small remnants of the settlement outside the fortifications, parts of the civilian settlement N of the military area, and numerous graves. Camps A to H2 had walls made of wood and earth. Inside, wooden buildings occur in Camp C, stone buildings probably no sooner than in Camp H2. The camp of the Legio VI victrix (H3) has been excavated fairly completely. Its stone ramparts surrounded a rectangle 432 by 570 m (24.7 ha). The most important streets had colonnades. In the middle of the camp was the forum, behind it the praetorium or the quaestorium. The baths W of it seem to have been a later addition. A valetudinarium is situated SW of the principia. Other buildings (a fabrica, horrea, schola) were in the praetentura, another horreum in the retentura. The billets accommodated ten legionary cohorts and one auxiliary unit. North of the main street were quarters for the

tribuni militum, N of these barracks for an auxiliary unit.

West of Camp H3 traces of the Canabae legionis were found, including a sacred area. In late Constantinian time a cult cellar was constructed here for the taurobolium of the cult of Kybele. West of the settlement, outside the fortifications, was a civilian settlement, which is now under the old part of modern Neuss. Adjoining it to the W was the necropolis of the civilian town, which extended to the modern railroad station. On the E border of the necropolis was a mausoleum, probably of the 3d c. A.D. and more likely pagan than Christian. The finds are either at the Clemens Sels-Museum in Neuss, or at the Rheinisches Landesmuseum in Bonn.

BIBLIOGRAPHY. C. Koenen et al., "Novaesium," Bonn-Jbb 111-12 (1904); H. v. Petrikovits, Novaesium. Das römische Neuss (1957); id., Das römische Rheinland (1960) 17ff, 129ff; id. & G. Müller, "Die Ausgrabungen in Neuss," BonnJbb 161 (1961) 449-85MPI; G. Müller, in Das Clemens-Sels-Museum Neuss (1962) 8-13; H. Borger, "Die Ausgrabungen an St. Quirin zu Neuss," Rheinische Ausgrabungen 1 (1968) 192-95, 204-6.

On the troops: E. Ritterling & E. Stein, Die kaiserlichen Beamten und Truppenkörper im römischen Deutschland (1932); G. Alföldy, Die Hilfstruppen der römischen Provinz Germania inferior (1968). On the finds: Novaesium I-IV (= Limesforschungen, hrsg. Römisch-Germanische Kommission 6ff [1967ff] in press).

H. v. Petrikovits, Die Innenbauten römischer Legionslager in der Prinzipatszeit (1975).

H. VON PETRIKOVITS

NOVAR [---] (Beni Fouda, formerly Sillègue) Algeria. Map 18. The colonial village destroyed all trace of the ancient settlement, which was fairly large. The name of this city is known only from incomplete inscriptions. It was situated in the rich valley of the Oued el Kebir (ancient Ampsaga) in Mauretania, occupying a flat area near a zone of springs.

Numerous Christian inscriptions of the 4th c. make it likely that there was a community from the 3d c. on. Possibly a bishop from the town attended the synod of Carthage in 256.

The site is notable for the many stelae to Saturn found there. Their quality is consistent. The craftsmen used a suitable fine-grained limestone, and increasingly original forms during the course of the artistic evolution of such stelae in the 2d, 3d, and (no doubt) beginning of the 4th c. These stelae belong to a group well represented on the sites of Cuicul, Mopth [---], and Sétif and are distinct from the products of other Numidian and Mauretanian workshops. Some of these stones are still in the village; others have been taken to the Algiers Museum.

BIBLIOGRAPHY. S. Gsell, Atlas archéologique de l'Algérie (1911) 16, no. 216; M. Leglay, Saturne africain, Monuments (1966) II 242-51. P.-A. FÉVRIER

NOVARA, see NOVARIA

NOVARIA (Novara) Piedmont, Italy. Map 14. A Roman municipium with a nearly square grid plan determined by the junction of the cardo and the decumanus, intersected by other minor streets. Recovered remains of the walls have permitted reconstruction of the boundaries of the urban plan, which enclosed nearly one square km.

Traces of the circuit wall are visible beneath the Palazzo Venezia and the dwellings of the Marzoni and Bossi Grai, while to the E there are remains beneath the Salesian Institute and the Quaglia dwelling. In the course of digging the foundations of new buildings such as the

San Lorenzo retreat and the San Luca orphanage, segments of the wall were discovered, but only recently in Largo Cavour has a significant section (about 60 m long) been discovered.

From these investigations the structure of the wall can be determined. It was very strong, with a rubble core and walls of opus incertum interrupted by two courses of brick. The portion beneath Piazza Cavour reveals traces of a postern gate, with a staircase, still perfectly preserved, hugging the inner wall. That the gate gave access to a hilly area indicates that, at least in this part of the ancient city, the buildings were set on an elevated plain.

The presence of grand buildings in the city is evidenced by an enormous wall complex unearthed in 1922 when the foundations for the Banca d'Italia were being dug. At that time, large sections of mosaic pavement were brought to light. A dedicatory inscription to Terentia Postumia shows the existence of public baths as do the remains of a water pipe which emptied in an area probably occupied by the baths, as even the present-day name, Canton Balineo, demonstrates. A dedicatory inscription to G. Torullius Fuscus indicates the existence of an organization of an office of public officials and of a public works department.

BIBLIOGRAPHY. H. Philipp in *RE* XVII (1936) 1135-1136; G. L. Stella in *Bollettino Storico per la Provincia di Novara* 41 (1950) 27ff; F. Cognasso, "Novara e la sua Storia," *Novara e il suo territorio* (1952) 3ff; L. Cassani in *Bollettino Storico per la Provincia di Novara* 44 (1953) 54ff; id., *Repertorio di Antichità preromane e romane rinvenute nella Provincia di Novara* (1962); R. Fumagalli in *Bollettino Storico per la Provincia di Novara* 45 (1955) 232ff. C. CARDUCCI

NOVEM CRARIS (Les Granges-Gontardes) Drôme, France. Map 23.

In Gallia Narbonensis. A statio, set up at the time Agrippa's road was built (which crosses it like a cardo), ca. 35 B.C. It stood at a native crossroads built possibly in the 4th c. B.C., judging from an amphora of the Massaliote type, some sherds of painted pseudo-Ionian ware and some local bucchero found there. Some 1st c. A.D. baths (a room with a hypocaust has been found) were part of the statio.

Close by were two buildings, their walls built of quarry stones bonded with mortar and faced with at least two layers of paint: the first layer, which is Augustan, is dotted to make the base of the second adhere well; in the second coat, a floral design dates from the Flavian era (late 1st c.). A number of white marble fragments have been found there as well as some sherds of La Graufesenque and Banassac ware. The second building, which is filled with iron slag, contains a furnace for reducing iron ore. Remains of other furnaces have also been located: the statio was a metalworking center. One of the furnaces is now in the Musée du Fer at Nancy. At the end of the 3d c. (250-280—the dates are known from coins and pottery) the statio was destroyed and the walls razed. This is corroborated by cremation tombs and cineraria where several objects were found, including a bone pin and coins, all post-313, and a store of 27 coins with a bronze key, dated 330-360. The statio was not rebuilt but served as a necropolis for the new settlement.

What took its place was probably a mutatio, mentioned under the name Novem Craris in 333 in the Itinerary from Bordeaux to Jerusalem. It was discovered in 1961 S of the 1st c. statio, and it includes a central building with annexes. Judging from the material found here and especially the grave gifts—remains of iron, bronze disks, a lamp fragment from the late 4th-early

5th c.—found in the tile-covered tombs of the necropolis (oriented NW-SE), the site was probably occupied by a barbarian garrison, possibly German. Many of the skeletons were those of women; often the skull was missing, suggesting decapitation, practiced in the Merovingian period.

The remains of some baths have been located in a Gallo-Roman villa near the presbytery, including three pools, separated by a courtyard 5.3 m long from a fourth pool farther E. The walls of the first pool, which is rectangular, are of quarry stones faced with a thick layer of mortar (opus-signinum) with a fresco of red and blue; the floor is made of pebbles bonded with mortar. The second, larger, pool is also rectangular, and the bottom is covered with opus-signinum. The third is semicircular; the presence of hypocaust piles and suspensurae show that it was a heated pool. The fourth, beyond the courtyard, is rectangular; the bottom is of opus-signinum and the sides are covered with mosaics.

BIBLIOGRAPHY. J. Sautel, *Carte archéologique de la Gaule romaine* XI, *Drôme* (1957) 30, no. 39; C. Boisse, "Rapports de fouilles à la Direction des Antiquités Rhône-Alpes, Lyon 1961-1969" (unpubl.); A. Bruhl & M. Leglay, "Informations," *Gallia* 20 (1962) 648; 22 (1964) 532; 24 (1966) 518-19; 26 (1968) 593-94; M. Leglay, "L'archéologie drômoise. Découvertes récentes," *Bull. Soc. d'archéologie de la Drôme* 76 (1966) 352.
 M. LEGLAY

NOVI BANOVCI, see LIMES PANNONIAE (Yugoslav Sector)

NOVIODUNUM (Isaccea) Dobrudja, Romania. Map 12.

The principal statio of the Roman fleet on the lower Danube and an important military and commercial center in Roman and Byzantine times at a ford of the river 27 km W-NW of Tulcea. A very large civil site lies S of the fortress. In A.D. 369 the Danube was crossed by the army of the emperor Valens on the trail of the Visigoths. The peace between Valens and Athanaric was concluded here on shipboard. Excavations have identified the N side of the fortress (mostly destroyed by the Danube), the remains of some baths and a Christian basilica. The name of the site is Celtic.

BIBLIOGRAPHY. Ptol. 3.10.2,5; *Tab. Peut.* 8.4; *Ant. It.* 226, 1; *Not. Dig.* or. 39.25.32,33; Procop. *De aed.* 4.11.1.

I. Barnea, *EAA* 5 (1963) 566-67; id., "Dinogetia et Noviodunum, deux villes byzantines du Bas-Danube," *Revue des études Sud-Est Européennes* 9 (1971) 3, 349-52; *TIR*, L.35 (1969) s.v.; E. Popescu, "Inscription grecque de Noviodunum (Scythie Mineure)," *Klio* 52 (1970) 373-78; A. Ştefan, *BMI* 42 (1973) 1.3-14.
 I. BARNEA

NOVIODUNUM (Nyon) Vaud, Switzerland. Map 20.

In the middle of the N shore of Lake Geneva. The name Colonia Julia Equestris is known from ancient sources (*HN* 4.106; *Ptol.* 2.9.10; *Ant. It.* 348.1; *Tab. Peut.*) The Celtic name Noviodunum (*Not. Gall.* 9.5) indicates an oppidum of the Helvetii, no traces of which have yet been discovered. The colonia was founded by Caesar between 50 and 45 B.C. in the SW corner of the Helvetian territory, between the Jura mountains, Lake Geneva and the Aubonne river. The colonists were veterans from the cavalry of various legions. During the 4th-5th c. A.D. the town may have been the seat of a bishop.

The Roman town was larger than the hill area enclosed by the mediaeval walls, but the main roads of the mediaeval town reflect the Roman grid. The site has not been excavated, but a few soundings have identified a (secondary?) forum (ca. 40 x 25 m) built in Flavian

times. It was surrounded by cryptoportici, one wing of which perhaps later became a Mithraeum. A building adjacent to this forum, with the remains of a large mosaic of ca. A.D. 200, was probably a bath. Large numbers of amphorae attest the activity of the harbor from the time of Augustus on; Noviodunum was on the main route, by land or lake, from Genava to Vesontio. The Historical Museum is in the castle.

BIBLIOGRAPHY. F. Staehelin, *Die Schweiz in römischer Zeit* (3d ed. 1948) 91-95, 613-14 & index s.v. Equestris; *Rev. Hist. Vaudoise* 66 (1958) vol. dedicated to Nyon; E. Pelichet, "Fouilles archéologiques à Nyon en 1958," *Jb. Schweiz. Gesell. f. Urgeschichte* 47 (1958-59) 117-21ᴾ; V. von Gonzenbach, *Die römischen Mosaiken der Schweiz* (1961) 153-61ᴵ; *Rev. Hist. Vaudoise* 75 (1967) 196. V. VON GONZENBACH

"NOVIOMAGUS," see SAINT-GERMAIN-D'ESTEUIL

NOVIOMAGUS BATAVORUM (Nijmegen) Gelderland, Netherlands. Map 21. On the S bank of the Waal and so outside the Insula Batavorum, but still the chief town of the Civitas Batavorum, which included a strip of land on the S bank. The name occurs only on the *Peutinger Table*; other names, perhaps earlier, are Oppidum Batavorum, Batavodurum (Tac.).

Roman occupation began in 12-9 B.C. when Nero Claudius Drusus used the area as a base for further conquest of Germania, and dug the canal called the Fossa Drusiana. The building of a legionary camp was started E of the modern town soon afterwards, but apparently it was never finished and from the scarcity of finds never occupied. In the Hunerpark W of this camp was a civil settlement, and to the E was the settlement identified as the Oppidum Batavorum. It is not certain whether the latter was contemporaneous with the surrounding rampart. The two settlements were destroyed in A.D. 70, during the revolt of Iulius Civilis. They were not rebuilt, but between the two, on the unfinished Augustan site, a new legionary camp was built, presumably at first for the Legio II Adiutrix but occupied about A.D. 71 by the Legio X Gemina. Both legions had contributed to the suppression of the Civilis revolt. Legio II crossed to England with Cerialis in A.D. 71. It is only from Tacitus that we know of its stay at Batavodurum in 70: no remains of this legion have been found at Nijmegen, but it probably began the rebuilding of the camp, later completed by Legio X.

The first wooden buildings were replaced later by stone ones. Inscriptions indicate that a vexillatio of Legio X Gemina quarried tufa in the Brohltal and another cut limestone from the Norroy quarries. Building activities continued until ca. A.D. 104, when the legion departed for the Danube. The camp was then guarded by the Vexillatio Brittannica, then for a short time by the remains of the Legio IX Hispana, and after A.D. 120 by a vexillatio of the Legio XXX Ulpia Victrix. It was abandoned ca. A.D. 175. The remains (ca. 688 x 429 m) consist of ditches from the three periods (Augustan, early and late Flavian) with ramparts of earth and wood and traces of wooden buildings of the first two periods within the ramparts; in the third period both wall and buildings were of stone. The Principia, during the late Flavian period, was a complex (94 x 66 m) with an atrium (48 x 38 m), a basilica (48 x 23 m), and a sacellum; it belonged to the type known as Forum with Basilica.

Three of the four gates have been excavated. Other buildings include officers' houses, barracks, and some mercantile structures, but the remains of the stone buildings consist only of clay and rubble packing, the bot-

tom layer of the foundations. The rest was removed in mediaeval times. Tile and pottery were made in the legionary works at the Holdeurn, some 6 km SE of Nijmegen, from ca. A.D. 70-270. During the stay of Legio X new civil quarters were built W of the modern town, which were inhabited until ca. A.D. 270. Perhaps this was the Noviomagus to which Trajan added his family name of Ulpia ca. 104, in connection with his military reorganization. Traces of this Ulpia Noviomagus include a Gallo-Roman temple complex, where many objects were found during the 17th c.

About A.D. 270 Frankish tribes broke through the frontiers, ransacked the area and settled in Brabant and the Insula Batavorum, but in the late 3d c. and throughout the 4th the site was controlled by the central power in Rome, and was fortified. The population in this period moved to the higher Hunerpark and down to the bank of the Waal. Some few traces of early Christianization have been found. Cemeteries from all habitation periods are known; cremation was used in the 1st-3d c. and inhumation in the 4th. Objects from these tombs are in the Rijksmuseum G. M. Kam.

The foundations of a Roman villa of the 2d-3d c. have been found near Overasselt, ca. 9 km S-SW of Nijmegen, and a few 4th c. potsherds may indicate a brief occupation in that period. Another villa near Mook, on a site called Plasmolen ca. 12 km S-SE of Nijmegen, was also inhabited during the 2d and 3d c. A few tile stamps of the Legio X Gemina indicate that building material was taken from the stores of that legion; perhaps the house was the residence of an officer. Both villas are a short distance from the Meuse.

BIBLIOGRAPHY. J. Smith, *Oppidum Batavorum* (1644-45); id.: J. Smetius, *Antiquitates Neomagenses* (1678); F. J. de Waele, *Noviomagus Batavorum* (1931); id., *RE* 10 (1936) s.v. Noviomagus; H. Brunsting, *Het grafveld onder Hees bij Nijmegen* (1937, repr. 1974); id., *400 jaar Romeinse bezetting van Nijmegen* (3d ed. 1969); J. E. Bogaers, "Civitas en stad van de Bataven en Canninefaten," *Ber. Rijksdienst Oud. Bod.* 10-11 (1960-61) 263-317; id., "Die Besatzungstruppen des Legionslagers von Nijmegen im 2. Jhdt. nach Christus," *Studien zu den Militärgrenzen Roms BonnJbb* Beih. 19 (1967) 54-76; A.V. M. Hubrecht, *Gids van het Rijksmuseum Kam* (1972) full bibl. H. BRUNSTING

NOVIOMAGUS LEXOVIORUM (Lisieux) Calvados, France. Map 23. At the confluence of the Orbiquet and Touques, 28 km from the English Channel. The name Noviomagus, which is Gaulish, was mentioned by the ancient writers. Before the Roman occupation there was a fairly large settlement here, a hypothesis confirmed by the Castelier camp W of the city. The camp is on a plateau sloping SE and bordered, also to the SE, by the stream known as Le Cirieux. The defenses were oval, the axes measuring 1300 and 1500 m, and the camp covered an area of ca. 200 ha. The construction of the vallum shows that it was Celtic in origin: the walls, 7-8 m thick and 3 m high, are made of horizontal courses of stones and of intersecting oak beams which form grilles 0.6 m apart. The vertical and horizontal beams are fastened with iron pins 0.3 m long. The wood and stone courses alternate.

At the time of Caesar's conquest the city was organized and had a government; apparently the city of the Lexovii was considered to be free and friendly. It grew with the Roman occupation, attaining the second rank of Gallic cities. The civitas occupied most of the area of the modern town; Gallo-Roman traces have been found everywhere beneath Lisieux. The artisans' quarters were in the heart of the modern city, the residential sections on the

hills to the W in the commune of Saint-Désir (amphitheater near the Le Merderet brook, villas in the field called Les Tourettes), and to the E (villa below the site of the modern hospital).

A commercial center, Noviomagus was an important meeting point for Roman roads, and the closeness of the sea enhanced the importance of the site. A port had been created at the junction of the Orbiquet and the Touques, in the axis of what is now the Place Thiers. During the first half of the 3d c. A.D. bands of Saxon pirates attacked the English and French coasts, and Noviomagus was probably sacked in one of these raids. After the first destruction the city recovered; repairs have been noted in the masonry of the amphitheater. The inhabitants set up a fortified camp in the most easily defended section of the city; it was protected by the port (Place Thiers), the valley of the Touques, and the Rathouyne forest E of the city (the Roques wood is a remnant of this forest). The rectangular complex, ca. 400 by 200 m, was bounded on its long side to the W by the Orbiquet and the port, and on the E by the forest. Part of the Boulevards Sainte-Anne, Jeanne d'Arc, and Emile Demagny are on the sites of the S and E trenches. Here and there towers projected above the rampart (foundations of one have been located in the Boulevard Jeanne d'Arc).

The castrum had several gates, the Porte d'Orbec to the S on the line of the modern Rue Victor-Hugo and to the E, the Porte de Paris, which led out of the city through the Rathouyne forest toward Lillebonne and Le Vieil Evreux. To the W, behind the port, there was probably a gate in the continuation of the old Rue Petite Couture (a section of a Roman road paved with flat stones has been uncovered on this line). Excavation in the Rue Pont-Mortain located the W side of the rampart: built on the ruins of the first structure (architectural debris, charred stones), the wall is built of rubble set in grayish-white mortar, with an outer facing. The inner facing is of small blocks, with horizontal bonding courses made of three rows of pink bricks. An aqueduct, a few meters from this wall, was built after the wall but before the city was destroyed. A well was also noted under the modern transport station, indicating arrangements necessary in case of siege.

The city was probably destroyed in the Saxon invasions ca. 268-270: its suburb was ruined, its monuments razed, and the castrum wall badly damaged. The civitas was not abandoned however; the survivors took refuge in the castrum and used the recovered stones to patch up the wall. At the end of the 4th c. the *Notitia Provinciarum* placed Noviomagus in the tenth rank of Lugdunensis Secunda. The city of the Lexovii survived inside the castrum—its walls badly repaired with mortar of poor quality—throughout the whole of the early Middle Ages.

BIBLIOGRAPHY. De Formeville, "Note sur un cimetière gallo-romain découvert en 1848 à Saint-Jacques de Lisieux," *Mémoires de la Société des Antiquaires de Normandie* 7 (1847) 285-94; A. Pannier, "Résumé des découvertes du XVIIIe s.," *Congrès Archéologique, 37e session, Lisieux* (1870) 29-32; R. M. Sauvage, "La Basse-Normandie Gallo-romaine," *Congrès Archéologique, LXXIVe Session, Caen* (1908) 502-15; C. A. Simon, "Lisieux à l'époque gallo-romaine," *Le Pays d'Auge* (Nov. 1956) 7-9; F. Cottin, "Noviomagus Lexoviorum, des temps les plus lointains à la fin de l'occupation romaine," *Bulletin de la Société des Antiquaires de Normandie* 53 (1955-56) 108-96; F. Caillaud & E. Lagnel, "Un Four de potier gallo-romain à Lisieux," *Annales de Normandie* 3 (1965) 233-51. C. PILET

NOVIOMAGUS REGNENSIUM (Chichester) Sussex, England. Map 24. The New Market of the Regnenses grew up in a territory defined by pre-Roman defensive dikes several miles N of the site of the earlier oppidum. The origins of the town are still somewhat obscure, but recent excavations have demonstrated beyond reasonable doubt that the site was first occupied as a military fort during the invasion period following the Roman landing of A.D. 43. Traces of timber buildings and a possible defensive ditch can be ascribed to this initial phase, together with a large number of military bronze fittings.

From ca. 45 to 75, after abandonment by the army, the site began to take on an urban appearance with more timber dwellings and the development of a pottery industry producing fine beakers imitating imported Gallo-Belgic types. Other buildings of a more monumental kind must have existed as well as benefactions, including an equestrian statue of Nero the inscribed base of which was found in the 18th c. During the 70s and 80s the somewhat haphazard arrangement of the town was apparently tidied up. Probably at this time the street grid was laid out and the forum and basilica built with a large (public?) bath close by. There was also a Temple to Neptune and Minerva, erected in honor of the Divine House by a guild of craftsmen with the permission of the local client king, Tiberius Claudius Cogidubnus. An inscription recording these facts was found in North Street in 1723 (where it is now exhibited), but the actual building has not been located. Other amenities of the late 1st or early 2d c. included an amphitheater and probably a public water supply canalized from the nearby Lavant river. A cremation cemetery grew up beside the main road leading NE towards London. Apart from the principal public buildings most of the structures of Noviomagus throughout the 2d and 3d c. were of timber construction, sometimes based on dry-stone footings.

Late in the 2d c. the nucleus of the town (ca. 40 ha) was enclosed within an earthen rampart with two V-shaped ditches outside. At this stage gates were probably of masonry, but little is known of them apart from a fragment of the N gate found recently. Early in the 3d c. the front of the earthen rampart was cut back and a masonry wall inserted. This wall, many times refaced, still stands for most of its original length. Later, probably immediately after the troubles of A.D. 367, forward-projecting bastions were added to the walls, necessitating refilling the inner ditch and recutting the outer one in a wide flat-bottomed shape. The new defensive measures were consistent with those taken elsewhere, and reflect the growing need felt by towns to defend themselves with permanently mounted artillery.

Within the walls the town continued to develop, with masonry houses and shops gradually replacing the old timber structures. Traces of buildings have been found in most parts of the town and a number of fragmentary mosaic floors have come to light, but building does not appear to have been as dense in Chichester as in other comparable British towns. It may be that Noviomagus experienced an economic setback during the 3d and 4th c. The fate of the town during the 5th c. is unknown, but it emerged as a center of some significance in the later Saxon period and has continued to be occupied since then.

Apart from its well-preserved walls and bastions, and the amphitheater, there is little to be seen of Roman Chichester. The City Museum now houses the archaeological collections.

BIBLIOGRAPHY. G. M. White, "The Chichester Amphitheatre: Preliminary Excavations," *AntJ* 16 (1936) 149-59; id., "A New Roman Inscription from Chichester," ibid. 461-64; A. E. Wilson, "Chichester Excavations

1947-50," *Sussex Arch. Collections* 90 (1952) 164-200; id., "The Beginnings of Roman Chichester," ibid. 94 (1956) 100-43; id., "Roman Chichester," ibid. 95 (1957) 100-43, id., *The Archaeology of the Chichester City Walls* (1957); J. Holmes, *Chichester: The Roman Town* (1965); A. Down & M. Rule, *Chichester Excavations* 1 (1971).

B. W. CUNLIFFE

NOVO OTRADNOE Bosporus. Map 5. An ancient fortress on the coast of the Sea of Azov. Founded in the 1st c. A.D. by the Bosporan Kingdom, it was inhabited solely by natives. A stone rampart (1st c. B.C.) was strengthened from within in the 1st c. A.D. Traces of two houses from the 3d c. A.D. reflect the Greek traditions of the inhabitants. The houses are 10 x 12 m square and built of hewn stone blocks. In the necropolis 45 burials (1st c. B.C.-3d c. A.D.) have been excavated. The site was destroyed in the late 3d c.

The few finds consist of agricultural implements and fishing equipment (Hermitage Museum).

BIBLIOGRAPHY. I. T. Kruglikova, "Pozdneantichnye poseleniia Bospora na beregu Azovskogo moria," *Sov-Arkh* 25 (1956) 236-60; T. M. Arsen'eva, "Raskopki u derevni Novo-Otradnoe v 1959 g.," *KSIA* 86 (1961) 66-69; id., "Nekropol' rimskogo vremeni u der. Novo-Otradnoe," *SovArkh* (1963) 1.192-203; id., "Mogil'nik u der. Novo-Otradnoe," *Poseleniia i mogil'niki Kerchenskogo poluostrova nachala n.e.* [Materialy i issledovaniia po arkheologii SSSR, No. 155] (1970) 82-149.

M. L. BERNHARD & Z. SZTETYŁŁO

NOYELLES-GODAULT Pas de Calais, France. Map 23. In the Lens arrondissement, canton of Henin-Liétard. Traces of paving found at La Borne des Loups on the road known as *le chemin vert* from Arras have been interpreted as remains of a Roman road from Arras to Tournai mentioned in the ancient itineraries. Various cremation burials have been discovered as well as many glass objects (phials, vases). Two chance finds should be mentioned for their rarity: a Christian lamp in the shape of a navicella, with the chrism in the middle surrounded by the busts of the twelve apostles; a collection of small bronzes including a statuette of the Dea Roma, and especially two little statuettes of Isis and Osiris. These objects were destroyed when the Arras museum was burnt down in 1915.

In 1952 fresh discoveries were made at Les Monts de Baye: carved flints, coins and, most important, some early Roman tombs. The site extends as far as Dourges, on the other side of the Paris-Lille highway. A room with hypocaust has been excavated and, 100 m farther W, a series of rectangular rooms. The state of the ground rules out any more extensive exploration. Several wells have been excavated: one appears to be a funerary shaft. Much farther N is a group of potter's kilns, which were molded out of the base of a clay-pit already in use at the end of the Roman period and active from the 1st to the 4th c. This period is confirmed by coins found on the site. Recent finds are in the Douai museum.

BIBLIOGRAPHY. L. Dancoisne, *Recherches historiques sur Henin-Liétard* (1846); id., "Découvertes des tombeaux gallo-romains à Noyelles-Godault," *Bull. Com. Ant. P. de C.* 3 (1869-74) 28; A. Terninck, "Nouvelles découvertes à Noyelles-Godault," ibid. 5 (1879-84) 344; Cte de Loisne, "Lampe chrétienne de Noyelles-Godault," *BAntFr* (1908) 86-89; id., "Figurines et verreries gallo-romaines découvertes à Noyelles-Godault," *Bull. Com. Dep. Mon. Hist. du Pas de Calais* 3 (1902-12) 300; G. Deneck, *Les origines de la civilisation dans le Nord de la France* (1943) 95 and pl.; J. Gricourt, "Le culte de Saint Piat, la voirie antique et les origines chrétiennes dans la région de Seclin," *Actes du Congrès des Sociétés Savantes du Nord* (1963) 47-97; id., "Un trésor d'antoniani à Noyelles-Godault," *REA* (1969) 228-54.

P. LEMAN

NUCERIA ALFATERNA (Nocera Superiore) Italy. Map 17A. An ancient city on the inland highway, subsequently the Via Popilia, from Etruria to Poseidonia. It stood near the headwaters of the Sarnus (Sarno) and commanded the important pass behind Mons Lactarius leading to Salernum (Salerno) and its gulf. Owing to its proximity to Vesuvius, its territory was fertile. The name is apparently Oscan and appears on coins as Nuvkrinum Alafaternum; the name Nuceria, known elsewhere in Samnite Italy, has been thought to mean "new city"; Alfaterna would then identify its population (cf. Plin. *HN* 3.63). There is some evidence that in an early period Nuceria had established a hegemony over the other cities in the Sarnus valley (Polyb. 3.91; Livy 9.38.2-3); at all events it was the only one of these to coin money. But by the time of the second Samnite war the members of this league appear to have been on equal terms. It played an important part in the Samnite wars, standing against Rome in 316 B.C., and it did not fall until 308. Thereafter Nuceria was faithful to Rome, though independent and with rights of asylum and coinage. It was destroyed by Hannibal in 216 (Livy 23.15.1-6).

In the social war, when the Samnite general Papius Mutilus was unable to win it to his side, he burnt the suburbs (App. *BCiv.* 1.42), in compensation for which at the end of the war it seems to have received part of the territories of Stabiae, which had been destroyed. Spartacus' men destroyed it again in 73 (Florus 2.8.5). In Sulla's time it must have received a veteran colony and was inscribed in the tribus Menenia. At the time of Philippi it appears as colonia Nuceria Constantia (*Lib. Colon.* 235); in A.D. 57 it received a new draft of colonists (Tac. *Ann.* 13.31). In 59 it appears in history for the disastrous riot in the amphitheater of Pompeii in which many of its citizens perished. In 62 it was shaken by the earthquake that knocked down much of Pompeii (Sen. *QNat.* 6.1.2), and in 79 it had to endure the great eruption of Vesuvius. According to Suetonius (*Vit.* 2.2) it was the home of the emperor Vitellius. Because of its strategic situation it never perished; as often as it was destroyed it rose again, and its history continues through the Middle Ages into modern times.

The ancient city seems to have lain between the two divisions of the modern town, Nocera Superiore and Nocera Inferiore. Unfortunately almost nothing is known of its topography. The 5th c. church of S. Maria Maggiore at Nocera Superiore, still in use, is the only building of interest; it is of round plan, related to S. Costanza in Rome. One can discover the names of the gods held in special esteem here: the river Sarnus, Juno Sarrana (Plin. *HN* 16.132; Sil. *Pun.* 6.468), the Dioskouroi, possibly Apollo, but their sanctuaries have never been located. Except for occasional fragments of tile and pottery, the site is bare. On the other hand the necropolis has been systematically explored, and tombs from the 6th c. B.C. to the 3d have yielded much fine material. This material is housed in the local museum. There are also some remains of villas of the Imperial period in the vicinity.

BIBLIOGRAPHY. J. Beloch, *Campanien* (1890) 239-47; V. Panebianco, *BdA* 49 (1964) 362.

L. RICHARDSON, JR.

NUCERIA CAMELLARIA (Nocera Umbra) Umbria, Italy. Map 16. A Roman town on the Via Flaminia, N of Fulginia (Foligno) and Forum Flaminii on the ap-

proach to the pass through the Apennines. From here a road branched NE to Ancona. Remains of antiquity are very scarce.

BIBLIOGRAPHY. *EAA* 5 (1963) 536-37 (U. Ciotti).

L. RICHARDSON, JR.

NUESTRA SEÑORA DE ORETO, *see* ORETUM

NUITS SAINT GEORGES, *see* LES BOLARDS

NUMANTIA (Muela de Garray) Soria, Spain. Map 19. Site 7 km N of Soria. The cultural sequence on the hill is as follows: 1) Material from the final phase of the Neolithic Age and from the Copper Age; 2) Iron Age occupation, with a later castrum dating from the 4th-3d c. B.C., possibly beginning ca. 850 B.C.; 3) Celtiberian Numancia, of the Arevaci, from the beginning of the 3d c. to 133 B.C.; 4) Roman town of the Augustan age, rebuilt after being abandoned for a century and lingering on to the end of the 4th c.; 5) Visigoth town or perhaps merely isolated buildings. Some of these phases may have included destruction and reconstruction; this certainly occurred with the invasion of the Franks and the Alamanni in the 3d c.

The fame of Numantia comes from its ten years of sustained and successful struggle against the Roman armies, a struggle which actually began in 153 and ended with the destruction and burning of the town in 133. The primary source is Appian, who obtained his information from Polybios, a friend and chronicler of Scipio and an eyewitness of the siege; also L. Anneus Florus (1.5, 9; 33.1, 13; 34.1, 5, 7, 10, 11, 17; 47.3) and many others (Diodorus Siculus, Livy, Dio Cassius, Frontinus, Paulus Orosius, and later Pliny and Strabo).

The history of Numantia is linked to the insurrections of the Celtiberians against the abuses of the Romans: the first of importance was in 197, which caused Cato to attack the towns of the Meseta; disturbances again occurred in 193 when the Arevaci helped the Vetones, Vaccaei, and Lusitani, causing Tiberius Sempronius Gracchus to attack them in 180. He defeated them near the Moncayo and reached a peace agreement which lasted until 154, the date of the great rising of the Celtiberians and the Lusitani. The insurrection began in Segeda (Belmonte), and Q. Fulvius Nobilior moved against it with an army of 30,000 men. The Belli and the Titi took refuge in Numantia with their chieftain Caros. Nobilior razed Segeda and in August 153 advanced on Numantia. He was fiercely attacked by the Celtiberians, defeated at Uxama (Osma) and Ocilis, and forced to take refuge in the Renieblas camp, where he spent the winter of 153-152 B.C. He relinquished his command to his successor, M. Claudius Marcellus, who skillfully pacified the region. A peace treaty was signed in 151, which lasted until 143, despite the atrocities of Lucullus at Cauca (Coca) and elsewhere. In 144 the Viriathus rising ended in a peace agreement; Q. Caecilius Metellus, after conquering Contrebia, the Lusitanian capital, and the tribes in the Jalon valley, laid waste the territory of the Vaccaei and attacked the Arevaci who took refuge in Numantia and Termantia (142). The war was resumed in 137 by C. Hostilius Mancinus, who was roundly defeated and capitulated, but the Senate again refused to recognize the peace agreement and left the Roman general to the mercy of the Numantians, naked, shackled, and on his knees before the walls of the town.

Finally in 134 Publius Cornelius Scipio Aemilianus reorganized the demoralized army, seized supplies from the Vaccaei, and blockaded the hill town with a circumvallation 9 km long, supported by six camps, with wall, ditch, and towers. Against the 10,000 Numantians, of which only 4000 were under arms, Scipio deployed 60,000 men, elephants, slingers, and Jugurtha's Numidian archers, cavalry furnished by Spanish auxiliaries, and 300 catapults. But it was hunger which finally defeated Numantia. Scipio refused to accept any terms other than unconditional surrender and the laying down of arms, so the defenders burned the town and most of them killed themselves. Only a few surrendered. Numantia was reduced to ashes in the summer of 133, after a nine-month siege, and reconstruction of the town was forbidden. In the triumph Rome gave to Scipio in 132, so poor was Numantia that only seven denarii could be distributed to each soldier.

The Muela de Garray is a hill 67 m high, protected by the Douro and the Tera, which meet at its foot to the W, and by the Merdancho (Merdancius) on the S; the N, S, and especially the W slopes are precipitous, while the E slope is gentle. According to Appian and Orosius the perimeter of the town of 150 ha was 4400 m, but excavations have given axes of 310 and 720 m and an area of ca. 24 ha. The center of the Celtiberian town lay slightly W of the crest of the hill: two long streets parallel to the main axis were crossed at right angles by 11 others, with steps at the intersections. A street parallel to the wall surrounded the urban complex, and the central part and the first two ring streets appear to be the oldest. The trapezoidal wall, built of boulders, is 3.4 m thick at its base and still stands to a height of 2 m, backed by houses facing inwards; excavations have unearthed two gates, simple openings in the wall. The streets were paved with small cobblestones but repaired with larger ones; they had raised sidewalks and stepping stones for crossing the gutter. The houses were arranged in rectangular blocks with exterior dry pebblestone walls; the surviving houses are Roman, with a cellar or storeroom, and one or two stories high. On the S slope there are two small circles of large stones, assumed to be platforms on which the dead were exposed (Silius Italicus, Elianus).

The Roman streets are clearly built over the Celtiberian ones, and usually separated from them by a layer of debris and ashes. In some cases they have been regularized and widened, and the pavement consists of large well-joined slabs. In the so-called first street was discovered the remains of a temple, at the place thought to be a forum of modest proportions and design. Numantia was undoubtedly reconstructed in the Augustan period as a town with ius peregrinum for the subjected Celtiberians, to protect the road from Asturica Augusta to Caesaraugusta. It is difficult to distinguish the Roman houses from earlier ones of the native type. They have no mosaic pavements or drains but have regular two-course ashlar walls bound with clay; in addition to the usual roofs of wood and boughs, tegulae, imbrices, and antefixes have been found; the Celtiberian silos of the houses were replaced by cisterns for collecting runoff water. Numantia may have had an amphitheater or theater on the N slope, of which only the cavea can be seen. There are also remains of large houses: one with a caldarium may have been a public bath.

On the surrounding hills were built the Roman camps: that on the Atalaya de Renieblas, 8 km away, was reconstructed five times and remains of all the reconstructions survive (Cato in 195, 193-181, Nobilior in 153 in accordance with the Vitruvian model, Mancinus in 137, and Scipio; the last occupation was in 75-74 in the wars between Sertorius and Pompey). Peñarredonda, on the S, has well-defined ruins, what is assumed to be the camp of Maximus with cavalry quarters and the houses of the tribunes; there are remains on the Castillejo, on the N of the camps of Marcellus (ruins of the praetorium and the

house of the tribune), Pompey, and Scipio, some remains of the catapult platform at Valdeborrón, on the E, and walls of the forts of Travesadas, Dehesilla, Alto Real, el Molino, Vega, and Saledilla, some of which perhaps were reused Celtiberian settlements.

All these camps have yielded remains of weapons, projectiles, ornaments, for the most part Celtiberian, as is the pottery. This is basically wheel-turned, smoked, painted pottery with animated scenes, many in the Iron Age tradition, and terra sigillata. Bronze fibulae, necklaces, rings, belt buckles, surgical instruments, and needles have also been found, and clay slingshots, few weapons, trumpets, horns, clay nozzles, an occasional iron tool, circular grindstones, Hispano-Roman and Imperial coins. The finds are in the Numantia Museum, the National Archaeological Museum in Madrid, and the museums of Mainz and Bonn.

BIBLIOGRAPHY. Varios, *Excavaciones de Numancia* (1912); A. Schulten, *Numantia. Die Ergebnisse der Ausgrabungen 1905-1912*: I. *Die Keltiberer und ihre Kriege mit Rom*. II. *Die Stadt Numantia*. III. *Die Lager der Scipio*. IV. *Die Lager bei Renieblas* (1914-31); id., *Historia de Numancia* (1945); B. Taracena, *La cerámica ibérica de Numancia* (1923); id., *Numancia* (1929); id., *Carta Arqueológica de España: Soria* (1941); id., "Los pueblos celtibéricos," *Historia de España de Menéndez Pidal* I, 3 (1954) 197; F. Wattemberg, *Las cerámics indígenas de Numancia* (1963); A. Beltrán, "Un corte estratigráfico en Numancia," *VIII Congreso Arqueológico Nacional* (1964) 451; T. Ortego, *Guia de Numancia* (1967); A. García y Bellido, *Numantia* (1969).

A. BELTRÁN

NURSIA (Norcia) Umbria, Italy. Map 16. The northernmost town of the Sabines, on the upper Nar system; it first appears in history in 205 B.C. when it furnished volunteers for Scipio (Livy 28.45.19). The birthplace of Sertorius and of Vespasia Polla, mother of Vespasian, it was a municipium at the time of the social war but did not become a colonia. It was famous for the rigors of its climate and its turnips. Ancient remains are scant.

BIBLIOGRAPHY. E. C. Evans, *The Cults of the Sabine Territory*, PAAR (1939) 119-25; *FA* 10 (1955) 4385 (U. Ciotti); *EAA* 5 (1963) 544 (U. Ciotti).

L. RICHARDSON, JR.

NYERGESUJFALU, see LIMES PANNONIAE

NYMPHAION Bosporus. Map 5. Ancient Greek city 17 km S of Kerch along the shore of the Kerch Strait near the modern village of Geroevka. It was founded by Ionian colonists in the first half of the 6th c. B.C. on the site of an earlier native (Scythian?) settlement. Owing to its good port, Nymphaion emerged as an important commercial center, especially for the grain trade. It was probably incorporated into the Bosporan state in the early 5th c. but ca. 444 B.C. became the main Athenian base in the E Crimea. With the decline of Athens in the late 5th c. it was again included in the Bosporan state. The city issued its own coins for a short period around this time. Following an apparent decline in the Hellenistic era, it recovered in the early centuries A.D. It was destroyed in the mid 3d c. by the Goths. (Aesch. *In Ctes.* 171; Steph. Byz.; Ps. Skyl. 68; Strab. 7.4.4; Ptol. 3.6.2; Plin. *HN*, 4.86; Anon. *Perpl. Ponti Euxini*, 76 [50]).

The site, located on a small hill, covered an area of some 9 ha but part of the ancient port and adjoining city are now under water. The architectural remains date primarily from the late archaic, Classical and Early Roman eras and include numerous residential, commercial, and public buildings along with the accompanying paved courtyards and streets. Recent excavations, however, have revealed several Hellenistic structures including a unique large building of the 3d c. B.C. made of rose marl. Large sections of the city were replanned and rebuilt during the 1st c. A.D. Many buildings were destroyed in the 2d c., after which time only a relatively few new buildings were erected.

The most interesting architectural monuments from the city are probably the sanctuaries of Demeter, Aphrodite, and the Kabeiri, the latter two located in the upper city (acropolis). The remains of the Sanctuary of Demeter are found in the lower terrace along the seashore and consist of parts of the perimeter and sanctuary walls as well as the foundations of the main altar. The original sanctuary, built in the mid 6th c. B.C., was a small quadrangular room of adobe brick walls on a stone foundation. It was subsequently destroyed and rebuilt on several occasions during the city's history. The Sanctuary of Aphrodite had several rooms. First constructed in the late 6th c. B.C., it was destroyed in the 4th c. The walls of the Sanctuary of the Kabeiri, built in the 6th c. B.C., still remain. Many terracotta statuettes, apparently used in votive offerings, were found in and around the sanctuaries.

Other notable architectural monuments include two winemaking establishments of the 4th c. B.C., the earliest thus far discovered in the N Black Sea, and the city's defensive walls, which date from the Classical era. Remains of potters' kilns date to the 6th c. B.C.

The kurgan necropolis contained rich burials of the 5th c. and first half of the 4th c. B.C. Among the graves were stone tombs with horse burials.

BIBLIOGRAPHY. E. H. Minns, *Scythians and Greeks* (1913) 560-61; M. M. Khudiak, "Predvaritel'nye itogi raskopok poslednikh let v Nimfee," *Arkheologiia i istoriia Bospora*, I (1952) 75-87; id., "Raskopki sviatilishcha Nimfeia," *SovArkh* 16 (1952) 232-81; id., *Iz istorii Nimfeia VI-III vekov do n.e.* (1962); V. M. Skudnova, "Skifskie pamiatniki iz Nimfeia," *SovArkh* 21 (1954) 306-18; L. F. Silant'eva, "Nekropol' Nimfeia," *Nekropoli bosporskikh gorodov* [Materialy i issledovaniia po arkheologii SSSR, No. 69] (1959) 5-107; A. L. Mongait, *Archaeology in the USSR*, tr. M. W. Thompson (1961) 196-97; C. M. Danoff, *Pontos Euxeinos* (1962) 1127-28 = *RE* Suppl. IX; E. Belin de Ballu, *L'Histoire des Colonies grecques du Littoral nord de la Mer Noire* (1965) 134-37; I. B. Brašinskij, "Recherches soviétiques sur les monuments antiques des régions de la Mer Noire," *Eirene* 7 (1968) 100-101.

T. S. NOONAN

NYON, see NOVIODUNUM (Switzerland)

NYSA (Sultanhisar) Turkey. Map 7. City in Caria or Lydia, 30 km E of Aydın. A Seleucid foundation, apparently on the site of an earlier Athymbra, founded according to Strabo (650; cf. Steph. Byz. s.v. Athymbra) by a Spartan Athymbros, by a synoecism with two other cities, Athymbrada and Hydrela. The founder was Antiochos I (Steph. Byz. s.v. Antiocheia), who acted in response to a dream and named the city after his wife Nysa (otherwise unknown). A letter of Seleucus and Antiochos dated 281 B.C. is addressed to the Athymbrianoi, and this name survived to the latter part of the 3d c. (*IG* XI, 1235). It seems that the name was changed from Athymbra to Nysa at some time towards 200 B.C.; the earliest coins, of the late 2d c., have the latter name. At Acharaka, on the territory of Nysa, lay the celebrated Plutonion and the cave Charonion.

Strabo was educated at Nysa, and his description of the city (649) can be verified in the existing ruins. It is,

he says, a sort of double city, divided by a stream which forms a ravine; part of this is spanned by a bridge connecting the two cities, and part is adorned with an amphitheater under which the stream flows concealed; below the theater is on one side the gymnasium of the young men, on the other the agora and the gerontikon. All these buildings are identifiable, though in some cases badly preserved.

The bridge was a huge platform nearly 100 m long, spanning the ravine below the theater, but very little is left of it. Parts of the substructure of the amphitheater and a few of the seats on either side of the ravine survive in the scrub. The theater, on the other hand, is well preserved: of Graeco-Roman type, its cavea is more than a semicircle; there are 23 rows of seats below the single diazoma and 26 above it. Nine stairways divide it into eight cunei; these are doubled above the diazoma. The front of the stage building is visible, with the usual five doors, but the back part has not been excavated. Low down on each side of the cavea is an arched vomitorium.

Not mentioned by Strabo is a fine tunnel, about 100 m long, through which the stream runs just below the theater. It makes an obtuse angle in the middle and at one point has a light-shaft in the roof. The builder's name is recorded in an inscription on the wall by the angle, but it is only partially legible.

The gymnasium lay on the W side of the ravine; its position is recognizable but virtually nothing survives. The baths, later covered by a church, were at the S end, but these were of late construction and did not exist in Strabo's day. Some 150 m N of the gymnasium are the ruins of a library, also later than Strabo's time. It apparently had three stories, but the lowest is now mostly buried and the highest almost entirely destroyed. The plan of the middle story is recognizable, and shows the usual separation of the bookshelves from the outer wall to protect them from damp.

In the agora on the E side of the ravine little remains but a few stumps of columns. Near its NW corner the gerontikon, or Council House of the Elders, is preserved virtually complete, though a good deal reconstructed. It forms a semicircle, with twelve rows of seats and five stairways, enclosed in a rectangle supported at the back by four large double half-columns. The floor is paved with regular limestone blocks. There is no indication that the building was ever roofed. On the S side, behind the speaker's platform, are three entrances between four large solid piers; behind these was a row of eight columns, the bases of which remain.

Another late building, between the agora and the amphitheater, has been dubiously recognized as a bath. Its spacious vaulted rooms contain many niches for statues, but it is in poor condition and the ground plan is not complete.

Nothing remains of the city wall which presumably existed in Hellenistic times. There are a few stretches of a Byzantine wall, but the circuit cannot be traced.

About 3 km W of Nysa lay the village of Acharaka; the road joining them crossed several gullies, and some traces of the bridges survive. The healing establishment of the Plutonion ccmprised a temple of Pluto and Kore and a remarkable cave called the Charonion; Strabo (649-50) gives a circumstantial account of the cure. Little remains of the temple, just E of the village of Salavatlı. It has been conjecturally reconstructed with a very unusual plan, including two parallel walls running the length of the interior. The peristyle had twelve columns on the sides and six at the ends; the orientation is N-S, with the entrance apparently on the N. At present a row of six unfluted column drums and a few other blocks are visible. The Charonion, by Strabo's account, should be somewhere above the temple, but no cave exists in this position today. A little to the W is a deep ravine, in which rises the sulphur-bearing stream that gave the place its healing properties; this has been proposed as the Charonion, but here again no cave of any consequence is to be found.

BIBLIOGRAPHY. W. von Diest, *Nysa ad Mueandrum* (1913)MI; C. B. Welles, *Royal Correspondence in the Hellenistic Period* (1934) no. 9; D. Magie, *Roman Rule in Asia Minor* (1950) 989-91; G. E. Bean, *Turkey beyond the Maeander* (1971) 211-20. G. E. BEAN

O

OAKWOOD Selkirkshire, Scotland. Map 24. Roman auxiliary fort 6 km SW of Selkirk. Excavation in 1951-52 showed that it was built ca. A.D. 80 and was square with an internal area of 1.4 ha. The defenses comprised a turf rampart and two ditches, and the four timber gateways were of unusual design. Subsequently an annex was added on the S and the defenses were overhauled, but the fort was abandoned soon after A.D. 100. The internal buildings have not been explored. To the N are some remains of a temporary camp.

BIBLIOGRAPHY. *Proc. Soc. Ant. Scotland* 86 (1952) 81-105. K. A. STEER

OBERADEN Kr.Unna, Land Nordrhein-Westfalen, Germany. Map 20. One of the earliest Roman sites in Germany, the fortress lies on the S bank of the Lippe, about 80 km from the legionary headquarters at Xanten (Birten)–Vetera. Oberaden is one of the great military stations that served as a base of operations under the emperor Augustus, placed as far across the Rhine in the direction of the enemy as possible. The fortress (820 x 670 m) is irregular in plan. The four gates are not placed exactly opposite one another. The area enclosed, 54 ha, would have been sufficient to accommodate two legions with their baggage train. But it is also possible that only large detachments from individual legions were stationed there or even auxiliary units, which changed often according to the needs of the military situation.

The fortress was protected on all sides by a ditch, 4 m wide and over 2 m deep. Within this lay an earthen rampart, 2.3 m wide, which was supported on its inner and outer faces by timber uprights. (The narrow trenches in which these posts were set have been found.) In this earth and timber rampart stood wooden towers at intervals of 45 m. Little is known of the internal arrangements in the fortress, but recent excavations have demonstrated that, contrary to earlier views, the structures were normal wooden buildings, such as are found in Roman forts elsewhere.

The fortlet at Beckinghausen lies ca. 2 km W of the fortress on gently rising ground immediately S of the Lippe. It is 1.6 ha in extent, oval in plan, and surrounded by three V-shaped ditches, except on the river side. One is inclined to think of harbor installations and to imagine that goods brought by ship up the Lippe for the great fortress at Oberaden were unloaded here. That is possi-

ble, but it is also conceivable that Beckinghausen was a largely independent supply base that played a role in military activities farther up the Lippe. At any rate, both Oberaden and Beckinghausen were occupied for more than just a summer. At Beckinghausen a long period of occupation is proved by the fact that pottery kilns were constructed here to supply the needs of the garrison.

On the evidence of Cassius Dio (54.32ff) both forts could have been founded in 12 B.C. or later when Drusus, Augustus' stepson, began his campaigns from the Rhine against the inhabitants of the Lippe area. Coin types showing the altar at Lyons (Lugdunum), minted in 12 B.C. or more likely 10 B.C., are absent from the forts and so both may well have been given up soon after the death of Drusus (9 B.C.) when the military dispositions were radically changed.

BIBLIOGRAPHY. C. Albrecht, ed., *Das Römerlager in Oberaden, Veröffentlichungen aus dem Städtischen Museum für Vor- und Frühgeschichte Dortmund* II,1 (1938); II,2 (1942); K. Kraft, "Das Enddatum des Legionslagers Haltern," *BonnJbb* 155-56 (1955-56) 108f; H. Aschemeyer, "Neue Untersuchungen im Römerlager Oberaden," *Prähistorische Zeitschrift* 41 (1963) 210ff; for plans see also *Saalburg-Jahrbuch* 19 (1961) 5,1; in general see H. Schönberger in "The Roman Frontier in Germany: an Archaeological Survey," *JRS* 59 (1969) 144ff with map A. H. SCHÖNBERGER

OBERHAUSEN, *see under* AUGUSTA VINDELICUM (Augsburg)

OBERSTIMM, *see* LIMES RAETIAE

OBERWINTERTHUR, *see* VITUDORUM

OCHRID, *see* LYCHNIDOS

OCILIS (Medinaceli) Soria, Spain. Map 19. Town 76 km S of Soria and SW of Calatayud. Framed in the Roman wall on the entrance road is the only Roman arch in Spain with three openings. It is 13.1 m long, 8.5 m high, and 2.05 m wide. Both niches in the facade are crowned with pediments. In the entablature was an inscription, now lost. It probably dates from the 2d c. A.D.

BIBLIOGRAPHY. J. R. Mélida, *Monumentos romanos de España* (1925)[I]; B. Taracena, *Ars Hispaniae* II (1947)[I].
R. TEJA

OCRICULUM (Otricoli) Umbria, Italy. Map 16. The southernmost town of Umbria, on the left bank of the Tiber just N of the point where the Via Flaminia crosses. In 308 B.C. it had already concluded an alliance with Rome. The original settlement, the graves of which go back to the Early Iron Age, stood on a hill, but was destroyed in the social war; it was probably then that the city was moved from the hill to the river plain below, reorganized, and inscribed in the tribus Arnensis. It would seem to have flourished as a center of commerce and rich villas and to have continued to be important through the Empire. It was probably destroyed at the time of the Lombard invasion, after which we find no mention of it, and by the 13th c. the community had transferred itself back to its more defensible hilltop.

Excavations were conducted here from a very early period, especially from 1776 to 1784, when a great quantity of material was removed. Somewhat fanciful plans of buildings were made by G. Pannini, but a detailed account of the work is lacking. Construction on the site is typical of the Empire: concrete faced with reticulate and small block, brick, or opus mixtum lista-

tum. The forum was explored and a basilica of exceptionally interesting plan was found; unfortunately today this is completely buried. It was rich in sculpture, producing a fine series of portraits of the Julio-Claudian family. A theater and an amphitheater outside the city provided places for spectacles; the theater seems to have had a scaena of concave front, argument for a comparatively late date. The baths, of the 2d c., with a winter baths annex, were unusually rich in inscriptions and mosaics. The most imposing of the ruins is a vast substructure of at least 14 parallel vaults in two stories destined to support a public edifice of which nothing is visible. Walls, cisterns, and the debris of ancient construction dot the site, and along the Via Flaminia in the vicinity are remains of several monumental tombs.

Pietrangeli was able to compile a list of 34 items known to have come from here; the most famous pieces are the heroic head of Jupiter and the octagonal mosaic pavement in the Sala Rotonda of the Vatican. All but a few pieces are in the Vatican collections. Other antiquities, especially inscriptions, are preserved at the site.

BIBLIOGRAPHY. T. Ashby & R.A.L. Fell, *JRS* 11 (1921) 163-65; C. Pietrangeli, *Ocriculum (Otricoli)*, Reale Istituto di Studi Romani (1943)[MPI]; *EAA* 5 (1963) 805 (C. Pietrangeli). L. RICHARDSON, JR.

ÖCSÉNY, *see* LIMES PANNONIAE

OCTAVIANUM (Sant Cugat del Vallés) Barcelona, Spain. Map 19. A town in Catalonia 12 km N of Barcelona whose name refers to the Monastery of Sant Cugat, at the eighth milestone of the road from Barcino to Egara. It was on the site of the passio of Cucufas, a martyr from Barcelona.

A fluted sarcophagus, in the monastery from the earliest times, is now in the Archaeological Museum of Barcelona.

Restoration work in the monastery revealed the existence of a late Roman necropolis with tombs preserving the ruins of mosaic laudae in the African style, an Early Christian meeting hall, and a building of square floor plan with projections that may have been towers. It was built with square stone blocks (opus quadratum), and the walls were 2 m thick, a construction justifying the name of castrum in the mediaeval documents. Among the material reutilized was a milestone of Claudius. The hall was modified in the 6th c. with a polygonal apse, and decorated with Visigothic ornamental sculpture.

BIBLIOGRAPHY. Bosch Gimpera & J. Serra Ráfols, "Scavi a Sant Cugat del Vallés," *RendPontAcc* 37 (1964-65) 307-24; P. de Palol, *Arqueología cristiana de la España romana* (1966) 42 s. 374. A. BALIL

OCTODURUS or Forum Claudii Vallensium (Martigny) Valais, Switzerland. Map 20. At the N foot of the St. Bernhard pass, summus Poeninus. The Celtic name is mentioned in the sources (*Ptol.* 2.12.3, Caes. *BGall.* 3.1, *It. Ant.* 351.5, *Tab. Peut., Not. Gall.* 9.13); the Roman name on inscriptions and milestones. From pre-Roman times this site controlled traffic to and from Italy, hence the unsuccessful attempt by Caesar in 57 B.C. to subdue the quattuor civitates vallis poeninae; Octodurus was the caput of one of them. Conquest by Rome, however, was achieved before 10 B.C., and the valley formed an administrative unit with Raetia and Vindelicia. When a new road over the pass was opened by Claudius, Octodurus was given the ius latinum, promoted to the status of a market town, and became the center of the new civitas Vallensium. Probably also at this time the valley was incorporated into a new province, Alpes Po-

eninae at Atractianae (later Graiae), together with the region at the S foot of the pass.

Octodurus was burned in the late 2d c. and again in the early 3d, but continued to flourish. In the 4th c. it was the seat of a bishop, who was transferred in the 6th c. to Sion. Dwindling traffic with Italy after A.D. 400 caused the town to decline, to the benefit of Acaunum (St. Maurice), 15 km down the Rhone.

A forum, two temples, and bits of insulae with commercial and residential quarters have been identified. The vicus lay on both sides of the river Drance, between Martigny-Bourg and Martigny-Ville. Traces of earth and timber construction of pre-Claudian times have been observed, but little is known of the Celtic and early Roman settlement except some cemeteries. Under Claudius, the vicus was rebuilt on a grid plan; the size of the insulae (90 x 70 m) is close to that of the Roman colonies in Switzerland. The forum (92 x 65 m) is a rectangular court with a monumental entrance; two sides have rows of 10-12 shops, and at the far end is a portico in front of the long side of a basilica. In its latest phase it contained, according to an inscription a fabrica, a porticus, tabernae, and an auditorium hypocaustum. Adjacent to the forum was a small temple (18 x 13 m) with an altar.

A temple of Gallo-Roman plan (12 m on a side) two insulae farther away has an orientation differing from the grid plan. It may be part of a larger sanctuary within an enclosure. At the foot of Mt. Chemain, on the outskirts of the settlement, are the remains of an amphitheater (74 x 62 m) seating ca. 6000.

The finds (inscriptions apart) are scattered among the Musée d'Art et d'Histoire in Geneva; the Musée Cantonal d'Archéologie in Lausanne, the Musée Cantonal de Valère in Sion, and the Schweizerisches Landesmuseum in Zurich.

BIBLIOGRAPHY. E. Howald & E. Meyer, *Die römische Schweiz* (n.d.) no. 44 (forum inscription); C. Simonett, "Kurzer Bericht über die Ausgrabungen 1938-39 in Martigny," *ZSchwAKg* 3 (1941) 77-175[PI]; F. Staehelin, *Die Schweizin römischer Zeit* (3d ed. 1948) 84-90, 158-65, 618-20; M. R. Sauter, *Préhistoire du Valais des origines aux temps Mérovingiens* (1950) 106-12[MPI]; E. Vogt, "Zwei kleine Beiträge zur römischen Archäologie der Schweiz," *ZSchwAKg* 25 (1963) 101-5[P].

V. VON GONZENBACH

ODERZO, *see* OPITERGIUM

OEA (Tripoli, Trablus) Libya. Map 18. The central one of the three cities (treis poleis) that gave the region its name. Founded as a trading station by the Carthaginians beside a small natural harbor, it prospered under Roman rule. In late antiquity its location in a fertile coastal oasis saved it to some extent from the rapid decline of its neighbors, and after the Arab conquest of A.D. 643 it was chosen to be the military and administrative capital of the whole territory between the two Syrtes. The heart of the Classical city, enclosed within its late antique walls, has been continuously occupied ever since, obliterating all but a few remains of the Roman town.

The principal surviving monument is an elaborately ornamental quadrifrons archway dedicated to M. Aurelius and L. Verus in A.D. 163, the central stone dome of which was carried on flat slabs laid across the angles and was concealed externally within the masonry of an attic, now destroyed. Early drawings show this attic in turn supporting a circular pavilion, but this seems to have been a later Islamic addition. The arch stood at the intersection of the two main streets of the town and the adjoining streets and alleyways of the post-Classical town

incorporate many elements of an orthogonal street plan. Near the arch are the remains of a temple dedicated to the Genius Coloniae (A.D. 183-85), and the forum probably lay nearby. There was a monumental bath on or near the site of the present castle. The city walls, demolished in 1913, incorporated long stretches of the late antique defenses.

Near the base of the W harbor mole was found a Punic and Roman cemetery, and scattered burials, including a small Jewish catacomb (now destroyed), have come to light towards the E, under the modern town. In and near the oasis are the remains of several villas, with mosaics; also two Christian cemeteries, one of the 5th c. at Ain Zara, and one of the 10th c., at En-Ngila.

The archaeological museum, housed in the castle, contains antiquities from the whole of Tripolitania except Sabratha. The fine series of sculpture from Leptis Magna includes the Julio-Claudian group from the Forum Vetus and the figured panels of the Severan Arch. Other notable exhibits are the mosaics and the Romano-Libyan sculpture from Ghirza.

BIBLIOGRAPHY. S. Aurigemma, "Le fortificazioni della città di Tripoli," *Notiziario Archeologico del Ministero delle Colonie* 2 (1916) 217-300; "L'arco quadrifronte di Marco Aurelio e di Lucio Vero in Tripoli," *Suppl. to Libya Antiqua* 3 (1969); G. Caputo, "Il tempio oeense del Genio della Colonia," *Africa Italiana* 7 (1940) 35-45; J. M. Reynolds and J. B. Ward-Perkins, *Inscriptions of Roman Tripolitania* (1952) 63-72; D.E.L. Haynes, *An Archaeological and Historical Guide to the pre-Islamic Antiquities of Tripolitania* (1955) 101-6; P. Romanelli, "Tripoli," *EAA* VII (1965) 986-87.

J. B. WARD-PERKINS

OESCUS Bulgaria. Map 12. Originally a Thracian city near modern Ghighen in the district of Pleven at the confluence of the Iskar river and the Danube. It was the headquarters of the Legio V Macedonica and later was raised to the status of a colony by Trajan. It regained military importance after Dacia was abandoned in 275 and when the bridge of Constantine was built over the Danube.

The town was an irregular pentagon in shape, surrounded by a wall and a ditch, and later expanded quite far beyond the initial circuit wall. The decumanus has been identified, and outside the walls an apsidal bath complex with subterranean galleries dating to the middle of the 3d c. The building operations of the legions stationed there are documented by brick stamps. There is evidence of ceramic and metal works. Most of the inscriptions and monuments belong to the 2d c. and give evidence of peoples from Asia Minor and from the province of Gaul, the establishment of the city, and numerous religious cults including Mithra. Noteworthy are sarcophagi decorated with festoons and masks and large architectural friezes of the same type. The funeral stelai, with a triangular pedimental element and later decorated with ornamental vines are distinguished from the two close groupings of Ratiaria and Novae. The medallion with portrait bust is also in evidence and numerous statues. A noteworthy mosaic with an emblem represents a scene from an unknown work of Menander: The Achaeans.

A museum has been built on the site.

BIBLIOGRAPHY. S. Ferri, *Arte romana sul Danubio* (1933) 381, 386[I]; C. M. Danoff, *RE* XVII (1936) 2033-38; A. Frova, "Lo scavo della Missione arch. it. in Bulgaria," *BIA* 10 (1943), 11 (1948)[PI]; id., "Antichi monumenti religiosi di Oescus," *Studi Mistrorigo* (1953)[I]; T. Ivanov, *Rimska mozaika ot Ulpia Eskus* (1954)[I].

A. FROVA

OFFEMONT Territory of Belfort, France. Map 23. Remains of a large establishment from antiquity much of it in the Forest of Arsot. The following have been discovered: 1) at the place called Le Martinet, the ruins of a small fanum of native design, square with a cella (4.2 m) and a surrounding gallery (9.3 m); 2) at La Cornée, traces of a pottery workshop which produced primarily glazed roller-decorated ceramics, but also some original sigillata; 3) at Le Ballon, the still only partially excavated ruins of a large villa which, judging from the coin finds, was destroyed under Constantius II.

BIBLIOGRAPHY. F. Pajot, "Les ruines d'Offemont," *Bulletin de la Société Belfortaine d'Emulation* 27 (1908) 166-88; M. Rilliot, "Fouilles archéologiques à Offemont," *Revue Archéologique de l'Est* 20 (1968) 247-70.

L. LERAT

OIANTHEIA, *see* WEST LOKRIS

"OIARSON," *see* IRUN

OINEON, *see* WEST LOKRIS

OINIADAI Greece. Map 9. Located in N Greece, in Akarnania at the mouth of the Acheloos river. The city first appears in history in the 5th c. B.C. when it was apparently already at least partially fortified. A friend of the Peloponnesian League, Oiniadai had to withstand pressure from Athens, including at least one siege conducted by Pericles. It held out, but eventually joined the Athenian League in 424. The city from this time on remained under Athenian influence and was a member of the second Athenian Confederacy in the 4th c. The Hellenistic period was marked by warfare with the Aitolians, until Philip V freed the city from their control in 219. Oiniadai reverted to Aitolia under the Romans but became Akarnanian again in 189. Its history under Roman rule is unclear.

The walls are particularly well preserved, extending some 6.5 km in length with a number of well-preserved gates and sally ports. Two types of masonry are employed, polygonal and trapezoidal. Latest research on the chronology of the fortifications leans to the opinion that the polygonal walls are datable to the period of Athenian pressure in the latter half of the 5th c., and that the circuit underwent modifications in the Hellenistic period.

Excavations in 1900-1901 revealed a number of important buildings. A Greek bath complex was found, consisting of two round rooms with basins and a number of other rooms, at least one of which had a large bathtub. The date appears to be the second half of the 3d c. B.C. This is probably about the time of the rebuilding in the theater of Oiniadai, which was partially excavated. At this time a proskenion was placed in front of an earlier stage building, which may have been originally erected in the 4th c. B.C. A row of four stone blocks within the present scene building probably marks the original front wall of the earlier skene. In the excavated portion of the cavea, some of the stone seats were found to have manumission inscriptions, datable to the 3d or 2d c. B.C., cut into their upper surfaces. Some remodeling was apparently undertaken in the early Roman period, and there is also some indication of a later reconstruction in the bath complex.

On the E side of the entrance to the harbor, the excavators with some difficulty identified what they considered a combination naval storage building and shipshed composed of five slipways for the careening and storage of vessels. Minor buildings uncovered include a small temple on a promontory W of the harbor and a private house on another hill.

BIBLIOGRAPHY. W. M. Leake, *Travels in Northern Greece* III (1835) 556-78[P]; B. Powell & J. M. Sears, "Oiniadae I-IV," *AJA* 8 (1904) 137-237[PIM]; E. Fichter, *Die Theater von Oiniadai und Neupleuron, Antike griechische Theaterbauten* 2 (1931)[PI]; *RE* 17 (1937) 2204-28 (E. Kirsten)[P]; F. E. Winter, "Greek Fortifications," *Phoenix* Suppl. IV (1971) 96-98; *Der kleine Pauly* (1972) 258-59.

W. R. BIERS

OINIANDOS, *see* EPIPHANEIA

OINOANDA (Incealiler) Turkey. Map 7. City in Lycia 32 km W-NW of Elmalı. Oinoanda first appears as a member of a tetrapolis headed by Kibyra and including also Bubon and Balbura. This was abolished by Murena about 81 B.C. at the end of the Mithridatic war (Strab. 631), and Bubon, Balbura, and presumably Oinoanda were attached to the Lycian League. Strabo does not in fact mention Oinoanda in this connection, but the city was subsequently a member of the League, as is clear from the inscriptions. On the other hand, if the Oeandenses of Pliny (*HN* 5.147) are the men of Oinoanda, it seems that the city was for a time attached to Galatia. If so, expulsion from the League may have been the result of Oinoandan support for Brutus in the civil wars. Only one coin of Oinoanda appears to be known; it belongs to the period before 81 B.C. In the 2d c. A.D. Oinoanda received from the millionaire Opramoas of Rhodiapolis the sum of 10,000 den. for the construction of a bath complex. Later the bishop of Oinoanda was under the metropolitan of Myra.

The ruins are on a high hill directly above the village of Incealiler; the hill is steep on all sides but the S, and rises to a summit on the N. The city lay on a series of levels facing S; the actual summit was occupied by a fort still partly preserved. The city wall is best preserved at the S end, where it stands in places to its full height of about 10 m; the masonry is partly ashlar, partly polygonal, and prominently bossed. The resemblance in the style of these walls to those of Pergamon suggest that they may have been erected at the time of Pergamene sovereignty in this region, after the treaty of Apamea in 190 B.C. Inside the wall, to the N, ruins and foundations of buildings are abundant, but the whole hill is heavily overgrown.

In about the center of the city is a rectangular level space identified as the agora, lined with statues; a number of bases remain. To the S and W are numerous ruins including a three-roomed building whose S side is formed by a terrace wall of smooth-faced polygonal masonry still standing some 4 m high.

Farther up the hill to the N is another open space generally referred to as the Esplanade; here too are numerous statue bases. In a stoa on its S side seems to have been inscribed a lengthy discourse on the Epicurean philosophy by a certain Diogenes of Oinoanda; about a quarter of this inscription has been recovered among the ruins. One of the buildings in this area has been tentatively identified as a gymnasium.

The theater lies farthest N, buried in woods. It has a diameter of 42 m, but a small capacity; 15 rows of seats have been counted, and the orchestra is unusually large in proportion. A considerable part of the stage building remains, but it has collapsed.

Tombs are abundant on all sides of the city. The most remarkable is a mausoleum outside the walls on the S, with a very long inscription giving the genealogy of a distinguished Oinoandan family. Sarcophagi are numerous; at least one has a recumbent lion on the lid, a type characteristic of this region. In the cliff-face on the W are several rock tombs of temple type, but not of the first quality. The site has never been excavated.

BIBLIOGRAPHY. T.A.B. Spratt & E. Forbes, *Travels in Lycia* I (1847) 272-76M; G. Cousin & E. Diehl, *BCH* 10 (1886) 218; E. Petersen & F. von Luschan, *Reisen in Lykien* II (1889) 177f; F. Stark, *Alexander's Path* (1958) 197f.
G. E. BEAN

OINOE (Myoupolis) Attica, Greece. Map 11. There are two Attic demes of this name.

1) The site of one presents little difficulty. Belonging first to the Aiantis tribe then later to the tribes of Attala and Hadrian (Imperial period), it is situated in the Marathon Plain 4 km W of the village of the same name and S of the stream known as Charadra. On the N slope of the acropolis is the grotto of Pan and the nymphs described by Pausanias (1.32.7). Nearby is a copious spring, known as Kephalari or Ninoe (whence the popular local name Ninoi). The deme formed part of the tetrapolis along with Marathon, Probalinthos, and Trikorynthos (Strab. 8.7.1).

2) The second deme belonged to the tribe Hippothontis, later to the tribe Ptolemais; its site is still disputed. It is probably somewhere along the boundary between Attika and Boiotia, in the NW part of Attiaa.

Herodotos (5.74) writes that in 507 Kleomenes, king of Sparta, eager to take revenge on the Athenian people and to set up Isagoras as a despot, "invaded the territory of Eleusis, while the Boiotians, as had been agreed with him, seized Oinoe and Hysiai, demes on the borders of Attica." When Euboia revolted in 446, Pericles learned that Megara had defected. The Peloponnesians made ready to invade Attica and the Athenian garrisons were massacred by the Megarians, except for one which had taken refuge in Nisaia (Thuc. 1.114). The Peloponnesians invaded Attica, penetrating as far as Eleusis and Thria: this was not only the direct route, blocking the passage from Pagai to Athens, but also the shortest, as it went through Panakton and Eleutheres as well as Oinoe. Finally, when war broke out, Thucydides (2.18) shows King Archidamos invading Attica by way of Oinoe, the first point of contact between the Peloponnese and Attica—which is unexpected, to say the least, seeing that the direct route went through Megara and Eleusis and along the coast. Thucydides notes unmistakably: "Oinoe, which is on the frontier of Attica and Boiotia, was in fact fortified, and Athens used it as an advance post in time of war. They therefore organized these assaults and, in this way among others, lingered there" (Thuc. 2.18.2). "The Athenians, as is well known, took advantage of this delay to carry all their possessions into safety, and the Peloponnesians grew impatient at this period of waiting imposed on them by their king, Archidamos." In spite of the pessimism of one scholar: "Its site is uncertain; for we have no specific archaeological evidence, and the literary evidence is vague," this important text allows us to select a site from those that have been suggested. Oinoe is clearly in the region of Boiotia and Attica, belonging now to one, now to the other (Strab. 9.2.31). Myoupolis, slightly E of Eleutheres, meets the topographical qualifications and possesses some notable ruins; it seems likely to be the site of Oinoe.

BIBLIOGRAPHY. 1) G. J. Frazer, *Pausanias* II (1898) 438-39; Philippson, *Gr. Landschaften* I, 3 (1952) 787; J. Wiesner, *RE* Suppltbd. 8 (1956) s.v.; R. Hope Simpson, *A Gazetteer and Atlas of Mycenaean Sites* (1965) 108-9, no. 379; W. K. Pritchett, *Studies in Ancient Greek Topography* I (1965) 83-88; II (1969) 9-11 and map p. 10, fig. 1; J. R. McCredie, *Hesperia* Suppl. 11 (1966) 37 n. 58.
2) Frazer 517; L. Chandler, *JHS* 44 (1926) 8-9, 15, figs. 4-5; Wrede, *AthMitt* (1933) 25; A. W. Gomme, *A hist. Comm. to Thuc.* I (1945) 341; II (1956) 66-69; III (1956)MP; Philippson I, 2 (1950) 525-26 (site of Mazi); I, 3, 975-76; W. Wallace, *Phoenix* Suppl. 1 (1952) 80-84; N.G.L. Hammond, *BSA* 44 (1954) 103-22 esp. 120-22MIP; J. de Romilly, ed. & trans. Thuc. (1962); id., *REA* 64 (1962) 287-98; E. Meyer, *Der kleine Pauly* (1970) s.v. Oinoe, 3.
Y. BÉQUIGNON

OINOI NE Corinthia, Greece. Map 11. Oinoi was a fort that overlooked the Halcyonic Bay not far from Megarian territory (Strab. 8.1.3, 6.22; 9.2.25). The fort was captured by Aigisilaus during his campaign in Piraion in 390 B.C. but was recovered not long afterwards by Iphikrates (Xen. *Hell.* 4.5.5, 19).

The site has long been recognized as the imposing fortified compound on the hill of Viokastro near the modern village of Schinos. The high (400 m) hill is difficult of access from the coastal plain and the summit is crowned by a network of polygonal walls that served both as partial terracing and fortifications. Some of the walls, which are preserved in places to a height of over 4 m, are closely parallel and so create a series of narrow corridors. The highest part of the fort appears to have been a keep and below it to the E is a small plateau, reached by a stairway, where there is a large cistern. The fort guarded one of the chief routes from Boiotia to the Peloponnesos and would have been also an effective coastal watch station for fleet movements.

BIBLIOGRAPHY. C. A. Robinson in H. N. Fowler & R. Stillwell, *Corinth I, i: Introduction. Topography. Architecture* (1932) 38-40; J. R. Wiseman, *The Land of the Ancient Corinthians* (forthcoming).
J. R. WISEMAN

OKTAPOLIS (Kızılkaya) Turkey. Map 7. Town in Lycia N of the gulf of Fethiye, 8 km inland from Göcek. As its name implies, Oktapolis was in Imperial times a synoecism of eight communities, of which the town at Kızılkaya was the most important. There are in fact more than eight ancient sites in the neighborhood, most of them very small; one is identified by an inscription as Hippokome. Among the ruins at Kızılkaya are three rock-tombs of Lycian type, but no inscription in the Lycian language.

BIBLIOGRAPHY. W. Arkwright, *JHS* 15 (1895) 98; G. Cousin, *BCH* 24 (1900) 44ff; *TAM* II, 1 (1920) 54; P. Roos, *Opuscula Atheniensia* 9 (1969) 85.
G. E. BEAN

OLBA (Uğura) Rough Cilicia, Turkey. Map 6. Now a village situated 22 km inland NE of Seleucia ad Calycadnum at an elevation of ca. 1000 m. It was probably capital of Pirindu (Rough Cilicia) in the 6th c. B.C. The priests of the Temple of Zeus at Uzuncaburç ruled a state of unknown extent in the Hellenistic period, possibly under nominal Seleucid control. There was an Olban polis organized by the 1st c. B.C. at the latest, and in the Olban territory the provincial natives known as Kennateis or Kannatai. The priestly family was confirmed in power by Antony, then by Augustus, under whom the High Priest Ajax son of Teucer was toparch of the Kennateis and Lalasseis, the last perhaps located somewhere in the Calycadnus valley. In the 1st c. A.D. M. Antonius Polemo appeared as dynast of Olba, the Kennateis and Lalasseis. The state and city lost their independence when all Cilicia was made into a province ca. A.D. 72, and by the time of Domitian the temple town was separated from Olba and incorporated as a city, Diocaesarea.

The city site lies on and around a hill at the edge of a fertile, well-watered plain, some 3 km to the E of the temple. The hill is fortified by a ring wall of polygonal masonry, perhaps of Hellenistic date. The great towers at Uzuncaburç and the town of the Kanytelleis were ded-

icated by the priest Teucer son of Tarkyaris around the late 3d or early 2d c. B.C. Other towers and forts possibly Hellenistic, few well described, some with carved symbols that appear on coins of Olba, guard all the approaches to Olba, between Seleucia and the Lamus river, near the coast and farther inland. All these towers and forts perhaps were used or built by Teucer as a defense system for his territories.

The remains of the city of Olba are few and unimpressive and, except possibly for the defense wall, all are of the Roman and Christian periods. The ravines that form the E and W sides of the fortified hill and join the ravine of the Karyağdı Deresi are riddled with rock-cut graves. A well-preserved section of an arched aqueduct, dated by an inscription to A.D. 199-211, which brought water from the upper Lamus, spans the ravine at the NE end of the hill. Around the sides of the hill are numerous house remains, some well preserved. The center city was at the W side on the plain, facing across to Diocaesarea. Here are the remains of a theater hollowed out of the hill with some remains of its scene building preserved, and a fairly well preserved nympheum consisting of a wall with returns flanking a basin, approached by three steps and a platform. Both theater and nymphaeum are probably of the 2d c. A.D. In the plain S of these is a grave temple or heroon, a small prostyle tetrastyle Corinthian building with a square cella about 8.5 m a side, only the walls are preserved. At the site are the remains of two churches; and on a ledge in the Karyağdı Deresi ravine just S of the citadel, a monastery (?).

BIBLIOGRAPHY. Strab. 14.5.10; E. L. Hicks, "Inscriptions from Western Cilicia," *JHS* 12 (1891) 269-70; J. T. Bent, "A Journey in Cilicia Tracheia," *JHS* 12 (1891) 222; R. Heberdey & A. Wilhelm, *Reisen in Kilikien, DenkschrWien*, Phil.-Hist. Kl. 44, 6 (1896) 90-91; J. Keil & A. Wilhelm, *Denkmäler aus dem Rauhen Kilikien, MAMA* III (1931) 80-89[MPI]; T. S. MacKay, "Olba in Rough Cilicia," Diss. 1968[M]. T. S. MAC KAY

OLBASA (Belenli) Turkey. Map 7. Site in Pisidia. 54 km S-SW of Burdur. The form of the name implies an early date for the foundation, but the city does not appear in history before the settlement of a military colony by Augustus ca. 6 B.C. (Colonia Julia Augusta Olbasenorum). The coins are colonial of the 2d and 3d c.

The site is on a hill precipitous on the N, dominating the valley of the Lysis, with a stream on either flank. The summit of the hill carries a circuit wall which has been thought to be Hellenistic, and on the S slope are numerous foundations and statue bases, though nothing is standing. Many ancient stones may be seen in Belenli village.

BIBLIOGRAPHY. L'Abbé Duchesne & M. Collignon, *BCH* 1 (1877) 370; B. Levick, *Roman Colonies in Southern Asia Minor* (1967) 48-50. G. E. BEAN

OLBIA Ukraine. Map 5. Greek city situated on the right bank of the Bug liman, S of the present-day village of Parutino. One of the most important cities on the N coast of the Black Sea, it was founded in the 1st half of the 6th c. B.C. by Miletian colonists and by inhabitants of the other Greek cities (Hdt. 4.78.79; Dio. Chrys. *Or.* 36).

The city rapidly became self-governing, reaching full prosperity in the 4th c. B.C. From the beginning of the 3d c. B.C. the danger of barbarian invasions grew. The Sarmatians and Scythians invaded the city in the 2d c. B.C., and from that period it started to decline. The Getae seized it in the 1st c. B.C., and the city gradually became barbarized and lost its Greek traditions. In the Roman Empire it was a small town, becoming part of the

province of Lower Mysia toward the end of the 2d c. A.D. when it was surrounded by fortifications. In the 4th c. the Getae again invaded Olbia and gradually destroyed it.

Olbia covered a triangular area originally of ca. 50 ha, but because of erosion only ca. 33 ha remain. The city was spread out on two terraces, the lower city along the river and the upper city with its business district and public buildings near the agora and the temenos. Covering an area of over 2000 sq. m, the agora was bordered by a stoa (45 x 17.5 m) of the 4th c. B.C. with 9 Ionic columns, a large public building of the 4th-2d c., two large commercial buildings divided into shops with basements for storage, and among other buildings a gymnasium (?) with baths. The temenos covered an area of over 3000 sq. m and was bordered by stone walls and porticos. Among its buildings are a temple of Zeus (13.9 x 7.7 m) of the 3d c. B.C., a temple of Apollo Delphinios (30-35 x 16 m) of the 4th-2d c. completely surrounded by porticos of Ionian columns; and from the 5th c. B.C. a temple in antis dedicated to Apollo with an Ionic portico, an altar for libations, and an altar for burnt offerings. By the 1st c. A.D. both the temenos and the agora had been abandoned and this area, now beyond the new city walls, became a commercial center with several pottery workshops, winemaking establishments, and granaries.

It is possible to trace the evolution of the residential section from the 6th c. B.C. In the beginning it consisted of small two-roomed houses with an area of 12 sq. m. The houses of the 5th c. B.C. are more spacious. The largest and most luxurious ones are those built in the 4th-3d c. B.C., especially in the residential quarter of the lower city, where they are aligned on a broad stone-paved street. These houses, covering an area of as much as 50 x 38 m, had a rectangular vestibule leading to a square inner courtyard with rooms arranged around it. Some contained as many as 25 rooms. Fragments of mosaics and wall paintings have been found in a few houses.

In the late 2d c. A.D. a kurgan of Zeus was erected in what had been a residential area of the 6th-2d c.: a burial mound 14.5 m high and 37 m in diameter surrounded by a small wall. A dromos 1.75 m wide led down steps into a stone burial chamber comprising two identical rooms.

The necropolis N and W of the city walls encompasses an area of almost 500 ha. About 2000 burials have been excavated. The most prevalent graves in all periods were simple rectangular holes dug into the ground, but from the 5th c. B.C. there are passage graves formed from a niche or passage cut into the side of a tomb, and from the 4th c. B.C. vaulted graves with steps lead down a dromos into a burial chamber. The burial of Heuresibius and Arete (2d c. A.D.) consisted of a large kurgan covering a vault composed of two rooms.

In the early centuries A.D. the S part of the upper city became a citadel with massive walls and towers. Among the buildings of this era are the barracks (?) of the Roman garrison and a metal-working shop of the 3d-4th c.

From the 6th c. B.C. Olbia minted its own coins, and in the 4th c. B.C. gold staters of Alexander and Lysimachos. Among the rich archaeological finds are wares of the 6th c. B.C. from Rhodes, Miletos, Samos, Corinth, Chios, Klazomenai, Chalkis, and black-figured Attic bowls, as well as the local production of bowls and terracottas imitating imported forms. The Hermitage Museum contains material from the site.

BIBLIOGRAPHY. E. H. Minns, *Scythians and Greeks* (1913) 453-89; B. Farmakovskii, *Ol'viia* (1915); *Ol'viia,* I (1940); *Ol'viia i nizhnee Pobuzh'e v antichnuiu epokhu*

[Materialy i issledovaniia po arkheologii SSSR, No. 50] (1956); Ol'viia, II [Arkheologichni Pam'iatky URSR, No. 7] (1958); L. M. Slavin, "Periodizatsiia istoricheskogo razvitiia Ol'vii," Problemy istorii Severnogo Pricherno-mor'ia v antichnuiu epokhu (1959) 86-107; A. L. Mongait, Archaeology in the USSR, tr. M. W. Thompson (1961) 180-85; C. M. Danoff, Pontos Euxeinos (1962) 1092-1104 = RE Suppl. IX; Ol'viia, Temenos i agora (1964); E. Belin de Ballu, L'Histoire des Colonies grecques du Littoral nord de la Mer Noire (1965) 44-72; id., Olbia: Cité antique du littoral nord de la Mer Noire (1972); L. M. Slavin, Zdes' byl gorod Ol'viia (1967); I. B. Brašinskij, "Recherches soviétiques sur les monuments antiques des régions de la Mer Noire," Eirene 7 (1968) 87-92; A. I. Karasev, "Raskopki Ol'viiskoi agory v 1967-1969 gg.," KSIA 130 (1972) 35-44.

M. L. BERNHARD & Z. SZTETYŁŁO

OLBIA (L'Almanarre) Var, France. Map 23. Olbia ("the Fortunate") is located near Hyères, 65 km from Marseille. According to ancient authors (Pseudo-Skymnos 215; Strab. 4.1.5 and 4.1.9; Ptol. 239.1; Steph. Byz. s.v.), it was one of four large fortified settlements established by Massilia on the Mediterranean coast E of the Rhône. Like Tauroention, Antipolis, and Nikaia, it was intended to contain the ascendancy of the Celto-Ligurian tribes of the confederation of the Salyes. It was founded at the end of the 4th c. B.C. and may have been taken by the Romans at the time of the siege of Marseille (49 B.C.). Later it was included within a larger built-up area. It is impossible, however, to affirm with certitude that this was the Pomponia mentioned by the Maritime Itinerary and by Pliny. The occupation seems to have lasted until the Early Christian period. In the Middle Ages the site was occupied by a monastery (12th to 15th c.).

The location of Olbia, for a long time not known for certain, was determined by the discovery on the site of a dedication to the Genius Viciniae Castellanae Olbiensium. Excavations have reconstructed the general features of the Greek settlement. The founding of Olbia is well dated stratigraphically to ca. 330-300 (there are no sherds earlier than the 4th c. B.C. and Etrusco-Campanian black-finish ware predominated). These years correspond to the economic renascence of Marseille. At this time the town was provided with a strong cyclopean rampart of large polygonal stones. This was later replaced, or perhaps supplemented, by a second enceinte of large ashlar (2d c. B.C.). From the beginning the town was organized according to a rigorous orthogonal plan: the ramparts form a square, 160 m on each side; the S flank is next to the seashore. It was defended by square towers (which are still in place on the N and W sides). The wall is pierced by gates of which the main one, to the E, led to the port.

The urban area was divided into quarters by two wide streets, one E-W 5 m wide, the other N-S 4 m wide. Streets parallel to these axes and 2.20 m wide delimited rectangular blocks 11 m wide (in other words, exactly five times the width of the streets). There are 36 blocks of dwellings in all, divided into nine series of four blocks each. The location corresponding to a last series along the W sector of the ramparts was reserved for a group of buildings arranged around an interior courtyard. It has only been partially cleared, but it may be supposed to be public, and probably religious, in character.

The blocks of dwellings and the streets include several Hellenistic levels. These more or less preserved the original city plan. There are many shops and private houses, carefully built of small ashlar, an intricate network of streets, a large square-sectioned well built in opus quadratum with sharp corners. But the most interesting building is a square monument, 5 m on each side, which leans directly on the N flank of the oldest rampart. Its nature has been revealed by a building block bearing the name of the goddess ΑΦΡΟΔΙΤΗΣ. Under the lowest floor there appeared well-aligned piles of terracotta cups, bases uppermost. Nearby, three lead plates were found which carry the inscriptions LVNAE, MERCVRIO, VENERI. A stone encased in a wall of the same block carries another Greek inscription: HPΩΣ. It follows that this block is religious in function. Curiously, it contains installations which show that it was also used for crafts: rooms, basins, water channels. (Could purple have been manufactured under the patronage of the goddess?) Also to be noted is the inscription MHTPΩN, of the 3d or 4th c. B.C., found on a milestone at the E gate.

The Roman stratum is placed on top of a destruction level dating to about the middle of the 1st c. B.C. The new built-up area overflowed the original enclosure and extended beyond the ramparts. The most . important monument is a complete set of baths. Other remains have been noted at various localities, notably those of port installations on the modern beach of l'Almanarre.

Of the mediaeval level, remains can be seen of a chapel with an apse, a church and its sacristy, and a cemetery.

BIBLIOGRAPHY. Forma Orbis Romani II: Var (1932); J. Coupry, "Les fouilles d'Olbia," CRAI (1964); "Chronique des circonscriptions arch.," Gallia (1965ff).

C. GOUDINEAU

OLBIA Sardinia, Italy. Map 14. City in the NE part of Sardinia, situated on a broad gulf (Ptol. 3.3.4). The foundation of Olbia, which Greek tradition attributed to the Foci (6th c. B.C.), is today attributed to the Carthaginians. With the Roman occupation Olbia acquired considerable importance as a commercial center in trade with the continent. In Imperial times the presence in the Olbian countryside of landed estates of the gens Claudia and of Atte, concubine of Nero, who erected a temple to Ceres here (CIL x, 1414), testify to its prosperity. The numerous main thoroughfares converging at Olbia attest to the continued importance of the city in the 3d and 4th c. A.D. and to an intensity of life that persists in the recollections of historians (Claudi. de Bello Gild. 15.519, who speaks of the circuit walls along the shore), and of the geographers (It. Ant. 81; Tab. Peut.). With the decline of the Empire the city suffered upheaval from the invasion of the Vandals in the 5th c. A.D., but revived in the early mediaeval period as the capital of the governors of Gallura.

The city was erected on the tongue of land projecting out into the sea, where the remains of a Punic temple (3d-2d c. B.C.) have been found. The Punic necropoleis, which were later reused by the Romans, contained ditch, shaft, and coffin burials and extended to the NW, W, and SW of the ancient center. Of the Roman walls, which were constructed of a double course of large isodomic granite blocks and date from the 3d-2d c., there remains a stretch with a rectangular tower and the opening of a gate into the Lupacciolu garden in Via R. Elena. On the axes of the city, beginning on the cardo and decumanus, which correspond to the modern Via R. Elena and the Corso Umberto, were built both private and civic structures. Among them there remains a large bath complex (1st-2d c.), and an aqueduct that brought water from the slopes of the Cabu Abbas mountains and carried it to the city. The ancient port occupied a space slightly larger than the modern seaplane air-

port. The Roman necropoleis extended over a large area in present Fontana Noa, Abba Ona, and Joanne Canu, entirely encircling the city. The burials, which in part reuse earlier building material, consist of ditch, shaft, and coffin tombs. The funerary fittings, other than ceramic material, consist of bronze or iron strigils, mirrors, and coins. The collection is preserved in the National Museum at Cagliari.

BIBLIOGRAPHY. A. Tamponi, *NSc* (1890) 224ff; A. Taramelli, *NSc* (1911) 223ffPI; E. Pais, *Storia della Sardegna e della Corsica*, I (1923) 374ff; R. Hanslik, *RE* 17 (1936) 2423; D. Levi, *Studi Sardi* 9 (1950) 4ffPI; D. Panedda, *Olbia nel periodo punico e romano (Forma Italiae)* (1952)MPI; id., *L'agro di Olbia nel periodo preistorico punico e romano* (1954)MPI; G. Pesce, *EAA* 5 (1963) 634ff. D. MANCONI

"OLBIA," *see* QASR EL-LEBIA

OLD BURROW Countisbury, N Devonshire, England. Map 24. A 1st c. fortlet on a hilltop overlooking the Bristol Channel (elev. 327 m). The earthwork, well preserved on moorland, consists of two concentric enclosures, 18-21 m apart: the inner one, 27 m square, is defended by a rampart and two ditches, the outer one, more circular, by a rampart and ditch. The entrance to the outer enclosure was on the landward side, to the inner enclosure on the seaward side, to force attackers to make a half-circuit under fire between the defenses before reaching the heavy timber-framed inner gate.

The only structure in the interior was a large rectangular field-oven built of stakes, wattle-work and clay, for communal cooking. The troops presumably lived in tents. The fortlet was occupied briefly during the reign of Claudius, probably under Ostorius Scapula, governor in A.D. 47-52. It was built as an outpost to watch for movements by sea of the Silures, the hostile tribe in S Wales led by Caractacus, and presumably to work in conjunction with patrol ships of the Classis Britannica stationed at Avonmouth (Abonae). Cf. Martinhoe. Finds are at the Athenaeum, Barnstaple, N Devon, and at the Somerset County Museum, Taunton.

BIBLIOGRAPHY. A. Fox & W. Ravenhill, "Old Burrow and Martinhoe," *Antiquity* 39 (1965) 253-58; id., *Proc. Devon Arch. Soc.* 24 (1966) 3. A. FOX

OLD CARLISLE, *see* OLENACUM

OLD CHURCH, *see* BRAMPTON

OLD DURHAM Durham, England. Map 24. Roman remains were discovered in 1940 near the river Wear and 1.6 km E of Durham City. In 1941-43 a small bath house was excavated, dating from the late 2d c. and partly lying over an earlier boundary ditch. This ditch contained Antonine pottery in its primary silt, but still earlier occupation was indicated by fragments of native ware, while the latest Roman pottery on the site was of the 4th c.

In 1948 two circular structures, probably threshing floors, were investigated; these were 36 m NW of the bath house and lay over late 2d c. pottery. In 1951 work was confined to two paved areas, some 50 m due N of the bath house; they lay over a rubbish pit and were associated with pottery of 3d-4th c. date. The bath house was of civilian, not military, type; and the remains are of interest as representing the most northerly complex, with claims to be a villa, so far discovered in the Roman empire.

BIBLIOGRAPHY. I. A. Richmond et al., "A Civilian Bath House . . . ," *Arch. Ael.* 22 (1944) 1-21MIP; R. P. Wright & J. P. Gillam, "Roman Buildings at Old Durham," ibid. 29 (1951) 203-12PI; id., "Third Report on the Roman Site at Old Durham," ibid. 31 (1953) 116-26PI. A.L.F. RIVET

OLD KILPATRICK, *see* ANTONINE WALL

OLD PENRITH, *see* VOREDA

OLD SARUM ("Sorviodunum") Wiltshire, England. Map 24. Old Sarum lies 2.4 km from the center of Salisbury, close to the E bank of the Avon. It was the site of an Iron Age hill-fort, later adapted by Norman hands into a superb motte-and-bailey castle which also included, most exceptionally, a cathedral. Beneath the Norman works lies a Roman settlement of unknown size and importance. This settlement, which lay at the crossing of two important roads, from Winchester to Charterhouse and from Silchester to Dorchester, is probably the Sorviodunum (or Sorbiodunum) of the *Antonine Itinerary*.

BIBLIOGRAPHY. *Wiltshire Archaeological Magazine* 57 (1960) 353. M. TODD

OLD SLEAFORD Lincolnshire, England. Map 24. A late Iron Age settlement here played an important part in the political geography of E Britain shortly before the Roman conquest: a Belgic coin mint is attested. The succeeding Roman settlement was a humble village at the crossing of the river Slea. The only building excavated is an aisled hall containing a large corn-drying oven. M. TODD

OLENACUM or Olerica (Old Carlisle) Cumberland, England. Map 24. The alternative name is suggested by a study of the *Ravenna Cosmography*. There has been no informative excavation of this site, which is best known for its inscriptions. The platform of the fort with a double ditch surrounding it can be clearly seen, and the civil settlement attached to it discerned on air photographs. It is obviously part of the Hadrianic defensive scheme for the NW in support of the W end of Hadrian's Wall and the coastal forts. The occupation was probably continuous from this time on.

A series of dedications show that the fort was garrisoned by the Ala Augusta, at least from 185 to 234. This is not, as was at one time thought, the Ala Petriana, which is known at Stanwix (Petriana) near Carlisle. The unit cannot have been more than 500 to fit into this fort. The main interest of the inscriptions is the evidence for the same garrison in occupation for 50 years, at a period of extensive troop movements in the late 2d c. The organization of the civil settlement in the mid 3d c. is attested by an altar to Jupiter and Vulkanus dedicated by the magistri vikanorum from money collected by the villagers. The occupation of the site is believed to extend at least into the 5th c., and perhaps even into the 9th. There is, so far, no archaeological evidence for this but a 10th c. compilation, the *Historia Brittonum*, mentions it if the identification of the place-name is correct.

BIBLIOGRAPHY. R. G. Collingwood, "Old Carlisle," *Trans. Cumberland and Westmorland Arch. Soc.* ser. 2, 28 (1928) 103-19; *RIB* 293-303; I. A. Richmond & O.G.S. Crawford, "The British Sections of the Ravenna Cosmography," *Archaeologia* 93 (1949) 42; E. B. Birley, "The Roman fort and settlement at Old Carlisle," *Trans. Cumberland and Westmorland Arch. Soc.* 51 (1951) 16-39. D. CHARLESWORTH

OLERICA (Ilkley) Yorkshire, England. Map 24. Originally a Flavian fort mentioned by Ptolemy and the *Ra-*

venna Cosmography, which together with Slack and Elslack was founded by Agricola to subdue the Brigantes. It stands on the S bank of the river Wharf and has streams (now running in underground conduits) as natural defenses on E and W. It stands on the trans-Pennine road from Manchester down the Wharf to Tadcaster and York. Numerous tile stamps show it was occupied by Cohors XXII of the Lingones, a cohort raised from the Gallic tribe of which Langres was the capital. This was a cohort quingenaria, an infantry cohort with a paper strength of 360 with 120 mounted men. The cohort remained at Ilkley until the 3d c. when it was moved to Whitehaven in Cumberland, which was threatened by an invasion from Ireland. There is an altar dedicated to VEROGIA (probably the river Wharf) by the prefect Clodius Fronto.

A considerable civilian settlement grew up S and E of the fort, but finds have been scattered and casual. The defenses have been destroyed, but excavation showed that the first fort had a clay rampart on a bedding of river pebbles; this was succeeded in the time of Trajan by a stone wall, which was later rebuilt with better material. There were four gates with guardrooms, the gates of the Flavian fort being of wood. The interior of the fort has been largely destroyed by the mediaeval church and manor house, but remains of the headquarters building, a granary, and the commandant's house have been found.

The headquarters building was square, with offices around a courtyard. It was in the usual place in the middle of the via principalis, joining the N and S gates and facing down the via praetoria which led to the main E gate. The granary to the N was rectangular (23.4 x 9 m) with internal partitions running the length of the building and stout buttresses. The commandant's house, 1.8 m to the N, in its first phase was a rectangular stone house (19.8 x 7.8 m), replacing an earlier wooden one. It was subsequently widened, and in its last form a suite of baths was added to the W end.

In the 4th c. some irregular paving was laid over the fort, unassociated with any buildings. K. F. HARTLEY

OLISIPO (Lisbon) Estremadura, Portugal. Map 19. Mentioned by Ptolemy (2.5), Strabo (3.3.1), Mela (3.1), and Pliny (*HN* 4.22). Isidore of Seville and the Ravenna Cosmographer call the city Ulyssipona and Olisipona respectively, from which the name Lisbon is derived. A settlement existed here in the Late Palaeolithic Age. Of the topography and history of the Roman city little is known. The site was occupied by the Romans in 138 B.C. The tradition according to which Cato the Censor was in Olisipo in 195 B.C. rests on an inscription now considered unreliable. According to Strabo, in 138 B.C. the consul Decimus Junius Brutus fortified the city, but it is not clear whether he encircled the existing village with fortifications or simply built a permanent castrum beside it. Pliny calls Olisipo Felicitas Julia and is uncertain whether it received this designation from Julius Caesar or Octavian. Also uncertain is the date when Olisipo was granted the status of municipium, mentioned by Pliny and confirmed by inscriptions.

No traces of the network of streets or the circuit of fortifications has been found, but it is likely that Olisipo, like Ebora, Pax Iulia, Egitania, Conimbriga, and other cities of Lusitania, was fortified at least by the end of the 3d or the beginning of the 4th c. The Roman city occupied the S and W slopes of the mountain where the Castelo de S. Jorge was later erected. On the S it certainly extended to the Tejo, and on the W at least to the present-day Rua da Prata, where there were some baths and a temple. The only remains of Roman public buildings are those of a theater and of the baths of the Augustales. The theater lies between Saudade and S. Mamede (Caldas) streets and was built in the time of Nero. Gaius Heius Primus, flamen augustalis, erected the proscenium and orchestra at his own expense. To judge from the representation of Lisbon on the royal pendent seal of 1352, the theater was then still well preserved, but it had disappeared by the time of Renaissance descriptions of Lisbon. In 1798 the proscenium, orchestra, and first seats of the cavea were discovered and a plan was published in 1815. Building again covered the site until recently, and the remains have not yet been completely excavated.

The baths under the Rua da Prata were built in the time of Tiberius, but no traces have been found of the other bath, reconstructed in A.D. 336, on the Rua das Pedras Negras.

Olisipo was supplied with water by an aqueduct about 10 km long which ran from below a dam, the dike of which is preserved. The dike is 50 m long and 7 m thick and is reinforced; part of it still stands 8 m high. The 3d c. A.D. date for its construction is uncertain.

BIBLIOGRAPHY. A. Vieira da Silva, *Epigrafia de Olisipo* (1944); F. de Almeida, "Notícias sobre o teatro de Nero, em Lisboa," *Lucerna* (1966) 561-71. J. ALARCÃO

OLLODUNUM, *see* OLTEN *and* LIMES, RHINE

OLOSSON Thessaly, Greece. Map 9. Chief city of Perrhaebia (Strab. 9.439f), identified with modern Elassona. Located at the N end of a small (5 km N-S, 10 km E-W) isolated plain N of the E Thessalian plain, it is on a crossroad where roads from W and E Macedonia (via the Bouloustana or Sarandaporou pass, and the Stená Petras), from the W Thessalian plain, and from Larissa in the E plain join. It appears in the *Iliad* (2.739 "white Olosson"), probably issued Perrhaebian coinage 480-400 and 196-146 B.C. It apparently played a negligible role in history.

The ancient acropolis was a steep-sided, white clay hill flanked by the deep ravines of the Elassonitikos (ancient Titaresios) and a tributary (Kouradhiaris). On the acropolis is a monastery of the Panaghia Olympiotissa. Some traces of isodomic ancient walls remain N of the monastery, and blocks and inscriptions are built into it. The ancient lower city was in the plain on the right bank of the Titaresios, but only very slight (1924) traces of the city walls remain. Ancient graves have been found on the left bank. Some 4th c. B.C. statuary and Roman grave reliefs have come from the city and its plain. There is a small archaeological collection in Elassona.

BIBLIOGRAPHY. W. M. Leake, *Nor. Gr.* (1835) III 345-47; A. S. Arvanitopoullos, *Praktika* (1914) 150-53, 160-68; id., *ArchEph* (1916) 89[I]; F. Stählin, *Das Hellenische Thessalien* (1924) 23f; B. Lenke, *RE* (1937) s.v. Olosson; H. Biesantz, *AA* (1959) 86-90[I]; id., *Die Thessalischen Grabreliefs* (1965) 127. T. S. MAC KAY

OLOUS (near Elounda) Greece. Map 11. On the W side of the Gulf of Mirabello, just N of Ag. Nikolaos, N coast of Crete. The remains of the ancient city lie on both sides of the isthmus which joins the peninsula of Spinalonga to the mainland; the area of the site is known as Poros.

Ancient literary sources merely locate the site. In late sources (e.g. *Notitiae*) the name has been corrupted to Alyngos. Most of our knowledge of the city's history is derived from inscriptions of the Hellenistic period. In one of post 260 B.C. Olous appears as a subordinate ally of Knossos. A number of 3d and 2d c. inscriptions show the city's close relations with Rhodes; in particular, parts

of a treaty between Rhodes and Olous dating from 201-200 have been discovered in recent years, by which Rhodes secured a great measure of control over Olous and her ports and anchorages, as she did over those of Hierapytna in the same year. Ptolemaic admirals had been honored at Olous at about the time of the Chremonidean war in the 260s. Olous does not appear among the cities of the Cretan koinon in the treaty with Eumenes II in 183, either because she was then subject to her neighbor Lato or because of her links with Egypt. A boundary dispute between Olous and Lato was referred to the Knossians for arbitration (117-116/116-115 B.C.); continuing wrangles led to Roman intervention and confirmation by the Senate of the Knossians' decision on the boundary line (ca. 113; see Sta Lenika).

Coins of ca. 330-280 B.C. are known, depicting in particular the heads of Britomartis and Zeus Tallaios. The latter was clearly the chief deity of Olous, in whose temple many inscriptions were displayed; for the same reason the cult of Asklepios must also have been important. Pausanias (9.40.3) mentions a statue of Britomartis by Daidalos at Olous. None of their temples at Olous has been found.

There is clear evidence that the site has been submerged by at least 2 m since antiquity, probably mainly as a result of land movements: by the actual isthmus some remains of houses are visible in shallow water. The channel at the isthmus was dug for the local fishermen by French sailors who occupied the area in 1897; their finds included the large stele now in the Louvre. The only ruins still clearly visible E of the isthmus are those of an Early Christian basilica with a mosaic in the nave.

Few remains of the archaic and Classical periods have been found, but part of the massive E wall of the city still stood 6 courses high in the 19th c. Graeco-Roman sherds have been found at Kolokythia Bay on the E side of the peninsula, and at the N end of Spinalonga is an islet fortified by the Venetians; no earlier remains are visible. There are many rock inscriptions around the peninsula.

West of the isthmus a few walls have been found, but the area served mainly as a cemetery. Graves with coffins or pithoi of the LM IIIB period have been found, and the Hellenistic necropolis with funerary inscriptions. Just to the N lies a significant Middle Minoan settlement, and a few Early Minoan pots have been found.

Just within the territory of Olous, to the SW, a prominent hilltop bears remains of a fort of uncertain (ancient) date (Mt. Oxa). Farther N another fort at Stis Pines guarded the road to Dreros. Just S of Mt. Oxa lies the site of Sta Lenika in Latian territory.

BIBLIOGRAPHY. T.A.B. Spratt, *Travels and Researches in Crete* I (1865) 117-29[I]; A. Mariani, *MonAnt* 6 (1895) 248-49; M. Guarducci, *ICr* I (1935) 243ff; J.D.S. Pendlebury, *The Archaeology of Crete* (1939); E. Kirsten, "Olus(2)," *RE* 17,2 (1937) 2504-8; H. van Effenterre, *La Crète et le monde grec de Platon à Polybe* (1948) esp. 226-34; id., *Nécropoles du Mirabello* (1948)[MI]; id., "Fortins crétois," *Mél. Charles Picard* II (1949) 1033-46[I]; A. Orlandos, *Praktika* (1960) 308-16; id., *Kret. Chron.* 15-16,1 (1961-62) 230-40; C. Tiré & H. van Effenterre, *Guide des fouilles françaises en Crète* (1966) 88-89[I]; *SEG* XXIII (1968) Nos. 546-55.
D. J. BLACKMAN

OLTEN Solothurn, Switzerland. Map 20. Vicus and fort on the left bank of the Aare, between Aarau and Solothurn. The ancient name Ollodunum is conjectured from mediaeval Oltun. The name and the location at the S foot of two passes over the Jura ridges make the existence of a pre-Roman oppidum probable, but in any case the vicus developed because the military road from Aventicum to Vindonissa crossed the Aare here. In the 4th c. a fortress was built to protect the Rhone-Rhine waterway, one of a chain of similar defenses on the Aare.

The vicus is attested mainly by tombstones and some few remains discovered accidentally. The walls of the mediaeval city, however, correspond roughly to those of the late Roman fortress, the plan of which was bell-shaped with the base towards the river (area ca. 1.23 ha). Parts of the ancient walls are visible in basements of the mediaeval town. The present wooden bridge is probably on the site of the Roman one; here also was the main gate, in the middle of the wall along the river front. The Historisches Museum is on the Konradstrasse.

BIBLIOGRAPHY. E. Häfliger, "Das römische Olten," *Festschrift E. Tatarinoff* (1938) 26-40; F. Staehelin, *Die Schweiz in römischer Zeit* (3d ed. 1948) 309-10, 363, 620[P]; V. von Gonzenbach, *BonnJbb* 163 (1963) 95; *Jb. Schweiz. Gesell. f. Urgeschichte* 49 (1962) 82-83; 51 (1964) 118; 56 (1971) 221-22; E. Müller, "Das römische Castrum in Olten," *Oltner Neujahrsblätter* 27 (1969) 37-43[PI].
V. VON GONZENBACH

OLYMOS (Kafaca) Turkey. Map 7. Site in Caria, 8 km N-NW of Milâs. Probably to be identified with the Hylimos which figures in the Athenian tribute lists. Incorporated with Mylasa in the 2d c. B.C. There are no standing ruins, but the site of the Temple of Apollo and Artemis has been located from inscriptions and other ancient stones.

BIBLIOGRAPHY. G. Cousin, *BCH* 22 (1898) 392ff; L. Robert, *RA* (1935:2) 158-59; id., *AJA* 39 (1935) 337; id., *Hellenica* 10 (1955) 224-27; A. Laumonier, *Les cultes Indigènes en Carie* (1958) 141ff.
G. E. BEAN

OLYMPIA Greece. Map 9. A sanctuary in the W Peloponnese, 18 km inland from the Ionian Sea, at the point where the Alpheios and Kladeos rivers meet (42 m), just S of the foot of the hill of Kronos (122.7 m). Throughout practically all of antiquity Olympia was under the control of Elis (q.v.). The settlement in the area of the shrine was continuously inhabited from the Early to the Late Helladic period (2800-1100 B.C.), as evidenced by the apsidal, rectangular, and elliptical structures of the Early and Middle Helladic periods which have been uncovered, as well as by numerous sherds, stone implements, and figurines of the EH, MH and LH periods. Similar buildings and small finds as well as an extensive cemetery with chamber tombs have been found in the area to the N (NW of the hill of Kronos), where stands the new Museum. The first signs of the cult of Pelops and Hippodameia at Olympia appeared as early as the LH period, as well as the first athletic contests. Of the tumuli of the two heroes remains were found only of the circular peribolos of Pelops, near the Pelopion of historical times. Recent objections to this identification have not been persuasive. The site of the Hippodameion remains unknown; it may have been in the S part of the Altis (Paus. 6.20.7; 5.15.7).

The cults of Kronos, Gaia, Eileithuia, Themis, et al., evidently date back to the same periods or even earlier. Their shrines center around the S foot of the hill of Kronos, whence come the majority of the prehistoric finds. With the predominance of the Aitolo-Dorian tribes of NW Greece in Elis after the Dorian invasion and the extension of their control over Olympia, which until then had been controlled by Pisa, the worship of Zeus was introduced to the Sanctuary. From that time to the

beginning of the 8th c. the Sanctuary gradually developed, but its activities were limited to the area of Elis and perhaps the neighboring territories. From this period come numerous offerings: bronze and terracotta statuettes of men and animals, chiefly bulls and horses, as well as chariots and drivers, all of primitive workmanship. After 776 B.C. when the Games were reorganized and established as Panhellenic (this marks the beginning of the historical period), Olympia developed rapidly, and the number of terracotta and bronze offerings multiplies. The greatest number of these are statuettes of horses and horsemen, symbols of the equestrian aristocracy which had evidently replaced the monarchy. There are also bronze cauldrons and tripods, and weapons of excellent workmanship. During this period the sacred grove of Olympia, the Altis, which was planted with plane trees, wild olives, poplars, oaks, and pines (Paus. 5.7.7, 13.1-3, 27.11; Strab. 8.353) and enclosed by a low peribolos or fence, acquired a very few, simple structures: altars of the Gods, and the heroa of Pelops and Hippodameia. The single column that was left of Oinomaos' megaron after Zeus, according to tradition, destroyed it with a lightning bolt, must also have been visible there; it was preserved into the time of Pausanias (5.20f). There was also the remnant of an ancient form of tree worship in a sacred wild olive tree which still flourished, and which Idaian Herakles, according to the myth, had brought from the lands of the Hyperboreans and planted there.

To the Geometric period belong the foundations of a rhomboid altar(?) built of unworked stones which was found within the site of the ancient Prytancion and which may have been the precursor of the altar of Hestia. To the end of the Geometric period belongs one of the apsidal buildings, no. 4, which until recently was considered to be prehistoric. The site of the stadium of this period is not known; it may have been on the same site as was the archaic one. In the Archaic period (7th and 6th c.) the activities of the Sanctuary involved not only the world of mainland Greece, but the colonies around the Mediterranean. The increased importance of Olympia brought about its decoration with the first monumental structures. At the foot of the hill of Kronos was built the Temple of Hera. According to the usual modern view this was begun ca. 650 B.C. as a small Doric building with only a pronaos (10 x 39.5 m) and not until ca. 600 B.C. was it enlarged by the addition of an opisthodomos and peristyle colonnade (18.76 x 50 m; 6 x 16 columns). Recent researches have shown, however, that the whole building was completed at one time, ca. 600.

The Heraion, narrow and of heavy proportions, is the oldest example of a monumental temple in Greece. The lower part and the huge orthostat blocks of the cella are preserved and are of a local shell limestone, while the upper parts of the walls were of mud brick and the superstructure of wood with terracotta tiles on the roof. At the peak of each gable was a round terracotta acroterion. One of these has been restored (diam. 2.42 m) but of the other only a few fragments remain. The original wooden columns were gradually replaced, at long intervals, by stone ones. The last wooden one, made of oak, was preserved to the time of Pausanias, in the opisthodomos of the temple (Paus. 5.16.1). Each of the replacement columns was in the style of its own period, so that the columns as a whole provide an example of the development of the Doric column, particularly in respect to the capitals, from the archaic to the Roman period. At the back of the cella is preserved the bench on which rested the stone statues of Hera and Zeus (Paus. 5.17.1). Only the head of Hera has been found.

Along a natural terrace on the S slope of the hill of Kronos, a little above the Heraion, the treasuries were built in the 6th c. These are naiskoi of megaron form, dedicated by the Greek cities, particularly by colonies. The oldest of these, the Sikyonian treasury in its first phase, was about contemporary with the Heraion, while the newer ones belong to the first half of the 5th c. (the Treasuries of Sikyon and Gela in their second phase). Arranged one beside the other, they border the N edge of the Altis. Pausanias (6.19.1f) gives their names. The remains of 15 are preserved, but two of them only as traces—the two under the Exedra of Atticus. Five only are certainly identified: the Treasuries of Sikyon, Selinos, Metapontis, Megara, and Gela. Numerous architectural fragments of the first and last have been preserved. Of the pedimental sculptures of the Treasuries only a few pieces remain, with the exception of the Treasury of the Megarians of which the pedimental sculptures, although badly mutilated, are preserved. They are carved in high relief. The treasuries, which may at first have had a sacred purpose, were later used to safeguard valuable offerings (Paus. 6.19.1f). The stepped supporting wall in front of the treasuries was built later, in 330 B.C.

The Pelopion (Paus. 5.13.1) was renewed in the 6th c. Its peribolos at that time had five sides and a propylon, which was replaced in the 5th c. by a more monumental one. Recent theory dating the Pelopion to the 4th c. does not seem well founded. To the late 6th c. belongs the older Prytaneion with the seats of the Prytanei at the N corner of the Altis. The sacred hearth with its everlasting fire was in a special area of the same building (Paus. 5.19.9). In the following centuries the Prytaneion was enlarged and continually altered.

No trace of the Great Altar of Zeus SE of the Temple of Hera is preserved (Paus. 5.13.8). Since it was a mound slowly built up from the ashes of sacrifices and from the altar of the Prytaneion (Paus. 5.13; 15.9), it melted away in the rains after worship at the sanctuary ceased. The area in front of the Altar and particularly the slope of the terrace where the treasuries stood was perhaps the Theater mentioned by Xenophon (*Hell*. 7.4. 31), so called from its view of the sacrifices at the Altar and of other rites.

The archaic stadium, which was plain and had banks not of the usual form, stretched along the slope in front of the treasuries. Its W end, where the starting line was, opened out towards the Great Altar of Zeus. The stadium of the 5th c. was on the same spot or a little to the E, but this one had a track at a lower level and the banks, now more nearly normal, along the long sides; it formed part of the sacred area, since the games had a clearly religious character. But in the mid-4th c. a new stadium was built, which is still visible 82 m to the E and 7 m N of its predecessor. It was outside the sanctuary, since the games had begun to be more secular in character. The track of the new stadium was 215.54 m long and ca. 28.5 m wide, while the stone starting-points were 192.28 m apart as opposed to the 186 m of the Classical stadium. The banks enclosed the track on four sides and could hold 45,000 spectators. There were only a few stone seats for important persons; others sat directly on the ground. The exedra for the Hellanodikai (judges) was of stone, and was opposite the altar of Demeter Chamyne (Paus. 6.20.9). In the Roman period the exedra was given a more resplendent form and the stadium was remodeled twice. In the Hellenistic period the NW corner of the stadium communicated with the sanctuary through a narrow, roofed corridor, the Krypte (Paus. 5.20.8), which had Corinthian columns at its W end. To the NE of the archaic stadium was a bronze-

smelting establishment, and a large number of wells to provide water for the thousands of spectators during the period of the games. Thousands of earlier dedications were thrown into them in the Classical period when the stadium was moved to the E and covered this spot.

The hippodrome, which had a length of four stadia (ca. 780 m) has not been excavated and has probably, at least in part, been washed away by the Alpheios river. It was S of the stadium and parallel to it. When it took its final form in the Classical period, Kleoitas worked out a new arrangement of the starting gates (Paus. 6.20.10f). The S end of the sanctuary was closed off in the mid-6th c. by the S building of the Bouleuterion (14 x 30.5 m). This was a rectangular building with an apse at one of its short ends, a continuation of the type of prehistoric and Geometric building found in the Altis. In the 5th c. a second apsidal room was added parallel to the first, and between them a rectangular room where stood the Altar of Zeus Horkios. Here the athletes made their prescribed vows (orkoi) before the Games. These three buildings were enlarged in the 4th c. by an Ionic portico across the E face. The chronology and purpose of the two structures W of the Bouleuterion are uncertain.

In the 5th c. the sanctuary reached its peak of greatness and wealth. The Truce, which had been in operation from the archaic period on, and the recognition of Elis as "sacred and unassailable" (Polyb. 4.73) secured the unhampered development and prosperity of the area and of the sanctuary. At this time the most important building, the gigantic Temple of Zeus, was erected in the middle of the Altis. It was begun ca. 470 B.C., immediately after the reorganization of the state, at the same time as Elis' synoecism, and it was finished in 456. The temple, Doric peripteral (27.68 x 64.12 m; 6 x 13 columns), was the work of the Elian architect Libo. It is the largest temple in the Peloponnese and was considered the finest expression and the standard of Doric temple architecture. It was constructed of local shell limestone, covered with white stucco. Only the roof and sima and lion-head water spouts were made of Parian marble, although later the frequent local earthquakes made replacements of Pentelic marble necessary. Each of the continual repairs was in the style of its own period. The marble pedimental groups on the E end represented the chariot race of Oinomaos and Pelops with Zeus in the center, and on the W end the battle of the Lapiths and Centaurs at the marriage of Peirithoos and Deidameia, with Apollo in the center. The twelve metopes, six each above the entrances of the pronaos and opisthodomos, represent the twelve labors of Herakles. These sculptures, now more or less restored, are the most representative examples of the severe style of Greek art from the period after the Persian wars. The central acroterion at each pediment was a gilded Nike, the work of Paionios, and the corner acroteria were gilded cauldrons. The chryselephantine statue of Zeus seated on a throne, the work of Phidias, was placed at the back of the cella in 430 B.C. Of this masterpiece, described in detail by Pausanias (5.10.1f) nothing remains but some representations, chiefly on coins of Elis. The gigantic figure (12.37 m) held in his right hand a chryselephantine Nike and in his left a scepter. The throne and base were decorated with mythical scenes, and with gods, demigods, and heroes made of gold, ebony, and precious stones. For the making of this piece a workshop (ergasterion) was put up W of the temple (Paus. 5.15.1) which survived, with various changes, until the late Roman period. It measured 14.57 x 32.18 m, and in and around it were found numerous tools, glass ornaments, clay molds and other artists' materials which definitely belong to the period of the chryselephantine Zeus.

Two other buildings were erected at about the same time N of the workshop. One of them, rectangular with a peristyle court, is probably identified with the Theokoleon, the meeting place of the Theokoloi, the priests of Olympia (Paus. 5.15.8). This was altered and enlarged to the E and S in the Hellenistic period. The other building, W of the Theokoleon, consists of a circle inside a square and is called the Heroon in a later Hellenistic inscription found on the spot. A recent theory that this was originally a bath and was later dedicated to its anonymous Hero is not based on any sound evidence. To the W again, towards the Kladeos river, were the baths (Loutra, 5.75 x 21.56 m) and a swimming pool (kolymbeterion, 16 x 24 m). The baths were enlarged in 300 B.C. and again in 100 B.C., when a hypocaust was put in underneath; the building was abandoned in the Roman period when baths were built in many parts of the sanctuary.

The later Classical period was for Elis one of internal problems and clashes with her neighbors, especially when the Arkadians took Olympia in 364 B.C. and with the Pisans directed the games of that Olympiad (104th Ol.). They withdrew in 362 B.C. and Elis again took over supervision of the sanctuary. These disturbances, however, did not prevent new building activity, which gave the sanctuary its final form and architectural organization. For the first time the delicate Ionic order and its relative, the Corinthian, were brought into the sanctuary, which had been dominated by the Doric. In the newer buildings white marble was used to the almost complete exclusion of the shell limestone previously employed. These were signs of a general change in the character of the sanctuary. When the stadium was shifted E to its present position, the isolation of the Altis was completed with the erection of the Stoa of the Echo (or the Seven Echo Stoa) 12.50 x 98 m along its E side. The name came from the fact that an echo in it was proliferated seven times. It was also called The Painted Stoa (Poikile) from the wall paintings in it (Paus. 5.21.17; Plin. NH 36.100). It was built shortly after 350 B.C. and had two colonnades: the inner one was Doric and the outer may have been Corinthian; there were also rooms along the back.

At this period the main sanctuary (ca. 200 x 175 m) was separated from the supporting complex and the secular buildings by a monumental peribolos with five gates, three on the W side and two at the S. At the beginning of the 4th c. the Metroon, the Temple of Kybele, mother of the gods, was built in front of the terrace on which the treasuries stood. Of this temple, which was Doric, peripteral (10.62 x 20.67 m; 6 x 11 columns) only the stylobate and portions of the stone epistyle are preserved, and of the pedimental sculptures only a marble statue of Dionysos reclining. From the time of Augustus on the metroon was used for the worship of the Roman emperors; sculptured portraits of many of them stood in the temple. Along the treasury terrace, between the metroon and the stadium, are preserved the bases of 16 bronze statues of Zeus, the Zanes. These were set up between 378 B.C. and A.D. 125 with the money paid as a fine by athletes who had committed fouls in winning the Games (Paus. 5.21.2f). The S boundary of the sanctuary in its larger sense was defined by the south stoa (80.56 m long), which had two colonnades, the outer Doric and the inner Corinthian, with a wall at the back. The stoa was in the form of a T with a colonnaded extension in its center towards the Alpheios river; it was built at the same time as the Stoa of the Echo, and its euthynteria and steps were similarly of marble. The recently suggested identification of this stoa with the proedria (Paus. 5.15.4) is not based on any evidence.

At the beginning of the 4th or end of the 5th c. B.C. the SE building was erected, which according to one opinion is the Sanctuary of Hestia (Xen. *Hell.* 7.4.31). The W part is preserved, a row of four rooms with Doric colonnades on their four sides (14.66 x 36.42 m). The building was altered and expanded to the E in the Hellenistic period. At the SE corner of the Hellenistic addition, an early 5th c. altar of Artemis was recently found. The SE building was destroyed in the 1st c. A.D. for the foundations of a peristyle villa, probably built for Nero.

The elegant circular peripteral building S of the Prytaneion, the Philippeion (diam. 15.24 m) was begun by Philip II after the battle of Chaironeia (338 B.C.) but finished by his son, Alexander the Great. It stood on a marble stepped krepidoma, mostly preserved, and was surrounded by an Ionic colonnade. Corinthian half-columns were placed at intervals around the interior of the circular cella, at the back of which, opposite the entrance, were five portrait statues standing on a semicircular base, representing Alexander the Great between his parents and his grandfathers. These statues were the work of Leochares and were of gold and ivory (Paus. 5.20.9). This type of circular building, used earlier for divine worship, was now for the first time utilized for worship of the hero cult of the Macedonian dynasty.

In the W part of the sanctuary, S of the Workshop of Phidias, stood the hostelry called the Leonidaion, built in 330 B.C., named for its donor and architect, Leonidas of Naxos. It is 74.82 by 81.08 m and on all four sides its rooms open inward on a peristyle court with Doric columns. On the outside the building was surrounded by an Ionic colonnade. Originally intended for distinguished visitors and illustrious spectators, the building was later used as a residence for Roman officials (Paus. 5.15.1f).

In the Hellenistic period (3d-1st c. B.C.) there was no new building in the middle of the main sanctuary. There was only restoration and repair, with very few enlargements, at fairly frequent intervals, because severe earthquakes were common. Vigorous building activity however, went on outside the area of the Altis, to provide comfortable accommodation for athletes and spectators.

To the W of the Altis, near the Kladeos, the Palaestra, was built in the 4th c., a training ground for practice in wrestling, boxing, and jumping. It was a nearly square (66.35 x 66.75 m) building with a peristyle court, around which were covered areas for dressing, applying oil, sand, etc. The columns of the peristyle were Doric, but those of the entrances to the rooms were Ionic. To the N of the Palaestra and connected with it was the gymnasium, an enclosed, rectangular building (120 x 220 m) with a wide court in the center and colonnades on the four sides. The columns were Doric on the long sides and Ionic on the short. Here the athletes trained for contests demanding space, such as javelin throwing, discus throwing, and running. This was built in the early 2d c. B.C., while the monumental entrance between the gymnasium and the Palaestra, in the form of an amphiprostyle Corinthian propylon, belongs rather to the late 2d c. B.C.

The sanctuary was crowded with thousands of altars and statues of gods, demigods, and heroes, of Olympic victors and kings and generals, the work of the most notable sculptors of antiquity (Paus. 5.14.4f; 21.1f; 6.1.1f). Very few statues remain, but a large number of bases have been found. Similar statues were put up in Roman times, but these were mostly of Roman notables and emperors, and were erected not by their own choice but by cities and private persons who wished to secure their good will. By that time the best of the older works

had been moved into the Heraion, which took on the appearance of a museum (Paus. 5.17.1f).

In 146 B.C., the consul Mummius dedicated 21 gilded shields after his victory over the Greeks at the Isthmus. He fixed them on the metopes of the Temple of Zeus. On the other hand, in 85 B.C. Sulla robbed the treasuries of the sanctuary (as well as those of Epidaurus and Delphi) to meet the demands made by the war against Mithridates. Sulla decided to shift the Olympic games to Rome and organized the 175th Olympiad (80 B.C.) there, but Olympia recovered from this period of decline in the time of Augustus, after 31 B.C. Roman emperors and magistrates showed their interest in the sanctuary and the Games in different ways which harmonized with their political programs in Greece. Under Nero the Altis was enlarged and surrounded by a new peribolos, 3 m wider on the W side than the old one, and 20 m on the S. The simple gates of the sanctuary were replaced by monumental propylaea. At about the same time baths were erected W of the Greek baths and N of the Prytaneion. Later other baths were built NE of Nero's villa, and W of the Bouleuterion. Another hotel (xenodocheion) rose W of Phidias' Workshop, and during this period the older buildings were maintained or altered. Finally, in A.D. 160 Herodes Atticus built a magnificent fountain, the Nymphaion or Exedra (width 33 m, ht. ca. 13 m). It took the form of a semicircle with a circular naiskos at each of the two ends. The walls were of brick faced with polychrome marble. Above the semicircular wall and in the apsidal recesses that made up the central facade were 20 statues of Antoninus Pius and his family as well as the family of Herodes Atticus. The space between the two naiskoi was occupied by two basins, one in front of the semicircular wall and the other on a lower platform. The water, brought from an abundant spring 4 km W of Olympia, ran first into the upper, semicircular basin, next into the lower rectangular one, and then, via a network of conduits, throughout the whole sanctuary.

The first serious destruction to the monuments of the sanctuary came with the threat of the Herulian invasion. In the end the invasion did not reach as far as Olympia, but a strong wall was built to protect the richer treasuries and particularly the chryselephantine statue of Zeus. This wall, which used to be thought Byzantine, surrounded the Temple of Zeus and the S part of the sanctuary up to the south stoa. It was built with material from other buildings, both within and without the sanctuary, which were demolished for the purpose, except for the Temple of Hera.

Even in this crippled state and although it continued to decline, the sanctuary lasted for another century. There were some restorations in this period, particularly in the time of Diocletian (A.D. 285-305). The end came in A.D. 393-394 with the decree of Theodosius I, which prohibited worship in pagan sanctuaries. In A.D. 426 an edict of Theodosius II caused the ruin of the monuments of the Altis, and it was completed by two violent earthquakes in 522 and 551. In the 5th and 6th c. there was a small settlement of Christians at Olympia, and the Workshop of Phidias, the only building left whole, was changed into a Christian basilica. The floods of the Alpheios and Kladeos and the earth washing down from the sandy hill of Kronos covered almost the whole of the sanctuary to a depth of 7 m. The Kladeos also changed its course and, washing through the sanctuary, swept away many of the buildings in the W part. The first discoveries of the monuments of Olympia were made in 1829; systematic excavation began in 1875 and has continued to the present day.

BIBLIOGRAPHY. A. Blouet, *Expédition scientifique de*

Morée I (1831) 56ff[MPI]; A. Bötticher, *Olympia²* (1886)[MPI]; E. Curtius & F. Adler, *Olympia. Die Ergebnisse* 5 vols. (1890-97)[MPI] (new ed. 1966); B. Leonardos, *Olympia* (1901)[PI]; D. Arch. Inst., *Berichte über die Ausgrabungen in Olympia* 8 vols., continuing (1937-)[PI]; J. Wiesner, *RE* XVIII, 1 (1939) s.v. Olympia 1ff; E. Kunze, *Olympische Forschungen* 6 vols. & atlas (1944-66)[PI]; id., *Olympia: Neue deutsche Ausgrabungen im Mittelmeergebiet und im vorderen Orient* (1959) 263ff[MPI]; I. Κοντῆς, Τό Ἱερόν τῆς Ὀλυμπίας, κατα τόν Δ ΄ π. Χ. αἰῶνα (1958)[PI]; H. Berve et al., *Griechische Tempel und Heiligtumer* (1961) 10ff, 118ff[PI]; U. Jantzen, *EAA* V (1963) 635ff[PI]; N. Papachatzis, Παυσανίου Ἑλλάδος περιήγησις, Books V & VI (1965); G. Gruben, *Die Tempel der Griechen* (1966) 43ff[MPI]; W. Dörpfeld, *Alt Olympia²* (1966)[PI]; E. Kirsten & W. Kraiker, *Griechenland Kunde⁵* I (1967) 265ff[MPI]; E. Meyer, *Pausanias' Beschreibung Griechenlands²* (1967) 605ff[MPI]; id., *Der kleine Pauly* 4 (1972) 279ff s.v. Olympia; L. Drees, *Olympia* (1968)[MPI]; P. Grunauer, "Der Zeustempel in Olympia," *Berr. der Koldway Gesellschaft* 25 (1969) 13ff[PI]; id., "Der Zeustempel in Olympia," *BonnJbb* 171 (1971) 114ff[PI]; S. Miller, "The Prytaneion at Olympia," *AthMitt* 86 (1971) 79ff[PI]; W. Hoepfner, "Zwei Ptolemaierbauten," ibid. Suppl. 1 (1971)[PI]; N. Yalouris, "Das Akroter der Heraions in Olympia," ibid. 87 (1972)[PI]; id., *Olympia* (1972)[MPI]; A. Mallwitz, *Olympia und seine Bauten* (1972)[PI]; H. V. Herrmann & M. Hirmer, *Olympia, Heiligtum und Wettkampfstätte* (1972)[MPI].

Cult, games, history: F. Mezö, *Geschichte der Olympischen Spiele* (1930)[PI]; L. Deubner, *Kult und Spiele im alten Olympia* (1936)[PI]; L. Ziehen, *RE* XVII, 2 (1937) 252ff s.v. Olympia; K. Meuli, "Der Ursprung der Olympischen Spiele," *Die Antike* 17 (1941) 189ff; L. Moretti, "Olympionikai, i vincitori negli antichi agoni," *MemLinc* ser. 8, 8, 2 (1957) 53ff; id., "Supplemente al Katalogo degli Olympionikai," *Klio* 52 (1970) 295ff; International Olympic Academy, *Reports* 12 vols. (1961-72)[I]; H. V. Herrmann, "Zur ältesten Geschichte von Olympia," *AthMitt* 77 (1962) 3ff[MPI]; W. Rudolf, *Olympischer Kampfsport in der Antike* (1965)[I]; N. E. Gardiner, *Athletics of the Ancient World²* (1967)[I]; A. Hönle, *Olympia in der Politik der griechischen Staatswelt* (1968); J. Jüthner, *Die athletischen Leibesübungen der Griechen* (1968)[PI]; H. Bengston, *Die Olympische Spiele in der Antike* (1971); H. A. Harris, *Greek Athletes and Athletics* (1972)[I].

Art: C. Seltmann, *The temple coins of Olympia* (1921)[I]; E. Buschor & R. Hamann, *Die Skulpturen des Zeustempels zu Olympia* (1924)[I]; id., "Die Olympiameister," *AthMitt* 51 (1926) 163ff; W. Hege & G. Rodenwaldt, *Olympia* (1936)[MPI]; G. Becatti, *Problemi Fidiaci* (1951)[I]; id., "Controversie Olympiche," *Studi Miscellanei* 18 (1971) 67ff[I]; J. Liegle, *Der Zeus der Phidias* (1952)[I]; C. M. Kraay, *Greek Coins* (1966)[I]; G. Richter, "The Pheidian Zeus at Olympia," *Hesperia* 35 (1966) 166ff[I]; B. Ashmole & N. Yalouris, *The Sculptures of the Temple of Zeus* (1967)[PI]; J. Fink, *Der Thron des Zeus in Olympia* (1967)[I]; E. Simon, "Zu den Giebeln des Zeustempel von Olympia," *AthMitt* 83 (1968) 147ff[I]; W. Heilmeyer, "Giessereibetriebe in Olympia," *JdI* 84 (1969) 1ff[I]; F. Eckstein, ΑΝΑΘΗΜΑΤΑ (1969)[PI]; B. Ridgway, *The Severe Style in Greek Sculpture* (1970)[I]; M.-L. Säflund, *The East Pediment of the Temple of Zeus at Olympia* (1970)[PI]; B. Ashmole, *Architect and Sculptor in Classical Greece* (1972)[MPI].

N. YALOURIS

OLYMPOS Cyprus. Map 6. On the E point of the island about 6 km from the Monastery of Apostolos Andreas. Far out in the sea are the Kleides islands (Hdt. 5.108.2; Strab. 14.682; Ptol. 5.14.7). At the foot of a rising mass of rock remains of a small town extend for some distance inland; farther W is the necropolis.

The name Kleides was also applied to the cape itself by such writers as Agathemenos and Hesychios. To Ptolemy it was also known as Oura Boos (bull's tail). In the *Stadiasmus* (*GGM* 2.476) it is simply called Akra. The name of the town has not been identified yet but on the evidence of Strabo, who calls the hillock Olympos, this name may also apply to the town itself.

The foundations of a building measuring about 35 x 17 m are still visible on the summit of the rock. These remains may belong to the Temple of Aphrodite Akraia, which women were not allowed to enter (Strab. 14.682; *Stad. GGM* 1.307, 315).

Of the lower town only scanty remains of a few houses are still visible above ground. Farther inland the site is overgrown with thick scrub. Several rock-cut tombs looted long ago, are still visible along the shore to the W of the town. Along the N shore Hogarth saw ancient wheel-marks and two underground pools, to which access was obtained by flights of steps.

On present-day archaeological evidence this town has been in existence from Classical to Graeco-Roman times. The S slope of the hillock, however, was occupied by a very small community in Neolithic times, as shown by recent excavations. The Classical town is still unexcavated.

BIBLIOGRAPHY. D. G. Hogarth, *Devia Cypria* (1889) 83-84; A. Sakellarios, Τὰ Κυπριακά I (1910) 161-62; G. Jeffery, "Classic Temples in Cyprus," Κυπριακὰ Χρονικά (1923) 165; V. Karageorghis, "Chronique des Fouilles et Découvertes Archéologiques à Chypre," *BCH* 86 (1962) 373-74[I].

K. NICOLAOU

OLYMPOS (Deliktaş) Turkey. Map 7. City on the E coast of Lycia near Çıralı, close to a mountain of the same name, probably the modern Tahtalı Dağ. Its existence is not attested before the 2d c. B.C., when it issued coins of Lycian League type; about 100 B.C. it was one of the six members of the League which had three votes in the assembly (Strab. 665, quoting Artemidoros). A little later it was occupied by the pirate chieftain Zeniketes until he was suppressed by Servilius Isauricus in 78 B.C.; Cicero called it an ancient city, rich and well furnished in every way. Later it was readmitted to the League, and remained a respected member under the Empire. In the hills nearby was (and still is) the remarkable perpetual fire which issues from the ground; the spot, sometimes called in antiquity Chimaera, was sacred to Hephaistos, whose cult was most important at Olympos. In the 2d c. A.D. the city received from Opramoas of Rhodiapolis a donation of 12,000 den. for the festival of the god. Evidently those authors (Pliny, Solinus) who speak of Olympos as having ceased to exist are wide of the mark; the mistake seems to have arisen from a misconception of the effects of the capture by Servilius. Among the bishops of Olympos the most distinguished was Methodius, about A.D. 300. The coinage, apart from the League types, is confined, as usual in Lycia, to the time of Gordian III.

The ruins lie on either bank at the mouth of a small stream, and are heavily overgrown; the principal occupation was on the N. The acropolis hill, low but steep, is covered with remains of buildings of poor quality and of late date; a little inland is a lake, now hardly more than a marsh, on whose shore stands a handsome doorway, apparently belonging to a temple of which nothing more survives. There are remains of other buildings in the heavy growth. On the S bank of the stream are the remains of a quay(?) in coursed polygonal masonry, a

small theater, poorly preserved, and the main necropolis, where a multitude of tombs has produced 217 inscriptions. Many of the tombs are vaulted chambers coated with white plaster; none are of Lycian type, and Lycian names are uncommon in the epitaphs. Olympos was not by origin a Lycian city, and no Lycian inscriptions have been found there.

The Hephaistion (Chimaera, called Yanar by the Turks) is a walk of an hour and a half to the NW some 250 m above sea level, and is approached by an ancient paved way. The fire is quite small, burning in a hole in the ground, and is unspectacular by day. Of the sanctuary of Hephaistos nothing remains but a few inscriptions, none relating to the fire or sanctuary; there are also some shapeless fragments of masonry from ruined buildings of the late Middle Ages.

BIBLIOGRAPHY. F. Beaufort, *Karamania* (1811) 35; T.A.B. Spratt & E. Forbes, *Travels in Lycia* I (1847) 191-94; *TAM* II, 3 (1944) pp. 362-63, 408-9; G. E. Bean, *Turkey's Southern Shore* (1968) 165-73.　　G. E. BEAN

OLYNTHOS Chalkidike, Greece. Map 9. About 3 km inland from the Bay of Terone and some 64 km SE of Thessalonika. Part of the site was inhabited in the Late Neolithic period but not in the Bronze Age. Continuously from perhaps as early as 1000 B.C. there was a small Iron Age settlement consisting, at least in part, of Boiotians. In 479 it was captured and turned over by the Persians to Terone and the Chalkidians. It appears on the tribute lists of the Delian League from 454 on (paying 2 talents) but in 432, encouraged by Macedon, it revolted and received a large accession of population from other revolting Chalkidic coastal cities. It was almost certainly at that time that the Chalkidic state ("league") was formed and that a large new section of the city was laid out to accommodate the increased population. Olynthos weathered the Peloponnesian War successfully and about 389 B.C. made a treaty with Amyntas III of Macedon. Its growing prosperity and power led to an attack by Sparta and, after a lengthy siege, to its capitulation in 379 B.C. Though forced to become temporarily an ally of Sparta, its economy seems not to have suffered severely. At any rate Philip II, after his succession to the throne of Macedon in 360, seems to have found it expeditious to conclude a treaty (357) with the Chalkidians, a fragmentary copy of which was found close to the site. By his adroit political maneuvers Philip kept Olynthos and Athens from combining against him until 349 when open war broke out. Despite the "Olynthiacs" of Demosthenes, Athenian aid proved too little and too late; the city fell in 348 and was destroyed by the Macedonians. Coins indicate a slight continued habitation or rehabitation of a few poor houses at the extreme N end of the N Hill as late as ca. 316 B.C. when the few survivors were no doubt among those Olynthians settled by Kassander at Kassandreia on the site of Poteidaia (Diod. Sic. 19.52).

Four expeditions between 1928 and 1938 uncovered a part of the S Hill (the site of the older town, with small irregular houses and slight remains of at least one public building), and about a quarter of the N Hill and slopes to the E (the site of the new housing district and of a stoa-like public building). The district was laid out on a very regular Hippodamian plan. Blocks of 300 Ionic feet (300 x 29.5 cm) E-W x 120 feet N-S were divided into two rows of five houses, each house approximately 60 feet square. Normal streets were 17 feet wide but Avenue B, the main N-S street, was 24 feet—the extra 7 feet being deducted from the length of the A blocks. The hundred-odd house plans recovered, including five complete blocks (50 houses) provide the best evidence available for the

form of the Hellenic house (430-348 B.C.). Each block was evidently built as a unit with continuous rubble foundation walls, and the individual houses, though no two are exactly alike, conform to a general pattern with court on the S and portico on at least the N side off which most of the principal rooms open; this S orientation, for shelter in winter, agrees with the prescriptions for domestic architecture given by Xenophon and Aristotle.

A typical house (A vii 4) has a porch (prothyron) opening from the street on the S into the SW corner of a cobble-paved court (aule) in the middle of the S side of the house (but the entrance is never axial). To the W of the court is a large storeroom or, possibly, shop; to the E is a cement-floored dining room (andron) with its anteroom; to the N is the broad portico (pastas —first identified at Olynthos) with a small storeroom at its E end. Off the N side of the pastas opens a series of rooms including a kitchen (ipnon), with flue (kapnodoke) and a cement-floored bathroom (balaneion) with built-in clay tub. A second story (with bedrooms?) was reached by wooden stairs from the court. The walls were of adobe brick on rubble foundations; the roof was sloping and tiled. The finest house discovered, the Villa of Good Fortune, measures about 85 x 55 feet; in addition to the pastas there were narrower and shorter porticos on the other three sides; pebble mosaic floors adorned four of the rooms, those in the andron and its anteroom having both patterns and mythological scenes (Dionysos in chariot; Thetis bringing armor to Achilles); the others bear inscriptions ('Αγαθὴ τύχη, Εὐτυχία καλή, 'Αφροδίτη καλή).

The Olynthos mosaics, occurring principally in the andron, occasionally in the court or the pastas, constitute the most extensive and finest group of Greek pebble mosaics known in the period of the late 5th and early 4th c. B.C. Some sixteen inscriptions found in the houses give information regarding the sale, mortgage, or rental of houses, and mention values from 230 to 5300 drachmas.

Public buildings so far discovered are few and unimportant: on the S Hill a fountain house and some remains of a larger structure; on the N Hill, at the E end of Block A iv, another fountain house, a building with a central row of Doric columns, and traces of what was apparently a stoa facing S on a large open space probably reserved for an agora to be enclosed eventually by other public buildings. A city wall of adobe brick on rubble foundations was traced along part of the W and N sides of the N Hill (at the rear of the houses). Two fairly extensive cemeteries with both inhumation (ca. 90 percent) and cremation burials were excavated, and a plundered stone chamber tomb was cleared on a hill to the W of the site.

Most of the finds (large amounts of pottery, figurines, loom weights, grain mills, and other household objects) are housed in the archaeological museum in Thessalonika. The large numbers of Chalkidic silver tetradrachmas, tetrobols, and other coins (many found in hoards concealed in the houses) are in the Numismatic Museum in Athens.

BIBLIOGRAPHY. D. M. Robinson in *TAPA* 59 (1928) 225-32; 62 (1931) 40-56; 65 (1934) 103-7; 69 (1938) 43-76 (inscriptions, public and private); Mabel Gude, *A History of Olynthus* (1929) provides a convenient collection of ancient sources referring to Olynthos and the Chalkidians, together with a prosopography of Olynthians known from literary or epigraphical sources; D. M. Robinson et al., *Excavations at Olynthus* (1930-52) I-XVI (Neolithic settlement: I; houses and other architecture: II, VIII, XII; coins: III, IX, XIV; pottery: V, XIII, XIV; figurines: IV, VII, XIV; minor objects: II, X; mosaics: V; cemeteries: XI; P. A. Clement in *Olynthus* 9 (1938) 112-

61 (further discussion of the history of Olynthos based on the numismatic evidence); J. W. Graham in *Hesperia* 22 (1953) 196-207; 23 (1954) 320-46; 27 (1958) 318-23 (further studies of houses); D. M. Robinson in *RE* s.v. Olynthos. J. W. GRAHAM

OMBOS (Kom-Ombo) Egypt. Map 5. A city on the E bank of the Nile, 168 km S of Thebes. It reached its glory during the Ptolemaic period and became the capital of the Ombite nome, which extended S to Elephantine. Its Graeco-Roman temple is unusual in that it is a double building dedicated to the cults of two gods, Sobek the crocodile god and Haroeris with the falcon's head.

BIBLIOGRAPHY. A. Weigall, *A guide to the Antiquities of Upper Egypt* (1913) 374-90. Plan of the temple on p. 381; Porter & Moss, *Top. Bibl., VI. Upper Egypt: Chief Temples* (1939) 178-203[P]; E. Brunner-Traut & V. Hell, *Aegypten* (1966) 634-37[P]. S. SHENOUDA

"OMPHAKE," *see* BUTERA

"OMPHALION," *see* LABOVË

ONCHESMOS S. Albania. Map 9. A port of call on the coast of Epeiros, just N of Santi Quaranta. Remains of a small Roman theater and of buildings and fortifications of the Late Roman Empire suggest that it became important only in Roman times. Its position is indicated by Strabo (7.7.5), and its wind favored Cicero in sailing to Italy (*Att.* 7.2.1).

BIBLIOGRAPHY. D. E. Evangelides, Ἡ Βόρειος Ἤπειρος (1919) 39f; N.G.L. Hammond, *Epirus* (1967) 111f.
N.G.L. HAMMOND

ONCHESTOS Boiotia, Greece. Map 11. A town NW of Thebes with a very ancient cult of Poseidon, the center of an amphictyony. It was the meeting place for the Boiotian confederacy in the Macedonian period. The town was burned by the Persians under Xerxes, and probably again by the Romans in 171 B.C. when nearby Haliartos was destroyed. Among the ruins, Pausanias saw the Temple of Poseidon, whose worship as inventor of the chariot was combined with that of the hero Hippodetes (Horsebreaker); divination was based on the behavior of unguided horses hitched to a chariot. The site, described by Pausanias as 15 furlongs (3 km) from the mountain of the Sphinx (Mt. Phaga), is generally agreed to be on the ridge between the two Boiotian plains. The road and railroad use the S and N passes over it; in the former there are a few blocks of an ancient wall at an angle to the road. Here Lauffer reported finding the limestone foundations of the temple.

BIBLIOGRAPHY. Strab. 9.2.33; Livy 42.63; Paus. 1.39.5; W. M. Leake, *Nor. Gr.* (1835) II 213; C. Bursian, *Geographie von Griechenland* (1872) I 231; J. G. Frazer, *Paus. Des. Gr.* (1898) V 139; S. Lauffer in *Arch. Anz.* (*JdI*) 55 (1940) 186; A. Philippson-Kirsten, *GL* (1950-59) I² 469, 712. M. H. MC ALLISTER

ONNUM, *see* HADRIAN'S WALL

OPHIOYSSA (Formentera) Baleares, Spain. Map 19. The name used for this island in several ancient sources (Avienus 148; Strab. 3.5.1; Ptol. 2.6.73; Mela 2.125; Plin. 3.78). A little Greek material has been found.

BIBLIOGRAPHY. A. García y Bellido, *Hispania Graeca* (1948)[M]. L. G. IGLESIAS

OPHOVEN Belgium. Map 21. Gallo-Roman vicus on the left bank of the Meuse along the Tongres-Nijmegen road. The vicus is in the hamlet of Geistingen. Systematic excavations have never been undertaken there, but scattered finds and investigations have revealed foundations, remains of smelting furnaces for the local production of iron out of the limonite in the marshes, five wells lined with wood, many potsherds, fibulas, glassware, pieces of grindstones, etc. Most of the finds date to the 2d and 3d c. A.D., but sherds of late Gallo-Roman pottery have also been found.

BIBLIOGRAPHY. M. Bauwens-Mesenne, *Bibliografisch repertorium van de oudheidkundige vondsten in Limburg* (1968) 272-80. S. J. DE LAET

OPITERGIUM (Oderzo) Italy. Map 14. A site in the low Venetian alluvial plain, certainly of the early Venetian age with Celtic traces. It developed at the frontier, marked by the river Livenza, between the Veneti and the Galli Carni. Very probably the center was on the Postumia, the great consular road constructed in 148 B.C. to link Genua with Aquileia. A corps of Opitergimi, siding with Caesar in his war with Pompey, preferred self extinction to surrender, according to the account of Lucan (*Scol.* al 1.4, 462; cf. also Livy *Epit.* 110, *Florus* 2.13.20). The city became a municipium after the promulgation of the well-known Lex Julia Municipalis in 49 B.C. Opitergium was assigned to the tribus Papiria. It was perhaps an administrative center for the many pagi in the rich surrounding countryside. Nothing remains of its religious and civic buildings. The only testimony of its existence are inscriptions and sculptures, now on display in a small museum. Recorded are Jupiter Ammon, the Vires, several decurioni who were members of the municipal council, and the usual Augustales. Notable among the material preserved are a relief with a maenad, several circular altars richly decorated with scrollwork. A beautiful bronze breastplate of the Augustan age is in the Archaeological Museum at Venice.

In A.D. 167 the Quadi and the Marcomanni reached its gates (Amm. Marc. 24.6.1), but a short time later normal daily life resumed. One of its citizens, L. Ragonius Urinatius Larcius Quintianus, became vice consul at the time of Commodius (*CIL* V, 2112). Opitergium's mosaics of civil life from the 3d and 4th c. are among the most interesting in the region. There are hunting and fishing scenes, and a representation in perspective of a villa rustica enclosed within a protective wall.

The Lombards in two successive expeditions in 635 and 667 destroyed the town, according to Paolo Diacono (4.38.45; 5.28). It revived only at the end of the 10th c.

BIBLIOGRAPHY. A. Degrassi, *Il confine nord-orientale dell'Italia romana* (1954) 114; R. Cessi, "Da Roma a Bisanzio," and G. B. Brusin, "Monumenti romani e paleocristiani" in *Storia di Venezia* (1957); P. Fraccaro, "La via Postumia," *Opuscula* (1957) IV; B. Forlati Tamaro, *Guida del Museo* (1959). B. FORLATI TAMARO

OPLONTIS (Torre Annunziata) Campania, Italy. Map 17A. The *Peutinger Table* places it ca. 5 km from Pompeii toward Herculaneum (cf. *Rav. Cosm.* Eplontis, Oplontis; *Guid.* Eplontis). Since there is no other mention in the ancient texts, the very existence of Oplontis has been doubted. However, the archaeological discoveries at Torre Annunziata make it certain that Oplontis is to be found there and that life in the area dates to a remote period. From the archaeological evidence the center, at least in the Roman period, appears to have been composed of villas and bath establishments in the same manner as nearby Stabiae, without a well-defined urban structure. It appears not to have been a suburb of nearby Pompeii. Oplontis also was buried by the eruption of Mt. Vesuvius in A.D. 79, partly by the lava flow, as was Herculaneum, and partly by ashes and

rock, as was Pompeii. The hypothesis, actually supported by sparse and dubious proof, has also been advanced that after the eruption the site was still inhabited for a long time.

Ruins of a bath building, dating to the last ten years of the existence of Oplontis, were discovered in the last century on the promontory of Uncino (today Terme Nunziante). Here, it appears that both the subterranean water reserves and sea water were utilized. An inscription found at Pompeii (*CIL* x, 1063) and related to this building has recorded the Baths of one M. Crassus Frugi.

As far as private building is concerned, only the existence of aristocratic villas scattered here and there have been documented. One such villa is being excavated on the present Via Sepolcri, at the center of the modern town. It can already be affirmed that the villa was very large, complex in plan and with wall paintings of the best workmanship. It was built at least as early as the middle of the 1st c. B.C. but underwent successive remodeling, the last of which was interrupted by the eruption in 79 A.D. On the central axis of the building an austere atrium of grand dimensions was decorated with paintings in the Second Style, with colonnades in perspective. Beyond it was a small garden and a large room that opens onto a propylon above a garden of which two ends of the portico are now distinguishable. On the left side of the house, there are still three walks with small paintings in the Second Style, the bath area surrounding a small courtyard, and the kitchen. On the right side a series of rooms is presently being excavated. Here too are wall paintings in the Second Style. The decorative painting of the other areas is mainly in the Third Style, with very delicate ornamental motifs on a bright background. Elegant sculptures have also been found, completely in harmony with Hellenistic taste, comprising centaurs and an amorino on a column capital. These must have adorned the garden.

BIBLIOGRAPHY. K. Miller, *Itineraria Romana* (1916) 353, 363; *Itineraria Romana*, ed. O. Cuntz & J. Schnetz (1929-40); H. Philipp, *RE* 18.1 (1939) 691ff; A. Maiuri, "Note di topografia pompeiana," *RendNap* (1959) 73ff; G. Alessio, "Oplontis," *StEtr* (1965) 699ff; A. de Franciscis, *Atti Convegno Magna Grecia, Taranto 1966*, 234; id., "La villa romana di Oplontis," *Parola del Passato* (1973) 653ff. A. DE FRANCISCIS

OPPIDUM BOCHORITANUM (Puerto de Pollensa) Majorca. Map 19. Just outside the town, on a hill to the right of the road to Pollensa, are the remains of the pre-Roman town of Bochoris of ca. 1400 B.C. The Roman town lies just below on what is now flat farm land. A short stretch of the Roman town wall and the entrance gate are still visible. The site is strewn with potsherds of Roman Imperial date, mostly clear sigillata and common pottery of the 3d and 4th c. The site has not been excavated. A tabula patronatus (*CIL* II, 3695) dates to A.D. 6: The Senate and the People of Bochoris selected by mutual consent the Roman Senator Marcus Atilius Vernus as their Patron, a man whose family seems to have been well considered in Spain. Pliny registers Bochoris among the federated cities (*HN* 3.76).

BIBLIOGRAPHY. S. Ferragut, *Disertación Historica Sobre una Inscripción Romana del Puebla Bocchoritano Hallada en Mallorca en el Territorio de la Villa de Pollensa en el Año de 1765* (1766); L. C. Watelin, "Contribution à L'Etude des Monuments primitifs des Iles Baleares," *RevArch* 4, 14 (1909) 333-50; E. Seeger, *Vorgeschichtliche Steinbauten der Balearen* (1932); A. D'Ors, *Epigrafica Juridica de la España Romana* (1953); C. Veny, *Corpus de las Inscripciones Balearicos Hasta la Dominación Arabe* (1965). D. E. WOODS

"OPPIDUM NOVUM," *see* KSAR-EL-KÉBIR

OPTATIANA (Sutoru) Cluj, Romania. Map 12. Roman camp and civil settlement on the imperial road from Napoca to Porolissum, S of the village on the left slope of the Almaş valley. The name appears in ancient sources (*Tab.Peut.; Rav.Cosm.* 4.7). Numerus Maurorum Optatianensium was stationed in the camp. Among funeral monuments were discovered the cippus of a Dacian family provided by the son, who became standard-bearer in Numerus Maurorum Optatianensium. This indicates local recruitment.

The material is to be found in the History Museum of Transylvania in Cluj.

BIBLIOGRAPHY. C. Daicoviciu, "Un nou milliarium din Dacia," *Anuarul Institutului de Studii Clasice* 1, 2 (1928-32) 52; D. Tudor, *Oraşe, tîrguri şi sate în Dacia romană* (1968) 235. L. MARINESCU

ORANGE, *see* ARAUSIO

ORBE, *see* URBA

ORBETELLO Grosseto, Italy. Map 16. The town faces the massif of the Argentario, at the end of a narrow tongue of land that stretches between two lagoon-like bodies of water. Strabo (5.225), after Cosa, mentions Porto Ercole and the characteristics of the lagoon.

Many notable changes have taken place in the lagoon of Orbetello since ancient times. In fact, during the Etruscan age the lagoon must have been separated from the sea by a single sandbar called the Feniglia, where the road linking Cosa and Porto Ercole passed; while the other sandbar, called the Giannella, had probably only begun to emerge from the sea.

The finds demonstrate that the area must have been inhabited from the late Villanovan to Hellenistic times. Material from Roman times was discovered during work near the Pertuso channel.

A large necropolis has been found on the tongue of land that connects the city to the mainland. Material found there and now on display in the Antiquarium of Orbetello includes vases of impasto, Italo-geometric pottery, bucchero, Etruscan black-figure vases, Attic ceramics and bronzes (fibulae, buckles, mirrors, and vases), some of which were found at the necropolis of Chiarone S of Orbetello. Imposing stretches of wall in large polygonal blocks and dating to the end of the 4th c. B.C. indicate that Orbetello was a prominent Etruscan city.

BIBLIOGRAPHY. G. Maetzke, *NSc* (1958) 34ff; P. Bocci in *EAA* 5 (1963) 708-9; T. G. Schmiedt, *Tenth Congress of International Society of Photogrammetry* (1964) 19; id., *Atlante di Aereofotogrammetria degli insediamenti* (1970) tav. CXXX. P. BOCCI PACINI

ORCHOMENOS (Kalpali) Arkadia, Greece. Map 9. The site is located N of Mantinea on an acropolis dominating the plains of Levidi and Candyla from an elevation of 936 m. The name Orchomenos appears in the Catalogue of Ships (*Iliad*) and in the *Odyssey*. At the time of Pausanias the higher part of the city had already been abandoned (Paus. 8.13.2), a fact confirmed also by the lack of Roman remains in that zone. A wall in polygonal masonry with a perimeter of ca. 2300 m enclosed the upper part of the acropolis. It appears to have undergone repeated renovation. The earliest wall must have been erected at the end of the 5th c. B.C. (Thuc. 5.61), though those parts actually visible are from the 4th and 3d c. and appear to be interrupted every 30 or 50 m by square towers. There were two gates, one opening to the W and the other to the SE toward the Cha-

radra, the principal fountain of the city. Inside the walled area a quadrangular agora has been found, flanked on the N by a portico and on the E by a bouleuterion. S of the agora is the Temple of Artemis Mesopolitis, the major sanctuary of the city, datable to the second half of the 6th c. B.C. In Ionic style, with foundation and socle in limestone, the upper section was probably of brick. To the NE of the agora was the theater, of which there remains part of the skene and proskenion, as well as a marble seat from the proedria with an inscription from the 4th-3d c. The lower city, seat of the modern village, was inhabited from the Geometric age until Roman times. There are recognizable remains of a peripteral temple from the end of the 6th c. B.C., which may be identified as one of the two temples mentioned by Pausanias and dedicated respectively to Poseidon and Aphrodite. Also found are cisterns, fountains, and private houses from both Greek and Roman epochs, one of which is served by thermal springs.

BIBLIOGRAPHY. E. Lattermann, "Arkadische Forschungen," in *Abh. Berl. Akad. Phil.-Hist. Kl.* (1911) 18-26, 44, plates I, II, VI, VII, VIII; G. Blum & A. Plassart in *BCH* 38 (1914) 71-88; D. Fimmen, *Die kret. Myk. Kultur* (1924) 10, 77; C. Weickert, *Typen der arch. Architektur in Griech. u. Kleinasien* (1929) 150-51, 166-67; E. Meyer in *RE* 18 (1939) 887-905; ibid., suppl. 9 (1962) 465; R. Martin in *RA* 21 (1944) 107-14; U. Kahrstedt, *Das wirtschaftl. Gesicht Griechenlands in der Kaiserzeit* (1954) 148-49. L. VLAD BORRELLI

ORCHOMENOS Boiotia, Greece. Map 11. One of the oldest and richest cities of heroic Greece, situated close by the village of Skripou (now Orchomenos) 13 km NE of Levadhia, at the E end of Mt. Akontion, which plunges like a javelin (whence its name) into the former Lake Kopais.

Inhabited from Neolithic times, the site became one of the most influential Mycenaean cities. It was the capital of the Minyans, a half-legendary people from the Thessalian seaboard, and its authority spread over the whole of the Kopaic basin and possibly as far as Thebes. The legends that sprang up about it (the buildings of Agamedes and Trophonios), its great engineering achievements (the first draining of the Kopais, erection of fortresses such as Gla), and its original pottery (the gray or yellow Minyan ware) all are proof that a brilliant civilization flourished there from the 15th to the 12th c. B.C. Its place was gradually won over by Thebes and it joined the Boiotian League in the 7th c. Allied with Sparta against Thebes at Koroneia (395) and Haliartos (394), it was destroyed by the Thebans in 364 B.C. Restored by the Phokaians in 353, again destroyed by Thebes in 349, Orchomenos was rebuilt by Philip II and Alexander and became one of the leading cities of the Boiotian League from 338 onward. Sulla fought Archelaos and Mithridates' army there in 86 B.C. Under the Empire the city rapidly fell into a decline.

The finds are divided between the Museum of Chaironeia and those of Thebes and Athens.

Throughout the centuries the different cities sprang up at the E foot of Mt. Akontion and on its E and NE slopes. On the E foothills of the hill Schliemann discovered the "Treasury of Minyas," a Mycenaean cupola tomb with a dromos. In the arched tholos is the gateway to the funerary chamber. In the middle of the tholos are the remains of a great funerary monument of the Macedonian period. The Mycenaean city extended from the plain to the lowest terrace. A little to the N on remains of a pre-Mycenaean or Mycenaean building (about 1700-1450) are the foundations of a temple of the Geometric period. At the foot of the E slope of the acropolis, to the

NE of the Treasure of Minyas, the theater of Orchomenos, probably built at the end of the 4th c. B.C., has been recently excavated. Twelve rows of seats are preserved; proedria seats have nice relief decoration. A number of bases of statues and of votive tripods have been discovered.

Four hundred m to the W on a second, higher terrace, a Temple of Asklepios was built in the Hellenistic period. A peripteral Doric structure (11.50 x 22 m, with six columns in front and 11 on each side), it is surrounded by remains of Classical buildings. On the terraces farther W, stretching to the top of the hill, was the Hellenistic city built by Philip II and Alexander. At the top, 230 m above the plain, is the acropolis; not much more than a large square tower, it was built after 335 B.C. In front of it is a large cistern.

The ramparts match the growth of the city. The oldest wall (7th c.), which is built around the bottom terrace, is in a poor state of preservation; in some places its masonry is polygonal, in others large blocks are arranged in irregular courses. Starting from the terrace of the Asklepieion, two ramparts, one to the N and the other to the S, climb up the steep slope, moving gradually closer together until they meet at the great tower on the top of the hill, which they fortify. About 2 m thick on an average, these walls have an outer facing in polygonal masonry dating from the 4th c. B.C. There are three gates, to the N and S and near the summit. Three transverse walls link the two outer ramparts: the first runs along the edge of the Asklepieion terrace to the E; the second, which has a square tower in the middle, overlooks this terrace to the W, while the third marked the upper city limit and the beginning of the hilltop fortress with its citadel. The third wall is on a level with the N and S gates.

At the N foot of the rocky spur below the Asklepieion and the Chapel of Hagioi Anargyroi, is the chief spring of the Melas river. This is the Akidalia or spring of the Charites, who were especially venerated at Orchomenos (the Charitesia festivals and contests). The Sanctuary and Temple of the Charites probably stood where the Convent of the Dormition (Kimisis tis Theotokou) is today; its church, built in 874 A.D., is on the site of the temple. Around the church are many inscriptions discovered at Orchomenos; the other inscribed stones have been removed to the Chaironeia and Thebes Museums.

BIBLIOGRAPHY. J. G. Frazer, *Paus. Des. Gr.* (1898) V 180-94; G. de Ridder in *BCH* 19 (1895) 137ff; H. Bulle & E. Kunze, *Orchomenos* I-III *Abh. Bayrischen Akademie* 24 (1909); Neue Folge 5 (1931); 8 (1934); P. Roesch, *Thespies et la Confédération béotienne* (1965); E. Kirsten & W. Kraiker, *Griechenlandkunde*[5] (1967) 211-15; N. Papahadjis, *Pausaniou Hellados Periegesis* V (1969) 205-23[MPI]; R. Hope Simpson & J. F. Lazenby, *The Catalogue of the Ships in Homer's Iliad* (1970) 38-39; Th. Spyropoulos, *AAA* 6 (1973) 392-95[I]; P. Amandry & Th. Spyropoulos, *BCH* 98 (1974) 171-246[I]. P. ROESCH

ORDAN-LARROQUE Gers, France. Map 23. A large Roman villa of the Late Empire at Saint-Brice-de-Cassan on the left bank of the Aulouse has been under excavation since 1966. The villa has decorative elements characteristic of the 4th c.: facings in white marble from Saint-Béat, polychrome mosaics of geometric design, painted pargets. After its abandonment, it was used as a cemetery in the Middle Ages, like many other villae in the Southwest.

BIBLIOGRAPHY. M. Labrousse in *Gallia* 24 (1966) 437; 26 (1968) 544; 28 (1970) 420, 422, & fig. 31.

M. LABROUSSE

ORDONA, *see* HERDONIA

ORDU, *see* KOTYORA

OREI, *see* HISTIAIA

ÖREN (Caria), *see* KERAMOS

ÖREN (Lycia), *see* ARAXA

OREOS, *see* HISTIAIA

ORETUM (Nuestra Señora de Oreto) Ciudad Real, Spain. Map 19. Site ca. 33 km W of Valdepeñas. Tributary city of the Oretani which belonged to the conventus of Carthago Nova, according to Pliny (3.3.25: Oretani qui germani cognominantur). Ptolemy (3.6.59) calls it Ὤρητον Γερμανῶν, and possibly it is identical with Ὠρία, mentioned by Strabo (3.3.2) together with Castulo as the principal cities of Oretania. Its ruins are known but have never been excavated. It had a bridge built by the Oretanian P. Baebius Venustus (*CIL* II, 3221).

BIBLIOGRAPHY. P. Bosch-Gimpera, "Infiltracões germânicas entre os Celtas peninsulares," *Revista de Guimarães* 60 (1950) 341-49; A. García y Bellido, "Algunos problemas relativos a las invasiones indoeuropeas en España," *ArchEspArq* 23 (1950) 487-90; S. Lambrino, "Les Germanis en Lusitania," *Actas e Memórias do I Congresso Nacional de Arqueología* 1 (1969) 478.

J. M. BLÁZQUEZ

ORGON, *see* URGO

ORHEIUL BISTRIŢEI Bistriţa-Năsăud, Romania. Map 12. Roman camp and civil settlement on the left bank of Bistriţa river at the NE extremity of Roman Dacia. The earth camp (203 x 144 m) was rebuilt in stone. The baths and praetorium have been excavated. Cohors I Hispanorum was stationed here.

In the neighboring civil settlement ceramics in the Dacian tradition, handmade and adorned with drawings, were discovered.

Tiles and bricks with stamps, weapons, fragments of sculpture, a brick kiln, coins from the time of Trajan to Severus are on display at the Bistriţa Museum.

BIBLIOGRAPHY. D. Protase, *Problema continuităţii în lumina arheologiei şi numismaticii* (1966) 45; D. Tudor, *Oraşe, tîrguri şi sate în Dacia romană* (1968) 268-69.

L. MARINESCU

ORIA, *see* URIA

ORIKON (Pascha Liman) S Albania. Map 9. At the head of the Gulf of Valona. The site is a low rocky outcrop on the coast, approached from the E by a swampy strip of shore and having on the W an open channel that connects the sea and a lagoon inland of the outcrop; the channel and the lagoon afforded small ships an excellent harbor, which was improved by a stone-built quay, still visible under water. Foundations of a circuit wall with towers can be traced in rock-cuttings, a small theater or odeum has been excavated, and there are remains of a road from the harbor to the Roman road which ran S inland of the Ceraunian peninsula. Inscriptions from the area·show that the Dioscuri, Aphrodite, and Eros were worshiped. Though the fortified area was small, Orikon was an important port of call on the coasting route and acted as a market for the hinterland of the Gulf; it issued coinage in the Hellenistic period. Julius Caesar described the place (*BCiv.* 3.11f).

BIBLIOGRAPHY. C. Patsch, "Das Sandschak Berat in Albanien," *Schriften der Balkankommission, Antiquarische Abteilung* 3 (1904) 71; Excavation report in *Bule-*

tin, Universitetit Shtetëror të Tiranës, Seria shkencat shoqërore (1960) 1.92f; N.G.L. Hammond, *Epirus* (1967) 127ff.

N.G.L. HAMMOND

ORITAS, *see* ALEXANDRIAN FOUNDATIONS, 11

ORLEA Olt, Romania. Map 12. The most important Roman vicus of the territorium Sucidavense on the banks of the Danube. The site was inhabited from the Neolithic period to the 13th-14th c., almost without interruption. The Dacian and Roman settlement was built along the bank of the river. The stamped amphorae of the Hellenistic period, as well as the Greek and Republican Roman coins, disclose economic ties with the Aegean Islands and Italy dating back to the 4th c. B.C. There are two deposits of Republican Roman coins.

Between Orlea and its Bulgarian counterpart, the village of Vadin, are the ruins of a bridge supported on both ends by masonry foundations and having wooden piles. It has been attributed to Cornelius Fuscus, who is said to have built it when he crossed the Danube during his expedition against the Dacians in A.D. 87. The Roman village occupied an area of ca. 40 ha. It is surrounded by several villae rusticae and a necropolis along the Roman road on the river bank. Traces of Roman dwellings are very frequent. Many of the small islands of the Orlea marsh, S of the village, were likewise inhabited (from Neolithic times to the Byzantine period). The slope of the plateau on which the Roman settlement was built has yielded, on the Danube side, the remains of several potter's ovens and brick kilns. Pottery vases and terracotta lamps have been found (the local potter was Marcus Martinus: 2d c. A.D.), and a terracotta bust representing a Moor. A stone altar dedicated to I.O.M. mentions the name of the landowner, P. Iul. Vitalianus. Engraved stones, one of which bears the inscription ANICETUS, imported from Romula, were discovered there. After the abandonment of Dacia (271), the settlement continued to belong to the Empire until the 5th c. as proven by the pottery and coins. An abraxas attests to the presence of Christianity in the 3d c.

BIBLIOGRAPHY. *AnÉpigr* (1959) 335.

D. Tudor, "Şapte pietre gravate de la Celei şi Orlea," *SCN* 3 (1960) 378-92; id., "Un pont romain ignoré dans la région du Bas-Danube," *Latomus* 20 (1961) 501-9; id., *Oltenia romană* (3d ed., 1968) passim; id., *Oraşe* (1968) 335; J. Winkler, "Circulaţia monetară în aşezările antice de pe teritoriile comunei Orlea," *Acta Musei Napocensis* 8 (1971) 161-72.

D. TUDOR

ORLÉANS, *see* CENABUM

ORMANA, *see* ERYMNA

"ORMINION," *see* GORITSA

OROLAUNUM (Arlon) Belgium. Map 21. A large vicus of the civitas Treverorum, at the intersection of the Reims-Trier and Tongres-Metz roads. The name is mentioned in the *Antonine Itinerary* and in an inscription found in 1936. The two roads crossed near the source of the Semois, at the foot of the hill of St. Donat (an ancient oppidum of the Iron Age?). The center of the built-up area must have been located at that spot. The most important finds of the period of the Early Empire include a rectangular building near the Wolkrange road, examined in 1840. Bases of columns and a capital in Differdange stone were found there. Another building, elongated in plan, was found at the beginning of the century at the Chemin des Vaches. Finally, the remains of a large bath building, perhaps of religious character,

was excavated in 1907 near the source of the Semois. The complex (14 x 12 m) was divided into four rooms, one of them above a hypocaust. It was attached to a pool (3.4 x 4.5 m). An industrial district with lime kilns and potter's kilns was located on the outskirts of the built-up area. The main necropolis of the Early Empire was located at the Hohgericht, where hundreds of tombs (the oldest of which seem to date to the time of Augustus) were pillaged by private collectors. Apparently the vicus was ravaged during one of the barbarian invasions of the second half of the 3d c. At the end of the 3d c. or beginning of the 4th, a keep was built on the hill of St. Donat. A rampart was built halfway up the hill, forming an oval (ca. 300 x 250 m) with a perimeter of ca. 1 km. The wall, 4 m thick, has massive semicircular towers on the inside as breastworks. A large number of sculpted stones from the funerary monuments of the necropoleis of the Early Empire were used in the foundations. The funerary monuments found in the wall form the finest collection of ancient sculpture found in Belgium, comparable to the discoveries at Buzenol, Trier, and Neumagen. (A few are visible in situ; the rest are at the museum in Arlon.) The sculptors very often reproduced scenes of daily life, as well as mythological and symbolic subjects. The building of the enceinte did not, however, lead to the complete abandonment of the ancient site of the vicus. The bath building at the source of the Semois was restored. Near these baths a small Christian sanctuary, basilican in plan, was built during the 4th c. It is to date the only Early Christian church found in Belgium.

BIBLIOGRAPHY. J. Sibenaler, "Les thermes d'Arlon," *Annales de l'Institut arch. du Luxembourg* 42 (1907) 253-61; R. De Maeyer, *De Overblijfselen der Romeinsche Villa's in België* (1940) 173-74; H. Van de Weerd, *Inleiding tot de Gallo-Romeinsche Archeologie der Nederlanden* (1944) 48-49, 75-76; M. E. Mariën, "Les monuments funéraires de l'Arlon romain," *Annales de l'Inst. arch. du Luxembourg* 76 (1945); C. Dubois, "Orolaunum. Bibliographie et Documents sur l'Arlon romain," *Annales de l'Inst. arch. du Luxembourg* 78 (1946); S. J. De Laet, "La Gaule septentrionale à l'époque romaine," *Bull. Inst. hist. belge de Rome* 26 (1950-51) 211-12, 215-16; A. Bergtrang, *Histoire d'Arlon* (2d ed. 1953); J. Breuer, "Le sous-sol archéologique et les remparts d'Arlon," *Parcs Nationaux* 8 (1953) 98-102[MI]; J. Mertens, "Le Luxembourg méridional au Bas-Empire," *Mémorial A. Bertrang* (1964) 191-201; id., "Nouvelles sculptures romaines d'Arlon," *Studia hellenistica* 16 (1967) 147-60.
S. J. DE LAET

OROPOS (Skala Oropou) Greece. Map 11. Pausanias describes Oropia as the territory between Attica and Tanagra (1.34.1); thus it was situated on the mainland side of the Euripos between Rhamnous and Delion, with Eretria opposite. Such a position easily explains its checkered history. Geographically more naturally related to Boiotia than Attica, Oropos was nevertheless of economic importance to Athens because of the short crossover from Euboia to Oropos and the direct road thence to the city through Dekeleia, one of Athens' main lines of supply (Thuc. 7.28.1). It is therefore not surprising that control of Oropos passed frequently back and forth between Athens and Thebes, with a few interludes of autonomy.

The town of Oropos was on the site of the present Skala Oropou, where a few ancient harbor installations and many architectural blocks have been noticed, in addition to a number of dedications to the "salty" nymph. In the next harbor to the E of Skala, 20 stades away, there are also remains from an ancient mole at Kamaraki, identified as Delphinion, Oropos' "Sacred Harbor" mentioned by Strabo (9.2.6). Three km N of this coast in the hills lay the territory's most famous possession, the Sanctuary and Oracle of Amphiaraos. Here, in a deeply wooded glen beside a ravine, the cult of Amphiaraos was established in the last years of the 5th c. B.C. It grew in popularity, and for the next three centuries the site was developed, not merely as a place of divination, but also as one of healing. The sanctuary continued to exist until the 4th c. A.D. when it was abandoned, probably because of the dominance of Christianity.

The excavations of the sanctuary have revealed development on both sides of the ravine: on the N, the temple, altar, spring, and other buildings associated with the observances of the cult; on the S, the dwellings and establishments, not only of the priests and their associates, but also of those who provided for the wants of the pilgrims and the sick.

Today one enters the sanctuary from the W on the N side of the torrent bed. The first building one sees is on the right, the Temple of Amphiaraos, with its porch of six Doric columns enframed by a pair of half columns. In front are the earliest remains yet found: the large altar, built around two earlier ones, with some traces of curved seating to the N, from which to view the sacred proceedings, and to the S the much rebuilt holy spring "where they say Amphiaraos arose as a god" (Pausanias 1.34.4). North and E of the temple is a line of bases to support the dedications made in Hellenistic times. Originally, this artificial terrace had been prepared for a small temple and stoa, the latter believed to have served as a place of incubation. This function was probably transferred to the long stoa E of the bases, a building securely dated ca. 350 B.C. Yet farther E are the foundations of a bathing establishment. The site's most interesting structure lies behind and above the W half of the long stoa: a small Hellenistic theater with auditorium, circular orchestra with five marble thrones, and scene-building complete with stone proscenium.

On the opposite side of the ravine, the remains, though extensive, are tenuous, and in most cases one cannot determine the purpose of the individual buildings. One exception lies directly opposite the altar, the unmistakable ruins of a klepsydra or water clock.

There is a small museum with courtyard in which have been placed a number of the sculptural, epigraphic, and architectural finds.

BIBLIOGRAPHY. B. Petrakos, Ὁ Ὠρωπὸς καὶ τὸ Ἱερὸν τοῦ Ἀμφιαράου (1968)[MPI]; id., Ἐπιγραφαὶ Ὠρωποῦ, *AAA* 1 (1968) 69-73; J. J. Coulton, "The Stoa at the Amphiaraion, Oropos," *BSA* 63 (1968) 147-83[PI].
C.W.J. ELIOT

OROSZVÁR-RUŠOVCE, see LIMES PANNONIAE

ORTHE, *see under* PHALANNA

ÖRVÉNYES County of Veszprém, Hungary. Map 12. A Roman settlement in the Balaton highlands between the villages of Örvényes and Udvari. Excavation has revealed that the walls stand to a height of 1.5 m, unusual in Pannonia. The settlement's most significant building is a house with a central corridor, divided in three sections, with a large hall added in front. Remains of stairs suggest that the building was more than one story high, at least in part. An added entrance to the hall had a marble-covered doorway, with a latticework marble gable over it. The door frame was decorated with an egg-and-dart jamb. From the remains of this decorated porticus the building's facade could be recon-

structed; the reconstruction can be seen in the Lapidarium of the museum at Tihany. In the front hall of the building the remains of two round marble tabletops were uncovered. On the terrazzo floor of one of the smaller rooms, opening from the center corridor, the equipment of a Roman goldsmith was found. The building seems to be from the 2d c. To judge from the rich decorations, marble door coverings, and remains of marble tables (built in the 4th c.), the place probably served the needs of a Christian cult in Late Roman times. It was a basilica rustica, probably with the living quarters of the Christian community attached. In addition to the excavated buildings, a larger Roman settlement existed here and is continually under excavation.

BIBLIOGRAPHY. T. Szentléleky, "La lampe de bronze d'Őrvényes," *VMMK 1965* (1966) 103-10; id., "Testa di Minerva di Őrvényes," *Arch. Ért.* (1961) 253-57; E. Thomas, *Römische Villen . . .* (1964) 107 pp.

E. B. THOMAS

ORVIETO ("Volsinii Veteres") Italy. Map 16. Although identification as Volsinii is tentative, Orvieto was a major Etruscan city; other identifications proposed for it, Fanum Voltumnae and Salpinum, are less attractive. It stands on a high, isolated tufa mesa above the plain of the river Paglia, not far from the Tiber.

Although traces of occupation dating from the Stone Age have been found, and recently Villanovan material, it is only with the appearance of the Etruscans that the city achieved brilliance. In two necropoleis, one on the S slope of the site at Cannicella, the other on the N slope at Crocefisso del Tufo, series of burials dating from the 8th to the 3d c. B.C., but of the greatest wealth from mid 6th to the end of the 5th c., have come to light. At Crocefisso del Tufo most are in small tombs of a single chamber with places for two occupants. The tombs are solidly built of tufa blocks with a name inscribed over the low door, roofed with corbeled vaults given a true keystone, and capped by low tumuli crowned with cippi of many shapes. They are laid out in straight streets meeting at right angles but seem to have been built for the most part individually. There are also a number of cremation graves *a pozzetto*. Most of the tombs of Cannicella were similar but could not be laid out with such regularity; these have now been reburied. There was also here a late group of tombs *a cassone* marked with phalliform cippi. A third necropolis at Settecamini produced three large painted tombs, late 4th to early 3d c.; the paintings have been removed to the Museo Archeologico in Florence. The contents of the tombs are often of high quality and have enriched many museums; the finds of Attic painted pottery are especially splendid. Many of the elements of the names on the tombs are not Etruscan, from which Pallottino concludes that a metic population was early admitted and then absorbed.

Of the city itself we know far less; even the general lines of its plan are unclear. A large temple was discovered in 1828 near the E end of the site (Belvedere). Since only foundations survive, it is impossible to say whether it was triple-cella or of the "ala class." It was certainly tuscanic in effect, strongly frontal, raised on a high podium behind a forecourt. The architectural terracottas indicate a building date in the 3d c.; other material is of Early Classical date.

Other finds of temple terracottas in Orvieto have been uncommonly rich; they range in date from the late archaic period to Augustan, their concentration coming down to the 3d c., after which there is only a trickle. In no case were these found together with significant remains of construction.

Near the center of the Cannicella necropolis was found a long terrace wall against which was a sanctuary including a half life-size archaic statue of a nude goddess in Parian marble, a base with a place for offerings, and a large basin. The sanctuary had been destroyed by fire, and votive material was scattered about. This remains unique and enigmatic.

According to the historical record Volsinii fell to the Romans in 265 B.C. and was sacked (Plin. *HN* 34.34). The population was then transferred elsewhere (Zonar. 8.7), and the site was virtually abandoned. This is in agreement with what we know of Orvieto from archaeology. It does not reappear in history until the Gothic wars.

Archaeological material from Orvieto is kept in the Museo Claudio Faina. A second important group is in the Museo Archeologico in Florence.

BIBLIOGRAPHY. A. Andrén, *Architectural Terracottas from Etrusco-Italic Temples* (1939-40) 153-203, pls. 58-76[MPI]; *Antike Plastik* 7 (1967) 7-25 (A. Andrén)[PI]; M. Bizzarri, *La necropoli di Crocefisso del Tufo in Orvieto* 1, 2 (1966)[PI]; *AA* (1970) 323-25 (H. Blanck).

L. RICHARDSON, JR.

OŠANIĆI, *see under* STOLAC

OSCA (Huesca) Huesca, Spain. Map 19. Oppidum Urbs Victrix Osca, an Iberian oppidum first named Bolscan and then Olscan, on a hill with fortifications 3 m thick to halfway up the slope. At the intersection of the Roman roads from Asturica Augusta to Tarraco and Caesaraugusta to Benearum, it belonged to the Conventus Iuridicus Caesaraugustanus and was inhabited by Roman citizens, in Vescitania (Pliny), in the territory of the Ilergetes (Ptolemy), or of the Iacetani (Strabo). In 208 B.C. it was the limit of the Roman power and was mentioned in the account of the struggles against the native tribes of the N, 206-97 B.C. It fell into the hands of Sertorius in 62. He made it his capital as the natural center of his territory, and between 80 and 72 (certainly before the battle of Lauro), he founded an academy where the sons of Iberian chieftains were given a Graeco-Roman education, including grammar and rhetoric. Sertorius also introduced the use of the toga praetexta and the gilded bulla. In 72 he was murdered in Osca by Perperna. The city had a strong Christian community from the middle of the 3d c. A.D. on, outstanding members of which were St. Lorenzo and St. Vicente.

No monuments remain but much Roman material has been found: the sarcophagus decorated with a clipius which today contains the body of Ramiro II (San Pedro el Viejo cloister); remains of a colossal bronze statue of the Imperial age in the Church of San Salvador; a statuette of Pan; a mosaic or tessellatum in the Ayuntamiento; lamps, cinerary urns, terra sigillata, inscriptions, and many coins. Livy spoke of the enormous amount of Oscan silver that was sent to Rome, at least in 195 and 179, not Iberian silver coins bearing the native names of the town and the horseman with a lance, but Iberian drachmae copied from those of Emporion. Oscan denarii and bronze coins, inscribed first in Iberian and then in Latin, included many plated pieces and were minted by Sertorius in great quantities. Latin issues began around 38, continuing the Iberian series and beginning with the denarius of Cn. Dimitius Calvinus, second consul in 40, the conqueror of the Cerretani in 39 and certainly the legate in the constitutio of the municipium; the coin bears the name OSCA, the Iberian head, and the priestly signs. Latin bronze coins were minted from the time of Augustus to that of Caius Caesar and bear their heads, the horseman, and the lengend V.V.OSCA.

The finds are almost all in the Huesca Provincial Museum.

BIBLIOGRAPHY. R. del Arco y Garay, *Catálogo Monumental de España: Huesca* (1942); A. Schulten, *Sertorio* (1949); A. Beltrán, *Las antiguas monedas oscenses* (1950).　　　　　　　　　　　　　　　A. BELTRÁN

OSIA, *see* SIA

OSIJEK, *see* MURSA

OSIMO, *see* AUXIMUM

OSMA, *see* UXAMA ARGELAE

"OSSA," *see* BABES

OSSONOBA (Faro) Algarve, Portugal. Map 19. The modern city lies over the ancient one which is mentioned by Strabo (3.2.5), Ptolemy (2.5), Pliny (*HN* 4.22), Mela (3.1), and in the *Antonine Itinerary*. Roman remains include a temple unearthed in the Largo da Sé, tombs in Bairro Letes, and a deposit of some scores of lamps in the Horta do Pinto. Additional evidence of identification comes from inscriptions found mostly in the fortifications. The finds are in the Archaeological Museum of Faro.

BIBLIOGRAPHY. A. Viana, "Ossonoba. O Problema da sua localização," *Revista de Guimarães* 62 (1952) 250-85.　　　　　　　　　　　　　　　J. ALARCÃO

OSTIA Italy. Map 16. A city on the W coast at the mouth of the Tiber. By tradition it was first settled by Ancus Marcius, the fourth king of Rome, to supply Rome with salt, but no such settlement has yet been found. The earliest Ostia known to us was built ca. 350 B.C. some 200 m S of the Tiber near its mouth and occupied only a little more than 2 ha, providing for some 300 families. Its original function was to guard the coastline and the river, and it was protected by strong walls of large tufa blocks quarried near Fidenae. Within the walls, which had four gates, the area was divided by narrow streets in a grid pattern. The colony increased in importance when Rome began to need imports from overseas, for the river mouth had to serve as Rome's harbor. During the wars against Carthage, Ostia also became an important naval base. In the 2d c. B.C. the growth of Rome's population increased the demand for imports from overseas, particularly grain. During the resulting increase of population in Ostia to service the growing volume of shipping the town expanded beyond its walls. By the early 1st c. B.C. the small fort had become a substantial town and the new walls that were then built enclosed 64 ha.

By now the main lines of the town plan were established. The centers of the original colony became the forum of the enlarged town where the two main roads crossed. The decumanus maximus continued in a straight line E to the Porta Romana by which the Via Ostiensis entered the town. To the W it forked a little W of the colony's wall, the main branch proceeding to the seashore, the other (Via della Foce) to the river mouth. The cardo maximus ran in a straight line to the river; southwards it turned SE after leaving the forum. The most important area for trade and commerce was the land between the river and the decumanus—Via della Foce, whose development was strictly controlled and reserved mainly for warehouses and public buildings. The most attractive residential area was in the SW towards the sea. The least impressive was the SE quarter which shows little sign of considered planning.

Ostia was neglected in the late Republic, but felt the benefit of Augustus' approach to social and economic problems. The expansion of trade in the early Empire showed that the river harbor was too restricted for the shipping now needed to maintain Rome, and the larger merchantmen could not negotiate the sand bar at the river mouth.

About 3 km N of the Tiber mouth Claudius built a large artificial harbor, and two canals were dug linking the new harbor with the Tiber and thus with Rome. In A.D. 62, however, 200 ships were sunk within the harbor according to Tacitus: the expanse of shallow water was too large to provide shelter except near the moles. It was not until Trajan added a large hexagonal basin, excavated from the land, that Rome's harbor problem was satisfactorily solved.

Though the new harbors were directly linked with Rome they brought increased prosperity to Ostia for a hundred years. The Ostian council and magistrates controlled the area, though imperial officials were responsible for the harbors themselves, and the majority of the harbor workers lived in Ostia. During the first half of the 2d c. Ostia was transformed. Her population was more than doubled, her housing was revolutionized and her public buildings and amenities reflected the new prosperity. These dramatic developments were made possible by the energy and initiative of Ostia's own citizens but they were also encouraged and aided by the emperors at Rome. Hadrian was almost certainly the emperor to whom Ostia owed most. In an inscription of 133 he was honored by the city "for having preserved it and enhanced it with all indulgence and generosity." Nearly half the Ostia we now see was built while Hadrian was emperor and the new work is notable for the coherent planning of large areas. Two of these building programs probably derived from imperial initiative. The first comes from the beginning of his reign and involved the building of a series of large warehouses NW of the forum, the remodeling on a more handsome scale of the cardo between the forum and the river, and the building of a new Capitolium to dominate the forum. The second, on the N side of the W decumanus, comes from the last years of Hadrian. At the center of this plan are two large public buildings, to the N the barracks of the Vigiles, the fire-fighters detached from the cohorts at Rome, and to the S of the barracks a large set of public baths, handsomely appointed. An inscription records that Hadrian paid for the building and that his successor added what was needed to complete the work after Hadrian's death. On the E and W sides of these two buildings, blocks of apartments and shops form part of the comprehensive plan.

The rebuilding of Ostia was needed to provide for a sharply increasing population in an area restricted by the town walls and the necropoleis lining the roads outside the gates.

Ostian architects profited from the experience of Rome's rebuilding after the great fire under Nero. There had been changes in the use of building materials since the Republic, when tufa had dominated. Buildings that had to be either strong or impressive were then built with large blocks of tufa; after concrete had been developed in the 2d c. B.C., houses and secondary walls of public buildings normally had a core of concrete faced with small blocks of tufa, at first of irregular shape, opus incertum, and by the end of the Republic of regular squares set diagonally, opus reticulatum. Travertine from the Tivoli quarries, stronger but more expensive, was used economically; Italian marble was introduced on a small scale under Augustus. By the 2d c. A.D. the brick industry, based on the rich clay fields near Rome, was

competing successfully against tufa, at first in association with large panels of small tufa blocks, opus mixtum, but alone by the end of Hadrian's reign. Travertine was now used in place of the cheaper tufa for columns and thresholds, and marble was freely used in public buildings—Italian marble for large surfaces, but a wide range of foreign marbles, from Greece, Asia Minor, and Africa for columns and paneling.

The most interesting feature of the rebuilding of Ostia is the type of housing adopted to meet the increase in population. Down at least to Augustus there were still many houses of Pompeian type with a series of rooms surrounding an atrium, sometimes with a second set of rooms surrounding a garden court, the peristyle. These houses looked inward for their light, and could expand only horizontally. With the increasing pressure on space it was necessary to build high and the private house gave way to the apartment block. These blocks had strong walls and could have as many as five stories. Some were purely residential, others combined shops on the ground floor with apartments above. The shopkeeper often lived in a mezzanine floor above his shop, reached by a staircase with its first treads in brick and the rest in wood; for the other tenants of the block there were separate staircases from the street. These multiple dwellings are either built round an open court, drawing light from outside and inside, or they have no court and draw their light exclusively from outside. The apartments vary in size and elegance, but many of them conform to a common plan, in which the rooms open off a wide corridor-hall, replacing the atrium, with the two largest, for reception and dining, at either end and the secondary rooms between. This plan is found with a varying number of rooms and is used in the cheapest as well as the most expensive blocks. In the better apartments the floors, except in kitchen and latrine, were covered with mosaics, usually in simple geometric patterns; figured scenes are more rare. The poorer apartments had to be content with herringbone pattern brick or *cocciopesto*. The painting on the walls is normally the work of house decorators rather than artists and depended for its effect primarily on contrasting masses of color.

The elevations of these blocks on the streets are plain and effective. The brick is rarely concealed behind plaster and there is no superfluous decoration. The main effect comes from the size and spacing of the windows. Doorways framed by columns or pilasters and pediment add distinction without fuss to some blocks.

The revolution in private accommodation was accompanied by an impressive improvement in public building and amenities. In the Republic the population had to rely on wells. In the Early Empire an aqueduct was built to bring a constant flow of water from the high ground 6.4 m to the E. The supply of water to private houses was limited but public fountains, and cisterns were provided in the streets. The aqueduct also made possible the extension of bathing facilities. The proliferation of public baths in a harbor town is one of Ostia's most engaging features. In the first half of the 2d c. A.D. three sets were built which must have dwarfed their predecessors. The bath by the seacoast outside the Porta Marina were built under Trajan, the Baths of Neptune on the N side of the E decumanus under Hadrian, and the forum baths off the SE corner of the forum under Antoninus Pius. From an inscription we know that the Baths of Neptune were paid for by Hadrian and his successor; there are also reasons for believing that the other two sets were imperial benefactions. All three sets covered large areas and were handsomely decorated with statues and fine mosaics, and the forum baths heralded a change in architectural fashions, from rigidly rectangular planning to the curving lines of apse, niche, and round temple. In addition to the three "imperial" baths, there were at least 14 smaller establishments.

The large number of public baths shows that a large proportion of the population must have attended regularly. The theater on the other hand was small. The original building under Augustus cannot have held more than 3000, and when it was rebuilt and enlarged at the end of the 2d c. there was room for not more than 4000. It is probable that gladiators and wild beasts attracted much larger audiences but no amphitheater has yet been found. There may have been one S of the river.

To match the reconstruction in so many parts of the town it was important to give more dignity to the civic center. Hadrian was probably responsible for the building of a new Capitolium at the N end of the forum. In order to dominate the tall blocks in its neighborhood, the new temple was built on a high platform, approached by a monumental marble stairway. The walls were originally lined with Italian marble, the fluted columns of its fronting portico were of pavonazetto marble from Asia Minor and the massive threshold stone of the wide doorway was a single block of African marble weighing some two tons. At the same time porticos were added to the E and W side of the forum.

Before the imperial harbors were built, Ostia's primary function was to provide the essential services for ships carrying cargoes for Rome and storage capacity for Rome's reserves. Ships up to ca. 150 tons could make the passage to Rome by a combination of sail and oars, but larger ships and especially ships carrying corn had to unload at the harbor and their cargoes had to be transferred to smaller boats that could be towed up river. During the summer months the volume of shipping was so large that it would have been impossible to keep the harbor open had it been necessary to send all cargoes to Rome when they arrived. The imperial harbors eased the problem but they did not ease the congestion on the Tiber route to Rome, and the problem became more acute when ships that had previously unloaded their Roman cargoes at Puteoli now came to the imperial harbors. How much storage capacity was provided by the Claudian harbor we do not know, but Trajan's harbor was almost entirely surrounded by warehouses. Storage capacity for Roman corn and perhaps other goods was still needed at Ostia, for it is certain at least that the number and capacity of horrea increased dramatically in the 2d c. Earlier warehouses, to judge from surviving evidence, were limited to a single floor; in the 2d c. there were normally stairs to one or more upper stories. The grandi horrea N of the W decumanus, near the forum, which had been built under Claudius were completely remodeled shortly after the middle of the 2d c. with stronger internal walls and stairways to additional storage above. In another warehouse, W of the Piccolo Mercato, only one wall was left, and the rest entirely rebuilt. The new granaries marked an improvement on the old, not only in their increased capacity, but by raising the floors on low brick walls to facilitate the circulation of air underneath.

Another type of warehouse can be recognized by large earthenware jars sunk in the ground, dolia defossa. Four such deposits can be seen and the largest, NE of the forum, has more than 100 jars with a total capacity of more than 84,000 liters. These jars contained oil or wine and since Roman supplies would have been stored in their containers we should regard the operators of these horrea as Ostian wholesalers supplying local demand.

The most interesting illustration of Ostia's importance

to Rome is the double colonnade behind the theater, off which in the 2d c. were 61 small rooms, many fronted by mosaic designs, some accompanied by inscriptions. In one an elephant with the legend, STAT(IO) SABRATENSIUM, signifies that this was the office of the traders whose main trade was in ivory from Sabratha in North Africa, for which there was a brisk demand in Rome. Another mosaic, set up by the shippers and traders of Cagliari in Sardinia, shows a merchantman between two grain measures. The shippers of Narbonne show a merchantman approaching the famous lighthouse at the entrance of the Claudian harbor. The rooms behind these mosaics, too small for the sale of goods, were offices where representatives of overseas shippers and merchants, and also of Ostian business firms could take orders and supply information.

Ostia's main importance was the service she rendered to Rome, but a considerable part of the labor force was needed for the maintenance of Ostia herself. Her own resources were limited. There was enough good land to the S of the city and across the Tiber to produce all the vegetables and fruit that were needed and there was plenty of oak and ilex in the woodland to the S, but grain, most building material, and the raw materials for her industries had to come from outside. Most production seems to have been on a small scale, and it was common practice for goods to be sold from the premises on which they were made. The number of shops in Ostia (over 800 are known) is one of the most striking features of the town. They line nearly all the streets and even the rich could not resist the economic attraction of using the street front of their houses for shops. In the whole excavated area only two bakeries have been found; both are very large. Most of the fullers' premises are small, but one, which is built round an arcaded court, has three big rinsing tanks in the court, sunken jars in the arcade for dyeing, and fixtures in the brick piers for hanging cloth. Some of the trades are illustrated in terracotta or marble reliefs inserted over the entrance to a tomb to show the occupation of the deceased. Probably the two biggest employers were the building and the ship-building industries.

Most of the main trades of Ostia had their guilds which were primarily social institutions. They had their own guild centers and elected a grand hierarchy of officials. The largest of them could afford to use expensive sites. The builders' premises, for example, immediately adjoined the forum on the S side of the E decumanus. It is significant that five of the rooms on the ground floor were permanently equipped as dining rooms with stone couches on which the diners reclined.

Religious patterns in Ostia reflect the town's history. The earliest established cults are those shared with the early Roman Republic and they remain prominent in the town plan. The greatest of them was the Capitolium. The earliest surviving temple is dedicated to Hercules and was built in the first half of the 1st c. B.C. on the N side of the Via della Foce leading to the river mouth. A relief found by the temple shows that this Hercules delivered oracles and suggests that the archaic cult statue was dredged from the sea. But the most important of the colony's cults and the most deep-rooted was the cult of Vulcan whose pontifex was the chief religious authority in the town. The restoration of Vulcan's temple is recorded in an inscription but the temple has not yet been found. Two temples of Bona Dea, whose fertility cult was reserved for women, have been excavated; both were built in the imperial period but they continue a cult which doubtless was established in the Republic. The Ostian games of Castor and Pollux were celebrated by magistrates from Rome and attracted distinguished en-

trants; a temple to the twins is recorded but not yet identified. Other cults which are of Augustan origin or earlier include those of Venus, Ceres, Fortune, and Hope.

Most of these cults were maintained in the Empire and their temples were restored, but it was inevitable that a population of such mixed origins as Ostia, including old families of Roman stock, newcomers from other towns of Italy, traders from overseas, slaves and ex-slaves from E and W, should increasingly feel the influence of the oriental cults that spread so vigorously through the empire. The cult of Kybele, the Phrygian Great Mother, was officially established at Rome towards the end of the 3d c. and Ostia is likely to have followed the capital. In the great rebuilding a large area by the walls near the Laurentine Gate was reserved for the goddess. In front of a small tetrastyle temple there was a large triangular field, flanked on its S side by a marble colonnade. This was the scene of the taurobolium in which a bull was sacrificed in honor of the goddess, and blessings were invoked for the emperor and the Roman senate and for the magistrates and council of Ostia. At the E end of the area was a temple for the associated cult of Bellona, and a guild house for the hastiferi who performed ritual dances in her honor; nearby was a shrine of Attis, Kybele's consort. Towards the W end of the town a temple was built, also under Hadrian, to Egyptian Serapis and inscriptions record a Temple of Isis and her priestesses. The discovery of a large and handsome synagogue near the seashore shows that in the Empire there was a strong Jewish community in Ostia. But the cult which has left the most widespread evidence is Mithraism. No less than 15 shrines of Mithras, none very large and some very small, can still be seen, built between the middle of the 2d c. A.D. and the end of the 3d. Mithraism seems to have made little or no impact on the ruling classes at Ostia, but it had wide appeal among the common people. During the 3d c., however, it found an increasingly strong rival in Christianity.

The archaeological evidence for Christianity in Ostia before the 4th c. is very slight. Ostian bishops attended church councils in the early 4th c., and Constantine is said to have endowed a basilica dedicated to SS. Peter and Paul. But the only 4th c. church so far found within the city is on the W decumanus: a small and unpretentious basilica which reused old walls. More impressive is a very handsomely decorated hall near Porta Marina. The walls are lined with bands of elaborate design in colored marbles (opus sectile) including two portrait heads, one of which represents a bearded Christ. This hall was violently destroyed and the last of the series of coins found in the building dates from the time when Rome's pagan aristocrats made a final bid to bring the old gods back. This movement must have evoked some sympathy in Ostia for it was at this time also that the Temple of Hercules was restored. The Christian hall was almost certainly destroyed by Ostian pagans.

Christian opposition to Mithraism was not always passive. In the Late Empire a Christian basilica was built in the W wing of a set of public baths N of the Via della Foce. Beneath it, in what had been a service corridor of the baths, a Mithraeum had been built and here the excavators found a marble sculpture of Mithras slaying the bull. The sculpture was found in scattered fragments, deliberately broken.

By the time Christianity was firmly established at Ostia the city was in decline. Ostia had lost her importance to Rome because the settlement by the imperial harbors could now service the reduced flow of shipping. The new situation was made explicit when Constantine gave the harbor settlement its own charter as Civitas Flavia Constantiniana Portuensis. In Ostia the population had shrunk

considerably. After the early 3d c. there was very little new building and some large buildings destroyed by fire were not replaced. Most repairs were carried out with old material and necropoleis were rifled for paving stones. In the Late Empire a new social pattern emerged. Private houses, which were eclipsed during the expansion, now became prominent again while the large multiple dwellings decayed. Many of the new houses made use of old walls but they shared common features. They expanded horizontally rather than vertically, fountains became a fashionable extravagance and marble was lavishly used to line floors and walls. These houses were occupied by rich men, among them Roman senators; for with trade concentrated at the harbors, seaside Ostia was more attractive to residents. That is why St. Augustine, returning with his mother to Africa, stayed at Ostia rather than at Portus. But with the collapse of Rome's power, Ostia soon became vulnerable to invaders and pirates. From the 5th c. conditions deteriorated until in the 9th c. the town was evacuated and Pope Gregory built for the survivors a small fortified settlement E of the ruins which took his name, Gregoriopolis. Nature gradually buried the ruins of the old town. Through the Middle Ages it became a quarry for building materials and lime; in and after the Renaissance it was a hunting ground for treasures. Systematic excavation was begun in the late 19th c. and sharply accelerated between 1938 and 1942 until roughly two-thirds of the town was uncovered. There is an excellent museum on the site.

BIBLIOGRAPHY. *Scavi di Ostia*, Libreria dello stato, Rome: I. *Topografia generale* (G. Becatti et al.) 1953; II. *I Mitrei* (G. Becatti) 1954; III. 1. *Le tombe di eta repubblicana e Augustea* (M. F. Squarciapino) 1958; IV. *Mosaici e pavimenti marmorei* 2 vols. (G. Becatti) 1961; V. 1. *I ritratti* (R. Calza) 1964; VI. *Edificio con opus sectile fuori Porta Romana* (G. Becatti) 1969; L. Paschetto, *Ostia colonia romana* (1912); R. Calza & E. Nash, *Ostia* (1959)[P]; R. Meiggs, *Roman Ostia²* (1974)[MPI]; J. E. Packer, *The Insulae of Imperial Ostia*, *MAAR* 36 (1971)[PI]; "The Horrea of Ostia and Portus" in G. E. Rickman, *Roman Granaries and Store Buildings* (1971)[PI]. R. MEIGGS

OSTIPPO, *see* ASTAPA

OSTROVO, *see* ARNISSA

OSUNA, *see* URSO

OTHONA (Bradwell-on-Sea) Essex, England. Map 24. The Roman fort has been at least two-thirds eroded by the sea, and the remains now overlook the partially silted Blackwell estuary. Very little is known of its history but some evidence suggests occupation lasting from the late 3d c. to the end of the Roman period. The *Notitia Dignitatum* records the presence of the Numerus Fortensium in the second half of the 4th c.

The wall, some 4.2 m thick and not more than 1 m above the present ground level, can be traced on three sides of the enclosure. At least two external bastions are known, both apparently bonded with the wall. A Saxon church was built over the W gate.

BIBLIOGRAPHY. T. Lewin, "On the Castra of The littus Saxonicum and particularly the Castrum of Othona," *Archaeologia* 41 (1867) 439; *VCH Essex* III (1963) 52-55. B. W. CUNLIFFE

OTRICOLI, *see* OCRICULUM

OUDENBURG Belgium. Map 21. A vicus of the Early Empire 18 km W of Bruges, a castellum of the Late Empire, which formed part of the Litus Saxonicum defense system, and a military necropolis of the same period containing more than 200 tombs.

The vicus of the Early Empire was occupied from the middle of the 1st c. until the time of the second Dunkirk marine transgression in the second half of the 3d c. It consisted mainly of remains of wooden houses. These remains were badly disturbed both during the building of the castellum and during the Middle Ages. The large quantities of potsherds and various artifacts still await exhaustive publication. The existence of a road linking the vicus of Oudenburg to Blicquy and Bavai is certain. Probably another road connected Oudenburg to Cassel (Castellum Menapiorum, capital of the civitas Menapiorum, of which Oudenburg formed a part) and to Bruges and to Aardenburg (in the Netherlands).

During the second Dunkirk marine transgression a part of the coastal plain in northern France, Belgium, the Netherlands, and probably as far as Denmark was submerged. This catastrophe may have precipitated the increase in the invasions, of the Saxons, the Germanic tribes living in the regions affected by the disaster. Against these attacks from the sea, the Roman authorities built the Litus Saxonicum defensive system on both sides of the North Sea, both in England and in northern Gaul. Several castella of this coastal defensive system are known in Great Britain; but before the Oudenburg excavations, none was known on the continent. The marine transgression probably submerged the vicus of Oudenburg for a short time. Later the new shoreline lay immediately N of the old vicus, which apparently never again had a civilian occupation. A castellum was built on top of the ruins of the built-up area of the Early Empire. The remains of three successive castella have been found. The oldest dates to the end of the 3d c. The excavations had as their primary goal the discovery of the plan of the fortress. To date, only the moats of the first two castella are known. The most recent fortress (4th c.) was built entirely of stone. A quadrilateral (163 x 146 m), it was surrounded by a moat about 20 m wide with a V-shaped profile. The slope of the ditch began only 2 m from the foot of the rampart. This wall was 1.8 to 2 m thick. Its lower course consisted of large fieldstone ashlar. At each corner the enceinte was reinforced by a large tower with an exterior diameter of 9 m. A gate, flanked on both sides by a hexagonal bastion, opened midway in each side of the castellum. As far as the chronology of the three successive forts is concerned, the second may be attributed to Carausius, the third to Constantius Chlorus.

Study of the soils at the site of Oudenburg has shown that at the end of the 3d c. and in the 4th the castellum was located on a slightly raised sandy strip, surrounded to the N, W, and S by a lagoon. The necropolis of the garrison of the fortress had been set up at the W end of this sandy strip. More than 200 tombs have been excavated systematically. These investigations have provided precious information about the funerary rites of the Roman regular army in the 4th c. All the burials were inhumation tombs. In a certain number of tombs, the sword-belt had been symbolically placed at the feet of the corpse. Most often, the bronze parts of this sword-belt were decorated with cut-out geometric and animal motifs (*Kerbschnitt*). A certain number of tombs have produced crossbow fibulas, which seem to have been the distinctive insignia of soldiers and officials in the 4th c. In addition, the grave goods sometimes included a knife, pottery, glassware, and coins. One soldier was buried with his purse, which contained 88 coins. (Possibly he had just been paid.) In contrast to the tombs of the Laeti at the same time, the tombs of these regular army sol-

diers contained no weapons. Most of the tombs seem to date to the second half of the 4th c.

BIBLIOGRAPHY. J. Vannérus, *Le Limes et les fortifications gallo-romaines de Belgique. Enquête toponymique* (1943) 262-71; M. Gysseling, *Toponymie van Oudenburg* (1950) 280 pp.; L. Devliegher, "Oudheidkundig onderzoek van de Sint-Pieterskerk te Oudenburg," *Handelingen van het Genootschap Société d'Emulation te Brugge* 85 (1958) 137-62; J. Mertens, "Oudenburg en de Vlaamse kustvlakte tijdens de Romeinse periode," *Bickorf* 59 (1958) 321-40; id., "Oudenburg et le Litus Saxonicum en Belgique," *Helinium* 2 (1962) 51-62[PI]; id., "Oudenburg, camp du litus saxonicum en Belgique," *V^e Congrès intern. du Limes, Zagreb* (1963) 123-31; id., "Laat-Romeins graf te Oudenburg," *Helinium* 4 (1964) 219-34; J. Lallemand, "Monnaies romaines découvertes à Oudenburg," *Helinium* 6 (1966) 117-38; J. Mertens & L. Van Impe, *Het Laat-Romeinse Grafveld van Oudenburg*, 2 vols. (1971)[MPI]. S. J. DE LAET

OUDNA, *see* UTHINA

OULED MIMOUN, *see* ALTAVA

OURANIA Cyprus. Map 6. The ruins of a small coastal town about 8 km due NE of the village of Rizokarpasso in the Karpass peninsula, have been identified with those of Ourania. The ruins cover a sizable area back from the coast on the last slopes of the ridge and on the plain below. The acropolis bounded the town to the S. The town possessed a harbor, W of which the necropolis lies near the shore. Three Byzantine churches are the only prominent monuments still standing.

Nothing is known of the origins of Ourania. Geometric and archaic tombs known in the neighborhood of the Classical site may belong to it. However, archaeological evidence is at present against a date earlier than the Classical period for its founding. The town flourished down to Early Byzantine times, when it was gradually abandoned after the first Arab raids of A.D. 647.

Very little is known of the history, and but for a doubtful reference in Nonnos (13.452), our only authority for its existence is Diodoros (20.47.2), who relates its capture by Demetrios Poliorketes. Demetrios, coming from Cilicia, landed his forces in 306 B.C. at Karpasia and, having stormed both Ourania and Karpasia, marched on Salamis.

The principal monuments now visible are, apart from the churches, the acropolis and the harbor. The ruins of the lower town are now under cultivation with great quantities of stones, fragments of columns, and other remains scattered about or piled up. To the E may be seen a large quarry, now called Phylakes. A number of tombs, dating from Classical to Hellenistic times, were excavated in 1938 in the necropolis but these are for the most part filled in.

To the S of the ruined town rises the acropolis, a rock projecting sheer on three sides from the hills into the plain. On its summit can still be seen the foundations of a building, possibly a sanctuary or a fortress. The entire ground plan of the building has been preserved because the lower portion of its rooms was excavated in the living rock to a depth varying from .61 to 1.21 m. Enough of the walls remain intact to determine the position of the doorways and the character of the approaches. The outer walls are generally .61 to .91 m thick and the party walls vary from .31 to .46 m. The building was approached from the SE by a wide passage, on the left of which are two rooms; a flight of four

steps and a gate, whose sockets remain, lead into an inner room, which again opens into a third room, the largest of the three.

Less than a km below the town lies a little horseshoe bay which served as a harbor. The entrance is narrow but the space within could afford room for many small craft. On the beach still stand four stone mooring-posts, ca. .91 m high. The remains of the masonry of the quay may be traced for some distance.

The finds from the excavations of the necropolis are in the Cyprus Museum, Nicosia but certain tomb groups have been allocated to the Ashmolean Museum in Oxford, to the Museum of Classical Archaeology in Cambridge, to the Institute of Archaeology in London, and to the Nicholson Museum in Sydney.

BIBLIOGRAPHY. D. G. Hogarth, *Devia Cypria* (1889); E. Dray & J. du Plat Taylor, "Tsambres and Aphendrika," *Report of the Department of Antiquities, Cyprus* (1937-39) 24-123[MPI]. K. NICOLAOU

OVILAVA (Wels) Oberösterreich, Austria. Map 20. Located in NW Noricum. It was an important road junction: the Alpine road for Aquileia, Virunum, and Ovilava terminated here, and the limes road for Lauriacum, Ovilava, Castra Batava (Passau) here intersected the interior road to Iuvavum. In addition Ovilava was situated at an excellent crossing of the Traun. Because of this advantageous location in the Roman communications net, Ovilava was predestined to be the replacement center for the Danube front. The place is mentioned several times in the ancient literature (*Ant.It.* 235.2; 249.2; 256.5; 258.4; 277.2; *Tab.Peut.* 4.2). Under the emperor Hadrian, Ovilava received a municipal constitution (municipium Aelium Ovilava). During the wars with the Marcomanni under the emperor Marcus Aurelius, legionary troops were transferred to Lauriacum and the legionary commander assumed the office of the governor. At that time some offices were transferred from the former provincial capital of Virunum to Ovilava. The increased importance of the town is indicated by the fact that it was, under Caracalla, elevated to the rank of a colonia (Aurelia Antoniniana). Caracalla also probably fortified the town when it was threatened by invasions from Germany. However, a permanent military garrison cannot be proven. During the administrative reform under Diocletian, Ovilava became the capital of the province of Noricum ripense and seat of the governor (praeses). Early Christianity is indicated by a tombstone, the only one found in Austria which has been completely preserved.

Owing to later building on the site, knowledge of the topography of Ovilava is very limited. The ground plan was an irregular rectangle with rounded corners and a bend in the W and E side (exterior measurements, ca. 900 x 900 m). The fortification consisted of a wall (ca. 1.4 m thick) with towers jutting out slightly, six of which have been found so far; the gates have not yet been discovered. The approaches were guarded by a system of quadruple trenches. The town plan is not evident, although many large remnants of buildings have been found. The location of some ancient roads may possibly be reflected in the plan of the modern town; and if it is, it can be assumed that a checkerboard plan existed, at least for the newer N section of the town. So far, none of the basic municipal buildings (forum, capitol, etc.) have been found or identified. The location of the amphitheater is unknown, although its existence can be deduced from a relief of the goddess Nemesis. However, the aqueduct from the S has been identified; it consisted in the 2d c. A.D. of wooden pipes

and was rebuilt as a vaulted canal in the 3d c. Two large necropoleis to the W and E are located on both sides of a long road that traversed the N part of the town. Another, in the middle, containing the oldest graves, was abandoned when the town wall was built. The mediaeval settlement developed in the SE corner of the ancient town and occupied only 12 ha of the original 90 ha of the Roman area.

The finds from Ovilava are mainly in the Städtisches Museum in Wels, some in the Oberösterreichisches Landesmuseum in Linz.

BIBLIOGRAPHY. E. Polaschek, "Ovilavis," *RE* XVIII (1942) 1986ff; R. Noll, *Der römische Limes in Österreich* 21 (1958) 60ff; G. Trathnigg, "Die Römerzeit," *Jahrbuch des Musealvereines Wels* 10 (1963-64) 16ff; id., "Beiträge zur Topographie des römischen Wels I," *JOAIBeibl* 48 (1966-67) 109ff. R. NOLL

OXIANA, *see* ALEXANDRIAN FOUNDATIONS, 7

OXYRHYNCHUS Egypt. Map 5. About 197 km S of Cairo, on the left side of Bahr Yusuf (present El-Bahnasa), halfway between Hermopolis Magna and Arsinoë. The shortest route to the Bahariah Oasis from the Nile Valley starts here. The ancient city was the capital of the Scepter nome, the Oxyrhynchite of the Greeks (Strab. 17.40), which was the nineteenth nome of Upper Egypt. Here they venerated the god Seth, incarnated in the oxyrhyne fish, from which the Greeks derived the name. The city flourished during the Roman and Coptic periods. During the latter period it became a monastic center, with 12 churches and a great number of monasteries. There is still to be seen a small part of a ruined Roman theater with one standing column. The fame of Oxyrhynchus depends entirely on its papyri, a few illustrated. Important Biblical fragments, texts of parts of the works of Homer, Bacchyllides, Pindar, Aristotle, and Callimachus are included. Most of the papyri, however, date from the Roman period.

BIBLIOGRAPHY. D. V. Denon, *Voyage dans la Basse et la Haute Égypte* (1902); W. M. Flinders Petrie, *Tombs of the Courtiers at Oxyrhynchus*, 12-18[1]; A. Minto, "Nuovi papiri figurati," *Pap. della Soc. Ital.* 12 (1951) 213-28; A. Von Salis, "Um Löwenkopf des Herakles," *Museum Helveticum* 12 (1955) 173-80; T. Kraus, "Sarapiskopf aus Oxyrhynchus," *JdI* 75 (1960) 88-99; E. Brunner-Traut & V. Hell, *Aegypten* (1966) 499; B. Grenfell & A. Hunt, *Oxyrhynchus Papyri* (35 volumes published); C. C. Walters, *Monastic Archaeology in Egypt* (1974) 172-75. S. SHENOUDA

ÖZLEN, *see* PYDNAI

OZZANO, *see* CLATERNA

P

PACHIA AMMOS ("Minoa") Ierapetra district, Crete. Map 11. On the SE corner of the Gulf of Mirabello a town where Greek and Roman remains have been found. These along with Minoan remains support the identification with Minoa. The ancient site may, however, have existed in the SW corner of the same gulf, at Katevati and Nisi below Kalochorio, serving as a port of Istron (at Vrokastro or Kalochorio?).

BIBLIOGRAPHY. T.A.B. Spratt, *Travels and Researches in Crete* I (1865) 137-41; L. Mariani, *MonAnt* 6 (1895) 281; H. A. Boyd, *Transactions of the Department of Archaeology of the University of Pennsylvania* 1.1 (1904) 13-15; H. Boyd Hawes, *Gournia* (1908) 20; Fiehn, "Minoa (5)," *RE* XV.2 (1932) 1858; M. Guarducci, *ICr* I (1935) 100, n. 1; III (1942) 168; E. Kirsten, "Istron," *RE* Suppl. VII (1940) 301-10; P. Faure, *KretChron* 13 (1959) 201-2. D. J. BLACKMAN

PACHTEN, *see* CONTIOMAGUS

PADUA, *see* PATAVIUM

PADULA, *see* CONSILINUM

PAESTUM (Pesto) Campania, Italy. Map 14. On the E coast 96 km S of Naples, the site stands in the center of the Sele plain between the sea and the W ridges of the Monte Alburno. Discoveries of handmade tools indicate that the site was inhabited in Palaeolithic and Neolithic times. Fragments of Protocorinthian pottery make it possible to date the founding of the Greek city to the middle of the 7th c. B.C. According to Strabo (5.4.13) the city was established by colonists from Sybaris, who built a fortified town by the sea, forcing the settlers already inhabiting the area to move inland; the Sybarite city was called Poseidonia. The fertility of the plain surrounding it, as well as its advantageous position for trade enabled it to become extremely prosperous. Around 400 B.C. this prosperity was shattered when the Lucanians, who had lived in the hills behind, captured the city, renaming it Paiston or Paistos. It enjoyed a brief period of freedom from 332 to 326 B.C. when Alexander the Molossian united the Greek peoples of S Italy against the Lucanians. In 273 B.C., the Romans established a colony on the site, renaming it Paestum. During the Roman period the city prospered, but in the 1st c. A.D. the silting up of the river Sele (Salso) caused the area to become infested with malaria. At the beginning of the Middle Ages the site consisted simply of a small community centered around the northernmost of the temples, which had been turned into a church. In the 9th c. A.D. the site was finally abandoned and subsequently hidden by forest and swamp, not to be rediscovered again until the middle of the 18th c. when a road was built through the area.

The entire Greek city was surrounded by a fortification wall, some 4750 m in length with an average thickness of 5 m. The present walls date to the Lucanian and Roman periods; the W section is the best preserved. The entire circuit was surrounded by a moat crossed by bridges at the points of the four major gates: the Porta della Sirena to the E, the Porta Aurea to the N, the Porta della Giustizia to the S, and to the W the Porta Marina, which consists of round and square towers forming a vestibule with guard rooms.

The major part of the modern excavations have been conducted in the central part of the city. Two major precincts flank a central agora. To the N is the area sacred to Athena, and to the S that dedicated to Hera. The S sanctuary includes two major temples, the southernmost of which is the older dating to the middle of the 6th c.

B.C. Because of its resemblance to a civic building, it has been called the Basilica, but it is actually a Temple to Hera. It is of the Doric order, facing E (enneastyle x 18; 24.5 x 54.3 m on its stylobate). The columns have a pronounced entasis, tapering at the top. The capitals have very flat echini, the bases of which are decorated with carved leaf designs (anthemion). Nothing remains above the architrave except part of the antithema of the frieze course. The temple probably did not contain sculptural decoration. The pronaos is tristyle in antis; the cella is divided into two aisles by a single row of eight columns down the center, three of which are still standing, their capitals carved with anthemion designs, and there probably was an adyton at the back. The interior columns are of the same height as those of the pronaos, but the level of the floor of the cella was higher than that of the pteron and was paved with limestone slabs, some still visible on the S side. In front of the temple stands a rectangular limestone altar with a bothros near its S side. To the S of the temple are the foundations of what was probably a small treasury distyle in antis (15.25 x 7.15 m). To the N of the altar are the remains of another treasury, of the Doric order, distyle in antis, and dating to ca. 450 B.C. Two smaller archaic altars in this area have also been found.

To the N of the Basilica stands the second temple of the S sanctuary, formerly called a temple of Poseidon (Neptune); but because of the votive offerings found, it is now considered a temple dedicated to Hera. This excellently preserved Doric temple faces E (hexastyle x 14; 24.3 x 59.9 m on its stylobate). It is variously dated to 460 B.C. and to 440 B.C. The columns of the peristyle have a slight entasis and are unusual in that they contain 24 flutes. The entablature is well-preserved, but nothing remains of the timber roof. This temple exhibits a number of refinements: all horizontal lines have a curvature of 0.02 m, the corner columns are elliptical in shape instead of round, and the columns of the E and W sides are wider in diameter than those of the flanks. The principle of double contraction has also been used. The pronaos is distyle in antis. The door of the cella is flanked by two smaller doors. The one to the N leads to a stone stairway which originally went to the wooden roof for repairs and for storage; the one to the S simply leads to a small closet. The cella itself is divided into three aisles by two rows of columns (7 on each side), which support a second tier of smaller columns, containing only 16 flutes each. These interior columns simply supported the wooden roof since there is no evidence for a gallery. At its W end, the temple contains an opisthodomos also distyle in antis. Much of the limestone paving of the pteron and cella still exists, and remains of stucco are visible on the walls. Neither the metopes nor the pediments contained sculptural decoration. Two altars belonged to this temple. The original one of the 5th c. B.C. stood in line with that of the Basilica. It was cut through in Roman times by a road to the forum and replaced by a smaller one to the W, nearer the temple, the podium of which still survives.

Several small sacred buildings have been located between the later Temple of Hera and the Roman forum. Near the NE end of the temple are the remains of a small temple distyle in antis with altar, both dating to the end of the 5th c. or the beginning of the 4th c. B.C. Six other small temples have been found in this area, one of which is an amphiprostyle temple dating to the 4th c. B.C. and standing on a podium (30 x 8 m). The temple contained four columns at each end and one at the sides. All these buildings were dedicated to Hera Argiva, the goddess of fertility. In the very NE corner of the S sanctuary dedicated to Hera are the remains of a four-sided portico, probably a palaestra.

To the N of the Sanctuary of Hera stands the Roman forum, a rectangular structure (57 x 150 m) occupying the site of the Greek agora. It was surrounded by a portico of reused Doric columns, probably carrying a second story.

The S side of the forum contains tabernae, a square building with an apse in the center of its S side built on the foundations of a Greek temple, and a rectangular building identified as the curia with walls decorated with engaged columns having composite capitals. On the SW side are the baths, built by M. Tullius Venneianus at his own expense. On the W side is a structure with three podia, probably serving as the lararium. On the N side are more shops and in the center stands a prominent temple, which, when it was found in 1830, was called the "temple of Peace." It probably served as the Capitolium of the Latin colony. It was begun in 273 B.C. (14.5 x 26.5 m on its stylobate, with a N-S orientation). It stood on a high podium with a deep porch and three cellae. There were six columns on the front (S) and eight on both sides, but none at the back (N). This plan was never completed. In 80 B.C., building on the temple resumed and changes in the original plan were made: only one cella was built, and the columns in the front were reduced to four. The entablature of the temple is basically Doric but with Ionic influences. The columns have four-sided capitals resembling the old Aeolic type with female heads projecting from each face.

There is a sculptural triglyph-metope frieze, above which runs a row of dentils. Adjacent to the E side of this temple are the remains of a circular structure with tiers of seats, variously identified as the Greek bouleuterion or the Roman comitium, but probably serving as a small amphitheater for the gladiatorial games of the Lucanian period. To the E of this building is another row of tabernae and to the NE stands the large Roman amphitheater, of which only the W half has been excavated because the national highway intersects it.

The main N-S street of the Roman city, the cardo maximus, runs along the same course as the Greek sacred way, passing by the W side of the forum. At the forum it meets the main E-W street, the decumanus maximus, at a crossroads (compitum) which is indicated by two columns. After it goes by the forum, the cardo passes on its E side the remains of a large building, identified as the gymnasium, having in its center a large swimming pool of Greek construction. Sometime before A.D. 79 this pool was partially filled in and converted to a cistern to help with the drainage of the area. After the gymnasium, the cardo turns sharply E for a short while and then turns N again to the Porta Aurea.

To the E and W of the cardo are the remains of Roman houses of the Samnite type with deep wells. Among these houses, to the E of the cardo, is a square temenos within which stands a small rectangular underground shrine (hypogaeum) to Hera (4.4 x 3.3 m). It was built of limestone blocks and had a gabled roof with clay tiles. The top of the roof stood below the road level, so that the entire shrine could be covered with earth. The interior walls were covered by white plaster but otherwise remained undecorated. In the center of the interior was found a stone bench on which were the remains of five iron rods wrapped in cloth. Similar rods were found under the Altar of Hera at Samos. The shrine dates to the end of the 6th c. B.C.

To the N of the Roman houses is the Sanctuary of Athena in which stands the third large temple at Paestum. It was formerly called a temple to Ceres but on the basis of the clay statuettes of Athena that have been found nearby, it is now identified as belonging to Athena. It is of the Doric order (hexastyle x 13; 32.8 x 14.5 m on

its stylobate). The Doric columns recall those of the Basilica, having a pronounced entasis with capitals decorated with anthemion designs. The temple has a tetrastyle prostyle porch, but no opisthodomos. The columns of this porch, however, were Ionic, with simple bases; two of the sandstone capitals also remain. The cella contains no interior columns. Above the architrave runs another Ionic feature, a sandstone egg-and-dart molding, replacing the conventional regulae and guttae. The pediment is of unusual construction: on the flanks, the horizontal cornice, instead of having the usual mutules and guttae, was decorated with a series of coffered sinkings. On the facades, there is no horizontal cornice, thus omitting the pediment floor which has been replaced by an egg-and-dart molding. The slanting cornice is also decorated with a series of coffered sinkings which join those of the flanks. To the E of the temple stands its altar, and to the S are the remains of a small temple dating back to the first half of the 6th c. B.C. To the NE of the temple stands a Doric votive column on a three-stepped base, also dating to the first half of the 6th c. B.C.

About 1.6 km N of the city at Contrada Gaudo a prehistoric necropolis has been found, yielding spherical vases, beakers, and askoi dating to between B.C. 2400 and 1900. Nearby, painted tombs of a 4th c. B.C. Lucanian necropolis have recently been discovered. The pottery from these tombs dates them to between 340 and 310 B.C. To the S of the city is a third necropolis. The most important of the tombs here is the Tomb of the Diver, discovered in 1968. The vertical sides of the tomb have been painted with symposium scenes and the underside of the cover slab has the representation of a boy diving from a tower into the sea. An attic lekythos in the tomb dates it to between 480-470 B.C. The paintings, as well as other finds from the area, are located in the museum at the site.

BIBLIOGRAPHY. R. Koldeway & O. Puchstein, *Die Griechischen Tempel in Unteritalien und Sicilien* (1899) 11-35; F. Krauss & R. Herbig, *Der Korinthisch-Dorische Tempel am Forum von Paestum* (1939)[PI]; Krauss, *Paestum* (1943)[PI]; id., *Die Tempel von Paestum* 1, pt. 1, *Der Athenatempel* (1959)[I]; W. B. Dinsmoor, *The Architecture of Ancient Greece* (1950) 92-98, 110-11; P. C. Sestieri, *Paestum* (8th Eng. ed. 1967)[MPI]; M. Napoli, *La Tomba del Tuffatori* (1970).

W.D.E. COULSON

PAGAI, *see* LIMES, ATTICA

PAGASAI Thessaly, Greece. Map 9. The city seems to have existed from the 7th or the 6th c. B.C. as the port of Pherai. In 353-352 B.C. it was taken by Philip II of Macedon, who made it an independent city, probably of Magnesia (Diod. Sic. 16.31.6, 35.5; Theopomp.: *FGrH* 115 fr. 53, 54; Dem. 4.35). In 293 B.C. it was absorbed into Demetrias. Pagasai was supposed to be 90 stades (14 km) from Pherai, 20 stades (ca. 4 km) from Iolkos (Strab. 9.436), between the latter and Amphanai (Skylax 64f). Ruins on the W shore of the Gulf of Volo, ca. 4 km S of Volo, were long recognized as those of Pagasai. Walls of two periods were involved. In 1908, however, Arvanitopoullos determined that the later part of the walls belonged to Demetrias and only the older wall circuit adjoining it to the S were the walls of Pagasai.

This wall runs from a hill called Prophitis Elias (44 m) which is ca. one km from the sea just to the E of the modern shore road Volo, SW across a dry wash (Ligarorema) and along the SW side of a low ridge about 2 km long, then around its end (Damari) and along the N side. The wall crosses the Ligarorema a little less than 2 km NW of the Prophitis Elias hill. It runs less than 1 km NW to the Kastro hill (201 m), and then N for a short

distance where it disappears. Both ends of the wall are very close to the walls of Demetrias. There is no indication of how the two ends joined; it seems likely the wall must have curved through the city area of later Demetrias. The masonry varies from roughly polygonal to rectangular blocks, depending on the native type of rock. It is poorly preserved. There are the remains of 69 towers to be seen, but apparently traces of 138 regularly spaced along the wall. The preserved section is 5 km long; the estimated original length about 8 km. The wall seems to date from the first half of the 4th c. The walls seem not to have included a harbor. Just to the E of the city is a promontory (modern Pevkakia, formerly Tarsanas, ancient Neleia). To the S and N of this are possible harbors (the N later included in the walls of Demetrias); it is not clear which Pagasai's harbor was, or whether both were used. Only one small square foundation has been found inside the city's SE wall and no buildings certainly earlier than Demetrias' foundation outside. Some sculpture, including a head of the 5th c., now in Volo, has been found in the area, and some graves belonging to the city. It has been suggested that the walled area was generally disused after Demetrias' foundation, as Hellenistic graves have been found outside the walls of Demetrias but inside those of Pagasai.

BIBLIOGRAPHY. F. Stählin, *Das Hellenische Thessalien* (1924) 65-67; Stählin & E. Meyer, *Pagasai und Demetrias* (1934)[MPI]; Meyer, *RE* (1939) s.v. Pagasai; H. Biesantz, *Die Thessalischen Grabreliefs* (1965) 112, 131[I]. (See also Demetrias).

T. S. MAC KAY

PAGUS URBANUS, *see under* CLUVIAE

PAIANION (Mastru) Aitolia, Greece. Map 9. Located about 500 m N of Mastru village, on a low scrub-covered chain of hills a short distance E of the Acheloos. The identification of the ruins as those of the Aitolian town of Paianion is now widely accepted. Paianion appears only once in ancient literature, in Polybios' account of the expedition of Philip V in 219 B.C. Philip stormed the town, razed its walls, houses, and other buildings, and floated the stone and other materials downstream, to be reused at Oiniadai. The sequence of sites and events in Polybios, together with the ancient sites now identifiable on the E bank of the Acheloos, suggests that the Paliokastro of Mastru must be Paianion.

Polybios gives the length of the circuit as less than seven stades; the Mastru circuit is given as 500 m by Kirsten, 850 m by Konstas. The presence of houses at Paianion indicates an urban settlement; at Mastru there seem to be remains inside the walls, many graves have been found at the foot of the hill, and chance finds go back to Subgeometric. Unfortunately no coins or inscriptions giving the ancient name have come to light. The name Paianion probably derives from Paian, indicating a special relationship to Apollo; but no temple is known.

Konstas thinks the extant walls predate 219 B.C.; Kirsten, more plausibly, dates them after the destruction by Philip V.

BIBLIOGRAPHY. W. J. Woodhouse, *Aetolia* (1897) 161ff[M]; E. Kirsten, *RE* XVIII[1] (1942) 2363ff[MP] (less accurate plan); K. S. Konstas, *ArchEph* (1945-47); id., *Chronika* 12-16[P] (new plan).

F. E. WINTER

PALAIA PHEVA, *see under* TITHOREA

PALAIOCHORA, *see* KARYSTOS

PALAIOKASTRO, *see* APTERA, BOUPHAGION, PYLOS

PALAIOKHORA ("Kalamyde") Selinos, Crete. Map 11. Roman, and possibly earlier, settlement 1 km NE of

the modern village. Remains on the site are confined to a heavy scatter of sherds, but a short distance to the NE are the remains of a fort built to defend Kantanos from the W. Traces of the defense wall, ending in a hollow circular bastion with inside entrance can be seen here.

BIBLIOGRAPHY. R. Pashley, *Travels in Crete* II (1837) 84; L. Savignoni, "Esplorazione archeologica delle provincie occidentali di Crete," *MonAnt* 11 (1901) 387ᴾ; M.S.F. Hood, "Some Ancient Sites in South West Crete," *BSA* 62 (1967) 48-49ᴹ. K. BRANIGAN

PALAIO-LARISA, *see* KRANNON

PALAIOPHARSALOS Thessaly, Greece. Map 9. Said by some ancient authors to be the nearest site to the battle where Caesar defeated Pompey in 48 B.C. (notably *Bell. Alex.* 48.1; Strab. 17.796; Frontinus, *Strateg.*, 2.3.22, etc.). The battle was apparently fought near Pharsalos, on the left (S) bank of the Enipeus, but the site is much disputed. It is otherwise mentioned as being near the Thetideion (Strab. 9.431, s.v. Pharsalos), and as having been sacked by Philip V in 198 B.C. (Livy 32.13.9; 44.1.5). Two sites in the Pharsalos area seem possible for Palaiopharsalos. At Ktouri, an isolated hill (211 m) on the left bank of the Enipeus ca. 13 km NW of Pharsalos are two fortress walls around the hill, the lower made of two-faced rough polygonal masonry, 1693 m in circuit, which appears to be at least in part Cyclopean, the upper of small irregular stones and blocks. The plan of the upper fortification was determined; it is roughly oval, ca. 125 m in circuit, with square towers. Inside this were a few small walls. It was apparent that the hill housed a garrison only. At the W foot of the hill is a mound (magoula). At the N of this were the foundations of a small, rectangular building (6 x 14 m) probably a temple. Two fragments of marble palmettes (acroteria?) of the archaic period were found here. Sherds from the magoula and E of it were mainly Mycenaean and Protogeometric. A handsome archaic bronze statuette of a warrior (Athens NM 15,409) was found by chance. Excavations by the nearby Chapel of Haghios Ioannis revealed an ancient peribolos wall around the chapel, which had evidently been erected over a Classical building. The site at Ktouri has variously been identified as Palaiopharsalos and Euhydrion (the latter favored by Béquignon and Stählin). Euhydrion is little known, and was destroyed in 198 B.C. by Philip V.

At Palaiokastro, a hill on the left bank of the Enipeus, which flows at its foot, by Ambelia (Derengli), some 9 km E of Pharsalos brief excavations were carried out by Béquignon in 1931. Traces of a circuit wall were discovered on the E and W sides of the hilltop. Only a foundation of small stones remained. Inside the circuit were parts of foundation walls, probably of houses. By one of these was found a black-figure dinos fragment signed by Sophilos (*ABV* 39.16). A number of tombs were discovered within the circuit. Sherds found range from Middle Helladic to black-glazed, and the site seems to have been abandoned around the end of the 6th c. B.C. The excavator identifies it as Palaiopharsolos, an identification favored also by Stählin. Near Ambelia a trial excavation in 1963 uncovered two graves and terracotta stamped plaques and figurines of the archaic-Classical period.

BIBLIOGRAPHY. F. Stählin, *Das Hellenische Thessalien* (1924) 142f; Y. Béquignon in *BCH* 52 (1928) 9-44ᴹᴾᴵ; 56 (1932) 89-191ᴹᴾᴵ; V. Milojčić in *AA* (1955) 228 (Cyclop. wall at Ktouri); D. Theocharis in *Deltion* 18 (1963) chron. 143ᴵ. T. S. MAC KAY

PALAIOPOLIS, *see* ANDROS

PALAIPAPHOS, *see* PAPHOS

PALATIA (Phokis, Greece), *see* ANTIKYRA

PALATITSA, *see* VERGHINA

PALEA GORITSA, *see* LIMES, GREEK EPEIROS

PALENCIA, *see* PALENTIA

PALENTIA (Palencia) Palencia, Spain. Map 19. Town of the Conventus Cluniensis, belonging to the Arevaci according to Strabo (3.4.13), but actually belonging to the Vaccaei (Plin. *HN* 3.3.26; Ptol. 2.6.50). With Numantia, the most prosperous town in the interior according to Mela (2.6.4). It has been identified with the town mentioned in the *Antonine Itinerary* (449.1; 454. 8) and with Peralancia mentioned by the Cosmographer of Ravenna (4.44; 313.4). Cited by Stephanos of Byzantium 497.

The town was involved in the Celtiberian wars (App. *Iber.* 55, 80, 82-83, 88) when Lucullus besieged it (151 B.C.) at the end of his campaign against the Vaccaei; subsequently Lepidus laid siege to it in 137-136 but abandoned the attack; in 135 Calpurnius Piso devastated its fields but did not dare to attack the town, and Scipio also raided it. In the Sertorian wars (App. *BCiv.* 1.112) it was besieged by Pompey, who burned the walls but was forced by Sertorius to raise the siege. In the 4th c. its fields were laid waste by the Honoriaci of Constans (Oros. 7.40.5) and it was sacked by the troops of Theodoric II (Hidacius 30.186) from Mérida. It was an episcopal see from 433 on. The modern city lies over the site.

In the 19th c. an extensive Roman cemetery was uncovered near the railway yards, and another on the opposite bank of the Carrión. Other outstanding finds are a gold and silver hoard, including native denarii of the 2d-1st c. B.C. in the Filipenses area, and many inscriptions (*CIL* II, 2716-24). Soundings in the Cathedral square have revealed superimposed layers from the times of Sertorius, Augustus, and Constantine, and reoccupation in the 9th c. continuing to the 14th c. Mosaics (Medusa in the National Archaeological Museum, Madrid) have also been unearthed.

BIBLIOGRAPHY. *RE* XVIII:3, 229; B. Taracena & F. Simón y Nieto, "La necrópolis romana de Palencia," *ArchEspArq* 21 (1948) 144ff; P. de Palol, "Estratigrafías en la ciudad antigua de Palencia," *IX Congreso Nacional de Arqueología, Valladolid* (1965) 27ff; A. García y Bellido, "Contribución al plano de la Palencia romana," *ArchEspArq* 39 (1966) 146ff. P. DE PALOL

PALEOKOULA, *see* LIMES, GREEK EPEIROS

PALEO SEBASTE, *see* EIBEOS

PALERMO, *see* PANORMOS

PALESTRINA, *see* PRAENESTE

PALIKÉ (Mineo) Catania, Sicily. Map 17B. Volcanic hill, today named La Rocca, which closes to the NE the valley of the river of Caltagirone or of the Margi, and which dominates to the N the small lake of the Palici. The site, which was uninterruptedly inhabited from the Paleolithic period until the Early Bronze Age, acquired particular importance after the foundation of the city of Paliké by Ducetius in 453 B.C. (Diod. 11.88.6). Destroyed and rebuilt, the city continued to flourish until the Early Hellenistic period. According to a new hypothesis, based

on a reference by Kallias (apud. Macrob., *Sat.* 5.19.25) and on excavational evidence, the site should be identified also with Eryke, archaic center of the 6th c. B.C., which would have been refounded in the 5th c. B.C. by Ducetius under the name of Paliké.

Near a grotto opening onto the side of the hill, stone tools of the Early Paleolithic period have been found, and probably the foundations of the Temple of the Palici. The plain before the hill has yielded Neolithic and Chalcolithic sherds of Serra d'Alto, Diana, and Serraferlicchio wares. Some oven-shaped graves of Castelluccio type attest that the site was also inhabited during the Early Bronze Age. On the plateau of the hill traces have been identified of an archaic settlement of the Licodia Eubea culture whose continuity is attested until the early Hellenistic phase.

BIBLIOGRAPHY. G. V. Gentili, "Cinturone eneo con dedica da Paliké," *RömMitt* 69 (1962) 14ff; P. Pelagatti, *FA* 17 (1965) n. 2767; L. Bernabò Brea, "Paliké. Giacimento paleolitico e abitato neolitico ed eneo," *BPI* 74 (1965) 23ff; A. Messina, "Menai-Menainon ed Eryke-Paliké," *CronArch* 6 (1967) 87ff. A. MESSINA

PALIOCHORI, *see* LIMES, ATTICA

PALIOKHORI BOTSARI, *see* LIMES, GREEK EPEIROS

PALIOPREVESA, *see* NIKOPOLIS

PALIOROFORON ("Elatria") S Epeiros, Greece. Map 9. A colony of Elis (D.7.32). Late 6th c. pottery has been found. The hill is fortified with a circuit wall ca. 1800 m long; tombs have yielded bronze mirror-disks.

BIBLIOGRAPHY. N.G.L. Hammond in Ἀφιέρωμα εἰς τὴν Ἤπειρον (1954) 26f; id., *Epirus* (1967) 52f and Plan 1. N.G.L. HAMMOND

PALLANO, *see* PALLANUM

PALLANTION Arkadia, Greece. Map 9. More important for Roman legend than for Greek history and archaeology, for the Romans believed that Evander set out from there to settle the Palatine in Rome. Though already mentioned in Hesiod (Fr. 162 Merkelbach-West), the town never attained importance. It subscribed to the Arkadian synoecism after the battle of Leuktra; a battle between Kleomenes and Aratos took place there in 228 (Plut. *Cleom.* 4.4, *Arat.* 35.5); because of the fancied Arkadian origin of the first settlers of the Palatine, the emperor Antoninus Pius made the village a city libera et immunis (Paus. 8.43.3).

The ancient city is located some 7 km SW of Tripolis, just E of the Tripolis-Megalopolis road. On a low hill rising in front of Mt. Kravari (ancient Boreion) the Chapel of St. John is set down in the foundations of a rectangular building (16.15 x 8.90 m) with an E orientation, probably the sanctuary dedicated to the Pure Gods mentioned by Pausanias (8.44.5). A few m to the N, with the same orientation, there is a smaller, earlier, megaron (10.45 x 4.50 m). A number of votive offerings (6th-5th c. B.C.), now in the museum at Tegea, were found beneath a terracotta paving of a small room in the area. Portions of the acropolis wall are still in place. On the S slope of the hill, on a large terrace, there are to be found the foundations of a temple (21.40 x 11.70 m), apparently of 5th c. date. About 1.6 km SW of Pallantion, on the N portion of Mt. Boreion in a place called Vigli there are observable the foundations of a temple (11.55 x 24.70 m), dated to the last quarter of the 6th c. which has been identified with that of Athena Soteira and Poseidon (Paus. 8.44.4). The structure replaces an earlier, 7th c. building on the same site.

BIBLIOGRAPHY. G. Libertini, *ASAtene* 1-2 (1939-40) 225-30 (report); M. Guarducci, ibid. 3-4 (1941-43) 141-51 (inscription); Reports in *BCH* 64-65 (1940) 241-42; *Praktika* (1958) 165-66; K. A. Romaios, *ArchEph* (1957) 114-62; N. A. Pappahatzis, *Pausaniou Ellados Periigisis* (1967) IV 384-90[MPI]. W. F. WYATT, JR.

PALLANUM (Pallano) Chieti prov., Abruzzo, Italy. Map 14. An oppidum of the Frentani or the N Lucani, on the right bank of the Sangro river near Atessa, ca. 900 m above sea level at the summit of Mt. Pallano. Remains of an imposing fortress have been found with megalithic walls pierced by three posterulae very close to the area of easiest access. The site was sparsely inhabited in the Roman period, when it was recorded in the land itineraries, as well as in the Middle Ages. According to a recent theory, the town was the center of the Lucanians, who sought an alliance with Rome in 330 B.C. and were subjugated by Scipio Barbatus in 298 B.C. On the slopes of the mountain, near Tornareccio, a 6th c. B.C. limestone statue of a warrior came to light in 1971.

BIBLIOGRAPHY. G. Colonna, "Pallanum," *ArchCl* 7 (1955) 164ff; *EAA* 5 (1963) 896 (G. Colonna); A. La Regina, *Dialoghi di Archeologia*, II (1968) 178ff. G. COLONNA

PALMA DI MONTECHIARO Sicily. Map 17B. In the vicinity of this small town between Licata and Agrigento, interesting archaeological discoveries have been made. At Tumazzo, ca. 1 km from the mouth of the river Palma, an important votive deposit was discovered near a sulphur spring. Besides the traditional female figurines, masks, and late Corinthian and Attic pottery, were found three rare wooden female statuettes, representative of Greek sculpture in the earliest archaic times (Syracuse Museum). About 5 km E of this spring, on the Castellazzo hill, a Greek archaic center has been discovered. This site too has recently yielded a votive deposit with terracotta figurines in Dedalic style, Corinthian pottery, and an unusual vase of Geloan manufacture with a highly naturalistic triskeles painted on its under side; this motif of the three legs was later to become the geographical symbol of Sicily. The finds from Castellazzo and the sulphur spring document the presence of the Rhodio-Cretan colonists from Gela who occupied this territory in the second half of the 7th c. B.C. during the march along the coast which ended with the foundation of Akragas. Another fortified center, probably a Greek phrourion, has been identified N of Palma at the site called Piano della città. The archaeological finds from Palma are displayed in the Syracuse Museum and in the new Museum in Agrigento.

BIBLIOGRAPHY. P. Orsi, *BPI* (1928) 58ff; G. Caputo, *MonAnt* 38 (1938) cols. 585ff; E. De Miro, *Kokalos* 8 (1962), 128ff. P. ORLANDINI

PALMYRA (Tadmor) Syria. Map 6. Great oasis in the Syrian desert E of Homs, occupied since prehistoric times. Palmyra grew at the end of the Hellenistic period and flourished until the 3d c. A.D., enriched by the caravan traffic between the Roman and Parthian Empires. After Valerian was captured by the Sassanid Shapur, a prince of Palmyra, Septimius Odaenathus, organized the defense of the Roman East. His widow, Zenobia, extended his empire to Egypt. Palmyra was defeated by Aurelian in 272, sacked, and occupied by a Roman garrison. First Diocletian and then Justinian fortified the town against the Persians. It surrendered to the Moslems in A.D. 637 and declined under the Abbassids.

The monuments include the three great sanctuaries of Bêl, Nabo, and Baalshamin; a wide avenue with colonnades at the sides which is crossed by other porticoed streets, a theater, an agora and its annexes, marble fountains, public baths, a palace often called the Camp of Diocletian, ramparts, and numerous necropoleis.

The oasis has two springs: one, not very abundant, is in the center of the ancient city, the other, the Efqa spring, on the W edge of the town. It wells up in a deep cave, shaped artificially into a long tunnel bordered by benches and by small rock-cut chapels with incense altars (*pyrat*) dedicated to the Spirit of the Spring.

The temple of Bêl, to the E, is a vast sanctuary of traditional Syrian plan. A quadrangular area, more than 200 m on each side, is enclosed by a high wall bordered on the inside by porticos; in the middle of this court stood a cella. On the outside, to the W, propylaea dating from the second half of the 2d c. A.D. included a portico with eight Corinthian columns. A wide stairway led up to the portico. In the wall of the peribolus three gates gave access to the W portico of the courtyard, built in the middle of the 2d c. A.D. On the other three sides the porticos (built between A.D. 80 and 120) have a double row of columns, lower than those of the W portico. The brackets jutting out from the shafts, very common at Palmyra, carried honorific statues.

The cella (first half of the 1st c. A.D.) was in the middle of the court, with its long side facing the entry and the door in the center of this long W side. Its original foundations of Hellenistic type, a crepis with steps on all four sides, were transformed into a large podium when the level of the courtyard was lowered at the time the porticos were built. The peristyle consisted of fluted columns, 15 by 8, with capitals bearing acanthus leaves of gilded bronze. A frieze of winged spirits holding garlands of fruit adorns the entablature, which is topped by stepped merlons, and many pieces of the frieze are scattered on the ground. The ceiling of the peristyle consisted of decorated stone compartments. Several limestone beams, now on the ground, have reliefs with traces of painting on them: divinities in front of sacrificial altars, a procession with veiled women and a dromedary carrying the draped image under a canopy, and hunting scenes.

The plan of the cella is unique in Syria. On each of the short sides was a deep niche with a monolithic sculptured ceiling; the niches held the cult statues. The ceiling of the N niche depicts the great god, surrounded by the planets and the signs of the zodiac. In front of the S niche a gently sloping ramp allowed the image to be moved easily to a processional litter.

Near the SW corner of the courtyard is another ramp that passed under the W portico, allowing easy passage for processions and sacrificial animals. Between the cella and the high portico the foundations of the sacrificial altar are visible to the N, and the remains of a consecrated basin to the S. Pieces of sculpture in soft limestone have been found beneath the courtyard (now in the museum). They are remains of a temple of the Hellenistic period.

A wide colonnaded street runs NW from the temple of Bêl, connecting most of the monuments. The street has three parts with different orientations. A monumental arch with three bays and sumptuous decoration marks the first change of direction, a (restored) tetrapylon the second. The first section has been partly cleared. It is about 40 m wide and dates from the first half of the 3d c. A.D. Shops with cut stone facade and banquet hall open under the S portico. Jutting out from the alignment of the colonnade, four tall Corinthian columns form the portico of a nymphaeum with sculpture; its basin occupies an apse flanked by two niches.

The temple of Nabo, S of the monumental arch, was begun in the second half of the 1st c. A.D. and was still under construction in A.D. 146. Following the normal Syrian plan, the cella stood on a high podium in the middle of the enclosure. A wide stairway with an altar on the first step led to the podium from the S, and the peristyle consisted of 6 columns by 12. The temple succeeded a Hellenistic one, pieces of architecture and sculpture from which have been found. A sacred well stood in front of the cella, as well as a monument with small columns and a frieze depicting standing figures— a small chapel or monumental altar. The columns of the porticos had Doric capitals and the roof was supported directly by the architraves. On the back walls, highly colored frescos depicted religious scenes. The propylaea opened to the S. The sanctuary had faced away from the great avenue, which cut off its N portico.

The middle section of the avenue, more than 300 m long and 30 m wide, is the best preserved. It has shops under the porticos and brackets for honorific statues on the columns. On the N side are four columns of pink Egyptian granite from the portico of public baths, which an inscription identifies as Baths of Diocletian. To the S, the colonnade passes beside the theater.

The theater, dating from the 2d c. A.D., was built on flat ground. It has a cavea with 13 well-preserved tiers of seats, an orchestra paved with large rectangular slabs, a scaenae frons whose five doors open on exedras with finely carved frames, and graceful Corinthian columns adorning the middle of the facade. The theater is surrounded by a semicircular court, with a colonnade on the outside. A street with porticos leads S, almost on the axis of the theater, to a triumphal gate with three openings which was later incorporated into the ramparts. West of the theater, a small building with a peristyle courtyard and a room with tiers of seats arranged in a semicircle was probably the Senate. Immediately to the S is a vast rectangular enclosure, with walls over 10 m high and no trace of roofing, porticos, or paving: this was an annex to the agora, on which it opens to the W. To the E it opens on the street of the theater, and to the S was a huge gate, big enough to admit loaded camels. The famous fiscal law of Palmyra, a tariff for caravans, was found just in front of the S wall.

The large agora, which dates from the beginning of the 2d c. A.D., was a quadrangular, walled area, surrounded on the inside by porticos. More than 200 brackets in the columns or walls bore statues of emperors (Septimius Severus and his family), of Roman or Palmyrene officials, Roman soldiers, and caravan leaders. In the SW corner is a banquet hall.

The paved platform and basin of a marble fountain with an apse lie on the N side of the great avenue, facing the street which enters it W of the theater. Immediately to the W, between two columns, a lane with irregular paving-stones leads N to the Temple of Baalshamin. A column on the S portico of the avenue bears an inscription in honor of Zenobia. The monument to the S may be a Caesareum. The tetrapylon (restored) stands on a paved base with two steps. Its 16 granite columns on four massive bases have Corinthian capitals and a sculptured entablature. Around the tetrapylon is an elongated oval space, bordered to the N by a continuous portico.

The W and longest section of the great avenue has a magnificent semicircular exedra under its S portico. The colonnade ends in a funerary temple of the 3d c. A.D., with six columns on its facade, outside the city gate.

To the S an avenue bordered by two porticos ends in an oval space and a gate with a triple bay. This was built at the beginning of the 2d c. A.D. The group of buildings called the Camp of Diocletian lies above this street on the slopes of the mountain chain which bounds the site to the W. Past the triple gate is a large quadrilateral area divided into four quarters by two streets which intersect at right angles under a tetrapylon. The axial street then entered a vast courtyard and ended in a stairway leading to a wide gallery, onto the center of which opened a large apsidal chamber, flanked on each side by several rooms. The dominant position, arrangement, and sculptured decoration suggest that this was the palace of the princes of Palmyra, later rearranged by the Roman governors. A temple dedicated to Arab divinities lay to the N, at the end of the transverse street. In the district NW of the great avenue was a grid of streets, between houses with peristyles of the 3d c. A.D. Two Christian basilicas of the usual three-nave plan were built there in the 5th c.

The Temple of Baalshamin, farther E, was dedicated in 132, two years after Hadrian's visit to Palmyra. It consists of a cella, without a podium, set in the middle of a complex group of courtyards. The cella is decorated with pilasters on the outside and lighted by windows; its facade has a portico of four Corinthian columns. Much of the sculptured adornment is in the museum. The temple replaced a sanctuary of the previous century, the S courtyard of which had been dedicated in A.D. 33 and the N portico (with a banquet hall partly covered by the 2d c. temple) built in 67. A large courtyard to the N contained archaic sculptures and dedications of the beginning of the 1st c. A.D. In the SW corner of a courtyard to the S, built in the middle of the 2d c. A.D., lay the main entry to the sanctuary.

Houses of the 3d c., E of the temple of Bêl, have produced fine mosaics: Achilles discovered at Skyros, Asklepios (both in the Palmyra museum), and Cassiopeia (Damascus museum).

The ramparts, which can be followed for ca. 12 km, have an alternating sequence of three rectangular bastions and one semicircular one. Although commonly attributed to Zenobia, they date to Diocletian and were restored by Justinian. Along the S stretch (ca. 3 m thick) the rampart makes use of the N crest of the wadi and the S walls of the agora. An older fortification, of the 1st c. B.C. at the earliest, included the Efqa spring and ran SW. The Damascus gate has been identified there, on the edge of the necropoleis.

These necropoleis surround the town and have several types of tombs: tower tombs (more than 150), house tombs, and hypogaea. The Valley of the Tombs opens to the SW along the Emesa road. The oldest tower tombs (the most remarkable is that of Atenatan, dating from 9 B.C.) have a lower story with vaults opening to the exterior. The tower tomb of Jamblichus (A.D. 83) has four stories still standing; in it were found pieces of Chinese silk used to wrap the mummified corpses. The tower tomb of Elahbel, finished in A.D. 103, also with four stories, has a balcony like a sarcophagus on the third floor. In the same necropolis was the hypogaeum of Yarhai (partly reconstructed in the Damascus museum). Its plan is normal, an inverted ⊥, but the end of the W lateral branch there is a sarcophagus with a sculpture depicting the deceased lying in the banqueting position, and in the exedra of the central branch (to the S) three sarcophagi form a triclinium for a funerary banquet. Funerary compartments in the walls are sealed by slabs on which are carved busts of the deceased, priests with ceremonial head-dress, and women adorned with heavy jewelry.

In the SW necropolis along the Damascus road, several hypogaea have fresco and stucco decoration: the hypogaeum of the Three Brothers (ca. A.D. 140) has a group of fine sculptures and an exedra with paintings of the beginning of the 3d c. A.D.; that of Atenatan (A.D. 98) has an exedra with a triclinium dating from A.D. 229. Its sarcophagi with sculptures still show traces of painting. The deceased is depicted with his pages and wears Persian costume. Another necropolis, farther E, also has several fine hypogaea: in one of them the two stone leaves of the door at the bottom of the staircase down to the chamber have been preserved. The finest of the house tombs of Palmyra, built in A.D. 236, is in the N necropolis. Many of the sculptures from these necropoleis are now in the museums of Palmyra and Damascus, and in the Louvre.

BIBLIOGRAPHY. R. Wood, *The ruins of Palmyra otherwise Tedmor in the desert* (1753)[PI]; T. Wiegand, *Palmyra, Ergebnisse der Expeditionen von 1902 und 1907* (1932)[MPI]; H. Seyrig, repr. from *Syria* in *Antiquités syr.* 1-6 (1934-68); J. Starcky, "Palmyre, Guide archéologique," *MélStJ* 24 (1941)[MPI]; id., "Palmyre," *Orient Ancien Illustré* VII (1952)[MPI]; id., "Palmyre," *Suppl. au Dictionnaire de la Bible* VII (1960)[MPI]; id. & Munajjed, *Palmyra, The Bride of the Desert* (1948)[MPI]; D. van Berchem, "Recherches sur la chronologie des enceintes de Syrie et de Mésopotamie," *Syria* 31 (1954)[P]; P. Collart, "Le sanctuaire de Baalshamin à Palmyre," *Annales archéologiques de Syrie* 7 (1957)[PI]; K. Michalowski, *Palmyre, Fouilles polonaises 1959-1964* 5 vols. (1960-66)[PI]; D. Schlumberger, "Le prétendu camp de Dioclétien à Palmyre," *MélStJ* 38 (1962)[PI]; A. Bounni & N. Saliby, "Six nouveaux emplacements fouillés à Palmyre," *Annales archéologiques de Syrie* 15 (1965)[PI]; id., "Fouilles de l'annexe de l'agora à Palmyre," ibid. 18 (1968); id., "Die Polnischen Ausgrabungen in Palmyra 1959-1967," *ArchAnz* 83 (1968)[PI]; A. Ostraz, "La partie médiane de la rue principale à Palmyre," *Ann. arch. arabes syr.* 19 (1969)[PI]; M. Gawlikowski, *Monuments funéraires de Palmyre* (1970)[PI]; id., *Palmyre, VI: Le temple palmyrénien* (1973)[PI]; E. Will, "Le temple de Bêl à Palmyre . . . ," *Ann. arch. arabes syr.* 21 (1971); Chr. Dunant, *Le sanctuaire de Baalshamin . . . III: Les inscriptions* (1971); R. A. Stucky, "Prêtres syriens, I, Palmyre," *Syria* 50 (1973); H. Seyrig et al., *Le temple de Bêl à Palmyre* I (1968), II (1974).

J.-P. REY-COQUAIS

PAMPLONA, *see* POMPAELO

PAMUKKALE, *see* HIERAPOLIS

PANAGJURIŠTE S Bulgaria. Map 12. A town in the district of Plovdiv, noted for its Thracian funerary tumuli of the 4th c. B.C. In them have been found precious golden fittings, as well as objects in silver and bronze, some imported from Greece and some showing Greek influence but of Thracian execution. Among the imported objects are two ornate silver disks showing in bas-relief the struggle between Herakles and the Nemean lion, and bronze amphorae with reliefs. Even more interesting are the examples of Thracian art, such as a silver lamina on which are represented a man, a siren with a lyre, and two winged swine. Typical of the barbaric zoomorphic taste that includes the Thracians in the great decorative tradition of Scythia and Sarmatia are the ornaments in white bronze in the form of lion feet, heads of birds, griffin heads, and other fantastic beasts. An exceptional trove of gold vessels includes four-head rhytons in the form of stags, rams, and goats, decorated with mythological scenes; three oinochoi in the form of female

heads ornamented with bestial figures; an amphora with two handles in the shape of centaurs, decorated with scenes of Achilles at Skyros, Herakles and the serpents, and satyrs with negroid heads. These are in the National Museum at Plovdiv.

BIBLIOGRAPHY. B. Filov, "Monumenti dell'arte tracia," *Izv. Bulg. Arch. Soc.* 6 (1916-18) 1; id., "Denkmäler der thrakischen Kunst," *RömMitt* 37 (1917) 21; id., *L'art antique en Bulgarie* (1925) passim; D. Zoncev, "The Gold Treasure of Panagurište," *Archaeology* 8 (1955) 218-27; id., & B. Svoboda, "Neue Denkmäler antiker Toreutik (Der Goldschatz von Panaguriste)," *Monumenta archeologica Ceskoslovenska Akademie*, IV (1956); id., *Der Goldschatz von Panagurischte* (1959)[I]; H. Hoffmann, *RömMitt* 65 (1958) 121ff. A. FROVA

PANAKTON, *see* LIMES, ATTICA

PANAMARA (Bağyaka) Turkey. Map 7. Site in Caria 25 km W of Muğla, a dependency of Stratonikeia and home of the important sanctuary of Zeus Panamaros. Apart from a visit by Philip V, the sanctuary makes one appearance in history; when Labienus in 40 B.C. failed to capture Stratonikeia, he made an attack on Panamara, but was foiled by the miraculous intervention of the deity (Dio Cass. 48.26).

The site, on a hill above Bağyaka, comprises a rectangular enclosure ca. 100 m square, with a powerful wall of which some 80 m is preserved at the W angle. A smaller enclosure at the summit contained the sanctuary itself, but the buildings within are utterly ruined, and the temples of Zeus and Hera have not been identified. A ruined building some 20 m long in one corner is also of unknown purpose. The principal festivals celebrated at Panamara were the Panamareia, the Komyria, and the Heraia.

BIBLIOGRAPHY. *BCH* 55 (1931) 70; A. Laumonier, *Les Cultes Indigènes en Carie* (1958) 221f; G. E. Bean, *Turkey beyond the Maeander* (1971) 98-100.
 G. E. BEAN

"PANDOSIA," *see* TRIKASTRON

PANEAS or Caesarea Philippi or Neronias (Banyas) Syria. Map 6. City on the NW slope of Mt. Hermon on one of the tributaries of the Jordan. Its great god was Pan, who was identified with Zeus and associated with the Nymphs. The city was refounded under the name Caesarea by Philip the Tetrarch, son of King Herod the Great, in 2-1 B.C., and renamed Neronias under Agrippa II.

The site has not been excavated. Remains of ramparts with towers were visible some time ago, as well as numbers of column shafts scattered in the orchards or incorporated in the mediaeval fortifications, and Doric frieze fragments reused in the parapet of the bridge on the Nahr es-Saari.

The Sanctuary of Pan and the Nymphs was a grotto from which the river emerged under an arched opening; it was set among plane trees and poplars. Niches with shells, framed by fluted pilasters to form little chapels, were carved in the rock face. Dedicatory inscriptions in Greek indicate that two of the niches held statues of Hermes and the nymph Echo. Two columns in front of the grotto may have supported a canopy. Gratings or openwork metal gates protected these rustic sanctuaries, which date from the Roman period.

BIBLIOGRAPHY. V. Guérin, *Description de la Palestine, La Galilée* II (1880); L. Lortet, *La Syrie d'aujourd'hui, Voyages dans la Phénicie, le Liban et la Judée* (1884); R. Dussaud, *Topographie historique de la Syrie antique et médiévale* (1927). J.-P. REY-COQUAIS

PANIONION Turkey. Map 7. Near Güzelçamlı in Ionia, 17 km S of Kuşadası. Here was the Sanctuary of Poseidon Helikonios, the religious place of assembly of the Ionian League. The site was unknown until quite recently; Herodotos (1.148) places it on Mt. Mykale facing N; Strabo (639) calls it the first place after the Samos strait going N, three stades from the sea. This region was disputed between Priene and Samos, but the priesthood belonged to the Prienians. The assembly was accompanied by a festival, the Panionia, held on the ample plain to the N. According to Diodoros (15.49.1) the festival was transferred, because of the constant wars, to a safe place near Ephesos, and it seems to be referred to as the Ephesia by Thucydides (3.104). It was suspended under Persian rule and revived after the time of Alexander.

The sanctuary lay on the summit of a low hill called Otomatik Tepe (formerly the hill of St. Elias) at the foot of the mountain; the remains are scanty in the extreme. From one to three courses of the enclosing wall may be seen, with an entrance on the W; in the middle are traces, mostly cuttings in the rock, of a structure some 18 by 4 m; this is evidently the altar of Poseidon, dated by the excavators to the end of the 6th c. B.C. No temple was found, and none is mentioned in the ancient authorities, who refer only to sacrifices (Diod. *l.c.*; Strab. 384).

At the SW foot of the hill is the council chamber of the Ionian League, a theaterlike building some 30 m in diameter with 11 rows of seats. There is no speaker's platform, but only the leveled rock. Diodoros says that nine cities, not twelve, shared in the assembly, and the excavators see some confirmation of this in the arrangement of the front row of seats; the historian's statement has generally been regarded as a mistake.

Between the council chamber and the sanctuary is a large cave in the hillside. This may well have played a part in the cult of Poseidon, though nothing of interest has been found in it.

BIBLIOGRAPHY. G. Kleiner, *Neue Deutsche Ausgrabungen* (1959) 172-80; G. E. Bean, *Aegean Turkey* (1966) 216-18. G. E. BEAN

PANOIAS Trás-os-Montes, Portugal. Map 19. Rustic sanctuary in the neighborhood of Val de Nogueiras, district of Vila Real. In spite of two inscriptions which refer to a templum, probably no building existed here. What does exist was described and illustrated in the 18th c. by Jerónimo Contador de Argote. There is a complex of rocks with inscriptions and rectangular or circular cuttings of various sizes, called in the inscriptions lacus, laciculus, and quadratam. The cuttings for the most part were prepared to receive wooden covers. One of these rocks has three inscriptions (*CIL* II, 2395) which indicate that the rock served as an altar for offerings to Serapis as well as to the other deities not named, perhaps the Magna Mater, Atys, and Proserpine. Some rocks, without inscriptions, have basins. One, in the time of Argote, had engraved feet—not surprising in a sanctuary of Serapis.

BIBLIOGRAPHY. A. García y Bellido, *Les religions orientales dans l'Espagne romaine* (1967) 132-35[PI].
 J. ALARCÃO

PANOPEUS (Haghios Vlasis) Phokis, Greece. Map 11. On the frontier with Boiotia, S of and below the Narrows of the Kephisos. Panopeus, called "kallichoros" by Homer, was on the "Sacred Road" from Athens to Delphi; Athenian women known as Thyiads danced there, on their way to Delphi (Hom. *Od.* 11.581; Paus. 10.4.1-5). The Phokian king Schedios resided there (Hom. *Il.* 17.306); Epeios, builder of the Trojan Horse, was son

of the eponymous hero Panopeus (*Od.* 8.493-5; *Il.* 23. 665); and Mycenaean remains have been found on the acropolis.

Pausanias found the site a wretched hamlet (no administrative buildings, gymnasium, theater, agora, or fountains, very poor houses). He was, however, shown the burial mound of Tityos, and a mudbrick shrine of Prometheus, near which lay two huge stones, said to be remains of the clay from which Prometheus molded mankind. He was impressed by the city walls, which are still imposing, especially on the S side of the hill. The curtains stand as high as 5 to 6 m; one tower, with its screen-wall partly intact, is ca. 9 m high; and in Dodwell's day some doors and windows of tower-chambers were preserved. These walls, like others in Phokis, must be later than the destruction of 346 (during the Third Sacred War). N of the citadel, Leake traced much of the line of wall descending to the edge of the plain, and enclosing the lower town; and grave inscriptions have been found around the village.

BIBLIOGRAPHY. J. G. Frazer, *Paus. Des. Gr.* (1898) v 216ff; E. Kirsten, *RE* XVIII[2] (1949) 637-49[P]; F. E. Winter, *Greek Fortifications* (1971) 146, 172-73, 248[I].

F. E. WINTER

PANORMOS (Palermo) Sicily. Map 17B. The ancient town is under the well-known city on the NW coast of Sicily. Together with Soloeis and Motya, it belonged to that group of W Sicilian cities to which, according to Thucydides (6.2), the Phoenicians retreated when the Greeks arrived in Sicily, especially in E Sicily where the Phoenicians themselves had settled. Greek imports found in the necropolis, especially proto-Corinthian vases, seem to confirm the foundation date mentioned by Thucydides, that is, ca. mid 7th c. B.C. The name of the city was presumably given to it by the Greeks, who must have been on excellent terms, at least at the commercial level, with the local inhabitants, as attested by the considerable Greek material found within the necropolis.

Besides Thucydides' account, no other information is available until the first Punic war; it is likely however that the city was involved in earlier Graeco-Punic relationships on account of its strategic position and harbor. The Phoenicians always defended Panormos not only during the Punic wars fought by Dionysios of Syracuse but also, more than a century later, when Pyrrhos made one last attempt to unify Sicily under Greek political domination. On that occasion (276 B.C.), Pyrrhos conquered the city but held it for only a short time. The Romans occupied it in 254 B.C. but in 250 B.C., Asdrubal tried to recapture it on behalf of the Carthaginians; he was defeated by the Consul Metellus near the river Oreto. Again in 247 B.C. the Carthaginian general Hamilcar Barca occupied the plateau of Mount Eircte near Panormos, which is almost certainly to be identified with Monte Pellegrino, while the Romans held the city at the foot of the mountain. After three years, Hamilcar abandoned his position and the city passed into Roman hands.

The habitation center was delimited by the sea to the N, Piazza Indipendenza to the S, and the two streams Papireto and Kemonia to the W and E respectively. The entire area was divided into palaeapolis to the S and neapolis to the N, and was surrounded by walls of which a few stretches remain, though heavily repaired in later periods.

The necropolis of Palermo occupies a considerable area defined by Piazza Indipendenza to the N, Via Cuba and Via Pindemonte to the S, Corso Pisani to the E, and Via Danisinni to the W. Several hundred graves have been found, both inhumation and cremation burials in rock-cut chambers or pits. Inhumation was practiced in limestone sarcophagi, cremation in amphoras and pots of various shapes and sizes. From the extent of the cemetery it is estimated that Panormos, after the Punic period, had a population of ca. 30,000, deserving Polybios' description of it (1.38) as the most important city of the Carthaginian dominions. The finds from the necropolis consist largely of Greek vases, both imports and local imitations, of various shapes and periods; there are also objects of silver, bronze, bone, glass, and a few coins and limestone cippi. Panormos had its own mint.

The Archaeological Museum in Palermo is one of the most important in Italy, containing all the archaeological material found in Selinus, Soloeis, Panormos, and many other Sicilian cities, as well as objects from various private collections.

BIBLIOGRAPHY. G. M. Columba, "Per la topografia antica di Panormo," *Centenario di Michele Amari* (1910) II, 396ff[MP]; M. O. Acanfora, "Panormo punica," *MemLinc* 8, 1 (1947) 197ff[PI]; G. Cavallaro, "Panormos preromana," *ASS* (1950-51) 7ff[MP]; I. Tamburello, "Palermo —Tombe puniche rinvenute in via Denisinni," *ArchCl* 20 (1968) 126ff (with previous bibliography); id., "Problemi ceramici di Palermo arcaica, "*Sicilia Archeologica* 6 (1969) 39ff.

V. TUSA

PANSKOE I Crimea. Map 5. An unfortified Greek-native agricultural settlement along the NE shore of Lake Sasyk-Panskoe on the NW Crimean coast. Founded by Chersonesus in the late 4th c. B.C., it perished in the mid 3d c. B.C. probably from a Scythian attack. Excavations indicate that the site was a complex of large villas or farmsteads organized according to a rectangular grid system. Although the rising lake level has covered several of the farmsteads, eleven still remain. The farmsteads are two-storied square buildings consisting of storage rooms, living quarters, and family shrines which enclose interior courtyards.

A necropolis of ca. 50 tumuli lies 100-150 m NE of the site. The most interesting of the excavated barrows, which all date to the time of the settlement, was surrounded by a cromlech and contained several cenotaph graves made of stone slabs. Some of the slabs come from anthropomorphic stelai of the Chersonesus type.

BIBLIOGRAPHY. A. N. Shcheglov, "Raskopki na territorii khory Khersonesa," *Arkheologicheskie Otkrytiia 1969 goda* 257-58; id. et al., "Issledovaniia bliz Iarylgachskoi bukhty v severo-zapadnom Krymu," *Arkheologicheskie Otkrytiia 1970 goda* 251-52; id. et al., "Tarkhankutskaia ekspeditsiia," *Arkheologicheskie Otkrytiia 1971 goda* 342-43; id. et al., "Issledovaniia na khore Khersonese," *Arkheologicheskie Otkrytiia 1972 goda* 353-54; id., "Kurgan-kenotaf bliz Iarylgachskoi bukhty," *KSIA* 130 (1972) 70-76.

T. S. NOONAN

PANTANASSA Haghios Vasilios, Crete. Map 11. Six km W of Sybrita, a small fortified Greek city, with a second larger fortified city just 3 km to the E. Apparently occupied only in Classical and Hellenistic times, and abandoned before the Roman occupation, the city was sited on a N slope on the E edge of the Gorge of Patsos, and covered an area in excess of 2 hectares. On the E side, and sporadically on the S side, the defense wall can be seen, built to a width of 1.5 to 2 m. At least one projecting rectangular tower was built on the E wall, and there are traces of a corner tower at the S end of the E wall. At the SW corner of the site, a stretch of more crudely built wall ending in a semicircular bastion of about 4 m diameter, seems to be a late (?Hellenistic) addition or repair to the original Classical defenses.

Both the city at Pantanassa and that nearby at Veni would presumably have belonged to the great city of Sybrita, but whereas Pantanassa saw no Roman occupation, the city at Veni was occupied continuously, it appears, from archaic to Roman times.

BIBLIOGRAPHY. J.D.S. Pendlebury, *The Archaeology of Crete* (1939) 340, 349, 369; E. Kirsten in F. Matz, *Forschungen auf Kreta* (1951) 151; M.S.F. Hood, P. Warren, & G. Cadogan, "Travels in Crete, 1962," *BSA* 59 (1964) 70-71; M.S.F. Hood & P. Warren, "Ancient Sites in the Province of Ayios Vasilios, Crete," *BSA* 61 (1966) 61[M]. K. BRANIGAN

PANTANO LONGARINI, see SHIPWRECKS

PANTELIMONUL DE SUS, see ULMEŢUM

PANTELLERIA, see KOSSURA

PANTIKAPAION (Kerch) Bosporus. Map 5. Chief city and port of the Kimmerian Bosporus, founded by Greek colonists from Miletos in the late 7th-early 6th c. on the site of an earlier settlement, Panti Kapa, on Mt. Mithridates (Strab. 7.4.4; Plin. *HN* 4.87). The city became the capital of the Spartocids in the 5th-4th c. Its economic decline in the 4th-3d c. was the result of the Sarmatian conquest of the steppes and the growing competition of Egyptian grain. In 63 B.C. the city was partly destroyed by an earthquake. Raids by the Goths and the Huns furthered its decline, and it was incorporated into the Byzantine state under Justin I in the early 6th c.

On Mt. Mithridates the earliest traces of houses can be seen. Dating to the end of the 7th c. and beginning of the 6th c. B.C., they are almost square in plan and consist of just one room. In the 6th c. B.C. the houses were enlarged to two rooms and nearby were built larger houses. These had several fairly luxurious rooms and painted stucco walls. From the end of the 5th c. B.C. date the remains of the walls that surrounded the city and traces of a sacred building on top of Mt. Mithridates, probably an Ionian peripteral temple (ca. 20 x 40 m), as well as a few fragments of the architrave and some column bases. A marble altar fragment has also been found. In the 4th c. the city covered an area of 100 ha with larger houses. In the 3d-2d c. B.C. a new type of house appeared having a peristyle courtyard; the walls of the rooms were decorated with reliefs of painted stucco or terracotta friezes, also in relief. The city was greatly influenced by indigenous cultures in the early centuries A.D., in which period several complexes were put up containing cisterns for wine production, as well as a considerable number of potters' kilns. Traces of religious architecture include a fragment of the Doric architrave containing the votive inscription of the temple that was dedicated to the cult of the Bosporan king Aspurgos, A.D. 23.

The funerary architecture is monumental: a succession of kurgans 4th c. B.C.-2d c. A.D.—the Golden Kurgan, Royal Kurgan, Kul Oba and Melek Cesme—show the complete evolution of this type of tumulus tomb (see below). The Demeter kurgan, which dates from the 1st c. A.D., is much smaller than these and has a well-preserved fresco. In the center of the cupola is a medallion containing the head of Demeter. A frieze on the walls represents Pluto, Demeter, the nymph Calypso, and Hermes. The frescos in still later tombs show mainly battle scenes, gradually giving way to more schematic, geometric designs. The rich grave gifts in the tombs indicate the wealth of the city and its inhabitants.

During the first centuries of the city's existence, imported Greek articles predominated: pottery, terracottas, and metal objects, probably from workshops in Rhodes, Corinth, Samos, and Athens. Local production, imitated from the models, was carried on at the same time. Athens manufactured a special type of bowl for the city, known as Kerch ware. Local potters imitated the Hellenistic bowls known as the Gnathia style as well as relief wares—Megarian bowls. The city minted silver coins from the mid 6th c. B.C. and from the 1st c. B.C. gold and bronze coins. The Hermitage and Kerch Museums contain material from the site.

BIBLIOGRAPHY. E. H. Minns, *Scythians and Greeks* (1913) 562-66; M. I. Rostovtsev, *Skifiia i Bospor* (1925) 176-250 = M. Rostowzew, *Skythien und der Bosporus* (1931) 164-227; I. B. Zeest, ed., *Pantikapei* [Materialy i issledovaniia po arkheologii SSSR, No. 56] (1957); id., & I. D. Marchenko, eds., *Pantikapei* [Materialy i issledovaniia po arkheologii SSSR, No. 103] (1962); V. D. Blavatskii, "Raskopki Pantikapeia v 1954-1958 gg.," *SovArkh* (1960) 2.168-92; id., *Pantikapei. Ocherki istorii stolitsy Bospora* (1964); A. L. Mongait, *Archaeology in the USSR*, tr. M. W. Thompson (1961) 192-93; C. M. Danoff, *Pontos Euxeinos* (1962) 1119-24 = *RE* Suppl. IX; E. Belin de Ballu, *L'Histoire des Colonies grecques du Littoral nord de la Mer Noire* (1965) 137-43; I. B. Brašinskij, "Recherches soviétiques sur les monuments antiques des régions de la Mer Noire," *Eirene* 7 (1968) 97-99; I. D. Marchenko, "Raskopki Pantikapeia v 1959-1964 godakh," *Soobshcheniia Gosudarstvennogo Muzeia izobraziteľnykh iskusstv imeni A. S. Pushkina* 4 (1968) 27-53; S. S. Bessonova, "Raskopki nekropolia Pantikapeia v 1963-1964 gg.," *SovArkh* (1969) 1.137-46.

Golden Kurgan. Tumulus tomb near Kerch dating to the 4th c. B.C. The mound, which is strengthened with stones at the base, is 21 m high and 240 m in circumference. The dromos is 4.75 m long, the circular burial chamber, which is 6.4 m in diameter and 9 m high, being built like a wall with 17 courses of stone blocks to make a false cupola. Excavations have shown that the tomb was looted in antiquity.

BIBLIOGRAPHY. E. H. Minns, *Scythians and Greeks* (1913) 194-95; G. A. Tsvetaeva, *Sokrovishcha prichernomorskikh kurganov* (1968) 36-39; E. A. Molev & N. V. Moleva, "Arkheologicheskie nakhodki v Kerchi," *Arkheologicheskie Otkrytiia 1972 goda* 314-15.

Royal Kurgan. Tumulus tomb dating to the last decades of the 4th c. B.C., situated 4 km NE of Kerch. It is one of the most striking examples of architectural remains of the Graeco-Roman era in the region along the N coast of the Black Sea. The mound 17 m high is fortified at the base by a wall 260 m in circumference. The burial chamber (4.4 x 4.24 m) is approached by a dromos 36 m long, covered by a false arch of stone. There is a similar cupola of 17 courses of stone in the burial chamber. Excavations have shown that the kurgan was looted in antiquity.

BIBLIOGRAPHY. E. H. Minns, *Scythians and Greeks* (1913) 194; I. Brashinskii, *Sokrovishcha skifskikh tsarei* (1967) 60; G. A. Tsvetaeva, *Sokrovishcha prichernomorskikh kurganov* (1968) 39-42.

Juz-Oba. A rocky mountain range just SW of Kerch is the site of a kurgan necropolis dating to the 4th c. B.C. Among the important burials are: Kekuvatskii kurgan, Ak-Burunskii kurgan, Pavlovskii kurgan, a kurgan with a dual vault (No. 48), a kurgan with a semicircular vault (No. 47), and Zmeinyi kurgan. Because these kurgans as a whole combine both Greek and Scythian elements, they appear to be connected either with Hellenized Scythians or barbarized Greeks from nearby Pantikapaion.

Most of the tombs are representative of one type of Bosporan tomb architecture, i.e., they consist of a dromos and square burial chamber with a false arch, the whole being covered over with the mound of earth. The only exception is the Pavlovskii kurgan, which consists of a simple rectangular tomb made of slabs of stone below the tumulus. Inside the tomb a wooden sarcophagus contains a woman's skeleton adorned with gold jewelry—a necklace, earrings with pendant in the shape of Nike, three rings, a gilt mirror, and a red-figured pelike with an Eleusinian theme: Demeter, Pluto, Kore, and Triptolemos. The tomb probably was that of a priestess of Demeter. Hermitage Museum.

BIBLIOGRAPHY. M. Rostovtsev, *Antichnaia dekorativnaia zhivopis' na iuge Rossii* (1914) 99-109; id., *Skifia i Bospor* (1925) 192-95 = M. Rostowzew, *Skythien und der Bosporus* (1931) 176-80; K. E. Grinevich, "Iuz-Oba. (Bosporskii mogil'nik IV v. do n.e.)," *Arkheologiia i istoriia Bospora, I* (1952) 129-47; G. A. Tsvetaeva, *Sokrovishcha prichernomorskikh kurganov* (1968) 50-60; M. I. Artamonov, *Treasures from Scythian Tombs in the Hermitage Museum, Leningrad* (1969) 72-73.

Melek Cesme. A kurgan in the N part of Kerch and dating to the end of the 4th c. B.C. The tumulus (12 m high, 60 m in diameter) consists of a long dromos (9 m; height, 3 m) and a square burial chamber (3.7 m to a side) with a false arch. There are three stone courses over the burial chamber. The kurgan was destroyed before its excavation, probably in antiquity. Among the finds are Attic wares of the 4th c. B.C., metal bowls and some Greek arms and jewelry. The Hermitage Museum contains material from the kurgan.

BIBLIOGRAPHY. G. A. Tsvetaeva, *Sokrovishcha prichernomorskikh kurganov* (1968) 42-44.

M. L. BERNHARD & Z. SZTETYŁŁO

PAPCASTLE, see DERVENTIO

PAPHOS or Nea Paphos (Kato Paphos) Cyprus. Map 6. On the W coast. The ruins cover an extensive area, about 100 ha, part of which is now occupied by the modern village of Kato Paphos. Vast necropoleis extend N and E. Nea Paphos, or simply Paphos, was the capital of Cyprus during the latter part of the Hellenistic period and throughout the Roman era. Nea Paphos should not be confused with Palaipaphos (q.v.), which lies some 16 km to the SE, which as the earlier of the two cities was the seat of the kingdom of Paphos and the center of the celebrated cult of Aphrodite. Nea Paphos is definitely a later city founded sometime in the 4th c. B.C. Apart from the contemporary cemeteries, a large necropolis of the Geometric, archaic, Classical, Hellenistic, and Graeco-Roman times exists further inland within the limits of the modern town of Paphos, but the city to which this necropolis belongs remains unidentified.

The historical sources for Nea Paphos are late and their evidence is confusing for it is not always clear to which of the two cities they refer, though generally speaking Paphos, at least in the earlier authors, denotes Palaipaphos. The use of Paphos, to designate Nea Paphos becomes current during the 2d c. B.C.

Nea Paphos was probably founded in the latter part of the 4th c. B.C. by Nikokles, the last king of the Paphian kingdom, to serve as his economic and political capital. The destruction of the city of Marion in 312 B.C. by Ptolemy Soter and the transfer of its population to Paphos may refer to this new city. Nikokles was awarded the people of Marion for his fidelity to Ptolemy and it is not unreasonable to suggest that the inhabitants of Marion were sent to people a newly founded city.

Nea Paphos gradually grew in importance and by the beginning of the 2d c. B.C. had taken the place of Salamis as capital of Cyprus.

Nea Paphos had in Ptolemaic times a shipbuilding industry. Ptolemy II Philadelphos (284–246/245) had two large ships built there by the naval architect Pyrgoteles son of Zoes, to whom a statue was erected in the Temple of Aphrodite at Palaipaphos.

Under the Ptolemies, Nea Paphos (hereafter Paphos) enjoyed certain forms of liberty, as for example, a βουλή and δῆμος and a γραμματεύς. The importance of Paphos is shown by the fact that this city along with Salamis and Kition preserved the right to issue coins. In fact, the Paphian mint was the most important, and was the only one still issuing coins in Roman times. Recent excavations brought to light a hoard consisting of 2484 silver Ptolemaic tetradrachmas, the majority of which were minted in Paphos. The others were minted in Salamis and Kition. Molds were found also for casting flans as well as bronze flans for making coins, again of the Ptolemaic period.

Paphos, which had been increasing in importance under the Ptolemies and had become the capital of Cyprus, retained this position throughout the Roman period until the 4th c. A.D. when it reverted to Salamis. The earliest written record of the city as capital of Cyprus occurs in the Acts of the Apostles (13:5-13), which describes the visit of St. Paul, John, Mark the Evangelist, and St. Barnabas to Paphos (A.D. 45), the seat of the proconsul Sergius Paulus, whom they converted to Christianity.

The cities of Roman Cyprus were governed by a δῆμος and βουλή and there is nothing to indicate that the Romans ever founded a colonia or municipium in the island. A joint organization termed the Κοινὸν Κυπρίων (Federation of Cypriots), which was functioning under the Ptolemies, continued during the Roman period.

At some time in the 4th c. A.D. Paphos yielded to Salamis its place as the metropolis of Cyprus, possibly because of the severe earthquakes of 332 and 342, in which both cities were badly shaken. Paphos was eventually rebuilt but it never regained its lost glory. The city became in Early Christian times the seat of a bishop and within reduced limits it continued to be a city of some importance. It survived the Arab raids.

The principal monuments uncovered to date include the House of Dionysos with floor mosaics, a large public building also with floor mosaics, an odeon, two Early Christian basilicas, and the Early Byzantine Castle. The city wall can still be traced for most of its course and the breakwaters of the ancient harbor are still there. Moreover we know the site of the gymnasium, of a Hellenistic theater, of a garrison camp, of the Temple of Apollo Hylates, and of other monuments. From inscriptions we are also informed of the worship here of Aphrodite, Zeus, Apollo, Artemis, and Leto. Most of the ruins of this city, however, remain unexcavated.

The House of Dionysos (ca. A.D. 3d c.) is of impressive dimensions; it occupies an area of ca. 2000 sq. m, of which about one-quarter is paved with mosaics. It is an atrium-type house with an impluvium in the center. The floor of the rectangular portico thus formed around the impluvium was paved with mosaics. The rooms all around the atrium were similarly paved. To the E lie the bedrooms and the bathrooms and a small peristyle vivarium. To the W are the kitchens and the workshops. The main entrance is at the SW, leading up from the S street. Remains of painted stucco indicate that the walls of the house were also decorated with polychrome geometric or floral patterns.

The pavement mosaics are composed of magnificent polychrome designs of great artistic value and beauty. On three sides of the atrium there are a series of hunting scenes. On the fourth (W) portico are four panels of figures from Greek mythology: Pyramos and Thisbe; Dionysos, Akme, Ikarios and the First Wine Drinkers; Poseidon and Amymone; and Apollo pursuing Daphne. The most important room is probably the tablinum. In its center a large rectangular panel depicts a vintage scene. Along its E, narrow end is another mythological scene representing the Triumph of Dionysos. This panel is flanked by the Dioskouroi. Other figure representations exist in other rooms: Hippolytos and Phaidra, Ganymede and the Eagle, the Peacock, the Four Seasons, and Narcissus. Moreover, many other rooms are paved with a geometric decoration only but again of a great variety of color and pattern.

What appears to be a public building of Late Roman times, due S of the House of Dionysos, has been under excavation since 1965. This edifice has an inner peristyle court, 56 x 43 m, surrounded by long porticos with rows of rooms adjacent to them. So far only parts of the N, the W, and the S wings have been excavated. The porticos and most of the rooms were paved with mosaics, but they are, with few exceptions, badly damaged. At the E end of the S corridor is an apsidal room, which was probably the corner chamber of the E wing. It contains within a medallion a mosaic pavement depicting Theseus slaying the Minotaur, Ariadne and personifications of Crete, and the Labyrinth. In one of the S rooms another relatively well-preserved mosaic floor depicts the Three Fates, Peleus, Thetis, and Achilles.

An odeion was recently excavated on the E slope of a low hill where the modern lighthouse stands, believed to be the acropolis. The odeion, which was entirely built, suffered much damage at the hands of quarrymen but 12 rows of seats were identified.

The parodoi were also badly looted but the remains of their foundations indicate that spectators entered the orchestra by a Γ-shaped parodos similar to those of the theater at Soloi. The stage-building, constructed of large well-dressed stones, extended beyond the parodoi. Only its floor survives. The diameter of the semicircular orchestra measures ca. 12 m. The lower course of the outside analemma is well preserved; the diameter of the cavea is ca. 47.7 m. The Paphos odeion, the first of its kind known in the island, dates from the beginning of the 1st c. A.D. It has been partly restored.

On the S slope of the Fabrica hill in the E sector of the city can be seen the remains of another theater, still unexcavated, looking S and commanding a wide and beautiful view over the city below and the sea beyond. The upper part of the cavea is cut in the solid rock, where many rows of seats are still visible. Inscriptions date the theater to the 3d c. B.C.

The city wall may be traced in practically all its course but the better preserved part lies to the NW. At this point the circuit follows the edge of the artificially scarped cliffs. Here too lies the NW gate, the foundations of which are cut in the rock. The approach from the sea was by a bridge, also rock-cut, which slopes gently outside the gate to a length of some 36 m. The gate itself was flanked by towers. There still exist some sally ports. A NE gate is also visible and there were probably a N and an E one. Apparently there were towers at regular intervals all along the circuit. This city wall may have been originally built by King Nikokles, the founder of Nea Paphos.

The ancient harbor, still used by small craft, was mainly artificial with its two breakwaters projecting into the sea for a considerable distance. The surviving length of the E arm is 350 m, that of the W one is 170 m.

A complex of underground chambers to the N of the city may be part of the camp of a garrison. The complex consists of a long vaulted passage with chambers opening along the E side and at the far end to the N. Two of these chambers resemble those of the Sanctuary of Apollo Hylates (see below) and it is possible that they served as a sanctuary but only as part of a larger compound of buildings and it appears that the whole was surrounded by a wall. The date to be assigned to them should be the end of the 4th c. B.C.

The Sanctuary of Apollo Hylates lies to the E outside the limits of the ancient city. Cut in the solid rock it is composed of two underground chambers entered by a flight of steps. The front chamber is rectangular; the back one, circular with a dome-shaped roof. Two rockcut inscriptions in the Cypro-syllabic script, cut above the entrance of the cave, inform us that it was dedicated to Apollo Hylates. These inscriptions are dated to the end of the 4th c. B.C., hence the sanctuary should be contemporary with the foundation of Nea Paphos.

The Tombs of the Kings lie in the N necropolis about 1.5 km from the city. They consist of an open peristyle court in the center with burial chambers all around, and are entirely cut in the solid rock below ground level and are entered by a flight of steps, also rock-cut. The peristyle is of the Doric order; each side of the court is decorated as a temple facade with Doric columns and an entablature of triglyphs and metopes. These tombs, which do not follow in the traditional tomb architecture of Cyprus, may have their prototypes in Alexandria. They date from Hellenistic times and were probably used for the burial of the Ptolemaic rulers of the island.

From the city site come a number of marble sculptures and inscriptions of the Hellenistic and Graeco-Roman period.

The finds are in the Nicosia and Paphos Museums.

BIBLIOGRAPHY. D. G. Hogarth, *Devia Cypria* (1889); A. Sakellarios, Τὰ Κυπριακά I (1890); I. K. Peristianes, Γενικὴ Ἰστορία τῆς νήσου Κύπρου (1909); Jean Berard, "Recherches Archéologiques à Chypre dans la région de Paphos," *RA* 43 (1954) 1-16[MI]; Jean Deshayes, "Chronique Archéologique, Les Fouilles Françaises de Ktima," *Syria* 35 (1958), 412-21[I]; id., *La Nécropole de Ktima* (1963); V. Karageorghis, "Chronique de Fouilles et Découvertes Archéologiques à Chypre," *BCH* 84 (1963) onwards; K. Nicolaou, "The Mosaics at Kato Paphos: The House of Dionysos," *Report of the Department of Antiquities, Cyprus* (1963) 56-72[MPI]; id., "Excavations at Nea Paphos: The House of Dionysos. Outline of the Campaigns 1964-1965," *Report of the Department of Antiquities, Cyprus* (1967) 100-125[PI]; id., *Ancient Monuments of Cyprus* (1968); id., *Nea Paphos An Archaeological Guide* (1970); W. A. Daszewski, "A preliminary report on the excavations of the Polish Archaeological Mission at Kato (Nea) Paphos in 1966 and 1967," *Report of the Department of Antiquities, Cyprus* (1968) 33-61[PI]; id., "Polish Excavations at Kato Paphos, in 1968-1969," *Report of the Department of Antiquities, Cyprus* (1970) 112-41[MPI]; id., "Polish Excavations at Kato (Nea) Paphos in 1970 and 1971," *Report of the Department of Antiquities, Cyprus* (1972) 204-36.

K. NICOLAOU

PAPHOS or Palaipaphos (Kouklia) Cyprus. Map 6. In W Cyprus, ca. 1.5 km from the sea, some 16 km SE of Nea Paphos. The ruins cover a large area, part of which is now occupied by the modern village of Kouklia. A vast necropolis extends NE, E, and S of the city.

Palaipaphos or simply Paphos was the capital of the kingdom of Paphos and the celebrated center of the cult of Aphrodite.

The traditional founder of Paphos was Agapenor, king of Tegea in Arkadia in the Peloponnese, who founded the Temple of Aphrodite in that city.

According to another legend, the cult of Aphrodite was established earlier by Kinyras, the proverbial king of Paphos or of all Cyprus, who, as the *Iliad* tells us, sent to Agamemnon a notable cuirass when he heard of the expedition against Troy. The priest-kings of Paphos traced their origin to Kinyras, and a dynasty called the Kinyradai ruled Paphos down to Ptolemaic times.

The Temple of Aphrodite was the most notable sacred edifice in Cyprus and the most famous Temple of Aphrodite in the ancient world. There, according to tradition, Aphrodite first set foot upon the shore after having been born of the foam of the sea. The Holy Grove and Altar of Aphrodite in Paphos are mentioned by Homer; since then many historians and geographers of antiquity have described and mentioned this Shrine of the Goddess of Beauty and Love, often called Paphia. The very Tomb of Aphrodite was shown in Paphos.

Strabo and Pausanias confuse Old and New Paphos and refer to Nea Paphos as the city founded by Agapenor. Archaeological evidence, however, is against this view for, whereas the presence of the Mycenaeans in Old Paphos is well attested, the founding of New Paphos cannot be earlier than the 4th c. B.C.

Recent excavations have shown that heavy fighting took place at the NE defenses of the city at the time of the Ionian Revolt (499-498 B.C.). Nikokles, son of Timarchos, the last king of Paphos, was also the founder of New Paphos. He remained faithful to Ptolemy and when in 312 B.C. Marion was razed, its inhabitants were transferred to Paphos, most likely New Paphos. Old Paphos, however, still flourished in Hellenistic and Graeco-Roman times and retained its status as the principal center of the cult of Aphrodite. In fact, Strabo tells us that at the annual festival of Aphrodite men and women, from other cities as well as from Paphos walked from New to Old Paphos, a distance of 60 stadia.

Very little is known of the earlier history of Palaipaphos. The name appears on the prism of Esarhaddon (673-672 B.C.) where Ituander, king of Pappa, is interpreted as Eteandros king of Paphos. Two gold bracelets of the late 6th or early 5th c. B.C. which are said to have been found at Kourion bear in Cypriot script the name Eteandros, king of Paphos. The sequence of its kings from the beginning of the 5th c. B.C. is fairly well fixed from coins and from inscriptions.

The principal monuments uncovered up to the present day include part of the fortifications of the city excavated in recent years and the Temple of Aphrodite, which was excavated towards the end of the 19th c. Most of the ruins of this large city, however, remain unexcavated. The existence of a gymnasium and of a theater is attested by inscriptions but their sites remain unidentified. The oracle is known both from an inscription and from literary sources.

Of particular importance are the NE fortifications of the city. The sector uncovered thus far is at the Marcello hill, due NE of the village of Kouklia. A wall running for ca. 90 m in a SE-NW direction was cleared. At the SE end a rectangular tower projecting from the outward face of the wall was uncovered. At the NW end are two bastions with a gate in between. But most important perhaps of all the fortifications is the siege mound between the gate and the tower. The city defenses date

from Late Geometric or early archaic down to Late Hellenistic times.

Of particular interest are the fortifications of the time of the Ionian Revolt (499-498 B.C.) with the construction of siege and countersiege works. The mound was raised by the Persians when besieging the city. The most striking feature of the siege mound is the variety of its contents: stones, earth, ashes, burnt bones, carbonized wood, and numerous architectural, sculptural and epigraphical fragments, many of which were damaged by fire.

The architectural finds include fragments of Proto-Ionic volute capitals, acroteria, architraves, and various moldings. There are a number of altars, bases, and many votive columns. More remarkable are the great quantities of limestone sculpture, among which are Kouroi clad in the Cypriot "belt" and parts of sphinxes and lions. All the sculptured remains date from the archaic period, mostly of the middle or the later part of the 6th c. B.C. To the same context belong over 190 syllabic inscriptions, many of them obviously dedications. The large amount of sculptural and architectural debris proves that there existed an important archaic sanctuary in the vicinity outside the walls and that this shrine was used by the Persians as a quarry for building the ramp in a hurry. The siege mound also contained a large number of rough, round-shaped stones, probably used as ballistic missiles. Besides the materials described the mound contained great quantities of weapons: javelin points, spearheads and arrowheads both of iron and bronze, and an exceptionally well-preserved late archaic bronze helmet of the Greek type with engraved ornaments, resembling the so-called Miltiades helmet from Olympia.

On the other hand, a series of underground sally ports were made by the besieged for mining the mound. Severe fighting took place during the construction of the ramp, to judge from the quantity of missiles found, and the defenders were able to mine the ramp by setting fire to the support of the tunnels, thereby causing it to collapse.

The set-back NE gate has an outer (N) cross-bastion and an inner (S) cross-bastion on the opposite side. The presence of many spearheads and arrowheads and the extensive damage to the gate also indicate heavy fighting at the time of the Ionian Revolt. In the 4th c. B.C. a series of guard rooms were built on the N side of the gate.

The temple of Aphrodite lies on a hill at the SW sector of Palaipaphos. Unfortunately very little of this temple survives and most of its ruins date from Graeco-Roman times (excavated in 1887).

The plan as uncovered to date may be divided into two sections: the S wing, of which very imperfect remains exist; and the great rectangular enclosure to the N; its sides are ca. 9 m long, within which area are included the S stoa, several chambers of various sizes, the N stoa, a large open court, and the central hall.

The great rectangular enclosure seems originally to have consisted of a range of buildings extending along the whole of the E side with a great open court to the W of it, which was flanked on the N by a wide stoa extending along its whole width and probably originally by a similar stoa extending along the S front. Whether this court ever had a W wall it is impossible to say without further investigation.

When in Roman times the temple was restored after its destruction by earthquakes on two separate occasions all traces of the S stoa were destroyed and a new one of large proportions was built. The central hall dates also from Roman times but the chambers running up

the E side belong to the pre-Roman period. To the same period may be assigned the walls of the N stoa.

Very little of the plan of the temple can be worked out from the existing remains and our knowledge of the temple is better derived from coins of the Augustan and later periods.

A large conical stone, now in the Cyprus Museum, came from the area of the Temple of Aphrodite and may be an aniconic representation of the goddess. It is possible that this stone once stood in the central room of the temple. The central feature of the shrine is shown on representations of the temple on Cypriot coins of the Roman era.

Many Greek alphabetic inscriptions of the Hellenistic and Roman era were found in the area of the temple. Of these some are dedications to Aphrodite Paphia while others are honorific. An important inscription of the Early Hellenistic period is a dedication of Ptolemy II to his naval architect Pyrgoteles son of Zoes. A house of the atrium type of the 3d-4th c. B.C. to the W of the Temple of Aphrodite was excavated in 1950 and 1951.

The finds are in the Cyprus Museum, the Paphos District Museum, and the site museum at Kouklia.

BIBLIOGRAPHY. Chr. Blinkenberg, "Le Temple de Paphos," *Det Kgl. Danske Videnskabernes Selskab. Historisk-filologiske Meddelelser* IX.2 (1924) 1-40[I]; A. Westholm, "The Paphian Temple of Aphrodite," *Acta A* 4 (1933) 201-36[PI]; T. B. Mitford, "The Kouklia Expedition," *The Alumnus Chronicle, The University of St. Andrews* 36 (1951) 2-8; J. H. Iliffe & Mitford, "Excavations at Kouklia (Old Paphos), Cyprus 1950," *AntJ* 31 (1951) 51-66[MPI]; id., "Excavations at Aphrodite's Sanctuary at Paphos," *Liverpool Bulletin* 2 (1952) 28-66[PI]; Jorg Schäfer, "Ein Persebau in Altpaphos," *Opuscula Atheniensia* 3 (1960) 155-75[MPI]; V. Karageorghis, *Nouveaux Documents pour l'Etude du Bronze Récent à Chypre* (1965); id., "An Early XIth century B.C. Tomb from Palaepaphos," *Report of the Department of Antiquities, Cyprus* (1967) 1-24[MPI]; id., "Nouvelles Tombes de Guerriers à Palapaphos," *BCH* 91 (1967) 202-47[MPI]; F. G. Maier, "Excavations at Kouklia (Palaepaphos)," *Report of the Department of Antiquities, Cyprus* (1967) 30-49[MPI]; (1968) 86-93[MI]; (1969) 33-42[MPI]; (1970) 75-80[I]; (1971) 43-48[PI]; (1972) 186-201[MI]; H. W. Catling, "Kouklia: Evreti Tomb 8," *BCH* 92 (1968) 162-69[MI].

K. NICOLAOU

PARAMYTHIA, *see* PHOTIKE

PARAVOLA ("Bukation") Aitolia, Greece. Map 9. The most important modern village between Agrinion and Thermon, N of Lake Trichonis, and the site of a large Hellenistic fortress. It has been identified with Phistyon and Bukation, both of which are located in the region by inscriptions. The site is an isolated hiil sloping down on the S side to the plain which it commands. The city wall included a sizable area of the lower ground, and appears to represent several building periods; the latest parts, such as the round towers, are comparable to the E wall at Thermon, dated to the 2d c. B.C.

BIBLIOGRAPHY. J. Woodhouse, *Aetolia* (1897); F. Noack in *Arch. Anz. (JdI)* 31 (1916) 231[I]; E. Kirsten in *RE* 20 (1941) 1297; A. Philippson-Kirsten, *GL* (1950-59) II 335, 339.

M. H. MC ALLISTER

PARENTIUM (Poreč) Croatia, Yugoslavia. Map 12. On the peninsula ca. 400 m long E-W and 200 m wide N-S, in the center of the W coast of Istria, a site settled by the Illyrians in the Late Bronze Age. Livy mentions it in the battles between the Romans and the Histri in 178-177 B.C. (41.11.1). In the second half of the 2d c. B.C. a castrum was built here on the consular road along the coast. Later it developed into an oppidum civium Romanorum (Plin. *HN* 3.19.129). Octavian gave the settlement the rank of municipium, and in the 1st c. A.D. Tiberius made it Colonia Iulia Parentium.

The colony had a large ager centuriatus extending between the Mirna (Ningus) river and Limski Channel. The settlement developed an orthogonal street grid with cardo and decumanus. Some of the ancient insulae are still preserved in the town grid. The decumanus is the principal street today and bears this name in its Croatian form (Dekuman). The forum (46 x 45 m), situated at the W end of the decumanus and peninsula, had glimpses of the sea. Its W side was closed by temples of Mars and Neptune, typical of Classical temple architecture in the 1st c. A.D. Poreč still preserves an important Early Christian church, the basilica of Bishop Euphrasius from the 6th c. In the environs of Poreč are many ancient villa sites with mosaics.

Tombs with the interesting tombstones are preserved with the other finds in the local Museum of Poreč County.

BIBLIOGRAPHY. A. Degrassi, *Inscriptiones Italiae, X/II* (1934); id., *Parentium* (1934); M. Prelog, *Poreč, Grad i spomenici* (1957); Š. Mlakar, *Die Römer in Istrien* (3d ed., 1966); A. Šonje, "La costruzione preeufrasiana di Parenzo," *Zbornik Poreštine* 1 (1971).

M. ZANINOVIĆ

PARGA ("Toryne") Greece. Map 9. A ladle-shaped port in S Epeiros which Octavian occupied before the battle of Actium (Plut. *Ant.* 62). The vicinity has yielded a Mycenaean tholos tomb and later tombs, and there are remains of ancient walls in the foundations of the Turkish fort.

BIBLIOGRAPHY. P. M. Petsas in *EphArch* (1955) 14; S. I. Dakaris in *Ergon* (1960) 110; N.G.L. Hammond, *Epirus* (1967) 76f, 688.

N.G.L. HAMMOND

PARGASA, *see* BARGASA

PARION (Kemer) Misia, Turkey. Map 7. A port of great strategic importance on the Hellespont between Lampsakos and Priapos. The city may have been founded by Parion, son of Jason, chief of the settlers of Erythrai; or by the mythic Parilarians, together with colonists from Erythrai and Miletos.

Parion enjoyed enviable prosperity because of its port; and once the kingdom of Pergamon was established, it came under the control of the Attalid dynasty. It passed to the Romans in 133 B.C. under the testament of Attalos III, and under Augustus must have been a flourishing center as the numerous coins coming from Parion designate the city Colonia Pariana Iulia Augusta. Strabo (*Geogr.* 13.588) records a colossal altar constructed at Parion by Hermokreon; and we know that prior to 354 B.C. the sculptor Praxiteles executed a statue of Eros there.

BIBLIOGRAPHY. B. V. Head, *Historia Numorum* (1911); M. Grant, *From Imperium to Auctoritas* (1946); id., *Emerita* 20 (1952); D. Magie, *Roman Rule in Asia Minor* (1950); L. Robert, *Hellenica* 9 (1950), 10 (1955), 11-12 (1960); id., *Villes d'Asie Mineure* (2d ed. 1962); L. Laurenzi, *Riv. Ist. Naz. Arch. St. Arte* 5-6 (1956-57); id., *Ann. Sc. Arch. Ital. Atene* 33-34 (1957); D. Nikolov, *Archeologia* (Sofia) 5 (1963).

N. BONACASA

PARIS, *see* LUTETIA PARISIORUM

PARK STREET Hertfordshire, England. Map 24. Roman villa W of the river Ver and Watling Street, 3.6 km

S of Verulamium (q.v.). It was excavated in 1943-45 (dwelling) and 1954-57 (subsidiary buildings). The site was occupied in the earlier and later Iron Age, and the fact that the Roman house was built directly over three successive Belgic structures (the latest, a pair of rectangular huts dated A.D. 43-60) indicates continuity.

Four Roman periods were distinguished. In the first (late 1st c.) a simple rectangular house (19.8 x 6.9 m) with footings of good masonry, was erected. This was divided into five rooms and had a cellar at its N end, approached by an external stair; a wooden-shuttered well was sunk 6 m to the E. In the second period (mid 2d c.) the house was greatly enlarged by the addition of a corridor on the W and further rooms on the N and S, to give an over-all size of at least 33.6 by 15 m; a channeled hypocaust (corn-drier?) was inserted in the room next to the cellar. This house appears to have fallen into decay and in the third period (ca. 300) extensive rebuilding was undertaken and many modifications made, including the insertion of three channeled hypocausts or corn-driers.

In the fourth period (ca. 340) the stairway to the cellar was filled in, probably being replaced by a ramp on the E, and a fire occurred in the cellar itself. There were no coins later than 360 and the villa appears to have been abandoned in the late 4th c. Subsidiary buildings included a bath block, 34.5 m NE of the house, constructed in the mid 2d c. and rebuilt ca. 300 to give over-all dimensions of 18.5 by 17.1 m; a small two-roomed building with pillared hypocaust 13.5 m SE of the house, attributed to the first period; another small building, 63 m SE of the house, related to periods 1-3; and a group of indeterminate timber structures near the Ver, with possible traces of a timber aqueduct. Two burials in lead-lined stone coffins, enclosed by walls, were found N of the bath block. The villa was never rich—there was no trace of mosaics—and along with Lockleys it has been taken as a type site for the smaller class of villa common in SE Britain.

BIBLIOGRAPHY. H. O'Neil, *ArchJ* 102 (1945) 21-110[MPI]; A. D. Saunders, ibid. 118 (1961) 100-35[MPI].

A.L.F. RIVET

PARLASAN, *see* PARNASSOS

PARMA, *see* COLONIA JULIA AUGUSTA PARMENSIS

PARNASSOS (Parlasan, Ankara) Cappadocia, Turkey. Map 5. The site is a large mound in the hills between the Halys and L. Tatta in the NW corner of Cappadocia. A small town, it was a meeting place of Eumenes and Attalos from Galatia and Ariarathes from Cappadocia in 180 B.C. for their campaign against Pharnaces of Pontos (Polyb. 24.14.8-9). Important junction of roads NW to Ankyra S to Archelais via Nitalis (Ortaköy?) and E via Mocissos (Kırşehir?) to Caesarea Mazaca.

BIBLIOGRAPHY. J.G.C. Anderson in *JHS* 19 (1899) 107-9.

R. P. HARPER

PARNDORF (Bruckneudorf) Austria. Map 20. A Roman country estate close to the Roman road which led from the S (Savaria-Scarbantia) to Carnuntum, about 15 km S of the Danube fortification and within its territory and that of the province of Pannonia (superior). An enclosure wall ca. 1.5 km long, with fortified gates, surrounded a roughly rectangular area of ca. 12 ha. At the center was a rectangular porticus villa (40.5 x 45 m) with protruding corners. The main facade was toward the S, a festive hall or aula with a large exedra 9 m in diameter protruding from the N side. This mansion contained 30 rooms on the ground floor, corridors, etc.; al-

most all of them were equipped for heating. Running water and drains were provided. The luxuriousness of the establishment is indicated by the fact that 11 rooms of ca. 500 sq. m had mosaic floors; of these 185 sq. m were in the aula. It is one of the largest mosaic finds in the Roman Danube provinces. Ca. 320 sq. m are fairly well preserved. The decoration consists partly of figures (e.g. Bellerophon on Pegasos fighting with the Chimera; a medallion with Diana Nemesis?), and is partly ornamental. Many rooms had been decorated at various times with frescos, those of the older periods using figures, those of later times pure ornament.

Several smaller buildings are grouped around the mansion: a well-preserved bathhouse (24 x 19 m), dwellings for the servants, workshops, and farm buildings. Two long farm buildings (each 110 x 18 m), forming the enclosure of a courtyard (24 m wide), indicate the economic capacity of this estate. Even more indicative is an unusually large granary (horreum) with an undivided room (56 x 26 m) two stories high, accessible by a ramp (21 m long).

All the buildings existed over a long period; in some parts three building periods could be identified. The first building phase of the villa, which may have existed as early as ca. A.D. 100, has become unrecognizable owing to rebuilding necessitated by the Marcomannic wars; a large part of the mosaics dates from an extensive renovation ca A.D. 300. The construction of the aula with exedra followed soon after. Clear signs of decline are noticeable in the 4th c. A.D., and the building was destroyed by fire when the Danube limes collapsed.

The whole complex of Parndorf is interesting with regard to the economic structure of the province as the center of a latifundium, or perhaps of a public domain; the architecturally interesting and impressive villa; the opulent mosaics. One may assume that beyond its primary function this villa served also as a residence for dignitaries or even emperors.

For financial reasons it has not been possible to exhibit all the mosaics. They were covered up, except for two, which were transferred to the Burgenländisches Landesmuseum in Eisenstadt.

BIBLIOGRAPHY. E. B. Thomas, *Römische Villen in Pannonien* (1964) 177ff[MPI]; B. Saria, *Festschrift für Alphons A. Barb* (*Wissenschaftliche Arbeiten aus dem Burgenland*, 1966) 252ff[MPI].

R. NOLL

PAROS Greece. Map 9. One of the larger Ionian islands, W of Naxos, celebrated for its fine, white marble. It was an important center of Cycladic culture of the 3d and 2d millennia B.C. (Neolithic finds have been made on the small desert island of Saliangos near Paros) and continued to flourish until Late Mycenaean times. Reflecting this period are the myths about the subjection of the island by Minos (it was on Paros that he learned about the death of Androgeus) and by his sons, who were expelled by Herakles when he captured the island. In historical times lyric poetry flourished here with Archilochos (7th c. B.C.), the poet and warrior, who is the primary source for the myths and history of the island. Paros took an energetic part in the fierce rivalry of the long Lelantine war (8th-7th c. B.C.) and then in the great wars caused by the spread of Greek trade and colonization. Paros' alliance with Eretria and Miletos explains the war with Naxos, which belonged to the rival combination of Chalkis, Corinth, and Samos; it also explains the colonization of Thasos by Telesikles, the father of Archilochos. Thasos, with the Thracian possessions on the mainland (gold mines) was the source of wealth and power, while Paros' chief natural resource was marble, exported everywhere throughout antiquity.

At the peak of its sculptural importance, Parian marble was used in all the major Greek temples and for the manufacture of marble furniture, even for the anthropomorphic sarcophagi of Sidon.

At the beginning of the 5th c. the strength of Paros was demonstrated by the failure of Miltiades' expedition against the island after the battle of Marathon, although he had vowed that he would take it with ease and bring back a wealth of gold (Hdt. 6.133). Themistokles later succeeded in part (Hdt. 8.112). Paros was a member of the Athenian Alliance after this, and as an ally during the Peloponnesian war tried vainly to revolt from Athens in 412-410. Governed either as a democracy or an oligarchy consistent with the style of the ruling power in the Aegean, Paros continued to exist as an important state until the Late Roman period. It maintained connections in various directions and with the support of Dionysios the elder, tyrant of Syracuse, it colonized Pharos, an island off Dalmatia (mod. Hvar) in 385 B.C., an area with which it had apparently had contacts since the prehistoric period, through its fleet. It achieved a cultural flowering in the Hellenistic period. From the 3d c. restoration of the 6th c. B.C. Archilocheion, a heroon which was probably a part of the Gymnasion, come important literary inscriptions: the Parian Chronicle and an extensive Biography of Archilochos with lines from his poetry (an epitome was added in the 1st c. B.C.).

The ancient city, of the same name as the island, is now covered by Paroikia, the modern capital; it was much larger, as can be seen by the preserved portion of the wall, which was continually renewed but whose earliest parts are archaic. The acropolis was on a low peak in the middle of the hill overlooking the modern jetty. A part of this hill including its W peak has fallen into the sea, so only the E end of a large Ionic temple of Athena on the summit has been preserved. This is distinguished by the large gneiss foundation slabs of the opisthodomos and cella, and a few marble courses over the foundations, on which rests the N wall of the church of Agios Konstantinos. Its exact plan is uncertain. Numerous architectural fragments from the buildings of the ancient city, including many from the temple, are built into the nearby Venetian fort; in particular there are parastades (h. 6 m, w. 0.9 m) and a lintel (l. 5.9 m). The doors were as big and as beautiful as those of the contemporary temple at Naxos, and the two may have been the work of the same artisans. Among the marbles in the kastro are also pieces of a Doric colonnade from a stoa of the Late Hellenistic period. The round structure in the kastro is half of a Hellenistic building (heroon?) which was reconstructed in its original form as the apse of a church with orthostates, courses, a Doric frieze, an internal meander and a geison, not in situ.

Remains of houses from the Cycladic town have been found near the archaic temple. These are the most important building remains from this period, although tombs have been found all over the island. Some remains which have not been scientifically investigated have also been found under the Basilica of Katapoliani (the only such building which has been preserved in its entirety; its present appearance dates from the time of Justinian). A noteworthy mosaic depicting the Labors of Herakles and numerous ancient carvings and inscriptions were built into the Basilica or have been discovered in its vicinity. Two archaic bas-reliefs from the frieze of the Archilocheion have been found: the funerary feast (of Archilochos) and a lion attacking a bull.

At the SW edge of the city, near Haghia Anna, are some scanty remains of the Pythion and the Asklepieion, and two high terraces. Only a trace of the supporting wall is preserved of the first, but on the second, the terrace of the Asklepieion, there are two fountains. The earlier one (4th c. B.C.) is smaller, surrounded with plain slabs; the other made of marble. There is a rectangular temenos in front, with colonnades, and an altar inside.

The remains of the Delion are more fully preserved. This is on the flat top of a hill (ca. 150 m) now called Kastro or Vigla, N of Paroikia, above the NW side of the harbor. It consists of a marble peribolos nearly square (26 x 24 m) with an entrance at the S. The peribolos encloses in its NW corner a small Doric temple in antis (9.5 x 5.4 m), the foundations of which are preserved. It dates no earlier than the beginning of the 5th c. Behind the temple, the peribolos wall is interrupted by a projecting terrace with two steps on each side. To the left of the temple are rooms with benches around a mosaic floor, perhaps a banqueting hall (hestiatorion). There are remains of an altar (and possibly another earlier one in front of the temple) under which were traces of an older building which contained finds of the 8th-7th c. B.C. Approximately in the middle of the peribolos is a rock outcropping surrounded by a circular wall which has been theoretically identified as the archetypal altar founded by Herakles in honor of Apollo (Pind., frg. 140a, Snell). There are notable sculptures of the Severe period in the museum. The sanctuary was dedicated to the Delian gods: Delian Apollo, Delian Artemis, Zeus Kynthios, and Athena Kynthia.

To the NW of the Delion, about an hour's drive from Paroikia, is a hill called Kounados with a chapel of Profitis Elias at the summit, where, according to an inscription found there, Zeus Hypatos was worshiped. A little to the W was a shrine of Aphrodite, a temple without a peribolos; S and lower down was a shrine of Eilethyia, a narrow terrace with a spring and a cave next to it carved out to receive offerings. The rock has collapsed so that it is now almost unrecognizable. Nearer the city, 1200 m beyond the Katapoliani, near the road to Naousa, the "Three Churches" or "Crossroads" were shown by excavation to have been built over a three-aisled basilica (6th-7th c. A.D.) into which a number of ancient marbles had been built: architectural fragments, sculpture, inscriptions. Among these is an archaic Ionic column capital with a later inscription (4th c. B.C.) mentioning Archilochos' tomb. It is not likely that all the pieces came from one nearby building, and especially not from the Archilocheion. Three orthostates from this building (including the two with the biographical inscriptions about Archilochos) were found in the E bank of the Elita river and other places in the city.

An hour's drive from Paroikia, near the old monastery of Aghios Mamas, are important marble quarries (lychnites lithos, because quarried by lamplight). There is a continuous underground gallery with entrance and exit close to each other. On the rock at the entrance is a carving of the Nymphs dedicated by Odryses the son of Adamas.

Of the sparse and little-known antiquities from the rest of the island, the most important is the cave of Aghios Ioannis at Dris harbor at the SE end, where there was a shrine of Artemis. Inscriptions and sculpture have been found, including a large statue of a seated Artemis (of the Muses).

The museum contains some prehistoric sherds and Cycladic idols. There are important archaic statues and reliefs, some pottery, inscriptions, and architectural fragments. There is an anthropomorphic sarcophagus as well as later ones, and fragments of funerary heroa.

BIBLIOGRAPHY. O. Rubensohn s.v. Paros, *RE* (1947); *AthMitt* 25 (1900) 341ff; 26 (1901) 157ff; 27 (1902) 189ff; 42 (1917) 1ff; *ArchAnz* (1923-24) 118ff, 278; Ionic temple: G. Gruben & W. Koenigs, "Der 'Hekatom-

pedos' von Naxos und der Burgtempel von Paros," *ArchAnz* (1970) 135ff; Delion: O. Rubensohn, *Das Delion von Paros* (1962) (cf. *Gnomon* [1966] 202ff); Three Churches: A. Orlandos, *Praktika* (1960) 246f; (1961) 184ff; Archilocheion: N. M. Kontoleon, Νέαι Ἐπιγραφαί περί τοῦ Ἀρχιλόχου, *ArchEph* (1952) 32ff.

N. M. KONTOLEON

PARTHENION Bosporus. Map 5. Greek settlement in the Bosporan kingdom, 5 km E of Mirmekion on the N shore of the Black Sea and dating to the 5th c. B.C. (Strab. 7.4.2; 11.2). From the 5th c. B.C. to the 1st-2d c. A.D. the settlement covered an area of 150 by 84.5 sq. m. Pottery and terracottas (busts of Kore) are from Bosporan workshops of the 4th-3d c. Stamped amphorae from Rhodes and Sinope dating to the 3d-2d c. have been found. The Hermitage Museum contains material from the site.

BIBLIOGRAPHY. V. V. Veselov, "Drevnie gorodishcha v raione Siniagino (K voprosu o mestopolozhenii Parfeniia i Porfmiia)," *Arkheologiia i istoriia Bospora*, I (1952) 227-37; E. G. Kastanaian, "Arkheologicheskaia razvedka na gorodishche Parfenii v 1949 g.," *Bosporskie goroda*, II [Materialy i issledovaniia po arkheologii SSSR, No. 85] (1958) 254-65.

M. L. BERNHARD & Z. SZTETYŁŁO

PASADA, *see* PASANDA

PASANDA or Pasada, Turkey. Map 7. Town in Caria, known as a neighbor of Kaunos from the Athenian tribute lists (tribute half a talent) and from the *Stadiasmus*; the latter places it 30 stades from Kaunos. It seems also to be mentioned by Diodoros (14.79: Sasanda) and by Stephanos Byzantios s.v. Passa. In the Hellenistic period, at least for a while, it had the status of a deme or Kaunos. At no time did it strike coins. A small site recently discovered a little S of the Solungur Gölü, at about the required distance from Kaunos, is likely to be that of Pasanda.

BIBLIOGRAPHY. *ATL* I (1939) 532; G. E. Bean, *JHS* 63 (1953) 21-22.

G. E. BEAN

PASCHA LIMAN, *see* ORIKON

"PASSARON," *see* RADOTOVI

PASSAU ("Batavis" and Boiodunum) Bavaria, Germany. Map 20. At the confluence of the Inn (Aenus) and the Danube. The Inn marked the boundary between the provinces Raetia and Noricum, and therefore the double military occupation of the river's mouth within Passau was necessary. On the small ridge between the Danube and the Inn a Late Celtic settlement (oppidum Boiodurum?) is supposed to have existed. One can assume after ca. A.D. 150 the existence of an auxiliary castellum on the Raetian side for the Cohors IX Batavorum (Batavis). The location is not known, but in Late Roman times the hill of the old town was fortified, probably on the site of Batavis, which is mentioned several times in Eugippius' *Vita St. Severini*. On the Noricum side a small castellum was built as early as the reign of Domitian (probably Boiodurum). Whether the castellum was destroyed in the 3d c. is not certain. A settlement in the 4th c. has been documented. The place is perhaps identical with the military field in the late 4th c. A.D. mentioned in the *Notitia dignitatum* (22.36).

The location of the Raetian castellum Batavis is not known. It is unlikely to have been on the hill of the old town. However, traces of a Roman vicus (?), which was fortified in Late Roman times, have been found there.

The castellum Boiodurum (ca. 142 x 90 m) in Noricum on the right bank of the Inn side has been partially preserved.

The Oberhausmuseum Passau contains numerous Roman finds from Batavis and Boiodurum.

BIBLIOGRAPHY. P. Reinecke, *Zur Frühgeschichte von Passau* (n.d.); id., "Grabungen auf dem Altstadthügel," *Passau: Kleine Schriften z. Vor- und frühgeschichtlichen Topographie* (1962) 124ff, 131ff; H. Schönberger, "Das Römerkastell Boiodurum-Beiderwies zu Passau-Innstadt," *Saalburg Jahrb.* 15 (1956) 42ff; J. Pätzold, "Zur Topographie von Passau," *Führer z. vor- u. frühgeschichtlichen Denkmälern* 6 (1967) 7ff.

G. ULBERT

PATALA, *see* ALEXANDRIAN FOUNDATIONS, 10

PATARA (Kelemiş) Lycia, Turkey. Map 7. On the coast 11 km S of Xanthos, 5 km E of the mouth of the Xanthos river. Patara was at all times among the most important cities of Lycia, and its principal port. The harbor, though reckoned too small to accommodate the Roman fleet of Aemilius in 190 B.C., was nearly 1.6 km in length by rather less than 0.4 km in width. It is now silted up and separated from the sea by a broad sand dune.

Patara was probably a Lycian foundation; its Lycian name, known from the inscriptions and coins, was Pttara. The city is mentioned in the 5th c. by Herodotos and Hekataios, and in the 4th by pseudo-Skylax; it surrendered peaceably to Alexander and was one of four cities whose revenues were offered by him to the Athenian Phokion, though the gift was not accepted. It was an important naval base during the wars of the Successors, and was occupied in this capacity by Antigonos in 315 B.C. and by Demetrios during his siege of Rhodes in 304. Later it came, with the rest of Lycia, into the hands of Ptolemy II Philadelphus, who changed the name for a while to Arsinoe. In 190 B.C. it was held by Antiochos III despite Rhodian efforts to capture it.

In the Lycian League Patara was one of the six cities of the first class possessing three votes in the League assembly; in 190 B.C. Livy calls it caput gentis. Under the Empire it continued to flourish, and held the rank of metropolis; it was the seat of the imperial legate and the repository of the archives of the Lycian League. Patara was the birthplace of Bishop Nicholas of Myra in the 4th c., and later its own bishop ranked 31st under the metropolitan of Myra.

Coinage began in the 5th c. After 168 B.C. the coins, though often varying from the familiar League types, constantly feature Apollo; this is not, however, the case with the earlier issues, where Hermes and Athena are predominant. Imperial coinage, as usual in Lycia, is confined to Gordian III; Apollo is still the constant type.

Apollo had a temple and oracle at Patara. The oracle is mentioned first by Herodotos (1.182). Despite the evident fame of the oracle, very little is heard of its activity. Of the temple building we have no description, nor has any trace of it ever been seen on the site itself.

The site of Patara is now quite deserted, and has never been excavated; the harbor has become a marsh which only partially dries up in summer. The ground is flat except for a hill some 19 m high at the E entrance to the harbor. Of the ancient city wall very little remains. A number of the buildings are still in good preservation. On the E side of the harbor, and apparently in the line of the city wall, is a triple arch standing virtually complete; six consoles on each face carried busts of the family of Mettius Modestus, governor of Lycia-Pamphylia about A.D. 100, and the building is accordingly dated to that time. To the S of this are the ruins of a bath building

and a basilica. Also to the S are the baths of Vespasian, identified by an inscription over the door; this building (ca. 105 x 48 m) is divided into five intercommunicating rooms; the inscription refers to swimming pools.

In the NE slope of the hill is the theater, unusually well preserved but now largely filled with drifting sand; an inscription records the dedication in A.D. 147 of the proscenium and the stage constructed by one Vilia Procula and her father. The theater is, however, much older than this, as is shown by another inscription recording repairs made to it in the time of Tiberius. The building is over 90 m in diameter, and the cavea is remarkable for its steep gradient. The ground floor of the stage building is in the Doric order, and above it is a row of windows.

Near the top of the hill is a deep circular pit 9 m wide with a square pillar of masonry in the middle; a stairway, partly rock-cut, leads down to the bottom. This was at one time supposed to be the oracle of Apollo. Others have regarded it as a lighthouse, but its situation, below the summit of the hill on the side away from the sea, is hardly suitable. It seems in fact to be a cistern, the central pillar being intended to facilitate roofing. Cisterns would be a necessity at Patara in early times, for the site was almost totally without water until aqueducts were constructed (see below). And the site near the top of the hill is obviously appropriate for distributing the water to the city below. There are some other traces of buildings on the hill, but not enough to constitute a true acropolis.

At the opposite (W) side of the harbor mouth is a rectangular foundation which supported a round building approached by steps; of its inscription only a few letters have been found. This is supposed, with much greater probability, to have been a lighthouse. Its date has not been determined.

Farther to the N, also at the edge of the harbor, is the granary of Hadrian, so identified by its inscription. In size and form it is remarkably similar to the granary of Hadrian at Andriake (Myra). Some 67 x 19 m, it is divided into eight intercommunicating rooms of equal size. Each room has also its own door in the facade, and above these are windows and consoles. Except for the loss of its vaulted roof, this building stands complete.

The principal necropolis is to the N of the site, consisting mainly of sarcophagi of Lycian type but not of early date; only one tomb of temple form has been found at Patara. Among other tombs around the theater hill and in the neighborhood of the granary is a conspicuous built tomb approached by eight steps, with a paneled ceiling, having originally four columns in front and two between antae, with a pediment above.

Ruins of two aqueducts are to be seen: one near the coast to the W of the Letoum, the other in the hills N of Kalkan. The former is of the usual Roman type; the latter, also of Roman date, is in the form of a wall of polygonal masonry 6 m high, pierced by two narrow doors, with a water channel above, preserved for a length of 0.4 km. One or both of these presumably fed Patara, though no remains of them are visible within 8 km of the city.

BIBLIOGRAPHY. C. Texier, *Description de l'Asie Mineure* (1836) III 192ff[I]; T.A.B. Spratt & E. Forbes, *Travels in Lycia* (1847) I 30-32; E. Petersen & F. von Luschan, *Reisen in Lykien* (1889) I 114-17; *TAM* II.2 (1930) 141-47M; G. E. Bean in *JHS* 68 (1949) 57-58. G. E. BEAN

PATAVIUM (Padua) Veneto, Italy. Map 14. A city of Cisalpine Gaul, probably founded by the Veneti. Rome found in it a strong and faithful ally when, after the fall of Taranto in 272 B.C., it turned to the N. Even during the war with Hannibal, the city remained faithful, and consequently was able to make a pact of foedus with the Romans, promising protection in exchange for arms and soldiers. The construction of the Via Annia took place during the second half of the 2d c. A.D. It was a continuation of the Flaminia (Rome-Rimini) and the Popilia (Rimini-Adria) to Aquileia by way of Patavium.

In 59 B.C., before the arrival of Caesar, the historian Titus Livius was born in Padova to an upper-class family which enjoyed Roman citizenship. His loyal attachment to his native city remained constant.

During the civil war, in spite of the many favors granted it by Caesar, Patavium took the side of Pompey, being the subject for this reason of the celebrated eulogy of Cicero (*Phil.* 12.4). But perhaps on account of Livy, whom Augustus held dear, Patavium suffered little from Pompey's defeat.

The city enjoyed a tranquil and industrious life for nearly three centuries afterwards. It is not certain whether the city was touched by the invasions of Alaric (A.D. 400) and of Attila. It came under the domination of the Goths, but remained in the territory of the Byzantine Emperor Justinian when they attempted to reconquer Italy. However, the city taken by the Lombards under Agilulfo after a ferocious siege; the population, with its bishop, sought refuge at Malamocco (Mathamaucus).

The development of Patavium was closely connected with the two rivers that flow through it: The Medoacus (today the Brenta), with a major and minor branch; and the Retone or Etrone (today the Bacchiglione). Besides the beautiful S. Lorenzo bridge, remains are preserved of three other bridges: the Altinate, the Corvo, and the Molin. Large traces of military installations are seen in the topography of the surrounding countryside. Research done at various sites between 1924 and 1932 in the zone between the S. Lorenzo and Altinate bridges have brought to light the structures of the river port including docks, access ramps, and three markets.

There is no longer any trace of the other monuments in which the city must have abounded, including the forum, the capitolium, and the baths. The remains of the amphitheater are meager, and noted now for the chapel decorated by Giotto that was erected in the Curtivo Arena. The foundations of the theater were discovered in the 18th c. Traces of temples are lacking except for those of a possible Mithraeum next to the apse of S. Sofia.

At the Museo Civico is a collection of objects found sporadically including mosaics, inscriptions, and a rich series of stelai, partly of popular production and partly examples of the so-called cult art. Examples of statuary are few.

The earliest church, dedicated to S. Giustina, was eulogized by Venanzio Fortunato in the 5th c. It dates to the Early Christian age, though little of it remains.

There is an Early Christian hypogeum preserved below a private house. It is in the form of a hall with several rooms intended for services. Probably a hospitium, at the edge of the city, it was destroyed by the Lombards under Agilulfo.

BIBLIOGRAPHY. L. Micheletto, "L'oratorio paleocristiano di Opilione," *Palladio* (1955) 268ff; R. Battaglia, "Dal paleolitico alla civiltà atestina," *Storia di Venezia* I (1957) 77ff; R. Cessi, "Da Roma a Bisanzio," ibid., 179ff; G. Gasparotto, *Carta Archeologica*, F. 50 (2d ed. 1959); G. A. Mansuelli, *I Cisalpini* (1962); F. Sartori, "Industria e artigianato nel Veneto romano," *Atti Dept. St. patria delle Venezie* (1964); G. Dei Fogolari, "Il Veneto romano," *Arte e civiltà romana nell'Italia Settentrionale* (1965) 159ff; G. B. Pellegrini & A. L. Prosdocimi, *La lingua venetica* I & II (1967); L. Bosio, *Itinerari e strade*

della *Venetia romana* (1970); G. A. Mansuelli, "Urbanistica e architettura della Cisalpina romana sino al III sec. d. C.," *Latomus* 3 (1971). B. FORLATI TAMARO

PATERNÒ, *see* HYBLA GELEATIS

PATHYRIS, *see* APHRODITOPOLIS

PATMOS The Dodecanese, Greece. Map 7. An island located to the S of Samos. Very few ancient authors mention the island: Thucydides (3.33.3), Strabo (10.5. 13, C488), Eust. (*Comm. ad. Dionys. Perieg.* 530), an anonymous author (*Stadiasmus Maris Magni*, 283-*GGM*, I 498) and Pliny (*HN* 4.70). Patmos was poorly inhabited in antiquity. The early inhabitants were Dorians. Ionian settlers came later. Political exiles were deported there during the Roman period. On the coastal area, N of the isthmus Stavros, are the foundations of the supposed Temple of Aphrodite. Artemis was worshiped in the place where the Cloister of St. John now stands. The center of ancient Patmos is situated E of the modern harbor of Skala, occupying a narrow isthmus. The acropolis (Kastelli) preserves sections of a fortification wall and three towers, belonging probably to the 3d c. B.C. and built in isodomic style. An ancient necropolis has been located in the vicinity of Kastelli, around Nettia. Tombs have been also reported at Kambos in the N part of the island.

BIBLIOGRAPHY. N. Chavarias, "The Acropolis of Patmos" (in Greek), "Elpis" of Syme (1916) no. 1; I. Schmidt, *RE* XVIII (1949) 2174-91, s.v. Patmos; P. Bocci, *EAA* 5 (1963) 989, s.v. Patmos; G. Manganaro, "Le Inscrizioni delle Isole Milesie," *Ann. Atene* (1963-64) 329-46; E. Kirsten & W. Kraiker, *Griechenlandkunde* (1967) II 559-60; R. H. Simpson & J. F. Lazenby, "Notes from the Dodecanese II," *BSA* 65 (1970) 48-51[MP].

D. SCHILARDI

PATRAI Achaia, Greece. Map 9. The first mythical inhabitants of the area were known to the ancients as "the Autochthonous Ones" or "People on the Shore." Triptolemos taught the art of cultivation to the Autochthonous king, Eumelos, and because of that the place was called Aroe. Eumelos' son was named Antheias, and a second city was called Antheia after him, while a third city was built between the first two and was called Mesatis.

The first Greeks who came were the Ionians from Attica. Later, the chief of the branch of Achaians from Lakonia who came into the area of Aroe was the Spartiate, Patreus. He brought together the inhabitants of both Antheia and Mesatis into Aroe. The new synoecism was then called Patras, which Strabo says was constituted from a synoecism of seven cities. The Achaians controlled the Ionic institution of the Dodecapolis. The kingship lasted from the Argive Tisamenos to Ogyges, but the latter's children were displeasing to the people, and the kingship ended. The democratic institutions of the Achaians which followed were famous, and served as a model for the Achaian settlements in Magna Graecia.

The Achaians took no part in the Persian Wars. On the other hand, they played an important part in the Peloponnesian Wars, when the strategic value of Patras' harbor was a matter of concern. The Athenians held Naupaktos chiefly as a *point d'appui* while the Corinthians tried vainly to control the entrance to the Gulf of Corinth by holding Patras. The Athenian fleet under Phormio fought the Corinthians at the entrance to the Gulf of Patras in the summer of A.D. 429. Ten years later Alkibiades persuaded the people of Patras to construct the Long Wall while he himself made plans to fortify Rhion.

In 314 B.C. Patras, which had been held by Alexander the son of Polyperchon, was taken by Aristodemos, the general of Antigonos. Between 307 and 303 B.C. it came into the territory of Demetrios Poliorketes. Patras, Dyme, Triteia, and Pharai were the founders of the second Achaian League. Men of Patras had a large part in the repulse of the Galatians in 279 B.C. Philip V as an ally twice landed at Patras when the Aitolians were ravaging Achaia. Shortly afterwards, in reaction against the Macedonians, the Achaians followed a policy of alliance with Rome. At the end of this period came the fearful destruction of Patras, following the taking of Corinth (146 B.C.). Thereafter it is mentioned only in connection with the careers of the Consul, Quintus Fabius Maximus, of Cicero, and of Cato. Nevertheless, the harbor of Patras was convenient for travel from Rome to Greece and the Near East. Therefore, Augustus, the victor of Actium (31 B.C.) and the founder of Nikopolis, made a synoecism of the Achaians at Patras. The city was declared free (civitas libera) and a colony under the name of Colonia Aroe Augusta Patrensis. After the time of Augustus, Nero, Hadrian, Antoninus, and Diocletian honored the city, where the Greek language and education continued through the Roman period. Plutarch set one of his dialogues in Patras. The "Lucius" or "Ass" is attributed to Lucian, and is for philological reasons supposed to be an epitome of the lost *Metamorphoses* of Lucius of Patras, who is placed in the 2d c. A.D.

Historical monuments of the city are known to some degree from Mycenaean times. Mycenaean tombs which have been discovered are attributed to Antheia and Mesatis, while the remains of Aroe are supposed to have been destroyed or covered over by the acropolis of Patras. Most of the finds in the region date to the later Mycenaean period. Pausanias (7.18-22) is the chief chronicler of the remains of Classical Patras. Of the buildings, temples, and statues that he mentions very little remains. The acropolis retains no apparent traces of the ancient wall, but there are numerous architectural fragments of ancient buildings as well as statuary built into the mediaeval wall. The line of the Lower City wall can only be guessed at. A certain amount of the odeion is preserved, and in part restored. Between the acropolis and the odeion may be placed, on the basis of Pausanias' description, the agora and the Temple of Zeus (near the Church of the Pantocrator). The seaside temple of Demeter has finally been located, and its oracular spring identified with the sacred spring near the Church of St. Andreas.

In recent years (1966-72) because of the increase in excavations for buildings, roads and squares, numerous parts of the Roman city of Patras have been discovered, the most noteworthy of which are the remains of the Roman roads, remains of buildings, baths, workshops, monumental graves along the ancient road to the NE, and poorer tile graves along the road leading SW out of the city.

Moveable finds are collected in the Museum of Patras. There is a great deal of Roman sculpture, including a copy of the chryselephantine statue of Athena Parthenos by Phidias. Mosaic pavements have been moved to the museum, and there are others in the area around the odeion and in the storehouse.

BIBLIOGRAPHY. Παυσανίας, Ἑλλάδος Περιήγησις, Ἀχαϊκά, ὑπομνήματα: J. G. Fraser (1889) IV σελ. 115 κ.ἑ.; Hitzig & Blumner (1904) II. 2 677 κ.ἑ.; Ν. Δ. Παπαχατζῆ (1967) IV 94ff[MPI]; J. Herbillon, *Les Cultes de Patras avec une Prosopographie Patréenne* (1929)[P]; *RE* λ. Patrai: Ernst Meyer, Ἀρχαιολογικά Ἀνάλεκτα ἐξ Ἀθηνῶν

(1971) IV 112ff, 305ff[PI]; Δομή, Ἔγχρωμη Ἐγκυκλοπαίδεια, s.v. Πάτραι (1972)[PI]. PH. PETSAS

"PATRAIOS," see GARKUSHI

PATRAS, see PATRAI

PAUTALIA (Kyustendil) W Bulgaria. Map 12. The principal habitation site at Pautalia goes back to the Thracian period and it was probably the capital of the Dentheleti. It is situated on the Strymon river, ca. 69 km SW of Sofia, in a valley rich in cereal grains and mineral springs.

In the Thracian age it became a Roman center (civitas Ulpia); in the time of Hadrian it received the title of Aelia. The center was an important crossroads, linked with the Aegean Sea across the Strymon, and with Serdica and Philippopolis. The acropolis is on the hill called Hissarlâk, and the inhabited area extends between this hill and the river. Only recently the fortifications of the city on the N, E, and W sides have been brought to light. From the first observation of these it seems possible to date them to the second half of the 2d c. A.D. During successive centuries the fortifications underwent a number of modifications until the Byzantine period. A secure date for the restoration of at least a part of the fortifications is found in an ancient source (Procop. *De aed.* 4.1.31), which places it in the age of Justinian. The latest excavation has also brought to light stretches of ancient roads crossed by cloacae in brick. Also recently found on the acropolis were stretches of fortifications provided with towers and posterns.

Among the major monuments of the city and of the acropolis are the temples of Zeus and Hera, and of Aesculapius, important because of the mineral waters. Other major monuments include the bath buildings and a gymnasium. All of these are mentioned in inscriptions or on the coins from the local mint.

The center was renowned for the number of its copies of major works of Greek art, as, for example, the Diskobolos of Naukidas, the statue of Hermes, or that of Dionysos and Pan.

Besides the large center of Pautalia, there were in the neighborhood numerous small unfortified settlements in which the cult of Aesculapius was predominant. These centers formed, very probably, the proasteion mentioned in the inscriptions found in the area around Pautalia.

BIBLIOGRAPHY. C. Jirecek, *Archäologisch-Epigraphische Mitteilungen* 10 (1886) 68; J. Iwanov, *Severna Makedonija* (1906); L. Ruzicka, "Zwei Statuen des Praxiteles auf Münzen von Ulpia Pautalia," *Strena Buliciana* (1924) 667ff; C. Patsch, "Beiträge zur Völkerkunde von Südosteuropa," 5 *Sitz-Ber. Akad. Wien* 214, 1 (1932); D. P. Dimitrov, "Za ukrepenite wili i rezidencii u trakite w predistoričeskata epocha," *Studia in honorem Acad. D. Decev* (1958) 683ff; C. M. Danoff, *RE*, Suppl. IX (1962) 800-824; T. Ivanov, *Bul. d'Archéologie sud-est européenne* (Association Internationale d'Études du Sud-Est Européen, Commission d'Archéologie 2; 1971) 44.
D. ADAMESTEANU

PAX JULIA (Beja) Alentejo, Portugal. Map 19. Mentioned by Ptolemy (2.5), it was made a colonia by Julius Caesar or Octavian. It was the seat of one of the three judicial districts into which Augustus divided Lusitania, and minted coins in the time of Octavius. The fortifications, reconstructed in the Middle Ages over the remains of the Roman ones, retained the three early gates: Aviz, Mértola, and Évora. Only the gate of Évora remains today. The foundations of a temple have been discovered, but were covered again.

BIBLIOGRAPHY. A. Viana, *Origem e evolução histórica de Beja* (1944). J. ALARCÃO

PAYAMALANI, see EIBEOS

PAZARLIK, see KASTABOS

PEAL DEL BECERRO, see TUGIA

PECH-MAHO, see SIGEAN

PÉCS, see SOPIANAE

PEDASA or Pedason (Gökçeler) Turkey. Map 7. In the hills of Caria above Halikarnassos. One of the eight Lelegian towns mentioned by Strabo (611; cf. Plin., *HN* 5.107). The Pedasans offered strong resistance to the Persian Harpagos ca. 544 B.C. (Hdt. 1.175), and shortly after 499 another Persian army was ambushed and destroyed by the Carians near Pedasa (Hdt. 5.121). In the Delian Confederacy Pedasa paid two talents at first, reduced to one talent in the second period, but nothing thereafter. (It is, however, disputed whether another Pedasa may be meant; see next entry). The town was incorporated by Mausolos into his enlarged Halikarnassos (Strab. *l.c.*), but continued to be occupied as a garrison post in Hellenistic times. It was perhaps occupied for a time by Philip V during his Carian campaign (Polyb. 18.44).

The site is assured by Herodotos' description of it as above Halikarnassos, and by the survival of the name at the neighboring village of Bitez. It comprises a walled citadel with a keep at its E end and an outer enclosure below on the S. The citadel wall is of irregular masonry, something over 1.5 m thick, and has a gate on the W. The keep is approached on the W by a ramp which is flanked by a tower in coursed masonry; in a corner of the tower is a staircase.

In a hollow below the site on the SW are remains which seem to be those of the Temple of Athena, as implied by an inscription found close by (*CIG* 2660). On the slopes to the SE are numerous chamber tumuli, comprising a vaulted chamber and dromos enclosed by a circuit wall and surmounted by a pile of loose stones; these have produced pottery of early Archaic date.

BIBLIOGRAPHY. W. R. Paton & J. Myres, *JHS* 8 (1888) 81f; 16 (1896) 202ff, 215 no. 4; A. Maiuri, *Annuario* 4-5 (1921-22) 425ff; G. E. Bean & J. M. Cook, *BSA* 50 (1955) 123-25, 149-51. G. E. BEAN

PEDASA or Pidasa Turkey. Map 7. Town in Ionia or Caria, almost certainly at Cert Osman Kale on the E side of Mt. Grion. Herodotos says (6.20) that the Persians, after taking Miletos in 494 B.C., themselves occupied the plain around the city, but gave the highlands to Carians of Pedasa to dwell in. This was apparently the origin of the city of Pidasa which appears in Milesian inscriptions; about 182 B.C. it was incorporated by sympolity in Miletos. The site lies high up on the mountain, perhaps 700 m above the sea; it comprises a roughly oval enclosure some 200 m long. The wall, 1.5-2 m thick, in roughly coursed masonry, is poorly preserved, but a number of towers are recognizable. In the interior some building foundations are discernible, and large quantities of worked stones, including some marble; tiles and pottery date in general to the 4th and 3d c. B.C.

BIBLIOGRAPHY. T. Wiegand, *Milet* I, 3 (1914) no. 149; J. M. Cook, *BSA* 56 (1961) 91-96. G. E. BEAN

PEDASON (Gökçeler), see PEDASA

PEDNELISSOS or Petnelissos, Turkey. Map 7. City in Pisidia, probably at a site in the hills above Kozan, 30 km N of Perge. It was listed by Artemidoros among the cities of Pisidia (Strab. 570), and is recorded also by Ptolemy. In or soon after 220 B.C. it was besieged by the Selgians; the siege was raised with some difficulty by Achaios and his lieutenant Garsyeris (Polyb. 5.72). The coinage is of the 2d and 3d c. A.D. Of the city's origin nothing is known.

The site near Kozan is not definitely identified; none of more than 20 inscriptions found there gives the city's name. But the situation is appropriate, and no rival site is known in the region. The ruins are considerable and cover a wide area. The city wall is preserved on the N and E, and especially to the S, where the acropolis is defended by a double line. In the lower town is a stretch of wall with two gate-towers, one preserved to a considerable height, and a similar stretch, also with a gate, higher up to the N. In the middle of the city is the agora, with rooms on two sides and a basilica adjoining; another building with columns is of uncertain purpose. Low down on the W are the scanty ruins of a temple some 16 by 10 m. The necropoleis lay outside the gates on N and S; sarcophagi are most frequent, but there are two heroa, one at the NW corner, one near the S gate. These appear to be of Hellenistic date, the rest is Roman. Also near the S gate is a Byzantine church, and another by the road from the valley. Water was supplied in cisterns, two of which are still used by the peasants.

BIBLIOGRAPHY. G. Moretti, *Annuario* 3 (1916-20) 79-133[MI].

G. E. BEAN

PEIRAEUM, *see* PERACHORA

PEIRAEUS or Peiraieus Attica, Greece. Map 11. About 7-8 km SW of the upper city of Athens. The deme and harbor town occupied the spacious peninsula of Akte, the rocky hill of Mounychia to the E, the lower ground in between these two, and a small tongue of land called Eetioneia on the W. The irregularities of the coastline created three natural harbors: Kantharos, the great main harbor on the W, Zea, the small round harbor between Akte and Mounychia, and the little inlet of Mounychia below the hill to the SE.

Hippias, son of Peisistratos, had fortified Mounychia late in the 6th c. B.C., but it was Themistokles who first realized the possibilities of the site and converted it into a strongly fortified harbor town. After the defeat of the Persians at Salamis in 480 B.C., he persuaded the Athenians to complete the scheme he had inaugurated during his archonship in 493-492 B.C. (Thuc. 1.93). Thucydides implies that he even thought of making Peiraeus the main asty in place of the ancient upper town; and in fact it became a kind of duplicate city, not a mere maritime suburb. The well-known Milesian architect Hippodamos was brought in to develop the site according to a systematic plan (Arist. *Pol.* 2.5).

In 411 B.C. the oligarchs made an abortive attempt to build a fortress on Eetioneia (Thuc. 8.90, 92). After Athens' crushing defeat by the Peloponnesians in 404 B.C., the fortifications of Peiraeus were dismantled, together with the Long Walls which joined the harbor town to the city (Xen. *Hell.* 2.2.23). But a few years later they were repaired, with Persian help, through the efforts of the admiral Konon (Xen. *Hell.* 4.8; cf. *IG* II² 1656.64). The city suffered badly in the assault by the Roman general Sulla in 86 B.C. (Plut. *Sulla* 14) and this time the walls were not rebuilt. Strabo found the town "reduced to a small settlement round the harbors and the shrine of Zeus Soter (9.1.15.396; cf. 14.2.9.654.)."

Finds here have been mainly fortuitous and sporadic;

visible and accessible remains are scanty. Bits of the walls, found at many different points, show a nice variety in style of masonry, as analyzed by Scranton, and obviously belong to a number of periods. A stretch of wall on Mounychia hill, in "Lesbian" masonry, probably belongs to Hippias' fortification. The slight remains which can be assigned to the work of Themistokles do not fully bear out Thucydides' statement that this wall was built wholly of solid masonry throughout, instead of having the usual rubble filling and upper structure of brick. Inevitably the remains belong chiefly to the later phases, to Konon's reconstruction, and to later repairs attested by inscriptions, which show that the maintenance of the walls was indeed an expensive and complicated task (*IG* II² 244, ca. 337-336 B.C., cf. Dem. 19.125; II² 463, 307-306 B.C.; II² 834, ca. 299-298 B.C.; by this time the Long Walls seem to have been abandoned).

The general line of the fortifications is fairly clear. On the N the Themistoklean Wall included the Kophos Limen (Blind Harbor) a N extension of Kantharos, but the Kononian Wall took a line more to the S, partly on moles, and excluded this area. On Akte have been found slight traces of a cross wall running SE to NW and cutting off the SW segment of the peninsula. This probably belongs to the Themistoklean line. The Kononian Wall followed the coast of Akte closely, and impressive remains have survived in this sector. At all three harbor-mouths the fortifications were continued on moles, narrowing the entrances. The wall was provided with stairways and with many projecting towers at close intervals on vulnerable stretches. The principal gate, through which the road to Athens passed, was just to the W of— i.e., outside—the point where the N Long Wall joined the city wall. Another gate was built a little farther E, within the area enclosed by the Long Walls. Similarly access was provided in the neighborhood of the junction with the S Long Wall, by means of a postern inside and a larger gate outside. Another important gate was at the N end of the Peninsula of Eetioneia, near the Shrine of Aphrodite.

The great harbor, Kantharos, was devoted mainly to commerce. On its E side was the emporion, with a line of stoas, of which slight remains have been found. Inscribed boundary stones indicate that the area between a certain street and the sea was designated as public property. It was towards the N part of this area that in 1959 a spectacular find of bronze sculpture, including a fine archaic Apollo, was made; the statues had apparently been mislaid at the time of the destruction by Sulla.

According to Demosthenes (22.76, 23.207) the ship-houses (neosoikoi) were among the glories of Athens. Fourth c. inscriptions (*IG*, II², 1627-1631) tell us that there were 94 ship-sheds in Kantharos, 196 in Zea, and 82 in Mounychia. Thus Zea was the main base of the war fleet. Remains have been found at various points, especially in Zea.

An inscription of the second half of the 4th c. B.C. (*IG* II² 1668) found N of Zea, gives detailed specifications for the construction of a great skeuotheke or arsenal for the storage of equipment, a long rectangular structure divided into three lengthwise by colonnades. Philon is named as the architect.

The general orientation of Hippodamos' rectangular street plan was probably very close to that of the center of the modern town. The lines of two apparently important streets crossing one another have been determined near the Plateia Korais. But there are indications that in some outlying parts a different orientation was used. Various boundary-markers, in addition to those mentioned above (*IG* I² 887-902), bear witness to the Hippodamian process of *nemesis* or careful allocation of sites. Peiraeus

had two agoras (Paus. 1.1.3): one near the sea and the emporion; the other, called Hippodameia after the planner, in the interior, probably to the W of Mounychia.

The great theater (Thuc. 8.93.1) was built into the W slope of Mounychia; it was used not only for dramatic performances but occasionally for meetings of the Ekklesia. Better preserved and more visible is a smaller theater built in the 2d c. B.C. a little to the W of the Zea harbor. We hear of an Old Bouleuterion (*IG* II² 1035.43f) and an Old Strategion (ibid., 44). Thus public buildings of the upper city were apparently duplicated in the harbor town.

Of the numerous shrines, some were duplicates of shrines in the upper city; some were peculiar to Peiraeus; several were foreign importations, notably a Shrine of Bendis, which was probably on top of the hill of Mounychia. East of Zea and at the SW foot of Mounychia remains have been found which may be assigned to the Shrine of Asklepios. On the coast to the S of this are niches in which were probably set dedications to Zeus Meilichios and Philios; and a curious bathing establishment which may perhaps be associated with a shrine called the Serangeion, belonging to a healing hero called Serangos. Slight remains at the N end of Eetioneia have been attributed to the Shrine of Aphrodite Euploia, founded by Themistokles and restored by Konon. A colonnaded enclosure whose remains came to light just N of the Plateia Korais seems to have belonged to the Dionysiastai, votaries of Dionysos. Many shrines are known from the ancient authors and from inscriptions. Artemis was worshiped on Mounychia, and Xenophon (2.4.11ff) indicates that a broad way led from the Hippodamian agora to the Artemision and the Bendideion. Of all he saw at Peiraeus (admittedly his account is rather sketchy) Pausanias thought the Sanctuary of Athena Soteira and Zeus Soter most worth seeing; its location is not known.

BIBLIOGRAPHY. W. Judeich, *Topographie von Athen*² (1931) 430-56 (with full citation of ancient authorities)ᴹ; D. Kent Hill, "Some Boundary Stones from the Peiraeus," *AJA* 36 (1932) 254-59; R. L. Scranton, *Greek Walls* (1941) 114-20; A. W. Gomme, *Commentary on Thucydides* (1945)¹ 261-70; W. B. Dinsmoor, *The Architecture of Ancient Greece* (1950) 241-42 (arsenal of Philon); R. Martin, *L'Urbanisme dans la Grèce Antique* (1956) 105-10; id., *AJA* 64 (1960) 265ff; F. G. Maier, *Griechische Mauerbauinschriften* I (1959) 17ff; II (1961); C. T. Panagos, *Le Pirée* (1968); J. S. Boersma, *Athenian Building Policy from 561/0 to 405/4 B.C.* (1970; see Index s.v. Peiraieus). R. E. WYCHERLEY

PEIRASIA ("Asterion") Thessaly, Greece. Map 9. A city on a rocky hill of white crystalline limestone, on the W bank of the Enipeus, S of Vlochos. Stephanos Byzantinos identified the city, which flourished in the 5th and 4th c., with Homeric Asterion, named for the brilliance of the white rock. Concentric walls of semipolygonal masonry surrounded the acropolis; they were strengthened by numerous towers and had two gates on the S side.

BIBLIOGRAPHY. C. Edmonds in *BSA* 5 (1898-99) 23ᴹ; F. Stählin, *Das hellenische Thessalien* (1924) 134.
M. H. MC ALLISTER

PELASGIS, *see* LARISSA

PELIKATE, *see under* ITHACA

PELINNA (Palaiogardiki) Thessaly, Greece. Map 9. A city of Hestiaiotis, on the left bank of the Peneios (Strab. 9.438), on the S slope of a spur which extends into the middle of the N edge of the W Thessalian plain. Pelinna

was flanked on the W by Trikka and on the E by Pharkadon (probably ruins at Klokoto) and formed a defensive square with Trikka, Gomphoi, and Metropolis (Strab. 9.437-438). It was the home of a Pythian victor (Pind., *Pyth.* 10). It issued coinage ca. 400 B.C. On Philip II's intervention in a quarrel between Pelinna and Pharkadon (?) in the late 350s B.C., the latter was destroyed, and Pelinna became the main city of W Thessaly, and loyal to Macedon (Polyaen. 4.2.18-19; Arr. *Anab.* 1.7.5; Diod. Sic. 18.11.1). In 191 B.C. it was taken by Amynander of the Athamanians, an ally of Antiochus III (Livy 36.10.5) but was retaken by M' Acilius in the same year (Livy 36.13.7-9, 14.3-5). It became the site of a bishopric in Christian times.

On the top of the acropolis hill (185 m) is a natural sink hole some 100 m deep. There are two ancient city walls. The upper starts from the E and W sides of the hole and includes a part of the hill slope. The other circuit starts from the N ends of the inner wall and includes a wider section of hillside and a considerable area of the plain. The upper wall, of polygonal masonry, was strengthened at its NW corner at the sink hole by a massive double-towered bulwark, apparently somewhat later in date than the wall. There are some 11 other towers irregularly placed along its extent, the 13th tower being at the NE end of the wall, next to the hole. This upper wall seems to be 5th c. B.C. in date. The lower city wall, fairly well preserved on the hill and poorly in the plain, was furnished with some 50 or more towers fairly regularly spaced at 30 m intervals. It had gates on the W, S, and E sides, all protected by towers, and is built of rectangular blocks. Stählin dated it to the mid 4th c. B.C. The length of the upper wall is 1630 m; of the lower, 2600.

Inside the lower city are numerous traces of roads and buildings. Just inside the S gate is a long foundation wall (59 m) presumably of a stoa or similar building, which would have flanked the E side of the road into the city. Opposite it and roughly parallel is a short section of another foundation wall. A hollow at the foot of the hill, in the center of the city, was probably the site of the theater. Stählin saw traces of digging (stone robbery?) where the scene building should be. About 110 m to the SW of this is the foundation of a rectangular building, perhaps a temple. A cistern is cut in the hill just below the middle of the upper wall, and another in the plain about 170 m E of the W gate. Near the bottom of the hill and about 200 m from the W wall is a raised area and on it the remains of a temple (ca. 8 x 14 m) divided into two inner rooms. Around this was a rectangular peribolos (30 x ca. 40 m) now destroyed on the N side. Along the S side of this was a long stoa-shaped building 40 m long and 6 m wide. This was divided by cross walls into two short outer rooms and one long inner one. On the hill above this temple complex are some remains, including a small rectangular foundation, perhaps of another temple, and the edging of a road which ran up the hill.

Outside the S gate is a grave tumulus near the Larissa-Trikka road, 2 km to S of the gate. This was investigated in 1906 and found to contain a vaulted chamber tomb. Near this two cist graves of the Hellenistic period, discovered in 1969, contained some remarkable gold jewelry (earrings, bracelet, necklace, ring, gold wreaths) dated from approximately 200-150 B.C. A certain amount of sculpture has been found, including pieces of the 6th and 5th c. B.C.

BIBLIOGRAPHY. *Deltion* (1888) 121; A. S. Arvanitopoullos, *Praktika* (1906) 127; F. Stählin, *Das Hellenische Thessalien* (1924) 117fᴾ; id., *RE* (1937) s.v. Pelinna 1ᴾ; W. M. Verdelis, *ArchEph* (1953-54) 1, 189-99¹; H. Bie-

santz, *Die Thessalischen Grabreliefs* (1965) 144f; D. Theocharis & G. Chourmouziades, *ArchAnalekta* 3 (1970) 204-7[1].

<div align="right">T. S. MACKAY</div>

PELLA Macedonia, Greece. Map 9. A city in the region of ancient Bottiaia to which King Archelaus (413-399 B.C.) moved the capital of Macedonia. It was the seat of Philip and the birthplace of Alexander.

Stephanos of Byzantium (s.v. Pella) mentions the prehistory of the place: "Pella of Macedonia was formerly called Bounomos or Bounomeia . . ." In historical times it was first mentioned by Herodotos (7.123) in the description of Xerxes' journey to the Axios river "which is the boundary between Mygdonia and Bottiaiis. The latter has a narrow coastal strip occupied by the cities of Ichnae and Pella." Later, Thucydides mentions Pella twice, first in the passage about the Macedonians spreading E, before his time, and then in the attack of the Thracians under Sitalces against the Macedonian king Perdiccas, in his own time (Thuc. 2.99.4, 100.4). Southern Greeks took scant notice of Archelaus' activities in the last years of the Peloponnesian War, and laughed at his building of a palace in Pella (Ael., *VH* 14.17). But in Archelaus' time the painter Zeuxis came to Pella to decorate the palace, and the poet Timotheus also came, and the dramatist Euripides, who wrote the *Archelaus* there and died in Macedonia. After the time of Archelaus, Pella grew larger, so that in Xenophon's time it was called the "largest of the cities of Macedonia" (*Hell.* 5.2.13). The statement of Demosthenes (18.68) that Philip grew up "in a small and insignificant village" was a rhetorical exaggeration. Information about Pella is curiously scanty in the time of Philip, Alexander, and the Diadochoi, but from a political and artistic point of view the best days of Pella were probably during the long reign of the philosopher king Antigonos Gonatas (274-239 B.C.).

The only description of Pella which has survived is that of Livy (44.46.4-7), who writes of the capture of the Macedonian capital by Aemilius Paulus after the battle of Pydna, in which Perseus, the last king of Macedonia, was defeated. On the basis of his description, travelers and archaeologists from the end of the 18th through the 19th c. vaguely located Pella at a few visible remains of an ancient city near the town of Agioi Apostoloi, N of the Giannitsa swamp. In the first year after the liberation of Macedonia from the Turks (1912), excavations uncovered the remains of peristyle-type houses, an underground cistern, a hoard of silver coins of Kassander, bronze and iron household implements, bronze bed fittings, etc. A fuller and clearer picture of the topography of the ancient city has only been gained after continuous surface observations which began in 1954.

The most ancient finds from the area, which go back at least to the Bronze Age, came from: (*a*) fields N of the so-called Baths of Alexander; (*b*) from a hill W of the town of Palaia Pella; and especially from (*c*) the top of the Phakos within the former marsh. Test trenches in the latter revealed a prehistoric settlement, like others around the marsh, the best known being that of Nea Nikomedeia, dating to the Early Neolithic period (7th millennium B.C.). The prehistoric settlement on the Phakos may be Bounomos or Bounomeia (Steph. Byz.).

Over 40 test trenches brought Classical and Hellenistic remains to light over the whole area between the Phakos and the towns of Palaia Pella and Nea Pella. This area is about 2 km sq. It was ascertained that the acropolis encompassed a part of a double hill, that is, the hill occupied by the town of Palaia Pella (formerly Haghioi Apostoloi) and another, to the W of it. On the

W hill, especially (Sections II and III), some rather scanty remains of important buildings were uncovered. Those which have come to light up to the present are: (*a*) walls ca. 2 m thick with huge poros orthostates (ca. one m high, under one m thick, up to 2 m long), (*b*) Ionic and Doric architectural members, the scale of which is shown by a Doric poros capital, dated to the first quarter of the 4th c. B.C. with the side of the abacus one m long, (*c*) parts of a triangular votive monument of bluish stone, (*d*) fragments of marble architectural members, statues, etc.

The position and scale of these constructions establish that here on this "W hill" was probably the palace of Archelaus, and the palace complex and temple, perhaps that known from Livy (42.51.2) as the Temple of Athena Alkidemos. It is probable that the fortified peribolos of the palace complex made a part of the acropolis wall and continued the city wall, which is now, however, invisible, since, in all probability, only its foundations and orthostates were of stone, while the upper parts were of mudbrick, which hid the stone parts under a layer of earth when they collapsed.

More striking are the discoveries around the center of the ancient city, N of the Thessalonika-Edessa road (Section I, from which Sections IV and V are separated by the road). Here, about six blocks of buildings were uncovered, constructed according to the Hippodamian system of town planning. One of the blocks had three peristyle courts with stoas and adjoining rooms on all sides, according to the Hellenistic type of house with peristyle. The others had approximately the same arrangement. They are surrounded by roads with a width of ca. 9 m along which are water pipes and drains. Parts of the buildings were at least two-storied, as apparent from the remains of stairs and from architectural fragments such as little columns and pillars. The floors of the ground floor rooms were covered with mosaic pavement, some completely plain, others with a geometric pattern, and others with figures, but all of them made of natural river pebbles. In 1957 the first four figured mosaics were uncovered. These show: (*a*) Dionysos, naked, on a panther, (*b*) a lion hunt, perhaps an episode known from the life of Alexander, when he was saved by Krateros, (*c*) a gryphon tearing a deer apart, and (*d*) a couple of centaurs, male and female. In 1961 in another block four more mosaic floors were uncovered, one of which is badly damaged. The others show: (*a*) the rape of Helen by Theseus, (*b*) a deer hunt with the inscription, "Gnosis made it," and (*c*) an Amazonomachy.

In another section near the former marsh (Section VI) a circular floor in the same pebble technique was discovered, mainly decorated with floral motifs, like the mosaics of Verghina.

The buildings with the mosaic floors are dated to around the last quarter of the 4th c. or the beginning of the 3d c. B.C. Some of the peristyle columns and walls have been reconstructed in place. The mosaic floors have been taken up and consolidated, and are in the local museum, except for the mosaic of Gnosis, which remains in situ.

Of the architectural fragments, besides the stone columns, pillars, and parts of a cornice, worth mention are Corinthian pan and cover tiles decorated with palmettes, painted simas from the pediments, etc. Among the tiles, some are stamped with the name of the city in the genitive case (ΠΕΛΛΗΣ. This was the first indisputable evidence, found in 1957, for the site of the Macedonian capital.).

Of the sculpture from the site, the older finds are the most notable: (*a*) a marble funeral stele taken to the museum at Constantinople and (*b*) a statue of a horse-

man, possibly from a pediment, in the Thessalonika Museum. Of the more recent finds the most interesting are: (*a*) a severe style marble dog, (*b*) a bronze statuette of Poseidon of the Lateran type. Other small finds are votive inscriptions (to Asklepios, the Great Gods, Zeus Meilichios, Herakles, the Muses, etc.), funeral inscriptions with bas-relief portraits, some bilingual in Greek and Latin, two unpublished milestones from the Via Egnatia, etc.

Of the pottery, most notable are some red-figure fragments and a class of local pottery which follows on old tradition (the technique is gray Minyan; the decoration early Mycenaean; the handles show its Hellenistic date). A large number of coins, chiefly of bronze, and many small worked pieces of bronze were found. The small finds are mainly kept in the local museum.

BIBLIOGRAPHY. G. P. Oikonomos, Πέλλα, *Praktika* (1914) 127-48[PI]; (1915) 237-44[PI]; id., Νομίσματα τοῦ βασιλέως Κασσάνδρου, *Deltion* 4 (1918) 1-29[I]; id., "Bronzen von Pella," *AthMitt* 51 (1926) 75-97[I]; E. Oberhummer, "Pella," *RE* XIX (1937) 341-48[M]; Ph. M. Petsas, "Alexander the Great's Capital," *ILN* 2 (Aug. 1958) 197-99; id., "New Discoveries at Pella, Birthplace and Capital of Alexander," *Archaeology* 11 (1958) 246-54[I]; id., "Pella, Literary Tradition and Archaeological Research," *Balkan Studies* 1 (1960) 113-28[I]; id., Πέλλα Μεγ. Ἑλλην.' Ἐγκυκλοπαιδεία, Συμπλήρωμα Δ', pp. 149-52[I]; id., "A few Examples of Epigraphy from Pella," *Balkan Studies* 4 (1963) 155-70[I]; id., *Pella* (1964)[MI]; id., "Ten Years at Pella," *Archaeology* 17 (1964); id., "Pella," *EAA* 6 (1965) 16-20[I]; id., *Mosaics from Pella, La Mosaïque Gréco-romain* (1965) 41-56[PI]; id., Χρονικά Ἀρχαιολογικά, Μακεδονικά 7 (1967) 306-7[I]; id., Ἀρχαιότητες καί Μνημεῖα Κεντρικῆς Μακεδονίας, *Deltion* 23 (1968) 334-36[I]; id., Χρονικά Ἀρχαιολογικά 1966-67, Μακεδονικά 9 (1969) 170-75[I]; id., Αἰγαί-Πέλλα Θεσσαλονίκη, "Ἀρχαία Μακεδονία," Α'Διεθνές Συμπόσιον (1970) 220-23[PI]; X. I. Makaronas, Ἀνασκαφαί Πέλλης 1957-1960, *Deltion* 16 (1960) 72-83[PI]; Ἀνασκαφή Πέλλης, *Deltion* 19 (1964) 334-44[PI]; id., Χρονολογικά Ζητήματα τῆς Πέλλης, "Ἀρχαία Μακεδονία," Α'Διεθνές Συμπόσιον (1970) 162-67[I]; G. Daux, "Chronique des Fouilles 1961," *BCH* 86 (1962) 805-13[I]; D. Papaconstantinou-Diamantourou, *Pella* (1971).
PH. M. PETSAS

PELLA (Khirbet Fahil) Jordan. Map 6. Town on the S slopes of the Gilead ca. 12.8 km SE of Scythopolis (Beisan). It is known from early Egyptian historical texts as Pehal, and evidence indicates that it was also settled in the Iron Age. Veterans of Alexander the Great's army founded the Greek settlement, naming it for the birthplace of Alexander in Macedonia. Polybios (5.70) mentions it among the cities conquered in 218 B.C. by Antiochos the Great, and during the Hellenistic period Pella was known as a center of Greek culture. Alexander Jannaeus conquered it after several futile attempts in 80 B.C., and the inhabitants who refused to convert to Judaism left the city (Joseph. *AJ* 13.397). Pompey conquered Pella, then freed it and made it part of the Decapolis (*AJ* 14.75). Gabinius, the procurator of Syria, rebuilt it, and Pliny (*HN* 5.16.70) mentions its famous spring. The city was destroyed in the war against the Romans in A.D. 66. In the late Roman and Byzantine periods, however, it was an important Christian center.

There are remains of the Israelite, Hellenistic, and early Roman periods, and four churches of the Byzantine era.

BIBLIOGRAPHY. F. M. Abel, *Géographie de la Palestine* II (1938) 405-6; M. Avi-Yonah, *The Holy Land* (1966) 40, 69, 74, 175.
A. NEGEV

PELLENE Achaia, Greece. Map 11. A city on the W side of the Sys, near the modern village of Zougra, commanding the road from the coast of the Corinthian Gulf at Xylokastro S to Trikkala. Homeric Pellene, whose site is not known, was destroyed by Sikyon; the Classical city dates from the 6th c. and was refortified in Late Roman times. Pausanias mentions a gold-and-ivory statue by Pheidias in the Temple of Athena, as well as Sanctuaries of Eileithyia, Poseidon, Artemis, Dionysos, and Apollo Theoxenios (god of strangers). Games called the Theoxenia were limited to native competitors; the famous Pellene cloaks were at one time given as prizes. Scattered remains of buildings and walls mark the site, which is divided by a barren ridge, the main part of the city being on the W side, the smaller on the E. There has been some controversy over the location of Aristonautai, the port of Pellene: it was probably at Xylokastro at the mouth of the river. The ruins at Kamari, some 6 km to the W at the mouth of the next river, are perhaps to be identified with 4th c. Oluros, described by Pliny as the fortress of the people of Pellene, but apparently no longer of any significance in the time of Pausanias. The Sanctuary (Mysaion) and Sanatorium (Kyros) of Asklepios near Trikkala also belonged to Pellene.

BIBLIOGRAPHY. Strab. 8.7.5; Plin. 4.5; Paus. 2.12.2, 7.6.1, 27.1f; W. M. Leake, *Morea* (1830) III 214, 224, 389; W. M. Leake, *Peloponnesiaca* (1846) 404[M]; E. Curtius, *Peloponnesos* (1851-52) I 480[M]; C. Bursian, *Geographie von Griechenland* (1872) II 340f; J. G. Frazer, *Paus. Des. Gr.* (1898) IV 181; E. Meyer in *RE* 19[1] (1937) 354f; A. Philippson-Kirsten, *GL* (1950-59) III 168.
M. H. MC ALLISTER

PELTUINUM Abruzzi, Italy. Map 14. A city of the Vestini and a Roman prefecture on the high plain of Aquila near Prata d'Ansidonia and Castelnuovo. The community referred to itself as pars Peltuinatium (*CIL* IX, 3420, 3430 = *ILS* 5668) or as civitas Peltuinatium Vestinorum (*CIL* IX, 3314 = *ILS* 5056).

The entire perimeter of the walls is recognizable, including long, exposed stretches with several towers and the W gate. The remains of several buildings are well preserved, including a theater and a rectangular foundation, perhaps for a temple. The Via Claudia Nova constituted the main axis within the urban area. The aqua Augusta was constructed under Tiberius and enlarged by Sex. Vitulasius L. f. Qui. Nepos, sub-consul in A.D. 78.

BIBLIOGRAPHY. *CIL* IX, p. 324ff; H. Nissen, *Italische Landeskunde* 2 (1902) 441; R. Gradner in *JRS* 3 (1913) 221ff; A. La Regina in *Quaderni Ist. Topogr. Ant. Univ. Roma*, I (1964) 69ff; id. in *MemLinc* 13 (1968) 396-400, 429ff.
A. LA REGINA

PEÑALBA DE CASTRO, *see* CLUNIA

PENDELI or Brilessos Attica, Greece. Map 11. At the NE corner of the Athenian plain, between Parnes and Hymettos, lies the mountain range of Pendeli, more commonly known in antiquity as Brilessos (e.g. Thuc. 2.23.1). It was famous for its fine-grained white marble, which, although at first used sparingly for sculpture in the early 6th c. B.C., later became a major source of material for Athenian buildings, particularly on the Acropolis. According to Pausanias (1.19.6) the quarries were largely exhausted in the 2d c. A.D. by the construction of the Panathenaic Stadium, a fact which modern exploitation has refuted.

The ancient quarries can still be seen on the mountain's SW face. The most conspicuous, Spilia, with its large cavern behind, has a towering vertical face cov-

ered with channelings made by the miners. From here the marble was taken down hill along a steep, well-preserved road, with holes cut in the rock on either side to receive posts for the ropes to control the sleds. "A few minutes' climb" above Spilia is a small cave that served as a sanctuary of the nymphs. Among the finds were two excellent reliefs of the nymphs with Pan and Hermes from the 4th c. B.C. On the skyline directly above the quarries, 400 m SE of the summit, is a man-made platform suitable for the statue of Athena mentioned by Pausanias (1.32.2).

BIBLIOGRAPHY. E. Meyer, "Pentelikon," *Kl.Pauly* 4.618; E. Vanderpool, "News Letter from Greece," *AJA* 57 (1953) 281; W. Fuchs, "Attische Nymphenreliefs," *AM* 77 (1962) 242-49[I]; A. Orlandos, *Les Materiaux de Construction . . .* pt. 2 (1968) 11-12, 22-24[I]. C.W.J. ELIOT

PEN LLYSTYN Caernarvonshire, Wales. Map 24. At the base of the Lleyn peninsula, between Segontium and Tomen-y-Mur, stood the earth and timber fort of Pen Llystyn. It has now been completely destroyed by the gravel working which led to its discovery. It proved possible to recover most of the plan of a fort of 1.8 ha, probably built for two cohortes quingenariae; as at other sites, the fort was partitioned in order to separate the two units. The presence of two commanding officers may explain the abnormally large house provided. It is noteworthy that water was piped into the fort through the NE gate. The fort showed a single period of occupation, ending in destruction by fire; the finds suggest that it was held from ca. A.D. 78 to ca. 90. There appears to have been a plan to build a fort of reduced area, but when rebuilding finally took place only the N quarter of the original fort was kept, giving a fortlet of ca. 0.5 ha. While not securely dated, this does not seem to have been occupied later than ca. A.D. 150.

BIBLIOGRAPHY. A.H.A. Hogg, "Pen Llystyn. A Roman fort and other remains," *ArchJ* 125 (1968) 101-92[MPI]; id. in V. E. Nash-Williams, *The Roman Frontier in Wales* (2d ed. by M. G. Jarrett 1969) 101-3[MP].

M. G. JARRETT

PENNOCRUCIUM Staffordshire, England. Map 24. Settlement at the junction of the roads to Wroxeter and central Wales (Watling Street) and the branch to Chester. Its military importance is shown by the presence of at least five forts, which have yet to be satisfactorily related.

1) Kinvaston: a fort of ca. 10.4 ha, reduced to 7.2 ha, which may be Neronian; 2) Stretton Mill: a sequence of two forts, the smaller 1.4 ha in extent but both as yet undated; 3) S of the road a fort of ca. 2 ha may be later in the sequence; 4) indications of marching camps N of the road at Water Eaton, and a small camp by the river Penk. A straggling civil settlement, presumably with shops and tabernae, grew up along the road. The small defended enclosure with three ditches and a wall(?) astride the road is, like others along Walting Street, presumably early 4th c.

A mile to the S at Engleton is a villa excavated in 1937. It was a winged-corridor type on the river, occupied from the late 2d to the middle of the 4th c. The name appears in the *Antonine Itinerary*.

BIBLIOGRAPHY. Military sites: *Trans. Birmingham Arch. Soc.* 69 (1951) 50-56; 73 (1955) 100-8; 74 (1956) 1-11; *JRS* 43 (1953) 83-84; 48 (1958) 94; 55 (1965) 76-77; 63 (1973) 233f. Villa: *Staffs Record Soc.* (1938).

G. WEBSTER

PENNYMUIR Roxburghshire, Scotland. Map 24. Three Roman temporary camps beside the road from York to the Forth at Pennymuir. The two W of the road, 16.8 and 3.6 ha in extent, are well preserved, the smaller one contained within the other. Each had six gates, a rampart 4.5 m thick, and a ditch of the same breadth. The third camp, E of the road, was of intermediate size and had only four gates. These camps presumably housed the troops who built the practice siegeworks on nearby Woden Law.

BIBLIOGRAPHY. *Inventory of the Ancient and Historical Monuments of Roxburghshire* 2 (1956) 375-77.

K. A. STEER

PENTESKOUPHIA Corinthia, Greece. Map 11. A hill surmounted by a Frankish fort ca. 1200 m SW of Akrocorinth. In a ravine on the N slope of the hill, ca. 3 km SW of ancient Corinth, over 1000 terracotta plaques were illicitly excavated in 1879. Excavation and chance finds at the site have increased the number of fragments to ca. 1500. The plaques, which are in Berlin, Paris, and the Corinth Museum, came from a nearby Corinthian Sanctuary of Poseidon of which no architectural remains have been found. Several plaques bear dedicatory inscriptions to Poseidon in the Corinthian epichoric alphabet and representations of the god and of Amphitrite with marine and equestrian attributes. Also depicted are scenes from everyday life, potters at work with wheels and kilns, woodcutters, ships, etc. Many plaques are pierced for suspension, perhaps from trees, and are painted on both sides. A few are as early as ca. 650 B.C. but the majority belong to the Late Corinthian black-figure style of ca. 570-500 B.C.

BIBLIOGRAPHY. A. Furtwängler, *Vasensammlung in Antiquarium* (1885) nos. 347-955, 3920-24; M. Fränkel, *AntDenk* (1886-1901) I, pls. 7-8; II, pls. 23-24, 29-30, 39-40[I]; *IG* IV 210-345; E. Pernice, *JdI* 12 (1897) 9-48[I]; Helen Geagan, *JdI* 85 (1970) Anz.[I]. R. STROUD

PEPEL, *see* LIMES, SOUTH ALBANIA

PERACHORA (Peiraeum or Peraea) Corinthia, Greece. Map 11. A large promontory at the E end of the Corinthian Gulf N of the Isthmus and opposite ancient Corinth. On the summit of Lutraki Mountain, which commands the promontory, are remains of a small Classical building, perhaps a temple. Other sites in the region include Therma (modern Lutraki) where a stone lion now in Copenhagen was found; the Classical fort of Oinoi on the N side of Mt. Gerania; a large ancient cemetery at the modern village of Perachora, the finding-place of a stone lion now in Boston; a small Classical settlement with cemetery at Monasteri; a larger one at Asprocampo with several archaic inscriptions. The most important site in Perachora is Heraion, a fortified town with Sanctuaries of Hera. It has been excavated. Finds are in the National Museum of Athens.

Originally in Megarian hands, the promontory and Heraion were taken over by Corinth ca. 750-725 B.C. Argive imports are prominent in the earliest deposits at Heraion. A flourishing center until the end of the Classical period, Heraion's shrines received vast quantities of rich dedications. In the Corinthian War, 391-390 B.C., Perachora served as grazing land and a supply center of sufficient importance to merit an attack by Agesilaus. Both 4th c. and Hellenistic buildings attest considerable activity at Heraion, but after the Roman sack of 146 B.C. the site almost died out. Only a few Roman houses occupied it.

Near the W end of the promontory is Lake Eschatiotis (modern Vouliagmene) along whose W shore there are remains of an ancient road that swings W past a 4th c.

B.C. fountain-house and through the town of Heraion. Below and N of the fortified acropolis are foundations of archaic and Classical houses. Beyond the town a valley falls off towards the sea, at the E end of which is the Temenos of Hera Limenia, a rectangular enclosure with a temple lacking porch and colonnade and built ca. 750 B.C. Inside the temple was a small altar with four low curbstones, three of which were reused stelai inscribed in the early Corinthian alphabet with dedications to Hera and originally carrying votive spits. This temenos, which produced the greatest deposits of votive objects until ca. 400 B.C., is one of the richest minor sanctuaries in Greece. West of the temenos is a circular pool in which 200 bronze phialai of the 6th c. B.C. were found, probably indicating the presence of an oracle (cf. Strab. 8.380). West of the pool is a large Hellenistic cistern with apsidal ends and a row of stone piers down the center. South of this lies a contemporary building with three large rooms, one of which contains couches.

Bordering the small harbor on the NE is an L-shaped stoa of the late 4th c. B.C. The building had two stories and is the earliest known stoa with an Ionic order standing above a normal Doric. A large, archaic triglyph altar at the W end of the stoa served the Temple of Hera Akraia. Ionic columns built round the altar ca. 400 B.C. probably supported a canopy. North of the altar are the meager traces of a late 9th c. B.C. Temple of Hera Akraia, the earliest on the site, which survived until ca. 725 B.C. Among the finds in the Geometric deposit were clay models of buildings imported from Argos. To the W is the 6th c. B.C. Temple of Hera Akraia, a long, narrow structure consisting of a simple cella with a Doric porch at the E, and divided longitudinally by two low walls which supported two rows of Doric columns. A cross-wall runs in front of the base for the cult statue. The base is later, as shown by a foundation deposit of the early 4th c. B.C. The roof was of marble tiles decorated with lateral acroteria of flying Nikai. South of the temple is an enclosed court with an L-shaped portico of wooden and stone pillars, which remained in use ca. 540-146 B.C. Built diagonally across it was a Roman house of the 2d c. On the lighthouse rock are cisterns, a Classical house, and a long stretch of Classical fortification wall on the N.

BIBLIOGRAPHY. H. Payne & T. J. Dunabin, *Perachora* I-II (1940, 1962MPI); Dunabin, *BSA* 46 (1951) 61-71; N.G.L. Hammond, *BSA* 49 (1954) 93-102M; J. J. Coulton, *BSA* 59 (1964) 100-131PI; id., 62 (1967) 353-71PI; H. Plommer, *BSA* 61 (1966) 207-15PI; J. Salmon, *BSA* 67 (1972) 159-204. R. STROUD

PERAEA, see PERACHORA

PERDHIKA ("Elina") Greece. Map 9. A port in Epeiros near Arpitsa. The top of a steep hill is fortified by a strong circuit wall ca. 1900 m long, and further fortifications descend to the side of Arilla Bay, which has a sandy beach suitable for small craft. There are remains of house foundations, a temple, and probably a theater. The harbor is well sited for trade with Kerkyra and with coastal shipping.

BIBLIOGRAPHY. P. M. Petsas in *EphArch* (1955) 14; N.G.L. Hammond in *JHS* 65 (1945) 27 and *Epirus* (1967) 77f, 678 and Plan 8. N.G.L. HAMMOND

PERGAMON Cyprus. Map 6. On the N coast. The ruins of a small town identified by Hogarth with Pergamon extend around the Church of Panaghia Pergaminiotissa, due NE of Akanthou village, some 500 m from the sea. A low, rocky hill to the N may have been the acropolis.

Nothing is known of the founding or history of this small town, which seems to have flourished in Graeco-Roman and in Early Byzantine times. The town site is now a field of ruins partly under cultivation and partly overgrown with scrub. The acropolis has been quarried but on its summit a single pillar of rock is still standing while on its gentle slope two depressions have been cut, connected with each other by a flight of four steps.

The site is unexcavated.

BIBLIOGRAPHY. D. G. Hogarth, *Devia Cypria* (1889) 96-98. K. NICOLAOU

PERGAMON Mysia, Turkey. Map 7. The site is 110 km to the N of Smyrna (Izmir) on the N shore of the basin of the Caïcus (Bakīr-Çay). The place became important under the Hellenistic dynasty of the Attalids (282-133 B.C.) when it was the center of an empire which at times covered almost all of W and S Asia Minor as well as including the Thracian Chersonese and, as a foreign possession, the Island of Aigina. The dynasty was founded by Philetairos, who was appointed by King Lysimachos to guard a war treasure in Pergamon. With his desertion of Lysimachos (282 B.C.) he laid the foundations of Pergamon's greatness. After him ruled Eumenes I (263-241), Attalos I, who was the first to take the title of king (241-197), Eumenes II (197-159), Attalos II (159-138), and Attalos III (138-133). The political and military successes of the Attalids consisted of their successful struggles against the Celtic peoples of Asia Minor and in the way they maintained themselves against the rival great powers of the Seleucids and the Macedonians. This was managed in part by a clever policy of alliance with Rome, which shortly after 133 B.C., incorporated the central areas of Pergamon in its territory as the province of Asia. At the time of the Attalids the art, literature, and science of Pergamon were of outstanding importance. The architecture and the sculpture of this period deeply influenced subsequent art. Pergamon went through a period of cultural renaissance in the 2d c. A.D., shown by the importance of the Sanctuary of Asklepios. Already in the 2d c. A.D. the city had a bishop. In 716 it was overrun by the Arabs.

To the W Pergamon was connected with the Aegean coast by the valley of the Caïcus while up the valley to the E near Thyatira (Akhisar) lay the Persian Royal Road joining Kyzikos with Sardis. Near the mouth of the Caïcus the town of Elaea served as her port. The Hellenistic city lay on the ridge of a mountain (355 m above sea level) which runs from NW to SE and is surrounded by the tributaries of the Caïcus, the Selinus (Bergama-Çay) on the W and the Cetius (Kastel-Çay) on the E. The main part of the Hellenistic city lay on the summit and the S slope of the ridge. The earliest enclosure wall, probably of the 4th c., surrounds the upper part of the hill. In the first half of the 3d c. this was extended towards the S to a point above the Sanctuary of Demeter and the gymnasium. Under Eumenes II a new and stronger fortification wall was built which enclosed the greatest part of the slopes of the hill to the S and W. The main gate lay on the SW terrace turned toward the thoroughfares of the Caïcus valley. On the inside it had a fortified, square court. From this point the paved principal road rose in sharp bends to the summit of the mountain. Already in the 2d c. parts of the city lay outside the wall of Eumenes on a small plateau (Musala Mezarlık) directly W of the Selinus. Three pylons and one arch (8.1 m span) survive of a Hellenistic bridge over the river at the SW foot of the acropolis. Farther S at Kızıl Avlu (see below) is a Roman bridge which crosses the river in two arches. During the Empire the city stretched out over the plain lying to the W of the acropolis (the area of the modern town of Bergama). A

fortification wall of the 3d c. A.D. built against the threats of attack by the Goths follows for the most part the wall of the 3d c. B.C.

The steepness of the mountain on which the city is built made necessary the creation of extensive systems of terraces and retaining walls. In the upper city can be seen a harmonious grouping of buildings well adapted to the difficult terrain. There the open spaces spread out like a fan around a small terrace, above which lies the cavea of the theater.

South Face. The main street runs from the S gate to the lower agora (34 m x 64 m, 2d c. B.C.) surrounded by Doric stoas. The stoas had two stories on the narrow (E and W) sides of the agora, three on the S side and probably three on the N side. Colonnaded corridors opened onto the square and in the S the ground floor also included an exterior colonnade. The corridors also opened into suites of rectangular rooms which doubtless had commercial uses. Principal access was from the NE side of the ensemble. Above the agora to the W stand two large, originally Hellenistic houses with peristyles, which are followed to the N by a similar structure which faces out over the slope. It was remodeled in Imperial times and inhabited by a consul named Attalos. Between the agora and the gymnasium the main street is flanked on either side by rows of small shops. The really extensive complex on the S slope is that of the gymnasium, which stands on three terraces set one above another (2d c. B.C. reconstructed under the Empire). Steps covered by barrel vaulting lead from the main street to the middle gymnasium terrace by way of a propylon flanked on the right by a fountain house and on the left by the small lower terrace of the gymnasium. On the E side of the middle terrace stand the remains of a marble Corinthian prostyle temple dedicated to Herakles. On the side against the mountain the terrace was bordered by a two-story Doric stoa whose upper story had a colonnade facing the terrace. The upper gymnasium terrace is enclosed on the N, E, and W by palaestrae bordered with two-story Ionic porticos (2d c. B.C.) which in Hellenistic times were originally built in the Doric order. Behind the N colonnade lie the odeion, the ephebeion, and a room which served for the cult of the emperor. In the W lay the loutron, in the E other structures, most notably the exedra built by the gymnasiarch Diodoros Pasparos in 127 B.C. Baths occupied the sides of the terrace, and to the S it was bordered by a basement with a roofed hall for running. Nothing is known to have closed the terrace on the side overlooking the valley. The main access to the upper terrace runs from a propylon in the E of the gymnasium by way of a ramp to the SE corner of the palaestra. In the W side of the upper gymnasium are the remains of a marble Ionic prostyle temple (2d c. B.C.), which was built in part from material taken from a previous Doric structure. It was probably dedicated to Asklepios. To the N, above the upper gymnasium, the temenos of Hera Basileia stands on two small terraces. Stairs lead to the Doric prostyle temple. The marble entablature carries the inscription of Attalos II. In the cella stood a colossal statue representing Zeus or a hero (Istanbul). The floor was decorated with Hellenistic mosaic. The Temenos of Demeter and Kore stands directly to the NW of the upper gymnasium on a small terrace some 100 m long. It is reached from the E by way of a propylon of which the prostyle facade has leaf-decorated capitals of an egyptianizing sort, as well as an inscription describing it as having been built by Queen Apollonis, wife of Attalos I. The terrace is surrounded on its remaining sides by Hellenistic stoas built in different orders and in some cases with more than one story. In the 2d c. B.C. the S stoa was rebuilt in

marble. In the N are also to be found tiers of seats for participants in cult festivals. An Ionic temple in antis stands near the middle of the terrace. It was decorated with a frieze of bucrania and bore an inscription showing it to have been built by Philetairos and his brother Eumenes. In the Imperial period a marble vestibule was added. There is likewise an inscription by Philetairos and Eumenes on the altar, which was decorated with volutes and stands to the E of the temple.

The Upper City. The main street leads through the upper agora (2d c. B.C.), the S side of which was bordered by a two-story Doric hall. The side of the hall opening on the square has a colonnade. Colonnades enclose the square on the E and NE as well. On the W side are the remains of a marble prostyle temple of mixed Doric and Ionic design. It was probably dedicated to Dionysos. Above the agora to the N is the trapezoidal Terrace of the Great Altar (first half of the 2d c. B.C.). The terrace was reached on its E side from the main street by a propylon. In the N the terrace was marked off by a long pedestal, behind which the cliff rises to the point where the Sanctuary of Athena is located. The nearly square foundations of the altar stand in the terrace above the remains of an older structure of religious nature. The marble construction (ca. 36 m x 34 m and ca. 16.5 m high; partially reconstructed in Berlin) consisted of a crepis of five steps, a socle and a superstructure with an inner courtyard. The courtyard, with its altar for burnt offerings, was reached by way of a set of steps which cut through the socle. It was surrounded on the N, E, and S by a solid wall in front of which ran a graceful Ionic colonnade. The wall and colonnade extended along the flank of the steps. The entrance side of the courtyard was bordered on the outside by a row of Ionic columns, on the inside by a row of piers with Ionic half-columns. A planned row of piers along the inside of the courtyard wall was not executed. The famous frieze in high relief ran along the socle of the structure (111 m long, 2.29 m high, approx. 118 panels). The major part of the frieze survives. It shows the fierce battle of the gods against the giants. Facing the entrance to the terrace are the panels near the center of the E frieze that show Zeus, Athena, and Nike. These are a remarkable artistic achievement. The remains of signatures by the artists on the frieze representing the giants testify to the participation of Pergamene and Attic masters. In the inside of the superstructure a second frieze in lower relief runs above the socle of the wall. It depicts the life story of Herakles' son Telephos, the mythical hero of the Pergamene countryside. The remains of a dedicatory inscription on the architrave of the colonnade does not indicate with certainty the dedication of the altar to a particular divinity. It is assumed that it was in fact dedicated to Zeus and victory-bringing Athena. To the NE of the terrace is a large building with peristyle which was remodeled on several occasions (3d c. B.C. to 1st or 2d c. A.D.). It is closed on the E by a wide space and a niche above which in Imperial times a towerlike story with a Corinthian pergola was erected. Judging from its resemblance to other structures (i.e. Kalydon in Aetolia), it must have been a heroon, and probably served for the cult of the Pergamene kings and their successors.

The main street then leads through a gate flanked with towers up to the highest part of the city. Buildings to the W of the street include the Sanctuary of Athena. Its terrace was surrounded on three sides by stoas. To the SW are the remains of a simple Doric peripteral temple (from the 3d c. B.C.). The E and N stoas each had two stories, with a Doric facade of marble opening from the ground floor onto the square; the upper floor had a

Doric-Ionic facade. The S part of the E stoa included the propylon (partially reconstructed in Berlin). The N stoa was divided by a center row of columns into two aisles. These columns have palm-leaf capitals, a development of an Aeolian type of the 6th c. B.C. The balustrade along the second story of the stoas is decorated with a frieze that shows battle trophies and plundered weapons. They are also of outstanding importance to art history. Of the S stoa, only the foundations remain. Pergamon's library, which Mark Antony took to Alexandria, was situated in an annex behind the N stoa. A copy in marble of Phidias's Athena Parthenos (Berlin) stood in the main room of the library. Around the Sanctuary of Athena were numerous bases of votive figures (Berlin) which referred to the victories in battle of the Pergamenes. Some of the names represented by the signatures appear in ancient literary sources. Depictions of the conquered Gauls, which were to be found on the bases along with other figures, have been recognized from Roman copies. The collection of copies of Attic sculpture (Berlin) which came from the area of the Sanctuary of Athena, as well as signed bases, are considered to be the remains of the art collection of the Pergamene kings.

To the NW of the Sanctuary of Athena the rectangular open space (58 x 68 m) of the Traianeum rests for the most part on barrel vaulting. This important ensemble was begun under Trajan and finished under Hadrian. On the valley side the terrace is bordered by a high supporting wall which does not, however, obstruct the view. On the other sides the plaza was enclosed by porticos of semi-Corinthian style. The rear portico was raised above the level of the square by a socle. Entrance was in the SE wing of the halls. On the center axis of the square stood the Corinthian peripteral marble temple. In the Late Hellenistic manner it stood on a podium with an open stairway. In the rubble of the cella were found fragments of colossal statues of the emperors Trajan and Hadrian. The remains of Hellenistic buildings and a Hellenistic exedra show that the Traianeum was built on an older cult site. The identification of the building as a Temple to Trajan is made certain not only by the fragments of the statues but also by coins that show a statue of Trajan as the synnaos of Zeus Philios standing in the temple. The same identity of cult is also attested in Pergamon by inscriptions.

Buildings E of the street: in the zone between the main street and the E fortification of the citadel lie six large complexes of buildings numbered from N to S as building complexes I-VI. Building-complex I served as a barracks; II includes a watchtower; III, which includes a deep round cistern and a rectangular religious structure, is of uncertain purpose; IV is an extensive house with peristyle and rich wall decorations similar to the First Pompeian Style; V, likewise built of marble, has a spacious peristyle and outstanding mosaics (Berlin) on the floor of the NE rooms. The mosaics are decorated with ornamental and naturalistic motifs, and bear the signature of one Hephaistion. These buildings belong to the Hellenistic period, V probably to the reign of Eumenes II. Both buildings with peristyle (IV and V) are considered to have been used as royal palaces.

The N projection of the mountain on which the city rests bore at least five long, rectangular storehouses oriented N-S between which ran narrow alleys (3d and 2d c. B.C.). The remaining stone socles are in part furnished with ventilation slits. Some of these buildings had stone superstructures, others wooden ones. The entrance was on the ends. Numerous discoveries of stone artillery balls and the remains of metal instruments show that the buildings were arsenals.

Below the Traianeum and the Sanctuary of Athena lies the cavea Hellenistic theater, with its stage on a long, narrow terrace.

The cavea is not completely semicircular in the lowest third around the orchestra, while the upper two-thirds are much abbreviated semicircular sections owing to the form of the slope. The andesite seats accommodated ca. 10,000 spectators. The loges of the privileged members of the audience lie above the first diazoma. The original skene (3d c. B.C.) was constructed with a frame of wooden posts. The well-preserved stone sockets on the terrace could be covered and indicate that the building could at times be taken down so that the traffic on the narrow terrace would not be impeded. In the 2d c. B.C. this structure was replaced by an equally movable wooden skene but now with proscenium. Finally, in the Roman period an andesite bema was built with marble parados pylons and a marble gate to the N. In addition, the retaining wall directly above the cavea was strengthened with arcades. The 250 m-long terrace resembled a street. It could be entered from the S through the double arches of a gate built in the Hellenistic period. South of the theater a Doric stoa bordered the upward slope of the terrace onto which it gave. On the downward slope was a three-story building the top story of which was a Doric stoa at the level of the terrace. In the wall of the stoa which faced the valley were doors and windows; below was a long, narrow terrace complex (the reconstruction of the building resembles the stoa in the agora of Aegae). To the N an Ionic temple marks the end of the terrace. Built on a platform (18.5 x 27 m; 4.5 m high) which is to a large extent a protrusion of the bedrock, it is oriented to the long axis of the terrace from which it is reached by an open stairway. Behind a vestibule of 4 by 2 columns lies the cella the walls of which were articulated on the inside by an architectural system. In the cella is preserved the broad plinth of a cult statue. The well-built structure was probably erected as an Ionic temple in the 2d c. B.C. and later restored under Caracalla, whose name is mentioned in the inscription on the epistyle. The temple was probably originally dedicated to Dionysos. The architectural remains on the W slope of the mountain, over the lower part of which the modern town stretches, have hardly been investigated. Above the Hellenistic bridge over the Selinus is a terrace (ca. 150 x 80 m) of the Imperial period supported by barrel vaults (modern Gournelia). This perhaps belonged to a gymnasium.

The City in the Plain. In the lower city the most important ruins are those of the "Kızıl Avlu" (the "Red Courtyard," 2d c. A.D.) which can still be seen from afar. This complex is built of brick in a symmetrical, tripartite architectural plan with a court laid out in front on the W (total length of the complex ca. 300 m). The rectangular central basilican structure (ca. 60 x 25 m) is flanked by two circular buildings (diameters ca. 18 m). In front of each of these on the W is an entrance court in which were found fragments of colossal double figures (Atlantes) with Egyptian coiffure. These finds together with an underground system of corridors, underground pillar stoas as well as several built-in water basins suggest, in conjunction with the tripartite division of the whole complex, that it housed the cult of an Egyptian triad (Isis, Osiris, Harpokrates or Anubis). Below the NW slope of the Musala Mezarlık are preserved the conspicuous ruins of an amphitheater of the Imperial period. It rises above a stream bed which runs into the Selinus. The orientation of the long axis (ca. 136 m) is roughly N-S (short axis ca. 128 m; arena ca. 51 x 37 m). The structure of the cavea, faced with andesite blocks, is still preserved in parts to a height of ca. 30 m above the stream bed. At the SE edge of the

Musala Mezarlık are the collapsed remains of a theater of the Imperial period. Its foundations are of volcanic tuffa. The superstructure was faced with slabs of andesite. One of the buttresses of the SW part of the cavea was pierced by a gate covered by an arch (modern name "Viran Kapı"). Through it runs the road between the Asklepieion (see below) and the city. On the NE slope of the Musala Mezarlık is a stadium of the Imperial period of which little more than the outline is preserved.

The oldest datable architectural remains of Roman Pergamon are represented by the fragment of an epistyle from a marble building which bears the name of P. Cornelius Scipio Nasica who died in Pergamon in 132 B.C. The inscription was found near Kızıl Avlu.

The Asklepieion. The Asklepieion is located at the edge of the Imperial city, SW of the Musala Mezarlık. It was connected to the city by a road which ran by the Roman theater (see above "Viran Kapı"). The W part of the road was renovated in the 2d c. A.D. and was made into a colonnaded street in the Corinthian order. The Asklepieion was founded ca. 400 B.C. as a private sanctuary but in the late 3d c. B.C. it received official status. Under Hadrian the sanctuary took on a spectacular appearance which eventually led to its being enrolled in the list of the "wonders of the world." Our knowledge of the importance of the sanctuary in this period is especially due to the hieroi logoi of Aelius Aristeides (A.D. 117 or 129-89) who spent a long time in the Asklepieion.

The sanctuary lies at the N edge of the bed of the Caïcus river on a slope facing S. In the early Hellenistic Period the first Temple of Asklepios Soter rose on a narrow terrace. Next to it were other temples, probably of Apollo Kalliteknos and of Hygieia, and several altars. Also dating to this early period is a fountain house built of blocks of andesite just to the E of the temenos. This was fed by a spring which still flows. The earliest incubation building is also to be dated to this phase of the sanctuary. It marks the S side of the temenos. Only the foundations or at most the socles of all these early Hellenistic buildings are preserved. In the course of the late Hellenistic period this plan was enlarged by an extension of the terrace to the S at which time it received its first monumental form. Now a rectangular plaza was bordered by stoas on the S, W, and E while on the N lay the enlarged incubation building. From this period essentially only the foundations of the stoas and some rectangular buildings are preserved in situ. West of this complex have been uncovered the remains of a Hellenistic gymnasium with a Doric stoa of andesite opening to the S. The buildings visible today belong for the most part to the 2d c. A.D. Except for the gymnasium, of the Hellenistic plan only the temple area together with the incubation building was retained. The latter were enclosed in the new plan of the rectangular plaza which was bordered on N, S, and W by Ionic marble stoas (area ca. 100 x 132 m). To the E was erected a rectangular forecourt which was connected to the colonnaded street (see above). The main buildings stand on the E side of the sanctuary. The marble propylon with its pediment carried by four Corinthian columns was dedicated according to its preserved inscription by A. Claudius Charax. The most prominent building of the E side of the sanctuary was the round temple of Zeus Asklepios which was dedicated by L. Cuspius Pactumeius Rufinus probably under Hadrian. The temple is reached from the plaza by an open stairway. It is entered through a marble vestibule in the Corinthian order. The substructure of the building, reveted with andesite slabs with a torus molding of the same material running around the base, is still well preserved. The naos (interior diameter 23.85 m) was covered by a cupola decorated with mosaics. In the marble incrustation wall were seven niches for the erection of the cult statues. One must imagine the statue of Zeus Asklepios in the main niche opposite the entrance. Both the form and function of this building are unmistakably dependent on the Pantheon in Rome. On the NE side of the plaza is an almost square stoa which is identified by an inscription as the library dedicated by Flavia Melitene. Inside was found the colossal statue of the heroized emperor Hadrian (Bergama Museum). To the SE and at a lower level than the Temple of Zeus Asklepios stands a two-story round building (diameter 26.5 m) which is connected with the N side of the plaza by a cryptoporticus. The function of this building is unknown. On the slope of the N edge of the sanctuary is a theater whose skene facade can be reconstructed from the preserved architectural members. A luxurious, two-part latrine, also partly of marble, lies behind the SW corner of the plaza. Of great importance for the dating of the Imperial rebuilding of the Asklepieion is the inscription on the architrave of the N colonnade which is in large part preserved. This inscription names among others the emperor Hadrian.

The Water Supply. The water supply was assured by a system which brought in water from an area up to 40 km distant. In addition to aqueducts in places several stories high, two Hellenistic high-pressure systems have been identified. One of these systems ran from the N to the summit of the acropolis with a pressure of 20 kg/cm^2.

The Cemeteries. Four grave mounds with stone krepis lie in the plain SW of the city. The largest, Yigma-Tepe (circumference ca. 500 m), belongs to the Hellenistic period. Its tomb chamber has, however, never been found. Two smaller mounds are also Hellenistic, probably of the 3d c. B.C. Each contained a sarcophagus with remains of the skeletons and grave gifts. Among the latter a wreath of gold oak leaves is particularly noteworthy. Mal-Tepe, by the modern road at the edge of the town, belongs to the Roman period of Pergamon. Here the dromos covered by a barrel vault leads to an eccentrically located tomb chamber which contained remains of a sarcophagus. On the summit of the mound can still be recognized the foundations of a monument of indeterminate nature.

The majority of the finds are in the Staatliche Museen of East Berlin (Pergamon Museum); others are in the museum in the town of Bergama and the Archaeological Museum of Istanbul.

BIBLIOGRAPHY. C. Texier, *Description de l'Asie Mineur*, II (1848) 217-37[MI]; W. Dörpfeld, "Die 1900-1901 in Pergamon gefundenen Bauwerke," *AthMitt* 27 (1902) 10-43[PI]; id., "Die Arbeiten zu Pergamon 1902-1903, Die Bauwerke," *AthMitt* 29 (1904) 114-207[PI]; id., "Die Arbeiten zu Pergamon 1906-1907," *AthMitt* 33 (1908) 327-74[PI]; id., "Die Arbeiten zu Pergamon 1908-1909, I. Die Bauwerke; Die Resultate der Ausgrabungen von 1910," *AthMitt* 35 (1910) 346-93, 524-26[PI]; id., "Die Arbeiten zu Pergamon 1910-1911, I. Die Bauwerke," *AthMitt* 38 (1912) 233-76[PI]; T. Wiegand, "2. Bericht über die Ausgrabungen in Pergamon, 1928-1932. Das Asklepieion," *AbhBerl* Phil.-Hist. Klasse Nr. 5 (1932)[PI]; O. Deubner, *Das Asklepieion von Pergamon* (1938)[PI]; H. Kähler, *Der Grosse Fries von Pergamon* (1948)[PI]; E. Boehringer, "Pergamon," *Neue deutsche Ausgrabungen im Mittelmeergebiet und in Vorderen Orient* (1959) 121-71[MPI]; id., "Die Ausgrabungsarbeiten zu Pergamon im Jahre 1965," *AA* (1966) 416-83[PI]; id., "Gesammelte Aufsätze," *Pergamenische Forschungen*, I (1972)[PI]; E. Rohde, *Pergamon, Burgberg und Altar* (1961)[PI]; J. Schäfer, "Hellenistische Keramik aus Pergamon," *Pergamenische Forschungen*, II (1968)[I]; *Die Altertümer von Pergamon*, I-XI (1885-1969)[MPI]; O. Zie-

genaus & G. de Luca, "Die Ausgrabungen zu Pergamon im Asklepieion," *AA* (1970) 181-261PI; E. V. Hansen, *The Attalids of Pergamon* (1971) 485-502.

J. SCHÄFER

PERGE (Aksu) Turkey. Map 7. City in Pamphylia, 16 km NE of Antalya. The tradition that the city was founded by the "mixed people" who wandered across Asia Minor soon after the Trojan War, led by Amphilochos, Mopsos, and Kalchas (Hdt. 2.91; Strab. 668), seems trustworthy; statue bases of the last two, described as founders, stood at the main gate in Roman times. In the Athenian tribute lists [P]erge is included, with an unknown tribute, in the assessment of 425 B.C., but does not occur earlier. When Alexander arrived in 333 Perge welcomed him, supplied guides to lead his army from Phaselis (Arr. 1.26), and served as his base for operations in Pamphylia. After Alexander's death the city came under the Seleucids until Magnesia in 190; in 188 a Seleucid garrison still remained to be expelled by Manlius (Polyb. 21.4; Livy 38.37). The city later came under the Pergamene kings, and was included in the province of Cilicia; the Temple of Artemis Pergaea offered rich booty to Verres in 79 B.C. St. Paul was twice in Perge (Acts 13:13; 14:24). Despite her distinction and prosperity it was only in the 3d c. A.D. that the city acquired the titles of asylos and metropolis. In Byzantine times Perge and Sillyon were normally combined under a single metropolitan, until he was replaced by the metropolitan of Attaleia.

It is generally agreed that the original settlement must have been on the flat-topped hill at the N end of the site, though no early remains have been found there. The lower town was not fortified until the 3d c. B.C. under the Seleucids; about the 4th c. A.D. the area of the city was slightly enlarged by the erection of an outer wall across the S end, but later, in Byzantine times, occupation seems to have returned to the acropolis hill; the scanty surviving ruins are all of this period. The acropolis hill was never fortified.

The main city is divided into four unequal quarters by colonnaded streets crossing at right angles towards the N end; the streets are not quite straight. Down the middle of each ran a broad water channel barred at intervals of 6 m by cross-walls. The N-S street continues outside the city on the S for ca. 0.8 km, and the streets were lined with stoas and shops. The city walls, dating from the 3d c. B.C., are well preserved, especially on the E, and many of the numerous towers stand almost complete. In addition to several posterns there are four main gates, two on the S—one in each of the two walls—and one each on E and W.

The inner, earlier, gate on the S is still in good condition. It has the form of a horseshoe-shaped court flanked by towers in the wall, as at Side and Sillyon; here the towers are round and still stand, though somewhat damaged, nearly to their full height. At the back of the court a triple arch was erected in Roman times, but only the lowest parts of this remain. On a ledge at the foot of the walls of the court stood statues of the founders of the city; these were mostly mythological heroes, including Mopsos and Kalchas. Two of them, however, are M. Plancius Varus and his son, also designated "founders." The inscribed bases survive, but the statues have not been found. Other statues stood in niches higher up in the wall.

M. Plancius Varus is described in the inscription as father of Plancia Magna, a lady mentioned in numerous inscriptions (nearly a score have been found) in various parts of the city; in some cases she dedicated statues of members of the imperial family, in others her statue was erected by the civic authorities. She was priestess of Artemis, and held the office of demiurgus in the early 2d c. A.D. Her tomb, now almost completely destroyed, stood beside the street outside the later S gate.

In Imperial times an open court was constructed outside the earlier S gate. Its E side was formed by a stoa. In the middle of the S side was a monumental gateway, now ruined; its ornamentation was exceptionally massive. When the 4th c. wall was built the S side of the court was made to form part of it, and the gate became the main gate of the city. Outside it a whole series of marble statues was found, representing the gods of the city. On the W side of the court stood a small nymphaeum, with a water basin backed by a two-storied facade; adjoining this on the N was a propylon with two rows of four Corinthian columns and rich decoration. These buildings, as an inscription shows, date to the time of Septimius Severus. Here also statues were found, two of which— one complete with head—represent Plancia Magna. Behind the nymphaeum to the W are large baths, not yet excavated, with walls standing to a considerable height.

Inside the Hellenistic S gate, E of the colonnaded street, is the agora, ca. 65 m square and surrounded with stoas and shops; it appears to date from the late 2d c. A.D. In the middle (as at Side) is a round building whose character has not yet been determined.

In the NW quarter is the earliest building known inside the wall. It is identified as a palaestra, and is dated by its dedication to Claudius by C. Julius Cornutus. Its S wall, on the street, is well preserved, with numerous windows. Nearby, beside the W city gate, is another bath.

Close below the acropolis hill, beside the short N arm of the N-S street, is a second nymphaeum. This has the familiar form of a water basin enclosed by a back wall with niches and two projecting wings. Along the length of the walls ran a podium supporting Corinthian columns. Statues were found of Artemis, Zeus, and a Roman emperor. An inscription on the podium seems to imply that the building was dedicated by a certain Aur. Seilianus Neonianus Stasias.

Outside the city on the SW are the stadium and the theater. The stadium, excellently preserved, is 234 m long, including a walled-off area 42 m long at the N end. There are twelve rows of seats, with a broad gangway at the top, and at the bottom a narrow passage originally separated from the arena by a barrier. The N end is rounded; at the S end stood an ornamental gateway of which hardly a stone remains. Under the seats on the E side is a vaulted passage divided by cross-walls into 30 rooms; from every third room a door opens into the narrow passage round the arena; the others were used as shops. In some of these the trade of the occupant, and sometimes his name, is inscribed on the wall; the trade of silversmith is mentioned twice.

The theater seated some 14,000 spectators. It has recently been partially excavated and the retaining wall restored. It is of Graeco-Roman type, largely built into the hillside, with a cavea of rather more than a semicircle and a high Roman stage building. The cavea is divided by 13 stairways into 12 cunei, doubled in number above the diazoma. At the top is an arcaded gallery, with an entrance at its middle point. On each side two vaulted vomitoria lead from the hillside to the diazoma. The stage building, of at least two stories, still stands to a considerable height; its frieze of panels with reliefs of Dionysiac scenes is still in fair condition. The outer E face of the building was later converted into a nymphaeum, with five large niches, the smallest in the middle.

The foundations of a temple have recently been excavated 0.8 km S of the city, near the end of the street. It was quite small, with a stylobate some 23 by 14 m,

and seems to have been prostyle tetrastyle, with pronaos and cella. The columns were unusual; they stood directly on the stylobate as in the Doric order, but had 24 flutes divided by narrow arrises. The main facade is on the W, and the date appears to be Hellenistic. There is no evidence for attributing the temple to any particular deity, but it is clearly not the Temple of Artemis Pergaia, which was large, in the Ionic order, stood on high ground outside the city, and has never been found. The old idea that its site was indicated by a small church on the acropolis hill was discredited when the church proved to be in reality a cistern, and other hills in the neighborhood have yielded no results.

Tombs stood beside the three roads leading to the city gates on E, W, and S, though only those on the W survive in any quantity: excavation of a street of tombs revealed some 30 sculptured sarcophagi, some of which are now in the Antalya museum.

BIBLIOGRAPHY. C. Fellows, *Asia Minor* (1838) 190-92; K. Lanckoronski, *Die Städte Pamphyliens* (1890) 33-63[MI]; G. E. Bean, *Turkey's Southern Shore* (1968) 45-58[MI]; excavation reports: *Excavations and Researches at Perge*, Türk Tarih Kurumu Publications 5.8 (1949); *AnatSt* (1968). G. E. BEAN

PERGUSA (Cozzo Matrice) Enna, Sicily. Map 17B. An ancient legend placed the Rape of Persephone/Kore by Plouto on the shores of the lake of Pergusa, and a grotto is shown today as the one through which the god's chariot is reputed to have passed. In the whole area N of the lake graves may still be seen in the shape of small artificial grottos (8th-6th c. B.C.) from which come goods including pottery of the so-called Licodia Eubea type, together with imported Greek material, such as one finds in many Sikel-Greek settlements of central and S Sicily. Of the habitation center connected with this group of graves only a few uninvestigated traces are left on the nearby Cozzo Matrice (857 m above sea level). Sherds found there suggest that the small town flourished until the 3d c. B.C. This archaeological material is visible in the Alessi Museum at Enna. A. CURCIO

PERIA, *see* LIMES, GREEK EPEIROS

PÉRIGUEUX, *see* VESUNNA PETRUCORIORUM

PERISSA, *see* THERA (Santorini)

"PERNACO," *see* BRAIVES

"PERNICIACUM," *see* BRAIVES

PERNICIDE PORTUM, *see* BERENICE

PERPIGNAN, *see* RUSCINO

PERUGIA, *see* PERUSIA

PERUSIA (Perugia) Umbria, Italy. Map 16. The city, 64 km SE of Arezzo, rose on an uneven hill that overlooks the valley of the Tiber. Recent finds testify to the presence of life in the Villanovan age, and continuous development from the second half of the 6th c. B.C. Perusia appears to have been a flourishing and populous center, particularly from the 3d to the 1st c. B.C. It was a Roman municipium ascribed to the tribus Tromentina. In 41-40 B.C. L. Antonius was besieged at Perusia and in 40 B.C. the city was taken and sacked by the troops of Octavian.

The ancient city was enclosed by a wall built of travertine blocks, which is preserved for long stretches; most of its circumference may be traced. Several ancient gates still open the wall. Among the most important are the so-called Arch of Augustus, flanked by two keeps, and the Marzia gate actually built into the bastion of the Paolina fortress. The gates and the walls have been variously dated. According to the most recent studies they were constructed in the second half of the 2d c. B.C. Probably contemporary with the walls is the well built of large blocks of travertine below Piazza Piccinino, at the foot of the city fortifications.

The area of habitation, which has provided very few remains, occupied the center of the modern city. A mosaic showing Orpheus and the wild beasts from the 2d c. A.D. probably comes from a bath building. It was found in the locality called S. Elisabetta, outside the ancient city walls.

Among the monuments surviving from the necropoleis that grew up around the city, particularly notable is the Hellenistic Hypogeum of the Volumni. It is dug into the earth and imitates the plan of a house. Its atrium, covered by a ceiling with a double slope, opens into various rooms. Several of the ceilings and triangular supports are decorated with reliefs. The tomb of S. Manno, a rectangular hypogeal room, is built of blocks of travertine and has a barrel vault.

The National Archaeological Museum of Umbria is housed in the former convent of S. Domenico in Perugia.

BIBLIOGRAPHY. Conestabile, *Dei monumenti di Perugia etrusca e romana* (1855-70); C. Shaw, *Etruscan Perugia* (1939); *EAA* 6 (1965) 84-88 (Pietrangeli-Feruglio) with bibliography; H. Blanck in *AA* (1970) 325f; U. Ciotti in *Umbria* (1970) 108ff. U. CIOTTI

PESAČA, *see* LIMES OF DJERDAP

PESARO, *see* PISAURUM

PESSINOUS Galatia, Turkey. Map 5. About 16 km off the Ankara-Eskişehir road near Sivrihisar, the center of one of the chief Celtic settlements of the 270s B.C. It was famous for its great shrine of the Mother Goddess (Kybele; locally often Agdistis) and was therefore a center of the cult of Attis as well (Paus. 1.4.5 and 7.17. 10-11). Strabo (12.5.3) describes Pessinous as being a major market center, her eunuch priests much enriched. The Attalids, who dominated the town, rebuilt Kybele's sanctuary, adding to or near it porticos constructed of white marble. At the end of the 3d c. B.C. the goddess' cult-stone, said to have fallen from heaven (Amm. Marc. 22.9.7) was transported to Rome and set up in the Temple of Victory on the Palatine, as a result of a Sibylline reading. By 25 B.C., when Augustus formed the province of Galatia, Pessinous was under Roman rule. In A.D. 362 the emperor Julian worshiped there (Amm. Marc. 22.9.8). The site has been excavated since 1967.

A temple has been uncovered, seemingly of Hellenistic date, that may derive from models farther W, such as the Temple of Athena at Priene. At Pessinous however the shorter ends of the peristyle are formed by walls, and on the long sides seven rectangular marble pillars appear, the walls of the short ends being turned along the long flanks to the extent of about two columns' distance. From the point of view of Classical design, this suggests a model based on a 6 x 11 column system. The structural techniques as reported seem to be Hellenistic.

The excavation of a necropolis has brought to light several Roman tombs of considerable importance; some of them have door facades in the manner of Phrygian and other Anatolian tombs. The local depot displays

some of the finds. Recently a canal, with step-sides, has been uncovered within the town, as well as what is apparently a regulatory dam system of Roman date.

BIBLIOGRAPHY. *TürkArkDerg* (1967) 113-31; P. Lambrechts, *De Brug* (1967ff)[PI]; K. Bittel, "Beobachtungen in Pessinus," *AA* (1967) 142-50[P]; *Coll. Latomus* 102 and 114 (3d ed. 1973) 404-14; E. Akurgal, *Ancient Civilizations and Ruins of Turkey* (2d ed. 1970) 277-78, and bibliography on p. 365[P]. W. L. MAC DONALD

PESTO, *see* PAESTUM

PETALIDI, *see* KORONI

PETINESCA (Studen) Bern, Switzerland. Map 20. Vicus and temple precinct at the E foot of the Jensberg, ca. 7 km SE of Biel. (The name appears in *It. Ant.* 353.1 and in *Tab. Peut.* as Petenisca.) The Roman settlement succeeded a fortified oppidum on the plateau of the Jensberg, some ramparts of which are still visible. The site is on the military highway from Aventicum to Salodurum, where the road over the Jura to Epamanduodurum (Mandeure) branches off. There was a military post here in the 1st c. A.D.; the mansio was fortified in the 3d c., and lasted into the 4th.

The vicus, the ruins of which cover the SE slopes of the Jensberg, has not been excavated. Part of the fortification walls and a tower with a gateway which closed off the main road are visible. Several buildings nearby are the remains of the mansio with its annexes and a bath. Above the posting station on the Gumpboden was a temple precinct which probably originally belonged to the oppidum. In the oblong enclosure (200 x 80 m) with entrances on three sides stood seven temples of Gaulish type (the largest 15 m on a side), two smaller chapels, and a service building. The cults have not been identified. The sanctuary has been partly restored. On the slope between this precinct and the settlement, at Ried, one temple of a second sanctuary has been found. The Museum Schwab is in Biel.

BIBLIOGRAPHY. E. Lanz-Bloesch, "Die Ausgrabungen am Jensberg 1898-1904," *AnzSchweiz* 8 (1906) 23-41, 113-27[PI]; F. Staehelin, *Die Schweiz in römischer Zeit* (3d ed. 1948) 351-52, 571, 621[P]; O. Tschumi, *Urgeschichte des Kantons Bern* (1953) s.v. Studen, 358-60; V. von Gonzenbach, *BonnJbb* 163 (1963) 93-95; H. Grütter, "Ein zweiter Tempelbezirk in Studen, Petinesca," *Ur-Schweiz* 28 (1964) 25-28[PI]. V. VON GONZENBACH

PETIT-BERSAC Dept. Dordogne, France. Map 23. A large Gallo-Roman area (4 ha), investigated since 1965. Among the construction uncovered in a stretch of 170 m were 12 rooms, one of them a fine chamber 7 x 18 m. In the E part of the site, an aqueduct built of small cut-stone masonry (0.66 m wide; height of the arch at the intrados, 1.55 m) was studied for a length of 20 m. It was covered by 4 rooms, one of them over a hypocaust on small piles. Remains of a villa of the Imperial period, razed in the 3d c. and partially reconstructed in the late Empire and in the Merovingian period, was also uncovered.

BIBLIOGRAPHY. J. Coupry, "Informations arch.," *Gallia* 27.2 (1969), 361ff[I]; 25.2 (1967) 353. M. GAUTHIER

PETNELISSOS, *see* PEDNELISSOS

PETRA Thessaly, Greece. Map 9. Modern name of a hill of three peaks on the W side of Lake Boibe (Karla), ca. 5 km E of Gerli (now Armenion). It was an island in antiquity. It is the site of a prehistoric settlement with extensive Cyclopean walls (ca. 4 km in length), estimated to be the largest Mycenaean walled site known in Greece. There was also an archaic-Hellenistic settlement here; sherds, some building remains, etc. are to be seen. It is sometimes identified as Armenion (Strab. 11.503, 530, a city between Larissa and Pherai) and sometimes as Kerkinion, a city somewhere near the Boibe Lake, taken by the Aitolians and Athymanians under Amynander in 200 B.C. when it had a Macedonian garrison (Livy 31.41. 2f).

BIBLIOGRAPHY. A. S. Arvanitopoullos, *Praktika* (1910) 232f; (1911) 346f; F. Stählin, *Das Hellenische Thessalien* (1924) 103; A. Philippson, *GL* I 1 (1950) 121, 274; V. Milojčić, *AA* (1955) 221-29[PI]; *BCH* 81 (1957) 597. T. S. MAC KAY

PETRA (Selah) Jordan. Map 6. In the mountains of Idumaea 300 km S of Amman, Petra was the capital of the kingdom of Nabataea and a flourishing caravan city. It was annexed by Trajan in A.D. 106 and visited by Hadrian in 130. The Moslem conquest in the 7th c. brought decline and oblivion.

The site, rediscovered in 1812, is a basin shut in by cliffs of brightly colored sandstone into which many monuments were cut. The monuments are often baroque in their variety of form and richness of decoration. The only access is by the Siq, a narrow defile 2 km long cut by the wadi Musa, whose waters were diverted by an ancient tunnel. A rock-cut necropolis at the entry to the Siq has *nefesh* (obelisks or stelai symbolizing the soul of the deceased) and, farther along, baetyls (aniconical representations of the divinity).

The most famous of Petra's monuments, the Khazné or treasury, rises in the middle of the Siq. Its pink sandstone facade, more than 40 m high, is exotically decorated, suggesting a Corinthian temple topped by a tholos in a courtyard with porticos. Its interior is a vast cross-shaped chamber. The monument may be a mausoleum of King Aretas IV, who died in A.D. 40.

At the exit of the Siq is a large theater cut into the rock in the 2d c. A.D. There is also a small theater, more recent in date, at a bend of the wadi Musa. A paved street, the cardo, ran along the wadi and was the town's main axis. To N and S the town rose tier on tier over fairly steep slopes. It was larger in circumference in the 1st c. B.C. than in the 2d c. A.D. First one sees the hemicycle enclosing the basin of a public fountain or nymphaeum, then the ruins which, to the S, may be markets and a large temple, and to the N a palace and a gymnasium. To the W the cardo reaches a monumental arch with three bays, which gives access to a sacred area of the 1st c. A.D. The area contains the base of a monumental altar and a square cella with stucco decoration. These are remains of the main temple, known as Qasr Firaun, consecrated to Dusares. According to Suidas, its gold-covered baetyl would have been enthroned in the axial chapel. The cliff of el-Habis, which dominates the Qasr to the W, was covered with Nabataean houses.

The E cliff has extraordinary funerary facades. To the S, at the exit of the Siq, are tiers of tombs crowned with merlons or steps. Farther to the left is the tall Doric urn tomb of the middle of the 1st c. A.D., which was turned into a cathedral in A.D. 446. Then come the Corinthian Tomb, which imitates the Khazné, and the Palace Tomb, resembling the long facade of a Parthian palace; both are the burial places of princes and princesses of the last Nabataean dynasty. The narrow and overburdened facade of the tomb of Sextus Florentinus (legate in Arabia ca. A.D. 127) stands 300 m farther N, cut into a rocky spur.

There are many High Places on the neighboring plateaus, with enclosing walls, sacrificial areas, altars, bases for baetyls, triclinia cut in the rock, and basins. On the ed-Deir plateau, the main one is dedicated to the god Dushara. There is also a theater in the gorge of the wadi es-Sabrah.

BIBLIOGRAPHY. L. de Laborde et Dinant, *Voyage de l'Arabie pétrée* (1830)[I] & *Journey Through Arabia Petraea . . .* (1836)[I]; R. E. Brünnow & A. v. Domaszewski, *Die Provincia Arabia* I (1904)[MPI]; G. Dalman, *Petra und seine Felsheiligtümer* (1908); H. Kohl, *Kasr Firaun in Petra* (1910)[PI]; W. Bachmann et al., *Petra* (1910)[PI]; A.B.W. Kennedy, *Petra, Its History and Monuments* (1925)[MPI]; A. Kammerer, *Pétra et la Nabatène* (1929); G. & A. Horsfield, "Sela-Petra, The Rock of Edom and Nabatene," *QDAP* 7 (1938)[PI]; G. L. Harding, *The Antiquities of Jordan* (1960); J. Starcky, "Pétra et la Nabatène," *Supplément au Dictionnaire de la Bible* VII (1966)[MPI]; P. J. Parr et al., "Découvertes récentes au sanctuaire du Qasr à Pétra," *Syria* 45 (1968)[I]; M. Lindner et al. *Petra und das Königreich der Nabatäer* (1970)[MPI]. J.-P. REY-COQUAIS

PETRELA Albania. Map 9. A village 13 km S of Tirana on the road to Elbasan (the ancient Scampa). Halfway up the hill on which Petrela is situated are noteworthy remains of defensive walls which comprise terracing operations on the S, E, and W sides; above each section is a level area. On the best preserved, which is on the W side, rises a building that is still extant to a height of 5 m and to a length of 20 m. The walls form a double ring, of which the outer section is built of square blocks which form a pseudo-isodomic structure strengthened by buttresses. In the vicinity, fragments of Hellenistic pottery have been discovered.

BIBLIOGRAPHY. K. Praschniker & Schober, *Archäologische Forschungen in Albanien und Montenegro* (1919) 31; P. C. Sestieri, "Esplorazioni archeologiche in Albania," *Rivista d'Albania* 3, 3 (1942) 153. P. C. SESTIERI

PETRIANA, *see* HADRIAN'S WALL

PETRIJANEC, *see* AQUA VIVA

PETROMANTALUM (Genainville) Dept. Val d'Oise, France. Map 23. The site, known locally as Les Vaux de la Celle, has been excavated systematically since 1961. It consists of a temple with two cellae (28 m sq) fronted by a flagstone path and with a nymphaeum on one side and a huge theater nearby. A few outlying buildings have been located in the vicinity.

From the coins and potsherds found on the site it is clear that it was inhabited from the Gallic period on. Both the theater and temple appear to have been built in the second half of the 2d c. The carved blocks discovered just near the temple facade show that in a place of a colonnade the monument had arched bays alternating with piers with niches carved in them, and several series of entablatures (architrave, frieze, cornice). A bronze statuette of Mercury was discovered inside the temple. In 1968 a collection of sculpture was found in the nymphaeum on the S side of the same temple: a group showing a seated god holding a patera and scepter with a child at his feet and a nymph beside him; another group representing a recumbent nymph with a child behind her, a child holding a tortoise, and a small figure offering a bird. Many pieces of wall paintings have been found near the temple (both white and colored), showing that it was no doubt richly ornamented. Like Châteaubleau, the site of Genainville belongs to the series of monumental complexes built in the countryside of Gaul after the conquest. But where the Genainville monuments appear isolated, with no residential quarters nearby, those of Châteaubleau are built next to a true vicus.

BIBLIOGRAPHY. M. Fleury, "Informations arch.," *Gallia* (1965, 1967). J.-M. DESBORDES

PETROVARADIN, *see* LIMES PANNONIAE (Yugoslav Sector)

PETUARIA or Pretorium, or Decuaria (Brough-on-Humber) Yorkshire, England. Map 24. On the N bank of the Humber 56 km N of Lindum at a point probably serviced by a ferry. It is mentioned by Ptolemy (*Geog.* 2.3.17). The *Antonine Itinerary* refers to it as Pretorium (464.1; 466.4), and the *Ravenna Cosmography* to Decuaria. In the *Notitia Dignitatum* (*occ.* 40.31) a unit takes its name from the site. Further evidence for the name is provided by an inscription (*RIB* 707) dated to A.D. 140-144.

A fort of ca. 1.8 ha and a supply base were established here ca. A.D. 70, and the latter was maintained after the fort was evacuated some 10 years later. The fort was briefly reoccupied ca. A.D. 125. On its abandonment, new earthwork fortifications were erected on different alignments to enclose a much larger area, and were probably connected with a naval base. The harbor was in the adjacent Brough Haven. It is not known if the vicus of the inscription, referred to above, was also included within this area. The vicus was probably the civitas capital of the Parisi, and the same inscription records the presence of a theater there. No public building has been identified, however, and those buildings which have been excavated are not typical of town houses. Furthermore, the later history of the site suggests a continuation of naval or military occupation. Consequently the vicus, although its 2d c. existence cannot be doubted, remains an enigma.

No later than the early 3d c. the fortifications were rebuilt on yet another alignment; turf was used for the rampart, and the gates were of timber. Much rebuilding also took place within the enclosure. About A.D. 270 work began on a stone wall, 2.4 m thick, intended to reinforce the front of the rampart. An interruption occurred before it was completed, and when work was resumed the plans were modified to include external bastions and gate-towers; this new scheme was completed by the early 4th c. It seems likely that the garrison then included the numerus supervenientium Petuerensium. A rise in sea level soon after A.D. 350 not only silted up the harbor but also destroyed the SW defenses, and the naval base was given up. The numerus was then transferred to Derventium (Malton). Only an ephemeral occupation, probably of civilian character, remained.

Nothing of the site is now visible. In 1933-37 the E defenses, the NE corner, and the E gate were uncovered, also a number of internal buildings, and the theater inscription. In 1958-61 the N and W gates, the SE corner and the N and W defenses were identified. The position of the early fort was revealed. Many finds from the early excavations were destroyed during WW II; the remainder are in Hull Museum, Yorkshire.

BIBLIOGRAPHY. P. Corder & I. A. Richmond, *Journal of the British Archaeological Association* 3 ser., 7 (1942) 5-34[MPI]; J. S. Wacher, *Excavations at Brough-on-Humber, 1958-61* (1969)[MPI]; id., in R. M. Butler, ed., *Soldier and Civilian in Roman Yorkshire* (1971) 166-67[P]; id., *The Towns of Roman Britain* (1974) 393-97[MPI]. J. S. WACHER

PETUKHOVKA I Ukraine. Map 5. Unfortified Hellenized settlement of ca. 1 ha located 17 km SW of Olbia along the right bank of the S Bug. Excavations have shown that the settlement arose in the late 6th c. B.C., flourished in the Hellenistic era, when many of its structures were built, and came to an end in the 2d c. B.C. It was probably an agricultural village having close ties with Olbia.

BIBLIOGRAPHY. G. S. Rusiaeva, "Poselennia Pitukhivka I bilia Ol'vii," *Arkheologiia* 21 (1968) 206-13.

T. S. NOONAN

PEVENSEY, *see* ANDERIDA

PEYMENADE Alpes-Maritimes, France. Map 23. Two km SW of Grasse are numerous remains of a Gallo-Roman settlement or farming estate: millstones, dolia, terra sigillata ware, coins, tiles. There is the stela of a flaminica (*CIL* XXI, 185, now in the Cannes Museum). Recent excavations have brought to light a large villa rustica of the Imperial Age containing an oil-processing establishment.

BIBLIOGRAPHY. *Forma Orbis Romani* (1931); *Gallia* (1971, 1973).

C. GOUDINEAU

PEYRIAC-DE-MER (Le Moulin) Aude, France. Map 23. A small pre-Roman trading post S of Narbonne on the edge of the Bages-Sigean lagoon—Strabo's Narbonities (4.1.6) and Mela's Rubresus (2.5.6)—in a region rich in salt marshes. The exploitation of these marshes, as evidenced by an epitaph from the Roman period (*CIL* XII, 5360), seems to have been the principal activity of the settlement. Founded in the 6th c. B.C. and held by the Elisyces, it was destroyed and abandoned toward the end of the 3d c. B.C. The settlement was then transferred to the nearby peninsula of Le Doul, which had been occupied since the Bronze Age.

The only architectural remains uncovered on the site of the port (ca. 1 ha) are some low foundations dating from the last occupation period. They belonged to houses of rustic masonry, generally consisting of two or three rooms. The streets, averaging 4 m in width crossed at right angles. The comparative regularity of the plan, combined with the finding of graffiti in Greek characters, suggest that the town was to some extent hellenized. A variety of objects found on the site are now in an excavation depot at Peyriac-de-Mer. They show continuous trade with the Greeks of Marseille and especially those of Ampurias; through the latter the trading posts had links with the Punic centers on the E coast of Spain.

BIBLIOGRAPHY. Y. Solier & H. Fabre, "L'oppidum du Moulin à Peyriac-de-Mer, fouilles 1966-1967-1968," *Bulletin de la Société d'Études Scientifiques de l'Aude* 69 (1969) 69-106.

Y. SOLIER

PFÜNZ, *see* LIMES RAETIAE

PHAISTINOS, *see* WEST LOKRIS

PHAISTOS Kainourgiou, Crete. Map 11. Classical and Hellenistic city situated 5 km W of Mires. The site is best known for its Minoan palace and underlying prepalatial village. There was, however, a flourishing Geometric settlement there, and occupation continued in the archaic, Classical, and Hellenistic periods. The extensive city of the last period was eventually destroyed by the neighboring city of Gortyn in the middle of the 2d c. B.C.

Remains of the Geometric settlement are most impressively preserved on the slopes at the SE foot of the acropolis hill. Here several well-constructed houses are served by a cobbled road which has been traced up the S slope of the hill toward the old W court of the Minoan palace. Traces of a Geometric defense wall around the acropolis have also been noted in excavation. Of the archaic period, the only building to survive in recognizable form is an oblong structure at the SW corner of the palace, which is usually identified as a temple, probably dedicated to Rhea. Archaic deposits have been found elsewhere on both the hill and the lower slopes, however.

Hellenistic remains are the most widespread and best preserved at Phaistos. They are known to cover an area extending from immediately W of the palace, down the slopes W of (and originally probably over) the W Court, and thence farther down the slopes either side of a Hellenistic successor to the Geometric roadway, to the area of the earlier Geometric settlement. On the SE slopes of the hill, Hellenistic houses were found to belong to two phases, the earlier destroyed by earthquake and the latter, presumably, by the Gortynians. A fine series of Hellenistic houses, terraced into the steep hillside, have been excavated on the S and SW slopes of the hill, but these were removed in order to facilitate the excavation of Minoan levels. The best-preserved Hellenistic houses are therefore those standing on a platform above the W Court. Most of the remains here belong to a single house with a small open courtyard around which were grouped the main domestic rooms.

Although the city was destroyed in the mid 2d c. B.C., it is clear that there was some sporadic Roman occupation of the site. Early excavations found Roman deposits above the palace, and more recently an extensive though shabbily built late Roman farmhouse has been discovered overlying the destroyed Hellenistic buildings on the SE slopes.

The city's water supply probably came from the river Hieropotamos, which runs around the base of the hill, and from a series of deep wells, of which a Hellenistic example has been excavated on the SW slopes. Matala, 9 km to the SW, served as the principal port for Phaistos, although Komo is thought to have continued to operate as its port after the close of the Bronze Age. Finds from the site are mainly in the Herakleion Archaeological Museum, although some of the pottery material is in the Stratigraphic Museum at Phaistos itself.

BIBLIOGRAPHY. Hom. *Od.* 2.293; L. Pernier, "Scavi della Missione Italiana a Phaestos 1900-01," *MonAnt* 12 (1902) 21; L. Savignoni, "Scavi e Scoperte nella Necropoli di Phaestos 1902-3," *MonAnt* 14 (1904) 350; M. Guarducci, *ICr* I (1935) 272; L. Pernier & L. Banti, *Guida degli*, "Scavi Italiani in Creta" (1947) 39-66; D. Levi, "Gli Scavi a Festos negli Anni 1958-60," *Annuario* NS 23-24 (1963) 377-504[IP]; "La Conclusione degli Scavi a Festos," ibid., 27-28 (1967) 313-99[IP].

K. BRANIGAN

PHALANNA Thessaly, Greece. Map 9. The chief city of the Perrhaibians in the region. Phalanna flourished in the 5th and 4th c., replacing Olosson in importance by 400 B.C.; although later outstripped by Gonnos, it was still useful to Perseus as a camp site in 171 B.C. Inscriptions indicate that the city records were kept in the Temple of Athena Polias, although the city decrees were dated by the tenures of the priests of Asklepios. There was also a theater and a Sanctuary of Hades and Persephone. The site, misleadingly described by Strabo as near Tempe, has not been certainly identified, but lay between Orthe and Gonnos in a position to control the roads from the N and the rich fields to the S. Although Karatsoli and Gritzova have been proposed, Phalanna was probably on the flat hill called Kastri 3 km E of modern Tyrnavos; there are building blocks scattered in the area, but no city walls.

BIBLIOGRAPHY. Livy 42.54. 6, 65.1; F. Stählin, *Das hellenische Thessalien* (1924) 31f^M; B. Lenk in *RE* 17² (1937) 2495f.　　　　　　　M. H. MC ALLISTER

PHALARA Thessaly, Greece. Map 11. A city of Malis which served as the port for Lamia. It was destroyed in an earthquake (Demetrios of Kallatis, ap. Strab. 1.20) possibly in 426 or 427 B.C. (Thuc. 3.89; Diod. Sic. 12.59) but perhaps later, according to Béquignon. In 208 B.C. ambassadors came here to ask Philip V to conclude a peace with the Aitolians (Livy 27.30.3, where Phalara is characterized as formerly prosperous on account of its remarkable port and roadstead, as well as other marine and land advantages). It appears as the port of Lamia again in 192 B.C. (Livy 35.43.8) and 191 B.C. (Livy 36.29.4) when it was used by Antiochus III.

The city was near Lamia (Steph. Byz. s.v.). According to Strabo (9.435) it was 20 stades from the mouth of the Spercheios, 50 stades from (Lamia, generally restored) and 100 stades by sea from Echinos. On these figures, Stählin placed it near Imir-bey (modern Anthili) and supposed the remains to have been covered by the silt of the Spercheios. Most scholars have disregarded Strabo and place it at Stylis, or Stylidha, which is still used as a harbor for Lamia. This town is on the N shore of the Malian Gulf, ca. 18 km E of Lamia, at the head of a shallow bay. About one km NE of the modern town is a steep oval hill with a Chapel of Prophet Elias on it. Around the top of the hill are the remains of an oval wall circuit very poorly preserved. One section on the E side is of polygonal masonry; the rest was built of rectangular blocks, in two faces with a filling of stones. The perimeter was ca. 330 m.

Just to the W of Stylidha, near the Churches of Haghia Triadha and Haghios Kyriakos is a long section (ca. 150 m, according to Béquignon) of a wall running N-S with a setback every 12 to 18 m. It was originally 3 m wide, and in the 1930s (when it was being used as a quarry) was preserved in one place to two courses high. It is built of large rectangular and trapezoidal rough-faced blocks. Béquignon supposed it to be the wall built by Leosthenes during his siege of Lamia in 323 B.C. to cut off supplies from the city (Diod. Sic. 18.13.3). The wall, however, looks rather too massive and carefully built for this to be likely. To the E of Stylidha on the sea are reported to be some remains built with mortar (Roman?), interpreted by Pappadakis as baths.

No reasonable identification save Phalara seems to have been advanced for the Stylidha site.

BIBLIOGRAPHY. N. G. Pappadakis, *Deltion* 6 (1920-21) 146; F. Stählin, *Das Hellenische Thessalien* (1924) 217f, 218, n. 1; Y. Béquignon, *La Vallée du Spercheios* (1937) 293-99^MPI; E. Kirsten, *RE* (1937) s.v. Phalara.　　　　　　T. S. MAC KAY

"PHALARION," *see* MONTE DESUSINO

PHALASARNA (Cape Kutri, near Azoyires) Kisamos district, Crete. Map 11. Barely mentioned by ancient authors except geographers, who refer to it as the westernmost city of Crete and mention its enclosed harbor ([Scylax] 47; Dion. Call. 119ff). The city served also as one port of Polyrrhenia, 60 stades inland across a range of hills, but it was never dependent on Polyrrhenia.

The city is mentioned only once by a historical source (Polyb. 22.55), when Appius Claudius made Kydonia restore its independence (184 B.C.). Very little can be gleaned from inscriptions. With Spartan mediation, the city made a treaty with Polyrrhenia in the early 3d c., when Spartan influence was strong in W Crete. It reached the zenith of its prosperity in that century, the period

when the city walls were probably constructed. There is evidence of good relations with Egypt later in the century. The city is not mentioned after the 2d c., when Kydonia became the predominant power in the area; it may well have been a pirate base in the 2d-1st c. It is not listed in the *Notitiae Dignitatum* and by the later Roman period the site may have been uninhabited. It seems to have had a temple of Diktynna (Dion. Call. loc. cit.), and perhaps one of Apollo by the harbor (*Stad.* 336). Coins were struck in the 4th-3d c., showing a trident or dolphin and female head (Diktynna, Aphrodite, or the eponymous nymph Phalasarne).

The earliest remains found so far are 6th c., the latest are Roman; they were first fully described by Pashley. The city lies on a high, rocky cape projecting W, and settlement later extended onto the isthmus (some 500 m wide) below to the E. The acropolis falls away sheer into the sea on the N and W sides, and slopes steeply on the landward (E) side, up which runs one difficult path. The top, some 100 m high, is divided into a smaller N and larger S knoll by a deep cleft and saddle, where Spratt thought he could see a temple. On top there are remains of towers and other poorly preserved buildings; some walls appear to belong to temples. There is no spring on the acropolis but several cisterns on its slopes. On the E slope are retaining walls of terraces with house foundations, some rock-cut. At the foot of this slope the city wall ran across the isthmus, with projecting rectangular towers and perhaps a second wall line 5 m inside to the W. The wall also ran round the harbor and SE to the coast; SW of the harbor it is poorly preserved.

Spratt first made comprehensible the ruins of the lower city, by establishing that this part of the coast has been uplifted 6-7 m since the Classical period (and herein may lie the cause of the city's decline or abandonment in the later Roman period, perhaps the 4th and/or 6th c.). Thus he first identified the enclosed harbor (now some 100 m inland from the S side of the isthmus), which with its entrance channel and the bare rock on either side lies now well above sea level, with a solution notch clearly visible across the rocks marking the ancient shoreline. (For the same reason the city wall at its N end stops well short of the modern coastline.) The harbor basin, established in the shelter of the acropolis, is now filled in; it formed an irregular hexagon (ca. 60 x 70 m) with its entrance on the SW side, and was surrounded by walls with towers projecting inwards and outwards. The rock-cut entrance channel is an enlarged natural fissure, irregular in course and 10 m wide, now filled with earth and stones. West of this and just above the ancient shoreline is a rock cutting, perhaps a small dock or water channel. The bays on either side of the isthmus are too exposed to be good harbors.

Other remains of the city E of the wall are still poorly understood (much less is visible now than when Spratt visited the site). No temple sites can be clearly identified. The most striking features are the large rectangular chambers cut in the sandstone, probably used as basements of houses or storerooms after quarrying. Southeast of the city, behind the coastal dunes, lies a necropolis with rock-cut and cist graves; most have been looted, but some produced 4th c. and Hellenistic pottery. Three rock-cut thrones are also visible, perhaps intended for the dead. East of the city another necropolis has recently been found, with pithos burials (early 6th to early 5th c.) and Early Hellenistic cist graves. In the plain S of the city Roman cisterns, walls, and graves have been found.

BIBLIOGRAPHY. R. Pashley, *Travels in Crete* II (1837; repr. 1970) 61-73; T.A.B. Spratt, *Travels and Researches*

in Crete II (1865) 227-35[MPI]; J.-N. Svoronos, *Numismatique de la Crète ancienne* (1890; repr. 1972) 268-71; L. Savignoni, *MonAnt* 11 (1901) 348-85[MPI]; K. Lehmann-Hartleben, *Die antiken Hafenanlagen des Mittelmeeres (Klio,* Beih. 14) 80-82 (1923; repr. 1963); E. Kirsten, "Phalasarna," *RE* XIX. 2 (1938) 1653-58; M. Guarducci, *ICr* II (1939) 218-25; H. van Effenterre, *La Crète et le monde grec de Platon à Polybe* (1948); G. Daux, *BCH* 85 (1961) 896; J. Tzedakis, *Deltion* 24 (1969) *Chronika* 2, 432-34; N. C. Flemming, ed., *Science Diving International* (1973) 51-54. D. J. BLACKMAN

PHALERON Attica, Greece. Map 11. Despite the antiquity, size, and importance of Phaleron, little of a precise nature is known of its Classical topography and monuments, even though it is clear from Pausanias especially that the number of its sanctuaries and altars was large. The general location of the deme is, however, well established: Herodotos (6.116) associates Athens' first port and arsenal with Phaleron; Pausanias describes it as on the coast (1.1.2), more specifically, 20 stades from both Athens (8.10.4) and Cape Kolias (1.1.5), the latter to be identified as Haghios Kosmas; and Strabo names it first in his enumeration of the coastal demes E of Piraeus (9.21). These indications, while not in complete harmony, still heavily favor the identification of the area and headland around the Church of Haghios Georghios in Palaion Phaleron as the site of the ancient town, with the broad open roadstead of the Bay of Phaleron between it and Mounychia to the W as the harbor. Discoveries at this location have been, and are still being, made suitable for a deme. Perhaps of greatest significance are the traces of a series of conglomerate blocks that have been followed across the heights of Old Phaleron to the sea, and interpreted as belonging to the Phaleric Wall recorded by Thucydides (1.107.1). Modern development, however, not only has obliterated almost all such ancient remains, but has also changed the very nature and position of the coastline.

BIBLIOGRAPHY. J. Day, "Cape Colias, Phalerum and the Phaleric Wall," *AJA* 36 (1932) 1-11; R. Scranton, "The Fortifications of Athens at the Opening of the Peloponnesian War," *AJA* 42 (1938) 525-36[MI]; A. Kalogeropoulou, Δύο ἀττικὰ ἐπιτύμβια ἀνάγλυφα, *ArchDelt* 24 (1969) A. Μελέται, 211-19; J. Travlos, *Pictorial Dictionary of Ancient Athens* (1971) 160, 164[M].

C.W.J. ELIOT

PHANAGORIA Taman. Bosporus. Map 5. A city on the S coast of the Gulf of Taman colonized from Teos ca. 540 B.C. (Strab. 11.2.10) on a site of which the earliest traces of habitation go back to the 2d millennium. From 480 B.C. on, the city belonged to the monarchy of the Archeactides but remained an independent polis, as is proved by the titles of its archontes contained in inscriptions.

The Greek city spread out on two terraces 37 ha in area of which nearly half (15 ha) was destroyed by the sea. The walls, which were of unhewn blocks, are partially preserved. The lower quarter was the city center and was dominated by the fortified acropolis. The city reached the height of its prosperity in the 4th c. B.C.; traces of paved streets, wells, water pipes, basements of rectangular houses with tiled roofs date from this period. Marble architectural fragments and Ionic capitals come from a temple of Aphrodite Urania. Demeter, Kore, Apollo, and Dionysos were worshiped in the city. The remains of a gymnasium from the 3d c. B.C. and a heroon with painted decoration have been found. Also to the 4th-3d c. date the Bol'shaia Bliznitsa barrow and the Mt. Vasiurina kurgans (see below). In the 2d c. B.C. the city was conquered by Mithridates. Several winemaking establishments date to the early centuries A.D. and the remains of baths (?). In the 4th c. A.D. the city was destroyed by the Huns but revived by the end of the century and became an important mediaeval center.

In a kurgan necropolis on the outskirts of the city rich archaeological finds provide evidence of contact with the great centers of Hellenic civilization. In the 6th c. B.C. Ionic wares were imported, followed by Attic wares and wares from Chios and Thasos. However, there was from the beginning considerable local production, consisting of imitations of Greek models, especially of pottery. The Hermitage Museum and the Pushkin Museum, Moscow, contain material from the site.

BIBLIOGRAPHY. V. D. Blavatskii, "Raskopki v Fanagorii v 1938-1939 gg.," *VDI* (1940) 3-4.287-300; id., "Otchet o raskopkakh Fanagorii v 1936-1937 gg." *Trudy Gosudarstvennogo istoricheskogo muzeia* 16 (1941) 5-74; id., "Raskopki nekropolia Fanagorii v 1938, 1939 i 1940 gg., *Materialy po arkheologii Severnogo Prichernomor'ia v antichnuiu epokhu* [Materialy i issledovaniia po arkheologii SSSR, No. 19] (1951) 189-226; A. P. Smirnov, ed., *Fanagoriia* [Materialy i issledovaniia po arkheologii SSSR, No. 57] (1956); A. L. Mongait, *Archaeology in the USSR,* tr. M. W. Thompson (1961) 199-200; C. M. Danoff, *Pontos Euxeinos* (1962) 1133-35 = *RE* Suppl. IX; M. M. Kobylina, "Issledovaniia Fanagorii v 1959-1960 i 1962 gg.," *SovArkh* (1963) 4.129-38; id., "Raskopki iugo-vostochnogo raiona Fanagorii v 1964 g.," *KSIA* 109 (1967) 124-29; E. Ballin de Ballu, *L'Histoire des Colonies grecques du Littoral Nord de la Mer Noire* (1965) 144-48; A. K. Korovina, "Raskopki nekropolia Fanagorii v 1964 g.," *KSIA* 109 (1967) 130-35; I. B. Brašinskij, "Recherches soviétiques sur les monuments antiques des régions de la Mer Noire," *Eirene* 7 (1968) 107-8.

Bol'shaia Bliznitsa. On the Taman peninsula to the SW of Phanagoria is a rich Greek barrow (15 m high and ca. 350 m in circumference) dating to the latter half of the 4th c. B.C. It contains five independent elements: an empty chamber of painted masonry, perhaps looted; a square stone tomb with corbeled roof containing a male burial in the remains of a wooden coffin with ivory inlay; a square tomb with corbeled roof reached by a short dromos and containing the so-called Priestess of Demeter, so named because of a head of Demeter or Kore painted on a slab in the middle of the cupola; another tomb with a female burial; a stone chamber roofed with timber containing a female burial in a wooden coffin. There are many rich grave gifts and traces of a great pyre. The gifts include a gold diadem and a group of terracottas.

BIBLIOGRAPHY. E. H. Minns, *Scythians and Greeks* (1913) 423-29; M. Rostovtsev, *Antichnaia dekorativnaia zhivopis' na iuge Rossii* (1914) 10-29; id., *Skifiia i Bospor* (1925) 371-74 = id., *Skythien und der Bosporus* (1931) 330-32; A. A. Peredol'skaia, "Terrakoty iz kurgana Bol'shaia Bliznitsa i gomerovskii gimn Demetre," *Trudy Gosudarstvennogo Ermitazha* 7 (1962) 46-92; G. A. Tsvetaeva, *Sokrovishcha prichernomorskikh kurganov* (1968) 71-78; M. I. Artamonov, *Treasures from Scythian Tombs in the Hermitage Museum, Leningrad* (1969) 73-79.

Mt. Vasiurina. A series of kurgans of the 4th-3d c. along a mountain range S of Phanagoria. The most interesting one dates to the 3d c. It has a stone stairway leading down to a rectangular passageway, the entrance to the burial chamber (3.70 x 3.75 x 4.70 m). These two areas are covered by an arch showing remains of painted decoration. The wall frescos imitate encrusted

marble. On either side of the entrance to the tomb long stone boxes contain four horse burials along with rich grave gifts; saddlery and harnesses of gold and gilded bronze. No objects were found in the tomb itself.

BIBLIOGRAPHY. M. Rostovtsev, *Antichnaia dekorativnaia zhivopis' na iuge Rossii* (1914) 30-69; id., *Skifiia i Bospor* (1925) 373 = M. Rostowzew, *Skythien und der Bosporus* (1931) 331; G. A. Tsvetaeva, *Sokrovishcha pricherno-morskikh kurganov* (1968) 79-81.

M. L. BERNHARD & Z. SZTETYŁŁO

PHANARION, *see* ITHOME

"PHANOTE," *see* RAVENI

PHANOTEUS, *see* PANOPEUS

PHARKADON Thessaly, Greece. Map 9. The Classical city has been identified with fortifications on an isolated hill above the modern town of Klokoto. The walls, of ashlar with some Byzantine repairs, circle the W and lower of two peaks. The line of the wall runs E along the saddle but turns S to the plain without enclosing the higher peak. The city presumably extended into the plain but has left no visible remains.

BIBLIOGRAPHY. Strab. 9.5.17; Livy 41.8; C. D. Edmonds in *BSA* 5 (1898-99) 20M. Also F. Stählin, *Das hellenische Thessalien* (1924) 116.

M. H. MC ALLISTER

PHARNAKEIA KERASOUS (Giresun) Pontus, Turkey. Map 5. A natural fortress and harbor on the S coast of the Black Sea (Pontos Euxeinos) in the former land of the Chalybes, it stood at the terminus of a route leading over the Pontic mountains (Paryadres Mons) from Armenia Minor. It was founded in newly conquered territory ca. 180 B.C. by Pharnakes I of Pontus, using citizens transferred from Kotyora. It was annexed to Galatia with the remainder of the Pontic kingdom in A.D. 64-65. The name Kerasous was used by Pharnakeia from the early 2d c. A.D.; the original Kerasous, 110 km farther E, had by then ceased to exist.

The city lay on a rocky promontory between two anchorages, of which the one or the other received shelter according to the direction of the wind. Some good lengths of the Hellenistic walls survive both on the summit and on the steep slopes running down to the sea.

BIBLIOGRAPHY. W. J. Hamilton, *Researches in Asia Minor, Pontus, and Armenia* (1842) I 262-65.

D. R. WILSON

PHAROS (Stari Grad) Island of Hvar, Croatia, Yugoslavia. Map 12. Situated in the deep, elongated bay on the longest Adriatic island, Pharos was founded by Ionian Greeks from Paros in 385 B.C. They were helped by Dionysios the Elder of Syracuse. It is the only Ionic settlement in the Adriatic, the others being Doric. Not long after its foundation, native Illyrians with help from the mainland attacked the settlers but were defeated by the fleet of Dionysios' governor from Issa (Diod. 15.13.1). It is the first recorded naval battle in what is now the Croatian part of the Adriatic. In the Illyro-Roman wars in 229 and 219 B.C. Pharos was the stronghold of Demetrius of Pharos, commander of the Illyrian army, and the husband of their queen, Teuta. When the Romans captured and destroyed the town in 219 B.C., Demetrius escaped to Macedonia. The town was rebuilt but lost its autonomy; and after the founding of the colony at Salona, it was administered as its praefectura. The fertile valley E of town was centuriated and settled by veterans.

During its period of autonomy Pharos was the only known Greek foundation in the Adriatic to mint coins that included silver pieces. The inscriptions confirm the relations of the polis of Pharos with its metropolis on Paros. The cyclopean parts of the city walls are still preserved. From the Roman period are fine mosaics covered by modern streets. In the environs of the city are remains of several villae rusticae.

The finds, mainly the inscriptions and coins, are preserved in the archaeological museums at Zagreb and Split and in the local collection in the Domenican Monastery at Stari Grad.

BIBLIOGRAPHY. G. Novak, *Prethistorijski Hvar, Grapčeva špilja* (English summary) (1955); id., *Hvar* (1960); L. Robert, "L'inscription hellénistique de Dalmatie," *Hellenica* 11-12 (1960) 505-41; N. Duboković-Nadalini, "Ager Pharensis," *Vjesnik za arheologiju i historiju dalmatinsku* 63-64 (1961-62) 91-97; D. Rendić-Miočević, "Ballaios et Pharos," *Archaeologia Iugoslavica* 5 (1964) 83-92.

M. ZANINOVIĆ

PHARSALOS Thessaly, Greece. Map 9. A city of (Tetras) Phthiotis. It lies in the E corner of Thessaly's W plain, on and at the foot of a N spur of Mt. Narthakion (Kassidhiaris), about 4 km S of the Enipeus River. Modern Pharsala (or Pharsalos) occupies the site of the lower city. The main road from the S via Thaumakoi to Larissa, etc., goes by Pharsalos. A road follows E up the river and then over a low pass to Pherai, or directly E to the gulf of Pagasai. Two more difficult roads lead to Phthiotic Thebes and Halos.

Pharsalos was the home of the aristocratic Echecratidai, allies of Athens after the Persian wars. In an attempt to restore one of the family the Athenians besieged the city in the mid 5th c. B.C., but failed to take it (Thuc. 1.111; Diod. Sic. 2.83). It issued coinage in the 5th c. and resisted the tyrants of Pherai from 400 B.C. although in 374 it was forced into an alliance with Jason (Xen. *Hell.* 6.1). It was an important member of the Thessalian League opposed to Pherai, and strong supporter of Philip II of Macedon. Before 346 B.C. with the help of Philip, it obtained the territory of Halos (Dem. 19.39, 334). After Alexander of Macedon's death, Pharsalos under Meno joined the anti-Macedonian revolt (Lamian war: Diod. Sic. 18.11-15) but was taken by the Macedonians under Antipater in 322 B.C. (Plut. *Mor.* 846E). It seems to have dwindled in importance thereafter. Justinian renewed the walls (Procop. *De aed.* 4.3.5) and it was the site of a bishopric.

The walls of the ancient city are the most conspicuous remains. The wall surrounded the acropolis, two rocky, flat-topped peaks at E and W joined by a narrow saddle. From each end of the acropolis walls run N down the hill to the plain, where few traces are preserved. The wall ran a long tongue into the plain where the modern road to the railroad station runs directly N from the city. It included the hill directly above the spring of the ancient Apidanos stream (now called Apidanos, formerly Tabachana). A wall dividing the lower and upper city connects the E end of the acropolis with an isolated hill (301 m) just N of the W peak of the acropolis. Hill 301 and the W peak are joined by a double wall. The total wall circuit is ca. 6 km. Traces of polygonal masonry can be seen in the walls surrounding the acropolis, down the hill from the acropolis' E peak to the plain, connecting the W peak of the acropolis with Hill 301 and in the cross wall which runs from that hill to the E peak of the acropolis. There is no trace of the polygonal E city wall which must have connected the acropolis or Hill 301 with the W wall. The polygonal wall is probably that of the late 6th or 5th c. It was improved and overbuilt by a double-faced wall of rectangular and trapezoidal blocks, and the circuit was apparently then enlarged to include

part of the plain, and a wide swing up the hill to the W peak of the acropolis. This wall was strengthened by towers at weak points. It is in places preserved to 8 courses in height. The enlargement and rebuilding of the city wall was very likely made in the time of greatest Pharsalian prosperity and power around the middle of the 4th c. B.C. The acropolis wall and the cross wall from it to Hill 301 were improved and strengthened in Byzantine times.

Very few ancient remains are to be seen in the city. Just above and to the S of the Apidanos spring, at the W side of the city is a mound on which is a Church of Haghios Paraskevi (earlier Fetiye Camı). The city wall runs along the edge of this mound, and traces of a square tower could be seen (1914). Test trenches here in 1964 turned up prehistoric sherds from the Neolithic period on, and through archaic to Roman, and some ancient remains including a poros capital of Early Classical times. Here or nearby was a Temple of Zeus Thaulios, to whom an inscription has been found. In the center of the modern town in the main plateia were found the foundations of a square building (13 x 13 m) with an inner peristyle court, of the 4th-3d c. B.C. Doric and Ionic architectural fragments from it are in the Volo Museum. In the Kurçunlı Camı N of the plateia were to be seen (1914) some remains of an ancient temple. In the Varusi quarter, just above the plain by the E wall, inscriptions to and a head of Asklepios have been found, and a Hellenistic water channel. On the hill in 1966 fragments of 5th c. B.C. terracotta protomes turned up, probably of Demeter and Kore. Twenty minutes W of the city a Hellenic wall (neither end visible), perhaps part of a temple peribolos, was seen in 1952.

In recent years the most notable discoveries have been in the necropolis. To the W of Sourla hill (ca. 3 km E of Pharsalos) is a necropolis largely of the 4th c. B.C. In a block hollowed to receive it was a handsome 4th c. bronze hydria with Boreas and Oreithuia in relief under the horizontal handle (now in the Volo Museum). Just W of the city, on the road to Dhomoko, was another necropolis. Most notable among other Mycenaean and Classical tombs found here was the bottom part of a tholos tomb with dromos, of stones and earth with a facing of good polygonal masonry, containing two sarcophagi. The mound over it was surrounded with a handsome polygonal terrace wall. The tomb was built in archaic times directly over and as a successor to a Mycenaean shaft grave, and was used until the Hellenistic period. Near this in a hollowed block was a 4th c. bronze hydria with a Nike under the handle (National Museum of Athens).

To the SW of the city on the slope of the Karabla (Karafla?) is a cave of Pan and the nymph which was investigated in 1922. Votive statuettes and inscriptions dating from the 6th c. B.C. to the Hellenistic period were found.

In the territory was the Thetideion (Polyb. 18.20.6; Strab. 9.431; Plut. Pel. 31-32) possibly to be found N of the Enipeus on a hill between Orman Magoula and Dasolophos (Bekides) where a Church of Haghios Athanasios incorporates Hellenic and Byzantine remains.

BIBLIOGRAPHY. W. M. Leake, Nor. Gr. (1835) I 449-54; IV 463-81; A. S. Arvanitopoullos, Praktika (1907) 148-52[I]; (1910) 176-83; F. Stählin, Pharsalos (1914)[PI]; id., Das Hellenische Thessalien (1924) 135-44[PI]; ArchEph (1919-20) 48-53[I] (cave); D. Levi, ASAtene 6-7 (1923-24) 27-42[PI] (cave); M. Verdelis, ArchEph (1948-49) chron. 40-42[MI]; (1950-51) 80-105[I] (bronze hydria); id., Praktika (1951) 154-63[I]; (1952) 185-204[I]; (1953) 127-32; (1954) 153-59[I]; (1955) 140-46[PI]; D. Theocharis, Deltion 16 (1960) chron. 175; 19 (1964) chron. 260-61[I]; 21 (1966) chron. 254[I]. H. Biesantz, Die Thessalischen

Grabreliefs (1965) 101-8[I] (Greek sculpture from Pharsalos); W. K. Pritchett, Studies in Ancient Greek Topography, pt. 2 (1969) 114-17[MI] (Thetideion).

T. S. MAC KAY

"PHARYGAI," see MENDENITSA

PHASAELIS (Khirbet Fasail) Occupied Jordan. Map 6. Town N of Jericho, founded by Herod the Great in memory of his elder brother Phasael (Joseph. AJ 16.145). Herod bequeathed the city to his sister Salome (AJ 18.31), who gave it to Livia, the wife of Augustus. The town was famous for its dates (Plin. HN 13.4.44). In the Byzantine period it figured on the Madaba mosaic map. Surveys have revealed a town built on the Hippodamian plan, with streets intersecting at right angles. Remains of some large buildings may be those of a palace and a temple. The city's water came from a distant spring through an aqueduct 10.4 km long.

BIBLIOGRAPHY. F. M. Abel, Géographie de la Palestine II (1938) 408-9; M. Avi-Yonah, The Holy Land (1966) 100, 164.

A. NEGEV

PHASELIS (Tekirova) Turkey. Map 7. On the E coast of Lycia, 50 km S-SW of Antalya. Founded according to tradition in 690 B.C. by the Rhodians, Phaselis was the principal commercial port on this coast, at least until the foundation of Attaleia, and shared in the Hellenion at Naukratis in the 6th c. At this time Phaselis was not reckoned as belonging to Lycia, but rather to Pamphylia, as the true and original Lycia did not extend E of the valley of the Alâkır.

Freed against her will from Persian rule by Kimon in 468 (Plut. Cimon 12), the city was enrolled in the Delian Confederacy, with a high tribute equal to that of Ephesos. When Mausolos acquired control of Lycia Phaselis aided him against the Lycian rebellion under Perikles, and concluded a treaty with him about 360 B.C. The city surrendered peaceably to Alexander, who spent some time there in the spring of 333. Taken by siege from Antigonos by Ptolemy in 309, Phaselis remained a Ptolemaic possession until Lycia was overrun by Antiochos III in 197. After Magnesia in 189 Lycia was given to Rhodes, but the gift was rescinded in 167 by the Senate, and Lycia was left free. As a result of this Rhodian occupation Phaselis, being a Rhodian colony, was officially attached to Lycia, and after 167 appears as a member of the Lycian League, striking coins of League type and adopting its magistracies. About 100 B.C., however, Phaselis seems to have been independent (Strab. 667, apparently quoting Artemidoros), and soon after that date was occupied by the pirate Zeniketes until he was suppressed by Servilius Isauricus in 78. After this the city was taken back into the League and continued to function as a full member from then on, her citizens taking predominantly Lycian names. The impoverishment caused by the pirates (Lucan, Pharsalia 249ff) was repaired under the Empire, and a visit by Hadrian about A.D. 129 was splendidly celebrated. Coinage continues down to Gordian III (238-44).

The site is now deserted and overgrown; it has recently been investigated but not excavated. It comprises a headland some 30 m high, with bays on N and S, and ground to the W and N. The city had three harbors (Strab. 666), still recognizable. The first, in the S bay, is the only one now used, and only by small craft; it was protected by a breakwater some 100 m long, of which parts survive under water. Since Pseudo-Skylax in the 4th c. B.C. mentions only one harbor at Phaselis, it is likely that this was the earliest of the three. The N harbor is more of an open roadstead, with reefs offshore connected by an

artificial breakwater; there are no remains of other port installations. The third harbor lies between the other two at the N foot of the acropolis hill; it is nearly circular and was closed on the E by a mole; the city wall ran over it, with an entrance 18 m wide towards the S end. On the S bank is a stretch of ancient quay some 40 m long; ships moored to bollards which projected horizontally from its face.

The city wall is preserved only in short stretches. It ran all round the acropolis hill, across the entrance to the closed harbor, along the S shore of the N harbor, and inland for some 45 m to the W; on the seaward side of the acropolis it has been carried away by erosion of the cliffs.

The city center lay at the foot of the hill on the landward side. Its main feature is a paved avenue extending from near the S harbor to the closed harbor, with an obtuse bend in the middle, and lined with buildings on both sides. It is 20-24 m wide, including raised sidewalks. At its SW end stood a triple-arched gateway, now collapsed, which bore a dedication to Hadrian; it was erected for his visit in 129 or 131.

The buildings flanking this avenue date, insofar as they are datable, to the 1st and 2d c. A.D., but later other buildings were added, in some cases overlying the earlier ones. Inside the gate of Hadrian on the right stood a group of rooms, and on the left a large open square, free of buildings, separated from the street by a row of three large chambers; between the second and third an elegant arched doorway is still standing. Farther ahead on the left is the Rectangular Agora, so identified by an inscription; a small church of basilican form was later inserted in its NW part. Across the street is a building complex which may have been a small bath building, adjoined on the N by a building of unknown purpose which projects into the street. The N part of the street was bordered on each side by a row of small chambers, probably shops; the row on the left (W) side is better preserved, but has been overlaid by an early Byzantine bath, to which is attached a columned building of uncertain purpose.

The surface of the acropolis, now heavily overgrown, shows many traces of houses, streets, and cisterns; these are of Roman or later date, but sherds go back to the 4th c. B.C. Two buildings are recognizable towards the S end, together with a round cistern, well preserved, with two of its roof slabs still in place. On the N slope of the hill is the theater, in fair condition but overgrown. The analemmata are in good ashlar masonry and date apparently from the Early Empire. The stage building stands up to 7 m high, but the masonry, especially in the upper parts, is of inferior quality. Five monumental doors opened on to the wooden stage; below these a row of six small doors opened onto the orchestra. On the hillside below are remains of a stepped path leading up to the theater.

To the N of this inhabited area is an extensive marsh, evidently the lake mentioned by Strabo (l.c.). Its water was replaced or supplemented by an aqueduct leading S from a spring, now dry, in the slope of the hill to the N; it ran as far as a knoll across the street from the theater. It is of the familiar Roman form, its arches well preserved in the S part, and dates from the Early Empire.

On the hill just N of the city, 70 m high, is a separate fortified enclosure of Hellenistic date. Its wall is preserved only on the S side; it is 1.7 m thick and stands up to 3 m in places; the masonry is of variable style. Other remains include a gate approached by a zigzag path, a rock sanctuary to the E, and to the SW the foundations of a building with Doric columns which is probably either a temple or a monumental tomb. On the S slopes of the hill and by the shore of the N harbor are other built tombs, but they are not of characteristic Lycian form.

BIBLIOGRAPHY. F. Beaufort, *Karamania* (1818) 61-76; C. Fellows, *Asia Minor* (1838) 211; *TAM* II, 3 (1944) pp. 413-16; G. E. Bean, *Turkey's Southern Shore* (1968) 151-64; H. Schläger & J. Schäfer, *AA* (1971) 542-61[MI].

G. E. BEAN

PHELLOS Lycia, Turkey. Map 7. On Felendaği above the village of Çukurbağ, 5 km N of Kaş, at an altitude of 750 m. The city is mentioned by Hekataios (ap. Steph. Byz. s.v., but erroneously located in Pamphylia), and in the 4th c. B.C. by pseudo-Skylax. Its Lycian name was apparently Vehinda, which appears on coins of the dynasts; the later coinage of Phellos is of federal type and Hellenistic date, and of Gordian III. A bishop of Phellos is recorded in the Byzantine lists.

The site has been disputed. It has also been identified with a small city on the coast at Bayındır Limanı, across the bay from Kaş (Antiphellos). At Felendaği the only two legible Greek epitaphs are both of citizens of Phellos, but this again is inconclusive, as we find Phellites buried in half a dozen other places also. It is clear from the extant monuments that Phellos controlled a wide area of territory, for which the small site at Bayındır Limanı appears inadequate both in size and in position; Felendaği on the other hand is three times as large and in a commanding situation.

The ring wall enclosed a long narrow area running EW along the crest of the hill; on the N side are several stretches of massive polygonal masonry of archaic appearance; on the S side the wall is mostly destroyed. The extant monuments consist almost entirely of tombs, inside and outside the wall. One tomb, of Lycian house type, stands free on all sides, cut solidly out of the living rock; others are sarcophagi, in some cases handsomely decorated with reliefs. At the W end is an interesting group, entirely rock-cut, which seems to have formed a burial complex; on one of the walls is a relief of a bull, over life-size and damaged. Two Lycian inscriptions have been found on the site. There is an abundant spring on the E slope of the hill, and two wells have recently been dug inside the city wall. Felendaği is the only site in central Lycia which has running water.

BIBLIOGRAPHY. T.A.B. Spratt & E. Forbes, *Travels in Lycia* (1847) I 75-77; E. Petersen & F. von Luschan, *Reisen in Lykien* (1889) I 130-31; O. Benndorf in *AnzWien* (1892) 65; G. E. Bean in *AnzWien* 2 (1958) 49-58.

G. E. BEAN

PHENEOS or Phenea N Arkadia, Greece. Map 9. A town on the N edge of the now-dry lake of the same name. Mentioned by Homer (*Il.* 2.605), it rarely entered the mainstream of Greek history, though it lay on a strategic route. It joined the Achaian League, and was taken by Kleomenes in 225 (Polyb. 2.52.2). Pausanias describes the site in Book Eight (14.1-15.4).

The site lies on a low hill just SE of the town of Kalivia. Little remains, save for some of the walls (now badly overgrown), and a Sanctuary of Asklepios lower down the slope on the SE. The sanctuary contains two buildings, one of them with a statue base of Asklepios sculpted by Attalos of Athens (2d c. B.C.). In front of the base there is a mosaic floor with a reservoir underneath. A colossal head of Hygeia in almost perfect condition, with inserted eyes and eyelashes still in place, was found in the same room. Coins found nearby confirm the site as that of Pheneos.

BIBLIOGRAPHY. J. G. Frazer, *Paus. Des. Gr.* (1898) IV 231-41; J. Baker-Penoyre, "Pheneus and the Pheneatike," *JHS* 22 (1902) 228-40; G. Daux in *BCH* (1959) 625; 85 (1961) 682[1]; E. Vanderpool in *AJA* 63 (1959) 280-81[1].

W. F. WYATT, JR.

PHERADI MAIUS Tunisia. Map 18. The site lies on a small terrace backed against the Jebel Chabet ben Hassen, at the bottom of a valley crossed by a wadi. Situated between Bou Ficha and Enfida, with the mountains behind it, it dominates the coastal plain and the Sebkha as well as the Gulf of Hammamet.

Certain monuments that are exceptionally well preserved or superbly placed give the site a look of grandeur. At the entrance to the valley stands an arch, its architecture sober and elegant; it dominates a large paved piazza lined on one side with an arcaded nymphaeum dedicated to Neptune, beyond which lies the forum square. On top of the Sidi Mahfoud hill stands the podium of a temple. Extremely high, it affords a vast panorama of the entire region. Other monuments that can be discerned by their shape or structure are identifiable, but have not as yet been excavated.

BIBLIOGRAPHY. A. Ennabli, "Pheradi Majus," *Africa* 3-4 (1969-70) 225-37.

A. ENNABLI

PHERAI Thessaly, Greece. Map 9. A city of Pelasgiotis, lying just S of the road between Larissa and the Gulf of Pagasai. The site is on the tail end of a N spur (modern Maluka) of the mountain Chalkedonion (modern Karadag); the spur flanked by two ravines, the Maluka revma to the SE and the Makalo to the NW. The city controls also the E end of a pass (modern railroad) which leads E from Pharsalos. Modern Velestinou occupies a part of the ancient city. The city site has been settled since prehistoric times. In antiquity it was known as the home of Admetos, whose son Eumelos figured in the Trojan war (Eur., *Alk.* etc.; Hom., *Il.* 2.711, *Od.* 4.798). It controlled the port of Pagasai by the late 5th c. B.C.; partly from this it grew powerful under the tyrant Lycophron and much more under his successor, Jason, who tried to unite Thessaly under his leadership. Jason was killed in 370 B.C. and was soon succeeded by Alexander, who was defeated by a Thessalian League-Theban alliance in 364 B.C. and his territory reduced to Pherai, Pagasai, and part of Magnesia. He was killed in 358 B.C. but his expansionist policies continued until Philip II of Macedon took over Magnesia and Pagasai and in 344 B.C. placed a Macedonian garrison in Pherai. The city remained fairly prosperous and was important in the post-196 B.C. Thessalian League. It was besieged by Antiochos III in 192 B.C. (Livy 36.8f, 14.11); it was at that time divided into an upper and lower city. Steph. Byz. says (s.v.) that it was divided into Old and New Pherai, 8 stades (one km) apart. Remains from the Imperial period are practically nonexistent, and his statement remains enigmatic.

A flat-topped prehistoric mound (150 m) was the acropolis. This is protected at the back by the Makalo revma, which flows NE. The Maluka revma is roughly parallel to the Makalo, ca. one km to the S. Between the streams the land slopes from the acropolis to the plain, about 50 m away. At the edge of the plain, under the S face of a rocky hill (Kastraki) is a copious fountain. Traces of the city wall can be seen at the back (W) of the acropolis hill above the Makalo ravine and following its bank towards the plain for about 500 m where it disappears. The S wall ran from behind the acropolis towards the Makalo revma and along its N edge to the plain. A wall, of which few traces remain, ran along the edge of the hill just above the plain, presumably connect-

ing the N and S sections of wall, but its junction with the NW side of the city wall is not clear. Béquignon saw blocks in the plain which led him to believe this wall along the edge of the hill was a cross wall, and that the lower city wall made a curve into the plain E of the modern railroad. The wall is double faced, ca. 3 to 5 m thick, of rough-faced rectangular and trapezoidal blocks laid in fairly regular courses. There are no towers visible. It must date from the first half of the 4th c. A short stretch of wall (or terrace wall?) on the N side of the Kastraki hill is built of careful, flat-faced polygonal masonry. No walls have been reported on or around the acropolis hill.

Very few ancient remains are to be seen within the city. Dedications to Herakles and a Doric column capital and parts of a wall (peribolos?) were found in 1907 by the Church of Haghios Charalambos S of the acropolis. Part of an early 5th c. marble statue of Athena, nearly life-sized, was found on the acropolis in 1967, which indicates the presence of a temple there. The fountain (ancient Hypereia) in the city center is bordered by a semicircular retaining wall of thin rectangular slabs laid in courses. This may or may not be ancient. The ground of the Kastraki hill above is littered with sherds, but no ancient foundations or blocks are visible. The sites of the ancient agora, theater, etc. are not determined. The most notable remains are those of a large Doric temple outside (?) the city walls, ca. 0.8 km NE of the acropolis, on the right bank of the Makalo revma. This was excavated in 1920-27. Here a temple of the later 4th c. had been built on the site of one of the 6th. The 4th c. temple was Doric, peripteral, 16 x 32 m, perhaps 6 x 12 columns. The foundations were of conglomerate and the exposed parts of the euthynteria and krepis of marble. At the E end the euthynteria and one step of the krepis were preserved. Of architectural fragments, some column drums, fragments of capitals, epistyle, a sima carved with a lotus and acanthus motif remain. Incorporated in the foundations are some Doric column drums of the earlier temple and around about were other architectural fragments including painted terracotta revetment and a capital fragment dating from the second half of the 6th c. B.C. In front of the later temple's E end were several small foundations for naiskoi, altar, and/or statues.

The temple had been built on top of an early Geometric necropolis. It must have been on or near the site of an early shrine, since a temple deposit pit S of it yielded a large number of terracotta and bronze offerings of the 8th through the 6th-5th c. Other bronzes had come from the area previously. Some are in the National Museum of Athens, some in Volo, and some probably in Cambridge. The temple, once thought to be to Zeus Thaulios, is more likely to be that of Artemis Ennodia, the chief goddess of Pherai.

The main necropolis of the city was on the road to Larissa, just outside the wall. Some grave mounds have been noted and/or excavated in the plain, near the railroad line. A chamber tomb was excavated at Souvleri Magoula in 1910. In 1899 a mound (Pilaf-Tepe, or Mal-Tepe) on the road about half way between Pherai and Pagasai was excavated. This contained a shaft grave and in it a silver situla of the 3d c. B.C. The grave seems to have dated from the 2d c. B.C. and may have held a notable citizen of Pherai. At Rizomylo, 5 km N of the city, foundations and various architectural remains have been discovered.

BIBLIOGRAPHY. W. M. Leake, *Nor. Gr.* (1835) IV 439-44; C. D. Edmonds, "The Tumulus at Piláf-Tepé," *JHS* 20 (1900) 20-25[PI]; A. S. Arvanitopoullos, *Praktika* (1907) 153-61; (1910) 229-33[1]; (1922-24) 107f; (1925-26) 37-42, 115-17[1]; F. Stählin, *Das Hellenische Thes-*

salien (1924) 104-8[P]; Y. Béquignon, *BCH* 53 (1929) 101-16[I]; id., *Récherches archéologiques à Phères de Thessalie* (1937)[MPI]; E. Kirsten, *RE* Supp. VII (1940) s.v. Pherai[PM]; H. Biesantz, *Die Thessalischen Grabreliefs* (1965) 108-14[I]; D. Theocharis, *Deltion* 22 (1967) chron. 296fI. T. S. MAC KAY

PHIALEUS, *see* PHIGALIA

PHIALIA, *see* PHIGALIA

PHIDHOKASTRO, *see* AMBRAKOS

PHIGALEIA, *see* PHIGALIA

PHIGALIA (var. Phigaleia, Phialia, or Phialeus) SW Arkadia, Greece. Map 9. A polis within the district of Parrhasia. Geographically isolated, Phigalia was linked historically with S Triphylia (viz., Lepreon) and the upper Messenian plain. The city (1500 x 2500 m) spreads over an uneven plateau 300 m above the deep gorge of the Neda river which permitted access to the coast of Triphylia 15 km to the W. Citizens frequently aided Messenians in their wars and revolts against Sparta; in reprisal, the Spartans besieged and occupied Phigalia several times in the 7th and 6th c. B.C. and between 421 to ca. 414 B.C. and again ca. 401-395. In Hellenistic times Phigalia was a member of the Aitolian and Achean Leagues; in the Roman period it went into decline, but has remained continuously occupied.

The site is unexcavated, but chance finds indicate that the site was occupied by the Late Bronze Age; considerable remains of the archaic, Classical, and Roman periods lie exposed. Fortification walls are preserved for a length of ca. one km along the E and N sides of the acropolis and stand to heights of 10 m in some parts. Stretches of the circuit may date as early as the 5th c. B.C. but in the mid 4th c. B.C. portions were rebuilt for the addition of square and circular towers. An outer, but uncharted, circuit of walls exists to the far W of the city.

In the SE a Hellenistic fountain-house continues to function; nearby, a Byzantine Chapel of the Panagia is built into the superstructure of an Ionic building. In the W section a long stoa with shafts of several columns still in situ delineates one side of an open, level area which appears to be the agora. Adjacent, a destroyed chapel contains architectural members from a building of the Classical period. An archaic kouros, found here in 1890, is now at Olympia and perhaps is to be identified as the victor Arrachion (564 B.C.), described by Pausanias. A Sanctuary to Athena is on a low hill to the W, overlooking the agora.

The acropolis of the city (elev. 720 m) lies in the N sector. A Sanctuary to Artemis Soteirias is on the crown, now occupied by a Church to Haghios Elias. Chamber tombs line the scarps of surrounding hills. Numerous but unidentified monuments are scattered throughout the confines of the city. Ancient sources attest to the existence of a Polemarchion, a theater, a gymnasium, a Temple of Dionysos Akratophoros, Sanctuaries of Hygeia and Asklepios, and Heröons of the Oresthasions and Lepreos.

BIBLIOGRAPHY. E. Meyer, *RE* XIX[2] (1938) 2065-85, s.v. Phigaleia; A. Tselalis, *Olympiaka* (1954) I 3; U. Kahrstedt, *Das wirtschaftliche Gesicht Griechenlands in der Kaiserzeit* (1954) 160-61; G.-J. te Riele, "Inscriptions de Pavlitsa," *BCH* 103 (1966) 248-73; F. Cooper, Temple of Apollo at Bassai, Ph.D. diss., Univ. Microfilms (1970), Appendices B, C, F (history and prosopographical index of Phigalia); F. E. Winter, *Greek Fortifications* (1971) 111-12; F. Cooper, "Topographical Notes from Southwest Arkadia," *AAA* 5 (1972) 359-67.

F. A. COOPER

PHILADELPHIA (Alaşehir) Turkey. Map 7. City of Lydia founded by Attalos II of Pergamon (159-138 B.C.) in the Cogamus (Koca Çay) valley on the road between Sardis and Laodicea. The city was spread out (Strab. 12.8.18, 13.4.10) on a slight plateau at the S edge of the river plain. Some of the city wall is preserved, and near the acropolis the location of the theater can be recognized, and perhaps a gymnasium and stadium. In the 19th c. the remains of a temple were visible outside the city on the Sardis road. Some finds are in the Manisa museum.

BIBLIOGRAPHY. H. Curtius, *AbhBerl* (1872) 93-95[P]; J. Keil & A. von Premerstein, *Bericht über eine Reise in Lydien . . . 1906, DenkSchrWien* 53, 2 (1908) 24-43[MI]; id., *Bericht über eine Dritte Reise in Lydien 1911*, ibid. 57, 1 (1914) 15-48; J. Inan & E. Rosenbaum, *Roman and Early Byzantine Portrait Sculpture in Asia Minor* (1966) nos. 210, 214, 216[I]. T. S. MAC KAY

PHILADELPHIA (Amman) Jordan. Map 6. Town E of the Jordan which received a Macedonian settlement and the name of Philadelphia from Ptolemy II Philadelphos (285-246 B.C.). In the 2d c. B.C. it passed under Seleucid control and in the 1st c. B.C., liberated by Pompey, it was one of the main cities of the Decapolis. In the 2d c. A.D. Philadelphia was incorporated into the Roman province of Arabia.

The ancient town, along a wadi, is mostly covered by the modern city. The citadel stands on a long steep hill to the N; the acropolis, a theater, and a nymphaeum are the principal remains of the Hellenistic and Roman periods.

The main artery was a long avenue with a colonnade on each side on the N bank of the wadi, which was channeled and covered by vaulting as it passed through the town. To the E was the entrance to the town, a monumental gate with three bays; a splendid tomb once stood near it. To the W another colonnaded avenue, at right angles to the first, ran NW. The public baths were near the crossroads to the N. Remains of a large nymphaeum with three apses, of the 2d or 3d c. A.D., lie to the S: the facade had a portico with tall Corinthian columns and three semicircular *frontoni siriachi* under triangular pediments, while the back wall was decorated with superimposed niches, the lower ones under segmental pediments, the upper niches under triangular ones. A building to the SW has very similar niches and may belong to the same group of buildings. The apse of the building to the SW was reused in a Christian church.

On the S bank a theater of the 2d c. A.D. is cut into a hill facing the citadel. Its hemicycle is open to the N and has three stories of 13, 14, and 16 tiers of seats; it is crowned by a pórtico and a high supporting wall with a large axial exedra. Access to the orchestra was by vaulted side corridors under the tiers of seats. All that remains are the foundations of the stage, the scaenae frons, and the wall of the exterior facade. A large trapezoidal space extended in front of the theater. Eight columns of the S portico are standing, four smaller columns of the N portico and, on the E side, a fairly well-preserved odeum, which was part of the theater complex.

The citadel has three terraces from E to W, with supporting walls of fine masonry. The N front of the acropolis is partly of Seleucid, partly of Roman date, and is a good example of ancient fortifications. The large W terrace had a monumental gate to the S, at the end of the stairways from the lower town; propylaea to the stairways have been identified beside the colonnaded avenue. The ruins of a large temple of Hercules, dated by an inscription to the reign of Marcus Aurelius, stand on the SE corner of the citadel, dominating the town. Its Corinthian

columns were more than 9 m high. A gigantic statue of Hercules (pieces of which have been found) stood next to the temple. A wall adorned with conch niches runs along part of the very high terrace. At the N end, the ruins of another Roman structure can be seen beyond Byzantine or Omayyad buildings.

BIBLIOGRAPHY. L. de Laborde et Dinant, *Voyage de l'Arabie Petrée* (1830); R. E. Brünnow & A. v. Domaszewski, *Die Provincia Arabia* II (1905); H. C. Butler, *PAES* II, *Architecture*, Sec. A, *Southern Syria* (1916); E. Frézouls, "Les théâtres romains de Syrie," *Syria* 26 (1959); 28 (1961)[I]; G. L. Harding, *The Antiquities of Jordan* (1960). J.-P. REY-COQUAIS

PHILAE Egyptian Nubia. Map 5. A small island (460 x 150 m) at the head of the First Cataract, 1500 m S of Elephantine, following the course of the Nile. The name appears in Diodorus (1.22), but in other writings it appears as Phicai and Filas (*Antonine Itinerary*), transliterations of the Egyptian name, Pa-Ju-rek. Plans to rescue its monuments, which are now submerged because of Sad Nasser (the Aswan High Dam), are being studied. The date ante quem of the history of the island has been fixed on the basis of an Altar of Taharqa of the 25th (Kushite) Dynasty (ca. 715 B.C.). The oldest structure on the island, a portico to the SW, dates however from the time of Nektanebos of the 30th Dynasty, just before Alexander's Conquest. It is not known when the worship of Isis began here. To the W lies the island of Bigge, where there had always been the Abaton, an inaccessible grotto-like tomb of her husband and brother Osiris. Around the tomb were placed 365 offering tables to receive a daily libation of milk (Diod. 1.22). Nearby was another grotto from which, according to the Egyptian belief, the rising waters at each new flood recalled the rebirth of the god. Although the island was highly esteemed during the Ptolemaic period as the original cult center of Isis, it was during the Roman period that the island, together with the cult of the goddess, reached its zenith. Christianity had difficulty in overcoming the cult of Isis on the island. It was not until 557 that Bishop Theodorus converted part of her temple into a church dedicated to St. Stephen.

The earliest temple on the island, that of Nectanebus II, is to the SW. Only the 13 columns that form its portico remain. The six columns on the W side are lotiform mounted by Hathor heads which support the architrave. The low screen walls between the columns are decorated with offering scenes. The temple was repaired by Ptolemy Philadelphos. Off the portico are two colonnades dating from Augustus and Tiberius. Nearby lies the temple dedicated to the Nubian god Arensnuphis, and a chapel to Mandulis, also Nubian, and a temple to Imhotep. The great pylon of the Temple of Isis (45 m wide, 18 m high), which had two obelisks (now in Kingstone Hall, England), dates from the time of Ptolemy Euergetes. Between the two pylons to the W of the court lies the Mammisi, begun by Euergetes II and completed under Tiberius. It consists of 22 rooms and a crypt decorated mainly with scenes from the story of the Birth of Horus. The reliefs of the outer walls of the Temple of Osiris are from the time of Augustus and Tiberius. To the W of the Isis Temple, in front of the side wall of the second pylon, stands the Gate of Hadrian, the walls of which were decorated under Marcus Aurelius and Lucius Verus. Here in the Osiris Chapel, scenes from the cult of Osiris were depicted. To the N lies the partly destroyed temple of Harendotes. It contains a dedication by Claudius. Farther N are the ruins of a temple built by Augustus with a city gate built by Diocletian beside it. The Temple of Philometer,

dedicated to Hathor-Aphrodite, lies to the E of the Isis Temple. The cartouches of Euergetes II appear here. To the S is the Kiosk of Trajan, sometimes called "Pharaoh's Bed," a four-sided portico. Fourteen campaniform, floral capitals, support the architrave, which carries a cavetto cornice. Screen walls rise between the columns, of which only two are decorated. Trajan burns incense before Unnefer and Isis in the first scene; he offers wine to Isis and Horus in the second. There are many Ptolemaic and Roman inscriptions.

BIBLIOGRAPHY. A.E.P. Weigall, *A Guide to the Antiquities of Upper Egypt* (1913) 465-89; Porter & Moss, *Top. Bibl.*, *VI. Upper Egypt: Chief Temples* (1939) 202-56[P]; P. Gilbert, "Elements Hellenistique de l'Architecture de Philae," *Chronique d'Égypte* 36 (1961) 196-208[I]; E. Brunner-Traut & V. Hell, *Aegypten* (1966) 653-58[MP]; K. Michalowski, *Aegypten* (1968) 542-43[MPI]; E. Winter, "Arensnuphis Sein Name und Seine Herkunft," *Revue d'Égyptologie* 25 (1973) 235-50. S. SHENOUDA

PHILANOREIA, see LAMBAGIANA

PHILIA Thessaly, Greece. Map 9. A small town in ancient Thessaliotis, on the right bank of the river Sophaditikos (probably ancient Kuarios, Kuralios). It is the site of a recent excavation (1963-67) of a Sanctuary of Athena, probably the Sanctuary of Athena Itonias mentioned by Strabo (9.438). Few architectural remains were found, the most notable being the remains (column drums and architectural fragments) of a stoa (?) of the Hellenistic period, remains of Roman walls, and the foundations and mosaic floor of a room of a 2d c. A.D. building. Architectural remains from the Geometric through Classical periods were virtually nil, leading the excavators to conjecture an open air shrine. Sherds of the Mycenaean through Roman periods were found in considerable quantity. The objects of most interest were a large number of offerings including Mycenaean terracottas, Geometric bronzes similar to those from Pherai: pins, fibulas, birds on openwork stands, human and animal figures, and archaic terracotta figurines, some pieces of ivory and gold, and iron weapons. A marble head of a kouros (early 5th c.) has been found, and earlier a bronze statuette of Perseus of the same period.

The temple is thought to have belonged to Kierion, the old chief city of Thessaliotis, identified in antiquity with Arne, the former capital of the Boiotoi (Steph. Byz. s.v. Ἄρνη). Kierion is most probably identified as an ancient site on a conspicuous hill by the river in the plain near the river Sophaditikos by the S *mahala* (quarter) of Mataranga, over 12 km N (downstream) of Philia. Remains of a wall circuit (Mycenaean?) are to be seen around the top of the hill, and ancient sherds, tiles, etc. are to be found in the plain below.

BIBLIOGRAPHY. W. M. Leake, *Nor. Gr.* (1835) IV 497-500 (Kierion); F. Stählin, *Das Hellenische Thessalien* (1924) 131 (Kierion); N. I. Giannopoulos, *ArchEph* (1925-26) 187ff (Perseus)[I]; V. Milojćić, *AA* (1955) 229-31; (1960) 168[I] (Kierion); D. Theocharis, *Deltion* 18 (1963) chron. 134; 19 (1964) chron. 244-49[PI]; 20 (1965) chron. 311-13[I]; 22 (1967) chron. 295f[I]. T. S. MAC KAY

PHILIPPI (Krenides) Thrace, Greece. Map 9. A city in the plain of Datos, proverbial for its fertility, at the 16th km of the Kavala-Drama road. In 360-359 B.C., colonists from Thasos, led by the exiled Athenian politician and rhetor, Kallistratos, founded a city on this site which they called Krenides (springs) from the abundant springs at the foot of the hill where the ancient settlement

was made. Four years later, in 356 B.C., King Philip II of Macedon took the city, fortified it with a great wall, collected new settlers in it, and changed its name to Philippi. Exploitation of the recently discovered gold mines of the area gave Philip an income of as much as 1000 talents a year.

During the period of Macedonian supremacy Philippi had no particular importance, but was simply one among the cities of the kingdom. In 42 B.C., a battle between the forces of Brutus and Cassius on the one side and Antony and Octavian on the other, made the name of the city known to the whole world. Immediately after the battle numbers of Roman colonists were settled at Philippi and the villages around, and the Roman colony, Colonia Augusta Julia Philippensis, was founded. The Apostle Paul came to Philippi in the fall-winter of 49 A.D. and founded the first Christian church. With the official establishment of Christianity, Philippi was raised to a metropolitan see with five to seven bishops subject to it, and became an important religious center, as its Early Christian monuments attest. The city appears to have existed into the mid 14th c. A.D., but already had passed its peak, and in a short time was deserted. So, when the traveler P. Belon visited the site between 1546 and 1549 there were no more than five or six houses and those outside the wall.

Among the older remains of the settlement which belong to the time of Philip II is the wall, which has a length of approximately 3500 m and is preserved chiefly on the slopes and summit of the acropolis hill. In Byzantine times the ancient wall was used as a basis for the fortification of the city (an inscripiton of 963-69 tells of the building or repair of the castle of Philippi).

Of three known gates in the section of wall in the plain, the "Neapolis gate" in the E and the "Krenides gate" in the W wall are noteworthy partly for their fortification, and partly because the road leading from Philippi to its port, Neapolis, and into the interior passes through them.

It appears that the earliest parts of the theater, the circular orchestra and the isodomic parados walls, were built in the time of Philip II. These were uncovered in the E part of the settlement at the foot of the hill near the wall. In the Roman period (2d-3d c. A.D.) new rows of seats were built on the upper part of the cavea, the scene building was reconstructed, and several changes were made to adapt the theater for the spectacles demanded in that period, and to change the orchestra into an arena for wild-beast hunts.

Also to the Hellenistic period belongs a small Ionic prostyle temple or heröon (2d or 3d c. B.C.) which was uncovered at the foot of the acropolis hill, SW of the theater, on the site of the Early Christian Basilica A. A second heröon, belonging to Euephenes son of Exekestos, according to the inscription carved on the cover of his tomb, was uncovered outside the E side of the forum. This heröon, which probably belongs to the second half of the 2d c. B.C., was an underground "Macedonian" chamber tomb with a temple-style building erected on top of it. Only the foundation of the latter is preserved.

Of other buildings of the Classical and Hellenistic city, the peribolos of the Temple of Apollo Komaios and Artemis (according to a dedicatory inscription of the second half of the 4th c. B.C.) was uncovered in the center of the city, E of the Roman agora.

The great military highway, the Via Egnatia, running through the city from the "Krenides gate" to the "Neapolis gate" was the decumanus maximus and the chief arterial of the Roman colony. A large part of this road, paved with marble slabs in which ruts are worn by cart wheels, has been excavated in different parts of the city.

Along the S edge of the road are the monumental propylaia of the "episkopeion" (Episcopal building complex), a semicircular portico 35 m in diameter, with 18 Ionic columns, and the imposing architectural complex of the forum, whose buildings are dated by inscriptions to the period of Emperor Marcus Aurelius. The buildings of the forum are arranged around a rectangular court 100 x 50 m, paved with marble. On the N side, a speaker's platform, two small temple-style buildings, and two large fountains have been uncovered. At the NE and NW corners are two matching Corinthian temples, each consisting of a naos and pronaos. The E side is occupied by the buildings of the library, and the W by government buildings. A large stoa divided in two lengthwise, which was used for public gatherings and commerce, bounded the S side of the forum.

South of the forum a wide road paralleled the Via Egnatia. Its side was bordered by a row of shops which backed on the outer side of the forum's S wall. Along the S side the excavations uncovered three large blocks of buildings bordered by roads at right angles to the one just mentioned. The middle block, with a hexastyle Corinthian colonnade on its facade, was a market; the W, a palaestra; and the E has not yet been investigated. In the palaestra, the exercise area, rooms, a small amphitheater, and a large underground lavatory have been uncovered. These structures date to the Antonine period. South of the palaestra are spacious baths. Their mosaic floor with animal and bird motifs has been destroyed. In the rock of the acropolis hill are open air shrines (Silvanus, Artemis Bendis, Cybele, Bacchus) and a Sanctuary of the Egyptian Gods. More than 140 bas-reliefs of the gods have already been discovered carved in the cliff. The marble arch symbolizing the political preeminence of the Roman colony, which was erected in the first half of the 1st c. A.D., two km W of the city, no longer exists. East of the city is the Roman and Christian necropolis.

The importance of Philippi in the Early Christian period is revealed by four large, magnificent basilicas and an octagonal chapel which make up a large part of the architectural whole of the Episkopeion. Finds from the excavations are in the museum at Philippi.

BIBLIOGRAPHY. L. Heuzey-H. Daumet, *Mission archéologique de Macédoine* (1876). For studies of various monuments, walls, and sculpture, see *BCH* (1928) 74ff; (1929) 70ff; (1933) 438ff; (1935) 175ff; (1937) 86ff; (1939) 4ff; P. Collart, *Philippes Ville de Macédoine depuis ses origines jusque á la fin de l'époque romaine* (1937); P. Lemerle, *Philippes et la Macédoine orientale á l'époque Chretienne et Byzantine* (1945); D. Lazarides, Οἱ Φίλιπποι (1956). The excavations of the Archaeological Society have been reported in *Ergon* by A. K. Orlandos (1958-69) and in ΠΑΕ (1958-67). The excavations of the Archaeological Service have been reported in *Chronika* ΑΔ (1960-63, 1967-69). D. LAZARIDES

PHILIPPOPOLIS (Chahba) Syria. Map 6. Market town at the N end of the mountains of the Hauran, on the road from Damascus to Dionysias (Soueida) and Bostra, the home of the emperor Philip the Arab (A.D. 244-49), who made it into a city.

The town was the usual large quadrilateral, and the cardo (the main axis of traffic) and the decumanus (on a steep slope) are well preserved. A tetrapylon marked their crossing. Large public baths and the piers and arches of an aqueduct are visible in the SE district, while the columns of the portico of a hexastyle temple stand to the W, on the N side of the decumanus. The Philippeion, the temple of the imperial family, is a little farther S, and nearby is a theater built of basalt, partly against the hill. All the arcades of the exterior facade, the scae-

nae frons, and the greater part of the hemicycle are preserved. The entrances, corridors, vomitoria, and stairways are well arranged.

Polychrome mosaic pavements have been found in the houses, depicting individuals or vast allegorical or mythological tableaus. They date from the middle of the 3d c. A.D. and some of them are now in the Damascus museum and in the Soueida museum.

BIBLIOGRAPHY. H. C. Butler, *AAES* Pt. II, *Architecture and other Arts* (1903)[MPI]; R. E. Brünnow & A. v. Domaszewski, *Die Provincia Arabia* III (1909)[MPI]; M. Dunand, *Syria* 7 (1926)[I]; E. Frézouls, "Les théâtres romains de Syrie," *Annales archéologiques de Syrie* 2 (1952)[I]; P. Coupel & id., *Le Théâtre de Philippopolis en Arabie* (1956) = *Bibliothèque Archéologique et Historique* 63 (1956); E. Will, "Une nouvelle mosaïque de Chahba-Philippopolis," *Annales archéologiques de Syrie* 3 (1953)[I].

J.-P. REY-COQUAIS

PHILIPPOPOLIS or Eumolpia or Trimontium (Plovdiv) Bulgaria. Map 12. A city on the right bank of the Maritza river in the great lagoon between the Balkan and Rhodopian mountains at the junction of the Belgrade-Istanbul and Danube-Aegean roads. The city was founded in 342 B.C. by Philip II of Macedon over a prior Thracian center (Pulpudava). Conquered again by the Thracians after the fall of the Macedonians, the city remained under Thracian control until it was conquered by the Romans, who made it the capital of the province of Thrace, the metropolis and seat of the provincial assembly; in 248 it became a colony. It was provided with a circuit wall by Marcus Aurelius. Captured temporarily and sacked by the Goths in 251, it became an episcopal seat in the 4th c. It was occupied by the Huns and restored during the reign of Justinian.

Traces remain of the Thracian-Macedonian (4th c. B.C.) polygonal circuit wall. It encircled the three hills (a prehistoric site) with an irregular and triangular surface area of ca. 80,000 m and was restored in the late Roman and Byzantine period in opus mixtum and rubble core. Only one gate of the original four has been preserved. The second and larger circuit wall (ca. 430,000 sq. m), in the shape of an irregular pentagon, was constructed during the reign of Marcus Aurelius as a defense against the Marcomanni (mentioned in fragmentary inscriptions). Very little of it has been preserved.

Of the ancient buildings, only the stadium, to the W and at the front of the hill between the second circuit wall in the central section of the modern city, remains. There are ruins of a temple of Aesculapius to the E, a large bath building with massive vaults on pilasters in the E section, aqueducts, and many architectural fragments belonging to various buildings that have since disappeared. The theater is supposed to have been in the S section of the city S of Taxim-tepe. It is quite probable that the city had a stadium (3d c. B.C. on the evidence of the architectural and decorative elements and according to the ancient sources). The length of the track is a little more than a stade—ca. 180 m—and the width was probably 25 to 30 m, with a capacity possibly of ca. 30,000. The orientation of the stadium was NW to SE. The W side occupied the slopes of Sahat-tepe, taking full advantage of the natural rock and slope of the land; the E side was for the most part artificially elevated with buttressing walls of brick and stone. Inscriptions document the existence of reserved seats for officials and organizers of the games. The monumental entrance to the track, set on a slightly curved line, was built of five large vaulted chambers. This monumental entrance, which must have been on three levels, was probably decorated in the three architectural orders. Herodian mentions the restoration of the Pythian games in the cities of Thrace at the behest of Caracalla in honor and memory of Alexander the Great. Coins minted by Caracalla and later by Elagabalus at Philippopolis commemorate this restoration by the provincial assembly of the Thracians. The coins represent fights, gladiators, a diskobolos, gymnasts exercising, and prizes. The games mentioned are the Pythian in honor of Apollo Pythius, the Alexandria in honor of Alexander the Great, and the Kendreiseia, local games of Thrace in honor of the Thracian deity Kendrizos. At the time of the Gothic invasions, the sources remark that the stadium was within the city.

The Byzantine chronicler Anna Comnena, who visited Philippopolis at the beginning of the 12th c., mentions a hippodrome without remarking on the stadium. That the stadium no longer existed in her time is proved by the stratigraphy of the excavations where the Byzantine coins are at a level higher than that of the stadium. Inscriptions give evidence of the participation of famous athletes at the games and of the commemoration of statues to them.

The modern city preserves traces of the old topography along with the separation of the ethnic sections and the irregular, winding course of the streets (characteristically, the houses are wood, the markets are covered, and the baths are Turkish). There is a typical lack of a real urban center.

The National Archaeological Museum in Plovdiv, second only in size to the one at Sofia, conserves the prehistoric, Thracian, Roman, and mediaeval antiquities. Particularly important are the religious reliefs, and the coin collection is noteworthy.

BIBLIOGRAPHY. B. Filov, "Il restauro della fortezza di F.," *Izv. Ist. Druz. v. Sofia* 4 (1915); G. Rudolff-Hille, "Die Stadt Plovdiv u. ihre Bauten," *Izv. Bulg. Arch. Inst.* 8 (1935)[MPI]; C. Danov in *RE* XIX (1938); D. Zoncev, *Contributions à l'histoire antique de Philippopolis* (1938)[PI]; id., *Contributions à l'histoire du stade antique de Ph.* (1947)[PI]; L. Botušarova, "Des données topographiques sur la ville de Philippopolis de l'époque romaine d'après les trouvailles funéraires," *Izv. Bulg. Arch. Inst.* 25 (1962).

Notices and reports in *Annuaire de la Bibliothèque et du Musée National de Plovdiv* from 1901; and in *Izvestia dell'Istituto Archeologico Bulgaro*, always in Bulgarian with summaries in French and German.

A. FROVA

PHILOSOPHIANA (Sofiana) Sicily. Map 17B. A statio of Roman Imperial date at the center of the large estate by the same name in the S central part of the island, on the inland route from Catania to Agrigento. The statio by this name mentioned in the *Antonine Itinerary* has been identified in the fertile green dell of Sofiana, between Piazza Armerina and Mazzarino, a few kilometers from the famous Imperial Villa of Casale, to which it was connected by a road visible in aerial photographs. Excavations have ascertained the area of the ancient town and uncovered a large structure with bath installations and cubiculi, dating to the first half of the 4th c. A.D. Under this building earlier structures were found, going back to the Augustan period. The late Roman building was in turn altered around the end of the 4th c. when a small Early Christian basilica with two apses was located within the calidarium of the baths. Further transformations occurred in Byzantine times, and the building, which was probably meant for travelers, continued in use until the Norman period, as shown by pottery and coins. Not far from this building an Early Christian basilica has been excavated; it has three naves,

central apse, prothyron, and funerary crypt with two cellas in the S aisle. The basilica was surrounded by a cemetery with adult and infant graves. Roman and Christian cemeteries around the city area have been largely explored. The Roman cemeteries yielded vases of terra sigillata and sigillata chiara, glass vessels, and necklaces. Christian tombs contained the usual unpainted striated ware, lamps with Christian symbols, gold rings and earrings. A remarkable gravestone engraved with the seven-branched Jewish candlestick carried the name of the presbyteros Attinis. All the archaeological material from the excavations is preserved in the Gela National Museum.

BIBLIOGRAPHY. D. Adamesteanu, *RendLinc* (1955) 199ff, 569ff; id., *BdA* (1956) 158ff; (1963) 259ff; L. Bonomi, *RACrist* 40 (1964) 169ff.　　　P. ORLANDINI

PHILOTERIA or Sennabris (Khirbet el-Kerak) Israel. Map 6. A town built by Ptolemy II on part of the mound of Khirbet el-Kerak (Talmudic Beit Yerah) on the SW shore of the Sea of Galilee. Josephus (*BJ* 3.447; 5.445) called it Sennabris.

The fortified town built in the Hellenistic period had an area of ca. 125 ha and a wall ca. 1.6 km around, built on a socle of basalt 4.5-6.3 m wide and 3.6 m high, with mud brick above. The wall was strengthened by alternating rectangular and round towers. Some private houses have also been found. Close to the lake was a Roman fort (54 x 54 m), with corner towers and a gate on the S protected by two towers. Within the fort were remains of a synagogue, built when the fort was in ruins. It was a basilica (30.6 x 19.8 m), with a niche in its S wall, facing Jerusalem. The nave had a mosaic pavement, with designs of plants and lions. On one of the column bases Jewish symbols were engraved. A bath was found in another area. The latest building on the site was a Christian basilican church, built in the 5th c., rebuilt in A.D. 528-29, and destroyed at the beginning of the 7th c.

BIBLIOGRAPHY. F. M. Abel, *Géographie de la Palestine* II (1938) 284; B. Maisler et al., *IEJ* 2 (1952) 165-73; P. Bar-Adon, ibid. 3 (1953) 132; 4 (1954) 128-29; 5 (1955) 273; P. Delougaz & R. C. Haines, *A Byzantine Church at Khirbat al-Karak* (1960); M. Avi-Yonah, *The Holy Land* (1966) 37, 70, 138.　　　A. NEGEV

PHILOTI, *see* NAXOS (Greece)

PHINTIAS (Licata) Sicily. Map 17B. A Greek city on Mt. Eknomos at the mouth of the river Himera, between Gela and Agrigento. The city took its name from the Akragan tyrant who founded it at the beginning of the 3d c. B.C. for the citizens of Gela, whose city he had destroyed in 286-282 B.C. Inscriptions and coins show that the new inhabitants long retained the name Geloi, which still appears in an inscription of the 1st c. B.C. listing victorious ephebes. Diodorus Siculus mentions (22.2) that the city had a large agora with porticos; however, since no regular excavation has yet taken place, the Hellenistic and Roman material which can be connected with Phintias comes from chance finds.

Before the founding of Phintias, Mt. Eknomos was occupied by archaic settlements. The first was probably a Greek center founded by Geloan colonists in their march along the S coast of Sicily. Later, during the second quarter of the 6th c. B.C., a phrourion was founded by the Akragan tyrant Phalaris (Diod. 19.2). This archaic phase is attested by Corinthian, Ionic, and Geloan pottery and figurines, sporadically found in the area and at present exhibited in the Museums of Palermo and Agri-

gento. A recent, though rather improbable, hypothesis would locate the Sikanian city of Inicos on the Eknomos.

BIBLIOGRAPHY. D. Adamesteanu, *Atti III Congresso Internazionale di Epigrafia Greca e Latina* (1959) 425ff; id. in *EAA* 4 (1961); E. De Miro, *La Parola del Passato* 49 (1956) 266ff; id., *Kokalos* 8 (1962) 124ff; G. Caputo, *NSc* (1965) 189ff; V. La Bua, *Atti Accademia Scienze Lettere e Arti di Palermo* (1966-67) 4ff.　　　P. ORLANDINI

PHLIOUS Peloponnesos, Greece. Map 11. Located in the NE part of the region in a broad plain W of the Nemean valley.

Excavations in 1924 indicated occupation from the Early Neolithic period to Byzantine times. Mycenaean finds were scanty, confirming the statement of the ancient authors (Strab. 8.382; Paus. 2.12.4-6) that the city of Homer (Araithyrea) was not located at the site of the later city. Phlious participated in the Persian Wars, contributing 200 men to Thermopylai and 1,000 to Plataia (Hdt. 7.202; 9.28.4). She was constantly an ally of Sparta and no doubt valuable to that state in providing a route to the Corinthian Gulf which did not pass under the walls of Argos. Her 4th c. history is one of internal strife and defense against various enemies (Xen. *Hell.*). Little is known of her political organizations, but a Hellenistic proxeny decree found on Delos may preserve the name of one of the tribes, Aoris. A Pythagorean school apparently flourished at Phlious at the end of the 5th c. (Diog. Laert. 8.46) and the city provides the setting for Plato's *Phaedo*. Pratinas, the composer of satyr plays, was a native (Suid. s.v. Pratinas). The Roman city as described by Pausanias (2.13.3-8) was extensive, and he states that Hebe was the principal deity. Numerous buildings are mentioned, among them a Temple of Asklepios located above a theater.

Traces of antiquity are abundant at Phlious, both on the acropolis and in the plain to the S, where the city proper was located. Portions of wall are visible along the N, E, and W sides of the acropolis and the E city wall can be traced for some distance in the plain. On one of the terraces at the W end of the hill stands a modern chapel, almost entirely constructed of ancient blocks, possibly the site of the Temple of Asklepios. Farther down the hill to the W lie a fountain-house and a large, partially excavated building with a hypocaust.

Most of the buildings discovered in the early excavations lie at the SW foot of the hill. An apparent hypostyle hall, explored by only a few test trenches, yielded pottery and architectural fragments of the late archaic period. East of this lies a rectangular structure with an interior colonnade (known locally as the Palati), and to the N a scene building and a theater cavea. Supplementary excavations reinvestigated the Palati, which appears to date to the 5th c. B.C., and the theater, the lower portion of which was excavated. This consists of the E retaining wall of the cavea, a line of poros benches, and a partially cleared exedra on the W.

The theater in its present form is Roman and no doubt it is the one seen by Pausanias below the Temple of Asklepios, which must be located either immediately above the cavea or farther to the E under the chapel, where most modern writers have placed it.

BIBLIOGRAPHY. H. Washington, "Excavations at Phlius in 1892," *AJA* 27 (1923) 438-46[PI]; C. W. Blegen, "Excavations at Phlius 1924," *Art and Archaeology* 20 (1925) 23-33[I]; E. Meyer, "Phleius," *RE* 20 (1941) 269-90; L. Robert, "Un Décret Dorien Trouvé à Délos," *Hellenica* 5 (1948) 5-15; R. Legon, "Phliasian Politics and Policy in the Early Fourth Century B.C.," *Historia* 16 (1967) 324-37; W. Biers, "Excavations at Phlius, 1924.

The Prehistoric Deposits," *Hesperia* 38 (1969) 443-58[PI]; "Excavations at Phlius, 1924. The Votive Deposit," *Hesperia* 40 (1971) 397-423[I]; "Excavations at Phlius, 1970," *Hesperia* 40 (1971) 424-47; 42 (1973) 100-20[PI].

W. R. BIERS

"PHLYA," *see* CHALANDRI

PHOINIKE (Finik) S Albania. Map 9. According to Polybios, this was the best fortified town of Epeiros. It rose on a hill shaped like the wrecked keel of a ship, with the village of Finik at the foot of the hill. The walls, in three sections, are preserved on the hill: the acropolis walls, the walls of the period of the enlarging of the acropolis, and the walls of the fortified city. These walls, constructed in ashlar masonry, employed huge blocks, and in some places rest in the living rock. They date between the 4th c. and 2d c. B.C. Inside the acropolis are the remains of Greek and Roman walls. In the village, there are few remains of Greek walls, but the Roman remains are numerous, incorporated for the most part into modern buildings. Some are in opus reticulatum and brick, others in opus incertum and can be dated even to the late Roman period. A small thesauros has been uncovered on the acropolis. In the Byzantine period it was transformed into a baptistery. Three cisterns, dating between the 5th c. B.C. and the 3d c. A.D., are recognizable, as are a few remains of minor buildings.

The necropolis, set on the slopes of the hill, contains tombs, all of the Hellenistic period, some chest-like in rock slabs and others covered with tiles.

BIBLIOGRAPHY. Strab. 7.324; Ptol. 3.14.7; Polyb. 2.5.8; 26.27; 32.22; Procop. *De Aed.* 4.1.

L. M. Ugolini, *Albania antica, II: L'Acropoli di Fenice* (1932). P. C. SESTIERI

PHOINIX Greece. Map 11. City on the S coast of W Crete, near Loutro, Sphakia district, 9.6 km E of Tarrha and 4.8 km W of Chora Sphakion; it was the port of inland Anopolis and also of later Aradena. The name is probably connected, not with the Phoenicians, but with the palm trees common on this coast. On Paul's voyage to Rome (A.D. 60) the majority wished to winter at Phoinix. Ptolemy lists a city called Phoinix on this coast, and a harbor called Phoinikous (3.15.3: probably the city near Loutro and Phoinika Bay to the W); the *Stadiasmus* (328-29) says Phoinix has a harbor and an island (the offshore rock Loutronisi?); Steph. Byz. lists a Cretan city called Phoinikous. Hierokles (651.1) mentions Phoinike with Aradena, and the two sites are linked in one see in the early 9th c. *Notitiae* (8.230; 9.139). The site may have been unoccupied from the Arab conquest until the Venetian period. A dedication to Iuppiter Sol Optimus Maximus Sarapis, of the Trajanic period, was found here. Cape Plaka, to the W, is probably Ptolemy's Cape Hermes (3.15.3), where a sanctuary of Hermes is likely.

Loutro was identified as Phoinix in the 15th c. The site is on a narrow enclosed bay on the E side of Cape Mouri, the best all-season harbor on the S coast of Crete. The city's prosperity must have depended almost entirely on maritime trade; its disadvantages were the small size of the harbor, the lack of good spring water, and the difficulty of inland communications. There were many remains in the 15th c., but those now visible are on the peninsula between Loutro and Phoinika Bay W of the promontory, and mainly on the plateau W of the Turkish fort: a vaulted cistern, tombs, terrace walls, and house foundations of the Roman and First Byzantine periods. Coarse Minoan sherds found S of the fort attest a prehistoric settlement. The coast seems to have risen some 4 m since antiquity.

A second city named Phoinix probably existed on the same coast some distance to the E, at Phoinikias near Sellia, in the Agios Vasileios district. This would have been the Phoinix in the territory of Lappa attested by Strabo (10.475).

BIBLIOGRAPHY. R. Pashley, *Travels in Crete* II (1837; repr. 1970) 241-43[I]; T.A.B. Spratt, *Travels and Researches in Crete* II (1865) 249-55; G. De Sanctis, *MonAnt* 11 (1901) 521-24; M. Deffner, *Odoiporikai entiposeis apo tin Dhitikin Kritin* (n.d.) 62-63, 143-44; A. Trevor-Battye, *Camping in Crete* (1913) 210ff[I]; M. Guarducci, *ICr* II (1939) 191-92, 226-29; E. Kirsten, "Phoinix (17)," *RE* XX (1941) 431-35; id. in F. Matz (ed.), *Forschungen auf Kreta* (1951) 126-29; P. Faure, *KretChron* 13 (1959) 198, 203; S. Hood, *BSA* 60 (1965) 113; id. & P. Warren, ibid. 61 (1966) 183-84; S. G. Spanakis, *Kriti* II (n.d.) 250-52, 384-85[M]; Brit. Adm. Chart 1633[M]. D. J. BLACKMAN

PHOINIX (Fenaket) Turkey. Map 7. Site in Caria, on the Loryma peninsula SW of Marmaris. According to Strabo (652) it stood on top of a mountain of the same name, which Fenaket does not; but the survival of the name seems conclusive for the site. The place seems also to be mentioned by Stephanos Byzantios s.v. Phoinike. It belonged with the rest of the peninsula to the incorporated Rhodian Peraea, and seems to have been the center of the deme of the Tloioi. Little survives apart from a fortified acropolis and numerous inscriptions.

BIBLIOGRAPHY. H. von Gärtringer, *Hermes* 37 (1902) 413f; P. M. Fraser & G. E. Bean, *The Rhodian Peraea* (1954) 34, 58, 95. G. E. BEAN

PHOKAIA (Foça) Turkey. Map 7. City on a small peninsula inside a gulf NW of Smyrna, the farthest N of the Ionian cities and in the Aiolian region. The Phokaians, directed from Athens, according to ancient authors (Nicol. Damasc. *FGrH* II, 1.35.2, frg. 51; Paus. 7.3.10; Strab. 14.633; Hdt. 1.146), settled on land given them by the people of Kyme. The 9th c. monochrome gray pottery found there may indicate that, like Kymians, these first inhabitants of Phokaia were Aiolians. According to Pausanias, Ionians from Teos and Erythrai settled there, perhaps in one of the earliest movements of the Ionian expansion. Indeed, the Protogeometric pottery probably indicates that the Ionians had lived at Phokaia at least since the end of the 9th c. B.C. From this it might be deduced that the city was accepted into the Panionion after the Ionians settled in the area at this early date.

The Phokaians were famous navigators, employing 50-oared vessels. They traded with Naukratis in Egypt and, in association with Miletos, they founded Lampsakos, at the N entrance to the Dardanelles, and Amisos (Samsun) on the Black Sea. But Phokaia's major colonies were in the W Mediterranean, especially Elea (Velia) on the W coast of Lucania in S Italy, Alalia in Corsica, Massalia (Marseilles) in France, and Emporion (Ampurias) in Spain.

The city wall mentioned by Herodotos (1.163) has disappeared. It was a defense against the Persians, and financed by King Argonthonius of Tartessos in Andalusia. In 546 B.C., however, the Persians captured Sardis and soon devastated most of the cities in W Asia Minor, including Phokaia. Many of the inhabitants emigrated to their Mediterranean colonies. Although some of them seem to have returned, there was no revival of the golden age of the first half of the 6th c. The Phokaians could send only three ships to the battle of Lade in 494; but owing to their naval skill, the command of the entire Hellenic fleet was given to Dionysios of Phokaia.

The city was a member of the Delian League during the 5th c. and paid a tribute of two talents, but in 412

Phokaia rebelled and left the League. During the Hellenistic period it was ruled first by the Seleucids and then by the Attalids, and in 132 B.C., although it participated in Aristonikos' uprising against the Romans, the city was saved from destruction by the help of Massalia. Pompey gave Phokaia its independence. In the Early Christian era, the city became the center of a diocese, and in A.D. 1275 the Genoese, who were mining alum there, fortified the town with a castle.

Phokaia was also famous for its coinage, made of electrum, and for its purple dye. Telephanes of Phokaia was a sculptor for Darius and Xerxes in the 5th c. B.C., and according to Vitruvius (7 *Praef.* 12) Theodoros of Phokaia wrote on the Tholos at Delphi and was probably the builder of it (beginning of the 4th c. B.C.).

In ancient times a temple stood on the highest point of a rocky platform at the end of the peninsula, where the secondary school now stands. Excavations have yielded many fragments of bases, columns, capitals, and architectural terracottas which may have been part of the Temple of Athena mentioned by Xenophon (*Hell.* 13.1) and Pausanias (2.31.6; 7.5.4). Constructed of fine white porous stone, the building seems to have been erected in the second quarter of the 6th c. B.C., and restored about the end of the same century after its destruction by the Persians. The architectural and other finds are in the Izmir Museum.

The rock monument N of the asphalt road, 7 km E of Foça, was not built but was carved out of the rock, like the tombs found in Lycia, Lydia, and Phrygia. The pattern of a door on the facade also appears on Lydian works in the vicinity; but on the other hand, the monument follows the Lycian custom in having two stories, with the upper one in the form of a sarcophagus. The burial chamber, however, was on the ground floor, and the presence of a stepped element between the two floors is indicative of Achaemenid influence. The building must have been erected in memory of a minor king, and therefore during a time when non-democratic Persian rulers dominated the region. There were tyrants close by at Larisa during the 5th and 4th c., and the Phokaian monument may have been that of a tyrant who ruled a small area in the 4th c. B.C.

The tomb called Şeytan Hamamı (the Devil's Baths), in Foça itself, is carved out of rock like some of the Lydian tombs. The Greek sherds found in this grave date from the end of the 4th c.

BIBLIOGRAPHY. F. Sartiaux, *De la nouvelle à l'ancienne Phocée* (1914); id., *CRAI* (1911) 119ff; (1914) 6ff; J. Keil, *RE* XXI, 444-48; E. Akurgal, *Anatolia* 1 (1956) 3ff; id., *Die Kunst Anatoliens* (1961) 17, 180, 283; id., *Ancient Civilizations and Ruins of Turkey* (1973); E. Langlotz, *Die kulturelle und künstlerische Hellenisierung der Küsten des Mittelmecres durch die stadt Phokaia* (1966).

E. AKURGAL

PHOTIKE (Paramythia) Greece. Map 9. Identified by inscriptions (*CIL* III, Suppl. 2. 12299), it is N of Paramythia in S Epeiros. A city of Roman and Byzantine times stood on the watershed between the Acheron valley and the Thyamis valley. Its predecessor of Greek times, situated above Paramythia, was strongly fortified then and later (Procop. *Aed.* 4.1.34); there are remains of ancient walls, gateways and rock cuttings, which indicate a circuit wall ca. 2100 m long.

BIBLIOGRAPHY. N.G.L. Hammond, *Epirus* (1967) 73f and 582.

N.G.L. HAMMOND

PHTHIOTIC THEBES Achaia Phthiotis, Greece. Map 9. A city located at the N end of the ancient Krokian plain (modern plain of Halmyros). It is also known as Thebes of Achaia and Thebes of Thessaly. Modern Mikrothivai (formerly Akitsi) is in the plain a little S of the ancient city. Thebes shared the plain with Halos to the S. Its inland neighbors were Pherai and Pharsalos, its neighbor to the N was Demetrias/Pagasai (Strab. 9.433, 435; Polyb. 5.99).

The site has been occupied since the Stone Age, but does not appear by name until the 4th c. B.C. It was enlarged by a synoecism with the neighboring cities of Phylake and Pyrasos (the latter at modern Nea Anchialos, on the shore ca. 6 km to the E) probably in the second half of the 4th c. B.C. It became the leading city of the Phthiotic Achaian League and flourished as the main harbor on the Gulf of Pagasai until the foundation of Demetrias in ca. 293 B.C. In the second half of the 3d c. B.C. it was joined to the Aitolians. Philip V of Macedon took it after a siege in 217 B.C. for that reason. He enslaved the inhabitants and placed a Macedonian colony there. In 189 B.C. it became again capital of the newly reformed Phthiotic Achaian League, which was in Augustus' time reattached completely to Thessaly. Thebes was then in existence and Pyrasos abandoned, but in the Roman Imperial period Thebes moved to the old site of Pyrasos, where it flourished then and later. The old site was apparently not abandoned completely, but the main development of the city was at its harbor.

The ancient acropolis was a rocky peak overlooking the plain. It was surrounded by a wall of large rough blocks, apparently Cyclopean. The wall surrounding the lower city is still visible, although in some places only the foundation is left. It makes a large circuit down the hill from the acropolis SE to the plain. It is ca. 2 m long. The acropolis and hill slope are flanked by two deep ravines. There are some 40 towers along the wall, which is constructed of rectangular and trapezoidal blocks of irregular size, laid in more or less regular courses except where stepped in the slopes. Stählin dated the wall to the 4th c. B.C.

Excavations, principally on the acropolis, uncovered prehistoric through Byzantine layers, and in the Greek level the foundations of a temple (9 x 12 m) perhaps originally distyle in antis. It may have been the Temple of Athena Polias, who is known to have had a cult at this site. It was built with materials from an earlier temple. Near the acropolis some post-Classical statuary was recently discovered, including a head of Asklepios? from a sanctuary.

A few remains of the lower city are visible. The ancient theater of which some seats are to be seen was about half way down the hill, looking towards the sea. South of this was a stoa of the Hellenistic period and another building excavated in 1907. South of these were the foundations of a large building (14 x 19 m) also excavated at that time.

Objects from Thebes are largely in the Museum of Volo, although some are in the small Halmyros Museum.

BIBLIOGRAPHY. F. Stählin, *AM* 31 (1906) 5-9[MI]; id., *Das Hellenische Thessalien* (1924) 170-73[P]; id., *RE*² (1934)³ s.v. Thebes[P]; A. S. Arvanitopoullos, *Praktika* (1907) 167-69; (1908) 163-83[I]; id., *ArchEph* (1910) 82-94[I]; N. I. Giannopoulos, *ArchEph* (1945-47) chron. 17-18; D. Theocharis, *Deltion* 16 (1960) chron. 183f[I]; H. Biesantz, *Die Thessalischen Grabreliefs* (1965) 135[I].

T. S. MAC KAY

PHYKTIA Argolis, Greece. Map 11. The name of a modern village N of Argos which has been used to identify a blockhouse 4 km beyond it to the NW. 11.6 x 11.8 m in plan, the fort is built of polygonal, conglomerate blocks, with bulging faces and no attempt at cours-

ing. The 3 m high wall rests on a two-course base at the lowest point and is topped with a course of slabs. The entrance door with a horizontal lintel is at the corner; the interior is divided into rooms. There is no evidence concerning the roof or upper story. The masonry and, in particular, projecting stone channels for the entry and exit of the water supply have been dated as no earlier than the 4th c. B.C. There are remains of two other blockhouses nearby.

BIBLIOGRAPHY. L. Lord in *Hesperia* 7 (1938) 496f[MPI]; Y. Bequignon in *RA*, sér. 6, 14 (1939) 48f.

M. H. MC ALLISTER

PHYLE Attica, Greece. Map 11. The most direct way from Athens to Thebes led from Chassia up Parnes by a difficult pass to the W of Harma and the deme of Phyle, over the watershed into the Skourta plain, and thus to Thebes. This was the route taken, in reverse, by Thrasybolos in 404-403 B.C. when he brought his followers from Boiotia to Phyle and later to Peiraeus (Xen. *Hell.* 2.4.2). In the 4th c. B.C. an ephebic garrison was stationed at Phyle (Dem. *De cor.* 38 and *IG* II² 2971). The fort was captured by Kassander, retaken in 304 by Demetrios (Plut. *Dem.* 23.2: surely καταστρεψάμενος does not have to mean "pulled down"), and returned to Athens. It continued to be used by the ephebes in Hellenistic times.

To guard this important pass, the Athenians built a compact, well-sited, naturally defended fort early in the 4th c. B.C. In style quarry-faced isodomic ashlar, the outside face still stands to a maximum of 20 courses, strengthened by towers, the one immediately N of the main gateway circular, the others rectangular. Linking these towers was a rampart walk, defended by an embattled parapet of embrasures and buttressed merlons covered with heavy coping blocks. Within the fortification, on its flat summit, are the slight remains of several buildings. From this citadel the guards could signal directly to Athens.

BIBLIOGRAPHY. W. Wrede, "Phyle," *AthMitt* 44 (1924) 153-224[MPI]; G. Säflund, "The Dating of Ancient Fortifications in Southern Italy and Greece," *OpusArch* 1 (1935) 107-10; F. Winter, *Greek Fortifications* (1971) 138-39.

C.W.J. ELIOT

PHYSKEIS, *see* WEST LOKRIS

PHYSKOS (Marmaris) Turkey. Map 7. Town in Caria, the most important deme of the Rhodian Peraea, attached to the city of Lindos. An inscription shows that it was incorporated in the Rhodian state at least by the mid 4th c. B.C. It fell normally under the command of a hagemon of Apeiros, Physkos, and Chersonasos, and is the only Peraean deme except Kedreai to be individually named in a governor's command. Its importance is explained by its superb harbor. Strabo (652) mentions a grove of Leto at Physkos, and built into a wall of the castle at Marmaris is a 4th c. dedication to her. Strabo (659) makes the curious statement that Physkos was the port of Mylasa; the error is the more surprising as elsewhere (652, 665, 677) he is aware of its true position.

The acropolis was on a hill some 2 km NW of Marmaris, now heavily overgrown, but some stretches of wall of Classical and Hellenistic date can be made out. In Marmaris itself nothing of the ancient city remains standing, but numerous inscriptions and sculptured blocks have been found there, especially in the Eyliktaşı quarter; some of these are collected at the school. The castle on the low hill at the S end of the town is mediaeval.

BIBLIOGRAPHY. C. T. Newton, *Travels and Discoveries* II (1865) 40; H. Collitz, *Sammlung d. griechischen Dialektinschriften* III (1899) 4266; E. Meyer, *Die Grenzen der Hellenistischen Staaten* (1925) 50; C. Blinkenberg, *Lindos* II, *Inscriptions* (1941) I, 51; P. M. Fraser & G. E. Bean, *The Rhodian Peraea* (1954) 57, 79, 97; Bean & J. M. Cook, *BSA* 52 (1957) 58; id., *TürkArkDerg* 9, 2 (1960) 7-10.

G. E. BEAN

"PHYSTYON," *see* NEROMANA

PIACENZA, *see* PLACENTIA

PIANO DEI CASAZZI Sicily. Map 17B. This small site lies ca. 16 km N of Caltagirone, in the arid hills overlooking the valley of Katane. It occupies a hilltop that was fortified with a wall and square towers; extensive traces of these remain. An adjacent Sikel necropolis with chamber tombs has been despoiled, but to be associated with this early habitation is a major bronze hoard, found nearby at San Cataldo and dated to the Finocchito period (730-650 B.C.). The Greek fortifications have been attributed to Hippokrates of Gela (ca. 495 B.C.), but without further excavation this suggestion must remain tentative.

BIBLIOGRAPHY. P. Orsi, *NSc* (1907) 488f; *BPI* (1927) 50f; T. Dunbabin, *The Western Greeks* (1948) 125f, 379f; L. Bernabò Brea, *Sicily before the Greeks* (1960) 190f.

M. BELL

PIANOSA, *see* PLANASIA

PIATRA FRECĂŢEI, *see* BEROE

PIAZZA ARMERINA Casale, Sicily. 17B. A Roman villa of the Late Empire, ca. 3 km SW of the Norman city from which the site takes its name. The site is at the foot of a semicircular plateau on the slope of the valley and overlooks the left bank of a stream that flows into the Gela river. The villa was reached from the S by a secondary road off the main route between Catana and Agrigentum in the statio of Philosophiana (Soffiana).

Now completely excavated, the villa was built in accordance with a well-defined plan within the great walls of the aqueducts to the E and NW and the walls flanking the approach to the magnificent triple-arched entrance. The main villa consisted of four groups of rooms with galleries, peristyles, courtyards, and baths. Overall, it is a remarkable complex of buildings, asymmetrical and oddly planned, with the predilection for exedral cavities so dear to the Late Imperial period. Each of the four major sections is easily distinguishable by the differences in level overcome by flights of steps, for the villa abounded in terraces imposed by the nature of the terrain.

From the porticoed polygon of the entrance one descends to the lower terraces where stand a great porticoed latrine and the principal nucleus of the baths, with the gymnasium and the tepidarium in the style of an atrium, apsidal at both ends, and the frigidarium. Octagonal, with the swimming pools and large niches disposed on a curve and thrusting outwards, bulwarked by sturdy supporting pylons, the whole scheme recalls the well-known type of the so-called temple of Minerva Medica in Rome.

On the middle terrace, to the E of the baths and the atrium of the entrance stands the rectangular peristyle, which, with its rooms to the N and S, comprises the *second* section. Its columns, with Corinthian capitals typical of the end of the 3d c. A.D., were nearly all found lying on the ground. To the S of the peristyle on a higher terrace rises the *third* group of buildings, erected round an oval court—a xystus—flanked on either of its long

sides by three small rooms. Its W end is an immense semicircular apse formerly colonnaded, with large niches and an external buttressed polygonal wall. Facing the apse on the E stood a huge trichora hall, the majestic triclinium. In the *fourth* group of buildings, together with the private apartments on the E side of the central peristyle, there is a large apsidal basilica, accessible from a majestic corridor, apsidal at both ends and serving as a chalcidicum or narthex.

The connected architectural structure of this splendid Late Roman Imperial Villa has precedents in other Imperial constructions with similar planimetry and arrangements of rooms. Its structural and architectural plan is substantially a rational development of the Domus Flavia on the Palatine and the Villa of Domitian at Castel Gandolfo, both in its concentration and in the distribution of groups of buildings over a large area.

The attribution of the villa to Tetrarchic times is based primarily on the fact that ceramics of light-colored clay characteristic of the 3d c. A.D. have been found below the mosaic pavements in all sectors where their removal was necessary for consolidation. Coins also were found, mostly of the type of the Antoniniani that span the period from Gallienus to Probus; and an Antoninianus of Maximianus Herculeus was found under the marble threshold of the SE apodyterium of the frigidarium. The attribution also takes into account the stylistic evidence of the mosaics and data which includes, for example, a comparison of the reliefs of the base of the Decennalia in the Roman Forum and those of the Arch of Galerius at Salonika with the watercolors left by Wilkinson of the Tetrarchic paintings of the Temple of the Imperial Cult in the Roman camp at Luxor.

In the richness of its marble columns, the rare and precious marbles that must originally have covered the walls of the rooms, the opus sectile of the Basilica, and the sheer magnificence of the mosaic pavement, extending for over 3500 sq. m, it can be compared to the splendors of Hadrian's villa at Tivoli or Diocletian's Palace at Split, which was apparently contemporary. The mosaics are for the most part large pictures designed by artists of remarkable talent to provide accent for the vast spaces of the rooms. They were undoubtedly executed by experienced master mosaicists from North Africa in a style expressive even today of a mood at times rash and bloody and at times veiled with sadness. The style reflects the grandiose art of the post-Severan period as exemplified by the athletes of the Baths of Caracalla, and certain aesthetic phenomena under Gallienus, influenced perhaps by theories of Plotinus. The mosaics appear to be a natural blending of these elements with stylistic components of the expressionistic and baroque art of the Tetrarchy. This style preceded the flowering of the classicizing renaissance under Constantine, to which period the mosaic of a mutatio vestis in the exedra of the frigidarium may be ascribed. The mosaics preceded the more mature and fluid style that appeared in the Theodosian period.

In the four sections of the villa described above, the major mosaics are: 1) in the bath complex, Chariot Race in the Circus Maximus; and in the vestibule to the bath complex from the living quarters, Domina with Her Children and Servants Entering the Baths; 2) in the peristyle, Beasts and Birds; in the tablinum that precedes the peristyle, Adventus; in the rooms off the peristyle, Small Hunt, Orpheus, Girl Gymnasts; 3) in the three apses of the triclinium, Labors of Hercules, Lycurgus and Ambrosia; 4) in the apsidal corridor preceding the large basilica, the celebrated Great Hunt; in the rooms on either side of the basilica, Polyphemus and Odysseus, Four Seasons, Little Circus, Pan and Eros, Arion on the Dolphin. Taken together the mosaics constitute in their complexity one of the major galleries of figurative art from the ancient world.

BIBLIOGRAPHY. G. V. Gentili, *NSc* 4 (1951) 332ff with bibliography; id., "I mosaici della villa romana del Casale di Piazza Armerina," *BdA* (1952) 33ff; id., *La villa imperiale di Piazza Armerina* (Itinerari di musei e monumenti d' Italia, 1956); id., "Le gare del circo nel mosaico di Piazza Armerina," *BdA* (1957) 23ff; id., *La villa erculia di Piazza Armerina. I mosaici figurati* (1959); *Enciclopedia Italiana* 3 (1961) 418f (G. V. Gentili); *EAA* 6 (1965) 146-54; B. Pace, "Note su una villa romana presso Piazza Armerina," *RendLinc* 5 (1951); id., *I mosaici di Piazza Armerina* (1955); H. P. L'Orange & E. Dyggve, "È un palazzo di M. Erculeo che gli scavi da Piazza Armerina portano alla luce?" *SimbOslo* 29 (1952) 114; L'Orange, "Aquileja e Piazza Armerina," *Studi Aquilejesi* (1953) 185ff; id., "The Adventus Ceremony and the Slaying of Pentheus as Represented in Two Mosaics of about A.D. 300," *Late Classical and Medieval Studies in Honor of A. M. Friend* (1955) 13ff; id., "Il Palazzo di Massimiano Erculeo di Piazza Armerina," *Studi in onore di A. Calderini e R. R. Paribeni* (1956) 593ff; id., *Likeness and Icon* (1974); S. Mazzarino, "Sull'otium di M. Erculeo dopo l'abdicazione," *RendLinc* (1953) 417ff; G. Giannelli & S. Mazzarino, *Trattato di storia romana*, II (1956) 417-578; N. Neuerburg, "Some Considerations on the Architecture of the Imperial Villa at Piazza Armerina," *Marsyas* 8 (1957/59) 22-29 PI; G. Manganaro, "Aspetti Pagani dei Mosaici di Piazza Armerina," *ArchCl* 11 (1959) 242ff; G. C. Picard, "Mosaiques africaines de III siecle ap. F.C.," *RA* (1960) II, 38; N. Duval, "Que savons-nous du palais de Theodoric à Ravenne?" *Mél-Rome* 72 (1960) 370; M. Cagiano de Azevedo, "I proprietari della villa di Piazza Armerina," *Scritti in onore di M. Salmi* (1961); A. Ragona, *Un sicuro punto di partenza per la datazione dei mosaici della villa romana di Piazza Armerina* (1961); id., *Il proprietario della villa romana di Piazza Armerina* (1962); I. Lavin, "The house of the Lord . . . ," *AB* (1962) 1ff; G. Lugli, "Contributo alla storia edilizia alla villa romana di Piazza Armerina," *RivIstArch* 11-12 (1963) 28-82; A. Carandini, "Richerche sullo stile e la cronologia dei mosaici della villa di Piazza Armerina," *Studi Miscellanei dell'Istituto di Archeologia* 7 (1964); M. L. Rinaldi, "Il costume romano e i mosaici di Piazza Armerina," *RivIstArch* 13-14 (1964-65) 200-62; W. Dorigo, *Pittura Tardoromana* (1966) 129-65; H. Kaehler, "La villa di Massenzio a Piazza Armerina," *Acta Inst. Norvegiae* 4 (1969); id., *Die Villa des Maxentius bei Piazza Armerina* [*Monumenta artis Romanae*, 12] (1973).

G. V. GENTILI

PICENTIA (Pontecagnano) Campania, Italy. Map 14. According to Pliny (*HN* 3.70) the Ager Picentinus on the Tyrrhenian coast NW of the Sele was once Etruscan territory. It got its Roman name in 268 B.C. when Rome transplanted Picenes here (Strab. 5.4.13). The exact site of the ancient town is unknown; the modern town is on the left bank of the river Picentino ca. 9 km E-SE of Salerno and a few km from the sea. It is above extensive tomb fields that date from the Early Iron Age to the Roman period, with a gap from the 6th c. to the 4th.

The river Picentino is a major highway to the interior, the only important one between Salerno and the Sele, and the great land route from Etruria to the S must have crossed the river at the city. It was a Villanovan site; the earliest burials are like those of the first Villanovan period at Tarquinia, but whether it was a colony of Tarquinia is disputed. Its Villanovan-Etruscan connections

were unbroken through the orientalizing period; impasto cups of Faliscan type, Caeretan *bucchero sottile* and painted pottery like that of Cumae and Tarquinia appear. Though far less wealthy than the cities in Etruria in the 7th c., Pontecagnano has produced a silver-gilt Phoenician bowl, faïence scarabs, and pottery from Aegean Greece. It is believed that the city's decline after the 7th c. B.C. was due to the aggressive growth of Paestum; the scanty graves of the 4th c. show strong dependence on Samnite Paestum.

Material from the early tombs is in the Museo Provinciale at Salerno; more is stored in an unfinished museum at Pontecagnano. The Phoenician bowl is in the Dutuit Collection in the Petit Palais, Paris. Excavations are currently in progress (1972).

BIBLIOGRAPHY. B. d'Agostino in *Mostra della Preistoria e della Protostoria nel Salernitano* (1962) 105-61; M. Napoli, "Pontecagnano, problemi topografici e storici," *StEtr* 33 (1965) 661-70; B. d'Agostino, NSc (1968) 75-196; G. d'Henry, *NSc* (1968) 197-204.

E. RICHARDSON

PIDASA, *see* PEDASA

PIEDIMONTE D'ALIFE, *see* ALLIFAE

PIERRE-BUFFIÈRE Dept. Haute Vienne, France. Map 23. Gallo-Roman site of the Villa d'Antone. It was partly excavated in 1931. A Gallo-Roman villa was found and its baths, with hypocausts, a pool, and some rooms of indeterminate purpose were uncovered. Also discovered were several aqueducts along with a huge circular structure 13 m in diameter; these interconnected structures may possibly be a reservoir.

BIBLIOGRAPHY. "Les fouilles de la Villa d'Antone," *Bull. de la Sahl* (1932) 5. P. DUPUY

PIERREFONDS Arrondissement of Compiègne, canton of Attichy, Oise, France. Map 23. A Gallo-Roman vicus, the largest and best preserved of Belgic Gaul, on the Roman road from Soissons to Senlis and at the W border of the civitas of the Suessiones. Some of its houses fronted the street and some were set back with porticos. Most of them were originally dug to some depth and were heated by hypocausts. In the center of the vicus a temple-fanum and a bath complex were uncovered. Around the temple and S of it an immense Merovingian cemetery was found (ca. 2000 sarcophagi).

These above discoveries were made 1866-70. In 1966 the Roman road was excavated at several points, the ground plan of the houses determined, and the existence of earlier habitations revealed by study of the stratigraphy. Occupation of the site does not appear to have survived the catastrophes of the Late Empire. Exploration of the surrounding area has indicated almost 50 ha of remains.

The finds from the 19th c. excavations are in the Musée des Antiquités Nationales, and the recent ones at the Pierrefonds town hall.

BIBLIOGRAPHY. F. Digues, "Les Fouilles de la Ville des Gaules (Le Mont Berny a Pierrefonds)," *Revue du Nord* 155 (1967) 691-701; M. Jouve, "Découverte d'un statère d'or . . . ," *Gallia* 30 (1972) 274-75.

P. LEMAN

PIETRABBONDANTE Isernia prov., Abruzzi e Molise, Italy. Map 14. Situated in territory which belonged in antiquity to the Pentri Samnites. Archaeological excavations in the last century uncovered a theater and a small temple. New excavations have led to the discovery of a large temple and have clarified the eminently religious character and the exclusively Samnite influence on the entire complex. As a result, the hypothetical identification with Bovianum Vetus has been abandoned.

Mt. Saraceno (1215 m above sea level) is fortified on its upper slopes by a circuit wall of large irregular stone blocks which descended to encircle the area of the inhabited area itself, but left outside its compass the area of the great sanctuary. This fortification, like others scattered thickly about Samnium, is probably to be dated to the period of the Samnite wars, and more precisely to the 4th c. B.C.

The sanctuary rises on a slope of the mountain, 966 m above sea level, and dominates a large section of Pentri Samnium. The oldest archaeological evidence collected to date demonstrates the existence of a vigorous building phase even in the second half of the 3d c. B.C. To this period belong weapons, coins, terracottas, and stone architectural elements. Throughout that level, there are signs of a total destruction linked to the period of the war with Hannibal when only the Pentri among the Samnites withheld support from the Carthaginians.

The small temple (Temple A) is in fact to be assigned to a period somewhat later. It sits on a high podium (1.65 m), is prostyle, tetrastyle, and has a floor plan of ca. 12.2 by 17.7 m. The building is badly preserved, but numerous epigraphic documents in Oscan have been discovered. One of those inscriptions has the name of the dedicator, the meddix tuticus Gn. Staiis Stafidins (Vetter, 151 = Rhein. Mus. 1966, no. 15), and another which, mentioning Samnium (safinim, Vetter, 149), shows the interest in the sanctuary related to the entire tribal unit of the Pentri Samnites. In that light, must also be understood the inscription on which the name of Bovianum appears (Vetter, 150) and which gave rise to the false identification with Bovianum Vetus.

The reason for the exceptional development of the sanctuary in the second half of the 2d c. B.C. must be understood as a direct result of the importance which the Samnites attached to the war with Hannibal, of the the emphasis placed by one segment of the population on Roman citizenship, and of the resurgence of the other segment, toward the end of the 2d c., of anti-Roman political persuasion. In that period, a grand theater-temple complex was built directly over the remains of the sanctuary which had been destroyed in the 3d c. and in connection with which the cult of Victory is evidenced by a dedicatory votive inscription in Oscan (Rhein, Mus. 1966, no. 1). The theater is the Hellenistic type, with a cavea surrounded by a polygonal wall and with an ornamental plan present also in the small theater at Pompeii, but already attested, ca. 150 B.C., at Sarno in Campania. The large temple (Temple B), which is situated above and behind the theater, is on a high podium similar to that of the Patturelli temple at Capua. Temple B is prostyle, tetrastyle, in antis, with a tripartite cella according to the usual form described by Vitruvius, with an ample pronaos containing Corinthian columns and flanked by a symmetrical portico. We also know the name of one of the magistrates who contracted the building: G. Staatis L. Klar (Vetter, 154). The floor plan of the temple as well as its connections with the theater reveal the adoption of architectural planning from Rome and Latium.

The interior of the sanctuary ceased to be used at the end of the social war. Archaeological evidence for a succeeding period shows that its precinct came under the control of private rural farms, so much so that it was used for occasional burial sites from the middle of the 3d c. A.D.

With the administrative order following the social war,

the territory of Pietrabbondante must have devolved upon the municipium of Terventum.

BIBLIOGRAPHY. E. Vetter, *Handbuch der italischen Dialekte*, I (1953) 149-55; *EAA* 6 (1965) (A. La Regina) with bibliography; id., *Rhein. Museum Philol.* 106 (1966) 260-86; id., *Dialoghi di Archeologia* 4-5 (1970-71); E. T. Salmon, *Samnium and the Samnites* (1967); H. Blanck, *AA* (1970) 335-43; M. J. Strazzulla & B. di Marco, *Il Santuario sannitico di Pietrabbondante* (Soprintendenza alle Antichità del Molise, 1971); M. Lejeune, *REL* 50 (1972) 94-111; M. Matteini Chiari, *Quaderni dell'Istituto di Topografia Antica dell'Università di Roma* 6 (1974) 143-82. A. LA REGINA

PIETRAGALLA Lucania, Italy. Map 14. Site of a fortification of the 4th c. B.C. on the neighboring eminence of Monte Toretta (approximately 1.6 km E of the modern town).

BIBLIOGRAPHY. F. Ranaldi, *Ricerche Archeologiche nella Provincia di Potenza 1956-1959* (1960); D. Adamesteanu in *Letteratura e Arte Figurata nella Magna Grecia, Atti del Sesto Convegno di Studi sulla Magna Grecia* (1967) 263. R. R. HOLLOWAY

PIGHADIA, *see* KARPATHOS

PILISMARÓT, *see* LIMES PANNONIAE

PINARA (Minare Köyü) Lycia, Turkey. Map 7. About 17 km N-NW of Xanthos. The site is proved by inscriptions and by the evident survival of the name, of which the old Lycian form was Pinale. According to Menekrates of Xanthos (ap. Steph. Byz. s.v. Artymnesos) the name means "round," with reference apparently to the rounded shape of the precipitous hill on which the city originally stood. A dozen inscriptions in the Lycian language have been found on the site. Pinara has no recorded history apart from Menekrates' assertion that it was founded by colonists from Xanthos, and Arrian's statement that it surrendered quietly to Alexander. In the Lycian League Pinara was one of the six-vote cities, and issued coins in the 2d-1st c. B.C.; no imperial coinage, however, is known. Bishops of Pinara are recorded down to the end of the 9th c.

The principal ruins lie in and around a small valley at the E foot of a hill over 450 m high, whose precipitous face is honeycombed with the openings of hundreds of tombs, quite inaccessible without tackle. The only approach was barred by a triple wall of massive masonry. On the flat but gently sloping summit nothing survives beyond some rock-cuttings, a few cisterns, and the remains of a fortified citadel at the highest point.

In the lower town, which was never walled, a much smaller hill forms a second acropolis, covered with the ruins of buildings now much overgrown; among these, on the W side, is a small theater or odeum in poor condition. To the NE of this, in the W face of another small hill, is the principal theater, in excellent preservation but also badly overgrown. Its plan is purely Greek and seems never to have been modified in Roman times; it has 27 rows of seats and 10 stairways; there is no diazoma. The stage building stands to a height of 2 to 4 m, with two of its doors complete, one leading from the parodos to the stage. The agora appears to have been situated to the N of the lower acropolis; here are the ruins of a temple and a large foundation.

Lycian rock tombs are numerous. Among them the largest and most remarkable is the so-called Royal Tomb, a tomb of house type with a porch and an inner grave chamber. The walls of the porch carry reliefs showing four Lycian cities (real or imaginary) within whose bat-tlements houses and tombs are visible. Another tomb has a facade resembling the end of a "Gothic" sarcophagus, adorned at the summit with a pair of ox's horns.

BIBLIOGRAPHY. C. Fellows, *Lycia* (1840) 138-50[I]; T.A.B. Spratt & E. Forbes, *Travels in Lycia* (1847) I 6-11[M]; E. Petersen & F. von Luschan, *Reisen in Lykien* (1889) I 47-56[MI]; *TAM* II.2 (1930) 185-88.

G. E. BEAN

PINCUM, *see* LIMES OF DJERDAP

PINDAKAS, *see under* PITYOUSSA (Greece)

PINNA Abruzzi, Italy. Map 14. A city of the Vestini and a Roman municipium in what is today the province of Pescara. After the confiscation of the territories of the Vestini to the W of Mt. Fiscellus (Gran Sasso) in the 3d c. B.C., Pinna became the capital of the Vestini and remained so until the social war. It maintained its position as the preeminent urban center in the area between Hatria and Teate Marrucinorum during the mediaeval period, when it was a diocesan seat, and into modern times.

In area the ancient urban center approximates the size of the mediaeval city but is unlike it in its internal conformation. The site has never been investigated by archaeologists but there have been chance finds. The ancient public buildings are mainly indicated through inscriptions. A series of stamped bricks documents the existence of a public brickyard and of temples dedicated to Vesta, Venus, and Juno.

BIBLIOGRAPHY. *CIL* IX (1883) 317ff; H. Nissen, *Italische Landeskunde* 2 (1902), 439; G. Colasanti, *Pinna: ricerche di topografia e di storia* (1907); K. Scherling in *RE* 20 (1950) 1710f; A. La Regina, in *MemLinc* 13 (1968) 416-19, 429-32; G. Cerulli Irelli, *Carta archeologica, Foglio 140* (1971) 43ff. A. LA REGINA

PIPERNO VECCHIO, *see* PRIVERNUM

PIRGOS, *see* LIMES, GREEK EPEIROS

PÎRJOAIA, *see* SUCIDAVA (Izvoarele)

"PIROBORIDAVA," *see* POIANA

PISA, *see* PISAE

PISAE (Pisa) Tuscany, Italy. Map 14. A settlement of debated origin (Greek, Ligurian, Etruscan) situated between an E-W bend in the Serchio (ancient Auser) and the Arno. A flourishing Etruscan town with port by the 5th c. B.C., its prosperity continued down to its occupation by Rome as an outpost against the Ligurians in 225 B.C. (Polyb. 2.16f; Livy 21.39). By this time Pisan territory reached Castiglioncello to the S and Luna to the N (Livy 34.56). After the Ligurians were subdued (ca. 177 B.C.), Luna was made a citizen colony while Pisae's importance diminished, and though later an Augustan colony, it is seldom mentioned in the sources.

The ancient city was roughly rectangular. The Piazza dei Cavalieri is probably the site of its forum, with an Augusteum. There are remains of a theater (on Via S. Zeno), the so-called Baths of Nero, an octagonal apsidal room of the 2d c. B.C., near the Lucca gate, an amphitheater N of the Serchio, and a Temple of Vesta. Of the Portus Pisanus, connected to the town by a road, some Augustan and Imperial traces remain. Archaic necropoleis existed near Porta a Mare (to the W) and the Lucca Gate.

Both the Camposanto and the adjacent Museo dell'Opera della Cattedrale contain fine Classical collections.

BIBLIOGRAPHY. N. Toscanelli, *Pisa nell'Antichità*, 3 vols. (1933-34); *EAA* 6 (1965) with bibliography.

D. C. SCAVONE

PISAURUM (Pesaro) Italy. Map 16. A Roman citizen colony founded in 184 B.C. on the Umbrian coast of the Adriatic at the mouth of the Pisaurus; it lies on the right bank of the river in a small plain between two spurs of the Apennines. It was a sister colony of Potentia in Picenum, founded the same year and with the same tresviri: Q. Fabius Labeo, M. Fulvius Flaccus, and Q. Fulvius Nobilior. A prehistoric necropolis (Novilara) has been discovered nearby, showing that the area was inhabited at least from the Early Iron Age. But the Roman city has its own plan, castrum-like, with a rectangular grid of streets, and a forum at the center near the crossing of arteries. Each colonist received six jugera of land (Livy 39.44.10); the colony was inscribed in the Tribus Camilia. Its most famous son was the tragic poet Accius (b. 170 B.C.).

Apparently the colony did not thrive, despite its situation on the Via Flaminia. It may have received a Sullan colony. Cicero (*Sest.* 9) speaks of it as a hotbed of discontent and full of men ready to join the Catilinarian conspiracy; Catullus (81.3) describes it as "moribunda" in the early fifties. It was briefly occupied by Caesar after the crossing of the Rubicon (*BCiv.* 1.11.4). It received a colony of Antony's veterans after Philippi (Plut. *Vit.Ant.* 60.2) and another of Augustus', after which it bore the name colonia Iulia Felix Pisaurum. It is mentioned under the Empire only by the geographers and reappears only in the Gothic wars, when it was burnt and its walls destroyed by Vittigis and rebuilt in haste by Belisarius in 544 (Procop. *Goth.* 3.11.32-34).

Of the walls of the ancient city enough has been traced to permit reconstruction of their rectangular plan (488 x 394 m), with an inward bow toward the N gate, whence the Via Flaminia issued. The base is of blocks of local sandstone, probably the wall of the original colony; the upper parts are a rebuilding in brick and mortar. Many mosaics have been found, many inscriptions, and other archaeological material, much of which is housed in Pesaro's Museo Oliveriano (formerly Athenaeum). The most famous of the finds is a bronze statue, the so-called *Idolino*, in the Museo Archeologico in Florence.

Nothing is known of Pisaurum's port, though inscriptions inform us it was an active shipbuilding center. There are noteworthy remains of an Augustan bridge over the Pisaurus (Foglia) and another over the Metaurus.

BIBLIOGRAPHY. P. Gazzola, *Ponti romani* (1963) 2.68, 74-76; G. Annibaldi in *Atti del XI Congresso di Storia dell'Architettura* (1965) 46-47, 52-54; I. Zicari, "Pisaurum," *RE* II (1968).

E. RICHARDSON

PISIKÖY, *see* PISYE

PISORACA (Herrera de Pisuerga) Palencia, Spain. Map 19. Town 76 km N-NE of Palencia, known because of several milestones. Ptolemy called it Sisaraka (2.6.51), and the Ravenna Cosmographer Pistoraca (318.13). Excavations have proved that in or near it was the camp of Legio IIII Macedonia, and that it survived until the 6th-7th c.

BIBLIOGRAPHY. A. García y Bellido, "Herrera de Pisuerga," *Excavaciones Arqueológicas en España* 2 (1960)[1]; id. et al., *Excavaciones y exploraciones arqueológicas en Cantabria* (1970)[1].

R. TEJA

PISTICCI Matera, Lucania, Italy. Map 14. An Oenotrian and Lucanian center 30.6 km S of Matera on a hill overlooking the ancient territory of Metapontion and a large part of the valley of the Basento river. It is covered by the modern town. The origins of the native settlement date to Iron Age II, but there are traces of a weak settlement dating to Iron Age I. In the second half of the 8th c. B.C., the settlement was consolidated on the NW end of the hill and, so far as can now be determined, gradually expanded over the remainder of the land extending to the N and E. On the extreme E end, around and below the mediaeval site of Santa Maria del Casale, is the main necropolis (6th-5th c.). By this period, the site had been so permeated by the Greeks that it is to be considered more Greek than native. In this period it took on the appearance of a phrourion because of its division into parcels from the territory of Metapontion between the Bradano and Cavone rivers.

The same change can be seen in the other new centers that sprang up during the Iron Age in the vast Pisticci plain, particularly in the area of San Leonardo, San Teodoro, and San Basilio. At the end of the 6th c. and during the 5th c. B.C., all these new settlements were overspread by the coastal civilization and, more exactly, by the Metapontine civilization.

Contrary to what happened in other centers of the area under the influence of the Greek coastal colonies, the life of Pisticci and of the other smaller centers, except the hillside of Incoronata, assumed an ever more lively existence during the 5th c. B.C. until the end of that century. At that time proto-Italic ceramic shops probably developed at Pisticci itself or in its territory and their products spread throughout Lucania.

The tombs of Pisticci are among the richest in bronzes and in Attic vases dating to the end of the 6th c. and throughout the 5th c. B.C. The tombs are like those at Metapontion, but their grave gifts are far richer. Helmets and weapons, certainly products of some native hellenized center, are totally lacking at Metapontion. The greatest prosperity came during the first quarter of the 4th c. when the necropolis was filled with vases and bronze objects, either imported or made in the area. The production of local ceramic ware started at the beginning of the 8th c. and continued until the end of the 4th c. or the beginning of the 3d c. B.C. Thus far, no trace of life during the Roman period has appeared.

BIBLIOGRAPHY. *NSc* (1902) 312ff; (1904) 196ff; (1947) 128-30; (1969) 139-57; D. Adamesteanu, "Problèmes de la zone archéologique de Métaponte," *RA* (1967) 28; id., *BdA* 1 (1967) 48; G. F. Lo Porto, *BdA* 2-3 (1968) 115-22; J. de La Genière, "Contribution à l'étude des relations entre Grecs et indigènes sur la Mer Jonienne," *MélRome* 82 (1970) 624-30; F. G. Lo Porto, "Civilta indigena e penetrazione greca nella Lucania orientale," *MAL* 48 (1973) 154-81.

D. ADAMESTEANU

PISTICCI, *see* INCORONATA

PISTIS (Pitres) Dept. Eure, France. Map 23. Situated on the right bank of the Seine where it joins the Andelle, 22 km from Rouen, Pistis was a fairly important settlement from Gallo-Roman times up to the early Middle Ages.

Excavations in 1854 revealed extensive buildings which some thought were a palace of Charles the Bald (823-77). Later digs in 1899 showed that in fact they belonged to a large Gallo-Roman villa consisting of several rooms. Among these were a caldarium with a hypocaust beneath, circular (9 m in diameter) and with four apses, and to the N a large rectangular room 12 x 9.50 m. Against its E wall is a third room of the same size, which has a paved floor and two semicircular structures at each end. Small baths were excavated at

the place called La Salle, and at Catelier the ruins of a theater, whose greater axis measures 85 m, were found. All these monuments were buried again. In contrast, an underground aedicula is still standing, down eight steps at the place known as Pierre St.-Martin. This is a nearly square building, 2.70 x 3 m; three niches are hollowed out of the walls. In the course of different excavations many potsherds of la Graufesenque and Lezoux sigillate pottery (1st and 2d c.) were found, also fibulae, among them some enameled ones of the 3d c. During the later excavations a circular Gallic hut was found at a depth of 2 m.

BIBLIOGRAPHY. Leon Coutil, "Les fouilles de Pitres (Eure)," *Bull. Arch.* (1901) 201-15, 434-56.

M. A. DOLLFUS

PISYE (Pisiköy) Turkey. Map 7. An old Carian village 9 km W-SW of Muğla. It was incorporated in the Rhodian Peraea before 200 B.C., about which time it was "recovered" from Philip V by the Rhodian general Nikagoras (*SIG* 586; cf. Livy 33.18). In the Peraea it was the center of a koinon which included Pladasa. The site is proved not only by the survival of the name, but also by an inscription. About 1.6 km NE of Pisiköy are some traces of a small theater and many ancient blocks, some inscribed; to the S is a low hill which seems to have formed the acropolis.

BIBLIOGRAPHY. *AnzWien* (1892) 5 (inscription); E. Meyer, *Grenzen* (1925) 54-57; *BCH* 60 (1936) 328; P. M. Fraser & G. E. Bean, *The Rhodian Peraea* (1954) 73.

G. E. BEAN

PITANE (Candarlı) Turkey. Map 7. Aiolian city on a small peninsula NE of Phokaia, near the mouth of the Kaikos (Hdt. 1.149; Strab. 13.614; Ov., *Met.* 7.357). It was not important in history, but it is the only Aiolian site in Anatolia to produce valuable archaeological material. Excavations in the 19th c. at the necropolis on the isthmus of the peninsula yielded a Mycenaean stirrup vase and Greek archaic pottery now in the Istanbul Museum, and the town itself has produced much terra sigillata.

Recent excavations in the archaic necropolis yielded mainly vases of ca. 625-500 B.C., but also some Geometric and Protogeometric pottery, fine specimens of Chian pottery, and a large number of orientalizing vases from the first half of the 6th c. (Istanbul Museum and Izmir Museum). An archaic statue discovered accidentally is now in the museum at Bergama.

BIBLIOGRAPHY. S. Reinach, *Chroniques d'Orient* (1896) 9f = *RA* (1883:1) 363f; G. Perrot & C. Chipiez, *Histoire de l'art* (1882-1911) VI, 923f; S. Loeschke, *AM* 27 (1912) 344ff (terra sigillata); K. Schuchhardt, *Altertümer von Pergamon* I, 1 (1912) 998M; H. T. Bossert, *Altanatolien* (1942) fig. 7 (Mycenaean vase); J. Keil, *RE* XX:2, 18; L. Robert, *Villes anatoliennes* 172, 6; E. Akurgal, *AJA* 66 (1962) 378f[I].

E. AKURGAL

PITHEKOUSSAI, see AENARIA

PITINO, see under SEPTEMPEDA

PITRES, see PISTIS

PITSA Achaia, Greece. Map 11. A modern village S of ancient Aigira on the N side of Mt. Chelydorea (Paus. 7.17.5) near the summit of which a rich votive deposit in a deep cave (Cave of Saphtoulis) has been excavated. Extending to a depth of over 20 m and divided into several chambers, the cave was a cult center for the worship of chthonic deities, especially the nymphs and possibly Demeter, from ca. 700 B.C. into the Roman Imperial period.

The finds, which remain largely unpublished, are in the nearby museum of Sikyon and in the National Museum of Athens. They include numerous terracotta figurines, votive pottery (mainly Corinthian), bronze mirrors and jewelry, Corinthian and Sikyonian coins, wooden statuettes, bone dice, etc. The cave is famous, however, for its beautifully painted and well-preserved wooden plaques. Represented on one plaque in free-style, polychrome technique of ca. 550 B.C. is a sacrificial procession with dipinto name-labels and the incomplete signature of a Corinthian painter in the epichoric Corinthian alphabet. Dipinti on this and on another plaque also show that these objects were dedicated to the nymphs. The four plaques from the cave are dated ca. 550-500 B.C. and supply almost unique evidence for nonceramic Corinthian painting of this period.

BIBLIOGRAPHY. A. K. Orlandos in *EAA* VI (1965) 200-206[I].

R. STROUD

PITYOUSSA (Chios) Greece. Map 7. So called in ancient times because of its abundant pines, it is an island in the Aegean separated from the W coast of Turkey by a strait 8 km wide. Its earliest inhabitants included the Pelasgi, the Lydians, and the Carians; later it was populated by people coming from the island of Euboia. The capital of the island, also called Chios, is one of the centers that claim to be the birthplace of Homer. The modern city has developed over the ancient one. It is situated in a rich industrial zone which made it a commercial center, as is attested by the first silver stater coins, issued in the late 7th and early 6th c. B.C. with a sphinx as an emblem. It is known that at the end of the 7th c. B.C. the city had a democratic regime. It sided with the Persians after their conquest of Asia Minor, and then fell under their rule. After 477 Chios entered the Delian League, remaining a member until 412, and then entered into the second constitution under the aegis of Athens. The center of the ancient city probably corresponded to the site of the ancient port. Inside the castle there are traces of Roman constructions. A necropolis of the 6th c. has been excavated, as have archaic houses on isolated terraces. The museum houses ceramics and sculpture, the finds from the excavations carried out at Emporio, and architectural fragments and miscellaneous objects dating between the 7th and 4th c. B.C. A ceramics factory, which had first been placed at Naucrati, is now attributed to Chios. The ware is characterized by decoration in black and polychrome on a white ground, and its manufacture flourished towards the end of the 7th c. B.C., when the products were exported all over the Mediterranean. From Pliny (*HN* 36.11) we know that a family of artists was active at Chios: Melas, Mikkiades, and Archermos, the grandson of Melas and father of Boupalos and Athenis.

Delphinion, a small port situated 15 km N of Chios, served as an Athenian naval base during the Peloponnesian War. The acropolis was destroyed by the Spartans in 412 B.C. It was enclosed by a wall, parts of which have been found, along with several towers. To the NE of the acropolis an artificial platform has been discovered, dating from the end of the 4th c., on which there are the remains of houses datable from the 4th to the 2d c. B.C.

Emporio is located 7 km SE of Phyrgi. The horseshoe-shaped port is open to the SE, and immediately to its N is the hill of the Prophet Elias, 240 m high. The fortified city of the Early Bronze Age was on a small promontory to the S of the port. Later the settlement moved, occupying the whole hill on which the acropolis

was located, and a large area around its foot. The city was destroyed and abandoned at the end of the Mycenaean period, ca. 1100 B.C. The pottery shows that the Mycenaean occupation of Emporio goes from Mycenaean III A to Mycenaean III C. Beneath the Mycenaean land, there are six levels that seem to correspond to those at Calcolitico in W Anatolia, and are contemporary with Minoan I in Crete. The neolithic levels seem to belong to the earliest emergence of the neolithic cultural age. In the Classical and Roman periods there was a small city near the port, but in a different location. Between the port and the acropolis there are four successive retaining walls, one above the other; and on the top of this terrace there are rich votive deposits dating from the end of the 8th c. to 600 B.C. On the hill of the Prophet Elias, N of the acropolis, a megaron and a Sanctuary to Athena have been found. The city was probably abandoned in 600 B.C., while the sanctuary was frequented intermittently from the 8th c. The temple was constructed in the middle of the 6th c. and remained in use until the Hellenistic period. It has a rectangular plan, with a portico and a square cella with a base for the cult statue and an altar. It was destroyed and rebuilt in the 4th c. B.C. The votive offerings were scattered on the floor of the cella and heaped behind the altar. They come from three distinct periods: ca. 600, mid 6th to mid 4th c. B.C., and from the period of the reconstruction. The city is outside the acropolis wall to the W. The houses are of the megaron type, oriented to the S, with two columns in the portico, a central door, and three internal columns. Others are without portico, oriented either N or S, and have a square plan. They were abandoned at the end of the 7th c. B.C. Beside the port are the remains of an apsidal sanctuary from mid 5th c. with four Ionic prostyle columns; and the remnants of an earlier 4th c. sanctuary. Hellenistic remains are rare. The construction was oriented to the E, with the entrance before the entrance to the port. The basilica which in part overlays the temple is perhaps Roman, but the other remains are from the 6th and 7th c. A.D., when the basilica became a church with a baptistery. The settlement ended with the arrival of the Arabs in A.D. 665.

Pindakas or New Emporio, whose name perhaps derives from πίδαξ, meaning fountain or spring, is located to the W. It is a small hill about 1.5 km from the port of Emporio, in the S part of the island of Chios, in a strategic position. A large polygonal wall has been explored which forms two terraces with the remains of houses from the Classic and Hellenistic periods. The finds show that the first period of occupation was not earlier than mid 5th c. B.C., and continued until the end of the 4th c., from which there are the incomplete remains of a building, perhaps a temple. On the lower terrace there are late Roman constructions, abandoned contemporaneously with the houses at the port of Emporio, in the 7th c. A.D.

BIBLIOGRAPHY. M. Foustel de Coulanges, "Mem. sur l'ile de Chio," *ArchMiss* (1856) v; G. Gilbert, *Griechische Staatsaltertümer* (1885) II 115; H. F. Tozer, *The Islands of the Aegean* (1890) 139; E. Busolt, *Griechische Geschichte* (1893) I 313; Escher, in Pauly-Wissowa III (1899) 2286-2301, s.v. Chios; Head, *Historia Nummorum* (1911) 599; K. Regling, *Antike Münze als Kunstwerk* (1924) I n. 22; H. Price, *JHS* 44 (1924) pl. 80; D.W.S. Hunt, *Arch.Anz.* (1930) 144; (1934) 186; (1938) 579; id., "An Arch. Survey of the Classical Antiquities of the Island of Chios . . . March-July 1938," *BSA* 41 (1940-45 [1946]) 29; M. Hanfmann, *Ionia, Leader or Follower?* (1953) LXI 1ff; J. Boardman, *BCH* 79 (1955) 286; 80 (1956) 326; id., "Delphinion in Chios," *BSA* 51 (1956) 41; id., "Excavations at Pindakas

in Chios," *BSA* 53-54 (1958-59) 295; id., "Underwater Reconnaissance off the Island of Chios, 1954," *BSA* 56 (1961) 102; id., *Greek Emporio: Excavations in Chios, 1952-55* (1967); W. G. Forrest, "The Inscriptions of South-East Chios, I-II," *BSA* 58 (1963) 53; 59 (1964) 32; S. Hood, *Arch.Anz.* (1964) pp. 216-17; (1968) pp. 95, 97; id., *Excavations at Emporio, Chios, 1952-55*, Atti VI Congresso Internazionale delle Scienze Preistoriche e Protostoriche II, 1963 (1965), pp. 224.

G. BERMOND MONTANARI

PITYOUSSA Rough Cilicia, Turkey. Map 6. Probably Kargıncık or Dana, the rocky island (3 x 1.5 km) ca. 3 km offshore and ca. 14 km SE of Incekum Burun (ancient Sarpedon) (Stadiasmus Maris Magni 187; Acrae St. Barnabae: *Actae* SS. Jun. II, 432). It was probably the Pitusu island taken by Neriglissar in 557-556 B.C. in the course of his campaign against the king of Pirindu (Rough Cilicia). There are a number of ruins of houses, gravehouses, and sarcophagi along the NW (inshore) side of the island, nowhere fully described.

BIBLIOGRAPHY. F. Beaufort, *Karamania* (1818) 206 [for Beaufort's chart and general map of the ruins see, e.g., U.S. Naval Chart no. 4254 (1954), *Mediterranean Sea, Plans on the South Coast of Turkey*, D]; R. Heberdey & A. Wilhelm, *Reisen in Kilikien 1891-1892, Denkschr-Wien*, Phil.-Hist. Kl. 44, 6 (1896) 98; J. Keil, *RE* (2d ed. 1950) s.v. p. 3; J. Wiseman, *Chronicles of the Chaldaean Kings* (1961) 40, 75, 88.

T. S. MAC KAY

PLACENTIA (Piacenza) Italy. May 14. In flat open country 60 km SE of Milan on the S side of the Po near its confluence with the Trebia. The conjecture that until 190 B.C. the town lay some 24 km farther W should be discounted. Situated on territory that once belonged to the Celtic Anamares and, before them, to the terramara folk, Placentia came into being in 218 B.C. when Rome established a large Latin colony of 6000 settlers on the site just at the onset of the second Punic war. The town is repeatedly mentioned in the third decade of Livy as the target of furious Gallic, Carthaginian, and Ligurian assaults: in 200 B.C. Gallic tribes actually succeeded in plundering it. But a new infusion of colonists in 190 B.C. and the construction in 187 B.C. of the great Ariminum-Placentia highway, the Via Aemilia, assured its future. Placentia became and has ever since remained one of the chief Cispadane cities even though it has repeatedly been the scene of fierce warfare for control of its strategically important river port and highway network. Acquiring full Roman citizenship in 90 B.C., it became a municipium and later a colonia.

Today no Roman monuments are visible at Piacenza, but the orthogonal plan of the city center retains the town plan of the original military settlement: it was a square castrum with sides ca. 480 m long. The limits of the castrum were roughly: N, Via Benedettine; S, Via Sopramuro; E, Via Dogana; and W, Via Mandelli. By Imperial times the city had far outgrown its original limits. The Via Aemilia, today's Via Roma, served as decumanus maximus; and today's Via Taverna follows the route of the ancient Via Postumia. The Duomo adjoins the site of the baths and the Biblioteca Comunale that of the forum.

Antiquities are mostly housed in the Museo Civico. The most notable is the famous bronze sheep's liver of ca. 200 B.C., which Etruscan augurs evidently used for divination purposes. Found at Piacenza in 1877, it has 16 principal divisions, each inscribed with the Etruscan names of a major and other divinities. Other interesting antiquities are a fragmentary statue of a woman of the 1st c. B.C. signed by the Athenian sculptor Kleomenes,

and a circular mosaic of the 1st c. A.D., depicting swan-like birds in good perspective.

Aerial photography of the surrounding countryside clearly reveals the Roman centuriation.

BIBLIOGRAPHY. T. Frank, "Placentia and the Battle of the Trebia" in *JRS* 9 (1919) 202-7; M. Corradi-Cervi & E. Nasalli-Rocca, "Placentia" in *Arch. Stor. per le Prov. Parmensi*, Ser. III, 3 (1938) 45-95; M. Pallottino, *Etruscologia* (6th ed., 1968) 245, 249-54, pl. xxx; D. E. Strong, *The Early Etruscans* (1968) 93f; J. B. Ward-Perkins, *Cities of Ancient Greece & Italy: Planning in Classical Antiquity* (1974) 28f, 122f, fig. 54.

E. T. SALMON

PLAKA, *see* BYLLIACE

PLANASIA (Pianosa) Tuscany, Italy. Map 14. A triangular islet of the Tuscan Archipelago lying between Elba and Montecristo. This is the place to which Augustus relegated his grandson Agrippa Postumus and where the latter was subsequently assassinated. Interesting remains of an elaborate Roman villa have been found, including sea baths and a little private theater.

BIBLIOGRAPHY. P. Moschella in *Dioniso* 8 (1940-41) 47-48P.

L. RICHARDSON, JR.

PLANIER III, *see* SHIPWRECKS

PLASMOLEN, *see under* NOVIOMAGUS BATAVORUM

PLASSAC, *see* BLASSIACUM

PLATAIAI Greece. Map 11. This Boiotian city is situated near the boundary of Attica, between the last slopes of Mt. Kithairon and the Asopos (Ptol. *Geog.* 3.15.20; Plin. *HN* 4.2.6). It was also mentioned by Homer (*Il.* 2.504).

In 519 B.C. the city obtained the protection of Athens against Thebes, which was trying to annex it. It remained allied with Athens in the battles of Marathon, Artemision, and Salamis, and was sacked by the Persians in 479. For its strenuous resistance to the Persians and for its fidelity to Athens, Plataiai was honored with a gift of 80 talents for the Temple of Athena Areia. Phidias executed the cult statue and Polygnotos painted the walls of the pronaos for the temple. In 431 the Thebans again tried to take over the city. In 429 it was besieged by Archidamos, but its meager forces finally succeeded in forcing the blockade and reached refuge in Athens. In 427 it was occupied and rased to the ground although the temple of Hera was saved and a shelter for visitors was built near it. The Plataians returned to their city only to have it sacked by the Thebans; they retook it with the aid of Sparta, but were attacked again in 372 and the Thebans destroyed the city a second time. From this period until 338 the citizens of Plataiai enjoyed the hospitality of the Athenians. Philip led them home after Chaironeia, and the city was rebuilt under Alexander. During the Roman occupation Plataiai was not molested, in fact Justinian restored its walls. From the end of the 6th c. on Plataiai was a flourishing cult center of Hera (Paus. 9.3.8), of Demeter (Paus. 9.4.3), of Athena (Paus. 10.4.1), of Zeus Eleutherios (Paus. 9.3.5.7), of Artemis (Paus. 1.15.4), and of other minor cults as attested by inscriptions and coins.

Few vestiges of the city before 338 are preserved although near the internal NE corner of the Hellenistic walls there are a few remains of prehistoric walls, and excavation has brought to light fragments of prehistoric pottery and Mycenaean vases. The walls are rather complex. The enclosure built after 338 resembles a bulky polygon with the higher part to the S, where the ex-

tremity is defended by a tower. Behind this spur is a second curtain wall with numerous square towers. Circular towers protect the NW and NE corners; and two other extensions of the wall, NW-S and W-E, cross the site of the city. The maximum axes of the circuit are 1500 by 750 m. The 5th c. walls are rather rude work with a tendency toward polygonal technique; the 385 B.C. walls is isodomic work with a squared face; the 338 B.C. walls, restored under Philip, is isodomic trapezoidal work with a rounded face; later repairs and partial rebuilding under Alexander (?) are in isodomic technique with a squared and partly chiseled face.

The temple of Hera (49.9 x 16.7 m), was identified in 1891 on a terrace inside the city wall. To the N of the temple was found the Katagogion, a large hostel with a square plan and rooms on two stories, erected by the Thebans after the destruction of the city in 427 B.C. on a site that was later occupied by the Roman agora (Thuc. *Hist.* 2.69). Outside the walls to the W and NE are the necropoleis. Not even the site of the temple of Athena Areia has been identified.

BIBLIOGRAPHY. H. S. Washington, *AJA* 6 (1890); A. De Ridder, *BCH* 44 (1920); R. L. Scranton, *Greek Walls* (1941); F. Chamoux, *BCH* 58-59 (1944-45); W. B. Dinsmoor, *The Architecture of Ancient Greece* (1950); M. Poëte, *La città antica* (1958); S. Karouzou, *Deltion 1960* 16 (1962); C. N. Edmondson, *JHS* 84 (1964); G.-J. M.-J. Te Riele, *Mnemosyne* 4 (1966); R. Weil, *REG* 80 (1967); Excavations: *Papers Amer. Sch. Athens* 5 (1886-90); 6 (1890-92); *AJA* 5-7 (1889-91); *Praktika* (1899); History of city and its battles: C. Fritsche, *Geschichte Plateas bis zur Zestörung d. Stadt durch die Thebaner in 4. Jahr. v.C.* (1898); W. K. Pritchett, *AJA* 61 (1957); id., *Studies in Ancient Topography* I (1965); A. Balil, *Est. Clás.* 6 (32) (1961-62); B. Moos, *Vorgeschichte und Vorlauf der Schlacht von Plataiai* (Diss. 1963).

N. BONACASA

PLESTIA Umbria, Italy. Map 16. A municipium of the tribus Ufentina in a pass by the Lacus Plestinus, midway from Fulginia to Serravalle. Colfiorito is the nearest town. It was the scene of a disastrous defeat of Roman cavalry by Hannibal shortly after the Battle of Trasimene. Excavations since 1960 have laid bare a Republican temple, an Iron Age settlement and graveyard, and an important Umbro-Picene sanctuary of Cupra Mater with a votive stips.

BIBLIOGRAPHY. *EAA* 6 (1965) 246 (G. Annibaldi); *AA* (1970) 322 (H. Blanck). L. RICHARDSON, JR.

PLEURON, NEA PLEURON Greece. Map 9. The city is in Aitolia-Akarnania. The name refers to two settlements, the older of which was at the foot of Mt. Kurios (Strab. 10.451) between the river Acheloos and the river Euenos, and was mentioned by Homer (*Il.* 2.638).

Pleuron, according to Strabo, was founded by the Kouretes; or Thoas, son of Aeneas, guided the Aitolians there (10.461). When Demetrios II of Macedonia destroyed Pleuron the inhabitants founded a new city on the uplands of Arakinthos, which had the protection of Rome before the taking of Corinth. During the Imperial age the uprisings in Aitolia continued. The ruins of the more ancient city are N of the newer one and consist of a few remnants of Cyclopean walls. Nea Pleuron has been identified on the Arakinthos (Zygos) in the locality of the castle of Κυρίας Εἰρήνης.

The city wall is a large rectangle with seven gates and 31 towers served by stairways. The masonry is partly trapezoidal and partly pseudo-isodomic with squared faces, well preserved almost everywhere, and datable to ca. 230 B.C. The acropolis occupies the upper part of the

site, but little of it remains. A Byzantine chapel was built on the remains of the Temple of Athena. The actual city occupies a vast terrace 243 m above sea level, with which it is linked N-S by a defense wall that also encircles the port. The civil buildings are to the S. The theater is in the SW part of the city with the proscenium leaning against the inside surface of the city wall. The central part of the building housing the skene is a tower. The proscenium had six columns, and the parascenia must have been elevated above it and must have leaned against the wall. The circle of the orchestra is tangent to the skene building. The cavea, well preserved at the N, had five sections and six staircases. The construction of the theater is contemporary with that of the walls.

Several other areas are recognizable within the city walls, including the site of the agora, with a stoa oriented N-S and ca. 62 m long, and the plan of the gymnasium. To the SE was a large communal cistern (30 x 20 m) with five rectangular basins. There are also remains of unidentifiable public buildings and rather extensive remnants of houses and cisterns. The necropoleis extend to the S of the terrace occupied by the city.

BIBLIOGRAPHY. *ArchAnz* 31 (1916); E. Fiechter, *Die Theater von Oiniadai und Neupleuron* (1931); P. E. Arias, *Il teatro greco fuori di Atene* (1934); R. L. Scranton, *Greek Walls* (1941); R. E. Wycherley, *How the Greeks Built Cities* (1949); W. B. Dinsmoor, *The Architecture of Ancient Greece* (1950). N. BONACASA

PLEVLJA Yugoslavia. Map 12. A town in SW Serbia on the Čehovina river to the S of which is an important Roman castrum. Inscriptions show that the castrum was in existence before A.D. 150. Graves have been found which date from the 2d to 5th c. Excavation within the fortified settlement has revealed several inscribed monuments of an official nature, but the name of the town is not known. Several municipia have been suggested, all beginning with the letter S.

BIBLIOGRAPHY. A. Cermanović-Kuzmanović, "Le Municipium S.," *Starinar* 19 (1969) 108-9.

 J. WISEMAN

PLOCË Albania. Map 9. The modern city lies on a high ridge between the Gulf of Orikon and the lower Aous valley, just below a city of the Hellenistic and Roman periods, ringed by a circuit wall ca. 2200 m long in ashlar style. Residential districts extended outside the circuit. A late Hellenistic stadium with steps on three sides has been excavated, and built tombs of Macedonian type have been opened. The site has yielded fine heads of Alexander and Dodonaean Zeus in marble and limestone, architectural members, sculptured reliefs, and coins of Hellenistic and Roman times. The name of this city, situated in the territory of the Amantes, is unknown; some suppose it to be Amantia, but that city lay probably on the route down the Aous valley (see Klos).

BIBLIOGRAPHY. C. Patsch, "Das Sandschak Berat in Albanien" *Schriften der Balkankommission, Antiquarische Abteilung*, III (1904) 31ff; L. M. Ugolini, *Albania Antica*, I (1927) 114ff; S. Anamali in *Buletin i Universitetit Shtetëror të Tiranës, Seria Shkencat Shoqërore* (1958) 2.106ff; N.G.L. Hammond, *Epirus* (1967) 223ff, 233ff, and 698ff. N.G.L. HAMMOND

"PLOTHEIA," *see* STAMATA

PLOUHINEC Morbihan, France. Map 23. The remains of Le Mane Vechenn, in the commune of Plouhinec, were excavated in 1970 and 1971. The substructures uncovered belong to a Gallo-Roman villa, with well-preserved walls faced with small blocks with alternate joints strengthened

with iron. Five rooms with concrete floors and walls decorated with painted stucco were found, arranged around a small paved courtyard. About 50 m to the NW a small square monument was uncovered, perhaps a fanum.

 M. PETIT

"PODALIA," *see* SÖĞLE

PODANDOS (Pozantı, Adana) Cappadocia, Turkey. Map 6. Hittite Paduwandaş. Small walled town on the E bank of Çakıt Suyu 15 Roman miles N of Cilician Gates on the Via Tauri. It is situated in a rich valley and is the nodal point for the fan of roads spreading from Tauros over the whole of central Anatolia. A project by Valens in A.D. 371-72 to make it capital of Cappadocia Secunda was rejected in favor of Tyana. As Butrentum it was known to the Crusaders.

BIBLIOGRAPHY. R. P. Harper, "Podandus and the Via Tauri," *AnatSt* 20 (1970) 149-53. R. P. HARPER

POETOVIO (Ptuj) Yugoslavia. Map 12. The city developed at a point where the Drau was crossed by a prehistoric trade route. It stands where a projection of the Slovenske Gorice hills approach the Drau on its left bank, and on the right bank the higher terraces come quite close to the river. The Drau has torn away considerable sections of the ancient city in the course of the centuries, and along with them the ancient legionary camp (VIII Augusta, XIII Gemina) whose presence is known with certainty from the water supply system. The position of the stone bridge built under Hadrian is known from the discovery of parts of it in the bed of the river. Poetovio was one of the Augustan occupation fortresses which kept the character of a military agglomeration throughout the whole of the 1st c. A.D.

The legionary legates of Illyricum, met in Poetovio in 69 and decided to support Vespasian's claim to the principate. The legions were immediately sent to N Italy and at Bedriacum played a decisive part in the struggle. Trajan sent the garrison to Vindobona and gave the agglomeration the status of a colonia.

Near the fortress on the S side of the Drau a canabae settlement formed around the head of the bridge. The road leading W from the fortress to the Norican border was flanked by the military necropolis. To the S of it was the Vicus Fortunae, known from inscriptions and in part from archaeological discoveries. It was probably a settlement for crafts and industries, and had its own forum with appropriate buildings as well as horrea and, from the 4th c., a Christian cult center. In this area along the road to Aquileia, the statio publici portorii Illyrici was established in the 2d c. It is well documented because those in charge of it were fanatical Mithraists. More to the S in this suburb was a sacred center for oriental gods (Nutrices Augustae, two Mithraea, sacrarium of Vulcan-Venus, sanctuary of Iuppiter Ammon with Fons perennis; preserved). In the fertile ager to the S, which was systematically parceled out under Trajan (literary and epigraphic sources mention a missio agraria for soldiers), were found villae rusticae.

The N bank of the Drau is narrow because of two strategically important hills which lie close together: the citadel hill on the E, the Panorama on the W. Between them runs the local road to Flavia Solva. At the foot of Panorama (and under the present-day city district called Vičava) a section of the Roman city was uncovered with military buildings from the 1st c. In the course of time it extended on terraces up the S side to the top and spread over onto the E and N sides. Along with sumptuous public buildings were found sanctuaries for oriental cults as well as a late antique necropolis with Christian monuments at the foot of the N slope in the valley of

the stream called the Grajena. Poetovio had its own bishop; and here in the time of Diocletian, Bishop Victorinus was martyred.

A Bronze Age and Hallstatt settlement was discovered on the neighboring citadel hill, as well as sporadic Iron Age finds and a Roman fortification (preserved). There was probably a Roman cult center there. The late antique buildings and an Early Christian church were in good condition. The road to Mursa runs E along the S foot of the citadel hill and near the port district. The road was flanked by a long necropolis which extended into the Early Christian graveyard. It is possible that the remains of the funerary basilica will one day be discovered. In this part of the city the artisans were grouped (potters, etc.).

M. Valerius Maximinus, who fought decisively in the wars of Marcus Aurelius and was named senator for his bravery, came from Poetovio. From that time on the city was never without a garrison, particularly during the 3d c. when Pannonia was an area of usurpers, barbarian raids, and ceaseless fighting. In the struggle between Magnentius and Constantius II for Italy and Illyricum (352) and between Theodosius and Maximus (388) decisive battles were fought before the walls of Poetovio. The period of consolidation which followed was interrupted in the 5th c. by Atilla. This was the time of the last Roman emperor, Romulus called Augustulus, son of a woman from Poetovio who was the daughter of Count Romulus.

BIBLIOGRAPHY. M. Abramić, *Poetovio* (1925)[MPI]; B. Saria, *Archäologische Karte von Jugoslavien, Blatt Ptuj* (1936)[MP]; id., *RE* 21 (1951); W. Schmid, "Izkopavanja v Ptuju," *Časopis za zgodovino in narodopisje* 31 (1936)[PI]; V. Hoffiller & B. Saria, *Antike Inschriften aus Jugoslavien* (1938)[I]; J. Klemenc, *Ptujski grad v kasni antiki* (1951); id., 21; Z. Šubic, "Le complexe de fours à briques romains," *Arheološki vestnik*, 19 (1968)[PI]; E. Will, "Les fidèles de Mithra à Poetovio," *Adriatica praehistorica et antiqua* (1970); J. & I. Curk, *Ptuj* (1970)[PI].

J. SASEL

POGGIO CIVITATE (Murlo) Province of Siena, Italy.

Map 14. One of the many hills within the metal-bearing mountains of N Tuscany, lies to the S of Siena near the Ombrone river. Excavations have revealed an Etruscan structure, probably a sanctuary, dating from ca. 650 to slightly before 525 B.C.

The latest building phase at the site is represented by a monumental sanctuary. The complex (over 61 m square) has a central court. Colonnades flank three sides of the court and a small rectangular enclosure, perhaps a templum, dominates the W flank. The building techniques consist of rubble stone foundations, pisé walls, and wooden structural members. The various units forming the complex were richly decorated with architectural terracottas: acroteria in the form of life-size standing and seated human figures, crouching and walking animals, and fantastic creatures adorned the ridgepoles. Gorgon antefixes or lateral simas molded with feline water spouts, rosettes, and human heads terminated the eaves while a raking sima, decorated by hounds chasing hares, edged the gables. Four frieze types further embellished the sanctuary. These are in low relief and depict a banquet, a procession, a horse race, and an assemblage of divinities.

The building's plan, its precision of construction, and the homogeneity of its architectural decoration suggest that the complex was constructed at one time. The stylistic evidence from the terracottas points to the period ca. 575 B.C. Ionic bowls and a middle Corinthian skyphos came from the burned debris of an earlier building, sealed under the sanctuary's floor of beaten earth. These pieces indicate that the sanctuary could not have been built much before 580 B.C.

The archaic sanctuary stood until the third quarter of the 6th c. when it was deliberately torn down. Its architectural terracottas were buried in specially constructed dumps and existing ditches, and an earthen mound was thrown up around the entire area of the sanctuary. This destruction, probably a ritual act intended to set the total area of the sanctuary out of bounds for future occupation, seems to relate to the rise of Chiusi as a city state.

The structures under the 6th c. sanctuary are only partially cleared but they display similar building techniques and were also adorned with architectural terracottas. As mentioned above, they were destroyed by fire around 580 B.C. and then sealed under the earthen floors of the later sanctuary. The debris layer is unusually rich in pottery, metal objects, and bone and ivory ornaments. Included are molded bucchero cups whose handles are decorated with winged women, ivory figurines in the shape of crouching animals, ivory and bone furniture inlays, and bronze, silver, and gold jewelry. These objects appear to be the contents of a rich dwelling, perhaps the house of a chief magistrate or priest.

During the summer of 1972 a small necropolis was discovered in the area of the site farthest W, a location known as Poggio Aguzzo. Simple fossa tombs and inhumation were found. The pottery has its best parallels with the material from the earlier structures.

No literary sources identify Poggio Civitate. Because of the rich finds and because of the well-planned and well-constructed buildings of both phases, the area appears to be a sanctuary. At the hub of N Etruria, Poggio Civitate perhaps served as a political and religious center for the N cities. Ultimately it may have incurred the wrath of one or more powerful centers and was thus ritually destroyed, much as Rome desecrated Veii.

The sanctuary from Poggio Civitate gives us a first glimpse of monumental archaic Etruscan architecture. This architecture rivals that of the Greek world and appears strong enough to influence later Roman Republican forms.

BIBLIOGRAPHY. K. M. Phillips, Jr., *Poggio Civitate (Murlo, Siena) The Archaic Sanctuary* (1970), reviewed by G. Caputo in *StEtr* 38 (1970) 409-11; L. Meritt, "Architectural Mouldings from Murlo," *StEtr* 38 (1970) 13-25; M. Cristofani & K. Phillips, "Poggio Civitate: Etruscan Letters and Chronological Observations," *StEtr* 39 (1971) 409-30; T. Gantz, "Divine Triads on an Archaic Etruscan Frieze Plaque from Poggio Civitate (Murlo)," *StEtr* 39 (1971) 3-24; J. Small, "The Banquet Frieze from Poggio Civitate," *StEtr* 39 (1971) 25-61. A. Andrén, "Lectiones Boëthianae I: Osservazioni sulle terrecotte architettoniche etrusco-italiche," *Opuscula Romana* 8.1 (1971) pls. 18-22. For further bibliography see *AJA* 76.3 (1972); 77.3 (1973); 78.3 (1974).

K. M. PHILLIPS, JR.

POGLA (Çomaklı, formerly Fığla) Turkey. Map 7.

Town in Pisidia 25 km N of Korkuteli. Pogla had city status in the later Hellenistic period, when it issued city decrees; its subsequent status depends upon the interpretation of an inscription found at Çomaklı, which perhaps implies that it belonged to the commune Milyadum mentioned by Cicero (*Verr.* 1.95). It is listed by Ptolemy and Hierokles (Sokla) and issued coins in the 2d and 3d c. A.D.

The acropolis hill, directly above the village, carries a rough polygonal circuit wall now reduced to a single course. Just below the wall on the S are four rows of

rock-cut seats. In the village itself are the remains of a massive building of the Roman period still standing up to 7 m high. Built tombs, originally handsome but now ruined, can be seen in the village and on the slopes above. Inscriptions and sculptured blocks of all kinds are exceptionally numerous.

BIBLIOGRAPHY. M. Rostovtzeff, *JOAI* 4 (1901) Beibl. 38-46; *IGRR* (1906-) III, 409; A. Wilhelm, *Glotta* 14 (1925) 81-82; A.H.M. Jones, *The Cities of the Eastern Roman Provinces* 2d ed. (1971) 142-43; G. E. Bean, *AnatSt* 10 (1960) 55-65.　　　　G. E. BEAN

POIANA ("Piroboridava") Moldova, Romania. Map 12. Settlement on the left bank of the Siret near the mouth of the Trotuş, at the crossing of the commercial roads which connect the Danube Delta with Dacia and the Carpathian-Baltic north. The oppidum of Poiana, founded in the Bronze Age, survived into the Iron Age. From the beginning of the 4th c. B.C. until the 1st c. A.D. it was a Geto-Dacian center, and has been tentatively identified with Piroboridava, which Ptolemy placed near the Siret (*Geog.* 3.10.8). The site was fortified by a ditch and a vallum. The houses built of wood and adobe were rectangular. About 20 tumuli containing cremation graves of the Dacian period were found near the settlement.

Archaeological research has revealed pottery, tools, arms, and ornamental objects both local and imported. The settlement was abandoned at the end of the 1st c. A.D., most probably after Domitian's war against the Dacians.

BIBLIOGRAPHY. R. Vulpe, "La civilisation dace à la lumière des fouilles de Poiana," *Dacia*, NS 1 (1957) 143-64; id., "La Valachie et la Basse-Moldavie sous les Romains," *Dacia*, NS 5 (1961) 365-93.

E. DORUTIU-BOILA

POIKILASION (Voukoliasi) Greece. Map 11. Small city in the Sphakia district on the S coast of W Crete, E of Syia and W of Tarrha. On a small bay cut off from the interior by the White Mountains, it is barely accessible except by sea and has little agricultural land. Little is known of its history; in the 3d c. B.C. it was a member of the league of Oreioi, and its gods are mentioned in the league's treaty with Magas of Kyrene (see Lisos). It is mentioned only by Ptolemy (3.15.3: site wrongly placed E of Tarrha) and a coastal pilot (*Stadiasmus* 330: Poikilassos, a city with an anchorage and water). No coins can definitely be ascribed to it, and it may never have been an independent city. A Temple of Serapis was consecrated or reconsecrated in the 3d c. A.D.

A few remains of houses survive on ancient terraces on the inland side of the valley at the mouth of the Tripiti gorge, about 1.6 km from the sea; there is now no safe anchorage, but if the relative sea level was some 6 m higher in antiquity there would have been at least a sheltered creek at the river mouth.

BIBLIOGRAPHY. R. Pashley, *Travels in Crete* II (1837; repr. 1970) 263-64; T.A.B. Spratt, *Travels and Researches in Crete* II (1865) 244-46; G. De Sanctis, *MonAnt* 11 (1901) 513-15; J.D.S. Pendlebury, *Archaeology of Crete* (1939) 371; M. Guarducci, *ICr* II (1939) 230-32; E. Kirsten, "Orioi," *RE* XVIII, 1 (1942) 1063-65; id., "Poikilasion" & "Poikilassos," ibid. XXI, 1 (1951) 1191; H. van Effenterre, *La Crète et le monde grec de Platon à Polybe* (1948) 120-26; S. G. Spanakis, *Kriti* II (n.d.) 303-4.　　　　D. J. BLACKMAN

POITIERS, *see* LIMONUM PICTONUM

POJANI, *see* APOLLONIA (Albania)

POLA (Pula) Croatia, Yugoslavia. Map 12. At the SW extremity of the Istrian Peninsula a native site of the Bronze and Iron Age civilization, whose early contact with the Greek world is reflected in the legend of Jason and Medea (Strab. 1.2.39; 5.1.9). After the Roman conquest of Histria in 178-177 B.C. a Roman military post was established here. The civil settlement which developed with the military post obtained colonial rank from Octavian between 42 and 31 B.C. (Plin. *HN* 3.129). Colonia Iulia Pola Pollentia Herculanea is the full title of colony on an inscription from the 2d c. A.D. (*CIL* V, 8139 = II 10.1.85). It was enrolled in the tribus Velina. In addition to its flourishing port, a large ager centuriatus producing wine, olive oil, and cereals included a great part of peninsula. Traces of centuriation are still preserved. In the area many great estates flourished. Pola with Histria was a part of Illyricum till 11 B.C. when Caesar Augustus joined the part of its territory from the Arsia (Raša) river to the regio X of Italy, which included Venetia and Histria. At the beginning of the 2d c. the exiled king of the Roxolani, Rasparaganus, found asylum here. He and his son died and were buried here. At the time of the Marcomannic invasions (166-167) the city walls were reinforced for the first time. In 326 by order of Constantine the Great his son Crispus was killed in Pola.

Late antiquity was a period of relative peace in S Histria, which was outside the area invaded by Huns and other barbarians. But the destruction of Aquileia by Attila in 452 forced the Pola to strengthen its walls again to a thickness of more than 4 m. Pola and S Histria became in late antiquity a refuge for many refugees from devastated neighboring provinces.

Architecturally the development of the town was conditioned by its inception as a hillfort settlement. In the Roman period there developed the upper town on the hill and on its slopes the lower town—"pars superior coloniae" and "pars inferior coloniae" as the inscriptions describe them. Circular streets surrounded the hill, and down the slopes streets led radially towards the city walls and to the sea. Near the sea and around the forum there were insulae. The plan of the streets on the hill still preserves the ancient street pattern. The city walls are preserved in several places for a total of 60 to 70 m in the S. The first circuit wall was built on rock. The second, constructed to the S outside the first, was built mainly between the 4th and 6th c. on foundations of architectural remains: columns, capitals, and funerary monuments with inscriptions. In the S part of the older wall were two round towers and four square ones.

The oldest city gate, the so-called Hercules' Gate, is in Liberation Square. It is 3.6 m wide and 4 m high; carved on the keystone of the arch is the curly head of the bearded Hercules in high relief. On the block to the left, his club is carved. Near the carving the names of the duoviri L. Cassius Longinus and L. Calpurnius Piso (mid 1st c. B.C.) are inscribed. At the N end of the walls and on the site of an earlier gate is the so-called Porta Gemina, with two vaulted passages. The massive pilasters have half columns with composite capitals on the external face, an architrave without decoration, and a richly decorated frieze. The gate was built in the Antonine period in the middle of the 2d c. From this gate the way led to the small theater on the E slope of the central city hill.

The Arch of Sergii, today isolated at the First of May street, was originally one of the city gates. On the top above the frieze an attic divided in three parts held statues of the three members of the Sergii family who were civil and military functionaries and to whose mem-

ory the arch was erected. In the center of the frieze, decorated with Erotes, garlands, and bucrania, there is the inscription: SALVIA POSTVMA SERGI(a) DE SVA PECVNIA. The arch can be dated not long after 28-29.

The forum (37 x 81 m) was in the central part of the lower town on the SW slope of the city hill near the sea. With its longer axis oriented N-S, the forum was well protected from the NE wind. It lies 1 m under the present Republic Square. On the N side of the forum at the time of the founding of the colony was a large altar. After the Augustan reconstruction between 2 B.C. and A.D. 14 two temples were built, identical in dimensions and the work of the same architect. The temple on the W side is still standing, a harmonious building constructed of Istrian limestone on an elevated podium with steps in front, 8.05 by 17.65 m. The pronaos has four unfluted columns with Corinthian capitals. The frieze of floral motives on the architrave is continued around the temple. On the front the bronze letters of the dedication read: Romae et Augusto Caesari Divi f. Patri Patriae. The temple, transformed into the Church of the Virgin Mary, houses a small collection of ancient sculpture today. Of the E temple, probably dedicated to Diana or Hercules, only the back wall can be seen. The smaller of the two theaters (2d c. A.D.) is on the E slope of the central city hill, the other (1st c. A.D.) is outside the walls on the S periphery of the town. The facade of the larger was 100 m long; the radius of orchestra, 25 m; that of cavea, ca. 50 m. A tradition persists that some of its columns were used in building S. Maria della Salute in Venice.

The most monumental among ancient buildings at Pola is the amphitheater, locally known as the arena. Built during the 1st c. A.D., it was probably begun by Augustus and completed by the time of Vespasian. It is on the NE periphery of the ancient town, ca. 200 m from the city walls near the sea. Between the building and the sea passed the via Flavia, the road that led to the cities along the W coast of Histria, Parentium (Poreč) and Tergestum (Trieste). The amphitheater ranks sixth in size among the surviving Roman amphitheaters, the five that are larger are in Rome, Capua, Verona, Arles, and Catania. The arena was 67.9 by 41.6 m and had an outer wall 32.45 m high. It had three stories on the seaward side and two opposite, where the hillside supported seats; its capacity was 23,000. The lowest story consists of massive arches supported by rectangular piers. The next arcade is of the same length. The second story has 72 arches around the entire building. The third story has 64 rectangular openings. Four shallow rectangular towers mark the four cardinal points. At the top of the towers water was stored for a system of waterworks carried around the top of the building by a channel. On the W tower a plaque commemorates Senator Gabriele Emo, who in 1584 prevented the destruction of the amphitheater and its transportation to Venice. Beneath the arena were the rooms and corridors for gladiators and animals. The central underground hall now houses an exhibition illustrating the wine and oil production in the ancient Histria.

In the Ulica 1. Maja (The First of May street) no. 16, a large mosaic in a room of a villa urbana was discovered in 1958. It represents the punishing of Dirke by Zetos and Amphion the sons of Antiope. The work is attributed to the 1st c. A.D.

There are remains of several Early Christian monuments in Pola. The Cathedral of St. Thomas was built during the 4th-6th c. A.D. on the foundations of baths (?); the Church of Sancta Maria Formosa from the 6th c.; the Church of St. John from the 5th c.

About 4 km NW of the Pula harbor are the Brijuni (Brioni) islands (Pullariae insulae) with many archaeological remains. In the environs of Pula were many luxurious villae rusticae.

The Archaeological Museum of Istria at Pula preserves the finds from Pola and Istria.

BIBLIOGRAPHY. A. Gnirs, Pola, *Führer durch die antiken Baudenkmäler und Sammlungen* (1913); T. Allason, *Antiquities of Pola* (1919); M. Mirabella-Roberti, "L'Arena di Pola," *Quaderni—Guida di Pola* (1943); A. Degrassi, *Porti romani dell'Istria* (1955); Š. Mlakar, *Antička Pula* (1965; German edition also); id., *Amfiteatar u Puli* (1965; German edition also).

M. ZANINOVIĆ

POLEMONION Pontus, Turkey. Map 5. Founded by Polemon I or (less probably) by Polemon II of Pontus in Sidene, a coastal district formerly belonging to Amisos, at the mouth of the Bolaman Irmaği (Sidenus fl.). Polemonion lay at the center of communications of the kingdom of Polemon I, being linked by sea with Pharnakeia and Trapezous and by road with Diospolis. A second inland route, leading to Armenia Minor, may have become important during the reign of Pythodoris, whose possessions included Armenia Minor. After Rome's annexation of the Pontic kingdom in A.D. 64-65 Polemonion ceased to have more than local importance. Only Byzantine remains have been recorded. It had a port 3 km W of the city at Fatsa (Phadissa or Phadisane), where there is an exposed anchorage.

BIBLIOGRAPHY. W. J. Hamilton, *Researches in Asia Minor, Pontus, and Armenia* (1842) I 270.

D. R. WILSON

POLIÇAN, see LIMES, SOUTH ALBANIA

POLICASTRO DI S. MARINA, see PYXOUS

POLICORO, see HERAKLEIA (Italy)

POLIS TIS CHRYSOCHOU, see under MARION

POLITIKO, see TAMASSOS

POLLA, see FORUM POPILLII

POLLENA TROCCHIA Campania, Italy. Map 17A. An ancient center 10 km SE of Naples, at the foot of Monte Somma and within the zone of country villas struck by the eruption of Vesuvius in A.D. 79. There are remains of a wine cellar and some marble statues, among which is a statue of Dionysus (Naples, Museo Nazionale, n. 152871). The few definite discoveries do not, however, permit a certain appraisal of the character of the ancient center. A decorated column base of the middle of the 1st c. A.D. in the parish church is noteworthy. Santangelo maintained at Pollena a villa where many Roman marble copies of Greek works were kept, among which was a statue of a draped female figure, the so-called Spinner of Munich and a statue of Apollo now in the Castello Vigilulfo in Milan.

BIBLIOGRAPHY. A. Caracciolo, *Sull'origine di Pollena-Trocchia* (1932); A. De Simone, "La Base decorata di Pollena-Trocchia," *Atti Acc. Lett. Arch. BB. AA.* (1973). For the Spinner of Munich: Arndt-Amelung, *Einzelaufnamen*, s. 1, p. 15, n. 260-261; vol. X, col. 69-70, n. 2945-48.

A. DE FRANCISCIS

POLLENTIA (Alcudia de Pollensa) Majorca, Spain. Map 19. Town 8 km from Pollensa on the bay of that

name. Like Palma, according to Strabo (3.5.1), it was founded in 123-122 B.C. by Caecilius Metellus Balearicus with 3000 Roman colonists. It was a colonia with some sort of special status, since Pollentia and Palma were the only colonies outside of Italy ascribed to the tribus Vellina. It flourished in the heyday of the Empire, was partially destroyed in the second half of the 3d c., and totally obliterated ca. A.D. 435.

Excavation began in the NW sector close to the city wall, and nothing is known as yet of the central area where the forum, temples, and main public buildings must have been. The chief remains now uncovered are the W city wall, a small theater, and a series of buildings which have helped in reconstructing the city's history. The numerous small finds—sculpture, inscriptions, ceramics, and coins—are in the local museum, in Palma, and in the National Museum in Madrid. The city must have been of considerable importance, extending from the open fields of Alcudia to the sea. Four phases can be recognized.

In Phase I circular structures of roughly hewn stone and plentiful native pottery marked the pre-Roman Talayot settlement. Phase II was on the level of the foundation of the Roman town of the end of the 2d c. B.C. and included house walls beneath the so-called House of the Bronze Head, as well as Campanian, Iberian, and pre-Arretine pottery. Phase III, ca. 100-60 B.C., is attested by a construction of squared blocks in the same location. Phase IV, lasting from the Augustan period to the destruction ca. A.D. 435, included the House of the Bronze Head (34 x 8 m). The N section and part of the E area are preserved, comprising a central peristyle 15 m long, with five aligned columns and a covered portico, adjoined by living rooms. The House of the Two Treasures (23 x 20 m), also of the Augustan period, has a small peristyle, 7 by 4 m. The rooms grouped around the peristyle are either paved or floored with heavily tamped earth. Between the two houses runs a street with a portico 3 m high. Among minor finds now dispersed, was some excellent sculpture, such as a veiled head of Augustus.

BIBLIOGRAPHY. A. García y Bellido, "Esculturas romanas de Pollentia (La Alcudia, Mallorca)," ArchEspArq 24 (1951) 53ff; id., "Las colonias romanas de Hispania," Anuario de Historia del Derecho Español 29 (1959) 458; M. Tarradell et al., "Las excavaciones de la ciudad romana de Pollentia (Alcudia, Mallorca)," VII Congreso Nacional de Arqueología (1960) 469ff; A. Arribas et al., "Pollentia: I. Excavaciones en Sa Portella, Alcudia (Mallorca)," Excavaciones Arqueológicas en España 75 (1973). J. M. ROLDÁN

POLLENTIA (Pollenzo) Piedmont, Italy. Map 14. An ancient city near the confluence of the Tanaro with the Stura and dominating a system of roads including the road for Alba - Hasta, Forum Fulvii - Dertona, that from Augusta Taurinorum and that for Augusta Bagiennorum, which crossed the valleys of the Tanaro and the Bormida and descended to Savona. It was enrolled in the tribus Pollia in the Augustan Regio IX. Its foundation by the Consul Q. Fulvius Flaccus in 179 B.C. seems to have preceded by some years the Roman occupation of the territory.

Pollentia was certainly a fortified city, as is confirmed by the sources. Cicero records it as the scene of encounters between the followers of Antony and of Brutus during the war of Modena (Ad. Fam. 11.14). Suetonius, reporting an episode in the revolt of the urban populace under Tiberius, mentions the numerous gates in the city

walls (Tib. 37). Hygenus the Surveyor drew Pollentia with its walled perimeter in the age of Trajan.

The city was rectangular in plan oriented approximately N, following the usual scheme of Roman military establishments. The remains of ancient walls, which may belong to the fortified enclosure, have been noted in the past between the road to Cherasco and the Tanaro. Other traces of public buildings, a temple and a theater, appeared in explorations made in 1805 but are no longer visible. In the Imperial age the city contained a temple dedicated to Victory and another dedicated to Plotina, which is mentioned in local inscriptions. There was also an aqueduct and an amphitheater. Outside the walls, along the principal roads, were monumental mausolea. One of these, with a circular plan, has been discovered on the way to Alba. The necropoleis were along the principal roads and provide the major part of the material from Pollentia housed in the Municipal Museum of Bra. The city was well-known and prosperous in the early centuries of the Empire. It produced dark-colored wool cloth, fine purple wool, and pleasing ceramic cups. The city was the base of a garrison of Sarmatae in the 4th c., and the scene in 402 of the victory of Stilicone over the Goths of Alaric.

BIBLIOGRAPHY. Cic. Fam. 11.14; Mart. 14. 157,158; Sil. Pun. 7, 599; Plin. 3.49; Suet. Tib. 37; Ptol. 3.1.45; Claud., Cons. Hon. 127,202; Oros. 7.37; Cassiod. Chron. 11.154; Not. Dig. occ. p. 21; Tab. Peut.

CIL v, 7615ff; Inscr. It. IX, 1; XVIII, 126ff; G. Franchi Pont., Delle antichità di Pollenzo (1806); F. Gabotto, Pollenzo (1895); P. Barocelli, "Sepolcreti di cremati," BSPABA (1933) 65ff; G. Pesce, "La necropoli in contrada Pedaggera," NSc (1936) 373; E. Mosca, "Note archeologiche pollentine," RStLig (1958) 137; id., Scavi nella necropoli di Pollenzo," BPC (1962) 135; S. Curto, Pollenzo antica (1964). S. FINOCCHI

POLLENZO, see POLLENTIA

"POLYGIUM," see BESSAN

POLYRRHENIA (Polyrrhinia, formerly Epano Paleokastro) Kisamos district, Crete. Map 11. Hill-top site 5.5 km S of Kastelli Kisamou. It was more important than surviving sources make clear. Literary references to the site are few except by the geographers: e.g. Skylax 47; Strabo 10.4.13. Polybios (4.53, 55, 61) provides details of several historical incidents. Inscriptions add a little.

According to tradition (Strabo, loc. cit.), Achaean and Laconian immigrants settled in one city the existing population, which lived in villages. This could refer to a foundation at the end of the 2d millennium or as late as the 8th c. Apart from possible slight traces of LM III occupation (cf. the tradition of Agamemnon's visit on his voyage home from Troy), the earliest pottery found so far is archaic. In the Classical period the city was a major power in W Crete, a city of tough mountain warriors, hunters, and herdsmen. It used the ports of Kisamos and Phalasarna, 30 and 60 stades away (Strabo, correctly). Phalasarna remained independent throughout, but Kisamos probably became independent only in the 3d c. A.D. Polyrrhenia allied itself with Phalasarna in the early 3d c. B.C. with Spartan mediation, honored a Spartan king ca. 273, and probably supported Sparta in the Chremonidean war (267/6-261). It supported Lyttos against Knossos and Gortyn in 220-219 and after the destruction of Lyttos continued the struggle with Macedonian and Achaean help, successfully detaching other W Cretan cities from alliance with Knos-

sos (Polyb. loc. cit.). By 201 it seems to have ceased to support Macedon, and soon showed pro-Roman feeling, honoring Scipio Hispallus (189), clearly as a result of a visit, and joining the alliance with Eumenes (183). It remained prosperous in the 2d c., but lost to Kydonia its preeminence in W Crete. It therefore supported the Roman conquest of Crete and was favorably treated: it continued to strike coins and gained (or perhaps regained) control of the Diktynnaion. In the Imperial period it seems to have declined in importance; Kisamos seems to have been still dependent in the 2d c. but independent from the 3d. Polyrrhenia is not heard of after the 3d c.; the site was reoccupied probably early in the second Byzantine period (late 10th c.). Coins were struck from the 4th c. B.C. to the Roman period; the most distinctive feature is the city symbol—the bucranium. The city's territory was extensive in W Crete, "from the north to the south (coast)" ([Scylax] 47), though it only certainly controlled the S part of the W coast and a stretch of the N coast.

The city lay in a naturally fortified position—on an isolated steep hill surrounded by ravines, dominating the valley approach from Kisamos. The ancient city covered the whole lower (SW) part of the hill, which slopes up NE to a steep summit, the ancient acropolis (418 m), with a lower spur beyond to the N. The visible fortifications around the hill and acropolis have clearly been much repaired and rebuilt in the second Byzantine and Venetian periods and the wall round the N spur and that along the S side of the acropolis (facing the city) seem to be entirely of those periods. But the ancient wall line can be traced on the N and NW sides of the acropolis and the NW side (with two towers) and SE side (with a gate) of the city; the line is totally lost on the SW side. These walls probably date from Early Hellenistic times, with repairs and additions in antiquity (e.g. the tower W of the village). The city was provided with water through at least two rock-cut aqueducts terminating on the W side of the modern village, with a cave nearby containing evidence of a cult of the Nymphs. A number of cisterns (perhaps all Byzantine or later) are visible in the acropolis or lower city; apart from these, few remains survive within the acropolis. On the N spur remains of a sanctuary may lie under the later chapel.

In the city area the main concentration of ancient remains lies on a terrace near the center, by the ruined chapel of the 99 Saints. Excavations in 1938 revealed a building of good Early Hellenistic construction (60.65 x 6.73 m), a stoa or perhaps a monumental altar bordering on the N a structure that was possibly a temple, not yet proved but indicated by the many inscribed blocks reused in the chapel: these include some honorific inscriptions and statue bases, and a large number of blocks bearing a mass of personal names, clearly inscribed by individuals (almost all Polyrrhenians) coming to the temple (3d-1st c. B.C.). Few remains have been found of houses: only some rock-cut foundations. Sherds from the site cover the archaic to Roman periods, and the second Byzantine period on (especially on the acropolis).

In the valley below to the E, at Sto Yero Kolymbo, are the poorly preserved remains of a small two-roomed building, probably a temple of the 3d c. B.C., with a bench across the rear wall of the cella. Inscribed blocks from a round structure reportedly found at Kappadoki probably derive from another sanctuary. None of the temples can be identified. The main necropolis lay on the lower W slopes of the hill at Ston Kharaka, with built tombs, and rock-cut graves and chamber tombs beyond. Another necropolis lay between the city and Kisamos. In both necropoleis all the tombs have been looted: none appears to have been earlier than 4th c. B.C.

BIBLIOGRAPHY. R. Pashley, *Travels in Crete* (1837; repr. 1970) I.48-49, 53-56, II.44-50; T.A.B. Spratt, *Travels and Researches in Crete* II (1865) 211-15[I]; L. Thenon, "Fragments d'une description de l'Ile de Crète, III: Polyrrhénie," *RA* (NS) 15 (1867) 416-27; J.-N. Svoronos, *Numismatique de la Crète ancienne* (1890; repr. 1972) 274-84 and Suppl. p. 373; L. Savignoni, *MonAnt* 11 (1901) 314-48[MPI]; G. de Sanctis, ibid., 474-94; M. Guarducci, *ICr* II (1939) 237-67; V. D. Theophanidis, *ArchEph* 81-83 (1942-44) *Chronika* 17-31; H. van Effenterre, *La Crète et le monde grec de Platon à polybe* (1948); E. Kirsten, "Polyrrhenia," *RE* XXI (1952) 2530-48; R. F. Willetts, *Aristocratic Society in Ancient Crete* (1955). J. D. BLACKMAN

POMAS-ET-ROUFFIAC (Lagaste) Aude, France. Map 23. A pre-Roman emporium in the upper Aude valley, is situated at the point where the Narbonne-Toulouse road through Les Corbières crosses the road connecting Carcassone with La Cerdagne. Occupied sporadically in the Iron Age, the site gained importance towards the end of the 2d c. B.C., its increased activity apparently coinciding with the founding of Narbonne. The emporium then served as a relay station for distributing the new colony's exports, mainly wine. The quantity of coins and amphorae found on the site, along with luxury articles (Italic oinochoai of bronze) bear witness to the prosperity of the market. It was short-lived, however: declining in the second half of the 1st c. B.C., probably after the trade roads were shifted, La Lagaste was almost totally deserted by the early 1st c. A.D.

The settlement, which was completely unfortified, is spread out over some 60 ha. It was thinly settled; there was no real urban center but merely groups of huts scattered about in no apparent order. Most of these are built of perishable materials and contain silos; in the NW section they are connected with potter's kilns and there was probably also a place of worship. The S section contains an incineration necropolis with pits; a funerary well has also been found, a sign of Volcaean influence. The finds are housed at Limoux.

BIBLIOGRAPHY. G. Rancoule, "L'oppidum protohistorique de La Lagaste," *Cahiers Ligures de Préhistoire et d'Archéologie* 14 (1965) 49-70; id., "Ateliers de potiers et céramique indigène au 1er siècle av. J.C.," *Revue Archéologique de Narbonnaise* 3 (1970) 33-70; *Gallia* 29 (1971) 376. Y. SOLIER

POMPAELO (Pamplona) Navarra, Spain. Map 19. Strabo (3.4.10) considered it the chief city of the Vascones. It has been much debated whether it was founded by Pompey. Plutarch (*Sert.* 21) and Sallust (2.93) relate that in 75 B.C. C. Pompeius, during his struggle with Sertorius, retired to Vascon territory for winter quarters and to provision his troops. He established himself in the vicinity of a Vascon oppidum which would have owed its name and growth to the presence of the Romans. However, nothing definitely proves the foundation of Pompaelo by Pompey, although there is an obvious resemblance of the names; on the contrary the remains excavated in the area of the present cathedral have yielded no evidence earlier than the Empire. Nonetheless, Strabo (3.4.10) calls it the city of Pompey.

Apparently there was a previous settlement on the site of the Roman occupation, but confirmatory data are lacking. The fact is that Pompaelo showed little vigor as a city after Pompey's defeat by Caesar, since Pliny (*HN.* 3.24), in the mid 1st c. A.D. in describing the Conventus

Caesaraugustanus to which Pompaelo belonged, cites it as a stipendiary town. It is named as a station on the Roman road system: Strabo (3.4.10) mentions it as "on the way from Tarraco to the territory of the Vascones . . . to Pompaelo and Oiason." According to the *Antonine Itinerary* it is the 18th station on the road from Asturica Augusta (Astorga) to Burdigalia (Bordeaux). St. Isidore mentions it as conquered by the Visigoths (*Chr.Gall.* 651.664), as does Gregory of Tours (*Hist. Franc.* II, 29) in reference to its capture by Childebert and Clothar. We know further that it was an episcopal see in the Visigothic period and that King Wamba rebuilt it.

Archaeological material is not abundant and some of it has been lost. There are a few inscriptions, and some objects are in the Navarre Museum, including two kinds of mosaics from different parts of the city. One consists of black and white tesserae with representations of the walls and towers of a citadel and a hippocamp, apparently from the Antonine period. The other, polychrome, from about the mid 2d c., includes a scene of the struggle of Theseus and the Minotaur. There was some bronze sculpture: a female head forming part of a statue or bust presumed to represent Juno, and a headless statue of a woman—presumably Ceres, judging from the ears of grain in her hand. Both pieces have vanished, but are known from photographs. A bronze Mercury and part of a bronze hand suggest the presence of a military encampment. There are also fragments of Corinthian columns and capitals.

Excavations in the area of the present cathedral, thought to be the forum of the ancient city, have produced terra sigillata, Arretine and Hispanic, from the 1st to the 4th c. A.D. Remains of baths have also come to light and much numismatic material, down to the sons of Constantine. It has been conjectured that the size of the city was about that of Caesaraugusta.

BIBLIOGRAPHY. M. Angeles Mezquiriz, *La excavación estratigrafica de Pompaelo* I (1958)^{PI}.　　　　J. ARCE

POMPEII *Italy. Map 17A.* A city on the end of a lava stream thrown out S-SE from Vesuvius and overlooking the sea just NE of the mouth of the Sarnus (Sarno). It was called Pompaia by Strabo, and the Sullan colony bore the name Colonia Veneria Cornelia Pompeianorum. In its last century (destroyed A.D. 79) it was the port and chief city of the S half of the bay of Naples, with an urban population not exceeding 20,000; Strabo (5.4.8) says it was port for Acerrae (NE of Naples) as well as Nola and Nuceria. In addition to trade and agriculture, its principal industries included cloth finishing, the manufacture of lava mills, and the production of fish sauces.

The name is of doubtful origin, possibly Oscan. Strabo says that the site was once held by Oscans, later by Tyrrhenians and Pelasgians, and after that by Samnites, who were also expelled. But the earliest remains that have come to light are Greek of the 6th c. B.C., a Doric temple on the S edge of the city and Attic black-figure sherds in deposits in the precinct of Apollo on the forum. Since Pompeii must have figured in the trade route that carried Etruscan metal to Poseidonia and Greek goods back to Capua, it is more likely that the Greeks who built the temple came from Poseidonia than from Cumae. Greek remains are scant, and no Etruscan remains have been positively identified. Probably Pompeii in this period was no more than a village and watch tower on the bay. The occupation of the site by the Samnites must fall toward the end of the 5th c. B.C. as in other cities of Campania. These tribes, moving down from the mountains, were already considerably Hellenized in their tastes and probably a good proportion of the existing popula-

tion was absorbed into the new amalgam. Temple antefixes of the 4th c. which have close affinities with others from Fratte di Salerno suggest that the pattern of commerce and communication at least remained unbroken.

Under the Samnites Pompeii flourished, reaching its apogee in the 2d c. B.C. (the so-called Tufa Period). By 290 it had allied itself with Rome, and while nothing is known of its role in the second Punic war, the evidence suggests that it emerged unscathed. Through the 2d c. the archaeological record shows continuous building and expansion. But in the social war it was allied with the other Campanian cities against Rome, took a leading part, and stood siege in 89 by L. Sulla. In 80 it had to bear the additional burden of a colony of Sulla's veterans and became as thoroughly Romanized as any city in the region, being inscribed in the tribus Menenia.

There is no indication that the Samnite population was generally dispossessed, nor was Pompeii's vigor diminished; under the Romans it continued to be a major port and city. Cicero and the Julio-Claudians had property there, and while it did not itself become a resort, as did its satellite Stabiae and Herculaneum, several rich villas have been discovered in the environs. In A.D. 59 a riot in the amphitheater between factions from Pompeii and Nuceria cost many lives (Tac. *Ann.* 14.17.1). In February A.D. 62 an earthquake nearly leveled the city (Sen. *QNat.* 6.1.1; Tac. *Ann.* 15.22.4), but the survivors bent energetically to the task of rebuilding it on a grander scale.

In late August A.D. 79, after centuries of inactivity, Vesuvius erupted with great violence. Pliny (*Ep.* 6.16, 20) has left an eye-witness account of the disaster. The eruption threw out vast quantities of dust, ash, and pumice; there is no mention of lava. Undisturbed deposits at Pompeii show a base of small pumice (lapilli) 2-4 m deep and a thinner (1-2 m) stratum of ash. It appears that for some hours the danger was not acute and operations of evacuation were orderly; more was to be feared from the collapse of roofs than from the volcano and from fires that broke out where hearths had been abandoned. Then a shift of wind brought ash saturated with poisonous gas and a downpour of rain, and those who had stayed behind were killed by this. It is hard to estimate how many may have perished, but clearly the large majority escaped.

The survivors did not contemplate rebuilding the city but ransacked the ruins; the Forum proper was stripped of every statue. Private houses were both thoroughly explored, sometimes by tunnels driven through walls, and selectively sampled by wells sunk to recover valuables. Pockets of residual gas killed many salvagers in the pits they dug. Titus had awarded the property of those who had died without heir to the survivors; but its recovery was perilous and, fortunately for us, was undertaken only sporadically. Consequently the site is our best evidence for Roman life in a prosperous Italian town in the 1st c.

Pompeii was forgotten in the Middle Ages and rediscovered in 1748. Excavation has proceeded intermittently since, first as a royal treasure hunt but since 1861 with ever increasing scientific precision. Nearly three-quarters of the city has now been uncovered.

The city is roughly oval (1200 x 720 m) and surrounded by a strong wall (3d-2d c. B.C.), originally a plain ashlar front with buttresses tailed into an earth agger backed in some sectors with great flights of steps that served both as retaining walls and as access for defenders. Rectangular towers at regular intervals in the NW and SE sectors are a late modification, perhaps in preparation for the siege of Sulla. In the agger were found remains of an earlier fortification that has been dated to pre-Samnite times. The seven gates are keyed

to the traffic pattern of the city; most of these, lofty and arched, are contemporary with the towers.

The city is divided by two approximately straight and parallel arteries running NE-SW, sometimes called decumani, the Strada di Nola and the Strada dell'Abbondanza with its continuation, the Strada Marina. There was probably a single artery NW-SE, the Strada Stabiana. All terminate at gates at both ends, except the Strada di Nola at the SW; here it turned its traffic NW into the Strada Consolare, which passes through the Porta di Ercolano. No gate is clearly more important than another.

The public buildings cluster in three areas: SW around the forum, around the Forum Triangulare, and SE around the amphitheater. The first area is the largest and most diversified. The forum, on the Roman pattern, is long and narrow, almost excessively so. Since the port of Pompeii seems to have been a river port on the Sarnus, which Strabo says was navigable in both directions, and its traffic must have gone through the Porta di Stabia, the location must depend on factors other than accessibility (cf. Vitr. 1.7.1). In its later life it had lost most of the aspect of a market, except on market day. The only frankly market buildings on the forum were set off at the N end, and the macellum at the NE corner was arranged to interfere as little as possible with other activities. The forum proper, closed to wheeled traffic, was a place for religion, politics, law, and spectacle, like the Forum Romanum. The insulae around the forum tend to be small and square, while elsewhere in the city they tend to be long and narrow, fronting at the end on a thoroughfare. Consequently it has been thought that the area around the forum was the original nucleus; a settlement has been postulated in which the Via degli Augustali-Vicolo del Lupanare was the wall street.

The forum is dominated on its long axis by a Corinthian temple on a high podium; originally (ca. 150 B.C.) the Temple of Jupiter, it became the Capitolium of the Roman colony. It had a deep Italic pronaos and lateral interior colonnades; vaults in the podium may have served as the aerarium. The other ancient temple on the forum is the precinct of Apollo; here an Ionic peristyle tightly encloses a peripteral Corinthian temple on a very high podium. The finds in the area show it to have been a cult center in the 6th c. B.C.; in its present form it must be largely 2d c., refurbished after A.D. 62. Across the forum lies the Temple of the Genius of the Emperor, more likely originally Nero than Vespasian, notable for its altar reliefs and the use of stucco panels with alternating pediments and lunettes on the enclosing walls, like the Aedificium Eumachiae, the grand cloth hall preceded by a chalcidicum next to it on the S.

A large trilobate building just N of this has been identified as the Sacellum Larum Publicorum; there is almost no support for the identification, and the building wants study. The Temple of Venus Pompeiana stood at the S point of the site, SW of the forum, dominating the sea and the mouth of the Sarnus. Since the richly porticoed sanctuary was at the start of rebuilding at the eruption, little remains.

The S end of the forum was assigned to politics and business. Along the deep S portico open three large halls, once revetted with marble, commonly identified as the curia and offices of the duoviri and aediles (or tabularium). Architecturally the identification is unlikely. Still less likely is the identification of the square building at the SE corner of the forum as the comitium (the theater would serve better).

The colony was governed by two duoviri iure dicundo and two aediles, all elected annually, the duoviri of every fifth year having censorial powers and responsibility for the lectio senatus. The aediles had charge of the public streets and markets, the temples, and baths. The supreme council of the city was the ordo decurionum; there was occasional recourse to popular referendum. Elections in Pompeii were warmly contested, as the wealth of programmata painted along the streets attests. About the administration of Samnite Pompeii we know comparatively little.

The basilica at the SW corner of the forum is one of the finest buildings (ca. 125 B.C.). It is approached from the forum on its long axis through an Ionic vestibule. The main hall had great fluted columns (4 x 12) around a central nave, with columns in two stories responding along the perimeter wall, an engaged Ionic lower order with Corinthian above, at least some of which stood free to light the gallery that ran on three sides. No capital of the main order survives. At the far end is a raised tribune with Corinthian columns in two superimposed orders, the upper engaged in the facade of a windowed gallery.

The forum was being refurbished with limestone colonnades in two stories at the time of the eruption. These were to have run along the whole W side and as far along the E as the Templum Vespasiani, Doric in the lower order, Ionic above. A separate Corinthian colonnade in marble preceded the macellum. Around the forum more than 50 statue bases, several for equestrian figures, can be counted.

The public buildings of the Forum Triangulare area, a center of cultural life, begin with the ruins of the archaic Doric temple, a pteron (7 x 11; possibly shortened at some time) and an exceedingly small cella, evidently not original. The temple fronts on a mysterious enclosure and poses many problems. In the tufa period the triangular precinct was given long Doric colonnades on two sides and a lofty Ionic propylaeum, and a race track was laid out along the NE portico as an adjunct to the little palaestra connected near the N corner, where a copy of the Doryphoros of Polyklitos served as cult image. Other doors lead E to the summa cavea of the Greek theater, and a grand stair, presumably for pompae, descends to the level of the orchestra behind the scaena. The theater, built on a natural slope, is not older than the 2d c. B.C., while the scaena, tribunalia, and upper gallery are later additions. In its final period the scaena conformed to Roman taste, even to having installations for jeux d'eau. Behind the scaena lies the spacious theater portico surrounded by small adaptable rooms, used in the last days as a Ludus Gladiatorius and perhaps always employed for a variety of purposes. East of the Greek theater a Theatrum Tectum was built after the foundation of the Roman colony. In the roof the architect used trusses of impressive span, but the details show decline from the best tufa period architecture. North of the Greek theater is the Temple of Isis, rebuilt after A.D. 62, remarkable chiefly for its stuccos and painted decorations, the latter now in Naples. The temple itself is bizarre in plan, with arrangements for theatrical effects; the aedicula in which Nile water was kept in an underground tank is of special interest.

In the E corner of the city lies the oldest known amphitheater (80-70 B.C.), built by piling earth dug from the arena around it as base for the cavea. The city wall acts as retaining wall for part, completed by an arc of massive vaults, to the top of which rise double stairs, while tunnels sloping to an anular corridor under the ima cavea pierce the base. Access to the arena is arranged on the long axis. West of the amphitheater is the "Great Palaestra," a vast enclosure of Augustan date with porticos on three sides and a big swimming pool in the open area. The attractive idea has been advanced that this was the

campus of Pompeii; it must have served as theater portico for the amphitheater as well as sports field and drill ground.

Three public bath establishments are known; two more seem to have been part of clubs; and a number of large houses have private baths. Oldest are the Thermae Stabianae, originally dependent on well water, later extensively rebuilt with not only separate facilities for men and women but a row of cubicles for men who wished to bathe in privacy. Although the big hot rooms had hypocausts and heated walls, there were only two of them and the fenestration was poor. In the Terme Centrali, still unfinished at the eruption, great windows to the SW were opened in the hot rooms and a laconicum added. Recently a Republican bath abandoned in antiquity has been discovered and excavated.

The water of Pompeii came originally from wells, public and private, driven through the lava plateau, and from rain collected in cisterns. An aqueduct, probably of the Early Empire, entered the city at its highest point, the Porta del Vesuvio, and was distributed into three channels by a castellum aquae inside the gate and carried throughout the city by a network of lead pipes, with pressure maintained by standpipes. Most of the water was delivered to public fountains and baths, and the street fountains were allowed to spill into the streets to flush them by running on the surface for some distance before entering a sewer. The number of aqueduct-fed fountains in private houses was very large. The extensive sewer system evidently emptied into the Sarnus.

Pompeii is most famous for its houses and their decoration. The houses range from mansions, occupying all or most of an insula, to one-room shops with lofts, the latter rarely decorated. In the better houses the atrium-peristyle plan of Vitruvius (6.3) is the rule. Although the tendency is toward rigidity of plan and proportion in older houses as well as grandeur of scale (Casa di Sallustio), comfort, intimacy, and the view were later considered important (Casa dei Vettii & Casa di Giuseppe II). Despite repeated search, no impluviate atrium older than the 3d c. B.C. is known, and perhaps the impluvium came after the vaulted cistern. In Pompeii the oldest houses are already impluviate but still bound to the rectangle framing the atrium, with a walled garden behind (C.d.Chirurgo). Then through the tufa period the Pompeians vied with one another in the splendor of their houses. They used relief stucco work to give the walls architectural articulation (First Style), mixing in marble dust to get luminosity and painting it rich colors; they paved the floors with fine colored mosaics free of the garishness of glass. They took the peristyle from their Greek neighbors and added it to the atrium, and a Tuscan atrium often has a second atrium with Ionic or Corinthian columns alongside it. Peristyles are Doric or Ionic, or Doric in the lower story with Ionic above. The gardens seem by preference to have been green gardens, and kitchen gardens seem to have been common in the peristyles. Triclinia and oeci multiplied, but furniture was scant, and the cooking was done in a back court. The finest house of this period is the Casa del Fauno.

Around the time of the Roman colony a new style of decoration appeared. It covered flat walls with painted vistas of architecture, beginning with illusion on the plane of the wall itself and developing beyond in vistas that approach Renaissance perspective (Second Style). Probably it began as an imitation of First Style in painted illusion, but it developed rapidly and the introduction of figures (first as statues) must have come early. To go with the richer decoration of the walls, the floors from now on were paved with black and white mosaic, with occasional color in the border, or with *cocciopesto*

picked out with lines of tesserae or bits of marble. House architecture did not change greatly from the preceding period, but there was more use of unusual forms: vaulted ceilings, Rhodian porticos, Corinthian and tetrastyle oeci. (C.d.Nozze d'Argento, C.d.Criptoportico, Villa dei Misteri.)

The Third Style of Pompeian decoration is Augustan, an egyptianizing style of flat panels framed by mannered architecture and miniature figures, alone, in friezes, and grouped in scenes against pale grounds; genre scenes are especially popular. The style is best suited to small rooms and small houses, but rich houses of small scale had now appeared; the finest in Pompeii is the Casa di Lucrezio Frontone. Sometimes the style is adapted to larger rooms by the introduction of panoramic landscapes in which myths are depicted with tiny figures.

The Third Style was essentially an aberration; the Fourth, no example of which is certainly pre-earthquake, returns to the architectural vistas of the Second, but with flamboyant theatrical architecture, and a cluttering of every part of the architectural frame with figures, statuary, objects, and small pictures. The central pictures are usually mythological; these repeat from house to house and must be copies of famous pictures, but far removed from the originals, and the originals are hard to trace. The subjects sometimes show curious taste (Achilles on Skyros, Hercules and Omphale); Roman subjects are very uncommon, except in landscapes. Such decorations tended to be heavy and served to furnish their rooms; to go with them the architecture of the houses emphasized windows and gardens, which were now livelier in plan and color and often populated with small bronzes and marbles, seldom of good quality, or given a nymphaeum encrusted with brilliant glass mosaic. Water was used extensively; the capitals and entablatures of peristyles were fantastically stuccoed and painted, and houses turned so much to their gardens that the tablinum, once the focus of the house, tended to become insignificant (C.d.Amorini Dorati) or was entirely suppressed (C.d. Vettii). There were now garden houses (C.d.Apollo, C.d.Loreio Tiburtino) and terrace villas with porticos in several stories overlooking the view (V.d.Diomede), but the atrium house continued to the end of Pompeii.

Much of the material, especially that from the Bourbon excavations, is in the Museo Nazionale at Naples. There is a small antiquarium at Pompeii.

BIBLIOGRAPHY. A. Mau, *Pompeji in Leben und Kunst* (2d ed., 1908; tr. F. W. Kelsey, 2d ed., 1902)[MPI]; L. Curtius, *Die Wandmalerei Pompejis* (1929; repr. Hildesheim 1960); A. W. van Buren, *A Companion to the Study of Pompeii and Herculaneum* (2d ed., 1938); R. C. Carrington, *Pompei* (1936); V. Spinazzola, *Pompei alla luce degli scavi nuovi di Via dell'Abbondanza*, 3 vols. (1953)[MPI]; A. Maiuri (tr. S. Gilbert), *Roman Painting* (1953)[I]; id. (tr. V. Priestly), *Pompeii, the new excavations, the Villa dei Misteri, the Antiquarium* (*Itinerari dei musei e monumenti d'Italia*, no. 3; 7th ed., 1965); K. Schefold, *Die Wände Pompejis* (1957); id., *Vergessenes Pompeji* (1962); P. Ciprotti, *Conoscere Pompei* (1959); H. G. Beyen, *Die pompejanische Wanddekoration vom zweiten bis zum vierten Stil*, 2 vols. (1938 & 1960); M. Della Corte, *Case ed abitanti di Pompei* (3d ed., 1965). L. RICHARDSON, JR.

POMPEIOPOLIS, see SOLOI

POMPEY Meurthe-et-Moselle, France. Map 23. The site of Pompey is an industrial center in the valley of the Meurthe, near its junction with the Moselle, in the territory of the Gallo-Roman civitas Leucorum. Since 1962 Gallo-Roman remains have been discovered there: the

foundations of a small villa rustica at the locality called Les Brévelles and a cremation necropolis at the locality known as Mal-de-Ventre. The excavated portion of the villa included a large building (18 x 21.2 m) used for farming and divided into two rectangles of different sizes. In the SE corner a cellar 2.3 m deep, furnished with air vents, contained abundant structural debris, notably polychrome wall paintings, as well as iron tools and 4th c. coins. Near the SW corner an annex sheltered baths: a bathing pool with a flagged bottom was uncovered; its walls still preserved some of their waterproof coating. In 1964 on the site of a house under construction, a stack of ceramic debris was discovered. There were terra sigillata and common wares (in particular over 450 jug necks), datable to the end of the 2d or beginning of the 3d c. Several potter's stamps permit the attribution of the sigillata to workshops in E Gaul. Hard by this dump there extended a 3d c. necropolis, evidently very poor. Their ashes were put in or covered by fragments of jugs, vases, or amphorae which had been broken beforehand.

BIBLIOGRAPHY. L. Geindre, *Pompey sous l'Avant-Garde* (1966) 71-85[MPI]; R. Billoret in *Gallia* 24 (1966) 277-80[PI]. R. BILLORET

PONS AELIUS, *see* HADRIAN'S WALL

PONSAS Drôme, France. Map 23.

In Gallia Narbonensis. In 1963-64 a necropolis was discovered in the inner courtyard of the Château de Fontager (13th c.). It contained inhumation tombs of two types: on the upper level, tiled tombs with no grave gifts, probably Early Christian, and on the lower one, pagan tombs dug in the ground and containing grave goods from the 4th c. A.D. The site had been occupied a long time: apart from stratigraphy, a Campanian potsherd and the fragment of a 4th c. A.D. Attic cup have been found.

BIBLIOGRAPHY. M. Leglay, "Informations," *Gallia* 22 (1964) 532-35. M. LEGLAY

PONS SARAVI (Sarrebourg) Moselle, France. Map 23.

A relay station 80 km SE of Metz on the Reims-Strasbourg road between Tarquimpol and Saverne, before the road crosses the Vosges. The city's origins go back to the Iron Age, but it was not important until the Sarre was crossed by the Roman road. The earliest bridge over the river was discovered ca. 20 years ago; it replaced a ford, and was in turn followed by a stone bridge. It is precisely oriented W-E, on the axis of the town's decumanus. In 1960 the cardo was traced; it cut across the decumanus roughly between the Grand'rue and Avenue Poincaré, coming from the S (Rue de la Marne). The forum probably lay W of this S-N street, possibly near what is now the marketplace; the basilica stood on the site of the modern parish church. The residential quarters spread out on the terraced slope from the Rue Foch to the Sarre; but from the 2d c. on the city spilled over onto the Marxberg and Rebberg hills to the SE, where altars to Sucellus and Nantosvelta have been discovered as well as a Mithraeum.

Study of 13 ancient strata date the first Roman settlement in the reign of Tiberius. The city flourished in the Julio-Claudian period and profited considerably from the Pax Romana; no less than 180 villas were built in the fertile countryside. One stratum shows signs of a fire, possibly an indication that the city suffered in the Germanic invasions of the 3d c., either in 244 or in 250-260. During this period many people left their country homes to take refuge in the city, which was protected by a rampart running from the river to the modern Rue Foch. It is not certain whether Sarrebourg had a garrison at that time. Several hoards have also been excavated.

The Sarrebourg museum has an archeological collection.

BIBLIOGRAPHY. M. Lutz, "La région dela Haute-Sarre," *Annuaire de la Société d'Histoire et d'Archéologie de Lorraine* 65 (1966) 14ff; E. Linckenheld, *Répertoire archéologique de l'Arrondissement de Sarrebourg* (1929). M. LUTZ

PONTCHEVRON and LE ROCHOIR Loiret, France. Map 23.

These two archaeological sites lie roughly midway between Ouzouer and Brivodurum (Briare). The village of Ouzouer sur Trézée (the name is derived from oratorium) lies 7 km E of Briare on the banks of the canal of the same name. Since the 17th c. this canal has linked the Loire and the Seine, which were connected in antiquity by portage. The region of Gien and Briare, now part of the department of Loiret, belonged in late antiquity to the city of Auxerre. Before it became autonomous the city was probably a pagus or dependent city of the Aedui; beyond Genabum (Gien) to the E lay the territory of the Carnutes and to the N that of the Senones.

Le Rochoir is the site farther S; it was excavated in 1858. A rectangular rampart (200 x 150 m), with small chambers backed against the wall, enclosed a number of rectangular buildings, some of which were paved with mosaics. The enclosed area is cut in two by a NE-SW road, the part to the E being considerably larger. Next to the road is a ruin with a circular plan which has been interpreted as a small amphitheater. Much pottery and two hoards of coins were discovered in the course of excavation. The plan of the complex recalls that of double-piazza conciliabula (Sanxay and Tours Mirandes), settlements found chiefly in frontier regions. No traces of the ruin can be seen today.

The site of Pontchevron lies 2 km N of Le Rochoir, in the grounds of a 19th c. château. At the bottom of a marshy valley are a number of springs. Here, in 1898, a building was discovered with mosaic floors, but they were covered again without being sketched or photographed. In 1962, however, the mosaics were located and restored, and they are now preserved in the château outbuildings.

The floors belonged to two connecting rectangular rooms (8.8 x 6.5 m and 6.3 x 4.3 m), with walls built of a core of mortared rubble faced with small blocks. The building, which had other unexcavated rooms to the S and SE, was burnt down. The mosaic in the larger room, which lies to the W, has a multiple decoration. The ground is divided into 35 panels 0.8 m square by white bands with black squares in them, placed point to point. Each panel has a geometric design of black on a white background. The central panel shows a maze with a stylized aedicula in the middle. There are 17 types of decoration, some of which are repeated two, three, or even four times, the similar motifs generally being symmetrical in relation to the axis of the room. Roughly one-third of the floor is destroyed.

The floor of the second room has a design of eight-pointed stars separated by hexagons. In the middle, a larger hexagon serves as a frame for a polychrome head of a man, seen full-face; long-haired and bearded, he has a deep-blue veil over his head. Near his right shoulder is a steering oar.

These two mosaics are related to those of the Rhône valley. The W one is very similar to one of the Verbe Incarné floors at Lyon, which has been dated from the reign of Marcus Aurelius or the Severan era. The Pontchevron floors are probably of the latter date.

The god in the middle of the mosaic may be Neptune, with a blue cloak over his head, but such a veil is unique

and Neptune's symbol is a trident, not a rudder, which is more often associated with the river-gods. These latter are rarely veiled; but on coins of Trajan representing the river of Rome overcoming Dacia the Tiber has a wind-filled veil (of the aurae velificantes type) over his head. The cult of river-gods is rare in Gaul, only the Rhine being personified in this way while lesser rivers are represented by goddesses. The latter have feminine names. The Loire (Liger), however, is masculine in Latin as it doubtless was in Gaulish. Therefore the Loire may be the river shown in this mosaic.

The function of the building is uncertain; in plan it resembles a house rather than a sanctuary. But the proximity of the spring and the fact that the mosaics are probably religious in character perhaps indicate the second interpretation.

BIBLIOGRAPHY. Mosaics: cf. H. Stern, *Recueil Général des Mosaïques de la Gaule* II (1967) Lyonnaise 1, 55-56 and pl. XLI, no. 59; the Tiber on coins: H. Mattingly & E. A. Sydenham, *The Roman Imperial Coinage* (1923-) nos. 556-59; J. Le Gall, *Recherches sur le Culte du Tibre* (1953) pl. XII. G. C. PICARD

PONTECAGNANO, *see* PICENTIA

PONTIA (Ponza, island of) Italy. Map 14. In the Tyrrhenian Sea S of Rome, 33 km off Cape Circe, the nearest point of land on the W coast of Italy, and 268 km from the E coast of Sardinia. The main island of the Pontine archipelago, its relative importance is due to the fact that it is the only island in the group with a naturally protected harbor. According to legend, this is Circe's mythical island, and it has been suggested that the NW Pontine group, consisting of the islands of Pontia, Palmarola, Zannone, and the rock of Gavi may be the islands of the Sirens. It lies in an area rich in Homeric tradition throughout classical antiquity (Cic. *Nat. D.* 3.19; Verg. *Aen.* 3.386; Strab. 5; Pliny *HN* 3.9).

So far, no archaeological evidence has appeared of a Greek or Mycenaean settlement in the Pontine group. The islands, however, provide the first landfall on a course from the W Mediterranean through the Straits of Bonifaccio to the Gulf of Gaeta and the Bay of Naples area, and Pontia's protected coves were surely known to mariners from earliest times. Pontia may be thought of as the outer edge of the maritime zone controlled by the cities of Magna Graecia: beyond it to the N and W lay the hostile waters of the Etruscans and their Phoenician allies.

A Latin colony was founded on Pontia by the Romans in 313-312 (Diod. Sic. 19.101.3; Livy 9.28.7), a significant proof of Rome's early concern with the sea and with its maritime defenses in the Tyrrhenian. According to Livy (27.9.1-10; 39.15) the colony was important enough by the year 209 to lend noteworthy assistance to Rome in the war with Hannibal, but no trace of the Republican settlement has been found.

During the Giulio-Claudian dynasty the island was famous as a place of exile for prominent members of the royal family; among them Nero, son of Germanicus, an adopted son of Tiberius (Suet. *Tib.* 54) and the sisters, Agrippina and Giulia, banished by Caligula (Dio. Cass. *Hist.* 84; Tac. *Ann.* 14.53). The major extant ruins belongs to two villas of the Augustan and early Julio-Claudian periods. One of these occupied a position on the high promontory near the S end of the E shore of the island known as the Punta della Madonna. This headland encloses the seaward side of Pontia's best protected cove, probably the location of the ancient harbor as it is of the modern one. Along the heights are remains of ancient terracing and it is possible to trace the outlines of several structures, one of which has been described as an odeon. At the base of the headland at water level, facing into the bay, a system of rock-cut chambers and basins are usually described as fisheries belonging to this villa. The largest of the basins (7.5 x 10 m) is located just outside the root of the breakwater at Punta della Madonna, which, together with the harbor embankments, was completely rebuilt in 1739. The other villa occupied a position on the landward side of the harbor at a place now called Santa Maria.

Along the heights of the ridge separating the harbor at Punta della Madonna from another deep cove on the W side of the island is a necropolis characterized by a standard type of Hellenistic rock-cut hypogeum: a single rectangular chamber containing both niches for cinerary urns and loculi for inhumation burials. All the known materials from this cliff-top necropolis are of the 1st and 2d centuries A.D., though architecturally it belongs to an earlier tradition.

Apart from the villas and the necropolis the bay area enclosed by Punta della Madonna and Santa Maria preserves an interesting feature which further suggests that this SE portion of the island was the center of ancient habitation on Pontia and perhaps the location of the early Republican settlement. This is a man-made tunnel 168 m long and lighted at intervals by a number of shafts cut through the rock overhead. The tunnel connects the main harbor area at Punta della Madonna with the Cala Chiaia di Luna, a cove facing W on the other side of the island's narrow spine. This tunnel, undoubtedly of Roman construction, is in many places reinforced with concrete faced with reticulate masonry. It connects what must have been the most thickly settled part of the island around the harbor on the S-SE coast with an alternative bay on the W, the Chiaia di Luna, which was no doubt used for mooring ships during periods of bad weather from E and NE winds.

On the N side of the island a system of ancient subterranean aqueducts has been reported with openings in the Calla dell'Inferno on the E, and possibly also farther S near Santa Maria. A recent underwater survey along the coasts of Pontia reported concentrations of amphora fragments and fragments of common and cooking ware dating mainly to the Late Republican and Early Empire. The main concentrations were located off Punta della Madonna and Santa Maria and seem to belong to the villa sites.

BIBLIOGRAPHY. G. Tricoli, *Monografia per la Isole del Gruppo Ponziano* (1859); A. Maiuri, "Ricognizioni archeologiche nell'Isola di Ponza," *BdA* 6 (1926) 224-32; L. Jacono, "Solarium d'una villa romana," *NSc* (1929) 232ff; id., "Un porto duomillenario," *Istituto di Studi Romani. Atti del III Congresso Nazionale* (1935) 318-24; id., "Ponza," *Enc. Ital.* 27 (1935) 907; id., "Una singolare piscina marittima in Ponza," *Campania Romana* (Sezione Campana degli Studi Romani, Naples, 1938) 143-62; L. M. Dies, *Ponza, perla di Roma.* (1950) with an introduction by A. Maiuri; A. M. Radmilli, "Le Isole Pontine e il commercio dell'ossidiana nel continente durante il periodo neo-eneolitico," *Origines (Scritti per M. G. Baserga)* (1954) 115ff; O. Baldacci, *Le Isole Ponziane* Memoria della Societa Geografica Italiana, XXII (1955); F. Castaldi, "L'Isola di Ponza," *Annali dell'Istituto Superiore di Scienze e Lettere Santa Chiara* 8 (1958) 167-215; *EAA* 6 (1965) 376 (L. Guerrini); M.F.A. Ghetti, *L'archipelago Pontino nella Storia del Medio Tirreno* (1968) esp. pp. 1-59 and bibliography, pp. 309-15; G. Schmiedt, *Il Livello Antica del Mar Tirreno* (1972) 177. V. J. BRUNO

PONZA, *see* PONTIA

POPULONIA Tuscany, Italy. Map 14. A city on a promontory 14 km N of Piombino. Inhabited from the Bronze Age, it had its major floruit in the orientalizing period (7th c. B.C.). The city encompassed the acropolis, 181 m above sea level, and to the E of it on a ridge a coastal settlement, with a small harbor on the Gulf of Baratti. Each had a fortified circuit wall. The name is found only on coins of the 4th c. B.C. In the Hellenistic period, when it mined the iron ore on the island of Elba, it became an industrial center. The city declined after the Roman conquest, was sacked by Totila in 546, and in 570 was nearly destroyed by the Longobard Gummaruth.

The archaic necropolis follows the curve of the gulf. The tombs of the orientalizing period have square chambers with funeral beds; the mound sometimes rests on a cylindrical base, sometimes directly on the ground. In the second half of the 6th c., the architectural stone sarcophagus appeared and in the 5th c. the niche tomb, constructed along the lines either of an architectural sarcophagus or of a cult shrine.

The Hellenistic necropolis on a nearby knoll has rock-cut chamber tombs. Covered tombs of the late Roman period have been discovered at many areas.

BIBLIOGRAPHY. A. Minto, *Populonia* (1943); K. R. Maxwell-Hyslop, "Notes on some distinctive types of bronzes from Populonia, Etruria," *Proceedings of the Prehistoric Society* 22 (1956) 126ff; M. A. Del Chiaro, "The Populonia Torcop Painter," *StEtr* 28 (1960) 142ff; G. Schmiedt, "Contribution of photo interpretation to the reconstruction of the geografic-topografic situation of the ancient ports in Italy," *Papers for the X International Photogrammetry Congress* (1964); A. De Agostino, "Scoperte archeologiche nella necropoli," *NSc* (1957) 1ff; (1961) 63ff; id., in *StEtr* 24 (1956) 255ff; 30 (1962) 275ff. A. DE AGOSTINO

POREČ, *see* PARENTIUM

POROLISSUM (Moigrad) Sălaj, Romania. Map 12. The most important military center in NW Dacia, a Roman town with canabae, in a region of hills and valleys, near Moigrad and Jac.

The name, of Dacian origin, appears in ancient sources (Ptol. 3.8.6; *Tab.Peut.; Rav.Cosm.* 4.7).

Before the Roman conquest, there was a Dacian settlement on the Citera hill, and on the Măgura hill a Dacian cremation cemetery (1st-2d c.).

Porolissum gave the name to Dacia Porolissensis, created by Hadrian in 124. There was a strong military garrison here in two camps. On Pomet hill is one of the largest camps (226 x 294 m) in Dacia. Built first of earth, it was rebuilt of stone. Inscriptions discovered at the gates testify to the rebuilding of the camp under Caracalla, and to the hasty rebuilding under Gallienus. The interior wall is 1.5 m thick and has two ditches.

At a distance of 700 m NE on Citera hill is another smaller camp (66.65 x 101.10 m) first built of earth and later rebuilt of stone. The gates have squared towers at every corner projecting from the interior wall, with trapezoidal towers inside. There is an inner and outer ditch. Stationed at Porolissum were Cohors I Brittonum milliaria Ulpia Torquata pia fidelis civium Romanorum, Cohors V Lingorum, Numerus Palmyrenorum Porolissensium Sagittariorum civium Romanorum (which later became Ala Palmirenorum Porolissensium) and Cohors I Palmirenorum Porolissensium.

The civil settlement, inhabited chiefly by veterans, developed on the S and W terraces of the camp. Porolissum, an important center for trade with the barbarians, was probably a customs station. Entering the province from Porolissum were roads that started from Aquincum and ended at the mouth of the Danube, and there ended here the main thoroughfare that started at the Danube and linked the most important centers of Dacia.

Under Septimius Severus the town became a municipium. Coins prove that it continued to be inhabited after the withdrawal of Aurelian in 271.

The town had no stone precincts but was defended from barbarians by limes consisting of a stone wall alternating with an earth wall and a ditch strengthened by small earth castella and stone towers.

Excavations at the civil settlement have revealed the baths, an insula composed of four buildings closely aligned, private dwellings, and a temple to Liber Pater. More recent excavations have concentrated on the amphitheater, the palestrae, and the necropolis with incineration tombs and small mausoleums on the Ursoieş hill.

The amphitheater, 100 m from the SW corner of the camp on Pomet hill, is on a terrace. Originally built of wood, it was later rebuilt of stone in the year 157 by order of the imperial procurator Tib. Claudius Quintilianus (*CIL* III, 836). The arena, elliptical in form, has an axis 60 m long. It is bordered by a stone wall, built in opus incertum and plastered on the side facing the arena. At the E gate, which has two rooms on either side, traces of the wooden piers of the first stage of construction have been discovered.

Among the finds are four military diplomas, one of which dates from August 11, 106, a time at which Dacia was already a Roman province. Bronze statuettes, an equestrian statue of the emperor Caracalla, inscriptions and sculptural monuments, gems of local cutting, are all to be found at the Museum of History and Art in Zalău and in the History Museum of Transylvania in Cluj.

BIBLIOGRAPHY. C. Daicoviciu, "Neue Mitteilungen aus Dazien," *Dacia* 7-8 (1937-40) 323-36; M. Macrea et al., "Santierul arheologic Porolissum," *Materiale şi cercetări arheologice* 7 (1960) 361-86; (1962) 485-501.
 L. MARINESCU

POROS, *see* KALAURIA

PORTCHESTER, *see* PORTUS ADURNI

PORTHMEION Bosporus. Map 5. An ancient Greek settlement NE of Pantikapaion along the W coast of the Kerch Strait near the village of Zhukovka (Anon., *Periplus Ponti Euxini*, 69, 76). Founded in the late 6th c. B.C., it was extensively rebuilt about the middle of the 3d c. B.C. on a grid pattern and was encircled with a powerful defensive wall, possibly in response to the threat posed to the Bosporus by the Scythian state established in the Crimea. The life of the city ended in the first half of the 1st c. B.C., most likely during the turbulent reign of Mithridates Eupator.

The city, whose remains today cover an area of 0.65 ha, has been studied since 1950 but only intermittently. Much of the original settlement was apparently destroyed during rebuilding, but remains of dwellings from the late archaic and Classical eras have been discovered. During the Hellenistic period, large one-block buildings seem to have been constructed which were then subdivided into a series of separate homes with common external walls bordering on the adjoining streets. At one point along the defensive wall, a city gate flanked by towers was uncovered. A paved street led from the gate into the city. Situated at the crossing from the European to the Asiatic side of the Kerch Strait, the city had a lively trade evidenced by numerous finds of various types of imported Greek pottery and by coins of Pantikapaion.

BIBLIOGRAPHY. V. V. Veselov, "Drevnie gorodishcha v raione Siniagino (K voprosu o mestopolozhenii Parfeniia

i Porfmiia)," *Arkheologiia i istoriia Bospora*, I (1952) 227-37; E. G. Kastanaian, "Raskopki Porfmiia v 1953 g.," *SovArkh* (1958) 3.203-7; id., "Raboty Porfmiiskogo otriada Bosporskoi ekspeditsii," *Arkheologicheskie Otkrytiia 1971 g.* 334-35; id., "Raskopki Porfmiia," *Arkheologicheskie Otkrytiia 1972 g.* 284-85; id., "Raskopki Porfmiia v 1968 g.," *KSIA* 130 (1972) 77-82.

T. S. NOONAN

PORTICELLO, see SHIPWRECKS

PORTITSA and VOUNESI Thessaly, Greece. Map 9. Two small fortresses 9.6 km W of Karditsa, on the N slopes of Mt. Korona (131.4 m). They form the SW part of the extensive fortification wall of the ancient town of Metropolis, whose fortification comprised the SE end of the four fortifications of Thessalian Hestiaiotis. Ruins of this surrounding wall can be followed partly for 5 km, as far as Gralista, Pyrgos, Portitsa, and Vounesi, up the river Lapardas, where a part of the wall was excavated. The wall at this point was built into a series of projecting and recessed portions. On Mt. Koutra was situated the highest part of the acropolis of Metropolis. The fortress near Portitsa is called Stephane (wreath) because of its round shape.

(See also Metropolis.)

BIBLIOGRAPHY. B. V. Head, *HN* (2d ed. 1911) 302; A. S. Arvanitopoulos in *Praktika* (1911) 337ffI; id. in *AthMitt* 37 (1912) 73ffI; F. Stählin, *Das hellenische Thessalien* (1924) 128ff; id., "Metropolis," *RE* xv 1491ff; A. Philippson & E. Kirsten, *GL* (1950) 161, 261, 291.

G. S. KORRÈS

PORTO CHELI, see HALIEIS

PORTOCIVITANOVA, see CLUANA

PORTO CONTE Sardinia, Italy. Map 14. Nuraghic settlement on the W coast of Sardinia to the NW of Alghero, between Capo Caccia and Punta del Giglio. It may perhaps be identified with the Nymphaion Limen mentioned by Ptolemy (3.3.1). After the Roman Conquest of Sardinia, a villa rustica was built at Santimbenia on the edge of the sea, almost midway on the gulf. Exploration of the villa in the 1960s revealed a rectangular structure with the long sides perpendicular to the sea, divided into large rooms with mosaic pavements. The building consists of a large central hall with rooms to the N toward the land and to the S toward the sea. Behind it a long hall runs along the E side. The structure is oriented NE-SW. On the W side rooms connect this building with the service area 50 m away. These connecting rooms include a long outer hall to the E whose upper interior walls preserve a band of stucco reliefs, datable by the style to the second half of the 1st c. A.D. Not far away, along the road to S. Maria la Palma, a necropolis has been discovered. It consists of pit burials and burials in coffins made of stone slabs or roof tiles. The meager funerary material is datable to the 3d c. B.C. Other remains indicate that the necropolis was used until the end of Republican times.

BIBLIOGRAPHY. A. Lamarmora, *Viaggio in Sardegna*, II (Ital. ed., 1927) 313; G. Maetzke, *Studi Sardi* 17 (1959-61) 657ffP.

D. MANCONI

PORTOCORRES, see TURRIS LIBYSONIS

PORTO GERMANO, see AIGOSTHENA

PORT ROMAIN (Kherbet Ramoul) Algeria. Map 19. A small settlement on the coast between Mostaganem and Ténès, ca. 274 km W of Algiers, on the ancient route from Caesarea (Cherchel) to Portus Magnus (Bettioua, ex-St. Leu). The excavations have been too limited to uncover the whole. The name is erroneous, since it was not in fact a port, but a quarry at the edge of the sea; one sees only the traces of blocks extracted from a cliff on which the ruins lie.

Near the road, a large rock is hollowed out into a funerary chamber with bench, of the Punic type. Further W, backed up against the rock, are the remains of a fairly important structure. To the N, and close to the sea, is a Christian basilica of perhaps the end of the 5th c., its apse flanked by two square rooms; this is the simplest type of rural church in the region, found also at Cap Ivi, 68 km farther W. Clandestine excavations have brought to light there a roofed tomb with a mosaic representing a standing figure, arms stretched out, by a candelabrum, on the model of the tomb mosaics of Tunisia, in particular Thabraca. Beside this structure are small baths and a cement-lined basin filled with fish scales and bones, possibly a garum factory. To the NW is a fine private house, of good masonry, opening to the E with a set-back porch giving on a concealed entry overlooked by a balcony; the asymmetrical construction is ordered around a courtyard open to the sky and bordered by a portico supported by four corner-pillars and by columns, two on the long sides, one on the short ends. To the S are four rooms, to the N two double rooms; to the W finally a suite with a semicircular oecus adorned with mosaic and marble opus sectile, and traces of wall paintings.

BIBLIOGRAPHY. J. Marcillet-Jaubert, "Mosaïque tombale de P. R.," *Libyca* 3 (1955) 281-86P; J. Lassus, *Libyca* 5 (1957) 126-29PM.

J. MARCILLET-JAUBERT

PORT-SAINTE-FOY Dept. Dordogne, France. Map 23. At Le Canet, on the W bank of the Dordogne, is a Gallo-Roman villa discovered in 1922. One wing of the villa (35 x 15 m) gives onto the river, and in it seven rooms have been identified, among them two laid out as a facade gallery (26.15 x 3.40 m). The various rooms were decorated with mosaics, among which are several Early Christian themes: anchors, cross, baskets adorned with symbolic grapes; the villa can be dated in the late Empire.

BIBLIOGRAPHY. J. Coupry, "Informations arch.," *Gallia* 17.2 (1959), 387.

M. GAUTHIER

PORT-SAINTE-MARIE Dept. Lot-et-Garonne, France. Map 23. On the ancient road linking Burdigala to Aginnum, on the right bank of the Garonne, at a place known as Flaon, is a Gallo-Roman villa whose construction apparently dates from the 1st c. A.D., according to chance finds of coins and fibulae. The construction, ranged in terraces on the flank of the hill overhanging the river, has been excavated to a width of 25 m. Other ancient structures have been noted at La Peillas and Rance; all were destroyed in the invasion of A.D. 276.

BIBLIOGRAPHY. J. Coupry, "Informations arch.," *Gallia* 23.2 (1965) 432; 25.2 (1967) 361.

M. GAUTHIER

PORT-SUR-SAÔNE ("Portus Abucinus" or Bucinus, or Buxinus) Haute-Saône, France. Map 23. The ancient name is mentioned in the *Notitia Galliarum* at the end of the list of places in the Provincia Maxima Sequanorum. It reappears in the account of the Passion of St. Valerius, archdeacon of Langres, as the place of his martyrdom (*Acta Sanctorum* 9, Oct. 22, 525, 526, 535). The site has been located at Port-sur-Saône, where there is a chapel to Saint-Valerius on the left bank across from the modern town. On the same bank, at the places

called Le Magny and Cuclos, are sizable Roman ruins; a large villa was excavated in 1860 and other discoveries have been made recently. (Bucey-les-Traves has also been suggested as the site of Portus Abucinus.)

BIBLIOGRAPHY. L. Suchaux, *Dictionnaire historique, topographique et statistique de la Haute-Saône* II (1866) 168-71; H. Stern, *Recueil général des mosaïques de la Gaule romaine* I, 3 (1960) 98-99, no. 367; L. Lerat, *Gallia* 22 (1964) 381-83. L. LERAT

PORTUS Italy. Map 16. A large artificial harbor built by Claudius 3.2 km N of the mouth of the Tiber. It was partly excavated from land in a bay and was protected by two moles enclosing an area roughly circular in shape with a maximum diameter of ca. 1000 m. The most spectacular feature of this harbor was a grand lighthouse for the foundations of which Claudius used the gigantic merchantman built to transport from Egypt the obelisk that was erected in the circus beside the Vatican hill. The vessel was filled with concrete and sunk to form ca. 90 m of the left mole some 200 m from its end. The new harbor was not a complete success, for 200 ships in harbor are reported by Tacitus to have been lost in A.D. 62. It was partly for this reason that Trajan added to the Claudian harbor a large hexagonal basin with sides measuring 358 m. Claudius had linked his harbor with the Tiber, and thus with Rome, by two canals, which Trajan replaced with a single new canal.

In 1925, when Trajan's basin was restored to approximately its original state, the main features were studied before it was filled. In the retaining walls large travertine mooring blocks were still in place, and there had been small columns with numbers round the basin, probably to identify berthing stations. Six meters from the quayside runs a wall which facilitated control, and the narrowness of the doorways shows that carts were not used to carry cargoes to the warehouses. The coins commemorating Trajan's harbor show warehouses round all sides except the NW. Most of the storage available was used for grain, but some sections were reserved for other commodities. A relief in the Torlonia Museum shows a merchantman unloading wine and in the background a statue of the wine god. A small circular peristyle temple of Liber Pater was found on the NE side of the harbor. The neighboring quay may have been reserved for the wine trade. Trajan's coins suggest that the buildings on the NW side of the harbor were different and this was confirmed by 19th c. excavations, which found traces of a small theater, baths, and a series of rooms round a large atrium. This is probably where the imperial procurator responsible for the control of the harbors had his headquarters and where the emperor would stay on official visits.

The harbor plans probably did not provide a residential area for the required labor force, but there had to be a nucleus of residents for emergencies, including a detachment of vigiles to fight fires, and the settlement was bound to grow. By the time of Constantine the harbor population was sufficiently large to manage its own affairs with the proud title of Civitas Flavia Constantiniana. The line of the brick-faced walls which were built at or near this time indicates the general plan. The two main housing areas were to the S between the harbor and Trajan's canal and in a large triangle to the E. It is at the apex of this triangle that the road from Rome enters the town by the Porta Romana and the aqueduct followed the line of the road. Of the buildings in this area only a large unidentified circular peristyle temple survives above ground near the gate. In the S area a Christian basilica has been traced, attached to which was a rest house for pilgrims built by the patrician Pammachius. South of the canal the elegant mediaeval campanile of S. Hippolito commemorates a martyr of Portus. The two main necropoleis developed along the roads that led to Rome and to Ostia. A large number of tombs excavated in the latter are among the best preserved in the Roman Empire, illustrating the transition from cremation to burial, which was completed by the end of the 2d c.

In the Late Empire Portus remained vital to Rome. Though it was sacked by Alaric in 408, one of its most famous monuments was built ca. 425, a marble colonnade stretching along the north bank of the canal for some 200 m, Porticus Placidiana. But by the 6th c. the harbors were silting up and grain from overseas was no longer essential for the maintenance of Rome's heavily reduced population.

BIBLIOGRAPHY. G. Lugli & G. Filibeck, *Il Porto di Roma Imperiale e l'Agro Portiense* (1935); G. Calza, *La Necropoli del Porto di Roma Imperiale nell'Isola Sacra* (1940); O. Testaguzza, *Portus* (1970); R. Meiggs, *Roman Ostia*[2] (1974). R. MEIGGS

"PORTUS ABUCINUS," see PORT-SUR-SAÔNE

PORTUS ADURNI (Portchester) Hampshire, England. Map 24. The castle stands on a low promontory projecting into the upper reaches of Portsmouth harbor. Limited occupation of the mid-1st c. A.D. has been found, but the main phase of use began in the late 3d c. with the construction of the Saxon Shore Fort. Excavations show that occupation continued throughout the Saxon period. In mediaeval times the Roman walls served as an outer bailey for a castle which, after a series of modifications, was eventually used as a prison during the wars between Britain and France in the late 18th and early 19th c.

The Roman fort consists of a regularly planned rectangle enclosing ca. 3.6 ha. The walls were built of coursed flint rubble with the occasional use of chalk blocks, and with bonding courses of stone and tiles at intervals. Originally 20 hollow D-shaped bastions projected from the wall, one at each corner and four regularly spaced along each side. They were floored with timber at the level of the rampart walk to form fighting platforms for men and artillery. The two main gates were in the centers of the E and W sides. In both the full width of the wall was turned into the fort, creating a courtyard, at the inner end of which the gate was erected (two guard chambers flanking a 3.3 m roadway). Simple postern gates, 3 m wide, pierced the centers of the N and S walls. Outside, enclosing the fort, were two V-shaped ditches.

Extensive excavations began in 1961 in the enclosed area. Buildings were of timber, arranged along graveled streets; between them were cesspits and wells. Several phases of occupation can be defined. The first represents the use of the fort under Carausius and Allectus (A.D. 285-296), during which time Britain was self-governed and the shore forts were probably defenses against the threat of Roman attack. After the reconquest of Britain by Constantius Chlorus in 296 the garrison at Portchester was removed and some, at least, of the internal buildings were deliberately demolished, but the interior continued to be occupied by civilians. Early in the 340s renewed building activity can be recognized. It was probably at this time that the fort was regarrisoned, perhaps by the Numerus exploratorum listed in the *Notitia Dignitatum*. Intensive occupation ended about 370 during the reorganization carried out by Count Theodosius; the force may have been transferred to Clausentum, but occupa-

tion of a less organized kind continued into the Saxon period. Several sunken huts (*Grubenhäuser*) of Germanic type have been found, dating from the early 5th c.; they suggest the presence of mercenaries among the population of late Roman times.

The walls of the fort and the foundations of part of the W gate can be seen, but no interior features are visible. While excavations are proceeding the excavated material is not on display.

BIBLIOGRAPHY. B. Cunliffe, "Excavations at Portchester Castle, Hants, 1961-63," *AntJ* 43 (1963) 218-27; "1963-65," 46 (1966) 39-49; "1966-68," 49 (1969) 62-74; id., "The Saxon Culture-sequence at Portchester Castle," ibid. 50 (1970) 67-85. B. W. CUNLIFFE

"PORTUS BLENDIUM," *see* SUANCES

PORTUS IULIOBRIGENSIUM or Portus Victoriae Iuliobrigensium Santander, Spain. Map 19. Cited by Pliny (*HN* 4.3). Its name refers to its status as Iuliobriga's outlet to the sea and to a victory of Augustus in the Cantabrian wars. The hypocaust of baths, perhaps belonging to a building of the 1st c. A.D., survives.

BIBLIOGRAPHY. J. González Echegaray, "Estudio sobre Portus Victoriae," *Altamira* 2-3 (1951) 282ff; A. García y Bellido, *Excavaciones y exploraciones arqueológicas en Cantabria* (1970). R. TEJA

PORTUS MAGNUS (Bettioua or St.-Leu) Algeria. Map 19. Forty km E of Oran, the site is, in spite of its name, perched on a cliff that is separated from the coast by a plain 600 to 800 m wide. There were buildings on the slope, and perhaps at the foot of the cliff, though the evidence is slight; also, archaeologists dispute the site of the port, which was known however to Pomponius Mela and Pliny. Some favor Port-aux-Poules, a little farther E, but the classical name of that site—Portus Puellarum—is known from inscriptions. Gsell assumed that the name Portus Magnus stood for the whole of the Gulf of Arzew even though, properly speaking, the port of Arzew is several km to the W.

The site was certainly occupied before the Romans got there. A Punic vase and some Iberian potsherds have been found in a tomb, and Campanian and Arretine pottery abounds. But it is a Roman city that has been excavated in part: even the neo-Carthaginian inscriptions date from Roman times.

Described by el Bekri, mentioned by Shaw in 1743, Portus Magnus was more often referred to than explored, or even described, until the excavations of 1950 to 1963. Digging is limited because of the modern village, which has covered part of the ruins; and the perimeter of the ancient city is far from being completely excavated. No doubt there was an enclosing wall, as evidenced in places by an embankment and a few blocks of stone. Edging the cliff are some retaining walls that connect with some cisterns lower down; they give the impression of a surrounding wall and towers.

The city forum was located long ago and has been completely excavated. It is roughly 50 x 40 m including porticos and lies almost at the middle of the E-W axis of the uncovered remains. It was only partly paved, the rock having been hewn to the required level. Leveling of the surface created a shift with the E section of the city; so the forum appears to have been added to a city that was already there, and the leveling work was done only where it was absolutely essential. The portico along the W half of the S side and all along the W side was paved. The N portico was aligned with the edge of the cliff. At each corner were huge cisterns set under the lateral porticos of the forum to catch rain water. A few elements of the columns have been uncovered; they were of limestone, stuccoed, with engraved fluting. In the S part of the axis of the forum was a building facing N—perhaps a small sanctuary.

Given the site of the forum, the buildings attached to it could only be behind the W portico. Chief of these is an oblong hall, its larger axis parallel to the portico, with a little apse in the middle of the long W side. In the apse is a pedestal, decorated with moldings, that once supported a statue. Measuring about 20 x 8 m, the hall is too small to be a basilica and most probably was the curia. It was paved with mosaics and its walls were faced with marble. Another hall, at right angles to it, gave onto the portico farther S; it had buildings attached to it, all now very badly damaged.

Behind the curia is another, square hall. It is laid out along a different axis, so that a small triangle is formed between the two monuments. This hall had four interior pillars, and there is a recess in the axis of the W wall. To the E the facade was fronted by a portico, probably distyle in antis. This was very likely a sanctuary, oriented in accordance with ritual.

Some 120 m W of the forum, and laid out along the same axis, is a temple courtyard. It has been unevenly preserved and is somewhat abnormal in arrangement. On three sides the courtyard was lined with porticos; the plinths and several bases of the columns are still standing. The facade wall, on the other hand, has gone. The courtyard is 23 m wide, but the temple does not occupy the whole of the rear. The temple was approached by stairways that started against the S wall, skirted the seventh column of the portico and swept out over an area 12 m wide, perhaps up to a retaining wall. On the platform, which is of concrete, the walls have almost completely disappeared; there were probably three cellae.

To the SW, behind the temple, are the remains of some elements of walls with box-tile jacketing: this must be the site of the baths pointed out by Gsell. To the E of the forum a street 80 m long has been uncovered. It is separated from the forum by the difference in ground level, and no connecting stair or ramp has been found. Doorsteps have been found on both sides of this street, along its entire length, but only one house has been investigated. It seems to have been a sizable complex, its rooms frequently joined by steps because of the sloping ground. The street door is flanked by columns. Just inside, a wide stairway leads to a vestibule that opens, through a triple-columned entrance, onto a courtyard. This has two porticos, and a cistern at one side. Two small rooms are located to the W and S. To the N are stepped corridors that give onto another courtyard. Farther to the W is a group of three cisterns, joined together, and beyond them, farther down, a large room with pillars, flanked by some tiny baths whose largest room covers only 9 sq. m; some are heated.

Beyond it, toward the SE, more houses stretched to the lowest edge of the cliff. There, other cisterns were joined by retaining walls. It looks as if these cisterns—numerous, large, and strongly built—served not only to supply abundant water to the houses but also to help irrigate the coastal plain. Lower down on the slope two terraces are edged by long walls, some of which at least belonged to monumental buildings.

The rest of the city has been excavated only here and there. The late 3d c. mosaic now in the Oran Museum was found near the enclosing wall, close to a gate, since disappeared. This mosaic was the floor of a triclinium measuring 8 x 12 m. The central area has a border decorated with medallions of geometric designs alternating with animated Bacchic groups. In the middle are

four bands, one on top of the other, of unequal depth, depicting mythological scenes; the composition is complicated rather than harmonious because of the profusion of secondary figures. Herakles is shown slaying the centaur Chiron, Latona is carried off to Delos by Aquilo amidst gods and sea nymphs, and then comes a narrow band representing Apollo's victory over Marsyas. In the center is one of the Kabeiroi, surrounded by figures from their myth. Another wealthy villa had a mosaic of the Triumph of Bacchus.

The decline of the site is confirmed by the sudden rarity of inscriptions; after referring to the Antonines, the Severi, and the Gordians, they abruptly disappear. Only one Christian epitaph has been found, and there is no reference to bishops. All this may seem to support the hypothesis that Diocletian abandoned the W section of Mauretania. In contrast, other sites like Altava seem to show how the influence of the Caesars persisted in the region.

In the course of digging, many pieces of sculpture, of mediocre quality, have been found, but some very fine capitals. These have flowing acanthus designs, showing a broad, original treatment. One of them consists of just one row of leaves; between them and above them are very prominent calyxes, whose curves support the corners of the abacus. To these should be added the fine collection of terra sigillata of high quality, found in the tombs.

BIBLIOGRAPHY. El Bekri, *Description de l'Afrique septentrionale*, tr.; Demaeght, *Bull. des Antiquités Africaines* 2 (1884) 113; *Bull. d'Oran* (1899) 485; S. Gsell, *Monuments antiques de l'Algérie* I 128; *Atlas archéologique de l'Algérie* (1911) 21, no. 6; M. M. Vincent, in *Libyca* (1953) 1; M. Leglay, in *Libyca* (1955) 182; J. Lassus, "Le site de Saint-Leu à Portus Magnus," *CRAI* (1956) 285; id. in *Libyca* (1956) 163; (1959) 225.

J. LASSUS

PORTUS VENERIS (Port-Vendres) Canton of Argelès-sur-Mer, Pyrénées-Orientales, France. Map 23. Excellent seaport located at the E extremity of the Pyrenees on the rocky shore of the Albère, near Cape Béar. It should be identified with Pyréné, a native harbor frequented by the Massaliots from the 6th c. B.C. on (Avienus *Ora maritima* v. 559). The Aphrodision mentioned by Strabo (4.1.3 and 6) should be located near this port, perhaps on Cape Béar itself. Standing on the last slope of Mt. Pyréné, it marked for sailors the dividing line between Gaul and Iberia, and during the Roman period gave its name—Portus Veneris—to the ancient city (Plin. 3.22; Ptol. 2.10.2).

Port-Vendres has yielded to date little in the way of antique remains, but a ship of the Late Empire laden with amphorae has been discovered in the port and explored.

BIBLIOGRAPHY. J. Jannoray. *RE* s.v. Portus Veneris, 22, 1 (1953) cols. 411-18; "Informations," *Gallia* 22 (1964) 475[I]; 24 (1966) 450-51[I]. G. BARRUOL

PORTUS VICTORIAE IULIOBRIGENSIUM, *see* PORTUS IULIOBRIGENSIUM

PORT-VENDRES, *see* PORTUS VENERIS

POSEIDONIA, *see* PAESTUM

POTAISSA (Turda) Cluj, Romania. Map 12. An important Roman town that developed near the legionary camp on the main strategic and commercial thoroughfare of Dacia. Its ruins lie under the present town.

The name is of Dacian origin and appears in the ancient sources (Ptol. 3.8.4; *Tab.Peut.; Rav.Cosm.* 4.7; Ulp. *De censie Dig.* L 15.1.8.9).

The Roman settlement, attested epigraphically from the time of Trajan (*CIL* III, 1627), for a long time was a vicus. Its development was due to the installation here in 168-69 of Legio V Macedonica. Under Septimius Severus (193-211) the town became a municipium and then a colony, and its inhabitants were given the ius Italicum.

Although known somewhat through systematic excavations, the remains have been greatly reduced by modern building. The center of the ancient town was near the present bridge over the Arieş, and remnants of it spread over an area of several square kilometers, within which several structures, canals, etc., have been discovered.

To the SW of Turda on Cetăţii hill is the legionary camp. Built of stone, it is an irregular square in shape and covers an area of 22.98 ha. It is currently under study.

On the slopes of Zînelor hill are workshops of potters and stone carvers, and in the S part of the modern town, a necropolis with sarcophagi.

The epigraphic material, sculpture, and other objects discovered at Potaissa are in the History Museum in Turda and in the History Museum of Transylvania in Cluj.

BIBLIOGRAPHY. I. I. Russu, "Descoperiri arheologice la Potaissa," *Anuarul Institutului de Studii Clasice* 3 (1936-40) 319-40; I. H. Crisan, "Santierul arheologic Turda," *Materiale şi cercetări arheologice* 7 (1960) 431-37; D. Tudor, *Oraşe, tîrguri şi sate dln Dacia romană* (1968) 209-21. L. MARINESCU

POTAKI, *see* ARTEMISION

POTAMIA, *see* KYME (Euboia)

POTAMOS TOU KAMBOU, *see* SOLOI

POTEIDAIA (Nea Poteidaia) Chalkidike, Greece. Map 9. On the isthmus of the Pallene peninsula, the modern Kassandra. Though founded by Corinth ca. 600 B.C., an earlier settlement on the site cannot be discounted. The city experienced a high degree of development and played a prominent role in the major events of Classical Greece until it was captured by Philip II in 356 B.C. and was handed over to the Olynthians.

With the destruction of Olynthos by Philip in 348 B.C., Poteidaia came under the direct dominion of Macedonia. In 316 B.C., Kassander founded on the same site a new city and named it Kassandreia. He included in his city additional land and provided for the settlement of Poteidaians, Olynthian survivors, and others from neighboring towns. Kassandreia soon became one of the most prosperous and powerful cities in Macedonia during the Hellenistic period and continued to play an important role during Roman times, especially after it received Roman colonists, the privilege of jus Italicum, and the right to coin money. In A.D. 269, it repulsed an attack of the Goths and, finally, was destroyed by the Huns and Slavs in A.D. 539-40. It seems to have accepted Christianity at an early period and served as the see of a bishop.

In spite of the prominence of the two cities and the length of their historical existence, the literary evidence that has survived is scanty and disconnected. The most important references for Poteidaia are to be found in Herodotos, Thucydides, Xenophon, and Demosthenes, while for Kassandreia there are references in Diodoros, Polybios, Livy, Pliny the Elder, and Procopius. Other writers add but little to our knowledge of either city. The archaeological record of the site, however, though limited thus far mainly to chance finds and a mass of material

(mostly architectural) unearthed during the cutting of the canal through the isthmus in 1935-37, is impressive enough in its content and variety.

Archaeologically, Poteidaia is best represented by a good number of silver and bronze coins, the foundations of a treasury at Delphi, several bronzes in the British Museum, and a few terracottas (including a 4th c. life-size female protome of clay), and a 4th c. "Apollo" relief. As for Kassandreia, the discovery of the ruins of a temple attributed to Poseidon deserves special mention. Other important finds include inscriptions, coins of the Roman period, and several sculptural fragments. Two Latin inscriptions provide information regarding Roman magistracies in the city and the presence of two Roman tribes, the Papiria and the Romilia. A bilingual inscription commemorating the construction of a gymnasium is also worth mentioning.

The finds from the site, which are now at the elementary school at Nea Poteidaia and at the Thessalonika Museum, are to be transferred to the recently erected museum at Polygyros, the capital of Chalkidike.

Valuable contributions to our knowledge of the two cities have been made by discoveries in other sites of the mainland and the islands where the Kassandreians, especially, are recorded as participants in some form of activity or as recipients of honors, such as proxeny and theorodicy.

BIBLIOGRAPHY. M. G. Demitsas, Ἡ Μακεδονία (1896): H. Gaebler, *Die Antiken Münzen Nord-Griechenlands* III (1935)[I]; D. Kanatsoules, Μακεδονικὴ Προσωπογραφία (1955); J. A. Alexander, *Potidaea: Its History and Remains* (1963)[MPI]; E. Meyer, "Potidaia," "Kassandreia," *RE* Suppl. x (1965); J. A. Alexander, "Cassandreia During the Macedonian Period: An Epigraphical Commentary," *Ancient Macedonia*, ed. B. Laourdas & Ch. Makaronas (1970). J. A. ALEXANDER

POTENTIA (Santa Maria a Potenza) Macerata, Marche, Italy. Map 14. Near the abbey in the district of Portorecanati are remains of a Roman colony derived from Picenum in 184 B.C. (Livy 39.44.10; 41.27.11-13; Vell. Pat. 1.15.2; Cic. *Har. Resp.* 28.62) on the left bank of the ancient mouth of the Potenza river. It flourished also in the Imperial period (Strab. 5.241; Mela 2.65; Plin. *HN* 3.13.111; Ptol. 3.1.18) and was an Early Christian diocesan seat. It disappeared in the Middle Ages.

Beneath the Casa dell'Arco, are visible in situ the remains of the Roman bridge over which passed the road to the coast (*It. Ant.* 101, 313; *Tab. Peut.*; *Rav. Cosm.* 4.31, 5.1). Within its territory, extensive traces of centuriation are recognizable. An important fragment of the Fasti Consulares and other discoveries from the Imperial period may be found in the National Museum at Ancona.

BIBLIOGRAPHY. *CIL* IX, p. 556; Nissen, *Italische Landeskunde*, II 420-21. F. Lanzoni, *Le diocesi d'Italia* (1927) 390; M. Ortolani & N. Alfieri, "*Deviazioni di fiumi piceni in epoca storica,*" in *Riv. geogr. ital.* 44 (1947), 1-16; id., "I Fasti consulares di Potentia (regio V)," *Athenaeum* 26 (1948) 110-34; id. et al. "Ricerche paleogeografiche e topografico-storiche sul territorio di Loreto," *Studia Picena* 33-34 (1965-1966) 11-34; E. T. Salmon, *The coloniae maritimae, Athenaeum* 41 (1963) 37; L. Mercando, in *I problemi della ceramica romana di Ravenna, della valle padana e dell'alto Adriatico* (1972) 203ff. N. ALFIERI

POUILLÉ, *see* TASCIACA

POUILLY-SOUS-CHARLIEU Loire, France. Map 23. Chance finds in the Sornin valley have yielded pottery, cremation urns, a vase (at the Musée Déchelette in Roanne), and many fragments of flanged tiles, indicating an inhabited site of the 1st-2d c. A.D.

BIBLIOGRAPHY. C. Chopelin, "L'implantation gallo-romaine dans la vallée du Sornin (Loire)," *Ogam* 15 (1963) 340-42. M. LEGLAY

POURI ("Cape Sepias") Thessaly, Greece. Map 9. Modern name of a promontory and town about half way down the E coast of the Magnesian peninsula, where the main mass of Pelion juts into the sea. The cape is very likely ancient Cape Sepias, where part of Xerxes' fleet was wrecked in a storm (Hdt. 7.188; Strab. 9.443) although the identification is uncertain and disputed; Magnesia's SE cape, Haghios Georgi, now Sepias, and the whole coast between the two capes are also suggested. There was also an ancient town of Sepias, whose population was later incorporated in Demetrias (Strab. 9.443). The tombstone of a man from Sepias was discovered near modern Keramidhi.

In the area of Pouri are some ancient landmarks and sites, none securely identified. Immediately N of the cape itself is a shallow bay (6 km wide), from Asprovrachos N to Kavos Koutsovou. The shore of the bay is formed of a steep cliff with a series of caves at sea level, almost certainly the "ovens" (ipnoi) of Herodotos (7.188), where some of the Persian ships were wrecked. The ships had been moored on and off a beach between Kasthanaie and Sepias; this was possibly the beach now called Koulouri to the E of modern Keramidhi and N of the "ovens." Kasthanaie has frequently been identified as an ancient site NE of modern Keramidhi, on a hill which slopes to the sea. Below the hill is a shallow beach at the mouth of modern Kakorema, which may have served as a harbor. The hill is abrupt on the N and S sides, easier to the W. The acropolis was on a low hill to the W. In the 19th c. the walls were impressive. They are of good Hellenic (4th c.?) masonry. The wall circuit included the acropolis, which was cut off from the lower city by a cross wall with round towers at each end. The walls were traceable down to the point above the sea and were furnished with towers. Apparently no wall was built on the steep slope at N and E. The circuit was about half a mile. No remains of buildings are reported. The hill is presently heavily overgrown, but some parts of the wall, preserved several courses high, can be seen. On a hill near Keramidhi is an ancient necropolis.

Other remains in the area have been reported from "Tamuchari" (modern Damouchari), a harbor about 11 km S of Pouri, and the site has been suggested for Kasthanaie. These ruins seem not to have been described by anyone. Hellenic and Byzantine ruins at a place called Kalyvi tou Panagiotou, near the modern town of Pouri have been reported and these have been suggested for the ancient Sepias town, but again, are nowhere described.

BIBLIOGRAPHY. W. M. Leake, *Nor.Gr.* (1835) IV, 383; M. Mezières, "Mémoire sur le Pélion et l'Ossa," *Arch-Missions Scient.* III (1854) 218-21 (Keramidhi); Tozer, *Researches in the Highlands of Turkey* (1869) II, 113[P] (Keramidhi site); Georgiades, Θεσσαλία (1894) 142-44, 213, 218; Wace, *JHS* 26 (1906) 145ff.; Woodward, *AAA* 3 (1910) 158-59; F. Stählin, *RE*[2] (1923) s.v. Sepias; id., *Das Hellenische Thessalien* (1924) 51f; W. K. Pritchett, "Xerxes' Fleet at the 'Ovens,'" *AJA* 67 (1963) 1-6[I] (photographs of wall at Keramidhi, beach below Keramidhi, "ovens"). T. S. MAC KAY

POZANTI, *see* PODANDOS

POZZUOLI, *see* PUTEOLI

PRAENESTE (Palestrina) Italy. Map 16. An ancient Latin town on the inland highway from Etruria to Poseidonia, ca. 36 km E of Rome, set on the steep slope of Monte Ginestro, an outcrop of the Apennines commanding the entrance to the Hernican valley. It possessed wealth early, as the finds from the necropolis S of the city at La Columbella show. Here just after the middle of the 19th c. were found a number of fossa tombs with extraordinarily rich furniture. The most famous of these are the Bernardini and Barberini tombs of the orientalizing period (third quarter of the 7th c. B.C.), the material from which is now in the Museo della Villa Giulia. But there were also other important finds, including the famous Praenestine gold fibula inscribed along its catch-plate in archaic Latin, showing that in the second half of the 7th c. this was Praeneste's tongue. The wealth of the Bernardini tomb shows a completely Etruscanized taste. The finds included personal jewelry, among it a large pectoral fibula of gold (0.17 x 0.06 m) covered with 131 tiny figures in the round of lions, horses, chimaeras, and harpies, all decorated with granulation; other large pins of different design, including a gold serpentine fibula and silver comb fibulas; a dagger with a sheath of silver and a hilt decorated with gold, silver, and amber. There was also table ware, including a gold bowl with embossed animals in single file in Egyptian style, other bowls more elaborately decorated in silver, a small silver cauldron decorated with similar embossing mounted with six silver snakes rising from rosettes, a gold skyphos of great beauty mounted with tiny sphinxes decorated with granulation, a great bronze cauldron mounted with six gryphon protomes, together with a decorated base for this, and numerous bronze vessels and mounts, some of which show lively wit and imagination. Other luxuries include glass and carved ivories. The Barberini tomb was equally rich and contained a similar pectoral fibula in gold and a similar great bronze cauldron; it also produced a bronze throne and a great bronze tray mounted on wheels, as well as numerous very fine carved ivories, including a cup supported by four caryatids, and a charming wooden box in the form of a fawn. The use of some of the ivories may remain in doubt, but not the wealth to which they attest. A silver situla from the Castellani tomb is another unusual piece of treasure.

Sporadic finds of fine terracotta temple revetments show the continuance of wealth and artistry in the 6th and early 5th c., but we have no buildings to associate with these, and there is then a gap that lasts from the early 5th c. to ca. mid 4th. Sometime in the 4th c. the city walls must have been constructed, fortifications in great polygonal blocks of the local limestone fitted together with varying degrees of precision but usually with some attempt to make the main beds nearly level, while there is virtually no coursing. These present differences of style in different stretches, and some try to distinguish different periods of construction. The walls are long (ca. 4.8 km), with rectangular towerlike bastions at irregular intervals. That they are built without knowledge of the arch suggests an early date, but the fact that they include the arx above the town (Castel S. Pietro) and the town itself in a single system that must climb the steep cliff face boldly suggests a late date. A mid 4th c. date best accommodates their peculiarities and is consistent with the reappearance of wealth in Praenestine burials, but the walls still need thorough investigation. Along the S front they are replaced by later walls of tufa.

From Livy (2.19.2) we know that Praeneste, one of the original members of the Latin League, went over just before the battle of Lake Regillus in 499 B.C. to alliance with Rome. But after the invasion of the Gauls it revolted from Rome and was at war with Rome down to the final dissolution of the Latin League in 338 B.C. Thereafter it kept its independence and rights of asylum and coinage and was governed by four magistrates, two praetors, and two aediles, responsible to its senate. It furnished Rome with a military contingent, when needed, the cohors praenestina, commanded by one of the praetors (Livy 23.19.17-18).

In excavations in the Columbella necropolis that began in the 18th c. and continued into the early 20th c. a great number of burials of the 4th c. and early Hellenistic period came to light. These were usually in sarcophagi of peperino or tufa, their places marked by cippi consisting of a block of limestone inscribed with the name of the deceased surmounted by either a rather crude portrait bust or a smooth, sharply pointed egg-shape usually poised on a base of acanthus leaves; the latter is characteristic of Praeneste. In the graves were found a great many bronze cistae, decorated boxes containing toilet articles and feminine adornments, and at first it was thought Praeneste was a center of the manufacture of these. But the handsomest of them, the Ficoroni cista in the Museo della Villa Giulia, bears an inscription stating that it was made at Rome. In general the cistae, when they are inscribed, are inscribed in Latin, while the mirrors they may contain are inscribed in Etruscan. The decoration of the cistae consists of engraving (or embossing with a point in dotted patterns, an early technique) and the addition of cast mounts and chains. The main scene on the body tends to be mythological, framed by formal borders; the mounts are usually without narrative content. Thus on the Ficoroni cista the main scene is the aftermath of the boxing match between Pollux and Amykos from the Argonaut story, some 19 figures. It is framed at the base with an engraved band of confronted sphinxes and palmettes and at the crown with a double interlace of lilies and palmettes, standing and hanging. The cover is decorated in two rings: the outer, a hunt; the inner, lions and gryphons. The handle of the cover is a youthful Dionysos standing between two young ithyphallic satyrs. The feet are lions' paws set on frogs with relief attachment plaques showing groups of three figures, one of whom is Hercules. The older cistae (mid 4th c.) tend to be oval, broader than deep, and with a handle of a single figure in an acrobatic arch. There are also some in which the bronze wall was worked à jour over a wooden lining (such a lining was probably always present). Among other objects in these burials one may note bronze implements (strigils, tweezers) and alabastra of glass paste.

The great glory of Praeneste was the Temple of Fortuna Primigenia, a sanctuary that grew up around the sortes praenestinae, a collection of slips of oak marked with words in an archaic alphabet kept in an olive wood box. When someone wished to consult the sortes, a young boy (sortilegus) drew one or more of these at random from their box in a ceremony we understand only poorly. The sortes were held in awe and honor, and the inscriptions of grateful devotees chart the cult's enormous success. It is uncertain whether the goddess' name comes from her being the eldest child of Jupiter, as some inscriptions have it, or from her having nursed Jupiter (Cic. Div. 2.41.85). The coins found in the excavation of the sanctuary show that it still flourished into the 4th c. A.D. The chief festival fell on April 10-11.

The sanctuary consists of two complexes, commonly known as upper and lower. The axis of the two is unified, but there is no direct connection between them, and they seem to express rather different architectural ideas, points that have led some to presume that the lower sanctuary was rather simply the forum of Praeneste. The lower sanctuary consists of three principal members, the "grot-

to of the sortes," to W, a large rectangular edifice in the middle, and an apsidal building to E. Walls of tufa before the grotto of the sortes and under the cathedral of Palestrina show that this area has been extensively rebuilt. The grotto is in part natural, in part artificial, an ample nymphaeum paved with a splendid colored mosaic of fish and other marine subjects; from what can be made out of the plan of the whole, this should have been the focus of a large hall balancing the apsidal building. To E of it a rectangular building enclosing a Corinthian colonnade is best completed as a basilica, despite some uncertainty; a basement story on the S with a Doric colonnade carried the S aisle down to the level of the street outside. To the E of this and communicating with it is the apsidal hall, its apse, like the grotto, cut into the rock and rusticated, also presumably a nymphaeum; it was originally paved with the famous Barberini mosaic of Nilotic subjects, now in the museum. The hall preceding it is ringed with a deep podium trimmed with a diminutive Doric frieze along the crown, above which rise engaged columns alternating with great windows that must have given this hall a very grand effect. It has been supposed that the podium was for statuary or ex-voto offerings, but certainty is impossible here. In the basement of this hall, accessible only from the exterior, is a vaulted chamber identified by an inscription of the aediles as an aerarium.

The upper sanctuary consists of a sequence of steep, shallow terraces rising to a great colonnaded square, above which stood the temple proper, the apex of the design. The first terraces are two of fine polygonal masonry separated by one of opus quadratum, possibly a survival from an earlier period. The upper polygonal terrace, relatively high, is cut at its ends by broad stairways that lead up to the base of a double ramp that sweeps across the whole complex. Throughout this part of the sanctuary the visitor is presented with a series of surprises, the height of the terraces preventing his forming any notion of what awaits him at the successive levels. To increase this effect the Doric colonnades along the great ramps turn to the hill and present a blank wall to the view to the S. At the top of the ramps a generous terrace spreads to either side. This is lined with a fine Corinthian colonnade with a high attic, in effect a second story, and develops into a hemicycle halfway along each arm. That to the E framed a tholos, that to the W an altar. The tholos is not centered on its hemicycle, and it covered a dry well that has been supposed to be the place where the sortes were believed to have been found.

From this level a monumental stair follows the main axis, rising through a terrace of vaults with a facade of arches alternating with rectangular doors, all framed by an engaged order, architecture similar to that of the tabularium in Rome, to emerge in a great ceremonial square surrounded on three sides by porticos in which the columns support vaulted and coffered roofing. At the back of this, lifted a story above it, a hemicyclical stair of broad shallow steps rose to a final hemicyclical colonnade that screened the tholos of the temple proper at the same time it made a grandiose entrance to it.

The whole building is generally consistent in fabric and style, with walls faced with fine opus incertum of the local limestone and carved members of travertine and peperino. On the basis of a building inscription that mentions the senate of Praeneste, the excavators wished to date the upper sanctuary toward the middle of the 2d c. B.C. and the lower to the time of the Sullan colony. This has been strongly opposed, especially by architectural historians, who see a difference between the two parts of little more than a decade at most and incline to ascribe the whole temple to the time of Sulla's colony. For Praeneste, after many decades of prosperity as an inde-

pendent municipium, refused to take sides in the social war with the Italian towns against Rome, but in the Marian war it had the misfortune to give shelter to the younger Marius and his army after their defeat by Sulla. There he stood siege for many months, but after the battle of the Colline Gate the Praenestines surrendered, and Marius killed himself. The sack of Praeneste was extraordinarily savage (App. BCiv. 1.94), and it is generally supposed that this gave the opportunity for replanning and rebuilding the temple of the goddess to whom Sulla was so devoted. And at this time the city became a colony.

Besides the buildings noted, one should mention extensive works of terracing in opus quadratum along the S front of the city that replaced the old city walls, an impressive series of vaulted rooms in opus incertum in continuance of the line of these (Gli Arconi), and a large imperial cistern of brick-faced concrete. All these works follow the orientation of the buildings of the sanctuaries higher up, but it is not clear what the purpose of all of these may have been, or even whether they formed part of the sanctuary. But it seems not unlikely that by the Sullan period the forum of Praeneste and all its appurtenances had been moved to the foot of the hill. Inscriptions mention numerous public buildings, including baths, an amphitheater, and a ludus gladiatorius, but these have not yet been located. There are remains of numerous villas in the neighborhood, the most impressive being the Hadrianic ruins near the cemetery (Villa Adriana) from which in 1793 Gavin Hamilton extracted the Braschi Antinous now in the Vatican (Sala Rotonda).

The Palazzo Barberini built on the hemicycle at the top of the temple of Fortuna has been converted to use as a museum, and an excellent collection of material from the site is displayed there.

BIBLIOGRAPHY. R.V.D. Magoffin, A Study of the Topography and Municipal History of Praeneste (1908); C. D. Curtis, MAAR 3 (1919) 9-90, pls. 1-71; F. Fasolo & G. Gullini, Il santuario della Fortuna Primigenia a Palestrina, 2 vols. (1953)MPI; P. Romanelli, Palestrina (1967)I. L. RICHARDSON, JR.

PRAESIDIUM (El-Kithara) Jordan. Map 6. A fortress on the limes Arabiae, 22.4 km NE of Aila on the Via Nova Traiana in the wadi Yitm. In the 4th c. A.D. the Cohors IV Frigium was stationed here (Not. Dig. 74.41). In a surface survey, remains of a trapezoidal, irregularly shaped fortress, with round towers and rooms inside its walls, were observed. On account of the numerous Nabatean sherds found here, it has been suggested that a Nabatean occupation preceded the Roman and Byzantine ones.

BIBLIOGRAPHY. H. Vincent, RB 41 (1932) 594-95; A. Alt, ZDPV 58 (1935) 27-28; N. Glueck, AASOR 15 (1935) 54; 18-19 (1939). A. NEGEV

PRAESIDIUM (Ghor el-Feifeh) Jordan. Map 6. A fortress along the inner line of the fortifications of the limes Arabiae, bordering the Arabah, S of the Dead Sea. In the 4th c. A.D. the ala II Felix Valentiniana was stationed here (Not. Dig. 73.35). In surface surveys remains of a building 75 m square, of mud brick on stone foundations, were recorded. On account of the Nabatean-Roman pottery, a Nabatean origin for this fortress has been suggested.

BIBLIOGRAPHY. F. Frank, ZDPV 57 (1934) 210-11; A. Alt, ibid., 58 (1935) 6-9; N. Glueck, AASOR 15 (1935) 9-10; 18-19 (1939) 147-49. A. NEGEV

PRAETORIUM (Copăceni) Racovița, Vîlcea, Romania. Map 12. Mentioned by Tab. Peut. at ca. 11 milia passum from Arutela and 9 milia passum from Pons

Vetus, an important military camp of the limes Alutanus in the Olt gorge, defended by two castra identified by excavations. The camp, preserved only on the W side, was 64 m in length and provided with buttresses on the inside. Two inscriptions were affixed to the W gate. One, dating from 138, states that the builders of the camp were the soldiers of the numerus burgariorum et veredariorum Daciae inferioris, on the order of the procurator Tit. Fl. Constans. The other mentions that the same numerus, on the order of the procurator Aquila Fidus, in A.D. 140, enlarged the camp, which it reinforced with towers and a high vallum. A deposit of ashes from a fire separates the two periods of the construction of the camp. A milliarium of Maximinus Thrax was placed near the gate. East of the camp was the civil settlement. Partial excavations have uncovered some military baths. The waters of the Olt apparently destroyed the camp ca. 220-30 and the camp of Racovița was built ca. 500 m farther N. It was quadrilateral (101.10 x 112.41 m), equipped with four gates, and has guard towers at the corners; inside was a horreum, a praetorium, and a schola (?). The paucity of the archaeological remains proves that it was occupied for only a short time, during the last decades before the evacuation of Dacia. The two camps were responsible for guarding the Titeşti depression and assuring the postal service and transportation in the Olt Valley.

BIBLIOGRAPHY. *CIL* III, 13795-96 = *ILS* 8909, 9180; 13797, 14216, 19; 14216, 40.

D. Tudor. "Castra Daciae inferioris, III: Racovița," *BCMI* 33 (1940) 35-41; id., "Castra Daciae inferioris, V-VII: Copăceni," *BMMN* 5 (1943-44) 95-99; id., *Oltenia romană* (3d ed., 1968) 274-77, 327-28; id., *Oraşe* (1968) 371-72; *TIR*, L.35 (1969) 35. D. TUDOR

PRAHOVO, *see* LIMES OF DJERDAP

PRAISOS Sitia, Crete. Map 11. Hellenistic city a little over 10 km S of Sitia. The two hills occupied by the Hellenistic city have yielded no traces of earlier occupation, although S of the city a third hill was the site of a sanctuary from the 8th to the 5th c. B.C., and S of this sanctuary two Late Bronze Age tholoi have been discovered. The Late Bronze Age settlement may have been another km to the S, where remains of well-built houses have been observed. The Hellenistic city was founded in the 4th c. and destroyed about the middle of the 2d c. B.C. by Hierapetra.

The Hellenistic city was situated on two hills and a low saddle between them, the whole area being flanked on E and W by streams and their respective valleys. Traces of the defense wall have been recognized, mainly on the E and S sides, and they, together with the general spread of debris, suggest that the walled city occupied an area of more than 10 hectares. Within this area, the higher of the two hills seems to have been fortified as a citadel and to have formed the center of the city as a whole. On the peak of this hill, remains of a major temple have been recognized.

On the slopes of both hills terrace walls can be traced, and on the S side of the lower hill rectangular cuttings in the rock are thought to represent the remains of houses cut back into the slope here. Narrow, stepped streets ran up the slopes and were flanked by built houses, only one of which was ever extensively excavated. This proved to be a fine house of ashlar, with six or seven downstairs rooms and traces of stairs leading to an upper floor. The whole building had a tiled roof, and was occupied from the 3d c. until the mid 2d B.C. The saddle between the two hills is thought to have been the site of the agora, and from it were recovered several architectural frag-

ments, including part of a Doric frieze and a fragment from an Ionic capital. A paved road led from this area up toward the summit of the lower hill.

The third hill, beyond the city walls to the S, was found to have first been used as a sanctuary in the Geometric period. To it belonged a thick deposit of soil containing many votive terracottas and miniature bronze pieces of armor. At the close of the 5th c. the whole hill summit was enclosed by a temenos wall, except where the hillside was particularly steep. An entrance in the SE corner of this wall led into an enclosure where there was an altar, a long building probably used as a repository for gifts, and probably a temple. No trace of the temple was found on the summit, but a leveled rectangular area of rock, 13 x 9 m, probably indicates its situation. From the fields immediately below the cliff traces of ashlar blocks and columns may well belong to this temple, presumably completely destroyed in the mid 2d c. B.C.

The city was supplied with water from a source more than 3 km to the S, where a small temple stood above the spring. Cemeteries were situated on the E, S, and probably W of the city, while some 400 m NW of the lower hill quarries used during the building of the city are still visible.

BIBLIOGRAPHY. L. Mariani, "Antichità Cretesi," *MonAnt* 6 (1895) 283-348; F. Halbherr, "Report on the Researches at Praesos," *AJA* 5 (1901) 371-92[M]; E. S. Forster, "Praesos. The Terracottas," *BSA* 8 (1902) 271-81[I]; R. C. Bosanquet, "Excavations at Praesos I," *BSA* 8 (1902) 231-70[MPI]; R. S. Conway, "Prehellenic Inscriptions of Praesos," *BSA* 8 (1902) 125-56; F. H. Marshall, "Tombs of Hellenic Date at Praisos," *BSA* 12 (1906) 53-70; G. Daux, "Chroniques des Fouilles en 1958," *BCH* 83 (1959) 733. K. BRANIGAN

PRAMANDA, *see* LIMES, GREEK EPEIROS

PRATICA DI MARE, *see* LAVINIUM

PRETORIUM, *see* PETUARIA

PRIENE (Turunçlar) Turkey. Map 7. Ionian city 15 km SW of Söke. This however is not the original site. The city was founded on an unknown site by Aipytos, grandson of Kodros, and the Theban Philotas (Strab. 633; Paus. 7.2.10). It was a member of the Ionian League and was severely treated by the Persians (Paus. *l.c.*), but provided twelve ships at the battle of Lade in 494 B.C. (Hdt. 6.8). In the Delian Confederacy Priene was assessed at one talent, a low tribute as compared with her neighbor Miletos. Priene was never in fact a large city. The move to the new site was made in the 4th c., probably at the instigation of Mausolos; apparently it had previously been that of the city's harbor, Naulochos.

Alexander reached Priene in 334. His offer to defray the cost of the new Temple of Athena, then still unfinished, if he might make the dedication, was accepted; the dedication was made on the temple wall. Alexander also exempted Priene from the syntaxis which he exacted from the other cities. The Panionion, assembly place of the Ionian League, lay on Prienian territory and was to some extent under Prienian control; but the land was disputed by the Samians, and the quarrel over it continued for centuries.

Under the Roman Republic and Empire Priene prospered less than most of the Ionian cities, no doubt largely because of the silting of the Maeander; Strabo says (579) that this had separated the city from the sea by 40 stades. The present distance is 12-13 km.

One coin is attributed to the early Priene; otherwise

the coinage begins after Alexander and continues, with an interruption in the 1st c. B.C., down to the time of Valerian. As a bishopric Priene ranked 21st under the Metropolitan of Ephesos.

The site at Turunçlar is the most spectacular in Ionia. It lies on sloping ground at the S foot of a nearly perpendicular cliff, on the top of which was the acropolis, the Teloneia. Only a part of its fortification wall remains. A narrow path leads up the rock face from its E foot. The main city wall is preserved to a greater or lesser height in its entire length from the E to the W foot of the hill, roughly a semicircle; it has an inner and an outer face, with a rubble core. There are three gates, two on the E and one on the W. The interior is laid out on the Hippodamian system; the slope required many of the N-S streets to be stepped. The walls and most of the surviving buildings date from the foundation of the city or soon after.

Of the main E-W streets the one farthest N leads from the NE gate straight through the city to its W end; about its middle point it passes the theater. This is among the best surviving examples of a Hellenistic theater, with only slight Roman alterations. The stage building is especially well preserved. It was a two-storied building with proscenium in front; the stage was supported on 12 pillars, to 10 of which Doric half-columns are attached, with an architrave and triglyph frieze above. The intercolumniations were variously filled: at the extreme ends with a wide-meshed grille, then with three double folding doors alternating with painted panels of wood. The stage itself was formed of wooden boards laid between stone crossbeams. A staircase led up from the orchestra at the W end.

The cavea is more than a semicircle, and is supported by handsome analemmata of cushioned ashlar. Some 15 rows of seats have been excavated, with five marble thrones spaced at intervals in the front row; in the middle is the altar of Dionysos. A royal box was added later in the fifth row. The parodoi were not closed in Roman times but remained open in the Classical fashion. At the W corner of the orchestra is the base of a water-clock, with somewhat enigmatical cuttings; this suggests that the theater may have been used at some period as a court of law.

On the S side of this street, farther E, is the Sanctuary of the Egyptian Gods, Isis, Sarapis, Anubis, and Harpokrates. It consists of a rectangular court with an altar in the middle, and is of Hellenistic date.

The next street to the S leads to the Temple of Athena. It passes the excellently preserved bouleuterion, a rectangular building with seats on three sides, covered with a roof supported on pillars; on the fourth side is a rectangular recess with stone benches, with a door on either side. In the middle of the floor is an altar. There is seating space for 640 persons, suggesting that the building may have been used also as an ecclesiasterion.

The poorly preserved building adjoining this on the E is identified as the prytaneion, restored in Roman times; it contained a water basin and, in the SE corner, the sacred hearth. Across the street from this is the upper gymnasium, Hellenistic in origin but much altered in later times; this too is in poor condition.

The Temple of Athena, chief deity of Priene, stood on a high bastion of admirable ashlar masonry dominating the town. It was of the Ionic order, with a peristyle of 11 columns by 6, and of standard plan with pronaos, cella, and opisthodomos. The cult statue, a copy of the Athena Parthenos, was installed later, in the mid 2d c. B.C. The architect was Pytheos, who wrote a book taking this temple as a model. At present only the foundations are preserved, but some of the columns have recently been reerected. The altar stood as usual in front of the temple on the E, but is now ruined. The temple was later rededicated to Augustus, and at the same time an entrance gateway, still partially preserved, was erected to the E.

About the middle of the S side of the same street is the agora, originally an open rectangle bordered on E, S, and W by a stoa backed by shops; in the middle of the S side the shops were interrupted by a hall divided down the middle by a row of eight columns. Later the E side was incorporated into the precinct of Zeus. In the center was an altar, probably for sacrifice to Hermes, and close by to the E another monument of uncertain purpose. Across the N side ran a row of honorific monuments and exedras. Across the street from the agora is the sacred stoa, 116 m long, dating probably from about 130 B.C. It is divided down the middle by a row of 24 Ionic columns; at the back is a row of 15 rooms, and in front a row of 49 Doric columns; in front again is an open flight of six steps.

At the extreme W end of the street, near the gate, is a small sanctuary of Kybele, with a pit for offerings. A little E of this is another sanctuary comprising a forecourt and several small rooms, in one of which is a sacrificial table placed over a cleft in the ground. A statuette found here and apparently representing Alexander suggests that this is the Sanctuary of Alexander mentioned in an inscription.

Farther up the hillside to the N is the Sanctuary of Demeter and Kore, consisting of an open space some 45 m long, with an entrance on the E and the temple at the W end. At the entrance stood two statues of priestesses; the base of one remains in place. The plan of the temple is unique: a columned porch in front, leading to a cella of irregular shape, with a high stone bench at the back for votive offerings. Two small chambers adjoin this on the N, one opening to the porch. Outside the temple on the SE is a sacrificial pit, square and lined with masonry; it was roofed with planks laid across between triangular stone blocks, one of which remains. A normal altar was later installed in the NE corner of the sanctuary.

The lower gymnasium is at the foot of the hill just inside the city wall. The palaestra, about 45 m square, is best preserved on the N side, where there is a row of five rooms. At the W end is the washroom, with basins at the back and at the entrance; the floor is paved with smooth pebbles. In the middle of the row is the ephebion, used as a lecture room, with benches round the walls; the back wall is covered with more than 700 names of students. The other three rooms should be the konisterion, korykeion, and elaiothesion.

Adjoining the gymnasium on the W is the stadium, constructed in the 2d c. B.C. and replacing an earlier one. The course is some 190 m long by 18 m wide, with permanent seating only in the middle of the N side; the slope of the ground prevented it on the S. At the W end are some interesting remains of the starting gate for the foot races. On a long stone foundation are the bases of ten square pilasters; these originally had Corinthian capitals and an architrave. In the surface of the foundation is cut a water channel, extending for its whole length and originally covered with wooden planks. In the sides of the bases are vertical rectangular cuttings, evidently belonging to the arrangements for operating the hysplex. Some 2 m in front (to the E) of this installation are the remains of an older and simpler form of starting sill, consisting merely of eight square slabs set in the ground, with a square hole in each one evidently intended to hold an upright post.

The private houses at Priene are in comparatively good

condition and of early date; many, if not most, go back to the 3d c. B.C. The normal plan comprises an entrance, often in the side street, with a vestibule and open courtyard leading to an antechamber and the main living-room; at the sides are other rooms. Bathrooms and latrines occur, but rarely. In a few houses remains of staircases have been found, but no upper stories are preserved.

BIBLIOGRAPHY. R. Chandler et al., *Antiquities of Ionia* I (1769); IV (1881) (temple of Athena); T. Wiegand & H. Schrader, *Priene* (1904); M. Schede, *Die Ruinen von Priene* (2d ed. 1964)^{MI}; G. E. Bean, *Aegean Turkey* (1966) 197-216 (suggested explanation of hysplex); E. Akurgal, *Ancient Civilizations and Ruins of Turkey* (1970) 185-206. G. E. BEAN

PRILEP Yugoslavia. Map 12. A town in Macedonia ca. 42 km NE of Bitola (Heraclea Lyncestis). It lies in the NE corner of the rich Pelagonian plain in the ancient district of Derriopus and at the entrance to the Pletvar pass that leads to Paeonia.

There are several ancient sites in the immediate vicinity including one at Markov Grad, a suburb of Prilep. A large Roman necropolis is known there and parts of numerous walls have been found; the settlement was probably the ancient Ceramiae mentioned in the *Peutinger Table*. Roman remains are also known in the vicinity of the Varoš monastery, built on the steep slopes of the hill, which was later occupied by a Slavic and mediaeval community. A large number of early Roman funeral monuments, some with sculpted reliefs of the deceased or of the Thracian Rider and other inscribed monuments of an official nature, are in the courtyard of the church below the S slope of Varoš. Some of the larger of those monuments were built into the walls of the church.

There has been only limited excavation within the limits of Prilep and most of this has been concerned either with the later Slavic community, various chance discoveries, or with the necropolis. The burial gifts found in the graves indicate a flourishing community throughout the Imperial period. The small objects are in the National Museum at Prilep and include a large number of early Roman glass vessels, numerous bronze statuettes of Mercury, and an interesting sequence of pottery types.

The monastery of Treskavec, in the mountains ca. 10 km N of Prilep, is probably the site of the early Roman town of Kolobaisē. The site, at the edge of a small upland plain, is at a height of over 1100 m above sea level and is a natural citadel. The name of the early town is recorded on a long inscription on stone which deals with a local cult of Ephesian Artemis. The inscription was reused as a base for a cross on top of one of the church domes. Other inscriptions at Treskavec include several 1st c. Roman dedications to Apollo.

The necropolis of the town is to the SW of the monastery where the remains of a chamber tomb and a sculpted and inscribed marble funeral monument (1st to 2d c.) can be seen.

An important site in the vicinity is Bela Crkva, some 6 km W of Styberra, where the Hellenistic town of Alkomenai was probably located. It is on the Erigon river. Rebuilt in the Early Roman period, it was a stronghold of the Macedonian kings, perhaps from the time of Alexander the Great, and was at the Pelagonian entrance to a pass leading to Illyria. Part of the city wall, a gate, and a few buildings of the Roman period were uncovered here in excavations. All recent finds from these sites are in the museum at Prilep.

BIBLIOGRAPHY. N. Vulić, *Spomenik* 77 (1934) 58; F. Papazoglu, *Makedonski gradovi u rimsko doba* (1957); I. Mikulčić, *Pelagonija* (1966). J. WISEMAN

PRIMA PORTA, *see* AD SAXA RUBRA

PRINIAS Malevizi, Crete. Map 11. A modern village near the site of an ancient city in central Crete. The "patela" is a flat-topped steep-sided acropolis (686 m) just N of the main watershed and dominating the two main N-S passes across the E foothills of Ida. Accessible only from the W, it had a mainly unfortified perimeter and measures ca. 230 x 560 m. The site has generally been identified with Rhizenia/Rhittenia (see Guarducci), but a plausible case has been made for Apollonia (Faure); either way it was probably normally subject to Gortyn in Classical and Hellenistic times. The excavations date to 1906-8 and since 1969.

Apart from a few Neolithic finds the earliest traces of occupation are of the latest Minoan period (LM III); evidence of early post-Minoan occupation has recently been increased by discovery at nearby Siderospilia of Proto-Geometric tholos tombs with inhumations and a Geometric cremation cemetery. Also of these periods is an important deposit of votive terracottas and vases found near the E edge of the plateau, including types with antecedents of the end of the Minoan period (female figures with cylindrical skirt and raised arms, sometimes with snakes; tall clay tubes with vertical rows of loop handles). A small enclosure found nearby against the rock formed the sanctuary of this snake-goddess, whose cult seems to last from Subminoan to late archaic times.

The site's most important remains are of the archaic period. Roughly in the middle of the plateau are the poorly preserved remains, close together, of two 7th c. temples. The more northerly (A: 9.7 x ca. 6 m) has a nearly rectangular elongated cella entered through a single door from a pronaos to the E with a single central square pier in antis. In the center of the cella is a slab-lined rectangular sacrificial pit or hearth, on each side of which stood a single (probably wooden) column on the central longitudinal axis. Many pieces were found of the limestone frieze (originally situated on the facade or at socle level) carved with horsemen in relief, and of two (later?) female statues each seated on a chair on the end of a sculpted architrave, probably from the upper part of the cella door (reconstr. in Iraklion Mus.): major works of Daedalic art. Temple B to the S was built in a similar technique but with dissimilar and less regular plan (ca. 18 x ca. 5.5 m); it had an opithodomos in addition, full of storage vessels, and both cella and pronaos had a central door on the E. Like A the cella had a hearth with an offering table at its W end, and a libation basin in the NW corner. Like the somewhat earlier Dreros temple (q.v.), these temples represent an early type deriving from the Mycenaean megaron with certain Minoan features added; the architectural order is not yet clearly defined. The cult seems not to have outlasted the archaic period.

A number of archaic house foundations have been found on the plateau. At its SW side, W of the temples, is a rectangular Hellenistic (probably 2d c.) fort, with square towers projecting from the corners, interior dimensions 40 x 36 m and entrance on the cliff edge at the SE corner. Reused in its walls were blocks bearing early inscriptions and primitive (7th c.) funerary stelai incised with a hoplite or female figure. Inside and round the fort were found many arrowheads and other iron weapons, and sling-bullets of lead.

Inscribed sherds (2d c.) attest a cult of Athena. No coins have been found at the site, which seems to have been gradually depopulated in the Hellenistic period and has little sign of city life after the 2d c. B.C. If the site was Apollonia, settlement probably largely moved to its

port (of the same name) near modern Gazi, just W of Iraklion.

BIBLIOGRAPHY. F. Halbherr, *AJA* 11 1st ser. (1896) 530-31; id., *AJA* 5 (1901) 399ff[I]; id., *RendLinc* 14 (1905) 401-4; A. Taramelli, *MonAnt* 9 (1899) 328-34[I]; L. Pernier, *RendLinc* 16 (1907) 301-3; id., "Di una città ellenica arcaica scoperta a Creta dalla missione italiana," *BdA* 2 (1908) 441-62[I]; id., "Vestigia di una città ellenica arcaica in Creta," *MemIstLombardo* 22 (1910) 53-62; (1912) 213-26[MI]; id., "Templi arcaici sulla patèla di Priniàs," *ASAtene* 1 (1914) 18-111[MPI]; id., "New elements for the study of the Archaic Temple of Prinias," *AJA* 38 (1934) 171-77[PI]; id. & L. Banti, *Guida degli scavi italiani in Creta* (1947) 75-80; M. Guarducci, *ICr* I (1935) 3-4, 294-302; id., *Historia* 7 (1933) 363-70; 8 (1934) 71-77; E. Kirsten, "Rhizenia," *RE* Suppl. VII (1940) 1138-53[P]; M. P. Nilsson, *The Minoan-Mycenaean Religion* (2d ed., 1950); P. Faure, *KretChron* 17 (1963) 16-17, 22-24; id., *BCH* 91 (1967) 131; G. Rizza, "Nuove ricerche sulla Patela e nel territorio di Prinias," *Chronache di Arch. e di Storia dell'Arte* 8 (1969) 7-32; reports in *BCH* 84 (1960) 840; 94 (1970) 1161; 95 (1971) 1055-56; *Deltion* 24 (1969) *Chronika* 2, 414; 25 (1970) *Chronika* 2, 454.

D. J. BLACKMAN

PRISTA, *see* SEXAGINTA PRISTA

PRIVERNO, *see* PRIVERNUM

PRIVERNUM (Priverno) Italy. Map 16. This is a Volscian town, originally probably set either between the rivers Oufens and Amasenus on the height occupied by Priverno, or on Monte Macchione nearby to the NW; both sites lie just E of the first elevations of the Volscian hills above the S end of the Pontine Marshes. The town fought Rome bitterly in the Volscian wars, and after its conquest by Rome in 330-329 B.C., its walls were dismantled, its senate was deported to Rome, and the senators' lands were given to Roman citizens, who were enrolled in 318 B.C. in the newly formed tribus Oufentina (Livy 8.20.6-9, and cf. 8.1.3). Sometime later the town was moved to lower ground in the area known as Piperno Vecchio, where it remained throughout antiquity. It has been argued persuasively that this cannot have been before Julius Caesar settled a veteran colony there in the middle of the 1st c. B.C., and there is no clearly Republican material to be seen on the site. The site was probably abandoned only in the 11th c. It is not known when the town received citizenship, but probably it was in 188 B.C., when its neighbor Fundi did.

The existing remains are few and unimpressive: shapeless remains of an arch in large blocks of limestone that spanned a street (conjectured to have been the decumanus, but there is no proof), a few bits of pavement and short stretches of masonry, the thick litter of tile fragments and potsherds that shows an ancient occupation, and two funerary inscriptions, clearly not in place. But from an area known as Piazza della Regina, plausibly identified as the forum of the ancient city, a number of sculptures were removed in the 18th and early 19th c., most notably the seated Tiberius now in the Vatican (Museo Chiaramonti no. 494) and a colossal head of Claudius (Vatican, Braccio Nuovo no. 18). The site has also yielded inscriptions in some number.

The neighborhood of Privernum is good land, and its wine was prized (Plin. *HN* 14.65). Many Romans owned property here, and there are remains of a number of villas.

BIBLIOGRAPHY. H. H. Armstrong, *AJA* 15 (1911) 44-59, 170-94, 386-402[M]; G. Saeflund, *OpusArch* 1 (1935) 83-84.

L. RICHARDSON, JR.

PRIZREN, *see* THERANDA

PROERNA Thessaly, Greece. Map 9. A city in Tetras or Achaia Phthiotis (Strab. 9.434) on the main road from Thaumaki to Pharsalos probably located (first by Leake) at Gynaikokastro, the end of a spur of Mt. Kassidhiaris which projects into the W plain of Thessaly halfway between Thaumaki and Pharsalos. It dominates a small marshy plain to the N of it. The modern town of Neon Monastirion is a little to the SE. Scarcely anything is known about Proerna's history.

In the plain just to the W of the modern Dhomoko-Pharsala highway is a large, oval, flat-topped mound, called Tapsi. This is surrounded on the top by a wall of polygonal masonry. In 1965-66 excavations on the mound uncovered foundations of 4th c. B.C. houses on its flat top and on the W and S slopes. A section of the circuit wall was excavated, which proved to be not just the archaic wall, but the Classical as well. Some remains of Classical houses were also discovered on the top of the mound, which had been occupied since at least the Bronze Age. East of the highway, 400 m E of the mound, can be seen another wall circuit preserved to several courses high. This wall has a circumference of ca. 2 km and encloses a hill with two peaks and a hollow between resembling a theater facing the plain on the N. The wall is double-faced, built of well-cut, thick, rectangular and trapezoidal blocks with rough faces, laid in fairly regular courses in the towers, more irregularly or in step fashion elsewhere. The wall is some 2 m thick. Twenty projecting square towers have been preserved along it. There are three gates with complex entrances flanked by towers preserved on the SW, S, and SE sides. The exterior face of the wall is pierced by drain channels. Just to the N of the SE gate can be seen a long section of a cross wall running E-W which cut off the highest, E, peak from the rest of the enclosure. The wall was disturbed by an earthquake in 1955, but was restored.

The most interesting discovery of 1965-66 was on the W side of a small hill in the modern town, and outside the ancient city walls. This was the rough stone foundation of a long, rectangular stoa-like building, 6 x 30 m, of the 4th c. B.C., oriented E-W. At the W end it overlay some older building(s), perhaps of the late 6th or early 5th c. A large number of objects were found, now in the Volo Museum, which identified this as a Shrine of Demeter. A number of terracotta figurines were discovered, all apparently earlier than the "stoa," some being of the 6th c. B.C. A small bronze vase and an archaic (7th c.) bronze figurine of a deer (?) came from the sanctuary area, among other bronze items such as rings and pins.

It appears that the acropolis of the archaic and Classical city was the mound Tapsi, and that the city of that period was located on the slopes of the mound, chiefly on the S side. The Shrine of Demeter (the first discovered for certain in Thessaly), which flourished from the 6th to at least the 2d c. B.C., was located on a low hill to the SE of the mound, near the road. The walls on the hill to the E of the road may date from the early 3d c. B.C. (as Stählin surmised) or somewhat earlier. Hellenistic sherds have been found within this circuit, but no remains of the city of that period.

BIBLIOGRAPHY. W. M. Leake, *Nor. Gr.* (1835) I 455, 459; F. Stählin, *Das Hellenische Thessalien* (1924) 157-58[PI]; G. Daux and P. de la Coste-Messelières, "De Malide en Thessalie," *BCH* 48 (1924) 355-59[MPI]; E. Kirsten, *RE* (1957) s.v. Proerna 2; D. Theocharis, *Deltion* 19 (1964) chron. 263[I]; 20 (1965) chron. 318f[I]; 21 (1966) chron. 249-52[PI].

T. S. MAC KAY

PROPHTHASIA, *see following* ALEXANDRIAN FOUNDATIONS, 2

PROTARAS, *see* LEUKOLLA

PRUSIAS AD HYPIUM (Konuralp or Üskübü) Turkey. Map 5. City in Bithynia 8 km N of Düzce, which lies midway between Istanbul and Ankara, and on the road from Düzce to Akçakoca on the Black Sea. It was an important city on the road from Nicomedia (İzmit) to Amastris (Amasra) in Pontos, and lay E of the Hypios river.

The site is on a defensible hill at the foot of Mt. Hypios, and is mentioned by Pliny and Memnon. According to the latter, King Prusias I conquered Kieros and changed its name to Prusias. When the city was conquered by the Romans in 74 B.C. it consisted of four phylai; it flourished under Roman rule, and inscriptions indicate that it had 12 phylai in the 2d c. A.D. Hadrian, Caracalla, and Elagabalus visited it, and in the 4th c. it became a bishopric. Georgios, bishop of Prusias ad Hypium, was present at the Council of Nicaea, and another bishop, Olympios, attended the Council of Calchedon in 451.

Remains are of the Roman period and Roman walls surround the site. The S and W walls and a S gate called Baltalı Kapı are still standing; they incorporate many earlier inscriptions. The theater, 100 by 74 m, probably dates from the 2d c. A.D. Most of the cavea is standing, and the scaenae frons and parodoi are visible. A three-arched bridge, 10 m long, outside the walls to the W, was intact until recently, when a flood ruined the pavement. A colonnaded street runs SE from the bridge; carved entablatures, arches, pediments, pavements, and drains are still visible. Pavement mosaics, now covered, have been found S of the city outside the wall. They include scenes of Achilles and Thetis and of Orpheus with the Seasons.

Buildings of the early Ottoman period include a bath and an aqueduct. Many inscriptions, architectural fragments, bomoi (especially the funerary bomos of an Athenian actor), and a garland sarcophagus can be seen in the museum depot. Other finds are in the Istanbul Archaeological Museum, including a bust of a boy, and statues of Tyche, a philosopher, and a seated woman.

BIBLIOGRAPHY. D. Magie, *Roman Rule in Asia Minor* (1950); F. K. Dörner, "Prusias ad Hypium," *RE* XXII (1959) 1128ff; L. Tuğrul, "New Inscriptions from Üskübü (Prusias)," *Annual of the Archaeological Museums of İstanbul* 10 (1962) 121-26; A. N. Rollas, *Guide to Prusias-ad-Hypium* (1967). N. FIRATLI

PSINA, *see* LIMES, GREEK EPEIROS

PSOPHIS (Tripotamos) Arkadia, Greece. Map 9. An old city NE of Olympia on the E side of Mt. Olonos, at an important intersection of streams and ancient routes. The fortifications enclosed the area between two spurs of a rocky ridge and the right bank of the Eurymanthos (Livartsino) making a naturally defensible site into a major stronghold, able to play a significant part in the Social War in 220 B.C. The site and its capture by Philip V are described at length by Polybios (4.706). The acropolis was probably on the highest part of the ridge at the NE, now crowned by a ruined mediaeval tower. The walls, of fairly regular blocks, were followed by Bursian for the complete circuit, and included one round tower and several square ones. The remains of several rows of theater seats were noted inside the W wall. Pausanias describes various sights (8.24) including a Sanctuary of Aphrodite Erykine in ruins, the Tomb of Alkmaion, and a Temple of Erymanthos with a marble statue of the river god. Bursian identified this last with some large foundations near the bank of the river; other ancient remains were seen near the place where the Aroanios joins the Erymanthos.

BIBLIOGRAPHY. W. M. Leake, *Morea* (1830) II 240fP; E. Curtius, *Peloponnesos* (1851-52) IP; C. Bursian, *Geographie von Griechenland* (1872) I 260f; J. G. Frazer, *Paus. Des. Gr.* (1898) IV 282f; E. Meyer in *RE* 23² (1959) s.v. Psophis. M. H. MC ALLISTER

PTOION Boiotia, Greece. Map 11. A mountainous ridge E of Lake Kopais and N of Lake Iliki, in which are the Sanctuaries of Ptoan Apollo and the Hero Ptoios; it lies somewhat E of the village of Karditsa (mod. Akraiphnion). The highest point of the ridge, Mt. Pelagia (726 m) is ringed with secondary peaks—Megalo Vouno (548 m) to the NW, Tsoukourieli (698 m) and Malidarda (697 m) to the NE—and hills. It dominates Lake Kopais to the W, Lakes Iliki and Paralimni and the Teneric plain to the E and S, and the Gulf of Euboia to the N.

From Mycenaean times a number of dwellings and fortifications sprang up in the region, notably at Haghios Joannis near the great Katavothra, at Haghia Marina, on the Megalo Vouno (Hellenistic round tower and surrounding wall on the Mycenaean site), and on Mt. Pelagia (Mycenaean wall, and round tower with polygonal Hellenistic masonry).

The sanctuary of Apollo Ptoios is on the W slope of Mt. Pelagia, on three terraces leading from SE to NW down to the Fountain of Perdiko Vrysi. It is the seat of a very ancient "infallible" oracle that prophesied in the name of a mountain divinity, soon identified with Apollo. It has been excavated since 1885.

In the upper terrace, near the oracular spring, are the sacred monuments. The ancient temple, which no doubt dates from the time of the Pisistratids, may have been built of wood on a subfoundation of poros. In front of it stood the admirable archaic kouroi (National Museum of Thebes), masterpieces of Boiotian sculpture of the 6th and 5th c. On the foundations of this temple, which doubtless was destroyed in 335 B.C., another temple was built after 316. It was peripteral Doric (11.8 x 23.3 m), with 6 columns in front and 13 along each side. The very elongated sekos (4 x 12 m), which has a pronaos with two columns in antis, has no opisthodomos. In front of the temple, on an esplanade surrounded by sustaining walls, are the foundations (4 x 7 m) of a large altar or a naiskos (Athena Pronais?), some bases of statues (6th-5th c.) and of tripods (4th-2d c.), and a ramp that led to the cave of the original oracle, where the sacred spring was. On the middle terrace is an archaic building of poros, on which two long parallel porticos separated by a paved walk were built in the 3d c. Farther E are the remains of a very large house. On the lower terrace, which is bounded to the N by a long sustaining wall, is a large rectangular cistern with six compartments into which water from the upper spring was fed by an artificial channel. Lower down was a building where suppliants made their ablutions before consulting the oracle.

The Sanctuary of the Hero Ptoios stands on the NE slope of the Kastraki hill, S of the Karditsa road and W of the Sanctuary of Apollo. The upper terrace bears the foundations of an archaic temple of local limestone. The sekos (6 x 17 m) was divided in two by a line of six wooden pillars. Possibly dedicated to the mother of the Hero Ptoios, Gaia-Demeter or Gaia-Europa, it is said to date from the end of the 7th c. (terracottas) and to have been restored at the end of the 4th c. B.C. On the lower terrace, dedicated to the Hero Ptoios, are two altars, several buildings, one of them an archaic polygonal structure, and 28 tripod bases offered by the city of Akraiphia between ca. 550 and 450.

Ptoion belonged to Thebes up to 335 except in the two periods when Akraiphia was autonomous (550-480 and 456-446); after the cities were made independent it became part of the territory of Akraiphia. The Ptoia, festivals held in honor of Apollo Ptoios, included penteteric musical contests. Founded at an unknown date, the contests were reorganized by agreement with the Delphic Amphictyony in 227-226, then again in about 120 B.C. They were held up to the beginning of the 3d c. A.D.

BIBLIOGRAPHY. Reports on the excavations in *BCH* from the year 1884; P. Guillon, *Les trépieds du Ptoion*, 2 vols. (1943)MPI; *La Béotie antique* (1948)MI; S. Lauffer in *RE* (1959), s.v. Ptoion, 1506-78MP; R. Hope Simpson, *A Gazetteer and Atlas of Mycenaean Sites* (1965), no. 415; N. Papahadjis, *Pausaniou Hellados Periegesis* V (1969) 129-35MPI; J. Ducat, *Les Kouroi du Ptoion* (1971). P. ROESCH

PTOLEMAIS (Acre) Israel. Map 6. Phoenician city called Akko on the coast S of Tyre, refounded by Ptolemy II Philadelphos (285-246 B.C.). According to Isaeus and Demosthenes, there was an Athenian merchant colony there as early as the 4th c. B.C. In Hellenistic times Ptolemais was an important strategic site. It passed under Seleucid control in the 2d c. B.C. and became the main base of the Syrian Greeks against the Jews during the Maccabaean wars, and of the Romans in the Jewish wars of Vespasian, Titus, and Hadrian in the 1st and 2d c. A.D. Claudius gave it the title of colony. The Moslems took it in A.D. 638. The town was completely destroyed at the end of the Crusades and rebuilt at the end of the 18th c. The aqueduct visible to the NE dates from ca. 1800.

There are virtually no ancient remains. The ramparts, the temples of gods known from the town's coinage, the gymnasium built by Herod the Great, the public baths where, according to the Michnah, the rabbi Gamaliel did not fear to bathe himself underneath a statue of Aphrodite, have all disappeared.

BIBLIOGRAPHY. N. Makhouly & C. N. Johns, *Guide to Acre* (1946); H. Seyrig, "Divinités de Ptolemaïs," *Syria* 39 (1962) (*Antiquités syriennes* VI). J.-P. REY-COQUAIS

PTOLEMAIS (Tolmeta) Cyrenaica, Libya. Map 18. About midway between Benghazi and Susa, this ancient port occupies a narrow space (2 km wide) between the sea and the lower spurs of the Jebel el-Akhdar. The harbor was sheltered W and N by a small promontory and two islets. A Greek settlement, name unknown, was established here in the late 7th c. B.C. and became the port of Barke, the rich colony of Kyrene 25 km inland on the plateau. Ptolemy III (246-221 B.C.) refounded it as Ptolemais. It came into the hands of Rome in 96 B.C., and under Diocletian became the capital of Libya Pentapolis, but subsequently it decayed and Apollonia (Sozusa) supplanted it as capital. Excavation began in the 1930s and there is now a small museum on the site.

The Hellenistic city was laid out regularly, forming a rectangle roughly 1650 x 1400 m. Two major cardines run from N to S; the standard insula measures 180 x 36 m. An imposing decumanus, the "Via Monumentale," was given a triumphal arch and a portico in the early 4th c. A.D. Little remains of the Hellenistic wall. The standard of masonry was good, though one section of the wall, carried a short way up the hillside to include a commanding point, was built of rough blocks of stone. Some square projecting wall towers have been found but the finest surviving part of the fortifications is the Taucheira Gate, built of masonry with the marginal drafting characteristic of many Hellenistic walls. Its inner side was altered, perhaps in the 3d c. A.D. when the

walls seem to have been rebuilt. Traces of another wall found near the sea may have been a Byzantine circuit protecting the harbor.

Ptolemais had an amphitheater, a hippodrome, and three theaters, one at least Hellenistic. The smallest, the Odeon, was adapted in the 4th-5th c. for water spectacles, the orchestra and stage walls being covered with a layer of watertight cement to form a swimming pool. Roman and Byzantine baths are known.

The public cisterns and reservoirs are impressive. A group of 17 Roman vaulted cisterns under a porticoed space, the Square of the Cisterns, had a capacity of 7,000 kl and may have been preceded by a Hellenistic reservoir. To the E are two later open reservoirs, which probably received at least part of their supplies from the catchment area provided by the lower slope of the Jebel. A Roman aqueduct, probably Hadrianic, coming from 20 km to the E, runs towards this quarter. Outside the town are remains of a bridge that carried the aqueduct and a road across the wadi.

Several houses, wholly or partly excavated, are of the standard Hellenistic type with peristyle. The "Palazzo delle Colonne," pre-Roman in its origin but with numerous additions in the 1st c. A.D., had a large pillared court and two impressive oeci. It stood high, with an upper story. Its height contrasts with a large, low Roman villa. Other houses have been dug out in the N part of the city. One excavated in 1961 has a 4th-5th c. mosaic floor with Orpheus singing to the wild beasts. Further excavations are in process.

Fragments of an unexcavated Doric building suggest that it may have been a pre-Roman temple. The imposing temple tomb, Qasr Faraoun, W of Ptolemais, is Hellenistic. The chamber tombs found in great numbers in the quarries E and W of the city have yielded a few sculptured tombstones and numerous inscriptions. A number of sculptures and important inscriptions, including the price edict of Diocletian and an edict of Anastasius have come to light within the city.

A fortified Christian basilica has narthex, apse, chambers on either side of the apse, nave, aisles, and is solidly built with a single narrow doorway on the N side. A fortified building (75 x 45 m) probably 5th c., is commonly regarded as the headquarters of the Dux of Libya Pentapolis; its walls are faced with good masonry and provided with stringcourses to stabilize the rubble filling. Two other forts within the city provided some security after the old walls had decayed.

BIBLIOGRAPHY. G. Caputo, "Tolemaide," *Encic. Ital.* XXXIII (1937); "Protezione dei monumenti de Tolmeide, 1935-42," *Quaderni di arch. della Libia* 3 (1954) 33-66; P. Romanelli, *La Cirenaica romana* (1943); G. Pesce, "Il 'Palazzo delle Colonne' in Tolemaide de Cirenaica," *Monograph. di archeol. libica* 2 (1950); "Tolemaide," *EAA* (1966) VII; Goodchild, "The Decline of Cyrene and Rise of Ptolemais," *Quaderni* 4 (1961) 83-95; "The Forum of Ptolemais," *Quaderni* 4 (1967) 47-51; R. M. Harrison, "Orpheus Mosaic at Ptolemais," *JRS* 52 (1962); C. H. Kraeling, *Ptolemais, City of the Libyan Pentapolis* (1962); J. Boardman, "Evidence for the Dating of Greek Settlements in Cyrenaica," *BSA* 61 (1966) 149-56; C. Arthur, "The Ptolemais Aqueduct," *SLS Ann. Rpt.* 5 (1973-74). O. BROGAN

PTOLEMAIS HERMIOU (El-Manshâh) Egypt. Map 5. A city 525 km S of Cairo on the W bank of the Nile. It was founded by Ptolemy I Soter to replace the Egyptian village Souit, which, like Rhacotis in Alexandria, formed the old quarter that was reserved for the native Egyptians. Strabo (17.1.42) described it as the largest city in the Thebaid nome, as large as Memphis, and

wrote that it had its own constitution like Greek cities. It is clear from the papyri and inscriptions that Ptolemais possessed a council and assembly, elected magistrates and judges, and had a citizenry divided into tribes and demes. It also had cults of Zeus and Dionysos as well as Greek temples. It did not, however, have its own coinage (cf. Naukratis), and its Temple of Isis did not have the right of asylum (cf. Theadelphia). The city instituted a special cult for the worship of the Ptolemies. Ptolemais kept its Greek characteristics during the Roman period. It is now believed that Ptolemy, the Alexandrian astronomer and geographer (ca. A.D. 90-168), was born in this city. Today there is nothing left except mounds of ruins and part of a quay.

BIBLIOGRAPHY. G. Plaumann, *Ptolemais in Oberägypten* (1910); I. Noshy, *The Arts in Ptolemaic Egypt* (1937) 7 et passim; E. Ball, *Egypt in the Classical Geographers* (1942) 85. S. SHENOUDA

PTOLEMAIS THERON or EPITHEROS (Aquiq or Trinkitat) Sudan. Map 5.
A port on the W coast of the Red Sea, S of Berenice. It was founded by the Ptolemies (Strab. 17.768-71) in the Land of the Troglodytes as a hunting preserve, especially for elephants. Ptolemy II appears to have been the first to train African elephants for war. At the battle of Raphia (217 B.C.), Ptolemy IV had 73 African elephants against the 102 Indian elephants of the victorious Antiochos the Great. Ptolemais Theron served also as a sea port to Meroe.

BIBLIOGRAPHY. M. A. Kammerer, *La Mer Rouge, L'Abyssinie et L'Arabie depuis L'Antiquité* (1929).
 S. SHENOUDA

PTUJ, *see* POETOVIO

PUERTO DE POLLENSA, *see* OPPIDUM BOCHORITANUM

PUISSALICON Canton of Servian, Hérault, France. Map 23.
Large Gallo-Roman villa 13 km N of Béziers on the banks of the Libron. It is near the old Romanesque church of Saint-Étienne-de-Pezan, of which only the splendid campanile remains. The ancient architectural ensemble, shaped like a U open to the N, includes a large pool, baths, living quarters, and outbuildings. The interior decoration was particularly elaborate (marble floors and wall facings, painted plaster). There are numerous signs of remodeling. The artifacts found, which are abundant and relatively luxurious, cover the entire Roman period. The leveled remains of this great agricultural estate, which possessed every refinement of comfort (water, heating, decoration) are no longer visible.

BIBLIOGRAPHY. "Informations," *Gallia* 24 (1966) 471; 27 (1969) 399; J. P. Bacou, "La villa gallo-romaine de Condoumine à Puissalicon," *Revue Archéologique de Narbonnaise* 4 (1971) 93-147[MPI]. G. BARRUOL

PUJO Hautes-Pyrénées, France. Map 23.
Since 1959 excavations have been gradually uncovering a 4th c. villa in the flood plain of the Adour at the locality of Arrious. The villa no doubt continued to be inhabited during the first centuries of the Middle Ages, before being partly converted into a cemetery.

BIBLIOGRAPHY. M. Labrousse in *Gallia* 17 (1959) 438; 20 (1962) 596-97 & fig. 60; 22 (1964) 467 & fig. 49; 24 (1966) 445; 26 (1968) 552; 28 (1970) 433.
 M. LABROUSSE

PULA, *see* POLA

PUNICUM (Santa Marinella) Italy. Map 16.
A site identified in the *Peutinger Table*, which places it on the Via Aurelia 9.6 km N of Pyrgi. The modern town lies along the S curve of Cape Linaro, the first distinct promontory N of the Tiber. The neighborhood had several scattered settlements in Etruscan times and many opulent villas under the Empire.

South of the Fosso Marangone, which separates the territory of Marinella from that of Civitavecchia, a site called La Castellina has yielded habitations and tombs dating from the 8th c. B.C. to the 3d. One, of the 4th-3d c., has been re-erected in front of the Municipio of Marinella; the material from the excavation is in the Museo Nazionale at Civitavecchia.

This museum also houses material from a Sanctuary of Minerva on a hill overlooking the Punto della Vipera just N of Marinella: architectural terracottas of the late 6th and 3d c., archaic and Hellenistic votive terracottas including several heads of Minerva, and Roman coins down to Trajan. Fine marbles, including an Apollo of Hellenistic type, from the neighboring villas, are also to be seen here.

The city is now so heavily built up that nothing ancient can be seen except two bridges of the 2d c. B.C. which once carried the Via Aurelia.

BIBLIOGRAPHY. O. Toti, *NSc* (1961) 125-33; (1967) 55-86; P. Gazzola, *Ponti romani* (1963) nos. 12, 14[I].
 E. RICHARDSON

PUNTA DI SCHISÒ, *see* NAXOS (Sicily)

PUNTA SCALETTA, *see* SHIPWRECKS

PUTEOLI (Pozzuoli) Campania, Italy. Map 17A.
Twelve km from Naples about midway on the shore of a bay formed by the promontories of Mons Posilypus and Misenum. To the rear it is ringed by a series of volcanic hills, and as far as Cumae the whole area was known as the campi phlegraei from its sulphurous atmosphere, hot springs, and other volcanic phenomena. Settled by Samian refugees ca. 520 B.C. and politically dependent upon Cumae, it was an outpost against Neapolis until conquered by the Samnites in 421. There is little literary or archaeological evidence until ca. 334 B.C. when much of Campania came under Rome. In 215 B.C. Puteoli successfully resisted Hannibal; in 199 it received a Roman customs station and a maritime colony in 194. By this time its proximity to the Via Appia at Capua had made it a port preferable to Naples. Sulla or Augustus may have conferred further colonial status; Nero and Vespasian certainly did, and the latter enlarged the city's territory from ca. 10 sq. km of coastline to include a substantial part of the agricultural ager Campanus.

Puteoli's attraction for upper-class Romans and its location only 5 km from Baiae's amenities must have influenced the city's cultural life, but its great fame and prosperity were based on its importance as a port of Rome, especially from the East and especially after Delos became a free port in 166 B.C. Even after Claudius installed the port of Ostia, its prosperity continued to such an extent that Nero undertook to link it with the Tiber by canal. Although by comparison Puteoli declined from the 2d c. onward, it nevertheless remained important until it was abandoned in the 6th c. The city's population, estimated to nearly 65,000, was commercial and highly cosmopolitan, as is reflected by oriental cults such as Sarapis (105 B.C.), Kybele, Jupiter Dolichenos, Bellona, Dusares, I.O.M. Heliopolitanus, Judaism and pre-Pauline Christianity (but not Mithraism), as well as by the usual Graeco-Roman and the imperial worship. Puteoli was likewise a gateway for Alexandrian artistry and artisanship, while its material imports were as varied as the world's products, especially eastern grain bound for the capital.

Return cargoes from Puteoli included oil, wine, and

probably Republican black "Campanian" pottery; also the locally made and widely distributed glass and early imperial terra sigillata.

The most conspicuous ancient monuments are reproduced and named on Late Classical globular glass vases from Piombino (now in the Corning [N.Y.] Museum of Glass), Odemira (Portugal), Ampurias, Populonia, and one now in Prague, and in Bellori's engraving of a wall painting now destroyed; interpretation of these illustrations and inscriptions is difficult and often conjectural. The city was eventually plundered to provide building materials for the cathedrals of Salerno and Pisa.

Puteoli naturally divides into a lower town, an upper town, and the environs. Since antiquity parts of the lower town have sunk ca. 8 m and risen again through bradyseism; high water has been marked by marine borers attacking the three columns standing since antiquity in the macellum. Since the 18th c. a new cycle of subsidence has progressed at about 2 cm annually.

The great macellum, formerly called the Temple or Baths (?) of Sarapis from a statue found there in 1750, consisted of a large rectangular courtyard (ca. 38 x 36 m), now submerged, surrounded by a portico into which shops on E and W opened, or onto the streets outside; the inner oriented shops were faced and paved with marble while the others were merely stuccoed. Stairs led to an upper story. The grand entrance, flanked by further shops or offices, was in the center of the S side; opposite it on the N was a large apse with capacious latrines in the courtyard's NE and NW corners. At some later time the courtyard was embellished by a circular colonnade of 16 African marble columns on a podium (18.2 m diam.); statues and putealia were in the intercolumniations, a fountain was at the center, and the whole structure was either roofed or hypethral. The entire macellum was surrounded by an even larger one-story enclosure of additional shops facing inward, and the whole must have been a spectacular unit worthy of the importance of the city it served.

Of the port little is now accessible. Ruins of the famous Augustan opus pilarum, a breakwater (15-16 m x 372 m), carried on 15 enormous masonry piers, with at least one triumphal arch, columns topped by statues, a lighthouse, and an architectural ship's prow at the end, are embedded in the modern solid breakwater. The colonnaded quay (ripa) and some docks are now below sea level.

The Temple of Augustus, contributed cum ornamentis by a local admirer, was situated on a low (36 m) acropolis. It was largely destroyed by the renovations of the present Cathedral, but some columns, an architrave, and inscriptions remain. In 1964 it was discovered to have encased the remains of a structure reusing late 5th c. Greek blocks, and of a Samnite or Italic temple with handsome base moldings. Other monuments of the lower town, conspicuous enough for identification on the glass vases and engraving mentioned above, have disappeared.

The upper town was residential and recreational. An outstanding discovery was the small Augustan amphitheater with axes of 130 and 95 m under the new Rome-Naples express railway line; it apparently lacked the subterranean chambers necessary for venationes. These and other improvements were supplied in the great Flavian amphitheater (149 x 116 m) nearby, which the Puteolans built at their own expense in the principate of their benefactor Vespasian. Accommodating 40-60,000 spectators, it was the third largest in Italy after those at Rome and Capua. Beasts and machinery went underground on ramps along the long axis reaching 6.7 m down to two subterranean levels of passageways and 80 cages; as needed, animals were returned to the arena on elevators

through rectangular openings in an ellipse paralleling the podium of the cavea and through other shafts. Cisterns and fountains were for decoration, not naumachiae. An elaborate sewer system concentrated all surface drainage under the arena.

The upper town also included the Baths of Trajan or Janus, which may be the same as the so-called Temple of Neptune or of Diana, a solarium portico, a circus, and several great cisterns served by a Republican aqueduct from the N and, from the E, by a longer one attributed to Agrippa.

In the environs, Puteolan opulence is evident in the magnificence of the columbaria, hypogea, and mausolea along the Via Consularis Capuam Puteolis (Via Campana) extending for ca. 2 km as far as S. Vito, especially that part closest to the city gate (Via Celle). Some are decorated with stucco or mosaics, or are otherwise impressively preserved, and in Christian times some were reused for inhumations. Similar but less ostentatious funerary monuments also flanked the ancient road to Naples.

The Via Campana was the only road connecting the coastal cities with the hinterland and the Via Appia until construction of the Via Domitiana linking Rome with Puteoli, a less expensive substitute for Nero's projected canal. Under Augustus the pre-Sullan road to Naples was shortened by the crypta Neapolitana; Nerva and Trajan improved this artery and made it a continuation of the Domitiana, and the latter placed a triumphal arch over it.

There is a museum at Pozzuoli but the statues, coins, pottery, and other antiquities from the city are mostly distributed among museums in various countries and at Naples.

BIBLIOGRAPHY. C. Dubois, *Pouzzoles antique* (1907)[PI]; J. Bérard, *Bibliographie topographique des principales cités grecques de l'Italie méridionale et de la Sicile dans l'Antiquité* (1942); annual entries in *FA* (1948-); H. Kähler, "Der Traiansbogen in Puteoli," *Studies Presented to David Moore Robinson* I (1951) 430-39[I]; W. Johannowski, "Contributi alla topografia della Campania antica I, La 'Via Puteolis-Neapolim,'" *RendNap* 27 (1952) 83-146[M]; A. Maiuri, "Studi e ricerche sull'anfiteatro flavio puteolano," *MemNap* (1955)[PI]; id., *The Phlegraean Fields* (Guide Books to Museums and Monuments in Italy, 32, 3d ed. 1958, tr. Priestley)[PI]; id., s.v. "Pozzuoli," *EAA* 6 (1965) 413-20[I]; A. De Franciscis & R. Pane, *Mausolei romani in Campania* (1957) 56-72[PI]; C. Picard, "Pouzzoles et le paysage portuaire," *Latomus* 18 (1959) 23-51[MI]; M. F. Fredericksen, s.v. "Puteoli" in *RE* 23, 2 (1959) 2036-60[P]; J. H. D'Arms, *Romans on the Bay of Naples* (1970); R. Ling, *BSR* 38 (1970) 153-82 (San Vito tomb)[PI].　　　　　　　　　　　　　H. COMFORT

PUYS-DE-VOINGT (Les) Communes of Voingt and Giat, Puy-de-Dôme, France. Map 23. A Gallo-Roman locality extended over ca. 28 ha on the S slope of a hill (altitude 821 m) divided between two communes. Excavations have been carried out on the site on various occasions since the 18th c. Since 1934 excavations have systematically investigated the following: (1) a district of dwellings, some modest, built of light materials (some may go back to the Gallic period), others more substantial, built of stone; (2) artisans' workshops (smithy, glass factory); (3) at the top of the hill, a temple of Celtic type, open to the NE, under whose cella were the remains of an older building made of light materials; (4) two cemeteries E of the built-up area. The coins range from the last Gallic issues to Maximus. The pottery series begins with some samples of Campanian ware and ends with terra

sigillata decorated with hatchings impressed with a cog-wheel. The artifacts collected are at Giat in M. Charbonneau's house.

BIBLIOGRAPHY. A. Tardieu, *La Villa gallo-romaine de Beauclair* (1882); G. Charbonneau, "Les Ruines gallo-romaines des Puys-de-Voingt," & "Nouvelles fouilles aux Puys-de-Voingt," *Gallia* 15 (1957) 117-28; 19 (1961) 226-31. P. FOURNIER

PUYSÉGUR Gers, France. Map 23. A Gallo-Roman dwelling of late date (3d to 5th c.) has been investigated at Les Arribères. It served as a cemetery in the early Middle Ages and undoubtedly included a small pagan sanctuary later converted into a Christian chapel.

BIBLIOGRAPHY. B. Duhourcau, "Etude sur deux chapiteaux trouvés dans les ruines d'un édifice gallo-romain à Puységur (Gers)," *Bull. de la Soc. arch. du Gers* 55 (1954) 200-204; M. Labrousse in *Gallia* 12 (1954) 222-23 & figs. 12-13; 13 (1955) 213 & fig. 13; 20 (1962) 584 & fig. 44. M. LABROUSSE

PYDNA Macedonia, Greece. Map 9. A city in Pieria, the ethnic being Pydnaios. It issued coinage as early as the late 6th c. B.C. Like Methone, Pydna was considered a Greek city, as opposed to the Thracian and Macedonian cities along the coast of the Thracian gulf and inland. It is mentioned first by Thucydides (1.137) in connection with Themistocles' flight to Persia, as "Pydna of Alexander," the king of Macedonia. It became important during the Peloponnesian War. In 432 B.C. it was besieged by the Athenians (Thuc. 1.61). Archelaus made a brief siege of the fortified seashore city of Pydna with the help of the Athenian navy (ca. 410 B.C.) and after taking it moved the city 20 stades inland from the shore (Diod. Sic. 13.14). But after Archelaus' death it appears that the citizens of Pydna moved their city back to the shore. Pydna issued coins again from 389 to 379 B.C. In 364-363 B.C. the Athenians took it, but in 357-356 B.C. it fell into Philip's hands. In 317-316 B.C. after a long siege of the city Kassander put Olympias, Alexander the Great's mother, to death there (Diod. 19.36.1, 49.1). In the same place the last act of the drama of Macedonian Hellenism took place: the battle of Pydna (22 June 168 B.C.) in which M. Aemilius Paulus defeated Perseus, last king of Macedonia, and put an end to Macedonian power.

Although the site of Pydna is disputed, it is reasonably well established. The city on the shore is on a hill S of the town of Makrygialos, called by the natives "Old Pydna" or Paliokitros. The Pydna of Archelaus is at Kitros. The port is by the promontory Atherida. The battle of Pydna, according to a recent study, took place on the hills on either side of the river now called Mavroneri (ancient Leukos), while its tributary, the Pelikas, is identified as the Aeson. Another theory is that the battle took place nearer Pydna, by the modern town of Ano and Kato Joannis, near Kourinos, where there are two grave tumuli.

There have never been excavations in the area of Pydna except for the discovery of a "Macedonian" tomb by Heuzey. The information about the topography of Pydna and the battle near it is based on continual surface observations by many investigators, and on chance finds, which are in the Thessalonika Museum and the Archaeological Collection of Katerini, the present capital of the Nome of Pieria.

BIBLIOGRAPHY. L. Heuzey & H. Daumet, *Mission Archéologique de Macédoine* (1876) 239-66MPI; Ch. Edson, "The Tomb of Olympias," *Hesperia* 18 (1949) 84-95I; id., *ATL* I (1939); III (1950) passim; V. Kahrstedt, "Städte in Makedonien," *Hermes* 81 (1953) 85-111; Chr. M. Danoff, "Pydna," *RE* Suppl. X (1965) 833-42;

W. K. Pritchett, *Studies in Ancient Greek Topography* II; Battlefields (1969) 145-76MI. PH. M. PETSAS

PYDNAI (Özlen) Turkey. Map 7. Site in Lycia, 5 km W of the mouth of the Xanthos. Mentioned only in the *Stadiasmus* (248), which places it 60 stades from the river mouth. It has been thought that this is the same place as Ptolemy's Kydna, which he calls an inland city. Neither of these terms is in fact applicable to the site at Özlen, which is merely a fortified enclosure, now known as Gâvuraglı, occupying the E slope of a hill near the shore; the wall is in excellent and well-preserved polygonal masonry, with eleven towers and seven stairways leading up to the battlements. The only building in the interior is a small church. Four or five inscriptions have been found in and around the fort; all are of Imperial date.

BIBLIOGRAPHY. C. Fellows, *Lycia* (1840) 161-63; E. Petersen & F. von Luschan, *Reisen in Lykien* I (1889) 124-25; *TAM* II, 1 (1920) p. 91. G. E. BEAN

PYLAE CILICIAE (Gülek Boğazı, İçel) Turkey. Map 6. One of the most famous mountain passes, this cleft to the S of Mt. Tauros has been used by armies from antiquity (Cyrus the Younger, Alexander) almost to the present day. It also carried a great weight of commercial traffic though this could be interrupted in winter (Cic. *Ep. ad Att.* 5.21.14). The Via Tauri was improved and the pass widened under Caracalla. A tablet recording his work survives at the Cilician Gates today.

BIBLIOGRAPHY. R. P. Harper, "Podandus and the Via Tauri," *AnatSt* 20 (1970) 149-53. R. P. HARPER

PYLOS (Palaio Kastro) Messenia, Greece. Map 9. The Classical town occupied Mt. Koryphasion, a rocky promontory at the N end of the Bay of Navarino. It is chiefly known as the camp fortified by the Athenians in 425 B.C. prior to the battle with the Spartans on the island of Sphakteria. There are traces of Greek walls of various types of masonry both earlier and later than those assigned to the Athenians; some served as foundations for the 13th c. Frankish castle. Also ancient are cisterns and rock-cut steps and the remains of a breakwater at the S tip of the cape. Pausanias (4.36.1-5) mentions a Sanctuary of Athena Koryphasion, unknown today, and within the city a house, tomb, and cave, all supposedly of Nestor. This last has been found to contain sherds dating from Mycenaean to Roman times, but the Mycenaean palace of Nestor has been excavated at Epano Englianos, 10 km to the N.

BIBLIOGRAPHY. R. Burrows in *JHS* 16 (1896) 55-76I; 18 (1898) 148I; G. Grundy in *JHS* 16 (1896) 1-54M; J. G. Frazer, *Paus. Des. Gr.* (1898) III 456, v 608. M. H. MC ALLISTER

PYRASOS (Nea Anchialos) Thessaly, Greece. Map 9. The harbor town of Thessalian Thebes on a small hill overlooking the Bay of Volo. A small fish pond between the hill and the sea represents the site of the ancient harbor, known in later times as Demetrion from the early and important Sanctuary of Demeter and Kore. The site of the sanctuary is disputed, but numerous gravestones attest the international character of the harbor. Stählin found an early circuit wall of field stones and mudbrick overlaid by Byzantine remains near the top of the hill, and other similar walls at the foot on the NE and E.

BIBLIOGRAPHY. Strab. 9.5.14; F. Stählin in *AthMitt* (1906) 10f, *Das hellenische Thessalien* (1924) 173M. M. H. MC ALLISTER

PYRGOS, *see* TEGYRA

PYRNOS Caria, Turkey. Map 7. A town of the Rhodian Peraea. It is named by Pliny (*HN* 5.104) between Kaunos and Loryma, and by Stephanos Byzantios. Earlier it was a member of the Delian Confederacy, with a tribute of one-sixth of a talent. It has been proposed to place it in the bay of Büyükkaraağaç, between Kaunos and Physkos; there are remains of walls and tombs on the W side of the bay.

BIBLIOGRAPHY. P. Roos in *Opuscula Atheniensia* 9 (1969) 60; *ATL* I 544. G. E. BEAN

PYRRHA, *see* LESBOS

PYRRHICHOS Lakonia, Greece. Map 9. Town situated in the center of the Maina on the only road crossing the peninsula to the S of Gytheion. The city was a member of the Eleutherolakonian League (Paus. 3.21.7 and 25.1). The site has been identified with the modern village of Kavalos (now renamed Pyrrhichos), in the environs of which is a place called Pourko whose name could be seen as derived from the ancient name. The area has not been excavated, and except for a few lintels and reused architectural fragments, nothing is today visible. Some chance finds (inscriptions, coins, etc.) have vanished or have been taken to the museum at Gytheion.

BIBLIOGRAPHY. E. Puillon-Boblaye, *Recherches géographiques* ... (1835) 88-89; R. Weil, *AthMitt* 1 (1876) 158; E. S. Forster, *BSA* 10 (1903-4) 160; C. Le Roy, *BCH* 89 (1965) 378-82. C. LE ROY

PYXOUS later BUXENTUM (Policastro di S. Marina) Lucania, Italy. Map 14. A port at the mouth of the Bussento, the only good harbor other than Sapri on the Golfo di Policastro (sinus terinaeus). In the 6th c. B.C. when it first appears in history, Pyxous was apparently a dependency of Sybaris and issued coins of Sybarite type that also bear the name of Siris on the Gulf of Tarentum. It is possible that an overland route connected these cities. Pyxous may have collapsed after the fall of Sybaris in 510 B.C., for it is next heard of as a foundation of Mikythos, tyrant of Messine and Rhegion in 467. The majority of the colonists planted there is said by Strabo (6.253) to have soon departed, and we next hear of it as the site of a Roman colony of 300 families in 194 B.C. that had then to be reinforced with a second draft of colonists in 186 (Livy 32.29.4; 34.42.6; 34.45.2; 39.23.4). Though it seems never to have flourished, it is mentioned by geographers in the Imperial period, and inscriptions show that it had duovirs as magistrates and was inscribed in the tribus Pomptina.

All that is known of the ancient city is a stretch of Roman road recently excavated. The name Buxentum, which Strabo (6.253) says was also given to the cape, harbor, and river, refers to the abundance of box growing in the vicinity.

BIBLIOGRAPHY. T. J. Dunbabin, *The Western Greeks* (1948); V. Panebianco, *BdA* 49 (1964) 364.

L. RICHARDSON, JR.

Q

QALAAT AL-MUDIK, *see* APAMEA

QANAWAT, *see* CANATHA

QANDAHAR, *see* ALEXANDRIAN FOUNDATIONS, 3

QASR EL-LEBIA ("Olbia") Libya. Map 18. Byzantine ruins 50 km SW of Cyrene, Libya, probably the remains of the small town of Olbia mentioned by Synesius (Ep. 76). The chief remains are two churches, one of which was rebuilt as an Italian fort. The second, excavated in 1957, has a nave and two aisles, with an apse at its W end. A remarkable mosaic (10.75 x 6.10 m) of 50 square panels framed with borders of guilloche pattern was found intact on the nave floor. Near its center an inscription records the laying of the mosaic by Bishop Makarios in A.D. 539. In the top line is a stylized picture of a town, Polis Nea Theodorias, indicating a refoundation in honor of the Empress Theodora. The most interesting panel shows a stepped tower, Pharos, entered over a bridge. This can scarcely be other than the Pharos of Alexandria, for a dark figure on top with radiate crown must be the bronze statue of Helios; behind is

a second figure on a building, presumably on the mainland.

In the N aisle a well-preserved mosaic shows the familiar Nilotic theme of a crocodile swallowing a cow which a man is trying to drag away by its tail. This scene and the Pharos panel hint that the floors are the work of Alexandrian mosaicists. A third mosaic, with crosses and animals, lay by the altar.

BIBLIOGRAPHY. R. G. Goodchild, *ILN* (14 December 1957) 1034-35; J. B. Ward Perkins, "A New Group of Sixth-Century Mosaics from Cyrenaica," *RACrist* 34 (1958) 183-92.

A work by J. B. Ward Perkins and the late R. G. Goodchild on the churches of Cyrenaica, with a chapter on mosaics by E. Rosenbaum, is forthcoming.

O. BROGAN

QASR QARÛN, *see* DIONYSIAS

QENURIO, *see* LIMES, SOUTH ALBANIA

QUADRATA, *see* LIMES PANNONIAE

QUINTIONIS, *see* SINOE

R

RABAT, *see* SALA

RABBATHMOBA later AREOPOLIS (er-Rabba) Jordan. Map 6. Town in the Provincia Arabia E of the Dead Sea, in Moab, built on the site of the biblical town of

Ir Moab. The first settlement of the Roman period was by the Nabateans, and the first mention in the sources is by Ptolemy (5.16.4). In the 2d c. A.D. it was an administrative center, as is attested by documents sealed there and found in the Dead Sea Caves, and by impressions

made by the official seal of Rabbathmoba, found in the 2d c. Nabatean necropolis of Mampsis in the central Negev. Eusebius (*Onom*. 124.15-17) states that the city was known as Areopolis, the city of Ares, a name which frequently figures in Byzantine sources. Ares, in the form of the Semitic god Phanebalos, appears on another seal impression of the city found at Mampsis. Rabbathmoba figures on the *Peutinger Table* and, according to the *Notitia Dignitatum*, a unit of Illyrian cavalrymen was stationed there. No excavations have been made, but surveys have identified the remains of a Nabatean temple with a tripartite plan.

BIBLIOGRAPHY. F. M. Abel, *Géographie de la Palestine* II (1938) 425; M. Avi-Yonah, *The Holy Land* (1966) 117; A. Negev, *IEJ* 21 (1971) 110-29. A. NEGEV

RĂCARI Dolj, Romania. Map 12. A Roman civil settlement and military center in the heart of the province, part of the chain of camps along the Jiu river. Its ancient name is unknown although Admutrium, Malva, Saldae, etc. have been proposed. Only the camp has been excavated. The civil settlement is now covered by the buildings of the railroad station of the modern town. Its remains are strewn over 9 ha (masonry, pottery, coins, etc.). The Roman camp (141.5 x 173.2 m) was built at the time of the Antonini and underwent numerous repairs especially during the 3d c. Rectangular in form, it had four gates, and towers stood at the corners and between the curtains. It contained a large praetorium and a horreum. It was built of brick by the soldiers of Legio V Macedonica and of the numerus Maurorum Σ . . . The archaeological excavations uncovered fragments of three bronze statues representing emperors of the 3d c. (Heliogabalus), many iron weapons, farm implements, many bronze or silver ornaments (sconces, buckles, needles, etc.), and a fragment of a military certificate of Antoninus Pius, all in the defensive trench of the camp. There is evidence of the worship of Diana, Hercules, Iupiter Dolichenus, Mercury, Mithras. There is evidence of fire toward the middle of the 3d c. Considerable repairs were made after this attack. Bronze coins, buckles, pottery, and a lamp with a cross prove that after the abandonment of Dacia (271), the camp was occupied by natives, who fortified it with trenches and continued to live there until the invasions of the Avars and Slavs. These settlers were converted to Christianity and had economic ties with the Eastern Empire.

Material from excavations are in the museums at Craiova and Bucharest.

BIBLIOGRAPHY. *CIL* XVI, 114; *AnÉpigr* (1957) 188; V. Pârvan, "Ştiri nouă din Dacia Malvensis," *ACRMI* 35 (1913) 54; G. Florescu, *Castrul roman de la Răcari-Dolj* (1930); N. Gostar, "Numele antic al castrului de la Răcari," *SCIV* 5 (1954) 607-10; D. Tudor, "Săpăturile lui Gr. Tocilescu la Răcari," *Apulum* 5 (1965) 233-57; id., *Oltenia romană* (3d ed., 1968) passim; id., *Oraşe* (1968) 309-13; *TIR*, L.34 (1968) 94. D. TUDOR

RADOTOVI ("Passaron") Greece. Map 9. The city in Central Epeiros in which the Molossian kings and people exchanged oaths (Plut. *Pyrrh.* 5.1). A temple of the late 4th c. B.C. has been excavated. Inscriptions show that the Molossian state and later the Epeirote Alliance passed resolutions here. The hill Gardhiki above Radotovi is crowned with a circuit wall ca. 1500 m long, built at various periods. Passaron controlled the route leading from the plain of Ioannina to the upper Kalamas valley.

BIBLIOGRAPHY. D. E. Evangelides in *PAE* (1914) 329 and (1952) 306ff; S. I. Dakaris in Ἀφιέρωμα εἰς τὴν Ἤπειρον (1954) 46 and fig. 3; id., in *ArchDelt* 20 (1965)

Chron. 348; N.G.L. Hammond, *Epirus* (1967) 181f and 576f. N.G.L. HAMMOND

RAEBURNFOOT Eskdalemuir, Dumfriesshire, Scotland. Map 24. Small Roman fort above the junction of the river Esk and the Rae Burn, 23 km N of Langholm. Recent excavation has shown that for a short time it stood inside a large compound on the W side of a steep scarp above the Esk, during the Antonine advance into Scotland, about the middle of the 2d c. A.D. The fort was defended by a turf rampart ca. 6 m wide, and by two ditches ca. 3 m wide. There were entrances not more than 6 m wide in the N and S sides, on either side of which the two ditches combined into looped ends. The internal buildings were of timber and apparently consisted only of quarters for troops. The internal area was 4 ha.

The outer compound, partly eroded, now measures internally ca. 164 m N-S and ca. 108 m E-W. The rampart, ca. 5.4 m wide, was constructed mainly of clay dug from the accompanying ditch of the same width. The compound, in which no buildings were found, had two entrances, N and S, exactly opposite those of the small fort. Evidently it served as an annex, corral, or wagon park for the small fort.

BIBLIOGRAPHY. A. Robertson, "Excavations at Raeburnfoot, 1959-60," *Trans. Dumfriesshire and Galloway Ant. and Nat. Hist. Soc.* 39 (1961) 24-49.

A. S. ROBERTSON

RAEDYKES Kincardineshire, Scotland. Map 24. A Roman marching camp 6 km NW of Stonehaven. Irregular in plan and ca. 660 by 540 m, it had six gates protected by titula. The rampart and ditch are not uniform throughout, being much more substantial at the N corners and along the E side. Excavation in 1914 produced no datable finds, but the size of the camp identifies it as one of a series believed to have been built during the late Severan campaigns in N Britain.

BIBLIOGRAPHY. *Proc. Soc. Ant. Scotland* 50 (1916) 317-48; *JRS* 59 (1969) 118-19. K. A. STEER

RAEVSKOE Kuban. Map 5. A fortified military settlement ca. 20 km SE of Anapa, founded in the mid or late 4th c. B.C. to protect the E border of the Bosporan state. The main defenses consist of an embankment in the shape of a parallelogram which encloses an area of ca. 4 ha. In the late 1st c. B.C. or early 1st c. A.D., a stone wall was built to strengthen the fortifications. The main monument uncovered by intermittent excavations begun in 1954 was a large stone building of the Hellenistic era for public use. The building (ca. 700 sq. m) consisted of several rectangular rooms and passageways along with an attached peristyle courtyard. The finds suggest close ties with Gorgippia and the growth of agriculture and handicrafts during the Roman era. Although life at the settlement ceased in the late 4th c., the site was inhabited again during the mediaeval period.

BIBLIOGRAPHY. V. D. Blavatskii, "Issledovaniia Raevskogo gorodishcha v 1954 godu," *KSIIMK* 77 (1959) 42-50; N. A. Onaiko, "Raskopki Raevskogo gorodishcha v 1955-1956 godakh," *KSIIMK* 77 (1959) 51-61; id., "O raskopkakh Raevskogo gorodishcha," *KSIA* 103 (1965) 125-30; id., "Ellinisticheskoe zdanie Raevskogo gorodishcha i ego mesto v arkhitekture Bospora," *SovArkh* (1967) 2.155-68. T. S. NOONAN

RAFAH, *see* RAPHIA

RAGUSA, *see* HYBLA HERAIA

RAJAT Commune of Murol, Puy-de-Dôme, France. Map 23. The plateau of Rajat constitutes the summit of a spur located N of Murol. It has an altitude of 1,084 m and dominates the valleys around it by ca. 200 m. The ruins of a small hilltop temple of Celtic type were excavated near the end of the plateau in 1954-57. The cella is open to the E and measures 4.40 sq. m. Around it there was a flagged area. However, the wall which must have enclosed this area has not been found around its entire circumference. A test pit under the beton floor of the ceila revealed no older remains. A bronze statuette of Harpokrates has been found in a small building next to the cella. Coins range from a small Gallic piece (Epad) to Arcadius. The artifacts are kept in the town hall at Murol.

BIBLIOGRAPHY. H. Verdier, "Le Sanctuaire de Rajat," *Gallia* 21 (1963) 241-47. P. FOURNIER

RAKOVAC, *see* LIMES PANNONIAE (Yugoslav Sector)

RAM, *see* LIMES OF DJERDAP

RAMACCA, LA MONTAGNA Catania, Sicily. Map 17B. A hill of calcareous formation, 560 m high, to the W of the modern village. A gentle slope leads to the plateau at the summit. Various finds seem to document the existence of a Sikel center at the site; these include a necropolis with 41 rock-cut chamber tombs and cist graves (nearby, terracottas of the 6th and 5th c. B.C.), along the slopes of the hill, on the SE side. On the plateau there are graves cut into the rock as well as foundations for a large building and remains of walls (nearby, fragments of Ionic cups), and, at the summit of the hill, the foundations of another structure. The site is identified with Eryx by some scholars.

BIBLIOGRAPHY. Messina-Palermo-Procelli, "Esplorazione di una città greco-sicula in contrada La Montagna e di un insediamento preistorico in contrada Torricella," *NSc* (1971). C. BUSCEMI INDELICATO

RAMAT RAHEL Israel. Map 6. An ancient site on the S outskirts of Jerusalem, on the way to Bethlehem, within the limits of the modern settlement of Ramat Rahel. This site has been tentatively identified with Biblical Beth ha-Kerem, which is said to have been in the district of Bethlehem. The site, excavated between 1954 and 1962, has revealed five main occupation levels from the Iron Age to Early Arab.

The earliest remains on the site were of a series of royal citadels of the Late Iron Age. Very few building remains of the Persian-Hellenistic periods were discovered, but the numerous coins and other small finds attest an extensive settlement on the site during the 5th-3d c. B.C. The earlier phases of this period are dated by coins, Attic pottery, and stamped jar handles. Among these are included several score of seals of the Yahud type, Yahud being the official name of the Persian satrapy of Judea. Other seal impressions had the name and title of the Jewish satrap of the province. There were also seals with the inscription in Hebrew "the City," and "Jerusalem," as well as private seals, and seals with representations of animals. The Hellenistic phases were dated by pottery and coins.

The Herodian period is represented by several simply built small rooms, used mainly for industrial installations. Remains of the Late Roman and Early Byzantine periods were more impressive. To the 3d c. A.D. belong the remains of a house centered around a hypostyle court, with a bath building of which the hypocaust was preserved. The bricks of the hypocaust were stamped with the seal of the Legio X Fretensis. Other buildings as well date to the Late Roman period. The site may have been an administrative center of the Legio X, stationed in Jerusalem until ca. A.D. 300. As indicated by the pottery found on the floors of the Late Roman buildings, these remained in use throughout the whole of the Byzantine period. The area of the Late Roman-Byzantine town was honeycombed with numerous cisterns. Some of these were originally burial caves, with the latest burials made in the 3d c. A.D.

There was some building in the Byzantine period. The more important structures were a church and the monastery attached to it. The church is a basilica (22.3 x 15 m) with a single external apse, semicircular inside, polygonal outside. The foundations, 2 m deep, were built with stones taken from Herodian buildings, as identified by the typical stone dressing. A third row of columns ran along the W side of the church, forming a third aisle, perpendicular to the two longitudinal ones. The whole church was paved with mosaics of geometric patterns. On stylistic grounds the mosaics were dated to the 4th c. A.D. To the S of the church was the monastery. A vestibulum in front of the church gave entrance to a court, which led to the numerous halls and rooms, including a bakery and installations for the production of wine and oil. Other rooms probably served as a guest house for pilgrims. The church and the monastery have been identified with the traditional Kathisma (halt) of the Virgin Mary, where she was refreshed by the waters of a spring on the way to Bethlehem. This identification is supported by the presence of a nearby well. The Kathisma Church is continually referred to by Christian travelers from the mid 5th c. throughout mediaeval times.

BIBLIOGRAPHY. Y. Aharoni, "Excavations at Ramat Rahel, 1954. Preliminary Report," *Israel Exploration Journal* 6 (1956) 137-57; id., *Excavations at Ramat Rahel, Seasons of 1959 and 1960* (1962); id., *Excavations at Ramat Rahel, Seasons 1961 and 1962* (1964).
 A. NEGEV

RAMBACIA, *see* ALEXANDRIAN FOUNDATIONS, 11

RAMET EL-KHALIL Occupied Jordan. Map 6. Site 2.4 km N of Hebron and 900 m above sea level, where there was an oak named Ogiges, or Terebinthos according to Josephus (*AJ* 1.186; *BJ* 4.533), near which Abraham lived, 6 stadia from Hebron. According to Hieronymus (*Commentar to Zechria* 9.2) Hadrian sold captives of the Bar Kohbah revolt into slavery here. A market is mentioned in both Jewish and Early Christian sources; a pagan altar is mentioned as well. Eusebius (*Vita Const.* 3.53) states that Constantine the Great destroyed the altar and built a church in its place.

Excavation below the area of the Constantinian church has uncovered remains of the Middle Bronze and Iron Age occupation of the 9th-8th c. B.C.; it seems probable that a high place existed here even at this early date. Above these remains were traces of the Hellenistic settlement. To the time of Herod the Great belongs a massive wall, similar to that around the Cave of Machpelah at Hebron. The wall was rebuilt by Hadrian, who also built a temple close to the E wall of the enclosure in which a statue of Hermes was found. The Constantinian church was built above the ruins of the temple; the church was destroyed during the Persian invasion of A.D. 614 but was subsequently rebuilt. From a deep well within the sacred compound came 1331 coins, ranging in date from Hellenistic to the time of the Crusaders, except for the period A.D. 70-135 when the site was temporarily abandoned.

BIBLIOGRAPHY. A. E. Mader, *Die Ergebnisse der Ausgrabungen im heiligen Bezirk, Ramat el-Halil* (1957).

A. NEGEV

RAMISTA (Formin) Yugoslavia. Map 12. A settlement mentioned in the *Peutinger Table* as being 10 miles (in *It. Burd.* 561.7:9) to the E of Poetovio on the road to Mursa. The most recent investigations of the course of the Roman road have shown that it crossed the Drau at Formin (to the E of Ptuj) and ran to Petrijanec (Aqua Viva). Both the distance mentioned and the quantity of different archaeological elements (Late Iron Age settlement with necropolis, Roman houses) near the fork in the road for Carnutum indicate that the riverbank settlement and road station with landing-place should be sought in Formin.

BIBLIOGRAPHY. S. Pahič, "K poteku rimskih cest med Ptujem in Središčem," *Arheološki vestnik* 15-16 (1964-65)ᴹ.

J. SASEL

RANDAZZO. ST. ANASTASIA ("TISSA") Catania, Sicily. Map 17B. About 6 km E of Randazzo, the fief of St. Anastasia is the site of a necropolis discovered at the end of the last century. The graves have yielded notable finds, now preserved at the Vagliasindi Museum in Randazzo and at the national museums of Siracusa and Palermo; they include prehistoric objects, Sicilian terracottas of the late archaic period, vases of the 5th c. B.C. The site is identified with Tissa by some scholars.

BIBLIOGRAPHY. E. Rizzo, "Una necropoli greca a S. Anastasia presso Randazzo e la Collezione Vagliasindi," *RömMitt* (1900) 237ff; Can. V. Raciti Romeo, *Randazzo, Origine e Monumenti* (1919); P. Virgilio, *Randazzo e il Museo Vagliasindi* (1969).

C. BUSCEMI INDELICATO

RAPHIA (Rafah) Jordan/Israel. Map 6. The southernmost city on the coast of Palestine and its port, identified with Tell Rafah. A halt under the same name is mentioned in ancient Egyptian sources in conjunction with the Via Maris. Diodorus (20.74) reported that Demetrius (in 306 B.C.), who sailed from Gaza, had many of his galleys driven by a storm to Raphia, "a city which affords no anchorage and is surrounded by shoals." Strabo (16.2.31) refers to a battle fought there between Ptolemy IV and Antiochos the Great in 217 B.C. At Raphia Antiochos V married the daughter of the same Antiochos the Great (Polyb. 5.82-86). The city was taken by Alexander Jannaeus (Joseph. *AJ* 13.357; 14.396), who annexed it to the Hasmonaean kingdom. It was freed again by Pompey in 64 B.C., and was subsequently rebuilt by Gabinius (Joseph. *BJ* 1.166). In A.D. 69 Titus went by Raphia on his way from Alexandria to Caesarea. On this occasion Josephus (*BJ* 1.662) wrote that Raphia is "the city where Syria begins." Ptolemy (5.15.5) knew it as a city of Judea and Raphia is frequently mentioned in Byzantine sources.

Raphia minted coins from the time of Commodus to that of Philip the Arab, and from these coins we learn that Apollo, Artemis, and Dionysos were worshiped there. There have been no excavations.

BIBLIOGRAPHY. F. M. Abel, *Géographie de la Palestine* II (1938) 431-32; M. Avi-Yonah, *The Holy Land from the Persian to the Arab Conquests (536 B.C. to A.D. 640). A Historical Geography* (1966). A. NEGEV

RAPHINA, see ARAPHEN

RAPIDUM (Sour Djouab) Algeria. Map 18. A Roman camp of the Mauretanian limes, 165 km S of Algiers. Beside the camp founded by Hadrian, there developed a town, which became a municipium in the 3d c. Taken and destroyed by rebels in the middle of the 3d c., Rapidum was rebuilt by Diocletian.

According to the excavations (1927 and from 1948 to 1953), there are two distinct parts to Rapidum: the camp and the town. The camp is rectangular with rounded corners. It dates to 122 (*CIL* VIII, 20833). The enceinte is made of two ashlar walls enclosing interior rubble fill. It is reinforced by towers standing on either side of the four gates, one on each side of the camp. The praetorium is located at the intersection of the decumanus and the cardo. It measures 28 x 24.5 m and, in accordance with the classic plan, has three parts: an entry in the form of a double gate, opening to the praetorian way to the E; a court (14.5 x 12.5 m), bordered on the N and S by three square rooms, possibly armamentaria; and to the W a large transverse room (23.40 x 5.75 m) with a tribunal at the N end. Five rooms open on this hall, all scholae, except for the middle one, which ended in an apse and must have been a chapel for the standards. Some meters S of the praetorium, a huge building may have served as a stable. Close by and to the S stands another large building, presumably the commander's residence (27 x 19.5 m); small private baths and seven rooms are arranged around a court. The rest of the camp was occupied by barracks and standard baths. Of note is a curious relief depicting the salutatio, encased in the W gate.

The town, contiguous to the camp on the S side (but not on the W), is itself surrounded by ramparts, built in 167 (*CIL* VIII, 20834, 20835). Of ashlar, it was restored under Diocletian with materials which sometimes came from wrecked buildings. Two gates fortified with towers open to the E and W. To the NE four-cornered bastions on the outside reinforce the ramparts.

Built on a sloping plateau, swept by the winds, at the end of the great plain of the Beni Slimane, the town covers 15 ha. Two walls running N-S and E-W, of very mediocre quality and probably of late date, rather curiously divide the town into three districts. They are connected by two gates opening in these poorly built walls. The forum has not been located. In the N and S districts one can still see the plan of the streets, oil presses, remains of corn mills, and some houses. Two rather large dwellings are built according to the classic plan, centered on an interior court with wells. In the E district, large columns, cut stone, and pieces of colossal statues of Jupiter and Minerva suggest the existence of a capitol. There also undoubtedly was a temple to Ceres.

Two conduits brought water, one from the S, the other from a spring located 2.5 km to the E. There were at least two necropoleis. The main one, to the W of the town, has produced mausolea, stone sarcophagi, urns, stelae with reliefs and inscriptions, and funerary mensae. Tombs have also been found to the N of the town.

On the plateau of Trab Amara one km NE of Rapidum beyond the wadi Baghla, there stood a temple dedicated to Saturn and to Caelestis. No trace of the building remains except for votive stelae. Finally, at Aïn Tamda, some kilometers W of Rapidum, a group of Christian buildings (church and monastery) has been excavated. The influence of Syrian Christian architecture has been discerned.

BIBLIOGRAPHY. S. Gsell, *Atlas archéologique de l'Algérie* (1911) 14, no. 90; W. Seston, "Le secteur de Rapidum sur le limes de Maurétanie Césarienne d'après les fouilles de 1927," *MélRome* 45 (1928) 150-83; "Le monastère d'Aïn Tamda et les origines de l'architecture

monastique en Afrique du Nord," *MélRome* 51 (1934) 79-113; M. Leglay, "Reliefs, stèles et inscriptions de Rapidum," *MélRome* 63 (1951) 53-91; *BAC* (1954) 152-54; *Saturne Africain. Monuments* (1966) II 310-12.

M. LEGLAY

RÂS EL-'AIN, *see* ANTIPATRIS

RAS-IL-WARDIJA, *see under* MELITA

RAS-IR-RAHEB, *see* MELITA

RASSVET Kuban. Map 5. Bosporan agricultural settlement of the 2d c. B.C.-1st c. A.D. 18 km NE of Anapa. Excavations since 1964 have uncovered a two-storied rectangular (16 x 11 m) farmhouse or a fortified tower. The main stone walls of the house were further strengthened by an attached secondary wall. In one of the two rooms in the house was a pottery kiln containing terracotta statuettes. Various agricultural tools were scattered around both rooms. Near the house was a Sindian cemetery of the 6th-4th c. in which most of the graves were stone boxes surrounded by cromlechs.

BIBLIOGRAPHY. Iu. S. Krushkol, "Antichnoe zdanie v raione Gorgippii," *Antichnaia istoriia i kul'tura Sredizemnomor'ia i Prichernomor'ia: Sbornik statei* (1968) 213-19; V. N. Karasev & L. S. Lebedenkov, "Grobnitsy iz khutora 'Rassvet' (Anapskii raion)," *KSIA* 130 (1972) 58-61.

T. S. NOONAN

RATAE CORITANORUM (Leicester) Leicestershire, England. Map 24. Capital of the Roman civitas of the Coritani in the E midlands. In late pre-Roman times this tribe had a coinage, but the importance of Leicester itself in that period is uncertain. It seems probable, on the evidence of pottery, that a small native settlement existed from at least ca. A.D. 10, and that after 43 this was enlarged as the vicus of a Roman fort or fortress. Ratae occupied a strategic position at the junction of the Fosse Way with a road from Colchester, near a crossing of the river Soar.

Little is known as yet of the strength of the military occupation or its duration, but the late appearance of civic public buildings may indicate that it lasted until the 2d c. A milestone of Hadrian (*RIB* 2244) inscribed A RATIS II implies the existence of the town as an administrative center by A.D. 119-120. A military diploma, or grant of Roman citizenship to an auxiliary soldier, found in Roumania (*CIL* XVI, 160) and issued in 106 to M. Ulpius Novantico son of Adcobrovatus, gives his origo as Ratis. This formula has been held to imply that by that date Leicester was already a chartered town (municipium); but the special circumstances of this grant make the conclusion doubtful.

Remains of the forum have recently been identified: 91 by 131 m overall, with a basilica 11.3 m wide at the N end. It was erected perhaps in the reign of Hadrian. Part of a large courtyard house NE of the forum has been excavated: the walls were built of unfired clay bricks on masonry sleeper walls. Erected early in the 2d c., it was later decorated with mosaics and some remarkable frescos of Classical character depicting human and other figures on a perspective architectural background; but before the end of the 2d c. it had fallen into decay and seems to have been used in connection with a tanning industry. About 180 it was replaced by a macellum planned like a smaller version of the forum, with a basilica at its S end. These facts point to more space being required by traders, and suggest increasing commercial and industrial prosperity. The public baths, excavated in 1936-39 just W of the forum, occupied half an insula. They were completed in two stages between ca. 130 and 150. Two parallel and symmetrical bath suites extend W from an enclosed exercise area, a basilica or palaestra. Much of the W wall of this area still stands ca. 7.2 m high: called the Jewry Wall, it is one of the major monuments of Roman Britain. Thus the main civic development of Ratae, as illustrated by its more important buildings, was delayed until the Hadrianic-Antonine period.

The defenses, consisting of contemporary rampart, wall, and ditch enclosing just over 40 ha, were erected probably early in the 3d c. The town has yielded over 40 mosaics, the best known being the Peacock pavement and one depicting Kyparissos and his stag. Another important find is the box flue-tile on which the maker scrawled the words PRIMVS FECIT X, interesting evidence for literacy in Latin among the working classes. But the sherd inscribed VERECVNDA LYDIA LVCIVS GLADIATOR is now known not to be a local find. Graffiti scratched on some of the wall plaster mentioned above express various obscenities in Latin, another indication that it was widely used as a language of first choice. A short distance S of the town is a linear earthwork, the Raw Dykes, which has been identified as an aqueduct although the low level of the system would have made it difficult to supply water to the baths and impossible in much of the town. Alternatively it may have been a canal.

BIBLIOGRAPHY. Graffiti: *JRS* (1964) 182; Forum: *Britannia* 4 (1973) 1-83; Baths: K. M. Kenyon, *The Jewry Wall Site, Leicester* (1948).

S. S. FRERE

RATIATUM (Rezé) Loire Atlantique, France. Map 23. The site, first identified in the 18th c., lies on the left bank of the Loire at the E end of the estuary, facing the modern city of Nantes. Occupied from the reign of Augustus on, the city of Ratiatum had many monuments of which little remains today except in the writings of local scholars of the last century: in 1853 a great colonnaded portico was found near the W portal of the present-day church.

Recent excavations at Rezé have uncovered a large quantity of material both from occupation strata and from funerary pits, which are particularly plentiful in the Saint-Lupien quarter. Many objects found at Rezé are in the Nantes museum.

BIBLIOGRAPHY. L. Maitre, "Rezé, La ville romaine et les ruines païennes," *Annales de Bretagne* (1895); P. Merlat, "Fouilles et sondages à Rezé," ibid. 64, 1 (1957); A. Plouhinec, "Les fouilles du quartier Saint-Lupien de Rezé," ibid. 71, 1 (1964).

M. PETIT

RAURANUM (Rom) Deux-sèvres, France. Map 23. An important Gallo-Roman settlement on the ancient Poitiers-Saintes road (*Peutinger Table* and *Antonine Itinerary*), and at the junction of roads from Nantes, Limoges, and Périgueux. Ausonius had a villa here. Some scattered finds made in the 19th c. drew attention to the site: milestones of Tetricus and Tacitus, a cippus from the Gallo-Roman cemetery, etc. These monuments are in the Musée des Antiquaires de l'Ouest at Poitiers.

In 1887 excavations on the boundary of the present village, toward the Couhé road, uncovered the Gallo-Roman substructures of a rectangular building with a number of rooms, two of them with hypocausts. Galleries ran all around the complex. Some meters from the praefurnium in one of the rooms was a well (1.8 m in diameter and 20 m deep) from which a set of leaden tablets were recovered. One of them (ca. 9 x 7 cm) had on each side a Celtic inscription in a cursive Latin script. It is an imprecation tablet and is now in the Musée de Saint-Germain.

In 1898 what may be the remains of a civic basilica

built at the crossroads were found in the area known as Tresvées just outside the settlement, at the junction of three Roman roads. The archaeologists' plan shows a rectangular building (73 x 44 m) with a 23 m semicircular apse on its N side.

In Merovingian times a huge cemetery was created in the ruins of the Roman city. The sarcophagi are said sometimes to lie three deep, especially around the church. They are usually trapezoidal, and their lids are generally decorated with a band with three cross-bars. Some 5th-7th c. funerary inscriptions have been found.

BIBLIOGRAPHY. J. Berthelé, *Antiquités gallo-romaines et mérovingiennes trouvées à Rom, Deux-sèvres* (1883); C. Jullian, "Les fouilles de M. Blumereau, à Rom," *Mémoires de la Société des Antiquaires de France* 58 (1899); A. Grenier, *Manuel d'archéologie gallo-romaine*, III (1958); for the Celtic tablets see C. Jullian, *Revue Celtique* (April 1898); E. Nicholson, *The Language of Continental Picts* (1900); id., *Zeitschr. f. cel. Phil.* 3 (1901); J. Rhys, *The Celtic Inscriptions of France and Italy* (1906); Abbé Chapeau, *Bulletin des Antiquaires de l'Ouest* (1924); O. Haas, *Bulletin des Antiquaires de l'Ouest* (1961). J. C. PAPINOT

RAVENGLASS, see GLANNOVENTA

RAVENI ("Phanote") Greece. Map 9. A site mentioned by Livy (45.26.37) on the Kalamas river in Epeiros. A steep hill in the fork between the Kalamas and a tributary is defended by a circuit wall ca. 800 m long, containing gateways and towers. It controls the narrows between the lower and upper reaches of the Kalamas.

BIBLIOGRAPHY. N.G.L. Hammond, *Epirus* (1967) 186f, 676, Plan 16 and Pl. XII *a*. N.G.L. HAMMOND

RAVENNA Emilia, Italy. Map 14. The city, broken by many canals and marshes, has an insular character which aided its defense and affected its history. The Adriatic gradually receded, necessitating construction of a new port, Classis, ca. 4 km S, to handle its commerce.

The city's dominant culture in pre-Roman times was Umbrian (Plin. *HN* 3.15.115; Strab. 5.1.7) though its name and early (6th-4th c. B.C.) art were Etruscan. Ravenna came into Rome's orbit ca. 191 B.C., gained citizenship by the Lex Julia of 89 (*CIL* XI, 863), was taken from the Marians by Metellus in 82, served as Caesar's base in 49 before he crossed the Rubicon (*BCiv* 1.5ff), and became the base for Augustus' Adriatic fleet, with capacity of 250 ships. As a result of this last, the city became more commercial and cosmopolitan. Classis rose, 1st c. A.D., to become an early center of Christianity. On account of its defensibility Ravenna was made capital of the Western Empire from 404 to the fall, and of Theodoric's Ostrogothic kingdom till 540, when it became the residence of the Byzantine Exarch of Italy.

Among the monuments mentioned in sources but completely lost are the pharos of the early port, probably near the Mausoleum of Theodoric (Plin. *HN* 36.18), a circus, amphitheater, theater, and temples to Apollo, outside the Porta Aurea, to Neptune, to Jupiter Optimus Maximus, and others.

The ancient wall, expanded by the Ostrogoths, can barely be reconstructed from remains of Porta Aurea and a round tower of Porta Salustra, both to the SW.

Though pre-Roman strata have not been reached, Etruscan art is represented by the warrior (now at Leida Mus.) and other 6th-4th c. B.C. bronze statuettes in the Mus. Naz. in the convent of S. Vitale. Nothing remains from the Republic, little from the Early Empire. Of Claudius' Porta Aurea, A.D. 43, the dedicatory inscription

(*CIL* XI, 4) and other elements are extant in the Mus. Naz., as well as the marble relief called Apotheosis of Augustus, which may derive from that gate. Foundations of piers of Trajan's 32 km long aqueduct, restored in 503 by Theodoric (Cassiod. *Var.* 5.38), are still seen in the Ronco, SW of the city.

Numerous 2d-6th c. funerary stelai and sarcophagi with inscriptions and portraits from Ravenna and Classis are housed in the Mus. Naz. There are also collections of ancient glass, coins, ivories, and ceramics. The Mus. Arcivescovile is also rich in epigraphy, including Christian examples, fragments of Roman reliefs, and a notable porphyry torso of a late emperor.

By far the most important remains date from the 5th-6th c. To the NW the tomb of Galla Placidia (d. 450), sister of Honorius, holds supposedly her sarcophagus and those of Constantius and her son Valentinian III, but these identifications have not been verified. In S. Vitale nearby, begun ca. 525, can be seen fragments of a Roman frieze and the famous contemporary mosaic of Justinian and Theodora with retinues, a fine documentation of Imperial costume and portraiture.

To the NE, ca. 1.6 km from town, a barbarian necropolis lies near the Mausoleum of Theodoric. The latter, built ca. 520 of Istrian stone, had a decagonal lower and a cylindrical upper level surmounted by a monolithic cupola ca. 10.98 m in diameter, weighing 300 tons.

S. Apollinare Nuovo to the E, originally built by Theodoric, contains the largest mosaic surface extant from antiquity, depicting his palace and the cities of Ravenna and Classis. Justinian's portrait is above the door. Foundations just to the S may be the actual remains of the palace while the extant so-called palace of Theodoric is thought to be in reality the later palace of the Byzantine Exarch. The oldest standing building, dated ca. 400, is the Neone (Orthodox) Baptistery. S. Apollinare in Classe (ded. 549) is rich in mosaics.

Air-photo studies prior to 1961 helped to define the ancient topography of Classis, where excavations of 1963-67 turned up Roman foundations of the 1st-4th c. beneath S. Severo. Necropoleis extending over 3 km along Via Romea Vecchia date from Augustus' time to the 4th c. and attest to a large population.

BIBLIOGRAPHY. Extensive discussion and bibliogr. up to 1962 in *EAA* s.v. Ravenna; F. W. Deichmann, *Frühchristliche Bauten und Mosaiken von Ravenna* (1958); id., *Ravenna, Geschichte und Monumente* (1969)[PI]; S. K. Kostof, *The Orthodox Baptistery of R.* (1965); *Atti del Convegno internaz. di studi sulle antichità di Classe* (1968) contains papers on all aspects; G. Bovini, *Saggio di biliogr. su R. antica* (1968) and *Corpus della scultura paleocristiana, biz. ed altomedioevole di R.* (1968); G. Bovini, ed., *Collana di quaderni di antichità ravennati, cristiane e biz.*; R. Heidenreich & H. Johannes, *Das Grabmal Theodorichs zu R.* (1971). See also *Corso di cultura sull'arte ravennate e bizantina* (1955ff).

D. C. SCAVONE

RAVNA, see LIMES OF DJERDAP

RAZGRAD, see ABRITTUS

REATE (Rieti) Italy. Map 16. A Sabine city at the point where the Via Salaria crosses the river Avens (Velino). Strabo says (5.228) that it was one of only two cities belonging to the Sabines, the other being Amiternum. Reate dominated an upland plain subject to flooding by the Avens and its tributary the Tolenus, and from an early period drainage and flood control was of vital importance to it and brought Reate into conflict with her neighbor Interamnum. At one point Cicero defended Reate in court (*Att.* 4.15.5). It was a praefectura down

to the time of Augustus, where justice was administered by a representative of the praetor urbanus; subsequently, at an uncertain date, it was elevated to the status of municipium. Under Vespasian it received a settlement of veterans but was not made a colonia. It was inscribed in the tribus Quirina and famous for the mules it bred (Strab. ibid.; Plin. *HN* 8.167). It was the home of the Flavian dynasty and a number of Republican figures, including the encyclopedist Varro.

Though systematic excavations have never been undertaken and the ancient city lies beneath the modern one, antiquities have come to light on numerous occasions. Parts of a fortification in large rectangular blocks set dry are still visible; a Roman bridge, much rebuilt, spans the Velino; another, better preserved, carried the Via Salaria over a small watercourse S of the city; and bits of Roman masonry have been found in various cellars. In the Palazzo Municipale is housed the Museo Civico, a collection of material from the neighborhood, including a hut-urn burial and Early Iron Age pottery from the vicinity of Lago di Ripasottile and Camporeatine, as well as Imperial marbles and inscriptions.

BIBLIOGRAPHY. F. Palmegiani, *Rieti e la regione sabina* (1932) passim; P. Gazzola, *Ponti romani* 2 (1963) 82, 187.　　　　　　　　　　　　　　　L. RICHARDSON, JR.

RECOULES-PRÉVINQUIÈRES　Aveyron, France. Map 23. Offerings uncovered in the fanum of La Fajolle on the hillock of Méjanel (height: 760 m) include 54 coins, more than 1200 vases (400 from La Graufesenque), 32 statuettes in white or reddish clay, etc. The cult seems to have lasted from the 1st c. B.C. to the 4th c. A.D.

BIBLIOGRAPHY. L. de Lescure in *P.V. de la Soc. des Lettres de l'Aveyron* 37 (1954-58) 366-67; L. Soonckindt in ibid. 39 (1968) 3-4; cf. M. Labrousse in *Gallia* 20 (1962) 552; 22 (1964) 434; 24 (1966) 416.

M. LABROUSSE

RED HILL, *see* VXACONA

REGENSBURG, *see* CASTRA REGINA *and* LIMES RAETIAE

REGGIO DI CALABRIA, *see* RHEGION

REGGIO EMILIA, *see* REGIUM LEPIDI

REGINA (Reina)　Badajoz, Spain. Map 19. Near Llerena. Pliny (3.14) locates this town in the Baeturia Turdulorum, and it is also mentioned by Ptolemy (2.4.10), the *Antonine Itinerary* (415.1), the Cosmographer of Ravenna (315.1), and the inscriptions (*CIL* II, 1037-38). Regina was a stage on the Roman road, of which several km survive nearby.

Remains of the theater include the outer walls and part of the vaulted passageway that supported the upper rows of the cavea. At the back of the stage building are parts of a wall with three doors set in vaulted niches; the rear wall of the building has smaller vaulted niches between these doors. The theater is small (diameter 55 m, wall of the scaena 38 m long) and is built of stone and concrete. The lower parts have not yet been excavated.

Casual finds include Roman iron tools, inscriptions, and fragments of sculpture, most of which are in the Badajoz Archaeological Museum. The perimeter of the ancient town has not yet been satisfactorily traced.

BIBLIOGRAPHY. J. R. Mélida, *Catálogo Monumental de España. Provincia de Badajoz* (1926) I, 418-22PI.

L. G. IGLESIAS

REGIUM LEPIDI (Reggio Emilia)　Italy. Map 14. Founded in 187 or in 175 B.C. by M. Aemilius Lepidus along the Via Aemilia between Modena and Parma (*It.*

Ant. 127, 283, 287; *It. Hieros.* 616; *Tab. Peut.*). A road leaves Reggio for Brescello and Cremona (*It. Ant.* 283). The urban street plan, along straight axes, is substantially preserved in the streets of the modern city: Via Emilia corresponds to the decumanus maximus and the alignment of Via Roma - Via San Carlo corresponds to the cardo maximus.

Reggio was a municipium (Plin. *HN* 3.116) and flourished particularly in the 1st c. A.D. as is shown by numerous mosaic pavements and by a noteworthy funerary monument in the suburbs to San Maurizio. The city was served by an aqueduct that came from Villa San Pellegrino.

An exceptional example of the goldsmith's art in a mingling of Roman and barbarian styles was discovered here and is preserved in the Museo Civico together with pre-Roman and Roman artifacts.

BIBLIOGRAPHY. *CIL* XI, pp. 171ff; M. Degani, *Il tesoro romano barbarico di Reggio Emilia* (1959); *EAA* 6 (1965) 646f (N. Alfieri & M. Degani); *NSc* (1961) 42-44 (G. Susini); (1964) 1-11 (M. Degani); (1965) 54-58 (M. Degani); G. Susini, "I Veleiati di Plinio e l'origine di Regium Lepidi," *Atti III Convegno Studi Velleiati* (1969) 173-78; M. Degani, "Regium Lepidi," *Quaderni di archeologia reggiana* 2 (1973).

N. ALFIERI

REIMS, *see* DUROCORTORUM

REINA, *see* REGINA

RENGINI, *see* NARYKA

RENNES, *see* CONDATE

RENTINA ("Angeia")　Thessaly, Greece. Map 9. One of a number of fortresses in the Dolopian mountains between the Spercheios Valley and the central plain to the N. They are characteristically small in circuit, generally little more than 200 m; much of the masonry is primitive and difficult to date. The ancient names are unknown or disputed, the identification depending largely on Livy's account of the Aitolian expedition in 198 B.C.

There are two sites, one to the S where a flat hilltop is encircled by a rough polygonal wall, the other to the W where double-faced rubble-filled walls present the most imposing remains in the area. Stählin dated them by a coin of the 3d c. The masonry is of small regular blocks, drafted on the corners of the towers. Although all the literary references for it are to the 2d c., these are probably the remains of the city of Angeia, which served at that time as Dolopian representative at Delphi, replacing Ktimenai as chief city. Delphic representative in the 4th c., Ktimenai is known to have been an old city, and is probably to be located at Anodranitsa, the only site in the region where there are traces of occupation from the end of the Mycenaean period. Its walls are faced with polygonal masonry and filled with small stones; Béquignon saw two towers. The original sanctuary of Omphale, known from inscriptions, was near the boundary between Angeia and Ktimenai.

At Smokovon a double peak was fortified by a rough polygonal wall with towers, laid out to take advantage of the natural precipices. An ashlar wall made an interior division, but the lack of house walls suggests the site was used only in emergencies or by summer herdsmen. At Kydonia there are three circuits of walls, again making use of natural scarps. In some parts of the innermost circuit there are as many as five courses preserved of double-faced wall formed of approximately rectangular blocks; there are traces of at least two towers. There are ashlar walls defending the long, narrow

acropolis SW of Kaitsa, which Stählin identified with the 4th c. city Kypaira. Palaiokastro, near Mavrillon, also had ashlar walls, now largely gone on the N side; Stählin dated the remains from coins of the 3d and 2d centuries. At Papa, a relatively large circuit (more than 400 m) of double-faced polygonal masonry apparently had two gates; coins were found of the 2d and 3d c. A.D.

BIBLIOGRAPHY. Livy 32.13.10; F. Stählin, *Das hellenische Thessalien* (1924)[MPI]; Y. Béquignon, *La Vallée du Spercheios* (1937)[MPI]. M. H. MC ALLISTER

REȘCA, *see* ROMULA-MALVA

"RESCULUM," *see* BOLOGA

RESINA, *see* HERCULANEUM

RETORTILLO, *see* IULIOBRIGA

REYCROSS Yorkshire, England. Map 24. A castra aestivalia large enough to hold a legion, probably constructed during Agricola's campaign. Originally 11 gates were observed, three on each side except the shorter S side which had two, each defended by a tutulus. As rock lies near the surface no ditch has been dug except at the NE corner.

BIBLIOGRAPHY. I. A. Richmond & J. McIntyre, "The Roman Camps at Reycross . . . ," *Trans. Cumberland and Westmorland Arch. Soc.* ser. 2, 34 (1934) 50-58.
 D. CHARLESWORTH

REZÉ, *see* RATIATUM

RHAMNOUS Attica, Greece. Map 11. One of the most remote of the Athenian demes, Rhamnous was situated more than 50 km from the city, at the N limit of Attica's E coast, on the sea overlooking the strait separating the mainland from Euboia. Because of this strategic location Rhamnous became something of a garrison town in the 5th c. B.C., with a detachment of ephebes on permanent duty in Hellenistic times. The chief sanctuary, that of Nemesis, is rightly described by Pausanias (1.33.2) as "a small distance back from the coast." The path linking the sanctuary with the town/fort was lined on both sides with graves. So varied a set of remains, together with the many inscriptions, makes it possible to visualize the lineaments of a miniature city-state with unusual clarity.

The Sanctuary of Nemesis contained two temples set on a flat terrace, in part supported by walls. The earlier, and smaller, is to the S, its plan a cella with Doric porch distyle in antis, built in the 480s B.C. Two thrones, originally placed in the porch, show that Themis was here worshiped together with Nemesis. A statue of the former and several other dedications were unearthed in the cella. They are now in the National Museum in Athens.

Fifty years later a larger temple, dedicated to Nemesis alone, was built to the N of the earlier. It was of local marble with a peristyle of Doric columns, 6 x 12, surrounding a cella with normal pronaos and opisthodomos. Although only a few blocks remain in place above the platform, enough parts of the colonnade and superstructure lie around to permit a detailed reconstruction. The temple was unfinished at the beginning of the Peloponnesian War, and completion was delayed until ca. 420 B.C. Even then, some final finishes, such as the fluting, were permanently abandoned. But at least the temple was fit to receive Agorakritos' famous cult statue, which, according to Pliny (*HN* 36.17), M. Varro preferred above all other statues. From Pausanias' description (1.33.3-8) and from the many fragments preserved both of the large figure of Nemesis and of the small figures on the base, some idea of the group's appearance can be gained.

The fortress has not been fully explored. The most prominent remains are those of the heavy outer fortification, best preserved to the S, with a gate flanked by two towers. The summit of the hill is enclosed by a second, lighter circuit, also best preserved to the S, with an entrance at the SE corner guarded by a single tower. The higher circuit is dated to the 5th c. B.C., perhaps as late as 412 (cf. Thuc. 7.28.1), the lower to the 4th or early 3d.

Between these two circuits, some excavation has taken place, sufficient to reveal a variety of structures and monuments, but not to explain their purposes or position within the town's plan. The one exception is a theater located directly S and W of the opening in the inner fortification. Here a rectangular open area was divided into auditorium and orchestra by a base for stelai and a foundation for prohedriai, three of which still exist and are dated ca. 350 B.C. These simple arrangements will have served for assemblies of the demesmen and ephebes as well as for the attested performances of comedies.

On the hillside overlooking the fortress' main gate, on an artificial terrace, a small sanctuary was established to Aristomachos, a local hero physician said to have been buried at Marathon. But in Hellenistic times, perhaps through the broadening influence of the ephebes, his place was taken by the neighboring healing god from Oropos, Amphiaraos.

BIBLIOGRAPHY. *The Unedited Antiquities of Attica . . .* (1817)[P]; W. H. Plummer, "Three Attic Temples," *BSA* 45 (1950) 94-112[P]; J. Pouilloux, *La Forteresse de Rhamnonte* (1954)[MPI]; G. I. Despines, Συμβολὴ στὴ μελέτη τοῦ ἔργου τοῦ Ἀγορακρίτου (1971)[PI]; A. N. Dinsmoor, *Rhamnous* (1972)[MPI]. C.W.J. ELIOT

RHEGION (Reggio di Calabria) Italy. Map 14. According to ancient sources, founded toward the middle of the 8th c. B.C. by Chalkidian colonists, near the Calopinace river (ancient Apsias) (Diod. 8.23.2) in an area called Pallontion (Dion. Hal. 19.2). The city expanded N between the right bank of the Calopinace and the Santa Lucia. The ancient urban plan is long and narrow on a sloping plateau between the ridges of the Aspromonte hills along the straits of Messina. Its limits have been ascertained by the remains of the circuit wall and by the presence of the necropolis.

Although the area of the settlement expanded in the course of time, what is known of the circuit wall dates from the period of expansion between the end of the 5th c. and the beginning of the 4th c. B.C. Nothing remains of the wall in the S sector and on that side the determining date, for the area outside the city, is given by the presence of the necropolis. In the E sector a section of crude-brick wall must be attributed to a building outside the wall rather than to a preceding phase of the walls. Some parts of the N sector are known, where the extent of the urban area has been ascertained. The W sector is almost entirely known as it is limited by the coastline. The wall construction shows a double ring, joined by transverse elements and a filling of the intervening area with earth and rubble. The lower sections were large sandstone blocks, with brick above. The exact location of the gates is unknown, but there must have been one at either end of the major urban axis, at least one toward the Aspromonte hills, and two on the seaside.

Probably the acropolis was in the high area of today's city in the district of Reggio Campi-Cimitero. The site of the Greek agora, and later the forum of the Roman

era, corresponds to the present-day Piazza Italia and there the principal public buildings were constructed. No evidence remains of the street system, and the continual rebuilding of the city on the same site and occasional earthquakes have made archaeological evidence scarce. Yet, in the NE sector, a large sacred area from the archaic and Classical periods has been identified. Interesting architectural terracotta elements have come from the area as well as votive materials) from the districts of Griso-Laboccetta, Sandicchi, and Taraschi-Barilla). Recent excavations have brought to light traces of a small temple and of other structures that point to the existence of a sanctuary. In the vicinity, the remains of an odeon have also been discovered. The stereobate of another temple has been partially unearthed beneath the modern prefecture. An inscription from the Roman period (*CIL* x, 1) attests the existence of a temple of Isis and Serapis, and another (*CIL* x, 6) mentions the templum Apollinis maioris. The latter inscription also mentions a prytaneum, while inscriptions provide a record of various other buildings. The most interesting of the inscriptions, dating to 374, mentions a porticoed basilica and a bath building. The excavations have brought to light ruins of bath buildings, private homes, and perhaps also public buildings. These ruins, interesting primarily because of their Late Empire mosaics, also include honorary column bases and other materials, particularly in the vicinity of Piazza Italia. Among other finds of special interest are those pertaining to the water supply of the city, particularly the cisterns.

Outside the city, necropoleis have been identified in the districts of Santa Lucia, Santa Caterina, and Pentimeli to the N, and Modena and Ravagnese to the S. Outside the walls toward the sea, a sanctuary of Artemis has also been discovered. Near it, the Athenian forces encamped at the time of the Sicilian expedition of 415 B.C. (Thuc. 6.44.3). The worship of that divinity at Rhegion has been attested by other sources. From the Classical sources it is known that the city was endowed with a fine harbor, which would therefore have had to be situated at the mouth of the Apsias river.

The city's territory was not large by comparison with the sphere of influence of other cities of Magna Graecia. Naturally limited by the mass of the Aspromonte hills and by the sea, it reached on the Tyrrhenian side as far as the Metauros river (in the archaic period perhaps even a little beyond) and on the Ionian side it ended at the territory of the Lokrians. At that point, in consequence of historic changes, the line of demarcation was formed at times by the Caecinos river and at times by the Halex river.

The Museo Nazionale di Reggio Calabria contains enormous documentation for the civilization of Magna Graecia, particularly material which concerns the territory of ancient Bruttium.

BIBLIOGRAPHY. O. Axt, *Zum Topographie von Rhegion und Messana* (1887); H. Philipp, *RE* IA (1920) 487ff; Ferrua, *BACrist* (1950) 227; G. Vallet, *Rhegion et Zancle* (1958); A. de Franciscis, *Agalmata, sculture antiche nel Museo Nazionale di Reggio Calabria* (1960); *EAA* 6 (1965) 644-46 (A. de Franciscis); E. Tropea Barbaro, "Il muro di cinta occidentale e la topografia di Reggio ellenica," *Klearchos* (1967) 5ff; A. de Franciscis, *Stato e società in Locri Epizefiri* (1972); G. Foti, *Il Museo Nazionale di Reggio Calabria* (1972).

A. DE FRANCISCIS

RHEINEIA, *see* DELOS

RHEINHAUSEN, *see* ASCIBURGIUM

RHETHYMNO, *see* RHITHYMNA

RHITHYMNA (Rhethymno) Crete. Map 11. An ancient city in W central Crete ca. 40 km E-SE from Khania. Little is known of its history. It is mentioned mainly by geographers (Plin. *HN* 4.12.59; Ptol. 3.15.5; cf. also Lycoph. *Alex.* 76; Steph. Byz. s.v.). If the emendation 'Rhithymna' is correct in Aelian (*NA* 14.20), there was a temple of Artemis Rhokkaia at or near the site, at that time (early 3d c. A.D.) a mere village. It is not mentioned in Hierokles or the *Notitiae*. The city itself is not mentioned in inscriptions (e.g. the mid 3d c. agreements with Miletos or the treaty with Eumenes, 183), but only individual citizens. It probably developed links with the Ptolemies in the 3d c., and seems to have been refounded as Arsinoe, probably in the late 3d c.; the old name was in use again by the early 2d c. (Le Rider). Coinage started in the 4th c. Athena seems to have been the chief deity. Inscriptions in Rhethymno Museum (mostly gravestones of the Roman and Early Christian periods) are from Rhethymno province, and few of them certainly from Rhethymno.

The site was settled before the end of the Bronze Age (LM III tombs from SE suburb of Mastaba). Very few remains of the ancient city have been found: part of a Late Roman house with columns was found under Kiouloubasi Square; mosaics found during construction of the Customs House (1931) were lost without study. The acropolis must have been on the high promontory (Fortetsa) where the Venetian fort was later built; here Belli (late 16th c.) claims he saw remains of a temple. The city and harbor lay below to the SE; SW of Fortetsa on the shore are remains of rock-cut slipways, probably ancient, and a fish-tank now barely awash (only a slight change in sea level is apparent here).

BIBLIOGRAPHY. T.A.B. Spratt, *Travels and Researches in Crete* II (1865) 111-13; J.-N. Svornonos, *Numismatique de la Crète ancienne* (1890; repr. 1972) 309-12; Bürchner, "Rhithymna," *RE* I A1 (1914) 923-24; M. Guarducci, *ICr* II (1939) 268-77; K. D. Kalokyris, *I arkhaia Rhithymna* (1950)[MI]; *KretChron* 7 (1953) 490; G. Le Rider, *Monnaies crétoises du V^e au I^er siècle av. J.C.* (1966) 242-45[I]; S. G. Spanakis, *Kriti* II (n.d.) 314-25 (in Greek)[M]; D. J. Blackman, *BSA* forthcoming (slipways at Rhithymna).

D. J. BLACKMAN

RHITSONA, *see* MYKALESSOS

RHIZENIA, *see under* PRINIAS

RHODANUS, *see* RHODE

RHODE or Rhodanus (Rosas) Gerona, Spain. Map 19. Greek trading establishment founded by the Rhodians in NE Spain, 18 km E of Figueras. According to an ancient tradition recorded by Scymnus (196) and Strabo (3.4.8), it was probably founded when the Rhodian thalassocracy, the rival of the Phoenicians, achieved its maximum expansion in the W Mediterranean (Balearics, Catalan coasts of Iberia, Gulf of Leon) at the end of the 9th or the beginning of the 8th c. In any event the colony was founded before the First Olympiad (Strab. 14.2.10), or before 776 B.C. Much Rhodian material, although dating a century later, has also been found in S France.

The original colony was on the site of the town of Rosas in the so-called Citadel of Rosas, at the N end of the Gulf of that name. Its location appears to indicate that originally it was a settlement of refuge and a port of call on the Rhodian route from the Balearics to S Gaul and the N Rhone, where goods from the Atlantic area (amber and tin) were assembled. It is undoubtedly the oldest Greek city in the West and antedates the foundation of Cumae in Italy by Greeks from Chalkis.

Its beginnings are obscure, documented only indirectly by the Rhodian goods found N of the Pyrenees. With the Phokaian colonization of these coasts and the foundation of Massalia (600 B.C.) and of Emporion, Rhode thrived; probably its Dorian origin enabled the town to maintain its personality in the face of the Phokaian Ionians, although it ended by falling into the commercial sphere of influence of Massalia-Emporion and subsequently became clearly Emporitan after the arrival of the Romans in 218 B.C. However, it always maintained its original Rhodian character. It was the first Greek city in the West to mint silver coins (drachmai). The wide dispersion of these coins indicates extensive commercial influence in the interior of Gaul, whose tribes copied the coins of Rhode.

In 195 B.C. the Roman consul M. P. Cato disembarked at Rhode and began the repression of the Iberian communities that had risen against the Roman domination, before establishing his headquarters in Emporion.

The Republic and the Early Empire was a period of economic balance for Rhode, which had been annexed by Emporion. However, it maintained its influence N of the Pyrenees while Emporion's trade was with the interior and the Spanish Levant. In the 3d A.D., with the destruction of Emporion by the Franks (265), Rhode gained a marked impetus which was maintained during the 4th-5th c. It became a large frontier town destined to play a major role under the Visigoths during the revolt of Count Paulus against Wamba.

BIBLIOGRAPHY. A. García y Bellido, *Hispania Graeca* (1948); *Revista de Gerona* (1965), special number on Rhode by various authors; J. Maluquer de Motes, "Rhode, las ciutat mes antiga de Catalunya," *Homenaje a J. Vicens Vives* (1965); id., *En torno a las fuentes griegas sobre el origen de Rhode* (1972); id., "Rodis i Foceus a Catalunya," *Homenaje a Carlos Riba* (1972).

J. MALUQUER DE MOTES

RHODES (including Ialysos, Kameiros, Lindos, Vroulia, the city of Rhodes, Mt. Atabyrion) Dodecanese, Greece. Map 7. The island of Rhodes emerged from the sea, according to Pindar (*Ol.* 7.54-76), to be the portion of the sun god, whose cult continued throughout antiquity more prominent there than elsewhere. Three grandsons of Helios and the nymph Rhodos, daughter of Aphrodite, were the eponymous heroes of the three ancient cities, Ialysos and Kameiros on the W coast and Lindos on the E. Its size, 80 km N to S and about half as much E to W, and its situation, "near the headland of broad Asia" (*Ol.* 7.18), with Crete about 140 km away to the SW, have always given Rhodes a peculiar importance among the islands. The many legends, supported by the archaeological finds, mainly from the cemeteries, suggest that in prehistoric times it was both a stepping-stone and in itself an important center, having connections with Minoan Crete, the Argolid and the Greek mainland, Phoenicia and Egypt. The Telchines, fabulous craftsmen, came from Crete by way of Cyprus; Kadmos stopped at Rhodes on his way from Phoenicia to Thebes, Danaos on his way from Egypt to Argos; Tlepolemos son of Herakles came from Argos, and led the Rhodian contingent of nine ships to Troy.

For Homer Rhodes was already old in story (*Il.* 2.653-670), with three notable cities, "Lindos, Ielyssos and shining Kameiros" (the epithet is arginoeis in our text, but one wonders whether in fact Homer said argiloeis, with reference to the clay used for pottery). As Hope-Simpson and Lazenby convincingly show, the Homeric Catalogue of Ships has reference to the late Mycenaean period, and there is no good reason to make an exception of the lines on Rhodes. The sites of all three cities were occupied in Mycenaean times; though in each case the acropolis has been obliterated, the cemeteries below, with their tombs containing pottery and jewelry, have provided evidence. The major site seems to be Ialysos, where the chamber tombs are very numerous. Lindos was relatively modest.

In course of time the Dorians arrived in large numbers, and took over the island and its neighbors; after a comparatively obscure period, Lindos, Kameiros, and Ialysos attained cultural and commercial prosperity, and a renown for seamanship embodied in the saying, "Ten Rhodians, ten ships." The Rhodians founded important and widespread colonies, notably Gela in Sicily (in co-operation with Cretans) early in the 7th c. (Thuc. 6.4.3-4, who says that the part of the city first fortified is called Lindioi). Together with Kos, Knidos, and Halikarnassos, the three cities formed a confederation called the Dorian Hexapolis (Hdt. 1.144).

The archaic culture of Rhodes is best represented by the plentiful pottery. The island produced fine work in the Geometric style (particularly in the later phase, i.e., in the 8th c.), found notably at Ialysos, Kameiros, and a cemetery at an inland site called Exochi. Certain E Greek fabrics of the 7th c. in orientalizing style have commonly been called Rhodian, or "Camiran"—vases of the "Wild Goat Style," so called from the friezes which run round them, and flat plates with animal figures and occasionally human scenes, such as the plate in the British Museum, on which Hektor and Menelaos fight over the body of Euphorbos. The lively Fikellura style, which followed in the 6th c., is named after a place in Rhodes, though it is spread over the S part of the E Greek area. Recent authorities are more cautious about the indiscriminate use of the name "Rhodian" (Samos must have been equally important), but undoubtedly Rhodes played a major part in the production and distribution of archaic E Greek pottery, besides importing Corinthian and other contemporary wares. A group of 6th c. cups which do indeed seem to belong to Rhodes in particular are known as Vroulian from their principal place of discovery. As the 6th c. proceeded, local wares at Rhodes as elsewhere succumbed to Attic competition.

Among archaic sites, Vroulia at the S end of the island is of peculiar interest. The name is modern, and the ancient name is unknown. A wall about 300 m long with a stone socle slightly over one m thick, no doubt originally surmounted by an upper structure of unbaked brick, encloses a coastal strip of land to the SW. Except for a section at the W end, the wall is perfectly straight, and against its inner face was built a continuous row of simple houses, consisting at most of a couple of rooms with a little court in front. At a distance of about 25 m was a second row of houses running parallel. The main gate was probably at the point where the wall changes direction; and nearby is a walled area containing two altars, and an adjacent enclosure which may be an agora. Pottery dates all these structures not much later than 700 B.C. Vroulia was only a little town, no doubt subordinate to one of the major cities, presumably Lindos, but its rectilinear planning represents the first tentative steps, taken at a remarkably early date, which were to lead to the sophisticated methods of Hippodamos, notably in Rhodes itself.

To proceed to times for which we have more solid historical evidence, in the latter part of the 6th c. and the early years of the 5th Rhodes was subject to the Persians. After that the three cities were members of the Delian League, until finally they broke with Athens (Thuc. 8.44), resumed their Dorian connection, and combined in 408 B.C. to found a federal city at the N tip of the island, calling it simply Rhodos. Lindos, Ialysos, and

Kameiros were inevitably reduced and subordinate, but by no means derelict. In the 4th c. and the Hellenistic period Rhodes became one of the great cities of the ancient world, preeminent in commerce and culture, in spite of vicissitudes consequent upon its choice of alliances in the great conflicts of the age. It triumphantly withstood a furious attack by Demetrios the Besieger in 305 B.C., vividly described by Diodoros (20.81-88, 91-100), and quickly rose again, with assistance from many sympathetic cities and kings, after the most disastrous of several earthquakes in 227 B.C. For a time it held control of an extensive area on the mainland opposite, the so-called Rhodian Peraea. In the middle of the 2d c. it incurred the displeasure of Rome, which, by developing Delos as a major commercial center, struck a severe blow at Rhodian trade. But though its commerce and naval power were much curtailed, Rhodes continued to be a main center of art and literature, philosophy and rhetorical training (Cicero and many other distinguished Romans studied there). In the Civil War after Caesar's death, the island was ravaged and the city thoroughly pillaged by Cassius; but Strabo still found it a city of unparalleled beauty (14.2.5, 652). The island suffered disastrous earthquakes again in A.D. 345 and 515, and the great city was reduced to the comparatively small mediaeval town which was eventually taken over by the Knights of St. John, and won fresh glory by its heroic resistance to the Turks.

The new capital was built on a new site, roughly triangular with the apex at the extreme N tip of the island, measuring about 3,000 m N to S and a little less E to W. The harbors were on the E side—the main harbor in the middle, a smaller one to the N, and a more open roadstead to the SE. The moles which protect the natural bays are ancient in origin. There was also a small harbor, now silted up, on the W coast towards the N. From the region of the E harbors the ground rises theater-like SW towards a plateau about 90 m high. This was the acropolis or upper town of ancient Rhodes, though it was never a fortified citadel.

The city walls were famous for their strength and beauty. Very little has survived—the Knights no doubt used the material to build the tremendous fortifications of their much smaller town; but sections of the foundation or socle here and there, mostly Hellenistic, are enough to determine the general course. The wall followed the coast on two sides of the triangle; on the base, to the S, it took an irregular line in search of defensible contours.

According to Strabo (14.2.9, 654), "the city was founded by the same architect who founded Peiraeus," i.e., Hippodamos of Miletos. The famous town-planner must have been very old by 408 B.C., but that is not a sufficient reason for denying him the credit. The plan of Rhodes as we know it is precisely what one has come to recognize as Hippodamian. Its general scheme has been drawn by Kondis, Bradford, and Konstantinopoulos. Excavation has necessarily been sporadic and largely fortuitous, since the mediaeval and modern city covers much of the area; but many sections of streets with their adjoining buildings have been uncovered at diverse points, revealing that the basic plan was a rectangular grid orientated very nearly N to S and E to W. Remains of underground drains and water-channels of various types have been found, and many of these fit into the same pattern. Once the grid had been determined, it became clear that some of the streets of the mediaeval town, including the famous Street of the Knights, follow the course of ancient predecessors; and that important stretches of the great walls built by Grand Masters Pierre d'Aubusson and Émery d'Amboise are based upon the lines of ancient streets. In addition, air photography has revealed features which one would hardly notice at ground level, especially in the SW region of the acropolis. We are told by the rhetorician Aristeides (43.6) that this part of the town was laid out in a spacious park-like manner; it is now largely rural in aspect, but the air photographs show that terraces, field boundaries, and lanes follow a rectilinear scheme which conforms with the ancient grid.

It is fair to assume that this master plan is the one conceived by Hippodamos in 408 B.C. There is no trace of any which is earlier and divergent. Admittedly the remains are mostly Hellenistic; but here and there they take us back to the 1st c. of the city. We can imagine that the Hippodamian method of nemesis or careful allocation of sites was applied from the beginning; but the process of building was a long one, punctuated by destruction, by siege and earthquake.

Some of the most important elements in the plan cannot now be securely placed. The agora, according to Bradford, probably extended W from the great harbor. A street which has been discovered, lined with colonnades in the Roman period, may have led into it from the S. The theater was somewhere near the wall on the inland side (cf. Diod. Sic. 20.98.6, 8).

The Colossus, a huge bronze statue of Helios, set up to commemorate the successful resistance to Demetrios, did not of course bestride the harbor mouth; and Maryon has shown that it could hardly have been constructed at the end of a mole, and more probably stood in the city center.

The most visible ancient monument in the lower city is the foundation of a Temple of Aphrodite, built in the 3d c. B.C. just W of the great harbor; of the superstructure only a few fragments survive. A little to the W are slight remains of a Shrine of Dionysos, incorporated in the foundations of a chapel (Clara Rhodos I 46; cf. Lucian Amores 8). To the N, in the neighborhood of the smaller (N) harbor, remains of ship-sheds have recently been further investigated.

The ancient buildings most worth seeing are away to the SW, finely placed on the E brow of the acropolis. Towards the N end are the foundations of the Temple of Zeus and Athena. Some distance farther S is the Temenos of Pythian Apollo, a rectangular enclosure, with a massive retaining wall on the E, where a broad flight of steps gives access. Within the enclosure is a Doric temple, built of limestone, in the 2d c. B.C.; several of the columns on the E facade have been reerected. Just below this point to the E is the N end of the great stadium, built into the hillside and extending over 183 m to its semicircular S end. Adjoining the stadium on the N is a small theater, which has been reconstructed, and to the E are remains which may belong to a gymnasium.

Beyond the S cross wall lie the extensive cemeteries. Southeast of the city are remains of an ancient (probably late Hellenistic) bridge, crossing a ravine. Not far from the park of Rodini is the most impressive of a number of rock-cut tombs, fancifully known as the Tomb of the Ptolemies, with a main chamber and an antechamber and a facade of half-columns.

When one reflects on the glories of the ancient city, the extant remains seem meager and disappointing, all the more so in comparison with the splendid mediaeval walls and houses. Even the known temples are not particularly grand. Apparently it was the general harmonious effect which impressed ancient writers. Aristeides (43.6) says that with all its varied splendors—walls, temples, works of sculpture, and painting—the city was like a single great house: Lucian (Amores 8) compares its beauty to that of Helios himself.

Outside the capital the most spectacular development took place at Lindos, in the famous Shrine of Athena

Lindia. The acropolis of Lindos falls in precipitous cliffs, undercut in places, to the sea on the E. Towards the N is the main harbor; to the S is the inlet where St. Paul is said to have landed. The Shrine of Athena on the summit of the acropolis was founded by Danaos, according to legend. The extant temple had at least two shadowy predecessors; the tyrant-sage Kleoboulos is said to have built a temple in the 6th c. B.C., and a rock-cut stairway probably belongs to this phase. The great architectural development of the site took place in the 4th c. B.C., though some elements may be later; precise dating is disputed. The 4th c. temple, built after a disastrous fire which is recorded in the inscription known as the "Lindian temple-chronicle," is modest in size and appearance compared with its setting, both natural and architectural. It is a rather narrow building, nearly 22 x 8 m, orientated NE and SW, with its SE side close to the cliff edge. It had a porch of four Doric columns at either end, and like the other buildings of the shrine, it was constructed of a local limestone. Some of the terracottas found on the site may give an idea of the cult statue. Not far from the NW corner of the temple have been found traces of what may be an altar; Athena Lindia was traditionally worshiped with fireless sacrifices. According to the scholia in Pindar, Gorgon, historian of Rhodes, said that the magnificent ode (*Ol.* 7) in honor of Diagoras, greatest of boxers, was inscribed in letters of gold in the Temple of Lindian Athena, but one might expect this monument to be set up rather at Diagoras' native town Ialysos. The temple-chronicle gives a list of notable offerings in the shrine.

The so-called propylaia are in fact a complex consisting of colonnades bordering three sides of the court in front of the temple, with rooms on the NW side (another small colonnade was added later on the SW side adjoining the temple); and an outer colonnade facing down the hill to the NE, with projecting temple-like wings at either end. A broad stair leads on down to another stoa, of great length (about 87 m) similarly facing outwards and downwards, and making a short return at either end. This was the latest element in the grand scheme. Portions of stoa, propylaia, and temple have been not very effectively or securely restored.

The great stoa opened onto a spacious terrace, reached from below by a stairway in the middle. In late Hellenistic times the terrace was extended to about double its original width, by means of vaulted substructures, and the stair was rebuilt in narrower form. Lower down the slope, to the NE, was a temple of Roman date, built on a podium, about 9 x 16 m, with a porch of four columns facing back up the hill. The shrine is assigned by some to a hero called Psithyros (Whisperer), known from an inscription, but by Dyggve to a deified emperor, possibly Diocletian.

Remains of the ancient wall of the acropolis are slight, Hellenistic in date, and mainly on the N. The whole site was eventually enclosed within the great fortifications of the Knights. At the foot of the stairway which leads up to the entrance on the N is a large Hellenistic rock-cut relief representing the elegant up-curving prow of a ship; a projecting platform carried a statue of one Agesandros, dedicated by himself.

A small theater, about 28 m in diameter, holding about 2,000, was built into the SW slope of the hill; the middle section of the seats, cut into the rock, is best preserved. Nearby are remains of a rectangular court with Doric colonnades, possibly associated with the cult of Dionysos.

A fine model made under the direction of Dyggve and installed in the National Museum at Copenhagen gives a vivid impression of the appearance of the acropolis in Hellenistic times.

The city of Lindos stretched inland and W, a good deal farther than the present town. Of the scanty remains outside the acropolis the most remarkable are the monumental tombs. One of these, situated to the W of the town on Mt. Krana, is the family mausoleum of Archokrates (late 2d c. B.C.), a chamber cut into the rock with a two storied facade whose lower element is adorned with Doric columns. On the N, on the farther side of the main harbor, is a circular structure 9 m in diameter, popularly known, without any good reason, as the Tomb of Kleoboulos. It has not yet been fully studied, and while Dyggve places it in the 2d c. B.C., Kondis thinks it may prove to be a good deal earlier. In the Middle Ages it was used as a church.

At Ialysos in the NW, in contrast with the extensive and highly productive cemeteries on the lower ground towards Trianda, structural remains of the city are scanty. On the summit plateau of the hill of Phileremos, the ancient acropolis, adjacent to the church of the monastery, are the foundations and column fragments of the Temple of Athena and Zeus Polieus, a Doric structure of the 4th c. B.C.; vestiges of a 6th c. temple and an older shrine have been found. The most impressive ancient monument on the site is a late 4th c. fountain-house built into the hillside lower down the slope to the S, one of the best examples of its type. A facade of Doric columns in limestone, now partly reconstructed, stood in front of a parapet consisting of two courses of slabs set between rectangular pilasters, behind which was the water basin.

Several km down the coast to the SW, towards the border of the territory of Kameiros, was a deme of Ialysos named Kastanioi. Here, near a place now called Tholos (a corruption of Theologos), are the ruins of the Temple of Apollo Erethimios, a Doric structure with two columns in antis, and of a theater nearby. The shrine is identified by inscriptions, and the title is derived from the place-name Erethima. The temple was probably built at the end of the 5th c., but the cult existed much earlier and continued into Roman times.

At Kameiros are more extensive and imposing remains, which show evidence of impressive planning in the Hellenistic period. Here again we have a theater-like site, with the ground rising to E and W; to the S the hill forms an acropolis or upper town, which does not seem to have been fortified as a citadel. In the middle of the lower town is a large open area partially bordered by colonnades, which may have been an agora, or perhaps a sacred temenos; on the W side are the remains of a Doric temple, of which some columns have been reerected. On the E is a retaining wall, behind which at a higher level runs a principal street. To the N of this area is a large semicircular exedra, and to the E of this a broad low flight of steps leading up to a smaller enclosure containing a number of altars, obviously an important sacrificial area, from which the same street could be reached by another flight of steps at the S end of its E side. The main street ran S in the direction of the acropolis, with cross-streets joining it, and the blocks thus formed were occupied by houses, some of which had colonnaded courts. Along the N brow of the acropolis hill a Doric colonnade of great length was built in the 3d c. B.C., forming an impressive background to the town as seen from the N. The excavators reerected a few of the columns to show the effect, only to have them flattened again by a storm. Behind the stoa, to the S, are the ruins of a Temple of Athena, an archaic shrine rebuilt in Hellenistic times. The city also has notable remains of cisterns, aqueducts, and drains. To the S stretch the principal cemeteries from which the treasures of the earlier periods have been retrieved.

Looking in this direction one sees the peak of Mt. Atabyrion, the highest point on the island (1,233 m), where as on many summits Zeus was worshiped. Parts of

a walled precinct have survived, but it is not clear whether or not the confused remains within prove the existence of an ancient temple. Many dedications to the god have been found, including small bronze bulls. The name of the mountain seems to be of Semitic origin, being the Greek form of the Palestinian Tabor. The cult of Zeus Atabyrios was of immemorial antiquity, founded, according to the story told by Apollodoros (*Bibl.* 3.2) and Diodoros (5.59), by Althaimenes, who, fleeing from Crete to avoid parricide, landed in Rhodes at a place which he named Kretinia. He established the shrine on the neighboring mountain top, from which he could survey the islands and see in the distance his native land. Polybios reports (9.27.7) that on the summit of the acropolis of Akragas (which was founded by Gela), "was established a Shrine of Athena and of Zeus Atabyrios, as among the Rhodians"; this suggests but does not prove that Athena too had a cult on the mountain. Appian (12.26) shows that in Hellenistic times Zeus Atabyrios had a more accessible shrine near the city wall; but the dedications prove that even then some devotees still climbed where Althaimenes stood.

The Archaeological Museum at Rhodes, now in process of reorganization, houses finds from the various sites on the island, as well as some from neighboring islands, though some of the material from the earlier excavations went to the British and other museums, and some sculpture from Lindos is at Istanbul and Copenhagen. The exhibits include archaic kouroi, fine funerary reliefs, a head of Zeus from Atabyrion, a head of Helios, the "Aphrodite of Rhodes" (a crouching figure less than life size) and another Hellenistic Aphrodite; Mycenaean jewelry; pottery ranging from Mycenaean through Geometric and orientalizing (notably the "Rhodian" fabrics, of course) to Attic black-figure and red-figure; mosaics (more can be seen in the restored Palace of the Grand Masters); and missiles used in the great sieges. Situated at the corner of Museum Square and the Street of the Knights, the museum itself is a "museum piece," since it is one of the finest and most interesting mediaeval buildings of Rhodes, the hospital in which the Order of St. John performed its original humane and merciful task.

BIBLIOGRAPHY. Legends: see esp. Pind. *Olymp.* 7; Apollod. *Bibl.* 3.2; Diod. Sic. 5.55-59; Strab. 14.2.6-8 (653-54); Ath. 8.360d-61c.

General: E. Billiotti & A. Cottret, *L'Île de Rhodes* (1881); C. Torr, *Rhodes in Ancient Times* (1885); S. G. Zervos, *Rhodes, Capitale du Dodecanèse* (1920)[I]; *Clara Rhodos, Studi e materiali publicati a cura dell'Instituto Storico Archaeologico di Rodi* I-X (1928-41); F. Hiller von Gaertringen, "Rhodos," *RE* Suppl. V (1931) 731-840 (historical and epigraphical bibliography 818-19)[M]; R. Matton, *Rhodes* (1949)[I]; J. Currie, *Rhodes and the Dodecanese* (1970); R. U. Inglieri, *Carta archeologica dell'isola di Rodi* (1936)[M].

Early Periods: H. F. Kinch, *Fouilles de Vroulia* (1914)[PI]; R. M. Cook, *Greek Painted Pottery* (1960) 116ff, 132ff, 140ff, bibliography 345-47; H. Drerup, *Griechische Baukunst in Geometrische Zeit* (1961) 51-52; Chrysoula Kardara, Ῥοδιακὴ Ἀγγειογραφία (1963)[I]; V. Desborough, *The Last Myceneans* (1964) 152-58; J. N. Coldstream, *Greek Geometric Pottery* (1968) 274-87[I]; R. Hope Simpson & J. F. Lazenby, *The Catalogue of the Ships in Homer's Iliad* (1970) 117-20; id. & id., "Notes from the Dodecanese," *BSA* 68 (1973) 127-79[M].

City of Rhodes: J. D. Kondis, Συμβολὴ εἰς τὴν μελέτην τῆς ῥυμοτομίας (1954); J. Bradford, "Aerial Discoveries in Attica and Rhodes," *AntJ* 36 (1956) 57-69[PI]; R. Martin, *L'Urbanisme dans le Grèce antique* (1956) 148-49; H. Maryon, "The Colossus of Rhodes," *JHS* 76 (1956) 68-

86[I]; J. Bradford, *Ancient Landscapes* (1957) 227-86[PI]; J. D. Kondis, "Zum antiken Stadtbauplan von Rhodos," *AthMitt* 73 (1958) 146-58[P]; R. E. Wycherley, "Hippodamus and Rhodes," *Historia* 13 (1964) 135-39; G. Constantinopoulos, "Rhodes, New Finds and Old Problems" (trans. by J. W. Graham), *Archaeology* 21 (1968) 115-23[PI]; see further annual reports in *Deltion, Ergon*, and *AAA*; for ship-sheds see forthcoming report by D. Blackman in *BSA*.

Lindos: C. Blinkenberg, *Die Lindische Tempelchronik* (1915); Blinkenberg, K. F. Kinch, & E. Dyggve, *Lindos, fouilles et recherches*, I (1931); II (1941); and esp. III (1960) *Le sanctuaire d'Athana Lindia et l'architecture lindienne*, by Dyggve, with a catalogue of sculpture by Vagn Poulsen[MPI]; note Kondis's detailed critique of this volume in *Gnomon* 35 (1963) 392-404; C. Konstantinopoulos (see "City of Rhodes" above; photo of model).

Ialysos: *Clara Rhodos* (1928) I 72ff (acropolis, temple of Athens, fountain-house)[PI]; B. Dunkley, "Greek Fountain Buildings," *BSA* 36 (1935-36); id., *Ialysos* 184ff; id., *RE* Suppl. V 748-49.

Kameiros: *Clara Rhodos* (1932) VI-VII 222-65 (acropolis); *Clara Rhodos* (1928) I 88ff.

Zeus Atabyrios: A. B. Cook, *Zeus* (1914) I 117; (1925) II 922-25. R. E. WYCHERLEY

RHODIAPOLIS Lycia, Turkey. Map 7. Among the hills some 6.5 km N-NW of Kumluca. According to Theopompos the city was named after Rhode, daughter of Mopsos; this however is no more than the usual eponymous fabrication, and the foundation from Rhodes which the name implies is generally accepted. Its existence in the 4th c. B.C. is proved by two rock tombs carrying epitaphs in the Lycian language; these are almost the only Lycian inscriptions yet found E of the Alagır Çayı (generally identified with the ancient Limyros). Coinage began in the Hellenistic period with issues of Lycian League type; under the Empire it is confined, as elsewhere in Lycia, to Gordian III. Later, the bishop of Rhodiapolis ranked twenty-sixth under the metropolitan of Myra.

The extant ruins are mostly of late date and somewhat unimpressive. The theater is in moderate preservation, with 16 rows of seats and some remains of the stage building; in front of it stood the well-known funerary monument of Opramoas, the local millionaire philanthropist. The inscription on this is among the longest known, covering three sides of the building (*TAM* II.3.905); it records the honors conferred on Opramoas and the benefactions, in the form of money, bestowed by him on most of the Lycian cities. Among numerous buildings, largely built with small stones and mortar, a Temple of Asklepios and Hygieia is identified by inscriptions. There are remains of two stoas, and to the NW of the city some piers of an aqueduct. On the summit of the hill is a solid rectangular tower. There is no sign of a city wall.

BIBLIOGRAPHY. T.A.B. Spratt & E. Forbes, *Travels in Lycia* (1847) I 165, 181-83[M]; E. Petersen & F. von Luschan, *Reisen in Lykien* (1889) II 76-137; *TAM* II.3 (1940) 326. G. E. BEAN

RIBCHESTER, *see* BREMETENNACUM VETERANORUM

RIBEMONT SUR ANCRE Somme, France. Map 23. Site in the areas known as Le Champ Crezette and Le Boeuf d'Or, ca. 20 km E of Amiens and a little S of the road from Amiens to Bavay through Albert, Bapaume, and Cambrai.

The existence of buildings was first discovered by aerial photography; they were thought to be a large

Roman villa and its dependencies, similar to ca. 600 others in Picardy located from the air. The photographs showed three rectangular courtyards arranged in a row, with buildings set symmetrically on either side. Excavation revealed that the buildings E of the N courtyard were heated by hypocaust and had painted walls, an indication of luxury also found in what was believed to be the main residential building; it had painted walls, marble plaques, and sculptured decoration. These finds, in rural villas, were in fact part of a great rural sanctuary, as the discovery of the square double plan of a fanum or temple later confirmed.

The cella, 16.75 m on a side, stood on a podium at least 2 m high. The open space around the podium was surrounded by a wall, also square, on the SE side of which a square niche impinging on the podium was later added. Here a small place of worship was set up (three rectangular blocks, perhaps an altar base) exactly on the axis of the cella, after the temple was destroyed in the Late Empire. The temple was decorated with carvings, had Corinthian capitals, engaged columns, a monumental entrance, and walls painted with floral designs. These remains date from an elaborate restoration in the Severan period. Before that the site seems to have been deserted for some time, as evidenced by an incineration tomb found in the niche area. It is still uncertain to which divinity the temple was dedicated: neither the decorative carving nor even the epigraphic evidence (a plaque, of which there are three copies, with the legend MIN/FER/QUE) provide a definitive answer.

The temple is merely the N section of the whole complex; to the S and on the same axis were a theater, later made into an amphitheater-theater, and farther S, at the edge of the Ribemont territory, an area containing remains of hypocausts. If baths are identified in this area the comparison with Champlieu will be evidence in itself.

Excavation has confirmed the identical chronology of temple and theater. It still remains to be proved that they date from the last years of independence, but the major foundation work certainly began under Nero and was followed immediately by a series of partial modifications. The change to amphitheater-theater may possibly date from Marcus Aurelius. The oval arena that was added is similar in dimensions to the amphitheater-theaters of Soissons, Augst, and Vieux (internal axis of arena ca. 10 m). The plan of the complex based on the archaeological evidence has been strikingly confirmed by more aerial photographs.

The original purpose of this group of buildings is still debated. Was it a religious complex built for a people whose city has not yet been located, or one of the rural fora that took over from the conciliabula, the meeting places of the Gallic tribes erected on their territorial boundaries? The discovery of a trench filled with objects from Iron Age III, the relatively early date of the first construction, and the absence of any Roman settlement in the immediate vicinity all argue in favor of the latter hypothesis, but decisive proof has yet to be found that the complex was first built in the Gallic period.

BIBLIOGRAPHY. R. Agache, "Archéologie aérienne de la Somme," *Bull. Soc. Préhist. du Nord* 6 (1964)[I]; id. et al., "Les villas gallo-romaines de la Somme, aperçu préliminaire," *Revue du Nord* 47 (1965) 541-76[P]; id., "Détection aérienne des vestiges protohistoriques, gallo-romains et médievaux," *Bull. Soc. Préhist. du Nord* 7 (1970) 178-80, 184-86[I]; A. Ferdière, "Première campagne de fouilles dans la villa gallo-romaine de Ribemont-sur-Ancre," *Revue du Nord* 48 (1966) 539-43[P]; E. Will, *Gallia* 27 (1969) 228-31[I]; J. L. Cadoux & J. L. Massy, "Ribemont sur Ancre: Etudes," *Revue du Nord* 52 (1970) 469-511[PI]; id., "Le sanctuaire gallo-romain de Ribemont sur Ancre (Somme)," *Bull. Soc. des Antiquaires de Picardie* (1971) 43-70; id., "Les premières campagnes de fouilles sur le théâtre gallo-romain de Ribemont sur Ancre," ibid. (1972) 448-72; C. Pietri, *Gallia* 29 (1971) 231-32[I].
<div align="right">P. LEMAN</div>

RICHBOROUGH, see RUTUPIA

RICINA Marche, Italy. Map 16. A town in Picenum on the left bank of the Flosis (modern Potenza) at the crossing of the road from Auximum to Urbs Salvia; after a restoration by Pertinax and Septimius Severus it was called colonia Helvia Ricina Pertinax. Extensive remains of an amphitheater, a theater, baths, and a bridge are to be seen. A collection of marbles, for the most part from this site, is in the Palazzo Comunale at Macerata.

BIBLIOGRAPHY. *Dioniso* 7 (1939) 104-9 (R. U. Inglieri)[PI]; *EAA* 6 (1965) 683 (N. Alfieri); *AA* 85 (1970) 313-15 (H. Blanck)[I].
<div align="right">L. RICHARDSON, JR.</div>

RIDER (Danilo Gornje by Šibenik) Croatia, Yugoslavia. Map 12. On the steep hill of Gradina 360 m N of the present village a strong hillfort of the Delmatian Riditae. The settlement was encircled with strong walls without mortar. The rock-cut foundations of numerous huts and a large quantity of native pottery have been excavated. The hill settlement continued to exist even after the Roman subjugation of the Delmatae by Tiberius in A.D. 9. Down in the large fertile valley a parallel Illyro-Roman settlement developed on the road from Salona to Scardona. It obtained municipal rank under the Flavii as the center of the Riditae. In the administration the members of native aristocracy "principes Riditarum" and "principes Delmatarum" participated as decuriones, as mentioned in inscriptions.

The Roman settlement had several monumental buildings of which a villa urbana has been explored. It had a bath complex which in late antiquity was rebuilt as an Early Christian church. There are several necropoleis on the periphery of the town. The importance of Rider lies in the unusually large number of the tombstones found there. They record the native Delmatian-Illyrian names to which its population steadily clung all through the Roman period.

The archaeological material is preserved in the Town Museum at neighboring Šibenik.

BIBLIOGRAPHY. D. Rendić-Miočević, "Novi ilirski epigrafički spomenici iz Ridera," *Glasnik Zemaljskog muzeja u Sarajevu* 6 (1951) 49-64; id., "Princeps municipi Riditarum," *Arheološki radovi i rasprave* 2 (1962) 315-31.
<div align="right">M. ZANINOVIĆ</div>

RIETI, see REATE

RIEUX, see DURETIA

RIEZ, see ALEBAECE REIORUM APOLLINARIUM

RIJSWIJK S Holland, Netherlands. Map 21. Site between The Hague and Delft, occupied by a civilian settlement covering ca. 3.5 ha from the 1st to the 3d c. A.D. The site lies behind the dunes in what is now Polder. Before the Roman period and after the end of the 3d c. A.D. the area was too wet for habitation, but in Roman times it was densely populated in spite of having no dikes and being exposed to flooding. About 3 km farther N lay a large township (probably Forum Hadriani), near which a Roman milestone has been found. The Fossa Corbulonis, the canal dug by Roman troops from the Meuse to the N branch of the Rhine, must have run not far from the settlement.

Excavation has provided information on the Roman-

ization of the local inhabitants, the Cannanifates. The basic dwelling in the settlement was the tripartite wooden house (20-38 x 5-7.5 m), typical of habitations along the North Sea coast as far as Denmark. As a rule the house was divided into a living area with a fireplace and a stable, both distinguished by a characteristic grouping of roof posts and entrances. In the last phase of the occupation, in the 3d c., the most important house was rebuilt in wood and stone according to Roman technique, but retaining the traditional local ground plan. A number of rooms were built entirely in stone, a material not available in the area which was brought from the Eifel and the Ardennes. These rooms were also decorated with wall paintings. In this period also the simple native granaries were replaced by two larger granaries raised on 3 or 4 parallel foundation trenches (9.4-11.6 x 6-10 m). In the 1st c. the two or three houses of the settlement were scattered in the open country, in the 2d c. four centers of habitation were grouped in a square and surrounded by a wide ditch, and in the 3d c. the ditch was connected with a system of ditches that covered at least 25 ha. This area was probably pastureland for livestock. The numerous animal remains from Roman times indicate that animal husbandry was the chief means of subsistence. There is some imported Roman pottery, but local ceramics are strongly represented. This pottery is closely related to the so-called Frisian ceramics of N Holland.

BIBLIOGRAPHY. J.H.F. Bloemers, *Nieuwsbull. Kon. Ned. Oud. Bond* (1968) 94-95; (1969) 40-42; (1970) 35-37; id., "Nederzetting uit de Romeinse tijd bij Rijswijk," *Spiegel Historiael* 4 (1969) 402-6. J.H.F. BLOEMERS

RIMINI, see ARIMINUM

RIPARBELLA Etruria, Italy. Map 14. Evidence in the area around the Cecina river of a Roman-Etruscan settlement (related to the kilns and salt beds of the Cecina?). Etruscan and Roman tombs, carved into the tufa at Gerbia and Melatina testify to such a settlement and Roman tombs at Belora where large finds were made in the 19th c. The archaeological finds are in the civic museums of Livorno and of Cecina.

BIBLIOGRAPHY. P. Mantovani, *Museo di Livorno* (1892); G. Monaco in *FA*, vols. 18-19, and in *StEtr* (Rassegna Scavi e scoperte) from 33 (1965) to 38 (1970); M. Failli in *Voce della Riviera Etrusca*, III, n. 17-18, pp. 2f. G. MONACO

RIRHA (Sidi Slimane) Morocco. Map 19. Ancient ruins in the S of Mauretania Tingitana, about 40 km NW of Volubilis on the Roman road to Tingi. Limited excavations in 1920-21 yielded remains of a small Roman settlement dating from the 2d-3d c. A.D.: baths with mosaic floors, various indeterminate buildings, and traces of a surrounding wall. In 1957 the site was dug deeply and traces were found of a pre-Roman settlement going back to at least the 2d c. B.C.

BIBLIOGRAPHY. L. Chatelain, *Le Maroc des Romains* (1944) 127-29; M. Euzennat, "Chroniques," *Bulletin d'Archéologie Marocaine* 2 (1957) 205-6; R. Rebuffat, "Rirha," *EAA* VI (1965) 694-95. M. EUZENNAT

RISAN, see RISINIUM

RISINGHAM, see HABITANCUM

RISINIUM (Risan) S Montenegro, Boka-Kotorska, Yugoslavia. Map 12. A city 11 km NW of Kotor. It was mentioned in the Pseudo-Skylax, Polybios (2.16), Pliny (3.144), and Ptolemy (2.16.3). It was well known

because of the Roman campaigns against the Illyrians under Teuta. The city consisted of a fortress in Gradine and a civilian community below in the NE part of Carine. The city was a colony from early Imperial times and developed into a typically Roman city with a strong Italian element added to the native Illyrian population. Economically important, Risinium had contacts with other cities, especially in the inner province of Dalmatia (Doclea, Municipium S.).

Archaeological investigations have so far been only preservative. The remains of one building in the forum are today in the city park of Risan.

A villa near the route Risan-Nikšić comprises ca. 1000 sq. m consisting of a central courtyard around which a number of rectangular rooms were arranged. Four of them were decorated with mosaics. In many places on the walls, traces of fresco paintings have been discovered. To the W of the atrium additional mosaics have been discovered but have not yet been investigated and published.

BIBLIOGRAPHY. D. Vuksan, "Les mosaiques romains de Risan," *Albania* 4 (1932); C. Marković, "Travaux conservativo-restauratifs dans la localité des mosaiques de Risan en 1963," *Annuaire de l'Institut pour protection des monuments historiques du Montenegro* 2 (1964) 103-16. A. CERMANOVIĆ-KUZMANOVIĆ

RIŞNOV, see CUMIDAVA

RITTIUM, see LIMES PANNONIAE (Yugoslav Sector)

ROANNE, see RODUMNA

"ROBRICA," see LE RUBRICAIRE

ROCAVECCHIA (Melendugno) Lecce, Apulia, Italy. Map 14. A Messapic city near the ancient harbor of Lupiae, ca. 15 km S of San Castaldo. It was of great importance, to judge by its great circuit walls of the 4th c. B.C. and its numerous rich tombs. Some Messapic inscriptions are preserved in the Museo Castromediano at Lecce.

BIBLIOGRAPHY. F. Ribezzo, *Nuove ricerche per il Corpus Inscriptionum Messapicarum* (1944) 182; M. Bernardini, *Panorama archeologico dell'estremo Salento* (1955) 42; O. Parlangeli, *Studi Messapici* (1960) 172. F. G. LO PORTO

ROCCANOVA Lucania, Italy. Map 14. An archaeological zone bounded roughly by the territory of the modern towns of Roccanova, Chiaromonte, and Castronuovo S. Andrea, with the most important concentrations on the hills of Battifarano, Marcellino, and Serre. This area of habitation postdates the Iron Age. Battifarano has long been known for necropoleis of the 5th and 4th c. B.C. Marcellino and Serre have more recently become renowned for the rich funeral offerings of the end of the 7th and the beginning of the 6th c., found during excavations of their necropoleis. Only Marcellino has traces of true habitations, dated to the 4th c., and fortifications built of blocks cut in the Greek style. An archaic settlement on the hill of Serre is surrounded by burials of the end of the 7th and the beginning of the 6th c. There is no evidence of settlement or necropolis of the 5th c., although a necropolis from the second half of the 4th c. has been found. The graves are lined with slabs, but are always without covering slabs. The funeral offerings are generally very rich in vases from the valley of the Agri, mixed with other vases from Siris on the Ionic coast. Although the vases of local production show little variation over an extended period, the Greek vases help date the burials and indicate the end of the 7th and beginning

of the 6th c. as the period of greatest wealth. Among the funeral offerings there are also bronzes, helmets of the Corinthian type, and fibulae with single- or double-pronged buckles. The vases of local production tend to be poor imitations of Greek prototypes. Ivory decorations are always present, along with amber used to decorate fibulae, and remains of necklaces in bone, ivory, or glass paste.

At the end of the 5th c. and all during the 4th c. this corner of Lucania produced red-figure vases inspired by the contacts between Greece and the valley of the Agri, the most important being those of the Primato painter and the Roccanova painter.

BIBLIOGRAPHY. D. Adamesteanu, *BdA* 1 (1967) 48-49; id., "Aspetti archeologici della Val d'Agri," *XVII Festa Nazionale della Montagna per l'Italia Meridionale* (1968) 109-17; id., "Siris-Heraclea," in *Policoro, Dieci anni di autonomia* (1969) 200-4; id., "Tomba arcaica di Armento," *AttiMGrecia* 11-12 (1970-71) 83-92; J. de La Genière, *Recherches sur l'Age du Fer en Italie méridionale* (1968) 247-48; id., "Contribution à l'étude des relations entre Grecs et indigènes sur la Mer Jonienne," *MélRome* 82 (1970) 630-33. D. ADAMESTEANU

ROCCA SAN FELICE, *see* AMPSANCTUS

ROCESTER Staffordshire, England. Map 24. On the road from Little Chester (Derventio) and Chesterton (Newcastle-under-Lyme); the NW portion has produced much Roman material. Limited excavation indicates the presence of a Flavian fort occupied until the early 2d c., but later forts may yet be discovered. There is also a large walled civil settlement of ca. 3.6 ha, with defenses of two periods; the wall was inserted probably in the 4th c. Finds, however, have been made well beyond these areas.

BIBLIOGRAPHY. N. *Staffs. J. Field Studies* 2 (1962) 37-52. G. WEBSTER

ROCHELONGUES, *see* SHIPWRECKS

ROCHESTER, see DUROBRIVAE

ROCKBOURNE Hampshire, England. Map 24. Roman villa in West Park, 4 km NW of Fordingbridge, discovered in 1942 and excavated in 1943-44 and since 1956. The buildings were grouped around a large courtyard, measuring at least 75 m NE-SW and with a maximum width of 60 m NW-SE; the fourth (NE) side has not yet been located. The gateway was in the SW side and the main residential buildings, including two bath suites and three mosaic pavements, flanked the W angle; the buildings on the SE side were of a simpler character and incorporated several corn-driers.

Four periods of occupation have been distinguished, from ca. A.D. 100 to the late 4th c.; many parts of the villa were altered, but the complete sequence of development has not been worked out. The villa is notable for the richness and variety of the finds, including a carved stone sideboard, stone finials, two reused milestones (Trajan Decius and Tetricus), many brooches, and much small metalwork. These are preserved in a museum on the site, which itself is open to inspection. The size and richness of the villa suggest a large estate, and a link has been suggested with the 38.4 ha Roman enclosure, with three corn-driers, which lies 4.8 km to the N on Rockbourne Down.

BIBLIOGRAPHY. H. Sumner, *Excavations on Rockbourne Down, Hampshire* (1914); H. C. Bowen in A.L.F. Rivet, ed., *The Roman Villa in Britain* (1969) 47; A. T. Morley Hewitt, *Roman Villa, West Park, Rockbourne* (1971). A.L.F. RIVET

RODEZ, *see* SEGODUNUM

RÖDGEN Kr. Friedberg, Land Hessen, Germany. Map 20. A fortification of the period of the emperor Augustus, founded during an advance from the Roman base on the Rhine NE into the Wetterau. It lies ca. 50 km from the legionary fortress at Mainz-Mogontiacum.

Established on a gently sloping hill E of the Wetter, its ground plan differs from that of the later rectangular forts. Since it follows the outline of the hill, it is oval. It encloses an area of ca. 3.3 ha and is surrounded by two V-shaped ditches, of which the inner reaches a depth of ca. 3 m in places. Behind the ditches stood an earthen rampart, 3 m wide, which had closely aligned timber uprights supporting its inner and outer faces. The main gate of the fort lay to the E where the hillside slopes upwards. It was built on stout wooden posts. In addition there were probably three smaller gates, in the N, W, and S sides.

The excavations of 1961-66 revealed at the center of the site traces of three huge horrea, of which the largest measured 47.25 m by 29.5 m. The floor of each granary was raised on rows of short posts set fairly close together. A series of narrow parallel trenches had been cut to take the posts and then filled in. In addition a headquarters building was discovered consisting of rooms grouped on two sides of an open court, which was itself surrounded by a colonnade. There were probably ca. 1000 soldiers in the garrison.

The character of the site is very clearly indicated by the three great horrea. Since they were far too large to have supplied only the needs of the unit stationed there, one must conclude that Rödgen was a supply base. There is as yet no parallel anywhere in the Roman Empire for a supply base of this type or of this date. It was founded from Mainz-Mogontiacum and served the troops who were operating in the N. On the basis of the information gleaned from the literary sources, it can be said that Rödgen was not founded before the fortress at Oberaden on the Lippe (q.v.), i.e. not before 12 B.C. Probably it was erected two or three years later when the emperor's stepson Drusus set out on his well-prepared campaigns against the Germans from the legionary fortress at Mainz. At Rödgen, as at Oberaden, none of the coins found are of the type showing the altar at Lyons (Lugdunum), minted in 12 B.C. or more likely 10 B.C., and so one must assume that the supply base at Rödgen also was given up soon after the death of Drusus (9 B.C.) when the military dispositions were radically changed.

BIBLIOGRAPHY. H. Schönberger, "Das augusteische Römerlager in Rödgen," *Germania: Anzeiger der Römisch-Germanischen Kommission* 45 (1967) 84ff; id., "The Roman Frontier in Germany: an Archaeological Survey," *JRS* 59 (1969) 144ff, 148[MI]. H. SCHÖNBERGER

RODUMNA (Roanne) Loire, France. Map 23. A trading city at the head of navigation on the Loire. Goods came from the Rhône valley and the Mediterranean to be sent N and W. Mentioned by Ptolemy and the *Peutinger Table*, it is cited as a city of the Segusiavi. The rise of this town of merchants, fishermen, and potters dates from the first half of the 1st c. A.D.; it started to decline at the end of the century, probably owing to competition from Lezoux, whose products were sold directly through the Allier valley.

Through excavations on the city boundaries we know roughly the area it covered, N-S between the Boulevard de Belgique and the Rue de Cadore and E-W between the Loire and the swamps that lay this side of the section where the railroad station is today. Thus the city ex-

tended along the road from Augustodunum (Autun) to Augustonemetum (Clermont-Ferrand). Its center was probably in the modern De la Livatte quarter, where many remains have been located.

Excavations in 1902 on the site of the Collège Saint-Paul (formerly Saint-Joseph) uncovered a graceful bronze statuette of Minerva and a fine bronze fibula. The site was again explored in 1962-68 and ancient rubbish pockets were found, similar to those discovered in 1958 on the site of the Nouvelle Poste. The original use of these pockets, shaped like funnels or vats with vertical sides and varying in depth (from 0.6 to over 2 m), is still an enigma. The walls of some are hard and brownish, showing that they were used as hearths or rudimentary furnaces. Two had ultimately been used to store clay, rolled into loaves. Among the rubbish were found Gallic coins from the late Republican and Augustan eras, fibulas of Iron Age II and III and the beginning of our era, objects of bronze, iron, and glass, and andirons. There was also a tremendous amount of pottery: from S Gaul, Campanian A, B, and C, Aco ware, Italic amphorae, and local pottery painted in a characteristic and original manner.

In the 1st c. the city produced great quantities of local pottery of Forez and Roannais clay, remarkable for the variety of its shapes, the texture of the paste, and the quality of its decoration. No less than 37 different shapes have been counted, divisible into four groups: vases shaped like an egg or a truncated cone, goblets, carinated bowls, and bowl-shaped vases known as Roanne vases. The forms range from slender pedestaled vases to low ones. The paste is sometimes delicate, light gray with a darker glaze, sometimes coarse, but some fine pieces vary in color from light yellow to brick red. The patterns, predominantly geometric, may be impressed, engraved, or painted.

Only one inscription has been found, an epitaph discovered in 1820 near the Werlé barracks. Few of the monuments have survived: what may be the remains of baths are near the Place du Château, some potters' kilns are near the Ecole de Musique in the Rue de Cadore. The kilns are 2 m down (covered by a Merovingian necropolis, 6th-7th c.). Pottery found in these kilns is principally everyday ware made of coarse clay; there are no painted vases. Built in the second half of the 1st c., these ovens ceased to be active before the end of the 2d c.; production had become heavy and industrialized before it disappeared.

In 1967-69 several houses in the Rue Gilbertès, in the heart of the Gallo-Roman settlement, yielded many small objects, coins and potsherds. Five strata could be identified, from the 1st c. B.C. (Campanian B and C, local ware, coins of the Segusiavi) to the 3d c. A.D. (everyday pottery, a denarius of Gordianus III). One house, built in the period of Tiberius-Claudius and modified in the 2d c., was apparently abandoned ca. 160-180.

At least two necropoleis have been located. One, excavated in 1893 in the Rue Benoît-Malon, held mainly cremation tombs. Four types of urns were listed: a limestone chest, a lead cylinder inside a copper-bound barrel, a gray clay vase with wavy decoration, and a simple amphora base. But inhumation was also practiced: a wooden coffin was identified by its nails. Among the finds were some statuettes of white terracotta from the workshops of the Allier valley, cast figurines usually representing Venus Anadyomene. In 1873 another necropolis was discovered in the Rue Anatole France; in it were a sarcophagus made of large bricks and several cremation urns.

The collections of Joseph Déchelette, a specialist in Gallo-Roman pottery, are housed in a museum named for him; it also has finds from the excavations. A little museum has been set up near the potters' kilns in the Rue de Cadore.

BIBLIOGRAPHY. M. Bessou, "Note préliminaire sur les fouilles de l'Institut St-Joseph," Celticum 9 (1963) 171; R. Perichon & J. Cabotse, "Analyse d'une fosse 'à deblais' de l'Institut St-Joseph à Roanne," ibid. 189-216; J. Cabotse, Roanne a 2000 ans. Les origines celtiques et gallo-romaines (1965); id. & R. Perichon, "Céramiques gauloises et gallo-romaines de Roanne (Loire)," Gallia 24 (1966) 29-75; A. Bruhl & M. Leglay, "Informations," Gallia 22 (1964) 425-26; 24 (1966) 488-92; 26 (1968) 564-65; 29 (1971) 411. M. LEGLAY

ROERMOND Limburg, Netherlands. Map 21. Site at the confluence of the Meuse and the Roer, which in Roman times was perhaps 1 km NW of the present one. Dredging for gravel in the old riverbed has brought to light many sandstone and tufa fragments of columns, and other architectural remains of at least two buildings. All were dredged up from a depth of ca. 13 m; nothing was found in situ, as the shifting of the river had destroyed the buildings. One of them must have been a temple, probably of Romano-Celtic type and dedicated to the goddess Rura, the personification of the Roer; an altar was dredged up near the other remains which bears the dedication RVRAE. The altar is made of sandstone from Nievelstein in Germany, and dates from ca. A.D. 200; the temple may be 2d c. The altar and other finds are in the municipal museum of Roermond.

Few Roman objects have been found in Roermond itself, only some graves and stray finds of pottery and coins. But on the W bank of the Meuse, at Haelen-Melenborg, are the remains of what may have been a Roman statio perhaps a statio beneficiarii consularis. Excavations have revealed the foundations of two buildings, the largest perhaps a bath or a villa. Pottery found here dates from the last quarter of the 1st c. to well into the 3d. A tile with the stamp of Legio X, LXGPF, suggests military occupation.

BIBLIOGRAPHY. A. W. Byvanck, Excerpta Romana III (1947) 53-54 (Roermond, Maasniel), 62 (Haelen); J. E. Bogaers, "Ruraemundensia," Ber. Rijksdienst Oud. Bod. 12-13 (1962-63) 57-68MI (French summary); id., Newsbull. Kon. Ned. Oud. Bond (1964) 33, 69, 134-35; (1965) 74-76. B. H. STOLTE

ROGNAC Bouches-du-Rhône, France. Map 23. Situated 18 km W of Aix-en-Provence and 20 km S-SE of Salon-de-Provence. One kilometer SE of the city is an extremely narrow finger of rock (240 x 30 x 70 m) belonging to the Arbois plateau on which is the site of Le Castellas, 159 m high. It is a spur with steep sides; which on the N is cut off by a fortified wall. Along the cliff are 18 huts arranged in two rows; they have walls of dry stones set firmly on the rock, which has been meticulously flattened and prepared (hearths, silos [?], furnace). Only a few objects have been found (a stone mill, some amphorae for storing food). In contrast the pottery is apparently abundant: Massaliot and Graeco-Italian amphorae, Campanian A, indigenous vases; pottery is also found in the neighboring sites of Les Fauconnières (2 km N-NE) and Les Coussous (2 km W). Coinage is represented chiefly by obols and drachmas of Massalia. A coin from Carthage, another from Nemausus, and a little gold ingot may be evidence of more far-flung trade. Occupied in the 3d c. B.C. and abandoned at the time of the Roman conquest of the territory of the Salyes (ca. 121 B.C.), the site belongs to the Celto-Ligurian civilization of Iron Age II and III. In the Gallo-

Roman period the town was established farther down from the plateau, nearer the Etang de Berre (sites of Les Canourgues, Le Vacon, etc.). Le Castellas was not occupied again until the Middle Ages when it was fortified, hence its name. The remains of the statue of a cross-legged figure (cf. Velaux) come from the area around Rognac.

BIBLIOGRAPHY. *Gallia* (1967) 405; (1969) 432; *Contribution a l'étude historique de Rognac* (1969) 11-30.

H. MORESTIN

ROGNÉE Belgium. Map 21. A large Gallo-Roman villa of a type uncommon in Belgium but with parallels in other provinces of the Roman Empire, for example, in Great Britain (Bignor, Sussex). The buildings of the villa are arranged around a central court (70 m square) with a continuous portico (4 m wide) along all four sides. The portico consisted of Tuscan columns (2.9 m high and 43 cm in diameter), placed on a small wall which formed a base. In the middle of the NW side, in front of the residential wing, this little wall was replaced by steps flanked by four columns (3.74 m high and of 50 cm in diameter). On the SE side another monumental entry was flanked by two large columns. This entry led to a summer pavilion. The dwelling proper, with its concrete paving, walls decorated with frescos, and cellars, was set up along the NW and NE sides of the portico. The dwelling continued along the NW wing in the form of a complete bath building, with caldarium, sudatorium with a cupola, tepidarium, and frigidarium. Along the SW side was an ironworks. In the middle of the SE side, as already mentioned, was a kind of summer pavilion, richly decorated. These two sides have not been completely excavated. The remains of the mausoleum of the family of the owner are 300 m N of the villa; the necropolis of the household and farm servants are in the nearby village of Berzée, a short distance from the villa. This necropolis included about 700 incineration tombs and dates to the 2d and 3d c. The beginnings of the villa go back to the first half of the 1st c. A.D. It was sacked during the Frankish invasions (probably ca. 268-75) and was never rebuilt.

BIBLIOGRAPHY. R. De Maeyer, *De Romeinsche Villa's in Belgium* (1937) passim, esp. pp. 103-6[P].

S. J. DE LAET

ROGOUS, *see* BOUCHETION

ROKSOLANY, *see* NIKONION

ROM, *see* RAURANUM

ROMA Italy. Map 16.

The Origins. The key to Rome's early importance and predominance is its geographic position on the Tiber, the largest river of central Italy. At a distance of ca. 20 km from its mouth, an island in the Tiber provides the easiest place to cross the river between Rome and the sea; and there is no other crossing place for many miles upstream. The left bank opposite the island became the natural halting place for the general overland traffic from N to S of the Italian peninsula as well as for the salt trade route which came from the salt marshes N of the mouth of the Tiber. The river was crossed at the island by bridges or by ferry, and the salt route continued over the Vicus Iugarius, the Argiletum and the Via Salaria towards the mountainous regions of the Sabines, whereas the traffic from the N of Italy into Latium and Campania took its way through the valley of the Forum along the Sacra Via towards the Alban hills. The earliest traces of settlements within the boundaries of later Rome have been found in the immediate vicinity of the Tiber island S of the Vicus

Iugarius. Excavations in the Area Sacra of S. Omobono, begun in 1937, point to pre-urban settlements from ca. 1500-1400 B.C. Early religious traditions like the festival of the Septimontium, which included the Palatium, Cermalus, Velia, Fagutal, Caelius (with Succusa), Oppius, and Cispius, show that the development of Rome as an organized township was based on the hills as natural strongholds. Owing to this geographic position there was uninterrupted habitation on the site of Rome from the second millennium B.C. on. In the Iron Age, an archaic city emerged on the left bank of the river enclosing the four regions: Suburana (Caelius), Esquilina, Collina (Quirinal and Viminal), and Palatina. The Capitoline, always regarded as the citadel of the united city, was not included in one of the regions. The archaeological evidence of Iron Age tombs and hut foundations is, however, not limited to the Palatine, Quirinal, Esquiline, and Velia; it also appears to a large extent in the valley of the later Forum Romanum although the legend describes this as a marsh made habitable only by the draining by the Cloaca Maxima, attributed to the engineering skill of the Etruscans. The fact that a hut settlement was found at the lowest point of the valley at the Equus Domitiani 5 m below the first Imperial pavement of the Forum is ample evidence that the open brook coming from the valley between Quirinal and Viminal, crossing the valleys of the Forum and the Velabrum and emptying into the Tiber, provided sufficient drainage to make the valley habitable and to keep the old road open for traffic. The spring-fed brooks that drained the valleys provided at the same time fresh water for the early dwellers. Through the Campus Martius flowed the Petronia Amnis, the only watercourse whose ancient name is known to us; it came from a spring, Fons Cati, on the slope of the Quirinal. The brook that drained the valley of the Circus Maximus (Vallis Murcia) between the Palatine and Aventine originated from two branches, one coming from the Oppius, crossing the site of the Colosseum and continuing between Palatine and Caelian; at the SE corner of the Palatine it joined another watercourse coming out of the valley S of the Caelian. After crossing the circus valley and the Forum Boarium it flowed into the Tiber ca. 100 m below the mouth of the Cloaca Maxima. It was not the marshy ground that made settling in the valleys difficult—there is no evidence that the settlements on the hillsides were populated more densely or earlier than those in the valleys—but the violent inundations of the Tiber which plagued the city until the beginning of the 20th c. The winter floods, many of them recorded by ancient writers, must often have destroyed the hut settlements in the valleys. Usually the flood exhausted itself in three to five days, and the inhabitants could easily repair the damage to their huts without giving up the place of habitation.

Forum Romanum. The archaic sepulcretum E of the Temple of Antoninus and Faustina and an extension towards the W below the Regia and the Temple of Divus Iulius with tombs from the 9th c. to about 700 B.C. was abandoned by the middle of the 7th c. At the same time the hut settlements disappeared to make room for a general common square. From the beginning the Forum Romanum was a market place with market booths on its long sides—later called Tabernae Veteres on the S and Tabernae Novae on the opposite side. The E and W sides were bordered by religious structures. At the spot where the Sacra Via, descending from the Velia, entered the Forum stood the hut-shaped Temple of Vesta which contained the sacred fire of the community. Across the street, the E boundary of the square was first formed by a stone platform which probably carried a religious monument; it was succeeded by an archaic temple by the first quar-

ter of the 6th c. At the very beginning of the Roman republic, i.e. during the last decade of the 6th c., the temple was replaced by the Regia, the sanctuary of the Rex Sacrorum where he performed the official sacrifices of the state. The opposite, W side of the Forum was bordered by the sacred precinct of Vulcan, the Volcanal, whose ancient pre-urban, rock-hewn altar is still extant. It lay about 5 m above the Comitium, the assembly place of the comitia curiata, and from it the assembled people could be addressed before a speakers platform was built. The area of the Comitium was laid out together with the Forum; both squares received their first pavement around 575 B.C. On the highest point of its N side stood the senate house, the Curia Hostilia, named after the third king Tullus Hostilius. On the S side facing the Curia, orators addressed the people from a tribune which, from 338 B.C., took the name of Rostra from the beaks of captured ships with which it was decorated. To the left of the Rostra stood a group of archaic monuments: a four-sided stele that carries the oldest Latin inscription, the stump of a conical column, and the foundation of a sacellum with tufa bases for statues of recumbent lions. When these monuments were covered in the 1st c. B.C. with a black marble pavement, the so-called Lapis Niger, their original meaning was already unknown; they were believed to belong to a tomb of Romulus or his foster father Faustulus or of Hostus Hostilius, the father of King Tullus. There are other early monuments in the Forum connected with the legendary history of the Roman kings: e.g., the Lacus Curtius, the plinth of a puteal marking the spot where, during the battle between Latins and Sabines, the horse of the Sabine leader Mettius Curtius stumbled into a swamp and thus brought the fight to a halt. On the same occasion Romulus is said to have vowed a temple to Jupiter Stator, which he built on the Velia. The remains immediately SE of the Arch of Titus belong to a reconstruction of the temple by the consul M. Atilius Regulus in 294 B.C.

After centuries of primitive village civilization, Rome, from the 6th c. B.C., developed rapidly into a town assimilating building types that were introduced from Etruria. There is no doubt that in the 6th c. the kings of Rome were of Etruscan origin, and the archaeological evidence from the towns and cemeteries around Rome confirms the priority of Etruscan culture. Thus the Forum Romanum, after having been established as the civic center of the town, soon became an architecturally closed space. In 497 B.C. the Temple of Saturn was dedicated at the SW corner of the square replacing an earlier Fanum Saturni which, together with the Volcanal, had closed the W side before. At the SE corner a temple was consecrated, in 484 B.C., to Castor and Pollux after the Dioscuri in 496 B.C. had brought news of the victory at Lake Regillus to Rome and had watered their horses at the Lacus Iuturnae immediately SE of where the temple was to stand. On the N side where the street of the Argiletum entered the Forum stood the Shrine of Janus Geminus, a small rectangular structure with doors at each end which were closed only when general peace was achieved. In front of the Tabernae Novae, first occupied by dealers in provisions and by butchers and later by money changers, stood the small round Shrine of Cloacina, the divinity of the Cloaca Maxima a branch of which entered the Forum at this point. On the W side above the Volcanal a Temple of Concord was erected in 366 B.C. after the conflict between Patricians and Plebs had been settled. It was rebuilt by L. Opimius in 121 B.C., restored by Tiberius, and dedicated as Aedes Concordiae Augustae in A.D. 10.

From the beginning of the 2d c. B.C. the building of basilicas emphasized the monumental character of the Forum. Nothing is left of the Basilica Porcia erected in 184 B.C. next to the Curia Hostilia and burned down together with it in 52 B.C. at the funeral of Clodius. The Basilica Opimia, built in 121 B.C. next to the Temple of Concord, has also entirely disappeared. On the S side behind the Tabernae Veteres, the censor Ti. Sempronius Gracchus erected in 170 the Basilica Sempronia on the site previously occupied by the house of Scipio Africanus, remains of which have been discovered under the Basilica Iulia. On the opposite long side of the Forum, the Basilica Aemilia was erected in 179 B.C., enclosing the Tabernae Novae within its portico.

The great town-planning schemes of Iulius Caesar included a new orientation of the buildings of the Comitium and the Forum. The Rostra was removed from the S border of the Comitium and given a new collocation at the W side of the Forum with the whole free area of the square in front of it. At the S end of the Rostra, Augustus erected in 20 B.C. the Milliarium Aureum, the Golden Milestone, which recorded the distances to the chief cities of the empire. At the N end stood the Umbilicus Romae, which marked the center of Rome and of the Roman world. The Curia Hostilia, rebuilt after the fire of 52 B.C. by Faustus Sulla, was torn down and with it disappeared the NS orientation of the Comitium, which was reduced to a small square in front of the new Curia Iulia, begun by Caesar and completed by Augustus. On the S side, the Basilica Sempronia was replaced by the Basilica Iulia, begun in 54 B.C. For its construction the Tabernae Veteres were removed. Augustus, who completed Caesar's plans and buildings, transformed the whole SE corner of the Forum into a building complex in honor of Caesar and of the gens Iulia. In front of the Regia on the spot where Caesar's body was burned, he erected the Temple of Divus Iulius. It was dedicated in 29 B.C., and the senate at the same time decreed a triumphal arch to him next to the temple for his victory over Antony and Cleopatra at Actium. An arcaded portico which surrounded the temple was named Porticus Iulia for the members of the gens Iulia and, across the street at the SE end of the Basilica Aemilia, a Porticus Gai et Luci was dedicated to Augustus' grandsons Gaius and Lucius Caesar. The Temple of Divus Iulius replaced a platform of tufa blocks, the site of the Tribunal Aurelium and the Gradus Aurelii, where trials were conducted from ca. 75 B.C.; it is no longer mentioned after the time of Cicero. Many other tribunals in the Forum were no more than wooden platforms like the Tribunal Praetorium of the praetor urbanus or that of L. Naevius Surdinus, "praetor inter cives et peregrinos" as he calls himself in an inscription on the pavement, next to the statue of Marsyas in the center of the square.

The view to the W had been closed ever since 78 B.C. when Q. Lutatius Catulus built the Tabularium, the state archives of the Roman republic, between the two summits of the Capitoline. In front of its facade facing the Forum stood, to the S, the Porticus Deorum Consentium, dedicated to the twelve Olympian gods and originally built in the 3d or 2d c. B.C. and restored for a last time in A.D. 367. Between the portico and the Temple of Concord, Titus and Domitian erected a temple to their deified father Vespasian.

The splendor of the Forum was enhanced by triumphal and other arches. The Sacra Via entered the Forum through the Fornix Fabianus, built in 121 B.C. by A. Fabius Maximus Allobrogicus, remains of which have been found at the SE corner of the Regia. The street then passed through the Arch of Augustus erected in 29 which was replaced by a triple arch decreed in 19 B.C., after the standards captured by the Parthians had been returned; on the piers of this arch the Fasti consulares

and triumphales were engraved. The W side of the Forum was adorned by the single Arch of Tiberius erected in A.D. 16 and a triple arch dedicated to Septimius Severus and his sons Caracalla and Geta in A.D. 203. The two main streets at the W end, the Vicus Iugarius and the Argiletum, also entered the Forum through street arches (Iani). The sites of three equestrian statues on the area of the Forum can be identified as the Equus Domitiani (A.D. 91), the Equus Constantini (A.D. 334) and the Equus Constantii (A.D. 352).

In A.D. 303 a monument of five columns was erected immediately behind the Rostra for the Vicennalia of Diocletian and Maximian and the Decennalia of the Caesars Constantius Chlorus and Galerius. This monument of Diocletian's tetrarchy is represented in relief on the N side of the Arch of Constantine. One of the column bases decorated with reliefs is still extant and the foundations of all five columns were excavated in 1959. The last monument to be erected in the Forum Romanum was the column in front of the Rostra dedicated to the Byzantine Emperor Phocas in 608.

Sacra Via. The region between the Forum and the top of the Velia was called the Sacra Via. After leaving the Forum area through the Arch of Augustus, the street passes on the S the precinct of Vesta with the temple and the Atrium Vestae, the dwelling of the Vestal Virgins. Their sumptuous residence with a large court decorated with three water basins, the remains of which are still to be seen, was built after the Neronian fire of A.D. 64. Just as Caesar changed the orientation of the Forum, so Nero changed the orientation of the Sacra Via and the buildings bordering it. The pre-Neronian Atrium Vestae followed the course of the original street parallel to the Regia and to the Domus Publica. This, the official residence of the Pontifex Maximus, became part of the Atrium Vestae when, in 12 B.C., Augustus, after his election as Pontifex Maximus, gave up the official residence in favor of his house on the Palatine. After passing through the Fornix Fabianus, the Sacra Via joins a second branch running N of the Regia and entering the Forum between the Temple of Divus Iulius and the Porticus Gai et Luci. On the N side of this street stands the temple which, in A.D. 141, Antoninus Pius erected to the memory of his deceased wife Faustina. After his death, in 161, it was dedicated to him as well.

Going E towards the Velia, one sees on the right a semicircular podium recognizable as the platform of a Sanctuary to Bacchus, which is known from a coin of the man who restored it, Antoninus Pius. Literary sources reveal the existence of a Temple of the Lares and a Tholos of Magna Mater on the Velia where the Clivus Palatinus meets the Sacra Via; of these temples no traces have been found.

From the early times of the hut settlements the Sacra Via was a densely populated residential quarter. The inhabitants were called sacravienses. Numerous remains of private buildings of the Republican and early Imperial period have been found and, according to tradition, some of the kings and many patrician families had their dwellings on the Sacra Via and on the height of the Velia ("in Summa Sacra Via"). Stone foundations of archaic houses from the first half of the 6th c. B.C. have been found over the tombs of the sepulcretum E of the Temple of Antoninus and Faustina. Next to it are basement rooms of a private house on both sides of a narrow corridor, dating from about the middle of the 1st c. B.C., which its excavator once erroneously called a "carcer." Higher up, about 30 m W of the Arch of Titus, are the remains of a rooming house of more than 35 rooms with a common bathing establishment dating from about 80 to 50 B.C. All these buildings were destroyed by the Neronian fire in A.D. 64, or they were sacrificed for the construction of the portico that Nero built leading to the vestibule of his new palace, The Golden House. The foundations of its colonnades cut through the curves of the Sacra Via and run in a straight line from the vestibule on the height of the Velia to the site of the Fornix Fabianus, flanking an avenue 30 m wide. Domitian soon transformed the N side of the portico into the Horrea Piperataria, a bazaar for eastern goods, pepper and spices; the jewellers' shops that existed on the S side were converted into the Porticus Margaritaria in the second quarter of the 2d c. In A.D. 81 Domitian erected at the summit of the Velia the arch in honor of his deceased brother Titus, commemorating his triumph for the conquest of Jerusalem in A.D. 70. At the beginning of the 4th c. the Horrea Piperataria disappeared under the new building of the Basilica of Constantine, which was begun by Maxentius under the name of Basilica Nova and completed by Constantine after A.D. 313. To the same period belongs the so-called Temple of Romulus between the Temple of Antoninus and Faustina and the Basilica of Constantine, which Maxentius—according to a conjecture based on coins showing a circular temple—built in memory of his son M. Valerius Romulus, who died in A.D. 309. On the site of the vestibule of Nero's Domus Aurea, Hadrian erected the Temple of Venus and Roma, consecrated in 136 or A.D. 137. The colossal statue of Nero in the midst of the vestibule was removed to a site opposite the Colosseum, where the last remains of its base were destroyed in 1936.

Palatine. The Sacra Via was the principal means of communication between the Forum and the Palatine. At the Arch of Titus there branched off from it the Clivus Palatinus which, passing through an arch probably built by Domitian, reached the summit of the Palatium, the S elevation of the Mons Palatinus. At the beginning of the Clivus Palatinus once stood the Porta Mugonia, one of the three gates of the early Palatine town (the others being the Porta Romana, somewhere on the Clivus Victoriae, and a nameless gate at the Scalae Caci). According to tradition the Palatine, where Romulus founded the town in the middle of the 8th c. B.C., was the first of the hills to be inhabited. A hut with a thatched roof which was believed to be the house of Romulus was regarded with great veneration, always restored and preserved until the 4th c. A.D. The foundations of three huts excavated in 1948 between the Temple of the Magna Mater and the Scalae Caci, a narrow path leading from the Palatine to the valley of the Circus Maximus, suggest the shape of Romulus' dwelling. The Temple of Magna Mater at the W corner of the Palatine was built sometime after 203 B.C. to house the sacred black stone of the goddess, which had been brought to Rome from Pessinus in Asia Minor. Some other early monuments that escaped being buried by the construction of the imperial palaces have been preserved on this corner of the hill: two archaic cisterns from the 6th c. B.C., situated between the temple and the house of Augustus, and the foundations of the Auguratorium, which may have marked the place where later ages thought that Romulus took the auspices for the foundation of his new town.

Very early in Rome's architectural history the Palatine had become a typical residential quarter. In the 1st c. B.C., it was the choicest residential area, where people like Lutatius Catulus, L. Crassus, Clodius, Cicero, Catilina, Mark Antony and Germanicus, the father of Caligula, lived. Augustus himself was born on the Palatine. Almost all these houses have disappeared. Under the "Lararium" of the Domus Flavia a private house, dating from about the middle of the 1st c. B.C., was excavated, the so-called Casa dei Grifi; and under the basilica of the

same building was uncovered an "Aula Isiaca" which shows Egyptian-style wall paintings from the end of the 1st c. B.C. Only one private dwelling from the time of the Republic survived the palatial buildings on the Palatine erected by Tiberius, Caligula, Nero, Domitian, and Septimius Severus. This was the house of Augustus, which he had bought ca. 36 B.C. from the orator Hortensius and which became the first imperial residence. This house has been identified with the so-called "Casa di Livia" excavated in 1869. Like the hut of Romulus, the house was spared destruction and remodeling and although it became surrounded by splendid palaces on a much higher level, lived on unaltered to the end of the principate. It was enlarged and extended towards the valley of the Circus Maximus; here, immediately W of the Temple of Apollo, rows of terraced rooms, partly decorated with wall paintings, have recently been excavated. The enlarged house must have been completed at about the time when the Temple of Apollo Palatinus was dedicated in 28 B.C. The temple is now generally identified with the podium and long flight of steps to the W of the Domus Flavia, formerly attributed to Iuppiter Victor. The library of the temple, Bibliotheca Apollinis Palatini, built and dedicated at the same time as the temple, has been unearthed SW of the triclinium of the Domus Flavia.

The NW part of the Palatine was covered by the palace of Tiberius. Very little is known of the original building. Caligula extended the palace towards the Roman Forum and enclosed the Temple of Castor in its precinct. After the fire in A.D. 80 Domitian reconstructed the whole building complex which, to the S, almost touches the house of Augustus and on the E borders the Area Palatina. A balcony with stuccoed arcades runs the whole length of the N facade overlooking the Forum, and to the N a great reception hall (formerly wrongly identified as Temple of Augustus) was added, thus making the palace accessible from the Vicus Tuscus. Next to the hall on the same street a warehouse has come to light; the inscription on an altar identifies it as the Horrea Agrippiana.

The SE corner of the hill was first occupied by Nero's Domus Transitoria, the palace which connected the imperial dwelling on the Palatine with the gardens of Maecenas on the Esquiline. After having been destroyed by the fire of A.D. 64, its burned ruins were covered by the Domus Aurea. All these structures disappeared less than a generation later under Domitian's Domus Augustiana, which occupied the whole of the SE half of the hill, the Palatium. Above the Area Palatina stood the colonnaded facade of the Domus Flavia behind which were the state rooms of the palace, namely a basilica (or courtroom), a reception hall, and a lararium. In the center of the domus was a peristyle garden and on the S of it the triclinium flanked by a nymphaeum on each side. East of this building is the Domus Augustiana itself with a peristyle surrounding a pool on the same level with the Domus Flavia. On a lower level is a courtyard with a fountain surrounded by the residential quarters and boasting a semicircular facade on the S slope of the hill towards the Circus Maximus. Still farther E the so-called Stadium of Domitian or Hippodromus Palatii, leads to the constructions of Septimius Severus consisting mainly of bathing establishments supported by huge vaults of masonry. A monumental freestanding facade erected in A.D. 203, the Septizonium, which faced the Via Appia, screened the SE corner of the imperial palace. Halfway down the S slope of the Palatine is a row of small rooms which were perhaps servants' quarters. On the basis of graffiti scratched on the walls the building has been called the Paedagogium. Still lower down on the Via dei Cerchi is a private house that also may have

belonged to the imperial palace. Its modern name, Domus Praeconum, results from wall paintings that show heralds and slaves receiving guests.

A temple area surrounded by porticos covered the NE corner of the Palatine. In its center the remains of a large temple (ca. 65 x 40 m) have been unearthed. The area may be the site of a sanctuary erected by Livia to Augustus, later used for the cult of all emperors under the name of Aedes Caesarum. The excavated ruins probably belong to the temple which Elagabalus (A.D. 218-22) erected to the Syrian sun god, Sol Invictus Elagabalus, and which was transformed into the Temple of Iuppiter Ultor by his successor, Alexander Severus. The temple area was accessible from the Clivus Palatinus through a monumental gateway, the Pentapylum, of which the remains are to be seen in the Via di S. Bonaventura.

Imperial Fora. The fora of the emperors formed the NW limit of the monumental center of ancient Rome. The new orientation that Caesar gave to the Forum Romanum—by removing the Rostra from the Comitium to the W end of the forum's area, by replacing the Curia Iulia, and by practically abandoning the Comitium in shape and function—was closely related to the construction of his new Forum Iulium. The back wall of the Curia Iulia stood in line with an uninterrupted row of shops which formed the long S side of the Forum Iulium, thus being at its SE corner. In 46 B.C. Caesar dedicated the still unfinished forum and the Temple of Venus Genetrix, the ancestress of the gens Iulia; both were completed by Augustus. Trajan extended Caesar's forum towards the Capitol and erected at the SW end the building called Basilica Argentaria. With the "insula Argentaria" on a higher level, the Forum Iulium bordered the Clivus Argentarius, the only direct connection between the Forum Romanum and the Campus Martius. At its beginning below the Arx of the Capitol was the Carcer Mamertinus, the old Roman state prison; it then passed along the W side of the Forum Iulium, leaving the tomb of C. Poplicius Bibulus on the right, to join the Via Flaminia.

Adjoining the Forum Iulium Augustus built his own Forum Augustum to provide additional room for the courts and to demonstrate, by a splendid architectural achievement as well as by a carefully chosen program of sculptural decoration, the continuity of Early Roman history down to his own rule as princeps. In its center stood the Temple of Mars Ultor, which was vowed during the battle of Philippi in 42 and consecrated in 2 B.C. On either side of the temple were porticos and behind these were exedrae with statues of the mythical ancestors of the gens Iulia, of triumphatores, and other distinguished citizens. A large part of the inscriptions, the Elogia, have been found. In A.D. 19 Tiberius erected triumphal arches in honor of his son Drusus and his nephew Germanicus on either side of the Temple of Mars Ultor.

In A.D. 71, after the capture of Jerusalem, Vespasian began the construction of the Temple of Peace, which was dedicated in A.D. 75. It stood at the SE side of the Forum Pacis, a spacious area decorated with flower beds and surrounded by a wall. Almost the whole space of the forum is now covered by the modern streets Via dei Fori Imperiali and Via Cavour. The only extant architectural remains is a building on the SE side, into which the church of SS. Cosma and Damiano was subsequently built. It probably was the library of the Forum, and the marble plan of Septimius Severus (Forma Urbis Romae) was later attached to its NE wall where the dowel holes for holding the slabs of the plan are still visible.

Between Vespasian's forum and the Forum Augustum passed the Argiletum, which was the street joining the Forum Romanum and the Subura, a populous quarter between Viminal and Esquiline. Vespasian had intended

to develop this unused space into another forum. His architectural concept was carried out by Domitian, who erected in the N part a Temple of Minerva. After the death of Domitian the forum and the temple were dedicated by Nerva in A.D. 97, and the forum was called Forum Nervae or Forum Transitorium. The colonnaded perimeter walls transformed the Argiletum into a monumental avenue; after leaving the forum at the E side of the temple, the street passed through a semicircular portico, the Porticus Absidata. This has been known since the 16th c. from a fragment of the Severan marble plan. Excavations in 1940 revealed the curved foundation that adjoins the perimeter wall of the Forum Augustum to the W and the Forum Pacis to the E.

With the last and largest of the imperial fora Trajan completed Caesar's original plan of connecting the Forum Romanum and the Campus Martius. The Forum Traiani, built by the architect Apollodorus of Damascus, was dedicated in A.D. 112. From the side of the Forum Augustum it was entered by a large triumphal arch. The main building, the Basilica Ulpia, constituted the NW boundary of the forum area, which on the two other sides was surrounded by porticos and apses. Behind the basilica stands the Column of Trajan, the pedestal of which served as tomb for himself and his wife Plotina, flanked by two libraries. Hadrian completed the forum by erecting at its NW end a Temple of Trajan and Plotina surrounded by a colonnade. This part of the forum has never been excavated.

Trajan's Market. Parallel to the NE apse of Trajan's Forum a complex of buildings constructed in brick-faced concrete rises against the slope of the Quirinal. It served as a market for general trading and probably also for the public distribution of grain and other provisions. The market buildings were erected in the first decade of the 2d c. A.D. and were finished before the Forum was dedicated. As a result of the excavation of 1929-30 more than 150 individual tabernae are now accessible. Toward the modern Via Quattro Novembre is a great two-storied hall, and on a higher level there are shops with water tanks for the sale of fish, and others with drains in the pavement for the sale of oil and wine. Larger rooms with niches in the walls were probably offices for administration. On three different levels streets provided access to the buildings: on the lowest level the shops of the hemicycle faced a street that skirted the perimeter wall of the forum. On a higher level a street with the mediaeval name of Via Biberatica led through the shops of the third story. The upper street running beside the modern Salita del Grillo gave access to the shops facing the Quirinal.

Capitol and Servian Wall. The Mons Capitolinus was the natural fortress for the hills and valleys united in the early city of Rome on the left bank of the Tiber. It was composed of two distinct elevations on N and S and a depression between them, and on all sides it was surrounded by steep cliffs. The N elevation was occupied by the citadel or arx; it is the only site in Rome where early fortification walls preceding the so-called Servian Wall have survived. A temple dedicated in 344 B.C. to Iuno Moneta stood on the part of the hill where the church of S. Maria in Aracoeli now stands. On the S elevation, the Capitolium proper, stood the Temple of Iuppiter Optimus Maximus, dedicated in 509 B.C., the first year of the Roman republic. The original name of this part of the Capitol was Mons Tarpeius. This ancient name in the form of Saxum Tarpeium or Rupes Tarpeia continued to be used for the precipice from which criminals were hurled. This Tarpeian rock rises on the SE corner of the hill overhanging the present-day Piazza della Consolazione. According to literary tradition more than ten other temples and altars stood in the Area Capitolina, of which only the podium of the Temple of Iuppiter Custos has been excavated and partly destroyed when the modern Via del Tempio di Giove was laid out. From the side of the Forum the Capitol was reached by the Clivus Capitolinus. The depression between the elevations was the Asylum, where, according to tradition, Romulus accepted refugees from other towns. In 192 B.C. Q. Marcius Ralla dedicated here a Temple of Veiovis, which was discovered under the SW corner of the Palazzo Senatorio in 1939. The remains date from a restoration coinciding with the construction of the Tabularium in 78 B.C., which closed the entire E side of the Asylum. Private houses extended from below up the slopes of the Capitolium and the arx. When, in 1927, the N side of the Capitol was being cleared, beside the steps leading to S. Maria in Aracoeli a six-story apartment house (insula) was discovered and excavated. When in 387 B.C. the Gauls entered and burned the undefended city, the arx withstood a siege of seven months, until the Gauls left. Only after their departure was the so-called Servian Wall which tradition attributes to the sixth king of Rome Servius Tullius (578-534 B.C.) constructed. This defense line of Republican Rome, still visible in many places, enclosed Rome's traditional seven Hills: Capitoline, Palatine, Aventine, Quirinal, Viminal, Esquiline, and Caelian. The wall followed the line of the Pomerium, the symbolic boundary between city and countryside, with the exception of the Aventine which remained outside until the extension of the Pomerium by Claudius in A.D. 49.

Campus Martius. The enceinte of the Republican fortification left a large part of the city outside the walls: the Campus Martius, the Tiber with the area of docks and warehouses, the Tiber Island, the Transtiberine quarter and the Ianiculum. From the beginning of the Republic the Campus Martius was state property. It was used when the people met in the comitia centuriata for assembly and voting, which took place in an enclosed space called the "saepta," and for the military and athletic training of the Roman youth. As early as 435 B.C. the Villa Publica was built in the S part of the Campus to serve as headquarters for taking the census or levying troops. At about the same time, in 431 B.C., a Temple of Apollo was dedicated; it stood immediately N of where later rose the Theater of Marcellus. The temple stood outside the Pomerium because it was dedicated to a foreign deity. There were other early cult centers besides a temple and altar of Mars to whom the Campus was consecrated: the Ara Ditis et Proserpinae in the Tarentum at the last stretch of the Corso Vittorio Emanuele near the Tiber, and the Temple of Bellona, built in 296 B.C. next to the Temple of Apollo. In the S part of the Campus Martius numerous other temples were erected which, after the construction of the Circus Flaminius in 221 B.C., were either called "in Circo Flaminio" or "in Campo Martis" according to their location. Fragments of the Forma Urbis Romae indicated the location of the Circus Flaminius between the Porticus of Octavia and the Tiber. Within the Porticus of Octavia stood the Temples of Iuno Regina and Iuppiter Stator, and, immediately to the W was the Porticus Philippi enclosing the Temple of Hercules Musarum. The Temple of the Lares Permarini, dedicated in 179 B.C. and discovered in 1938 in Via delle Botteghe Oscure, was surrounded by the Porticus Minucia. The construction of the Theater of Pompey in 55 B.C. started a new trend in filling the Campus Martius with public buildings. Caesar planned the construction of a theater between the Forum Holitorium and the Circus Flaminius. It was built by Augustus and dedicated in 13 B.C. to the memory of his nephew Marcellus. At the same time L. Cornelius Balbus

erected a theater with a porticus, the Crypta Balbi, the remains of which are under the Palazzo Mattei di Paganica. On the Via Flaminia, which ran through the Campus Martius from S to N, the Ara Pacis was dedicated to the Pax-Augusta in 9 B.C.; even earlier in 28 B.C., in the N part, Augustus had built a ustrinum (crematory) and the mausoleum for himself and his family. At about the same time his son-in-law Agrippa erected the Pantheon and began the construction of public baths just N of a square with four Republican temples (Area Sacra del Largo Argentina) so far unidentified. Between the Pantheon and the baths he built the Basilica Neptuni and, immediately to the E of this building complex, he completed the great voting precinct started by Caesar, the Saepta Iulia. Some 85 years later Nero built Rome's second public baths and a gymnasium to the NW of the Pantheon. To the SE of it Domitian restored a Temple of Isis and Serapis and built next to it, in memory of his father Vespasian and brother Titus, the Templum and Porticus Divorum; between the two structures he erected a small round temple of Minerva Chalcidica. He also built a stadium whose outline is preserved in the Piazza Navona and immediately S of it an Odeum, a theater for musical performances. Agrippa's Pantheon was entirely rebuilt by Hadrian and consecrated between A.D. 125 and 128. Next to it he erected a temple in honor of his mother-in-law Matidia and, immediately W of this temple stood the Hadrianeum built to his memory by Antoninus Pius, of which eleven marble columns and the wall of the cella are still standing on the Piazza di Pietra. The Antonines concentrated their building activities in the zone of the Campus Martius N of the Hadrianeum. On the Piazza Colonna the Column of Marcus Aurelius still stands, and the ustrina of Antoninus Pius and Marcus Aurelius have been found near Piazza Montecitorio and Piazza del Parlamento. The column of Antoninus Pius, excavated in front of the ustrinum in 1703, did not survive except for the sculptured pedestal now in the Cortile della Pigna in the Vatican. Meanwhile, the Via Flaminia whose intramural part was later called Via Lata, had become the main thoroughfare of the Campus Martius. It was spanned by three triumphal arches, one for Claudius, the Arcus Novus for Diocletian, and the "Arco di Portogallo" the attribution of which is uncertain. On the E side of the street traces of shops and private dwellings have been discovered. On the same side, between Piazza S. Silvestro and Via Borgognona, Aurelian built a Temple of the Sun (Templum Solis) after his return from the east in A.D. 273.

Markets and Warehouses. Immediately S of the Campus Martius the left bank of the Tiber was entirely occupied by open and covered markets and by warehouses. The vegetable market—Forum Holitorium—had been greatly reduced in size by the encroachment of the Theater of Marcellus. The remaining space was taken up by the Temples of Ianus, Spes, and Iuno Sospita, the remains of which exist beneath and beside the church of S. Nicola in Carcere. The E boundary against the slope of the Capitoline was formed by a portico; the ruins are still extant N of the Vicus Iugarius. South of it is the cattle market—Forum Boarium—bounded on the SE by the Circus Maximus and by the Tiber on the W. It was filled with temples, monuments, and other buildings dating from the beginning of the city to the period of the late empire. The twin temples of Fortuna and Mater Matuta were first built at the end of the 6th c. B.C., together with the archaic altars in front of them. Nearby stand two well-preserved temples, a round one of marble from the beginning of the 1st c. B.C. and an Ionic rectangular temple; one of these may have been dedicated

to Portunus. In A.D. 204 at the entrance from the Velabrum a gate was erected to Septimius Severus and his family; a four-sided marble arch, Ianus Quadrifrons, stands next to it over the course of the Cloaca Maxima. Under the church of S. Maria in Cosmedin was the ancient Republican Temple of Ceres; along its NW side a hall for the headquarters of the Praefectus Annonae was built in the 4th c. A.D. The columns of this Statio Annonae are still visible in the church.

From the Forum Boarium extended for ca. 350 m a narrow street under the steep cliff of the Aventine along the Tiber. Here, remains of the landing stage and warehouses of the Emporium have been found which extended for ca. 1 km. It handled goods coming up the river from Ostia and served for 450 years the needs of the city's population. The covered market hall alone, the Porticus Aemilia, of which the remains in opus incertum date from a restoration in 174 B.C., measured 487 m in length. In front of it on the river bank and also in back were shops and warehouses, of which the Horrea Galbae have recently been uncovered. Testimony to the busy commercial traffic is the Mons Testaceus, an artificial hill some 50 m high made entirely from broken amphorae discarded after the transfer of their contents.

Tiber and Transtiberim. The Emporium embraced the city's river port, which from the beginning of the 2d c. B.C. to the 2d c. A.D. was equipped with harbor facilities such as wharves, mooring-rings, loading ramps, and warehouses. Before arriving at the Tiber island from the S, the river was first bridged at the Forum Boarium by the wooden Pons Sublicius, perhaps only a footpath. For religious reasons it was preserved until the late empire although after 179 B.C. it was replaced, for all practical purposes, by the Pons Aemilius, the first stone bridge. The island in the Tiber "inter duos pontes," was probably always connected with the banks of the river by some kind of wooden bridges. The still extant Pons Fabricius dates from 62 B.C. and the Pons Cestius, which leads to the right bank, is also of ancient origin. The island was dedicated to Aesculapios, whose temple stood at the S end from the beginning of the 3d c. B.C. To the N of the island, the left bank of the Tiber was occupied by the Navalia, the arsenal and shipyards of the Roman navy. The Pons Aurelius and Pons Agrippae crossed the river just inside of the Transtiberine section of the Aurelian Wall. The Pons Neronianus led the Via Recta, which branched from the Via Flaminia to cross the Campus Martius towards the gardens of Agrippina on the right bank; here, since the time of Caligula, stood the Circus Gai et Neronis with the Obelisk, which now stands in Piazza S. Pietro. When Hadrian built his Mausoleum on the right bank he connected it with the Campus Martius by the Pons Aelius completed in A.D. 134. In the N, the Via Flaminia, built in 220 B.C., crossed the Tiber by the Pons Milvius. Although the transtiberine quarter became a densely populated part of the city, only a few ancient remains have been identified. Under the church of S. Cecilia a private house including a tannery, the Coraria Septimiana, came to light and, near the Viale Trastevere, barracks of a cohors vigilum (police and fireguard) were excavated in 1866. On the slope of the Ianiculum next to the holy grove of the Nymph Furrina, Lucus Furrinae, a sanctuary of Syrian gods was unearthed; it was dedicated to Iuppiter Optimus Maximus Heliopolitanus. When in 1878-80 the Tiber was widened, a storehouse for imperial wine and a luxurious villa were discovered in the grounds of the Villa Farnesina. Nothing is left of a Naumachia of Augustus for which he built a new aqueduct, the Aqua Alsietina, from the lacus Alsietinus (Lago di Martignano).

The Aventine and the Baths of Caracalla. The valley between the Palatine and the Aventine was occupied by the Circus Maximus which, according to legend, was founded in the time of the kings. The extant remains of the SE curve belong to the Imperial period. On the Aventine the oldest temple was the Temple of Diana Aventina founded as a common sanctuary of the Latin league. Nothing remains of the temple nor of several others known only from literary sources. In 1935 a temple to the Syrian Bal under his Roman name of Iuppiter Dolichenus was found under the Via San Domenico. The Aventine was public property until 456 B.C. when it was given to the plebs for settlement; it remained a plebeian quarter to the end of the Republic. During the Empire, however, the rich settled here. Licinius Sura, a friend of Trajan, built his house on the side of the Circus Maximus the baths of which, Thermae Suranae, came to light in 1943. Next to it, under the church of S. Prisca, a Mithraeum was excavated in a large Roman house that could have been the Privata Traiani, the house in which Trajan lived before his adoption by Nerva. On a second elevation (Aventinus Minor), SE of the main hill, stood a famous Temple of the Bona Dea Subsaxana, of which no remains have ever been found. Just above, in the former convent of S. Balbina, walls are still visible of the house which Septimius Severus gave to his friend L. Fabius Cilo. Below this house are the ruins of the Baths of Caracalla, dedicated in A.D. 216. In the subterranean service corridors a Mithraeum was found in 1912, the largest so far discovered in Rome.

Caelius. Branching off the road between the Colosseum and Circus Maximus, the Clivus Scauri leads to the Caelian hill. It passes the Domus Johannis et Pauli, two Roman houses from the 2d and 3d c. A.D., with a common facade, which is now the S side of the church of SS. Giovanni e Paolo. Under its campanile and convent are remains of the Temple of Claudius, begun by his widow Agrippina, almost destroyed by Nero and completed by Vespasian. The E buttress wall of the temple terrace was transformed into a nymphaeum in the park of Nero's Golden House. Through the Arch of Dolabella et Silanus of A.D. 10 the Clivus Scauri leads out of the enclosure of the Servian Wall. To the left, between the Via Celimontana and Via S. Stefano Rotondo, a building dedicated to the cult of the Magna Mater was discovered in 1889, identified through an inscription as the Basilica Hilariana. The street then passes between two barracks, the Castra Peregrina to the left, for soldiers detached for special service in Rome from provincial legions, and to the right the Statio V of the cohortes vigilum (police and firemen).

At the beginning of the Empire, the E part of the hill became a favorite place for the residences of the affluent. When, in 1959-60, a new wing of the hospital S. Giovanni was being constructed, a whole group of palaces with gardens and terraced garden architecture came to light. Northwest of the Via Amba Aradam were the gardens of Domitia Lucilla, mother of Marcus Aurelius, and the house of Annius Verus in which Marcus Aurelius grew up. On the other side of the street, remains of the houses of Calpurnius Piso and of the Laterani were found. Where the Via Amba Aradam enters Piazza S. Giovanni in Laterano, stands the frigidarium of the Thermae Lateranenses, which dates from the beginning of the 3d c. A.D. This bathing establishment perhaps served the barracks of the Equites Singulares, the mounted guards of the emperor, which were discovered and excavated under S. Giovanni in Laterano in 1934-38. On the extreme E part of the Caelian, Heliogabalus (A.D. 218-222) built a villa which in size and type was comparable with Nero's Golden House or Hadrian's villa at Tivoli. The Amphitheatrum Castrense, the Circus Varianus, and the Thermae Helenae belonged to it. The palace, Palatium Sessorianum, became the residence of the empress Helena and was later converted into the church of S. Croce in Gerusalemme. Running from the Porta Maggiore along the whole Caelian ridge, the Aqua Claudia supplied the water for the Caelian, Palatine, and Aventine. The arches of this branch of the aqueduct were known as the Arcus Neroniani or Caelimontani.

The valley of the Colosseum and the Esquiline. On the way from the Lateran towards the Colosseum on the right side of the Via S. Giovanni in Laterano stands the church of S. Clemente, which was built over two Roman buildings, one a market hall or warehouse and the other a private house from the end of the 1st c. A.D. At the beginning of the 3d c. a Mithraeum was built into it. Before arriving at the Colosseum, about 60 m to the E, are the remains of the Ludus Magnus, the principal training school for gladiators. Of two other schools known to have been E of the Colosseum, the Ludus Matutinus and Ludus Dacicus, no traces have been found. Immediately N of the Ludi and the modern Via Labicana stood the Castra Misenatium, the barracks for sailors from the naval base at Misenum, who were detailed for service in the amphitheater to handle the awnings (velaria) which shielded spectators from the sun. The construction of the Amphitheatrum Flavium (Colosseum), at the site previously occupied by a lake in the grounds of Nero's Golden House, was begun by Vespasian and dedicated by Titus in A.D. 80. Southeast of the amphitheater stands the arch erected in honor of Constantine to commemorate his victory over Maxentius, completed in A.D. 315. In front of its N side stood the Meta Sudans, a monumental fountain built in the reign of Domitian; it was destroyed in 1936. Together with the Colosseum Titus inaugurated his baths, the Thermae Titi on the slope of the Esquiline (Oppian hill). Immediately NE of them Trajan, in A.D. 109, built another, larger bathing establishment over the ruins of the main palace of the Golden House which was burned down in A.D. 104. The Thermae Traiani, built by Apollodoros of Damascus, became the architectural model for all the later public baths in Rome. West of the Thermae was a Temple of Tellus, and next to it the seat of the Praefectus Urbi with the Secretarium Tellurense, a courthouse for closed proceedings. Immediately N of the Thermae Traiani stood the Porticus Liviae, built by Augustus and dedicated to his wife Livia in 7 B.C. No remains of any of these buildings have ever come to light. Below in the valley, in the general direction of the modern Via Cavour, the Clivus Suburanus continued the street of the Argiletum toward the Porta Esquilina of the Servian Wall which, in 262 A.D., was transformed into an arch dedicated to Gallienus and his wife Salonina. A large portion of the Esquiline was occupied by parks, the Horti Maecenatis, Lamiani, Liciniani, Lolliani, Tauriani, Pallantiani, and others. The so-called Auditorium Maecenatis, a semi-interred nymphaeum, was excavated in the grounds of the Horti Maecenatis in 1874. Another nymphaeum near Rome's Termini station, erroneously called "Templum Minervae Medicae," belonged to the Horti Liciniani and, on the Piazza Vittorio Emanuele, stand the ruins of a monumental fountain, the terminal of a branch of the Aqua Iulia. The remains of the Basilica of Iunius Bassus, who was consul in A.D. 331, were excavated and then destroyed in 1930 when the Oriental Seminary (Russicum) was built on the site.

Viminal, Quirinal, Collis Hortorum. North of the Esquiline was the Viminal, bordered on the SE by the Vicus

Patricius which ran to the Porta Viminalis of the Servian Wall; the remains of this gate are still visible near the Termini railroad station. On the N side of the Vicus Patricius, under the church of S. Pudenziana, houses of the late Republic and early Empire have been found. Above these houses, by the middle of the 2d c. A.D., the Thermae Novatianae sive Timotheanae were built. Less than 0.8 km N of them are the Baths of Diocletian, dedicated in A.D. 305 or 306, now occupied by the church of S. Maria degli Angeli and the Roman National Museum. On the extreme E part of the hill, between the Via Nomentana and the Via Tiburtina, Tiberius erected the barracks for the praetorian guard, the Castra Praetoria, built after the pattern of a legionary camp. Aurelian incorporated the camp into his city wall. The Quirinal from the time of the kings onward, was the seat of many early religious cults. Of the numerous temples known from literary sources almost nothing is preserved. The main temple dedicated to Quirinus in 293 B.C. stood on the N side of the ancient street Alta Semita (corresponding to the modern Via del Quirinale) in the E part of the modern Quirinal gardens. On the W edge of the hill stood the Temple of Serapis built by Caracalla; a monumental stairway led from it to the Campus Martius. Considerable remains of the temple, its terraces facing the Campus Martius, and the walls of the stairway lie in the gardens of Palazzo Colonna and in the Università Gregoriana. In front of the temple, on the other side of the street, Constantine erected public baths in ca. A.D. 315. The site is now occupied by the Palazzo della Consulta and the Palazzo Pallavicini-Rospigliosi. In the valley between the Quirinal and the Collis Hortulorum (Pincio) the Horti Sallustiani were laid out in ca. B.C. 40. After the death of Sallust they became imperial property and a favorite resort of the Roman emperors. Remains of the palace are still visible in the center of Piazza Sallustio. Bordering the Horti Sallustiani to the N as one ascends the Pincio were the Horti Luculliani from ca. 60 B.C., which also became imperial property. They were regarded as the most beautiful of the imperial gardens. Recently a piece of terraced garden architecture came to light under the building of the Bibliotheca Hertziana. The Horti Aciliorum, belonging to the Acilii Glabriones in the 2d c. A.D., occupied the whole N part of the Collis Hortulorum.

Aurelian Wall and tombs. For centuries Rome had been secure from hostile aggression, and the fortifications of the Servian Wall were neglected or no longer existed. By the end of the 3d c. A.D., however, the situation had changed and, in anticipation of a sudden barbarian invasion, Aurelian began, between 270 and 272, the construction of a new wall which was completed by Probus (A.D. 276-82). This wall enclosed not only the city of the seven hills but also the Campus Martius with the left bank of the Tiber, transtiberim, and part of the Ianiculum—areas which had been left outside the Servian fortification. The new imperial wall frequently incorporated already existing structures such as the Castra Praetoria, the Amphitheatrum Castrense, the Pyramid of Cestius, the retaining walls of the Horti Aciliorum (Muro Torto), and private houses. Since the general course of the wall was determined by defensive strategy, it abandoned the religious boundary of the Pomerium. Thus, many of the tombs once erected outside the gates of the Servian Wall were now inside the imperial enceinte or were covered by the new gates and fortifications. Next to the Porta Ostiensis stood, as part of the wall, the pyramid tomb of C. Cestius. On the Via Appia, inside the gate, was the family tomb of the Scipios and, next to the Porta Latina, the columbarium of Pomponius Hylas. On the Via Labicana inside the Porta Praenestina, the monumental tomb of the Arruntii has disappeared, but the

tombs of the Statilii were unearthed in 1875. The tomb of the baker Eurysaces came to light when the towers of the gate were torn down in 1834. The tomb of Q. Haterius was incorporated in the Porta Nomentana, and under the towers of the Porta Salaria, demolished in 1871, were found the tomb of Q. Sulpicius Maximus and the remains of a tomb of Cornelia. On the Campus Martius the Mausoleum of Augustus and the tombs of C. Vibius Pansa and A. Hirtius (under the Palazzo della Cancelleria) fell within the enclosure of the wall and also, on the right bank of the river, the tomb of the Sulpicii Platorini.

The greater part of the Aurelian Wall is still preserved. It continued to be the defense of Rome until 20 September 1870 when the army of the king of Italy breached it with modern artillery NW of Porta Pia, and entered the city.

BIBLIOGRAPHY. For the monuments and sites of Ancient Rome a complete bibliography up to 1928 is offered by S. B. Platner and T. Ashby, *A Topographical Dictionary of Ancient Rome* (1929) (*P-A*) and up to 1967 by E. Nash, *Pictorial Dictionary of Ancient Rome* (2d ed., 1968) (*PDAR*). Both works list them in alphabetical order. The names of monuments and sites mentioned in this article correspond to those used in the two dictionaries. For topographical features and buildings no longer visible see *P-A*; for remains still visible or graphically documented see *PDAR*. Only additional and more recent bibliography is cited below. For literature published after 1967 the following additional abbreviations are used: *Dial* = Dialoghi di Archeologia, rivista quadrimestrale, Milano 1967- ; *StudTopRom* = Studi di Topografia Romana, Quaderni dello Istituto di Topografia Antica, Univ. di Roma V, 1968.

The Origins. P-A: Esquiliae, Quirinalis, Velia; S. M. Puglisi, *MonAnt* 41 (1951) 3-98; P. Romanelli, ibid. 101-24; A. Davico, ibid. 125-34; E. Gjerstad, *Early Rome*, Acta Inst Sueciae XVII, 1 (1953); XVII, 2 (1956); XVII, 3 (1960); XVII, 4 (1966); H. Müller Karpe, *Vom Anfang Roms* (1959); id., *Zur Stadtwerdung Roms* (1962); R. Bloch, *The Origins of Rome* (1960); M. Pallottino, *ArchCl* 12 (1960) 1-36; F. E. Brown, Fondation Hardt, entretiens XIII (1967) 45-60; *PDAR*, Forum Boarium (area sacra di S. Omobono), Forum Romanum (prehistory), Sepulcretum; P. Somella, *StudTopRom*, p. 65, n. 5; H. Riemann, G.G.A. 222 (1970) 25-66; 223 (1971) 33-86 (review of Gjerstad, *Early Rome*, III).

Forum Romanum and Sacra Via: G. Carettoni & L. Fabbrini, *RendLinc* 16 (1961) 53-60; G. Lugli, *Itin. di Roma Antica* (1970) 251 (Bas. Sempronia); M. Grant, *The Roman Forum* (1970); F. Zevi, *RendLinc* 26 (1971) 1-15 (Chalcidicum); P. Zanker, *Forum Romanum* (1972); G. Lugli, *Mon.Minori del Foro Rom.* (1947) 157-64 (rooming house).

Palatine: G. Carettoni, *NSc* (1967) 287-319 (Domus Augusti); M. L. Morricone Matini, *Mosaiche Antiche in Italia*, Roma reg. X, Palatium (1967); H. Finsen, *Anal. Romani Instituti Danici* v, Suppl. 1969 (Domus Augustiana); P. Castrén & H. Lilius, *Graffiti del Palatino*, II Domus Tiberiana, Acta Inst.Rom. Finlandiae IV, 1970.

Imperial Fora, Trajan's Market: G. Fiorani, *StudTopRom* (1968) 91-103 (Forum Iulium); P. Zanker, *Forum Augustum* (1969); id., "Das Trajansforum als Monument imperialer Selbstdarstellung," *AA* (1970) 499-544; C. F. Leon, *Die Banornamentik des Trajansforums* (1971); L. Rossi, *Trajan's Column and the Dacian Wars* (1971); M. E. Blake, *Roman construction in Italy*, III (1972) 10-29 (Trajan's Market), in *Memoirs of the American Philosophical Association*, Vol. 96.

Capitol and Servian Wall: H. Riemann, *RömMitt* 76 (1969) 110-21 (Iuppiter Capitolinus); 103-10 (Servian Wall); J. Packer, *BullComm* 81 (1968-69) 127-49 (in-

sula); H. Lyngby & G. Sartorio, *BullComm* 80 (1965-67) 5-36 (Porta Trigemina).

Campus Martius: G. Gatti, *Quaderni dell'Ist. di Storia dell'Architettura* (1961) 49-66 (residential quarter E of Via Flaminia); L. Cozza, *StudTopRom* (1968) 9-20 (Porticus Minucia); F. Coarelli, *Palatino* 12 (1968) 365-73 (Area Sacra dell'Argentino); id., "Il Tempio di Bellona," *BullComm* 80 (1965-67) 37-72; id., *Dial* 2 (1968) 302-68 (Neptunus Templ.); id., *StudTopRom* (1968) 27-37 (Navalia, Tarentum); A. M. Palchetti & L. Quilici, *StudTopRom* (1968) 77-88 (Iuno Regina); K. De Fine Licht, *The Rotonda in Rome* (1968); S. Giedion, *Architecture and the Phenomena of Transition* (1971) 152-60 (Pantheon); P. Fidenzoni, *Il Teatro di Marcello*, s.d. (1970).

Markets, Warehouses, Tiber: J. Le Gall, *Le Tibre, fleuve de Rome dans l'antiquité* (1953); G. Cressedi, *NSc* (1956) 19-52 (Emporium); F. Rakob et al., *Der Rundtempel am Tiber in Rom* (1973); C. D'Onofrio, *Castel S. Angelo* (1971).

Caelius: A. M. Colini, "Storia e topografia del Celio nell'antiquità," *MemPontAcc* 7 (1944); V. Santa Maria Scrinari, *Egregiae Lateranorum Aedes* (1967); id., *RendPontAcc* 41 (1968-69) 167-89 (Gardens of Domitia Lucilla, Domus A. Veri); G. M. Rossi, *StudTopRom* (1968) 113-24 (Nymphaeum in the house of the Laterani).

Esquiline, Aurelian Wall: M. Cagiano De Azevedo, *RendPontAcc* 40 (1967-68) 151-70 (Basilica of Iunius Bassus); G. Becatti, *Edificio con opus sectile* (Scavi di Ostia VI, 1969) 181-215 (Basilica of Iunius Bassus); P. Grimal, *Les Jardins Romains* (2d ed. 1969); J. A. Richmond, *The City Wall of Imperial Rome* (1930); L. G. Cozzi, *Le porte di Roma* (1968).

Maps: R. Lanciani, *Forma Urbis Romae* (1893-1901); G. Lugli & I. Gismondi, *Forma Urbis Romae imperatorum aetate* (1949); G. Lugli, *Itinerario di Roma Antica* (1970) pl. I: Ancient Rome; pl. II: The monumental center; pl. III: The southern Campus Martius; *Capitolium* XL (1965) 179: The ancient remains of the Capitoline.

E. NASH

ROMULA-MALVA (Reşca) Dobrosloveni, Olt, Romania. Map 12. The most important urban center of Dacia inferior and capital of the province (*Tab. Peut.* and the Geographer of Ravenna). Malva, the Geto-Dacian toponym of the city, means bank. Located on the Olt (Alutus) river bank, Romula belonged to the limes Alutanus. Under Hadrian, veterans colonized the former Geto-Dacian village, settling in this rich farm area. It is during this period that it was given its Roman name. Today, the site of the ruins of Romula is also called Antina.

Two quadrilateral camps defended the city, both of which are still unexplored. The stamped bricks show that the permanent garrison was Cohors I Flavia Commagenorum (2d c.) and, later, the numerus Surorum sagittariorum (2d-3d c.). The civil fortifications show three stages of development. In the era of Trajan and Hadrian, a quadrilateral wall consisting only of the fossa and the agger, enclosed an area ca. 250 by 300 m. This is where the first colonists took shelter. This earthen fortification was reinforced by a protecting wall 2 m thick in the beginning of the 3d c. In a third stage, the civil agglomeration and military center were surrounded, over an area of 64 ha, by an outer wall. An inscription on the N gate of this wall mentions the building, manu militari, of this irregular polygonal fortification in 248, under Philip the Arab. Other texts tell of the participation in these works of the legions VII Claudia, XXII primigenia, and the numerus Sur. sagitt. Its remains are still visible. Hastily erected under the menace of a Gothic invasion, it has no towers. Some sections of the city were not in-

cluded in the fortifications, and near its N gate was a large villa suburbana. At the end of the reign of Antoninus Pius, Romula-Malva appears as a municipium and capital of Dacia inferior, but it apparently acquired this rank under Hadrian. Its promotion to the rank of colonia probably occurred under Septimius Severus.

In 248, Philip the Arab as restitutor reconfirmed this rank by calling it "colonia sua." From all appearances, the city suffered greatly as a result of the Carpic invasion of 245-47. Excavations have succeeded in finding the remains of a few important public buildings. At the beginning of the 20th c. the principal baths of the city were excavated; 11 rooms remained, decorated with marble, mosaics, and paintings. The water supply, as well as the supply for part of the city, was assured by a large underground aqueduct, 5 km long, which supplies the drinking water for the present village of Frăsinetul de Pădure. Another large building (14.4 x 25.7 m) contained three halls of imposing proportions and was identified as the curia of the city. The central sewer of the city, which emptied the waste waters into the Teslui river, was built of brick and was 1.7 m high. The four necropoleis were on the roads leading to Sucidava, Acidava, Castra Nova, and Slăveni.

Owing to the fertility of its farm land and its position on an important crossroads, Romula was prosperous. Among its religious monuments, the gods of the field and pasture held first place. Potters' ovens and brickworks have been found, as well as studios for gem engraving. Jasper, onyx, and cornelian were imported.

The inscriptions on the handles of amphorae and terra sigillata vases are proof of importation of wines, oils, and luxury vases from the Orient, Gaul, the Rhine Valley, Pannonia, etc. To judge from its inscriptions, the population included Dardanian colonists and veterans of E origin. The local pantheon included Atargatis, Jupiter Turmasgadis, Dea Dardanica, Mithra, the Danubian Rider-Gods, Isis, Serapis, Cybele. However, the patron goddess of the city was the goddess Fortuna. Greek or Latin verses, occasional or used as epitaphs, have been discovered and the Palmyran alphabet was also employed. The Carpo-Gothic invasions of the period of Gallienus-Aurelian destroyed this flourishing city, and in the 4th c. only a village remained.

The material from excavations is in the museums in Caracol, T. Severin, and Bucharest.

BIBLIOGRAPHY. *CIL* II, 1180 = *ILS* 1403; *CIL* III, 8023-30, 8031 = *ILS* 510; 8032-37; 8075, 45-46; 14486-89; *An-Épigr* (1914) 120; (1939) 28; (1940) 13-14; (1957) 188, 334; (1959) 318.

L. F. de Marsigli, *Description du Danube* (1744) 69; G. Tocilescu, *Fouilles et recherches archéologiques en Roumanie* (1900) 94-96; V. Pârvan, "Ştiri nouă din Dacia Malvensis," *ACRMI* 36 (1913); D. Tudor, *Monumente inedite din Romula*, I-II (1938-40); id., "Sextus Iulius Possessor în Dacia," *Omagiu lui C. Giurescu* (1944) 523-31; id., "Colonia Romula într-o nouă inscripţie," *Rev. Univ. Cuza şi Instit. Pol.-Iaşi* 1 (1954) 293-312; id., *Romula* (1967); id., *Oltenia romană* (3d ed., 1968) 185-202, 331-34; id., *Oraşe* (1968) 342-56; H. Nesselhauf, "Sex. Iul. Possessor," *Madrider Mitteilungen* 4 (1963) 180-84; F. Vittinghoff, "War die Kolonie Malva mit Romula (Reşca) identisch?" *Acta Musei Napocensis* 6 (1969) 131-47; M. Babeş, "Zu den Bestattungsarten im nördlichengräbersfeld von Romula, Ein Beitrag zur Grabtypologie des römischen Daziens," *Dacia*, NS 14 (1970) 167-206.

D. TUDOR

ROQUEFORT-SUR-SOULZON Aveyron, France. Map 23. Excavations have uncovered a summit sanctuary with a temple on the Roc du Combalou, which overlooks Roquefort. The sanctuary (9.5 x 0.8 m) has

a double enclosure of Celtic tradition. The offerings consisted of Roman coins dating from the reign of Augustus to the 4th c., jewelry and other small bronze artifacts, votive terracotta figurines, terra sigillata from La Graufesenque, and Early Christian stamped pottery of the Late Empire.

BIBLIOGRAPHY. L. Balsan, "Une station gallo-romaine sur le Combalou," *P.V. de la Soc. des Lettres de l'Aveyron* 36 (1949-53) 313-18 (= *Rev. du Rouergue* 7 [1953] 419-24); id., "Temples et *fana* des Rutènes," ibid. 38 (1959-62) 266-70 (= *Rev. du Rouergue* 15 [1961] 417-23); id., "Céramiques inédites de La Graufesenque," *Ogam* 12 (1960) 174-75 & pl. xx; J.-P. Serres, "Le temple gallo-romain du Combalou," *Bull. de la Soc. d'études roquefortoises*, nos. 1-2 (1956) 6-8, 13-15; P.-F. Fournier, "Monnaies du Combalou," ibid. 16-17; M. Labrousse in *Gallia* 17 (1959) 412-13 & figs. 3-4; 20 (1962) 554 & fig. 7; J. Rigoir, "Les sigillées paléochrétiennes grises et orangées," *Gallia* 26 (1968) 212-13, 238.

M. LABROUSSE

ROQUELAURE Gers, France. Map 23. A Gallo-Roman villa has been excavated on the plateau of La Sioutat. It goes back at least to the time of Augustus and has produced polychrome frescos in a Pompeian manner. These have been restored and are now exhibited at the Auch museum.

BIBLIOGRAPHY. M. Cantet & A. Péré, "Les fouilles du plateau de la Sioutat, à Roquelaure (Gers)," *Bull. de la Soc. arch. du Gers* 64 (1963) 171-203; id., "Les fresques gallo-romaines de La Sioutat, à Roquelaure (Gers)," ibid. 349-58; cf. M. Labrousse in *Gallia* 22 (1964) 454-56 & figs. 32-35; 24 (1966) 438; 28 (1970) 422.

M. LABROUSSE

ROQUEMAURE Locality of La Barre, Gard, France. Map 23. The oppidum of La Barre overlooks the town from the N. Roquemaure was established during the second half of the 6th c. B.C. Then the dwellings occupied the rather steep S slope and the summit of a long hill orientated E-W. To the N there juts a rocky hillock, also inhabited in the same period. The sheer cliffs to the N and to the E and the steep declivity to the W provided adequate natural defenses. On the S slope, where the settlement was densest, the rock was cut out to permit the construction of huts. The Rhône flowed at the very foot of the oppidum, which formed a sort of cove suitable for boat landings. The inhabitants made large profits on the trade of Greek Marseilles along the Rhône axis: Massaliot amphorae are particularly abundant on the site. In the Roman period human settlement shifted to the alluvial plain S of the oppidum. Several 1st c. tombs have been discovered in the St.-Joseph district.

Part of the finds are kept in the Musée d'Histoire Naturelle at Avignon; some pieces are in the Musée Borély at Marseilles.

BIBLIOGRAPHY. P. Jacobsthal & J. Neuffer, "Gallia Graeca" in *Préhistoire* (1933) II, 17-18; J. Maureau, "Sépultures gallo-romaines à Roquemaure," *Bull. Soc. Et. Sciences naturelles du Vaucluse* 2 (1934) 44-46; C. Lagrand, "La céramique 'pseudo-ionienne' dans la Vallée du Rhône," *Cahiers Rhodaniens* 10 (1963) 54-56[I]; F. Benoit, "La ceramique peinte de Roquemaure à l'époque grecque," *Cahiers Rhodaniens* 11 (1964) 30-61[MI]; id., *Recherches sur l'hellénisation du Midi de la Gaule* (1965) passim[MI].

J. CHARMASSON

ROQUEPERTUSE (La), *see* VELAUX

ROSARNO, *see* MEDMA

ROSAS, *see* RHODE

ROSELLE, *see* RUSELLAE

ROŞIA MONTANĂ, *see* ALBURNUS MAIOR

ROSSANO DI VAGLIO Basilicata, Italy. Map 14. An archaeological zone in the NE section of the territory of Vaglio di Basilicata among low hills watered by the spring of the Madonna di Rossano. The area was already known in the 19th c. as the site of a temple or sanctuary, now identified by the discovery of Oscan inscriptions, written mainly in Greek, as a Sanctuary of Mephitis. Thus far the excavations have uncovered a large altar built of blocks cut in the Greek style and bearing quarry marks in the form of Greek letters, two rooms on the E side with walls of regularly dressed stones, and a third room defined by dry walls constructed according to the same system. The altar occupies the center of a large area paved with blocks of very hard stone. On the W side, a door has been found and beside it two semicircular containers where water from the large spring in the mountain W of the sanctuary collected after passing through lion-head spouts. Around the altar a channel collected the water and carried it towards a drain, which was repaired more than once during antiquity.

The earliest coins, the oldest ex-voto, and the numerous inscriptions indicate that the sanctuary was founded between 340 and 330. From this time until the first half of the 1st c. A.D. the monument was subject to various transformations, owing especially to a number of landslides caused by the pressure of the water from the spring.

From investigations carried out in the environs, it is known that the sanctuary, a locus sacer for the area, stood in the midst of a series of indigenous Lucanian centers: Serra di Vaglio, Torretta di Pietragalla, Carpina di Cancellara, Acerenza, Oppido Lucano, Civita di Tricatico, Anzi, and Torre di Satriano. Towards the end of the Republic and the beginning of the 1st c. A.D., the cult of Mephitis was removed from Rossano to Potentia. No documents exist after the first half of the 1st c. A.D.

BIBLIOGRAPHY. *CIL* X, 2 (1883), 96; G. Fiorelli, *NSc* (1881) 123-24; A. Lombardi, *Mem.Ist.Corrisp.Arch.* I (1832) 220-21; M. La Cava, *Topografia e Storia di Metaponto* (1891) 8-9; M. Lejune, *REL* 45 (1967) 194-231; *PdP* 22, 126 (1968) 281-302; D. Adamesteanu, *Atti IX Congresso Taranto* (1969) 222-27; id. & M. Lejune, *MemLinc* 16, 2 (1971) 39-83; M. Lejeune, "Inscriptions de Rossano di Vaglio 1972," *RendLinc* 27,7-12 (1973) 399-414.

D. ADAMESTEANU

ROSSOMANNO (Mount Rossomanno) Enna, Sicily. Map 17B. A site located 9 km to the S of Valguarnera, at 889 m above sea level. On the highest part of the hill are remains of houses, which go back to the 5th c. B.C., with evidence of life down to the 3d c. B.C. The necropolis, which occupied a large area to the NW of the mount, is largely unexplored; a few graves have yielded funerary goods also attributable to the 5th-3d c. B.C. The area has not been systematically investigated.

A. CURCIO

ROTOMAGUS (Rouen) Seine-Maritime, France. Map 23. A city of Gallia Lugdunensis, on the Seine ca. 50 km from its estuary. The second part (magus) of the Celtic place name indicates that this was a trading post, possibly under the protection of a hypothetical local divinity. From earliest times the site was linked geographically to the Loire and central Gaul by the Seine and Eure waterways, and it was particularly favored by its situa-

tion on the ancient axis which, crossing the Channel and following the valley of the Seine, links the British Isles with the territories of the Saône and the Rhône.

Little is known of the Gallic occupation of the site, the only evidence being a necropolis on the lowest slopes of the N hills and some scattered finds of potsherds and late coins. The name Rotomagus appears in the texts, including the 2d c. Geography of Ptolemy. Believed to be the capital of the civitas of the Veliocassi, it owed its development to Romanization.

It is not known whether it had a port, but the Roman road network, duplicating and completing that of the waterways, made the city an important road junction and gave it its structure. The decumanus maximus (now the Rue du Gros Horloge) starts at the outlet of the Iuliobona (Lillebonne) road, to the W, and in the E joins the road from Lutetia (Paris). The cardo (now the Rue des Carmes and Rue Grand-Pont) proceeds in its N section from a crossroads leading to Portus Itius (?) or toward the Rhine along a strategic highway W-E (Caesaromagus—Beauvais, Augusta Suessionum—Soissons, etc.) then bridges the Seine and joins the road leading to the regions of the Loire (Genabum—Orléans, Suindinum—Le Mans) by way of the city of the Aulerci Eburovices.

In the city center the planners succeeded fairly well in retaining the grid system of Roman streets set parallel to the two great axes. However, nothing remains of its monuments. We do not know where the forum, the theater, or the baths stood. Three old churches or chapels, now gone, apparently took the place of two sanctuaries of Roth (?) and Venus (?), the latter being at the NW corner of the cardo and decumanus. The lives of St. Romain and St. Ouen contain mention of a huge amphitheater inside which was an altar, also dedicated to Venus. The foundations of this monument are buried underneath the Jeanne d'Arc tower in the NW section of the city.

During the 1st c. the Roman settlement seems to have grown chiefly N of the decumanus and particularly, from Claudius' reign, in the NW quarter near the Iuliobona road. In the 2d c. and the first half of the 3d c. the number of houses increased and the residential quarter expanded, particularly to the N and E. We know how far this expansion went from the necropoleis found in the Boulevard des Belges (the modern Rectorat) to the W, the Rougemare quarter to the N and the Robec river to the E.

Evidence shows that the area S of the decumanus was settled from the beginning of the Roman period. Its main period of growth apparently was in the 3d c. The 3d c. rampart has been traced to the N (Rue des Fossés Louis VIII) and has been fairly well determined to the W and E, slightly back from the banks of the Renelle and the Robec. However, no trace has yet been found of the S part; the same is true for the ancient river banks. Some carved blocks have been found, reused to build the rampart which, according to archaeologists, formed a quadrilateral covering 15-20 ha—a fourth of the area of the earlier city.

After the invasions of 253-277, the city recovered rapidly, most probably around 280. Diocletian made it the capital of Lugdunensis Secunda, which was modified by Gratian in the 4th c. and corresponded exactly to what would later become the province of Normandy.

In the 4th c. Rotomagus became a religious center. Tradition attributes to St. Mellon the building of the first cathedral church between 260 and 270. Rebuilt by St. Victrice at the beginning of the 5th c., it may have stood on the site of the present cathedral or outside the city walls in the Saint-Gervais quarter W of the city,

where an important interment cemetery has been found (sarcophagi in the museum). Two more cemeteries, in the Rue d'Ernemont to the N and in the Saint-Hilaire quarter to the E, no doubt mark the limits to which the city spread in the 4th and 5th c. The amphitheater most probably dates from this reconstruction period.

Both an administrative capital and a religious center, Rotomagus was also a garrison city and along with Coutances and Avranche served as a base of operations for those troops (Ursarienses) responsible for defending this section of the litus saxonicum against the invasions of pirates. The defeat of Syagrius at Soissons in 486 marked the end of the Roman presence and the coming to power of the Merovingians.

BIBLIOGRAPHY. Abbé Cochet, La Seine-Inférieure historique et archéologique (1866)[MPI]; E. Naillon, Collection des 10 Plans de la Cartographie de Rouen (1955)[P]; G. Dubois, "Etude des remparts de Rouen antérieurs au XIe siècle," Actes du 19e Congrès des Sociétés Savantes, Rouen-Caen 1956 (1958)[P]; M. Mangard, "Rouen, problèmes d'histoire urbaine," Revue des Sociétés Savantes de Haute-Normandie, 51 (1968)[P]; G. Sennequier, Rouen gallo-romain et Mérovingien, "Connaître Rouen" (1970)[I].
　　　　　　M. MANGARD

ROTTENBURG AM NECKAR, see SUMELOCENNA

ROTTWEIL, see ARAE FLAVIAE

ROUEN, see ROTOMAGUS

ROUGH CASTLE, see ANTONINE WALL

ROYAL KURGAN, see PANTIKAPAION

ROYAT Communes of Royat and Chamalières, Puy-de-Dôme, France. Map 23. There are many mineral springs all along the W fault escarpment of the Limagne. The Royat springs, near the old mill of Saint-Mart at the mouth of the gorge of the Tiretaine, were exploited in Roman times. A pool is preserved in the park of the modern bath.

BIBLIOGRAPHY. E. Thibaud, Royat, ses eaux et ses environs (1843); Frédet, Note sur les thermes romains de Royat (1883); A. Petit, Recherches sur la découverte à Royat des substructions de l'établissement thermal gallo-romain (1884); E. Desforges et al., Nouvelles recherches sur les origines de Clermont-Ferrand (1970) 372-78.　　　　　　P. FOURNIER

RRMAIT ("Kodrion") Albania. Map 9. To the N of Mt. Tomor. The earliest coins yielded by excavation are of Philip II of Macedon; the massive circuit wall with a fine gateway dates probably to the late 4th c. B.C. Names are preserved on tile stamps and amphora seals; weapons, tools, and fibulas were found. Kodrion figured in the wars between Macedon and Rome (Livy 31.27.4).

BIBLIOGRAPHY. F. Prendi & Dh. Budina "Kalaja e Irmajt" in Buletin i Universitetit Shtetëror të Tiranës, Seria shkencat shoqërore (1963) 4.3-60; N.G.L. Hammond, "The Opening Campaigns and the Battle of the Aoi Stena in the Second Macedonian War," JRS 56 (1966) 43.　　　　　　N.G.L. HAMMOND

RUBI (Ruvo di Puglia) Bari, Apulia, Italy. Map 14. A city 8 km SE of Corato and in antiquity an ancient center of great importance, to judge by the wealth of archaeological evidence. Almost all of it comes from its necropolis, which extends along the base of the hill below the mediaeval and modern city. That the settlement dates to the 7th c. B.C. is suggested by geometric pottery

and imported Corinthian vases. It is certain that between the end of the 6th c. and the mid 4th c. B.C. the city witnessed a period of great prosperity, documented by imported Attic and Tarentine vases, by tomb paintings, such as the dance scene now in the Naples Museum, and by exceptionally beautiful jewelry produced in Italy. During the 3d c. B.C., the city began to coin its own money in silver and bronze of the Tarentine type. These coins indicate that the inhabitants were called Rubasteinoi, similar to the name Rubustini mentioned by Pliny (*HN* 3.105) and to ager Rubustinus mentioned in the *Liber Coloniarum* (p. 262). Horace (*Sat.* 1.5.94) stopped there on his journey from Rome to Brindisi. In the Roman period Rubi had a certain importance, particularly after the opening of the Via Traiana of which it became a statio (*It. Ant.* 116; *Hier. It.* 610). An inscription with a dedication to Gordian III attests that the city was a municipium and had its own group of Augustales (*CIL* IX, 312).

The Museo Jatta preserves a rich collection of pottery coming from the necropolis.

BIBLIOGRAPHY. *EAA* 6 (1965) 1039 (A. M. Martini); H. Sichtermann, *Griechische Vasen in Unteritalien aus der Sammlung Jatta in Ruvo* (1966).　F. G. LO PORTO

RUČAR Muntenia, Romania. Map 12. Small Roman castellum at the entry into the Bran Pass, built during the Dacian wars on one of the principal routes across the Carpathian mountains into Dacia. The castellum, built of earth, was rectangular (60 x 80 m). The wall of the castellum, 7.7 m wide at the base, was surrounded by a double ditch.

Archaeological research has established only one level, destroyed by fire, with pottery from the beginning of the 2d c. A.D. The castellum was contemporary with and belonged to the same complex as the castella of Drajna and Mălăieşti in the Subcarpathian area of Muntenia. Its chronological connection with the limes transalutanus has not yet been clarified. The Cohors II Flavia Bessorum was garrisoned here.

BIBLIOGRAPHY. D. Tudor, "Consideraţii asupra unor cercetări arheologice făcute pe Limes Transalutanus," *Studii şi Cercetări de Istorie Veche* 6 (1955) 1-2, 87-97.
　E. DORUTIU-BOILA

RUDCHESTER, *see* VINDOBALA *under* HADRIAN'S WALL

RUDIAE Apulia, Italy. Map 14. A Messapic city ca. 2 km SW of Lupiae (Lecce), in a low-lying area called La Cupa. Although it is frequently mentioned by ancient writers, who call it the birthplace of the poet Ennius, nothing precise is known of its origins (Cic. *Arch.* 9.22; Sil.It. 12.397). Strabo (6.281) thought it was founded by the Rhodians, who, together with colonists from Crete, appear to have colonized the Salentine peninsula, according to a tradition handed down by Herodotos (2.222). The archaeological excavations have brought to light towered circuit walls and a ditch about 4 km long. A second, inner circuit wall surrounded a zone where the acropolis is thought to have been. The floruit of the city between the 5th c. and the 3d c. B.C. is corroborated by the rich tomb appointments, often painted and with Messapic inscriptions, which have been discovered in the vast necropolis surrounding the inhabited area. The city was a municipium (*CIL* IX, 23) in the Roman period and was perhaps enrolled in the tribus Fabia (*CIL* IX, p. 5). A series of large public buildings, perfectly paved streets, an amphitheater, and Latin inscriptions are among the numerous traces from that period which are visible in the zone of recent excavations and in the Museo Castromediano at Lecce. Numerous objects from the necropolis are also preserved there.

BIBLIOGRAPHY. *RE* 1.1 (1914) 1175-78; E. Ciaceri, *Storia della Magna Grecia,* I (1928) 108; M. Bernardini, *La Rudiae Salentina* (1955); O. Parlangeli, *Studi Messapici* (1960) 153.　F. G. LO PORTO

RUDSTON E Riding, Yorkshire, England. Map 24. A Roman villa on the chalk Wolds, 47 km E of York and 8 km from the coast. The site seems to have been founded in the first half of the 1st c. A.D., before the Roman conquest of Yorkshire (A.D. 71). Traces of at least six small circular huts belonging to the first phase of the settlement have been uncovered, varying from 4.5 to 7.2 m in diameter and defined by curved drainage gulleys. At this stage all the pottery was of coarse local ware, although several brooches had been imported from the S of England.

The buildings so far excavated (1933-37, 1962-66) were occupied during the 4th c. A.D.; none can yet be assigned to the 2d or early 3d c., but artifacts suggest that occupation was not interrupted. They are arranged on three sides of a square, and constructed in friable local chalk, sometimes with more durable quoins. On the E side was a comparatively substantial gateway, and beyond it a road leading towards the present village of Rudston. Immediately adjacent was a small house (25.2 x 8.7 m) built on the site of an earlier farm building. There were three living-rooms at the N end and a small bath suite at the S end. Outside the baths was a well, almost 30 m deep and, surprisingly, 2.4-2.7 m in diameter. On the S side of the site was a rectangular farm building (19.8 x 10.8 m) with several circular hearths and piles of sorted tesserae against the W wall. The principal building on the W side may have had a domestic use, but it is cut by a modern road and cannot be completely excavated. It seems likely that other buildings will be found on the N side of the site, across the modern road.

Rudston's main claim to fame lies in its mosaics, particularly the remarkable Venus pavement. A central circular panel shows the goddess bathing and attended by a Triton; surrounding panels depict hunters and wild beasts; and the border at one end (the other has not survived) has a central bust of Mercury. Although in subject matter it is conventionally classical, in execution it is a primitive, full of life and originality. The pavements are in Hull Museum.

BIBLIOGRAPHY. Interim reports on 1933-37 excavations: *Yorks. Arch. Journ.* 31 (1934) 366-76; 32 (1936) 214-20; 33 (1938) 81-86, 321-38; 34 (1939) 102-3; I. A. Richmond, *The Roman Pavements at Rudston* (1933) revised as *Hull Museum Publication* 215 (1963).　I. M. STEAD

RUMST Belgium. Map 21. A Gallo-Roman vicus on the Bavai-Asse-Antwerp-Utrecht road, where it crosses the junction of the Nèthe and the Dyle rivers. It was on the boundary between the civitas Nerviorum and the civitas Tungrorum, which became the boundary between Belgica Secunda and Germania Inferior during the Late Empire. Numerous isolated finds have been made there and some fairly unsystematic excavations were undertaken in 1863, 1873, and 1930. The location of the center was identified in the locality of Molenveld (where many potsherds, coins, large quantities of tegulae, pieces of painted plaster, and traces of an ironworks, etc., were found). The necropolis, situated in the vicinity of Kattenberg, was destroyed by brickmaking operations before it could be excavated. Tiles stamped CGPF (Classis Germania Pia Fidelis) suggest that part of the fleet of Germania Inferior was stationed at Rumst. This is understandable since the Nèthe and the Dyle, after their junction, form the Rupel, a large tributary of the Scheldt. From Rumst it would have been easy to watch the whole region of the estuaries of the Scheldt, the

Meuse, and the Rhine. The most remarkable of the stray finds was a bronze votive hand, of the cult of Sabazios. This vestige of an oriental cult may perhaps be related to the presence at Rumst of sailors of the fleet.

We have almost no precise information about the history of the vicus. It seems to have replaced an Iron Age settlement, of which some remains have been found, notably huts at the localities of Holbeekstraat and Bussestraat. In contrast, the vicus apparently was no longer occupied during the Late Empire.

BIBLIOGRAPHY. M. Bauwens-Lesenne, *Bibliografisch repertorium des oudheidkundige vondsten in de provincie Antwerpen* (1965) 150-55. S. J. DE LAET

RUSADDIR (Melilla) Morocco. Map 19. An ancient city mentioned by Pliny (5.18), Ptolemy (4.1.12) and the *Antonine Itinerary*. A necropolis at the Cerro de San Lorenzo shows traces of occupation dating at least to the 2d and 1st c. B.C., during which period the city minted its own coins, with a neo-Punic legend. Scattered remains, now gone, show that the Roman settlement extended W of the Old Spanish city, which no doubt held the original Punic settlement.

BIBLIOGRAPHY. R. Fernández de Castro, *Melilla prehispánica* (1945); M. Tarradell, *Marruecos púnico* (1960) 63-73. M. EUZENNAT

RUSCINO (Perpignan) Pyrénées-Orientales, France. Map 23. Important Iberian oppidum and subsequently a town of Narbonese Gaul. In antiquity it was the prestigious and active political, commercial, and religious capital of the province of Roussillon, to which it gave its name. The position of this easily defensible hill was an economically effective one, for it lay behind the coastal basins and near the sea, as well as on the formerly navigable river Têt. Thus it was a natural way station on the great route that in prehistoric times was the Heraklean Way, and in Roman times the Via Domitiana, an international route which joined Italy to Iberia and served all of S Gaul.

The city was founded at the beginning of the 6th c. B.C. on a spur overlooking the river Ruscinon, from which Polybios and Strabo say it took its name; it was almost continuously occupied until the Early Middle Ages, when it was supplanted by Perpignan. The spur has steep W, N, and E flanks, and to the S a deep manmade trench separated the settlement from the plateau. The ancient city covered almost 10 ha. Its wealth and historical importance are attested by discoveries, made both by chance and as the result of regular exploration, since the end of the 18th c.

Recent excavations, to be recommenced on a larger scale, have revealed the major periods of occupation. In the 6th c. B.C., a village of modest huts covered the hill. The inhabitants lived by agriculture, fishing, and handicrafts. They already, however, had regular commercial relations with Italy, Greece, Iberia, and the interior of Gaul. In the 4th c. the huts were replaced by houses of dry stones and cobwork, and the use of storage pits dug in the earth became general. This period of occupation was characterized by luxury ceramics imported from Greece. From the 3d to the 1st c. B.C. Iberian was the common language at Ruscino, as is indicated by numerous graffiti on ceramics and the abundance of coins with Iberian inscriptions which circulated in the region along with Massalian and Celtic money.

From the end of the 2d c. B.C. on, with Roman colonization, the settlement underwent a radical transformation. Beautiful houses replaced the earlier, modest dwellings and the luxury items came from Italy. Finally, towards the end of the 1st c. B.C. the town benefited from con-

siderable urban planning: a forum, baths, and other edifices have been located but not yet excavated. The clearing of a large public monument (forum) has yielded some 40 dedications to members of the Julio-Claudian dynasty and to high provincial officials. The finds made on the site since the beginning of the century (sculptures, bronzes, inscriptions, ceramics of every sort, coins) are preserved in the public collections of the town of Perpignan.

BIBLIOGRAPHY. R. Lantier, "Antiquités du Roussillon," *REA* 21 (1919) 271-89; E. Espérandieu, *Inscriptions latines de Gaule Narbonnaise* (1929) nos. 614-41; id., *Répertoire archéologique des Pyrénées-Orientales* (1936) 21-26; G. Claustres, "Stratigraphie de Ruscino," *Etudes Roussillonnaises* 1 (1951) 135-95[PI]; "Informations," *Gallia* 8 (1950) 108-10; 11 (1953) 90-93; 12 (1954) 411-12; 14 (1956) 203-5; 17 (1959) 449-50; 20 (1962) 611-12; 22 (1964) 473-74; 24 (1966) 449-50; 27 (1969) 381-82. G. BARRUOL

RUSE, see SEXAGINTA PRISTA

RUSELLAE Tuscany, Italy. Map 14. About 9 km inland and N of Grosseto, one of the twelve cities of the Etruscan federation. Its position controlled the valley of the Ombrone at the mouth of which was probably the city's harbor. The site was perhaps sparsely occupied during the Villanovan period, but the first urban center dates to the 7th and 8th c. B.C. A second period, to which the oldest sections of the circuit walls belong, begins in the 6th c. and continues until the 4th c., probably until the Roman conquest.

Ancient sources make mention of it for the first time when, along with Chiusi, Arezzo, Volterra, and Vetulonia, it promised help to Rome against Tarquinius Priscus (Dion. Hal. 3.51). Later, it appears to have become part of various Etruscan alliances against Rome and because of that was defeated in 298 and, after a long siege, captured in 294 B.C. (Livy 10.4, 37.3). Evidently it was quickly rebuilt, for in 205 it was able to furnish grain and wood for Scipio's fleet (Livy 28.45.14). The inhabitants were inscribed in the tribus Scaptia. From inscriptions and from Pliny's list, it is known that it became a colonia, but the date is not known. (Plin. *HN* 3.51; Ptol. 3.1.43; *CIL* XI, 2618). It had a period of prosperity and new public buildings in the Julio-Claudian period. It continued to thrive into the 4th c. A.D., but in the 5th c. it appeared half-abandoned (Rut. Namat. 1.220). Later notices refer more often to the county (or district) of Roselle, which belonged to the Aldobrandeschi and later to Siena, than to the ancient city. It was the seat of a bishop, mentioned in 499 and on the occasion of the synods of 649 and 680.

The city occupies the summit of a small hill formed by two projections that enclose a central valley. Here the forum stood in the Roman period and, in the Etruscan period, the center of the city. Almost the entire circuit of the city walls (ca. 3 km) is preserved, in some places more than 7 m high. In the N and NE sections are undressed polygonal blocks. Elsewhere squared or roughhewn polygonal blocks, with various refacings, date to the Hellenistic and Roman periods. Remains of mudbrick structures of the 7th c. B.C.—perhaps from an older circuit wall or from a terrace wall—have been noted beneath a section of the 6th c. walls. There are no towers; of the five gates, only the N gate has been excavated.

Excavations have brought to light some buildings of the 8th and 7th c., constructed simply of mudbrick with pavements of beaten earth. One of these buildings, surrounded by a large rectangular enclosure, is perhaps, to judge from its site and careful workmanship, a public

building with a tholos inscribed in a square structure which buttresses at the corners the spring of a domical covering. Other square rooms are preserved almost to the impost of the roof. The 6th c. city, its houses with plinths of stone and with the side walls of mudbrick, spread into the valley and onto the two elevations. A district of potters on the SE hill dates to this period. The Hellenistic city, whose large central square was supported by wide terracing along the W end of the valley, in several areas crowds right up to the circuit wall with its houses and artisan shops. The Roman colony appears to have been more restricted, even after the reconstructions of the beginning of the Empire. Among these were the paved square of the forum, the basilica, the office of the Augustales decorated with statues of the Julio-Claudian emperors, and the small amphitheater set on the summit of the N hill. From the early Middle Ages only the remains of a church and various tomb groupings are extant; after that, the area was completely abandoned.

The objects discovered in the city and in the cemeteries that surround it, excavated for the most part during the last century, are kept in the museums at Grosseto and at Florence.

BIBLIOGRAPHY. G. Micali, *Antichi Popoli d'Italia* (1832)[M]; G. Dennis, *Cities and Cemeteries of Etruria*, II (1883); R. Bianchi Bandinelli, "Roselle," *Atene e Roma* 6 (1925); D. Levi in *Boll. Soc. Stor. Maremmana* 3 (1926); C. Laviosa in *StEtr* 27 (1959) see also vols. 28, 29, 31, 33, 37, 39[MPI]; Naumann-Hiller, *RömMitt* 66 (1959)[MPI] see also vols. 69, 70; L. Banti, *Il mondo degli Etruschi* (1960); P. Bocci in *StEtr* 31 (1963) see also vols. 33, 39[PI]; *EAA* 6 (1965) s.v. Roselle, with complete bibliography. C. LAVIOSA

RUSGUNIAE (Tametfoust) Algeria. Map 18. At Cape Matifou, which closes the bay of Algiers to the E, ruins have been identified as those of this site, known from Pomponius Mela, Pliny, and the ancient itineraries. The root *Rus* suggests the existence of a pre-Roman center, possibly linked to the development of the Carthaginian empire, but no remains of this original occupation have been found.

A colony was founded on the site, perhaps by Lepidus, at the latest during the reign of Augustus. Inscriptions attest its existence to the Byzantine period. In the Middle Ages, the site was ruined and the stones were used for building in the neighboring town of Algiers.

Excavations in the 19th c. brought to light a large Christian basilica with three naves and eleven bays. The central nave was decorated with figurative mosaics, pieces of which are in the Algiers Museum. In the Byzantine period the building was remodeled and expanded to five naves. The monument had a counterapse, perhaps from its foundation.

Public baths were noted as early as the 19th c. In the last few years one of these (the SE) has been excavated and the hot and cold rooms have been cleared and carefully restored. Part of a mosaic pavement has been found, and in the course of the work remains of late dwellings were noted.

BIBLIOGRAPHY. S. Gsell, *Atlas archéologique de l'Algérie* (1911) 5, no. 36; P. Salama, in *Revue africaine*, 99 (1955) 5-52; 101 (1957) 205-25; R. Guéry, in *Bulletin d'archéologie algérienne* 1 (1962-65) 21-40; N. Duval, in *XVII corso di cultura sull'arte ravennate e bizantina* (1970) 133-38. P.-A. FÉVRIER

RUSICADA (Skikda) Algeria. Map 18. Except for a badly damaged theater, practically nothing remains of the ancient town, which was a very important port in the Roman period and no doubt even before. Ruins were seen at the beginning of the French occupation but they have disappeared under the modern town.

As with Rusguniae and Rusucurru, the root *Rus* suggests a Punic settlement or Punicized native town. There is, however, no trace of archaeological evidence. The attribution of coins with a Punic legend to the town remains hypothetical.

In the Roman period Rusicada was a colony which participated with Cirta, Milev, and Chullu in the so-called confederation of the IV colonies. It was one of the confederation ports, together with Chullu and Stora. The town was the coastal terminus of the road from Cirta rebuilt by Hadrian, a road that facilitated the export of wheat from the surrounding region and from Numidia. The town's role as a port explains connections which inscriptions reveal among Rusicada and Rome and Pozzuoli, as well as the rapid social climb of some of the town's families during the course of the 1st c.

Thanks to the drawings of Ravoisié and Delamare in the middle of the 19th c., we can still form an idea of the town's monuments: cisterns and mausolea in the immediate surroundings, the theater with its back against the slope of a hill, an amphitheater installed in a gully. A mithraeum and sculptures have also been found. Many inscriptions and sculptures were kept in a local museum, which was destroyed between 1954 and 1962. The artifacts which it contained are in safekeeping.

BIBLIOGRAPHY. S. Gsell, *Atlas archéologique de l'Algérie* (1911) 8, no. 196; H. G. Pflaum, *Inscriptions latines de l'Algérie* II (1957) no. 1-378. P.-A. FÉVRIER

RUSIPPISIR, *see under* IOMNIUM

RUSPE (Koudiat Rosfa) Tunisia. Map 18. This site, on the coast of the Sahel 30 km N of Sfax, appears in the Peutinger Table between Uzilla and Acholla. The ancient name has survived in its current toponymy as Koudiat Rosfa, 10 km N of Inchilla and 9 km S of Botria. A port and some remains have been found there, among them baths which were excavated in 1953. A little farther S, an important road coming from Thysdrus ends at the coast. The identification of the city has been difficult, but final identification of Botria with Acholla has permitted the location of Ruspe at Koudiat Rosfa. The city owes its fame to St. Fulgence, who held the office of bishop there at the end of the Vandal age.

BIBLIOGRAPHY. J. Thirion, *CRAI* (1953) 322. A. ENNABLI

RUSSI Emilia–Romagna, Italy. Map 14. A town 14.4 km W-SW of Ravenna in whose territory an extensive Roman villa, altered and enlarged several times in the Imperial period, has been found and explored. The Roman level, because of repeated floods, is now 11 m below the present average ground level. No inscriptions have been found to date, and thus there is no clue to the ownership. It is situated on the border between the territory of Faventia and the Ravenna marshes, not far from the important vicus of Bagnacavallo. A channel has been found immediately to the N of the villa which follows an approximately SW-NE course, and which can be related to the system of internal navigation of the Ravenna back country. The villa, oriented N-S, was not far from the ancient road that joined Faventia and Ravenna. The road is designated as the Strata Faventina or the Strata Ravignana in mediaeval documents. Under the villa a burial from the late Iron Age has been found.

Recent excavations show that the villa was enclosed by a U-shaped colonnaded ambulatory, partly closed, whose S side measures ca. 55 m, and measuring at least 170 m in its entirety. Inside, the complex was organized

around a central peristyle, flanked on the N and S by rooms of residential character arranged regularly on an axis. The rooms had geometric mosaic pavements. To the N is another smaller peristyle, to the W of which were other residential rooms with very ancient cocciopesto and mosaic pavements; to the E was a large storeroom divided into aisles. The contiguity between residential and functional areas is evident also in the rest of the villa. Along the W side of the lobby, starting at the N, were aligned several groups of rooms with mosaics. Then followed a room occupied by a small kiln for the manufacture of ceramics and a space with a well and a watering place. Other utilitarian rooms have been identified in the SE corner. Such a lack of separation between residential and functional parts seems to indicate the permanent residence of the manager of the agricultural establishment on the property. The villa, although very large and having large peristyles and halls, is not at all luxurious, as is indicated also by the lack of precious building materials. In most of the residential areas the remains of painted plaster have been found. The central part of the N sector probably had an upper story.

The original building probably dates to the end of the 1st c. B.C. and employed wood for the bearing members and structural parts. Toward the end of the 1st c. A.D. the villa was considerably altered and several rooms were added; during the 2d c. the structural part of the complex was rebuilt in masonry. The improvements and alterations, as well as the discovery of coins, provide testimony that the complex was occupied until late antiquity. Because of flooding, the villa seems to have been abandoned and most of the fittings were removed. It then served as a source of reusable material, and in the mediaeval period became the site of a furnace for the calcification of stone. The excavations have brought to light a large bath building to the SE with pipes, basins, and rooms with mosaics.

BIBLIOGRAPHY. G. A. Mansuelli, "La villa romana di Russi," *FelRav* 66 (1954) 64-68; id., "Russi, scavo di una villa romana," *BdA* 57 (1957) 449MPI; id., *La villa romana di Russi* (1962)MPI; Scagliatini, "La villa romana di Russi," *La villa romana* (Società di Studi Romagnoli) (1971) 117-42MPI. G. A. MANSUELLI

RUSUCURRU or Rusuccuru (Dellys) Algeria. Map 18. The names of certain localities on the coast between Icosium (Algiers) and Saldae (Bedjai)—Cissi, Rusucurru, Iomnium, Rusippisir, Ruzasus—are known from ancient itineraries and geographers. On the other hand, an inscription preserved in situ on the lintel of a temple at Tigzirt stated that the building was dedicated to the tutelary deity of the municipium of Rusuccuru. Accordingly, it was proposed that this center was situated at Tigzirt itself or at the site of Taksebt nearby. However, a milestone was found which indicated a distance of 4.8 km to Rusuccuru; the find was made 4.5 km W of Dellys. This suggested that the ancient site should be placed, not at Tigzirt but rather farther W, under the modern town of Dellys. The argument has not seemed convincing to everyone and a controversy has sprung up. This controversy seems to me to have been settled in favor of the Dellys-Rusucurru identification because of a dedication found recently on Cape Djinet, which mentions the inhabitants of Cissi. This still unpublished text dates to the time of Alexander Severus. It puts on firm ground the location of Cissi at Cape Djinet. Therefore, Rusucurru must be at Dellys, Iomnium at Tigzirt, and Rusippisir at Taksebt. As far as Ruzasus is concerned, it can still be identified with Azeffoun, some distance above the shore, SE of Port-Gueydon.

At Dellys practically nothing remains of the ancient town. It has been covered by the settlement which has expanded since the beginning of the French colonization.

BIBLIOGRAPHY. E. Frézouls and A. Hus, *MélRome* 66 (1954) 147-63; M. Euzennat, ibid., 65 (1955) 127-48 and 69 (1957) 75-80. P.-A. FÉVRIER

RUTIGLIANO, *see* AZETIUM

RUTUNIUM Shropshire, England. Map 24. From its position in the *Antonine Itinerary* (469.5), 12 Roman miles from Mediolanum (Whitchurch) and 11 from Viroconium (Wroxeter), and from its name, this must lie near Harcourt Mill, where the Roman road crosses the river Roden, in the territory of the Cornovii. Roman pottery has been found near the line of the road, but no details of the settlement are yet known.

BIBLIOGRAPHY. H. E. Forrest, *Trans. Salop Arch. Soc.* 49 (1937-38) 92; *Itinerary*: A.L.F. Rivet, *Britannia* 1 (1970) 42. A.L.F. RIVET

RUTUPIA (Richborough) Kent, England. Map 24. The Roman settlement lies on a sandy hill overlooking the valley of the river Stour, now largely silted, which marks the position of the Wantsum Channel, a waterway of some significance in the Roman period. The site was first used in the year of the invasion (A.D. 43) as a bridgehead and storage depot for the invading army, which constructed two parallel defense ditches and a rampart to protect the anchorage and its immediate vicinity. By the next year the ditches had been filled in and a substantial storage base had been laid out: a properly constructed grid of graveled roads, a series of batteries of granary buildings, workshops, and what appears to be an administrative building, all built in timber.

By ca. A.D. 85, after a series of modifications and rebuildings, the storage base was abandoned and the buildings demolished to make way for new development. A massive monument was constructed on a concrete base (37.8 x 24.3 m, and 9 m deep). Originally it was a quadrifrons, encased in marble and ornamented with bronze statuary, but all that now remains is the foundation. Its size and elaboration, and its position at the head of Watling Street, virtually the gateway to Britain, suggest that it may have been erected to commemorate the final conquest of the country after Agricola's victory at Mons Graupius. In front of the monument the streets were remetaled and a series of shops and workshops were constructed, while nearby a mansio was built in masonry. To the S lay temples and an amphitheater.

In the early 2d c. the settlement developed further: drains were laid, some of the shops were rebuilt in masonry, and the mansio was substantially reconstructed. The early 3d c., however, appears to have been a period of economic decline, with burials, including a masonry tomb, encroaching upon the built-up area. One possible explanation is that the nearby port of Dubris (Dover) had captured the cross-channel trade, leaving Richborough to decay.

Towards the middle of the 3d c. much of the built-up area around the monument was flattened and the monument itself was probably turned into a lookout post. The settlement was now enclosed by a rampart and a system of triple ditches, with a single entrance in the center of the W side. It is possible that a small garrison was housed within the 0.4 ha enclosure, but no trace of its accommodation has been recorded.

Later, probably in the 280s, the monument was demolished, the ditches filled up, and the whole central area enclosed by the massive masonry wall of a Saxon shore fort. The wall, which still stands for a substantial part of the circuit, was built of flint boulders faced with

coursed limestone and bonded at intervals with horizontal courses of tiles. Originally it was ca. 9 m high. The main gate, consisting of two guard chambers flanking the single carriage roadway, was in the W side, and the N wall had a postern. Probably there was a corresponding postern in the S wall, but details are unknown. Circular turrets projected from the two surviving corners of the fort, and the intervening walls each had two rectangular bastions. Outside the walls the fort was defended by two V-shaped ditches. The inner ditch on the W side appears to have been misaligned and was dug again in a short time.

Interior details are obscure, but some evidence suggests that the principia was built on the platform once occupied by the monument, while a small bath suite was erected in the NE corner. Two other simple masonry structures, possibly guild rooms, were found, but elsewhere the buildings must have been of timber. Occupation continued throughout the 4th c. and probably well into the 5th. During this time Richborough maintained an important position in the Saxon shore system. It was here that Count Theodosius landed in 369 to reorganize the country after the so-called "barbarian conspiracy." It is also the place where, traditionally, St. Augustine landed in 597.

The main excavations were from 1922 to 1938, and many of the structural details discovered can be seen today. The objects are displayed in a museum on the site.

BIBLIOGRAPHY. J. P. Bushe-Fox, *First Report on the Excavations of the Roman Fort at Richborough, Kent* (1926); *Second Report* (1928); *Third Report* (1932); *Fourth Report* (1949); B. W. Cunliffe, ed., *Fifth Report* (1968); J. S. Johnson, "The Date of the Construction of the Saxon Shore Fort at Richborough," *Britannia* 1 (1970) 240-48.　B. W. CUNLIFFE

RUVO DI PUGLIA, *see* RUBI

RUZASUS (Azeffoun) Algeria. Map 18. Pliny the Elder (5.20) says that the town was a colony of Augustus; inscriptions prove that the Colonia Julia Augusta was founded by veterans of the Seventh Legion, just as were the towns of Saldae (Bedjaia) and Tubusuctu (Tiklat) in the valley of the Soumam. This undoubtedly occurred at the time when Octavius controlled Mauretania before that region was once again put in the hands of Juba II.

The small, picturesque village of Azeffoun is located on the plateau that dominates the site of Port-Gueydon. In it one can still see some remains of buildings, in particular a bath building. Concerning the identification of the site, see also under the entry Rusucurru.

P.-A. FÉVRIER

S

SAALBURG Bad Homburg v.d.H., Germany. Map 20. A Roman auxiliary castellum 20 km S of Frankfurt a.M. on the level of the Taunus mountain range, near Bad Homburg v.d.H. During Domitian's war against the Chatti (A.D. 83-85), the limes was constructed in the forefield of the legionary camp Mogontiacum (Frontin. *Str.* 1.3.10). In stretches it follows the ridge of the Taunus mountain range. Auxiliary troops were stationed in castella on the limes to guard the frontier. One of these castella was Saalburg; its ancient name is unknown. The oldest fortification was a small wooden castellum (area 0.6 ha, constructed ca. A.D. 90); its garrison is not known. About A.D. 135 cohors II Raetorum c.R. (equitata?) was stationed here, and at this time a larger castellum was built over the original one. Its wall consisted originally of a peculiar wood and stone construction. The interior buildings were of wood. During the second half of the 2d c. a stronger wall of stone and mortar was built. Some of the interior buildings also were rebuilt in stone, especially the principia and the horrea.

The first destruction of the camp probably occurred in the second half of the 2d century in the battles with Germanic tribes. The castellum also suffered from the raid of the Alamanni of 233 but was always rebuilt. Germanic attacks in the 3d c. were fatal. Together with the limes, Saalburg was abandoned by the Romans not later than 260.

The fortifications and the most important interior buildings of the cohors castellum have been reconstructed and contain a museum in which the finds from the excavations are exhibited. They give an idea of daily life in a Roman auxiliary castellum.

The reconstructed castellum has the customary rectangular ground plan with rounded corners (area 3.2 ha). Each of the four sides has a gate. Excavations in the interior of the castellum have established barracks, sta-bles, and workshops, which completely filled the area. The buildings were arranged in a strictly geometrical pattern. In front of the main gate of the castellum were a bath building and a mansio; these ruins are visible. The remains of a vicus have been excavated; its houses in front of the gates of the castellum were situated along the Roman road to Nida (main town of the civitas Taunensium, today Frankfurt a.M.-Heddernheim). Adjoining the village and on both sides of the road was a necropolis, which is no longer visible. In the vicus were sanctuaries of Jupiter Dolichenus and Cybele; a mithreum has been reconstructed.

The limes runs for a distance of ca. 200 m N past the castellum. In its final form (earth wall and trench), it is fairly well preserved here and can be followed for many kilometers through the Taunus.

BIBLIOGRAPHY. H. Schönberger, *The Roman Fort at the Saalburg* (1967)M; D. Baatz, *Die Saalburg, ein Führer durch das römische Kastell und seine Geschichte* (1968)M.　D. BAATZ

SAARBRÜCKEN, *see* SARAVUS

SABLÉ Sarthe, France. Map 23. Excavations in the area known as La Ferme de la Tour near the village of Sablé have determined the nature and plan of some buried Gallo-Roman structures which had been detected by aerial photography. Clearly the buildings uncovered are part of a religious complex, consisting of a circular cella surrounded by a concentric wall. The space between the two forms an ambulatory, thus constituting a structural group somewhat similar to that discovered in Crozon, Finistère. Some 30 m away are two more religious buildings, contiguous fana, this time square in shape. Their walls have disappeared, but the plan could be deduced from traces left by the bottom of the foundation trenches.

At Avoise, a small village near Sablé, are the substruc-

tures of a large Gallo-Roman building. It contained a fine hypocaust, many 4th c. objects, and a large pool, the bottom and sides of which were carefully built of slabs.

BIBLIOGRAPHY. "Informations," *Gallia* 27, 1 (1969) 244-46.

M. PETIT

SABRATHA Libya. Map 18. On the coast 64 km W of Tripoli, the farthest W of the three cities (treis poleis) that gave the region its name. Traditionally founded by the Phoenicians, under the Carthaginians it was successively a seasonal trading post and a permanent settlement. During the earlier empire it prospered and expanded, but in A.D. 363-65 it was sacked by the Austuriani and, though restored, it declined rapidly under Vandal rule. Reoccupied and refortified by Justinian's troops in A.D. 533, it dwindled and was finally abandoned after the Moslem conquest of A.D. 643. The remains uncovered comprise large stretches of the built-up area of the ancient city, including domestic and commercial quarters, and in this respect they are complementary to the intrinsically finer but more selectively excavated monuments of Leptis Magna.

The siting and development of the city were determined by the possession of a small natural harbor, strengthened in Roman times by a concrete mole, and by the lines of two intersecting roads, the main coastal road (here the "decumanus") and a road running S from the harbor towards Cydamus (Ghadames) and the trans-Saharan caravan route. The irregular plan of the quarter beside the harbor marks the site of the original Punic settlement. On the landward side of this, on the site of an earlier open market place, was superimposed the neatly rectangular Roman forum, an early imperial creation. The city developed from this nucleus. To the S this took place about an orthogonal grid based upon the intersecting axes of the two main streets, and in the 2d c. there was a similar development to the E on a slightly different alignment, based on a change of direction in the line of the decumanus. The area W of the forum awaits excavation. To the S the orderly growth of the city was limited by an irregular line of quarries and cemeteries. The only known fortifications of the Roman period are a short stretch of 4th c. wall at the E end of the excavated area. The Byzantine defenses enclosed a greatly reduced area, some 16-18 ha in extent, around the forum and the original harborside nucleus.

The now visible remains of the forum complex were preceded by two constructional phases: an irregular development of the harborside town to the S, apparently in the 2d c. B.C., which was then swept away to create an open rectangular space occupied only by temporary structures, presumably an occasional market place. In the 1st c. A.D. this was replaced by a permanent, elongated rectangular enclosure extending to right and left of the main street to the S and flanked longitudinally by shops and offices, of which the foundations of some of those along the S side are still exposed. Only three of the surviving public buildings can be shown to belong to this early phase: a large temple, dedicated probably to Liber Pater, which stood in the middle of the E half; a smaller temple at the NW corner, possibly dedicated to Serapis, the slightly oblique alignment of which suggests that it antedates the formal plan of the forum; and along the S side of the W half of the forum a basilica. The basilica (mid 1st c. A.D.) was of the Vitruvian type, with internal ambulatory and entered from the middle of one long side; opposite the entrance was a rectangular tribunal containing a group of imperial statues. The Temple of Serapis was a small, free-standing edifice of native type set in the middle of a porticoed enclosure. That of Liber Pater, though of more conventional Classical plan, was faced with gaudily painted stucco.

During the 2d and 3d c. this complex was gradually transformed. The shops of the W half were replaced by porticos with Egyptian granite columns, and the Temple of Liber Pater was enlarged and framed on three sides within a double portico. Opposite it, at the W end was added (early 2d c.) a capitolium, a broad, shallow pedimental building with three cellas standing on a very lofty podium, of which the central part rose sheer from the forum and presumably served as a rostrum. Along the N side of the W part of the forum was added a curia, of conventional Roman plan. The tribunal of the basilica was transferred to a new range of rooms at the W end of the basilica, and between this extension of the basilica and the capitolium was inserted a cruciform vaulted chamber of uncertain purpose. Other modifications and additions during the later 2d c. were the remodeling of the Temple of Serapis on more conventionally Roman lines and the S extension of the forum complex, replacing earlier houses by two large new temples: one dedicated to M. Aurelius and L. Verus (A.D. 166-69), S of the Temple of Liber Pater; the other, of unknown dedication, S of the basilica, of which it partly suppressed the tribunal. Of all these buildings only the Temple of Liber Pater retained its traditional structure of sandstone, stuccoed and painted; all the rest were built or partially rebuilt in marble during the last 60 years of the 2d c.

The only other large public building in the old part of the city is the public bath at the NE corner of the forum. Beside it is a fine public latrine. Two more temples were situated in the new quarter to the E: one (A.D. 186-93) a conventional prostyle building dedicated to Hercules, the other, of Flavian date and dedicated to Isis, free-standing within an elaborately porticoed temenos beside the sea at the E end of the excavations. This new, 2d c. quarter is dominated by the theater, a late Antonine building of which substantial parts of the cavea and the three orders of the marble scaenae frons have been restored, giving a unique visual impression of the stage of a large but otherwise typical N African theater. The figured marble reliefs decorating the front of the pulpitum include representations of divinities, dancers, and philosophers, scenes from tragedy and pantomime, and a group with personifications of Rome and Sabratha joining hands in the presence of soldiers.

Characteristic of the site are the extensively excavated domestic and commercial quarters. In the early city these were irregular and crowded, with shops and storerooms occupying the frontages of well-to-do houses with mosaics and painted stucco ceilings. There are many indications of upper stories of timber and crude brick. The insulae S and E of the forum illustrate the emergence of more orderly planning, while those of the 2d c. town are neatly squared, many with shallow porticoed frontages, as at Timgad. The roofs were regularly flat, and any building of substance had its own cisterns. On the periphery are several large peristyle houses with fine mosaics, notably the House of the Oceanus Baths near the Temple of Isis. The predominantly commercial quarters along the harbor front include barrel-vaulted warehouses and the foundations of a large basilical hall.

In the later 4th and 5th c. the city underwent many changes. The fate of the individual temples is uncertain, but after the Austurian sack the civil center was restored and remodeled. The forum itself was divided into two by a transverse portico; the curia was restored on traditional lines, though with an arcaded atrium; and the basilica was completely remodeled on the pattern of the

Severan basilica at Leptis, with longitudinal naves and two opposed apses. In the 5th c. it was again rebuilt, this time to serve as a church, with a single W apse. Two similar but smaller churches were built between the theater and the sea, a quarter which was probably already largely depopulated, as it certainly was in the 6th c. when the Byzantine defenses were drawn to enclose an area corresponding approximately to that of the early 1st c. city, centered on the forum and the harbor and excluding the later S and E extensions. The basilica underwent a final restoration, with a baptistery installed in the adjoining cruciform building, and a new church, with imported marble fittings and a magnificent mosaic, was inserted between the curia and the sea. Though Arabic graffiti and remains of hovels found in the forum area and in the theater attest some later habitation, effective city life was extinguished by the Arab conquest.

Outlying monuments include an amphitheater, to the E; traces of an aqueduct; remains of several villas, with mosaics and baths, mainly along the adjacent coasts; and extensive though scattered cemeteries. The latter include a towerlike Punic mausoleum of the 2d c. B.C. (and traces of a second), in an area that was later incorporated in the SW outskirts of the town. This was a building of scalloped triangular plan with several superimposed orders crowned by a pyramidal spire. There is also a small Christian catacomb, to the E.

The museum on the site includes Classical sculpture, wall-painting, and stuccos; the marble fittings and mosaics of the Byzantine church; and a large series of domestic bronzes and pottery.

BIBLIOGRAPHY. R. Bartoccini, "La curia di Sabratha," *Quaderni di Archeologia della Libia* 1 (1950) 29-58; J. M. Reynolds & J. B. Ward-Perkins, *Inscriptions of Roman Tripolitania* (1952) 20-72; J. B. Ward-Perkins & R. G. Goodchild, "The Christian antiquities of Tripolitania," *Archaeologia* 95 (1953) 1-82; G. Pesce, *Il tempio di Iside in Sabratha* (1953); D.E.L. Haynes, *An Archaeological and Historical Guide to the pre-Islamic Antiquities of Tripolitania* (1955) 107-34; G. Caputo, *Il Teatro di Sabrata* (1959); R. Bartoccini, "Il tempio antoniniano di Sabrata," *Libya Antiqua* 1 (1964) 21-42; P. Romanelli, "Sabratha," *EAA* VI (1965), 1050-60; A. Di Vita, "Influences grecques et tradition orientale dans l'art punique de Tripolitanie," *MélRome* 80 (1968) 7-80.

J. B. WARD-PERKINS

SABUCINA Sicily. Map 17B. Successive settlements on a mountain that rises ca. 8 km E of Caltanissetta and controls the pass in the valley of the river Salso (fl. Himera). Because of this strategic position, Sabucina was occupied by prehistoric settlements and by a Sikel-Greek fort on the S slope of the mountain. This sequence is attested also on Mt. Capodarso, opposite Sabucina, on the other side of the river.

Recently Sabucina has been the object of several campaigns of excavation, which are uncovering the remains of the successive settlements. At the foot of the mountain, in the area called "lower Sabucina," are the necropoleis of the Early Bronze Age with characteristic oven-shaped, rock-cut graves. At the end of the Bronze Age, between the 12th and the 10th c. B.C., a large new settlement was established at a higher level on the mountain; it was formed by rows of sturdy circular stone huts that can still be seen in ruin in the next habitation level of the Greek period. These huts contained great quantities of vases in the style called North Pantalica, molds for the manufacture of bronze weapons, and a single kiln. This village was destroyed at an undetermined date and was replaced in the 8th-7th c. B.C. by a new indigenous

center with large rectangular houses comprising several rooms. In these houses and in the grotto-tombs of the same period, local material has been found together with large quantities of Protocorinthian, Geloan, and imitation Greek pottery, which document the first contacts with Gela's colonists. About the middle of the 6th c. the habitation area was smaller and the site became a typical phrourion of Greek type, with walls blocking the S side of the slope, the only access to the houses. The necropoleis developed at the same time, with cist and sarcophagus graves filled with Greek vases, especially bronze vessels and Attic red- and black-figure pottery. The dwellings were rectangular with two or three rooms. Quite likely this thorough transformation of the site was caused by actual occupation by Geloan or Akragan Greeks. Only some decorative elements remain from the religious structures of this phase, in particular some fine polychrome antefixes in the shape of a Gorgon, similar to those found at Morgantina. The existence of sacred buildings is further documented by an unusual terracotta model of a shrine, with acroteria and antefixes.

This Greek center was violently destroyed shortly before the middle of the 5th c. B.C., probably during the Sicilian revolt led by Ducetius. It was rebuilt in the second half of the 5th c., and to this phase must belong most of the ruins at present uncovered, including the new circuit of fortifications with a fine series of rectangular and semicircular towers, two postern gates, and a main entrance. Houses were crowded behind the walls, with courtyards and empty spaces left for defensive purposes. The city, abandoned at the end of the 5th c. B.C., was rebuilt in the time of Timoleon. Like the neighboring centers of Capodarso, Vassallaggi, and Gibil Gabib, it was completely destroyed around 311-310 B.C., probably by Agathokles, tyrant of Syracuse. Habitation of the site was resumed only during the Roman Imperial period; a few graves and ruins of farmhouses have been found, especially in the lower area, well supplied with water. All the material from the new excavations at Sabucina is in the Archaeological Museum of Caltanissetta.

BIBLIOGRAPHY. D. Adamesteanu, *RA* 49 (1957) 173; P. Orlandini, *Kokalos* 8 (1962) 10ff; id., "Sabucina," *ArchCl* 15 (1963) 86ff; 17 (1965) 133ff; 20 (1968) 151ff; id., *RendLinc* (1965) 457ff. P. ORLANDINI

SACIDAVA Constanţa, Romania. Map 12. Ruins of a Roman camp in the territory of the village of Mîrleanu. Built in the 2d c. A.D., it was partly destroyed in the 3d c., and restored several times in the 4th and 5th c. References in the itineraries are confirmed by several inscriptions (one of them a Decius milestone), making it possible to identify this camp with Sacidava (*Not. Dig. or.* 39-40) the seat of a cuneus equitum scutariorum. Excavations have uncovered the circuit wall and a large building inside the castrum.

BIBLIOGRAPHY. N. Gostar, *St. clasice* 5 (1963) 306-8; A. Aricescu, *Dacia* NS 14 (1970) 297-301; C. Scorpan, *Pontica* 5 (1972) 301-23. D. M. PIPPIDI

SADABA Zaragoza, Spain. Map 19. There are interesting Roman remains in the vicinity of the modern villa. There is question whether Clarina or Aquae Attilanae, 11th station on the military highway from Asturica Augusta to Tarraco, should be inserted here.

Roman remains include a paved roadway, the piers of an aqueduct, a villa, a tomb known as the Sinoga (synagogue), and the mausoleum of the Attilios. The villa, some 150 m long, has two distinct portions, one intended for living quarters, the other for a bath, the longer sector of which ends in a polygonal apse. Not far from the villa is a tomb in the shape of a Greek cross with

apses and exedras, probably dating from the 4th c. But the most important and best preserved monument (although with one facade missing) is that known as the Mausoleum of the Attilios (9.20 x 4.72 m). Standing on a podium are five arches flanked by pilasters decorated with floral and vegetal motifs. The entablature carries three inscriptions dedicating the edifice to the Attilia family. The suggested date varies between the second half of the 2d c. and the first half of the 3d.

BIBLIOGRAPHY. A. García y Bellido, "La villa y el mausoleo romanos de Sádaba," *Excavaciones Arqueológicas en España* 19 (1963)[PI]; J. Menéndez Pidal, "El Mausoleo de los Attilios," *ArchEspArq* 43 (1970) 89-112[PI]. J. ARCE

SADAK, *see* SATALA

SAEPINUM (Altilia) Italy. Map 17A. The city was part of the territory of the Pentri Samnites, who withstood a memorable siege, in 293 B.C., mounted by Roman troops under the command of C. Papirius Cursor. The Samnite city, situated on the NW slopes of Mt. Mutria in the area of Torrevecchia, was destroyed. Its inhabitants went down into the low lying plain of the Tammaro river (fl. Timmarus) and there established their settlement anew. At the outset, it had the aspect typical of a Roman town dependent upon the cattle track that crossed the plain and became the decumanus within the city.

Roman Saepinum had a municipal constitution and was enrolled in the Voltinia tribe. Essentially a farming and cattle raising center, it does not seem to have had great influence upon the region; however, from one of its families, the Neratii, Rome gained one of its greatest legal experts, Neratius Priscus.

During the early Middle Ages, the Roman settlement was abandoned, perhaps because of the flooding of the Tammaro, and the place came to be called Altilia. Conversely, the old name was inherited by the district formed at the base of Mt. Mutria, but in a place other than Samnite Saepinum. It has been possible to trace large stretches of the polygonal circuit wall of Samnite Saepinum. Two gates have been recognized in the wall; within, a late mediaeval settlement has been ascertained.

The Roman city, still to be explored for the most part, preserves a series of monuments constructed almost without exception of local stone. Only the principal monuments are here described. The walls have a perimeter of about 1250 m and are quadrilateral in plan. Covered in opus reticulatum, they are interrupted by round towers—two octagonal ones have been noticed—and in these towers four gates mark the terminations of the cardo and the decumanus. A smaller gate opens directly into the theater. The gates—Terravecchia, Boiano, Tammaro, and Benevento—are named for the places toward which they open and are similar in their architectural organization.

The Porta di Boiano, the only one so far restored, has a single archway with a vault on the inside; it is flanked by a pair of round towers. There are statues of barbarians on high pedestals on the sides of the arch, which displays the head of a divinity at the center of the vault. On the arch, an inscription—identical on all the gates—commemorates Tiberius and Drusus through whose efforts the circuit wall was completed. The inscription dates to A.D. 4.

A trapezoidal forum at the crossing of the cardo and the decumanus—it has been entirely uncovered—is completely paved in huge rectangular blocks on which a fragmentary inscription commemorates C. Papius Faber, the magistrate who had the forum paved. Numerous public buildings have been brought to light on the S side, the only area of the forum so far excavated.

The basilica which flanks the NW side and along which the cardo runs resembles a peristyle constructed of 20 Ionic columns. The building is perhaps to be assigned to the 4th c. A.D.; however, materials used in its construction come from an older building. Between the basilica and the Porta di Boiano, along the decumanus, are the remains of public buildings and private dwellings.

The theater is in the N sector of the urban area. Only its circular corridor beneath the upper cavea has been completely excavated. This corridor leads to the outer city and ends in two grand tetrapyla.

Outside the city, along the cattle track, are the remains of numerous mausolea. Outside the Porta di Benevento the mausoleum of C. Herennius Marsus has been partially reconstructed. It is of the so-called tumulus type, on a square base. Outside the Porta di Boiano, it has been possible to reconstruct in toto the grandiose mausoleum of P. Numisius Ligus, of the so-called ad ara type.

BIBLIOGRAPHY. V. Cianfarani, *Guida della antichità di Sepino* (1958); id., "Vecchie e nuove iscrizioni sepinati," *Atti III Congr. Inter. Epigrafia Greca e Latina* (1959) 371-80; id., *EAA* 7 (1966) 201-2; G. Ambrosetti, "Testimonianze preaugustee da Sepino-Altilia, *ArchCl* x (1958) 14-20; A. Maiuri, "Ritorno a Saepinum," *Dall' Egeo al Tirreno* (1962) 271-75; G. Colonna, "Saepinum—Ricerche di topografia Sannitica e medioevale," *ArchCl* 14 (1962) 80ff. V. CIANFARANI

SAFFURIYEH, *see* SEPPHORIS

SAGALASSOS or Sagalessos (Ağlasun) Turkey. Map 7. City in Pisidia N of Antalya, whose name and variants thereof have been transmitted through many sources (Strab. 12.569-70, 13.631; Ptol. 12.19; Arr. 1.28.2; Diod. 18.44ff; Plin. *HN* 5.94). Little is known about its early history and development, but it is thought that in the Hellenistic period it was forcibly occupied by Alexander.

The city was SE of Apamea in Phrygia and near the source of the Cayster river in the mountainous area of Milyas; it dominated a considerable area of Pisidia. Its territory was devastated by Gn. Manlius Vulso. In the Imperial period, it was called magnificent, first city of Pisidia, friend and ally of Rome, and belonged to the province of Galatia.

The ruins were described in detail by 19th c. travelers. The subdivision of the urban center follows the highly developed city plan of the Hellenistic type spread under Alexander and repeated in the mountain cities of Asia Minor, of which Sagalossos and Termessos are the more notable examples. The grid is oriented E-W along a rocky ridge (Davras Daği), and the site is terraced upward, culminating in the level area of the Temple of Antoninus Pius. A cross-street joins the upper terraces to a nympheum. To the W is the Temple of Apollo Klarios and to the E the gymnasium, opposite which are the theater and the basilica.

The Temple of Antoninus Pius is Corinthian (13.87 x 26.83 m) while that of Apollo Klarios is Ionic, peripteral and hexastyle; a Christian basilica was built on its foundations. The theater, of the last quarter of the 2d c. A.D., has a cavea of the Hellenistic type, horseshoe-shaped and partially resting upon rock; the NW section was constructed in the Roman period. A diazoma with a vaulted circular corridor divided the cavea in the middle, and the scaenae frons was unusually complex and architecturally interesting. An odeon of the Imperial period is one of the most complete ever discovered. There was also a palaestra (53 x 44 m, with a paved central court

and porticos along its sides), and an upper agora, set on a terrace above that of the Temple of Antoninus Pius, which dates from the Claudian period.

BIBLIOGRAPHY. C. Lanckoronski, *Städte Pamphyliens und Pisidiens* II (1892); Head, *Hist. Num.*; R. Paribeni & P. Romanelli, *MonAnt* 23 (1914); M. Grant, *NC* 10 (1950); G. E. Bean, *Belleten* 18 (1954) 72; R. Martin, *L'Urbanisme dans la Grèce antique* (1956); J. Delorme, *Gymnasion* (1960); M. Bieber, *The History of the Greek and Roman Theater* (1961); A. Neppi Modona, *Gli edifici teatrali greci e romani* (1961); S. A. Hall, *AnatSt* 18 (1968); A. de Bernardi Ferrero, *Teatro classici in Asia Minore* II (1969). N. BONACASA

SAGALESSOS, *see* SAGALASSOS

SAGII (Sées) Dept. Orne, France. Map 23. Sagii was the name of a people generally recognized as identical with the Esuvii mentioned by Caesar (*BGall.* 3.7), who does not refer to any town in their connection. Straddling the deep valley of the Orne, their territory reappears relatively late after the Roman conquest, forming the civitas Sagiorum mentioned in the *Notitia Galliarum* among the cities of the second Lugdunensis province. The name of the Sagii was carried over to what very likely was their capital, whence the present name Sées.

The settlement undoubtedly dates from before the Roman conquest. Originating as a ford over the Orne, it seems to have played an essentially commercial role and does not appear to have been fortified by the Romans. The absence of any important remains from the last years of the Late Empire (coins found there range from the 1st c. to the beginning of the 3d c.) may possibly mean that a deep decline set in after the invasions, following which an episcopal see was established after the town was Christianized, perhaps at the very end of the 4th c.

The site is covered over by the modern town. Chance finds made in the 19th c. have been indifferently exploited. The most significant of these is a bath furnace found under the N arm of the cathedral transept. Although the majority of the finds were made to the N and W of the cathedral, this does not prove conclusively that there was a forum in this area, as has sometimes been suggested. On the other hand, the present rue de la République can be said to follow the general lines of the road that crossed the city N-S.

In 1966, a wall 1.5 m thick was revealed when a trench was dug in the rue Conté, 65 m W of the cathedral. Built of a rubble of limestone rocks bedded in pink mortar, it was bonded horizontally with brick and shows traces of a somewhat coarse facing. The wall seems to have been part of an octagonal building, perhaps a religious edifice of the fanum type. This hypothesis is strengthened by fragments of sculpture that have been found in the nearby embankment, among them a youthful figure that might be Bacchus, whom the Gallo-Romans sometimes identified with the Gallic god Esus. From the style of the bas-reliefs, a provincial version of the Hellenistic style, and the motifs used in the friezes—Greek interlaced borders, stylized sycamore leaves—the pieces can be dated from the first half of the 2d c. (Musée Départemental des Antiquités et Objets d'Art, Sées). The deepest stratum found close by revealed pottery dating from the beginning of the 1st c., some of it from Arezzo.

The remains of a dwelling were located through a chance discovery in 1968 in the rue Amesland, N of the cathedral.

BIBLIOGRAPHY. Maurey d'Orville, *Recherches historiques sur la ville, les évêques et le diocèse de Sées* (1829) passim; J. Mallet, "Débris architecturaux trouvés dans le sous-sol de la cathédrale de Sées," *Soc. hist. et arch. de l'Orne* V (1866) 331-40; J. Barret, "A propos de quelques vestiges gallo-romains trouvés dans les fondations de la cathédrale de Sées," ibid. X (1891) 480-86; G. Mathière, "Etudes normandes et gallo-romaines. Le pays de Sées (Esuvii, Sagii ou Saii)," *Rev. Catholique de Ndie* 43e année (1934) 123-27; C. du Mesnil du Buisson, "Une voie commerciale de haute antiquité dans l'Orne. Les origines de . . . Sées," *Soc. hist. et arch. de l'Orne* LXVII (1949) 24-34[P]; P. Véron, "Découvertes archéologiques à Sées," ibid. LXXXIV (1966) 257-59[I]; C. Varoqueaux, "Vestiges d'époque gallo-romaine découverts à Sées," *Annales de Ndie* 16 (1966) 384-88[PI]; J. J. Hatt, "Note sur les fragments de sculptures découverts à Sées," ibid., 389-92[I]. J. J. BERTAUX

SAGUNTO, *see* SAGUNTUM

SAGUNTUM (Sagunto) Valencia, Spain. Map 19. City near the coast 25 km N of Valencia, built above the Palancia river on the top and slope of a mountain, the last spur of the Iberian range towards the sea (Polyb. 3.17; Plin., *HN* 3.21; Mela 2.92; Strab. 3.4.9). The destruction of the earlier Iberian city, Arse, by Hannibal in 219 B.C. (Livy 21), caused the second Punic war. Influenced by its indigenous name, Silius Italicus (*Punica* 1.271) and Livy thought it was founded by the Ardea, whereas Strabo (3.4.6) and Pliny (16.216) associate the name Saguntum with a hypothetical Zacynthian colony (neither theory is tenable). Arse (high fortress) changed its name to Saguntum, and these two names have led to the theory that there were two cities, Iberian on the mountain top and Roman in the plain, but this does not seem probable. The barbarian invasions of the 5th c. left it mostly in ruins, and from the time of the Arabs on it was called Murbiter, Murviedro, Morvedre (murus vetus), and regained the name of Sagunto only in 1868. The river flowing through the city (erroneously called Palancia from the 16th c. on) must have been the Udiba (Plin. 3.21), known in the Middle Ages as Riu de Sogorb, after the town upstream from Sagunto.

There are abundant pre-Roman and Roman remains. The plateau, about 1000 m long, on which the indigenous city was built, continued to be inhabited in Roman times and was later used as a fortress, a key point in the defense of coastal and inland roads. Excavations have located various Roman buildings, including the peristyle of a possible temple, part of the forum, cisterns, and the theater, much damaged, on the E slope of the mountain. Only the hemicycle preserves the infrastructure carved in the rock, showing three lower rows of seats, six of the ima cavea, seven of the media cavea, and ten of the summa cavea, separated by horizontal aisles. Radial stairways divide the rows of seats into sections. The maximum width of the building was 89.85 m, and the pulpitum was 54.75 by 6.5 m. Its capacity is estimated at 10,000. Its acoustics are extraordinary, as confirmed by modern performances. No dating material has survived, but comparison with other Roman theaters suggests the 1st c. A.D.

The so-called Temple of Diana (Plin. *HN* 16.216) was probably on the acropolis, but today it is identified with some large wall surfaces inside the city, constructed with care about the 5th c. B.C. The circus is located between the river and the mountain. Until recently its perimeter, the outline of the spina, part of the lateral walls, and the hemicycle facing the carceres could be traced, although the porta triumphalis had disappeared. The whole length of the spina was excavated in 1945, but urbanization of the area has now covered the circus,

with the exception of a side gate. It was 354 by 73.4 m, and the spina, composed of two parallel walls, 190 by 3.4 m. It is estimated that it held 10,000 spectators, and it dates from the 2d c. or the beginning of the 3d.

Epigraphical remains are rich: 173 Roman tablets have been published (*CIL* II, 3819-57, 6019-24, 6026-37, 6039-53). Later finds make a total of ca. 225 whole inscriptions and fragments, and a Corpus is in preparation. Mosaics are also numerous (Archaeological Museum). In 1745 an opus tesselatum mosaic (7.36 x 5.06 m) was found with Bacchus on a panther in the center and, in the four corners, kantharoi from which rise vines with branches and bunches of grapes being harvested by twelve cupids. This mosaic disappeared shortly after its discovery, as have several others of opus signinum and opus sectile found in the area of the acropolis. Others, however, from the 2d c. exist.

Little sculpture has been found, a few togate figures, one female head, one Bacchic Hermes, and two reliefs depicting an animal tamer or Epona (Fine Arts Museum, Valencia). There is, however, terra sigillata from various periods and studios.

Saguntian coins are abundant, but there is disagreement on their chronology. The most ancient coins are of silver and give the name of the city as ARSE-ETAR (of the people of Arse), ARS-GIDAR (silver of the people of Arse?), and ARSA-GISGUEGIAR in Iberian. There is only one known specimen with ARSESKEN (of the people of Arse). The heavier of these coins probably date from 212 to 195 B.C., the lighter from 195 to 94 B.C. On the face is the head of Pallas or Hercules, and on the reverse, a bull. Towards the middle of the 2d c. B.C. the reverse shows the typical Iberian horseman and the inscription ARSE. On bronze coins the prow of a ship replaces the horseman about 133 B.C., but the Iberian ARSE remains. Shortly thereafter the bilingual ARSE-SAGUNTINU appears, and later only the Latin inscription SAGUNT. The quadrans has a scallop shell on the face, a dolphin and SAGUNT on the reverse; the sextans has a scallop shell and, on the reverse, a caduceus and UNT. It seems that minting was suspended about the end of the Sertorian War and resumed from A.D. 14 to 20, under Tiberius. Coins bearing the inscription AIDUBATS, attributed to Sagunto, probably come from another town nearby.

BIBLIOGRAPHY. A. Chabret, *Sagunto. Su Historia y sus Monumentos* (1888); D. Fletcher, "Que fueron los barros saguntinos?" *Arse* 1 (1957) 3ff; id., "El teatro Romano de Sagunto," *BIM* 55 (1967) 26-43; M. Vall, "Mosaicos romanos de Sagunto," *Archivo de Prehistoria Levantina* 9 (1961) 141-75; S. Bru, "El circo romano de Sagunto," ibid. 10 (1963) 207-26; id., "El Castillo de Sagunto," *BIM* 55 (1967) 5-25; A. García y Bellido, "Das Artemision von Saguntum," *MadrMitt* 4 (1963) 87-98; E. Pla, "Los Museos de Sagunto," *BIM* 55 (1967) 44-59; L. Villaronga, *Las monedas de Arse-Saguntum* (1967). D. FLETCHER

SAIDA, *see* SIDON

SANT'ANASTASIA, *see* RANDAZZO (Sicily)

SAINTE-ANASTASIE Locality of Castelvieil (Marbacum in the Middle Ages), canton of St-Chaptes, Gard, France. Map 23. Important pre-Roman and Gallo-Roman oppidum overlooking the Gardon gorges N of Nîmes. Although this fortified native settlement has never been systematically explored, it has yielded an abundant and precious collection of artifacts, particularly pre-Roman ones.

One funerary bust of a helmeted warrior with engraved breastplate, and another of the torso of a seated figure, have been discovered at the village of Russan in the environs of Sainte-Anastasie, an area heavily populated in antiquity. These sculptures and all finds from the oppidum are in the Musée Archéologique in Nîmes.

BIBLIOGRAPHY. *Carte archéologique de la Gaule romaine*, fasc. VIII, Gard (1941) 185-86, nos. 275-76; F. Benoit, *L'art primitif méditerranéen de la vallée du Rhône* (1955)[I]. G. BARRUOL

SANT'ANGELO IN FORMIS Italy. Map 17A. A sanctuary complex, Fanum Dianae Tifatinae, N of the Campanian lowlands, on the lower slopes of Mt. Tifata, not far from the Volturno. The site was inhabited between the end of the Bronze Age and the beginning of the Iron Age, as is shown by the existence of a cremation necropolis a short distance from the sanctuary. From literary and epigraphic notices, we learn that Sulla, following his victory over Norbanus in 83 B.C., donated to the precinct a part of the surrounding territory along with its springs. A Benedictine monastery was built on the site of the sanctuary in the 10th c.

Some architectural terracottas of the late 6th c. bear witness to an archaic phase; the votive material discovered in the second half of the 19th c. is not well known. We know the plan of a Hellenistic temple which, to judge from the molding on the lower part of the podium, must be dated to the 3d c. B.C. The temple is of the Etruscan-Italic type, with the cella flanked by open aisles, at least in front, while the flooring, some column bases, and enlargements date to a restoration that is recorded on a floor inscription of 74 B.C. The supporting works of the front terrace are dated by an inscription to 135 B.C.; the peribolos was restored at the beginning of the Imperial period. Beyond the enclosure are also preserved remains of a late Hellenistic bath complex, of another from the end of the 1st c. or first half of the 2d c. A.D., and various sepulchral monuments, some from the Republican period.

BIBLIOGRAPHY. J. Beloch, *Campanien* (2d ed. 1890) 361ff; A. de Franciscis, *Templum Dianae Tifatinae* (1956). W. JOHANNOWSKY

SANT'ANGELO MUXARO ("Kamikos") Sicily. Map 17B. A Sikan center (9th & 5th c.) ca. 20 km N of Agrigento on a high rocky hill that dominates the valley of the Platani river (fl. Halykos). The archaeological data derive exclusively from the finds in the necropolis since no excavation has been carried out in the area of the ancient settlement, which lies almost entirely under the modern village. It is, however, likely that the strong natural position of the hill conferred special strategic importance to the center, specifically in connection with Akragas' expansionistic policy on the Platani valley.

The necropolis includes a series of tombs in the shape of small artificial grottos dug into the W and S slopes of the mountain. The earlier graves lie at the foot of the rock and are dated to the 9th c. B.C. by the types of bronze objects found in them. More important, however, are the round tombs, on the slope of the hill, which differ from other Sicilian graves of this general type not only because of the inclusion of a second funerary chamber, but also for their considerable size and their domed roofs, which recall the architectural conception of the great Mycenaean tholoi. The largest of these graves, the so-called grotto of Sant'Angelo, is 8 m in diameter and preserves all around a bench on which the corpses were laid. These tombs were used for multiple burials from the 8th to the 5th c. B.C. The funerary gifts range from the typical native ware with incised decoration to ware painted under the influence of Greek prototypes and fi-

nally to Greek pottery, either Attic or Corinthian. Of greatest interest are precious objects, such as two heavy gold rings with incised bezels, one showing a wolf, the other a cow suckling a calf, or some small gold bowls, of which the only one still extant (British Museum) is decorated with a frieze of cattle in relief. Except for this bowl, the finds from the Sant'Angelo Muxaro necropolis are housed in the Syracuse and Agrigento Museums. These precious objects are attributed by some to Cretan, by others to Cypro-Phoenician workshops of the 7th c. B.C. Because of the wealth attested by this jewelry and by the graves themselves, most scholars tend to identify the site with ancient Kamikos, the famous and impregnable citadel which Daidalos, according to the legend, built for the Sikan king Kokalos. This hypothesis is highly attractive and fairly plausible, but only a stratigraphic excavation in the habitation area can produce decisive evidence in its support.

BIBLIOGRAPHY. P. Orsi, *Atti Accademia Lettere, Scienza e Belle Arti di Palermo* 17 (1932) 1ff; P. Griffo, *Archivio Storico Sicilia Orientale* 7 (1954) 58ff; B. Pace, *ArchEph* (1953-54) 273ff; G. Pugliese Carratelli, *Kokalos* 2:2 (1956) 1ff; E. De Miro, *La Parola del Passato* 49 (1956) 271ff; L. Bernabo Brea, *Sicily before the Greeks* (Ancient Peoples and Places 3, London 1957) 177ff; G. Caputo, *La parola del Passato* 93 (1963) 401ff; Langlotz-Hirmer, *Die Kunst der Westgriechen* (1963) 13ff, 55.

P. ORLANDINI

SANT'ANGELO IN VADO, *see* TIFERNUM METAURENSE

SANT'ANTIOCO, *see* SULCIS

SAINT-AUBIN SUR GAILLON Dept. Eure, France. Map 23. Situated 93 km W-NW from Paris and 25 km from Evreux, at the edge of a plateau overlooking the left bank of the Seine, this was the site of a sanctuary in Gallo-Roman times.

Excavations carried out from 1910 to 1913 revealed small twin temples (fana) with their annexes. All these buildings stood in a large walled courtyard 80 x 58 m. Backed against the N wall was a rectangular building, 26 x 3 m; it was divided into six rooms, one of them a cellar 2 m deep reached by a flight of eight steps. The principal fanum in the middle of the courtyard consisted of a cella measuring 9 x 6.50 m and opening to the E. An altar was kept in the middle of the cella; steps faced with marble led up to it. Surrounding the cella was a concentric portico, 17.50 x 15.40 m, built on a raised floor and approached by a flight of steps. Twelve m to the S was the second fanum; smaller than the first (5 x 4.10 m), it was built with its back to the S face of the great surrounding wall. Between the main fanum and the N wall was a little two-room building of workmanlike construction. In the course of digging, several marble fragments were found; also sigillate pottery consisting of vases from Lezoux (2d c.) and Argonne (4th c.); a bronze tripod; mirrors, fibulae, and coins ranging from Claudius to Magnentius, as well as neolithic stone axes and fossils of sea-urchins.

Examination of the coins and pottery suggests that this place of worship was occupied from the 1st to the 4th c. No ruins can be seen today.

BIBLIOGRAPHY. Leon Coutil, "Les Ruines romaines de St Aubin sur Gaillon," *Journal d'Evreux* (18 Jan. 1911); G. Poulain, "Les fana de St Aubin sur Gaillon," *Bull. arch.* (1912) 403; id., "Le péribole du temple de St Aubin sur Gaillon," *Bull. de la Ste Normande d'Etudes prehist.* 31 (1913); id., *Les fana de St Aubin sur Gaillon* (1919). M. A. DOLLFUS

SAINT-AUBIN-SUR-MER Calvados, France. Map 23. A watering place on the English Channel, 16 km N of Caen. The shore, which faces N, is bordered to the W by a cliff about 8 m high, a headland known today as Cap Romain. The Saint-Aubin promontory was occupied well before the Romans came; various finds from the Paleolithic Age to the Bronze Age are evidence of a very ancient settlement. However, the site, which was covered by villas and hotels in the 19th c., was never systematically explored. During WW II a German soldier started excavations. The building of three blockhouses permitted the ground to be opened up but at the same time limited any real archaeological explorations. The site was thoroughly excavated only in part and in the face of great difficulties.

Below a cemetery of the Frankish period was a Gallic fanum dating from the beginning of the 2d c., along with its cult statue, as well as traces of an earlier Celtic sanctuary, a late Gallo-Roman villa built around the Gallic temple, and a bath building, perhaps belonging to the villa.

The excavations revealed the foundations of a square building 11 m on each side, surrounding a second structure, similar in shape but only 5 m on a side. The complex is oriented to the four points of the compass. The foundations are 0.7-0.9 m thick, and remains of a paved stone floor are still visible. The monument is a small temple similar to those in the Seine-Maritime. The only evidence for the date is a sherd of terra sigillata dating from the 2d c. A.D. To the E were some foundations, probably of an annex to the fanum.

The N wall of the fanum was later split open to make room for a well. Here, at a depth of 2.5-3.4 m, were found five fragments of a statue of a seated goddess with two children, one on either side; the statue is now at the Faculté des Lettres et Sciences Humaines at Caen.

Traces of a foundation trench oriented E-W were discovered under the Gallo-Roman fanum. Below the stone floor of the Gallo-Roman temple were found some broken foundation stones and a great quantity of charcoal. These belonged to a structure earlier than the fanum; there is no indication as to its purpose since the foundations were destroyed when the fanum was built. However, the fact that religious monuments tend to be erected in the same places suggests that it is a very old religious building. Whether the fanum was isolated or connected to a settlement we do not know.

A complex of structures was found near the sanctuary, but they belong to the end of the 3d c. A.D.: a villa rustica with two towers connected by a gallery, and with a great hall in the rear. It was built in two stages: the first complex was put up in the second half of the 3d c., and it was then that the well was added where the fragments of the statue were found. Towards the end of the 4th c. (as evidenced by coins of Constantine and Valerius) the villa was completed by two symmetrical towers joined by a gallery-facade. The foundations of the building, 11 m square, were well built; portions of the vertical section were still standing. The floor was paved with mosaic. Two rectangular annexes containing furnaces have been uncovered to E and W. A paved pathway led from the bath building to the well. Two apses were added to this complex, probably when the villa was redesigned at the end of the 4th c.

When the villa was destroyed (exact date unknown) the site was not abandoned. The discovery of Merovingian tombs in a number of places proves that it continued to be occupied.

BIBLIOGRAPHY. De Vesly, *Les fana ou petits temples gallo-romains de la région normande* (1909); E. Eblé,

"Découvertes à Saint-Aubin-sur-Mer," *Gallia* 6, 2 (1948) 365-83[PI]; H. Van Effenterre, "Saint-Aubin-sur-Mer," ibid. 9 (1951) 83-84; R. Lantier, "Recherches Archéologiques en Gaule en 1950," ibid. 10 (1952) 119-20.

C. PILET

SAINT-BÉAT Haute-Garonne, France. Map 23. On both banks of the Garonne the white marbles of the Montagne d'Arrie and the dun-colored marbles of the Pène Saint-Martin were exploited on a large scale during the Roman Empire. Remains of the ancient quarries are still visible. At La Mailh de las Figuras an abandoned quarry face was transformed into a cliff sanctuary dedicated to Silvanus and to the local god Erriapus.

BIBLIOGRAPHY. B. Sapène, "Autels votifs, ateliers de marbriers et sanctuaire gallo-romains découverts à Saint-Béat en 1946," *Rev. de Comminges* 69 (1946) 283-325 & figs. 1-20; M. Labrousse, "Un sanctuaire rupestre gallo-romain dans les Pyrénées," in *Mélanges Charles Picard* (1948) 481-521; Espérandieu-Lantier, *Recueil . . .* 13 (1949) 14-15 & pls. XVIII-XIX, nos. 8119-25; P. Wuilleumier, *Inscriptions latines des Trois Gaules* (1963) 1-10, nos. 2-30.

M. LABROUSSE

SAINT-BEAUZELY Aveyron, France. Map 23. Remains of ancient mine workings were identified near Azinières in 1961. They are dated to the 1st c. A.D. by terra sigillata from La Graufesenque. Their purpose must have been to find copper, lead, or silver.

BIBLIOGRAPHY. L. Balsan, "Nouvelles découvertes d' exploitations minières gallo-romaines dans la région de Millau," *P.V. de la Soc. des Lettres de l'Aveyron* 38 (1959-62) 254-56; cf. M. Labrousse in *Gallia* 20 (1962) 554.

M. LABROUSSE

SAN BENEDETTO DEI MARSI, *see* MARRUVIUM

SAINT-BERTRAND-DE-COMMINGES, *see* LUGDUNUM CONVENARUM

SAINT-BLAISE Bouches-du-Rhône, France. Map 23. Saint-Blaise is the name of a present-day chapel built on a site that was, in turn, a protohistoric oppidum (possibly called Mastramela, cf. Plin. *HN* 3.4.5; Festus Avienus, *Ora Mar.* v. 700-2), an early mediaeval city called Ugium, and finally a village, Castelveyre, destroyed in 1390. The site is at one end of an easily defended plateau which is protected on two sides by the Lavalduc and Citis lagoons; it has a commanding view of the area around the Etang de Berre, the Crau, and the approach to the Rhône.

Excavations (1935-69) produced some reused stelai and a tumulus of ashes, indicating that the site was occupied at a very early date, before the 7th c. B.C. From the 7th c. on, remains are plentiful—Etruscan amphorae and pottery (bucchero nero), potsherds of Rhodian origin (a skyphos with a bird, another with rosettes), followed after 600 by Massaliote imports or products (gray Phokaian and pseudo-Ionian ware with a wavy design). Fragments of a rampart in polygonal masonry and some very poor huts belong to this first phase. The simplicity of the settlement and the abundance of native ware make the argument for an early Massaliote occupation somewhat uncertain.

Little is known of the site in the 5th and 4th c. B.C.; some remains of a native sanctuary, which were found reused, may go back to this period. In the Hellenistic city the oppidum was fortified, probably in the 3d c. B.C., with a new rampart which barred approach to its accessible side for more than 1 km. Built of large blocks by Greek master masons (workmen's marks?), it was protected by a forewall, and had solid foundations, and merlons, exactly like Sicilian ramparts. Inside the rampart of the city was laid out more or less on a grid plan: streets paved with slabs, stone sidewalks, better designed houses, shops with dolia. Etrusco-Campanian ware, Hellenistic amphorae, and Marseille coins are well represented. At this time the city was more likely to be a Massaliote post, working the salt marshes in the region and controlling commercial traffic going towards the Rhône.

Stone balls have been found in a stratum of destroyed remains, evidence of a siege (not mentioned in the texts) which has been attributed to Caesar's campaign against Marseille. Marius' creation of the port of Fos and the digging of the Marian canal at the end of the 2d c. B.C. must have considerably reduced the importance of the town as well as its population.

After five centuries the abandoned site was occupied again. A rampart built of irregular quarry stones and poor mortar was built on the earlier Greek wall. The houses, extremely poor, yielded sherds of terra sigillata chiara D and gray stamped ware. Two churches and a rectangular building with an apse (civil basilica?) date from the 5th c. A document of 874 indicates that Ugium was destroyed by the barbarians. Archaeological finds are housed in a depot near the site.

BIBLIOGRAPHY. H. Rolland, "Fouilles de Saint-Blaise," *REA* 39 (1937) 111ff[PI]; id., "Chronologie des fouilles dans la basse vallée du Rhône," *REA* 45 (1943) 81ff; id., "Un problème de géographie antique: les fouilles de Saint-Blaise et la toponymie," *Latomus* 7, 3 (1948) 1ff; id., "A propos des fouilles de Saint-Blaise," *REA* 51 (1949) 83ff[I]; id., "Fouilles de Saint-Blaise," *Gallia* Suppl. 3 (1951) and Suppl. 7 (1956)[MPI]; "Informations," *Gallia* (1956-71) passim; F. Benoît, *Recherches sur l'hellénisation de la Gaule* (1965).

C. GOUDINEAU

SAINT BONNET-YZEURE Allier, France. Map 23. Site of a Gallo-Roman pottery active from the Augustan period to the end of the 2d c. A.D. At the beginning of the 1st c. the potters turned out imitations of Aco goblets and delicate black-glazed ware. At the end of the 1st c. A.D. they produced bowls with a lead glaze and modeled ware. Six kilns were found that produced well-turned delicate gray ware in the native tradition, as well as amphorae, hypocaust pipes, and ewers of coarse ware. In the middle of the 2d c. a little smooth and molded terra sigillata, influenced by Lezoux but of poor quality, was produced, along with white clay figurines and ordinary ware (clay pit, one potter's kiln, several dumps).

Imported terra sigillata from Lyon (Tiberian) and La Graufesenque (Nero-Flavian period) has also been found.

H. VERTET

SAINT-CLAIR-DU-RHÔNE Isère, France. Map 23. In Gallia Narbonensis. On the left bank of the Rhône was a Gallo-Roman vicus covering several ha. In the area known as Clarasson a quantity of tiles were unearthed and, at least 100 m from the site, enormous clay pits, suggesting that this was the site of the Clarianus workshops, which flooded the W Empire with their products. There is also a villa with mosaics and floors of opus-signinum of the Glanum type.

BIBLIOGRAPHY. M. Leglay, "Informations," *Gallia* 26 (1968) 586-88; 29 (1971) 427.

M. LEGLAY

SAINT-CLAR Gers, France. Map 23. 1. On the plateau of Frans and Empourruche have been found the remains

of a rich Gallo-Roman villa and of a monumental tomb decorated with statues and bas-reliefs.

2. At La Bénazide in 1964 and 1965, another, more modest villa has been excavated. It was occupied from the 2d to the 5th c. A.D., and was later turned into a cemetery. A Gallo-Roman limestone head of Celtic manufacture comes from a nearby field.

BIBLIOGRAPHY. Y. Le Moal, "Les fouilles du tombeau gallo-romain d'Empourruche," Bull. de la Soc. arch. du Gers 59 (1958) 537-49; M. Labrousse in Gallia 12 (1954) 224 & fig. 15; 13 (1955) 214 & fig. 14; 15 (1957) 270-71 & figs. 15-16; 17 (1959) 417-19 & figs. 8-9; Espérandieu-Lantier in Recueil . . . 15 (1966) 62-63 & pls. L-LI, nos. 8908-12.

2. M. Labrousse in Gallia 22 (1964) 456; 24 (1966) 438-39 & figs. 30-31.　　　　　　　　M. LABROUSSE

SAINTE-COLOMBE　　Gironde, France. Map 23. A Gallo-Roman villa first noted in 1843 (mosaic), excavated in part in 1884-85, and again explored in 1963-66. The construction is regular, a core of mortared rubble faced with small blocks. The excavated area (60 x 20 m) represents the S wing of the complex. The W half of this wing, which is largely covered by the village church, contained two geometric mosaics (lozenges bordered with cable moldings). The E half belongs to the artisans' quarter; four tiled basins (3.5 x 1.5 m; 1.5 x 1.5 m) set on two levels connect with each other and empty into a drain made of tiles. A small cup at the bottom of each one allowed them to be drained completely. These basins, which were watertight, are similar in size and construction technique to those uncovered in Gironde (Loubens, Bagas, Merignas, Cadillac), Dordogne (Montcaret, Allas-les-Mines), and Charente, and apparently were part of a wine-making installation. The excavated remains date from the 4th c., but must have an Early Empire stratum below them. The site was filled in again in 1966.

BIBLIOGRAPHY. R. Guinodie, Compte-rendu de la Commission des Monuments Historiques (1843) 19; J. Coupry, "Informations," Gallia 23, 2 (1965) 421-22[PI]; 25, 2 (1967) 342[I]; R. Coste, "Fouilles gallo-romaines à Sainte-Colombe," Revue Historique et Archéologique du Libournais 127 (1968) 18-20[PI]; 133 (1969) 93-104; 134 (1969) 113-28.　　　　　　　　M. GAUTHIER

SAINT-CYR-SUR-MER　　Var, France. Map 23. The resort of Les Lecques (commune of Saint-Cyr), located between La Ciotat (Citharista) and Toulon (Telo Martius), has been identified as the Massaliot settlement of Tauroention, but the remains found in situ are no earlier than the Roman occupation. Essentially the site consists of a very large villa, excavated in the 18th c. It included a long portico overlooking the sea, with corner pavilions, several suites of rooms rising tier upon tier over several levels, a peristyle, basins, and appended establishments such as a potter's kiln. A necropolis, located nearby, has produced a tomb with two stories. A museum has been installed in rooms of the villa adorned with mosaics of the 1st c. A.D. Architectural fragments are collected there as well as pottery from private collections, notably Greek vases of Italian provenience.

BIBLIOGRAPHY. E. Duprat, Tauroentum (1935); F. Benoît, "Chronique arch.," Gallia (1950); Gallia (1971, 1973).　　　　　　　　C. GOUDINEAU

SAINT-DENIS, see CATULLIACUS

SAINT-DENIS-LÈS-MARTEL and VAYRAC, see UXELLODUNUM

SAINT-DIÉ　　Vosges, France. Map 23. A Gallo-Roman settlement, no doubt of commercial character, existed on the site of the modern town, on the left bank of the Meurthe at the crossroads of several routes traversing the Vosges range. The ancient remains collected by the local museum during the 19th c. were destroyed in the fire which devastated the town in 1944. The museum is being rebuilt.

Since 1964 systematic excavations have been under way on a blocked-off projecting ridge in the mountainous massif of La Bure, ca. 4.5 km from the center of Saint-Dié as the crow flies. The site could simultaneously control the routes of communication and protect mining installations. In the period of Gallic independence it was used as an oppidum; it later became a place of cult and refuge for the Gallo-Romans. The Gallo-Roman rampart, whose final construction seems to date to the 4th c., made use, among other materials, of large sculptured pieces which apparently date to the 2d c., and in particular of funerary stelae, occasionally complete. Other pieces of sculpture were found scattered in the talus and ditch. Inside the oppidum a number of cisterns have been discovered; they seem to have been linked to native cults. One has yielded an inscription dedicated to the Dianas (Dianis); near another, sculptures were found which evidently belong to groups of a snake-footed riding god.

BIBLIOGRAPHY. M. Toussaint, Répertoire archéologique Vosges (1948) 148-50; Bull. de la Soc. Philomatique Vosgienne 68 (1964-65ff)[MPI]; R. Billoret in Gallia 24 (1966); 26 (1968); 28 (1970)[PI]; 30 (1972).
　　　　　　　　R. BILLORET

SAINT-DIONISY, see NAGES

SAINT-DIZIER　　Haute-Marne, France. Map 23. Sarcophagi containing a variety of burial gifts have been discovered on the left bank of the Marne; also a house, one wall of which has been explored for a considerable length. The house included a cold pool and a caldarium. The finds are diverse (metal and bone objects, pottery from different sources, a bronze statuette, and coins) and indicate occupation lasting from the 1st or 2d c. A.D. to the 5th c., possibly with interruptions.

On the banks of the Marne, 3 km to the S, arms and Roman coins of the 1st c. A.D. have been found; in another section, a number of pottery bowls and some silver coins of Caletedu. The town itself has yielded some Merovingian sarcophagi and, especially to the W at Saint-Dizier-Hoericourt, a sizable necropolis of the 5th-6th c. built on the site of some Gallo-Roman inhumation tombs. The finds are in the Saint-Dizier museum.

BIBLIOGRAPHY. P. Ballet, La Haute Marne antique (2d ed. 1971) 155f, 294-96; L. Lepage, Mém. Soc. des Lettres de Saint-Dizier 1 (1967) 18-25; E. Frézouls, Gallia 25 (1967) 296[PI]; 27 (1969) 315; 29 (1971) 308f[I].
　　　　　　　　E. FRÉZOULS

SANTA EULALIA DE BOVEDA　　Lugo, Spain. Map 19. A town 16 km from Lugo, where a square underground building divided into three aisles covered by a barrel vault was discovered. On the outer walls are preserved, although in bad condition, reliefs of what seem to be dancing human figures. The interior is decorated with frescos covering the vault and elsewhere with representations of birds, roosters, ducks, and doves.

The paintings and the building as a whole may date from the end of the 3d c. A.D., or perhaps the 4th or 5th c. Eastern influences have been suggested. From a fragment of a stele bearing an inscription and from the fragment of the edge of a pool inside the building, it is believed that this may have been a nymphaeum; the waters in this area had a medicinal value.

BIBLIOGRAPHY. M. Chamoso Lamas, "Sobre el origen del Monumento soterrado de Sta. Eulalia de Bóveda (Lugo)," Cuadernos de Estudios Gallegos 22 (1952) 231-51; M. G. Moreno, Miscaláneas I (1949) 415ff; H. Schlunk, Sta. Eulalia de Bóveda, Das Siebenle Jahrzehnt für A. Goldschmidt (1935) 1-13. J. ARCE

SAINTE-EULALIE-DE-CERNON Aveyron, France. Map 23. A small Gallo-Roman sanctuary on the Puech Caut (elev. 861 m), on the edge of the Larzac plateau, excavated from 1960 to 1963. It includes an enclosure (32-35 m square) and a rectangular cella (7.5 x 5.4 m). The artifacts recovered include a sheet-bronze patera with handles decorated with swans' necks, 15 coins ranging from a small Massaliot bronze with a goring bull to a middle-sized bronze of Faustinus II, and a large amount of La Graufesenque terra sigillata.

BIBLIOGRAPHY. A. Soutou, "La patère à têtes de cygne du temple gallo-romain de Puech Caut," Ogam 14 (1962) 393-406ᴵ; id., "Trois sites gallo-romains du Rouergue: I, Le temple de Puech Caut," Gallia 25 (1967) 111-27ᴵ.
M. LABROUSSE

SAINT-FREGANT Finistère, France. Map 23. Excavations on the site of Keradennec in the commune of St-Fregant have disclosed the SE corner of a building, most of it taken up by small private baths. These consisted of a caldarium with hypocaust, with a terracotta bath inside it. Little pipes running both horizontally and vertically along the walls were, like the hypocaust, connected to a praefurnium by an arched opening. Adjoining the caldarium is a large square room with a brick bath in the SE corner that was supplied with cold water by a small pipe. Completing the complex was a vestibule and another room of undetermined function.

The walls of the cold room and vestibule were covered with painted stucco, showing a series of fluted columns with Corinthian capitals joined by arcades. Stratigraphical studies show that this part of the site was occupied from the end of the 2d to the 4th c. A.D. The finds, mostly potsherds and frescos, are housed in the archaeological laboratory of the Faculté des Lettres de Brest.

BIBLIOGRAPHY. R. Sanquer & P. Galliou, "Le château gallo-romain de Keradennec en St Fregant," Annales de Bretagne 77, 1 (1970).
M. PETIT

SAINT-GENCE Dept. Haute Vienne, France. Map 23. Prehistoric earthwork oppidum that covers ca. 6 ha, situated E of the village. Over the years chance finds have revealed quantities of Graeco-Italian amphorae dating from the 1st c. B.C. These can be seen at the town hall of Saint-Gence.

BIBLIOGRAPHY. "Fouilles de sauvetage de St. Gence," Rev. Arch. du Centre (1969) 24.
P. DUPUY

SAINT-GERMAIN-D'ESTEUIL ("Noviomagus") Gironde, France. Map 23. Situated on the S bank of the Gironde estuary, and probably one of the two cities of the Bituriges Vivisques mentioned by Ptolemy, the other being Burdigala (Bordeaux). It lies on the Roman road linking Bordeaux to Verdon (Dumnotonus) by way of the Médoc. Founded in the 1st c. A.D., the city probably started to decline at the end of the 2d c. when Burdigala became the chief city of Aquitania, and it disappeared almost completely in the wake of the 276 invasion. The remains, noted 1865, occupy at least 50 ha, and are spread over the high points of the area; the low sections correspond to a gulf, now filled in, which may have served as a port in the Roman period. Some walls, built of mortared rubble faced with small blocks, have been located over the whole site, but the chief excavated remains are on the Brion mound (600 x 250 m). The only building to have been identified is a theater (outer diam. 58 m) discovered in 1967. The hemicycle of the cavea was studied, along with some of the radiating walls, which support the tiers, and a section of a rampart arch which had the same function. An entrance was also located.

BIBLIOGRAPHY. L. Drouyn, La Guienne militaire I (1865) XCIII, XCV; R. Coustet, Rev. Hist. de Bordeaux et de la Gironde 13 (1964) 5, 11; J. Coupry, "Informations," Gallia 25, 2 (1967) 329fᴾᴵ.
M. GAUTHIER

SAINT-GERMAIN-SOURCES-SEINE, see SEQUANA

SAINT-GILLES Estate of Espeyran, Gard, France. Map 23. Important pre-Roman and Gallo-Roman settlement situated along what was formerly the westernmost arm of the Rhône, near the Étang de Scamandre at the locality called L'Argentière. It is virtually unexplored to date, but excavation would be amply rewarded. Recent magnetic prospecting over the whole of the site, and stratigraphic soundings in the center of the tell, have shown that the site was occupied from the 6th c. B.C. to the Roman era. It has already yielded numerous ceramics, both pre-Roman and Gallo-Roman, as well as a Gallo-Greek inscription, votive and funerary Roman inscriptions, a coin hoard, and Roman tombs. There is an archaeological collection nearby at the château of Espeyran.

BIBLIOGRAPHY. Carte Archéologique de la Gaule romaine, fasc. VIII, Gard (1941) 9-10, no. 21; "Informations," Gallia 20 (1962) 636; 29 (1971) 400.
G. BARRUOL

SAN GIOVANNI, see ARMENTO

SAN GIOVANNI DI SINIS, see THARROS (Sardinia)

SAN GIOVENALE Italy. Map 16. Minor Etruscan town 72 km NW of Rome near the river Vesca. The acropolis is an isolated tufa plateau, ca. 600 m long, surrounded by deep ravines. The site was inhabited in pre-Etruscan times as is shown by the finds of material of the Apennine Bronze Age culture datable ca. 1200-800 B.C. and by the discovery of oval huts of the Iron Age datable in the 8th and the 7th c. B.C. The earliest Etruscan buildings are from ca. 625-600. The town flourished in the 6th and the 5th c. The ancient name of the site is not known. It has been suggested that it is to be identified either with Cortuosa or with Contenebra, two strongholds at the S border of the territory of Tarquinia, captured by the Romans in 388 B.C. (Livy 4.4). During the following centuries, under Roman rule, the acropolis was abandoned. A great number of farms, among them the so-called Villa Sambuco were erected in the environs in the 2d c. B.C. and later. A castle was built on the hill in the 13th c. A.D.

The excavations, in the years 1956-65, have shed light above all on the domestic architecture of central Italy during the archaic period. The houses were built with walls of tufa ashlars or were half-timbered and usually contained two or three rooms. A two-room house, dated ca. 600, has benches of pebbles along the walls of the inner room and is reminiscent of the Tomba della Capanna at Cerveteri. The city plan was irregular. A cluster of houses uncovered in the area named the Borgo is probably typical of the minor settlements of this period in central Etruria. The city wall of tufa blocks was probably erected in the early 4th c. B.C., shortly before the Roman conquest of this region of Etruria. The acropolis is surrounded by large necropoleis of rock-cut chamber tombs: Porzarago and La Staffa to

the N, Valle Vesca and Pietrisco to the E, Castellina Camerata to the S, Grotte Tufarine to the W.

BIBLIOGRAPHY. O. Rispoli, "Bieda," *NSc* 1 (1877) 467ff; E. Berggren, "San Giovenale," *NSc* 16 (1960) 1ff; A. Boëthius et al., *Etruscan Culture* (1962); B. Blomé, "Un inedito insediamento arcaico etrusco in San Giovenale," *Paladio* 1-4 (1969) 139ff.

Of the final publication *Results of Excavations Conducted by the Swedish Institute at Rome and the Soprintendenza alle Antichità dell'Etruria Meridionale* (*Acta Instituti Romani Regni Sueciae* 4, XXVI), Vol. I is in print (1972): Topographical introduction and history of excavations. Photogrammetric methods and survey. Tombs.

C. E. ÖSTENBERG

SAINT-HERMENTAIRE, *see* DRAGUIGNAN

SAINT-JEAN D'AUBRIGOUX Haute-Loire, France. Map 23. A Gallo-Roman site 30 km N of Saint-Paulien (Ruessio), apparently occupied from at least the 1st c. B.C. on.

A Gallo-Roman building has been uncovered, dating probably from the 1st-2d c. A.D., in the area known as La Fontboine. Its purpose has not yet been determined. The building, only the foundations of which have been preserved, is rectangular (11.5 x 7.8 m) and divided into three compartments by two crosswalls at right angles to each other. Remains of brick paving have been found in two of the compartments, at different levels.

BIBLIOGRAPHY. C. Vatin, *Gallia* 25 (1967) 304-5[P].

J. C. POURSAT

SAINT-JEAN-DE-VERGES Arièges, France. Map 23. On the top of the Tour d'Opio, which dominates the valley of the Ariège, excavations have revealed several 1st c. B.C. hut floors within retrenchments built of dry stone at various times. There were many more Gallo-Roman dwellings on the slopes and on the plain. A fanum has been found on the N.

BIBLIOGRAPHY. M. T. Maris, "Vestiges gallo-romains à Saint-Jean-de-Verges," *Bull. de la Soc. ariégeoise des Sciences, Lettres et Arts* 25 (1969) 97-111; cf. M. Labrousse in *Gallia* 20 (1962) 427; 24 (1966) 411; 28 (1970) 397.

M. LABROUSSE

SAINT-JEAN LE VIEUX, *see* IMUS PYRENAEUS

SAINT-JUST-PEPIRON Charente-Maritime, France. Map 23. Excavations at Pepiron (commune of Saint-Just, near Marennes in Charente-Maritime) have brought to light the remains of a villa rustica. It was built on the S flank of an anticline separating the marshes of Brouage and La Seudre. It is located about 30 km as the crow flies from Saintes (Mediolanum Santonum), which in the 1st c. was the capital of the province of Aquitaine.

The country of the Santoni was thickly settled at the end of Gallic independence. Many Gallo-Roman establishments have been noted along the seashore or the edges of the littoral marshes. They are revealed by foundations or simply by a concentration of potsherds or coins. In very few have excavations or test trenches been made.

The villa of Pepiron has been partially brought to light during the course of eight successive seasons of excavation from 1960 to 1968. The plan of the foundations shows a rather classical arrangement. The patron's house and its dependencies were set around a central court at least 150 x 30 m wide. It is orientated E-W along the long axis. Only the buildings on the S side

have been completely investigated. Only limited test trenches have been made in other parts of the villa.

The patron's house was located in the NW corner. Only a group of foundations and some bare walls very carefully built of ashlar masonry survive. The whole included baths and some rooms heated by a hypocaust. It covered only the small area of 21 x 10 m. To the N was a garden enclosed by a hemicycle with a radius of 8 m. A covered drain ran all along the N wall and crossed the garden diagonally before spilling into a cesspool on the outside. The very compact network of the foundations and the reuse of hewn stones faced with ashlar indicate that there was remodeling during the long occupation of the site. There are indications of a certain concern for comfort: remains of a praefurnium; underground heating channels; a hypocaust whose small piers still stand to a height of 0.40 m (the debris of its suspensura littered the ground); another praefurnium near the remains of a small semicircular swimming pool. A degree of artistic elaboration is indicated by polychrome painted plastering and fragments of relief stucco scroll ornaments, statues, and stone moldings. The dependencies continued to the E. Most of their shallow foundations consisted of dry stone walling.

Abundant finds were made during the excavations: jewelry, coins, tools, various artifacts of metal, bone, wood, etc., and quantities of potsherds. Terra sigillata and Early Christian pottery indicate that the site was occupied throughout the Gallo-Roman period. Study of the kitchen refuse has shed some light on stockraising, agricultural production, and diet.

Finds from the excavations are in the archaeological museum of the Société de Géographie de Rochefort.

BIBLIOGRAPHY. Robert Fontaine, "Le site gallo-romain de Pepiron: Roccafortis," *Bull. Soc. de Geo. de Rochefort*, nos. 4-10, 12 (1961-67); C. Gabet, "La céramique recueillie à Pepiron," *Gallia* 27.1 (1969) 45-70; id., "L'habitat gallo-romain entre la basse Charente et la Seudre," *Celticum* 9 (1963) 239, 245[MPI].

C. GABET

SAINT-LÉGER-SOUS-BRIENNE Aube, France. Map 23. Gallo-Roman villa E of Troyes in Champagne, near the Langres-Reims road (milestone from the Severan period). The villa walls, which are much broken down, were decorated with marble facings, frescos, and mosaics. Local and imported pottery, from La Villeneuve-au-Chatelot, Argonne, and the Rhineland, have been found on the site.

BIBLIOGRAPHY. E. Frézouls, *Gallia* 25 (1967) 280[I]; 27 (1969) 299; 29 (1971) 289.

E. FRÉZOULS

SAINT-LÉOMER Vienne, France. Map 23. The Gallo-Roman sanctuary discovered in 1964 at the place called Masamas in the commune of Saint-Léomer is at the boundary of the cities of the Pictavi, the Bituriges Cubi, and the Lemovices. It consists of a rectangular peribolos (39 x 54 m), oriented E-W and built of small blocks pointed with iron. The entrance, on the short side, consists of a large N-S gallery and an axial passage; the foundations of early and late walls can be discerned.

In the W half of the sacred enclosure stood twin temples, separate and built with similar masonry. Their walls suggest a Classical plan, prostyle perhaps, with a podium and steps; the whole measured 14.25 by 7.5 m, and the walls were ca. 7.5 m high. Little has been found above the foundations: a cornice angle with cyma and terracotta antefixes decorated with gorgons with snakelocks. At a

later date the pronaos of the S temple was spoiled by an oblique construction. Outside the peribolos have been found the remains of walls with the same orientation and doubtless of the same date. The artifacts are poor: fragments of statues of a seated goddess and a naked ephebe, terra sigillata and common ware of the 1st-3d c. The presence of Gallic sherds indicates pre-Roman occupation of the site, but the construction of temple and peribolos dates from the 1st c. A.D. The later buildings probably date from a reoccupation of the site in the 3d c. Masamas is similar to numerous rural sanctuaries in frontier zones, which normally include other buildings, such as a theater, bath building, and forum, not yet found here.

BIBLIOGRAPHY. *Gallia* 23 (1965) 376-77; 25 (1967) 265; 27 (1969) 282-84; 29 (1971) 273, 276; F. Reix et al., "Les fouilles de la commune de St Léomer à Masamas," *Bulletin de la Société des Antiquaires de l'Ouest* (1968) 565-70. G. NICOLINI

SAINT-LEU, *see* PORTUS MAGNUS

SAINT-LEZER Hautes-Pyrénées, France. Map 23. The oppidum of Saint-Lezer is enclosed by a rampart of Roman date. Some consider it the first capital of the "city" of Begorra. Since 1956 new investigations have been conducted on the site. These have led to better knowledge of the ramparts and of the stratigraphy of the settlement, to the survey of a funerary mole, and to numerous individual finds, especially pottery, and a funerary head in white Saint-Béat marble.

BIBLIOGRAPHY. R. Coquerel, "Recherches archéologiques sur les vestiges antiques de Saint-Lézer. Campagnes de fouilles de 1956-1959 . . . ," *Ogam* 16 (1964) 51-76; cf. M. Labrousse in *Gallia* 15 (1957) 267; 17 (1959) 438-40 & figs. 37-38; 20 (1962) 596-97; 26 (1968) 552. M. LABROUSSE

SAN LIBERATO, *see* FORUM CLODII

SAINT-LIZIER, *see* CONSORANNI

SAINT-LOUP-DE-COMMINGES Haute-Garonne, France. Map 23. On a slope dominating the Gesse, the remains of a Gallo-Roman establishment were excavated in 1947. Apparently it was occupied from the end of the 3d to the 5th c. A.D. In it were found carved ivories, Alexandrian products of the 3d or 4th c. These are now on exhibit at the museum of Saint-Germain.

BIBLIOGRAPHY. G. Fouet & M. Labrousse, "Thermes et édifices romains de Saint-Loup-de-Comminges," *Gallia* 7 (1949) 32-39 & figs. 9-22; id., "Ivoires romains trouvés à Saint-Loup-de-Comminges," *C.R.A.I.* (1950) 147-53; id., *Monuments Piot* 46 (1952) 117-29; Espérandieu-Lantier, *Recueil . . .* 15 (1966) pls. XLVII-XLVIII, nos. 8876-88. M. LABROUSSE

SAN MARCO DI ALUNZIO, *see* HALONTION

SAINT-MARD, *see* VERTUNUM

SANTA MARIA A POTENZA, *see* POTENTIA

SANTA MARIA CAPUA VETERE, *see* CAPUA

SANTA MARIA DI FALLERI, *see* FALERII NOVI

SANTA MARINELLA, *see* PUNICUM

SAINT MARTORY, *see* CALAGURRIS CONVENARUM

SAINT-MAURICE-LES-CHÂTEAUNEUF Loire, France. Map 23. An ancient site in the Sornin valley occupied in the 1st-2d c. A.D. Finds include a fragment of a stone statue representing a sun (or moon) figure with an eagle above; below the figure are a boar and two domestic animals. Excavations have yielded tiles, and sherds of sigillata and everyday ware.

BIBLIOGRAPHY. C. Chopelin, "L'implantation gallo-romaine dans la vallée du Sornin (Loire)," *Ogam* 15 (1963) 343. M. LEGLAY

ST-MICHIELSGESTEL N Brabant, Netherlands. Map 21. Many Roman remains have come to light in the hamlet of Halder near St-Michielsgestel: coins, pottery, glass, tiles, and slag, indicating that some kind of settlement existed here ca. A.D. 50-270. No traces of houses have been found as yet, but seven wells with wooden casings (oak and pitchpine) have been discovered. One well had a double square casing of ingenious construction. Iron slag and fragments of a crucible and of molds indicate that iron was smelted here, from the bog ore found in the vicinity. A square pit, lined with stakes and filled with loam, suggests the existence of a local pottery industry. As yet only one grave has been found: a square wooden chest, about 1.5 x 1.5 m, probably originally covered by a little tumulus of sods like the rich graves of Esch, a few km to the W. The grave dates from ca. A.D. 150. Much of the stamped pottery is of Flavian date and coins of Domitian are frequent. The end came in the second half of the 3d c.

Perhaps there is a connection with the treasure of some 4800 coins discovered at Vught, a little W of Halder, and hidden ca. A.D. 275. In the hamlet of Ruimel, St-Michielsgestel, two inscriptions were found in 1679, one a tombstone (now lost), the other a dedication to Hercules Magusanus by Flaus, son of Vihirmas, summus magistratus civitatis Batavorum (now in the Leiden museum). This does not prove that Ruimel belonged to the civitas Batavorum, as that civitas did not extend S of the Meuse, but there may have been a sanctuary of Hercules Magusanus at Ruimel. The Halder finds are in the Institute for the Deaf at St-Michielsgestel, and the Vught treasure in the Noordbrabants Museum at 's-Hertogenbosch.

BIBLIOGRAPHY. A. W. Byvanck, *Excerpta Romana* II (1935) 97-99; III (1947) 80-81; B. H. Stolte, "Hercules in Noord-Brabant. Verering te Ruimel(?) en Diessen," *Brabantia* 3 (1954) 50-53; J. E. Bogaers, "Civitas en stad van de Bataven en Canninefaten," *Ber. Rijksdienst Oud. Bod.* 10-11 (1960-61) 263-317 (English summary); id., *Niewsbull. Kon. Ned. Oud. Bond* (1962) 174-76; (1965) 53-56; (1966) 93-94; (1967) 57; (1968) 65-66; H. J. Kanters, "De Romeinse muntschat van Vught (Valerianus-Aurelianus)," *Jb. v. Munt- en Penningkunde* 52-53 (1965-66) 73-126. B. H. STOLTE

SAINTE NITASSE Dept. Yonne, France. Map 23. The name is a corruption of Saint Anastase. The site lies 2 km SE of Auxerre close by a spring. In 1966 salvaging work was done on villa rustica, since destroyed in the making of a sand-pit. The main part of the building was 80 x 100 m and was ringed with courtyards and a garden. Inside, it was divided into irregularly shaped rooms; wings were built onto its E facade. The plan of the building, and the objects found on the site, prove that the house was altered from the 2d to the 4th c., when it was finally abandoned. The ruins, the main elements of which had been recovered since antiquity, still served as a place of worship for the Merovingians. Traces of a prehistoric dwelling were also discovered

in the deepest strata: hearths, rough pottery, a disc bracelet of hard gray stone, and some Gallic coins.

BIBLIOGRAPHY. P. Richard, "Sainte Nitasse, Enigmatique appellation d'un 'climat' du territoire de la ville d'Auxerre," *Echo d'Auxerre*, no. 73 (Jan.-Feb. 1968) 31-33; J.-B. Devauges, "Notes sur les fragments de sculpture lapidaire d'époque gallo-romaine trouvés à Sainte Nitasse," *Echo d'Auxerre*, no. 74 (Mar.-Aug. 1968) 3-4. R. Martin, "Informations arch.," *Gallia*, 26.2 (1968) 506-8[P]. J.-B. DEVAUGES

SAINT-NIZIER-SOUS-CHARLIEU Loire, France. Map 23. An ancient site, known since 1884, in the Sornin valley at the place called Les Varennes. A Gallo-Roman villa, most of which has disappeared, has yielded an abundance of material: sigillata and everyday pottery, amphorae, painted vases of the Roanne type.

BIBLIOGRAPHY. P. Quoniam, "Informations," *Gallia* 19 (1961) 445; C. Chopelin, "L'implantation gallo-romaine dans la vallée du Sornin (Loire)," *Ogam* 15 (1963) 339-40; M. Leglay, "Informations," *Gallia* 29 (1971) 416. M. LEGLAY

SAN PANTATEO, *see* MOTYA

SAN PAOLO DI CIVITATE, *see* TEANUM APULUM

SAINT-PAUL-DE-LOUBRESSAC Lot, France. Map 23. Near Prousse a Gallo-Roman potter's kiln has been found. In the 4th c. it produced a gray or reddish stamped ware. The site had been occupied since the 1st c.

BIBLIOGRAPHY. Abbé Vialettes, "Saint-Paul-de-Loubressac: une sépulture du Ier siècle," *Bull. de la Soc. des Et. du Lot* 88 (1967) 213-19; G. Foucaud & Abbé Vialettes, "Saint-Paul-de-Loubressac: céramique gallo-romaine du IVe siècle," ibid. 223-27; cf. M. Labrousse in *Gallia* 22 (1964) 463 & fig. 46; 24 (1966) 442. M. LABROUSSE

SAINT-PAUL-LES-ROMANS Drôme, France. Map 23. A site in Gallia Narbonensis near Romans in the plain of the Isère. Between 1865 and 1956 fragments of mosaics were found here, as well as pottery, several hoards of coins, and two marble busts.

Since 1964 a large Gallo-Roman villa has been excavated, and the plan is beginning to emerge. Porticos lined three sides of an inner courtyard (80 x 23 m). A gutter encircles the portico, leading on the N side to a very long, rectangular pool (1.5 m wide) with a semicircular apsidal exedra. On the N side the portico is flanked by three rooms with mosaics, one showing the seasons, another Orpheus, and the third the Labors of Hercules. The E portico has four rooms on its outside wall, one is decorated with frescos, two have a hearth and hypocausts, and the fourth has a floor of monochrome white mosaic. To the S the gutter ends in a sewer. The villa dates from the 2d-3d c., but the site was occupied from the 2d c. B.C. to the 4th c.

The regional museum of Romans houses the principal finds; the mosaics are protected in situ.

BIBLIOGRAPHY. M. Vignard, "La villa gallo-romaine de Saint-Paul-lès-Romans (Drôme)," *Ogam* 17 (1965) 127-37; M. Leglay, "Informations," *Gallia* 24 (1966) 521-22; 26 (1968) 594-95; 29 (1971) 435. M. LEGLAY

SAINT-PAUL-LEZ-DURANCE Dept. Bouches du Rhône, France. Map 23. Remains of a Gallo-Roman villa are at the site known as Les Convents, up the river from the Mirabeau pass on a plateau overlooking the Durance. Excavations, still incomplete, have revealed a complex of walls built of regular coursed and mortared rubble. A small private bath consists of a praefurnium, a hot room with hypocaust, and a pool. Pottery finds date from between the 2d c. (La Graufesenque) and the 6th (gray-figured Early Christian ware). The villa appears to have been destroyed by fire, but a mediaeval structure was later built on part of these remains. J. DENEAUVE

SAN PAWL MILQI, *see* MELITA

SAINT-PÉ-D'ARDET Haute-Garonne, France. Map 23. The Church of Saint-Pé-d'Ardet was built on the site of a pagan sanctuary where Jupiter Optimus Maximus was worshiped along with the local divinities, Artahe and Idiatte, and the deified mountains. The sanctuary was surrounded by a necropolis which has produced many cremation graves.

BIBLIOGRAPHY. Espérandieu-Lantier, *Recueil* . . . (1949) XIII, nos. 8038, 8039, 8046, 8053, 8071; XV (1966) 51-52 & pl. XLV, nos. 8844-8850; G. Fouet, "Les monuments funéraires gallo-romaines de Saint-Pé-d'Ardet," *Actes du II Congrès International d'études pyrénéennes, Luchon et Pau* (1954) VI, sect. V, pp. 21-36; M. Labrousse, ibid., 5-19; id., "Nouvelle inscription romaine de Saint-Pé-d'Ardet," *Rev. de Comminges* 77 (1964) 49-57; id. in *Gallia* 22 (1964) 444; P. Wuilleumier, *Inscriptions latines des Trois Gaules* (1963) 11-13, nos. 36-40. M. LABROUSSE

ST. PETER IM HOLZ, *see* TEURNIA

SAINT PIERRE D'AURILLAC Gironde, France. Map 23. Gallo-Roman substructures below the choir of the present church. They consist of a room arched like a horseshoe (max. diam. 8.1 m), inside which were found a straight partition wall joined to the foundation and a floor made of a concrete of broken tiles on which stood two altar bases. The Early Christian church was made into a necropolis in the Merovingian period. At La Chapelle there is a Late Empire Gallo-Roman villa, with a number of walls made of a core of mortared rubble faced with small stones.

BIBLIOGRAPHY. J. Coupry, "Informations," *Gallia* 25, 2 (1967) 339-40[PI]. M. GAUTHIER

SAN PIETO, *see* SHIPWRECKS

SAINT-PLANCARD Haute-Garonne, France. Map 23. The Chapel of Saint-Jean, famous for its Romanesque frescos, was built on the site of a pagan sanctuary. This was dedicated to Jupiter Optimus Maximus and to the local god Suttugius, and was surrounded by a small necropolis.

BIBLIOGRAPHY. J. Laffargue & G. Fouet, *Peintures romanes. Vestiges gallo-romains à Saint-Plancard (Haute-Garonne)* (1948) 79-111; G. Fouet & M. Labrousse, "Sanctuaire et nécropole de Saint-Plancard," *Gallia* 7 (1949) 25-27; Espérandieu-Lantier, *Recueil* . . . (1949) XIII 16 & pls. XX-XXI, nos. 8127-31; P. Wuilleumier, *Inscriptions latines des Trois Gaules* (1963) 13-14, nos. 42-50. M. LABROUSSE

SANKT PÖLTEN, *see* CETIUM

SAINT-PRIEST-SOUS-AIXE Dept. Haute Vienne, France. Map 23. A Gallo-Roman dwelling, known locally as Chez Roger. Overlooking the valley of the Vienne, the site was excavated in part from 1946 to 1951, then again from 1961 to 1968. As a result, part of the foundations of a Gallo-Roman villa were uncovered. Only the two "arms" of the U-shaped structure have been excavated. Two heads of statues, in limestone, Doric capitals, columns, etc., suggest that the villa was fairly luxurious. Objects found on the site range from the beginning of the 2d c. A.D. to the middle of the 4th c.

BIBLIOGRAPHY. "Le site gallo-romain de 'Chez Roger,'" *Bull. de la Sahl* (1969) 41. P. DUPUY

SAINT-QUENTIN ("Augusta Vermanduorum") Aisne, France. Map 23. The origins of this city on the upper Somme are still little known, and it has been much debated as to whether Saint-Quentin or Vermand, ca. 9 km to the W, was the site of Augusta Vermanduorum.

It now seems more likely that Saint-Quentin was the Roman capital of the civitas Vermanduorum. The absence of any remains from the Gallic period suggests that the site had not been previously occupied, and only a few traces from the prehistoric period were discovered in the early 19th c. (quarries in Tombelles and Moulin Brûlé). As in the case of Pommiers and Soissons, Etrun and Arras, there is every reason to believe that the Veromandui, a small Gallic tribe living next to the Ambiani, the Remi, the Suessiones, and the Nervii (Pliny the Elder adds three more tribes, the Nemetes, Suecones, and Vangiones, about whom nothing is known), had their first capital city at Vermand, where the modern town lies over the center of the oppidum. Many finds were made in Vermand in the last century, in particular some rich tombs dating from the 4th c. A.D. (the grave gifts from one of these, gold jewelry and parade arms, are in the Metropolitan Museum); these finds in fact argued in favor of Vermand as the 4th c. chief city of the civitas. Recently, however, a complex of religious buildings, located by aerial photography, has been unearthed at the E exit of Vermand.

The only ancient sources that mention Saint-Quentin are the itineraries (Peutinger Table: road from Soissons to Cambrai; Antonine Itinerary: road from Thérouanne to Reims). These roads are well preserved, as are others not mentioned in the ancient texts. Thus Augusta Veromanduorum (the mediaeval quarter, Aouste, recalls the early name) was connected to Soissons, Reims, Arras, Beauvais, and Amiens; of links with the E, however, there is little evidence. Some believe that the road pattern represents a first settlement near Vermand and that the city was later rebuilt in the neighborhood of Saint-Quentin.

As with Cassel or Noyon, we know next to nothing about the ancient topography of Saint-Quentin or its evolution. The main body of evidence is based on 19th c. excavations although the first discovery was in the 17th c., when a huge Gallo-Roman necropolis containing close to 8000 tombs was found NE of the city. Two more necropoleis of lesser importance were located at the end of the 19th c., one in the suburb known as the Faubourg de l'Isle, the other to the E, at the Place Paringault. On the hypothesis that necropoleis were usually placed on the outskirts, it seems likely that the ancient city covered an area roughly equal to the center of the modern town, ca. 25 ha.

A few remains have been discovered in a section bounded by the Rue Villebois-Maroeul, Rue Emile Zola, Rue d'Aumale and Rue de l'Hôtel de Ville: some plans of square houses without porticos, and mosaics with geometric or animal designs. On the other hand there are no traces of the usual public monuments, no theater, forum, basilica, or odeum. The discovery at the collegiate church of a carved marble block representing Mercury and Vulcan has been interpreted as proof of a temple on this site. The block, which was built into one of the church pillars in the 19th c., was removed in 1917 and has since disappeared.

A cache of coins discovered in 1882 in the Rue des Bouloirs is the only evidence of the catastrophe that struck the city in the last quarter of the 3d c. A.D. The fact that no trace has been found of any Late Empire fortification at Saint-Quentin, whereas Vermand contains abundant evidence of 4th c. occupation, suggests that there was a transfer of administrative power. The only reference to Quentin's martyrdom (he was executed by Rictiovarus, a prefect of Maximian, in 287) is in a 12th c. text.

On the other hand, a church was built in the 4th c. on the site of the martyr's tomb, and pilgrims became numerous. After the church was destroyed in the barbarian invasions, St. Eloi placed St. Quentin's body in the collegiate church. Later, in the 9th c., a wall was built, enclosing not only the small market town which had grown up around the church, but also the settlements of Augusta and l'Isle. The only certain evidence of occupation in this period comes from a Merovingian cemetery on the site of the market.

Saint-Quentin has been destroyed several times and its archaeological collections dispersed. Some finds, however, are in the Musée Lecuyer and the Musée de la Société Académique.

BIBLIOGRAPHY. E. Lemaire, "Les problèmes de Saint Quentin et de Vermand," Mém. Soc. Académique de Saint Quentin 4, 1 (1878) 349f; T. Eck, Trouvailles faites à Saint Quentin (1879); id., Saint Quentin dans l'Antiquité et au Moyen Age (1881); E. Will, "Recherches sur le développement urbain sous l'empire romain dans le Nord de la France," Gallia 20, 1 (1962) 79-101M.
P. LEMAN

SAINT-RÉMY-DE-PROVENCE, see GLANON

SAINT RÉMY EN ROLLAT Allier, France. Map 23. A small pottery center near Vichy. Some workshops and a pottery dump have been excavated. The center is noted for its lead-glaze bowls found on the site: Aco-form goblets, unguentaria, skyphoi, and Drag. 29 cups, molded in white clay. It also produced white clay statuettes (Venus), oscilla (mold signed SEXTUS), modeled bowls, and andirons shaped like rams' heads, as well as ordinary ware. It flourished from the end of the 1st c. B.C. to the middle of the 1st c. A.D., and was probably most active in Tiberius' reign.

BIBLIOGRAPHY. J. Dechelette, "L'officine de St Rémy (Allier) et les origines de la poterie sigillée gallo-romaine," RA (1901) 360-94; H. Vertet, "Céramique commune de St Rémy en Rollat," Gallia 19 (1961) 218-26.
H. VERTET

SAINT RÉVÉRIEN, see CHAMPALLEMENT and COMPIERRE

SAINT-ROMAIN-DE-JALIONAS Isère, France. Map 23. A large, luxurious Gallo-Roman villa was found here in the 19th c. and has been excavated since 1967. This villa (ca. 300 x 250 m) was inhabited between the middle of the 1st c. B.C. and the 5th-6th c. A.D. A variety of objects was found: Arretine, La Graufesenque and Lezoux ware (2d-c. olla with graffiti in Latin and Greek), Allobrogian ware, painted wall coatings, marble plaques, coins, objects of bone and bronze.

BIBLIOGRAPHY. M. B. Lacroix, Histoire de Saint-Romain (1884); M. Leglay, "Informations," Gallia 26 (1968) 588-89; 29 (1971) 428.
M. LEGLAY

SAINT-ROMAN-LE-PUY Loire, France. Map 23. A settlement (walls, stone floors) has been located on the Chézieu site. To judge from the abundant material found there (pottery, fibulas, coins), it was inhabited from Iron Age III to the second half of the 2d c. A.D. Nearby are houses with mosaic floors (a mosaic of fish and inscriptions was discovered in the 19th c.). Among the houses is a pit that has yielded various kinds of pottery (sigillata, white, everyday ware), some 2d-c. coins, and a bracelet of pendant coins, one of them dating from the end of the Republic.

BIBLIOGRAPHY. M. Leglay, "Informations," Gallia 26 (1968) 567-68; 29 (1971) 415.
M. LEGLAY

SAINT-ROME-DE-CERNON Aveyron, France. Map 23. The cave of Sargel, probably occupied since the Neolithic Age, has yielded many artifacts of the Iron Age and Gallo-Roman periods (coins, fibulas, pottery, rings). These were offerings and attest the continuity of a cult which lasted at least until the 1st c. A.D.

BIBLIOGRAPHY. L. Balsan, "Spéléologie du département de l'Aveyron," *Mém. de la Soc. des Lettres de l'Aveyron* 26 (1946) 241-43, no. 452 (detailed bibl.); A. Albenque, *Inv. de l'archéologie gallo-romaine du département de l'Aveyron* (1947) 138-39, no. 398; A. Soutou, "La grotte-sanctuaire de Sargel," *Ogam* 18 (1966) 1-16.

M. LABROUSSE

SAN SALVATORE DI CABRAS Sardinia, Italy. Map 14. On the Sinis peninsula on the W coast of Sardinia, between the pool of Cabras and that of Mistras. The church of the same name is built in part on a hypogeum (10 m sq.) adapted as a pagan sanctuary in the age of Constantine. Oriented NE-SW, it is a cella trichora of two lateral rooms of elliptical plan flanking a semicircular room, all opening onto a circular atrium with a well at its center. The entire lower part is constructed of masonry with alternating courses of bricks and small sandstone blocks. The entrance corridor and the cellae and their apses are all vaulted, and the circular atrium is covered by a low dome with a central opening over the well; there are other small openings centered in the vaults of the other rooms.

Pictures and graffiti cover the interior walls. The incised inscriptions are in Roman cursive and some include Greek letters. Among the most common graffiti, aside from the inscriptions, are representations of ships, easily identifiable as Roman. The quality of the figural representations, traced in black, presumably in fresco, is uneven and difficult to place in time. The principal subjects, Aphrodite, Nymphs, Eros, and Hercules, are associated with the cult of water. Hercules Soter, the most important deity in the Classical pantheon and the one most closely associated with this vital element, has in effect been perpetuated in the later, Christian cult of San Salvatore. The style of the pictures and graffiti, as well as the plan of the building, suggests that the monument dates to about the middle of the 4th c. A.D. The building seems to have been in use for about a century and then, falling into oblivion during the mediaeval period, it was later reused in the construction above of a building adapted to the new cult.

BIBLIOGRAPHY. D. Levi, *GBA* 34 (1948) 17ff; id., *L'ipogeo di S. Salvatore di Cabras in Sardegna* (1949)MPI; id., *EAA* 6 (1965) 114ff. D. MANCONI

SANTO SEBASTIÃO DO FREIXO, *see* COLLIPO

SAINT-SERNIN-SUR-RANCE Aveyron, France. Map 23. At the Camp de l'Andel near Boutaran (where a menhir-statue was found in 1961), the ruins of a small building of dry stone construction was excavated in 1962-63. It consisted of two adjoining rooms and was probably a rustic temple built near a spring, perhaps as early as the middle of the 1st c. B.C.

BIBLIOGRAPHY. A. Soutou, "Trois sites gallo-romains du Rouergue: III, Le bâtiment cultuel du Camp de l'Andel," *Gallia* 25 (1967) 145-61I. Menhir-statue, cf. L. Balsan, *P.V. de la Soc. des Lettres de l'Aveyron* 38 (1959-62) 271-73; A. Soutou, "Le statue-menhir du camp de Landel," *Ogam* 16 (1964) 25-29.

M. LABROUSSE

SAINT SERVAN SUR MER, *see* ALETO

SAINT-THIBÉRY, *see* CESSERO

SAINT-THOMAS ("Bibrax") Aisne, France. Map 23. In the Laon arrondissement, canton of Sissonne. The commune of Saint-Thomas is known chiefly for its oppidum, called Camp des Romains, Vieux-Laon, or Camp de Saint-Thomas. Scholars have differed about this Gallic fort, mainly in connection with the location of Caesar's theater of operations against the Belgae (*BGall* 1.2.6) after he had crossed the Aisne. There have been a number of excavations and the ramparts, trenches, and central plateau are now being investigated.

The oppidum occupies the N of the commune, an area of ca. 32 ha; its highest point is at contour 206. It was built at one end of a plateau; a rampart oriented E-W bars access to it, and the other three sides were defended by the natural slopes of the spur, probably closed off with a palisade. Inside, the camp was divided into two parts by a rampart ca. 5 m high, oriented N-S; the larger part is known as Camp de César, the smaller as Cour Lévêque. The outer rampart was of the murus gallicus type: holes have been found where beams were placed horizontally to reinforce the rampart, along with big iron stakes. The structure of the transverse rampart is closer to the Belgian type: there is no trace of a murus gallicus but instead there is a flat trench with a path in front of it. The hypothesis that the transverse rampart was erected after the N one, which is of a later type of construction, is reinforced by the discovery of a post-Alesia coin of the Calauni. Many other Gallic coins have been found on the plateau surface along with sherds from Gallic potteries, but no other finds from the Roman era.

Recent arguments based on geography, topography, and toponymy claim that Saint-Thomas is Bibrax, the city of the Remi that Caesar conquered in A.D. 57. Various finds, chiefly flints, prove that the spur that the Gauls made into a fortress was occupied to some extent from early prehistory and its surface probably cleared in the Neolithic Age. Remarkably well preserved, the site has recently been classified.

BIBLIOGRAPHY. G. Lobjois, "L'Oppidum de Vieux Laon à Saint-Thomas (Aisne)," *Revue du Nord* 46, no. 181 (1964) 159-74; id., "Les fouilles de l'oppidum gaulois de Vieux Laon à Saint-Thomas (Aisne)," *Celticum* XV, *Actes du Vème colloque international d'Etudes Gauloises, Celtiques et protoceltiques* (1965); id., Suppl. *Ogam—Tradition Celtique* 106 (1966) 1-34; E. Will, "Informations archéologiques," *Gallia* 25, 2 (1967) 189.

P. LEMAN

ST-ULRICH Moselle, France. Map 23. In the commune of Dolving 4 km NW of Sarrebourg. A Gallo-Roman estate, the greater part of which is in the territory of Dolving, the rest in that of Haut-Clocher.

A large villa was excavated in 1894-97; 117 rooms were counted but the total is higher, as excavation was not complete. The villa consists of six sections, four living areas, one for baths, and an outlying building. The earlier plan is related to certain Pompeian villas; toward the Flavian period a new, more open construction called provincial was added on the S to the original. Deep excavations since 1968 have yielded pottery indicating a first settlement in the late Julio-Claudian period. Later changes included raising the level of the baths more than 1.8 m, probably towards the end of the 3d c.

The St-Ulrich estate was discovered only about 20 years ago, but 32 buildings have been found, besides the villa. In the W the remains appear to be covered with alluvial deposits; the excavated section, mostly in the

NE, covers some 100 ha. The St-Ulrich estate may be compared with that of Anthée, in the Belgian province of Namur, but the great villa of St-Ulrich stands on the W boundary, that at Anthée on the E. The buildings are arranged in a more orderly fashion at Anthée, aligned on two parallel lines starting from the villa, while those at St-Ulrich are scattered in a fan E of the main house. The Anthée estate was more or less industrial in character, while that of St-Ulrich was more occupied with agriculture and crafts: its purpose was to provide everything necessary to the life of the villa.

Three sites have been excavated since 1963. The first is a small villa 16 m square with two hypocausts, which apparently was occupied at three different periods. The second is a small native fanum dedicated to some god of the springs, a rectangular sanctuary (8.15 x 6.77 m) with one surrounding wall, also rectangular. The cella was simply a small shelter with a roof supported by four wooden posts. A votive gift had been placed in each post-hole (a coin or the skeleton of a small animal). Most of the potsherds found there come from ewers. Finally, a rectangular structure (24.7 x 10.5 m) was excavated; it, too, showed signs of three periods of occupation, the first two given over to agriculture, the last to crafts (forge). Pottery shows that the first stage dates from the late Julio-Claudian period. The building was abandoned in the 4th c., as was the small villa; the fanum was apparently used only in Trajan's reign and part of Hadrian's (coins and pottery).

The Sarrebourg museum has an archaeological collection.

BIBLIOGRAPHY. K. Wichmann, "Die römische Villa in St. Ulrich bei Saarburg i.L.," *Annuaire de la Sté d'Histoire et d'Archéologie de Lorraine* 10 (1898) 171ff; M. Lutz, "La région de la Haute-Sarre à l'époque romaine," ibid. 65 (1966) 14ff. M. LUTZ

SANTA VITÓRIA DO AMEIXIAL Alentejo, Portugal. Map 19.

Village between Estremoz and Sousel, site of a Roman villa of the 4th c. A.D. In the baths is a mosaic (ca. 10 x 7 m) representing the Rape of Europa, the Cortege of Amphitrite, and Odysseus with the Sirens. There are also various tabulae lusoriae and medallions representing the winds. This and other mosaics, some of the richest in Portugal, are in the National Museum of Archaeology in Lisbon. The urban section of the villa has been only partially excavated.

BIBLIOGRAPHY. L. Chaves, "A villa de Santa Vitoria do Ameixial (Concelho de Estremoz. Escavações em 1915-1916)," *O Archeologo Português* 30 (1938) 14-117MPI. J. ALARCÃO

SAN VITTORINO, see AMITERNUM

SAINTES, see MEDIOLANUM SANTONUM

SAITTAI (Sidas kale) W Anatolia. Map 7.

Situated between modern Demirci and Kula, on the N bank of Hermos (Gediz) and near the sacred stream Hyllos, which rises in the high mountains to the S of modern Simav. Cited at the Council of Constantinopolis (3.502) as Sitai and at the Council of Nicaea (2.521) as Setai, a non-Grecian place name. Today the ruins of the ancient city are called Sidas kale. Saittai was an autonomous city and on its coins the river gods Hyllos and Hermos were represented. In the city, the moon god Mên Akziottenos was honored, but Zeus, Dionysos, Aphrodite, Hygieia, Asklepios, Apollo, Kybele, and Herakles were also revered. In the Christian era Saittai was attached to the Archbishopric of Sardeis. The site has not been excavated.

BIBLIOGRAPHY. W. M. Ramsay, *Historical Geography of Asia Minor* (1890) 121, 148f; Bürchner, *RE* ia (1920) 1767. U. SERDAROĞLU

SALA (Rabat) Morocco. Map 19.

Ancient city of W Mauretania, 88 km NE of Casablanca. Its ruins have been located SE of Rabat in the Merinid ribat at Chellah and just beside it. Frequently mentioned by the ancient writers from Pomponius Mela to the *Notitia Dignitatum*, its name is confirmed by inscriptions found during excavation.

The city lay some 4 km from the sea, on the left bank of the wadi Bou Regreg—Pliny's flumen Salat (*HN* 5.9). It rose in successive levels from an ancient abandoned loop of the river, where the port probably was situated, up to the top of the Chellah hill. Potsherds found in the levels underlying the Capitolium of the Roman period suggest that the site was visited at least occasionally in the 7th-6th c. by the Phoenicians who sailed along the Moroccan coasts at that time. However, the earliest structures that have been found do not appear to antedate the 1st c. B.C. In this period Sala minted its own bronze coinage, which had a neo-Punic legend; and the pottery, which is abundant, shows that the city enjoyed vigorous trade with the Mediterranean, Cadiz and S Spain being its leading partners.

The great number of monuments, which are considered, quite reasonably, to be contemporary with the reign of Juba II (d. ca. A.D. 23), bear witness to the city's prosperity: a public square dominated by a sanctuary with five cellae fronted by a common portico (Temple A); two more temples (B and C) built one above the other between this agora and the Capitolium, the second one set on a three-stepped podium edged by a portico-staircase; farther S, underneath the Roman decumanus maximus, what is taken to be a fourth sanctuary, which matches Temple A in plan. Added to these are several public monuments of doubtful identification that have been located near the agora, SW and N of the Capitolium. They are generally well built, and in many of them the mediocrity of the local soft stone is hidden beneath a decoration of stucco or imported Italian or Greek marble facing. A few sculptures of high quality have been found in the course of excavating these buildings, including two large statues of Greek marble, one of which represents Ptolemy of Mauretania.

After Mauretania was annexed, the city was gradually rebuilt almost in its entirety, probably in the second half of the 1st c. A.D.: it is not known whether, like Tamuda or Lixus, Sala suffered in the disorders that followed the death of Ptolemy. Most of the ancient monuments were razed and banked up, although some were preserved and integrated into the new city plan. This was carried out on either side of a major decumanus linking the port with the high city. A forum 750 m square, enlarged with strong supporting walls containing tabernae, took the place of the old Mauretanian agora while, however, retaining Temple A to the NE. Behind the forum the street widens into a square lined with shops and a number of buildings, including one that is presumed to be the curia; another may possibly be a basilica. The latter is closed to the W by a three-bay arch, only the bases of which remain. To the N a wide terrace supported by shop vaults runs 5-6 m above the decumanus. A paved esplanade has been uncovered here, surrounded on three sides by porticos that frame a rectangular temple fronted by an altar. It is

clear, both from its dedication and from the fragments of a colossal statue of Jupiter, that this monument is the Capitolium. The N side of this complex is bordered by a secondary decumanus which also passes in front of a series of shops dating from the Mauretanian era. Behind the shops can be seen another row of Roman buildings and the remains of a colonnade. Some baths have been uncovered on the S side, down from the decumanus maximus and the forum. The largest of these lies S of the arch, others near the modern gardens.

Outside the Merinid wall the decumanus maximus has been excavated to the E, and traces of several secondary roads have been found along with some buildings as yet unidentified. Remains of paving stones and wall alignments found at the level where the old wadi flowed also suggest that some large buildings stood here. To the W, on the other hand, the city does not seem to have extended much beyond the excavated area. There was a workers' quarter beyond the Capitolium, but the abrupt slope with the main ribat gate on top of it is not considered to have been built in the Roman period. Nevertheless, outside the surrounding wall, traces have been found of a military camp that can be seen in aerial photographs but was recently covered over by a cemetery; the ala II Syrorum was quartered here in the middle of the 2d c. A.D. One of the unit's prefects, Sulpicius Felix, was honored in 144 by a statue with an inscription on the base setting forth the composition of the ordo of the municipium of Sala and the text of a decree made in its favor, which honored it for having protected the city and restored peace.

About 10 km to the S Sala was protected by a fossatum and a wall that had probably been put up in this period between the sea and the wadi Bou Regreg. Thus the city apparently survived intact the troubles that beset the province in the second half of the century. In contrast to the other cities of S Tingitania, Sala was not abandoned under the Tetrarchy and retained a Roman garrison, mentioned in the *Notitia Dignitatum*. Aside from pottery, only rare remains are attributable to this late period: an inscription dedicated to Constantine, discovered at the forum; a monument decorated with a mosaic of the Christian period, and a few tombs; yet the city essentially still kept its former appearance. During the 4th c. the Capitolium and forum were abandoned and turned into public dumps. From that time on Sala was merely a large village, surviving up to the Arab conquest and maintaining, if sporadically, its contacts with the Byzantines of S Spain and Ceuta. In the 11th c. the geographer El Bekri saw nothing but ruins on the site, and the importance of these, and their neglected state, was to impress El Idrisi in the next century.

The necropoleis encircled the city from E to W from the Hassan Tower to the Bab Zaer gate. Excavations carried out between that and Chellah in 1918 and 1966 uncovered close to 500 tombs, including several mausoleums and burial plots. They were found to contain a great quantity of grave gifts, proving that the site was in continuous use from the beginning of the 1st c. B.C. to the end of the 2d A.D. A few later tombs date from the 4th c.

BIBLIOGRAPHY. L. Chatelain, *Le Maroc des Romains* (1944) 81-100; M. Euzennat et al. "Chroniques," *Bulletin d'Archéologie Marocaine* 2 (1957) 218-23[MPI]; 4 (1960) 550-53[MPI]; 5 (1964) 363-67; 6 (1966) 546-50; 7 (1967) 659-62; L. Harmand, "Observations sur l'inscription de Sala," *Mélanges d'archéologie et d'histoire offerts à André Piganiol*, III (1966) 1211-20; J. Boube, "Fouilles archéologiques à Sala," *Hespéris-Tamuda* 7 (1966) 23-32. M. EUZENNAT

SALA CONSILINA Campania, Italy. Map 14. About 32 km SW of Potenza on the E side of the Val di Diano, a long, flat-bottomed valley, very fertile, the floor of a vanished lake in the high Apennines E of Paestum. The Tanagro, a tributary of the Sele, connects it with the coast. Consilinum was 10 km to the S.

Alexander the Molossian is said to have traversed the Val di Diano to get from the Ionian coast to Paestum where he won a victory over the Lucanians and Samnites in 332 B.C. (Livy 8.17.9-10), but the approaches to the valley are too difficult to have made it much of a highway. When the Romans conquered the region in 298 B.C., the inhabitants were Lucanians who spoke Oscan. The pre-Lucanian inhabitants were known to the Greeks as Oenotrians.

The earliest burials here are of the Early Iron Age. Both cremation and inhumation appear, the grave goods resembling the early Villanovan material of Etruria. A painted geometric pottery in the *a tenda* style of Apulia and the Ionian coast is found with the Villanovan material, and this imported style seems to have been inspiration for a handsome Geometric ware made locally in the orientalizing period. Greek imports are late: two Corinthian helmets, a few Middle and Late Corinthian pots. Not till the third quarter of the 6th c. were Attic pots imported; and with them, in a princely tomb found in 1896, were handsome bronze vases and carved amber. The bronzes are kin to those of the Heroon of Paestum, and the tomb form was similar, evidence that Paestum had a brisk trade with the interior by the second half of the century. Nothing later than the 6th c. has been found.

Material from the excavations is in the Museo Provinciale at Salerno and the Certosa di S. Lorenzo at Padula. The contents of the princely tomb are in the Petit Palais in Paris.

BIBLIOGRAPHY. K. Kilian, *Mostra della Preistoria e della Protostoria nel Salernitano* (1962) 63-78[I]; J. de la Genière, *Recherches sur l'age de fer en Italie Meridionale. Sala Consilina*. Bibl. de l'Institut Français de Naples, 2d ser. vol. 1 (1968)[I]. E. RICHARDSON

SALACTA, *see* SULLECTHUM

SALAMANCA, *see* HELMANTICA

SALAMIS Cyprus. Map 6. On the E coast of the island, ca. 6.5 km N of Famagusta. The ruins occupy an extensive area, ca. 150 ha, along the shore and for a considerable depth now covered by sand dunes and a forest. The harbor lies to the S near the mouth of the river Pedhiaios. Traces of the city wall of the archaic period have recently been discovered to the S. The vast necropolis lies in the plain W of the city and extends towards the villages of Enkomi, Haghios Serghios, and the Monastery of St. Barnabas.

The traditional founder was Teukros, son of Telamon, king of the Greek island of Salamis and one of the heroes of the Trojan War. He was also the founder of the Temple of Zeus Salaminios and the ancestor of its dynasty of priest-kings. A sepulchral epigram to him exists among those on the Homeric heroes. The dynasty of Teukridai ruled for a long time and even the kings of later times claimed descent from Teukros. This dynasty of priest-kings lasted down to the time of Augustus.

Salamis must have succeeded the Mycenaean city of Enkomi, ca. 2 km further inland, sometime in the 11th c. B.C. probably when the harbor of the latter was silted up. This earlier theory has now been corroborated by the recent discovery within Salamis itself of a Proto-

geometric tomb, and of 11th c. sherds found at the S sector of the city.

Salamis was the most important city in Cyprus and King Euelthon (560-525 B.C.) claimed to be ruler of the whole island. He was the first king of Cyprus to issue coins, and his silver staters of Persic standard show on the obverse a lying ram with the reverse at first smooth and then with an ankh. His name appears on the obverse in syllabic script.

His grandson Gorgos was reigning at the time of the Ionian Revolt (499-498 B.C.) but refused to rise against the Persians, so he was overthrown by his younger brother Onesilos, who succeeded in liberating most of the island for a while. Onesilos, however, fell in the battle that ensued on the plain of Salamis, and the Cypriots, after a year of freedom, were "again enslaved to Persia" (Hdt. 5.104, 108-15).

The most important of all the kings of Salamis, however, was Euagoras I (411–374-373 B.C.) for whom Isocrates wrote an oration (*Evagoras*). In an attempt to liberate Cyprus from the Persians Euagoras met with little resistance. He was a close ally of Athens and received much military help but in spite of all his initial successes he was forced to submit to the Great King although he did retain his throne as king of Salamis. Euagoras remained throughout his reign a friend of Athens and under his philhellenic policy Greek philosophers, artists, and musicians enjoyed the patronage of his court.

As a result of the Wars of the Successors Salamis was in 306 B.C. the scene of heavy fighting, both on land and sea, between Demetrios Poliorketes and Ptolemy I Soter for the possession of the city. It finally fell to Ptolemy, who soon took possession of the whole island. The city continued to flourish in Hellenistic and Graeco-Roman times and was embellished with important public buildings. During the Ptolemaic rule Salamis ceded its place to Paphos as the leading city of the island sometime in the 2d c. B.C. but in the 4th c. A.D. Salamis, now called Constantia, had once more superseded Paphos as the metropolis of Cyprus. The city became in Early Christian times the seat of a bishop and continued to flourish down to Early Byzantine times when it was gradually abandoned after the first Arab raids of 647 A.D.

The principal monuments uncovered towards the end of the 19th c., and again recently, include the gymnasium, the baths, the theater, the reservoir, the agora, the Temple of Zeus Olympios, part of the city wall, two Early Christian basilican churches and the Royal Tombs. Most of the ruins of this large city, however, remain unexcavated.

The Graeco-Roman gymnasium, originally built in Hellenistic times, was probably destroyed in the 4th c. A.D. earthquakes, after which it was restored as public baths. The central court, the palaistra, measuring 50 x 38 m and paved with opus sectile, is surrounded on all four sides by monolithic marble columns crowned by Corinthian capitals of various types which were salvaged from other derelict buildings when the gymnasium became the baths. The present columns originally carried arches of stone to support the roof which covered the portico. When first excavated this gymnasium was thought to be a marble forum.

The entrance to the gymnasium was through the S portico. On the step between the entrance columns is an inscription of the Hellenistic gymnasium. In the central part of the W wing, behind the portico, is a semicircular platform the floor of which lies about one m above the level of the floor of the portico. At the S end of this wing lie the gymnasium's latrines, a semicircular structure with a roof supported on columns; it had facilities for about 44 persons.

The E portico is larger and furnished with fluted columns higher than those along the other three sides of the court. At the N end of this portico, steps lead up into the N annex with a rectangular pool which replaced an earlier circular one. The sculptures now grouped there come from other parts of the gymnasium. In the middle of the E portico was found the marble altar of the gymnasiarch Diagoras, son of Teukros, in the 2d c. A.D. style. The large group of buildings to the E belongs to the period of the baths. There are still, in a relatively good state of preservation, hypocausts, sudatoria, caldaria, praefurnia, and large halls with niches decorated with mosaics, among others one depicting the river Eurotas and another Apollo slaying the children of Niobe.

The theater was built early in the Imperial period, probably during the reign of Augustus, but was repaired and remodeled during the 1st and 2d c. A.D. It has a semicircular orchestra measuring about 27 m in diameter; its cavea, measuring 104 m in diameter, consisted originally of over 50 rows of seats with a capacity of about 15,000 spectators. Of the stage-building little survives and the cavea has been restored in its greater part.

The stage-building consists of two parallel walls measuring ca. 40 m in length. The span between them, ca. 5 m, was covered with wooden planks at a height of ca. 2 m above the level of the orchestra. Rectangular colonettes offered additional supports to this wooden platform on which the actors performed. This was the proscenium, the facade of which was decorated with frescoes, traces of which survive in one of its niches. The back wall of the proscenium is a massive structure which supported the scenae frons; this was richly decorated with columns, statues, and honorific inscriptions. The theater, ca. 100 m to the S of the gymnasium, was connected with the latter by a colonnaded paved street.

Towards the S of the city is a group of buildings composed of the main reservoir, the agora and the Temple of Zeus Olympios. The reservoir adjoining the agora to the N consists of a large rectangle which had a vaulted roof supported on 39 piers in three rows. This is assigned to the reign of Septimius Severus and it appears that it was supplied with water from the spring at Kythrea some 56 km away. Traces of the aqueduct can still be seen in the plain between the village of Haghios Serghios and Salamis. Repairs to this aqueduct were made as late as the Early Byzantine period.

The Graeco-Roman agora between the reservoir and the Temple of Zeus Olympios measures 217 x 60 m. Considerable remains survive of the stone colonnades extending on either side of the central open space. The stone drums stood ca. 8.20 m high at intervals of 4.60 m and carried Corinthian capitals. Behind the two long porticos were rows of shops. On the S side of the agora lies the Temple of Zeus Olympios, originally built in Hellenistic times. The temple stands on a high stylobate and has a square cella at the rear. Fallen column-drums and Corinthian capitals of a considerable size suggest an impressive building.

Trial trenches at the S sector of Salamis near the harbor brought to light the existence of a complete system of defenses consisting of many parallel walls. The lower course of the walls was of stone, while the upper part was built of mudbricks. The city defenses at this point run E-W along the edge of the plateau, which overlooks the harbor. This circuit has been provisionally

dated to the end of the Geometric and to the archaic period.

Substantial remains of the breakwaters of the harbor near the mouth of the river Pediaios still survive; however, most of the harbor itself has silted up.

Tombs dating from Late Geometric to Graeco-Roman times are known in the vast necropolis W of Salamis, but the most important of these are the archaic Royal Tombs, a number of which were excavated in recent years (1956 onwards). Unfortunately only the dromoi were found intact, the burial chambers having been looted long ago. The characteristic features of these tombs are their large dromoi, and their Homeric burial customs. One of these tombs, Tomb 50, is the so-called Prison or Tomb of Haghia Haikaterini. The sloping dromos, measuring 28 x 13 m, had its sides revetted with well-dressed stones. The skeletons of two yoked horses, their iron bits still in their mouths, and several vases were found in the dromos. The tomb in its original form dates from the 7th c. B.C.

Tomb 79 lies to the S of the Tomb of Haghia Haikaterini, and is beyond doubt the wealthiest tomb found thus far at Salamis. The chamber was built, like that of the tomb of Haghia Haikaterini, of two very large blocks of stone, rectangular in shape and with a gable roof. In front of the chamber there was a kind of propylaeum. This tomb dates from the end of the 8th c. B.C. but was reused in the 7th c. and still later during the Graeco-Roman period, so that the chamber was found looted of its earlier contents. The dromos, however, remained intact and its excavation proved most rewarding. The 8th c. burial was associated with the sacrifice of horses, and a chariot and a hearse were found in the dromos. In addition to the pottery the tomb furniture included three ivory chairs, of which only one was in fairly good condition, ivory plaques with relief decoration, a large bronze cauldron standing on an iron tripod decorated around the rim with griffin heads, bird-men, and sphinxes; also various bronze horse-bits, such as frontlets, blinkers, and breastplates, all decorated with figure representations. The 7th c. burial was also associated with chariot and horse burials.

A number of rock-cut tombs were recently excavated due S of the Royal Tombs. These tombs were enclosed by a peribolos wall. Of particular interest is the discovery of pyres in the dromos on which clay figurines and fruit were offered in honor of the dead. This custom was known in ancient Greek religion as pankarpia or panspermia. Several infant burials made in jars were brought to light. The jars are as a rule of Rhodian import but two came from Attica. The furniture of the tombs includes a number of beautiful vases of the 7th c. B.C. decorated with lotus flowers, alabaster vases, bronze mirrors, good jewelry, seals, and scarabs.

Half-way between the Salamis forest and the Monastery of St. Barnabas, in the middle of the plain, lies a large tumulus of soil, Tomb 3. Above the tumulus traces of a beehive construction have been found, probably a reminiscence of the Mycenaean tholos tomb. The dromos measures 29 x 6 m. Remains of two chariots have been found in it. The four horses which drew the chariots were sacrificed with all their trappings. Various weapons were found including an iron sword, .92 m in length. The border of the broad tang was of silver soldered on the iron by means of copper. This tomb dates from ca. 600 B.C.

Another tumulus, Tomb 77, is to be seen close to the outskirts of the village of Enkomi. This one, however, dates from the end of the Classical period. Under the tumulus was an exedra of rectangular shape, built of mudbricks and measuring 17 x 11.50 m. Almost at the center of the exedra was found a large pyre in which were, among other objects, a number of fragments of life-size statues made of unbaked clay but hardened by fire. Among the five heads found, two seem to be portraits. Their style dates them to the end of the 4th c. B.C. These heads are acrolithic and there is evidence that they were mounted on wooden posts at the time of the funerary ceremony. No traces of burial have been found and the conclusion has been reached that this was a cenotaph, probably of Nikokreon, the last king of Salamis, who committed suicide with the members of his family in 311 B.C. and was buried under the ruins of the burnt palace because he would not submit to Ptolemy.

From the Hellenistic and Graeco-Roman necropolis come a number of funerary inscriptions. The finds are in the Nicosia and Famagusta Museums.

BIBLIOGRAPHY. Alexander Palma di Cesnola, *Salaminia*, 2d ed. (1884); V. Karageorghis, "Chronique de Fouilles et Découvertes Archéologiques à Chypre en 1959," *BCH* 84 (1960) onwards; id., "Recent Discoveries at Salamis (Cyprus)," *AA* 1 (1964)[I]; 2 (1966) 210-55[I]; Karageorghis & Cornelius Vermeule, *Sculptures from Salamis* II (1966)[I]; Karageorghis, *Excavations in the Necropolis of Salamis* I (1967)[PI]; II (1971)[MPI]; id., *Salamis in Cyprus, Homeric, Hellenistic and Roman* (1969)[I]; Porphyrios Dikaios, "A Royal Tomb at Salamis, Cyprus," *AA* (1963) 126-210[MPI]; K. Nicolaou, *Ancient Monuments of Cyprus* (1968); Th.-J. Oziol & J. Pouilloux, *Salamine de Chypre I, Les Lampes* (1969)[MI]; Pouilloux, "Fouilles à Salamine de Chypre 1964-1968," *Report of the Department of Antiquities, Cyprus* (1969) 43-55[PI]; *Salamis: A Guide*, new ed. (1970)[PI]; M. Yon, *Salamine de Chypre II, La Tombe T.1 du XIᵉ s.av. J.-C.* (1971)[PI]; Y. Calvet, *Salamine de Chypre III, Les timbres amphoriques* (1972)[MI]; J. Pouilloux et al., *Salamine de Chypre IV, Anthologie Salaminienne* (1973)[MPI]. K. NICOLAOU

SALAMIS Attica, Greece. Map 11. Classical Salamis, occupied by Athenian settlers, was "on a peninsula-like place" (Strab. 9.1.9, C.393), that is, on the promontory between Kamatero and Ambelaki Bay, facing Attica, where travelers 150 years ago saw remains of fortifications, public buildings, and roads. A decree of the thiasotai of Artemis was found on the acropolis and her precinct extended to the N shore by Kamatero (Hdt. 8.77). A trophy in the town was probably on the tip of the promontory (Paus. 1.36.1). Its harbor was in Ambelaki Bay and the agora was probably on the level ground at the head of the bay, where walls are still visible. A Precinct of Ajax was in this vicinity (Paus. 1.35.3). Lines of walls which are discernible under the water show that here as elsewhere the level of the sea has risen since antiquity, probably by some 150 cm. Early travelers reported a fortification wall extending from E of the harbor to the base of Cape Varvara, the ancient Cape Kynosoura. From there the wall followed the ridge of the cape as far as a mound, itself fortified, known as the Magoula. On the S side of the cape near its base there are remains of a tower, 5th or 4th c. B.C. in date. Two-thirds of the way down the cape the foundations of what was probably a marble trophy were noted by early travelers. Another trophy was set up on an island called Psyttalia (Plut. *Arist.* 9). The three trophies indicate the scene of the Battle of Salamis in 480 B.C. when the Persians were decisively defeated. The trophies at Salamis and on Cape Kynosoura suggest that the battle was fought inside the channel. The island Psyttalia has been identified with

Haghios Georghios in mid-channel (Hammond, Broadhead) or with Lipsokoutali outside the channel towards Peiraeus (Pritchett, Wallace).

In the vicinity of the Naval Arsenal early travelers noted the foundations of temples, and the remains of terracing which are probably ancient. Some have proposed to locate the Temple of Athena Skiras there, but a position farther N on Cape Arapis is more probable (Hdt. 8.94.2). There are some small forts on the coast, undoubtedly built as strongpoints against raiders from the sea; there are similar forts in Attica. One is on the promontory facing Megara; it may be identified with the Boudoron of Thucydides (2.94.3 and 3.51.2; W. McLeod). Another is on the S coast near Peristeria Bay, facing Aegina (Milchhöfer).

BIBLIOGRAPHY. *IG* I² 1; II 467.2; II 620; A. Milchhöfer in E. Curtius & J. A. Kaupert, *Karten von Attika* (1881-1903) VII 36; A. Philippson, *GL* (1952) I iii 864ff; G.L.N. Hammond, *JHS* 76 (1956) 32f; H. D. Broadhead, *The Persae of Aeschylus* (1960) Append. vi; W. McLeod, *Hesperia* 29 (1960) 316f; W. K. Pritchett, *Studies in Ancient Greek Topography* I (1965) 94f; P. W. Wallace, *AJA* 73 (1969) 293. N.G.L. HAMMOND

SALAPIA Foggia, Apulia, Italy. Map 14. An ancient city on the Adriatic coast N of Trinitapolis, near the Salapina palus (Luc. 5.377) Lago di Salpi, today largely drained. According to legend, it was founded by Diomedes or by Elpias of Rhodes (Vitr. 1.14.12; Strab. 14.654). Others attribute Trojan origins to the city (Lycoph. 1129). The city was not, however, colonized by the Greeks in the historic period. As an important center of Daunia with its own mint (the name Salapinon or Salpinon are found on bronze coins), it participated actively in the second Punic war. In 214 B.C. Hannibal seized the city and set up his winter quarters there, but M. Claudius Marcellus reoccupied it in 210 (Livy 24.20; 26.38). During the social war (*App. BCiv.* 1.51), the city was destroyed, and it gradually disappeared because the lagoon was becoming a swamp. The ruins of the ancient town are found along the road which leads from Zapponeta to the district of Torre Pietra.

According to Vitruvius (loc. cit.), the old city was abandoned, made unhealthy because of malaria, and the inhabitants in the 1st B.C. moved ca. 6.4 km away to a healthier place, where a harbor was developed by joining the Lago di Salpi with the sea. The new Salapia was a Roman municipium and is mentioned by the writers of land survey as a colony (Grom. Vet. 210.261). Significant traces have recently been brought to light in the zone called Monte di Salpi, where it is believed that the second city rose.

BIBLIOGRAPHY. W. Smith, *Dictionary of Greek and Roman Geography*, II (1857) 879 (E. H. Bunbury); *RE* 1.2 (1920) 2007-9; *EAA* 6 (1965) 1072 (N. Degrassi); M. D. Marin in *Atti VIII Convegno Studi Magna Grecia* (1968) 242; S. F. Tinè, ibid. 233ff. F. G. LO PORTO

SALARIA Jaén, Spain. Map 19. An Augustan colony identified with the Ubeda la Vieja ruins in the municipality of Baeza 30 km SE of Linares. The site has not been excavated but Roman graves and fragments of reliefs, now in the Madrid and Jaén museums, have been found here.

BIBLIOGRAPHY. J. Gongora, *Memoria fijando definitivamente el sitio de la colonia Salaria* (1867); A. García y Bellido, *Esculturas romanas de España y Portugal* I (1949) 309; id., "Las colonias romanas de Hispania,"

Anuario de Historia del Derecho Español 29 (1959) 498-99. A. BALIL

SALDAE (Bejaia or Bougie) Algeria. Map 18. The Punic settlement in Mauretania Caesariensis was later a Roman colony. It is mentioned by Pliny (*HN* 5.20), Ptolemy (4.2.2), the *Antonine Itinerary*, the *Peutinger Table*, and the Ravenna Geographer. The port of Saldae was fairly important (Strab. 17.3,12). The Roman colony was founded by Augustus in 27-26 B.C. for veterans. A bishop from Saldae is known in the 5th c. The Byzantines presumably established themselves there. Very little has survived from the Punic period, only some votive stelae of Carthaginian type and perhaps some tombs, presumed to be Punic.

The Roman period has left more abundant remains. Vestiges of the ramparts are visible at several places. The ancient town is placed on the slopes of the Gouraya mountain. It occupies the two spurs of Moussa (to the W) and of Bridja (to the E), which are separated by a gully. Of the monuments which have been preserved or noted, particularly interesting are the remains of a temple underneath the church, built on the site of a mosque. The temple was undoubtedly near the forum, whose location is indicated by the bases of statues. In the immediate vicinity the public baths have produced a large ornamental mosaic (a piece of it is on exhibit in the church). Other public baths were on the site of the Civil Hospital. Two similar mosaics were found there; they depict heads of Oceanus flanked by Nereids. One is at the Algiers Museum, the other at the town hall of Bejaia. A third public bath was located near the high school.

Cisterns and basins are still visible (indeed, still in use) at several places in the upper town. They were fed by the Toudja aqueduct, which brought water from springs located 21 km to the W. Large fragments of the aqueduct can be seen at some points, especially at El Hanaïat, where some 20 piles reach heights up to 15 m. The canalization made use of a tunnel 428 m long. An inscription, found at Lambaesis (*CIL*, VIII, 18122) and now in the main square at Bejaia, tells of the vicissitudes of its construction in the middle of the 2d c. The tunnel was begun at both ends, and instead of meeting the two galleries diverged; a military engineer had to rectify the situation.

West of the middle town a rounded depression has been supposed variously to have been the site of a circus, an amphitheater, and a theater. No ancient remains are known that settle the question. A single inscription (*CIL*, VIII, 8938) mentions ludi circenses.

Many Roman sculptures have been found in the area around the town, some carved in the rock, some found in the ground, others as sarcophagi. A sarcophagus with strigils is at the Louvre. Few sculptures come from Saldae itself, mainly some capitals and votive stelae dedicated to Saturn. They are kept in the small local museum.

BIBLIOGRAPHY. S. Gsell, *Les monuments antiques de l'Algérie* (1901) 249-52^PI; *Atlas archéologique de l'Algérie* (1911) 7, no. 12^P; J. Lassus, "L'archéologie algérienne en 1958," *Libyca* 7 (1959) 275-78; M. Leglay, *Saturne Africain. Monuments* (1966) II 297-98. M. LEGLAY

SALDUBA, see CAESAR AUGUSTA

SALDUM, see LIMES OF DJERDAP

SALERNO, see SALERNUM

SALERNUM (Salerno) Campania, Italy. Map 17A. An important Roman colony whose founding, deliberated in 197 B.C. (Livy 32.29.3), was accomplished in 194 B.C. (Livy 34.45.1-5) as an effective garrison against the rebellious Picentini, who sided with Hannibal after Cannae. Salernum constituted a new advanced position on the Tyrrhenian coast as part of the military program devised by Scipio Africanus after the war with Hannibal.

At the outlet of the Irno valley in the section called Fratte, remains of the pre-Roman complex named Irna and of the rich Opican-Etruscan-Campanian archaic necropoleis are being brought to light. They show a flourishing mercantile economy, explained by the excellent geographical position of the site in the NE corner of the gulf.

The importance of Salernum up until the late Empire is attested by numerous inscriptions (*CIL* x, 514-544), which also record monuments no longer extant because materials from the ruins of Roman buildings were reused in construction during the early mediaeval period.

Among the most interesting monuments from the Roman epoch are a few honorific statues, particularly an Augustan base with figures, and several sarcophagi. With the exception of one presently in the church of S. Domenico, these are preserved in the Cathedral.

All the rest of the archaeological material from pre-Roman and Roman Salerno is preserved in the Museo Provinciale of S. Benedetto. Particularly noteworthy is an Italic bronze head of Apollo from the first half of the 1st c. B.C., brought up from the sea off Salerno.

BIBLIOGRAPHY. V. Panebianco, *La colonia romana di Salernum* (1945), with bibliography; P. C. Sestieri, *NSc* (1952) 86ff; (1949) 101ff; *Apollo, Bollettino dei Musei Provinciali del Salernitano* (July 1961ff).

V. PANEBIANCO

SALIHADASI ("Karyanda") Turkey. Map 7. An island between Myndos and Bargylia in Caria with a sheltered anchorage. At its E end on a hill above a deserted village are considerable remains of a town or city now buried in almost impenetrable scrub. A wall some 160 m long and 1 m thick runs N-S; it is built of dry rubble, with two facings and a filling of small stones. Numerous other walls, from fortifications and houses, are to be seen, but under present conditions it is hardly possible to determine the full extent of the site. Tiles and sherds seem to be of the 4th c. B.C. So far as the material evidence goes, this appears to be by far the most likely site for the island of Karyanda. The location (Pseudo-Skylax, Strab. 658, Mela 1.85, Plin. *HN* 5.107) has long been sought, and Pliny (*HN* 5.134) and Strabo make it clear that two sites, one mainland and one island, are required. Strabo speaks of "Myndos . . . and after this Bargylia, also a city, and in between these a lake Karyanda and an island of the same name where the Karyandans used to dwell."

Apparently the Karyandans, early in the 3d c., crossed to the mainland and settled on the shore around Göl, the only lake in this area, where there was later a flourishing Byzantine township; they thus became citizens of Myndos (whose territory had been depopulated by Mausolos' transference of the Lelegians to Halikarnassos), in effect replacing the now deserted Lelegian site on the hill above (cf. Madnasa). Their settlement, naturally unfortified, has left no traces, having been completely covered by the Byzantine occupation.

BIBLIOGRAPHY. W. R. Paton, *BCH* 12 (1888) 282 (Pserimos, name); id. & J. Myres, *JHS* 14 (1894) 375f; Head, *Hist. Num.* 612; A. Maiuri, *Nuova Silloge . . .* (1925) (inscriptions); *ATL* I (1939) 498; G. E. Bean & J. M. Cook, *BSA* 50 (1955) 155-60 (full discussion).

G. E. BEAN

SALINAE (Droitwich) Worcestershire, England. Map 24. As the Roman name, given in the *Ravenna Cosmography*, implies, the settlement here was connected with salt workings, but on the high ground E of Dodderhill traces of military sites of the 1st c. have been investigated. The only civil buildings studied are those in Bays Meadow, where a tessellated pavement was found in 1849. A winged-corridor house of 4th c. date was excavated in 1954-55. The site was enclosed with a ditch system of uncertain date of which only the NE corner survives.

BIBLIOGRAPHY. J. Allies, *Antiquities of Worcestershire* (1852) 98-106; *Trans. Birmingham Arch. Soc.* 64 (1946) 39-52; 75 (1959) 1-23; military sites: ibid., 62 (1943) 27-31; *Trans. Worcs. Arch. Soc.* 39 (1963) 55-58; *W. Midlands Archaeol. News Sheet* 8 (1973) 12f.

G. WEBSTER

SALINAE (Middlewich) Cheshire, England. Map 24. The site, 30.4 km E of Chester (Deva), lies at the confluence of the rivers Dane and Croco, and covers an area of ca. 20 ha. Occupation began soon after A.D. 80 and continued until the mid 4th c. All buildings were of timber and daub, with thatched or tiled roofs, and took the form of strip shops, workshops, and living quarters, with the narrow ends adjacent to the street.

The single N-S street ran along the line of the Roman road from Lancaster to Littlechester (Derventio), and occupation extends from the crossing of the Dane, for 900 m or more. The structures varied in size from 7.3 x 15 m in the 2d c., to 13.1 x 30 m in the 4th c.

Local industries included iron smelting and smithing, lead casting, glass making, and salt making from local brine springs. A small salt works has been excavated consisting of a brine kiln, timber workshop, and two large dolia, one bearing the graffito AMVRCA (possibly meaning waste from brine).

BIBLIOGRAPHY. W. T. Watkin, *Roman Cheshire* (1886); F. H. Thompson, *Roman Cheshire* (1965)ᴹᴾᴵ; J. D. Bestwick, "Roman Britain," *JRS* 50 (1960) 238; 58 (1968) 213; 59 (1969) 210-11; "Roman Britain," *Britannia* 1 (1970) 282, 313; 2 (1971) 255; 3 (1972) 314; 4 (1973) 284.

J. D. BESTWICK

SALINS Jura, France. Map 23. A large oppidum in a region rich in salt and iron deposits that have been worked since prehistoric times. Known today as the Camp du Château, it flourished during the Late Bronze Age and up to the end of Iron Age I. Gray pottery with wavy decoration (Phokaian) and several fragments of red-figure and black-figure Attic vases have been found.

BIBLIOGRAPHY. M. Piroutet & J. Déchelette, "Découverte de vases grecs dans un oppidum hallstattien du Jura," *RA* (1909) fasc. 1, 193ff; id., *La citadelle hallstattienne à poteries helléniques de Château sur Salins, Vᵒ Congrès international d'archéologie* (1930) 1-40; M. Dayet, "Recherches archéologiques au camp du Château (Salins)," *Revue Archeologique de l'Est* 18 (1967) 52-106.

L. LERAT

SALODURUM (Solothurn) Solothurn, Switzerland. Map 20. Site on the left bank of the Aare at the foot of the Jura ridges (*It. Ant.* 353.2; *Tab. Peut.*; *CIL* XIII, 5170 = Howald-Meyer no. 245). The military road from Aventicum divides here, one branch continuing along the Aare to Vindonissa, the other crossing the Jura to Augusta Raurica. From its very location a relay station and river port, the vicus developed as a military post during the 1st to the 4th c. In the 4th c. a fortress was built, a link in the chain of defenses protecting the Rhone-Rhine waterway. The vicus developed to the W towards Bellach, while the early and late military installations were

in the area of the mediaeval town. Remains of the harbor have been found near Marktplatz-Roter Turm. Temples to Jupiter and Apollo are attested by inscriptions.

The Late Roman fortress was bell-shaped, with its base (ca. 150 m) along the river (main axis ca. 120 m; area 1.32 ha). Parts of the walls and some towers are visible (Westringstrasse, Löwengasse, Hauptgasse). One bridge was located at the W corner of the fort, another possibly on the site of the modern Wengibrücke. Finds are in the Museum der Stadt Solothurn.

See also Limes, Rhine.

BIBLIOGRAPHY. F. Staehelin, *Die Schweiz in römischer Zeit* (3d ed. 1948) 309-11, 621; W. Drack, "Die archäologischen Untersuchingen auf dem Friedhofplatz," *Jb. Solothurnische Gesch.* 21 (1948) 1-57[PI]; E. Müller, "Solothurn (Grabung 1964-65)," ibid. 38 (1965) 279-84[PI]; summary: *Jb. Schweiz. Gesell. f. Urgeschichte* 38 (1947) 64-67[PI]; inscription: *RGKomm* 40 (1959) 141 no. 52. V. VON GONZENBACH

SALONA (Solin) Croatia, Yugoslavia. Map 12. A suburb of Split in Kaštelanski bay (Manios Kolpos) was the site of the capital of ancient Illyricum and later the capital of the Roman province of Dalmatia. It is first mentioned in 119 B.C. (App. *Ill.* 11) as an important port and fortification of the Illyrian tribe of the Delmatae, when L. Caecilius Metellus with his army wintered there. The neighboring settlements of Epetion (Stobreč) to the E and Tragurion (Trogir) to the W were foundations of the Syracusan colony of Issa (Vis). The area was early under strong Greek influence. C. Cosconius took it from the Delmatae in 78-77 B.C. (*Eutrop.* 6.4). A nucleus of traders and settlers from Italy was attracted here early, and they formed a conventus civium Romanorum. About 47 B.C. Caesar established a colony, Colonia Martia Iulia Salona (or Salonae), to reward his allies (Caes. *BCiv.* 3.9; Dio Cass. 42). The settlers, enrolled in the tribus Sergia and the tribus Tromentina, were given a large fertile area on the bay. The traces of this limitatio are still visible. The economic and strategic importance of Salona made it the seat of the governor of the province. One of them, P. Cornelius Dollabella, with the soldiers of Legio VII and Legio XI began the construction of the five roads toward the frontiers of the province. Salona, becoming the focal point for a large area of Illyricum and beyond, developed into a flourishing city of ca. 60,000 inhabitants in the 2d c. A.D. It continued to prosper under its native son Diocletian, who built his magnificent palace 5 km SW of Salona in what is now the town of Split. Between 449 and 458 the town was attacked by Huns and Goths. In 461 Marcellinus from Salona proclaimed himself the king of Dalmatia. His nephew was Iulius Nepos. In the 6th c. the town was under the protection of the Eastern Empire. The Avars and Slavs destroyed it ca. 613-614. The citizens took refuge in Diocletian's palace and on the islands of the central Adriatic.

The elongated city plan, measuring ca. 1600 by 700 m, perhaps inspired Lucan's description of the city as "longae Salonae" (*Phars.* 4.104). The oldest part of the town was in the central part of this elongated area, where stood the E town gate, the so-called Porta Caesarea, which later growth left in mid town. The new town walls were built in A.D. 170 by the units of the Roman army in the period of the Marcomannic wars. In the 6th c. the walls were reinforced with several towers. The amphitheater, built in the 2d c., served as part of the city defenses in the NW corner of the town. It was built of stone and had a seating capacity of more than 15,000. Only its foundations are preserved because in the Middle Ages it became a quarry for the building of Split and

Solin. To the W of the amphitheater there is a necropolis of the 1st-4th c., the so-called Hortus Metrodori. A long wall of megalithic blocks extending 1.5 km W is perhaps the remains of the earlier Graeco-Illyrian settlement which protected the settlement from the N. The forum was in the central and oldest part of the colony. It was connected with the theater, only partly preserved, on the S side. Not much of the forum can be seen. The foundations of two temples, the curia, and basilica have also been found. Of several baths the most important was the one near the forum; but the best preserved are those in the E part of the town. They were built in the 2d c. A.D., and parts of the heating installations are still visible. The main archaeological and historical glory of Salona lies in its Early Christian basilicas and cemeteries which made this town, after Rome and Carthage, the most important center for the study of the beginnings and development of the Christian cult. Between the 4th and 6th c. a grandiose episcopal center developed. In its last phase it consisted of two basilicas. The N one was a large three-aisled cathedral built in the beginning of the 5th c. by bishop Sympherius and his nephew Esychius, under whom the church of Salona was made a metropolitan church. The S basilica is a large cruciform church built by the bishop Honorius in the 6th c. The basilicas had a common narthex. The interiors of the churches were decorated with splendid mosaics. The rooms of the episcopal house are to the E of the baptistery. Inside the city walls there are remains of eight other basilicas.

Outside the city walls are three necropoleis. North of the city walls, and to the E of the amphitheater, is Kapljuč, a place of Christian cult over which the basilica was built ca. 350. The Marusinac cemetery is situated ca. 1.5 km from the city walls N of the amphitheater. The complex of Manastirine is the largest Christian cemetery from antiquity at Salona. Several memorial chapels were covered by or included in a three-aisled basilica ca. 400. It was destroyed ca. 600 in Avaro-Slavic attacks.

The rich finds from the site of Salona are preserved in the Archaeological Museum at Split.

BIBLIOGRAPHY. F. Bulić, Yearly reports in *Bull. di Arch. e storia dalmata* 10-40 (1886-1919); W. Gerber et al., *Forschungen in Salona,* I-III (1917-1933); J. Brøndstedt et al., *Recherches à Salone,* I-II (1928-33); E. Dyggve, *History of Salonitan Christianity* (1951); M. Suić, "O municipalitetu antičke Salone," *Vjesnik za arheologiju i historiju dalmatinsku* 60 (1958) 11-38. M. ZANINOVIĆ

SALONA (Greece), *see* AMPHISSA *under* WEST LOKRIS

SALSOVIA (Mahmudia) Dobrudja, Romania. Map 12. A Roman-Byzantine city on the right bank of the Danube 25 km E of Aegyssus. It is mentioned by the ancient itineraries on the road from Aegyssus to Histria (*Tab. Peut.* 8.4; *Ant. It.* 226.3; *Geog. Rav.* 4.5.14). It was built of stone and covered an area 150 by 120 m. An inscription of A.D. 322 documents a castrum at the beginning of the 4th c. and a vexillatio commanded by a praepositus, belonging probably to Legio I Iovia with headquarters at Noviodunum. During the Late Empire Salsovia was a garrison for milites quinti Constantiani (*Not. Dig.* or. 39.26) and in the 6th c. an episcopal residence (De Boor, *Not. Episc.* 532).

BIBLIOGRAPHY. V. Pârvan, *Salsovia* (1906); J. Weiss, *Die Dobrudscha im Altertum* (1911) 54-55; R. Vulpe, *Histoire Ancienne de la Dobroudja* (1938) 301, 345.

E. DORUTIU-BOILA

SALTUS CASTULONENSIS Jaén, Spain. Map 19. In the Sierra Morena (Livy 22.30.11; 26.20), and famous for its silver mines; the Baebelo mine paid Hannibal 300

pounds per day. In Pliny's time (33.97) it was excavated to 1500 paces. It has produced many mining instruments now in the Linares museum, and two reliefs of miners, one in the National Archaeological Museum in Madrid, the other lost.

BIBLIOGRAPHY. R. Contreras, "El verdadero sentido de los textos clásicos relativos al Monte de la Plata," *Oretania* 8 (1966) 198-205. J. M. BLÁZQUEZ

SALVATLI, *see* ACHARACA

SALZBURG, *see* IUVAVUM

SAMARIA later SEBASTE Jordan/Israel. Map 6. The capital of Israel, built by Omri. In 332 B.C. the place was conquered by Alexander the Great, who settled thousands of Macedonian veterans there. The city was conquered several times by Hellenistic rulers, and in 108 B.C. by John Hyrcanus, who utterly destroyed it (Joseph. *BJ* 1.164). In 63 B.C. Pompey annexed Samaria to the Roman Provincia Syria (*BJ* 1.156), and it was rebuilt under Gabinius in 57 B.C. (*BJ* 1.166). In 30 B.C. Augustus gave Samaria to Herod, who rebuilt it and renamed it Sebaste in honor of the emperor. Josephus left a detailed description of the magnificence of the new city (*AJ* 15.217, 292, 296-97). Herod also settled foreign veterans there so that Samaria had a mixed population. During the Great War of 66-70 Samaria was destroyed but was soon rebuilt. Septimius Severus raised it to the rank of colony in A.D. 200. In the Late Roman period Samaria declined. It was a rather small town in the Byzantine period. A popular Christian tradition placed the tomb of John the Baptist at Samaria, for which reason several churches were built there. After the Arab conquest of Palestine the city was completely deserted.

Samaria was extensively excavated in 1908-1910 and again in 1931-1935. In the Iron Age, Israelite Samaria consisted of a fortified acropolis, where stood the royal palaces, and the lower city. This was not materially changed in Hellenistic and Roman times. In the Early Hellenistic period the old walls of the acropolis were still in use, but huge round towers were added. One of these has a diameter of 19 m, and its 19 courses still rise to a height of 8.5 m. The tower is dated to the late 4th c. B.C. The gate was on the W, at about the same place as was the Iron Age gate.

About the 2d c. B.C. a new wall 4.2 m thick was built at the base of the acropolis, surrounding an area of 230 by 120 m. It was strengthened by rectangular towers. This is most probably the wall destroyed by John Hyrcanus in 108 B.C. In the Roman period the entire town was surrounded by a new wall, enclosing an area of ca. 68 ha. The city measured 1 km from E to W, and a little less than 1 km from N to S. The city gate, on the W, was protected by two massive round towers, 14 m in diameter, and still preserved to a height of 8-11 m. The square bases on which the towers stand are of the Hellenistic period. The gate is Herodian with some additions made during the reign of Septimius Severus. From this period dates the colonnaded street 800 m long, which connected the W and E gates. It was 12.5 m broad, and there were shops on both sides.

On the W part of the acropolis hill were discovered remains of a residential quarter, probably built during the reconstruction of the town by Gabinius. Above this quarter, which is on the highest part of the hill, Herod built the Temple of Augustus (35 x 24 m). In front of it was a spacious court resting on an artificial platform (87 x 72 m). The platform was supported by vaulted corridors. Its retaining walls were 15 m high on the N

side. A broad flight of steps led from the court to the temple, which stood on a podium 4.5 m higher than the court. A portico led from the stairs to the temple, which had a wide nave and very narrow aisles. During the reign of Septimius Severus the temple was rebuilt on approximately the same plan. To this phase belong the broad flight of steps and the altar in the court in front of the temple. The torso of a large statue, probably of Augustus, was discovered close to the altar. North of the temple of Augustus another temple, dedicated to Kore, was erected. Only the foundations remain. In the fill of this building were found architectural fragments of an earlier temple, of the 3d c. B.C. An inscription from the fill helped to identify this earlier building as a Temple of Isis, probably destroyed by John Hyrcanus.

In the NE part of the town was a stadium, which, according to an inscription, was also connected with the cult of Kore. The building is only partly excavated. Two building phases were observed. To Herod's time belongs a Doric building, with painted plastered walls. The later building, of the 2d c. A.D., was of the Corinthian order. A statue of Kore and a dedicatory inscription were found in a nearby cistern.

On the NE slope of the acropolis was a theater with an outer diameter of 65 m. Sections of the scaenae frons, pulpitum, orchestra, and the cavea were unearthed. The scaenae frons was decorated with alternating round and square niches. The cavea consisted of two parts, of which the lower had 14 rows of seats, separated by flights of steps into seven cunei. The theater is dated to the early 3d c. A.D. To the E of the acropolis, at the base of the hill, lies the forum (128 x 72.5 m), also erected on a raised platform. There were colonnades on all four sides with 24 columns on the W, traces of most of which were discovered in situ. Adjoining the forum on the W lay a basilica (68 x 32 m) with a single nave and aisles on three sides. The columns were 6 m high. Some of these still stand with their capitals, which were of the Corinthian order. At the N end of the nave is a half-rounded niche with four benches.

The building in its present state dates from the 2d c. A.D., but there were also traces of an earlier basilica, of Gabinian or Herodian construction.

Under the S part of the forum was an acqueduct, bringing water from springs in the hills to the E of the city.

To the SE of the city a mausoleum of the Roman period was discovered. It is 5.5 m square and built of ashlar, with a single chamber inside (3.3 m square). Two sarcophagi in niches in the walls and five others standing on the floor were found. The building had a dome, which rose to the height of 5 m above the floor. In the portico in front of the mausoleum were placed two beautifully decorated sarcophagi. The mausoleum is dated to the late 2d or early 3d c. A.D. Other tombs were discovered to the E of the city, outside the walls.

BIBLIOGRAPHY. G. A. Reisner et al., *Harvard Excavations at Samaria (1908-10)* I-II (1924); J. W. Crowfoot et al., *The Buildings of Samaria* (1942); id., et al., *The Objects from Samaria* (1957). A. NEGEV

SAMAROBRIVA or Samarabriva (Amiens) Somme, France. Map 23. City of the Belgica province of Gaul. The Gallic city of Samarabriva (bridge over the Samara, or Somme) is mentioned several times in Caesar's Commentaries (*BGall* 5.24.1; 47.2; 53.3) yet its exact site is difficult to pinpoint (on a defensive site as the oppida of the Ambiani generally were, i.e. on the arms of the Somme or the high ground to the N?). It was succeeded during the 1st c. A.D. at the latest by the Roman city of the same name, built on flat dry ground on the S bank

of the river. Situated at the point where the roads from Beauvais, Rouen, Senlis, and Soissons converge before they cross the Somme and continue on to Boulogne and Brittany or to the territory of the Morini and the lower Rhine, Samarobriva under the Antonines became an important regional city. Ca. 277-278, after the first barbarian invasion (256), it withdrew inside a narrow surrounding wall and in the 4th c. adopted the name of Civitas Ambianensium (or Ambianorum; *Not. dig. occ.* 6.36), becoming an important military stronghold behind the threatened Rhine frontier. It was near one of the city gates, ca. 334, that St. Martin, who was garrisoned there, came across the beggar with whom he divided his cloak. Magnentius, the usurper, was born in Amiens and set up a mint there, and here the emperor Valentinian I, who spent several months in the city, proclaimed his son Gratianus emperor Augustus 24 August 367. The fortified city succumbed to another barbarian assault in 406. In the Merovingian period life went on in two sections: the count took over the ancient civitas, whose fortifications had been restored, while a quarter of merchants and artisans grew up around the bishop's residence, in a suburb to the E. At the beginning of the 12th c. the two were joined by a new rampart to form what was to become modern Amiens.

Very little is left of the monuments that adorned the Roman city. The *Passio S. Firmini* recalls temples built in honor of Jupiter and Mercury; of the altars consecrated to the eponymous goddess and a local divinity, Veriugodumnus, only the dedications remain (*CIL* XIII, 3490, 3487). Some traces of the harbor installations on the river (Rue des Tanneurs) and of two other buildings were discovered in excavations undertaken in the 19th c. and resumed after the last war: near the Hôtel de Ville, substructures of a nearly circular (100 x 107 m) 1st c. amphitheater; in the Rue de Beauvais, two rectangular rooms with opposed apses, the cold and heated pools (the latter with hypocausts) of a bath building from the first half of the 2d c. In the foundations of these rooms were some carved fragments originally used in a large public building of the preceding century.

The plan of the streets, however, can be traced exactly thanks to recent finds. The city was designed on a grid plan oriented N-S and E-W. This network enables us to trace the growth of the Empire city in its successive stages: a narrower grid (insulae of 100 x 80 Roman feet, or ca. 160 x 125 m) in the NE section represents the original urban center, which covered a modest area of 40 ha. This was the 1st c. city, at whose W limit stood the amphitheater. In the 2d c. the plan was modified and enlarged (to 105 ha) by the construction of new residential sections made up of larger insulae (100 Roman feet or 160 m each side), and an improved street and sewer system. The new city limits were extended W to enclose the 1st c. amphitheater which ended up in the heart of the city, a most unusual position; then to the S the city took in an area that had previously been the cemeteries, as evidenced by traces of funerary buildings uncovered in the foundations of the baths. No trace of the ancient grid has remained in the mediaeval or modern streets, except for the decumanus, which is a continuation of the road from Soissons (Rue des Trois Cailloux), and the cardo (Rue du Bloc, Rue de Flatters and Rue des Sergents).

At the end of the 3d c. the city shrank inside a rampart. This plan, too, can be traced. The walls, 1300 m long, enclosed an urban area of only ca. 10 ha. The fortified city was situated not to the E, around the cathedral, as has long been believed, but actually W of the cardo (the great Beauvais-Boulogne road), so that it overlooked the river to the N and was supported to the S by the amphitheater, now a fortress. Three of the rampart gates can be approximately located: the Porta Clippiana, mentioned in the *Passio S. Firmini*, stood to the S, close to the amphitheater; the W gate, near the church of Saint-Firmin-à-la-Porte; and the E gate was high up by Saint-Martin-au-Bourg (the episode of the charity of St. Martin is supposed to have taken place beside this last gate).

Fewer traces of the Roman occupation are to be found in the environs (poor remains of a dwelling near the modern Citadelle) but we know more about the series of cemeteries that surrounded the city except in the marshy areas. The cemeteries of the Empire (cremation and especially inhumation) contain some rather poor monuments and grave gifts. As usual the necropoleis were along the main access routes: to the W, along the Rouen road, to the E, on that of Noyon. To the W, along the Senlis and Beauvais roads, are two series of burials that together make up the largest cemetery, while the last one, to the N along the road to Boulogne, was used up to the Constantinian era. In the Late Empire and the Merovingian period the cemetery area shifted; as the city shrank it came closer (to the area round the cathedral) and occupied an old quarter of the Empire city that had been left outside the walls. To the E, conversely, a late Christian cemetery grew up beyond the old Empire cemetery area, near the tomb of St. Firmin at Saint-Acheul. The archaeological finds are in the Musée de Picardie at Amiens.

BIBLIOGRAPHY. St. Martin: Sulpicius Severus, *Vita Martini* 3.1; Gratianus: Amm. Marc. 27.6; barbarian invasion: Jerome, *Epist.* 123, 81; F. Vercauteren, "Etudes sur les civitates de Belgique seconde de la fin du IIIe siècle jusqu'a la fin du XIe siècle," *Mémoires de l'Acad. Belge* 33 (1934); Fr. Vasselle & E. Will, "Les cimetières gallo-romains d'Amiens," *Revue du Nord* 38 (1956) 321-30; id., "L'enceinte du Bas-Empire et l'histoire de la ville d'Amiens," *Revue du Nord* 40 (1958) 467-82; id., "L'Urbanisme romain à Samarobriva-Amiens," *Revue du Nord* 42 (1960) 337-52; E. Will, "Recherches sur le développement urbain sous l'empire romain dans le nord de la France," *Gallia* 20 (1962) 79-101; J. L. Massy, *Revue du Nord* 53 (1973) 23ff; *Gallia*, periodic reports of the excavations. C. PIETRI

SAME (Sami) On the island of Kephallenia, Greece. Map 9. The Homeric name (*Il.* 2.634; *Od.* 1.246; 4.671; 9.24; 15.29) has been handed down, designating either the entire island or only its E part (cf. Hdt. 9.28; Plin., *HN* 5.54). The present name refers to a small port not far from the ruins of the ancient city. Same, the capital of the island, was taken and destroyed in 189 B.C. by M. Fulvius Nobilior because of its resistance to the Romans. Situated at the center of a fertile, well-watered zone near the sea, the city developed considerably and was defended by a vast wall of ca. 3500 km. In ancient times Same had two acropoleis, of which the one farthest S has been identified in the locality of Kyathis.

Several Hellenistic tombs, a grotto sacred to the cult of Pan, and a notable thermal complex datable to the late 2d-early 3d c. B.C. have been excavated near the urban center. A fine male portrait in bronze from the late period of the Emperor Gallienus has recently been found.

BIBLIOGRAPHY. J. Partsch, *Kephallenia und Ithaka* (1890); B. V. Head, *Historia Numorum* (1911); A. K. Orlandos, *To Ergon tis archaiologhikis Etaireias 1959* (1960), *1960* (1961); V. Kallipolitis, *MonPiot* 54 (1965); G. Daux, *BCH* (1961, 1967). N. BONACASA

SAMI, *see* SAME

SAMIKON Triphylia, Greece. Map 9. A few km from Olympia. The ruins of the city have been identified on a broad upland to the S of Mt. Makistos (or Lapithos). Inhabited by the Epeans who named it Samos, and then by the Pylians, from whom it took the name Arene, the city later passed to the Minii who called it Makistos; only under the Eleans did it retake the original name of Samia or Samikon (cf. Paus. 5.6.1; Ptol. 4.80.12; Strab. 8.148; Herod. 4.148). It was the seat of the religious confederation of the six cities of Triphylia, and there was erected a Temple to Poseidon, whose cult was greatly renowned. A vast wall enclosed the S, where two types of masonry are found: polygonal blocks already in the 5th c. B.C., which were also used in several towers; and a trapezoidal technique with squared face, perhaps dating prior to the 3d c. B.C. In 1825, Fort Klidi (The Key), taking advantage of the ancient foundations, was erected on the site. A tumulus with pottery from the Middle Helladic period to Mycenaean II has been found at the NE base of the rocky hill on which stands Klidi.

BIBLIOGRAPHY. H. Bisbee, *Hesperia* 6 (1937); R. L. Scranton, *Greek Walls* (1941); N. Yalouris in *Deltion* 20, 1965 (1966). N. BONACASA

SAMOS Greece. Map 7. One of the Sporades Islands, 2.35 km from the coast of Asia Minor, to which it is geographically and geologically linked. According to Strabo (14.637) the island's earliest inhabitants would have been Carians, who called it Parthenia, but Samos is also an Asian word. From the 3d millennium B.C. the island was inhabited by a population of Anatolian culture, until, at the beginning of the 1st millennium, it was occupied by Ionian colonists. It knew its maximum splendor during the reign of Polykrates (ca. 538 B.C.), to whom is owed a period of intensive building and a vast territorial expansion (Hdt. 3.41,54ff). Samos participated in turn in the Persian wars and in the wars between Athens and Sparta, and in 365 B.C. it became an Athenian colony. After the battle of Magnesia in 190 B.C. Samos was ceded by the Romans to Eumenes II of Pergamon; from 129 B.C., when the reign of Pergamon fell, it became part of the Roman province in Asia. The first archaeological expedition to Samos was undertaken in 1764. Systematic excavation was initiated in 1910, and continues today.

The ancient city occupied the site of the modern village of Tigani, and was enclosed together with the port by a 6th c. wall with a perimeter of 6.7 km, of square and polygonal masonry, provided with gates and with circular and rectangular towers. On the acropolis (Astypaleia) rose the fortified palace of Polykrates, of which no trace remains. The port was bound by two piers which enclosed military and commercial activities in a single basin. A part turned back towards land in such a way as to form a shelter for the ships, and probably reflects in its originality Polykrates' new ideas about naval engineering (Hdt. 3.45; Plin. *HN* 7.209). Water from the Agiades fountain reached the port by means of a tunnel 1 km long and 1.75 m high dug into the mountain, an admirable work of Eupalinos of Megara. Near the port was the Hellenistic agora, and on the slope of the hillside are the remains of a small theater. The Roman habitation site was to the SW, while on the castro of Tigani the prehistoric remains are overlapped by a Hellenistic-Roman villa where a statue of Trajan was found, and by an Early Christian basilica. The necropoleis were situated immediately adjacent to the walls.

About 6 km W of the city, at the mouth of the Imbrasos river, was the Sanctuary of Hera. A very ancient cult place, it was probably originally dedicated to a local divinity, mother of nature, trees, and marshes. Greek mythology said that here, near a sacred bush, occurred the birth and matrimony of Hera. There, at the beginning of the 1st millennium, was miraculously found an aniconic wooden image of the goddess, which was still extant at the time of Pausanias in the 2d c. A.D. Every year a festival celebrated the sacred marriage there of Hera and Zeus (ἱερὸς γάμος). One of the rites consisted in a purificatory bath of the cult effigy, which was then wound with foliage of the sacred lygos tree to restore to the deity her virginity until the day of the wedding. Subsequently she was redressed in a gown sewn every year by the women of Samos. There followed a procession of armed men that departed from the city. Polykrates and his brothers profited from the occasion by taking possession of the entire island.

On the site of the Heraion the remains of prehistoric settlements from eight successive periods have been recognized. The earliest corresponds to the first Trojan age (2500 B.C.), while the most recent is of the Late Mycenaean and Geometric ages. These communities are characterized by houses with a megaron plan and encircling walls. Belonging to the last phase is a Mycenaean tumulus with a diameter of 6 m and four bothroi filled with fragments of pottery, figurines in terracotta and alabaster, Egyptian statuettes, and Oriental objects. Among the most precious finds is an ivory representing a kneeling youth from mid 7th c. B.C. The earliest architectural complex of the sanctuary dates from the 9th-8th c. B.C. and includes a paved square with traces of ashes, an altar, and a hekatompedon temple. It is ca. 33 x 6.50 m, divided into two aisles, with the entrance to the E. On a socle of small limestone blocks were placed walls of crude bricks. In the middle of the 8th c. the temple was surrounded by a colonnade of wooden pillars that supported the roof, and on the earlier foundations were constructed the walls of the cella. A century later, following a flood, this, the earliest example of a large peripteral temple in the Greek world, was replaced by an analogous temple, also peripteral with a single nave and a pronaos decorated by an incised and painted frieze of a procession of warriors. In the cella was kept the ancient aniconic image, which was later replaced by a statue by Skelmis or Smilis (the sources are not agreed on the name), whose image perhaps was reproduced on coins. Before the temple at the front was the altar. The earliest altar, from mid 10th c., was succeeded by seven more by the end of the 7th c., each overlying the preceding altar until a large rectangle was formed. For this reason the altars are exceptional with respect to the axis of the temple.

To the S of the temple and contemporary with its 7th c. addition, is a portico with two aisles, 70 m long, and open to the E. This was built on the original bed of the river, whose course was changed at that time. Also nearby was the sacred pool, fed by the waters of the Imbrasos and connected with the sea, which was used for ritual baths of the goddess's image. Later other pools were added. At the end of the 7th c. an enclosing wall was built, opening to the N with a large gate, earlier considered a propylaeum. Naiskoi and votive statues, whose bases remain in place, lined the square and the sides of the sacred ways leading to the city and to the port. The most conspicuous is that bearing the signature of the sculptor Geneleos, on which there were six marble statues datable to the middle of the 6th c. Three of these are preserved in the museum at Vathy.

A little before the middle of the 6th c. a period of intense building activity transformed the sanctuary. The construction of the new Temple of Hera was entrusted to Roikos and Theodoros, two names which tradition also

links with the invention of sculpture by the lost wax process. It was a colossal building in poros, measuring 51 x 102 m, with a double colonnade of two rows of 8 columns each on the front, 21 on the long sides, and 10 on the back. On the interior two rows of columns, 5 in the pronaos and 10 in the cella, supported the roof. On the front the intercolumnal spaces appeared to vary from the center to the sides. The forest of columns that resulted have earned this temple the epithet of labyrinth. The columns had a characteristic type of Ionic capital, with lotus flowers around the collar, and without an abacus. Before the temple, and on an axis with it, rose a new altar measuring 36.57 x 16.58 m, preceded by a flight of stairs. This was also Ionic in type, the first in this style. In Roman times it was first restored and then replaced by a precise copy in marble in the 1st c. In place of the S portico Roikos constructed another structure, the so-called S building, provided with a peristyle and a row of columns on an axis with the cella. In this building has been recognized a Temple of Aphrodite and Hermes, two divinities honored in the sanctuary since the end of the Geometric period, as is known from the sources and from numerous inscriptions. Perhaps two other small temples were also dedicated to them. The temple of Roikos and Theodoros was soon destroyed by fire. According to Pausanias this would have happened at the time of the Persian conquest of the island in 530 B.C. Its reconstruction, initiated by Polykrates, was conceived on such a grandiose scale that it was never completed. The Ionic temple, measuring 52.40 x 108.70 m, rose on a high platform. It had a double colonnade of 24 columns on the sides, and three rows of columns on the ends (8 on the E and 9 on the W). The pronaos was divided into three aisles by two rows of 5 columns each. The columns differ in diameter and material (poros and marble) according to the period in which they were erected. They bear a capital characteristic of the Samos-Ionic style. The pronaos and the cella were decorated by a frieze in poros that was never finished. Construction continued until the Roman epoch, when the hope of ever completing such a gigantic work was abandoned.

In the 2d c. A.D. two modest little temples rose beside the altar. An Ionic peripteral temple and other minor buildings belong to the age of Polykrates. Among the marvels of the Heraion Strabo (14.1-14) mentions an art gallery with works of Timantes, Parrhasios, and Apelles, and three statues by Miron representing Zeus, Athena, and Herakles, whose bases have been found. The Zeus statue was probably transported to the Campidoglio in Rome by Augustus. Besides the two little temples near the altar, other remains from the Roman epoch include other temples; naiskoi; votive offerings; an exedra; private houses, some with two stories from the 2d c. A.D.; an honorific monument of the family of Cicero; baths; a new network of canals; and a wide paved road toward the city from the 3d c. A.D. In 260 the sanctuary suffered violent destruction by the Herulians. Towards the end of the 5th c. there rose a basilica measuring 18 x 30 m, with three naves, testifying to a considerable Christian community.

The material from the early explorations of the city and especially from the Heraion, which includes monumental sculpture, ceramics, and objects in bronze, wood, and ivory are preserved in various museums of the world, including those in Berlin, Paris, and Athens. Finds from more recent excavation are in the local museum at Vathy. These have permitted a reconstruction of the stylistic features of the Samos school, and give an idea of the ample communication network during the archaic period, linking the island to the great Mediterranean and Anatolian centers of Cyprus, Egypt, Assyria, Syria, and others. With the decline of political power at the end of the 7th c., the artistic activity of Samos also declined, and the importation of foreign goods ceased. Pythagoras, the last of the great sculptors originally from Samos, recorded by the sources, and active around the beginning of the 5th c., emigrated to Reggio in Magna Graecia.

BIBLIOGRAPHY. T. Wiegand in *Abh. Berl. Akad.* (1911) v; M. Schede in *AthMitt* 44 (1919) 1-46; in *Abh. Berl. Akad.* (1929) III; L. Bürchner in *RE* II (1920) 2162-2218; K. Lehmann-Hartleben, *Die antiken Hafenanlagen des Mittelmeers* (1923) 32, 55-57, 120, 280; G. Klaffenbach in *AthMitt* 51 (1926) 26-40; A. M. Schneider in *AthMitt* 44 (1929) 96-141; W. Technau in *AthMitt* 44 (1929) 6-64; W. Wrede in *AthMitt* 44 (1929) 65-95; 60-61 (1935-36) 112-24; C. Weickert, *Typen der archaischen Architektur in Griecheland und Kleinasien* (1929); E. Buschor in *AthMitt* 55 (1930) 1-99; Buschor et al. in *AthMitt* 48 (1933); in *Arch. Anz.* 52 (1937) 203-22; in *AthMitt* 68 (1953 [1956]); in *AthMitt* 74 (1959); Buschor, *Neue Deutsche Ausgrabungen in Mittelmeergebiet und in vorderen Orient* (1959) 197-224; W. Buttler in *AthMitt* 60-61 (1935-36) 184-200; E. Johannes in *AthMitt* 62 (1937) 13-37; D. Ohly in *AthMitt* 65 (1940) 57-103; R. L. Scranton, *Greek Walls* (1941) 159-71; R. D. Barnett in *JHS* 68 (1948) 1-25; U. Jantzen, *Griechische Greifenkessel* (1955); id. in *Arch.Anz.* (1966) 164-65; O. Reuther, *Der Heratempel von Samos* (1957); A. Laumonier, *Les cultes indigenes en Carie* (1958) 695-709; W. Kastenbein in *Arch. Anz.* (1960) 178-98; P. Herrmann in *AthMitt* 75 (1960) 68-183; H. Berve et al., *Griechische Tempel und Heiligtümer* (1961); V. Milojcic, *Samos* (1961) I; E. Homann-Wedeking in *Arch. Anz.* (1965) 428-46; (1966) 158-64; H. Walter, *Das griechische Heiligtum: Heraion von Samos* (1965); G. Kopcke in *Arch.Anz.* (1966) 165-70; B. Freyer-Schauenburg, *Elfenbeine aus dem Sam. Heraion* (1966); G. Schmidt, *Samos* (1968) VII; R. Tolle, *Die antike Stadt Samos* (1969).

L. VLAD BORRELLI

SAMOSATA (Samsat) SW Anatolia. Map 5. The city is cited in a Latin inscription as Samosate (*CIL* VI, 1409). On the coins from the time of Hadrian to that of Philippos (244-49) it appears as Samosateon. The ruins are located 140 km S of modern Malatya and on the W bank of the Euphrates (Ptol. *Bell.* 1.17.22f). The city was at the crossroads of five important routes going to Melentenis (Melitene), Comana, Heracome, Tarsa, and Zeugma. Today the Euphrates passes some 500 m from the city as it has changed its course.

Founded on a plain bordered by high mountains at the NW and the Euphrates at the SE, it controlled Euphrates traffic. It is divided into two parts, the lower city and the acropolis (Lucian *De Hist. Conscrib.* 24), which is somewhat conical in shape, 45 m above the level of the plain. In both parts of the settlement, remains of the city walls, of different heights, can still be seen. The acropolis (approximately 250 x 150 m) is situated in the S part of the city. Little was to be seen before the excavations. The necropolis, in the N and NE part of the city, was covered with alluvial deposits of the river. In some parts of the city walls Roman opus reticulatum, which is very rare in this area, can clearly be seen.

For the earlier phases of the settlement we have little information, but a stele from the Hittite period and the pottery collected from the surface indicate earlier habitation than Roman. Samosata was the capital of Commagene, which is cited as the Land of Qummuh in Assyrian cuneiform inscriptions. Lucullus in 69 B.C. and Ventidius in 38 B.C. occupied the province, but it is not

known whether Samosata was also occupied at these times. In A.D. 17 Samosata became a Roman province and Caligula appointed Antiochos IV as king of Commagene and perpetuator of the native dynasty. Later, in the time Vespasian, L. Caesennius Paetus, consul of Syria, with the permission of the emperor, attacked Commagene; and Antiochos left Samosata. Vespasian then stationed the 16th Legio Flavia in the city (Cass. Dio 55.24.3; Ptol. 5.14.8). Samosata was mentioned once again, during Trajan's (A.D. 114) Parthian raid, and in A.D. 120 was the birthplace of the famous satirist Lucian. For a short time after Diocletian, the region was called Euphratesia (Amm. Marc. 14.8.7 Eufraten-sis). At the time of Justinian the Arabs attacked and occupied the area extending from Samosata and its environs to Edessa. After the 7th c. Commagene became a province of the Islamic world.

In 1964 soundings were made at the city gate called Urfa Kapısı, SE of the modern village and on the S end of the acropolis. Excavations were carried out in 1967 and 1970, and at the top a typical fortress settlement composed of magazines, halls, kitchens, baths, and several rooms were cleaned out. On the mound Roman terra sigillata have been found.

BIBLIOGRAPHY. Moltke, *Briefe* (1841) 224ff; W. F. Ainsworth, *A Personal Narrative of the Euphrates Expedition* (1888) I 195f; Humann-Puchstein, *Reisen in Kleinasien und Nordsyrien* (1890) 181ff; Weissbach, *RE* Ia (1920); M. Mellink 74 *AJA* (1970) p. 280 no. 3.

U. SERDAROGLU

SAMOTHRACE (Σαμοθράκη), Greece. Map 9. A mountainous island in the NE Aegean famous in antiquity for its Sanctuary of the Great Gods. Sporadic finds indicate that it was inhabited in the Neolithic Age, and pottery dating from the Bronze Age has been found at Kariotes to the E of the later Greek city. The island was settled ca. 700 B.C. by Greek-speaking colonists whose Aeolic dialect suggests that they came from NW Anatolia or Lesbos. They mingled with the local population, whose Thracian tongue is documented as the ritual language of the cult as late as the Augustan age. The archaic city, as yet little explored, was protected by an impressive city wall. A naval power owning territory on the Thracian coast, it became part of the Attic empire in the 5th c. As its power waned, the fame of the sanctuary outside its walls grew, culminating in the Hellenistic and early Imperial ages. Under the patronage of the royal Macedonian house and the Diadochs, the venerable sanctuary was embellished with splendid buildings that remained in use until the cult ceased in the late 4th c. A.D. In the 6th c. it was destroyed by an earthquake. But small Christian churches dot the island and, like the 10th c. fortification built in the sanctuary of spoils from its destroyed buildings, attest its continuing habitation.

The Great Gods of the Samothracian mysteries included a central divinity of pre-Greek origin, a Great Mother (called Axieros in the native tongue, Demeter in Greek), her spouse (Kadmilos, Hermes), and attendant demons (the Kabeiroi, Dioskouroi) as well as the Greek Hades and Persephone (locally known as Axiokersos and Axiokersa). Their nocturnal rites were available to men and women, freemen and slaves, unlike the related rites at Eleusis. Initiation took place in two degrees, the myesis and the epopteia, the latter not required but, if taken, preceded by an obligatory rite of confession. It was not restricted to the annual festival but obtainable at any time. The Great Gods were special patrons of those at sea. Through their mysteries the initiate gained protection, moral improvement, and probably the hope of immortality. Although the initiation halls

were accessible only to initiates, the sanctuary was otherwise open to all visitors.

It lies to the W of the ancient city, is framed by two streams at its E and W, and cut at its center by a third. The earliest monument, a rock altar to the Great Mother, antedates the Greek settlers. In the 7th c. it was incorporated in the N part of a double precinct beneath the later anaktoron, sacristy, and Rotunda of Arsinoe, the S section receiving a bothros for libations to the Greeks' underworld gods. Another rock altar outside the precinct and remnants of a small sanctuary below the later temenos date from this period. In the 6th c. a rock altar possibly dedicated to Hekate was added to this area and further to the S, within and near the later temenos, additional altars and escharai were built. In the debris from the sacrificial meals at one such place, quantities of fine wheel-made local pottery of the 7th c. were found along with handmade ware. Within the later Altar Court, a great rock altar arose and, adjacent to it, a rectangular lesche, a Hall of Votive Gifts to judge by its contents, was constructed of small limestone blocks and wooden ties. Its Doric colonnaded facade faced the central river. The first halls of initiation were probably built at this time. The present anaktoron, a rectangular building for the myesis, evidently succeeded a hall of similar size, traces of which are preserved to its W. Built of stuccoed polygonal masonry over the part of the earlier double precinct farther N, the anaktoron contains two rooms, the larger entered through doors on its long W side; the smaller and higher, at its rear, accessible only to initiates, who entered it through internal doors. Installations in the larger chamber (a bothros in the SE corner, a wooden circular platform, a grandstand along two walls) reflect the initiatory rites. Spanned by wooden beams resting on piers engaged to its long walls, the anaktoron is the earliest example of the Samothracian taste for clear spans of exceptional size (10.58 m). A small building to its S served as a sacristy. Traces of the first epopteion, an apsidal building for initiation into the higher degree of the mysteries, are visible in the apse of its Hellenistic successor, the Hieron, as are those of an intermediate early Classical epopteion.

About 340, an area long occupied by altars and escharai was enclosed within a rectangular precinct preceded by a terrace. At its NE corner, where a road descending from the E hill led down into the sanctuary, a propylon was built. An Ionic porch with projecting wings preceded its door wall, its columns distinguished by an ornamental necking, its coffered ceiling carved with male and female heads shown in frontal, three-quarter, and profile views. Its entablature, the earliest example of the later standard combination of dentils with a sculptured frieze, also shows the first extensive use of the archaistic style for architectural sculpture: a figural frieze probably alluding to the venerable ceremonies performed within the precinct. The design of both the building and its sculptures may be attributed to Skopas.

This first marble building in the sanctuary was followed by a series of splendid structures largely built of Thasian marble. The Altar Court, dedicated ca. 340-330 by Arrhidaios, half-brother and successor of Alexander the Great, succeeded the rock altar beside the Hall of Votive Gifts. The Doric colonnade of this unroofed enclosure also faced the river. Within it, steps now led to a marble altar. The Doric Hieron was built ca. 325 to replace the early Classical epopteion. Its rectangular cella lined with lateral benches ended in a raised abaton, a segmental apse covered by a tentlike wooden roof. The painted stucco walls of the cella imitated its outer drafted-margin masonry beneath a wooden coffered ceil-

ing and trussed roof (clear span 10.72 m). Candidates for the epopteia entered the Hieron through its front door; epoptai, through lateral doors. A lustral drain near the entrance, an eschara, and the curtained abaton were centers of ritual action. The deep, hexastyle prostyle porch was not completed until 150-125 B.C. when it received a sculptured coffered ceiling (centaurs, grapes) and the building was adorned with pedimental sculptures and akroteria at both ends (front: the Nurturing of Aëtion; rear: relief busts of the Samothracian Gods; central: floral akroteria; lateral: Nikai pouring libations). Damaged by an earthquake, the rear akroteria were replaced in the early Imperial age. Toward A.D. 200, the cella was remodeled when the Kriobolia and Taurobolia of the Great Mother were added to the cult, necessitating enlargement of the main door and the introduction of parapets before the benches. A pair of monumental torches stood at the corners of the porch. A third torch flanked by a pair of stepping stones outside the cella was the scene of the rite of confession preliminary to the epopteia.

Between 323 and 316, another hexastyle prostyle Doric building was erected over a Classical predecessor. Standing on the E hill, near the entrance to the sanctuary, it was a gift of Philip Arrhidaios and Alexander IV. A shallow Ionic porch abutting its rear wall overlooked the paved stepped ramp leading downhill toward the Temenos. Its coffered ceiling was carved with floral motifs. In front of the Doric facade stood an altar or monument. Below it lay a paved circular area ca. 9 m in diameter. Encircled by rows of concentric steps of Classical date, it may have had a central altar. Statues, monuments, and inscriptions framed this area.

Between 289 and 281, the rotunda dedicated to the Great Gods by Arsinoe rose over the old double precinct. Built for sacrificial purposes, it is ca. 20 m in diameter. Its plain marble drum was surmounted by a gallery, Doric on the exterior, Corinthian on the interior, decorated with a parapet of sculptured bucrania and paterai. Its conical roof crowned by a hollow finial may have been screened on the interior by a wooden dome. Inside and at its periphery, there were altars and shafts for libation. Construction of the rotunda led to removal of the sacristy, which was now rebuilt against the anaktoron. Marble benches, lamps, and stelai recording initiations inserted into its stuccoed polygonal walls attest its use. Like other buildings in the sanctuary, it shows traces of Late Roman repair.

The Propylon of Ptolemy II erected between 285 and 281 gave access to the sanctuary from the city. On both sides of its door wall there was a deep hexastyle porch, Ionic on the outer city side, Corinthian on the inner sanctuary side. This is the first documented use of the latter order as an exterior structural member in Greek architecture. Bucrania alternate with rosettes on its sculptured frieze. A marble forecourt preceded the Ionic porch; another may have lain before the ramp leading down to the circular area on the E hill. The river bounding the sanctuary on the E originally passed through the cut-stone barrel vault running diagonally through the propylon's foundation. In the wake of an earthquake, probably in the 2d c. A.D., it assumed its present course to the W of the building. A wooden bridge now led across the river from the propylon to the higher barren area above the buried Classical circular structure. Neither it nor the royal dedication on the hill was replaced.

A stuccoed limestone Doric stoa built on the W hill overlooking the sanctuary in the 3d c. provided shelter for visitors. Two-aisled and ca. 106 m long, its inner order was Ionic. Its painted stuccoed walls were incised with lists of initiates. Probably its rear wall was pierced

by doors giving access to a broad area where a two-roomed structure was built against the stoa in the 4th c. A.D. A line of monuments stood to the E of the columnar facade above the terraced hillside where structures, probably for ritual dining, were successively built from the 4th c. B.C. to Late Roman times. A Hellenistic niche of pseudo-Mycenaean style may have represented the tomb of a Samothracian hero. To the S, the outline of the theater built ca. 200 B.C. appears. The white limestone and red porphyry seats of the cavea faced the Altar Court which served as its skene. Above the theater stood the Victory of Samothrace, part of a ship-fountain of the same period framed by an enclosure of retaining walls. The rectangular precinct is divided into an upper basin in which the prow of the vessel stood and a lower reflecting basin from which natural boulders emerge and water was drawn.

North of the stoa, the W hill is largely occupied by a 10th c. Byzantine fortification built of spoils from the sanctuary. Beneath it lie the foundations of a large unfinished building of the early Hellenistic age; to its W a row of three treasury-like late Hellenistic buildings once stood; to its E, a marble building with an Ionic porch that led into the central of three rooms. Dedicated by a Milesian lady in the 3d c., it, like other structures on the W hill, is still under investigation.

Beyond the S limits of the sanctuary lies the S Necropolis, the most extensive of the several burial grounds hitherto explored. Its tombs range from the archaic period to the 2d c. A.D. and reveal the use of both cremation and inhumation. The rich finds from the necropolis including ceramics, terracottas, glass, jewelry, and other objects are exhibited in the Museum at the entrance to the site.

Finds made since 1938 as well as the restored entablatures of several buildings may be seen in the five galleries and courtyard of this museum. Objects found by earlier expeditions, especially sculpture and architectural members, were taken to the Louvre, the Kunsthistorisches Museum in Vienna, the Archaeological Museums of Istanbul and the Archaeological Seminar of the Charles University, Prague.

BIBLIOGRAPHY. Preliminary Reports in *Hesperia* 19 (1950) 1ff; 20 (1951) 1ff; 21 (1952) 19ff; 22 (1953) 1ff; 24 (1955) 93ff; 34 (1965) 100ff; 37 (1968) 200ff. Blau & Schlottmann, "Altertümer von Samothrake und Imbros," *Berl. Ber.* (1855); A. Conze, *Reise auf den Inseln des Thrakischen Meeres* (1860); G. Deville & E. Coquart in *ArchMiss* 4 (1867) 253ff; A. Conze et al., *Archaeologische Untersuchungen auf Samothrake* (1875-80); O. Rubensohn, *Die Mysterienheiligtüner in Eleusis und Samothrake* (1892); J. Dragoumis, Σαμοθράκη (1909; German trans. by R. Hampe 1941); C. Fredrich, ed., *IG* XII 8 (1909) 36ff; H. Seyrig, "Sur l'antiquité des ramparts de Samothrace," *BCH* 51 (1927) 353ff; H. Thiersch, "Die Nike von Samothrake ein rhodisches Werk und Anathem," *GöttNachr*, Phil.-hist. Kl. (1932); B. Hemberg, *Die Kabiren* (1950) 49ff; F. Chapouthier, A. Salač, & F. Salviat, "Le Théâtre de Samothrace," *BCH* 80 (1956); E. B. Dusenbery, "A Samothracian Nekropolis," *Archaeology* 12 (1959) 163ff; "The South Nekropolis of Samothrace," ibid. 17 (1964) 185ff; "The South Nekropolis," *Archaeology* 20 (1967); F. Salviat, "Addenda Samothraciens," *BCH* 86 (1962) 268ff; "Ancient Glass from the Cemeteries at Samothrace," *JGS* 9 (1967) 34ff; K. Lehmann, *Samothrace, A Guide to the Excavations and the Museum*, 4th ed. (1975).

Samothrace. Excavations Conducted by the Institute of Fine Arts, New York University. K. Lehmann & P. W. Lehmann, Eds. (in progress): 1. *The Literary Sources*, ed. and trans. by N. Lewis (1958); 2,I. *The*

Inscriptions on Stone, by P. M. Fraser (1960); 2,II. *The Inscriptions on Ceramics and Minor Objects*, by K. Lehmann (1960); 3. *The Hieron*, by P. W. Lehmann (1969); 4,I. *The Hall of Votive Gifts*, by K. Lehmann (1962); 4,II. *The Altar Court*, by K. Lehmann & D. Spittle (1964); P. W. & K. Lehmann, *Samothracian Reflections* (1971)[MPI]; P. W. Lehmann, *Skopas in Samothrace* (1973). P. W. LEHMANN

SAMOUSSY Aisne, France. Map 23. Site in the E canton of the Laon arrondissement.

A Roman villa has been excavated N of the present-day village. No complete plan has resulted, but the finding of some post-holes suggests that the site contained wooden structures. Potsherds are abundant, in the main of crudely made ware. A few samples may possibly date from the Late Empire, while certain other forms are probably Carolingian. If so, this would be the first example of a settlement on the E borders of France occupied continuously from the Late Empire to the beginning of the 11th c.

BIBLIOGRAPHY. E. Will, *Gallia* 25, 2 (1967) 189; id., *Revue du Nord* 49 (1967) 771. P. LEMAN

SAMSAT, *see* SAMOSATA

SAMSUN, *see* AMISOS

SAMUM (Căşei) Cluj, Romania. Map 12. An important military center at the N frontier of Dacia identified by inscriptions. Both camp and vicus were on the right bank of the Someş, 1.5 km from the modern village.

The earth camp (165 x 165 m) was rebuilt in stone probably under Hadrian. The enclosure is provided with internal buttresses for defending the rampart walk. The gates have semicircular bastions.

Palmyreni sagittari ex Syria and the Cohors I Britannica milliaria civum Romanorum were stationed here.

Inscriptions from the 3d c. attest that the vicus had a command center at the border under the military jurisdiction and control of a beneficiarius consularis.

Two military diplomas were found here: one from A.D. 120, the other from 164. Important archaeological and epigraphic materials can be found in the Dej Museum and in the History museum of Transylvania at Cluj.

BIBLIOGRAPHY. E. Panaitescu, "Castrul roman de la Căşeiu. Din cercetările nouă," *Anuarul Comisiei Monumentelor Istorice, Secţia pentru Transilvania* 2 (1929) 327-40; V. Christescu, *Istoria militară a Daciei romane* (1937) 136-37. L. MARINESCU

SANCTUARY OF THE MUSES Mt. Helikon, Greece. Map 11. Situated in the upper valley of the Permessos (Archontitza) between Mt. Zagara and Mt. Marandali (Helikon) to the S and Mt. Koursara and Mt. Pyrgaki (Ascra) to the N, 8 km W of Thespiai. Formerly wooded, the valley was the alsos or Sacred Grove of the Muses; the sanctuary has been located around the Haghia Trias Chapel on the right bank of the Permessos.

Underneath the walls of the Chapel of Haghia Trias, which stands on a terrace 50 m from the Permessos, was found the base of the Great Altar of the Muses (until 1954 mistakenly called "Temple of the Muses"). It faces E, is 5.80 m long and 9.80 m wide, and stands on two courses of white poros and one leveling course of conglomerate. The platform, built of well-bonded limestone blocks, was approached up a step on the W side; the altar covered two-thirds of its surface to the E.

Forty m W of the altar the remains of a long N-S portico was discovered; it was open to the E and measured 96 x 10 m. The E colonnade (36 monolithic col-

umns) was Ionic, the side colonnade, which supported the roof, Corinthian. Architectural fragments of this portico, of stone and terracotta, are in the Thebes Museum. N of the altar, on the left bank of the Permessos, a second portico was identified at least 48 m long. All these monuments date from the 3d c. B.C. at the earliest.

Some 300 m SW of the great portico on the foothill of the mountain is a natural semicircular depression that marks the site of the theater. There were no stone tiers, but the seats in the proedria row were no doubt of marble. The skene, which was more than 7 m deep and erected on an artificial terrace, has collapsed; the proskenion, which was about 22 m wide and 3 m deep, was built on the ground; the limestone stylobate supported 12 Doric half-columns 2 m high, monolithic and engaged in square pilasters.

There were many statues in the Valley of the Muses, some of the bases of which are in the Thebes Museum. Near the altar and the portico, possibly, was the great semicircle on which stood the statues of the nine Muses.

The site has been excavated.

BIBLIOGRAPHY. P. Decharme, "Notice sur les ruines de l'Hieron des Muses dans l'Hélicon," *ArchMiss* 2d sér. IV (1867) 169-80; P. Jamot in *BCH* 19 (1895) 321-85; 26 (1902) 129-60; *En Grèce* (1914); Fiehn in *RE* (1933), s.v. Musental; M. Mayer, ibid. s.v. Musai; G. Roux, "Le Val des Muses et les Musées chez les auteurs anciens," *BCH* 78 (1954) 22-45[MPI]; N. Papahadjis, *Pausaniou Hellados Periegesis* V (1969) 178-90[MPI].
 P. ROESCH

SANTIAGO DO CACÉM, *see* MIROBRIGA

SANTICUM (Villach) Carinthia, Austria. Map 20. An important junction of the road Aquileia, Santicum, Virunum, Ovilava and the road Santicum, Teurnia, Iuvavum, located at a favorable crossing over the Drau. It is mentioned by Ptolemy (*Geog.* 2.13.3) as among the poleis of Noricum, and is also found in the *Antonine Itinerary* (276.4).

The extensive settlement area has three centers: 1) building fragments in the old quarter near the Stadtpfarrkirche; 2) the hill of St. Martin's Church where numerous building fragments and reliefs were found, indicating a temple and large sepulchers; 3) the area of Warmbad Villach where a temple existed for the indigenous goddess Vibes, a fortified refuge from Late Classical times, and a villa to which an Early Christian cemetery chapel had been added. Here a long stretch of the remarkable Roman road can be observed; its tracks hewn into the rock are excellently preserved. The main necropolis was situated at the N bank of the Drau. Here was found a considerable coin hoard (162 aurei and 4 denarii), which had been buried about A.D. 197.

Most finds are in the Museum of Villach, some in the Museum der Kuranstalt of Warmbad Villach.

BIBLIOGRAPHY. H. Dolenz, "Altstrassen und Altsiedlungen im Stadtgebiet von Villach," *Carinthia* 148 (1958) 235ff. R. NOLL

SANTI PONCE, *see* ITALICA

SANTORINI, *see* THERA

SANXAY Vienne, France. Map 23. The rural sanctuary of Sanxay in Herbord is 35 km SE of Poitiers on the road from ancient Limonum, on the N side of the Sinus Pictonum, to the center of the Pictonic territory. It forms, with Vendeuvre and Vieux-Poitiers, a group of rural sanctuaries at some distance from the capital and did not, therefore, play the role of sanctuary-frontier between two cities like La Terne, Chassenon, or St. Léomer.

The buildings are on both banks of the Vonne, a small tributary of the Clain which must have influenced the original choice of a site for the native cult. On the left bank, three terraces rise from W to E, that on which the temple was located dominating those of the forum and the baths. Below, the populated quarters spread along the river. The theater and a small fanum have been discovered to the S on the right bank.

Temple: the rectangular peribolos, oriented E-W, consists of two parallel walls forming a courtyard in the center of which was the temple. The W side of the peribolos was a long building, reached from the outside by a ramp. To N and S the inner wall of the peribolos supported the colonnade of a portico; traces of the bases have been found. To the E the colonnade was probably higher, and the exterior wall was probably reinforced by buttresses. Monumental steps on this side led to the temple. Two secondary sets of steps at each end of the gallery led directly to the N and S porticos. In the center, an octagonal structure like that at Chassenon was reinforced with pilasters at its interior angles. It had at least two entrances, at E and W. Around the octagon, walls 1.25 m thick form a Greek cross, the E arm of which was connected to the portico by a monumental rectangular vestibule. It has been suggested that these walls formed the stylobate of a colonnade, but it is more likely that they were the foundations for walls lower than those of the octagonal cella. Fragments of Corinthian and composite capitals found on the site perhaps belong to the temple. They are of a developed type, with a high cylindrical bell of acanthus leaves, volutes partially hidden by the leaves, and high striated abaci.

Forum: extending the terrace on which the temple is built, and below it, stretches a vast esplanade (88 x 94 m) bordered with walls and including a courtyard on the S and E sides. In the center is a small circular edifice 7 m in diameter which has sometimes been called the Tomb of the Hero. Nothing supports such an identification. The esplanade doubtless served as a gathering place, but it is not certain that it fulfilled all the roles of a forum. The finds identify it as being, like the temple, from the 2d c.

Baths: on the E, and off axis to the N, a third esplamade (60 x 110 m), runs E-W. It was bordered by porticos stretching from the W to the N and E. A large palestra has been identified in the W part, and in the NW section were the baths. The original building was a double bath building. To the E was a large swimming pool, with three apses to the N to which were attached a caldarium, a tepidarium with a hypocaust, and a frigidarium. To the W, two rooms with hypocaust and subsidiary rooms formed a second group. In a later remodeling, a third room with a hypocaust was built on to the W half of the large swimming pool. The original plan was further modified by other rooms with hypocausts added to the N on each side of the entrance vestibule. The original construction was 2d c., the modification at the end of the 3d.

Theater: S of the river the theater is built against a steep slope facing NW. A vast structure 90 m in diameter, it consisted of stone foundations and wooden tiers, like most rural theaters in Gaul. The cavea was considerably more than a semicircle. The tiers in the central section were cut into the rock, but only the lower ones were covered with masonry—the seats for important guests. The others had a wooden superstructure. On the sides can be seen the foundations of a double circular exterior wall, of three precinctions, and of the podium wall. All the vomitoria are strangely oriented, parallel to the long diameter of the theater and to the stage wall. To the S two narrow ones serve the upper tiers. Two others, towards the center, lead to the podium. The main entrances were two large corridors behind the stage wall, divided into four compartments by extensions of the precinct walls, on either side of the orchestra. The orchestra is very large, and almost perfectly circular, the diameter varying from 37.4 to 37.7 m. Remains of an oval structure are perhaps those of an earlier arena. The stage is small, with two doors opening onto the orchestra, and forms a projection in the exterior of the stage wall. Such an arrangement would seem to reduce the role of the actors to a minimum, while permitting audience participation, unless one postulates a wooden proscenium extending into the orchestra. The theater dates from the 2d c. A.D.

Residental area: one neighborhood extended along the river at the foot of the temple-forum-bath ensemble, but separated from it by extended terraces. There were four great buildings with a central peristyle courtyard which have been identified as hostelries for pilgrims, besides more modest houses. Another ensemble has been partially uncovered to the NE, behind an E-W street. Buildings with large courtyards have also been found along the Vonne, and simpler dwellings higher up. Finally, some isolated structures to the W and N hint at an extension of the settlement. It is hard to maintain that there was a real town at Sanxay, however. It is probable that here, as at Vendeuvre, the residential quarters were built after the public buildings.

Artifacts: common ware and terra sigillata, including some beautiful pitchers with handles, numerous iron tools, iron and bronze keys, and objects of personal ornament. The most important finds are two bronze statuettes, a Mercury with a purse and an Attis with double axe, as well as a terracotta from the Allier district decorated with a Venus pudica.

BIBLIOGRAPHY. P. C. de La Croix, *Mémoire archéologique sur les découvertes d'Herbord, dites de Sanxay* (1883); id., *Mémoire de la Société des Antiquaires de l'Ouest* (1883) 7; J. Héron de Villefosse, "Inscriptions romaines de Sanxay," *Revue poitevine et saintongeaise* (15 Jan. 1885) 341ff; G. Chauvet, "Le temple romain de Sanxay et le culte des Empereurs," *Bulletin de la Société des Antiquaires de l'Ouest* (1922-23) 381-428; H. Koethe, "Die keltische Rund- und Vielecktempel," *RGKomm* 23 (1933) 68-174; J. Formigé, "Le sanctuaire de Sanxay," *Gallia* 2 (1944) 43-97[PI]; F. Eygun, "Liste des objets recueillis à Sanxay par le P. de La Croix," ibid. 98-120; Grenier, *Manuel* III:1, 54-55[I]; III:2, 939-43[I]; IV:2, 553-67[PI].
G. NICOLINI

SAPAJA, *see* LIMES OF DJERDAP

ŞAR, *see* COMANA CAPPADOCIAE

SARANDA, *see* THYSSANOUS

SARAVUS (Saarbrücken) Saarland, Germany. Map 20. A Roman settlement founded early in the 1st c. A.D. at the Saar crossing of the Metz-Worms road. There, in the angle of the Halberg and the river, developed a considerable settlement of craftsmen and merchants. Within the town the Trier-Strassburg road intersected the Worms road. A characteristic middle-class house contained three adjacent rooms with hypocaust, cellar, and deep well. The eaves ran parallel to the road. Parts of a larger villa urbana were discovered near the banks of the Saar. A wooden bridge nearby had been replaced by one built of stone. Drinking water was brought in through an impressive rock tunnel. A well-executed stone statue of Mercury was found in a cult place outside the settlement; inside, the torso of a Jupiter was found. During Late Imperial times a natural cave in the side of the Halberg was enlarged for the Mithras cult.

Extensive fire damage followed a raid by Germanic tribes, probably at the end of the 3d c. A.D.; the houses were rebuilt. In a second raid ca. 350 the villa was destroyed. In that area a small castellum with a polygonal ground plan (77 x 93 m) was built as part of the reorganization under Valentinianus. The land side had four round towers. Within the settlement and on the outskirts necropoleis contained graves with both inhumations and cremations. From the late period date ceramics of the Mayen type and a coin of Honorius (392-395). The construction of the aqueduct is of special interest.

BIBLIOGRAPHY. C. Klein, "Die Ausgrabungen und Funde in der Heidenkapelle auf dem Halberg bei Saarbrücken," *Bericht des Konservators der geschichtl. Denkmäler im Saargebiet* 1 (1923) 13-20; id., "Ein spätrömisches Kastell bei Saarbrücken," *Germania* 9 (1925) 58-62; A. Kolling, "Funde und Untersuchungen im Vicus Saarbrücken," *Germania* 39 (1961) 480-83; id., "Der Name des römischen Saarbrücken," *Bericht der Staatl. Denkmalpflege im Saarland* 12 (1965) 61-65; R. Schindler, "Neues vom Römerkastell und Vicus Saarbrücken," *Bericht der staatl. Denkmalpflege im Saarland* 9 (1962) 12-22; D. Kienast, *Die Fundmünzen der römischen Zeit in Deutschland, III: Saarland* (1962) no. 1087; J. Keller, *Der römische Wasserleitungsstollen am Halberg bei Saarbrücken*, ibid., 67-77. A. KOLLING

SARBAZAN Landes, France. Map 23. Gallo-Roman villa of Mouneyres excavated in 1891-92. It consists of a rectangle (40 x 42 m) around a central court, and adjoining constructions; five rooms had mosaic floors with designs of plants and animals (foliated scrolls, vines, grapes, ivy, baskets of flowers and fruit, blackbirds, thrushes). One floor had a design of diabolos. A bath building 200 m SE consists of three rooms, one of them a three-lobed pool paved with a mosaic with a design of dolphins. The villa was used from the 3d c. on.

BIBLIOGRAPHY. "L'Aquitaine Historique et Monumentale," *Bulletin de la Société de Borda* (1892) 237-63MPI; J. Coupry, "Informations," *Gallia*PI 13, 2 (1955) 200; 15, 2 (1957) 254; 21, 2 (1963) 529; 23, 2 (1965) 434; 25, 2 (1967) 365; 27, 2 (1969) 369. M. GAUTHIER

SARDIS or Sardes Turkey. Map 7. In the plain of the Hermus river about 10 km inland from the Aegean coast at the foot of Mt. Tmolos, a spur of which forms its acropolis. The site occupies ca. 2.5 sq. km astride the modern E-W highway between Izmir and Salihli, and extends S into the valley of the Pactolus river, famed in antiquity for its gold-bearing sands.

Excavations have established continuous habitation of the region since at least 3000 B.C. Mycenaean IIIC and Protogeometric pottery (ca. 1200-ca. 900 B.C.) lends credence to Herodotos' claim that Greek warriors, "sons of Herakles," seized Sardis and founded a dynasty in ca. 1185 B.C. About 680 B.C. Gyges took Sardis from Kandaules, the last of the Heraklid kings, and founded the Mermnad dynasty. Under the Mermnads, Gyges, Ardys, Sadyattes, Alyattes, and Croesus, Sardis achieved international prominence as capital of Lydia. The period of greatest Lydian artistic and technical achievement was 650-550 B.C. Economic prosperity derived from the supply of gold and the ability to purify it, and from the invention of coinage and the establishment of a bimetallic monetary standard. In the time of Croesus (560/1-547) the population is estimated at 50,000.

In 547 Sardis fell to Cyrus, who made it his western capital from which the Anatolian and Ionic Satrapies of the Persian Empire were ruled. It was the western terminus to the Royal Road maintained by the Persian kings from Iran to the Mediterranean. In 334 B.C. the satrap

Mithrines surrendered the city to Alexander the Great, whose generals held it until its capture in 282 B.C. by Seleucus I, satrap of Babylon. Antiochos III besieged and destroyed Sardis in 213 B.C. but let the city be replanned along Hellenistic lines.

The kings of Pergamon took over Sardis about 180 B.C., and in 133 B.C. it was left to the Romans by the bequest of the last Pergamene king, Attalos III. Although its power as an administrative center was lost to Ephesos, Sardis continued an important center throughout the Roman period and increased in size and prosperity. An important Jewish community existed at Sardis from the 5th c. B.C., attaining such influence that their synagogue was uniquely situated within the Roman gymnasium complex. The Revelation of St. John lists Sardis as one of the Seven Churches of Asia. The end of the Classical city probably came in A.D. 616 by a raid of the Sassanian king Chosroes II.

Ten m below the Byzantine bastion on the S side are three pre-Hellenistic wall segments, the remains of the triple defenses admired by Alexander the Great in 334 B.C. (Arr. *Anab.* 1.17.3-6).

The Lydian city was an irregular agglomeration (499 B.C.: Hdt. 5.101) with an extension S into the Pactolus valley along a sacred road to the Artemis precinct. As observed by Herodotos and Vitruvius, both public and private buildings were of mudbrick, many with thatched roofs. The excavation of the Lydian bazaar area can be seen near the highway on the S side. An open area was transformed into an industrial and commercial center enclosed by an irregular stone wall which is preserved for ca. 32.8 m. Abutting it were single-room houses or shops. Farther S, excavation of a section of the Lydian city on the E bank of the Pactolus has revealed more sophisticated architectural units attached in urban complexes to form court-like spaces. Houses with interior hearths were built on high foundation walls of mudbrick. Both terracing and split level design occur. In this sector can be seen the remains of an archaic altar to Kybele and sacral precinct. South and W of the altar are industrial areas where conclusive evidence for gold refineries active ca. 600-547 has been found. Two floors of cupels (cavities for obtaining electrum from base metals) set in a layer of gravel were identified. Adjacent are remains of two sets of small furnaces used for cementation, the process of separating gold from silver, as indicated by the presence of scraps of gold foil. Other Lydian houses are known in a creek NE of the Artemis temple.

Outstanding among the Lydian remains are the huge burial mounds in the cemetery of Bin Tepe (Turkish "Thousand Mounds") 6.4 km N of the city area across the Hermus, S of the Gygean Lake (Marmara Gölü). At the E end of the cemetery stand three mounds larger than the rest. A poem by Hipponax (ca. 540 B.C.) suggests that the central one, with a diameter of over 200 m, is that of Gyges. Within is a retaining wall or krepis of finely cut local limestone blocks for a smaller interior mound, on which the monogram GuGu, the name by which Gyges was known in Assyrian records, appears. The burial chamber has not been located. The E mound of Alyattes, largest of the three, was compared by Herodotos to the pyramids. It had a retaining wall of huge masonry, now vanished, which was recorded as 1,115.23 m in circumference in 1853. A small burial chamber is built of highly polished marble blocks fitted together with precision and held with iron clamps. Pottery finds indicate construction in the late 7th or early 6th c. B.C. In the precipitous necropolis ridge on the W bank of the Pactolus are hundreds of Lydian rock-cut chamber tombs.

Attributable to the Persian era is the "Pyramid Tomb," a stepped platform of limestone in Şaitan Dere gorge,

E of the Pactolus. The masonry resembles that of Cyrus' structures at Pasargadai and the stepped sandstone altar adjoining the Artemis temple on the W.

In the 3d c. B.C. the city was Hellenized, and the great Ionic Temple of Artemis in the Pactolus valley was begun. It was fronted on each end by eight columns almost 17.8 m high; twenty such columns were on each side. The extant columns are largely Roman replacements. The two shrines of the double cella were converted to the Roman Imperial cult ca. A.D. 140—that to the E dedicated to Antoninus Pius, that to the W to his wife Faustina. The earliest parts of the theater (at the foot of the acropolis, S of the highway), especially the masonry walls supporting the two sides of the semicircular auditorium, and the plan of the adjacent stadium belong to the Early Hellenistic period. The Hellenistic orientation of the city featured a diagonal artery from the Pactolus to the gymnasium area to the NE corner of the city. This thoroughfare obliquely crossed the colonnaded main avenue of the Roman plan.

In A.D. 17 earthquakes leveled the Hellenistic city, and Tiberius and Claudius offered funds for rebuilding. A master plan was formulated but the building of individual structures lasted several generations. A marble-paved and colonnaded main avenue was laid out S-W. It is now N of and under the modern highway. On its N side an artificial terrace with substructures more than 5 m deep supported the gymnasium complex. Symmetrical to the E-W axis, the gymnasium has a palaestra on the E and large baths of imperial type on the W. The central unit, comprised of a pair of double-apsed halls flanking a rectangular room, was completed by A.D. 166 when an inscribed base was erected in honor of Lucius Verus.

The E section of the baths centered around a monumental hall, called by the excavators the Marble Court, which has been restored (1964-73) to the top of the second story. A dedicatory inscription to Caracalla, Geta, and Julia Domna dates the facades to A.D. 211. The carved friezes, cornices, and floral soffits are among the finest examples of the Severan Baroque style. The facade is comprised of alternating two-story aediculae. Benches with Early Byzantine inscriptions run along the N, S, and parts of the W sides. On the W side is an ornate gate with four fluted spiral Ionic columns supporting an arcuated pediment, which leads into a barrel-vaulted hall with a pool and fountains, possibly the aleipterion, mentioned in inscriptions. On the E side the court was closed by a screen colonnade which opened into the palaestra. Early Byzantine restoration is attested by inscriptions.

Between the palaestra and the main road, oriented E-W, is a large basilican building which was used as a synagogue from ca. A.D. 200 to 616. Now partly restored, the building comprises three parts: the entrance porch, which fronted on a colonnaded road, a peristyle forecourt, and a long main hall ending in an apse. The colonnade of the forecourt has been re-erected and a replica of its krater fountain replaced. On the N wall above a marble dado is a restored sample from a redecoration dating in the 5th or 6th c. A.D.: short pilasters support arcades with a pattern of doves and kraters against a recessed background filled with red mortar. In its earlier phase the masonry was covered with frescoes. Between the three doors leading from the forecourt to the main hall are two small shrines, one Doric and one Late Corinthian in style, which face the apse. The main hall was divided into seven bays by six pairs of piers; at the W end is an apse lined by three marble benches. The ritual furnishings include a massive marble table supported by eagles in relief and flanked by two pairs of adorsed lions. The floors of both the forecourt and hall were covered with geometric mosaics of the 4th c. A.D. The walls were revetted with polychrome marble. The architectural system, including donors' inscriptions, has been restored in one bay on the N wall and one on the S. Samples of restored marble panels are on the S wall. Roughly a hundred Hebrew and Greek inscriptions provide information about the Jewish community, which may have numbered between 5000 and 10,000. Along the S side of the gymnasium complex runs a continuous row of shops (ca. A.D. 400-600) which opened onto the main avenue. One had a marble tank decorated with crosses and fed by terracotta water pipes; apparently Christian and Jewish shopkeepers traded side by side.

South of the Byzantine Pactolus bridge, above the Lydian gold refineries, are excavated ruins of a Roman bath and a small Middle Byzantine church. At the NW corner of the Artemis Temple is a nearly complete church of the 4th-6th c. with two apses *en echelon*. Major unexcavated buildings are remnants of the Roman civic center on a terrace S of the highway, a Byzantine fort (farther S and uphill), tunnels to the citadel, the theater, stadium, and a Roman odeum. By the N side of the highway are piers of a large Justinianic church, perhaps a cathedral. Farther down and N is a fine Roman basilica with apses at either end.

First scientific excavations of the site were undertaken from 1910 to 1914 and resumed for one season in 1922. Finds are in the Istanbul Museum, Izmir Museum, Metropolitan Museum, New York, and Princeton University Museum. In 1958 excavation was again resumed. Finds are in the Archaeological Museum, Manisa, Turkey.

BIBLIOGRAPHY. *Sardis, Publications of the American Society for the Excavation of*: I,1 H. C. Butler, *The Excavations, 1910-1914* (1922); II,1 *Architecture, The Temple of Artemis* (1925); V,1 C. R. Morey, *Roman and Christian Sculpture, the Sarcophagus of Claudia Antonia Sabina* (1924); VI,1 Enno Littmann, *Lydian Inscriptions* (1916); VI,2 W. H. Buckler, *Lydian Inscriptions* (1924); VII,1 W. H. Buckler & D. M. Robinson, *Greek and Latin Inscriptions* (1932); X,1 T. L. Shear, *Architectural Terracottas* (1926); XI,1 H. W. Bell, *Coins, 1910-1914* (1916); XII,1 C. D. Curtis, *Jewelry and Gold Work, 1910-1914* (1925).

G.M.A. Hanfmann, et al. (eds.), *Archaeological Exploration of Sardis*: Monograph 1, G. E. Bates, *Byzantine Coins* (1971)[MPI]; 2, J. G. Pedley, *Ancient Literary Sources on Sardis* (1972); 3, R. Gusmani, *Neue epischorische Schriftzeugnisse aus Sardis* (1958-1971) (1974)[MPI]; 4, Clive Foss, *Byzantine and Turkish Sardis* (forthcoming)[MPI]. Report 1, G.M.A. Hanfmann, J. C. Waldbaum, *A Survey of Sardis and Major Monuments Outside the City Wall* (forthcoming)[MPI].

Preliminary reports by G.M.A. Hanfmann and others have appeared annually in *BASOR* and *TürkArkDerg*.

In D. G. Mitten, et al. (eds.), *Studies Presented to G.M.A. Hanfmann* (1971)[MPI]: M. S. Balmuth, "Remarks on the Appearance of the Earliest Coins," 1-8; C. H. Greenewalt, Jr., "An Exhibitionist From Sardis," 29-46; A. T. Kraabel, "Melito the Bishop and the Synagogue at Sardis," 77-86; A. Oliver, Jr., "A Bronze Mirror From Sardis," 113-20; A & N. H. Ramage, "The Siting of Lydian Burial Mounds," 143-60.

G.M.A. Hanfmann, *Letters From Sardis* (1972)[MPI] includes earlier bibliography. C. H. Greenewalt, Jr., "Two Lydian Grave Sites at Sardis," *CSCA* 5 (1972) 113-45[MPI]; A. R. Seager, "Building History of the Sardis Synagogue," *AJA* 76 (1972) 425-35[MPI]; "Archaeology at the Ancient Synagogue of Sardis, Turkey," *Ball State University Faculty Series* (1974)[MPI]; G. Yüğrüm, *A Guide to the Excavations of Sardis* (1973)[MPI]; E. Akurgal, *Ancient Civilizations and Ruins of Turkey* (1973) 124-32[MPI]; D. G. Mitten, G. Yüğrüm, "Ahlatli

Tepecik Beside the Gygean Lake," *Archaeology* 27 (1974) 22-29^MPI; G.M.A. Hanfmann, *From Croesus to Constantine* (1975)^MPI. J. A. SCOTT & G.M.A. HANFMANN

ŠARENGRAD, *see* LIMES PANNONIAE (Yugoslav Sector)

SARIMAĞARA, *see under* ANTIOCH BY THE CALLIRHOE

SARINASUF ("Ad Stoma") Dobrudja, Romania. Map 12. On the N side of Lake Razelm an indigenous settlement (6th-4th c. B.C.). It developed under the influence of Histria, being perhaps on its territory. The excavations have revealed dwellings and pottery fragments which clarify the role of Greek influence in the formation of the Thracian-Getic civilization. Nearby were found many ruins of stone buildings, coins from the 2d c. B.C., and inscriptions. The settlement has been identified tentatively with Ad Stoma (*Tab. Peut.* 8.4).

BIBLIOGRAPHY. C. Moisil, "Cetăți romane la Dunărea de Jos," *Buletinul Comisiunii Monumentelor Istorice* 2 (1909) 91. E. DORUTIU-BOILA

SARMISEGETUZA, *see* ULPIA TRAIANA

SARREBOURG, *see* PONS SARAVI

SARSINA or Sassina Italy. Map 14. This town, once an Umbrian center, was conquered by the Romans in 266 B.C. and subsequently became a civitas foederata, and then a municipium and administrative center of the middle valley of the Savio. It was the home of Plautus. During the Empire it was an important center for agriculture, especially milk and cheese products, and was known for its hot springs. The road through the Savio valley was important for communications between the Tiber valley and Ravenna.

The city was reconstructed about the time of Sulla, who died in 78 B.C. A circuit wall in opera quadrata was erected; and the forum, corresponding to the modern Piazza Plauto, may have been made more systematic at the same time. Sewers were dug underground in an octagonal pattern that probably corresponds to the arrangement of the ancient streets. A residential area was built on terraces on the lower slopes of the Calbano hills, which dominate the city on the N. In this area were private buildings of some prominence and a large bath complex, later enlarged several times. The entire area was fairly small as it was limited to the terrace above the Savio. At the E entrance to the area are important remains. On the E side of the forum are remains of a circular building, transformed in Christian times but perhaps originally the building where C. Cesius Sabinus, an influential figure of the Flavian period, dedicated a series of bronze statues of the divinities of the Italo-Roman pantheon. Marble statues which reproduce Hellenistic prototypes, and which belonged to a cult center of Oriental divinities have been found in the SW sector of the forum. This Sanctuary of the Oriental Gods dates to the Antonine period. Next to it was a large building with extensive mosaics.

Between 1927 and 1931 excavations were carried out in the necropolis of the plain of Bezzo on the bank of the Savio, on both sides of the road from Caesena. The necropolis included graves of various types and sizes, among which were found, besides a tumulous monument and various enclosed graves and graves with stelai, large spired tombs datable to the last quarter of the 1st c. B.C. In these buildings Hellenistic designs from Asia Minor were adapted to Roman needs, and assumed special forms that are clearly Italic. Certain sepulchers indicate that there were Orientals in the Sarsinate community from late Republican times.

The famous hot springs are perhaps those of S. Piero in Bagno still in use where a deposit of the Imperial period has recently been found.

BIBLIOGRAPHY. Alessandri, *I municipi romani di Sarsina e Mevaniola* (1928); Solari, "Topografia archeologica di Sarsina," *RendLinc* 8 (1952) 256; G. Susini, "Documenti epigrafici di storia sarsinate," *RendLinc* 10 (1955) 235; id., "Poleografia sarsinate," *Studi Romagnoli* 5 (1956) 181-217; id., "La data delle mura di Sarsina," *Atti e Memorie Deputazione di Storia Patria prov. Romagna*, NS (1956-57) 171; Finamore, "Calbano, castello di Sarsina," *Studi Romagnoli* 11 (1962) 22; S. Aurigemma, *I monumenti della necropoli romana di Sarsina* (1963)^MPI; G. V. Gentili & G. Mansuelli, "Sarsina," *NSc* Suppl. (1965) 110-25^MPI; Gentili et al., *Sarsina, la Citta romana, il Museo archeologico* (1967)^MPI.

G. A. MANSUELLI

SASAMÓN, *see* SEGISAMA

SASSINA, *see* SARSINA

SATALA (Sadak, Kelkit, Gümüşane) Armenia Minor, Turkey. Map 5. The site came into prominence when the Legio XV Apollinaris was placed there, probably by Trajan, to control the N sector of the E limes between the Euphrates and Trabzon (Trapezos). The legion was still there in the 4th c. A.D. (*Not. Dig. or.* 38.13). The city growing out of the civil settlement connected with the legionary camp is thought to have been founded in the 2d or 3d c. A.D. but the first evidence of it is provided by Basil in A.D. 372 (*Ep.* 102). From Theodosius (*Nov.* v.3, A.D. 441) it can be inferred that the territory was very extensive, reaching to the Euphrates and the border with Greater Armenia. In A.D. 530 the Persians were defeated before the walls of Satala (Procop. *Bell. Pers.* 1.15) and it was subsequently refortified by Justinian.

"It lies in a low lying plain and is dominated by many hills which tower around it" (Procop., *De aed.* 3.4). The massive roughly rectangular walls partly survive and surround the village of Sadak on the sloping floor of the Sadak çay valley, tributary of the Kelkit (Lycus) river. Within the walls only insignificant ruins stand out. The interior level stands high above the plain, squared stones abound and occasional inscriptions can be seen. To the S stand the meager remains of an aqueduct. On the hill to the W are traces of perhaps an earlier auxiliary fort.

BIBLIOGRAPHY. F. & E. Cumont, *Studia Pontica* II (1906). R. P. HARPER

SATICULA Campania, Italy. Map 17A. A Samnite site on the borders of Campania; S. Agata de' Goti (province of Benevento) is usually identified as its arx. The Romans took it in 315 B.C., and a Latin colony was sent there in 313. A large necropolis 2 km from S. Agata has been repeatedly explored, intensively in 1771-1811. The finds led to a classification of pottery, believed to be of local manufacture, as Saticula I, II, and III. More recently this has been proved false, and none of this pottery is now considered local.

BIBLIOGRAPHY. L. Forti, *RendNap* NS 23 (1946-48) 203-23. L. RICHARDSON, JR.

SATRIANUM Lucania, Italy. Map 14. Between the towns of Satriano di Lucania and Tito in NW Lucania. The site was inhabited from the 7th c. until the early 3d c. B.C. Sections of the walls of the 4th c. are visible surrounding the acropolis. Sporadic finds and material from the excavations are in the Potenza Museum.

BIBLIOGRAPHY. R. R. Holloway, *Satrianum, The Archaeological Investigations Conducted by Brown University* (1970). R. R. HOLLOWAY

SATRICUM (Conca) Italy. Map 16. A small Volscian town in the coastal plain of Latium on the road from Antium to Velitrae. It first appears in history as an ally of the Latins in the battle of Lake Regillus (Dion.Hal. 5.61.3). According to Livy it was the scene in 377 B.C. of a battle in which the Romans defeated a combined army of Latins and Volscians. When the Antiates then wished to capitulate to the Romans, the Latin forces withdrew and in their fury burned Satricum. All but the Temple of Mater Matuta perished in the fire; it was saved by a miraculous voice from the temple that ordered the removal of the brands from its walls (Livy 6.32.4-33.5). A repetition of these events is recorded for 347-346 B.C., following a rebuilding of Satricum by a colony from Antium (Livy 7.27.2-8). Thereafter Satricum is not heard of, though the temple long continued to be a pilgrimage shrine.

The site was excavated in 1896, and the temple area thoroughly explored. It was an unusually important discovery in every way, but no full publication of it has appeared. The temple building shows at least two major periods of construction, the earlier on a different orientation from the later, possibly built over a pit belonging to a time when this was an open-air sanctuary. The material from the pit belongs to the 7th c. and first half of the 6th. The older temple building may have been peripteral or may have been of Tuscan plan with alae; there were, in any event, columns down its flanks. The later temple was certainly peripteral, and the foundations for steps around it make it look very much more Greek than Italic. In the later temple there were four columns on the short sides, eight on the long; the cella was long and narrow with a pronaos ending in antae without columns between.

The architectural terracottas fall into two groups, possibly representing the two building periods. The earlier (third quarter of the 6th c. B.C.) comprises antefixes, a frieze showing pairs of riders, a plaque with a gorgon, plaques with animals, a hanging frieze of purely formal design, and eaves tiles. The later (early 5th c.) has pedimental sculptures, acroteria and figured columen plaques, as well as an extraordinary range of antefixes, including the famous series of couples of satyrs and maenads, at least five sets of revetment plaques, raking cornice, pierced cresting, and eaves tiles. It is probably the richest find of a single temple decoration to date.

Associated with the earliest sanctuary were discovered foundations of huts, round, elliptical, and rectangular in plan, over which lay foundations in blocks of tufa that could not be dated. In exploring the environs a number of tombs were discovered, as well as a number of structures that indicate occupation of the site into the Roman Empire. The material from the temple, on the other hand, stops in the 2d c. B.C. All the material recovered is now in the Museo della Villa Giulia.

The site is now much overgrown, and an ancient agger fortification without stone facing which used to bound the city site on the W has disappeared in the course of the last 20 years, presumably a victim of agricultural advances with heavy machinery.

BIBLIOGRAPHY. F. Barnabei, A. Cozza, R. Mengarelli, *NSc* (1896) 23-48, 69, 99-102, 167, 190-200; A. Della Seta, *Museo di Villa Giulia* (1918) 233-320; A. Andrén, *Architectural Terracottas from Etrusco-Italic Temples* (1940) 453-77, pls. 137-52. L. RICHARDSON, JR.

SATURNIA, *see* AURINIA

SATYRION (Torre di Saturo) Apulia, Italy, Map 14. An ancient city on the Ionian coast ca. 12 km SE of Tarentum in the territory of Leporano. The site was associated with the historical problems of the Laconian colonization of Tarentum. In all the sources, it is always named before Tarentum itself (Ant. apd. Strab. 6.278; Ephor. apd. Strab. 6.279; Dion. Hal. 19.1.2; Diod. 8.21) so that it appears to be the oldest Laconian settlement in Puglia. This has recently been confirmed by extensive excavation. It is probable that its name survives from the Ausonian or pre-Iapygean place-name stratum and pertains to the way station associated with traffic in the late Mycenaean world (14th-12th c.) preceding the Iapygean or pre-Laconian settlement of the late Bronze Age and of the Iron Age (11th-8th c.). Somewhat after the middle of the 8th c., the arrival of the Spartans on Apulian shores marks the first phase of the Laconian colonization of Tarentum.

Fruitful excavations conducted on the promontory of Torre Saturo, between Porto Saturo and Porto Perone, have brought to light intriguing bits of evidence on the life led in this region. In the National Museum at Tarentum are displayed rich finds of very early local pottery associated with imported Mycenaean ware, Iapygean geometric ware, articles coming from a votive depository of the 7th-6th c. B.C. and tomb appointments of the 6th-3d c. B.C.

BIBLIOGRAPHY. F. G. Lo Porto, "La stazione protostorica di Porto Perone," *NSc* (1963) 280ff; id., "Satyrion-Scavi e ricerche nel luogo del più antico insediamento laconico in Puglia" *NSc* (1964) 177ff. F. G. LO PORTO

SAUVE Locality of Mus, Gard, France. Map 23. Large and important pre-Roman and Gallo-Roman oppidum in the territory of the Volcae Arecomici, on the W edge of the Cévennes at the confluence of the Crespenon and the Valsave, which flow into the Vidourle. Partial exploration since the 18th c. has uncovered remains of Early Empire buildings, and a large quantity of artifacts. Water was brought to the town from a spring several km away by an aqueduct that was partly freestanding and partly cut through the rock.

BIBLIOGRAPHY. *Carte archéologique de la Gaule romaine*, fasc. VIII, Gard (1941) 211 no. 402.

G. BARRUOL

SAVA DI BARONISSI Campania, Italy. Map 14. About 10 km NE of Salerno, the so-called *Catacombe* has recently been excavated. It is the lower floor of a Roman villa constructed in the Republican period, but enlarged in the 1st c. A.D., with a sequence of rooms opening from a quadrangular cryptoporticus (33 x 30.7 m). It opens to the W, through carefully spaced arches, onto a garden. The garden is the focus of terraces that encircle the exterior of the upper story.

The ground floor rooms were used from Early Christian times, as a monumental cemetery.

BIBLIOGRAPHY. *Apollo, Bollettino dei Musei Provinciali del Salernitano* 2 (1962) 146-50MPI.

V. PANEBIANCO

SAVARIA, *see* COLONIA CLAUDIA SAVARIA

SAVOYEUX, *see* SEGOBODIUM

SAXON-SION Meurthe-et-Moselle, France. Map 23. The Côte de Sion, one of the high places (max. 542 m) of the civitas Leucorum, is ca. 35 km from the capital, Tullum (Toul). It is a sickle-shaped headland towering 200 m over the Xaintois plain, always a rich agricultural region. Numerous traces of ancient occupation from pre-

history on have been noted. The presence of ramparts, towers, walls of houses, hypocausts, and sculptures has often been ascertained, all evidence of dense Gallo-Roman occupation. At least three Roman roads converge on the hill. Stray finds have been numerous: an inscription honoring Mercury and Rosmerta (in the Musée Lorrain at Nancy), a bronze hermaphrodite (at the Epinal museum; height: 0.5 m), and many coins, some of which have been collected in a small storage depot on the site. In 1937 a necropolis was investigated which contained both late (4th c.) Gallo-Roman tombs and barbarian graves. The cemetery produced many grave-goods. In 1964 upon the occasion of the straightening of a road and the laying-out of a parking lot, it was possible to establish, thanks to a precise stratigraphy, the following sequence: a Celtic settlement, a villa of the Early Empire, an arcaded building of the 2d c., and a concrete floor of the 4th c., which was finally destroyed by grave pits in Christian times.

BIBLIOGRAPHY. E. Salin, *Le Haut Moyen-Age en Lorraine* (1939) 33-72[I]; M. Toussaint, *Répertoire archéologique Meurthe-et-Moselle* (1947) 57-62; L. Deroche, "Edifices gallo-romaine découverts à Sion," *Gallia* 23 (1965) 242-44[P]. R. BILLORET

SBEITLA, *see* SUFETULA

SBIBA, *see* SUFES

SCAFATI Italy. Map 17A. A suburban district of Pompeii, lying E of it on the Sarnus (Sarno). It is not known whether this was organized as a pagus. In the neighborhood, along the road leading from Pompeii to Nuceria, have been found villae rusticae and tombs to be associated with Pompeii.

BIBLIOGRAPHY. R. C. Carrington, *Pompeii* (1936) 94-97; W. Jashemski, *CJ* 66 (1970-71) 105-10.

L. RICHARDSON, JR.

SCAMNUM (Muro Tenente) Brindisi, Apulia, Italy. Map 14. An ancient Messapic center on the plain of Mesagne 2 km from Latiano. It is now being systematically explored. Its circuit wall is known; a large number of tombs have come to light dating from the 6th c. to the 4th c. B.C. with Messapic inscriptions. The Roman ruins of this native center are believed to correspond to those of ancient Scamnum, which is cited in the *Peutinger Table* along the Via Appia on the Taranto-Brindisi road, as the last statio before Brindisi.

BIBLIOGRAPHY. K. Miller, *Itineraria Romana* (1916) 343; F. G. Lo Porto in *Atti IX Convegno Studi Magna Grecia* (1969) 261. F. G. LO PORTO

SCARABANTIA, *see* SCARBANTIA

SCARBANTIA or Scarabantia (Sopron) Hungary. Map 12. A statio 59 km S-SE of Vienna on the important route that connected the Adriatic Sea with the Danube. It was on the SW end of Lake Fertö. Pliny (*HN* 3.146) calls the settlement Oppidum Scarbantia Iulia, which still belonged to Noricum under Tiberius. The town reached the rank of municipium under Vespasian (tribus Quirina . . .), at this time it already belonged with its territorium to Pannonia. With its developed network of streets, its forum with the Capitolium, its waterworks, its amphitheater, it was one of upper Pannonia's busy commercial towns from 106, after the division of the province into two parts. Imperial building projects took place at the forum under Antonius Pius. Between 167 and 180, during the time of the Quadic-Marcomannic wars, the town was sacked several times by the enemy; it was rebuilt afterwards, but did not develop significantly during the

3d c. As a result of the reorganizations during the Tetrarchy, the town's strategic significance came to the fore; it defended the new capital of Pannonia Prima and the road to Italy from the N, i.e. it supplied the troops, stationed on the limes, with food and weapons. Under the Constantinian dynasty an area (250 x 404 m) in the center of town was surrounded by an elliptically shaped fortress wall. The stretch of wall (3 m thick and ca. 8 m high) had 34 horseshoe-shaped bastions, two gates fortified with towers, and several smaller passages. The Passio S. Quirini mentions a well-populated Early Christian congregation on the territory of Civitas Scarabatensis at the beginning of the 4th c. Peasant soldiery lived behind the town walls in the second half of the 4th c. (*Not.Dig. occ.* 34 dux Pann. 1.30). At the beginning of the 5th c. one of the barbaric groups of the Hun-Alan-Goth triumvirate lived in the town together with the remaining romanized families. Their legacy can be traced through the 6th c.

Since the 1950s excavations of Roman architectural remains have been pursued in the section of town which has been thickly populated since antiquity. Of these are to be seen some sections of stone-covered streets, several rooms of the bath and ruins of its calidarium with hypocaust, the remains of a group of buildings with a portico which closed in the forum's E side. The outline of the amphitheater can be traced on a hillside outside the city. Several sections of the elliptical city wall of the Late Empire, with a few bastions, were excavated and restored. The ruins of the N city gate can be seen in a protective building at the foot of the mediaeval fire-tower; the more important remains of stone were also placed here.

The Franz Liszt Museum contains the more important Roman remains, among them carvings, glass and bronze objects. In the museum's Roman lapidarium are the statues of deities of the Capitolium, altars, a relief of Mithras, tombstones, and carvings from buildings.

BIBLIOGRAPHY. F. Kenner, *Mitt. d. k. k. Centr. Comm.* (1857) 381; Fluss, Scarbantia, *RE* II (1923) 355; K. Praschniker, *Öst. Jahreshefte* 30 (1937) 111; A. Radnóti, "Sopron és környéke régészeti emlékei," *Csatkai-Dercsényi Sopron és környéke müemlékei* (1956); A. Mócsy, *Die Bevölkerung von Pannonien bis zu den Markomannen-Kriegen* (1959); L. Barkóczi, *Acta Arch. Hung.* 16 (1964) 257ff; S. K. Póczy, *Sopron a római korban* (1966); *Soproni Szemle* I-XXII, passim.

SZ. K. PÓCZY

SCARBOROUGH Yorkshire, England. Map 24. Excavation on the N cliff has revealed successive settlements: an Iron Age village, a Roman signal station, and a mediaeval castle and chapel. The signal station is well preserved except for some coastal erosion and damage caused by later building. It is of the normal 4th c. type, a rectangular enclosure with a wall surrounding it, a central stone tower, and a well. The coins found date from as late as Arcadius. The pottery is of the handmade signal station type common in the last 50 years of Roman rule in Britain. The purpose of the tower, one of a chain from the Tees to the Wash, was to signal to the Roman fleet at sea, the Classis Britannica, about the presence of Saxon pirates. G. F. WILMOT

SCARDONA (Skradin) Croatia, Yugoslavia. Map 12. An ancient town on the S border of the Liburni, ca. 12 km from the sea where the Krka (Titius) river enters the Prokljan lake. It is mentioned by Pliny (*HN* 3.141) as "Liburniae finis et initium Dalmatiae Scardona." In the pre-Roman period it was a member of the great territorial community of the Varvarini. After the Roman conquest it was the judicial seat for the 14 civitates of Liburni and the tribe of Iapodes. In the second

half of the 1st c. A.D. it was a municipium Flavium and the center of the imperial cult in Liburnia (ara Augusti Liburniae). The cities of Liburnia dedicated there before A.D. 31 a statue to Nero, son of Germanicus. The bishop from Scardona attended the church council at Salona in 530. The town was destroyed by the invading Avars and Slavs about 615.

The exact area of the ancient settlement is not yet established but probably it lies under the modern town in whose surroundings many ancient tombs, both incineration and inhumation, and sarcophagi, were found. Many coins, inscriptions, and other finds are preserved in the Archaeological Museum at Zadar and in the City Museum at neighboring Šibenik.

BIBLIOGRAPHY. M. Suić, "Municipium Varvariae," Diadora 2 (1960-61) 196; J. Medini, "Epigraphic data concerning munifices and other public building in Liburnia," Radovi Filozofskog fakulteta u Zadru 6 (1964-67) 63.
M. ZANINOVIĆ

SCARPONNA or Scarpona Dieulouard, Meurthe-et-Moselle, France. Map 23. Mentioned in the Antonine Itinerary and the Peutinger Table, Scarponna was a way station along the great road from Langres to Trier. It stands at a crossing of the Moselle, which seems to have been the boundary between the territories of the Leuci and the Mediomatrici. The only historical reference to Scarponna is by Ammianus Marcellinus (27.2), who recounts that Jovinus, the emperor Valentinian's magister equitum, exterminated two bands of Alemanni there in 367. The vicus was occupied continuously from the 1st c. A.D. to Carolingian times, most intensely in the 1st and 4th c. Recent salvage excavations (1969-70), necessitated by large public works projects, have shown that from the 1st to the 3d c. residential houses were arranged along the Roman road. Remains of a bridge crossing an old channel of the Moselle were found as well as, nearby, two milestones, one (incomplete) bearing the name of the emperor Hadrian, the other (complete) with the name of Postumus and the distance (XIII leugae) from Scarponna to Metz. In the 4th c. Scarponna served as a defensive bridgehead against barbarian invasions. A castellum was built on both sides of the great road and the course of the Moselle was changed to serve as a moat for the fort, which became an island. In 1970 at the bottom of the branch of the Moselle which runs along the W side of the castellum, remains were found of a first phase of the fortifications. These had been hastily built with reused materials—in particular funerary stelae. The walls had tipped into the river, undoubtedly after a particularly violent Moselle flood. A second wall, built farther back than the first, is still partly visible today, as well as the abutment of a bridge and an old embankment. Other parts of the same fortification, with remains of towers, can be seen in gardens and house cellars. The total area of the fort, which was trapezoidal in shape, was ca. 1.3 ha.

An inhumation necropolis dating to the 4th c. was recently excavated SW of the castellum. (It replaced a 1st and 2d c. cremation cemetery of which only a few funerary urns survive.) The bodies are variously orientated; sometimes they are surrounded by a row of unworked stones; sometimes they are enclosed in sarcophagus-boxes made of tiles set together in different ways. A large and very well-preserved assemblage of grave-goods was collected, including glass and ceramic vases and ornaments (bronze bracelets, rings, necklaces, charms). The many finds collected during the recent salvage excavations are kept in a small storage-depot at Dieulouard: common iron and bronze artifacts, abundant 1st to 4th c. pottery, weights, glass vases, fibulae, coins, as well as several stelae of the house type. The Musée Lorrain at Nancy

has most of the lapidary artifacts from chance discoveries or old excavations: a milestone in honor of the emperor Caracalla found in 1778, gravestones with sculptured reliefs and inscriptions (including several stelae of the house type), a basin of a fountain with an inscription, an altar dedicated to Mercury, a group sculpture representing ironsmiths at work.

BIBLIOGRAPHY. Lamoureux, "Notice de la ville et du comté de Scarpone" (an extract from "Mémoires du P. Le Bonnetier, dernier curé et prieur de Scarpone"), in Mém. de la Soc. royale des Antiquaires de France (1829) VIII 172-215; (1834) X 55-100 (the MS memoirs of P. Le Bennetier are in the Bibliothèque municipale de Nancy); M. Toussaint, "Scarponne au temps de la Gaule romains," in Pays Lorrain (1938) 529-50[PI]; id., Répertoire archéologique Meurthe-et-Moselle (1947) 24-41; R. Billoret in Gallia 26 (1968), 28 (1970)[PI].
R. BILLORET

SCEAUX DU GÂTINAIS, see AQUAE SEGETAE

SCHAAN Liechtenstein. Map 20. Late Roman fortress 4 km N of Vaduz, on the road to Feldkirch, Austria. Its ancient name is not known. It guarded the highway from Italy between Curia and Brigantium, on the right bank of the Rhine. The fort, overlooking the valley, is in the center of the modern town. It was built after the middle of the 4th c. A.D. and abandoned probably in A.D. 401, when Stilicho recalled most of the troops N of the Alps. Some occupation, however, may have lasted into the 5th c.

The E half has been excavated. The fort was almost square (59-60.5 m on a side), with square towers at the corners and in the middle of the N and S sides. The entrance was through the N tower (8.5 x 7.6 m), which had inner and outer gates (2.9 m wide) and a room between (4.2 x 4.1 m). The walls were thick for the size of the fort (3.6 m in the curtain walls, 1.9 m in the towers). Inside were baths (13 x 5 m), wooden casemates, a kitchen, perhaps a granary, and traces of workshops for iron and hartshorn.

In the 5th or 6th c. a baptistery and a church of St. Peter were built inside the walls. Parts of the N wall and its middle tower survive in and outside the church, which dates in its present form from ca. 1500. Remains of the earlier periods of the church are also preserved. Finds are in the Liechtensteinisches Landesmuseum in Vaduz.

BIBLIOGRAPHY. F. Staehelin, Die Schweiz in römischer Zeit (3d ed. 1948) 275-76; D. Beck, "Das spätrömische Kastell und die St. Peterskirche in Schaan," Jb. Schweiz. Gesell. f. Urgeschichte 49 (1962) 29-38[PI]; E. Ettlinger, "Die Kleinfunde aus dem spätrömischen Kastell Schaan," Jb. Hist. Vereins f. das Fürstentum Liechtenstein 59 (1969) 229-99[PI].
V. VON GONZENBACH

SCHOINOUS (Kalamaki) Corinthia, Greece. Map 11. The diolkos, a paved roadway for transporting ships and cargo across the Isthmus of Corinth, terminated at Schoinous on the Saronic Gulf (Strab. 8.6.4, 22; 9.1.2; Pompon. 2.48; Ptol. 3.16.13; Plin. HN 4.7). According to Schol. on Pindar Isthm. Argum., the body of Melikertes, who was worshiped as the god Palaimon at the Isthmian Sanctuary, was carried here by a dolphin.

BIBLIOGRAPHY. IG IV² 71, lines 23-24. H. N. Fowler & R. Stillwell, Corinth I, i: Introduction. Topography. Architecture (1932) 49; J. R. Wiseman, The Land of the Ancient Corinthians (forthcoming). J. R. WISEMAN

SCHWARZENACKER (Einöd) Saarland, Germany. Map 20. The present village originated about the middle of the last century, within the deserted Roman area in

a place where black earth containing ashes was found and which was called the Schwartzacker. The chronicle of the nearby Cistercian monastery Wörschweiler (16th c.) states that there was once a town here as big as Worms. Details about the remains of buildings date from 1751. In 1783 Duke Carl II August of Zweibrücken had the adjoining necropolis searched for antiquities. Important finds were made in the 18th and 19th c. (a centaur's head from the Schwartzacker; the center piece of a shield with the depiction of a Ganymede). About 5000 silver coins were found dating from Caracalla to Postumus. Systematic excavations began after WWII. Initial smaller excavations (1954 and 1963) were continued in 1966 on a larger scale; so far an area of 1.5 ha has been excavated.

The Roman settlement covered a gentle slope bordered by the Blies (a tributary of the Saar), two brooks, and a steep slope. Streets crossed at right angles and generally had porticos. Among the buildings found, two distinct ground plans can be distinguished. The first, nearly square, had a court surrounded by rooms, some with cellar or hypocaust. The second was narrow but had considerable depth (45 m). On the street side was the housekeeping unit adjacent to a living room with hypocaust and another room with a cellar. Behind the garden was the latrine. These houses stood in a row, evenly spaced. The cellars were built of big blocks or stone slabs. The buildings on these foundations were either solid stone or timber framework. In the latter case the filling was of brick or loam. Square deep wells built of large stone slabs and stone "cold cellars" are characteristic. Smaller cellars were usually vaulted. On the cellar floor collapsed stone tables were found.

One house differed from the standard types. It had a hall with a full-length cellar (5.95 x 14.2 m). A row of five columns (two of them were table columns: round stone slabs between the column section) carried the wooden ceiling of the cellar. On one wall life-size figures were represented. Six bronze statuettes were found in the cellar: a genius populi Romani; a seated Mercury with wild boar, he-goat, and rooster; a standing Mercury; an Apollo, a seated Neptune; and a Victory. The house was probably the seat of a cult.

The streets were of gravel with an overlay of pebbles. Between portico and street were the sewage ducts which branched out from the individual houses. Fresh water was usually carried by wooden pipes. At one well a stone relief with Venus, Cupid, and the Three Graces was found. There are also stone effigies of Jupiter, Vulcan, and Epona. The inhabitants were cloth makers, weavers, smiths, and potters.

Undoubtedly this was one of the more important municipia between the Moselle and the Rhine and it is likely that equestrian sculptures found at Breitfurt farther down the Blies (the largest Roman statues found N of the Alps), were intended for it. However, the center of the town, where the forum might be sought, is today built up.

The last settlement was preceded by a smaller one of wattle-and-daub construction. It developed during mid Imperial times and finally extended over the necropolis that was located originally outside an earlier settlement. The graves date from the Bronze Age to the end of the Iron Age. A new necropolis was developed on a nearby hill. The settlement was destroyed by fire probably in A.D. 275. Since the site was located some distance from the important junction of the Metz-Worms and Trier-Strassbourg roads and had no other strategic significance, it remained unfortified. The sections destroyed by Germanic tribes were not rebuilt. The latest coin is from the time of Honorius. Annexed to Schwarzenacker are the porticus villa and the temple area of Bierbach. Cult places were also found on the nearby Klosterberg of Wörschweiler.

Since the town was not built over in the Middle Ages and since alluvial sand covered the ruins, the results of the excavations have been rich. There are many small finds of statuettes, utensils, building hardware, etc.

BIBLIOGRAPHY. J. D. Schoepflin, Alsatia illustrata I (1751) 539-40; H. Menzel, Die römischen Bronzen aus Deutschland I (1960) nos. 14, 15; A. Kolling, "Die römerzeitliche Siedlung Schwarzenacker an der Blies, Kr. Homburg," Germania 39 (1961) 483-85; id., Forschungen im römischen Schwarzenacker, I: Die Bronzestatuetten aus dem Säulenkeller (1967); ibid., II: Die Villa von Bierbach (1968); ibid., III: Der "Römerhügel" von Wörschweiler—Das frührömische Gräberfeld vom Bliesbergerhof (1969); id., Germania Romana, III: Römisches Leben auf germanischem Boden (1969) 70ff.

A. KOLLING

ŠĆITARJEVO, see ANDAUTONIA

SCOLIVA (Escolives-Sainte-Camille) Yonne, France. Map 23. On the left bank of the Yonne valley, 180 km S of Paris and 10 km S of Auxerre (along national road 6). No historical document mentions the site, which was discovered by accident in the spring of 1955. The origin of the settlement seems to lie in a Vauclusian spring called Le Creusot. In its immediate vicinity, excavations have brought to light burials going from the Neolithic to the Iron Age period. The remains of the Gallo-Roman settlement extended over several hectares. The Merovingians placed their burials in the Gallo-Roman ruins.

The investigations begun in 1955 are still in progress. A bathing establishment has been brought to light at Le Pré du Creusot. Two stages have been described in detail. The first is mainly attested by a rectangular basin whose bottom and sides were lined with slabs of white marble. The second, probably dating to the beginning of the 4th c., consists of several series of swimming pools with their adjoining rooms. It is all connected by a rather large courtyard, partly flagged. East of this courtyard is located a large basin (9 x 5 x 0.8 m) flanked by two small semicircular pools. To the N can be seen the remains of two rooms with hypocausts; they end in apses. Near them stand the latrines, whose floors were made of large limestone slabs which have been preserved intact. To the W, the largest baths consist of three semicircular pools, each preceded by a room heated by a hypocaust. The whole is under the shelter of metal sheds.

What gives this site prominence is that the walls of the last period were built on foundations made of architectural blocks from one or several monuments whose location, plan, and function are unknown. These pieces have been extracted, cleaned, given protection, and put on display conveniently in a warehouse built on the site, where they may be studied. More than 100 blocks have been stored up to the present, not counting the many fragments collected here and there during the work on the totality of the excavated area. They consist essentially of bases and drums of columns, keystones, architraves, friezes, and cornices. They are worked or carved on two sides, which makes them even more attractive. Most of them seem to belong to one and the same monument. It must have consisted of a series of arches, each with an opening of less than 2 m. For that reason and also because it was ca. 0.4 m thick, it must have had a certain elegance. Seen from the outside it presented a series of engaged columns. The frieze must have been illustrated with scenes which changed at each bay. Thus,

one can see themes of the vine, of palmetto decorations, of animals, or mythological scenes. This group can be compared to the portico at Vienne (France), but the similarity is in any event a distant one. One may suppose the date to be in the 2d c. Besides these blocks, the following should be mentioned: a stela dedicated to the goddess Rosmerta alone, with an inscription (185-215); a votive altar dedicated to Smertulus (?); a block depicting a hunting scene; several funerary stelae; and some pyramidal tombstones.

From the remains which have been found, the site seems to have been occupied from the 1st c. to the end of the Gallo-Roman period. The latest piece of evidence seems to be a gold coin of Arcadius. The site was destroyed by a fire, which brought an end to the prosperity of ancient Scoliva. The Roman road named after Agrippa passed nearby and served the site.

BIBLIOGRAPHY. C. Bémont, "A propos d'un nouveau monument de Rosmerta," *Gallia* 27.2 (1969) i; R. Martin, Reports in *Gallia* (1958, 1960, 1962, 1964, 1966, 1968) i; R. Kapps, *Escolives-Sainte-Camille Gallo-Romain* (1974).

R. KAPPS

SCORDIA, *see under* MONTE SAN BASILE

SCORNAVACCHE Ragusa province, Sicily. Map 17B. On a hill rising from the left bank of the Mazzaronello, NW of Chiaramonte Gulfi in the district of Scornavacche, a small Greek settlement, perhaps of Syracusan origin. Founded during the first half of the 6th c. B.C., it was destroyed in 406-405 by Carthaginians who had occupied Akragas. At the time of its reconstruction under Timoleon, the urban center was moved E to an area once occupied by the archaic necropolis, which was thus partly destroyed. The settlement was finally destroyed around 280 B.C., perhaps during the struggles between the Carthaginians and Sicilian Greeks.

No traces remain of the 6th c. urban plan. The 4th-3d c. plan presents a system of parallel streets onto which open rectangular blocks, each containing houses with few rooms arranged around a spacious inner courtyard. Narrow alleys run between blocks. The potters' quarter, comprising numerous kilns, clay deposits, and many molds, was active between the second half of the 4th and the beginning of the 3d c. B.C. The pottery and the numerous figurines made there were exported to neighboring indigenous centers. Among the terracottas is a statuette of Athena Ergane. The most varied influences can be detected in the production of these coroplasts, as attested by the different molds, and in the pottery in Gnathian and red-figure styles. These influences, stemming from Syracuse, Akragas, and South Italy, can be explained by the fact that the site was basically a trade station on the interior route from Syracuse to Selinus through Gela and Akragas. The finds are housed in the Hyblaean Archaeological Museum of Ragusa.

BIBLIOGRAPHY. A. Di Vita, "Recenti scoperte archeologiche in Provincia di Ragusa," *ArchStSir* 2 (1956) 36-41; id., "La penetrazione siracusana nella Sicilia sud-orientale alla luce delle recenti scoperte archeologiche," *Kokalos* 2 (1956) 203-4; 4 (1958) 91-99; id., *BdA* (1959) 347-63.

M. DEL CAMPO

SCUPI Yugoslavia. Map 12. The remains of the ancient town on the Vardar (ancient Axius) river in a suburban community ca. 5 km NW of modern Skopje in Macedonia.

The Roman town was founded in the 2d c. B.C. on the site of a Dardanian settlement. It later became the Colonia Flavia Aelia Scupi and many veteran legionnaires were settled there. Scupi was the chief center for romanizing Dardania. Bishops of Scupi are known from the 4th to the 6th c. The city suffered greatly in the earthquake of 518. (Scupi was once thought to have been the site of Justiniana Prima, now identified with a city discovered near the village of Caričin Grad.)

Excavations have revealed a large but not well-preserved Roman theater and a public bath. An episcopal basilica nearby, the cemetery basilica, and a large building near the theater have also been excavated. Sections of the city wall have been exposed in recent years and a large cemetery of the Early Roman period has been excavated.

The Archaeological Museum of Skopje, the largest in Macedonia, contains finds not only from Scupi but from numerous other sites, including Stobi and Demir Kapija.

BIBLIOGRAPHY. F. Papazoglu, *Makedonski Gradovi u Rimsko Doba* (1957) 24, 46, 87, 132, 205.

J. WISEMAN

SCYTHOPOLIS Israel. Map 6. A city of ancient Palestine on the right bank of the Jordan, S of the Sea of Galilee. In the Bronze and Iron Ages it was known by the name of Beth-shean and, from the Hellenistic period onward, also by the name of Scythopolis, possibly because Scythians were settled there by Ptolemy II in the middle of the 3d c. B.C. It is mentioned for the first time by Polybios (5.70), in connection with its conquest by Antiochos III, who enlarged its territory and granted it autonomy. After the conquest of Palestine by the Ptolemies, it was given the status of a polis and the additional name Nysa, the name of the nurse of Dionysos. The city then officially adopted the worship of that god. At the beginning of the Maccabean wars the city was either bought from its Greek ruler (Joseph. *AJ* 13.280), or was taken by force by Simon (Joseph. *BJ* 1.66). According to Jewish tradition, the Greek inhabitants were exiled or left voluntarily (*AJ* 13.397). After the conquest of Palestine by the Romans in 63 B.C., the city was restored to its former inhabitants (*AJ* 14.88) and thus separated from Jewish territory. During the Jewish war of A.D. 66 the Roman legions spent the winter at Scythopolis, which had formerly been laid waste by the Jews (*BJ* 2.458). Our knowledge of it in the later part of the Roman period is scanty. During the latter half of the 3d c. and the early part of the 4th, Christians were martyred there. The Byzantine period was an age of great prosperity for both the Jewish and Christian communities there, as attested by literary sources and archaeological finds.

Extensive excavations took place at the mound during the years 1921-1933. To the Early Hellenistic periods are dated remains of a temple situated on the S part of the mound, where the earlier Canaanite temples were and where later a church was to be built. Of the building (37 x 22 m) only fragmentary foundations remain. It was dedicated either to Dionysos or to Atargatis. Since the small finds and decorated architectural fragments are mostly Roman, there has been a tendency to redate this temple to the Roman period. Other finds relating to the Hellenistic and Roman periods were found in the local necropoleis. To the Byzantine period belong remains of a large round church, built on top of the pagan temple. It consisted of two concentric walls, with an outer diameter of 38.8 m, an apse on the E, and a rectangular narthex on the W. Both narthex and ambulatory were decorated with a mosaic pavement of geometric designs.

The only building excavated before 1950 outside of the limits of the mound was a 6th c. monastery, discovered on the W slope of the mound. Since 1950 excavations within the modern town of Beth Shean have brought to light remains principally of the Byzantine period. A synagogue was discovered to the N of the mound, out-

side of the limits of the city wall of the Byzantine period. In 1964 there came to light remains of a villa to the SW of the mound. The building, apparently of the courtyard type, was built in the mid 5th c. A.D. Of special interest were the mosaic floors, a panel of which was partly preserved in one of the halls. It had representations of a scene from the Odyssey, a Nilotic scene, and an inscription set on a background of pairs of birds. The inscription contains the name of the owner, Kyrios Leontis, and the Jewish seven-branched candlestick.

In 1960-62 the Roman theater was unearthed to the S of the ancient mound. The building, in an excellent state of preservation, has a diameter of 70 m, and a scaenae frons 90 m long flanked by round staircase towers. The scaenae frons was two stories high, decorated in opus sectile. The marble and granite columns supported a frieze decorated with imaginary animals, masks, and foliage. The theater could accommodate 4500-5000 spectators and was built during the time of the Severii, restored in the time of Julian, and abandoned by the middle of the 5th c. Between the mound and the theater are remains of a colonnaded street and a large bridge, both of the Roman period.

BIBLIOGRAPHY. F. M. Abel, "Beisan," *RBibl* 21 (1912) 409-23; A. Rowe, *The Topography and History of Beth-Shean* (1930); G. M. Fitzgerald, *Beth-Shean Excavations 1921-1923; the Arab and Byzantine Levels* (1931); id., *A Sixth Century Monastery at Beth-Shean (Scythopolis)* (1939); M. Avi-Yonah, "Scythopolis," *Israel Exploration Journal* 12 (1962) 123-34; id., *The Holy Land from the Persian to the Arab Conquests (536 B.C. to A.D. 640). A Historical Geography* (1966); N. Zori, "The House of Kyrios Leontis at Beth Shean," *Israel Exploration Journal* 16 (1966) 123-34; id., "The Ancient Synagogue at Beth-Shean," *Eretz-Israel* 8 (1967) 149-67 (Hebrew with English summary). A. NEGEV

SDRAVIK, *see* DRABESKOS

SEA MILLS, *see* ABONAE

SEBASTE (Sıvaslı) Turkey. Map 5. One of the 12 important cities in Phrygia, 35 km S of Uşak (Temenothyrae). The site is at the foot of Mt. Bulkaz, in the plain of the Banaz çayı (the ancient Senaros river). Sebaste was one of the cities founded during the Romanization of Asia Minor. It lies midway between Acmonia (Ahat köy) on the Royal Road and Eumenia in the Maeander valley. Augustus founded the city in 20 B.C. at the suggestion of the oracle of Apollo, on the site of several earlier Anatolian settlements. Imperial coinage runs from the time of Augustus until after Gordian III. The main types are: obverse, head of Dionysos, Men, young Herakles; reverse, Zeus, Kybele, Perseus slaying Gorgo, Caracalla on horseback, and a river god. Inscriptions with the words polis, strategos, and agoranomos indicate the city's importance. In the Byzantine period it became a bishopric.

The remains include Early Bronze Age mounds not yet explored, and three Lydian tumuli (5th c. B.C.) with funerary chambers. One of them has marble masonry of high quality.

Roman remains are inscriptions (historical, funerary, votive), including one with the name of Sebaste reused in a Byzantine church wall; foundations of a Roman building under a Byzantine church; a marble votive statue of Zeus now in the Istanbul Archaeological Museum; many fragments of architraves, columns, capitals, sarcophagi, and Phrygian door-stelai scattered over the site.

There are also Byzantine buildings, especially of the 6th and 10th c. A.D.: a complex of churches, including the remains of two large basilicas and several chapels within a surrounding wall. Marble iconostases with colored glass inlays are in the Selçikler museum depot and the Uşak Museum.

BIBLIOGRAPHY. W. M. Ramsay, *Cities and Bishoprics of Phrygia* II (1897) 5; Head, *Hist. Num.* 684; J. Keil & A. von Premerstein, *Bericht uber eine zweite Reise in Lydien* (1911) no. 265; G. Mendel, *Catalogue des Sculptures . . .* (Istanbul Museum) III (1914) no. 813; Ruge, *RE* III A (1921) 209; D. Magie, *Roman Rule in Asia Minor* (1950) I, 472ff; II, 1334 n. 14; N. Fıratlı, *CahArch* 19 (1969) 151-66; id., *TurkArkDerg* 19, 2 (1970) 109-60; Ü. İzmirligil, *TurkArkDerg* 21, 1 (1974).

N. FIRATLI

SEBASTE (Rough Cilicia), *see* ELAEUSSA

SEBASTE (Jordan/Israel), *see* SAMARIA

SEBASTEIA Pontus, Turkey. Map 5. This is almost certainly the same as Megalopolis, which Pompey founded (64 B.C.) in the southernmost region of Mithridates' former kingdom. Parts of the city's large territory were transferred by Antony to Comana Pontica and to the Galatian chieftain Ateporix. At a later stage Megalopolis belonged to Pythodoris of Pontus. The name Sebasteia is likely to commemorate a refoundation when the city was annexed to Galatia between 2-1 B.C. and A.D. 1-2. Sebasteia had metropolitan status from the time of Verus. In Diocletian's reorganization of the provinces it became metropolis of Armenia Prima.

Sebasteia evidently lay at or near modern Sivas on the Kizil Irmak (Halys fl.). Excavation on the citadel of Topraktepe in Sivas has revealed nothing Roman, and the exact site remains to be discovered. D. R. WILSON

SEBASTOPOLIS (Colchis), *see* DIOSCURIAS

SEBASTOPOLIS HERAKLEOPOLIS (Sulusaray) Pontus, Turkey. Map 5. In the upper valley of the Çekerek Irmaǧi (Skylax fl.) 68 km SW of Tokat, where the road from Amaseia to Sebasteia was crossed by one of the routes from Tavion to Neocaesarea. The district of Kouloupene, in which Sebastopolis lay, belonged formerly to Megalopolis. All or part of Kouloupene was probably transferred by Antony to the Galatian chieftain Ateporix, on whose death it was annexed by Rome and, according to Strabo (12.560), formed "an organization on its own, the little city of those who synoecized Karana." The era of Sebastopolis (3-2 B.C.) should thus be the date at which Karanitis was annexed, while the name itself is likely to mark a refoundation by Augustus later in his reign. The additional name Herakleopolis was commonly used at least from the time of Trajan. Sulusaray contains abundant ancient stones, both inscribed and uninscribed, but the only structure visible in situ is a single arch of the Roman bridge over the Çekerek Irmaǧi, NW of the village.

BIBLIOGRAPHY. J.G.C. Anderson, *Studia Pontica* I (1903) 34-36; F. & E. Cumont, *Studia Pontica* II (1906) 201-8. D. R. WILSON

SEBEDA, *see under* ANTIPHELLOS

ŞEBINKARAHISAR, *see* COLONIA

SEEB Zurich, Switzerland. Map 20. There was Roman villa near Winkel ca. 7 km N of Zurich. It was built in the mid 1st c. A.D. and flourished into the late 3d c., with several alterations and additions. The estate was

surrounded by a wall (ca. 400 x 200 m), and divided by a cross wall into a residential area and a larger agricultural one (250 x 200 m). The bath had simple geometric mosaics of the 2d c. In the agricultural section were eight buildings, built in pairs against the enclosure wall. There is also a round fountain house, roofed and built over a well. Finds are in the Schweizerisches Landesmuseum in Zurich.

BIBLIOGRAPHY. *Jb. Schweiz. Gesell. f. Urgeschichte* 54 (1968-69) 148-54[MPI]; W. Drack, "Der römische Gutshof bei Seeb," *Arch. Führer der Schweiz* 1 (1969)[MPI].

V. VON GONZENBACH

SÉES, *see* SAGII

SEGEDUNUM, *see* HADRIAN'S WALL

SEGELOCUM Nottinghamshire, England. Map 24. Identified by its position in the *Antonine Itinerary* (475.4, 478.9) with Littleborough, 6.4 km S of Gainsborough, where the Roman road from Lincoln to Doncaster crossed the river Trent. Many remains have been found, including pottery and coins (1st-4th c.), two kilns, and an inscribed altar (*RIB* 277), but the extent of the settlement is not known. An early fort commanding the river crossing is likely and the main concentration appears to have been on the W bank.

BIBLIOGRAPHY. *VCH Nottinghamshire* II (1910) 19; J.K.S. St. Joseph, *JRS* 59 (1969) 127; *Britannia* 1 (1970) 284; *Itinerary*: A.L.F. Rivet, ibid. 47, 51-52.

A.L.F. RIVET

SEGESSERA (Bar-sur-Aube) Aube, France. Map 23. On the Roman road from Reims to Langres that runs parallel to the Aube, Segessera replaced a prehistoric settlement in the oppidum of Sainte-Germaine, S of Bar-sur-Aube. The center of the Gallo-Roman city lay 2 km to the N, at Val de Thor. Remains have been found over more than 1 km, as well as many objects: statuettes, coins (especially 3d and 4th c. A.D.), and pottery. At Bar-sur-Aube itself some metal and glass objects have been uncovered, also local wares, and pottery of high quality imported in the second third of the 1st c. A.D. from La Graufesenque and even from Italy—evidence that the settlement was large and was romanized at an early stage.

A few km away, probably close to a mansio on the Reims-Langres road, is the villa of Etifontaine. It includes sophisticated bath installations, which were succeeded perhaps by a Christian chapel until the whole building was abandoned at the end of the 4th c.

BIBLIOGRAPHY. E. Frézouls, *Gallia* 25 (1967) 274f; 27 (1969) 297f; 29 (1971) 283f; 31 (1973) 402-4; R. Rubaud, *Bull. Soc. Arch. du Département de l'Aube* 2 (1968) 46-86.

E. FRÉZOULS

SEGESTA Trapani, Sicily. Map 17B. In the NW part of the island on Monte Barbaro near modern Calatafimi, the principal city of the Elymi. Still almost totally unknown, this ethnic group, together with the Phoenicians, were in possession of W Sicily until the island was unified under Roman control around the middle of the 3d c. B.C. Thucydides (6.2) says that the Elymi were Trojans who escaped their city's destruction, fled to Sicily, and there fused with the Sikans whom they found in the area; they were later joined by some Phokaians. Thucydides' largely legendary narrative reflects a cultural truth in that, as recent studies seem to confirm, it appears increasingly probable that the Elymi came from the W Mediterranean. That Monte Barbaro was previously inhabited is attested by some prehistoric remains; these have been found in the area of the theater, specifically in the cavea, under

which, at the time of construction, a cave, perhaps with religious connotations, was carefully preserved with its prehistoric material.

Segesta occupies a prominent place in the history of ancient Sicily since some of its political maneuvers gave rise to two episodes with important consequences: the Athenian expedition to Sicily, and the war between Greeks and Carthaginians in 409 B.C. Throughout its entire existence Segesta may have been in constant conflict with Selinus, which probably sought an outlet on the Tyrrhenian Sea. The first encounters between Segesta and Selinus can probably be dated to 580-576 B.C. (Diod. 5.9); the same source (Diod. 11.86) relates another episode of this struggle in 454. Within the framework of this conflict, falls the episode of 415 B.C. when Segesta asked for Athenian help and succeeded in promoting the disastrous expedition to Sicily (Thuc. 6.6; Diod. 12.82). Shortly afterwards Segesta asked for Carthaginian help (Diod. 13.43), provoking the war that brought about the destruction of Selinus, Akragas, Gela, and Himera in 409 B.C.

At the time of Dionysios' first campaign into W Sicily (397 B.C.), Segesta was allied with the Carthaginians (Diod. 14.48); it was later allied with Agathokles, who in 307 B.C. destroyed it and changed its name to Dikaiopolis, as if to stress the justice he believed himself to be bringing. Not long afterwards Segesta resumed its former name and alliance with the Carthaginians, but shifted to the Roman side at the beginning of the first Punic war (Diod. 13.5). It was heavily besieged by the Carthaginians, but since the war ended in Roman victory, Segesta was rewarded: it became a city libera et immunis (Cic. *Verr.* 3.6.13) and obtained vast territories, including possibly those of Eryx.

Probably during the Roman period the city was moved N, near modern Castellammare, in the vicinity of sulphur springs where Roman remains have been found. This new Segesta is reputed to have been destroyed by the Vandals. At the site of the ancient city on Monte Barbaro, no excavation has been conducted. The exact location of the necropolis is unknown, with the exception of a few Hellenistic graves (3d c. B.C.) found at the foot of Monte Barbaro, on the SW side. In recent years many sherds have been found on the NE slopes, presumably thrown down from the ancient city above. They include local incised and painted ware as well as Greek imports. Some of the Greek sherds carry graffiti in Greek script but in a language which may derive from an Anatolian source; it must be the Elymian language, which hitherto has been known only through faint traces of inscriptions on coins. On this same side of the mountain some rock-cut niches have been found; they are obviously connected with a cult. In front of them ran a rock-cut road which led from the city on the summit to an area now called Mango at the foot of the mountain, where a large sanctuary has recently been identified. The sanctuary consists of a temenos (83.4 x 47.8 m) which has not yet been entirely excavated but which contains several structures, including an archaic Doric temple (6th c. B.C.), rebuilt during the following century. These two centuries represent the life-span of the sanctuary itself.

Certain clues suggest that, after the city's destruction by Dionysios, it was probably rebuilt, like Soloeis, according to the Hippodamian system. Unlike Soloeis, however, Segesta would have been rebuilt on the same site as the earlier town, as is attested by the two roads previously mentioned which connect the sanctuary with the plateau on Monte Barbaro. The city was surrounded by a double circuit of walls, which are still visible in a few stretches including a gate and some towers. The walls were presumably erected at various times.

The two best-known monuments are the theater and the so-called temple. The former is within the city, at the extreme NE tip of the plateau from which one enjoys a vast view expanding as far as the gulf of Castellammare. The theater is usually dated to the middle of the 3d c. B.C., but it may be earlier, that is, contemporary with the reconstruction of the city, which must have occurred during the previous century. It is surrounded by a high circular wall which has both a delimiting and a retaining function and includes two high analemmata parallel to the stage building; the lower koilon comprises 20 rows of steps divided into seven cunei; the upper koilon above the diazoma is no longer preserved. The stage building is flanked by paraskenia, according to the stage type prevalent in Sicilian Hellenistic theaters; worthy of note are the two poorly preserved statues of Pan, which functioned as telamones in the paraskenia.

The so-called temple, outside the city walls to the W, is a peristyle of the Doric order, with 6 columns on the facade and 14 on the sides, all unfluted; it is generally dated to the last third of the 5th c. B.C. This building has always been considered an unfinished temple, but it has recently been suggested on rather good grounds that the building was conceived solely as a Greek Doric peristyle meant to delimit a space within which the non-Greek population of Segesta would have practiced an open-air cult on a temporary altar according to the Oriental custom. This peristyle rises outside the city walls, to the W.

Segesta had a mint that was among the most notable of ancient Sicily.

BIBLIOGRAPHY. R. van Compernolle, "Ségeste et l'Hellenisme (1st part)," *Phoibos* 5 (1950-51) 183ff; *V. Tusa*, "Aspetti storico-archeologici di alcuni centri della Sicilia Occidentale, I," *Kokalos* 3 (1957) 79ff; II, *Kokalos* 4 (1958) 151ff[MPI]; A. Burford, "Temple building at Segesta," *CQ* 11 (1961) 87ff[I]; S. Stucchi, "Alla ricerca della cella del tempio di Segesta," *Studi in onore di F. Fasolo* (1961) 13ff[I]; V. Tusa, "Il santuario arcaico di Segesta," *Atti del VII Congresso Internazionale di Arch. Class.*, 2 (1961) 31ff[PI]; id. "La questione degli Elimi alla luce degli ultimi rinvenimenti archeologici," *Atti e Memorie del I° Congresso Internaz. di Micenologia* (1968) 1197ff[I]; R. Ambrosini, "Italica o anatolica la lingua dei graffiti di Segesta?" *Studi e Saggi linguistici* 8 (1968) 160ff; M. Lejeune, "Observations sur l'epigraphie élyme," *REL* (1970) 133ff. V. TUSA

SEGISAMA (Sasamón) Burgos, Spain. Map 19. Town NW of Burgos and NE of Castrojeriz, belonging to the Conventus Cluniensis (Plin. *HN* 3.26). He attributes it to the Turmodigi and distinguishes two localities, Segisamo and Segisama Julia. It was a town of the Vaccaei according to Polybios, cited in Strabo (3.4.13), and a military camp of Augustus in 26 (Florus 2.33.48). Ptolemy cites it as a town belonging to the Vaccaei and calls it Iulia, for Augustus. In the *Antonine Itinerary* Segisamo is between Lacobriga and Deobrigula (394.5); it is also mentioned by the Cosmographer of Ravenna (308.10; 318.2). There is an Augustan pillar mentioning the Legio IV Mac. (*CIL* II, 5807) and a tabula patronatus dating from A.D. 239 (*CIL* II, 5812).

BIBLIOGRAPHY. *RE* IIA, 1074; B. Osaba, "Catálogo Arqueológico de la provincia de Burgos," *Noticiario Arqueológico Hispanico* 6 (1962) 265. P. DE PALOL

SEGNI, *see* SIGNIA

SEGOBODIUM (Seveux, Savoyeux) Haute-Saône, France. Map 23. Way station mentioned by the *Antonine Itinerary* as lying on the road from Vesontio (Besançon) to Andematunnum (Langres). The name survives in the name Seveux, the village at the point where the Roman road crosses the river on a bridge, and in the name Savoyeux, the village on the other bank. The two sites have yielded remains from the Roman period. In the woods of Membrey, the large villa described in the 19th c. as having 50 rooms, should apparently be associated with the station.

BIBLIOGRAPHY. L. Suchaux, *La Haute-Saône, Dictionnaire historique, topographique et statistique* II (1866) 251-54; Poly, "La Haute-Saône sous la domination des Romains," *Bulletin de la Société d'Agriculture . . . de la Haute-Saône*, 3 sér., 28 (1897) 58-59; M. de La Tour, "Ruines romaines de Membrey," *Mémoires de la Société d'Agriculture . . . d'Angers* 6 (1847) 117ff; H. Stern, *Recueil général des mosaïques de la Gaule romaine* I, 3 (1960) 94-98, no. 366; P. Lebel, *Catalogue des collections archéologiques de Besançon, V. Les bronzes figurés* (1961) nos. 115, 175, 188. L. LERAT

SEGOBRIGA Cuenca, Spain. Map 19. On the Cabeza de Grego hill 4 km S of Saelices, SE of Tarancón. It was the chief town of Celtiberia (Plin. 3.3.25) and a noble and powerful town (Liv. 40.50.1), subdued by T. Sempronius Graccus in 179 B.C. and attacked by Viriatus in 146 B.C. Under Augustus it belonged to Tarraconensis and to the Conventus iuridicus of Carthago Nova, and was the see of a bishop under the Visigoths.

The town had a wall with towers (diameter 400 m). Monuments included the theater, the baths, the curia converted into the St. Bartholomew sanctuary, the aqueduct, several cisterns, a columbarium, a late Roman cemetery, a sacellum dedicated to Diana, with inscriptions, and a Visigoth basilica. Finds in the Cuenca Archaeological Museum include a female togate statue, columns, capitals, friezes, inscriptions, coins, and terra sigillata. The town was abandoned at the time of the Moorish invasion.

BIBLIOGRAPHY. N. Sentenach, "Segobriga," *Memorias de la Junta Superior de Excavaciones* 34 (1921); H. Losada & R. Donoso, "Excavaciones en Segobriga," *Excavaciones Arqueológicas en España* 43 (1965)[MI].

M. PELLICER CATALÁN

SEGODUNUM (Rodez) Aveyron, France. Map 23. The Gallic oppidum of Segodunum and the Gallo-Roman town which was the capital of the civitas of the Ruteni both occupied the steep hill—now the site of the modern town—above the right bank of the Aveyron. The amphitheater was excavated on two occasions in the 19th c. The aqueduct is known over a length of ca. 30 km. Apart from these, it has never been possible to undertake systematic investigations inside the town. The finds of the past twenty years, the accidental products of road and housing construction, include a large collection of pottery dating from the 1st c. B.C. to the 4th c. A.D. They have led to the accurate determination of the ancient stratigraphy of certain districts, to the discovery of several funerary pits of the 1st c. B.C., and to the probable discovery of a very large building near the cathedral and of an important villa near Saint-Amans.

BIBLIOGRAPHY. A. Albenque, *Inv. de l'archéologie gallo-romaine du département de l'Aveyron* (1947) 108-32, nos. 282-362; id., *Les Rutènes* (1948) 187-211; L. Balsan, "Découvertes d'amphores rue Séguret-Saincric, à Rodez," *Rev. du Rouergue* 13 (1959) 102-5; id., "Découvertes archéologiques place Emma Calvé, à Rodez," ibid. 20 (1968) 30-33; J. Boube, "Les sarcophages paléochrétiens de Rodez," *Pallas* 6 (1958) 79-111. Cf. M. Labrousse in

Gallia 20 (1962) 552-53 & fig. 6; 22 (1964) 434; 24 (1966) 416-17 & fig. 7; 26 (1968) 521-22 & fig. 7.

<div align="right">M. LABROUSSE</div>

SEGONTIUM Caernarvonshire, N Wales. Map 24. An auxiliary fort of 2.2 ha in the command of Legio XX V.V., garrisoned by a cohors milliaria equitata and in the 3d c. by the quingenary Cohors I Sunicorum. Founded ca. A.D. 78 at the time of Agricola's Welsh campaign (Tac. *Agric.* 18); occupied (with intermissions) until ca. 390, after the garrison was withdrawn by Maximus (the Macsen Wledig of the Mabinogi) thereafter appearing as the Seguntienses (*Not. Dig. occ.* 7.49) in the command of the Comes Illyrici.

The cardinal position of Segontium as the NW outpost of the Welsh military region, as well as the importance of the copper mines of Anglesey and Caernarvonshire, explain its long occupation. The fort, terminus of an *Antonine Itinerary* route, occupies the top of a rounded hill above the tidal mouth of the Seiont (and the famous Edwardian castle adjacent to it); it was excavated mainly in 1920-23. The much reduced circuit of the walls and three of the four double gateways are visible; inside, part of the latera praetorii (headquarters with underground strongroom in the sacellum and added tabularium, with hypocaust; commandant's house; workshops) and six centurial barracks and a forage store in the retentura, all arranged per scamnum. Outside, a Mithraeum (built over) was excavated, and near the cliff above the river are the remains of a large walled compound. The museum at the site is a branch of the National Museum of Wales (Cardiff).

BIBLIOGRAPHY. R.E.M. Wheeler, *Segontium and the Roman Occupation of Wales* (1923-24)MPI; O. Cuntz, ed., *Itineraria Romana* (1929-) 73-74; G. C. Boon, "A Temple of Mithras . . . ," *Archaeologia Cambrensis* (1960)MPI; id., *Segontium Roman Fort* (1963)MPI; id. in V. E. Nash-Williams, *The Roman Frontier in Wales*, ed. M. G. Jarrett (1969)MPI; id., *Amgueddfa: Bulletin of the National Museum of Wales* 18 (1974).

<div align="right">G. C. BOON</div>

SEGOVIA Segovia, Spain. Map 19. Celtic oppidum, belonging to the Arevaci according to Pliny (3.27) and Ptolemy, although according to Livy (91) it was in the territory of the Vaccaei. It lies at the confluence of the Eresma and Clamores, and was a stage on the Roman road from Miacum to Salmantica. There are few references to it, but during the Lusitanian wars the town preferred to sacrifice the hostages delivered to Viriatus rather than break the pact concluded with Rome in 151 B.C. (Frontin. 4.5.22). A battle was fought there in 75 B.C. by Metellus against the defeated Hirtuleius, Sertorius' deputy.

The aqueduct, mentioned in inscriptions as early as the 1st c. A.D., carried water from the Acebeda for some 16 km and delivered it to the Castellum of Caseron (*CIL* II, 2746, 2751). The arches, 728 m long and of granite ashlar, cross the valley at an angle; the two tiers are 30 m high and 5.72 m thick. Outside the town are two Roman bridges, called Castellano and Lavadores.

BIBLIOGRAPHY. F. Javier Cabello, *Guia de Segovia* (1949); S. Alcolea, *Segovia y su provincia* (1958).

<div align="right">M. PELLICER CATALÁN</div>

SEGUSIUM (Susa) Italy. Map 14. The city, cited in the itineraries, is mentioned by Strabo (4.1.6), Pliny (3.17), Suetonius (*Ner.* 18), and Ptolemy (3.1.40); and recorded by Ammianus Marcellinus, Cassiodorus, and Nazario in the Panegyric to Constantine. It is situated in the foothills of the Alps where roads lead through the Alpine passes of Monginevro and Moncenisio to the valleys of the Durance and of the Arc. A Celto-Ligurian oppidum of the Segusians, the city came under Roman rule in the Augustan age, and under Nero became a municipium at the time the province Alpium Cottiarum was instituted. Segusium was fortified during the Late Empire, and witnessed the siege of Constantine during the contest with Maxentius in A.D. 312.

The city plan shows characteristics of spontaneous formation, radiating from the primitive nucleus which excavation has localized near the present Porta Castello. At the intersection of the major roads in the forum indeterminate remains of important buildings have been found, including remnants of statues and a large votive base. From there the Gallic road continues toward the S and arrives at the summit of the hill, where there are ruins of ancient structures, perhaps large homes or public buildings. There is also an Arch of Augustus, with a single arch between pilasters and Corinthian columns at the corners. It bears an inscription and a figured frieze commemorating the friendship pact concluded with Rome in 9 B.C. by Julius Cozius, king of the Segusians and of the 14 cities of the Cottian Alps.

Little is known of the city in the early centuries of the Empire. Remains of roads and buildings furnish fragmentary and uncertain dates, except for clues from the presence of a bath building in the area of the present theater.

The only public building of which significant remnants have been found is the amphitheater, erected on the edge of the inhabited area in the SW section of the city. Using the fan-like formation of the hillside, it is in part supported by the terrain. The axes of the arena (33 x 44 m) are almost circular in shape, and the podium which delimits it is 3 m high. The cavea has an annular substructure with stone tiers, and a rostrum at the center of the S side. Of the three entrances to the arena, one leads to the extremity of the lesser axis on the side toward the valley. On this side the monument was adjacent to the shoulder of a paved road, perhaps the Via Gallia itself, at the point in which, from the bottom of the valley flanking the necropolis, it rose toward the W. Constructed in the 2d c. on the remains of an earlier building, the amphitheater indicates how far out of town the suburbs extended in the early centuries of the Empire. To the N and to the E the position of the necropoleis along the roads leading from Torino furnishes equally significant information about the city's development.

The city walls probably were not constructed before the second half of the 3d c. A.D., when the W strip of the city was excluded, perhaps for reasons of security. The perimeter, of which the entire course is known though sometimes partially preserved and sometimes greatly altered or indicated only by the alignment of the roads, extends for ca. 1250 m and encloses an area of almost 5 ha. The preserved stretches, in dry masonry faced in opus incertum, have a maximum preserved height of about 6 m, a width of 3 m, and jutting circular towers.

Of the two main gates to the city, opening at the extremities of the principal E-W axis, there remains today the W gate called the Porta Savoia. Its two circular towers, each 5 m in diameter, are joined by a span. Its single arch was altered in the 17th c.

A third gate opens at a projection of the wall at the W extremity of the mediaeval castle on the summit of the hill. It has a single arch, with a blind span between two circular towers. On the inside is a courtyard (7 x 6 m), perhaps covered, from which rooms opened. Not far from the gate two arches span the road. They are faced with reused squared blocks with stone chips filling the cracks. It is believed that the remains, subsequently

inserted into the defensive system against which they rest in the SW corner, belonged originally to the aqueduct feeding the Baths of Gratianus, which were noted in an inscription (*CIL* v, 7250), now lost.

The material found in the excavations is housed in the local Museo Civico, in the Museo del Seminario, and in the Museo di Antichità at Torino.

BIBLIOGRAPHY. A. Taramelli, "Note archeologiche segusine," *NSc* (1898) 263ff; E. Ferrero, *L'arc d'Auguste à Suse* (1901); F. Studniczka, "Uber den Augustusbogen in Susa," *Jahrbuch des Kaeserlich Deutschen Archaeologischen Instituts* (1903); P. Barocelli, "Segusio," *Boll. Soc. Piem. Arch.* (1929) 62ff; id., "Susa-Anfiteatro," *NSc* (1932) 3; id., "Appunti di topografia segusina," *BMusImp* 7 (1936) 3ff; C. Carducci, "Scavi nel Castello di Adelaide in Susa," *NSc* (1938) 328ff; id., "Scavi nella area del Castrum," *NSc* (1941) 20ff; id., *Guida di Susa* (1961); id., "Problemi urbanistici e artistici dell'antica Segusio," *Atti I Congr. Int. Arch. Italia Sett.* (1961, 1963) 129ff; id., *Arte romana in Piemonte* (1968) 26ff; B. M. Felletti May, "Il fregio commemorativo dell'arco di Susa," *Rendiconti Pontif. Accad. Arch.* (1961) 129ff; S. Finocchi, "Susa-Anfiteatro romano," *BdA* (1964) 389ff; J. Prieur, *La province romaine des Alpes Cottiennes* (1968).

Strab. 4.1.6; Plin. 3.17.123; Ptol. 3.1.40; Amm. Marc. 15.10.3, 7; *Tab. Peut.*; *Rav. Cosm.* 4.30.249.

S. FINOCCHI

SEIA (Sî) Syria. Map 6. On an escarpment 3 km SE of Qanawat (ancient Canatha), Seia had a sanctuary dedicated to the god Baalshamin, built in several stages between the 1st c. B.C. and the 2d c. A.D. The architecture and the sculptured decoration reveal local traditions increasingly marked by Roman influence.

The sanctuary had three successive enclosures running from E to W. The first two were flanked by terraces cut into the rock, higher to the S and lower to the N.

A paved road about 300 m long came from the E, passed S of the public baths and under a monumental arch, and ended 150 m farther on at the entrance to the sanctuary. A Roman gate with three bays, erected in the 2d c. A.D., opened onto the first courtyard, rectangular and paved. A stairway went up to the S terrace, where the high podium of a small temple of Classical plan still stands. The details of its construction are purely Nabataean, dating the first building period to 33 B.C.-A.D. 50. In the NW corner of the courtyard a monument of the Roman period, with good sculptures, sealed off two of the five bays of a Nabataean gate. The monument dates from the beginning of the 1st c. A.D. and was remodeled later. The gate opens onto a second flagged courtyard, longer and differently oriented. At the W end of the high terrace is the well-preserved podium of a temple of Iranian plan, probably dedicated to Dushara. An inscription dates it to the 33d year of the tetrarch Philip (A.D. 29-30). Above the central intercolumniation on the facade was a semicircular *frontone siriaco* under a triangular pediment.

A wall with fine basalt blocks separated the second from the third courtyard, which was reached by some steps and an elaborate gate (restored molding at Princeton University). The third courtyard is a long quadrangular enclosure with the temple of Baalshamin in the middle. In front of the temple facade a colonnade lines the three sides of the courtyard; it has two steps or levels, forming a theatron, as the Nabataean dedicatory inscription calls it. The walls of the enclosure extend to right and left of the temple, leaving a narrow passage on either side which leads to a paved area in the rear.

The temple was erected in 33-32 B.C. of magnificent masonry, which still stood 2 m high some time ago. It had an unusual square plan with the diagonals oriented on the points of the compass. The porch was supported by two columns between two pavilions adorned with corner pilasters, and a continuous frieze ran along the entire facade. The upper story of each pavilion formed a tower. The intercolumniation was topped by a triangular pediment with a sculptured tympanum. Beneath the portico four pedestals with Greek or Nabataean inscriptions carried statues, one of which was of Herod the Great. The frame of the main door had a magnificent decoration of vines, and the lintel was decorated with a bust of Baalshamin (all now in the Louvre). There was a wide corridor between the outer walls and the cella, which had a single door to the SE, and four columns in the middle. These formed an impluvium or, more likely, supported a lantern.

Two reliefs of Mithra slaughtering bulls, found at Seia, are now in the Damascus museum.

BIBLIOGRAPHY. M. de Vogüé, *Syrie centrale, Architecture civile et religieuse* (1865-77)[1]; H. C. Butler, *PAES* Pt. II, *Architecture*, Sec. A, *Southern Syria* (1916)[MPI]; P. Collart, "Orientation et implantation de deux grands sanctuaires syriens," *Annales archéologiques arabes syriennes* 21 (1971)

J.-P. REY-COQUAIS

SELAEMA (Slem, es-Soulem, or Soueilim) Syria. Map 6. Site in the NW Hauran, N of Athil, which belonged first to the Nabataean kingdom, then to the Roman province of Syria, and finally, from the end of the 2d c. A.D. on, to the Roman province of Arabia.

The modern village has ruins of many ancient buildings (some still used as dwellings), as well as many Greek inscriptions. The most important monument, to the NE, is a temple unprecedented in character. Although it is in ruins, an almost certain reconstruction has been possible.

The massive cella, open to the E, was more than 18 m long. Its walls were flanked on the outside by rectangular pilasters which served as buttresses. The cella was built on a high podium, very well preserved and decorated with a molding at its base. The stairways, more than 5 m wide, were built within the podium itself, under a porch formed by two columns set on high pedestals between two narrow projecting wings (like thick antae), reinforced by corner pilasters. The S wing still stands 3 m high. It contained a very small chamber with a stone ceiling and a stairway to the upper parts of the building. The same arrangement must have existed in the N wing. The NE corner, over 12 m of which is intact, had an extraordinary entablature. Columns and pilasters with composite capitals carried an architrave adorned with sculptured maeanders, roses, masks, and kanthari. This is topped by a frieze with garlands and bucrania and a pediment adorned with palmettes and underlined by a Greek key pattern. On the sides, above each corner pilaster, the cornice carried a small triangular pediment, whose pitched roof reached the roof of the cella. Two giant Corinthian capitals, one on each side, emerged from the roof at the corners of the facade; they probably served as bases for statues or equestrian groups. No similar arrangement has been found elsewhere in Syria. Acroteria shaped like large palmettes adorned the tops of the pediments and the corners of the cornice.

The inside of the cella is divided longitudinally by an arch supported on each side by a square pilaster jutting out from the side wall. At the W end of the cella is a small chamber flanked by two rectangular cubicles. Four small columns in front of these three niches probably supported a sort of canopy.

The sculptured decoration of the entrance to the cella

was delicate and vigorous, testifying, like the unusual plan and architectural features, to an art released from traditional influences and formulas and thus difficult to date.

BIBLIOGRAPHY. H. C. Butler, *PAES* Pt. II, *Architecture*, Sec. A, *Southern Syria* (1916)[PI]; R. Amy, "Temples à escaliers," *Syria* 27 (1950). J.-P. REY-COQUAIS

SELAH, *see* PETRA (Jordania)

SELEF, *see* SELEUCEIA SIDERA

SELEUCEIA (Caria), *see* TRALLES

SELEUCEIA SIDERA later CLAUDIOSELEUCEIA (Self) Turkey. Map 7. Town in Pisidia 15 km N of Isparta. Founded by Seleukos I or Antiochos I as a colony to protect the military road across N Pisidia. In the 1st c. A.D. the name was officially changed to Claudioseleuceia; this name is retained on the coins down to the time of Claudius II, though in Ptolemy, Hierokles, and the *Notitiae* the prefix is dropped.

The site is now much denuded. The city wall is best preserved at the SE angle, where it is formed of huge squared blocks. Some traces of a theater remain, and sherds of Roman date are abundant. The necropolis covers the NW slope of the hill; it includes underground rock-cut chambers with rectangular doors, tombs of Carian type with rock-cut grave and covering slab, and a single built tomb still standing.

BIBLIOGRAPHY. G. Hirschfeld, *MonatsbBerl* (1879) 312-14; H. Rott, *Kleinasiatische Denkmäler* (1908) 351, 354; L. Robert, *Hellenica* x (1955) 239, 243-44.

G. E. BEAN

SELEUCIA or Seleucia on the Eulaeus (Karun) Iran. Map 5. The very ancient site of Susa on the Eulaeus river, renamed in Seleucid times. In that period a small Achaemenid palace was drastically restored, and excavations there have brought to light ten stone pedestals of bronze statues, some with Greek inscriptions, part of a female torso in Greek marble, and smaller fragments of statues.

BIBLIOGRAPHY. R. Ghirshman, *Iran from the Earliest Times to the Islamic Conquest* (1954) 236.

D. N. WILBER

SELEUCIA ABILA, *see* ABILA

SELEUCIA AD CALYCADNUM (Silifke) Rough Cilicia, Turkey. Map 6. A city founded by Seleucus Nicator, probably between 296 and 280 B.C. after his seizure of Cilicia, and for which he brought inhabitants from Holmi, a nearby port. It is said to have been known as Hyria or Olbia before Seleucus' foundation. Situated on the right bank of the Calycadnus (Gök Su), which was navigable up to the city in Strabo's time, Seleucia lies at the seaward end of a route to the interior of Asia Minor which either followed the modern car road up the Calycadnus to Claudiopolis (Mut) or led inland to Uzuncaburç and then NW and W over the mountains to Claudiopolis and thence to Laranda. The extent of its territory is unknown but must have included the rich delta of the Calycadnus. How it weathered the 3d c. Ptolemaic-Seleucid fighting is not known, or the infighting among the Seleucids in the 2d and 1st c. B.C. The city seems to have remained independent while most of the rest of Rough Cilicia was divided among Rome's protégés and client kings, before the formation of one province of Cilicia in ca. A.D. 72. In the 4th c. it was metropolis of Isauria. It dwindled from the 15th c. to the 1880s when it revived as a port and market center.

Above the city to the W is a steep conical hill crowned by a well-preserved Armenian castle built largely of ancient blocks. The few visible remains of the ancient city are scattered among the houses of the modern town, on a natural terrace which extends E from the castle hill, and below that E along the river into the plain. All the remains in situ seem to be of the Roman and Christian periods.

The theater is dug into the terrace below the citadel and faces E. Virtually all its stonework is gone, save for one entrance arch. On the terrace are a number of ancient blocks, cuttings, etc., and a large cistern, the roof originally supported on arches, probably Byzantine or Armenian. A little E of the schoolyard, in the center of the modern town, is a temple, of which one fluted column and Corinthian capital remains standing, and some of the other column bases are in place. The temple was peripteral, 8 x 14, and had a flight of stairs at its E end. Two frieze blocks carved with Nikes carrying a garland remain from it. The date appears to be the 2d c. A.D. at the earliest. On the river bank E of the temple is some of the foundation for the two sides of a stadium. In a house in the town is a late mosaic of a checkerboard pattern with animals and various objects in the squares.

The present bridge across the river was built in the 1870s to replace an earlier six-arched bridge, at least in part Roman. An inscription recording the building of the Roman bridge in A.D. 77-78 was found.

On the slopes to each side of the road leading to Mut, SE of the castle hill, is an extensive Roman necropolis of rock-cut chambers and sarcophagi, some cut in the rock and some freestanding. A large number of inscriptions has been recorded. The Christian necropolis is S of the town on the ancient paved road with steps cut in the rock which leads from the center of Silifke S to the monastery and churches of Meriamlik, a site where Thekla, a saint of the 1st c., is supposed to have lived. It was famous by the 4th c. as a pilgrimage site; the main buildings are apparently of the 5th and 6th c.

The ancient road from Seleucia to Diocaesarea (Olba), largely followed by the modern road, led across the Calycadnus and up steeply to a rocky upland slope seamed with deep ravines. Along the road and east of it from about 8 to 10 km from Seleucia are some ancient sites which may have belonged to the territory of Seleucia. On the road in the area now known as Taş evler or Kuleıer are various house remains and numerous well-preserved heroa of the 2d and 3d c. A.D. These are in the form of a small temple distyle in antis, or prostyle tetrastyle, some of the latter with a basement also fronted with columns. All are Corinthian in style with Ionic for the lower story columns. All have a door from porch to cella. Ten km from Seleucia is a grave tower, square in plan, pilasters at the corners, Corinthian capitals and epistyle, and a pyramidal roof, and off the road to the W another similar tower lacking the roof, the blocks separated by earthquake. South of it is a low hill covered with the ruins of a town, ancient Imbriogōn Komē, probably an outlying possession of Seleucia, or possibly of Diocaesarea. There is no indication of what place the deceased of the heroa were citizens, although Seleucia as the closer is more likely. Well to the E of the road at a place known as Bey Ören are the remains of a basilica, and at Topalaryn Tsheshme house remains, a memorial column and two heroa. Remains of four different sites lie along or near the ravine leading SE from the Seleucia Diocaesaria road to Persenti, at the E edge of the Calycadnus delta; these may have belonged to Seleucia or Diocaesarea/Olba.

In the school and schoolyard, where several columns, perhaps from a stoa, have been re-erected, are collected

various blocks with inscriptions, some statuary, capitals and other antiquities collected from Silifke and the surrounding district. At least one portrait head is in the Adana Museum.

BIBLIOGRAPHY. F. Beaufort, *Karamania* (1818) 214-18; L. de Laborde, *Voyage dans l'Asie Mineure* (1838) 130fMPI; V. Langlois, *Voyage dans la Cilicie* (1861) 182-93; L. Duschesne, "Les Necropoles Chrétiennes de l'Isaurie, I, Selefkeh," *BCH* 4 (1880) 192-202; R. Heberdey & A. Wilhelm, *Reisen in Kilikien, DenkschrWien*, Phil.-Hist. Kl. 44, 6 (1896) 100-17; C. R. Cockerell, *Travels in Southern Europe and the Levant* (1903); J. Keil & A. Wilhelm, "Vorlaufiger Bericht über eine Reise in Kilikien," *JOAI* 18 (1915) 19-34; id., *Denkmäler aus dem Rauhen Kilikien, MAMA* III (1931) 3-33; R. Paribeni & P. Romanelli, "Studii e recherche archeologiche nell'Anatolia Meridionale," *MonAnt* 23 (1915) 95-99; E. Herzfeld & S. Guyer, *Meriamlik und Korykos, MAMA* II (1930)MPI; G. H. Forsyth, "Architectural Notes on a trip through Cilicia," *DOPapers* 11 (1957) 223-25I (Meriamlik); L. Robert, *Documents de l'Asie Mineure Meridionale* (1966) 101-5; D. H. French, "Prehistoric Sites in the Gök Su Valley," *AnatSt* 15 (1965) 181; T. S. MacKay, "Olba in Rough Cilicia," Diss. 1968 (Univ. Microfilm)M; L. Budde, *Antike Mosaiken in Kilikien* II (1972) 153-62MPI; O. Feld, "Bericht über eine Reise durch Kilikien," *IstMitt* 13-14 (1963-64) 88-97. T. S. MAC KAY

SELEUCIA ON THE EUPHRATES, *see* ZEUGMA

SELEUCIA or Seleucia on the Tigris (Tel Umar) Iraq. Map 5. The site covers 1.3 ha of mounds. The city was founded by Seleucus (305-281 B.C.) at the location of the Babylonian town of Opis. Here, at the narrowest point between the Euphrates and the Tigris a canal joined the two, running just N of the site, now 3.2 km W of the Tigris. Just across the river is Ctesiphon, and Baghdad is 32 km to the N.

The Seleucid city was laid out in rectangular blocks and is said by Strabo to have had 600,000 inhabitants. Prior to the excavations visible areas included sections of its stone wall, built on foundations of baked bricks from Babylon, and its defensive ditches and canals. Excavation concentrated on the three upper levels of the city and particularly on Block B, an entire city block 150 by 72 m. Very little of Level IV, the Seleucid city, was uncovered, although coins and figurines of that period were found. That level ceased to be occupied about the time of a Parthian invasion in 143 B.C. Level III was a Greek autonomous city under Parthian suzerainty and ended about A.D. 116 with Trajan's invasion.

BIBLIOGRAPHY. L. Waterman, *Preliminary Report upon the Excavations at Tel Umar, Iraq* (1931); id., *Second Preliminary Report upon the Excavations at Tel Umar, Iraq* (1933); R. H. McDowell, *Coins from Seleucia on the Tigris* (1935); id., *Stamped and Inscribed Objects from Seleucia on the Tigris* (1935); W. van Ingen, *Figurines from Seleucia on the Tigris* (1939); P. Jouguet, *L'Impérialisme Macédonien et l'Hellénisation de l'Orient* (1937) 175, 429-31. D. N. WILBER

SELEUCIA PIERIA Turkey. Map 6.

Founded by Seleucus I Nicator (301-281 B.C.) on the Syrian coast N of the mouth of the Orontes, the city was the port of Antioch. The Lagids ruled it for a long time in the 3d c. During the Roman Empire a Roman war fleet was based on Seleucia. Vespasian in the 1st c. A.D. and Constantius in the 4th renovated the port. Hadrian and Julian came to sacrifice on Mt. Casios, which borders the bay of Seleucia to the S.

Today the site is almost deserted. It is located between the village of Magharadjek in the plain and that of Keboussie on the mountain. The ancient town was established where the sea, the plain of the Orontes, and the slopes of the Amanus meet. The site consists of a lower town to the SW, an upper town rising in tiers on the plateau of the NE, and an acropolis high up to the NE. The main visible remains are the ramparts, market gate, martyrion, Doric temple, canal of Vespasian, and necropoleis, as well as mosaics taken to various museums.

The long line of the walls has been investigated, including bastions and gates of the upper and lower towns on the SE where the road from Antioch entered. The ramparts are of fine polygonal Hellenistic ashlar. The entry to the lower town, the market gate, was turned into a fortress at a late date. Two tall semicircular towers rising from square bases are still standing.

Not far away, along the busiest avenue to the NW, are the foundations of a sanctuary. It was built on a radiating plan at the end of the 5th c. A.D. and was restored in the 6th c. It is a cross-shaped martyrion surrounded by an annular ambulatory; the choir has a rectangular bay and an apse. A baptistery adjoins the choir to the N.

The foundations of a large Doric temple of Hellenistic date (almost 37 x 19 m) dominate the town. The temple is peripteral (6 columns x 12). The cella opens to the E through a deep porch with two columns between the antae; it has an adyton and a crypt.

Almost nothing can be seen of the Roman theater. Luxurious Roman villas were arranged in tiers along the slopes of the upper town. Their sumptuous polychrome mosaic pavings are now in the Antioch museum, at the Art Museum of Princeton University, and in other public collections in the United States.

North of the site a canal, dug in order to divert a stream which crossed the port, can be followed for more than 1300 m, sometimes open to the sky, sometimes as a tunnel; inscriptions on the walls date its construction to Vespasian and Titus. The double port with its piers and entry channel has long since been completely silted up.

Numerous necropoleis surround the town with various types of rock-cut tombs, caves, and sarcophagi. Modest tombs of sailors of the Roman fleet have been found between the canal and the port. Large funerary cippi of the officers bordered the Antioch road in front of the market gate.

BIBLIOGRAPHY. V. Chapot, *Séleucie de Piérie*, extract from *Mémoires de la Société des Antiquaires de France* 66 (1906)MPI; H. Seyrig, "Le cimetière des marins à Séleucie de Piérie," *Mélanges syriens offerts à René Dussaud* (1939); R. Stillwell, ed., *Antioch on-the-Orontes III: The Excavations of 1937-1939* (1941)PI.
 J.-P. REY-COQUAIS

SELGE (Sirk, or Serük) Pisidia, Turkey. Map 7.

In the high valley of Eurimedon, at the W extremity of the Taurus chain (Strab. 12.570). Its political boundaries were: to the W the territory of Sagalassos, to the S that of Aspendos, and to the E that of Katemna. Very little is known of its earliest history. It is certain that the city was settled by Lakedaimonian colonists, and that it was not subdued by the Persians. Because its independence was threatened, Selge sided with Alexander against Sagalassos and Termessos when the king rose up against Phrygia (Arr. *Anab.* 1.28.1). Its government, composed of fierce and tenacious mountaineers (Pol. *Hist.* 5.75), opposed Achaios, the kings of Pergamon, and finally the Goths (Zos. 5.15).

The ruins of ancient Selge consist of the remains of an encircling wall and an acropolis (Kesbedion), the structures of the theater, and scanty traces of the stoas, the agora, the gymnasium, the stadium, and a basilica. Barely recognizable are outlines of two temples. The theater is the best-preserved building. Rebuilt in the 3d c. A.D., it is noted both for its stateliness (diam. 104 m) and for its striking setting between two hills. Outside the perimeter of the walls are the remains of an aqueduct and several chambered tombs, situated to the N and S of the city.

BIBLIOGRAPHY. C. Lanckoronski, *Städte Pamphyliens und Pisidien* II (1882); B. V. Head, *Historia Numorum* (1911); G. K. Jenkins, *BMQ* 18 (1953); L. Robert, *Villes d'Asie Mineure* (2d ed. 1962); G. E. Bean, "Anadolu Araştirmaları," *JKF* 2 (1965); D. De Bernardi Ferrero, *Teatri classici in Asia Minore* I (1966); R. Fleischer, *Oest. Jahr* 49 (1968-69); A. Machatscher, *Oest. Zeitschr. f. Kunst u. Denkmalpflege* 23 (1969). N. BONACASA

SELIMIYE, *see* SIDE

SELINOS (Gazipaşa, formerly Selinti) Turkey. Map 6. City in Cilicia Aspera, among the principal ones on this coast and mentioned by most of the ancient geographers from Pseudo-Skylax on. It was one of the towns taken by Antiochos III in 197 B.C. (Livy 33.20), but is best known as the place where Trajan died in A.D. 117 on his way back from the East. After this event Selinos took for a time the name of Trajanopolis, which occurs on coins and inscriptions. The coinage begins under the kingdom of Antiochos IV of Kommagene, and continues later from Trajan to Philip. A bishop of Selinos is recorded, under the metropolitan of Seleukeia.

The city stood on the slopes and at the foot of a steep hill with a perpendicular cliff on the seaward side. A fortification wall, mostly of rubble, descends the landward side, but the ruins lie chiefly on the level ground below. An aqueduct of inferior masonry crosses the marsh near the mouth of the neighboring stream. Conspicuous is a large rectangular building surrounded by a colonnade, sometimes wrongly supposed to be a mausoleum of Trajan; though the colonnade is ancient, the building itself is apparently a mediaeval caravanserai. There are some undistinguished remains of a theater, and a necropolis extends along the foot of the hill; most of the tombs are constructed of masonry. Numerous column shafts, partly buried, mark the line of a street from city to harbor.

BIBLIOGRAPHY. R. Heberdey & A. Wilhelm, *Reisen in Kilikien* (1896) 149-51; G. E. Bean & T. B. Mitford, *AnatSt* 12 (1962) 206-7; id., *Journeys in Rough Cilicia 1964-1968* (1970) 153-55. G. E. BEAN

SELINTI, *see* SELINOS

SELINUNTE, *see* SELINUS

SELINUS (Selinunte) Trapani, Sicily. Map 17B. An ancient city on the S coast of Sicily, ca. 12 km S of Castelvetrano and approximately 40 km W of Sciacca. The river Modione (Selino) forms its W border, the river Cottone (Calici) its E border. The city had for the S part of Sicily the same function that Himera had for the N: it was an outpost of Greek civilization against W Sicily which was inhabited by Phoenicians and Elymi. It was founded by the Megarians who had arrived a century earlier from Megara Nysaia in Greece, and had founded Megara Hyblaia in the vicinity of modern Augusta. The location was selected for its strategic position: a hill jutting into the sea between two rivers, both of

which were ideal for debarkation and provided excellent penetration routes toward the interior.

The colonists from Megara Hyblaia were led by the oikistes Pammylos, who came expressly for this assignment from the mother city in Greece (Thuc. 1.24.2; Diod. 13.59.4). Disagreement in the sources on the foundation date (Thuc. 628-627 B.C.; Diod. 651 B.C.) has been settled by recent studies and excavations which specify that Selinus was founded 651-650 B.C. The colonists almost certainly found the territory occupied by small settlements of indigenous populations, perhaps of Sikan origin; recent finds indicate the presence of such settlements at least as early as the beginning of the Bronze Age.

On the strength of its position, Selinus rapidly became a large and powerful city and the major protagonist in the history of W Sicily, from the 6th c. until its destruction in 409 B.C. It soon promoted a movement of expansion to the N, which caused inevitable conflict with the Elymi of Segesta and the Phoenicians of Motya. This expansion, perhaps during a later phase, pointed also toward the E, where the colony of Herakleia Minoa was founded (Her. 5.46). Despite its frequent struggles with the Elymi and the Phoenicians in Sicily, Selinus almost always managed to stay on good terms with Carthage. This permitted long periods of peace and the attainment of extraordinary prosperity, such as it must have enjoyed after Pentathlos' expedition (580 B.C.) and until the first battle of Himera (480 B.C.). Building activity in this period outstripped that in every other Greek city in Sicily, and at Olympia the city erected a treasury containing a chryselephantine statue of Dionysos (Paus. 6.19.6).

Selinus maintained good relationships with Carthage even after the first battle of Himera when the Carthaginians were defeated by Syracuse and Akragas. It even housed Giskon, whose father Hamilcar had died at Himera (Diod. 13.43.5). However, this friendship with Carthage did not prevent Selinus from espousing the Greek cause on occasion (Diod. 11.68.1) for although the aristocratic party promoted the alliance with Carthage, the democratic party favored alliance with the Greeks. These two parties, alternating in political power presumably account for the city's shifts in international policy.

In 409 B.C. Selinus was destroyed by Carthage (Diod. 13.54-59) in a battle that marked the end of the city's power. The Syracusan general Hermokrates tried to recapture it soon afterwards, and for this purpose hastily rebuilt the city walls (Diod. 13.63.3), but he failed. From then on Selinus lived poorly under Carthaginian political control until, during the first Punic war, in the middle of the 3d c. B.C., it was again destroyed and definitely abandoned. Small groups of people settled there both in Christian-Byzantine times and in the Arab period; afterwards the name itself was lost, and the site came to be known as Casale degli Idoli or Terra di Pulci. The site was identified by Fazello (*De Rebus Siculis* [Palermo 1558] 146ff).

The archaeological investigation of Selinus began during the early 1800's when the three famous metopes were found in the area of Temple C. Since that time investigation has continued but no excavation has been carried out in the area of the ancient city. The city as a whole comprises the following zones: A) the acropolis; B) the ancient city; C) Temples on the E hill; D) Malophoros Sanctuary; E) the necropoleis.

A) The acropolis. The Megarian colonists leveled the hill before building the first structures and surrounding them with a circuit wall of which traces have been found. Later on (perhaps late 6th-early 5th c. B.C.), building on the acropolis was augmented and surrounded by the

fortifications that are still visible today, including the sloping stretch near the modern entrance to the ruins. After the defeat in 409 B.C., the surviving inhabitants retreated within the acropolis. To this last phase (4th-3d c. B.C.) belong the houses visible today as well as the urban system, which probably utilized some of the earlier streets or repeated the alignment of some earlier buildings, but the city plan at present evident on the acropolis should, as a whole, be attributed to the Carthaginian phase of the city. The structures belonging to this period present all the characteristics of Punic settlements at that time: ladder masonry, sacred areas of the Punic type in every block, symbols of Tanit on the house floors, coins and movable objects found on the dirt-paved streets and in the houses; an earlier building was perhaps dismantled and its material re-employed in the new constructions.

Since the acropolis is still largely unexcavated, it is difficult to distinguish clearly between what predated and what followed the Carthaginian occupation. Starting from the S, the first identifiable structure is Temple O, of which only the foundations remain. It is quite similar, even in dimensions, to Temple A a short distance to the N; it is hexastyle with pronaos and opisthodomos in antis. Temple A is peripteral, with 6 by 14 columns; its stylobate measures 40.23 by 16.23 m. It can be dated, together with Temple O, between 490 and 480 B.C. On the E side the altar connected with the temple has recently been uncovered; both temples were utilized as a fortress during the mediaeval period; to this purpose they were joined, and could provide a well-fortified tower projecting on the S side.

On the axis of Temple A, 34 m to the E, lies a T-shaped structure fronted by a porch (13.1 x 5.6 m); it is a propylon leading into the sacred area of Temples A and O and dates after 480 B.C.

Crossing the road that runs E-W, one enters an area containing the ruins of perhaps the earliest sacred buildings on the acropolis, with the exception of the small Temple B, perhaps dedicated to Empedokles, the Akragan philosopher and scientist who, according to Diogenes Laertius (8.70), had drained the Selinuntine marshes. It is a small building (8.4 x 4.6 m) of the Hellenistic period (perhaps as early as the 4th c.), a tetrastyle prostyle aedicula with pronaos and cella located on a natural rise of the terrain and accessible on the E by means of nine steps. Its entablature carried traces of color.

Temple C, built on the highest point of the acropolis during the first half of the 6th c. B.C., is hexastyle peripteral with 17 columns on the sides; 14 columns of the N side were re-erected in 1925-26 together with portions of the entablature. The early date of this building is attested not only by its very elongated plan, but also by the fact that monolithic columns were at first employed on the S and E sides; moreover the columns taper from bottom to top. The stylobate measures 63.7 x 24 m; the cella building comprised an adyton, a long and narrow cella, and a pronaos. The triglyph frieze carried carved metopes and was surmounted by a cornice revetted with polychrome terracotta slabs; two gorgoneia, also of painted terracotta, decorated both pediments of the temple, one of which has been reconstructed at full scale in the Palermo Museum. On the temple roof, the ridge pole was covered by the kalypteres also of polychrome terracotta. Of the two large altars the earlier lies to the SE; the later is in front of the temple to the E. The area in front of Temple C must have been the Hellenistic agora. Just to the N is Temple D, built around the middle of the 6th c. B.C. It is hexastyle peripteral, with 13 columns on the sides and a stylobate of 56 by 24 m. Its plan includes a prostyle porch, pronaos, cella, and ady-

ton. Near the SE corner are the remains of a sacrificial altar, diagonal to the temple axis. Not far from the NE corner of Temple D are the foundations of a rectangular structure whose early archaic date can be inferred from its very elongated plan.

The whole acropolis is surrounded by walls that represent the largest fortification complex in the whole of Greek Sicily, second only to the Euryalos castle in Syracuse. Since the walls of Selinus have never been studied in their entirety, the following description is based on superficial observation. Various repairs can easily be recognized, and the most important are the work of Hermokrates; to his rebuilding also should be attributed the two round towers on the N and W, which reused materials from earlier temples. Blocks from the same buildings were, however, reused in several other places and in greatest number within the small N chambers. This demonstrates that at least some temples had collapsed after the battle in 409, a fact hinted at by Diodoros' description of the battle itself (13.54-59). Only two gates survive, the one to the W and the more important one on the N side, which connected the acropolis with the city. There are many postern gates, both on the E and W sides, several of them blocked. Several square towers dot the circuit of the walls on all sides; one of them has recently yielded two archaic metopes probably reused by Hermokrates.

B) Ancient city. To the N of the acropolis, on the hill called Manuzza, stood the city proper, also surrounded by walls of which only traces remain; its street pattern has recently been identified through aerial photography. There have been no excavations.

C) Temples on the E Hill. At a certain moment in the city's history, for reasons as yet unknown, the Selinuntines built three temples on the hill to the W of the city and acropolis, beyond the river Cottone. These must have been built about the middle of the 6th c. B.C. since this is the date given to the earliest of the three temples, Temple F. This building, the smallest of the three, has a stylobate measuring 61.83 by 24.43 m and lies between the other two. It was hexastyle with 14 columns on the sides; its plan includes a pronaos, cella, and adyton, but no opisthodomos. Its metopes, like all the others, are now in the Palermo Museum.

To the S lies Temple E; it belongs to the best phase of Doric construction, the phase that is usually called developed Doric and is generally dated 480-460 B.C. It is hexastyle peripteral with 15 columns to the side and was probably set within a temenos, as suggested by a recently discovered wall. Its plan comprises pronaos, cella, adyton, and opisthodomos in antis, its stylobate measures 67.82 by 25.33 m; in the adyton stands the base for the cult statue of the patron deity, probably Hera. The pronaos frieze carried sculpted metopes, four of which are in the Palermo Museum. The building has been recently restored.

Temple G is one of the largest temples of antiquity: its stylobate measures 110.36 by 50.10 m and its columns are 16.27 m high with a diameter of 3.41 m. The building was never completed, probably because it was still unfinished at the time of the city's destruction in 409 B.C.; it must have been started at the beginning of that century. Either because the length of the period it was under construction allowed for various changes and modernizations or because its proportions favored the expression of the architects' imagination, this temple presents peculiarities not found in other Doric temples. It was hypaethral since the central nave was left unroofed; the vast cella had three doors corresponding to the three inner naves formed by two rows of ten monolithic col-

umns in two tiers. The stone to build this temple came from the quarries of Cusa, which are ca. 9 km NW of Selinus as the crow flies. These quarries are still in the condition in which they were when the work was suspended and one finds there some partly cut column drums that correspond in dimensions to the columns of Temple G; the stone, moreover, is the same.

D) Sanctuary of the Malophoros. Scarcely more than a km separates the acropolis and the city from this structure, which lies to the W beyond the river Modione (Selinos). The dedication of the sanctuary is indicated by various inscriptions and by several thousand terracotta statuettes depicting a goddess with a pomegranate. The sanctuary is quadrangular (50 x 60 m) with a precinct wall encompassing several interior structures. The main building is shaped like a megaron and is dedicated to the major divinity, the Malophoros, perhaps to be equated with Demeter; in front of it lies a large rectangular altar. Within the peribolos is a smaller shrine dedicated to Zeus Meilichios where the famous twin stelai depicting a god and a goddess were uncovered; they belong to the Punic phase. There is also a Hekataion. This is obviously a sanctuary dedicated to the chthonian deities. The temenos was entered through the propylaia, which seem to have been remodeled during the Punic period; at that time the sanctuary was still in use, and even later, during the Byzantine phase, when the main megaron was adapted to a new function. The earliest evidence from this site goes back to the middle of the 7th c. B.C., and is thus contemporary with the earliest finds from the acropolis at Selinus, but here the aspect both of the buildings and of the divinities worshiped suggest that this sanctuary served not only for Greek Selinus but also for other neighboring centers inhabited by peoples of different origins.

Near the sanctuary a spring, which is still flowing, may have been the reason for the erection of the temenos in this area.

E) Necropoleis. The cemeteries attributed to Selinus lie E and W of the river Modione. Those to the E are the necropoleis of Galera-Bagliazzo and Buffa; those to the W, Manicalunga-Timpone Nero, Bresciana, and Pipio. There are several tens of thousands of graves, both cremation and inhumation: built graves, tile graves (*a cappuccina*), earth cists. The cemeteries E of the Modione may be dated as early as the mid 7th c. B.C.; those to the W, no earlier than the 6th. The latter extend as far as 5 km from the city, with the added obstacle of the river crossing and therefore may belong to another settlement not yet found.

This was the only Greek city of Sicily to have decorated its temples with sculptures (Palermo Museum). They belong to at least four periods, extending from the end of the 7th to the middle of the 5th c. B.C. Although they are all Classical Greek sculptures, certain aspects are obviously local and prevent exact classification within any of the known categories. A clear example of what might be called Sicilian, is the bronze statue of the so-called Ephebe, which dates to the beginning of the 5th c. B.C.

It has been hazarded that the temples were dedicated to the following divinities: Shrine of the small metopes to Apollo, Leto, and Artemis. For the three temples replacing this small temple—Temple C to Apollo, Temple A to Leto, and Temple O to Artemis; Temple G is attributed to Zeus; Temple F to Athena; Temple E to Hera, and Temple D to Aphrodite.

Selinus had its own mint and some coins carry the device of the wild celery, which gave the city its name.

BIBLIOGRAPHY. M. Santangelo, *Selinunte* (1961) (J. M.

Bovio) with previous bibliography[MPI]; *EAA* 7 (1966)[MPI]; E. Gabrici, "Studi archeologici selinuntini," *MonAnt* 43 (1956)[MPI]; G. Vallet & F. Villard, "La date de fondation de Selinonte: les données archéologiques," *BCH* (1958) 16ff[I]; A. Di Vita, "Le stele puniche del recinto di Zeus Meilichios a Selinunte," *Atti del Convegno di Studi Annibalici* (1964) 238ff; id., "Per l'architettura e la urbanistica di età greca arcaica: la stoà del temenos del tempio C e lo sviluppo programmato di Selinunte," *Palladio* (1967) 3ff[PI]; C. Kerényi, "Le divinità e i templi di Selinunte," *Kokalos* 12 (1966) 3ff; V. Tusa, "Aree sacrificali a Selinunte e a Solunto," *Mozia*, II (1966) 143ff[PI]; id., "Le divinità e i templi di Selinunte," *Kokalos* 13 (1967) 186ff; id., "Due nuove metope arcaiche da Selinunte," *ArchCl* 21 (1969) 153ff[I]; id., "Tombe della necropoli di Selinunte," *Sicilia Archeologica* 11 (1970) 11ff[I]; id. "Le necropoli di Selinunte," *Odéon* (1971) 177ff[PI]; D. White, "The post-classical cult of Malophoros at Selinus," *AJA* 71 (1967) 335ff[I].

V. TUSA

SELLASIA Lakonia, Greece. Map 11. Settlement a few km to the N of Sparta overlooking the valley of the Oinous (modern Kelephina), a tributary of the Eurotas. Situated at the issue of the road from Arkadia by way of Tegea and Kynouria by way of Karyai, it occupies a strategic position. It was burned and pillaged in 370 B.C. by the Thebans of Epaminondas (Xen. *Hell.* 6.5.27). Retaken in 365 by the Spartans, who were aided by the Syracusans (ibid., 7.4.12), it was destroyed and its population reduced to slavery after the defeat in 222 B.C. of King Kleomenes III of Sparta (Polyb. 2.65-69; Plut. *Cleom.* 27 & *Phil.* 6; Paus. 2.9.2; 3.10.7).

The site itself has not been identified with certainty. The hill of Haghios Konstantinos (9 km to the N of Sparta and 830 m high) is surmounted by an important fortress of apparently triangular shape (ca. 480 x 260 m). The walls, which are 2 to 3 m thick, are constructed without mortar of undressed stone. Two faces of large blocks hold together rubble-work. A cross wall isolated the summit of the hill to the NE. Inside the walls there are few signs of occupation, but the site has never been excavated.

The lower hill of Palaiogoulas (1.5 km to the N, 108 m in height) is surmounted by a wall with a perimeter of some 300 m. There also a cross wall isolates a part of the fortress. The walls, which are ca. 1.75 m thick, are constructed in the same fashion as those of Haghios Konstantinos. Inside the walls are to be found numerous signs of dense habitation: walls of small houses and sherds dating from the 5th to the 2d c. B.C. These finds, and the situation itself of Palaiogoulas, correspond most closely to Polybios' account and Pausanias' description of the final destruction in the Roman period. But Diodoros (15.64) describes Sellasia as a polis. The small dimensions of Palaiogoulas suggest only a small settlement of perioikoi, while the greater dimensions of Haghios Konstantinos do not correspond to those of a nameless fort. The question cannot, therefore, be considered as resolved.

BIBLIOGRAPHY. A. Mézières, "Description de la Laconie," *ArchMiss* (1854) 5; A. Jochmus, *Journ. Roy. Geog. Soc.* 27 (1857) 35[M]; W. Loring, "Some ancient routes in the Peloponnese," *JHS* 15 (1895) 73[MP]; J. Frazer, *Paus. Des. Gr.* (1897) III 320; J. Kromayer, *Antike Schlachtfelder* (1903) I 215-77[MI]; G. Sotiriadis, Τὸ πέδιον τῆς ἐν Σελλασίᾳ μαχῆς, *BCH* 34 (1910), 5-57[I]; J. Kromayer, "Sellasia," ibid. 508-37[M]; G. Sotiriadis, *Praktika* (1910) 277; id., "Anti-Sellasia," *BCH* 35 (1911) 87-107[I]; F. Bölte, *RE*, s.v. Sparta, col. 1320;

W. K. Pritchett, *Studies in Ancient Greek Topography* (1965) I 59-70[MI].

<div align="right">C. LE ROY</div>

SEMENOVKA Bosporus. Map 5. A Bosporan agricultural settlement on the N shore of the Kerch peninsula 3 km N of the modern village of Semenovka. Founded in the late 3d-early 2d c. B.C., the site was destroyed in the second half of the 3d c. A.D. probably during the Gothic raid of 267. By the late 3d-early 4th c. life had resumed on a small area of the original settlement.

The village included a small hill and the surrounding coastal lowlands. Walls were constructed around the hilltop in the late 1st c. B.C.-1st c. A.D. and then rebuilt in the 1st c., when towers were added. Excavations have shown that within the citadel three streets ran parallel to the main E-W avenue and were connected with it by alleys. This irregular rectangular street pattern created blocks of residential homes with adjacent walls—ca. 90 rooms as well as courtyards have been uncovered. All the houses had stone walls and there are traces of wall paintings from dwellings of the 1st c. B.C.-1st c. A.D. Many homes of the 3d c. A.D. were two-storied with living quarters on the second floor.

BIBLIOGRAPHY. I. T. Kruglikova, "Poselenie u derevni Semenovki," *KSIA* 83 (1961) 73-82; id., "Itogi semiletnikh raskopok poseleniia u d. Semenovki," *KSIA* 95 (1963) 43-51; id., "Nekropol' poseleniia u der. Semenovki," *SovArkh* (1969) 1.98-119; id., "Raskopki poseleniia u der. Semenovki," *Poseleniia i mogil'niki Kerchenskogo poluostrova nachala n.e.* [Materialy i issledovaniia po arkheologii SSSR, No. 155] (1970) 4-81.

<div align="right">T. S. NOONAN</div>

SEMIBRATNOE Kuban. Map 5. A Hellenized Sindian town on the left bank of the lower Kuban 12 km W of Varenikovskaia. The site covered an area of 9 ha and was surrounded in the 5th c. B.C. by a wall 2.5 m wide built of cut stones. There were square towers at 15-18 m intervals. Remains of a large residence of the 3d c. B.C. indicate a rectangular structure with an inner courtyard, five rooms, and walls 1.4 m thick. On the outskirts of the city is a kurgan necropolis from the 5th-4th c. containing the tombs of rulers of the Sindi tribe. The grave gifts consisted of Greek ceramics and articles of silver and gold. The Hermitage Museum contains material from the site.

BIBLIOGRAPHY. N. V. Anfimov, "Novye dannye k istorii Aziatskogo Bospora (Semibratnee gorodishche)," *SovArkh* 7 (1941) 258-67; id., "Raskopki Semibratnego gorodishcha," *KSIIMK* 37 (1951) 238-44; id., "Issledovaniia Semibratnego gorodishcha," *KSIIMK* 51 (1953) 99-110.

<div align="right">M. L. BERNHARD & Z. SZTETYŁŁO</div>

ŠEMPETER OB SAVINJI, *see* CELEIA

SENAGALLIA, *see* SENA GALLICA

SENA GALLICA or Senagallia (Senigallia) Ancona, Marche, Italy. Map 16. A settlement of the Galli Senoni in the 4th c. at the mouth of the Misa river above an alluvial plain at the center of a coastal lagoon depression. After the battle of Sentino (295 B.C.), the Romans made it a jurisdictional colony (Polyb. 2.19.12; Livy *Per.* 11, 27.38.4), which the sources mention particularly in connection with the battle of Metaurus in 207 B.C. (Cic. *Brut.* 18.73; Liv. 27.46.4; Sil. 15.552; App. *Hann.* 52; Eutr. 3.18.2; Oros. 4.18.3; Zonar. 9.9). In 82 B.C., the city was sacked by Pompey in his struggle with the followers of Marius (App. *BCiv.* 1.87-88). It was an Early Christian diocesan seat. In A.D. 551, it was a Byzantine naval base during the Gothic war (Procop. *Goth.*

6.23) and subsequently became part of the Pentapolis. Two roads ended here: the Adriatic coastal road (*It. Ant.* 100, 316; *Tab. Peut.*; *Rav. Cosm.* 4.31; 5.1) and a branch of the Via Flaminia coming from Cagli (*It. Ant.* 315-16; *CIL* XI, 2, p. 997).

The remaining Roman works are limited to the ruins of a tower and of a stretch of the circuit walls toward the sea, today contained in the Renaissance la Rocca. The ancient urban plan was square with its N angle blunted (to adapt to the area of the alluvial plain) and oriented according to the coastline. In the modern Via Arsilli the cardo maximus may be recognized and the decumanus maximus in the Renaissance Strada Grande (today a part of Via 2 Giugno). The forum is in the Piazza Roma.

BIBLIOGRAPHY. *CIL* XI, p. 922; Nissen, *Italische Landeskunde*, II, 385; F. Lanzoni, *Le diocesi d'Italia* (1927) 492-93; N. Alfieri, "Topografia della battaglia del Metauro," *Rend. Ist. Marchigiano di Scienze, Lettere ed Arti* 15-16 (1939-40) 93; id., "I fiumi adriatici delle regioni augustee V e VI," *Athenaeum* 27 (1949) 128; A. Baviera, "Alcune memorie dell'epoca romana a Senigallia," *Nel bimillenario della nascita d'Augusto* (1948) 42-52; M. Ortolani & N. Alfieri, "Sena Gallica," *RendLinc* 8, 8 (1953) 152-80.

<div align="right">N. ALFIERI</div>

SENANTES, *see* BÛ

SENÈMES, *see* DILIS

SENIA (Senj) Croatia, Yugoslavia. Map 12. A Liburnian port on the N coast of the ancient province of Dalmatia. It had a good harbor and was one of the few places from which a road passed across the great barrier of the Velebit mountain into Iapudian interior. It served as a base for Octavian's operations against the Iapodes in 35 B.C. (App. *Ill.* 16-19). Its role as a place for the exchange of goods between the Liburnian coast and the Iapudian interior was heightened in the Roman period. It was a crossroads town on the coastal road that passed Aquileia, Tergeste, Tarsatica, Iader, and Salona and which led N toward Siscia in Pannonia. Listed as an oppidum by Pliny (*HN* 3.140), the town became under Octavian either a colonia or municipium. The inscriptions attest the existence of a college of Augustales, which in Dalmatia was usual in the colonies. The town was settled by natives and by traders from Italy and the Eastern provinces, among them a Jew from Tiberias in Palestina, the first one known in the ancient Dalmatia. These people introduced the cults of Mithras, Serapis, and the Magna Mater. In the 2d c. A.D. there was a customs office (portorium publicum Illyrici). The city was fortified with the walls. The Temple of Liber near the present cathedral has been excavated as well as the foundations of other cult buildings, most probably of the Magna Mater because the fragments of her statue were found. In A.D. 239 the governor L. Domitius Gallicanus Papinianus reconstructed the city baths. The foundations and installations of these baths were found at a place called Stele. Everywhere under the present city the foundations of the Roman buildings are found. On the periphery of the town several necropoleis have been excavated. The Roman town seems to have survived until the arrival of Croats in the 7th c.

The archaeological material is preserved in the Senj City Museum.

BIBLIOGRAPHY. J. Klemenc, "Senj u prethistorijsko i rimsko doba," *Senj* (1940) 1-10; I. Degmedžić, "Arheološka istraživanja u Senju," *Vjesnik za arheologiju i historiju dalmatinsku* 53 (1950-51) 251-62; A. Glavčić, "Arheološki nalazi iz Senja i okolice," *Senjski zbornik* 2 (1966) 383-420.

<div align="right">M. ZANINOVIĆ</div>

SENIGALLIA, *see* SENA GALLICA

SENJ, *see* SENIA

SENLIS, *see* AUGUSTOMAGUS

SENNABRIS, *see* PHILOTERIA

SENS, *see* AGEDINCUM

SENTINO, *see* SENTINUM

SENTINUM (Sentino) Ancona, Marche, Italy. Map 16. A Roman municipium of the tribus Lemonia, ca. 1 km E of modern Sassoferrato at Civita. The ruins were identified in 1891. In the territory of Sentinum (Polyb. 2.19.6; Livy 10.27.30; Frontin. Str. 1.8.3) was fought the battle in which the coalition of Samnites, Umbrians, Etruscans, and Gauls was defeated by the Romans under the consuls Q. Fabio Rulliano and P. Decio Mure, who was killed on the battlefield in 295 B.C. Owing to the extent of their losses, the Gauls retreated and were forced to cede part of their territory to Rome. During the war of Perugia in 41 B.C. Sentinum, which sided with Antony, was taken for Octavian by Salvidienus Rufus, who destroyed it (Cass. Dio 48.13.2.5; App. BCiv 5.30).

At that time, the second half of the 1st c. B.C., the city must have been planned anew, according to Vitruvian principles. On a nearly triangular area at the confluence of the Sentino and the Marena, the city walls were built of limestone in opus vittatum along the jagged shoreline. They were under construction from the end of the Republic until late in the Augustan age, by which time the city was part of Regio VI. The internal plan of the city is based on the intersection of axes astronomically oriented, not perfectly centered, but more heavily concentrated toward the W because of the irregularity of the higher ground. Two gates have been recognized at the extremities of the E-W cardo, opening on entrances in the walls. The W gate on the N-S decumanus, the decumanus maximus, seems securely identified. The urban streets are paved with large polygonal stones. Below them the sewage system is aligned with the network of streets in a plan rigidly following the Roman urban tenets on which the refounded city was based. The catch basins for surface water, mostly rectangular in section, were installed when the streets were laid. The excavations, conducted systematically since 1954, have brought to light, in addition to the remains of the domus in the rectangular insulae, an industrial sector of the city and public buildings. A bath building from the first Empire was already known from the earlier recovery of a large figured mosaic pavement preserved in the Museo Nazionale delle Marche. The bath is of the usual type with a frigidarium, furnished with a natatorium, tepidarium, and calidarium. Among the mosaic pavements of particular interest is that showing Europa on the Bull from the first Imperial period, now in the museum at Sassoferrato, together with other material from Sentino, and a polychrome mosaic of Mithra-Sol dating to the 2d c. A.D. in the Gliptoteca in Munich.

Of sculpture there remains a statue of a figure wearing a lorica from the Imperial period and a portrait of a woman from the Hadrianic period. A low relief in the popular style showing a triclinium is now in the Museo Nazionale delle Marche. Other bas-reliefs were reused in the Church of S. Croce. They show evocative figures of animals, which appear to represent the various stages of the initiation rites and thus attest the presence of a Sanctuary of Mithra, whose cult is also documented by inscriptions (*CIL* XI, 5736-37). Bronzes include an Athena from a Greek prototype and an Isis-Fortuna in the Alexandrian style. A mask of Zeus, now in the Museo Nazionale delle Marche, is 19 cm high and free-standing, carved in oak. It dates to the age of Antoninus but shows the influence of the art of Bryaxis. The life of Sentinum seems to have ceased at the time of the invasion of Alaric (Zosimus 5.37).

In the environs of Sentinum is a place called Civitalba, where the temple terracottas now in the Civic Museum at Bologna were found. The myth of Ariadne at Naxos is shown on the pediment and the rout of the Galatians from the Delphic sanctuary on the long sides. Inspired by Hellenistic models created in the 3d c. B.C., the second episode in particular was probably executed in celebration of the Roman victory over the Gauls in the battle of Sentinum.

BIBLIOGRAPHY. C. Ramelli, *Monumenti mitriaci di Sentinum* (1863); id. in *AZ* (1877) pl. 3; E. Brizio in *NSc* (1890) 279f; T. Buccolini, *NSc* (1890) 346ff; R. Mengarelli, *Notizie sulla topografia di Sentinum* (1892); F. Cumont, *Mystères de Mithra*, II (1898) 419; E. Bormann in *CIL* XI (1901) 837ff; H. Nissen, *Italische Landeskunde*, II (1902) 346; Philipp, *RE* II A (1923) col. 1508; G. Moretti, *NSc* (1925) 110-13; L. Allevi, "Culti misteriosofici nel Piceno antico," *Rassegna marchigiana* 7 (1929) 275ff; M. E. Blake, "Roman Mosaics of the Second Century in Italy," *Mem. Am. Ac. Rome* (1936) 151f, pl. 37, 2-4; G. V. Gentili, *NSc* (1940) 30f; id., in *Nuovo Didaskaleion*, III (1949) 1ff; id., *EAA* 7 (1966) 200f; id., *Atlante aereofotografico delle Sedi umane in Italia* (1970) I, passim; II (ed. G. Schmiedt) pl. 117; D. Levi in *Hesperia* 13 (1944) 287f, fig. 14; id., *Antioch Mosaic Pavements*, I (1947) 86, 264, 265, 356; A. Pagnani, *Sentinum, Storia e Monumenti* (1957); L. Fabbrini, "Sentinum," *Atti VII Congresso Internaz. di Archeologia Classica*, II (1961) 315-23; G. Annibaldi, "L'architettura dell'antichità nelle Marche," *Atti XI Congresso Storia Architettura* (1965) passim.

For Civitalba. L. Laurenzi, "Il frontone e il fregio di Civita Alba," *BdA* (1927) 259ff; G. Q. Giglioli, *L'Arte etrusca* (1935) 71, pls. 380-82; G. A. Mansuelli, *Etruria* (1963) 188, 194, 196ff. G. V. GENTILI

SEPPHORIS later DIOCAESAREA (Saffuriyeh) Israel. Map 6. A town in lower Galilee, the capital of Galilee before Tiberias took its place. It is mentioned for the first time during the reign of Alexander Jannaeus, in conjunction with the attack of Ptolemy Latyrus (Joseph., *AJ* 13.338). After the conquest of Palestine by Pompey in 64 B.C. it became the capital of one of the five new districts (*AJ* 14.91). After Herod's death the royal palace of Sepphoris was looted, and Judah son of Hezekiah made it the capital of the Galilee (*AJ* 18.27). During the war against the Romans Sepphoris remained loyal to them, but after the destruction of the Second Temple it became an important Jewish center and the seat of the Sanhedrin, the supreme Jewish council, for some time. Vespasian made it a polis, and Hadrian changed its name to Diocaesarea (Hieron. *Onom.* 17.14), the City of Zeus. According to the *Notitia Dignitatum* it was a military center. Constantine the Great gave permission to Joseph the Convert to build a church there.

Excavation on the acropolis has uncovered a Crusader citadel, built mainly of Roman sarcophagi and stones taken from Roman buildings. An earlier fortress was found below the citadel, while remains of a basilica belong to the Byzantine period. Outside the town is a Roman theater, partly excavated. It has a diameter of ca. 30 m, and seated some 4-5000 spectators. The scaenae frons was 27 m long and 5.4 m deep. Also Roman

are an aqueduct and a tunnel which was also part of the water system.

BIBLIOGRAPHY. L. Waterman et al., *Preliminary Report of the University of Michigan Excavations at Sepphoris* (1937); F. M. Abel, *Géographie de la Palestine* II (1938) 305-6; M. Avi-Yonah, *The Holy Land* (1966) 84, 97, 110-11, 123, 135-38. A. NEGEV

"SEPTEM FRATRES," *see* CEUTA

SEPTEMPEDA Marche, Italy. Map 16. A municipium of Picenum on the left bank of the Flosis (modern Potenza) 2 km E of S. Severino Marche at Pieve di S. Martino. Little is known of its history.

Excavations have explored the imposing fortifications in large tufa blocks with towers of several forms, assigned to the 3d c. B.C., and the city plan, but buildings have not been cleared. Marbles and inscriptions from the site decorate several of the buildings of S. Severino, notably the stair of the Palazzo Comunale.

At nearby Pitino a large necropolis has yielded a particularly rich and informative sequence of Picene burials.

BIBLIOGRAPHY. *AA* (1959) 196 (B. Andreae); *EAA* 7 (1966) 202-3 (G. Annibaldi) L. RICHARDSON, JR.

SEQUANA (Saint-Germain-Sources-Seine) Côte-d'Or, France. Map 23. The sanctuary of Sequana (the name is attested in 11 inscriptions) is 30 km N of Dijon on the E side of the vale where the Seine rises. It is built around a smaller spring—the sacred source of the river. Badly preserved and excavated at extremely long intervals, the complex is not easy to make out. At the upper level are the spring and its catchment, which pipes the water off into a basin. The latter is enclosed in a large peristyle courtyard leading off into small chambers. The whole complex measures ca. 100 m. A little farther down is a small fanum of the Celtic type. On a lower level is an elliptical building enclosing a rectangular pool (4.5 x 3 m), which has a system of pipes running across it. At the bottom of the vale is a marshy area at least 40 m long with two N-S walls at either end. At first mistaken for a piscina, since 1963 it has been found to contain wooden votive offerings.

There seem to have been two major construction periods, one represented by the first stage of the basin and fanum, the other (not before the 2d c. A.D.) by the rest of the buildings. However, the complex was always on a small scale.

The votive sculptures found on the site make up the richest collection in Gaul. Great numbers of stone carvings had been unearthed in early excavations—statues modeled in the round and stelai—as well as two large bronzes. In the excavations carried out in 1963, 1966, and 1967, several hundred wooden objects were found in the marshland, many of them stuck in the ground, around the point where the river rises. Aside from two bronzes (Sequana standing upright in a boat, and a dancing fawn), the stone and wooden sculptures are all on the same subjects. They include representations of pilgrims, often wearing the bardocucullus (Gaulish cowled cape), or sometimes naked in the wooden versions. Other versions portray only the head; several wooden sculptures show superimposed heads, not yet separated one from another. The series of ex-votos prove that this was a healing sanctuary, for parts of the body are depicted—limbs or torsos, in the round, little bronze plaques depicting eyes, breasts, sexual organs, and, in wood alone, very arbitrary schematic representations of internal organs. A medical significance should probably also be given to the representations of swaddled infants;

on the other hand attempts to see on adults' heads traces of a disease of which they were asking to be cured are hardly convincing. Finally, there are a few wooden statuettes of animals.

The coins show that the sanctuary was active from the 1st to the 4th c. A.D. The wooden ex-votos date, in the context of the other archaeological finds, to A.D. 50 or 60 at the latest.

BIBLIOGRAPHY. Baudot, "Rapport sur les découvertes archéologiques faites aux sources de la Seine," *Mémoires de la Commission des Antiquités de la Côte-d'Or* 2 (1842-46), 95-144; Corot, "Les fouilles des sources de la Seine, découverte de bronzes figurés," ibid. 20 (1933-35) 107-20; R. Martin, "Fouilles aux sources de la Seine campagne 1953," *Rev. Arch. de l'Est* 5 (1954) 289-95; id., & S. Deyts, *Ex-voto du sanctuaire des Sources de la Seine* Musée archéologique (1966); Deyts, *Rev. Arch. de l'Est* (1965ff: several papers); id., *Scientific American* (July 1971) 65-73. C. ROLLEY

SERDICA (Sophia) Bulgaria. Map 12. An ancient Thracian center, today the national capital, situated in a valley surrounded by mountains at the juncture of the road from Belgrade to Istanbul and the natural waterway of the Danube to the Aegean. It was occupied by the Romans, conquered by Licinius Crassus (29 B.C.), raised to the status of a colony by Trajan, and coined its own money from the reign of Marcus Aurelius to that of Gallienus. The city was the seat of the council that condemned the Arian heresy (343). It was destroyed by the Huns in the 5th c., was reconstructed by Justinian, under whom Santa Sophia was built. Originally, the Romans had probably established a garrison in the village and area of the Thracian market, giving the city a praetorium and a castellum. The city did not gain great military importance but in the 4th c. when it became the capital of the frontier province, Dacia Mediterranea, it was surrounded by walls (brick and rubble core on a stone base) with round towers. One walled area within the city with the remains of large structures is thought to have been the praesidium. The plan of the city is rectangular, covering an area of ca. 84 ha. The remains of the buildings belong to two distinct periods: 2d and 3d c. stone architecture, and 3d c. and 4th c. brick architecture. Except for some traces of the walls, round towers, and triangular abutments, only the foundations of some buildings are known: a temple of Serapis and its pediment; a brick calidarium of a 3d c. Roman bath, transformed into the church of St. George in the 5th c. Probably the 6th c. a basilica of Santa Sophia was built. It had three aisles and an apse which was close to the ancient necropolis where there are remains of two small ancient churches (with mosaics) and many chambered tombs. The tombs were painted between the 4th and 5th c. with floral motifs, birds, and candelabra, and one with the busts of archangels. In all these tombs we may recognize Hellenistic-Oriental and Roman elements. On the coins of Serdica various buildings are represented. Funeral stelai, religious inscriptions, architectural fragments, and inscriptions are collected in the National Museum and displayed in the great nine-domed mosque. The Museum houses antiquities not only from the city but from all over Bulgaria.

BIBLIOGRAPHY. B. Filov, *La chiesa sofiota di S. Sofia* (1912)PI; id., *La chiesa sofiota di S. Giorgio* (1933)PI; K. Mjatev, *La peinture décorative de la nécropole de Serdica* (1925)PI; N. Musmov, *Le monete di Serdica* (1926)I; S. Bobcev, *Serdica, Beitrag zur Kenntnis der Topographie, Gestaltung u. Architektur der Stadt* (1943)MPI; "Serdica" in *Mat. et Recherches Archéologiques*, I (1964).

Notes and reports in *Izv. della Soc. and Ist. Arch. Bulg.* and *Ann. Museo Naz. di Sofia* (in Bulgarian, with summaries in French and German). A. FROVA

ŞEREFÖNÜ, *see* KOMAMA

SERGIA, *see* FLAVIA NEAPOLIS

SERGILLA Syria. Map 6. In the *villes mortes* region of N Syria between Hama and Aleppo, a prosperous agricultural center during the Late Empire and Early Byzantine times. The village consisted of two built-up areas separated by a ravine. A church of the 4th c. A.D. and houses, built of polygonal blocks and inhabited by peasants, are on the E side, the larger villas and a necropolis of monumental sarcophagi lie to the W. The andron and public baths (built by a notable at the end of the 5th c. A.D.) are between the two, at the crossroads in the bottom of the gully.

The baths are the best preserved in Syria, and have harmonious arrangements of architectural masses. The careful masonry of the exterior has an austere appearance: the only decorations are the moldings which underline the triangular pediments and the semicircular windows. The inside walls, however, were plastered and painted. The main chamber, two stories high, has a rostrum at the W end, supported by four Corinthian columns, and a mosaic pavement of A.D. 473. A stable with feeding troughs cut into the rock can be seen near the entrance. In front of the S facade is a huge cistern covered with large slabs supported by stone arches.

The andron, a graceful building with two gables, was both an inn and a meeting hall. Its S facade has two superimposed colonnades with Doric or Tuscan capitals of a type peculiar to N Syria. On the ground floor is a chamber separated by rock-cut feeding troughs from a stable, and on the upper story a large room opens on the portico.

At least a dozen villas still stand, excellent examples of domestic architecture arranged for comfort, pleasure, and security. Loggias and porticos open to S or E onto courtyards or closed gardens, which are reached from the street by porches that serve as vestibules. Dominating the site from the SE, the largest villa consists of two buildings joined together. A portico of Corinthian columns runs in front of the W house, which has a spacious room with a ceiling supported by three stone arches. The N building has two stories of colonnades on its S facade, and loggias and towers with staircases at each end.

The church is a basilica with three naves, built on the hillside during the second half of the 4th c. and remodeled and enlarged in the 5th and 6th c. The columns between the naves are topped by arches, and the apsidal choir flanked by chapels which widen into transepts. On the exterior a gallery with porticos runs the length of the side naves. The W facade dominates a courtyard built farther down the slope. Agricultural buildings are attached to the church to the W, where the upper story of the house is on the level of the court in front of the church, and to the S, where an irregular group of elegant buildings, with porticos, towers, and a large square chamber supported by four columns, surrounds a courtyard. In the vicinity is a cistern and presses are cut into the rock.

BIBLIOGRAPHY. M. de Vogüé, *La Syrie centrale, Architecture civile et religieuse* (1865-77)[I]; H. C. Butler, *AAES* II, *Architecture and other Arts* (1903)[PI]; id., *PAES* Pt. II, *Architecture*, Sec. B, *Northern Syria* (1920)[PI]; J. Mattern, "A travers les villes mortes de Haute Syrie," *MélStJ* 16 (1933)[MI]; G. Tchalenko, *Villages antiques de la Syrie du Nord* 3 vols. (1953-58)[MPI].
J.-P. REY-COQUAIS

SERRA DI VAGLIO Lucania, Italy. Map 14. In the upper valley of the Casuentus river (Basento) near Potenza and immediately N of Vaglio della Basilicata. The site is unrecorded in history but was occupied by an important indigenous city, the predecessor of Roman Potentia (Potenza). The city walls, of the 4th c. B.C., are best preserved on the NE side of the site. Excavation is in progress around the temple and in the city area N of it where a rectangular street plan was laid out at the beginning of the 6th c. B.C. over an Iron Age hut village. The city underwent a transformation in the second quarter of the 4th c. B.C. and became impoverished in the 3d c. B.C. To the NE of the city is the site of Rossano di Vaglio where the excavation of a monumental sanctuary of the goddess Mefitis is under excavation.

Material from the excavations is at the Potenza Museum. It includes the building inscription in Greek of Nummelus, ruler of the town in the 4th c. B.C. and an extensive series of architectural terracottas (both antefixes and cover plaques).

Potentia is unknown except for sporadic finds under the mediaeval and modern city.

BIBLIOGRAPHY. F. Ranaldi, *Ricerche Archeologiche nella Provincia di Potenza 1956-1959* (1960); D. Adamesteanu in *Letteratura e Arte Figurata nella Magna Grecia, Atti del Sesto Convegno di Studi sulla Magna Grecia* (1967) 263-65; M. Napoli, *Civiltà della Magna Grecia* (1969) 289-94; R. R. Holloway, "Archaeological News from South Italy and Sicily," *AJA* 75 (1971) 77.
R. R. HOLLOWAY

SERRA LUSTRANTE, *see* ARMENTO

SERRA ORLANDO, *see* MORGANTINA

SERRE, *see* ROCCANOVA

SERÜK, *see* SELGE

SESTINO, *see* SESTINUM

SESTINUM (Sestino) Umbria, Italy. Map 16. A site near the headwaters of the river Pisaurus. It is mentioned only by Pliny (*HN* 3.114), but inscriptions show that it belonged to the tribus Clustumina, and the site still preserves its ancient name. Its graves go back to the 6th c. B.C., and inscriptions attest a flourishing life through the 4th c. of our era. There is a small Antiquarium Sestinate adjacent to the Pieve.

BIBLIOGRAPHY. A. Minto, *Sestinum*, Istituto di Studi Romani (1940)[MI]; *EAA* 7 (1966) 220-21 (A. Talocchini).
L. RICHARDSON, JR.

SESTO FIORENTINO Tuscany, Italy. Map 14. At the sesta mansio from Florentia on the Via Cassia, in the plain at the foot of the Appennines, on the right side of the Arno. This was a favorable position, near the commercial roads that joined Etruria with its spreading population in the Padana valley. Some Orientalizing tombs have been discovered recently: In addition to the Tomba della Mula, the Tomba della Montagnola at Quinto Fiorentino, and the tombs of Montefortini and of the Boschetti at Comeana are now known. Except for the Boschetti tumulus, which is more modest, consisting of one chamber whose raised part is only partially preserved, the tombs are monumental in appearance. At the Tomba della Montagnola the access corridor has been found, a vestibule with small rooms on either side. The Montefortini tomb has a rectangular chamber, the Tomba della Mula has a circular chamber; the Tomba della Montagnola also has a circular chamber with a central pilaster.

The roofing system, corbel slabs held in place by their own weight, has a double slope at Montefortini. This corbelling system is used in the burial chambers and in the dromos of the Montagnola tomb. The same technique forms pseudo-cupolas in the tombs of the Mula and of the Montagnola. The connection with the funerary monuments of N Etruria is evident.

The objects accompanying the burials from the last quarter of the 7th c. B.C. are particularly significant for their richness and variety, some imported and some of local manufacture; and for the presence of Etruscan inscriptions.

The remains of a Villanovian burial place near Quinto Fiorentino, in the locality called Palestreto, indicate habitation prior to the Orientalizing period; and at Poggio del Giro there is a small habitation site of the Hellenistic period. These discoveries show that the area was inhabited from archaic to the Roman times. Fragments of architecture and sarcophagi from Roman times come from Sesto Fiorentino; at Quinto Fiorentino there are remnants of a building from the same period.

BIBLIOGRAPHY. Fiorelli, *NSc* (1883) 76; F. Magi, *Carta Archeologica* F. 106; G. Caputo, *EAA* 6 (1964); id., *La tomba della Montagnola* (1969); F. Nicosia in *Atti del Convegno di Studi sulla città etrusca e italica pre-romana* (1970) 241ff.　　　　　　P. BOCCI PACINI

SESTOS Turkey. Map 7. City of the Thracian Chersonese on the Hellespont shore, opposite (due N of) Abydos and having the advantage over that harbor in wind and current. Mentioned in Homer's Trojan catalogue (*Il.* 2.836). It was claimed by Athens against Persia and Sparta, often successfully, from ca. 550 B.C. to the mid 4th c., for the protection of her grain shipments. The city was relatively unimportant in the Hellenistic and Roman periods, but later Justinian refortified it (the modern Choiridion castle). The ancient site apparently lay on a plateau ca. 100 m above sea level on the S side of a good bay. (Ak Başı limanı). Sherds, coins, and some inscriptions have been found.

BIBLIOGRAPHY. A. Hauvette-Besnault, *BCH* 4 (1880) 515ff; H. G. Lolling, *AthMitt* 6 (1881) 209; W. Leaf, *Strabo on the Troad* (1923) 117-33[MI]; S. Casson, *Macedonia* (1926) 216f[I].　　　　　T. S. MACKAY

SETAIA, *see* SETEIA

SÈTE Hérault, France. Map 23. The promontory of Sète, mentioned by the geographers of antiquity, bears no trace of ancient habitation. However, Roman buildings have been found on the peninsula of Barrou, along the Étang de Thau; the waters near the shore contain pre-Roman and Roman substructures and artifacts. Baths were discovered in the 18th c. near some hot springs and more recently exploration has uncovered factories which processed fish and shellfish. These installations were in use during the 1st c. and, to judge from the many ceramics and coins, appear to have been greatly developed under the Late Empire. The artifacts are at the Musée Paul-Valéry at Sète.

BIBLIOGRAPHY. *Carte archéologique de la Gaule romaine,* fasc. x, Hérault (1946) 15, nos. 38-39; "Informations," *Gallia* 20 (1962) 627; 22 (1964) 497; 24 (1966) 472; 27 (1969) 400; 29 (1971) 387.　　　　G. BARRUOL

SETEIA or Setaia (Siteia) Greece. Map 11. City on the N coast of E Crete. The ancient site is probably under the modern town, which goes back certainly to the Venetian period. Another site nearby has been suggested (Petras), but the only good harbor, then as now, is on the W side of the bay, sheltered from the N wind.

Little is known of its history. One of the Seven Sages, Myson, was born at Eteia or Etis, probably to be identified with Seteia. No coins are known, and it may never have been a fully independent city in antiquity, but a dependency of inland Praisos, serving as its port on the N coast: an early 3d c. inscription of Praisos refers to the Setaetai making overseas voyages on behalf of Praisos. When that city was destroyed (145-140) the Praisians may have continued to hold Seteia; later it was a bishop's see.

Objects belonging to the EM, MM, and LM, Archaic, Classical, Roman and Byzantine periods have been found at the modern town site, but few remains of buildings: only some Roman walls at the river mouth on the S side, and a Classical wall on the SW side. Part of the ancient site may now be submerged, owing to local subsidence. On the coast at Petras, 3 km E-SE of the town, are remains of a major Minoan site, with EM, MM, and LM finds but hardly a trace of post-Minoan settlement, so that it is unlikely to be Seteia. On the E side of a headland just E of Petras, called Karavopetra or Trypeti, is a rock cutting—a "shipshed" for a guardship, probably for protection against piracy.

BIBLIOGRAPHY. Bürchner, "Eteia," *RE* VI (1909) 706; id., "Setaia," ibid. II, A2 (1923) 1894-95; J.D.S. Pendlebury et al., *BSA* 33 (1932-33) 96f; M. Guarducci, *ICr* III (1942) 142-47, 164-66; C. Davaras, *ArchEph* (1967) 84-90[M]; S. Spyridakis, *Ptolemaic Itanos and Hellenistic Crete* (1970) 29-32.　　　　　　D. J. BLACKMAN

SETIA (Sezze) Italy. Map 16. Founded, according to legend, by Herakles, the first historical mention of this city in Volscian territory comes from Velleius Paterculus (1.14) and dates to 382 B.C., the date of the settlement of the first Roman colony on the site. Earlier, the territory had probably been seized and controlled by the Volscians (cf. Dion. Hal. 6.61). Setia was attacked in 379 B.C. by its warlike neighbor Privernum and received help from Rome. Yet in 340, Setia participated along with all the Latin cities in the League in opposing Rome (Livy 27.9.7; 29.15.2). During the second Punic war, although not siding with the Carthaginians, Setia refused to help the Romans and for that was severely punished. After the war, the Carthaginian hostages were kept under guard in the city because of its particularly defensible position on the ridge of the Lepini mountains (Livy 32.36.5). The slave revolt of 198 B.C. against Rome had its beginning at Setia (Livy 32.26.9). During the struggle between Marius and Sulla, Setia openly sided with Marius and was devastated by the victorious Sulla (App. *BCiv.* 87; Plut. *Caes.* 58). In the Liber coloniarum Setia is included among the cities in which the triumvirs, Antonius, Crassus, and Lepidus, in 43 B.C., established a second Roman colony. That notice, which would appear to be confirmed by an inscription found at Setia, is directly contradicted by Pliny (*HN* 3.5.64), who places the city among the municipia and not among the colonies.

Numerous traces of the city's polygonal walls (chiefly in the third and fourth style) are still preserved, and they are sufficient to give an idea of the exact perimeter of the walls. One of the postern gates, with a monolithic architrave, is perfectly preserved.

Near the church of San Lorenzo was found a fragment of a Doric frieze with metopes decorated with alternating vine leaves and rosettes. Perhaps it comes from the ruins of the Temple of Apollo, an inscription from which has been found not far away (*CIL* x, 6463).

Along the modern street that proceeds from the plain into the city is an imposing foundation in opus quadratum generally called, but without real reason, the Tem-

ple of Saturn. The base is most likely a part of the fortification works at the entrance to the city.

Near the ponte della valle was found a bronze votive tablet dedicated to Mercury and Augustus by the Sexviri Augustales and by a Sexvir Augustalis named Lucius Sotericus Theossenus, with a funerary inscription (*CIL* x, 6461, 6469). In all likelihood, a temple to Augustus was built not far from that spot.

On the street that leads to the Porta Romana are a few remains of what might possibly be an amphitheater. Near the monastery of the Bambin Gesù were once visible the remains possibly of a basilica; today the only record of it is an inscription (*CIL* x, 6462). Imposing ruins of Roman country villas are scattered in numerous areas of the surrounding countryside.

The discovery of funerary inscriptions in specific areas has caused speculation that necropoleis may exist there but systematic investigations have not yet been carried out. The areas include Piagge Marine, I Colli, Madonna della Pace and an area near Sezze Scalo.

In the past few years an Antiquarium has been established to house geological, prehistoric (rock paintings have been discovered in the mountain caves around Sezze), and archaeological materials. Among the more valuable finds in the Antiquarium is a bronze statuette of Mars, coming from Archi di San Lidano, and a piece of mosaic pavement with polychrome tessera.

BIBLIOGRAPHY. F. Lombardini, *Della istoria di Sezze* (1876); V. Tufo, *Storia antica di Sezze* (1908); H. H. Armstrong, "Topographical Studies at Setia," *AJA* 19 (1915) 42ff; L. Zaccheo & F. Pasquali, *Guida all' Antiquario ed ai maggiori monumenti di Sezze* (1970); id., *Sezze, dalla preistoria all'eta romana* (1972).

B. CONTICELLO

SÉTIF, *see* SITIFIS

SEUTHOPOLIS Kazanlak, S. Bulgaria. Map 12. A Thracian city near the village of Koprinka. It was founded at the end of the 4th c. B.C. by Seuthes III. The large quantity of material discovered during the excavation has shown that Seuthopolis was not only a center of production, but also of commerce. The city rises on a terrace circumscribed on three sides by the Tundza and by one of its tributaries. It was a fortified city of ca. 5 ha with a pentagonal circuit wall 2 m thick and 890 m in perimeter, with a quadrangular tower at each angle. At the N, between two towers, is the principal gate; and at the S are two gates between bastions. The wall is constructed of clay bricks and wood on stone foundations. The city's orthogonal plan is regular, with two large arteries that lead from the gates to the center. The agora is in the NW sector. In the NE zone is a walled and towered trapezoidal area within which is enclosed the palace of the prince and the Sanctuary of the Great Gods of Samothrace. In the houses, which are built with rooms around a court, has been found a type of plaster. Elements of porticos have been found and upper galleries of wood. The houses were furnished with wells and drainage systems, with a channel in the center of the street. The influence of Hippodamos is evident, though the democratic distribution of living quarters is lacking. Seuthes III built his city on the site of an earlier settlement, and he also followed the Hellenistic fashion of the Diadochi in giving it his own name. Greek influence is prevalent in the urban elements cited and in decoration such as antefixes, stucco, and incrustation, and in the use of the Doric capital.

BIBLIOGRAPHY. D. Dimitrov, "Seuthopolis, die trakische Stadt in der Nähe der Dorfes Koprinka, Kreis Kazanläk," *Sovetskaja Archeologia* 1 (1957) 199ff; id., "Das Entstehen der thrakischen Stadt und die Eigenart ihrer städte-

baulichen Gestaltung und Architektur," *Atti del VII Congr. Int. di Archeologia Classica* (1961) I, 379-87[1].

A. FROVA

SEVEUX, *see* SEGOBODIUM

SEXAGINTA PRISTA or Sexanta Prista, or Prista (Ruse) Bulgaria. Lower Moesia. Map 12. On the right bank of the Danube, a camp and station of the Danube fleet under the emperor Vespasian (69-79). In 100 Roman citizens and veterans settled in here. At the beginning of the 2d c. it is described as a polis (Ptol. 3.10.10). It was the station of Cohors II Flavia Brittonum equitata and Cohors II Mattiacorum. In the 4th and 5th c. it was the station of the cuneus equitum armigerorum and of Cohors V pedatura inferior of Legio I Italica (*Not. dig.* or. 40.14.32). It was a rest stop on the Via Danubiana (*Tab. Peut.*; *It. Ant.* 222.3). Fortifications were built in the reign of Diocletian. It became the seat of a bishop in the 4th and 5th c. (Socr. *Hist. eccl.* 7.36). The city was destroyed by the Avars and Slavs after 596.

No excavations have been undertaken since the modern city of Ruse lies on the site. In the course of construction activities inscriptions, milestones, coins, and pottery have been uncovered. In the surrounding area of the city have been found votive stelai to Mithras and Diana Plestrensis (the cult name derived from the name of the city).

BIBLIOGRAPHY. V. Velkov, "Eine neue Inschrift über Laberius Maximus und ihre Bedeutung für die ältere Geschichte der Provinz Moesia Ingerior," *Epigraphica* 27 (1966) 109; J. Kolendo, "Une inscription inconnue de Sexaginta Prista et la fortification du Bas Danube sous la tétrarche," *Eirene* 5 (1966) 139-54.

V. VELKOV

SEXANTA PRISTA, *see* SEXAGINTA PRISTA

SEXTANT, later Substantion Dept. Hérault, France. Map 23. The earlier form of the name is known from a marble base from the Jardin de la Fontaine at Nîmes. No doubt it is Celtic, as is Ledus, the old name of the river Lez on which the city was built, ca. 1 km upstream from Castelnau-le-Lez. The city guarded the ford by which the very ancient road from the Rhône to the Pyrenees, known from 136 B.C. as the Via Domitia, crossed the river. It then met a N-S road that ran alongside the Lez from Lattes and went on to St. Drézéry. The earliest settlement to be traced dates from the era of urn burials (8th-7th c.). It seems to have become more densely populated from the 6th c. on; trading brought pottery from Asia Minor (gray Phokaian ware, Ionian ware) and Etruria (amphorae, bucchero nero), then Attic ware of the 6th, 5th, and 4th c. Consisting essentially of mud huts roofed with straw, the settlement spread beyond the plateau named after it (the Naviteau hill, on the banks of the Lez near La Gardie). However, a funerary stele carved with a shield, sun wheels, and two sculptures, one of them a portrait head, are evidence that there was some activity in the arts. In the 4th or 3d c. a surrounding wall was put up and the inhabitants gathered inside it. In the Roman period at least one temple was built (of which only an entablature fragment and capital remain) along with some masonry houses, paved streets, and a bridge over the Lez. Some 1st c. A.D. mosaics and inscriptions (C. Plaetorius Macrinus, a Mithraic priest) have been found, as well as coins. In the Middle Ages (A.D. 737) Substantion was a haven for the chapter of Maguelonne, which had been destroyed by Charles Martel. The city minted coins in the 9th c. and was the seat of a count. Thereafter it declined, giving way to Castelnau and especially Montpellier, when the road was moved closer to the sea. By the 17th c. nothing was left of it but ruins.

BIBLIOGRAPHY. E. Bonnet, *Antiquités et Monuments du Département de l'Hérault* (1905); J. Vallon, "L'Hérault préhistorique et protohistorique," *Mém. de la Soc. Arch. de Montpellier*, 39-40 (Roman and mediaeval periods).　　　　　　　　　　　　　　　　F. DAUMAS

SEYSSES-SAVÈS Gers, France. Map 23. Necropolis in the district of Lasserre excavated 1955-56. From the 4th to the 7th c. it belonged to a Gallo-Roman agricultural community under Germanic and Christian influences.

BIBLIOGRAPHY. J. Boube, "Le cimetière barbare de Seysses-Savès," *Bull. de la Soc. arch. du Gers* 57 (1956) 370-92; id., "Le cimetière romain tardif et barbare de Seysses-Savès," ibid. 60 (1959) 181-204.
　　　　　　　　　　　　　　　　M. LABROUSSE

SEZZE, see SETIA

SFAX, see TAPARURA

SHAHAT, see CYRENE

SHEIKH-'IBADA, *see* ANTINOÖPOLIS

SHIPWRECKS Melian obsidian and large fish bones in the Franchthi Cave of the Peloponnese indicate Aegean seafaring since at least the eighth millennium B.C., with an estimated loss of more than 100,000 ships in the Mediterranean since that time. Shipwrecks with cargoes have yielded art works as well as ceramic, stone, metal, glass, and other artifacts in closed contexts, sometimes dated by coins. Hulls which have been partially protected by mud or sand against teredos (shipworms) reveal that from at least the 5th c. B.C. until the 4th c. A.D., Graeco-Roman ships were constructed by the so-called shell-first technique, their planks held together with mortise-and-tenon joints and their ribs inserted later. By the 7th c. A.D. these joints had become structurally less important, and at least some ships were built by the more modern skeleton-first technique above the waterline; the increased use of iron rather than copper nails at this time suggests that the new, cheaper technique came into vogue for economic reasons.

Hundreds of ancient wrecks have been located, mostly carriers of Roman amphorae or stone which are most easily spotted by divers. Some have been surveyed or photographed, a few salvaged, and a very few excavated.

BIBLIOGRAPHY. *Atti del II Congresso Internazionale di Archeologia Sottomarina, Albenga 1958* (1961); J. du Plat Taylor, ed., *Marine Archaeology* (1965, 1966); G. F. Bass, *Archaeology Under Water* (2d ed. 1970, 1972); id., ed., *A History of Seafaring based on Underwater Archaeology* (1972)[MPI]; *Atti del III Congresso Internazionale di Archeologia Sottomarina, Barcellona 1961* (1971); L. Casson, *Ships and Seamanship in the Ancient World* (1971) esp. 201-16.

Agde See Rochelongues.

Albenga Lead-sheathed merchant ship sunk 80-60 B.C., 44 m deep off NW Italy. Salvage operatons with a diving bell and clamshell grab have raised over 1000 of an estimated 3000 amphorae, pottery from the ship's galley, three bronze helmets, and hull pieces.

BIBLIOGRAPHY. N. Lamboglia, "Il Primo saggio de scavo sulla nave romana di Albenga," *RStLig* 30 (1964) 219-28[PI]; id. et al., "Albenga," *Marine Archaeology* 53-66[M].

Antibes A pillaged cargo of Etruscan amphorae and fine pottery, from the first quarter of the 6th c. B.C., excavated off Cap d'Antibes in S France.

BIBLIOGRAPHY. F. Benoît, "Épaves de la côte de Provence," *Gallia* 14 (1956) 32-34; id., "Nouvelles épaves de Provence," ibid. 16 (1958) 30-31.

Antikythera Wreck of 80-50 B.C. discovered near this Greek island in 1900, ca. 60 m deep, by sponge divers who subsequently salvaged the famous bronze Youth, bearded Philosopher, and other bronzes, 36 poorly preserved marble statues, and numerous other finds including a unique astronomical computer. National Museum, Athens.

BIBLIOGRAPHY. G. D. Weinberg et al., "The Antikythera Shipwreck Reconsidered," *TransPhilSoc* 55, 3 (1965)[I]; D. Price, "An Ancient Greek Computer," *Scientific American* 200 (June 1959) 60ff; *Marine Archaeology* 34-39[M].

Artemision End of 1st c. B.C. or beginning of 1st c. A.D. The bronze Zeus or Poseidon, a bronze jockey, and fragmentary horse (all in the National Museum, Athens), and bits of wood and pottery have been salvaged from a depth of 40 m off Cape Artemision in N Euboea.

Chretiènne A small offshore rock near Cap Dramont in S France, and the site of at least four ancient wrecks. The badly looted wreck A, a 1st c. amphora carrier, is the best known; its mast step is preserved.

BIBLIOGRAPHY. Dumas, *Épaves antiques* (1964) 99-188[MPI].

Dramont A Amphora carrier sunk 35 m deep near a reef 1 km S of Cap Dramont in S France in the 1st c. B.C. Partially excavated after being looted and dynamited.

BIBLIOGRAPHY. C. Santamaria et al., "Dramont A," *Marine Archaeology* 93-103[MI].

Fiumicino Remains of seven Roman vessels, three of them harbor barges of the 3d-5th c. A.D., discovered in Claudius' Harbor near the Rome international airport.

BIBLIOGRAPHY. O. Testaguzza, "The Port of Rome," *Archaeology* 17 (1964) 173-79[MPI]; Casson, *Ships and Seafaring* passim.

Gelidonya Ca. 1200 B.C. A small ship, carrying over 900 kg of copper ingots, tin ingots, and scrap bronze when it sank in 33 m of water off Cape Gelidonya in SW Turkey. The lamp, cylinder seal, scarabs, and stone objects recovered suggest a Semitic origin. Bodrum Museum, Turkey.

BIBLIOGRAPHY. G. F. Bass et al., "Cape Gelidonya: A Bronze Age Shipwreck," *TransPhilSoc* 57, 8 (1967)[MPI].

Giannutri See Punta Scaletta.

Grand Congloué A lead-sheathed Roman amphora carrier, ca. 38-45 m deep off the Grand Congloué, an island near Marseilles. It produced over 100 different forms of Campanian pottery dated to between 180 and 150 B.C., but two wrecks may be involved.

BIBLIOGRAPHY. F. Benoît, *L'Épave du Grand Congloué a Marseille, Gallia* suppl. 14 (1961)[MPI], rev. by G. F. Bass, *Antiquity* 37 (1963) 155-57.

Huelva A 7th c. B.C. cargo of scrap bronze (swords, spearheads, arrowheads, fibulas) dredged from 9 m below the bed of the Huelva estuary NW of Gibraltar in Spain.

BIBLIOGRAPHY. P. Bosch-Gimpera, "Huelva," in Ebert, *Reallexikon der Vorgeschichte* V (1926).

Kyrenia A 4th c. B.C. merchantman, ca. 19 m long, which sank 30 m deep near the N coast of Cyprus in the early 3d c. B.C. Its lead-sheathed hull carried a mixed cargo of amphorae, almonds, and stone grain mills. Restored in the Kyrenia Museum, Cyprus.

BIBLIOGRAPHY. M. L. Katzev, "The Kyrenia Ship," *A History of Seafaring*[MP]; id., "Kyrenia 1969: A Greek Ship is Raised," *Expedition* 12, 4 (1970) 6-14.

London Although built in N Europe in the 3d c. A.D., the ship found on the site of the County Hall in 1910 was constructed in the Roman manner; coins on board date its sinking to after A.D. 293.

BIBLIOGRAPHY. P.R.V. Marsden, "The County Hall Ship," *Trans. London and Middlesex Arch. Soc.* 21, 2 (1965) 109-17; id., "Ships of the Roman Period and After in Britain," *A History of Seafaring*[MPI].

Mahdia Shipwreck of the 1st c. B.C. found about 42 m deep 4.8 km off the Tunisian coast by sponge divers. The salvaged cargo of art works included a bronze herm signed by Boethos of Chalkedon. Stone capitals, bases, and 60 columns remain mostly on the sea bed. Bardo Museum, Tunisia.

BIBLIOGRAPHY. G. de Frondeville, *Les visiteurs de la mer* (1956); id., "Mahdia," *Marine Archaeology* 39-53[MP]; W. Fuchs, *Der Schiffsfund von Mahdia* (1958)[I].

Marseilles Part of a Roman hull, dated to the 2d or 3d c. A.D. by pottery, found in 1864 and given the fanciful name of Caesar's Galley.

BIBLIOGRAPHY. P. Throckmorton, "Romans on the Sea," *A History of Seafaring*[I]; F. Benoît, *L'Épave du Grand Congloué, Gallia* suppl. 14 (1961) 145.

Marzamemi A cargo of ca. A.D. 500, including all of the stone ornamental features of a church, discovered off the coast of Sicily in ca. 6 m of water. Nearby were 15 large blocks of unworked stone from Greece, sunk in the 3d c.

BIBLIOGRAPHY. G. Kapitän, "Schiffsfrachten antiker Baugesteine und Architekturteile vor den Küsten Ostsiziliens," *Klio* 39 (1961) 290-302[MPI]; F. van Doorninck, "Byzantium, Mistress of the Sea: 330-641," *A History of Seafaring*.

Mellieha A shallow wreck from the turn of the 2d and 3d c. A.D., investigated in Mellieha Bay, Malta. The main cargo was of mortaria, but amphorae, domestic pottery, and glass were also found.

BIBLIOGRAPHY. H. Frost, *The Mortar Wreck in Mellieha Bay* (1969).

Methone Two stone shipments, one of granite column fragments, probably Roman, and the other of granite sarcophagi, probably sunk in the 2d or 3d c. A.D., were surveyed in shallow water near Cape Spitha in the Peloponnese.

BIBLIOGRAPHY. P. Throckmorton & John Bullitt, "Underwater Surveys in Greece: 1962," *Expedition* 5, 2 (1963) 16-23.

Nemi Two huge pleasure barges of the 1st c. A.D., 78 and 79 m long, were recovered over a four-year period from the bottom of Lake Nemi, 26 km SE of Rome, by the partial draining of the lake. The lead-sheathed hulls were burned during WW II, but models and many of the finds are displayed in a museum near the lake.

BIBLIOGRAPHY. G. Ucelli, *Le Navi de Nemi* (1950)[MPI].

Pantano Longarini A wreck of the 5th-7th c. A.D. was discovered in excavation of a drainage canal in a marsh in S Sicily; its transom stern is unique and important for its early date.

BIBLIOGRAPHY. P. Throckmorton & G. Kapitän, "An Ancient Shipwreck at Pantano Longarini," *Archaeology* 21 (1968) 182-87[MPI]; F. van Doorninck, "Byzantium . . . ," *A History of Seafaring*; P. & J. Throckmorton, "The Roman Wreck at Pantano Longarini," *IJNA* 2 (1973) 243-266.

Planier III An amphora carrier of the middle of the 1st c. B.C., 29 m deep off the small island of Planier, near Marseille.

BIBLIOGRAPHY. A. Tchernia, "Les Fouilles sous-marines de Planier (Bouches-du-Rhône)," *CRAI* (1969) 292-309[MPI]; id., "Direction des recherches archéologiques sous-marines," *Gallia* 27 (1969) 465-99.

Porticello Late 5th or early 4th c. B.C. ship lost in the Straits of Messina. The looting of two life-size bronze statues from the site led to its excavation. The hull was mortise-and-tenon joined and lead-sheathed. Reggio Calabria Museum.

BIBLIOGRAPHY. D. I. Owen, "Excavating a Classical Shipwreck," *Archaeology* 24 (1971) 118-29[I]; id., "Picking up the Pieces . . . ," *Expedition* 13, 1 (1970) 24-29[MP].

Punta Scaletta Mid 2d c. B.C. shipwreck 35 m deep off the island of Giannutri. Finds include the cargo of Campanian pottery, coins, roof tiles, and a mixture of four lead composite anchors and three iron anchors.

BIBLIOGRAPHY. N. Lamboglia, "La Campagna 1963 sul relitto de Punta Scaletta all'isola di Giannutri," *RStLig* 30 (1964) 229-57[PI].

Rochelongues Cargo of copper ingots, scrap bronze, metal-working tools, and bronze buckles, chains, razors, and arrowheads of the 6th c. B.C., excavated at a depth of 6 to 8 m off Rochelongues near Agde in S France.

BIBLIOGRAPHY. A. Bouscaras, "Découverte d'une épave du premier âge du fer a Agde," *RStLig* 30 (1964) 288-94[I]; id., *Bull. Soc. Arch. . . . Béziers (Herault)* 4 ser. 30 (1964) 5-19; 5 ser. 1 (1965) 81-99; 2 (1966) 5-15; id., "Epave des bronzes de Rochelongues, campagne de 1968," ibid. 4 (1968) 5-16.

San Pietro A 2d or 3d c. cargo of 22 unfinished sarcophagi, surveyed in 4-7 m of water near San Pietro, SE of Taranto, Italy.

BIBLIOGRAPHY. J. B. Ward-Perkins & P. Throckmorton, "The San Pietro Wreck," *Archaeology* 18 (1965) 201-9[PI].

Spargi Roman amphora carrier sunk between 120 and 100 B.C. in 20 m of water between the island of Spargi and Sardinia. Its lead-sheathed hull, 33-38 m long, held ca. 3000 amphorae and hundreds of dishes, bowls, and pitchers.

BIBLIOGRAPHY. G. Roghi, "Spargi," *Marine Archaeology* 53-66[MP]; N. Lamboglia, "La Nave romana di Spargi (La Maddalena)," *Atti del II Congresso . . .* 141-66[I].

Titan An amphora carrier 27 m deep off the E end of the Ile du Lévant (Toulon) in France, sunk ca. 50 B.C. Excavation revealed galley roof-tiles, domestic pottery, lamps, and a good part of the hull.

BIBLIOGRAPHY. P. Tailliez, "Travaux de l'été 1958 sur l'épave du 'Titan,' a l'ile du Lévant (Toulon)," *Atti del II Congresso . . .* 175-98[MPI]; English tr. in *Marine Archaeology* 76-93.

Torre Sgarrata A merchant ship carrying ca. 154 metric tons of marble, including sarcophagi, from Asia Minor when she sank near Taranto in S Italy in the late 2d c. A.D. Well-preserved hull fragments have been excavated.

BIBLIOGRAPHY. P. Throckmorton, "Romans on the Sea," *A History of Seafaring*[MPI]; id., "Ancient Ship Yields New Facts—And a Strange Cargo," *National Geographic* 135, 2 (1969) 282-300.

Yassi Ada A small island also known as Lodo between the Turkish mainland and the Greek island of Kalymnos. Its dangerous reef sank perhaps a dozen ships in antiquity. Two have been completely excavated.

1) A 4th c. A.D. merchantman ca. 19 m long, excavated at a depth of 36-42 m. Its cargo of 1000 amphorae has been dated by a complete set of galley wares; the hull was well preserved. Bodrum Museum, Turkey.

BIBLIOGRAPHY. G. F. Bass & F. van Doorninck, "A Fourth-Century Shipwreck at Yassi Ada," *AJA* 75 (1971) 27-37[PI]; Van Doorninck, "Byzantium, Mistress of the Sea: 330-641," *A History of Seafaring*.

2) An amphora carrier of the same size lost ca. A.D. 625. This wreck has given perhaps the most complete picture of any ancient ship yet discovered, with its 11 iron anchors, tiled galley roof, and sets of weights, iron tools, coins, and galley wares. Bodrum Museum, Turkey.

BIBLIOGRAPHY. G. F. Bass, "A Byzantine Trading Venture," *Scientific American* 224, 2 (1971) 22ff; F. van Doorninck, "Byzantium . . . ," *A History of Seafaring*.
 G. F. BASS

SHIROKAIA BALKA
Ukraine. Map 5. A strongly Hellenized settlement ca. 1.6. km S of Olbia along the steep right bank of the S Bug and dating from the first half of the 6th to the first half of the 5th c. B.C.

Owing to erosion, much of the ancient site has been lost. However, excavations have uncovered the remains of six rectangular or circular semisubterranean dwellings, one of which contained a hearth and may have been used to dry grain. Among the pottery finds, local wheel-made sherds probably from Olbia were predominant. Most of the imported Greek pottery comes from the late 6th and early 5th c. although Ionian and Attic sherds of the late 7th and the first half of the 6th c. were discovered. The settlement seems to have been one of the first of many small agricultural settlements which appeared in the vicinity of Olbia.

BIBLIOGRAPHY. B. M. Rabichkin, "Poselenie u Shirokoi Balki," *KSIIMK* 40 (1951) 114-24. T. S. NOONAN

SĪ, *see* SEIA

SIA or Osia
Turkey. Map 7. Small town in Pisidia near Karaot, 10 km NE of Dağ Nahiyesi; it is apparently recorded by Hierokles in the entry Demousia, but is otherwise unknown. The name, of which the termination is uncertain, and site are proved by an inscription on the spot. The ruins are picturesque, covering the W slope of a low pine-clad hill, at the top of which is a stretch of wall in excellent polygonal masonry with a small gate. Many buildings are standing more or less complete, including a small building with an apse at its E end, and another containing eight or nine straight rows of seats with paving below them. At the foot of the hill are numerous built tombs, in good condition.

BIBLIOGRAPHY. V. Bérard, *BCH* 16 (1892) 434; G. E. Bean, *AnatSt* 10 (1960) 74-75. G. E. BEAN

SIBDA or Side
Turkey. Map 7. Recorded by Stephanos Byzantios s.v. as a city of Caria and presumably identical with the Side listed by Pliny (*HN* 5.107) among the six Lelegian towns incorporated by Alexander (but really by Mausolos) in Halikarnassos. No other mention occurs. It is not improbably to be identified with the site on Karadağ in the Myndos peninsula, where Telmissos had been placed. Here are two Lelegian settlements close together, with walls of dry rubble masonry, numerous houses, and sherds of 5th-4th c. date, but nothing later.

BIBLIOGRAPHY. W. R. Paton & J. Myres, *JHS* 14 (1894) 373f; G. E. Bean & J. M. Cook, *BSA* 50 (1955) 123, 155. G. E. BEAN

SIBIDUNDA (Bozova, formerly Zivint)
Turkey. Map 7. Site in Pisidia 18 km N of Korkuteli. Recorded by Hierokles (Sindaunda) and the Byzantine bishopric lists; the coinage extends from M. Aurelius to Gordian III. The site, proved by the survival of the name and by an inscription found on the spot, is on a low flat hill without fortification. Good squared blocks and foundations are frequently exposed by digging; sherds of Roman date are abundant, but nothing is standing. About 1.6 km to the E, and underground, is a well-preserved built tomb. Inscriptions are not scarce and include an imperial rescript concerning forgeries in business contracts.

BIBLIOGRAPHY. A. J. Smith, *JHS* 8 (1887) 254; W. M. Ramsay, *Klio* 23 (1931) 248; id., *Cities and Bishoprics* II (1897) 751-54; G. E. Bean, *AnatSt* 10 (1960) 68-73.
 G. E. BEAN

SIÇAK, *see* APOLLONIA

SIÇAK ISKELESI, *see* APERLAI

SICCA VENERIA (Le Kef)
Tunisia. Map 18. Against the S flank of Mt. Dyr, built high up, between 850 and 750 m, on a spur of the rock from which it draws its present name. It dominates the surrounding rich plains and controls the crossroads of the important artery which, coming from Carthage, divides to the W toward Constantine and to the SW toward Tebessa. A stronghold from the time of the independence of the Numidian princes, then a colony—among the first—under the Romans, a town with a bishop at the time of the triumph of the church, a Byzantine fortress, it has survived to the present in its role of metropolis of this region.

One of the oldest references to it in ancient sources is Sallust's statement that the day after its defeat by Rome, Carthage exiled to Sicca the mercenaries who revolted. There is also a reference to the city's providing wheat for the victorious Marius. It is possible that when Nova Africa was created, Sicca was for a brief time its capital. The city is also known for having introduced the cult of Sicilian Venus Erycina. Apart from the unknown or destroyed remains, deeply buried under the present town, the following are the largest buildings or those integrated in the surviving structures. Outside the town: a small amphitheater and a theater situated near the Casbah; several sections of town walls fortified in the Byzantine era. The most important group is made up of a large hexagonal hall preceded by a double portico and forming part of important baths which have recently come to light. They were probably fed by the gigantic group of cisterns made up of 12 rooms with barrel vaults, remarkably preserved, which were served by springs coming from the mountain.

Three other monuments: the basilica of Ksar el Ghoula, with mosaic-paved naves, partially explored in 1882; Dar el Kous, another basilica built in the grand style, utilized the component parts of what was probably a pagan temple. The apse 6 m wide is standing; the three naves are preceded by an atrium communicating by three doorways. The whole was paved with mosaic. It has been uncovered since the end of the 19th c. The present grand mosque of Le Kef, an edifice of great magnificence, is well preserved. It comprises a vast vaulted apse with vaulted rooms adjoining on each side, the lateral walls of which were indented by regular niches. This group of rooms opened on a peristyle court which, in the Arab period, was completely covered with vaults and a cupola, and converted into a prayer room. It has recently been restored.

Some chance discoveries without precise context may be mentioned: a very extensive mosaic representing a scene in the amphitheater, as well as numerous statues and inscriptions which became the primary acquisitions of the Bardo Museum in Tunis.

BIBLIOGRAPHY. P. Quoniam in *Karthago* 3 (1952) 157-65. A. ENNABLI

SIDAS KALE, *see* Saittai

SIDE (Selimiye, formerly Eski Antalya) Turkey. Map 7. City in Pamphylia 6 km SW of Manavgat, the chief port on the coast until supplanted by Attaleia. According to Strabo (667) and Arrian (1.26) Side was colonized from Aiolian Kyme, presumably in the 7th or 6th c. B.C., and Arrian adds that on landing the colonists forgot their Greek and began to speak a barbarous tongue peculiar to themselves. This is evidently the language, unknown elsewhere, which appears on coins and in three inscriptions found locally, but is not yet satisfactorily deciphered. It is no doubt the original language of Pamphylia, which survived at Side when the other cities were speaking a form of Greek introduced by the colonists under Mopsos and others after the Trojan War. Of an earlier Side nothing is known except that Eusebios places its foundation in 1405 B.C.

Side submitted peaceably to Alexander in 333 B.C. and accepted a garrison from him (Arr. *l.c.*). Relations with neighboring Aspendos were not good, and in 219 B.C., when the Aspendians contributed 4000 men to Garsyeris' force, the Sidetans refused to make any contribution (Polyb. 5.73). In 190 B.C. an indecisive sea battle was fought off Side between the Rhodians and Antiochos III. The Cilician pirates, powerful during the 2d c., used Side as a base and as a market for their prisoners until their suppression by Pompey in 67 B.C. For the first three centuries of the Roman Empire Side continued prosperous, but it declined in the 4th c. largely because of the inroads of barbarians from Isauria, and the size of the city was reduced. In the 5th c. the original area was reoccupied, but with the Arab invasions of the 7th c. the final decline began.

The harbor, on which the city's prosperity mainly depended, was almost entirely artificial; half the basin is now sanded up, though the mole still stands, with an entrance passage less than 10 m wide. The harbor was notorious for both the difficulty of entering and the constant necessity of dredging; the expression "a harbor of Side" became proverbial for a task that needed to be done again and again.

The city wall is thought to date from the 2d c. B.C., though the part along the S shore is much later. The E side is the best preserved, but its S end is buried by the drifting sand that has covered the SE corner of the site. The outer face of the wall, in regular ashlar masonry, carries a decorative cornice molding and has towers at unequal intervals; the inner side is in three stories. The lowest of these serves merely to raise the upper parts from the ground; the middle story consists of a series of casemates, and the top story, only partly preserved, was simply a parapet with windows. Each story was set back from the one below, so as to provide two passages for the defenders.

There are two gates in this part of the wall. The main gate, towards the N end, has a plan similar to the main gates of Sillyon and Perge, for example, a horseshoe-shaped court flanked by towers. In Imperial times it was adorned with niches, statues, and pillars; many fragments of these have been found, but almost nothing of the building itself survives above ground. The present road passes through this gate.

The second gate is near the S end. It was buried under sand, but excavation has revealed a plan different from that of the N gate. A row of reliefs representing pieces of armor, almost certainly spoils taken from an enemy, was found on a terrace above the gate; these are now in the museum.

In Roman times an aqueduct 32 km long brought water to the city from the N; in some places the channel was cut in the rock, in others it was carried on high arches, some of which still stand. It entered the city a little N of the main gate. Just outside this gate is a large nymphaeum, evidently fed from the aqueduct; it has the familiar form of a water basin enclosed by a high back wall, with projecting wings on either side. The decoration was rich. Both aqueduct and nymphaeum probably date from the 2d c. A.D., and the nymphaeum was restored about the middle of the 3d c. How the city was supplied with water in earlier times is not clear; the natural sources on the site are scanty and of poor quality.

Inside the main gate the present road follows the line of an ancient colonnaded street towards the theater; a second similar street ran S from the gate, but this has not been cleared and soon disappears under the sand. Before reaching the theater the street passes on the right (N) a bath, now a museum, and on the left the entrance to the agora. The bath, probably of the 5th c. A.D., has the usual features—frigidarium, tepidarium, caldarium, sudatorium—with a small circular bathing pool adjoining; it was fed from the aqueduct, which ends close by.

Of the agora and its surrounding buildings only the foundations remain. It was some 100 m square and enclosed by a stoa backed by shops; it was entered from the street by a monumental gateway. In its W corner is a latrine, a semicircular vaulted passage, with a water channel below the seats. Near the center of the agora stood a round building of the 2d c. A.D., very probably a temple of Tyche. Only the core of the podium remains in place, with a flight of steps in front; above this was a circular chamber surrounded by 12 Corinthian columns. The ceiling was adorned with the signs of the zodiac, and above this was a roof in the form of a 12-sided pyramid. Surprisingly, no statue bases have been found in the agora.

When the size of the city was reduced in the 4th c. a wall was built across the narrow neck of the peninsula immediately W of the agora; the colonnaded street passes through it just N of the theater. At this point there stood in Roman times a high arched gateway which became the main city gate; the arch was blocked with masonry and a smaller gate inserted in it. The arch still stands, but the smaller gate has recently been removed.

Close to the gate is the monument of Vespasian, but this is not in its original position. It was erected elsewhere in the city in honor of Vespasian and Titus; the fragmentary inscription gives the date 74. After the building of the 4th c. wall it was put in its present place and converted into a fountain house; it has two water basins in front and a pipe in the central niche where the statue of Vespasian originally stood. Projecting wings enclose the basins on either side.

The theater, apart from the stage building, is remarkably well preserved, probably dating from the 2d c. A.D. and replacing an earlier Hellenistic theater. It is among the largest known. Its position takes advantage of the slight rise in the ground W of the agora, but this sufficed only for the lower half of the building; the upper part is freestanding. This upper part is surrounded by two concentric corridors, the outer one with vaulted roof supported on massive piers; the openings between these lead either to the inner corridor or to covered chambers of uncertain purpose. The inner corridor opens to the diazoma. The cavea contains 29 rows of seats below the diazoma, divided by 12 stairways into 11 cunei; above the diazoma there were probably another 29 rows, but a few are lost at the top; here the number of stairways is doubled. The upper seats were accessible not from the diazoma but by staircases in the outer walls. The stage building still stands at the back to a height of some 23 m, but its decorated facade is ruined. The bottom story com-

prises nine rooms, five of which open through to the agora behind; the proscenium projects about 6 m. The scaenae frons is in two stories, the lower carrying a long frieze with reliefs now unrecognizable, but apparently of mythological scenes. The richness of the decoration is evident from the architectural blocks now lying in the orchestra. In the later Roman age a wall 2 m high was erected around the orchestra for wild beast shows and similar exhibitions. In the 5th c., during the city's revived prosperity, the fabric of the outer corridor, which had apparently suffered from earthquakes, was extensively repaired. When the 4th c. wall was built the back of the stage building became in effect a part of it, and the openings to the agora were blocked.

Between the theater and the colonnaded street are the scanty remains of a small temple. Only a part of the podium is visible, but this indicates that the cella was pseudoperipteral. It has been thought that this may be a temple of Dionysos, but there is no actual evidence apart from its proximity to the theater. It is dated by the excavators to the 1st c. B.C.

To the SE of the theater, just outside the 4th c. wall, is a complex which has been identified as a gymnasium. The palaestra is an open court over 60 m square, surrounded by a stoa now destroyed; on its E side is a building comprising three rooms. That on the N has not been excavated; that on the S may have been a library; the principal room, richly decorated, was in the middle. Its front was open, separated from the palaestra by a row of six columns; on the other sides niches and projecting bases alternated; they were two stories high and held statues. The bases also supported columns and an entablature. Many of the statues have been recovered; they are mostly copies of Greek works representing deities and athletes, and are now in the museum, except for a statue of Nemesis which has been left in the SE corner.

The central niche, however, was occupied by a statue of a Roman emperor; this seems to have been Antoninus Pius, but the face has been altered to that of another emperor, possibly Gordian III. The building as a whole dates apparently from the 2d c. A.D. It is not certain, however, that it is in fact a gymnasium, though no other building has been found at Side which can be so identified. There is no visible provision for a supply of water, still less any bathing establishment, and the usual lecture rooms and rooms for the athletes are lacking. Possibly therefore we should recognize a second agora.

At the S end of the city the outstanding buildings were the two temples which stood side by side on a platform overlooking the sea and harbor. In form, though not in size, they are virtually identical, dating probably from the late 2d c. A.D. In each case the order is Corinthian, with 11 columns by 6, and each comprises a pronaos and cella but no opisthodomos. Hardly more than the foundations survives in place, but numerous architectural members have been recovered. Even without definite evidence there can be little doubt that these were the temples of Athena and Apollo, the principal deities of the city; and this is to some extent confirmed by a series of 3d c. inscriptions relating to a Landing Festival of Athena and Apollo, with which the position of the temples by the harbor would accord. At some time during the 5th or 6th c. a large basilica was erected just E of the two temples, which must have been in ruins by that time, since the forecourt of the basilica occupied the ground on which they stood. The N temple was then entirely removed, but the S one seems to have survived somewhat longer, as the building of the forecourt was not completed on that side. The basilica, still largely preserved, was of the usual form, with three aisles and apsis containing a

synthronon; a smaller building attached to it on the S appears to have been a martyrium.

The main colonnaded street, running SW from the theater among the houses of the modern village, ended near the shore a little E of the basilica. Here stood a small temple. On a podium 2 m high, approached by a flight of steps, was a semicircular chamber facing W, with a platform in front which carried a row of six columns with entablature; little more than the podium now survives. The temple has been tentatively attributed, without much evidence, to Men.

The necropolis lay E of the city, extending from the N shore to the S, an area now cultivated, so that the tombs have suffered greatly. Several sarcophagi have been unearthed and installed in the museum, but many others—built tombs, altars, and cippi—have been removed or destroyed. The most impressive is a fine mausoleum still standing in large part some 400 m W of the city close to the shore. It is in temple form, on a high podium surrounded by a courtyard, with a much larger courtyard in front extending to the shore. The date is thought to be around A.D. 300, and the richness of the decoration is remarkable.

BIBLIOGRAPHY. C. Fellows, *Asia Minor* (1838) 203-4; C. Lanckoronski, *Die Städte Pamphyliens* (1890) 125-52; A. M. Mansel, *Die Ruinen von Side* (1963)[MI]; G. E. Bean, *Turkey's Southern Shore* (1968) 78-100; excavation reports, Türk Tarih Kurumu publications, Ser. 5, nos. 11, 15, 20. G. E. BEAN

SIDE (Caria), *see* SIBDA

SIDI ALI BEN AHMED, *see* THAMUSIDA

SIDI ALI BOU DJENOUN, *see* BANASA

SIDI KACEM, *see* SIDI SAÏD

SIDI LARBI BOUJEMA ("Vopisciana") Morocco. Map 19. A station of the *Antonine Itinerary* (23.5) The city probably stood in the valley of the Sebou, perhaps near the marabout of Sidi Larbi Boujema, 6 km S of Mechra bel Ksiri, where some Roman ruins have been found, rather than at Ouezzane or the Jebel Kourt as some have suggested. Eight km to the S are important ruins buried in the alluvial deposits of the Sebou, between the wadi and the railroad, at Souk el Djemaa el Haouafat.

BIBLIOGRAPHY. L. Chatelain, *Le Maroc des Romains* (1944) 114-15, 122-23; M. Euzennat, "Chroniques," *Bulletin d'Archéologie Marocaine* 2 (1957) 216; "Les voies romaines du Maroc dans l'Itinéraire Antonin," *Hommages à Albert Grenier*, coll. *Latomus* 58 (1962) 606-7. M. EUZENNAT

SIDI MOULAY YAKOUB, *see* AQUAE DACICAE

SIDI MOUSSA BOU FRI (Aïn Jemaa) Morocco. Map 19. Important Roman ruins 19 km SW of Volubilis consist of a castellum 95 m square, occupied in the 2d c. A.D. by a cohors Ulpia Parthorum, and the remains of a small settlement to the S and E protected by a surrounding wall that is supported by its rampart.

BIBLIOGRAPHY. J. Baradez, "Deux missions de recherches sur le *limes* de Tingitane," *CRAI* (1955) 294-95.
 M. EUZENNAT

SIDI SAÏD (Sidi Kacem) Morocco. Map 19. Important Roman ruins 1 km S of the village of Sidi Kacem, on the right bank of the Rdom as it flows out of the Bab Tisra pass. These consist of probable remains of

a camp occupied in the 3d c. A.D. by the cohors IV Gallorum, traces of baths, and various buildings; also a Latin inscription, coins, and much pottery.

BIBLIOGRAPHY. L. Chatelain, "A propos d'une inscription de Petitjean," *BAC* (1943-45) 196-201; *Le Maroc des Romains* (1944) 117-19. M. EUZENNAT

SIDI SLIMANE, *see* RIRHA

SIDON (Saida) Lebanon. Map 6. Maritime city and Phoenician metropolis celebrated by Homer, subjected to Egyptian influence, and vassal of the Achaemenids. Hellenism reached Sidon in the 5th c. B.C., it was conquered by Evagoras of Cyprus in the 4th c., and then by Alexander the Great, who made Abdelonymus, the gardener, king. It was the naval shipyard of the Diadochos Antigonus. Successively ruled by the Lagids, the Seleucids, and the Romans, Sidon always remained an important town.

The mediaeval and modern city covers the ancient town, which occupied a huge mound, the accumulation of millennia. It extended from the Land Castle to the W to the gardens on the E, on the other side of the wide modern street. Only the SE corner of the Hellenistic rampart is known. A late Latin inscription attributes the construction of the rampart facing the sea to the Diadochos Antigonus. Recent excavations have found remains of a Roman theater on the N flank of the castle hill. The palace of the Achaemenid viceroys has been sought farther N, because of the discovery of marble fragments from bases and columns, and especially of a large capital with foreparts of two kneeling bulls (now in the Beirut museum). Clandestine excavations in the 19th c. uncovered a dozen fine Mithraic statues from a Mithraeum of the 4th c. A.D. (now in the Louvre). On the W side of the mound deposits of murex shells (which form an actual hill farther S) indicate workshops where purple dye was manufactured.

Sidon had two ports, one to the S in a big cove, the other to the N: the inner port was on the site of the modern one, and efficient dredging kept it from silting up; the outer port was protected by a jetty and by the islet of the Sea Castle, the open roadstead by a mole and another rocky islet.

In the valley of the Nahr el-Awali, N of the town (the ancient river Bostrenus), the sanctuary of Eshmun (a healing god assimilated to Asklepios) stood in the middle of orchards which recall the sacred wood mentioned by Strabo. Phoenician inscriptions date to the Persian period the high, massive walls with bosses which support two large terraces built on the slope. The terraces formed the podium of a temple which has disappeared. Parts of a monumental altar about 7 m high have been found near the NW corner of this podium, and many installations, dating from the 4th c. B.C. to Byzantine times, were built against its N wall. Through all of them runs a network of canals and conduits which provided running water for the nymphaeum, the sacred basins, and therapeutic pools.

At a lower level, to the E, is a large chapel with a wide bay to the N. The floor is a basin paved with thick slabs. To the S against the back wall a stone throne, flanked by winged lions, stands on a high monolithic base. A sculptured frieze depicts a hunting scene on the wall above the throne; on the side wall to the right it shows standing figures. This chapel of Sidonian Astarte may date to the 4th c. B.C.

A monumental stairway of the 1st c. A.D. stands against the middle of the N wall of the podium. Somewhat in front and W of this stairway, a cubic altar was built in the 2d c., flanked to E and W by staircases rising to half its height. Farther W a marble base adorned with winged lions, and dating to the 2d c. B.C. at the latest, was reused in a podium of Roman date. Still farther W is an Achaemenid or Early Hellenistic capital with four foreparts of bulls, enclosed in a sort of chapel supported by a masonry base of the 4th c. A.D. Some columns of a huge portico built around the swimming pools and cult installations in the 3d c. A.D. have survived, and many fragments of sculpture (Hellenistic putti playing with animals), dating from the 5th c. B.C. to the 2d c. A.D., have been found in a favissa. Other statues of children and athletes are now in the Chapel of Astarte.

The necropolis of Ayaa, E of the town, has yielded decorated marble sarcophagi of the end of the Classical and beginning of the Hellenistic period, called the sarcophagi of Alexander, the Lycian, the Satrap, and the Weeping Women (now in the Istanbul museum). Anthropoid sarcophagi of Greek marble have been found in other necropoleis, particularly at Ain el-Hilwe. The collection in the Beirut museum illustrates the diversity of types, and the transition from Oriental to Greek influence from the middle of the 5th c. to the 4th c. B.C. Besides the well-known sarcophagus of king Eshmunezar, the necropolis of Mogharet-Abloun to the S has produced a limestone sarcophagus of Roman date with an exact picture of a ship (Beirut museum) and several Hellenistic painted stelai depicting mercenaries (Istanbul museum). Other more recent painted and stuccoed stelai are also in the Beirut museum.

Small cippi of Roman date, with their small columns characteristically adorned with garlands and their cubic bases with epitaphs, are in museums in Beirut, Istanbul, and Paris. Tombs and hypogaea have produced much gold and silver jewelry, and particularly a number of the glass vases which were a specialty of Sidon at the beginning of the Roman period.

BIBLIOGRAPHY. E. Renan, *Mission de Phénicie* (1864-74)[MPI]; Hamdi Bey & T. Reinech, *Une nécropole royale à Sidon* (1892)[MPI]; M. Meurdrac & L. Albanese, "A travers les nécropoles gréco-romaines de Sidon," *BMBeyrouth* 2 (1938); 3 (1939); A. Poidebard & J. Lauffray, *Sidon, Aménagements antiques du port de Saïda* (1951)[MPI]; E. Kukahn, *Anthropoide Sarkophage in Beyrouth und Geschichte diesen Sidonischen Sarkophagkunst* (1955)[I]; I. Kleemann, "Der Satrapensarkophag aus Sidon," *IstForsch* 20 (1958)[I]; M. Dunand, "Rapport préliminaire sur les fouilles de Sidon," *BMBeyrouth* 19 (1966); 20 (1967)[I]; R. Saïdah, "Chronique, F. Fouilles de Sidon," ibid. J.-P. REY-COQUAIS

SIDYMA (Dudurga Asarı) Lycia, Turkey. Map 7. About 14 km NW of Xanthos, high up on Mt. Cragus. First mentioned in the 1st c. B.C. (by Alexander Polyhistor). No Lycian inscription has been found there; and the extant remains are of the Roman period. The name, however, appears ancient, and there are some indications of an earlier city on the site. The ruins lie in a valley at the foot of a steep hill, at whose base is a stretch of "cyclopean" wall containing a gate; this appears to have defended a city on the hill, though the summit now carries nothing beyond the remnants of a Byzantine fortification. The known coinage seems to be confined to a single specimen of League type (2d-1st c. B.C.). The city flourished in a modest way under the Empire, but was never important. It is related that when the emperor Marcian, then still only a simple soldier, was at Sidyma, a portent revealed his future elevation to the purple. Later, the bishop of Sidyma ranked tenth under the metropolitan of Myra.

The ruins include a number of buildings of good Roman work, among them a small Temple of the Augusti and a columned stoa, but none stands to any consider-

able height. The theater mentioned by Fellows is now in wretched condition. The inscriptions record a gymnasium and baths, but these have not been identified. Nothing is known of games at Sidyma, nor does the city possess a stadium. Tombs are numerous, including "Gothic" sarcophagi, temple tombs and other built tombs, and some plain rock-cut chamber tombs. The more impressive Lycian rock tombs familiar on other sites are totally lacking.

The port of Sidyma, named apparently Calabatia, lay on the coast to the W at the foot of a steep valley which seems to be that called by Strabo (665) "the valley Chimaira," associated with the legend of Bellerophon.

BIBLIOGRAPHY. C. Fellows, *Lycia* (1840) 151-56; E. Petersen & F. von Luschan, *Reisen in Lykien* (1889) I 57-83; *TAM* II.1 (1920) 60-62.　　　G. E. BEAN

SIGA Algeria. Map 19. Some remains of buildings can be seen on a hill with a flat top in the lower valley of the Tafna at a bend of the river. A milestone found nearby names the site.

Siga was the capital of the kingdom of Syphax, mentioned during the 4th c. in the Periplus. Thus, an ancient native center was located there, but it has not been excavated. A part of a necropolis on the plain has produced material of the 1st to 3d c. A.D. Under this the excavator recognized an older settlement dating to the time of the Mauretanian kingdom.

The so-called Beni Rhenane mausoleum facing the town on a height on the right bank of the river has been excavated. The plan of the building was in the shape of a triangle with concave sides. The masonry is of ashlar construction. It was found standing several meters high, and was adorned with half-columns and Ionic capitals. The funerary chambers, at a lower level than the masonry block, are vaulted rooms connected by narrow corridors. This complicated architecture must be related both to tombs of native tradition and to the decoration of Punico-Hellenistic tradition, and is also seen at Sabratha.

There is a rocky island at the mouth of the Tafna, and on its S peak a settlement has been noted and a necropolis excavated on the N plain. The artifacts accompanying the burials date the oldest tombs to between the second half of the 7th and the 6th c. B.C. The oldest finds recovered from the settlement site confirm this date, in particular pieces of 7th c. Attic amphorae. This site is related to other settlements along the Oran coast: Mersa Madakh, Les Andalouses, and also the neighboring site of Siga. As at Tipasa, one can see the emergence of a native settlement open to commerce, first with the Greek and then with the Carthaginian world.

BIBLIOGRAPHY. P. Grimal, in *MélRome* 55 (1937) 108-41; G. Vuillemot, *Reconnaissances aux échelles puniques d'Oranie* (1965); in *CRAI* (1964) 71-95; in *Antiquités africaines* 5 (1971) 39-86.　　　P.-A. FÉVRIER

SIĞACIK, see TEOS

SIGEAN (Pech-Maho) Aude, France. Map 23. An advanced defensive post of Narbonne, overlooking the former mouth of the Berre on the Lacus Rubresus (Etang de Sigean) and the Iberian road, on the S boundary of the territory of the Elisyces. Used as a relay station by Greek navigators from the first half of the 6th c. B.C. on, the oppidum continued to flourish until the end of the 3d c. B.C. when it was destroyed, probably by the Volcae, and finally abandoned. Meanwhile, the fortress had been destroyed again twice, slightly before the middle of the 5th c. B.C. and at the end of the 4th c.; the causes are still unknown.

Finds and observations made both in the settlement and the fortifications, each ca. 1 ha in area, show that the site was hellenized early: Greek wares, which are plentiful and of high quality; various kinds of Hellenic arrows; graffiti and stamps in Greek characters; a regular city plan; elaborately built ramparts. The defense system especially, of the barred spur type, is a rare example of Greek influence on native architecture in the 6th c. B.C. With the Berre and the inland sea providing natural defenses, the site was protected by a series of ramparts 200 m long in front of which, in the most vulnerable S-SE section, was a wide ditch. In the 6th c. B.C. two ramparts were erected beyond the ditch employing a fairly regular, unhewn masonry of mortared rubble faced with small stones. The first rampart, which is larger, is topped with low merlons, and has a rampart walk, two square towers, and a sturdy bastion (8 x 6 m). The carriage gate is set obliquely between two independent segments of this rampart; it has double leaves of wood, is protected by a redan, and has a postern gate.

A series of changes were made in the second occupation period: three new walls were added as well as a rampart in front of the main one, which was rebuilt at several points, a forewall in front of the entrance, and an inner circuit wall to replace the original second rampart; on the other hand, at the E end of the trench, a system of supplementary defenses was built using *chevaux de frise*. This last arrangement is unknown elsewhere in Gaul and may show Celtic influence. However, the ramparts of Pech-Maho, which are clearly indigenous in their masonry, seem in general to be a clumsy imitation of Greek fortifications.

The fortified area, as yet hardly excavated, consists of three strata of ruins containing quadrangular houses of one or more rooms, built mainly of stone. This built-up section remained unchanged from one occupation phase to the next, but with a slight modification of plan between the first and second cities. The plan of the original settlement is still not clear, but the few streets that have been excavated suggest a rough grid. The main road, which had a drain for collecting rainwater, let to a complex of religious buildings. Near the carriage gate and on its axis stood a pillar, apparently used to exhibit severed heads, and, 17 m away behind the inner rampart, some blocks forming a seat over the tomb of a warrior who was consecrated as hero-protector of the site about 250 B.C.

This whole area near the entrance to the city contained traces of the fighting that brought about the end of the oppidum: slain horses, fragments of weapons, and a good many domestic objects from houses that had burned down. These show evidence of trade with Ampurias, in particular. The finds are housed in the Sigean museum.

BIBLIOGRAPHY. J. Campardou, "L'oppidum préromain de Pech-Maho à Sigean," *Études Roussillonnaises* 6 (1957) 35-65; Y. Solier, "Une tombe de Chef à l'oppidum de Pech-Maho," *Revue Archéologique de Narbonnaise* 1 (1968) 7-37; *Gallia* 27 (1969) 388-91[I]; 29 (1971) 377-79[I].　　　Y. SOLIER

SIGHIŞOARA Mureş, Romania. Map 12. A Roman camp on the left bank of Tîrnava Mare river, 3 km W of the modern town. It was an earth camp (180 x 133 m), in shape an irregular quadrilateral, with two external ditches. It was used in the first half of the 2d c. A.D., and a detachment of Legio XIII Gemina was stationed here. In the second half of the 2d c., a Roman civil settlement was built over the camp. Votive and funeral inscriptions, ceramics, stamped tiles and bricks, gems and coins are in the Sighişoara Museum.

BIBLIOGRAPHY. D. Protase, *Problema continuităţii în*

lumina arheologiei şi numismaticii (1966) 50-51; I. Mit-
rofan & Gh. Moldovan, "Castrul roman de la Sighişoara,"
Acta Musei Napocensis 5 (1968) 99-109.

L. MARINESCU

SIĞIRTMAÇ, *see* KINDYA

SIGNIA (Segni) Latium, Italy. Map 16. According to
tradition Segni was founded by Tarquinius Superbus and
recolonized by the Romans in 494 B.C. Strategically lo-
cated on Monte Lepino with only one means of access,
it became one of the best fortified towns in Italy with
two, and in some places three, lines of walls, begun in
the 5th c. B.C. The Porta Saracena is notable for its
ogival arch. On the acropolis stood a temple built in
the early 5th c. and repaired after the social wars. Terra-
cotta finds extend from the archaic period through the
Sullan period.

BIBLIOGRAPHY. Dion.Hal. 4.63; Livy 1.56.3.
RE XI² 2347-48; G. Lugli, *La technica edifizia romana*
(1957) 121ff; *EAA* 7 (1966) 154 with bibliography.

J. P. SMALL

SIKINOS Cyclades, Greece. Map 9. One of the small-
est of the southern islands. Referred to by Solon as the
epitome of unimportance, it nevertheless appears in 5th
c. tribute lists and joined the Athenian Alliance in 378
B.C.

The only existing monument stands isolated on a
mountain ridge high above the sea, an hour's walk SW
from the modern town. The ancient town, which has not
been excavated, lay above it, just below the peak of the
ridge. Formerly known as the Temple of Apollo Pythios,
the building is actually a tomb of the 3d c. A.D. It and a
number of smaller tombs, of which only the cuttings
remain, line the road leading up to the town. The plan
is that of a temple distyle in antis. The order is Ionic but
the capitals are Doric. A crypt underlies the cella and
the steep slope of the hillside was used to provide two
exposed entrances on the S side. Paved terraces sur-
rounded the tomb on all sides. The two chambers of the
crypt are barrel-vaulted, as was the cella. The ceiling of
the pronaos was made of marble beams, laid flat. A
sepulchral inscription was carved on the inner face of
the doorway. A half statue found nearby may have come
from the pediment. The original walls, solidly built of
local grayish-blue marble set in mortar, are preserved up
to the cornice. The vaulted roof, destroyed by earth-
quake, was replaced in the 17th c. by a dome supported
on pointed arches when the building was in use as a
church.

BIBLIOGRAPHY. A. Frantz, H. A. Thompson, & J.
Travlos, "The 'Temple of Apollo Pythios' on Sikinos,"
AJA 73 (1969) 397-422PI, with earlier bibliography.

A. FRANTZ

SIKYON (Basiliko) Peloponnesos, Greece. Map 11. On
the Corinthian Gulf about 26 km W of Corinth. Little is
known of the city's earliest history except for close ties
with Argos, which were broken under the Orthagorid
tyrants who ruled it ca. 656-556 B.C. Under Kleisthenes
the city enjoyed its greatest power and prosperity and
supported a flourishing school of painting. After the re-
moval of the tyrants by Sparta, Sikyon became a loyal
member of the Peloponnesian League, until Epaminon-
das made it the center of Theban power in the Pelopon-
nese after Leuktra in 371 B.C. In the 4th c. B.C. it was
again the home of famous painters and sculptors, includ-
ing Lysippos. Through the efforts of Aratos, the city
joined the Achaian League in 251 B.C. and became a
leading power in the confederacy until 146 B.C. Follow-

ing the destruction of Corinth, Sikyon for a time super-
vised the Isthmian Games but after the Romans had
exacted a large public debt in 56 B.C. and disastrous
earthquakes had struck in the 2d c., the city was reduced
to the half-ruined and depopulated condition in which
Pausanias found it ca. A.D. 160.

Old Sikyon lay in the plain near its port on the Corin-
thian Gulf, at modern Kiato, but in 303 B.C. Demetrios
Poliorketes moved it to the two lofty plateaus of the
acropolis, which lie ca. 4 km inland. On the upper ter-
race was the acropolis proper, while the lower terrace,
now partly occupied by the village of Basiliko, was the
site of the agora, several public buildings, and private
houses. The natural strength of the site, which is sur-
rounded by deep ravines cut by the Asopos and Helisson
rivers, was increased by a stone circuit wall, traces of
which survive. Another massive wall separates the acrop-
olis from the lower terrace.

On the acropolis Pausanias (2.7.5) records Sanctuaries
of Tyche Akraia and the Dioskouroi. Probably to be
associated with the former are some meager foundations
and a colossal marble head of Tyche, in the Sikyon
Museum, which is a Roman copy of the famous Tyche
of Antioch by Eutychides of Sikyon. Cut into the N and
NE slopes of the acropolis are the seats of a large, unex-
cavated stadium and the cavea of the theater, partly exca-
vated. Built probably in the early 3d c. B.C. and repaired
at least twice in Roman times, the theater is one of the
largest on the Greek mainland. Of interest are its vaulted
entrances to the lower diazoma and a Doric colonnade
behind the stage building which faces N and terminates in
a fountain-house at the W and at the E in a large, rec-
tangular room. Slight traces of an adjacent temple, pos-
sibly that of Dionysos (Paus. 2.7.5), were seen by Leake
but are no longer visible.

Excavations have revealed several important public and
sacred buildings to the SE and below the theater. Here
lies the gymnasium, a square structure of the 3d c. B.C.,
which is built on two levels. An open court on the lower
level is framed on three sides by an Ionic colonnade with
rooms opening off it; around three sides of the upper
court is a simple Doric colonnade, repaired in Roman
times. Two fountain-houses lie on the lower level, built
into the retaining wall that separates the two terraces.
Near the W side of the gymnasium is a spring in a small
rock Sanctuary of the Nymphs.

In the agora, which lies to the SE of the gymnasium,
is the bouleuterion, a square hypostyle hall of Ionic col-
umns built in the 3d c. B.C. and later transformed into
a Roman bath. It opens onto the agora on the N and is
separated by a road on the E from a long Doric stoa,
perhaps of the 2d c. B.C., which formed the S edge of
the agora. Behind a double colonnade of 45 x 22 columns
the stoa contained a row of 21 shops, only the foundations
of which are preserved. The rest of the agora is still to
be excavated, with the exception of the foundations of
a long, narrow temple on the W side. Constructed in the
archaic period, the temple was renovated in Hellenistic
times and later converted into a Christian church. Its
identification is uncertain: the excavators suggest Arte-
mis, but Roux's suggestion that it was the Temple of
Apollo described by Pausanias (2.7.8) as being in the
agora is attractive. A colossal statue of Attalos I, who
was a great favorite at Sikyon, stood beside the temple
(Polyb. 17.16).

A large and well-preserved Roman bath of the 2d or
3d c. lies to the N of the agora and has been partly
restored to serve as a museum and storehouse for the
finds from the Greek excavations. Remains of walls run-
ning in straight lines for considerable distances and inter-
secting at right angles are visible on the surface of the

lower terrace. They indicate that the new city of Demetrios was laid out on a grid pattern.

On the low hill of Haghia Paraskevi near the ancient port a Christian basilica has been excavated which is constructed of blocks reused from a Classical temple. It is possible that the source of this material was the Temple of Athena reported by Pausanias (2.5.6) as standing on the acropolis of the archaic city.

Attested at Sikyon by Pausanias and other authors are the shrine and grave of Aratos, Stoas of Kleisthenes and Lamia (Painted Stoa), and Sanctuaries of Apollo Lykios, Herakles, Asklepios, Aphrodite, Artemis, and Demeter; none of these has yet come to light.

BIBLIOGRAPHY. N. Philadelphus, *BCH* 50 (1926) 175-82[PI]; C. H. Skalet, *Ancient Sikyon* (1928)[PI]; E. v. Fiechter, *Das Theater in Sikyon* (1931)[PI]; A. K. Orlandos, "La Fontaine de Sicyone," *AJA* 38 (1934) 153-57[PI]; id., *Praktika* (1932-44 & 1951-54)[PI]; G. Roux, *Pausanias en Corinthie* (1958) 134-58[PI]; J. Delorme, *Gymnasion* (1960) 99-102[P]; L. Guerrini, *EAA* VII (1966) 276-79[PI].

R. STROUD

SILCHESTER, see CALLEVA ATREBATUM

SILIFKE, see SELEUCIA AD CALYCADNUM

SILLANS-LA-CASCADE Var, France. Map 23. Thirty km E of Draguignan, the site has sporadically produced remains of an occupation of the Gallo-Roman period: pottery of various types dating from the 2d to the 5th c., coins, pieces of floors, and tombs under tiles. As yet no important structure has been found.

BIBLIOGRAPHY. *Forma Orbis Romani*: Var (1932); "Chronique des circonscriptions arch.," *Gallia* (1967, 1969).

C. GOUDINEAU

SILLÈGUE, see NOVAR [- - -]

SILLYON (Asar Köyü) Turkey. Map 7. City in Pamphylia 28 km E-NE of Antalya. Founded presumably by the mixed migrants under Amphilochos, Mopsos, and Kalchas after the Trojan War; a statue base bearing the name of Mopsos was recently found on the site. The city is mentioned by Pseudo-Skylax in the mid 4th c., and by Ptolemy and Hierokles. Strabo (667) records, between Perge and Aspendos, a lofty city visible from Perge, 40 stades from the sea, which can be no other than Sillyon, though the distance is underestimated by more than half. When Alexander came to Pamphylia in 333 B.C. Sillyon was the only place to resist him; it was held, says Arrian (1.26), by a garrison of the native barbarians and foreign mercenaries. Alexander's first improvised attack failed, and he abandoned the idea of a second. Coinage begins in the 3d c., giving the city's name as Selyviys. Pseudo-Skylax and Arrian give it as Syllion, but Sillyon is the form used on the later coins. In Byzantine times Sillyon was joined as a bishopric with Perge.

The city stood on and around a conspicuous flat-topped hill some 210 m high. All sides of the hill are precipitous except the W, and fortifications were needed only there. Occupation seems to have been originally confined to the flat hilltop, but later a wall was built on the SW slope to extend the inhabited area. At the S end of this wall is an entrance gate of the same type as at Perge and Side, a horseshoe-shaped court flanked by towers in the wall. At the N end of the wall is a tower still virtually complete, in two stories with six windows; from the upper story doors opened onto the ramparts, and in the lower story two other doors lead into and out of the city.

The original city gate, however, stood at the top of the steep W slope, and was approached from N and S by a ramp. The gate itself is poorly preserved, but the ramp, especially on the S, is impressive. A road 5 m wide leads obliquely up the hill, flanked on one side by the face of the hill and on the other by a wall of regular masonry supported by buttresses, with a number of windows; the date is Hellenistic. Of the N ramp a part of the stone paving remains near the top.

The theater stood at the edge of the cliff on the S, with a smaller theater or odeion beside it on the E. The theater is small, and was split by a great cleft in the rock; the odeion was better preserved, but in 1969 a landslide carried away the lower part of the theater and all of the odeion; all that now remains is a few of the upper rows of seats in the theater.

A short distance to the E is a series of terraces, cut in the rock and joined by steps, where there are ruins of houses, partly rock-cut, partly of masonry. At the edge of the cliff is a small temple of Hellenistic date, with walls in handsome broad-and-narrow masonry; the S wall, however, has disappeared over the precipice.

Some 50 m N of the theater is a group of buildings which seem to have formed the city center; three of them are comparatively well preserved. The most conspicuous is a large Byzantine structure of unknown purpose; the other two are Hellenistic. The larger of these is long and narrow, evidently a public hall of some kind; its W wall stands 6 m high and contains 10 windows. The smaller building is remarkable for its elegantly decorated doorway, and particularly for the inscription carved on one of the door-jambs. This is in the Pamphylian dialect of Greek, 37 lines long, and the most important document known in that dialect; little progress, however, has been made in its interpretation. Other buildings on the plateau include a small temple, badly preserved, a round tower, and a large cistern. In the lower part of the city, close to the later city gate, is a large building of uncertain purpose, sometimes called a palace, and below this on the W are the scanty ruins of a stadium.

Tombs are mostly on the low ground below the hill on the W: plain rectangular graves cut in the surface of large boulders apparently fallen from above, with steps leading up to them, and in some cases holes for the pouring of libations. Inscriptions at Sillyon are unusually scarce.

BIBLIOGRAPHY. K. Lanckoronski, *Pamphylien* (1890) 64-84[MI]; G. E. Bean, *Turkey's Southern Shore* (1968) 59-66[MI]; Pamphylian inscription; H. Collitz, *Sammlung d. griechischen Dialektinschriften* I (1884) 1266.

G. E. BEAN

SILVIUM (Gravina di Puglia) Bari, Apulia, Italy. Map 14. The ancient city lies in the Botromagno district of the present town. Strabo (6.283) mentioned it for its position on the inner side of Peucezia, and Pliny (*HN* 3.105) included it among the principal cities of the region. The first mention of it in the literary sources (Diod. 20.80) pertains to its conquest by the Romans, who seized it from the Samnites in 306 B.C. Known in the itineraries also as Silitum, or Silutum, it is doubtful that this Roman statio should be identified with the Greek Sidis or Sidion. The Museum at Gravina preserves rich grave gifts dating from the 7th to the 3d c. B.C.

BIBLIOGRAPHY. K. Miller, *Itineraria Romana* (1916) 343; *RE* 3.1 (1927) 129-30; M. D. Marin in *Atti II Convegno Studi Magna Grecia* (1962) 87; G. B. Ward Perkins et al., "Excavations at Botromagno, Gravina di Puglia" *BSR* 37 (1969) 100ff.

F. G. LO PORTO

SIMBOTIN, see CASTRA TRAIANA

SIMENA (Kale, formerly Kekowa) Turkey. Map 7. On the Lycian coast 11 km W of Myra. First mentioned by Pliny (who misplaces it), then by Stephanos and the *Stadiasmus*. Apparently it was an independent city until Imperial times, when it became a minor member of a sympolity headed by Aperlai. There is no coinage.

The picturesque site is on a hill rising directly from the shore. The S part of the hill carries a fortification wall constructed mainly of bossed ashlar, with polygonal masonry in places. On the N part is a well-preserved mediaeval castle, inside which is a tiny theater, entirely rock-cut, with seven rows of seats holding some 300 persons, but no stage. Below the castle are remains of a stoa, and on the shore modest baths dedicated to Vespasian. There are many Lycian tombs, especially on the N hill; among them is a rock-tomb with an inscription in Lycian, proving the antiquity of the site.

BIBLIOGRAPHY. E. Petersen & F. von Luschan, *Reisen in Lykien* (1889) I, 28-29; II, 48-52; R. Heberdey & E. Kalinka, *Bericht über zwei Reisen* (1896) 17-18.

G. E. BEAN

SIMITHU (Chemtou) Tunisia. Map 18. Tucked between the Jebel Chemtou and the wadi Medjerda and its tributary the wadi Melah, the city was situated at the junction of two great routes, one going from Carthage to Hippo through Bulla Regia, the other from Thabarka to Sicca Veneria. The city owed its growth to the rich soil and its wealth to celebrated quarries of yellow-orange Numidian marble (*giallo antico*) that were part of the imperial domain. A municipium from the early days of the empire, the city became Colonia Julia Augusta Numidica Simithu from the end of the principate of Augustus or one of his immediate successors, its citizens being members of the Quirina tribe.

The site covers a fairly large area and has many remains (only partially excavated) besides the quarries. We shall note only the most outstanding remains.

On the hilltop near the quarries is a ruined Roman temple. Built of a masonry of large blocks, it was erected on the site of an earlier monument, probably Punic, of which several architectural fragments in Greek style and ornamentation have been found as well as some inscriptions and fragments of geometric mosaic. At the foot of the hill are some large ruined baths, their water supplied from a great cistern of seven parallel vaulted rooms and connected to an aqueduct on the left bank of the wadi Melah. Also at the foot of the hill is a theater, of which the orchestra, paved with a geometric mosaic 12 m in radius, the pulpitum, and part of the scena and tiers, have been excavated. A semicircular monument built of a masonry of large stones opened onto a piazza (40 x 23 m) paved with limestone and shale slabs and had a system of pipes running through it. This monument has been identified as a schola giving onto the forum. Here also was a fountain with a large basin.

Nearby are two sizable rubblework structures, their apses still standing. They have been identified by some as a civil basilica, as a Christian basilica by others. One of these buildings, oriented N-E and measuring 24 x 10.78 m, was designed with an apse at each end, one of which is remarkably well preserved; 6.9 m in diameter and 3.45 m deep, it had three tall, narrow niches not a little reminiscent of those in a library or schola.

On the river are the remains of a gigantic bridge, now badly eroded, built in Trajan's reign; its five semicircular arches were supported by piles of ashlar with a core of concrete. On the left bank immediately downstream from the bridge beyond its guard-wall, and level with the river, is a structure with a system of channels, locks, and sluices. No doubt it was designed to drive wheels for some industrial or agricultural purpose. Water was provided by a penstock that brought the water from well upstream down towards a series of reservoirs whence it was piped off by a conduit to the area. Still on the left bank, upstream from the bridge near the locks, is a building once identified as an inn.

Two hundred m from the theater, along the Sicca-Thabraca road, of which a fragment still survives a little to the N, the remains of a triumphal gate were once to be seen. Today all that is left are the bases of the two piers, some 6 m apart. Another, larger triumphal gate stood on the other great road from Carthage to Hippo, going towards Bulla Regia. Only its bases have survived. Beyond these are the necropoleis, one by the road to Thabarka, the other towards Bulla Regia.

BIBLIOGRAPHY. R. Cagnat & Saladin, "Chemtou," *ArchMiss* 13 (1887) 385-427; J. Toutain, "Le théâtre romain de Simithu," *MélRome* 12 (1892) 359-69[P]; id., "Fouilles à Chemtou," *MémAcInscr* 10 (1893) 453-73.

A. ENNABLI

SINEKKALESI, see HAMAXIA

SINGIDUNUM (Belgrade) Yugoslavia. Map 12. Roman town was on the high cliff overlooking the confluence of the Sava and Danube. This strategic position had been occupied as early as the Neolithic period, and the Roman castrum itself lies above the remains of a Celtic settlement. The city of Belgrade and the Fortress of Kalemegdan, whose mediaeval, Turkish, and modern ramparts were built above the Roman walls, now occupy the original site of the castrum and settlement.

Legio IV Flavia was stationed at Singidunum in the late 1st c. A.D. and traces of the walls of its camp are visible in the upper fortress of the Kalemegdan. The town had been founded earlier in the century. The Roman Danubian fleet was also stationed here after being transferred from Viminacium, and a bridge was constructed across the Sava below the fort. Singidunum became a municipium in 169 and a colony in 239. The city suffered in the Gothic and Hunnic invasions of the 4th and 5th c. and came under Slavic control in the late 6th c.

Parts of walls belonging to the original castrum and to structures within the fort have been revealed under and near the W wall of the upper fortress of the Kalemegdan. The ancient city spread S at least as far as the present Republic Square. The main cemetery of Singidunum lay farther S and many graves were discovered during the construction and later repair of the parliament building. Graves have also been found in other parts of the city. The most significant early structure yet found is a Roman temple, only partially excavated, which was discovered beneath the foundations of the national bank on July 7th Street.

The Museum of Military History in the Kalemegdan presents an informative display of weapons and armor that belonged to the inhabitants of the site of Singidunum, and other Serbian towns, from prehistoric times to the present, as well as models and drawings of ancient fortifications. The National Museum of Belgrade on Republic Square is the largest museum in Yugoslavia and contains many of the discoveries from Belgrade as well as from other sites in Yugoslavia.

BIBLIOGRAPHY. M. Grbić, "La Serbie centrale a l'epoque romaine," *Monuments et stations archéologiques en Serbie* (1956) 29-50[M]; M. Mirković, "Fragmenti iz istorije rimskog Singidunuma," *Limes u Jugoslaviji* (1961) 109-15; V. Kondić, "Singidunum—Castra Tricornia," ibid., 117-23.

J. WISEMAN

SINOE Dobrudja, Romania. Map 12. Near the modern village, on the banks of two lakes, Sinoe and Zmeica, are remains of many settlements, indigenous, Greek, and Roman. Archaeological research in one of the settlements on the edge of the Lake Zmeica has revealed foundations of houses built of stone according to the method of construction known as Olbian. At this site the oldest level is dated by pottery fragments to the 6th c. B.C. A Roman settlement lies on the promontory which separates Zmeica from Sinoe. It was defended by a vallum orientated N-S. Archaeological research and aerial photography show that these settlements were closely connected to Histria, and at least one was a Greek foundation. At Sinoe was probably stationed the vicus Quintionis, mentioned in an inscription discovered here, but which may have been brought from elsewhere.

BIBLIOGRAPHY. V. Pârvan, "Histria, IV," *Academia Română. Memoriile Secţiunii Istorice*, ser. 2, tom. 2, mem. 1 (1916) 536f, 617-21; id., "Histria, VII," ibid., ser. 3, tom. 2, mem. 1 (1923) 55-60, 62ff; R. Vulpe, *Historie Ancienne de la Dobroudja* (1938); S. Lambrino in *Mélanges Morouzeau* (1948) 319f; E. Dorutiu-Boila, "Observatii aerofotografice în teritoriul rural al Histriei," *Peuce* 2 (1971) 37-46.	E. DORUTIU-BOILA

SINOPE (Sinop) Turkey. Map 5. City on the isthmus of a peninsula in the middle of the S coast of the Black Sea, W of the mouth of the Halys, the earliest colony that Miletos founded in the Pontos (Xen., *An.* 6.1.15; Diod. 14.31.2; Strab. 12.545). Eusebios (*Chron.* 2.88-89) records that Sinope was twice colonized, in 756 and 630 B.C., but 8th c. Greek colonization in the Pontos is unlikely. The oldest find is an aryballos of Middle Corinthian type of the beginning of the 6th c. or ca. 600 B.C. at the earliest, suggesting that the second date, 630 B.C., may be accepted. Excavations in other Greek cities of the Pontos, such as Olbia (Borysthenes), Istria, and Apollonia Pontica, have yielded nothing earlier than the last quarter of the 7th c., and it has also been pointed out that the Greeks were first in a position to colonize the Black Sea about 700, when they began to build triremes.

The excavations also yielded Phrygian vases of the late type, dating from the second quarter of the 6th c., indicating that when the Greeks came to Sinope they found native peoples (Paphlagonians?) at least partly mixed with Phrygians. There is, however, no evidence of Assyrian colonization (Ps. Skymnos 94ff) or Kimmerian occupation (Hdt. 4.12).

A large number of 6th-4th c. Greek vases from the necropolis are now in the museums of Ankara, Kastamonu, and Sinop, and much of the Achaemenid metalwork on the black market seems to have come from there. Late archaic gravestones have also been found, and the remains of a Hellenistic temple with altar and surrounding colonnades.

Sinope flourished as the port of a caravan route (Hdt. 1.72; 2.34) between the Euphrates and the Black Sea from the 6th to the 4th c., and issued its own coinage as early as the 6th c. Kotyora, Kerasos, and Trapezos were its colonies, and among its exports was red sulfate of arsenic from Cappadocia, called Sinopic red earth (Μίλτος Σινωπική). It escaped Persian domination until the early 4th c., and in 183 B.C. it was captured by Pharnakes I and became capital of the Pontic kingdom. It was conquered by Lucullus in 70 B.C., and Julius Caesar established a Roman colony, Colonia Julia Felix, in 47. Mithradates Eupator was born and buried here, and it was the birthplace of Diogenes, of Diphilos, poet and actor of the New Attic comedy, and of the historian Baton.

BIBLIOGRAPHY. D. Robinson, *Ancient Sinope* (1906); Ruge, *RE* III A 1 (1927) 252-55; L. Robert, *Etudes Anatoliennes* (1937) 259-300; R. M. Cook, *JHS* 66 (1946) 76ff; R. Carpenter, "The Greek Penetration of the Black Sea," *AJA* 52 (1948) 1-10; E. Akurgal, "Zwei Grabstelen vor klassischer Zeit aus Sinope," *111 Winckelmanns-Programm* (1955); id. & L. Budde, *Vorläufiger Bericht über die Ausgrabungen in Sinope* (1956)[I]; Budde, "Eine Tierkampfgruppe aus Sinope," *Antike Plastik* II (1963) 53-74[I].	E. AKURGAL

SINOU, *see* LIMES, GREEK EPEIROS

SION, *see* SAXON-SION

SIPHNOS Greece. Map 9. Cycladic graves, figurines, and pottery have been found in various parts of the island, and there is a fortified acropolis site at Haghios Andreas. The town of Siphnos lay in the center of the E coast at modern Kastro; its acropolis and slopes have been excavated only partially as the site has been continuously inhabited from before 800 B.C. Among the discoveries were part of a probable circuit wall from that date, Geometric houses, and two 7th c. votive deposits containing pottery, figurines, and objects of ivory, bone, and bronze. Further walls and other signs of habitation dated from archaic Greek to Roman Imperial times. (There are also considerable mediaeval architectural remains.)

Herodotos calls Siphnos the richest of the islands ca. 525 B.C., mentioning a Parian marble prytaneion and agora (no traces have been found), and the treasury at Delphi (q.v.), built from a tithe on the gold and silver mines. Siphnians fought for Greece at Salamis, paid 3 talents a year to the Delian League, joined the Second Athenian Confederacy, and resisted Macedon, at least in the 330s. Some 40 so-called Hellenic towers are recorded. As the mines ceased to produce (those at Haghios Sostis were perhaps inundated), the island declined. Reasonably rich glass and other finds in the Roman cemetery indicate revival under the Early Empire. Various sarcophagi are reported. The island was (and is) known for its pottery; the ancient potter's Siphnian stone was probably a steatite, not the lead-slag favored by the modern workmen.

BIBLIOGRAPHY. Hdt. 3.57-58, 8.46, 48; Isocr. 19.36; *Syll.*[3] 359 etc.; *SEG* 17.19; Theophr. *Lap.* 7.42; Diod. 31.45; Plin. *HN* 4.66, 36.159; Paus. 10.11.2; Arrian *Anab.* 2.2.4ff; *Suda:* ἰσοῦφεῖς, Σίφνιοι.

L. Pollak, "Von griechischen Inseln," *AthMitt* 21 (1896) 188-228; H. Hauttecoeur, "L'île de Siphne," *BSocBelgGeog* 22 (1898) 183-203[M]; C. Tsountas, "Kykladika II," *ArchEph* (1899) 73-134; C. Karousos, "Archaike Kephale Leontos en Siphnoi," ibid. (1937) 599-603; J. H. Brock & G. M. Young, "Excavations on Siphnos," *BSA* 44 (1949) 1-92[PI]; J. H. Young, "Ancient Towers on the Island of Siphnos," *AJA* 60 (1956) 50-55[P]; K. Scholes, "The Cyclades in the Later Bronze Age: A Synopsis," *BSA* 51 (1956) 9-40; A. G. Troullos, *Siphnos* (1961)[MI]; B. Philippaki, "He akropolis tou Hagiou Andreou Siphnou," *AAA* 6 (1973) 93-103.	M. B. WALLACE

SIPONTO, *see* SIPONTUM

SIPONTUM (Siponto) Foggia, Apulia, Italy. Map 14. An ancient Daunian city, on the Adriatic coast immediately S of the Gargano promontory. It was founded, according to a legend common to many nearby cities, by Diomedes (Strab. 6.284). As a strategic area and harbor for Arpi, Alexander of Molossos occupied it in 330 B.C. The Romans subjugated the town and made it a colony

in 194 B.C. (Livy 34.45). It seems not to have prospered, perhaps because of the unhealthy air. Later, however, favorable climatic conditions did permit a new influx of colonists (Livy 39.22), after which the city gained a certain importance in the grain trade (Strab. loc. cit.; Plin. 3.103; Ptol. 3.1.16; Polyb. 10.1). During the Civil War, Mark Antony occupied the town in 40 B.C. (App *BCiv.* 5.56), and under the Roman Empire it had municipal magistrates (*CIL* IX, 697-699).

The entire area of the city is still to be explored. Recently, sections of the circuit walls of the city have been brought to light; their date is still to be clarified. In the area of Siponto limestone stelai of the 7th-6th c. B.C. have come to light with various pictures either scratched or painted on in a typically Daunian fashion.

BIBLIOGRAPHY. W. Smith, *Dictionary of Greek and Roman Geography*, II (1857) 1011 (E. H. Bunbury); K. Miller, *Itineraria Romana* (1916) 219; *RE* 3.1 (1927) 271-72; S. Ferri, "Stele daunie," *BdA* (1962ff); A. Stazio, "La documentazione archeologica in Puglia," *Atti V Convegno Studi Magna Grecia* (1965) 234.

F. G. LO PORTO

SIPOVO Bosnia-Herzegovina, Yugoslavia. Map 12. Remains of a Roman settlement, and at nearby Gromile the ruins of a Roman castrum. Inscribed epigraphical monuments have also been found in this area. An inscription ". . . l(oco) d(ato) d(ecurionum) d(creto)" with traces of the letters ELVE or LLV, may indicate the name of a municipium. The monument in honor of the legate of the Legio XV pia fidelis dates from the 2d c. A.D. Remains of a sepulchral inscription reveal that a mausoleum had been built. There is a fragment dedicated to Augustus and Roma. Various unrelated artifacts date the Roman ruins to the 1st and 2d c. A.D.

Remains of Early Christian churches with vaulted tombs have been found.

BIBLIOGRAPHY. W. Tomaschek, "Die vorslavische Topographie der Bosna, Herzegovina," *Mittheilungen der geographischen Geselschaft in Wien* (1880) 497-528i, 515-67; C. Truhelka, *GZM Sarajevo* 4 (1892) 315-20. W. Radimsky, *WMBH* 3 (1895) 249-56; C. Patsch, *WMBH* 12 (1912) 137-45; D. Sergejevski, *GZM Sarajevo* 38 (1926) 155-58; id., *Spomenik SAN* 88 (1938) 102; J. J. Wilkes, *Dalmatia* (1969). V. PASKVALIN

SIRACUSA, *see* SYRACUSE

SIRK, *see* SELGE

SIRKAP (Taxila) India. Map 5. A Graeco-Bactrian city, one of several cities at the site known as Taxila. Founded either by Demetrios I ca. 189 B.C., or more probably by his sons Agathokles and Pantaleon ca. 182. Since the Greek city lies 3.9-5.4 m beneath the surface, and under later Saka and Parthian rebuildings, relatively little of its area has been excavated. The general plan, however, which was retained in later times, has been recovered: a broad main street with lesser cross streets at right angles and at equal intervals. Houses were of rubble masonry, and fairly symmetrical in plan with rooms grouped around a central courtyard. The foundation and sections of the upper levels of a wall of limestone masonry survive; it ran for nearly 5.6 km around the city. Objects from the Greek levels include coins, terracotta figurines, vases, and stone dishes. The city was first rebuilt by the Sakas, who took it ca. 90 B.C., and later by the Parthians.

BIBLIOGRAPHY. J. Marshall, *Taxila. An Illustrated Account of Archaeological Excavations* (1951) 39-40, 113-

18, 123-30; G. Woodcock, *The Greeks in India* (1966) 81-82, 86-90, 107. D. N. WILBER

SIRMIO (Sirmione) Brescia prov., Lombardy, Italy. Map 14. A site celebrated for a large Roman villa called the Grottos of Catullus, on the peninsula that juts out into Lake Garda. Built in the 1st c. A.D. above an earlier U-shaped building from the middle of the 1st c. B.C., it is 240 by 105 m and is supported on the side toward the lake by high vaulted foundations. The villa is rich in porticos, cisterns, and fountains. It has a grand ambulacrum 159 m long and a large garden, now planted in olives. Excavation has brought to light parts of beautiful frescos in the Second and Fourth Styles, now preserved in the Antiquarium.

BIBLIOGRAPHY. G. Orti Manara, *La penisola di Sirmione sul lago di Garda illustrata* (1856); M. Mirabella Roberti in *Storia di Brescia*, I (1963) 291-95.

M. MIRABELLA ROBERTI

SIRMIONE, *see* SIRMIO

SIRMIUM (Sremska Mitrovica) Yugoslavia. Map 12. The modern city covers the site of Sirmium on the Sava river, ca. 76 km W of Belgrade (Singidunum). The Roman town was founded in the late 1st c. B.C. on the site of an earlier Pannonian settlement. It is mentioned first in history in accounts of the Pannonian-Dalmatian rebellion of the 1st c. A.D. It became a colony under the Flavian emperors and remained for centuries one of the most important cities on the Danubian frontier. It was frequently the headquarters for military operations and was visited by the emperors Trajan, Marcus Aurelius, Septimius Severus, Maximinus, and Gallienus. Four emperors of the 3d c. were born in Sirmium or the vicinity: Trajan Decius, Aurelian, Probus, and Maximian.

Sirmium was the residence of the governor of Lower Pannonia and later was the capital of Illyricum. An important mint was founded here by Constantine I. The city was an ecclesiastical center and several church councils were convened here during the 4th c. The Huns destroyed the city in the mid 5th c. but it was restored to the Byzantine empire in the mid 6th c. Sirmium fell to the Avars after a long siege in 582.

Excavations have revealed a number of ancient monuments and have considerably expanded our knowledge of the ancient city. Among the more recent discoveries are a part of the imperial palace (4th c.) and the hippodrome attached to it. The hippodrome, between 350 and 400 m in length, was built shortly after 315 and, after one major rebuilding, fell into disuse before the end of the century. Parts of the foundations for the seats, a cryptoporticus, the spina, and the raceway have been found.

Sections of the city wall and two large cemeteries have been cleared. Near the center of the city the public horreum (4th c.), a large, rectangular structure with square piers, and part of the baths of Licinius have been excavated.

Artifacts from recent excavations are in the Museum of Sremska Mitrovica; some earlier finds, including a mosaic of the late Roman period, are in the Vojvodina Museum in Novi Sad. The Sremska Museum is built above a large private dwelling (4th-5th c.) and a mosaic with geometric patterns is preserved in situ within the museum courtyard. Frescos from the same dwelling have been restored and are displayed nearby along with a Roman ship, numerous inscriptions, and architectural pieces.

BIBLIOGRAPHY. *Sremska Mitrovica* publ. by the Museum of Sremska Mitrovica, 1969; E. Ochsenschlager & V. Popović, *Sirmium. Archaeological Investigations in Syrmian Pannonia* I[MPI] and II[PI] (1971-72). Vol. I contains

a general survey of the history of the city and the excavations as well as the publication of the non-Christian inscriptions; II deals with various aspects of the new excavations.　　　　　　　　　　　　　J. WISEMAN

SIROUNO, *see* LIMES, GREEK EPEIROS

SIRT, *see* ETENNA

SISAK, *see* SISCIA

SISCIA (Sisak) Croatia, Yugoslavia. Map 12. First mentioned by Strabo (7.5.2), the Iron Age settlement Segestica, on an island at the mouth of the Kupa (Colapis) in the Sava river, preceded a later Celtic settlement Siscia at the mouth of the Odra in the Kupa river. Being at the confluence of three rivers, the place "was strongly protected by the river and with a large ditch encircling it" (App. *Ill.* 22; Dio Cass. 49.37.3-4). In 35 B.C. Octavian captured the town after a thirty-day blockade. The town was used as a base for a campaign against the Dacians. In the time of the great Illyrian rebellion in the winter of A.D. 6, Tiberius reached Siscia and kept it as the base for his army, which with a strength of ten legions and seventy auxiliary cohorts, stamped out the rebellion in A.D. 9. Siscia became the station of the river fleet against the Dacians, and Vespasian gave to the town the status of colonia Flavia Siscia. Because of the new influx of the colonists this status was confirmed by Septimius Severus (colonia Septimia). The town had the state mint and treasury in the 3d and 4th c. It was the capital of Pannonia Savia, and from the 3d c. it was a bishop's seat (St. Quirinus). In 530 Ioannes from Siscia attended a provincial synod at Salona. Since the modern town is built over the ancient one, it has not been possible to establish its exact size. Every excavation in the town encounters ancient walls and constructions and often inscriptions and other monuments are found in a secondary use in these walls. Bath buildings near the Kupa river have been discovered. The bed of this river has yielded many important finds of arms, metal ware, and small bronze statuary from the numerous workshops. Tiles stamped SISC(ia) are also known.

The rich archaeological material is in the Archaeological Museum at Zagreb and in the City Museum at Sisak.

BIBLIOGRAPHY. J. Brunšmid, "Kameni spomenici Hrvatskog Narodnog muzeja," *Vjesnik Hrvatskog arheološkog društva*, NS, 7-12 (1904-12); G. Veith, *Die Feldzüge des C. Iulius Caesar Octavianus in Illyrien in den J. 35-33 v. Chr.* (Schriften der Balkankommission, Antiq. Abt. 8; 1914), 51ff, map 7; V. Hoffiller & B. Saria, *Antike Inschriften aus Jugoslawien* (1938) 237-68.

M. ZANINOVIĆ

SISTROUNION, *see* LIMES, GREEK EPEIROS

SITEIA, *see* SETEIA

SITIFIS (Sétif) Algeria. Map 18. A colony of veterans 110 km W of Constantine. Founded during the reign of Nerva, it was called Colonia Nerviana Augusta Martialis Veteranorum Sitifensium, as attested by inscriptions.

The center was established in a region of friable limestone hills that dominate the plain of the wadi Bou Sellam. The hills are a part of the high plains of the Constantinois, from which they rise gradually. The size of the area that belonged to the town is not known. To the E, the existence of settlements just as old as Sétif—Mopth [- - -] or Novar [- - -]—suggests that the boundary was scarcely more than 16 km away. To the S, localities were established during the 2d c. and referred to as castella in numerous 3d c. texts (Castellum Dianense, Citofactense, Perdicense). It is not known whether these were once connected with Sétif. The W boundary is equally uncertain.

In the first half of the reign of Diocletian and Maximian, a new province was created, Mauritania Sitifensis, detached from Mauritania Caesariensis. Sétif was its capital, and the province stretched from the coast to the Chott el Hodna.

The existence of a Jewish colony is attested by undated texts. The presence of a Christian community in the town itself is not attested before the second half of the 4th c. (by funerary inscriptions) or even the beginning of the 5th c. (by the bishops).

At the time of the French conquest the field of ruins was clearly visible. In the middle stood the walls and towers of the four-cornered fortress built at the instigation of Solomon at the time of the Byzantine reconquest. It measured 158 x 107 m and was protected by a rampart built in large-scale ashlar and by towers placed at the corners and along the sides. The building was partially restored when French troops were installed, and partially destroyed when it was included in a new military quarter. Beginning in 1843 the colonial center was built over a part of the ancient town. Thus, for a long time, to write a history of the town one had to be satisfied with brief notices and drawings done in the middle of the 19th c. and with inscriptions discovered by chance. The excavations conducted from 1959 until 1966 permit one to be more precise.

Only a small part of the original Roman settlement has been uncovered. Probably the center of the colony was under the Byzantine citadel, where in the past the theater was discovered and where the forum must have been located. Only remains of houses have been found, W of the fortress at the very foot of the walls. Stratigraphic test pits indicate that they must be attributed to the end of the 1st c. A.D. These houses were themselves destroyed and covered with a layer of fill when a large temple was built in the second half of the 2d or beginning of the 3d c. The foundations of the cella and the peribolus of the temple have been brought to light. Streets intersecting at right angles have been found immediately to the N, S, and W of the temple; they must go back to the same period.

Other discoveries have been made opposite, in an E necropolis of the 2d c. Funerary stelae and cremation tombs with grave goods (local pottery, terra sigillata, lamps) have been excavated. They permit the study of funerary customs; in particular, one can trace the introduction of new rites—inhumation burials and, above all, flexed ones—into a context characterized by typically Roman customs. This can perhaps be interpreted as the arrival from the countryside to Sétif during the 3d c. of groups who had preserved older indigenous traditions.

At the end of antiquity the town changed greatly. New districts must have been built. One of these, to the NW of the original center, has been excavated. Very extensive walls enclosed the original town and the new districts. At the same time, public monuments were built (circus) or restored (amphitheater). Most of these constructions date to the second half of the 4th c., though some are of the period of the Tetrarchy.

The NW district, which has been partially cleared, is laid out according to a regular plan with streets at right angles. Test pits have proved that this quarter cannot be earlier than the second half of the 4th c. and is undoubtedly later than 355. Houses and shops have been identified. Within a large, very damaged residence small

hot baths happened to be preserved, with a mosaic depicting the Toilet of Venus. In this network of streets, in fact partially blocking the course of some of them, two Christian funerary basilicas were erected side by side. One was built before 378 (probably only a little before), the other before 389. These dates are provided by mosaic funerary inscriptions that formed the floors of the central and lateral naves. New inscriptions, dated by the provincial year, were put in regularly until 429, with one text from 471.

Inside the town, inscriptions and older excavations reveal the existence of other cult sites as well as public monuments: the amphitheater restored about 297 and again under Julian, a temple to the Magna Mater restored in 288, a water tower (still visible) where the town aqueduct ended. Outside the walls, N of the town, a hippodrome has now been found. It was badly preserved, but its plan is quite clear. The building measures 500 x 80 m. Test pits force one to conclude that this also was built in the second half of the 4th c. One must suggest a similar date for the ramparts. The walls are over 5,000 m long; their outline has been established by recent excavations and by the 19th c. drawings of Ravoisié and Delamare.

Until now excavations have not elucidated the history of the town after the 5th c. Even though a necropolis was found within the ramparts, it consisted merely of inhumations under flagstones, without grave goods or inscriptions; thus they cannot be dated. At various points near the Byzantine citadel, storage pits have been discovered which sometimes contained handmade or (rarely) glazed pottery. Their presence indicates that the site was occupied in the Middle Ages.

BIBLIOGRAPHY. S. Gsell, *Atlas archéologique de l'Algérie* (1911) 16, no. 364; P.-A. Février, "Notes sur le développement urbain en Afrique du Nord, les exemples comparés de Djemila et Sétif," *CahArch* 14 (1964) 1-47; *Fouilles de Sétif, les basiliques du quartier nord-ouest* (1965); with A. Gaspary, "La nécropole orientale de Sétif," *Bulletin d'archéologie algérienne* 2 (1966-1967) 11-93; P.-A. Février, "Inscriptions de Sétif et de la région," *Bulletin d'archéologie algérienne* 4 (1969); with A. Gaspary & R. Guéry, *Fouilles de Sétif, le quartier nord-ouest* (1970) 1st supplement to *Bulletin d'archéologie algérienne*. P.-A. FÉVRIER

SIVASLI, *see* SEBASTE (Phrygia)

SKALA OROPOU, *see* OROPOS

SKAMNELI, *see* LIMES, GREEK EPEIROS

SKELANI Bosnia-Herzegovina, Yugoslavia. Map 12. A settlement on the river Drina which may have been the urban center for the region surrounding the Drina. Various monuments of Roman provenance were discovered. Inscriptions here indicate that the settlement was organized to be self-governing. Altars, dedicated to Jupiter, Minerva, and Juno, were built by the beneficiarii of the Legio I Ad(iutrix), Legio X G(emina), Legio XI Cl(audia) p(ia) f(idelis). There are also altars dedicated to Silvanus and Martius, and one dedicated to Aesculapius and Hygieia. Some tombstones with busts of the dead have been excavated. The inscription "Dind(ariorum)" points to the presence of the Dindari, an Illyrian tribe.

Soldiers and beneficiarii of Legio V Macedon(ica) and Legio I Ital(ica) Moes(iae) inf(erioris) were quartered here. Remains of an Early Christian church (4th to 6th c.) have been found.

BIBLIOGRAPHY. C. Patsch, *WMBH* 11 (1909) 140-77;

D. Sergejevski, *GZM Sarajevo* 42 (1930) 2, 164. D. Sergejevski, *Spomenik srpske akademije nauka* 88 (1938) 112; *Spomenik SAN* 93 (1940) 146-48; *GZM Sarajevo*, NS 6 (1951) 307-8; J. J. Wilkes, *Dalmatia* (1969).
 V. PASKVALIN

SKHIRA, *see* LARISCUS

SKIKDA, *see* RUSICADA

SKILLOUS Peloponnesos, Greece. Map 9. City in Triphylia, 20 stades (3.5 km) S of Olympia, on the Selinus River (Xen. *Anab.* 5.3.11; Strab. 8.343; Paus. 5.6.4). The land of Skillous was fertile, as it is today, and also abounded with game (Xen. *Anab.* 5.3.7; Paus. 5.6.5). In the 7th and early 6th c. B.C., Skillous, a close friend and ally of Pisa, which at that time assumed control of the Olympic sanctuary, built the heraion at Olympia (Paus. 5.16.1). In 570 B.C. the people of Skillous were evicted from the city after the total defeat of their allies the Pisaians in battle with the Eleians (Paus. 5.6.4, 6.22.4). In 400 B.C. Skillous was resettled by Sparta. After the peace of Antalkidas (King's Peace) the city was proclaimed free (Xen. *Hell.* 6.5.2) but shortly afterwards it came under the control of Sparta. The farm assigned by Sparta to the Athenian exile, Xenophon, was in the territory of Skillous. Xenophon erected a shrine there which was a copy of the Temple of Ephesian Artemis (Xen. *Anab.* 5.3.7f; Paus. 5.6.4). A short distance from the shrine, Pausanias (5.6.6) saw the tomb of Xenophon with his statue. In the area of Skillous was also a remarkable Temple of Skillountian Athena (Strab. 8.343). After the battle of Leuktra (371 B.C.) Skillous again came under Eleian control. Skillous was probably deserted in the Hellenistic period and for this reason is not mentioned at all by Polybios. Pausanias, on the road to Olympia after Samikon, mentions the uninhabited remains of Skillous in the distance to the left; that is, in the area between the present communities of Krestaina, Makrysia, and Ladikou, where the city must have been.

BIBLIOGRAPHY. Geyer in *RE* III A (1929) 526, s.v.; Partsch in *Olympia* I 12; *Annales de la Faculte des Lettres d'Aix en Provence* 29 (1955) ed. Delebeque 5ff; E. Meyer, *Neue Peloponnesische Wanderungen* (1957) 63ff[I]; Themelis, *Deltion* 23 (1968) A 284ff[MPI].
 N. YALOURIS

SKIONI Chalkidike, Greece. Map 9. A city near the end of the Pallene peninsula E of Mende. The importance of the town, which figured in the Peloponnesian War, is indicated by the high assessment assigned to it in the Athenian tribute lists. The mound of ruins marking the site lies between Cape Paliuri and Cape Kassandra.

BIBLIOGRAPHY. Hdt. 7.123, 8.128; Thuc. 4.130; Strab. 7,330, fr. 27; E. Oberhummer in *RE* 3A[1] (1927) 529.
 M. H. MC ALLISTER

SKITI, *see* MELIBOIA

SKOPJE, *see* SCUPI

SKORĖ, *see* LIMES, SOUTH ALBANIA

SKOTOUSSA Thessaly, Greece. Map 9. A city in the mountains of Pelasgiotis W of Volo. It was already important in the 5th c. as the seat of the tree oracle of Zeus Phegonaios; the sanctuary was considered by the Thessalians to be the Homeric Dodona, forerunner of the oracle in Epeiros. The wealth of the town in the Classical period was based on grain. A number of battles were fought at Skotoussa and at Kynoskephali, which lay in

its territory to the N. A second period of importance followed on the fortification of the site by Philip V of Macedon, but it was deserted when Pausanias saw it. Within the city territory, Plutarch records a polyandrion built by Philip V, a tumulus over the mass grave of the Macedonians raised by Antiochos in 191 B.C., and a solitary hill known traditionally as the grave of the Amazons. Traces of walls remain around the acropolis, 1 km W of Soupli, and at intervals around a much larger outer circuit. The rubble-filled walls of local stone are strengthened by numerous towers and had gates on the E and W. Leake saw some stretches of good ashlar masonry. A theater lay in a natural hollow just inside the wall on the SW. The site of the oracle, not at the city itself, has not been identified.

BIBLIOGRAPHY. Plut. *Flam.* 7; Steph. Byz.; Strab. 7, fr. 1ª; 9.5.20; W. M. Leake, *Nor. Gr.* (1835) IV 454; C. Bursian, *Geographie von Griechenland* (1872) I 70f; J. Kromayer, *Antike Schlachtfelder in Griechenland* (1907) II 68, 72, n. 2; F. Stählin, *Das hellenische Thessalien* (1924) 109fMP; E. Oberhummer in *RE* 3A¹ (1927) 615.

M. H. MC ALLISTER

SKOUTELA Corinthia, Greece. Map 11. The site of an Early Christian basilica of the first quarter of the 6th c. ca. 2 km NW of ancient Corinth. Some fine marble architectural fragments excavated in the basilica are in the Corinth Museum. That Skoutela, which lies in the plain below the N cemetery, was inhabited in ancient times is clear from archaic and Classical pottery under the basilica, from a Classical grave nearby, and from Roman coins found in the excavations.

BIBLIOGRAPHY. P. Lawrence, *Hesperia* 33 (1964) 106-7 I; D. Pallas, *Praktika* (1953-55)PI. R. STROUD

SKRADIN, *see* SCARDONA

SKRIPOU, *see* ORCHOMENOS (Boiotia)

SKYROS Major island of the N Sporades, Greece, near Kyme in Euboia. Map 11. Famous for the legends of Theseus and of Achilles.

In 470 B.C. Kimon seized the island, enslaving the inhabitants and replacing them with Athenian colonists. In 332 B.C. the Macedonians freed it from Athenian domination. To the S of the village of Skyros, on the hill that dominates the present village a Venetian fort has taken full advantage of the Greek substructures. In the walls of the acropolis, trapezoidal masonry alternates with irregular courses (attributable to the 5th c. B.C.) and with isodomic blocks having squared faces. Very scarce remains of the enclosing wall are datable to ca. 450 B.C. Traces of stratification indicating habitation during the Early and Middle Bronze Ages have recently been found by D. R. Theocharis. During the Empire, breccia, which was much in demand for its decorative quality, was quarried.

BIBLIOGRAPHY. P. Graindor, *Histoire de l'île de Skyros* (1906); R. L. Scranton, *Greek Walls* (1941); D. R. Theocharis, *EphArch* 1945-47 (1949); H. D. Hansen, *Studies Presented to D. M. Robinson* I (1951); K. Karouzos, *AthMitt* (1956); F. Schachermeyer, *Arch.Anz.* (1962) Heft 2; R. Gnoli, *Par.d.Pass.* (1966). N. BONACASA

SLANKAMEN, *see* LIMES PANNONIAE (Yugoslav Sector)

SLAVA RUSĂ, *see* LIBIDA

SLĂVENI (Gostavăţ) Olt, Romania. Map 12. A Roman settlement and camp on the limes Alutanus. The civil center is traversed by the Roman road (6 m wide).

The center (1 km x 300 m) was flanked by two necropoleis to the N and S. Excavations made during the last century have uncovered a mithraeum dug out of the bank of the Olt, and have revealed the foundations of several important buildings. The first earthen camp was built during the era of Trajan and Hadrian by a few detachments of the legions V Macedonica, XIII Gemina, ala I Hispanorum, ala I Claudia, Cohors I Fl. Commagenorum. These troops from Moesia inferior marched against the Dacians in 105, going up the Olt Valley. A second camp, built on the first, was constructed in 205. It was slightly larger than the first (198 x 176.6 m) with four gates, corner towers, a praetorium (43.20 x 37.4 m), a horreum, etc. It was the work of the ala I Hisp. and the numerus Syrorum sagittariorum. The inscriptions in the camp mention a basilica castrensis, a collegium duplariorum, a series of names of officers and soldiers, dedications to Septimius Severus and his sons, to Philip the Arab, etc. A deposit of coins buried in A.D. 248 and other isolated coins are proof that the civil settlement and the camp were finally destroyed by the Carpo-Gothic invasions of 249-50. To the E of the camp, excavations have unearthed some bath installations.

Material from excavations is in the museums of Craiova and Slăveni.

BIBLIOGRAPHY. *CIL* III, 8038; 13779-80; 14216,7, 16-39; *AnÉpigr* (1963) 125; (1966) 314-17; D. Tudor, "Castra Daciae inferioris II: Slăveni," *BCMI* 33 (1940) 34-38; id., *Oltenia romană* (3d ed., 1969) 306-11, 334-36; id., "Collegium duplariorum," *Latomus* 22 (1963) 240-51; id., "Distrugerea castrului roman de la Slăveni pe Olt," *Historica* 1 (1970) 67-83; id., "Basilica castrensis de la Slăveni," *Drobeta* 1 (1972); G. Popilian, "Termele de la Slăveni," *Apulum* 9 (1971) 627-41. D. TUDOR

SLEM, *see* SELAEMA

SMINTHEION Troas, Turkey. Map 7. Strabo (13. 604.46-605.49) calls Smintheion an Apollo sanctuary, which still in his time was in Chrysa, a site in S Troas. The cult image of Apollo Smintheus is supposed to have been fashioned by Skopas. The name Smintheus supposedly referred to the mouse that was fixed to the feet of the Apollo statue. According to Strabo there were several sanctuaries so named, located especially in Troas and on the nearby island of Tenedos. The sanctuary, i.e. the temple, in Chrysa was evidently the most important of these.

In 1853 the English captain Spratt discovered in the SW corner of Troas below the village then named Kulahli the remains of ancient Chrysa, at that time probably better preserved than they are now. The location is called Gülpinar today and lies at the end of a paved road 25 km long, leading W from Assos. The W coast of Troas (near the ancient Hamaxitos) is only 3 to 4 km distant, the coast of the Gulf of Edremit (Atramyttion) somewhat farther. Thirteen years after Spratt's discovery, the Society of Dilettanti commissioned R. P. Pullan to investigate the site of the Smintheion of Chrysa. In the autumn of 1866 Pullan's excavations were completed. His report appeared in 1881 (*Antiquities of Ionia*, IV, pp. 40ff, pls. 26-30). The plates depict not so much the state of the excavated findings as Pullan's reconstructions. In vol. 5 of the same work (1915) appeared some supplements to Pullan's publications by W. R. Lethaby (see below for further references). Since the temple edifice excavated by Pullan no longer exists and the other architectural remains have also almost all been lost, great importance has accrued to the early publication even if it no longer satisfies present-day points of view.

According to Pullan the Temple of Chrysa was an

Ionic pseudo-dipteral structure (8 x 14 columns); the substructure of 11 steps has, however, been questioned (see Dinsmoor below, p. 272, n. 2). The stylobate was 40.4 by 22.5 m. In front of the cella to the E lay a deep pronaos or vestibule, in back, a short opisthodomos, each with two columns in antis. The narrow Ionic columns of 24 flutes stood upon an extraordinary base that represented a type of "Ephesian-Attic" mixed form (cf. H. C. Butler, *Sardis*, ii, p. 114, fig. 11). The columns carried richly decorated Hellenistic capitals, one of which is still preserved. The visible parts of the building were of marble. There was in addition a decorated figure frieze (0.8 m in height) above the architrave. Pullan was not able to display the six frieze slabs in his publication. They have now for the most part been lost, along with the other remains of the temple, so that a few years ago only one complete slab in Gülpinar and a few fragments were rediscovered and could be published (see below, H. Weber). Depicted are a two-horse chariot with driver and two other persons, two battle scenes between armed men, and single male and female figures, which unfortunately have recently become detached from the relief.

To judge from the building ornamentation and the style of the frieze, the temple was constructed ca. 200 B.C. or in the early 2d c. Accordingly the cult image by Skopas (see below, Grace and Lacroix) must have been carried over from an older edifice into the later Hellenistic temple.

The building remains that can still be seen in the valley below the village of Gülpinar consist partly of brick walls and could belong to the site of Chrysa seen by Strabo.

BIBLIOGRAPHY. H. Schliemann, *Reise in der Troas im Mai 1881* (1881) 15f; W. R. Lethaby, *Greek Buildings Represented by Fragments in the British Museum* (1908) 195; W. Leaf, *Strabo on the Troad* (1923) 240ff; *RE* 3 A (1927) 724 s.v. Sminthe (Bürchner); V. R. Grace, *JHS* 52 (1932) 228-32; L. Lacroix, *Reproductions de statues sur les monnaies grecques* (1949) 84ff, 318; W. B. Dinsmoor, *Architecture of Ancient Greece* (3d ed. 1950) 272f; J. M. Cook, "Archaeological Reports for 1959-60," 30 fig. 2; H. Weber, *IstMitt* 16 (1966) 100-114.

H. WEBER

SMOKOVON, *see under* RENTINA

SMOKTOVINA, *see* LIMES, GREEK EPEIROS

SMORNE, *see* LIMES OF DJERDAP

SMYRNA (Izmir) Turkey. Map 7. The early Hellenic settlement lay on a small peninsula, inhabited since the beginning of the 3d millennium B.C., on the NE coast of the gulf of Smyrna. This site is now a hill E of the town of Bayraklı, 4 km N of Izmir. Strabo (14.646) reported that it lay 20 stadia from the city of his time, on a bay beyond it, and gave the exact location.

The earliest Protogeometric pottery found in abundance at Bayraklı reveals that the first Hellenic settlement was founded in the 10th or even the 11th c. B.C., confirming the traditions (Eusebios, Eratosthenes, pseudo-Herodotean *Life of Homeros*), which place the Aiolian and Ionian migration relatively soon after the collapse of the Mycenaean civilization. The Protogeometric pottery of Bayraklı is closely related to that of Athens, but it is also individual and probably of local manufacture. Geometric pottery (ca. 825-675 B.C.), in each of its three phases, also shows some Attic influence and relationship with neighboring E Greek centers, but is likewise of local origin.

The oldest building of the Hellenic settlement is an oval house consisting of a single room built ca. 900 B.C.; its wonderfully preserved courses of mudbrick and intact ground plan present the best available example of early Greek building, and in fact is the oldest one in existence. In the 9th c. rectangular houses appear: these likewise consist of a single large room but have stone foundations. Three well-preserved examples have been uncovered. In the next level, from before the middle of the 8th c. to the mid 7th, the oval house is dominant and rectangular ones rarely appear.

The earliest Greek defensive system dates back at least to the 9th c. Originally a deep core with thicknesses of mudbrick and stone packing in some places, and a facing of stout, irregular masonry, it was restored or enlarged more than once down to the late 7th c.

The early Hellenic stratum (1050-650 B.C.) reveals a simple existence based mainly on agriculture. There are no cultural artifacts except pottery, no sign of imports from the E, and of course no evidence of writing. The settlers, however, kept alive the custom of singing tales of their ancestors' achievements; they must have preserved as an oral tradition the song of the deeds of Achilles and Agamemnon, and the tales of the Achaean heroes who preceded them in colonization. Thus emerged the Homeric epos, composed in both Aiolian and Ionian dialects. Smyrna, on the border of Aiolis and Ionia, was probably the actual birthplace of Homer and the *Iliad*, in the second half of the 8th c. B.C.

The city enjoyed its greatest prosperity between 650 and 545 B.C. The houses of this period are of the megaron type, consisting of a porch and two rooms; in one example two megara were coupled to form a relatively elaborate house type, composed of a porch, three rooms, and one courtyard, and some houses had terracotta bathtubs. The houses were always oriented N-S or W-E, indicating some axial planning as early as the 7th c.

The well-preserved temenos terrace of the temple, with walls of carefully fitted polygonal and rectagonal masonry, is now entirely uncovered. The first monumental structure of the sanctuary dates from the third quarter of the 7th c.; it was destroyed by Alyattes (Hdt. 1.16; 14.646) about 600 B.C., rebuilt and its temenos enlarged about 580, and completely ruined by the Persians about 545 B.C. The temple in its last phase, with its carved Proto-Aiolic capitals, was the earliest monumental sanctuary of the E Greek world; it was dedicated to Athena, according to the inscription on a small bronze bar recently excavated.

The houses have yielded bird bowls, charming examples of vases in the wild goat style, and statuettes in bronze, ivory, and terracotta. Fragments of delicately carved stone statues date from about 600 B.C. The abundance of Cypriote and Syrian statuettes and of Lydian pottery demonstrates the international trade developed by the Ionians after the middle of the 7th c. After 580 Attic imports provided models for the new style of E Greek black-figured vase painting.

The city was insignificant during the 5th-4th c.; the houses were of the long type and still arranged on an axial plan. In the time of Alexander the Great, however, the population outgrew the peninsula, and a new, larger city was founded on the slope of Mt. Pagos. Coins of Marcus Aurelius, Gordianus, and Philippus Arabus, show Alexander sleeping under the plane tree, on Mt. Pagos, and the two Nemeses who directed him in a dream to build a city here.

Strabo (14.646) described Smyrna as the finest Ionian city of his time, the turn of the 1st c. B.C. The city was centered around the harbor, on flat land where the Temple of the Mother Goddess and the gymnasium also stood. The streets were straight and paved with large stones. The orator Aelius Aristeides, who came from

Smyrna, also mentions the straightness and the paving, and states that the two main thoroughfares, the Sacred Way and the Golden Road, ran E-W, so that the wind from the sea cooled the city. Some years ago an ancient road was unearthed, running E-W. It was well paved, 10 m wide, and had a roofed-over pavement for pedestrians along the side near the mountain; possibly it is part of the Sacred Way. Strabo also mentioned a stoa called the Homereion (probably in the shape of a peristyle house).

Nothing remains of the theater on the NW slope of Mt. Pagos, or of the stadium on the W. A silo built by Hadrian once stood near the harbor, indicating that the commercial agora lay close to the docks, but it has not been located. On the other hand, the state agora is well preserved: a courtyard 120 by at least 80 m, with stoas on the E and W sides (excavated for 35 and 72 m respectively). These stoas were 17.5 m wide and had two stories, each of which was divided into three, longitudinally, by two rows of columns. On the N side a similar two-storied colonnade consisted of a nave and two aisles, 28 m wide. The main stoa of the agora was called a basilica. There is also a magnificent vaulted basement beneath the N colonnade, still in splendid condition. The N aisle in the basement was composed of shops, which must have opened onto a street in Roman times. Court cases were heard in an exedra in the W part of the N colonnade. The stoa on the S side, not yet excavated, must also have had two stories with a nave and two aisles.

After an earthquake in A.D. 178 the city was reconstructed with help from Marcus Aurelius. This is confirmed by a portrait of his wife, Faustina II, still visible over an arch of the W colonnade, which must have been restored shortly after the earthquake. Stylistic considerations probably date construction of the N stoa to the end of the 2d c. A.D.

Aelius Aristeides relates that ca. 150 B.C. an altar to Zeus occupied a central position in the agora. Two high reliefs depicting a large group of gods, possibly connected with the altar, have been uncovered, on which Demeter is shown standing next to Poseidon. It may well be that placing these deities side by side was intended to demonstrate that Smyrna at that time dominated commerce by both land and sea.

BIBLIOGRAPHY. Bürchner, *RE* III A 734ff; F. Miltner, *WJh* (1931) Beibl. 127-88; C. J. Cadoux, *Ancient Smyrna* (1938); E. Akurgal, "Smyrna à l'époque archaïque et classique," *Belleten* 37 (1946) 72-80; id., *Bayraklı* (1949); id., *Die Kunst Anatoliens* (1961) 8-16, 178-88, 282-84; id., *AJA* 66 (1962) 369-79; id., *Ancient Civilizations and Ruins of Turkey* (1970) 119-24; J. Cook, "Old Smyrna," *BSA* 53-54 (1958-59); id., "Greek Settlement in the Eastern Aegean and Asia Minor," *CAH* (1961); id., *The Greeks in Ionia and the East* (1962) 1-35; id., "Ionic Black-figure," *BSA* 60 (1965) 114-53; R. V. Nicholls, "Fortifications," ibid. 53-54 (1958-59) 36-137; J. K. Anderson, "The Corinthian Pottery," ibid. 138-51; J. Boardman, "The Attic Pottery," ibid. 152-81; L. H. Jeffery, "Inscriptions," ibid. 59 (1964) 39-49.
E. AKURGAL

SOFIA, see SERDICA

SOFIANA, see PHILOSOPHIANA

SÖGLE ("Podalia") Lycia, Turkey. Map 7. Almost certainly at Söğle, 13 km SE of Elmalı. First mentioned by Pliny (*HN* 5.101), then by Ptolemy, who places it in Milyas, and Hierokles. A bishop of Podalia is recorded in the Byzantine lists. In the 2d c. A.D. the city was among those which received benefits from Opramoas of Rhodiapolis (*TAM* II 905), and was one of those which honored Jason of Kyaneai (*IGRR* III 704). The very rare coins of Podalia are of the time of Gordian III.

The site is not determined with absolute certainty. Early locations at Eskihisar and at Armutlu are unsupported by evidence and are to be rejected. A more satisfactory suggestion was a site on a hill at the NW corner of the lake Avlan Gölü, 16 km S of Elmalı; this is surrounded by a ring wall of ashlar masonry well preserved on the W side, enclosing a small tower and quantities of uncut building stones. There are also two small rock-cut tombs. Pottery on the hill is Hellenistic and later; on the plain below some Early Bronze pieces have been found. These remains are not in themselves suggestive of a city site so much as a military fortress; but the place was known locally as "Podalia," with a variant "Podamia."

The site at Söğle is of quite different character. At the edge of the village is a hill, lower on the N side than on the S, strewn with abundant sherds ranging in date from the Early Bronze Age to Byzantine times. In the village are numerous evidences of urban occupation—altars, exvotos, and many other carved blocks, and inscriptions of Roman and Byzantine date. Here is undoubtedly a city site, which can hardly be other than Podalia. In this part of Lycia only two cities are known, Podalia and Choma, and Choma is now located with certainty at Hacımusalar to the SW of Elmalı. The plain of Elmalı falls into two distinct parts, to the S and to the NE, both good fertile land; in the former is Choma, with Comba a little farther to the SW; if Podalia be placed at Avlan Gölü there are three cities in this region, while the NE plain remains blank. It seems that for Avlan Gölü the alternative name Podamia (Potamia) should be accepted; this is eminently suitable for a site close beside the spot where the river Akçay, the ancient Aedesa, runs into the lake.

BIBLIOGRAPHY. E. Petersen & F. von Luschan, *Reisen in Lykien* (1889) II 161-62; G. E. Bean in *AnzWien* 8 (1968) 157-63; id., *Journeys in Northern Lycia 1965-1967* (*DenkschrWien* No. 104, 1971) 28-32. G. E. BEAN

SÖĞÜT ("Amnistos") Caria, Turkey. Map 7. Ruins at a town 12 km N-NW of Marmaris. Amnistos was a Rhodian deme attached to the city of Kamiros. The demotic is fairly common in Rhodian inscriptions, but the only evidence for the site is an epitaph of an Amnistian found ca. 1.6 km from Söğüt; this is of course inconclusive, and it is not in fact certain even that Amnistos was in the Peraea and not on the island.

The ruins at Söğüt consist of a substantial fort on a headland with a wall of mixed ashlar and polygonal masonry, the approach guarded by a tower; on the shore of the bay below is a stretch of quay wall in good isodomic ashlar.

BIBLIOGRAPHY. G. E. Bean & J. M. Cook, *BSA* 52 (1957) 61. G. E. BEAN

SOISSONS, see AUGUSTA SUESSIONUM

SOLICIA, see SOLIMARIACA

SOLIMARIACA or Solicia Soulousse-sous-Saint-Elophe, Vosges, France. Map 23. A way station along the great Langres-Trier road, at the crossing of the small river Vair. In antiquity two names were applied to the site. Solimariaca (*Antonine Itinerary*) and vicani Solimariacenses (*CIL* XIII, 4681, 4683) may be the name of the establishment of Celtic origin on the hilltop, whereas Solicia (vicus Soliciae: *CIL* XIII, 4679) may designate the

valley settlement. Several campaigns of excavation were conducted on the site between 1822 and 1890. Of particular note was a small rectangular fort of the 4th c., built to control the river crossing. Its walls were built of disparate elements, among others reused funerary stelae, now kept at the Epinal museum. This museum has other monuments found at various times in the gardens and fields of the village. One such find is a piece of an altar dated precisely to 27 June 232; it bears the names of Alexander Severus (erased) and his mother, with a dedication to the tutelary spirit of the pagus (*CIL* XIII, 4679). Two votive monuments are dedicated to Mercury and his cult associate, Rosmerta. A stela depicts Mercury standing in a niche. An altar depicts the mallet-god and, below, busts of the seven gods of the week. Numerous funerary monuments depict a married couple, or scenes of family life, or motifs recalling the profession of the deceased; several bear an ascia. The Metz museum, for its part, has acquired 22 funerary stelae. Another, depicting three human figures, can be seen encased in the wall above the S door of the village church. In 1856 a mosaic (16 m square) was uncovered, and in 1890 a Roman edifice with an apse, possibly a basilica; today no trace remains of either. The majority of the finds (coins and artifacts of bone, bronze, iron, glass, and pottery) are deposited in the Epinal museum. The Musée Lorrain at Nancy has acquired an ivory statuette of Apollo.

In 1958 public works led to the discovery of several carved stones. Among these were a large stela depicting Rosmerta carrying a libation cup and a cornucopia, and a capital with a sculpted head leaning against it, no doubt part of a funerary monument. In 1966 a test pit dug a little outside the village at the locality called La Potière brought to light the foundations of a villa. There were two cellars (perhaps used as sanctuaries); they yielded a fairly large assemblage of finds: a piece of a limestone table, earthenware tumblers, a dolium, a small bronze vase, and a small bronze bust of a divinity. The building seems to have been destroyed in the invasions of the second half of the 3d c. and was never reoccupied later on.

Also in 1966 excavation inside the village led to the discovery of two milestones, broken in situ, but complete. They were erected, apparently in 321, in honor of the two sons of Constantine the Great, the Caesars Flavius Crispus and Flavius Claudius Constantinus. The distance indicated on them (VIII leugae) still has not been interpreted satisfactorily.

BIBLIOGRAPHY. J.B.P. Jollois, *Mémoires sur quelques antiquités remarquables du département des Vosges* (1843) 57-68, pls. XVII-XX[MPI]; M. Toussaint, "Soulosse et ses antiquités gallo-romaines" in *Pays Lorrain* (1935) 529-45[MI]; id., *Répertoire archéologique Vosges* (1948) 56-74; R. Billoret, "Découverte de deux bornes milliaires à Soulosse (Vosges)," *Rev. arch. de l'Est et du Centre-Est* 20 (1969) 219-33[MI]; 30 (1972). R. BILLORET

SOLIN, *see* SALONA

SOLOEIS or SOLUNTUM Sicily. Map 17B. The ruins of an ancient city ca. 20 km E of Palermo, near the village of Santa Flavia, on a plateau of Monte Catalfano.

Among the ancient sources, the only definite reference to the site is Thucycides (6.2.6), which says that when the Greeks began to arrive, the Phoenicians abandoned most of their settlements and retired to Motya, Soloeis, and Panormos. These events must have occurred between the end of the 8th and the first half of the 7th c. B.C., at a time when the Greek colonization of Sicily could be considered for the most part accomplished. Motya and Panormos correspond closely in their historical and the archaeological evidence; but at Soloeis the archaeological remains clearly illustrate its Hellenistic-Roman phase, which was originally dated to the 2d c. B.C.-2d c. A.D.

Recent excavation has shown that the city was founded about the middle of the 4th c. B.C. by the inhabitants of an earlier Soloeis which had been destroyed by Dionysios a few years before (Diod. 14.48.5; 78.7). The earlier city may possibly be identified with the nearby area of Cannita, from which come two sarcophagi (Palermo Museum) and where the finds date at the latest from the 4th c. B.C. By 307 B.C. the new city must already have been in existence since Agathokles' African veterans were sent here (Diod. 20.64.4). It surrendered to the Romans in 254 B.C. (Diod. 23.18); Cicero (*Verr.* 3.103) mentions it among the civitates decumanae which were victimized by Verres. An inscription mentioning a dedication by the respublica Soluntinorum to Fulvia Plautilla (*CIL* x, 2 no. 7336) dates from the time of Antoninus Pius. The latest archaeological finds are some coins of Commodus (A.D. 180-192): in this period or perhaps to the following century the city was probably abandoned.

The extensive remains were identified at the end of the 16th c. by the Sicilian topographer T. Fazello, who also noted long stretches of the walls, which have been recently located. In 1825 the statue of a seated god, 2d-1st c. B.C., was discovered; the sculpture is now in the Palermo Museum. Since that time several excavation campaigns have uncovered most of the ancient city.

The very regular urban plan was carefully studied and rigorously applied to a difficult terrain, an elevated hilly area which at some points presents differences in level as great as 60 m. A street partly paved with large tiles and approximately 6 m wide crosses the city almost in its center with a SE-NW direction. Two streets run parallel to this road on either side of it; they are all crossed at right angles by other streets paved with large stone blocks, ranging in width from 3 to 5.8 m and often with an inclination which in places is as great as 1:4. These streets form a regular network which isolates rectangular blocks of consistent dimensions (40 x 80 m); these insulae are in turn divided lengthwise down the middle by a narrow alley, the so-called ambitus (0.80 - 1.00 m in width) which serves a double function as a channel to collect rain water and as a ventilation shaft for the inner rooms of the houses.

The houses fall into two main types: those with a central peristyle of Hellenistic-Roman type surrounded by the various rooms of the house, and those without this typical courtyard. Houses of the first type are grouped in the center of the city, while those of the second are on the periphery. As many as six houses of the first type stood within one insula, some of them are as large as 540 m square and exhibiting a certain refinement both in architectural details and interior decoration; their rooms are often adorned with wall paintings. The second type, never larger than 400 m square, could accommodate up to eight houses in one block.

The public buildings are confined to a section at the SW end of the city; this civic area begins with an open-air altar of Punic type, located where the main road paved with bricks widens into a large square; there are other sacred structures, the square proper, the theater, the odeon (or bouleuterion) a large public cistern, and several other buildings, one of which was probably a gymnasium. This general area is not crossed by side streets, but is perfectly inserted within the grid system since the size of each public building is an exact multiple of the basic unit for the insula.

This Greek urbanistic context has certain Punic fea-

tures, which reflect the spiritual needs of the city's non-Greek inhabitants—major and minor monuments particularly connected with religion, the cult of the dead, or the objects of daily living.

Besides the open-air altar previously mentioned, two more religious structures, clearly of Oriental derivation, have been found in the city. One of these comprises several rooms accessible through a long corridor, and is located on the highest point of the city (the "high places" of the Bible). The second structure lies somewhat lower down, and has two vaulted rooms, each of which must have contained the statue of a divinity, in one a male and in the other a female. Of these statues, the first is most likely to be the god found in 1825 and previously mentioned; the second perhaps Astarte (also Palermo Museum) seated on a throne flanked by two winged sphinxes. The size of this work, which is considerably smaller than that of the male divinity, makes the attribution to the sanctuary somewhat uncertain.

The necropolis lies at the foot of Monte Catalfano; most of its graves are of Punic type and are cut in the rock, either as a simple cist into which a stone sarcophagus was placed, or as one or two subterranean chambers with a dromos; within these chamber tombs, on benches, were one or more sarcophagi, together with funerary offerings.

Both the houses and the graves have yielded Punic pottery together with Greek and Hellenistic-Roman wares.

Perhaps better than other sites in Western Sicily the city can testify to that encounter between Greek and Punic culture which represented one of the most interesting components for our knowledge of ancient Mediterranean history. The city had its own mint and issued coins bearing both Greek and Punic legends.

At the entrance to the archaeological zone is a small antiquarium.

BIBLIOGRAPHY. A. Tusa-Cutroni, "Vita dei Medaglieri," *Atti Istituto Italiano di Numismatica* 2 (1955) 192ff; V. Tusa, "La questione di Solunto e la dea femminile seduta," *Karthago* 12 (1963-64) 3ff[MI]; id., "Edificio Sacro a Solunto," *Palladio* 17 (1967) 155ff[PI]; E. Gabrici, "Alla ricerca della Solunto di Tucidide," *Kokalos* 5 (1959) 1ff; L. Natoli, "Caratteri della cultura abitativa soluntina," *Scritti in Onore di Salvatore Caronia* (1965) 1ff[MPI]; A. M. Bisi, "Le stele puniche di Solunto," *ArchCl* 17 (1965) 211ff[I]. V. TUSA

SOLOI (Potamos tou Kambou) Cyprus. Map 6. On the NW coast in the area of Morphou Bay. The ruins cover a large area, part of which is now occupied by the modern village. The city extended on the summit of a hill, a little back from the coast and over its N slope overlooking the bay; it also extended over a narrow strip of flat land below as far as the harbor. The city consisted of two parts, the acropolis and the lower city.

The city wall can still be traced along the S ridge of the acropolis. To the E it follows the edge of the hill down to a point ca. 100 m E of the theater, where it disappears in the plain. In all likelihood it reached the coast and was continued by the E breakwater of the harbor, the end of which is still visible above the water. The W part of the city wall runs from the acropolis in a NW direction and disappears in the village near the modern main road. Near the middle of the last portion of the wall traces of the W gate have been located. This wall must have also reached the coast, where it was continued by the W breakwater, the end of which is again visible above the water. These two extremities formed the entrance to the harbor, now entirely silted

up. A similar arrangement of walls and breakwaters is to be seen at Nea Paphos (q.v.). This then was the winter harbor of Skylax (*GGM* 1.103), also mentioned by Strabo (14.683). The necropolis extends E and S, with the earliest tombs found in the E necropolis.

Soloi, one of the ancient kingdoms of Cyprus, was, according to tradition, founded by Akamas and Phaleros. According to another version, a city called Aipeia (supposed to have been the predecessor of Soloi) was founded by Demophon, brother of Akamas. The name is connected with the visit of the Athenian lawgiver Solon to Cyprus and to Philokypros of Aipeia. Solon advised the king to remove the city of Aipeia from its inconvenient position in rough country to the plain by the sea. Philokypros took the advice and founded a new city, which he called Soloi in honor of his friend.

Owing to the existence of copper mines, the richest in the island, the area was inhabited at an early date and the presence of Late Bronze Age settlements in the vicinity is well attested. On archaeological evidence available today, the city site has been occupied since Geometric times and like some other cities in the island such as Salamis, Soloi may have succeeded a Late Bronze Age town in the neighborhood. It owed its prosperity to the nearby copper mines, and flourished down to Early Byzantine times, when it was gradually abandoned after the first Arab raids of A.D. 647.

Little is known of its earliest history, though from Classical times onwards the city played an important role in the history of Cyprus and at least in the times of Alexander the Great seems to have been the most important city of the island after Salamis.

During the rising against the Persians at the time of the Ionian Revolt the king of Soloi, Aristokypros, son of Philokypros, was killed in the battle on the plain of Salamis. Soloi itself successfully resisted the siege of the Persians for five months but was finally captured, when the city walls had been undermined. After this time there are but a few records of the city in literature. From inscriptions, however, we know the names of Kings Stasias and Stasikrates, probably living in the 4th c. B.C.

The kings of Cyprus assisted Alexander the Great actively during the siege of Tyre and some of them accompanied him on his way to the E. The kings of Salamis and Soloi paid the expenses for the choruses, when celebrating in 331 the capture of Tyre. Nikokreon of Salamis and Pasikrates of Soloi vied with each other as choregoi, the Athenian tragic actor Athenodoros, provided by Pasikrates, being victorious. Nikokles, the son of Pasikrates, was one of the leaders of the Cypriot fleet, which was used by Alexander on his expedition to Indus. And Stasanor, possibly a brother of Pasikrates, also accompanied Alexander. Alexander made Stasanor governor of Areia and Drangiane in 329 and later in 321 he also received Bactria and Sogdiane. Hiero of Soloi, also was sent to circumnavigate the Arabian peninsula and got as far as the mouth of the Persian Gulf. Soloi is the birthplace of the peripatetic historian Klearchos, a pupil of Aristotle.

The last king of Soloi was called Eunostos, probably the elder son of Pasikrates. All the kingdoms of Cyprus were abolished by Ptolemy I Soter with the exception of Soloi, which seems to have been in an exceptional position. How long Pasikrates continued to reign after we last hear of him in 321, when he sided with Ptolemy, we do not know; Eunostos, however, was his successor.

During the Ptolemaic period little is known of Soloi though contacts with Alexandria must have been maintained. The city continued to flourish in Graeco-Roman times and soon became the seat of a bishop. According

to the *Acta Auxibii* (8-9), the saint was baptized and ordained bishop by John Mark the Evangelist and sent to Soloi, where he lived for fifty years (A.D. 52–102/3).

The principal monuments uncovered so far include the theater, an archaic Greek temple on the acropolis, both excavated in 1929, and part of the lower city and an Early Christian basilican church in 1965 onwards.

Of the temples at Cholades excavated by the former expedition nothing is visible, the site having been filled up subsequently. The temples date from Hellenistic and Graeco-Roman times and the gods worshiped there have been identified with Aphrodite, Kybele, Isis, Serapis, the Dioskouroi, Canopos, Eros, Priapos, and possibly Mithras. Strabo mentions a Temple of Aphrodite and Isis and from the *Acta Auxibii* we learn of the Temple of Zeus near the W gate. A city of the importance of Soloi could not have been without a gymnasium, but of it nothing is known. Trial trenches on the S side of the acropolis have shown that the royal palace should be located here.

Excavations in the lower city revealed several buildings dating from archaic to Graeco-Roman times. The structures in the late Graeco-Roman period were erected on workshops of the early Graeco-Roman period. Among the workshops were identified a glass factory and a dyer's factory. In the lower layers were remains of Hellenistic buildings and among the Classical levels a public building built of well-dressed stones. Below the levels of the Classical period, represented by an accumulation of debris corresponding to the Persian wars, were found the remains of the archaic city.

Probably the most important discovery to date is that of a large street paved with stone slabs. The part revealed measures 4.95 m in width. On the S side was a portico with columns of which the bases are preserved in situ. This was certainly the main E-W street in Graeco-Roman times—it probably dates from the 3d c. A.D.—and may have been a colonnaded street.

The theater lies on the N slope of the lower hill, E of the acropolis, overlooking the sea to the N. It consists of the cavea, which had been cut in the rock, of a semicircular orchestra, and of the stage-building. A diazoma encircled the cavea two-thirds of the way up. The semicircular cavea had a diameter of 52 m. The floor of the orchestra was plastered with lime-cement on a substructure of rubble; it had a diameter of 17 m. The stage-building is rectangular, 36.15 m x 13.20 m; but of this structure only the platform on which it was built is preserved. The theater could hold about 3500 spectators. It has recently been reconstructed to its diazoma.

The recent excavation of tombs in the E necropolis yielded some very interesting results. One of the tombs dates from the Cypro-Geometric period, a fact which adds about two centuries to the material hitherto known from the area. But the most important discovery was that in the dromos of one of the archaic tombs: in front of the burial chamber of the rock-cut tomb were found the remains of a horse and of a smaller animal, probably a sheep, sacrificed in honor of the dead. Similar customs of sacrifice and burial of animals are known at Salamis, Tamassos, and Palaipaphos, but in Soloi they were recorded for the first time.

The finds are in the Cyprus Museum, Nicosia.

BIBLIOGRAPHY. A. Sakellarios, Τὰ Κυπριακά I (1890); I. K. Peristianes, Γενικὴ Ἱστορία τῆς νήσου Κύπρου (1910); Alfred Westholm, *The Temples of Soloi* (1936)[PI]; Einar Gjerstad et al., *Swedish Cyprus Expedition* III (1937)[MPI]; Jean des Gagniers et al., "Trois campagnes de Fouilles à Soloi," *Report of the Department of Antiquities, Cyprus* (1967) 50-58[PI]; id., "Soloi. Fouilles de l'Université Laval, Quebec," Πρακτικά τοῦ Α'Διεθνοῦς Κυπρολογικοῦ Συνεδρίου (1972) 41-49[I]; Demos Christou, "Νέαι Ἀρχαιολογικαί Μαρτυρίαι ἐκ τῆς Νεκροπόλεως πῶν Σόλων," *Report of the Department of Antiquities*, Cyprus (1973) 91-102[MI]; id., "Τά μέχρι τοῦδε ἱστορικά καί ἀρχαιολογικά δεδομένα τῶν Σόλων," Κυπριακαί Σπουδαί ΛΖ' (1973) 235-54[MI]. K. NICOLAOU

SOLOI later POMPEIOPOLIS Cilicia Campestris, Turkey. Map 6. A coastal city ca. 11 km W of Mersin on the river Mezetli. Founded by Argives and Rhodians from Lindos, and first mentioned by Xenophon, Soloi was fined 200 talents in 333 B.C. by Alexander for siding with Persia. Ravaged in the mid 70s B.C. by Tigranes of Armenia during the Mithridatic war, many inhabitants were deported to Tigranocerta; their city remained almost deserted until 67 B.C. when it was settled with ex-pirates by Pompey and renamed in his honor. That "solecisms" are derived from the atrocious Greek spoken in Soloi is perhaps untrue, for the poets Philemon and Aratus (quoted by St. Paul) at least were natives. As a bishopric Pompeiopolis was visited by Etheria, but succumbed to the Arabs in the 7th c.

There was more to be seen 150 years ago than today. The theater on the hill to the E has gone, but "the beautiful harbour, or basin, with parallel sides and circular ends" seen by Beaufort is still there, though silted up and robbed of its stone facing, leaving only the concrete core. Leading inland is a colonnaded street of which only 22 columns still stand to capital height, and inscribed brackets let into the shafts may have supported statues. One inscription at least, of the 320 m street (much of which was built in the 3d c.), is a fine solecism: "P. Aelius Hadrianus Traianus Decius."

BIBLIOGRAPHY. F. Beaufort, *Karamania* (1818) 259ff; Paribeni & Romanelli, *MonAnt* 23 (1915) 87-88; J. Keil & A. Wilhelm, *JOAI* 18 (1915) 55-58; P. Verzone, "Hieropolis Castabala, Tarso, Soli—Pompeiopolis, Kanytelleis," *Palladio* 1 (1957) 54-68. M. GOUGH

SOLOTHURN, *see* SALODURUM

SOLUNTUM, *see* SOLOEIS

SOLVA, *see* LIMES PANNONIAE

SOMMIÈRES and VILLEVIEILLE ("Vindomagus") Gard, France. Map 23. Important pre-Roman and Roman town situated N of the Via Domitiana on the coastal river of the Vidourle, on a secondary road running from Nîmes to Lodève. The Roman road crossed the river on a bridge with 17 arches, which is still fully preserved but partially hidden by the progressive extension of the modern town into the river bed.

The Roman town, which is little known, appears to have stood for the most part on the Villevieille plateau overlooking Sommières. The plateau has yielded numerous ancient remains (dwellings, mosaics, statues, inscriptions). There was doubtless also a suburb on the left bank of the Vidourle, near the bridge, where the mediaeval town stood. The location of the pre-Roman oppidum, on the other hand, is definitely known to have been on the eminence overlooking the river, exactly W of the present village of Villevieille. The site, in a commanding and naturally strong position, is surrounded by a dry stone wall. Recent explorations show it to have been inhabited from the 6th c. B.C. on. The name of this ancient city of the Volcae Arecomici may have been Vindomagus (Ptol. 2.10.10).

BIBLIOGRAPHY. *Carte archéologique de la Gaule romaine*, fasc. VIII, Gard (1941) 18-19, nos. 54-55; M. Py, "L'oppidum préromain de Villevieille (Gard)," *Revue Archéologique de Narbonnaise* 4 (1971) 917-32.

G. BARRUOL

SOPHIA, see SERDICA

SOPIANAE (Pécs) Hungary. Map 12. A Roman town lying under the center of the present town.

Rooms (4 x 4 m and 4 x 6 m) were found in the ruins of a Roman palace (ca. 50 m long). The foundations of nearly 50 Roman buildings have been unearthed and at a distance of 50 m the walls of still other, large Roman buildings were found, among others a bathing pool with pipes (5 x 5 m), remains of a hypocaust, white marble veneer, remains of frescos, and nearly 1000 coins of the 2d, 3d, and 4th c. (in the Pécs museum). The ruins of a municipal building (75 x 150 m), built in the first half of the 2d c., has been found. About 500 m S of this another building complex (30 x 17 m) of the same era was discovered. The ruins of the Roman town were used as cemeteries by the end of the 4th c.

The location of the cemetery of the 2d c. is not known but the cemeteries of the 3d and 4th c. lay to the N and E of the town. In the 3d c. graves were found rich golden jewelry, bracelets, glass, pottery, coins, etc. Decorated and painted ancient Christian burial chambers and numerous (ca. 300) graves found in their vicinity make the cemetery of Sopianae the largest ancient Christian cemetery in Pannonia. Continuous burial in it can be traced from the third decade of the 4th c. to the beginning of the 5th. Written documents do not mention a bishop's seat, but on the basis of its Christian relics, it can be assumed that a bishopric was established here in the 4th c. From the middle of that century it is probable that the Arian heretic movement was as strong in Sopianae as in the rest of Pannonia.

The Roman population survived in the city into the 5th and 6th c.

BIBLIOGRAPHY. J. Koller, *Prolegomena in historiam episcopatus Quinqueecclesiarum* (1804)[P]; G. Gosztonyi, *A pécsi ókeresztény temető*[MPI]; F. Gerke, "Die Wandmalereien der neugefundenen Grabkammer in Pécs," *Neue Beiträge zur Kunstgeschichte des 1. Jahrtausends* 1 (1952) 115-37[PI]; id., *Die Wandmalereien der Petrus-Paulus-Katakombe in Pécs* (1954) 147-99[PI]; F. Fülep, *Sopianae római kori emlékei* (1963)[MPI].

F. FÜLEP

SOPRON, see SCARBANTIA

SORA Italy. Map 16. Some 96 km E-SE of Rome in fertile country in a bend of the river Liris. First mentioned as a Volscian town, Sora fell to Rome in the 4th c. B.C. and was made a Latin colony in 303 B.C. It acquired Roman citizenship in 90 B.C. and soon became a Roman colonia. Marius' birthplace, Cereatae, lay some 16 km to the SW, where the abbey of Casamari now stands.

The visible ancient monuments in the town proper are the substructures of the Duomo and a large (temple ?) podium; polygonal fortifications exist on the pyramidal citadel, Monte S. Casto, which, as vividly described by Livy (9.24), towers some 244 m above the town. Since 1883 a modern bridge has replaced the Roman one across the Liris, but another Roman bridge (Ponte Marmone, probably of the 2d c. B.C.) still survives ca. 4 km below Sora, near the church of San Domenico, which incorporates Roman masonry thought by some to belong to the villa where Cicero was born.

BIBLIOGRAPHY. S. Aurigemma, *Configurazione Stradale della Regione Sorana nell' Epoca Romana* (1911); A. Lauri, *Sora e il Suo Castello Romano-medioevale* (1958).

E. T. SALMON

SORCY-SAINT-MARTIN Meuse, France. Map 23. Dominating the valley of the Meuse, the village of Sorcy, and the old abbey of Saint-Martin, the Cote-Chatel has been a center of religious activity from ancient times until the end of the 18th c. Excavations undertaken in 1967 revealed the existence of a Gallo-Roman fanum on the site. It was approximately square (average length of sides: 19.4 m) with a cella inside, also square (average length of sides: 7.4 m). The pottery and coins found date the destruction of the monument to the end of the 4th c.

A necropolis surrounded the foundations of the above building. The almost total lack of grave goods makes it hard to date, but some sarcophagus burials are from Merovingian times.

Below the edifice the remains of two other temples have been identified. They have the same plan as the other, but are smaller in size. Their construction seems to go back to the 1st c. A.D.: architectural and sculptural debris and 1st c. coins and fibulae were found in a pit belonging to the first period of construction. An architectural ornament depicting a mask of Apollo also seems to belong to one of the two monuments of the first period; it fits pieces of gabling discovered in the talus surrounding the more recent building.

BIBLIOGRAPHY. R. Billoret in *Gallia* 26 (1968); 28 (1970); 30 (1972).

R. BILLORET

SORDE L'ABBAYE Landes, France. Map 23. Commune of the Pays d'Orthe. (In the Middle Ages it was known as Sordo or Sordi, later Sordua; the Benedictine abbey was called Monasterium Sorduense.) In the Roman period the region was part of Novempopulania, whose capital was Eauze. Situated upstream from the confluence of the mountain torrents of Pau and Oloron, Sorde was a crossing-point and settlement from prehistoric times on.

To the N a rocky spur rises above it, with sites that go back to the Acheulian period under its S cliff. In the Bronze Age camps were set up on top of the spur. With the coming of the Pax Romana the people moved down into the plain and a settlement grew up on the banks of the Oloron river close to a road running from Burdigala (Bordeaux) to Spain. Sorde was probably the first stopping-place on this road after Aquae Tarbellicae (Dax), the ancient capital of the Tarbelli. The Roman road is still visible and in use.

The cultivated land in the commune abounds with Roman and mediaeval potsherds. Two structures have been partly excavated, one in the area called Barat de Vin, the other in the abbey close.

1) Barat de Vin or de Bin. The site has attracted attention because of some exceptionally well-preserved walls, 4.5 m high with gateways and windows of stone and brick masonry, and also because of a mosaic floor discovered at the beginning of the century. Excavations in 1964-67, not yet published, uncovered several buildings belonging to a complex that may have served as a statio: a large courtyard, with a series of rooms on the NE side opening onto a portico, and a great gallery on the SW with an openwork rear wall overlooking what used to be a branch of the river. At the W corner are baths; their plan is clear and the superstructures are partially preserved. Built apparently in the 3d c., they were modified in the 4th c. and embellished with stucco and geometric mosaics. The plan is very like that of the baths excavated in the abbey of Sorde at Las Hies in Jurançon.

An alveus projecting toward the outside opens into the frigidarium. The adjacent heated rooms were probably vaulted. Their hypocausts are well preserved; hot air was drawn off vertically by means of wall flues. The spacing and fixing of these flues is recorded by terracotta sockets fastened to the walls with large nails. The caldarium has two pools along its W wall. The windows lighting the hot rooms are exceptionally large, and many glass fragments have been found below them. The common use of window glass in the 4th c. made it possible to improve lighting without loss of heat.

2) Villa of the abbey (2 km W of Barat de Vin). Mosaics were found in 1870 and 1957 in the abbey close, and excavations 1957-64 led to the discovery of a group of buildings that extend into nearby estates where they cannot be investigated. Three periods are represented. A bath building, originally freestanding and erected ca. the 3d c., was joined (ca. 5th c.) to the W wing of another building by a peristyle courtyard. All the mosaic floors of the latter building can be dated to the 4th c. by coins of Constantine's reign; one coin was included in the nucleus of one of the floors. These are decorated with geometric designs: checkerboards, octagons formed by two interlaced squares and developed by lozenges. Some emblema have designs of plants, birds, and canthari. These finds are in a collection in the abbey. The plan of the baths is very like that of Barat de Vin.

BIBLIOGRAPHY. L. Palustre, *Congrès scientifique de Dax* (1882) pl. LXXI; Dufourcet et al., *L'Aquitaine historique et monumentale* (1890) 51; J. Lauffray, *Bulletin des amis de Sorde et du Pays d'Orthe* (1962, 1965, 1969); C. Lacoste, "Les mosaïques gallo-romaines du département des Landes," *Bulletin de la Société de Borda* (1962); J. Coupry, "Informations," *Gallia* 19 (1961) 396; 21 (1963) 332-35; 23 (1965) 436-39; 25 (1967) 367-69; H. P. Eydoux, *Les terrassiers de l'Histoire* (1966). J. LAUFFRAY

SORÈZE Tarn, France. Map 23. The oppidum of Berniquaut, on a spur of the Montagne Noire, dominates the plain of Sorèze and Revel from a height of 300 m. The site was a natural fortress. Investigations since 1967 have shown that the site was occupied throughout the Iron Age and until the beginning of our era. It was abandoned during the centuries of the Pax Romana, but was reoccupied in the 3d c. and remained in use throughout the early Middle Ages. Excavations have cleared a dry stone rampart (1.2-1.4 m thick) with bastion and postern. It was rebuilt several times; at present, it cannot be dated.

BIBLIOGRAPHY. M. Labrousse, "Informations," *Gallia* 26 (1968) 555; 28 (1970) 436; 30 (1972) 508.
 M. LABROUSSE

SORRENTO, see SURRENTUM

"SORVIODUNUM," see OLD SARUM

SOSINOU, see LIMES, GREEK EPEIROS

SOST, see FERRERE

SOSTOMAGUS (Castelnaudary) Aude, France. Map 23. The *Burdigalense Itinerary* indicates the post-station of Sostomago as 38 Roman miles E of Toulouse, on the Narbonne route, which situates it at Castelnaudary. This little town, whose name is mentioned for the first time in 1118 (Castrum novum Arri), is built on a hill whose highest point is called le Pech. It is generally thought that the ancient relay station Sostomagus, whose name is Gaulish in origin, was situated at the foot of the mediaeval settlement, on the site of the present basin of the Canal du Midi. In any case, excavations carried out in 1966 have uncovered the foundations of huts and of great silos dating from the 1st c. B.C. on the Pech itself and, 800 m from it, on the site of St.-Jacques.

BIBLIOGRAPHY. M. E. Griffe, "Les voies romaines du pays narbonnais," *Annales du Midi* 200 (1938)M; E. Baux, "La voie romaine de Narbonne à Toulouse," *Bull. de la Soc. d'Etudes scientifiques de l'Aude* 55 (1955)M; A. Grenier, *Carte arch. de la Gaule romaine, fasc. XII, Aude* (1959)MP; M. Passelac & G. Rancoule, "Les fosses à amphores du Pech et de Saint-Jacques à Castelnaudary (Aude)," *Bull. de la Soc. d'Etudes scientifiques de l'Aude* 68 (1968)PI. M. GAYRAUD

SOTIN, see LIMES PANNONIAE (Yugslav Sector)

SOUEIDA, see DIONYSIAS

SOUEILIM, see SELAEMA

SOUK EL ARBA DE SIDI-SLIMANE, see GILDA

SOUK EL ARBA DU GHARB, see TREMULI

SOUK EL JEMAA EL GOUR, see EL GOUR

SOULENA, see SOULIA

SOULES, see EUPALION under WEST LOKRIS

SOULIA or Soulena (Agia Galini), Crete. Map 11. A small ancient city on S coast of Crete in the Agios Vasileios district. Mentioned only by a coastal pilot (*Stad.* 324-25: a harbor with good water), it was the harbor of inland Sybrita; no coins of it are known. Its main deity was Artemis.

Remains, including an aqueduct, were noted by Buondelmonti at "Suveta" (1415); Halbherr confirmed the site's identification, first suggested by Pashley. When the site was reoccupied and rebuilt after 1884, remains were found of the sanctuary of Artemis (and many votive inscriptions to her), but no clear ground plan was recovered. All remains found were of Roman Imperial date, but the sanctuary could be of earlier origin. Halbherr also noted traces, not now visible, of poor buildings, perhaps ancient houses, around the sanctuary, which lies in a small coastal valley at the mouth of a stream, and tombs have been found above to the NE and E, but no traces of other public buildings. Near the shore are remains of a Roman concrete wall, probably a quay or seawall. The main settlement, or part of it, may have lain on a hill ca. 1 km NE of Agia Galini, on the W side of the mouth of the Platis (ancient Elektra), where sherds have been found on the top and E slope of the hill.

Remains of an ancient wreck have been found in shallow water by Cape Kakoskalo, E of Agia Galini and near Kokkinos Pirgos; the finds were mainly bronze objects, including statuettes and statue fragments, with a coin hoard probably dating from the reign of Probus (276-282). The collection was either the stock in trade of an itinerant smith or a pirate's haul.

BIBLIOGRAPHY. R. Pashley, *Travels in Crete* II (1837; repr. 1970) 303-4; F. Halbherr, *AJA* 11 (1896) 593-94; G. de Sanctis, *MonAnt* 11 (1901) 535-39; Honigmann, "Sulia," *RE* IV A1 (1931) 727; M. Guarducci, *ICr* II (1939) 278-88; E. Kirsten in F. Matz (ed.), *Forschungen auf Kreta* (1951) 136-37; S. Hood & P. Warren, *BSA* 61 (1966) 167-69MI. D. J. BLACKMAN

SOULOUSSE, see SOLIMARIACA

SOUNION Attica, Greece. Map 11. A rocky peninsula jutting into the sea at the S end of the region lies 69 km SE of Athens. It is famous for its classical marble temple which was built on the highest point of the cape and dedicated to the god Poseidon. It became the site of religious activities at least as early as 700 B.C. and in later times it was frequently used as a place of sanctuary by slaves who had run away from the nearby silver mines at Laurion. The earliest literary reference to the site occurs in the *Odyssey* (3.278) where it is said that Phrontis, Menelaus' pilot, was struck down by Apollo as he was passing the sacred cape; in the winter of 413-412 B.C. during the Peloponnesian War, it was fortified to protect the ships carrying corn to Athens (Thuc. 8.4); and later it was held by the slaves from the mines at Laurion during a civic unheaval (Posidonios, cited by Athenaeus, 6.272ff).

The marble Temple of Poseidon, built soon after the middle of the 5th c. B.C., is the main archaeological attraction of Sounion. Originally a colonnade encircled the pronaos, the cella, where the cult statue of Poseidon was placed, and the opisthodomos. Of the original colonnade, which had 6 columns across the facades and 13 along the sides, 2 columns still stand on the N and 9 along the S flank. These unusually thin columns are articulated by 16 flutes, rather than 20 the more common number. The lower two steps on which these columns stand are unusual in their variegated surface and the cavetto molding which undercuts the vertical raisers. One column still stands between the two antae of the pronaos; these are aligned with the third column of the colonnade, an unusual characteristic of this architect. Originally a sculptured frieze lined the four sides of the area in front of the pronaos. The frieze depicted the Battle of the Centaurs, the Battle of the Gods and Giants, and the deeds of Theseus. Several of the frieze blocks can be seen on the site resting against the fortification wall on the left as one approaches the temple. The pediments once held sculpture (no longer preserved) and the whole was crowned by floral akroteria. One of the akroteria, found almost complete, can be seen in the National Museum in Athens. The temple is built of coarse-grained marble from the nearby quarry of Agrileza. It was designed by the same architect who built the Temples of Hephaistos and Ares in Athens and the Temple of Nemesis at Rhamnous, as indicated by the design (for example the relationship of the porches to the lateral colonnade), proportions (the unusually thin columns combined with a heavy superstructure), dimensions, and style (the Ionic moldings and frieze). The Classical temple was constructed on top of the remains of an earlier unfinished temple made of poros limestone, begun in the early years of the 5th c. B.C. and destroyed by the Persians in 480. The foundations, steps, and scattered fragments of the columns and entablature of the earlier structure can be seen beneath the later one. Immediately to the S there is a small structure with partially preserved rubble walls which may have served as a temporary shrine after the destruction of the earlier temple and before the construction of the new one. The poros column drums that can be seen in its walls came from the earlier temple.

Stoas (about which little is known) once lined the N and W sides of the sacred area. Next to the stoa on the N lay the entrance into the precinct. This gateway consisted of two Doric porches of unequal length separated by a gate wall pierced by three doorways. A ramp led through the central door, similar to the Propylaea in Athens, so that animals for sacrifice could be led into the sanctuary. Marble benches lined the two porches. Fragments of 17 early archaic kouroi were found in a deep pit E of the Temple of Poseidon. The statues were probably damaged by the Persians at the time they destroyed the earlier temple. Since they were sacred dedications, they could not be entirely discarded, and thus they were deposited in the pit to make way for newer, undamaged dedications. The best preserved of the statues are on exhibit in the National Museum of Athens.

A fortification wall encircling the summit of the peninsula protected the inhabitants of the site. A few of the houses within the fortification have been excavated. They face onto a street roughly parallel to the N fortification wall and ca. 60 m distant from it. The houses were inhabited from the 5th c. B.C. to Roman times. The fortification wall can best be seen to the NE of the gateway. It is roughly 4 m thick, constructed of rubble masonry and faced with marble blocks. Square towers punctuated the wall at intervals of roughly 20 m. The fortifications were constructed toward the end of the 5th c. B.C.; during the Hellenistic period they were repaired and expanded. At this same time a ship-shed was constructed in a natural cove adjacent to the wall along the E side of the cape. A deep rectangular cutting ca. 21 m x 12 m can be seen extending inland from the sea. On the sloping floor of the cutting, two slipways were constructed to hold the ships; marble masonry originally surrounded the cutting and supported the roof.

On the low hill N of the main sanctuary there is a smaller temenos dedicated to Athena. Foundations of two small Classical temples and an enclosing precinct wall can be seen here. The larger of the two temples was built soon after the middle of the 5th c. B.C. and dedicated to the goddess Athena. Contrary to the normal plan of Greek temples, the colonnade of this temple was placed only across the front and along one side leaving the rear and N side without columns. Originally there appear to have been 10 columns across the front or E side and 12 columns along the S side. A small pronaos led to the main room of the temple. The remains of the base for the cult statue and foundations for 4 columns lie within this room. The two marble slabs at the E end mark the position of the threshold. Fragments of Ionic unfluted columns and various moldings of local gray-blue marble from Agriliza were found on the site. Identical fragments have been found in the Agora in Athens; it would appear that during the reign of the Emperor Augustus in the 1st c. A.D. part of this temple was transported to Athens and reerected in or near the Agora. One of the better-preserved capitals is on display in the Agora Museum and two of the capitals are in the National Museum.

To the N of the Athena Temple are the foundations of a smaller, later 5th c. B.C. temple. Foundations for the two columns which originally stood along the front, the marble threshold, the side and back walls made of local brown stone, and the blue Eleusinian base for the cult statue can be seen.

In the area around Sounion remains of at least five farming establishments have been found. Their most prominent feature is a towerlike structure, which probably served to protect both the inhabitants of the farm and the farm goods during piratical raids.

BIBLIOGRAPHY. B. Stais, Σουνίου Ἀνασκαφαί, *ArchEph* (1917) 168-213; A. K. Orlandos, Τοῦ ἐν Σουνίῳ ναοῦ τοῦ Ποσειδῶνος τοῖχοι καὶ ὀροφή, *ArchEph* (1917) 213-226; E.J.A. Kenny, "The Ancient Docks on the Promontory of Sounion," *BSA* 42 (1947) 194-200; J. H. Young, "Studies in South Attica, Country Estates at Sounion," *Hesperia* 25 (1956) 122-46; W. H. Plommer, "Three Attic Temples, Part II. The Temple of Poseidon," *BSA* 45 (1950) 78-94; W. H. Plommer, "The Temple of Poseidon on Cape Sunium: Some Further Questions," *BSA* 55 (1960) 218-33; H. F. Mussche, "Note sur les fortifications de Sounion," *BCH* 88 (1964) 423-32; A.

Delivorrias, "Poseidon-Tempel auk Kap Sunion. Neue Fragmente der Friesdekoration," *AM* 84 (1969) 127-42; W. B. Dinsmoor, Jr., *Guide to Sounion* (Athens 1970); H. A. Thompson & W. B. Dinsmoor, Jr., "The Sanctuary of Athena Sounias," *Hesperia* (forthcoming).

<div align="right">I. M. SHEAR</div>

SOUR DJOUAB, *see* RAPIDUM

SOUSSE, *see* HADRUMETUM

SOUTH SHIELDS, *see* ARBEIA *under* HADRIAN'S WALL

SOUYIA, *see* SYIA

SOZOPOL, *see* APOLLONIA DEL PONTO

SOZUSA, *see* APOLLONIA (Israel)

SPARGI, *see* SHIPWRECKS

SPARTA Lakonia, Greece. Map 9. In the heart of the fertile Eurotas valley ca. 56 km S of Tegea and 48 km N of Gytheion; the alluvial soil is fertile, the climate auspicious, and the low hill site protected by mountains and sea. Very few prehistoric remains are known, but a major contemporary settlement has been excavated about 3 km NE at the Menelaion. About 950 B.C. at the earliest Sparta was occupied by Dorians and settled as an agglomeration of villages (Pitana, Limnai, Mesoa, and Kynosura); the city wall, not begun until the late 4th c. and eventually completed in 184, measured 10 km in circumference and enclosed an elliptical area 3 x 2 km lying N-S.

In the 8th c. B.C. led by its two kings, the city embarked on the warmaking which by about 545 had brought "two-fifths of the Peloponnese" (Thuc.) under her immediate control. The inhabitants of the fertile Eurotas and Pamisos (Messenia) valleys were reduced to serfdom (Helots); those occupying more marginal land remained free but were denied political rights in Sparta (perioikoi). Thereafter Sparta expanded through diplomacy and by 500 B.C. had organized its subject-allies into the Peloponnesian League. In 405, supported by its allies and Persian gold it defeated Athens, but its supremacy in Greece was soon cut short by the Thebans: defeat at Leuktra in 371 was followed by the very first invasion of Lakonia and the liberation of Messenia in 369. After 243 Sparta was weakened by successive attempts, also led by its kings, at necessary social reform and in 195 lost its perioikic dependencies. But under the Roman Empire the city enjoyed a remarkable renascence of prosperity and reverted superficially to the rigid self-discipline of its heyday. Having survived the incursion of the Heruli in A.D. 267, the city was ruined by the Goths in 395, and finally abandoned.

As Thucydides warned, the power of Sparta should not be gauged from its surviving monuments. Of the settlement all but the foundations of a few Classical houses and some fine Roman mosaic floors is lost irreparably; only seven datable graves, four of about 600 B.C. and three Hellenistic, have been found, although burial was permitted within the settlement area, contrary to normal Greek practice; of the agora not even the location is certain. The acropolis is comparably denuded but at least its chief edifice, the Temple of Athena Chalkioikos, has yielded a crude two-layer stratigraphy. The material associated with part of the earliest altar consisted of a fair quantity of Protogeometric and Geometric pottery, none certainly earlier than the 8th c., and a few bronze votives. The temple was rebuilt in the 6th c. and the richer "Classical" stratum contained, inter alia, pottery, including Panathenaic amphora fragments; objects in bronze, ivory, and lead; the fine late archaic marble statue known as "Leonidas" (in the National Museum of Athens); and a number of bronze plates, some with nails still attached, which may have been used to face the temple and have given rise to the epithet of the goddess. The Hellenistic theater built into the foot of the acropolis is remarkably well preserved.

Our main evidence for the early settlement and the entire development of Spartan art is derived from careful excavations at the Sanctuary of Ortheia (later assimilated to Artemis) situated on the W bank of the Eurotas in the village of Limnai; it remained throughout its history closely linked to the severe military and educational regime. The earliest known worship centered on an earthen altar with a polar orientation, but toward the end of the 8th c. (on the current interpretation of the stratigraphy) the sacred area was paved with cobbles, enclosed by a peribolos wall, and the altar was given a stone casing; simultaneously a primitive temple, measuring at least 12.5 x 4.5 m, was built on an interpolar axis. About 570 B.C. the entire sanctuary was remodeled, perhaps in consequence of a flood of the Eurotas. The sacred area was enlarged and covered by a layer of sand, the altar refurbished and the first temple replaced. Its successor, built entirely of limestone and measuring ca. 16.75 x 7.5 m, was in the Doric style; the scanty remains of the substructure suggest it was prostyle in antis, and a few gaily painted fragments probably belong to a pedimental group of heraldic lions. The sand, besides being a clearcut stratigraphical feature, has sealed in a treasury of early Greek art from the late 8th to the early 6th c.; dedications continued above the sand into the Roman era. The material includes bronze figurines, mainly of animals, and other bronze objects; over 100,000 lead figurines; some of the earliest and finest figural ivory carvings in Greece; a plethora of mold-made terracotta figurines and masks; finally, and most important for chronology, a continuous pottery series.

The picture which seems to be emerging indicates that Spartan craftsmen, especially bronzesmiths, shared in the Greek cultural renaissance of the 8th c.; in the 7th, her ivory-carvers were quick to assimilate and adapt oriental types and motifs, but the vase-painters appear backward by comparison with those of Corinth and Athens; in the 6th c. the roles are reversed and the potters and painters, soon followed by the bronze-workers, produce high-quality wares both for domestic and, more especially, foreign consumption. We know from Pausanias the names of several Lakonian craftsmen and some were almost certainly Spartan citizens; Sparta was also the temporary domicile of foreign artists from at least the early 7th c.

But about 525 B.C. the whole picture changed; imports, which had never been plentiful, ceased—apparently abruptly; so did exports, although painted pottery and superior bronze figurines continued to be made for local use. By the 5th c. Sparta seemed to have acquired the sterile character for which she was praised or blamed by other Greeks; her retention of an iron currency is a symptom, though not a cause, of the change. Not altogether surprisingly the next major alteration to the Sanctuary of Artemis was the construction of a semicircular theater to enable spectators, including foreign tourists, to watch Spartan youths being flogged to death in a painful simulacrum of the initiation rite which had performed so useful a military and political function in a better age.

BIBLIOGRAPHY. M. N. Tod & A.J.B. Wace, *A Catalogue of the Sparta Museum* (1906); A.J.B. Wace, M. S. Thompson, & J. P. Droop in *BSA* 15 (1908-9) 108-57

(Menelaion); R. M. Dawkins in *BSA* 16 (1909-10) 4-11 (Mycenaean settlement at Menelaion); R. M. Dawkins, ed., *Artemis Orthia, JHS* Suppl. Vol. v (1929)[PI]; R. M. Dawkins, J. P. Droop, & A.J.B. Wace, "A Note on the Excavation of the Sanctuary of Artemis Orthia," *JHS* 50 (1930) 329-36; E. A. Lane, "Lakonian Vase-Painting," *BSA* 34 (1933-34) 99-189[I]; J. Boardman in *BSA* 58 (1963) 1-7 (revised stratigraphy of Artemis Ortheia); C. Christou in *Deltion* 19.1 (1964) 123-63, 283-85 (archaic burials); B. Bergquist, *The Archaic Greek Temenos* (1967)[P]; L. Marangou, *Lakonische Elfenbein- Und Beinschnitzereien* (1969)[I]; A. J. Toynbee, *Some Problems of Greek History* (1969) Part 2[M].

P. CARTLEDGE

SPELLO, *see* HISPELLUM

SPEOS ARTEMIDOS Egypt. Map 5. A small Egyptian temple 1500 m SE of Bani Hasan, hewn in the rock and known to the local people as Istabl Antar (the stable of Antar). Champollion (1790-1832), identified this grotto temple with the Greek Speos of Artemis, which appears as Poes Artemidos in the *Antonine Itinerary* and as Poisarietemidos in the *Notitia dignitatum*, where it is mentioned that a Roman military garrison settled there. The temple, which the inscriptions on the walls call Hut Neter Onet, the sacred house of the valley, was dedicated to Pakhit, one of the goddesses whom the Greeks seem to have equated with their Artemis at a later date. The temple was hewn by Hatshepsut of the 18th Dynasty (1504-1483 B.C.) while Thoutmosis III was the nominal ruler. When she died, her name was erased from the cartouches and replaced by the name of Seti I (1312-1300 B.C.). The portico of the temple has two rows of unfinished and partly destroyed columns, eight in all. A narrow passage (3 m deep) leads to a sanctuary (4 m square) of which the S wall had been prepared to receive the statue of the deity. The goddess, with a lioness' head, is represented on the columns receiving homage from the king. To the right of this Great Speos is a smaller one built during the Roman period. The cornice on the doorway bears the cartouches of Alexander Aigos. On the left-hand lintel the king is represented in three scenes, first before Horus, then before Ammon Re, and finally with a goddess offering an image of Maat to Pakhit. Likewise, on the right-hand lintel, the king is seen, first before Shu, then before a god, and finally with Hathor offering an image of Maat to Pakhit.

BIBLIOGRAPHY. E. Brunner-Traut & V. Hell, *Aegypten* (1966) 508; J. F. Champollion, *Monuments de l'Égypte et de la Nubie* (1835ff) II.322-34.

S. SHENOUDA

"SPERCHIEIAI," *see* KASTRORACHI

SPERLONGA Latium, Italy. Map 17A. Situated on a promontory by the sea a few km S of Terracina, the village has become famous through the discovery in 1957 of a large number of fragmentary sculptures and other antiquities in a nearby grotto.

The grotto had long been associated with a neighboring building identified as a villa of Tiberius, hence its popular name l'Antro di Tiberio. In fact it has been thought that this very grotto had been the scene of the incident, related by Tacitus (*Ann.* 4.59) and Suetonius (*Tib.* 39), in which Tiberius was almost killed by falling rocks during a banquet. A circular pond, slightly more than 20 m in diameter, occupied the forward part of the cave, and in front of that lay a large, rectangular pool with a small island in its midst. To left and right, in the depths of the grotto, are two smaller caves, in one of which it is suggested that the Blinding of Polyphemos may have been

placed. The disposition of the various sculptures is still a matter for study.

The antiquities found on this site ranged from the 5th c. B.C. (a few red-figure Attic vases) to sculptures and terracotta lamps of late antiquity. The most important among the more than 7000 marble fragments were what proved to belong to five large sculptured groups representing: 1) The blinding of Polyphemos by Odysseus and his companions, 2) The wreck of Odysseus' ship, 3) The killing of Odysseus' companions by Scylla, 4) Menelaos carrying the body of the dead Patroklos, 5) The rape of the palladion by Diomedes and Odysseus.

The identification and reconstruction of these sculptured groups were aided by an inscription in Latin hexameters (datable to the 3d or 4th c. A.D.) in which a certain Faustinus cites three of the groups, adding that they would have evoked the admiration of "the divine poet of Mantua" (i.e., Vergil).

The dating of the Sperlonga group must be computed on stylistic grounds. The style obviously is that of the late Hellenistic "baroque" period, for which we fortunately have a monument dated by external evidence, namely, the reliefs on the Altar of Pergamon, presumably erected by Eumenes of Pergamon in the second quarter of the 2d c. B.C. The delicate modeling of the Sperlonga sculptures suggests original Greek workmanship; and it is significant that the marble of these sculptures has been identified as of the same Rhodian variety as that of the Pergamene reliefs, i.e., lithos larticos.

We may, therefore, surmise that the sculptured groups from Sperlonga were imported from Greece during the time of the Roman conquest of the Hellenistic kingdoms when Greek works of art were brought to Italy in large quantities, and were then set up with new bases on which the original inscriptions were transcribed.

The sculptural groups, as well as the other antiquities found at Sperlonga—e.g., a Ganymede, a kneeling satyr, and a portrait of Faustina—are now all admirably installed in a newly built museum. The reconstructed statues and reliefs are in the exhibition galleries; fragments still awaiting identification are in storerooms.

BIBLIOGRAPHY. G. Jacopi, *L'Antro di Tiberio a Sperlonga* (1963); id., *L'Antro di Tiberio e il Museo Archeologico di Sperlonga* (1965); H. P. L'Orange, "Odysseen i Marmor," *Kunst und Kultur* 47 (1964) 193ff with English summary on pp. 227ff; id., "Osservazioni sui ritrovamenti di Sperlonga," *Acta Instituti Romani Norvegiae*, II (1965) 261ff; B. Andreae, *RömMitt* 71 (1964) 238ff; id., *Gnomon* 39 (1967) 84ff; id., *Bild der Wissenschaft* (1969) 457ff; P. Krarup, *Analecta Romana Instituti Danici* 3 (1965) 73ff and 4 (1967) 89ff; id., *Acta Instituti Romani Norvegiae* 4 (1969) 19ff; H. Sichtermann, "Das veröffentliche Sperlonga," *Gymnasium* (1966) 238ff; G. Saflund, "Sulla ricostruzione dei gruppi di Polifemo e di Scilla a Sperlonga," *Opuscula Romana* 7,2 (1967) 25ff; P. H. Blanckenhagen, "Laocoon, Sperlonga und Vergil," *Arch. Anz.* (1969) 256ff; B. Conticello, "The one-eyed Giant of Sperlonga," *Apollo* (1969) 188ff; id., "Restoring the Polyphemus of Sperlonga," *Archaeology* 22 (1969) 204ff; E.S.P. Ricotti, "Il Gruppo di Polifemo a Sperlonga, problemi di sistemazione," *RendPontAcc* 42 (1969-70) 117ff.

G.M.A. RICHTER

SPHAKTERIA Greece. Map 9. An island off shore from the Bay of Navarino. It belonged to Sparta after the second Messenian war. In 425 B.C. during the Peloponnesian war it was the site of the famous battle that ended with the Athenian capture of 400 Spartans who had landed on the island. The remains of the ancient fort in which the Spartans sought refuge (Thuc. 4.31.2), on the mountain of Haghios Elias in the N section of

the island, which have been visited and described by many scholars, are no longer easily recognizable. They were destroyed by military installations during WW II.

BIBLIOGRAPHY. H. Schliemann, *AthMitt* 14 (1889) 132; R. M. Burrows, "Pylos and Sphacteria," *JHS* 16 (1896) 55ff; 18 (1898) 147ffPI; U. von Wilamovitz-Moellendorf, "Sphacteria," *SBPreussAK* (1921); W. Kendrick-Pritchett, *Studies in Ancient Greek Topography* (1965) 25ffM. M. G. PICOZZI

SPHETTOS (Korope) Attica, Greece. Map 11. To the E of Mt. Hymettos lies the rich plain of the Mesogaia, today farmed from four large rural centers, Spata, Liopesi, Markopoulo, and Koropi. The situation in antiquity was little different, and it was early recognized from the numbers of inscriptions, pieces of sculpture, and architectural blocks built into the houses and churches at Koropi and its vicinity that an ancient deme had once existed near the location of its modern successor. The identification of this deme as Sphettos, one of the original twelve townships that formed the union of Attica under Theseus (Philochoros 328 F 94), was, until recently, more a matter of conjecture than of fact, being largely based on the account in Philochoros (328 F 108) and Plutarch (*Thes.* 13) of the attack of the Pallantidai on Theseus, a march that originated at Sphettos. In 1965, however, virtually all doubt was removed by the discovery at the chapel on the Kastro tou Christou, a prominent hill crowned with a monastery a little more than 3 km W of Koropi, of an inscribed base for a statue of Demetrios of Phaleron dedicated by the demesmen of Sphettos (cf. Diog. Laert. 5.75-77). Not only did this inscription make the identification certain, but it also demonstrated that the center of the deme of Sphettos was in all probability nearby. Also close to the chapel are a number of cuttings, suitable for votive reliefs, and traces of terracing which may possibly be construed as the remains of a small rural sanctuary. In the plain immediately to the NE of the hill are several chapels and the ruins of a village, from which much ancient material has been recovered. To the W, overlooking the Mesogaia on the nearest heights of Hymettos at the Chapel of Prophet Elias, are two small Classical temples (q.v. Hymettos). From their dramatic position in full view of all who lived in the predecessor of Koropi, one assumes that this sanctuary belonged to Sphettos.

BIBLIOGRAPHY. W. Wrede, "Sphettos," *RE* III (2d ser.) (1929) 1700-1701; A. G. Kalogeropoulou, "Base en l'honneur de Démétrius de Phalère," *BCH* 93 (1969) 56-71PI. C.W.J. ELIOT

SPINA Emilia-Romagna, Italy. Map 14. An important pre-Roman city, which excavations of the last 50 years have brought to light in the ancient delta of the Po, and in the lagoon basins ca. 6 km W of Comacchio (province of Ferrara).

Founded by the Pelasgians, or by the Thessalians, or by Diomedes at the mouth of a branch of the Po (Hellanicus fr. 1 apud Dion. Hal. 1.28.3, 1.18.3-4; Ps.-Scyl. 17; Just. *Epit.* 20.1.1; Plin. *HN* 3.120), the city attained the thalassocracy of the Adriatic and maintained at Delphi a famous thesaurus (Dion. Hal. 1.18.4; Strab. 5.1.7, 9.3.8). It was within a road journey of three days from Pisa and was linked to Adria by a navigable canal built by the Etruscans. The invasion of the Gauls provoked the decline and desertion of the city (Dion. Hal. 1.18.5), and on the site in the Roman period there was no more than a small village (Strab. 5.1.7).

The city's period of greatest prosperity coincided with the expansion of the Etruscans N of the Apennines beginning in the middle of the 6th c. B.C. Although the sources speak of Greek Spina in Etruscan territory, it was actually an Etruscan city in which Greeks, including an active group of Athenian merchants, exerted a strong cultural influence. In this light, the large amount of archaeological evidence, fundamental in understanding the civilization of Spina, may be understood.

Land reclamation in the Trebba valley and in the Pega valley has opened up for investigation two adjacent necropoleis situated on the sandy dunes of an ancient shoreline (today ca. 10 km from the sea). From these have come 4061 earthen graves dating from the end of the 6th c. to the beginning of the 3d c. B.C. The prevailing custom is inhumation with the corpse oriented NW to SE. The burial finds reflect large commercial enterprises and the economic prosperity of the market of Spina. Attic red-figure ware abounds, particularly from the early Classical and Classical periods. The Spina collection has a documentary unity and an array of the work of vase painters (of Berlin, of Penthesilea, of the Niobid Painter, of Boreas, of Peleus, Polygnotos, Polion, Shuvalov) without comparison either in Greece or elsewhere. Other pottery is Etruscan, Faliscan (from Magna Graecia), Sicilian, and Boiotian, in addition to notable local production of the so-called early Adriatic group. There are Etruscan bronzes and gold jewelry and some early Venetic bronzes, as well as numerous examples of glazed ware and amber.

Land reclamation in the Mezzano valley (1960) led to the identification of the site of Spina W of the necropoleis and exactly along a middle branch of the ancient Po delta, called the Padus Vetus in mediaeval documents. It is a characteristic settlement on a marshy site: an irregular perimeter, protected by multiple palisades and earthen ramparts, streets on a square grid plan oriented NW to SE, and wooden dwellings. Two km SE, near Motta della Girata, a canal, 15 m wide, leaves the river and cuts across the dunes of the Etruscan shoreline. This is evidently the work of the Etruscans intent upon maintaining close connection between the city and the sea, which kept moving farther away as a result of the extension of the coastal land. The presence there of the Early Christian parish church of Santa Maria in Padovetere shows the extreme demographic tenacity of the city which had then disappeared.

Because they demonstrate a knowledge of the N Etruscan alphabet, the many graffiti on pottery from Spina are notable. All articles can be found in the National Archaeological Museum in Ferrara.

BIBLIOGRAPHY. S. Aurigemma, *Il R. Museo di Spina* (1st ed., 1935; 2d ed., 1936); id., *La necropoli di Spina in valle Trebba*, I.1 (1960), I.2 (1965); B. M. Felletti Mai, "La cronologia della necrop. di Spina . . . ," *StEtr* 14 (1940) 43ff; N. Alfieri et al., *Spina* (1958); P. E. Arias, "Due situle paleovenete a Spina," *Hommages Grenier* (1962) 141-44; *EAA* 7 (1966) 446-53 (P. E. Arias); G. V. Gentili, "Spina: individuazione dell'abitato," *BdA* 52 (1967) 246. N. ALFIERI & G. V. GENTILI

SPINIS Berkshire, England. Map 24. Both references to this place in the *Antonine Itinerary* (485.6, 486.6) indicate a location at Speen, 1.6 km NW of Newbury, or more precisely at Woodspeen, which lies just to the NW; but although finds of Roman material are not uncommon in the area, no nucleation has so far been noted. The excavated settlement at Thatcham lies too far E to fit the figures. The derivation of the modern name from the ancient one (Latin: at the thorn-bushes), though superficially straightforward, presents some etymological difficulty.

BIBLIOGRAPHY. H. Peake, *The Archaeology of Berkshire* (1931) 229; *Itinerary*: A.L.F. Rivet, *Britannia* 1

(1970) 58; name: K. H. Jackson, ibid. 79; Thatcham: W. E. Harris, *Trans. Newbury and District Field Club* 7 (1934-37) 219-55. A.L.F. RIVET

SPLIT, see SALONA

SPOLETIUM (Spoleto) Umbria, Italy. Map 16. A town set on a height at the SE end of the Clitumnus valley, on the E branch of the Via Flaminia from Narnia. Though there is proof of habitation in the zone from the Early Iron Age, Spoletium appears in history only with the deduction of a Latin colony there in 241 B.C. (Livy, *Per.* 20). The Romans had had trouble with the Umbrians for 70 years, and the colony was to be a watchdog over the Clitumnus valley. The site was likely chosen for advantage and was not an existing town; the oldest parts of the walls, the city plan, and street grid seem to date from the foundation of the colony. In the Hannibalic war Spoletium remained faithful to Rome, and according to Livy (22.9) in the aftermath of the Battle of Trasimene threw back an assault on its walls with such losses to the Carthaginians that they were discouraged from marching on Rome. Its record in this war won Spoletium high esteem in Rome, and it flourished, becoming a municipium inscribed in the tribus Horatia in 90 B.C. In 82 B.C., in the struggle between Marius and Sulla, it had the misfortune to give asylum to Carinas after his defeat by Pompey and Crassus and, apparently in reprisal, was simply sold at auction (Florus 2.9.27). A repair of the fortifications, probably made necessary by an earthquake of 63 B.C. (Obsequens 61), is recorded in an inscription (*CIL* XI, 4809). Under the Early Empire, it prospered. In the time of Constantine it entered on a period of new brilliance; it figures in the letters of Symmachus and Theodoric and the campaigns of Belisarius and Totila. Around 570, with the creation of the duchy of Spoleto, it passed into a new era.

The walls of Spoletium can be followed around their whole circuit of 2 km, with good stretches along the Via dei Cecili, S of the Rocca, and in the Piperno garden on Via Benedetto Egio. The base is in polygonal blocks of limestone of medium size, sometimes irregular in shape, sometimes tending to trapezoidal. Above this is masonry in squared blocks, the faces and joints carefully worked, probably of the same build as the base, though this carries the inscription recording a Late Republican restoration. Above work of the second sort in places is yet a third type of masonry in long thin blocks. The curtains run mostly in short straight sections joined at obtuse angles with gates overlapped or in reentrant angles. There were no towers; small gates had lintels, while major gates were probably arched. The city plan is orthogonal with insulae along the main slope of the site, which is terraced to regularize the terrain. The long rectangular forum lay near the middle of the slope, close to the Porta Romana. At its SW end was a small temple on a high podium (Tempio di S. Ansano), prostyle tetrastyle, probably Corinthian. Beside this an arch spanned the approach to the forum, dedicated in A.D. 23, as an inscription on the forum side informs us, to the dead Drusus and Germanicus. At the opposite end of the forum rose a large Corinthian temple, probably the Capitolium, and beside this was a complex building with a handsome stone arcade. Lower in the city, breaching the S wall, was a theater (diam. 72 m) of late Augustan date. Outside the walls in the river plain was the amphitheater (115 x 85 m), well preserved because Totila converted it into a fortress but stripped it of its stone facing, which went to build the papal castle of Spoleto.

A good part of a house with atrium and peristyle and fine mosaic pavements has been excavated under the Palazzo Comunale, and many other lesser remains are known. Two aqueducts have been traced, and there are substantial ancient parts of the Ponte Sanguinario over the Tessino. Graves of the 7th c. B.C. have been found near Campello, but so far not in Spoletium itself. Here the tombs are numerous, but all are Roman.

Antiquities from the region are kept in the Museo Civico. Perhaps the most interesting items are two Leges Spoletinae, early inscriptions respecting a sacred grove (*CIL* XI, 4766-67).

BIBLIOGRAPHY. C. Pietrangeli, *Spoletium (Spoleto)*, Istituto di Studi Romani (1939)[MPI]; B. Toscano, *Spoleto in pietre*, Azienda del Turismo, Spoleto (1963)[I].

L. RICHARDSON, JR.

SPOLETO, see SPOLETIUM

SPRINGHEAD, see VAGNIACAE

SREBRENICA Bosnia-Hercegovina, Yugoslavia. Map 12. Located 80 km NE of Sarajevo. The exploitation of the silver mines in the area reached its high point in the early part of the 3d c. A.D., as indicated by the extensive traces of Roman settlement and mining activity uncovered there. In the Middle Ages Srebrenica succeeded Domavia as the administrational center of mines in the region.

BIBLIOGRAPHY. E. Pašalić, "O antičkom rudarstvu u Bosni i Hercegovini," *Glasnik Zemaljskog Muzeja u Sarajevo* NS 9 (1954) 47-75[M]; J. J. Wilkes, *Dalmatia* (1969)[M].

M. R. WERNER

SREMSKA MITROVICA, see SIRMIUM

STABIAE (Castellammare di Stabia) Campania, Italy. Map 17A. An early Oscan settlement that became part of the confederation of Nuceria. With a natural port in the SE corner of the Gulf of Naples, it had from its origin defensive and commercial purposes in connection with the Sannio river route. An important road led from Stabiae to Nuceria by the 8th-7th c. B.C.; and after the descent of the Samnites into Campania and the formation of the federation of Nuceria, Stabiae became the port of Nuceria, whose political and administrative structures it imitated. During the Samnite wars, Stabiae was the military port of the fleet until the fall of Nuceria and the alliance with Rome. Stabiae, together with Nola and Salerno, was occupied by Papius Mutilus during the social war in 90 B.C., and was destroyed by Sulla on April 30, 89 B.C. It was quickly transformed into a health resort. The town felt the effects of the earthquake of 62 only slightly.

The site of pre-Roman Stabiae, built as oppidum of the federation of Nuceria, is not known. The destruction by Sulla, earthquakes, and volcanic eruptions have wiped out every trace. The remains of walls in opus reticulatum and of buildings similar to the hot baths of Pompeii in the area known as Fontana Grande, near the ancient coastline, suggest that the site may be sought there.

In any case, the town was transferred from the coast to the hill of Varano. It became an extravagant residential area, a town of country resorts. A complex of government buildings encompassed more than a kilometer. The builders of the villas tended to subordinate the architectural to the natural environment in an attempt to realize new forms. The villas are characterized by a long ambulatio set in the design of a porticus triplex and by the separation of residents' and servants' quarters in different levels of terraces. A series of winding ramps beneath arches gave access to the beach. The remains of

the decorations provide noteworthy samples of painting of the Flavian period.

In the environs of Stabiae a spacious pre-Roman necropolis (8th-2d c. B.C.), beneath the road to Nuceria, contains rectangular graves (inhumations?) encased in limestone blocks or tufa slabs with abundant funerary furnishings. Other Roman and pre-Roman tombs have been discovered at Gragnano. Rectangular inhumation graves encased in tufa slabs from the Hellenistic period were placed along the road to Sorrento. Chamber tombs with sarcophagi of the Republican period have been discovered in the area known as Sant'Antonio Abate along the main route from Stabiae to Nuceria.

BIBLIOGRAPHY. L. Cosenza, *Stabia. Studi archeologici, topografici et storici* (1907); L. D'Orsi, *Gli scavi di Stabia* (1954); id., *Gli scavi archeologici di Stabia* (1961); O. Elia, *Le pitture di Stabia* (1957); A. Maiuri, *Pompei, Ercolano e Stabia* (1961). F. PARISE BADONI

STAKLEN, *see* NOVAE

STA LENIKA Greece. Map 11. A village on the W side of the Gulf of Mirabello, N coast of Crete; in a coastal valley S of Elounda and N of Ag. Nikolaos, just S of the ridge which formed the ancient frontier between the territories of Olous and Lato (q.v.).

Near the village lies a double Sanctuary of Ares and Aphrodite, excavated in 1937-38. The temple consists of two rooms of equal size, adjoining but not intercommunicating, dedicated to Ares and Aphrodite. They are built of rough blocks of local limestone; the walls are plastered, and form a rough square (12 x 12 m). Both rooms contain a bench-altar at the rear, and on the E side open on to a common vestibule (described as a pastas in the inscription found on the site which describes the work on the building). Below the level of the vestibule the plan and remains of a low altar can be made out, similar to that at Dreros; this belonged to an earlier temple of the Geometric period, clearly the Old Aphrodision mentioned as lying close to the frontier in inscriptions relating to the frontier dispute between Lato and Olous. When the dispute was finally settled Latian possession of the site was confirmed (ca. 113 B.C.); inscriptions found at the site have added much new information about the dispute. The temple was built after the settlement, replacing the separate temples of Aphrodite and Ares.

BIBLIOGRAPHY. J. Bousquet, "Le temple d'Aphrodite et d'Arès à Sta Lenikà," *BCH* 62 (1938) 386-408; H. van Effenterre, "Querelles crétoises," *REA* 44 (1942) 31-51; id., "Documents édilitaires de Lato," *REA* 45 (1943) 27-39; C. Tiré & H. van Effenterre, *Guide des fouilles françaises en Crète* (1966) 89.

D. J. BLACKMAN

STAMATA ("Plotheia") Attica, Greece. Map 11. To the N of the main mass of Mt. Pendeli, and due W of Mt. Aphorismos, approximately midway between Kephissia and the modern Marathon, is the once small village of Stamata, its rural character now threatened by fast-developing housing schemes. While the village itself does not seem to be built on an ancient site, antiquities have been discovered nearby. Less than a km to the S, at Palaio-Stamata, in the ruined walls of a Byzantine church were found many remains, including several pieces of sculpture and three inscribed blocks, each one the dedication of a demesman of Plotheia (*IG* II² 4607, 4885, 4916). A similar distance to the N of Stamata, at Amygdalesa, architectural pieces were also found in another Byzantine church. There is thus ample justification for claiming the existence of an ancient settlement in the

vicinity of Stamata, to be identified in all probability as that of Plotheia. If the finding-place of *IG* II² 1172, a decree of the demesmen of Plotheia concerning the finances of the community and certain sacred expenses, had been recorded, one might have been able to locate the deme's center with greater precision.

BIBLIOGRAPHY. E. Meyer, "Plotheia," *RE* (1951) XXI 467-70. C.W.J. ELIOT

STANWIX, *see* PETRIANA *under* HADRIAN'S WALL

STARI GRAD, *see* PHAROS

STARI SLANKAMEN, *see* LIMES PANNONIAE (Yugoslav Sector)

STEIERMARK, *see* FLAVIA SOLVA

STEINDORF, *see* IMMURIUM

STENAI, *see* DEMIR KAPIJA

STOBI Yugoslavia. Map 12. The site lies along the left bank of the Crna (Erigon) river where it empties into the Vardar (Axius) ca. 160 km N-NW of Thessalonica. It occupied the juncture of two of the most important ancient routes in the Balkans: the corridor of the Vardar was the chief route between the middle Danubian regions and the Mediterranean, and a road from the Via Egnatia at Heraclea Lyncestis passed through Stobi and continued NE into Moesia. The cut for the modern highway from Athens to Belgrade and the railway for the Orient Express passes through the NE limits of the ancient city.

Livy (39.53.16) referred to Stobi, and the town figured prominently in his account of the N campaigns of Philip V of Macedonia in the 2d c. B.C. Stobi became a municipium during the early Roman Empire and minted its own coins at least from the reign of Titus to that of Elagabulus (69-222). The city continued to flourish during the later empire and may even have become the capital of the province of Macedonia Salutaris in the late 4th c., and even later of Macedonia Secunda. Theodosius I resided briefly in the city and issued two edicts. Stobi was an especially flourishing community during the 5th c. when Johannes Stobaeus resided there and a number of palatial structures, public and private, were erected or remodeled and lavishly decorated. The grandeur of its Episcopal Basilica and related buildings, along with the presence of at least four other basilicas, indicates its importance as a wealthy ecclesiastical center.

The historian Malchus records that Stobi was sacked in 479 by the Gothic army of Theodoric. There is considerable evidence of rebuilding at the site, but the city seems never again to have recovered its former prosperity. It ceased to exist as an urban community before the end of the 6th century.

Most of the monuments revealed by excavations belong to the 4th-6th c. and lie on the S slope of the low ridge that projects into the angle of the two rivers. The fortified area of the town measures ca. 450 by 450 m and the line of the city wall, exposed in a few places, can be followed for most of its extent. Part of a Turkish pavement is preserved above the city wall near the center of its E line and leads to the ruins of a bridge across the Crna.

The N basilica (5th-6th c.) lies at the NE end of the lower excavated street and is distinguished by the presence of a small quatrefoil baptistery with a sunken cruciform piscina attached on its N side. The next building to the SW is a civil basilica and beyond that a large complex that included, in the 3d c., the residence of

Polycharmus and the Jewish synagogue. A second synagogue with a mosaic floor and frescoed walls was superposed on the first and was followed in the next century by a Christian basilica at a still higher level. Mosaics with both animal and geometric motives are preserved in the adjoining residence to the SW and a small bath lies to the E. Structures dating to the 2d c. b.c. lie below the civil basilica and the synagogue where a hoard of some 500 silver Roman denarii was found in 1971.

Beyond a cross street is a large bath, partly restored, in which were found a number of late Roman portrait statues. Large private residences occupy the next two blocks to the SW including one with a colonnaded court and fountain adorned with Hellenistic and Roman bronze and marble statues. These latter large complexes fill the area between the upper and lower of two roughly parallel streets. Farther to the SW along the upper street is another large residence on the right and opposite it the spacious residence of the bishops of Stobi. The street is paved with flagstones and lined on both sides by colonnades for the remaining 100 m or so to the Porta Heraclea, the only gate yet excavated.

A semicircular, colonnaded court stands at the N end of this main street opposite the entrance to the two-storied basilica of the Bishop Philip, whose name is preserved in the dedication inscribed on the lintel of the entrance to the nave. The basilica in the 5th c. was decorated with figured frescos and elaborate mosaics, partly preserved in the narthex and S aisle. The carved marble screens of the ambo and the presbyterium, along with numerous figured capitals of fine workmanship were found in the earlier excavations and are in the National Museum of Belgrade. The three aisles of the naos were increased to five in the late 5th or early 6th c. by the addition of mullioned screens in the side aisles. A vaulted crypt lies below the S wall and there is a sunken confessio in the apse. An earlier building with well-preserved wall frescos bearing geometric motives has been found below the S aisle. The floor of this earlier structure, perhaps a church, lies some 4 m below the earlier of the two superposed mosaics in the S aisle of the Episcopal Basilica.

A broad sandstone stairway led from the narthex to the area S of the basilica where the episcopal baptistery was located nearly 5 m below the floor of the basilica. The baptistery, uncovered in recent excavations, is basically quatrefoil in plan with corner apses, all set within a quadrangle, ca. 9.4 m square. The walls were covered with fresco, of which thousands of fragments were found, including many depicting human faces. The floor is a well-preserved and colorful mosaic of animals in paradise. A circular pool (interior diameter 2.4 m) is centered in the room and set off from it by a low parapet. The pool was revetted with marble and slate slabs and covered by a baldacchino. A marble kantharos nearly 1 m high and 60 cm in diameter was set into the parapet.

Many of the marble architectural pieces used in the Episcopal Basilica and elsewhere in Stobi during the 4th to 6th c. were originally part of the 2d c. theater that lies immediately E of the basilica. The cavea was built in two tiers of gray-white marble from nearby Pletvar and could hold over 7600 spectators. The scena frons was built of rose and green breccia and fine white marbles. Rubble screen walls and parapets and a sanctuary of Nemesis point to its later use as an arena. Nearly half of the lower tier, both paradoi, and much of the scene building are still in place. The seats bear hundreds of inscriptions listing the names of patrons. A small building NE of the theater seems to have been devoted to entertainment and pleasure in the last years of Stobi: its rooms included an apsidal gaming room and a room with marble-encrusted bathing cubicles.

A cemetery (1st to early 4th c.) has been partly excavated just outside the Porta Heraclea. A Christian basilica with adjoining cemetery is located ca. 300 m SW of the gate; another basilica, ca. 1000 m farther SW, was cleared near the bridge to the village of Palikura.

Large and elaborately decorated structures have recently (1972-74) been explored below the flood plain of the Crna river. The Casa Romana on the banks of the river E of the Synagogue has walls decorated with molded stucco panels and pilasters as well as colorful frescos. A yet larger structure lying below the 4th c. Inner City wall has mosaic floors and marble-encrusted walls with arched niches preserved to a height of over 4 m. Both buildings were in use in the 2d and 3rd c. and may have been built still earlier.

There is a small museum at the site where some of the recent discoveries may be seen. Material from the excavations in the 1920s and 1930s is in the National Museum in Belgrade and a few items, mainly inscriptions, are in the Archaeological Museum of Skopje.

BIBLIOGRAPHY. R. Egger, "Die stadtische Kirche von Stobi," *JOAI* 24 (1929); B. Saria, "Neue Funde in der Bischofskirche von Stobi," *JOAI* 28 (1933) 132-33; id., "Pozorište u Stobima," *Godišnjak Muzeja Južne Srbije* 1 (1937)[PI] (shortened German version, "Das Theater von Stobi," *AA* [1938] 81-148); D. Mano-Zissi, "Mosaiken in Stobi," *BIABulg* 10 (1936)[I]; E. Kitzinger, "A Survey of the Early Christian Town of Stobi," *DOP* 3 (1946) 81-161; E. Dyggve, "Le théâtre mixte du bas-empire d'après le théâtre de Stobi et les diptyques consulaires," *RA* (1958) 1, pp. 137-57 and 2, pp. 20-39; R. E. Hoddinott, *Early Byzantine Churches in Macedonia and Southern Serbia* (1963)[PI]; J. Wiseman & D. Mano-Zissi, "Excavations at Stobi, 1970," *AJA* 75 (1971)[PI]; id., "Excavations at Stobi, 1971," *AJA* 76 (1972)[MPI]; id., "Excavations at Stobi, 1972," *AJA* 77 (1973) 391-403[MPI]; id., "Excavations at Stobi, 1973-1974," *JFA* 1 (1974)[MPI]; id. (eds.), *Studies in the Antiquities of Stobi* I (1973) and II (1974)[MPI]; J. Wiseman, *Stobi. A Guide to the Excavations* (1973)[MPI]. J. WISEMAN

STOLAC ("Diluntum") Bosnia-Hercegovina, Yugoslavia. Map 12. A Roman town on the Bregava river ca. 50 km SE of Mostar. It has been identified tentatively as Diluntum (*Tab.Peut.*).

Before the arrival of the Romans, the principal settlement in the area was based at Ošanići, a hilltop site across the river from Stolac. This was the stronghold of the Illyrian Daorsii, mentioned frequently from this region in ancient sources (App. *Ill.* 2; Plin. *HN* 3.143; Polyb. 32.18; Ptol. *Geog.* 2.16; Strab. 7.5.5). Archaeological evidence indicates that the Daorsii had close commercial contacts with the Greeks on the Adriatic via the Neretva river. In the 1st c. A.D., with Roman control and pacification of the area, a large settlement of Roman immigrants and native Illyrians grew up on the site of modern Stolac. The settlement attained municipium status and became the most prosperous city on the territory of Narona outside of the Neretva valley. Its native inhabitants were granted citizenship under the Flavians, and two inscriptions attest to the existence of a statio of beneficiarii consules (both from Legio XIII Gemina). The high point of prosperity for the community (3d-4th c.) was apparently based on agriculture and on the trade resulting from the town's position on the main road between Salona and Doclea.

Ošanići is a typical Illyrian site and includes one of the best-preserved examples of megalithic wall construction in Dalmatia. The site is a combination of fortified acropolis and a settlement containing various public and private buildings. The acropolis commands a dominating view of the Bregava valley and employs both natural and

man-made defenses for its protection. The S side of the acropolis is fortified with a cyclopean wall with towers at either extremity, all dating to the end of the 4th c. B.C. Within the acropolis the principal remains are those of cistern and a large building, circular in plan, perhaps the residence of the ruler and his family. The site was inhabited to the Roman period; with peace established and the need for fortification gone, the settlement moved down to the Bregava valley. The Roman remains around Stolac consist mainly of upper-class dwellings and farm buildings. The buildings are small and generally not complicated in plan although the quality of construction is good. Some of the houses included bath blocks, and many had mosaic floors. The mosaic patterns are traditional, with mythical and allegorical figures on a field of elaborate geometric designs. The stamped tiles associated with the remains are Italian imports, dating to the 1st c. A.D., whereas most of the coins are assigned to the 3d and 4th c. The finds from excavations on both sites, including some of the preserved mosaics, are displayed in the Zemaljski Muzej in Sarajevo.

BIBLIOGRAPHY. K. Hörmann & V. Radimsky, "Ošanić kod Stoca," *Glasnik Zemaljskog Muzeja u Bosni i Hercegovini* 4 (1892) 40-49; D. Basler, "Gradina na Ošanićima kod Stoca," *Naše Starine* 3 (1955) 79-94MPI; E. Pašalić, *Antička naselja i komunikacije u Bosni i Hercegovini* (1960); J. J. Wilkes, *Dalmatia* (1969)MP; I. Bojanovski, "Mogorjelo: Rimsko Turres," *Glasnik Zemaljskog Muzeja u Sarajevo*, NS 24 (1969); Z. Marić, "Gradina à Ošanići, Stolac," *Epoque préhistorique et protohistorique en Yougoslavie—Recherches et résultats* (1971) 58-60; id., "Gradina na Ošanićima kod Stoca: centar ilirskog plemena Daorsa," *Bosna i Hercegovina iseljenićki almanah* (1972) 226-30. M. R. WERNER

STOLNICENI, *see* BURIDAVA

STRACATHRO Angus, Scotland. Map 24. Roman auxiliary fort 5 km SE of Edzell. There are no surface remains, but crop marks on air photographs show two ditches on the NW and SW fronts, and three on the SE. The area within the ditches is ca. 2.4 ha. Trial excavation in 1969 revealed part of a timber building, perhaps a barrack block, of a single period. The finds included Flavian pottery and an unworn as of A.D. 86. The fort was probably built in A.D. 83 and abandoned ca. 87.

BIBLIOGRAPHY. *JRS* 51 (1961) 123; *Britannia* 1 (1970) 273I. K. A. STEER

STRAGEATH Perthshire, Scotland. Map 24. Roman fort (1.7 ha) on the river Earn between Ardoch and Bertha. Excavation begun in 1973 indicates that there were three successive forts, one Flavian and two Antonine. During the first and last phases the barrack accommodation in the retentura included provision for cavalry, but it is uncertain whether the unit was an ala or a cohors equitata.

BIBLIOGRAPHY. W. Roy, *The Military Antiquities of the Romans in Britain* (1793)I; *JRS* 48 (1958) 90; *Britannia* 5 (1974) forthcoming. K. A. STEER

STRALEGG, *see* LIMES ON WALENSEE, RAETIA

STRATONIKEIA (Eskihisar) Turkey. Map 7. City in Caria 25 km E of Milâs. Founded early in the 3d c. B.C. by Antiochos I of Syria, and named in honor of his stepmother-wife Stratonike. The foundation seems to have been made on the site of an old Carian town, Chrysaoris or Idrias (Paus. 5.21.10), said by Stephanos Byzantios s.v. Chrysaoris, quoting Apollonios cf Aphrodisias, to be the first city founded by the Lycians. Idrias appears to figure in the Athenian tribute lists in the form Edrieis,

and in 425 B.C., together with Euromos and Hymessos, it was assessed at the high sum of six talents.

Strabo (660) says that Stratonikeia was embellished by the Seleucid kings, but within a few years it was presented by them to Rhodes (Polyb. 30.31.6). The Rhodians lost it on some unrecorded occasion, but recovered it in 197 B.C. (Livy 33.18.22), and the city remained Rhodian until 167, when with the whole of Caria it was declared free by the Roman Senate. In 130 it was the scene of Aristonikos' final surrender, and in 40 B.C. was attacked unsuccessfully by Labienus and his Parthian troops.

Stratonikeia was the home of the Chrysaoric League, a federation of all the villages in Caria; the League met at the temple of Zeus Chrysaoreus, which is said to have been near the city. The earliest evidence for this League is an inscription of 267 B.C., but it may have been in existence much earlier. Recorded as a free city under the Empire, Stratonikeia continued to flourish, but Stephanos' statement that it was "founded" by Hadrian under the name of Hadrianopolis seems to be a confusion with another city of the same name. Coinage extends from the liberation from Rhodes in 167 to the time of Gallienus (A.D. 253-268).

The acropolis hill is on the S, and has a circuit wall round the summit; on a terrace on its N slope are the ruins of a small temple dedicated to the Emperors, and below this is a large theater. The cavea has a single diazoma and nine cunei, and the foundations of the stage building survive underground.

In the inhabited part of the city, on the level ground to the N, the most conspicuous ruin is that of the Serapeum, a massive building dating from about A.D. 200. Its lower parts are buried, but the walls are standing to a considerable height in solid broad-and-narrow masonry; they bear many inscriptions. Of the temenos, some 100 m square, little survives apart from the entrance gate on the W, which stands complete with lintel.

The city wall, originally ca. 1.6 km long, has almost totally disappeared, but part of the main city gate on the N is standing: a single-arched gateway. The piers remain, also in broad-and-narrow masonry, and the spring of the arch above them. Just inside, a single column survives from the interior colonnade; it is unfluted and of the Corinthian order. At the NE corner of the city is a large fortress some 80 m long, built of large squared blocks regularly coursed, but repaired in places with reused material.

The agora lay W of the Serapeum, but nothing remains but a row of blocks on its E side. To the N are the ruins of a building of unknown purpose and unusual form; it has a long wall of good regular masonry to which part of a curved wall is attached on the S side. The site as a whole has never been excavated.

The temple of Zeus Chrysaoreus has not been decisively located. There are some rather scanty ancient remains near the main road about 4 km E of Eskihisar which might be those of a temple; if so, this may be the spot called White Pillars by Herodotos (5.118).

BIBLIOGRAPHY. R. Chandler, *Travels in Asia Minor* (1817; repr. 1971) 116-18; A. Laumonier, *BCH* 60 (1936) 322-24; C. Fellows, *Asia Minor* (1838) 254-56; G. Cousin & G. Deschamps, *BCH* 15 (1891) 180f; L. Robert, *Études Anatoliennes* (1937) 523-31; G. E. Bean, *Turkey beyond the Maeander* (1971) 88-93MI. G. E. BEAN

STRATOS (Surovigli) Greece. Map 9. Located between Agrinion and Amphilochia in Akarnania, on the right bank of the Acheloos.

The name and the history of Stratos are noted in the sources (Strab. 10.450; Ptol. 5.13.10; 96.3). During the

Peloponnesian War the city was allied with Athens. In 314 Kassander completed the synoecism between Stratos, Saurias, and Agrinion; and in 270, after the death of Pyrrhos, it was assigned to Aitolia. Antiochos, and later Nikander, found refuge at Stratos. In 167 it was included in the Roman province.

The ruins of Stratos, with an extensive city wall that encloses the modern village of Surovigli, extend over three hills. The walls, because of their numerous spurs and many towers, should antedate 429 B.C. although the building technique is pseudo-isodomic trapezoidal, more typical of the 4th c. Actually, since the W sector encloses the Temple of Zeus, it is probable that the dating of the entire wall should be lowered to 314 B.C. A median wall, a diateichisma running N-S, cuts the enclosed area approximately in half. It was intended for the concentration of the defense in case of attack. The large gate in the wall opens to the S, and is defended by powerful buttresses. To the N of the surrounding wall is the acropolis, protected by its own encircling wall which is linked to the defensive system.

The theater, of the 4th c. B.C., is on a hill E of the village of Surovigli. The city probably also had a gymnasium, since an inscription of the 2d c. B.C. (IG^2 IX, 1.24.408) records the appointment of a gymnasiarchos.

Also datable to the 4th c. B.C. is the agora, SW of the modern village. The entire W side of the structure, with its portico, was built on a row of subterranean rooms, a Hellenistic peculiarity.

The Temple of Zeus, a peripteros 16.5 x 32.4 m on the W hill, may be dated to the 4th c., as is suggested by its connection with the city wall. It has a miscellany of orders: Doric in the peristasis, Ionic in the architrave, and Corinthian in the interior.

BIBLIOGRAPHY. A. K. Orlandos, *Deltion* 8 (1923); C. Picard & F. Courby, *Recherches archéologiques à Stratos d'Acarcanie* (1924); P. E. Arias, *Il teatro greco fuori di Atene* (1934); R. L. Scranton, *Greek Walls* (1941); W. B. Dinsmoor, *The Architecture of Ancient Greece* (1950); R. Martin, *Recherches sur l'agorà grecque* (1951); id., *L'Urbanisme dans la Grèce antique* (1955); A. Neppi Modona, *Gli edifici teatrali greci e romani* (1961); G. Roux, *L'architecture de l'Argolide aux IVe et IIIe siècle, avant J.C.* (1961). N. BONACASA

STRAVROUPOLIS Thrace, Greece. Map 9. A modern market town near the Nestos river, 17 km straight NW of the modern city of Xanthi. There is no known ancient settlement either in Stavroupolis or its neighborhood, but 2 km SE of Stavroupolis near the E bank of the Nestos, a Macedonian tomb was discovered in 1950. This probably belonged to the first half of the 2d c. B.C.

The tomb, built of marble blocks in a pseudo-isodomic style, has a total length of ca. 12 m. It consists of a vaulted dromos ca. 5 x 2 m, a prothalamos chamber 2 x 3 m, and the burial chamber 3 x 3 m. The floor of the prothalamos and the burial chamber are paved with rectangular marble slabs. The entrance to the burial chamber is closed by two marble door leaves with some ornamentation. At the back of the chamber are two marble couches set at an angle to each other, each having two double pillows. The feet of the beds are decorated with painted encaustic palmettes, spirals, rosettes, and moldings.

A painted molding 0.20 m wide, made up of Ionic and Lesbian kymatia runs around the prothalamos and the burial chamber at the level of the springing of the vault. On the kymatia and on the door leaves the vivid painted decoration is in encaustic. Although the tomb had been robbed, two gold rings and fragments of terracotta fig-

urines (now in the Kavala Museum) were found in the excavation. Three of the figurines are winged adolescent Erotes, with lively movements. The careful plastic rendering of body and face makes these figurines resemble monumental sculptures.

BIBLIOGRAPHY. X. I. Makaronas, Ἀνασκαφή τοῦ παρά τήν Σταυρούπολιν-Ξάνθης "μακεδονικοῦ" τάφου, ΠΑΕ (1953) 133ff; D. Lazarides, Νεάπολις Χριστούπολις Καβάλα, Ὁδηγός Μουσείον Καβάλας (1969) 160, πίν.61. D. LAZARIDES

STROMBOLI, *see* AEOLIAE INSULAE

STROUD Hampshire, England. Map 24. Roman villa 1.6 km W of Petersfield, excavated in 1907-8. In its final (4th c.) phase it consisted of buildings grouped around a nearly rectangular courtyard, ca. 51 m E-W and 48-52 m N-S. The dwelling flanked the N side, baths the W side, and a simple rectangular building, with a granary in its N end, lay on the E; the S side was bounded simply by a wall, with a gateway slightly E of center.

The dwelling in its earliest form was a simple aisled building (43.5 x 15 m) with projecting rooms at its SW and SE corners, an entrance at the E end, and probably another entrance, subsequently blocked, in the middle of the S side. At a later stage, while the E section was left unchanged, the 18 m to the W was subdivided into eight rooms and a corridor; this converted house had painted walls, hypocausts in two rooms and apparently a patterned mosaic (badly preserved) in the corridor. The date of the alteration was not established, but the pottery and coins were predominantly of the 3d and 4th c. The small size and simplicity of the living accommodation, in contrast with the size of the baths and the courtyard itself, strongly suggest that this was an establishment run by a bailiff rather than a residential villa.

BIBLIOGRAPHY. A. Moray Williams, *ArchJ* 65 (1908) 57-60[P]; 66 (1909) 33-52[PI]; J. T. Smith, "Romano-British Aisled Houses," ibid. 120 (1963) 1-30[PI].
 A.L.F. RIVET

STUDEN, *see* PETINESCA

STYBERRA, *see* STYMBARA

STYLIS (Stylidha), *see* PHALARA

STYMBARA (Styberra) Yugoslavia. Map 12. A large city in the middle of the Pelagonian plain showing Greek form and influence (triangular plan, ca. 550 x 220 m). It lay on the river Erigon (now the Vardar) and the road from Stobi to Herakleia Lynkou, near the present-day village of Čepigovo. Its origins go back to the late archaic period, and it was continually inhabited from then until late antiquity. Still visible are the city walls and the excavated gymnasium.

Strabo mentions the city, as does Livy, who tells us that in 200 B.C. the Roman army fighting Philip V turned to the N from Lynkos (Herakleia) and came to Stubera, where it could get wheat. Further on he mentions the city as the Macedonian base during Perseus' struggle with the Illyrians in 169. Stymbara is also mentioned in the work by the Ravenna Geographer (4.9.2). From the many inscriptions it is to be concluded that it belonged to the circumscription of Deuriopos, that it was included in the tribus Scaptia, and that the conventus civium Romanorum was to be found in it. The lists of city epheboi for the years 190, 203, 206, and 223 survive, enabling us to calculate that in the 2d c. the city had some 20,000 free inhabitants. A few marble statues are

of artistic worth. The base is extant for the statue of Septimius Silvanus Nichomachus, member of a family which produced a few Macedonarchs and a consul. The city may have been destroyed in an earthquake.

BIBLIOGRAPHY. N. Vulić, *Spomenik* 98 (1941-48) Nos. 390-92[I]; F. Papazoglu, "Jedan nov natpis iz Čepigova," *Živa antika* 3 (1953); id., *Makedonski gradovi u rimsko doba* (1957); D. Vučković-Todorović, "Styberra, antike Ansiedlung im Dorfe Čepigovo in der Umgebung von Prilep," *Archaeologia Iugoslavica* 4 (1963)[MPI]; I. Mikulčić, *Pelagonija u svetlosti arheoloških nalaza* (1966).

J. SASEL

STYMPHALOS Arkadia (Corinthia) Greece. Map 11. A town of NE Arkadia in antiquity, but presently in the nome of Corinthia. It was here that Herakles dispatched the fabulous birds. Mentioned by Homer (*Il.* 2.609) as an Arkadian town, it was said (Paus. 8.22.2) to have been founded by Temenos (Argive influence?). The town was of little importance in antiquity. Philip V decisively defeated the army of Euripidas (who had fled) there in 219-218 (Polyb. 4.67-69). It was one of the emperor Hadrian's benefactions to lead spring water from Stymphalos to Corinth.

The ancient acropolis lay on a promontory extending out toward the lake. On the highest point there are preserved the remains of a tower in the circuit wall from which can be observed the walls as they extend out on the landward side: the course of the wall, with its rounded towers, can be well followed in the plain, but disappears on the E under the waters of the lake. Descending toward the lake, one comes upon a small Temple of Polias with an altar in front and a nearly square building abutting it. Continuing down, one enters the agora (?), partially cut out of the rock of the acropolis. It contains a peculiar qoppa-shaped structure of ashlar polygonal masonry (4th c.) in part cut out of bed rock, a spring, and the remains of another structure (a stoa?) partially submerged in the lake. Also submerged in the lake are a Hellenistic temple and a palaestra. Farther along there are some rock-cut steps leading to the acropolis, a large dedication base, an exedra, the rock-cut cavea of a theater with some lower seats scattered about, and a rock-cut seat. The city of Pausanias' (8.22) time lay to the N near and under the ruined Frankish Katholikon.

BIBLIOGRAPHY. Report in *AthMitt* 40 (1915) 71-90, with tables 13-14[I]; A. Orlandos in *Praktika* (1924-30, particularly 1924-26; 1925[P]); *RE* VII (1931) 436-53; R. Scranton, *Greek Walls* (1941) 166; J. Delorme, *Gymnasium* (1960) 235-37 and passim; F. E. Winter, *Greek Fortifications* (1971) 34.

W. F. WYATT, JR.

STYRA S Euboia, Greece. Map 11. At modern Nea Styra on the W coast. Styra was the most substantial prehistoric settlement in the region. Two Cycladic figurines have been reported, and Neolithic, Early Helladic, and Middle Helladic sherds, as well as some obsidian, continue to be found at at least five sites.

Otherwise the only certain remains are Classical. The Dryopian inhabitants were no doubt in some sense subject to Eretria during the archaic period (cf. Strab. 446), but their formal independence dates at least from the Persian sack of Eretria in 490 B.C. Styrans served at Artemision, Salamis, and Plataia; joined the Delian League (normally paying one talent); and fought for Athens in the Peloponnesian War until 411, when they revolted with the other Euboians. At an unknown date before the 340s they had fallen back under Eretria, and shares its later history.

Quarries are frequent in the area. Three small dragon

houses reminiscent of the great building on the summit of Mt. Ocha (see Karystos) are the principal remains. A further puzzle is provided by some 450 lead tablets with unusual names, dating from the early 5th c. The acropolis, now surmounted by the Frankish castle Larmena, still shows old fortifications.

Near the landing Nimporio are ancient quarries, and two tombs with monolithic sarcophagi; half an hour inland at Pyrgos there is a tower with reused Classical blocks.

BIBLIOGRAPHY. Hom. *Il.* 2.539; Hdt. 6.107, 8.1, 46.9.28, 31; Thuc. 7.57; Strab. 444; Ptol. 3.15.25; Paus. 4.34.11.

F. Geyer, *Topographie und Geschichte der Insel Euboias* (1903); F. Johnson, "The Dragon Houses of Southern Euboea," *AJA* 29 (1925) 398-412[I]; K. A. Gounaropoulos, *Historia tes Nesou Euboias* (n.d.); W. P. Wallace, "The Demes of Eretria," *Hesperia* 16 (1947) 115-46; id., "The Euboian League and its Coinage," *NNM* 134 (1956); L. H. Sackett et al., "Prehistoric Euboia . . . ," *BSA* 61 (1966) 33-110[MP]; T. Zappa, *Ta Styra tes Euboias* (1967).

M. B. WALLACE

SUANCES ("Portus Blendium") Santander, Spain. Map 19. On the coast 31 km W of Santander. Pliny (*HN* 4.3) located Portus Blendium in Cantabria, the nearest port E of Portus Victoriae Iuliobrigensium. The *Itinerarium* of Varro makes it the terminus of the road from Iuliobriga to the coast, a stretch of which is preserved. It is either in Suances or nearby, where several Roman objects have been found.

BIBLIOGRAPHY. A. García y Bellido, "Exploraciones arqueológicas en la provincia de Santander," *ArchEspArq* 29 (1954).

R. TEJA

SUASA (Castelleone di Suasa) Umbria, Italy. Map 16. A Roman municipium in the Gallic march of Umbria (Suasa Senonum) and belonging to the tribus Camilia. It was situated in the Piano Volpello ca. 3 km from the modern settlement and was served by a road from Cales to Sena Gallica. It was probably destroyed by Alaric in 409. The ruins, extensive but overgrown, include walls and gates, a theater, and an amphitheater. Architectural spoils from the ruins and inscriptions ornament buildings at Castelleone, and a small museum is maintained at S. Lorenzo in Campo. Much material is now elsewhere, notably a large fragment of a gilt bronze horse's head (Walters Art Gallery, Baltimore).

BIBLIOGRAPHY. G. Giorgi, *Suasa Senonum*, Istituto Saveriano, Parma (1953)[MI]; *EAA* 7 (1966) 536 (G. Annibaldi).

L. RICHARDSON, JR.

SUAUX Charente, France. Map 23. Gallo-Roman establishment at Chez Migeau, in the commune of Suaux, on a hill overlooking the valley of the Bonnieure, not far from the road from Saintes to Limoges. It is at the E edge of the civitas of the Santones and near the territory of the Lemovices.

A vast edifice discovered in 1961 is still only partially excavated. A large gallery and three rooms attached to it, with a concrete floor, have been uncovered. The gallery, 3.3 m wide, has been uncovered for a length of 35 m. The walls, of small blocks, have semicircular projections which must have served as bases for half-columns, or for columns of which a few drums and Doric capitals with flared echinus and square abacus have been found. The surfaces were painted with fine frescoes with a plant motif towards the end of the 1st c. A.D., and the finds, gray rouletted ware, terra sigillata and flat tripods also date construction to the middle of the 1st c. The building was later remodeled, and was occupied until at

least the end of the 2d c. Its purpose is not yet determined.

BIBLIOGRAPHY. *Gallia* 21 (1963) 438-39; 23 (1965) 353-55; 25 (1967) 245; 27 (1969) 263-65; 29 (1971) 258.

G. NICOLINI

ŞUAYP ŞAHR, *see under* ANTIOCH BY THE CALLIRHOE

SUBDINUM or Vindinum (Le Mans) Sarthe, France. Map 23. The site was occupied from the 1st c. B.C. on, but we know little about it in the Late Empire. Ancient harbor installations, however, discovered in the 19th c., indicate that the city was an important economic center as early as the end of the 1st c. B.C.

Towards the end of the 3d c. A.D. Subdinum acquired a fortified circuit wall, still visible today. The outer facing of the walls and of the projecting round towers has a core of mortared rubble faced with small blocks, and is decorated with a simple design of white stones (chevrons, lozenges, bars, small rosettes). Near the Tour Madeleine a very fine ashlar masonry of large blocks may be seen at the base of the walls; it is decorated with arcs, circles, and ovolos engraved in intaglio. One of the city's postern-gates, discovered in 1953 (the rampart has two other gates of the same type), consists of two parallel walls of cyclopean stones supporting a brick vault. The floor of the postern is made up of large flat slabs, on which the side walls rest. This was probably a sea-gate leading directly to the Sarthe, which in this area reached the level of the rampart.

BIBLIOGRAPHY. P. Cordonnier-Dietrie, "Informations," *Gallia* 12, 1 (1954) 172-75; 15, 1 (1957) 202-3.

M. PETIT

SUBIACO, *see* SUBLAQUEUM

SUBLAQUEUM (Subiaco) Italy. Map 16. This locality, recorded by Pliny the Elder (*HN* 3.109) and by the *Peutinger Table*, is on the bank of the Aniene at the foot of the Simbruini mountains, about 70 km from Rome. Nero had a villa constructed here (Tac. *Ann.* 14.22; Frontin. *Aq.* 93), already completed in A.D. 60. The villa, of which there survive conspicuous remnants, was built as a series of detached buildings and rooms of varying height along the shores of two or more artificial lakes created by enlarging the Aniene with two or three dams; one is the tallest known Roman example (ca. 42 m). Three nuclei have been noted on the left bank. One, perhaps a viridarium, is in the locality called Pianello. A second, very large, is in the locality called Casa delle Streghe, and is made up of a nymphaeum-veranda above and a series of rooms for habitation arranged along a windowed corridor below. A third, which is much less well known, is in the locality called S. Lorenzo where the Via Sublacensis passed. On the right bank were placed a like number of buildings, two on the upper part and one on the lower. Only the first two have been explored. One includes an ample room from which comes the celebrated Ephebe of Subiaco, near the ditch of S. Croce. The other is a complex of rooms giving on a gallery, before the Casa delle Streghe and the terminus of the first dam. The villa was inhabited until the late Imperial period and was later among the first refuges of St. Benedict, who founded nearby the important convent of S. Scolastica. In the lower part of the villa grew up the mediaeval nucleus of Subiaco. The sculptures found in the villa are preserved in the Museo Nazional Romano in Rome.

BIBLIOGRAPHY. L. Canina, *Gli edifizi antichi nei contorni di Roma*, V (1856) 137-39MPI; R. Lanciani, *NSc* (1883) 19-20; G. Fiorelli, *NSc* (1884) 425-27; H. Phil-

ipp, *RE* IV A (1931) 480; *EAA* 7 (1966) 537-38 (M. Torelli); N. Smith, "The Roman Dams of Subiaco," *Technology and Culture* 11 (1970) 56-68. M. TORELLI

SUBSTANTION, *see* SEXTANT

SUCIDAVA or Pîrjoaia (Izvoarele) Constanţa, Romania. Map 12. On the right bank of the Danube, 3 km downstream from the village, are the ruins of a Roman fortress of the 4th c. A.D. It has not been excavated systematically. The path of the rampart can still be seen as well as the outline of a Christian basilica inside the city walls. The *Peutinger Table* and the *Antonine Itinerary* identify the site as Sucidava (in Moesia Secunda). According to a recent hypothesis, this would be the site of Daphne, which Procopius includes among the phrouria on the left bank of the Danube (*De aed.* 4.7) but which A. Marcellinus, perhaps with more justification, places on the right bank of the river.

BIBLIOGRAPHY. A. Aricescu, *Dacia* NS 14 (1970) 301; P. Diaconu, *Pontica* 4 (1971) 311-17. D. M. PIPPIDI

SUCIDAVA (Corabia) Romania. Map 12. Most of the ancient remains of this settlement are covered by a section in the modern city called Celei. The settlement flourished on a high terrace on the left bank of the Danube, at the end of an ancient road connecting the river to the Carpathian mountains. The plain extending to the N, one of the most fertile, is suitable for the growing of grain. The proximity of the river assured the local inhabitants a supply of fish, as well as reeds and wood for building. Across the river, Sucidava was connected to the S Balkans by the Isker valley. The ancient locality of Sucidava is mentioned in the *Notitia dignitatum* and in Procopius (*De aed.*).

During the free Dacian period, Sucidava was the political and economic center of the Suci, a Dacian tribe that had trade relations with Hellenistic cities and the Roman Empire, as proven by coins and stamped amphorae. It came under Roman domination during Trajan's Dacian wars. It is during this time that the Dacian citadel was destroyed and replaced by a Roman necropolis. The Romans built an earthen camp and founded a civil center covered today by modern houses. Its first garrison was Cohors I Lingonum. The Roman city (2d-4th c.) covered an area of ca. 25 ha and had a port on the Danube. Toward the middle of the 3d c., it was protected by a trapezoidal fortification including a trench, a stone wall, and an agger. Excavations have uncovered the N and S gates of this fortification, which were guarded by square or semicircular towers. Towers are also found on the corners. The Roman road, 5.5 m wide, crossed the city (N-S). It was paved with stones that still show the ruts left by many vehicles. Judging from these ruts, the distance between the two wheels was 1.5 m. A puteus was discovered in the city. It was reconstructed and is still in use as a source of drinking water, although it dates from the 2d c. A.D.

Sucidava remained a simple pagus from the administrative point of view. However, it was the capital of a territorium Sucidavense, administered by two quinquennales assisted by the curiales delegated from the villages. As a meeting place, they chose the Temple of Nemesis. In addition to growing grain, the inhabitants were also vine-growers, to judge from the will of a local landowner carved on a stone slab. Many veterans of the Roman garrisons of Moesia inferior settled in Sucidava. An inscription of the period of Commodus gives proof of the presence of a customs post between Dacia and Moesia, controlled by two servi villici. In addition to

the brick and pottery works, among the workshops of the city were plumbarii, for the excavations have revealed over 100 lead frames for mirrors. Terra sigillata and wines were imported. The economic prosperity of the locality is also shown by the many discoveries of Republican, Imperial, and Byzantine coins, of which there were seven deposits. Under Gallienus and Aurelian, a citadel was constructed on the terrace, over the Roman necropolis. This defensive construction was continually reinforced and restored under the Tetrarchy or under Constantine the Great. It was twice destroyed by the invasions of the Huns. Its last restoration was ordered by Justinian. It was finally destroyed by the Avars and the Slavs.

Inside the citadel was found the oldest Christian basilica known N of the Danube. A secret fountain provided with an underground corridor brought in drinking water from outside the wall (6th c.). Constantine the Great had a great stone and wood bridge across the Danube built here. This bridge, 2400 m long, was a copy of the bridge of Apollodorus at Drobeta. In 328, the same emperor repaired the Roman road that went from Sucidava to Romula (milliarium). A strong Roman garrison was stationed at Sucidava after the abandonment of Dacia. In the 4th c., it was commanded by a praefectus legionis V Macedonicae.

The material from excavations is in the museums of Corabia, Bucarest, and Orlea.

BIBLIOGRAPHY. *CIL* III, 8042; 14490-93; *AnÉpigr* (1914) 122; (1939) 19, 95, 96, 321; (1959) 321-23; (1961) 87; (1969) 202.

V. Pârvan, "Ştiri nouă din Dacia Malvensis," *ACRMI* 36 (1913) 63; D. Tudor, "Sucidava, I-VII (Rapports de fouilles)," *Dacia* 5-6 (1935-36) 387-422; 7-8 (1937-40) 359-400; 11-12 (1945-47) 145-208; and *MCA* 1 (1953) 693-742; 7 (1961) 473-94; 8 (1962) 555-64; 9 (1970) 281-96; id., "Ein Konstantinischer Meilenstein in Dazien," *Serta Hoffilleriana* (1940) 241-47; id., *Prima basilică creştină descoperită în Dacia Traiană* (1948); id., "Sucidava: une cité daco-romaine et byzantine en Dacie" = coll. *Latomus* 80 (1965); id., *Sucidava* (1966); id., *Oraşe* (1968) 323-40; id., *Oltenia romană* (3d ed., 1968) 202-14, 425-49; id., *Podurile romane de la Dunărea de la Dunărea de Jos* (1971) 155-92; R. Syme, *Danubian Papers* (1971) 171. D. TUDOR

SUFES (Sbiba) Tunisia. Map 18. A city in the great N-S corridor that cuts through the Dorsale chain, with Le Kef and Sbeitla at either end—both important meeting points of the N Tell and the great S steppes. Sbiba, which lies midway between the two cities, is also a crossroads between E and W, with the road leading to Thala and Algeria on one side and, on the other, the road leading to Mactar and the coast over the mountain passes. With this commanding position on an inland route, ancient Sufes stood on a hillside overlooking the plain ringed by the distant Jebel Mhirla and the plateaus of Rohia which flows into the wadi Hatob. Owing to the city's strategic position and its fertile soil, its prosperity survived to the early Middle Ages.

In the Roman period it evidently served the same purpose as a link between Sicca Veneria through Assuras and Suffetula; these connected it with the great route from Carthage to Theveste to the N and the emporia route to the S, as well as the road from Thala and Ammaedara on one side, from Mactaris to Hadrumetum through Aquae Regiae.

A castellum in the early days of the Empire, Sufes became a colonia probably under Marcus Aurelius, and its principal monuments date from this period: the baths,

the square reservoir, and especially a great semicircular nymphaeum which obtained its water from an aqueduct that brought water from the wadi Sbiba 9 km away.

The incident of the massacre of 60 Christians in 399 after the smashing of a statue of Hercules is described by St. Augustine, and this enables us to identify that god with the Genius of the city. Various other references to Catholic and Donatist bishops from 256 and 484 up to 883 show that Christianity penetrated Sbiba, and the fact that it triumphed is proved by two basilicas, one with three naves and apse, the other larger (21.6 x 25 m) and with 10 rows of columns; this monument later became the Jemma Sidi Okba mosque.

In the unstable days of the Late Empire the region was one of the great areas of confrontation and Sufes again came into its own as a stronghold on the inland route. Two ramparts erected by the Byzantines and used in the Arabian period are still standing, though now considerably demolished. Hurriedly built, they surround a series of earlier monuments. At one corner is a fortress 45 x 40 m with four corner towers; better preserved than the rest, it seems to have been erected by Salomon, the prefect of the praetorium of Justinian (see both *CIL* VIII, 259 and 11429, which presumably refer to it), to defend the city—still an open city at this time—before it was swallowed up in the great rectangular wall (190 x 110 m) that was put up later.

There are more, and more widespread, ruins at Sbiba than this brief listing of the most easily recognized of them indicates. However, they have never been officially excavated and the rebuilding of the modern village has often been done at the expense of the ruins.

BIBLIOGRAPHY. C. Diehl, *L'Afrique byzantin* (1896) 196; P. Gauckler, *Basiliques chrétiennes de Tunisie* (1913) pls. VIII & IX. A. ENNABLI

SUFETULA (Sbeitla) Tunisia. Map 18. At the crossroads of the highways from oases to the S to the great plains to the N, and of the mountains of the interior to the low steppes and the sahel, the city is at the heart of the high steppes. Mistress of the communications among these diverse regions, it was also at one time a center of olive culture. The site of the ancient village extends between the wadi Sbeitla to the NE and on both sides of the road from Kasserine to Sbeitla.

Founded, if not already in existence, in the era of Vespasian, it was the theater of the great confrontation between the Byzantines and the Arabs in 646. The defeat of the patrician Gregory marked the end of the town and that of the Empire.

Because of its extent and the fine preservation of some of its monuments, the site of Sufetula was often visited by travelers, beginning as early as the 18th c. with Ximenes. In 1883, Saladin and Cagnat gave an important description of it. At the end of 1904, the site was excavated and published. Numerous buildings have been uncovered: the forum, presided over by the triple capitol at one side and by the triumphal gateway at the other. This homogeneous ensemble, probably built in the middle of the 2d c. at the center of the site, was excavated and restored between 1906 and 1921.

The forum is surrounded by porticos on three sides and hemmed in by an enclosure. The capitol is made up of three juxtaposed temples, prostyle, tetrastyle, and pseudo-peripteral; the middle one, of the composite order, is more elevated than the other two, which are Corinthian. They stand on podia sheltering vaulted cellars. The triumphal gateway has a large center arch flanked by two smaller ones, carrying on the attic a dedication in honor of Antoninus Pius. In the Byzantine

period, this whole complex was converted into a citadel, the openings closed, the walls raised or strengthened with reused material, among which inscriptions have been found. In the immediate neighborhood is a Byzantine cemetery.

Several streets started at the forum. Even before excavations had uncovered them, the grid plan of the town was suggested by the alignment of the visible remains of walls. Excavation confirmed this observation, but it has established that the plan of the grid was not always strictly followed.

Although few of the individual houses have been excavated or published, one of them was so extensive and rich that it has been thought to be possibly a public edifice or even a basilica. It is the Building of the Seasons, excavated partially in 1909-10 and completely uncovered in 1964; the plan which appeared from it is a vast peristyle with a great oecus with double apses.

Among the other buildings uncovered, the most important form the episcopal group; these are two large basilicas called Vitalis and Bellator, parallel to each other and separated from each other by the Jucundus Chapel. This complex is surrounded by annexes, among them small baths and probably the dwellings of the clergy. The Church of the Bellator excavated in 1907 has three naves and a double apse; it is built in part on the foundations and with the large-scale blocks of an earlier edifice. It includes several levels, which bear witness to long occupation. The Church of Vitalis seems to have been the later one, and excavations were begun in 1911 and finished in 1963. It is larger, having five naves and double apses and including several occupation levels. Its mosaic pavements are among the most varied that exist at Sufetula. Numerous tombs with epitaphs occupy the floors of the naves, among them that of the priest Vitalis, whose inscription is preserved today at the Bardo Museum in Tunis. Behind the SW apse is the baptistery, oblong in form, entirely sheathed with mosaic. Between the two basilicas, the funerary chapel of Jucundus was excavated in 1911.

The Church of Servus, several meters to the E of the Arch of Antoninus, almost square in plan, was originally a temple of African type; a large peristyle court surrounding a square cella enclosed by two exedrae opening on the area. This plan was converted to a basilica with five naves and the cella changed to a baptistery. Close to this church is a monumental fountain excavated in 1955, a large rectangular basin surrounded on three sides by a thick stylobate of worked stone.

Lower to the E-SE, in the direction of the street which leaves from the forum, is the quarter of the theater and the great baths. The theater, built against the bank of the river, was excavated completely in 1923; it appears not to have been completely finished. Later on, a statue of Dionysos on a panther was found there.

The great baths, constructed in the 3d c., were excavated during several campaigns in 1916-17, 1922, 1946-49. Several inscriptions were found there. The triumphal arch of the Tetrarchy, SE of the town, appears to be a mediocre imitation of the one at Ammaedara.

Finally, there should be mentioned the existence of an amphitheater, and a bridge-aqueduct over the wadi which, by means of three arches resting on enormous pillars, spans the ravine and led the water from the mountain towards the town.

BIBLIOGRAPHY. Merlin, *Forum et église de Sufetula* (1912)[PI]; P.-M. Duval in *CahTun* (1964) 87-103[P]; in *BAntFr* (1964) 50-57. A. ENNABLI

SUGOLIN, *see* ZLITEN

SUIAR DES BENI AROS, *see* AD NOVAS

SŪKĀS, *see* TELL SŪKĀS

SUKHUMI, *see* DIOSCURIAS

SULCIS (S. Antioco) Sardinia, Italy. Map 14. A city on the island of the same name, facing the SW coast of Sardinia. The historians (Strab. 5.2.7, Paus. 10.17.9) attribute its foundation to the Carthaginians, but probably the locality was earlier the site of a Phoenician colony superimposed upon a nuraghic settlement. A secondary colony of Sulcis was the little center near Mount Sirai, a few kilometers toward the interior of the island. During the civil war Sulcis took the part of Pompey and thus was subject to heavy confiscations imposed by Caesar in 46 B.C. In the 1st c. A.D. it became a Roman municipium and was inscribed in the Quirina tribe. Numerous inscriptions from the 1st and 2d c. record public works and statues erected in honor of the Emperors. The life of the city continued into the mediaeval period in spite of the Saracen invasions.

Systematic excavation, which began in 1954, has localized the site of the ancient city, whose urban complex extended to the N and S of the isthmus which unites it with Sardinia. The remains consist of a few fragments of mosaic pavements from the Roman Imperial period. The walls surrounding the city were constructed to the W, on Mount "De Cresia," and continued to the port. On the N side, about midway up the hill of the Fortino, the various building phases of a sacred structure of Classical type have been discovered. It is oriented E-W, and surrounded by a portico with columns. In the area immediately to the N is a vast complex of courtyards. It includes three rectangular enclosures, two of which overlap, that are aligned on the outer side with another broad enclosure. The complex has been identified as the tophet, which in part takes advantage of the natural rock formation. The earliest objects from this sanctuary, which is contemporaneous with the origin of the city, date from the 9th to the 7th c. B.C. The uppermost stratum extends to the Republican period. The necropoleis of Sulcis extend along the sides of the two hills on which the modern city lies. The tombs are of the Punic type, and were reused by the Romans and again by the early Christians. The remains of a painted arcosolium in one of the tombs and crematory urns scattered on the surface of the area date from the time of Constantine. A few remains from the Roman period have been found at Is Solus, probably within city limits in the Republican epoch. They include large cisterns, a drainage basin for water, a funerary mausoleum in stone in Via Eleonora d'Arborea, and from a house in Via Garibaldi a pavement from the 2d c. A.D. To the E, on the isthmus, is a Roman bridge with a single arch. Remains of the docks from the ancient port are along the beach. Imperial statues were found at Su Narboni, and on the property of the Rivano family. It is not known where the temple dedicated to Isis and Serapis (*CIL* x, 7514) was located. The objects from the excavations are presently preserved in the Antiquarium, in small local private collections, and in the National Museum at Cagliari.

BIBLIOGRAPHY. A. Taramelli, *NSc* (1908) 145ff[I]; (1914) 406ff[I]; (1925) 470ff; E. Pais, *Storia della Sardegna e della Corsica*, I (1923) 20, 112, 361ff; A. Lamarmora, *Viaggio in Sardegna*, I (1927) 128ff; P. Mingazzini, *Studi Sardi* 8 (1948) 73ff[PI]; G. Pesce, *Sardegna punica* (1961) 43f[MPI]; id., in *EAA* 7 (1966) 551ff[I].

D. MANCONI

SULLECTHUM (Salacta) Tunisia. Map 18. Situated at the tip of a small protecting promontory 15 km S of Mahdia. The homes in a village of farmers and fishermen are scattered over the ruins of the ancient site along the shore. The main coast road ran through the ancient city, which was linked to the hinterland, especially to Thysdrus, by a direct route; the city grew up around a port that was connected with the rest of the Mediterranean, particularly Ostia, where the site of its warehouse was found in the Square of the Corporations.

The site has never been systematically excavated, but remains have continually been discovered. A rectangular rampart several dozens of meters long runs around the port; the basins of the latter are protected by moles sheltered by a long jetty.

Among the remains partially excavated are small baths situated a few meters from the shore. An aedicula opens onto the frigidarium; a sort of nymphaeum designed like a grotto, it consists of an almost square basin with raised walls containing six niches and, most probably, with a vault over all. In front of the opening of this basin was a wide platform (2.87 x 1.73 m) paved with a geometric mosaic; in the middle of the mosaic was a tablet (1.07 x 0.38 m) containing a quatrain, in black letters on a white ground, proclaiming the fall of the envious.

To the E of the small baths, which very probably belonged to a professional or religious association, was a salting and garum factory that can be identified by its appurtenances: basins of various sizes, placed at ground level, which were vaulted or open and had walls faced with opus signinum.

Also on the seashore is another house with baths that were partly explored on account of their mosaic floors. The floor of one of the rooms (4.65 x 4.05 m) has a design of dolphins frolicking in the sea with, among them, two sailing ships, one decorated with a lion, the other with a dog, and labeled respectively "Leontius" and "Caneius" below the stern. The design has been badly damaged since excavation. To the E is another room with a mosaic (also very badly damaged) where a design of a lion devouring a boar, and an illegible inscription, were noted. There is a corridor, leading to a doorway, decorated with footmarks to the N, and to the S another room with a mosaic of a lion measuring 4.5 m (now at the Sousse Museum) and on the threshold the design of a boat, now also almost totally destroyed. Other older mosaics have also been found.

Particularly important are the various necropoleis spread out along the entire coastline, which have been located in active prospecting for a long period of time: dolmens of Berber origin, Punic vaults, Roman tombs, Early Christian catacombs, in which various grave gifts and epitaphs have been found. Also aligned along the shore are some mounds of pottery. Here many fragments of amphora necks have been found, complete with potters' stamps. There are remains of some fine villas a few kilometers S of the site, at El Alia and La Chebba. In one of these the famous mosaic of the Triumph of Neptune, now at the Bardo Museum in Tunis, was discovered.

BIBLIOGRAPHY. D. Anziani, "Nécropoles puniques du Sahel tunisien," *MélRome* (1912) 245-303; L. Foucher, "Note sur l'industrie et le commerce des salsamenta et du garum," *Actes du 93e Congrès National des Sociétés Savantes* (1968) 17-21. A. ENNABLI

SULLONIACAE (Brockley Hill) Hertfordshire, England. Map 24. The site, 19.2 km from London and 14.4 from Verulamium on Iter II of the *Antonine Itinerary*, is partly built on and has no visible remains. Finds point to continuous occupation from ca. A.D. 60, with pre-Roman activity. It was presumably a small town or roadside settlement, although little is known of its buildings. Its importance lay in the production of pottery ca. A.D. 65-150. The extent of the kilns is unknown, but they belonged to a complex of related potteries including Radlett ca. 3 km away, and probably unknown sites nearer London. The potteries sold most of their products locally, but they also specialized in mortaria which were sold throughout the province, accounting for about half of those in use in Britain ca. A.D. 70-120. They were stamped with the maker's name: Bruccius, Doinus, Lallans, Matugenus (die found), Melus and Ripanus (Q. Rutilius) are well attested. The potteries were favorably situated, with Verulamium and London providing large local markets and major roads radiating to all regions of Britain. Finds are in the London Museum.

BIBLIOGRAPHY. C. E. Vulliamy, *The Archaeology of Middlesex and London* (1930) 202-7; various authors in *Trans. London and Middlesex Arch. Soc.* n.s. 10 (1951) 1-23[PI], 201-28[PI]; 11 (1954) 173-88[PI], 259-76[PI]; 18 (1955) 60-64[I]; 19 (1956) 64-75[PI]; notes on potters outdated: see S. S. Frere, *Verulamium Excavations* I (1971); Reports of Research Comm., Soc. Ant. London 28 (1971). K. F. HARTLEY

SULMO (Sulmona) Abruzzi, Italy. Map 14. The city is situated near the S extremity of the territory inhabited by the Paeligni, on a plateau delimited by the rivers Gizio and the Vella, near their confluence. Together with Corfinium and Superaequum, Sulmo was one of the principal centers of the Paeligni population, maintaining its importance into the mediaeval period. No traces of the Paeligni settlement remain, but the conspicuous number of burials found in the area demonstrate that the population must have been distributed in numerous pagi of modest size. The first inhabited center at Sulmo must have been similar to these, but it must have become more important than the other settlements in the last centuries of the Republic because of its position on the road that led to Samnium. In the 1st c. B.C. after the social war, Sulmo was designated a municipium under the Roman state.

The plan of the ancient city is recognizable in the orthogonal arrangement of the network of mediaeval streets at the center of the modern urban center. The urban area is almost square ca. 400 m to the side (Ovid, *Am.* 3.15.12: moenia quae campi iugera pauca tenent).

Outside the city on the slopes of Mt. Morrone, near the Abbey of S. Spirito, are the ruins of a large sanctuary built on terraces. Because of its massive bulk the building has always been partially visible, and the mediaeval tradition identified it with the *poteche di Ovidio*, linking it with the native poet. Excavations have revealed the religious character of the monument and its pertinence to the cult of Hercules Curinus. The complex is arranged on two artificial terraces oriented SW, but not precisely aligned. The upper terrace, which is earlier, is built against the rocky side of the mountain and is sustained by a mighty wall in polygonal work that is 4.25 m high. On the shelf-like area, built against the back wall, is a chapel in which votive gifts with inscribed bases have been found. In front of the entrance was a votive altar in bronze. The lower terrace, which is larger, is constructed of masonry and follows the architectural plan common in the sanctuaries of Latium in the 1st c. B.C. The front of the terrace, which is 13.7 m above ground level at its highest point, is supported by vaulted chambers; and the lower parts rest on a filled wall faced with

alternating courses of opus incertum and opus reticulatum.

BIBLIOGRAPHY. *EAA* 7 (1966) 555-57 (A. La Regina); id., *Quaderni dell'Istituto di Topografia Antica dell'Università di Roma* 2 (1966) 107-16; H. Blanck, *AA* (1970) 344-46; F. van Wonterghem, *AntCl* 42 (1973) 36-48; id., *Documenti di Antichità Italiche e Romane*, II (Soprintendenza alle Antichità degli Abruzzi, 1973); id., *Forma Italiae (Paeligni)*. In preparation. A. LA REGINA

SULMONA, *see* SULMO

SULTANHISAR, *see* NYSA

SULUSARAY, *see* SEBASTOPOLIS HERAKLEOPOLIS

SUMATAR HARABESI, *see under* ANTIOCH BY THE CALLIRHOE

SUMELOCENNA (Rottenburg am Neckar) Baden-Württemburg, Germany. Map 20. A Roman settlement midway on the Neckar, ca. 50 km SE of Stuttgart. Its name is found in the *Peutinger Table* (4.1) and mentioned in many inscriptions (*CIL* XIII, 2506, 6358, 6365, 6384, 9084, 11726, 11727). As its name suggests, the Roman settlement superseded a Celtic one. From 85 to 90, it was part of the Roman Empire and the seat of a procurator of the saltus Sumelocennensis. Later, it became capital of the civitas Sumelocennensis. A city wall over 2 km long survives and the ruins of various buildings, among them a bath currently accessible under the modern gymnasium. The town was provided with water by a stone-built aqueduct 7 km long, of which numerous traces may still be seen. The finds are preserved at the Württemburg Landesmuseum in Stuttgart and at the Sülchgau-Museum in Rottenburg am Neckar.

BIBLIOGRAPHY. F. Haug & G. Sixt, *Die römischen Inschriften und Bildwerke Württembergs* (2d ed. 1914) 199ff; O. Paret, *ORL* B, 61 (1936); D. Planck, "Neues zur römischen Vicusmauer in Rottenburg a.N.," *Der Sülchgau* 11 (1967) 9ff. D. PLANCK

SURA Turkey. Map 7. Town in Lycia, ca. 4 km W of Myra (Kale, formerly Demre) and still known by its ancient name. Sura was not an independent city, but a dependency of Myra; as such it naturally struck no coins. It is in fact virtually unknown apart from its celebrated fish oracle.

The village extends around a low hill which on the E rises only some 12 m above a small level plain, but on the W descends steeply over 100 m to sea level at the head of a marshy inlet. The buildings on the hill seem all to be tombs; several are rock tombs of Lycian type, and two carry inscriptions in the Lycian language. On the S side of the hill is a row of stelai with inscriptions listing the names of Prostatae of Apollo Surius; there seem to be 21 names in each case. Scattered about the plain to the E are a dozen Lycian sarcophagi with Greek inscriptions.

The Temple of Apollo still stands up to 8 m high at the W foot of the hill close to the marshy inlet. On its interior walls are a number of inscriptions recording the devotions paid by suppliants—not, however, to Apollo Surius but to Sozon and in one case to the Rhodian deity Zeus Atabyrios. The site of the fish oracle is clearly recognizable from the ancient accounts (Ath. 8.333-34; Plin. *HN* 32.17; Steph. Byz. s.v. Sura; Plut. *De sollertia animalium* 23). It appears that a whirlpool arose on the shore of the harbor; into this consultants threw spits bearing pieces of meat, whereupon the pool swelled up and a variety of fishes appeared, from whose species and behavior an oracle was drawn. Pliny also mentions a fountain of Apollo whom they call Curius (or Surius). These features are still identifiable. The harbor is the marshy inlet, which was certainly sea in antiquity; the fountain, with an abundant head of water, issues from the ground a few paces from the temple and forms a stream which flows through the marsh to the sea, 1-2 km away. In this stream, just in front of the temple, a number of springs well up, creating a swirling effect which resembles a whirlpool; this answers exactly to the account given by the local inhabitants in Athenaeus (l.c.). The swelling of the pool was presumably managed by the priest's controlling the flow of water from the large spring. No actual oracles obtained at Sura are recorded.

BIBLIOGRAPHY. T.A.B. Spratt & E. Forbes, *Travels in Lycia* (1847) 135-37; E. Petersen & F. von Luschan, *Reisen in Lykien* II (1889) 43-46; G. E. Bean, *AnzWien* (1962:2) 6-8. G. E. BEAN

SURDUK, *see* LIMES PANNONIAE (Yugoslav Sector)

SUROVIGLI, *see* STRATOS

SURRENTUM (Sorrento) Campania, Italy. Map 17A. A Greek colony, as attested by an inscription in Doric dialect and dated by the epigraphic characters to the 4th c. B.C. This indicates that the city remained at least culturally Greek, even after an Etruscan domination, probably brief, at the beginning of the 5th c. B.C., and after a stable Oscan occupation from 420 B.C. on. Surrentum was probably part of the Nucerian League, together with Stabiae, Pompeii, and Herculaneum. Nothing is known of its political relations with Rome, but it appears almost certain that the city did not join Hannibal after the battle of Cannae. During the social war Surrentum accommodated the insurgents and as a consequence had a settlement of Sullan colonists, followed by the stationing of some of Augustus' veterans there. Later, but before the time of Hadrian, the population had Roman citizenship as a municipium. Surrentum became a vacation spot for rich Romans, particularly in the 1st c. B.C. and A.D.

The few vestiges of Greek and Oscan Surrentum consist almost exclusively of meager remnants of statues from the 4th c. B.C., and of a necropolis in use from the end of the 7th to the middle of the 3d c. B.C. (with a gap in the 5th). The necropolis was discovered at Vico Equense, a settlement which was certainly part of Surrentum. The only visible remains of the pre-Roman city is the remnant of a gate, and it is uncertain whether this dates to the late 5th–early 4th c. B.C. when the city was still Greek and had to defend itself from Etruscan and Oscan expansion, or whether it is from the beginning of the 1st c. B.C. when the social war was imminent. In any case, even if the more recent date is correct, there is no doubt that the gate, together with a second gate and a section of the W screening wall, occupied about the same position as the primitive Greek city walls. The same may be said of the paved road, now Punta della Campanella, which led to the famous Temple of Athena. Nothing remains of the temple. Only a few votive objects confirm that it stood where the unanimous testimony of the historians and the *Peutinger Table* place it. Apparently the city, which suffered neither devastating fire nor sack in ancient times, has preserved in general the plan of the Greek city, with streets intersecting at right angles. Even the modern market corresponds to the Greek agora.

There are abundant remains of the Roman city, however, particularly from the Early Imperial period. They include: the villa of Agrippa Postumus, which seems to have existed on the site of the modern Albergo delle Sirene and the adjacent area; the villa of Punta di Sor-

rento, the so-called Bagno della Regina Giovanna; the villa of Punta di Massa, separated from the Puolo beach by the Villa di Pollius, of which almost nothing remains; the villa near Punta della Campanella, probably a *pied-à-terre* for those, including originally the Emperor, in transit for Capri; and other minor villas scattered on the coast of the Gulf of Naples and on one of the Sirenusan Islands. Together these villas are notable for their beauty and architectural individuality, especially the installations on the sea, which are fairly well preserved and of great variety.

BIBLIOGRAPHY. P. Mingazzini & F. Pfister, *Forma Italiae di Surrentum* (1946)[IP] (il testo illustra ogni notizie anteriore); *Athenaeum* (1947) 108-12 (recensione di Fraccaro con osservazioni di carattere storico e topografico); Sartori, *Problemi di costituzione italiota* (1953) 75-77 (questioni storiche); *FA* (1963-64) n. 7508 (tomba a camera di età claudia); *FA* (1966) n. 2342 (necropoli di Vico Equense); *Archeologia* 6 (1967) 418-22.

P. MINGAZZINI

SUSA, *see* SEGUSIUM

SUTORU, *see* OPTATIANA

SYANGELA later THEANGELA Turkey. Map 7. City in Caria, a member of the Delian Confederacy when governed by a dynast Pigres (Pikres, Pitres), with a tribute of one talent. It is recorded by Strabo (611), following Kallisthenes, as one of the two Lelegian towns preserved by Mausolos—not incorporated by him in Halikarnassos. It is now agreed that Mausolos in fact refounded and greatly enlarged Syangela under the name of Theangela. The new city stood on the lofty hill directly above the village of Etrim, 14 km E-NE of Bodrum, and substantial ruins remain. On the question whether this was also the site of Syangela opinions have differed. It has been proposed to recognize Syangela in the ruins of the Lelegian town at Alâzeytin, some 5 km to the SW; but a more recent view prefers a newly discovered site on Kaplan Dağ about half this distance to the W. It is suggested that this site was destroyed by the Persians, whereupon its inhabitants moved to the hill above Etrim and stayed there until Mausolos' reconstruction.

The two sites are of similar size. At Alâzeytin the circuit consists partly of a fortification wall, partly of the outer walls of 60-70 houses; an agora, several sanctuaries and public buildings, and the seats of a theaterlike building are recognizable. The main occupation seems to have lasted from the 7th to the 4th c.; a tower on the summit is in regular masonry of later date than the rest. A short distance to the S is a group of six building complexes of the kind now called Compound-Anlage; buildings of this kind were formerly supposed to be tombs, but are now generally understood to be pens for the protection of herds. On Kaplan Dağ the ruined remnants of a once considerable settlement with a massive fortification wall lie on top of the mountain, and on a neighboring summit is a fort which evidently served as a refuge; here stood at least six grave tumuli with dromos, one of which is still 4 m high. There are traces of other buildings in the hollow between the two summits.

The site of Theangela at Etrim is long and narrow, occupying three hilltops; it is 1300 m long from E to W, with an average width of 250 m. The city wall is traceable for its entire length, and the three summits are separately fortified. The masonry is variable and only in some places Lelegian in character. At a point somewhat E of the middle the city is divided in two by a cross-wall running N-S, with a gate in its S half. Almost all the buildings are E of this wall; evidently the same trouble was

experienced here as at Halikarnassos and Myndos in manning the new city, and it was found expedient to reduce its size by more than half. The main city gate, on the other hand, is in the S wall near its W end; a road runs E from it. In two places in the N wall a gate may have stood, but nothing tangible remains. At the extreme W end the walls run up to a powerful fort on the summit of the W hill; it has a tower at each corner and was evidently designed to resist artillery. The entrance to it from the city makes a double right-angled bend. Just below this fort on W and S are two remnants of curved wall, in dry rubble masonry, which appear to have belonged to an earlier fortification surrounding the summit; if Kaplan Dağ is in fact the site of the early Syangela, this wall may have been erected by the refugees from the Persian sack. In the S wall beside the fort is a postern gate; at the E end and on the S the walls run out to other forts of more modest proportions.

The E summit is separately enclosed as a citadel by a ring wall and joined to the city circuit by a slender wall on N and S. At the top is a rectangular tower; on the E slope, which is terraced, are two fine cisterns and a mosaic floor. A little below the citadel on the W is a remarkable and well-preserved tomb. It is built in the hillside, running parallel to it; it is ca. 7 m long, with a corbeled roof, and contained bones and fragments of 5th c. vases. The roof is exceedingly solid, with several layers of stone blocks, and on it were found ca. 40 round stone balls which seem to show that the roof was at some time used as an artillery emplacement. It has been suggested that this may be the tomb of the dynast Pigres.

The principal public buildings stood between the E citadel and the central cross-wall, but little survives of them above ground. Several statues have been found here, including an archaic kore, and the Temple of Athena attested by inscriptions must have stood in this area. There is also a stadiumlike building surrounded by a wall 1.1 m thick; it is only 50 by 10 m, and no rows of seats are to be seen. There are also two more cisterns, one of which is still used by the fire guardian stationed on the W summit.

Apart from the vases found in the royal tomb the pottery is in the main Hellenistic, with some sherds and tiles apparently of the middle and late 4th c. There seems to have been no occupation in Classical Roman times, but there is some evidence of a later resettlement.

No necropolis has been discovered, but on the mountainside below the city on the NE is a group of tomb chambers carefully built of squared blocks, with vaulted roofs and paving slabs above. These also appear to be of Hellenistic date.

BIBLIOGRAPHY. W. Judeich, *AthMitt* 12 (1887) 331-36; L. Robert, *Collection Froehner* (1936) 65-86; G. E. Bean & J. M. Cook, *BSA* 50 (1955) 112-15, 145-47; and 52 (1957) 89-96; W. Radt, *IstMitt* Beih. 3 (1970) 17-71, 107, 223-24, 262.

G. E. BEAN

SYBA, *see* SYIA

SYBARIS Italy. Map 14. An archaic Greek colony founded by Achaians and Troezenians about 720 B.C. on a fertile plain drained by the Crati and Sybaris rivers in a region lying between Metaponto and Kroton. Sybaris and the two successive cities of Thurii and Copia built on the same site are mentioned by at least 70 Greek and Roman writers, notably Herodotos (5.45), Aristotle (*Pol.* 5.2.10), Diodorus Siculus (11.90.3-4; 12), Strabo (6.1.13), and Athenaeus (*Deip.* 12.519). There is general agreement that the original city was destroyed by the Greeks of Kroton about 510 B.C.

Ancient authorities agree in placing the archaic colony

somewhere on the plain of the Crati (125 sq. km). Systematic search for the site, begun in 1879, was finally rewarded in 1968. The precise location was defined and it was concluded that archaic Greek Sybaris was succeeded by Thurii and Copia on the same site (see Thurii).

Archaic Greek pottery was found in several hundred drill borings at a depth of 4.5-6 m; later Greek and Roman pottery in upper levels was still below 3 m in depth. The archaic deposits are now some 3 m below sea level and 4-5 m below the water table. Soundings exposed stone foundations of 6th c. B.C. structures, masses of roof tiles, and archaic pottery in a single level of occupation in the N sector of the site, i.e., not covered over by later Greek and Roman structures. But in the S sector only later Greek and Roman structures were found overlying a level of archaic Greek pottery at ca. 6 m in depth. A stone retaining wall was traced by the magnetometers, drills, and soundings for 800 m roughly parallel and to the N of the Crati river. The lower part of the wall was built in the Hellenistic period (Thurii) and the upper part during the period of Roman settlement.

Since 1968 there have been three seasons of excavation at the site. Utilizing a well point system, large sectors have been pumped constantly so that the water table has been reduced to a depth below the archaic level allowing dry excavation to at least 6 m. Four separate excavations have been made, the largest extending over 2 ha in the Parco del Cavallo area where a Roman structure protruding above ground was found in 1928, and where there were excavations in 1961-62. The principle structure now unearthed there is a theater of the 1st and 2d c. A.D., surrounded by a residential area of the period of Roman Copia. There is also a major road of the same period passing the theater in an E-W direction. Below the Roman theater, soundings have exposed Greek structures and pottery extending over the period from the 8th to the 5th c. B.C., indicating no significant period when the site was not occupied after the original settlement by the archaic Greeks. This excavation indicates that the site was abandoned in the 4th c. A.D.

The second major excavation was made in the N sector (Stombi—now called the Parco dei Tori) where the earlier research disclosed only an archaic level. Here the foundations of the three buildings have been uncovered; also a pottery kiln. Although unidentified, the structures appear to be part of an organized town settlement of the 6th c. B.C.

A third excavation in the locality of Casa Bianca, at the E end of the long retaining wall, exposed more of the Roman habitation area and part of a road which probably connects with another passing the Parco del Cavallo section in an E-W direction. The fourth excavation in the San Mauro area to the S and outside the limits of the Sybaris zone, exposed a small Roman structure in the upper level.

The almost total destruction of the archaic city, indicated by the six soundings excavated in the years 1962-67, is borne out by the large excavations in the Stombi area. The recent excavations also clarify the problem of the physical deposition of the ruins. It is now clear that the plain of the Crati settled below the present sea level after the period of Roman occupation rather than before, as assumed in the 1968 report. The problem of preserving the site is still to be solved. At present, constant and expensive pumping is required to expose Roman buildings which lie below the water table.

BIBLIOGRAPHY. F. G. Rainey & C. M. Lerici, *The Search for Sybaris* (1967). [In introductory chapters all the pertinent material from the ancient authors is translated and the early excavations are summarized.]; Rainey, "The Location of Archaic Greek Sybaris," *AJA* 73 (1969) 261-73; Autori vari, *Sibari, NSc* 1969, Suppl. I. Report on the Italian excavations at Parco del Cavallo.

F. RAINEY

SYBRITA or Sybritos (Thronos) Amari district, Crete. Map 11. On a hill (Kephala, 618 m) dominating the watershed at the NW end of the enclosed and fertile Asomatos valley. Although remote, the city controlled the main route W of Mt. Ida from the S coast and Mesara plain to the N coast. First settled before the end of the Minoan period, it survived into the first Byzantine period. It was more important than the sparse literary and epigraphic references (mostly ca. 200 B.C.) indicate. Little is known of its history, but it was one of the early Cretan cities to strike coins (5th c. on), and was prosperous in the late archaic-Classical period; archaeological evidence shows that it flourished in the Hellenistic period and the 3d c. A.D. (in each case because of its position, during periods of flourishing trade). The city had a port on the S coast only (Soulia). Its fine coins portray Dionysos and Hermes (apparently the main deities), also Zeus and Apollo (?). To the city may belong the cult of Hermes Kranaios in a cave near Patsos to the W (dedications of LM III to the Roman period, but not all periods represented). Coins show that it was then, as now, a wine-producing area.

The summit of Kephala formed the acropolis, and its lower terraces (mainly on the SW) the city area; some stretches of fine isodomic ashlar and a gate belonging to the city wall circuit (probably Hellenistic) have been found on the E side, but the line on the W is not certain though the location of an ancient necropolis at Yenna defines its maximum extent. Geometric sherds, archaic sherds and figurines, and Classical bronzeware and figurines have been found, but no related structures. On the slopes of Kephala are a number of terrace walls of uncertain date, and on the main SW terrace (Sta Marmara) are houses of the 3d-2d c. B.C. and a Late Roman house with mosaic. A number of large Roman buildings lie under the village of Thronos on the S terrace of Kephala, and the Early Christian basilica (probably 5th c.) with mosaics lies under the modern church and square. The temple of Dionysos may have been just SW of the summit of Kephala; on its W slope a terrace (Ellinika) has remains of houses, and higher up is the only spring on the acropolis slope itself. There was apparently a sanctuary at Ayia Photini near the watershed. The ancient necropoleis lay at Yenna to the SW, where most of the surviving gravestones were found, and at Sta Pelekita near Klisidi to the NE. In the Roman period settlement was less concentrated within the city area, and by late antiquity some of that area was no longer occupied for graves have been found inside the E wall. Besides the basilica, a number of remains of late brick and stone buildings survive W of Thronos.

BIBLIOGRAPHY. T.A.B. Spratt, *Travels and Researches in Crete* II (1865) 102-9; J.-N. Svoronos, *Numismatique de la Crète ancienne* (1890; repr. 1972) 313-16 & Suppl. p. 375; L. Mariani, *MonAnt* 6 (1895) 215-17[I]; F. Halbherr, *AJA* 1st ser. 11 (1896) 589ff; R. Paribeni, *MonAnt* 18 (1907) 374-76; Honigmann, "Sybrita," *RE* IV A1 (1931) 1012; M. Guarducci, *ICr* II (1939) 289-98; T. J. Dunbabin, "Antiquities of Amari," *BSA* 42 (1947) 184-90; E. Kirsten, "Siedlungsgeschichtliche Forschungen in West-Kreta," in F. Matz (ed.), *Forschungen auf Kreta, 1942* (1951) 118-52[MI]; K. D. Kalokyris, *KretChron* 13 (1959) 7-38[PI]; S. Hood et al., *BSA* 59 (1964) 71-72; G. Le Rider, *Monnaies Crétoises (Études Crétoises* 15: 1966).

D. J. BLACKMAN

SYBRITOS, *see* SYBRITA

SYEDRA Turkey. Map 6. Site in Cilicia Aspera near Demirtaş, 15 km SE of Alanya; the hill itself is called Asar Tepe. The ancient name survives in the neighboring Sedra and Sedra Çayı. The city is mentioned by Lucan (*Phars.* 8.259), and is listed in Ptolemy, Hierokles, and the *Notitiae*, but has no other history. (The conjectural emendation of Arsinoe to Syedra in Strabo 669 is to be rejected.) The coinage runs from Tiberius to Gallienus.

The ruins are extensive but overgrown. The city wall, of large squared blocks, is well preserved, especially on the SE, but the other remains seem all to be later. On the E slope are the foundations of a temple, roughly constructed of reused stones and originally veneered. A tower on the summit, a large church, and numerous other walls and buildings may be seen among the overgrowth, and many inscriptions are built into them; over a dozen of these record agonistic victories. The necropolis lay to the S, between city and sea, but it has been destroyed.

BIBLIOGRAPHY. R. Heberdey & A. Wilhelm, *Reisen in Kilikien* (1896) 141ff; G. E. Bean & T. B. Mitford, *AnatSt* 12 (1962) 191-94; id., *Journeys in Rough Cilicia in 1962 and 1963* (1965) 21-24; id., *Journeys in Rough Cilicia 1964-1968* (1970) 106-7; L. Robert, *Documents de l'Asie Mineure Méridionale* (1966) 91-100.

G. E. BEAN

SYÊNÊ (Aswan) and ELEPHANTINE Egypt. Map 5. A double city 964 km S of Cairo, below the First Cataract. Syênê lies on the E bank of the Nile. Opposite, at a distance of only 150 m, is the Island of Abu, whose name the Greeks translated into Elephantine. The function of the double city had already been established in the 1st Dynasty (3200 B.C.): Syênê as a market place for all kind of goods coming from the S and as a quarry of the famous Syenite stone (Pliny 5.9,59), the red granite; and Elephantine the actual city, fortress against invaders from Nubia and the religious center and residence of the god Khnum, lord of the Cataract.

In 1918 the discovery of Aramaic papyri from the Persian period indicated that in the 6th c. B.C. a Jewish colony was established in Elephantine and had its own synagogue. Under the Ptolemies the prosperity of Elephantine depended on the increasing interest in the cult of Isis on the Island of Philae. About this time, Eratosthenes (250 B.C.) made his visit to Syênê where, by measuring the difference between the sun's shadows here and in Alexandria, he was able to estimate the circumference of the earth.

During the Roman Conquest Syênê became the battle ground for wars between the Romans and the Blemmyes until the Roman general Maximius was forced to make peace with them (A.D. 451). With the fall of Roman power, Syênê became Christian and a Coptic church was erected here. Monuments of interest are: the Temple of Isis, which lies behind Aswan in the midst of the ancient city and dates from the time of Ptolemy III and Ptolemy IV; the Temple of Trajan to the W of the island; and, still farther W, the granite gateway of the Temple of Alexander II. The local museum on the island contains some of the finds from excavations.

BIBLIOGRAPHY. E. Jomard, *Description de l'Égypte Antiquités* (1809-22) Ch. 3[I]; A.E.P. Weigall, *A Guide to the Antiquities of Upper Egypt* (1913) 391-419; Porter & Moss, *Top. Bibl., V. Upper Egypt: Sites* (1937) 221-58; J. B. Pritchard, *Ancient Near Eastern Texts* (1955) 492; E. Brunner-Traut & V. Hell, *Aegypten* (1966) 640ff; K. Michalowski, *Aegypten* (1968) 540-42; B. Porter, *Archives from Elephantine: The Life on an Ancient Jewish Colony* (1968).

S. SHENOUDA

SYIA or Syba (Souyia) Greece. Map 11. Small city on the S coast of W Crete, in the Selino district between Lisos and Poikilasion. Little is known of its history; it was probably a member of the league of Oreioi in the 3d c. B.C. (see Lisos). Its surviving remains belong to the Imperial and First Byzantine periods, and it was probably destroyed in the Arab conquest. It had a good harbor and served as the port of inland Elyros (*Stadiasmus* 331; Steph. Byz. s.v.). It apparently did not strike its own coins.

The site lies at the mouth of the valley running down from Elyros. There is no harbor now, but if relative sea level was some 6.6 m higher in antiquity there would have been one W of the river mouth and protected from the S by a mole. Most of the ancient remains lie E of the river: remains of houses, an aqueduct to the N, a bath building to the S, and built and rock-cut tombs on the slopes to the E. A large basilica of the 6th c. has been excavated just W of the village, and two other basilicas lie E of it.

BIBLIOGRAPHY. R. Pashley, *Travels in Crete* II (1837; repr. 1970) 98-102; T.A.B. Spratt, *Travels and Researches in Crete* II (1865) 240-43M; L. Thenon, *RA* 14 (1866) 396-404; L. Savignoni, *MonAnt* 11 (1901) 443-48[PI]; G. De Sanctis, ibid. 510-13; Honigmann, "Syia," *RE* IV A1 (1931) 1024-25; J.D.S. Pendlebury, *Archaeology of Crete* (1939) 365-71; M. Guarducci, *ICr* II (1939) 299-301; A. Orlandos, *KretChron* 7 (1953) 337-59; S. G. Spanakis, *Kriti* II (n.d.) 356-61.

D. J. BLACKMAN

SYMI Greece. Map 7. An island in the S Sporades group. Diodorus (5.53) cites the first king of the island, Kthonios, whose son Nereus led three triremes to Troy (*Il.* 2.671ff). In historic times Symi spoke the Doric dialect and belonged to the Rhodian state before the synoecism. It remained Rhodian thereafter except for a brief period of Athenian supremacy in the 5th c. B.C. Incorporated into the mediaeval castle of the Knights of Rhodes are the remains of two circuits of polygonal wall from the acropolis of the ancient city. On the E slopes of the castle there are two courses of a circular tumulus. There is a small museum in the town.

BIBLIOGRAPHY. G. Gerola, "Le Simie," *ASAtene* 2 (1916) 1ff; R. Hope Simpson & J. F. Lazenby, "Notes from the Dodecanese," *BSA* 57 (1962) 168; 65 (1970) 63[MPI].

M. G. PICOZZI

SYRACUSE (Siracusa) Sicily. Map 17B. The site of the ancient city, now entirely covered by the modern one, lies on the SE coast of Sicily and once comprised a small island, Ortygia, which has yielded evidence of prehistoric life starting in the Early Paleolithic period. The Corinthians, led by Archias of the family of the Bacchiads, routed the Sikels and founded the colony in 734 B.C. The foundation of sub-colonies—Akrai in 664, Kasmenai in 624, Kamarina in 559—indicate that the city flourished. Gelon brought to the city a period of splendor and political power. In the battle of Himera in 480 B.C., Gelon and Theron of Akragas won a great victory over the Carthaginians, while the naval battle of Cumae in 474, which Hieron I won against the Etruscans, ensured the city's control over the S basin of the Mediterranean. Arts and letters flourished; philosophers and poets, among whom were Aeschylus, Simonides, and Pindar, came here to live. In 466 B.C. with the expulsion of Thrasyboulos, the successor of Hieron I, the city adopted a democratic government and for ca. 40 years enjoyed prosperity and power. Successes against the Etruscans and against Ducetius greatly enlarged the city's sphere of influence and prestige throughout Sicily.

In the last quarter of the 5th c., in answer to Segesta's request for help by Leontinoi against Syracuse, Athens sent a fleet which was defeated in the Great Harbor. About this time Dionysios, an extremely able politician who had managed to concentrate all power into his own hands and who had negotiated peace with Carthage, transformed Ortygia into a well-provided fortress, and began the fortification of Syracuse, which included the large plateau of the Epipolai. After his death, the city lived under the rule of mediocre men until the arrival of Timoleon, who was sent from Corinth at the head of an expedition. He conquered the city and began the reorganization and rebuilding not only of Syracuse but of Greek cities that had been subject to Carthage. He was succeeded by Agathokles, son of a potter, who defeated (310 B.C.) and laid siege to Syracuse. He was successful also in Magna Graecia, thus securing for Syracuse a large territorial domain. After his death, the Carthaginians were fended off by Pyrrhos, king of Epeiros and Agathokles' father-in-law.

In 275 B.C. Hieron II seized control of the city and ruled for 54 years. He was succeeded by his grandson Hieronimos, under whose rule the city became an ally of Carthage and fell to Rome.

The city declined under Roman rule until Augustus sent a colony there in 21 B.C. The city's recovery lasted through the first centuries of the empire. St. Paul stopped in Syracuse on his trip to Rome, staying with the Christian community, which must have enjoyed considerable prestige in Sicily. Syracuse was served by two excellent natural harbors: the Great Harbor, formed by a large bay closed by Ortygia and the Plemmyrion (the modern peninsula of the Maddalena) into which flow the Anapo and the Ciane rivers, and the Small Harbor or Lakkios, delimited by Ortygia and the shoreline of Achradina. The five districts of the ancient city were Ortygia, Achradina, Tyche, Neapolis, and Epipolai. In Ortygia, which was supplied with fresh water (Arethusa fountain) and was easily defensible, the Corinthian colonists created the first urban nucleus. This must have soon extended to the mainland, in the area immediately beyond the isthmus, where another district was formed, Achradina, containing the agora and surrounded by the earliest cemeteries of the city (the necropolis of Fusco, of the former Spagna Garden, and of Via Bainsizza) which thus gave us the approximate limits of the district. Achradina early acquired a fortification wall. Tyche, the district which corresponds approximately to the modern S. Lucia, must have clustered around the sanctuary of the deity after whom it was named. Neapolis developed to the NW of Achradina, that is, to the W of the modern highway to Catania and as far as the Greek theater; in the Hellenistic period it received a complex of important public buildings of monumental nature and expanded into the area formerly occupied by the archaic necropoleis. Epipolai represents the vast plateau, triangular in shape, which extends to the N and W of the city and culminates in the Euryalos Fort. In the closing years of the 5th c. the plateau was encircled by a huge fortification wall that united it with the urban area solely for defense.

Ortygia retains vestiges of the earliest sacred buildings erected by the Greek colonists. The Temple of Apollo, at the point of access into Ortygia, goes back to the beginning of the 6th c. B.C. and has considerable importance for the history of Doric architecture in the West.

The temple, discovered in 1862 and completely excavated in 1943, was repeatedly transformed through the centuries. It has an elongated plan, a stereobate (crepidoma) with four steps and is hexastyle with 17 columns on the flanks. In front of the cella there is a second row of six columns; the cella, preceded by a distyle-in-antis

pronaos, was divided into three naves by two rows of columns in two levels; its W end contained the closed area of the adyton.

The columns of the peristyle, all set very close together, lack entasis, and are marked by 16 very shallow flutes; they are surmounted by heavy capitals with strongly compressed abaci, on which rests an unusually high epistyle. The temple frieze had tall triglyphs and narrow metopes, which took no account whatever of the spacing of the columns. Fragments of terracotta revetments with lively polychrome decoration are also preserved. The lack of equilibrium among the temple parts, the marked elongation of its forms, the depth of the front of the building, the presence of the adyton, the lack of coordination among the spatial elements of the peristyle, are the most obvious traits of the architecture of this temple. An inscription on the stylobate of the E facade attests that the building was dedicated to Apollo and was the work of Kleomenes son of Knidios.

Another temple, on a small elevation S of the city, was dedicated to Zeus Olympios; it resembles the Apollonion but shows improved correlations among its parts. A section of the crepidoma survives, together with two incomplete shafts of the monolithic columns of the peristasis. The temple was divided into pronaos, cella, and adyton, and had 6 columns on facade and 17 on the sides. There are remains of two other impressive temples on the highest elevation of the island. Of the earlier, which was begun in the second half of the 6th c., the structures of the stereobate and several architectural members have recently been exposed. It is the only Ionic temple known in Sicily. It must have had 6 columns on the facade and 14 on the sides; it was left unfinished, presumably on the arrival of the Deinomenids. At the beginning of the 5th c. B.C., a second temple was erected parallel to the Ionic temple on the S. An Athenaion, it was probably built after Gelon's victory over the Carthaginians at Himera in 480 B.C. It was constructed within a large sacred area which already comprised sacred structures, altars and votive deposits dating from the beginning of the 6th c. The temple, hexastyle with 14 columns on the sides, contains cella, pronaos and opisthodomos, both distyle in antis. The building, constructed of local limestone and surmounted by tiles and sima in Greek marble, conforms fully with developed Doric.

The Athenaion was transformed into a Christian church and in the 8th c. Bishop Zosimo transferred to it the episcopal see; it is even now a cathedral. The transformation of the temple into a church required the screening of the intercolumniations and the opening of arches into the isodomic outer walls of the cella. Of the Greek temple, the facades are no longer extant, but clearly visible are a good deal of the peristyle (both from within and from without the cathedral), a segment of the entablature on the N side and the general structure of the cella. No other important ancient remains survive in Ortygia.

In Achradina, which must have been surrounded by a defensive system, almost nothing is left of the important civic buildings, for instance the stoas, the chrematisteria, the prytaneion, which are mentioned by the ancient sources. The only monumental complex partly preserved is the so-called Roman gymnasium S of the agora area. This architectural complex, comprising a small theater facing a marble temple and set within a large quadriportico, is of the 1st c. A.D.

Neapolis is the district preserving the most conspicuous complex of ancient monumental buildings, among which the theater is particularly well known. The form of the existing theater may be 3d c. B.C., but probably there was an earlier theater by Damokopos on the site

(early 5th c. B.C.?) where Aeschylus produced *The Persians* and *The Women of Aetna*, and where Epicharmos' comedies were performed. What remains of the theater today is only what was cut into the rock of the hill from which this impressive and unified structure was almost entirely derived. The cavea, ca. 134 m in diameter, is divided vertically into nine cunei separated by klimakes and horizontally by a diazoma that breaks it into summa cavea and ima cavea. Each section, at the level of the diazoma, presents inscriptions, partially preserved, which give the names of the divinities or of the members of the ruling family to which the section was dedicated. The central cuneus was dedicated to Zeus Olympios, two of the sections toward E to Demeter and Herakles, and those toward W are inscribed to Hieron II, his wife Philistis, his daughter-in-law Nereis, and his son Gelon II. These inscriptions, which must be dated between 238 and 215, are instrumental in establishing a precise chronology for the building of the theater. As for the orchestra and the whole stage building, of which almost nothing is preserved above ground level, innumerable cuttings and trenches are preserved in the rocky scarp; they are variously interpreted by scholars and bear witness to the many alterations, adaptations, and phases of this part of the theater.

The remains of the stage, belonging to the period of Hieron II, are few and badly fragmented; it was probably of the type with paraskenia, as in the theaters at Tyndaris and Segesta. The interpretation of some markings before the stage of the Greek scene building (a long trench and a series of cuttings in the rock) has suggested the use of a wooden stage which might have been employed to perform phlyakes. More consistent evidence, especially the long foundation built with limestone blocks, further suggests a major alteration in the stage building in the Late Hellenistic period: the facade was probably provided with thyromata. In the Roman period the whole monumental stage building was moved forward toward the cavea. This move involved the covering over of the earlier parodoi, which were replaced by passageways in cryptae above which were built tribunalia. The theater was also adapted for ludi circenses and for variety shows during the Late Empire. A vast terrace overlooks the cavea and in antiquity housed two stoas set at right angle to each other.

To the W of the theater an altar, bases for stelai and votive offerings, seem to provide evidence for the Sanctuary of Apollo Temenites whose area was crossed by the last retaining wall of the theater cavea.

Not far from the sanctuary, a short distance to the SE of the theater, lies the so-called Altar of Hieron II. It is 198 m long and retains only an enormous rock-cut podium, with two large ramps leading to the central part of the structure where public sacrifices were offered by the city. The whole area in front of the monument was planned to impress: a vast square extended the length of the altar and had a rectangular pool in the center; it was bordered by porticos with propylaia of the Augustan period.

The amphitheater, probably dating from the 3d c. A.D., is one of the largest known (external dimensions 140 m and 199 m). The entire N half was cut out of the rock, and the opposite half built on artificial fill. It had two large entrances to the arena on the N and S, three corridors leading to the steps, and a service passage around the arena. In the center of the arena is a large pool serviced by two canals. In the area of the steps a podium is bordered by a marble parapet inscribed with the names of the people for whom the seats were reserved. Outside the amphitheater a large area was flanked by retaining walls and provided with entrances, rooms of various types, and water tanks; it was connected with the S entrance to the building.

These monumental structures of Neapolis are bordered on the N by a series of quarries which provided the blocks for the ancient buildings. The so-called Ear of Dionysios, the Grotto of the Ropemakers, the Grotto of Saltpeter are famous for their acoustical properties and their picturesque appearance.

The Epipolai, the rocky plateau of roughly triangular shape which dominates the immediate hinterland of Syracuse, was incorporated into the city for defensive reasons at the end of the 5th c. B.C. At the time of the war against Athens (416-413 B.C.), only Achradina was fortified. Dionysios fortified the Epipolai between 402 and 397 B.C. against the threat of Carthage. He produced an immense defensive system: 27 kms of fortification walls deployed at the edge of the limestone terrace and culminating at its highest point in the Euryalos Fort, one of the most grandiose defensive works in dimensions and conception to have survived from antiquity. Three huge ditches were dug into the rock to prevent a massive frontal attack against the keep of the fortress. Between the second and third ditch a defensive apparatus was accessible by means of a stepped tunnel opening onto the bottom of the third ditch; from this moat, the veritable nerve center of the entire defensive system, a network of passageways and galleries branched off and connected all the various parts of the fort. At the S end of this third ditch rose three powerful piers which supported a drawbridge. In the space between the third ditch and the main body of the fortress is a pointed bastion, S of which are the remains of a structure linking the drawbridge with the fort proper. This latter is in two parts; the first is almost rectangular in shape, defended by five towers connected by wall curtains and protected on the S by a ditch; the second part, an irregular trapezoid, contains three cisterns for the water supply of the castle; it had the function of connecting the fortress to the main defensive system. To the NE of this section of the fortress a town gate with two arches, built according to the pincer system, was protected by towers and external cross walls which channeled traffic into narrow passageways close to the wall curtains from which defense was easy.

Not all the parts of this defensive system, brilliantly engineered under Dionysios, were contemporary but were gradually perfected through the 4th and 3d c. B.C. to conform with the changing requirements of the art of war. Transformations and adaptations were also carried out in the Byzantine period, especially in the rectangular section of the fortress.

The Archaeological Museum includes among its exhibits much material of the Classical period.

BIBLIOGRAPHY. F. S. Cavallari et al., *Topografia Archeologica di Siracusa* (1883); id., *Appendice alla topografia di Siracusa* (1891); E. A. Freeman, *The History of Sicily*, I-IV (1891-94); P. Orsi, *NSc* (1893) 445ff, (1894) 152, (1895) 109ff (Fusco necropolis), id., "Siracusa, Nuovo Artemision a Scala Greca," *NSc* (1900) 353ff; id., "Siracusa, Scavi e scoperte nel Sud-est della Sicilia, Luglio 1904-Giugno 1905," *NSc* (1905) 381ff; id., "Siracusa, Esplorazioni dentro ed intorno al tempio di Athena in Siracusa," *NSc* (1910) 519ff; id., "Gli scavi intorno all'Athenaion di Siracusa negli anni 1912-17," *MonAntLinc* 25 (1919) 353ff; id., "Siracusa, Nuova necropoli greca dei sec. VII-VI," *NSc* (1925) 176ff; R. Koldewey & O. Puchstein, *Die Griechischen Tempel in Unteritalien und Sicilien* (1899); G. E. Rizzo, *Il teatro greco di Siracusa* (1933); id., *Monete greche della Sicilia* (1946); E. Böhringer, *Die Munzen von Syrakus* (1929); K. Fabricius, "Das Antike Syrakus, Eine historisch-archäolo-

gische Untersuchunge," *Klio* 28 (1932); Wickert, "Syrakusai," *RE* IV A (1932) 1478; B. Pace, *Arte e Civiltà della Sicilia antica*, I-IV (1935-49); L. Mauceri, *Il Castello Eurialo nella storia e nell'arte* (1939); P. E. Arias, *CVA Italia 17, Siracusa*, I (1941); G. Cultrera, "Siracusa, Scoperte del Giardino Spagna," *NSc* (1943) 33ff; id., "L'Apollonion-Artemision di Ortigia in Siracusa," *MonAntLinc* 41 (1951) 701ff; T. J. Dunbabin, *The Western Greeks* (1948); W. B. Dinsmoor, *The Architecture of Ancient Greece* (3d ed. 1950); G. V. Gentili, "Siracusa, Scoperte nelle due nuove arterie stradali . . . ," *NSc* (1951) 261ff; id., "Siracusa," *EAA* 7 (1966); id., *Palladio* (1967) 66ff; M. Guarducci, "Note di epigrafia siceliota arcaica, I. L'Origine dell'alfabeto siracusano," *ASAtene* 27-29 (1952) 103ff; G. Vallet & F. Villard, "Les dates de fondation de Mégara Hyblaea et de Syracuse," *BCH* 76 (1952) 298ff; id., "A propos de dates de fondation de Mégara Hyblaea, de Syracuse et de Sélinonte," *Bull. Inst. belge de Rome* 29 (1955) 199ff; G. Vallet, "La colonisation chalcidienne et l'hellénisation de la Sicile Orientale," *Kokalos* 8 (1962) 30ff; R. Van Compernolle, "A propos des dates de fondation de Syracuse, de Mégara Hyblaea et de Sélinonte," *Bull. Inst. belge de Rome* 29 (1955) 215ff, see also (1953) 165ff; A. Di Vita, "La penetrazione Siracusana nella Sicilia sud orientale alla luce delle più recenti scoperte archeologiche," *Kokalos* II.2 (1956) 177ff; L. Bernabò Brea, *Musei e Monumenti in Sicilia* (1958); id., *La Sicilia prima dei Greci* (1958); id., "Studi sul teatro greco di Siracusa," *Palladio* (1967) 96-154; id. & A. M. Fallico, *Siracusa* (1970); L. Pareti, *Sicilia Antica* (1959); M. Guido, *Siracusa, Guida Storico-pratica ai suoi principali monumenti . . .* (1960); H. Berve & G. Gruben, *Griechische Tempel und Heiligtümer* (1961); E. Langlotz & M. Hirmer, *Die Kunst del Westgriechen in Sizilien und Unteritalien* (1963); H. P. Drögemüller, *Syrakus. Zur Topographie und Geschichte einer griechischen Stadt, Beihefte zum Gymnasium* 6 (1969). G. VOZA

SYRNA (Bayır) Turkey. Map 7. Town in Caria on the Loryma peninsula SW of Marmaris. Founded, according to the legend (Steph. Byz. s.v.), by Podaleirios son of Asklepios and named after his wife Syrna. The site was determined in 1948 by a decree of the Syrnians, found near Bayır, recording a donation for the celebration of sacrifices in the precinct of Asklepios. An Asklepieion at Bayır was previously known from another inscription listing contributions to some building connected with it. Both inscriptions date from the 2d c. B.C. when Syrna was included in the Rhodian Peraea, though not actually a deme. The ruins are scanty, almost entirely isolated ancient stones; the site of the Asklepieion has not been located. The former identification of Bayır with the deme of Hygassos on the strength of an epitaph of husband and wife, both Hygassians, found there, is now superseded.

BIBLIOGRAPHY. G. Cousin & R. Dechamps in *BCH* 18 (1894) 30; E. Hula & E. Szanto, *SBWien* 132 (1894) 32-33; P. M. Fraser & G. E. Bean, *The Rhodian Peraea* (1954) 28-32, 57. G. E. BEAN

SYROS Greece. Map 9. An island in the Cyclades group, cited in the *Odyssey* (15.414) as the kingdom of the father of Eumaios. It seems to have been colonized by Athens, and appeared in the tribute lists of the Delio-Attic League. Modern Hermoupolis, the port on the E coast, is the site of one of the ancient centers, but almost no trace of it remains. Near Chalandriani in the N of Syros an ancient Cycladian necropolis was discovered in 1895. Recently on an upland near Kastri a settlement from the same period (Ancient Cycladian II) has been found, with partially preserved fortification walls. The greater part of the finds are at the National Museum in Athens. There is also a small museum at Hermoupolis.

BIBLIOGRAPHY. X. Tsountas, "Kykladica," *ArchEph* (1899) 77ffPI; W. Zschietzschmann, *RE* IV A (1900) 1789ff; J. L. Caskey, "Chalandriani in Syros," *Essays in Memory of K. Lehmann* (1964) 63-68; E. M. Bossert, "Kastri auf Syros," *Deltion* 22 (1967) 53ffPI. M. G. PICOZZI

SZÁZHALOMBATTA, *see* LIMES PANNONIAE

SZÉKESFEHÉRVÁR Hungary. Map 12. A minor settlement in antiquity, perhaps a mansio, may have existed in the N part of the modern city, which in mediaeval times was the capital of Hungary. The settlement would have been situated along the road leading N from Gorsium toward Brigetio and Arrabona.

The city's importance for Classical archaeology is the King Stephen Museum whose archaeological collection is surpassed in Hungary only by that in the Hungarian National Museum in Budapest.

BIBLIOGRAPHY. J. Fitz, *Székesfehérvár* (1957); id. et al., *Székesfehérvár* (1966). J. FITZ

SZENTENDRE, *see* LIMES PANNONIAE

SZOMBATHELY, *see* COLONIA CLAUDIA SAVARIA

SZŐNY, *see* BRIGETIO *and* LIMES PANNONIAE

T

TABERNAE (Lalla Djillalia) Morocco. Map 19. A station of the *Antonine Itinerary* (8.1), mentioned in the *Notitia Dignitatum* (*occ.* 26), in Mauretania Tingitana on the road from Tingis to Lixus. The ruins cover nearly 10 ha. One can recognize a castellum about 90 m square and a settlement protected by a rampart, beyond which spread some indeterminate suburbs. Coins and potsherds show the site was occupied continuously from the 1st c. A.D. to the end of the 4th, but it was probably largely destroyed in the second half of the 3d c.

BIBLIOGRAPHY. L. Chatelain, *Le Maroc des Romains* (1944) 49-52; M. Tarradell, "La crisis del siglo III de J.C. en Marruecos," *Tamuda* 3 (1955) 83-84; M. Ponsich, "Contribution à l'Atlas archéologique du Maroc: région de Lixus," *Bulletin d'Archeologie Marocaine* 6 (1966) 418, no. 68. M. EUZENNAT

TADCASTER, *see* NEWTON KYME

TADMOR, *see* PALMYRA

TAINARON (Cape Matapan) Peloponnesos, Lakonia, Greece. Map 9. A promontory at the S tip of the center peninsula. The isthmus connecting with the mainland is flanked by two harbors, Psamathos (Amathous) on the E and Achilleus on the W. Pausanias saw there a temple

resembling a cave with an image of Poseidon, and Plutarch mentions an oracle of the dead. The remains of the sanctuary, which served as a refuge for criminals, are near the Church of the Asomaton, which employed some of the blocks. The temple was partly cut from the rock and partly built with rough stones. A door on the N side opened into a passage that bisected the building, leaving large rooms on the E and W. Herakles was supposed to have dragged Kerberos from Hades through a cave nearby. On the W side of the peninsula at Kyparissos there was a settlement in the Roman Imperial period, nicknamed Caenopolis (New Town) but in official inscriptions called "the town of the Tainarians." There are ancient remains in the vicinity which may indicate the sites of the Temple of Aphrodite and Megaron of Demeter mentioned by Pausanias.

BIBLIOGRAPHY. Thuc. 1.128, 133; Plut. *De sera numinis vindicta* 17; Paus. 3.25.4; J. G. Frazer, *Paus. Des. Gr.* (1898) III 395f; F. Bölte in *RE* 4A² (1932) 2049.

M. H. MC ALLISTER

TAINTIGNIES, *see under* HOWARDRIES

TAKINA (Asar) Turkey. Map 7. Site in Pisidia near Yaraşlı, 34 km SW of Burdur, identified by an inscription found in the village. The actual site is on a hill to the SW; like many others in the region it is unfortified. Foundations of several small buildings are to be seen on the summit and a more considerable building at the S foot. On the adjoining hill is an extensive necropolis; the whole slope is covered with rock-cut sarcophagi. A milestone (*IGR* IV, 880) found at Takina belongs to the series erected by M'. Aquilius about 129 B.C. It has been suggested that Takina is Ptolemy's Gazena and the Ravenna Geographer's Tagena.

BIBLIOGRAPHY. W. M. Ramsay, *Cities and Bishoprics* I (1895) 295-96; G. E. Bean, *AnatSt* 12 (1959) 89-91.

G. E. BEAN

TAKSEBT, *see under* IOMNIUM

TALAMONACCIO, *see* TELAMON

TALAVERA LA VIEJA, *see* AUGUSTOBRIGA

TALIATA, *see* LIMES OF DJERDAP

TALL SŪKĀS, *see* TELL SŪKĀS

TAMÁSI County of Tolna, Hungary. Map 12. Conquering Romans of the Early Empire settled in this area, originally inhabited by Pannonian tribes. The lack of finds from later than the 2d c. A.D. shows that the tribal and villa settlements were destroyed during invasions in the reign of Marcus Aurelius. Roman finds, consisting of bronze statues, have been discovered in the vicinity of the village and appear to have been a hoard of objects from a house shrine. The most outstanding piece is a seated goddess, 35 cm high, hollow-cast in bronze. The statue probably represents the empress Domitilla in the form of Concordia Augusta, for there is a strong resemblance between the features in the statue and on the Domitilla coins. The quality of the statue exceeds the usual workmanship of small bronzes. It appears to be a provincial copy of a good model, made at the end of the 1st c. either in N Italy or Raetia. The other statue from the hoard, a bronze Jupiter 26.5 cm high, evokes the school of Skopas; a statue of Zeus must have served as model. A bronze pitcher 19.5 cm high was also found. Its body is smooth, its handle is cast separately, ending in a female mask decoration. The pitcher shows Alexandrian influence, and belongs among the Italian prod-

ucts of the 1st and 2d c. The hoard comes from the early years of the Roman occupation.

The second find at Tamási, a statuette 15 cm high of the goddess Minerva, was discovered in 1952. In this area traces of Roman buildings indicate the row of former villas. The small statue is a fortunate mixture of archaic and Late Hellenistic style. Modeled on the Athena of the Temple of Aphaia, the statue must have been made during the period from Antoninus Pius to Marcus Aurelius, in the middle third of the 2d c. The finds are in the museum at Szekszárd.

BIBLIOGRAPHY. J. Csalog, "Römische Kleinbronzen aus Tamási," *Arch. Ért.* (1944-45) 193-97; E. Thomas, *Rómaikor-Römerzeit. Vezetö a szekszárdi Balogh Ádám Muzeum kiállitásaiban* (1965) 30-47; id., "A tamási Athena szobor," *Antik Tanulmányok* (1956) 167-74; id., *Römische Villen* (1964) 418 pp.; id., *Römerzeitliche Hausheiligtümer aus Tamási* (1963) 24 pp.; id., "Athene-Statuette aus Tamási," *Arch. Funde* (1956) 234-35.

E. B. THOMAS

TAMASSOS (Politiko) Cyprus. Map 6. In the copper mining area SW of Nicosia. The ruins of a large town lying on the left bank of the river Pediaios extend on the top and over the N slopes of a hill overlooking the rich Pediaios valley below. The site is now partly occupied by the village of Politiko. The town consisted of two parts, the acropolis and the lower town. The acropolis is believed to lie on top of the hill to the S of the town, where now stands the village elementary school. Remains of the city wall can still be traced for part of its course. The necropolis extends N and W.

Tamassos, one of the ancient kingdoms of Cyprus was probably the Homeric Temese. Nothing is known of its origin but it certainly succeeded a Late Bronze Age settlement in the area, the best known one being on the other side of the river on a height due N of Pera village. A Late Bronze Age necropolis, however, exists at Lambertis, a small hill due SE of the ancient town and E of the Monastery of Haghios Herakleidios. Owing mainly to the existence of copper mines, the area of Tamassos was inhabited even earlier. The city naturally owed its prosperity to these mines, as has been stressed by ancient writers.

Very little is known of the history. On the prism of Esarhaddon (673-672 B.C.) is mentioned the name Atmesu, king of Tamesu (Admetos, king of Tamassos), were the identification certain. The earliest known historical event goes back to the middle of the 4th c. B.C., when Pasikypros, king of Tamassos, sold his kingdom for 50 talents to Pumiathon, king of Kition, and retired to Amathous, where he spent his old age. Later on we hear again of Tamassos when this city was taken away from Pumiathon by Alexander the Great and presented to Pnytagoras, king of Salamis. Thereafter it is frequently mentioned (Strab. 14.684; Ptol. 5.14.6; Plin. *HN* 7.195; Steph. Byz.). Tamassos is one of the Cypriot cities mentioned in the list of the theodorokoi from Delphi (early 2d c. B.C.). The city flourished mainly from archaic to Graeco-Roman times; in Early Christian times it became the seat of a bishop.

The worship of Apollo and of the Mother of the Gods at Tamassos is attested by epigraphic or archaeological evidence. The Sanctuary of Apollo may be located to the NE of the town by the left bank of the river Pediaios. It was near here in 1836 in the bed of the river that a bronze statue of Apollo was found. Its head only has been preserved. Known as the Chatsworth head, it is now in the British Museum. The Sanctuary of the Mother of Gods may be located just inside the N city wall. From inscriptions or from literary sources we

learn of the worship of Aphrodite, of Dionysos, of Asklepios, and of Artemis, but nothing is known of their sites.

There are no coins attributed to Tamassos and nothing is known of the existence of a gymnasium or of a theater though a town of this importance should have had both.

The town site is practically unexcavated but two imposing royal built tombs, one with two chambers, dating from the archaic period, were excavated in 1889. These tombs had been looted long before their excavation but both are well preserved.

The first tomb has a stepped dromos, the sides of which are revetted with well-dressed stones. The facade is beautifully molded. On either side of the stomion the walls are decorated with a pilaster surmounted by Proto-Ionic capitals of extremely fine workmanship. The chamber is rectangular; its side walls are built of large ashlar blocks; the roof is saddle-shaped and made of two huge slabs resting on the side walls and leaning against each other. Along the rear wall there is an open sarcophagus.

The second tomb, near the first, is very much the same construction but it has a more elaborate decoration imitating wood carvings. A stepped dromos leads down to the entrance. The two chambers have molded saddle-shaped roofs imitating wooden logs, which are supported on a molded beam running lengthwise at the top of the roof. Along the rear wall of the back chamber there is a sarcophagus. The first chamber is provided with two square niches in the shape of false doors. On the upper part of these doors a door-lock is sculptured in stone: four vertical projections through which a bar has been pushed horizontally.

BIBLIOGRAPHY. M. Ohnefalsch-Richter, *Kypros, the Bible and Homer* (1893); Alfred Westholm, "Built tombs in Cyprus," *Opus. Arch.* 2 (1941) 36-39[PI]; Olivier Masson, "Kypriaka I. Recherches sur les antiquités de Tamassos," *BCH* 88 (1964) 199-238[MPI]; id., "Kypriaka. VIII—Deux statuettes de bronze de Tamassos," *BCH* 92 (1968) 402-9[I]; H.-G. Buchholz, "Politiko-Tamassos 1971," *Report of the Department of Antiquities, Cyprus* (1972) 183-86[I]; id., "Tamassos, Zypern 1970-72," *AA* (1973) 295-388[MPI].

V. Karageorghis, "Chroniques des Fouilles et Découvertes Archéologiques à Chypre en 1970," *BCH* 95 (1971) 418-21[I], and thereafter yearly under the heading Fouilles; K. Nicolaou, "Archaeological News from Cyprus 1970," *AJA* 76 (1972) and yearly under the heading Excavations. K. NICOLAOU

TAMETFOUST, *see* RUSGUNIAE

"TAMNUM," *see* BARZAN

TAMUDA (Tetuan) Morocco. Map 19. City of Mauretania Tingitana, 5 km SW of Tetuan on the right bank of the homonymous river, today called the wadi Martin. Its name is mentioned by Pliny (*HN* 5.2), who considers Tamuda a pre-Roman oppidum, and is confirmed by the neo-Punic legends of local coins and, in Roman times, by an inscription. Between 1921 and 1958 the remains of a pre-Roman city were unearthed, as well as a castellum dating from the Roman period.

The pre-Roman settlement, which covers 4 ha, seems to have been founded at the beginning of the 2d c. B.C. First laid waste about 38 B.C. in the struggle between Bogud and Bocchus, Mauretanian rulers, it was destroyed and abandoned a century later, in A.D. 40-41, in the course of the revolts that followed Ptolemy's as-

sassination and the Roman annexation of the Mauretanian kingdom.

Its regular grid plan plainly shows Hellenistic influence, but the organization of the city is unclear; no trace has yet been found of any public monument, civil or religious; all that can be seen is a great rectangular piazza in the S part of the city. Most of the buildings that have been excavated are houses and, very probably, shops. The outer walls of the houses were of mud or unburnt brick on systematically built foundations of stones, sometimes large blocks. The internal partitions are less clear, and the distribution of the rooms uncertain and irregular. There are no traces of peristyles or atria, and it would be more accurate to compare the plans of these houses with those of the pre-Roman houses of Lixus than those of Kerkouane in Tunisia. There is no true city wall: except toward the W, the walls around the built-up area do not seem to have had any defensive value. This is surprising so close to the Rif mountains and indicates that the region was relatively peaceful. A necropolis has been located and partly excavated to the W.

The material unearthed in the course of this digging is abundant but lacking in variety. Except for a bronze statuette of Bacchus, it generally consists of everyday or votive pottery in the Punic tradition, imported Roman vases or local imitations, and coins—Numidian, Mauretanian Iberian or, more rarely, Roman. Among them is an important series with neo-Punic inscriptions from Tamuda.

Contemporary settlements have been discovered in the valley of the wadi Martin, notably at Kitzan, SE of Tetuan, and at Sidi Abdeselam del Behar near the mouth of the river.

A castellum 80 m square was built in the 2d c. A.D. on the ruins of the pre-Roman city of Tamuda, then modified in the 3d c. by the addition of exterior, semicircular towers. This is recognized as the Tamuco camp of the *Notitia Dignitatum* (*occ.* 26), which was occupied by the ala Herculaea. Some indeterminate buildings to be seen on the fringe of the camp date from the same period. The main necropolis was towards the W, on the site of the pre-Roman one, but other scattered tombs have been located all around the camp and fairly far to the SE.

BIBLIOGRAPHY. Alta Comisaria de España en Marruecos, Delegación de Educación y Cultura, *Excavaciones en Tamuda* nos. 2, 5-10 (1941-48)[MPI]; M. Tarradell, "Estado actual de los conocimientos sobre Tamuda y resultados de la campaña de 1948," *Archivo Español de Arqueologia* (1949) 86-100; "Las excavaciones de Tamuda de 1949 a 1955," *Tamuda* 4 (1956) 71-85; "Breve noticia sobre las excavaciones realizadas en Tamuda y Lixus en 1958," *Tamuda* 6 (1958) 378-79; *Marruecos Punico* (1960) 97-119[MPI]. M. EUZENNAT

TANAGRA Boiotia, Greece. Map 11. An ancient city some 20 km E of Thebes and 5 km SE of Schimatari. The city was situated on a hill off the E end of Mt. Kerykeion, on the left bank of the Asopos where it meets the Lari stream. The hill, which slopes down in terraces toward the NE, stands in a rich rolling plain.

Tanagra, which is not mentioned in the Catalogue of Ships of the *Iliad*, is said to have played a part in the founding of Heraklea Pontica and of Cumae in Italy. From the 6th c. the city minted silver coins, and was part of the Boiotian League up to 480 B.C. Not far from the city were fought the battles of Tanagra and Oinophyta (457), and Delion (424), where many Tanagrans fell, their names being inscribed on a stele in the museum. From 386 to 374 or 372 it was occupied by a Spartan

garrison. After 338 its territory comprised Delion, Hyria, the sanctuary of Aulis, Salganeus on the Euripos, and the Tetrakome (Mykalessos, Harma, Heleon, Pharai). In 145 B.C. Rome granted the city the status of civitas libera et immunis: in the 1st c. A.D. Tanagra and Thespiai were the only prosperous cities in Boiotia.

The site has never been excavated systematically. Only the Mycenaean necropolis (LH III B), at the place called Gephyra, has been excavated since 1969; a number of fine painted terracotta sarcophagi, now in the Thebes Museum, and pottery have been unearthed. The Classical city is covered over with a thick layer of spoiled earth. The rampart, which forms a rough irregular pentagon, runs round the edge of the hill. At the highest point, to the W, is a tower that overlooks the city and the Asopos valley. In the W wall, which is 1.90 m thick and built of irregular blocks of dark gray local limestone, was a gate that looked toward Chalkis; the N, NE, and SE walls are fortified with a number of towers (roughly one every 30 m) and surround the lower city. To the E was the Athens gate and in the S corner that of Thebes. The SW wall links up with the great tower on the top of the hill. In 1950 sections of the rampart were uncovered, intact, in the upper part of the city when a canal was dug to drain the waters of Lake Iliki to the Marathon reservoir.

Beside the citadel is a ruined chapel that was built on the foundations of a temple (of Dionysos?). Both the black stone of the foundations and entablature and the crumbly yellowish limestone of the columns and Ionic capitals were used for the building (remains in the museum). A little lower down to the NE is the great theater, without stone seats; here the musical contests of the Sarapieia were held in Hellenistic and Roman times. To the NE, on the next terrace down, Leake discovered the well-built foundations of a large rectangular building, possibly a temple, of local black stone; they are no longer visible. Beyond the N rampart some 20 m farther on are the foundations, still standing, of a small temple "outside the walls." No trace can be seen of the temples, public buildings, or statues, including that of the poetess Korinna, mentioned by Pausanias. Several hundred inscriptions found on the site or nearby are in the museums at Schimatari and Thebes or are set in the walls of buildings (Church of Haghios Thomas).

A number of necropoleis were uncovered beginning in 1870, notably on the other side of the Lari, in the plain to the NW, and along the side of roads leading out of the city. In these tombs were found the thousands of terracotta figurines for which Tanagra is renowned. From the pre-Hellenic, then the archaic, period, the workshops of Tanagra, Rhitsona, Thebes, and Thespiai turned out statuettes, popular votive offerings that were placed in temples or familiar objects that were laid inside or on top of tombs. In the 7th c. the use of molds increased production and made it possible for these figurines to be sent out throughout the Greek world. The bell-shaped idols of the 8th c. were succeeded by flat idols with modeled, then molded, heads. In the 6th c. appeared replicas of the great religious statues, chariots, riders, everyday subjects. From the end of the 6th c. to ca. 350, these familiar subjects disappeared, giving way chiefly to statuettes inspired by the works of the great sculptors—Kalamis, Phidias, Polykleitos—offered in the sanctuaries. Toward 350-330 the production of Tanagra increased considerably and developed along different lines from the other workshops, possibly under the influence of Praxiteles. The beauty of these figurines, representing women in different attitudes, ephebes, actors, and people from everyday life, accounts for their growing popu-

larity: statuettes and molds were exported in great numbers, especially to the Aeolian city of Myrina. Production slowed down at the beginning of the 2d c. B.C. and ceased in Imperial times.

BIBLIOGRAPHY. J. G. Frazer, *Paus. Des. Gr.* v (1898) 76-91; Fiehn, in *RE* (1932), s.v. Tanagra; P. Roesch, *Thespies et la Confédération béotienne* (1965); M. Calvet & P. Roesch, "Les Sarapieia de Tanagra," *RA* (1966) 297-332[I]; W. K. Pritchett, *Studies in Ancient Greek Topography*, II (1969) 24-34[MI]; N. Papahadjis, *Pausaniou Hellados Periegesis* v (1969) 117-25[MI]; Th. Spyropoulos, *AAA* 3 (1970) 184-97; *Ergon* (1971) 11-21; J. P. Michaud, *BCH* 96 (1972) 695-99[I].

On the terracottas: R. Kékulé von Stradonitz, *Griechische Tonfiguren aus Tanagra* (1878); G. Kleiner, *Tanagrafiguren* (1942); S. Mollard-Besques, *Les terres cuites grecques* (1963); R. A. Higgins, *Greek Terracottas* (1967). P. ROESCH

TANAIS Russia. Map 5. An ancient city on the steep right bank of the Mertvyi Donets, a branch of the Don delta, near the village of Nedvigovka. Founded in the 3d c. B.C. (Strab. 11.2.3), it replaced Elizavetovskoe as the chief commercial center in the lower Don and the main intermediary between the Graeco-Roman world and the inhabitants N of the Sea of Azov. Its mixed population is proved by the indigenous names found in Greek inscriptions. The city was destroyed by the Bosporan king Polemon ca. 8 B.C., but it recovered and began to flourish in the late 1st c. A.D. Its destruction ca. 240, perhaps by Goths, put an end to the city as a major economic and cultural center but it revived in the late 4th c. and existed very modestly until it died out sometime before the mid 5th c.

Two walls encircled the city: the inner one of stone enclosed an area of ca. 5 ha; at a distance of 215 m from it was an earthen wall. Between these two rings of fortification were the huts of the poor. Within the walls traces of houses have been found, built of uncut stone bonded with mud and roofed with clay tile. There is no evidence of a street plan. There are potters' kilns and evidence of local glass production.

The necropolis outside the walls contained inhumation burials and a few cremations. Grave gifts include many Greek objects.

BIBLIOGRAPHY. E. H. Minns, *Scythians and Greeks* (1913) 566-69; T. N. Knipovich, *Tanais: Istoriko-arkheologicheskoe issledovanie* (1949); D. B. Shelov, *Nekropol' Tanaisa: Raskopki 1955-1958 gg.* [Materialy i issledovaniia po arkheologii SSSR, No. 98] (1961); id., ed., *Drevnosti Nizhnego Dona* [Materialy i issledovaniia po arkheologii SSSR, No. 127] (1965); id., ed., *Antichnye Drevnosti Podon'ia-Priazov'ia* [Materialy i issledovaniia po arkheologii SSSR, No. 154] (1969); id., *Tanais i Nizhnii Don v III-I vv. do n.e.* (1970); id., *Tanais i Nizhnii Don v pervye veka nashei ery* (1972); A. L. Mongait, *Archaeology in the USSR*, tr. M. W. Thompson (1961) 202-3; E. Belin de Ballu, *L'Histoire des Colonies grecques du Littoral nord de la Mer Noire* (1965) 148-50; I. B. Brašinskij, "Recherches soviétiques sur les monuments antiques des régions de la Mer Noire," *Eirene* 7 (1968) 102-3. M. L. BERNHARD & Z. SZTETYŁŁO

TANGIERS, *see* TINGI

TANOS, *see under* KISAMOS (Kalami)

TAORMINA, *see* TAUROMENION

TAPARURA (Sfax) Tunisia. Map 18. The ancient city is completely covered over today by a huge extension of the town of Sfax. The only vestiges which were recognized and excavated in 1886 were at the foot of the Casbah, outside the ramparts—a basilica with a mosaic baptistery established in the middle of a ruinous necropolis. Other chance discoveries have been made as the modern town extended. In two campaigns in 1907 and 1937, in the sector of St.-Henri, situated 5 km to the NE of the town and near the shore, a number of tombs—some with mosaics, others with amphorae and tiles—with late furnishings have been revealed.

The most important discoveries were made outside and to the N of the town on the Mazghani mounds along the coast. Between 1886 and 1899 a baptistery was excavated. Six mosaic niches adjoin a basilica surrounded by a Christian necropolis. In 1916 another basilica was discovered in the same district; the walls had disappeared, but a mosaic pavement remained and some epitaphs. In the neighborhood a vast necropolis was excavated in 1918-19.

In the immediate environs to the W of the town a large dwelling, the House of the Poet, built on a small eminence was excavated in 1953 and 1957. Its walls were faced with marble or frescoed and the floor was paved with mosaics, some geometric, but some remarkable for their composition and decoration. One is composed of eight medallions containing muses surrounding a central medallion in which is represented a poet—identified by some as Ennius—with the muse Clio; the angles of the composition were occupied by figures of the seasons. The pavements of another room contained, inserted in the geometric decoration, an octagonal emblema showing an inebriated Herakles.

The most interesting discovery, made several meters from this house in 1957, was a triclinium paved with a large mosaic. In one part a geometric horseshoe frames a tableau representing nereids, cupids, and marine animals, with the corners occupied by heads of Oceanus. This tableau has been set up at the Bardo Museum in Tunis.

BIBLIOGRAPHY. Thirion in *MélRome* 67 (1955) 149-79)[PI]; M. Fendri, *Découvertes archéologiques dans la région de Sfax* (1963)[PI]. A. ENNABLI

TAPOSIRIS MAGNA Egypt. Map 5. A city 48 km SW of Alexandria (Strab. 17.1.14), second only in the Mareotic nome to the capital Marea in importance and wealth (Herod. 2.18.30). On the basis of the still extant enclosure of what seems to have been the Temple of Osiris mentioned in the *Stadiasmus* and of a Greek inscription referring to the priests of Taposiris, the locality has been identified with the present archaeological site on the Mediterranean Littoral of the Libyan Desert known as Abû Sir.

The city owed its prosperity to the fact that it was a transit port with two harbors, one controlling the waterways through the lake into the Canopic branch of the Nile, the other on the Plinthinete Gulf of the Mediterranean. The Canopic branch dried up in the 8th c., the lake disappeared at some time during the Middle Ages. As a result, not only Taposiris but the whole district declined.

Approaching the site from the E one would stop at Plinthine (Strab. 17.1.14), identified with the large town site "extending over 3.2 km along the Abû-Sir ridge," with a foundation plan of one of its houses, a stadium, and its necropolis of 40 tomb chambers hewn from rock. Farther N, there is a restored Roman lighthouse supposed to be a miniature of the Pharos of Alexandria. This marks the site of the necropolis of Taposiris Magna.

At a distance one would be impressed by the two pylons on the E side of the Temple of Osiris. The void inside the enclosure, measuring 86 m square, contained at a later time a monastery and a church. Surrounding the temple is a vast complex of ruined buildings: houses, baths and a necropolis for animals. Down the S side of the hill are the ruins of the dyke that marked the W entrance to the lake.

TAPOSIRIS PARVA (El-Mandara) Egypt. Map 18. A city 17 km NE of Alexandria, where a feast used to be celebrated by Alexandrian youth (Strab. 17.1.16). The site has been identified with the modern suburb of Alexandria called El-Mandara. Because of building activity there little remains of the ancient town. Within walking distance to the S, however, is a reconstructed Roman tetrastyle temple with its four marble columns and Ionic capitals. Marble statues of Isis and Harmanobis have been found, two Canopic jars, and the foot of an oversize figure with the base, on which is the dedication to the goddess by a certain Isidor.

BIBLIOGRAPHY. E. Breccia, *Alexandrea ad Aegyptum* (1922) 335ff; A. De Cosson, *Mareotis* (1935); A. Adriani, "Sanctuaire de l'Epoque Romaine a Ras El Soda," *Ann. Mus. Gr. Rom.* (1935-39) 136-48[I]; J. B. Ward Perkins, "The Monastery of Taposiris Magna," *Bull. Soc. Roy. d'Archéol. d'Alexandrie* 36 (1943-44) 48-33[PI]; A. Rowe, "A Contribution to the Archaeology of the Western Desert," *Bull. of the John Rylands Library* 36 (1953) 128-45; 37 (1954) 484-500; R. Nouweir, "Les fouilles de la Zone d'Abou-Sir," *La Revue du Caire* (1955) 66-68. S. SHENOUDA

TARARE Rhône, France. Map 23. A Gallo-Roman site unknown until 1967-68. A variety of finds made in the area called Patirot (tiles, bricks, amphorae, sigillata, painted Roanne ware, and everyday local pottery) indicate that the site was occupied from the second half of the 1st c. to the end of the 2d c. A.D.

BIBLIOGRAPHY. M. Leglay, "Informations," *Gallia* 26 (1968) 578. M. LEGLAY

TARANTO, *see* TARAS

TARAS later Tarentum (Taranto) Apulia, Italy. Map 14. On the N coast of the Gulf of Taranto, the city lies some 366 km SE of Naples on a peninsula to the W of which is the main outer harbor (Marina Grande), protected from the sea by the small islands of St. Peter and St. Paul (the ancient Choerades), and to the E of which lies an inland lagoon (Mare Piccolo), serving as an inner harbor. The acropolis of the city (the modern Città Vecchia) lay at the tip of the peninsula between the two harbors. During the Middle Ages it was made into an island by the construction of a canal to the SE connecting the two harbors.

The presence of stone-lined graves at Scoglio del Tonno on the mainland to the NW of the acropolis indicates that the area was inhabited as early as Neolithic times. Nearby, in 1899, were discovered Neolithic hut foundations with stone hearths; above this a Bronze Age settlement of the Apennine type, consisting of a wooden platform supported by piles, on which five huts had been built; and, above the Apennine settlement, Late Mycenaean pottery. The earliest Iron Age inhabitants of the site may have been Iapygians who imported Greek pottery for their own use. There is an Early Iron Age settlement in the Città Nuova, that portion of the city on the mainland to the SE of the acropolis. In a well on the Via Cavour some 350 vases of native manufacture were found. These vases, both in decoration and in shape, ap-

pear to be the ancestors of Apulian Geometric and may have been produced by those Iapygians who occupied the site before the Greek colonists arrived.

Eusebius (*Chron.* 91b Helm) gives 706 B.C. for the founding of the colony by the Spartans. The first settlement may have been a few kilometers to the S at Satyrion (Leporano), which had been named in an oracle to Phalanthos, the founder of the colony (Diod. Sic. 8.21). According to the legend, the city was founded by the Parthenians, the illegitimate children of Spartan women, who lived with Helots while their husbands were fighting in Messenia. Denied the full rights of citizenship, these children founded a colony at Taras (Strab. 6.3.2; Paus. 10.10.6-8).

At the end of the 6th c. B.C., Taras was ruled by Aristophilides (Hdt. 3.136), who appears to have been king according to the Spartan system. At the beginning of the 5th c. B.C. the city won a series of victories over the neighboring populations and dedicated at Delphi two victory monuments. But in ca. 473 B.C. Taras suffered a severe defeat at the hands of the Iapygians, who headed a native confederation (Hdt. 7.170; Diod. Sic. 11.52). After this defeat, a democracy was established in the city. By the middle of the 5th c., after the decline of Kroton, it became an extremely wealthy and powerful city. In 433-32 B.C., it founded a colony at Heraklea (modern Policoro). During the Peloponnesian War, Taras allied itself with the Syracusans and contributed ships to the fleet (Thuc. 8.91.2). In the first half of the 4th c. B.C., under the administration of the philosopher-mathematician Archytas, the city enjoyed especial fame and prestige; but later it had difficulty in maintaining itself against pressure from the surrounding native populations and turned first to its mother city for aid and then to foreign mercenary kings.

The city first came into contact with the Romans in 282 B.C. when ten Roman ships sailed into the Gulf of Tarentum. The Tarentines called in Pyrrhos of Epeiros to aid them. Pyrrhos, after two initial victories, was finally defeated in 275 B.C., and Taras surrendered to the Romans. During the second Punic war, the city was captured by Hannibal in 213 B.C., but was retaken three years later by Q. Fabius Maximus and thoroughly looted (Liv. 27.16.7). In 122 B.C., C. Gracchus attempted to revive the city by establishing a Roman colony there, but he only transformed it into a provincial Italian town, which Horace mentions (*Carm.* 3.5.53-6) as a quiet retreat suitable for a tired businessman. After the reign of Justinian the town, together with the rest of S Italy, belonged to the Byzantine Empire. In A.D. 927 it was completely destroyed by the Saracens, but in A.D. 967 it was rebuilt by the emperor Nikephoros Phokas, who once again established Greek as the common language of the city.

Little remains of either the Greek or the Roman city, since the modern town has been built on top. Remnants of an archaic Doric temple, dating to ca. 575 B.C. and perhaps dedicated to Poseidon, survive on the acropolis (Via Maggiore). The two surviving columns of the peristyle together with their stylobate have now been freed from the surrounding modern buildings; the drum of a third column and the SE corner of the temple have also been found. The columns are rather heavy in proportion, and the intercolumniation is narrow. Nearby, at the crossroads of the Via di Mezzo and the Vico della Pace, were found fragments of a sculptured frieze belonging to a temple of the Corinthian order. The subject matter represents a combat in which Tarentine warriors take part. The frieze has been dated to the second half of the 4th c. B.C., but the style of the sculptures seems to be that of the 1st c. B.C. The temple may have been dedi-

cated to Pax. Also in the old city, an Altar of Aphrodite, perhaps belonging to a temple, was found near the church of S. Agostino.

Deposits of terracottas indicate the presence of sanctuaries going back to the 7th and 6th c. B.C. In the region of Pizzone in the SE part of the new city, the deposits go back to the 7th c. and identify the place as a Sanctuary of Demeter and Persephone. At Fondo Giovinazzi, also in the new city between the churches of S. Antonio and Santa Lucia, some 30,000 terracottas were found, the earliest group going back to the 6th c. B.C., the latest dating to the first half of the 3d c. B.C. The character of the terracottas seems to identify the sanctuary as having belonged to Kore and the chthonic Dionysos. A third sanctuary, also located in the new city, to the S near the Castello Saraceno, overlooking the Marina Grande, was dedicated to Apollo and the Muses. The terracottas of Apollo holding a lyre and those of the Muses date from the end of the 5th c. B.C. to the beginning of the 3d c. B.C. A series of reliefs dedicated to the Dioskouroi and dating from the 4th and 3d c. B.C. were found near the Chiesa del Carmine in the SW part of the new city and may indicate the presence of a sanctuary to the Dioskouroi in this spot.

Before the late 6th c. B.C. the city probably lay within the walls of the acropolis, which, according to Strabo (6.3.1) was completely fortified although no traces of the wall remain. After this date the city began to expand towards the SE into the region now called the Città Nuova. This new area also received a fortification wall, only a few traces of which are now visible. On the side of the Marina Grande, the walls have been destroyed, but become visible in places where they leave the outer sea and turn E through the area now called Montegranaro. About half way along, they turn N through Marmarini and Collepazzo. On the side of the Mare Piccolo they can be found in two places under water. The large blocks probably date to ca. 400 B.C., the greatest period of Tarentine expansion. Nothing now remains of the cross-wall built by Hannibal in 213 B.C. in the extreme NW end of the new city between the outer and inner harbors as a protection against the attacks of the Romans from the acropolis. Hannibal thus completed the entire fortification of the lower city, which comprised an area of over 3 square km.

Strabo tells us that the agora was located just outside the acropolis and therefore may be placed in the NW end of the new city. In this area was the main crossroad of the town, leading from the outer to the inner harbor. This can be identified as the Broad Street mentioned by Livy (25.11.17) and Polybios (8.29.1). No traces of this street remain, but it probably ran along the same course as the modern Corso Due Mari. It seems likely that the street plan of the modern city follows in many respects that of the ancient one. The Broad Street was crossed at the N by a major E-W street called Batheia which led to the Temenid gate through which Hannibal entered the city. A second major street, called Soteira, may have crossed the SW part of the city, taking much the same course as the modern Lungomare Vitt. Emanuele III. A portion of pavement 2.5 m wide discovered N of the Castello Saraceno may have belonged to the Sotera street. Other portions of the ancient street system have been found to the SW of the Villa Peripato on the Via Pitagora (here a segment 5 m wide was uncovered) and in the region of Solito.

In the new city scattered house remains have been found, but imperfectly recorded. A rectangular foundation at Scoglio del Tonno near the pre-Greek settlement indicates the presence of a suburb in this area. In 1880 in the grounds of the Villa Peripato were found the re-

mains of a Greek building, identified as a peripatos (public lounge). Tarentum had two theaters, neither of which has been uncovered. It has been suggested that the Roman amphitheater, situated to the SW of the Chiesa del Carmine, was built on the site of the larger of the two Greek theaters. On the other hand, it may have stood either on the site of the Castello Saraceno or in the region to the E of the Villa Peripato overlooking the Mare Piccolo. The smaller theater may have been near the agora.

Like the Spartans, the Tarentines buried within the walls of their city. Several thousand graves have been found within the new city, spanning the entire life of the Greek city from the 7th to the 2d c. B.C. Tombs are especially concentrated in the areas of Santa Lucia, the Arsenal, Fondo Tesoro, and Vaccarella. The majority of the burials consists of rectangular trenches either cut into the native rock or constructed of blocks and covered with stone slabs. Because of the large number of Protocorinthian vases which have come from the Via d'Aquino in the W part of the new city, it is likely that the oldest cemetery was here. Other Protocorinthian and Corinthian vases have been found at the Arsenal and at Vaccarella. An especially fine archaic tomb on the Via Capotagliata has yielded twelve Attic B-F vases, dated to the second quarter of the 6th c. B.C. A second type of burial consists of chamber tombs with painted walls, inside of which are funeral couches, with their fronts decorated in relief, and ornate sarcophagi some of which have painted lids in the form of temple pediments. The walls themselves served as the foundation for a naiskos which surmounted the tomb.

A good tomb of this type belonging to athletes was found on the Via Crispi. It had two Doric columns supporting a gabled roof and yielded Attic B-F pottery, including a panathenaic amphora, from the end of the 6th c. B.C. During the 4th and 3d c. B.C., a shallow gabled naiskos became popular, such as on the *tomba a Camera* no. 1 in the Via Umbria (a second tomb was found 20 m away). This naiskos, made from local limestone, is in the form of a small temple containing both metope (combat scenes) and pedimental sculpture. The chamber tomb itself is built out of stuccoed sandstone; it yielded a large quantity of Gnathia ware. Numerous wells have been found throughout the city. These have yielded statuettes and terracotta reliefs of the 5th and 4th c. B.C.

Remains belonging to the Roman city are few. Baths have been discovered in two places in the new city, by the Castello Saraceno and by the church of S. Francesco. Over the bridge connecting the acropolis with the Scoglio del Tonno runs an aqueduct known as Il Triglio. A second aqueduct, Il Saturo, is to be found in the SE part of the city. By the Masseria del Carmine runs a wall built in the opus reticulatum technique. In 1960 the remains of a villa were uncovered in the Via Nitti. A fine museum houses not only the finds from the city itself but also objects from the neighboring provinces.

BIBLIOGRAPHY. L. Viola, *NSc* (1881) 487-547; H. Klumbach, *Tarentiner Grabkunst* (1937)[I]; P. Wuilleumier, *Tarente des Origins a la Conquête Romaine* (1939)[MPI]; T. J. Dunbabin, *The Western Greeks* (1948); L. Bernabò Brea, "I Rilievi Tarantini in Pietra Tenera," *RivIstArch* NS 1 (1952) 5-241; F. G. Lo Porto, "Ceramica Arcaica dalla Necropoli di Taranto," *AsAtene* 37-38 (1959-60) 7-230[I]; id., "Tombe di Atleti Tarantini," *AttiMGrecia* 8 (1967) 31-98[PI]; J. C. Carter, "Relief Sculptures from the Necropolis of Taranto," *AJA* 74 (1970) 125-37. W.D.E. COULSON

TARBA or TURBA (Tarbes) Hautes-Pyrénées, France. Map 23. The Gallo-Roman town, the civitas Turba or Tarba of the *Notitia Galliarum*, whose very existence had been called into question, has gradually come to light in the course of construction in Tarbes since 1960. It seems to have been restricted to a fairly small settlement, located on sandbanks surrounded by many rivulets with shifting beds.

BIBLIOGRAPHY. R. Coquerel, "Les découvertes archéologiques de Tarbes," *Ogam* 20 (1968) 201-72; cf. M. Labrousse, "Informations," *Gallia* 20 (1962) 598-99[I]; 24 (1966) 445; 26 (1968) 552-53; 28 (1970) 433.
 M. LABROUSSE

TARBES, *see* TARBA

TARENTUM, *see* TARAS

TARIFA, *see* IULIA TRADUCTA

TARIVERDI Constanța, Romania. Map 12. Recent excavations carried out near the modern village 18 km W of Istros (Histria) have revealed a rural complex, the earliest strata of which go back to the 6th c. B.C., the latest to the Roman period. The houses are fairly primitive and ringed with grain ditches, but the great number of pottery fragments—most of them imported wares—and the many coins found there suggest that this was a Greek advance post on the territory of the Getae which allowed the Istrians to amass their grains and dispose of their goods in the heart of the native population.

BIBLIOGRAPHY. C. Preda, *Pontica* 5 (1972) 77-86.
 D. M. PIPPIDI

TARPANCHI Crimea. Map 5. A Greek agricultural settlement of the large fortified farmstead type along the NW Crimean coast by the village of Okunevka. Founded by Chersonesus in the late 4th c. B.C., the settlement was seized and destroyed no later than the mid 2d c. B.C. by the Scythians, who erected a small fortress on the site. By the 1st c. B.C., Tarpanchi had become the acropolis for a large native settlement. In the 2d-3d c. A.D. the fortifications were replaced by dwellings, and at the same time Sarmatian influence grew stronger. Suddenly abandoned sometime in the 3d c., perhaps because of a Gothic raid, the site was again occupied in the 8th-10th c.

The limited excavations since 1959 have not uncovered the remains of the original Greek fortifications. The Scythian fortress, rectangular in shape, enclosed an area of ca. 1800 sq. m and was composed of a deep wide trench, stone walls and towers, and an additional stone barrier designed to counter battering rams. Among later monuments, the excavations revealed a farm complex of the 2d-3d c. A.D. (The House with Buttresses) consisting of living quarters, storage rooms, and adjoining courtyards. Other finds suggest the local production of handmade pottery and iron objects in the 1st-3d c.

BIBLIOGRAPHY. A. N. Shcheglov, "Razvedki 1959 g. na zapadnom poberezh'e Kryma," *Soobshcheniia Khersonesskogo muzeia* 2 (1961) 70-80; id., "Raskopki gorodishcha Tarpanchi v 1960 g.," *Soobshcheniia Khersonesskogo muzeia* 3 (1963) 67-75; id., "Tarkhankutskaia ekspeditsiia v 1962-1963 gg.," *KSIA* 103 (1965) 140-47; id., "Poseleniia Severo-Zapadnogo Kryma v antichnuiu epokhu," *KSIA* 124 (1970) 19-24. T. S. NOONAN

TARQUIMPOL, *see* DECEMPAGI

TARQUINIA, *see* TARQUINII

TARQUINII (Tarquinia, formerly Corneto) Italy. Map 16. By repute the oldest city of the Etruscans in Italy, founded by Tarchon the brother of Tyrsenos, who led

the Etruscans from Lydia to the W shortly after the fall of Troy (Hdt. 1.94). It was, so far as we know, the earliest settlement in Etruria of the Villanovans, who came to Italy by sea early in the Iron Age bringing a culture of mingled Danubian, Western European, and Aegean elements. The date of their arrival is not inconsistent with Herodotos' date for the Etruscan migration.

The city lies 5 km from the sea on the left bank of the Marta, the emissary of Lake Bolsena, whose tributaries drain Tarquinii's territory. The site is a plateau bounded N by Fosso degli Albucci and S by Fosso San Savino. The Villanovan settlement was on the same site as the Etruscan and its biggest tomb-field, Monterozzi, a long ridge parallel to the city across Fosso San Savino, became the Etruscan necropolis, a fact which speaks strongly for the identity of Villanovans and Etruscans at Tarquinii. The Villanovan burials are rich in bronze: helmets of European type, shields and swords recalling Aegean forms, bridle-bits, horse trappings, and fittings for chariots as well as hammered bronze vessels and cast bronze ornaments; Etruscan Tarquinii had no such wealth of metal. Possibly the metal-rich mountains of La Tolfa to the S belonged to Villanovan Tarquinii although in Etruscan times they belonged to Caere.

Tarquinii's early and continuing importance is attested by the many stories told about the city. It was in her fields that the child Tages sprang from the plowed furrow and dictated to the Lucumones the books of the Etruscan Discipline (Cic. *Div.* 2.50). It was there that Demaratos of Corinth settled when the expulsion of the Bacchiads drove him into exile; he brought with him Greek craftsmen who taught the art of clay modeling to the Etruscans (Pliny *HN* 35.152). Tarquinii gave Rome her Etruscan dynasty, the Tarquins, and the insignia of rank that became the symbols of the Roman state: curule chair, fasces, the triumphal and consular robes, trumpets "and all music used publicly" (Livy 1.34.1-3; Strab. 5.220).

In Roman history Tarquinii first appears as an enemy in 397 B.C. during the siege of Veii (Livy 5.13), and the city spent most of the 4th c. at war with Rome. The city walls presumably date from this time. The early wars ended with a 40 years' truce in 351. At the end of it a great Etruscan alliance against Rome involved Tarquinii again, but in 308 she made a separate peace. About 287 a Roman colony was founded at Castrum Novum on land taken from Tarquinii and in 181 another at Graviscae. These were coastal towns on the Via Aurelia, Castrum Novum between Pyrgi and Centumcellae, Graviscae between Centumcellae and Cosa. Thereafter Tarquinii fades from history. We know only that as an ally of Rome in 205 she furnished sails for Scipio's fleet (Livy 28.45) and that under the Empire she was the center of a semi-official Roman priesthood of 60 haruspices.

Tarquinii's painted tombs are her finest remains. They range from the third quarter of the 6th to early 1st c. B.C. and are scattered along the whole length of Monterozzi. The tomb chambers are rock-cut, approached by steep dromi and originally covered by tumuli. The earlier tombs (6th c. and first half of 5th) are small, usually a single rectangular room with a gabled roof and broad rooftree brightly painted in geometric designs. Often a kingpost fills the center of the tympanum and is flanked by heraldic animals like the gables of some Lydian temple tombs. In the Tomb of the Lionesses slender Doric columns are painted at the corners and in the center of each long wall. Clearly the architecture depicted here is of wood, light and open, a cloth-roofed pavilion rather than a house, set up to house the funeral banquet that is the subject of the wall paintings. Canonically (Tombs of the Triclinium, Leopards, Ship, and Black Sow) the

banquet is painted on the wall opposite the door; the banqueters, men and women, recline on couches, served by young boys and entertained by flute and lyre, while their numerous and heterogeneous pets lurk under the tables. On the side walls are painted men and women dancing among trees, or athletes engaged in the various contests that compose the games to honor the dead.

The later tombs are larger, and their walls are often peopled with winged demons, some hideous and armed with axe or serpents, some young and handsome. There are still banquet scenes but they take place in dark surroundings and the games and dancers have disappeared. Only in the recently discovered Tomb of the Warrior does a winged figure appear hovering above a racing chariot.

Many tombs of the 4th and 3d c. contained tufa sarcophagi, the chest carved with reliefs, a reclining figure on the lid. The earliest show animal combat and winged spirits; the figure on the lid is supine, with closed eyes. Later effigies recline on the left elbow, a drinking cup in the right hand; the funeral bed has become a banquet couch. The chest reliefs are now often mythological and usually violent; some, however, represent an important personage's journey to the underworld. He rides in a chariot, led by demons but attended by trumpeters and lictors, the ancient insignia of power. These must be magistrates' sarcophagi.

The Pian di Città, the site of the ancient city, still has stretches of the city walls, of rectangular tufa blocks, without towers, a circuit of 8 km. But the chief ruin is the temple called Ara della Regina at the E end of the plateau. A massive platform (77.15 x 35.55 m) of large rectangular tufa blocks is approached on the E by a flight of steps between parotids trimmed with heavy moldings. The temple is set back and the terrace projects beyond it on both sides and behind. It had a single cella with alae and two rows of columns in the pronaos; the columns were of tufa, unfluted, with Tuscan capitals. The walls of the temple must have been of sun-dried brick; the gable and roof were decorated with terracottas. A fine pair of winged horses once yoked to a chariot is perhaps part of the plaque that covered the columen. The temple dates from the 3d c.

Although material from Tarquinii is widely scattered, the best concentration of it is at Tarquinia in the Museo Nazionale Tarquiniese (Palazzo Vitelleschi).

BIBLIOGRAPHY. M. Pallottino, "Tarquinia," *MonAnt* 36 (1937); id., *Etruscan Painting* (1952); P. Romanelli, *NSc* (1948) 193-270; R. Herbig, *Die jüngeretruskischen Steinsarcophage* (1952) 51-70; M. Moretti, *Nuovi monumenti della pittura etrusca* (1966); H. Hencken, *Tarquinia, Villanovans and Early Etruscans* (American School of Prehistoric Research, Peabody Museum Bulletin no. 23; 1968); id., *Tarquinia and Etruscan Origins* (Ancient Peoples and Places, vol. 62; 1968)MPI; L. Banti, *The Etruscan Cities and their Culture* (1973) 70-84.

E. RICHARDSON

TARRACINA (Terracina) Italy. Map 17A. A city on a high hill along the sea on the border of Latium and Campania, half way between Rome and Naples. Strabo derives the name from *trachys* (rough)—well suiting its cliff. Prehistoric remains testify to its desirable location. After occupation by the Ausoni, it was taken over by the Etruscans, then by the Volsci, who called it Anxur and made it a fortress against the Romans. There is no evidence to support an ancient theory that it was colonized by Sparta in the days of Lykourgos.

Rome overpowered Anxur in 406 B.C. and in 309 sent 300 colonists to establish Colonia Anxuras, later assimilated to the Tribus Ufentina. The Samnites failed to

capture the citadel in their battle against Rome in 315. A few years later, the Via Appia was built, climbing to Tarracina on its way S. Horace took that route in 38 B.C. and admirably describes the site: impositum saxis late candentibus Anxur. Galba was born here in 3 B.C. The town was greatly built up in the days of Sulla and later by Trajan, who brought the Via Appia down to sea level by cutting through the cliff below the citadel along the coast. He and Antoninus Pius expanded the lower town and drained the nearby Pomptine Marshes. Much later, Theodoric repaired the Appia here.

The most notable monument of Tarracina is the Temple of Jupiter Anxur, situated on the edge of the high cliff (ca. 198 m) overlooking the sea. It dates from the days of Sulla in the early 1st c. B.C. The orientation is N-S in the Italic manner, set at an angle on the great courtyard which was made by cutting into the hill at the back and building up a supporting base on the S and W sides resting on 12 massive arches in opus incertum, still visible from afar. The cella is almost square (13 x 14 m); its outer walls carried 6 engaged Corinthian half-columns; a deep porch with 6 columns along the front and 4 down the sides was reached by a flight of steps at the center. The base of the Jupiter statue survives at the back of the cella.

Behind, on a higher level, was a U-shaped ambulatory. Just E of the temple was an oracular site: a hollowed-out rock surrounded by a wall. A small square structure (the "Little Temple") at the S corner of the temple courtyard was probably for civic use. In a votive pit near the Oracle were found many small representations of Jupiter, usually as an infant, most of them of lead.

West of the Jupiter Temple, on the rest of the hilltop, lay the original town, surrounded by fortification walls of various dates, of which massive towers and a gate exist.

Much of this acropolis development dates to the age of Sulla. The Via Appia served as decumanus, the main longitudinal street. A stone arch, four-sided, stood at the entrance from Campania. The basilica was nearby. The forum area (modern Piazza Municipio) still has its ancient pavement, which was laid at the expense of Aulus Aemilius. A massive substructure of arches supports the edge of the forum facing the sea. The medieval Romanesque cathedral stands on the site of a Roman temple (perhaps of Rome and Augustus) and incorporates some of its columns.

Another temple, probably the Capitolium since it has a triple nave, survives rather extensively. In opus reticulatum, it probably dates to ca. 40 B.C., replacing a much earlier one. Raised on a podium, it had four columns across the front, with projecting antae behind the corner ones and a door leading into each of the three naves. The general plan is square (16.57 m on each side) with pillars 2.33 m high. The naves are each 9.25 m long and half as wide. Under each of them was a covered treasury of opus reticulatum. A ramp of 11 steps led up the front through the central intercolumniation. To the W was another temple, possibly of Minerva. Its massive podium survives (25 m long, 7 high). There is some evidence of a theater N of the Capitolium near the Porta Nova.

The lower town, between the sea and the relocated Via Appia below the cliff, is mostly of 2d and 3d c. construction, though the amphitheater (its arena 90 x 68 m) is somewhat earlier—built mostly in opus reticulatum. A large baths structure, of the mid 2d c., stands near the sea. Other baths, more elaborate and of earlier and later construction periods, are at the SE edge of the lower town.

The harbor, going back to Volscian times but thereafter silted up, was much improved and enlarged by Trajan and reworked by Antoninus Pius. The mole was an arc from W to E, with extensive dock areas on each side and a curving breakwater at the entrance, on which probably stood a lighthouse.

Three aqueducts have been traced. Numerous villas have been located in the vicinity, a proof of the site's attractiveness. A small Museum holds local finds.

About 5 km from the city, at the foot of Mt. Leano, was a Sanctuary of Feronia—a goddess of agriculture and patroness of freed slaves—which Horace mentions visiting. It comprised a sacred grove, a fountain, and a small temple. A fine stretch of the old Via Appia used to be visible between the sanctuary and Tarracina.

BIBLIOGRAPHY. Strab. 5.3.6; Dion. of Hal. *Ant.Rom.* 2.49; Tac. *Hist.* 3.57-61; Plin. *HN* 3.5.9; Cic. *Att.* 7.5.3; *Fam.* 7.23.3; Hor. *Sat.* 1.5.24-26; Verg. *Aen.* 7.799-800; Pomp. Mela 2.4.

M. de la Blanchère, *Terracine: Essai d'Histoire Locale* (1884); L. Borsari, "Terracina: Tempio di Giove Anxure," *NSc* (1894) 96-111; R. Fish, *Tarracina-Anxur und Kaiser Galba* (1889); G. Lugli, *I Santuari Celebri del Lazio Antico* (1932) 111-14; id., *La Tecnica Edilizia Romana* (1957) 144-48; S. Aurigemma, *Circeo, Terracina, Fondi* (2d ed., 1966)[PI]; *EAA* 7 (1966) 729-32 (B. Conticello)[P].

R. V. SCHODER

TARRACO or Kallipolis, Cissa, or Cissis (Tarragona) Spain. Map 19. One of the most important cities of Roman Spain, identified with Kallipolis mentioned in Avienus (*Or. Mar.* 514-15). It may have had an old Etruscan population. In the pre-Roman period it was the principal urban center of the Iberian tribe of the Cessetani. On coins and in some sources (Polybios and Livy), it appears under the name Cissa or Cissis. References to it become more frequent during the Punic Wars. Ancient Cissa was destroyed by C. Scipio in 218 B.C. After that Rome continually beautified Tarraco (Livy 21.60ff; 22.14ff; 26.17ff; 27.7.17; 28.4.13, 16, 17, 21, 42; Polyb. 3.76; 10.6; 11.25; App. 16 c.15; Frontin. *Str.* 2.3.1) and Pliny refers to it as Scipionum opus, which seems to correspond with the latest and definitive date assigned to the city walls (3d c. A.D.).

After the arrival of Scipio, Tarraco was the base for the Roman wars against the Carthaginians and Iberians. Tiberius Graccus landed in its port in 179 B.C.; Scipio Emilianus, the destroyer of Numantia, disembarked there in 134 B.C. In the wars between Caesar and Pompey, Tarraco was loyal to Pompey, but later, either voluntarily or of necessity, joined Caesar's party. Caesar was the first great protector of the city. In 45 B.C. Tarraco received a colony of Caesar's (not composed of veterans) and was given the title Colonia Ivlia Vrbs Triumphalis Tarraco; the abbreviations CVT or CVTT appear on the coins of the city between A.D. 16 and 22. However, Tarraco received its highest honor and attained its greatest importance when Augustus withdrew to it to recuperate from the illness contracted during the Cantabrian and Asturian wars (26-25 B.C.: Dio Cass. 53.25.2). Thanks to him Tarraco became the capital of Hispania Citerior (Suet. *Aug.* 26), and gave its name to Tarraconensis.

During the rising of Galba against Nero, the inhabitants sided with the former (Suet. *Galba* 12). Hadrian spent the winter of the year 121 in Tarraco, calling together an assembly of representatives of all the cities of the province. Septimius Severus governed Tarraconenis from this city and later, while emperor, ordered that the temple of Augustus be restored at his expense.

Imperial Tarraco flourished until 257 when, according to Aurelius Victor (*Caes.* 33) and Eutropius (*Breviarium* 9.8), it was destroyed by the Franks. It seems to have revived, however, since the poet Ausonius in 370 refers to it as one of the principal cities of Spain along with Emerita and Corduba, although this may be from a lit-

erary point of view. In 476 it was destroyed by King Euric. This was the end of Roman Tarraco, but the city continued, and attained great importance during the Visigothic period.

Tarraco was the seat of the legatus Augusti pro praetore and the nucleus of the administration of Hispania Tarraconensis, as well as one of the seven conuentus into which that province was divided. Once a year it was the meeting place of the 300 municipalities of Tarraconensis and, according to inscriptions discovered there, it had a full detachment of the Legio VII Gemina, established by Galba in Clunia. The founding of Tarraco by Rome was probably because of the need to establish a key post for the later conquest of the middle basin of the Ebro. Strabo considered it the most important city of Spain (3.4.7); and Mela, in the time of Claudius, does not hesitate to state: "urbs erat, in his oris maritimaris opulentissima" (2.6.5).

In the Augustan age Tarraco covered ca. 36 ha and had a population of about 30,000. There were many later alterations to the city and much reuse of material but there are still considerable ancient remains, the best preserved of which are the walls. Probably they were originally 4 km long, 1 km of which survives. Their date has been the subject of controversy, but today it seems clear that they contain features of two periods of construction: the 6th c. B.C. (the Iberian Period), and the 3d c. B.C., which, moreover, agrees with Pliny's description. On a base of Cyclopean construction of huge, rough-hewn blocks, some of which are 3 by 4 m, are preserved some more typically Roman stretches of wall built with parallelepiped, projecting stones.

The plan of Tarraco, as reconstructed today, is composed of three nuclei: the upper city, with the forum and the Temple of Jupiter (now the cathedral); the middle city, with several Imperial buildings; and the lower city near the port, probably the oldest. We know from the inscriptions (*CIL* II, 4071-4451) that, in gratitude for the honors that the city received from Augustus, it dedicated an altar to him. The altar was replaced in the year 15 of the Augustan age by a temple dedicated to Diuus Augustus; this temple appears on coins with eight Corinthian columns on the facade, a few remains of which are preserved in the Archaeological Museum of the city. The columns were 1.55 m in diameter and 12 m high. The temple was built on the highest point of the city, and the emperor was depicted as Zeus. Suetonius (*Galba* 12) writes of the existence of a temple dedicated to Jupiter, and Florus tells us that Europa was venerated in the same temple. There is also information on the worship of Jupiter-Amon and Isis. Also worth mentioning are the remains of the Palatine, a palace belonging to Augustus and later to the governor, which contain some mediaeval additions. The city had a theater and an amphitheater (*CIL* II, 4280), the latter estimated as 93 by 68 m, baths (*CIL* II, 4112), a forum (*CIL* II, 4275), a basilica, and a circus. In the Archaeological Museum of Tarragona are sculptures such as a Venus of the knidos type, a Bacchus of the school of Praxiteles, a head of Alexander, fragments of the temples of Minerva and of Tutela, a mosaic with a Medusa motif and one with fish.

On the left bank of the Francoli river, near the city, was found a Romano-Christian necropolis of ca. 2000 sq. m, buried about 1.8 m deep. It dates from the 3d-6th c. and contains about 2000 tombs. Sarcophagi and mosaic tombstones may be seen in the museum in the necropolis. A basilica has been discovered over the sepulchers of the martyrs Fructuosus, Augurius, and Eulogius, who died under Valerian and Gallienus, and the necropolis is now called San Fructuoso.

BIBLIOGRAPHY. J. Serra Villaro, "Excavaciones en la necrópolis romano-cristiana de Tarragona, Junta Superior de Excavaciones y Antiguedades," *Memorias* 93, 1927 (1928); 104, 1928 (1929); 111, 1929 (1930); 133, 1934 (1935); id., "Excavaciones en Tarragona, Junta Superior de Excavaciones," ibid. 116, 1930 (1932); A. Schulten, *RE* IV A (1932) 2398ff; id., *Tarraco* (1948); P. Pericay, *Tarragona: Historia y Mito* (1952); J. M. Recasens, *La citat de Tarragona* I (1966); J. Avella Vives, *Tarragona romana* (1967); Th. Hauschild, "Römische Konstructionen auf der oberen Stadtterrasse des antiken Tarraco," *ArchEspArq* 45-47 (1972-74) 3ff.

J. ARCE

TARRAGONA, *see* TARRACO

TARRHA Greece. Map 11. City in the Sphakia district on the S coast of W Crete, near modern Ag. Roumeli, at the mouth of the Samaria Gorge. It is first mentioned by Theophrastos (*Hist.Pl.* 2.2.2). In the early 3d c. B.C. it had a coinage alliance with neighboring Lisos, Elyros, and Hyrtakina, and may have been a member of the league of Oreioi; it was certainly in the Cretan League in the early 2d c. It was best known as the legendary home of the seer Karmanor (Plaus. 2.7.7; 2.30.3; 10.7.2; 10.16.5) and for its oracle and Sanctuary of Apollo Tarrhaios (Steph. Byz. s.v. Tarrha). It is mentioned by Ptolemy (3.15.3: wrongly listed W of Poikilasion) and the *Stadiasmus* (329-30: a small city with an anchorage).

Ancient remains attest occupation from the 5th c. B.C. to the 4th or 5th c. A.D. Tarrha was then apparently abandoned, probably because of pirate raids and consequent decline in communications by sea. The remains were described in the 15th c. and identified in the 19th, though epigraphic confirmation is not available. Remains W of the river bed include architectural members from a temple (probably that of Apollo Tarrhaios) reused in a later building over whose ruins now stands the chapel of the Panagia; below the building is a 1st c. B.C. mosaic, perhaps connected with the sanctuary. Farther W lay a cemetery. To the E of the river are remains of Roman fortification walls and buildings, a few still standing to some height on the hill below the cliffs in back of the site. Excavation of some of these buildings revealed Greek walls at a considerable depth below them, and some tombs of the 5th-4th c. B.C. and of the Roman period.

The factory indicated by abundant glass fragments has not been found, but it remains likely that one existed here or nearby. The coast appears to have been lifted some 3.6 m since ancient times, so that the bay is now open and exposed, but the harbor may once have been better. Minoan occupation of the site is possible, if only for export of cypresses from the White Mountains; no certain Minoan finds are known, but some LM III vases may come from here rather than from near Sphakia.

BIBLIOGRAPHY. R. Pashley, *Travels in Crete* II (1837; repr. 1970) 263-64[I]; T.A.B. Spratt, *Travels and Researches in Crete* II (1865) 247-49; G. De Sanctis, *MonAnt* 11 (1901) 515-17; M. Deffner, *Odoiporikai entiposeis apo tin Dhitikin Kritin* (n.d.) 179-89; Fiehn, "Tarra (2)," *RE* IV, A2 (1932) 2395; M. Guarducci, *ICr* II (1939) 305-9; E. Kirsten in F. Matz (ed.), *Forschungen auf Kreta* (1951) 130-31; G. D. Weinberg, "Excavations at Tarrha, 1959," *Hesperia* 29 (1960) 90-108; T. S. Buechner, ibid. 109-17; R. F. Willetts, *Cretan Cults and Festivals* (1962) 270-71; S. G. Spanakis, *Kriti* II (n.d.) 32-34, 371-73; *Deltion* 25 (1970) *Chronika* 2, 473.

D. J. BLACKMAN

TARSUS Cilicia Campestris, Turkey. Map 6. A very ancient city founded on the earlier course of the Tarsus Çay (Kydnos) only 40 km from Adana in the center of the alluvial plain. Known from excavation as a settlement from Neolithic times, Tarsus was long a Semitic city with

important Oriental connections through its landlocked port of Rhegma. Indeed, apart from a brief period under the Satrap, it had local autonomy under the Persian Empire with rulers known as *syennesis*. Such it was when Xenophon and his Ten Thousand passed through Cilicia at the beginning of the 5th c. B.C. After Alexander's conquests, however, Tarsus was in dispute between the Seleucid and Ptolemaic factions, and was known for a while as Antioch on the Kydnos for Antiochos Epiphanes, and in order to prove a respectable pedigree chose to claim Perseus and Herakles as founders. In 67 B.C., after two centuries of turbulent misrule, Tarsus was occupied by Pompey during his Cilician campaign against the pirates, and it is at least possible that the father of St. Paul (a Tarsiot and Roman citizen by birth) had been honored for his services as a tent contractor to the Roman army at this time. If Paul was Tarsus' most illustrious son, among spectacular events in the city's history, Cleopatra's regal progress up the Kydnos for her rendezvous with Antony ranks high.

N of Tarsus, Septimius Severus' passage through the Cilician Gates in pursuit of Pescennius Niger in 193 is marked by an inscription on the rock face. Tarsus was designated "first, greatest and most beautiful; the metropolis of the three provinces of Cilicia, Isauria and Lycaonia" and was the seat of a great university. Under Diocletian, Tarsus became metropolis of Cilicia Prima, the W part of the plain, while Anazarbos administered the E half. The retreat of the sea, due to silt carried downstream by the Kydnos, and the resulting abandonment of Rhegma, led Justinian in the 6th c. to divert the river into the channel E of the modern city, and through which it still flows. With the Arab occupation of Cilicia, Tarsus was laid in ruins, but was rebuilt by Harun-ar-Rashid to become the military base for the annual Moslem campaign against Byzantine territories N of the Taurus. It was reconquered by Nikephoros Phokas in the 10th c., only to fall again, first to the Christian kingdom of Little Armenia, then to the Egyptian Mamelukes, and finally to the Ottoman Turks.

Classical Tarsus lies deep beneath the modern city, and the port of Rhegma is surely to be found in the eucalyptus forest that drains the swamps that marked the course of the Kydnos when it became choked with silt. A battered brick-faced arch on the road W of the city, and sometimes known as St. Paul's Gate, is of Arab date, and the only certain Roman monument is a massive concrete foundation known locally as Donuk Taş (The Frozen Stone), which was probably the podium of an important public building, since fragments of marble veneer are scattered nearby. In the Museum of Adana is the material discovered during excavations at Gözlü Kule, the original settlement, which shows evidence of a continuous occupation from the Neolithic to the Arab period. Also in the Adana Museum are the chance finds of pottery, figurines, statuary, mosaic, and other objects encountered by workmen on civic projects. Among them is a fine marble sarcophagus decorated with the scene of Priam begging Achilles for the return of the corpse of Hector.

BIBLIOGRAPHY. W. M. Ramsay, "Cilicia, Tarsus, and the Great Taurus Pass," *The Geographical Journal* (Oct. 1903) 1-56; G. Le Strange, *The Lands of the Eastern Caliphate* (1930) 130-34; A.H.M. Jones, *Cities of the Eastern Roman Provinces* (2d ed. 1971) Index s.v.; H. Goldman, ed., *Excavation at Gözlü Kule, Tarsus* (1950-1963). M. GOUGH

TARTESSOS SW Spain. Map 19. By Tartessos the literary sources mean a city, a river, and a region. Avienus

(*Ora maritima* 85.270, 290, 297) calls it a rich city surrounded by walls and watered by a river. For some authors (Avienus, *Ora maritima* 85.269-70; Just. 44.4.14; Plin. 4.120, 7.156; Sall. *H.* 2.5; Val. Max. 8.13.4) Tartessos is identical with Cádiz. For others (App. *Hisp.* 63; Plin. 3.7) it is Carteia. It was on an island (Schol. of Lycophron 643), in the middle of the ocean (Schol. of the *Iliad* 8.479), or near the Pillars of Hercules (Steph. Byz. voz. Tartessos). Tartessos is localized at the mouth of the river of the same name (Avienus, *Ora maritima* 284-90; Steph. Byz. voz Tartessos; Paus. 6.19.3), between the two arms of the river (Poseidonius in Strab. 3.140, 148). It was two sailing days distant from Cádiz (Scymn., *Ephebos* 161-64). The description of Stesichorus (Strab. 3.2.11) on the sources of the river Tartessos agrees to an astonishing degree with the origin of the Rio Tinto in the Cueva del Lago (Cave in the Lake) (Avienus, *Ora maritima* 291-95). Scymnus (162), in describing the river Tartessos, mentions tin, but none of the rivers identified with Tartessos contains tin. The only river that could attract attention because of the peculiar substance contained in it is the Rio Tinto.

The Tartessos region probably embraced the whole S part of the Iberian Peninsula S of the Sierra Morena as far as Mastia Tartessiorum, the E border of the kingdom of Tartessos (Strab. 3.2.11). This entire region was under the cultural influence of the Phoenicians, and then of the Etruscans and Greeks, beginning in 1100 B.C. when Cádiz was founded by Phoenician traders. They established a series of trading posts on the coast of the Straits of Gibraltar: Sexsi (Almuñecar), which contains the oldest Phoenician necropolis in Spain, dating from 700-670 B.C., Los Toscanos (Málaga), dating from the 8th-6th c. B.C., and the necropolis of Cabezo de la Esperanza (Huelva); both the latter have produced Phoenician material of the 7th-6th c. B.C. The Phoenicians and Greeks traded with the S of the Iberian peninsula and established an orientalized culture such as that existing in Etruria, Carthage, and N Africa. This culture, called Tartessian and of Phoenician origin with Greek and Etruscan influences added, is known through a great and varied quantity of archeological material now distributed through a number of museums in Spain and the U.S.A., and in the British Museum, London, and the Musée St. Germain, Paris.

About 630 B.C. Kolaios of Samos traveled to Tartessos and took home riches estimated at 60 talents; the wealth in metals was the attraction behind the Phoenician and Greek trips to Tartessos. With one tenth of these riches the Samians made an Argolic style caldron which they placed in the Heraion of Samos (Hdt. 4.152). Two ivory pieces like those from Carmona, confirming such journeys, have been found in Samos. Pausanias (6.19.2, 3-4) refers to a chamber from the treasury of Myron in Olympia weighing 13 tons, made of Tartessian bronze, according to the Elians. The Phokaians established relations with King Argantonius (670-550 B.C.) of Tartessos, who gave them money to erect a wall around Phokaia (Hdt. 1.163); later they founded Mainake on the Malaga coast (Strab. 3.4.2). Tartessos was governed by kings, some of whose names are known, such as Theron (Macrob. *Sat.* 1.20.12), Habis (Just. 44.4), who taught agriculture, promulgated laws, and finally converted himself into a god. Other legends, such as the references to the cattle of Gerion (Strab. 3.148) and the wealth in gold and silver of his father (Diod. 5.17.4), clearly show the two axes of the economy of Tartessos: metals and cattle. Another king was Gargoris, mentioned in the myth of Habis. Many poems and laws in Tartessos were written in verse, and the Tartessians claimed they were 6000 years old. A

syllabic writing with Greek vowels was developed ca. 700 B.C. Tartessian culture disappeared in the beginning of the 5th c. B.C.

BIBLIOGRAPHY. A. García y Bellido, *Historia de España. España Protohistórica* (1952) 281-308[MPI]; M. Gómez Moreno, "La escritura bástulo-turdetana (primitiva hispánica)," *Revista de Archivos, Bibliotecas y Museos* 69 (1961) 879-948[MI]; J. M. Blázquez, *Tartessos y los orígenes de la colonización semita en Occidente* (1968)[MPI]; J. Maluquer et al., *Tartessos y sus problemas* (1969)[MPI]; id., *Tartessos* (1970)[MPI]. J. M. BLÁZQUEZ

TARVISIUM (Treviso) Veneto, Italy. Map 14. The site is in the plain of the Silis river, a short distance from the ancient Via Claudia Augusta. There have been finds in the area and in surrounding zones from the prehistoric and early Venetic periods. The name is probably of Celtic derivation. The written documentation (Plin. *HN* 3.126,130; Paul. Diac. 2.12-13; 3.26; *CIL* v, 201ff) is scarce and late. A municipium of the tenth Augustan region, perhaps by 49 B.C. it was at the center of an agricultural area with indication of centuriation and traces of roads. Inscriptions attest to several structures including a quadrivium, walls, a crypt, and a templum. The small finds (funerary stelai, portraits, minor objects) are preserved in the local Museo Civico, along with other material of various provenance collected between 1873 and 1932.

BIBLIOGRAPHY. Fluss, "Tarvisium," *PW* 4A (1931) 2452-53; G. Traversari, *Arte antica e moderna* (1964) 117ff, 249ff, 382ff; G. Pilla, "Nota preliminare sul rilevamento della centuriazione trevigiana," *AttiVen* 74 (1965-66) 405-10; L. Beschi, "Treviso," *EAA* 7 (1966) 980-81. L. BESCHI

TASCIACA (Thésée) and **POUILLÉ** Loir-et-Cher, France. Map 23. The village of Thésée is on the right bank of the Cher, midway between St. Aignan and Montrichard. Opposite, on the other side of the river, is the village of Pouillé. On the *Peutinger Table* Tasciaca is the name of one of the stations on the Caesarodunum Avaricum route between Caesarodunum (Tours) and Gabris (Gièvres). Excavations now in progress on the latter site reveal that it was an important pottery-manufacturing center.

At Les Mazelles, W of the modern Thésée, is one of the most important ancient monuments in Gaul, a rectangular building, A (44 x 13.5 m), oriented E-W. Its walls are 5-6 m high and built of a core of mortared rubble faced with small stones with interlacing bands of brick. The building consists of two rooms of different periods: the larger one (38 m long), to the W, is older. There are also two small rectangular pavilions connected by a gallery and joined to the S facade, one at the W end of the large room, the other where it meets the small room.

Some have thought that this building was at the back of a huge rectangular courtyard that had a series of rooms along its N side, but excavations since 1965 have shown a very different plan. There are three distinct buildings, oriented differently. The SE building, B, has been thoroughly explored. It has two adjacent parts. The N section consists of a large square room ca. 13 m on a side, with three small rooms in front of it to the W. The S section, its facade turned slightly to the E, consists of two rectangular rooms of different sizes separated by a N-S wall. Building C, to the SW, consists of one square room near the surrounding wall, which at this point has a monumental gate opening to the W.

Probably the three buildings stood within this common

surrounding wall, which is clearly visible to the W and S, but has not yet been located to the E. The ground between the three buildings, which slopes steeply from N to S, has never been flattened or terraced. Excavations inside buildings A and B have revealed no archaeological strata, nor has any object been found to date the complex. The skeleton of a horse was buried inside building A.

The masonry is generally a core of mortared rubble faced with small blocks, with iron joints, and interlaced with layers of brick. But opus spicatum appears in the same layer, cutting across the rectangular masonry. The foundation bases are on different levels. The roofing, lighting, and movement inside the buildings also pose difficult questions. The great room in building A is reached by a door in the middle of the S facade, and there was a second door on the small W side. The upper part of the walls are pierced by a regular row of windows. It has been pointed out that these arrangements are normally found in basilicas, yet there is no trace of an inner colonnade, and it is hard to imagine a framework with only a single span. The small E room seems to have been reached only from the larger one. The two facade pavilions are not connected to the outside in any way. Despite these difficulties, building A looks like a villa with a galleried facade of the familiar type represented, for instance, by the villa of Mayen. Buildings B and C are probably outbuildings.

Judging from the masonry construction, Les Mazelles seems to have been built no earlier than the end of the 2d c. Excavations since 1961 at Pouillé on the left bank of the Cher have revealed an earlier form of the settlement. This is an industrial vicus where nine potter's kilns have been unearthed. The population lived in large rectangular houses with cellar-sanctuaries similar to those at Alesia. A little square fanum was surrounded by a polygonal wall. This village lasted from the beginning of the 1st c. to the end of the 2d c. It was then abandoned, probably as a result of floods, and reoccupied in the 3d c. by poor villagers who buried their dead inside the abandoned buildings. Another potter's kiln has been found, very well preserved, in the middle of the village of Thésée.

BIBLIOGRAPHY. A. Grenier, *Manuel d'archéologie galloromaine* I, 2 (1931) Archéologie du sol, 784ff; II, 1 (1934) Les routes, 205-8; G. Gaume, *Rev. Arch du Centre* 4 (1965) 101-23; id. & B. Hoffmann, ibid. 6 (1967) 291-304; *Gallia* 26, 2 (1968) 339-40. G. C. PICARD

TASGAETIUM (Untersechenz and Stein am Rhein) Thurgau and Schaffhausen, Switzerland. Map 20. Vicus and fort on the Rhine just below the SW end of Lake Constance, mentioned by Ptolemy (2.12.3) and inscriptions (*CIL* XIII, 5254, 5256-57 = Howald-Meyer nos. 368-370). Tasgaetium was immediately E of the frontier of Germania Superior, where the roads from Ad Fines and Vitudurum crossed the Rhine.

In the early 1st c. A.D. a military post was built on Werd, an island in midstream which also supported a bridge. The earth and timber fort, which must have stood on the left bank of the river during the 1st c., has not been found, but is tentatively located at In Höfen. The vicus developed under its protection in the early 1st c. A.D., and by the 2d c. had extended to both sides of the river. During the 2d and 3d c. there was probably a statio of beneficiarii. Under Diocletian a fort was built on the left bank, on an elevation called "Burg" 1.5 km downstream. It was probably abandoned in A.D. 401.

Little is known of the vicus, built over today, except for the baths, a rectangular building (21 x 13.2 m; 6 rooms) built in the 1st c. A.D., probably by the garrison.

On each side of Werd island four wooden piles to carry the bridge (6.4 m wide) have been found. On the left bank to the right of the bridge was a boat landing. The bridgehead on the right bank has been washed away.

The Late Roman fortress was almost square (ca. 90 m on a side; area 8000 sq. m), with circular towers at the corners. Regularly spaced on each side were two towers, with rounded foundations and polygonal walls. The main entrance in the middle of the S wall was flanked by two more towers. The walls were 2.85 m thick, and faced with hewn blocks. The N wall has collapsed but the others are visible, as well as a tower at the S corner and the main gate. A ditch 10 m wide ran 43 m outside the S wall. Inside the fortress, where there is now a church and its appendages, a few traces of Roman installations have been found, including a rectangular structure (32 x 12 m).

The Klostermuseum St. Georgen is in Stein am Rhein and the Heimatmuseum am Untersee in Steckborn.

(See also Limes, Rhine.)

BIBLIOGRAPHY. F. Staehelin, *Die Schweiz in römischer Zeit* (3d ed. 1948) 184-85, 272-74, 622[P]; H. Urner-Astholz, "Ur- und Frühgeschichte," *Gesch. der Stadt Stein am Rhein* (1957) 20-41[P]; bridge: *AnzSchweiz* 2 (1900) 166-70[P]; 4 (1902-3) 121-37[P]; bath: V. von Gonzenbach, *Die römischen Mosaiken der Schweiz* (1961) 105-6; summaries: *Jb. Schweiz. Gesell. f. Urgeschichte* 43 (1953) 84-85; 94 (1962) 84.

V. VON GONZENBACH

TASSIESHOLM Dumfriesshire, Scotland. Map 24. Site of two superimposed Roman forts and two later fortlets. The earlier fort (2.4 ha) had a unique T-shaped plan caused by staggered entrances on the N and S. Its successor was almost square, ca. 165 m on a side (2.76 ha). Occupation of the site began ca. A.D. 80, but the first fort was soon dismantled to make way for the second, which came to an abrupt end before A.D. 100. At least one fortlet is of 2d c. date.

BIBLIOGRAPHY. *Trans. Dumfriesshire and Galloway Nat. Hist. and Ant. Soc.* 3d ser. 28, pp. 199-221.

K. A. STEER

TAS SILĠ, *see* MELITA

TAŞYAKA ("Krya") Turkey. Map 7. Krya was a town in Lycia or Caria, probably at Taşyaka, formerly Charopia, on the shore of a small bay 8 km N of the headland of Kapı Dağı, on the W side of the gulf of Fethiye. Krya figures in the Athenian tribute lists with a tribute of one-third of a talent, and is mentioned by Pliny, Mela, Artemidorus ap. Steph. Byz., and in the *Stadiasmus*. Its general situation on the gulf of Fethiye appears clearly from the authorities, and no more probable site is known than that at Taşyaka, though no actual proof is available. The site is very small, comprising a tiny acropolis on a steep hill with remains of an early wall and a tower, approached by a rock-cut stairway. On the shore is an Ionic temple tomb with an inscription in Carian. Krya is said to have possessed islands in the gulf, and is called by Pliny Crya fugitivorum, though the reason for this is not known. It is in any case to be clearly distinguished from the Rhodian deme of Kryassos.

BIBLIOGRAPHY. *TAM* I (1901) 151; A. Maiuri, *Annuario* 4-5 (1921-22) 422-24; *ATL* I (1939) 507; P. M. Fraser & G. E. Bean, *The Rhodian Peraea* (1954) 55-56.

G. E. BEAN

TAUCHEIRA, later ARSINOE (Tawqrah or Tocra) Libya. Map 18. A city of the Libyan Pentapolis on the coast between Berenice and Ptolemais. The name (*Hdt.* 4.171) is probably Libyan. In the 3d c. B.C. the city was named Arsinoe after the consort of Ptolemy II Philadelphus. The country around was fertile and there were many wells, which may help to explain why, despite its poor anchorage, Tocra became the last Byzantine stronghold in Cyrenaica.

The archaic pottery from the excavations (1963-65) in a small area of the city by the shore, shows that there was a settlement here in the twenties of the 7th c. B.C., within a decade of the traditional foundation of Cyrene. The great mass of it came from votive deposits and indicates that there was already close at hand a much frequented shrine of Demeter and Kore. Among the early sherds are imports from Corinth, Rhodes, the Cyclades, Lakonia, and Crete. Few structural remains were found, but there were remains of early huts and stretches of a wall which may, it is suggested, have been part of a defensive wall protecting the early settlement. The votive offerings continue more sparsely into the 5th and 4th c. and the beginnings of the Hellenistic period.

The most prominent remains of ancient Tocra are its Byzantine walls. Many of the 30 great square or polygonal towers and an advance wall (proteichisma) on the W and S sides are clearly Byzantine, but the main circuit is built on the line of the Hellenistic walls. The walls, described and drawn by various early travelers, form a rough square with sides of about 650 m. On the landward sides they still stand in places several meters high, but they have almost entirely vanished on the seaward side.

The quarries, in which numerous tombs had been cut, have yielded fine vases. Many inscriptions, some of them Jewish, have been found among the tombs. Among inscriptions found within the city was part of an Edict of Anastasius.

Systematic excavation within the walls was begun in 1939. The general lines of the main streets had long been visible, showing a grid of insulae. Three churches, each with an apse at the E end, were known, one outside the W wall. A large, solid building near the center of the town is regarded as probably the Byzantine governor's palace. In 1966 and 1967 a detailed survey of the town buildings and of the walls was prepared, making use of recent air photographs. The existence was established of three main periods of construction of the city wall and the street system and 18 internal buildings were related to the new survey.

BIBLIOGRAPHY. F. W. and H. W. Beechey, *Proceedings of the Expedition to explore the northern coast of Africa 1821-22* (1828) 367[P]; Kees, "Taucheira," *RE* IV 2 (1932); G. Oliverio, "F. Halbherr in Cirenaica," *Africa italiana* 4 (1933)[I]; *Documenti antichi dell' Africa italiana, Cirenaica* I-II (1936)[I]; P. Romanelli, *La Cirenaica romana* (1943); G.R.H. Wright, "Excavations at Tocra," *PEQ* (1963) 22; J. Boardman and J. Hayes, *Excavations at Tocra, 1963-65* I: *The Archaic Deposits* (1968); II: *The Archaic Deposits and Later Deposits* (1973).

O. BROGAN

"TAUROENTION," *see* LE BRUSC

TAUROMENION (Taormina) Sicily. Map 17B. A city on the slopes of Mt. Tauro, 250 m above the sea, on the road from Messina to Katane. Of the early Sikel habitation little is known; only the necropolis, on the hillside above the city, has been excavated. The Greek city was founded in 358 B.C. by descendants of the Naxians, whose city on the shore below had been destroyed by Dionysios of Syracuse in 403.

The Greek agora corresponds roughly to the modern Piazza Vittorio Emanuele; its W edge may have been delimited by a Doric peristyle temple, one corner of

which can be seen behind the church of S. Caterina. The foundations of a large building have lately been excavated behind the Caserma of the Carabinieri; this structure probably defined the N side of the agora. Outside the adjacent Messina gate are traces of the city wall, which appears to have followed the lines of the extant mediaeval walls. The nearby church of S. Pancrazio is founded on the ruins of a temple in antis, probably dedicated to Zeus Serapis. The scanty remains possibly of a third temple can be seen above and to the E of the theater; they underlie the upper portico of the theater structure. An important building of the Greek period has recently come to light in Via Bagnoli Croce below the theater: situated on a sloping terrace, it has a central peristyle, behind which are rooms on at least three sides. On the N is a larger room at a higher level; fragments of inscribed wall plaster suggest that this room was a library. The entire complex may then be identified as the gymnasium, the existence of which had been known from inscriptions.

Tauromenion flourished during the Roman domination, especially after the founding of a colony by Augustus in 30 B.C. The agora was retained as a forum. Behind the Greek building that delimited the N side of the agora were the municipal baths, a part of which has recently been excavated. Three large rooms of brick-faced concrete formed the S exposure of the building; these were heated, two with hypocausts. Other rooms to the N are incorporated in modern houses; parts of these can be seen in the extant walls known as the Zecca. Abutting on the temple at the W side of the forum is a small odeion, dated like the baths to the Imperial period. The scaena, directly in front of the peristyle temple, was decorated with niches; the entire structure had a wooden roof. About 100 m E of the forum is the theater, cut into the slopes of one of the city's acropoleis. It was constructed of brick and concrete in the 2d c. A.D. An earlier Greek theater was probably on the same site; to it may belong some inscribed seats and masonry walls, used as foundations for the Roman stage building. The scaenae frons, inaccurately restored, was articulated by two superimposed colonnades and pierced by three arches; the latter are open, representing a concession to the splendid site with its superb view of Aetna and the sea. The upper cavea was crowned with a vaulted colonnade. At a later period the theater was transformed into an arena. Below the forum of the city is the handsome brick wall known as the Naumachia. Decorated with alternating niches and false windows, this structure had a purely functional role; it formed the outer wall of a large two-aisled cistern, now mostly destroyed; and it served to terrace the steep hillside. Other large vaulted cisterns have survived in Vicolo Floresta and in Contrada Giafari above the town, indicating the existence of a complex system for the collection and distribution of water. Important local inscriptions, works of sculpture, mosaics, and other antiquities are kept in the small antiquarium above the theater, in anticipation of the completion of the Museo della Badia.

BIBLIOGRAPHY. P. Rizzo, *Tauromenion* (1928); G. Libertini, "Il Teatro di Taormina," *Boll. Inst. del Dramma Antico* (1930) 111f; M. Santangelo, *Taormina e dintorni* (1950); P. Pelagatti, "Scoperta di un edificio termale a Taormina," *Cronache di Archeologia e Storia dell' Arte* 3 (1964) 25-37; *FA* (1967) 2968 (gymnasium).

M. BELL

TAURUNUM, *see* LIMES PANNONIAE (Yugoslav Sector)

TAVIERS Belgium. Map 21. A Gallo-Roman vicus on the Bavai-Tongres road. The ancient name was probably Tabernae, which would indicate that a mansio of the cursus publicus was located there. Many foundations have been found at the locality of Terre aux Pierres, N of the roadway. The beginnings of the center go back to the first half of the 1st c. and maybe even to the end of the Iron Age. An inscription mentions the presence of a well with medicinal waters, dedicated to Apollo. Among the foundations were those of a temple. Many pieces of sculpture have been found, including a fine torso of an ephebe in white stone. The vicus was destroyed during one of the first Frankish invasions, shortly after A.D. 250. Shortly thereafter, a small blocking fort was built, almost square in plan and surrounded by a ditch 4 m wide. It was built on the ruins of the temple mentioned above, on the W edge of the vicus. Soon the fort was rebuilt and surrounded with wider ditches (8 m on the E side, 11 on the S, and 14 on the W). The slopes of these ditches were set with fascines placed 20 to 30 cm apart from one another. The inside of the ditch was reinforced by two rows of stakes which formed a high palisade for surveillance by the patrol. Apparently the first burgus was destroyed around A.D. 275 and rebuilt immediately. A hoard of coins, buried in the bottom of the ditches of the burgus in the time of Valentinian I (364-78), may indicate the end of the Roman occupation. The large tumulus of Hottomont had a diameter of 48 m and a height of more than 10 m. Its rich grave goods were pillaged during the wars of Louis XIV.

BIBLIOGRAPHY. P. Claes, "Découvertes de l'époque romaine à Taviers," *Annales de la Soc. archéol. de Namur* 47 (1953-54) 225-55; L. Halkin, "L'inscription romaine de Taviers," ibid. 257-65; M. E. Mariën, *Par la chaussée Brunehaut de Bavai à Cologne* (1967) 68-73[PI].

S. J. DE LAET

TAVIRA, *see* BALSA

TAVIUM Galatia, Turkey. Map 5. The center of the Trocmian tribe. It is described by Strabo (12.5.2) as a phrourion and minted coins in the 1st c. B.C. but did not become a city, in the Greek sense, until 21-20 B.C. when its era begins. It was always the least considerable of the three cities of Galatia, but owed its importance to its position in the road network of E Asia Minor. It continued to be a place of some importance during the Byzantine period.

The position of Tavium was a subject of considerable dispute until discoveries in 1884 proved beyond question that it lay beside Büyük Nefes köy, some 30 km W of Yozgat. The site is on the S slope of the ridge that forms the watershed of the basin of the Delice Irmak (Cappadox flumen?). Two natural outcrops of rock ca. 1 km W of the modern village carried the original site, and on both a few walls have been exposed by village digging. Sherds indicate that the W mound had been occupied long before the Classical period. The main part of the Roman city lay to the N of these two outcrops under an area of gardens and vineyards belonging to the modern village. Architectural fragments are strewn all over this area and built into field walls, but too little is visible to allow any attempt to reconstruct the plan of the city. There are traces of a Late Roman or Byzantine wall around the site. Remains from Tavium have been carried to Büyük Nefes köy and the surrounding villages and cemeteries.

BIBLIOGRAPHY. J.R.S. Sterrett, "An Epigraphical Journey in Asia Minor," *Papers of the American School of Classical Studies at Athens* II (1883-84) 308-20; K. Bittel, "Kleinasiatische Studien," *IstMitt* 5 (1942) 6-38.

S. MITCHELL

TAWQRAH, *see* TAUCHEIRA

TAXILA, *see* SIRKAP

TAZZOULT, *see* LAMBAESIS

TEANO, *see* TEANUM SIDICINUM

TEANUM APULUM (San Paolo di Civitate) Apulia, Italy. Map 14. On the hill of Civitate, near San Paolo, a prior Apulian settlement named Teate was conquered by the Romans in 318 B.C., together with Canusium. It was subjugated by the Roman consuls M. Foslius Flaccinator and L. Plautius Venno (Livy 9.20). During the second Punic war, M. Junius Pera (Livy 23.24) selected it as his winter quarters. It is mentioned in passing by Cicero (*Clu.* 9) as a municipium, 18 Roman miles from Larinum. The name of the city also appears in the lists of the cities of Apulia (Strab. 6.285; Mel. 2.4.6; Plin. 3.103; Ptol. 3.1.72). Its role as a municipium is confirmed by the discovery of inscriptions (*CIL* IX, 705), in addition to its citation in the *Liber Coloniarum* (p. 210). The city seems to have been enrolled in the tribus Cornelia (*CIL* IX, p. 67). Remains of walls, as well as of the Roman aqueduct, are left in the zone; recently a temple has been discovered. The local Museo Civico preserves numerous pieces of archaeological evidence.

BIBLIOGRAPHY. W. Smith, *Dictionary of Greek and Roman Geography*, II (1857) 1115 (E. H. Bunbury); K. Miller, *Itineraria Romana* (1916) 219; *RE* 5.1 (1934) 96-97. F. G. LO PORTO

TEANUM SIDICINUM (Teano) Italy. Map 17A. An ancient city in N Campania of about the same size as the present town. Although there have been discovered in the area tombs of the 7th c. B.C., we have for the first time in the period of the Samnite wars our first evidence of the Sidicini. In the Hellenistic period, to judge from literary notices, archaeological data, and coinage, which began toward the end of the 4th c., Teanum was one of the most important centers of central Campania. In fact, it was the most outstanding site on the Via Latina. The settlement was reduced to the area of the citadel in the high Middle Ages.

A sanctuary complex in the area of Loreto on the banks of the Savone (Safo) has yielded architectural and votive terracottas of the last ten years of the 6th c. and much votive material of the 5th and 4th c. After the establishment of the city, which apparently occurred in the last third of the 4th c. to judge from archaeological finds, the sanctuary was significantly enlarged and equipped with a terrace; gradually buildings rose in the area until the period of Sulla. Among the most interesting structures thus far uncovered are four temples with podia of the 3d c. and first half of the 2d c. The monumental works of the late 2d c. were enlarged in the Sullan period. Some small molded temples of the 3d c. and 2d c. are of particular interest among the votive offerings and a sculpture group from the Augustan age.

The citadel was adapted very skillfully to the city plan. Various traces of the isodomic fortification works on the citadel are preserved. In the Late Hellenistic period, an apparent expansion to the S and E made Teanum one of the largest cities in Campania.

Among the structures partially explored are a bath complex of the Sullan period, rebuilt again and again until the Late Empire, and a sanctuary complex which embraced the theater. The theater, begun in the last ten years of the 2d c. B.C., had its models in Caria and strong analogies at Pietrabbondante. Supported by massive, vaulted substructures, it may be the oldest theater built entirely of masonry. The stage building dates to a partial restoration of the Sullan period and its very ornate marble architecture has largely survived, even though in a state of collapse. To the S of the city on the Via Latina are the remains of the late Republican amphitheater with its more recent restorations.

Farther downstream, on the right of the Savone, is a large Hellenistic necropolis in which were discovered tombs, some partially chambered, some with decorative paintings. A Roman monumental necropolis extends N along the Via Latina.

In the area many remains have been noted of country villas and of a would-be urban villa of the 3d c. A.D. near the source of the Santella. On the hillside of Santa Giulianeta, S of Teano, are the remains of a temple of the Sullan period and in the valley of Assano are mines that had been worked out even in antiquity. Everything leads to the conjecture that Rufrae, near the modern Presenzano, was part of the territory of Teanum. Rufrae appears to have been an autonomous center during the Samnite wars and in the late Republican period was reduced to a pagus.

A type of black glaze ware is attributed to Teanum. Of the first Hellenistic period, this ware is covered with decorations and occasionally incised and painted over with forms that derive, in part, from Attic models.

BIBLIOGRAPHY. Th. Mommsen in *CIL* X, p. 471f; E. Gabrici, "Necropoli di età Ellenistica a Teano," *Mon. ant. Lincei* 20 (1910) pp. 5ff; H. Philipp in *RE* V A1, col. 97f; W. Johannowsky, "Relazione Preliminare sugli scavi de Teano," *BdA* 48 (1963) 131-65.

W. JOHANNOWSKY

TEATE MARRUCINORUM (Chieti) Abruzzi, Italy. Map 14. An ancient city under the capital of a province, situated on the right bank of the Pescara river ca. 15 km from the sea. The city spreads over a hill, set between the parallel valleys of the Pescara and Alento rivers, which makes up the W edge of the pliocene terrace that was spread between the Maiella chain and the Adriatic.

Teate's pre-Roman origins can be reconstructed at a cult area evidenced by a very ancient sacred well. However, this center of the Marrucini—a Sabellian tribe which probably assumed the name of a more ancient ethnic group—was preceded by a settlement recently discovered at the base of the Maiella range in the district of Rapino. The present name of that area—Tuta Maruca—is identified with the Touta Marouca cited on a bronze plaque discovered in the vicinity, written in the dialect of the Marrucini and known as the Tavola di Rapino. The oldest settlement shows circuit walls of irregular blocks, and between the walls floors of huts carved into the rock have been discovered. It is probable that the settlement rose on a protected mountain pass toward the country of the Peligni. It is possible that the change in the road system—from mountain passes to a great traffic artery, the Via Valeria, opened between the Adriatic and Tyrrhenian—accounts for the decline of the ancient settlement and the rise to power of those centers which were found along the length of the new road. The cult site, already mentioned, must have been one of them.

The sacred well is set within structures of isodomic work which set apart a sacred area and preserved the well. These structures may be temple buildings, surely prior to the social war and probably dating to the 3d c. B.C. Decorative terracotta elements discovered in the vicinity of those structures may be dated to the following century, as well as terracotta materials that come from one or more of the temples on the highest level of the city, the district of Civitella, set at the S end of the settlement and certainly the Arx Marrucina. That is all that remains of the most ancient phase of Teate, still thought to be in the Italic period.

Under the influence of Rome, the site, which bordered the Via Valeria on both sides, had the traditional urban plan. The district of Civitella still preserves intact the square grid plan with its NW-SE orientation. Along the slopes, in the direction of Pescara, spreads the cavea of the theater, with a diameter of 80 m. It is now supposed that a considerable section of this area was destroyed by the landslides that have occurred from antiquity onward. At the N end of Civitella, two series of temples mark the adjacent sides of the forum. At the SE end of the forum, the Via Valeria crossed and on the opposite side, set into the hill, a series of three temples rose on a prominence. Two temples are identical, while the smallest was apparently constructed at a later date. Because of the characteristic refacing in dichrome opus reticulatum, the two identical temples may be thought to be of the same date as the theater. In the construction of the temples, the oldest structures, already mentioned, were enclosed and they preserved the sacred well.

The baths are situated in the hollow of a small valley at the foot of the SE slopes of the hill. The complex is divided into two major sections: a cistern and the baths proper. The cistern (ca. 60 x 14 m) is partially cut into the hill and displays a front made up of nine apses. On the inside, those correspond to a similar number of chambers joined to one another by means of arches opened in the dividing walls. In front of the cistern runs a level stretch where one descends into a rectangular courtyard around which the rooms of the bath were constructed. The baths may be dated to the middle of the 1st c. A.D.

Throughout the city are numerous water works, canal systems, and cisterns. There is also a grandiose terracing operation between the Palazzo del Governo and the theater—most probably outside the limits of the Roman city—which was destined to form a part of the bath cistern. Except for the chorographers, only Silius (8.552) among the ancient writers mentions Teate. However, the Asinii, who later participated in the struggle against Rome with Asinius Herius, did come from Teate and gave to the Augustan period famous personalities in politics and letters such as Asinius Pollio and Asinius Gallus.

In the Roman organization, Teate had a municipal constitution. Quattuorviri are known, as are aediles, a curator muneris publici, and members of the college of the seviri augustales. With the Augustan division of Italy, Teate became part of Regio IV, Sabina et Samnium, and was enrolled in the tribus Arniense. In the 4th c., it was a part of Flaminia et Picenum and thereafter of Valeria.

BIBLIOGRAPHY. V. Cianfarani, "Note di antica e vecchia urbanistica teatina," Atti del settimo Congresso Internazionale di Archeologia Classica (1961) 295-313; id., "Touta Marouca," Studi in onore di Aristide Calderini e Roberto Paribeni, III (1956) 311-27. V. CIANFARANI

TEBESSA, see THEVESTIS

TEGEA Arkadia, Greece. Map 11. Old and important city in SW part of the region, some 12 km to the S of Tripolis. Mention is made of it as early as the Catalogue of Ships (Il. 2.607). In the archaic period (before 600), nine demes whose names are given by Pausanias (8.45.1) came together to form the city, which is situated in the Tegeatis, which on the E borders Kynuria and Argolis (though separated from them by Mt. Parthenion), in the S on Lakonia, in the W on Mainalia, and in the N on Mantineia. The city district lies between the villages of Piali (now Tegea), Haghios Sostis, Omertsaousi, and Achouria. In the absence of recent excavations, the location of the city walls remains uncertain.

Tegea had a role to play in the saga of the Dorian migrations: Echemos, king of Tegea, killed Hyllos, son of Herakles (cf. Hdt. 9.26). In its early period, Tegea fought with Sparta, which sought in vain to conquer it (Hdt. 1.66-68) but from 550 B.C. incorporated it in its Peloponnesian League. Tegea remained in the alliance with Sparta, and furnished the second strongest Peloponnesian army in the Persian War. At the battle of Marathon, the Athenians adopted the Arkadian goat-god Pan from the Tegean mountains (Hdt. 6.105-6). The Tegeans fought with 1,500 hoplites at Plataiai (Hdt. 9.28) and are mentioned on the snake-column at Delphi. Between 470 and 465 a rivalry grew up between the Arkadians and the Spartans, and the Tegeans suffered defeats (Hdt. 9.35). An oligarchic party bound Tegea closer to Sparta, and thus brought the city into conflict with Mantineia. In the Peloponnesian War, Tegea fought on the Spartan side. Around 430-420 Tegea began to strike its own coins. It was given a city wall ca. 370 B.C. at the instigation of the pro-Sparta party (Xen. Hell. 6.4.18, 6.5.6-15, 7.5-8). In 362 at the battle of Mantineia Tegea fought on the Theban side, and in 316 successfully withstood a siege by Kassandros, but was taken in 222 by Antogonos Doson, in 218 by Lykourgos, and 210 by Machanidas. Directly afterwards Philopoimen made it a base for his struggle with Sparta. In 174 B.C. King Antiochos IV Epiphanes of Syria gave money for the rebuilding in marble of the cavea and the analemmawall of the theater which had been standing since the end of the 4th c. B.C. Remains of it are incorporated in the Christian basilica of Palaio Episkopi.

Although it lost in importance during the Hellenistic period, in comparison to other Arkadian cities Tegea maintained its position well (Strab. 8.8.2.388) and is described extensively by Pausanias ca. A.D. 170 (8.45-54). In 124 the emperor Hadrian visited Tegea, and had the baths rebuilt. This led to the adoption of a new chronological reckoning-point (IG v.2 no. 51-52). About 395 Tegea was destroyed by Alaric and his Goths (Zosimos 5.6.4-5, Claudian, Bell. Goth. 575f). But the presence of Christian basilicas show that Tegea continued to be inhabited in the 5th and 6th c.

The holiest sanctuary in Tegea and the old cultic center of the region was the Temple of Athena Alea, in the neighborhood of which Late Mycenaean sherds have been found. The votive gifts show that the cult of the goddess dates back to the Geometric period. According to tradition the shrine was founded by Aleos, and from the distant past it possessed the right of asylum, and was famous as a place of refuge not merely for fugitives and exiles, but also for various kings of Sparta. On the N side of the temple was the brook where Herakles is supposed to have ravished Aleos' daughter Auge. Her exposed son Telephos later became king of Mysia and Pergamon.

In the area of the sanctuary have been found the remains of an archaic temple whose cult-statue was carved by the Attic sculptor Endoios and transported by Augustus to Rome, where it was placed in the Forum Augustum. The archaic temple burned down in 395-394 and was replaced in the middle of the 4th c. Skopas designed the new temple and its sculptures. The remains of this temple were discovered in 1879-80 and excavated from 1900 to 1902. A complete reconstruction of the architecture is now possible, but our knowledge of the accompanying sculptures (metopes and pediments) is still unsatisfactory, despite the fact that outstanding fragments are to be found in the museums at Tegea and Athens (nos. 178-180). The surviving sculptures should be dated around 340 B.C.

The temple foundations are of rubble-work. The krepis and the other parts of the building are of marble from Doliana. On the stylobate, which measures 47.52 x

19.16 m, was the peristalsis, 14 Doric columns long and 6 wide. The columns were 19.16 m high. Two ramps to the N and E lead to the stylobate. The cella also had a door to the N. The pronaos and opisthodomos also had Doric columns. Above them were carved metopes which have almost completely vanished but inscriptions for which remain on the architrave (*IG* v.2 no. 78-79). Inside the cella were Corinthian half-columns arranged in such a way that the Ionic bases are an extension of the wall base. The Corinthian capitals show the henceforth canonical acanthus leaves between the volutes, instead of the palmette seen at Bassai-Phigalia.

On the E the metopes showed the fight of Herakles with Kepheus and his sons; on the W, the Telephos myth. The E pediment showed the Calydonian boar hunt with Meleager and Atalanta, the W pediment again depicting the Telephos myth. Counting the splendid plant-acroteria of the pediment, the temple was 15.7 m high. In the E of the temple the substructure of the altar measured some 11 x 23 m.

In the 5th c. an Early Christian basilica was installed in the cella, use being made of a salvaged door.

The market, which was rectangular according to Pausanias, has been identified as having been W of the theater and the Church of Palaio Episkopi. The agora had colonnades. An inscription and various finds show the existence of a common table and a weights and measures office of the agoranomon, as well as a macellum.

In the park to the W of the Palaio Episkopi are the remains of an Early Christian basilica of the 5th c., with one nave and mosaic paving showing the twelve seasons and the rivers Tigris and Euphrates.

Tegea's acropolis was located on the hill of Haghios Sostis, which was inhabited from Mycenaean times. It is identical with a place named Phylaktris or Akra (Paus. 8.48.4, Polyb. 5.17.2). Here was situated the Temple of Athena Polias, which was not the same as that of Athena Alea. No remains of it have been found. On the NE side of Haghios Sostis excavations have uncovered a Sanctuary of Demeter-Kore which cannot be identified with that mentioned by Pausanias as belonging to the agora. Finds are in the National Museum at Athens and in the museum at Tegea. There are important questions concerning the city area that can be answered only after further excavations.

For finds collected in the museum, see the Bibliography below.

BIBLIOGRAPHY. Paus. 8.45ff; Hiller v. Gärtringen in *RE* v A 1, 107-118, s.v. Tegea; id. in *IG* v.2 (1913) 1-259; C. Callmer, *Studien zur Geschichte Arkadiens* (1943) 22ff, 67ff, 109-35MP; L. Vlad Borrelli, *EAA* 7 (1966) 659ffPI; E. Kirsten & W. Kraiker, *Griechenlandkunde* (5th ed. 1967) 399-402MP.

On the Temple of Athena Alea: C. Dugas, u.a. *Le Sanctuaire d'Aléa Athéna* (1924)MPI; W. B. Dinsmoor, *The Architecture of Ancient Greece* (1950) 217-20PI; G. Gruben, *Die Tempel der Griechen* (1966) 124ffPI.

On the Sculpture for the Temple of Athena Alea: P. E. Arias, *Scopas* (1952) 16ff; G. Lippold, *HdArch.* III (Griech. Plastik) 250f; Neufunde: Christou, *Deltion* 20 (1965); *Chronika* 170, pl. 151, 152a, *Deltion* 21 (1966) 152ff, pls. 146-47, 149a (Relief with Artemis); A. Delivorrias, *AAA* 1 (1968) 117ff, ill. 1.

Reconstruction of the West Pediment: J. Boardman et al., *Die Griech. Kunst* (1966) 177, ill. 196; D. Delivorrias, *BCH* 97 (1973) 111-35.

On the Akroterion: H. Gropengiesser, *Die pflanzlichen Akrotere klass. Tempel* (1961) 29ff, pls. 23-29.

On the Theater: Vallois, *BCH* 50 (1926) 135-73; H.

Bulle, *Untersuchungen an griech. Theatern* (1928) 259-60.

The Bronzes from Tegea: Dugas, *BCH* 45 (1921) 340-94I; W. Lamb, *Greek and Roman Bronzes* (1929) 91-96, 152f; W. Fuchs, *Arch.Anz.* (1956) 1ff.

On Archaic Sculpture from Tegea: V. Müller, *Frühe Plastik in Griechenland und Kleinasien* (1929) passim.

On the Christian Basilica: A. K. Orlandos, *ArchByzMnem* 1 (1935) 103f, 145ff (Palaio Episkopi); id., *He xylostegos palaiochristianike Basilike* (1954) passim; id., "Die einschiffige frühchristl. Basilika westl. von Palaio Episkopi," *Arch.Anz.* (1934), 156; G. A. Soteriou, *Atti del 4° Congresso Internazionale di Archeologia Christiana* I (1940) 365f, ill. 12-13.

The Museum: In the museum at Tegea (also in Athens) are the finds from the Sanctuary of Athena Alea, along with the Late Mycenaean sherds (Inv. 942.946) and the Cyclades-idol (Dugas, *BCH* 45 [1921] 403 & 427 no. 362, fig. 65); Late Mycenaean containers from the cupola-grave near Serantapotamos (the Alpheios of Pausanias [Callmer 24f, unpublished]); the prehistoric ceramics from Agiorgitika (Blegen, *MetrMusStud.* 3 [1930-31] 55-70) and Asea (E. J. Holmberg, *The Swedish Excavations at Asea* [1944]), as well as the archaic discoveries from the Athena-Poseidon sanctuary in Asea (Rhomaios, *Ephemeris* [1957] 114ff); also the finds from the Sanctuary of Artemis Knakeatis S of Tegea (Paus. 8.53.11, Rhomaios, *Ephemeris* [1952: 1955] 1-31). W. FUCHS

TEGYRA (Pyrgos) Boiotia, Greece. Map 11. A rock situated N of Lake Copais and the Melas river, 5 km NE of Orchomenos and W of Topolia. Ranging in height from 250 to 150 m, it is easily recognized by the mediaeval tower rising in the middle of it (whence the popular name).

Pelopidas fought the Spartans here in 375 B.C. Two miraculous springs gushed forth by the Temple of Apollo, no trace of which remains. It was the seat of an Oracle of Apollo Tegyraios up to the Median wars (Plut. *Ages.* 286; *De def. or.* 412 B).

It is unlikely that this small rocky island can be identified with Delos, as has been claimed. Nearby is the Church of Haghios Nikolaos sta Kambia (11th c.).

BIBLIOGRAPHY. J. G. Frazer, *Paus. Des. Gr.* (1898) V 110-111M (in ed. of N. Papachatzis: [1969] V 18M & 224 n. 1); E.J.A. Kennys in *Annals Arch. and Anthrop.* 22 (1935) 189-206 & 201-2M; P. Guillon, *Trépieds du Ptoion* (2d ed. 1943) 196, n. 2; A. Philippson, *GL* (1951) I.2 487; R. Hope Simpson, *A Gazetteer and Atlas of Mycenaean Sites* (1965) 115-16, no. 400; W. K. Pritchett, *Studies in Ancient Greek Topography*, pt. II (1969) 90, 92 fig. 10. Y. BÉQUIGNON

TEICHIUSSA (Doğanbeleni) Turkey. Map 7. Town in Ionia near Kazıklı, 26 km SE of Miletos. The town appears first on the 6th c. statue base of a certain Chares, described as ruler of Teichiusa. In the Delian Confederacy it is listed as a dependency of Miletos, and is called by Archestratos a village of Miletos near to the Carians. Thucydides (8.26) and Athenaeus (351 A) also refer to it as a Milesian possession, and the Spartans used it as a base for an attack on Iasos (Thuc. 8.28). Later it appears as a deme of Miletos.

The site is the only pre-Roman one between Didyma and Iasos. It occupies a low hill barely over 40 m high, surrounded by a massive wall of irregular trapezoidal masonry 2.6 m thick, of which hardly more than a single course remains above ground; from its style this wall can scarcely be later than the 5th c. There are five towers more or less equally spaced, but nothing remains in

the interior apart from a tower of poor masonry standing 1 m high on a hillock. The surface sherds are characterless.

There are numerous ancient village sites in the neighborhood, and tombs are common. Some of these consist of a grave chamber sunk in the rock and covered with large flat slabs of stone; most of the others, and all the epitaphs yet discovered, are of Roman date.

BIBLIOGRAPHY. P. LeBas & W. H. Waddington, *Voyage archéologique en Grèce et en Asie Mineure* 4 vols. (1888) 238, 242; *BMCatalogue of Sculpture* I, 1 (1928) B 278; L. Robert, "Une Epigramme de Carie," *RevPhil* 31 (1957); id., "Note Additionelle," ibid. 32 (1958); G. E. Bean & J. M. Cook, *BSA* 52 (1957) 106-11.

G. E. BEAN

TEIMIUSSA (Üçağız, formerly Tristomo) Lycia, Turkey. Map 7. It is on the coast, a dependency of the neighboring city of Tyberissos and known only from an inscription found on that site. The ruins include a great number of tombs, mostly sarcophagi with "Gothic" or rounded lids, closely packed along the shore, a small fort on a knoll, and a rock-cut quay backed by a sunken road also cut in the rock.

BIBLIOGRAPHY. E. Petersen & F. von Luschan, *Reisen in Lykien* (1889) II 55-59. G. E. BEAN

TEKIJA, *see* TRANSDIERNA

TEKIROVA, *see* PHASELIS

TELAMON (Talamonaccio) Italy. Map 16. In the province of Grosseto, an Etruscan town known for the battle fought with the Gauls in 225 B.C. (Polyb. 2.25-31). C. Marius landed here in 87 B.C. to renew his struggle with Sulla (Plut. *Vit. Mar.* 41). As punishment for this, Telamon appears to have been destroyed by Sulla's troops in 82 B.C. In 1888, when fortification work was being carried on, the remains of the burned city were uncovered. The ceramics and coins dated from the 7th to the 1st c. B.C. In 1892 the foundation walls of a temple built in 300 B.C. were found, along with terracotta architectural fragments and votive weapons. More recent excavation has indicated that it was a podium temple (12.9 x 22.6 m) oriented N-S with a single cella and a pronaos two columns deep. Before the entrance steps was a paved area with an altar.

The finds are in the Museo Archeologico in Florence. Of particular importance is a terracotta pediment covered with figures. It was found in 1892 and dates from ca. 170-150 B.C. The figures show the defeat of the Seven against Thebes.

BIBLIOGRAPHY. G. F. Gamurrini, "Talamone," *NSc* (1888) 682-91; L. A. Milani, *Il Museo Archeologico di Firenze* (1912) 66-69, 257-60, pls. 114-16; A. Andrén, *Architectural Terracottas from Etrusco-Italic Temples* (1940) 227-38, pl. 82f; O. W. v. Vacano, "Die Figurenanordnung im Giebelrelief von Telamon," *RömMitt* 76 (1969) 141-61; id., "Zum Grundriss des Tempels auf dem Talamonaccio," *Hommages à M. Renard* (Collection Latomus vol. 113, 1969) 675-94; P. Somella, *Antichi campi di battaglia in Italia* (1967) 11-34.

O. W. V. VACANO

TELENDOS The Dodecanese, Greece. Map 7. A small island located to the W of Kalymnos. The narrow strait between the two islands must have served as anchorage in ancient times. A tentative theory suggests that the deme-center of Panormos, a deme of Kalymnos, lay on Telendos, but we lack evidence. Ruins of a Hellenic fort have been observed in the N part of the island.

On the E side there is a badly preserved rock-cut theater. Other ruins of Roman and later times are evident throughout Telendos.

BIBLIOGRAPHY. L. Ross, *Reisen auf den griechischen Inseln des Aegaeischen Meeres* II (1841) 96ff; C. T. Newton, *Travels and Discoveries in the Levant* I (1865) 318; M. Segre, *Ann. Atene* 22-23 (1944-45) 219; G. E. Bean & J. M. Cook in *BSA* 52 (1957) 130-32 (passim).

D. SCHILARDI

TELESIA Campania, Italy. Map 17A. A Samnite town between Telese and San Salvatore Telesino 38 km from Beneventum on the right bank of the Calor near its junction with the Volturnus. It was always an important road center and figured repeatedly in the second Punic war. Under Rome it became a municipium that at least occasionally minted coins inscribed TELIS. It received a colony in the 1st c. B.C. which took the name Colonia Herculea Telesina, being inscribed in the tribus Falerna and governed by duoviri praetores as chief magistrates.

The well-preserved fortifications are 2.5 km in circuit, faced with opus pseudo-reticulatum. There are three major gates and 35 towers, both round and polygonal. The curtains are bowed inward to give the towers maximum effectiveness, and the whole wall system is highly sophisticated. Outside the walls are remains of an early amphitheater. Inside, the street grid of long narrow blocks, two baths, and a theater have been traced. Systematic excavations have never been carried out, but the area has proved extremely rich in inscriptions, and tombs have come to light on numerous occasions. A recent tomb group of the 3d-2d c. B.C. is interesting for the relationship of pottery of local manufacture to Centuripe vases. Some material from the site is in the Museo del Sannio at Benevento.

BIBLIOGRAPHY. A. Rocco, *NSc* (1941-42) 77-84; L. Quilici, *Studi di urbanistica antica* (*Quaderni dell'Istituto di Topografia Antica dell'Università di Roma* 2, 1966) 85-106MPI. L. RICHARDSON, JR.

TELL ABIL, *see* ABILA

TELL-ATRÎB, *see* ATHRIBIS

TELL-EL-FUL, *see* GIBEAH

TELL EL-KHULEIFA, *see* AELANA

TELL ERANI, *see* TELL GATH

TELL GATH or TELL ERANI Israel. Map 6. An ancient mound in the Shephelah, near the modern Israeli town of Qiryath Gath. The excavations (1956-61) sought the remains of biblical Gath. As no Philistine pottery was found, this identification had to be rejected. The mound consists of a large acropolis (1.6 ha) and of a lower mound comprising an area of 16 ha. Occupation on the mound extended from the Early Bronze Age to the Persian and Hellenistic periods. To the Persian period belong round storage bins. Most building remains of the two latter periods have been completely obliterated.

BIBLIOGRAPHY. S. Yeivin, *IEJ* 10 (1960) 193-203; id., *RB* 67 (1960) 391-94; id., *First Preliminary Report on the Excavations at Tel Gat (Seasons 1956-1958)* (1961); id., *Oriens Antiquus*, 205-13; A. Ciasca, ibid., 1 (1962) 23-9 and 2 (1963) 45-63. A. NEGEV

TELL SANDAHANA, *see* MARISSA

TELL SŪKĀS (Tall Sūkās) Syria. Map 6. An ancient town mound on the coast between two natural harbors

37 km S of Latakia, identified as Bronze Age Shuksu on the S frontier of the kingdom of Ugarit. The modern village lies 600 m E of the mound.

Excavation has shown that the first occupation of the site was in the Neolithic period (7th millennium B.C.), that in the Late Bronze Age and Early Iron Age the town was touched by Mycenaean trade, and that in the NE quarter there were remains of a sanctuary. At the end of the Early Iron Age Greek pottery of the 8th c. B.C. appeared, a sign of the settling of Greek traders. The following period saw the establishing of a Greek sanctuary, together with a renewal of the old cult place. Apparently the town was destroyed at the beginning of the 5th c. B.C. (perhaps in 498) and lay in ruins until ca. 380, when it was refounded as a Neo-Phoenician town. The earthquake of 69 B.C. probably put an end to it; the few Roman finds date from the 3d and 4th c. A.D.

The town mound became a fortress, constructed by the Byzantines, enlarged by the Crusaders, occupied by the Muslims, and deserted in the 14th c. Ancient cemeteries have been identified N and S of the harbors; at the S harbor there was also a Neo-Phoenician sanctuary. Most of the finds are in the National Museum, Damascus.

BIBLIOGRAPHY. E. Forrer, "Eine unbekannte griechische Kolonie des sechsten Jahrhunderts v. Chr. in Phönikien," *Bericht über den 6. internationalen Kongress fur Archäologie* (1939); A.M.H. Ehrich, *Early Pottery of the Jebeleh Region* (1939); P. J. Riis, "L'activité de la Mission archéologique danoise sur la côte phénicienne," *Annales archéologiques de Syrie* 8-9 (1958-59); 13 (1963); 15, 2 (1965)[MPI]; id., *Sūkās* I (1970)[MPI]; G. Ploug, *Sūkās* II (1972); P. J. Riis & H. Thrane, *Sūkās* III (1974)[MPI]. P. J. RIIS

TELMESSOS Caria, Turkey. Map 7. One of the eight Lelegian towns incorporated by Mausolos in Halikarnassos. It was noted especially for an oracle of Apollo and a priestly family of diviners. These Telmessian soothsayers were consulted by the Lydian kings (Hdt. 1.78.84) and are frequently mentioned. The town was situated 60 stades from Halikarnassos (Suidas s.v.) in a particularly fertile country (Cic. *Div.* 1.42.94). It was formerly believed to be located at the Lelegian town site on the Karadağ above the village of Belen, but a more probable identification is with another Lelegian site near Gürice some 3 km W of Müsgebi; both sites are at the required distance from Halikarnassos, but the latter accords much better with Cicero's description than the wild and bare hillsides of the Karadağ. Apollo Telmisseus is figured on an imperial coin of Halikarnassos and is mentioned in a local inscription (Michel 459) as "founder of the race"—that is, of the family of diviners. After the incorporation into Halikarnassos, Telmessos seems to have survived merely as a small community centering around the Temple of Apollo.

BIBLIOGRAPHY. W. M. Paton & J. Myres in *JHS* 14 (1894) 373; G. E. Bean & J. M. Cook in *BSA* 50 (1955) 151-55. G. E. BEAN

TELMESSOS (Fethiye, formerly Makri) Lycia, Turkey. Map 7. Its origin is uncertain; although five inscriptions in the Lycian language and script have been found there, the city was not always, especially in early times, reckoned a part of Lycia. In the Athenian tribute lists in the 5th c., Telmessos and the Lycians are listed separately; in the mid 4th c. the Lycians under their dynast Perikles fought against the Telmessians and apparently brought them into Lycia, for pseudo-Skylax reckons Telmessos as Lycian. After Magnesia in 189 B.C. by the

treaty of Apamea, Telmessos was given neither to Eumenes nor, with the rest of Lycia, to the Rhodians. It remained in the hands of a certain Ptolemy son of Lysimachos, who had received it as a gift from Ptolemy III in 240 B.C. After 168 B.C., on the other hand, it is clear from the coins that Telmessos was a normal member of the Lycian League, and remained so thereafter.

In 334 B.C. the city submitted peaceably to Alexander by agreement; not long afterwards, however, his officer Nearchos the Cretan was obliged to capture the city from a certain Antipatrides, which he did by means of a stratagem (Polyaenus, *Strat.* 5.35). In the Lycian League, Telmessos was not among the six cities of the first or three-vote class; under the Empire, however, it had the rank of metropolis of Lycia. In Byzantine times its bishop ranked second under the metropolitan of Myra. The name seems to have been changed for a while to Anastasiupolis, and from the 9th c. to Makri. Coins were perhaps struck at Telmessos under the dynasts in the 5th c.; the later coinage is not abundant, and ceases altogether under the Empire.

There is some evidence that divination was practiced at Telmessos (Suidas s.v.), but most of the numerous references to Telmessian seers relate rather to the Carian city of the same name.

The surviving monuments are today confined to the tombs. The acropolis hill, steep and rocky, carries only a mediaeval castle, and of the two theaters, one of which was described by Spratt in 1842 as "very perfect," nothing now remains. The tombs are numerous and of various ages; two in particular are remarkable. The first of these is cut in the hillside just outside the town on the E, and is identified by its inscription as the tomb of one Amyntas; it has the form of an Ionic temple with pediment and acroteria. Other similar tombs are to be seen close by. The second, which stands in the town, is a superb example of a Lycian sarcophagus, ornamented with reliefs on the crest and sides of the lid.

BIBLIOGRAPHY. C. Fellows, *Asia Minor* (1840) 244-46; T.A.B. Spratt & E. Forbes, *Travels in Lycia* (1847) I 2-4; E. Petersen & F. von Luschan, *Reisen in Lykien* (1889) I 35-44; *TAM* II.1 (1920) 1-3. G. E. BEAN

TEL UMAR, *see* SELEUCIA

TEMAŞALIK BURNU, *see* GRYNEION

TENEA Corinthia, Greece. Map 11. Tenea was a city in the S Corinthia where Oedipus was said to have spent his childhood. The city had a famous Sanctuary of Apollo. It supplied most of the colonists when Corinth founded Syracuse in the late 8th c. B.C. It became an independent city, probably in the Hellenistic period and, thanks to its good relations with the Romans, continued to exist after Lucius Mummius sacked Corinth in 146 B.C. (The chief ancient sources are Soph. *Oed. Tyr.* 774, 827, 936, 939; Xen. *Hell.* 4.4.19; Cic. *Att.* 6.2.3; Strab. 8.6.22; Paus. 2.5.4.)

Ruins of the large ancient city extend from the S edge of the modern town of Chiliomodhion to the village of Klenia, a distance of about 2 km. A dramatic mountain pass (Haghionorion) opens to the S of Tenea and leads to Argolis. Chance finds have resulted in the excavation of several burials ranging in date from the Early Geometric period to late Roman times. There are Roman chamber tombs on a ridge projecting N from Klenia and a small cloth-dyeing establishment was excavated near its NW base in 1970. The so-called Tenean Apollo, an archaic kouros, was found not at Tenea but on a ridge about 20 minutes by foot to the SE of the modern town of Athikia.

BIBLIOGRAPHY. S. Charitonides, "A Geometric Grave at Clenia near Corinth," *AJA* 59 (1955) 125-28; I. Papachristodoulou, *ArchDelt* 24 (1969) *Chronika* 103-4; J. R. Wiseman, *The Land of the Ancient Corinthians* (forthcoming).
J. R. WISEMAN

TENEDO (Zurzach) Aargau, Switzerland. Map 20. On the left bank of the Rhine, ca. 30 km N of Zurich, and mentioned in the *Peutinger Table*. The site is at the confluence of the Aare and the Rhine, where a pre-Roman trade route from the Helvetian plateau to the Danube crossed the Rhine. It is probably one of the 12 towns mentioned by Caesar (*BGall.* 1.5.2). During the 1st c. A.D. a detachment of the legions garrisoned at Vindonissa, 13 km to the S, guarded the bridge and the highway on the left bank. Throughout the 2d and 3d c. the post was probably occupied by beneficiarii, and in the 4th c. a double fortress was added, and a bridgehead on the right bank at Rheinheim. After the departure of the garrison, ca. A.D. 401, the main fort was used as a refuge from the raids of the Alamanni, and in the 5th c. a church and a baptistery were built in it. At Mittskirch there is a Late Iron Age cemetery belonging to the oppidum.

The site is on a terrace rising steeply above the Rhine in an originally swampy region. The road to the bridge runs along a natural depression in the plateau which separates the elevations carrying the late Roman forts. The foundations of piles for two bridges, one probably pre-Roman, are visible when the water is low. The older bridge was carried on wooden piles, the other on four stone piles. The 1st c. fortification was built on the higher hill, Kirchenbuck, 20 m above the Rhine, but any remains were probably destroyed by the later fort. A small bath (28 x 10 m; 5 rooms) in the low part of the site was probably built by the 1st c. garrison, but used until the 4th c. Little is known of the vicus which spread inland at Brückliäcker and lies under the mediaeval town. It probably developed on both sides of the Roman road, which ran S from the river.

In the 4th c. a fort was built on each of the two hills. They were connected by a wall through which the road passed, and side walls ran down to landing places on the river. No remains of these have yet been found. The smaller fort on Sidelen (area 1480 sq. m) is rhomboid (ca. 50 m on a side), with four round corner towers. Its foundations survived until the late 19th c., but nothing is visible today. Inside it a stone casemate was built along the W wall. The larger fort on Kirchenbuck has an irregular plan, owing to the configuration of the hill and perhaps also to earlier building periods. The longest straight side, facing the Rhine, is 100 m, the width 50-70 m (area 4900 sq. m). The five corner towers are round, while the others are semicircular outside and angular inside; they are massive up to the sentry walk. The buildings inside were of wood.

In the 5th c. an almost square church (16 m the side) with apse and a baptistery were built inside the fortress. This is important proof for the survival of the old Roman Christian population on the site of a late Roman fortification through the migration period. The S wall with 5 towers and the sanctuary may be visited.

The Messe- und Bezirksmuseum in Höfli is in Zurzach. (See also Limes, Rhine.)

BIBLIOGRAPHY. J. Heierli, "Das römische Kastell Burg bei Zurzach," *AnzSchweiz* 9 (1907) 23-32, 83-93PI; P. Hüsser, "Das Römerbad in Zurzach," *Argovia* 52 (1940) 265ffP; F. Staehelin, *Die Schweiz in römischer Zeit* (3d ed. 1948) 52-53, 169-70, 182-84, 622; V. von Gonzenbach, *BonnJbb* 63 (1963) 106-7; *Archaeologia Helvetica* 1 (1970) 45-54PI; church: R. Laur-Belart, "Eine frühchristliche Kirche mit Baptisterium in Zurzach," *Ur-Schweiz* 19 (1955) 65-90PI; id., "Ein zweites frühchristliches Kultgebaude in Zurzach," ibid. 25 (1961) 40-57PI; recent excavations: *Jb. Schweiz. Gesell. f. Urgeschichte* 46 (1957) 149; 50 (1963) 89-91PI; 53 (1966-67) 160-62; *Jber. Gesell. Pro Vindonissa* (1969-70) 11-23P.
V. VON GONZENBACH

TENTYRA or TENTYRIS (Dandara) Egypt. Map 5. On the W bank of the Nile 60 km N of Thebes. Beside being one of the oldest cult centers of the goddess Hathor, Tantyra (Strab. 17.1.44) during the Graeco-Roman period became the capital of the 6th nome of Upper Egypt. Its great Temple of Hathor was begun by the late Ptolemies and finished in the Roman period. The 24 columns of its hypostyle hall were carved to represent the sistra, the musical symbol of the sky goddess. The long crypts built in the thickness of the walls are decorated with many ritual and religious writings. The zodiac map of the sky, now in the Louvre, was removed from one of the chapels of this temple.

BIBLIOGRAPHY. G. Posener, *Dictionnaire de la Civilisation Égyptienne* (1959); K. Michalowski, *L'Art de l'Ancienne Égypte* (1968) 542-44PI; F. Daumas, *Dendara et le temple d'Hathor. Notice sommaire* (1969)PI.
S. SHENOUDA

TEOS (Sığacık or Sığacak) Turkey. Map 7. City in Ionia 40 km SW of Smyrna. Founded according to tradition (Paus. 7.3.6) by Minyans from Orchomenos, joined later by Ionians and Athenians under the sons of Kodros. Because of its central situation Teos was proposed by Thales as the seat of a common political assembly of the Ionian cities, but this was not done. When Teos fell to Harpagos the citizens, unable to endure the Persian arrogance, sailed in a body to Thrace and founded Abdera (Hdt. 1.168; Strab. 644), but many of them soon returned. The city sent 17 ships to the battle of Lade (Hdt. 6.8). In the Delian Confederacy Teos was assessed at six talents, roughly on a par with Miletos and Ephesos; she revolted after the Sicilian expedition, but was quickly reduced (Thuc. 8.16.20). In 303 B.C. Antigonos was intending to synoecise Teos, which was poor at that time, with Lebedos, and to transfer the Lebedians thither, but Lysimachos took Teos from him in the following year, and instead transferred many Teians and Lebedians to his new foundation at Ephesos. About 200 B.C. Teos was selected as headquarters of the Asiatic branch of the Artists of Dionysos, but dissension caused a move to Ephesos within half a century. In the war against Antiochos III the Romans and Rhodians won a naval victory over the king at Teos (Livy 37.27). Coinage begins in the 6th c. B.C. and continues, with an interruption in the 3d c., down to the time of Gallienus.

The site is on the neck of a peninsula, with harbors to N and S. The N harbor, where the village now stands, is used today; remains of an ancient quay or mole may be seen in the water. It is called by Strabo Gerrhaiidai, by Livy Geraesticus. The S harbor is now deserted and silted up; a line of quay wall survives, with projecting blocks at intervals, pierced with round holes to form mooring stations. Now hardly above the water line, these blocks originally stood 1.5-1.8 m above sea level. The scrub-covered headland W of the city seems to have been unoccupied in ancient times.

The acropolis is on a separate hill halfway between the N and S shores; on its summit are some scanty fragments of polygonal wall. The inhabited city lay between this hill and the S harbor; an area of ca. 0.5 sq. km is enclosed by rectilinear walls of Hellenistic date at right

angles to one another. These are poorly preserved, but a short stretch on the W has recently been excavated.

At the S foot of the acropolis hill is the theater, indifferently preserved. The building was originally Hellenistic, but was provided in Roman times with a new stage building; a vaulted gallery runs under the cavea. The stage building, recently cleared, has some puzzling features, in particular horizontal holes pierced through the projecting blocks of the proscenium. The stage is about 4 m deep.

Below the acropolis on the NE are the meager ruins of a large building identified as a gymnasium, and SE of the theater is the odeum. It is fairly well preserved with 11 rows of seats, and is adorned with two tall statue bases of Roman date.

The temple of Dionysos Setaneios, chief deity of Teos, stood just inside the W wall; some of the columns have been reerected. The temple, in the Ionic order, was the work of Hermogenes in the 2d c. B.C. The stylobate is 35 by 19 m; the peristyle has 11 columns by 6, equally spaced, giving a ratio of length to breadth of exactly 2:1. The temenos is trapezoidal. In the 2d c. A.D. the building was restored and rededicated to Hadrian. Adjacent to the temple excavation has revealed a narrow paved street with a central water channel, and a similar one a little to the N.

The blue limestone used at Teos came from a hill beside the present road from Seferihisar to Sığacık. In the 19th c. 15 or 20 huge blocks cut into curious shapes were visible around a small lake less than 1 km to the NW; they seem to have been intended for export as bulk material. One or two are still lying by the lake, and another in the sea at the N harbor.

BIBLIOGRAPHY. R. Chandler et al., *Antiquities of Ionia* (1797-1915) vols. 1 & 4; *SIG* 344; Y. Béquignon & A. Laumonier, *BCH* 49 (1925) 281ff; G. E. Bean, *Aegean Turkey* (1966) 136-46; E. Akurgal, *Ancient Civilizations and Ruins of Turkey* (1970) 139-42. G. E. BEAN

TERAMO, *see* INTERAMNIA PRAETUTTIORUM

TERENUTHIS (Kom Abou Bellou) Egypt. Map 5. An artificial mound near El Tarana, a village 110 km SE of Alexandria on the edge of the Libyan Desert. Near Lake Maryut a stela, now in Cairo Museum, was found. It dates from ca. 1085 B.C. and describes a gift of land to Hathor of Terenuthis by a caravan leader and a chief of Libya. In El Tarana there used to be a ruined Ptolemaic temple with blocks bearing the names of Ptolemy I Soter, Ptolemy II Philadelphos, and Penamun. Undoubtedly, owing to its situation at the head of the caravan road between Egypt and Libya, Terenuthis became prosperous, as the finds from her necropolis indicate. By far the most important among these finds are limestone grave stelae, belonging mostly to the first half of the 3d c. A.D.

BIBLIOGRAPHY. C. Bonner, "The Ship of the Soul on a Group of Grave Stelae from Terenuthis," *ProcPhilSoc* 85 (1941) 84-91; Z. Ali, "Some funerary Stelae from Kom Abou Bellou," *BSRAA* 38 (1949) 55-88; 40 (1953) 1-50; J. Schwartz, "Les Stéles de Terenouthis et la mort d'Alexandre Severe," *Chronique d'Égypte* 30 (1955) 124-26; S. Farid, "Preliminary Report on the Excavations of the Antiquities Department at Kom Abu-Billo," *ASAE* 61 (1973) 21-26. S. SHENOUDA

TERGESTUM (Trieste) Italy. Map 14. A settlement, probably founded by the Veneti and heavily damaged by the Giapidi in 52 B.C. A Roman colony was founded there either by Julius Caesar in 46 B.C. or in 42-41 by the Triumviri after the battle of Filippi.

The colony's strategic importance is indicated by its walls. Made of sandstone blocks, they encircled the city, following the descent from the hill toward the sea. Inside traces of the right-angled urban establishment are preserved. One gate survives, the so-called Arco di Riccardo. It is on the decumanus, is built of Sistiana stone, and is the city's oldest monument.

The city developed commercially, being the point of departure for both Nauporto and the towns along the Danube. Later, at the time of Vespasian, it was linked to the Istrian centers on the Via Flavia.

During the long period of the Pax Romana, that is from Augustus to the first barbarian skirmishes, the city spread outside the walls with beautiful villas of great archaeological interest. Inside the walls the monumental buildings multiplied.

An Early Christian basilica has been discovered under the cathedral dedicated to S. Giusto. It is rectangular in form and dates from the first half of the 5th c. It was adapted from a Roman temple constructed in the age of Domitian and perhaps restored by Hadrian or by Antoninus Pius. One entered the temple from a propylon of Hellenistic type, perhaps the only example of its kind in N Italy. It was probably built by P. Palpellius Clodius Quirinalis, retired prefect of the Ravenna fleet, ca. A.D. 80 (*CIL* v, 533). Before the temple stood an equestrian monument, dedicated to C. Calpentanus Ranzius Quirinalis Valerius Festus, vice consul in A.D. 71 (*CIL* v, 531).

To the N of the temple opened the forum, connected by a portico with the large civil basilica, divided into three naves with an internal apse. The donor was Q. Baienus Blassianus (I.I. 10.4.37-40), procurator of Trajan before A.D. 120-125.

Also from the age of Trajan is the beautiful theater in the Greek style, with a single balcony and two loggias superimposed on it. The scena was ornamented by many votive statues in marble which constitute a notable body of sculpture of the so-called cult type from the 2d c. A.D. Represented are Athena, Knidia, Asklepios, Apollo, and Hygieia.

The aqueduct of Rosandra is still partly preserved.

During the last ten years a succession of Early Christian buildings have been discovered in the center of the old city.

It is probable that Trieste remained outside the routes of the invasions that in the 6th c. destroyed Aquileia, and that it continued to enjoy a tranquil life until the beginning of the mediaeval period.

Besides the monuments cited, Trieste is rich in museums. The Civic Museum of History and Art deserves special mention. Besides the public collections there are numerous private collections of varying interest and importance.

BIBLIOGRAPHY. A. Tamaro, *Storia di Trieste* (1924); F. Farolfi, "L'Arco romano detto di Riccardo," *Archeografo triestino* 3, 21 (1936); V. Macchioro, "Le statue del teatro romano di Trieste," *Rivista della città di Trieste* (1938); V. Scrinari, *Tergeste* (1951); A. Degrassi, *Il confine nord-orientale dell'Italia romana* (1954); B. F. Forlati, "Il Veneto orientale," *Arte e Civiltà romana dell' Italia settentrionale* (1964); "La Basilica romana di Trieste sul Colle di S. Giusto," in *Istituto Lombardo Scienze e Lettere* 103 (1969); M. M. Roberti, *EAA* (1971) s.v. S. Giusto, Trieste.

B. FORLATI TAMARO

TERICIA (Mouriès) Bouches-du-Rhône, France. Map 23. Gallo-Greek oppidum of Salyens (les Caisses de Servane) on a rocky spur of the Alpilles chain, 3 km NE of Mouriès (Tericiae in the *Peutinger Table*). Excavations in 1939 and 1942 uncovered house walls of

rough stones, and a large wall in which were found reused piers and lintels of limestone decorated with friezes of men on horseback and heads of horses, carved in an archaic style, the remains of a Celto-Ligurian cultural center (in the Museum of St-Rémy-de-Provence). Gallic silver and bronze coins and pottery from Iron Age II were also found.

A crematorium at the SE foot of the oppidum was excavated in the 19th c. Some of the finds are in the Musée de Saint Germain en Laye: an anthropoid dagger, a lance head, an iron knife and boss of a shield, two bronze kyathoi, cremation urns, and Campanian plates. In the Château of Servane near Mouriès are preserved some iron knives, vases for liquids, and Campanian bowls, as well as two lions of local limestone and a head of Hercules wearing a lion skin (a theater mask). To the S, lower than the oppidum, are the ruins of a Roman villa containing marble columns, fragments of tiles, amphorae, dolia, various vases, and imperial coins. The settlement was destroyed by the Visigoths at the end of the 5th c.

BIBLIOGRAPHY. L. Rochetin, "Tericiae, une des stations de la voie Aurélienne," *Mémoires de l'Académie de Vaucluse* (1895); P. de Brun, "Le cimetière gallo-grec de Servane, près de Mouriès," *Provincia* 13 (1933)[I]; F. Benoit, *Des chevaux de Mouriès aux chevaux de Roquepertuse* (1948)[MPI]; id., *L'art primitif méditerranéen de la vallée du Rhône* (1955)[I]; M. Pezet, *Sur les traces d'Hercule* (1962)[MPI]. A. DUMOULIN

TERINA Cantazaro, S Italy. Map 14. The city was founded by Kroton at the beginning of the 5th c. B.C. Later it passed under several different rules until it was destroyed during the second Punic war. Most recent studies identify the ancient site with unexcavated remains in the abbey of S. Eufemia Vecchia; but others with Nocera Terinese. Terina is best known for its coinage (480-400 B.C.).

BIBLIOGRAPHY. Scymn. 306ff; Pliny *HN* 3.72; Solin. 2.10.

RE s.2 5[I] 725-27; J. Bérard, *Bibliographie topographique des principales cités grecques de l'Italie méridionale et de la Sicile dans l'antiquité* (1941) 112; *EAA* 7 (1966) 714-15; M. Napoli, *Civiltà della Magna Grecia* (1969) 181-84; P. Zancani-Montuoro, "Dov'era Temessa?" *RendNap*, NS 44 (1969) 14ff. J. P. SMALL

TERIOLIS (Zirl) Tirol, Austria. Map 20. In the Inn valley, ca. 12 km W of Innsbruck, on the Roman road which led from Veldidena via the Seefeld saddle (1185 m) to Augusta Vindelicum (Augsburg). This road was the N continuation of the Brenner road. About 2 km E of the site there rises a limestone ledge (ca. 500 x 200 m), the Martinsbühel, between the Inn river and the steep wall called Martinswand. Between Martinswand and Martinsbühel there was only a very narrow passage for the Roman road, and thus nature had provided an excellent roadblock. This was further enhanced by a blocking wall (2 m thick) built up against the Martinswand (the age of the wall is still uncertain). The Martinsbühel itself is for ca. 360 m (W-E) surrounded by a wall 2 m thick, reminiscent of similar fortifications of Late Roman times. There seems to have been an E gate. Although no systematic excavations have as yet been undertaken, casual explorations have confirmed the existence of Roman buildings, some with hypocausts. Numerous coins date the site: they occur in larger numbers dated from the middle of the 3d c. A.D., and are most numerous in the 4th c. The development of this fortified place is obviously connected with the threat to the roads after the Raetic limes collapsed (ca. A.D.

259-60). According to *Notitia dignitatum* (35.31; 35.22) not only a "tribunus gentis per Raetias deputatae" had his seat here, but also a "praefectus legionis tertiae Italicae transvectioni specierum deputatae."

Teriolis is therefore an impressive example of a Late Roman roadblock at the foot of an important pass, here serving to secure the flank of the castellum Veldidena. It also had the function—under the command of the dux Raetiae—of a supply and reenforcement base.

A discovery made in 1964 fits in with the Late Classical character of the Martinsbühel. During an excavation (not yet published) within St. Martin's church were found remnants of an Early Christian church (ca. 14 x 8.5 m) with a semicircular clergy bench, in the apse. No traces have been found of the altar; an oval pit with a stone wall probably held the reliquary. The church can be dated (although in the absence of finds) to the 6th c. on the basis of similar ground plans. Teriolis is a good example of the fact (frequently observable in Late Classical times) that a small Christian church appears in fortifications.

BIBLIOGRAPHY. O. Menghin, "Die Lage von Teriolis," *Forschungen und Mitteilungen zur Geschichte Tirols und Vorarlbergs* 10 (1913) 177ff[MP]; W. Cartellieri, *Die römischen Alpenstrassen über den Brenner, Reschen-Scheideck und Plöckenpass* (1926) 146ff; A. Wotschitzky, "Grabung in der Kapelle St. Martin am Martinsbühel bei Zirl," *Pro Austria Romana* 14 (1964) 36ff. R. NOLL

TERMANTIA, see TERMES

TERME, see THEMISKYRA

TERMERA (Asarlık) Turkey. Map 7. Town in Caria, an early Lelegian foundation, in the hills above Aspat, 15 km SW of Bodrum. The name first appears on a silver drachma of the late 6th or early 5th c., inscribed on the obverse with the name of Tymnes and on the reverse Termerikon. Tymnes is probably identical with the Termeran tyrant mentioned by Herodotos (5.37; 7.98). In the Delian Confederacy Termera paid two and a half talents down to 447 B.C.; thereafter the tribute dropped to half a talent, but the same sum was paid by "the Carians whom Tymnes rules." This is presumably the grandson of the earlier Tymnes, expelled from Termera but controlling territory elsewhere on the peninsula.

In Pliny's list of six Lelegian towns incorporated in Halikarnassos by Alexander (really by Mausolos) Termera is not included (*HN* 5.107); this however is generally agreed to be an error, as is certainly Pliny's later notice of Termera libera. Sherds on the site make it clear that the main occupation ceased during the 4th c., though the place continued in existence, probably as a guardhouse. Suidas observes that it was used by the tyrants (presumably the Hekatomnids) as a prison. Both Suidas and Strabo (657) speak of it in the present tense.

Asarlık is a characteristic Lelegian site, with an inner citadel and an outer wall circuit. The citadel wall, of smallish squared blocks, is only partially preserved, with a gate on the NW; inside are some traces of buildings and a large double cistern. The outer circuit is preserved chiefly on the E side, where a wall of polygonal masonry, in places approximating ashlar, runs S from a rocky knoll for ca. 100 m; it is continued farther S by a 60 m stretch of massive wall, with a gate 2 m wide which tapers to form a corbeled arch now partly destroyed. From the style of the masonry and the sherds this wall appears to date from the 5th c.

There are at least three tombs of varying styles on the site itself, and many others to the E, W and especially S. They include chamber tombs, corbeled tombs, and tomb

enclosures; particularly notable is an extensive cemetery at the head of the valley to the S, where the pottery goes back to the Bronze Age.

BIBLIOGRAPHY. C. T. Newton, *Halicarnassus, Cnidus and Branchidae* II (1863) 580f; W. R. Paton & J. Myres, *JHS* 8 (1888) 64f, 245f; 16 (1896) 203f; B. V. Head, *BMCatalogue of the Great Coins of Caria* . . . (1897) 176 no. 2; G. E. Bean & J. M. Cook, *BSA* 50 (1955) 116-18, 147-49; W. Radt, *IstMitt* Beih. 3 (1970) 226-33.

G. E. BEAN

TERMES or Termeste or Termantia Soria, Spain. Map 19. Site near Montejo de Liceras and Osma, an oppidum belonging to the Arevaci in the Conventus Cluniensis. Cited by Appian and Diodorus. Mentioned during the Celtiberian wars when it defeated Q. Pompeius (141 B.C.), but in 97 B.C. it was captured by T. Didius. It rallied to Sertorius against Rome but was finally subdued. The acropolis stands on a height with defensive works hewn out of the sandstone, rock-cut dwellings following the contour lines, and a kind of grandstand 70 m high for spectacles.

The Roman town, covering 21 ha, was surrounded by a wall protected by semicylindrical towers 5 m in radius, probably dating from the 1st c. A.D. A tunnel 105 m long, in the lower part of the acropolis, may be an aqueduct, a fortification, or a sewer. In the center of the town stands a large rectangular fortification with two covered passages one over the other. There was apparently a forum to the NW, a basilica, two or three baths with mosaics, and a temple. Excavations have yielded sculptures, mosaics, columns, capitals, antefixes, bronzes (Galba, Tiberius, Apollo, Eros, a warrior) fibulas, pottery, glassware, silver vases, altars, votive and funerary inscriptions, Celtiberian and Roman imperial coins, almost all of which are in the National Archaeological Museum in Madrid. There are also some architectural remains of the age of the Visigoths.

BIBLIOGRAPHY. N. Sentenach, "Las ruinas de Termes," *Revista de Archivos, Bibliotecas y Museos* (1911) 102-16[PI]; B. Taracena, *Carta Arqueológica de España. Soria* (1941); A. García y Bellido, "Las 'trullae' argenteas de Tiermes," *ArchEspArq* 39 (1966) 113ff.

M. PELLICER CATALÁN

TERMESSOS Turkey. Map 7. An old Pisidian foundation on Güllük Dağ, 25 km NW of Antalya, more or less Hellenized by the 3d c. B.C. In poetic inscriptions the Termessians call themselves Solymians (*TAM* III.1.103, 127, 135; cf. Strab. 650), and probably they originally spoke a language which Strabo (631) calls Solymian and distinguishes from Pisidian; later this dialect died out, apart from personal names. The Solymi appear in Homer in the tale of Bellerophon (*Il.* 6.184).

In 333 B.C. Alexander, having completed his business in Pamphylia, contemplated an attack on Termessos, but decided to march directly to Sagalassos (Arr. 1.27-28). In 319 Alketas, defeated by Antigonos, took refuge in Termessos; Antigonos demanded his surrender. To avoid falling into his enemy's hands Alketas killed himself.

In 189 B.C. Termessos besieged neighboring Isinda, but the siege was raised by Manlius Vulso in response to an appeal from the Isindians and Termessos was fined 50 talents (Livy 38.15; cf. Polyb. 21.35). Probably at about the same time the city became involved in a war with the Lycian League (*SEG* XVIII 570), of which the outcome is unknown. At some time during the 2d c. Termessos concluded an alliance with Adada (*TAM* III.1.2) in which reference is made to the democracy in each of the cities. About 70 B.C. a treaty of friendship was made with Rome (*CIL* I², 589 = *ILS* 38), apparently as a

reward for the city's opposition to Mithridates. From 36 to 25 B.C. Termessos, with the rest of Pisidia, was governed by Amyntas of Galatia; later, under the Empire, Termessian coins claim the title of Autonomous.

The city was approached by a Royal Road leading up the valley from the NE to a gate through the outer fortification wall; higher up is a second wall still standing in part to its full height. The site has never been excavated and is heavily overgrown, but the ruins are considerable.

The agora, in a central position, is a paved area flanked on NW and NE by the stoas of Attalos II and of a citizen named Osbaras. The latter apparently dates from the 1st c. A.D., and both are in poor condition. Under the paving is a row of five large stone-vaulted cisterns with circular mouths, and in the SW corner is a remarkable heroon cut in an outcrop of rock. A flight of steps leads up to a platform with a semicircular bench, above which is a wall containing a plain grave lacking its lid. There is no inscription or other indication of the owner's identity, nor is the monument datable. In the W face of the rock are three large semicircular niches which may be connected with the heroon.

A little to the E is the theater, small but well preserved. It dates from Hellenistic times, with some later alterations. The stage building is simple, a long narrow chamber with five doors opening onto the stage; between the doors were columns, but only the supports remain in place. Below the stage is a hyposcaenium, with five doors into the orchestra. The parodoi were open in the Greek manner, but the S one was later replaced by a vaulted passage with a loggia above it in the Roman style; above this again the rows of seats have been extended to join the stage building. The cavea, facing E, is more than a semicircle, and has 24 rows of seats, 8 above and 16 below the single diazoma. Six stairways divide it into five cunei; these are doubled above the diazoma. At the top of the central stairway is a door 2.5 m wide.

Some 100 m SW of the theater is a well-preserved building identified as an odeion, with walls standing up to 10 m high. It is thought to date from the 1st c. B.C. It is rectangular in plan and faces roughly E; the upper part of the walls is decorated on the outside with pilasters, and on the S and E sides are 11 large windows. In the E front are two rectangular doors, and in the back wall is a third. In the interior are some remains of rows of seats with a shallow curve, forming an arc much less than a semicircle.

Close to the odeion on the S is the Temple of Artemis, identified by an inscription at the door. This door stands complete with lintel and statue bases at either side. The temple apparently dates from the 3d c. A.D. and probably replaced an earlier temple the foundations of which still exist a few paces to the SE, and in which a dedication to Artemis was found. Behind the odeion is another small building, standing 5 m high, which may have been connected with the cult of Solymian Zeus; it consists of a single chamber, beautifully built, with a bench across the back wall.

To the SW of the agora is a large, ruined building which has been called the Founder's House, a splendid villa of Roman type. The front door is over 5 m high, with a window to its left; inside is a vestibule leading to the central atrium, where the impluvium is surrounded by columns.

Heavy overgrowth impedes the investigation of other features, notably a large and handsome gymnasium N of the theater, several large cisterns, and a street in the W part of the city lined with stoas and shops and adorned with statues.

The necropolis is vast; there are tombs on all sides of

the city, but the main concentration is on the higher ground to the W and S. No fewer than 650 epitaphs have been published. The rock tombs in the NW quarter are the earliest; they include a tomb of Lycian type with round beam ends, a pediment, and akroteria; a group of five tombs including three arcosolia; and a remarkable tomb which has been thought to be that of Alketas. The grave is cut in a ledge in an angle of the rock face, with a bench below; above is trellis-work in relief between pilasters, and above that a pediment and an eagle with spread wings holding a snake. Various damaged rock-cuttings and reliefs, on either side of the tomb, include figures of Hermes and Aphrodite, and in particular a fine relief of a horseman, with a suit of infantryman's armor just below. The main mass of later tombs consists of built tombs and sarcophagi, some very handsome.

Arrian, in his account of Alexander's visit, observes that the hills below Termessos come down close to the road on either side, leaving only a narrow passage easily defensible. This spot is identifiable on the present main road about 1 km E of the Yenice Kahve, close to the new road leading to the site. Here a wall bars the valley; it is built of excellent ashlar masonry, with 10 towers and a gate, and is thought to date from the 2d c. B.C. The towers, surprisingly, are on the W side of the wall, so as to halt an enemy only after he had passed the foot of the city; but it may be that the wall served as much for the purpose of exacting tolls as for military defense.

BIBLIOGRAPHY. T.A.B. Spratt & E. Forbes, *Travels in Lycia* I (1847) 232-41; R. Heberdey, "Termessische Studien," *DenkschWien* 69 (1929); *TAM* III.1 (1941)[M]; G. E. Bean, *Turkey's Southern Shore* (1968) 119-37[MI].

G. E. BEAN

TERMESSOS (Kemerarası) Turkey. Map 7. Site in Lycia, just below that of Oinoanda. Founded as a colony of Termessos Major, apparently during the 3d c. B.C., and presumably with the agreement of the Oinoandans. It is mentioned only by Stephanos Byzantios (who assigns it to Pisidia) and Eustathius; Strabo (631) confuses it with Termessos Major. The site consists of two low mounds, virtually defenseless, between which the present road runs. There are considerable quantities of ancient stones, including some well-cut blocks, but no buildings are standing. The inscriptions of the city, in which it is called Termessos by Oinoanda, were normally erected in Oinoanda, and it seems that under the Empire, if not earlier, Termessos Minor must have been in effect absorbed into that city. It had its own constitution and magistrates, however, and struck its own coins, and a long inscription has recently been found at Kemerarası containing a letter, as yet unpublished, of Hadrian addressed to the People.

BIBLIOGRAPHY. E. Petersen & F. von Luschan. *Reisen in Lykien* II (1889) 178; *DenkschrWien* 45 (1897) 1, 50ff; D. Magie, *Roman Rule in Asia Minor* (1950) 1377; G. E. Bean, *Turkey's Southern Shore* (1968) 122-23.

G. E. BEAN

TERMESTE, *see* TERMES

TERMINI IMERESE, *see* THERMAI HIMERAIAI

TERNI, *see* INTERAMNA NAHARS

TEROVO, *see* LIMES, GREEK EPEIROS

TERRACINA, *see* TARRACINA

TERVANNA (Therouanne) Pas-de-Calais, France. Map 23. A village on the Lys, in the canton of Aire and the Saint-Omer arrondissement. The massive remains of ramparts still mark the area of the Old City, now reverted to fields, but the mediaeval town covers the remains of the chief city of the Civitas Morinorum. This Belgic people, whom Caesar mentioned as few in number and whose fate is often linked with that of the Menapii, seems to have settled on the wooded plateaus between the Canche and the Aa rivers after a long exile beyond the Rhine and the Meuse, but no indication of Gallic occupation has come to light at Thérouanne itself.

Excavation down to the virgin soil has made possible a chronology of ancient Tervanna. At the beginning of the 1st c. A.D. the island of Lys with the Arras road running across it had modest dwellings on the S slope. Not until the end of the 1st and beginning of the 2d c. was there denser settlement, but no evidence of any city plan. The town was probably destroyed in A.D. 160-170; and some traces of reconstruction have been found at the site of the cathedral, carried out before the devastations of the late 3d c.

Four necropoleis suggest the limits of the inhabited area from the 1st to the mid 3d c. A.D. The necropolis of Mont Saint Martin, bordering the road from Thérouanne to Cassel to the NE, for the most part contains incineration tombs. In the area known as Le Bois Brichet, to the N along the Boulogne road, is a large necropolis which yielded rich grave gifts, and a third on the Arras road to the S was used until the Merovingian period. Finally, a few inhumation tombs have been found in the Old City on the Late Empire site. None of the necropoleis has been thoroughly excavated.

The few houses identified were separate, rebuilt several times in a modest style, and all destroyed during the invasions of the late 2d and 3d c. A.D. A few carved blocks may suggest the presence of a monumental complex, but the impression remains that Thérouanne was probably never more than a small country town. The same uncertainty persists in the case of the Late Empire rampart. A large section of wall has been unearthed below the Gothic cathedral, but there is some disagreement about what it represents.

The few inscriptions found have not clarified the history and origins of the city: the mention of Colonia Morinorum probably does not indicate a military colony or even an honorary one, but only a prestigious title. The discovery of a bronze votive hand may be evidence of worship of the Oriental god Sabazius.

The earlier finds are in museums at Lille, Calais, and Arras; the more recent ones are in the Saint Omer museum.

BIBLIOGRAPHY. Heron de Villefosse, "Inscriptions mentionnant la civitas Morinorum," *BAntFr* (1899) 383; C. Enlart, *Villes mortes du Moyen Age* (1920); H. Bernard, "La reprise des fouilles de Thérouanne," *Revue du Nord* 44 (1962) 339-56[PI]; R. Delmaire, "Les fouilles archéologiques de Thérouanne," *Bull. Soc. des Antiquaires de Morinie* 20 (1965) 385-95[P]; id., "Céramique sigillée découverte à Thérouanne," *Revue du Nord* 47 (1965) 607-13; id. & Y. Delmaire, "Découvertes archéologiques à Thérouanne," ibid. 51 (1969) 353-62; id., "Etude archéologique de la partie orientale de la civitas Morinorum" (1972 unpubl.); L. Thery, unpubl. ms, Archives departementales du Pas-de-Calais. P. LEMAN

TERVENTUM (Trivento) Isernia prov., Molise, Italy. Map 14. This was a Roman municipium in the territory of the Pentri Samnites. It was established in the course of the 1st c. B.C. after the social war to provide for the administration of the Samnite territories newly incorporated into the Roman state. It occupies an elevated position dominating the valley of the Trigno, and is near important Samnite sanctuaries at Pietrabbon-

dante and Schiavi d'Abruzzo. The modern town is superimposed on the ancient, and though no buildings remain visible, numerous epigraphic documents are preserved. In the surrounding countryside agricultural settlements (villae) from the late Republican and Imperial periods have been identified at Castel Guidone and Roccavivara.

BIBLIOGRAPHY. *EAA* 7 (1966) 996 (A. La Regina); M. Matteini Chiari, *Quaderni dell'Istituto di Topografia Antica dell'Università di Roma* 6 (1974) 143-82.

A. LA REGINA

TETUAN, *see* TAMUDA

TEURNIA (St. Peter im Holz) Upper Carinthia, Austria. Map 20. Located 4 km W of Spittal on the Drau, on the Roman road Virunum-Aguntum-Brenner where this intersected with the road to Iuvavum (via Radstädter Tauern). The origin of the name is obscure, and of the history of Teurnia little is known. We know from Pliny (*HN* 3.146) that it became a municipium with Virunum, Celeia, Aguntum, and Iuvavum at the time of Claudius (A.D. 41-54); Ptolemy (*Geog.* 2.13) mentions it among the Noric towns. It had no garrison since its location was strategically unimportant. Because of its out-of-the-way location the town was evidently unaffected by the Marcomannic wars and the invasions of the 3d c. A.D.; at least no traces of sacking have been found.

The settlement is located on an elongated, isolated hill, the so-called Lurnfeld, on the N bank of the Drau. The first excavations (1910-15) provided only scant information about the town of Early and Middle Imperial times. Only two buildings from this period are known, both located on a flat stretch on the SE spur of the hill: the baths (ca. 48 m long), axial in plan, and N of the baths the forum (incompletely excavated), a paved place surrounded on three sides by porticos. The town of this period seems, however, not to have been limited to the hill but to have extended into the plain. At the E foot of the hill was the pagan necropolis.

More is known about Teurnia in Late Imperial times when the town began to be more important. It is known from the *Vita Sancti Severini* of Eugippius (v. 17; 21; 25) and from other sources that Teurnia (then called Tiburnia) was at that time a bishopric. In the 5th c. A.D., when the former provincial capital Virunum began to decline, it even became metropolis of the remaining Roman province of Noricum (mediterraneum). It suffered from the increasing attacks of Germanic tribes (siege by the Goths ca. A.D. 473) and perished ca. A.D. 590 in the invasions of the Slavs and Awari. About A.D. 400 the hill was fortified with walls and towers. Beneath St. Peter's church, judging by the meager finds, was the bishop's church, which has been built over and destroyed. The Early Christian cemetery is located on the plain at the NW foot of the hill where a cemetery church, probably in the early 5th c., has been discovered. Because of the unusually rich finds there, it is the most interesting Early Christian church building in Austria Romana. The plan is unusual, without clear parallels. Its latest condition is certainly the result of several building periods. The original plan included a rectangular hall (ca. 22.2 x 9.25 m) with two apsidal side chapels including anterooms. Later additions are a narthex, two corridors on the sides, and the vestry for the N side chapel. The foundations and fragments of the stone furnishings give an idea of the interior. The presbytery was set off by barriers decorated with reliefs. The unattached clergy bench had a service table at either end. The reliquary was sunk into the paved altar square, and above it rose the four-legged table

altar. Fragmented stone reliefs from the presbytery barrier are all that is left of the other side chapel. The right side chapel was better preserved. The apse was separated, and the pedestal table altar stood on a reliquary that had been constructed from a Roman sepulchral altar of the 1st or 2d c. A.D. The most important find was a floor mosaic (6.10 x 4.25 m) in the nave. Dating from ca. 500, it is the latest work of art of Austria Romana. It is in excellent condition, containing within an ornamental frame 12 fields, representations predominantly of animals. One field is reserved for the inscription of the donors: the governor Ursus, called a vir spectabilis, and his wife Ursina.

These buildings—unique in the E Alpine area—have been turned into a museum. The ground plan has been preserved, and a protective building has been constructed over the right side chapel with the mosaic floor.

BIBLIOGRAPHY. R. Noll, *Frühes Christentum in Österreich* (1954) 95ff[MPI]; R. Egger, *Teurnia. Die römischen und frühchristlichen Altertümer Oberkärntens* (7th ed. 1973)[MPI].

R. NOLL

TEUTHRONE Lakonia, Greece. Map 9. Town and port at the back of the Bay of Kolokythia in the Gulf of Lakonia, close to the modern village of Kotronas. The oldest settlement is on Cape Skopa, a former islet now attached to the coast. The site was occupied from the end of the Neolithic to the Middle Helladic period. No Mycenaean or Geometric remains have been found, but given the lack of any systematic excavation, no conclusions can be drawn from this. The agglomeration then spread onto the mainland. There is an archaic remnant, a baetyl decorated with a ram's head and dating probably from the end of the 7th c., but the majority of the chance finds or visible remains date from the Hellenistic-Roman period. Under the Empire, Teuthrone was one of the cities of the Eleutherolakonian League (Paus. 3.21.7 and 25.4). An inscription testifies to the presence of a gymnasium. A paved room near Cape Skopa suggests a bathing establishment. Inscriptions, reliefs, architectural fragments, and remains of mosaics have also been found. The houses of Kotronas and of the neighboring village of Phlomochori contain much reused marble from the site.

BIBLIOGRAPHY. Cyriacus of Ancona (ed. Sabbadini), *Miscellanea Ceriani* (1910) (= *Fontes Ambrosiani* II 29); W. M. Leake, *Morea* (1830) I 272, 277, 312; id., *Peloponnesiaca* (1847) 172; Bory de Saint Vincent, *Expédition de Morée: Relation* (1829) 443; E. Puillon-Boblaye, *Recherches géographiques* (1835) 89; R. Weil, *AM* 1 (1876) 157; A. M. Woodward, *BSA* 13 (1906-7) 256-57; H. Waterhouse & R. Hope Simpson, *BSA* 56 (1961) 119[I]; C. Le Roy, *BCH* 85 (1961) 215-31[I]; id., *BCH* 89 (1965) 358-78[I]; A. Delivorrias, *Deltion* 23 (1968) II 1,153-55.

C. LE ROY

TEUTOBURGIUM, *see* LIMES PANNONIAE (Yugoslav Sector)

THAENAE (Henchir Thina) Tunisia. Map 18. On the coast, 12 km S of Sfax near the lighthouse. Mentioned several times by ancient authors, the city marked the termination of the royal fossa built by Scipio to delimit Roman from Numidian territory. A civitas, then a colony under Hadrian, the town prospered as the extent of the site and the richness of some of the excavated buildings indicate.

From 1900 to 1914, the site was rifled by the soldiers of the garrison for funerary furnishings contained in the tombs; several hectares of necropoleis which extended along the principal exit routes of the town were

turned topsy-turvy. Mausolea—some of them hexagonal in form—were found. In the middle of the most important of these necropoleis, some great public baths of exceptionally advanced, baroque plan were excavated in 1904 and the only mosaic, representing Orpheus, which had been laid aside, was destroyed during the Second World War.

Later on, especially between 1947 and 1955, the digging principally reached the monuments in the interior of the town, the most remarkable among them a monumental enclosure of which one side was 2.5 km comprising a gate with two semicircular towers.

In 1954-55 a bathing establishment situated in the section SE of the town was uncovered. Constructed of mediocre material and altered during the course of the centuries, the edifice presented—in spite of a very bad state of preservation—two important levels that indicate a change of function. A bath belonging to a private house must have been later converted into public baths because the plan of the edifice does not correspond with the usual type of plan for baths. Mosaics paved the floor, some fragments of which are notable for their decoration: a boxing bout, a rural villa, a ship manned by cupids. Some fragments of painted frescos were also collected there.

The Baths of the Months, excavated in 1961, are more remarkable for their extent and their state of preservation since the walls have survived to a height of several meters, allowing the reconstruction even of the roof, which was built of groin and barrel vaults. There were luxurious latrines. Frescos and a veneer of marble covered the walls. The whole was paved with geometric and figured mosaics, among them the one called The Seasons and the Months. In the course of the excavation, a coin hoard dating from the end of the 3d c. and the beginning of the 4th was found.

Two other houses, still unpublished, were uncovered at the same time. The mosaic in the triclinium of one is of a marine scene portraying cupids fishing, ships, and fish, and includes a head of Oceanus. The other house revealed a painted portrait of Dionysos with a nimbus, remarkably well-preserved, which has been taken to the Bardo Museum in Tunis. Several of these objects found in the course of the excavations are on display at the Sfax Museum.

BIBLIOGRAPHY. *CRAI* (1955) 343; Thirion in *MélRome* (1957) 207-54; M. Fendri in *CahTun* (1964) 47-67[PI].

A. ENNABLI

THAMARA Israel. Map 6. A fortress on the border between the Negev and the Arabah. The site is twice mentioned in the ancient sources: Eusebius (*Onom.* 8.8) states that the village of Thamara is situated one day's march from Mapsis (= Mampsis), on the road from Hebron to Aila, and that in his day there was a fortress with soldiers there. The *Nototia dignitatum* (34; 40), of the early 4th c. A.D., places a Palestinian cohort there.

Thamara is generally identified with Qasr el-Juheinieh (Mesad Thamar), on the road from Beersheba to Sodom. Before excavation (1973; not yet published), a large fortress (44 x 42 m) had been observed there, apparently of the Late Roman period. It has a large central court (44 x 42 m) and projecting corner towers. There is a gate and several large halls on its N side, with stairs leading to an upper story from inside the court. Large halls occupied the E side with smaller rooms to the S and W. There are indications of a large cistern in the middle of the court.

BIBLIOGRAPHY. F. Frank, "Aus der Arabah I," *ZDPV* 57 (1934) 199[P]; A. Alt, "Aus der Arabah II," ibid., 58 (1935) 33-35.

A. NEGEV

THAMUGADI (Timgad) Algeria. Map 18. Colonia Marciana Trajana Thamugadi was built in A.D. 100 by Minucius Gallus, legate of the Third Legion which had been stationed since 81 at Lambaesis (Lambèse), 27 km farther W. The new city lay on the road going W-E from Lambaesis to Theveste (Tébessa) then NE to Ammaedara (Haïdra) and Carthage—the route the Roman army had followed to occupy the S region of the Maghrib. At this point it was crossed at right angles by a road coming from Cirta (Constantine) down to the Aurès mountains.

Created by the army for veterans, the original town was designed rather like a camp. It was surrounded by a more or less square enclosing wall, about 355 m on each side, and had two axes that crossed at right angles. The N axis, the cardo, climbed gradually until it reached the E-W decumanus. Here it met the N wall of the forum and had to continue S 70 m farther W. This latter section of the road can be seen in aerial photographs because of a peculiar pavement of blue limestone; the other streets are paved with sandstone.

The streets formed a regularly shaped grid of blocks 20 m square, six of them E of the cardo, just five to the W. As they went N, they continued on either side of the forum complex. Altogether there were 111 more or less equal blocks, some occupied by public buildings, baths or markets, others divided by walls into two or three individual houses. Leaving aside later modifications to the plan, the total number of colonists, assigned one lodging place each, may be assessed at roughly 200.

Over the four centuries of the colony's life, the surrounding wall was largely torn down; only part of it still stands on the N side; the rounded S-W corner was uncovered in the course of excavations. The original N and E gates are partially preserved, that of the W having been replaced by a monumental arch.

From its inception, the planners saw to it that the city would have all the monuments befitting its political status. For example, the theater, which was not begun until 160, has its parodoi aligned right along the axis of the cardo. This makes it seem extremely unlikely that Timgad was a military camp transformed into a city, as has been strongly maintained.

The rectangular forum is set apart N of the decumanus but reached by some axial steps. Colonnades surrounded it on all four sides. The open space is 50 x 43 m. Behind the N portico are a series of stalls, obviously shops, backed by more shops that are aligned along the decumanus. Some of these have columned entrances and may be small sanctuaries.

Below, to the E, is a public lavatory. The E side of the forum is flanked by a basilica measuring 28.50 x 15 m. To the N is an apse (not raised) set between two annexes, while to the S, in contrast, there is a raised tribunal decorated with columns; to the E are a row of offices.

The S side of the forum is occupied by a row of shops opening alternately on the square and the street which, behind the square, climbs toward the theater. Near the SW corner is a gate that opens onto this street. Here one finds a complex of buildings, possibly a police station, then the curia. The latter is divided in two by steps and a balustrade; at the rear is a raised platform that very likely was ornamented with statues. Farther N is a small temple, 8 m square, in front of which is not a flight of steps but a rostrum. On either side of this rostrum are plinths dedicated to the victories of Trajan to whom, as founder of the city, the temple was no doubt consecrated. Behind the temple was a little colonnaded garden and underneath the temple a room with a grille—very probably the treasury. Beyond, a deco-

rated hall, somewhat similar to the curia, formed the NW corner.

The central piazza of the forum was filled with monuments of which only a few pedestals, fortunately inscribed, remain. Others have been found in the basilica. A number of divinities figure in the inscriptions, in particular Marsyas, who seems to have had a symbolic importance in the colonies; also most of the emperors, especially the Severi and Julian, and local notables, among them the young son of one of the colony's patrons and another patron renowned for his eloquence, P. Flavius Pudens Pomponianus, called Vocontius. A sundial was carved on the paving stones. Some of the inscriptions are engraved in script that foreshadows the cursive script of the Middle Ages.

Behind the forum is the theater, its cavea facing W. Although it has been largely rebuilt, its scaenae frons has completely disappeared. The theater was believed to be cut in the hillside; in fact, recent research has shown that the N section of the cavea rested on concentric arches. Crowning it was a semicircular colonnade and on the hill behind that are several anonymous temples. One of these had a peribolus around it; and joined to it, though on a lower plane, was a semicircular annex, also for religious purposes, which was built at the same time as the cavea. It is somewhat rare for a Roman theater to be so closely linked with a place of worship.

Tucked between the N facade of the basilica and the decumanus is a charming house, the so-called Maison des Jardinières, which is linked to the forum by a hidden gate. Built in the space reserved for official buildings, it is clearly an official residence. Perhaps it was here that the legate of the legion, who acted as governor of the province of Numidia, was received when he visited the colony.

Still to the N of the decumanus, the second block E of this house is taken up by a market. Original in design, it is made up of two small semicircular courtyards surrounded by colonnades that intersect behind an outer building. This latter consists of a row of stalls. Other shops surround the two semicircles. The market is joined to a row of shops that may be said to form the facade of the forum along the decumanus. The sidewalk facing it is especially wide, and the area is a continuation of the colony's commercial center.

Most of the other blocks are taken up by houses. On the N cardo and the decumanus these are set behind porticos that are connected to the houses and do not conform to an over-all city plan. One is reminded of the regulations Nero laid down for Rome after the fire of A.D. 64. The other streets are paved with stone and have no sidewalks. No typical house plan is apparent. Generally there is a paved courtyard with a portico on one side or more, and a moderate-sized triclinium opening on the courtyard, along with other rooms. Some houses had two stories; others had shops. The best designed houses are those of later date; nevertheless, the earlier ones sometimes boasted elaborate mosaics.

The bath buildings—14 have been located—take up sometimes just one block, sometimes two. As may be expected, they are of simple design although consisting of frigidarium, tepidarium, and caldarium. Some of the baths may have been laid out at the very beginning of the colony. On the other hand, one of the most remarkable city monuments, a library set on the N cardo, apparently dates from the 4th c. It was housed sumptuously in a semicircular room with recesses, separated by columns, for the scroll-cases; in the axis was a statue of Minerva.

The city as thus conceived all at once became too small. Its plan did not allow for extension. Besides the forum temple and the theater temple, there were a few small sanctuaries in the S section of the city, but they were hardly monumental. If, as one is led to assume, the forum temple was consecrated to Trajan or Trajan's victories, the city had no Capitol and there was no room to build one. Thus, almost at the same time as the theater was built, about 160, construction began SW of the city on an immense peribolus, larger than the forum, which served as a frame for an imposing temple. This temple had not been planned for originally, as the city was oriented according to surveyors' charts at its foundation and the Capitol was erected along a different axis, no doubt for religious reasons.

The temple podium is 53 x 23 m; it stands back to back with the W wall of the city. Very tall, it was supported on vaults and ringed with columns 14 m high. This brought it up to the level of the nearby hills, on which were a few small sanctuaries. The capitals of the temple, which are 1.55 m high, are Corinthian and conform strictly to contemporary Roman style. Still majestic in spite of damage, such a monument is certainly out of proportion with the original city, tightly packed as it is inside its enclosing wall.

In fact, 50 years after its foundation, the city had already burst its bonds. New monumental gates had been built, at least to the E and W, under the Antonines; these marked the new city limits: 100 m wider to the E, almost 400 m to the W.

The new town did not conform in any way to the grid system of the earlier one. In laying out Trajan's city at a crossroads, the planners had not taken into account the direction of the roads that met there. At the W exit of the city in particular, the road going toward Lambaesis formed an extremely sharp angle with the decumanus. It was the same with the road going E toward Mascula and that going S to the mountains. Thus the suburb that grew up round the colony spread untidily in these directions without any thought being given to continuing the original grid: there were no more right-angled roads or regular blocks. Also, the suburban roads tend to follow the level of the terrain, in the fashion of spontaneous town growth. The peculiar siting of the Capitol and its surrounding wall naturally heightened the relative disorder; outside the wall only a few monuments—the nearest ones—were built according to the original orientation. Among these are the N baths and, to the W, the first two monuments of the street turned avenue—the Temple of the Spirit of the Colony to the N and the Market of Sertius to the S. The temple, in particular, is built along the old axes; a typical tetrastyle temple, it has in front of it a courtyard that follows the same orientation on three sides but on its S side is, as it were, cut into by the oblique road.

Toward the end of the century, under Septimius Severus, the wall itself must have been pulled down, at least to the S and W. The place where it had been, with its inner boulevard and sloping ground, was taken up by houses built systematically to fill the open space completely without extending the streets of the inside grid. The gate was also demolished and replaced by a fine triumphal arch marking the junction of the decumanus and the new avenue.

This beautiful arch has been restored. It has three openings corresponding to the decumanus and its sidewalks. On top of the two side arches, which are lower, were tall niches decorated with statues. The facade was framed with columns supporting an entablature that arched above the niches, which in turn were flanked by colonnades. Over all was a high cornice. This noble

monument welcomed visitors to the Numidian capital and expressed the new splendor of the colony.

At the foot of it a rich citizen, M. Plotius Faustus Sertius, built a large market at his own expense. It had a forecourt that extended to the avenue; the facade was colonnaded, and through it one reached a rectangular courtyard with porticos on all sides and a fountain in the middle. To the S was a huge roofed exedra fronted by a row of columns, much taller, set on three steps. These columns carried arches. At the back of the exedra were seven radiating stalls, six along the entrance wall.

Around this market is a sizable open space that stretches to the N and S, between the exedra and the enclosing wall, and from there to the Capitol. Here, very probably, was an open-air market. One may perhaps add to this commercial complex the avenue of Lambaesis, as it was first reorganized, probably at the same time. It is 350 x 21 m, 6.5 m of the width being highway, the rest broad colonnaded sidewalks. This magnificent street climbs in an almost straight line from the new gate to the arch; it has a grandeur striking in a city that was after all of only secondary importance.

At the beginning of the 4th c. the city acquired other monuments that were adapted to the new scale. The spacious N bath, which measures 80 x 65 m, is arranged symmetrically. Two sets of large rooms led out, on either side of a common entrance hall, to a caldarium, also common to both. The construction is of brick and is particularly workmanlike and robust. The decoration has unfortunately disappeared.

In complete contrast to this traditional symmetry is the extraordinary freedom of plan of the S baths. As one leaves the city, on this side, the N cardo slants E as it climbs up to a draw between the hills. It is joined by the other great avenue which follows the wall and then skirts the peribolus of the Capitol. The triangle thus formed was filled with stalls. Farther E, in the obtuse angle of the decumanus, some baths were built, less spacious than those of the N but quite original. Furnaces and hypocausts are particularly well preserved.

On the site of the wall that was torn down at the SW corner of Trajan's city are its two grandest houses— that of Sertius, the donor of the marketplace, and another called the Hermaphrodite after a mosaic found there.

To the description of the city as it was in the 3d c. should be added another temple which was located 350 m S of the S baths underneath an immense Byzantine fortress. Consecrated to the water divinities, it had at the entrance a large pool, then three separate cellae joined by terraces and stairs. The cellae were richly decorated with a number of works of art. The heads of statues of Serapis-Aesculapius and Dea Africa were found. A third god is unknown. According to an inscription, Caracalla enriched this sanctuary, in particular by adding some colonnaded gardens, which have been found N of the fortress. This complex was designed to sanctify a spring, since disappeared—the Aqua Septimiana Felix. This spring had medicinal properties, no doubt appreciated by Septimius Severus when he passed through. The source contributed to the city's water supply along with another one (known today as the Aïn Morri) and to the recovery of marsh waters accomplished by means of the filters of an Aqua Paludensis.

Another smaller sanctuary is situated to the N of the town, 400 m from the great baths. A temple dedicated to Saturn, it was doubtless very old but was rebuilt at a later date. It was the favored center of indigenous religion; near it have been found a large number of stelae, dedicated to the god, which retain the traditional local style of sculpture. These stelae show how, in a colony of veterans, traditional religious practices persisted and a faith was kept alive in the midst of imported Roman cults.

In the 4th c. Christianity was introduced alongside the pagan cults, but is hard to tell when the latter were abandoned. At that time the African church was torn by the Donatist schism, and it is not surprising to find two sets of Christian buildings at Timgad, both cathedral-like, one situated behind the Capitol, the other near the NW corner of the original city. The first is the Donatist center: it has a huge basilica fronted by an atrium, with a baptistery that appears to be linked to some small baths. In the nave is a tomb, specially venerated. To the E is a chapel, oriented in the normal direction for prayer. Surrounding the church are a number of annexes—apsidal halls, a triclinium, and a house with an inscription bearing the name of bishop Optatus, who was the leader of the sect at the end of the 4th c. The other basilica is not so large but has a baptistery and a wide colonnaded courtyard, this time behind the church. Its link with the orthodox community is merely hypothetical.

Other churches have been uncovered, one on the Lambaesis road at some distance from the city gate; one right inside Trajan's city, built on top of a private house but containing a baptistery; and others behind the Capitol and, to the S, in cemeteries. However, these date from the Byzantine reoccupation.

When the Byzantines occupied it Timgad had been pillaged and partly destroyed at the end of the 5th c. by an attack of raiders from the Aurès mountains. The Byzantine general Solomon took advantage of these ruins to assemble the materials necessary to build an enormous stone citadel, which has been completely excavated. It is a rectangular structure 112 x 67 m, whose 2.5 m thick walls still stand over 15 m high. Square towers are set at the corners and in the middle of the wall faces, one of which, to the N, is divided by the entrance gate. The walls are built of blocks that are reused, simply placed one on top of another with coursed facings. Inside were barracks, two or perhaps three stories high. In the W section, around the pool of the old temple, the walls stand on the Roman surface, paved in opus testaceum. Here are what no doubt was the praetorium, set between baths of a type far removed from the Roman model, and an unmistakably Byzantine chapel, vaulted and built of brick.

A few hundred meters S of the fort some very large Christian cemeteries have been uncovered, with sarcophagi and monumental tombs, but chiefly tombs under roof tiles. Two chapels have been found there, one of which was built in the time of Gregory the patrician (641-47) at the end of the Byzantine period. A few pagan necropoleis have been found along the Lambaesis road.

Timgad is noteworthy for the quality of its works of art. Apart from the many stelae, so full of life, devoted to Saturn, there are few statues. Those that have been found are religious images and portraits of noble ladies —local imitations of Roman models, which have a peculiar appeal. The mosaics, of which an inventory has just been published, are exceptionally significant. Besides pavements with geometric designs or, more rarely, with figures, there is an astonishing profusion of plant designs—highly original developments of acanthus leaf motifs, with scroll patterns forming colored surfaces. The colors are often extremely delicate, the shadings very precise.

BIBLIOGRAPHY. A. Ballu, *Les ruines de Timgad, antique Thamugadi* (1897), with supplements of 1903 and 1911; E. Boeswillwald, R. Cagnat, A. Ballu, *Timgad. Une cité*

africaine sous l'empire romain (1891-1905); S. Gsell, *Les monuments antiques de l'Algérie* (1901) I & II; *Atlas archéologique de l'Algérie* (1908) 27, no. 225; M. Christofle, *Rapports sur les travaux des fouilles et des consolidations effectués par le Service des Monuments historiques de l'Algérie* (1930, 1935, 1938); L. Leschi, *Etudes d'épigraphie, d'archéologie et d'histoire africaines* (1957) passim; S. Germain, *Les mosaïques de Timgad* (1969). Guides: C. Courtois, *Timgad, antique Thamugadi* (1951); J. Lassus, *Visite à Timgad* (1969); see also *Bulletin archéologique du Comité, Revue Africaine, Libyca*, and C. Saumagne in *Revue Tunisienne*.

J. LASSUS

THAMUSIDA (Sidi Ali ben Ahmed) Morocco. Map 19. A Roman city in the province of Mauretania Tingitana, situated on the road from Tingi to Sala and mentioned by Ptolemy, the *Antonine Itinerary* and the Geographer of Ravenna. Its identification with the ruins of Sidi Ali ben Ahmed, which cover ca. 15 ha on the left bank of the wadi Sebou—the amnis Sububus of Pliny (*HN* 5.5) 10 km upstream from Kenitra—seems certain even though no inscription has yet come to light to provide irrefutable confirmation. Sporadic excavations beginning in 1932, followed by more systematic exploration in recent years, have made it possible both to clarify the city's history and to uncover a certain number of monuments, generally very badly damaged.

About the middle of the 2d c. B.C. a small indigenous settlement grew up on the flattish hillock of Sidi Ali ben Ahmed that rises some 12 m above the river, out of danger of floods. From the first half of the next century the inhabitants were engaged in continuous contact with Cadiz, southern Spain, and the Mediterranean basin. However, the earliest traces of construction found up to now seem not to predate the Augustan period, and before Rome annexed Mauretania the settlement seems to have been only moderately active. After that it took advantage of the fact that the wadi Sebou was navigable; since the effects of the tide were felt even at that point, the river could be reached by most ships in antiquity. Under the Flavians Thamusida acted as garrison for a detachment of soldiers and must already have had the appearance of a city. Several monuments date from this period, in fact: a temple with a triple cella known as the "temple à bossage" alongside the wadi, only the foundations of which unfortunately now remain, together with the first stage of the River Baths and several groups of houses. At the beginning of the 2d c. A.D. the city was redesigned on an orthogonal plan and enlarged. The forum has not been located, and the orientation of the streets is still conjectural at this stage of excavation. However, the majority of the monuments that have been uncovered date from this period: in the E quarter, a small square rustic temple in the Punic tradition, possibly dedicated to a Venus-Astarte with, in front of it, a flight of steps flanked by two columns; along the banks of the river, a sanctuary of the African type consisting of three cellae opening onto a porticoed courtyard, and a third temple, now razed, with a single cella and a wide pronaos. The last two temples were built in the second half of the century. The River Baths, for their part, were continually enlarged and modified, finally covering an area of about 3,000 sq m. They consisted of two juxtaposed buildings, probably the larger for men and the smaller for women. Lastly, even though only one large peristyled domus of a common Tingitanian type—the House with the Stone Floor—has been excavated so far, others can be discerned, and several insulae have also been found to contain smaller dwellings with rooms laid out on an irregular plan. The presence of a fish-salting works, shops, an ironworks, and a huge rectangular building, apparently a warehouse, are evidence of considerable economic activity, and this in turn is confirmed by pottery finds.

Under Marcus Aurelius a large camp (165.85 x 138.78 m) was built along the SE boundary of the settlement. Its size suggests that the camp was large enough to house a military cohort or cavalry wing, and stamped bricks provide evidence that it in fact did so. The camp rampart, which had 14 inside towers and four gates flanked by rectangular projecting towers, has been located along its entire length. The praetorium, too, has been completely cleared: it consists of a rectangular porticoed courtyard with rooms along three sides; one of the rooms, in the axis of the W side, was built on a polium with a flight of steps in front of it. In the Severan period a hall of basilical plan was built on the N section of the praetorium, projecting into the courtyard.

The city is encircled by a wall having projecting semicircular towers, which cuts through some of the buildings and is supported against each end of the W rampart of the camp. The wall apparently dates from Commodus' reign. Thus protected, Thamusida in the 3d c. continued to be active and, apparently, prosperous. It was abandoned suddenly, at the same time as the camp, probably after it was decided to evacuate the site between 274 and 280. A few huts still remained on the site, then even these were abandoned at a date well before the Arab conquest.

Among the few inscriptions found are two fragments of military diplomas, an indication that veterans lived there. Other finds are of slight importance: aside from fragments of equestrian statues, a few small bronzes of mediocre quality and a small statue of a barbarian prisoner (probably from a trophy) found in the camp.

BIBLIOGRAPHY. J.-P. Callu et al., *Thamusida, fouilles du Service des Antiquités du Maroc*, I, 1965 (École Française de Rome, Mélanges d'Archéologie et d'Histoire Suppléments, 2; 1965); R. Rebuffat & G. Hallier, *Thamusida, fouilles du Service des Antiquités du Maroc*, II (1970). M. EUZENNAT

THARROS Sardinia, Italy. Map 14. Ancient city in W Sardinia, on the peninsula between the village of S. Giovanni di Sinis and Capo S. Marco. It was mentioned by the historians (*Sall. Crispi Hist. rel.*; Lipsia [1893] II, fr. 12 p. 64) and by the geographers (Ptol. 3.3.2; *It. Ant.* 84; *Rav. Cosm.* 5.26). The city, founded by the Phoenicians on an earlier nuraghic settlement, was an important way station on the commercial route between Carthage and Massilia. In the 3d c. B.C. it passed under Roman domination and was abandoned after the Byzantine period. The presence on Capo S. Marco of a chapel of the Canaanite type with a rectangular plan led to the identification of that spot as the original Semitic establishment.

There are two necropoleis: the earlier is N of the inhabited area outside the walls; the other to the S of the urban center. Both were robbed in the 19th c. They consist of chamber tombs excavated in the rock with vertical pit burials or with an access dromos. The grave goods, datable between the 7th and the 2d c. B.C., are in the museums of Oristano, Cagliari, Torino, and London.

The urban settlement in the Punic period was located along the E slope of the peninsula. In front of it extended the complex of port structures, now submerged. On the upper hillside fortification walls have been identified. The houses were probably constructed on stepped terraces descending along the hillside. At the foot of the slope arose a sacred area of the Semitic type and

a monolithic temple from the 4th-3d c. B.C. which was ornamented along part of its flanks by Doric half-columns and pilasters. The city's drainage system survived intact. It is made up of channels excavated in the rock, as is the hydraulic system which carried water from wells and cisterns that were also dug in the rock and faced with waterproof plaster. The tophet, which is the largest in Sardinia, consists of a rectangular area characterized by small walled courtyards, and is delimited on the E and the N by the city walls. It was erected on the NE border of the inhabited area and dates to the 3d-2d c. B.C. The urns contain the remains of cremations.

Under Roman domination the urban complex, in part overlapping the plan of the Punic city, consisted of insulae placed along a network of streets oriented NS-EW. Among the most significant public buildings are two bath buildings and a castellum aquae. Of the first bath building only the caldarium survives. The second, which is larger, is in the area called Convento Vecchio. Disposed on three levels of stepped terraces it includes the remains of the apoditerium, the frigidarium with two swimming pools and a mosaic pavement of black and white tesserae, the tepidarium, and three interconnected caldarii. For the last of these and for other large buildings brick was used, or brick alternating with courses of small stones. Dwellings, dating from the 2d-3d c., have either a central or an anterior courtyard but the various rooms are not distinguishable; only the hydraulic and drainage systems remain. Later monuments include an Early-Christian baptistery from the 5th-7th c., near the smaller bath building; and the church of S. Giovanni Battista (5th c.), with 19th and 20th c. restorations. It was built on the N necropolis, around which the last population of Tharros settled.

BIBLIOGRAPHY. G. Spano, *Notizie sulla città di Tharros* (1851); A. Lamarmora, *Itineraire de l'île de Sardaigne* (1860) 574ff; E. Pais, *Storia della Sardegna e della Corsica*, I (1923) 103, 368; G. Pesce, "Il primo scavo di Tharros," *Studi Sardi* 14-15 (1955-57) 307ff[PI]; id., *Boll. del Centro di Studi per la Storia dell'Arch.* 17 (1961) 5ff[PI]; id., *Oriens Antiquus* 2.1 (1963) 142; 3.1 (1964) 137f[I]; id., *Tharros* (1966)[MPI]; id., *EAA* 7 (1966) 800ff; F. Barreca, *NSc* 12 (1958) 409ff.

D. MANCONI

THASOS Greece. Map 9. An island with a town of the same name, in the N Aegean Sea about 8 km off the Thracian coast. The island is roughly circular in shape and about 25 km in diameter. It is well wooded and well watered and rises to a height of 1203 m in Mt. Hypsarion. It was rich in minerals, and its gold mines were very productive in the 6th and 5th c. B.C. They were seen and described by Herodotos. The island also produced an excellent white marble with large crystals which was widely exported, and its wine was famous all over the ancient world. The climate of Thasos in the late 5th c. B.C. is described by the physician Hippokrates (*Epidemics* 1.1,4,13). The city-state of Thasos also held territory on the mainland opposite, both along the coast and inland. The most important spot was Skaptesyle on Mt. Pangaion, with its rich gold mines. Some of these were owned by the historian Thucydides, who lived here and wrote his history during his exile from Athens.

Before the arrival of the Greeks, the island had been called Odonis and was occupied by the Sintes, a Thracian tribe. Nothing had been known archaeologically about prehistoric Thasos until two sites were discovered in the S part of the island, a cave on the W coast near Maries with Neolithic and Early Bronze Age sherds, and an inland site at Kastri with a settlement that has Neolithic and perhaps later sherds and an extensive cemetery of the Late Bronze and Early Iron Ages. At the dawn of history the Phoenicians were exploiting the mines under their leader Thasos, who gave his name to the island.

The history of Thasos really begins ca. 680 B.C. with the coming of Ionian Greek settlers from the island of Paros under the leadership of Telesikles, the father of the poet Archilochos. The poet himself was active there ca. 650 B.C. and his poems give us tantalizing glimpses of the place and the times. The funeral monument of Glaukos, son of Leptines, a companion of Archilochos, has been found in the Agora, identified by a contemporary inscription. Pottery of the 7th c. B.C. in Cycladic orientalizing style has been found in votive deposits, and house remains of the same period have been discovered. The 6th and early 5th c. B.C. were the time of Thasos' greatest prosperity. The mines, both on the island and on the mainland, were producing 200 talents a year on the average, and 300 in good years, and the city had built a circuit wall over 4 km long which had gates decorated with large sculptured reliefs. In 491 B.C., however, the Thasians yielded to Persian demands, demolished their walls, and surrendered their fleet. Again in 480 they offered no resistance to Xerxes. In 477 B.C. they joined the Delian League and contributed a force of 30 ships. In 465 they wanted to withdraw, but Athens resisted and laid siege to the town, which capitulated in the third year, leaving Thasos a dependency of Athens. In 411 B.C. they again tried to break away, calling in Spartan help, but the pro-Athenian party resisted and ten years of civil strife followed. In 377 B.C. Thasos joined the second Athenian Confederacy. In Macedonian and Roman times Thasos was politically subsidiary to the great powers, but her commercial prosperity was considerable. Polygnotos, the 5th c. painter, was a native of Thasos.

The town of Thasos lay on the N coast of the island, looking across the strait to the mainland. It had two harbors, one enclosed within the fortifications, the other next to it, unfortified but protected by a breakwater. The Agora lay near the closed harbor. It was a quadrangular area, ca. 100 m on a side, with colonnades on three of its sides and administrative and religious buildings on the fourth. Sanctuaries, altars, and monuments occupied some of the open spaces. Elsewhere in the lower town sanctuaries of Poseidon, Dionysos, Artemis, and Herakles have been found. Herakles was the principal god of the Thasians, and his image appears on their coins and the stamps on their wine jars. His worship had been introduced by the Phoenicians before the coming of the Greeks. On the acropolis, which rose steeply behind the town to a height of 150 m, were sanctuaries of Pythian Apollo, Athena Poliouchos, and Pan. A theater lay on the slopes.

Thasos was visited, described, and excavated by a number of persons in the 19th c., and antiquities were removed to museums abroad, particularly to Constantinople and Paris. The museum on the site contains more recent finds of sculpture, inscriptions, and pottery.

BIBLIOGRAPHY. Ecole française d'Athènes, *Guide de Thasos* (1968)[MPI] (authoritative guide with bibl.); id., *Etudes Thasiennes*, I-VIII (1944-62, continuing)[MPI]; D. Lazarides, *Thasos and its Peraia* (1971)[MP] (Vol. V of *Ancient Greek Cities*); J. Pouilloux, "Archiloque et Thasos: Histoire et Poésie," *Entretiens* X (1963); *ArchEph* (1970) Chronika 16-22 (cemetery).

E. VANDERPOOL

THAUMAKOI Thessaly, Greece. Map 9. A city in Achaia Phthiotis (Strab. 9.435). It lay on the pass between the Spercheios valley and the W plain of Thessaly, overlooking the latter. The sudden and spectacular view

of the sea-like plain gave the ancient derivation for its name from the verb "to marvel" (Livy 32.4.3). It was evidently not an important place except strategically, and was a member of the Aitolian League, probably from the 3d c. B.C. It was besieged by Philip V in 199 B.C., but an Aitolian band entered the city and helped it hold until Philip withdrew (Livy 32.4). The next year Aitolian troops used it as a supply base (Livy 32.13.14). It was taken easily by M' Acilius Glabrio in his campaign against Antiochus III and his allies in 191 B.C., while he was on his way from the Thessalian plain to the Spercheios valley (Livy 36.14. 12-15). In 189 B.C. it was probably freed with the rest of Thessalian Achaia. The city was the site of a bishopric in Christian times. Its neighbor to the S was Xyniae; to the N Proerna.

The city lies just to the W of the modern (and ancient) road over the pass, ca. 4 km S of the Thessalian plain. The acropolis is a small, round, rocky, abrupt peak (639 m) surrounded on top by a Byzantine (?) wall of stones and mortar, on the site of an ancient wall, of which virtually nothing is visible. The modern town is centered on the slope S of the acropolis. The ancient city wall is visible in places forming a concentric circle some 800-900 m in circumference around the acropolis. Southeast of the acropolis is one small section with four courses in place (1924); the wall is of rectangular blocks, laid in even courses. Brief excavations behind the school (gymnasium) S of the acropolis uncovered a section of the city wall built of polygonal masonry, making a solid bastion at this point. At the S edge of the wall was uncovered the foundation of an isolated tower, presumably to guard the access from the road. The finds from this excavation mainly consisted of 4th and 3d c. B.C. pottery fragments. A little N of the acropolis is a flat area on which is the Church of Haghios Aemilianos. Here a foundation of large stones, 6 x 3 m, was discovered, probably of a tower outside the walls guarding the approach from the plain. In the N side of the preserved city wall is a gate which may have given access to this tower. The city wall appeared to Stählin to date from the 3d c. B.C.; the polygonal section recently discovered, however, must be a part of the Classical defenses.

Some 2 km N of Dhomoko, near Milyai (1910) was an ancient foundation, probably of a temple, near which was found a boundary inscription concerning Angeia and Ktimenai (see Dhranista). A treasure of Hellenistic gold objects now mainly in the Benaki and Stathatos collections found in Thessaly in 1929 may have come from the vicinity of Dhomoko.

BIBLIOGRAPHY. A. S. Arvanitopoullos, Praktika (1910) 197f; F. Stählin, Das Hellenische Thessalien (1924) 156-58[P]; id., RE[2] (1934) s.v. Thaumakoi[PM]; BCH 75 (1951) 115; P. Amandry, ASAtene 24-26 (1946-48) 181-98[I] (treasure); id., Collection Hélène Stathatos, Les Bijoux Antiques (1953).	T. S. MAC KAY

THEADELPHIA (Batn-Ihrît) Egypt. Map 5. A city 30 km NW of Medinet El-Faiyûm. Of the seven temples that were here during the Ptolemaic period, four had the right of asylum. The main temple was that dedicated by Ptolemy III Euergetes to the local god Pnepherôs, the crocodile god. The city seems to have been still active during the Roman period. A large wooden press has been transferred to the garden court of the Graeco-Roman Museum in Alexandria, where are also the reconstructed pylons and the altar of the main temple of Theadelphia. This temple was built on the plan of the Egyptian sanctuaries: three successive courtyards preceded the portico of the principal chapel. The Greek inscription carved over the doorway at the entrance of the temple dates it to the year 34 of the reign of Ptolemy III Euergetes. The pylons and the stone portico were dedicated to the god Pnepherôs on behalf of the Ptolemaic family by a certain Agathodoros, a citizen of Alexandria.

BIBLIOGRAPHY. E. Breccia, Alexandria ad Aegyptum (1922) 153-54, 284-86[I].	S. SHENOUDA

THEANGELA, see SYANGELA

THEBES (Luxor) Egypt. Map 5. Known to Homer (Il. 9.381-83), it lies 714 km S of Cairo. It was known to the Egyptians as Waset, the city of the south, and more popularly as Diospolis Megale (Diod. 1.15.97), the great city of Zeus, identified with the Egyptian god Amun. It became the capital of Egypt in the 11th Dynasty (ca. 2052 B.C.), supplanting Memphis, the earlier capital. Its great period was during the 18th-20th Dynasties (ca. 1550-1100 B.C.) when it was the capital of the Egyptian Empire. Although Thebes had long ceased to be the political center of Egypt in the Ptolemaic period, it was still important. However the city revolted against Ptolemy V Epiphanes and was severely punished. The city is extensively described during that time by both Diodorus (1.15.97) and Strabo (17.1.46). Under Roman rule, building activities continued and the city attracted attention because of the colossi of Memnon as they were then known. During the Early Christian period, the W part of the city became a monastic settlement, and most of the temples were converted into churches. Modern Luxor contains but a small part of the remains of the ancient city, which extended to cover Karnak and a number of villages on the W bank of the Nile. The contribution both of the Ptolemies and of the Roman emperors to the religious continuity of the city is to be seen scattered all over the vast area. Alexander the Great has a naos within the enclosure of the Luxor Temple. The granite sanctuary at Karnak commemorates the coronation of Philip Arhidaeus by the Egyptian gods in the presence of Amun Ra. The Temple of Ptah—identified with the Greek Hephaistos, and Hathor, identified with Aphrodite—has gateways which were added during the Ptolemaic period. The fine granite gateway which lies in front of the temple of the war god Mont was built by Ptolemy Philadelphos. The small chapel to the W of the temple is also a work of the Ptolemies. The gateway of the Temple of Mut was erected by Ptolemy I Soter. Here the king is represented shaking the sistrum, the queen plays the harp, and a princess beats a tamborine before Mut and Sekhmet. In Thebes West, across the river, there still stand the two colossi representing Amenhotep III seated upon a throne of which the figure to the N was thought by the Greeks to be that of Memnon, one of the great heroes of the Trojan War, who was said to have led an army of the Ethiopians to the siege of that city. The rather small but beautiful temple at Deir el-Medina is entirely a work of the Ptolemies. Augustus appears in the Temple of Amun where a statue of him was found. The additional court and pylon which are to be seen in the Temple of Nectanebos at Medinet Habu, were dedicated by Domitian. Hadrian, who visited Thebes with his wife Sabina (A.D. 130), began the construction of the temple that stands to the S of Medinet Habu and dedicated it to Isis. Antoninus Pius completed it.

BIBLIOGRAPHY. A. Weigall, A Guide to the Antiquities of Upper Egypt (1913) 60 et passim; C. F. Nums, Thebes of the Pharaohs: Pattern for Every City (1965)[PMI]; K. Michalowski, Aegypten (1968) 518ff[PMI].

S. SHENOUDA

THEBES Boiotia, Greece. Map 11. The Kadmeia, the acropolis of Thebes, is situated midway along a chain of hills running from Tanagra to Mt. Helikon, in

a natural ridge. It is a huge plateau 700 m long and 400 m wide with steep slopes on all sides except to the S and flanked by two deep gullies: that of Dirke to the W and Ismenos to the E. The Kadmeia rises some 50 m above the fertile Teneric plain. The lower city was spread out N and E of the acropolis.

According to legend Thebes was founded by Kadmos after he had consulted the oracle at Delphi. Theban mythology is among the richest in Greek civilization. The legends surrounding the founding of the city, the birth of Herakles, the curse that fell on the Labadakidai, the war of the Seven against Thebes, and the fate of the Epigonoi inspired the tragic poets. The Kadmeion or "palace of Kadmos" is beneath the modern city; the partial excavations at the beginning of the century revealed traces dating probably from the 15th c. B.C. Recently a rich collection of Babylonian cylinder seals of the 15th and 14th c. was found, as well as, underneath the palace, remains of buildings dating from the end of the third millennium. The Kadmeia apparently was abandoned in the 13th c. as a result of fires.

Long a rival of Orchomenos, Thebes finally gained the upper hand and from the 7th c. grouped a dozen cities into a koinon with itself at the head. But for centuries three cities resisted Thebes: Orchomenos, Plataiai, and Thespiai. From the 6th c. Thebes opposed Athens, sided with the Persians in 480 and was defeated by Athens at Oinophyta in 457. Ten years later Thebes reorganized the Boiotian League, dividing the region into 11 districts and becoming powerful by absorbing the districts of Plataiai (427) and Thespiai (423). Faced with the Spartan threat, Thebes made a short-lived alliance with Athens in 395 but was defeated in 394 at Koroneia. At the King's Peace (386) the city recovered its power, thanks to Epaminondas who fought the Spartans at Leuktra (371) and Pelopidas. Epaminondas' death at the battle of Mantineia (362) marked the beginning of the decline of Thebes. In 338 Philip II captured the Kadmeia and in 335 Alexander razed it. Rebuilt from 316 by Kassander, the city once again took its place, modestly, in the new Boiotian Koinon organized in 338, but was no longer at its head. It was captured in 173 by the consul Licinius and destroyed in 146 by Mummius as reprisal for a revolt. Barely rebuilt, Thebes was sacked by Sulla. After three centuries of obscurity it regained importance with the advent of Christianity and, in spite of the invasions, became a prosperous provincial capital.

Having seen so much destruction Thebes has few traces of the past. The modern town is built over the Kadmeia, and its suburbs of Pyri and Hagioi Theodori occupy the lower city. Only very partial excavations can be carried out. The finds can be seen in the museum.

Little remains of the Kadmeian walls: only some Mycenaean traces near the Proitides gate and some remains of a 4th c. wall near the "Frankish" tower and Electra gate. The rampart had seven gates: Borrheai to the N, Proitides and Homoloides to the E, Electra, flanked by two round 4th c. towers, and Onka to the S, and Kreneai and Neistai to the W. A second rampart fortified the city and the Kadmeia; traces of its four square towers can be seen on the hill E of the Ismenos gully and beside the Hypsistai gate to the SW.

On the Kadmeia were Pindar's house and the Sanctuary of Dionysos where a "statue fallen from heaven" was venerated. In his honor Thebes celebrated the Agrionia, which included a musical contest. Apollo Hismenios had an oracle to the SE of the Electra gate. The original temple (9th or 8th c.), which was of wood and brick, was burned and replaced in the 6th c. by a poros temple with Doric columns; this is the "temple of the golden tripods" (Pind.) that Herodotos visited. The 4th c. temple was a peripteral Doric building 22.80 x 46.25 m with six columns in front and 12 on each side; the sekos (9.30 x 21.60 m) was fronted by a spacious pronaos.

E of the Kadmeia, near the Fountain of Oidipous, may have been the agora with its great portico and next to it the Temple of Artemis Eukleia, the Heroon of Alkmeon, and the funeral pyres of the Seven Chiefs of Argos. On the hill of Kastelli a large Mycenaean chamber tomb has recently been discovered; it has two dromoi and is decorated inside with frescos representing papyrus flowers and female figures. On top of the hillock N of the Kadmeia was the Tomb of Amphion and Zethos. In the middle of a circular tumulus (diameter 20 m) made of crude bricks, the tomb is a mere cist (2.20 x 1.15 m); it was richly fitted as shown by very fine gold jewels, but it had already been plundered in ancient times. It was covered with a stepped pyramid in the Egyptian or Oriental manner, built at the beginning of the second millennium. Farther NE is a depression that may mark the site of a theater built by Sulla in 86 B.C. In the plain, NE of the railroad station, is said to be the site of the Temenos of Iolaus that included the heroon, a gymnasium, and a stadium; remains of a portico can be seen. Near the stadium were the hippodrome with Pindar's tomb and an ancient Sanctuary of Poseidon Hippodromios. No trace remains of any of the monuments W of the city.

The Temple of Herakles was S of the Kadmeia, near the Haghios Nikolaos Chapel, along with a stadium and a gymnasium. To honor Herakles Thebes celebrated the Herakleia, a festival with gymnastic contests. To the SW, near the Paraporti spring, is the Haghia Trias Chapel which is built on ancient foundations, perhaps those of the Temple of Athena Onka.

Outside the city were a number of sanctuaries: the Amphiareion whose oracle was consulted by Croesus (traces on the road to Athens, 2 km S of the Onka gate); the Sanctuary of Herakles Hippodetes (in the Teneric plain on the road to Kabeirion), that of Demeter Kabeiraia and Kore (no traces) and especially that of the Kabeiroi. The Kabeirion, situated 8 km W of Thebes, in a valley opening on the Teneric plain, has been excavated. A four-columned prostyle temple, roughly 7 x 23 m, was built to the E in the 4th c. on prehistoric, archaic and Classical remains (a great peribolos wall, circular buildings outside the peribolos). To the S of the temple a portico 40 x 6 m and open to the SE was modified in the 1st c. B.C. Behind the portico and N of the temple are several unidentified buildings. In front of the pronaos of the temple a large Hellenistic and Roman theater was uncovered (diameter of the orchestra: about 26 m); its tiers, 0.30 m high and 0.65 m wide, are of local limestone. The sanctuary has not yet been completely excavated. Most of the bronze objects and vases dedicated to "the Kabeiros and his son" are in the National Museum.

BIBLIOGRAPHY. A. Kéramopoullos, "Thebaïka," Deltion 3 (1917); F. Schober & L. Ziehen in RE (1934), s.v. Thebai^M; P. Cloche, Thèbes de Béotie (1952); F. Vian, Les origines de Thèbes, Cadmos et les Spartes (1963); "Chronique des Fouilles" BCH (1964) 775-79; (1966) 848-53; (1968) 856-62^PI; E. Touloupa, Deltion 19 (1964) 191-97^PI; P. Roesch, Thespies et la Confédération béotienne (1965)^MI; "Thèbes de Béotie," in La Civilisation grecque de l'Antiquité à nos jours II (1969) 377-88^I; N. Papahadjis, Pausaniou Hellados Periegesis V (1969) 46-90, 99-108, 148-50^MPI; Th. Spyro-

poulos, *AAA* 4 (1971) 161-64; 5 (1972) 16-27; J. P. Michaud, *BCH* 96 (1972) 694-99.

On Kabireion: E. Szanto, *AthMitt* 15 (1890) 396ff; P. Wolters & G. Bruns, *Das Kabirenheiligtum bei Theben* I (1940); G. Bruns, *Arch. Anz.* (1964) 231-65[PI]; N. Papahadjis, *Pausaniou Helpados Periegesis* V (1969) 150-59[MPI]. P. ROESCH

THELEPTE (Medinet-el-Kedima or Henchir Houri) Tunisia. Map 18. Situated in the valley between the Jebel Fériana and Jebel Fej-en-Naam chains, with the Thelepte railroad station to the N and the station and camp of Fériana to the S. One of the first cities in the N section of Proconsular Africa, Thelepte was founded by citizens, probably veterans, of the Papiria tribe. It may have been made a municipium under Vespasian before being promoted to a colonia under Trajan. Owing to its position on the Ammaerada-Capsa road, it became an important military stronghold and guarded the road from the borders of Byzacena to the S Sahara. It was situated on the edge of a vast territory of which it became chief city. Thelepte was also the seat of a council in 418; it boasted a long line of bishops that continued to the 9th c. and was the birthplace of Fulgentius, Bishop of Ruspe.

It is a large site with imposing ruins, abandoned and cruelly ravaged since the late 19th c. To the E it stretches from the left bank of the ech-Charrik, Ras-el-Aïn, and Bou Haïa, over the foothills of Jebel Fériana, covering an area more than 2 x 1.5 km and 5 km in perimeter. Today route GP 23 from Gafsa to Kasserine and the railroad run through the middle of it.

Settled close to an important spring, Ras-el-Aioun, the city seems to have been founded on a grid plan. Although no systematic excavations have ever been carried out to confirm it, the plan of the streets, the alignment of the toothing-stones of the ruined monuments, as well as aerial photography, all provide ample proof of a consistent NE-SW orientation.

Although travelers and scholars continually noted and described the importance of the site, scientific investigation has been slight.

Among the monuments is the Byzantine citadel, a rectangular structure (350 x 150 m) built of large blocks and fortified at the corners with square and round towers. It was probably built by Justinian in the heart of the ancient city (Procop. *De aed. Just.*), whose plan can be made out through the streets that intersect inside the fortress. Of the buildings excavated there the most important was at the SW corner, backed against the surrounding wall: a rectangular colonnaded building with a floor paved with mosaics and opus sectile, it was interpreted by some of the excavators as a praetorium and by others as a basilica. At the opposite end is another colonnaded monument, containing a well faced with mosaic.

Near the spring that supplies the city stand large baths, some of the most impressive and best preserved ruins on the site. Designed on a symmetrical plan, they are built of rubblework, their brick arches and pottery pipes still intact. The floors are paved with mosaics.

A building known as El Akhouat, because of its four columns with Corinthian capitals and carved corbels, was still standing not many years ago but has never been excavated. The columns apparently stood at the four corners of a great hall 8 m square.

NE of this monument, at the E end of the ruins, stood a basilica, presumed to be the Basilica of the Apostles, where the Council of 418 was held. It is oriented W and is built of a core of mortared rubble faced with small blocks. It has a quadratum populi of five naves measuring 51.8 x 25 m fronted by a portico 9 m deep and termi-

nating in a great apse paved with mosaic. The colonnade was decorated with Christian motifs.

Another large basilica to the N is oriented SE and measures 45 x 18.8 m. It too had five naves and an apse. A sarcophagus was found on its porch. Its floor was paved with slabs of stone and its roof was tiled. In addition to these two large churches, several other basilicas and chapels have been excavated. On an isolated mound 300 m from the SE corner of the citadel is a basilica constructed of reused ashlar; it measures 36 x 19 m with a central nave of 7 m and two lateral ones of 4.70 m. It has an apse and counter-apse, the former paved with a polychrome mosaic (now destroyed). In front of the church, which was roofed in wood and tile, was an atrium, probably porticoed.

Another basilica stood on the left bank of the tributary of the wadi Bou Haïa. Oriented NW and measuring 25 x 10 m, it has three naves and an apse paved in mosaic which contained an inscription now at the Bardo Museum in Tunis. The choir was also paved in mosaic with a martyrological inscription. Certain tombs found in the necropolis surrounding the basilica are covered with mosaics containing epitaphs.

There are three other basilicas; one, badly preserved, 200 m SW of the great Basilica of the Apostles, is built of reused materials. Facing N-NW, it measured 28 x 12.8 m with a framed apse measuring 4.15 m. The second, W of the citadel near the wadi Bou Haïa, was oriented SW and measured 21 x 11.6 m. It was built of ashlar and had three facade entrances with a portico in front opening onto a street. The third, NE of the city and measuring 29 x 11 m, was oriented SW. It was built of ashlar and had three naves.

To this list of basilicas should be added four chapels, more or less well preserved. The first, 200 m from the great basilica, measures 16.4 x 10.8 m and has three naves built of ashlar. The second is 150 m from the NE corner of the citadel to the E. The third is to be found 200 m NE of the great baths, and the fourth to the SW, on the right bank of the tributary of the wadi Fériana.

Several large quarries are situated at the S boundary of the city (Mokta El Bethouma). Two hundred m E of the N end of these quarries, near the road from Sbeïtla to Fériana, at the 200 km mark, a slave's collar was found. The outer surface was engraved with an inscription consisting of a line underlined in red giving the name of the wearer, who belonged to a centurion of the Constantine period (between 294 and 325).

On a hill 100 m from the Sidi Ahmed Tlili marabout, inside the old military camp, was excavated a large round basin (52 m in diameter and 1.5 m deep) fed by an aqueduct. A statue of a draped figure was found there.

In September 1899, when the road was being widened N of the site, a great semicircular apse measuring 3.35 m was discovered near the Thelepte station, at the point where the road forks toward Tébessa. It was presumed to belong to a basilica. An epigraphic text was engraved in the mosaic.

BIBLIOGRAPHY. P. Gauckler, *Basiliques chrétiennes de Tunisie* (1913) pls. xx-xxv; S. Gsell, "Edifices chrétiens de Thélepte et d'Ammaedara," *Rev. Tunisienne* (1932) 5-56. A. ENNABLI

THEMETRA (Chott Mariem) Tunisia. Map 18. Midway between Sousse and Hergla, along the ancient trail, now black-topped, which led from Hadrumetum to Carthage. Situated on a promontory overlooking the sea, the site, limited on the N by the wadi Temra and on the S by another ravine, is overrun by dunes. It is identified as Themetra by a base of the time of Antoninus Pius.

The site has not been officially excavated. One can see there the harbor moles, several cisterns, wells, and walls. Only one building has been uncovered to any great extent; it is a bath building rather well-preserved, veneered with marble and paintings, paved with mosaics, geometric and with figures, the most remarkable of which represents a marine scene: a sea with fish in it with a boat and fisherman, a bank with a resort dwelling, and in the midst, an immense head of Oceanus. Another mosaic is decorated with two large bowls from which flow scrolls of vine peopled with cupids harvesting grapes. In the center is a device showing Augeas and Herakles.

Another edifice, revealed by chance but not excavated, has resulted in the discovery of a room paved with mosaics decorated with twenty crowns of ivy, each one containing a figure or an object.

BIBLIOGRAPHY. L. Foucher, *Thermes romains des environs d'Hadrumète* (1958)[PI]; in *Antiquités Africaines* 1 (1967) 83-98. A. ENNABLI

THEMISKYRA (Terme) Pontus, Turkey. Map 5. A minor city in Amisene territory, in the district also called Themiskyra, ca. 60 km E of Samsun (Amisos). The district, traditionally associated with the Amazons, comprised the delta of the Yeşil Irmak (Iris fl.), an alluvial plain projecting more than 15 km out into the Black Sea (Pontos Euxeinos). At the E margin of this delta is a second river, the Terme Çayi (Thermodon fl.), on which the city lay. Themiskyra was besieged (perhaps destroyed) by Lucullus (71 B.C.) and must have had walls of some strength. No trace of these is known, but the site is presumed to lie beneath modern Terme, some 5 km from the river mouth. The Thermodon was navigable in antiquity up to the city, which lay on both sides of the river. D. R. WILSON

THÉNAC Dept. Charente, France. Map 23. The theater of Thénac is very close to Route Nationale No. 137, on the same side as the spot called Les Arènes and a little S of it; at Les Arènes can be seen a Roman wall, well built, made of mortared rubble faced with small blocks, which belonged to some unidentified monument. Partial excavations in 1828 discovered a theater of unusual plan: a semicircle that was split into five sections separated by vomitoria. It was not possible to dig farther at that time, so excavation was abandoned. Later the cavea wall was uncovered and not five but six sections were revealed, divided by as many vomitoria. Each section was made up of three semicircular balconies, joined together with the middle one projecting beyond those at each side. Also, the section at the outer rim of the general semicircle was divided radially in two, small balconies again being attached to the vomitoria walls towards the center of the semicircle. Curiously, the theater axis does not pass through a balcony but through the axis of the middle corridor.

Only one coin was found on the site, in the most recent excavations; it dates from the reign of Claudius II (268-70), which seems to indicate that the theater was still functioning just before the destruction of Saintes.

BIBLIOGRAPHY. Grenier III, 2 (1958) 851[P]; *Gallia* 25.2 (1967) 254; ibid. 27.2 (1969) 269-71[PI].
 F. EYGUN

THEODOSIA Bosporus. Map 5. Greek city occupying the Karantinnaia Hill area of the modern town of Theodosia (Feodosiia). It was founded by Miletian colonists in the second half of the 6th c. B.C., possibly on the site of a pre-Greek settlement. Theodosia emerged as a commercial rival of Pantikapaion in the E Crimea and, by the late 5th c. B.C., began to issue its own coins. In the first half of the 4th c. B.C., it was conquered by the Spartocid ruler Leucon I and incorporated into the Bosporan state. The city experienced its heyday as an international trading center in the 4th-3d c. B.C. when it exported to Greece huge quantities of Bosporan grain obtained from the enslaved natives of the surrounding areas. The harbor, at this time capable of accommodating up to 100 ships, rivaled that at Pantikapaion. The city probably suffered from the conflicts between the Bosporan state and the Crimean Scythians in the 2d c. B.C., and later in the century it was seized by rebellious slaves. After the forces of Mithridates Eupator ended the rebellion, Theodosia came under his rule but subsequently joined the revolt against him. The city was in part apparently destroyed ca. 2d c. A.D. but by the 3d c. had recovered. It survived the collapse of the Bosporan state in the 4th c. and became one of the early mediaeval Byzantine towns of the Crimea.

Although Theodosia is mentioned by many ancient sources (Strab. 7.4; Demos. *Lacrit.* 31-34; *Lept.* 33; Ulp. *Schol. a Demos. Lept.* 33; Arr. 30; Anon., *Peripl. Ponti Euxini* 77(51), 78(52); App. *Hist. Rom.* 12. 108) and was one of the major centers of the N Black Sea in ancient times, the only excavations at the site have been exploratory. These have been impeded by a thick mediaeval stratum as well as by modern buildings and construction projects. Most of the earlier finds from Theodosia were obtained by chance during the pre-1914 construction of a new harbor.

A necropolis containing burial mounds with many cremation graves of the 5th-4th c. B.C. was excavated in the mid 19th c.

BIBLIOGRAPHY. E. H. Minns, *Scythians and Greeks* (1913) 555-60; M. I. Rostovtsev, *Skifiia i Bospor* (1925) 251-53 = M. Rostowzew, *Skythien und der Bosporus* (1931) 227-30; N. S. Barsamov & A. Polkanov, *Feodosiia: Proshloe goroda i arkheologicheskie pamiatniki* (1927); I. B. Zeest, "Razvedochnye raskopki v Feodosii," *KSIIMK* 37 (1951) 185-90; id., "Raskopki Feodosii," *KSIIMK* 51 (1953) 143-48; D. B. Shelov, "Vozniknovenie Feodosii," *Numizmaticheskii Sbornik* 2 [Trudy Gosudarstvennogo Istoricheskogo Muzeia 26] (1957) 19-26; C. M. Danoff, *Pontos Euxeinos* (1962) 1131-32 = *RE* Suppl. IX; V. M. Korpusova, "Pro naselennia khory antychnoi Feodosii," *Arkheologiia* 6 (1972) 41-51.
 T. S. NOONAN

THEOTOKOU (Church of the Panaghia Theotokou) Thessaly, Greece. Map 9. Near the town of Kato Georgi, an ancient site at the SE corner of the Magnesian peninsula, just to the N of Cape Haghios Georgi (now Sepias). No ancient name is known for it. The site is at the seaward end of a dry wash valley with a steep hill (Kastro) to the S of it. At the site is a modern chapel dedicated to the Virgin. To the W of this are ruins and fragments of Doric columns. An ancient wall N of the chapel was uncovered. Fourth century B.C. column drums and a capital of limestone, originally covered with stucco, suggested a temple. To the S of the chapel the corner of a wall of polygonal masonry was found, and to the W of this a row of squared blocks, perhaps part of a foundation. Immediately S of the chapel was part of another wall and by it some fragments of painted terracotta antefixes of the 6th c. B.C. Black-glazed and Geometric sherds were found on the Kastro hill. Early Iron Age graves yielded vases, fibulas, etc. The foundations of an Early Byzantine basilica are near the modern chapel.

Some ancient remains (tiles, etc.) are reported from Kato Georgi.

BIBLIOGRAPHY. A.J.B. Wace, "The Topography of Pelion and Magnesia," *JHS* 26 (1906) 147f; id., "Addenda," *JHS* 28 (1908) 337; Wace & J. P. Droop, "Excavations at Theotokou, Thessaly," *BSA* 13 (1906-7) 309-27[PI]; Wace & M. S. Thompson, *Prehistoric Thessaly* (1912) 209-14[I] (Iron Age graves); A. S. Arvanitopoullos in *Praktika* (1906) 126f; (1910) 219; *AthMitt* 31 (1906) 369; E. B. Van Buren, *Greek Fictile Revetments in the Archaic Period* (1926) 63f; E. Kourkoutidou, *Deltion* 23 (1968) chron. 275[I] (early basilica, modern chapel, triglyph). T. S. MAC KAY

THERA (Santorini) Greece. Map 7. The island is one of the Greek Cyclades group. Its modern name appears during the mediaeval epoch, and is a corruption of Santa Irini. It is the most striking of the Greek islands, reduced to a half-moon shape by successive volcanic eruptions and earthquakes from prehistoric times to the present. According to the ancient sources Thera would have been first inhabited by Carians, then by Phoenicians, followed by Achaeans, Dorians, and Minyans. Scheria, the Homeric island of the Phaiakians, has been recognized in Thera; others identify it with the mythical Atlantis, destroyed according to legend by a gigantic cataclysm similar to that which must have hit Thera ca. 1520 B.C. The submarine earthquake would in fact have reached the island of Crete, where volcanic debris from Thera has been found. It largely destroyed the Minoan palaces, including that of Knossos, which was subsequently occupied by a new Achaean dynasty; and it caused a large part of the population to emigrate to the mainland.

The exploration of Thera, begun in 1845, was systematically carried on from 1895 to 1903, and has been resumed since WW II. A spot on the SW promontory, in the locality of Akrotiri, is held because of its geographic position to be probably the most ancient center of the island. There, sealed under a thick blanket of lapillus, have appeared the imposing remains of constructions of palatial character. They go back to a time contemporaneous with LM I, and attest the close ties of Thera with Crete. They were buried at the end of the 16th c. after an eruption that destroyed every trace of life and even changed the geographical aspect of the island. Another settlement of Minoan type has been discovered on the S coast of the small island of Therasia, which closes, on the N, the large gulf formed by the caving-in of the volcano which occupied the center of the island in prehistoric times.

At the beginning of the 1st millennium the Dorians landed at Thera, bringing the cult of Apollo Delphinios and Karnesios. They settled on a sheltered rocky highland on the sea, joined by a narrow ridge to mount St. Elias in the SE part of the island. Here they founded a city, built on a single axis to conform to the long narrow hill. Nothing remains of the most ancient city. Although the actual remains are almost all post-6th c., it is probable, given the peculiar geographic position, that the general plan of the primitive city coincided with the later plan and extended beyond it, from the spring of Sellada to the N to the religious zone to the S. This was closed by a vast temenos, inside of which rose the Temple of Apollo Karneios, the oldest sanctuary of the Dorian colony, perhaps datable to the 7th c.

The foundations of the temple were cut into the rock, while the upper part was built of breccia and mudbrick. The plan is unusual, resembling a house more than a temple. From the propylaeum, with two wooden columns in front of it the stone bases of which are still visible, one enters a square court on which open two rooms to the right, and to the left a pronaos communicating with the cella (7.3 x 12.15 m) cut into the rock. The cella communicates with two other rock-cut rooms which perhaps served as treasuries. Next to the temple, and sustained by a Cyclopean wall, is the terrace where the festivals of Apollo (Karneia) were celebrated. The interior rock walls and those of a small quadrangular room intended for offerings are covered by numerous dedicatory inscriptions. The most ancient of these go back to the 7th c. and are important in the history of Greek epigraphy.

Although there are many terrace walls from the archaic period, the most conspicuous remains of the city belong to the Ptolemaic period, when Thera became a powerful naval base. The road that crossed the entire inhabited area opens in the middle and highest part of its route into an agora with an irregular plan, ca. 20 m wide. Here other divinities were honored, including Athena Polias, perhaps Zeus, and later Dionysos. On the W side of the agora rose the basilike stoa, whose name perhaps recalls the Dorian kings, but which probably belongs to the Ptolemaic period. It has the form of a basilica, divided into two naves by a row of Doric columns. In the Roman period its N part was closed in to make a room where statues of the imperial family were kept, including Faustina the Elder, Marcus Aurelius, and Lucius Verus. A road to the W led to the barracks of the Ptolemaic garrison (275 B.C.) on the summit of the hill, which consisted of various rooms that could be approached from inside or outside the city. Beside the barracks was a building enclosed in a square court that has been interpreted as a gymnasium, although others claim that the construction is pre-Classical.

Between this building and the stoa were other constructions, among them one with a cistern, a potter's wheel, perhaps the Temple of Dionysos, and the Ptolomeion which Octavian, after the battle of Actium in 31 B.C., transformed into a Kaisareion. Beside the Roman baths, S of the stoa, is the theater, in which four building periods are recognizable between the late Hellenistic era and that of Tiberius. Near the portal of the theater was found a Hellenistic house with columns where the son of Ptolemy III Euergetes, who was brought up on Thera ca. 260 B.C., is presumed to have lived. In front of the theater, where the main road veers to the E, a lateral road goes W to a small square with a Sanctuary of Apollo, which has been transformed into a church. It also contained, among the rocks, the Ptolemaic Sanctuary of Isis, Serapis, and Anubis, probably hypoethral.

At the S extremity of the city is a building complex that has been identified as the gymnasium for young men because of inscriptions including lists and ephebic names, some still in archaic characters, and dedications to Hermes. The gymnasium is constructed in part on the rock and in part on an artificial terrace supported by three strong terrace walls. Still preserved is an archaic nucleus with a grotto dug into the rock and later transformed into a room. It is dedicated to Hermes and to Herakles. Later structures were added in the 3d c. B.C., including a rotunda with columns. At the center opens a roughly trapezoidal court.

At the N extremity of the city is the Sanctuary of Demeter and Kore, and a temenos dedicated by Artemidoros of Perge to various divinities, dating from the 3d c. B.C. The necropolis in use during archaic, Classical, and Hellenistic times is still being explored. It is at Sellada, on the NE slope of the hill, along the road that led to the port of Oia. The archaic tombs were pits containing cremation burials, with a simple cube on which was writ-

ten the name of the deceased serving as a funerary monument. In the Classical and Hellenistic tombs the ashes were deposited in vases. Notable among the rich finds are three kouroi from the end of the 7th c., painted local and imported pottery, and sculpted stelai from the 5th c.

Descending from Sellada toward Perissa one finds the remains of a heroon transformed into a sepulchral building during the early years of the Empire, and the ruins of a Byzantine convent. The remains of Byzantine fortifications are found N of the city. In the region of Akrotiri a temple from the 3d c. B.C. in white marble with a rectangular plan, dedicated to Thea Basileia, has been transformed into a chapel of St. Nicholas Marmarotis. Inside, before the door, a niche flanked by two columns on each side held the ancient cult image. A new museum was constructed at Thera in 1968.

BIBLIOGRAPHY. F. H. von Gaertringen et al., *Thera* (1899-1904); id., *RE* 5 A (1934) 2260-2302; id., *ArchEph* (1937) 48-66; id., *Klio* 33 (1940) 57-72; E. Pfuhl, *AthMitt* 28 (1903) 1-288; J. Braun, *De Thereor. rebus sacris* (1932); C. Anti, *Teatri greci arcaici* (1947) 114-19; N. M. Kontoleon, *ArchEph* 1939-41 (1948) 1-33; E. Fiechter, *Das Dionysos-theater in Athen, das Theater im Piraeius, das Theater auf Thera* (1950) 42-49; J. P. Droop, *Studies Presented to D. M. Robinson* (1951) 52-53; R. Martin, *L'urbanisme dans la Grèce antique* (1956) 82-83, 206; J. Delorme, *Gymnasios* (1960) 82-86; K. Orlandos, *Ergon 1961* (1962) 202-11; A. Giuliano, *Urbanistica delle città greche* (1966) 30-34; S. Marinatos, *Some Words about the legend of Atlantis* (1969); id., *Excavations at Thera* I, II, III (1968-70); id., *AAA* 4 (1971) 407-12. L. VLAD BORRELLI

THERA (Yerkesik) Turkey. Map 7. Small town in Caria 12 km SW of Muğla, part of the subject Rhodian Peraea. It was one of a chain of strongpoints held by Orontobates, the successor of the Hekatomnids, in 334-333 B.C.; the others were Myndos, Kaunos, and Kallipolis (Arr. *Anab.* 2.5.7). It is listed also by Ptolemy (5.2.16) and by Stephanos of Byzantium s.v. Thera was apparently a member of the Chrysaoric League (*IG* XII, 5.977). The site is determined by inscriptions found on the spot, but nothing remains apart from ancient stones and foundations unearthed by the local inhabitants.

BIBLIOGRAPHY. L. Robert, *Études Anatoliennes* (1937) 499; P. M. Fraser & G. E. Bean, *The Rhodian Peraea* (1954) 47-49, 72. G. E. BEAN

THERANDA (Prizren) Yugoslavia. Map 12. A Roman town ca. 76 km SW of Priština on the Bistrica river in the region of Kosovo and Metohija. It lay on the direct route from Lissos in Macedonia to Naissus in Moesia Superior. The town continued to exist during the 4th to 6th c. but was of far greater significance during the mediaeval period and was even capital of Serbia for a short time during the 14th c.

BIBLIOGRAPHY. E. Čerškov, *Les romains en Kosovo et Metohija* (1969). J. WISEMAN

THERAPNAI or Therapne Greece. Map 9. The site lay at the top of the bluffs beside the E bank of the river Eurotas, to the SE of Classical Sparta. Remains of a Late Helladic settlement have been found on the hill tops, but nothing of a palatial character. It has been suggested that the Homeric city of Lakedaimon was at or near Therapnai (Toynbee); others, however, argue that Lakedaimon in Homer means the country ruled by Menelaos, not the seat of his power (Hope Simpson & Lazenby).

A massive platform (16 x 23 m) built in the 5th c. B.C. supported an altar—and perhaps a temple—of Helen, who together with Menelaos was worshiped at Therapnai as a divinity. A temple at Therapnai is mentioned by Alkman (F 14 Page). The cult center was also called the Menelaion (Polyb. 5.18.3; 5.22.3). Helen of Therapnai may originally have been a Lakonian nature goddess (cf. Helen's tree: Theok. *Idyll* 18.47). Bronze, lead, and other votives found at the Menelaion show that a cult lasted from early Geometric times until the 4th c. B.C. Pindar in *Nemean* 10 associates the Dioskouroi with Therapnai, but they were less significant there than Helen and her husband.

BIBLIOGRAPHY. Hdt. 6.61; Isok. *Helen* 63; J. G. Frazer, *Paus. Des. Gr.* (1898) III.358-60; A.J.B. Wace & M. S. Thompson, *BSA* 15 (1908-9) 108-16; A. J. Toynbee, *JHS* 33 (1913) 246-47; F. Bolte, *RE* X (1934) 2350-65; F. W. Walbank, *A Historical Commentary on Polybius* (1957-) I.553; H. Waterhouse & R. Hope Simpson in *BSA* 55 (1960) 72-73; R. Hope Simpson & J. F. Lazenby, *The Catalogue of the Ships in Homer's Iliad* (1970) 74.
 G. L. HUXLEY

THERMA (Lutraki), *see* PERACHORA

THERMAI, *see* IKARIA

THERME, *see* THESSALONIKE

THERMAI HIMERAIAI (Termini Imerese) Sicily. Map 17B. The ancient settlement lies under the modern town, which is 39 km E of Palermo on the N shore of Sicily. Few ancient monuments are known, either because they were destroyed, like the forum, or because they lie under modern structures.

The Carthaginians, together with some Libyan volunteers, founded the city in 407 B.C., immediately after the destruction of Himera (Diod. 13.79.8). The area had been inhabited since the earliest prehistory, as shown by the numerous prehistoric caves which range from a rather early phase of the Paleolithic period to the Bronze Age. The best known of these caves is the so-called Riparo del Castello.

The city was presumably founded here because of the hot springs, already known in earlier times (Pind. *Ol.* 12). Its history is not easy to trace since the city shifted frequently from Greek to Carthaginian domination. Agathokles was born there ca. 361-360 B.C. and at that time the site was under Carthaginian control. It was conquered by the Romans during the first Punic war in 252 B.C., and from that moment, to judge from its monuments, it must have prospered. It became civitas decumana in 210 B.C. and colony at the time of Augustus. It had its own mint, both before and after the Roman occupation, and issued silver and bronze coinage.

We have information on, as well as actual remains of, many monuments of the Roman period but none for earlier times. The rather large forum (130 x 18.4 m), near the present Duomo and Belvedere, consisted of an open square; remains of columns and steps of exedrae have been found. In the Palmieri garden are remains of a large building, perhaps the curia. Other ruins have been found in other parts of the city, among which a mosaic floor depicting a fishing scene, probably dating from the Antonine period. The most important monuments known at present are the amphitheater and the aqueduct. The former is very poorly preserved, but since it was studied during the 19th c. its main details are known. The amphitheater (87 x 58 m) had two sections of seats each containing 14 rows of steps; it could therefore accommodate ca. 4000 spectators. The arena was 51 by 27 m. Impressive remains of the aqueduct, perhaps the largest in Sicily, lie outside the city, partly

along the road to Caccamo and partly near the Palermo-Catania highway. These are two branches of a single aqueduct which brought water to Termini from two different sources; the major spring is that of Brucato, ca. 8 km distant. Worthy of note are a hexagonal tower which served as a castellum aquae, and a few arches, some single and some in two superimposed rows, scattered through the fields. The aqueduct, at least in its initial phase (it remained in use until 1860) dates from the end of the 2d or the beginning of the 1st c. B.C. This date is suggested by an inscription once in evidence on the hexagonal tower but now lost.

Most of the finds from the area, including the Fishing Scene mosaic, various sculptures and numerous inscriptions, are in the Civic Museum of the city; some items are in the National Museum of Palermo.

BIBLIOGRAPHY. V. Tusa, "Restauri all'Acquedotto Cornelio di Termini Imerese," *BdA* (1953) 270ff[PI]; G. Meli, "Nuove 'facies' del paleolitico in Sicilia," *Quaternaria* 5 (1962); N. Bonacasa, *Museo Civico di Termini Imerese —Sculture romane inedite* (1960). V. TUSA

THERMAI PHAZEMONITON (Havza) Pontus, Turkey. Map 5. A spa in the territory of Neoclaudiopolis, 31 km SE of Vezirköprü, where the hot springs still exist. There are no remains. Inscriptions attest repairs by a 2d c. A.D. ἀστυνόμος and dedications to Asklepios and to the Nymphs of the springs.

BIBLIOGRAPHY. J.G.C. Anderson et al., *Studia Pontica* III.1 (1910) 37-46. D. R. WILSON

THERMOPYLAI Greece. Map 11. A locality on the S side of the Malian Gulf, named partly for the presence of a hot mineral spring. By more ancient usage it was known simply as Pylai, the Gates, a name describing its situation at the narrowest point of the mainland route from the N into central and S Greece. At some time in the post-Mycenaean period, it became the seat of the Pylaian Amphictyony, a religious assembly of representatives of the Greek-speaking tribes around the Malian Gulf. This body later became famous under the less accurate title of Delphic Amphictyony, but even in the 3d and 2d c. B.C., when its membership consisted largely of proxies for external powers situated far from the original place of assembly, the more official name, and the ostensible pattern of membership, continued to reflect the early tribal settlement of the region around the Malian Gulf.

The Pylaian Amphictyony was a natural focus for the resistance to the Persian invasion of 480 B.C., and the famous Spartan defense of the pass on the Kolonos hill, at the narrowest point of the Gates, was probably influenced by religious as well as tactical considerations. The Gates were again the site of significant military actions against the Gauls in 279, and against the Romans in 191 B.C. They continued to be important in Byzantine and even in modern military planning.

The locality has three main foci of interest: the pass itself, the Shrine of Demeter at Anthela, where the Amphictyonic council met, and the numerous fortifications associated with the defense of the pass. The pass, through which the road at this point ran W-E, lay between the steep slopes of the mountain to the S and the shore of the Malian Gulf to the N. The extensive silting of the gulf has now made this an easy passage, but in antiquity the sea came close to the mountains at three points, and Herodotos called each one a gate. The site of the Spartan defense is the farthest E; it is marked by a modern monument in a place that may well have been under water in antiquity. The monument faces the semi-isolated Kolonos hill where the Spartans stood. Inland from here are the remains of a rough zigzag, identified as the wall built by the Phokians as a defense against the Thessalians (Hdt. 7.176). A structure at the SW end of this wall, which had been identified as a polyandrion, seems rather to be a part of the defense work. Burials have been found on and around the hill, also some evidence of habitation, but the most significant discovery was a large number of bronze arrowheads that could be identified with Persian armament. Most of the finds are in the museum at Lamia.

Traces of the Pylaian Sanctuary of Demeter at Anthela (Hdt. 7.200) were discovered in the foothills S of the road, ca. 2.5 km W of the Kolonos. The only identifiable monuments are a stoa and a stadium, the latter of rough construction built into a natural depression in the limestone. Of interest is the special construction at the W end of the stadium designed to keep the winter rains from washing out the floor. No traces of the Demeter shrine itself have yet been found.

BIBLIOGRAPHY. Stählin's article in *RE* is still the best overall source. Further details and new interpretations appear in the articles by Pritchett and MacKay, where some additions to Stählin's references may be found. Nearly all the more important 19th and early 20th c. travelers visited Thermopylai, and nearly all have something to contribute. The most significant accounts, by Leake and Grundy, are noted below, and a discussion of some of the others occurs in MacKay. Béquignon and Marinatos provide the only significant evidence from excavation.

W. M. Leake, *Travels in Northern Greece* II (1835) 23-65[M]; G. B. Grundy, *The Great Persian War* (1901) 257-317[MI]; F. Stählin, "Thermopylen," *RE* 2d ser. V, 2 (1934) 2398-2423[M]; Y. Béquignon, "Recherches archéologiques dans la vallée du Spercheios," *RA* Sér. 6, 4 (1934) 14-33[MI]; id., *La Vallée du Spercheios, Bibl. Ec. franc.* 144 (1937) 181-204 & passim[MI]; W. K. Pritchett, "New Light on Thermopylae," *AJA* 62 (1958) 203-13[I]; id., *Studies in Ancient Greek Topography* I (1965) 71-82[I]; P. A. MacKay, "Procopius' *De Aedificiis* and the Topography of Thermopylae," *AJA* 67 (1963) 241-55[MI] (includes unexcavated peripheral fortifications).

P. A. MACKAY

THERMOS Aitolia, Greece. Map 9. Located on a mountain plateau above the NE end of Lake Trichonis, 34 km from Agrinion, near the modern village of Kephalovryso, the site was settled in the Late Bronze Age. Described as place or topos (Polyb. 5.7.8), the Classical site was the center of Aitolian worship and the meeting place of the Aitolian League, where annual magistrates were elected and large market fairs held (Polyb. 5.8.4ff). Some time after the invasion by Antipater and Krateros in 323 B.C. the site was organized in its present form as a fortified temenos. Twice ravaged by Philip V of Macedon, in 218 and 206 B.C. (Polyb. 5.9; 11.7.2), the site continued in use until the reduction of the League in 168 B.C. and perhaps longer. This is attested by a number of inscribed monument bases of the 2d c. B.C. found within the temenos. The discovery of graves of the 1st c. B.C. over some of the public buildings indicates that the site was no longer the League center at this time.

Excavations have uncovered a large temenos 340 m long and 200 m wide, laid out at the base of Mt. Mega Lakkos. It is enclosed on three sides by a massive fortification wall with square towers at intervals of 42 m. The main entrance to the enclosure, guarded by two round towers, lies at the SW corner. A second smaller entrance lies near the NE corner of the temenos. Within the enclosure near the main entrance is a long stoa facing N, which runs parallel to the S peribolos wall at a distance

of 35 m from it. Only partially excavated, the stoa has buttressed foundations along the S side, eight columns across the narrow E and presumably also across the W end. To the SE of the stoa near the SE corner of the enclosure is a large rectangular building 20 x 26 m with a three-stepped crepidoma and a broad porch on the N side. Although the interior is as yet unexcavated, the building has been identified as the meeting house or bouleuterion of the League. In front of the porch is a row of statue and stelai bases. A broad avenue 25 m wide, framed to E and W by long stoas, extends N from the bouleuterion. The E stoa, which runs along the base of the mountain slope, is 173 m long with Doric columns across the W face. Behind the stoa to the E is a strong retaining wall, and between wall and stoa were found many roof tiles and terracotta antefixes. The W stoa is ca. 185 m long with buttressed rear wall, Doric columns on its facade, and bases for an interior colonnade. In front of both stoas are many monument bases of primarily 3d c. B.C. date, undoubtedly those destroyed by Philip V in his two attacks on the site. Near an exedra located before the middle of the E stoa were found six fragments of a trophy commemorating the victory of the Aitolians over the Gauls in 279 B.C. The fragments preserve elliptical shields, tasseled cloaks, and armor. Pausanias (10.18.7) describes a similar monument depicting armed Aitolia erected at Delphi. Just N of the W stoa there is a small fountain in polygonal masonry built about a natural spring. At the N end of the long avenue near the NE quarter of the temenos is the Temple of Apollo Thermios. The identification is known from an inscribed bronze stele found beneath the floor, a record of a treaty between Aitolians and Acarnanians to be set up within the temple. Oriented N-S, the temple is Doric peripteral with 5 x 15 columns. The stylobate and lowest drums of eight columns are preserved intact. The cella consists of a long narrow naos without pronaos, and opisthodomos. A single row of columns runs down the central axis of the cella. Since no fragments of a stone superstructure were found, the entablature must have been of wood, the cella walls of mudbrick. Among the reused blocks incorporated into the foundations was a fragmentary inscription of the mid 3d c. B.C., which thereby dates the temple in this form to the latter part of the century, presumably after Philip's second sack in 206 B.C. The 3d c. temple represents a remodeling of an earlier temple having the same plan and dimensions, also of mudbrick and wood on stone foundations. Part of the foundations were incorporated into the W pteron of the later structure. To this earlier building belongs an elaborate series of terracotta revetments found scattered about the temple site. These include roof tiles, simas, at least two series of antefixes decorated in relief with human busts, a sphinx acroterion and 10 fragmentary metope plaques with painted representations. The plaques are less than a m in height or in width, with two tangs projecting from the upper edge for socketing into the overlying cornice. Decoration is confined to the center of the plaque, framed on two sides by a broad border of painted rosettes. Among the representations are Perseus with the head of Gorgo, a hunter (Herakles ?) with boar and fawn, and Chelidon and Aidon about to dissect Itys. The pictorial style of the metopes indicates that the building was erected late in the 7th c., ca. 630-610 B.C. It is therefore one of the earliest developed Doric temples known and a monument of primary importance for our knowledge of the history of Greek architecture. The second, more advanced series of antefixes with bearded men and silenes attest to a partial remodeling of the roof in the second half of the 6th c. B.C. Generally considered to be a product of Corinthian workmanship, the temple is more probably a product of local workshops, perhaps under Corinthian influence. The metopes are inscribed in a mixed alphabet which may well be Aitolian and are executed in local clay. The simas, moreover, are crowned with antefixes in a manner unknown to date at Corinth. Beneath the archaic temple is a still earlier building of Geometric date, the so-called Megaron B, a long three-roomed structure with slightly different axis, surrounded by an elliptical colonnade. Although often identified as a chieftain's house, the building enclosed thick layers of ash, containing burnt animal bones, pottery, and several bronze votive statuettes, and it was undoubtedly also a temple. Beneath Megaron B and to the N of it were found several houses of Late Mycenaean date, part of the earliest settlement which occupied the site. Immediately E of the Hellenistic temple is a retaining wall incorporating reused blocks from a Doric stoa, as a fragmentary inscribed epistyle reveals. Nearby to the E is a smaller temple, a small rectangular cella with double colonnade across the S facade, identified by an inscription found nearby as that of Apollo Lyseios. Painted terracotta metopes found within the temple with representations of the Charites, Iris, and the Centaur Polos, may belong to its original construction in the late 7th c. To the NW of the main temple near the NE entrance to the temenos is a small, poorly preserved structure tentatively identified as a Temple of Artemis. To it have been assigned several architectural revetments. A few isolated foundations were uncovered outside the temenos to the SE. Best preserved is a small fountain possibly of the 3d c. It is well built in ashlar masonry with five spouts and is fed by a terracotta drain from a source within the sanctuary.

Most of the finds from the excavations are located in a small museum on the site. A few of the best preserved metopes and roof tiles are in the National Museum of Athens.

BIBLIOGRAPHY. G. Soteriades, *Praktika* (1897) 18-21; (1898) 104-10; (1899) 57-66; (1901) 34-37; (1902) 49-52; id., "Anaskaphai en Thermo," *ArchEph* (1900) 161-212; (1903) 71-96; (1905) 55-100; id., "The Greek Excavations at Thermos," *Records of the Past* I (1902) 172-81; G. Kawerau & Soteriades, *AntDenk* 2.5 (1902-8) 1-8, pls. 49-52a; K. Rhomaios, "Erevnai en Thermo," *Deltion* 1 (1915) 225-84; 2 (1916) 179-89; id., *Praktika* (1931) 61-70; H. Payne, "On the Thermon Metopes," *BSA* 27 (1925-26) 124-32; L. H. Jeffery, *Local Scripts of Archaic Greece* (1961) 225-27; H. Drerup, "Zu Thermos B," *Marburger Winkelmann-Programm* (1963) 1-12.

N. BOOKIDIS

THEROUANNE, see TERVANNA

THÉSÉE, see TASCIACA

THESPIAI Boiotia, Greece. Map 11. An ancient city situated between Thebes and Mt. Helikon, on the right bank of the Thespios (Kanavari) at the foot of the twin hills on which are the villages of Thespiai (formerly Erimokastro) and Leondari (formerly Kaskaveli).

Inhabited from Neolithic times, Thespiai played an important part as a trading center in the Mycenaean era, thanks to its port Kreusis. Seven hundred Thespians fought in the ranks of the Greeks at Thermopylai in 480 B.C., and Xerxes razed the city. It was rebuilt by Athens, which provoked the lasting hostility of Thebes. From 447 to 423 Thespiai headed two of the 11 Boiotian districts; they included the Sanctuary of the Muses, Eutresis, Leuktra, Kreusis, and three independent cities from 338: Thisbe and the ports of Siphai and Chorsiai. The city lost many men at the battle of Delion in 424. Thebes razed the ramparts of the city in 423; the Spartans rebuilt them after 386, and in 371 Epaminondas made

Thespiai a kome of Thebes. At his death (362) the city was restored, minted coins, and in 338 became one of the first cities of the new Boiotian Confederacy. From then on it remained prosperous until the Late Empire. The Attalids of Pergamon endowed it handsomely; the city enjoyed good relations with Macedonia, then with Rome which granted it the status of civitas libera et immunis (47 B.C.). Thespiai organized the Panhellenic festivals and contests in honor of the Muses (Mouseia) and Eros (Erotideia).

The ancient city, which was excavated in the 19th c. has almost completely disappeared. S of the Kanavari river was a Byzantine surrounding wall (Kastro) whose demolition yielded more than 400 inscriptions and reliefs, some statues and architectural fragments (in the Thebes Museum and the National Museum). In the Kastro was discovered the Temple of the Muses (16.80 x 35.60 m) mentioned by Pausanias. The remains of a Temple of Apollo dating from the 5th c., a peripteral building with slender columns, were uncovered 2 km to the SW. To the E of the Kastro, on the Leuktra road, stood the great limestone lion on which the Lion of Chaironeia was modeled. The lion dominated a rectangular peribolos (32 x 23 m) within which were found a large number of cremated bodies, 5th c. vases, terracottas, and bronze and iron objects. In front of the lion were nine aligned stelai bearing the names of 102 Thespians who fell at the battle of Delion (424), as well as a paved pathway lined with tombs.

Twelve km to the S in the Livadostro bay was the port of Thespiai, Kreusis. It was protected by a 4th c. fortress; the rampart, which is built in regular courses, has several square towers and an older round tower at the top. At the E end of the bay of Domvraina is the port of Siphai (Aliki) whose fortress, built on a steep rock, is well preserved. At the summit (Mavrovouni) of the coastal chain, on the road from Thespiai to Siphai, is a square 4th c. tower; close by, inside a surrounding wall of partly polygonal masonry are the remains of an archaic temple, possibly dedicated to Artemis Agrotera. The port of Chorsiai (Paralia) is farther W, 8 km S of Thisbe on the bay of Sarandi; overlooking it is a fortress built on a rocky spur that runs down from Mt. Helikon. N of the fortress are the foundations of a Temple of Hera mentioned in an inscription.

BIBLIOGRAPHY. P. Stamatakis in *Praktika* (1883), 65-74[PI]; P. Jamot in *BCH* 15 (1891) 659-60; 18 (1894) 201-15[I]; 19 (1895) 321-385; A. Kéramopoullos in *Praktika* (1911) 153-63; G. Rodenwaldt, "Thespische Reliefs," *Jahrbuch* 28 (1913) 309-39; *En Grèce* (1914); G. de Ridder in *BCH* 46 (1922) 217-306[I]; W. A. Heurtley in *BSA* 27 (1923-24) 38-45; Fiehn in *RE* (1936) s.v. Thespeia; P. Roesch, *Thespies et la Confédération béotienne* (1965)[MPI]; N. Papahadjis, *Pausaniou Hellados Periegesis* v (1969) 162-72, 187-90[MI]; J. M. Fossey & R. A. Tomlinson, *BSA* 65 (1970) 243-63[PI]. P. ROESCH

THESSALONIKE (Thessaloniki), Greece. Map 9. At the N end of the Thermaic Gulf, probably on the site of Therme. Founded ca. 316 B.C. by Kassander as a result of a synoecism of 26 local cities, and so called after his wife, Alexander's sister. It owed its existence and continued prosperity to the fact that it lay at the Aegean end of the route to Central Europe via the valleys of the rivers Axios (Vardar) and Morava. It became the capital of the Roman province of Macedonia in 146 B.C., received the neocorate under Gordian III (A.D. 238-44), was made a colonia in the reign of Decius (A.D. 250), and in the mid 5th c. became the seat of the prefects of Illyricum. It suffered various vicissitudes in

the Middle Ages, including capture by Saracens and Normans, before falling to the Turks in 1430 and to the Greeks in 1912.

The foundations of an archaic Ionic temple of ca. 500 B.C., presumably belonging to Therme, were found before the Second World War S of Government House, and its disiecta membra have been found elsewhere since then.

The regular plan, which has survived in part down to the present, was probably laid out at the time of the city's foundation, and it has close parallels with the plans of other Hellenistic cities, especially in the proportions of the insulae (some 100 x 50 m). The site of the archaic temple very likely continued as a sacred area through Hellenistic times into Roman. But the only Hellenistic cult center whose site is definitely known is the Serapaion in the W of the lower city, which was excavated in 1917, though never published. There was a gymnasium in the N of the city at least from the late Hellenistic period, if not before, and a nearby stadium (once to be seen S of the basilica of St. Demetrius) probably went back to Hellenistic times as well. The Hellenistic fortifications probably followed the lines of the later walls, and Hellenistic tombs have been found outside the city in the area of the Roman cemeteries.

Very little is known about earlier Roman buildings. Cicero, who spent some of his exile at Thessalonike, mentions the Quaestorium and also refers to the inhabitants seeking refuge from invading Thracians in the citadel. Inscriptions have been found referring to the imperial cult, and the center of emperor worship was probably near where the archaic temple had stood, for some imperial portrait statues have been found there.

A remarkable feature of the Roman period is the building activity that went on in Antonine and Severan times, probably as a result of rivalry with neighboring Beroia. An arch of ca. A.D. 150 stood until 1874 at the W end of what was the principal artery of the Roman city (the so-called Via Egnatia; the name is in fact a misnomer). An agora of the Antonine or Severan period has been found in Plateia Dikasteriou in the upper city. It occupied two insulae, was surrounded by stoas, and had an odeum to the E (modified in the Tetrarchic period). Along the S side there was a cryptoporticus, and steps led down to a further open space to the S, the extent of which is unknown. Nor do we know the original position or the precise function of the "Incantadas," a mid 2d c. colonnade surmounted by piers decorated in high relief with figures of Ganymede, a Dioskouros, Aura, and Nike on one side, and Leda, Ariadne, Dionysos, and a maenad on the other (the sculpture was removed to the Louvre in 1864). A small trapezoidal exedra of Antonine date can still be seen on Odos Egnatia. Not far from the Acheiropoietos basilica Roman house walls, a colonnade, and a large drain have been found, and a Roman mosaic floor still exists inside the basilica itself. Large mosaics of Ganymede and of Dionysos and Ariadne were found in 1965 on Odos Sokratous. The threat of attacks by the Goths in the middle years of the 3d c. was met by the construction of a city wall replacing the Hellenistic fortifications.

At the turn of the 3d and 4th c. A.D., a large Tetrarchic palace was built on the city's E edge, and it probably stretched from the sea to a point some 800 m inland. The width of the palace area was ca. 200 m. Surviving structures include part of an arch decorated with sculptured panels built to commemorate Galerius' victories over the Persians, and a rotunda which was probably intended for his mausoleum, although it was never used as such. Foundations of an octagon some 30 m in diameter were found in 1950, a courtyard of the palace was

discovered during the 1960s, and enough stretches of the hippodrome have been found to show that the length of the running track was just over 400 m.

There was a great deal of building in the mid 5th c. The seat of the prefects of Illyricum had been at Sirmium, but in the face of the threat presented by the Huns it was moved to Thessaloniki in 441-42. The city had to be defended and given suitably prestigious public buildings. Thus new city walls were built, incorporating marble seating blocks from the hippodrome in their foundations. Churches also were built, including the Acheiropoietos basilica, the first basilica of St. Demetrius (whose cult was brought from Sirmium), and a basilica some 100 m long found recently underlying the 8th c. Aghia Sophia. The foundations of its hexagonal baptistery are visible to the S. To the same period (mid 5th c.) belong the conversion of the Tetrarchic rotunda into a church (since 1912 the church of St. George) and the decoration of its cupola with mosaics.

The E and W walls are some 1,800 m apart and the acropolis is the same distance from the sea. The Istanbul Archaeological Museum houses the principal antiquities found in the area before 1912; subsequent finds are kept in the Thessaloniki Archaeological Museum.

BIBLIOGRAPHY. O. Tafrali, *Topographie de Thessalonique* (1913); E. Hébrard, "L'Arc de Galère et l'église St Georges de Salonique," *BCH* 44 (1920); H. von Schoenebeck, "Die Stadtplanung des römischen Thessalonike," *Bericht über den 6. Internationales Kongres für Archäologie* (1940); Ch. Makaronas, *Makedonika* 1 (1940); 2 (1953); id., Τὸ ὀκτάγωνον τῆς Θεσσαλονίκης, *Praktika* (1950); id., "Via Egnatia and Thessalonike," in *Studies Presented to D. M. Robinson* (1951) I; id., Ἡ Καμάρα, τὸ θριαμβικὸ τόξο τοῦ Γαλερίου στὴ Θεσσαλονίκη (1969); G. & M. Soteriou, Ἡ Βασιλικὴ τοῦ Ἁγίου Δημητρίου Θεσσαλονίκης (1952); E. Dyggve, "La région palatiale de Thessalonique," *Acta Congressus Madvigiani* I (1958); L. Guerrini, "'Las Incantadas' di Salonicco," *Archeologia classica* 13 (1961); G. Bakalakis, "Therme-Thessalonike," *AntK* Beiheft 1 (1963)M; id., "Vorlage und Interpretation von römischen Kunstdenkmälern in Thessaloniki," *AA* (1973); P. Papadopoulou, *Deltion* 18 (1963); 19 (1964); P. Drossoyanni, *Deltion* 18 (1963); M. Karamanoli-Siganidou, *Deltion* 20 (1965); 25 (1970); Ph. M. Petsas, *Deltion* 21 (1966); 22 (1967); (1968); M. Vickers, "The Date of the Walls of Thessalonica," *Istanbul Arkeoloji Müzeleri Yilligi*, 15-16 (1969); id., "The Date of the Mosaics of the Rotunda at Thessaloniki," *BSR* 35 (1971); id., "A Note on the Byzantine Palace at Thessaloniki," *BSA* 66 (1971); id., "Hellenistic Thessaloniki," *JHS* 92 (1972)P; id., "Further observations on the date of the walls of Thessaloniki," *Makedonika* 12 (1972); id., "The Hippodrome at Thessaloniki," *JRS* 62 (1972); id., "Observations on the Octagon at Thessaloniki," ibid. 63 (1973); id., "Epilegomena to *IG* x, 2, 1," *JHS* 93 (1973); id., "Fifth century brickstamps from Thessaloniki," *BSA* 68 (1973); id., "Where was Procopius' Therme?" *CR* NS 24 (1974); id., "Sirmium or Thessaloniki? A critical examination of the St. Demetrius legend," *ByzZeit* 67 (1974); G. Gounaris, Παρατηρήσεις τινὲς ἐπὶ τῆς χρονολογίας τῶν τειχῶν τῆς Θεσσαλονίκης, *Makedonika* 11 (1971); B. Brenk, "Spätantiker attischer Sarcophag in Saloniki," *JOB* 21 (1972); St. Pelekanides, 'Τὸ θέατρον τὸ καλούμενον στάδιον' τῆς Θεσσαλονίκης, ΚΕΡΝΟΣ, *Festschrift Bakalakis* (1972); C. Edson (ed.), *IG* x, 2, 1 (1972); id., & G. Daux, "*IG* x, 2, 1: Prolegomena, Epilegomena," *BCH* 98 (1974); J.-M. Spieser, "Note sur la chronologie des remparts de Thessalonique," *BCH* 93 (1974).　　　　M. VICKERS

THEVESTIS (Tebessa) Algeria. Map 18. The Merdja plain is a corridor between the high plains of the Constantinois and the Tunisian steppe. To the S the Merdja plain is bounded by a mountain chain which rises to more than 1,500 m. The urban center of Thevestis was situated at its foot on an ancient alluvial cone. The only irregularity in the terrain is provided by the very narrow bed which the wadi Zarour cuts into the gravel.

Human occupation of the region around Tebessa began at a very early date. The Acheulian locality of El ma el Abiod, the Aterian site of Bir el Ater, and numerous Capsian remains attest to the antiquity of human settlement. Texts of Diodorus and Jerome seem to suggest the existence of a pre-Roman town. This is often identified with the Hecatompylus of Polybios and Diodorus, which is supposed to have given 3,000 hostages to Hanno.

At the beginning of the 1st c. A.D., the Third Augustan Legion, which was charged with pacifying the S part of the province of Africa, had its camp at Ammaedara (Haïdra in Tunisia, a short distance from the frontier). This town became a colony in the Flavian period. It is thought that Thevestis then became the residence of the legate and his legion. This would explain the presence of many inscriptions about soldiers and the administrative role which Thevestis retained after the legion set up its camp farther W at Lambaesis, either in the reign of Titus or at the beginning of the 2d c.

After the legion left, the town was raised to the rank of colony. It was also the capital of an administrative and estate district, for numerous imperial domains existed in the area. They were connected either with the domains in the countryside around Hippo or with those near Hadrumetum, and were run by a procurator. A whole bureaucracy of freedmen and imperial slaves, as well as augustales, appears in the funerary inscriptions of the town.

From the time of the synod of Carthage in 256, Thevestis had a Christian community and a bishop. The acts of the martyrs Maximilian and Crispina attest to persecutions there at the beginning of the 4th c. Possibly, the great Christian basilica in the N necropolis was built in honor of Crispina and her colleagues.

The Vandal presence is indicated by various funerary inscriptions and also by wooden tablets and the ostraca found in the region, both to the SE and in the Nementcha hills.

Like the nearby center of Ammaedara, Thevestis seems to have recovered military importance with the Byzantine reconquest. A very large enclosure was built by the general, Solomon. Under its ramparts he engaged the natives of the region in combat and emerged victorious. The town preserved a certain importance after the reconquest. Arab geographers from the 11th to the 14th c. mention it many times.

The extent and plan of the ancient town are poorly known. Certain monuments have been restored or excavated and can help us establish an impression of the colony. The modern town has, in effect, occupied both the interior of the Byzantine fortress and the built-up area of the 1st to the 5th c. The forum seems to have been in the middle of what became the fortress; a theater had been built not far away. Over the last few years an amphitheater on the left bank of the wadi Zarour has been uncovered. It was enlarged and remodeled several times. The original building could well go back either to the beginning of the colony or to the time of the presence of the Third Augustan Legion. The oval construction (about 86 x 80 m) was made of seats placed directly on the ground by means of cut and fills. The

monument was greatly altered either at the end of the 3d c. or during the 4th c. The wall of the podium dates to this period; on it ran a balustrade on which one can read the names of the leading families of the town. During the 5th c., or later, after the reconquest, the amphitheater was used for habitation.

A temple, mistakenly attributed to Minerva, is almost perfectly preserved within the Byzantine walls. The cella has preserved its exterior decoration: pilasters, frieze, and an attic decorated with marble columns. Not far away stands a four-sided arch built under Caracalla in 214.

Farther N stands the great Christian basilica, excavated and restored in the last century. It is placed within a large rectangular enclosure reinforced by towers on the inside. A large garden preceded a monumental staircase. This went up to an atrium which led to the church proper, a three-aisled structure with galleries. Paving of geometrical mosaics has been preserved. To the right a staircase led down to a large trefoiled room, apparently a martyrium: excavations have uncovered an inscription about a group of martyrs. In the vicinity of the basilica within the enclosure, there were other buildings: a baptistery, a smaller basilica, and a huge stable above which, on the second floor, there may have been an inn. Recent work permits one to affirm that the date of this group of buildings must be the beginning of the 5th c.

As for the Byzantine fortress, it has the shape of a rectangle, 320 x 280 m. It is built of large-scale ashlar and is reinforced with rectangular towers at the corners and upon the fortified curtains. One of these towers included the Arch of Caracalla. The whole is relatively well preserved and restored. Mosaics, inscriptions, and various artifacts are in the Temple of Minerva. Other inscriptions are collected either in an epigraphical garden or in the gardens of the Christian basilica, which with its associated structures belongs to a uniform program conceived and executed about A.D. 400. It was intended primarily as a shrine for pilgrims and secondarily as a monastery.

Near the town is another large site, which has been partially excavated: Tebessa Khalia. It consists of a complicated group of buildings: large trefoiled rooms, an oil works, a round temple, public baths; to these is added a huge rectangular enclosure. The monuments and pieces of decoration discovered apparently belong to the end of antiquity.

BIBLIOGRAPHY. A. Ballu, *Le monastère byzantin de Tebessa* (1897); S. Gsell, *Les monuments antiques de l'Algérie* (1901) esp. I 133-37, 179-85; II 265-91, 354-57; *Le musée de Tebessa* (1902); *Atlas archéologique de l'Algérie* (1911) 29, no. 101; L. Leschi, *Etudes d'épigraphie, d'archéologie et d'histoire africaines* (1957) 117-31; R. Lequément, "Fouilles à l'amphithéâtre de Tebessa," *Bulletin d'archéologie algérienne* 2 (1967) 105-22; P.-A. Février, "Nouvelles recherches dans la salle tréflée de Tebessa," *Bulletin d'archéologie algérienne* 3 (1968) 167-91; J. Christern, "Il complesso cristiano di Tebessa, architettura e decorazione," *Corsi di cultura sull'arte rav. e biz.* (1970) 103-17. P.-A. FÉVRIER

THIBILIS or Tibilis (Announa) Algeria. Map 18. Situated 18 km SW of Calama, this village was built on a narrow, mountainous stretch 700 m high. It was probably part of the confederation of Cirta entrusted to Sittius by Caesar and then linked again to Numidia. The chief place of the district, it became a municipium in A.D. 305 at the latest and was perhaps elevated to the status of colony in the 4th c.; seat of a bishop in the 5th.

Although the town was only partly excavated from 1903 to 1909, numerous structures are evident: forum, gates and arch, temples (one of which, the capitol, is in the S part of the village), and a Byzantine fortress, but the whole gives the impression of an important village; it appears to have had neither theater nor even public baths. Most of the objects collected are preserved in the Guelma Museum.

The town opens to the S through an arch with two openings, exceptional in Africa (12.9 m in width) and probably dating from the end of the 3d c.; a large street bordered with porticos passed under a triumphal arch with one opening, total breadth 10.9 m; the opening is flanked by two pair of projecting parts formed of columns, each one resting on an independent raised pedestal. There is another gate with one bay to the E.

The forum is trapezoidal in form (27 m, 12.15 m, 9.7 m); access to it was from the main street by two arches without archivolts which could be closed by grilles. Paved with sandstone, this area did not have elaborate structures but was partly bordered by porticos. A neighboring hall was probably the curia.

Near the arch of triumph was found a public building with apse and court which is difficult to identify: basilica or market? In the N quarter there was a small rectangular market (13 x 15.7 m), where was found an interesting table of linear measures.

One of the excavated houses is particularly interesting because it belonged to the family of the Antistii, of whom two members became consuls under Marcus Aurelius and Commodus. A central part with four columns led into the neighboring rooms (a sort of atrium) and contained an interesting altar to the household guardian. One part of half-moon shape, enclosing a fountain of the same form, was undoubtedly decorated with a peristyle.

To the S of the town is a Christian basilica (19.6 x 13.15 m), rather indifferently built. The nave has a floor of beaten earth, and the aisles are paved. A second basilica, situated NW of the town, also occupies an elevated position. The church measures 14.3 x 12.3 m and includes a nave and 2 aisles with a ciborium and a rounded apse; the whole is paved. These two basilicas are probably of the Byzantine period. A chapel has also been found in the N quarter in the midst of some altered dwellings; it opens on the R side wall and has a projecting apse.

Finally there is a citadel, probably Byzantine, to the NW, trapezoidal in form (70 x 45 x 35 m) with scattered buildings on the W side; it was made of double walls without a core of reused materials; in the interior a large quadrangular structure was perhaps a redoubt. A rampart was constructed at a later date at the citadel.

BIBLIOGRAPHY. S. Gsell, *Les monuments antiques de l'Algérie* (1901) I-II PI; *Atlas archéologique de l'Algérie* (1906) 18, Souk-Arrhas, no. 107 MP; and C. A. Joly, *Khamissa, Mdaourouch, Announa* (1918) PI. G. SOUVILLE

THIGILLAVA (Djillaoua) Algeria. Map 18. This settlement was no doubt originally a part of the territory of the colony of Cuicul. It is placed at the edge of the high plains. From the time of Hadrian it was the center of a pagus, placed under the responsibility of a magister. Perhaps Roman citizens lived there rather early in the 2d c. In 411 and 484 a bishop is known to have been there. The ruins are distributed over a huge area, but no monument is identifiable.

BIBLIOGRAPHY. S. Gsell, *Atlas archéologique de l'Algérie* (1911) 16, no. 269; P. Petitmeng in *MélRome* 79 (1967) 190-205. P.-A. FÉVRIER

THIRIAKISION, *see* LIMES, GREEK EPEIROS

THISBE (Thisvi, formerly Kakosi) Boiotia, Greece. Map 11. A city at the S foot of Mt. Helikon, on the site of the modern town; it is situated in a corridor 350-700 m wide between a rocky hill to the N (Palaiokastro) and, to the S, the edge of a plateau linked to Mt. Helikon (Neokastro).

The site had an important Mycenaean settlement; in Classical times, up to 338 B.C., Thisbe formed part of one of the districts of Thespiai. Thereafter the city was independent. In 172 B.C. it sided with Perseus but was forced to open its gates to Flamininus; a senatus consultum of October, 170, settled the matter to the advantage of the Romans (*IG* VII 2225). The city ramparts ran around the two hills and the lower city. A wall of coarse polygonal masonry runs across the NW part of Palaiokastro (acropolis). The E wall of the lower city and the Neokastro rampart are of regular 4th c. masonry; the eight towers have finely grooved corners. The W rampart has disappeared. Remains of the ancient city include some hundred reliefs and inscriptions dating from the 5th c. B.C. to the 3d c. A.D. (at the Thebes Museum and in modern buildings at Thisvi and Korini, 1.5 km to the SE), as well as quantities of pottery ranging from the Mycenaean to the Roman period.

To prevent flooding in the lower (E) section of the Thisbe basin a long dike was built N-S, noted by Pausanias; two sluices regulated the passage of water. The road running from Thisbe to its port, now Vathy, on the Gulf of Corinth, passed over the dike.

BIBLIOGRAPHY. J. G. Frazer, *Paus. Des. Gr.* v (1898) 160-64; Fiehn in *RE* (1936) s.v. Thisbe; F. G. Maier in *AthMitt* 73 (1958) 17-25ᴾ; P. Roesch, *Thespies et la Confédération béotienne* (1965); N. Papahadjis, *Pausaniou Hellados Periegesis* v (1969) 191-94ᴹᴾᴵ.

P. ROESCH

THISTLETON DYER Rutland, England. Map 24. A Roman settlement and religious center known only from air photography and excavation. The remains comprise a large villa, a settlement probably associated with it, and a religious site with a circular timber building of the 1st c. A.D., replaced by a stone structure, also circular.

In the late 3d c. the circular shrine was swept away and a large basilican temple (19.5 x 13.5 m overall) was built. A votive deposit in this temple contained a small silver plaque, inscribed with a dedication by one Mocuxsoma to the god Veteris, the first recorded occurrence of the cult outside the military areas of Roman Britain. Basilican temples, whether in urban or rural contexts, are rare in the W Roman provinces, and surprising in a rustic area. It is possible that the temples attracted worshipers from a considerable area around Thistleton, perhaps to occasional fairs or festivals. The presence of Iron Age pottery and coins suggests that the site had a religious significance before the Roman conquest. Outside the temple, and at right angles to it, was a large hall-like structure, perhaps a place of assembly.

BIBLIOGRAPHY. M.J.T. Lewis, *Temples in Roman Britain* (1966) 84, 93ff; R. G. Collingwood & I. A. Richmond, *The Archaeology of Roman Britain* (1969) pl. XIIA; *JRS* 52 (1962) 171ᴵ.

M. TODD

THISVI, *see* THISBE

THIVERNY Oise, France. Map 23. In the Senlis arrondissement and the canton of Creil. Thiverny, on the Roman road from Senlis to Beauvais, was a center inhabited from the Neolithic Age on. In 1823, while stone was being quarried, a grotto was unearthed containing ca. 30 Neolithic tombs, and nearby an important stratum of carved flints apparently designed for scraping furs. A considerable quantity of protohistoric pottery was also found. Clearing the surface soil revealed a fairly large protohistoric village. Triangular in shape, it was made up of isolated houses protected from the valley wind by a curved wall. The hearth took up part of the floor, which was covered with unsquared stones; the walls were of earth supported by logs. Objects found there date the village from the Late Bronze Age or Iron Age I.

In the area known as Les Carrières, an underground room 5.7 m square was found. The masonry construction is very curious: large rectangular stones with a dry joint, occasionally in trapezoidal form, to make a buttress near the entrance, embedded in the wall. Various architectural fragments suggest to some a structure of Greek origin. Next to this room was found a well and a complex of bath buildings, rectangular rooms arranged on either side of a semicircular pool. Probably the complex had a gallery in front of it. The walls of the largest of these rooms were covered with a rich, varied, painted decoration: a sea-green palm-leaf on a bright red or black ground, big flowers, extremely slender reeds, and framing them either a band with an imitation marble design or a golden arrow on a black background. This room was later used as a storehouse, and many small objects have been found: depilating tweezers, spatulas, a bronze spoon.

Chance finds made in the last century include the discovery of quarries and in 1843 of a remarkable gold torque. Acquired by the Cabinet des Médailles, this is the so-called torque of Saint-Leu d'Esserent, dating from the Late Bronze Age.

BIBLIOGRAPHY. J. Dechelette, *Manuel d'archéologie prehistorique, celtique et gallo-romaine* 2, 1 (1910) 355; A. Piganiol, "Informations archéologiques," *Gallia* 9 (1951) 82; 12 (1954) 145; 15 (1967) 168-70; P. Durvin, "Les silex de Thiverny," *Revue archéologique de l'est et du centre est* 7 (1956) 64-72; id., "Le village protohistorique de Thiverny et son milieu archéologique," *Ogam* 13 (1961) 537-56; id., "La céramique protohistorique de Thiverny," *Celticum* 9 (1963) 29-44; id., "Le monument souterrain de Thiverny," *Ogam* 17 (1965) 279-94; id., "Les découvertes de La Tène au pays des Bellovaques," *Celticum* 15 (1965) 134-35; id., *La région de Creil a l'époque gallo-romaine* (1967) 59-71.

P. LEMAN

THORIKOS Attica, Greece. Map 11. Situated on the E coast about 10 km N of Sounion, it was one of the 12 independent cities of this area said to have been unified by Theseus under Athenian hegemony (Strab. 9.1.20). In the later years of the Peloponnesian War it was fortified (Xen. *Hell.* 1.2.1) in order to protect the sea route to Athens and to help protect the silver mines at Laurion. Under the Romans it fell into decay, but its earliest habitation remains, dating from the Neolithic period, and numerous tomb groups indicate that it had a long and continuous history up to this time.

The site consists of three areas: the plain of Thorikos where the Society of the Dilettanti in 1812 uncovered part of an ancient building, now no longer visible, the hill of Velatouri where the majority of ancient remains have been found, and the peninsula of Haghios Nikalaos, now the site of a modern chemical plant.

The ancient theater, located on the S slope of Velatouri and excavated in 1886, is notable for the irregular shape of its orchestra. It was originally thought that the roughly rectangular orchestra reflected the early date of the theater. Further study, however, suggests that the theater was primarily constructed in the 5th c. B.C., and that its irregular orchestra reflects the gradual enlargement of the theater's seating capacity. It would appear that the original

stone seats, made of local bluish stone, consisted of 19 straight rows. These were later expanded by the addition of curved sections to E and W, and still later in the 4th c. a curved section of 12 new rows was added to the N. Scanty remains of a temple can be seen to the W of the orchestra; an altar lies to the E. Along the S side lies a terrace wall built to support the orchestra; this wall appears to be the oldest surviving architectural feature of the theater.

On the hill above the theater, excavations have uncovered remains of the city's industrial quarter. Here traces of houses, stairs, and roads can be seen. A series of basins connected by channels formed part of a metal-working establishment. Nearby a Mycenaean tholos tomb, graves from various periods, and parts of a prehistoric settlement, including a Mycenaean metal-working establishment, have been uncovered.

Fortifications consisting of over 600 m of walls can be traced on the peninsula; at least six towers, four stairways, and seven gateways were included in this fortification system.

BIBLIOGRAPHY. O. A. Dilke, "Details and Chronology of Greek Theatre Caveas," *BSA* 45 (1950) 25-28; H. F. Mussche, "La forteresse maritime de Thorikos," *BCH* 85 (1961) 176-205; H. F. Mussche, J. Servais, J. Beingen, & T. Hackens, "Thorikos 1963," *AntCl* 34 (1965) 5-46; R. Ginouves, "Comptes Rendus," *AntCl* 37 (1968) 777-79; C. A. van Rooy, "Fortifications in South Attica and the Date of Thorikos," *Acta Classica* 12 (1969) 171-80.

I. M. SHEAR

THORPE, *see* AD PONTEM

THRONOI Cyprus. Map 6. The ruins of a small town, mentioned by Strabo (14.683) and Ptolemy (5.14.1-4), on a headland called Cape Pyla, on the E shore of Larnaca Bay. Strabo's reference, however, does not make it clear whether Thronoi refers to the cape or to the town or to both. It is mentioned in the list of the theodorokoi at Delphi (early 2d c. B.C.), provided the restoration of the name is correct.

Substantial remains of the town, dating from Hellenistic and Graeco-Roman times, are still visible. Remains of the town wall running for a considerable distance along the inland side of the town, underground chambers cut in the rock, and vestiges of a sanctuary with fragments of stone statues have been reported.

The site is still unexplored.

BIBLIOGRAPHY. Luigi Palma di Cesnola, *Cyprus: Its Ancient Cities, Tombs and Temples* (1877) 183-84; A. Sakellarios, Τὰ Κυπριακά I (1890) 187-88.

K. NICOLAOU

THRONOS, *see* SYBRITA

THUBURBO MAIUS (Henchir Kasbat) Tunisia. Map 18. The site occupies the slopes of a hill in the arc of a circle opening to the W and to an area where the plain of Fahs rejoins the valley of the Kebir river, in the midst of an agricultural region rich in grain production. This double advantage of being at the crossroads and at the center of a fertile region near the capital gave the city an economic and administrative role—surveillance of the roads and collection of taxes—activities which contributed to its prosperity.

For a long time an erroneous interpretation of certain texts and inscriptions had led to the assumption that there existed at Thuburbo Maius a double commune set up by the juxtaposition of a Julian colony, founded by Augustus, and a native city with which it eventually coalesced. Actually, this hypothesis came from a confusion between Thuburbo Maius and Minus, and from having attributed to the former the earlier date of founding. In fact, having become a town inhabited by mercenary soldiers after the fall of Carthage, Thuburbo Maius remained a civitas until its elevation to a municipium by Hadrian and to the rank of colony under Commodus.

These advancements augmented the prosperity of the town, and from this period the principal public buildings and the most beautiful dwellings date. After the general crisis of the Empire in the 3d c., the city experienced a rebirth in the 4th c.; under the impetus of the imperial authority and with the assistance of the municipality, the most important buildings and those most essential to the life of the city were repaired and restored. Thanks to this effort, municipal life experienced a profound transformation. The contrast is striking between the mediocrity of the repairs performed in the buildings and the bombast of the dedications which commemorate their completion. From the time when imperial authority slackened, the town suffered an irremediable decline. The small number and poverty of the Christian edifices are proof of this change, which is further confirmed by almost total absence of all mention in literary sources. With the arrival of the Vandals, the town, left to itself, became a village. The site of Thuburbo Maius was excavated from 1912 to 1936. Aside from the edifices uncovered, a great quantity of objects—in particular inscriptions, sculptures, and mosaics—have been gathered and are preserved at the Bardo Museum in Tunis, where one room is devoted to them. Neither the excavations nor the discoveries, have been completely published.

Built in the 2d c., repaired in the 4th, the forum is bordered on three sides by porticos and on the fourth by a hexastyle prostyle capitol of the Corinthian order; this temple, raised on a high podium, overshadows the plaza. The curia-temple of Peace, opening onto the NE portico, was formed of a court with a peristyle giving on a large hall paved and veneered with marble, which contained an aedicula intended for a statue of Peace. On the SW portico was the Temple of Mercury, dedicated in A.D. 211; its square cella faces a pronaos consisting of a court with a tholos open to the sky. At the S corner of the forum was the market (and its two annexes), a square plaza paved and bordered on three sides by small shops.

Around the forum are several quarters of dwellings including numerous luxurious houses, most of them paved with mosaics which now serve to identify them according to the subject depicted: Neptune, Palms, Theseus. In the NE corner is a house with peristyle, the mosaic of which is signed "Nicenti."

The SW quarter, excavated between 1915 and 1919, is set between two great baths, a winter one to the NE, a summer one to the SW, and included a group of public buildings and private houses.

The winter baths cover a surface 1600 m square and are surrounded on three sides by streets; they open on a large square at the intersection of two streets. Built in the 2d c., they were restored at the end of the 4th c. To the SW, 150 m from the forum, the summer baths include halls luxuriously decorated with mosaics, paving, and facings of marble, as well as inscriptions and statues. Coupled with the NW facade but independent of it, a semicircular building contains public latrines. Adjacent to the NE side of these baths and serving as a palestra, is a rectangular plaza surrounded by an elegant portico dedicated by the family of the Petronii. To the SE of the palestra is a vast enclosure, overgrown and deteriorated, where an apse survives and where several inscriptions dedicated to Caelestis were found. This enclosure is next to a large area paved with marble, bordered on two sides by porticos with mosaic floors. Still farther to the SE, but separated from this group of monuments by a street, is the temple called Baalit.

Its cella is approached by a prostyle tetrastyle pronaos and is elevated on a podium paved with opus sectile of marble. A wall surrounds the sanctuary, straight on three sides, semicircular on the fourth, and pierced with a gate opening on a small square. Between this series of public monuments to the SW and the winter baths to the NE is situated a quarter of private houses. It is crossed by several paved streets, narrow and winding; the two most important go between and border the long insulae and rejoin at the intersection, on which opens the principal entry to the winter baths. Built onto the NW side of these baths, the House of the Victorious Charioteer is richly decorated with mosaics and painted stucco.

More to the W of this quarter, the Temple of Ceres is elevated on sloping terrain at the edge of a public square. It is a temple of Eastern type, without podium. The court (30 x 30 m), preceded by a portico comprising three gates without and bordered within on the three remaining sides by a peristyle, surrounds a square cella paved with mosaic. The discovery of a votive naos and several reused architectural elements carrying symbols of Demeter permitted the identification of this temple. At a later epoch it was transformed into a church; the cella became the baptistery, and in the S half of the court, a church with three naves was installed, utilizing the ancient portico as side aisles. Numerous tombs were placed in the church, one of which revealed jewels. Still farther W, in the outskirts of the town and on the highest point of the site, the Temple of Saturn, explored as early as 1912 and later incompletely excavated, is set on a platform which necessitated navvying and earthworks for propping up. The sacred enclosure surrounds the sanctuary, which is elevated on a podium. An apse was added later to the rear facade.

An amphitheater hollowed out of rising ground on the outskirts of the site was excavated between 1930 and 1940. Only the inscriptions that were found have been published. Investigations in 1957 produced an inscription mentioning a temple consecrated to Mercury between 117 and 138. Nearby is an immense cistern, once vaulted in concrete.

To the S of the town, a house with a trefoil apse and heated outbuildings was partially dug. This edifice was paved with a large mosaic decorated with half-figures of animals.

To the W of the house is a district rather regular in plan with large streets and insulae of private houses much fallen to ruin. It has been excavated but is unpublished. The house named the Chariot of Venus, with peristyle, had a main room that was trifoliate and paved with mosaic; among the subjects were a stag hunt, a sea with boats and fishermen, as well as the chariot of Venus, preserved at the Bardo Museum in Tunis. One of the city's three large gates still stands 70 m to the W, constructed of limestone.

BIBLIOGRAPHY. Merlin, *Le Forum de Thuburbo Majus* (1922)[P]; Feuille in *Bulletin Economique et Social* (1950) 77-110[PI]; P. Quoniam in *Karthago* 10 (1959) 67-79; A. Lézine, *Architecture romaine d'Afrique* (1963) 91-142[PI]; M. Maurin in *CahTun* (1967) 225-54[PI].

A. ENNABLI

THUBURSICUM, *see* THUBURSICU NUMIDARUM

THUBURSICU NUMIDARUM or Thubursicum (Khamissa) Algeria. Map 18. Situated 32 km NW of Thagaste and 40 km SE of Calama, this city is probably the town of which Tacitus speaks in connection with the revolt of Tacfarinas in the time of Tiberius. Chief site of an indigenous tribe, it was a municipium by A.D. 100, elevated by Trajan (Municipium Ulpium Traianum Au-

gustum Thubursicu), and its inhabitants enrolled in the Papiria tribe. It became a colony before A.D. 270. The seat of a bishopric and twice visited by St. Augustine, it was later occupied by the Byzantines.

Excavations were conducted from 1900 to 1922. Only one part of the town has been cleared. The town was set up first on a nearly triangular hill and afterwards spread toward the N and NW over the slopes and even into the valley. The town included especially an early public square and a basilica; in the lower town are found the new forum, baths, and an arch with three openings. A number of other monuments may be pointed out: two arches, a theater, pools around a fountain, a chapel with three aisles (probably Byzantine), small Byzantine forts with a trapezoidal surrounding wall of the early era, undoubtedly used as a refuge. Most of the objects collected, especially the statues, are in the Guelma Museum.

The ancient public square was built on the steep N slope of the hill, which had to be cut into in order to provide a level surface; it was extended to the N by a retaining wall where there were buildings, some of which were undoubtedly shops. The square measures 21.7 m on the E and W sides, 29.3 m on the S, and 20.8 m on the N. It served perhaps as the forum for the municipality whereas the new forum would date from the colony; the ancient square, however, was not abandoned; the paving was repaired between A.D. 323 and 333. There were no entrance arches; access was gained by stairs. To the S, E, and N the place was bordered by porticos. Several luxuriously decorated buildings adjoined it, among them some temples, one of which was no doubt the capitol; one of these temples shows the persistence of Punic traditions. To the E there is a rectangular basilica (39.1 x 28.4 m) with a cryptoportico, an entrance on one long side, and a rectangular colonnade. Paved in limestone, with walls covered with marble, decorated with statues, it was undoubtedly constructed in the 2d c., then restored.

L'Aïn el Youdi was considered as the origin of Medjerda; several structures were established there: a large rectangular pool with a sluice gate, a rectangular pool with a semicircular end, and a third pool intervening; several buildings adjoined them, one of which was a temple to Saturn. The theater was nearby at the foot of the hill. It is one of the most beautiful and best-preserved theaters in Africa. It measures 70 m in breadth; the maximum diameter of the hemicycle is 56.8 m. Entirely of worked stone, it undoubtedly was not completed and does not seem to have an exterior portico. It was not constructed exactly according to the standards of Vitruvius; two vaulted galleries led to the orchestra and the lower part of the cavea; the stage was spacious (breadth 43.6 m, depth 9 m), framed on the E and W by two parascenia; the wall of the stage is still well preserved (9 m high). The theater perhaps dates from the 2d c., or at the latest from the 3d.

The new forum, situated NW at the foot of the hill, dates from A.D. 360-70. It is entered by an arch with three bays. A market with porticos adjoined, as did baths with a circular tepidarium and semicircular latrines. A large hall measures 14.6 x 13.9 m.

BIBLIOGRAPHY. S. Gsell, *Les monuments antiques de l'Algérie* (1901) I-II[PI]; *Atlas archéologique de l'Algérie* (1906) 18, Souk-Arrhas, no. 297[MP]; and C. A. Joly, *Khamissa, Mdaourouch, Announa* (1904)[PI]; L. Leschi, *Algérie antique* (1952)[MI].

G. SOUVILLE

THUGGA Tunisia. Map 18. A city 100 km W of Tunis, 7 km from Terboursouk. Its ruins are spread out on the plateau and steep hillside, dominating the broad valley of the Ouadi Khaled with the high road from Tunis to Le Kef crossing it below. Established at a very early

date in an area between the coastal region (continuously held by Carthage) and the great plains of the Numidian hinterland, Thugga lies at the center of a rich agricultural territory that was a Numidian dependency but came under strong Carthaginian influence. It was one of the chief cities of the region, probably even a residence of the Numidian kings from just after the third Punic war until the territory was annexed in 46 B.C. and came into the orbit of Rome. With the creation of Africa Nova, its evolution and growth were merged with the general history of the province and empire.

Along with the indigenous civitas, whose inhabitants continued to be administered by ancient local institutions, there was a pagus of Roman citizens governed in Roman fashion. When first created, this pagus was dependent on Carthage until its economic development, the social improvement of its inhabitants, and its political evolution enabled the metropolis gradually to relax its protection and finally to relinquish it altogether. Romanization was profound and progressive. Several members acquired Roman citizenship, some having brilliant careers in the Empire. Nevertheless, it was not until the beginning of the 3d c., in 205, that the city became Municipium Thuggense, and in 261 Colonia Licinia Septima Aurelia Alexandriana Thuggenses.

Evidence of this individual and collective betterment exists not only in stone inscriptions but in the profusion of monuments whose remains have given the city its fame. Set up on a defensive site, the city had to adapt itself to a difficult terrain. The narrow, winding streets edged with massed blocks of buildings present a tiered architectural arrangement with the most striking monuments rising from it at the most favored points.

One of the most remarkable of these monuments is the Capitolium, which stands out from far off amidst all these remains. Dedicated to the Capitoline Triad in 166-67, it consists of a cella (13 x 14 m) preceded by a portico of four monolithic columns, which are 8 m high and have Corinthian capitals supporting an architraved frieze. The frieze, which bears the dedication to the Triad for the salvation of the emperors Marcus Aurelius and L. Verus, supports a pediment whose tympanum has a decoration of the imperial apotheosis, represented by the eagle carrying off a human figure. The cella stands on a podium with a tripartite crypt in front of the facade of the podium is a monumental stairway leading to a small piazza, a continuation of another. On either side of the temple this piazza connects with a moderate-sized esplanade; to the E, it connects with the so-called Square of the Wind Rose, to the W, with the forum. The paving of the piazza, which measures 24 by 38.50 m, is now gone and its surface buckled; formerly it was surrounded by a portico with buildings opening onto it. The erection of a small fort in this quarter during the Byzantine period caused many monuments to be overturned and destroyed; evidence of their existence is provided by the architectural and epigraphical fragments reused later here and there in the walls.

On the other side, the Square of the Wind Rose (so-called from a compass rose cut into the paving) is lined with a portico whose E side, opposite the temple, is semicircular. To the N stands the Temple of Mercury with its rectangular cella flanked by two exedrae. To the E, behind the semicircular portico, is the Temple of Fortune with the Temple of Augustan Piety alongside it, while a market extends along the S side. This is a large courtyard bordered on its two long sides by a series of small shops, and terminating at the S in a large exedra that probably held a statue of Mercury. The forum area dates mainly from the second half of the 2d c. Lower down is a residential quarter, two of the houses, the House of the Cupbearers and the House of the Stairs, being the most characteristic.

Below this level is a complex of private houses, some of which were found to contain remarkable mosaics of Dionysos, Ulysses, a Maze, and Three Masks; most are now in the Bardo Museum. In the midst of these houses stand the Licinian Baths, their great mass dominating the entire hillside. Large embankments made a fairly regular plan possible. All sections are quite complete, including the palaestra opposite the great entrance hall.

Nearby, to the E, are the temples of Concordia, Frugifer, and Liber Pater. The latter, which is the largest, has a great square area surrounded by porticos, and on its N side a great central cella flanked by two lateral cellae. Down from it, to the S, can be seen the seats of a small, somewhat irregularly shaped theater. Its proximity to the Temple of Liber Pater suggests that it may have been used to celebrate divine mysteries.

Lower still is another quarter, not yet completely excavated. The beautiful house called the House of the Trifolium is the most noteworthy structure. A great stairway leads to a peristyle, a central garden surrounded by a portico with a mosaic floor. Wings containing the living quarters are aligned on the S and W sides. The W rooms are particularly remarkable: a vaulted, trefoil-shaped room with three apses, its architecture still well preserved, was connected to the rear of a rectangular oecus with three doorways opening onto the gallery; a mosaic depicts circus games. Opposite, a semicircular pool projects into the garden.

Close by this house, to the E, still in the same group of houses in this section, are the Cyclops Baths, so named from the design of the mosaic floor in the frigidarium. Still farther E is the Temple of Pluto, whose sanctuary stood on a podium ringed with a peribolos. Close by the House of the Duck and the House of the Seasons is the triumphal Arch of Septimius Severus, set astride a street leading down the hill.

Still farther down, almost on the edge of the site and in the middle of an olive grove, is a Libyo-Punic tower mausoleum (21 m high), the only great monument of the Carthaginian period still standing. Built around the end of the 3d c. or the beginning of the 2d for a Numidian prince in Massinissa's reign, it is composed of large stones. It is exceptionally interesting both for its architecture and its decoration, architectural as well as sculptural, which is full of religious references. Its three stories, rising from a plinth of five steps, are topped with a pyramidon, the upper corners of which are decorated with equestrian statues. Overturned in the middle of the 19th c. during the recovery of the bilingual (Libyan and Carthaginian) inscription now in the British Museum, it has been restored.

The main theater on the top of the plateau is remarkably well preserved. Its cavea is backed against the hillside and the seats, arranged in a semicircle, are closed off at the top by a portico (now destroyed). The columns of the scenae frons have been set upright again, but the back wall of the stage is gone, so that from the stage one has a fine panorama of the plain below. The dedication, several fragments of which have been found, shows that the monument was built in 168 or 169 under Antoninus Pius by P. Marcus Quadratus.

Beyond the theater, almost outside the city limits, stood the Temple of Saturn. Erected on a spur at the edge of the plateau, it dominated the whole valley below; some of the columns of the portico are still standing. A vast area, preceded by a long outer portico, was lined with a gallery on the inside of the other three sides, and at the rear opened onto three frontally aligned cellae. To the W in the interior of the plateau is the Temple of

Caelestis, which stands in the middle of an olive grove. The sanctuary, which is peripteral (6 x 8 Corinthian columns), stands on a podium preceded by a flight of steps, in the middle of a large semicircular enclosure with a portico, also circular, around it. In front of the sanctuary is a broad paved esplanade built into the temple precinct, each side of which has two lateral doorways with porches in front of them.

Some well-preserved cisterns are to be seen toward the upper reaches of the site. Mosaics and other finds are chiefly at the Bardo in Tunis.

BIBLIOGRAPHY. C. Poinssot, Les ruines de Dougga (1958) with biblio.; id., "Immurita Perticae Carthaginiensis," CRAI (1962) 55-76. A. ENNABLI

THUIN Belgium. Map 21. The town, on the right bank of the Sambre, formerly seemed no earlier than the 9th c. A.D. since no remains of the Roman period had been found there except for two hoards of coins, one buried during the reign of Septimus Severus, the other after 246. However, a necropolis, excavated in 1963 and 1964, disclosed ca. 55 cremation tombs with rather poor grave goods. It was in use between the end of the 2d c. and the middle of the 3d. There was, therefore, a Roman establishment at Thuin, but at present it is impossible to determine whether it was a vicus or a villa.

BIBLIOGRAPHY. G. Faider-Feytmans, La nécropole gallo-romaine de Thuin (1965) 106 pp.MPI; M. Thirion, Les trésors monétaires gaulois et romains trouvés en Belgique (1967) 157-58. S. J. DE LAET

"THURIAE," see MONTE SANNACE

THURII later COPIA Apulia, Italy. Map 14. On the E coast of the toe of Italy, the city lies some 134 km SW of Taranto. The colony was founded in 443 B.C. by the Athenians, together with citizens from the former city of Sybaris. Diodorus (12.10.6) states that it was not far from Sybaris by a spring called Thuria. As early as 426 B.C. the port of Thurii was considered an important one. During the 4th c. B.C., there was constant warfare with the Lucanians and Bruttians, and the city became a voluntary Roman dependency. As such it opposed Pyrrhos and Hannibal (App. Hann. 9.57). In an attempt to revive the town after Hannibal, the Romans planted the colony of Copia there in 194 B.C., but it quickly declined and finally was abandoned (App. BCiv. 5.56).

Although Diodorus says that Thurii was founded not far from Sybaris, the archaeological evidence points to the fact that it was built over the S section of Sybaris. Hippodamos reputedly planned the city by dividing it up into twenty wards formed by three main avenues which were bisected at right angles by four streets. In the NE corner of the Serra Pollinara are the remnants of a Roman villa; other Hellenistic and Roman remains have been found in the area. Late Classical, Hellenistic, and Roman graves have come to light by the church of S. Mauro, by the Torre Monachelle, and near the village of Frassa.

BIBLIOGRAPHY. H. Philipp, "Thurioi," RE 6 A (1937) 646-52; F. Rainey, "The Location of Archaic Greek Sybaris," AJA 73 (1969) 261-73; O. H. Bullitt, The Search for Sybaris (1969). W.D.E. COULSON

THYATEIRA W Anatolia. Map 7. Situated in the township of Akhisar, which is attached to the city of Manisa. The name suggests an ancient Lydian settlement. The city, located in the middle of the fertile Lykos valley and at the crossroads of important trade routes, was under the domination of Pergamon between the early 3d and the 2d c. B.C. It was an autonomous city, and on its

coins Apollo and Artemis were represented. Apollo and Helios were especially honored. Its zenith coincided with Caracalla's visit to the city (A.D. 215). Soundings on the acropolis brought to light a part of an apsidal structure and various architectural elements (i.e. capitals, columns, column bases) from the Roman period. Little else remains except inscriptions, 21 of which, recently found, are in the Manisa Museum.

BIBLIOGRAPHY. J. Keil, Premerstein II. Bericht über Eine Zweite Reise in Lydien (1911) 11ff; id., RE VI A1 658, Thyateira (1936); D. Magie, Roman Rule in Asia Minor (1950); Duyuran, TürkArkDerg 17.2 (1968) 73-76. U. SERDAROĞLU

THYSDRUS (El Djem) Tunisia. Map 18. The vestiges of this ancient site spread below and around the modest modern village. Situated on the great axis of the communication routes linking north and south, it is 200 km SE of Tunis, midway between the towns of Sousse and Sfax.

The origins of Thysdrus remain obscure. The recent discoveries cast little light on the pre-Roman period. Traces of occupation before the 3d c. B.C. are rare. From its name the city seems to have had Berber rather than Punic origins. The name appeared for the first time in the period of Caesar's African campaign when the city, although closely involved with the events which shook the country, seems to have been no more than a small town. Towards the end of the 2d c. it became a municipium, competing with Hadrumetum for the second place in the province.

In A.D. 238, its opulence, almost isolated in the midst of the empire in crisis, attracted the covetousness of the Emperor Maximianus. Under severe pressure, Thysdrus initiated a revolt which led to the assassination of a procurator of the treasury and the proclamation of the proconsul of Africa, Gordian, as emperor. However, Maximianus triumphed over Gordian, and the town of Thysdrus was severely punished. Numerous traces of fire have been found in certain strata of the site. The combined effects of this punishment and the economic crisis which resulted from it brought an end to the city's importance. It sank into anonymity and is barely mentioned by the Catholic bishops, in 393, 411, 641, and by a Donatist in 411.

Thysdrus owed its fortune in ancient times to commerce. Its situation made it a market town at a crossroads of the communication routes of Central Tunisia. It served as intermediary between the ports and the hinterland as much for imports as for exports. The merchants of Thysdrus were active as far as the distant regions of the Orient. Yet Thysdrus owed the great part of its fortune to the spread, from the end of the 2d c., of its olive plantations and its trade in oil, for which it became a sort of capital like Sufetula in the 6th c. or Sfax in our time. Today with its remains spread over 150 to 200 ha, it is classed among the most extensive sites in Tunisia. Although an important part of its remains is yet to be explored and other parts are covered over again by modern structures, there are existing or recently excavated monuments in a good state of preservation. Among the most remarkable for their scientific interest or for their high architectural and artistic value are the following:

The large amphitheater (148 x 122 m) is the most celebrated and the best preserved of all the Roman monuments in this category in Africa. The dimensions of the arena are 65 x 39 m. The rows of seats rise 36 m in height. With a capacity of 45,000 spectators, it is classed among the largest amphitheaters of antiquity. In the absence of an inscription, the exact date of the construction of the building is not known. Some at-

tribute it to Gordian III who, towards the middle of the 3d c., might have built it for the glorification of the town which had brought his grandfather Gordian I to the throne. On the basis of style, others prefer the end of the 2d c. However, the most tempting hypothesis, founded on architectural and historic arguments, puts the date of construction between A.D. 230 and 238 and attributes the monument to Gordian I.

The small amphitheater is situated some 7.20 m to the S of the large one. It has been partially uncovered and seems to have undergone a curious evolution: originally worked in tufa, it was reconstructed in a second phase, then redone and enlarged in the course of a third.

The circus is scarcely visible on the terrain. Its existence was revealed with remarkable clarity by aerial photography. While it is not yet uncovered, one can tell it is as large as the Circus Maximus at Rome, measuring nearly 550 x 95 m, and capable of accommodating about 30,000 spectators.

The baths, covering a surface of 2400 sq. m, have revealed fine mosaics.

A large capital, measuring 1.82 m, is the largest found up until now in Tunisia. The height of the column to which it must have belonged can be estimated at 15 m. Similar supports suggest that it belonged either to a temple of the dimensions of the great sanctuaries of Rome, or to imposing baths. This capital was uncovered by chance in an unexcavated sector that is probably the forum.

Elsewhere, mosaics that number among the most beautiful and the most numerous of Tunisia continue to be uncovered. The mosaics are for the most part on exhibit in the museums of Tunis (the Bardo), Sousse, and El Djem. The houses to which they belonged have been filled up, but during the last 15 years an attempt has been made to preserve the mosaics in situ.

About 250 m to the W of the small amphitheater, behind the museum, it is possible to see a district of houses bounded on the S by a necropolis and to the E by a fine street with well-preserved ancient flagstones. Each house, planned according to the classic plan of Romano-African architecture, has a garden surrounded by a peristyle around which are found rooms richly decorated with mosaic representing very diverse scenes: the Four Seasons, the Abduction of Ganymede, Leda and the Swan, Diana the Huntress, the Nereids, scenes of the amphitheater, and Dionysiac themes. These houses are noteworthy for their dimensions and for walls of masonry or unbaked brick lying on a shallow foundation of stone. Nearby is the House of the Dionysiac Procession of which the plan and decorative details suggest that it was the center of a band of revelers.

About 600 m to the W of the large amphitheater, some recent excavations not yet finished have revealed remains of an immense house with beautiful and restrained decoration. At the side of this veritable palace, two temples, one of which seems to have been dedicated to the imperial cult, have been likewise excavated. Behind this sector was found a new quarter that is strikingly original in its plan and in the appearance of the houses, which seem to recall certain Punic traditions. In the middle of the same sector were found remains of workshops, where are preserved traces of activities of various artisans: potters, molders, founders, and even makers of hairpins.

BIBLIOGRAPHY. A. Lézine, H. Slim, J. Salomonson in *CahTun* (1960) 29-61[PI]; L. Foucher, *La maison de la procession dionysiaque à El Jem* (1963)[PI]. H. SLIM

THYSSANOUS (Saranda) Caria, Turkey. Map 7. On the Loryma Peninsula. A deme of the incorporated Rhodian Peraea, mentioned by Pomponius Mela (1.84). The site is identified by a number of inscriptions. The acropolis is close above the village, with a wall of polygonal masonry.

BIBLIOGRAPHY. Chaviaras in *ArchEph* (1911) 60-63; P. M. Fraser & G. E. Bean, *The Rhodian Peraea* (1954) 34-39, 59. G. E. BEAN

TIBERIAS Israel. Map 6. A city on the W shores of the Sea of Galilee, founded ca. A.D. 18 by Herod Antipas, who named the city after the reigning emperor. According to Josephus the city was established on the site of an ancient necropolis, an act contrary to Jewish law, which considers such a site ritually unclean (*AJ* 18.36-38; *BJ* 2.168). According to the same authority (*Vit.* 69.134,278,296; *BJ* 2.641), it had the status of a polis, and had an archon, a Council of Ten, and a Senate of Six Hundred. It soon developed into the most important city of its district. After Herod Antipas' death Tiberias became part of the domain of King Agrippa I, and later of Agrippa II, who held it until his death. After crushing of the Revolt of A.D. 66, the Romans made Tiberias autonomous and conferred on it the right of minting coins. On its coins appears the title Tiberias Claudiopolis Syriae Palaestinae. According to Jewish sources and others, Herod Antipas built a fortress at Tiberias and a wall was later built around it. Within the city were a stadium, a Hadrianeum, a forum, and numerous synagogues. An aqueduct conveyed water to the city from springs 15 km away. A bridge connected Tiberias with its S suburb Hamtha, or Hammath, where there were hot springs (Plin. *HN* 5.45). The Romans built a temple dedicated to Hygieia, and the Jews built a synagogue there. Tiberias was still a famous city in the 4th c. (Eus. *Onom.* 16.1). The city is frequently mentioned by writers in the Byzantine period.

Tiberias was never abandoned, and for this reason the remains of the earlier period lie deeply buried. Surface survey has shown that the city of the Roman period occupied an area of ca. 80 ha as against the 14 ha of the mediaeval town. The perimeter of the walls was 4 km and some remains of the wall and of one gate are still seen today. Excavation of the S gate (1973-74) has not yet been published.

During the last two decades excavations have uncovered remains of a Roman basilica, a bath, and buildings of the Byzantine period. Between 1961 and 1963 the synagogue of Hammath, close to the hot springs, was excavated. The earliest remains found in that area were of a building of the Hellenistic period, of which little remained. Above this were remains of a large Early Roman building, possibly a palaestra, or a gymnasium. The earliest remains of a Jewish prayer house date from the first half of the 3d c. A.D., when a basilican building was constructed. In the early 4th c. this was replaced by a basilica of four aisles, still with no apse. The floors of the side aisles were decorated with mosaics of geometric pattern, while the floor of the second aisle from the W was divided into three mosaic panels, in which were depicted two lions standing at either side of several dedicatory inscriptions, a zodiacal circle with Helios riding the celestial carriage in its center, and a Torah Shrine flanked by two seven-branched candlesticks and other Jewish symbols. The workmanship of this mosaic pavement is by far the best in synagogual art. The synagogue was rebuilt in the Byzantine period and again in the Ommayad period.

BIBLIOGRAPHY. M. Avi-Yonah, "The Foundation of Tiberias," *Israel Exploration Journal* 1 (1950-51) 160-69; id., *The Holy Land from the Persian to the Arab*

Conquests (536 B.C. to A.D. 640). A Historical Geography (1966); M. Dothan, "Hammath-Tiberias," *Israel Exploration Journal* 12 (1962) 153-54. A. NEGEV

TIBILIS, *see* THIBILIS

TIBISCUM (Jupa) Caraş-Severin, Romania. Map 12. A Roman town and camp at the junction of roads that led from the Danube, from Dierna and from Lederata, towards Ulpia Traiana, the Dacian capital. The ruins are spread over an area of several hectares within the villages of Jupa, Ciuta, and Iaz. The name, of Thraco-Dacian origin, is mentioned in ancient sources (Ptol. 3.8.4, as Tiviscon; *Tab.Peut.; Rav.Cosm.* 4.14) and in inscriptions.

Excavations have revealed that the earth camp (140 x 160 m) was rebuilt in stone. Several levels were found. The first phase dates probably from the days of the Dacian wars. Cohors I Vindelicorum, Numerus Maurorum Tibiscensium, and Numerus Palmyrenorum Tibiscensium were stationed here.

The civil settlement, developed from canabae, was initially a pagus that belonged to the Ulpia Traiana territory. It is probable that it became a municipium under Septimius Severus, but the title is attested by an inscription from the reign of Gallienus (*CIL* III, 1550).

Most of the archaeological and epigraphical material—among which are two military diplomas, one from 120 and the other from 156 or 157—is to be found in the Timişoara Banat Museum.

BIBLIOGRAPHY. N. Gostar, "Populaţia palmireniană din Tibiscum în lumina monumentelor epigrapfice," *Arheologia Moldovei* 2-3 (1964) 37-42; D. Tudor, *Oraşe, tîrguri şi sate în Dacia romană* (1966) 94-204; M. Moga, "Pagus Tibiscensis, în legătură cu teritoriul rural al Ulpiei Trainana," *Tibiscus* 1 (1970) 41-50.

L. MARINESCU

TIBUR (Tivoli) Italy. Map 16. The town is 27 km E-NE of Rome, elevated beside gorges and cascades of the river Anio in the foothills of the Sabine range. On the ancient Via Tiburtina and visible from Rome (Strab. 5.238), it is mentioned by many Latin writers (Catull. 44; Livy 34.45; Plin. *Ep.* 8.17); it was a very ancient site, inhabited long before Rome was founded. A powerful member of the Latin League (Plin. *HN* 16.237), it long remained independent of, and in conflict with, Rome (Livy 9.30), but in 90 B.C. the Tiburtines entered into Roman citizenship.

The setting is spectacular, bounded on two sides by precipices and cascades (Hor. *Carm.* 1.7.13). Travertine (lapis tiburtinus) was and is quarried there, fruit was raised, and from Late Republican times the Tivoli slopes were dotted with elaborate villas of the well-to-do; the celebrated Zenobia was installed in one of these (A.D. 273; S.H.A. *Tyr. Trig.* 26). The modern city preserves at its center a semblance of the ancient, irregular town plan. Tivoli is very rich in remains. Within the city and its immediate environs over 200 monuments or fragments of monuments can be identified; only a few of the most significant of these are mentioned here.

The forum extended from the duomo toward the SW, apparently supported above the hillside in part by an interesting cellular vaulted construction, dating from the early 1st c. B.C., which has sometimes been identified as a covered market street. Farther downhill to the SW are the considerable remains, embedded in modern construction, of a Sanctuary to Hercules Victor (ca. 120 x 180 m). Probably of Sullan date, it consisted of a terrace, supported on vaulted concrete substructures, that carried a temple somewhat like that of Mars Ultor at Rome. Along three sides of the terrace were two-story, arcaded porti-

cos; on the fourth was a sunken, theater-shaped place of assembly flanked by ceremonial staircases. Plans are afoot to clear this major monument.

At the N tip of the town, atop an acropolitan cliff, stand the remains of two travertine temples of late Republican date and uncertain identification. The rectangular one (ca. 9 x 15.3 m overall) is Ionic tetrastyle prostyle, pseudodipteral. The circular one (to Tiburnus? Hercules?), contemporary with or slightly later than its neighbor, is an elegant Corinthian tholos, of 18 columns, ca. 13.8 m in maximum diameter. At the S extremity of the town was an amphitheater, built or renovated in the middle of the 2d c. A.D. Across the Anio to the NW of the town are the vaulted and terraced remains of a grand villa known as that of Quintilius Varus; much of what can be seen is of the 2d c. A.D. Finally, on the Clivus Tibertinus at the W edge of the town is a well-preserved rotunda, probably of the 4th c. A.D. and known as the Tempio della Tosse. It is ca. 16.8 m in diameter and bears some resemblance to the so-called Temple of Minerva Medica in Rome of A.D. 320, though the Tivoli building has unusual projecting rectangular niches. The original concrete hemispherical vault is intact.

Just outside the town's S and E perimeter were the necropoleis. Copious sources of clear water in the hills NE account for the many aqueduct bridges across the neighboring valleys; four of Rome's aqueducts passed by Tivoli. Over the Anio not far W of the town an ancient bridge, the Ponte Lucano, stands nearly intact; nearby is the cylindrical, travertine-faced Tomb of the Plautii, similar to the Tomb of Cecilia Metella on the Via Appia near Rome.

About 4 km SW of Tivoli, on a fairly low and level site, stand extensive remains of the most famous of Tivoli's villas, Hadrian's, built in the twenties and the thirties of the 2d c. A.D. There had been a smaller villa of Republican date here before the emperor, who was deeply interested in architecture, began to spread almost every kind of building across hundreds of hectares. Excavation began here in the 16th c. and has continued intermittently ever since; the museums of Rome (Vatican, Terme, Capitoline, Villa Albani) contain mosaics and much sculpture from the Villa, and there is a small museum on the site. There is also a useful model showing the main parts of the Villa restored (a duplicate is in Room 40 of the Museo della civiltà romana at the EUR suburb of Rome). The statement by "Spartianus" (S.H.A. *Hadr.* 26.5) that the emperor gave to various buildings the names of famous places has established a certain nomenclature, accurate or not.

The Villa is planned along axes of various lengths that intersect obliquely; most individual elements, however, are symmetrical in plan, erected on artificial terraces of concrete. The building typology is sometimes highly experimental. Structure is largely concrete and the spaces are vaulted more often than not. The typically Hadrianic synthesis of old with innovatory ideas is seen at the Piazza d'Oro, a large rectangular enclosure with elaborate waterworks along its main axis. At the centers of the shorter sides of the enclosure are architectural forms and spaces previously unseen in architecture: serpentine curves, undulating complex vault surfaces, and elegant orders used purely visually. At the Teatro Marittimo an artificial, circular island, decked out with pavilions and chambers, is surrounded by a moat and a colonnaded and vaulted circular walkway. Of the three bathing establishments the Small Baths are unique in ancient architecture. The planning is anti-classical: rooms whose plans are based on half a dozen geometric figures are fitted together like a jigsaw puzzle, and their roofs, of various shapes of vaulting, rise to different heights. Nearby is a

complex of pools and stage architecture known as the Canopus and Serapaeum. A shallow pool over two hundred feet long is set in a draw between other Villa structures; on one side is a file of urban tabernae. At the end of the pool a vast niche, vaulted in undulating forms and once sheathed with mosaic of colored glass, is the central feature of a richly worked complex of nymphaea. Back from the center of the niche, projecting deep into the hillside, is a cleverly lighted sanctuary.

Water ran and spurted everywhere. The quality of finish varies from the highest to the quite crude. Some extremely fine mosaics have been found at the villa, and the sculpture ranges from really significant examples to peculiarly lifeless copies of Greek favorites. In some cases the architectural whims of the emperor seem to have been dead ends; at the least the Villa preserves evidence of most of the developments in Roman architecture during the century or so before it was built.

BIBLIOGRAPHY. G. Cascioli, *Bibliografia Tiburtina (Studi e fonti per las storia della regione tiburtina* 3; 1923); *RE* 6A (1937) 816-41[P]; *EAA* 7 (1966) 887-92[MPI]; C. F. Giuliani, *Tibur, pars altera* (1966)[MPI], and *pars prima* (1970)[MPI]. For Hadrian's Villa: H. Winnefeld, *Die Villa des Hadrian bei Tivoli* (Berlin 1895; =*JdI*, Erganzungsheft 3)[MPI]; H. Kähler, *Hadrian und seine villa bei Tivoli* (1950)[P]; S. Aurigemma, *Villa Adriana* (1961)[PI].

W. L. MACDONALD

TIDDINGTON Warwickshire. England. Map 24. Small settlement on the river Avon, near Stratford, excavated 1925-27. Several buildings were found, and furnaces for iron working and smelting; there was also a small furnace thought to have been for the cupellation of lead and for silver extraction. A structure identified as a tile kiln was probably for corn drying.

BIBLIOGRAPHY. Fieldhouse et al., *A Romano-British Industrial Settlement near Tiddington, Stratford upon Avon* (1931).

G. WEBSTER

TIDDIS, *see* CASTELLUM TIDDITANORUM

TIEION, *see* TIOS

TIENEN (Tirlemont) Belgium. Map 21. A Gallo-Roman vicus of the civitas Tungrorum, located on the Tongres-Cortoriacum-Castellum Menapiorum road. Diverticula linked it to Taviers and Namurcum, to Baudecet and Bavai, and to Grobbendonk and Antwerp. Since the vicus is located under the modern town, it is mainly known from scattered remains and stray finds (potsherds, coins, tiles, bronze artifacts, etc.), which permit an estimate of its size. Foundations of buildings have been noted in various places, but systematic excavations have been undertaken only in the vicinity of Avendoren, where a rather large building (or villa suburbana) was discovered in 1891. A Merovingian necropolis was established in its ruins in the 7th c. Some incineration tombs and barrows have been found all around the vicus. Three barrows in the vicinity of Grimde were excavated at the end of the 19th c. Two contained rich grave goods: bronze oenochoe, a bronze furniture leg, a small silver vase, a bronze patera, a gold stiletto sheath with the inscription M(arcus) Probius Burrus, a gold ring, a sardonyx cameo in a gold setting, etc. The funerary chamber of another barrow, leveled long ago, was found in the vicinity of Avendoren. It produced equally rich grave gifts, which included a bronze casket which served as an urn, a bronze wine pitcher, a bronze patera with a picture of the abduction of the Palladion by Diomedes on it, a bronze askos, a bucket with channeled sides, two large bronze basins, a tinned bronze chandelier, a

silver cup, bone and horn artifacts, several pieces of glassware, pottery, iron, and stone. Like those of Grimde, this tomb dates to the 2d c. A.D. Little is known of the vicus save that it seems to have prospered in the 2d c. but was no longer occupied in the 4th.

BIBLIOGRAPHY. A. de Loë, "Exploration des tumulus de Grimde-lez-Tirlemont," *AnnArchBrux* 4 (1893) 22ff; J. Mertens, "Une riche tombe gallo-romaine découverte à Tirlemont," *AntCl* 21 (1952) 39-73; M. Desittere, *Bibliografisch repertorium der oudheidkundige vondsten in Brabant* (1963) 144-49.

S. J. DE LAET

TIFERNUM METAURENSE (S. Angelo in Vado) Umbria, Italy. Map 16. A site mentioned only by Pliny (*HN* 3.114) but attested by several inscriptions. It is situated across an Apennine pass from Tifernum Tiberinum near the sources of the Metaurus. It belonged to the tribus Clustumina.

BIBLIOGRAPHY. *EAA* 7 (1966) 851-52 (G. Annibaldi).

L. RICHARDSON, JR.

TIFERNUM TIBERINUM (Città di Castello) Umbria, Italy. Map 16. A municipium in the upper Tiber valley, known chiefly from Pliny's letters (3.19; 4.1; 5.6; 10.8). He had his "Tuscan" villa near here. Tifernum belonged to the tribus Clustumina. Except for inscriptions, some of which are kept in the Palazzo Comunale, there are only scant remains of buildings and fragments of mosaics. At Trestina, nearby down the Tiber valley, rich tombs have been found and an important sanctuary deposit of the early orientalizing period. The material is in the Museo Archeologico in Florence.

BIBLIOGRAPHY. *EAA* 2 (1959) 699 (C. Petrangeli).

L. RICHARDSON, JR.

TIGANI, *see* SAMOS

TIGZIRT, *see* IOMNIUM

TIKLAT, *see* TUBUSUCTU

TILOS One of the Dodecanese, Greece. Map 7. An island situated between Rhodes and Nisyros. Pliny (4.23.3) says that its older name was Αγαθοῦσσα. The early settlers of Tilos were Dorians. Tilos joined Rhodes in the foundation of Gela during the 7th c. B.C. (Hdt. 7.153). It appears in the tribute lists in 427-426 B.C. The acropolis and the town lie at Megalo Chorio to the N of the island. They are protected by a fortification system, probably early Hellenistic. At Kastello, near modern Livadhia, there is a steep area protected by a fortification wall and a round Hellenistic tower. Tilos possesses a collection of Classical and Hellenistic sculpture and inscriptions.

BIBLIOGRAPHY. R. M. Dawkins & W.J.B. Wace, *BSA* 12 (1905-6) 159-65; B. D. Meritt, *ATL*, I (1939) 555; G. E. Bean & J. M. Cook, *BSA* 52 (1957) 116-18; R. H. Simpson & J. F. Lazenby, *BSA* 65 (1970) 63-68[MP].

D. SCHILARDI

TILURIUM Gardun by Trilj, Croatia, Yugoslavia. Map 12. The site of the fortress of Legio VII Claudia pia fidelis. Situated on the top of the hill of St. Petar over the steep gorge of the Cetina (Hippius) river, it controlled a large central Delmatian area. There was a crossing over the Cetina and the camp commanded it just as Burnum commanded the crossing over the Krka (Titius) river on the W border of the Delmatae. Both Tilurium and Burnum were the final fortifications on a limes of the Roman army established against Illyrian tribes. The site of camp has not yet been explored archaeologically. The parts of the defenses built into farm

buildings can be seen. The site yielded many inscriptions, mostly the tombstones of the legionnaires. A part of a 1st c. Roman triumphal monument is preserved in the Archaeological Museum at Split, showing the Delmatian prisoners bound at the foot of the Roman tropaeum. Legio VII left Tilurium ca. 60 A.D. for Moesia, and the auxiliary Cohort VIII voluntariorum civium Romanorum remained there until the 3d c.

The finds are preserved in the Archaeological Collection of the Franciscan Monastery at neighboring Sinj.

BIBLIOGRAPHY. S. Gunjača, "Nov prinos ubikaciji Tiluriuma," *Vjesnik za arheologiju i historiju dalmatinsku* 52 (1935-49) 50-52; G. Alföldy, "Tilurium, ein römische Legionslager in Dalmatien," *Bonner Jahrbücher* 165 (1965) 105-7. M. ZANINOVIĆ

TIMGAD, *see* THAMUGADI

TIMMARI Basilicata, Italy. Map 14. An eminence formed by two narrowly separated ridges overlooking the broad valley of the river Bradano, ca. 11 km W of Matera. Excavations have confirmed the occupation of the E ridge from the end of the 2d c. B.C. until the late Middle Ages. In addition to a strategic location, a good water supply, especially on the W side of the complex, favored the establishment of settlements and towns.

The first traces of habitation go back to a settlement in Neolithic times followed by another, datable to the beginning of the Iron Age, which practiced cremation burials with situlae in unrefined clay of the proto-Villanovian tradition. In the late burials from the first phase of the Iron Age, tomb offerings of vases or bronzes are very rare. In the second half of the 6th c. Greek imports from the colony of Metapontion supplement indigenous vases characterized by geometric decoration. This indirect contact with Greece is indicated by so-called Ionic bowls and by a few fragments of black-figure vases.

Although there is no evidence for habitation during the 5th c., the site was reoccupied in the second half of the 4th c. B.C. when the houses were built with regular blocks or with river stones. In this period, black-varnished and black-figure Greek pottery from nearby Apulia predominated. A sanctuary was built on the NW side of the eminence around a spring; and on the highest terrace of the E ridge a large villa. The statuettes from the votive deposit of the sanctuary are local but conserve Tarantine-Metapontine characteristics. Habitation continued, although on a reduced scale, into the Hellenistic-Roman period.

BIBLIOGRAPHY. D. Ridola, *BPI* 27 (1901) 37-41; Q. Quagliati, *MonAnt* 16 (1906) col. 5-166; D. Adamesteanu, *Atti IV Convegno Taranto* (1965) 134-36; id., *Popoli anellenici in Basilicata* (1971) 39-44.
 D. ADAMESTEANU

TINDARI, *see* TYNDARIS

TINGI (Tangiers) Morocco. Map 19. An ancient city of W Mauretania, possibly the Θυμιατήριον of Hanno's Periplus, situated on the outlet of the Straits of Gibraltar on the Atlantic, on the rim of a wide, only moderately sheltered bay. The ruins, which could still be seen in the 11th c. according to the Arabian geographer El Bekri, have been completely covered over by the Casbah and the old quarters of Tangiers, which have never yielded anything more than insignificant archaeological finds.

Legend has it that the city was founded by Antaeus (Pomp. Mela, 1.5; Plin. *HN* 5.2); in fact, nothing is known of its origins. Yet in the 5th c. B.C. and probably earlier the inhabitants of the hinterland, whose necropoleis have been found from Ras Achakar to Malabata, were in continuous contact with the Punic traders of

S Spain. It is possible therefore that a first settlement was built in this period on the Marshan plateau—an acropolis 62 m above the sea—and on the hillsides that slope down to the SW toward what is now the port. Some "Phoenician" tombs are claimed to have been found at several points in the old city and on its immediate outskirts, yet the earliest remains that have been preserved hardly go back beyond the 2d c. B.C. (Marshan necropolis). Tingi appears to have been an autonomous city in this period, minting coins with neo-Punic legends and probably ruled by local dynasties that more or less recognized the authority of the Mauretanian kings. Sertorius seized the city some time in 81, and in 38 its inhabitants, who had sided with Octavius against King Bogud, Anthony's supporter, received Roman citizenship (Dio Cass. 48.45). Called Colonia Iulia Tingi on its coins, governed most likely under Latin law and at first attached administratively to Spain, it became under Claudius a Roman colony and chief city of the province of Mauretania Tingitana after it was set up. In 297 the city probably served Maximianus as a base during his campaign against the Moorish rebels, and it was very likely about this time that the Christians Marcellus and Cassienus were put to death. The former belonged to a Spanish community, the latter, however, probably to a local church which funerary inscriptions show existed in the 4th-5th c. although there is no mention of a bishopric until the 6th c.

The limits of the ancient settlement are clearly marked by the necropoleis discovered to the NW (that of Marshan and Avenue Cenario), to the W (Mendoubia) and S (Bou Kachkach). Nothing remains of the substructures, which could still be seen on the seashore at the beginning of the century. There were also some baths underneath the Casbah, and confused remains of a monument—apparently a Christian basilica—have been uncovered in the Rue de Belgique. So far as the rest of the city is concerned one can only presume that the forum was situated on the site of the Petit Socco and what was perhaps a temple on the site of the Great Mosque, and that the decumanus maximus corresponded roughly to the Zenga Es Siaghine. Among the few antiquities that have been discovered, the only noteworthy finds, aside from inscriptions and a few mosaic fragments, are a statue of a woman of indifferent workmanship and a mutilated head of the emperor Galba.

Several agricultural estates and brick-making works from the Imperial period have been located in the suburbs and hinterland.

BIBLIOGRAPHY. E. Michaux-Bellaire, *Tanger et sa zone* (1921); A. Beltrán, "Las monedas de Tingi y las problemas que su estudio plantea," *Numario hispánico* 1 (1952) 89-114; R. Thouvenot, "Les origines chrétiennes en Maurétanie tingitane," *REA* 71 (1969) 368-69; M. Ponsich, *Recherches archéologiques à Tanger et dans sa région* (1970)MPI. M. EUZENNAT

TINOS Cyclades, Greece. Map 9. An island situated between Andros and Mykonos, Tinos was famous in antiquity for the abundance of its springs. Subjugated by the Persians, Tinos passed to the Greeks before the battle of Salamina, for which reason its name appears among the dedicators of the Delphic tripod or stool used by the oracle. It therefore entered the Delian League and participated in the Athenian expedition against Syracuse. In the 3d c. B.C. Tinos became one of the principal representatives of the Nesiotic League and developed close ties with Rhodes. After vicissitudes in the 1st c. B.C., Tinos again flourished in the Imperial age.

The ancient site, in the SW part of the island, corresponds to that of modern Tinos, ca. 300 m from the

coast. Around the modern sanctuary of the Evangelistria there are visible remains of the ancient enclosing wall, equipped with towers which may be dated to the 5th c. B.C. Numerous rebuildings, however, are attributed to the 3d c. B.C., the period to which an inscription on the blocks of a tower are dated.

Outside the modern center to the W, in a place called Kionia, are the remains of a particularly well-attended Sanctuary of Poseidon, which was mentioned by Strabo (10.5.11). The Phokian Confederation, in the mid 3d c. B.C., granted this sanctuary the right of shelter and contributed to the expense of its erection. These rights were later renewed by the emperor Tiberius. The sanctuary could also be reached from the sea by a road 150 m long which connected it with a pier. The approach to the cult room was through the propylaeum, behind which are visible the remains of an altar (11 x 30 m) of the in antis type, with a frieze of garlands and ox skulls. The work is of a modest artistic level, and the construction is contemporary with the temple. The latter, which dominated the center, is oriented E-W. It is a Doric peripteral temple, with 6 by 8 columns, and with a nearly square internal cella. The base of the temple is 1.7 m high and is connected on the E and S sides to the ground level by stairs. Several sculpted fragments of the pediment have been found, depicting sea monsters. Numerous titles bear dedicatory inscriptions to Poseidon.

Parallel to the temple, but farther to the N, is another construction linked to a second building. Viewed from the front its architectural elements include a central exedra with lateral porticos consisting of Doric columns surmounted by architraves and friezes with metopes and triglyphs. The construction has been identified as a refectory in which visitors to the temple assembled (one of the estiatoria mentioned by Strabo). At the N limits of the sanctuary, another rectangular building, whose construction dates from Roman times, was probably set apart for the lodging of pilgrims. The monumental systematization of the sanctuary already known is attributable to the Hellenistic and Roman periods, at which time the cult of Poseidon was particularly strong, together with those professed on the island of Delos. However, traces of older walls oriented in the same direction and probably dating from the 5th c. B.C. have been found under the temple and under the altar.

A second center has been discovered at the foot of Mt. Exoburgo, where visible remains of an encircling wall constructed of unworked granite blocks form an irregular screening wall on fill from the 8th c. B.C. The defensive system has been dated to the 7th c., as has a building situated outside the walls, with an irregular plan, in which a tesmophorion has been identified. At the E extremity of this city excavations have been carried out in a necropolis which, however, is no longer visible. It contained rectangular coffered tombs, most of which had been plundered, datable to the 5th c. B.C. The tombs had been furnished with funerary stelai, of which only the bases remain.

A third locality which has furnished archaeological material is modern Kardiani, where a necropolis containing coffered tombs from the Geometric age has been discovered on terraced ground above the sea. The tombs, which are no longer visible, contained besides the skeleton only meager funerary material, consisting mostly of rough local ceramics and painted ceramics of the Cycladean type attributable to the Middle Geometric period. The site is the earliest habitation on the island as indicated by Neolithic material from one of the inhabited grottos.

In the city of Tinos is a small collection of antiquities found on the island. The late pre-Geometric and Geometric pottery includes cups, amphorae, and kantharoi with panel decoration of pendulant semicircles in the earlier period and with meanders in the more recent, that is up until ca. mid 8th c. B.C. There are also numerous examples of orientalizing impasto pottery with decorations in relief, mostly made on the island between mid 8th and mid 7th c. B.C. The older examples bear geometric designs, while the more recent often are decorated with real and fantastic animals. A large amphora discovered on Mykonos, with a representation of the Trojan horse, has been attributed to Tinos. Also in the museum is the material from the Sanctuary of Poseidon, including several inscriptions and several statues of the Roman period.

BIBLIOGRAPHY. There is no monographic treatment of the island's antiquities. A number of studies relate to the excavations: P. Graindor & H. Demoulin in *BCH* 26 (1902) 399ff; *Musée Belge* 8 (1904) 64ff; 10 (1906) 309ff; 14 (1910) 5ff; *REA* 20 (1918) 33.

Discussions of the monument in the sanctuary: A. Orlandos in *ArchEph* 2 (1937) 608ff; C. Picard, *CRAI* (1944) 147ff. On the excavations at Kardiani: D. Levi in *ASAtene* 8-9 (1925-26) 203ff.

On the excavations near Exoburgos: M. N. Kondoleon in *Praktika* (1953) 258ff; (1955) 259ff; (1958) 220ff. For other objects preserved in the museum: J. Schäfer, *Studien zur den griechischen Reliefpithoi de 8.-6. J.v.Chr.* (1957); J. N. Coldstream, *Greek Geometric Pottery* (1968) 165ff. M. CRISTOFANI

TINTIGNAC Corrèze, France. Map 23. Called Quintinhac in the 13th c., Tintignac is in the commune of Naves. Excavations in the 1840s and especially in 1884 have produced a fairly clear but still incomplete picture of the site and its complex of important buildings: the theater, temple, and the so-called shops (which appear to have been burned). Coins found on the site cover the period from Augustus to Constantine; it is possible, however, that it was occupied before the Roman conquest.

The theater faced SE and stood on a slope (67.5 m along its axis, 85 m wide). Higher up and on the same axis is another building the inner wall of which impinges on the cavea of the theater. At each end of this wall is a nearly square pavilion. The outer wall, consisting of a gallery with 10 semicircular and two rectangular niches, all richly decorated, runs in a semicircle around a courtyard paved with marble. In the center of the outer wall is another square pavilion. Although this monument has been taken to be a temple, where each of the niches formerly held the statue of a divinity, such a plan is extremely unusual, the only other example known being the temple overlooking the theater at Vienne.

A building 74 m long has been uncovered a few m NE of the temple and on the same level: a large rectangular hall with an opening, in the middle of the wall opposite the entrance, into a square pavilion with semicircular apses on each side. The hall is flanked by two rectangular pavilions. These are probably the three main temples of a sanctuary similar to those at La Roche, near Poitiers, and Le Vieil-Evreux.

The so-called shops, some 30 m to the NW, are housed in a rectangular building with two courtyards. The inner one contains two small square aediculae, the outer one is surrounded by a gallery.

These buildings, similarly oriented, are part of a complex that may be compared to such centers as Sanxay and Chassenon.

BIBLIOGRAPHY. P. Lalande, "Ruines de Tintignac, Corrèze," *Bull. Soc. Scient. Hist. et Archéo. de la Corrèze* 7 (1885) 632-713; V. Forot, *Les ruines gallo-romaines de Tintignac* (1905); Grenier, *Manuel* IV, 2 (1960) 582-86.
 G. LINTZ

TIOS or Tion or Tieion (Filyos) Turkey. Map 5. City in Pontos or Bithynia, 23 km NE of Zonguldak. A Milesian colony at the mouth of the Filyos Çayı, the ancient Billaios. In the mid 4th c. Tios was a dependency of its neighbor Herakleia, and was later incorporated by Amastris in the city which she founded under her own name. Following a period of independence after 280 B.C. Tios was restored to Herakleia by Nikomedes of Bithynia. In 189 B.C. it was given to Eumenes of Pergamon, and after some further vicissitudes was captured by Mithridates VI (Strab. 541). Under Pompey's settlement of the region Tios seems to have acquired some measure of autonomy. The coinage begins in the 4th c. B.C. and extends to the 3d c. A.D.

Although Strabo (543) regarded Tios as an undistinguished town, its ruins are considerable; they date, however, after Strabo's time and at present are much overgrown. The acropolis, the original place of settlement, is on a headland N of the site; it carries a mediaeval fortification based on ancient defense lines; two Hellenic towers are recognizable. The inhabited town lay below the acropolis on the S; in the hillside facing W is the theater, judged in the late 19th c. to be among the best preserved in Asia Minor. Today this cannot be said, but parts of the cavea and stage building can still be made out among the dense overgrowth. To the S of the theater are the ruins of a rectangular building of regular ashlar, parts of which still stand to a considerable height. Other buildings include one with apse and peristyle, in regular bossed ashlar, with numerous doors. A fragment of an aqueduct, with three or four arches remaining, extends towards the shore, where some traces of the ancient harbor are visible. The necropolis spread over the NE slope of the acropolis; the finds were chiefly much damaged sarcophagi.

BIBLIOGRAPHY. W. F. Ainsworth, *Travels and Researches* I (1842) 49-52; W. von Diest, *PM* 94 (1889) 73-75; G. Mendel, *BCH* 25 (1901) 36-39; E. Kalinka, *JOAI* 28 (1933) 53-54, 89-94; L. Robert, *Études Anatoliennes* (1937) 266ff[MI]. G. E. BEAN

TIPASA Algeria. Map 18. Probably Tipasa is the most beautiful ancient site on the Algerian coast. Although a village of colonists was placed on part of the ancient town, it has been possible to protect a large area on the seacoast where the combination of forest, ruins, rocks, and water make the site a paradise.

The excavation of the E and W necropoleis has proved that people lived at Tipasa as early as the 6th c. B.C. Thus, whether it owes its origin to a Phoenician depot or to a native center which entered into contact with Carthaginian seamen, the settlement is very early. These necropoleis, in particular the graves cut into the rock, have brought to light a great quantity of artifacts. These enable one to follow the increasing importance of a site which certainly was no mere port of call. As yet, however, the town, properly speaking, has not been found. One must suppose that it was placed on the plateau, which is now dominated by the lighthouse and where the forum and capitol stood in ancient times. This supposition is strengthened by the presence, some kilometers E of Tipasa, of the huge mausoleum called the Tomb of the Christian (see below) which seems to date to the 1st c. B.C. This monument and the proximity of the capital of the kingdom of Mauretania, Iol (later called Caesarea, Cherchel), make this region one of the coastal areas best integrated with the Mediterranean world. This large and precocious urban development in some way justifies the new vigor which the region enjoyed when Octavius established the colonies of Aquae and Zucchabar nearby and those of Gunugu and Cartennae farther to the E.

Tipasa became a municipium with Latin privileges under Claudius and a colony under Hadrian or Antoninus Pius. This also demonstrates the importance which the town acquired after the kingdom of Mauretania was transformed into a Roman province in A.D. 40. At this time (when the inhabitants of the city gained Roman privileges), a vast enceinte was built. It included some of the ancient necropoleis (especially those to the E), which were covered by the expanding settlement.

This enceinte has been partly cleared to the E. There one can see that it is pierced by two gates. Two other passages have been excavated to the SW and W. Only scattered districts and monuments have been excavated within the walls.

The platform of the forum extends over a rocky hillock that juts out into the sea. Porticos bordered it on three sides. On the fourth side the forum was formerly dominated by the mass of the capitol, of which only the thick foundations survive. A stairway led down to the civil basilica, a large chamber with three naves ending in an apse and two appended rooms. Tribunes must have been placed on the aisles. In its plan and elevation, this building (which dates to the end of the 2d c.) heralds the Christian basilicas of North Africa.

A district of houses is being excavated N of this plateau on the seashore. The rooms of these houses open onto peristyles and are sometimes decorated with mosaics. The decumanus passes nearby. The courts of two temples with periboli open onto it. A monumental semicircular nymphaeum was somewhat farther W, with a theater beyond. Its tiers of seats were supported by radiating arches, and only the foundations of the stage are preserved. An amphitheater and public baths were located S of the decumanus.

A colossal cathedral attests to the presence of Christianity within the walls. The cathedral matches the mass of the capitol on the other side of a small bay. The edifice has seven naves, of which the central one ends in a semicircular apse. To the NE there is a square baptistery with a circular pool, and the bishop's house is to the N.

Outside the walls, the necropoleis extended very far along the shore, both to the E (on the Algiers road) and to the W (towards Cherchel). There still is a circular mausoleum to the W, just next to the ramparts. A few hundred meters farther on, the basilica of Bishop Alexander was constructed near a space where martyrs had been buried at the beginning of the 4th c. During the 4th c. a martyry was built there, and a little later a basilica.

The ancient port is located at the foot of the cliff which bears the E necropolis. It lay between the coast and two small islands. Underwater diving has led to the discovery of dikes destroyed by storms. A large number of quarries of marine sandstone are found farther E along the shore, from which blocks must have been transported by sea.

The Tomb of the Christian is some 10 km E of Tipasa on a hill of the Sahel overlooking the sea. The semicircular drum of this mausoleum is adorned with engaged Ionic columns, and the whole is topped by a stepped cone. On the inside, a helicoidal corridor with a cylindrical vault leads to a funerary chamber.

The artifacts found during the excavations of Tipasa are collected within a private garden (the Angelvy property) and in a museum and its storage rooms. Marble sarcophagi (the Dioscuri, the Shepherd, the Seasons) and pieces of architecture are arranged all along the walks of the garden. The museum shelters mosaics (in particular the so-called Mosaic of the Captives, which comes from the civil basilica) and part of the ceramic material found in recent excavations. Also to be noted

are stelae of local manufacture and tables for funerary repasts.

BIBLIOGRAPHY. In the two guides of J. Baradez, *Tipasa, ville antique de Maurétanie* (1952) and S. Lancel, *Tipasa de Maurétanie* (1966) can be found all the earlier bibliography. Recent bibliography follows: S. Lancel, *Verrerie antique de Tipasa* (1967); S. Lancel, in *Bulletin d'archéologie algérienne* 1 (1962-1965) 41-74; 2 (1966-1967) 251-59; 3 (1968) 85-166; J. Christern, ibid. 3 (1968) 193-258; N. Duval, in *XVII corso di cultura sull'arte ravennate e bizantina* (1970) 127-33; P.-A. Février, ibid., 191-204; M. Bouchenaki, in *Revue d'histoire et de civilisation du Maghreb* 8 (Jan. 1970) 23-41.

On the Tomb of the Christian: M. Christofle, *Le tombeau de la Chrétienne* (1951); M. Bouchenaki, *Le mausolée royal de Maurétanie* (1970). P.-A. FÉVRIER

TIRLEMONT, *see* TIENEN

TIRMISIN ASARI, *see* TYBERISSOS

TIRYNS Greece. Map 11. An age-old town in the SE part of the plain of Argos, a short distance from the sea. Its origins go back to legendary times, and it was from Tiryns that Herakles performed the twelve labors for King Eurystheus. The town was famed for its massive walls, thought to have been built by the Cyclopes and mentioned by Homer. The Tirynthians took part in the Trojan War under the leadership of Diomedes. Though only a small place in Classical times, it sent a contingent to fight at Plataia and was a thorn in the side of Argos until the Argives destroyed it, probably in the sixties of the 5th c. B.C. The exiled Tirynthians settled in Halieis in the S Argolid.

The remains, particularly the walls, have always been conspicuous. The first large-scale excavations of 1884 have been continued at intervals in the 20th c. The site is a low eminence ca. 300 m long and up to 100 m wide, rising only ca. 20 m above the surrounding plain. This forms the acropolis and was fortified with strong walls. The lower town lay in the flat surrounding area.

Potsherds indicate that the site has been inhabited since Late Neolithic times, though no walls of this period have been found. In the Early Bronze Age it was an important place, but the Late Bronze Age was the greatest period: the higher S part of the acropolis was occupied by an extensive palace, one of the best preserved on the Greek mainland. The principal unit was the megaron which opened off a large colonnaded court. The lower, N part of the acropolis was also enclosed within the walls but seems to have had no important buildings.

The palace was destroyed at the end of the Bronze Age, but the site continued to be occupied in Geometric and Archaic times. A Doric temple is attested by a column capital. Boustrophedon inscriptions of the 6th c. B.C., found in 1962 on the cover slabs of water tunnels passing under the walls should, when deciphered and published, give interesting information on the government and religion of the archaic town. The exile of the Tirynthians at Halieis (Porto Cheli) is confirmed by Tirynthian coins found in excavations there. The site was deserted in the time of Strabo and Pausanias. The movable finds from Tiryns are divided between the museums of Athens and Nauplia.

BIBLIOGRAPHY. H. Schliemann, *Tiryns* (1886); D. Arch. Inst., Athens, *Tiryns* I-VI (1912-72, continuing)[MPI]; G. Karo, *Fuehrer durch Tiryns*[2] (1934), a full authoritative guide[PI]; W. Voigtlaender, *Tiryns*, Eng. trans. S.C.D. Slenczka (1972), small but up-to-date site guide[PI]. E. VANDERPOOL

"TISSA," *see* RANDAZZO

TITAN, *see* SHIPWRECKS

TITELBERG Luxembourg. Map 21. Prehistoric oppidum near Pétange, later a Celtic and Roman vicus with many industrial activities. In the 19th c. parts of some Roman houses were found, a lead fragment stamped FLAVINIOS FLAVOS FEC(it), baths, some fragments of what may have been a Graeco-Roman sanctuary, and portions of a Roman(?) fortification wall that had been known since the 17th c. Later excavations revealed a narrow, rectangular Roman house of urban type, and the Celtic settlement. Coins have proved that there was a prosperous Celtic village before the Romans came: the coins of 43 civitates attest well-organized trade focusing on the Titelberg agglomeration.

Since WW II excavations have produced many Roman objects, mainly of the 2d and 4th c.: walls, houses, cellars, a glass factory, potters' officinae, and coins from all four centuries of Roman occupation. Among the most characteristic objects are an altar dedicated to the Genius Vosugonum by one Sabinus, a public slave; a huge bronze ring intended for Mercurius or Mithra; a number of stone miniatures of votive character in the shape of houses, fana, sanctuaries, and public buildings; tituli; a clay statuette signed by FIDELIS; stamped pottery from many parts of Gaul and Germany. Unfortunately the mountain is undermined by abandoned galleries which make stratigraphic research impossible. Finds are in the Musée d'Histoire et d'Art in Luxembourg.

BIBLIOGRAPHY. C. M Ternes, *Répertoire archéologique du Grand-Duché de Luxembourg* (1971) I, 153ff; II, 229ff; id., *Das römische Luxemburg* (1974) 165ff; id., "Le T. vue par Alexandre Wiltheim," *Kohrspronk* 3 (1974) 7-32, with bibl. C. M. TERNES

TITHOREA (Velitsa) Phokis, Greece. Map 11. A city on the S side of the Kephissos Plain, where the ground rises to Mt. Parnassos; the local olive oil was noted for color and sweetness. It has been identified with Velitsa by 3d and 2d c. B.C. inscriptions, dated by the archon of Tithorea. Several refer to Isis, Serapis, and Anubis, recalling the sanctuary that Pausanias (10.32) said was the holiest of those built to Isis in Greece. Varying opinions have arisen from Herodotos' statement (8.32) that a number of Phokians fleeing Xerxes took refuge on the isolated peak of Tithorea, near Neon. It is probable that Velitsa was then called Neon, Tithorea referring to the heights above the great cliff rising S of the village, later applied by extension to the whole district. Others, however, have supposed Velitsa was the refuge site, and that Neon is to be identified with the remains of a walled site of considerable size at Palaia Pheva on the right bank of the Kephissos about 5 km to the N. Plutarch (*Sull.* 15) described Tithorea as merely a fortress in the early 1st c. B.C. but of much greater importance a century later. It had declined again by the time of Pausanias, who saw a theater, an ancient market, a Temple and Grove of Athena, and the tomb of Antiope and Phokos. In the vicinity, there was also a Temple of Asklepios Archegetos (Founder). Scattered theater seats have been noted outside the walls as well as other foundations for large buildings. The most important remains are those of the fortifications, classed with Messene and Eleutherai as the finest examples of 4th c. work. The walls, supplementing the natural defenses of cliff to the S and gorge to the E, are of trapezoidal ashlar masonry, as much as 14 courses high. On the steep W slope, the top is both inclined and stepped, and crowned with coping blocks.

The towers are square with windows and loopholes. Neon is listed by Pausanias as one of the Phokian towns razed in 346 B.C.; the walls were probably rebuilt soon after the battle of Chaironeia eight years later.

BIBLIOGRAPHY. Hdt. 8.32; Plut. *Sulla* 15; Paus. 10.32.8-11; J. G. Frazer, *Paus. Des. Gr.* (1898) v 402f; L. B. Tillard in *BSA* 17 (1910-11) 54f[MI]; *GL* I 725, n. 65.

M. H. MC ALLISTER

TIVISA, *see* TIVISSA

TIVISSA (Tivisa) Tarragona, Spain. Map 19. An Iberian town at the mouth of the Ebro. It was probably destroyed by Cato in 195 B.C. Several small treasures have been found. One included silver coins, five pairs of gold earrings, bracelets, rings, a silver clasp, the handle of a bronze mirror, a plowshare, all from the beginning of the 2d c. B.C., and now in the Archaeological Museum of Tarragona. A second treasure consisted of three coins and a bronze yoke, now in the Archaeological Museum of Barcelona. The third treasure included several paterae, two bracelets, ten vases, and fragments of others.

The houses were rectangular, with stone foundations and adobe above. The town was walled. The gate is flanked by two towers, triangular on the outside and quadrangular elsewhere, 13.75 long by 6.50 m wide. The town had a central street beginning at the gate, 7.7 m wide and crossed by two transverse streets; the gates in the S wall were 2 m wide. One of the streets has a drainage ditch 6 m long, and remains of two others. Parts of the streets were paved with large, smooth slabs, also used in some houses. A nozzle from a foundry, three stoppers with molded, hand-painted, ceramic decorations, and Campanian pottery have also been found.

BIBLIOGRAPHY. J. de C. Serra-Ráfols, "El poblado ibérico del Castellet de Banyols," *Ampurias* 3 (1941) 15-34[I]; S. Vilaseca et al., *Excavaciones del plan nacional en el Castellet de Bañolas de Tivisa (Tarragona)* (1949)[MPI]; A. García y Bellido, "Le 'tresor' de Tivisa," *GBA* 41 (1953) 229ff; J. M. Blázquez, "La interpretación de la pátera de Tivisa," *Ampurias* 17-18 (1955-56) 111-30[I].

J. M. BLÁZQUEZ

TIVOLI, *see* TIBUR

TLOS Lycia, Turkey. Map 7. Near the village of Düver, 24 km N of Xanthos on the E side of the Xanthos river. One of the six cities possessing three votes in the Lycian League; the name appears in the Lycian language as Tlava or Tlave, and eight or ten Lycian inscriptions have been found on the site. Panyassis mentions Tlous as one of the sons of Tremiles, Termilae (Tremili) being the name by which the Lycians called themselves. At an uncertain date in the 2d c. B.C. a certain Eudemus attempted to establish a tyranny at Tlos, but was suppressed by the forces of the League. Otherwise the city has no recorded history. The citizens were divided into demes, named mostly after local heroes, Bellerophon, Iobates, Sarpedon. Coinage, of League types, begins after 168 B.C.; imperial coinage, as elsewhere in Lycia, is confined to Gordian III.

The ruins consist chiefly of a theater and tombs. The theater, outside the city on the E, is of very fine Roman work excellently preserved, but at present badly overgrown. It is large and purely of Roman type, standing on almost level ground with a surrounding wall of masonry; the cavea is an exact semicircle, except that the ends of the retaining wall are straight for a few meters. Much of the stage building survives. Numerous Lycian rock tombs, of house and temple types, are cut in the N and E faces of the hill on which the city stands; the most remarkable is a temple tomb carrying a number

of reliefs, one of which represents Bellerophon on Pegasos.

BIBLIOGRAPHY. C. Fellows, *Lycia* (1840) 132-37; T.A.B. Spratt & E. Forbes, *Travels in Lycia* (1847) I 32-36; E. Petersen & F. von Luschan, *Reisen in Lykien* (1889) I 138-40; *TAM* II.2 (1930) 204-5.

G. E. BEAN

TOCOLOSIDA (Bled Takourart) Morocco. Map 19. Station at one end of the *Antonine Itinerary* (23.1) in Mauretania Tingitana, 4.5 km S of Volubilis. A castrum 160 m square was built, probably in the reigns of Marcus Aurelius and Commodus, on the site of a hamlet destroyed in the middle of the 2d c. A.D. A small settlement, whose rampart was joined to the camp's rampart, grew up next to the castrum and seems to have outlasted the latter after it was abandoned. Only very limited excavations have been carried out on the site.

BIBLIOGRAPHY. L. Chatelain, *Le Maroc des Romains* (1944) 129-34; M. Euzennat, *Bulletin d'Archéologie Marocaine* 2 (1957) 225; *BAC* (1965-66) 160-61.

M. EUZENNAT

TOCRA, *see* TAUCHEIRA

TODI, *see* TUDER

TOKOD, *see* LIMES PANNONIAE

TOLEDO, *see* TOLETUM

TOLETUM (Toledo) Toledo, Spain. Map 19. Town in Carpetania, first mentioned in 193 B.C. as small but strongly fortified (Livy), but captured by M. Fulvius. His strategy was based on the Tagus and the plateau roads.

Roman villas with mosaics have been unearthed in the Vega (the Tagus plain NW of the city). The most important monument is the circus (ca. 400 m x 95 m), with some foundations, arches, passageways, the main arch, and a lateral gate with external stairway like that of the theater of Pompeii. There were also an amphitheater in the suburb of Covachuelas, a theater N of the circus, stretches of an aqueduct with earthworks, channels, cleaning wells, and an arch. Inside the town is the so-called cave of Hercules, an underground construction with semicircular arches and large ashlar masonry, and the praetorium which occupied the highest part towards the E. Besides the mosaics, the scanty finds consist of coins, including some native ones, and Celtiberian and Roman pottery.

BIBLIOGRAPHY. J. Ainaud, *Toledo* (n.d.); M. González, *Toledo* (1929).

M. PELLICER CATALÁN

TOLFA Italy. Map 16. A modern town 24 km NE of Cerveteri. In its environs are two important centers, one protohistoric and the other Etrusco-Archaic. The latter is on the height where the mediaeval castle of Rota stands. It is an important pagus of Etruscan Caere, surrounded by numerous necropoleis in the vicinity of Ferrone, Pian Cisterna, Pian Conserva, Pian Li Santi, S. Pietro and Brandita. It is characterized by chamber tombs of the Caerean type dating from the 7th to the 5th c. B.C. A small country sanctuary with two little temples within a temenos and a small votive deposit are at Grasceta dei Cavallari. The material excavated in the area is largely preserved in the Civic Museum of Tolfa and in the antiquarium at Allumiere.

BIBLIOGRAPHY. S. Bastianelli, *StEtr* 13 (1939) 94ff; O. Toti, *I Monti Ceriti nell'Età del Ferro* (1961)[MPI]; id., *Allumiere e il suo territorio* (1969)[M]; M. Del Chiaro, *AJA* 66 (1962) 49ff[M]; *EAA* 7 (1966) 904-6 (M. Torelli); A. Stefanini, *Recenti scoperte archeologiche nel territorio di Tolfa* (1966)[MP].

M. TORELLI

TOLMETA, see PTOLEMAIS (Cyrenaica)

TOLNA, see LIMES PANNONIAE

TOLOSA (Toulouse) Haute-Garonne, France. Map 23. City in Gallia Narbonensis. The metropolis of the Volcae Tectosages, it was allied with Rome from the conquest in 120-118 B.C. on. In 106 B.C., after a rebellion, it was retaken and pillaged. Tolosa flourished, thanks to the Italian wine trade, from the time of Fonteius and Caesar on; it attained Latin, then colonial status. During the Empire it was well known for its schools of rhetoric and its level of culture, which earned it the surname Palladia. It surrendered to the Visigoths in 418 and became their capital.

The walls, on the right bank of the Garonne, were 3 km long with curtains 2.4 m thick and round towers 10.5 m in diameter. They may go back to the 2d c. A.D., but only the late curtain walls on the edge of the Garonne can still be seen. The town, covering 90 ha, was laid out on a checkerboard plan which can be recognized in the modern streets. Its monuments were buried to a depth of 4 m, and only one has been identified (1868-69): the theater, with a diameter of 90 m. The location of the Capitol, famous for the martyrdom of St. Saturninus, remains uncertain.

The ruins of the amphitheater (arena 59 x 49 m) and the remains of two large public baths, recently excavated, can be seen in the suburban district of Saint-Michel-du-Touch 4 km downstream on the left bank of the Garonne, near a sanctuary built at the junction of the river Touch.

BIBLIOGRAPHY. M. Labrousse, *Toulouse antique, des origines à l'établissement des Wisigoths* (1968)[PI]. Recent excavations, esp. at Saint-Michel-du-Touch: "Informations," *Gallia* 26 (1968) 531-37 and 28 (1970) 410-12; see also A. Baccrabère, "L'aqueduc de la 'Reine Pédauque' à Toulouse," *Mém. de la Soc. arch. du Midi de la France* 30 (1964) 59-116.

For recent excavations of the wall: M. Labrousse, *Gallia* 30 (1972) 486-88[I]; id., "Une forte de l'enceinte gallo-romaine de Toulouse," *Mélanges . . . William Seston* (1974) 249-66[I]; id. & M. Vidal, "Tour et courtine de l'enceinte gallo-romaine de Toulouse dégagies place Saint-Jacques," *Pallas* 21 (1974) 99-109; Labrousse in *Histoire de Toulouse* (1974) 7-47. M. LABROUSSE

TOLPHON, see WEST LOKRIS

TOMEN-Y-MUR Merioneth, Wales. Map 24. On an exposed but commanding site on the S side of the Vale of Ffestiniog, this Roman fort enjoys wide views to the S, W, and N. It is important for the remarkable preservation of its earthworks. These include not only the fort but several of its ancillary structures: parade ground with tribunal, ludus, two practice camps (with others at Dolddinas, 2.4 km to the SE), and the causeway for a timber bridge over a nearby stream. Together they provide a more complete picture of the environs of an auxiliary fort than is available anywhere else.

Excavation reveals that the fort is of two periods. The earlier one (ca. 152 x 109 m; ca. 1.7 ha) had earth and timber defenses and timber barracks, and must be dated ca. A.D. 75-85. About A.D. 120 the fort was reduced to an area of 1.3 ha by the abandonment of the retentura, and the reduced area was given a stone defensive wall. It was apparently given up by ca. A.D. 140. Finds from Tomen-y-Mur are in the National Museum of Wales, Cardiff, and the Segontium Museum, Caernarvon.

BIBLIOGRAPHY. C. A. Gresham, "The Roman Fort at Tomen-y-mur," *Archaeologia Cambrensis* 93 (1938) 192-211[P]; M. G. Jarrett, "Excavations at Tomen-y-mur, 1962: interim report," *Journal Merioneth Hist. and Record Soc.* 4 (1961-64) 171-75[I]; V. E. Nash-Williams, *The Roman Frontier in Wales* (2d ed. by M. G. Jarrett 1969) 111-13[MPI]. M. G. JARRETT

TOMIS Constanţa, Romania. Map 12. A Milesian colony on the Romanian coast of the Black Sea, between Istros (to the N) and Kallatis (to the S). It was probably founded in the 6th c., although its name does not appear in the texts until the 3d c. In the Hellenistic period, the only known phase of its history, it was involved in the war between Byzantium and Kallatis (allied to Istros), which in fact was fought for control of the Tomis emporium (Memnon, fr. 21 = FHG 3, p. 537). Tomis was a member of the Pontic koinon created toward the end of the 1st c. B.C. and immediately annexed by Rome (the period when Ovid, sent into exile by Augustus, came to Tomis to die), and quickly became the chief city of the Dobruja region as well as the metropolis of the whole W part of Pontus.

This prosperity was gravely threatened in the 3d c. A.D. by the invasions of the Goths, and was not reaffirmed until the time of the Tetrarchy, when Tomis was made chief city of the new province of Scythia. Under the protection of Constantine and his successors, Tomis, now Christianized and the seat of a bishop, was to flourish for the last time. Toward the end of the 7th c. it was abandoned by its inhabitants as were all the Scythian cities.

The ancient Milesian colony has not been excavated systematically because it lies under the modern city. However, there have been chance finds of epigraphic and architectural monuments.

The most important of these monuments is the circuit wall that protected Tomis on the N-NW and S-SW sides by closing off the promontory on which the city was built. This wall seems to have been built in the 2d c. A.D., but it was rebuilt several times up to the end of antiquity. Roughly 3 m thick, it has an external facing of large squared blocks; semicircular towers flank the gates. One of these towers apparently dates from Justinian's reign, but constructions of the same type are attested in the reigns of Diocletian and Anastasius.

Another significant monument, unearthed in 1959, is the so-called mosaic building. This is a huge complex of commercial buildings designed on three levels, which also served to cover and support the cliff, which is 20 m high at this point. The upper terrace, which overlooked the sea, had a mosaic floor surrounded on three sides by walls faced with polychrome marble. The mosaic covers an area of roughly 2000 sq. m and is fairly well preserved. It gives the impression of a brightly colored carpet decorated with geometric and plant motifs. The story below consists of 11 vaulted rooms designed to be used as warehouses. Some of them were found to contain dozens of amphorae along with several anchors and some iron clamps. On the first floor up from ground level, which gives directly onto the nearby quays, a certain number of warehouses were found, also filled with amphorae; others are in the process of excavation. Close by this fine complex several warehouses designed for storing grain are being excavated, along with the ruins of a bath building (one large room that has been uncovered measures not less than 300 sq. m).

The port installations date from the 4th c. A.D. By this time Tomis had been Christianized and its four basilicas date to the 4th and 5th c. One, on the W cliff, is small and somewhat poorly preserved. A second is in the courtyard of No. 2 secondary school. It has not been possible to excavate this building completely, but it is larger than

the first basilica and more carefully built. Near the altar is a rectangular crypt, its walls covered with paintings. The third, in the W section of the city, is ca. 35 m long and 18.8 m wide; it has an apse 8 m in diameter and a vaulted crypt, poorly preserved. The fourth is the largest in the whole of Dobruja. It had three naves, separated by marble columns and a huge crypt divided into seven interconnecting rooms arranged in the shape of a cross. Close by this great basilica a cache of 23 statues and reliefs was found, no doubt a remnant of the religious war that raged throughout the Empire in the 4th c.

BIBLIOGRAPHY. V. Pârvan, *An. Acad. Rom., Mem. Sect. Ist.* 37 (1915) 415-50; R. Vulpe, *Hist. anc. de la Dobroudja* (1938); I. Stoian, *Tomitana* (1962); A. Rădulescu, *Monumente romano-bizantine din sectorul de vest al cetății Tomis* (1966); D. M. Pippidi, *I Greci nel Basso Danubio* (1971); V. Barbu, *Tomis* (1972).

D. M. PIPPIDI

TONGRES, *see* ATUATUCA TUNGRORUM

TORIAION (Kozağacı) Turkey. Map 7. Town in Lycia, 5 km S of Kızılcadağ, 32 km N of Elmalı. The name seems to be concealed in Hierokles (685: Komistaraos, i.e. κώμης Τοριαίου vel sim.), but since it is not otherwise recorded in the ancient literature the termination is uncertain. It is known from an inscription found in the village of Kozağacı, a dedication to Septimius Severus by the pentacomia of the Toriaeitae of the city of Balbura. Toriaeum itself appears to have had the title of colonia, and to have stood at the head of a community of five villages on the plain at the SE end of Lake Caralitis (Söğütgölü). The city of Balbura lies ca. 32 km to the W, and must accordingly have had a wide territory.

The immediate neighborhood is full of remnants of antiquity, though no actual buildings are standing. Directly above the village a stream falls down a precipitous cliff in a succession of cascades; this is perhaps the river Pyros mentioned in an inscription. In the face of this cliff and on the adjoining slopes is a remarkable series of rock-cut reliefs, many of Hellenistic date. They include a large number of rock-cut stelai, some with an inscription, some with decoration (wreath, olive-branches, bucranium), others quite plain; but most are groups of human figures, from one to five in number, some with an inscription, some without. These are simply commemorative monuments; the inscriptions consist of a name in the nominative followed by one or more names, usually of relatives, in the accusative. They are not strictly epitaphs, as no tombs are in evidence. There also are one or two votive dedications.

Higher up the mountain, some 300 m above the plain, is a little valley containing many ancient stones, including a list of contributions to the construction of a prostoon of the lord Mases. In the steep slope of the valley is a small sanctuary with four votive reliefs representing a horseman deity; one of these carries a dedication to Mases.

Tombs are scarce. High up on the mountain are a few simple graves, and on the plain below is a sarcophagus lid with recumbent lion of the type familiar in N Lycia.

BIBLIOGRAPHY. A. Schönborn reported in K. Ritter, *Die Erdkunde . . .* XIX (1859) 851; E. Petersen & F. von Luschan, *Reisen in Lykien* II (1889) 172-73; R. Heberdey & E. Kalinka, *Bericht über zwei Reisen* (1896) 9-11; G. E. Bean, *BSA* 51 (1956) 152-56. G. E. BEAN

TORINO, *see* AUGUSTA TAURINORUM

"TORONE," *see* NISTA

TORRE ANNUNZIATA, *see* OPLONTIS

TORRE ASTURA, *see* ASTURA

TORRE DEL MORDILLO Calabria, Italy. Map 14. A Hellenistic city on the plain of Sybaris. Some 18 km from the sea at the juncture of the Esaro and Coscile rivers, it controlled ancient trade routes across this part of the Italian peninsula. There are at least two and probably three destruction levels, the first possibly at the end of the 8th c. with the arrival of the Greek colonists to found Sybaris. A second period of destruction (at the turn of the 4th-3d c.) called for the leveling and grading of the site, completely destroying the stratification. The city was rebuilt early in the 3d c. on a grid system over and with the debris of earlier levels.

The archaeological evidence points to continued occupation, to extents as yet unknown, from Neolithic times to the last decade of the 3d B.C. when it was destroyed by assault and siege, whether by Hannibal or Rome is as yet unknown. Recent finds are in the museum at Sybaris Station and in the National Museum in Reggio Calabria. There is fragmentary evidence for a building of some pretension, probably a temple of the late 6th or early 5th c. Although some preliminary reports have been published, the major publication is still in press.

BIBLIOGRAPHY. A. Pasqui, *NSc* (1888) 248-68, 579-92, 648-71; O. C. Colburn, "A Habitation Level of Thurii," *Expedition* 9, 3 (1967) 30-37; id., "The Quest for Thurii" (Diss. Univ. of Pennsylvania, 1973); F. Rainey & C. Lerici, *The Search for Sybaris* (1967) 85-98, 286-92; G. R. Edwards, "Torre del Mordillo 1967," *Expedition* 11, 2 (1969) 30-32. O. C. COLBURN

TORRE DE PALMA Alentejo, Portugal. Map 19. Large Roman villa 5 km from Monforte, inhabited from at least the 2d c. A.D. to the Visigoth period. The villa has both an urban and a rural section, constituting a unique architectural complex of ca. 100 by 50 m. A large courtyard separates this complex from the press and storerooms for olive oil. Two baths serve both masters and servants. The mosaics, of excellent quality, are in the National Museum of Archaeology in Lisbon. From the Visigoth period are remains of a basilica with two apses, a baptistery, and a cemetery.

BIBLIOGRAPHY. M. Heleno, "A villa lusitano-romana de Torre de Palma (Monforte)," *O Arqueólogo Português* NS 4 (1962) 313-38MPI. J. ALARCÃO

TORRE DI SATURO, *see* SATYRION

TORRE SGARRATA, *see* SHIPWRECKS

TORRES NOVAS Ribatejo, Portugal. Map 19. One of the most important villas in Portugal is ca. 2 km from this village. Partial excavations have uncovered ca. 350 sq. m of mosaics, for the most part with polychrome geometric designs. One of them, from the 4th c. A.D., has an inscription, VIVENTES CARDILIUM ET AVITAM FELIX TURRE, in a panel with two portraits which perhaps represent the owners.

BIBLIOGRAPHY. A. do Paço, "Mosaicos romanos de la 'villa de Cardilius' en Torres Novas (Portugal)," *Archivo Español de Arqueologia* 37 (1964) 81-87PI.

J. ALARCÃO

TORRETTA DI PIETRAGALLA Potenza, Basilicata, Italy. Map 14. An indigenous center of ancient habitation at the W boundary of the territory of this community. Its position on a hill more than 1000 m high, controlled a large part of the ancient road from Melfi and Venusia

to Potentia, and settlements at Carpine di Cancellara, Acerenza, Oppido Lucano, and Serra di Vaglio.

The remains include three fortified areas with perfectly cut blocks showing quarry marks in Greek letters. The highest area of the town was defended by a fortification which reaches a height of 3.4 m; to this area, which appears as an acropolis, is joined another fortification also built in blocks cut in the Greek style and bearing quarry marks in Greek letters. This second fortification is reached from the first by means of a door. Excavations reveal that a trapezoidal tower was built, probably at a later time, at the NW corner of this fortification. Below these two fortifications a third, finished only on the NE side, has been found. These fortified areas, like those of the indigenous centers mentioned, date, in their earliest sections, from the second half of the 4th c. B.C.

Pottery and bronzes from the end of the 7th or the beginning of the 6th c. B.C. give clear evidence, however, of earlier habitation of the area. It has not been possible so far to establish the outlines of fortifications existing in this earlier period. Both the pottery and the bronzes are typical of the area's production of ancient Lucania in archaic times. Among the artistic remains characteristic of the area from the end of the 4th c. is a large terracotta antefix in the form of a Gorgon whose face—and particularly the treatment of the eyes—is typical of Lucanian art, an awkward imitation of its Greek prototypes. A bronze candelabra, and several bronze figurines of Herakles further document this period. The town ceased to exist about the middle of the 3d c. B.C.

BIBLIOGRAPHY. F. Ranaldi, *Attività archeologica nella Provincia di Potenza* (1960); O. T. Zanco, *PdP* 19 (1964) 365-72; D. Adamesteanu, *Atti VI Convegno Taranto* (1967) 263-66; id., *Atti IX Convegno Taranto* (1970) 223-26. D. ADAMESTEANU

TORTONA, *see* JULIA DERTONA

"TORYNE," *see* PARGA

TOSKESI, *see* LIMES, GREEK EPEIROS

TOSSA DE MAR, *see* TURISSA

TOULON SUR ALLIER France. Map 23. A Gallo-Roman pottery manufacturing center for white clay statuettes (Venus, mother goddesses, Mercury, Jupiter, Minerva; busts of men, women, and children; lions, bulls, rams, pigeons, a snake). The pottery also produced bowls of terra sigillata from molds made at Lezoux or Vichy workshops, as well as from molds made on the spot, all in an interesting rustic style. A number of the plain sigillata bowls are signed, and the backs of the statuette molds are frequently signed in a cursive script. The workshop also turned out bowls painted with a brush and sponge (like the terra sigillata, signed on the rim), as well as plates and ewers.

The period of greatest activity was the middle of the 2d c. A.D. Exports went to Normandy.

BIBLIOGRAPHY. H. Vertet, "Découverte de poterie peinte à Toulon sur Allier," *Gallia* 17,2 (1959) 216-23[1]; id., "Les Statuettes en terre cuite gallo-romaines," *Revue du Louvre* (1963). H. VERTET

TOULOUSE, *see* TOLOSA

TOURINNES-ST.-LAMBERT Belgium. Map 21. Gallo-Roman vicus of the civitas Tungrorum, on the Baudecet-Tourinnes-Elewijt-Rumst road, a secondary road linking the Bavai-Tongres and Bavai-Ganda-Utrecht roads.

The remains of the vicus are found on both sides of this road over a distance of more than 3 km. Excavations, undertaken in 1910, were left incomplete. Although ca. 10 dwellings had been noted, only two were studied. One was a humble wooden cabin (5 x 3.5 m), with a stamped earth floor and wattle-and-daub walls. The tile roof had collapsed in one piece over the room, without greatly disturbing the rows of tiles and their imbrication. All these tiles, of various sizes, were refuse items. The other dwelling (12.15 x 4.1 m) had a porch (4.1 x 2 m) in front of the facade. The interior of this dwelling was divided by a brick wall. It was heated by a hypocaust which extended under the whole building. The outer walls were made of white sandstone ashlars and were 0.9 m thick. The roof was covered with slates measuring 0.6 m square. A ditch full of plastic clay mixed with sand was found beside the house. A potter's kiln with an interior diameter of 2.2 m was excavated nearby and dumps full of sherds and defective pieces were also found. The potter made mainly large dolia, mortars, and pottery for daily use. During the same excavations, a funeral pyre and some incineration tombs with very poor grave goods were found 200 m from the potter's kiln. Three large barrows were erected N of the vicus, two of which survive. They were 5 m high and 15 m in diameter. Neither funerary chambers nor grave goods have been located. The remains found so far date the vicus to the 2d and 3d c.

BIBLIOGRAPHY. R. De Maeyer, *De Overblijfselen der Romeinsche Villa's in België* (1940) 27-28; J. Martin, *Le Pays de Gembloux des origines à l'an mil* (1950) 49-55; M. Desittere, *Bibliografisch repertorium der oudheidkundige vondsten in Brabant* (1963) 150-51.

S. J. DE LAET

TOURMONT Jura, France. Map 23. A site with the remains of a large villa decorated with mosaics. It has been excavated several times but never completely, and no ground plan has ever been published. Four mosaics have been noted, and recent searches have turned up another whose composition recalls that of the Arlay and Mantoche mosaics. The site has also yielded a 3d c. hoard of more than 10,000 coins.

BIBLIOGRAPHY. H. Stern, *Recueil général des mosaïques de la Gaule* I, 3 (1963) no. 346, cf. 338, 363; L. Lerat, "Les trésors de monnaies romaines de Franche-Comté," *Revue Archéologique de l'Est* 19 (1968) 165-66.

L. LERAT

TOURNAI, *see* TURNACUM

TOURS, *see* CAESARODUNUM

TOURVES, *see* AD TURREM

TOWCESTER, *see* LACTODORUM

TOYA, *see* TUGIA

TRABLUS, *see* OEA

TRABZON, *see* TRAPEZOUS

TRAGIS, *see* TROINA

TRAIANOPOLIS (Doriskos) Thrace, Greece. Map 9. The ancient capital of Rhodope, founded by Trajan on the site of the earlier town of Doriskos. Darius left a small garrison at a fort there after his war with the Scythians. At Doriskos, Xerxes gathered men and supplies in preparation for the invasion of Greece. Even though the surrounding territory returned to Thracian

control, the fort was still held by the Persians in the time of Herodotos, later in the 5th c. It was garrisoned by both Philip II and Philip V of Macedon. The site has been identified with an acropolis near Loutros at the edge of the high ground W of the Evros (ancient Hebros) delta. In addition to prehistoric remains, marble architectural fragments and inscriptions have been found, the latter including a precinct boundary stone at the foot of the acropolis. Dumont reported extensive remains of houses and streets on the plain near the sea, but no sign of monumental public buildings.

BIBLIOGRAPHY. Hdt. 7.25, 58f, 105f; A. Dumont-Homolle, *Mélanges d'archeologie et d'épigraphie* (1892) 224f; *BCH* 37 (1913) 147. M. H. MC ALLISTER

TRAIECTUM (Utrecht) Netherlands. Map 21. One of the forts in the Limes Germanicus Inferior was in the center of the Utrecht (*It. Ant.* 368). In A.D. 47 Claudius made the Rhine below Bonna the frontier of the empire; the legions beyond the river were retired and the line fortified. In the Netherlands, where there were three or more branches of the river, the military authorities chose the one that Pliny (*HN* 4.101) called a modicus alveus, which kept the name of Old or Crooked Rhine. The fort was rebuilt in 818 after devastation by the Vikings. A mediaeval town grew up around it which became an episcopal see.

Remains of the fort of A.D. 47 have been found 3.8 m below the cathedral square. It was rebuilt four times, and each time fill was brought in to reach a higher level, from ca. 1.5 to 3 m + NAP Dutch Datum Level = sea level. In periods I-IV it was built of wood with ramparts of earth and wood (110 x 130 m), but in period v it was rebuilt in stone (125 x 150 m); in all periods the fort was surrounded by a ditch (fossa fastigata). Periods I-II: 47-69; III-IV: 70 to end of 2d c.; v: end of 2d c. to middle of 3d. Two of the four gates have been found, the porta principalis dextra and the porta decumana; the stone gates of period v were flanked by towers with semicircular bastions on the outside. Some remains of the barracks of successive periods have come to light, but the principia has been completely excavated; in all periods it was a building ca. 27 x 27 m, with an atrium, a cross hall, and a series of five rooms. The middle room was the sacellum, or shrine of the standards, and in period v it had a stone altar. The foundations of an altar were found also in the center of the atrium.

The destruction caused by the revolt of Iulius Civilis in A.D. 69-70 is indicated by a heavy burnt layer, dated by a treasure of 50 aurei (the two latest coins were struck in 68). The fort seems to have been destroyed some decades before the invasion of the Franci in A.D. 270; some sherds of 4th c. pottery perhaps show some patrol activity by the Roman army, but the limes forts were not reconstructed. The finds are in the Central Museum.

BIBLIOGRAPHY. A. E. van Giffen et al., *Wetenschappelijke verslagen der opgravingen op het Domplein te Utrecht*, I-IV (1934-38). H. BRUNSTING

TRAIZE Savoie, France. Map 23. Near Yenne, on the site called Combe de Pépet, a square room was discovered in 1966, probably a workshop connected with a group of houses on the edge of the Vienne-Geneva road. The finds indicate occupation from the 1st c. B.C. to the middle of the 3d c. A.D. Digging in the area of La Grotte des Sarradins revealed a habitation site used from the Chalcolithic Age to the 4th c. A.D.

BIBLIOGRAPHY. M. Leglay, "Informations," *Gallia* 26 (1968) 600. M. LEGLAY

TRALLES (Aydın formerly Güzelhisar) Turkey. Map 7. City in Caria (or Ionia or Lydia), founded according to tradition by a mixed company of Argives and barbarian Tralleis from Thrace (Strab. 649). In 400 B.C. the Spartan Thibron attempted to take it from the Persians, but was defeated by the strength of the place (Diod. 14.36). Taken by force by Antigonos in 313 (Diod. 19.75), the city later came under the Seleucids and took the name Seleuceia; this is confirmed by the coins, but Pliny's statement (*HN* 5.108) that it was also called Antiocheia is unsupported and generally regarded as a mistake. Other names which Tralles is alleged to have borne in early times are Euantheia (Plin. *loc.cit.*), Polyantheia, Erymna, and Charax (Steph. Byz.). After Magnesia Tralles passed to Eumenes and remained Pergamene until 133 B.C., even supporting Aristonikos against the Romans. At the time of the first Mithridatic war the city was under the tyranny of the sons of Kratippos (Strab. *loc.cit.*), who were apparently responsible for the slaughter of the Roman residents. In 26 B.C. Tralles suffered from a severe earthquake, and in gratitude for Augustus' help in restoration took the name of Caesareia; by the end of the 1st c., however, this name had fallen into disuse. Despite the great wealth of the citizens as recorded by Strabo, Tralles was refused the privilege of building a temple to Tiberius on the ground that she lacked sufficient resources. The abundant Imperial coinage continues down to the time of Gallienus. Later Tralles, as a bishopric, ranked second after Hypaipa under the metropolitan of Ephesos.

The site is accurately described by Strabo (648) as on a plateau, well defended all round, with a steep acropolis. The hill is now occupied by the army, and visitors require a military escort. Little is left of the remains visible in the 19th and early 20th c., a theater, stadium, agora, and gymnasium, but the finds are in the Istanbul museum, and include a fine marble statue of a young athlete of the time of Augustus.

All that is now standing is a part of the gymnasium, comprising three high arches of mixed masonry of stone and brick, with much mortar; this has been dated to the 3d c. A.D. It is called Üç Göz and is conspicuous from the road and railway, looking from a distance very like a triumphal arch. The theater faced S at the foot of the acropolis, which rises from the N end of the plateau. It was interesting chiefly because it had a T-shaped underground passage from the stage building to the middle of the orchestra, but this has been obliterated. All that now survives is an arched entrance at the level of the upper diazoma and a fragment of the retaining wall of the cavea.

BIBLIOGRAPHY. K. Humann & W. Dörpfeld, *AthMitt* 18 (1893) 395ff; G. E. Bean, *Turkey beyond the Maeander* (1971) 208-11. G. E. BEAN

"TRAMPYA," *see* VOUTONOSI

TRANSDIERNA (Tekija) Yugoslavia. Map 12. On the right bank of the Danube near Kladovo. First mentioned in the 4th c. A.D. under the name Transdierna; the earlier name is unknown. The settlement played an important role in the Dacian wars and also later after the loss of Dacia.

During excavations the contours of a late castle from the 3d to 4th c. were investigated as well as a number of buildings in the civilian section of the city (1st-2d and 3d-4th c.). These buildings, often up to 30 m long, had promenades, columned halls, paved floors, and traces of fresco paintings. The finds include luxury ceramics and bronze objects.

BIBLIOGRAPHY. D. Mano-Zisi, *Les trouvailles de Tekiya*

(1957); M. Mirković, *Römische Städte an der Donau in Obermösien* (1968) 110-11; A. Cermanović-Kuzmanović, *Chronique des fouilles archéologiques en Yougoslavie* 11 (1969) 88-93. A. CERMANOVIĆ-KUZMANOVIĆ

TRAPANI, *see* DREPANA

TRAPEZOUS (Trabzon) Pontus, Turkey. Map 5. On the S coast of the Black Sea (Pontos Euxeinos), it was the N terminus of a trade route leading over the Zigana Pass from Armenia and the Euphrates, and the first Greek city to be reached by the Ten Thousand in 400 B.C. (Xen. *Anab.* 5.5.10). The foundation date given by Eusebius, 756-755 B.C., may refer to an early emporium in Colchian territory; if so, this was subsequently refounded (after 630 B.C.?) by Sinope, to whom Trapezous paid annual tribute. The city was added to the Pontic kingdom by Mithridates VI Eupator, and under Polemon II, if not before, it became the depot of the royal fleet. When the kingdom was annexed to Galatia as Pontus Polemonianus (A.D. 64-65), Polemon's fleet became the nucleus of the Roman classis Pontica, and Trapezous assumed increasing importance as a supply port for the Euphrates frontier. It was, nevertheless, still a harborless roadstead when visited by Hadrian (ca. A.D. 131), and it was described by Arrian at that period as culturally backward (*Perip.P.E.* 1.2 Roos). A harbor was built by Hadrian. The city was sacked by the Goths ca. A.D. 257 and was slow to recover. Legio I Pontica was based there in the Late Empire. The Byzantine period saw the old trade route regain importance, and in the 8th-10th c. Trapezous was a major commercial center. The Empire of Trebizond, established 1204, fell to the Turks in 1461.

The walled city, on a coastal ridge at the foot of the Pontic mountains (Paryadres Mons), is cut off on E and W by two parallel steep-sided ravines. Some sectors of the walls rest on Hellenistic masonry, but most of the fabric is Byzantine. Below the citadel two moles of large undressed blocks are the only traces of Hadrian's harbor. In a suburb E of the citadel and S of the modern harbor the Church of Panaghia Theoskepastos occupies the site of a probable mithraeum.

BIBLIOGRAPHY. F. & E. Cumont, *Studia Pontica* II (1906) 363-71; K. Lehmann-Hartleben, "Die antiken Hafenanlagen des Mittelmeeres," *Klio* (1923) suppl. 14 (= NF 1) 199P. D. R. WILSON

TREA Marche, Italy. Map 16. An ancient municipium of Picenum, its site, now known as Mura de'Saraceni, ca. 1 km NW of modern Treia. The ruins are unimpressive, but the site has been extensively explored and has yielded a considerable harvest of inscriptions and marbles, a number of which are kept in the Palazzo Municipale of Treia.

BIBLIOGRAPHY. F. Benigni, *Lettera sugli scavi fatti nel circondario dell'antica Treja* (1812)PI; *EAA* 7 (1966) 972 (G. Annibaldi). L. RICHARDSON, JR.

TREBENIŠTE Yugoslavia. Map 12. The name has been applied to a necropolis near Lake Ochrid in Macedonia where a number of graves were found to contain burial gifts of remarkable intrinsic and artistic value.

The necropolis is in the environs of Gorenci near the village of Trebenište on the road from Ohrid to Kičevo. The site was discovered in 1918, and the treasures of seven graves were removed by Bulgarian soldiers to Sofia, where they can now be seen in the National Museum. Some of the more recent discoveries are in the National Museum of Ohrid and the rest are in the National Museum in Belgrade.

Fourteen of the graves contained hundreds of gold, silver, and bronze vessels and jewelry, many of which had been imported from Greece along with a number of terracotta vessels decorated in Attic black-figure style. The Greek objects, which include large bronze tripods and kraters adorned with human and mythical figures, date to the second half of the 6th c. B.C., but the many Illyrian objects that accompanied them show that the burials took place only in the second half of the 5th c. B.C. Among the artifacts of special magnificence are a gold death mask, chased silver cups, and bronze Illyrian helmets.

BIBLIOGRAPHY. B. Filow, *Die archaïsche Nekropole von Trebenischte am Ochrida-See* (1927); L. Popović, *Katalog Nalaza iz Nekropole kod Trebeništa* (1956).

J. WISEMAN

TREBENNA Turkey. Map 7. Site in Lycia, near Karcıbayırı at the N end of the Sivri Dağ, ca. 17 km W of Antalya. The termination of the name is uncertain. Not mentioned by any ancient writer and known only from its coins and from inscriptions found on the spot or in the neighborhood. From one of the latter it appears that Trebenna was a member of the Lycian League in the 3d c. A.D. Hellenistic coins of League type inscribed TP can hardly be attributed to Trebenna, which at that time belonged rather to Pamphylia; the only certain coinage is of the time of Gordian III.

The ruins are on a small steep hill, which carries fortifications of mediaeval or later date; earlier remains are confined to a handful of inscriptions built into the walls, and a few sarcophagi. Trebenna is not to be confused with Trebenda, a dependency of Myra.

BIBLIOGRAPHY. K. Lanckoronski, *Die Städte Pamphyliens und Pisidiens* II (1892) 78; L. Robert, *Hellenica* X (1955) 206-8. G. E. BEAN

TREBULA MUTUESCA Latium, Italy. Map 16. An ancient Sabine center ca. 65 km from Rome and a little more than 1 km E of the modern village of Monteleone Sabino. At the center of a region renowned for its olives (Verg. *Aen.* 7.711), Trebula was situated near the junction of the two major roadways of the region, the Via Salaria and the Via Caecilia, which led to Amiternum, both following very closely the most ancient itineraries.

The region probably entered the Roman sphere of influence only after the conquest by Manius Curius Dentatus in 290 B.C. and the subsequent individual allotment of a large section of Sabine territory. This kind of colonization corresponded to a territorial organization of rural type, but lacked a real and proper urban plan. Trebula is still called a vicus in the tituli mummiani. Its importance as a religious center is attested by the most ancient cults of Sabine origin such as those of Angizia and Feronia, evidenced by inscriptions. Trebula appears to have been set up in a municipium administered by octoviri only in the Imperial period—perhaps under Augustus, if a notice in the Liber Coloniarum (ed. Lachmann, p. 258) may be so interpreted. The site of the ancient city has for some time been set in the Pantano district, a small valley surrounded by hills dotted with ruins. On one of the hills, called today Colle Foro, the forum of the city was likely situated. On the heights that face more toward the NE, there are prominent remains of polygonal limestone walls. They are perhaps to be interpreted as defensive works and agricultural terracing, not unusual in terms of Roman colonization of the 3d c. B.C. A large, square-block base, brought to light in 1958 on the edge of the Pantano valley, may also date to that period. It is probably the foundation of a sacred building to which is related a depository for votive terracotta ob-

jects, mostly of Roman workmanship, of the first decade of the 3d c. B.C.

The period of greatest prosperity for Trebula was the 2d c. A.D. when the entire area of Pantano and the surrounding heights were walled and terraced and provided with a series of public buildings. Among those at the NW end of the area there is the indication of a small amphitheater which may have had a partially wooden superstructure. On the hill of Castellano remains of a bath complex have been discovered with a black and white mosaic of a marine subject (today covered over), and probably also the colonnades of forum buildings were restored at the same period. A series of large cisterns, of which three have been excellently preserved, assured an adequate supply of water. It has been suggested that this complex, together with the public works, be connected with the name Laberia Crispina (daughter of the consul Laberius Maximus and wife of Bruttius Praesens (cos II 139), who certainly held important praedia in the zone.

Christianity, which showed special devotion here to the virgin Victoria martyred under Decius, is evident in the area of the necropolis not far from the previously mentioned sanctuary and perhaps representing a replacement of it. The little romanesque church of Santa Vittoria stands over a small catacomb, perhaps of late antiquity, where a 3d-4th c. marble sarcophagus was said to have contained the body of the saint. The body was removed in the 9th c., when the Saracen invasions caused the abandonment of the ancient city and the removal of the inhabitants to the present-day site of Monteleone.

BIBLIOGRAPHY. G. A. Guattani, *Monumenti Sabini* 3 (1830) 90ff, tav. VII (I); N. Persichetti, in *RömMitt* 13 (1898) 195ff; E. Martinori, *Via Salaria* (1931) 72ff; L. Evans, *The Local Cults of the Sabine Territory* (1939) 54ff; G. Radke, *Philologus* 103 (1959) 311ff; M. Torelli, *Epigraphica* 24 (1962) 55ff; id., *RendLinc* 8, 18 (1963) 230ffPI; id., *Mél.Ec.Franç.* 81 (1969) 601ff. F. ZEVI

TREMETOUSIA, *see* TREMITHOUS

TREMITHOUS (Tremetousia) Cyprus. Map 6. The site of a small town identified with Tremithous is partly occupied by the modern village in the Mesaoria plain. The necropolis lies to the S. This town seems to have flourished from Hellenistic to Early Byzantine times.

Nothing is known of its founding. Its later history, however, is fairly well known for it is mentioned by Ptolemy (5.14.6), who counts it as one of the interior towns of Cyprus, and by Stephanus Byzantius. In Early Christian times it became the seat of a bishop. Its first bishop was Spyridon, who was present at the Council of Nicaea in 325 and at that of Sardica in 343-344.

The worship of Apollo is attested by an inscription. Another inscription records a horoscope of Flavian date. The road system in Roman times connected Tremithous directly with Salamis and Kition.

Towards the end of the 19th c. an excavation uncovered a number of tombs of the Hellenistic period producing mainly plain pottery. The town site, however, is unexcavated though many finds have been recorded among which are a number of inscribed funerary cippi.

BIBLIOGRAPHY. I. K. Peristianes, Γενικὴ Ἱστορία τῆς νήσου Κύπρου (1910) 633-37. K. NICOLAOU

TREMULI (Souk el Arba du Gharb) Morocco. Map 19. A station of the *Antonine Itinerary* (24.1), on the Roman road from Tingi to Volubilis, often placed at Basra, where there are only the ruins of an Arab town of the 9th-10th c. It is more reasonable to place the site at Souk el Arba du Gharb, where the remains of the

E section of a Roman camp 100 m square were found in 1954-55, near the marabout of Sidi Aïssa. The W part of the camp was destroyed when a trench was dug for the Rabat-Tangiers railroad, beyond which some baths have been partly uncovered.

BIBLIOGRAPHY. L. Chatelain, *Le Maroc des Romains* (1944) 113-15; M. Euzennat, "Chroniques," *Bulletin d'Archéologie Marocaine* 2 (1957) 216-18; "Les voies romaines du Maroc dans l'Itinéraire Antonin," *Hommages à Albert Grenier*, coll. *Latomus* 58 (1962) 606-7. M. EUZENNAT

TRESKAVEC, *see under* PRILEP

TRESQUES Locality of Courac, Gard, France. Map 23. The Gallo-Roman presence at Courac took the shape of a scattered settlement; it lasted from the 1st to the 4th c. The ancient remains occupy terraces on the S slope and the summit of the S spur of a chain of hills which run N-S, 1 km N of the village of Tresques. One can distinguish three main deposits:

Courac I, at the summit, produced a group of rich cremation tombs of the 1st c. These were next to a sumptuous early imperial villa, whose nymphaeum was used as a dump in the 4th c.

Courac II, ca. 800 m S of Courac I, at the foot of the slope, revealed foundations of a Gallo-Roman temple, several architectural fragments of which have been gathered at the nearby farm of Saint-Loup. The temple was still in use at the end of the 4th c.

Courac III, 200 m W of Courac I, comprised an inhumation necropolis, a dump, and a complex of dwellings arranged around a court. The whole dates to the 2d and 3d c.

The archaeological finds are kept in the museum and the excavation storage depot at Bagnols-sur-Cèze, in the Avignon museum, and in various private collections at Tresques.

BIBLIOGRAPHY. G. Sudres, *Rapports de fouilles* (1962-69)PI; "Informations archéologiques," *Gallia* 22 (1964) 505-6; 24 (1966) 481; 27 (1969) 411I. J. CHARMASSON

TRETOS Corinthia, Greece. Map 11. Tretos is the name of the mountain on the W side of the main road between Kleonaia-Corinthia and Argolis. The mountain was called Tretos ("perforated") because there was a ravine at its foot. It was in that ravine that the Nemean lion had its den (Hes. *Theog.* 327-31; Apollod. 2.5.1; Diod. Sic. 4.11; Paus. 2.15.2). The modern road and the railway follow the ancient route through the pass, now called Dervenakia.

BIBLIOGRAPHY. J. G. Frazer, *Paus. Des. Gr.* III (2d ed. 1913) 86; J. R. Wiseman, *The Land of the Ancient Corinthians* (forthcoming). J. R. WISEMAN

TRÈVES, *see* AUGUSTA TREVERORUM

TREVISO, *see* TARVISIUM

TRIER, *see* AUGUSTA TREVERORUM

TRIESTE, *see* TERGESTUM

TRIGUÈRES Loiret, France. Map 23. This is the most important site in the Ouanne valley. It was discovered when a road was cut across the valley linking Sens to Montbouy by way of Courtenay and St.-Maurice-sur-Aveyron. In the Gallic period an oppidum commanded the crossroads; it was surrounded by an earthwork vallum that can still be seen today. The site was excavated in 1857-62. The chief monuments (none of which remain)

were a theater, a huge quadrilateral ringed with porticos (a forum?), a temple built around a menhir and another temple with a square cella (both NW of the theater), some baths, a house, and a funerary pit. The complex has the characteristics of conciliabula, i.e., social centers for a population of small and medium farmers scattered over a fairly broad area. Particularly characteristic is the fact that the theater and the great quadrilateral are connected; the latter monument would seem to belong to the category of double forums (of the Paris and Augst type) frequently encountered in conciliabula (notably at Sanxay and Tours Mirandes).

BIBLIOGRAPHY. A. Grenier, *Manuel d'archéologie gallo-romaine* III, 2 (1958) 944ff; André Nouel, *Les origines gallo-romaines du Sud du Bassin Parisien* (1968).

G. C. PICARD

TRIKASTRON ("Pandosia") Greece. Map 9. A colony of Elis (D.7.32) on a crag above the Acheron gorge in Epeiros. The circuit wall, ca. 1050 m long, has strong towers, probably a later addition. The site controls the entry from Cassopaea in the S to the upper valley of the Acheron river. A famous oracular utterance of Dodona associated "three-hilled Pandosia" with the Acheron (Strab. 6.1.5); it issued coinage for a short time.

BIBLIOGRAPHY. N.G.L. Hammond in Ἀφιέρωμα εἰς τὴν Ἤπειρον (1954) 26ff; *Epirus* (1967) 162f, 554, 642f, and Pl. IX b. N.G.L. HAMMOND

TRIKKA (Trikkala) Thessaly, Greece. Map 9. A city of Hestiaiotis known to Homer (B.729); its Asklepieion was reputed to be the oldest in Greece (Strab. 8.360; 9.437). It issued coinage in the 5th and 4th c. B.C., but virtually nothing is known of its history. It may have been destroyed by Philip II of Macedon along with Pharkadon since its exiles and Pharkadon's were later refused permission to return (Diod. Sic. 18.5.5). It became a member of the Aitolian League, however (Livy 39.25.3f), and it prospered in Roman times and later.

Trikka is situated in the W Thessalian plain, at the end of a long ridge which runs S from the (modern) Antichasia Mts. and cuts the NW part of the plain in two. The last hill of the ridge stops just N of the Lethaios (Trikkalinos) river. Routes from Epeiros and Macedonia met at Aiginion (near modern Kalambaka); the road then led to Trikka, and from it roads led S and E. The ancient city lay on the left bank of the Lethaios river; modern Trikkala lies on both sides. An impressive mediaeval castle is built around the last hill of the ridge, near the river's left bank, on the site presumed to be the ancient acropolis. The plan of the ancient city is scarcely known, since very few remains of it are left.

In the early part of the century Kastriotis uncovered what he took to be the asklepieion. In 1956 further excavations were carried out on this building, which lies to the E of the Church of Haghios Nikolaus in the old section of Trikkala (ca. 100 m N of the river, ca. 200 m E of the castle). The excavations were carried out amid great difficulties, and it was possible to uncover only the NE end of the building. In its final form this building was made up of a large room (N part only exposed) at the SE end (its length running NE-SW) and a series of four narrow rooms to the NW of it, then a wide room with a hypocaust floor which was evidently an addition to the earlier structure. The hypocaust room apparently dated from the 4th c. A.D., and the original building, although not certainly dated, was of the Roman Imperial period. The total NW-SE dimension (whether length or width) is unknown. The original purpose of the building is not known.

In 1958 another building was discovered to the NW of the last, and was more thoroughly investigated in 1965-66, although again, only a part of it was uncovered. This was oriented in the same direction as the last, and lies ca. 22 m to the NW of it. The S corner of two adjoining stoa-shaped buildings at right angles to each other was also discovered. The buildings are ca. 13 m wide; the discovered length of the SE wing was 34 m. Part of the outer wall of a similar building parallel to the SE one was discovered. The whole complex is tentatively identified as a square or rectangular court surrounded by stoas, the NE side is undiscovered. The outer dimension of the complex (NW-SE) is 78 m, and for the court 53 m if the NW stoa was also 13 m wide. The construction of the walls and the finds from the foundation trench seem to date the building to the 2d c. B.C. Most significant in regard to it was the discovery within the court of fragments of decrees. Theocharis considered that, since such decrees are normally found in the chief sanctuary of a city, this building may well have been (part of) the ancient asklepieion. In the 2d c. A.D. the SE wing had been provided with a very handsome figured mosaic floor, of which a considerable part remains. The rest of the building seems to have been considerably altered at this time.

In test trenches during the recent series of excavations part of a Roman peristyle was uncovered near the Church of the Phaneromene. Sherds from the Early Bronze Age through Hellenistic and Roman periods were found in several of the trenches. Tests on the acropolis revealed no remains earlier than the Roman period, although sherds indicated the area had been in use in prehistoric times. A test near the fortress gate revealed no ancient wall under this part of the mediaeval one, although Leake noted some remains of "Hellenic masonry forming part of the wall of the castle," no longer visible today. In the late 19th c. Ziehen saw some ancient architectural fragments, including two statue bases near the Gurna spring S of Haghios Nikolaus, by the river.

BIBLIOGRAPHY. W. M. Leake, *Nor. Gr.* (1835) I 425-30; IV 285-87; J. Ziehen, *AM* 17 (1892) 195-97; P. Kastriotis, τὸ ἐν Τρίκκῃ Ἀσκληπιεῖον (1903); id., *ArchEph* (1918) 66-73PI; A. S. Arvanitopoullos, *Praktika* (1915) 169f; F. Stählin, *Das Hellenische Thessalien* (1924) 119fPI; E. Kirsten, *RE* (1939) s.v. Trikka; D. Theocharis, *Praktika* (1958) 64-80PI; id., *Deltion* 16 (1960) chron. 169f; 20 (1965) chron. 313-16PI; 21 (1966) 247-49I; H. Biesantz, *Die Thessalischen Grabreliefs* (1965) 143I; M. S. Thompson, *ANSMN* 11 (1964) 77-80I. T. S. MAC KAY

TRIKKALA, see TRIKKA

TRIMONTIUM (Newstead) Roxburghshire, Scotland. Map 24. The Roman fort, which took its name from the triple peaks of the nearby Eildon Hills, lies on the E side of the village of Newstead, guarding the point at which the Roman road from York to the Forth crossed the Tweed.

Excavations in 1905-10 and 1947 disclosed that there were four superimposed forts. The earliest, built by Agricola ca. A.D. 80, covered 4.14 ha and was defended by a clay rampart, 6.9 m thick, and double ditches. Its outline was unusual, the rampart alignment being staggered at each of the four gates. Only one internal building, a timber-framed stable, is known, but it is possible that the garrison comprised two alae quingenariae. This fort was replaced in the late 80s by another, 5.7 ha in extent. The new rampart was 13.5 m thick and the single ditch over 4.8 m wide; the scale of the defenses reflect the fact that Trimontium was now the most important Roman military position N of the Cheviots. The barracks were of wattle-and-daub set on stone sill-walls, and their

size suggests that they were designed for legionaries. About A.D. 100 this phase terminated in disaster, and an interval of some 40 years elapsed before the third fort was built during the Antonine reoccupation of the Lowlands. Enclosing an area of 5.9 ha, the early Antonine rampart was faced with a stone wall, in front of which there were two ditches.

The buildings of this period are known in some detail. The praetentura contained 12 barracks, while the main buildings comprised a principia; two horrea, one on either side of the principia; and a praetorium with private bathing establishment. The retentura was cut off from the rest of the fort by a dividing wall with a single central gateway flanked by towers: this feature, unique in Britain, is best explained by the fact that the garrison was a dual one, a legionary vexillation occupying the praetentura, while the retentura housed a regiment of auxiliary cavalry. The fourth fort, of late Antonine date, succeeded the third after a brief interruption. Although the existing curtain wall was retained, the rampart backing was increased in width and a third ditch added. Inside the fort the dividing wall was demolished and new barracks and stables erected for an ala milliaria. The date of the final abandonment of the site is uncertain, but occupation may have extended into the 3d c.

Outside the fort were annexes of different periods on all sides except the N; the W annex contained a courtyard building, perhaps a mansio, and a bath house. A number of temporary camps and a small roadside post of Flavian date have also been found in the area while a signal station, of which traces are still visible, has been identified at the N end of the Eildons. The excavations of 1905-10 produced rich finds, now in the National Museum of Antiquities of Scotland. Most of these came from pits in the S annex. Especially noteworthy are the arms and armor of both legionaries and auxiliary troops, tools and other items of daily use, and large quantities of pottery.

BIBLIOGRAPHY. J. Curle, *A Roman Frontier Post and its People* (1911); *Proc. Soc. Ant. Scotland* 84 (1950) 1-38; 86 (1952) 202-5; *Inventory of the Ancient & Historical Monuments of Roxburghshire* 2 (1956) 312-20; *Britannia* 3 (1972) 53-54. K. A. STEER

TRINKITAT, *see* PTOLEMAIS THERON

TRIPOLI, *see* OEA

TRIPOLIS Lebanon. Map 6. City on the coast, at the N foot of the Lebanon mountains and the end of an excellent route from the interior of Syria. As Diodorus and Strabo report, it consisted of three separate quarters founded by the Phoenician cities of Arados, Sidon and Tyre. It was the seat of the Council of the Phoenicians, which decided to rebel against Artaxerxes Ochus in 351 B.C. In the 1st c. B.C. Pompey freed it from a tyrant. As its coins show, Tripolis was the capital of a conventus of a Roman province. In the 3d c. it had a temple of the Imperial cult and under Diadumenus it was a base of the Roman war fleet.

Almost nothing remains of the ancient town. It was not at the foot of the Crusaders' castle, beneath the modern and mediaeval town but on the end of the peninsula, in the suburb of al-Mina (the navy).

The area inland from Tripolis is rich in sanctuaries of the Roman period: Bzija, Naous, Sfiré.

BIBLIOGRAPHY. R. Dussaud, *Topographie historique de la Syrie antique et médiévale* (1927); D. Krencker & W. Zschietzschmann, *Römische Tempel in Syrien* (1938)[MPI]; J. Sauvaget, "Note sur les défenses de la marine de Tri-

poli," *BMBeyrouth* 2 (1938); H. Seyrig, "Ères de quelques villes de Syrie," *Syria* 27 (1950) (*Antiquités syriennes* IV). J.-P. REY-COQUAIS

TRIPONTIUM (Caves Inn) Warwickshire, England. Map 24. A roadside settlement along Watling Street. It is mentioned in the *Antonine Itinerary*. Much has been found in sand and gravel-working, including a military mess-tin, which suggests a 1st c. fort S of the main finds. Excavation has revealed a spread of occupation for at least 1.6 km along the road, and a scatter of 4th c. burials. The only substantial building with a stone foundation is a house of courtyard type which may have been a mansio. A small, rectangular, single-ditched enclosure is bisected by the road; and like others along this road is presumably 4th c.

BIBLIOGRAPHY. *Trans. Birmingham Arch. Soc.* 83 (1969) 130-79. G. WEBSTER

TRIPOTAMOS (Arkadia), *see* PSOPHIS

TRISTOMO, *see* TEIMIUSSA

TRITEIA, *see under* WEST LOKRIS

TRIVENTO, *see* TERVENTUM

TROESMIS Dobrudja, Romania. Map 12. Roman municipium near the castra of the Legio V Macedonica at a strategic point on the right bank of the lower Danube ca. 15 km S of Măcin. It is mentioned by Ovid as a Thraco-Getic fortress of the pre-Roman period. After the conquest of Dacia, Trajan transferred the Legio V Macedonica from Oescus to Troesmis, where it remained until A.D. 163 (Ptol. *Geog.* 3.10.5; and many inscriptions). Near the castrum developed two settlements, canabae legionis V Macedonicae and the civil settlement, called Troesmis, which became a municipium during Marcus Aurelius' reign. At the time of the Gothic invasions of the second half of the 3d c., the town was destroyed and on the sites of the old municipium and castrum were built two cities, garrisoned by the Legio II Herculia and the milites Secundi Constantini (*Not. Dig.* or. 39.22.29. 31). Procopius (*De aed.* 4.11.33) numbered Troesmis among the cities reconstructed by Justinian. The last literary mention is by Constantine Porphirogenitos (*De them.* 47.17). Excavations at Troesmis have uncovered the walls of two cities. The E city (120 x 145 m) was defended by exterior semicircular towers and by a vallum and a ditch. In the interior were found three basilicas, one with one nave and two with three naves, dating from the time of Justinian. The remains of these have disappeared but the plan can still be made out. The W city, 500 m from the other, is trapezoidal (150 m on the long sides and 100 m and 80 m on the short) and was defended by exterior semicircular towers and a deep ditch. It was covered by buildings in the 10th-12th c.

BIBLIOGRAPHY. *CIL* III, 773-76, 6162-6217, 7498-7511, 12481-85; V. Pârvan, "Descoperiri nouă din Scythia Minor," *Academia Română, Memoriile Secţiunii Istorice*, ser. 2, tom. 35 (1913) 27-35; R. Vulpe, "Canabenses et Troesmenses," *Studii şi Cercetări de Istorie Veche* 4 (1953) 557-82; E. Doruțiu-Boila, "Castra legionis V Macedonicae und Municipium Troesmense," *Dacia* 16 (1972). E. DORUTIU-BOILA

TROIA ("Caetobriga") Alentejo, Portugal. Map 19. The site of a large Roman town on the Troia peninsula on the left bank of the Sado river. It was settled at least by the 1st c. A.D. Ptolemy (2.5) mentions a city of Caetobrix S of Tejo, and the *Antonine Itinerary* cites a

Catobriga in the same region. Some house facades, well aligned, were visible on the surface during the 19th c. in a region of Troia known as Rua da Princesa. At least two of these houses had two stories, and there were mosaics on the floors of the upper rooms facing on the main road. In one of the houses was found a hoard of bronze coins of the late Empire. A bath was also excavated; tanks for preparing garum were found along the river; and at the end of the 19th c. an Early Christian church was discovered and a round structure, perhaps a baptistery. One of the cemeteries of the city, Aldeira, contained over a hundred graves with rich grave goods.

The finds are in the National Museum of Archaeology in Lisbon.

There is some speculation that the site of Caetobriga lies in Setúbal, 32 km SE of Lisbon. The name seems to derive from Caetobriga. In the area occupied by the modern city the S. Sebastião hill could correspond to ancient Caetobriga. The Roman finds in Setúbal, although numerous, do not prove, however, that there was anything more than a small village there, like the many others that existed on the right bank of the mouth of the Sado.

BIBLIOGRAPHY. Marques da Costa, "Estudos sobre algumas estacões da época luso-romana nos arredores de Setúbal," *O Archeólogo Português* 29 (1930-31) 2-31[I]; F. Castelo-Branco, "Aspectos e problemas arqueológicos de Troia de Setúbal," *Occidente* 65 (1963) 21f; F. de Almeida & J. L. Matos, "Frescos da 'capela visigótica' de Troia, Setúbal," *Actas do II Congresso Nacional de Arqueológia, Coimbra* (1971) 529-33[I].

J. ALARCÃO

TROINA ("Tyrracium") Enna, Sicily. Map 17B. The site occupied the summit and S side of a hill. To it have been attributed the names of the ancient towns of Imachara, Engyon, Tragis, Herbita, but these identifications seem excluded both by topographical position and archaeological evidence. At present the earliest finds are in fact datable to the early 4th c. B.C. Local products are too few to suggest a Sikel settlement. At the site have been found: stretches of the walls in pseudo-isodomic masonry (3d c. B.C); a building outside the walls (3d c. B.C.) with trapezoidal plan and eight units; a split-level (terraced) building of the Roman period.

The site could be the Tyrracium mentioned by Cicero (*Verr.* 3.29). The necropolis, on Mt. Muanà, has yielded goods datable to the 4th-2d c. B.C.

BIBLIOGRAPHY. E. Militello, "Scavi effettuati dall'Istituto di Archeologia dell'Università di Catania negli anni 1958-1960," *NSc* (1961) 322-404. A. CURCIO

TROIZEN Argolid, Greece. Map 11. The city, ca. 15 stadia from the coast of the Saronic Gulf, was situated on the N slope of the mountain anciently called Phorbantion. Its territory extended to the sea and included the island of Calauria, bordered on the W by Epidauros and on the SW by Hermione. Originally an Ionic city, Troizen was particularly bound to Athens, united by common traditional mythology concerning both the legend of the founding of the city and because one of its ancient princes may have been an ancestor of Theseus, the principal hero of Athens, whose son Hippolytos was particularly venerated at Troizen. Subjugated to the more powerful Argos, Troizen nevertheless attempted to sustain its own policies, entering the Peloponnesian League, and in 480 B.C. welcoming the Athenians in flight from Attica after the battle of Thermopylai. Reference to these events is found in a recently discovered inscription of the 3d c. B.C., which is considered an ancient falsification of the 4th c. In the course

of the Peloponnesian War Troizen was initially allied to Athens, and later to Sparta. The city, because of its favorable geographical position, enjoyed particular prosperity through the Roman period.

The principal monuments of the city, discovered by French archaeologists between 1890 and 1899, include the acropolis and the habitation center that extended into the plain to the N. An encircling wall in polygonal masonry, descending from the acropolis, constituted the city's defensive system. Not until the 3d c. B.C., with contributions of the citizens (Paus. 2.31), was there a defense wall, built in transversal isodomic masonry, to separate the city from the citadel. Part of the fortifications are actually visible near the Church of Haghios Georghios, where there is also a Hellenistic tower restored in modern times. On the acropolis was a small temple dedicated to a divinity, perhaps Pan, or more probably to Aphrodite Akraia, whose remains are scarcely visible. It was in antis with rich decoration of polychromed terracotta dating to the 6th c. B.C. Revealing traces of monuments also appear in the agora, described by Pausanias (2.31.1). Outside the encircling wall to the W several monuments dedicated to Hippolytos, whom Greek mythology places at Troizen, have been discovered: a temple, a gymnasium, and a stadium. The sources speak also of a statue erected in his honor, and of a temple he dedicated to Lykeian Artemis in the city's agora. The Temple of Hippolytos (ca. 10 x 12 m), whose remains today are insignificant, was a peripteral temple with 6 x 12 columns, probably dating from the 4th c. B.C. Nearby was the Asklepieion, comprising a propylon, a small prostyle temple, a monumental fountain, and a sacred refectory. The latter includes a large hall (hestiatorion) with three central columns which support the ceiling and a peristyle surrounded by rooms. The complex of monuments may be placed between the end of the 4th and the beginning of the 3d c. B.C. Outside the city to the E, near the modern village of Damala, there has been discovered a place sacred to the cult of Demeter, of which Pausanias also speaks (2.32.8), though its remains are no longer visible. A votive deposit with pottery and votive terracottas attest to the continuity of the cult from the 7th to the 4th c. B.C.

BIBLIOGRAPHY. *IG* IV 748-852; *IG* IV[2] 76-77; G. Welter, *Troizen und Kalaureia* (1941) 748-52[MPI]; on the inscription of Themistocles: C. Dow in *CW* 55.4 (1962) 105-8; G. Maddoli in *ParPass* 18 (1963) 419-34; A. R. Raubitschek, *Gymnasium* 72 (1965) 511-22. M. CRISTOFANI

TROJA, see AECAE

TROPAEUM ALPIUM (La Turbie) Alpes-Maritimes, France. Map 23. Situated in a small market town between Menton (13 km) and Nice (18 km), the Tropaeum Alpium dominates the slopes which descend abruptly to Monaco and the sea. It was built under Augustus and abandoned at the end of the Empire. Included in a fortress in the Middle Ages, it has been dilapidated on many occasions. For a century the Tropaeum Alpium has been the object of numerous investigations and several restoration projects. Recent studies of reconstruction have determined the essential features of its original appearance.

The trophy stands at the highest point crossed by the Via Julia Augusta (built in 13 B.C.) between Albintimilium and Cemelenum. La Turbie is the mansio called Alpis summa in the *Antonine Itinerary.* On this height, the boundary between Italy and Gaul, the monument was erected to commemorate the pacification of the Alps, between 25 and 14 B.C. The text of the dedication is known to us from Pliny (*HN* 3.136-38), and excava-

tions have permitted the reconstruction of its location and arrangement. It enumerated the names of the 45 Alpine tribes subjected by the legions of Augustus. The inscription tells us the date of the monument was begun (between 1 July of the year 7 and 30 June of the year 6 B.C.)—Augustus' 17th year as a tribune—but some years must have been necessary to complete it.

It stood on a site cut out of the rock and covered with flagstones. A socle was made of a single course of large blocks protected at regular intervals by small rectangular fender stones. It supported a base of two courses on which, set slightly back, there stood a high square podium (32.52 m on each side). This podium was faced with large ashlar and included a cement nucleus with 24 foundation piles of big blocks, going from top to bottom. The inscription was placed on its W side. It was carried by a marble slab (17.45 x 2.66 m), framed by two reliefs depicting trophies of arms and four captives in chains. The N and S sides of this podium were pierced by two doors giving access to interior staircases leading to the colonnade on the second story. Above this first podium there rose a second, also square but of smaller size; its corners were adorned by four eagles. The second story had a rectangular plan. It included a large ashlar base which supported a cylindrical shell surrounded by a colonnade of 24 unfluted columns. These are made of local limestone and adorned with capitals of white Carrara marble. The metopes of the architrave presented reliefs in a local style (breast plates, ornamental ox-skulls, bows of ships, etc.). Behind the columns, sunk into the ashlar walls of the cylindrical shell, there were niches containing statues. The whole was crowned by a final story, conical and apparently stepped. It carried a monumental statue (of Augustus? a trophy?). The total height of the edifice was probably 49.68 m, or, in other words, three times the diameter of the central shell.

At the museum on the site, there are inscriptions, fragments of architectural pieces and of reliefs.

BIBLIOGRAPHY. J. Formigé, "Le Trophée des Alpes, la Turbie," *Gallia* Suppl. 6 (1949)[PI]; G. C. Picard, *Les trophées romains* (1957) 291ff; N. Lamboglia, "Le trophée d'Auguste à la Turbie," *Itinéraires ligures* 4 (1964); G. Barruol, *Les peuples préromains du Sud-Est de la Gaule* (1969). C. GOUDINEAU

TROPAEUM TRAIANI (Adamclisi) Dobrudja, Romania. Map 12. A Geto-Dacian settlement S of Dobrudja midway on the route between Constanţa and Silistra (Bulgaria) at an important crossroads. The site was changed by Trajan into a statio; and a vicus sprang up nearby.

Mentioned in only three sources of the late antiquity, the site was identified by excavations at the turn of the century. The life of the site in the 2d and 3d c. is known particularly through inscriptions reused as building material for the 4th-6th c. fortress. In the beginning the site was populated by Dacians and veterans of Roman military units from the lower Danube. In 115-116 the inhabitants, under the name of Traianenses Tropaeenses, dedicated a statue to the emperor Trajan. A milliarium (A.D. 118), discovered S of the site, indicates that early in his reign the emperor Hadrian ordered the repair of the imperial road passing through the settlement. Under Antoninus Pius a powerful detachment of Legio XI Claudia settled here. The site became a municipium shortly before 170 (the year of the invasion of the Costoboks) during the reign of Marcus Aurelius.

In the course of the 3d c. the fortress was repaired under Septimius Severus, Severus Alexander, and Gordian, but later, the site gradually lost its importance and

was destroyed by the Goths at the end of the 3d c. Rebuilt from the foundations by Constantine the Great and Licinius (313-16) after the general victory over the barbarians, the Tropaeensium civitas existed until the late 6th c. when it was destroyed by the Avaro-Slavians.

The visible ruins belong to the 4th-6th c. The circuit wall enclosed an irregularly shaped plateau of ca. 10 ha and was provided with horseshoe-shaped defensive towers (a single one was rectangular). Three gates have been unearthed: two on the E and W sides and a smaller one on the S side. The main street (ca. 300 m long), lined on both sides with porticos, linked the E and W gates. Under its pavement lay one of the aqueducts and a drain.

A large basilica forensis (4th c.) stood near the center of the fortress, S of the main street. On both sides of the same street, excavations have brought to light the ruins of four Christian basilicas (4th-6th c.), three of them with crypts, and one with an elegant baptistery. A cemetery basilica stood on the hill N of the fortress.

On a high plateau (ca. 2 km E of the site) was the triumphal monument erected by Trajan (109) to commemorate his victory over the Dacians and their allies. The only remnant of it preserved in situ is the nucleus (in opus coementicium) with seven steps and the first (incomplete) row of regularly cut stone blocks. The relief-carved stones, once dressing the monument, as well as the tropaion are exhibited nearby. The monument, ca. 40 m high, consisted of a cylindrical structure with diameter equal to the height with a conical roof of scale-like stone plates. Two superposed hexagonal bases supported the tropaion (over 10 m high). A row of 54 metopes (48 are preserved) were placed between two richly adorned friezes. The metopes were separated by pillars, also carved in relief. The sculptures of the metopes illustrated episodes in the battles against the Dacians and their allies. The cylindrical structure was crowned by 26 crenellations (22 are preserved in place) each showing a prisoner in relief carved, bound to the trunk of a tree. The same inscription was engraved on two opposite facades of the upper hexagonal base, and states that the monument was dedicated to Mars Ultor, in honor of Trajan's victory over the Dacians and their allies.

The remains of a square altar (12 x 12 m; 6 m high) are ca. 200 m E of the triumphal monument. Some 3800 names of soldiers who died in battle are inscribed on its walls. About 50 m N of the same monument, an earthen mound covered a circular mausoleum (40 m in diameter), probably the tomb of the commander killed in battle and listed first on the altar. Both the altar and the mausoleum seem to be contemporary with the triumphal monument.

BIBLIOGRAPHY. G. Tocilescu et al., *Das Monument von Adamklissi: Tropaeum Traiani* (1895); V. Pârvan, "Cetatea Tropaeum. Consideraţii istorice," *BCMI* 4 (1911) 1-12, 163-91; V. Barbu, *Adamclisi* (1965); F. Florescu, *Das Siegesdenkmal von Adamklissi: Tropaeum Traiani* (1965); G. Bordenache & R. Vulpe, "Tropaeum Traiani," *EAA* 7 (1966) 1022-25; R. Vulpe & I. Barnea, *Din istoria Dobrogei*, II (1968) passim; *TIR*, L.35 (1969) s.v.; A. Ştefan, *BMI* 41.3 (1972) 43-53. I. BARNEA

TROY, see ILION

TROYES, see AUGUSTOBONA

TRYSA Lycia, Turkey. Map 7. On the inland route between the coastal stations of Myra (Kale-Demre) and Antiphellos (Kaş), the hillside city of Trysa was built at an elevation of 866 m. It developed from an ancient Lycian aristocratic seat, as indicated by the restricted size of the acropolis and an archaic pillar grave with a

relief-decorated burial chamber. The socles and fragments of the monolithic shaft of this ruined funeral monument are preserved, W of the citadel, bearing parts of a continuous frieze, whose warriors and riders could refer either to a historical event or to a representation of the Ekphora. This monument may be grouped, with the Lion Grave of Xanthos and the pillar graves of Isinda-Belinkli (Istanbul Archaeological Museum) and Gürses—all of which may be dated in the last quarter of the 6th c. B.C.—among the oldest witnesses of the Lycian culture.

In the Classical period, the gravestones of the dynasts of Trysa were erected on two terraces E of the citadel. On the upper terrace is a heroon of the temenos type with rectangular plan (19.66 x 20.7 m x 23.5 x 24.54 m). Reliefs were carved on the exterior S wall and on all interior surfaces of the two upper courses of the isodomic temenos wall. In the SE corner was a wooden cubicle for the celebration of funeral ceremonies.

The main grave was not erected on the main axis of the entrance in the S wall, but on an E-W diagonal, in the form of a typical Lycian funeral hut, imitating wooden architecture. Within the precinct stood other relief-decorated sarcophagi and sculptures, of which only a few marble fragments remain: a lion, a life-size female figure, and a winged figure, probably a sphinx. The site was discovered in 1841 and in 1883 the architectural sculpture (211 m of frieze with ca. 600 figures) was taken to the Kunsthistorisches Museum in Vienna. The form of the entrance complex shows oriental influences: the four-winged bull protomes which adorn the outer jambs go back to Persian models. On the inner face there are dancing and instrument-playing demon dwarfs, which go back to Bes, the Egyptian god of the underworld.

The friezes in Greek style show Amazonomachies, Centauromachies, and scenes from mythology: the rape of the Leukippides, the War of the Seven against Thebes, the Siege of Troy, Odysseus killing the suitors, the Calydonian Boar Hunt, and the deeds of Theseus and Perseus. The Kalathos dancers on the inner door jambs and the banquet scenes on the inner S face symbolize the cult of the dead.

We do not know the name of the builder, a dynast of Trysa, the political vassal of the high king of Persia; the representation of Bellerophon killing the Chimaera from a galloping quadriga on the S inner face shows an armored warrior standing in the chariot as a descendant of this Lycian national hero. The style of the reliefs dates the heroon to the first half of the 4th c. B.C.

On the lower terrace, next to the relief-decorated sarcophagus of Deireimis and Aischylos, also removed to Vienna, stood three more mausolea in Lycian style with eagle roofs, all of which may similarly be dated to the 4th c. B.C.

A mid 4th c. date may also be assigned to a large relief cut into the cliff below the S wall of the acropolis, belonging to a heroon, as indicated by the theme well known in Lycian relief sculpture: priests, acolytes, and sacrificial animals.

Of the numerous Lycian sarcophagi S of the city from the Hellenistic period, one found its way to the Istanbul Museum. The lifting-bosses on its lid have been transformed into bulls' heads and Gorgoneia. In the sunken field between the Gorgoneia is a heraldic-looking lion and opposite him, a quadriga. The dolphins on the gables and the images on the ridge-beam complement one another: the occupant was apparently a merchant of the 2d c. B.C. who owed his riches to overseas trade, as indicated by the representations of a ship's prow and a large amphora.

There are numerous ruins in the dense maze of the S side of the city. During the construction of a road for the removal of the reliefs from the heroon, the remains of a temple in antis SW of the citadel were revealed. Inscriptions found there refer to decrees of the demes in the 1st c. A.D., and bear witness to the cult of Zeus Eleutherios and of Helios at Trysa. The community survived into the Byzantine period, as evidenced by a church on the acropolis.

BIBLIOGRAPHY. J. A. Schönborn, *Museum of Classical Antiquities* (1851) I 41f; O. Benndorf, "Vorläufiger Bericht über zwei österreichische Expeditionen nach Kleinasien," *Arch.-Epigr. Mitt. Österr.* 6 (1882) 151ff; E. Petersen & F. von Luschan, *Reisen in Lykien, Milyas und Kibyratis, Reisen im südwestlichen Kleinasien* 2 (1889) 8ff[1]; O. Benndorf & G. Niemann, *Das Heroon von Gjölbaschi-Trysa* (1889); W. Ruge, *RE* VII A1 (1939) 746f; F. Eichler, *Die Reliefs des Heroon von Gjölbaschi-Trysa* (1950); R. Noll, "Ein fürstlicher Grabbezirk griechischer Zeit in Kleinasien," *Antike Welt* 4 (1971) 40ff. J. BORCHHARDT

TSAMANDA, *see* LIMES, GREEK EPEIROS

TSOURILA, *see* LIMES, GREEK EPEIROS

TUBUSUCTU or Tubusuptu (Tiklat) Algeria. Map 18. Situated 3 km from El Kseur and 30 km S of Bougie, on the Soummam River. Its ancient name is attested in Plin. (*HN* 5.21); Ptol. (4.2.7); Ammianus Marcellinus (29.5. 11); the Ravenna Geographer, and Julius Honorius (*GLM* 48); it is missing from the *Antonine Itinerary*, on the route joining Saldae (Bougie) and Rusuccuru (Dellys) via the interior.

Like Saldae, it was a colony founded by Augustus with veterans of the 7th legion, hence its appellation of Colonia Iulia Augusta Legionis VII. Bishops of the town are mentioned in 411 and 484.

The town lies in a valley on the left bank of the Soummam, occupying an eminence and the plain running along it on S and E, where there are still vestiges of ramparts. The ruins have suffered from the cultivation of the region. To the S of the eminence are important baths, 50 m square in plan. To the N, in the center of the ruins, and to the E are the remains of immense cisterns. The N cisterns, fed by an aqueduct coming from the W, measure 35.5 x 77 m and are made up of 15 connected basins; the vaults were semicircular in section and there were interior and exterior buttresses. The ruins of the E cistern, fed by an aqueduct leading from the S, crossing the river via a bridge now gone, are confused and disjointed. Not all the important waterworks appear to be contemporary; it seems that the military importance of the site, in a region where there were numerous revolts in the 3d and 4th c., justified these creations.

Alluvial flooding of the plain revealed, 900 m S of the modern farm, a network of walls representing funerary edifices with concrete benches to which were fixed little cinerary urns; these must have been columbaria. One of the chambers terminates in a tripartite sanctuary, preceded by a courtyard. Next to the funerary structures, traces of industrial establishments have been found. The region was particularly rich in olive trees; amphorae marked as coming from Tubusuctu have been found at Rome. There are numerous traces of agricultural establishments in the environs and, 1 km to N, the remains of a mausoleum. Several Latin inscriptions are preserved in the garden of Tiklat farm; certain epitaphs have an aspect very rare in Africa, the form of a column-base; there are stelae to Saturn and some pottery in the Bougie Museum.

BIBLIOGRAPHY. S. Gsell, *Atlas archéologique de l'Algérie* (1911) 7, no. 27; J. Lassus, *Libyca* 7 (1959) 278-93[PM]; Birebent, *Aquae romanae* (1962) 473-83[PM].

J. MARCILLET-JAUBERT

TUBUSUPTU, *see* TUBUSUCTU

TUDER (Todi) Umbria, Italy. Map 16. A site on the left bank of the Tiber at the confluence of the Naia, served in Roman times principally by the Via Amerina. Grave goods show that this city, which inscribed its coins TVTERE, early prospered as a middleman between the Etruscans and Umbrians. Fine bronzes of the 6th c., Attic cups, and bucchero appear. In the Hellenistic period its wealth increased. The city must have come under Rome in the 3d c.; in 89 B.C. it was inscribed in the tribus Clustumina and under the triumvirate received the colonia Julia Fida Tuder.

The walls are in two circuits, one enclosing the hilltop and an extension around the S and E fronts; the work in both is very similar. There are no towers, but a sewer in one stretch, evidently original, is nicely engineered and vaulted. If they are not of the Roman colony, they can be not much earlier.

The forum has been located under Piazza del Popolo, but the city plan is elusive. There are poor remains of a theater and amphitheater and a number of cisterns and miscellaneous finds. The pride of Todi is an ancient terrace wall in Piazza del Mercato Vecchio in which open four beautiful half-domed niches. Above the crown of these runs a Doric frieze under a row of dentils. The date must be mid 1st c. B.C.

There is an archaeological museum in Palazzo del Capitano and tomb groups in the Museo Archeologico in Florence and the Villa Giulia in Rome. The Late Classical Mars of Todi is in the Vatican's Museo Gregoriano.

BIBLIOGRAPHY. *Forma Italiae VII.1 Tuder-Carsulae* (1938) (G. Becatti)[MPI]; *EAA* 7 (1966) 893-95 (U. Ciotti). L. RICHARDSON, JR.

TUGIA or Toya (Peal del Becerro) Jaén, Spain. Map 19. Iberian city at the confluence of the Guadiana Menor with the Guadalquivir. In the necropolis was a large cellar with three stone chambers, burials with chariots, three Greek kraters by the schools of the Painter of Thebes, the Retorted Painter, the Painter of the Black Thyrsos, the Painter of Toya, and a lekythos, all in the National Archaeological Museum of Madrid; and a kylix in the Instituto de Estudios Giennenses, Jaén. All date from the first half of the 4th c. B.C.

BIBLIOGRAPHY. J. Cabré, "Arquitectura hispánica. El sepulcro de Toya," *ArchEsp* 1 (1925) 73-101[PI]; A. García y Bellido, *Hispania Graeca* II (1948) 183-85[MPI]; J. M. Blázquez, "La cámara sepulcral de Toya y sus paralelos etruscos," *Oretania* 5 (1960) 233-37[MI]; G. Trías, *Cerámicas griegas de la Península Ibérica* (1971) 465-73[I]. J. M. BLÁZQUEZ

TULCEA, *see* AEGYSSUS

TULLUM Toul, Meurthe-et-Moselle, France. Map 23. Capital of the civitas Leucorum, one of the most extensive in Roman Gaul, Tullum owed its relative importance, which apparently was mostly administrative, to its location on the westernmost point of the course of the Moselle, and on the crossroads of two great roads, one going from Lyon to Trier by Langres and Metz, the other coming from Reims by Nasium. The town is cited by Ptolemy (2.9.12), the *Antonine Itinerary*, the *Peutinger Table* (Tullo), and in the *Notitia provinciarum* (civitas Leucorum Tullo). Fabius Valens, Vitellius' lieutenant, may have first heard at Tullum of the murder of Galba and the accession of Otho (Tac., *Hist.* I.64).

The ramparts of the ancient town were in large part preserved (with 15 towers) and kept in use until 1700, when military works almost completely obliterated them. However, the destruction suffered by the town in 1940 led to the discovery at several places, not merely of foundations, but of fairly well-preserved sections of the ancient walls. A fairly precise map of their plan can be established. Indeed, a section of the fortifications survives today in the middle of the town. The enclosed area was approximately circular, had a circumference of ca. 1300 m, and covered 10 to 11 ha. What is known about the construction of the ramparts suggests that they date to the end of the 3d or beginning of the 4th c. At any rate, they are earlier than the reign of Valentinian. As yet there have been no systematic excavations at Toul. However, many ancient remains have been collected since the 18th c., especially when the ramparts were demolished, for they had been built with reutilized fragments of architecture and funerary and religious monuments.

Many of these remains no longer exist, mostly as a result of the 1940 fire. For example, only a drawing survives of an altar with a representation of the mallet-god. The most recent finds have been collected in a small museum which is being restored. Among the most interesting finds are the following: a funerary stela of the house type with an inscription and decoration of three rosettes; two pieces of a bas-relief depicting Mercury; a group of three personages in high relief, probably a trinity of Gallo-Roman deities; and several bronze objects, among them a bust of Apollo, a bull, a cornucopia, a very worn statuette depicting Jupiter, and a dish decorated with palmettes and twining vegetal motifs. A certain number of interesting architectural and sculptural fragments (in particular a relief apparently depicting Attis in an attitude of sorrow) are kept in the Musée Lorrain at Nancy. Most of the artifacts found testify to the close connections which existed throughout the Gallo-Roman period between Toul and the other Moselle towns, Metz and Trier.

The observations made during the rebuilding of Toul suggests that the built-up area in antiquity was never very large. The Gallo-Roman town occupied the site of a small Gallic settlement. Subsequently it spread S. Then, at the end of the 3d or beginning of the 4th c., it shrank and shut itself up behind ramparts built with materials taken from the edifices of the original town, or their ruins.

BIBLIOGRAPHY. M. Toussaint, *Répertoire archéologique du département de Meurthe-et-Moselle* (1947) 116-24; J. Choux & A. Liéger, "Découvertes archéologiques à Toul," *Gallia* 7 (1949) 88-101[PI]. R. BILLORET

TUPHIUM (El-Tôd) Egypt. Map 5. On the E bank of the Nile, 20 km S of Thebes. The Asiatic Deposit, now in the Cairo Museum, was found here in the foundation of the temple. The ruins of the temple consist today of a naos built by Sesostris I, a pronaos dedicated by Euergites II to the falcon god Mont; and a Roman court with four columns, a small central hall, and a chapel, all three of which were dedicated by Antoninus Pius to the goddess Tenenet.

BIBLIOGRAPHY. Porter & Moss, *Top. Bibl., V. Upper Egypt: Sites* (1937) 167-69; F. Bisson de la Roque, *Trésor de Tod* (1950; 1953); E. Brunner-Traut & V. Hell, *Aegypten* (1966) 626. S. SHENOUDA

TURBA, *see* TARBA

TURDA, *see* POTAISSA

TURICUM (Zürich) Zurich, Switzerland. Map 20. Vicus and fort at the W end of Lake Zurich and on the Limmat river (*CIL* XIII, 5244 = Howald-Meyer no. 260). It was a harbor and depot on an old route from Raetia to the Rhine via the Walensee and Zurichsee, and there was therefore a small fort during the Augustan campaigns ca. 25-15 B.C. During the 1st c. A.D. its toll station, a statio Trigesimae Galliarum, was guarded by detachments of the legions garrisoned in Vindonissa. A fortress was built, under Valentinian I, and abandoned probably in A.D. 401. The settlement lies below the mediaeval city, but the fort has been excavated.

All the military installations occupied Lindenhof hill, above the Limmat, and the vicus was located near the bridge. Despite the characteristic location on a spur no trace of a pre-Roman oppidum has been found. The late Roman fort was of irregular shape (E wall toward the river 48 m; N 96; W 60; S 80; area 4500 sq. m). The ten towers protruded considerably inside the walls (av. width 7-8 m). Most of them were pentagonal on the outside, and built on square foundations, but the N and S gate towers, through which the road passed (modern Lindenhofstrasse-Pfalzgasse), were square. Some material in the fortress was reused. A ditch lay outside on the N (Fortunagass), and some traces of buildings have been found inside the fort. No late Roman houses are known outside it. Parts of the fortress are visible in modern buildings. Finds are in the Schweizerisches Landesmuseum.

(See also Limes, Rhine.)

BIBLIOGRAPHY. E. Vogt, *Der Lindenhof in Zürich* (1948); V. von Gonzenbach, *BonnJbb* 163 (1963) 103-5; E. Meyer, "Zürich in römischer Zeit," in Vogt et al., *Zurich von der Urzeit bis zum Mittelalter* (1971) 107-62[MPI]; C. M. Wells, *The German Policy of Augustus* (1972) 53-54. V. VON GONZENBACH

TURIN, *see* AUGUSTA TAURINORUM

TURISSA (Tossa de Mar) Gerona, Spain. Map 19. A village on the Costa Brava in Catalonia 82 km NE of Barcelona. It retains its defensive wall, protected by circular towers, dating from the Middle Ages. Excavation of a Roman villa (both farmhouse and large estate) dating from the 1st-2d c., which was destroyed during the invasion of the Franks in 265 and rebuilt in the 4th c., has yielded pottery, glassware, and mosaics; an inscription on one mosaic gives the ancient name: SALVO/VITALE FELIX TURISSA/EX OF/ICINA FELICES. The Roman remains are housed in a small museum.

BIBLIOGRAPHY. J. Puig i Cadafalch, "Els mosaics de Tossa," *Anuari de l'Institut d'Estudis Catalans* (1915-20); id., *Arquitectura romana a Catalunya* (1934); A. del Castillo, "La Costa Brava en la Antigüedad," *Ampurias* 1 (1939) 186. J. MALUQUER DE MOTES

TURNACUM (Tournai) Belgium. Map 21. A large Gallo-Roman vicus of the civitas Menapiorum, on the Bavai-Cassel (Castellum Menapiorum) road, where it crosses the Scheldt. The heart of the vicus was on the left or Menapian bank of the Scheldt, but there were important bridgeheads on the right or Nervian bank of the river, notably at St. Brice and at Le Luchet d'Antoing. The beginnings of the center go back to the Iron Age. Some huts of that period, found and excavated on the slope between the Scheldt and the hill of La Loucherie, were cabins of wattle and daub containing coarse pottery decorated with fingernail, comb, and stick impressions. Some Celtic coins found at Tournai date to the period of the Roman conquest.

During the Roman period Tournai developed rapidly, both because of its favorable position at the intersection of a large road and a navigable river, and because of the intensive working of limestone quarries. The limestone, exported over a radius of more than 100 km, was used as building material and in ironworks. The growth of the vicus dates mostly to the period of Claudius. Probably Caligula and Claudius concentrated here the troops intended for the invasion of Britain. A V-shaped ditch, sectioned in 1954 and 1955, dates to Claudius and seems to have belonged to the defenses of a temporary camp. The building of a large part of the road network in NW Gaul also dates to this time. The Tournai limestone was very intensively used in the construction of these roads. The first quarries worked in this period were located in the center of the modern town on the site of the cathedral. Limekilns, several of which have been excavated, were placed all around this pit. The kilns were circular (4 m in diameter) and looked like a hemispherical tub with clay walls furnished with an air vent 40 cm wide. In the 1st c. the center was provided with a checkerboard street plan. Under the streets conduits were found, both for bringing fresh water (masonry channels 30 to 35 cm wide and 35 to 90 cm high with walls coated with red plaster) and for taking away waste waters. The growth of the vicus also led to the filling of the first quarry mentioned above. (Houses were built on the fill.) The stone industry was relocated on the outskirts of the vicus in the district of Bruyelles-Antoing. Possibly the quarries were nationalized and put under the direction of an imperial official. The foundations of a barrow were discovered at Antoing. Its structure included a circular enclosing wall of carefully fitted large stones and a dromos leading to a double funerary chamber, recalling Roman mausoleums of Etruscan tradition. The barrow may be the mausoleum of an imperial official.

The vicus continued to grow at the end of the 1st c. and during all of the 2d. The destruction of a part of Tournai in 1940 made possible the excavation, unfortunately in rather scattered and incomplete fashion, of a certain number of buildings of the Gallo-Roman vicus. The dwellings of this period were characterized by the use of very fine masonry with fine outside facings. The interiors were enhanced by painted plastering. The paving was of cement, the roofing of imbricated tiles. A number of these dwellings were heated by hypocausts. They were provided with masonry cellars with storage niches set in the walls. The largest edifice found to date (52 m long) was on the summit of the hill of La Loucherie. It may have been a public building. Two large rooms at the wings were separated by a gallery with columns, which opened on a vast courtyard. This building was enhanced by figurative frescos and by columns whose capitals were topped by a cornice with modillions.

A dwelling excavated in 1942 had a bath building with plunges lined with marble. Large necropoleis have been found all around the vicus, for example, under the modern Grand-Place (hundreds of tombs), under the Rue de Monnel (ca. 100 tombs). Tournai was not only an industrial center but also the commercial center for all the surrounding region, a very fertile area with many rich villas. The town, sacked during the invasions of the Chauci in 172-74, rose from its ruins, but was not very prosperous in the Severan period although some fine artifacts (splendid jet medallions, for example) date to that time.

The town was destroyed a second time during the

first invasions of the Franks just after the middle of the 3d c. Many hoards of coins, found at Tournai and neighboring villages (Howardries, Beloeil, La Hamaide, Basecles, Ellezelles, Bailleul), were buried between 258 and 268. At the end of the 3d c. Tournai was turned into a fortress. Residential districts were leveled and the materials from these demolitions were used to build a rampart 2.4 m thick. It included the building of La Loucherie, whose corners were furnished with towers 1.45 m thick. This rampart can be traced for ca. 100 m. During the administrative reorganization under Diocletian, Tournai replaced Cassel as the caput of the civitas Menapiorum. A gynaecum (a workshop for military equipment) was installed at Tournai. The military garrison consisted of Germanic Laeti, and their tombs have been found in the town hall park. The grave goods of these tombs are characterized by belt trimmings with excised decoration with geometric and animal motifs.

In the 4th c. there still was a large civilian population whose necropoleis have been found at Grand-Place, the Rue Perdue, and St.-Quentin Church. In 407 the town was ravaged again, this time by the Vandals. Shortly thereafter it was reoccupied by the Salian Franks, who repaired the fortifications and made Tournai the capital of their kingdom. It was the residence of Clodion, Merovaeus (who, allied with the Romans, conquered Attila), and Childeric, who died at Tournai in 481. His tomb, with its very rich and famous grave goods, was found in 1653 near the church of St.-Brice. The artifacts from that tomb are kept at the Cabinet des Médailles in Paris. Clovis, Childeric's son and successor, moved the capital to Paris.

BIBLIOGRAPHY. M. Amand & I. Eykens-Dierickx, *Tournai romain, Dissertationes Archaeologicae Gandenses* V (1960)[MPI]; M. Amand, "Les véritables origines de Tournai," *Helinium* 3 (1963) 193-204; id., "Un nouveau quartier romain à Tournai. Les fouilles du Luchet d'Antoign," *Arch.Belgica* 102 (1968)[PI]; id., "L'approvisionnement en eau du Tournai Romain," *Arch.Belgica* 143 (1973)[PI]. S. J. DE LAET

TURRIS LIBYSONIS (Portocorres) Sardinia, Italy. Map 14. An ancient city on the N coast to the E of the Asinara, at the mouth of the Rio Turritano. The city was mentioned by the geographers (Ptol. 3.3.5, *It. Ant.* 83, *Tab. Peut.*). Despite the fact that the name recalls Libya, no archaeological data to the present time has verified any connection with the Punic world. The city became a colonia civium Romanorum and was inscribed in the Collina tribe under Caesar (*CIL* X, 7953). One of the most important cities of Sardinia, it was connected by a major road with Carales from the second half of the 1st c. B.C. onward. A record of the naviculari Turritani in the Piazzale delle Corporazioni at Ostia is evidence of its commercial importance. In the 5th c. the city was, like the rest of the island, seized by the Vandals; and ca. 1000 it was abandoned, eventually to revive in late mediaeval times.

Constructed on the axes of the cardo and decumanus, the city seems to have had a homogeneous plan. During partial exploration of the site, several public and private buildings have been discovered near the present railroad station. Among these is a large bath building, popularly known as the Palazzo di Re Barbaro. The original plan, superimposed on earlier buildings, dates from the end of the 1st c. B.C. It is arranged axially, with the entrance to the W and the caldarium to the E, and it is possible to distinguish various phases in its construction. The earliest part is brick, to which is added a part in striped technique and a part in irregular masonry. The caldarium has remains of interesting mosaics. Pilasters at the corners sustain cross vaults. Above the rooms is a reservoir for the water that served the caldarii below. The suspensurae are constructed of blocks of local calcareous stone. Nearby are remains of other bath buildings of similar construction. A Roman bridge of the 1st c. A.D. over the Rio Mannu is relatively well preserved. It has seven arches, of decreasing spans, and is constructed of regular blocks of limestone, the arches framed by mouldings. A few remains exist of an aqueduct (1st-2d c.) that carried water from the valley of S. Martino near Sassari. The modern port has completely obliterated the ancient one. The remains of Roman buildings are on the slope of the upland between Rio Turritano and S. Gavino, a few meters from the ancient shore line. There is part of a peristyle paved with squared blocks of limestone, bordered on the E side by a portico with marble columns and a polychrome mosaic pavement superimposed on an earlier pavement of marble slabs. In the same area is the large marble base of a statue of Valerius Domitian, procurator of Constantius Chlorus (305-306). Inscriptions record the existence of a temple dedicated to the goddess Fortuna, a basilica, a tribunal, and a catacomb. Marble statues and sarcophagi are in the National Museum of Sassari.

BIBLIOGRAPHY. E. Pais, *Storia della Sardegna e della Corsica*, I (1923) 381ff; M. Pallottino, *Studi Sardi* 7 (1947) 228ff; G. Lilliu, ibid. 8 (1948) 429ff; V. Mossa, ibid. 14-15 (1955-57) 373ff[PI]; G. Maetzke, *Boll. del centro per la Storia dell'Architettura* 17 (1961) 54f.
D. MANCONI

TURUNÇLAR, *see* PRIENE

TUSCANA (Tuscania) Etruria, Italy. Map 16. A city in the valley of the river Marta, half way between Tarquinia and the Lake of Bolsena. Villanovian ceramic fragments found on the hill of San Pietro, the acropolis of the later city, provide evidence of habitation at the site from the Late Bronze Age. From the 7th to the 5th c. B.C. the city appears to have flourished, owing to its position on the commercial routes between Tarquinia and the Lake of Bolsena and Orvieto, and between Caere and Vulci. The necropoleis in the valleys of the Marta and the Maschiolo date from this period. Some of the chamber tombs have real doors that open directly on the rocky mountainside. There are several rock-cut tombs with architectural facades, various tumuli, and the so-called *tomba a Dado*, consisting of a dado completely excavated from the surrounding rock.

The city also flourished during the Hellenistic period from which numerous sculpted sarcophagi survive. These come mainly from the late necropolis of the Madonna dell' Olivo, a km S of the city, into which opens the so-called Grotta della Regina, a large hypogeum consisting of a central chamber from which tunnels not yet completely explored lead underground. In the 3d c. B.C. the Via Clodia, of which large sections are preserved near the city, was opened, built in part over an existing road.

By Imperial times Tuscana was in decline. The only remains of monumental structures are the terracing on the hill of San Pietro, the structures under the church of Santa Maria Maggiore, and the bathing establishment on the city's outskirts.

BIBLIOGRAPHY. S. Campanari, *Tuscania e i suoi monumenti* (1856); S. Quilici Gigli, *Tuscana* (1970).
S. QUILICI GIGLI

TUSCANIA, *see* TUSCANA

TUSCULUM Latium, Italy. Map 16. The remains of the city, which for the most part belong to the Roman Imperial period, are situated on the hill of the same name, ca. 23 km SE of Rome. The name is of Italic

origin and indicates the zone in which the Latin peoples recorded the presence of earlier Etruscan settlements. Along the N slope of the hill has been discovered archaeological material that attests the presence of human habitation from the Early Iron Age, thus including the area in the wider context of the protohistoric necropoleis of the Alban Hills. Owing to its strong position (the acropolis rises to a height of 670 m), which allowed control of the route leading N from the Algidus Pass (territory of the Aequi and the Volsci) to Rome, Tusculum was inevitably involved in Rome's struggle for supremacy over her neighbors, though not always on the Roman side. In 381 B.C., according to Livy, Tusculum, at that time allied with the Volsci, was occupied peacefully by the Romans and obtained Roman citizenship and the status of municipium (cf. Cic. *Planc.* 8.19). After Sulla's victory over the Marians, Tusculum, which had taken the part of the Marians, became a colonia and parts of the city wall were rebuilt. By the end of the Republic, Tusculum had become the country seat of many of the leading Roman families: the most famous of the villas built there were those of Cicero, Asinius Pollio, Passienus Crispus, Matidia Augusta, and Tiberius (the evidence is in most cases literary, not archaeological). After the fall of the Roman Empire Tusculum apparently continued under the government of a comes but was much reduced in population. It was finally attacked and destroyed by the Romans in 1191 as the result of growing conflict with the Papacy.

In Roman times Tusculum was divided into two parts: the acropolis where, according to the literary sources, stood the temples of the Dioscuri and of Juppiter Maius although no trace of these temples is to be found today; and the city proper, which expanded along the ridge of the hill. Here the main street leads through the forum area to the theater where it branches off on either side and then continues to the acropolis. It is possible to distinguish the remains of the curia, of the amphitheater, and of blocks of flats and villas of the Imperial period, which are built in particular along the S slope of the hill, as well as on the far W boundary, outside the circuit of the walls. Not all that remains of the city is easily visible, but a stretch of the city wall along the N slope is well preserved and can be dated between the 5th and 4th c. B.C. on the grounds of its type and technique of construction. A good part of the theater has survived; it is built into the side of the hill in the Greek fashion, but is typically Roman in its construction, and is dated to the beginning of the 1st c. A.D. The so-called Villa of Tiberius is slightly later. The theater and the Villa of Tiberius are accessible as a result of excavations carried out between 1825 and 1841. The amphitheater and the greater part of the ancient city and the acropolis have yet to be systematically explored.

BIBLIOGRAPHY. L. Canina, *Descrizione dell'antico Tuscolo* (1841); A. Nibby, *Analisi dei dintorni di Roma*, III (1849) pp. 293ff; D. Seghetti, *Memorie storiche di Tuscolo antico e nuovo* (1891); F. Grossi Gondi, *Il Tuscolano nell'età classica* (1908); Th. Ashby, "The Via Latina," *BSR* V (1910) 339ffᴾ; G. Tomasetti, *La Campagna Romana* IV (2d ed., 1926) 351ff; G. McCracken, in *RE* VII A2 (1948)ᴾ; M. Borda, *Tuscolo* (1958)ᴹᴾᴵ.

B. GOSS

TUTUGI (Galera) Granada, Spain. Map 19. An Iberian city near Huescar in NE Granada. The burial chambers in its necropoleis have yielded eight Greek kraters belonging to the group of Polygnotos, of the Munich Painter, of the Painter of the Battle of the Griffins of Oxford, and the Painter of the Black Thyrsos; also three kylikes, two of them Attic (two from the 5th c. B.C., the other from the 4th), and two pelikes from the beginning of the 4th c. in the Kertch style. There are also two rectangular urns with animals lying on the covers and scenes on the sides, one of which shows Greek influence. Most of the finds are in the National Archaeological Museum of Madrid.

BIBLIOGRAPHY. J. Cabré & F. de Motos, "La necrópolis ibérica de Tútugi (Galera, Provincia de Granada)," *Junta Superior de Excavaciones y Antigüedades* 25 (1920); W. Schüle & M. Pellicer, "Ein grab aus der iberischen Nekropole von Galera (Prov. Granada)," *MadrMitt* 4 (1963) 39-50ᴵ; G. Trías, *Cerámicas griegas de la Península Ibérica* (1967) 455-69ᴵ.

J. M. BLÁZQUEZ

TYANA (Kemerhisar/Bahçeli, Bor, Niğde) Cappadocia, Turkey. Map 6. Capital of a Hittite kingdom in the 2d millennium B.C., Xenophon mentions it (*An.* 1.2.20), under the name of Dana, as a large and prosperous city. In the Cappadocian kingdom it was the second of the only two proper cities, its territory, Tyanitis the rich strategia in the SW of the country, stretching down to the Cilician Gates. At a spring near the city was the Temple of Zeus Asbamaeus (Amm. Marc. 23.6.19). Renamed Eusebeia by Tauros in honor of the Hellenizing king Ariarathes V Eusebes, Philopater, 163-30 B.C., it was more usually known by its former name. It was birthplace of Apollonius, "Trappist" philosopher of the 1st c. A.D., whose biography was written by Philostratus. Under Caracalla it became a colony as an important station on the main highway to Syria. In the provincial reorganization by Valens in A.D. 371-72, it became capital of Cappadocia Secunda.

The chief surviving monument is the fine stone aqueduct with many arches still standing. It brought water from Köşk Pınar, a strong spring below a small Neolithic settlement, where the rectangular spring-head basin from Roman times has recently been commercially excavated and restored as a swimming pool. Other small remains abound in Kemerhisar where there is an open-air museum of inscriptions and architectural fragments. There are more in Niğde Museum.

BIBLIOGRAPHY. W. J. Hamilton, *Researches in Asia Minor, Pontus and Armenia* (1842).

R. P. HARPER

TYBERISSOS or Tyberisos (Tırmısın Asarı) Turkey. Map 7. Site in Lycia 3 km S of Kyaneai, 15 km W of Myra. The city is known only from its inscriptions and has no history. The name was at first read erroneously as Tybenissos; the true name is preserved in that of the village. The antiquity of the site is proved by two Lycian rock tombs with inscriptions in the epichoric script. Some rare coins of Lycian type inscribed TY are probably to be ascribed to Tyberissos; otherwise there is no coinage. The inscriptions indicate that the principal deity was Apollo Tyberisseus, with the epithet Patroos, and that Tyberissos was united in a deme with Teimiusa.

The hill, high and steep, has a summit in two parts. The higher N part formed the acropolis, and has remains of a fortification wall in solid ashlar, and some small buildings; on the lower S part is a church built largely from the stones of a Doric temple. Among the ruins are many sarcophagi with so-called Gothic lids of the familiar Lycian type. At the foot of the mountain, immediately above the E end of the plain of Tırmısın, is a glade containing a dozen more Gothic sarcophagi and a number of pigeon-hole tombs; at the lower end is an unusual tomb with the door and two sides cut from the rock, and the two other sides of masonry. In several cases the epitaphs make the fine for violation payable to Myra.

BIBLIOGRAPHY. E. Petersen & F. von Luschan, *Reisen in Lykien* II (1889) 52-54; L. Robert, *Hellenica* X (1955) 194-95. G. E. BEAN

TYMNOS (Bozburun) Turkey. Map 7. City in Caria 27 km SW of Marmaris, a deme of the incorporated Rhodian Peraea, attached to the city of Kamiros. The town lies on a fine harbor, referred to by Mela (1.84) as sinus Thymnias. Tymnos was previously placed at Selimiye (formerly Losta), 3 km to the N, where numerous epitaphs of Tymnians are found, but this would in any case be on Tymnian territory. Bozburun is not only by far the finer site, but has produced many inscriptions, including a decree of the koinon of the Tymnians, and one of the few dedications to Roman emperors and magistrates found in the Peraea. Neither site has any standing ruins of consequence.

BIBLIOGRAPHY. M. Chaviaras, *ArchEph* (1911) 68-69; P. M. Fraser & G. E. Bean, *The Rhodian Peraea* (1954) 39-43, 61, 80. G. E. BEAN

TYNDARIS (Tindari) Sicily. Map 17B. The modern village, built upon the ancient site, is between Cape Calavà and the Cape of Milazzo on the Gulf of Patti, 10 km E of the town of Patti on the main highway that encircles the island.

Tyndaris began as a colony of Dionysios I in 396 B.C. It remained faithful to Rome during the Punic wars and prospered under the Empire. Pliny (2.206) records a landslide of the 1st c. A.D., in which part of the town fell away into the sea 280 m below the steep cliffs. Tyndaris became a diocese, and its role in Graeco-Roman events ended with the advent of the Arabs.

The site extends ca. 1 km SE-NW. The Greek acropolis is covered by the modern sanctuary of the black Madonna, and the agora by the village; tests, however, have been carried out. The ashlar circuit wall with its later accretions is the most imposing monument datable to the colony's beginnings. The single-nave Republican basilica marks the SE boundary of the excavations open to the public. Its restoration is in progress. A walk to the upper decumanus, which leads NW from its start at the basilica, reveals the museum on the left, and the insulae of Graeco-Roman houses and a public bath on the right. The two peristyle houses and the baths nearby show signs of later embellishment. Poor huts of the 4th-5th c. A.D. lie over the baths. At the end of the decumanus is the Greek theater (remodeled by the Romans).

BIBLIOGRAPHY. P. Zanker, "Zwei akroterfiguren aus Tyndaris," *RM* 72 (1965) 93-99; L. Bernabò Brea & M. Cavalier, "Tindari—area urbana: l'insula IV e le strade che la circondano," *BA* s. 5, 50 (1965) 205-9; *EAA* 7 (1966) 865-68; *TCI Guida d'Italia: Sicilia* (1968) 389-94. H. L. ALLEN

TYRAMBE Kuban. Map 5. A Greek settlement on the S coast of the Sea of Azov, 20 km E of Phanagoria. Founded in the 6th c. B.C., probably by Greek colonists from Phanagoria (Strab. 11.2.4), the settlement has been almost completely destroyed by the sea.

In the 1st c. B.C. the city was ringed with a brick wall and became a fortification within a general defensive system set up by the Bosporan state against Rome. Destroyed in the 1st c. A.D., it survived to the 3d c. and was then laid waste by the Getae.

The necropolis (5th c. B.C.-3d c. A.D.), contains tumulus tombs with a dromos and burial chamber cut in the earth. There is no stone work. The archaeological finds made here are richer than those in the city: red-figured Attic lekythoi, jewelry of gold and bronze (ring repre-

senting Eros and Psyche). Among the terracottas is one showing Aphrodite and Priapos, another showing Aphrodite with a dolphin; some plaster Gorgon masks probably served to decorate the sarcophagus. The Pushkin Museum, Moscow, contains material from the site.

BIBLIOGRAPHY. A. K. Korovina, "Raskopki nekropolia Tiramby v 1959 g.," *KSIA* 89 (1962) 70-73; id., "Drevniaia Tiramba," *VDI* (1963) 3.126-31; id., "Tiramba (gorodishche i nekropol'): Itog arkheologicheskii rabot ekspeditsii GMII za 1959, 1961-1963 i 1965 gody," *Soobshcheniia Gosudarstvennogo Muzeia izobrazitel'nykh iskusstv imeni A. S. Pushkina* 4 (1968) 54-84. M. L. BERNHARD & Z. SZTETYŁŁO

TYRAS (Belgorod Dnestrovskii) Ukraine. Map 5. A Greek city on the W bank of the Dniester liman near Belgorod-Dnestrovskii. It is mentioned in ancient sources (Strab. 7.3.16; Ptol. 3.10.8; Ps. Skyl. 68; Steph. Byz. and Anon. *Peripl.* 88.62). Founded in the 6th c. B.C., it was destroyed by the Getae in the mid 1st c. B.C. The city recovered, was replanned, and was destroyed again ca. 240 A.D., probably by the Goths.

Excavation has been hampered by thick mediaeval strata, but there are remains of buildings with cellars from the 4th c. B.C. and some dwellings of later eras. Parts of an ancient defensive wall with a circular tower (probably 2d c. A.D.) have been excavated, and from the same century a broad street with rows of houses on either side. During this period Legio I Italica was stationed in Tyras as well as Legio V Macedonia and Legio XI Claudia.

Pottery is represented by Ionian wares from the 6th c. B.C. and red-figured Attic wares from the 5th c. From the 3d c. B.C. on, relief wares from Asia Minor predominate. The city minted its own coins from 360 B.C. The Hermitage and Kiev Museums contain material from the site.

BIBLIOGRAPHY. E. H. Minns, *Scythians and Greeks* (1913) 445-49; C. M. Danoff, *Pontos Euxeinos* (1962) 1091-92 = *RE* Suppl. IX; A. I. Furmanskaia, "Antichnyi gorod Tira," *Antichnyi gorod* (1963) 40-50; E. Belin de Ballu, *L'Histoire des Colonies grecques du Littoral nord de la Mer Noire* (1965) 38-41; I. B. Brašinskij, "Recherches soviétiques sur les monuments antiques des régions de la Mer Noire," *Eirene* 7 (1968) 82-83. M. L. BERNHARD & Z. SZTETYŁŁO

TYRE, *see* TYRUS

TYRITAKE Bosporus. Map 5. Greek coastal town 11 km S of Kerch founded in the mid 6th c. B.C. on the site of a Kimmerian (?) settlement of the Late Bronze Age. Incorporated into the Bosporan state, the town prospered until its destruction by the Huns ca. 370 (Ptol. *Geog.* 3.6.3.; Anon., *Peripl. Ponti Euxini* 76(50); *Steph. Byz.*). Life at the settlement was resumed on a much reduced scale: excavations have uncovered a three-naved basilica (5th-6th c.) built of stone and brick, and the remains of dwellings from the 8th-9th c.

The town was encircled in the 5th c. B.C. by a stone defensive wall, which was greatly strengthened in the 4th-3d c. and partially rebuilt in the early centuries A.D. The fortifications also contained corner and intermediary towers. Knowledge of the city in the archaic and Classical eras is limited since most dwellings of this time were apparently dismantled and utilized in later construction, but there are traces of a three-room rectangular house from the period ca. 540-475 with adobe brick walls on a stone socle. Buildings from the 1st c. A.D. were found on both sides of a paved lane which passed through part of town at this period. Notable among later houses was

a large stone home of the 3d-4th c. consisting of seven living and storage rooms, some two-story, grouped around a paved courtyard.

The town was a center for the production of wine and salted fish. The earliest wine-making establishment, 3d-2d c. B.C., consisted of a smooth paved area used for pressing grapes by foot and an adjacent vat. Establishments of the 2d-4th c. A.D. contained three pressing areas in a row. The grapes were first pressed by foot in the two end areas and then crushed by a mechanical lever press in the middle area. A system of stone sluices directed the flow of wine into three or four adjoining vats. For salting fish 59 tanks, most dating from the 1st-3d c., were found in one small area of the town, and one establishment had a complex of 16 tanks. Herring, khamsa, and the more valuable sturgeon were the main fishes salted. The discovery of a bronze stamp from the 3d-2d c., used to make gold plaques with the bust of Aphrodite, indicates some local metalworking.

The necropolis, only partially excavated, contained slab tombs of the 4th-3d c. and earthen crypts of the 1st-4th c. The remains of an unfortified settlement of the 6th-4th c. have been noted ca. 400 m SW of Tyritake.

BIBLIOGRAPHY. V. F. Gaidukevich, "Bosporskie goroda Tiritaka i Mirmekii na Kerchenskom poluostrove (Po raskopkam 1932-1936 gg.)," *VDI* (1937) 1.216-39; *Arkheologicheskie pamiatniki Bospora i Khersonesa* [Materialy i issledovaniia po arkheologii SSSR, No. 4] (1941); id., "Raskopki Tiritaki v 1935-1940 gg.," *Bosporskie goroda*, I [Materialy i issledovaniia po arkheologii SSSR, No. 25] (1952) 15-134; id., "Raskopki Tiritaki i Mirmekiia v 1946-1952 gg.," *Bosporskie goroda*, II [Materialy i issledovaniia po arkheologii SSSR, No. 85] (1958) 149-85; A. L. Mongait, *Archaeology in the USSR*, tr. M. W. Thompson (1961) 194-96; C. M. Danoff, *Pontos Euxeinos* (1962) 1126-27 = *RE* Suppl. IX; E. Belin de Ballu, *L'Histoire des Colonies grecques du Littoral nord de la Mer Noire* (1965) 151-54.

T. S. NOONAN

"TYRRACIUM," see TROINA

TYRUS (Tyre) Lebanon. Map 6. On the Mediterranean coast ca. 72 km S-SW of Beirut, one of the most important Phoenician cities and a fortified major port. Tyre was a city to be reckoned with as early as the 14th c. B.C.; it is mentioned in the Tell-el-Amarnah archives. There is a splendid evocation of its early wealth and magnificence in Ezekiel 27, but it does not appear in Homer. Tyre's influence was widespread in the W Mediterranean by 800 B.C., roughly when the Tyrians founded Carthage. The city capitulated to Alexander in 332 B.C. after a siege, and later it became involved in Seleucid-Ptolemaic rivalry. In 64 B.C. Pompey assigned it to the new Roman province of Syria, and Septimius Severus elevated it to the rank of colony late in the 2d c. A.D. It is frequently mentioned by Josephus, and there are descriptions of it by Strabo (16.2.22-24) and Pliny (*HN* 5.17). Trade is often the reason for mentioning it (Luc. *Phars.* 10.41), and that trade flourished until at least the late 3d c. A.D. (Hieron. *Comm. ad. Ezek.* 26.7; 27.2; and see Procop. *Secret History* 25.14). In the crusading era it was a principal city of the Kingdom of Jerusalem.

The city was originally on an island ca. 1.6 km long, parallel to the shore and some 630 m from it. From early times it was connected by a causeway to the mainland, where another region of Tyre stood. It was this causeway that Alexander expanded into his famous mole 60 m wide; over the years a sandy isthmus has built up.

There were two harbors, the Sidonian at the N of the island and the Egyptian at the S. Aerial photography and both marine and land excavation have revealed not a little about these harbors, especially the S one; this is significant information as Tyre was one of the major ports of the ancient Mediterranean, ranking with Portus, Carthage, and Caesarea. The S harbor was protected by a lofty mole at least 675 m long and ca. 7.5 m wide. A system of broad terraces ran along its inner face, and there were at least two passages through it, one of them zigzag. Both the mole and the city proper were fortified with towers, some of them of considerable size. Docks lined the harbors; there was even a paved dry dock. Here lay the headquarters of a major merchant fleet that maintained offices in both Puteoli and Rome during the Early Empire, here also was the seat of the Roman fleet in the E Mediterranean.

Remains N of the S harbor have been uncovered; what can be seen today is almost entirely Roman Imperial and Early Byzantine in date. Septimius Severus was responsible for much construction here, for Tyre supported him in his struggle with Pescennius Niger, and after his victory he rewarded the city appropriately. The main urban element so far revealed is a colonnaded street which originally ran the length of the island to connect the two ports (cf. Lepcis' grand colonnaded boulevard to the Severan port). It has been partially excavated: doubled columns flanked a street some 10.5 m wide, paved at least in part with mosaic of geometric patterns; it was repaired at some late date with roughly-cut stone blocks. There is a theater of Hellenistic date, rectilinear not only in outline but also in the arrangement of the tiers of seats; there are similarities to the bouleuterion of Priene. Nearby are cisterns of Roman date. A massive triumphal arch, with a single opening and rather simple architectural treatment for its late 2d c. date, has been partly restored, and this is the most visible of Tyre's monuments so far recovered. The Roman forum has been located SE of the Cathedral, and remains of the Hippodrome include the base of the spina and the canonical obelisk of Roman times.

The city, once a center of philosophy, embraced Christianity enthusiastically. It was the seat of a bishop as early as the 2d c. A.D.; Origen died there about the middle of the 3d c. There are remains of a Byzantine basilica. The Venetian Cathedral, begun early in the 12th c. and built partly of ancient stones, was on the site of an early 4th c. church; it is traditionally the burial place of Frederic Barbarossa.

There is a considerable necropolis, including a long avenue flanked in part by late antique and early Byzantine sarcophagi (some are now in the National Museum in Beirut). About 9.6 km SE of Tyre is the so-called Tomb of Hiram, which would date from the 10th c. B.C. if it were his; it is celebrated as such in Freemasonry, but it cannot be of so early a date.

BIBLIOGRAPHY. A. Poidebard, *Un grand port disparu: Tyr* (1939)[PI]; *RE* 7 A (1948) 1876-1908[P]; M. Chébab, "Fouilles de Tyre," *BMBeyrouth* 9ff (1948ff); id., *Tyr, histoire, topographie, fouilles* (1969)[PI]; *EAA* 7 (1966) 877-79[P].

W. L. MACDONALD

U

ÜÇAĞIZ, see TEIMIUSSA

ÜÇ TEPELER, see LEUKAI

UCETIA (Uzès) Gard, France. Map 23. Situated 25 km N of Nîmes, on the Alzon, a tributary of the Gardon, this oppidum, whose ancient name is known from inscriptions (*CIL* XII, 3362), should be identified as one of the 24 heavily populated oppida of the Volcae Arecomici, which under the Early Empire still formed a confederation with Nemausus as its capital (Strab. 4.1.12; Plin. 3.37).

The pre-Roman and Roman towns are covered by the modern city, but construction work continues to turn up chance architectural remains and especially inscriptions. In the environs of Uzès are found the Airan and Eure springs (Ura fons), which supplied Nîmes with its water by way of an aqueduct; numerous vestiges of it remain, such as the famous segment known as the Pont-du-Gard. There is a local archaeological museum.

BIBLIOGRAPHY. *Carte archéologique de la Gaule romaine*, fasc. VIII, Gard (1941) 166-70, nos. 198-99, 160-62, no. 179; *RE* 8 A1 (1955) col. 547.　　G. BARRUOL

UCUBI or Ucubis (Espejo) Cordoba, Spain. Map 19. To the SE of Cordoba, W of Castro del Rio. A colony exempt from the jurisdiction of the Conventus Iuridicus Astigitanus, known as Claritas Julia according to Pliny (*NH* 3.12), and mentioned by Sallust (1.123) in a passage that must refer to the entry of Sertorius into Baetica after having defeated Metelus in Lusitania in 79-78 B.C. The cache of 700 Roman denarii found near Ucubi must have been hidden on that occasion. *Bellum Hispaniense* contains several references to Ucubi during the struggle between Caesar and the sons of Pompey in 45-44 B.C. Pompey camped between Ategua and Ucubi when besieged by Caesar; the latter finally occupied the site, but not until Pompey had ordered the execution of all those he suspected of being Caesar's partisans (*Bell.Hisp.* 20.1; 24.2).

Remains apparently from that period include the amphitheater N of the town, partly hewn out of a hillside. Only the walls of the substructure remain, but the diameter of the arena must have been ca. 35 m. There is a Roman bridge nearby. Inscriptions and the remains of houses and fortifications have been found in Ategua vetus and Ucubi, and ceramic fragments in Ategua which date from the 1st c. B.C. and even earlier. The town is reputed to have been the birthplace of Annius Verus, grandfather of Marcus Aurelius, and this accounts for the alleged Cordovan origin of the emperor.

BIBLIOGRAPHY. A. García y Bellido, "Colonias romanas de Hispania," *Anuario de Historia del Derecho Español* 29 (1959) 464f.　　C. FERNANDEZ-CHICARRO

UCUBIS, see UCUBI

UGENTO, see UXENTUM

UGERNUM (Beaucaire) Gard, France. Map 23. Important way station on the Via Domitiana at the head of the Rhône delta, on the right bank of the river, facing Tarusco (Tarascon), at a point which according to ancient itineraries was one of the principal crossings (Trajectus Rhodani).

The pre-Roman town was on the rocky butte dominating the river on which the mediaeval castle is built. There is evidence of human occupation there from the 6th c. to the Roman era. On the flat space on which the castle is built are the remains of a large and strong Roman edifice, sometimes identified as a castellum. The main Roman settlement was at the foot of the native oppidum, on the site of the mediaeval and modern town, and is attested by numerous discoveries: remains of structures, mosaic pavements, architectural elements, statues, inscriptions, and other objects. To the NW of the city, along the Via Domitiana, necropoleis have recently been discovered and partially explored; they have yielded Roman cremation burials of unusually early date. Both early and recent discoveries are found for the most part in the archaeological museums of Beaucaire and Nîmes.

BIBLIOGRAPHY. *Carte archéologique de la Gaule romaine*, fasc. VIII, Gard (1941) 1-5, nos. 3-5; *RE* 8 A2 (1958) col. 1908; "Informations," *Gallia* 20 (1962) 628I; 22 (1964) 498I; 24 (1966) 474; 27 (1969) 403.
　　G. BARRUOL

UĞURA, see OLBA

ULCISIA CASTRA later CASTRA CONSTANTIA (Szentendre) County of Pest, Hungary. Map 12. A Roman military camp, built at the beginning of the 2d c., 14.41 km N of Aquincum (VIII miles according to the *It. Ant.* 266.10). The camp was rebuilt after its destruction during the invasions at the end of the 2d and the beginning of the 4th c. In the 4th c. its name was changed to Castra Constantia (*Not. Dig. occ.* 33.13.34). The Romans abandoned it at the beginning of the 5th c.; during the migrations, it was the headquarters of an Avar tribe. During the 2d c. the Cohors IV Voluntariorum, then the Cohors I Antoniniana, in the 3d c. the Cohors Milliaria Nova Surorum Sagittatiorum and part of the Legio II Audiatrix, and in the 4th c. the Equites Dalmatae were garrisoned here.

The large, trapezoidal auxiliary camp (134 x 205 m) had square towers built inside the walls during the early period; during the rebuilding of the 4th c. horseshoe-shaped towers were built on its four sides, and fan-shaped ones at its corners. The camp wall was surrounded by a double moat. Among the interior buildings only the principia has been completely excavated; the questorium and other buildings are only partly known.

The ruins of an extensive area of huts came to surface at the W and S sides of the camp. There is a large necropolis of the 2d-4th c. S of the camp. The one of the 4th c. lies at the site of the abandoned huts; an Early Christian cella memoriae was discovered in it. The camp's bath building was on the side facing the Danube, in front of the praetoria. To the S and N of the camp, 2 km distant each way, are the ruins of small Roman forts. At the site of both camp and necropolis ca. 90 fragments were discovered, mostly of stone. All findings are in the Ferenczy Károly Museum.

(See also Limes Pannoniae.)

BIBLIOGRAPHY. L. Nagy, "Les monuments se rapportant à l'Asie mineure, dans le cours moyen du Danube," *Archaeologiai Értesitő* 52 (1939); id., "Indagini sul territorio di Ulcisia Castra," *Archaeologiai Értesitő* (1943); id., "Bericht des Archäologischen Instituts von Budapest," *Budapest Régiségei* 13 (1943); B. Saria, "Ulcisia castra," *PWRE* 9 A; *Tabula Imperii Romani L 34* (1968).　　S. SOPRONI

ULMEȚUM Constanța, Romania. Map 12. Near the modern village of Pantelimonul de Sus on a high plateau protected to the SE and NE by deep ravines are the ruins of a castellum built in Justinian's reign on the site of a Roman vicus of the 2d c. A.D. The ruins are fairly well preserved. All that remains of the ancient village, which was inhabited by Romans and Thracians, are some inscriptions giving information on the organization of the vicus and its magistrates as well as its material development, which was furthered by the nearby Marcianopolis-Tropaeum-Noviodunum imperial highway. From the 3d c. on there is little information. According to Procopius (*De aed.* 4.7.17) there was a Roman fortress here before Justinian's reign, but excavations have revealed the phrourion built by that emperor to protect the surrounding territory from the invading Slavs. The 6th c. castellum is trapezoidal in shape (140 x 160 m). The rampart wall, which is fairly well preserved, is 2.6 m thick. Built of well-beaten concrete, it has an outer surface of squared blocks and an inner face of opus incertum. There are 13 bastions, all projecting outward; three are round, three semicircular, and the rest square or rectangular. The curtains all have double staircases on the inside cut into the thickness of the wall. Little remains of the buildings inside the camp. The most important ruin is that of an apsidal monument (35.5 x 17.7 m). The many rooms do not connect but open onto two corridors that divide the building lengthwise.

BIBLIOGRAPHY. V. Pârvan, "Cetatea Ulmetum," *An. Acad. Rom., Mem. Sect. Ist.* 34 (1912) 497-607; 36 (1913) 245-420; 37 (1914) 265-304. D. M. PIPPIDI

ULPIANA (Gračanica) Yugoslavia. Map 12. An important town of Dardania on the route Naissus (Niš)-Stobi. The ancient site is occupied by the Monastery at Gračanica in Kosovo ca. 10 km S of Priština. Ulpiana was founded on the site of a large Bronze Age settlement probably during the reign of Trajan. The fact that the town was a municipium by the middle of the 2d c. is attested by numerous inscriptions. Its territory included the fertile valley of the Lab and the Drenica. Its location on the major route from the Danube to the Via Egnatia and its proximity to important mining areas made it important during the Early Empire. It was the residence of a procurator by the 3d c. and continued to be of importance during the Early Christian period.

The town was probably one of the many communities destroyed by the Gothic army of Theodoric in A.D. 479. Ulpiana, in any case, was in ruins when Justinian restored it in the early 6th c. and renamed it Justiniana Secunda.

Excavations have revealed several buildings of the later city and some sections of the city wall, including one of the principal gates on the N side. A three-aisled basilica (34 x 14 m) was cleared within the settlement and two phases of construction were detected, dating to the 5th and 6th c. Parts of the cardo maximus were cleared as well as several dwellings within the fortified area.

The N gate is flanked by two towers of horseshoe-shaped plan. Not far from the gate outside the wall a large industrial building of the 4th c. and a nearby basilica were excavated. Cemeteries to the N, W, and S of the town have been explored. Near the wall at the edge of the W necropolis a small Christian mortuary has been cleared which has two lateral apses in its principal room. The N cemetery has a three-aisled basilica with a crypt and numerous burials below it. Near the center of the necropolis was found a monumental marble sarcophagus (probably 4th c.) and parts of a floor mosaic were uncovered, with geometric motives (early 4th c.) belonging to a building earlier than the basilica. Graves in the N

cemetery date mainly to the 4th c., but the basilica was dated by the excavators to the time of Justinian.

Most of the material from the excavations belongs to the 4th-6th c., but a number of stone inscriptions dating from the time of Trajan through the 3d c. were found and some contain the official name of the community, municipium Ulpiana. Among the works of art from Ulpiana are several statuettes in marble and two bronze statuettes of Apollo and Mercury. A large bronze medallion of the Emperor Probus is also of interest.

Finds from Ulpiana are in the Museum of Kosovo and Metohija in Priština.

BIBLIOGRAPHY. Excavation reports by E. Čerškov appeared periodically in *Glasnik Muzeja Kosovo i Metohija* from 1956.

M. & D. Garašinin, *Arheološka nalazišta u Serbiji* (1951); E. Čerškov, *Les romains en Kosovo et Metohija* (1969)[MI]. J. WISEMAN

ULPIA TRAIANA (Sarmisegetuza) Hunedoara, Romania. Map 12. The capital city of Roman Dacia, on a plain in the SW corner of Hațeg, is now partly covered by the modern village.

Founded between 108 and 110 as Colonia Dacia, Hadrian gave it the Roman name of Ulpia Traiana Augusta and the Dacian name of Sarmisegetusa, the name of the capital of the Dacians before the Roman conquest. Severus Alexander added the title of metropolis. The inscription commemorating the founding of the town (*CIL* III, 1443) is preserved, as well as a sestertius minted by Trajan, which marked the event.

The capital was colonized by Roman citizens belonging to the tribus Papiria, and was granted the ius Italicum.

The political and administrative center of the province as well as the residence of the governor, it became in the 3d c. the residence also of a concilium Daciarum trium. On the main highway crossing the province from SW to N, the city was a customs station and became the most important cultural and religious center of Dacia.

The town, surrounded by walls, covered an area of 32.5 ha. Inside the walls, public buildings, both religious and profane have been discovered; outside the walls, excavations have uncovered villae suburbanae, temples, an amphitheater; and E and NE of the town, two necropoleis along the main Roman highway.

The town wall, built under Trajan, was 1.8 m thick and 4 to 5 m high. Outside the wall were a berma and two ditches, with rectangular bastions at each corner; only the one at the SE corner has been preserved.

In the middle of the town is an Aedes Augustalium (85 x 65 m). It was built in the middle of the 2d c. and rebuilt in the 3d c. (*CIL*, III, 6270, 1425).

The governor's palace was built of stone, brick, limestone, and marble; the walls were painted various colors and the roof was tiled. In the middle of the palace two interior paved courts are separated by an arcade and marble half-columns. The court facing N was larger and contained basilicas (one towards the W and the other towards the E), and on the N was a building with several rooms. In the middle of this court was an altar for the cult of the emperor and Rome. The court facing S was smaller and formed a portico in front of the main building, which contained several rooms. One underground was used to safeguard cult objects; another, with two cisterns under it, served as a sanctuary. The remaining rooms were used for dwelling and for conference halls.

The forum, partially excavated, has two parts. The narrower, close to the building of the Augustales, is a kind of basilica 85 m long. It is surrounded by walls faced

with marble. Along the N and E walls were honorary monuments. From the basilica one could enter the forum proper, 42 m wide, which was open and was stone-paved.

Outside the town, beyond the N side of the interior wall, was the amphitheater (88 x 69 m), which could seat ca. 5000 people. It was built in the first half of the 2d c. of stone and brick. At the ends of the long axis were the gates for the gladiators, and on the shorter axis a secondary entrance with well-preserved thresholds. In front of the secondary entrance, towards the N is a channel for waste water from the arena, and in the middle of the arena a squared underground room, serving probably as water basin; there are traces of wooden pipes. The arena is surrounded by a wall, 3 m high, with a stone parapet, interrupted by the four gates and ornamented with columns of marble. Close to the amphitheater and the E gate are the ruins of a sanctuary to the goddess Nemesis.

In the necropolis in the E part of the town a mausoleum of the Aurelian family was discovered, built in the middle of the 3d c. It is of brick and circular (21 m in diam.).

Among earlier discoveries, lost today was a multi-colored mosaic representing the Judgment of Paris and another representing Priam pleading for Hector's body. Temples of Mithras and of the Syrian gods were found outside the town. Recent excavations have brought to light two temples: one of Aesculapius and Hygeia and the other of Liber Pater.

The epigraphic and archaeological material is in the Deva-Hunedoara county museum, the local museum of Sarmizegethuza, and in other major museums of Romania.

BIBLIOGRAPHY. C. Daicoviciu, "Fouilles et recherches á Sarmisegetusa," *Dacia* 1 (1924) 224-63; 3-4 (1927-32) 516-56; id., *Ulpia Traiana* (1966). L. MARINESCU

ULRICHSBERG Carinthia, Austria. Map 20. A mountain (1020 m high) on the W side of the Zollfeld, near Virunum, the provincial capital of Noricum. On the top of the isolated mountain stands the ruin of the Late Gothic Church of St. Ulrich which gave the mountain its name. In the Middle Ages it was called Mons Carantanus. Many spoils have been built into the walls of this church, and above the main entrance one finds a fragment of an inscription which refers to a procurator's votive offering for Isis Noreia. This and other observations led to excavations in 1934-38, and 1948, during which buildings from two Roman periods were identified, the 1st and 6th c. A.D. In the center of each of the two building complexes is a cult building.

One of these is a structure 43 m long in a slight hollow N of the modern St. Ulrich's. Its strange plan suggests a cult building with a double function: a) for the above-mentioned Isis Noreia, comparable to the goddess Isis; b) for the otherwise unknown god Casuontanus, whose name is found on an inscription in the large basin. The carefully waterproofed basin would indicate that water must have played an important part in this cult as in other native Celtic temples. This sanctuary was somewhat isolated from the rest of the buildings to leave sufficient room for the attendance of the faithful at the outdoor ceremonies. The finds indicate that the cult originated in pre-Roman times. Adjoining buildings include a large, well-equipped dwelling (for the priests) and three houses, one with a bath, to shelter pilgrims. This place of pilgrimage seems to have functioned until late in the 5th c. A.D. It came to an end when nearby a cult building of the new Christian religion was erected.

This Early Christian church (26.5 x 16.3 m) became in turn the center of a small building complex. It had one nave (16.3 x 9.8 m) and on the N side two rooms

(prothesis and diaconicon) and in the W an entrance hall (narthex) with a masonry bench. The outside of the apse was decorated with shallow pilasters. The semicircular clergy bench has been moved from the apse closer to the audience; in front of it was the altar. The advanced architecture (pilasters, narthex, etc.) justify dating it to the late 5th c. A.D.

Around the church was grouped a small settlement consisting of a few miserable primitive stone houses. The mountain top was, however, not protected by a wall or developed as a refuge, as elsewhere. Since the end of ancient times a few families had lived here in this remote place, which was protected by woods. Thus a new type of settlement, the first Almdorf (mountain village) in the E Alps was developed here. It perished with the invasion of the Slavs and Awari at the end of the 6th c. A.D.

BIBLIOGRAPHY. R. Egger, "Der Ulrichsberg. Ein heiliger Berg Kärntens," *Carinthia* 140 (1950) 29ff[MPI]; id. in *EAA* 7 (1966) 1051ff; R. Noll, *Frühes Christentum in Österreich* (1954) 106f; H. Vetters, "Virunum," *RE* IX A 1 (1961) 282ff, 297. R. NOLL

UMM QEIS, *see* GADARA

UNTERSCHWANINGEN, *see* LIMES RAETIAE

UNTERSECHENZ *and* **STEIN AM RHEIN,** *see* TASGAETIUM

"URANION," *see* BURGAZ

URBA (Orbe) Vaud, Switzerland. Map 20. Vicus and villa 10 km SW of Yverdon. (Mentioned in *It. Ant.* 348.3 and *Not. Gall.* 9.6.) The settlement developed around a bridge and relay station on the Orbe, where the roads from Lousonna and Eburodunum joined to cross the Jura towards Ariolica and Vesontio.

Little is known of the vicus, which lies beneath the mediaeval town, but 2.5 km to the NE at Boscéaz there is a villa with outbuildings constructed in the 1st c. A.D. It was enlarged and remodeled several times, and destroyed during the incursions of the Alamanni ca. A.D. 270. Parts of it were inhabited, however, into the 4th c., and eight mosaics (four geometric, four figured) of ca. A.D. 200-230) are preserved in situ in the main building and baths.

BIBLIOGRAPHY. F. Staehelin, *Die Schweiz in römischer Zeit* (3d ed. 1948) 357-58, 623; V. von Gonzenbach, *Die römischen Mosaiken der Schweiz* (1961) 173-99[PI]; id., "Die römische villa von Orbe und ihre Mosaiken," *Arch. Führer der Schweiz* 3 (1974) [MPI].

V. VON GONZENBACH

URBINO, *see* URVINUM METAURENSE

URBISAGLIA, *see* URBS SALVIA POLLENTINORUM

URBS SALVIA POLLENTINORUM (Urbisaglia) Marche, Italy. Map 16. An important center in inland Picenum from which roads radiated to Tolentinum, Ricina, Pausulae, Firmum, and Falerio. Probably a rebuilding of an older community (Pollentini) by a Salvius ca. 60 B.C., it flourished under the Empire and was made a colony by the end of the 1st c. A.D. It was inscribed in the tribus Velina. It was completely destroyed by Alaric.

The city, roughly rectangular in plan, lay on a slope E of modern Urbisaglia, near the church of La Maestà. The towered walls are well preserved, 2 km in circuit, faced with brick. The ruins are impressive: an amphi-

theater (96.6 x 74.6 m) and theater (both recently excavated, both Flavian), baths, an aqueduct, a reservoir, and tombs. Numerous inscriptions have been recovered, some of which, together with figured aqueduct tiles, are in the Palazzo Comunale of Urbisaglia.

BIBLIOGRAPHY. H. Nissen, *Italische Landeskunde* (1902) 2.422-23; *AA* 74 (1959) 196-201 (B. Andreae)[PI]; *EAA* 7 (1966) 1075 (G. Annibaldi); *Atti del Convegno sui Centri Storici delle Marche* (1967) 191-93[MI].

L. RICHARDSON, JR.

URFA, see ANTIOCH BY THE CALLIRHOE

URGO (Orgon) Bouches-du-Rhône, France. Map 23. A Gallo-Greek oppidum of the Salyens, on the hill of Beauregard at the extreme NE of the Alpilles chain. A strategic site dominating the Durance Valley, where there are many foundations of Gallic huts carved out of the rock. Coins have often been found on the surface, almost all minted in Massalia (Marseille); noteworthy are two silver obols with sunken reverse dating from the 6th c. B.C. The obverse of one coin shows a Corinthian helmet with visor and sidepieces; the reverse, a bearded, helmeted head. There are also obols with the head of Apollo on the reverse side with M A, and little bronze coins with a bull (3d-1st c. B.C.).

Excavations in the gully of the cemetery in 1887 and 1958 have yielded seven Gallic terracotta andirons with a ram's head, fragments of bricks impressed with decorations of persons, animals, and geometric designs (museums of Avignon and St-Rémy-de-Provence), and many pottery sherds. Other discoveries include an altar to Jupiter Taranis with an inscription in Greek letters, and Roman altars dedicated to Apollo and Sylvanus. In 1967 a terracotta Jewish oil lamp from the 1st c. B.C. was found in the Vau quarter (type 3 of Dressel's classification) decorated on the top with a double candlestick with seven branches. This is the oldest menorah found in Gaul (Musée Judéo-Comtadin, Cavaillon).

BIBLIOGRAPHY. A. Sagnier, "Une inscription gauloise trouvée à Orgon," *Mémoires de l'Académie de Vaucluse* (1887); id., *Forma Orbis romani* V (1936) No. 492; F. Benoit, *L'art primitif méditerranéen de la vallée du Rhône* (1955)[MI]; L. Poumeyrol, "Le site de Beauregard à Orgon," *Cahiers ligures de Préhistoire et d'Archéologie* 8 (1959)[PI]; B. Blumenkranz, "Les premières implantations de Juifs en France," *CRAI* (1969)[MI].

A. DUMOULIN

URIA or Hyria (Oria) Apulia, Italy. Map 14. An ancient city about midway between Taranto and Brindisi on the Via Appia. Strabo (6.282) places it on the isthmus between the two seas and mentions that the palace of a native king was there. Herodotos (7.170) considers it the most ancient Messapic city, founded by colonists from Crete on their return from Sicily. In the civil war between Octavian and Mark Antony, Servilius was besieged there (App. *BCiv.* 5.58). In the *Liber Coloniarum* (p. 262), among the Civitates Provinciae Calabriae, the "Uritanus ager" is undoubtedly associated with this center (Plin. *HN* 3.100).

Recent excavations in the districts of Ciriaco and Maddalena have brought to light numerous tombs of the 6th and 4th-3d c. B.C. The archaic burial chambers, with the bodies usually contracted, have grave gifts among which Greek ceramic ware is found beside the typically local products. Yet in the tombs of the Hellenistic period, it is not unusual to find some interesting Messapic inscriptions or a few bronze coins incised with the city name ORRA. A rich archaeological collection belonging to Martini Carissimo is preserved in the Castello di Oria.

Other finds, particularly epigraphic ones, are on exhibition in the local Biblioteca Civica.

BIBLIOGRAPHY. W. Smith, *Dictionary of Greek and Roman Geography*, I (1856) 1106 (E. H. Bunbury); K. Miller, *Itineraria Romana* (1916) 343; *RE* 9.1 (1961) 1001; F. G. Lo Porto, "L'attività archeologica in Puglia," *Atti VIII Convegno Studi Magna Grecia* (1968) 195.

F. G. LO PORTO

URIUM or Hyrium (Carpino) Foggia, Apulia, Italy. Map 14. An ancient city on the N coast of the Gargano promontory. It is mentioned by Pliny (3.103) and Ptolemy (3.1.17) among the cities of Daunia. Its position as a maritime city at the entrance to the Adriatic Sea is affirmed by other literary sources (Dionys. Per. 380; Strab. 6.284), but there is no historical mention of the city. Coins with the inscription ΥΡΙΑΤΙΝΩΝ are attributed to Uria. Ruins of a Roman bath found near Carpino on Lago di Varano are believed to have been within the area of the ancient city.

BIBLIOGRAPHY. W. Smith, *Dictionary of Greek and Roman Geography*, I (1856) 1107 (E. H. Bunbury); *CIL*, IX, p. 66; *RE* 9.1 (1961) 1030.

F. G. LO PORTO

URSO or Ursone (Osuna) Sevilla, Spain. Map 19. Town 24 km SW of Ecija. Pliny (3.12) calls it Colonia Genetiva Urbanorum, under the jurisdiction of Astigi (Ecija). The city mint is shown by its coinage, with the name written Urso or Ursone. In Appian 65 it appears as Ὄρσωνα. The coin types, although struck during the Roman period of Baetica, continue Iberian traditions, with the bear on the oldest and the sphinx, resembling that of Castulo (Cazlona) in Jaén, on the later issues, along with the magistrates' names.

Appian (*Hisp.* 16) tells us that in 211 B.C. the brothers Scipio spent the winter between Urso and Castulo, awaiting the outcome of the struggle against the Carthaginians wintering in Turdetania, and Urso was the concentration place for the army of Quintus Fabius Maximus Aemilianus in 145-144 B.C. (App. *Hisp.* 65). In 139 B.C. Audas, Ditalkes, and Minuros or Nikorontes, natives of Urso, are cited as the most faithful companions of Viriatus, who employed them for peace negotiations with the Romans and then, under Scipio's influence, put them to death (Diod. 33.21; App. *Hisp.* 71). Finally, when Urso sided with Pompey, it was forced to fight against Caesar, who conquered it in 45 B.C. (*Bell. Hisp.* 22.1; 26.3; 28.2; 41.2; 42.1). Urso became colonia immunis and appears to have been inscribed in the Galeria or Sergia tribe. Perhaps related to it was a certain Sergius Paulus, who was chosen patron of Urso (*CIL* II, 1406).

Many reliefs survive from buildings constructed after Caesar's conquest, also statues, inscriptions, and coins. The theater, portions of the Roman burial ground, remains of villas, mosaics, and parts of the circuit walls (destroyed in 1932) are also known. In 1870 five bronze sheets, of the original nine, containing part of the Lex Ursonensis or Lex Coloniae Genetivae Juliae were found (now in the National Archaeological Museum in Madrid). Although the law was originally codified in Caesar's time, this definitive text must have been engraved and transmitted to Urso in the Flavian period. Approximately a third of the law has survived. It is of extraordinary interest in that it deals with the interior administration of Urso. The whole text is of interest also for the fuller understanding of Roman law in the Iberian peninsula.

Among archaeological finds was a mosaic (now lost) in which the river Acheloos in the center, labeled in Greek, was surrounded by busts of SIRE(ne), NYMPHE, etc. Roman burials have yielded thin-walled vases, terra

sigillata, unguent jars, glass vessels, coins, and fragments of sculpture. Some of this material is in the archaeological museum at Osuna, much of the rest in private collections. There have also been finds from the Early Christian and Visigoth periods, particularly baked clay bricks from the latter, when the city apparently enjoyed considerable prosperity: in the 4th c. a certain Natalis was bishop of Urso and participated in the Council of Iliberri (Granada).

Other relics from the Roman period, a head possibly of Juno, and a pedestal inscribed with a dedication to the Sacred Tree, are in private collections.

BIBLIOGRAPHY. A. Engel & P. Paris, *Une forteresse iberique à Osuna (Fouilles de 1903)* (1906); A. García y Bellido, "Las colonias romanas de Hispania," *Anuario de Historia del Derecho Español* 29 (1959) 465ff; Laws: A. D'Ors, *Epigrafia juridica de la España romana* (1953) 167ff.　　　　C. FERNANDEZ-CHICARRO.

URSONE, *see* URSO

URVINUM HORTENSE (Collemancio)　Umbria, Italy. Map 16. A municipium of the tribus Stellatina, situated on a hill overlooking the Clitumnus valley from the W. The epithet Hortense is odd, and the relation to Urvinum Metaurense is obscure. It was presumably here, not at Urvinum Metaurense, that Vitellius' lieutenant Fabius Valens was killed (Tac. *Hist.* 3.62). Excavations have uncovered a road, a stylobate of a Republican temple, and part of an Imperial baths (or villa) 300 m N of the modern village.

BIBLIOGRAPHY. *EAA* 7 (1966) 1078 (U. Ciotti).

L. RICHARDSON, JR.

URVINUM METAURENSE (Urbino)　Marche, Italy. Map 16. A municipium inscribed in the tribus Stellatina, situated on a hill between the rivers Metaurus and Pisaurus (Foglia) in what was once Umbria. Its origins are obscure; in 1903-4 at Monte Rossano between Urbino and the Metaurus were found hut foundations of the Early Iron Age. Fortifications around the crown of the hill can be traced with some uncertainty; from these it appears to have been more a fortress than a town. In 1942 remains of a Roman theater came to light near S. Domenico but were reburied.

BIBLIOGRAPHY. F. Mazzini, *Guida di Urbino* (1962)MI; *EAA* 7 (1966) 1074 (G. Annibaldi).

L. RICHARDSON, JR.

USK, *see* BURRIUM

ÜSKÜBÜ, *see* PRUSIAS AD HYPIUM

UTHINA (Oudna)　Tunisia. Map 18. On the route from Tunis to Pont-du-Fahs, 25 km SW of Tunis, an extensive site, rises on the first slopes of Mt. Mekrima, which shuts off the plain of Mornay to the S. Still little explored, the only excavations were undertaken more than half a century ago. A large aristocratic area was excavated N of the town on the flank of the hill; 20 houses were partially or fully uncovered. Numerous pieces of sculpture, figural and architectural, as well as other objects were found, but it is the great number and the quality of the mosaics—67 of them are decorated with figures—which have made the site famous. They are for the most part preserved at the Bardo Museum in Tunis.

The largest and most luxurious of these houses is that of the Laberii, which, aside from the principal building, comprised numerous outbuildings: cisterns, reservoirs, shops, and private baths. Built against the side of the hill, the peristyle of the house was surrounded by rooms and apartments, some reception rooms having their own small colonnaded peristyle. All these rooms, porticos, and the atrium were paved with rich and beautiful mosaics. The one of rural life, and the one of Dionysos making the gift of the vine to Ikarios are preserved at the Bardo. Following a landslide, one of the sides of the house was rebuilt and a new pavement superimposed on the earlier one. Later, when the house was abandoned, a potter's workshop was set up in the private baths; numerous lamps and plates of red clay were found.

The large public baths were partially excavated in 1947; conceived according to an axial and symmetrical plan, the facades embellished with apses and exedras, the edifice consisted of three levels. The excavation of certain vaulted halls has furnished inscriptions and especially 13 pieces of sculpture, which have been transported to the Bardo.

Although of consequence and often identified, many other buildings still remain poorly known in spite of having been excavated; for example, under the acropolis—considered by some as the citadel—are constructed two huge halls in a magnificent style. Seven large symmetrical and parallel cisterns are fed by an aqueduct. There is a theater and, a little outside the town, an amphitheater.

BIBLIOGRAPHY. Gauckler in *MonPiot* 2 (1896) 177-229PI; P. Quoniam in *MélRome* 60 (1948) 35-54I.

A. ENNABLI

UTICA (Utique)　Tunisia. Map 18. An important site established on a former promontory, today overlooking an alluvial plain, Utica is accessible by a short road leaving the village of Zana, 33 km along the route from Tunis to Bizerta. The location of this town was not, as it is today, in the midst of spacious lands but on the shore at the foot of a gulf, which the Medjerda has gradually filled up with its alluvium.

Being at the opening of a rich hinterland as well as a port at the center of the Mediterranean, it was one of the oldest and most celebrated Phoenician settlements. Even when Carthage outstripped it as the metropolis of a vast maritime empire and subsequently as the capital of a great imperial province, Utica remained for a long time second only to it. With the fall of Carthage in 146 B.C., Utica became the capital of the newly created province of Africa, would become the residence of the governor, with a garrison for Roman troops, and the center of a strong group of Roman citizens. Both rich and powerful, these men were called to play a crucial role in certain episodes of the civil war which led to the setting up of the empire. With the triumph of Caesar and the renaissance of Carthage, Utica's role was about to decline under the empire. In 36 B.C. it became a municipium, enrolled in the tribe of Quirina, and a colony under Hadrian. Already eclipsed by the preeminence of Carthage, Utica was faced with the progressive silting up of its port and consequent isolation in the midst of marshy lands. By converting its activity to further cultivation of its agricultural territory, it prolonged its life right up to the end of ancient times.

Utica had been endowed from the 2d c. B.C. with the buildings essential to comfortable urban life: forum, temples, baths, amphitheater, circus, in addition to dwellings. Most of these structures were placed in the grid of an orthogonal plan which covered a large part of the city.

Adequate in the beginning, during the Republican period, many of these buildings were replaced in the Imperial epoch by others larger and more luxurious.

This explains the existence of two theaters for example, the one fitted into the side of the hill, the other built in open country. Enormous cisterns were constructed, fed by an aqueduct. Still extant on the summit of the acropolis overlooking the town, is a quadrangular edifice habitually referred to as "the citadel," which could perhaps be simply a water tower. For various reasons, properly scientific archaeological research came very late, between 1948 and 1958, and is now active again. Such research has contributed a great deal to improving the knowledge of a city of which the history had already survived in literary texts. Monuments brought to light in the course of recent excavation are cited below.

The great baths were established to the W at the foot of the hill on a small eminence in the center of a depression that is often taken for a circular Punic harbor surrounding the admiral's palace. Uncovered in 1949-51 their surface covers more than 26,000 sq. m. The rooms are symmetrically arranged according to an axial plan.

Situated to the NE at the foot of the acropolis is a sector excavated between 1948 and 1958. All this part is enclosed in a city grid. The main axis is a monumental avenue bordered with porticos supported by an imposing colonnade on which shops open from either side.

On the S side of this avenue a residential district was established covering in part a Punic necropolis, which became the object of numerous researches; some discoveries of Punic and Hellenistic objects were made there. One complete insula (86.8 x 39.6 m) divided into 12 lots was uncovered where six houses of unequal size were counted—including The Treasure, The Cascade, The Decorated Capitals, The Hunt. These dwellings, constructed at the end of the 2d c. B.C., were long inhabited and incessantly altered and restored as the town developed and its population increased.

The House of the Cascade, the largest of this small block, was entered through a gate with two folding doors on the decumanus. A U-shaped corridor permitted access to the peristyle, around which the house was built. A large reception hall with triclinium paved in multicolor opus sectile stood between two small rooms provided with basins with fountains; on the offset side was another smaller reception hall; in the other wings were simple chambers opening on the garden, ornamented with a pool with a jet of water.

The House of the Hunt next to it followed the classic plan of houses with a peristyle; it included a large garden surrounded by a portico. During alterations, several rooms were divided into two parts. Some of the floors of these rooms, belonging to different periods of the house, were paved with mosaics. The most important—which gave its name to the house—is that of the hunt.

The House of the Historiated Capitals, adjacent on the E to the House of the Cascade, is oblong in plan, including on only one side a peristyle square on which opened a series of three rooms. This house included a second-story portico with capitals as fine as those of the main floor representing human figures. West of the House of the Cascade, the House of the Treasure, so named because of the finding of a coin hoard, had a complete peristyle with triclinium with a three-part entrance. Not much of it is still extant.

On the other side, N of the great avenue, the lower part of the town, traditionally but falsely called the Isle, shows numerous remains. Owing to the quality of their construction material, they have undergone an intensive exploitation by stone robbers and have been reduced in places to the foundations.

In 1957 a large rectangular plaza was brought to light bordering the portico of the principal street. Its length has not been fully uncovered. It was surrounded by a large portico paved with marble of which there remains only the imprint of the laying on the concrete. A very large quantity of marble chips coming from the work of the quarrymen and the finding of numerous statues suggest that this was the forum—probably of the imperial epoch. The remains of a temple on a podium and of numerous houses, large and rich but despoiled of their decor and their materials, have also been uncovered.

BIBLIOGRAPHY. G. Ville in *RE* 9 (1962) col. 1869; A. Lézine, *Utique* (1970)[PI]; A. Alexander & M. Ennaifer, *Corpus des mosaiques de Tunisie*, I (1973).

 A. ENNABLI

UTIQUE, *see* UTICA

UTRECHT, *see* TRAIECTUM

ÜVEYIK BURNU, *see* LYSINIA

UXAMA ARGELAE Soria, Spain. Map 19. Town of the Arevaci on the Cerro de Castro, near Osma. It is mentioned by Pliny (3.27), Flores (3.22.9), and Ptolemy, among others. The walls, protected by rectangular towers, are N, E, and S of the town, which covers two plateaux with axes of ca. 600 m and an area of 28 ha. The town survived into the Visigoth age and was the seat of a bishopric.

The most important monuments are the Mina (section of a sewer), cisterns, baths, and a probable basilica with mosaics. In the Portugui vineyards part of an extensive Celtiberian cemetery has been excavated, with incineration graves of the 3d-2d c. B.C. The finds, in the Soria Celtiberian Museum and the National Archaeological Museum in Madrid, include sculptures, Roman capitals, iron weapons, miscellaneous metal ware, Celtiberian, Campanian, and terra sigillata pottery, coins, the inscription from the Osma bronze (*CIL* II, 3819), altars, funeral stelai.

BIBLIOGRAPHY. P. Bosch, "Hallazgos de las Necrópolis de Osma y Gormaz," *Anuari del Institut d'Estudis Catalans* 7 (1921-26) 171ff; B. Taracena, *Carta Arqueológica de España. Soria* (1941).

 M. PELLICER CATALÁN

UXELLODUNUM (Saint-Denis-lès-Martel and Vayrac) Lot, France. Map 23. The isolated plateau of Le Puy d'Issolu has been occupied since prehistoric times. It is generally regarded as the site of Uxellodunum, the last Gallic fortress besieged and taken by Caesar in 51 B.C. (but see Capdenac, Lauze, Luzech). At the summit of the plateau at the locality of Les Temples, continuity of occupation is attested by the discovery of Gallic coins, of Gallo-Roman hardened tiles, of a Merovingian gold farthing, and of sarcophagi of the feudal period. On this site a pagan sanctuary must have been the precursor of a Christian shrine.

BIBLIOGRAPHY. A. Viré, *Les oppida du Quercy et le siège d'Uxellodunum (51 av. J.-C.)* (1936) 20-21, 29-79; M. Lorblanchet, "Céramiques des Champs d'Urnes découvertes au Puy d'Issolud," *Ogam* 17 (1965) 9-16; M. Labrousse, "Au dossier d'Uxellodunum," in *Mélanges Jérome Carcopino* (1966) 563-86; cf. M. Labrousse in *Gallia* 15 (1957) 277-78; 17 (1959) 437; 20 (1962) 592-94 & figs. 54-56; 28 (1970) 431; 30 (1972) 502-3.

 M. LABROUSSE

UXELLODUNUM (England), *see* HADRIAN'S WALL

UXENTUM (Ugento) Lecce, Apulia, Italy. Map 14. An ancient city in the territory of the Salentini, situated

8 km from the Ionian coast and 25 km from the Iapygean promontory (Capo di Leuca). The name of this Messapic, and later Roman, center is found in the literary sources in various forms: Ouxenton, whence Uxentum, in Ptolemy (3.1.76); Uzentini in Pliny (3.105) and Livy (22.61.12); Uzintum in the *Peutinger Table* along the road which led from Tarentum to the end of the peninsula. Coins with the Messapic inscription OZAN are from the 1st c. B.C.

The circuit walls ca. 4700 m long are certainly Messapic but perhaps rebuilt in the Roman period. Inside and outside the walls, numerous tombs have been discovered dating from the end of the 7th c. B.C. to the Roman period. One tomb with two successive burials, recently discovered inside the modern town, contained rich bronze furnishings (ca. 510-490 B.C.) which came from the Peloponnesos, nearly contemporary with the bronze statuette of Poseidon in the museum at Taranto. Rich grave gifts of pottery, coins, and Messapic inscriptions of the 4th-2d c. B.C. have come to light at various times. Other tombs with Latin inscriptions belong to Roman Uxentum. In the Palazzo Colosso at Ugento, an interesting collection of materials from the area is preserved.

BIBLIOGRAPHY. W. Smith, *Dictionary of Greek and Roman Geography*, II (1857) 1332 (E. H. Bunbury); K. Miller, *Itineraria Romana* (1916) 362; *RE* 9.2 (1967) 1325-29; O. Parlangeli, *Studi Messapici* (1960) 215; G. Susini, *Fonti per la storia greca e romana del Salento* (1962) 77; N. Degrassi, "Il Poseidon di Ugento," *La Parola del Passato* (1965) 93; F. G. Lo Porto, "Tomba messapica di Ugento," *Atti e memorie della Società Magna Grecia* (1970-71) 99. F. G. LO PORTO

UYUN ES-SARA, *see* CALLIRRHOE

UZDINA, *see* LIMES, GREEK EPEIROS

UZÈS, *see* UCETIA

UZITTA (Henchir Makhreba) Tunisia. Map 18. A city of high antiquity, famous for certain episodes of Caesar's campaign in Africa and for its role in 46 B.C. It has been identified with the site of Henchir Makhreba, situated about 24 meters along the route from Sousse to Mahdia by Jemmal.

The ruins are scattered on a small eminence overlooking the surrounding plain. Until recently, the site, although known and even identified, had not been the object of excavations. A large sector belonging to a residential district was uncovered around 1960. Although surviving to only a small height, the walls reveal the plans of the houses, which constituted fairly regular insulae. There were large villas with a peristyle, some with private baths, next to others more modest in dimensions and appearance. The most luxurious are paved with mosaics whose geometric or pictorial art is remarkable: peacock plumes, a scene of the hunt, fish flowing through a trap. Some mosaics bear inscriptions. So far these excavations are unpublished.

BIBLIOGRAPHY. L. Foucher in *Karthago* 9 (1958) 135-36P. A. ENNABLI

ÜZÜMLÜ, *see* KADYANDA

UZUNCABURÇ, *see* DIOCAESAREA

V

VADU Dobrudja, Romania. Map 12. At the S extremity of the Lake Sinoe the ruins of a walled city, probably founded by the Greek colonists from Histria, in the 6th c. B.C., to judge from ceramic fragments. Nearby, toward the S, lies another rural settlement defended by a vallum and a ditch. On the surface were found a considerable number of architectural and sculptural fragments, and Greek and Latin inscriptions, dating from the Hellenistic and Roman periods. On the W side of the modern village are many tumuli. At Vadu was located the vicus Celeris, mentioned in an inscription discovered here.

BIBLIOGRAPHY. J. Weiss, *Die Dobrudscha im Altertum* (1911) 58-60; R. Vulpe, *Histoire Ancienne de la Dobroudja* (1938) 193, 194, 209, 221.

E. DORUTIU-BOILA

VAGALAT, *see* LIMES, SOUTH ALBANIA

VAGNIACAE (Springhead) Kent, England. Map 24. A settlement on Watling Street, some 32 km SE of London, mentioned in the *Antonine Itinerary*. Excavation on both sides of the Roman line of Watling Street has revealed numerous buildings, of both stone and timber. There appears to have been no appreciable occupation of the site in prehistoric times and it was abandoned entirely at the end of the Roman period.

The planning of the settlement, which appears never to have been defended, was elementary. The constituent buildings were mostly aligned on Watling Street, close to the road margins. At least three streets left the main road on the S side, and two on the N. The buildings, however, make it plain that Springhead was not an ordinary roadside village: no less than seven of the structures in the complex appear to have been temples or cult buildings. The site is thus of unique character in Roman Britain and is one of the few cult centers of the W provinces to have been extensively explored.

At the heart of the cult center lay a walled temenos, entered through a square monumental gateway from which steps led down into the temple precinct. In the entrance court stood a statue base or altar, before which was a votive pit containing two animal burials and a number of coins. Within the temenos lay two large temples of the square Romano-Celtic type, both of them with wings, or antae, on their E sides. One building (Temple I) had a square central cella containing a base for altars, while the other (Temple II) had a number of pier bases arranged on a square plan in the center, suggesting that the central area had been an open court. Temple I also had an unusual and puzzling feature on its W side, a square projecting room, apparently contemporary with the main structure.

The temenos included at least three other stone buildings which had religious functions, though they may not all have been temples. All were small, rectangular structures, two of them without subdivisions. Votive objects were found in all three buildings, and beneath each of the four corners of one ("Temple" IV) lay a foundation burial of a child. Indications of the cults practiced at Springhead are slight. A terracotta figurine of the Gaulish pseudo-Venus type was found in Temple I, and a bronze model of a thumb from the same area hints at a healing cult.

On the other side of Watling Street lay other buildings

which are likely to have been temples, one of which yielded a bone statuette of a genius cucullatus. Yet another temple lies less than 1 km to the S. Domestic buildings appear to have been few and simple in plan.

BIBLIOGRAPHY. *Archaeologia Cantiana* 73 (1959) 1; 74 (1960) 113; 77 (1962) 110; 80 (1965) 107. M. TODD

VAISON-LA-ROMAINE, *see* VASIO VOCONTIORUM

VALCUM Zala, Hungary. Map 12. A Roman settlement 7 km S of the city of Keszthely, between the hamlet of Fenékpuszta and the railroad stop. It lies on the road between ancient Sopianae (Pécs) and Savaria (Szombathely) and was built under Constantius II in the 4th c. The walls can be clearly identified on three sides as well as the round towers 20 m apart. The E wall is defective, partly because of the erosion of the lake shore, partly because of the building of the railroad. The walls are connected at a 90 degree angle, with only a slight deviation; the size of the fortress is 380 by 370 m. The latest excavations established two gates, N and S. Along the W and E walls are 10 towers each, on the N and S walls eight each, plus two gate towers. Also there were four corner towers, larger than the wall towers. Inside the walls 17 buildings were discovered. The simple, two- and three-room dwellings may have been houses or agricultural buildings. The large villa, discovered in the E part of the fortified town, must have been the center of the settlement. Among the buildings the basilica of the 1st and 2d c. is clearly identified. In 1959, next to the W wall, a large horreum came to light; on its E side a 6th c. cemetery with 31 graves.

The Roman cemetery, outside of the S wall, lasted into the 5th c. The cemetery of the leading citizens of the 6th c., inside the town next to the horreum, disclosed unusually rich grave gifts. The cemetery from the middle of the same century lies outside the S wall on its W side, and traces of it extend into the 7th c. The 9th c. cemetery, S of the S wall, was used during the middle and latter part of the century. Population of the town at that period must have been strongly mixed; beside the local elements one can observe Avar remains and a few Carolingian military materials.

There are no satisfactory answers yet as to why the town was destroyed. Research indicates that nearby Fenékpuszta belonged to the fortress line, formed after the Frankish campaigns for the defense of Italy, and was destroyed by Magyar settlers.

BIBLIOGRAPHY. B. Kuzsinszky, "A Balaton környékének archaeologiája," *Archäologie der Plattensee Umgebung* (1920) 45-74; A. Graf, "Übersicht der antiken Geographie von Pannonien," *Diss.Pann.* I, fasc. 5.124, 126, 128; Cs. Sós A., "Das frühmittelalterliche Gräberfeld von Keszthely-Fenékpuszta," *Acta Arch. Hung.* 11 (1961) 247-305; D. Simonyi, "Fenékvár ókori neve," *Antik Tanulmányok* 9 (1962) 13-30; K. Sági, *Magyarország régészeti topográfiája I Veszprém megye régészeti topográfiája, Keszthely-Tapolcai járás* (1966) 81-87; id., "Das Problem der Pannonischen Romanisation, *Spiegel der völkerwanderungszeitlichen Geschichte von Fenékpuszta*; L. Barkóczi, "A 6th century cemetery from Keszthely-Fenékpuszta," *Acta Arch. Hung.* 20 (1968) 275-311.
 L. BARKÓCZI

VALENCE, *see* VALENTIA (France)

VALENCIA, *see* VALENTIA (Spain)

VALENTIA (Valence) Drôme, France. Map 23. A city of the Segovellauni in Gallia Narbonensis, situated on the Rhône at an important crossroads where the N-S road of Agrippa branched off towards Italy by way of the Drôme valley, and secondary roads led towards the Isère valley and the Vivarais region. The Roman colony, which may have been founded by Caesar, is mentioned in Pliny's list of cities that received Roman citizens. At the latest it was founded in Augustus' reign.

Traces of Roman city planning are still to be seen in the grid plan of the old quarter of the modern town; remains of the cardo maximus pavement and the S city gate have been found. The decumanus and cardo probably met near the modern Place de la Visitation. Several Roman burials have been discovered in the Saint-Jacques suburb, indicating that the area of the ancient city was ca. 30 ha. The city had a number of surrounding walls: the first one, dating from the Republican era, was razed and reused in the foundations of the second, which goes back to the Early Empire. The foundations of a tower 7 m in diameter have been unearthed; the walls were 1.6 m thick.

Almost nothing is known of the forum, temples, baths, or houses. However, the outer theater wall has been found near the Place Saint-Jean in the modern Saint-Ursule quarter, and perhaps a trace of an amphitheater. The cathedral apparently stands on the remains of a pagan temple, as does the Chapelle Saint-Martin. A Temple of Kybele and a Mithraeum are known from inscriptions.

Christianity was introduced at the end of the 2d c. by the priest Felix and his deacons Fortunatus and Achilleus, martyred in 212. The first bishop, as evidenced by the texts, was Saint Aemilian (362-374). The only known Christian monument of the period is the baptistery (13 x 17 m), discovered in 1886 and explored in 1952, near the modern cathedral. Designed in the form of a cross around an octagonal pool, it was probably built in the 4th c., of material from Roman baths(?); mosaics were added in the 5th-6th c., and in the 7th-8th c. it was made into a chapel by the addition of an apse (mosaic of Eve). Finally, in the Early Middle Ages it was covered by the Chapelle des Penitents.

The museum has architectural remains, fragments of statues, a Christian sarcophagus and bas-relief, altars, and inscriptions.

BIBLIOGRAPHY. A. Blanc, "Valence romaine," *Cahiers Valentinois* 1 (1953)[PI] (with bibl.). M. LEGLAY

VALENTIA (Valencia) Valencia, Spain. Map 19. A city on the banks of the Turia, ca. 3 km from the sea (Mela 2.92; Plin. *HN* 3.20, referring to it as a colony; Ptol. 2.6.61). It was founded by Junius Brutus in 138 B.C. (Livy, *Per.* 55: Junius Brutus consul in Hispania iis qui sub Viriato militaverant agros et oppidum dedit quod vocatum est Valentia). Based on lines 479-82 of the *Ora Maritima* of Avienus, it has been claimed that the Roman city was built over the indigenous city of Tyris, but there is no archaeological confirmation. Identification with any of the Valencias on the border of Portugal may be rejected since they received the name, with the meaning of fortress, only in the 13th c., and the only Valencia whose stone tablets mention the valentini is that on the Mediterranean.

There are two schools of thought about the first inhabitants: one relates the text of Livy to those of Appian (*Iber.* 72) and Diodorus Siculus (33.1.3) and claims that they were the defeated troops of Viriatus; the other, taking into account that no indigenous names appear on the tablets, that no Iberian money was coined, that indigenous remains are scarce compared to Roman, and that "militare" is inappropriate for Viriatus' men, supports the thesis that they were discharged from the Roman army, and translates "at the time" and not "under the orders" of Viriatus. Some tablets bear the inscrip-

tions "valentini veterani et veteres" and "uterque ordo decurionum," proving that there were two stages of settlement, one with the veteres, the first inhabitants, and the other with the veterani who came later, perhaps with Afranius, which would justify the tablet that the Valencians dedicated to him (*CIL* IX, 5275).

The location of the Roman city and its area is unknown, but the greatest density of finds indicate the vicinity of the Cathedral. Fragments of Roman buildings and tablets are incorporated in the facade of the 17th c. basilica. In general, the Imperial levels are 3 m down, and the Republican on virgin soil, at 4.5 m, with Campanian pottery A and B mixed, as in Ventimiglia and Pollentia. Above 3 m are the Visigoth levels (tablet of Bishop Justinianus, A.D. 546). A necropolis, La Boatella, has been excavated (over 200 tombs with poor furnishings, 3d to 5th c. A.D.), as have other tombs within the city.

There is abundant pottery from Arezzo, S Gaul, Spain, and Campania A and B (more of B). The most interesting mosaic is one of Medusa (2d c.) similar to that of Tarragona. Little is known about sculpture, since a collection formed in the 18th c. disappeared when Napoleon's troops were transporting it to France by ship. About 70 tablets are known (*CIL* II, 3710, 3725-75, 3903, 4948, 5127, 6004-5). Valentia coined money, ca. 123 to 75 B.C., with asses of various weights (19.25-13 gm). On the face was the head of Roma on the right with a winged helmet and the names of the quinquennales, and on the reverse a cornucopia tied with a sheaf of six rays and the name VALENTIA. There are also semisses and quadrantes. Most of the finds are in the Museum of Fine Arts and the Museum of Prehistory in Valencia.

BIBLIOGRAPHY. J. Sanchis Sivera, *Epigrafía romano-valenciana* (1920); D. Fletcher, *La Tyris ibérica y la Valentia romana* (1953); id., *Consideraciones sobre la fundacion de Valencia* (1963); S. Roda, *Aportacion al estudio de la arqueología valenciana* (1955); various authors, in *Dos miel cien años de Valencia* (1962) and *La ciudad romana de Valencia* (1962). D. FLETCHER

VALENTINE Haute-Garonne, France. Map 23. In the district of Arnesp, on the alluvial terrace of the Garonne, a sumptuous villa of the Late Empire is comparable to that at Montmaurin in its monumental plan and its marbles and mosaics. Excavations have begun. The SW portion was successively occupied by a pagan mausoleum, an Early Christian necropolis, a barbarian necropolis, a Carolingian(?) chapel, and the mediaeval church which was the priory of Arnesp.

This villa probably belonged to Nymfius, an important personage of the 4th c., who is known from a metrical inscription (*CIL* XIII, 128) now in the Musée des Augustins at Toulouse.

BIBLIOGRAPHY. H.-P. Eydoux, *Résurrection de la Gaule* (1961) 333-60; G. Fouet, *Rev. de Comminges* 78 (1965) 173-76; cf. M. Labrousse, "Informations," *Gallia* 9 (1951) 133-34; 17 (1959) 430-33P; 22 (1964) 449-50; 24 (1966) 428-29; 26 (1968) 537. M. LABROUSSE

VALESIO, *see* BALETIUM

VALKENBURG S Holland, Netherlands. Map 21. Castellum of cohors III Gallorum on the left bank of the Old Rhine, a few km from its mouth, identified by tabellae ceratae found on the site. The need for a stronghold in this N outpost of the empire was probably linked with Claudius' plan for an invasion of Britain in A.D. 43.

The first fort (132 x 108 m), probably built in A.D. 40, was surrounded by ditches and by earthworks strengthened with wood and topped by a palisade. There were

towers on the long sides, double towers at the rounded corners, and a gate on each side except to the SW. Inside the camp the via principalis, between the NW and SE gates, divided the stronghold into a retentura, backed by the unbreached rampart, and a praetentura, entered by the porta praetoria which led to the river. Left of the via praetoria was a peristyle house for the commander. The function of the complex to the right of the via praetoria is uncertain, but it may have been occupied by a detachment of cavalry. In the central section of the retentura were the headquarters of the cohors and the sanctuary; here also the vexilla were kept. To E and W were eight barracks, each of which held 60 soldiers, while the officers' dwellings lined the via principalis. This force of 500 men constituted a cohors quinaria.

Castellum I was replaced in A.D. 42 by a similar camp (Ia), perhaps because of flooding. The burned layer which covers castellum II (44-45) may indicate a disastrous raid by the Chauci, and III (47-69) may be a rebuilding by Corbulo after his victory over the invaders. Near this fort the Praetorium Agrippinae of the *Peutinger Table* probably stood, contemporary with the castellum of Traiectum. Castellum III was destroyed in 69 in the rebellion of the Batavi and the Canninefates. Cerialis crushed the revolt, and in 70 or shortly thereafter rebuilt the camp (IV); this phase is believed to have lasted through the Flavian period, but identification of the various buildings must remain conjectural.

Castellum V, more solidly constructed, may have contributed to the military efforts of Trajan or may have repulsed renewed attacks by the tribes in the century of the Pax Romana. A tile stamped with the legend SVB DIDIO IVL COS recalls the consul Didius Iulianus, governor of the Provincia Belgica (178) and new attacks by the Chauci (170-74). Castellum VI (122 x 140 m) was built largely of stone; only the barracks were timber. This camp may date from the reign of Septimius Severus at the end of the 2d c., but there is no positive proof. Excavations have revealed no evidence of a violent final destruction. The small military force may have been shifted to other service towards the end of the 3d c.

BIBLIOGRAPHY. A. E. van Giffen, "De Romeinse castella in de dorpsheuvel te Valkenburg aan de Rijn (Z.H.) (Praetorium Agrippinae)," *Jaarverslag van de Vereeniging voor Terpenonderzoek* 33-37 (1948-53); W. Glasbergen, "42 n.C. Het eerste jaartal in de geschiedenis van West Nederland," *Jb. Kon. Ned. Ak. Wetenschappen* (1965-66) 1ff; id., *De Romeinse castella te Valkenburg Z.H. De opgravingen in de dorpsheuvel in 1962* (1972) (former date 42 now corrected to A.D. 40), bibl.; id. & W. Groenman, *The Pre-Flavian Garrisons of Valkenburg Z. H.* (1974); W. A. van Es, *De Romeinen in Nederland* (1972) 66-69; J. E. Bogaers & C. B. Rüger, *Der nidergermanische Limes, Materialien zu seiner Geschichte* (1974) 40-43. F. J. DE WAELE

VALLANGOUJARD, EPIAIS-RHUS Dept. Val d'Oise, France. Map 23. A complex of Gallo-Roman substructures has been under excavation since 1956 in the La Garenne area, one of which may well belong to a sanctuary used in the 3d c., as shown by the coins and pottery found there. Adjoining the building were a series of rooms with hypocausts.

Aerial photographs have revealed a few km away traces of buildings scattered over an area of about 40 ha, at the place known as Les Terres Noires. A number of Gallic and Roman coins were found on the surface as well as a bronze statue of a sleeping Cupid, now in the Louvre. The settlement included at least two fana and some baths, possibly a basilica and a theater. The pottery dates from the 1st and 2d c.

Some archaeologists believe the site to be Riobe, which is mentioned in the *Peutinger Table*; others have located that statio at Maison-Rouge, a village near Châteaubleau, or next to the Mirvaux farm (in the commune of Saint-Just).

BIBLIOGRAPHY. Archives de la direction des Antiquités hist. de la Région parisienne (1960-70).

J.-M. DESBORDES

VALLATUM (Manching) Bavaria, Germany. Map 20. Station of the High Empire mentioned in the *Antonine Itinerary* as on the road along the Danube to the S, and in the *Notitia Dignitatum* as a Late Empire fort. The name almost necessitates its location in or near the ring wall of Manching in the district of Ingolstadt. This wall, segments of which are still preserved, was over 7 km long and enclosed an area of 380 ha. These are the remains of a true murus gallicus, renewed in a second phase in a prehistoric technique.

Excavations have shown that, except for a strip just inside the walls, the entire enclosed area was settled. It was crisscrossed with apparently regular streets, and the buildings, all of wooden construction, show a certain systematic plan, so the settlement may justly be counted as one of the oldest examples of town planning N of the Alps. The inhabitants were Celts, probably Vindelicans, and the oppidum at Manching may have been their capital. The remains of the buildings and the artifacts indicate a considerable population.

Settlement within the wall began and ended in the Iron Age. There are indications that the town was taken and destroyed by the Romans in 15 B.C. The site was unoccupied for a time, and then a Roman village grew up inside the wall, on the E-W road which was still in use. When the defense of the limes collapsed in the mid 3d c. with the invasion of the Alamanni, the fortified settlement received refugees from the surrounding territory, as is shown by a series of finds such as a large hoard of silver vessels. After the station was destroyed, the site again remained unoccupied until a late Roman border fort was erected in the 4th c. According to the *Notitia Dignitatum*, the praefectus of the Legio III Italia was stationed here as commander of this section of the border (pars superior), as was the praefectus of the Ala secunda Valeria singularis, so the fort can hardly have been small. Stones from the wall were used in its construction. When the E gate was excavated, a fibula with onion-shaped bosses was found which dates from the time of Valentinian.

BIBLIOGRAPHY. W. Krämer, "Manching, ein vindelikisches Oppidum an der Donau," *Neue Ausgrabungen in Deutschland* (1958) 175-202; id., "The Oppidum of Manching," *Antiquity* 34 (1960) 191-200; id., *Ausgrabungen in einer keltischen Stadt. Das Bild der Wissenschaft. Neue Funde aus alter Zeit* (1970) 94-103; id. & F. Schubert, "Die Ausgrabungen in Manching 1955-1961," *Die Ausgrabungen in Manching* I (1970) esp. 48-56 on the Roman period. H.-J. KELLNER

VALLE OTTARA near Cittaducale (Rieti) Latium, Italy. Map 16. The site preserves three prehistoric levels separated from each other by sterile layers. They appear to have been culturally independent of each other. Level B has produced some sporadic Roman remains.

BIBLIOGRAPHY. M. Ornella Acanfora, "Gli scavi di Valle Ottara presso Cittaducale," *BPI* 71-72 (1962-63) 73-154.

J. P. SMALL

VALS Ariège, France. Map 23. At Le Roc Taillat are the remains of what may have been a sanctuary, first native, then Gallo-Roman.

BIBLIOGRAPHY. A. Durand, "La période gauloise et le gallo-romain en Ariège," *Actes du XVI° Congrès d'études de la Fédération des Sociétés académiques et savantes Languedoc-Pyrénées-Gascogne (Foix, 28-30 mai 1960)* 28-30, 42-44; id., "L'oppidum de Vals (Ariège)," *Celticum* 3 (1961) 249-67[I]; id., "Le temple gaulois de Vals (Ariège)," *Bull. de la Soc. ariégeoise des Sciences, Lettres et Arts* 20 (1962-63) 65-77; cf. M. Labrousse, "Informations," *Gallia* 13 (1955) 209; 20 (1962) 548[I]; 26 (1968) 515-16. M. LABROUSSE

VANNES, see DARIORITUM

VĂRĂDIA, see ARCIDAVA

VARAŽDINSKE TOPLICE, see AQUAE IASAE

VARDAGATE (Casale Monferrato) Piedmont, Italy. Map 14. About 28 km N-NW of Alessandria and in antiquity a city in the Augustan Regio IX. It was mentioned by Pliny (3.21) and identified with Terruggia on the basis of the discovery of a plaque, today lost, which mentioned the collegium centonariorum vardagatensium. The later unearthing at Casale of a bronze tablet bearing three imperial rescripts meant for an influential citizen of the municipium of Vardagate has reopened the problem of identifying the capital. The weight of new topographical and archaeological evidence, places it unquestionably in this center of Monferrato whose natural avenues of communication (the roads to Turin and to Asti and Vercelli) reshaped the two axis streets that crossed at the base of the plain. The regular configuration of the Roman city, outlined by the present state of the roads, seems to reflect the military character of the urban plan at the very moment of the founding of the city: the period of military and administrative organization of the territory, between 173 and the last ten years of the 2d c. B.C. The necropolis has yielded abundant material, now largely scattered. It extended into the area of the small town, of the Carmelite convent, and along the road to Asti, indicating the city limits very much like the circuit walls whose remains are evident on the N side (Via Rivetta). At the juncture of the cardo and the decumanus, the area of the forum corresponds to the present-day Piazza Mazzini. Occasional finds of the remains of buildings near the Church of Santo Stefano, in Via F. Cane, and in Piazza Coppa, the discovery of amphora depositories in Piazza Rattazzi and in Via Rivetta, and the indication of a fountain of late antiquity in the area of Priocco all pertain to the Roman city.

After the inhabitants scattered, during the period of the first invasions, memory even of the name was lost. The theory of a new barbarian settlement over the ruins of Vardagate seems to have been suggested by the name Sedula which the Atti del martirio di S. Evasio places at Casale. The name recurs in a tablet containing a copy of a precept of King Luitprand which is preserved in the Cathedral Chapter.

BIBLIOGRAPHY. Plin. 3.49; *CIL* v, 841, 4484, 7452; XII, 6906; XIV, 222.

V. de Conti, *Notizie storiche della citta di Casale* (1893); G. Rivetta, *Fatto storico della città di Casale* (1889); F. Gabotto, "Municipi romani dell'Italia occidentale," *Biblioteca Soc. Stor. Bibliografica Subalpina* 33 (1908) 275; V. Arangio Ruiz & A. Vogliano, "Tre rescritti in tema di diritto municipale," *Athenaeum* 20 (1942) 1ff; A. Degrassi, "Mittente e destinatario dei rescritti imperiali riguardanti il municipio di Vardagate," *Athenaeum* 26 (1948) 254ff; U. Erwin, "The early colonisation of the Cisalpine Gaul," *BSR* 20 (1952) 54ff; P. Fraccaro, "Un episodio dell'agitazione agraria dei

Gracchi," (1953); P. A. Coppo, "Dove sorgeva l'antica Vardagate?," *La Provincia di Alessandria* (August 1960) 10ff; S. Finocchi, "Casale Monferrate sede di municipio," *Atti del IV Congresso di antichità e d'arte della Soc. Piemontese di Archeologia e Belle Arti* (in preparation).

<div align="right">S. FINOCCHI</div>

VÁRDOMB, *see* Limes Pannoniae

VARI Attica, Greece. Map 11. Just to the E of Cape Zoster and the S end of Mt. Hymettos is a small plain, in area little more than 3.2 km deep and 1.6 km wide, its limits clearly marked by the sea to the S, Hymettos to the W, and lesser hills to N and E. Until recently the plain's center of habitation was at Vari, a town centrally located at the place where the coastal road from Athens enters the plain on its W edge through a natural break in the long chain of Hymettos. Today a second, rapidly expanding, community has been established at the seashore, with the name of Varkiza.

In Classical antiquity this plain was in all probability the deme of Anagyrous, placed by Strabo in his list of coastal demes after Halai Aixonides (with a sanctuary at Zoster) but before Thorai (9.1.21), and described by Pausanias as having as a notable feature a shrine of the Mother of the Gods (1.31.1). While the position of this last has not been established, no doubt surrounds the location of the deme-center: It was at Vari, where a great variety of remains have been unearthed, many illicitly. Even so, the picture they present is one of a city-state in miniature.

The hill directly W of Vari and S of the road from Athens can be considered the acropolis of Anagyrous. Its peak is fortified by a low rubble wall; within this enclosure at the summit are traces of a building and perhaps an altar. The fort was occupied at least in the 5th c. B.C., and would have made an excellent signaling station. Lower down the hill, on a ridge overlooking the town, is a group of more than 20 closely set buildings of various shapes—circular, rectangular, apsidal—from the archaic period, whence was recovered literally thousands of offerings of terracotta and metal. Some, if not most, of these structures must have been places of popular worship. In another part of the hill, at the same level, is the foundation of a small Classical sanctuary. On the hill's lowest slopes, to the E there are copious remains of walls and building blocks from the living quarters of the Classical settlement, while to the N, alongside the road from Athens, is a large cemetery with well preserved grave-terraces of the 5th and 4th c. B.C.

A second, and more important, cemetery lies a little to the N of Vari, where graves and grave-enclosures from Late Geometric to late archaic times have been either excavated or pillaged. From here comes much of the remarkable collection of early Attic black-figure pottery displayed in the National Museum at Athens. These funerary offerings, as well as some sculptured monuments originally from the same area, make it obvious that in the archaic period Vari must have been home for at least one rich aristocratic family.

A few isolated structures, probably farmhouses, have been noticed elsewhere in the plain. One of these, on the same slope of Hymettos as the Cave of the Nymphs but lower, on a spur above a narrow valley entered from the plain, has been recently excavated. It was a rural villa, of the pastas type, with its rooms built around three sides of a courtyard and screened by porticos. It had a short existence, ca. 330-280 B.C.

BIBLIOGRAPHY. C.W.J. Eliot, *Coastal Demes of Attika* (1962) 35-46^M (with earlier references); S. Papaspyridi-Karouzou, Ἀγγεῖα τοῦ Ἀναγυροῦντος (1963); B. Kallipolitis, Ἀνασκαφὴ τάφων Ἀναγυροῦντος, *ArchDelt* 18 (1963)

A. Μελέται, 115-32^{PI}; 20 (1965) B. Χρονικά, 112-17^{PI}; J. R. McCredie, "Fortified Military Camps in Attica" (*Hesperia*, Suppl. XI [1966]) 28-29^{PI}; J. E. Jones, *The Greeks* (1971) 33-52^{MPI}; id. et al., "An Attic Country House below the Cave of Pan at Vari," *BSA* 68 (1973) 355-452.

<div align="right">C.W.J. ELIOT</div>

VARIBOBI, *see under* Kastrorachi

VARISCOURT Aisne, France. Map 23. Site of a Gallic oppidum in the Laon arrondissement, canton of Neuchatel sur Aisne, at the boundary of the communes of Variscourt and Pignicourt. Situated in the area known as Viel Reims, this oppidum is the largest in ancient Belgica, covering close to 170 ha.

The site has not been thoroughly excavated, but chance finds and salvage operations have revealed two types of occupation: one dating from Iron Age I (marlaceous facies), the other, more important, from Iron Age III. In the actual bed of the Aisne was found a superb bronze helmet, now in the Soissons museum. The site was skirted by two major Roman roads, from Reims to Arras to the W and Reims to Bavay to the E. The city was apparently still occupied in the Roman period, and must have been connected with the river commerce of the Remi; it lies at the head of navigation of the Aisne.

BIBLIOGRAPHY. E. Will, *Gallia* 25, 2 (1967) 189; G. Lobjois, "La nécropole gauloise de Pernant," *Celticum* 18 (1967) 3-6.

<div align="right">P. LEMAN</div>

VARNAVA, *see* Limes, Attica

VAROŠ, *see under* Prilep

VARVARIA (Bribir) Croatia, Yugoslavia. Map 12. A hill fort settlement of the Liburni in N Dalmatia 12 km NW of Scardona (Skradin). It was the center of the Varvarini, one of the 14 Liburnian communities (civitates) administered from their iudicial conventus at Scardona. First tribute exemption and then municipal rank was granted to the settlement, most probably by Augustus. Because the municipium was administered by the four viri, some judge that this grant dates from Caesar's reign. The families of native Liburnian origin kept their privileged positions in the Roman period.

Strong defensive walls from the Preroman period encircle the top of the hill, enclosing an area of 72,000 sq. m. The current excavations have uncovered large stretches of these walls, which were to 2 m thick and 3-4 m high constructed of big stone blocks. Mediaeval building destroyed much of the ancient settlement, but many ancient foundations and cisterns have been excavated. The forum was probably on the site of the present Turkish tower because many fragments of the monumental architecture have been found there. Many inscriptions, coins, and pottery fragments have been found. The settlement was destroyed in the invasions of the Goths and Slavs in the 6th and 7th c.

The finds are preserved in the Archaeological Museum at Zadar and in a small collection on the site.

BIBLIOGRAPHY. M. Suić, *Municipium Varvariae, Diadora* 2 (1960-62) 179-98; M. Suić, "Bribir u antici," *Starohrvatska prosvjeta* 3, 10 (1968) 217-34; G. Forni, "Varvariana," *Adriatica praehistorica et antiqua—Miscellanea Gregorio Novak dicata* (1970) 573-77.

<div align="right">M. ZANINOVIĆ</div>

VARVIL, *see* Bargylia

VASIO VOCONTIORUM (Vaison-la-Romaine) Vaucluse, France. Map 23. On the right bank of the Ouvèze ca. 20 km from the colony of Arausio (Orange), Vaison

was the capital of the civitas of the Vocontii. These people, who occupied a large territory between the Durance and the Isère, were defeated in 124 and 123 B.C. by M. Fulvius Flaccus and C. Sextius Calvinus. They rebelled in 78 B.C. and were harshly treated by the governor, Fonteius (Cic. *Font.*). However, after individual favors accorded by Pompey, they obtained the privileged status of civitas foederata (Strab. 4.6.4; Plin. *HN* 3.37; 7.78) at an unknown date (perhaps under Caesar). The first text which mentions Vaison itself is barely earlier than the middle of the 1st c. A.D.: Pomponius Mela (2.5.75) calls it one of the urbes opulentissimae of Gallia Narbonensis. Strabo does not refer to it, although a poor reading of the text has sometimes suggested that he did. The complete name was presumably Vasio Iulia Vocontiorum.

Vaison was probably the capital of the Vocontii when they were independent. However, no prehistoric settlement has yet been found in the immediate vicinity, and the development of the town must be placed in the Augustan period. The choice of the site is something of a mystery, since Vaison is on the periphery of the territory of the Vocontii, far from the great routes, and the valley of the Ouvèze does not lead to an important outlet. Thus Vaison was supplemented by a religious capital farther N, Lucus Augusti, which during the Late Empire was replaced by Die (Colonia Dea Augusta Vocontiorum). At that time the territory of the Vocontii was split into two civitates, and Die was the larger one; both towns, however, became the seats of bishoprics. A number of well-known men were born in the area of Vaison, including S. Afranius Burrus, Nero's tutor; L. Duvius Avitus, consul and legate of Aquitaine; C. Sappius Flavius, military tribune; and the historian Cn. Pompeius Trogus, whose grandfather, according to Justinus, received Roman citizenship from Pompey.

The excavations of Vaison, conducted for half a century from 1906 onward, indicate that in size (several ha), in variety (public and private buildings), and in the richness of artistic and epigraphic finds, Vaison outstrips other Gallo-Roman sites. Unfortunately, however, it is practically impossible to reconstruct a reliable chronology for the growth of the town, because early excavations were not sufficiently concerned with method and stratigraphy.

The oldest remains have been found recently under the House of the Dolphin, where levels dating to the beginning of Augustus' rule have appeared beneath floors of the Flavian period. Terraces were found, bordered by retaining walls of irregular masonry. On one of them, utilitarian constructions (workshop, basin-reservoir) stood next to a house of Greek type: three sets of rooms arranged around a peristyle, and the fourth side closed by a blind wall. The plan is exactly like that of certain houses at Delos or Glanum (Saint-Rémy-de-Provence), but the construction resembles that of the traditional walls built by the natives of Provence. The only trace of Romanization is the use of a very thin mortar of lime and sand. The differing orientations of the terraces and the irregular masonry of the walls suggests that the first Vaison was more native than Roman; moreover its growth was not controlled as severely as that of other cities of Provence which were Roman colonies. Truly Roman techniques appeared only during the 1st c. A.D., particularly the use of opus vittatum, rubble fill faced with small stones.

These remains of the Augustan period, so far removed from traditional Roman technique and regularity, explain a number of Vaison's singular features. First, no remains of an enclosing wall have been found, probably because the Vocontii were a civitas foederata.

Since it was not a colony, the town was open and had no ramparts. Moreover, since there is no regular checkerboard plan with parallel or perpendicular streets, one cannot recognize a regular cardo on the map: there are distinct differences in orientation between houses and public buildings. An attempt has been made to reconstruct the main axes and an orthogonal plan, based on the arrangement of the main public sewers, but the result is inconclusive. Only at a later date, perhaps at the end of the 1st c. A.D., was city planning attempted, and it could not entirely correct the original irregularity. The forum, for example, has not been found, and cannot be located by studying the plan. At least two sites are possible: along the S extension of the Street of the Shops or directly E of the cathedral. Finally, the Hellenistic plan of the house which preceded the House of the Dolphin may be classed with other arrangements which seem more Greek than Roman: the predominance of peristyles over atria (House of the Silver Bust with no atrium), the absence of an atrium-tablinum-peristyle axis (House of the Messii), the presence of hypostyle rooms (House of the Messii, House of the Silver Bust), and the importance of the vestibule (idem).

Apparently the earliest Roman remains are those of the bridge crossing the Ouvèze. It is a single semicircular arch with a span of 17 m, and is built of large blocks on which ruts have been found. No Gallo-Roman remains have appeared on the left bank of the river; on the right bank are two excavation zones, Puymin to the NE and La Villasse to the SW.

The largest building in the Puymin district is the theater (diam. 95.9 m). Only a few tiers of seats and the foundations of the stage wall have survived, but it has now been completely restored. It was built on bedrock in the 1st c. A.D. and was repaired in the 3d c. Several imperial statues have been found there, including those of Sabina, Tiberius, and Hadrian.

Another public building, S of the theater, is called the Portico of Pompey and is surrounded by a wall 52 m on a side. The gallery, 4 m wide, had columns with Tuscan capitals and niches holding statues, among them the statue of the Diadumena now in the British Museum. In the middle of the courtyard was a large basin.

Buildings E of the portico have been interpreted as tenements. Farther N is a monument called the nympheum (insufficiently studied), and to the NE a small district on two terraces includes a house with 2d c. A.D. mosaic floors and a series of shops opening on a street paved with stone.

The House of the Messii, named for an inscription to Messia Alpina, is W of the Portico of Pompey. Excavation is incomplete but one may note the absence of alae in the atrium (the impluvium is no longer visible), the trapezoidal vestibule, and the hypostyle room decorated with painted stucco, where the head of the Venus of Vaison was found. The house also included private baths and some marble opus-sectile, well preserved. In spite of the complete lack of stratigraphic information, the house must date from the 2d c. A.D.

Finally, two series of buildings occupy the W flank of the Puymin hill. Their plan is not clear, but they probably consist of two houses of somewhat unusual type; one has been called, without foundation, a praetorium.

The second excavation sector extends over the S flank of the Villasse hill, and is crossed by two streets, not parallel, oriented ca. NE-SW. The first, the Street of the Shops, 4.2 m wide, is paved in stone and covers a main sewer 1.1 m deep. On the E side of the street is a series of shops, and then a group composed of a large building and four smaller rooms. The large hall could not be completely cleared: only its width (12.5 m) is

known. The back wall to the N is interrupted by a recess (1.5 x 5.3 m). The recess is framed by two pilasters with fluted and cabled shafts supporting an arch which once framed a statue. The building, which has been restored, has been interpreted as a commercial basilica. The very careful decoration, the floor of opus-sectile, and the architectural and sculptural fragments attest the importance of the monument, which may go back to the 1st c. A.D. The building was surrounded by a drainage ditch. Small narrow rooms bordered it to the W, among them a latrine. In contrast, to the E a spacious room with an apse probably belonged to a large bath, now buried under the modern town.

The W side of the Street of the Shops is bordered by a portico running downward, with a series of levels intended to compensate for the steep slope of the street. The bases of the columns of the portico are set in a wall which helps to support the roadway. Eight shops open on this portico, as does the door to one of the richest houses, the House of the Silver Bust. This house has a triple entrance: two lateral corridors frame a spacious vestibule with a porch in front of it. The vestibule (10.5 x 6.5 m and paved with stone) had three doors separated by two massive piers. This very un-Roman arrangement led to a peristyle of the Tuscan order, in which five altars, several oscilla, and fragments of sculpture have been found. To N and S were private apartments. A second peristyle SW of the first, more spacious but with only three branches, includes a large pool. To the N, approximately along the axis of this peristyle, are found a room with columns, an oecus with a large bay, and other fairly large rooms.

A third peristyle has been accredited to the House of the Silver Bust. It was very large (3.4 m wide and over 130 m around) with 38 Doric columns. It has an irregular plan and a large central pool. North of this portico a staircase led to a court behind which were small baths. It is far from certain that this vast construction was private.

Elements of another house have been partly cleared, S of the portico and nearly 2 m lower. It had an irregular peristyle, mosaic pavements, and frescos, and has been called the House of the Atrium. Another building, farther E, has produced two rooms decorated with mosaics and frescos with figures.

Finally, the House of the Dolphin lies to the W. The original house, of Hellenistic type, was changed in the 1st c. by the addition of a tetrastyle atrium, several rooms to the W, and a series of shops, variously oriented. The floor was raised ca. 0.9 m. The remodeling can be linked to the opening of a street, called the Street of Columns because of the portico which borders it to the W. There is a perfect atrium-tablinum-peristyle axis; the atrium, however, lacks alae. Baths and latrines accentuate its Roman character. To the S a large court, adorned with a basin with niches, opens directly on the street; it could be either a public promenade or a part of the house.

An area as yet little explored extends W on the other side of the Street of Columns. It mixes elements of various periods: structures of the time of Augustus, altered or buried, and basins of later date, one of which was remodeled with a niche in the 4th c. On the N slope of the hill, N of the Château de la Villasse, some modest dwellings have been cleared, including some with irregular masonry.

Outside the two large excavation areas there are the remains of baths ca. 1.5 km to the N, which include a large portico with a mosaic floor. Three other public baths have been found: one under the Place de la Poste, another in the Roussillon district, a third in the La Tour district. Under the floor of the cathedral are large architectural fragments (column drums, double columns, capitals). There are buildings on piles on the right bank of the Ouvèze (wharves?). Finally, tombs, both cremation and inhumation, indicate the approximate boundaries of the settlement.

There is no archaeological evidence for the devastation of the city in the second half of the 3d c., although such an event cannot be ruled out. It did not, however, mark the end of the town. A bishop of Vaison was present at the council of Arles in 314, another at the Riez council in 439. In 442 a regional council was held in the town, and a bishop is recorded about 475.

Epigraphically, Vaison is rich in documents of all kinds, especially Gallo-Greek inscriptions (*IG* XIV, 890; *CIL* XII). Many of the inscriptions and artifacts are scattered in different museums, but a collection is being reassembled in a museum on the site.

BIBLIOGRAPHY. J. Sautel, *Vaison dans l'Antiquité*, 3 vols. (1926)MPI; id., *REA* (1940) 600-70; id., *Vaison dans l'Antiquité, Travaux et recherches de 1927 à 1940*, 3 vols. (1941)MPI; id., *Le théâtre de Vaison et les théâtres romains de la vallée du Rhône* (1951); id., "Remarques sur les vestiges d'un grand edifice romain," *CRAI* (1955) 427-32; id., *Vaison-la-Romaine, site, histoire, monuments* (1955)MPI; R. Ginouvès, "Remarques sur l'architecture domestique à Vaison," *RA* (1949) 58-65; P. Goessler, "Vasio," *RE* 8 A (1955)P; S. Gagnière, "Recherches stratigraphiques dans les fouilles récentes de Vaison," *Journées archéol. d'Avignon 1956* (1957) 126-27; H. Rolland, *Vocontii, RE* 9 A1 (1961)MP; J. Lassus, "Remarques sur les mosaïques de Vaison," *Gallia* (1970) 35-66; Reports in *Gallia* (1960) 279-83; (1962) 680-85; (1964) 563-68; (1967) 378-83; (1970) 443-47; (1972) 540-42.

C. GOUDINEAU

VASSALLAGGI ("Motyon") Sicily. Map 17B. An ancient Sikel-Greek settlement near San Cataldo on a group of five small hills. Excavation has clarified the history of this unknown city which, as some evidence indicates, should perhaps be identified with Motyon, the Akragan fortified site destroyed by the Sicilian leader Ducetius in 451 B.C. and immediately reconquered by the Greeks the following year. Excavation has indicated a phase in the Early Bronze Age. The first Greek vases appear around the second quarter of the 6th c., perhaps after contact with Akragan colonists. During the 5th c. B.C. the village assumed the appearance of a small Greek polis, with houses on terraces, streets on a grid plan, and a sanctuary with a small temple decorated by painted antefixes of Geloan-Akragan type.

Shortly after mid 5th c. destruction, the city recovered with great vigor; houses and sanctuary were rebuilt, and the small temple received a new decoration with molded antefixes. Coins of this period are exclusively Akragan and the graves of men in the necropolis invariably produce the same funerary gifts: one krater and one pelike of Attic red-figure ware, an iron dagger, and a bronze strigil. The city appears to have been repopulated mainly for military reasons since it was located on the Akragan border; this fact could validate its identification as Motyon. Excavation has also shown that the city, like others in the same area, was abandoned at the end of the 5th c. B.C., probably at the time of the Carthaginian invasion, and was rebuilt in the second half of the 4th c. B.C. as part of the general program of Sicilian recolonization promoted by Timoleon. Even this city, however, like the neighboring centers of Gibil Gabib, Sabucina, and Capodarso, was completely destroyed ca. 311-310 B.C., probably by Agathokles, tyrant of Syracuse.

At the end of the 4th c. A.D., it was again inhabited by a small Christian community, as shown by the discovery

of cist and arched tombs containing lamps of African type. Of the excavated areas, only the sanctuary has been left uncovered in the single-level area within the center of the city. It includes a small temple with temenos and altar, and it is surrounded by rectangular structures, some of which contained votive offerings. The archaeological finds (vases, bronzes, statuettes, architectural terracottas) are displayed in the museums of Gela and Agrigento.

BIBLIOGRAPHY. D. Adamesteanu, *RA* 49 (1957) 174; E. De Miro, *Kokalos* 8 (1962) 143; P. Orlandini, *FA* 16 (1964) n. 2247; id., *Cronache di Archeologia e Storia dell'Arte* (1964) 20ff; id., "Vassallaggi I," *NSc* Suppl. (1971).
P. ORLANDINI

VASTE, *see* BASTA

VASTOGIRARDI Isernia, Molise, Italy. Map 14. At an altitude of 1200 m between Pietrabbondante and the valley of the Sangro river, a village where excavations have partially unearthed a temple of the Samnite type. It is comparable to the nearby temples at Pietrabbondante, Schiavi d'Abruzzo, and Quadri. Only the podium remains, 2.25 m high of finely cut limestone. The elevation of the building has been totally destroyed, but the ruins of the foundations permit a conjecture of the plan (a staircase fitted into the podium, a very deep pronaos, a relatively large cella). Some stone blocks scattered near the podium give useful information about the structure. A polygonal wall encloses the podium and marks off a corridor, as at Pietrabbondante. Within the temple a large stone block (the top of an altar?) decorated on all four sides by a Doric frieze with comic and tragic masks has been discovered.

The temple probably dates to the 2d c. B.C. The fill of the podium shows some traces of a prior building, probably of the 2d c. (fragments of cocciopesto and of First Style wall paintings). Nearby remains of other buildings have been uncovered. The excavations have not yet been published.
J.-P. MOREL

VAUX Corrèze, France. Map 23. In the commune of Saint-Julien-Près-Bort. Ruins were discovered in 1965 and excavated in 1966-68. One building was uncovered and three strata revealed.

The lowest stratum, covered with a thick layer of grit, has yielded many potsherds in the Gallo-Roman tradition and shows signs of occupation from the end of Gallic independence to the reign of Nero.

In the middle stratum a villa, now almost completely excavated, has a series of rooms opening on a large courtyard to the SW.

Only the foundations of the third stratum remain. Here the ground level of an estate seems to have been raised and the building enlarged. These changes took place quite late: coins found in the two levels show they were occupied from the reign of Volusianus to that of Crispus. However, pottery found in the same strata points to a 2d c. occupation. The function of this building remains uncertain, and the small size of some of the rooms is as yet unexplained.

BIBLIOGRAPHY. Reports of excavations 1966 & 1968, Groupe Spéléologique et Archéologique du Camping-Club-de-France.
G. LINTZ

VEDÈNE ("Vindalium") Vaucluse, France. Map 23. A commune 9 km NE of Avignon. It has been identified by certain scholars with the ancient Vindalium of Strabo, where the famous battle was fought in 120 B.C. between the Roman legions of consul Cn. Domitius Ahenobarbus and the Gallic army of the Allobroges aided by the Voconces. In 1965, at the place called Confines, Aiguille

quarter, several large blocks of calcareous sandstone, in a row, were uncovered. Hasty probes carried out underwater revealed no archeological deposit but confirmed the existence of the foundations of two parallel walls of considerable height running NE-SW, ca. 1.5 m apart and constructed of stone blocks arranged either lengthwise or as headers. One of the blocks is decorated on one side, above two string moldings and one level molding, with a plant scroll with rosettes and quadrilobate flowers. This is apparently a rampart wall, with some reused materials, perhaps belonging to the monument erected by the Romans to commemorate their victory (according to the Latin historian Annius Florus).

BIBLIOGRAPHY. A. F. d'Urban, *Antiquités et monuments du département de Vaucluse* (1808); J. Courtet, *Dictionnaire des communes du département de Vaucluse* (1876); A. Sagnier, "Vindalium," *Mémoires de l'Académie de Vaucluse* (1891); "Informations," *Gallia* 25, 2 (1967)[1].
A. DUMOULIN

VEII Latium, Italy. Map 16. Etruscan city and Roman market town beside the river Cremera, a W-bank tributary of the Tiber, 16 km NW of the center of Rome. Although there was scattered settlement here in the Bronze Age, the establishment of a large organized community was the work of Villanovan I settlers from the Tarquinia-Vulci area, probably in the 9th c. B.C. The city was the center of a large territory (the Ager Veientanus) which at the time of its maximum extension occupied the whole of the countryside N of the Tiber, from the confines of the Faliscan cities of Capena and Falerii down to the coastal salt marshes and extending N-NW to Lake Bracciano and possibly, in the 5th c. B.C., to Nepet and Sutrium. Relations with Rome were close; but as Rome's power and ambitions grew, a clash was inevitable and in 396 B.C. the city was destroyed and its territories annexed. As the road center of a rich agricultural area the town was soon reoccupied, but it was never again politically important. Its subsequent history was one of steady decline, only briefly arrested by the grant of municipal rank under Augustus (municipium Augustum Veiens). It is last heard of in the 4th c. A.D.

The site of the Etruscan town was defined by the steep-sided and, in many places, precipitous valleys of the Fosso della Valchetta (the river Cremera) on the N and the Fosso Piordo on the S. Only at the NW end was there relatively easy, level access. Here the streams are barely 500 m apart. They then diverge to enclose a rolling promontory of high ground ca. 180 ha in extent, converging again at the SE end below the cliffs of the acropolis, the Piazza d'Armi. Except on the Piazza d'Armi there are no traces of any artificial defenses before the closing years of the 5th c. B.C., when the entire plateau was strengthened with a rampart and a facing wall of tufa blocks.

The Villanovan settlement on the Piazza d'Armi was partially overlaid in the 6th c. by an orthogonal grid of streets, but elsewhere there is no trace of any such orderly plan; the plan of the town was markedly irregular, being determined mainly by the natural configuration of the plateau and of the roads giving access to it. One road ran the full length of the plateau from the NW gate to the Piazza d'Armi, where an artificial terrace carried it down into the valley. This was the axial street, and upon it converged a network of roads serving the Ager Veientanus and linking Veii directly with Rome, Caere, Tarquinia, Vulci, Nepet, Falerii, Capena, and the Tiber valley. Most of these roads met at a point W of the middle of the plateau, which was successively the center of the Etruscan city and the site of the Roman forum.

The inhabited area has been little explored, but from

surface finds it is clear that most of the plateau was occupied in Etruscan times, though in varying density. A few houses have been excavated on the Piazza d'Armi and beside the NW gate (both of which lie over Villanovan settlement) and others near the NE (Capena) gate. The principal known public monuments are the sanctuaries. The situations of two of these are known from massive deposits of votive terracottas, one overlooking the Valchetta near the Piazza d'Armi, the other (the Campetti deposit) near the center of the town, on the N slopes. The foundations of an archaic temple with associated terracottas of the early 6th c. B.C. have been excavated on the Piazza d'Armi. It was a simple rectangular building, possibly with a central column supporting the ridgebeam (columen) of the gabled roof. The well-known Portonaccio sanctuary occupied a terrace outside the walls, opposite the mediaeval village of Isola Farnese. This was probably in origin an open temenos with an altar, to which was added ca. 500 B.C. a temple with three cellas and a columnar pronaos. The magnificent series of architectural terracottas from this sanctuary includes the life-sized group of the Apollo of Veii, very possibly the work of the famous Etruscan coroplast, Vulca. This group, now in the Villa Giulia Museum, was displayed freestanding along the ridgebeam of the temple.

The Etruscan city was ringed around with cemeteries. Four of these go back to Villanovan times: Grotta Gramiccia, outside the NW gate; Valle la Fata, on the S side beside the early pack trail to Rome; and Vacchereccia and Quattro Fontanili opposite the NE gate. To these were added later those of Casale del Fosso and Oliveto Grande (Pozzuola) on the W side of the city, Casalaccio and Monte Campanile on the S, Macchia della Comunità on the E slopes of the plateau, N of Piazza d'Armi, and Monte Michele opposite the NE gate. Among the half dozen large outlying tumuli, princely graves of the later 7th c., was the Chigi tomb on Monte Aguzzo. Painted tombs were rare, a notable exception being the archaic Campana Tomb on Monte Michele.

The city was liberally equipped with cisterns and with underground rock-cut cuniculi both for the supply of water and for drainage. One such channel, the Ponte Sodo, cut out an awkward loop of the Valchetta, preventing flooding; another carried water from the Valchetta to the Fosso Piordo; a third supplied water to the Portonaccio sanctuary. An elaborate system of cuniculi drained the cultivable valleys to the N of the town.

After the construction of the Via Cassia in the 2d c. B.C. Veii lay off the main traffic routes, and there began a steady drift of population away from the city to the villas and farms of the countryside and to the road station of Ad Nonas on the Cassia. The Roman town occupied only a small area immediately adjoining the central crossroads. Inscriptions refer to a temple of Mars, a theater, a bath building, the schola of a collegium, and a Porticus Augusta. None of these has been located, except possibly the last-named, which may have housed the colossal heads of Augustus and Tiberius found in the forum area in the excavation of 1812-17 and now in the Vatican. From the same excavations came the twelve Ionic columns used in 1838 for the porch of the post office building in Rome, in the Piazza Colonna. The Roman cemeteries are small and undistinguished, the most notable features being a rock-cut columbarium outside the NE gate and a pair of stuccoed tombs in the Vignacce valley, S of the forum.

BIBLIOGRAPHY. W. Gell, *The Topography of Rome and its vicinity* (1834) 320-37 (cf. *Memorie dell'Istituto di Corrispondenza Archeologica*, I [1832] 3-29); L. Canina, *Descrizione dell'antica città di Veii* (1847); G. Dennis, *The Cities and Cemeteries of Etruria* (3d ed. 1883) 1-42; E. Stefani, *MonAntLinc* 11 (1944) 225-90 (Piazza d'Armi); id., *NotSc* (1953) 29-112 (Portonaccio sanctuary); J. B. Ward-Perkins, *Veii; the history and topography of the ancient city* (= *BSR* 29 [1961] with full previous bibliography); *NotSc* (1963) 77-236; (1965) 49-236; (1967) 87-286; (1970) 181-329 (interim reports on excavation of Quattro Fontanili cemetery); M. Cristofani & F. Zevi, "La tomba Campana di Veio: il corredo," *ArchCl* 17 (1965) 1-35; A. Kahane et al., *The Ager Veientanus north and east of Veii* (= *BSR* 36, 1968); L. Vagnetti, *Il deposito votivo di Campetti a Veio* (1971).

J. B. WARD-PERKINS

VELATHRI, *see* VOLATERRAE

VELAUX Bouches-du-Rhône, France. Map 23. Situated 16 km W of Aix-en-Provence. The archaeological importance of the area comes from the site known as La Roquepertuse, 1.5 km N-NE. Here a plateau ends in a limestone shelf facing S-N, shaped in plan like a sickle with a very narrow handle and a wide hooked blade. The steepest side rises straight up some 20 m above the stream of the Arc, ca. 300 m away. The opposite side, which faces SW, forms a concave semicircle overhanging the terraced slopes; these were built (or rebuilt) recently, for the most part, to hold the arable soil. However, the highest one was created in antiquity: steps lead up to it, and the rocky cliff, a few meters high, that it backs up against is easily climbed. On the top of the hill a trench cuts the site, leaving a narrow crest leading to a few remains of huts, probably marking the site of a watchtower. Farther down is a little arch hollowed out by erosion that explains why the site is also known as Roche percée. In the last century two stone statues were discovered, both representing a person sitting cross-legged in a Buddha pose. One has a sort of short chasuble on his shoulders decorated with a cruciform design, and a scapular on his breast marked with a radiating cross. The other statue is set on a tablet decorated with acroteria, which suggest that it too once stood on a pedestal. Fragments of a similar statue were unearthed at Rognac in 1909, and since then a number of similar figures have been found at Entremont and Glanum. In 1919 a dig, confined to the first two terraces, completed excavation of those statues already known and located a third. The most unusual find was a polychrome double herm with opposing heads whose powerful design owes nothing to Classical tradition. Also found were some carefully quarried stones that seem to have belonged to a monumental portico (restored in the Musée d'Archéologie at Marseille, in the Parc Borély). Its pillars have egg-shaped cavities inside which some human skulls were still set. A fantastic bird is perched on the lintel, which has an engraved or painted decoration of animals (horses, birds), plants, or geometric motifs (polychrome checks). The cross-legged figures (gods? priests? worshipers?) may possibly have been placed in front of the portico, sheltered by light lean-to roofs. At the foot of the wall of the first terrace are nine tall dolia that served for storage or for keeping a (ritual?) supply of water. Nearby are the skeletons of two (sacrificed?) horses, reminding us that the horse is represented on some symbolic reliefs at Entremont and Mouriès. It was common practice to exhibit decapitated heads in pre-Roman Provence (Entremont, Glanum, Cadenet). Thus all the evidence makes it appear likely that Roquepertuse was a sanctuary which, having no settlement of any size itself, was connected with the oppida nearby (Les Fauconnières, Sainte-Eutropie, Meynes, Roquefavour). When Rome conquered the territory of the Salyes, the site suffered an extremely violent

attack and was systematically destroyed (ca. 121 B.C.). Local pottery abounds: dolia, pink or yellow; potsherds scalloped or decorated with the finger, with twisted or rolled edges; modeled vases of very black, gritty clay. More rare is imported ware, from Protocampanian to Campanian B; there are frequent native imitations. It is possible that the sanctuary replaced a prehistoric place of worship (reuse of a menhir and some stelai cut into pieces); but it certainly developed in Iron Age I and II (which makes it Celto-Ligurian). Still to be determined are: the exact area of the site, the place where the portico was set up, and the age of the anthropomorphic statues.

BIBLIOGRAPHY. H. de Gérin-Ricard, "Le sanctuaire de Roquepertuse," *Société de statistique . . . de Marseille, volume de Centenaire* (1927) 3-53; *Gallia* (1960) 295; (1962) 693; (1969) 446.　　　　　H. MORESTIN

VELDIDENA (Wilten, Innsbruck) Tyrol, Austria. Map 20. In Roman times in the province of Raetia. The derivation of the name is still disputed. The town is mentioned several times in the *Antonine Itinerary* (256; 258; 259; 275; 279; 280) but does not occur elsewhere in the literature. Veldidena was at the junction of the road which went N (to Augusta Vindelicum) from Italy (Verona) via the Brenner and Teriolis, and the road that followed the Inn downstream. The center of the site is supposed to have been in the area of the modern Wilten Convent. The area of finds extends N to the line of the Arlberg railroad, in the E to the Sill river, in the S to the Isel mountain, and in the W not far beyond the Brenner road. Hardly anything is known about the history of the place in Early Imperial times. After the Roman occupation it may have had a certain importance as a way station on a supply road. During the Alemannic wars this importance increased when Septimius Severus is known to have guarded the Brenner road with particular care. A silver hoard of 527 denarii and some ornaments indicate that the place was within an endangered area.

Excavations in 1953-57 unearthed a castellum (72 m square) immediately N of the convent. The enclosure wall is 2.5 m thick. At the corners stood four towers (8.3 m square); in addition there were four intermediate towers (6 m square) jutting out from the wall. The intermediate tower on the W side was constructed as a gate tower. Ramparts and trenches were not found. In the interior, tripartite halls (60 x 15 m) were attached to the N and S wall; they served probably as shelters and warehouses. Between them was a paved courtyard. To judge from the ground plan, the castellum dates from the time of Diocletian and the coins confirm this; they are without exception from the 4th c. A.D. Comparable to it are the castella from Irgenhausen (Canton Zürich, Switzerland) and from Schaan (Liechtenstein). Another tripartite hall of similar size had been built ca. 100 Roman feet S of the castellum. The whole establishment represents a combination of fortifications and horrea. It certainly housed a small garrison and in addition served a double function (like Teriolis only 10 km W of Innsbruck) as a fortification on the second line of defense, and as a supply station fortified in later times.

A necropolis contains both cremation and inhumation graves from the 2d and 3d c. A.D. North of it was the civilian settlement.

When toward the end of the 6th c. A.D. the Bavarians invaded from the N on their way S via the Brenner, Veldidena perished. Clear signs of fire in the castellum testify to the destruction.

The finds from Veldidena are mainly in the Tiroler Landesmuseum in Innsbruck, a small part in the Wilten Convent.

BIBLIOGRAPHY. A. Wotschitzky, "Veldidena," *RE* VIII A 1 (1955) 613ff; id., "Veldidena. Zweiter vorläufiger Bericht über die Ausgrabungen 1954-1957," *JOAIBeibl* 44 (1959) 5ff[PI].　　　　　R. NOLL

VELEIA or Beleia (Iruña) Alava, Spain. Map 19. The *Notitia dignitatum*, the *Antonine Itinerary*, and the Ravenna Cosmographer note this oppidum, 11 km from modern Vitoria. It forms a triangular area enclosed by walls, and had a native Iberian population, for which a Roman one was substituted on the occasion of the Cantabrian wars. The site flourished in the 2d c., from which the chief remains date; it was abandoned towards the 4th c., although its walls survived into the 5th. Finds include specimens of terra sigillata, column shafts and bases, and glass. The most outstanding remains are a torso armed with breastplate, now in the museum of Vitoria, and an unidentified female statue.

BIBLIOGRAPHY. G. Nieto Gallo, *El oppidum de Iruña (Alava)* (1958).　　　　　J. ARCE

VELEIA (Velleia) Emilia, Italy. Map 14. A city between Parma and Genoa, some 30 km S of Piacenza (Placentia). Its location on the Roman road from the Po valley near Placentia to the sea at Luna made it an important center of agricultural trade from the later 2d c. B.C. until its destruction in the 4th c. A.D.—probably by barbarian invaders, to judge from the burned and confused state of the ruins. The name probably comes from the local Ligurian tribe Eleates. The town became a Latin colony in 89 B.C. and in 49 B.C. attained full Roman citizenship as part of the Tribus Galeria. It prospered most from the 1st c. A.D. into the 3d. Fragments of the Lex Rubria found on the site indicate that its administration included duoviri, praefecti iure dicundo, quatuorviri aedilicia potestate, and severi augustales (in charge of celebrations in honor of the imperial family).

Excavations in the 18th c. revealed much of the forum and adjacent structures and some notable statues, with additional finds in various later explorations. It is an attractive site today.

The forum is one of the best preserved in Italy, with its pavement of sandstone (provided by Lucius Lucilius at his own expense) almost wholly intact and its drainage system still complete. It is oriented precisely, its N-S dimension being twice that of the E-W (32.75 x 17.25 m) rather than the Vitruvian norm of 3 to 2. Until the 2d c. A.D. it was a bit smaller than this, as the border construction shows. The adjacent area on the E and S is somewhat higher, owing to the slope there, with private houses on the elevated terracing. At the middle of the N and S ends are bases for equestrian statues: the S one of Claudius, the other seemingly of Vespasian. A third, larger base toward the NE corner is without extant identifying evidence. In the very middle a small base of red Verona stone probably carried a dedicatory inscription to the numen Augusti. Tuscan columns on the E, N, W sides formed a framing portico, the rounded brick pillars spaced at intervals of 6 m. Midway in these colonnades on the E and W sides are matching tables of colored marble, probably for banking use or for official measures.

The whole S end of the forum is closed, on a higher ground level, by the basilica (34.85 x 11.70 m). Its single nave has access at each end from inside the E or W portico, by way of a few steps. A rectangular room flanks the hall at each end, with connecting doorways. At the back wall opposite the forum there stood, on a raised platform, a notable series of marble statues of the Julio-Claudian family. Twelve survive. Among these, Livia, Drusus the Elder, Drusus the Younger, Claudius are identifiable.

At the N end of the forum stood a small temple (9.55 x 7.25 m) with a tetrastyle pronaos. The square building just E of it was probably the curia; that to the W, the Hall of Magistrates. The W side of the forum had a row of offices, including a chalcidicum (here probably used as a cloth market); on the E side were tabernae.

On a raised level to the SW of the forum are the baths: separate accommodations for men and for women. Much of their substructure survives. The amphitheater is SE of the forum area (54.85 x 44.10 m). Little of it remains, though its location and plan are clear.

Numerous imported bronze statuettes have been found in the ruins, many of them quite fine. Some are in the little museum on the site; the rest, along with other art finds at Veleia, are in the Parma museum.

The most notable epigraphic discovery is the Tabula Alimentaria of the time of Trajan (*CIL* XI, 1147), found by accident in the basilica area in 1747. This bronze plaque records the deposit by Trajan of 1,116,000 sesterces to promote agricultural development in Veleia, with the interest from it (at 5 percent) to provide food for 300 poor children of the town. Many details of economic, topographical, and administrative arrangements are also included. Another bronze tablet preserves part of the text of the Lex Rubria de Gallia Cisalpina on judicial administration followed here.

BIBLIOGRAPHY. G. Antolini, *Le Ruine di Velleia Misurate e Disegnate* (1822 and 1831); G. Mariotti, "Gli Scavi di Velleia," *NSc* (1877) 157-192; R. Andreotti, *Velleia* (1934); S. Aurigemma, *Velleia* (1940)[PI]; *EAA* 7 (1966) 1116-17 (G. Mansuelli). R. V. SCHODER

VELESTINOU, see PHERAI

VELIA, see ELEA

VELIANI, see LIMES, GREEK EPEIROS

VELIKI GRADAC, see LIMES OF DJERDAP

VELIKO GRADIŠTE, see LIMES OF DJERDAP

VELILLA DE EBRO, see CELSA

VELILLA DE GUARDO, see FONTES TAMARICI

VELILLA DEL RIO CARRIÓN, see FONTES TAMARICI

VELITRAE (Velletri) Italy. Map 16. A city in the Alban Hills, probably of Volscian rather than Latin origins (cf. Livy 2.30.14), set high on a spur of Monte Artemisio that descends toward the Pontine plain. Livy (ibid.) speaks of Rome's sending a colony there following Velitrae's defeat by the consul P. Virginius in 494 B.C., and there is record of a new draft of colonists in 404 B.C. (Diod. 14.34.7). Velitrae sided with Aricia and Lanuvium in the Latin war, and when conquered in 338, it was punished by the destruction of its fortifications, the deportation of its senate to Rome, the confiscation of the senators' property and its distribution among colonists from Rome (Livy 8.14.5-7). This was the punishment also meted out to Privernum only a little later, and as the record shows, Veliternian sympathies were with the Volscians of Antium and Anxur rather than with the Latins. In the 3d c., as an inscription proves, Volscian was still spoken at Velitrae. After 338 it became a municipium, its people, except for the Roman colonists, having civitas sine suffragio, and so it remained until it received a settlement of veterans under Claudius and became a colonia. Its later history is meager; its greatest fame derives from its having been the home of the family of Augustus' father (Suet. *Aug.* 1).

Though no ancient building is to be seen in the city today, it was a flourishing community from a very early period, as is attested by the remains of a temple with richly figured and colored terracotta revetments of the archaic period. These first came to light in 1784 around the church of SS. Stimmate, and systematic excavations of the area were carried out as far as they could be in 1910. Unfortunately it was not possible to obtain a satisfactory plan of the temple. The fact that many of the relief scenes of the plaques are identical with others from Rome and Veii indicates a centralized manufacture. There are also recorded in inscriptions or old documents a basilica, an amphitheater, a theater, and temples of Apollo and Sangus (Livy 32.1.10).

An abundance of antiquities has been taken from Velitrae and its neighborhood (Tomassetti and Wagener-Ashby give impressive lists of those known to them with their present locations). By and large the marbles seem to have belonged to the villas of rich Romans—then as now Velitrae was a center of wine production (Pliny *HN* 14.65)—but no villa that can with any assurance be assigned to the Octavii is known.

Burials in the neighborhood range from an Early Iron Age necropolis (including a hut-urn burial) to an Early Christian one. In 1956 a richly carved sarcophagus of ca. A.D. 200 came to light. This, with a collection of minor sculptures, inscriptions found in the territory and archaic architectural terracottas, is housed in the municipal museum in the palazzo comunale. The Borgia collection of material from Velitrae is in the Museo Nazionale in Naples.

BIBLIOGRAPHY. R. S. Conway, *The Italic Dialects* (1897), no. 252; A. P. Wagener & T. Ashby, *AJA* 17 (1913) 399-428; G. Tomassetti, *La campagna romana* 2 (1910); G. Mancini, *NSc* (1915) 68-88; T. Ashby, *The Roman Campagna in Classical Times* (1927) 200-201; A. Andrén, *Architectural Terracottas from Etrusco-Italic Temples* (1940) 407-16, pls. 126-29; G. Cressedi, *Velitrae (Velletri) (Italia Romana: Municipi e Colonie*, Series 1, vol. 12, 1953)[MPI]; M. Lawrence, *AJA* 69 (1965) 207-22, pls. 45-54. L. RICHARDSON, JR.

VELITSA, see TITHOREA

VELLEIA, see VELEIA

VELLETRI, see VELITRAE

VELVINA (Helleniko) W Lokris, Greece. Map 9. An ancient acropolis NW of Naupaktos at the summit of a hill (510 m) between the towns of Haghios Georgios and Velvina.

The long, narrow acropolis, oriented N-S, was uncovered in 1924. It is surrounded by a continuous wall without corners or towers, built of massive blocks, roughly fitted into an irregular isodomic masonry, and preserved from the foundations to a height of 1.50 m. The area inside the wall, approached along the even N and S slopes of the hill, forms two levels. On the lower one to the N have been uncovered the more significant remains of the acropolis: a temple, with a stoa to the N of it. The temple, oriented NW-SE, was erected on a three-stepped krepidoma resting on the euthynteria (0.295 m high) which is for the most part visible. The krepidoma (31.45 x 14.37 m) was found virtually intact. It was carefully worked and shows drafting on the vertical joints of the blocks, and also a double block system in the stylobate arranged so that each column rests on every second block, and on the middle of the block rather than on the joint. Owing to these two features and the number of the columns in the peristyle (6 x 13), the

temple is dated to the 4th c. B.C. or a little later. From the superstructure were found only a half column drum and a corner triglyph. A careful examination of the foundations revealed the plan of the temple, which was peristyle and distyle in antis with a pronaos and opisthodomos (3.25 m deep) and with an inner colonnade along the walls of the cella. It was noted that in the foundations poros architectural fragments from an earlier building were used, perhaps from a preexistent temple. Poorly built foundations of unknown purpose were found along the front of the temple. The foundations (38.80 x 11.40 m) of a double stoa were found parallel to the axis of the temple and to the N of it. Here were found bases supporting square pillars. The thinness of the walls and their poor construction are, according to the excavator, evidence of the temporary character of the building, which may have been a workshop.

On the upper level of the hill were found the irregularly constructed foundations (11 x 16 m) of a rectangular building, surrounding another rectangle. Here was also found a cubical stone foundation (altar?) to the N of which was uncovered a third building. All of these are of unknown purpose.

Outside the walls there are remains of buildings and tombs visible on the N side of the acropolis as well as a large circular cistern built of large blocks to the S, which possibly belonged to a habitation situated near there.

The acropolis is actually identified by the most reliable scholars with ancient Molykreion (or Molykreia), a city of Lokris mentioned by numerous ancient writers (Thuc. 2.84.4; Strab. 9.4.8, 10.2.4; Paus. 9.31.6; Polyb. 5.94.7-8; Ptol. 3.15.3; Skylax 38.35; Plut., *Mor. Conv. Sept. Sap.* 162f) in the area of modern Antirrhion. This city, which goes back to the 8th c. B.C., was under Corinthian control until the 5th c., but was taken by the Spartans and Aitolians at the beginning of the Peloponnesian War, and was thereafter under Aitolian government. Three mutilated inscriptions were found, of which one, restored, refers to Athena, but this fact does not prove that she was worshiped in the temple, since there is mention of a Temple of Poseidon to which Hesiod's murderer fled. Absence of inscriptional evidence for the name of the city has led investigators to a number of different theories. Some would place the city Molykreia on the promontory of Antirrhion, and others on the hill where are the remains described above. According to the second hypothesis, the city that is visible above the springs at the shore by Antirrhion would be a harbor of the same name for the inland city, or finally, the name Molykreia (or Molykreion) would refer not only to the city but to the whole area, as would appear in the occasional epithet of Molykreian (sometimes Aitolian) applied to Rhion, in contrast to the Achaian Rhion across the way, as epithets characteristically designate the area rather than a particular city (cf. also Rhion of Messenia).

BIBLIOGRAPHY. A. K. Orlandos, *ArchDelt* 9 (1924-25 [1927]) 55-64; W. Oldfather, *RE* XVI (1933) 35; Fiehn, "Molykria," ibid. 39; L. Lerat, *Les Locriens de l'Ouest* (1952) I-II; Bibl. des Ecoles franç. d'Athènes et de Rome, no. 176PM; Fraser & Lerat, "Les Locriens de l'Ouest," *Gnomon* 26 (1954); F. W. Walbank, *A Historical Commentary on Polybius* (1957) I; E. Kirsten & A. Philippson, *Griech. Landschaften* (1958) II 2 322; G. Klaffenbach, *IG* (1958) IX 3. **M. GAVRILI**

VELZEKE-RUDDERSHOVE Belgium. Map 21. A Gallo-Roman vicus located on the Bavai-Blicquy-Ganda road where it crosses a diverticulum going from Turnacum to Hofstade. Antiquities have been discovered there on several occasions since the 16th c.: bronze statuettes, coins, rings, bronze and iron tools, pottery, vases, glassware, etc. Some tombs and wells were also found. Excavations undertaken since 1953 have uncovered the foundations of a rectangular dwelling and of other buildings. Numerous ditches were also found, dug to obtain clay for the tile-works, and later used as garbage dumps. The beginnings of the vicus go back to the first half of the 1st c. A.D. The pottery indicates occupation until the beginning of the 3d c., but the series of coins is uninterrupted until the end of the 4th c. A hoard of coins, found in the neighboring village of Grotenberge, must have come from this vicus. It was buried in the reign of Postumus and suggests that the vicus must have suffered during the Frankish invasions of that period. Another hoard, found at Velzeke-Ruddershove itself, was buried in the time of Constantine.

BIBLIOGRAPHY. S. J. De Laet & J. Nenquin, "Een gallo-romeinse vicus te Velzeke-Ruddershove," *Kultureel Jaarboek voor de provincie Oostvlaanderen* 7 (1953) 1-57MPI; W. Jamée, "Nieuwe romeinse vondsten te Velzeke-Ruddershove," *Handelingen Geschied- en Oudheidkundige Kring Oudenaarde* 11 (1958) 241-54; M. Bauwens-Lesenne, *Bibliografisch repertorium der oudheidkundige vondsten in Oostvlaanderen* (1962) 217-25; M. Thirion, *Les trésors monétaires gaulois et romains trouvés en Belgique* (1967) 87-88, 165-66.

S. J. DE LAET

VENAFRUM (Venafro) Molise, Italy. Map 17A. A center of the Pentri Samnites in the valley of the Volturno ca. 19 km SW of Isernia. The Roman city was listed among the prefectures by Festus (262 L.), and later became an Augustan colony. It was noted for the products made by its artisans and for the fertility of its soil, particularly for the cultivation of olives, which is still a major activity of the area. On the slopes of Mt. S. Croce the city (ca. 595 x 462 m, with an area of 274,000 sq m) was subdivided into blocks (70 x 75 m) delimited by parallel roads. The network of roads largely survived as mediaeval and modern streets. The theater is toward the upper extremity of the city, built against the slope of the mountain; and the amphitheater is in the lower part of the city. Several stretches of the city walls in opus incertum (to which the inscription *CIL* x, 4876, must refer) remain above the inhabited center.

The outline of an aqueduct from the Volturno has been noted, along with the Augustan edict relative to it. Among numerous constructions in the environs the most important are monumental terraces in polygonal work in the vicinity of the Madonna della Libera.

BIBLIOGRAPHY. *CIL* x, pp. 477ff; S. Aurigemma in *BdA* (1922-23) 58-76; G. Radke in *RE* VIII A (1955) coll. 668-70; A. Pantoni in *RendPontAcc* 33 (1960-61) 153-71; A. La Regina in *Quaderni Ist. Topogr. Ant. Univ. Roma*, I (1964) 55-67; id.; *EAA* Suppl. (1970) 894-95.

A. LA REGINA

VENDEUIL-CAPLY Canton of Breteuil, arrondissement of Clermont, Oise, France. Map 23. The field of ruins at Vendeuil-Caply, long known for surface discoveries, has been explored only since 1956. Aerial photography has indicated the outline of this vanished city, possibly Bratuspantium, which covered almost 130 ha.

The area immediately surrounding the site was occupied long before the Roman period. To the NE a group of Neolithic flint-extraction pits at the site known as Les Plantis at Hardivilliers has been excavated. To the S, several ritual circles from the Bronze Age have been discovered, and one excavated. Finally, the hill of

Calmont, which overhangs the narrow valley of Saint-Denis through which a tributary of the Noye once flowed, has turned out to be the site of a Celtic oppidum of 60 ha, protected by a deep entrenchment on the N and E faces. On the other side of the valley Mt. Catelet was occupied by a Roman army camp of some 10 ha, all of whose structures (titulus, bracchia, vallum) have been identified by aerial photography. A sunken road led to the camp from a spring which furnished the necessary water. This camp is thought to be one of those established in the territory of the Bellovaci on the orders of Caesar after his return from Britain in 57 B.C., and the one from which Crassus set out to rejoin Caesar, who was quartered at Amiens (BGall. 5.46.1-2). This opinion has been strengthened by the excavation of entrenchments similar to those of the Roman camps of Alesia.

The town itself seems to date to the first decades of the 1st c. (Aretine ceramics). Many traces of dwellings have been found on the ground on both sides of the cardo and the decumanus, which intersected at a right angle. These streets are still partly traceable in the country roads crossing the site.

In the NW angle of the cardo and the decumanus a noticeable rise marks the site of a large theater, recently excavated. A peripheral wall 150 m long surrounded the central building, which had a diameter of 83 m; the first two radiating walls have also been found. Numerous remains of carvings with human figures and plant motifs have been recovered from a deep bed of land-fill in the center. The walls are 2 m high, and both the outer wall and that of the cavea have been reconstructed and strengthened. Like Lyon, the town had two theaters. The second, on the N side of Mt. Catelet, was smaller (diam. 73 m), and its construction necessitated considerable terracing. The upper tiers rested on land-fill and the lower ones were cut into the limestone.

There were also two temples and a bath complex. A residential quarter has been excavated and two cellars uncovered. One, with niched walls, has been preserved and can be visited.

This town of the civitas of the Bellovaci was linked to Amiens, Beauvais, and Senlis by a network of Roman roads which are still preserved. The city did not survive the catastrophes of the 3d c., and it was never rebuilt. The artifacts are at the Musée Municipal of Breteuil.

BIBLIOGRAPHY. R. P. Noché & G. Dufour, "Fossés romains d'Alesia et fossés récemment découverts sur les Chatelets près de Breteuil sur Noye," Celticum 6 (1962) 201-14; R. Agache, "Découverte aérienne de retranchements révélés aux abords du site présumé de Bratuspantium," BSPF 109 (1962) 357-66; id., "Les retranchements romains de Folleville et des environs de Breteuil sur Noye," Celticum 15 (1965) 139-45; G. Dufour, "Rencontre avec le site de Vendeuil Caply," Celticum 9 (1963) 229-38; C. Pietri, "Informations," Gallia 29, 2 (1971) 228.　　　　　　　　　　P. LEMAN

VENDEUVRE DU POITOU ("Vindobriga") Vienne, France. Map 23. The township of Vendeuvre, 20 km N-NW of Poitiers, takes its name from a Gallic settlement dating from before the Roman conquest. It overlooked it to the E.

Surrounding the site, today called Tours Mirandes, are remains from the Paleolithic, Neolithic, and Bronze Ages, as well as a prehistoric necropolis. The Gallo-Roman substructures are enclosed in a rectangle of nearly 200 ha, stretching from Vendeuvre to Chéneché. This part of the site was occupied from the 1st to the 5th c. A.D. It was destroyed twice, in the barbarian invasions of 275

and 406, and finally abandoned in the Merovingian period.

The principal monuments are: a very curious religious monument of Celtic origin; an adjoining basilica; a ritual basin; a large forum; a theater in the Greek style designed as a semicircle and stage. A road, probably the decumanus, has also been located, as well as the site of the baths, some insulae belonging to a commercial quarter and a residential section, some more roads, a necropolis, and other large monuments on the outskirts.

The circular temple has a rotunda 33 m in diameter and is ringed with an enormous stylobate wall. Its pronaos opens in the middle of a galleried facade that is bordered to the W by a staircase 86 m long on the same axis, leading to a ritual marble basin. This monument, dated by a deposit found in situ below the foundations, goes back to the end of the 1st c. A.D. It was richly decorated, as evidenced by the finding of some 40 varieties of marble and porphyry from every part of the empire, and ornaments and nails of bronze faced with gold or silver. Fragments of a stele and an ex-voto would seem to show that the building had a religious purpose.

About 15 m from the N side of the temple is an apsed basilica (26 x 13 m) with a somewhat unusual heating system consisting of underground galleries connected to three praefurniae. This monument is of a type rarely encountered in Gaul.

On the line of the temple to the E is an immense forum, slightly larger than the Forum of Trajan in Rome, with a gallery along its E side. Along its axis is a series of square pedestals, one of them 8 m square. It was paved with flat stones.

The site of the baths have been located to the E. In the same direction, 150 m away, is the theater, a huge semicircle with tiers, 120 m in diameter, oriented S-SW on a rectilinear stage. The seating capacity was more than 5000. The inscription dedicating the theater mentions as donor a certain Nepos who was High Priest of Rome and Augustus.

Excavations, aerial photography, an electromagnetic surveys have located an insula in a residential section S of the forum, where a great street lined with houses can be seen clearly. Among the houses is a villa in the Classical style, consisting of 21 rooms arranged around an atrium.

Aside from 140 m of well-preserved Roman walls S of the forum, the buildings were either razed or buried below ground after the barbarian invasions of 276 and 406. They also suffered from Norman pillaging in the 9th c., and especially from mediaeval exploitation of the large blocks of stone.

The site is interesting on several counts. It contains a complete, highly urbanized complex that served as a rural meeting place for the inhabitants of a rich agricultural region near the city of the Turones; the area was on an ancient tin and amber route linking W central Gaul with the mouth of the Loire, and a pre-Roman sanctuary was lavishly enriched from the 1st c. A.D. on, especially under Hadrian and the Antonines. As a political and commercial center, with its civil basilica and great forum, the site attracted the rural people from the surrounding area for meetings, festivals, pilgrimages, and markets throughout the Pax Romana.

All the evidence indicates a peak of prosperity between the beginning of the 2d c. A.D. and the first barbarian invasions—the techniques used in its architecture; the masonry of the walls; the absence of courses of brick; the beauty of the epigraphy, which has no abbreviations; the fragments of sculpture, capitals, and parts of lions modeled in the round and portrayed larger than life size; the

coins, and especially the pottery series. The settlement lasted, with difficulty, until the 4th c. when the coins and late pottery become very rare. And the site, centered on its ancient sanctuary, and especially the temple, apparently suffered systematic ideological destruction at the hands of the Christians from the time of St. Martin of Tours on.

BIBLIOGRAPHY. *Gallia* 23 (1965) 377-80[PI]; 25 (1967) 267-70[I]; 27 (1969) 284-88[PI]; 29 (1971) 276[P]; C. Potut, *Bulletin de la Société des Antiquaires de l'Ouest* (1969); G. C. Picard, *RA* (1970:1) 185ff[P].　　　　C. E. POTUT

VENDOEUVRES EN BRENNE Indre, France. Map 23.

A small village of N Bas Berry 25 km W of Chateauroux, at the N edge of the pond country known as the Brenne and NW of the Forêt de Lancosme. In antiquity it was part of the march between the territory of the Bituriges and that of the Turones and Pictones.

No ruins are clearly visible at Vendoeuvres, whose name is Gallic in origin and comes from Vindobriga, apparently meaning white fort. However, traces discovered there show that it was once a Gallo-Roman center of major importance.

An inscription is preserved in the Chateauroux museum. The text should be compared with a number of inscriptions in the region, in particular some dedications of Néris and that of the theater at Tours Mirandes. It indicates that the city had a forum, several basilicas, some baths, and offices (diribitoria) grouped around a temple and erected by a number of distinguished citizens, former duumviri, and flamines of the Bituriges. Complexes of this type are probably conciliabula, ca. 40 are known, the most remarkable being at Sanxay and Tours Mirandes in the territory of the Pictones, at Champlieu (the Silvanectes), and Genainville (the Veliocasses). There is another belonging to the Bituriges at Derventum.

An altar now in the church at Vendoeuvres is decorated on each of its four sides with a bas-relief framed by pilasters; the upper part of the altar is ornamented with a listel. On the main face of the listel is the dedicatory inscription, at the beginning of which the word num[ini] can be made out followed by the name of the dedicator, Martia. The carved relief beneath it shows the emblems of Apollo: the Delphic tripod, bow, and quiver, as well as an unidentified bell-shaped object and a garland. On the opposite side are two joined hands, the familiar symbol of Pax, Fides, or Concordia, with below them a garland. The right side has a bunch of acanthus at the foot and three figures above it: a goddess, seated and nursing a baby, and a winged figure holding two wands. The fourth side shows two billing doves.

Another relief with a religious subject is preserved at Chateauroux. It shows a crouching god, wearing a sagum; he holds between his legs a large round object, and has two antlers on his head, the tines are held by two putti standing on either side above some large snakes. This is the well-known Celtic god whose main name, Cernunnos, appears on the Nautes pillar in Paris and whose image appears on several documents, some of them dating from before Caesar's conquest. Cernunnos is essentially a chthonic god, a dispenser of riches. His image here is remarkable chiefly for its baroque character, showing the influence of Hellenistic sculpture. The figures accompanying him occupy the place that Apollo and Mercury hold at Reims; they are worshipers (the one on the right is holding a crown which he is about to place on the antlers of the god), but they are also symbols of Cernunnos' manifold power, power which Celtic art proper expresses by giving the god more than one face. The altar and bas-relief may be dated from the end of the 2d c.

BIBLIOGRAPHY. *CIL* XIII, 11151 = Dessau 9361; cf. Néris, *CIL* XIII, 1376-77, and Mirandes, *Gallia* 25, 2 (1967) 270.　　　　G. C. PICARD

VÉNÉJEAN Locality of Lombren, Gard, France. Map 23.

Research carried out from 1960 to 1966 proved that there were two periods of activity at the oppidum of Lombren. Of the first, which goes back to the end of the Early Iron Age, there remains nothing but some pieces of native pottery and Massaliot amphorae. During the second period, which began at the end of the 4th c. and continued into the 5th, these ceramic fragments were mixed with earth and used to level off the floors of dwellings. Almost all the finds belong to this last period of the site's occupation, which is connected with the Visigothic invasions. The inhabitants, some of them of Jewish faith, made their living from very active local crafts and a brisk trade along the Rhône valley. To the S the oppidum was protected by a limestone cliff 18 m high, and on the three other sides, by a well-preserved dry-stone rampart, reinforced by solid towers. Inside, the huts leaned against one another and were set along streets arranged at right angles. The dwellings were built on the bare rock, their dry-stone walls holding up roofs made of tiles and imbrices. Most of the dwellings were limited to a single, rectangular room. Some buildings were used as marts and workshops. The finds from the excavation are kept in the archaeological museum and storage depot at Bagnols-sur-Cèze (Gard).

BIBLIOGRAPHY. J. Charmasson, *Rapports de fouilles* (1961-64); id., "L'oppidum bas-rhodanien de Lombren (Gard), l'habitat paléochretien," *Cahiers Rhodaniens* 9 (1962) 64-102[MPI]; id., "Un oppidum du Bas-Empire, Lombren à Vénéjean (Gard)," *Archéologia* 36 (Sept.-Oct. 1970); "Informations archéologiques," *Gallia* 22 (1964) 506; 24 (1966) 481-82; 27 (1969) 412; M.-C. Valaison, *Rapports de fouilles* (1965-66).

J. CHARMASSON

VENONAE (High Cross) Leicestershire, England. Map 24.

Site at the junction of Watling Street and the Fosse Way, presumably an important strategic center. The name appears in the *Antonine Itinerary*. No military remains are known, however, except a small, as yet undated fort N of the junction, nor is much known of the civil aspects. Much pottery has been found but limited excavation has produced only traces of timber buildings, yards, hearths, and drainage ditches, datable from the end of the 1st to the 4th c. Much of the site has now been destroyed.

BIBLIOGRAPHY. *Trans. Leicestershire Arch. & Hist. Soc.* 40 (1966) 3-41.　　　　G. WEBSTER

VENOSA, see VENUSIA

VENTA BELGARUM (Winchester) Hampshire, England. Map 24.

Situated 20.8 km N of Southampton Water, at a natural focus of communications reflected in the network of Roman roads approaching the city from all directions. The capital of the civitas of the Belgae, by the 2d c. A.D. Venta was the fifth largest city of Roman Britain, with a walled area of 58.2 ha.

The Roman town lay on a sloping site W of the river Itchen. The higher W area was occupied in the 1st c. B.C. by an extensive defended settlement of the pre-Roman Iron Age, which was abandoned perhaps a century before Romano-British occupation began on the lower slopes and on the valley floor. Despite the name Venta Belgarum, there is no evidence that the site was occupied in the immediate pre-Roman period by a Belgic oppidum, and the town seems to have been entirely a Roman creation.

There is no evidence as yet for a military origin of the Roman town, and little trace of Romano-British occupation of any kind before A.D. 55. The earliest structures recorded are timber buildings on the lower slope of the W hill, considerably W of the center of the later walled area; they were burnt down about A.D. 60. Settlement of the valley bottom became much more intense during the Flavian period, but was apparently quite unplanned, and probably not of urban character.

The town was founded at the end of the 1st c. A.D., when the laying out of the streets, the construction of the first defenses, and the building of the forum followed in quick succession. The street plan was a regular grid pattern, with evidence for insulae of 400 Roman feet square. The initial plan may have been confined to the valley bottom and the lower slopes of the hill, but the first defenses enclosed a larger area to the W, although their course to N and S is not yet established. The forum was built in the central insula, on a previously domestic site. Its structure is imperfectly known, but it may have measured ca. 123 by 93 m, with its longer axis E-W.

Urban development along the new streets was rapid; the houses were mostly timber-framed, and remodeled on stone ground-walls in the second half of the 2d c. Sometime after A.D. 150-160, and perhaps as late as the end of the century, the defenses were reconstructed in earth and timber, enclosing an area of over 57 ha. The new defenses followed the earlier line on the W, but to N, E, and S followed a new course which was to remain the line of the city's defenses for more than 1500 years. The early street plan may at this time have been extended W to fill the defended area, although occupation of the W part remained slight. These defenses were again remodeled in the first half of the 3d c. by the addition of a stone wall pierced by perhaps five gates, all presumably, like the excavated S gate, on the site of earlier timber gateways.

Development within the walls continued throughout the 3d c., but at the end there were great changes, perhaps associated with reorganization after Constantius I's suppression of the British revolt. The nature of 4th c. Winchester is uncertain. Occupation seems to have been denser than before, and to have spread for the first time over the whole walled area. There is evidence for suburban development, and the extramural cemeteries to N and E spread far from the walls. The town was perhaps changing from its role as the cantonal capital of the civitas of the Belgae to a more complex function in which an imperial weaving works, known from the *Notitia Dignitatum* to have existed in Britain at a town called Venta, played a major part.

Some houses were now suppressed and part of the forum abandoned, but elsewhere houses continued to be remodeled and were clearly occupied into the 5th c. Soon after the middle of the 4th c. A.D. there is evidence of alien elements in the population which grave goods and burial rites suggest were of S German origin; they may have been laeti, barbarians settled in the Winchester area for defense of the 4th c. civitas. At about this time bastions were added to the town wall. In the first half of the 5th c. there was a second implantation of barbarians, laeti or foederati, but this time from N Germany. These people, whose pottery in Winchester antedates by nearly a century the arrival there of the English, according to the Anglo-Saxon Chronicle, were established within the framework of a still functioning Romano-British community. By the middle of the century the economic basis for this community had disappeared, urban population dwindled and only the barbarian mercenaries remained to become in course of time the foundation from which the Old English captial emerged into a new urban life at the end of the 9th c.

The Winchester City Museums hold the finds and records up to 1960. Those of later excavations by the Winchester Excavations Committee are maintained by the Winchester Research Unit, 13 Parchment Street.

BIBLIOGRAPHY. F. Haverfield, *VCH Hampshire* I (1900) 285-93; C.F.C. Hawkes et al., "Saint Catharine's Hill, Winchester," *Proc. Hampshire Field Club* 11 (1930); M. Biddle, Interim Reports on the excavations of 1961-71 in *ArchJ* 119 (1962) 150-94; *AntJ* 44 (1964) 188-219; 45 (1965) 230-64; 46 (1966) 308-32; 47 (1967) 251-79; 48 (1968) 250-84; 49 (1969) 295-329; 50 (1970) 277-326; 52 (1972) 93-131[MPI]; B. W. Cunliffe, *Winchester Excavations 1949-60* I (1964)[MPI]; *Britannia* 3 (1972) 348-49[P]. M. BIDDLE

VENTA ICENORUM (Caistor St. Edmund) Norfolk, England. Map 24. Capital of the Roman civitas of the Iceni ca. 5 km S of Norwich. This tribe occupied Norfolk and part of NW Suffolk, as is shown by the distribution of their pre-Roman coinage. The position of the capital before the Conquest is unknown: Venta itself was a foundation of the Flavian period. Until 60 the tribe was ruled by Prasutagus who was recognized as a client king by Rome. After his death and the rebellion of his wife Boudicca the period of independence ended and the tribe was formed into a civitas peregrina within the Roman province. Venta was its capital, but very little civic development is apparent before the 2d c., no doubt because of the poverty and backwardness resulting from punishment for the rebellion. It was one of the smallest civitas capitals in the province.

Apart from the wall, rampart, and ditch which enclose only 14 ha, nothing of the town remains on the surface, which has been ploughed for centuries. Attention was first attracted to the site by some vertical air photographs taken in the dry summer of 1928: these showed in brilliant clarity the street grid and some of the buildings. Excavations in 1929-35 explored three town houses, some pottery kilns, two temples, the public baths, and the forum, as well as the defenses. The original air photographs proved that the visible defenses were later than the street system, for streets could be seen truncated by them; it was not until 1959 that further air photography revealed an outer and no doubt earlier line of defenses on the S side, with which the street system conformed. The date of the early defenses has not yet been established; the reduced system has been dated to the 3d c., but the very broad ditch and external towers hint at a later phase of reinforcement probably datable to 369.

The forum was constructed perhaps as late as 150-160; it occupies an insula central to the early town. The building is of modified principia type with a courtyard (30.9 x 29.1 m) surrounded on three sides by rooms and on the fourth by the basilica, which lay at the back of a narrow terrace reached by steps. The basilica (53.1 x 12.75 m) consisted of a nave with a single aisle; a tribunal lay at one end and the curia at the other, and on the narrow axis was a transept, best interpreted as the civic shrine. The forum was damaged by fire but repaired late in the 2d c.; during the 3d c. a second fire destroyed it completely. A new forum of simpler plan was erected perhaps ca. 270-290.

The public baths were only partially excavated: a colonnaded palaestra with disrobing room beside it adjoined a frigidarium (ca. 26.7 x 12 m), beyond which was a tepidarium and laconicum; there were traces of several reconstructions. Immediately N of the forum two Romano-Celtic temples were found to date from the early 3d c., a date also attributed to three nearby houses built of half-timber on stone foundations. These re-

placed earlier houses wholly in half-timber, though one was found to occupy the site of some pottery kilns of the first half of the 2d c. A glass kiln of the early 4th c. was excavated, but the most inexplicable discovery was that of 36 human skulls and bones in the ruins of a small room burnt down at the end of the 4th c. This has suggested a massacre of the inhabitants, possibly in a revolt of foederati for whom there is evidence in a 5th c. cemetery close to the town; but the room in question is too small to hold 36 persons, and photographs show that it lies so close to the surface that doubts must remain about the circumstances of burial.

BIBLIOGRAPHY. S. S. Frere, "The Forum and Baths at Caistor by Norwich," *Britannia* 2 (1971) 1-26; J.N.L. Myres & B. Green, *The Anglo-Saxon Cemeteries at Caistor by Norwich and Markshall* (1973).

S. S. FRERE

VENTA SILURUM Caerwent, Monmouthshire, S Wales. Map 24. The cantonal capital of the civitas Silurum, a tribe with a long record of resistance before final conquest by Julius Frontinus in A.D. 74 (Tac. *Agric.* 17). Today a small village between Newport and Chepstow, the Roman town was about two-thirds excavated, 1899-1912, and subsequent work has thrown light on the chronology. The large collections of material are mainly at Newport Museum, and the National Museum of Wales (Cardiff). In Caerwent church is preserved an important pedestal from a statue dedicated to Ti. Cl. Paulinus, former commander of Legio II Augusta (based at Caerleon, q.v.), shortly before 220 (*RIB* no. 311). This monument, set up ex decreto Ordinis by the "community of the *civitas Silurum*," without mention of the town, is one of the few to refer to local government arrangements in Britain.

The defenses enclose a rectangle, and comprise (as visible today) impressive lengths of wall (3d c.?) up to 5.1 m high: the S wall is the best-preserved section of town wall in Britain, and is notable for the multangular towers added after ca. 335; similar towers have recently been cleared on the N. Since the modern road occupies the same line as its predecessor (Silchester-Carmarthen via Gloucester or Bath), little is left of the E and W double gateways, but single gateways on N and S are visible: they were blocked presumably when the towers were built. Behind the wall is the usual earlier rampart, Hadrianic or later; the ditches appropriate to the rampart and wall periods have largely been silted up. The defenses may have been imposed around a built-up area continuing beyond their line as at Silchester (q.v.). They enclose 20 insulae averaging 84 m square, 10 on either side of the main E-W street, on the N side of which, centrally, stood the forum-basilica (principia type, 1st-2d c.). The basilica (54.6 x 20.1 m) had Corinthian columns 8.1 m high, and on the W of the forum court, 60 m square, a secondary podium may mark the site of a civic temple. Opposite the forum lay the principal baths; another set of baths, a late amphitheater, and two Romano-Celtic temples complete the list of public buildings. One temple stood in a walled temenos next to the forum (visible); the other lay outside the E town wall and was of octagonal plan within a circular enclosure. Religious dedications include one to the Rhenish Mars-Lenus by a collegium of unspecified type. A late structure on the site of the baths has incorrectly been called a church; but Christianity is attested by a sealed deposit of ritual vessels including a pewter bowl with the Chi-Rho monogram.

The excavations revealed about 50 houses (parts of two visible), and the total may be ca. 80-90. They fill the insulae much more densely than at Silchester. In type they range from the usual strip (combined shop, workshop, and living accommodation) gable-end on to the main street, Flavian and later, to elegant courtyard houses fitted with hypocausts, mosaics, and painted walls of good quality (some are 4th c.). In two cases large latrine accommodation suggests identification as an inn, one presumably the mansio of the *Itinerary*. There are fairly extensive traces of a water supply carried in wooden pipes; streams rise in the hills to the NE.

The population of Venta cannot well have been more than 2500. In the 4th c. the town appears to have had a garrison of Germanic mercenaries, to judge from equipment found, and became, with the late fort at Cardiff, a strongpoint in the defense of the Bristol Channel region against sea rovers. Occupation terminated, however, by ca. 440.

BIBLIOGRAPHY. O. Cuntz, ed., *Itineraria Romana* (1929-) 74; O. E. Craster, *Caerwent Roman City* (1951)[MPI]; C. Barnett, *Handbook to the Roman Caerwent Collection* (1954ff)[I]; E. Nash-Williams in *Carnuntina (Röm. Forsch. in Niederösterreich* III) (1956)[MI]; G. C. Boon, "A Christian Monogram . . . ," *Bulletin of the Board of Celtic Studies* 19 (1962)[I].

Excavations: *Archaeologia* 36, 57-64, 80 (1856, 1899-1913, 1930)[MPI]; *Archaeologia Cambrensis* ser. 6, 16, 86, 103 (1916, 1931, 1954)[MPI]; *Bulletin of the Board of Celtic Studies of the University of Wales* 13, 15 (1948, 1953)[MI].

G. C. BOON

VENTIMIGLIA, *see* ALBINTIMILIUM

VENUSIA (Venosa) Lucania, Italy. Map 14. On the borders of Apulia and Samnium, the city was originally Samnite and was colonized by the Romans in 291 B.C. Here the consul Terentius Varro and the survivors of Cannae sought refuge after their defeat by Hannibal (216 B.C.). The area of the excavations includes a bath complex of the Hadrianic period, the amphitheater, the Early Christian baptistery and the Romanesque Basilica of the Holy Trinity in the walls of which are incorporated numerous ancient gravestones with family portraits in the Roman Republican manner.

BIBLIOGRAPHY. N. Jacobone, *Venusia* (1909); D. Adamesteanu in *Letteratura e Arte Figurata nella Magna Grecia, Atti del Sesto Convegno di Studi sulla Magna Grecia* (1967) 260-63.

R. R. HOLLOWAY

"VERBE," *see* YELTEN

VERCELLAE (Vercelli) Piedmont, Italy. Map 14. About 6 km NE of Turin and in antiquity a city in the Augustan Regio IX. It became a Roman municipium after A.D. 49 and was enrolled in the tribus Aniense. It developed on the site of an oppidum of the Libici, whose name it preserved. The city had a regular urban plan within a fortified circuit wall, which presumably was rectangular. A section of the N side of the wall has been identified among the houses on Via Gattinara. At the intersection of the axis streets recognizable in the modern Via Gioberti and Via Ferraris, the forum rose in the area of present-day Piazza Cavour. (Via Gioberti is built over the road from Augusta Taurinorum to Mediolanum, while Via Ferraris joins to the S the direct route for Dertona - Placentia and to the N the road for Eporedia.) Beneath the pavement of Piazza Cavour, imposing structures emerged in the course of excavations in the last century and more recently porticos with tabernae and a bath building. Remains of baths have also been located in Via del Duomo. A shrine with a dedicatory inscription to the Matronae was discovered in Via Verdi and ruins of unidentified buildings in Via Gioberti.

In Via Simone di Colloviano, outside the walls, occasional discoveries have unearthed the structure of an imposing building whose function is uncertain and in Via Monte di Pietà, in the area of the civic theater, a building with an external ambulacrum, probably a cistern, a castellum for the distribution of water according to the structure of the aqueduct whose remains have been found in Corso della Libertà. The aqueduct had lead piping, some of which carried 22 liters per second. Still extra moenia was the theater, mentioned in a document of 1142, the amphitheater, and the cemeteries. The latest burial ground is in the area of Piazza Duomo and the most extensive is on the road to Piacenza and along the road to Milan.

In the Early Empire, the city was the headquarters of a garrison of the Sarmati and the temporary quarters for a contingent of Armenian equites. In the 4th-5th c., it was among the major cities of the region. It became an active center for the spread of Christianity and for its organization in Piemonte. Statues, architectural fragments, amphorae, and sepulchral articles have been brought to light in the city and in its territory and have been preserved in the local Museo Leone.

BIBLIOGRAPHY. Cic. *Fam.* 11.19; Strab. 5.1.12; Sil. *Pun.* 8.597; Plin. 3.21; Tac. *Hist.* 1.70; Ptol. 3.1.36; Amm. Marc. 22.3.4; *Not. Dig.* 121; *Ant. It.* 341, 344, 347, 351; *Tab. Peut.; Rav. Cosm.* 4.30.252.

CIL v, 6652; L. Bruzza, *Iscrizioni vercellesi* (1874) G. C. Faccio et al. *Vecchia Vercelli* (1926); P. Barocelli, "Ritrovamenti di sepolcreti di età romana," *BSPABA* (1926) 87f; V. Viale, "Scoperta di un edificio romano a Bercelli," *BSPABA* (1931) 69ff; G. Faccio, *Le successive cinte fortificate di Vercelli* (1963); V. Viale, *Vercelli e il Vercellese nell'antichità* (1971). S. FINOCCHI

VERCELLI, *see* VERCELLAE

VERCOVICIUM, *see* BORCOVICUS *under* HADRIAN'S WALL

VERECUNDA (Markouna) Algeria. Map 18. Located just NE of Lambaesis, its population consisted primarily of veterans of the Third Augustan Legion. It became a municipium at the end of the 3d c. No bishop from there is known.

The most notable of the monuments found is an arch with one opening (3.62 m wide) to the NE on the road from Lambaesis to Timgad. The arch proper survives, traced by an archivolt and flanked by pilasters with columns in front. Above, part of the attic remains, carrying an inscription dedicated to Marcus Aurelius in A.D. 172. To the SW, on a road coming from Lambaesis, stands another arch dedicated to Marcus Aurelius and Lucius Verus in 162. It is simpler, its single opening flanked by two large pilasters.

The location of the forum is known by the many bases of statues erected in honor of divinities, emperors, and important personages, as well as by six heads of emperors (Lucius Verus, Annius Verus [?], Commodus or Marcus Aurelius, Lucilla, Septimius Severus, and Julia Domna), all now in the Louvre. Tombs have been found SW of the town.

Other sculpture includes: a toga-clad statue, votive stelae, a bas-relief depicting a spirit performing a sacrifice between Neptune and Bacchus, capitals, and a stone marked with the monogram of Constantine. Most of these items are kept at the Lambaesis Museum.

BIBLIOGRAPHY. S. Gsell, *Les monuments antiques de l'Algérie* (1901) I 165-67, 159; *Atlas archéologique de l'Algérie* (1911) 27, no. 240. M. LEGLAY

VERENIKI, *see* LIMES, GREEK EPEIROS

VERETO, *see* VERETUM

VERETUM (Vereto) Apulia, Italy. Map 14. A Messapic city of ancient Calabria in the territory of the Salentini near Serra di Vereto and Madonna di Vereto, not far from the village of Patù, where there are ruins of ancient buildings. It was known to the geographers (Strab. 6.281; Plin. 3.105; Ptol. 3.1.76). It is 6 Roman miles from the Iapygean promontory (Capo di Leuca) and 10 Roman miles from Uxentum. (*Tab. Peut.*)

Tombs and Messapic inscriptions have come to light in the zone. In the *Liber Coloniarum* (p. 283) mention is made of the ager Veretinus. Traces of the Roman municipium are found in the remains of some buildings with mosaics and in occasional funerary plaques.

BIBLIOGRAPHY. W. Smith, *Dictionary of Greek and Roman Geography*, II (1857) (E. H. Bunbury); K. Miller, *Itineraria Romana* (1916) 362; *RE* 8.1 (1955) 1013; O. Parlangeli, *Studi Messapici* (1960) 222; G. Susini, *Fonti per la storia greca e romana del Salento*, 75.

F. G. LO PORTO

VERGHINA ("Balla") Macedonia, Greece. Map 9. In the modern nome of Emathia (capital, Veroia) in the region of ancient Pieria, S of the Haliakmon river. Remains of an ancient city stretch between it and the town of Palatitsa, ca. 2 km to the E. The most notable remains are: (*a*) an extensive prehistoric cemetery, (*b*) remains of the city and acropolis, (*c*) a Macedonian palace, and (*d*) two "Macedonian" tombs. The name of the ancient city to which these remarkable ruins belong is not certainly known. The excavators of the area, however, from the time of the French archaeologist Leon Heuzey (first visit 1855) and K. A. Romaios (who began excavations in 1937) to the present, all scholars consider this to be the city of Balla (Steph. Byz. s.v. Βάλλα, Οὐάλλαι, Ptol. 3.13.40 [Nobbe]; Vallaei, Plin. *HN* 4.34).

The prehistoric necropolis, which extends for ca. one km, contains over 300 graves. About 100 of these have been excavated. Some contain only burials of the Early Iron Age (11th-7th c. B.C.). In other graves of this period there are burials also from the Hellenistic period, while others, finally, belong entirely to the early Hellenistic period. The prehistoric tombs are separated in groups, and since each tomb contained several burials (the richest having up to 50) it is probable that each tomb belonged to a family, and each group to a larger single community. The offerings in the tombs were mainly pottery, metal ornaments, and weapons.

The remains of the acropolis and settlement are known only from surface exploration and from more or less chance finds. The investigator traces with difficulty the remains of the acropolis walls in the thick brush growing over the hill which lies S of and above the cemetery. It appears that the settlement extended between the acropolis and the cemetery, and probably continued from the 11th c. B.C. to the Roman period, as indicated by various chance finds. The post-Byzantine Chapel of Haghia Triadha was in a ruinous state at the time of Huezey's first visit in 1855. It stands on the site of the palace, from whose ruins it is largely constructed, as are Haghios Demetrios of 1570 A.D. and other churches in the neighborhood, and the houses of Palatitsa.

The palace (105 x 89 m) is located in a splendid site between the acropolis and the cemetery, on a small plateau, which is probably in part artificial. Recent excavations to N and W have established that there were additions which enlarged the whole dimension of the complex. The building material is largely poros stone from Mt. Bermion. Mudbrick was used for the upper parts above the orthostates. Marble was used only for

the thresholds. Shining stucco covered the walls, columns, etc. The plan of the palace was basically that of the Hellenistic house with peristyle, but enriched in an unusual way. One entered by the E wing through a Doric stoa with a pediment and then, through a triple porch arrived at a square, central peristyle court (45 m on a side) with 60 Doric columns, 16 to a side. Around the court were arranged stoas and rooms, one of which, a circular tholos for some religious purpose, is worthy of special note, as are rooms in the S wing with pebble mosaic floors. In places there was a second story. The abundance of Doric and Ionic architectural fragments and terracotta elements allows for restoration and, in many places, some reconstruction. The other small finds were oddly few in number, which hinders the understanding of the palace both as a whole and in particular areas. Only quite recently was a single significant inscription found in the area of the circular tholos, a dedication to Herakles Patroos. The palace dates to the time of Antigonos Gonatas' long reign (274-239 B.C.) or a little earlier.

The two tholos tombs of Macedonian type are standard underground tomb buildings. They are largely built of poros stone from Bermion, covered by stucco on which are painted decorations in color. They have a temple-type facade, two vaulted tomb chambers, marble doors and furniture. One of the two has fallen into ruin since excavation. The other, also excavated, has an Ionic temple-type facade and, in addition to the marble door, it has a unique marble throne.

The small finds from the area are mostly to be found in the Museums of Thessalonika and Beroia.

BIBLIOGRAPHY. L. Heuzey & H. Daumet, *Mission archéologique de Macédoine* (1876) 175-238MPI; K. A. Romaios, 'Ο μακεδονικός τάφος τῆς Βεργίνας (1951); M. Andronikos et al., Τό ἀνάκτορον τῆς Βεργίνας (1961); Andronikos, *Vergina: The Prehistoric Necropolis and the Hellenistic Palace* (1964)PI; id., Βεργίνα I: Τό νεκροταφεῖον τῶν τύμβων (1969)MPI; Ph. M. Petsas, 'Ανασκαφή νεκροταφείου Βεργίνης 1961-62, *Deltion* 17 (1961-62) 218-88PI; 18 (1963) Χρονικά 217-32PI; id., "The Multiple Brush . . . ," in *Essays in Memory of Karl Lehmann* (1964) 255-58MI; id., "Verghina," *EAA* VII (1966) 1135I; id., Χρονικά 'Αρχαιολογικά, Μακεδονικά 7 (1967) 324-33PI; 9 (1969) 193-95; N.G.L. Hammond, *A History of Macedonia*, I (1972). PH. M. PETSAS

VERLUCIO Wiltshire, England. Map 24. Identified from its position in the *Antonine Itinerary* (468.4: the very bright town) with Sandy Lane, 8 km NW of Devizes, on the Roman road from Aquae Sulis (Bath) to Cunetio (Mildenhall). Finds of tesserae, pottery, coins, and brooches have been made over a large area, and several villas are known in the vicinity, but the extent of the settlement and the length of its occupation have not been determined.

BIBLIOGRAPHY. *VCH Wiltshire* I, i (1957) 53-54; *Itinerary*: A.L.F. Rivet, *Britannia* 1 (1970) 58; name: K. H. Jackson, ibid. 80. A.L.F. RIVET

VERMAND, *see* SAINT-QUENTIN

VERNEMETUM (Willoughby) Leicestershire, England. Map 24. The *Antonine Itinerary* (Iter VI and Iter VIII) indicates that Vernemetum lay 13 Roman miles N of Ratae Coritanorum (Leicester) on the Fosse Way. Its position has been ascertained by excavation in 1947 and 1964-68, but little is known of the settlement. It seems to have been a humble one with simple buildings and no defenses. The Roman name implies the existence of a temple or other sacred site, but of this there is no recorded trace. M. TODD

VERNEUIL EN HALATTE Oise, France. Map 23. In the Senlis arrondissement, canton of Pont-Sainte-Maxence. The configuration of the land in this area bordering the Oise has been exploited as a defensive position since the Iron Age. The Tremblay promontory (at La Cavée Douché) is nearly 200 m long, 100 m at its widest point and 80 m at the level of the narrow strip linking it to the plateaus. The Romans reinforced the natural defenses of the site by creating a vallum and a trench on the SW and N edges, and building a rampart 2 m wide on the trench side that separated the oppidum from the plateau. After a period during which the site was abandoned, the trench filled in, and the rampart pulled down, building started again in the interior of the site. Toward the NE entrance a building ca. 12 m on each side with an extra room added to it has been found. The occupation stratum covered the whole surface, but the evidence is not conclusive as to the function of this complex of buildings. Was it a group of shops, a signal tower, or a religious complex? Whatever their purpose, the invasions of the Late Empire destroyed all the buildings. Mention should also be made of the oppidum, at the crossroads of the ancient routes linking Senlis with the oppidum of Catenoy and the Oise.

The residential settlement is better known. A large villa has been uncovered in the area known as Bufosse. The S section is completely destroyed, but the plan of the central court has been recovered: the master's house was separated from the court by a long wall, and there are outlying farm buildings. The master's house was heated by hypocaust; water from the bath building in the workers' complex was drained off by a leaden pipe. The finds suggest that the whole complex dates from the middle of the 2d to the end of the 3d c. Other villas of this type have been located near Verneuil. The objects found in the Neolithic and Iron Age II tombs discovered at the foot of the oppidum are now in the Senlis museum.

BIBLIOGRAPHY. P. Durvin, "Apropos de quelques oppida du pays des Bellovaques," *Ogam* 14 (1962) 38-43; id., "Les sépultures du second âge du fer à Verneuil en Halatte," *Celticum* 6, *Actes du IIIème colloque international d'études gauloises, celtiques et protoceltiques* (1962) 103, 111; id., "La villa rustique de Bufosse à Verneuil," *Revue du Nord* 38, no. 152 (1956) 289-306; M. Roblin, "Le plan cadastral de Verneuil en Halatte, toponymie, histoire et archéologie," *Revue Internationale d'Onomastique* 16 (1964) 204. P. LEMAN

VEROLI, *see* VERULAE

VERONA Veneto, Italy. Map 14. On the Adige river 104 km W of Venice, the original settlement, even in earliest times, was a center of the early Veneti. The first contacts with Rome are not well known. The Veneti remained loyal to Rome against Hannibal and were amply rewarded, for the Romans respected the territory of the Veneti from Livenza all'Olio to the borders of Brixia. The oldest Latin inscription from Verona is a miliarium from the Via Postumia dating to 148 B.C. (*CIL* I, 624 = V.8045) and presently preserved in the Museo Maffeiano. The road crossed Regio X, joining Genoa and Aquileia by way of Piacenza, Cremona, Verona, Vicenza, and Oderzo. Originally a defensive road, it later became a powerful commercial artery.

Already at the time of the Via Postumia, the first bridge over the Adige must have been constructed at the site of a very early ferry. It was on that spot that

the Ponte della Pietra would later span the river. Two arches of that bridge remain, with definite traces of later restorations.

Historical and epigraphical sources are silent until the age of Caesar. There has been and still is much discussion regarding the legal status of Verona during this interlude of nearly a century. Although Catullus called Verona a Latin colony (17.1) it seems improbable that it was a true colonia, with the introduction of new inhabitants as colonists, particularly in the period when Aquileia and Lucca (181-179 B.C.) were the last two definite colonies in Italy under Roman law.

From an archaeological point of view, no trace of a center antedates the Roman city. As a result of the social war Latin law was extended to the entire territory between the Alps and the Po, but it was only in 49 B.C. that all the Latin colonies beyond the Po river became municipia. From then on an ever-increasing number of inscriptions and of monumental buildings confirm the development of Roman Verona, cited by Strabo (5.213) and by Martial (14.195.1) as one of the most important cities of Venetia. The gens Gavia, originally from the S central area of Italy, is mentioned in particular as responsible for the famous arch, an aqueduct, and perhaps the first theater.

Tacitus (*Hist.* 3.8.1) mentions that Verona was at the center of the struggles between the Flavian faction and the followers of Vitellius. Gallienus later revitalized the city, incorporating it into a defensive system from Concordia to Milan. His actions are mentioned in the inscription of 265 set on the architrave above the vault of the Porta Borsari (*CIL* v, 3329). The text mentions Verona as the Colonia Augusta Nova Gallieniana, an honor conferred upon it probably by Gallienus himself.

After the reform of Diocletian, which reduced Italy to the status of a province, Verona preserved its importance, becoming a vacation haunt of emperors. The famous laterculum maius, list of the provinces of the late Empire, dating to the first years of the 4th c., comes from here. After the defeat of Brescia, the troops of Maxentius took refuge in Verona. An inscription (*CIL* v, 3331) and one panel of the Arch of Constantine in Rome commemorate the victorious siege of Constantine.

An inscription of Valerius Palladius records the decline of the city. As governor of Venetia et Histria (*CIL* v, 3332) from 379 to 383, he had re-erected a statue (surely of votive type) which had lay for a time in the Capitolium. The importance accorded a pagan relic focuses attention on the struggles between pagans and Christians which characterized the second half of the 4th c. in the provinces as well as at Rome. Christianity had its first Ecclesia in a building recently unearthed near the cathedral. The building shows a plan which had already reached a sophisticated development. At the end of the 4th c. or at the beginning of the 5th, it was probably abandoned in favor of the large basilica which usually bears the name of the first important bishop of Verona, San Zeno. With it ended the series of ancient buildings.

Verona's monuments are particularly well preserved. In addition to the gates and walls there is the theater, along the Adige opposite Colle di San Pietro. It had two upper passageways which offered the spectator a unique view of the stage. The entire complex recalls Augustan art where, as on the arch of the Gabii, traditional Hellenistic elements are mingled with others of clearly Roman taste.

Within the circuit walls of the city in the period of Caesar, the huge amphitheater, usually called the Arena, was built. Numerous restorations, both mediaeval and modern (e.g., the 16th c. reconstruction of the stairways), make it difficult to assign a precise date, despite the recent excavations of the substructures, of the vaulted galleries, of the monumental entrances, and of the series of arcades, and despite the strengthening of the Ala.

Other buildings of which there is definite evidence include the Thermae Juventianae (*CIL* v, 3342), dating to the beginning of the 3d c.; the Capitolium, whose high podium and inner underground reservoir have been discovered; a basilica of perhaps the Flavian era; and an interesting house, also of the Flavian period, discovered some years ago around Valdonega, with mosaic pavements and remains of frescos.

In the Museo del Teatro are notable sculptures of the so-called sophisticated art, among which is a splendid portrait of an emperor of the Julio-Claudian house and a torso in armor. Although the Bevilacqua collection and many other private collections of importance have been sold, Verona still maintains the oldest epigraphic museum in Italy, owing to the efforts in the middle of the 18th c. of the great humanist Scipione Maffei. The Museo Civico of Castelvecchio preserves the Venera coin repository (more than 50,000 pieces) discovered at the end of the last century.

BIBLIOGRAPHY. *CIL* v, 319ff, 942ff; 1074ff; C. Anti, "L'Arco dei Gavi a Verona," *Arch. e Arti decorative,* I (1921-22) 121ff; B. Forlati Tamaro, "Un iscrizione votiva di Sommacampagna," *Epigraphica* 3 (1941) 271ff; id., "Iscrizioni votive di Verona," ibid. 4 (1942) 159ff; id., "La casa romana nel Veneto e una nuova scoperta a Verona," *ArchCl* 10 (1958) 116ff; id., "La romanizzazione dell'Italia settentrionale vista nelle iscrizioni," *Aquileia nostra* 32-33 (1961-62) 109ff; id., "A proposito degli Arusnates," *Atti X riunione scientifica Istitut. ital. Preistoria e Protostoria* (1965) 237ff; id., "Verona" in *Arte e Civiltà romana nell'Italia settentrionale* (1964) 564ff; id., "Il restauro della porta detta dei Leoni," *NSc* Suppl. (1965) 12ff; id., "Scavi e scoperte negli ultimi anni nelle Venezie," *Atti II Congr. Arch. Crist.* (1970) 185ff; id., "Statua loricata scoperta a Verona," *Gli archeologi italicini in onore di A. Maiuri,* ed. Di Mauro, s.d.; A. Zarpellon, "Verona e l'agro veronese in età romana," *Nova Historia* (1954); H. Kähler, "Die römischen Stadtore von Verona," *JdI* 4 (1955) 138ff; L. Beschi, "Verona romana e i monumenti," *Verona e il suo territorio,* I (1960) 368; id., *I bronzetti romani di Montorio Veronese* (1962); F. Sartori, "Verona romana, Storia politica, economica, amministrativa," *Verona e suo territorio,* I (1960) 157ff; P. Gazzola *Ponti romani,* I (1963); L. Franzoni, "L'iscrizione di Valerio Palladio dal Foro di Verona," *Atti e Memorie Accad. Agric. Sc. e Lettere di Verona* (1965-66) 425ff; id., *La Galleria Bevilacqua* (1970); L. Bosio, *Itinerari e strade della Venetia romana* (1970); G. Fogolari, "Ritrovamenti archeologici nell'ultimo decennio," *Atti II Congr. Arch. Crist.* (1970) 35ff; G. Tosi, *La casa romana di Valdonega e il problema degli Oeci collonnati* (1971).

B. FORLATI TAMARO

VERSIGNY Aisne, France. Map 23. In the arrondissement of Laon, canton of La Fère. Excavations since 1966 have revealed an important religious complex in the wood SE of the commune, in the area known as Les Longues Tailles. From the early 19th c. on interest had been aroused by the many Gallo-Roman ruins at the foot of the hill called the Butte du Chateau Julien. A fanum was found with a cella 7 m square, ringed with a 13 m peristyle and with a concrete courtyard in front of it. Seven smallish rooms (3-4 m each side) were uncovered next to the fanum, to the E. One of these is built around

a circle made of broken tiles. These adjoining rooms may be houses or, more likely, altars. An inventory of the many coins found on the site show that it was occupied for a long time, up to the mid 4th c.; this is confirmed by the ordinary ware and sigillata found here. The most spectacular finds are some miniature bronzes (average ht. 3 cm), amazingly well preserved: a ram, a retiarius, a key, fibulas, letters provided with holes for attachment, and some terracottas (Epona).

BIBLIOGRAPHY. M. Peigné-Delacourt, *Supplément aux recherches sur l'emplacement de Noviodunum et de divers autres lieux du Soissonnais* (1859) 88-90; E. Will, "Informations archéologiques," *Gallia* 25, 2 (1967) 190-91; J. Desbordes, *Gallia* 31 (1973) 327. P. LEMAN

VERS-SUR-SELLE Canton of Amiens Sud, arrondissement of Amiens, Somme, France. Map 23. An entrenchment discovered from the air has been excavated: some 15 soundings have been made of the single and double trenches which protected a rectangular area of 700 sq. m. A second trench ran outside the whole S side, attached to part of that side at a hairpin angle. On the E, an inner trench ran behind one shaped like a bayonet. The trenches were either flat-bottomed or V-shaped, and 0.9-1.5 m deep. The artifacts recovered consist primarily of kitchen pottery, both sigillata and plain, probably from the second half of the 1st c. A.D. Soundings in the central area have yielded no results, and it is uncertain whether or not this was a Roman camp; if so, it was erected at a time described by ancient sources as one of relative peace. Possibly, however, it was connected with the troubles which disturbed the N borders of Belgic Gaul at the time of Nero's death. An identical though smaller set of entrenchments has been found in the neighboring commune of Taisnil.

In the 18th c. a fine mosaic showing a woman's head surrounded by birds was discovered in the vicinity of the village. In the 1880s a Merovingian cemetery and numerous Gallo-Roman coins were found.

The artifacts are at the Musée de Picardie at Amiens.

BIBLIOGRAPHY. R. Agache, "Archéologie aérienne de la Somme," *Bulletin de Société de Préhistoire du Nord* 6 (1964) 51^I; F. Vasselle, "Compte rendu des découvertes archéologiques," *Bulletin de la Société des Antiquaires de Picardie* (1966) 1 trim. 164-72. P. LEMAN

VERTAULT, *see* VERTILLUM

VERTERAE (Brough-under-Stainmore) Westmorland, England. Map 24. The fort is partly covered by a mediaeval castle and few excavations have been made. It lies on an important line of military communications between Eburacum (York) and Luguvallium (Carlisle). The first occupation is probably Agricolan. A civil settlement grew up around the fort and part of a 3d-4th c. cremation cemetery has been found E of it. A tombstone, unusual for Britain, built into the wall of the church (since removed), bears an inscription in Greek hexameters commemorating Hermes of Commagene.

The most important finds on the site are lead sealings, thrown onto a rubbish pit outside the fort. These had been removed from official consignments of goods which were repacked at the fort. The sealings are probably 3d c., stamped by the senders.

BIBLIOGRAPHY. I. A. Richmond, "Roman lead sealings from Brough-under-Stainmore," *Trans. Cumberland and Westmorland Arch. Soc.* ser. 2, 36 (1936) 104-25; *RIB* 255-57. D. CHARLESWORTH

VERTILLUM (Vertault) Côte-d'Or, France. Map 23. Located 20 km NW of Châtillon-sur-Seine, the Gallo-

Roman town of Vertillum is situated on a spur of a plateau on the site of a Celtic oppidum of promontory fort type. The Gallo-Roman built-up area covers about 25 ha and has been known since 1651. Excavations were conducted from 1846 to 1853 and from 1882 to 1940.

The spur on which the town stood is enclosed by a wall of murus gallicus type with wooden posts. It merely served to hold back earth and to set the boundaries of the city established after the conquest. The town was oblong in shape and was built according to an irregular plan. Several districts were separated by paved streets whose width varied from 3 to 8 m. The main artery, 350 m long, was orientated NW-SE. The forum was located approximately in the middle of the city. It was bordered to the E by a series of shops, to the N by a portico, and to the S by another portico and a temple. It had an area of more than 1 ha, out of proportion with the size of the town.

The density of the built-up areas is extremely variable. To the W, near the end of the spur, dwellings are spaced out and one finds numerous remains of the workshops of smelters and bronze-workers. Cellars are very well built with carefully pointed walls. They may have been used as winter quarters since the climate in this region is harsh. Heating was particularly well worked out. There are many fireplaces with round hearths as well as hypocausts with small pillars.

The baths occupied more than 600 m sq. and represent the most notable and complete building on the site. However, we have yet to solve the problem of their water supply, which is posed by the baths' location on a spur with no known water sources. Many pits, 3 to 8 m deep, have been excavated, but they were rubbish pits, meant to receive sewage and garbage.

A building located at the very center of the town may be considered a temple. It was a parallelogram in shape. Its S facade was fronted by a colonnade. Several hemicycles or apses were set up at the back of the building.

The systematic exploration of the site has produced a considerable number of various artifacts, statues, inscriptions (the most important of which gives the name of the site), tools, instruments. As far as the pottery is concerned, one should note the relative abundance of products of the Arezzo workshops. This attests to the prosperity of this settlement from the start of the 1st c. A.D. on.

The town underwent two destructions. The first can be dated to about 276, at the time of the great invasion. It was rebuilt and survived until the beginning of the 5th c. The most recent coins collected were of Honorius (395-423). Then the ruined town was completely abandoned and the modern village of Vertault was set up at the foot of the promontory. At present, no ancient remains can be seen on the site, since the excavations were filled in as they proceeded.

The artifacts collected before 1882 are to be found in the Musée Archéologique at Dijon. Those found in later investigations are in the Musée Municipal at Châtillon-sur-Seine.

BIBLIOGRAPHY. Mignard & Coutant, *Fouilles de Landunum près de Vertault* (Côte d'Or), Mém. de la Comm. des Ant. de la Côte d'Or (1856) IV; H. Lorimy, "Vertillum—Vicus Vertillensis," *Pro Nervia* 3 (1927); id., "Inscriptions céramiques gallo-romaines conservées au Musée de Châtillon-sur-Seine," *Bull. Arch.* (1926); R. Joffroy & R. Paris, "Le Verre à Vertillum," *Bull. de la Soc. Arch. du Châtillonnais* 3 (1950-51); Joffroy, "Catalogue des lampes recueilles à Vertillum," *Bull. de la Soc. Arch. du Châtillonnais* 8 (1956). R. JOFFROY

"VERTIS," *see* WORCESTER

VERTUNUM (St.-Mard) Belgium. Map 21. A large Gallo-Roman vicus extending over the Majerou plateau and the hamlet of Vieux-Virton, N of the junction of the Vire and the Ton. The many Gallic coins found on the site indicate that its origins go back to pre-Roman times, but it began to grow from the beginning of the Roman period. A market located in the middle of a rich agricultural region (many villas have been noted in the vicinity), the center may have suffered during the revolt of the Treviri in A.D. 21 as the discovery of two hoards of coins of the Republic, Augustus, and Tiberius seems to indicate. In the 19th and 20th c. there have been many chance discoveries of foundations and masonry wells (one of which was 14 m deep). Systematic excavations (1961-63) have cleared part of the vicus, revealing remains of rectangular houses, divided into two or three rooms, and aligned along both sides of a road linking the vicus to the great Reims-Trier road. The houses were first built of wood, then rebuilt and enlarged in masonry during the 1st c. The walls (60 to 70 cm thick) were built of large, regular sandstone ashlars bound with clay. The floor was most frequently of stamped earth. Most of these houses had a very carefully built cellar, with a stone or wooden staircase. The cellar floors kept the imprint of the amphoras and dolia which had been pushed into them. This part of the vicus was occupied from the 1st to the 3d c.

East of the vicus a necropolis with 3d c. incineration tombs has revealed a series of funerary monuments with reliefs like those of Arlon and Buzenol N of the built-up area. The discovery of a votive plaque to Mars Lenus, fragments of two other votive inscriptions, two column bases with snake-footed giants, and an altar, suggests that there was an important sanctuary at Vertunum. The wealth of the vicus is also attested by the discovery of artifacts made of gold, silver (a plate with a diameter of 30 cm), bronze, etc. During the Frankish invasions of the second half of the 3d c., Vertunum may have played a strategic role under Gallienus, Postumus, Victorinus, Tetricus I and II, and Claudius II. Thousands of coins of these emperors have been found on the Majerou plateau. A large burning level and several hoards of coins buried at the time indicate that the vicus was ravaged during the great invasion of 275-76 but was rebuilt and remained inhabited all during the 4th c. It is not impossible that a castellum was built there.

BIBLIOGRAPHY. C. Dubois, *Le vicus romain de Vertunum* (1938)[MI]; J. Mertens, "Quelques aspects de la romanisation dans l'ouest du Pays Gaumais," *Helinium* 3 (1963) 205-24; id., "Le Luxembourg méridional au Bas-Empire," *Mélanges A. Bertrang* (1964) 191-202; M. Thirion, *Les trésors monétaires gaulois et romains découverts en Belgique* (1967) 144-46. S. J. DE LAET

VERULAE (Veroli) Latium, Italy. Map 16. A city in the foothills S of the Ernici Mountains in the chain of ancient centers that dominated the valleys of the Sacco and the Liri rivers, an important military and commercial access route since the pre-Roman age. When in 307-306 B.C. the Hernici declared war on Rome (Livy 9.42.11), Veroli, like Alatri and Ferentino, did not participate in the revolt. To that time dates the construction of the walls in polygonal work of the second type. A long stretch is preserved near the N side of the upper city. The wall, in which opens a beautiful architraved postern was modified at various times in the Roman period (in *Lib. Colon.* 239L: Verulae oppidum muro ductum). Among the finds are fragments of the

Fasti (called Verulani) which refer to the months January to March. No particularly representative monument has been noted in the interior of the city. The walled center was placed on the slopes of a hill for strategic reasons and several terrace walls in polygonal work are preserved on which urban buildings must have been erected. They are found under the municipal building, in Vicolo Paolini, and in other locations. A passage more than 30 m long has been discovered under the Cathedral and the Piazza Duomo. It has a vaulted covering and walls in coarse opus incertum, and was perhaps a cistern.

BIBLIOGRAPHY. C. Scaccia Scarafoni in *NSc* (1923) 194ff; id., *Una inedita costruzione a volta . . . in Veroli* (1961); G. Radke, "Verulae," *RE* VIIIA, 2 (1935) 1688ff; G. Lugli, "Un'antica costruzione sotto la Piazza del Duomo a Veroli," *Studi Romani* 10 (1962) 1, p. 50ff.

P. SOMMELLA

VERULAMIUM Near St. Albans, Hertfordshire, England. Map 24. A pre-Roman and Romano-British town and chief center of the Catuvellauni, 33 km NW of London on Watling Street. The Roman town now lies beneath open country and has been available for excavation: there is a good museum on the site. The name Verlamio first appears as mint mark on coins of Tasciovanus (ca. 20 B.C.-A.D. 5), and the pre-Roman oppidum is today represented by various earthworks extending well beyond the Roman walls: one of its cemeteries was excavated in 1966-68.

The Roman site was first occupied by a military post ca. A.D. 43-44; civil buildings and a rectangular street-grid were laid out ca. A.D. 50, and were probably from the first surrounded by a bank and ditch enclosing 47.6 ha. The town may well have had the status of a Latin municipium (Tac. *Ann.* 14.33). Excavation in Insula XIV has revealed a row of shops, originally under a single roof and therefore probably under single ownership. The building technique, timber framing filled with clay, was new to British builders and is evidence for the part played by the Roman army in the government's urbanizing program in the new province. Some of the shops were occupied by bronzeworkers. These buildings and others were destroyed in the rebellion of Boudicca in A.D. 60-61. The shops were not rebuilt for 15 years: they rose again under Vespasian, to whom the large new forum was dedicated with an inscription of A.D. 79, mentioning the governor Julius Agricola (cf. Tac. *Agr.* 21). It was a building of unusual plan, more closely resembling the forums of Roman Gaul than the normal principia type of Roman Britain. The Flavian period also saw the construction of a masonry shopping precinct and temple; domestic and commercial buildings were still half-timbered.

Towards the end of the reign of Antoninus Pius Verulamium was again devastated by fire; the remains of the half-timbered buildings roofed in thatch or shingles have yielded frescos now in the museum. The city, however, was full of vigor; it had already expanded beyond its 1st c. defenses, and now the forum was rebuilt, a theater of Gallo-Roman type was provided for the temple ceremonies, and for the first time large courtyard houses of 30 or 40 rooms are found. It is possible that there was a local firm of mosaicists at this date, whose products have also been found in nearby villas and at Colchester. Towards the end of the 2d c. a new defensive bank and ditch with masonry gateways was laid out to enclose 90 ha, but not finished; this may date from the rebellion of Albinus. Though no material traces of Christianity have been found with the exception of a possible cemetery church outside the London gate, it is certain that the martyrdom of St. Alban occurred at

Verulamium, possibly in A.D. 208-209. In the 3d c. a town wall was built, excluding part of the area formerly embanked and enclosing only 80 ha. Earlier theories about the devastating effects of the 3d c. economic crisis have not been confirmed by recent excavations.

In the early 4th c. many 2d c. structures were replaced, and again many mosaics were laid. Substantial houses continued to be built or altered until almost 400, and only with the 5th c. is there any sign of decline. During that century a corn-drying oven was inserted into a large mosaic in Insula XXVII, suggesting insecurity in the surrounding farmlands; but the same site yielded evidence for two further structural phases that leave no doubt that urban life was maintained behind the walls until at least 450. Thereafter evidence ceases, for the upper levels have been mostly ploughed away. In time, with the breakdown of commerce and of the food supply, the city became deserted, but the absence of early Saxon settlements and burials in the neighboring region points to the maintenance of Romano-British rule during the 5th c. Later, with the revival of the shrine of St. Alban on the opposite hill, a new town sprang up on a different site.

BIBLIOGRAPHY. R.E.M. & T. V. Wheeler, *Verulamium, a Belgic and Two Roman Cities* (1936); S. S. Frere, interim reports in *AntJ* 36-42 (1956-62); id., "Verulamium, Three Roman Towns," *Antiquity* 38 (1964) 103-12; id., *Verulamium Excavations 1955-61* I (1972); I. Stead, "Verulamium 1966-8," *Antiquity* 43 (1969) 45-52.

S. S. FRERE

VERVOZ Belgium. Map 21. A vicus of the civitas Tungrorum, on the Tongres-Arlon road. Its prosperity is attested by the presence of bases of several funerary monuments and many artifacts among the grave gifts (lead urns, a bronze candelabrum, a bronze tripod, many pieces of glass including two kanthari, jewelry, and pieces of sculpture including the drum of a column depicting an Attis).

Recent excavations have brought to light the foundations of several buildings on both sides of the ancient road, including perhaps a covered market. The most important discovery is a large bath building. The frigidarium (4.5 x 2 m, with apses 1.6 m deep at two ends) has been excavated, as well as the tepidarium on a suspensura, and several appended rooms. This building was remodeled on at least two occasions. The potter's district is located on the outskirts of the vicus. A dozen kilns have been excavated there which were in use during the 1st c. A hoard of coins buried ca. 254 and another ca. 260 indicate that the vicus must have suffered from the barbarian invasions of the second half of the 3d c. Except for a hoard of coins that was buried during the reign of Arcadius ca. 402, there are no certain remains of occupation of the site during the Late Empire.

BIBLIOGRAPHY. F. Cumont, "Notice sur un Attis funéraire découvert à Vervoz," *Bull. de l'Inst. arch. liégeois* 29 (1900) 65-73; R. De Maeyer, *De Overblijfselen der Romeinsche Villa's in België* (1940) 136-39; A. M. Defize-LeJeune, *Répertoire bibliographique des trouvailles archéologiques de la province de Liège* (1964) 24-26; J. Willems et al., "Les potiers gallo-belges de Vervoz," *Bull. du Cercle arch. Hesbaye-Condroz* 6 (1966) 47-112; M. Thirion, *Les trésors monétaires gaulois et romains trouvés en Belgique* (1967) 61-62; J. Willems & E. Lauwerÿs, "Le vicus belgo-romain de Vervoz," *Helinium* 13 (1973) 155-74MPI.

S. J. DE LAET

VESONTIO or Visontio later BISONTII (Besançon) Doubs, France. Map 23. At the time of the Roman conquest, Vesontio was the maximum oppidum Sequanorum. Caesar (*BGall*. 38.4-6) and especially Julian (*Epist*. 26. Bidez, 38 cd.) emphasized the strength of its position, in a bend of the Doubs and at the foot of a hill which forms a natural citadel on its landward side. After the conquest, only one historical event is known to have taken place there: the fight beneath its walls between the forces of Vindex, who had revolted against Nero, and the loyal forces of Verginius Rufus. The battle ended with the defeat and suicide of Vindex (Cass. Dio 63.24). Otherwise, the city must have shared the history of the Sequani (participation in the revolt of Sacrovir under Tiberius, loyalty during the revolt of Civilis, unrest under Marcus Aurelius). The period from the Flavians to the Antonines was its heyday, and after the Tetrarchy it was still the capital of the Provincia Maxima Sequanorum, but by 360 (cf. Julian) it was in decline.

Our knowledge of the topography of the Roman city comes from chance discoveries. The road from Italy crossed the citadel, on which during the Middle Ages four unidentified columns were still visible. It entered the lower city through the "Black Gate," a commemorative arch built perhaps under Marcus Aurelius and still standing, which is notable for its double rows of columns and for the variety and profusion of its sculptured decoration. From that point on the road formed the principal cardo of the city. On its right, it passed the distribution basin for the water brought from the springs at Arcier by an aqueduct 10 km long, then a square surrounded by porticos with alternating round and rectangular exedrae, which probably also included an underground gallery. In the center of the square was a large temple, which some have called a capitolium. The road finally reached the river, which it crossed on a bridge which, repaired and enlarged, survived until WW II.

Only one public edifice at a distance from the cardo is known with certainty: on the W, at a spot near the river called Chamars (Campus Martius?) a semicircular double wall (exterior diam. 91.4 m), which was built on a cremation cemetery of the Julio-Claudian period. It was most probably a sacred enclosure surrounding a temple (of Mars?). It is not clear where the sanctuary of Mercury Cissonius, mentioned in an inscription, was located. Various cults (Apollo and Mercury combined, the Mother Goddesses, and the God with the Mallet) are attested by dedications or by sculptures. The remains found under the Place du Marché are probably those of large baths, and other ruins are those of private dwellings, often ornamented with mosaics and marble facing.

On the other side of the bridge the road split into three branches, to Lyon, Langres, and the Rhine. On the left of the road to Lyon was an amphitheater, built partly on level ground and partly into a hillside. Two segments of foundations remain. Later cemeteries (after the Julio-Claudian period) lay along these roads.

BIBLIOGRAPHY. L. Lerat, in *Histoire de Besançon* (1964) 27-142 with earlier bibl. Later excavations: *Gallia* 22 (1964) 386-91; 24 (1966) 354-56; 26 (1968) 440-48.

L. LERAT

VESUNNA PETRUCORIORUM (Périgueux) Dordogne, France. Map 23. Oppidum of the Petrucorii, a federation of tribes organized into a sovereign state, which answered Vercingetorix' call to arms. After the Roman conquest the city, following the customary pattern of Romanization, was moved down from the hill and set up in the valley of the Isle, protected by a bend in the river. Becoming part of Augustan Aquitania in 27, it flourished until the invasion of 276 when it became a reduced castrum of 6 ha, girded with ramparts made of the stones of destroyed monuments.

Claudius had linked this free city to the tribus Quirina; it was the administrative and religious capital of the region, its public and private monuments displaying the wealth characteristic of the magnificent imperial cities.

The settlement grew up around the indigenous sanctuary of Tutela Vesunna, the central cella of which, shaped like a round tower (21 m in diameter, 27 m high), has been preserved. The cella stood on a paved podium with a colonnade encircling it, save for a stairway 9.6 m wide that led down to an inner courtyard (141 x 122 m) with religious buildings on every side (excavated since 1964). South of the temple was the forum (195 x 100 m), excavated 1908-13 and yielding many architectural fragments. The amphitheater, built by A. Pompeius Dumnomotus, praefectus fabrum, was N of the temple; a few stumps can be seen in a public park.

Residential architecture is represented by the Great Villa with its polyfoil impluvium, and the villa of the Rue des Bouquets (3000 sq. m excavated since 1959), which contains some important frescos, with geometric, animal, and flower motifs.

Long sections of the castrum rampart can still be seen: the Mars Gate (Porte de Mars), Norman Gate (Porte Normande), and part of the Château Barrière. The principal architectural and epigraphic finds are housed in the municipal museum.

BIBLIOGRAPHY. P. Barrière, *Vesunna Petrucoriorum, histoire d'une petite ville à l'époque gallo-romaine* (1930); G. Lavergne, *Histoire de Périgueux* (1945); Grenier, *Manuel* III 1 (1958) 440ff[PI]; J. Coupry, "Informations," *Gallia* 21, 2 (1963) 514; 23, 2 (1965) 422; 25, 2 (1967) 346; 27, 2 (1969) 358. A. BLONDY

VEŢEL, *see* MICIA

VETERA AND COLONIA ULPIA TRAIANA (Birten and Xanten) Kreis Moers, Germany. Map 20.

A double legionary camp on a glacial moraine: just opposite the Roman side of the mouth of the Lippe (Vetera I) and to the E on an adjoining lower terrace (Vetera II). On the site of Vetera I the first camp had been constructed before 12 B.C. and had two successors, under Tiberius and Claudius. Probably under Nero, Vetera I (902 x 621 m) was constructed of stone for the Legio V Alaudae and the Legio XV Primigenia. It was besieged and destroyed during the rebellion of the Batavi in A.D. 69-70 (Tac. *Hist.* 4.22f, 28-30, 34-36, 60). After the victory of Civilis in 70 (Tac. *Hist.* 5.14-18), Vetera II was built, closer to the Rhine, for one legion. From ca. 120 until at least Diocletian times the Legio XXX Ulpia Victrix was garrisoned here. The canabae legionis were located E and SE of Vetera I and probably W of Vetera II. The usable land of the legion extended to the E, W, and S. A civilian settlement, which developed ca. 3 km NW of the camp in Late Augustan or Tiberian times, was elevated by Trajan to the status of colonia and completely rebuilt. Large parts of the town were destroyed by fire before 160, including the forum; they were soon rebuilt with imperial help (*CIL* XIII, 8036 and 8643). The town still existed in the 4th c.; evidence found in the baths points to a violent end.

One third of Vetera I has been explored. In front of the defensive wall (3 m thick) of sun-dried bricks with wooden facing are two V-shaped trenches. On both sides of the via principalis, oriented E-W, were colonnades. In either half of the camp a legion was stationed; both legions shared the principia and the quaestorium. On each side of the principia was an accommodation for the praetorium. The military tribunes and perhaps also the prefects lived in peristyle houses. Near the W gate a valetudinarium was located. Vetera II was destroyed by a flooding of a branch of the Rhine in the Early Middle Ages. Divers have discovered ruins, and dredging has disclosed small finds.

The Colonia Ulpia Traiana (83 ha) was laid out as a rectangle, the direction of its E side determined by its proximity to a branch of the Rhine. So far, eight gates and doors have been found in the town wall. To the SE of the town center a temple was situated within a large open area, probably the capitol. Another temple seems to have stood near the harbor gate. In the W half of the colonia were large baths (105 x 107 m), serial in arrangement, and an extensive palaestra, opposite which were probably warehouses and an imposing building the size of two building quarters. In three other sections rows of elongated rectangular houses were discovered, often with shops for craftsmen. In the SE corner of the town wall was an amphitheater. Originally a wood and stone structure, it was rebuilt in stone in the 2d c. Almost all finds are at the Rheinisches Landesmuseum in Bonn; a few at a museum in Xanten.

BIBLIOGRAPHY. Vetera: H. Lehner, *Vetera* (1930)[MPI]; H. v. Petrikovits, "Vetera," *RE* VIII A (1958) 1801-34; id., "Die Legionsfestung Vetera II," *BonnJbb* 159 (1959) 89-133[MPI]; H. v. Petrikovits, *Die Innenbauten römischer Legionslager in der Prinzipatszeit* (1975).
Colonia Ulpia Traiana: P. Steiner, *Xanten* (catalog, 1911); H. v. Petrikovits, "Die Ausgrabungen in der Colonia Traiana bei Xante," *BonnJbb* 152 (1952) 41-157; H. Hinz, *Xanten zur Römerzeit* (3d ed., 1967)[MPI]; G. Binding & C. Rüger in *Rheinische Ausgrabungen* 20 (1971); C. Rüger, *BonnJbb* 172 (1972) 293ff.

H. VON PETRIKOVITS

VETTONA (Bettona) Umbria, Italy. Map 16.

An Etrusco-Umbrian site on a hill above the confluence of the Chiasco and Topino. It preserves stretches of walls of squared blocks of sandstone laid in courses of varying height. The town seems to have been small, a long oval with the forum roughly centered. As a municipium it belonged to the tribus Clustumina. The necropolis material runs from the 4th c. B.C. to the 2d c. A.D., and from nearby Colle come temple terracottas of the 1st c. B.C. Some material is assembled in Palazzo del Podestà.

BIBLIOGRAPHY. *StEtr* 8 (1934) 397-400 (G. Becatti)[MI]; *EAA* 2 (1959) 75f (C. Pietrangeli)[P].

L. RICHARDSON, JR.

VETULONIA Tuscany, Italy. Map 14.

A small center NW of Grosseto, situated on a height that dominates the plain of Grosseto, at one time below sea level. It ranks with Rusellae as one of the most ancient and prosperous cities of N Etruria. The broad marine inlet below had become a lake by Roman times (lacus Prile), and later a marsh. Here must have been the port, placed in a protected corner of the gulf, opposite Rusellae 16 km away.

The city is mentioned by Dionysios of Halikarnassos (*Arch.* 3.51); Silius Italicus (*Pun.* 8.484-489); Pliny (*HN* 3.51); and Ptolemy (*Geogr.* 3.1.49). Two mediaeval documents, dated 1181 and 1204 respectively, refer to Vetulonia and its territory. After the Middle Ages the name Vetulonia was replaced until 1887 by the name Colonna di Buriano.

No information has been handed down concerning the occupation of Vetulonia by the Romans, though this must have happened peacefully about 241 B.C. during the construction of the Via Aurelia, on which Vetulonia came to hold a dominant position. Following the Lex Julia the Vetulonian population was ascribed to the tribus Scaptia (Plin. *HN* 3.52). A number of inscrip-

tions (*CIL* IV, 2375b; II, 41 and 2382-86) attest to the survival of the Etruscan city until the 2d c. A.D.

An abundance of archaeological material attests the vitality of Vetulonia, with alternating periods of prosperity and decline, from the 8th c. B.C. to the 2d c. A.D. The city, whose sphere included elements of a Villanovan population evidenced by cinerary urns with biconical ossuaries, flourished mainly from the end of the 8th c. B.C. to the end of the 6th c. B.C. After that it apparently declined until Roman times (3d c. B.C.) when it again became a center of some importance. Nothing precise is known of the territorial expansion of the older Vetulonia, but its flourishing, especially in the 7th c. B.C., was certainly due to exploitation of the mines of Massetano. For this reason it is probable that the small settlements bordering the Lago dell'Accesa, S of Massa Marittima, became its dependents.

The entire perimeter of the circuit wall is not clearly defined, but from parts still visible, including the so-called Mura dell'Arce of large polygonal blocks incorporated between two mediaeval towers, it probably extended ca. 5 km. Of the actual Etruscan city little is known as exploration has been limited to a quantity of shafts and galleries cut in the living rock, and to several walls and rooms found beneath modern houses. The exceptional extent of its necropoleis suggests that a large city occupied the highest summit, where the present town is situated, as well as two other heights to the NW known as Costa Murata and Castelvecchio. A small part of the city from the Hellenistic and Etrusco-Roman periods to the NE of the modern town was excavated at the end of the last century and recently re-exposed, the so-called Scavi Città. Along a winding paved street generally following an EW path (decumanus), flanked by a sidewalk and drain, shops and houses are aligned, separated by cross streets which climb toward Poggiarello Renzetti and divide the inhabited area into blocks. Still visible are traces of brick pavement in opus spicatum or in small rhomboids. Walls of crude sun-dried bricks, notable traces of which remain, must have surmounted the unmortared foundation walls. Beyond the decumanus a tunnel with a light-well is visible. It led in through a large hole to a quadrangular basin with beveled corners, whose plaster of cement and *pozzolana* is still preserved, today covered over to preserve it. Another rectangular basin formed of large stone blocks, squared and chiseled, communicated with the drain of the decumanus.

Besides the Scavi Città, in the level zone called Le Banditelle, mosaics belonging to a Roman villa have been found, as well as ruins of Roman buildings in brick and cement. In the zone between the Convento and Le Banditelle probably lay the center and the forum of Roman Vetulonia. An inscription dedicated to Caracalla has been found here and two inscriptions belonging to a society in honor of Mars. There is also evidence from several recent test trenches. Recent excavations in the area called Costia dei Lippi have brought to light terrace walls of notable strength and remains of buildings flanking a paved Roman road, which seem to indicate occupation of this quarter of the city during the Hellenistic period. Remains of buildings from the Hellenistic and Etrusco-Roman periods were found at Costa Murata under the present school building, and recent excavations have turned up other structures closely related to the first, as well as a monumental building, probably a temple.

On the highest hills closest to the city were the Villanovan necropoleis. Around these burials, at a lower level on the same hills, following in immediate topographical and chronological succession the primitive Villanovan

pits, have been found the circular tombs characteristic of Vetulonia. These are datable to the 7th c. B.C., and they abound in objects of bronze, gold, silver, and pottery, all characterized by the orientalizing style.

Of the monumental tholos tombs from the most recent orientalizing period along the Via dei Pepolcri, two of the most interesting are visible today: the Tomba della Pietrera and the Tomba del Diavolino. Other smaller tumulus-covered chambered tombs have been excavated but are no longer visible, with the exception of the Tomba del Belvedere, recently reworked and restored, and a small tomb called the Tomba della Fibula. The material found in the latter is on exhibit in the Antiquarium of Vetulonia.

BIBLIOGRAPHY. I. Falchi, *Vetulonia e la sua necropoli antichissima* (1891); D. Levi, "Carta Archeologica di Vetulonia," *StEtr* 5 (1931) 13-40; G. Radke, *RE* VIIIA 2 (1958) 1874-80; *EAA* 7 (1966) 1157-61 (A. Talocchini).
A. TALOCCHINI

VETUS PICTAVIS (Vieux Poitiers) Commune of Naintre, Vienne, France. Map 23. A Gallo-Roman vicus, built in the 1st c. A.D. The center was a continuation of a Celtic settlement, an oppidum which stretched 1500 m along the hill separating the rivers Clain and Vienne. The construction of the town follows ancient norms in its ritual arrangement of the cardo and the decumanus. Aerial photography, checked on the ground, has led to the discovery of the lines of these two main streets and several others: the streets form a grid. The site covers more than 70 ha. The vicus seems to have been most prosperous in the 1st c. A.D. and in the first half of the 2d c. The carving on stones is characteristic of the 1st c., and the use of marble, porphyry, and other imported stones is characteristic of the 2d c.

The vicus began to decline in the 2d c. although some villas continued to be inhabited. Ancient remains found in the fields attest the continuity of human occupation in the Gallo-Roman period. Although no buildings have been located in the central area, the fields, now under cultivation, conceal many walls and abundant scattered ancient remains.

Many remains are still visible. In the middle of the town is an unfinished menhir of Cenomanian sandstone, bearing a Celtic inscription (RATIN BRIVATION FRONTU TARBELSONIOS IEURU). The cellar of La Font des Berthons, excavated in 1969, was built in the 2d c. and cut into a floor of Gallic date. The potter's kiln of Les Groseillers was excavated in 1971. It probably dates to the 2d c. A.D. and has produced ca. 50 kg of ordinary pottery. The theater is large (diam. 115 m) and of Classical type. It is the fifth largest Gallo-Roman theater, and has been the object of many investigations during the 18th, 19th, and 20th c. It has been excavated since 1963, and has given data that permits a reconstruction of the history both of the building and of the people who inhabited the site. Built for spectacles, it was used for somewhat precarious dwellings during the final Gallo-Roman centuries, and then became a quarry. To date, the excavations have produced 151 coins, 25 rings (one of gold), 5 bronze fibulas, 30 bone pins or needles, a large number of potsherds, and interesting artifacts of bone and metal.

All the investigations carried out on the site help make this, archaeologically high point of Poitou, a center for the discovery of the ways of life of the Celtic population, the Pictones of Pictaves.

BIBLIOGRAPHY. Note: Vieux-Poitiers has often been confused with Poitiers, ca. 30 km away.

Texts: *Commentaries of Caesar* (siege of Poitiers);

Annals of Eginhard (division of the kingdom in 742 between Charlemagne and Pepin); Gregory of Tours, *Historia Francorum* (Battle of Poitiers, which took place in 732 near Vieux-Poitiers); J. Bouquet, *Annals of the Franks* (Charter of Charles the Bald in favor of the Abbey of St. Florent-le-Vieux, signed at Vieux-Poitiers in 849); the oldest testimony mentioning the ruins of the theater and nearby monuments dates from 1408.

Excavation reports: E. Ginot, "Fouilles à Vieux Poitiers," *Bull. Soc. Française des fouilles arch.* (1941); R. Fritsch, "Nouvelles fouilles à Vieux-Poitiers, Commune de Naintre," *Bull. Soc. Antiquaires de l'Ouest* (July-Sept. 1969); id., *Bull. Soc. des Sciences de Chatellerault* 6 (1969).

On the site: De la Massardière, "Esquisses Archéologiques sur le Vieux-Poitiers," *Bull. Soc. des Antiquaires de l'Ouest* 3 (1837) 103-19; C. Page, "Conférence sur le Vieux-Poitiers," *Bull. Groupe Chatelleraudais* (1905).

Menhir and inscription: E. Esperandieu, *Epigraphie romaine du Poitou et de la Saintonge* (1888) 107; Dechelette & Grenier, *Manuel* 3 (1914) 435; E. Ernault, "Notes sur l'inscription du Vieux-Poitiers," *Revue Poitevine et Saintongeaise* 5; E. Grugeaud, "Nouvel essai de traduction de l'inscription du menhir" (mimeo 1967).

Selected references: Thibeaudeau, *Histoire du Poitou* (1839) 430ff; R. Delanoue, "Memoire" (1780) repr. in *Bull. de la Soc. d'Emulation de Chatellerault* 2 (1840); Bourignon (de Saintes), "Dissertation sur l'endroit appelé Vieux-Poitiers," ibid. 56ff; E. Siauve, "Sepultures antiques du Vieux-Poitiers," ibid. 3 (1841); A. Lalanne, *Histoire de Chatelleraud et du Chatelleraudais* 1 (1859) 75ff; M. de la Tour, *La capitale du Poitou sous les Gaulois et les Romains* (1881); E. Esperandieu, *Recueil général des bas-reliefs de la Gaule romaine* (1907-) 2, nos. 1407, 1415, 1424; G. Dottin, *La langue gauloise* (1920) R. FRITSCH

VETUS SALINA (Adony) Fejér, Hungary. Map 12. Roman camp and settlement on the E limes of Pannonia inferior, on the shore of the Danube. Its name is mentioned in Ptolemy (2.15.3), the *Antonine Itinerary* (245.-4), and on inscriptions (*CIL* III, 10505). During excavations only the walls of the SW corner were unearthed, the rest was swept away by a tributary of the Danube. Several consecutive periods of construction can be traced.

The earliest wooden camp (I), built at the end of the 1st c. (probably between 88-92), was one of the first Roman fortifications in this area. A 70 m section on the S (longer) side of the wall remains and a 130 m section on the W (shorter) side. The rest of the walls disappeared completely during later changes. To judge from the relatively small vallum in front of the walls, it is probable that this was a transitional camp surrounded by earthen ramparts. On the W wall are traces of two round towers 25 m apart. The post-holes discovered inside the towers indicate a storied, wooden-beamed building, the earliest Pannonian example of this type of tower. Among the findings some terra sigillata of the Po area and much-worn coins of Claudius I were discovered.

The settlement to the S of the camp belongs to this period. Only traces of foundations and post-holes were found.

The walls of the second wooden camp were built somewhat farther S. The vallum was deeper and wider than in the previous period but of the same shape. It was constructed probably in the era of Domitian and destroyed during the beginning of the Dacian wars of Trajan when the garrison of the first camp (cohors II Batavorum) left. Their place was taken by the cohors II Alpinorum, which built the third wooden camp. Built directly on the walls of the first, its S wall stretched about 50 m farther S. Of the walls 81 m on the S side and 151 m on the W side remain. The walls, constructed of double post rows, were reinforced by a third supporting wall. On the S side the foundation of a square tower, jutting halfway out of the wall, was unearthed. Only a few traces of the inner buildings survive, one of them the remains of terrazzo-floored buildings. The road, leading through the porta decumana, led 88 m from the SW corner of the camp. From this it can be calculated that the shorter camp wall was 176 m long, as at Intercisa.

The cohors II Alpinorum, which built the camp, arrived most probably in 102, the first year of the Dacian wars, and stayed till 117-20, when the cohors III Batavorum took over.

The fourth camp was built over the first and third, but occupied a larger territory. Its walls were built over the filled-in vallum of the third camp, partially in front of it. The construction of the wall, built of three post-rows, was similar to that of the third camp. The walls were reinforced by stone-floored towers jutting out of the walls. Traces of the road inside the camp, crossing the porta decumana, coincide with the main road of the third camp. Probably this wooden camp too was rebuilt in stone during the great limes fortifications of Hadrian.

The first stone camp was also built by the Cohors III Batavorum, almost exactly on the spot of the fourth wooden camp. During the change-over they left the vallum intact and erected a stone wall 75-80 cm thick in front of the towers. They also used inner buildings of the previous camp. The first known tile stamps are from this period with the name of the cohors. (The earlier period could be identified through data from military diplomas.) The existence of this camp lasted from the reign of Hadrian—when the conversion to stone of all camps can be observed to the Marcomannic wars.

The second stone camp was built probably after the ravages of the Marcomannic wars; its stone walls were pilfered completely during Roman times. This camp had a double vallum, its first trench was unusually deep. Apart from this, the camp was only the rebuilding of the first stone camp. Its garrison remained the same.

The settlement, belonging to different periods of the camp, was destroyed through river floods and road building. Aside from primitive dwellings of the first wooden camp, the settlement may be said to have developed only after the construction of the third wooden camp. Traces of houses with beamed framework were discovered.

Among the finds apart from the terra sigillata, many fragments of the gray so-called Pannonia pots came to surface. These seal-decorated ceramic fragments are of the type frequently found in the Aquincum area, in the counties of Fejér and Veszprém, without, however, being connected with any definite workshop. On the basis of these pots it can be established that the inhabitants of the settlement were mostly natives of Pannonia.

Of the rather poor epigraphical legacy of the camp and settlement—beside the milliarium above (*CIL* III, 10631-3723)—an altar stone deserves special mention. This was consecrated to Dea Vagdavercustis by one of the tribunes of the cohors III Batavorum. The name of this Batavian goddess is otherwise unknown in Pannonia.

A late Roman burial ground was discovered on the site of the camp, already destroyed during Roman times. Only six of the approximately 20-25 tombs could be unearthed. The findings of these show that the population of the area in the 4th c. already mixed with that of the area between the Danube and Tisza.

BIBLIOGRAPHY. L. Barkóczi & É. Bónis, "Das früh-

römische Lager und die Wohnsiedlung von Adony (Vetus Salina)," *Acta Archaeol. Acad. Scient. Hungaricae* 4 (1954) 128-99; J. Fitz, "Fejér megye története I, 4," *A római kor fejér megyében* (1970) 164-65=8-9.

L. BARKÓCZI

VÉZELAY Yonne, France. Map 23. Perhaps named after the estate of a 4th c. Gallo-Roman landowner, Vercellacus, but the site undoubtedly dates from before that time. It was a market, overlooking the vineyards and standing at the junction of two main roads.

A Temple of Bacchus lies under the church of St. Etienne (noted in 17th c. archives), but the visible traces of Roman occupation are on the wooded plateaus SW of the city (Forêt des Ferrières, Forêt du Crot au Port). In 1960 the first elements of a Gallo-Roman ironworks were uncovered, dating from the 2d c. A.D. Vézelay lies in the middle of a vast region (including parts of the modern departments of Aube, Loiret, Nièvre, and Côte d'Or) where the Romans extracted iron ore, goetite, and limonite, not far below ground (2-7 m) in the Eocene silts. Traces of this activity abound: the slag heaps, mounds of molten metal scraps which contain 10,000-80,000 metric tons, are still rich in iron (20-40 percent). There are roughly 2000 pits (round holes 4-6 m in diameter and 5-7 m deep) over a 6 ha stretch in the area known as Les Ferrières. One of the places where the ore was washed was easily located, but the smelting areas and batteries of ovens have been difficult to pinpoint.

Each district had its own pits, its apparatus for washing the ore, and its own ovens and slag heaps, as well as its own administrative manpower and slave labor. In the district of Crot au Port the administrator's villa and a fanum have been excavated. The villa (20 x 25 m), in the Pompeian style, consists of a paved porch, two lateral rooms (one with a cellar), and an inner courtyard with three adjoining rooms, one of which has a hypocaust. Some frescos and stuccos were found in this room. The house was built at the end of the 1st c. A.D. on a leveled slag heap.

The fanum (4 x 4 m) stands on a small hillock overlooking the crossing of two roads (one links the Yonne and Cure rivers, the other runs from the ironworks to the baths of Fontaines Salées). A carved altar stone dedicated to Mercury and a bronze statuette of the same god have been found there; they point to Mercury as the protector of miners.

The ironworks apparently ceased to function at the end of the 2d c. A.D. and both villa and fanum were burnt down.

Another important discovery is that of the wooden structure (a fixed table) for washing the ore, in a pond used for the purpose in the Ferrières district. It is a unique piece. The wooden elements, 3-6 m long, are remarkable examples of the carpenter's skill.

This is the first complete example of Gallo-Roman ironworks. The collection of finds is at Vézelay.

BIBLIOGRAPHY. R. Louis, *Les fouilles gallo-romaines de St-Père* (1937); R. Dauvergne, *Sources minérales, thermes, et occupation du sol aux "Fontaines Salées"* (1944); B. Lacroix, *Un sanctuaire de source circulaire aux "Fontaines Salées"* (1963); id., *Les origines proto-historiques et gallo-romaines de Vézelay* (1963); id., *Une installation artisanale aux "Fontaines Salées"* (1965); id., *Les "Fontaines Salées" à l'aube de l'âge du fer* (1966); id., "Une piscine du Iᵉʳ S.," *Echo d'Auxerre* (1967); id., *Dieux gaulois et romains de la vallée de la Cure* (1970).

B. LACROIX
J. M. SIMON

VIBINUM (Bovino) Foggia, Apulia, Italy. Map 14. An inland city 8 km from Aecae (Troia) and 24 km from Luceria. Its name is found in Pliny (3.105) and in inscriptions (*CIL* IX, 966). Hannibal encamped there in 217 B.C. (Polyb. 3.88). The ager Vibinas is mentioned in the *Liber Coloniarum* (p. 210). There are remains of walls and towers, as well as numerous inscriptions, an aqueduct, and some cisterns.

BIBLIOGRAPHY. W. Smith, *Dictionary of Greek and Roman Geography*, II (1857) 1307 (E. H. Bunbury); *RE* 8.2 (1958) 1947-48.

F. G. LO PORTO

VIBO VALENTIA, *see* HIPPONION

VICENZA, *see* VICETIA

VICETIA (Vicenza) Veneto, Italy. Map 14. A city at the N foot of the Berici hills, on the river Togisonus (Bacchiglione). A prehistoric nucleus extending into the suburban area must have been a very important center of early Venetic culture. In 148 B.C. the Via Postumia passed through the center of the city and by 135 B.C. its territory had been noticeably extended (*CIL* v, 2490). It was one of the municipal towns in N Italy (49 B.C.) and belonged to the tenth Augustan region. It was the home of the grammarian Remmius Palaemon (Suet. *Gram.* 23). There is evidence of the cults of Diana, Fortuna, Nemesis, the Nymphs, Venus, and the Imperial Genius.

The Roman city was rectangular in plan (500 x 560 m) with internal blocks about 60 m square. It was surrounded by a brick wall of which considerable remains have come to light in Piazza Castello. The urban plan is probably of the 1st c. B.C., with the Via Postumia constituting the decumanus. This road crossed the Togisonus at the E end of the urban area. Remains of a bridge there were partially preserved until 1889 (Ponte degli Angeli). A second bridge, Ponte S. Paolo, destroyed in 1875, crossed the river Retrone on the S side of the city, where the road led to the theater. Each bridge had three low arches, with technical details of the early Imperial period. Inside the city, under the area of the mediaeval piazzas, parts of public buildings have been found which probably belong to the forum. Elsewhere fragments of mosaic pavement have been found, probably from private houses. A cryptoporticus belonged to a structure enclosed in a city block in the SW part of the urban area. It was 3.4 m wide, branching out to surround the structure on three sides. It was part of a rich domus of the 1st c A.D. and remained in use for several centuries. The most important relic of the ancient city—which, however, is outside the walls—is the theater, called "di Berga" from the name of the mediaeval quarter in which its ruins are preserved. The cavea, with a maximum diameter of 76.7 m, faced N and was subdivided into an ima cavea on a full substructure and a summa cavea with a radial substructure covered by barrel vaults. The lower part of the facade is partially preserved and has half-column pilasters. The stage enclosure, joined to the cavea through the crypts, exhibits three niches with a semicircular plan, framed by columns and rich in sculptural decoration (portrait statues of the Julio-Claudian period and friezes in relief). Several phases are distinguishable; the original phase, dating from the first half of the 1st c. A.D., was restored and enriched in the course of the 2d c. A.D.

Outside the city walls in the suburb of Lobia are preserved the remains of an aqueduct, its concrete covered by decorative tufa. Datable to the first Imperial age, the aqueduct carried water to a storage place near the walls of the city. In the heart of the W necropolis is the ruin

of a small basilica above the tombs of SS. Felice and Fortunato with mosaic pavements from the first half of the 4th c. In the 5th c. it was supplanted by a basilica with three naves, with a quadriporticus, baptistery, and martyrion in the form of a Greek cross. Its interior walls are decorated with mosaics. Another Late Antique complex has been discovered under the area of the cathedral. On remains of houses from the 1st c. A.D. rest the remains of a basilica from the 5th c. with mosaic pavements. Finds from the area include early Venetic stipe, funerary stelai, series of reliefs, inscriptions, and minor objects. These, together with material of various provenance, have been donated to the local Museo Civico.

BIBLIOGRAPHY. Cic. *Fam.* 11.19.2; Strab. 5.214; Tac. *Hist.* 3.8; Plin. *HN* 3.121,130,132; 6.218; Ptol. 3.1.30; Ael. 14.8; Paul. *Diac.* 2.14; 5.23; *CIL* v, 306ff.

V. Barichella, *Alcune notizie sul teatro di Berga* (1869); id., *Relazione sul ponte sopra il Retrone* (1875); H. Dütschke, *Antike Bildwerke in Oberitalien* v (1882) 1-24; B. Morsolin, "L'acquedotto romano di Vicenza e il teatro di Berga," *Memorie Storiche Dep. St. Patr.* III (1884); A. De Bon, *La romanità del territorio vicentino* (1937); G. Fasolo, *Guida al Museo Civico di Vicenza* (1940); F. Franco, "Il teatro romano dell'antica Berga," *Atti III Conv. Naz. Stor. Arch.* (1941) 171-82; G. Brusin et al., *Studi Mistrorigo* (1958) 20ff, 41ff, 749ff; Brusin, "Danzatrici orgiastiche su monumenti funerari della Venetia," *AttiVen* 119 (1960-61) 389-99; G. Radke, "Vicetia," *PW* 8A (1958) 2053-54; C. Anti, *Cisalpina* I (1959) 257; C. Gasparotto, *Carta archeologica d'Italia*, I.G.M., F. 50 (1959) 83ff; G. Fogolari, *Paleoveneti a Vicenza* (1963); *EAA* 7 (1966) 1162 (L. Beschi).
L. BESCHI

VIC-FEZENSAC Gers, France. Map 23. In 1965, on the ancient site of Saint-Jean-de-Castets, a funerary pit 7 m deep was found and excavated. Like the funerary pits of Lectoure and those of the Toulouse region, it contained grave goods datable to the 1st c. B.C.

BIBLIOGRAPHY. M. Labrousse, *Gallia* 24 (1966) 439.
M. LABROUSSE

VICH, *see* AUSA

VICHY, *see* AQUIS CALIDIS

VICOHABENTIA, *see* VICOVENTIA

VICOVENTIA or Vicohabentia (Voghenza) Ferrara, Italy. Map 14. A section of the district of Voghiera mentioned in the ecclesiastical documents of the late Roman period and of the Middle Ages. It is a Roman archaeological area for which inscriptions (*CIL* v, 2385, 2386, 2411; cf. 2383, 2410) lend credence to the idea that the administrative seat of imperial properties in the ancient Po delta was there. In the Early Christian era, it was the seat of a diocese, which was transferred to Ferrara in the 8th c.

Inscriptions and Roman sarcophagi from Voghenza are found in situ near the sanctuary of San Leo or at Ferrara in the Museo Lapidario of the Palazzo dei Diamanti. In the Cathedral Museum there are two parapets of a pulpit in the Ravennate style of the 8th c.

BIBLIOGRAPHY. *RE* v (1903) 1193-94 (Liebenam); De Ruggiero, *Diz. Epigr.* II (1900), p. 1922 (N. Vulić); III (1922), p. 98 (R. Rostowzew); F. Lanzoni, *Le diocesi d'Italia* (1927) 811; O. Vehse, "Ferrareser Fälschungen," *Quellen und Forschungen aus italienischen Archiven und Bibliotheken herausgegeben vom Preussischen Histor. Inst. in Rom* 27 (1936-1937) *passim* (= *Le origini delle storia di Ferrara*, 1958); G. Bovini, "Sculture paleocris-

tiane e altomedievali conservate a Ferrara," *Felix Ravenna* (1954) 31-34; G. A. Mansuelli, *Le stele del territorio ravennate e del basso Po* (1967) 10-13, 150-151; Aubert, *Dictionn. d'histoire et de géographie ecclésiastiques*, XVI (1967) 1192-93 (D. Balboni). S. Uggeri-Patitucci, "Il popolamento di età romana nell'antico delta padano," *Atti e Mem. Deputazione prov. ferrarese di Storia patria* 3, 9 (1972) 55ff.
N. ALFIERI

VICUS IULII (Aire sur l'Adour), Dept. Landes, France. Map 23. On the ancient road joining Aginnum and Burdigala at Beneharnum (Lescar). On the banks of the Bitou are the remains of a temple dedicated to Mars Lelhunnus; 29 votive altars were discovered here in 1884. On the site of the vicus itself mosaics have been known since 1651, in 1888 located in the garden of the bishop's palace. Other mosaics, of the late Empire (decorative geometric design of octagons) were found in 1928. After the invasion of A.D. 276, Diocletian authorized a rampart for Vicus Iulii. The episcopal seat is dated to 506.

BIBLIOGRAPHY. C. Lacoste, "Mosaïques gallo-romaines des Landes," *Bull. de la Soc. de Borda* (1961) 231; J. Coupry, "Informations arch.," *Gallia* 25.2 (1967) 365.
M. GAUTHIER

VICUS MARACITANUS (Ksar Toual Zammel) Tunisia. Map 18. Ruins 22 km N of Maktar and 1 km from the well-known monument Kbor-Klit. The modest country town is unquestionably pre-Roman in origin. The chief monument, the Capitolium, which is in the form of a temple with a pronaos that was probably hexastyle, stood on the square of a forum opposite a larger building of unknown purpose. A section of a street, some cisterns, and what may have been a Christian chapel have been excavated. In one of the two necropoleis is a well-preserved two-story mausoleum with a pilastered facade, which gave the place its modern name of Ksar (castle or fort).

A stele inscription gives the Roman name, proving that the site is not identical, as has been suggested, with Zama Regia, the site of the decisive battle of 202 B.C.

BIBLIOGRAPHY. N. Davis, *Ruined cities within Numid. and Carth. territories* (1862) 52; J. Poinssot, "Inscr. inédites," *Bull. Ant. afr.* 2 (1884) 370 pl. 28; R. Cagnat & A. Merlin, *Atlas arch. de la Tunisie*, f. 32 Maktar; *CIL* VIII, p. 1236; A. Merlin, *Inscr. lat. de la Tunisie* 98; Ch. Saumagne, "Zama Regia" *CRAI* (1941) 445-53; id., "Zama Regia" *Rev. Tun.* (1941) 235-69; L. Déroche, "Les fouilles de Ksar Toual Zammel et la question de Zama," *MélRome* 60 (1948) 55-104.
J. CHRISTERN

"VICUS SPACARUM," *see* VIGO

VID BY METKOVIĆ, *see* NARONA

VIDY BY LAUSANNE, *see* LOUSONNA

VIÉ-CIOUTAT, *see* MONS-ET-MONTEILS

VIEILLE-TOULOUSE Haute-Garonne, France. Map 23. In the 1st c. B.C. about 10 km S of Toulouse on the plateau of "La Planho," which dominates the right bank of the Garonne, a settlement that was neither an oppidum nor the ancestor of Toulouse. Until the time of Augustus, however, it was remarkable for commercial activity linked to the Italian wine traffic, and for handicrafts producing small bronze objects and inlaid work. Italian merchants, their slaves, and their freedmen mingled with the natives. The houses, built of wood

and clay, were of a prehistoric type, and a sanctuary discovered in 1970 is of very primitive character. The numerous funerary pits, often containing rich grave goods, are in the Gallic tradition, but most of the coins, weapons, lamps, and luxury pottery come from Italy and testify to the beginning of a truly Gallo-Roman civilization.

BIBLIOGRAPHY. L. Joulin, "Les stations antiques des côteaux de Pech-David," *Mém. de l'Acad. des Sciences de Toulouse* 10e sér. 2 (1902) 377-94; G. Fouet, "Fouille d'un puits funéraire à Vieille-Toulouse," *Gallia* 16 (1958) 115-57; M. Labrousse, "Informations," *Gallia* 15 (1957) 256-58[I]; 17 (1959) 433-35[I]; 20 (1962) 573-78[I]; 22 (1964) 449-51[I]; 24 (1966) 429-30[I]; 26 (1968) 537-38[I]; 28 (1970) 413-15[I]; id., *Toulouse antique . . .* (1968) 92-105 & passim (bibl. 92, n. 63). M. LABROUSSE

VIENNA (Vienne) Isère, France. Map 23. In Gallia Narbonensis, a bridge site in a bend of the Rhône, dominated by five hills. On the left bank of the river are the Gère pass and the alluvial terraces of the Gère and the Rhône; on the right bank the Rhône foothills lead to the Gier valley and the W. Hence it was a meeting-place for trade routes from the Rhône to the Loire (Strab. 4.1.2, 14): the E-W road ran from the Alps to the Massif Central, and the S-N road followed the Rhône on the left bank and crossed it at Vienne to avoid the marshes in the Lyon area.

When Gaul was independent, the Allobroges had two settlements on the left bank at Vienne. The oppidum-refuge was on the Sainte-Blandine hill, where material from Iron Age III was found from 1895 to 1955; the trading-post was lower, on the banks of the Gère. Here a fragment of an Attic cup of the early 4th c. was discovered in 1968 in a stratified site; 11 strata, from the 4th c. B.C. to the end of the 1st c., were identified. Two layers showing traces of fire and destruction probably mark the attack of the Cimbri and Teutoni in 105 B.C., then the revolt of the Allobroges in 62-61 B.C. and its repression. Vienna was conquered by Rome in 121 B.C. and absorbed into the Narbonensis province. Caesar passed through it in 58 and 52, and made it a colony under Roman law. In 43 a revolt of the Allobroges uprooted the Roman citizens, who left to found the colony of Lyon; Vienna lost its rights. Augustus restored them, and in A.D. 40 Caligula made the city a colony with full rights: colonia Iulia Augusta Florentia Vienna. It soon became prosperous, and in his speech to the Senate in 47-48 Claudius described it as "ornatissima ecce colonia ualentissimaque Viennensium." Martial called it "pulchra Vienna" and Ausonius praised its opulence. Capital of the Viennois diocese from the reign of Diocletian on, and of the Viennois province from the reign of Constantine, it is given the title of metropolis in the *Notitia Galliarum* 11.3; it was then the second Gallic city, after Trèves, and it remained so until superseded by Arles at the end of the 4th c. After suffering in the Germanic invasion of 275, the city was seized by the Burgundians ca. 468 and became one of their royal residences.

Vienna had three successive surrounding walls. The 1st c. wall, which Augustus presented to the city in 16-15 B.C., measured 7250 m (the longest in Gaul) and gave the city an area of over 200 ha. This impressive fortification had 54 towers 8-12 m in diameter surrounding the five hills: Mont Salomon, Mont Arnaud, Sainte-Blandine, Saint-Just, and Pipet in the middle, overlooking the theaters. A 1 km length on Mont Salomon still stands 4-5 m high and 2.5 m thick, built of quarry stones with gates of large blocks. In the 4th or late 3d c., after the invasion of 275, a second, much smaller wall was erected (1920 m), enclosing only the heart of the city—

Mont Pipet and the middle and upper parts of the deposit mound of the Gère, an area of 36 ha. It survives in four places and one can see the opus-mixtum, a mixture of quarry stones and brick. In the Middle Ages a third wall was built, which at first followed the same line, but later was enlarged to NE and SW.

Chief among the well-preserved major monuments is the Temple of Augustus and Livia in the city center, near the crossroads of the cardo and decumanus; it can be compared with the Maison Carrée at Nîmes. Dedicated first to Rome and Augustus in the emperor's lifetime, and then, under Claudius, to the Divine Augustus and Divine Livia, it later underwent another modification: the inscriptions, of which traces can be seen on the frieze and architrave (nail holes where the bronze letters were attached), are subject to debate. The dimensions of the temple (23.85 x 14.25 m) are nearly the same as those of the Maison Carrée. Hexastyle and partly peripteral, it has a flight of 12 steps, a pronaos with two intercolumniations and a cella against the rear wall.

Not far from the temple are the theater and odeum: Vienne and Lyon are the only cities in Gaul to possess two such theaters. The theater, discovered and restored between 1922 and 1938, is built against the W flank of Mont Pipet. With a diameter of 130.4 m and space for 13,500 spectators, it is the largest Gallic theater after that of Autun. The cavea has two maeniana and 46 tiers; the first maenianum is divided into four cunei by five flights of steps, the second into ten, with as many vomitoria. A portico around the top was reached by double stairways built against the outer wall. In the axis of the theater stood a temple (13.85 x 8.8 m) dedicated to Apollo (a tripod and capitals with serpentiform volutes are in the Musée Saint-Pierre). In the lower part of the cavea four low seats of white marble were separated from the rest by a balustrade of green cipollino. The orchestra was paved with yellow and pink marble slabs; it had two entrances 5.2 m wide to N and S, which served the cavea stairways and two foyers adjacent to the stage. The stage (72 x 5 m) has the customary three doors at the back. The pulpitum has seven semicircular and rectangular niches, and above them a frieze decorated with reliefs (satyrs' heads, lions, mastiffs, a bull, panthers, ibexes).

The theater can be dated from the Augustan period. Nearby, on a slight rise to the S and perpendicular to it is an odeum from the period of Hadrian, similar to that at Lyon but less well preserved. Excavated in 1960, it includes a cavea hollowed out of the hillside, its floor covered with a layer of masonry to receive the tiers. The orchestra was decorated with marble slabs which have disappeared, but their traces can be seen in the tile mortar covering the floor. The substructures of the stage building are still visible. In front is a pit for the curtain, worked by a mechanism of which some elements remain. Several pieces of decorative sculpture have been found, including fragments of the pulpitum frieze, an altar base ornamented with foliated scrolls and rams' heads, and the fragment of the bust of an emperor (young Nero?). The whole structure was 73 m in diameter and could accommodate 3000 people. A fragment of an inscription bearing ODE, marks the first appearance in Latin epigraphy of the word odeum.

Vienna had a third theater, part of a complex of buildings attributed to the cult of Magna Mater. Near the theaters, on the site of the old hospital, the following buildings have been excavated: first, a rectangular (15.9 x 10.6 m) temple with a flight of seven steps and a podium supporting the pronaos and cella. Apparently dating from Claudius' reign, it was then embellished with mosaics in the 2d c. and enlarged (18.5 x 10.6 m) in

the late 2d or early 3d c.; the mosaics were covered with three layers of stones and a layer of limestone slabs, making a new pavement for the raised podium. Adjacent to this temple is an underground room with pools (purification chamber?), then to the E three little rooms with hypocausts and a number of pools connected by piping systems. Next to the rooms with the hypocausts is a small building that may have been used for initiations. These rooms seem to have been linked by an underground passage to a building consisting of curved tiers enclosed by three long blind walls, and facing a stage built of large cut stones. Several inscriptions, reliefs, and carvings suggest a theater reserved for the mysteries of Cybele.

There was also a circus, located in 1903-7 on the banks of the Rhône S of the city. Built of masonry at the beginning of the 2d c. (455.2 x 118.4 m), it must have taken the place of a smaller monument made of wood. It was used until the end of the 4th c. and then disappeared, except for the pyramid known as L'Aiguille which adorned the center of the spina. The pyramid (23.35 m high) consists of a square base with an arch cut on each face, on which was built a pyramidal spire of 24 courses of cut stones. Apparently unfinished (some decoration on the base is merely rough-hewn), the monument dates from the time the circus was restored, after the invasion of 275.

Separated from the Kybele theater by a paved street is a monumental double arcade that goes back to the 2d c. Recent excavations indicate it should be related to baths.

The Capitolium may have stood on Mont Pipet. There are no traces of it, but in excavations ca. 1935 a castrum of the Late Empire was revealed: a rectangle (95 x 87 m) closed to the W by a semicircular wall that gives the complex the plan of a basilica. The entrance is to the E, through a semicircular arched doorway. Built of small quarry stones with bands of brick, it dates from the beginning of the 4th c. and was enclosed within the surrounding wall built in the Late Empire. In the same period the city must have had two palaces: a palatium, the residence and offices of the vicarius, and a praetorium for the provincial governor. Neither has been located.

The general plan of the streets and the orientation of the monuments changed in different periods. Beneath the temple in the Kybele quarter the 1st c. B.C. buildings are oriented obliquely to the temple axis, but from the reign of Claudius on the orientations are clearly N-S and E-W (modern streets frequently follow the ancient plan). The decumanus maximus ended at the bridge over the Rhône, the cardo maximus led to a narrow passage between the river and the Bâtie-Montsaléon hill N of the city. They crossed near the Temple of Augustus and Livia, in the forum. Many traces of the decumani and cardines have been found.

A number of houses of the classical type have been uncovered in different places, many of them with mosaic floors. Among the most recent discoveries is a house S of the underground room in the Kybele quarter, across a narrow street. A gold and jade necklace from the 2d c. was found in one of the rooms. A villa in the Place Saint-Pierre, excavated in 1967, contained frescos and mosaics, including the mosaic of the victorious athletes.

The city received water through a system of at least 10 aqueducts, five parallel to each other on the left bank of the Gère. All of them began in the region E of Vienne. Many remains have been located. The water-tower, where four of the aqueducts ended, was near Saint-André-le-Haut. The oldest date from the beginning of the 1st c., other more complicated ones from the 2d c. At least one,

dating from the first half of the 1st c., was erected, according to the inscriptions, by private enterprise.

The official city with its public buildings spread out on the left bank of the Rhône, but from the 1st c. on the chief residential section developed on the right bank, at the end of the bridge linking the two city centers. The bridge, built of cut stones, had five arches and was decorated with dolphins of gilded bronze (now in the municipal museum).

At least three complexes developed on the right bank: a residential quarter at Saint-Romain-en-Gal (see below), a port, and some baths. The port, with its docking basins and quays, was discovered in 1964-65 on the site of the modern Olympic swimming pool. Behind it to the W is the Palace of Mirrors, actually a complex of sumptuous bath buildings. (Among the works of art found there are a Nemesis-Tyche, the crouching Venus now in the Louvre, and a torso of Venus.) The buildings extended over an area more than 116 m long and 100 m wide; they included a large frigidarium with two pools, underground piping systems, and to the E a garden esplanade ending in two great semicircular apses. The other parts of the monument have not been excavated.

It is not known where the first Christian community had its meeting-place, but 10 Christian buildings from the Late Empire and Early Middle Ages have been located, only one of which is inside the 4th c. rampart. The earliest place of worship was perhaps in the Place Aristide-Briand, where two subterranean rooms have been discovered: one of them is square (4 x 4 m) and vaulted, and leads into another smaller room (3 x 3 m), also vaulted, with an apse to the S. The only church inside the city was that of the Sept Frères Macchabées, which at some time from the 4th c. on became the cathedral. A rectangular building (23 x 16 m) with three aisles and oriented E-W, it took the name of Saint-Maurice in the early 8th c.

Early churches outside the rampart include SS Gervais and Protais S of the city (5th c. on); around it lay a necropolis where ca. 100 tombs have been excavated. The church was destroyed in the 8th c. by the Saracens and never rebuilt. To the N lay Saint-Sévère (5th c.; some remains can be seen), and Notre-Dame-d'Outre-Gère, known from three inscriptions of the 5th-6th c.

The finds are housed in three museums. The small objects (pottery, bronzes, bones, and tools) are mainly in the municipal museum. The Musée Saint-Pierre, in the church of the same name, contains the mosaics and sculpture (statue of Nemesis-Tyche and the bronze statue said to be that of Pacatianus), the reliefs, and capitals. In the cloister of Saint-André-le-Bas are the later monuments and Christian inscriptions.

Saint-Romain-en-Gal. A residential quarter of Vienna on the right bank of the Rhône, excavated since 1967. Houses, workshops, and commercial buildings are grouped around three streets, one of which is a part of the route to Lugdunum. These three streets, one at right angles to the others, have been excavated along a 150-200 m length. The pavements of all three are intact (large polygonal blocks of granite), and each one has a portico on one side. A sidewalk of large slabs covers a deep drain designed to carry off excessive water from the soil. The sewers (1.7-2 m high) are vaulted and follow the street plan. At the crossing of the N-S and E-W roads is a semicircular nymphaeum, projecting into the street.

Twelve peristyle villas have been partially excavated. In some the atrium, which serves chiefly as a reception room, is raised to avoid the damp ground. The walls, which are very thick, are strengthened with relieving arches. Between two of the buildings, instead of party

walls there are walls separated by drainage pipes. The peristyles or garden-courts have three-lobed pools; the lobes are horseshoe-shaped, and the living rooms are on two sides only. The many fragments of marble and mosaics found there indicate that these were luxurious houses. Over 20 mosaics have been located in an area of almost 400 sq. m. Few sculptures have been found, but there are some capitals, Corinthian or decorated with aquatic foliage, statue fragments, and a stele to the god Sucellus.

Next to the houses are three commercial establishments. One is a small market, at least one of whose rooms was used to store goods that had to be kept dry (grain or salt). Its basement is filled with rows of earthenware jars placed necks down, tips up, so as to create a vacuum. Also on the W side of the quarter, but farther N, is an immense warehouse; its huge rooms open on a wide central avenue leading to a peristyle courtyard with two fountains and a U-shaped pool. This warehouse served as both a trading center and a meeting place for the guilds (attested at Vienne by inscriptions). On the other side of the N-S street is a market; its 12 rooms (workshops and shops) are arranged on either side of a central passageway opening on two streets.

Next to the market on the N and between the same two streets is an industrial establishment. Five large pools, exceptionally well preserved, two drying areas, and an extremely complex piping system, suggest that it is a fullonica—apparently, judging from its size, on an industrial scale.

The abundance and variety of the finds indicate great activity: weavers' counterweights, stamped lead pipes, engraved glasses, pottery of all sorts, appliquéd medallions, Allobrogian pottery, coins, and objects of iron, bronze, and bone.

Contrary to the accepted view that Vienna did not spread out on the right bank of the Rhône until the 2d c., these latest excavations show that this section and its street plan go back to the beginning of the 1st c. The 2d c., however, was the period of its greatest prosperity, and it lasted until the early 3d c. (no coins have been found later than Caracalla).

There is a temporary storehouse for the finds on the site.

BIBLIOGRAPHY. P. Schneyder, *Histoire des antiquités de la ville de Vienne en Dauphiné* (n.d.); id., *Nouvelles recherches* . . . (1785); H. Bazin, *Vienne et Lyon gallo-romains* (1891); A. Bruhl, "Vienna," *RE* ser. 2, 16 (1958) 2113-28; Grenier, *Manuel* III-IV (1958-60); G. Chapotat, *La croisée de Vienne* (1959); id., "Le problème des enceintes successives de Vienne depuis la conquête romaine jusqu'au Bas-Empire," *Celticum* 6, *Actes du 3e coll. intern. d'etudes gauloises*, suppl. *Ogam* 86 (1963) 307-22; M. Leglay & A. Bruhl, "Informations," *Gallia* (1960-70); A. Pelletier, "De la Vienne gauloise à la Vienne romaine: essai d'étude stratigraphique," *Cahiers Rhodaniens* 13 (1966) 144-54; id., *Vienne gallo-romaine de la conquête aux invasions alamanniques* (forthcoming); id., "Vienne gallo-romaine de 275 à 468 apr. J.C.," *Bull. des Amis de Vienne* (1973). Monuments: E. Bizot, *Découverte d'un cirque antique à Vienne (Isère)* (1910); J. Cottaz, "Notes relatives au castrum de Pipet," *Rhodania* (1935) 72-88; P. Wuilleumier et al., *Le cloître de Saint-André-le-Bas à Vienne* (1947); M. Faure, *Vienne, ses monuments chrétiens* (1948); J. Formigé, *Le théâtre romain de Vienne* (1950); E. Will, *La sculpture romaine au Musée lapidaire de Vienne* (1952); C. Picard, "Le théâtre des mystères de Cybèle-Attis à Vienne et les théâtres pour représentations sacrées à travers le monde méditerranéen," *CRAI* (1955)

229-48; A. France-Lanord, "La statue de bronze reconstituée dite de Pacatianus au musée de Vienne," *MonPiot* 51 (1960); A. Pelletier, *Vienne gallo-romaine de 275 à 468 après J.C. Etude critique des sources* (unpubl. 1967).

G. Lafaye, "Mosaïque de Saint-Romainen-Gal," *RA* (1892); M. Leglay & S. Tourrenc, *Saint-Romain-en-Gal, quartier urbain de Vienne gallo-romaine* (1970)[PI].

M. LEGLAY

VIENNA (Austria), *see* VINDOBONA *and* LIMES PANNONIAE

VIENNE, *see* VIENNA (France)

VIENNE EN VAL and NEUVY EN SULLIAS Loiret, France. Map 23. Vienne en Val is a village ca. 20 km SE of Orléans and 7 km S of Jargeau, on Route Nationale 751; this road is built over an ancient route that followed the Loire, on the edge of the frequently flooded Val region and the Sologne.

The foundations of a Merovingian church were discovered in 1968 on the Place de l'Eglise. This church had been replaced in the 13th c. by another, slightly farther N, which was torn down in the early 20th c. after the present church, E of the Merovingian sanctuary, was built. The Merovingian foundations were largely composed of reused blocks from a Gallo-Roman monument, many of them carved in the round or in relief. The most important of those carved in the round are:

1) A headless statue of Jupiter on horseback, borne by a recumbent giant. The god's accouterments include a cylindrical cuirass, similar to a Greek type of cuirass, and a short cloak that forms a square on the back and falls on the chest in two rectangular panels; the horse's harness is like that of the horse ridden by C. Romanius, whose funerary stela (in the Strasbourg museum) dates from the period of Claudius or Nero. The statue must have been carved around the middle of the 1st c. A.D.

Also recovered were the shaft of a column, covered with scales, and a Corinthian capital that probably crowned it, but the capital is too small to have supported the group. Since another fragment, the hindquarters of a horse on a larger scale, has been preserved, there must have been at least three statues of this type in the sanctuary.

2) The statue of a male lion, without a mane, sitting on its hindlegs and holding in its mouth a small human figure. This is the largest representation of a man-eating monster discovered in Gaul. In attitude it resembles the Etruscan lions with which the type originated, and it may be dated from the 1st c. A.D.

3) Fragments of several statues of Minerva.

4) A headless female torso, probably Gallia, clothed in a tunic that leaves one breast bare, and wearing a torque.

Among the bas-reliefs is a rectangular block carved on four sides, probably the base of a Jupiter column. The front of the block has a carving of Jupiter striking down a giant, above an inscription. The same text appears in slightly different order on the opposite side beneath a front-view image of Mars, naked, with helmet and spear. The right side shows Venus standing, naked, with Eros beside her. Paired with her is Vulcan, his foot on a ship's prow. To judge from style and epigraphy, the monument may be dated from the third quarter of the 2d c.

There are also two altars, carved on four sides but without epigraphs. On the first one are Mars, Vulcan, Virtus (represented as an Amazon, after a statue in the

Capitoline Museum sometimes attributed to Phidias and sometimes to Kresilas), and a goddess with a cornucopia, probably Fortuna; the second shows Apollo, Hercules, Minerva, and Sirona. These two altars may be dated from the period of the last Severi.

Another altar, now in several fragments, had Jupiter on one side, a goddess, probably Juno, sitting beside an altar on another, and an eagle on another. It may be dated from the last Antonines. An elongated base, larger in proportion, was made of at least four blocks, only one of which has been recovered. Hercules, Minerva, and Mercury can be made out on the lower section.

Another elongated base showed putti hunting birds, after a Neo-Attic model. Various emblems of the Gallo-Roman Apollo are included: the tree, spring, birds, snake, etc. The carving may have been executed in the first half of the 2d c.

Also noteworthy are a block representing a putto sitting at the top of a ladder, with a dedication to Sulevia, a Celtic goddess of springs comparable to Minerva; a stela showing an armed goddess, not Minerva; and another stela representing a bull. All these sculptures probably came from a large sanctuary consecrated primarily to Jupiter Taranis: the majority of the gods of the Gallo-Roman pantheon are subordinate to him, grouped according to their functions. First come the gods of war—Mars, Vulcan, Venus, Virtus, and Fortuna. A similar grouping can be seen on the pillar of the Eglise St. Landry in Paris; it is borrowed from Roman religion and may possibly derive from a monument dedicated by Caesar. The gods dispensing riches and fertility include Apollo, Minerva, Hercules, Sirona, and Mercury, who is relegated to a secondary role.

The most important clue as to the organization of the sanctuary is in the dedication by Perpetuus and Maternus, which mentions a curia Ludn. Unfortunately this institution remains a mystery. It seems unlikely that it refers to a municipal curia; more acceptable is the suggestion that in Gaul curia might sometimes be equivalent to pagus. Another curia, probably of the same type, appears in a dedication engraved on the base of a bronze statue of a horse found at Neuvy en Sullias in 1861, in a cache containing a rich collection of bronze ex-votos.

Neuvy en Sullias lies ca. 20 km E of Vienne en Val, on the same road following the Loire. The question arises whether the treasure found there, valuable and worthless objects piled together, was not removed from the Vienne en Val sanctuary to a safe place when the building was destroyed.

There are good reasons to suppose that in the region of these two sites stood the federal sanctuary where the annual convocation of the Druids was held. In any event, Vienne en Val is the most important of the extra-urban Gallo-Roman sanctuaries and of the whole territory of the Carnutes.

BIBLIOGRAPHY. C. Jullian, *Histoire de la Gaule* (1908-26) II, 97-98; Neuvy en Sullias: A. Grenier, *Manuel d'archéologie gallo-romaine* IV, 2 (1960) Villes d'eaux et sanctuaires, 727-30; Vienne en Val: J. Debal, *Rev. Arch. du Centre* 7 (1969) 211-20; G. Ch. Picard, ibid. 195-210; id., "Le Sanctuaire Gallo-Romain de Vienne en Val," *CRAI* (1970) 176-91. G. C. PICARD

VIEUX, *see* AREGENUA

VIEUX POITIERS, *see* VETUS PICTAVIS

VIGO ("Vicus Spacarum") Pontevedra, Spain. Map 19. City on the Atlantic coast of Galicia. A Celtic camp located here was replaced by a Roman town, probably the Vicus Spacorum of the *Antonine Itinerary*. Finds include 20 funeral stelai, the work of local Romanized artists. They bear symbolic reliefs and inscriptions (discs, radiated circles, stars), and one of them is an altar to Mercury.

BIBLIOGRAPHY. J. M. Alvarez Blázquez & F. Bauza Brey. "Inscripciones romanas de Vigo," *Cuadernos de Estudios Gallegos* 16:48 (1961) 5-42[I]; D. Julia, *Etude épigraphique et iconographique des stèles funéraires de Vigo* (1971). R. TEJA

VIKTOROVKA I Ukraine. Map 5. A Hellenized settlement dating from ca. 550 to the early 3d c. B.C. on the steep W bank of the Sositsko-Berezan liman ca. 1.6 km N of its junction with the Black Sea. While a large part of the site was destroyed by erosion, excavations have uncovered the remains of several dwellings, various pits, walls, assorted pottery sherds (Olbian ware, Greek imports, local hand-made), and even a bronze harpoon. The earlier dwellings, as in Berezan and other nearby sites, were semisubterranean. These gave way, in time, to surface structures with stone walls.

BIBLIOGRAPHY. S. A. Kaposhina, "Iz istorii grecheskoi kolonizatsii nizhnego Pobuzh'ia," *Ol'viia i Nizhnee Pobuzh'e v antichnuiu epokhu* [Materialy i issledovaniia po arkheologii SSSR, No. 50] (1956) 239-54; F. Rudyk, "Drevnee poselenie Viktorovka I," *Materialy po arkheologii Severnogo Prichernomor'ia* 1 (1957) 63-66.
 T. S. NOONAN

VILLACH, *see* SANTICUM

VILLALIS León, Spain. Map 19. Site 57 km SW of León where six Roman tablets were found. Reliefs and inscriptions disclosed the date of the creation of the Legio VII Gemina (III idus iunias of A.D. 68) and gave information on the auxiliary units and the names of officers of the legion.

BIBLIOGRAPHY. A. García y Bellido, "Las lápidas de Villalís," *ArchEspArq* 39 (1966)[I]. R. TEJA

VILLANUEVA DE LA FUENTE, *see* MENTESA ORETANORUM

VILLARDS D'HÉRIA Jura, France. Map 23. A large group of ruins was explored at the end of the 17th c. in the incorrect belief that it was the ancient town of Aventicum.

At the highest point on the site, near lake Antre, a sanctuary has been identified by dedicatory inscriptions to Mars and to Bellona; it contained a rectangular temple, a round or oval one, and other buildings.

Lower down the Héria brook, formed in part by the lake's water via an underground passage, is straddled by the Pont des Arches, built of large blocks. It consists of two parallel galleries covered with flat slabs and it supported a building that was presumably a temple. There are large structures on both sides of the stream. On the right bank the 17th c. excavations uncovered baths and other remains, perhaps those of a theater.

Excavations on the left bank since 1961 have unearthed a large ensemble. East of the bridge is a square paved with slabs, with a well-built catchment basin in the middle, and a stairway like that of the so-called temple. Farther S, a gallery with two perpendicular arms frames another square. The gallery is decorated with frescos and contained a bronze statue of C. Licinius Campanus, priest of the Three Gauls, which was dedicated by the Sequani. Finally, there is a bath bordered to the E by a gallery with exedrae and divided into two parts, each including a cold pool built of large blocks, a hypocaust, and various associated structures.

BIBLIOGRAPHY. L. Lerat, "La 'ville d'Antre.' Mythes et réalités," *Annales Littéraires de l'Université de Besançon* 19 (1965); "Informations," *Gallia* 18 (1960) 256-60; 20 (1962) 528-39; 22 (1964) 407-10; 24 (1966) 365-70; 26 (1968) 453-65.
L. LERAT

VIMINACIUM (Kostolac) Yugoslavia. Map 12. An important Roman city on the Danubian frontier to the E of Singidunum (Belgrade). It is on the right bank of the Mlava river, a subsidiary channel of the Danube, 12 km N of Požarevac.

A castrum was built at the site in the early 1st c. and it served as the headquarters for the emperor Trajan during the first Dacian war. It became Municipium Aelium under Hadrian (117-38) and Colonia Viminacium during the reign of Gordian III (238-44). Legio IV Flavia and Legio VII Claudia were stationed at Viminacium and it served as the Danubian fleet base before Singidunum.

The city minted coins during the 3d c., from 239. It was destroyed by Attila and the Huns in 441, was restored under Justinian, and was lost to the Slavs in the late 6th c.

Excavations have revealed the walls of the original castrum, which enclosed a large rectangle (ca. 443 x 386 m). The excavations also revealed sections of paved streets and part of the drainage system, wells, and the foundations of various dwellings, including one with a hypocaust. A necropolis of the 2d to 3d c., including some chamber tombs, was excavated. Artifacts from the excavations are in the museum in Požarevac.

BIBLIOGRAPHY. M. & D. Garašanin, *Arheološka nalazišta u Serbiji* (1951); M. Mirković, *Rimski Gradovi na Dunavu u Gornjoj Meziji* (1968); Dj. Orlov, *Viminacium* (1970).
J. WISEMAN

"VINDALIUM," *see* VEDÈNE

VINDINUM, *see* SUBDINUM

VINDOBALA, *see* HADRIAN'S WALL

VINDOBONA (Vienna) Austria. Map 20. The name is Celtic and its meaning uncertain. Possibly it was taken over from a Celtic settlement on the Leopoldsberg. The name occurs for the first time in Ptolemy (*Geog.* 2.14.3), in the *Peutinger Table* (5.1, where it is misspelled as Vindomana), twice in the *Notitia dignitatum* (34.25;28), and also in the reports on the death of Marcus Aurelius (Aur. Vict. *Caes.* 16.14; *Epit. de Caes.* 16.12). Vindobona was on the Danube and the limes road, at the E edge of the Wiener Wald, i.e. the E Alps. At the termination of the W branch of the Amber road, it belonged in Roman times to the province of Pannonia Superior, near the Noricum-Pannonia border. Owing to its location, Vindobona controlled the Vienna basin and the Marchfeld. At the same time it provided, as a military base, effective flank protection for the legionary camp Carnuntum (40 km downstream) in case of an outflanking maneuver from the W. The Vindobona area had been fortified relatively early, probably in the first half of the 1st c. A.D. Possibly a castellum for cavalry had existed here since the time of Domitian (Ala I milliaria Britannica). The legionary camp was not constructed until about A.D. 100 by the Thirteenth Legion. This unit was replaced by the Fourteenth Legion, which continued the construction work. From A.D. 115 until the end of Roman rule the Tenth Legion was stationed here. Vindobona suffered during the wars with the Marcomanni, as indicated by traces of destruction and reconstruction. It may have been at Vindobona that Marcus Aurelius died in A.D. 180. Otherwise it was little known, overshadowed by Carnun-

tum, the more important fortification on the Danube. Correspondingly, as indicated by finds, the standard of living was more modest. It is uncertain when Vindobona became a municipium; this elevation seems to have taken place at the beginning of the 3d c. A.D.

Our knowledge of Vindobona is very fragmentary since it is impossible to conduct systematic and extensive excavations. The plan of the camp is still partly recognizable in the modern street plan. It was located on the plateau of the Hohe Markt, and protected on the N from the Danube by a dike (12-15 m high). It was similarly protected on the W and E by steep dikes and was surrounded on all sides by flowing water. Of the circumference the porta principalis sinistra is known, also the porta decumana, three intermediate towers, and parts of the wall (2-3 m thick) with a trench. A simple gate without towers led to the military harbor at the N. Hardly a building in the interior can be identified, although the general plan is basically recognizable. The area was divided by the via principalis, ca. 20 m wide, lined on both sides by porticos, the via praetoria, and the via decumana. Also known are the location of the principia at the S side of the main camp road, the so-called palace of the legate nearby, military barracks on both sides of the via decumana, N of the main road six houses for tribunes, the camp's hospital (valetudinarium), and the legionary baths. In general, two building periods can be ascertained: the camp was rebuilt after destruction around the end of the 4th c. A.D. Repairs were made for the last time under Valentinian. Extensive necropoleis are found along all the roads leading out; nearby to the W were probably the canabae, farther on the legionary brick works. The civilian town was located SE of the camp, its confines marked by the Wienfluss, today's Danube canal, and the arsenal. Its center may have been at the Aspang railway station where the forum is also supposed to have been. It is, however, impossible to gain an over-all understanding of the site despite the numerous finds. No amphitheater has been found, but an aqueduct coming from the Wiener Wald has been identified.

The end of Vindobona came with the collapse of Roman rule in Pannonia in the 5th c. A.D. Shortly before its decline, the Danube fleet stationed at Carnuntum was transferred to Vindobona. A small residual town survived; the mediaeval town grew out of the Roman camp, not the civilian town.

Finds from Vindobona are in the Historisches Museum der Stadt Wien and in the Kunsthistorisches Museum; preserved fragments of buildings are in the Römische Ruinenstätte auf dem Hohen Markt, and in the Feuerwehrzentrale Am Hof.

BIBLIOGRAPHY. A. Neumann, "Vindobona," *RE* IX A 1 (1961) 53ff[MP]; id., *Der Raum von Wien in ur- und frühgeschichtlicher Zeit* (1961)[MPI]; id., *Vindobona, Die römische Vergangenheit Wiens* (1972)[MPI].
R. NOLL

"VINDOBRIGA," *see* VENDEUVRE DU POITOU

VINDOCLADIA (Badbury Rings) Dorset, England. Map 24. Although only 90 m high, this little hill-fort occupies an important vantage-point. The roughly egg-shaped enclosure, which has not been excavated, has two lines of defense surrounded by a slighter rampart and ditch, with two narrow entrances at the ends. At the crossing of two Roman roads immediately W of the fort lay the Roman posting-station of Vindocladia. Beside the road which leads towards Dorchester (Durnovaria) lie three mounds which are probably funerary monuments of Roman date.

BIBLIOGRAPHY. O.G.S. Crawford & A. Keiller, *Wessex from the Air* (1928).
M. TODD

VINDOLANDA, *see* HADRIAN'S WALL

"VINDOMAGUS," *see* SOMMIÈRES

VINDOMORA (Ebchester) Durham, England. Map 24. Site of Roman fort of ca. 1.2 ha, on Dere Street overlooking the bridge over the river Derwent, 16 km SE of Corstopitum (NZ 104555). It was occupied from the Flavian period to the end of the 4th c. (not necessarily continuously), and the original clay rampart was reinforced by a stone wall, probably under Hadrian. Traces of a late barrack block have been found in the W corner, and of a bath house in the E one. The garrison in the 3d c. was Cohors IV Breucorum (*RIB* 1101).

BIBLIOGRAPHY. E. Birley, *Trans. Archit. and Archaeol. Soc. of Durham and Northumberland* 11 (1958) 57; M. G. Jarrett, *Arch. Ael.* 38 (1960) 193-229; A. Reed, ibid. 42 (1964) 173-85; id., *JRS* 55 (1965) 203; B. Dobson, *Trans. Archit. and Archaeol. Soc. of Durham and Northumberland* NS 2 (1970) 38. J. C. MANN

VINDONISSA (Windisch) Aargau, Switzerland. Map 20. Roman legionary camp and vicus just E of Brugg, at the confluence of the Aare, the Reuss, and the Limmat. The site, at the foot of a pass over the Jura, also dominated access to the Rhine 15 km to the N, and was thus a strategic crossroads. Three roads met here: the highway on the left bank of the Rhine via Augusta Raurica to Lake Constance, the road from the Rhone valley via Genava to Tenedo and the Danube, and that via Aquae Helveticae, Turicum, and Curia to Italy. When the Rhine was the frontier of the Empire, before A.D. 75 and again after 260, Vindonissa was vital in the communications system between the armies on the Rhine and the Danube. It also guarded that part of the Rhine frontier made vulnerable by the sharp bend of the river at Basel.

A fort was built here when the Rhine became a defense line under Tiberius, and the legionary camp at Oberhausen-Augsburg in Vindelicia was abandoned, probably ca. A.D. 16-17. It is possible that a small fort had existed since early Augustan times, but this is attested only by small finds. From A.D. 16 to 45-46 Vindonissa was occupied by the Legio XIII Gemina from Oberhausen; from 46 to 69 by the Legio XXI Rapax and two auxiliary cohorts, first the III Hispanorum and VI Raetorum, later the VII Raetorum equitata and the XXVI voluntariorum civium Romanorum. In A.D. 70 Vespasian, after defeating the adherents of Vitellius (Tac., *Hist.* 1.67-69), sent the Legio XI Claudia pia fidelis as the new garrison from Burnum in Dalmatia.

When the frontier was transferred from the Rhine to the Upper German Limes, Vindonissa lost its strategic importance. The legion probably left in 101, but the base continued to be manned by a detachment of Legio VIII in Argentorate. After A.D. 150 it apparently became part of the vicus Vindonissensium (*CIL* XIII, 5195, 5194 = Howald-Meyer nos. 265-266), but a statio of beneficiarii remained to guard the roads and bridges. About 260 it was refortified (*CIL* XIII, 5203 = Howald-Meyer no. 294) to an unknown extent, and occupied by troops ca. 260-70. Numismatic evidence indicates occupation throughout the 4th c. A smaller fortress was built on the spur between the Aare and the Reuss, just W of the legionary fort. An inscription mentions Valentinian I (*CIL* XIII, 5205).

This Castrum Vindonissense (*Not. Gall.* 9.5) is mentioned in the early 5th c. as the seat of a suffragan bishop, and bishops are attested in the 6th and 9th c. After the departure of the garrison, probably in A.D. 401,

the vicus continued to flourish. Cemeteries of the Early Middle Ages have been found.

A ditch (20 m wide), going back to the Celtic oppidum indicated by the name Vindonissa, has been identified. It barred off the spur E of the site of the Roman fortress. The legionary camp was oriented to the S. Its irregular shape, with seven corners, arose partly from the terrain (area 221.7 ha). Inside it the principia were not in the center at the crossing of the main roads, but at the angle between them. The via decumana and via principalis (4 and 6 m wide without the porticos) ran straight through from gate to gate, crossing at right angles. There were three building periods. The two earlier ones (A.D. 14 to 25-30; 25-30 to 45, Legio XIII) had wooden structures, but in the third and main period (A.D. 45-69, Legio XXI) the camp was rebuilt in stone with some additions and alterations. In periods 1 and 2 the walls and gates were earth and timber, and in period 2 the fort was enlarged on the N.

In the stone fortress of the third period three main gates have been explored. The N and S gates (porta praetoria) were almost identical (3 and 3.5 m wide) and there were two towers (7 x 6.3 m); the W gate dates from the late 2d c. The walls were 3.5 m thick, and carried six towers of various types. Along the S and W walls ran double ditches (berm 1.3 m; ditches 7.8 and 4.8 m wide); the other sides were partly protected by the steep slopes. Among the buildings identified are the principia, baths, a hospital(?), an arsenal, a granary, two more storehouses, and the scant remains of what was probably a first period praetorium and sanctuary.

The rectangular principia (190 x 150 m), dated by building inscriptions to A.D. 47, consists of two open courts divided by a wall. The courts are surrounded on three sides by rows of small rooms (double row in the back), comprising the armories and a shrine. On the fourth side, across the via principalis, which was spanned by two monumental archways, was a basilica (95 x 20 m) with an apsidal tribune at each end. The baths (70 x 44 m) had frigidarium, tepidarium, and caldarium side by side on the long axis, with dressing-rooms on both sides of the cold baths and two sweating-rooms between the warm and the hot baths. The baths were decorated with wall paintings and floor mosaics (geometric, black and white). A granary (33.8 x 10.8 m) lay E of the N gate, with two rows of six pillars; farther E was an arsenal (41 x 33 m) with portico, vestibule, two lateral wings for carts, and a freestanding cella surrounded by pillars. The hospital (70 x 63.8 m) consisted of two concentric series of small identical chambers around a rectangular court. The praetorium of period 3, not certainly identified, was perhaps located, like the earlier one, in the corner W of the via decumana and N of the via principalis, opposite the principia.

The barracks were mostly oriented N-S, parallel to the decumanus, and comprised 10-12 contubernia. Four of the six houses of the military tribunes have been excavated, and two more identified on the via principalis sinistra. They vary in size (40 x 32 m, 49 x 39 m), and have open inner courts (12 x 7; 5.25 x 22 m) surrounded by porticos. The reduced function of the fort after A.D. 75 is reflected in the addition of a basilica to the baths, the reduction of the principia to smaller size, and the demolition of some barracks in order to build a large storehouse (81 x 43 m). After A.D. 150, when civilians took over the fort, the principia and baths were torn down, and some buildings remodeled for private use.

To the 3d c. fortifications (ca. 260) belong the stone walls and towers, and the monumental W gate flanked by polygonal towers (overall width 28.4 m). The gate-

way proper had a concave facade and three passageways (1.5; 6; 1.5 m). Inside the fort some barracks and possibly a new praetorium built on the axis of the 1st c. principia, have been investigated.

The 4th c. fort had three concentric ditches (8 m wide) in the area of the 1st c. E wall, barring off the tip of the spur between the Aare and the Reuss. The topographical distinction between the vicus and canabae is not clear as yet. The former was W of the legionary camp, the latter surrounding it to the S and E. Buildings outside of but connected with the 1st c. fort include an amphitheater (112 x 98 m; arena 64 x 51 m) with stone retaining walls and earth and timber seating arrangements; a forum (138 x 122 m) with a rectangular court surrounded on at least three sides by rows of small rooms; an aqueduct, partly subterranean, which comes from Birrfeld and is still functioning. The military cemeteries lay along the main roads, SW to Aventicum and NW to Augusta Raurica and Tenedo.

The dump at Vindonissa on the slope outside the N wall (ca. 200 x 16 m, 15 m deep), used A.D. 30-100 by the legionary camp, has produced remarkably well-preserved organic material such as wood, leather, ink, and plants. The Vindonissamuseum is in Brugg.

BIBLIOGRAPHY. R. Laur-Belart, "Vindonissa, Lager und Vicus," *Römisch-Germanische Forschungen* 10 (1935)MPI with bibl.; E. Ettlinger, *RE* IX A (1961) 82-105; H. R. Wiedemer, "Der Stand der Erforschung des römischen Legionslagers Vindonissa," *Jb. Schweiz. Gesell. f. Urgeschichte* 53 (1966-67) 63-77MPI; C. M. Wells, *The German Policy of Augustus* (1972) 49-53; museum: C. Simonett, *Führer durch das Vindonissamuseum* (1947); reports & summaries: *AnzSchweiz; ZSchwAKg; Jber. Gesell. Pro Vindonissa* (1942-); *Jb. Schweiz. Gesell. f. Urgeschichte* passim & bibl. 54 (1968-69) 85-86; 56 (1971) 231; 57 (1972-73) 345; *Veröffentlichungen der Gesellschaft Pro Vindonissa* 1-7 (1942-70).

V. VON GONZENBACH

VINKOVCI, *see* CIBALAE

VINOVIA (Binchester) Durham, England. Map 24. Site of Roman fort 1.6 km N of Bishop Auckland, on Dere Street 34 km N of Cataractonium (NZ 208314). The fort may have been over 2.4 ha in size, and was occupied from the Flavian period probably to the early 5th c. The original clay ramparts were reinforced with a stone wall, probably in the 2d c. A catapult platform of early 4th c. date was found abutting the wall on the SE side. A hypocaust still visible on the site may have formed part of the commander's house. The 3d c. garrison was the ala Vettonum (*RIB* 730, 1028, 1035) and probably in the 4th c. a unit of Frisians (*RIB* 1036), perhaps equites catafractarii. Industrial activity is attested in the large extramural village.

BIBLIOGRAPHY. R. E. Hooppell, *Vinovia, a Buried Roman City* (1891); E. Birley, *Trans. Archit. and Archaeol. Soc. of Durham and Northumberland* 11 (1958) 56; B. Dobson & M. G. Jarrett, ibid. 115-24.

J. C. MANN

VIONNOS, *see* KERAME

VIPASCA (Aljustrel) Alentejo, Portugal. Map 19. A village near Beja which exploited copper, gold, and silver mines. A structure which served perhaps as the administrative center has been partially uncovered, E of the mine. A necropolis, however, has been completely explored.

The political disturbances of A.D. 260-270 seem to have reduced mining activity. In the shafts (square or circular, ca. 1 m in diameter or on a side) and in the

galleries (1 m wide, max. ht. 1.2 m) were found baskets for carrying the ore, reels, winches, pulleys, spoons, and gutters made of oak. One gallery, 750 m long and 60 m deep, 20 m below the water level, apparently served as a drainage channel. Since the Roman works went down to 120 m, there must have been some method of raising the water from the lower levels up to this channel or gallery. In the slag were found two bronze tablets: the first contains the measures in effect for the local mining district (metallum vipascense); the second, passages of the laws referring to the Roman mines. The finds have been distributed among the museums of Aljustrel and Beja, and the National Museum of Archaeology and the Geological Service in Lisbon.

BIBLIOGRAPHY. A. & J. Alarcão, "O espólio da necrópole luso-romana de Valdoca (Aljustrel)," *Conimbriga* 5 (1966) 7-104P; R. Freire d'Andrade, "A lavra romana das minas de Algares e na herdade de Montinho," *Actas e Memórias de I Congresso Nacional de Arqueologia, Lisboa* 2 (1970) 273-85; C. Domèrgue & R. Freire d'Andrade, "Sondages 1967 et 1969 à Aljustrel," *Conimbriga* 9 (1971) 99-116MPI.

J. ALARCÃO

VIRAN EPISKOPI Mylopotamou, Crete. Map 11. Six km W of Perama, remains of a Hellenistic and Roman settlement, with Minoan remains to the E. Below the modern church are the remains of a Hellenistic hieron, and on the summit of the hill on which the site stands is a large rectangular building with several rooms of probable Roman date. Traces of house walls are found on the slopes of the hill, and the site may have extended onto the level ground to the S.

BIBLIOGRAPHY. M.S.F. Hood, P. M. Warren, & G. Cadogan, "Travels in Crete, 1962," *BSA* 59 (1964) 59-60.

K. BRANIGAN

VIROBESCA (Briviesca) Burgos, Spain. Map 19. About 40 km NE of Burgos. The most important community of the Autrigones, mentioned by Pliny (*HN* 3.27) and by Ptolemy (2.677.52.64). A magnificent Early Christian sarcophagus was found here, with biblical scenes on one face and the martyrdom of Santa Perpetua on the other. It dates from about the middle of the 4th c. and is now in the Burgos museum.

BIBLIOGRAPHY. H. Schlunk, "Zu den frühchristlichen Sarkophagen aus der Bureba (Burgos)," *MadrMitt* 6 (1965) 139-66MIP.

J. ARCE

VIROCONIUM CORNOVIORUM (Wroxeter) Shropshire, England. Map 24. Roman site on the Severn, dominated by the Wrekin hill 3 km away. On the crest of the hill is the Iron Age fortress of the local chieftains, and a large Roman fort and several marching camps lie near its foot.

Apart from the conquest of the local Cornovii, the Roman army was mainly concerned in the mid 1st c. with the tribes of Wales under Caratacus, and later with the reduction of the whole of Wales. Wroxeter was strategically situated for this purpose, at the point where the Severn emerges from the Welsh foothills. The earliest occupation was probably ca. A.D. 50 under Ostorius Scapula; a little later Legio XIV was moved here, and remained until replaced in 69 by Legio XX from Gloucester. Tombstones from the military cemetery to the N, identifying both legions, are now in Rowley House Museum, Shrewsbury, with other material from Viroconium.

Aerial surveys have shown a number of military sites in the area including large march camps and large and small permanent forts. Excavations in the baths insula have uncovered military structures of several phases: evidently successive legionary fortresses lie buried under the

later city. The army remained until ca. 90, although Legio XX had moved to a new base at Inchtuthil in Scotland. This fortress was never finished and apparently part of the Wroxeter unit, perhaps the administrative staff, did not move. But Wroxeter had now ceased to have much strategical significance; and the Viroconium site passed into civil hands and became one of the largest and most prosperous cities of Roman Britain.

Below the forum, a bath of a large and elaborate type was discovered, built at the end of the 1st c. when the town was first laid out, but it was never completed. In ca. 120 a forum was erected. This has been precisely dated by the finely cut inscription found in scattered fragments: the building was dedicated in A.D. 129, in the reign of the emperor Hadrian and under the auspices of the Civitas Cornovii. The forum was a large open market, surrounded by shops and a great aisled basilica for public assemblies and the law court. Attached to the rear were the administrative offices. Excavations in 1923 below the forum uncovered the 1st c. bath already mentioned.

In 1912-14 excavations on the W side of the main N-S road S of the forum disclosed simple rectangular shops of the early 2d c., which had been replaced after a fire ca. 155 by more substantial and complicated structures. These included a temple, which may have had a priests' house and a sacred enclosure at the rear. Outside the forum stood the bath, and beneath it an earlier and unfinished building of uncertain purpose. The bath was not finished until the second half of the 2d c.; by the early 3d c. an additional suite was added, and the original piscina no longer used. Early in the 4th c. use of the baths ceased. Aerial reconnaissance has recovered an almost complete street plan, and has identified houses and temples.

The end of Viroconium is puzzling. At one time it was thought that the Saxons took the city by storm and burnt it to the ground (skeletons found in the bath were cited as evidence), but excavation has produced no destruction layer. A tombstone found in 1967 in ploughing bears an inscription to Cunorix. The use of the word *macvs* for "son of" is an Irish form and dates the stone to the late 5th c. or later. Probably the man was an Irish mercenary employed by the citizens to protect them from wandering bands of brigands. At some time in the 6th or 7th c., however, the town was abandoned by all but a small community.

BIBLIOGRAPHY. Summary to 1908: *VCH Shropshire* 1 (1908); "The Cornovii," *Culture and Environment* (1963) 251-62; excavations: T. Wright, *Uriconium* (1872); *Soc. Antiquaries Research Reports* (1913, 1914, 1916); forum: *Excavations at Wroxeter 1923-27*, (1942); bath house: *ArchJ* 54 (1897) 123-73; *Archaeologia* 88 (1940) 175-228; *AntJ* 46 (1966) 229-39; town defenses: *Trans. Birmingham Arch. Soc.* 78 (1962) 27-39; town plan: *Trans. Shropshire Arch. Soc.* 57 (1962-63) 112-31; aqueduct: ibid. 56 (1959) 133-37; Cunorix stone: *AntJ* 48 (1968) 296-300. G. WEBSTER

VIROVIACUM (Wervik) Belgium. Map 21. A vicus on the road from Turnacum (Tournai) to Castellum Menapiorum (Cassel), mentioned in the *Antonine Itinerary* (376) and the *Peutinger Table* (which gives the form Virovino). The identification with Wervik was essentially based on toponymy, but for a long time remained uncertain because the two documents gave contradictory distances; excavations conducted in 1950 confirmed it. These excavations cut through the Tournai-Cassel road (7 m wide at that point) and uncovered an important archaeological level with remains of wooden buildings, dumps, a potter's kiln, traces of ironworks (with a smelting furnace), and a well. The upper part of the well was a masonry drum with large ashlars; the lower part consisted of a square wooden lining. Study of the pottery indicates that the vicus was occupied from the middle of the 1st c. A.D. until about the middle of the 3d. Probably the center was sacked during one of the barbarian invasions of the second half of the 3d c. There is no proof that the site was reoccupied during the 4th c.

BIBLIOGRAPHY. M. Bauwens-Lesenne, *Bibliografisch repertorium der oudheidkundige vondsten in Westvlaanderen* (1963) 128-31; H. Goeminne, "Opgravingen in de Romeinse Vicus te Wervik," *Arch.Belgica* 117 (1970)MPI. S. J. DE LAET

VIRUNUM Austria. Map 20. Situated NE of Klagenfurt, on the Zollfeld, near the town by the same name on the E flood-free terraces of the Glan valley. It was a favorable location; from the S came the road from Aquileia which itself was of great importance for the cultural and economic development of the E Alpine area. From Virunum two important roads went N to the Danube frontier. Finally, there was an E-W road from Virunum in the Drau valley to the W via Teurnia and Aguntum to the Brenner road (Via Claudia Augusta), and in the E to Celeia which in turn connected to the military road Aquileia-Carnuntum. Therefore Virunum is mentioned both in the *Antonine Itinerary* (276.5) and in the *Peutinger Table* (5.2). The place name is evidently Celtic but not connected with the location since no preceding settlement has been found. Rather, Virunum was a new settlement which, after the occupation phase, took the place of the town on the Magdalensberg, the former political, economic, and religious center of Noricum. As Pliny (*HN* 3.146) indicates, Virunum belonged, with Celeia, Teurnia, Aguntum, and Iuvavum, to the first series of new towns in Noricum and was constituted as municipium Claudium Virunum about A.D. 50. It never was a colonia, but became the seat of the imperial provincial administration of Noricum, at first with a procurator as governor. This accounts for the numerous municipal and provincial functionaries known through their monuments; it also explains the high cultural level of the town, which surpassed all other municipia of Noricum. When legionary troops during the wars with the Marcomanni were transferred to Noricum, the commander of the legion became the governor with the title legatus Augusti pro praetore and had his seat of government in Ovilava. During the administrative reforms under Diocletian, Virunum became the capital of the new province of Noricum mediterraneum, seat of the civilian governor (praeses).

Nothing further is known about the history of the town from ancient literature. Until the wars against the Marcomanni, Virunum evidently developed quietly, had no garrison, and had never been fortified. During the reign of Gallienus it must have suffered from invasions. This is evidenced by archaeological research, which unfortunately has been discontinued.

The town plan indicates that the town was developed according to a Graeco-Roman architectural plan. Its main feature is two axes at right angles with roads (up to 14.5 m wide) crossing at right angles to form rectangular insulae extending as far as the sloping terraced terrain permitted. The spiritual center of the town, the capitol and the forum, which formed an architectural unit, were not located in the geometric center, but toward the E. The capitol was situated N, the forum S of the assumed cardo. The over-all size was ca. 204 x 95 m. The temple area was located on an artificially created terrace, surrounded on three sides by walls; access was from the forum. In the middle rose a large podium temple in antis. The three

niches inside suggest the veneration of the Capitoline triad. To the W of the temple area the base for a large monument was found. The forum was a large rectangular structure (ca. 120 x 95.5 m), opening on the capitol. A paved inner courtyard was framed on the long sides by peristyles behind which a series of large rooms of different sizes was located. The side of entrance was the narrow S side with its three gates. Toward the square the full width was occupied by a long hall with apsidal niches, probably a basilica with one nave. On the outside were four more rooms, some heatable, probably the offices of the municipal dignitaries (duumviri, aediles).

The size of the adjoining buildings has been determined, but only two insulae (W of the forum) have been excavated: a) the small insula IV with a peristyle-like inner courtyard, heatable living rooms, stores on the S side, and later baths: b) the so-called bath area, a not quite appropriate designation for a multi-purpose building almost 70 m square. It contains rooms from different building periods (1st to 5th c. A.D.), among them dwellings, stores, public rooms, and baths. The baths were located midway on the W front, toward the decumanus. In the SW corner was a meeting room of a Dionysiac group. The large mosaic floor (ca. 30 m sq.) of Dionysos and his followers (from the 3d c. B.C.) found here represents one of the most beautiful finds in Noricum. The bath area is known as the location of numerous marble statues, mostly two-thirds life size, copies from Greek originals of Classical times; also a statue of Isis-Noreia, a national mother goddess, based on a Classical prototype. These were, without exception, the work of a sculpture workshop in Virunum at the time of Hadrian and Antoninus Pius. The bath area is also important in furnishing a chronology for the whole town, and for that reason has been published separately.

Among other public buildings the theater, which is unique in the E Alpine countries, has been investigated. The spectators' area which was built into the slope is known, also the orchestra and the stage building with a stage (35 x 6 m) constructed with a lavish use of marble. The building period may be indicated by a marble sculpture of Hadrian. On the same slope a little farther N (at the E edge of town) are unexcavated walls surrounding an area of elliptical plan (ca. 96 x 42 m), supposedly the amphitheater. At the N edge of town a small Sanctuary of Jupiter Dolichenos had been excavated and a large bipartite podium temple. The extension of the town to the W is delineated by the graves found along today's federal highway, the extension to the S is unknown. The built-up area must have been ca. 1000 x 1000 m. There was a good water supply (fountains and water pipes), a sewage system with masonry canals below the middle of the road, and a main canal 1.8 m high.

During the restless decades of late antiquity when Germanic tribes repeatedly invaded the country (ca. 408 the Gothic king Alarich probably had his headquarters in Virunum), the unfortified town lost its importance. The population moved in part onto fortified hills in the vicinity, and in the 5th c. Teurnia—located farther to the W and fortified—became metropolis of Noricum. However, Virunum had become a bishopric. Early Christian culture is evident in the relief on a sarcophagus with the depiction of the Good Shepherd, and the churches on the Grazer Kogel. This Kogel, located N of the town and fortified in later times, harbored a rectangular hall church and an apsidal church, both with the clergy bench typical of Noricum. Toward the end of the 6th c. Virunum, owing to the Slavic invasion, faded away. It was never resettled.

Since the area has since been used for farming, no buildings have been preserved. However, numerous antiquities have been built into churches and houses; a small lapidarium is found in the octagon of the Maria Saal cathedral, and the Landesmuseum für Kärten in Klagenfurt also contains many finds. On the Zollfeld itself the Prunnerkreuz, a chapel dating from 1692, is of historical interest. It was built specifically to house in its walls the then existing stone monuments from Virunum.

BIBLIOGRAPHY. C. Praschniker & H. Kenner, *Der Bäderbezirk von Virunum* (1947)[MPI]; R. Noll, *Frühes Christentum in Österreich* (1954) 105f[PI]; H. Vetters, "Virunum," *RE* IX A 1 (1961) 244ff[MP]; H. Kenner in *EAA* 7 (1966) 1186f. R. NOLL

VIS, *see* ISSA

VISEGRÁD, *see* LIMES PANNONIAE

VISEU Beira Alta, Portugal. Map 19. The absence of literary and epigraphical references, as well as the lack of remains other than Roman blocks reused in the Romanesque cathedral, suggests that this was a village of little importance. In the lower part of the town, now within the urban district, is the Cava de Viriato, an encampment of the Republican era. It is a polygon, with well-preserved walls of compacted earth. No structures have been found inside, and few remains. The encampment, perhaps a camp of Julius Caesar, was the point of convergence of some of the main roads of the district.

BIBLIOGRAPHY. O. Ribeiro, "Em torno das origens de Viseu," *Revista Portuguesa de História* 13 (1970) 211-29. J. ALARCÃO

VITO SOLDANO Sicily, Italy. Map 17B. A statio (?) on the large Roman traffic artery between Catane and Agrigentum, similar to Sofiana (Mazzarino) but not yet matched, through brick stamps, with any of the stationes mentioned by the *Antonine Itinerary*. Quite probably it corresponds to the statio Corconiana. A bath complex of Imperial date has been uncovered.

On the basis of excavation and chance finds it can be assumed that the statio remained in existence until the 8th c. A.D.

BIBLIOGRAPHY. M. Rosaria La Lomia, *Kokalos* 7 (1961) 157-65; *EAA* 2 (1959) 276 (E. De Miro). D. ADAMESTEANU

VITUDORUM or Vitudurum (Oberwinterthur) Zurich, Switzerland. Map 20. Site 2.5 km SW of Winterthur (*It. Ant.* 251.5; building inscription of late Roman fortress, *CIL* XIII, 5249 = Howald-Meyer no. 264). The pre-Roman oppidum indicated by the name has not yet been located, but the Roman site is on a S spur of the Lindberg, 15 m above the Eulach brook. About 20 B.C. the hill was occupied briefly by a garrison in connection with the campaign of Tiberius and Drusus against the Raeti.

With the foundation of Vindonissa, 45 km to the W, Vitudurum also received a garrison throughout the 1st c. A.D. as a post on the Rhine-Danube highway. The vicus developed in the 1st c., was destroyed during the events of A.D. 69 (Tac. *Hist.* 1.67), but was immediately rebuilt. A fort was built under Diocletian, and abandoned probably in A.D. 401. The military installations of ca. 20 B.C. are attested by traces of earth and timber construction along the E border of the spur. The highest point was left free as an observation post. The vicus developed along the Roman road (beneath the Römerstrasse) and NW towards the Lindberg and the slopes of the Kirchhügel. The highest point of the Kirchhügel was left open except for a temple of Gallo-Roman plan (16.10 x 15.35

m). This was an earth and timber building on stone foundations which had tufa capitals on wooden posts. Its plan is marked on the stone pavement beside the church.

The Late Roman fortress was somewhat bell-shaped, with the base towards the highway. The main entrance must have been on this side, but has not yet been identified. The walls followed the contour of the hill with several wide-angled corners, max. w. 66 m, max. l. 120 m; area 7200 sq. m). Part of the NE wall has fallen down the slope and part of the SW wall was destroyed by a later cemetery, but two stretches of ca. 60 m each are visible near the church and parsonage. In the wall (av. thickness 3 m; foundations 3.7 m) there is much reused material. Immediately N of the church is a semicircular tower (2.4 x 3.6 m). Large hewn blocks seem to have been used in this area only, which may indicate a gate, destroyed by the church tower. A ditch (35 m long, 3.5 wide, 2 deep) ran outside the SW wall. Parts of a cemetery have been excavated along the Roman highway. Finds are in the Heimatmuseum Lindengut.

(See also Limes, Rhine.)

BIBLIOGRAPHY. F. Staehelin, *Die Schweiz in römischer Zeit* (3d ed. 1948) 271-72, 633-34; H. Bloesch & H. Isler, "Bericht über die Ausgrabungen in Oberwinterthur-Vitudurum 1949-1951," *83. Neujahrsblatt der Hülfsgesellschaft Winterthur* (1952)[PI]; E. Meyer, *RE* IX (1961) 489-91; C. M. Wells, *The German Policy of Augustus* (1972) 56-57; summaries: *Jb. Schweiz. Gesell. f. Urgeschichte* 41 (1951) 129-32[P]; 47 (1958-59) 193; 48 (1960-61) 183-85[PI]; 50 (1963) 87-88[PI]; 56 (1971) 231-32; 57 (1972-73) 345-52. V. VON GONZENBACH

VIX, *see* MONT-LASSOIS

VIZAČE, *see* NESACTIUM

VIZARI Amariou, Crete. Map 11. Greek and Roman settlements about 20 km NW of Timbaki. A hill S of modern Vizari was occupied by a small Classical and Hellenistic city, and this seems subsequently to have been abandoned in favor of a site just W of the present village. Here a Roman settlement of about 15 hectares was built and occupied at least until the Arab conquest. Suggestions that the city of Sybrita may have been transferred to this site ca. A.D. 800 are unconvincing. On the site of the Greek city there is little to see, although remains of houses cover about a hectare. Limited excavations in the Roman settlement have revealed a late 3d c. mosaic, and nearby remains of a bath suite are visible. The main feature of interest and the main focus of excavations have been the Early Christian basilican church, which was built about the beginning of the 9th c. A.D.

BIBLIOGRAPHY. K. Kalokyres in *Praktika* (1955 [1956]) 250-52[I]; K. Kalokyres in A. K. Orlandos, *Ergon* (1958 [1959]) 177-80[PI]; M.S.F. Hood, P. Warren, & G. Cadogan, "Travels in Crete, 1962," *BSA* 59 (1964) 77-78. K. BRANIGAN

VIZE, *see* BIZYE

VLOCHOS, *see* PEIRASIA

VODGORIAĆUM (Waudrez) Belgium. Map 21. The Gallo-Roman vicus of the civitas Nerviorum, on the Bavai-Tongres road 12 leugae from Bavai, is mentioned in the *Antonine Itinerary* (378) and in the *Peutinger Table* (under the form of Vogodorgiaco). The identification with Waudrez is based on the distance from Bavai, on toponymy, and also on archaeological finds. These include some wells, a potter's kiln, many potsherds, and some bronze artifacts (bracelets, keys, a spatula,

a pin). The many late Gallic coins indicate that the vicus developed from a native center. The remains date mainly to the 1st and 2d c. and the series of coins is interrupted at Gallienus (253-68). This seems to indicate that the vicus was ravaged during one of the barbarian invasions of the period. Nevertheless, 4th c. pottery was found in the fill of a building excavated in 1953. In 1890 a hoard of coins was found which was buried ca. 134-38 during the reign of Hadrian.

BIBLIOGRAPHY. R. De Maeyer, *De Overblijfselen der Romeinsche Villa's in België* (1940) 104; J. Mertens, *FA* 8 (1953) no. 4633; M. E. Mariën, *Par la Chaussée Brunehaut* (2d ed. 1967) 33-35[PI]; M. Thirion, *Les trésors monétaires gaulois et romains trouvés en Belgique* (1967) 172. S. J. DE LAET

VOGHENZA, *see* VICOVENTIA

VOLATERRAE (Volterra) Tuscany, Italy. Map 14. A city on a high ridge commanding the Cecina river valley to the W, and the Era river valley to the E. In antiquity it was in Regio VII, Etruria. It is mentioned by Pliny (*HN* 10.29.78), by Cicero (*Quinct.* 6.24), by Strabo (1.1), by Rutilius Namatianus (1.453), in the *Antonine Itinerary* (p. 292), in the *Itinerarium Marit.* (p. 501) and in numerous mediaeval documents. The city was very important in the Etruscan period, when it was called Velathri, and even into the Roman period. In the Etruscan era, it was the defensive fortress of N Etruria and its influence spread from the river Pesa in the E, to the sea at Cecina and Vada in the W; from the river Cornia in the S, to the mountain stream Fine in the N. The city's influence is also documented on gravestones (from Bologna) of the 5th c. B.C., wherein the Cecina, the principal family of Volterra, are mentioned twice; it controlled, in all practical matters, the entire mid area of the river Arno.

Archaeological evidence, both in and around Volterra, begins in the Stone Age, with invasions by the Rinaldone and Remedello civilizations. In the Iron Age there was a notable increase in population, particularly between the 10th and the 7th c. B.C. to judge from tombs at Badia Guerruccia; and then, in the Late Iron Age, by numerous rock-cut tombs at Guerruccia, at Santa Chiara, and from San Giusto to Porta Diana. The empty chambers are still partially visible. From these tombs have come significant ceramic and bronze ware. In this era, the first settlement was established on the acropolis (Piano di Castello), with massive retaining walls, in an area still quite limited. Between the 6th and 5th c. B.C. an enlarging of the area, now the area of the modern city, is notable. It was a self-sustaining settlement (agricultural and mining), with only scattered traces of imports. During the first half of the 4th c. B.C. the encircling walls reached a perimeter of more than 7 km, enclosing an area of 116 ha. With mounting pressure from Rome, the city became the center for the protection of the Etruscan elements of the twelve lucumonies of which Volterra formed a part. In the 3d c. B.C. the city was very nearly subject to Rome, but preserved, by enrollment in the Sabatine tribe, its own organization and continued to exert considerable influence on a large surrounding area. The Cecina (Cic. *Fam.* 6.6 and *Att.* 16.4), owners of vast tracts of land, clay pits, kilns and salt beds, dedicated the great theater at Vallebona, N of the settlement. The city's importance outlasted the Middle Ages.

The visible monumental remains of Volterra begin with the Etruscan period. In 1926 there were brought to light the remains of a building, recognized for its sacred character, on the ancient citadel of Piano di Castello.

The podium and a meager bit of wall from the building still remain. A road paved with large slabs extends outside the building, which is flanked by other structures, at least one of which is clearly recognizable as a temple. Thus a temple complex is defined which dates from the 4th-3d c. B.C., together with lower structures that have been identified as belonging to the period from the 8th c. to the 5th c. In the excavated area are private dwellings and one or more very deep cisterns probably antedating the 4th c. There seems to have been another area, perhaps sacred in character, at Vallebona, to the E of the present excavations on the Roman theater. A significant foundation of an Etruscan structure has appeared. In addition, remains of a wall probably Etruscan have come to light beneath the orchestra of the theater. The great circuit of the walls, an imposing Etruscan monument, has already been mentioned. Better preserved and visible remains are at Santa Chiara (to the SW), at San Giusto (to the N), and from San Giusto to Porta Diana (from N to E), and some minor remains also; everything is well built of squared blocks.

In the circuit of the walls are two large gates, the Porta Diana and the Porta dell'Arco (the latter entirely rebuilt during the Roman period) with three large human protomi. Notable Etruscan traces are from the necropolis, the rock-cut tombs, at Badia or Montebradoni, at Portone, Marmini, Ulimeto, and Poggio alle Croci. Among all the tombs, one of the most famous is the Inghirami, reconstructed in the National Archaeological Museum in Florence. Also from the Etruscan period came pottery and bronzes and in particular alabaster funerary urns that date from the 3d to the 1st c. B.C., well into the Roman era.

In the Roman period, the settlement was already beginning to shrink, as is evident from the cemeteries (the hypogea of the aristocracy of the Etruscan period were abandoned and the tombs were scattered everywhere, with a dirth of furnishings) and from the public buildings. However, an entire quarter developed outside the Etruscan circuit wall to the N, beginning at the mediaeval Porta Fiorentina. It included a forum, a theater, and a bath building (still another archaeological area probably exists W of the theater). From discoveries of the last few years in the area, some excellent figured mosaics have been recovered. There are remains of another bath building (mosaics and a calidarium) to the SW outside the Porta San Felice and a fine swimming pool on the acropolis of Piano di Castello which continued in use from the Etruscan into the Roman period.

The most significant building, however, is the theater. It was completely hidden, from the Middle Ages on, by the dumping of urban waste from the top of the walls. The theater building itself is now almost totally excavated. Its large cavea, facing N, is crowned to the S by a cryptoporticus to which two inner staircases give access to the theater as they descend to the upper row of seats. A fairly substantial number of the seats, reused in the area to the N of the stage building, were recovered, with names inscribed of the persons for whom they were reserved. The orchestra and the parodoi have been uncovered and, above all, the imposing structure of the stage building, which undoubtedly had two sections. As a result of different finds (busts of Augustus and Drusilla; remains of a dedicatory inscription of the Cecina from the front of the stage), it is almost certain that the theater was erected between 35 and 25 B.C. Behind the stage building, there was a large square with a portico definitely identified on three sides. But to the N, a fourth portico must have closed the square and faced the natural slope of the terrain from a terrace buttressed by a huge sustaining wall. The theater must have fallen into disuse between the 3d and 4th c. Inside the quadriportico and behind the stage building, a bath building was constructed in the square. Nearly all of the environs of the bath have been uncovered.

Most of the finds from Volterra are in the Museo Guarnacci in Volterra and in the National Archaeological Museum in Florence.

BIBLIOGRAPHY. G. Dennis, *Cities and Cemeteries of Etruria* (1848); A. Cinci, *Guida di Volterra* (1885); D. Levi, *NSc* (1928) 34-44; G. Caputo & G. Monaco in *FA*, vols. 4, 9-19; G. Maetzke, *StEtr* (Rassegna Scavi e scoperte) 25 (1957) 37 (1969) and G. Monaco, ibid., from 27 (1959) to 40 (1972); C. Laviosa, *Guida alle stele arcaiche e al materiale volterrano* (1962).

G. MONACO

VOLCEI (Buccino) Italy. Map 14. In the valley of the Platano river an ancient city 72 km inland from Salerno. Recent excavations have brought to light ancient remains beginning in the Early Neolithic period. The most significant are a necropolis of chamber tombs of the eneolithic period and a habitation site of the Early Bronze Age. In the modern town the podium of a Roman temple (the so-called Temple of Vulcan) is visible below houses near the piazza. Near San Mauro, 1.6 km E of the provincial road to Romagnano al Monte, there is a large terrace of polygonal masonry of the 3d or 2d c. B.C., which supported a small temple and its precinct. Near Pareti, 0.8 km E on national highway no. 407, there are remains of a podium of polygonal masonry datable to the 2d c. B.C. At Ponte San Cono near the juncture of national highways 407 and 19, there are the remains of the Roman bridge over the Platano.

BIBLIOGRAPHY. R. R. Holloway et al., *Buccino, the Eneolithic Necropolis of S. Antonio and Other Prehistoric Discoveries Made in 1968 and 1969 by Brown University* (1972); id., "Excavations at Buccino: 1968," *AJA* 72 (1969) 199-201; "Excavations at Buccino: 1969," *AJA* 73 (1970) 145-48; id., "The Sanctuary at San Mauro, Buccino," *AJA* 78 (1974) 25-32; S. L. Dyson & R. R. Holloway, "Excavations at Buccino: 1970," *AJA* 74 (1971) 151-54; S. L. Dyson, "Excavations at Buccino: 1971," *AJA* 75 (1972) 159-63. R. R. HOLLOWAY

"VOLSINII VETERES," *see* ORVIETO

VOLTERRA, *see* VOLATERRAE

VOLUBILIS (Ksar Pharaoun) Morocco. Map 19. An ancient city of W Mauretania at the foot of Djebel Zerhoun, 20 km N of Meknès. It is mentioned by Pomponius Mela, Pliny, Ptolemy, the *Antonine Itinerary* and the Geographer of Ravenna.

Its location has been confirmed by the discovery of numerous inscriptions.

The first traces of occupation go back to prehistoric times. By the middle of the 3d c. B.C. its inhabitants appear to have been open to the influence of the Libyphoenicians from the Atlantic coast. Evidence that an urban community existed is to be found in the mention, about this time, of suffetes in a Punic inscription. However, the earliest buildings excavated so far do not seem to predate the end of the 3d or the beginning of the 2d c. B.C. Within this period dates the first stage of two pre-Roman houses found in the W quarter. The houses on the S spur seem to be later. This was probably the site of the early acropolis; the N and E sides of its rampart have been uncovered. Near the NE corner of this first city wall a large stone tumulus ca. 10 m high was found to contain several Carthaginian funerary stelai: it perhaps marked the boundary of the settlement. Spread over ca.

15 ha, the settlement had the characteristics of a true city in that it was built according to a regular plan, modified by curves to the E and S to conform with the steep slope of the spur.

The public monuments excavated to date include a monumental altar preserved in the E portico of the Capitolium; two pairs of temples found beneath the paving stones of the forum and 200 m SW; the remains of a large mausoleum to the N; and what is probably the first stage of an indigenous sanctuary, erroneously called a temple of Saturn, which stands E of the ruins. All these monuments seem to belong to the Augustan period, that is, to be contemporary with the reign of Juba II (d. ca. A.D. 23). The abundance of Mediterranean imports—first, Campanian ware then Arretine or Italiote bowls—is evidence that at this time the city was in continuous contact with the Roman world; on the other hand, the Hellenistic influence clearly seen in all these buildings is hardly surprising under a dynasty that united the last of the Lagids with the descendents of Masinissa.

After Caligula disposed of Ptolemy and annexed Mauretania, the inhabitants of Volubilis fought alongside the Romans and in A.D. were rewarded with citizenship and various other privileges granted the new municipium. At this time the city grew rapidly. A large porticoed forum was built over the former monuments in the city center, probably in Nero's reign, and before the end of the century several insulae formed an urban grid to the N. By degrees this was to include the section of the city between the House of the Horseman and the House of the Compass as well as the insula of the House of the Trefoil Pool, much farther E. This orientation was slightly modified in the first half of the 2d c. when the N baths and the insula of the House of Venus were built, and again in the second half of the century with the construction of the NE quarter, which is roughly contemporary with a rampart erected in 168-169. Built with a core of mortared rubble faced with small regular ashlar blocks and 2.35 km in length, the wall has eight gates and is flanked by semicircular towers. It marks the new dimensions of the city, embracing an area of ca. 40 ha, without the suburbs and the necropoleis. The last phase of major construction in the city followed in the Severan era. The forum was completely rebuilt as a rectangular esplanade closed to the W by a raised portico with four cellae opening onto it and, on the opposite side, by a squat basilica with two apses and some adjoining rooms on its E side. The porticoed courtyard of the Capitolium S of it was completed under Macrinus. Erected on a tall podium, this temple probably was peripteral and hexastyle but was clumsily restored in modern times as a four-columned prostyle building. Also from the Severan period is a monumental arch dedicated to Caracalla; it stands at the W end of the great decumanus of the NE quarter. This monument also has been improperly restored; fragments of its sculptural decor are preserved. From then on, the city underwent only minor changes and was finally abandoned between 280 and 285, along with the other cities of the S part of the interior of Mauretania Tingitana.

Aside from the forum area, only a few religious monuments date from the Roman period: a little temple of unknown dedication E of the tumulus, and farther off the indigenous sanctuary mentioned above, which continued to be used up to the 3d c. However, together with the Capitoline triad and the imperial cult, for which there is ample evidence, all the traditional Roman gods were represented at Volubilis, as were Mithras, Isis, and the other Eastern divinities worshiped by a sizable Syrian colony. So far, no traces have been found either of their sanctuaries or of the synagogue, whose existence is known from a Greek inscription. Three medium-sized bath buildings—the forum baths, N baths, and the so-called Gallienus baths—and a small macellum opening S of the forum onto a secondary square (probably a market) comprise the list of public monuments. The many houses belong to two types: the first is frequently to be seen in the old quarters of the S and W and shows the continuing use, or reuse, of pre-Roman houses reminiscent in plan of those at Tamuda or Lixus. The other type, which is especially well represented in the N and NE quarters, is that of the domus adapted to Africa: a peristyle takes the place of the atrium while the private rooms of the home are grouped around an atriolum and court. The many shops and oil presses are often joined with the houses, even the richest ones.

For most buildings stone from the local quarries was used, but also unbaked bricks and mud. Decorative carvings (often rough), painted walls, and many mosaics, uneven in quality, have been found. Most of the marbles disappeared into the lime kilns of the Arab period. Many of the bronzes are of exceptionally high quality. The great Ephebe, perhaps Augustan, the Old Fisherman, and several other famous pieces like the portrait of Juba II could date from the city's pre-Roman heritage; the bust of Cato of Utica, some copies of Greek works, and fragments of imperial or municipal statues obviously date from the Roman period. Thus we can reject the frequently heard suggestion that these pieces are the Moroccan counterpart of the personal collection that Juba had assembled at Caesarea.

Little is known of the history of Volubilis after the Romans abandoned it. A population retaining in 655 a semblance of Roman organization and still Christian went on living in the ruins; the people were converted to Islam during the 8th c. In 788 they rallied to the side of Idriss, the founder of the first Moroccan dynasty who, after staying in the city for some time, transferred his capital to nearby Fez, thus dooming the ancient city to inevitable decline.

The Rabat Museum contains material from the site.

BIBLIOGRAPHY. L. Chatelain, *Le Maroc des Romains* (1944) 139-250; R. Thouvenot, *Volubilis* (1949)[PI]; M. Euzennat, "Le temple C de Volubilis et les origines de la cité," *Bulletin d'Archéologie Marocaine* 2 (1957) 41-64[PI]; id., "Volubilis," *RE* IX A 1 (1960) 864-73; R. Etienne, *Le quartier nord-est de Volubilis* (1960)[PI]; A. Jodin, "L'enceinte hellénistique de Volubilis (Maroc)," *BAC* (1965-66) 199-221[PI]; R. Rebuffat, "Le développement urbain de Volubilis au second siècle de notre ère," *BAC* (1965-66) 231-40[P]; A. Luquet, "La basilique judiciaire de Volubilis," *Bulletin d'Archéologie Marocaine* 7 (1967) 407-45[PI]; id., *Volubilis* (1972).

M. EUZENNAT

"VOPISCIANA," *see* SIDI LARBI BOUJEMA

VOREDA (Old Penrith) Cumberland, England. Map 24. Unexcavated fort and civil settlement, 20.8 km S of Carlisle. Many inscriptions have been found of the Cohors XI Gallorum, one mid 3d c., one of a detachment of Marsacians ca. 222-235, and one of a vexillation of Legio XX V.V.

BIBLIOGRAPHY. F. Haverfield, "Voreda, the Roman fort at Plumpton Wall," *Trans. Cumberland and Westmorland Arch. Soc.* ser. 2, 13 (1913) 177-98; *RIB* 304-14.

D. CHARLESWORTH

VOREMWALD, *see* LIMES ON WALENSEE, RAETIA

VOSTITSA, *see* AIGION

VOUKOLIASI, *see* POIKILASION

VOULISTA PANAYIA, *see* CHARADRA

VOUNESI, *see* PORTITSA

VOUNI PALACE Cyprus. Map 6. On the NW coast above Morphou Bay, ca. 7 km W of Soloi. Vouni is the local name of a rocky hill rising directly from the sea. The palace occupied the summit of the hill but the N slope overlooking the sea was also inhabited. The site was surrounded by a wall which followed the edge of the plateau and can still be traced for most of its course. The site may have been a small town or, more likely, a fortified royal summer residence. The ancient name of the place is not known and an earlier theory that these ruins belonged to Aipeia, the predecessor of Soloi, must now be dismissed.

Within the ramparts the space is divided in a significant way. The area on the very top to the S is reserved for the Temple of Athena; on the second and largest terrace is situated the palace surrounded by small sanctuaries. To the N the palace area is delimited by means of a high terraced wall. Below that there are some rock-cut tombs and on the lowest part within the ramparts were the rest of the habitations on the hill. Narrow roads and steps linked the three levels.

The palace belongs to the period between 500 and 380 B.C. with two main building periods, ca. 500 to ca. 450 and from ca. 450 to ca. 380 B.C. These dates coincide with some interesting historical events. The revolt against the Persians ended with the capture of Soloi in 498 B.C. This is the period of the first palace. The capture of Marion by Kimon in 449 B.C. coincides with the second building period. It has been suggested, therefore, that a pro-Persian king of Marion built the first palace, of an oriental character, in order to protect his city from pro-Greek Soloi. Then the situation was reversed in the second building period, when the palace was altered to a Greek style, this time by a pro-Greek king of Marion, the theory being that the palace was from the beginning to the end in Marian hands. At the beginning of the 4th c. B.C. Soloi, now turned pro-Persian, attacked and destroyed the palace, which was then finally abandoned.

This is certainly an ingenious interpretation but in view of the fact that Vouni Palace is near Soloi and far from Marion this theory should be reconsidered. It is difficult to believe that the distant Marians traveled all the way across a rough country in order to build an advanced post at the gates, so to speak, of Soloi without meeting any resistance. Indeed the excavators themselves admit that these historical connections and the deductions based thereon are hypothetical, in spite of important indications in their favor. The palace, therefore, might be directly connected with Soloi.

The first palace consists of a number of rooms grouped round a central open court and of the state apartments. During this period the entrance to the palace was to the SW and led to the state apartments, which consisted of a tripartite complex of rooms with a main central section and two lateral parts. The central section consists of an outer entrance hall, the main room, and an inner hall opening onto the court. The side rooms have outer doors of their own and are in direct communication with the main room and the other parts of the palace.

From the central section of the state apartments one descends to the central court by a grand staircase of seven steps occupying the whole width of the court. A peristyle surrounded the three other sides, with columns supporting a portico. The central part of the court was open, with a basin-cistern in the middle. Around the three sides of the court were the private rooms of the palace which, with one exception, were narrow-fronted rooms opening directly onto the court. The bathrooms were to the NE, the kitchen quarters to the SE. Some living rooms, bathrooms, and a row of storerooms lay to the NW.

The second building period was an expanded version of the first, including an important change in the orientation of the palace. The entrance through the state apartments was blocked and a new one was built on the NW, leading through a vestibule to the central court of the original palace. In this way the entrance complex with the state apartments of the first period were relegated to the rear of the central court and the palace now took the shape of a megaron building. At the same time an upper story was built. A suite of storerooms to the SE and NE was also added. In this way, a backyard enclosed on three sides was formed, in the middle of which a cistern was built to receive the water from the roofs of the newly built rooms. Close to the SW corner of the palace was erected a group of rooms forming an irregular unit. The purpose of these rooms is not certain but this place may have been used for washing.

A series of shrines surrounded the palace. Outside the main NW entrance of the palace is a shrine consisting of a small rectangular room, an anteroom, an inner room, and at its back a rectangular recess. At the NE side of the palace towards the sea lies an open-air temenos consisting of an altar room, a large forecourt, and behind it a small room. Close to the E corner of the palace are the remains of another shrine consisting of a rectangular room with an altar in the center, and of a corridor. Outside the SE row of storerooms another sanctuary was built. It consists of two rooms, in one of which is a large altar. At a small distance from the S corner of the palace are the remains of a shrine consisting of a single square room. None of the above shrines has been identified.

The remains of the Temple of Athena lie on the very top of the Vouni hill at the S extremity of the plateau. The sanctuary comprises a group of structures consisting of a cella fronting a large court and a second smaller forecourt entered from an open space with a block of three continuous treasuries along its S side. This sanctuary belongs to the first phase of the second building period of the royal palace. The cella, square in shape, is a later addition; on its floor were found some fine bronzes including a small solid statue of a cow, probably reproducing the famous work of Myron, and two identical groups in relief, each with two lions attacking a bull. The inner temple court is rectangular and may have been used for setting up sculptures. The forecourt, roughly rectangular with a semicircular altar at its NW corner, was used for setting up sculptures, as can be seen from the depressions on the rock in which the statue bases were secured. The treasury buildings are rectangular and narrow-fronted.

Finds are in the Nicosia and Stockholm Museums.

BIBLIOGRAPHY. Einar Gjerstad et al., *Swedish Cyprus Expedition* III (1937)MPI; V. Karageorghis, *A Guide to Vouni Palace* (1965). K. NICOLAOU

VOURTA, *see* LIMES, GREEK EPEIROS

VOUTONOSI ("Trampya") Greece. Map 9. A city below Metsovon in S Epeiros, reputedly founded by Odysseus (*StBiz* s.v.). There are remains of a circuit wall ca. 940 m long; and inscriptions and bronzes have been found.

BIBLIOGRAPHY. N. M. Verdelis in *BCH* 73 (1949) 19f; Ph. M. Petsas in *EphArch* (1950-51) 44f and (1952) 7f; N.G.L. Hammond, *Epirus* (1967) 261f, 708; I. Vokotopoulou in *ArchDelt* 23 (1968) *Chron*. 293.

N.G.L. HAMMOND

VRAONA, *see* BRAURON

VROULIA, *see* RHODES

VROUSINA, *see* LIMES, GREEK EPEIROS

VULCI Italy. Map 16. An Etruscan city on the Fiora river ca. 144 km N of Rome. It was mentioned by the ancient geographers (Plin. *HN* 3.51,52; Ptol. 3.1.43-49; Steph. Byz., s.v.) and marginally by other Classical writers (Festus 536 L 16-18; Arn. *Adv. Nat.* 6.7). It was subdued by Rome in 280 B.C. In its territory, where important centers such as Regisvilla, Forum Aurelii, and the pagi of Ischia, Castro, and Pescia Romana developed, the Latin colony of Cosa was founded in 273 B.C.

The city rises on a high almost quadrangular plateau, bathed on the E side by the Fiora. It was enclosed by a wall of tufa blocks, which dates to the 4th c. B.C. Several stretches of it and at least two gates are known. A wide road with a N-S axis constitutes the backbone of the inhabited area. Along it are placed a grandiose temple *ad alae* from the 4th c. B.C. with a plan identical to the so-called Ara della Regina at Tarquinia; a beautiful *domus* from the 1st c. B.C. with cryptoportico, nymphaeum, and small private baths; and a chapel dedicated to Hercules with an annex for housing the youths. During excavations in the 18th c. many public buildings were discovered, including the forum and the baths; but the plans and locations of these buildings are today unknown. At the edge of the city near the N gate was a sanctuary with a votive deposit from the 1st c. B.C.

Two beautiful bridges spanned the Fiora. The Rotto bridge, poorly preserved, had five arches and carried the Via Aurelia vetus. The majestic bridge of the Badia, of the 1st c. B.C., had three arches, of which the central one was 20 m wide and 70 m high. Necropoleis extend to the N and E of Vulci and contain a great number of tombs; more than 15,000 have been excavated, largely in the 19th c. The oldest tombs are in the N necropoleis in the locality called Osteria and at Cavalupo, Ponte Rotto and Polledrara in the E necropoleis. They consist of pit tombs of Villanovian culture from the 9th to the 8th c. B.C., often with a tufa cover, containing biconical cineraria or cineraria *a capanna* with accompanying vases and objects of personal adornment. Two tombs in the N necropoleis are particularly noteworthy. One contained a small Sardinian bronze from the 9th c. B.C. and the other an urn *a capanna* in bronze from the middle of the 8th c. B.C. In the second half of the 8th c. B.C. the use of pit graves appeared, with rich gifts characterized by bronzes and by Italo-geometric pottery clearly of Eu-boean-Cycladean inspiration. From the beginning of the 7th c. B.C. chamber tombs were used, preceded by a room open to the sky. Among these tombs a recently excavated chamber is notable for the richness of the bronzes it contained, including several orientalizing vessels.

By the end of the 7th c., besides Greek pottery, these tombs contained the characteristic Etrusco-Corinthian ceramics as well as the local bucchero; and a few decades later the high relief sculptures representing animals, monsters, and centaurs were placed as guards at the entrances of the graves. To this late orientalizing phase belong the *tomba del Sole e della Luna* with eight chambers having decorated ceilings in the N necropoleis, the stately and still not well-known tumulus almost 65 m in diameter called *la Cuccumella*, and the *tomba di Iside*. The latter contained an alabaster statuette, Egyptian scarabs, figured alabastra, decorated ostrich eggs, and an interesting hydria of local manufacture. The 6th and 5th c. chamber tombs are among the richest in Attic ceramics in the Mediterranean, and the importation of this ware declines only after the middle of the 5th c. B.C. At the beginning of the 4th c., with the economic and political revival of Etruria, numerous large tombs were built with a central T-shaped room and lateral cells. This type is represented by several beautiful hypogea. The "François" tomb had exceptional frescos with representations of the deceased, mythological scenes, and a very rare representation of the Etruscan saga of Mastarna, Servius Tullius.

After these tombs of the 4th c., more modest hypogea with a single chamber or with a central corridor were built, from which open burial cells in the 3d and 2d c. B.C. They reflect the decline of Vulci during the Roman period. The city was abandoned in the 8th c. The material excavated is dispersed among the principal museums of Europe. In Italy they are preserved at the Museum of the Villa Giulia in Rome for the most part and in the local museum of Vulci (Castello della Badia).

BIBLIOGRAPHY. F. Messerschmidt et al., *Nekropolen von Vulci* (1930)[MPI]; R. Bartoccini, in *Atti del VII Congresso di Archeologia Classica, Roma 1958*, II (1960) 257-81[MPI]; *EAA* 7 (1966) 1208-14 (M. Torelli)[P]; A. Hus, *Vulci* (1971).

M. TORELLI

VXACONA (Red Hill) Shropshire, England. Map 24. Site on Watling Street on high ground overlooking the Shropshire plain. The name appears in the *Antonine Itinerary*. Aerial photographs show a number of military establishments imposed one upon the other, N of the Roman road. It would have been a good site for a signal station, but there may also be a small fort. A settlement developed along Watling Street about which nothing is known. There are, however, crop-marks of a small, single-ditched enclosure probably 4th c. burgus like others on this road.

BIBLIOGRAPHY. *JRS* 43 (1953) 84; *Trans. Shropshire Arch. Soc.* 57 (1962-63) 132-33.

G. WEBSTER

W

WADDON HILL Stoke Abbott, Dorsetshire, England. Map 24. A long flat-topped hill on which a Roman fort was constructed ca. A.D. 45 and dismantled ca. 65. More than half the hill has been removed in stone quarrying, but the remainder on the E side was excavated in 1959-69. The partial plan of timber buildings was revealed, including barrack-blocks, principia, praetorium, and a large building which may have been a hospital or second praetorium, as well as latrine-pits and water-holes. The excavations also produced a wealth of equipment associated, as at Hod Hill, with both legionaries and auxiliaries, much of which is now in the Bridport Museum.

BIBLIOGRAPHY. *Proc. Dorset Nat. Hist. and Arch. Soc.* 82 (1960) 88-108; 86 (1965) 135-49; final report forthcoming.
G. WEBSTER

WALASGIRD, *see* ALEXANDRIAN FOUNDATIONS, 13

WALDMÖSSINGEN, *see* LIMES G. SUPERIORIS

WALL, *see* LETOCETUM

WALLSEND, *see* SEGEDUNUM *under* HADRIAN'S WALL

WALLTOWN Shropshire, England. Map 24. Site of a sequence of forts, near Cleobury Mortimer. Excavations have revealed remains of the turf rampart of a Flavian fort of ca. 1.8 ha. The bank on the S, the best preserved side, is still 2.1 m high and had at least four layers of timber strapping. The bank had been in existence long enough to be repaired before a stone wall 1.5 m thick was inserted in front of it. This rebuilding, associated with a new ditch system, is dated by pottery to the early 2d c. There is ample evidence of later occupation but its character is not clear.

There is also a larger and earlier fort below the one investigated, but it has not been possible to date it precisely or to estimate its size. The site extends the area of the permanent military occupation of Wales much farther E than had been appreciated.

BIBLIOGRAPHY. *Trans. Shropshire Arch. Soc.* 58 (1965) 8-18.
G. WEBSTER

WANBOROUGH, *see* DUROCORNOVIUM

WARNACH Belgium. Map 21. A Gallo-Roman vicus on the Arlon-Tongres road, known only from old excavations and rather imprecise reports. These noted several buildings interpreted as villas, a small building of wattle-and-daub, the foundations of a mutatio (?), barrows, etc. In addition, a castellum, excavated in 1865, consisted of a round tower, 20 m in diameter, with very thick foundations. It was surrounded by two wide, deep moats separated by an agger, forming a square enclosure. The potsherds and coins found during this excavation have been lost, so that it is impossible to date the fort precisely.

BIBLIOGRAPHY. V. Balter & C. Dubois, "Le vicus de Warnach," *Bull. de l'Inst. archéol. du Luxembourg* 13 (1937) 25-33; id., "Contribution à la Carte archéologique de la Belgique," *Annales de l'Inst. arch. du Luxembourg* (1936) 42-48; R. De Maeyer, *De Overblijfselen der Romeinsche Villa's in België* (1940) 220-21.
S. J. DE LAET

WATERCROOK, *see* ALONE

WAUDREZ, *see* VODGORIACUM

WEHRINGEN District Schwabmünchen, Bavaria, Germany. Map 20. About 15 km S of the Raetian provincial capital Augusta Vindelicum (Augsburg), the extensive complex of a villa rustica was discovered near a gravel pit. It was on the road to Cambodunum and not far from the Via Claudia Augusta. So far only some of the adjoining buildings have been excavated and investigated. A necropolis ca. 150 m N has revealed the foundations of four pillared graves (12 to 14 m in diameter or length) three polygonal and one rectangular in plan. One grave from the second half of the 2d c. A.D. contained ashes and remains of China silk. Another contained extraordinarily rich grave goods: a tripod, a small four-legged table, 18 bronze vessels, paterae, bowls, 66 clay vessels, an alabaster bowl, and many glass objects. Gifts in a skeleton grave from the time of Gordian III identify the deceased as a physician. Both settlement and necropolis functioned until the middle of the 3d c. A.D., and late Roman finds are rare. Finds are in the Prähistorische Staatssammlung in München.

BIBLIOGRAPHY. N. Walke, "Römisches Gräberfeld in Wehringen," *Germania* 41 (1963) 122f[PI]; H.-J. Kellner, *Münchner Jahrbuch der Bildenden Kunst III. F.* 16 (1965) 268-70[I]; H. U. Nuber & A. Radnóti, "Römische Brand- und Körpergräber aus Wehringen," *Jahresber.d. Bayer. Bodendenkmalpflege* 10 (1969) 27-49.
H.-J. KELLNER

WELS, *see* OVILAVA

WELSCHBILLIG Bitgau, Germany. Map 20. A Roman villa at Welschbillig, 12 km NW of Trier in the S Eifel. In the Frankish period Welschbillig was the government center of the Long Wall region, a domain of ca. 220 sq. km, surrounded by a wall 72 km long. The walls were built in the second half of the 4th c. At that time the domain was an imperial possession.

In 1891 a systematic excavation at the Gothic Burgtor in Welschbillig uncovered a nymphaeum, a pool (58.3 x 17.8 m) with 70 herms, which had supported a balustrade at the pool, and other remains of a large villa. The herms, made ca. 370-80, form one of the largest sculptural groups of unified conception dating from the Late Antique period. They represent gods, philosophers (Socrates), poets (Menander), orators (Demosthenes), generals (Philip II of Macedonia), emperors (Antoninus Pius), and barbarians. As in the contemporary contorniates, the number of imaginary portraits is large. The villa was apparently an imperial summer palace in the 4th c. All finds from Welschbillig are today at the Rheinische Landesmuseum in Trier. The dig has been reburied.

BIBLIOGRAPHY. H. Wrede, "Die spätantike Hermengalerie von Welschbillig," *Römisch-Germanische Forschungen* 32 (1972).
H. WREDE

WERVIK, *see* VIROVIACUM

WESTERWOOD, *see* ANTONINE WALL

WEST LOKRIS Greece. Map 9; Chaleion, 11. In central Greece, on the N shore of the Gulf of Corinth, extending from the W section of the Gulf of Krisa to beyond the promontory of Antirrhion to Mt. Taphiassos (Klokova). To the E it borders on the ἱερὰ χώρα of Delphi, to the NE on Doris, and to the N and W on Aitolia. It is a narrow coastal strip roughly 60 km long, varying in depth from about 30 km to the E to about 10 km yet father E. In the literary texts its inhabitants were given the general name of Ozolian Lokrians (Λοκροὶ οἱ Ὀζόλαι), but in official documents they were also called Lokrians of the W (Λοκροὶ οἱ Ἑσπέριοι), which simply related them to their kindred Lokrians (Λοκροὶ οἱ ὀπούντιοι or Ὑποκνημίδιοι) from whom they were separated by Phokis. Some modern scholars have considered this separation of the two branches of the ἔθνος the result of a Phokian invasion. Yet there is no ancient tradition linking the Ozolians to the territory of the Phokians, and it is preferable to claim, with the ancients, that the Ozolians came from E Lokris. As late as the 5th c. colonists were sent from Opous to Naupaktos.

From the literary texts and from inscriptions we know of many West Lokris toponyms and ethnic names. But the only ancient toponym that has survived in situ is Naupaktos (Ἔπαχτός, whence Italian Lepanto). The name Myania lasted until 1580, when it gave way to the

modern Ἁγία Εὐθυμία. Everywhere else the ancient names were replaced by Slavic names; then later an effort was made to eliminate these by substituting either completely new names (Haghioi Pantes instead of Vidavi, Panormos instead of Kisseli, Monodendri instead of Kolopetinitsa) or neo-Classical ones, sometimes correctly (Amphissa for Salona) or hypothetically (Eupalion instead of Soules), sometimes erroneously (Tritea for Kolopetinitsa, Tolophon for Vitrinitsa). Fresh epigraphic discoveries and the close study of known documents have made it possible for some sites to be identified.

Amphissa (Salona). "The greatest and most illustrious city of the Lokrians," wrote Pausanias. Used as a refuge by the Phokians and Delphians during the Persian invasion of 480, it supported the expedition of the Spartan Eurylochos against Naupaktos in 426. During the Third Sacred War, it sided against the Phokians who had seized Delphi. Accused of sacrilege for having encroached on the ἱερὰ χώρα, it was the cause of a Fourth Sacred War and was seized by Philip II. In 321, the city resisted the besieging Aitolians and, in 279, joined in defending the Sanctuary of Delphi against the Galates. On becoming part of Aitolia, it successfully resisted the Romans' siege, and was freed from Aitolian rule in 167. After Actium and the founding of Nikopolis, it was inhabited by Aitolian refugees and henceforth claimed to be Aitolian and not Lokrian.

Pausanias saw a Temple of Athena here on the acropolis as well as a bronze statue said to have been brought back from Troy by Thoas; he also noted a cult of the Ἄνακες παῖδες—identified as the Dioskouri or Kouretes or, more reasonably according to Pausanias, the Kabeiroi, seeing that their cult included a τελέτη—as well as the tombs of the eponymous hero Amphissos, the nymph Amphissa, the hero Andraimon, the founder of the city, and his wife Gorge. From inscriptions we also know of a cult of Asklepios. Amphissa's calendar differed from that of the other Ozolian cities.

Amphissa has been located with certainty at Salona. There are traces of a powerful rampart that surrounded not only the citadel (where the Frankish castle was set up on its ruins) but also the lower city, up to the stream now called Katsikopniktes; the masonry is of the pseudo-isodomic type characteristic of the 3d c. Lokrian ramparts, but older polygonal blocks were reused in it. The discovery of the manumissions by sale to Asklepios suggests that the sanctuary stood on the S side of the acropolis, near a spring. There are scattered Roman mosaics. Recent salvaging excavations have revealed tombs, the earliest going back to the Geometric period.

Bouttos. Known chiefly by the manumissions found in its Sanctuary of Asklepios ἐν Κρουνοῖς in the area known as Longa, not far from Naupaktos, which mention several Lokrian or Aitolian ethnic names of the region: Ἀκωτιεῖς, Δαστίδαι, Ἱστωρίοι, Καρεῖς, Περόχθεοι, Πώριοι, Σπάττιοι, Φυλλαῖοι.

Chaleion. A port formerly believed to be at Itea, but should in fact be located at Galaxidi, as is proved by the epigraphic finds. From inscriptions we know that there was a Sanctuary of Apollo Nasiotas, which should be sought in one of the nearby islets. The oval plan of the ancient wall can be traced (ca. 300 x 250 m). Objects found in the tombs that Threpsiadis excavated have not yet been listed. Some Early Helladic buildings have been located on the small island of Apsiphia and on the outskirts of Galaxidi on the Naupaktos road.

Erythrai. A port where Philip V's fleet landed, near Eupalion. If Eupalion is Soules, Erythrai is at Monastiraki.

Eupalion. Chosen by Demosthenes in 426 for the deposit of his plunder after his expedition against the Aitolians; in the same year it was taken by Eurylochos. Its location at Soules, where there is an ancient rampart, some tombs, and an inscription to Aphrodite, seems likely but is not confirmed.

Makynia. The texts place it W of Antirrhion. Most likely at the Mamakou kastro.

Molykr(e)ion or *Molykr(e)ia.* A city often mentioned in connection with the naval operations around Antirrhion; also called Μολυκρικον Ῥίον. A Sanctuary of Poseidon stood on the promontory. Some historians place the city on the site of the Velvina ruins but this presents problems.

Myania. Here Pausanias noted a sacred grove and an altar of the Θεοὶ Μειλίχιοι, with nocturnal sacrifices where the victims' flesh had to be destroyed before sunrise; also a Sanctuary of Poseidon with a temple. At Olympia Pausanias saw a shield dedicated by the Myanians. Myania has been located at Haghia Efthymia. There are important remains of the rampart in the village.

Naupaktos. According to tradition, the naval shipyard of the Dorians before they invaded the Peloponnese (hence the city's name); received colonists from Opous and Chaleion in the 5th c.; in 456 the Athenians settled the Messenian refugees here, and thenceforth Naupaktos served as a base for the Athenian fleet throughout the Peloponnesian War. It was given back to the Lokrians after Aigospotamoi, then passed to the Achaians under the Theban hegemony, and finally was given to the Aitolians by Philip II in 338 and remained part of Aitolia, serving as its diplomatic center in the 3d and 2d c.

Thucydides mentions an Apollonion. Pausanias saw a Temple of Poseidon on the shore, a Sanctuary of Artemis Aitole, a grotto sacred to Aphrodite and the ruins of a Sanctuary of Asklepios, the only one of these located by inscriptions. Other manumissions provide evidence of the cults of Dionysos and Serapis. Important remains of the ancient rampart were incorporated in the mediaeval and modern fortifications.

Oianthe(i)a, later also *Euanthe(i)a.* Pausanias saw a Temple of Aphrodite here and, some distance away, a Sacred Grove of pines and cypresses consecrated to Artemis. Long believed to be at Galaxidi, Oianthea should more likely be placed in the town whose ruins can be seen on the seashore S of the village of Vitrinitsa (officially, and erroneously, Tolophon) where the well-known inscription of the "maidens of Lokris" was found.

Oineon. Probably a port, the point of departure of Demosthenes' expedition of 426 and, after its failure, a rallying point for the survivors. It was then captured by Eurylochos. On its outskirts there was a Sanctuary of Zeus Nemeios where tradition has it that Hesiod was murdered). Its location is undetermined (Magoula? or Glypha).

Phaistinos (Eratini or Kisseli). The discovery at Eratini of two manumissions by sale to Apollo of Phaistinos caused that city to be chosen as the site of Pliny's "portus Apollinis Phaesti." But other manumissions have since been found, reused in the Kisseli churches. Near one of the churches is a great ancient retaining wall; however, it may be that the ancient sanctuary was situated in the coastal plain where was formerly the village.

Physkeis (Malandrino). Never cited in any historic text, yet from the 4th c. it was the capital of a West Lokrian koinon of unknown size. After the liberation of 167 it became a capital once again but this koinon was restricted to the center of the country (Myania, Tritea, Tolophon, Oianthea). There are substantial ruins of a rampart, including a redoubt, with substructures visible inside it. Outside it, to the E, is an exedra with a dedication to Zeus and the Ἀγαθοὶ Θεοί. Farther E is a foundation of limestone. Manumissions point to two

cults: one of Athena Ilias, i.e., no doubt, Athena of Ilion who, according to tradition, received a tribute of young maidens in expiation of the sacrilege committed by Ajax the Lokrian, son of Oileus (cf. the inscription of the maidens of Lokris found at Vitrinitsa); the other of Basileia, the exact nature of whose cult is unknown, but who is presumably the great goddess of Lokris since she is found at Tolphon, Glypha, and Laphron.

Tolphon or *Tolophon.* A Lokrian city on the coast (harbor mentioned by Dion. Kall.) on the route of Eurylochos' march. It is in Vidavi (not, as officially, in Vitrinitsa). The fortification, triangular in plan, is well preserved.

Triteia. A Lokrian city of Eurylochos' route. It was next to Chaleion, as is shown by an agreement between the two cities, and apparently located in the village of Pendeoria. There was a rampart on the hill, as well as a dedication to Artemis Tauropolos.

Other less important places of which we know both from toponyms and ethnic names (Alpa, Axia, Hypnia, Kyra) or just ethnic names (Ἀχαιοί, Δυμᾶνες, Ἴστοι, Μεσσάπιοι, Πέλεοι, Στιεῖς) have not been located with certainty. On the other hand, important ruins like those at Glypha with the double-walled acropolis and its dedication to Basileia, or those at Sigditsa, are still anonymous. The distribution of certain ethnic names and ruins between Lokris and Aitolia is uncertain.

BIBLIOGRAPHY. L. Lerat, *Les Locriens de l'Ouest.* I. *Topographie et ruines*; II. *Histoire, Institutions, Prosopographie* (1953); G. Klaffenbach, *Inscriptiones Locridis, IG* IX², I; J. P. Michaud, *BCH* 93 (1969), 85-91.

L. LERAT

WESTON UNDER PENYARD, *see* ARICONIUM

WHILTON LODGE, *see* BANNAVENTA

WHITCHURCH, *see* MEDIOLANUM

WHITEMOSS Renfrewshire, Scotland. Map 24. Roman auxiliary fort 1.6 km W of Bishopton, built ca. A.D. 140 to protect the W flank of the Antonine Wall. No surface remains survive, but excavation has shown that it faced N, and that the turf rampart and ditches enclosed an area of almost 2 ha. Evidence of three structural periods is reported. The finds are in the Hunterian Museum, Glasgow.

BIBLIOGRAPHY. *Proc. Soc. Ant. Scotland* 83 (1949) 28-32; annual summaries of excavations, *JRS* 40-45 (1950-55).

K. A. STEER

WHITLEY CASTLE Northumberland, England. Map 24. Fort with a well-preserved series of ditches, three on each side except for the SW side which has seven. The fort itself is a parallelogram with four gates, on the road from Bravoniacum to Magna, in the middle of a lead mining area. Cohors III Nerviorum garrisoned the fort in the 3d c.

BIBLIOGRAPHY. N. Shaw, "Excavation at Whitley Castle, 1957-8," *Arch. Ael.* ser. 4, 38 (1959).

D. CHARLESWORTH

WHITTON S. Glamorgan, Wales. Map 24. Whitton is 16 km SW of Cardiff on the plateau W of the river Waycock. In its earliest form it consisted of a pre-Roman farmstead (ca. 60 x 58 m) enclosed by a bank and massive ditch. This phase, characterized by circular timber houses and rectilinear granaries raised on a grid of posts, need not be earlier than the beginning of the 1st c. A.D.

In the Flavian period we find sub-rectangular houses. From the second quarter of the 2d c. on stone buildings were normal: a succession of them continued the occupation down to ca. A.D. 350, when the site was abandoned. Whitton never conformed to any of the standard villa plans, and its accommodation was not luxurious. Tessellated pavements were unknown, and the two hypocausts which were built were never used. At all periods the pre-Roman ditch marked the limit of the farmstead although it had ceased to be an effective defense because of gradual silting and deliberate filling. Outside it the only finds were a rock-cut corn-drying kiln and a well-paved track leading E from the only entrance to the site.

BIBLIOGRAPHY. M. G. Jarrett, *The Iron Age and Roman Farm at Whitton, Glamorgan,* forthcoming[MPI].

M. G. JARRETT

WIEN-SCHWECHAT, *see* LIMES PANNONIAE

WIESBADEN, *see* AQUAE MATTIACAE *and* LIMES G. SUPERIORIS

WILDERSPOOL Lancashire, England. Map 24. Roman industrial site on the Mersey crossing and now on the N side of the Manchester Ship Canal, Warrington. Excavations at the turn of the century brought to light the widest range of industrial remains (kilns, furnaces, hearths, and ovens) known in Roman Britain. Military occupation was also postulated on the basis of a rampart and ditch said to be of Agricolan date, but this was disproved by excavation in 1966-67.

The site proved to have been first occupied in roughly the last decade of the 1st c. A.D. Its heyday appears to lie in the Antonine period, but evidence for continued 3d c. occupation has largely been destroyed by building. In the interior the earliest buildings, large industrial structures, were constructed ca. A.D. 100. The largest was 50 m long, comprising partly an aisled workshop and partly an elongated shed, but this and other early timber buildings uncovered show no trace of military plan. The bulk of the industrial features appear to be of 2d c. date and would repay further technological study. Wilderspool lay at the beginning of the route leading N to the Ribble crossing at Walton-le-Dale, another site not occupied until after A.D. 90. Wilderspool therefore falls into place as a river crossing site which developed with the creation of communications across the Lancashire plain. Finds are kept in the local museum.

BIBLIOGRAPHY. T. May, *Warrington's Roman Remains* (1940 (G.D.B. Jones, "The Romans in the Northwest," *Northern History* 3 (1968) 1ff[MPI].

G.D.B. JONES

WILLOUGHBY, *see* VERNEMETUM

WILTEN, *see* VELDIDENA

WINCHESTER, *see* VENTA BELGARUM

WINDISCH, *see* VINDONISSA

WINTERTON Lincolnshire, England. Map 24. Mosaic pavements at Winterton were found and recorded in the 18th c., and were subsequently damaged by ploughing. Extensive excavations, begun in 1958, are still in progress. The site seems to have been settled from the time of the Roman conquest, but the earliest building yet found dates from ca. A.D. 100. The first period is represented by three circular houses. One is 17.1 m in diameter, with substantial stone walls and foundations and a

concrete floor bordered by a quarter-round molding; it is probably a domestic building, not a temple.

The circular buildings were demolished ca. A.D. 180 and replaced by an assemblage of rectilinear structures arranged along the sides of a square. The principal house on the W side had mosaic pavements from the beginning —unusual in a Romano-British villa of the 2d c. In the NW corner was a bath building, and on the N side a large aisled house, subdivided into domestic accommodation at the W end and a storage and working area at the E. Later a similar aisled house was built on the S side of the site.

A major reconstruction took place early in the 4th c. The main house was completely rebuilt, but little of the new building has survived. The aisled house on the N side was enriched with mosaic pavements, and a bath suite was built into the E end of the S aisle. Occupation continued to the end of the 4th c., after which the site was used as a cemetery, with graves dug into the ruins of the N aisled house.

BIBLIOGRAPHY. *AntJ* 46 (1966) 72-84. I. M. STEAD

WODEN LAW Roxburghshire, Scotland. Map 24. About 3.2 km N of the Border the Roman road from York to the Forth swings round the shoulder of a prominent hill, Woden Law, at the start of its descent to the Kale Water. On the summit of the hill is a small multivallate native fort partially enclosed by a series of Roman investing works. Excavations in 1950 showed that the fort was erected in the Early Iron Age and had a single rampart; subsequently further ramparts were added, but during the Roman occupation of the district the fort was abandoned.

The investing works are of more than one period, and were presumably constructed by troops quartered in the neighboring temporary camps at Pennymuir. They consist of straight or curving banks built in short sectors with upcast from accompanying ditches. Two of the banks are built round the E half of the fort at an even distance of 21 m from the defenses, just beyond the range of hand-thrown missiles; the others are farther out, on the S and E faces of the hill. The inner pair of banks incorporate ballasted platforms designed as emplacements for siege engines, and there is a similar, isolated platform S of the fort. The fact that the works are unfinished, and only partly invest the fort, implies that they were constructed by troops in the course of training exercises and not during active operations.

BIBLIOGRAPHY. *Inventory of the Ancient & Historical Monuments of Roxburghshire* 1 (1956) 169-72.
K. A. STEER

WOODCHESTER Gloucestershire, England. Map 24. Roman villa, 2.4 km S-SW of Stroud, beneath and around the ruined Norman church. It was excavated in 1793-96 and partially in 1954. Its origins and development are not known, but in its final 4th c. form the buildings were grouped around a series of two, or probably three, rectangular courtyards. The main residential buildings surrounded the innermost (NW) court (30 x 27 m). From this a passage in the SE side led to the second court (48 x 45 m), which was flanked by farm buildings. Of the presumed third court only the NW and SW sides were located.

The butt-ends of walls on the 18th c. plan indicate that further buildings existed outside those flanking the inner court, and the main bath suite was not found. Even so, however, the villa was large (150 by 97.5 m) and had at least 65 rooms. It was also very rich, with marble statuary and no less than 20 mosaics, including the celebrated Orpheus pavement. Adorning the triclinium, 14.7 m square and placed centrally in the NW side of the inner court, it is the finest known product of the 4th c. Corinian school of mosaicists, to whom the other pavements are also attributable. The remains of the villa are buried, but the Orpheus mosaic is periodically opened to public inspection in aid of local charities.

Further excavations were begun in 1973.

BIBLIOGRAPHY. S. Lysons: *An Account of Roman Antiquities discovered at Woodchester in the county of Gloucester* (1797); id., *Reliquiae Britannico-Romanae* II (1813); H. O'Neil, *Trans. Bristol and Glos. Arch. Soc.* 74 (1956) 172-75; R. G. Collingwood & I. A. Richmond, *The Archaeology of Roman Britain²* (1969) 143; mosaics: D. J. Smith in A.L.F. Rivet, ed., *The Roman Villa in Britain* (1969) 97-101; D. J. Smith, *The Great Pavement and Roman Villa at Woodchester*, (1973).
A.L.F. RIVET

WORCESTER ("Vertis") Worcestershire, England. Map 24. Buried below the Saxon, mediaeval, and modern city lies the Roman town. Although quantities of pottery and other objects, now in the City Museum, have been found in excavations, little is known about this early period. There is evidence of a pre-Roman settlement at a crossing of the Severn, and its tactical significance probably caused a 1st c. fort to be located here. Civil defenses have been found but remain to be resolved, as does the street plan. To the N was a substantial suburb, associated with iron working. It is possible that the name Vertis in the *Ravenna Cosmography* may apply, indicating a bend in the river, or the place at which the road turned away from it.

BIBLIOGRAPHY. *Trans. Worcestershire Arch. Soc.* 2 (1970) 15ff. G. WEBSTER

WRAXALL Somerset, England. Map 24. Roman villa 11.1 km W of Bristol, 0.4 km S of Birdcombe Court, excavated in 1950-53. The remains consisted of a subrectangular structure (18 x 6 m) divided into five rooms and facing E onto a yard or possibly a roofed hall (19.5 x 7.5 m). Along the S side of this and of the first building was a well-constructed suite of baths (19.5 x 4.5 m). Three phases of building were distinguished in the baths, but the whole occupation appeared to be limited to A.D. 250-350. The site had been thoroughly robbed of stone. The standard of construction of the baths is so high that there were probably other Roman buildings.

BIBLIOGRAPHY. C. M. Sykes & G. A. Brown, *Proc. Somerset Arch. and Nat. Hist. Soc.* 105 (1961) 37-51.
A.L.F. RIVET

WROXETER, see VIROCONIUM CORNOVIORUM

WYCOMB Gloucestershire, England. Map 24. On the White Way just S of the hamlet of Syreford, in the parish of Whittington and N of Andoversford (by which name it has sometimes been known). Correlation of excavations carried out in 1863 with air photographs and recent rescue excavations suggests that this extensive site was predominantly of a sacred character, corresponding with the complexes common in Gaul, but rare in Britain, in which a temple is associated with baths and a theater. Several houses have been noted and a Romano-Celtic temple, 13.7 m square, while the outline of a probable theater appears to the N.

BIBLIOGRAPHY. W. L. Lawrence, *Proc. Soc. Ant. London²* 2 (1861-64) 302-6, 422-26; H. O'Neil & A. D. Saunders, *Trans. Bristol and Glos. Arch. Soc.* 78 (1959) 161-62; J.M.T. Lewis, *Temples in Roman Britain* (1966)

77, 194[P]; J.K.S. St. Joseph, *JRS* 59 (1969) 128; M. Todd, *Britannia* 1 (1970) 117, 123; 295.　A.L.F. RIVET

WYOMPONT Belgium. Map 21. A Gallo-Roman *vicus* located at the place where the Arlon-Tongres road crosses the Ourthe. Systematic excavations have never been undertaken there, but public works have on several occasions cut into foundations of various sorts. Potsherds, pieces of frescos, etc. have been found. In 1851 the remains of a villa were partially examined at a short distance from the *vicus* proper. Six rooms were cleared, two of which were built over a hypocaust and had mosaic pavings. Some tombs have been found at various times near the *vicus* and the villa.

BIBLIOGRAPHY. A. Geubel, "Wyompont gallo-romain," *Bull. de l'Inst. arch. du Luxembourg* (1939); R. De Maeyer, *De Overblijfselen der Romeinsche Villa's in België* (1940) 183-84.　S. J. DE LAET

X

XANTEN, *see* VETERA

XANTHOS Lycia, Turkey. Map 7. The chief city of Lycia (Strab. 14.3.6), on the left bank of the river of the same name (now Koca Çayı) ca. 12 km from the port town of Patara (see below) near the river mouth. Xanthians appear in the *Iliad*, and Herodotos' story (1.176) of the siege of Xanthos by the Persian commander Harpagos in 545 B.C. is famous. The city submitted to Alexander, became the seat of a Lycian religious federation, sided with Rome in her struggle with Mithridates, and was besieged and taken by Brutus in 43 B.C. during the round of civil wars that followed Caesar's murder. In the succeeding centuries the history of Xanthos parallels that of many E cities of Greek tradition: it was prosperous and relatively quiescent. On the site there are the ruins of Early Christian and Byzantine churches and of a large Byzantine monastery. In the 7th c. Arab attacks brought Xanthos to an end.

The defensive walls describe an irregular parallelogram in plan over the hilly site, with the longer (N-S) diagonal a little less than a kilometer in length. The walls enclose two summits, on one of which, at the W edge of the site just above the river, was the Lycian acropolis; on the other, towards the N angle of the walls, was the Hellenistic-Roman acropolis. Important sculpture was removed to the British Museum in the 1840s; since 1950 the site has been under excavation and study.

One of the most striking features of Xanthos was the prevalence of monumental tombs and heroa, some of which took the form of massive square pillars, surmounted by sarcophagi or funerary chambers, ranging up to 11 m in overall height. Dating from the 6th c. B.C. through the 1st c. A.D., a few of these structures still stand, the pillared ones in distant consanguinity with the later tower tombs of Palmyra and other sites. Only the foundations of the famous Monument of the Nereids, near the S entrance to the city, survive. This was a heroon of about 400 B.C., the funerary building of which took the form of an Ionic temple of reduced scale; the sculptures are in the British Museum. By the NE corner of the Lycian acropolis are the remains of a Lycian pillar tomb of perhaps the late 4th c. B.C. which was probably moved to its present site when the theater was constructed in Roman times. North of the Lycian acropolis and beside the theater are the ruins of a Roman pillar tomb of early Imperial date. Beside it is one of the most spectacular of Xanthian monuments, a Lycian pillar tomb preserved nearly intact, its typically Lycian sarcophagus, with a lid of ogival section, still perched atop its robust, square-sectioned shaft. It dates from the 4th c. B.C. and is 8.6 m high overall. An archaic relief (ca. 545 B.C.), now in the Istanbul Archaeological Museum, was found inside.

Just to the N is the celebrated Tomb of the Harpies (more correctly, Sirens), dating from the early 5th c. B.C. and nearly 9 m high. The funerary monument, atop its monolithic shaft, was decorated with dynastic reliefs that are now in the British Museum (they have been replaced on the monument itself by casts). The Sirens carry small-scale female figures representing dead souls. Still farther to the NE, beyond the Roman agora, is another remarkable dynastic pillar tomb, probably of the last quarter of the 5th c. B.C. It is almost completely preserved except for the dynast's statue, which, with its lion base, once surmounted the whole 11 m ensemble. The funeral chamber, below the projecting roof atop which the statue was placed, was decorated with reliefs (now in the Istanbul Archaeological Museum) showing the ruler's victories. The monolithic pillar proper is inscribed in both Lycian (as yet undeciphered) and Greek. Across the site to the NE, some 550 m distant, are the sites or remains of three more tombs: the Pavaya Tomb (4th c. B.C., all in the British Museum); the Lion Tomb, the Earliest Lycian pillar tomb so far known, dating from about 545 B.C. (the reliefs are also in the British Museum); and a well-preserved pillar tomb of the 4th c. B.C. with a monolithic shaft supporting a marble burial chamber that is surmounted by a sharply defined, projecting horizontal roof.

Of public monuments there are a number of identifiable remains. Rebuilding was frequent over the centuries, and the usual palimpsests of Classical, Hellenistic, Roman, and Byzantine construction appear. There is a Hellenistic gate at the S entrance to the city of the 190s B.C.; just behind it is a Roman arch dedicated to the emperor Vespasian (A.D. 69-79). Immediately S of the Lycian acropolis are polygonal walls of the 4th c. B.C.; nearby are Hellenistic walls. The theater is of Roman date and type and is fairly well preserved; the stage building's essential form is readable. Beyond the theater to the N lies the Roman agora, about 50 m square and perhaps dating from the end of the 2d c. A.D. or the beginning of the 3d. It was surrounded by porticos and dedicated to the twelve Lycian gods.

BIBLIOGRAPHY. F. Demeargne, H. Metzger, et al., *Fouilles de Xanthos* 1 (1958), 2 (1963), 3 (1969)[MPI]; *EAA* 7 (1966) 1225-31[PI]; *RE* XVIII A (1967) 1375-1408; E. Akurgal, *Ancient Civilizations and Ruins of Turkey* (3d ed. 1973) 258-61, with bibliography on p. 364[PI].　W. L. MAC DONALD

XEROPIGADI, *see* KIRRHA

XYDAS, *see* LYTTOS

Y

YANIK KÖY Turkey. Map 7. Town in Aiolis, 6 km N of Menemen. It may be the site of Neonteichos, which was founded, according to Strabo (621), by Greek immigrants as a base for their attack on Larisa, 30 stades away. The town is also mentioned by Pliny (*HN* 5.121) and in an anonymous *Vita Homeri*. It never issued any coinage.

The site at Yanık Köy has produced no identifying evidence and has never been excavated; its identity depends upon that of Larisa at Buruncuk. The only remains are a number of pieces of terrace wall and a longer stretch of city wall, all of polygonal masonry, and a paved road leading up from the present village. Sherds are mostly of the 4th and 3d c. B.C.

BIBLIOGRAPHY. J. M. Cook, *BSA* 53-54 (1958-59) 20; G. E. Bean, *Aegean Turkey* (1966) 98-103.

G. E. BEAN

YASSI ADA, *see* SHIPWRECKS

YAVNEH, *see* JAMNEIA

YAVU, *see* KYANEAI

YELTEN ("Verbe") Turkey. Map 7. Site in Pisidia, at or near Yelten, 17 km N of Korkuteli. It is known from an inscription and other evidence, but the city has not been exactly located. There are numerous ancient stones in Yelten village, and a dozen or so inscriptions have been found there or in the neighborhood; some of these relate to agonistic festivals, and city status is proved by mention of Council and People.

BIBLIOGRAPHY. W. M. Ramsay, *AthMitt* 10 (1885) 338; A. M. Woodward, *BSA* 16 (1921) 115-21; G. E. Bean, *AnatSt* 10 (1960) 67-68. G. E. BEAN

YERKESIK, *see* THERA

YEŞILYAYLA, *see* NIKOPOLIS (Armenia Minor)

YIATELIO, *see* LIMES, GREEK EPEIROS

YORAN, *see* DIDYMA

YORK, *see* EBORACUM

YOUNGA, *see* MACOMADES MINORES

Y PIGWN Carmarthenshire, Wales. Map 24. Four Roman earthworks 6 km SE of the fort at Llandovery. I and II are marching camps, presumably of the period A.D. 47-77; both have internal claviculae. The areas are 16 and 10 ha. III is a small fortlet, probably used after the abandonment of Llandovery (ca. A.D. 160), and IV is a practice camp, probably built by the unit stationed at Llandovery.

BIBLIOGRAPHY. G.D.B. Jones, "The Roman Camps at Y Pigwn," *Bulletin of the Board of Celtic Studies* 23 (1968-70) 100-3[MI]; V. E. Nash-Williams, *The Roman Frontier in Wales* (2d ed. by M. G. Jarrett 1969) 6, 123-25, 130[MPI]. M. G. JARRETT

YSTRADFELLTE Wales. Map 24. An 8.4 ha Roman marching camp on the Brecknock-Carmarthenshire border at SN 924162. It lies on high moorland close to the Roman road running S from the Brecon Gaer to Coelbren. It was discovered in aerial photographs, which show the camp as a parallelogram with an internal clavicula in the middle of the E rampart. Excavation showed that the rampart was 1.4 m wide and built of turf with a nearly vertical face. A berm of 0.5 m separated the rampart from a single V-shaped ditch ca. 1.8 m wide.

BIBLIOGRAPHY. G.D.B. Jones, *Bulletin of the Board of Celtic Studies* 21 (1966) 174ff[MPI]. G.D.B. JONES

YVERDON, *see* EBURODUNUM

YZEURES, *see* ICIODURUM

Z

ZADAR, *see* IADER

ZAGHOUAN, *see* ZAQUI

ZAGORA, *see* ANDROS

ZAKISOVAIA BALKA Ukraine. Map 5. An unfortified Hellenized settlement (800 x 100 m) ca. 3.2 km S of Olbia along the high right bank of the S Bug. While some archaic finds exist, the settlement reached its height in the 4th-3d c. B.C. and came to an end in the 2d c. B.C. Among the various structures on the site was a large rectangular dwelling consisting of nine rooms and a paved courtyard. The walls of the house were made of adobe on a stone foundation. Excavations suggest that this was an agricultural village in close contact with neighboring Olbia.

BIBLIOGRAPHY. F. M. Shtitel'man, "Poselennia bilia Zakysovoi Balky," *Arkheologichni Pam'iatky URSR* 7 (1958) 131-42. T. S. NOONAN

ZALAMEA DE LA SERENA, *see* IULIPA

ZALONGON, *see* LIMES, GREEK EPEIROS

ZAMA ("Aelia Hadriana Augusta") Tunisia. Map 18. Famous for the great battle that ended in Rome's victory over Carthage, the city is cited in all accounts, ancient as well as modern, of the second Punic war. Yet up to the present time its site has not been precisely determined.

A royal city of the Numidian kingdom when it was independent, Zama was the scene of the decisive battle in 202 B.C. when two armies, Scipio's coming from near Carthage and Hannibal's from the Sahel, met in this central region for the great confrontation. The city was left in Numidian territory after the province Africa Vetus was organized, remaining one of the chief cities of the Numidian princes. Loyal to Jugurtha, it did not surrender to Metellus, who failed in his attempt to seize it in 109 B.C. Rallying to Caesar after his defeat of the Pompeians at Thapsus, the city closed its gates to its king Juba, who

killed himself in a nearby farm (46 B.C.). After the victors created Africa Nova, the city was rewarded by being made chief city of the province and Sallust was its first governor. From then on its history was the same as that of most imperial cities: an oppidum liberum according to Pliny's lists, it was promoted later, under Hadrian, to a "Colonia Aelia Hadriana Augusta Zamensis Regia," as is proved by an inscription dated 322 discovered in Rome (CIL VI, 1686).

Ancient writers are too brief in their references to the city to clarify its situation. Polybios places it five days' journey from Carthage; Sallust, who lived there, describes it as a citadel built on flat ground and defended more by man's ingenuity than by its natural surroundings. Vitruvius notes that the rampart, which Juba I built, had a double wall. Pliny adds that the waters of the spring had the property of beautifying the road. The *Peutinger Table* places the statio between Uzappa and Assuras, on the road from Thysdrus to Sicca. Even though the exact location of the site is still undetermined, the region where the events took place is fairly well defined. This is the region of Jebel Massouge, with the plains of Siliana and Sers close by, and the plateau of Rêbaa de Youled Yahia. There is no doubt that this region of fertile plains commanding forced passes was the territory of the Zamenses.

The fact that several epithets were attributed to Zama suggests that there must have been several cities of this name: one "major" or "minor," another "regia," and one of these, or another one, that was a colony. If the great city was also royal and later became a colony, there would have been just two Zamas. Four sites have been considered possible for each of these two cities: 1) Sidi Amor Jedid, situated near the Ouadi Mahrouf, 4 km E of Lemsa on a small rise overlooking the valley, contained an inscription mentioning a colonia Zamensis. It was published as Zama Minor, later to become a colony. However, the ruins are insignificant and the geographic position too far E. 2) Jama is a village perched high on one of the N spurs, ringed with hills and deep ravines, that divide the valley of the Siliana from that of the Ouadi Tessa. The site contains many ruins, in particular an aqueduct supplying three huge cisterns that have crumbling arches; a circular building made of large stones, set on a peak and noted by Cagnat; a citadel, probably Byzantine, dominating another peak; and finally in the village itself some more ruined buildings, including one made of rubble, with a spring in the midst of them. An inscription mentioning a Colonia Augustua Zama M was found here and the ancient form of the name Zama is believed to have survived in the name of the present-day village. However, the wildness of the place does not fit Sallust's description, and the site of the ancient city is not located on the Uzappa-Assuras road according to the *Peutinger Table*. Some archaeologists have suggested this might be great or even little Zama rather than the royal city.

3) Sebaa Biar is to be found near the road linking Maktar and Le Kef, 7.5 km N of Ellès. Situated on the Ouadi Masmoudi, it overlooked the road running from Carthage through the valley of the Ouadi Meliane and Massouge up to the beginning of the Sers plain at the W end of the Massouge pass, between Uzappa and Assuras. Half in the plain and half on a hillside, it is a site with many ruins (hardly explored, however), with abundant water, as its modern name suggests, and a citadel. In all these respects it would seem to match Sallust's description of ancient Zama.

BIBLIOGRAPHY. Louis Déroche, "Les Fouilles de Ksar Toual Zammel et la Question de Zama," *MEFR* 60 (1948) 55-105 (with preceding bibliography); F. M.

Russell, "The Battlefield of Zama," *Archaeology* 23.2 (1970) 120-29[MI]. A. ENNABLI

ZANA, *see* DIANA VETERANORUM

ZANKLE later Messene (Messina) Sicily. Map 17B. A city at the NE tip of Sicily on the Straits ca. 10 km to the S of Cape Pelorus in the narrow alluvial plain between the foothills of the Peloritan mountains and the small sickle-shaped peninsula which creates a natural harbor.

At first it was a nest of Chalcidian pirates within Sikel territory. Toward the middle of the 8th c. B.C. the site received, with the name of Zankle, a colony of Greeks from Euboia and from Italic Kyme (Thuc. 6:4, 5-6). Its formidable position in control of the trade routes across the straits accounts for the city's prosperity throughout the archaic period. It participated in the foundation of Rhegion (Strab. 6.257); on the Tyrrhenian side of the Peloritan mountains it occupied Mylai; it sent sub-colonies to Matauros (against Etruscan claims on the Lower Tyrrhenian Sea) and in 649-648 B.C. to Himera (as a bulwark against Carthaginian expansion on the W Tyrrhenian). From the beginning of the 5th c. B.C. Zankle's supremacy shifted to Rhegion; with Anaxilas' help some Ionians from Samos occupied the city, but shortly afterwards, in 486 B.C., Anaxilas settled a group of Messenians at the site, changing its name to Messene (Thuc. 6.4.5-6). From then onward, because of its geographical position, the city remained spectator rather than actor during historical events. After the Mamertine occupation in 284 B.C., which changed its name to Mamertina (Diod. 21:18), the city carried out an expansionist policy against the Sikels, at times with help from the Phoenicians, who finally invaded it; hence, in 264-263 B.C., Messene's request for help from Rome and the outbreak of the first Punic war. In the 1st c. B.C. it was still civitas foederata (Cic. *Verr.* 3.6.13). During the Imperial period it must have been one of the many maritime cities for commercial transit, since its existence was conditioned by the harbor activities. It was occupied by the Muslims in 843.

The modern city lies over the ancient. The borders of the Classical town, however, seem marked to the N by the Roman necropolis (1st-3d c. A.D.), to the SW by the large arc of the Hellenistic-Roman cemetery in the area of the Orti della Maddalena; recent reports confirm that the Hellenistic site also included the hill of Montepiselli (acropolis?) to the W. In this whole area very few monumental remains have been recorded: traces of Roman houses and various finds between the Duomo and Via Garibaldi; a thick wall (Mamertine fortification) in two sections of Via Università and Via Garibaldi. A grandiose chamber tomb with dromos, walls and funerary beds (klinai) perfectly preserved, has been uncovered in Piazza Avignone. It is datable between the end of the 4th c. and the 3d c. B.C., and is the first monument of Classical Messina to be preserved and opened to visitors. Almost nothing was known of Zankle's topography except for the archaic sanctuary (8th-7th c. B.C.) located at the tip of the harbor sickle. Excavation has identified a section of the archaic habitation area, at the point where the sickle-shaped zone joins the mainland (present city block 224-Hotel Reale); these are remains of houses separated by means of stenochoria, which follow an orthogonal system and are built with river stones (two to the thickness of the wall) set on virgin soil, in a layer rich with proto-Corinthian pottery (a section of the excavation has been reconstructed in an area adjacent to the original find spot, within the garden of the Villa

Comunale on Via T. Cannizzaro). The finds are housed in the National Museum of Messina.

BIBLIOGRAPHY. G. Vallet, *Rhégion et Zancle* (1958)[MPI]; P. Orsi, "Messana," *MonAnt* (1916)[MPI]. G. SCIBONA

ZAQUI (Zaghouan) Tunisia. Map 18. A monumental nymphaeum at the foot of Mt. Zaghouan near the village marks the origin of an aqueduct (132 km long) to Carthage. A large artificial terrace is bordered by a U-shaped portico with Corinthian columns and mosaic floor; its rear wall is articulated by piers into bays, each covered by a cross vault. Semicircular niches in alternate bays must have held statuary. The portico is interrupted in its center by a square cella with an imposing stepped facade, a large rectangular niche and a barrel vault. The cult statue(s?) stood directly over the water source, which disappeared into an underground gallery and emerged at the foot of the terrace in a figure-8 basin with stepped sides. Construction, probably started under Hadrian, was finished in time to supply water for the great Antonine Baths at Carthage.

BIBLIOGRAPHY. A. Graham, *Roman Africa* (1902) 116-17; R. H. Chowen, *AJA* 60 (1956) 273-77; F. Rakob, "Das römische Quellheiligtum bei Zaghouan in Tunesien," *AA* (1969) 284-300[PI]; id., "Le sanctuaire des eaux à Z.," *Africa* 3-4 (1969-70) 133-176[PI]; P. Romanelli, *Topografia e Archeologia dell'Africa Romana* (1970) 219-20[I]; F. Rakob, "Das Quellenheiligtum in Z. und die römische Wasserleitung nach Karthago," *RömMitt* 81 (1974) 41-89[PI]. B. S. RIDGWAY

ZARAGOZA, *see* CAESAR AUGUSTA

ZARKA ("Zaretra") Euboia, Greece. Map 11. The remains of an ancient fort, probably Dryopian, near Zarka have been identified with the deme of Zarex and the Eretrian fort of Zaretra; Plutarch describes the location as the narrowest part of the island of Euboia.

BIBLIOGRAPHY. Plut. *Phokion* 13; W. Wallace in *Hesperia* 16 (1947) 138ff; L. Sackett et al. in *BSA* 61 (1966) 76. M. H. MC ALLISTER

ZA RODINA Kuban. Map 5. Fortified Bosporan site 1 km W of the village in the Temriuk area. It was founded no later than the 4th c. B.C. The most interesting discovery from the excavations, begun in 1970, was the foundation of a tholos of the 3d-2d c. B.C., encircled by a paved portico. The tholos, a structure hitherto unknown in the N Black Sea, had Ionic columns while the colonnade of the portico was evidently Doric. West of the tholos was a long building of the same period composed of at least nine adjoining rooms, one of which was apparently an andron used for symposia. The rooms opened on a paved portico with a richly decorated colonnade. The tholos and long building may have formed part of a sanctuary. In the late 2d or early 1st c. B.C. both buildings were partially destroyed and repaired. In the NW corner of the site arose a rectangular two-story fortified dwelling with thick walls, probably the residence of some high official. Most of the structures consisted of adobe brick walls on stone foundations. In the late 1st c. B.C. all the buildings perished in a major fire. Soon after, the site was fortified by a rectangular embankment and trench. An adobe brick wall probably ran atop the embankment; the foundations of several towers have been uncovered. Among the remains from this last period were a paved street and the foundations of several homes.

BIBLIOGRAPHY. V. S. Dolgorukov et al., "Raboty Tamanskoi ekspeditsii," *Arkheologicheskie Otkrytiia 1970*

goda 118-19; N. I. Sokol'skii et al., "Raskopki gorodishcha u poselka 'Za Rodinu,'" *Arkheologicheskie Otkrytiia 1971 goda* 147-49; id., "Arkhitekturnyi ansambl' na Tamanskom poluostrove," *Arkheologicheskie Otkrytiia 1972 goda* 145-46. T. S. NOONAN

ZATONJE, *see* LIMES OF DJERDAP

ZEA, *see* KEOS

ZELA (Zile) Pontus, Turkey. Map 5. Some 57 km S of Amasya (Amaseia) on the old route to Sebasteia, where this was crossed by one of the Roman roads from Tavion to Neocaesarea. Under the Mithridatids Zela was a temple settlement with its own territory tilled by the temple serfs and governed by the priest of Anaitis. The Hellenized Persian cult of Anaitis, Omanos, and Anadatos was apparently established during the Persian occupation. Zela was a less important sanctuary than Comana Pontica, 67 km to the E, but it had special sanctity for making oaths. The precinct of Anaitis was defended by a wall. In Pompey's settlement of Pontus (64 B.C.) Zela, unlike Comana, received a civic constitution and a sizable territory. It was near here that Julius Caesar defeated Pharnakes II of Pontus (47 B.C.) and reported "Veni, vidi, vici." Under Antony, Zela lost the E part of its territory to Comana and temporarily reverted to its previous status as a temple domain. A generation later it was in the hands of Pythodoris of Pontus, and it remained in the Pontic kingdom until its annexation by Rome in A.D. 64-65.

The site is a low hill rising from the fertile plain of Zile Ovasi, ca. 18 km from the Yeşil Irmak (Iris fl.). Byzantine and Turkish fortifications have replaced the temple precinct of Anaitis on the summit. On the NE flank a small theater was partly carved in the living rock, partly built up in masonry or timber. Nearby is a single rock-cut tomb.

BIBLIOGRAPHY. F. & E. Cumont, *Studia Pontica* II (1906) 188-94; J.G.C. Anderson et al., *Studia Pontica* III.1 (1910) 233-42. D. R. WILSON

ZEMUN, *see* LIMES PANNONIAE (Yugoslav Sector)

ZENICA ("Bistue Nova") Bosnia-Herzegovina, Yugoslavia. Map 12. An indigenous site on the right bank of the Bosnia river 78 km NW of Sarajevo. There are remains of a large Roman building with two inscriptions in Latin which have preserved the name of the municipium and another inscription which mentions the priest who performed the cult "urbis Romae." Family names on other inscriptions indicate that the inhabitants received Roman citizenship under the Flavian emperors. There are ruins of a small Roman bath and a nymphaeum near the modern town. The seat of a bishop from 530 to 534, the town has the remains of an Early Christian church.

BIBLIOGRAPHY. C. Truhelka, *WMBH* 1 (1893) 273-78; C. Patsch, *WMBH* 11 (1909) 108; D. Sergejevski, *GZM Sarajevo* 44 (1932) 35-56; J. J. Wilkes, *Dalmatia* (1969); V. Paskvalin, *Arheoloski Pregled* (1968) 153. V. PASKVALIN

ZEPHIRIA, *see* MELOS

ZEPHYRION (Mersin) Cilicia Campestris, Turkey. Map 6. About 48 km W of Adana towards the end of the alluvial plain where the mountains of the Taurus range begin closely to approach the Mediterranean. The city's history is elusive, though archaeology suggests a very ancient settlement including, in its pre-Islamic phase, an unbroken pottery sequence from Mycenaean to ar-

chaic Greek times. Literary evidence is scanty, though Zephyrion seems to have changed hands frequently in the Hellenistic period, from Seleucid to Ptolemaic, and then back to Seleucid control. A short period of semi-autonomy ended with Pompey's Cilician settlement, and like Mopsuestia and Alexandria ad Issum the city chose 67 B.C. as the opening of a new era. It was apparently a relatively small and unimportant city, but was nevertheless a bishopric under the Metropolitan of Tarsus in the Christian period. Its modern successor is capital of the Mersin vilayet, and except at Soğuksu Tepe, N of the town, no excavation has been undertaken. Some ancient building material found in reuse was probably taken from the ruins of Soli-Pompeiopolis some 11 km to the W. Until recently these were housed in Mersin, but are now in the Museum of Adana.

BIBLIOGRAPHY. Skylax, *Periplus* 102; Livy 33.20.
B. V. Head, *Hist. Num.* (2d ed. 1911) 724; J. Garstang, *Prehistoric Mersin* (1953) 253-59. M. GOUGH

ZEUGMA later SELEUCIA ON THE EUPHRATES (Balkis) Syria. Map 6. Seleucus I Nicator (301-281 B.C.) founded the town on the W bank of the Euphrates NE of Aleppo. It owes its name to the ancient bridge of boats, replaced under Trajan by a stone bridge, which joined Commagene and Mesopotamia. An inscription gives its official name: Seleucia on the Euphrates. On the frontier between the Roman Empire and the Parthian, then Sasanian Empire, the position had great strategic and commercial importance. Justinian enclosed Zeugma in high, wide walls. The Moslems took it in A.D. 637.

The ancient city occupied the terrace of the modern village and extended over the hills to the W. The acropolis was a conical hill, on which there is no trace of the temple depicted on a coin or of the castle where Tigranes had Queen Cleopatra Selene killed. Several necropoleis have been found in the vicinity, also fine mosaic pavements. One depicts the Labors of Hercules, another an emperor surrounded by personifications of the provinces of the Empire (the medallions are now dispersed among several museums, especially those in Berlin and Leningrad). A rocky spur N of the village is cut by a Roman road, which then follows the Euphrates on a narrow ledge. Farther upstream, a double wall, the remains of an access road, probably marks the location of the bridge.

BIBLIOGRAPHY. F. Cumont, *Etudes syriennes* (1917).
J.-P. REY-COQUAIS

ZILE, see ZELA

ZILIS (Dchar Jedid) Morocco. Map 19. An Augustan colony of W Mauretania (Iulia Constantia Zilis) mentioned by Pliny and the Roman geographers. Because of a doubtful toponymic similarity it is usually placed at Asilah, which however has no Roman ruins. The site should rather be identified with the extensive ruins of Dchar Jedid 13 km to the NE: there, inside a vast surrounding wall, can be seen the remains of a temple, some houses, baths, large cisterns, and what is probably a theater. The site was occupied from the first years of the Christian era until at least the 4th c. A.D. The port lay 5 km to the W, on the right bank of the Gharifa, at Kouass, where some scattered ruins attest to its occupation in ancient times: potters' kilns in use from the 5th to the 1st c. B.C.; a pre-Roman fortified surrounding wall 48 m long (3d to 1st c. B.C.?); fish-salting works, and a Roman aqueduct.

BIBLIOGRAPHY. L. Chatelain, *Le Maroc des Romains* (1944) 44-49; M. Euzennat, "Les voies romaines du Maroc dans l'Itinéraire Antonin," *Hommages à Albert Grenier*, coll. *Latomus* 58 (1962) 601-2; M. Ponsich, "Kouass port antique et carrefour des voies de la Tin-

gitane," *Bulletin d'Archéologie Marocaine* 7 (1967) 369-405; "Note préliminaire sur l'industrie de la céramique préromaine en Tingitane (Kouass, région d'Arcila)," *Karthago* 15 (1969-70) 77-97. M. EUZENNAT

ZIMARA (Altıntaş, İliç, Erzincan) Armenia Minor, Turkey. Map 5. A fort in a key position on the Roman E frontier. It lay 11 km N of the great bend S of the Euphrates. Ruins have been noted a short distance E of the modern village. Adatepe (formerly Pingan) on the Euphrates bank nearby has produced inscriptions, especially a tombstone of a decurion of Ala II Ulpia Auriana (*CIL* III, 6743), which is not necessarily to be identified with the Ala Auriana stationed at Dascusa. Early identifications of Pingan with Dascusa are erroneous.
R. P. HARPER

ZIMNEC, see LIMES, SOUTH ALBANIA

ZIRL, see TERIOLIS

ZIVINT, see SIBIDUNDA

ZLATNA, see AMPELUM

ZLITEN Libya. Map 18. A town 35 km E of Leptis Magna, on or near the site of ancient Sugolin. There is a large Roman mausoleum at Souk al-Jumah a few km to the W. On the coast, 4.5 km to the N, is Dar Buk-Ammarah, a Roman villa excavated in 1914 and 1923, which contains fine mosaics and a number of excellent though fragmentary frescos. These are all in Tripoli Museum. The villa was built on a terrace overlooking the sea. On the sea side was a corridor with a portico 50 m long; behind it was a range of rooms and then a cryptoporticus parallel to the N corridor. There were more rooms, and baths, at the E end. The villa had a long life, during which its floors were repaired from time to time; as many as five superimposed layers of plaster have been found on some of its walls.

Among the pavements were found opus tessellatum, opus sectile, and opus vermiculatum. Opus tessellatum, was used to cover large spaces, such as the N corridor, but both it and the opus sectile were also used as backgrounds on the floors with emblemata in opus vermiculatum. The emblemata were prepared in terracotta trays which were afterwards cemented into place in the pavements. The complex mosaic pictures they held were carried out in tesserae so small that they average 9-15 tesserae to the sq. cm and are cut in different shapes the better to fit into the picture. The Zliten emblemata include agricultural scenes, Nilotic scenes, groups of fish, animals, etc. and a set of the Four Seasons. The excellence of the mosaic-work suggests a well-equipped studio, perhaps in Alexandria, whose strong influence is manifest at Zliten and elsewhere in Tripolitania, or perhaps in Leptis Magna, where there were probably highly skilled mosaicists trained in the Alexandrian style.

The well-known amphitheater scenes in opus vermiculatum constitute the four borders of a handsome floor. These borders have 15-18 tesserae to the sq. cm in their figure-work and are only excelled by one other mosaic which paved a small room shaped as a quarter-circle. Its design consists of an acanthus scroll intertwined with flowers and inhabited by animals and other creatures, among them the rat (or mouse), chameleon, lizard, locust, and chaffinch with a nest of fledglings. Below are fish and mythical sea-beasts. This exquisite floor, with tesserae as many as 40 or even 63 to the sq. cm, must have been the work of a very talented artist, doubtless a Greek, perhaps from Alexandria or at any rate trained

under Alexandrian influence. Aurigemma argues that the vermiculatum of the two last mosaics, like that of the emblemata, was prepared in a studio, fashioned in sections which were then assembled at the villa, the joins being carefully filled with tesserae brought for the purpose.

He has always claimed that the amphitheater mosaic is Flavian, and moreover believes it to record games held at Leptis to celebrate the victory of Valerius Festus in A.D. 70 over the Garamantes, whose chiefs we see here being cast to the leopards. Others held the mosaic to be Severan or later, while Doro Levi was in favor of about A.D. 100. Picard and Foucher have supported Aurigemma's Flavian dating and Ville has shown that the costumes worn by the bestiarii of Zliten are of 1st c. type. In assessing the date of the villa and its decoration it is also important to take into consideration the frescos, which come mainly from the ceiling of the cryptoporticus. Among them is Apollo on his leopard, and a scene of a seaside village. Aurigemma maintained that the delicate and restrained style of the painting is of the best period of Flavian art.

BIBLIOGRAPHY. S. Aurigemma, *I Mosaici di Zliten* (1926)[MPI]; *Tripolitania. I Monumenti d'Arte Decorative* I, pt. 1, *I Mosaici* (1960)[I]; pt. 2, *Le Pitture d'Età Romana* (1962)[I]; G. W. Elderkin, *Art in America* 35 (1947) 53; Doro Levi, *Antioch Mosaic Pavements* (1947) 347; A. Rumpf, *Malerei und Zeichnung* (1953) 191; G. Picard, *Karthago* 5 (1954) 207; M. Rostovtzeff, *Social and Economic History of the R. Empire*[2] (1957) 313; M. Cagiano de Azevado, coll. *Latomus* 58 (1962) 374; L. Foucher, *Libya Antiqua* 1 (1962) 1; G. Ville, in *La Mosaïque greco-romaine* (1965) 157.

O. BROGAN

ZMAJEVAC, *see* AD NOVAS *under* LIMES PANNONIAE (Yugoslav Sector)

ZOLLFELD, *see* VIRUNUM

ZOSTER Attica, Greece. Map 11. From Strabo's description of the demes, capes, and islands between Peiraeus and Sounion (9.1.21), Zoster can be securely identified as the promontory that juts into the sea at modern Vouliagmeni, in essence the S point of Hymettos. Of the three tongues that constitute the headland, only the central one, Mikro Kavouri, corresponds to Stephanos' precise description of Zoster as a peninsula (s.v. Ζωστήρ). Thus it appears that, although the name Zoster was applied generally to the whole cape, as for example by Herodotos (8.107), it was also used in a narrow sense to refer only to the projection that forms the E side of the deep bay in front of Vouliagmeni. A reason for this focus is not hard to find. According to Pausanias (1.31.1) it was at Zoster that Leto "loosened her girdle with a view to her delivery," and that there was an Altar of Athena, Apollo, Artemis, and Leto.

Archaeological discoveries have confirmed the special character of the central promontory. At the neck of the peninsula, in the so-called Laimos where the spit of land is so low that it is easily flooded, remains have been recovered of a small sanctuary, dedicated, as is known from several inscriptions, to Apollo of Zoster. The temple was originally built about 500 B.C. and consisted of a sekos only, later partitioned to make two rooms of unequal size, to which was added, no earlier than the second half of the 4th c., a peristyle of unfluted columns, 4 x 6, each set on its own base with no connecting stylobate. Within the front part of the cella were found three marble bases, a table, a throne, and a fragment of a votive fluted column preserving the beginning and end of an inscribed distych in honor of golden-haired Apollo. To the E of the temple on its axis are the foundations of a large rectangular altar. As the inscriptions show, the sanctuary was administered by the demesmen of Halai (Aixonides).

One hundred and fifty m to the N of the sanctuary, directly above the shore road, are the remains of a large rectangular building that at the time of its construction, about 500 B.C., contained a tower, gateroom, enclosed courtyard, colonnade, and, behind, three rooms. By the end of the 4th c., however, this spacious design had gradually given way to one that involved the creation of several additional small rooms, particularly at the expense of the colonnade. Because this building does not seem to be part of a community, and because it is so close in place and time to the sanctuary, it has been interpreted as the house for the priest and, after the remodeling, as a sort of katagogion for those visiting the sanctuary. Some of the finds made within the house can also be used to suggest such an identification.

Immediately S of the Sanctuary of Apollo on the first of the peninsula's several hills is the Astir resort with its hotel and bungalows. Prior to its completion, emergency excavations had revealed the presence on this wooded hill of houses of the Early Helladic period and a fort with rubble walls strengthened by towers. It is unlikely that the latter is prehistoric. More plausibly it should be associated with coins of Ptolemy II also from Cape Zoster, and be included among the several fortifications in Attika known to belong to the times of the Chremonidean War.

BIBLIOGRAPHY. K. Kourouniotes, Τὸ Ἱερὸν τοῦ Ἀπόλλωνος τοῦ Ζωστῆρος, ArchDelt 11 (1927-28) 9-52; Ph. Stauropoullos, Ἱερατικὴ οἰκία ἐν Ζωστῆρι τῆς Ἀττικῆς, ArchEph (1938) 1-31; E. Varoucha-Christodolopoulou, Συμβαλή εἰς τὸν Χρεμωνίδειον πόλεμον 266/5-263/2 π. Χ ArchEph (1953-54) 3.321-349; J. McCredie, *Fortified Military Camps in Attica* (*Hesperia*, Suppl. XI [1966]) 30-32.

C.W.J. ELIOT

ZUGLIO, *see* IULIUM CARNICUM

ZUGMANTEL, *see* LIMES G. SUPERIORIS

ŽUPANAC, *see* DELMINIUM

ZÜRICH, *see* TURICUM

ŻURRIEQ, *see* MELITA

ZURZACH, *see* TENEDO

ZWAMMERDAM, *see* NIGRUMPULLUM

GLOSSARY

A term used only once is normally defined in context and not repeated here. A term defined in a standard desk dictionary (*Webster's Collegiate Dictionary*, for example) appears here only if the dictionary definition is not readily applicable.

ABRAXAS: A cabalistic word sometimes inscribed on gems as a charm

AEDICULA: A small temple-like shrine

AEDILE: A Roman magistrate in charge of public works

AEDIS ROTUNDA: A round house or small temple

AGER PUBLICUS: Public property; land confiscated by the State as punishment for resistance to conquest

AGGER: A pile of rubbish, stone, etc., raised to serve as a rampart, pier, or mole

AIAKEION: A temple of Ajax

AKROTERIA: The figures or ornaments at the apex of a pediment or at the lower angles

ALAE: In architecture, the rooms on either side of a court or atrium

ALA QUINGENARIA: The wing of an army, consisting of 500 men

ALEIPTERION: The oiling room in a gymnasium or bath

ALVEUS: A bathtub

AMPHICTYONES: The political and religious assembly of the confederated Greek states (Amphictyony). The first of its semestrial sessions (pyle) was held at Thermopylai; the second at Delphi. Representatives to the Amphictyonic Council were called hieromnemones and their advisers were called pylagorai.

ANAKTORON: A dwelling of the gods or the most sacred part of it; a royal dwelling

ANALEMMA: The sustaining wall at the side of an auditorium

ANTEFIX: Decorative termination, at the eaves, of the cover tiles over the joints between the flat tiles of a roof

ANTEPAGMENTUM: Decorative element on the exterior of a building, e.g., revetment plaque of terracotta

APODYTERIUM: A room for disrobing in a bath

APOLLINARIAN TRAVELING CUPS, *see* VICARELLO, TRAVELING CUPS OF

APOTHECA: A storehouse, repository, warehouse

ARCOSOLIUM: An arched recess designed to receive a sarcophagus

ARMAMENTARIUM: An arsenal

ARRETINE WARE: A type of Roman pottery made in Tuscany and exported to Gaul and elsewhere from the reign of Augustus onward

ASCIA: As used and illustrated on grave stelai, a mason's trowel

ASHLAR MASONRY: A type of solid stone construction, all rectilinear

AUGURACULUM: The place where auguries were taken; the citadel of Rome

AULA: A hall of princely proportions

AUTOELOGIUM: An inscription provided by a man for his own tomb or monument

BAETYLS: Aniconic representations of the divinity

BALBIDES: The starting mechanism for foot races in the stadium. For races two or more times the length of the stadium, the sill served also as the turning-point or finish line.

BALLISTARIA: Catapult platforms

BALNEUM: A bath

BARBOTINE: A term used to describe coarse pottery coated with a clay paste that was incised to form relief decoration, as for example Samian ware

BAZINA: A Berber tomb

BEMA: A raised place or tribune from which to address a public assembly; in a church, the chancel area

BOMOS: The base of a statue; an altar; a tomb

BOTHROS: A pit or trench dug in the earth, especially one into which libations to the nether gods were poured or offerings thrown

BOULEUTERION: An assembly hall for magistrates or members of the council; town hall

BRADYSEISM: A slow rise and fall of the earth's surface

BUCCHERO: Black, burnished, wheel-made pottery characteristic of Etruria in the 7th-6th c. B.C.

BUCRANIA: Ox-skulls, often wreathed, as represented in architectural decoration

BULLA: An amulet

BURGUS: A castellum, fortress, citadel

CADASTRE: A survey map

CALDARIUM or CALIDARIUM: A room with hot water for bathing

CALIGA: A heavy-soled military boot

CANABA or CANNABA: A hut or hovel

CAPITOLIUM: The Temple of Jupiter in Rome or the hill on which it stood; hence, the citadel or state temple of a Roman city or town

CAPUT: Of roads, the beginning, the end, or the principal point on

CARCERES: The stalls of a hippodrome or circus from which the chariots began their courses

CARDO: The principal N-S street of a Roman town; surveyors' centuriation line

CASTELLUM: A Roman fortress or stronghold; also the reservoir fed by an aqueduct

CASTRUM: A Roman fortified place, sometimes applied to an entire city; in the plural, encampments

CAVEA: The auditorium of a theater

CELLA: The enclosed chamber or sanctuary of a temple

CENTONARIUS: A rag dealer

CENTURIATION, ROMAN: A method of subdividing large areas on a grid system, used for settlers' allotments

CHALCIDICUM: A chamber at the corner of a basilica; one on each side of the central tribunal

CHORION: A settlement

CHRYSELEPHANTINE STATUE: One in which ivory (for the flesh) and gold (for the drapery and ornaments) was applied to a wooden core

CIPPUS: A graven stone used to mark the boundaries of a city or territory

CIVITAS: A self-governing community of citizens, the body politic

CIVITAS DECUMANA: A tithe-paying civitas

CIVITAS FOEDERATA: A state allied to Rome by treaty

CIVITAS SINE SUFFRAGIO: A community or state without voting rights

CLAVICULA: The bar or bolt of a door; hence, in Roman military usage, the projecting quarter circle of earth rampart that protected the entrance to a marching camp

CLERUCHY: A type of colonial activity practiced most notably by Classical Athens in which the colonists ("cleruchs") seem to have maintained their citizenship but were independent of the mother city

COCCIOPESTO, *see* OPUS SIGNINUM

COHORS: In military usage, a company of soldiers, a division of an army, a cohort; cohors milliaria, a cohort numbering a thousand

COLLEGIUM FABRUM: An association of artisans connected with the building process

COLONIA: A settlement of Roman citizens

COLUMEN: Vitruvius' term for the ridgepole of a temple

COLUMNA CAELATA: A column carved with reliefs

CONCILIABULUM: A place of assembly; a public place

CONVENTUS: An assembly, a judicial assembly or court of justice; also, persons associated in a provincial town for the sake of trade

COROPLASTIC: Having to do with the modeling of figures in clay

CREPIDOMA: The stepped platform of a Greek temple

CRUCK-BUILDING: In primitive domestic architecture in England, a structure characterized by the pair of curved timbers forming the principal support of the roof

CRYPTOPORTICUS: A gallery or passage partly or completely enclosed and usually below the major level of the building it served

CUCULLATUS: Hooded, having a hood

CUNEI: The wedge-shaped divisions of the rows of seats in a theater

CUNEUS EQUITUM SCUTARIORUM: A phalanx of cavalry troops

CURATOR MUNERIS PUBLICI: A keeper of public buildings erected at private expense

CURSUS PUBLICUS: The Roman imperial post, divided into relays, for the transmission of mail and the passage of officials

DAMNATIO MEMORIAE: The removal of a man's name from all public records as a punishment or as posthumous revisionism

DECUMANUS: The principal E-W street of a Roman town; surveyors' centuriation line

DEDUCTIO: The transfer of a body of people to a colony; colonization

DEMIURGES: The artisan class; a class of citizens at Delphi endowed with full political rights

DENDROPHORUS: A woodsman; (pl.) a guild in the cult of Kybele

DIATEICHISMA: A cross-wall, especially one connecting the inner and outer circuits of a fortification

DIAZOMA: The horizontal passage in the auditorium of a theater. It divided the lower rows of seats from the upper

DIOLKOS: The slipway for the portage of ships and cargo

DIOSKOUROI (or DIOSCURI): Castor and Pollux, twin sons of Leda and Zeus; the Gemini

DISKOBOLOS: A discus thrower

DISTYLE IN ANTIS: Having two columns between antae

DOLIA DEFOSSA: Large earthenware jars sunk into the ground

DOLICHENUM: A temple of Jupiter

DOLIUM: A globular amphora

DROMOS: A long, narrow passage or runway

DUOVIRI: A Roman municipal board or court consisting of two persons charged with particular duties

EARTHWORKS: In principle, a ditch of which the contents are banked for defense; hence, the earthen walls with which the Romans sometimes surrounded camps and towns during their occupation

ECCLESIA: An assembly

ECHINUS: The curved element in a Doric or Ionic column making the transition from the shaft of the column to the abacus

ENEOLITHIC: Chalcolithic; pertaining to the transition from the Neolithic to the Bronze Age

ENKOIMETERION: A grave

ENTABLATURE: In an architectural order, the horizontal element supported by columns or arches and carrying the roof

ENTASIS: The curve in the vertical profile of a column

EPHEBOS: A young man of eighteen or over. An ephebeion was a building or apartment reserved for the use of the epheboi, especially for physical exercise.

EPIMELETES: A supervisor

EPISCOPUS: An overseer; in an ecclesiastical context, a bishop

EPITHALASSIOS (-ON): Lying or dwelling along the sea

ERGASTULA: Houses of correction

ESCHARA: An altar for burnt-offerings

ESTIATORION: A banquet hall

EURIPOS: A gutter or channel between the orchestra and the first row of seats in a theater or hippodrome

EUTHYNTERIA: In temple architecture, the leveling course between the foundations and the superstructure

EXEDRA: A rectangular or semicircular space opening from a hall or colonnade, often furnished with seats

EXTRA MOENIA: Outside the walls

FABRICA: An artisan's workshop

FANUM: A place dedicated to a deity, a sanctuary or temple

FAVISSA: An underground storage chamber of a temple for water or for sacred utensils no longer in use but too hallowed to discard; a covered treasury

FLAMEN: The priest of a particular deity; his wife, the flaminica, assisted at the sacrifices

FOEDERATI: Barbarian troops under their own command providing garrison and frontier defense or serving as

buffer-states on the frontiers of the Late Empire under treaty arrangements with Rome

FOEDUS, FOEDERA: A league, treaty, compact

FRIGIDARIUM: A room with cold water for bathing

FRUSTRUM: A piece or portion

GENIUS CUCULLATUS: A spirit in Roman Britain that wore the hooded cloak used by the inhabitants of the region

GENTILES: Foreigners, as opposed to Romans (not in an ecclesiastical sense)

GEROUSIA: A council of elders in the ancient Dorian states, especially the Spartan senate

GORGONEION: A Gorgon mask

GUTTA: A slight projection, suggesting the head of a peg, under the regula or mutules of a Doric entablature

HALLSTADT: The name used in Europe to describe Late Bronze Age - Early Iron Age culture, as first studied at burial sites near Hallstadt in Bavaria. For later Iron Age culture, see LA TÈNE

HARUSPEX: An interpreter of omens

HEKATOMPEDON: A building (normally a temple) 100 feet long

HEROON: The burial place of one receiving posthumous veneration; a shrine or sanctuary of a demi-god or hero

HIEREIA: A sacrifice

HIEROMNEMONES (or HIEROMNAMONES), see AMPHICTYONES

HIERON: A sacred place

HORREUM (HORREA): A storehouse, granary, magazine

HOSIOI: A sacerdotal board of five noblemen at Delphi

HYPETHRAL: Open to the sky; unroofed

HYPOCAUST: A heating system providing for the circulation of hot air under the floor of a building

IIVIRI, see DUOVIRI

IMA (or PRIMA) CAVEA: The lower section of theater seats, reserved for the privileged

IMBREX (IMBRICES): A tile covering the joint between two adjacent tiles on a roof

IMPASTO: The coarse, brownish fabric of the handmade clay pots of early Italy

IMPLUVIUM: A skylight; the opening in the roof of the atrium of a Roman house for the escape of smoke and collection of rainwater

INCOLA (-AE): A resident, inhabitant

INSULA (-AE): A Roman residential block

INTERVALLUM: The space within the mound or breastwork of a camp, the space between two palisades

INVIDUS MOSAIC: A mosaic floor with a design or inscription intended to avert evil

IRON AGE, SECOND: La Tène period divided into La Tène I, II, III

ISODOMIC MASONRY: A type of masonry in which blocks of equal length and thickness are laid in courses, with each vertical joint centered on the block below

IUS ITALICUM: The rights enjoyed by colonies on home soil extended to a provincial colony

IUS LATII: The political rights and privileges which originally belonged to the Latins but were later granted by the Romans to other people

IWAN: A vaulted chamber or hall with one side open to a court

KASTRO, see CASTRUM

KATAGOGEION: An inn, lodging, hostelry

KATOIKIA: A colony, settlement

KLIMA: a region or part

KLIMAKES: In a theater context, the steps separating the cunei or wedge-shaped sections of seats

KOME: An unwalled village, or a quarter within a city

KONISTRA: An arena in a wrestling school; also the wall that separates the cavea from the orchestral area

KOUROS (KOUROI): In sculpture, the statue of a young man, undraped

KOUROTROPHE: An epithet meaning "nurturing mother," applied especially to Aphrodite

KREPIDOMA, see CREPIDOMA

KRIOBOLION: The ritual sacrifice of a ram

KURGAN: A burial mound in the Black Sea area

KYATHOS: A ladle; an Attic measure

KYMATIA: Moldings of double curvature

LACONICUM: The sweat room of a Roman bath

LACUS: A lake; also basin, tub, reservoir

LAETI: Barbarian troops under Roman command providing garrison and frontier defense in the Late Empire in return for cash or land grants

LAMINA (-AE): A thin piece of metal, wood, marble, etc.

LA TÈNE: The name of a valley in Switzerland often used to describe Iron Age culture and industry as first studied in a votive deposit in shallow water at the east end of Lake Neuchâtel. For earlier Iron Age culture, see HALLSTADT

LATIFUNDIUM: A large estate or farm

LATOMIA: A stone quarry

LAUS (LAUDAE): A tomb inscription praising the deceased

LESCHE: A building, a lounge or place of resort

LIMES (LIMITES): A Roman frontier; fortified boundary

LUDI CIRCENSES: Games in the circus

LUDUS: A place for exercise, practice, or games

LUPERCAL: A grotto on the Palatine Hill sacred to Lupercus, the Lycean Pan, who protected the flocks from wolves

MADABA MAP: A mosaic map (6th c. A.D.) depicting Palestine; it was found at Madaba

MAENIANUM: A gallery or balcony of a house; used also to refer to a gallery in a theater or amphitheater

MANSIO: An inn or lodging, sometimes marking a day's journey; also, a stop on the cursus publicus

MANTEION: A place for consulting an oracle

MATRES or MATRONAE: The protecting goddesses of a place

MEANDER: A continuous fret or key pattern

MÉDAILLONS D'APPLIQUÉ: Circular medallions of terracotta fastened as decoration to Gallo-Roman vases made in the Rhone valley

METIC: A term applied to a resident alien in a Greek town, distinguished by the grant of special privileges but with few civic rights (i.e. he could not own land or contract legal marriage with a citizen)

MILLIARY (fort): A fort built to accommodate a thousand troops

MITHRAEUM: A place for the celebration of the rites of Mithras

MONOPTEROS: A circular structure with a ring of columns only and no walls

MUNICIPIUM: A town having the social right of Roman citizens but governed by its own laws: a free town

MUTULE: Vitruvius' term for the beams that join the cella walls and the columns of the Tuscan temple; in the Doric order, the exposed beam ends which adorn the soffit of the cornice

MYESIS: Initiation

NAOPES: The overseers of a temple

NAOS (NAISKOS, dim.): A shrine

NAUMACHIA: The representation of a sea battle; the place where a mock sea battle was performed

NEMESEUM: A temple of the goddess of justice

NEMUS: A wood or grove

NUMERUS: As a military term, a division of the army

NYMPHAEUM: A cave with running water, dedicated to the nymphs: a fountain, a grotto

ODEON: A small theater, often roofed, for competitions in music and poetry

OECUS, see OIKOS

OFFICINA: An artisan's workshop

OIKISTES: The founder of a city

OIKOS: A house or habitation; used in a religious context

OLLA: a jar or pot

OPAION: An opening in a roof for ventilation and light; an oculus

OPISTHODOMOS: The porch at the rear of the cella of a temple, entered from the colonnade

OPPIDUM LIBERUM: A town independent of alien rule

OPUS EMPLECTON: A construction with two faces of built stone work tied together by cross members or headers and filled with earth and small stones; also, a construction with headers and stretchers giving the appearance of basket weave

OPUS INCERTUM: A facing for concrete, of irregularly shaped small blocks of stone

OPUS MIXTUM: Construction in which courses of bricks are alternated with small stone work

OPUS QUADRATUM: Masonry of squared stones

OPUS RETICULATUM: Roman masonry of concrete faced with small squared stones creating a diagonal pattern

OPUS SECTILE: Decoration of colored marble sheets cut in pattern shapes

OPUS SIGNINUM: Cement coating containing crushed potsherds or bricks

OPUS SPICATUM: A floor or wall of small bricks laid herringbone fashion

OPUS TESSELLATUM: Mosaic of small square stones of approximately uniform size

ORANTES: Worshipers

ORIENTALIZING: The period, roughly the 7th c. B.C., when Oriental motifs were first imitated in Greek and Etruscan art

ORTHOSTATES: A course of blocks laid on edge, normally in the lower part of the wall of a building

OSCILLUM: A small image of a face or a mask, made to hang and turn in the wind

OSTRAKON: A potsherd inscribed for use as a ballot

PAGUS: A place with fixed boundaries, such as a district, canton, province

PALLADION: The statue of Pallas Athena, which was believed to have fallen from heaven at Troy during the reign of Ilus

PALLIUM: A rectangular cloth worn in antiquity as a cloak

PANATHENAIA: An Athenian festival celebrated annually (and with greater pomp every fourth year) in celebration of Athena's official birthday

PARASKENION or PARASCENIUM: One of the two side wings of a theater building

PARASTAS: A flanking wall generally terminating in an anta

PARODOS: One of the lateral entranceways to a theater

PATERA: A flat dish or saucer; a libation saucer or bowl

PEDIMENT: A gable; the triangular termination of a pitched roof; the area enclosed is called the tympanon (tympanum)

PELANOS: The tax imposed on those consulting the oracle at Delphi

PELTA: A small shield in the shape of a half moon

PEPERINO: The lapis albanus of antiquity, so called because quarried near Lago d'Albano

PERIBOLOS: A sacred enclosure

PERIOIKOI: Part of the population of Lakonia, of free personal status, allowed to cultivate land of their own and to practice trade and handicrafts but deprived of political rights and subject to Spartan full-right citizens

PERIPOLARCHOS: The commander of a military patrol

PERIPOLION: A military patrol

PERIPTERAL: A term applied to a temple whose cella is surrounded by a peristyle

PERISTYLE: A covered colonnade surrounding a building, or an inner court lined with a colonnade

PHLYAKES: Farcical or burlesque performers in the theater

PHRATRY: A tribe or clan

PHROURION: A fort or citadel, especially a hill fort as distinguished from a fortified town

PISÉ: Rammed earth, puddled mud, or a combination of sun-dried brick and puddled mud to form a wall

PLUMBARIUS: A worker in lead

PLUTEUS: A low wall, usually not more than waist-high

POMERIUM or POMAERIUM: The religious boundary of a city; by extension the space immediately inside and outside the city walls

POROS: Soft limestone, originally quarried on the island of Poros, used extensively as building material

PORTA DECUMANA: The gate of a Roman camp which opened on the side farthest from the enemy

PORTA PRAETORIA: The gate of a Roman camp which opened opposite the general's tent, directly toward the enemy

PORTUS POST SCAENIUM: A portico behind the scene building of a theater stage

POSTERULA: A small back door or gate, a postern

POSTSCAENIUM: The rooms behind the stage buildings, or its back rooms

PRAECINCTIO: The corridor separating the galleries of a theater

PRAEFURNIUM: A bath furnace

PRAESIDIUM: In military terms, a fortification, camp, post, or entrenchment; in the plural, a chain of posts in a limes

PRAETORIUM: A general's tent, or the official residence of a governor in a province; also the imperial body-guard

PRESBYTERION: An assembly of elders

PRIMUS PILUS: The senior centurion of a Roman legion, commander of the first century of the first cohort but with much grander responsibilities

PRINCIPIA: A Roman general's headquarters; the front line of an army

PRISM OF ESARHADDON: A six-sided clay prism (673-672 B.C.) bearing a cuneiform text which recounts the history of Esarhaddon, son of Sennacherib

PROHEDRIAI: The front seats in a theater or stadium, usually of special design and reserved for officials

PRONAOS: The porch in front of the cella of a temple

PROPYLAION: The entrance gate to an enclosure, as to the sacred enclosure of a temple

PROSTAGMA: Ordinance, command

PROSTYLE: A term applied to a temple with a portico of columns in front

PROTEICHISMA: A second wall constituting an outer line of defense

PROTHALAMOS: The anteroom to a burial chamber in a tomb

PROTOME: The upper part of a human or animal figure, especially as used decoratively in architecture

PROXENOS: A citizen of a city state appointed by another state to have charge of its interests and of the welfare of its citizens while in his state

PRYTANEION: A town hall, where the chief magistrates assembled

PTEROMATA: The colonnades of a temple

PURPURARIUS: A purple-dyer

PUTEALIA: A well-curb

PUTEUS: A well

PYLAGORAI, see under AMPHICTYONES

PYTHION: A temple of the Pythian Apollo

QUAESTOR: The title of a class of Roman magistrates, some of whom had responsibilities for the financial affairs of the state

QUINGENARY (fort): A fort built to accommodate 500 troops

REGIA: The royal door; the central stage-door of a Roman theater

REGULA: A narrow strip under the taenia of a Doric architrave (below each triglyph), beneath which the guttae were carved

RETIARIUS: A gladiator who fought with a net

RETENTURA: The rear section of a Roman camp or legionary fortress, where auxiliary or irregular troops were located, as opposed to the praetentura, the place of the legionaries proper

ROULETTED WARE: Ware decorated with the impression made by rotating a small carved cylinder (roulette)

SACELLUM: An unroofed space dedicated to a divinity

SALUTATIO: A formal greeting

SARAPIEIA: A festival of the Egyptian god Osiris-Apis

SCROBIS: A ditch, dike, or trench

SECUNDUM CAELUM: According to the heavens (i.e. centuriation oriented NS-EW)

SEKOS: A sacred enclosure or precinct

SEVIR AUGUSTALIS: A member of a college of priests dedicated to Augustus

SIGILLATE WARE, see TERRA SIGILLATA

SIMA: Term given to the terracotta or marble gutter of a building, both on the gable and on the flanks

SKENE or SCAENA: The stage building of a theater; scaenae frons is the decorated interior of the stage building

SPECULATOR: As a military term, a spy or a scout; also a courier entitled to use the public posting service (cursus publicus)

SPELAEUM: A cave, cavern, den

SPINA: A long, low wall which divided the racecourse of a circus or hippodrome lengthwise and around which the chariots raced

SPINARIO: As a motif in sculpture, a boy removing a thorn from his foot

SPOLIA: Arms stripped from a defeated soldier; prey, spoils

SPOLIA OPIMA: Spoils taken from the enemy's general

STACKING or STACK-WORK: A method of filling certain joints in walls of polygonal or trapezoidal masonry by means of "stacks" of small, thin slabs of stone laid flat

STAGNUM: A swamp; a pool; a pond

STATIO: In a military context, a station or post; also, a post-station, see CURSUS PUBLICUS

STENOPOI: Narrow alleys

STOA or PORTICUS: A building having its roof supported by one or more rows of columns parallel to the rear wall; often a market building

STOMION: The entrance to a tomb

STRATEGEION: The headquarters of a military commander

SUMMA CAVEA: The upper rows of seats in a theater, reserved for the commoners

SUSPENSURA: Large square tiles forming a floor over a hypocaust and resting on small piers of brick or stone

SYMPOLITY: A union of several states

SYNEDRION: A council chamber

SYNOECISM: The union of several communities into a city state

SYNTAXIS: Tribute

SYNTHRONON: A church structure that combined the bishop's throne and clergy's seats and was placed behind the altar against the east (apsidal) wall

TABELLA (or TABULA) CERATA: A wax writing tablet or what was recorded on it

TABERNA: A store; a lodging place; a tavern; an artisan's workshop

TABULA PATRONATUS: An honorific plaque set up in the house of a patron by his clients

TELESTERION: A hall of initiation into the mysteries of Eleusis

TEMENOS: The enclosed area in which a temple stands; a sacred precinct

TEPIDARIUM: A room with warm water for bathing

TERRA SIGILLATA or SAMIAN WARE: Pottery produced in south central Gaul, the Moselle valley, and the east-

ern Mediterranean countries, in the first three cen-
turies of our era. It shows the influence of Arretine
ware.

TETRAPYLON: An edifice with four gateways; a four-way
arch

THEORODICY: The office of one authorized to receive
foreign envoys

THESMOPHORION: A temple of Demeter

THOLOS: A circular building occasionally associated with
chthonic deities; in tomb architecture, a beehive
tomb

THYMIATERION: A vessel for incense

THYROMA (THYROMATA): A wide opening in the second
story of a theater, forming the background, and
sometimes the rear stage, of the Hellenistic theater

THYSIA: Burnt offering, sacrifice

TITULI MUMMIANI: Records of the Roman gens Mum-
mius

TOGA PRAETEXTA: A toga bordered with purple and worn
by magistrates and free-born children

TOPARCH: The governor of a district called a toparchy

TRAVERSE: A short stretch of earth rampart (with a
ditch in front) placed before the entrance to an
earth-ramparted Roman camp

TRIA NOMINA: The three names of every free-born Ro-
man: praenomen (given name), nomen (name of
gens), cognomen (name of family)

TRICONCH: Having three apses

TRIERARCHIA: The fitting out of a trireme for the public
service

TROPAION or TROPHEUM: A memorial of victory. Origi-
nally the trunk of a tree on which arms taken from
the enemy were fixed

TURMA (-AE): A troop, a squadron of horse

TYMPANON, *see* PEDIMENT

URNFIELD CIVILIZATION: A term used to describe Bronze
Age cultures in Europe characterized by cemeteries
in which the ashes of the dead were buried in pottery
vessels or funerary urns

UNGUENTARIA: Containers for perfume

USTRINA: An area set aside for cremation

VALETUDINARIUM: A hospital; an infirmary

VALLUM: An earthen wall, rampart, entrenchment

VALVAE: The leaves of a door of two or more moving
panels

VENATIO (VENATIONES): The combat of wild beasts with-
in the arena

VENUS ANADYOMENE: A representation of Venus rising
from the sea

VERSURAE: The parts of the stage building flanking the
stage of a Roman theater

VEXILLATION: A company of Roman troops under one
standard and detached for special service from the
main body; also, a regular troop of cavalry or veter-
ans of a legion

VIA PRAETORIA: The main N-S street in a Roman town;
also called the cardo

VIA PRINCIPALIS: The main E-W street in a Roman town;
also called the decumanus

VICARELLO, TRAVELING CUPS OF: Four silver vases shaped
like Roman milestones and engraved with an itiner-
ary from Cadiz to Rome. Three date from the reign
of Augustus and one possibly from Tiberius' reign.

VICUS: The smallest agglomeration of buildings to form
a recognized unit, either as a country village or as a
ward of a town

VOMITORIA: Theater entrances or exits

XOANON: An ancient wooden idol

MAPS

NOTE ON THE MAPS

Each entry in the foregoing text is keyed to one of the 16 area maps listed opposite. The map number corresponds to the number of the page on which the map appears in the 24-page section that follows.

The military frontiers (the two walls in Britain and the Limes of Djerdap, etc.) are traced in red; the only sites shown on them are those for which separate entries appear in the text.

The map indexes supply a listing of the sites country by country, information not available elsewhere in the book.

Because of the small scale of the maps, the location of some sites is only approximate. Kiepert's *Atlas Antiquus* will be found a useful supplement to them and the *Carta archeologica* (Istituto geographico militare, edizione archeologica della carta d'Italia) of which a number of sections have now been issued.

MAPS

Location Key, map pp. 2-3

Egypt, Turkey, Syria, Iraq to India, Black Sea area, 5

Turkey; Cyprus; Syria, Lebanon, Israel, Jordan, 6

Turkey, Greek Islands, 7

Greece, Greek Islands, South Albania, 9

Greece, Greek Islands, Crete, 11

Balkans, Hungary, 12

Italy, Sardinia, 14

Central Italy, 16

Italy: Naples area, 17A
 Sicily, 17B

Algeria, Tunisia, Libya; Malta, 18

Iberian Peninsula, Morocco, West Algeria, 19

Austria, Germany, Switzerland, 20

Belgium, Holland, Luxembourg, 21

France, 23

Britain, 24

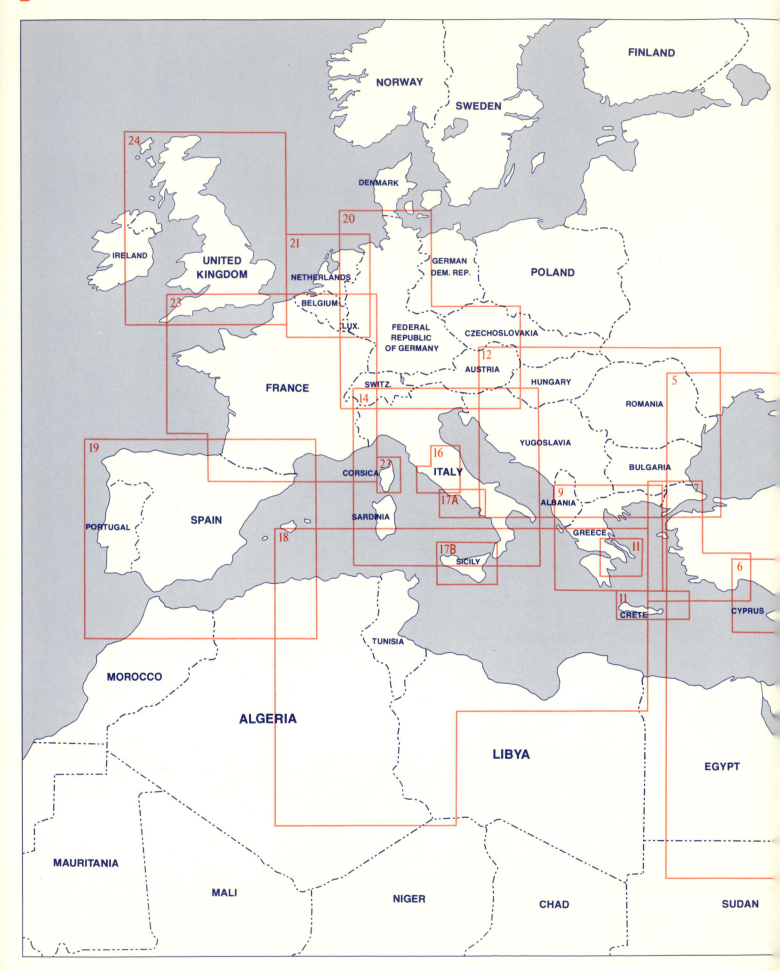

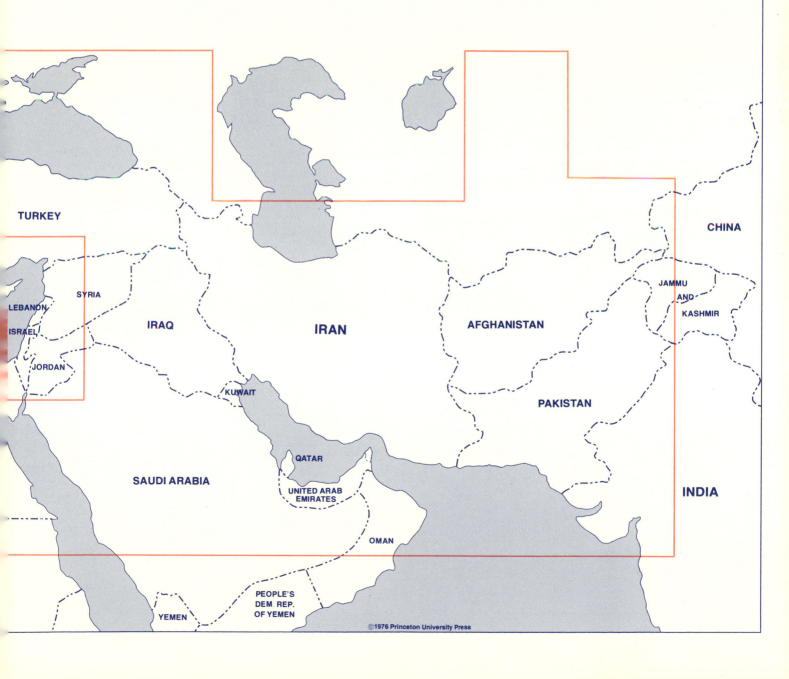

SOVIET UNION

TURKEY

CHINA

SYRIA

LEBANON

ISRAEL

JORDAN

IRAQ

IRAN

AFGHANISTAN

JAMMU

AND

KASHMIR

KUWAIT

PAKISTAN

QATAR

SAUDI ARABIA

UNITED ARAB
EMIRATES

INDIA

OMAN

PEOPLE'S
DEM. REP.
OF YEMEN

YEMEN

©1976 Princeton University Press

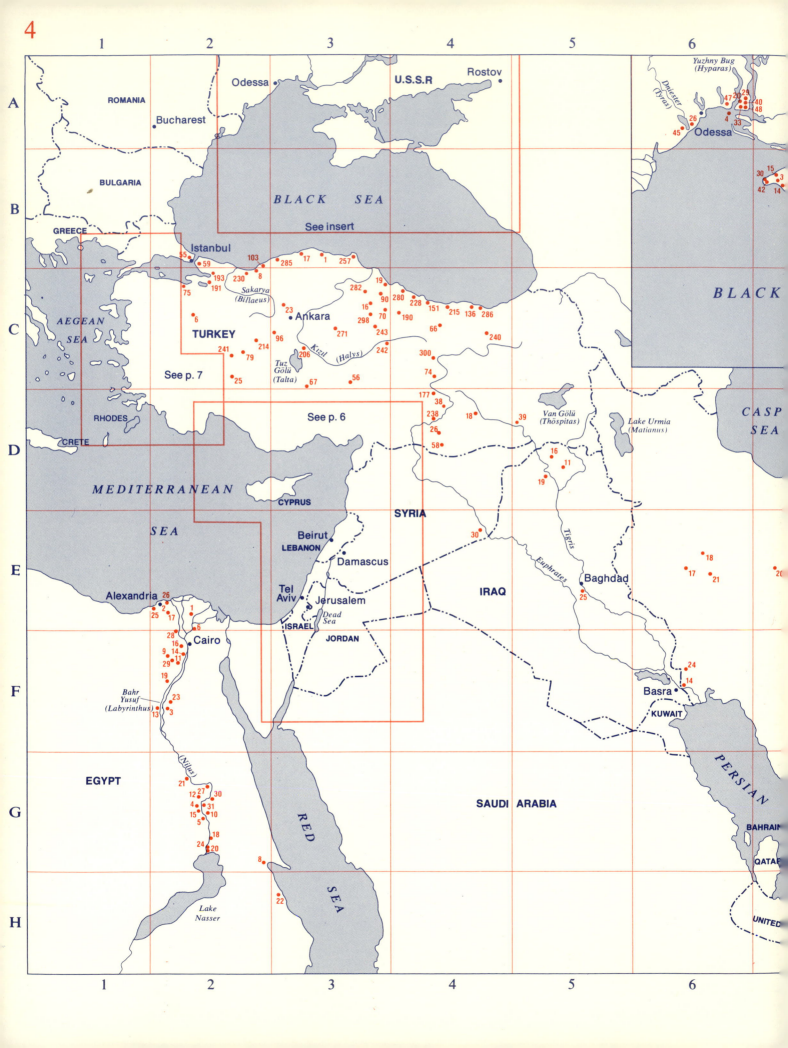

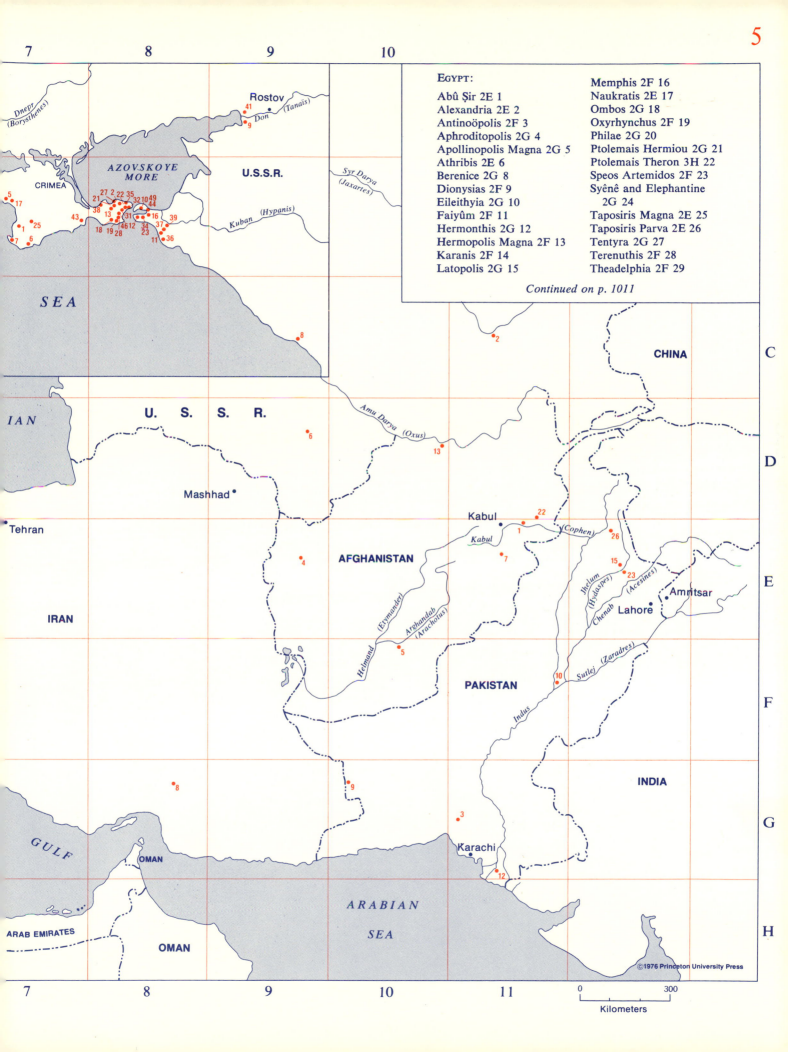

5

Continued on p. 1011

EGYPT:

Abû Şir 2E 1
Alexandria 2E 2
Antinoöpolis 2F 3
Aphroditopolis 2G 4
Apollinopolis Magna 2G 5
Athribis 2E 6
Berenice 2G 8
Dionysias 2F 9
Eileithyia 2G 10
Faiyûm 2F 11
Hermonthis 2G 12
Hermopolis Magna 2F 13
Karanis 2F 14
Latopolis 2G 15

Memphis 2F 16
Naukratis 2E 17
Ombos 2G 18
Oxyrhynchus 2F 19
Philae 2G 20
Ptolemais Hermiou 2G 21
Ptolemais Theron 3H 22
Speos Artemidos 2F 23
Syênê and Elephantine
 2G 24
Taposiris Magna 2E 25
Taposiris Parva 2E 26
Tentyra 2G 27
Terenuthis 2F 28
Theadelphia 2F 29

Kilometers
0 300

6

TURKEY

Burdur Gölü

MEDITERRANEAN SEA

• Nicosia

CYPRUS

SYRIA

LEBANON

Beirut

27 • Damascus

L. Tiberias (Cennesaritis)

Tel Aviv

Jerusalem

(Asphaltites)

Dead Sea

ISRAEL

JORDAN

EGYPT

SAUDI ARABIA

RED SEA

Continued on p. 1011

Kilometers

TURKEY:

For sites in 1A-B,
 see also Map 7.
Adana 4B 5
Alexandria ad Issum
 5B 11
Al Mina 5B 14
Anazarbos 4A 22
Anemurium 2B 25
Antiocheia ad Cragum
 2B 27
Augusta 4B 44
Cambazli 3B 57
Charadros 2B 61
Claudiopolis 3B 64
Cocusus 5A 65
Comana Cappadociae
 5A 69
Dağ Pazarı 3B 71
Diocaesarea 3B 77
Elaeussa 3B 80
Epiphaneia 5B 85
Faustinopolis 4A 92
Flaviopolis 4A 93
Guney Kalesi 2B 98
Hamaxia 2B 101
Hieropolis Castabala
 5A 105
Iotape 2B 116
Isaura Vetus 2A 117
Kagrai 2A 122
Kanli Divane 3B 125
Kasai 2B 128
Kelenderis 3B 134
Kestros 2B 137
Kolybrassos 2B 143
Korakesion 2B 145

Korykos 3B 149
Kotenna 2B 150
Laertes 2B 158
Lamos 2B 162
Mallos 4B 175
Mopsuestia 4B 181
Nagidos 3B 187
Nemrud Dagh 6A 189
Olba 3B 199
Pityoussa 3B 225
Podandos 4A 226
Pylae Ciliciae 4A 232
Seleucia ad Calycadnum
 3B 244
Seleucia Pieria 5B 245
Selinos 2B 248
Soloi 4B 262
Syedra 2B 266
Tarsus 4B 269
Tyana 4A 292
Zephyrion 4B 299

CYPRUS:

Amathous 3D 1
Aphrodision 3C 2
Arsinoe 2C 3
Chelones 3C 4
Chytroi 3C 5
Drepanon 2C 6
Golgoi 3C 7
Idalion 3C 8
Karpasia 3C 9
Keryneia 3C 10
Kition 3C 11
Knidos 3C 12
Kourion 2D 13
Lapethos 3C 14

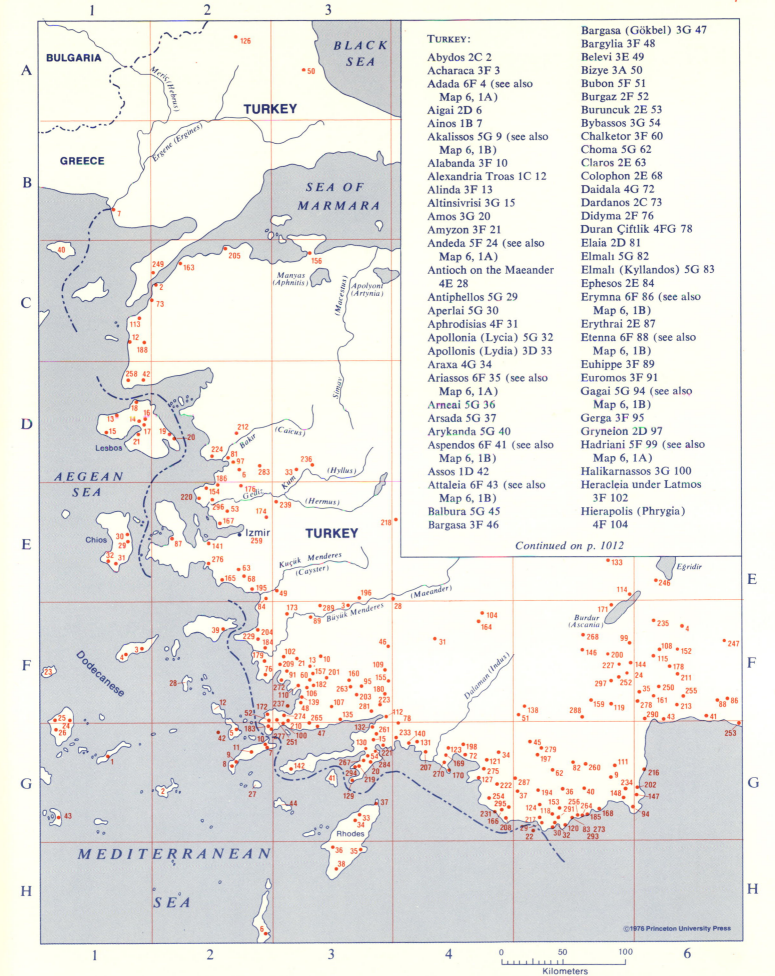

7

TURKEY:

Abydos 2C 2
Acharaca 3F 3
Adada 6F 4 (see also Map 6, 1A)
Aigai 2D 6
Ainos 1B 7
Akalissos 5G 9 (see also Map 6, 1B)
Alabanda 3F 10
Alexandria Troas 1C 12
Alinda 3F 13
Altinsivrisi 3G 15
Amos 3G 20
Amyzon 3F 21
Andeda 5F 24 (see also Map 6, 1A)
Antioch on the Maeander 4E 28
Antiphellos 5G 29
Aperlai 5G 30
Aphrodisias 4F 31
Apollonia (Lycia) 5G 32
Apollonis (Lydia) 3D 33
Araxa 4G 34
Ariassos 6F 35 (see also Map 6, 1A)
Arneai 5G 36
Arsada 5G 37
Arykanda 5G 40
Aspendos 6F 41 (see also Map 6, 1B)
Assos 1D 42
Attaleia 6F 43 (see also Map 6, 1B)
Balbura 5G 45
Bargasa 3F 46

Bargasa (Gökbel) 3G 47
Bargylia 3F 48
Belevi 3E 49
Bizye 3A 50
Bubon 5F 51
Burgaz 2F 52
Buruncuk 2E 53
Bybassos 3G 54
Chalketor 3F 60
Choma 5G 62
Claros 2E 63
Colophon 2E 68
Daidala 4G 72
Dardanos 2C 73
Didyma 2F 76
Duran Çiftlik 4FG 78
Elaia 2D 81
Elmalı 5G 82
Elmalı (Kyllandos) 5G 83
Ephesos 2E 84
Erymna 6F 86 (see also Map 6, 1B)
Erythrai 2E 87
Etenna 6F 88 (see also Map 6, 1B)
Euhippe 3F 89
Euromos 3F 91
Gagai 5G 94 (see also Map 6, 1B)
Gerga 3F 95
Gryneion 2D 97
Hadriani 5F 99 (see also Map 6, 1A)
Halikarnassos 3G 100
Heracleia under Latmos 3F 102
Hierapolis (Phrygia) 4F 104

Continued on p. 1012

© 1976 Princeton University Press

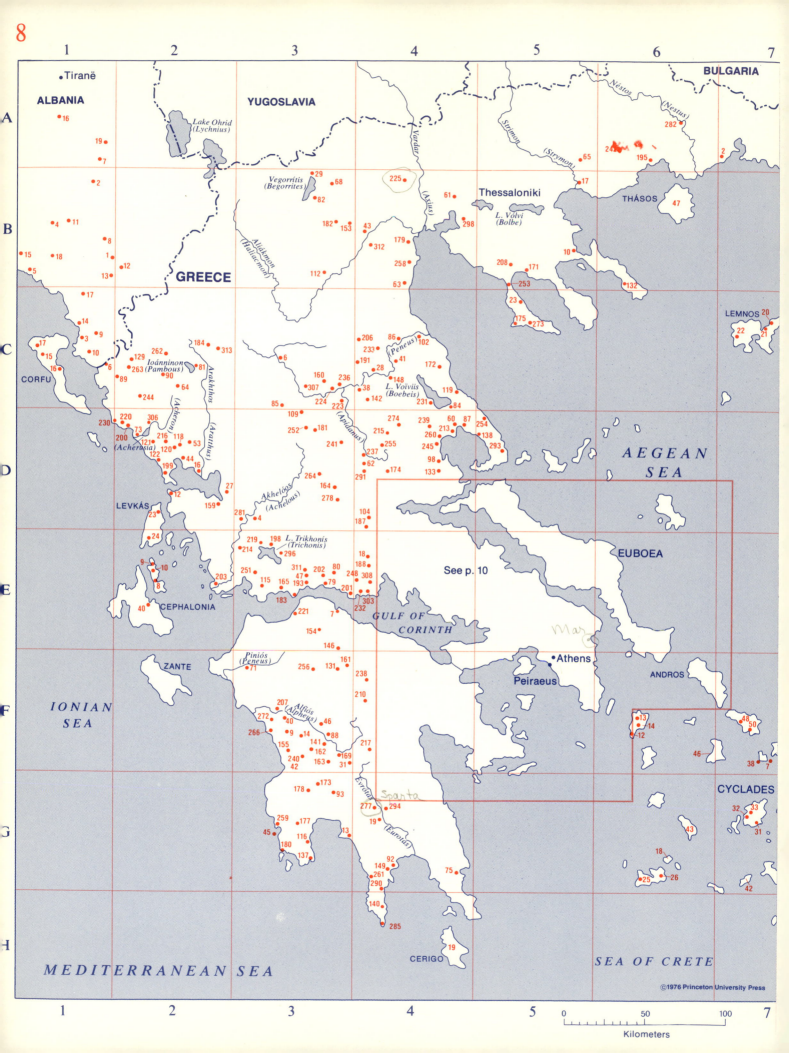

8

1 2 3 4 5 6 7

•Tiranë

BULGARIA

ALBANIA

YUGOSLAVIA

A

Lake Ohrid
(Lychnius)

Néstos
(Nestus)

282

16

19
7

Vegorrítis
(Begorrítes)

29
68

225

Strimon
(Strymon)

247
195

2

2

82

65

Thessaloniki

THÁSOS

47

B

4 11

182 153

43

179

61

Vardar
(Axiós)

298

L. Vólvi
(Bolbe)

17

15 18

8

1

312

258

10

5

13

12

112

63

208 171

253

132

GREECE

Aliákmon
(Haliacmon)

23

LEMNOS 20

17

175 273

22 21

C

14

3 9

262

184 313

206 86

233

102

(Peneus)

17 15

10

6

129

Ioánninon
(Pambous)

81

6

191

41

172

16

263

90

64

28

148

119

89

160

236

38

L. Voïviis
(Boebeis)

231

84

244

307

224 223

142

274

239 60 87

254

AEGEAN

85

109

252 181

215 255

260 213

138

SEA

230

220 306

241

237

245

98

293

73

216 118

62

174

133

200

121 120

53

291

(Acherusia)

122

44

199

16

264

164

27

278

D

CORFU

Arakhthos

(Acheron)

(Arathus)

Apidanus

Akhelóos
(Achelous)

12

159

281 4

104

187

LEVKÁS

23

24

219 198

L. Trikhonís
(Trichonis)

EUBOEA

9

10

214

296

18

251

311 202 80

188

8

115

47

79

248 308

E

40

CEPHALONIA

165 193

201

See p. 10

183

303

232

221

7

GULF OF
CORINTH

40

154

146

•Athens

Piniós
(Peneus)

161

Peiraeus

ANDROS

ZANTE

256 131

238

71

210

IONIAN

207

Alfiós
(Alpheus)

272

46

13

48

SEA

40

14

50

266

9

88

12

155

141

217

46

240 162

169

38 7

42

163

31

173

CYCLADES

178

93

Evrótas

32 33

277 294

Sparta

259

177

43

31

45

19

(Eurotas)

180

116

13

18

137

92

25 26

149

75

42

261

290

CERIGO

19

SEA OF CRETE

140

285

F

G

H

MEDITERRANEAN SEA

©1976 Princeton University Press

0 50 100

Kilometers

1 2 3 4 5 6 7

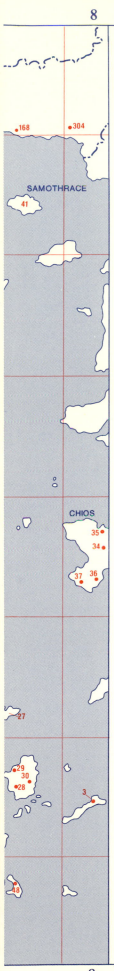

GREECE:

Abdera 7A 2
Agrinion 3D 4
Aiginion 3C 6
Aigion 3E 7
Aipion 3F 9
Akanthos 5B 10
Aktion 2D 12
Alagonia 3G 13
Alipheira 3F 14
Ambrakos 2D 16
Amphipolis 5B 17
Amphissa (West Lokris)
 4E 18
Amyklai 4G 19
Aphytis 5C 23
Argos Amphilochikon
 2D 27
Argura 4C 28
Arnissa 3B 29
Asea 3F 31
Atrax 4C 38
Babes 3F 40
Bakraina ("Mopsion")
 4C 41
Bassai 3F 42
Beroia 4B 43
Bouchetion 2D 44
Bouphagion 3F 46
Bouttos (West Lokris)
 3E 47
Charadra 2D 53
Demetrias 4D 60
Dherveni 4B 61
Dhranista 4D 62
Dion 4B 63
Dodona 2C 64
Drabeskos 5A 65
Edessa 3B 68
Elis 3F 71
Ephyra 2D 73
Epidauros Limera 4G 75
Erythrai (West Lokris)
 3E 79
Eupalion (West Lokris)
 3E 80
Eurymenai 2C 81
Farangi 3B 82
Glaphyrai 4C 84
Gomphoi 3C 85
Gonnos 4C 86
Goritsa 4D 87
Gortys 3F 88
Goumani 2C 89
Grammeno 2C 90
Gytheion 4G 92
Haghios Phloros 3G 93
Halos 4D 98
Homolion 4C 102
Hypata 4D 104
Ithome 3D 109
Kaliane 3B 112
Kalydon 3E 115
Kandianika 3G 116
Kassope 2D 118
Kasthaneia 4C 119
Kastri 2D 120

Kastrion 2D 121
Kastrorachi 3D 278
Kastrosikia 2D 122
Khrisorrakhi 2C 129
Kleitor 3F 131
Kleonai 6B 132
Kokoti 4D 133
Koroni 3G 137
Korope 5D 138
Kourno 4H 140
Krambovos 3F 141
Krannon 4C 142
Kynaitha 3E 146
Larissa 4C 148
Las 4G 149
Lefkadia 3B 153
Leontion 3E 154
Lepreon 3F 155
Limnaia 2D 159
Limnaion 3C 160
Lousoi 3F 161
Lykaion 3F 162
Lykosoura 3F 163
Makra Kome 3D 164
Makynia (West Lokris)
 3E 165
Maroneia 7A 168
Megalopolis 3F 169
Mekyberna 5B 171
Meliboia 4C 172
Meligala 3G 173
Meliteia 4D 174
Mende 5C 175
Mesopotamon 3G 177
Messene 3G 178
Methone (Macedonia)
 4B 179
Methone (Messenia)
 3G 180
Metropolis 3D 181
Mieza 3B 182
Molykreion (West Lokris)
 3E 183
Moni Voutsa 2C 184
Mt. Oeta 4D 187
Myania (West Lokris)
 4E 188
Mylai 4C 191
Naupaktos (West Lokris)
 3E 193
Neapolis 6A 195
Neromana ("Phystion")
 3E 198
Nikopolis 2D 199
Nista 2D 200
Oiantheia (West Lokris)
 3E 201
Oineon (West Lokris)
 3E 202
Oiniadai 2E 203
Olosson 4C 206
Olympia 3F 207
Olynthos 5B 208
Orchomenos (Arkadia)
 4F 210
Pagasai 4D 213
Paianion 3E 214

Palaiopharsalos 4D 215
Palioroforon 2D 216
Pallantion 4F 217
Paravola 3E 219
Parga 2D 220
Patrai 3E 221
Peirasia 3C 223
Pelinna 3C 224
Pella 4B 225
Perdhika 1D 230
Petra 4C 231
Phaistinos (West Lokris)
 4E 232
Phalanna 4C 233
Pharkadon 3C 236
Pharsalos 4D 237
Pheneos 4F 238
Pherai 4D 239
Phigalia 3F 240
Philia 3D 241
Philippi 6A 242
Photike 2C 244
Phthiotic Thebes 4D 245
Physkeis (West Lokris)
 4E 248
Pleuron, Nea Pleuron
 3E 251
Portitsa 3D 252
Poteidaia 5B 253
Pouri 5D 254
Proerna 4D 255
Psophis 3F 256
Pydna 4B 258
Pylos 3G 259
Pyrasos 4D 260
Pyrrhichos 4G 261
Radotovi 2C 262
Raveni 2C 263
Rentina 3D 264
Samikon 3F 266
Skillous 3F 272
Skioni 5C 273
Skotoussa 4D 274
Sparta 4G 277
Stratos 3D 281
Stravroupolis 6A 282
Tainaron 4H 285
Teuthrone 4G 290
Thaumakoi 4D 291
Theotokou 5D 293
Therapnai 4G 294
Thermos 3E 296
Thessalonike 4B 298
Tolphon (West Lokris)
 4E 303
Traianopolis 8A 304
Trikastron 2D 306
Trikka 3C 307
Triteia (West Lokris)
 4E 308
Velvina 3E 311
Verghina 4B 312
Voutonosi 2C 313

GREEK ISLANDS:

Amorgos
 Amorgos 8G 3

Delos 7F 7
Ithaca
 Alakomenai 2E 8
 Exoghi 2E 9
 Pelikate 2E 10
Keos
 Haghia Irini 6F 12
 Ioulis 6F 13
 Karthaia 6F 14
Kerkyra
 Kardaki 1C 15
 Korkyra 1C 16
 Mon Repos 1C 17
Kimolos 6G 18
Kythera 4H 19
Lemnos
 Chloe 7C 20
 Hephaistia 7C 21
 Myrina 7C 22
Leukas
 Leukas 2D 23
 Leukatas 2E 24
Melos
 Klima 6G 25
 Zephiria 6G 26
Mykonos 7F 27
Naxos
 Gyroulas 7G 28
 Naxos 7G 29
 Philoti 7G 30
Paros
 Dris Harbor 7G 31
 Mt. Kounados 7G 32
 Paros 7G 33
Pityoussa
 Chios 8E 34
 Delphinion 8E 35
 Emporio 8E 36
 Pindakas 8E 37
Rheneia 7F 38
Same 2E 40
Samothrace 7B 41
Sikinos 7G 42
Siphnos 6G 43
Sphakteria 3G 45
Syros 6/7F 46
Thasos 6B 47
Thera
 Thera 7H 48
Tinos
 Kionia 7F 48
 Tinos 7F 50

SOUTH ALBANIA:

Antigonea 1B 1
Antipatrea 1B 2
 (see also Map 12)
Buthrotum 1C 3
Byllis 1B 4 (see also
 Map 12)
Cemara 1B 5
Dhespotikon 1C 6
Dimale 1A 7 (see also
 Map 12)
Hekatompedon 1B 8
Kara-Ali-Bey 1C 9
Kestria 1C 10

Continued on p. 1013

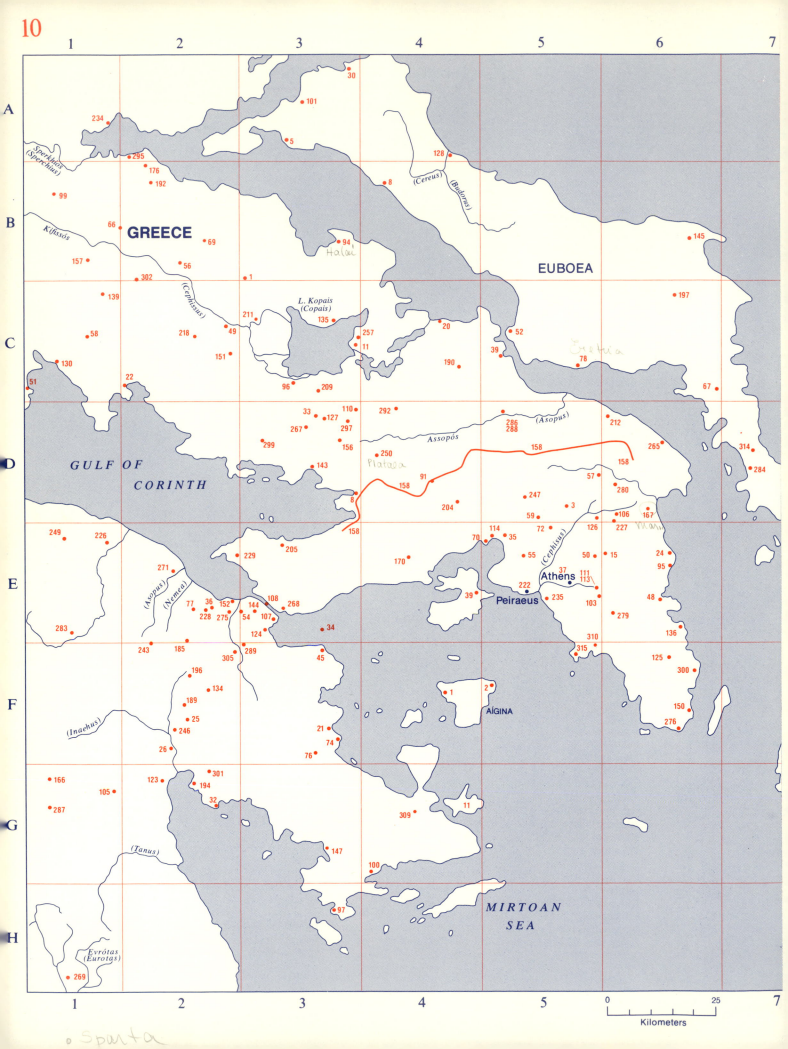

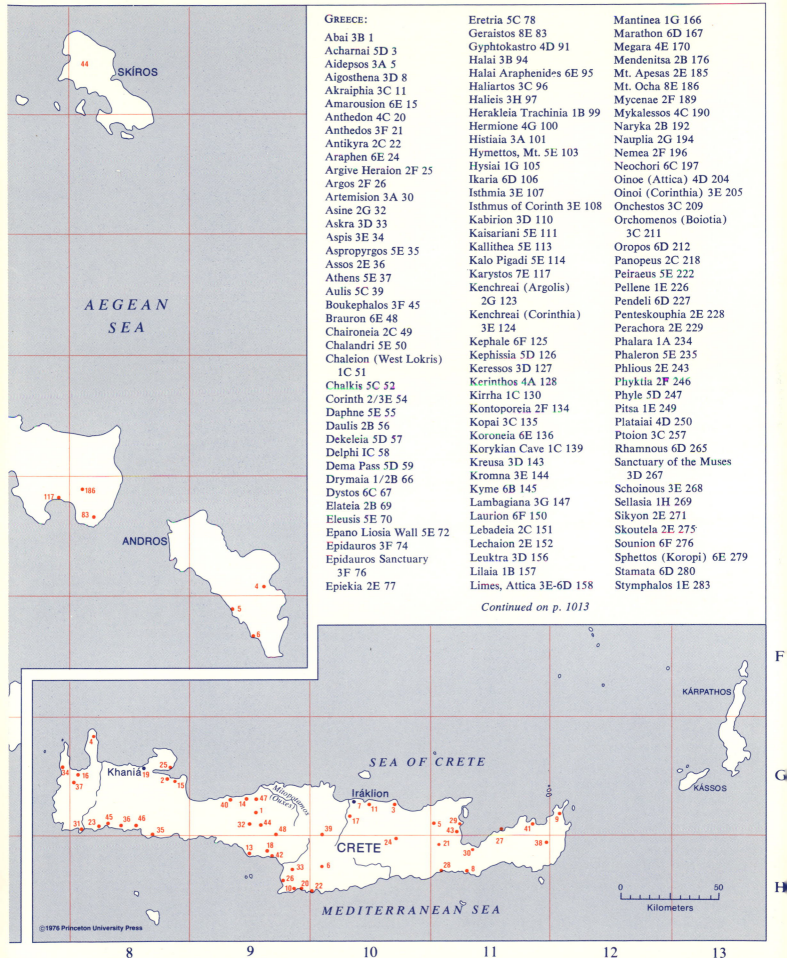

8 9

SKÍROS

AEGEAN SEA

ANDROS

GREECE:

Abai 3B 1
Acharnai 5D 3
Aidepsos 3A 5
Aigosthena 3D 8
Akraiphia 3C 11
Amarousion 6E 15
Anthedon 4C 20
Anthedos 3F 21
Antikyra 2C 22
Araphen 6E 24
Argive Heraion 2F 25
Argos 2F 26
Artemision 3A 30
Asine 2G 32
Askra 3D 33
Aspis 3E 34
Aspropyrgos 5E 35
Assos 2E 36
Athens 5E 37
Aulis 5C 39
Boukephalos 3F 45
Brauron 6E 48
Chaironeia 2C 49
Chalandri 5E 50
Chaleion (West Lokris) 1C 51
Chalkis 5C 52
Corinth 2/3E 54
Daphne 5E 55
Daulis 2B 56
Dekeleia 5D 57
Delphi 1C 58
Dema Pass 5D 59
Drymaia 1/2B 66
Dystos 6C 67
Elateia 2B 69
Eleusis 5E 70
Epano Liosia Wall 5E 72
Epidauros 3F 74
Epidauros Sanctuary 3F 76
Epiekia 2E 77

Eretria 5C 78
Geraistos 8E 83
Gyphtokastro 4D 91
Halai 3B 94
Halai Araphenides 6E 95
Haliartos 3C 96
Halieis 3H 97
Herakleia Trachinia 1B 99
Hermione 4G 100
Histiaia 3A 101
Hymettos, Mt. 5E 103
Hysiai 1G 105
Ikaria 6D 106
Isthmia 3E 107
Isthmus of Corinth 3E 108
Kabirion 3D 110
Kaisariani 5E 111
Kallithea 5E 113
Kalo Pigadi 5E 114
Karystos 7E 117
Kenchreai (Argolis) 2G 123
Kenchreai (Corinthia) 3E 124
Kephale 6F 125
Kephissia 5D 126
Keressos 3D 127
Kerinthos 4A 128
Kirrha 1C 130
Kontoporeia 2F 134
Kopai 3C 135
Koroneia 6E 136
Korykian Cave 1C 139
Kreusa 3D 143
Kromna 3E 144
Kyme 6B 145
Lambagiana 3G 147
Laurion 6F 150
Lebadeia 2C 151
Lechaion 2E 152
Leuktra 3D 156
Lilaia 1B 157
Limes, Attica 3E-6D 158

Mantinea 1G 166
Marathon 6D 167
Megara 4E 170
Mendenitsa 2B 176
Mt. Apesas 2E 185
Mt. Ocha 8E 186
Mycenae 2F 189
Mykalessos 4C 190
Naryka 2B 192
Nauplia 2G 194
Nemea 2F 196
Neochori 6C 197
Oinoe (Attica) 4D 204
Oinoi (Corinthia) 3E 205
Onchestos 3C 209
Orchomenos (Boiotia) 3C 211
Oropos 6D 212
Panopeus 2C 218
Peiraeus 5E 222
Pellene 1E 226
Pendeli 6D 227
Penteskouphia 2E 228
Perachora 2E 229
Phalara 1A 234
Phaleron 5E 235
Phlious 2E 243
Phyktia 2F 246
Phyle 5D 247
Pitsa 1E 249
Plataiai 4D 250
Ptoion 3C 257
Rhamnous 6D 265
Sanctuary of the Muses 3D 267
Schoinous 3E 268
Sellasia 1H 269
Sikyon 2E 271
Skoutela 2E 275
Sounion 6F 276
Sphettos (Koropi) 6E 279
Stamata 6D 280
Stymphalos 1E 283

Continued on p. 1013

F

KÁRPATHOS

SEA OF CRETE

Khaniá
Iráklion

KÁSSOS

G

Mitopotamos (Ouxes)

CRETE

0 50

Kilometers

MEDITERRANEAN SEA

H

8 9 10 11 12 13

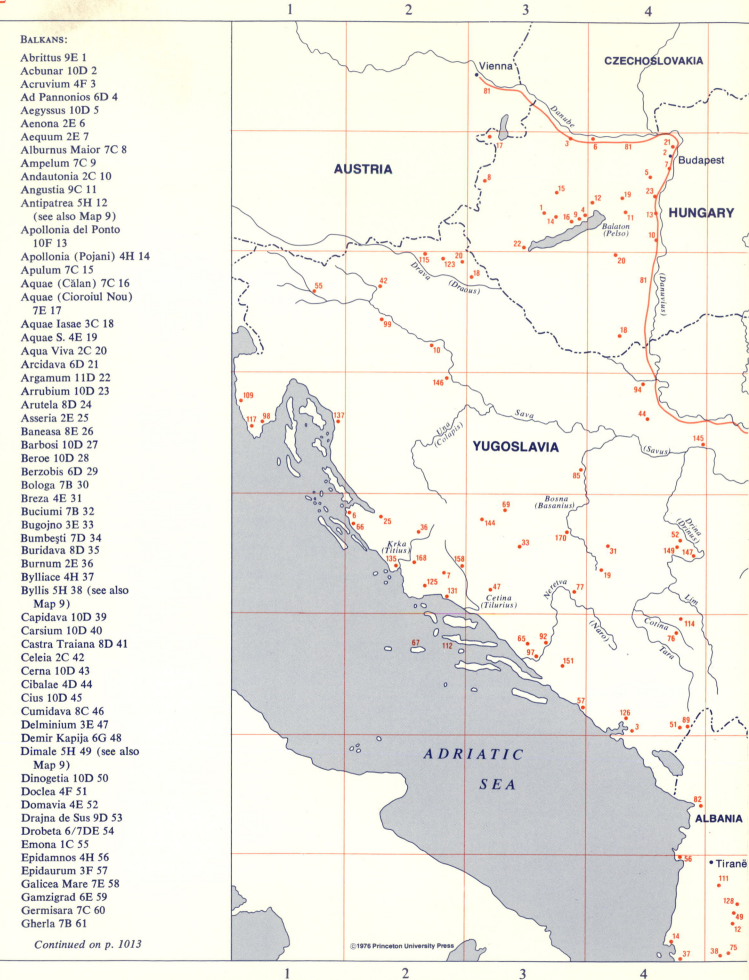

12

BALKANS:

Abrittus 9E 1
Acbunar 10D 2
Acruvium 4F 3
Ad Pannonios 6D 4
Aegyssus 10D 5
Aenona 2E 6
Aequum 2E 7
Alburnus Maior 7C 8
Ampelum 7C 9
Andautonia 2C 10
Angustia 9C 11
Antipatrea 5H 12
 (see also Map 9)
Apollonia del Ponto
 10F 13
Apollonia (Pojani) 4H 14
Apulum 7C 15
Aquae (Călan) 7C 16
Aquae (Cioroiul Nou)
 7E 17
Aquae Iasae 3C 18
Aquae S. 4E 19
Aqua Viva 2C 20
Arcidava 6D 21
Argamum 11D 22
Arrubium 10D 23
Arutela 8D 24
Asseria 2E 25
Baneasa 8E 26
Barbosi 10D 27
Beroe 10D 28
Berzobis 6D 29
Bologa 7B 30
Breza 4E 31
Buciumi 7B 32
Bugojno 3E 33
Bumbeşti 7D 34
Buridava 8D 35
Burnum 2E 36
Bylliace 4H 37
Byllis 5H 38 (see also
 Map 9)
Capidava 10D 39
Carsium 10D 40
Castra Traiana 8D 41
Celeia 2C 42
Cerna 10D 43
Cibalae 4D 44
Cius 10D 45
Cumidava 8C 46
Delminium 3E 47
Demir Kapija 6G 48
Dimale 5H 49 (see also
 Map 9)
Dinogetia 10D 50
Doclea 4F 51
Domavia 4E 52
Drajna de Sus 9D 53
Drobeta 6/7DE 54
Emona 1C 55
Epidamnos 4H 56
Epidaurum 3F 57
Galicea Mare 7E 58
Gamzigrad 6E 59
Germisara 7C 60
Gherla 7B 61

Continued on p. 1013

©1976 Princeton University Press

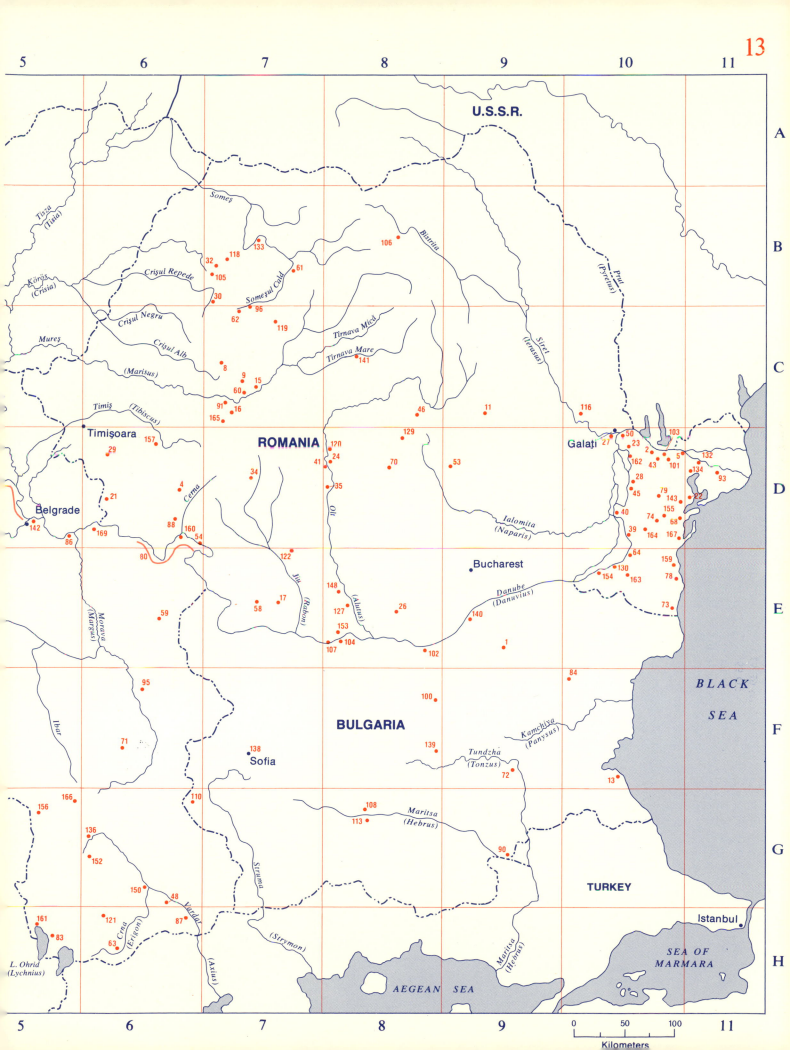

14

ITALY:
Acelum 4A 1
Ad Aquas Gradatas 5A 3
Adria 4B 4
Aecae 6E 6
Aeclanum 6E 7
Aegilium Insula 3D 8
Aeoliae Insulae 6H 10
Aesernia 5E 11
Alba Pompeia 1B 16
Albintimilium 1C 17
Aletium 8F 18
Aliano-Alianello 7F 21
Altamura 7F 23
Altinum 4A 24
Ampsanctus 6E 27
Aquae Statiellae 2B 31
Aquileia 5A 32
Argos Hippion 6E 35
Ariminum 4C 38
Armento 7F 39
Arretium 4C 41
Asculum 6E 42
Augusta Bagiennorum 1B 47
Augusta Praetoria 1A 48
Augusta Taurinorum 1B 49

Azetium 7E 54
Bagnacavallo 4B 55
Baletium 8F 57
Bantia 7E 58
Barium 7E 59
Basta 8F 60
Bononia 3B 63
Brixia 3A 66
Brundisium 8F 67
Caelia (Ceglie di Bari) 7E 68
Caelia (Ceglie Messapica) 8F 69
Caesena 4C 71
Cannae 7E 74
Canusium 7E 75
Carreo Potentia 1B 79
Cavallino 8F 85
Cecina 3C 86
Clastidium 2B 88
Claterna 4B 89
Cluana 5CD 91
Clusium 4D 92
Cluviae 5D 93
Colfosco 4A 94
Colonia Julia Augusta Parmensis 3B 95
Comum 2A 96

Consilinum 6F 97
Corfinium 5D 99
Cortona 4CD 100
Cozzo Presepe 7F 102
Cremona 3B 103
Croccia Cognata 7F 104
Cugno dei Vagni 4C 105
Desenzano del Garda 3AB 107
Elea 6F 109
Eporedia 1B 110
Faesulae 3C 111
Fagifulae 6E 112
Faventia 4C 117
Ferrandina 7F 120
Firmum Picenum 5D 121
Florentia 3C 122
Foce del Sele 6F 123
Forum Cornelii 4B 126
Forum Julii 5A 127
Forum Livi 4C 128
Forum Popili 6F 129
Forum Popillii 4C 130
Garaguso 7F 136
Genoa 2B 137
Gnathia 8E 139
Grumentum 7F 142
Hadria 5D 143

Hasta 1B 144
Herakleia (Policoro) 7F 145
Herdonia 6E 147
Hipponion 7G 148
Ilva 3D 152
Incoronata 7F 153
Industria 1B 154
Interamnia Praetuttiorum 5D 156
Iulia Concordia 4A 157
Iulium Carnicum 5A 158
Julia Dertona 2B 159
Kallipolis 8F 160
Karbina 8F 161
Kaulonia 7H 162
Krimisa 7G 163
Kroton 7G 164
Lainus 7F 165
Larinum 6E 167
Lavello 6E 168
Libarna 2B 170
Lokroi Epizephyrioi 7H 172
Luca 3C 173
Lukeria 6E 174
Luna 2C 175
Lupiae 8F 177

Manduria 8F 178
Mantua 3B 179
Massaciuccoli 3C 181
Massa Marittima 3D 182
Matauros 7H 183
Mediolanum 2A 185
Medma 7H 186
Melfi 6E 187
Metapontion 7F 188
Mevaniola 4C 189
Miglionico 7F 190
Misano 3C 193
Moio della Civitella 6F 195
Monte Sannace 7EF 197
Muro Leccese 8F 198
Mutina 3B 199
Noepoli 7F 203
Novaria 2A 207
Opitergium 4A 212
Paestum 6F 217
Pallanum 5/6D 218
Patavium 4B 219
Peltuinum 5D 220
Picentia 6F 222
Pietrabbondante 6E 223
Pietragalla 7EF 224
Pinna 5D 225

Pisae 3C 226
Pisticci 7F 228
Placentia 2B 229
Planasia 3D 230
Poggio Civitate 3D 232
Pollentia 1B 234
Pontia 5F 236
Populonia 3D 237
Potentia 5C 239
Pyxous 6F 244
Ravenna 4B 245
Regium Lepidi 3B 247
Rhegion 7H 248
Riparbella 3C 250
Rocavecchia 8F 251
Roccanova 7F 252
Rossano di Vaglio 7F 254
Rubi 7E 255
Rudiae 8F 256
Rusellae 3D 257
Russi 4B 258
Sala Consilina 6F 260
Salapia 7E 261
Sarsina 4C 265
Satrianum 6F 267
Satyrion 8F 269
Sava di Baronissi 6F 270

Scamnum 8F 272
Segusium 1B 273
Serra di Vaglio 7F 277
Sesto Fiorentino 3C 279
Silvium 7E 282
Sipontum 6E 283
Sirmio 3A 284
Spina 4B 287
Sulmo 5E 292
Sybaris 7F 294
Taras 7F 295
Tarvisium 4A 298
Teanum Apulum 6E 299
Teate Marrucinorum 5D 301
Tergestum 5A 304
Terina 7G 305
Terventum 6E 306
Thurii 7G 307
Timmari 7F 311
Torre del Mordillo 7F 313
Torretta di Pietragalla 6F 314
Uria 8F 321
Urium 6E 322

Continued on p. 1014

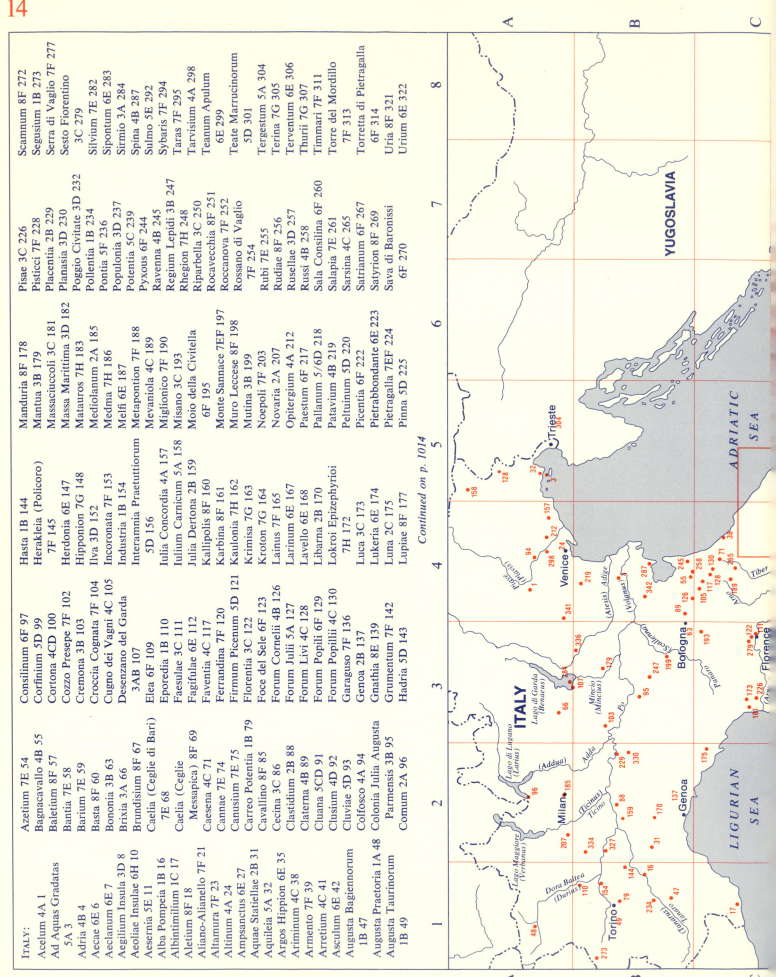

IONIAN SEA

TYRRHENIAN SEA

Taranto

Naples

Rome

Livorno

Bastia

Ajaccio

Cagliari

SICILY
See p. 17

SARDINIA

CORSICA

ELBA

See p. 16

See p. 17

Bradano (Bradanus)

Basento

Ofanto (Aufidus)

Calore (Calor)

Ofanto

Sabato (Sabatus)

Volturno (Volturnus)

Pescara (Aternus)

Velino (Himella)

Nera (Nar)

Arrone (Arro)

Lago Trasimeno (Trasumenus)

(Tiberis)

Lago di Bolsena (Suana)

Lago di Bracciano (Sabatinus)

(Clanis)

Ombrone (Umbria)

Golo (Giolas)

Tavaro (Tavo)

Tirso (Thyrsus)

Flumendosa (Saeprus)

Mannu

Calaggio (Casuentius)

Kilometers
0 100

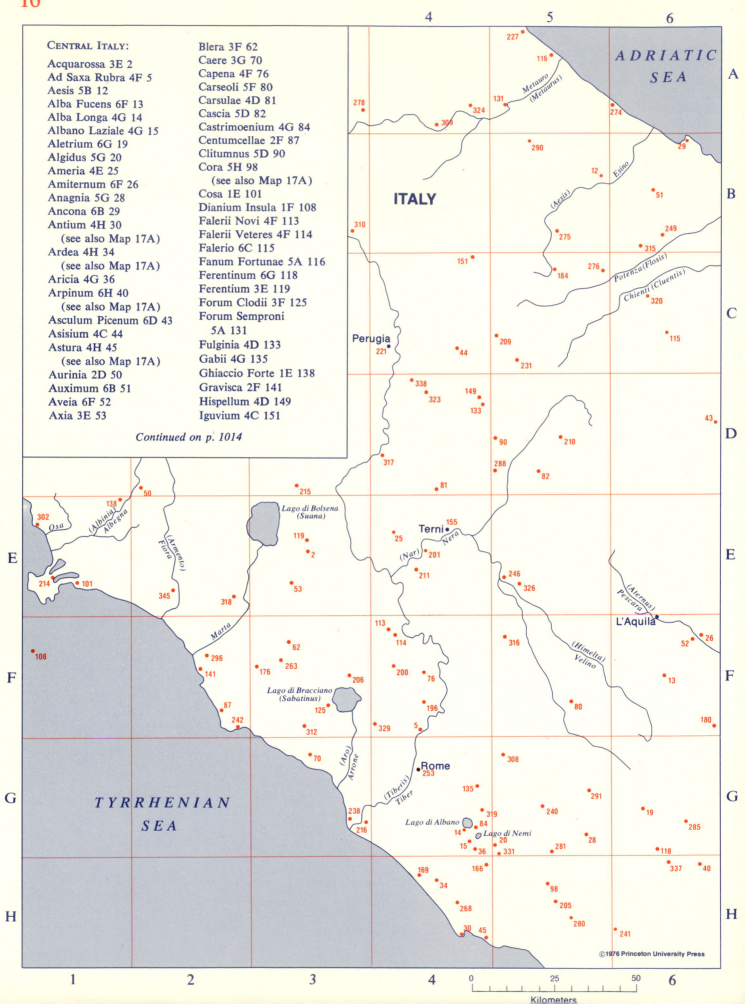

16

CENTRAL ITALY:

Acquarossa 3E 2
Ad Saxa Rubra 4F 5
Aesis 5B 12
Alba Fucens 6F 13
Alba Longa 4G 14
Albano Laziale 4G 15
Aletrium 6G 19
Algidus 5G 20
Ameria 4E 25
Amiternum 6F 26
Anagnia 5G 28
Ancona 6B 29
Antium 4H 30
 (see also Map 17A)
Ardea 4H 34
 (see also Map 17A)
Aricia 4G 36
Arpinum 6H 40
 (see also Map 17A)
Asculum Picenum 6D 43
Asisium 4C 44
Astura 4H 45
 (see also Map 17A)
Aurinia 2D 50
Auximum 6B 51
Aveia 6F 52
Axia 3E 53

Blera 3F 62
Caere 3G 70
Capena 4F 76
Carseoli 5F 80
Carsulae 4D 81
Cascia 5D 82
Castrimoenium 4G 84
Centumcellae 2F 87
Clitumnus 5D 90
Cora 5H 98
 (see also Map 17A)
Cosa 1E 101
Dianium Insula 1F 108
Falerii Novi 4F 113
Falerii Veteres 4F 114
Falerio 6C 115
Fanum Fortunae 5A 116
Ferentinum 6G 118
Ferentium 3E 119
Forum Clodii 3F 125
Forum Semproni
 5A 131
Fulginia 4D 133
Gabii 4G 135
Ghiaccio Forte 1E 138
Gravisca 2F 141
Hispellum 4D 149
Iguvium 4C 151

Continued on p. 1014

ITALY

ADRIATIC SEA

TYRRHENIAN SEA

Perugia

Terni

L'Aquila

Rome

Lago di Bolsena
(Suana)

Lago di Bracciano
(Sabatinus)

Lago di Albano

Lago di Nemi

Osa

(Albinia) Albegna

(Armento) Fiora

Marta

(Aro) Arrone

(Tiberis) Tiber

Metauro (Metaurus)

(Aesis)

Esino

(Potenza (Flosis)

Chienti (Cluentis)

(Nar)

Nera

(Himella) Velino

(Aternus) Pescara

Kilometers

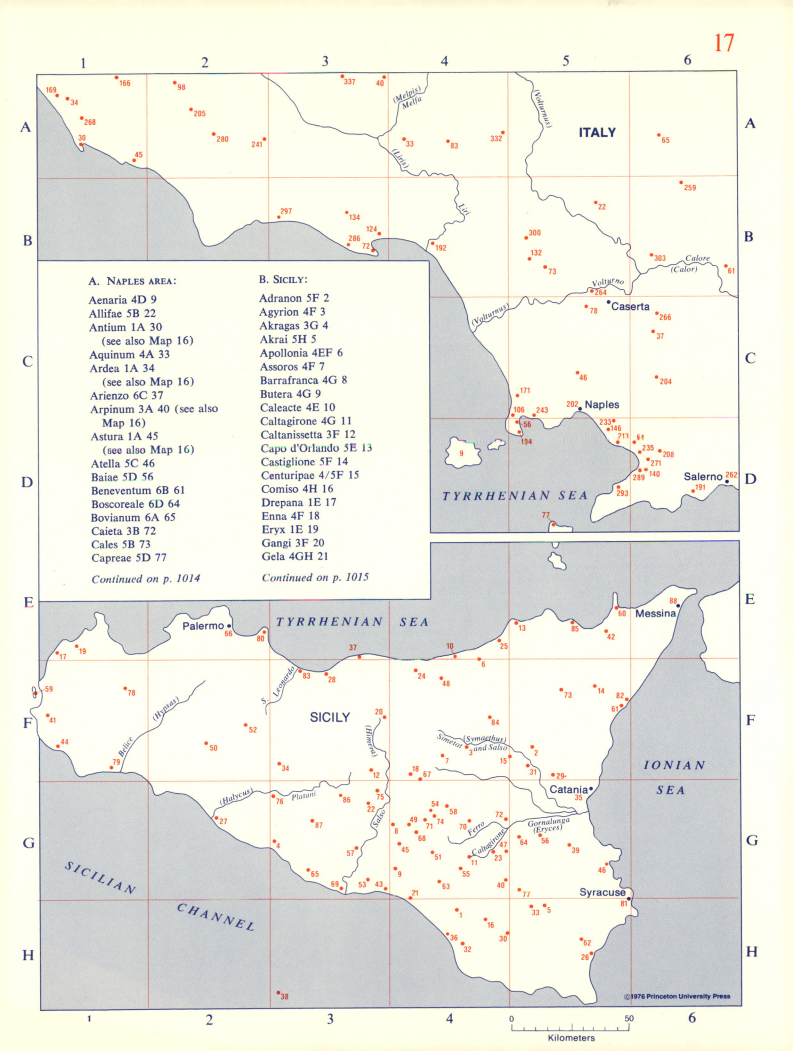

17

ITALY

(Melpis)
Melfa

(Volturnus)

(Liris)

Liri

(Volturnus)

Caserta

Calore
(Calor)

Volturno

Naples

TYRRHENIAN SEA

Salerno

A. Naples area:

Aenaria 4D 9
Allifae 5B 22
Antium 1A 30
 (see also Map 16)
Aquinum 4A 33
Ardea 1A 34
 (see also Map 16)
Arienzo 6C 37
Arpinum 3A 40 (see also
 Map 16)
Astura 1A 45
 (see also Map 16)
Atella 5C 46
Baiae 5D 56
Beneventum 6B 61
Boscoreale 6D 64
Bovianum 6A 65
Caieta 3B 72
Cales 5B 73
Capreae 5D 77

Continued on p. 1014

B. Sicily:

Adranon 5F 2
Agyrion 4F 3
Akragas 3G 4
Akrai 5H 5
Apollonia 4EF 6
Assoros 4F 7
Barrafranca 4G 8
Butera 4G 9
Caleacte 4E 10
Caltagirone 4G 11
Caltanissetta 3F 12
Capo d'Orlando 5E 13
Castiglione 5F 14
Centuripae 4/5F 15
Comiso 4H 16
Drepana 1E 17
Enna 4F 18
Eryx 1E 19
Gangi 3F 20
Gela 4GH 21

Continued on p. 1015

TYRRHENIAN SEA

Palermo

Messina

SICILY

S. Leonardo

(Hypsas)

Belice

(Himera)

(Halycus)

Platani

Salso

Simeto *(Symaethus)*
and Salso

Catania

IONIAN
SEA

Ferro

Caltagirone

Gornalunga
(Eryces)

Syracuse

SICILIAN

CHANNEL

Kilometers

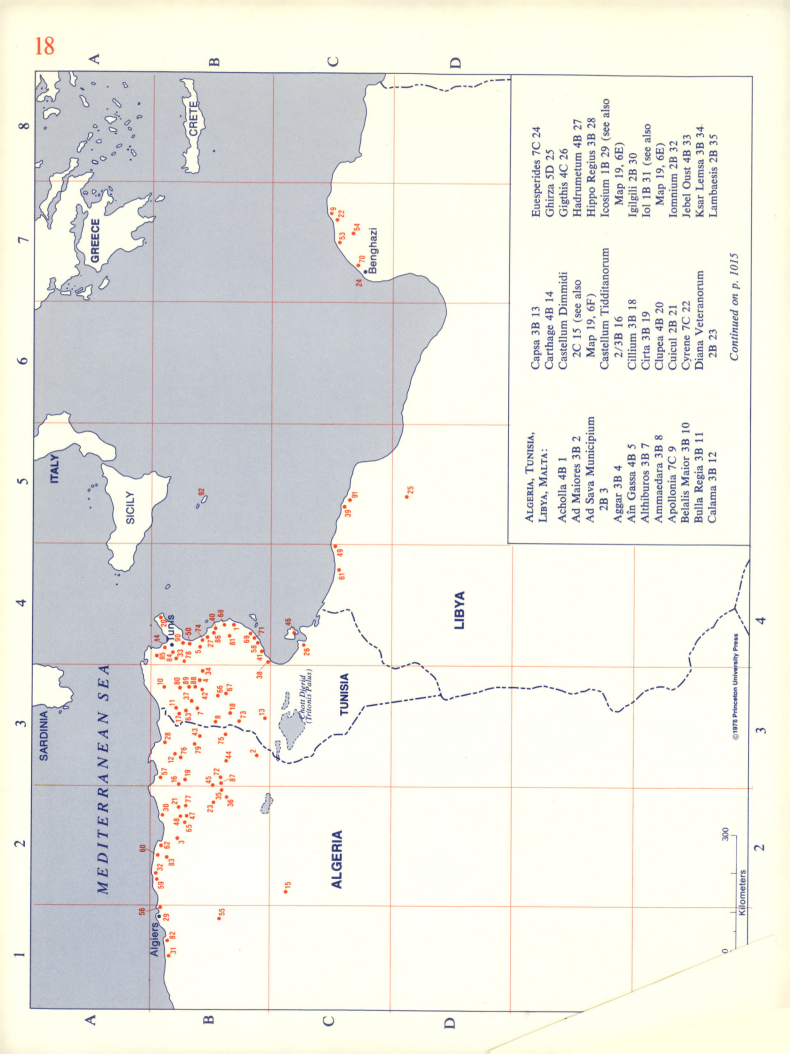

18

CRETE

GREECE

ITALY

SICILY

SARDINIA

MEDITERRANEAN SEA

Tunis

Algiers

TUNISIA

ALGERIA

LIBYA

Benghazi

Chott Djerid (Tritonis Palus)

©1978 Princeton University Press

Kilometers

0 300

ALGERIA, TUNISIA,
LIBYA, MALTA:

Acholla 4B 1
Ad Maiores 3B 2
Ad Sava Municipium
 2B 3
Aggar 3B 4
Aïn Gassa 4B 5
Althiburos 3B 7
Ammaedara 3B 8
Apollonia 7C 9
Belalis Maior 3B 10
Bulla Regia 3B 11
Calama 3B 12

Capsa 3B 13
Carthage 4B 14
Castellum Dimmidi
 2C 15 (see also
 Map 19, 6F)
Castellum Tidditanorum
 2/3B 16
Cillium 3B 18
Cirta 3B 19
Clupea 4B 20
Cuicul 2B 21
Cyrene 7C 22
Diana Veteranorum
 2B 23

Euesperides 7C 24
Ghirza 5D 25
Gigthis 4C 26
Hadrumetum 4B 27
Hippo Regius 3B 28
Icosium 1B 29 (see also
 Map 19, 6E)
Igilgili 2B 30
Iol 1B 31 (see also
 Map 19, 6E)
Iomnium 2B 32
Jebel Oust 4B 33
Ksar Lemsa 3B 34
Lambaesis 2B 35

Continued on p. 1015

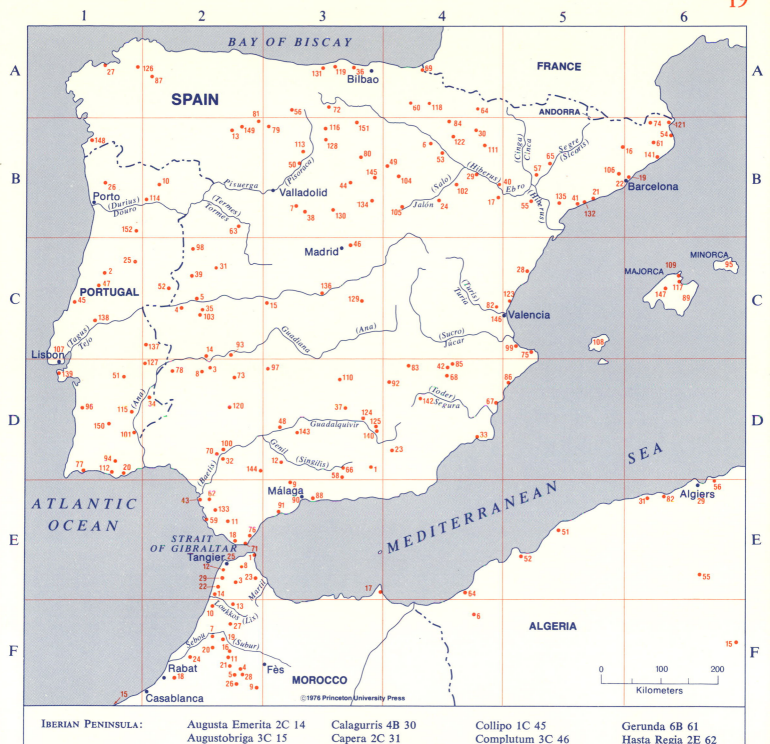

BAY OF BISCAY

FRANCE

SPAIN

Bilbao

ANDORRA

Valladolid

Porto

Madrid

PORTUGAL

Valencia

MINORCA

MAJORCA

Lisbon

ATLANTIC
OCEAN

SEA

MEDITERRANEAN

Málaga

Algiers

STRAIT
OF GIBRALTAR

Tangier

ALGERIA

Rabat

Fès

MOROCCO

Casablanca

©1976 Princeton University Press

0 100 200
Kilometers

IBERIAN PENINSULA:

Acci 3D 1
Aeminium 1C 2
Alange 2D 3
Alcántara 2C 4
Alconétar 2C 5
Alfaro 4B 6
Almenara de Adaja
 3B 7
Almendralejo 2D 8
Anticaria 3DE 9
Aquae Flaviae 2B 10
Asido 2E 11
Astapa 3D 12
Asturica-Augusta 2B 13

Augusta Emerita 2C 14
Augustobriga 3C 15
Ausa 5B 16
Azaila 4B 17
Baelo 2E 18
Baetulo 6B 19
Balsa 1D 20
Bara 5B 21
Barcino 5/6B 22
Basti 4D 23
Bilbilis 4B 24
Bobadela 1C 25
Bracara Augusta 1B 26
Brigantium 1A 27
Cabanes 5C 28
Caesar Augusta 4B 29

Calagurris 4B 30
Capera 2C 31
Carmo 2D 32
Carthago Nova 4D 33
Castelo da Lousa 2D 34
Castra Caecilia 2C 35
Castro Urdiales 3A 36
Castulo 3D 37
Cauca 3B 38
Caurium 2C 39
Celsa 4B 40
Centum Cellae 5B 41
Cerro de Los Santos
 4D 42
Chipiona 2E 43
Clunia 3B 44

Collipo 1C 45
Complutum 3C 46
Conimbriga 1C 47
Corduba 3D 48
Cuevas de Soria 3/4B 49
Dueñas 3B 50
Ebora 1D 51
Egitania 2C 52
El Ramalete 4B 53
Emporion 6B 54
Fabara 5B 55
Fontes Tamarici 3A 56
Fraga 5B 57
Gabia La Grande 3D 58
Gadir 2E 59
Gastiain 4A 60

Gerunda 6B 61
Hasta Regia 2E 62
Helmantica 2B 63
Iacca 4A 64
Ilerda 5B 65
Iliberris 3D 66
Illici 4D 67
Ilunum 4D 68
Irun 4A 69
Italica 2D 70
Iulia Traducta 2E 71
Iuliobriga 3A 72
Iulipa 2D 73
Iuncaria 6B 74
Jávea 5C 75
Karteia 2E 76

Continued on p. 1015

20

NORTH SEA

DENMARK

Hamburg

NETHERLANDS

Elbe (Albis)

Ems (Amisia)

Weser (Visurgis)

Utrecht

Waal (Vacalus)

FEDERAL REPUBLIC

OF GERMANY

GERMAN DEM. REP.

BELGIUM

Cologne

Luxembourg

Elbe (Albis)

Prague

Frankfurt

Main (Moenus)

CZECHOSLOVAKIA

FRANCE

Moselle (Mosella)

Rhine (Rhenus)

Stuttgart

Neckar (Nicer)

Danuvius Danube

Isara Isar

Munich

Linz

Vienna

Neusiedler See

L. Constance *(Venetus)*

Basel

Aare (Arurius)

Zürichsee

Zurich

Walensee

Bern

L. de Neuchâtel

L. Murten

SWITZERLAND

Rhine

Inn (Aenus)

AUSTRIA

Graz

(Lemanus) L. Geneva

Rhône (Rhodanus)

ITALY

YUGOSLAVIA

AUSTRIA:

Aguntum 4H 1
Brigantium 2G 2
Carnuntum 6G 3
Cetium 6F 4
Duel 5H 5
Favianis 6F 6
Flavia Solva 6H 7
Immurium 5G 8
Iuvavum 4G 9
Laubendorf 5H 10
Lauriacum 5FG 11
Lavant 4H 12
Lentia 5F 13
Löffelbach 6G 14
Magdalensberg 5H 15
Mauer an der Url 5G 16
Ovilava 5G 17
Parndorf 6G 18
Santicum 5H 19
Teriolis 3G 20
Teurnia 5H 21
Ulrichsberg 5H 22
Veldidena 3G 23
Vindobona 6G 24
Virunum 5H 25

GERMANY:

Abodiacum 3G 1
Abusina 4F 2

Ad Confluentes 2E 3
Altaiensium 2E 4
Aquae Granni 1D 5
Aquae Mattiacae 2E 6
Arae Flaviae 2F 7
Asciburgium 1D 8
Augusta Treverorum 1E 9
Augusta Vindelicum 3F 10
Bingerbrück 2E 11
Bingium 2E 12
Bonna 1D 13
Brigobanne 2F 14
Cambodunum 3G 15
Castra Regina 4F 16
Colonia Agrippinensis 1D 17
Contiomagus 1E 18
Cruciniacum 2E 19
Echzell 2E 20
Fliessem 1E 21
Gelduba 1D 22
Haltern 1C 23
Hildesheim 3C 24
Igel 1E 25
Limes Germaniae Inferioris 1C-D 26
Limes Germaniae Superioris 2D-E 27
Limes Raetiae 2E-6G 28
Lopodunum 2E 29

Continued on p. 1016

0 100 200

Kilometers

6

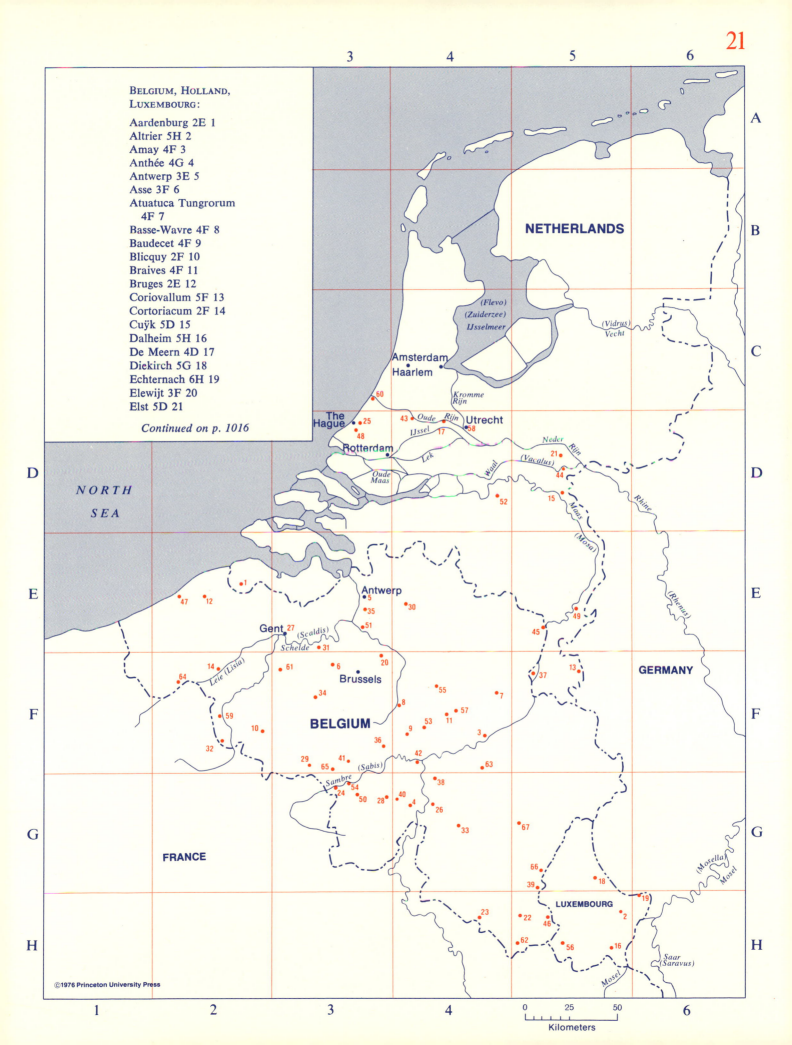

21

BELGIUM, HOLLAND,
LUXEMBOURG:

Aardenburg 2E 1
Altrier 5H 2
Amay 4F 3
Anthée 4G 4
Antwerp 3E 5
Asse 3F 6
Atuatuca Tungrorum
 4F 7
Basse-Wavre 4F 8
Baudecet 4F 9
Blicquy 2F 10
Braives 4F 11
Bruges 2E 12
Coriovallum 5F 13
Cortoriacum 2F 14
Cuÿk 5D 15
Dalheim 5H 16
De Meern 4D 17
Diekirch 5G 18
Echternach 6H 19
Elewijt 3F 20
Elst 5D 21

Continued on p. 1016

NETHERLANDS

(Flevo)
(Zuiderzee)
IJsselmeer

(Vidrus)
Vecht

Amsterdam
Haarlem

Kromme
Rijn

The
Hague

Oude Rijn Utrecht
IJssel

Neder
Rijn

Rotterdam

Lek

(Vacalus)
Waal

Oude
Maas

Maas
(Mosa)

Rhine

Rhine
(Rhenus)

NORTH
SEA

GERMANY

Antwerp

Gent (Scaldis)

Schelde

Leie (Lisia)

BELGIUM

Brussels

Sambre
(Sabis)

FRANCE

LUXEMBOURG

(Mosella)
Mosel

Mosel

Saar
(Saravus)

0 25 50
Kilometers

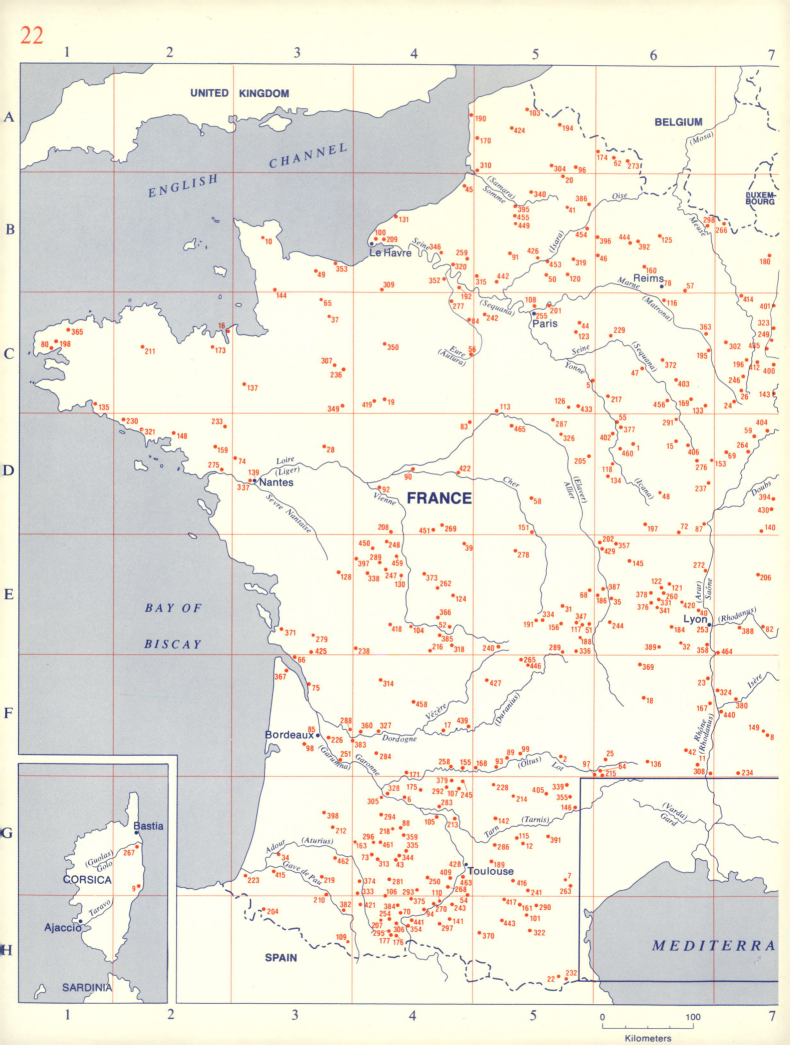

FRANCE:

Aballo 6D 1
Ad Silanum 5F 2
Ad Turrem 12G 3
Agatha 9G 4
Agedincum 5C 5
Aginnum 4G 6
Aigues-Vives 5G 7
Aix-en-Diois 7F 8
Alalia 2G 9
Alauna 3B 10
Alba Helviorum 6F 11
Àlbi 5G 12
Albias 10G 13
Alebaece Reiorum
 Apollinarium 12G 14
Alesia 6D 15
Aleto 2C 16
Allas-les-Mines 4F 17
Allegre 6F 18
Allonnes 4C 19
Allonville 5AB 20
Ambrussum 10G 21
Amelie-les-Bains 5H 22
Andance 6F 23
Andematunum 7C 24
Anderitum 6F 25
Andilly-en-Bassigny
 7C 26
Anduze 10F 27
Angers 3D 28
Antipolis 13G 29
Aquae 7E 30
Aquae Neri 5E 31
Aquae Segetae 6E 32
Aquae Sextiae
 Salluviorum 11G 33
Aquae Tarbellicae
 3G 34
Aquis Calidis 6E 35
Arausio 11F 36
Aregenua 3C 37
Arelate 10G 38

Argentomagus 4E 39
Asa Paulini 6E 40
Athies 5B 41
Aubenas 6F 42
Auch 4G 43
Augers-en-Brie 5C 44
Augusta Ambianorum
 4B 45
Augusta Suessionum
 5/6B 46
Augustobona 6C 47
Augustodunum 6D 48
Augustodurum 3B 49
Augustomagus 5B 50
Augustonemetum 5E 51
Augustoritum
 Lemovicum 4E 52
Aumes 9G 53
Auterive 4G 54
Autessiodurum 6D 55
Autricum 4/5C 56
Auve 6BC 57
Avaricum 5D 58
Avrigney 7D 59
Axima 7E 60
Baeterrae 9G 61
Bagacum 6A 62
Balaruc-les-Bains
 9G 63
Banassac 6F 64
Baron-sur-Odon 3C 65
Barzan 3F 66
Beaucaire-sur-Baise
 10G 67
Begues 5E 68
Beire-le-Chatel 7D 69
Belbèze-en-Comminges
 4H 70
Bessan 9G 71
Bibracte 6D 72
Biran 4G 73
Blain 2/3D 74
Blassiacum 3F 75

Boucheporn 7B 76
Boutae 7E 77
Bouy 6B 78
Brenthonne 7E 79
Brest 1C 80
Brignon 10G 81
Briord 7E 82
Briou 4D 83
Bû and Senantes 4C 84
Burdigala 3F 85
Cabelio 11F 86
Cabillonum 6D 87
Cadeilhan-Saint-Clar
 4G 88
Cadrieu 5F 89
Caesarodunum 4D 90
Caesaromagus 5B 91
Caino 4D 92
Cajarc 5F 93
Calagurris Convenarum
 4H 94
Calvisson 10G 95
Camaracum 5A 96
Campagnac 6F 97
Canéjan 3F 98
Capdenac 5F 99
Caracotinum 4B 100
Carcaso 5H 101
Carpentorate 11F 102
Cassel 5A 103
Cassinomagus 4E 104
Castelferrus 4G 105
Castelnau-Magnoac
 4GH 106
Castelnau-Montratier
 4G 107
Catulliacus 5C 108
Cauterets 3H 109
Cazères 4H 110
Ceilhes 9G 111
Cemelenum 13G 112
Cenabum 5CD 113
Cessero 9G 114

Continued on p. 1016

BRITAIN:

Abonae 3G 1
Ad Pontem 4F 2
Alauna (Maryport) 3D 3
Alchester 4G 4
Alone (Watercrook) 3E 5
Ancaster 4F 6
Anderida 5H 7
Antonine Wall 3C 8
Aquae Arnemetiae 4E 9
Aquae Sulis 3G 10
Ardoch 3C 11
Ariconium 3G 12
Arosfa Gareg 3G 13
Baginton 4F 14
Baldock 5G 15
Bannaventa 4F 16
Barnsley Park Villa 4G 17
Bertha 3C 18
Bewcastle 3D 19
Bibra 3D 20
Bignor 4H 21
Birdhope 4D 22
Blaen-cwm-Bach 3G 23
Blatobulgium 3D 24

Continued on p. 1018

MAP INDEXES

CONTINUED FROM MAP PAGE 5

Thebes 2G 30
Tuphium 2G 31

TURKEY:

Abonuteichos 3B 1
Aezani 2C 6
Akçakoca 2C 8
Amaseia 3C 16
Amastris 3B 17
Amida 4D 18
Amisos 3C 19
Ancyra 3C 23
Antioch 2C 25
Antioch by the Callirhoe
 4D 26
Arsameia 4D 38
Artaxata 5D 39
Byzantium 2B 55
Caesarea Cappadociae
 3C 56
Carrhae 4D 58
Chalkedon 2B 59
Colonia 4C 66
Colonia Archelais 3C 67
Comana Pontica 3C 70
Dascusa 4C 74
Daskyleion 2C 75
Eıbeos 2C 79
Eupatoria 3C 90
Gordion 3C 96
Herakleia 2B 103
Kerasous 4C 136
Kotyora 4C 151
Melitene 4D 177
Neocaesarea 4C 190
Nicaea 2C 191
Nicomedia 2C 193
Nikopolis 4C 196
Parnassos 3C 206

Pessinous 2C 214
Pharnakeia Kerasous
 4C 215
Polemonion 4C 228
Prusias ad Hypium 2C 230
Samosata 4D 238
Satala 4C 240
Sebaste 2C 241
Sebasteia 3C 242
Sebastopolis Herakleopolis
 3C 243
Sinope 3B 257
Tavium 3C 271
Themiskyra 4C 280
Thermai Phazemoniton
 3C 282
Tios 3B 285
Trapezous 4C 286
Zela 3C 298
Zimara 4C 300

SYRIA:

Dura Europos 4E 30

IRAQ TO INDIA:

Alexandria-ad-Caucasum
 11E 1
Alexandria-ad-Tanais
 11C 2
Alexandria apud Oritas
 11G 3
Alexandria (Herat) 9E 4
Alexandria-in-Arachosia
 10F 5
Alexandria Margiana 9D 6
Alexandria near Ghazni
 11E 7
Alexandria near
 Gulashkird 8G 8

Alexandria near Mashkid
 10G 9
Alexandria near Multan
 11F 10
Alexandria of Mygdonia
 5D 11
Alexandria or Patala
 11G 12
Alexandria Oxiana 10D 13
Antioch later Charax
 6F 14
Buchephala 12E 15
Chala 5D 16
Concobar 6E 17
Ecbatana 6E 18
Hatra 5D 19
Khurha 7E 20
Laodicea 6E 21
Nikaia (Jalalabad) 11D 22
Nikaia near Mong 12E 23
Seleucia on the Eulaeus
 6F 24
Seleucia on the Tigris
 5E 25
Sirkap 12E 26

BLACK SEA:

Alma Kermen 7B 1
Andreevka Iuzhnaia 8B 2
Belius 7B 3
Berezan 6A 4
Chaika 7B 5
Charax 7B 6
Chersonesos 7B 7
Dioscurias 9C 8
Elizavetovskoe 9A 9
Garkushi 8B 10
Gorgippia 8B 11
Hermonassa 8B 12

Iluratum 8B 13
Iuzhno-Donuzlav 7B 14
Kalos Limen 7B 15
Kepoi 8B 16
Kerkinitis 7B 17
Kimmerikon 8B 18
Kitaion 8B 19
Malaia Chernomorka
 6A 20
Mikhailovka 8B 21
Mirmekion 8B 22
Mt. Maiskaia 8B 23
Neopolis Scythica 7B 25
Nikonion 6A 26
Novo Otradnoe 8B 27
Nymphaion 8B 28
Olbia 7A 29
Panskoe I 7B 30
Pantikapaion 8B 31
Parthenion 8B 32
Petukhovka I 6A 33
Phanagoria 8B 34
Porthmeion 8B 35
Raevskoe 8B 36
Rassvet 8B 37
Semenovka 8B 38
Semibratnoe 8B 39
Shirokaia Balka 7A 40
Tanais 9A 41
Tarpanchi 7B 42
Theodosia 7B 43
Tyrambe 8B 44
Tyras 6A 45
Tyritake 8B 46
Viktorovka I 6A 47
Zakisovaia Balka 6A 48
Za Rodina 8B 49

CONTINUED FROM MAP PAGE 6

Ledrai 3C 15
Leukolla 3C 16
Limenia 2C 17
Makaria 3C 18
Marion 2C 19
Melabron 2C 20
Morphou 2C 21
Neapolis 2D 22
Olympos 4C 23
Ourania 3C 24
Paphos or Nea Paphos
 2D 25
Paphos or Palaipaphos
 2D 26

Pergamon 3C 27
Salamis 3C 28
Soloi 2C 29
Tamassos 3C 30
Thronoi 3C 31
Tremithous 3C 32
Vouni Palace 2C 33

SYRIA, LEBANON, ISRAEL,
JORDAN:

Abila 4E 1
Aelana 4H 2
Aelia Capitolina 4F 3
Anthedon 4F 4

Antioch on the
 Orontes 5B 5
Antipatris 4F 6
Apamea 5C 7
Apollonia 4F 8
Arad 4G 9
Aradus 5C 10
Araq El-Emir 4F 11
Ascalon 4F 12
Azotus 4F 13
Baetocece 5C 14
Beroea 5B 15
Berosaba 4G 16
Berytus 4D 17

Besara 4E 18
Bethlehem 4F 19
Bostra 5F 20
Byblos 4D 21
Caesarea Maritima 4F 22
Callirrhoe 4F 23
Canatha 5E 24
Capitolias 5E 25
Chorazin 4E 26
Damascus 5E 27
Dionysias 5E 28
Dora 4E 29
Ecdippa 4E 31
Eleutheropolis 4F 32

Map page 6 continued

Elusa 4G 33
Emesa 5D 34
Emmaus 4F 35
Engedi 4F 36
Etam 4F 38
Flavia Neapolis 4F 39
Gabala 5C 40
Gadara (es-Salt) 4F 41
Gadara (Umm Qeis)
 4E 42
Gaza 4F 43
Gerasa 5F 44
Gibeah 4F 45
Gibeon 4F 46
Hebron 4F 48
Heliopolis 5D 49

Herodium 4F 50
Hyrcania 4F 51
Jamneia 4F 52
Joppa 4F 53
Khirbet el-Main 4F 54
Khirbet et-Tannur 4G 55
Khirbet Qumrân 4F 56
Kidron 4F 57
Kyrrhos 5B 58
Laodicea ad Mare 4C 59
Legio 4E 60
Machaerus 4F 61
Madaba 4F 62
Mampsis 4G 63
Marathos 5C 64
Marissa 4F 65
Masada 4F 66

Mesad Hashaviahu
 4F 67
Nessana 3G 68
Palmyra 6D 69
Paneas 4E 70
Pella 4F 71
Petra 4G 72
Phasaelis 4F 73
Philadelphia 5F 74
Philippopolis 5E 75
Philoteria 4E 76
Praesidium (El-Kithara)
 4H 77
Praesidium (Ghor
 el-Feifeh), 4G 78
Ptolemais 4E 79
Rabbathmoba 4G 80

Ramat Raḥel 4F 81
Ramet El-Khalil 4F 82
Raphia 3G 83
Samaria 4F 84
Scythopolis 4E 85
Seia 5E 86
Selaema 5E 87
Sepphoris 4E 88
Sergilla 5B 89
Sidon 4E 90
Tell Gath 4F 91
Tell Sūkās 5C 92
Thamara 4G 93
Tiberias 4E 94
Tripolis 4/5D 95
Tyrus 4E 96
Zeugma 6B 97

CONTINUED FROM MAP PAGE 7

Hydai 3F 106
Hydisos 3F 107
Hyia 6F 108 (see also
 Map 6, 1A)
Hyllarima 3F 109
Iasos 3F 110
Idebessos 5G 111
 (see also Map 6, 1B)
Idyma 3F 112
Ilion 1C 113
Ilyas 5E 114 (see also
 Map 6, 1A)
Incirlihan 6F 115
 (see also Map 6, 1A)
Isinda (Lycia) 5G 118
Isinda (Pisidia) 5F 119
 (see also Map 6, 1A)
Istlada 5G 120
Kadyanda 4G 121
Kalynda 4G 123
Kandyba 5G 124
Karakoç Köyü 2A 126
Karmylessos 4G 127
Kasara 3G 129
Kastabos 3G 130
Kaunos 4G 131
Kedreai 3G 132
Kelainai 5E 133
 (see also Map 6, 1A)
Keramos 3F 135
Kibyra Maior 5F 138
Kindya 3F 139
Kızıltepe 4G 140
Klazomenai 2E 141
Knidos 3G 142
Komama 5F 144
 (see also Map 6, 1A)
Kormasa 5F 146
Kormi 6G 147 (see also
 Map 6, 1B)
Korydalla 5G 148
 (see also Map 6, 1B)
Kremna 6F 152 (see also
 Map 6, 1A)

Kyaneai 5G 153
Kyme 2E 154
Kys 3F 155
Kyzikos 3C 156
Labraunda 3F 157
Lagbe 5F 159
Lagina 3F 160
Lagon 6F 161 (see also
 Map 6, 1A)
Lampsakos 2C 163
Laodicea ad Lycum
 4F 164
Lebedos 2E 165
Letoum 4G 166
Leukai 2E 167
Limyra 5G 168
Lissa 4G 169
Lydai 4G 170
Lysinia 5F 171 (see also
 Map 6, 1A)
Madnasa 2F 172
Magnesia ad Maeandrum
 3F 173
Magnesia ad Sipylum
 2E 174
Mamurt Kale 2E 176
Melli 6F 178 (see also
 Map 6, 1A)
Miletos 2F 179
Mobolla 3F 182
Mylasa 3F 180
Myndos 2G 183
Myous 2F 184
Myra 5G 185
Myrina 2E 186
Neandria 1C 188
Nisa 5G 194
Notion 2E 195
Nysa 3E 196
Oinoanda 5G 197
Oktapolis 4G 198
Olbasa 5F 200 (see also
 Map 6, 1A)
Olymos 3F 201

Olympos 6G 202 (see also
 Map 6, 1B)
Panamara 3F 203
Panionion 2F 204
Parion 2C 205
Pasanda 4G 207
Patara 4G 208
Pedasa 3F 209
Pedasa (Gökçeler)
 3F 210
Pednelissos 6F 211
 (see also Map 6, 1A)
Pergamon 2D 212
Perge 6F 213 (see also
 Map 6, 1B)
Phaselis 6G 216 (see also
 Map 6, 1B)
Phellos 5G 217
Philadelphia 4E 218
Phoinix 3G 219
Phokaia 2E 220
Physkos 3G 221
Pinara 4G 222
Pisye 3F 223
Pitane 2D 224
Pogla 5F 227 (see also
 Map 6, 1A)
Priene 2F 229
Pydnai 4G 231
Pyrnos 4G 233
Rhodiapolis 5G 234
 (see also Map 6, 1B)
Sagalassos 6F 235
 (see also Map 6, 1A)
Saittai 3D 236
Salihadasi 3F 237
Sardis 3E 239
Seleuceia Sidera 6E 246
 (see also Map 6, 1A)
Selge 6F 247 (see also
 Map 6, 1A)
Sestos 2C 249
Sia 6F 250
Sibda 3F 251

Sibidunda 5F 252
 (see also Map 6, 1A)
Side 6G 253 (see also
 Map 6, 1B)
Sidyma 4G 254
Sillyon 6F 255 (see also
 Map 6, 1A)
Simena 5G 256
Smintheion 1D 258
Smyrna 2E 259
Söğle 5G 260
Söğüt 3G 261
Stratonikeia 3F 263
Sura 5G 264
Syangela 3FG 265
Syrna 3G 267
Takina 5F 268
Taşyaka 4G 270
Teichiussa 3F 272
Teimiussa 5G 273
Telmessos (Caria) 3F 274
Telmessos (Lycia) 4G 275
Teos 2E 276
Termera 2/3G 277
Termessos 6F 278
 (see also Map 6, 1B)
Termessos (Kemerarası)
 5G 279
Thera 3F 281
Thyateira 2D 283
Thyssanous 3G 284
Tlos 5G 287
Toriaion 5F 288
Tralles 3F 289
Trebenna 6F 290
 (see also Map 6, 1B)
Trysa 5G 291
Tyberissos 5G 293
Tymnos 3G 294
Xanthos 4G 295
Yanık Köy 2E 296
Yelten 5F 297 (see also
 Map 6, 1A)

GREEK ISLANDS:

Amorgos 1G 1
Astypalaia 2G 2
Ikaria
 Kataphygion 1F 3
 Thermai 1F 4
Kalymnos
 Vathy 2G 5
Karpathos
 Pigadia 2H 6
Kassos 2H south of
 Karpathos
Kos
 Asklepieion 2G 7
 Astypalaia 2G 8

Kardamena 2G 9
Kos 2G 10
Pyli 2G 11
Leros 2F 12
Lesbos
 Antissa 1D 13
 Arisba 1D 14
 Eresos 1D 15
 Klopedi 1D 16
 Mesa 1D 17
 Methymna 1D 18
 Moria 2D 19
 Mytilene 2D 20
 Pyrrha 1D 21
Megiste 5G 22

Mykonos 1F 23
Naxos
 Gyroulas 1F 24
 Naxos 1F 25
Nisyros 2G 27
Patmos 2F 28
Pityoussa
 Chois 1E 29
 Delphinion 1E 30
 Emporio 1E 31
 Pindakas 1E 32
Rhodes
 Ialysos 3G 33
 Kameiros 3G 34
 Lindos 3H 35

 Mt. Atabyros 3H 36
 Rhodes 3G 37
 Vroulia 3H 38
Samos
 Samos (Tigani) 2F 39
Samothrace 1C 40
Symi 3G 41
Telendos 2G 42
Thera
 Thera 1G 43
Tilos
 Megalo Chorio 3G 44

CONTINUED FROM MAP PAGE 9

Klos 1B 11
Labovë 2B 12

Meliani 1B 13
Onchesmos 1C 14
Orikon 1B 15

Petrela 1A 16
 (see also Map 12)
Phoenike 1C 17

Plocë 1B 18
Rrmait 1A 19 (see also
 Map 12)

CONTINUED FROM MAP PAGE 11

Styra 7D 284
Tanagra 5D 286
Tegea 1G 287
Tegyra 5D 288
Tenea 3EF 289
Thebes 4D 292
Thermopylai 2A 295
Thespiai 3D 297
Thisbe 3D 299
Thorikos 6F 300
Tiryns 2G 301
Tithorea 2BC 302
Tretos 2F 305
Troizen 4G 309
Vari 5EF 310
Zarka 7D 314
Zoster, Cape 5F 315

GREEK ISLANDS:

Aigina
 Aigina 4F 1

Aphaea 5F 2
Andros
 Chora 9E 4
 Palaiopolis 9F 5
 Zagora 9G 6
Kalauria 4G 11
Salamis
 Salamis 4E 39
Skyros 8A 44

CRETE:

Amnatos 9G 1
Aptera 8G 2
Chersonesos 10G 3
Diktynnaion 8G 4
Dreros 11G 5
Gortyn 10H 6
Herakleion 10G 7
Hierapytna 11H 8
Itanos 12G 9

Kaloi Limenes 9H 10
Karteros 10G 11
Kerame 9H 13
Khamalevri 9G 14
Kisamos (Kalami) 8G 15
Kisamos (Kastelli
 Kisamou) 8G 16
Knossos 10G 17
Korion 9H 18
Kydonia 8G 19
Lasaia 9H 20
Lato 11H 21
Lebena 9/10H 22
Lisos 8G 23
Lyttos 10GH 24
Marathi 8G 25
Matala 9H 26
Mochlos 11G 27
Myrtos 11H 28
Olous 11G 29

Pachia Ammos 11H 30
Palaiokhora 8G 31
Pantanassa 9G 32
Phaistos 9H 33
Phalasarna 7G 34
Phoinix 8GH 35
Poikilasion 8G 36
Polyrrhenia 8G 37
Praisos 11H 38
Prinias 10G 39
Rhithymna 9G 40
Seteia 11G 41
Soulia 9H 42
Sta Lenika 11G 43
Sybrita 9G 44
Syia 8G 45
Tarrha 8G 46
Viran Episkopi 9G 47
Vizari 9G 48

CONTINUED FROM MAP PAGE 12

Gilau 7C 62
Herakleia Lynkestis
 6H 63
Herakleia 10E 64
Humac 3F 65
Iader 2E 66
Issa 2F 67
Istros 10D 68
Jajce 3E 69
Jidava 8D 70
Justiniana Prima 6F 71
Kabyle 9F 72
Kallatis 10E 73
Kasianon 10D 74

Klos 5H 75 (see also
 Map 9)
Komini 4F 76
Konjic 3E 77
Lazu 10E 78
Libida 10D 79
Limes of Djerdap 6D-E 80
Limes Pannoniae
 3A-5D 81
Lissos 4G 82
Lychnidos 5H 83
Madara 10F 84
Makljenovac 3D 85
Margum 5D 86

Marvinci 6H 87
Mehadia 6D 88
Meteon 4F 89
Mezek 9G 90
Micia 7C 91
Mogorjelo 3F 92
Murighiol 11D 93
Mursa 4D 94
Naissus 6F 95
Napoca 7C 96
Narona 3F 97
Nesactium 1D 98
Neviodunum 2C 99

Nicopolis ad Istrum
 8F 100
Niculiţel 10D 101
Novae 8E 102
Noviodunum 10D 103
Oescus 8E 104
Optatiana 7B 105
Orheiul Bistriţei 8B 106
Orlea 8E 107
Panagjurište 8G 108
Parentium 1D 109
Pautalia 6G 110
Petrela 5H 111
 (see also Map 9)

Map page 12 continued

Pharos 2F 112
Philippopolis 8G 113
Plevlja 4F 114
Poetovio 2C 115
Poiana 10C 116
Pola 1D 117
Porolissum 7B 118
Potaissa 7C 119
Praetorium 8D 120
Prilep 6H 121
Răcari 7E 122
Ramista 2C 123
Rider 2E 125
Risinium 4F 126
Romula-Malva 8E 127
Rrmait 5H 128
 (see also Map 9)
Ručar 8D 129
Sacidava 10E 130
Salona 2E 131
Salsovia 11D 132
Samum 7B 133

Sarinasuf 10D 134
Scardona 2E 135
Scupi 6G 136
Senia 1D 137
Serdica 7F 138
Seuthopolis 8F 139
Sexaginta Prista 9E 140
Sighişoara 8C 141
Singidunum 5D 142
Sinoe 10D 143
Sipovo 3E 144
Sirmium 4D 145
Siscia 2D 146
Skelani 4E 147
Slăveni 8E 148
Srebrenica 4E 149
Stobi 6G 150
Stolac 3F 151
Stymbara 6G 152
Sucidava (Corabia)
 8E 153
Sucidava (Izvoarele)
 10E 154

Tariverdi 10D 155
Theranda 5G 156
Tibiscum 6D 157
Tilurium 2E 158
Tomis 10E 159
Transdierna 6D 160
Trebenište 5H 161
Troesmis 10D 162
Tropaeum Traiani
 10E 163
Ulmeţum 10D 164
Ulpiana 5G 166
Ulpia Traiana 7C 165
Vadu 10D 167
Varvaria 2E 168
Viminacium 6D 169
Zenica 3E 170

HUNGARY:

Ajka 3B 1
Aquincum 4B 2
Arrabona 3B 3
Balácapuszta 3B 4

Baracska 4B 5
Brigetio 4B 6
Campona 4B 7
Colonia Claudia
 Savaria 3B 8
Csopak 3B 9
Dunaföldvár 4B 10
Gorsium 4B 11
Gyulafirátót-Pogánytelek
 4B 12
Intercisa 4B 13
Kékkút 3B 14
Nagydém 3B 15
Örvényes 3B 16
Scarbantia 3B 17
Sopianae 4C 18
Székesfehérvár 4B 19
Tamási 4C 20
Ulcisia Castra 4B 21
Valcum 3B 22
Vetus Salina 4B 23

CONTINUED FROM MAP PAGE 14

Uxentum 8F 325
Vardagate 2B 327
Vastogirardi 5E 328
Veleia 2B 330
Venusia 6E 333
Vercellae 2B 334
Veretum 8F 335

Verona 3B 336
Vetulonia 3D 339
Vibinum 6E 340
Vicetia 4A 341
Vicoventia 4B 342
Volaterrae 3C 343
Volcei 6F 344

SARDINIA:

Antas 1G 1
Caralis 2G 3
Cornus 1F 4
Forum Traiani 2F 5
Neapolis 2G 6
Nora 2G 7

Olbia 2F 8
Porto Conte 1F 9
San Salvatore di
 Cabras 1F 10
Sulcis 1G 11
Tharros 1F 12
Turris Libysonis 1F 13

CONTINUED FROM MAP PAGE 16

Interamna Nahars
 4E 155
Lanuvium 4H 166
 (see also Map 17A)
Lavinium 4H 169
 (see also Map 17A)
Luni 3F 176
Marruvium 6F 180
Matilica 5C 184
Montefiore 4F 196
Narce 4F 200
Narnia 4E 201
Norba 5H 205
 (see also Map 17A)
Norchia 3F 206
Nuceria Camellaria
 5C 209
Nursia 5D 210
Ocriculum 4E 211

Orbetello 1E 214
Orvieto 3D 215
Ostia 3G 216
Perusia 4C 221
Pisaurum 5A 227
Plestia 5C 231
Portus 3G 238
Praeneste 5G 240
Privernum 6H 241
 (see also Map 17A)
Punicum 2F 242
Reate 5E 246
Ricina 6B 249
Roma 4G 253
San Giovenale 3F 263
Satricum 4H 268
 (see also Map 17A)
Sena Gallica 6A 274
Sentinum 5B 275

Septempeda 5C 276
Sestinum 3A 278
Setia 5H 280
 (see also Map 17A)
Signia 5G 281
Sora 6G 285
Spoletium 5D 288
Suasa 5B 290
Sublaqueum 5G 291
Tarquinii 2F 296
Telamon 1E 302
Tibur 5G 308
Tifernum Metaurense
 4A 309
Tifernum Tiberinum
 3B 310
Tolfa 3F 312
Trea 6B 315

Trebula Mutuesca
 5F 316
Tuder 4D 317
Tuscana 2E 318
Tusculum 4G 319
Urbs Salvia
 Pollentinorum 6C 320
Urvinum Hortense
 4D 323
Urvinum Metaurense
 4A 324
Valle Ottara 5E 326
Veii 4F 329
Velitrae 5G 331
Verulae 6H 337
 (see also Map 17A)
Vettona 4D 338
Vulci 2E 345

CONTINUED FROM MAP PAGE 17A

Capua 5C 78
Casinum 4A 83
Cora 2A 98 (see also
 Map 16)

Cumae 5C 106
Formiae 3B 124
Francolise 5B 132
Fundi 3B 134

Gragnano 6D 140
Herculaneum 5D 146
Lanuvium 1A 166
 (see also Map 16)

Lavinium 1A 169
 (see also Map 16)
Liternum 5C 171
Minori 6D 191

Minturnae 4B 192
Misenum 5D 194
Neapolis 5C 202
Nola 6C 204
Norba 2A 205 (see also
 Map 16)
Nuceria Alfaterna
 6D 208
Oplontis 5D 213

Pollena Trocchia
 5CD 233
Pompeii 6D 235
Privernum 2A 241
 (see also Map 16)
Puteoli 5CD 243
Saepinum 6B 259
Salernum 6D 262

Sant'Angelo in Formis
 5B 264
Saticula 6C 266
Satricum 1A 268
 (see also Map 16)
Scafati 6D 271
Setia 2A 280 (see also
 Map 16)
Sperlonga 3B 286

Stabiae 6D 289
Surrentum 5D 293
Tarracina 3B 297
Teanum Sidicinum
 5B 300
Telesia 6B 303
Venafrum 4A 332
Verulae 3A 337
 (see also Map 16)

Continued from map page 17B

Gibil Gabib 3G 22
Grammichele 4G 23
Halaisa 4F 24
Halontion 4E 25
Heloros 5H 26
Herakleia Minoa
 2G 27
Himera 3F 28
Hybla Geleatis 5F 29
Hybla Heraia 4H 30
Inessa 5F 31
Kamarina 4H 32
Kasmenai 5H 33
Kassar 3F 34
Katane 5G 35
Kaukana 4H 36
Kephaloidion 3E 37
Kossura 3H 38
Leontinoi 5G 39
Licodia Eubea 4G 40

Lilybaion 1F 41
Longane 5E 42
Manfria 3G 43
Mazara 1F 44
Mazzarino 4G 45
Megara Hyblaea 5G 46
Menai 4G 47
Mistretta 4F 48
Montagna di Marzo
 4G 49
Monte Adranone 2F 50
Monte Bubbonia 4G 51
Monte Cavalli 2F 52
Monte Desusino 3G 53
Monte Navone 4G 54
Monte San Basile
 5G 56
Monte San Mauro
 4G 55

Monte Saraceno 3G 57
Morgantina 4G 58
Motya 1F 59
Mylai 5E 60
Naxos 5F 61
Netum 5H 62
Niscemi 4G 63
Palike 5G 64
Palma di Montechiaro
 3G 65
Panormos 2E 66
Pergusa 4F 67
Philosophiana 4G 68
Phintias 3G 69
Piano dei Casazzi 4G 70
Piazza Armerina 4G 71
Ramacca, La Montagna
 4G 72
Randazzo 5F 73

Rossomano 4G 74
Sabucina 3G 75
Sant'Angelo Muxaro
 3G 76
Scornavacche 5G 77
Segesta 1F 78
Selinus 1F 79
Soloeis 2E 80
Syracuse 5/6G 81
Tauromenion 5F 82
Thermai Himeraiai
 3F 83
Troina 4F 84
Tyndaris 5E 85
Vassallaggi 3G 86
Vito Soldano 3G 87
Zankle 6E 88

Continued from map page 18

Lambiridi 2B 36
Lares 3B 37
Lariscus 3/4BC 38
Leptis Magna 5C 39
Leptis Minor 4B 40
Macomades Minores
 4B 41
Mactaris 3B 42
Madauros 3B 43
Mascula 3B 44
Medracen 2/3B 45
Meninx 4C 46
Mopth[---] 2B 47
Novar[---] 2B 48
Oea 4C 49
Pheradi Maius 4B 50

Ptolemais 7C 53
Qasr el-Lebia 7C 54
Rapidum 1B 55 (see also
 Map 19, 6E)
Rusguniae 1B 56
 (see also Map 19, 6D)
Rusicada 3B 57
Ruspe 4B 58
Rusucurru 2B 59
Ruzasus 2B 60
Sabratha 4C 61
Saldae 2B 62
Sicca Veneria 3B 63
Simithu 3B 17
Sitifis 2B 65
Sufes 3B 66

Sufetula 3B 67
Sullecthum 4B 68
Taparura 4B 69
Taucheira 7C 70
Thaenae 4B 71
Thamugadi 3B 72
Thelepte 3B 73
Themetra 4B 74
Thevestis 3B 75
Thibilis 3B 76
Thigillava 2B 77
Thuburbo Maius 4B 78
Thubursicu Numidarum
 3B 79
Thugga 3B 80
Thysdrus 4B 81

Tipasa 1B 82 (see also
 Map 19, 6E)
Tubusuctu 2B 83
Uthina 4B 84
Utica 4B 85
Uzitta 4B 86
Verecunda 3B 87
Vicus Maracitanus
 3B 88
Zama 3B 89
Zaqui 4B 90
Zliten 5C 91

Malta (Melita) 5B 92

Continued from map page 19

Lacobriga 1D 77
La Cocosa 2D 78
Lancia 3B 79
Lara de Los Infantes
 3B 80
Legio 2AB 81
Leiria 4C 82
Libisosa 4D 83

Liedena 4AB 84
Llano de la Consolación
 4D 85
Lucentum 5D 86
Lucus Augusti 2A 87
Mainake 3E 88
Majorca 6C 89
Malaca 3E 90

Marbella 3E 91
Mentesa Oretanorum
 4D 92
Metellinum 2C 93
Milreu 1D 94
Minorca 6C 95
Mirobriga 1D 96

Mirobriga Turdulorum
 3D 97
Mirobriga Vettonum
 2C 98
Montgó 5C 99
Munigua 2D 100
Myrtilis 1D 101
Nertobriga 4B 102

Map page 19 continued

Norba Caesarina 2C 103
Numantia 4B 104
Ocilis 4B 105
Octavianum 5B 106
Olisipo 1D 107
Ophioyssa 5C 108
Oppidum Bochoritanum
 6C 109
Oretum 3D 110
Osca 4B 111
Ossonoba 1D 112
Palentia 3B 113
Panoias 2B 114
Pax Julia 1D 115
Pisoraca 3B 116
Pollentia 6C 117
Pompaelo 4A 118
Portus Iuliobrigensium
 3A 119
Regina 2D 120
Rhode 6B 121
Sadaba 4B 122
Saguntum 5C 123
Salaria 3D 124

Saltus Castulonensis
 3D 125
Santa Eulalia de
 Boveda 1A 126
Santa Vitória do
 Ameixial 1/2CD 127
Segisama 3B 128
Segobriga 3C 129
Segovia 3B 130
Suances 3A 131
Tarraco 5B 132
Tartessos 2E 133
Termes 3B 134
Tivissa 5B 135
Toletum 3C 136
Torre de Palma 2C 137
Torres Novas 1C 138
Troia 1D 139
Tugia 3D 140
Turissa 6B 141
Tutugi 4D 142
Ucubi 3D 143
Urso 2/3D 144
Uxama Argelae 3B 145
Valentia 4/5C 146

Veleia 6C 147
Vigo 1B 148
Villalis 2B 149
Vipasca 1D 150
Virobesca 3B 151
Viseu 1B 152

MOROCCO:

Ad Novas 2E 3
Aïn Schkor 2F 4
Aquae Dacicae 2F 5
Babba Iulia Campestris
 2F
Banasa 2F 7
Ceuta 2E 1
El Benian 2E 8
El Gour 2F 9
Frigidae 2F 10
Gilda 2F 11
Jibila 2E 12
Ksar-el-Kébir 2F 13
Lixus 2E 14
Mogador 1F 15 (off map)
Rirha 2F 16
Rusaddir 3E 17

Sala 2F 18
Sidi Larbi Boujema
 2F 19
Sidi Moussa Bou Fri
 2F 20
Sidi Saïd 2F 21
Tabernae 2E 22
Tamuda 2E 23
Thamusida 2F 24
Tingi 2E 25
Tocolosida 2F 26
Tremuli 2F 27
Volubilis 2F 28
Zilis 2E 29

W. ALGERIA:

Altava 4F 6
Port Romain 5E 51
Portus Magnus 5E 52
Siga 4E 64

For sites in 6D-F, see
Map 18.

CONTINUED FROM MAP PAGE 20

Marzoll 4G 30
Mogontiacum 2E 31
Münster-Sarmsheim
 2E 32
Nennig 1E 33
Nida 2E 34
Novaesium 1D 35
Oberaden 2C 36
Passau 5F 37
Rödgen 2E 38
Saalburg 2E 39
Saravus 1E 40
Schwarzenacker 1E 41
Sumelocenna 2F 42

Vallatum 4F 43
Vetera and Colonia
 Ulpia Traiana 1C 44
Wehringen 3F 45
Welschbillig 1E 46

SWITZERLAND:

Altenburg 2G 1
Aquae Helveticae 2G 2
Arbor Felix 2G 3
Augusta Rauricorum
 1G 4
Aventicum 1G 5

Basilia 1G 6
Castrum Rauracense 1G 7
Curia 2G 8
Eburodunum 1G 9
Enge 1G 10
Genava 1H 11
Irgenhausen 2G 12
Lenzburg 2G 13
Limes, On Walensee,
 Raetia 2G 14
Limes, Rhine 2E-G 15
Lousonna 1GH 16
Munzach 1G 17

Noviodunum 1G 18
Octodurus 1H 19
Olten 2G 20
Petinesca 1G 21
Salodurum 1G 22
Schaan 2G 23
Seeb 2G 24
Tasgaetium 2G 25
Tenedo 2G 26
Turicum 2G 27
Urba 1G 28
Vindonissa 2G 29
Vitudorum 2G 30

CONTINUED FROM MAP PAGE 21

Etalle 5H 22
Florenville-Chameleux
 4H 23
Fontaine-Valmont
 3G 24
Forum Hadriani 3D 25
Furfooz 4G 26
Ganda 3E 27
Gerpinnes 3G 28
Givry 3F 29
Grobbendonk 4E 30
Hofstade-Lez-Alost 3E 31
Howardries 2F 32

Jemelle 4G 33
Kester 3F 34
Kontich 3E 35
Liberchies 3F 36
Maastricht 5F 37
Maillen 4G 38
Martelange 5G 39
Mettet 4G 40
Morlanwelz 3F 41
Namurcum 4F 42
Nigrumpullum 4D 43
Noviomagus Batavorum
 5D 44

Ophoven 5E 45
Orolaunum 5H 46
Oudenburg 2E 47
Rijswijk 3D 48
Roermond 5E 49
Rognée 3G 50
Rumst 3E 51
St-Michielsgestel 4D 52
Taviers 4F 53
Thuin 3G 54
Tienen 4F 55
Titelberg 5H 56

Tourinnes-St.-Lambert
 4F 57
Traiectum 4D 58
Turnacum 2F 59
Valkenburg 3C 60
Velzeke-Ruddershove
 3F 61
Vertunum 5H 62
Vervoz 4F 63
Viroviacum 2F 64
Vodgoriacum 3F 65
Warnach 5G 66
Wyompont 5G 67

CONTINUED FROM MAP PAGE 23

Cestayrols 5G 115
Châlons-sur-Marne
 6C 116

Chamalières 5E 117
Champallement 6D 118
Champigneulles 7C 119

Champlieu 5B 120
Chandon 6E 121
Charlieu 6E 122

Châteaubleau 5C 123
Châteauponsac 4E 124
Château-Porcien 6B 125

Châteaurenard 5C 126
Châtillon-sur-Seine,
 Fôret 11G 127
Chavagné 3E 128
Chémery 7B 129
Civaux 4E 130
Colleville 4B 131
Collias 10F 132
Colmier-le-Bas 6C 133
Compierre 6D 134
Concarneau 1C 135
Condate (Condres)
 6F 136
Condate (Rennes)
 3C 137
Condatomagos 9F 138
Condevicnum 3D 139
Conliege 7D 140
Consoranni 4H 141
Cordes-Tolosane 5G 142
Corre 7C 143
Cosedia 3BC 144
Coulanges 6E 145
Creissels 5G 146
Cularo 7F 147
Darioritum 2D 148
Dea Augusta
 Vocontiorum 7F 149
Decempagi 7C 150
Derventum 5D 151
Dilis 11G 152
Divio 6/7D 153
Divodurum
 Mediomatricorum
 7B 154
Divona 4F 155
Dôme (Puy de) 5E 156
Donon 8C 157
Draguignan 12G 158
Duretia 2D 159
Durocortorum 6B 160
Eburomagus 5H 161
Eguilles 11G 162
Elusa 4G 163
Ensérune 9G 164
Entremont 11G 165
Epamantadurum 11G 166
Erome 6/7F 167
Esclauzels 5F 168
Essarois 6C 169
Etaples 4A 170
Excisum 4F 171
Fabrègues 10G 172
Fanum Martis
 (Corseul) 2C 173
Fanum Martis (Fahars)
 5/6A 174
Fauroux 4G 175
Ferrere 4H 176
Ferrere and Sost 4H 177
Flayosc 12G 178
Fleury 9G 179
Florange-Daspich-Ebange
 7B 180

Fontvieille 10G 181
Forum Domitii 9G 182
Forum Julii 12G 183
Forum Segusiavorum
 6E 184
Fox-Amphoux 12G 185
Gannat 5/6E 186
Gaujac 10F 187
Gergovia 5E 188
Geroussens 5G 189
Gesoriacum Bononia
 4A 190
Giat et Voingt 5E 191
Gisacum 4B 192
Glanon 11G 193
Gondecourt 5A 194
Gourzon 6C 195
Grand 7C 196
Gueugnon 6D 197
Guipavas 1C 198
Haute-Yutz 7B 199
Hultehouse 8C 200
Iatinum 5C 201
Iciodurum 6E 202
Illiberis 9H 203
Imus Pyrenaeus 3H 204
Intaranum 5D 205
Isarnodurum 7E 206
Izaux 4H 207
Jaulnay-Clan 4DE 208
Juliobona 4B 209
Jurançon 3G 210
Kerilen 2C 211
Labastide d'Armagnac
 3G 212
La Bastide-du-Temple
 4G 213
La Bastide-l'Évêque
 5G 214
La Canourgue 6F 215
La Chapelle-
 Montbrandeix 4E 216
La Chapelle-
 Vaupelteigne 6C 217
Lactora 4G 218
Lalonquette 3G 219
Lansargues 10G 220
Lanuejols 9F 221
Lapanouze-de-Cernon
 9F 222
Lapurdum 3G 223
Lardiers 11F 224
Latara 10G 225
Latresne 3F 226
Laudun 10F 227
Lauze and Saint-Projet
 5G 228
La Villeneuve-au-
 Châtelot 6C 229
Le Bosseno 2D 230
Le Brusc 11G 231
L'Ecluse 5H 232
Le Langon 2D 233
Le Pegue 7F 234

Le Rozier 9F 235
Le Rubricaire 3C 236
Les Bolards 6D 237
Les Bouchauds 4E 238
L'Escale 12F 239
Les Cars 5E 240
Les Martys 5G 241
Les Mesnuls 5C 242
Lézat-sur-Lèze 4H 243
Lezoux 6E 244
Lhospitalet 4G 245
Liffol-le-Grand 7C 246
Ligugé 4E 247
Limonum Pictonum
 4E 248
Liverdun 7C 249
Lombez 4G 250
Loupiac 3F 251
Loupian 9G 252
Lugdunum 6E 253
Lugdunum Convenarum
 4H 254
Lutetia Parisiorum
 5C 255
Luteva 9G 256
Luxovium 7C 257
Luzech 4F 258
Lyons-la-Fôret 4B 259
Mably 6E 260
Magalas 9G 261
Magnac-Laval 4E 262
Mailhac 5G 263
Mantoche 7D 264
Margerides 5F 265
Margny 7B 266
Mariana 2G 267
Marquefave 4G 268
Martizay 4D 269
Martres-Tolosane 4H 270
Massalia 11G 271
Matisco 6E 272
Maubeuge 6A 273
Mauressip 10FG 274
Mauves 2D 275
Mediolanum (Malain)
 6D 276
Mediolanum Aulercorum
 4C 277
Mediolanum Biturigum
 5E 278
Mediolanum Santonum
 3E 279
Mesua 9G 280
Mirande 4G 281
Mittelbronn 8BC 282
Moissac 4G 283
Monségur 4F 284
Mons-et-Monteils
 10F 285
Montans 5G 286
Montbuoy 5D 287
Montcaret 3/4F 288
Mont-Dore 5E 289
Montferrand 5H 290

Mont-Lassois 6D 291
Montlauzun 4G 292
Montmaurin 4G 293
Montreal-du-Gers 4G 294
Montsérié 4H 295
Mouchan 4G 296
Moulis 4H 297
Mouzon 6B 298
Murviel-les-Montpellier
 10G 299
Nages and Saint-Dionisy
 10G 300
Narbo 9G 301
Nasium 7C 302
Nemausus 10F 303
Nemetacum 5A 304
Nérac 4G 305
Nistos and Sacoue
 4H 306
Noiodunum 3C 307
Novem Craris 6F 308
Noviomagus Lexoviorum
 4BC 309
Noyelles-Godault 5A 310
Offemont 8D 311
Olbia 12G 312
Ordan-Larroque 4G 313
Petit-Bersac 4F 314
Petromantalum 4/5B 315
Peymenade 13G 316
Peyriac-de-Mer 9G 317
Pierre-Buffière 4E 318
Pierrefonds 5B 319
Pistis 4B 320
Plouhinec 2D 321
Pomas-et-Rouffiac
 5H 322
Pompey 7C 323
Ponsas 7F 324
Pons Saravi 8C 325
Pontchevron and Le
 Rochoir 5D 326
Port-Sainte-Foy 4F 327
Port-Sainte-Marie
 4G 328
Port-sur-Saône 7D 329
Portus Veneris 9H 330
Pouilly-sous-Charlieu
 6E 331
Puissalicon 9G 332
Pujo 4G 333
Puys-de-Voingt (Les)
 5E 334
Puységur 4G 335
Rajat 5E 336
Ratiatum 3D 337
Rauranum 4E 338
Recoules-Prévinquières
 5G 339
Ribemont sur Ancre
 5B 340
Rodumna 6E 341
Rognac 11G 342

Map page 23 continued

Roquefort-sur-Soulzon
 9F 343
Roquelaure 4G 344
Roquemaure 11F 345
Rotomagus 4B 346
Royat 5E 347
Ruscino 9H 348
Sablé 3C 349
Sagii 4C 350
Sainte-Anastasie 10G 351
Saint-Aubin-sur-Gaillon
 4B 352
Saint-Aubin-sur-Mer
 3B 353
Saint-Béat 4H 354
Saint-Beauzely 5G 355
Saint-Blaise 11G 356
Saint Bonnet-Yzeure
 6E 357
Saint-Clair-du-Rhône
 6E 358
Saint-Clar 4G 359
Sainte-Colombe 4F 360
Saint-Cyr-sur-Mer
 11G 361
Saint-Dié 7C 362
Saint-Dizier 6C 363
Sainte-Eulalie-de-Cernon
 9G 364
Saint-Fregant 1C 365
Saint-Gence 4E 366
Saint-Germain-d'Esteuil
 3F 367
Saint-Gilles 10G 368
Saint-Jean d'Aubrigoux
 6F 369
Saint-Jean-de-Verges
 5H 370
Saint-Just-Pepiron 3E 371

Saint-Léger-sous-Brienne
 6C 372
Saint-Léomer 4E 373
Saint-Lezer 4G 374
Saint-Loup-de-
 Comminges 4GH 375
Saint-Maurice-les-
 Châteauneuf 6E 376
Sainte-Nitasse 6D 377
Saint-Nizier-sous-
 Charlieu 6E 378
Saint-Paul-de-
 Loubressac 4G 379
Saint-Paul-les-Romans
 7F 380
Saint-Paul-lez-Durance
 11G 381
Saint-Pé-d'Ardet 3H 382
Saint-Pierre-d'Aurillac
 3/4F 383
Saint-Plancard 4H 384
Saint-Priest-sous-Aixe
 4E 385
Saint-Quentin 5B 386
Saint Rémy en Rollat
 6E 387
Saint-Romain-de-
 Jalionas 7E 388
Saint-Roman-le-Puy
 6E 389
Saint-Rome-de-Cernon
 9F 390
Saint-Sernin-sur-Rance
 5G 391
Saint-Thomas 6B 392
Saint-Ulrich 8BC 393
Salins 7D 394
Samarobriva 5B 395
Samoussy 5/6B 396
Sanxay 4E 397

Sarbazan 3G 398
Sauve 10F 399
Saxon-Sion 7C 400
Scarponna 7C 401
Scoliva 6D 402
Segessera 6C 403
Segobodium 7D 404
Segodunum 5G 405
Sequana 6D 406
Sète 10G 407
Sextant 10G 408
Seysses-Savès 4G 409
Sigean 9H 410
Sillans-la-Cascade
 12G 411
Solimariaca 7C 412
Sommières and
 Villevieille 10G 413
Sorcy-Saint-Martin
 7C 414
Sorde l'Abbaye 3G 415
Sorèze 5G 416
Sostomagus 5GH 417
Suaux 4E 418
Subdinum 4C 419
Tarare 6E 420
Tarba 4H 421
Tasciaca and Pouillé
 4D 422
Tericia 11G 423
Tervanna 5A 424
Thénac 3EF 425
Thiverny 5B 426
Tintignac 5F 427
Tolosa 4G 428
Toulon sur Allier 6E 429
Tourmont 7D 430
Traize 7E 431
Tresques 10F 432
Triguères 5C 433

Tropaeum Alpium
 13G 434
Tullum 7C 435
Ucetia 10F 436
Ugernum 10G 437
Urgo 11F 438
Uxellodunum 4F 439
Valentia 7F 440
Valentine 4H 441
Vallangoujard 5B 442
Vals 5H 443
Variscourt 6B 444
Vasio Vocontiorum
 11F 445
Vaux 5F 446
Vedène 11F 447
Velaux 11G 448
Vendeuil-Caply 5B 449
Vendeuvre du Poitou
 4E 450
Vendoeuvres en Brenne
 4D 451
Vénéjean 10F 452
Verneuil en Halatte
 5B 453
Versigny 5B 454
Vers-sur-Selle 5B 455
Vertillum 6C 456
Vesontio 7D 457
Vesunna Petrucoriorum
 4F 458
Vetus Pictavis 4E 459
Vézelay 6D 460
Vic-Fezensac 4G 461
Vicus Iulii 3G 462
Vieille-Toulouse 4G 463
Vienna 7E 464
Vienne-en-Val and Neuvy
 en Sullias 5D 465
Villards d'Héria 7E 466

CONTINUED FROM MAP PAGE 24

Blestium 3G 25
Bourton on the Water
 4G 26
Brading 4H 27
Brampton 3D 28
Brantingham 4E 29
Braughing 5G 30
Bravoniacum 3D 31
Bravonium 3F 32
Brecon Gaer 3G 33
Bremenium 4D 34
Bremetennacum
 Veteranorum 3E 35
Brocavum 3D 36
Broomholm Knowe
 3D 37
Burnswark 3D 38
Burrium 3G 39
Caer Gybi 2E 40
Caersws 3F 41

Caister on Sea 6F 42
Caistor 5E 43
Calleva Atrebatum
 4G 44
Cambridge 5F 45
Camelon 3C 46
Camerton 3G 47
Camulodunum 5G 48
Canovium 3EF 49
Cappuck 3D 50
Cardean 3C 51
Cardiff 3G 52
Carpow 3C 53
Castell Collen 3F 54
Castledykes 3C 55
Castle Greg 3C 56
Castleshaw 4E 57
Castra Exploratorum
 3D 58
Cataractonium 4E 59

Cawthorn 4E 60
Charterhouse-upon-
 Mendip 3G 61
Chedworth 4G 62
Chesterton 4F 63
Chew Green 4D 64
Clanville 4G 65
Clausentum 4H 66
Coelbren 3G 67
Combretovium 5G 68
Concangium 4D 69
Condate 3F 70
Corinium Dobunnorum
 4G 71
Corstopitum 4D 72
Cramond 3C 73
Crawford 3D 74
Crococalana 4F 75
Cunetio 4G 76
Dalginross 3C 77

Dalswinton 3D 78
Darenth 5G 79
Derventio (Little
 Chester) 4F 80
Derventio (Malton)
 4E 81
Derventio (Papcastle)
 3D 82
Deva 3EF 83
Ditchley 4G 84
Dolaucothi 3G 85
Dorchester 4G 86
Dorn 4G 87
Dubris 6G 88
Durisdeer 3D 89
Durnovaria 3H 90
Durobrivae (Chesterton)
 5F 91
Durobrivae (Rochester)
 5G 92

Durocobrivis 4/5G 93
Durocornovium 4G 94
Durovernum
 Cantiacorum 5G 95
Eboracum 4E 96
Eccles 5G 97
Ely 3G 98
Esgair Perfedd 3F 99
Ewhurst 5G 100
Fendoch 3C 101
Fishbourne 4H 102
Forden Gaer 3F 103
Frocester Court 4G 104
Galava 3E 105
Gariannonum 6F 106
Gask Ridge 3C 107
Gatcombe 3G 108
Gelligaer 3G 109
Glannoventa 3E 110
Glenlochar 3D 111
Glevum 4G 112
Gobannium 3G 113
Godmanchester 5F 114
Goldsborough 4D 115
Great Casterton 5F 116
Great Chesterford
 5G 117
Great Weldon 4F 118
Great Witcombe 4G 119
Greensforge 4F 120
Habitancum 4D 121
Hadrian's Wall 3/4D 122
Haltwhistle Burn
 4D 123
Hambleden 4G 124
Harlow 5G 125
Heronbridge 3F 126
High Wycombe 4G 127
Hinton St. Mary 4G 128
Hod Hill 4H 129
Horncastle 5F 130
Ilchester 3G 131
Inchtuthil 3C 132
Innerpeffray 3C 133

Inveresk 3C 134
Irchester 4F 135
Isca 3G 136
Isca Dumnoniorum
 3H 137
Isorbrigantium 4E 138
Ixworth 5F 139
Kaims Castle 3C 140
Kingsweston 3G 141
Kirkbuddo 3C 142
Lactodorum 4FG 143
Lagentium 4E 144
Lancaster 3E 145
Langton 4E 146
Latimer 4G 147
Lavatrae 4D 148
Lemanis 5G 149
Letocetum 4F 150
Leucarum 3G 151
Lindum Colonia
 4/5EF 152
Llandovery 3G 153
Llandrindod Common
 3F 154
Llanio 3F 155
Llantwit Major 3G 156
Lockleys 5G 157
Londinium 5G 158
Longovicium 4D 159
Longthorpe 5F 160
Low Borrow Bridge
 3DE 161
Low Ham 3G 162
Luguvalium 3D 163
Lullingstone 5G 164
Lurg Moor 2C 165
Lydney 3G 166
Lyne 3C 167
Magiovinium 4G 168
Magnis 3G 169
Maiden Castle 3H 170
Mamucium 4E 171
Manduessedum 4F 172
Margidunum 4F 173

Martinhoe 3G 174
Mediobogdum 3DE 175
Mediolanum 3F 176
Melandra Castle 4E 177
Metchley 4F 178
Moridunum 2G 179
Nanstallon 2H 180
Navio 4F 181
Nettleton Scrub 4G 182
Newton Kyme 4E 183
Nidum 3G 184
North Leigh 4G 185
Noviomagus Regnensium
 4H 186
Oakwood 3D 187
Old Burrow 3G 188
Old Durham 4D 189
Old Sarum 4G 190
Old Sleaford 5F 191
Olenacum 3D 192
Olerica 4E 193
Othona 5G 194
Park Street 5G 195
Pen Llystyn 3F 196
Pennocrucium 4F 197
Pennymuir 3/4D 198
Petuaria 4E 199
Portus Adurni 4H 200
Raeburnfoot 3D 201
Raedykes 4B 202
Ratae Coritanorum
 4F 203
Reycross 4DE 204
Rocester 4F 205
Rockbourne 4H 206
Rudston 5E 207
Rutunium 3F 208
Rutupia 6G 209
Salinae (Droitwich)
 3/4F 210
Salinae (Middlewich)
 3F 211
Scarborough 5E 212
Segelocum 4E 213

Segontium 3F 214
Spinis 4G 215
Stracathro 4B 216
Strageath 3C 217
Stroud 4G 218
Sulloniacae 5G 219
Tassiesholm 3D 220
Thistleton Dyer 4F 221
Tiddington 4F 222
Tomen-y-Mur 3F 223
Trimontium 3C 224
Tripontium 4F 225
Vagniacae 5G 226
Venonae 4F 227
Venta Belgarum 4G 228
Venta Icenorum 5F 229
Venta Silurum 3G 230
Verlucio 4G 231
Vernemetum 4F 232
Verterae 4D 233
Verulamium 5G 234
Vindocladia 4H 235
Vindomora 4D 236
Vinovia 4D 237
Viroconium
 Cornoviorum 3F 238
Voreda 3D 239
Vxacona 4F 240
Waddon Hill 3H 241
Walltown 3F 242
Whitemoss 2C 243
Whitley Castle 4D 244
Whitton 3G 245
Wilderspool 3E 246
Winterton 4E 247
Woden Law 3/4D 248
Woodchester 4G 249
Worcester 4F 250
Wraxall 3G 251
Wycomb 4G 252
Y Pigwn 3G 253
Ystradfellte 3G 254

LIBRARY OF CONGRESS CATALOGING IN PUBLICATION DATA
Main entry under title:

The Princeton encyclopedia of classical sites.

 1. Classical antiquities. 2. Excavations
(Archaeology) I. Stillwell, Richard, 1899-
II. MacDonald, William Lloyd. III. McAllister,
Marian Holland.
DE59.P7 938'.003 75-30210
ISBN 0-691-03542-3